KU-341-550

AFRICA

The Art of a Continent

Royal Academy of Arts, London
4 October 1995–21 January 1996

709.6

HV

5083

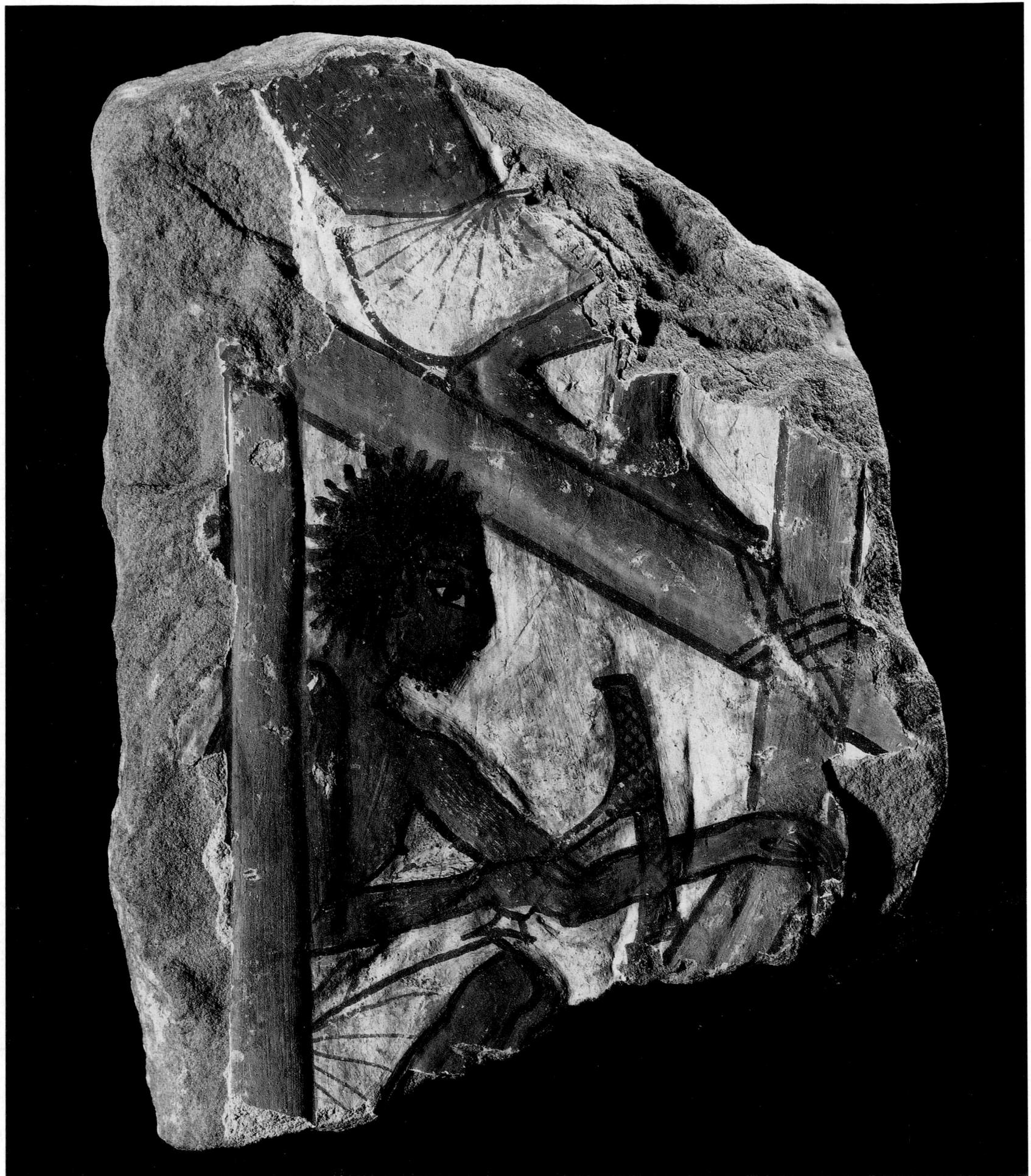

AFRICA

The Art of a Continent

Edited by
Tom Phillips

Royal Academy of Arts, London

Prestel, Munich · New York

709.6

41

5083

First published on the occasion of the
exhibition *Africa: The Art of a Continent*,
Royal Academy of Arts, London,
4 October 1995–21 January 1996

The Royal Academy of Arts is grateful to
Her Majesty's Government for its help in
agreeing to indemnify the exhibition
under the National Heritage Act 1980 and
to the Museums and Galleries Commission
for their help in arranging this indemnity.

Front cover: **Figure of a woman**,
Benin, Nigeria, 17th–18th century
(detail, cat. 5.60h)
Back cover: **Lyre (kissar)**, Nubia, Sudan,
late 19th century (cat. 2.13)
Frontispiece: **Tomb relief**, Egypt,
c. 1200 BC (cat. 1.59)
© Royal Academy of Arts, London, and
Prestel Verlag, Munich · New York

All rights reserved. This book may not be
reproduced in whole or in part in any
form (beyond that permitted by Sections
107 and 108 of the U.S. Copyright Law
and except by reviewers for the public
press), without written permission from
the publishers.

Die Deutsche Bibliothek—CIP-Einheitsaufnahme
Africa: the art of a continent; [first published
on the occasion of the exhibition “Africa,
the Art of a Continent”, Royal Academy of
Arts, London, October 1995 – 21 January
1996] /Royal Academy of Arts, London.
Ed. by Tom Phillips. [Transl. from the
French by Caroline Beamish]. – Munich;
New York: Prestel, 1995
ISBN 3-7913-1603-6
NE: Phillips, Tom [Hrsg.]; Exhibition
Africa, the Art of a Continent <1995–1996,
London>; Royal Academy of Arts <London>

Catalogue design by Petra Lüer
in association with Hansjörg Mayer
and Tom Phillips

Maps by ML Design
Offset lithography by ReproLine, Munich
Printed and bound by Passavia Druckerei
GmbH, Passau
Printed in Germany

CONTENTS

Preface	
Cornel West	9
Introduction	
Tom Phillips	11
Why Africa? Why Art?	
Kwame Anthony Appiah	21
Europe, African Art and the Uncanny	
Henry Louis Gates, Jr	27
The African Past	
Peter Garlake	30
1 ANCIENT EGYPT AND NUBIA	
Edna R. Russmann, László Török	41
2 EASTERN AFRICA	
John Mack	117
3 SOUTHERN AFRICA	
Patricia Davison	179
4 CENTRAL AFRICA	
Daniel Biebuyck, Frank Herreman	231
5 WEST AFRICA AND THE GUINEA COAST	
John Picton	327
6 SAHEL AND SAVANNA	
René A. Bravmann	479
7 NORTHERN AFRICA	
Timothy A. Insoll, M. Rachel MacLean, Nadia Erzini, Rachel Ward	535
Bibliography	
Lenders to the exhibition Photographic credits Friends of the Royal Academy Royal Academy Trust Sponsors of Past Exhibitions	597
	615

Sponsored by

Anglo American Corporation, De Beers and MINORCO

in association with THE TIMES

BRITISH AIRWAYS official airline to *africa95*

Support has been given to the exhibition by:

The Brown Foundation
The A. G. Leventis Foundation
The Henry Moore Foundation
The Nigerian Friends of *africa95*
The Calouste Gulbenkian Foundation (Lisbon)
The Elephant Trust
The Beit Trust
Price Waterhouse

Support has been given to the catalogue by:

The Rockefeller Foundation

Personal Patrons

Lady Gosling
N. Roditi & Co.
Count and Countess Labia
The Britto Foundation

*Corporate Patrons of *africa95*:* ALLIED TRUST

Deutsche Morgan Grenfell

*Corporate Benefactor of *africa95*:* Silhouette[®]
EYEWEAR

Anglo American Corporation and De Beers have their roots deep in South African soil, as well as strong links with many other countries in Africa, including Botswana, Namibia, Zimbabwe, Angola, Sierra Leone, Zaire, Guinea, Tanzania, Mali and Zambia. They, together with their associated company Minorco, are therefore delighted to sponsor an exhibition which they believe will focus international attention on the ancient, rich and diverse art and culture of Africa, thus helping the continent to claim its rightful place in world culture.

Anglo American Corporation of South Africa Ltd. and Allied Trust Bank Limited are award winners under the 'Pairing Scheme' (The National Heritage Arts Sponsorship Scheme) for their support of Africa: The Art of a Continent. The Scheme is managed by The Association for Business Sponsorship of the Arts (ABSA).

Her Majesty The Queen
President Nelson Mandela
President Léopold Sédar Senghor

*Advisory Committee for Africa:
The Art of a Continent*

Dr John Mack
Dr Rowland Abiodun
Dr Codjovi Joseph Adande
Dr Claude Daniel Arduouin
Sir David Attenborough
Ms Viviana Baeke
Mr Omar Bwana
Mr Vivian Davies
Dr Ekpo Eyo
Dr Yaro T. Gella
Mr Lorenz Homburger
Mr Frank Herreman
Dr Hans-Joachim Koloss
Dr Germain Loumpet
Mme Francine N'Diaye
Dr John Picton
M. Jean Polet
Dr Doran H. Ross
Dr Christopher Roy
Dr Mohammed Saleh
Mr Thurstan Shaw
Dr John Wembah-Rashid

Executive Committee
Piers Rodgers, Secretary,
Royal Academy of Arts (chairman)
David Barker,
Director of Finance and Administration,
Royal Academy of Arts
Annette Bradshaw,
Deputy Exhibitions Secretary,
Royal Academy of Arts (secretary)
Diana Brocklebank, Sponsorship Manager,
Royal Academy of Arts
Lisa Brown, *The Times*
Trevor Clark, Bursar,
Royal Academy of Arts
Carina Corbett,
Public Affairs Manager, Minorco
Katharine Jones, Press and Promotions
Officer, Royal Academy of Arts
Emeline Max, Exhibition Coordinator,
Royal Academy of Arts
Rory More O'Ferrall, Manager,
Special Events, De Beers
James Robinson, Assistant to the Secretary,
Royal Academy of Arts
Norman Rosenthal, Exhibitions Secretary,
Royal Academy of Arts
Sarah Seex, Sponsorship Executive,
British Airways
Fleur de Villiers, Public Affairs Consultant
to Anglo American Corporation of South
Africa and of De Beers

Exhibition Curator
Tom Phillips
Exhibitions Secretary
Norman Rosenthal
Assistant Exhibition Curator
Simonetta Fraquelli
Exhibition Coordinator
Emeline Max

Exhibition Designers
Eva Jiricna Architects:
Eva Jiricna with Carolina Aivars

Catalogue
Editorial Committee
Petrine Archer Straw
Vivian Davies
Patricia Davison
Simonetta Fraquelli
John Mack (*chairman*)
Jane Martineau
Tom Phillips
John Picton
Norman Rosenthal
Rachel Ward

Catalogue Editor
Tom Phillips
Coordinating Editor
Petrine Archer Straw
Catalogue Supervisors
Jane Martineau, Michael Foster
Assistants
Vivienne Redhead,
Zachary Kingdon
Text Editors
Ruth Thackeray, Kate Harvey
Proof Reader
Antony Wood
Photographic Editor
Simonetta Fraquelli
Photographic Coordinator
Miranda Bennion
Translations from the French by
Caroline Beamish

Acknowledgements
We would like to extend our thanks to the
advisors, lenders, directors and curators,
and to the following people who have
contributed to the organisation of the
exhibition and the preparation of the
catalogue in many different ways:

Sir David Attenborough, Georg Baselitz,
Ezio Bassani, Lance Entwistle, Roberta
Entwistle, Bernard de Grunne, Etienne
Féau, Frank Herreman, Lorenz
Homburger, Julie Hudson, Jacques
Kerchache, Hans-Joachim Koloss, Hélène
and Philippe Leloup, Hansjörg Mayer,
Francine N'Diaye, Heini Schneebeli,
Sylvia Schoske, Louis de Strycker, Marie-
France Vivier, Dietrich Wildung

We are also grateful to the following
for their help:

Noelle Adams, Peter Adler, Dr Johanna
Agthe, Chief M. A. Ajao, Tola Ajao,
Dorothea Arnold, Ray Ayres, Dirk Bakker,
Glyn Balkwill, Walter Bareiss, Peter
Barker, Nigel Barley, Rayda Becker, Simi
Bedford, A.V. M. Abdul Bello, Sylvia Bello,
Prof. Feliciano Benvenuti, Olivier
Berggruen, Morris Bierbrier, Dr Adotey
Bing, Tim Boon, Christopher Chippindale,
Dr Michael A. Cluver, Jeremy Coote,
Kevin Conru, Susan Davidson, Louise
Davies, Kent and Charles Davis, Sheila de
Vallée, Victoria Dickie, Roberto di
Giacomo, Sylvia Duggan, Stuart Emmens,
Marc Felix, Genevieve Fisher, Bert Flint,
Matthi Forrer, Rita Freed, Jane Freeman,
Annabel Teh Gallop, Hubert Goldet, Jim
Hamill, William Hart, John Hayman,
Josef Herman, Lindsay Hooper, Udo
Horstmann, Barry Iverson, Fred Jahn,
Tony Jackson, Michael Kan, Alan
Keohane, Helen O. Kerri, John Kinahan,
Ruth Klumpp, Wulf Kopke, Nessa
Leibhammer, Jacqueline Leopold, Prof. J.
David Lewis-Williams, Luc Limme,
Louise Lincoln, Rainer Lienemann,
Lawrence Lipkin, Robert Loder, Wulf
Lohse, Eve Lowen, Jonathan Lowen, Katie
Marsh, Marilyn Martin, Laurence Mattet,
Evan Maurer, Margaret McCord, Trevor
McDonald, Gwyn Miles, David Noden,
David O'Conner, Bernard O'Kane, Allyson
Rae, Ian Rogers, James Romano, Halina
Sand, Yaya Savane, Dr Karl-Ferdinand
Schädler, Kevin Smith, Thyrza Smith,
Chris Spring, Robin Symes, Dominique
Taffin, Julie Taylor, Keith Taylor, Pat
Terry, Anne Teuwissen, Kate Todd, Eleni
Vassilika, Iris Walsh, Kirsten Walker,
Helen Whitehouse, Robert Williams,
Christiane Ziegler

FOREWORD

For many years it has been the dream of the Royal Academy to stage an exhibition devoted to the art of Africa. In 1982 the travelling exhibition *Treasures of Ancient Nigeria* was shown at the Academy. For many visitors it was a revelation, including as it did not only the justly famous bronzes from Benin, but also the far older terracottas and bronzes from Nok, Ife and other sites in Nigeria which had been recovered comparatively recently. It demonstrated the existence of artistically sophisticated cultures in the continent of Africa stretching back over millennia. The idea was born that we should attempt to make a bold, synoptic survey of the visual culture of Africa stretching back in time to the very beginnings of artistic endeavour and geographically over the entire continent. The attempt to show the art of the continent in a single exhibition has never been made before. Much still remains to be learned, and our principal aim is to encourage a spirit of enquiry.

Many individuals in Africa, Europe and the United States, as well as in Great Britain, have helped and encouraged us as we steered the project towards realisation. Tom Phillips, a Royal Academician, who for many years has been passionately involved in African art, has acted as the principal curator of the exhibition with assistance from Norman Rosenthal, Exhibitions Secretary. Advice and support have come from many quarters. In particular we wish to thank the scholars in Africa and elsewhere whose encouragement and counsel have supported us throughout the planning of the exhibition. In the early stages of planning, Susan Vogel, then director of the Museum of African Art in New York, gave us much help and encouraged us to take on the idea of representing the entire African continent, including the north as well as sub-Saharan Africa. The curatorial staff at the British Museum has been exceptionally supportive. Simonetta Fraquelli has relished the burden of coordinating the exhibition. Over 180 lenders, both private individuals and public institutions, thirty of the latter in Africa itself, have been exceptionally generous in allowing us to show works in their collections. In particular we wish to thank the major public collections in Berlin, Cairo, Cape Town, Lagos, London and Paris who have lent some of their most precious and fragile works. We are particularly happy that the exhibition will be seen at the Solomon R. Guggenheim Museum in New York from June 1996.

We wish to extend our thanks for the help of many individuals who, realising the importance of the exhibition, worked tirelessly to see it come to fruition. In particular we thank the High Commissioners for Nigeria and South Africa and the Ambassadors in London for Egypt, France, Morocco and Tunisia. We are also grateful to HM Ambassadors in Ethiopia and the Sudan as well as to the Hon. Kent Durr, Mr Howard Thompson, Director of the British Council in Egypt, and the museum authorities in Namibia.

For the generosity of our sponsors and supporters we are deeply grateful, in particular for the help of those companies from South Africa. We have worked closely with the organisers of the festival, Africa 95, an ambitious demonstration of the richness of African culture today which was launched to coincide with our exhibition, and which has succeeded in putting together a remarkable programme of new art, theatre, music, literature, dance and many other events from contemporary Africa. We are deeply honoured that Her Majesty The Queen, President Nelson Mandela and President Léopold Sédar Senghor have graciously agreed to act as patrons of Africa 95.

Finally, we hope to provoke a positive response from the British public, both from those who visit the Academy on a regular basis and from those doing so for the first time. The arts in Great Britain have been greatly enriched by the cultural contribution of those from Africa and the Caribbean; this exhibition seeks to celebrate the grandeur and diversity of the arts of the continent of Africa and their contribution to the art of the world.

Sir Philip Dowson CBE
President
Royal Academy of Arts

PREFACE

Cornel West

This monumental exhibition is unprecedented in the history of the art world. Never before has there been gathered such a rich and vast array of African art-objects and artefacts from such a broad timespan. And rarely has any exhibition embraced the artistic treasures of the whole of Africa, from Egypt to Ife to Great Zimbabwe.

This historic public showing of beautiful and complex African gems takes place at an upbeat moment in African art criticism and a downbeat time of African political life. With fascinating new breakthroughs in archaeological and anthropological investigations into African empires and societies, we are able to appreciate better the complex diversity and incredible creativity of past and present African artists. Yet the pernicious legacy of European imperialism coupled with the myopic and corrupt leadership of many African élites has left much of the continent politically devastated and economically impoverished. Gone are the old intellectual frameworks predicated on crude white supremacy and subtle Eurocentrism. The once popular categories of ‘barbarism’, ‘primitivism’ and ‘exoticism’ have been cast by the academic wayside. The homogeneous definitions and monolithic formulations of ‘African art’ have been shattered. The Whiggish historiographical paradigms of cultural ‘evolution’ and political ‘modernisation’ have been discredited. Instead we are in search of new ways of keeping track of the fully fledged humanity of Africans by seriously examining their doings, makings and sufferings under circumstances not of their own choosing. By taking their humanity for granted, we are in danger of being neither apologists for European colonialism nor romantic celebrants of African achievements. Rather we take Africans seriously by taking African history seriously – an ambitious endeavour still in its embryonic stage in the West. This important exhibition is a crucial step in such a world-historical endeavour. To take African history seriously requires a careful and cautious scrutiny of the distinct and sometimes disparate contexts of particular African traditions, rituals, kinship networks, patronage relations and disciplines of craftsmanship. This kind of historicist enquiry – with its stress on the complex interplay of the local with the regional, continental and global forces at work – enables us to highlight the specific ways in which African artists, critics, patrons and communities create, sustain and deploy art-objects.

An intellectually challenging and morally humane approach of this order – be it to metalwork, rock art, male masked performance, female pottery sculpture, body decoration or architecture – rests on a deep knowledge and sophisticated analysis of the particular histories of specific African peoples. Intellectual ferment in the art world in regard to African artworks may contribute to overcoming the invisible status of African life in late 20th-century international relations. The tragic plight and predicament of most present-day Africans remains forgotten on the world scene. And the old ugly stereotypes of African persons as exotic and transgressive objects – as hypersexual and criminal abstractions in the white imagination – are still pervasive in much of the post-modern West.

Art never simply reflects reality. Rather it forces us to engage our past and present so that we see the fragility and contingency of our prevailing views of reality. In this way, art can and does change the world. This unparalleled exhibition at the end of a barbaric century confirms the tenacious human will to survive and thrive – with artistic beauty and worldly engagement – in history, then and now.

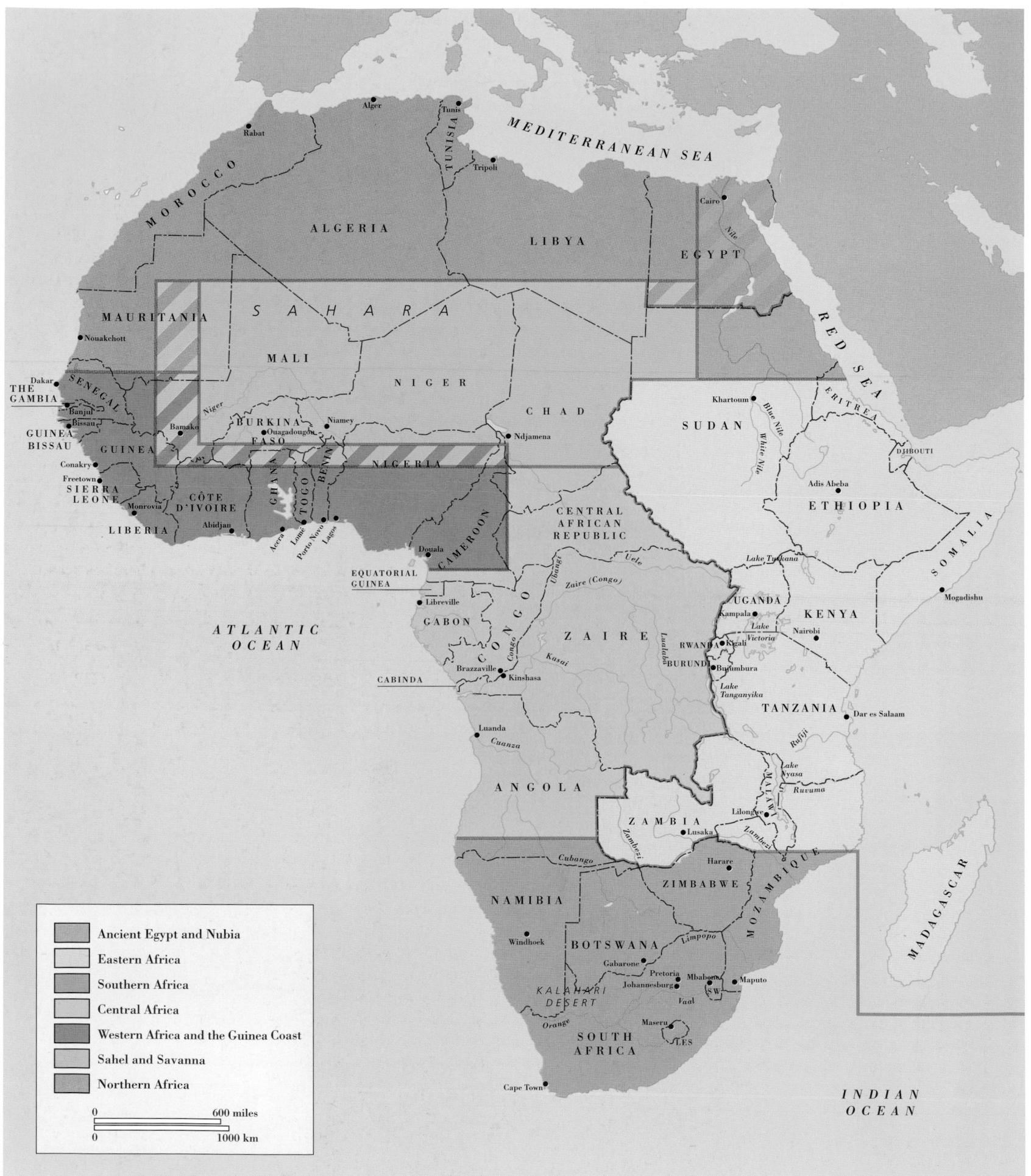

INTRODUCTION

Tom Phillips

I

With a bold and sweeping gesture of words, President Nelson Mandela, who honours this project with his patronage, in his address to the Organisation of African Unity in 1994, set the agenda for the exhibition which this catalogue chronicles. In the first sentence of that speech he, who had spent so many unwilling years at the southernmost reach of the continent, pointed the long finger of African memory towards Carthage, its northernmost corner, the destruction of whose splendour by the colonising Romans began ‘a long reign of humiliation for the continent’ which is only now drawing to a close. In terms of space and time and largeness of imagination the Royal Academy’s present exhibition tries to live in the grace of that idea of a new era for Africa and a new unity for the continent.

The time is at last ripe perhaps for such an assertion of Africa’s artistic wealth to need no alibi, either political or ethnographic, nor require some sociological peg to hang it on, nor a link to some new-minted piety or rectitude. It may even dispense with titles which sell art short by means of loaded or lurid words (blood, power, thrones etc.). Best of all it might start not to require the service of European art to give it its credentials of definition, labels as misleading and anachronistic as ‘cubist’ or ‘gothic’. As Louis B. Gates affirms in his essay, it no longer needs such mediation.

Under the plain wrapper of a simple title therefore, and in the Royal Academy’s long tradition of enlightened foolhardiness, is presented a sampling of the art of the entire continent. There has been no previous attempt, either in terms of an exhibition or a book, to cover with relative even-handedness the visual culture of the land-mass as a whole: the endorsement of being associated in this enterprise with the Guggenheim Museum in New York gives pleasure and courage. Needless to say the selection falls into the traps of its own time: it can only be an interim statement whose best critique will be provided

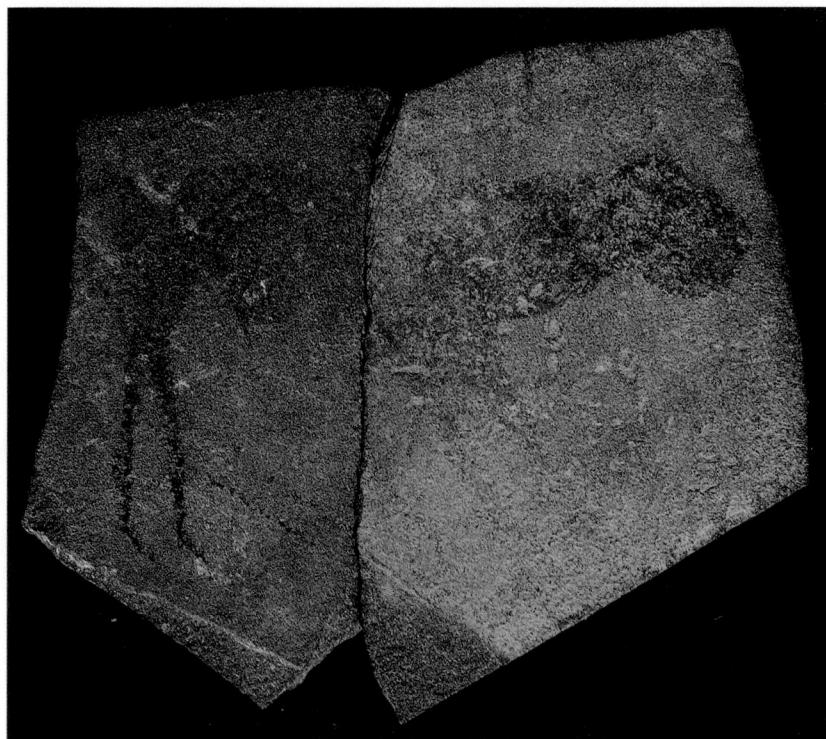

Fig. 1 Charcoal painting of animal-human figure, Namibia, 27,500–25,500 BP (cat. 3.3b)

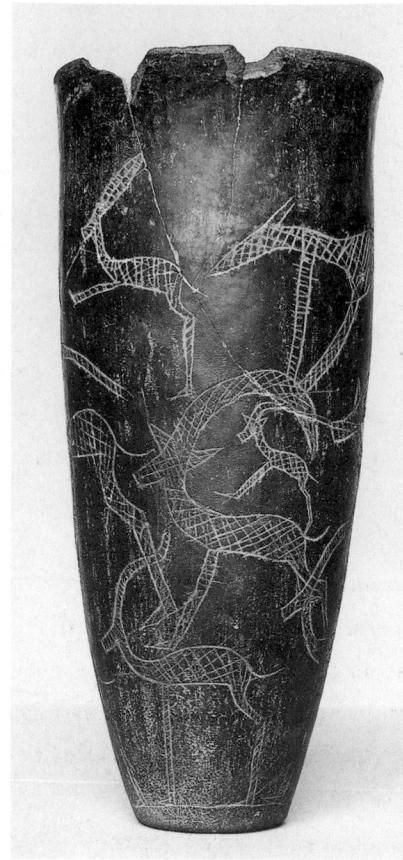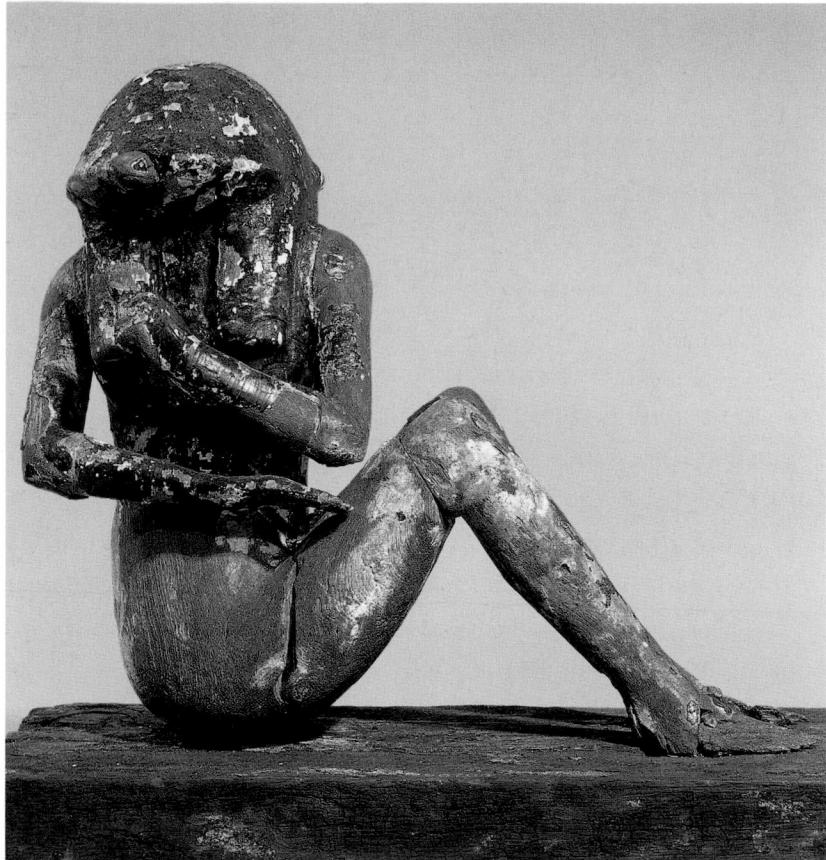

by subsequent surveys. It should, however, be regarded as a heartening sign that the many voices from Africa, Europe and America that sound in the essays and entries of this catalogue make no attempt to agree with each other except in their common and manifest willingness to take part in its forum.

The two major organising principles of the selection echo President Mandela's vision of geography and time. No area has been more sliced up and divided by conquest, campaign, annexation and subjugation than Africa, and none more arbitrarily. Later boundaries conceal and contradict its ancient kingdoms and territories. Even that great natural divide, the Sahara Desert, is a relatively recent interpolation: art itself (in the Tassili frescoes) documents its prior state as pastoral land. The exigencies of making a coherent exhibition demanded that it be split up yet again so that visitors would know at each point where they were in a journey that takes them clockwise around the continent beginning and ending in Egypt. For this purpose national frontiers have been ignored and Africa is segmented into seven broad areas using dispassionate lines of latitude and longitude.

Each of these areas in the catalogue has an editor who has provided or supervised the introductory material and corralled the necessary scholarship that annotates every work. Specialists may quibble (indeed *have* quibbled) at the precise delimitation of the areas. Yet no expert could be satisfied with any circumscription since the whole continent is a continuum of people, their movements, commerce and influence. Indeed doubts about division underline the unities of Africa which provide one of the themes of the exhibition.

There is an Africa beneath Africa, as yet only patchily understood since outside the Nile Valley archaeology is still in its infancy, and even there new versions of history are beginning to be worked out. At this moment archaeology is busy reversing our understanding of Ancient Nubia and its relationship with Egypt; ten years ago an exhibition such as this would have given Nubia less prominence and the catalogue would have presented a radically different account.

Fig. 2 Vase decorated with hunting scene, Egypt, predynastic, c. 3800–3600 BC (cat. 1.9)

Fig. 3 Tortoise-headed god, Egypt, 18th Dynasty, c. 1320 BC, from the tomb of Horemheb, Valley of the Kings, Thebes (ex. cat. 1.11)

II

The civilisations of the Nile (Section 1) begin this expository tour with an explosion of artistic invention in predynastic Egypt, one of the world's earliest laboratories of formal experiment, especially in the representation of the human figure. This is the Burgess Shale of art, a repertoire of figuration and abstraction that has scarcely been extended in modern times (fig. 2). Towards the end of this period there are works of great complexity whose emblematic content as well as artistic command still look freshly relevant. The five-thousand-year-old Battlefield Palette (cat 1.18), whose two substantial pieces are brought together for the first time, describes on one side that turmoil of a warring Africa we see on the news; the other shows an idyllic scene of nature at peace that is the received Africa of the travel brochure. Five hundred years later in the Mycerinus Triad (cat. 1.30), still the supreme three-dimensional statement of human confidence, the Egyptian artist announces that no feat of carving either technical or stylistic is beyond his powers.

Amid the gigantic proto-fascist statuary that dominates the great halls of museums the world over it is difficult to appreciate the more humanistic virtues of Egyptian art, some of it like the jewellery made for display and some, though still executed with artistic devotion, like the wooden tomb figures of Horemheb (fig. 3) and the wrappings of the mummified cats (cat. 1.69) never to be seen by human eye again. The tale of Egypt in its later Coptic and Islamic flowerings is taken up in Section 7. Ancient Nubia ends the first section, starting with its own less well known prehistory and ending with kingdoms whose names are slowly becoming more familiar to the non-specialist world, Meroë and Kush.

The journey southward is taken up in Section 2 with the neglected area of eastern Africa. In most general works on African art there is a map whose dots represent the distribution of pieces illustrated or mentioned in the text. Invariably the picture resembles a beehive situated in central west Africa obliterated by its swarm, whereas to the east and south the few stragglers suggest vast areas of visual inarticulacy, while none strays north at all. The reason for this lies in colonial history as can be seen if the traditional distribution map is overlaid with one showing the francophone ex-colonies and their immediate neighbours. The art literature of Africa has for most of this century been produced by connoisseurs, collectors and scholars from France and Belgium, the basis of whose connoisseurship has been the material gathered by their compatriots. German ethnographers also visited the peoples of Africa (while the English tended to concentrate on places). Perhaps it is fitting that an exhibition originating in Britain should belatedly start to redress that imbalance.

In fact from modern Sudan and the splendours of Christian Ethiopia in the north to the distant architectural complexes of Great Zimbabwe with which Section 3 begins, this region presents a series of cultures subject to more disparate influences than any other, including those artistic incursions from the East which flavour the culture of the coastal region and give a unique character to that of the island of Madagascar.

It is in east Africa also that we first meet the single most important unifying element in the wood-carving pattern of Africa south of the Sahara; the practice of making virtually all objects (from a spoon to a funerary post many feet high) from a single piece of wood. This monoxylous tradition leads, to take examples from this region, from the cunning adaptation of the chance form of a branch in a Dinka head-rest (cat. 2.17a) to the virtuosity of a Nyamwezi throne (fig. 4) and the multiply pierced architectural structure of a Mahafaly post (cat. 2.30). The monoxylous carver gives himself problems, but gains great potential advantages of artistic unity. He has a threefold power: the power over abstraction by what he removes, the power over figuration by what he causes to remain and the power over nature by the continued presence of the form of the original tree. In terms of figure sculpture there is also the rising growth present in the vertical grain of the wood: all are present in another more austere ceremonial

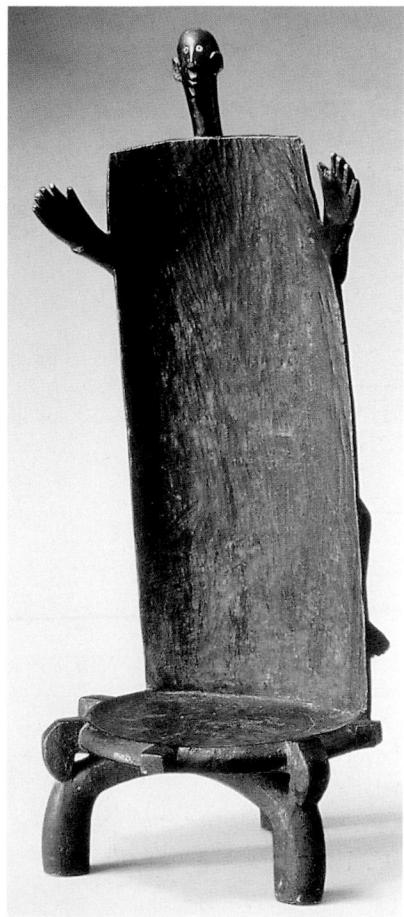

Fig. 4 High-backed chief's stool,
Nyamwezi, Tanzania, late 19th century
(cat. 2.49)

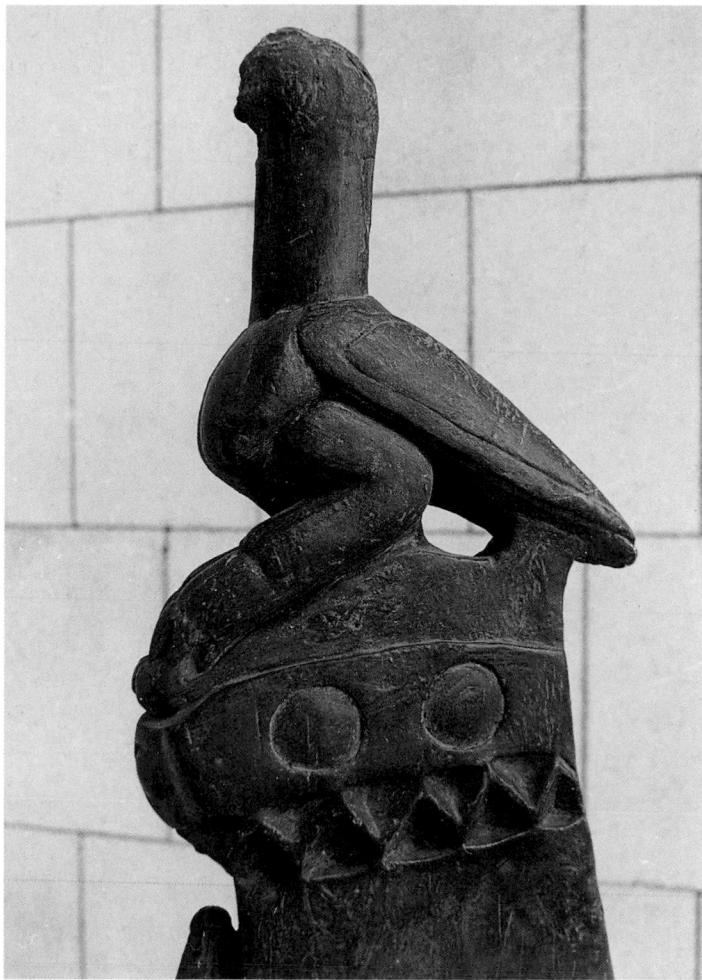

Fig. 5 Bird, found at Great Zimbabwe, 13th–15th century, steatite, National Museums and Monuments of Zimbabwe

throne from the Nyamwezi (cat. 2.50). Perhaps the most extreme example, however, of the extra dimension of negative space (where what is taken away is as much part of the sculpture as what remains) is the remarkable Songye-Sungu stool (cat. 4.54); although the shape of the tree is vitally present in the final work, almost all of it has been removed to create an object of almost perverse fragility, whose wit and virtuosity was no doubt appreciated by a sophisticated client.

This region now commands our special respect, for it is only late in this century that archaeology, anthropology and genetic research have jointly confirmed that here, in the border area of Kenya and Tanzania, the whole adventure of humanity began.

Nearly every book on the art of Africa moves more or less in the contrary direction to that taken in this exhibition, coming to east Africa as an afterthought and representing southern Africa, the subject of Section 3, rather perfunctorily with a bowl and a spoon or two. One reason for this invisibility has been that its art seldom takes the form of those staples of the European image of African art, the figure and the mask. With the recent habilitation of South Africa this perspective has slowly begun to change and the exhibition aims to reinforce that trend by making southern Africa the pivot of its journey. Luckily, as can be seen, scholarship has been thriving even in dark years, as witness the outstanding work of David Lewis-Williams and his colleagues at the University of Witwatersrand who have largely unravelled the secrets of San rock art. This is the longest continuous artistic tradition in Africa whose beginnings can be noted in the world's earliest portative paintings from Namibia (cat. 3a and fig. 1), dated with some certainty to c. 25,000 BC.

The monumental architecture of Great Zimbabwe with its magnificent stone birds (cat. 3.12 and fig. 5) is not the only trace of an ancient civilisation in this area. The seven Lydenburg heads, the most

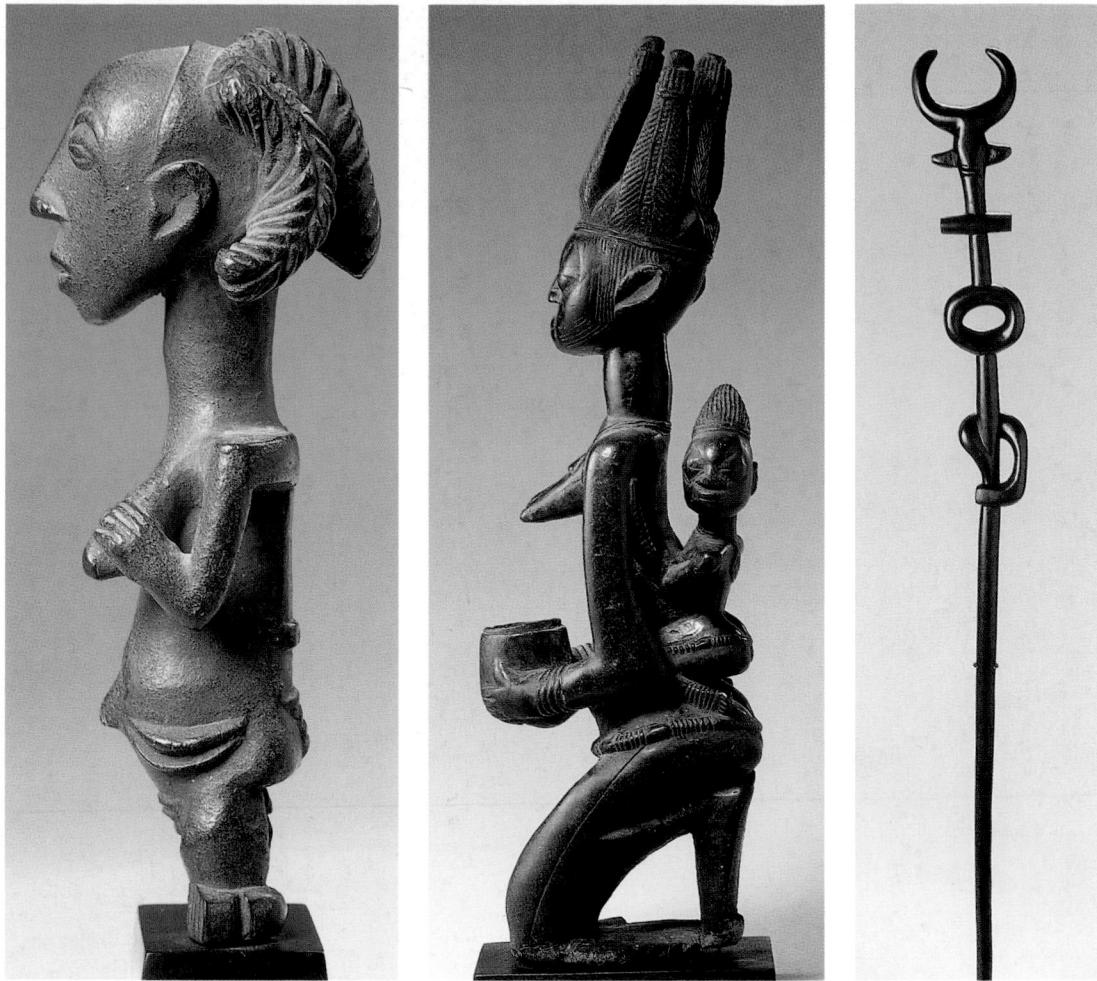

Fig. 6 Ancestor figure, Hemba, Zaire (cat. 4.66c)

Fig. 7 Shrine figure with child, Yoruba, Nigeria, late 19th century (cat. 5.84)

Fig. 8 Zulu staff, KwaZulu-Natal, South Africa, 19th century (cat. 3.27c)

imposing of which (cat. 3.10) can stand comparison with the terracottas from Djenne (cat. 6.4), which they predate, indicate the existence of a highly developed 10th-century culture.

From the more recent past come the many variations on the theme of the headrest with its play of symmetry and asymmetry; the snuff bottles whose delicacy and elegance of design recall the art of Japan and the abstract triumphs of a Zulu staff or meat dish (cat. 3.27 and fig. 8, cat. 3.41b).

Section 4 is where the exhibition reunites itself with the customary expectations engendered by the words 'African art', i.e. those statues and masks from the Congo region which have already become canonical. To quote a canonical film (and one despite its title, *Casablanca*, with only the most tenuous African connections since every inch of it was shot in Hollywood), there is a great temptation in this and in the succeeding section merely to 'round up the usual suspects', those works that appear in virtually every book (invariably seen from the same viewpoint in a familiar photograph). To some extent this happens here: a masterpiece is after all a masterpiece, and since this is a non-specialist venue the large majority of its audience will be seeing such works for the first time. The compact strength of Chokwe figures, the solemn and otherworldly Hemba statues (fig. 6) and the densely magisterial Fang reliquary pieces are still touchstones of a sculptural quality equal to that of the great epochs of European art. Textiles and pottery extend the range together with sculpture less frequently feted. Even those familiar with this material may well be surprised by the different aspects shown in the illustrations, almost all of which were specially commissioned for this catalogue (e.g. figs 4, 6, 7).

Section 5 contains the largest number of objects, since the southern part of what is broadly called the Guinea Coast is inhabited by so many stylistic groups (the word 'tribe', though noble sounding, has become for good post-colonial reasons inadmissible).

Putting their artistic heritage before the public gaze would not seem strange to the royal chiefs of Cameroon whose palace treasures act as museums housing spectacular (often beaded) sculpture by court artists which is frequently brought out for display. Nigeria is particularly difficult to compress since it contains layer upon layer of cultures. The city of Benin, which perhaps in the general consciousness stands for the older African civilisations, occupies only the late middle period of Nigeria's history. Nevertheless, the great series of bronze plaques that once covered the palace walls represent, however formulaic some of them became, a prodigious achievement of technical ingenuity and organisation over centuries (fig. 9).

As one moves west via the panoply of the Asante one encounters an endless range of solutions for invoking (without merely copying) the human face. The visitor might expect to see a huge gathering of masks especially in this and the previous section: in many books they outnumber all other works as part of the mythology of modernism. While it is true that the African masquerading tradition is the richest in the world, the mask itself without dancer or movement or paraphernalia of costume is the most incomplete of objects and must be considered a fragment. Many, even thus denuded and stilled, yet transcend their fate in the collections of the world and some, like the 'Tetela' example (cat. 4.53), retain that arresting power that can almost stop one's heart in a firelight masquerade with drums and pounding feet.

One kind is, however, complete in itself: over twenty miniature masks from Dan-related groups (cat. 5.128) have the advantage in the space allowed of giving an idea of the range of expression and interpretation within a single format. Like the headrest, the mask is found in virtually all parts of Africa, and our earliest examples of either come from dynastic Egypt. The mask of Anubis (cat. 1.64) is a sole survivor of what perhaps was a thriving tradition; it seems to question the interpretation of images of Egyptian ritual.

Section 6 poses particular problems in that it covers an area not conventionally treated as a unit, including as it does the northern regions of Nigeria, Ghana etc. Where the true continuities and discontinuities lie between the various ancient cultures this area embraces and their more recent counterparts is still the subject of active debate. Systematic and scientific archaeology is scarce, while unofficial digging and treasure seeking is rife (as it has been on and off in Africa since the robbers of later dynasties rifled the tombs of the earlier). Aesthetics play no part in this except at the very end of the line where those whom John Picton describes in his essay with wily irony as 'art-hungry savages' wait to see, enjoy and own what turn out to be bronzes and terracottas of revelatory interest: thereby artistic experience is extended, but at the expense of scientific knowledge. The rest of the story is about money, however the moral absolutes are phrased in treaty and resolution.

What lends irony to the situation is that archaeologists are, in the strict sense, indifferent to aesthetic quality. All objects, be they marvellous or mawkish, are of equal value to their declared priority, the archaeological record, that scientific documentation of site and find from which pictures of a culture are built up. This is not incompatible with the needs of museums and collectors, especially at sites like those of Djenné where artefacts are found by the thousand. That African archaeology is underfunded compounds the irony since, given this present stance, it cannot benefit from the large sums available in the art market. Until some dialogue is entered into and some compromise is reached the status quo will continue. The general public will be denied even a glimpse of the treasures that exist since the collector, though invariably willing, cannot share by lending, nor can the institution show for fear of reprisal. In many cases the relevant state intervenes when the art market has given value to the objects in question. Archaeology in more senses than one has its head in the sand. It is the Academy's conviction that in the long term to show such works in this present context would not only enhance the artistic reputation of

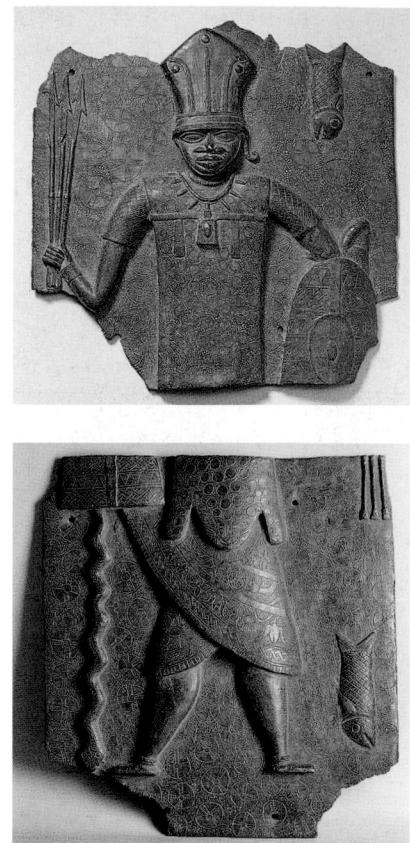

*Fig. 9 Plaque, Benin, Nigeria, 16th century, brass
upper half: h. 38 cm, Staatliche Museen zu Berlin, Preussischer Kulturbesitz, Museum für Völkerkunde, III C. 10879
(ex catalogue)
lower half: h. 40 cm, Museum für Völkerkunde, Hamburg, C. 2434
(ex catalogue)*

countries like Mali and Nigeria, but provoke public interest in the furtherance of archaeological activity in Africa, even to the point of attracting enabling funds. Its equal commitment to present loyalties makes it, however, desist from breaking an unproductive stalemate.

The last of the sections concerns the region least often brought under the rubric of African art. This necessarily gives a broad picture of an Africa north of the Sahara which continues to have in some European museums a separate department, '*l'Afrique Blanche*', as if the Mediterranean were the positive, attractive end of a magnet and the Sahara the repelling negative. Throughout there are at least two layers of culture; that preceding Islam or running independently and in tandem with it, like the nomadic groups and the Berbers of Morocco, and the largely Islamised world itself. Colonisation here has a long history; the Maghrib is full of well-preserved Roman ruins often with fine mosaics in a markedly individual style (cat. 7.10). Here also we meet the other end of Nelson Mandela's image in the ruins of Phoenician Carthage. Since, however, the exhibition is dedicated to art actually made in Africa and not imported by colonising groups from their place of origin (and guesswork must play some part) it was decided not to include some Roman works of great quality found in Africa, which are in effect the equivalent of those statues of Queen Victoria still to be seen in the capitals of the ex-colonial nations.

Although Moslem influence penetrates deep into sub-Saharan African, where, like Christianity, it can prove a mixed artistic blessing, the pure character of Islamic art reaches its African peak in that medieval Cairo whose Arabian Nights atmosphere is conjured up by Rachel Ward in her essay and whose genius is expressed in the massive 15th-century *minbar* (fig. 10), the final exhibit, which acts as an imposing and perhaps prescient ending to the exhibition.

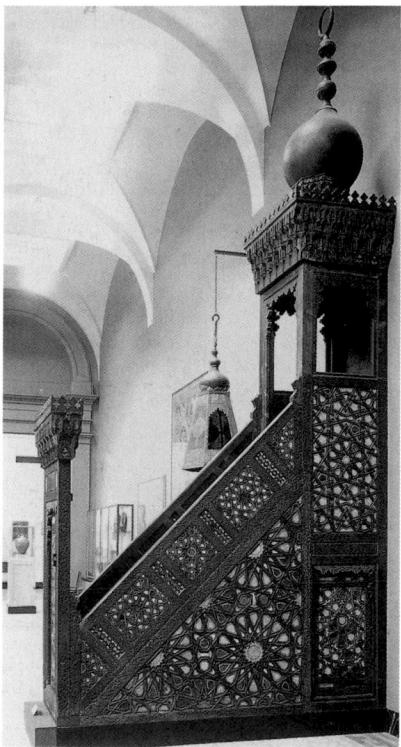

Fig. 10 Minbar for the Sultan Qa'itbay,
Egypt, Mamluk, late 15th century
(cat. 7.67)

III

As this last object could be seen to be emblematic of the imminent future so the very first exhibit (to return to the beginning in every sense) announces an important theme of the exhibition: the age of Africa and the unique length of its cultural history. The handaxe from Olduvai (cat. 2.1), over a million and a half years old, a first thing made by man, prefigures the whole world of making and shaping. No earlier artefact exists on earth, and all art and technology begins here (as all history begins with those miraculously recorded proto-human footsteps on Tanzanian soil; fig. 11). Since no aesthetic criteria apply to it, it stands as a prologue to the exhibition in general, accompanied by other stone axes the first of which, from South Africa and half its age (to speak of a time span where even tens of thousands of years would be a mere quibble), announces the entry of the artistic imperative (cat. 3.1). Almost ceremonial in size, this axe shows that in a world where tools are the only things made, their inherent qualities were sometimes brought to a visual and tactile perfection far beyond the needs of practicality. Symmetry and surface elegance speak of that pride in creation, pleasure in contemplation and prestige in possession that will eternally give art its motivation.

This prelude of shaped stones serves to introduce the aspect of time which is emphasised in all the sections. Each has its own chronology or chronologies as it moves from one culture to another. There is much common ground in man's early artistic aspirations that is overlaid by later developed cultural differences. Beneath the accretions of localised structures of belief and hierarchy there are universals; the desire for containers or the need to rest one's head. Similar solutions can arise independently, as in the case of the decorated ostrich eggs to contain liquids which occur both in predynastic Egypt and among the San far away in the south of the continent (cat. 1.11; 3.9). Coincidence can look like influence, but it needed no messenger hot foot from the Nile to tell a Bushman that an ostrich egg can be a ready-

made pot or that it could be individualised with engraved lines. Thus the presence of such rhymes in the exhibition is usually not an attempt to imply connection but rather to furnish the enjoyment of affinities.

In some cases of course there may prove to be unexpected cultural links or a chain of such. In the rock engraving from the western Sahara for example the drawing of the upper parts of the animals, as taut and economical as a Matisse, seems at variance with the drifting elongation of the legs. That this phenomenon is one of the central observations about the San rock paintings in Lewis-Williams's thesis of trance and ritual provokes speculation, as does the similarity between the spiral markings seen both in rock engravings from Morocco and South Africa that the same author relates to entoptic phenomena (those abstractions seen by otherwise unseeing eyes on entering trance). The Linton panel (cat. 3.4), the grandest separated fragment of rock art in Africa, is here making a unique journey from Cape Town and gives an opportunity to link such scattered examples to a great narrative painting tradition.

What the gathering of earlier works in each section clearly demonstrates is that in no century when art thrived in Europe and elsewhere was there inactivity in Africa. To take examples from within the present-day boundaries of Nigeria alone, the Nok civilisation (cat. 6.45–54 and fig. 12) before the dawn of the Christian era gives proof of a highly organised urban society, while around the 10th century the complexities of developed social existence, technological brilliance and refinement of spiritual values are clearly to be seen in the terracottas and bronzes so far excavated at Igbo-Ukwu (cat. 5.45–53). Contemporary with the European Renaissance is both the high elegance of Ife culture and the beginnings of the artistic virtuosity of Benin which lasts (as can be seen in the remarkable ivory leopard [cat. 5.60q] whose seldom-photographed profile shows a stunning command of formal language) well into the period from which the bulk of our material comes, i.e. from the 19th and early 20th centuries, collected in the age of pioneering ethnographers (Torday, Frobenius etc.) whose massive gleanings fill the storerooms of European museums. What of this largely wooden treasure would have survived if not collected at the turn of the century is an intriguing question in the light of recent debates about artistic patrimony. With the possible exception of missionaries, there are no more effective vandals and destroyers than the termite. In most areas only the chance survival of the occasional fragment like the 9th-century animal head from Angola (cat. 4.1) remind us of what has disappeared.

The aspect of the age of things, limitless at one end of the scale, faces problems at the other. To have made a fixed cut-off date would seem to imply that art in Africa just came to a halt. The opposite is the case, for in recent decades there has been an explosion of individual talent. The festival of which this exhibition is part provides a more properly expansive arena for the new art of Africa to show itself on its own terms. The work of the most senior of such artists would be roughly contemporary with what is likely to be our most recent exhibit, a pair of Zulu earplugs (cat. 3.36b,d) whose use of vinyl asbestos would date it to the 1950s.

As with the breadth of space and the length of time covered here the distance between a stone axe and a vinyl asbestos earplug indicates the vast range of materials used. In terms of hierarchy this runs from dung to gold, and in terms of the unfamiliar from carpet tacks to animal intestine. Recycling has a long pedigree throughout Africa where little goes to waste. The remains of Soba, the capital of the Christian kingdom of Alwa in the Sudan, were used to build Khartoum, and the brass taps from colonial bathrooms in the Gold Coast became the goldweights of the Akan (cat. 5.103–7). The millions of beads often cynically manufactured in Europe for exchange were transmuted into the splendour of a Cameroon royal throne (cat. 5.14), or a prestige object at the command of a Yoruba chief (cat. 5.85), or the spectacular marriage train of an Ndebele bride in South Africa (cat. 3.35). Thus countries as unlikely as Czechoslovakia are embedded into the history of African art. Discarded silk clothing from England was unpicked to make *kente* cloth for Akan dignitaries. Strip by strip they begin to return to Britain to make hatbands for Rastafarians.

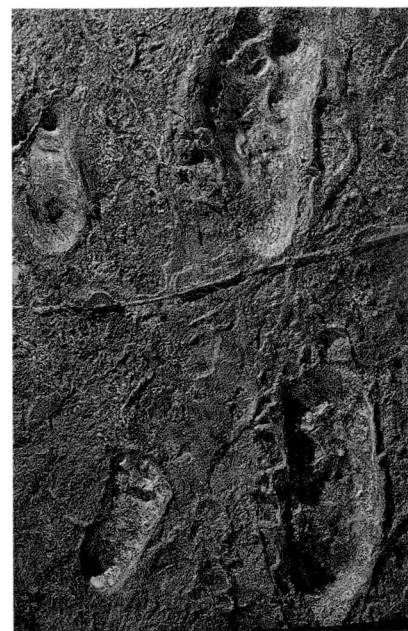

Fig. 11 The footprint trails from Site G, Laetoli, near Olduvai Gorge, Tanzania, 3,500,000 BP

The majority of works, however, are made in the more traditional materials, especially in wood, which is the dominant medium even in a survey which tries to cast a wide net. The frontispiece (cat 1.59) shows an Egyptian using an adze, the tool with which almost without exception all the wooden objects here were made. He is a carpenter, however, and south of the Sahara carpentry is rare. Even when it is alluded to or imitated, as in Cetshwayo's Chair (cat. 3.26), the derived object is monoxylous.

Fig. 12 Human/bird-figure, Nok, Nigeria (cat. 6.52)

This chair alone reveals the futility in terms of Africa of introducing into the selection that cultural apartheid which in Europe and America separates art from craft. Such a demarcation has led, for example, to the neglect of the art of nomadic people whose artistic investment is in portable objects such as jewellery. The necessities of a travelling life can none the less be spectacular as witness the Tuareg bed (cat. 7.1d) which when assembled commands a large space with its ornately decorated poles. It is precisely such objects of daily use like the snuff bottles of the Zulu (cat. 3.31) that announce their owners' prestige and discernment. Basketry seems the lowliest of forms, yet the Tutsi reserve their greatest skill for the condensed elegance of their Lilliputian baskets (cat. 2.44). More secretive are the loin-cloths of the forest Pygmies of Zaire, humdrum pieces of barkcloth which provide as it were the canvases upon which women make drawings of breathtaking intricacy and freedom of linear language (cat. 4.74). At the furthest extreme are those groups documented by Jeremy Coote whose art could not be shown without filling these rooms too fashionably with cows, since it is located in the comparative colour and disposition of the markings on their cattle.

The absence of perpetuated names among the artists of Africa (whose work was well-known enough in its time for patrons to travel long distances to seek them out) has led to a practice, not extended in this exhibition, of imitating historians of European art in giving what might be called adze-names to stylistically identifiable masters. This soon complicates itself into the issues of 'school of' and 'apprentice of', and so on. A name such as the 'Buli Master' (fig. 13) has already attracted peripheral and disputed works, and possibly even a fake or two.

This lack of easy labels has marked certain epochs and cultures as 'primitive'. One still occasionally hears the term 'Italian primitives' used of those artists who worked up to and including the time of Giotto. In both cases this cunning and insidious word has been an alibi for ignorance; regularly applied not to art that lacks sophistication but to that art for whose sophistication the world was not yet ready. Thus the art of other societies is only validated when our own artists have caught up with it. We clutch the handrail of Western art to discover stage by stage through its mediation the abstract, the minimal, the assemblage etc. (which then are found also to have their equivalents in our own past): in this way we obscurely take the credit for the idea. This attitude was unintentionally but dangerously compounded by the 'Primitivism' exhibition in New York some years ago, after which it became even more common for collectors to describe some etiolated Dogon masterpiece (which may well date back to medieval times) as 'my Giacometti' or to call anything with sharp edges, be it from the 9th or 19th century, 'cubistic'.

In his essay, Louis B. Gates describes how it was believed first that Africans had no art and, if by accident they were found to, had no aesthetic interest in it: most 'tribes', it was maintained, had no word for art. This would of course be like saying that lacking a word for economics they did not know if they were affluent or broke. Such talk continued well into the post-war period. Recently the tide has turned with the invention of a mysterious quantity called African aesthetics (largely the province of Europeans and Americans), a means of appropriation which can be as divisive as that which preceded it. Aesthetics follows in the wake of art, and no simple category of people has special access (that is, after all, the virtue of art). The lid was definitively put on the topic by Barnett Newman's epigram 'aesthetics is to the artist as ornithology is to the birds'. The aesthetic response as understood in this exhibition is best put by the

Bamana of Mali (as reported by Kate Ezra) who refer to special artefacts as ‘things which can be looked at without limit’.

The matter of context is at the heart of such debate, and works so recently redeemed from the bank of ethnography still carry their stamp and question: the issue of ‘decontextualisation’ seems more alive for them than for the Venus de Milo or the Mona Lisa, both of which have suffered a loss of context as absolute as any African object. In the same museum that houses those two masterpieces, works from Ancient Egypt and Islamic north Africa enjoy that state of honourable retirement which the art institution provides (though it should be noted that the museum in question has barred its gates as yet to art from the rest of Africa). As Théophile Gautier says, ‘only art is robust.... the bust outlives the Emperor’, and the very test of what we call art is its capacity to survive independently of a context it can never revisit.

In essence the problem of looking at the works in this exhibition is no different from a visit to the National Gallery where, representing the continent of Europe, a similar variety of style and reference is on view, divided between countries whose art developed in radically different directions. Those accustomed to the psychic shift necessary to move from a Duccio to a Rembrandt or from a Van Dyck to a Picasso should not be daunted by this survey. There, as here, the eloquent reminder that Patricia Davison gives in her essay would serve the visitor well: ‘All the works selected for this exhibition once evoked other meanings, for other people, in other places.... Sensitivity to historical and social context enriches an understanding of art forms, but it must also be acknowledged that the sensory presence of a work of art can transcend historical context and move the viewer, even if it is not fully understood.’

These words can stand as an epilogue to the experience of *Africa: The Art of a Continent* in their encouragement to enjoy, respect and engage with what is shown. The first task in any exhibition is to open oneself to the art itself: this will reward as it has rewarded the many people, not least the present writer, who have had a hand in selecting and bringing the exhibition together. For each of them the experience has given rise to a growing love for the work on view and an ever more profound admiration for its makers. It is a privilege to celebrate for the first time, in these rooms, the fertile contribution to the visual culture of the world from the whole of this vast and infinitely various continent; and to make here a praise song for Africa.

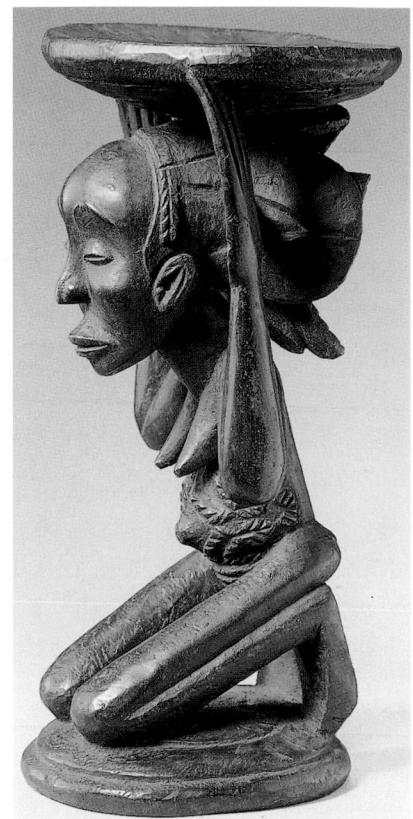

Fig. 13 Stool, Hemba, Zaire, late 19th century (cat. 4.64), attributed to the Buli School

WHY AFRICA? WHY ART?

Kwame Anthony Appiah

Tenabea nyinaa nse.

(All dwelling-places are not alike.)

Asante proverb

I learned about art growing up in my home-town, Kumasi, the capital of Asante, an old kingdom at the heart of the new republic of Ghana. There were paintings and drawings on our walls; there were sculptures and pots, in wood and ivory and earthenware and brass; and there were art-books in the bookcases. But above all, my mother collected Asante goldweights: small figures or geometrical shapes, cast in brass from wax originals, that had been used for weighing gold-dust when it was (as it was well into this century) our currency. The figurative goldweights are wonderfully expressive: they depict people and animals, plants and tools, weapons and domestic utensils, often in arrangements that will remind an Asante who looks at them of a familiar proverb.

Quite often, for example, you will find a weight that represents two crocodiles with a shared stomach (fig. 1), which will evoke the proverb: *Funtumfunafu ne Denkyemfunafu baanu yafunu ye yafunkoro; nanso woredidi a na woreko no, na firi atwimenemude ntira.* It means, roughly: Stomachs mixed up, crocodiles' stomachs mixed up, they both have one stomach but when they eat they fight because of the sweetness of the swallowing. The idea of the proverb – which expresses one of the dilemmas of family life – is that while the acquisitions of each family member benefit the whole family (there is only one stomach), the pleasure of enjoyment is an individual thing (the food has to get into the stomach through one of the mouths).

Even the abstract geometrical weights, with their surfaces decorated with patterns, often use the *adinkra* symbols, which are found as well on Akan stools and funeral cloths, each of which has a name – Gye Nyame, for example – and a meaning – in this case, the power of God. But quite often, also, you will find that one of these elegant weights, so obviously crafted with great skill and care, has a lump of un-worked metal stuffed into a crevice, in a way that completely destroys its aesthetic unity; or, sometimes, a well-made figure has a limb crudely hacked off. These amputations and excrescences are there because,

Fig. 1 Goldweight, Asante,
18th–19th century, Private Collection

after all, a weight is a weight: and if it does not weigh the right amount, it cannot serve its function. If a goldweight, however finely crafted, has the wrong mass, then something needs to be added (or chopped off) to bring it to its proper size.

There is, thus, an extremely elaborate cultural code expressed in these miniature sculptures; and with the patina that comes from age and human handling, and the exquisite detail produced in the lost-wax process that made them, many of them have an obvious aesthetic appeal. It does not take long to recognise that the goldweights of Asante differ from those of other Akan societies: Fante or Baule, say. Nor is it hard to recognise stylistic change over the centuries. There are histories of taste written in these objects, if only we could read them. Goldweights, in sum, have many of the features that we expect of works of art. In Ashanti itself, they were appreciated for their appeal to the eye; or for the proverbial traditions they engaged. But in the end, as I say, they were weights: and their job was to tell you the value of the gold dust in the weighing pan.

The best of the Asante goldweights are among the splendours of African creativity. But they were not the product of a culture that valued these objects *as art*. Their decorative elegance was something prized and aimed for, of course; but it was an ornament, an embellishment, on an object that served a utilitarian function. It is clear that some people – chiefs among them, but also the richest commoners – made particularly fine collections of weights, and that, in using them in trade, they advertised their wealth at the same time, by displaying the superior craftsmanship of their possessions. Perhaps once, when the weights were still being used, people knew the names of those who made them best; but no one now knows the names of the great casters of goldweights from the past. Still, to insist upon my point, in appreciating and collecting these weights as art we are doing something new with them, something that their makers and the men and women who paid them, did not do.

The goldweight tradition is also very particular. The use of figurative and abstract weights, made in brass by the lost-wax process, is not widespread in west Africa, let alone Africa more generally. Outside the Akan region of Ghana and Ivory Coast, there are, so far as I am aware, no traditions that have produced objects that could be mistaken for Akan goldweights. Akan goldweights are African, because the Akan cultures are in west Africa: but these traditions are local, and while they reflect the complex cultural and economic exchanges between, say, Asante and the Islamic traders of the Sahel, or Baule culture and the European trade of the coast (and thus reflect currents of life wider than those of the societies in which they were made) it would be a mistake to see them as capturing the essence of the vast gamut of African creativity.

Anyone who has looked at collections of masks from western and central Africa will tell you that you can soon learn to recognise roughly where most of them come from: the traditions of each society in masking, even those that have influenced and been influenced by neighbouring traditions, are still quite recognisably distinct; as are the roles masks play in the different forms of performance where they have their fullest life. The point here is the same: Africa's creative traditions are various and particular. You will no more capture the essence of Africa's arts in a single tradition than you can grasp the meaning of European art by examining Tuscan painting of the 15th century. And what goes for art, goes, even more, for life. Africa's forms of life are too diverse to capture in a single ideal type. An understanding of our goldweights requires that you know something not of African but of Akan life: the generalities about African life are, by and large, human generalities.

So we might as well face up to the obvious problem: neither *Africa* nor *art* – the two animating principles of this exhibition – played a role *as ideas* in the creation of the objects in this spectacular show.

Africa

Take, first, ‘Africa’: through the long ages of human cultural life in the continent, and, more particularly, in the half-dozen or so millennia since the construction of the first great architectural monuments of the Nile Valley, most people in the continent have lived in societies that defined both self and other by ties of blood or power. It would never have occurred to most of the Africans in this long history to think that they belonged to a larger human group defined by a shared relationship to the African continent: a hundred years ago, it would not have occurred to anyone in my home-town. Only recently has the idea of Africa come to figure importantly in the thinking of many Africans; and those that took up this idea got it, by and large, from European culture.

The Europeans who colonised Africa thought of sub-Saharan Africa as a single place, in large part because they thought of it as the home of a single – Negro – race. (That is why, when we speak of Africans, black people come to mind: despite the fact that lighter-skinned north Africans – Arabs, Berbers, Moors – are unequivocally inhabitants of continental Africa.) In the European imagination, the cultures and societies of sub-Saharan Africa formed a single continuum, reflecting an underlying racial unity, which expressed itself in the ‘savage rhythms’ of African music, the ‘sensuality’ of African dance, the ‘primitive vigour’ of sculpture and masks from what was called the ‘Dark Continent’.

As intellectuals in Africa came to think of themselves, for the first time, as members of a Negro race – and as Africans – they drew not only on this general Western framework, but also on the ideas of African-American intellectuals – Alexander Crummell, E. W. Blyden, W. E. B. Du Bois – who had been taught to understand themselves as Negroes in the context of the New World system of racial domination, the framework left by slavery. In the New World, where so many dark-skinned people had been brought together from Africa, and deprived of the specific cultural knowledge and traditions of their ancestors, the common experience of the Middle Passage and of enslavement bonded together people whose ancestors had lived very diverse styles of life, hundreds, sometimes thousands, of miles apart. In the New World – in Brazil, or Cuba or the United States – people of diverse African ancestries, bound together in each place by a shared language, might end up experiencing themselves as a unity.

But in Africa itself, the great diversity of societies and cultural forms was not homogenised by the slave trade. Over the last millennium, as Islam spread across north Africa and into west Africa, and down the east African littoral; over the last few centuries, as Christianity came (with its multiple inflections) in the footsteps of European trade and colonisation; over the last century, as colonial empires bound African societies increasingly tightly into the new global economic system and into the modern order of nation-states; over the last decades, as the global spread of radio and television and the record and film industries has reached its tentacles into villages and towns all over Africa; there have, of course, been enormous forces bringing the experiences of African societies closer together. But despite all these forces, the central cultural fact of African life, in my judgement, remains not the sameness of Africa’s cultures, but their enormous diversity. Since many of the objects in this exhibition antedate some or all of these energies of incorporation, their origins are more diverse yet.

This should not be surprising. We are speaking of a continent, of hundreds of millions of people. But the fact is that the legacy of the old European way of thinking, in which what unites Africa is that it is the home of the Negro, makes it natural for us, here in the West, to expect there to be a shared African essence: and that tradition makes us equally likely to expect that this essence will show itself in the unity of African art. In this older way of thinking, after all, all the arts everywhere expressed the common genius of a people. (This is one reason why so many of the objects collected by Europeans in Africa in the last two centuries are labelled not with the name of a maker, but with the name of a ‘tribe’, an ethnic group whose shared conceptions these masks or bronzes or shrine-figures were thought to

express.) But, as you will see as you travel through the works on display here, it would take an eye completely insensitive to the particular to reduce this magnificent miscellany to the expression of the spirit of a singular, coherent, African nature.

What unites these objects as African, in short, is not a shared nature, not the shared character of the cultures from which they came, but our ideas of Africa; ideas which, as I have said, have now come to be important for many Africans, and thus are now African ideas, too.

Art

It is time now to explore, for a moment, the second side of the difficulty I have been adumbrating: the fact that what unites these objects as art is our concept as well. There is no old word in most of the thousand or so languages still spoken in Africa that well translates the word ‘art’. This, too, is not too surprising once you think about it: there is, after all, no word in 17th-century English (or, no doubt, in 17th-century Cantonese or Sanskrit) that carries exactly that burden of meaning either. The ways of thinking of ‘art’ with which we live now in the West (and the many places in the world where people have taken up this Western idea) began to take something like their modern shape in the European Enlightenment. And it is no longer helpful to try and explain what art has come to be for us by offering a definition; in an age in which, as John Wisdom liked to say, ‘every day, in every way, we are getting meta and meta’, the art-world has denizens whose work is to challenge every definition of art, to push us beyond every boundary; to stand outside and move beyond every attempt to fix art’s meaning. Any definition of art now is a provocation, and it is likely to meet the response: Here, I have made (or found) this thing that does not meet your definition and I dare you to say it is not art.

Still, we have received ideas about art and about artists: and my point is that most of these ideas were not part of the cultural baggage of the people who made the objects in this exhibition. For example: since the 19th century especially, we have had an important distinction between the fine and the decorative arts, and we have come increasingly to think of fine art as ‘art for art’s sake’. We have come, that is, increasingly, to see art as something we must assess by criteria that are intrinsic to the arts, by what we call aesthetic standards. We know art can serve a political or a moral or even a commercial purpose: but to see something as art is to evaluate it in ways that go beyond asking whether it serves these ‘extrinsic’ purposes. Many of the objects in this exhibition, on the other hand, had primary functions that were, by our standards, non-aesthetic, and would have been assessed, first and foremost, by their ability to achieve those ends. Something about our attitude to art is captured by the incomprehension we would feel for someone who looked at a painting and said: ‘It’s profoundly evocative, of course, but what is it for?’

A response

If African art was not made by people who thought of themselves as Africans; if it was not made as art; if it reflects, collectively, no unitary African aesthetic vision; can we not still profit from this assemblage of remarkable objects?

What, after all, does it matter that this pair of concepts –*Africa, art* – was not used by those who made these objects? They are still African; they are still works of art. Maybe what unites them as African is our decision to see them together, as the products of a single continent; maybe it is we, and not their makers, who have chosen to treat these diverse objects as art. But it is also *our* show – it has been constructed for us now, in the Western world. It might be anything from mildly amusing to rigorously instructive to speculate what the creators of the objects celebrated here would make of our assemblage. (Consider:

some of these works had religious meanings for their makers, were conceived of as bearers of invisible powers; some, on the other hand, were in use in everyday life.) But *our* first task, as responsible exhibition-goers, is to decide what *we* will do with these things, how *we* are to think of them.

In presenting these objects as art objects, the curators of this exhibition invite you to look at them in a certain way, to evaluate them in the manner we call ‘aesthetic’. This means, as you know, that you are invited to look at their form, their craftsmanship, the ideas they evoke, to attend to them in the way we have learned to attend in art museums. (It is hard to say more exactly what is involved here – at least in a brief compass – but most adults who go regularly to exhibitions of painting and sculpture will have practised a certain kind of attention and found it worthwhile: and if they have not, it is hard to see why they should keep going.) So what is important is not whether or not they are art or were art for their makers: what matters is that we are invited to treat them as art, and that the curators assure us that engaging our aesthetic attention will be rewarding.

We can also accept that they were selected on a continental basis that guarantees nothing about what they will share, nothing about how these objects will respond to each other. Provided you do not expect to discover in these creations a reflection of an underlying African artistic unity, an engagement with the whole exhibition will be more than the sum of the unrelated experiences of each separate object, or each separate group of objects from a common culture. How these individual experiences add up will depend, of course, as much as anything else, on the viewer; which is as it should be. But there are questions that might guide a reading of this show – it is part of the pleasure we can anticipate from it that there are so many – and, in closing, I would like to suggest a few of mine.

Let me start with a datum: this exhibition decisively establishes that anyone with half an eye can honour the artistry of Africa, a continent whose creativity has been denigrated by some and sentimentalised by others, but rarely taken seriously. I have been arguing that to take these African art works seriously does not require us to take them as their makers took them. (If that were so, we should, no doubt, be limited to religious evaluations of Western European art of the High Middle Ages.) And one other way to take them seriously would be to reflect through them on how the enormous temporal and spatial range of human creativity exemplified in this exhibition has been adapted in our culture over the last few centuries to an interpretation of Africa as the home of people incapable of civilisation.

What does it teach us about the past of Western culture, that it has had such great difficulty learning to respect many of the art works in this exhibition, because they were African? Many of these objects come from European collections, and were assembled as curiosities or as puzzles or as scientific data: they were undoubtedly appreciated – loved even – by many of the individuals who gathered them. But they have rarely lived at the heart of our aesthetic consciousness; and when they have, it has often been with astonishing condescension: Ladislas Szesci told readers of Nancy Cunard’s *Negro* (a work published in 1934 in celebration of black creativity; see Cunard, 1970):

The Negroes have been able to create works of art because of their innate purity and primitiveness. They can be as a prism, without any intentional preoccupation, and succeed in rendering their vision with certitude and without any imposition of exterior motive.

It is part of the history of *our* culture – something that bears reflection as we travel among these African artefacts – that half a century ago, this was an obvious way of speaking up for African art.

What (more hopefully, perhaps) does it tell us about our cultural present that we have now, for the first time, brought together so many, so marvellous African artefacts not as ethnographic data, not as mere curiosities, but for the particular form of respectful attention we accord to art? How, in short, may

we interpret our exhibition itself as part of the history of our Western culture: a moment in the complex encounter of Europe and her descendant cultures with Africa and hers? This is a question that everyone who visits this exhibition is equipped to reflect on: all of us can dredge up a common sense that we have picked up about Africa, and we can test that common sense against these uncommon objects.

These, then, are some questions that I bring to this show. But, like each of you, I will bring many others, some of them peculiar to my own history, some more widely shared.

These artefacts will speak to you, and what they say will be shaped by what you are as well as by what they are. But that they speak to you – as the goldweights of Asante spoke to my English-born mother – should be a potent reminder of the humanity you share with the men and women that made them. *As* they speak to you, they will draw you into an exploration of the worlds of those who made them (this is always one of our central responses to art). What you will discover in that exploration is not one Africa, but many: a rich diversity reflected in – but by no means exhausted by – the parade of wonders in this extraordinary exhibition.

EUROPE, AFRICAN ART AND THE UNCANNY

Henry Louis Gates, Jr

Charles de Gaulle was frequently heard to wonder aloud if, without black Africa from which he mounted the resistance to the Nazi regime, modern France would even exist. One might also wonder whether or not, without black African art, modernism as it assumed its various forms in European and American art, literature, music and dance in the first three decades of the 20th century could possibly have existed as well. Especially is this the case in the visual arts, where dramatic departures in the ways of seeing, particularly in representing the human figure, would seem to be directly related to the influence of sub-Saharan African art. In this sense, it is not too much to argue that European modernity manifested itself as a mirrored reflection of the mask of blackness.

European encounters with visual arts in Africa have long been fraught with a certain anxiety, often calling to mind Freud's account of the anxieties accompanying encounters with the uncanny, encounters that elicit a feeling of 'dread and creeping horror'. In the second edition of an essay entitled 'Of National Characters', David Hume, writing in the middle of the 18th century at the height of the European Enlightenment, maintained that one could survey the entire area of Africa below the Sahara and find not even one work of visual or written art worthy of the name. In a survey of the world's major cultures, civilisations and races, which in its first edition excluded completely any reference to Africans, Hume concluded in a footnote added to the second edition that all of black Africa contained 'no arts, no sciences'. Beauty, as perceived in all its sublimity in European cultures, at least since the time of the Ancient Greeks, is not to be found in black human or plastic forms.

Writing just a decade later, Immanuel Kant, in his *Observations on the Feeling of the Beautiful and the Sublime* (1764), meditated on Hume's conclusions about Africa, ratifying and extending them without qualification. In Section IV of his essay entitled 'Of National Character', Kant cites Hume's opinion favourably, then makes the startling claim that 'blackness' denotes not only ugliness, but stupidity as well:

In the lands of the black, what better can one expect than what is found prevailing, namely the feminine sex in the deepest slavery? A despairing man is always a strict master over anyone weaker, just as with us that man is always a tyrant in the kitchen who outside his own house hardly dares to look anyone in the face. Of course, Father Labat reports that a Negro carpenter, whom he reproached for haughty treatment toward his wives, answered: 'You whites are indeed fools, for first you make great concessions to your wives, and afterward you complain when they drive you mad.' And it might be that there were something in this which perhaps deserved to be considered; but in short, this fellow was quite black from head to foot, a clear proof that what he said was stupid.

Here we see the bold conflation of 'character' – that is, the foundational 'essence' of a culture and the people who manifest it – with their observable 'characteristics', both physical and, as it were, metaphysical.

Three decades later a more liberal, or cosmopolitan, Kant would allow in *The Critique of Judgement* (1790) that black Africans no doubt had standards of beauty among themselves, even if they did not correspond to European standards of beauty – a bold speculation given the revolutionary transforming role that the cotton gin had begun to play in the nature of New World slavery and the increased traffic in African human beings that this major technological innovation engendered. (Hegel, however, was not persuaded by Kant's new generosity of spirit; in the *Philosophy of History*, written around the same time,

I have felt my strongest artistic emotions when suddenly confronted with the sublime beauty of sculptures executed by the anonymous artists of Africa. These works of a religious, passionate, and rigorously logical art are the most powerful and most beautiful things the human imagination has ever produced. I hasten to add that, nevertheless, I detest exoticism.

Pablo Picasso

African art? Never heard of it.

Pablo Picasso

he reaffirmed implicitly Hume's claim about the absence of civilisation in black Africa, and added that because Africans had not developed an indigenous script or form of writing, they also lacked a history.)

If Europe's traffic in black human beings needed a philosophical justification, Enlightenment philosophy, by and large, obliged sublimely. European aesthetic judgement of African art and culture, in the 18th and 19th centuries at least, was itself encapsulated in, and became an integral part of, the justification of an economic order largely dependent upon the exploitation of cheap labour available to an unprecedented degree on the west coast of Africa, from Senegambia to Angola and the Congo. Never could the European encounter with the African sublime be free of the prison of slavery and economics, at the expense of African civilisation and art themselves. The prison-house of slavery engendered a prison-house of seeing, both African peoples and their attendant cultural artefacts.

This curiously tortured interrelation between ethics and aesthetics, between an economic order and its philosophical underpinnings, remained largely undisturbed until the turn of the century. For a variety of reasons, too numerous and subtle to be argued here, revaluations of African art gathered momentum at the turn of the century. Dvořák's admiration, and formal uses, of African American sacred music as a basis for a bold, new approach to orchestral music is only the high-culture equivalent of Europe's and America's obsession with black-faced minstrelsy as a popular mode of debased theatre and dance. The role of the Fisk Jubilee Singers in this process of revaluation, performing spirituals on worldwide tours during these decades, cannot be gainsaid. But it would be in the visual arts where the role of African ways of seeing would become pivotal, in a manner unprecedented in the history of European aesthetics. The experience of African art profoundly shaped the forms that modernity assumed early in the 20th century.

Modern art is often considered to have taken its impetus from the day in 1907 when Pablo Picasso visited the Musée d'Ethnographie in the Palais du Trocadéro, Paris. Indeed, Sieglinde Lemke has argued that there could have been no modernism without 'primitivism' – a term, I confess, that I detest – and no 'primitivism' without modernism. They are the ego and the id of modern art. How uncanny that encounter was for Picasso – and, by extension, for European art, its critics and historians – can be gleaned not only from his own account of the discomfort he felt at that moment, but also from the curious pattern of denial and affirmation propagated both by Picasso himself and later critics in relation to that great moment of transition in the history of European and African aesthetics, *Les Demoiselles d'Avignon*.

Picasso's discomfort – and the discomfort of critics even today – with the transforming presence of African art in painting underlines the irony of an encounter that led to the beginning of the end of centuries of European disapprobation of African art – art that is now taken to be neither 'primitive' nor 'ugly', but to embrace the sublime.

Picasso's ambivalence about the significance of his chance encounter with the faces of Africa that day at the Trocadéro manifested itself almost as soon as critics asserted its importance. As early as 1920 Picasso was quoted in Florent Fels's *Action* as saying 'African art? Never heard of it!' The literature is full of Picasso's denials, the energy of which seems only to emphasise Picasso's own anxieties about his African influences. Eventually, in 1937, in a conversation with André Malraux not reported publicly until 1974, Picasso admitted the African presence in his work:

Everybody always talks about the influences that the Negroes had on me. What can I do? We all of us loved fetishes. Van Gogh once said, 'Japanese art – we all had that in common.' For us it's the Negroes.... When I went to the old Trocadéro, it was disgusting. The Flea Market. The smell. I was alone. I wanted to get away. But I didn't leave. I stayed. I stayed. I understood that it was very important: something was happening to me, right? The masks weren't just like any other pieces of sculpture. Not at all. They were magic things... The Negro pieces were *intercesseurs*, mediators.... I always looked at fetishes. I understood; I too am against everything. I too believe that everything is unknown, that everything is an enemy! Everything! Not the details – women,

children, babies, tobacco, playing – the whole of it! I understood what the Negroes use their sculptures for. Why sculpt like that and not some other way? After all, they weren't Cubists! Since Cubism didn't exist. It was clear that some guys had invented the models, and others had imitated them, right? Isn't that what we call tradition? But all the fetishes were used for the same thing. They were weapons. To help people avoid coming under the influence of spirits again, to help them become independent. Spirits, the unconscious (people still weren't talking about that very much), emotion – they're all the same thing. I understood why I was a painter. All alone in that awful museum, with masks, dolls made by the redskins, dusty manikins. *Les Demoiselles d'Avignon* must have come to me that very day, but not at all because of the forms; because it was my first exorcism painting – yes absolutely.

Françoise Gilot had reported a similar comment a full decade before Malraux's publication. It is even more dramatically open about his conscious indebtedness to African sources:

When I became interested, forty years ago, in Negro art and I made what they refer to as the Negro Period in my painting, it was because at the time I was against what was called beauty in the museum. At that time, for most people a Negro mask was an ethnographic object. When I went for the first time, at Derain's urging, to the Trocadero museum, the smell of dampness and rot there stuck in my throat. It depressed me so much I wanted to get out fast, but I stayed and studied. Men had made those masks and other objects for a sacred purpose, a magic purpose, as a kind of mediation between themselves and the unknown hostile forces that surround them, in order to overcome their fear and horror by giving it a form and image. At that moment I realized what painting was all about. Painting isn't an aesthetic operation; it's a form of magic designed to be a mediator between this strange, hostile world and us, a way of seizing the power by giving form to our terrors as well as our desires. When I came to that realization, I knew I had found my way. Then people began looking at those objects in terms of aesthetics.

In these idiosyncratic and cryptic statements, Picasso reveals that his encounter with African art was a seminal encounter. Yet, he dismisses the primary influence that African art had upon his work, its *formal* influence, a new way of seeing, a new way of representing. But why would Picasso suddenly identify with modes of representation peculiar to African art, thereby breaking the long-held tradition of disparaging those same black traditions as 'ugly' or 'inferior'?

What these passages reveal is Picasso's aesthetic wrestling with his own revulsion at the forms of African art, and, by extension, the traditional revulsion of the West towards African aesthetic conventions generally. Picasso vividly describes his encounter in terms that Freud used to describe the uncanny. His description of the smell, followed by the realisation that he was alone and his desire 'to get out fast', which he managed to resist, are all symbolic. The description serves as a metaphor for a visceral repulsion of the artist and, as it were, the visceral repulsion of Western aesthetics itself. What is also striking about Picasso's recollections is his denial of the formal influence of African art – to which he was patently indebted – and the fact that 30 years later (when he made his confession to Malraux) he was still haunted by the memory of a tormenting odour. The unpleasant sensations are metaphors for Picasso's anxiety and for the very sublimity of this encounter with the black uncanny.

Perhaps even more bizarre, Picasso substituted for his own obvious embrace of formal affinities with African art a cryptic and obviously bogus claim to be embracing African art's *affect*, its supposed functionality, its supposedly 'exorcist' uses, about which he knew nothing. In a way that he did not intend, this curious dichotomy would come together in his use of the forms of African art to exorcise the demons of his artistic antecedents.

Picasso's anxieties with his shaping influences are, in part, those of any artist wishing to be perceived as *sui generis*. But it is impossible to separate the anxiety about influence, here, from Europe's larger

anxiety about the mask of blackness itself, about an aesthetic relation to virtually an entire continent that it represented as a prime site of all that Europe was not and did not wish to be, at least from the late Renaissance and the Enlightenment. Even in those rare instances early in the 20th century when African art could be valued outside a Eurocentric filter, the deepest ambivalences about those who created the art still obtained. Thus Frobenius on his encounter with a classic work of Yoruba art, some time between 1910 and 1912: 'Before us stood a head of marvellous beauty, wonderfully cast in antique bronze, true to life, encrusted with a patina of glorious dark green. This was, indeed, the Olokun, Atlantic Africa's Poseidon.'

'Yet listen', Wole Soyinka, the Nigerian playwright, argued in 1986 at his Nobel Laureate address, 'to what he had to write about the very people whose handiwork had lifted him into these realms of universal sublimity':

Profoundly stirred, I stood for many minutes before the remnant of the erstwhile Lord and Ruler of the Empire of Atlantis. My companions were no less astounded. As though we have agreed to do so, we held our peace. Then I looked around and saw – the blacks – the circle of sons of the 'venerable priest', his Holiness the Oni's friends, and his intelligent officials. I was moved to silent melancholy at the thought that this assembly of degenerate and feeble-minded posterity should be the legitimate guardians of so much loveliness.

The deep ambivalences traced here were not peculiar to white Europeans and Americans; African Americans, for their part, were at least as equivocal about the beauty of African art as were Europeans. As Alain Locke – the first black American Rhodes Scholar, who was to graduate from Harvard with a PhD in Philosophy, and then become the first sophisticated black art critic – put it in his pivotal essay 'The Legacy of the Ancestral Arts' (1925), they 'shared the conventional blindness of the Caucasian eye with respect to the racial material at their immediate disposal'. Racism – aesthetic and other – Locke concludes ruefully, has led to a 'timid conventionalism which racial disparagement has forced upon the Negro mind in America', thus making even the very *idea* of imitating African art for African American artists a most difficult ideal to embrace.

Locke's solution to this quandary, as Lemke argues, is as curious as Picasso's waffling about influences upon him: by imitating the European modernists who so clearly have been influenced by African art (of whom Locke lists Matisse, Picasso, Derain, Modigliani, Utrillo and ten others) African Americans will become African by becoming modern. The route to Africa, in other words, for black as well as white Americans and Europeans, is by way of the Trocadéro. Locke even points to the work of Winold Reiss, whom he chose to illustrate his classic manifesto of African American modernism, *The New Negro*, 'as a path breaking guide and encouragement to this new foray of the younger Negro artists'.

Judging by the 'African-influenced' work that artists such as Aaron Douglas produced, and given the circuitous route that Locke mapped out for them as their path 'back' to Africa, perhaps we should not be surprised that these experiments led not to the 'bold iconoclastic break' or 'the ferment in modern art' that Picasso's afternoon at the Trocadéro yielded, but rather to a sort of Afro-Kitsch, the use of decorative motifs such as cowrie shells, Kente cloth patterns and two-dimensional reproductions of 'African masks', in which 'Africa' never becomes more than a theme, as an adornment, not a structuring principle, a place to be visited by a naive tourist. Ways of seeing, these experiments tell us, are not biological. Rather, they result from hard-won combat with received conventions of representation. They are a mysterious blend of innovation and convention, improvisation and tradition. And if the resurrection of African art, in the court of judgement that is Western art, came about as a result of its modernist variations, this exhibition is testament to the fact, if there need be one, that African art at the end of the century needs no such mediation. It articulates its own silent sublimity most eloquently. For centuries it has articulated its own silent sublimity most eloquently.

Bibliographical note

Quotations of Picasso are taken from *Les Demoiselles d'Avignon*, ed. William Rubin, Studies in Modern Art, 3, MOMA, New York, 1994; quotation of Immanuel Kant from *Observations on the Feeling of the Beautiful and Sublime*, translated by John T. Goldthwait, Berkeley and Los Angeles, 1960, p. 113. References to Sieglinde Lemke's ideas are based on her book *Was Modernism Passing?*, forthcoming from Oxford University Press.

THE AFRICAN PAST

Peter Garlake

To begin to penetrate the African past of the last 12,000 years, it is essential first to assess the nature and quality of the evidence on which interpretations of African history depend as well as the concerns and preconceptions of the practitioners and limitations of their disciplines. Oral histories, traditions, genealogies and folklore are an uncertain guide for all but the past few centuries and require as skilled analysis and reinterpretation as any other form of evidence. Indigenous historical records scarcely exist outside the literate worlds of Egypt and Islam. Other than these there are travellers' stories written by outsiders whose experiences were limited and whose perceptions survived from the world from which they came; for them Africa was the exotic other.

Inadequate though they still are, the most significant contributions to an understanding of the African past have come from archaeologists. The early history of a continent is intertwined with the history of a discipline. It began in Egypt with the revelations of the monuments and treasures of the pharaohs and the recording and reading of hieroglyphic texts. Philology has so skewed our understanding of that civilisation that, until the archaeology of settlements is fully addressed, Egypt's place in African history and the influences that permeated to and from the far interior will remain in the realm of polemic. The concern with dramatic visible monuments and artistic treasure goes further than Egypt. Ife and Benin in west Africa, Kilwa on the east African coast and Great Zimbabwe (fig. 1) in the southern

Fig. 1 *The Conical Tower within the Great Enclosure at Great Zimbabwe, photographed during the first rudimentary excavation at the site in 1891*

African interior have been the subjects of debate ever since they came to the attention of the outside world.

It was only some 40 years ago in the twilight of colonialism that the richness and importance of indigenous African history began to receive the attention that it deserved. The first researchers were concerned with origins – the ambiguous minutiae of the earliest domesticated crops or animals or ceramic or metal technologies. These were all envisaged as having single points of origin, usually outside the continent, which were dispersed and diffused through successive migrations and within a framework of unilinear evolutionary development. Foreign trade and trade routes were seen as prime stimulants of change for their passive recipients. Change was equated with the movements, invasions and conquests of successive tribes, with no awareness that the very identities of many of these tribes were as much foreign colonial concepts as the boundaries that were imposed on them. Some of the tribes that were once believed to be major historical protagonists and that once most concerned archaeologists, like the Bacwezi of Uganda or the Shirazi of the east African coast, have subsequently proved to be almost entirely legendary.

Whether it is made explicit or not, archaeologists bring to their researches particular concepts, theories, techniques and biases. These are still almost all derived from outside Africa and were originally intended to meet problems of other continents and periods. Within Africa, the theoretical bases that must form the foundations of any significant research programmes remain stunted. The archaeologist's traditional tools were ceramic classifications. Interest in the typologies of ceramics, however, lessened as their relationships to social identity were recognised to be complex and problematic. Though they continue to provide chronological indicators, even here their usefulness has decreased now that reasonably firm and precise temporal frameworks can be built up using radiocarbon dating.

Most researchers have now become increasingly engaged with the realities of the societies of Africa themselves. Archaeologists have seldom recognised the potential contributions of other human sciences. On the few occasions that alliances have been formed, the results can be dramatic. The understanding of the art of the Drakensberg San, almost the last Stone Age hunters and gatherers of southern Africa, has been transformed in the last twenty years by the cautious and sensitive incorporation into these studies of 19th- and 20th-century ethnographic work on San beliefs and religious practices. Comparative iconographic analysis, a traditional tool of art historians, has enabled these insights to be extended to the much older art and more extensive concerns of the long vanished San of Zimbabwe. Later we shall see how art historians and anthropologists have helped in an understanding of more recent periods.

Archaeologists have almost entirely abandoned grand theory for research programmes and strategies on the level of defined ecological regions. They now study people, resources and settlements regionally rather than concentrating exclusively on single sites, however important. This has led to the recognition of the autonomy, creativity and innovative dynamism of indigenous local societies at every technological, economic and social level as, through conscious rational choices and decisions, they have recognised and responded to the challenges and opportunities of new lands, resources, products and technologies, and changing patterns of rainfall, vegetation and fauna. Archaeologists are also now much more aware of how important to an understanding of the past are studies of the internal dynamics, structure, institutions and beliefs that underlay the processes by which wealth and power became concentrated in the hands of the few, of the ways in which control or coercion was exercised to maintain the stability and permanency of states and their economic, political and institutional management.

As detailed knowledge of more regions accumulates and recognition of the creative responses of any community to its situation grows, many of the old sharp distinctions fade and blur. Categories like the Later Stone Age, Neolithic, Early and Later Iron Ages lose their separate identities and much of their

Later Stone Age, Neolithic, Early and Later Iron Ages lose their separate identities and much of their meaning. They may remain a useful descriptive shorthand, but become restrictive concepts. Ceramic groups no longer have the same sharp definition and many seem arbitrary creations of archaeologists. Distinctions between hunters, pastoralists, farmers and craftsmen also often become difficult to sustain. The hunter becomes a fisher, builds semi-permanent villages by lakes and rivers and collects wild cereals habitually and intensively. The pastoralist plants grain after good rain and hunts when his herd diminishes with disease or drought. Cultivators shift their energies to cattle-raising when they occupy new environments. Innovative responses to new conditions and new challenges, the exploitation of the new opportunities and new ecological niches are the stuff of the African past.

All this can be seen first in what is now the most unpromising location, the central Sahara. Yet, for at least 4000 years after about 10,000 BC, this was a land of lakes and rivers with populations living off fish and the riverine mammals, collecting wild sorghum and millets, and grinding these for meal and, in some areas, concentrating their hunting on the indigenous wild Barbary sheep. By 8000 BC, people everywhere in the region had developed pottery for their cooking and storage vessels, though they continued to make all tools and weapons in stone and wood.

As the region became drier, many turned to a pastoral life, herding sheep in the Atlas and cattle elsewhere, and tended to move south and east towards the Nile. In the river valley, hunting, fishing and the gathering of tuberous food plants could continue, but in villages on the desert edges people also began to cultivate domesticated wheat and barley to provide a more predictable, controlled and varied addition to their diet when the plain was flooded and food was short. By 4000 BC villages in the Fayum, at Merimda at the head of the Nile Delta and elsewhere could rely almost completely on their domesticated grains and livestock.

At Kintampo, on the edges of the rainforests of what is now Ghana, the continuity between later Stone Age groups and the first cultivators has been established. Evidence of domesticated stock or crops from this site looks less certain, but it is clear how, from 1600 BC, people made progressive economic adjustments to the opportunities of agriculture. The forest was gradually cleared – as shown by the new animal species attracted to the clearings. People settled down; the quantity and variety of their possessions increased, particularly pottery; systems of local exchange were established; and dwellings were made more substantial and durable.

In the central Rift Valley of east Africa during the second and first millennia BC, ecological variety permitted peoples with very different lifestyles and economies to coexist in close proximity for many centuries. Interactions between them then took many different forms, comprehending traditional archaeological concepts like migration, diffusion, assimilation and economic transformation. People who were predominantly foragers settled in the dry, lightly wooded floor of the valley and its margins and adapted their hunting to different habitats. Goat herders lived in rock shelters on the forested sides of the valley and in large settlements in the highlands. Open grasslands were grazed by the cattle of at least five different pastoralist groups whose forebears lived in northern Kenya throughout the second millennium BC and had their ultimate origins on the Ethiopian highlands. Some were nomadic; others settled near permanent waterholes. Their pastoralism can even be seen as an ideological system in which a cultural bias towards herding exceeds its functional value and herding defines identity.

On the southern edge of the Sahara substantial evidence for very early metal working has been recovered, particularly around Agadez in Niger. Native copper began to be smelted here before 2000 BC on a small scale (and probably seasonally) by craftsmen who traded with Saharan pastoralists. It was over a thousand years before technology advanced sufficiently for copper ores to be smelted successfully. Development was then rapid. Between 700 and 500 BC, the difficult task of smelting iron ores was

mastered, and along a hundred-mile stretch of small smelting settlements, craftsmen were making iron ornaments and weapons as status symbols. Within a hundred years iron smelting furnaces could be found as far south as the central plateau of Nigeria.

In the east African interior, on the western Buhaya shores of Lake Victoria, there is evidence of intensive iron smelting industries from 600 BC. These were sophisticated, extensive, specialised and almost industrial, incorporating technological innovations that enabled the furnaces to reach high temperatures that were not developed outside Africa until centuries later. The environmental impact of metal production on this scale, of the amount of mature hardwood that had to be felled and burnt to produce the charcoal for the furnaces, and of the devastation that this caused has been emphasised. This may have had some advantages as it turned forests into pasture that allowed cattle herds to multiply, but it also forced communities to move frequently.

The most far-reaching changes to society and its institutions, economy and culture come with the aggregation of peoples in towns or cities. Their development in sub-Saharan Africa is best traced in the delta of the Middle Niger, where the river splits into a changing silting network of a myriad temporary channels, lakes and swamps and has at its head the city of Djenne. Timbuktu stands at the lower end of the delta and Gao further downstream, where the course of the river swings south. In the flat and otherwise featureless floodplain around Djenne, inundated to a considerable depth each year, over 400 tells of ancient occupation have been identified from aerial photographs suggesting a population density ten times that of today. By 300 BC the delta was drying up, the areas of permanent lakes in it decreasing and the dangers of waterborne diseases diminishing. The first signs of permanent settlement, small hamlets of mixed agriculturalists, appeared about 250 BC. Their inhabitants fished, hunted wild bovids and collected wild grasses but they also grew rice, sorghum and millet and herded goats and cattle. From the start, they also imported stone grindstones, stone beads and iron ore from beyond the floodplain. Over the following five or six centuries the settlements remained predominantly rural but few in numbers and size. Resources were drawn from further afield – copper, probably from the Sahara, appeared by AD 400 and gold, probably from the far south, by AD 800. Crafts diversified and some were clearly the products of at least part-time specialists. By AD 500 several settlements had coalesced into a fully urban town. At the height of its prosperity, about 800, Djenne covered over 100 acres, many buildings were of brick and the town was surrounded by a massive wall. However, there is no evidence that it had a ruling group or any system of coercion or authoritarian control; it had no palaces, temples or citadel, very few luxury imports and little wealth concentrated in the hands of a few. What is significant is rather the way specialised craftsmen in a variety of manufactures were organised into cohesive bodies, physically separated and living in their own settlements round the edge of the town, identified by village mounds slightly over a quarter of a mile apart, with three to fifteen villages forming a cluster, each in its way an independent manufacturing and social centre. These units may have had an ethnic as well as a productive basis. Nevertheless, town, craft villages and country formed a single social and economic system. The ambiguities of personal and group identity within this system may well have been expressed and resolved through the proliferation of art, particularly ceramic statuary, which is a feature of Djenne: symbols of the disparate, interacting and overlapping loyalties of groups with different origins, ethnic allegiances, occupations, beliefs and values.

The intensity and spread of the regional trade through the delta is shown by the homogeneity of the material culture, particularly pottery, over a wide area, evidence either of the spread of objects from the urban manufacturing centres or of the way the high fashion of the city was everywhere emulated by local craftsmen. Downstream large grave mounds or tumuli, built with ever-greater elaboration over wooden burial chambers, contain rich gravegoods and Djenne pottery. They have now been dated to between the

8th and 11th centuries, contemporary with Djenne's greatest prosperity. More than anything in the city, they suggest that some people grew wealthy and powerful through control of the flow of trade goods through the delta. North African, Arab and Islamic influences only appear at Djenne after 1000, when the city was already over 500 years old. At this point the climate became wetter. The river floods were more extensive, higher and longer, and rice growing had to be largely abandoned and with it many settlements. The population of the floodplain declined, and settlements were reduced to a cluster round Djenne itself. The end came by 1400 when the town was abandoned.

The eastern edges of the Kalahari Desert, monotonous flat open country, covered in thorn scrub and grass and broken by isolated flat-topped sandstone hills, contain the earliest evidence in southern Africa of the growth of wealth, inequalities, a ruling group, sustained political control over wide territories, considerable populations and rich herds. This occurred in a place far from any foreign trade contacts, in an area without the gold of Zimbabwe and far less attractive for farmers or ranchers with even less rain and a sparser vegetation than its eastern neighbour. Cultivation, even of drought-resistant and fast-maturing indigenous grain crops, is hazardous. Today it is the heartland of traditional Tswana cattle owners and their almost feudal economy with client herders guarding their cattle, for much of the year at cattle posts far from the vast traditional towns where the owners live. Until very recently, so little was known of the prehistory of this part of the subcontinent that it was assumed that it had only been the hunting grounds of nomadic San foragers. A single research programme has discovered over 250 Iron Age settlements, occupied between AD 600 and 1300.

Settlements centred round cattle pens. Debris from these, hardened and burnt over the centuries, encourages so distinctive a grass cover that sites can be identified from aerial photographs. The settlements vary considerably in size, depth of occupation deposits and length of occupation and fall into four distinct categories. The largest were substantial hilltop towns, with cattle middens 25 acres in extent, sited for defence and taking little account of distance from water or agricultural land. Large villages, though little more than a tenth of the size of the towns, were built on smaller hilltops around the town. In the plains below were hamlets and homesteads comparable in size to contemporary Tswana cattle posts and occupied for two generations at most. They differed from the villages and towns in being located near water courses and within reach of both heavy and light soils: crops planted on one or other of these soils would survive whatever the rains brought.

By the 9th century, there were three hilltop towns, 60 miles apart from each other. Large villages clustered at some distance from the towns and hamlets in turn clustered round the villages: a distinctive pattern and hierarchy of settlements indicative of three independent, self-sufficient and competing city states, each in control of its own territories and each with its own infrastructure of agricultural villages and cattle posts. Their control over their populations was strong enough for them to extract cattle, presumably in the form of tribute, to sustain the town. The pattern of culling shows that the townsfolk subsisted on the meat of cattle killed in their prime while in the lesser settlements only young bulls and animals past reproduction were killed: the characteristic pattern of ranchers seeking to maintain and increase herd growth. Although external contacts certainly existed, and glass beads and sea shells reached the Toutswe settlements, the real trade was internal, with cattle and grain passing between the settlements, and skins, hides, ivory and probably salt being exchanged with San hunting groups beyond the Toutswe territories.

The developments in Botswana were not unique. Far to the west lies a dramatic monument that still suffers from more speculation than serious research. Great Zimbabwe is the largest and one of the earliest of some 200 granite masonry enclosures demarcating rulers' courts that were built around the high plateau of the southern African interior between the 12th and 18th centuries (fig. 1). It is the apogee

Fig. 2 The minaret of the Friday Mosque in Mogadishu, one of the earliest port cities in east Africa. The entrance to the minaret bears a dedicatory inscription dated AD 1238 (636 AH). The photograph was taken in 1963

of the progressive aggregation of population and power in southern Africa. It is unnecessary to posit any direct ethnic or cultural connection between such very different centres as Toutswe, Mapungubwe in the valley of the Limpopo River and Great Zimbabwe, let alone assume migration of their populations or ruling classes. Rather they are each in their own way culminations of similar, though autonomous, indigenous processes of centralisation and hierarchical differentiation; responses to the ways that cattle ownership can be manipulated to meet the human quest for wealth and power like that traced so well in Botswana. Certainly it can be demonstrated that at least one *zimbabwe* (Shona: palace) lay at the node of seasonal cattle movement and that there, as at Great Zimbabwe, cattle were brought to the court and slaughtered in considerable numbers in their prime to provide meat exclusively for the inhabitants of the stone courts. The pattern of the major courts across the plateau, almost certainly independent politically and economically but sharing a common culture, suggests that this was the case everywhere. Here archaeology must give way to other, more sophisticated disciplines. Cattle were not simply an economic resource, but mediating symbols of relationships in marriage, between chiefs and their subjects and between people and their ancestors and gods. In the same way, the great granite structures themselves are not fortifications but primarily symbolic expressions of the political, cultural and religious, embodying beliefs about relationships between land and people, ruler as custodian of land and its wealth responsible to ancestors and subjects, between ruler and spirit medium.

All this demands investigation far deeper than inappropriate, superficial and unproven ethnographic analogies that archaeologists too often grasp at to flesh out their material. Their 'cavalier and often inaccurate' misuse and 'gross misinterpretation' of his material can drive the anthropologist to despair. Witness the almost universal rejection of the interpretations of Great Zimbabwe based on South African Venda customs of the very recent past.

Great Zimbabwe was one of the extremities of a communication system that stretched from the deep African interior to the farthest reaches of Asia and the Mediterranean. Its node was the Swahili cities along the Indian Ocean. A common Swahili culture based on a local, coastal seaborne trade, carried by traditional indigenous craft with sewn wood hulls and square matting sails, had mastered difficult reefs, winds and currents to spread 3000 miles along this coast from Somalia to Mozambique. The first villages in the 8th century were traditional African round houses of clay arranged round a central cattle pen. Their inhabitants still hunted, but developed inland fishing techniques of spearing and trapping to exploit the inshore reefs. Tiny mud-walled mosques, which could accommodate only a minuscule fraction of the growing population, mark the beginnings of the Swahili conversion to Islam in the 10th century. This in turn began the integration of products of the African interior into a far-flung network reaching first to Mesopotamia and Tang China and, when these became unstable, exporting African gold, ivory and rock crystal to the Mediterranean to such an extent that a convincing claim can be made that these new imports stimulated an artistic revival in Byzantium, Muslim Spain and Sicily and the Holy Roman Empire that lasted for nearly a century between AD 960 and 1050.

The populations of the larger towns of the coast grew to up to 10,000 people (fig. 2). Local coinages were minted in several of them, the forms of the inscriptions derived from Fatimid Sicily. Building in coral masonry began, reaching its peak in the early 14th-century complex of palace, warehouses, caravanserai and market of Husuni outside the town of Kilwa. The geometry of the domes, vaults, pools and courtyards was Islamic, but the arrangements of the domestic quarters were Swahili and later reproduced in substantial houses in every town on the coast. They are evidence of the great prosperity that trade stimulated.

Its effects on the interior were more complex and problematic. Numerous pre-existing indigenous networks of local exchange systems transmitted the new imports, whose value and meaning changed

Fig. 3 A group of broken pottery torsos and heads, both naturalistic and reduced to simple conical shapes, buried in Ife in the 14th century and excavated in 1972. Broken pottery statuary and dismembered human bodies were treated in similar ways at this site

Fig. 4 A pottery vessel buried up to its neck at the centre of a 14th-century patterned potsherd and quartz pavement in Ife, excavated in 1972. The reliefs include a small shrine containing three ceramic heads and a basket from which protrude the up-ended legs of a sacrificial victim

as they passed from society to society. By the time they reached the courts of the far interior, as small quantities of glass and glazed wares were to reach Great Zimbabwe, their effects are still imponderable. Certainly no cultural or political influences accompanied them. Such trade was incorporated in complex pre-existing indigenous productive, political and economic systems. The causal connections between long-distance trade and internal changes have yet to be analysed and established.

A contemporary site to Great Zimbabwe and the Swahili cities both in its rise and decline is Ife, or Ile-Ife, sacred to the Yoruba people of west Africa as the place where the world and humanity were created, and the location of some of Africa's great works of sculpture. Its origins remain obscure though much speculated about. Sadly, the full results of the many excavations undertaken before 1970 have not been published. The only firm evidence we have is the immediate context of some of the celebrated sculptures (fig. 3). On the outskirts of the present city and just beyond the ancient city walls, after an initial occupation in the late 12th century, large and substantial family compounds were built in the 13th century, the clay walls falling into decay less than a century later. These houses were arranged around rectangular courtyards precisely oriented north to south, the walls and columns decorated with mosaics of pottery discs and paved in geometric patterns which draw attention to semicircular altars and the neck of a pot buried in the centre of the yard. An art historian has been able to interpret the altars as Yoruba *ijoko orisa*, the god's seat, and the central pot as *ojubu*, the face of worship. The sculpted reliefs on at least one of these pots (fig. 4) can be shown to illustrate the apparatus and insignia of extant Yoruba secret societies, Oro and Osugbo, both once concerned with law and order and with executions such as that depicted on the same pot. The same vessel also depicted a small shrine containing both highly stylised and realistic sculpted heads: the first firm contemporary evidence to bring the sculpture into the context of now lost Yoruba religious practice. Outside the compounds, a small wooden shrine contained dismembered human heads mixed with sculpted heads broken from their bodies and depicting men deformed and distorted by disease and anger: a demonstration of the perceived equivalence between sculpture and reality. Here small-scale archaeological excavations combined with art-historical analysis have been able to establish the age of the sculptures, something of how they were perceived and used and the time depth of key Yoruba institutions.

Yoruba institutions have their roots deep in the past. The structures of Great Zimbabwe, as yet unstudied, are best seen as controlled forms and spaces symbolising deep and ancient communal relationships. In the end it will not be only through technological, ecological or economic studies that the distinctive characteristics of the African past will be best understood, but also through consideration of its very varied modes of social organisation and structure, its institutions and symbols. It is these that archaeology has so far proved insufficiently sensitive and adaptable to penetrate. When it comes to terms with such deficiencies, and this is by no means impossible, we can expect new and greater understanding of a rich and varied past.

Bibliographical note

Reports of archaeological work in Africa are most rapidly and readily accessible from journals such as *African Archaeological Review* (Cambridge University Press), *Journal of African History* (Cambridge University Press), *Azania* (British Institute in Eastern Africa), *South African Archeological Bulletin* and *West African Journal of Archaeology*. Important work on the early settlement of Egypt has been done by O'Connor, on revision of the Kintampo, Ghana, sequence by Stahl, on early east African settlement by Robertshaw and ironworking by Schmidt, on Djenne by the McIntoshes, on the Toutswe sequence by Denbow, and on the Swahili coast by Horton. Papers by all except Schmidt and Denbow, though not always their most recent or comprehensive ones, appear in a collection of conference papers, Shaw et al., eds. This also includes a synopsis by Muzzolini of research on early Saharan food production. For aspects of the controversies over Great Zimbabwe discussed here see Garlake, 1978² and 1982; for rejections of the 'initiation school hypothesis' by archaeologists see Collett et al., and by the anthropologist whose material formed its basis see Blacking, 1985. For Ife, archaeological work is reported in Garlake, 1974 and 1977, and interpreted by the art historian Drewel in Drewel and Pemberton, 1989. For the interpretation of rock paintings in South Africa see Lewis-Williams and Dowson; for Zimbabwe see Garlake, 1995.

Owing to unforeseen circumstances, certain works described in the catalogue cannot be shown in the exhibition. Their places have been taken by the works listed below, and we are particularly grateful to their owners for agreeing to their loan at such short notice.

1 ANCIENT EGYPT AND NUBIA

ex cat. 1.1 **Cult image of a falcon**, Egypt, late predynastic, c. 3000 BC, stone, w. 17.5 cm, Staatliche Museen zu Berlin, Preussischer Kulturbesitz, Ägyptisches Museum und Papyrussammlung, 1/79

ex cat. 1.2 **Base of a royal statue with heads of foreigners**, Egypt, 2nd–3rd Dynasty, calcite, 20 x 36 x 29 cm, Staatliche Sammlung Ägyptischer Kunst, Munich, ÄS 6300

ex cat. 1.3 **Triad of Mycerinus**, Egypt, 4th Dynasty, reign of Mycerinus (c. 2529–2501 BC), granite, 800 x 63 cm, Museum of Fine Arts, Boston

ex cat. 1.4 **Stela and statue of Sihathor**, Egypt, 12th Dynasty, c. 1900 BC, limestone, 100 x 60 cm, The Trustees of the British Museum, London, EA. 569/570

ex cat. 1.5 **Pectoral with Horus and Seth**, Egypt, 12th Dynasty, electrum (gold alloy), h. c. 5 cm, by courtesy of the Provost and Fellows of Eton College, The Myers Museum

ex cat. 1.6 **Kohl pot**, Egypt, 18th Dynasty, c. 1900 BC, anhydrite and gold, h. c. 7.5 cm, The Trustees of the British Museum, London, EA. 32150

ex cat. 1.7 **Squatting figure of Senenmut**, Egypt, Thebes/Karnak (?), 18th Dynasty, c. 1475 BC, granite, 100.5 x 100.5 cm, Staatliche Museen zu Berlin, Preussischer Kulturbesitz, Ägyptisches Museum und Papyrus-sammlung, 22872

ex cat. 1.8 **Head of an Amarna princess**, Egypt, 18th Dynasty, Amarna period (1352–1336 BC), quartz/sandstone, h. 21 cm, Staatliche Museen zu Berlin, Preussischer Kulturbesitz, Ägyptisches Museum und Papyrussammlung, 21223

ex cat. 1.9 **Seated figure of Maya**, Egypt, 18th Dynasty, c. 1450 BC, limestone, h. 74 cm, Staatliche Museen zu Berlin, Preussischer Kulturbesitz, Ägyptisches Museum und Papyrussammlung, 19286

ex cat. 1.10 **Ram-headed (?) god**, Egypt, probably from the tomb of King Horemheb, Thebes (Valley of the Kings), 18th Dynasty, c. 1320 BC, wood coated with black resin, h. c. 40 cm, The Trustees of the British Museum, London, EA. 50703

ex cat. 1.11 **Tortoise-headed god**, Egypt, probably from the tomb of King Horemheb, Thebes (Valley of the Kings), 18th Dynasty, c. 1320 BC, wood coated with black resin, h. c. 40 cm, The Trustees of the British Museum, London, EA. 50704

ex cat. 1.12 **Amulet**, Napatan period, from Gebel Barkal, Sudan, c. 700–300 BC, faience, h. c. 25 cm, The Trustees of the British Museum, London, EA. 54412

ex cat. 1.13 **Head of an ibex**, Egypt, 19th–20th Dynasty (?), c. 1300–1100 BC, bronze with gold, h. 32 cm, Staatliche Museen zu Berlin, Preussischer Kulturbesitz, Ägyptisches Museum und Papyrussammlung, 11404

7 NORTHERN AFRICA

ex cat. 7.1 **Capital with vine leaves and lions**, Egypt, Coptic, 6th century, limestone, 37 x 36 cm, Staatliche Museen zu Berlin, Preussischer Kulturbesitz, Museum für Spätantike und Byzantinische Kunst, 6159

ex cat. 7.2 **Stand with container for cosmetics**, Egypt, Coptic, late 6th century–early 7th century, wood, 33.5 x 6.5 cm, Staatliche Museen zu Berlin, Preussischer Kulturbesitz, Museum für Spätantike und Byzantinische Kunst, 24/83

ex cat. 7.3 **Stand with container for cosmetics**, Egypt, Coptic, late 6th century–early 7th century, wood, 17.5 x 4 cm, Staatliche Museen zu Berlin, Preussischer Kulturbesitz, Museum für Spätantike und Byzantinische Kunst, 25/83

ex. cat. 7.4 **Tombstone of Pathermouthis**, Egypt, Coptic, 6th–8th century, sandstone with traces of red paint, 86 x 41 x 4.5 cm, The Trustees of the British Museum, London, EA. 1765

ex cat. 7.5 **Basket capital with foliage design**, Egypt, Coptic, 6th–8th century, limestone, 40.5 x 50 x 50 cm, The Trustees of the British Museum, London, EA. 1556

ex cat. 7.6 **Carved panel**, Egypt, Fatimid, 11th century, wood with traces of gesso, 32.9 x 152.7 cm, al-Sabah Collection, Kuwait, LNS 55 W

ex cat. 7.7 **Jar**, Egypt, 12th–13th century, glazed earthenware, h. 42.8, diam. 29.5 cm, al-Sabah Collection, Kuwait, LNS 340 C

ex cat. 7.8 **Bowl with central blazon**, Egypt, Mamluk, 14th century, earthenware with yellow slip, h. 11.3 cm, diam. 22.6 cm, al-Sabah Collection, Kuwait, LNS 7 C

ex xat. 7.9 **Mirror**, Egypt, Cairo, Mamluk, mid-14th century, steel inlaid with silver and gold, diam. 21 cm, The Trustees of the British Museum, London, OA. 1960.2-15.1

ex cat. 7.10 **Penbox**, Egypt, Cairo, Mamluk, mid-14th century, brass inlaid with silver and gold, l. 30.7 cm, The Trustees of the British Museum, London, OA. 1881.8-2, 20

ex cat. 7.11 **Jug**, Cairo or Damascus, Mamluk, mid-14th century, brass inlaid with silver and gold, h. 28.5 cm, The Trustees of the British Museum, London, OA. 1887.6-12.1

ex cat. 7.12 **Circular tile with epigraphic blazon of Sultan Qa'itbay**, Egypt, Mamluk, late 15th century, glazed earthenware, diam. 30 cm, al-Sabah Collection, Kuwait, LNS 190 C

EDITORIAL NOTE

Catalogue entries are signed with the initials of the following contributors

AA	Alden Almquist	WD	William J. Dewey
BA	Barbara Adams	WVD	Vivian Davies
CARA	Carol Andrews	EE	Ekpo Eyo
CJA	C. Joseph Adande	ME-K	Marianne Eaton-Krauss
DA	David Attenborough	NE	Nadia Erzini
JA	James Anquandah	AF	Angela Fagg-Rackham
MA	Monni Adams	EF	Etienne Féau
APB	Arthur Bourgeois	JMF	Joyce Filer
EB	Ezio Bassani	REF	Rita Freed
HvB	H. van Braeckel	RFF	Renée Friedmann
JB	Jean Brown	TFG	Timothy Garrard
JDB	J. D. Bourriaud	BH	Barry Hecht
JRB	John Baines	LdeH	Luc de Heusch
MCB	Marla Berns	RH	Rachel Hoffmann
MLB	Marie-Louise Bastin	SH	Stanley Hendrickx
NB	Nigel Barley	TNH	Thomas Huffmann
PB	Peter Beaumont	WH	William Hart
RAB	René A. Bravmann	RI	Robert Irwin
RB	Rayda Becker	TAI	Timothy Insoll
AC	Anna Contadini	FJ	Frank Jolles
CC	Christopher Chippindale	CK	Curtis Keim
ELC	Elisabeth Cameron	CMK	Christine Kreamer
HMC	Herbert Cole	JK	John Kinahan
JC	Joseph Cornet	SK	Sandra Klopper
JXC	Jeremy Coote	TK	Timothy Kendall
KC	Kevin Conru	ZK	Zachary Kingdon
LHC	L. H. Corcoran	BL	Babatunde Lawal
MC	Margret Carey	FL	Frederick Lamp
MWC	Michael Conner	JDL-W	David Lewis-Williams
HJD	Henry Drewal	LL	Luc Limme
JD	Janet Deacon	NL	Nessa Liebhammer
PD	Patricia Davison	RL	Raoul Lehuard
PJD	Patricia Darish	CM	Carla Marchini
		DM	David Morris
		JM	John Mack
		MRM	Rachel MacLean

PdeM	Pierre de Maret	JvS	Jan van Schalkwyk
PMcN	Patrick McNaughton	RS	Roy Sieber
PRSM	Roger Moorey	TS	Thurstan Shaw
SJMM	Stanley J. Maina	ZSS	Zoe Strother
WM	Wyatt MacGaffey	JHT	John Taylor
AN	Anitra Nettleton	NT	Natalie Tobert
FN	François Neyt	RFT	Robert Farris-Thompson
KN	Keith Nicklin	TT	Tanya Tribe
KNe	Karel Nel	EV	Eleni Vassilika
NIN	Nancy Nooter	MFV	Marie-France Vivier
DO	David O'Conner	DAW	Derek Welsby
JP	Judith Pirani	DW	Dietrich Wildung
JP III	John Pemberton III	FW	Frank Willett
JWP	John Picton	HW	Helen Whitehouse
LP	Louis Perrois	JW	Justin Willis
MP	Merrick Posnansky	RAW	Rosalind Walker
RP	Robert Papini	RJAW	Roger Wilson
TP	Tom Phillips	RW	Rachel Ward
SGQ	S. G. Quirke	AY	Abd'el-Rauf Youssouf
AFR	Alan F. Roberts	KY	Kenji Yoshida
CDR	Christopher Roy	CZ	Christiane Ziegler
CHR	Catherine Roehrig		
DHR	Doran Ross		
ERR	Edna R. Russmann		
JFR	J. F. Romano		
MNR	Mary Nooter-Roberts		
PR	Patricia Rigault		
PLR	Philip Ravenhill		
AS	Abdul Sheriff		
BS	Bettina Schmitz		
CS	Christopher Spring		
EMS	E. Margaret Shaw		
ES	Enid Schildkrout		
HS	Hamo Sassoona		
HSa	Helmut Satsinger		
HSo	Hourig Sourouzian		

Bibliographical citations in the text and at the foot of the entries refer to the general bibliography

Dimensions are given in centimetres; height precedes width and depth.

The phonetic symbols /, !, /', ≠ are standardised representations of the click sounds in various khoisan languages.

/Xam is the name of a southern San group, Ju/'hoan and !Kung refer to northern San groups.

The following abbreviation is used: BP, Before the Present time

M E D I T E R R A N E A N S E A

I S R A E L

J O R D A N

Kingdoms

Mountains

Archaeological sites

0 200 miles
0 300 km

E G Y P T

S A U D I
A R A B I A

R E D
S E A

S U D A N

E R I T R E A

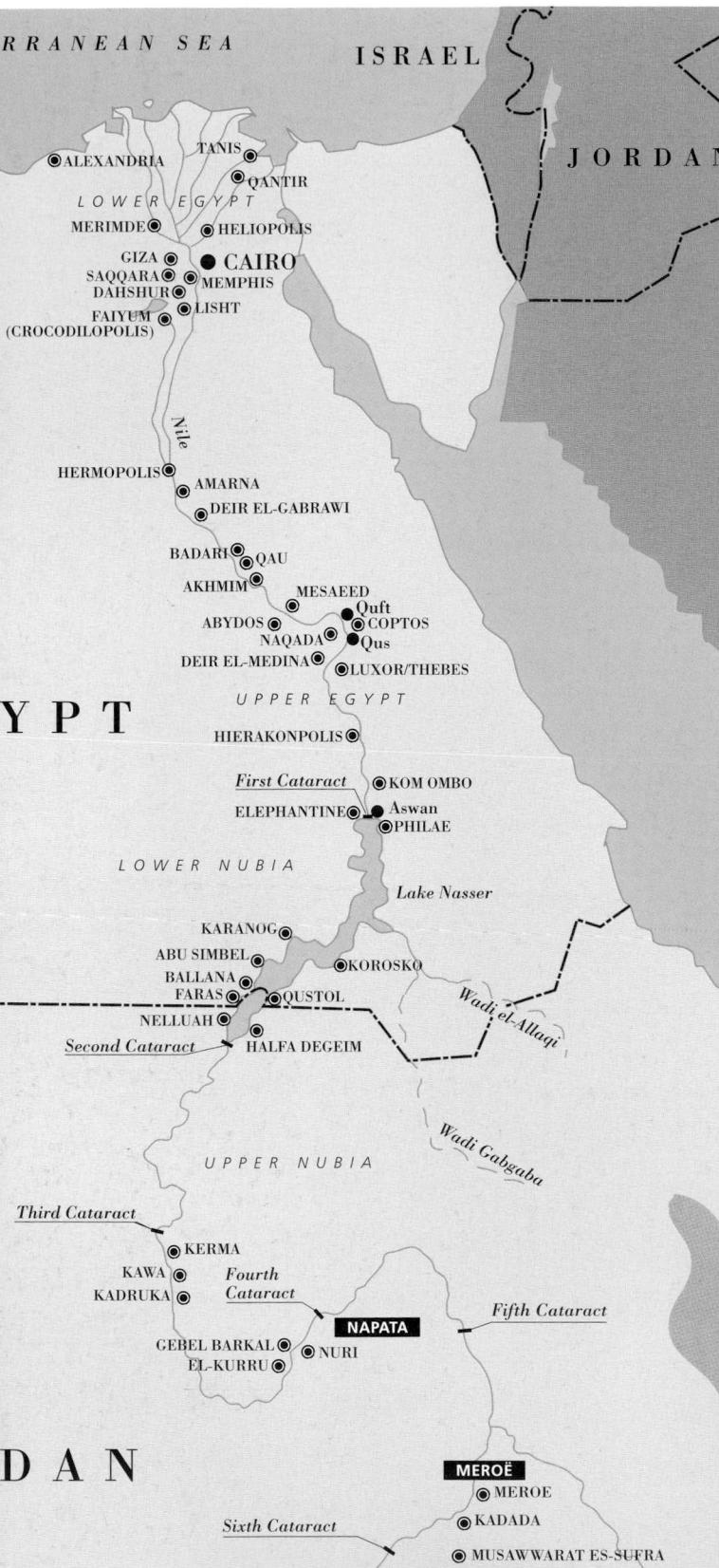

1 ANCIENT EGYPT AND NUBIA

ANCIENT EGYPT

Edna R. Russmann

The art of Ancient Egypt is the art of a people who tended to think in terms of concrete, graphic images. Throughout their history, they persisted in using the original pictorial forms of hieroglyphic writing, often carving or painting them in great detail, despite the fact that scribes had long since developed more abstract scripts that were much easier and faster. Hieroglyphic forms were retained partly because they were sanctified by religious tradition; but they also satisfied a deep-rooted taste for pictorial imagery. Thus, more than in most societies, Egyptian art was a vital expression of its culture.

It was a religious art, the visible focus for a complex system of beliefs and practices, many of which were based on magic: in the earliest periods, this magical element was particularly predominant. The objects placed in a grave were believed to be magically at the disposal of the deceased in the after-world; images of people and animals in the tomb would accompany and serve him or her. Temple images had the same magical life; the bound captive carved on the socket of a temple door was believed to suffer real agony every time the door post inserted in his back was pivoted open or closed (cat. 1.24).

Much Egyptian art was made for tombs and was never intended to be seen again by the living. In the temples, the most precious works of art were hidden in the innermost chambers, accessible only to a few high-ranking priests. None the less, there is a distinct public element to the art of Ancient Egypt. Many of its most spectacular creations, clearly designed to impress, were placed where they would be widely seen. Such considerations may have influenced the size and siting of the Giza pyramids and Great Sphinx (fig. 1). They certainly encouraged the use of monumental scale and rich decoration on temple façades, the soaring obelisks and colossal statues that flanked their entrances. Considerations of this kind come

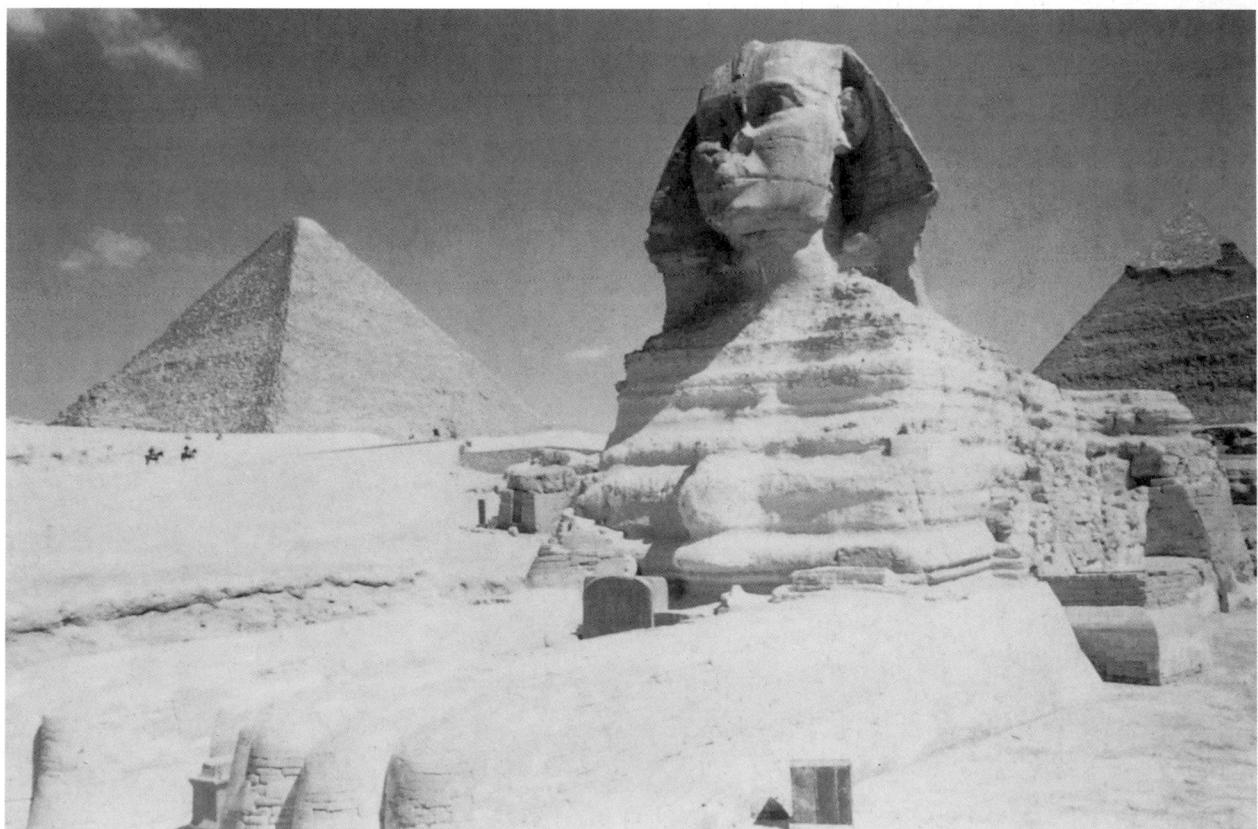

Fig. 1 The sphinx and pyramids at Giza

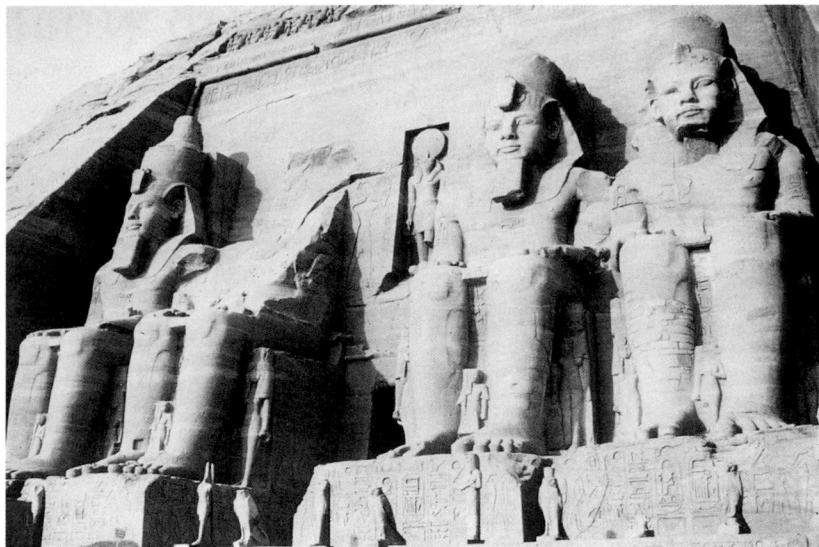

very close to modern ideas of propaganda in monuments such as the famous temple of Abu Simbel, with its gigantic statues of Ramses II. Situated on the Nile some distance south of Egypt's southern border, this monument was planned, in part, to intimidate travellers approaching the land of this mighty king (fig. 2).

Artistic production was so fully integrated into a religious context that Egyptians never felt the need for a specific word for art. In a similar spirit, Egyptian artists almost never signed their work, for it was not, in any real sense, 'theirs'. Anonymous though they may be to us, however, the builders, sculptors, painters and fabricators of Ancient Egypt were well known to their contemporaries. Artists were judged by the quality of their work; the best of them worked for the king and on the great temples.

Few societies have been more resistant to change than that of Ancient Egypt. This deliberate conservatism is very apparent in their visual culture. Whenever possible, the Egyptians would respond to change by ignoring it; alternatively, aspects of change would be 'corrected' by reference to examples from the past. A striking example of such a correction occurred during the New Kingdom (1550–1069 BC) in the aftermath of the Amarna period. Not only was the memory of the heretical king Akhenaten expunged from official records, but the visible evidence of his reign was destroyed: his temples and statues were dismantled and their remains hidden; the distinctive new style in which they had been made was repudiated. The style of temples, wall decoration and statuary made in the years after the Amarna period reflects a conscious attempt to return to that of the time of Akhenaten's great predecessors, Amenhotep III and Thutmose III. Evidence of archaism – the deliberate imitation or evocation of earlier styles – can be found in every major period of Egyptian art, most notably during the Late period (664–332 BC).

The fact that tombs and temples were the focus of Egyptian art did not inhibit artists from expressing humour, generally at the expense of the labourers and semi-skilled craftsmen who were their social inferiors (cat. 1.58–9). For those who could afford it, enjoyment of art was an important part of life. The many personal items that people treasured and caused to be placed in their tombs – jewellery and fine vessels, furniture and clothing that they had actually used – showed the pleasure they took in beautiful, elegant and rare objects. It is important to note, however, that the symbolic forms and decoration of such things show that they were often designed to serve the added function of magical protection for their owners, both in this world and the next (cat. 1.31, 33–4, 53).

The culture of Ancient Egypt was a single entity that spanned more than five millennia. Its rise and development were closely linked to its geographical situation at the north-eastern corner of Africa, where the Nile flows unimpeded from the cataracts at Aswan, north to the Mediterranean Sea. It was, as it still

Fig. 2 *Abu Simbel: view of façade of main temple*

is, a subtropical land with little rainfall, but the annual flooding of the Nile provided an almost unparalleled reliability for early methods of agriculture. This huge natural advantage helps to explain Egypt's emergence as one of the earliest complex societies. The Nile also provided efficient, fairly rapid transport and communication, indispensable to the government of this long, narrow land. Egypt's natural boundaries – the cataracts that interrupt the river at Aswan in the south, the sea to the north, and the deserts on the east and west – protected the land from invasion and left it free, through most of its ancient history, to develop along its own lines.

From beginning to end, Ancient Egypt was essentially an indigenous culture. It is not known when the area was first settled, or where the people came from, but communities along the Nile were well established by earliest predynastic times. As in most early societies, pottery-making was a major craft, and the main stages of predynastic development have been defined primarily in terms of their increasingly sophisticated ceramic production: the fine, rippled-wares of the Badarian period (c. 4500–4000 BC; cat. 1.7), the attractive, often inventive white-painted redware vessels of the Naqada I period (c. 4000–3600 BC; cat. 1.8); the red-painted buffware of Naqada II (c. 3600–3200 BC), decorated with subjects that are often more elaborate, but also more standardised, than before. Only in the latest stage, Naqada III (3200–3000 BC), does stone sculpture and relief really begin to come into its own (cat. 1.18) but throughout the predynastic period, as in all later Egyptian art, some of the finest objects are statues representing the human figure, in ivory (cat. 1.1–2,20c), clay (cat. 1.3–4), wood and stone (cat. 1.6,19). Most of these early figures are extremely stylised, but some are quite naturalistic in their depiction of maternal poses (cat. 1.2) and even physical deformity (cat. 1.20c).

Although they were originally independent settlements, predynastic communities had considerable contact, to judge from the similarity of pottery, figurines and other objects found at different sites. In time, some of the more powerful centres began to exert control over their neighbours, a process which accelerated during the later part of the period. Representations of fighting on many objects made towards the end of the predynastic period suggest that expansion was achieved at least partly through military conquest (cat. 1.18), although the rapid development of the arts and the beginnings of hieroglyphic writing in this same period give evidence of intense cultural activity. Even if the battle scenes are exaggerated, the late predynastic wars among Egyptians and perhaps also with foreigners helped to define the role of the king as protector of his land and guardian against all evil which, throughout Egypt's subsequent history, was graphically symbolised by the representation of bound and helpless captives (cat. 1.24,35).

The dynastic period began about 3100 BC, with the unification of the whole of Egypt and the establishment of the 1st Dynasty, under the semi-legendary King Menes. Menes is also credited with the founding of Memphis, Egypt's great capital near the strategic juncture of the Nile Delta and Nile Valley (very near modern Cairo). The art of the first two dynasties continued the forms and traditions of the latest predynastic period, but was notably more ambitious, producing large-scale stone sculpture and massive funerary architectural complexes, in which stone began to be used as a building element.

A burst of creativity in the first part of the Old Kingdom established the basic artistic conventions that were to govern Egyptian art for the rest of its history. Early in the 3rd Dynasty (c. 2700 BC), the Step Pyramid, the first monumental stone structure, was built in the Memphite cemetery of Saqqara for King Djoser, whose sculptural and relief representations, though still somewhat stiff and archaic in style, show the beginnings of portrait likenesses. These achievements were consolidated and surpassed in the 4th Dynasty (c. 2613–2494 BC). This is the age of the huge stone royal pyramids and the Great Sphinx at Giza, near Memphis (fig. 1). The Great Sphinx, one of the first of the human/animal composites so characteristic of Egyptian art, established a tradition of colossal sculpture, while the

increasing sophistication of portraiture in the statues of the kings and their courtiers (cat. 1.25,30) was matched by the development of a convincing, though highly idealised, way of representing the human form. These traditions continued throughout the rest of the Old Kingdom; pyramids were smaller, but the increasing use of relief as wall decoration encouraged sculptors to portray complicated scenes in a vivid manner. With the 6th Dynasty (*c.* 2345–2181 BC), sculptural forms became much less naturalistic and more expressive: the musculature of the body was suppressed in favour of emphasis on an unnaturally large head dominated by huge eyes. This style was to persist into the first years of the Middle Kingdom (cat. 1.28).

The Old Kingdom collapsed under the weight of political and economic problems that degenerated into civil strife and episodes of famine. The Middle Kingdom (*c.* 2055–1795 BC) began with the reunification of Egypt achieved by Mentuhotep II, a prince of the southern city of Thebes (modern Luxor). His dynasty, the 11th, was short-lived; the first king of the 12th Dynasty (1985–1955 BC) moved his capital north, probably to be near Memphis. Here, the royal artists had access to the imposing works of the Old Kingdom and, under their influence, once again built pyramids for the burial of their kings and created a suavely naturalistic style of sculpture and relief. Late in the dynasty, under Senusret III (*c.* 1874–1855 BC), portraiture was reintroduced in statues representing this king (fig. 3) and his successor, Amenemhat III (*c.* 1854–1808 BC). Unlike those of the Old Kingdom, however, these Middle Kingdom portraits convey a strong impression of weary or disillusioned age.

The Middle Kingdom was brought to an end by the conquest of foreigners from the east, the Hyksos, an episode terminated by a military revolt led by princes from Thebes. Their remarkable family, the 18th Dynasty (*c.* 1550–1295 BC), dominated the first part of the New Kingdom (*c.* 1550–1069 BC). Members of this dynasty include the female King Hatshepsut, the military genius Thutmose III, whose extensive conquests in the east and the south established Egypt as the great imperial power of its day, and the magnificent, self-aggrandising Amenhotep III. Much of the enormous wealth that poured into Egypt during the New Kingdom was lavished on the building and furnishing of great temples such as Karnak, and on the kings' funerary establishments which, in this period, consisted of vast underground tombs in the Valley of the Kings, and separate funerary temples of a magnificence that rivalled the temples of the gods. Much wealth was also at the disposal of the upper ranks of priests, officials and military men, who spent it on their own impressive tombs, on extravagant fashions and on some of the most luxurious and engaging decorative objects ever made (e.g. cat. 1.43).

The ferment of new ideas under Amenhotep III, developed by courtiers with great sophistication and much leisure, and perhaps influenced in part by the many foreigners now in Egypt, took a curious turn in the reign of his son, Amenhotep IV. Soon after coming to the throne, the new ruler changed his name to Akhenaten and took up residence at a new city, Akhetaten. The modern name of this site, Amarna, has given its name to the entire period of his reign (*c.* 1352–1336 BC). Akhenaten's moves were part of his attempt to impose a new religion centred on worship of the sun-disc (the Aten), which he intended should replace the many cults of the traditional gods. It is entirely characteristic of Ancient Egypt that these radical religious ideas were accompanied by almost equally revolutionary changes in the style of art. It was an art of exaggeration, centred on Akhenaten's own image which showed him with a grotesquely elongated head and jaw, and an almost female fleshiness of body. These features were also imposed on his queen, Nefertiti, and the couple's six daughters. At Amarna, however, they were softened into a more attractive, naturalistic form (cat. 1.44–5) probably under the influence of the only great Egyptian artist whose name we know, the sculptor Thutmose.

At Akhenaten's death, his religion was repudiated, and with it his artistic canons. The greatest king of the later New Kingdom, Ramses II (*c.* 1279–1213 BC), was a great builder of temples which were adorned

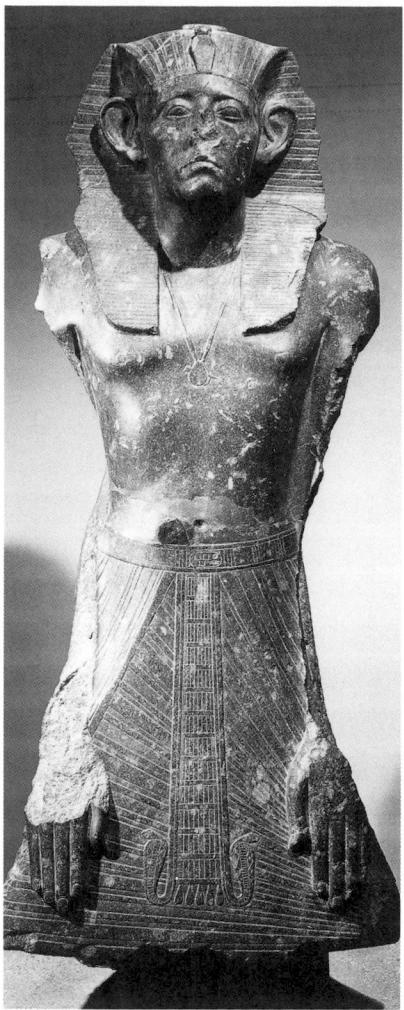

Fig. 3 Statue of Senusret III
grano-diorite, h. 122 cm
The British Museum, London, EA 686

with numerous statues of the king, often on a colossal scale. Egypt was still an empire, but its power began to dwindle under his successors of the 19th and 20th Dynasties (c. 1213–1069 BC), by virtue of the twofold pressures of struggles within the royal family and the rising power of neighbouring states.

Once again, Egypt's government and economy broke down. The next reunification, at the start of the Late period, was imposed by the conquering Kushites from the south, who formed the 25th Dynasty (c. 747–656 BC). The rest of Egypt's dynastic history is a succession of native dynasties, interspersed with conquests by the Persians and the Assyrians. Finally, following the conquest in 332 BC by Alexander the Great – who was welcomed by the Egyptians because he drove out the hated Persians – Egypt came under the rule of a dynasty founded by Alexander's general Ptolemy. The long period of Ptolemaic rule (305–30 BC) was ended when Cleopatra VII and Mark Antony were defeated by Augustus Caesar, who incorporated Egypt into the Roman Empire, not as a province, but as an imperial possession. During all these centuries, Egyptian art maintained its vitality, the cultural tradition was still strong and it was reinforced by continual reference to art of the Old, Middle and New Kingdoms. Archaism is a major factor in art of the Late period; in some cases, we can see actual copying from earlier monuments (cat. 1.60).

This brief discussion of Ancient Egypt's history and art has necessitated many references to foreigners. Natural boundaries were distinct, but they were never so strong as to prevent constant movement among and contact with surrounding peoples: the Egyptians themselves were often tempted to campaign abroad, and their prosperity was an even greater magnet for people from all the surrounding lands. Some foreigners came to trade, others to stay. All had some impact on the culture, although these contributions, being largely intangible, are extremely difficult to evaluate.

The most constant – and probably, overall, the most important – contributions to Egyptian culture came from the south, particularly from the adjacent area now known as Nubia. During predynastic times, the settlements along the Nile both north and south of Aswan may even have formed a sort of cultural continuum. Throughout the dynastic period, Nubians were constantly arriving in Egypt, some as captive slaves, but many as voluntary immigrants who established themselves as soldiers, agricultural workers and household servants (cat. 1.43). Some of them moved to the top of Egyptian society. In the early Middle Kingdom, the wives of Mentuhotep II included at least three Nubian women; and the founder of the next dynasty, Amenemhat I, is said to have had a Nubian mother. As the 'African' features of a royal daughter-in-law of the Old Kingdom (cat. 1.25) suggest, these were certainly not isolated cases. Reliable documentation, however, is almost non-existent, and theories about the Nubian ancestry of other specific Egyptian kings and queens are almost entirely speculative. Contact between Nubians and Egyptians increased during the Middle and New Kingdoms; eventually Egypt's control over Nubia was intensified to an almost colonial form of occupation. Many Egyptian temples were built throughout Nubia, and some Nubians were schooled in Egyptian practices. In the 8th century BC, long after the collapse of the New Kingdom and Egypt's withdrawal from Nubia, an Egyptianised ruling family from Nubian Kush took advantage of a weakened Egypt to invade and rule as the 25th Dynasty. The Kushite kings made no pretence of being Egyptian, but they claimed full pharaonic legitimacy by the grace of the Egyptian gods, particularly Amun, whose worship was well established in their homeland. Their claim appears to have been accepted by many Egyptians, especially in the south.

The Egyptians often skirmished with the peoples of the Libyan desert, to the west. Like the Bedouin herdsmen of the eastern desert, Libyans sometimes sought refuge in Egypt during times of famine; such refugees, on the verge of starvation, were represented in some royal tombs of the Old Kingdom. Libyans also enlisted in the Egyptian army, and many of them eventually settled in the western Nile Delta, from which their descendants began to rule parts of Egypt and finally the entire land as the 26th Dynasty (664–525 BC).

Some of the most visible contributions to Ancient Egyptian culture came from the lands to the east. During the late predynastic period, contacts with the emerging civilisations of Sumeria and Elam (modern Iraq and Iran) seem to have provided a stimulus to writing and the arts at this crucial time in Egypt's development. In dynastic times, eastern traders were regular visitors. At the end of the Middle Kingdom, eastern warriors managed to impose themselves as the Hyksos kings of Egypt. The powerful kings of the New Kingdom conquered much of the civilised east. Late in Egypt's history, the tables were turned again as the Achaemenid Persians, then the Assyrians, then again the Persians conquered and ruled or looted the land. Whatever their nature, all these events left their mark on Egyptian art: ideas and decorative motifs were borrowed from the east, and probably also knowledge of the techniques for working with bronze and glass.

Minoans and Myceneans from the north were represented in Egyptian paintings of the New Kingdom; their pottery, and even fragments of their wall-paintings, have been found in Egypt, and their spiral and meander patterns were incorporated into Egyptian art. Much later, during the 6th century BC, Egyptian canons influenced Greek art. At the end of its history, under the Ptolemies and especially under the Roman emperors, Egypt was gradually but inexorably drawn into the orbit of an emerging new world order.

NUBIA

László Török

Nubia is in Africa, is part of Africa, and has been essentially African in Antiquity as it is today. Therefore it is surprising how art historians, much more than anthropologists and traditional historians, have overlooked this rich field of painting and sculpture. If anything, they have stressed the connections with Egypt, Egyptian influence, the Egyptianizing derivatives found in abundance in Nubia and the northern Sudan. Instead it is now essential to search under the stratum of antiquities which show an affinity with Egypt for the native element which can truly be called Nubian and to formulate from this material a new chapter of art history, of African art history.

In these sentences Bernard V. Bothmer, the organiser of the first great exhibition of Nubian art in 1978, gave clear expression to what historians and archaeologists dealing with the ancient cultures of the Middle Nile Region – i.e. Lower Nubia between the first and second Nile cataracts, Upper Nubia between the second and sixth Nile cataracts, and the northern Sudan – had begun to feel, and had tried to explain, ever since the first great archaeological discoveries were made in the course of the UNESCO Nubian Salvage Campaign in the early 1960s. This generation of scholars was participating in the greatest rescue campaign in the history of modern archaeology: the investigation of the Lower Nubian Nile Valley from Aswan to the second Nile cataract before it was submerged by the waters of the new Aswan High Dam, and the saving of the monuments of the area – among them the temples of Abu Simbel and Philae. They realised at an early stage of the work that, though deeply influenced by the powerful northern neighbour, Nubian culture was a genuine expression of indigenous experience and perceptions.

Thirty years later, students of the Middle Nile Region regard Ancient Nubia more as a rival than a dependent of Egypt; the Nubian adoption of the vocabulary of Egyptian civilisation is interpreted as having been a means of giving more precise formal expression to Nubian religion and state ideology.

From the colonial presence of Egypt in Ancient Nubia, interest has shifted to the investigation of the vestiges of Nubian social structures, institutions and intellectual achievements as they may survive in the historical and archaeological record. New confidence in their subject has inspired scholars of Nubian history to create from the fragmentary evidence a different picture, showing now an ethnic and cultural continuity through the millennia of alternating independent and colonial periods, instead of reconstructing, as their predecessors did, alternating cycles of Egyptianisation and cultural decline in the absence of Egyptian impetus. While old clichés about Nubia's cultural subordinacy and the imitative character of Nubian art have been abandoned, it has also become clear that the genuine features of Nubian culture cannot be understood without appreciating their relation to Egyptian ideas, conceptual and stylistic inspirations, influences and imports. The investigation and apperception of the arts of Nubia as a province of African art history does not mean a denial of the impact of the northern neighbour but requires instead the analysis of the interaction between Egyptian and Nubian cultural achievements.

The history of Nubian–Egyptian contact is determined by the geographical situation, which explains the similarities in their historical development as well as the conflicts between them. Life in both Nubia and Egypt depended entirely on the waters of the Nile. Each also needed the gold and other material resources of the desert area east of Upper Egypt and Nubia as well as the exotic wares to be acquired from the interior. Nubia as a trading corridor and entrepreneur was vitally important for Egypt; the management of commerce between Egypt and the Mediterranean world on the one side, and the interior of Africa on the other, continued to determine the relationship of the two countries and explains their constant struggle for political control over stretches of that corridor. A further important factor in their contact was, from the Egyptian Old Kingdom onwards, the expansionist nature of the Egyptian state which was primarily based on the ideology of universal regency and not, as 19th-century rationalism would have it, economic interest.

The inhabitants of prehistoric Upper Nubia were nomadic cattle herders who did not live in permanent settlements. Around 3500 BC and in the subsequent centuries the Lower Nubians developed a sedentary agriculture based on flood irrigation, similar to that of Egypt. They came to live in increasingly complex and expanding chiefdoms. Around 3100 BC, in the period when in Egypt the political unification of the country was being achieved, Lower Nubia seems to have been united into a powerful chiefdom whose rulers were buried for several generations in the same monumental cemetery at Qustol. They were in contact with Egypt and borrowed Egyptian symbols of royal power (e.g. maces), decorating them with symbolic figures of animals. Their pottery production included fine vessels with extremely thin walls and painted geometrical decoration (cat. 1.76), indicating that they were prestige objects rather than artefacts of daily use. Early 1st-Dynasty Egyptian aggression drove out the Lower Nubians from their land in order to gain direct control over the trade corridor leading to the sources of gold, minerals, precious stones and African wares. The towns built by the Egyptian conquerors became the agents of the Egyptianisation of material culture when Nubians started to return to Lower Nubia around the middle of the 3rd millennium BC.

In Upper Nubia a powerful chiefdom with its centre at Kerma began to emerge in the course of the second half of the same millennium. Contemporary with the Egyptian Middle Kingdom and Second Intermediate period (*c.* 2055–1550 BC), the Kerma chiefdom developed from a tribal society into a real state with a social stratification comparable with that of Egypt. This was a centralised state structure extending over increasingly large areas of Upper Nubia and was in control of Lower Nubia as well from around 1650 BC. Its capital was the earliest settlement in Africa south of Egypt which may be termed a city. In the Classic Kerma phase (*c.* 1750–1580 BC) its core was enclosed by fortified walls about 10 metres high with four gateways, and was dominated by monumental edifices serving the cults, royal representa-

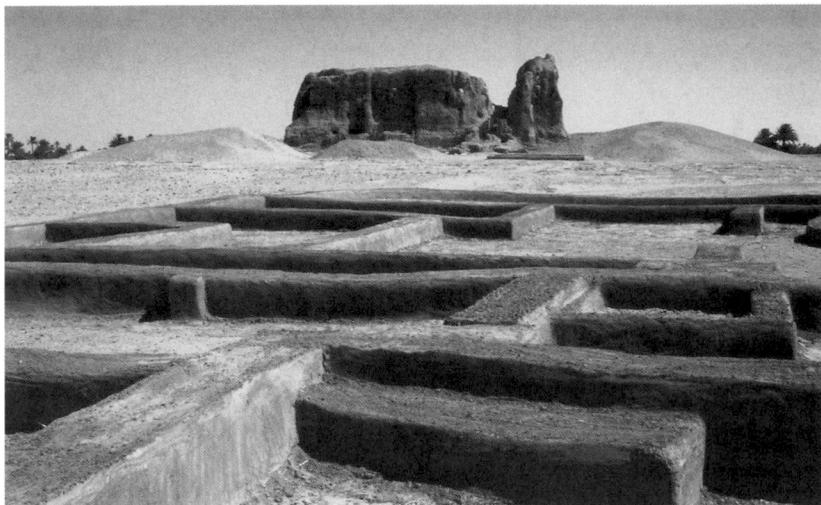

tion and centralised economy (fig. 4). In the centre stood the royal residence, a large temple and a circular building. The latter was erected of wood and mudbrick with a diameter of c. 16 metres, doubtless a royal audience hall: the monumental version of an African house type. The temple, occupying 1,400 square metres, also reflects indigenous developments and an independence from the influence of Egyptian architecture. It was a solid brick mass with a stairway leading up to a long, passage-like sanctuary with an altar of stone and with a further stairway to the temple roof. The great cemetery of Kerma east of the city contained royal burials of an enormous size (average diameter over 80 metres), with an earth mound covering a funerary chamber, storerooms and the burials of hundreds of sacrificed attendants. The kings and élite were buried on wooden beds with artefacts of partly Egyptian origin. The mound-covered royal tomb represents a monumental variant of an ancient tomb type of the Middle Nile Region and may be regarded ideologically as well as architecturally as a counterpart of the Egyptian royal pyramid. Two mortuary cult temples in the cemetery show the influence of Egyptian architecture and are, among other features of the city's culture, a testimony to the presence of Egyptians. Their ritual use differed greatly, however, from that of the Egyptian equivalents.

While techniques such as the manufacture of faience objects were adopted from Egypt, other industries had indigenous origins as, for example, the carving of ivory inlays for the footboards of the funerary beds. The small inlays (about 5–10 centimetres high) represented animals and mythical creatures. Some of the motifs indicate the spread of Egyptian popular beliefs (rather than the official cult of deities), and the animals and birds, though their rendering shows Egyptian influence, are all taken from African fauna. Copper daggers, knives and mirrors display unmistakably Nubian forms, and clay figurines of animals and human beings and zoomorphic pottery vessels reflect types of sculpture in the round which, remaining completely untouched by contemporary Egyptian art, seem to represent an unbroken tradition from prehistoric figures that are thought to have had religious significance (cat. 1.72–3).

The highest achievement of Kerma art was without question its distinctive pottery (cat. 1.77). The sophistication of the manufacturing technique of the extremely thin-walled, black-topped, red-polished vessels, the elegance of the tulip-formed, oval or long-spouted spherical vessels, the playfulness of cup types with ribbed or corrugated walls all point towards the origins of this industry in royal workshops. Though products of a court, they were nevertheless manufactured, as prestige objects, in considerable quantity. Thus being widely distributed, the fine Kerma pottery wares provide an example of the standardisation of a high level of technology and, what is equally significant, the cultural influence of a court art exerted through the medium of artefacts of general daily use.

Fig. 4 View of palatial remains at Kerma, with a large temple (western Deffufa) in the background

With the restoration of central power after the troubled times of the Second Intermediate period, Egypt set out to crush her wealthy rival at Kerma and regain control over the resources of Nubia. After almost a century of strong resistance by the Nubians, by the middle of the 15th century BC Egypt had conquered Nubia and established her domination as far south as the fourth Nile cataract. In the course of the next four centuries, Nubian culture was substantially Egyptianised, although important elements of native social structure and culture survived. In the shadow of the monumental Egyptian cult temples erected in Nubia during the New Kingdom (1550–1069 BC), native mortuary religion persisted and Nubian gods merged with Egyptian divinities.

The Egyptian domination collapsed in the early 11th century BC and a native kingdom grew from its ruins around the early 10th century BC. The ties of the new indigenous state with both the native traditions surviving under Egyptian domination and the Egyptianised vocabulary of government and cultural self-expression of the preceding centuries are obvious. By the 8th century BC the Nubian rulers were overlords of a vast kingdom extending from the first Nile cataract to the region of the sixth, organising it with the help of an ideology in which pharaonic kingship dogma and religious concepts were intertwined with native traditions. Taking advantage of a divided Egypt, the rulers of Nubia, encouraged by the powerful priesthood of the Theban Amun, conquered Egypt and succeeded in re-establishing her political unity for almost a whole century (*c.* 747–656 BC) during which they combined rule over their native land with rule over Egypt.

Nubian culture was Egyptianised; the language of expression was Egyptian, literally so in the case of monumental royal inscriptions and other texts, and stylistically in the case of architecture, sculpture, relief and the minor arts. New temples modelled on Egyptian New Kingdom buildings were erected in various centres, the most important being those dedicated to the Nubian counterpart of the Theban god Amun in the temple-towns centred around royal residence-temple compounds. A hieroglyphic inscription even informs us of the work of Egyptian sculptors from Memphis in one of the most spectacular temples (Kawa, Amun temple of King Taharqo). In their kingship ideology Nubian rulers amalgamated the concept of the king as maintainer of order in the cosmos and the world (related to the imperial past of Egypt) with a more recent interpretation of the king's dependence on the favour of the gods. Their new, eclectic kingship dogma also greatly influenced the attitude towards the themes and styles of earlier periods of Egyptian art.

While the period of Nubian rule over Egypt and the subsequent 'Napatan' period (*c.* 664 BC—the mid-4th century BC) represent indeed the most profoundly Egyptianised centuries of Nubian culture, it must be emphasised that the most intense Egyptianisation occurred during the century when Nubian kings ruled Egypt, and not in a period when Nubia was under the Egyptian thumb. This must be realised if the pattern of the interaction of the two cultures is to be understood; and it also has to be stressed that the adoption of the Egyptian cultural vocabulary served the articulation of a culture that made an organic unity of Nubian and Egyptian traditions and experiences.

Works of architecture, monumental sculpture and reliefs continued to be executed under the impact of the eclectic style that emerged in the 7th–6th centuries BC (cat. 1.77, 79; fig. 5). In the repertoire of themes, however, Nubian gods and the pictorial aspect of Nubian kingship came increasingly to the fore. Two periods of intense contact with Egypt – preceded by major military conflicts – in the early Ptolemaic period (in the 3rd century BC), and then at the beginning of Roman rule (from the late 1st century BC to the late 1st century AD), brought new stylistic influences and an influx of architects, sculptors and artisans. The influence of Hellenistic Alexandrian sculpture explains, however, only partly the creation of a water sanctuary complex at Meroe City in which Nubian renderings of classical sculptures were erected side by side with Egyptianised and Nubian divine figures. The iconographical programme of the water

Fig. 5 *Sphinx of King Taharqo,*
25th Dynasty, granite, height 40 cm
The British Museum, London, EA 1770

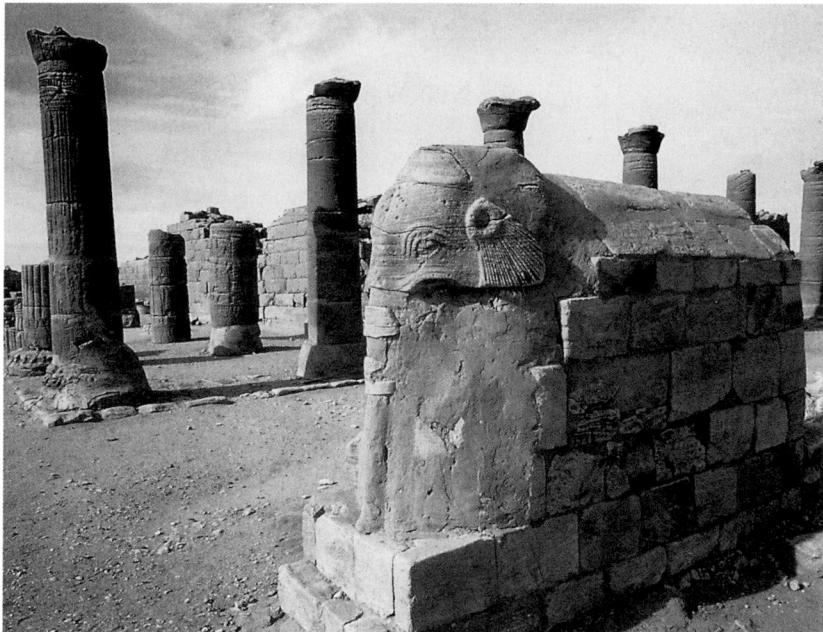

sanctuary sculptures was derived from the representation of the Ptolemaic king as Dionysus with his entourage and from the depiction of the Nubian royal ancestors as fertility gods. The apparently heterogeneous ensemble was unified by the closely related religious and political significance of its individual elements.

Between the 3rd and 1st centuries BC there was considerable urban development. In the walled enclosure of central Meroe City, in the southern part of the kingdom, palaces for the aristocracy and high priesthood were built. These had an Eastern Greek-type ground-plan, unknown in Egypt (except for Alexandria), and were decorated with polychrome faience tiles and Hellenistic architectural elements. Initially in the 2nd century BC, and then in the 1st–2nd centuries AD, monumental avenues were opened through the city to connect the royal residence with the temples. The later avenue was flanked by smaller sanctuaries of different, partly traditionally Nubian, partly Ptolemaic-Egyptian, types. Other urban settlements, presumably of a similarly planned character, await scientific excavation. A desert palace of the kings of Meroe at Musawwarat es Sufra, going back to 5th-century BC origins, was decorated with monumental architectural sculptures of unparalleled types, displaying Nubian artistic invention at its apogee: columns with relief scenes supported by figures of lions and elephants, walls terminating in monumental elephant figures (fig. 6), bold relief images of divinities flanking doors, and sculptured protomes of divine triads decorating door lintels (cat. 1.80). Audience halls and cult chapels in the vast palace were erected on high podia and interconnected by ramps and long corridors. While the architectural plan and some of the details betray a remote Egyptian influence, the whole of the ensemble reflects one of the remarkable moments in the development of Nubian art when a special function – in this case the desert palace of the ruler who was identified with the Nubian hunter and warrior gods – generated new structural and formal solutions.

Meroitic vase painting also emerged as an art form during this period. In the early phase (2nd–1st centuries BC) Nubian potters worked under the influence of Upper Egyptian workshops, which in turn absorbed inspirations derived from Hellenistic-style luxury wares from Alexandria. In the course of the 1st century BC and the 1st century AD, however, Nubian artists developed a variety of painting styles based on a bold interpretation of traditional Nubian motifs – mostly religious symbols – and Hellenistic patterns. The finely executed decoration usually covers the whole surface of the superbly wheel-turned vessel; and the polychromy of the painting reflects a genuine development, independent of any Egyptian

Fig. 6 Remains of a royal building in the 'Great Enclosure' at Musawwarat es Sufra, with a statue of an elephant in the foreground

influence. Workshop styles and even individual hands are clearly distinguishable in the surviving large ceramics traded originally to all parts of Nubia and reflecting, as in Kerma pottery, the impact of court art on the taste of the whole population.

The contribution of Roman Egyptian art is manifest in the fine pottery produced from the late 1st century BC, mainly at the royal manufactories at Meroe City, in which Nubian technology and Eastern and Western Mediterranean vessel shapes and decorations were united with the traditional late Ptolemaic Egyptian decorative style to form a homogeneous and unmistakably Nubian ceramic art. As in earlier encounters with Egyptian art, Nubia used borrowed forms and styles in order to articulate indigenous discoveries and concepts. The same sort of cultural interaction continued to take place in the course of the subsequent centuries when Nubia received the remote echo of Late Antique art and also when, after the Christianisation of the country in the 6th century AD, churches were erected all over Nubia. These are richly decorated with frescoes and display again the results of a fruitful amalgamation of Coptic Egyptian and Byzantine models with Nubian iconography and the functional demands of Nubian church liturgy.

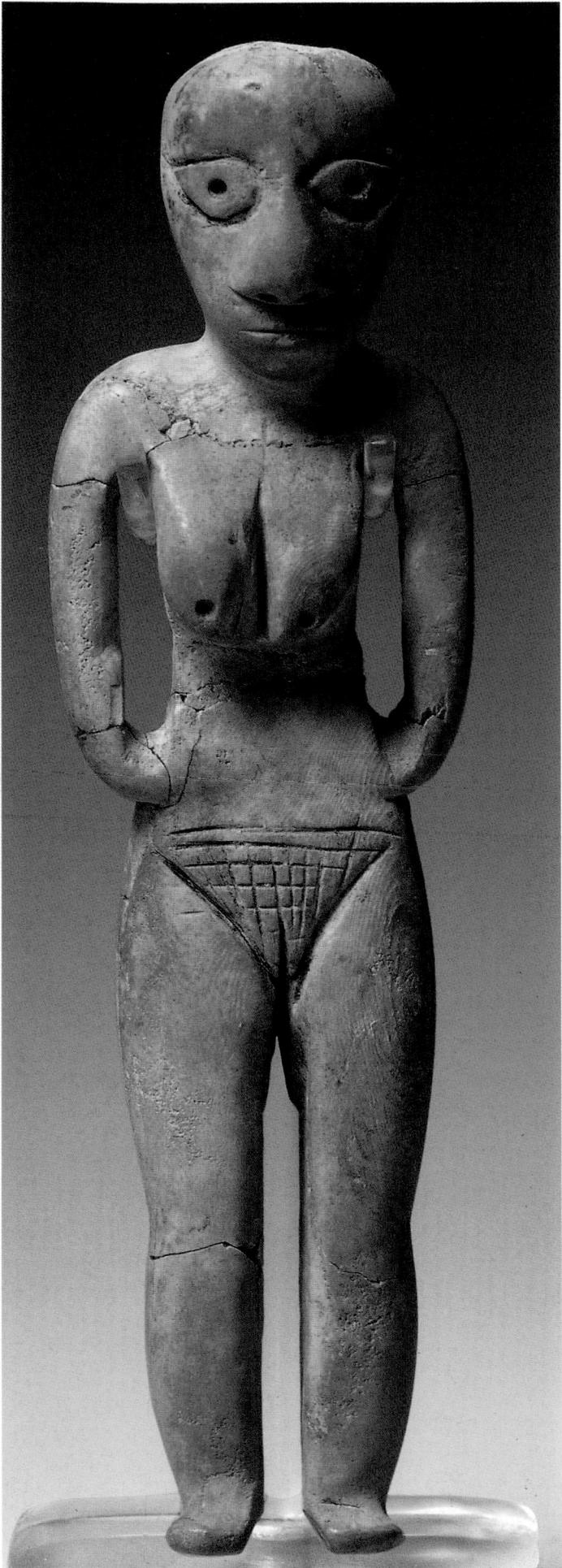

1.1

Female figurine

Egypt

predynastic, Badarian, c. 4500–4000 BC
hippopotamus ivory

14.5 x 4 cm

The Trustees of the British Museum,
London, EA. 59648

The remarkable face with its huge almond-shaped eyes, large triangular nose and small slit of a mouth belongs to one of the oldest human figures in the round known from Egypt. The great attention given to details and the evocative, if somewhat robust, modelling show that the Badarians, the first settled inhabitants of the Nile Valley, were already highly skilled craftsmen, adept in the use of carving, incision, drilling and polishing.

Within the disproportionately large, bald and slightly off-centre head, details of the face have been indicated with care: the incised eyes have drilled pupils; the modelled nose has large drilled nostrils; the thin lips and small chin are well realised. The body is skilfully smoothed and polished. From the bent and slightly sloping shoulders, two separately carved arms hang down the side of the body and merge with the hips without any indication of hands. Each leg is carved separately and ends in a small out-turned foot.

Long pendulous breasts, set unequally with a crudely incised line dividing them, and the wide incised and cross-hatched pubic triangle with a deep vertical incision for the vulva serve to indicate the sex. Unlike many female statuettes of the predynastic period, these elements are not accompanied by other attributes of the idealised female anatomy. The somewhat flattened buttocks protrude only slightly, perhaps owing to the nature of the medium; nevertheless, the exclusively feminine lumbar dimples have been carefully placed at the base of the back and expertly drilled. It is possible that the drilled nipples, like the eyes and the pupils, may originally have been inlaid with coloured paste or shell.

The statuette was found in a heavily plundered grave which contained in addition only a polishing pebble and some beads, but no remnant of the tomb owner's body. As a result, its purpose or function, whether as representative of the deceased, as servant or as goddess, remains uncertain. *RFF*

Provenance: 1924–5, Badari grave 5107, excavated by Guy Brunton

Exhibition: London 1962

Bibliography: Brunton and Caton-Thompson, 1928, pp. 7, 29, pl. xxiv.2, xxv; Petrie, 1939, pl. iv.46; Vandier, 1952, pp. 221–2, fig. 141; Ucko, 1968, p. 70, fig. 2; Spencer, 1993, p. 25, fig. 9

Mother and child

Egypt
late predynastic/Naqada III, c. 3100–3000 BC
ivory
h. 7.5 cm
Staatliche Museen zu Berlin, Preussischer Kulturbesitz, Ägyptisches Museum und Papyrussammlung, 14441

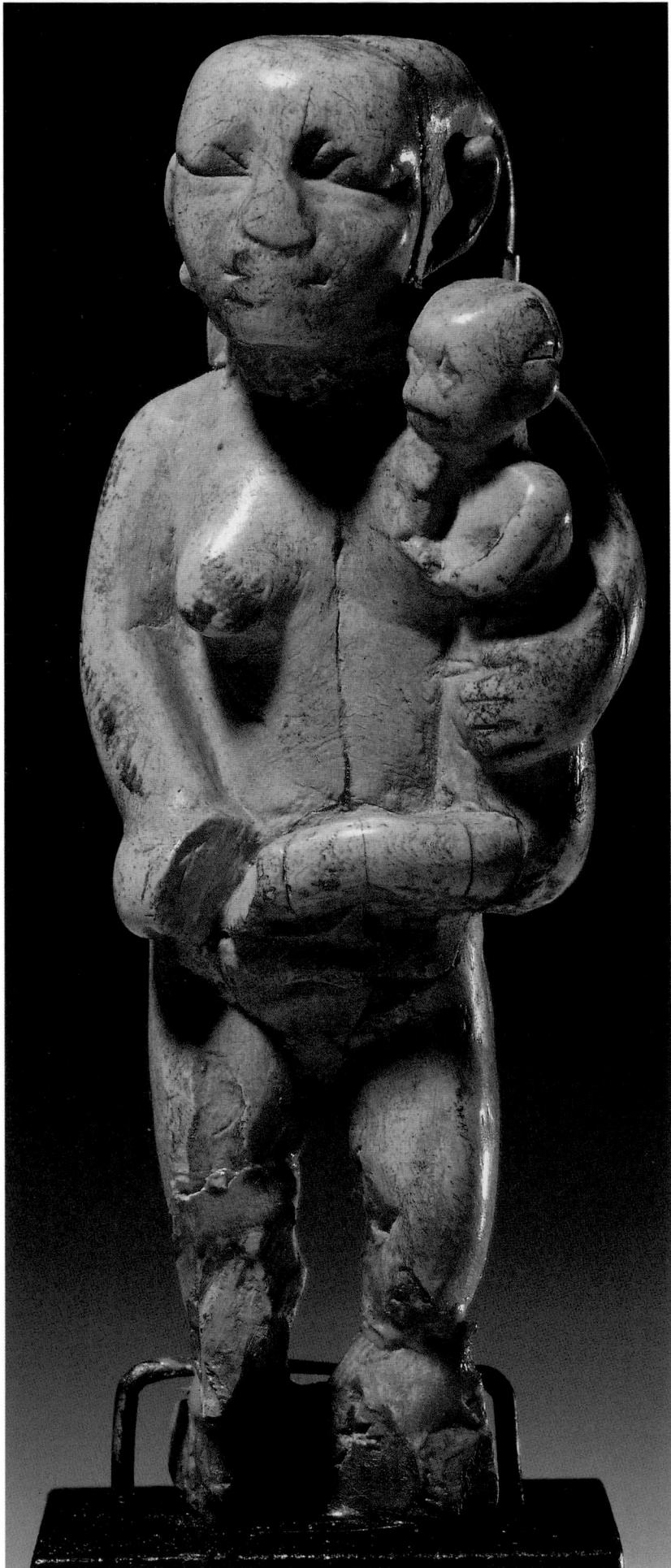

At different epochs Egyptian tombs contained as part of the funerary equipment small figurines of naked women, often called 'concubines of the dead'. No doubt they were a guarantee of fertility in the afterlife, since many of them are combined with figures of children. This ivory figurine is one of the early examples of this type, showing a standing naked woman. Her left arm holds a baby sitting on her left hip, its legs clasping the body of the mother. The only iconographic detail is the long hair falling on her shoulders and back, leaving the forehead completely bald. This coiffure is typical of pregnant women and mothers.

Notwithstanding the lively posture of this statuette, the principles of Egyptian art are already applied: frontality, axial symmetry, expressionistic exaggeration of the essential part of the motif. One key element of the plasticity and the volume of this statuette must not be overlooked – the rectangular basis, partly preserved at the back of the sculpture. It creates an imaginary, virtual space around the figure, defines its orientation and makes it a part of the cosmic order.
DW

Provenance: 1900, acquired by the museum

Exhibition: Berlin 1990, no. 5b

Bibliography: Smith, 1949, p. 3, fig. 4; Wolf, 1957, p. 53, fig. 18

Female figurine

Egypt

predynastic, Badarian, c. 4500–4000 BC

fired clay, ochre wash

11 x 4.6 cm

The Trustees of the British Museum,
London, EA. 5964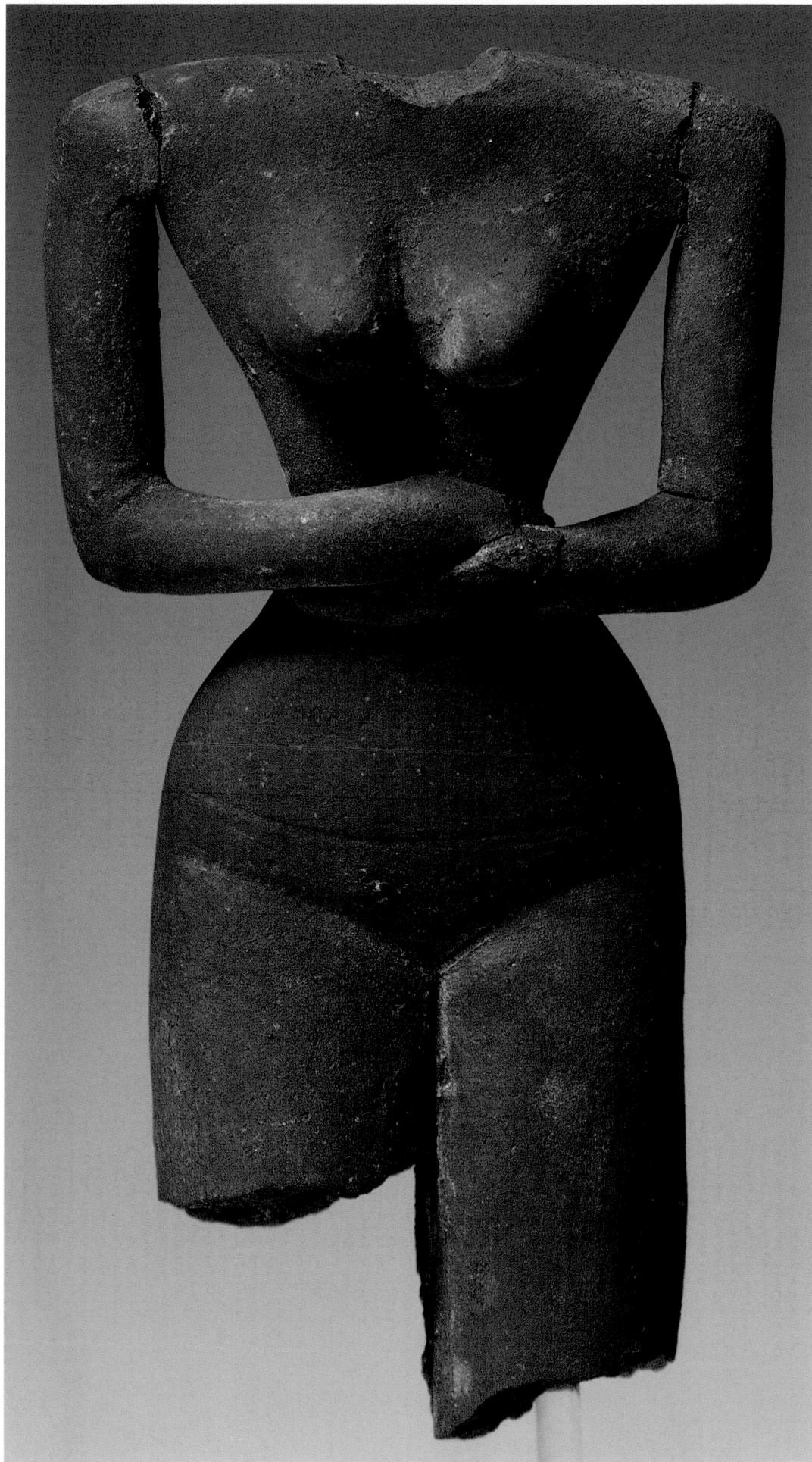

This charming figure is not only an exceptionally fine example of the Egyptian ideal of feminine beauty, but also one of the earliest. Complete except for the head and the bottom of the legs, the figurine was found in the fill of a badly plundered grave at Badari in conjunction with some fine Badarian rippled pottery. Thorough sifting of the contents of the tomb and a considerable area around it failed to produce any trace of the head.

The separately modelled arms bend at the elbow and cross over the abdomen, the right hand resting on the palm of the left. The wide pubic triangle is indicated by shallow incised lines across the belly and over the tops of the legs. The separately formed legs are divided by a deeply incised line and on the reverse an incision also separates the protruding buttocks. The suggestion that the exaggeration of the posterior and thighs is a representation of steatopygia, a condition which leads to excessive storage of fat in the buttocks, seems unfounded, as the emphasis of that area is better explained in terms of the balance of the upper and lower parts of the body.

The five human figurines datable to the Badarian period are the earliest three-dimensional human representations in the Egyptian Nile Valley. All are female figures and this and the ivory figurine (cat. 1.1) are two of the most outstanding examples. Although the female form is approached in a different manner in each case, the experimentation of the Badarian artists resulted in the full range of prototypes for later predynastic and Early Dynastic female representation. In accordance with the interests of their time, earlier scholars sought to identify each type as an accurate reflection of the different strains of humanity populating prehistoric Egypt. For example, Petrie distinguished an advanced energetic type in the ivory figurine (cat. 1.1), which he believed represented the progressive element in predynastic society, a heavy forbidding type, and a steatopygous type in this figure which he considered to reflect Egypt's earlier, less-developed, native population. The apparent evidence of steatopygeity in this and the other figurines is now rejected. *RFF*

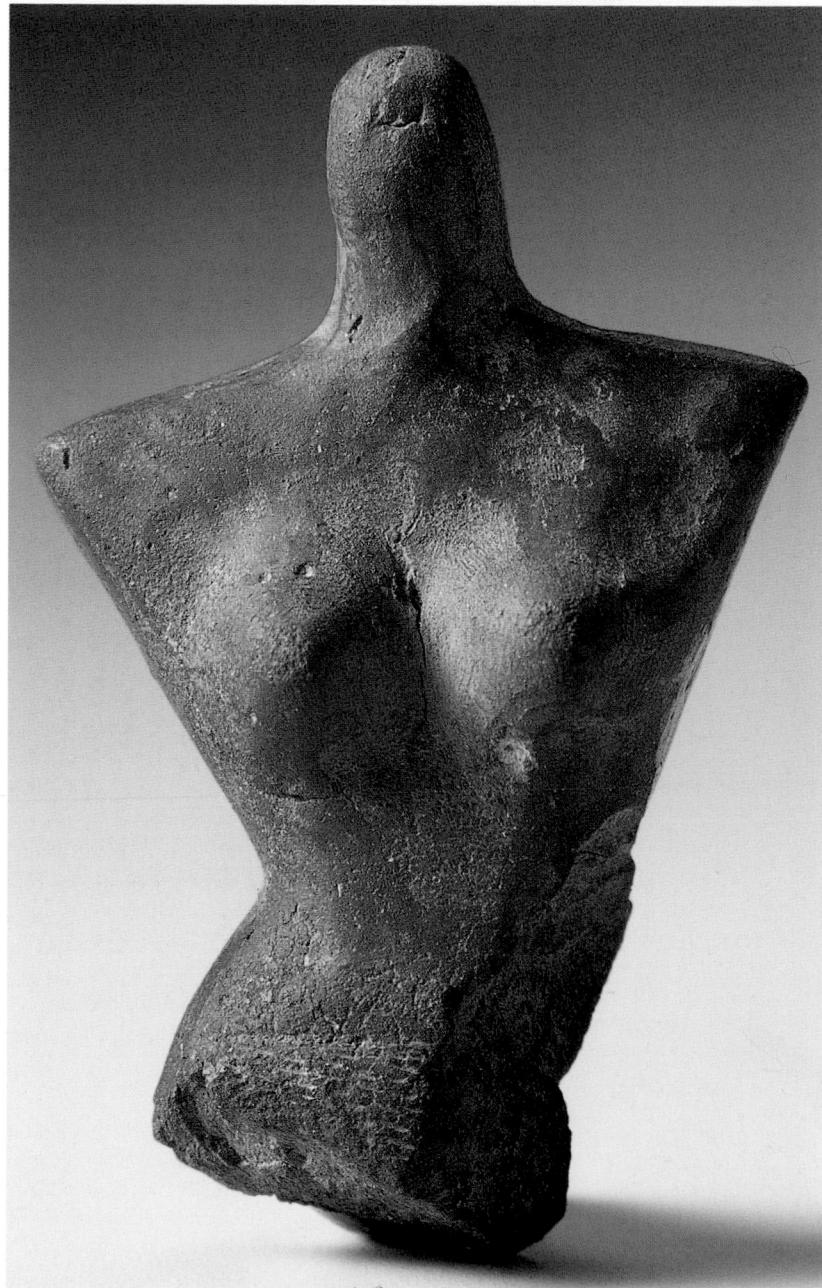

Provenance: 1924–5, Badari grave 5227, excavated by Guy Brunton

Bibliography: Brunton and Caton-Thompson, 1928, pp. 9, 29, pls xxiv.1, xxv.6–7; Petrie, 1939, pl. iv.47; Vandier, 1952, p. 222, fig. 142; Ucko, 1968, p. 69, fig. 1; Spencer, 1993, p. 25, fig. 10

1.4

Female torso

Egypt

predynastic, Gerzean (Naqada II),
c. 3500–3300 BC
fired Nile silt
6.6 x 4.4 x 2.15 cm

Petrie Museum of Egyptian Archaeology,
University College, London, UC. 9601

This Nile silt pottery torso is a fragment of a female figurine, fired a brown-patched red, from a predynastic cemetery at Qua in Middle Egypt. Up to 1974 its ancient authenticity was doubted. Although not as accurate as might be hoped, the thermoluminescence date obtained then of 5020–2835 BC at least confirmed its antiquity.

The upper part of the torso remains with a featureless head merely drawn up from the clay and laterally pinched; the fingermarks left by this operation can still be seen. There are no arms and the shoulders are cut off sharply, as may be seen in other predynastic figurines (but in this case the left shoulder is raised). As the rest of the body is so slender and shapely, the tilt to the right gives it an arresting stance while accentuating the small waist. The upper chest slopes naturally down to the carefully modelled breasts, which are in proportion to the whole. The body is broken below the pinhole navel, where the horizontal incised lines indicating the pubic triangle can just be seen.

The very truncation of the form adds to its charm, which might have been less attractive to modern eyes had it been complete with its blocked, rounded-off legs, normal in the period. In the centre of the back there is an incised design like a fan, its meaning unknown, which indicates one of the tattoos that were employed at this time. Whether it was a mark of ownership or locality, or can be given the sort of religious interpretation so beloved of archaeologists, is uncertain. It is entirely possible that it was made by a female potter at the dawn of the Gerzean age who knew her craft and her sex, as well as the mores of her time. *BA*

Provenance: 1922–5, found by Guy Brunton in cemetery 23/100 at Qua and Badari

Exhibition: Marseilles 1990

Bibliography: Brunton, 1927, pls XXXIV, 6, LIII, 48; Ucko and Hodges, 1963, pp. 219–20; Ucko, 1968, p. 106; Adams, 1988, fig. 38, p. 56

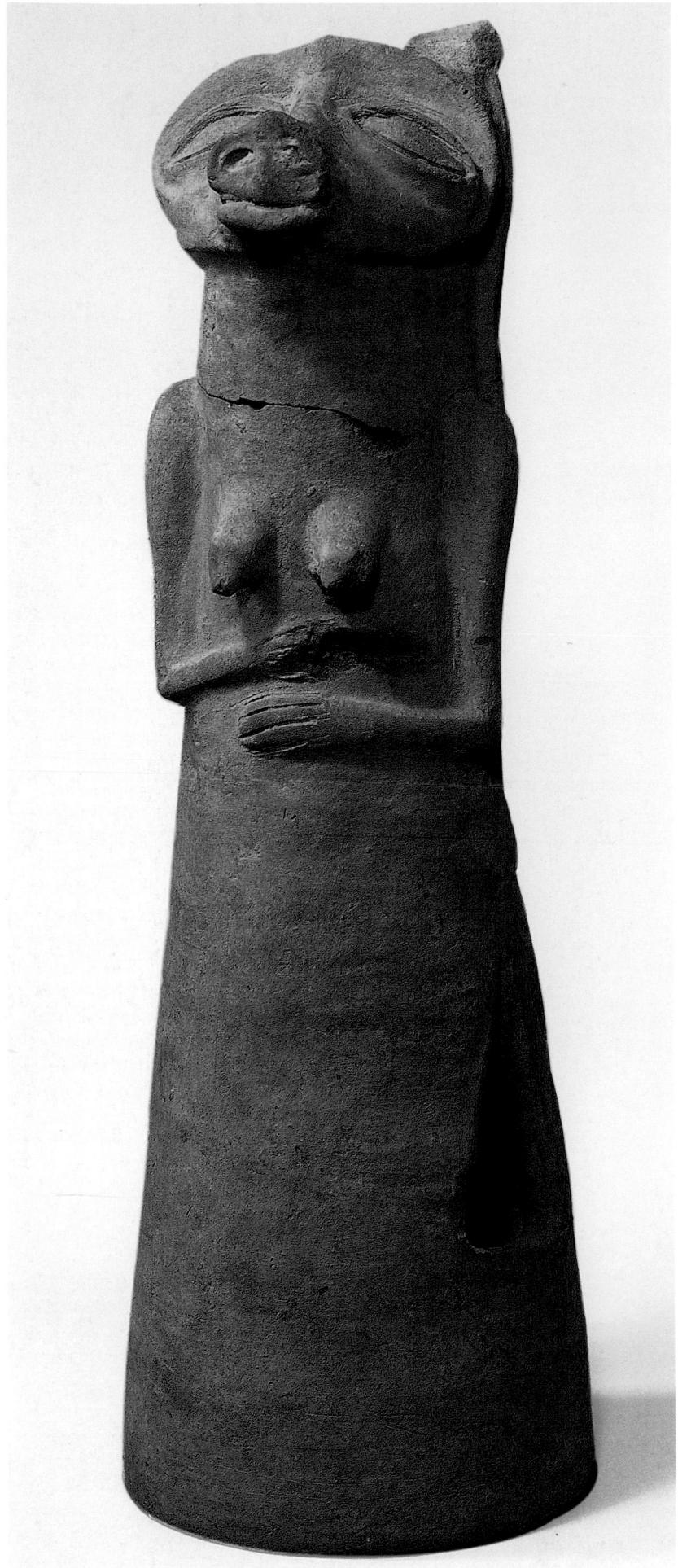

1.5

Pig deity

Egypt

predynastic period, end of
4th millennium BC
fired clay
h. 56 cmStaatliche Museen zu Berlin, Preussischer
Kulturbesitz, Ägyptisches Museum und
Papyrussammlung, 1/69

Terracotta sculptures are rare in Egyptian art except during the prehistoric period in the second half of the 4th millennium BC. This pig deity shows close similarities to a group of sculptures dated to late predynastic times (3200–3000 BC). Its unusual conical lower part resembles the offering stands of the Middle Kingdom (2050–1759 BC), but thermoluminescence tests have confirmed the early date of the sculpture.

The animal face is reduced to the essential, vital organs such as mouth and eyes. The female human body is conveyed by the simplified formula of two breasts. The arms are placed horizontally in front of the chest – a typical gesture of early pharaonic sculpture. The Egyptian idea of god finds its most impressive artistic expression in these mixed figures combining human and animal elements to create a new being outside the normal world.

Egyptian religious iconography of the historical period ignores the pig almost completely. Its meaning is mostly negative; as one of the forms of the god Seth it is the symbol of evil. A positive aspect can be found in rare pictures of the sky goddess as a pig. In daily life the pig is attested as a domestic animal through all periods, but it ranks among the least popular. The relatively large size of this pig deity signals its religious role in late prehistoric and predynastic times, before the decline of the pig's importance in religion and mythology. DW

Exhibition: Berlin 1989, no. 3

1.6a

Bearded male figure

Egypt

predynastic, Amratian-Gerzean
(Naqada I-IIb), c. 3800–3400 BC
breccia
50 x 20 x 20 cm
Musée Guimet, Lyons, 90000171

1.6b

Bearded male figure

Egypt

predynastic, Amratian-Gerzean
(Naqada I-IIb), c. 3800–3400 BC
schist
32 x 7 x 5 cm
Musée Guimet, Lyons, 90000172

Exceptional in their material, dimensions and economy of form, these two stone statuettes are clearly derived from a mysterious class of object known as 'tusks'. Adopting the form of the hippopotamus canine or incisor after which they were carved, the slender cylindrical tusks were often plain except for a groove or perforation to ensure secure attachment to a leather thong. Only occasionally were they decorated at the top to represent a man with a pointed beard, either schematically with crude incision, as seen on the dramatic dark schist statuette (cat. 1.6b), or more realistically with fine modelling, as seen on the white example (cat. 1.6a). The long cylindrical body always remained plain and without any indication of the limbs.

Such figures are almost always found in pairs, one solid and the other hollow; a magical or fertility function has been suggested. Their placement in intact predynastic graves indicates that they were not worn as personal adornment, but were perhaps suspended as protection for a house, boat or other personal property, including a grave. Derived from these tusks and apparently serving a similar purpose is another class of object known as 'tags'. These small amuletic charms, made of ivory, bone, slate, limestone or alabaster, which took the form of cylindrical or flat 'imitation tusks' or rectangular plaques surmounted by a bearded head, seem to have been inspired by the same beliefs that created the long tradition of bearded figures.

It is unknown whether the two statuettes exhibited here would have formed a dramatically contrasting pair. The wide shoulders of cat. 1.6a

suggest that the form of contemporary amuletic tags also played a part in its unique conception. Like many human-headed charms, the head is bald, the ears are pronounced and the body is decorated, although the complete perforation of the body as a decorative unit is unique. The characteristic perforation or knob by which the tusks were suspended is missing, and both statuettes, it seems, may have been meant to rest on their bases and as such may be early precursors of the bearded figure of MacGregor Man (cat. 1.22). *RFF*

Provenance: said to have come from Gebelein

Exhibition: Marseilles 1990, nos 359 and 358

Bibliography: Vandier, 1952, pp. 416–21; Baumgartel, 1960; Needler, 1984, pp. 346–7; Pierini, in Marseilles 1990

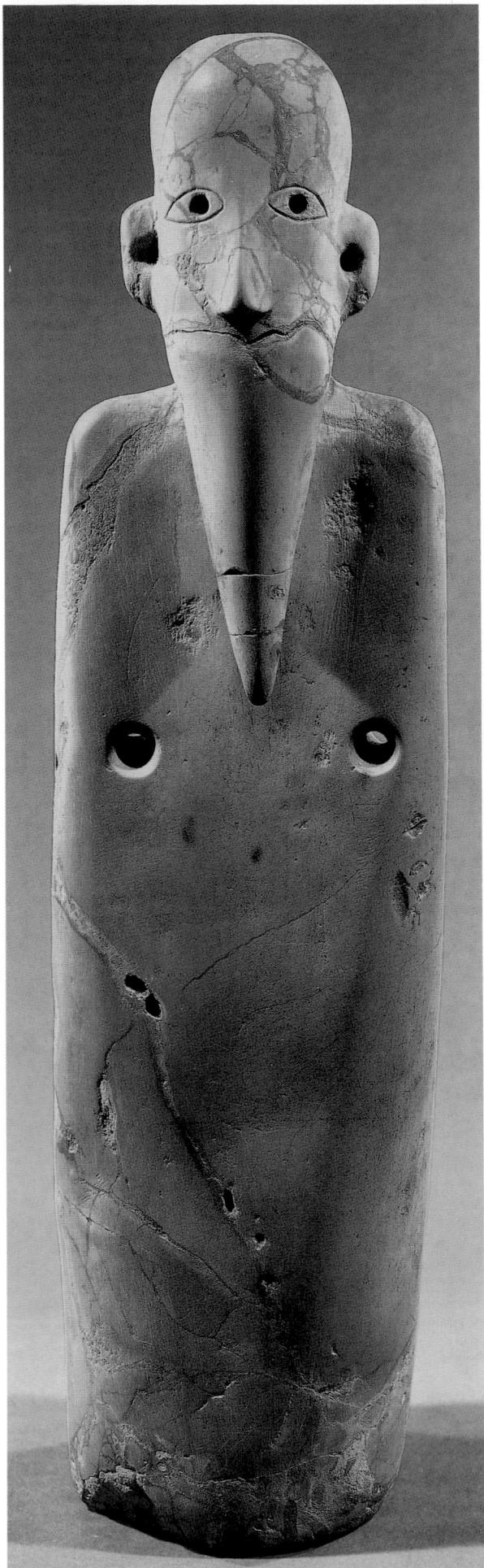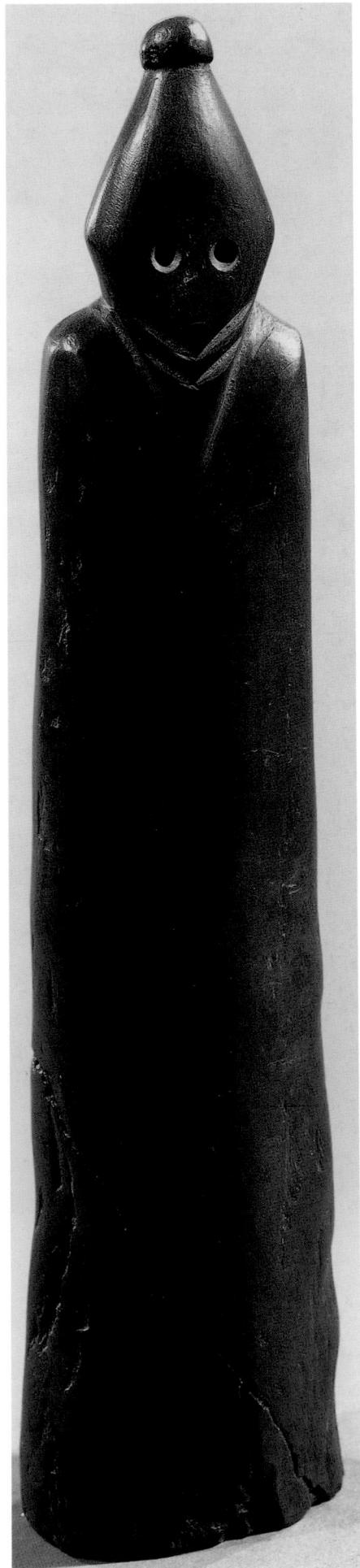

1.7

Vessel with rippled decoration

Egypt
predynastic, Badarian, c. 4500–4000 BC
fire Nile silt
h. 39 cm; diam. 24 cm
(wall thickness: 0.04 cm)
The Trustees of the British Museum,
London, EA. 59634

The earliest of the well-attested predynastic cultures in the Egyptian Nile Valley is known as the Badarian after the Middle Egyptian village of el-Badari in whose vicinity most of the evidence has been retrieved. The most distinctive product of this early culture is its pottery. Characteristic are simple but elegant bowls and canisters of exceptional thinness with a combed or 'rippled' surface. It was this unique peculiarity which led to the discovery of the Badarian culture in 1923. The finest efforts of the Badarian potters with respect to the care taken in

thinning the wall, refining the clay and enhancing the vessel's surface were never equalled in any subsequent period in Egypt, and this vessel is an excellent example of their abilities.

Like all early predynastic pottery, the Badarian wares are entirely hand made without any traces of turning. Careful polishing has obliterated any marks that might indicate how the vessel was manufactured. In the case of such a large pot, it is likely that coils of highly refined clay were added to a moulded base to create walls that were beaten to remarkable thinness and hardness through the use of a paddle and anvil. The distinctive surface decoration was produced by running a serrated tool or comb, or in this case perhaps a fish spine, diagonally across the damp surface of the unfired pot. As is usually the case, the combing runs down to the left, while the strokes of the burnishing

pebble run perpendicular to it so as to obscure and smooth out the grooves and create a pleasing, spiralling, rippled effect. The rim and interior were intentionally blackened by placing the vessel top down in a bed of smoke-producing matter (dung, straw or ashes) either during or after firing. The carbon in the smoke and a lack of oxygen together worked to transform the iron oxides in the clay and the ochreous coating into an almost metallic black.

Jars of this size are extremely rare. Their thin walls made them very fragile and few have survived the collapse of the shallow graves into which they were placed as offerings. This pot, pieced together from fragments found *in situ* must have been a prized possession. This is also suggested by the ancient repair visible at the base. Many fine Badarian vessels show evidence of damage and repair before their deposition in the grave. The base, which cracked in ancient times, was repaired by drilling a series of holes on either side of the break. A leather thong would then have been threaded through the holes to bind the pieces together. RFF

Provenance: 1924–5, Badari grave 5104,
excavated by Guy Brunton

Bibliography: Brunton and Caton-Thompson, 1928, p. 7, pl. xiv.10F

1.8

Bowl with hippopotami

Egypt
predynastic, Amratian (Naqada I),
c. 4000–3600 BC
fired Nile silt
h. 6.8 cm; diam. 19.4 cm
Museum of Fine Arts, Boston
Harvard-Boston Expedition, 11.312

Egypt's earliest pottery is among its finest, and this bowl offers a splendid example. Shaped by the coil method from local Nile clay, it was subsequently coated with a thin clay wash (known as slip) and then painted on the interior only with a white line decoration. This type of white linear decoration on pottery is characteristic of an early phase of predynastic development known as the Amratian or Naqada I period. Although these vessels share the geometric style of decoration, most are unique in their design and layout.

Not only decorative, this bowl is also 'readable'. It features an abstract landscape of Upper Egypt, the area in which it was found. The rosette in the centre represents the Nile and the marshes beyond its banks, inhabited by hippopotami. High cliffs, represented by continuous zigzag lines, define the limit of visibility. Profile and aerial views are thereby combined into a balanced composition. Although Egyptian art was in its infancy when this bowl was

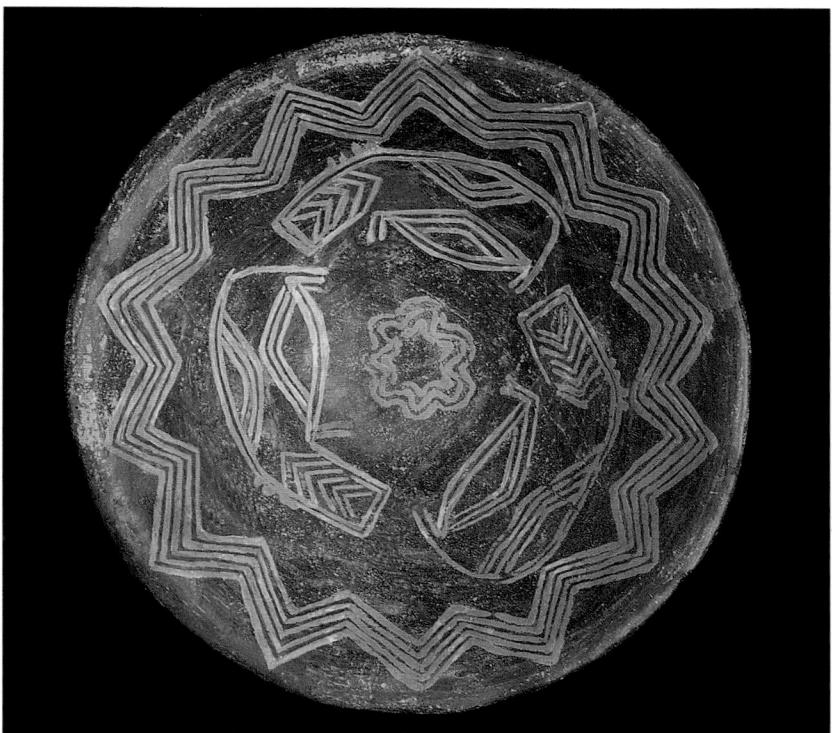

made, some of its canons are already apparent. For example, the hippopotami are outlined in profile and their salient aspects – their powerful mouths and swollen bodies – are emphasised. Four bumps on top of the heads represent two eyes and two ears. Although in fact only one of each would have been visible, the depiction of both was apparently deemed necessary.

Hippopotamus amphibius found a home in Egypt until the beginning of the 19th century. Their rotund forms led to their deification as Taweret, goddess of childbirth, and their brute strength caused them to be identified with the forces of evil and chaos which had to be overcome so that order (*ma'at*) might prevail. REF

Provenance: 1911, excavated at Mesaeed
Bibliography: Bothmer, 1948; Berlin 1974;
Finkenstaedt, 1980

decoration is exceptional and the vase under discussion is the only published example decorated over its entire surface. However, engravings are well attested for the predynastic period. Numerous rock drawings of that date can be found in southern Egypt and Nubia. The style of the decorated vase is equally well attested. The simplified but naturalistic contours allow the identification of the animals, but the bodies are filled with motifs which show no relation to reality. These motifs were also used for animal representations on contemporaneous White Cross-lined vases, as well as a number of rock drawings.

One can recognise three superimposed rows of animals. Their identification is primarily possible from the shape of the horns. The lower register shows four gazelles. The middle register contains four large animals and a far smaller fifth, placed between the horns of one of the former. All of them can be identified either as oryx or Nubian ibex. In view of the small tail the ibex is to be preferred. The upper register shows more variety. One can recognise a gazelle, a hare and two dogs. The last two are especially interesting because they have collars and are therefore evidently domesticated. Similar dogs, with the profile of a greyhound, a long head with pointed ears and a short upward pointing tail, are well attested among pharaonic representations of hounds. In contrast to the two other registers, the animals of the upper register are represented running. One may therefore consider the dogs as hunting the hare and the gazelle and, by extension, all the animals on the vase. Like the ibex, the hare and the gazelle are desert animals. Between the legs of one of the gazelles in the lower register, three triangles can be seen. These occur frequently on decorated predynastic vases and are generally taken to symbolise mountains and the Egyptian desert. The whole can be interpreted as a scene of hunting in the desert, without the human hunters being depicted.

Finally, the question remains as to why this scene occurs on a predynastic vessel. Hunting in the desert figures regularly in Old Kingdom mastabas, as one of the activities the deceased wished to repeat in the hereafter. A similar funerary purpose might be

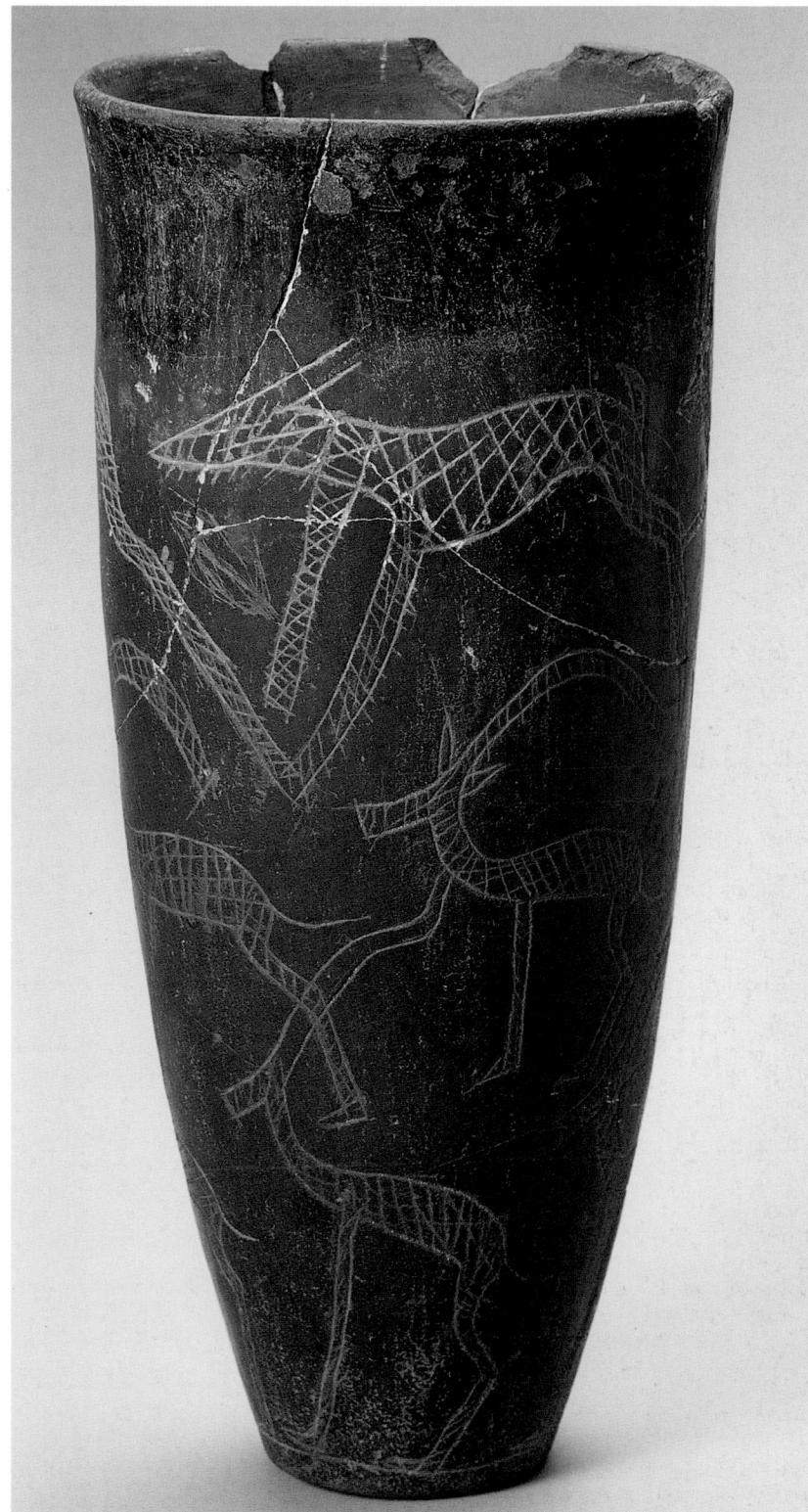

1.9

Vase decorated with hunting scene

Egypt
predynastic, Amratian (Naqada Ic–IIa),
c. 3800–3600 BC
fired Nile silt
h. 35.1 cm; diam. 15 cm
Musées Royaux d'Art et d'Histoire,
Brussels, E. 2631

Among the late Neolithic cultures of predynastic Egypt, the south Egyptian Naqada culture (4th millennium BC) is the best documented. Black-topped pottery is the most diagnostic characteristic of the period from Naqada I to early Naqada II. These vessels were polished before firing. The black and red contrast was most probably obtained by placing the vessels upside down in the kiln and covering them partially with ashes. The decoration of the present vase was carved after firing. Incised

suggested for the predynastic period, but unfortunately the provenance of the vase is unknown and its funerary context cannot be proven. A more complex socio-religious explanation may also be admissible. In this case the dogs are to be considered symbols of power or even of kingship, while the rows of animals could reflect the maintenance of social order through this power. SH

Provenance: 1908, purchased Cairo
Exhibition: Marseilles 1990, no. 289
Bibliography: Capart, 1909; Balty et al., 1988, p. 12; Hendrickx, 1992; Hendrickx, 1994, pp. 18–191.9

1.10

Vase decorated with victory scene

Egypt

predynastic, Amratian (Naqada Ic-IIa),
c. 3800–3600 BC
fired Nile silt
h. 28.6 cm; diam. 11.8 cm
Musées Royaux d'Art et d'Histoire,
Brussels, E. 2631

Red polished pottery with painted white decoration is characteristic of the early part of the Naqada culture. Only a few of such vessels show elaborate figurative decoration and the present vase is one of the most important of the type. Eight figures can be distinguished, all of them probably male. The neck of the vase is decorated with seven horizontal bands. From an eighth band hangs a row of drop-lines and two other enigmatic objects. The two largest figures raise their arms above their heads, with their palms turned inwards. This gesture is common in the Naqada II period, but is used mainly for female figures, whether fertility goddesses, concubines for the dead, mourning figures or representations of the *ka*, the 'life force'. On their heads are branches and small bulges probably indicating the coiffure. The two

figures wear large penis gourds, a feature known from contemporary sculpture (cf. cat. 1.20a–b, 22) and which could also be a symbol of power.

Of the six remaining figures, four are roped together two by two at their neck, the rope held by one of the larger figures. The other two stand below the smaller of the two enigmatic objects. The first four figures seem to be captives; their arms are not depicted, perhaps indicating that they are trussed behind their backs. They seem to have rather long dishevelled hair (or blood streaming from their heads), and no penis gourds.

The larger of the enigmatic objects may represent a palm tree. The smaller object could be an animal hide, functioning as a standard or symbol representing a god or a geographic region. Because of the ropes connecting the figures, there can be little doubt that the decoration represents a single scene and that the 'palm tree' occupies an equivalent place to the large figures, each of the three separated from the other by two smaller ones; similarity in shape between the figures with raised arms and the 'palm tree' is also discernible. The scene most probably represents a victory in which military, political and religious symbols are combined. SH

Provenance: 1909, bought Luxor

Exhibition: Marseilles 1990, no. 302

Bibliography: Scharff, 1929; Kantor, 1944, fig. 6F; Baumgartel, 1955, fig 14; Asselberghs, 1961, p. 302; Williams, 1988, pp. 47–8; Balty et al., 1988, p. 12; Hendrickx, 1994, pp. 22–3

The ostrich is the first species of bird for which there is physical and pictorial evidence in Egypt. Its distinct form can be recognised from rock drawings carved by predynastic hunters on the cliffs lining the Nile Valley and in the deserts of Upper Egypt and Lower Nubia. As the ostrich is often depicted beside or as part of a spirited chase of desert fauna by a hunter, it is not surprising to find desert animals, perhaps in an abbreviated chase scene, decorating an ostrich egg. The simple lines are filled with a black pigment and depict two elegant quadrupeds with twisted or lyrate horns and short tails, perhaps intended to be gazelles or hartebeest. The diagonal placement and the shortened forelegs suggest that the animals are in flight. The zigzag bands incised on the bodies are decorative features common to early predynastic animal representation, whether painted on White Cross-line pottery or incised on pots and other ostrich eggs; probably they do not represent leashes.

Throughout historic times, the ostrich was valued for both its plumage and its eggs. The eggs are so large that a single one can feed as many as eight people. In the predynastic period, once emptied or blown, the shells were carved into beads and inlays. More rarely, intact eggshells were used as light and durable containers. Excavations have revealed only a few ostrich eggs or clay models of them in graves of the predynastic period in Upper Egypt. Many are plain, some are painted with white spots or black zigzag bands in imitation of woven holders, but only a very few excavated pieces are incised. More common in the graves and settlements of the A-Group in Nubia, ostrich eggs have been found most frequently in the graves of children. This custom does not appear to have been current in Egypt, where ostrich eggs are found only in the most wealthy of predynastic tombs. RFF

Provenance: 1895, Naqada tomb 1480, excavated by W. M. Flinders Petrie

Bibliography: Petrie and Quibell, 1896, p. 28; Capart, 1905, p. 39, fig. 16; Kantor, 1948, pp. 46–51; Houlihan and Goodman, 1986, pp. 1–5; Payne, 1993, p. 253, fig. 85, no. 2104

1.11

Decorated ostrich egg

Egypt

predynastic, Gerzean (Naqada IIa),
c. 3600–3400 BC
ostrich egg
h. 15 cm; diam. 13.4 cm
The Visitors of the Ashmolean Museum,
Oxford, 1895.990

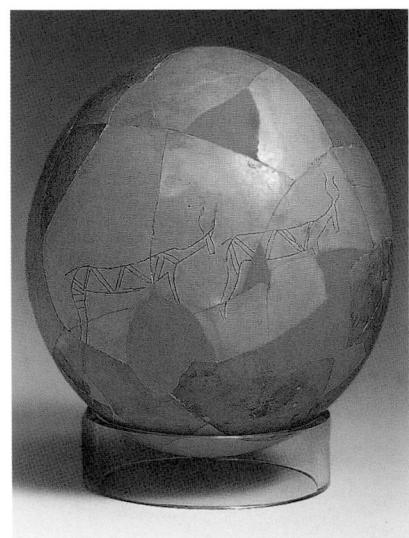

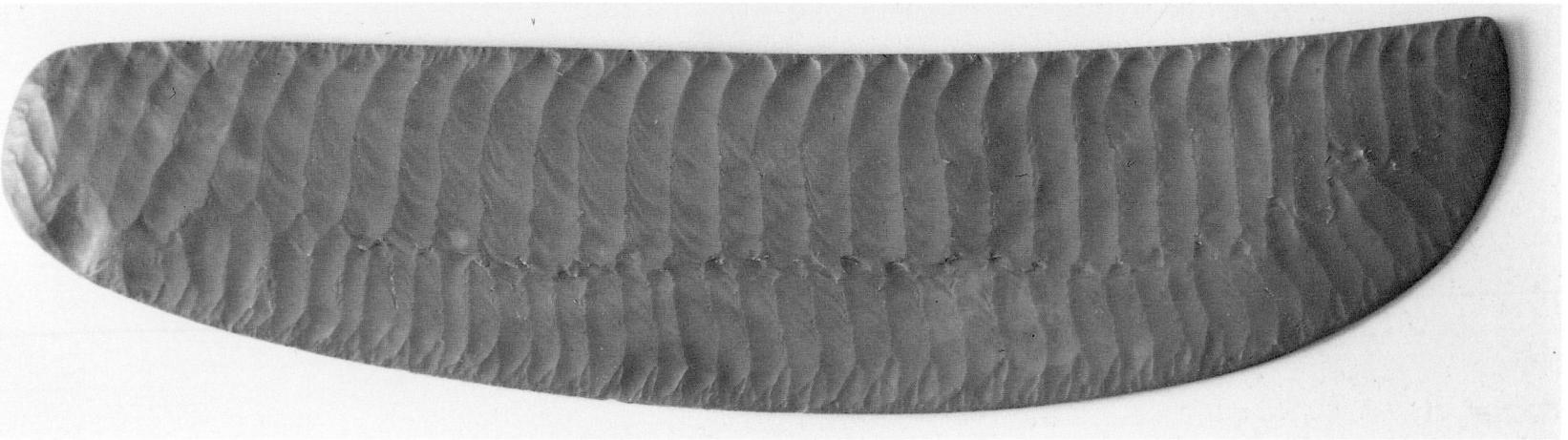

1.12a

Ripple-flaked knife

Egypt

predynastic, late Gerzean

(Naqada IIc–IIIa), c. 3400–3200 BC

flint

l. 25.2 cm

The Trustees of the British Museum,
London, EA. 59255

1.12b

Ripple-flaked knife

Egypt

predynastic, late Gerzean

(Naqada IIc–IIIa), c. 3400–3200 BC

flint

l. 26.8 cm

The Trustees of the British Museum,
London, EA. 29286

The most admired of prehistoric stone tools and perhaps the most beautiful flint implements ever made by man are the pressure- or ripple-flaked knives. Their outstanding characteristics are the two rows of pressure-induced, long, parallel fluted facets meeting at a carefully centred median line, the very particular marginal retouch and the extremely fine serration of the cutting edge, which is best seen under magnification.

Production of these blades required high precision, extreme regularity and the right combination of a number of simple but delicate steps. There were six basic steps, each involving different technologies, which suggests that a number of craftsmen (each with his own separate skills) were involved. Nevertheless, a surprisingly small number of tools were necessary: a range of copper-tipped pressure-flaking points, some grinding stones and a slotted block to support the blade during work.

Ripple-flaked knives are made of superb flint, which is often glossy and has practically no visible grain. Although more than one quarry source was used, each slab of flint must have been carefully selected and checked before being flaked to shape and then ground smooth. These steps set the stage for the pressure-flaking, the overlap of each flake being responsible for the rippled effect. Starting from the upper rounded end and progressing anti-clockwise, the pressure-flaking was done with great discipline and an emphasis on visual beauty. A combination of the correct depth and spacing of the pressure

point and the proper angle resulted in just the right amount of flake overlap. The edges of the knife were then retouched with extremely fine pressure-flaking and in the final stage the cutting edge was ground down and then carefully serrated with some 10–15 microscopic teeth per cm.

Only one face was worked, the other was ground smooth. The smooth face being the back of the knife, the cutting edge is always to the left as a right-handed man would hold it. The rounded or butt end of the knife was probably covered in leather, wrapped in cord or covered with gold sheathing to form a handle. If hafted to a more elaborate ivory or wooden handle, a short tang was roughly flaked out of the rounded end. Each perfect specimen means 60 faultless ripple flakes in a row, 200 successful microflakes and 250 serrations. Needless to say, not all are perfect, but regularity and rhythm were clearly given high priority from a technical and aesthetic point of view.

There must have been a significance attached to these knives which is not explained merely by their function. The duality within the two

ranges of pressure flakes and between the two faces, one plain and one worked, has been considered symbolic. Although these knives are not uncommon in museum collections, the discovery of them in context is rare. A limited number have been found in relatively wealthy graves, sometimes intentionally broken or ritually ‘killed’. Fragments of such knives and sharpening flakes have been found in the courtyard of an early temple at Hierakonpolis and must have been associated with ritual sacrifices. Although the shape continued to be popular into the Old Kingdom, high-quality ripple-flaked knives were produced for only about 200 years. *RFF*

Provenance: cat. 1.12a: 1929, purchased by the museum; cat. 1.12b: 1897, purchased by the museum (said to have come from Abydos)

Bibliography: Kelterborn, 1984; Midant-Reynes, 1987; Holmes, 1992; Spencer, 1995, fig. 27; Payne, 1995, pp. 172–5

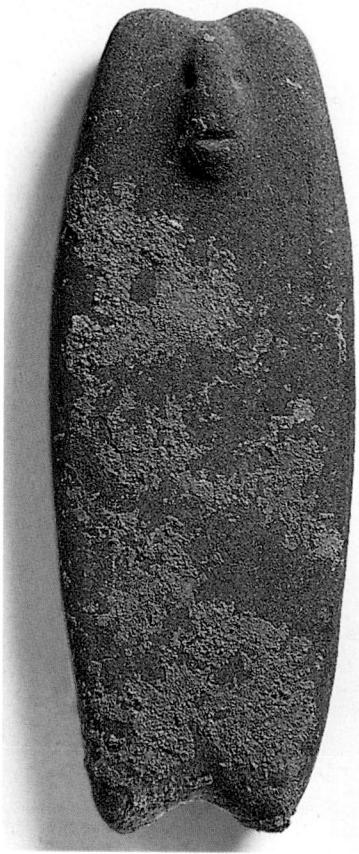

1.13

Anthropomorphic (?) palette

Egypt
predynastic, c. 5th millennium BC
sandstone
19 x 7 x 2.7 cm
Musée Barbier-Mueller, Geneva, 203-38

As evidenced by spectacular examples from later periods (cat. 1.18) the grinding palette for the preparation of cosmetic pigments has in early Egyptian culture a significance far beyond its apparently quotidian function. Like the flywhisk in some west African societies it is capable of huge symbolic, ritual and ceremonial accretions. This Neolithic example is finely carved as an object of evident value. The economy of suggestion whereby the incorporation of a head in an otherwise abstract form leads that form to have physical resonance as a body with legs, torso, even coiffure is typical of predynastic mastery of sculptural language. Though described as anthropomorphic, it suggests (in the bilobate process around the tiny face) other primates as they appear in later dynastic representations, for example the upper section of the representation of a baboon in cat. 1.38. This would link the present object with the

host of other palettes which embody animal references with similar virtuosic simplicity and account for the beardlessness of an assumedly male face from this epoch. TP

Bibliography: Beltor and Valloggia, 1990

1.14

Barrel-formed figure

Egypt
predynastic, c. 5th millennium BC
stone
h. 26 cm
Private Collection

For anyone studying the range of human representations in predynastic art there can be no certainty of expectation. As seen in this exhibition the earliest artists of Egypt explored a huge range of possibilities in the depiction of the human figure (cat. 1.1-3 etc), so comprehensive in fact that there have been few additions to the repertoire up to the present day (many variations we think now turn out to have ancient precedent). Here the whole fecundity of the female figure is suggested with the highest invention and minimal formal fuss. Although a solid piece, there is evident reference to woman as container, the vessel of the future. This theme reappears independently throughout Africa where so many societies are strongly based on lineage. It can be seen as far away as Zaire, and with almost uncanny similarity in a wooden vessel from the Zulu (cat. 3.44). In this particular small statuette (idol?) the position of the breasts at the pregnant point of swelling gives unambiguous meaning to ambiguity of form. TP

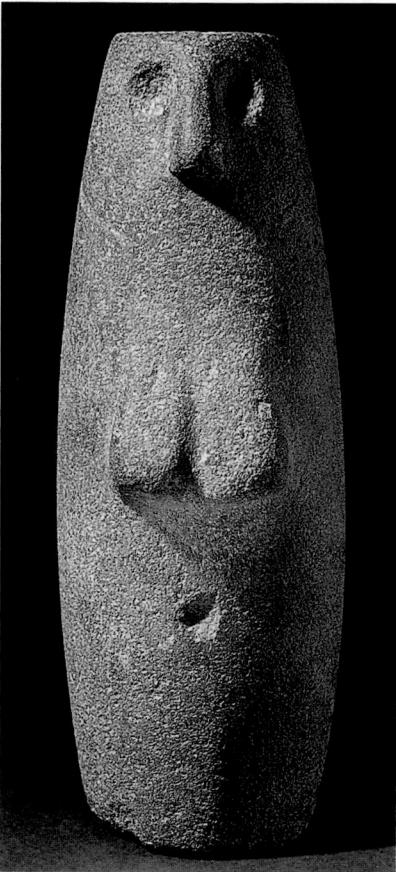

1.15

Boat-shaped mortar

Egypt
predynastic, Gerzean (Naqada II),
c. 3600-3500 BC
breccia
7 x 16.5 cm
Musée Guimet, Lyons, 90000091

From the earliest periods down to modern times, the Nile has been the main artery for commerce and communications in Egypt. Boats plying its waters carried grain, wine and cattle from farm to market; hauled stone and building materials to cities and temples; brought luxury goods from afar. They bore officials on their rounds and armies on the move.

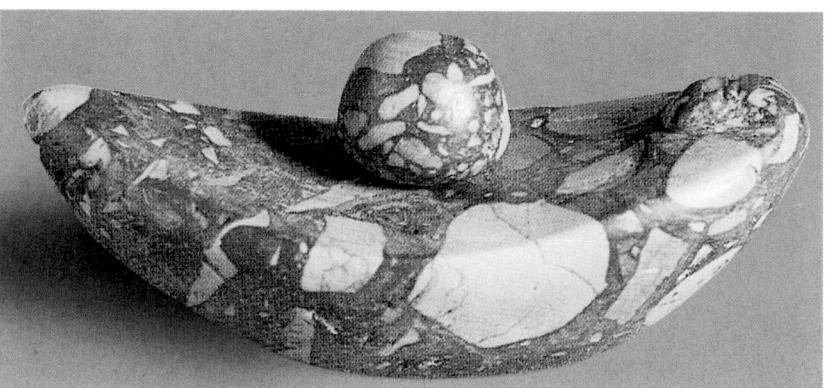

Boats also carried images of gods from temple to temple and served as houses for the gods within their temples. They transported the dead from this world to the next and moved the gods across the sky. Thus, it is not surprising that boats were a dominant feature in the lives of the Ancient Egyptians and profoundly affected their mental processes and religious thinking.

The earliest evidence for boats comes in the form of simple models made of clay. Throughout the pre-dynastic period, boats were common motifs on decorated pottery and rock art and also lent their outline to cosmetic palettes carved of grey slate. It is to the boat-shaped slate palettes that this unique stone mortar corresponds most closely in form and function. Like the flat, two-dimensional palettes, one end is turned in on itself, perhaps in imitation of the prow terminals composed of the bundled papyrus stalks out of which ships were made. The accompanying grinding-stone may represent the cabin placed in the centre of the palettes.

Regardless of shape, slate palettes served as a platform upon which to grind ores such as malachite or galena for use as cosmetic paints. The size and quality of this mortar suggests that it, too, was used for cosmetic production rather than food preparation. Crude, roughly boat-shaped sandstone mortars have frequently been found in predynastic settlements and occasionally in cemeteries, some twice the size of this example. In a few cases traces of malachite and ochre show that they were occasionally used for the preparation of pigments, but their primary purpose was to grind cereals. The fine modelling and polishing of the highly valued red breccia indicates that this mortar was not meant for such hard labour. It may be possible to view the mortar and grinding pebble as a three-dimensional rendition of the boat-shaped cosmetic palette. RFF

Provenance: said to have come from Rizakhat

Exhibition: Marseilles 1990, no. 386

Bibliography: Landstrom, 1970; Needler, 1984, p. 298; Vinson, 1994

1.16a

Bull's head

predynastic, Naqada IIa, c. 3500 BC
hippopotamus ivory
3.2 x 3.3 x 1.25 cm
Petrie Museum of Egyptian Archaeology,
University College London, UC.6005

1.16b

Bull's head

predynastic, Naqada IIa, c. 3500 BC
elephant ivory
4.9 x 4.3 x 1.9 cm
The Visitors of the Ashmolean Museum,
Oxford, 1895.908

The broadly abstract style of these amulets symbolises a bovine animal that is usually considered to be a bull, although it may represent a cow. The horns are turned down and curled into the face, with hollows separating them from the columnar neck which, in cat. 1.16a, terminates in a thin ridge around the flat base. On cat. 1.16a the eyes are not hollowed for inlay with another material, as is often the case in other examples of this genre, but indicated with two concentric incised circles. The back is pierced horizontally for stringing to wear on the person, and the vertical surface ridges of the curved hippopotamus tusk are still clearly visible below the perforation.

The grave where cat. 1.16a was found also contained a companion amulet of the same type (cat. 1.16b), of elephant ivory and very similar to the first, but without a ridge around the base. The eyes are indicated as pinholes which still contain what might be traces of resin. There is green staining on the front owing to an earlier proximity to copper. The condition of the elephant ivory amulet is poorer than that of the hippopotamus pendant, a result of the more rapid decay of the elephant ivory. The distinctive cross-section of the elephant ivory tusk can be seen on the back of the head.

This type is well attested in predynastic times, and probably dates from at least the beginning of Naqada II. The size ranges from small examples in bone and ivory which were threaded onto necklaces to larger examples in stone from votive deposits in temples. It seems to evolve from a squat, rounded version in the middle predynastic period to an elongated, more cursory version in the Early Dynastic period. Although the

supernatural power that it represented is unknown, it no doubt conferred the benefit of protection and stability on the wearer, and the strength of the bull was later associated with the king. Cow goddesses existed in the pre-dynastic period, but are usually depicted with their horns turned up.

Price, an assistant on the excavation at Naqada, recorded the grave as that of a child whose body lay crouched on its left side with the head south facing to the west. Three bone hairpins lay behind the head and there was a collection of objects in front of the face and over the hands. These included agate and cornelian beads, a clay wig from a figurine and a haematite plummet with a suspensory knob. A small metal cup was found next to the plummet and an elephant ivory pendant, which explains the green staining. Similar staining, indicating the original presence of copper jewellery, was also observed on the forearms and one knee of the skeleton. Metal and ivory objects such as these signify the importance of the grave's occupant. Although no pottery remained, Petrie assigned a relative date for the grave, equivalent to Naqada Ic-IIb in modern terminology. During this part of the pre-dynastic period, hippopotami were still extant in the Egyptian Nile Valley, but the elephant ivory would have been brought in from further south in Africa, indicating access to a wide trading network. BA

Provenance: cat. 1.16a: 1895, excavated by W. M. Flinders Petrie and J. E. Quibell from Naqada tomb 1788

Exhibition: cat. 1.16a: Erbach 1986

Bibliography: Petrie, n.d., no. 137; Petrie and Quibell, 1896, pl. LXI, iv, p. 46; Baumgartel, 1970¹, pl. LVIII; Drenkhahn, 1986, p. 46, no. 49; Adams, 1988, fig. 31, p. 51; Payne, 1993, p. 207, no. 1693

1.17

Bull's head

Egypt
late predynastic/Naqada III, c. 3100 BC
limestone, faience
3.6 x 3.7 x 2.2 cm
Lent by the Syndics of the Fitzwilliam
Museum, Cambridge, E.G.A. 3205. 1943

Although stylised and represented frontally, this head captures the visual characteristics of a bull's head. The delicate, raised-relief modelling of the horns continues the convex contour of the top of the head; by bringing the horns onto the face, the sculptor avoids the difficulty of carving them free. Inlaid eyes give an impression of depth and liveliness to the otherwise flat, almost abstract face, whose lower part is nearly cylindrical, with a raised disk at the end of the nose. The top of the head curves back to the underside and is pierced laterally.

The domestication of cattle in Egypt seems to have begun around 4500 BC, under the influence of nomadic Saharan people moving into the Nile Valley. The wild ancestor of domesticated cattle, living in the Saharan desert fringes and perhaps in the swampy areas of Egypt, must have already exerted a powerful influence on the imagination. Celebrated in later texts for his physical strength and sexual power, the bull was identified with the Egyptian king as 'Strong Bull' or 'Bull of his mother'. From predynastic and Early Dynastic times there is already evidence for important bull cults throughout Egypt which were gradually submerged into the kaleidoscope of Egyptian beliefs. The Early Dynastic image of the wild bull trampling and goring a prostrate enemy is the most powerful image of early kingship and possibly survived in the royal regalia as the bull's tail worn at the back of the king's kilt.

The bull's head may have been worn as an amulet to ensure good fortune and protection in a ritual wild bull hunt, or to bring to the wearer strength and fecundity. In funerary contexts, the amulets were buried with their owners (cat. 1.16a), perhaps as prized possessions or so as magically to endow the dead with the strong life force of the bull in the afterlife. Such amulets may also have been brought as votive offerings to shrines, for example at Hierakonpolis, so that the divine aspect of the bull would act

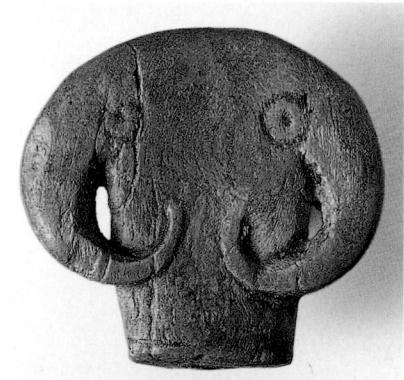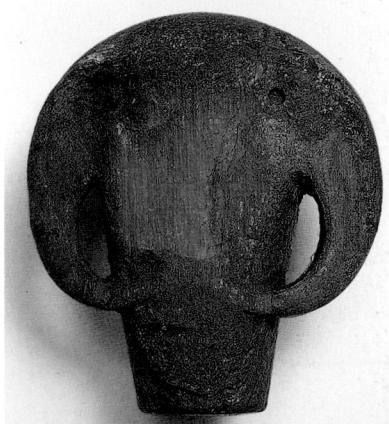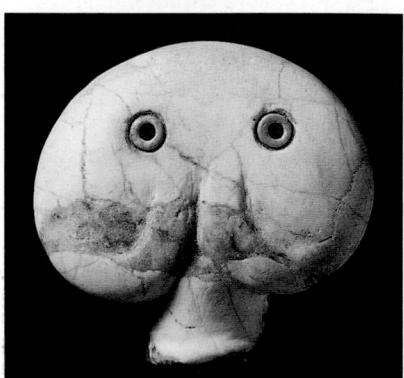

favourably on behalf of the offerer (cat. 1.16b). These early votive offerings show that the beginnings of the complex system of temple and state economy in Egypt were already well advanced by the Naqada II period. The bull's head is one means of expressing control over the innate forces of nature, both in a supernatural and economic sphere. Those who controlled the herds of cattle and the supply of meat undoubtedly encouraged their association with the animals, in order to increase their own status and prestige. EV

Provenance: ex collection Major R. G. Gayer-Anderson

Bibliography: Adams, 1974, p. 22, no. 110/15, 17; Störk, 1984, pp. 257–63

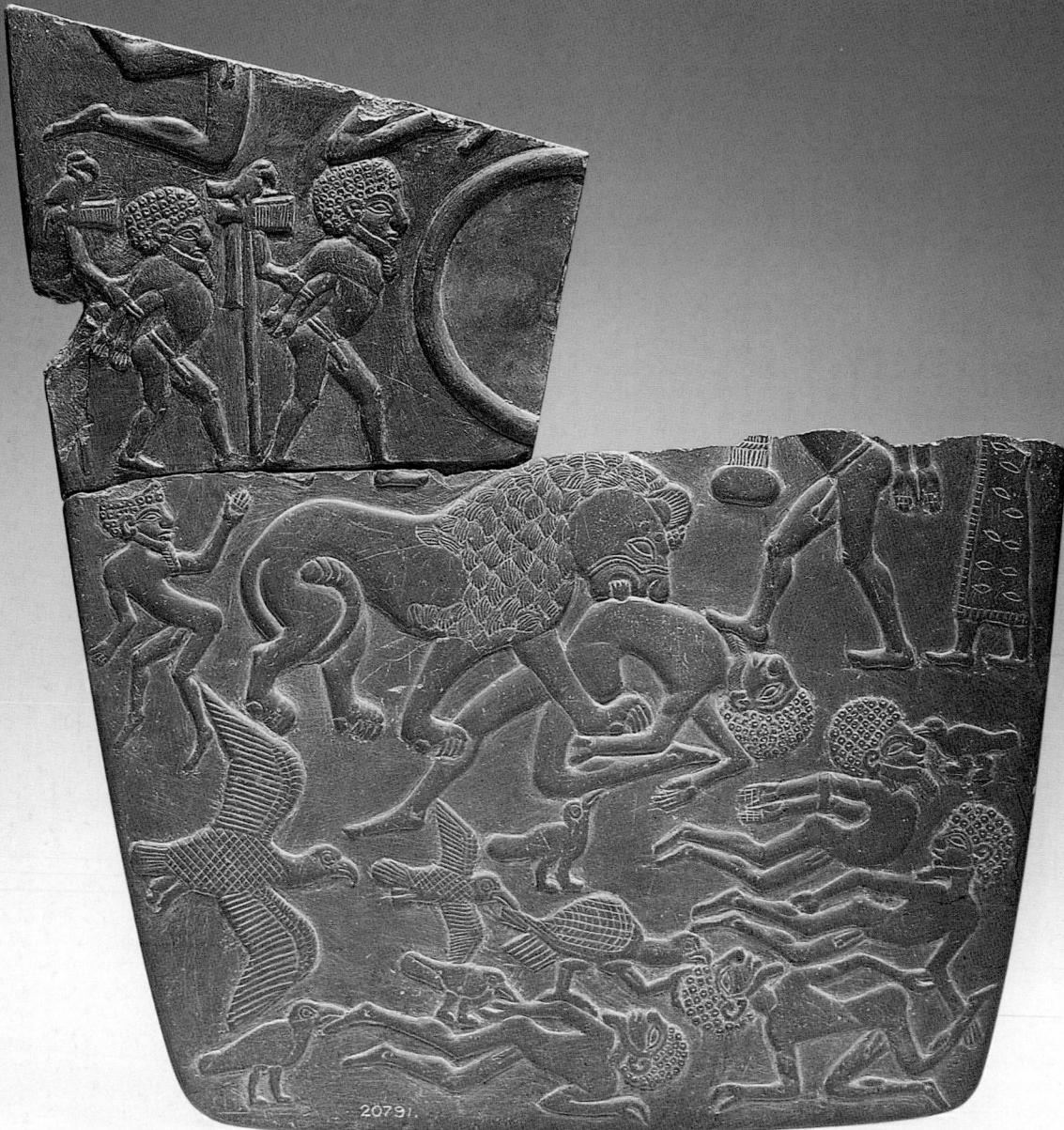

1.18

Decorated ('Battlefield') palette

Egypt

late predynastic/Naqada III, c. 3100 BC
slate

16.5 x 17 x 0.9 cm (upper section); 32.5 x
31 x 1 cm (lower section)

The Visitors of the Ashmolean Museum,
Oxford, 1892.1171, and The Trustees of
the British Museum, London, EA. 20791

Understanding the development of pharaonic art and civilisation depends in large part on interpreting the antecedents of its characteristic images. The great decorated palettes created at the cusp of the historic period provide important illustrations of the developments in imagery and iconography that led to the crystallisation of the distinct dynastic style.

Exhibited together for the first time is the lower half of a grey slate plaque known as the 'Battlefield palette' from the British Museum, with its adjoining fragment from the Ashmolean Museum, Oxford. The palette is carved on both sides in low raised relief with a good deal of interior modelling of the forms. Each figure has been elaborated with many

minute rounded details of anatomy: incised lines depict feathers, hair, eyebrows, claws, leg muscles, knee-caps and so forth. The surface bears many fine scratches made in the process of carving out the background with tools of copper and flint. Placed at the original centre of the palette is an undecorated once-circular area defined by a raised ridge. This was reserved for the grinding of ores such as malachite or ochre for cosmetic use, and it is for this reason that such objects are called palettes. Although decorated on both faces, the side with the cosmetic pan was the more important and on this and other palettes bears the more complex scenes. The reverse was often dedicated to large central figures in more straightforward compositions, this palette being a good example.

On the reverse, two long-necked giraffe antelopes browse among the fronds of a date palm. The better preserved animal appears to inhale with extended nostrils the appetising scent of the cluster of fruit at the apex. The textured treatment of the palm branches and trunk forms a decoration of great elegance set in the simplicity of the remainder of this face of the palette. The palm tree flanked by giraffes is a composition which also appears in the art of Nubia and may have originated there. It has been suggested that this combination is a metaphor for the king in his temporal aspect as the balance and mediator between symmetrical and complementary elements – a concept of kingship maintained throughout the dynastic period.

Behind the head of one animal is a bird with a hooked beak, which has been identified as a helmeted guinea fowl (*Numida meleagris*), later encountered in Egyptian art only as a hieroglyph used in the spelling of the word 'eternity'. Uncommon in Egypt but significant in Nubia for a long time, the guinea fowl in this, its earliest depiction is characterised by the two protuberances on its head common to the dynastic hieroglyphic sign, although in reality the bird has only one. An additional fragment of this palette in a private collection preserves an identical guinea fowl placed to balance the composition. Fragments of the upper scene, visible above the heads of the animals, are unclear but may include the hull of a boat.

The other, more celebrated, face of the palette portrays the gruesome aftermath of a battle. A flock of vultures and crows preys upon the bodies of fallen men. Dominating the battlefield is a stylised lion, which has seized one of the corpses by the abdomen and is attempting to tear it to pieces. The other vanquished soldiers on the battlefield are depicted in the extraordinary twisted attitudes typical of dynastic scenes of the slain, but never again in such grisly detail. The defeated are bearded, have curly hair and are circumcised. It is unclear whether they are meant to be Egyptians or foreigners similar to those depicted on the famous palette of Narmer (Egyptian Museum, Cairo).

Above, on either side of the raised ridge outlining the cosmetic saucer, men with bird-topped standards (on the left) and an official wrapped in a long-fringed mantle (on the right) march with bound captives. In front of one of the prisoners is an enigmatic oval object which has been variously identified as a stone hanging around his neck or an ideogram representing his land of origin. The common Egyptian convention of supplying inanimate objects with human features is evident in the anthropomorphic representation of the ibis- and falcon-topped standards from which issue human arms that seize other captives.

The top of the palette seems to have been devoted to more representations of the vanquished. The Ashmolean fragment shows a dead soldier and a scavenging jackal. As no more than one half of the palette is preserved, it is difficult to interpret the scene. Should it be seen as a vignette accompanying a depiction of the king on the now lost upper portion? Or should it be viewed as the main focus of attention, a celebration of the power of the king and the rout of the enemy?

The large lion probably represents the king defeating his enemies, but, like the vultures and crows, it scavenges among the bodies of the dead, humiliating rather than attacking the enemy. The vulture tearing at its victim was also used as a symbol of royal victory in predynastic iconography. In this formative period, the king is associated with various wild animals, his power being naturally derived and unchallenge-

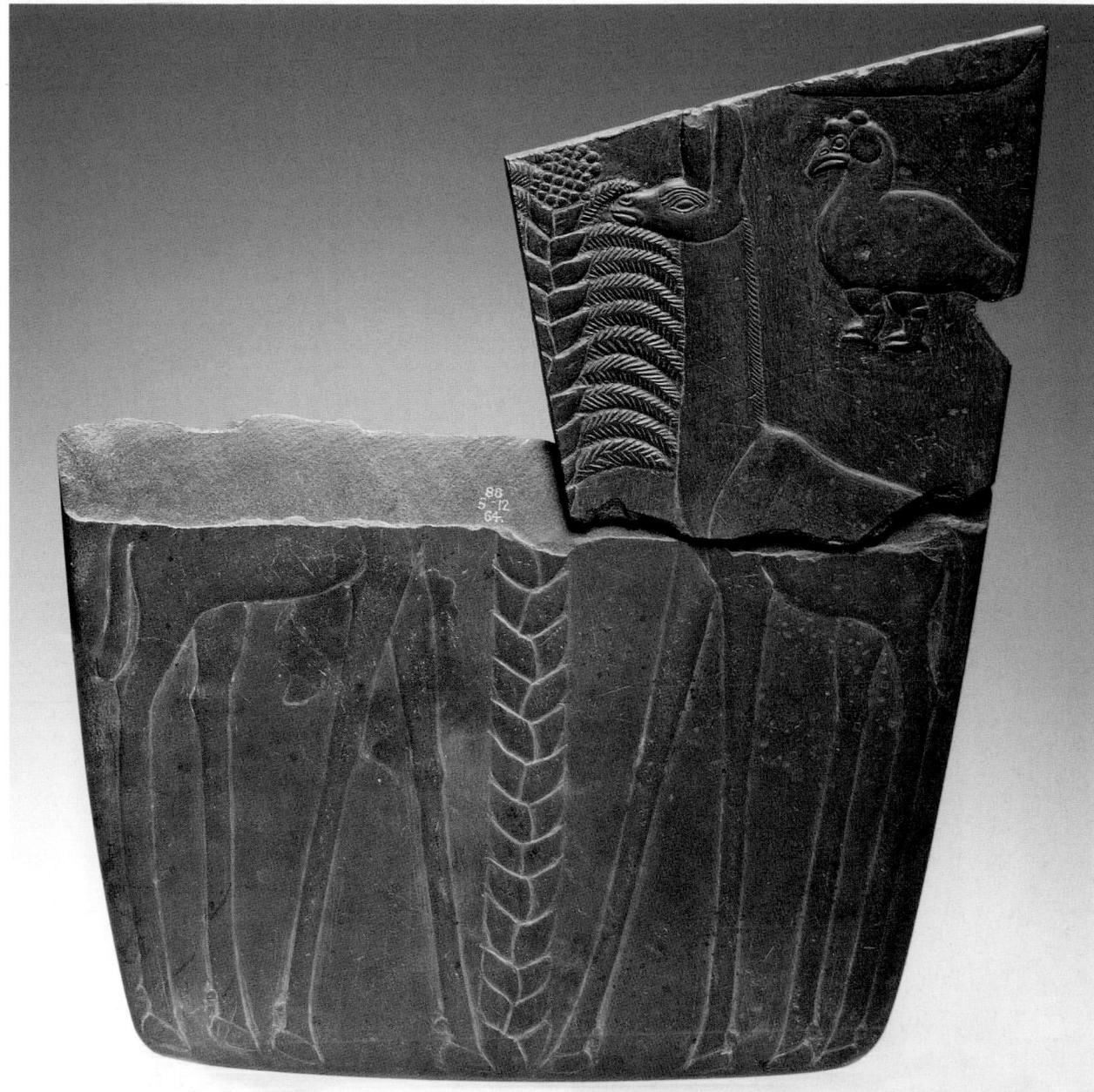

able. Thus it has been suggested that this battlefield scene should be interpreted as a sort of expanded litany detailing the victorious king in his many manifestations.

The form of this and other great plaques was clearly inspired by the common cosmetic palette, which in the predynastic period was sometimes adorned with surface decoration. That it was conceived as a cosmetic palette is evident from the circular pan for eye paint integrated into the decoration. The elaborately decorated palettes, however, are quite distinct in quality, size and function from the common type; all probably came from temples. Only two, from archaeological excavations of the temple at Hierakonpolis, have a known context,

but it is highly likely that this one, among others, came from an early temple at Abydos. Their traditional function may have been connected with the ritual of the god's toilet, but the explicit symbolism of the carving makes it clear that they were primarily dedicated as votive objects by the rulers to celebrate great events and great, if perhaps only symbolic, victories. *RFF*

Provenance: unrecorded (said to have come from Abydos); 1888, lower section acquired by the British Museum; 1892, upper section acquired by the Ashmolean Museum

Exhibition: lower section: London 1962, no. 12

Bibliography: Petrie, 1953, p. 14, pls D–E; Capart, 1905, pp. 238–42, figs 177–80; Vandier, 1952, pp. 584–5, figs 384–7; Spencer, 1980, pp. 79–80, pl. 64; Housman and Goodman, 1986, pp. 41, 82–3, 132, fig. 117; Seipel, 1983, p. 28, figs 13 a–b; Spencer, 1993, pp. 57–8, fig. 34

1.19

Female figurine

Hierakonpolis, Egypt

1st–2nd Dynasty, c. 3000–2700 BC

Lapis lazuli

8.9 x 2.5 x 1.8 cm

The Visitors of the Ashmolean Museum, Oxford, 1896-1908 E.1057 + 1057a
Gift of the Egyptian Research Account and Harold Jones

The body of this naked female figurine, with a wooden peg surviving in the neck socket, was found in 1898 during excavations in the temple enclosure at Hierakonpolis beneath a brick wall to the south of the Main Deposit. Remarkably, eight years later, renewed excavations in the same area revealed the detached head, which fitted perfectly on the peg. It is

probable that the figurine never had feet, but was fitted directly to another object at that point, possibly to serve as the handle of a spoon. In later Egyptian art naked servant girls appear in this role.

The use of lapis lazuli, the most highly valued ornamental stone in Ancient Egypt, immediately distinguishes this object. The closest source of lapis lazuli known to have been exploited in antiquity is that in Afghanistan, whence it had been reaching Egypt, perhaps by sea from Syria, for some time before this figurine was made. Neither in Egypt nor in the Near East would an object like this normally have been made from separate pieces of stone. The lapis lazuli used for the head is the rarer, deep blue type most admired, whereas the body is of the commoner, more mottled variety. It is likely that the juxtaposition is either a deliberate economy with the more valuable variety or else the result of an accident during manufacture (or afterwards) requiring a replacement head.

It has been suggested that this figurine might have been made outside Egypt, closer to the lapis lazuli mines. However, the distinctive gesture of the hands and the stylisation of the hair in tight little curls close to the head – characteristics found on other contemporary works of art certainly made in Egypt – make it more likely to have been created there. Indeed, such parallels suggest that this woman may have been a member of one of the peoples on the periphery of the earliest centralised state in Egypt drawn into it in the late 4th millennium BC by the military activities of the first pharaohs.

PRSM

Provenance: Hierakonpolis, temple enclosure; body excavated by Garstang and Jones 1897–8; head excavated by Quibell and Green 1905–6

Bibliography: Quibell, 1900, p. 7, pl. XVIII.3; Quibell and Green, 1902, p. 58; Garstang, 1907, p. 135, pl. II.2–3; Porada, 1980

Ivory figures from Hierakonpolis

The site of Kom el-Ahmar ('The Red Mound') in Upper Egypt, ancient Nekhen, has important associations with kingship and the formation of Egypt as a unified state (late 4th millennium BC). The city was the major cult place of the god Horus, to whom every king of Egypt was assimilated and whose sacred bird figured in the town's later Greek name, Hierakonpolis, 'City of the Falcon'. The enormous growth of the settlement and cemetery in late predynastic times testifies to the importance of Nekhen as a regional centre of power.

'The Red Mound' was the site of successive shrines of the falcon god from predynastic times to the New Kingdom (1550–1069 BC). Excavations of the 1890s in the enclosure on the mound revealed the so-called Main Deposit – caches of temple furnishings and votive offerings, seemingly cleared from the temple in the Early Dynastic period and buried within the sacred precinct. Among them were hundreds of ivory figures and fittings, found as a tangled mass in a muddy trench run through by plant roots. When disentangled and conserved, the ivories were seen to fall into distinct categories by size and form – models of boats and animals, decorated cylinders which may have been the handles of ceremonial maces, figures of women with long hair, men wearing penis-sheaths, and bound captives. Many figures have tenons or sockets, indicating that they were components of furniture or fitted into bases made of other materials. Despite the lack of clear archaeological evidence for their date, the ivories' distinctive style suggests that they belong to the earliest unified period of Egyptian civilisation, now commonly called Dynasty 0.

No trace survives of any surface painting on the ivories, although some had incised decoration or were inlaid with other materials. It is possible that they were brightly coloured in addition. JW, HW

1.20a

Fragmentary statuette of a man

Egypt

late predynastic/Naqada III, c. 3100–3000 BC
hippopotamus ivory
25 x 4.8 x 4.7 cm
The Visitors of the Ashmolean Museum, Oxford, 1896-1908 E.180 E.174 (00)
Gift of the Egyptian Research Institute

1.20b

Fragmentary statuette of a man

Egypt

late predynastic/Naqada III, c. 3100–3000 BC
hippopotamus ivory
20.8 x 6.8 x 3.7 cm
The Visitors of the Ashmolean Museum, Oxford, 1896-1908 E.174

1.20c

Fragmentary statuette of a woman

Egypt

late predynastic/Naqada III, c. 3100–3000 BC
hippopotamus ivory
11.9 x 6.1 x 3.5 cm
The Visitors of the Ashmolean Museum, Oxford, 1896-1908 E.299
Gift of the Egyptian Research Account

Cat. 1.20c is depicted with the physical characteristics of disproportionate dwarfism arising from a condition such as achondroplasia, with a notable pelvic tilt and bowed legs. She wears a knee-length dress and heavy bouffant wig which frames the face with long, curling strands and falls at the back in a single curled or braided mass to waist level. The curling front strands were associated in later Egyptian

iconography with the goddess Hathor. In the succeeding Old Kingdom (2600–2150 BC) dwarfs are frequently attested as members of the households of the élite, serving as personal servants, animal-keepers, entertainers and jewellers. In the Early Dynastic period their service may have been the preserve of royalty, to judge by the presence of dwarfs among the retainers at court. Their burials and grave stelae in the funerary complexes of the kings of the 1st Dynasty show that they accompanied their masters into the next life. This figure and others like it in the cache may have been associated with the exalted persons of royal dwarfs, but their attire suggests a more specific connection. The iconography of dwarfism was later associated with fertility and protection of the child at birth, and was embodied in particular in the dwarf god Bes, who in turn was closely connected with Hathor.

Many figures from the Main Deposit show men wearing elaborate penis-sheaths, standing with their legs together or striding with the left leg forward. Their size, technique and iconography vary, but all are very well carved. The smaller of these two statuettes (cat. 1.20b) was made in several pieces. The arms (now lost) were separately attached; the hands, however, remain as they were carved with the legs against which they are held. There is no trace of an attachment of arm to hand. The legs are missing from the knee down. The head, which was broken into two pieces, has been re-attached to the body.

The face is finely carved, with the eyebrows and lips shown in detail, and a distinctive, downcurving mouth. The eyes, which have the appearance of plain sockets, were probably inlaid, but no trace of any material remains. The cheeks are full and rounded, the head and face clean-shaven. The damaged ears projected some way from the head and were subtly modelled in considerable detail.

The body is slender and elongated, with careful carving of the central depression of the chest, beneath which the navel is indicated. The arms, too, were elongated, ending against the lower thighs. The back is quite plainly modelled, again with a vertical division; the buttocks are placed very low. The only garment is

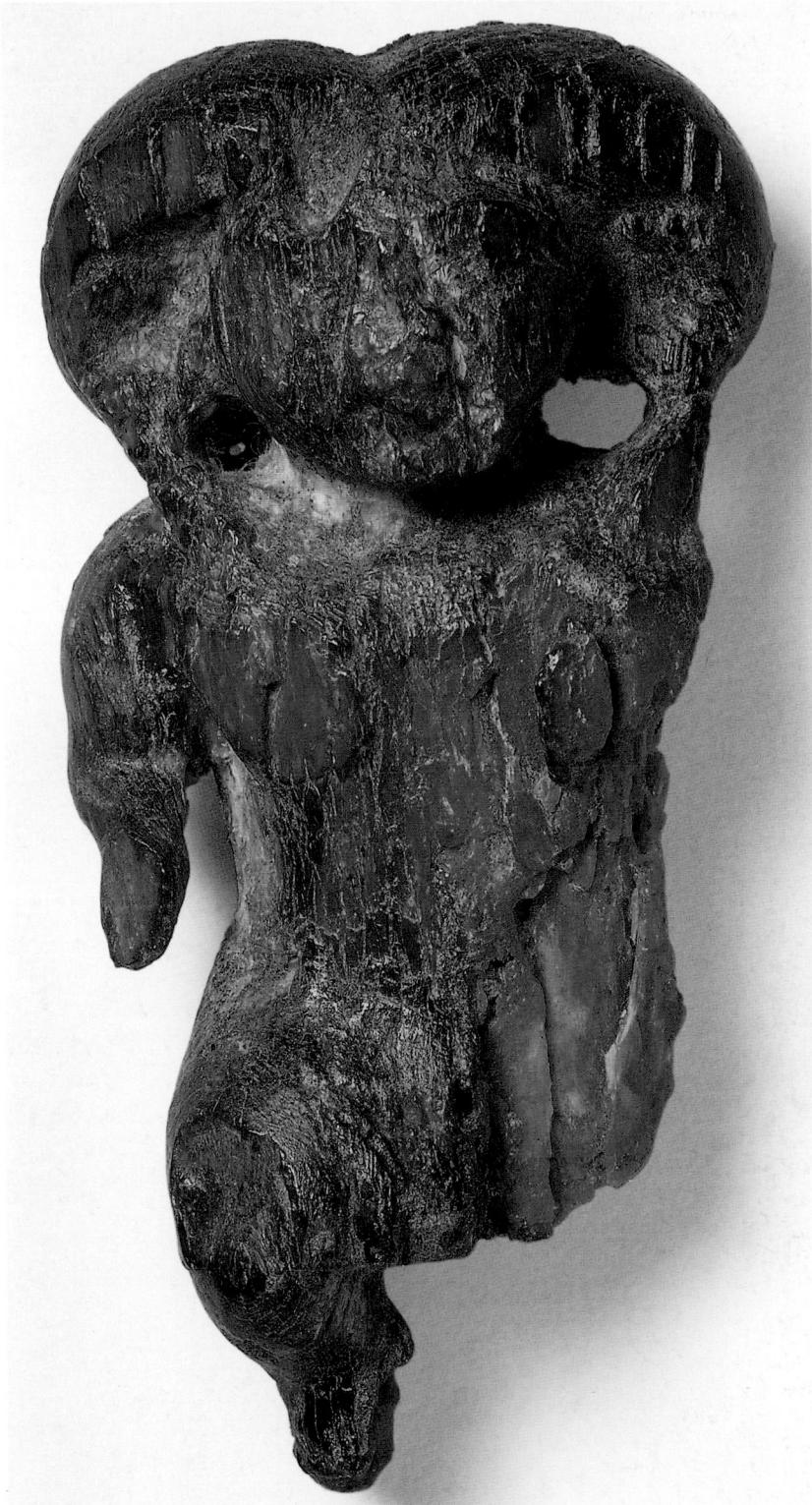

a penis-sheath suspended from a thick belt around the hips. The sheath has a rounded knob above the belt, and is divided into two sections with the scrotum visible behind the junction. The upper section, which appears to have details of a knot next to the belt, is rounded, with diagonal incised lines suggesting wrapping or cordage. Below is a damaged and much thinner section of uncertain form.

The larger fragment (cat. 1.20a) represents part of a similar figure, but differs in technique and iconography. The head is lost and the legs are preserved only to the knee. The body is rather flat and the torso small and thin in proportion to the hips and thighs. Similar bodily proportions are known on other works of the same general period and may have signified the figures' strength. The torso

appears not to have been decorated. The arms, which are partially separated from the torso, are very thin and long, as are the hands, which are pressed against the thighs. A thin belt on the hips supports a penis-sheath with a rounded knob at the top that comes down nearly to the knees, ending in a loop with a central depression. On the figure's back an unidentifiable object, flat and elongated in shape, is tucked into the belt above the right buttock and extends upward to the middle of the torso.

It is difficult to say who is represented by this category of figure. The penis-sheath was a relatively common piece of late predynastic attire, but was largely replaced in dynastic times by kilts or belts with strips covering the genitals. A few later examples of penis-sheaths are on figures of deities, the king and military personnel.

Both these ivory statuettes and the later parallels suggest that the penis-sheath was a status item; hence these figures depict high-ranking persons, perhaps with military associations. In form, the sheath in cat. 1.20b resembles the dynastic period hieroglyph for 'life', or *ankh*; the hieroglyph may well derive from a sheath, or both the sign and the sheath may evoke a piece of cloth arranged in a specific amuletic knot. In dynastic Egypt 'life' was a gift of the gods to the king and through him to others, so that this association would emphasise the prestige of the penis-sheath. In dynastic times there was also a clear association between penis-sheaths and sheathed daggers tucked into kings' belts. Despite the parallel with the god Min (cf. cat. 1.21) and the implications of the penis-sheaths, none of the ivory statuettes has features that are exclusively royal or divine. No other objects from votive deposits of the period clearly represent deities, and it is probable that later rules of decorum, according to which deities could only be depicted directly in special contexts, already applied. The ivories are therefore likely to represent human beings rather than deities. Those shown may include royalty or members of the royal retinue – suggested by the presence of statuettes of dwarfs (cat. 1.20c) – as devotees of the falcon god. They are thus probably among the oldest

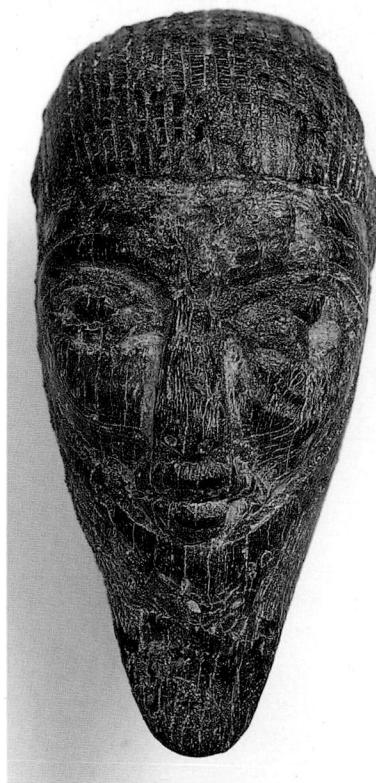

sculptural representations of the élite in an early civilisation.

JRB, HW

Provenance: 1897–8, excavated by Quibell and Green at Hierakonpolis, temple enclosure, Main Deposit

Bibliography: cat. 1.20c: Dasen, 1993, pp. 39, 108, 275, no. 107; cat. 1.20a–b: Quibell, 1900, p. 6, pls VIII.1, X.2; Quibell and Green, 1902, pp. 29–30; Capart, 1905, p. 157, fig. 120; Baines and Málek, 1980, p. 78. On penis sheaths, see Ucko, 1969; Baines, 1975

1.21

Head of a man

Egypt

late predynastic/Naqada III, c. 3100–3000 BC
hippopotamus ivory

5.1 x 2.5 x 1.8 cm

The Visitors of the Ashmolean Museum, Oxford, 1896–1908 E.342

Gift of the Egyptian Research Account

This head, of which the back is lost, has sheared almost vertically from the object of which it formed part. The carving is very detailed and of the finest quality. The head has an elaborate wig, or possibly natural hair, arranged in parallel strands running back from the forehead. The wig or hair merges with a beard that covers much of the face and descends almost to a point, finishing well below the face. The face is modelled as a protrusion within the area framed by wig and beard. The chin recedes beneath the beard, giving a characteristic downward cast to the face as a whole. The eyebrow ridges are marked and above them a line is incised for the eyebrows; this could have been inlaid with another material. Beneath the eyebrows, the eyelids are carefully indicated and the pupils of the eyes brought out in raised relief. Below, the damaged nose forms a group with the narrow mouth, which stands out from the surface of the face.

This head could have belonged to a figure with penis-sheath (cf. cat. 1.20a–b). The finished carving behind the beard would, however, have been difficult to execute on a statuette and it is possible that the head formed part of some other type of object, perhaps as a knob or finial. The piece has a different style of head from the statuettes. The treatment of the beard and wig is paralleled on the colossal head of the god Min from Koptos (Ashmolean Museum, Oxford) and on other pieces of the same general date as the Main Deposit. The statue to which the head of Min belonged is ithyphallic, but otherwise resembles the iconography of the Hierakonpolis figures in several respects. There is also a very close parallel between the treatment of this ivory head and of the basalt statue (cat. 1.22).

JRB, HW

Provenance: 1897–8, excavated by Quibell and Green at Hierakonpolis, temple enclosure, Main Deposit

1.22

Statuette of a man

Egypt

late predynastic/Naqada III, c. 3100 BC
basalt

59.5 x 10.8 x 7.5 cm

The Visitors of the Ashmolean Museum, Oxford, 1922.70

This figure of a man wearing a belt and penis-sheath was one of the most remarkable items in the collection of Egyptian antiquities formed by the Rev. William MacGregor (1848–1937). 'MacGregor Man', as he has come to be known, seems to have been acquired between 1898 and 1900, together with a group of ivory figures said to have been found at the site of Naqada in Upper Egypt, where Flinders Petrie had excavated a vast predynastic cemetery in 1894–5 (cat. 1.16–17).

The statuette is reassembled from three fragments and the legs are missing from below knee-level. It has a pronounced cylindrical form, flattening at the shoulders and expanding below the waist to accommodate the neat buttocks and the large sheath at the front. A belt around the waist holds the sheath in place and is tied over it. Above, the projecting top of the sheath is broken away; below the belt it is divided into two sections, with the scrotum visible behind the dividing line. The long, amorphous arms, held against the body, end at mid-thigh in sharply detailed hands. The face is rendered schematically, with eyebrows and nose (now damaged) executed as a single unit. The eyes are given an unnatural largeness by their emphatic raised outlines, and the mouth is cut with overhanging upper lip and receding lower. The rounded ears, also damaged, would have projected well beyond the head and have bore ear-holes. Over the head is a cap or stylised representation of hair which merges into a long, pointed beard that virtually covers the chest.

Ever since this figure first came to the notice of scholars, its authenticity has been disputed, not least because of the lack of an extant statuette in hard stone with which it might be compared (only recently has a similar figure been recorded on the American art market). Its technical accomplishment, with sharp angles and high surface finish, has been contrasted with the more rudimentary work

observable on other early pieces of stone sculpture, such as the colossi of Min from Koptos or the Hierakonpolis torso (cat. 1.19), and many features of its iconography and style have been used as arguments against its genuineness.

None the less, telling comparisons may be drawn with the smaller-scale figures in ivory which display the same iconography; these were seen for the first time in 1897, and were not widely known until a few of them were published in 1900 – little opportunity for a master forger to absorb their iconography and create ‘MacGregor Man’. The detail of the head, including the prominent lips and pointed beard, the heavy shoulders, long arms, and complex, knobbed sheath on a belt all appear on the ivories (cat. 1.20a–b); a similar figure, now in Birmingham Museum and Art Gallery, was among the ivories acquired with ‘MacGregor Man’. The projecting ears are also known from ivory figures wearing close-fitting caps (cf. cat. 1.20b). Even the one detail that is not paralleled in the ivories may be found in other early works – the relief-like cutting of the eyes is identical to the treatment of eyes on the ceremonial palettes cut in the hard medium of greywacke (cat. 1.18). The cylindrical form in itself suggests a transition to stone from ivory, where the medium would constrain the shape, and may be observed also on the Min statues.

The details of beard, belt and sheath have been compared with representations of these as ethnic attributes of Libyans from west of the Nile Delta, seen on the ceremonial palettes in scenes of subjugation (e.g. cat. 1.18). The ivory figures show that such features also appeared on native Egyptians, while the head of Min from Koptos shows that the beard may be the attribute of a deity. The bearded heads on earlier stone and ivory ‘tags’ are also relevant here. The parallels with Libyans suggest that Egyptians and Libyans, who may have had similar ethnic origins, shared items of attire that were later seen as ethnic markers as well as symbolising status.

In the absence of reliable information on the statuette’s provenance, it is bound to remain enigmatic and its identity uncertain, although a dating in the late predynastic period or

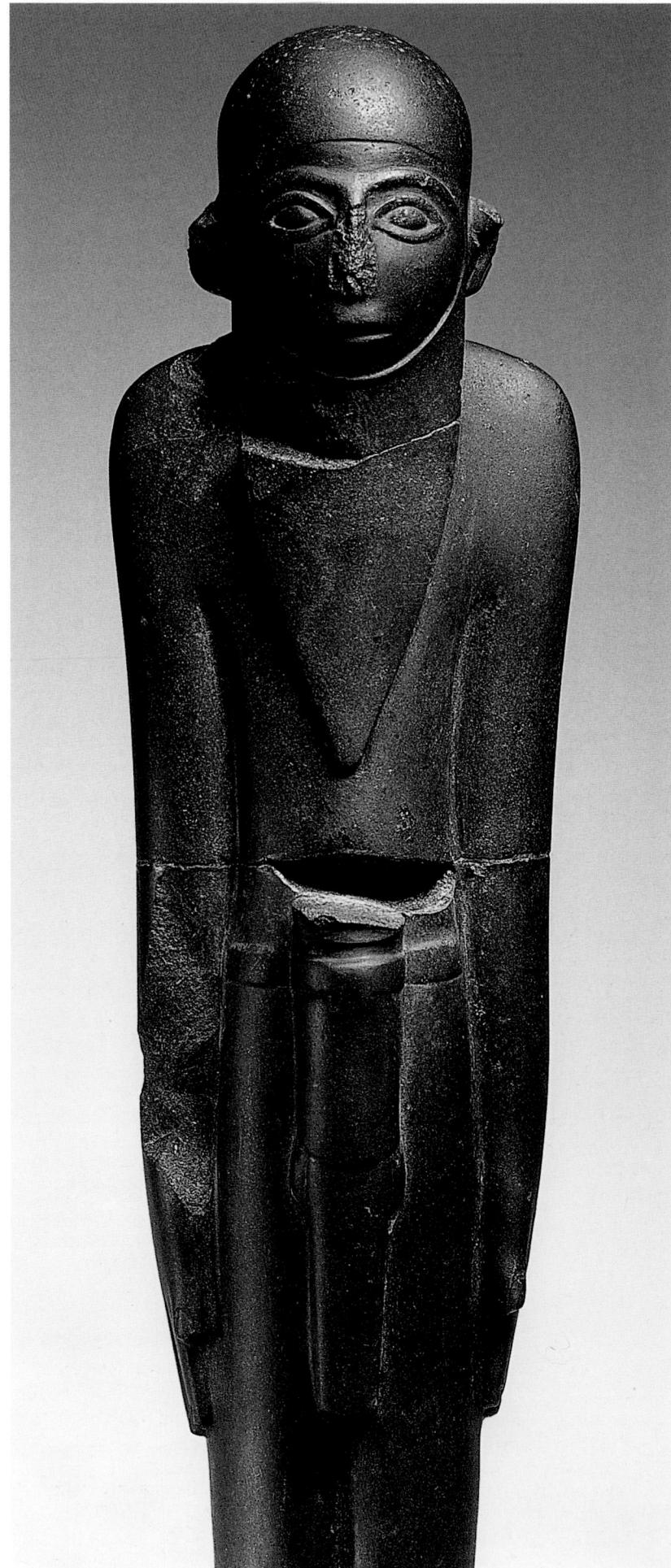

Dynasty 0 seems plausible. It is unlikely that it formed a cohesive group with the ivory figures that accompanied it onto the antiquities market. There is no parallel for statuary in tombs until the fragmentary wooden pieces found in major tombs of the 1st Dynasty, and it is most likely to have been set up in a temple. It is conceivable that it could have come from Hierakonpolis, whose temple area was being excavated at the date at which ‘MacGregor Man’ emerged. *JRB, HW*

Provenance: 1965, said to have been found at Naqada; ex MacGregor Collection

Exhibition: Vienna 1992

Bibliography: Ucko, 1968, p. 151, no. 196; Baumgartel, 1970, p. 10; Ucko, 1970, p. 47; Malek, 1986, pp. 24–5; Davis, 1989, pp. 173–4, 177, 179; Bianchi, 1990, p. 35; Seipel, in Vienna 1992, pp. 78–9, no. 6; Payne, 1993, pp. 13–14, no. 5.

1.23

Hierakonpolis torso

Egypt

predynastic (Naqada III), c. 3150 BC

limestone

h. 1.37 m (estimated original h. c. 2 m)

The Visitors of the Ashmolean Museum, Oxford, E 3925

The most important art form produced in Ancient Egypt was stone statuary representing the human figure. Although sculptors created a variety of types over three millennia of pharaonic history, there were only two basic postures: the seated statue and the striding figure. This headless sculpture, named after the site where it was found, is the earliest preserved example of the striding type. It was created before the founding of the 1st Dynasty.

The left leg strides forward and bears the weight of the torso. In dynastic times a back pillar, carved in one piece with the figure, was introduced into the composition of striding statues to maximise stability. As in the Hierakonpolis torso, the left leg was advanced, but in later, canonical sculpture the figure's weight was displaced backwards onto the right leg; this shift resulted in a less convincing rendering of movement.

The torso's legs are preserved only to the knees. Their massive form contrasts markedly with the shallowness of the torso and reflects the sculptor's concern to ensure that the figure remain upright. The base, now missing, was probably quite high to allow for its insertion deep into the ground as another precaution against toppling.

The left arm is bent at the elbow and the hand is held flat on the chest underneath a garment that leaves the right shoulder bare and ends just above the knees. The right arm is pressed against the figure's side and the right hand was pierced for the addition of a sceptre or the like in another material, as in some other early statues.

The slightly raised surface of the break on the upper chest attests to the original presence of a full beard; it is therefore certain that the statue depicts a male figure.

By contrast with dynastic limestone statues, which were carved with a chisel, the torso was shaped by hammering, as were three roughly contemporary limestone statues found

at Coptos. Justly called colossi (they were originally more than 4 m tall), all three statues from Coptos depict an ithyphallic figure with legs together, a posture specific to Min, the god of the temple in front of which they once stood. Their monumental scale suggests that they signalled the presence of the deity, regardless of other functions that they might have performed in the cult.

Hierakonpolis, with its temple mound, was a crucial centre for the evolution of the Egyptian state during the period leading to the establishment of the 1st Dynasty about 3100 BC. The torso was excavated from a secondary context outside the town's mudbrick wall. Whether it was originally set up in association with a temple inside the town or near the gateway close to the spot where it was found is a matter for speculation.

The series of cup-like depressions down one side of the figure is another feature that the torso shares with the Coptos colossi. They were apparently made after the statues no longer stood in their appointed places but lay on the ground. It has been suggested that people grinding away at the figures in ancient times made the depressions 'to obtain magically efficacious dust' (Kemp, 1989, p. 82). Their presence would then document the power attributed to all these statues long after they ceased to perform the function for which they were created.
ME-K

Provenance: 1898–9, Hierakonpolis, excavations of the Egyptian Research Account

Bibliography: Quibell and Green, 1902, pp. 15–16, 47, pl. LVII; Williams, 1988; Kemp, 1989, pp. 80–2

Door-socket

Egypt

c. 3100 BC

dolerite (diabase)

19 x 45 x 78 cm

University of Pennsylvania Museum of Archaeology and Anthropology,

Philadelphia

Gift of the Egyptian Research Account, 1898, E. 3959

This very rare example of early Egyptian three-dimensional art is of exceptional aesthetic, symbolic and functional interest. Carved from a single block of stone, the door-socket evokes, rather than fully depicts, a bound prisoner, imagined prostrate or as doubled up in a kneeling position. The head projects from one end and is expressively uplifted; the arms, bent inwards to suggest that the elbows are bound, are outlined more schematically on top of the block. A deep depression between the arms is regularly striated, and served as the socket for the pivot – metal, or metal-sheathed – of a wooden door. The top of the block and of the head are carefully flattened, so that the door could swing freely.

The door-socket was found *in situ* (some doubt this) at Hierakonpolis in a context suggesting that it was once part of a now largely vanished early temple. The socket's base was left rough, as were the other three sides, for they were concealed by adjacent masonry: one corner was dressed, perhaps to fit against an adjacent, irregularly shaped stone, possibly the threshold of the doorway itself, which would have provided access to temple or precinct. In this same temple the famous Narmer palette (Cairo) was perhaps once housed.

The head faced outwards, and the socket as a whole is the earliest example of a frequent symbolic element in later temples, representations of bound prisoners (nearly always foreigners) being subjugated by the pharaoh. Most relevant are slabs, a similar head or heads, and used for doorways and windows in which the pharaoh literally appeared, seemingly treading on their prostrate bodies. Foreigners (or Egyptian rebels) were emblematic of cosmic disorder or chaos manifest on earth. The Hierakonpolis door-socket is however a unique variation, for here the emblematic prisoner repeatedly has

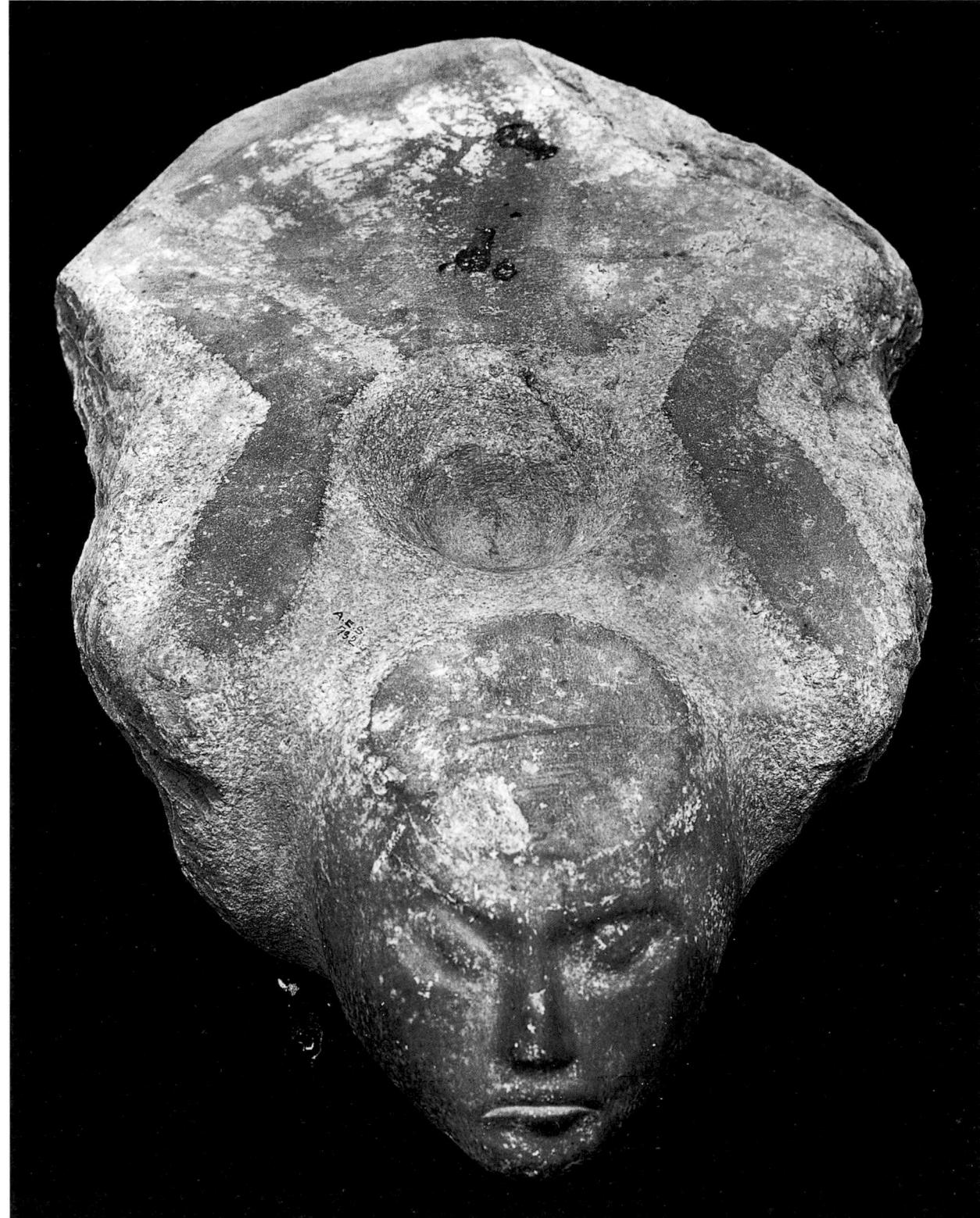

the pivot of a temple door (daily opened and closed for ritual) cruelly grinding into his back, the temple itself, rather than the Pharaoh, representing the triumphant order.

The rendering of the head is powerful but simplified into strongly defined planes, lacking the more careful detail seen in later but still relatively early examples, and prob-

ably dates to Naqada III, c. 3100 BC or even earlier. Whether a foreigner or, in the turbulent days of national unification, an Egyptian is meant cannot be determined. DO

Provenance: 1898, Hierakonpolis (Kom el Ahmar), Egypt

Bibliography: Quibell, 1990, p. 6, pl. 3; Quibell and Green, 1902, pp. 34–6, pl. 62; Vandier, 1952, ch. 5; Adams, 1974, pp. 2, 52; Page, 1976, pp. 2–5; Helck, 1977, cols 315–21; Ranke, 1980, pp. 26, 30; Bothmer, 1982, pp. 30–7; Williams, 1988, pp. 57–8; Dorf, in preparation

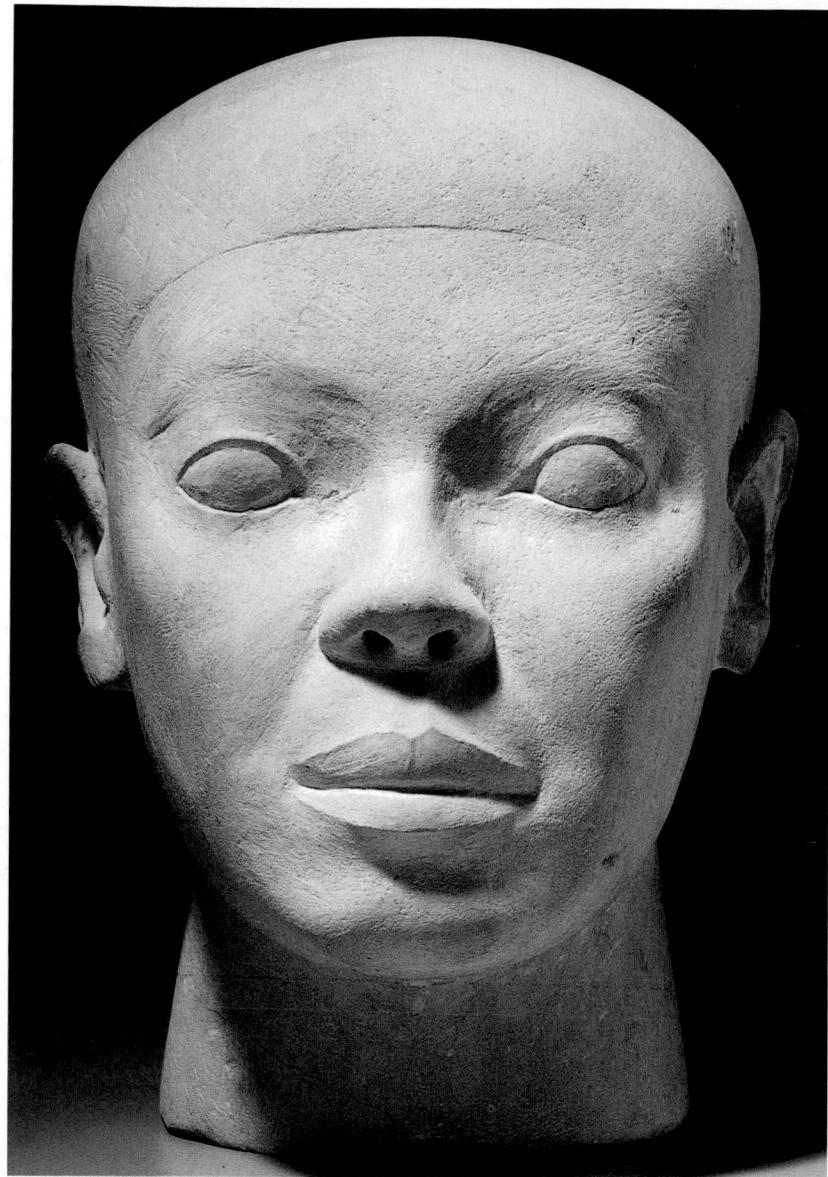

1.25

'Reserve head' of a woman

Egypt

4th Dynasty, c. 2630–2524 BC

limestone

29 x 19 x 25 cm

Museum of Fine Arts, Boston

Harvard-Boston Expedition 14.719

Egyptian artists generally created idealised likenesses of their subjects rather than true portraits, but in a small number of instances there are possible exceptions to the rule. Such is the case with this life-size head, one of a category of similar pieces known as 'reserve heads', most of which come from Giza and date to the 4th Dynasty. Complete in itself, the sculpture consists of a head wearing a close-fitting wig (as indicated by a line across the forehead). The features are rendered naturalistically but sparingly, and consist of faintly modelled brows

surmounting high arching eyes, set far apart, and high cheekbones. Shallow furrows and a 'love cup' connect a short, straight nose with drilled nostrils and a full but unsmiling mouth. Its excavator, George Reisner, labelled it a Negroid princess because of its striking and non-Egyptian facial characteristics. The round face with its pronounced cheekbones and full sensuous lips is comparable with much later representations of Nubian kings from Kush, Egypt's southern neighbour. Whether it is a true portrait of a Nubian or a more generic representation, it is a striking and beautiful sculpture which incorporates the Old Kingdom ideals of restraint and aloofness.

Exactly how these 'reserve heads' functioned has never been properly explained. Recent research has suggested that they served as models

for embalmers who reconstructed the face (and sometimes also the torso) of the deceased in plaster over the mummy as one of the final stages of the mummification process. Most, including this example, were found neither in the above-ground chapel nor in the burial chamber, but seemingly discarded in the vertical shaft leading to the latter. Most are either damaged or unfinished in some way, as if to destroy their magical potency.

Giza tomb 4440 is a mastaba in the cemetery west of the Cheops pyramid (Western Cemetery), where that king's high-ranking officials were buried. Found in the burial shaft with cat. 1.25 was a second head with strikingly different features. The identity of the owners of the tomb was not preserved. *REF*

Provenance: Giza, Tomb G 4440, excavated by George Reisner

Bibliography: Reisner, 1915, pp. 32, 34; Smith, 1949, pp. 23, 25, 29; Vandersleyen, 1975, p. 223

1.26

Unguent vessel in the form of a monkey with young

Egypt

6th Dynasty, reign of Pepy I,
c. 2320–2280 BC

calcite (Egyptian alabaster)

14.4 x 6 x 6.5 cm

Kunsthistorisches Museum, Vienna,
ÄS 3886

The monkey squats on the ground, pressing its young one to its chest. There is a groove around the mother's neck, showing less patina than on the rest of the surface. It can be deduced from similar pieces that it was originally filled with paste or stone inlay, indicating a necklace or rather a collar.

This is a functional vessel; it is carefully hollowed out, with the top of the head, worked of a different stone of black colour, serving as a lid. In Ancient Egypt vessels of stone were preferred as containers of unguents and cosmetic oils because,

unlike pottery, the material does not absorb the contents and probably preserves them better. The favourite stone for this was what is generally termed 'alabaster'; its more accurate scientific designation is calcite. The majority of these unguent vessels have a cylindrical or slightly conical shape. Cosmetic articles are often fancifully shaped and have symbolic meaning. The form of a loving monkey-mother may be intended to evoke the care she bestows on her baby and thus serve as a reminder that unguents are meant for the care of the body, in particular for the skin.

The vessel bears an inscription on the upper right arm in the form of the royal name 'Mery-ra', enclosed by a cartouche. This is the praenomen of king Pepy I of the 6th Dynasty. One may assume that the vessel – filled with costly cosmetics – was presented by that king to a person of high merit. *HSA*

Provenance: reportedly from Elephantine Island at Aswan

Exhibitions: Vienna 1961, no. 50; Speyer, Mexico City and Zurich 1993–4, no. 58

Bibliography: Demel, 1932; Demel, 1947, 8, fig. 16; Leibovitch, 1959, pp. 118–120; Valloggia, 1980; Satzinger, 1987, p. 78; Vienna museum guide 1988, p. 45; Satzinger, 1994, p. 52, fig. 34

**Statue of Queen Ankhnesmeryre II
and King Pepy II**

Egypt

6th Dynasty, c. 2269–2181 BC
calcite (Egyptian alabaster)

38.9 x 17.8 x 25.2 cm

The Brooklyn Museum

Charles Edwin Wilbour Fund, 39.119

Sculptors of the Old Kingdom not only carved colossal stone statues of their rulers but also fashioned royal images on a far more intimate scale. One of the most accomplished of these smaller royal works depicts the 6th-Dynasty Queen Ankhnesmeryre II seated and holding her young son, King Pepy II, on her lap. The queen supports the boy's back with her left hand while extending her right hand over his thighs. A tight-fitting, ankle-length dress reveals the contours of her body. She wears a vulture headdress on top of a striated tripartite wig; the circular hole on her forehead once accommodated a vulture's head (now broken off). This emphasis on the vulture – the Egyptian hieroglyph for 'mother' and the symbol of the goddess Nekhbet – signifies the queen's role as divine mother. Pepy II, shown much smaller than his mother, sports two traditional elements of royal iconography on his head: the *nemes*-headcloth and the uraeus (cobra), which protected Egyptian kings from harm.

Pepy II enjoyed one of the longest reigns in Egyptian history. When he came to the throne following his brother's death, Pepy II was a true 'boy king', probably no more than six years old. He reigned for at least 64 years. Shortly after his death, the Old Kingdom collapsed into a century or so of political disunity called the First Intermediate period.

Although the Egyptian king was the most powerful individual in pharaonic society, on this statue, at least, his mother is the primary focus of attention. Scholars interpret the piece in various ways. Some would see it as an expression of Ankhnesmeryre II's role as queen mother or as regent for her son during his minority. Others view the statue from a religious angle. A passage in the Pyramid Texts, a series of spells carved on the interior walls of later Old Kingdom pyramids, mentions the king's ascension to the sky after death in metaphorical terms, relating the act

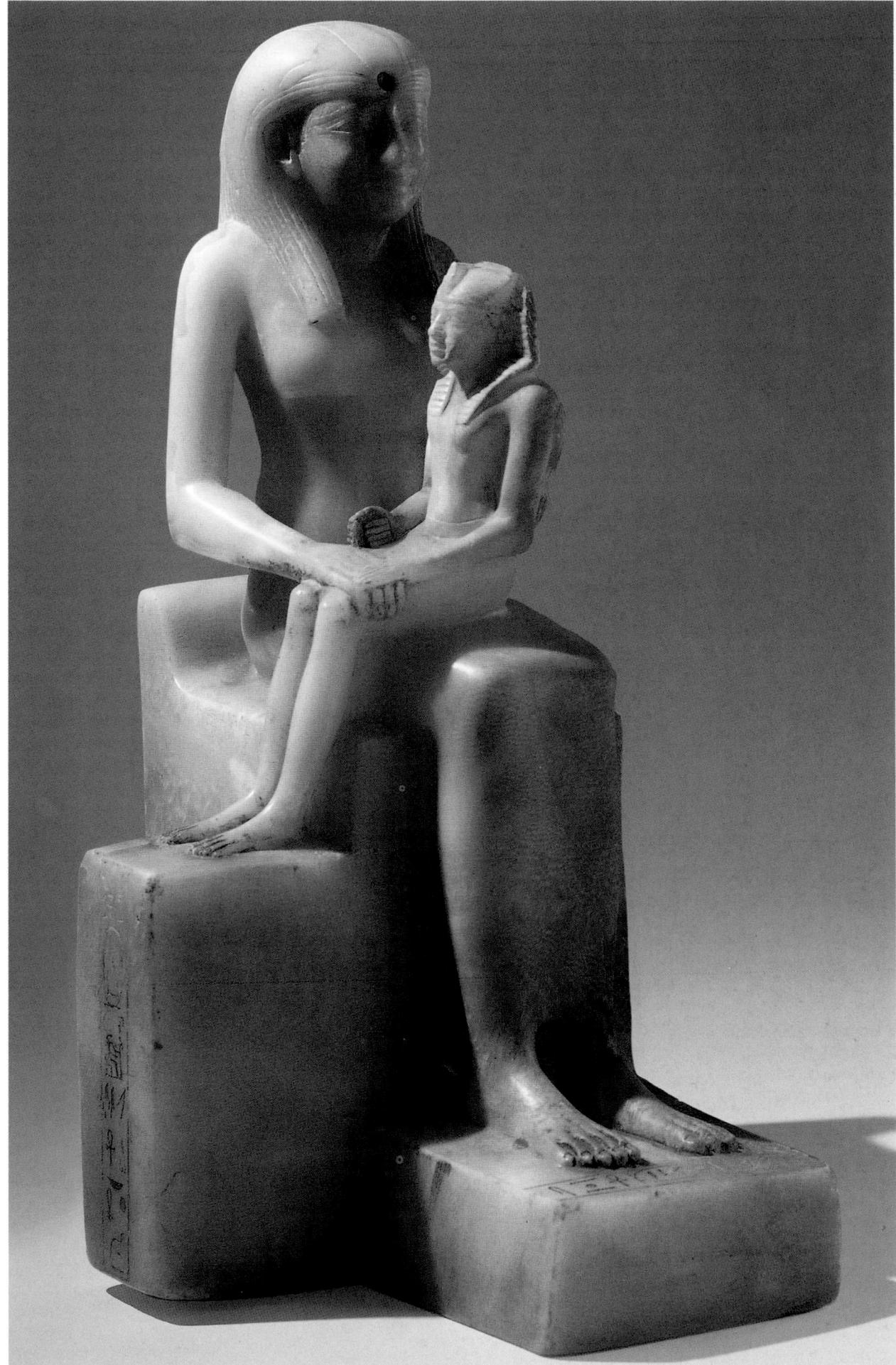

to climbing onto a goddess's lap: 'the king ascends upon the thighs of Isis; the king mounts the thighs of Nephthys.'

The statue probably came from either Ankhnesmeryre II's as yet undiscovered burial place or a shrine dedicated to her memory. The historical record documents at least one such shrine. A royal edict, almost certainly issued by Pepy II, mentions that a statue of the queen was set up in the temple of the god Khenty-imentyu at Abydos.

This is the finest Old Kingdom example of the traditional Egyptian motif of the mother and child. Much earlier, in the predynastic period and the first two dynasties, craftsmen made mother-and-child figures in bone, stone and faience. They may have represented mortals or deities. Later, particularly in the Late period, the theme was used to depict the goddess Isis suckling the infant god Horus. *JFR*

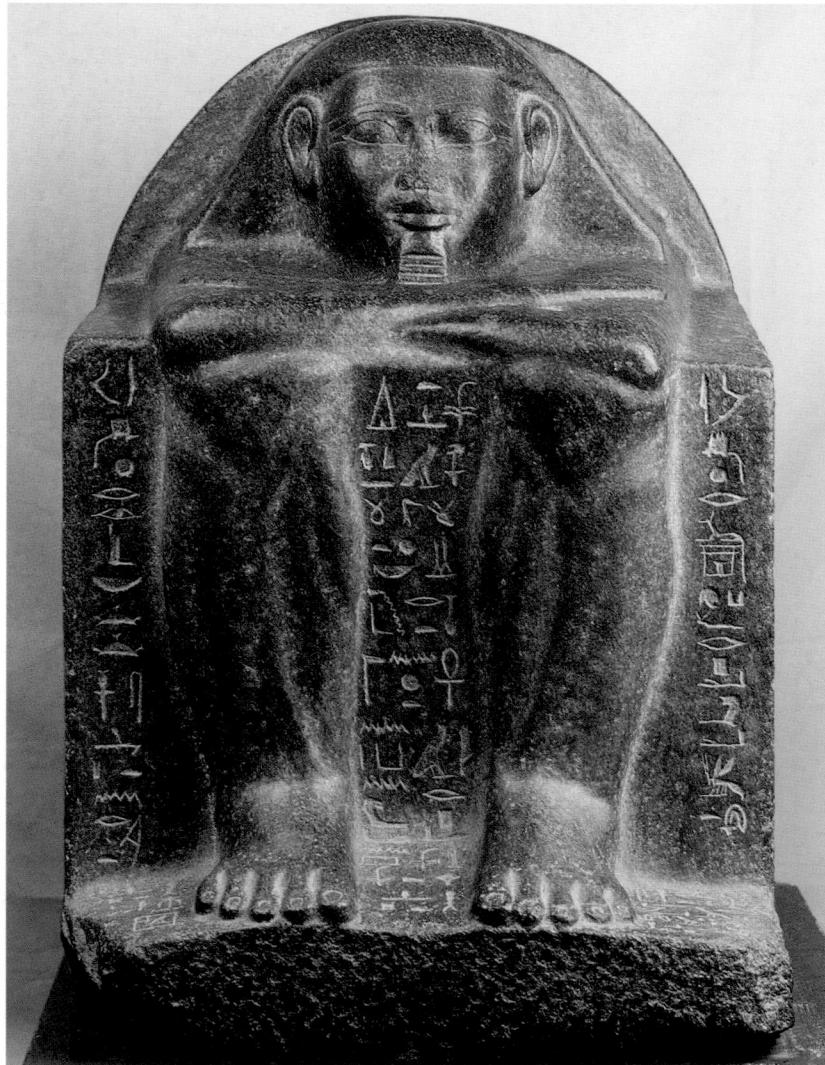

1.28

Tomb statue of Hetep

Egypt

12th Dynasty, reign of Amenemhat I

(1985–1955 BC)

grano-diorite

h. 73.7 cm

Museum of Egyptian Antiquities, Cairo,

JE 48858

Exhibitions: San Francisco 1975, no. 19; Berlin 1976, no. 17; Brussels 1976–7, no. 17; San Juan 1979, no. 9; Tokyo et al. 1983–4, no. 15; Hildesheim 1985, no. 105; Vienna 1992, pp. 102–3, no. 16

Bibliography: Cooney, 1949, p. 75; Wolf, 1957, pp. 175, 187; Vandier, 1958, p. 38; James, 1974, p. 28; Seidel and Wildung, 1975, p. 228; Aldred, 1979, p. 205; Bianchi, in San Juan 1979, no. 9; Aldred, 1980, p. 95; Smith, 1981, pp. 144–5; Ferber et al., 1988, p. 28; Fazzini et al., 1989, no. 15

Among his other duties, Hetep served as a priest in the funerary cult of Tety (c. 2345–2322 BC), who reigned during the late Old Kingdom. Hetep's tomb, which he had built near Tety's pyramid, was provided with a pair of large statues; these are similar in most respects, although the one exhibited here (the better preserved example) is of a hard dark stone, while the other was carved in white limestone. The use of contrasting materials probably had meaning, but its significance is unclear.

Hetep sits or squats, with his crossed arms upon his bent knees. Little can be seen of him, however, except the front of his head, his forearms and hands, his massive lower legs and big, stumpy feet. Everything else is encased in a rectangular construction with high arms, a rounded back and a seat that also serves as a footrest. The composition has a geometric solidity, which is emphasised by the flatness of the arms.

Apart from its companion piece and a second pair in an adjacent tomb of the same date, this statue appears to be unique. Its curious form has provoked considerable comment, especially because of its similarity to block statues, which first appeared at about this time and were to become one of the most important of all Egyptian statue types. Block statues show men in the same squatting pose as Hetep, but their bodies are covered only by a cloak or long skirt. Hetep, on the other hand, appears to be enclosed in an awkwardly shaped piece of furniture, the form of which resembles a carrying chair, a prestigious mode of transport.

Carrying chairs were prominently featured in the tomb reliefs of some officials of the late Old Kingdom. The style of Hetep's statue – the flaring curve of its wig, its big staring eyes and its taut grimace of a smile – also derives from the art of the late Old Kingdom. Both the form and the style of Hetep's statue thus reflect art from the time of Tety, whose cult he maintained. This may be an example of archaism, but more probably it reflects the extraordinary longevity of traditions characteristic of Egyptian culture. *ERR*

Bibliography: Russmann, 1989, no. 19, pp. 52–4, 215; Schultz, 1992, i, no. 173, pp. 310–11, ii, pp. 753–4, fig. 96

1.29

Two model sceptres

Egypt

11th Dynasty, c. 2050 BC
faience

h. 29 cm (tallest)

Museum of Ancient Egyptian Art, Luxor,
J224

When the Ancient Egyptians constructed a building, especially a temple, they placed in substructure pits groups of miscellaneous objects. These two pieces come from such 'foundation deposits' found beneath the central structure (possibly a pyramid) of the funerary temple of Mentuhotep II at Deir el-Bahri.

The taller has a top that resembles a poppy-head; the binding beneath suggests that the piece might represent a form of architectural column. If so, no trace of any such column-type has been found. The other object also appears to be based on a plant prototype.

Another suggestion is that both pieces are sceptres, symbolic of the ones that were carried by the king during the final rites of the temple's foundation ceremony. Unfortunately, neither conforms to any known type. These two pieces are unique among objects found in Ancient Egyptian foundation deposits. *CARA*

Provenance: 1970; Deutsches Archäologisches Institut, Cairo, Bibliography: Arnold, 1971, p. 128; Luxor catalogue 1979, no. 16

King Mycerinus with deities

Egypt

4th Dynasty, reign of Mycerinus

(c. 2529–2501 BC)

stone, greywacke

92.5 x 46.5 cm

Museum of Egyptian Antiquities, Cairo,

JE 40679

Mycerinus's pyramid at Giza is much smaller than those of his predecessors, Cheops and Chephren, but the sculpture in his two pyramid temples has been much better preserved. Among the statues found in the Valley Temple was a series of triads representing Mycerinus with the goddess Hathor and a personification of one of the nomes (districts) of Ancient Egypt. Four, including this one, were intact.

Mycerinus stands in the centre, wearing the tall White Crown of Upper Egypt, an artificial royal beard and the pleated, wrapped royal *shendyt* kilt. At his sides, cylindrical objects are held in his fists. As on most Egyptian statues of standing men, his left leg is advanced. The depiction of his youthful, muscular body (its strength emphasised by the tension apparent in the clenched forearms, the high, broad pectorals, and the tautness of the torso) clearly represents a masculine ideal rather than an individual. The expressionless face seems equally impersonal, although its rather bulging eyes and fleshy cheeks, the slightly bulbous nosetip and the contours of the full mouth are features found on all statues of Mycerinus. This is a portrait of the king, even though it is highly idealised – the face of a god on earth.

Hathor stands to the king's right. She holds a *shen*-sign, symbolic of universality, and wears a headdress composed of cow horns, emblematic of her manifestation as a cow, and a sun-disc, signifying her close connection with the sun god, Re. The shorter stature of the nome personification suggests her lesser importance. Her headdress, carved in relief on the broad back slab, is the emblem of her nome, the Cynopolite or Jackal nome of Upper Egypt. Each woman has an arm around the king, and both stand with their feet nearly together, in the passive stance of Egyptian female images. Hathor's left foot, however, is slightly advanced, to betoken her status as one of Egypt's great deities. The women wear the

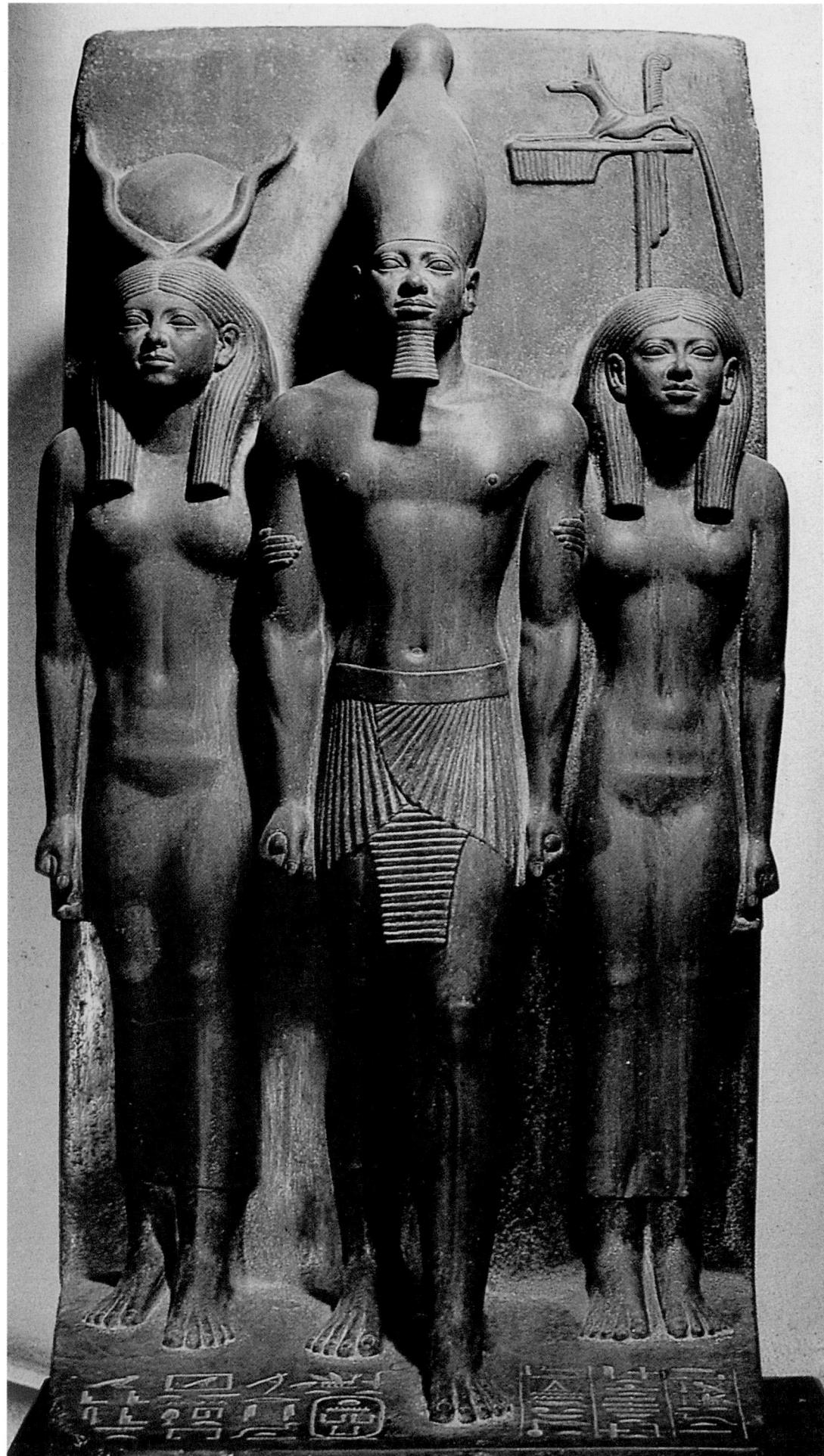

thick-tressed wigs of goddesses and long dresses, whose shoulder straps would have been indicated in paint. This dress, a standard garment of Egyptian women, was actually a sack-like linen tube. It was represented as unrealistically tight, in order to display the body. This is the Old Kingdom feminine ideal: young and athletic-looking. The emphasis on the pubic area clearly indicates a woman's paramount function in Ancient Egypt as the bearer of children. The faces of the goddesses, modelled on the features of the only god on earth, are softer, rounder versions of the king's.

ERR

Provenance: 1908, found in the Valley Temple of the Mycerinus pyramid complex at Giza

Bibliography: Reisner, 1931, p. 109, pls 37b, 38c, 43a-d, 46e; PM III, 1, p. 28; Woods, 1974, pp. 82-93; Saleh and Sourouzian, 1987, no. 33

1.31

Girdle

Egypt

12th Dynasty, reigns of Amenemhat II-Senusret III, c. 1922-1855 BC

gold, lapis lazuli
l. 78.5 cm

Lent by The Metropolitan Museum of Art, New York
Rogers Fund, 1934, 34.1.154

In Egyptian jewellery, cowrie shells were used as a decorative motif from prehistoric times. The cowrie seems to have been associated with female fertility and was used in girdles to be worn around the hips. Real shells continued to be used in dynastic times but, in 12th-Dynasty jewellery of upper-class and royal women, imitations of gold or silver are common. Metal cowries were made in two halves that were either cast or punched with the same stamp and then finished by hand. Most metal cowries have small pellets inside which would have made a noise as the wearer moved. One of the present examples retains its pellets.

The elements of this girdle were found in the coffin of a young girl named Hepy, whose intact burial was discovered in a small chamber of the construction shaft of a mastaba tomb. The stringing of Hepy's jewellery had decomposed, leaving eight metal cowrie shells and a variety of

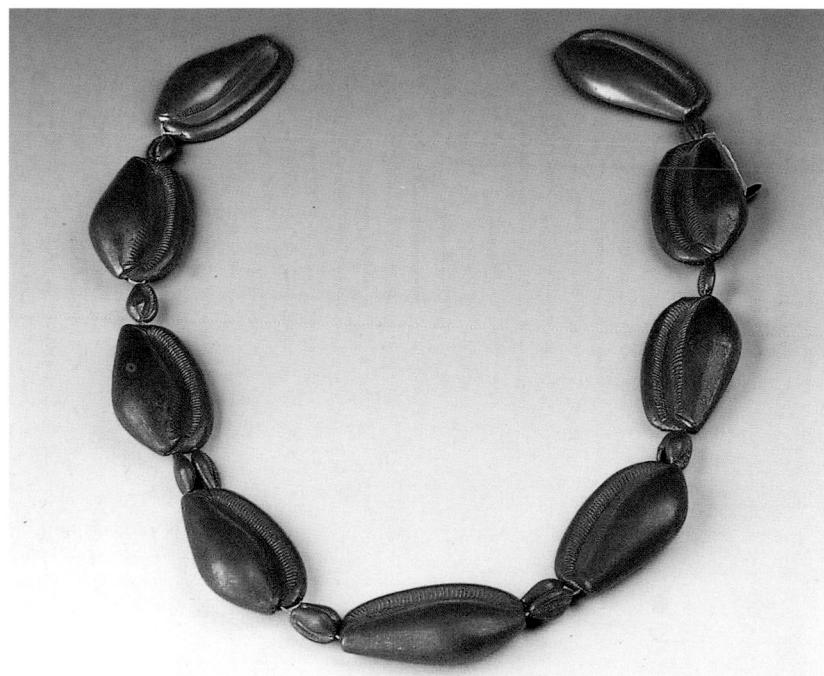

cornelian and lapis lazuli beads lying loose in the coffin. Only the small lapis barrel beads were numerous enough to have formed a girdle and they were restrung with the metal cowries in the present form. One metal shell forms a sliding clasp. The date of the burial is still under discussion, but pottery and stone vessels seem to place it in the middle of the 12th Dynasty. *CHR*

Provenance: Lisht, south cemetery, coffin of Hepy

Bibliography: Lansing, 1934; Hayes, 1953, p. 232, fig. 140

1.32

Girdle

Egypt

12th Dynasty, c. 1850 BC

gold

l. of each larger shell 5.7 cm
Museum of Egyptian Antiquities,
Cairo, 53074, 53165

Each of the cowrie shells is made in two halves punched into a mould and soldered around the outer edge. The larger contain loose pieces of metal which would have rattled as the wearer walked (cf. cat. 1.31). The shell forming the clasp has a base-plate soldered to the underside of each half bearing a tongue-and-

groove closing device. Each large shell is pierced by two stringing holes and the smaller shells are strung in pairs between them; it is not certain, however, that the latter were originally part of this girdle.

Girdles with elements in the shape of cowrie shells were the prerogative of women. Because of the shell's fancied resemblance to the female genitalia it was believed to provide special amuletic protection to that part of the female anatomy. As a girdle element it would be worn in the right place to ward off evil forces.

Although actual cowrie shells must have served this purpose in pre-dynastic burials, already by the 6th Dynasty (c. 2300 BC) the form was being imitated in other materials. Hollow cowries of precious metal are particularly characteristic of the Middle Kingdom: examples in silver and electrum as well as gold have been found in non-royal burials of the period (cat. 1.31). Of the other royal ladies of the 12th Dynasty whose jewellery has survived, Sithathor owned a girdle of identical cowries.

Contemporary cosmetic containers in which female figures act as a supporting element and so-called 'concubine' figures, the latter at least intended to stimulate sexual activity whether in this life or the next, are frequently depicted wearing a cowrie girdle. However, Mereret, the owner of this girdle, was a queen, daughter of the 12th-Dynasty pharaoh Senusret III, which suggests it was funerary in nature, to stress her feminine allure in the other world rather than to be worn in this life in company with dancing girls and courtesans.

Although Mereret's burial was robbed in antiquity, the contents of her jewellery box escaped the notice of the ancient tomb robbers. Some of her jewellery can be dated to the reign of her father, other pieces to that of his successor Amenemhat III; all demonstrate the skill of the jeweller during the 12th Dynasty, probably never surpassed during the remainder of the dynastic period. *CARA*

Provenance: 1894, excavated from the burial of Mereret at Dahshur, near the pyramid of Senusret III, by J. de Morgan, Director of the Egyptian Antiquities Service

Bibliography: de Morgan, 1895, p. 65, no. 7, p. 66, no. 11; Aldred, 1971, p. 196; Wilkinson, 1971, p. 80; Andrews, 1990¹, p. 141

Anklet

Egypt

12th Dynasty c. 1895 BC

gold, turquoise, cornelian, lapis lazuli
l. of claws 2.15 cm
Museum of Egyptian Antiquities, Cairo,
52911-2

These matched amuletic claw pendants, one facing right, the other left, originally would have formed the main elements of a pair of anklets. The claws are of gold, the section at the top of the upper surface incised to look like granulation, the area below inlaid with semi-precious stones to look like feathering. The single suspension loop shows that, unusually, they were intended to be strung with a single row of beads, some of which must have been gold discs, rather than with a double row of amethyst ball beads (as in other contemporary examples). The hollow gold clasp is made in two parts, each punched into a mould, with a tongue-and-groove closing device on the base-plates of the undersides.

Cloisonné work involved inlaying shaped pieces of semi-precious stone into metal cells or *cloisons* formed by soldering strips of metal at right angles to the baseplate. Granulation was usually formed by attaching tiny precious metal balls in a pattern to a precious metalwork base.

Khnumet, the owner of this piece (and of the clasps at cat. 1.34), was the daughter and wife of 12th-Dynasty pharaohs.

Hollow gold knots are characteristic of the Middle Kingdom. All other royal ladies of the 12th Dynasty

whose jewellery has survived owned a number of them; like Khnumet's, these served as clasps. However, contemporary solid semi-precious stone examples show they had an amuletic function, possibly funerary, of protection by binding or union, for the Egyptians had a terror that their limbs, head and torso might become separated in the other world.

Amuletic claw pendants were worn exclusively by women and are also a particular feature of the Middle Kingdom: Sithathor, Sithathorunet and Mereret owned pairs, and further examples have been excavated in contemporary non-royal burials. A dancing girl is depicted wearing anklets with attached claws in a 12th-Dynasty tomb.

Amuletic claws are usually of precious metal, sometimes (as in this instance) with *cloisonné* inlays, but others are of semi-precious stones; real claws have been found in burials of predynastic date some thirteen centuries earlier. Their symbolism is unclear. They are usually identified as those of a leopard, but examples like these with imitation feathering suggest that a bird's claw was intended. Perhaps the speed and swooping actions of a bird were to be assimilated by the women who wore them. *CARA*

Provenance: 1895, excavated from the intact burial of Khnumet, at Dahshur, near the pyramid of Amenemhat II, by J. de Morgan, Director of the Egyptian Antiquities Service

Bibliography: de Morgan, 1903, p. 59, no. 11; Aldred, 1971, pp. 180–1; Wilkinson, 1971, p. 62; Andrews, 1990¹, pp. 163, 173

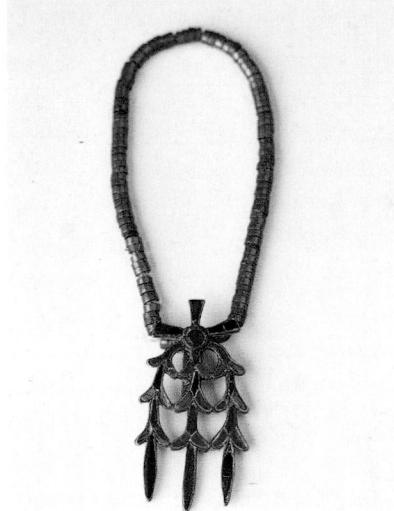

1.34a

Motto clasp

Egypt

12th Dynasty, c. 1895 BC

gold, turquoise, cornelian, lapis lazuli
h. 1.9 cm
Museum of Egyptian Antiquities, Cairo,
52956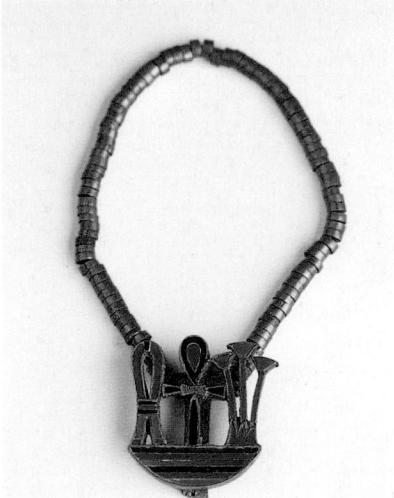

Both these clasps are of gold, inlaid with semi-precious stones in *cloisons*. They are currently strung with short lengths of tiny gold disc beads, but the suggestion is that they were originally worn on longer strings so as to hang on the chest as pendants. Each has a horizontal suspension tube at the back which divides into two, one half remaining attached to a fixed T-shaped rod over which slips a sleeve attached to the other half of the suspension tube. The *cloisons* or cells into which the shaped pieces of semi-precious stone are inlaid are formed from strips of metal (cf. cat. 1.33). Khnumet, the owner of these clasps, was the daughter and wife of 12th-Dynasty pharaohs.

The amuletic motto clasp in the shape of an *ankh*-sign flanked by a looped *sa*-sign and papyrus clump over a semicircular basket spells out to the wearer the hieroglyphic message 'all life and protection are behind (her)'. The other takes the shape of the hieroglyphic sign *mes* formed from three knotted fox skins, possibly representing a primitive apron, which is used to write such words as 'birth'. Perhaps this piece was intended to endow its wearer with the capability for new birth or resurrection. *CARA*

Provenance: 1895, excavated from the intact burial of Khnumet at Dahshur, near the pyramid of Amenemhat II, by J. de Morgan, Director of the Egyptian Antiquities Service

Bibliography: de Morgan, 1903, p. 65, nos 34, 63; Aldred, 1971, p. 188; Wilkinson, 1971, pp. 57–8; Andrews, 1990¹, p. 177

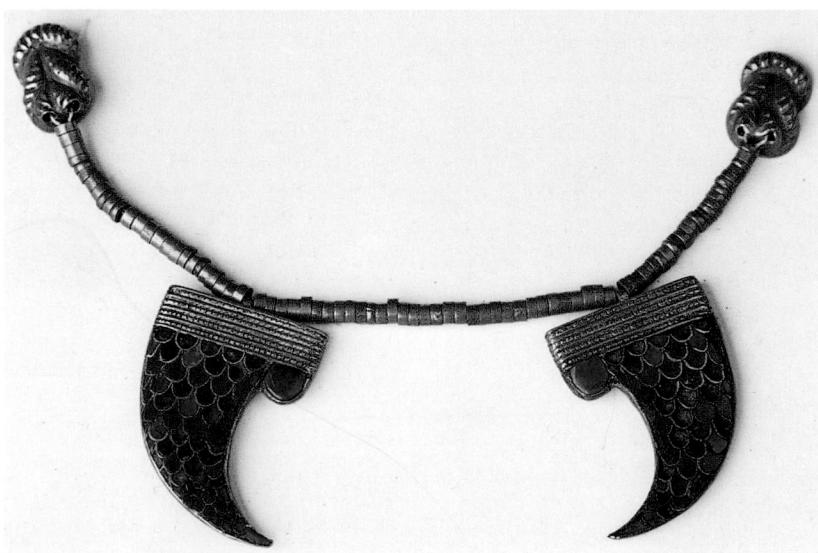

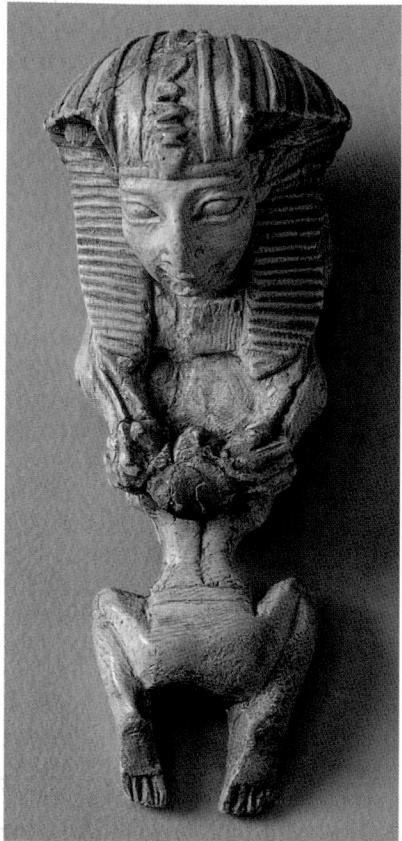

1.35

Miniature sphinx holding a captive

Egypt

Middle Kingdom,
c. 1985–1800 BC (?)

ivory

3 x 2.5 x 6 cm

The Trustees of the British Museum,
London, EA. 54678

The forepart of a sphinx – a composite creature with a king's head and a lion's body – holds in its claws the head of a prostrate captive, probably a Nubian, one of the traditional foes of Egypt (cf. cat. 1.48). The king wears the characteristic *nemes*-headdress with the royal uraeus at the front, its tail winding backwards over the head, the end now lost. The captive's knees are drawn up and his arms extended beneath the sphinx's legs. He appears to be naked except for a belt at the waist and a short wig. The line of his backbone is clearly indicated, as are his toes. His back is concave and his head tilted up towards the king, the face expressionless. The king's gaze is directed, regally, above and beyond his victim. The latter's rear and legs are disproportionately large, balancing the bulk of the royal head and headdress.

This ivory is a masterpiece of small sculpture, showing minute and very

skillful attention to significant detail, outstandingly so in the case of the royal features, which form a striking and distinctive portrait. The king has wide eyes with slightly bulging orbs, a prominent aquiline nose, high cheekbones, a small mouth with protruding lips – curved into a perceptible smile – a narrow pointed chin and enormous ears, which are splayed against the wings of the headdress (the latter feature a commonplace of royal sculpture of this period). In contrast to the delicacy of the face, the lion's body is suitably robust, with the underlying bone and muscle, particularly of the forelegs, strongly emphasised and the long sharp claws individually modelled, so as to indicate both the great power of the sphinx and the hopeless predicament of the captive. The composition symbolises, albeit on a small scale, the archetypal view of the king as the strong, invincible protector of Egypt.

The piece was not made to stand by itself, the presence of two peg-holes in its base indicating that it was originally meant to be attached to something else. It may perhaps have served as the handle to the lid of a box, for which its shape and size would have been well suited. Unfortunately its date is uncertain. Although it comes from an excavation, the context was disturbed and so ill-recorded as to allow at best only a general dating to the Middle Kingdom or Second Intermediate period. The head was once thought to be a portrait of one of the foreign 'Hyksos' kings who ruled Egypt for part of the latter period, but this view is now discounted. Recent stylistic analysis favours an attribution to the 12th Dynasty and, more particularly, to the reign of Senusret I, although the evidence remains inconclusive.

The ivory is in a very good state of preservation, although it is cracked and abraded in parts. Discoloration at the rear of the captive's head looks like charring. *WWD*

Provenance: 1908, excavated from tomb 477 by Garstang at Abydos; 1920, given to the museum by Mrs Russell Rea

Exhibitions: Cambridge and Liverpool 1988, no. 138; Vienna 1994, no. 362

Bibliography: Garstang, 1928, pp. 46–7, pl. vii; Schweitzer, 1948, p. 40, pl. ix, 3; Bourriau, in Cambridge and Liverpool 1988, pp. 136–8; Quirke, in Vienna 1994, no. 362

1.36

Figurine of a man holding a container

Egypt

late Middle Kingdom, c. 1700 BC (?)
stone (steatite)

4.2 x 3.6 x 6.7 cm

The Trustees of the British Museum,
London, EA. 74528

This cosmetic object is in the form of a squatting man, his knees bent and his arms extended on either side of a large rectangular basin with a sloping front. The man's head is rendered fully in the round, his limbs in shallow relief. He is shown wearing a short wig and a belt but is otherwise naked. He is possibly meant to represent a Nubian. The treatment of detail is economical with the slope of the vessel neatly balanced by the curve of the man's back, which is further complemented by the upward tilt of the head.

The combination of round and relief work was a popular technique of decoration on cosmetic objects, with animals, particularly monkeys, being favoured subjects (cat. 1.26). Human figures are less common in such contexts and the iconography of this piece, which partly anticipates that of the more formal type of statue represented by cat. 1.39, is highly unusual for its date. *WWD*

Provenance: 1994, purchased by the museum

1.37

Decorated ostrich egg

Egypt

2nd millennium BC or later
ostrich egg

h. 15.5 cm; diam. 11.5 cm

Musées Royaux d'Art et d'Histoire,
Brussels, E. 2538

In northern Africa ostrich eggs have been used as containers for water from epipalaeolithic times, and even after the introduction of pottery they continued to be used for this purpose.

In Egypt ostrich eggs were only exceptionally used as a containers. A number of eggs, some of them decorated, have been found in tombs (cat. 1.11) dating to the predynastic period, and especially in Nubia. Their use as material for beads was also mainly restricted to Nubia.

The decoration of cat. 1.37 consists of 37 spirals, linked in one running motif, starting at the base of the egg and leading to the small opening in the top. The spirals are incised with great care, and they are evenly distributed over the surface of the egg. Running spiral motifs are unknown in Egypt before the First Intermediate period, although they occur far earlier in the Eastern Mediterranean region. From the 2nd millennium BC onwards, they are especially characteristic of Aegean art. Nevertheless, there is no reason to accept a foreign origin for the running spiral motifs found in Egypt, since the earliest examples on early Middle Kingdom scarabs were

The carving is done in a rather summary way, owing largely to the hardness of the material, which could be worked only by hammering and grinding. Nevertheless, it is a fine composition and an impressive piece of sculpture.

In religious iconography, the baboon has several meanings. It is best known as the sacred animal of Thoth, god of wisdom and the local god of Hermopolis. Equally important is its relation to the solar cult. The baboon with its hands raised in adoration signifies the greeting of the morning sun when it emerges from the underworld and rises above the horizon. The origin of this imagery is thought to lie in the fact that when baboons leave their sleeping places in the early morning they indulge in great noise and commotion; Egyptian symbolism equated this with the greeting of the sun.

The sun is the symbol of death and rebirth. Sunset and sunrise are the critical phases in its imagined orbit. When the sun god passes the horizon in the solar boat, either upwards or downwards, he needs the co-operation of all his crew and entourage. On earth the pharaoh, his son and his deputy must assist the process. This is obviously what the sculpture expresses: the king performs the appropriate rites for sunrise.

A fragmentary group of a baboon and a king (in Berlin) may have formed a pair with this piece. It is probable that both pieces originate either from an obelisk or from the sun altar of a royal mortuary temple. Stylistically, the dating of the sculpture has recently been narrowed down to the reign of Amenhotep II. On the baboon's chest, a king's name is incised rather carelessly in shallow relief. It can be identified as that of Sety I of the 19th Dynasty. However, the stylistic evidence, indicating an earlier date for the sculpture, is so strong that the inscription must be regarded as secondary.

The temple-building activities of Amenhotep II, included the erection of obelisks, are attested at Heliopolis and Elephantine Island; he also contributed to the great temple of Karnak. His own mortuary temple, which lay north of the Ramesseum, on the west bank at Thebes, has been destroyed and there are no traces of a sun altar. In the publication of the

probably derived from an Egyptian hieroglyph. Nothing definitive can be said about a symbolic meaning for this motif within the Egyptian context.

SH

Provenance: 1905, bought Cairo
Exhibition: Brussels 1988, p. 116, no. 11
Bibliography: Scharff, 1929, p. 85; Kantor, 1948, p. 46, n. 4

1.38

Baboon in adoring posture with small figure of a king

Egypt

18th Dynasty, most probably reign of Amenhotep II, c. 1427–1400 BC
red granite
h. 150 cm
Kunsthistorisches Museum, Vienna
Miramar Collection, 1878, ÄS 5782

The baboon is standing on its hind-legs, hands raised with open palms turned outwards. This is the canonic posture that signals 'adoration' both in Egyptian art and in hieroglyphic writing. In front of the animal is the figure of a king, exactly three-fifths its size. He is in another, specifically royal, posture of prayer that signifies 'to adore the god four times': his palms are lying flat on the protruding triangular front part of his royal kilt. Apart from the kilt and the royal *nemes*-headcloth, the figure is naked.

The surface has suffered in some areas, including of the king's face; his ceremonial beard is also broken away.

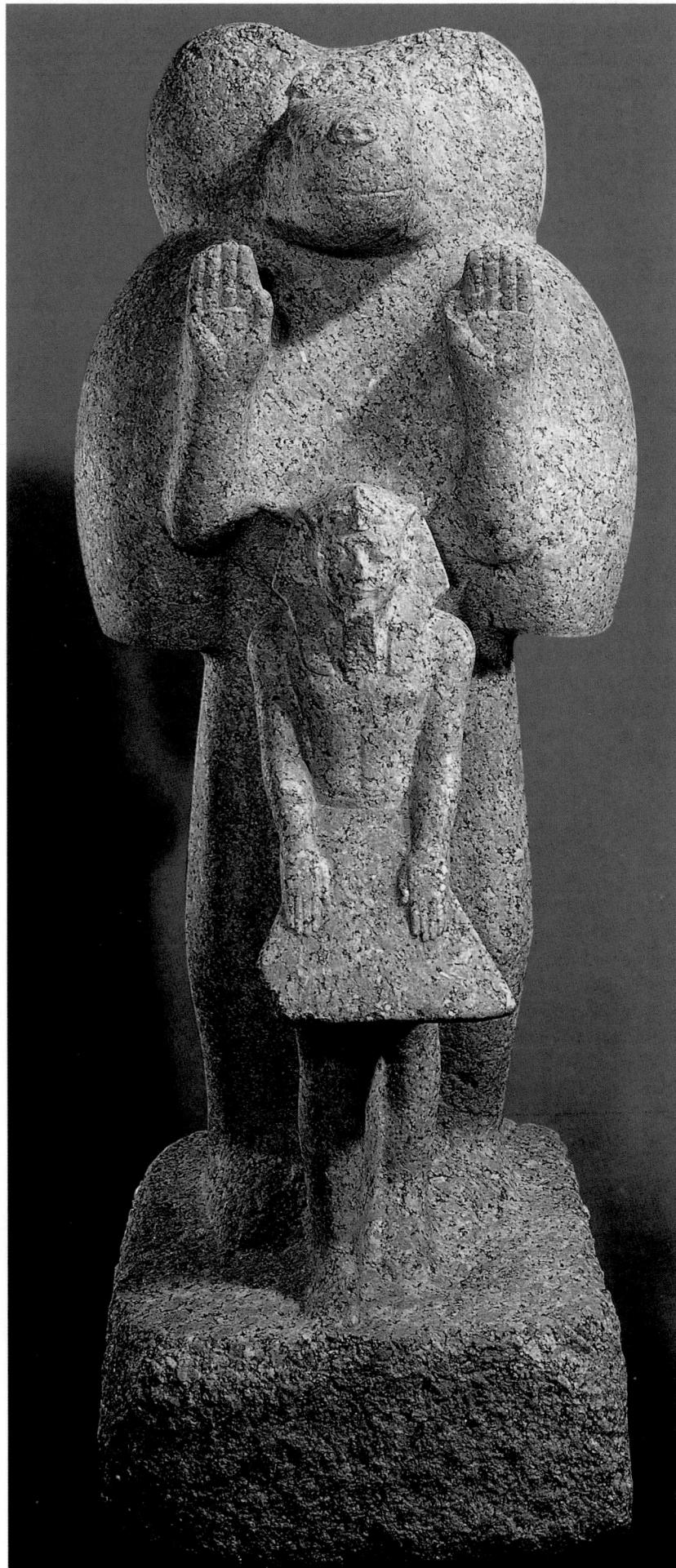

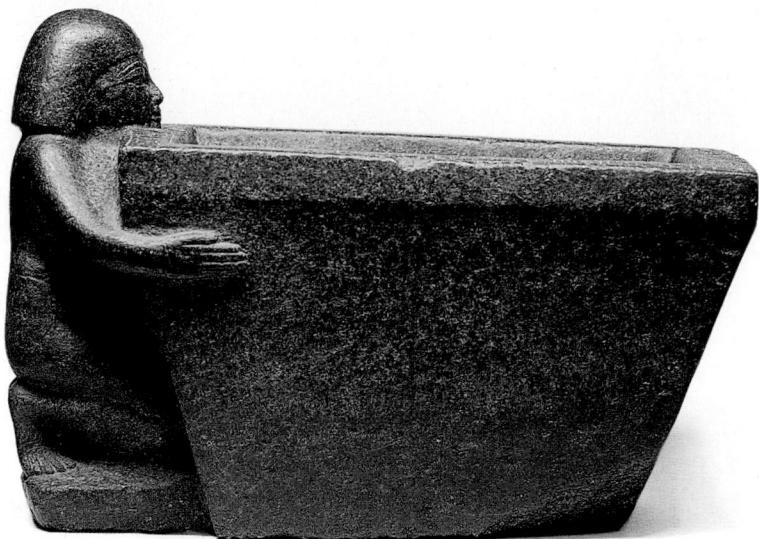

Miramar Collection (Reinisch, 1865) it is stated that this statue comes from the ruins of ancient Memphis. If this is to be taken seriously, it can be assumed that it originated from a Memphite sanctuary that has now completely disappeared (like nearly all buildings of that city), unless it was transported there from Heliopolis in antiquity. This might have occurred in the reign of Sety I, whose name can be read on the baboon. *HSa*

Provenance: reportedly from Memphis
Exhibitions: Essen 1961, no. 112;
Stockholm 1961, no. 96; Vienna 1961,
no. 116; Zurich 1961, no. 167; Trieste 1986,
no. II. 24; Vienna 1992, no. 89; Speyer,
Mexico City and Zurich 1993–4, no. 85
Bibliography: Reinisch, 1865, p. 243,
no. 59 Porter and Moss, 2nd edition,
1981, III/2, 864; Jaros-Deckert, 1987,
pp. 152–8; Satzinger, 1987, p. 19; Vienna
museum guide, 1988, p. 31; Sourouzian,
1991, p. 72; Satzinger, 1994, p. 74, fig. 50;
Satzinger, in preparation

1.39

Kneeling figure with offering basin

Egypt
18th Dynasty, c. 1390–1352 BC
gabbro
24 x 19 x 33.5 cm
Private Collection

One of the extraordinary qualities of Ancient Egyptian art is the visualisation of complex and abstract ideas through simple icons. The Last Judgement, for example, is represented in a balance where, in the presence of Osiris, the heart of the dead is outweighed against the symbol of Maat, the goddess of justice. In an equally simple and impressive motif the dependence of men on the blessing of god is formulated in this statue. The kneeling male figure embraces a rectangular offering tank. The chin slots into one of the sides of the basin; the lips touch its upper rim and seem to drink from the liquid to be offered in the container.

Hieroglyphic texts run around the rim and cover the opposite side of the basin. Their offering formula addresses the goddesses Astarte and Kadesh, both foreign gods introduced into Egypt from Syria at the beginning of the 18th Dynasty and venerated especially in the city of Memphis, at this time the political centre of Egypt. Ptah-anhk, the owner of this statue, was assistant of Ptah-mose, the high priest of the Memphite god Ptah. It is remarkable that Ptah-anhk does not address 'his' god Ptah but puts faith in more popular gods such as the foreign goddesses Astarte and Kadesh – typical for a cosmopolitan city like Memphis. The attitude of this statue expresses his devotion to these two goddesses and his hope that he might participate in the offerings presented to them. *DW*

Exhibition: Paris 1993, no. 40bis

Bibliography: Wildung, 1985, pp. 17–38

1.40

Vase in the form of a kneeling woman

Egypt
Amenhotep
1390–1352 BC
fired clay, dark red slip
13.9 x 6.2 x 6.8 cm
The Visitors of the Ashmolean Museum,
Oxford, 1896–1908 E2432

This vase, more sculpture than container, depicts a pose passive but alert, suggesting a maid-servant awaiting instructions. It is mould-made and there is a trace of a side seam under the left arm. The head may have been cast in a separate mould, as shown by a fragmentary second vase either from the same mould or, since it is slightly larger, used to create the moulds for this vase. The arms and spout were shaped by hand and applied. The fabric is a fine marl clay and the surface has been coated with a dark red slip. Red pigment has been used to emphasise the mouth and to indicate jewellery: necklace, breast ornament and girdle.

The vase was found in the intact burial of a young girl, datable by pottery to early in the reign of Rameses II, c. 1270 BC. The context is thus approximately 100 years later than the vase itself, and this is confirmed by the fact that the second vase comes from the 18th Dynasty. The vase exhibited here was either reused or was an heirloom and the

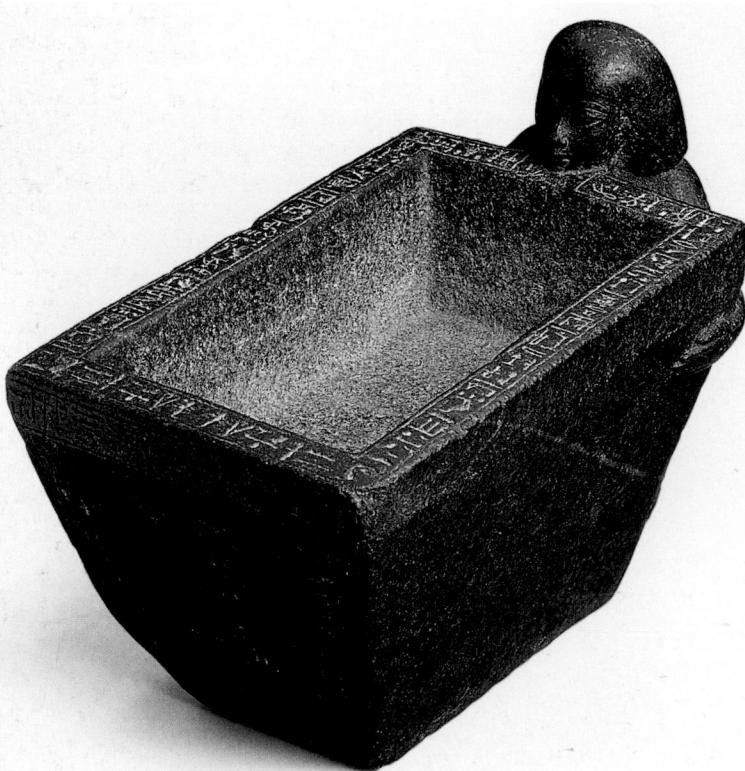

surface shows some loss of detail through handling. A string of beads had been placed around the neck, a reminder of the Egyptian belief that images of living beings held a latent power of life which could be animated by magic, in this case perhaps with the purpose of providing a serving maid for the dead girl in the afterlife.

Between c. 1450 and c. 1300 BC figure vases were popular in Egypt and the most common subject was a female servant in a variety of poses. They were the product of specialist workshops, since both their material and their technology distinguish them from the coarser, wheel-thrown pottery of their time. Their Egyptian origin is now recognised, although their excavators assumed they were Aegean in inspiration and manufacture. It is an archaeological accident that all the excavated examples have been found in tombs, since the vases were not made for funerals but show signs of everyday use as containers for perfumes and medicines, precious commodities used in the smallest quantities. *JDB*

Provenance: Abydos, grave W 1; given to the museum by the Egyptian Exploration Society

Exhibition: Cambridge 1981

Bibliography: Randall-MacIver and Mace, 1902, pl. XLVIII. D29; Ayrton et al., 1904, pp. 49–50, pl. XVI; Murray, 1911, pl. XXV. 66; Cambridge 1981, pp. 34–5; Bourriau, 1985, pp. 35–6, fig. 10; Bourriau, 1987, p. 90, pl. XXXIX.1; Hope, 1987, fig. 51

reinforcing fill employed on most Egyptian stone sculpture. The sculptor, obviously an accomplished stone carver, may have deliberately shortened the bodies, in order to make the statue's overall scale as large as possible, within the dimensions of the block.

Nebnefer is represented in sunk relief on both sides of the base. On one side, wearing the wig and costume of an official, he raises his hands in adoration of Amenhotep III. As often in Egyptian art, the king's image is represented by his name, enclosed within the royal oval or cartouche. His divine status, alluded to by Nebnefer's worshipful pose, is made explicit by a god's headdress of sun-disc and plumes, which crowns the cartouche. On the other side of the base, Nebnefer, his head shaven to denote the priestly aspect of his office, is shown worshipping both Sobek and the goddess Hathor.

The front of the base is filled with a sunk relief depiction of the emblem of Hathor: a woman's face with the ears of a cow, incorporated into a shrine-topped sistrum (a musical instrument particularly associated with her cult). The neck of the Hathor head rests on three hieroglyphs which again spell out the name of Amenhotep III. Thus, while worshipping Sobek within his temple, Nebnefer emphasised his devotion to the king and to Hathor. Since the goddess, who was often depicted as a cow, could also manifest herself in other animal forms, it is likely to be she who is represented by the second crocodile statue. *ERR*

1.41

Temple monument dedicated by Nebnefer

18th Dynasty, reign of Amenhotep III (1390–1352 BC)

grano-diorite

55.5 x 30 x 30.5 cm

Museum of Ancient Egyptian Art, Luxor, J. 136

This unusual monument was found in a temple of the crocodile god Sobek, where it had been dedicated by the Overseer of the Treasury of Amun, Nebnefer. Carved from a block of dark grano-diorite, it consists of the statues of two crocodiles on top of a pedestal-like, decorated base. The animals are shown crouching, with their tails hanging down at the back and their long snouts supported by the kind of

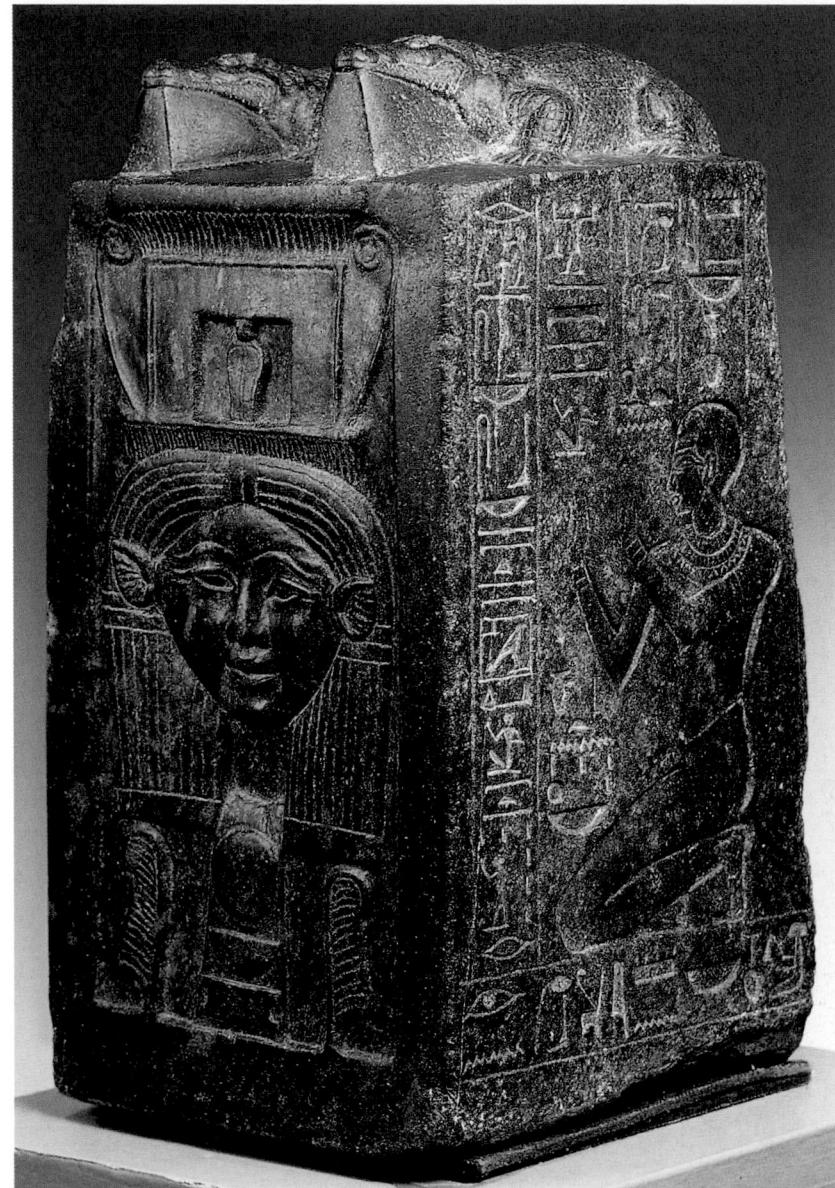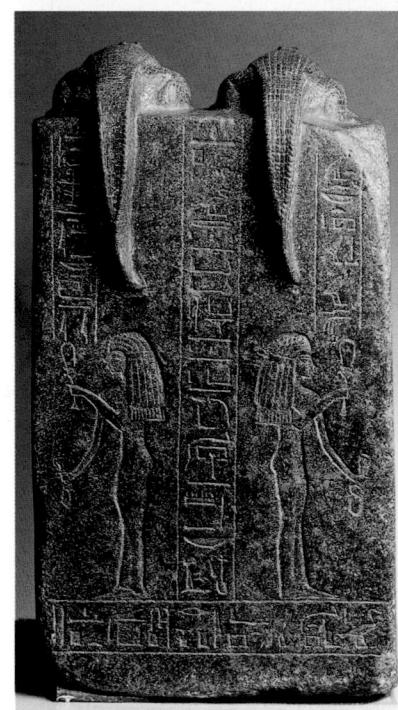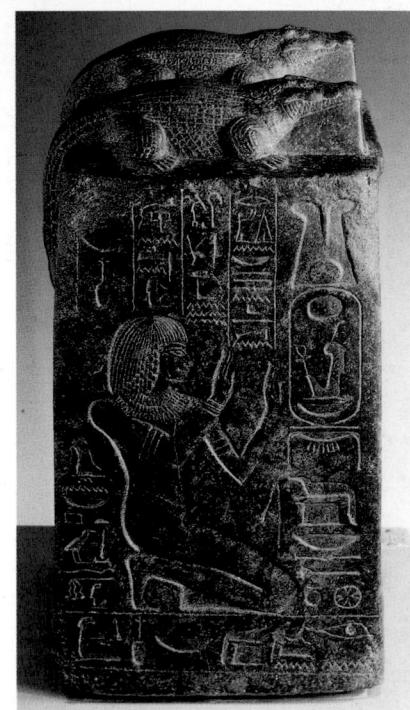

1.42

Fragment of a colossus of Akhenaten

Egypt

18th Dynasty, c. 1350 BC
sandstone

32.2 x 18.8 x 25 cm
Staatliche Sammlung Ägyptischer Kunst,
Munich, 6290

More famous than any other period of pharaonic history, the epoch of Akhenaten and Nefertiti, called the Amarna period after the modern name of the capital founded by the king in Middle Egypt, is not at all typical of Egyptian art. The highly impressionistic style is marked by the exaggerated features of the king himself.

The established proportions of Egyptian art having been set aside, the individual forms took on a new appearance: the face thin and elongated with a drooping chin, the lips turned up, and deep lines drawn from the fleshy sides of the nose to the corners of the mouth.

The more the personal, individual style of Akhenaten came to the fore in Amarna art, the less distinctive became the representation of others. Everything was subordinated to the image of the king, and thus his appearance determined the representation of man himself.

This fragment of a face comes from one of the colossal statues of Akhenaten erected in the temple of Aten, the monotheistic god, in Karnak, Thebes, during the first years of the reign. These statues show the king as both male and female, with voluptuous hips and full thighs, thus taking upon himself the role of the creator god. DW

Provenance: Karnak, temple of Aten east of Amun temple

Bibliography: Hamburg 1882, pp. 50–1;
Munich 1993, no. 27

1.43

Nubian girl with monkey and dish

Egypt

18th Dynasty, c. 1390–1352 BC

ebony

17.5 x 8.7 x 5.6 cm

Petrie Museum of Egyptian Archaeology,
University College, London, UC. 9601

This figure of a Nubian child is set on a rectangular base made separately of the same wood. It was reconstructed from fragments by the restorer Martin Burgess when he worked at the Petrie Museum in the 1950s. The girl is naked with her left foot forward, in striding mode; her head is shaved except for four round patches of tightly curled hair. Her ears are pierced. The arms are made in two parts, joined at the shoulders and elbows. As is usual in Egyptian wooden statuary, the feet are made separately and attached to the legs. Pegs through the right and left sides of the base join the two pieces together.

The slave girl carries a large serving-dish, decorated on the interior with a daisy-wheel design with dotted petals. This design is found impressed into bronze dishes of this period, and the shape is common in stone and faience in the New Kingdom. The zigzag decoration on the rim is also found on spoons of this period. The long, splayed foot of the dish rests on the head of a monkey, which faces out to the left side. This type of monkey was especially popular in the reign of the pharaoh Amenhotep III towards the end of the 18th Dynasty. The material of which this object is made would have been imported from elsewhere in Africa, as would the monkey and the object itself, a fashionable accessory for New Kingdom ladies.

BA

Provenance: 1896, bought by W. M. Flinders Petrie in Cairo (said to be from Thebes)

Exhibitions: Boston 1982; Cleveland 1992

Bibliography: Capart, 1905, pl. LXVIII; Page, 1976, no. 88; Brovarski et al., 1982, no. 239; Kozloff and Bryan, 1992, no. 88

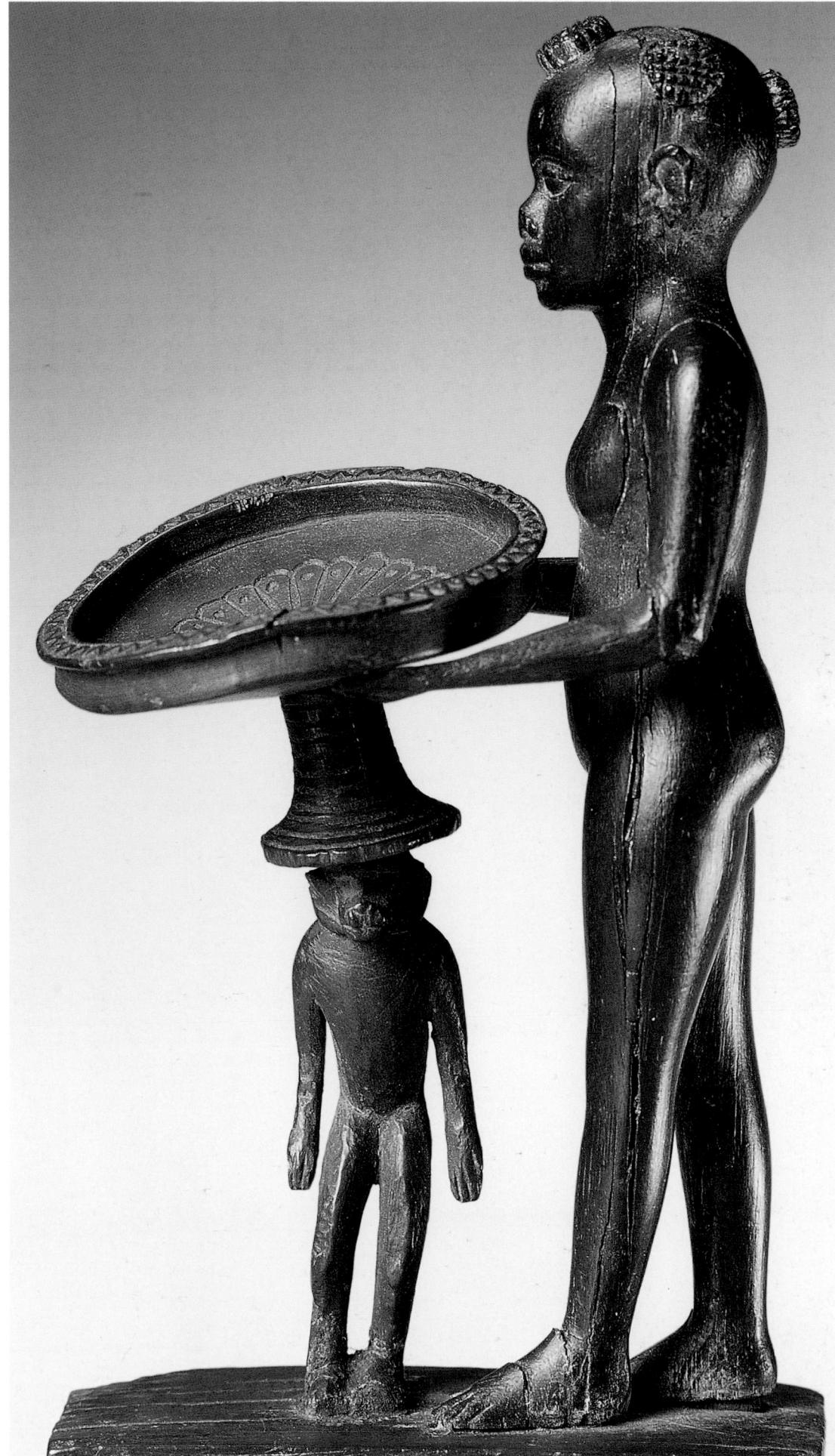

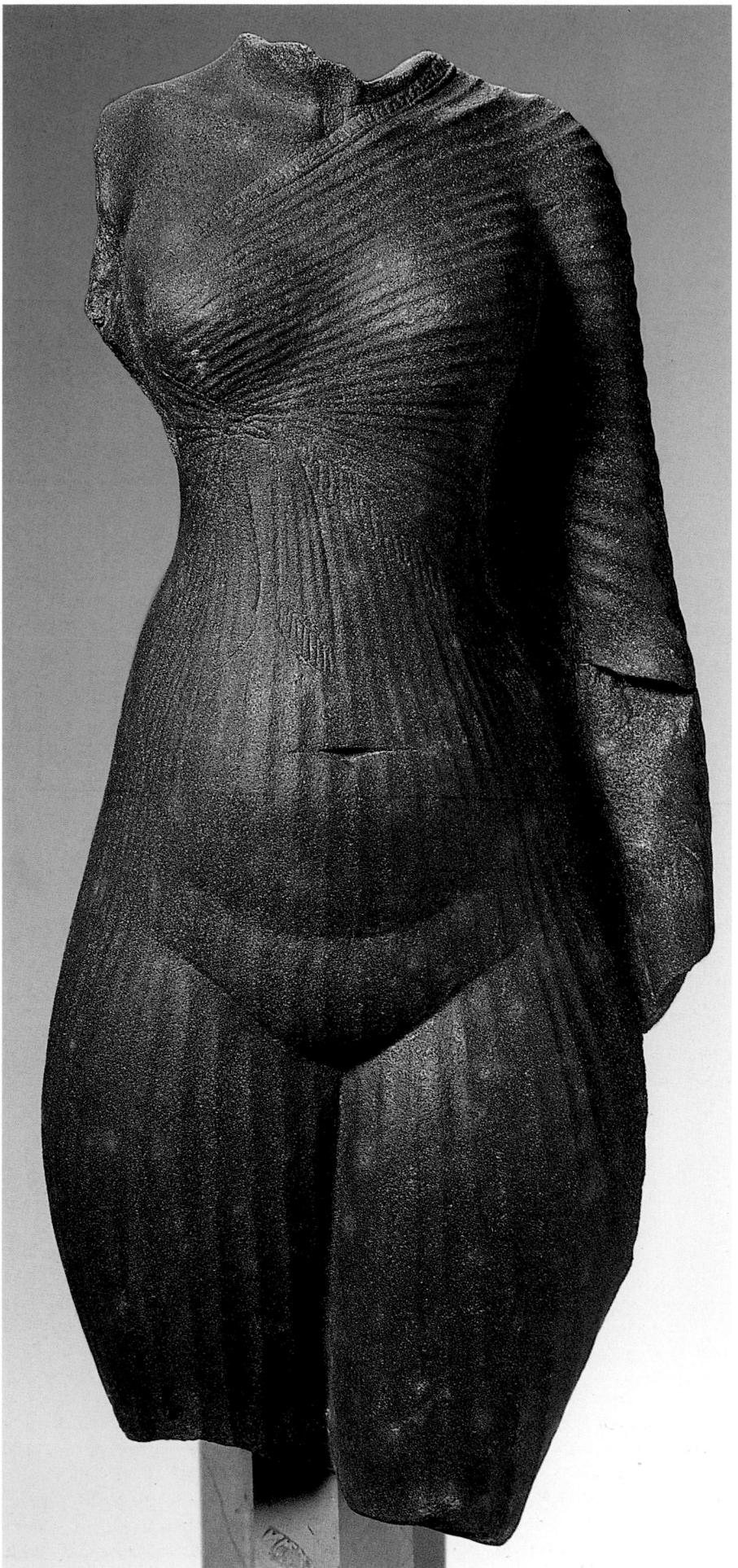

1.44

Female torso, probably Queen Nefertiti

Egypt

18th Dynasty, Amarna period,
c. 1352–1345 BC

quartzite

h. 29 cm

Musée du Louvre, Paris, E 25409

This admirable statue, unfortunately fragmentary and without inscription, probably represents Queen Nefertiti, wife of the Pharaoh Amenhotep IV (Akhenaten). The head, the right arm, the left hand and the legs from the knees down are lost, as is the top of the pillar behind the figure. She is wearing a clinging pleated dress; a shawl with a border and a fringe covers her left shoulder and arm, leaving her right shoulder bare. The clothing is knotted below her right breast. Under the sheer fabric the curvaceous body is sensuously modelled. This statue illustrates the virtuosity of the sculptors of the Amarna period, who created a new, naturalistic manner of representing the female form: every detail can be seen under the careful pleating of the dress, the latter revealing more than it conceals.

The top part of the body is modelled with great delicacy and this is accentuated by the fan-shaped disposition of the narrow pleats; in contrast, the lower half is much heavier and the pleats are broad and vertical. The shoulders are straight, the top of the back flat and the bust small but finely modelled: the effect is elegant and regal. The slim waist and long torso contrast with the amply proportioned hips and thighs. A long furrow underlines the base of the softly curving stomach.

The exaggeration of the forms, very evident from the side view, is typical of the art of the early Amarna period. In the case of Nefertiti it may be a symbol of her priestly status in the Aten cult, of which sensuality is an important feature.

This piece of sculpture is a superb example of the artistic innovations of its period; innumerable later female statues were to echo its style and lines.
PR

Bibliography: Vandier, 1958, pp. 340, 351–2; Aldred, 1975; Aldred, 1988, pp. 223–4, figs 69–70

Head of an Amarna princess

Amarna, Egypt

18th Dynasty, Amarna period

(1352–1336 BC)

brown quartzite

h. 21 cm

Museum of Egyptian Antiquities, Cairo,
JE 44869

This head was made for a composite statue of one of the six daughters of Akhenaten and Nefertiti. The long tang that extends below the neck was intended to fit into a body made of white stone or some other material that simulated the colour of her linen dress. Hands and feet would have been carved in the same brownish quartzite, and the completed statue would probably have been embellished with gilding, and perhaps with the attachment of real jewellery.

The princess's shaven skull and her lack of a wig suggest that she was still a child, but her features indicate that she was well past infancy. The depressions in her earlobes show that she was old enough to wear the heavy, ornately jewelled earrings fashionable in this period for both men and women.

The most striking element of this representation is the girl's elongated skull which, though beautifully balanced in terms of sculptural form, is greatly in excess of normal physical proportions. By contrast, the face is attractive and appears quite normal. Its features, however, are also somewhat exaggerated: the eyes are large and heavy-lidded; the narrow-bridged nose is quite long; the full mouth is large in relation to the narrow jaw; the long chin juts forward in an oversized knob. All of these exaggerations derive from the images of Akhenaten, whose physical peculiarities were imposed on the representations of his wife and children. Nevertheless, the portraits of the princess's mother, Nefertiti, achieve her likeness by the use of slight but distinctive variations in the shapes of her lips and other features. The face of this princess may well be a similar kind of portrait, but with features too subtly distinguished for us to recognise. In any case, her distended skull is certainly fictitious, an artistic rather than a genetic inheritance from her father.

In the earliest representations of Akhenaten and his family, physical

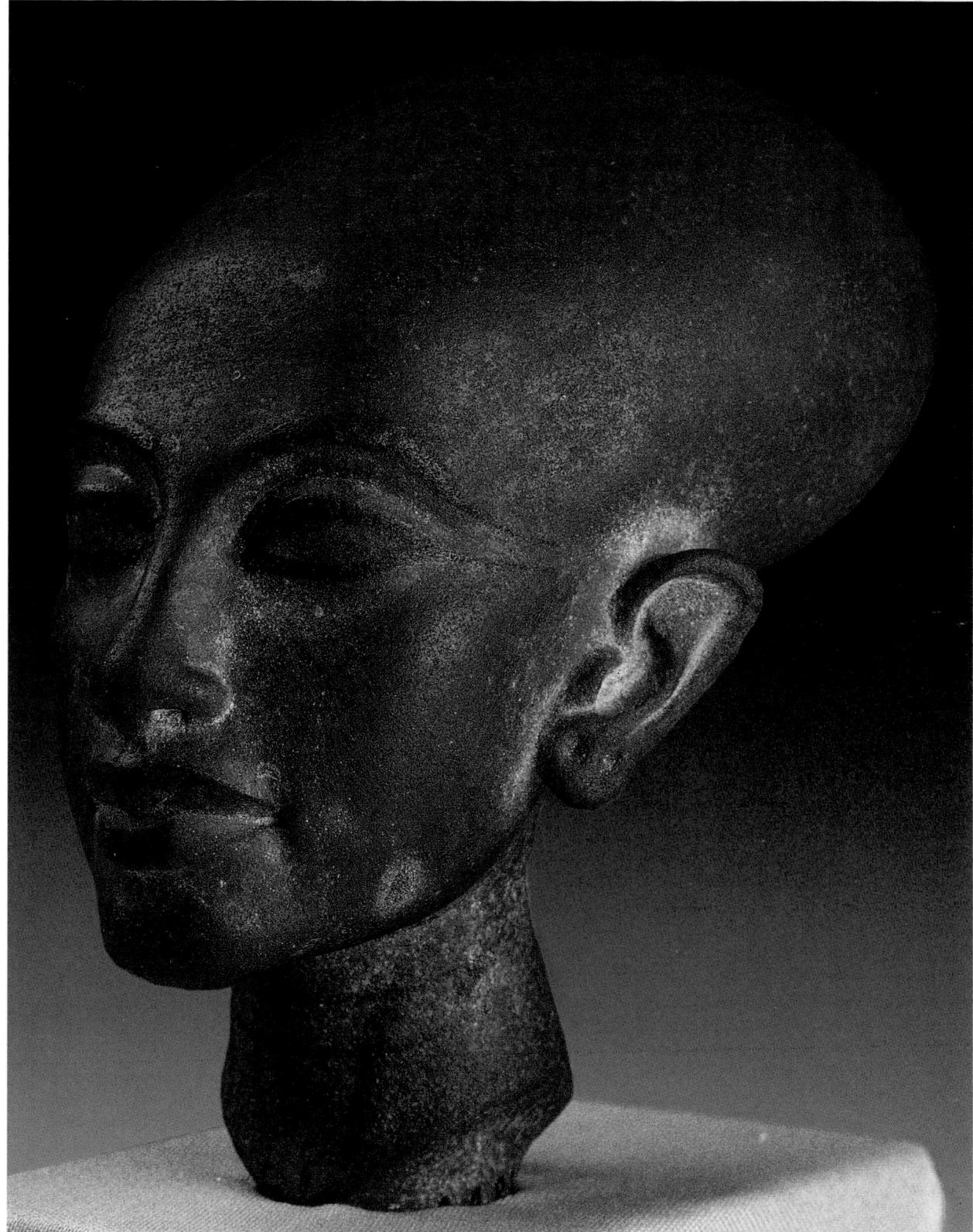

peculiarities were emphasised to an almost grotesque degree. Later in the reign, this harshly unflattering style was superseded by the softer, more naturalistic version seen in this head. This new style may have been the contribution of the master sculptor Thutmose, in whose workshop the head was found. If it, and other works

from his studio, were indeed made by him, Thutmose must be counted among the world's great sculptors; statues like this not only exemplify the feat of transmuting the king's revolutionary ideas into attractive images, but also evidence a refined handling of sculptural volumes and planes, combined with an

extraordinary ability to infuse the human face with a beauty that seems to emanate from the spirit as well as the flesh. *ERR*

Provenance: 1912, found at Amarna, in the workshop of Thutmose

Bibliography: Aldred, 1980, fig. 26; Saleh and Sourouzian, 1987, no. 163

1.46

Dwarf bearer

Egypt

18th Dynasty, Amarna period,
c. 1352–1336 BC

wood

5.9 x 1.8 x 2.6 cm

Museum of Fine Arts, Boston
Helen and Alice Colburn Fund, 48.296

Whether colossal in scale or just a few centimetres in height, Egyptian art is monumental, and that is nowhere better conveyed than in this representation of a dwarf carrying a jar. Wearing a short, wrap-around kilt, he strides forward on his left leg and uses both hands to balance a vessel on his shoulder. This is a true masterpiece in miniature, with every aspect of the dwarf's tiny body bending to accommodate the weight of the jar. The jar is hollow and may have been used to hold a small amount of a precious unguent, judging by larger examples. On the jar are two tiny cartouches bearing the names of the royal couple, Akhenaten and Nefertiti. The entire composition, including the rectangular base on which the dwarf stands, was made from a single piece of wood. It is possible that it was intended as a royal gift.

Provenance: said to be from Tell el-Amarna
Exhibition: Boston, Baltimore and Houston 1982, p. 205
Bibliography: Keimer, 1949, p. 139, n. 10 E; Bothmer, 1949, pp. 9ff.; Terrace, 1968, pp. 49–56

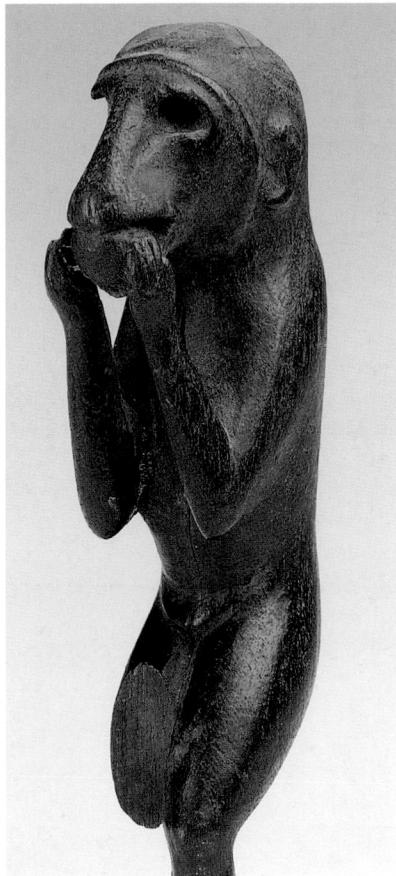

1.47

Monkey nibbling fruit

Egypt

New Kingdom, 1550–1186 BC

wood

h. 12 cm

Museum of Fine Arts, Boston, 148.70

On loan from the William Kelly Simpson Collection

Although native to Egypt, at least until the Middle Kingdom, monkeys were also imported from further south in Africa. Here, a crouching monkey nibbles on a piece of fruit that he holds in his mouth with both hands. On his face, which is set off by a raised ridge, deep-set eyes merge into a long snout with nostrils indicated by two nicks. The body is sparingly modelled.

Unlike baboons, which were deified and worshipped as the reckoners of time and messengers of the sun god, monkeys served to amuse and to entertain. They may have been kept as pets (cf. cat. 1.43). Their human-like antics made them a popular favourite of Egyptian artists, and they are frequently depicted in the round, in relief and in painting. They may assist women at their toilette or help in the harvest. In other examples they replace humans and mimic their actions. Crouching monkeys nibbling food were especially popular in the 18th and 19th Dynasties, the period to which this example is attributed. Its function is uncertain. *REF*

Exhibitions: Katonah 1977, p. 64; Boston, Baltimore and Houston 1982, p. 276

1.48

Protome of a lion with the head of a Nubian in its jaws

Egypt

early 19th Dynasty, reign of Ramses II,
c. 1279–1213 BC

Egyptian blue, gold

l. 4.3 cm

Lent by The Metropolitan Museum of Art, New York

Given by the Trustees of the Norbert Schimmel Trust in 1989, 1989.281

In Egyptian iconography the lion symbolises the power of the king, and the animal is a common decorative element in minor arts. One of the duties of the pharaoh was to protect Egypt from its traditional foreign enemies – Asiatics to the east, Nubians to the south and Libyans to the west. Thus, the image of a lion subjugating a foreigner is a frequent theme in early Ramesside art, especially under Ramses II. The common rendition shows a bound captive kneeling before a lion who holds the back of the man's head in his jaws. This protome (representation of the animal's forepart) employs the theme in an abbreviated form. The contours of the faces of the lion and the Nubian are modelled with superb naturalism, while details of the animal's mane, ears and mouth are more stylised. Three of the lion's eight gold teeth are preserved on the proper right side and the stub of another may be seen on the left. The gold linings of the animal's eye sockets are preserved, but the inlaid

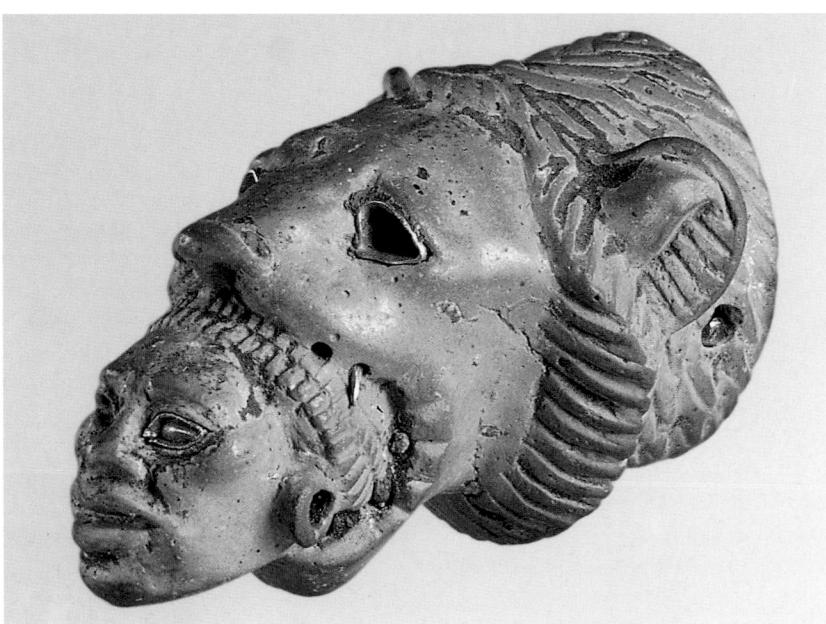

eyes are gone. The Nubian's right eye, rimmed and inlaid with gold, remains intact.

Two flywhisks, decorated with gilded lion heads, were found in the tomb of Tutankhamun. Although somewhat smaller, this protome also may have decorated a royal flywhisk or whip handle. The neck of the lion is hollow, with two small holes allowing the piece to be dowelled in place.

An 18th-Dynasty date has been suggested for this piece. However, the animal's head, especially its profile, closely resembles those of the lions that once decorated newel posts in the palace of Ramses II at Qantir. Like those from Qantir, this lion lacks any indication of the tear lines beneath the eyes that are a common feature of late 18th-Dynasty representations of felines, but are usually lacking in early Ramesside examples. *CHR*

Bibliography: Muscarella, 1974, no. 202; Settgast and Gehrig, 1978, no. 232; Kozloff, 1983; Roehrig, 1992; Kozloff, 1992, p.224

1.49

Relief depicting soldiers

Egypt

18th Dynasty, Amarna period,
c. 1352–1336 BC
limestone
17.5 x 25 x 6 cm
Lent by the Syndics of the Fitzwilliam Museum, Cambridge, E.G.A. 4514. 1943

The Amarna period is traditionally thought of as a time when military preoccupation was suspended while king and court devoted themselves to the new cult. However, written documents and representational evidence (such as this relief) indicate that the Egyptian military establishment held firm throughout.

This scene shows how the Amarna artisans experimented and challenged traditional representational conventions. Two soldiers moving to the right, one armed with spear and axe and a shield slung over his near shoulder, the other with shield under his arm and a rope in his near hand, are both pitched forward at the waist, the second more markedly than the

first, in apparent great haste. The men are depicted with large heads, sharply sloping foreheads, but horizontal and centrally positioned eyes whose lids are sculpted naturalistically and without the artificial rims and cosmetic stripes previously represented. The jaws jut out prominently, and all the features follow the iconography of the royal family. The size of the heads equals the breadth of the shoulders, the waist is sculpted high at the midriff and the limbs are thin. Gawkiness is emphasised by the deep but uneven contours.

All these artistic mannerisms are characteristic of the Amarna style, yet artistic licence was clearly permitted to the extent that details could be handled differently from scene to scene. Thus, one soldier in this relief wields his axe with one hand implausibly twisted, whereas his spear is more correctly held in a closed fist.

To avoid serial repetition, so common in traditional Egyptian multiple figure representations, the Amarna artisan spaced his figures more

generously and has varied their positions. This scene, probably part of a narrative over a large expanse of wall, is unencumbered by the usual texts, and it should not be surprising that the figures were not firmly fixed to ground lines; they were possibly surrounded by landscape. Although the relief is sunk, there is some overlapping of forms and a consequent interplay of raised and sunk relief.
EV

Provenance: given to the museum by R. G. Gayer-Anderson

Bibliography: Vassilika, 1995, no. 29

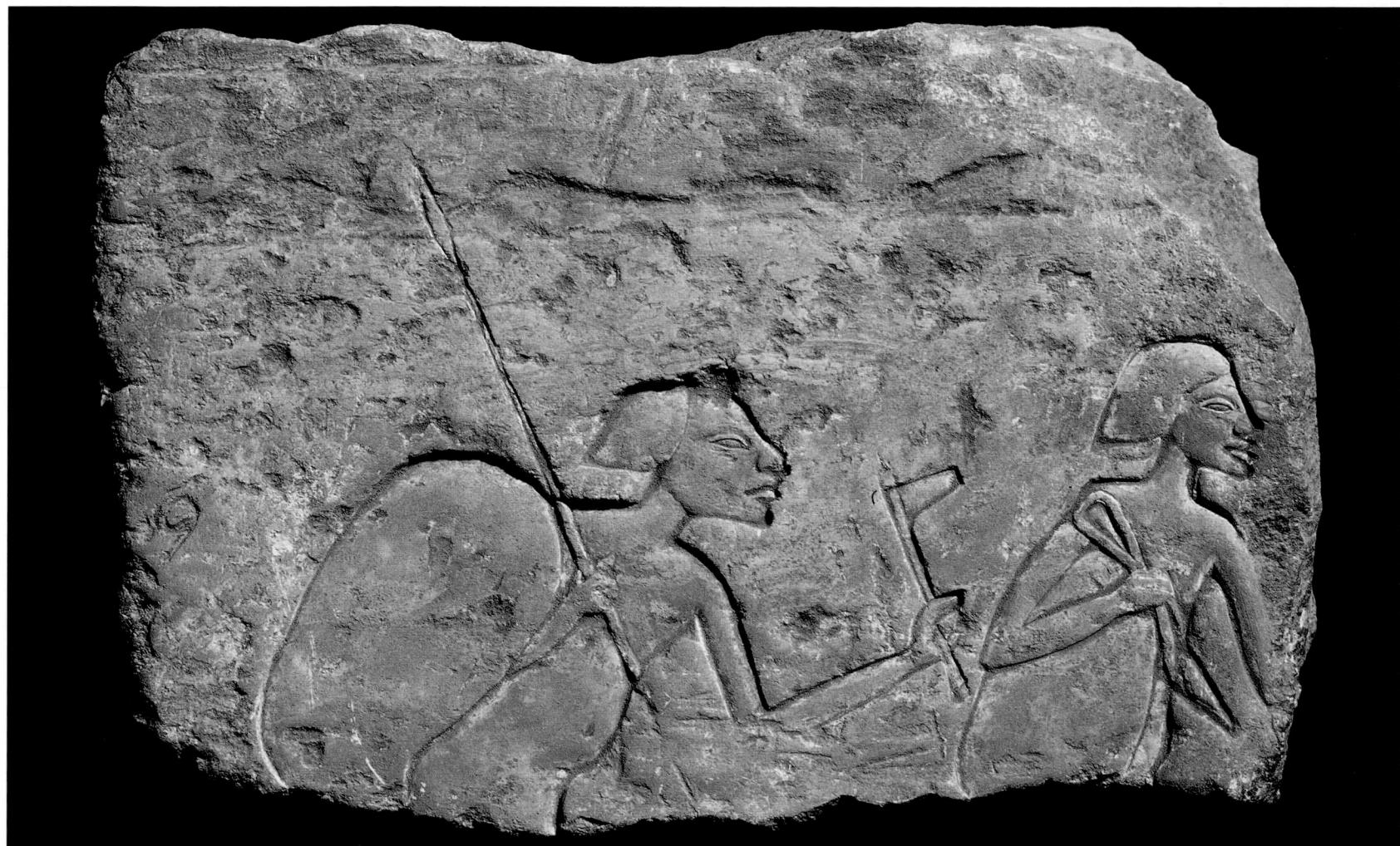

Statue of Ramses I

Egypt

19th Dynasty, c. 1294 BC

wood (sycamore fig), black resin

180 x 51 x 48 cm

The Trustees of the British Museum, London, EA. 883

Two life-size wooden figures were found by Belzoni in a royal tomb at Thebes, which is now believed to be that of Ramses I. First of the modern surveyors of the Valley of the Kings, Belzoni started his investigations on 6 October 1817, in an area where most of the tombs had been plundered in antiquity; some lay open and accessible to visitors, others were filled with rubble (as a result of heavy rains). On 11 October, when Belzoni cleared his passage through the third of the rediscovered tombs, he found in a corner of the burial chamber a wooden statue standing erect and a similar one (cat. 1.51) in a side room to the right. The figures were later transported to Cairo and joined the famous collection of the British consul Henry Salt.

At that time, hieroglyphic writing had yet to be deciphered and the owner of the tomb was unknown, as was the purpose of such statues. The discovery, at the end of the 19th century, of similar wooden figures in other major tombs of the Valley of the Kings and, most significantly, of the intact pair of Tutankhamun flanking the sealed entrance to his burial chamber, was to show that this type of statue, now commonly known as a 'guardian figure', was an integral part of royal funerary equipment. In fact, wooden sculptures are attested in royal tombs from the 1st Dynasty.

This figure represents the king standing, left foot forward. From the companion piece in the British Museum (EA. 854) and analogous statues, it is known that the left arm was bent forward to hold a long staff while the right hung straight down the body, the hand holding a mace. The king wears the bag-shaped headgear called *khat*, as opposed to the companion piece which wears the *nemes*-headcloth. The costume consists of a short kilt with a projecting triangular apron.

Like all wooden figures of this type, the statue was carved from separate pieces of wood, joined together by means of tenons and

mortises. The uneven joins were concealed with gesso, the whole piece coated by a thin layer of black resin, and the attire, consisting of the headgear, the kilt, the broad collar, bracelets and armlets, was overlaid with gold on a base of gesso and linen. The face of this statue was fixed into the head, which in turn fitted into the torso. The eyes and the eyebrows were inlaid – a remnant of the original mortar backing can be seen in the right eye. The beard (now lost) was fixed under the chin and the ears were likewise fitted into the sides of the head. A large appendage in the form of a flap was once attached to the back of the headdress, and on its forehead the royal uraeus was inserted in a rectangular slot. Traces of a collar are discernible on the chest. The arms, usually worked in two jointed pieces, were fixed to the torso by tenons and mortises that are visible on the sides. On the triangular forepart of the kilt, several slots attest to the fact that an apron was once attached; this would have been overlaid with gold leaf. One leg, both feet and the base of the statue are modern restorations.

Although very badly damaged, the characteristic features are still discernible on the preserved parts. The top of the headdress is domed. The face is oval-shaped, the forehead very low and the chin rounded. The eyebrows are arched above the eyes and prolonged obliquely on the temples; the eyes are narrow and slanting, elongated by horizontal cosmetic bands. The upper torso is bent forward, the collarbones rendered by oblique ridges. The chest is smoothly modelled, the waist is thick, the hips are slightly projecting and a belt curves under the stomach, which protrudes somewhat; the latter is marked by a vertical depression ending at the navel, rendered by a circular hollow.

These features coincide with the style of the late 18th Dynasty, which was likely to have been still current in the early 19th. This statue and its companion piece seem to be the only preserved sculptures to represent the king Ramses I. Owing probably to the short reign of the sovereign, very few figures of him exist. Of seven fragmentary stone sculptures bearing his name, only two statue-bases remain. Three other sculptures were dedicated

to him by his son and successor Sety I. The preservation of these wooden figures is a stroke of good fortune, not only advancing knowledge of royal iconography of the early 19th Dynasty, but also pointing to the fact that the provision of such sculptures was compulsory in the royal tomb.

HSo

Provenance: Thebes, Valley of the Kings, tomb no. 16; ex collection Henry Salt

Bibliography: Belzoni, 1820, pp. 229–30; British Museum guide 1909, p. 190 (685); Christophe, 1959, pp. 257–65; Mayes, 1959, pp. 178, 206, 310, 330, no. 685; Porter and Moss, 1973, p. 535; James and Davies, 1983, p. 49, fig. 55 (right); Reeves, 1990, pp. 91–2; Penny, 1993, pp. 125–6, fig. 115

of three tenons. Only the *nemes*-headcloth is here dissimilar, corresponding to the companion statue of Ramses I (British Museum, EA. 854).

The style is also different. The eyebrows are rendered naturally by slightly raised arches; the eyes are bulging and have heavy eyelids. The nose is narrow and aquiline. The mouth is well defined by sharp-ridged contours and sinuous lips. The stern expression is accentuated by lateral furrows and an incurved depression under the lower lip, which enhances the projection of the large chin. The head seems disproportionately large in relation to the upper torso; the chest is schematically modelled; the waist is very high and slim. The hips are narrow and the stomach is a simple bulge, without any detailed modelling.

One of the last rulers of the New Kingdom, Ramses IX, whose tomb is among the best preserved in the Valley of the Kings, is otherwise known only from a small number of statues: cat. 1.51 is important for confirming that this type of tomb sculpture remained in use up to the late New Kingdom. It was certainly one of a pair, as the earlier examples show, differing from each other in their headgear.

According to the inscriptions preserved on the kilt of the similar statues of Tutankhamun, the king standing on the east side with the *nemes*-headcloth was 'living forever like Re, each day'; and the western counterpart, wearing the *khat*, is 'the royal Ka of Re-Harakhty, the Osiris, King and Lord of the Two Lands, Tutankhamun, justified'. Thus such statues represented the two aspects of the sun god with whom the king was united after his death: the diurnal sun, Re-Harakhty, and his nocturnal *ka*, Osiris. Representations of these statues are found carved on the descending corridors of royal tombs. A long sequence of funerary scenes depicts priests performing rites on the statues, which are being towed down to the grave.

More than mere guardians, even though they seem to watch over the burial chamber, these wooden figures, indispensable to the royal funerary equipment from the earliest dynasties, act as substitutes for the king and his *ka*, as diurnal and nocturnal sun, and stand there to participate in all the rituals through which the king will live for ever. HSo

Provenance: Thebes, Valley of the Kings,
tomb no. 6; ex collection Henry Salt

Bibliography: Arundale, Bonomi and
Birch, 1840, p. 112, pl. 47, fig. 171; Porter
and Moss, 1973, p. 507; James and Davies,
1983, p. 49, fig. 55 (left); Reeves, 1985,
pp. 40–1, 45, no. 16; Reeves, 1990,
pp. 119–20, no. 56; Penny, 1993, pp. 124–6,
fig. 114

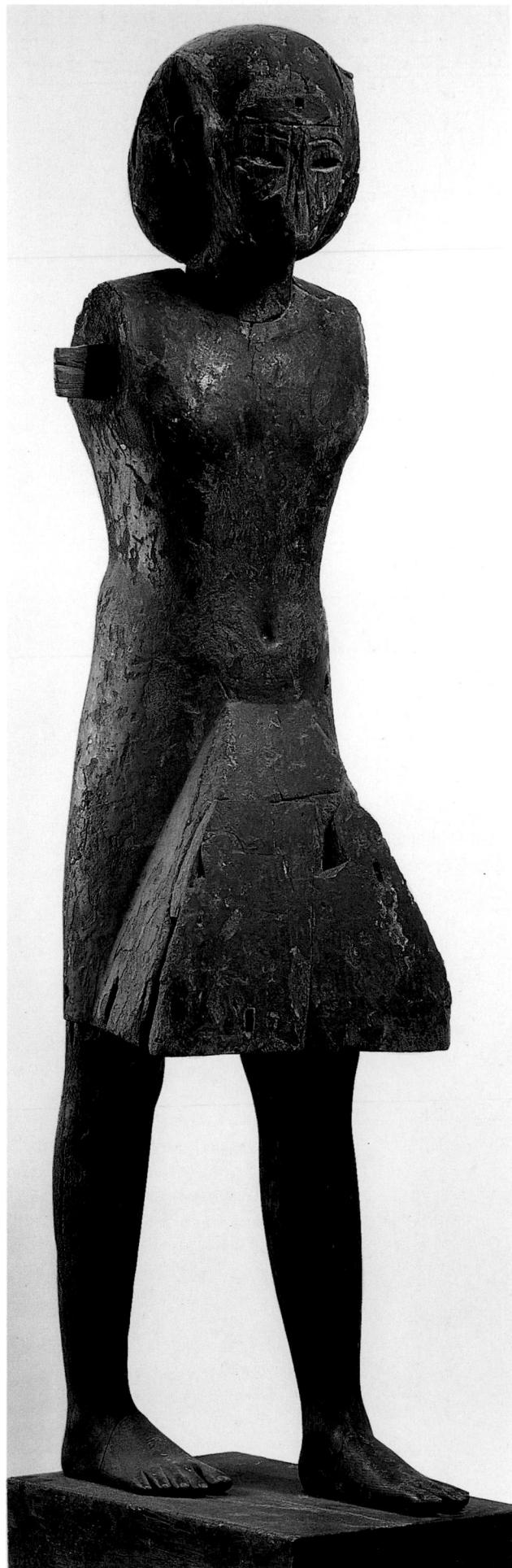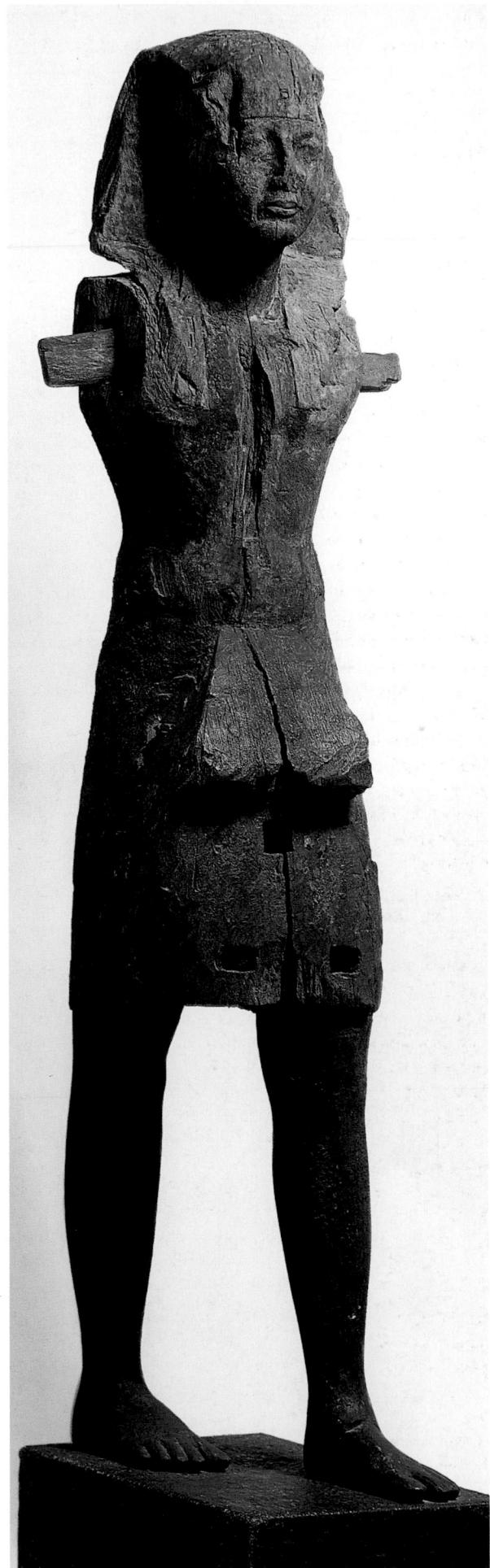

Box with conical lid

Egypt

New Kingdom (?), 1300–1100 BC

faience

h. 15.5 cm.; diam. 11.9 cm

Musée du Louvre, Paris

Fould Collection, E 3610

The original painting on this small, flat-bottomed, cylindrical receptacle, with its lid shaped like an upturned lotus flower, is almost intact. The box is decorated in black and bright blue, the latter having become almost blue-green in places.

The scene depicts a man standing facing the ibis-headed god Thoth, with his left leg forward and his arms hanging at his side; his hair is shoulder-length and cut in a curve; he is wearing a full-length loincloth. Thoth is slightly less tall and wears a short loincloth and a collar. In his left hand he holds an *ankh*, the cross symbolising life, and in his right, which is outstretched, a *was* or sceptre. The relief is somewhat sketchy, as are the details, probably on account of the materials and technique employed. Between the two

figures a text, shared between two vertical columns separated by the divine sceptre, places the harem scribe (?), Hor (?), the owner of the box, under the protection of Thoth, Lord of Hermopolis.

The background of this scene is decorated with (below) four zigzagging lines on a black background, symbolising water, and (above) five lines in the form of a chequered pattern, composed of blue and black squares. On the upper edge six small, regularly spaced holes still contain the remains of the cord that must have kept the lid in place. The lid also has a cord passing through a hole at the top. The decoration of the lid is not in good repair, but a few details of lotus petals in dark blue can still be made out. The interior and base of the box and the interior of the lid are black.

Containers of similar shape and with similar decoration have been found in a number of places, in particular the tumuli at Kerma in the Sudan; but this piece is most closely paralleled by a small receptacle in stucco found in a tomb at Deir el-Medina. The boxes are similar both

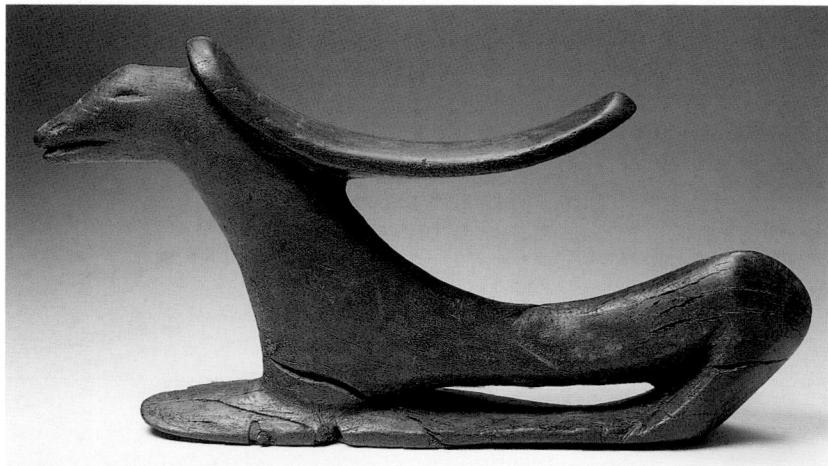

in size and shape; the chequerboard design and their lids in the shape of an upturned lotus flower suggest a shared source of inspiration and an obvious relationship with wicker baskets. PR

Exhibition: Boston 1982, p. 151, no. 159

Bibliography: Wenig, 1978, p. 160, no. 68; Bruyère, 1937, p. 56, fig. 27

Although a fine and unusual sculpture, this hare is unlikely to have been simply the result of an artistic fancy. Egyptian headrests were often decorated with inscriptions or with figures of apotropaic deities, whose function it was to protect the owner against various dangers in this life or the next. Amulets in the shape of the hare were worn by the living and the dead in Ancient Egypt. The exact purpose of this amulet is unknown. The hare potentially embodied both dangerous and benevolent properties. As a wild thing of the desert, the animal might have represented the forces of chaos, against which the amulet would have provided protection, while at the same time perhaps endowing its wearer with the hare's special attributes: alertness, speed of limb, fertility and the power of regeneration.

The date of the headrest is uncertain. A similar one is in the Petrie Museum, London, without provenance. The wood species was recently identified by Caroline Cartwright of the British Museum. WWD

Provenance: 1888, given to the museum by E. A. Wallis Budge

Bibliography: Budge, 1904, p. 70, no. 58; Petrie, 1927, p. 35, pls XXXII, 35; Costa, 1988, p. 44, fig. 15; Hart, 1990, pp. 42–3; Andrews, 1994, pp. 63–4

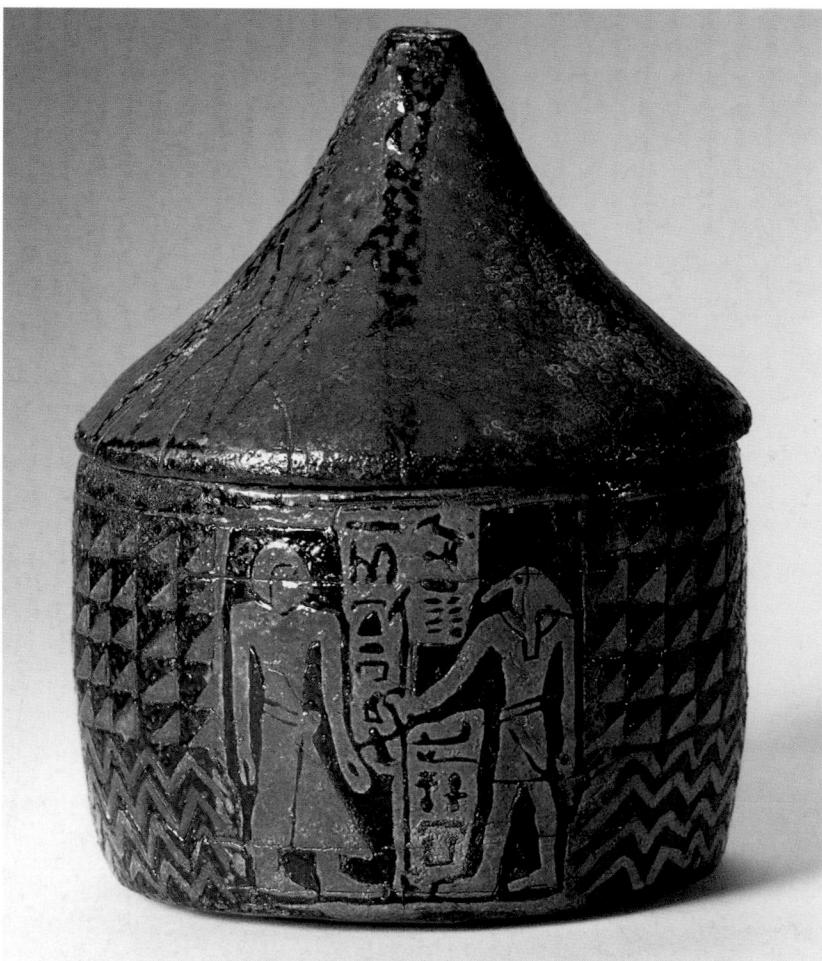

1.55

Headrest in the form of a hare

Egypt

New Kingdom (?), c. 1550–1069 BC

wood (tamarisk)

19.6 x 38.4 cm

The Trustees of the British Museum, London, EA. 20753

Headrests are normally tripartite, consisting of a central shaft placed on a flat base and surmounted by a concave platform, a form well known from Ancient Egypt (cat. 1.54), the Sudan and other parts of Africa (cat. 2.9a). The present example is unusual in shape and concept. It is carved from a single piece of wood in the form of a crouching hare. Imaginative use is made of the hare's long ears to form the headrest's concave platform. The piece was polished after carving, although chisel marks remain in the more inaccessible parts. There are no traces of paint. It is well preserved but there are small areas of damage and the surface is cracked in a number of places, largely owing to dessication of the wood. The front left of the base was once broken and subsequently repaired with the aid of wooden dowels.

1.54a

Headrest

Egypt
New Kingdom (?), c. 1550–1069 BC
wood
18.4 x 17.6 x 6.4 cm
Musées Royaux d'Art et d'Histoire,
Brussels, E. 7220

1.54b

Headrest

Egypt
New Kingdom, c. 1550–1069 BC
17 x 21.2 x 8.1 cm
Musées Royaux d'Art et d'Histoire,
Brussels, E. 2406

The Ancient Egyptians, like certain African peoples today, were in the habit of sleeping on their side, with the flat part of their head, below the ear, placed on a headrest. Headrests were particularly common during the Old Kingdom and through to the New Kingdom. They are made in a wide variety of materials (limestone, calcite, ivory, clay, faience, wood, etc.) and in various shapes. Most consist of three main parts: the base (generally oblong), a vertical part that acts as a support, and a top part, usually crescent-shaped; this could be wrapped in several layers of fabric to make it more comfortable to sleep on. Although headrests were used in everyday life, surviving examples come mostly from tombs. In a funerary context the headrest became a talisman with magical properties: it would ensure the resurrection of ‘he who went to sleep’ (the deceased) by keeping malevolent spirits at bay, in particular the gods who ‘cut off heads and rip out hearts’.

1.54b

Cat. 1.54a bears no decoration and no inscription and is an extremely simple shape. Two slightly curved columns rise from an elliptical base. As usual, the top part is crescent-shaped; it has a rectangular support that serves as an abacus to the columns. The headrest is made from four pieces of wood, carved separately and held together by pegs.

Cat. 1.54b has a rectangular and very elongated base and a vertical support of an original and decorative shape, that of a pointed vessel with two handles, standing on a trapezoid support. The top part of the headrest is attached to the vase with a tenon and mortise. LL

Provenance: cat. 1.54a: ex collection C. W. Lunsingh Scheurleer; cat. 1.54b: 1905, purchased Cairo
Bibliography: Vaulathem, 1983, pp. 42–43; Lefebvre and van Ruisveld, 1991, p. 119.

1.55

Tool in the shape of a finger

Egypt
period unknown
wood
40.1 x 4.2 cm
Musée du Louvre, Paris, N 1527

This curious object, made of a single piece of wood, has two distinct parts. One is cylindrical and is carved in the shape of a finger with a very pronounced curve; the fingernail is carved in detail. Traces of wear can be seen under the curved part of the finger. The other part, longer and wider, is rounded on top and almost flat beneath. The end has a bevelled edge, meticulously rounded.

The use to which this object was put can only be surmised. The hypothesis suggesting that it was an instrument used during the ‘opening of the mouth’ in the ritual of the dead seems implausible because the flat part of the object is too large, disproportionately so in comparison with the finger; the finger appears to have been used for picking things up. The suggestion that it was a mason’s smoothing trowel is supported by small details: the base of the long part

is quite flat and the bevelled edge would permit the labourer to use the tool in corners without disturbing the plaster on the adjacent wall. However, the masons’ trowels that have survived are not generally shaped like this. They are shorter and broader with a horizontal handle. If the function of this tool was to smooth, perhaps it belonged to a different craft; could it, for example, have been used in the processing of papyrus, a function for which it appears equally well adapted? PR

Exhibition: Boston 1982, p. 56, no. 28

Bibliography: Petrie, 1917, p. 42, pl. XLVII

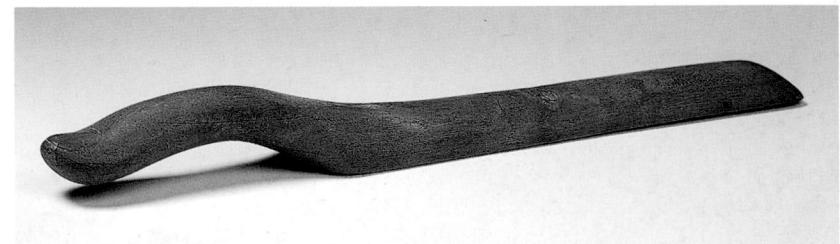

Ostracon depicting a bull

Egypt

19th Dynasty, c. 1295–1186 BC

limestone

11.8 x 16.2 x 2.2 cm

Musées Royaux d'Art et d'Histoire,
Brussels, E. 6371

The Egyptians often used fragments of limestone or shards of pottery, to be found in abundance around their dwellings, for writing on or for sketching or painting. Documents of this kind, called *ostraca* (plural of the Greek word *ostrakon*, 'inscribed shard'), have come down to us by the thousand. *Ostraca* bearing drawings are often very attractive; most have been discovered in West Thebes, in

Deir el-Medina and other villages, where the labourers and artisans responsible for digging and decorating the tombs of the pharaohs and the queens of the New Kingdom lived. These *ostraca* were decorated using the same technique that was used for walls of tombs; many of them are small masterpieces.

A variety of members of the ox family were known in the Nile Valley, and they were a favourite subject with Egyptian artists. The Brussels *ostracon* shows a walking bull. The animal bears a strong resemblance to a zebu, a semi-domesticated bull distinguishable by its short, inward-curving horns and by a pronounced hump on its back. Although this drawing shows

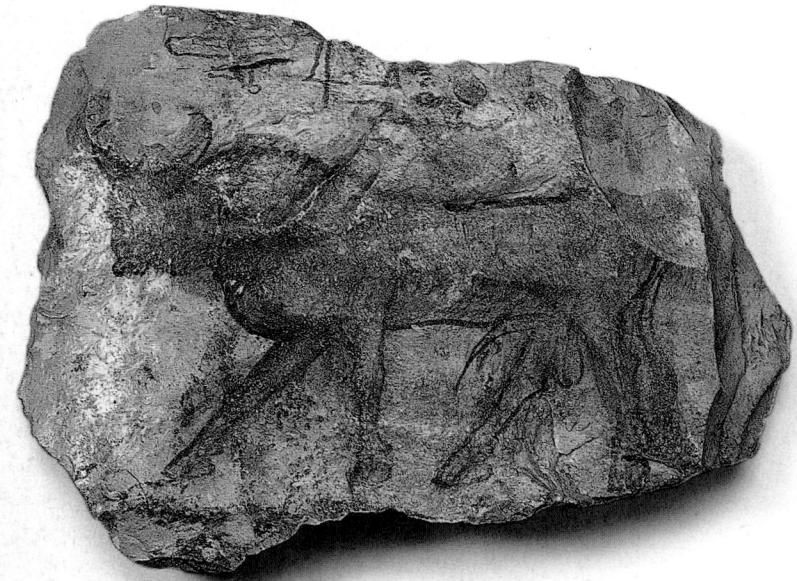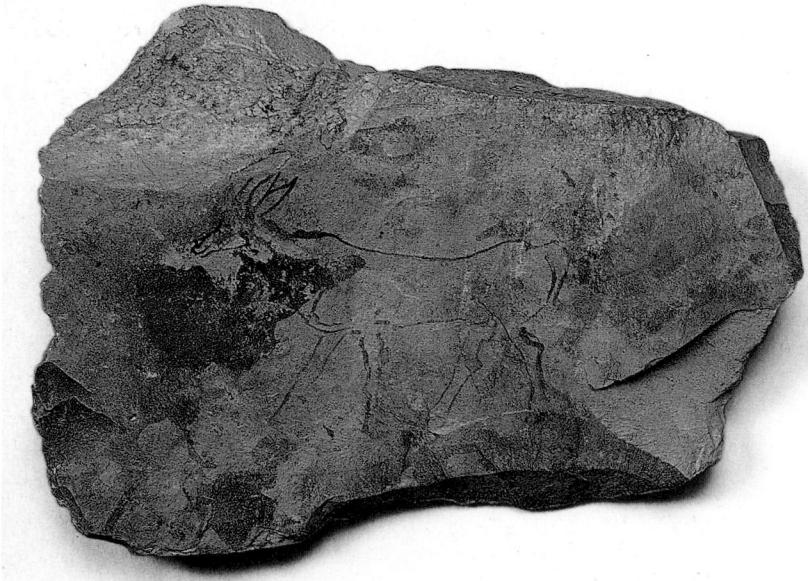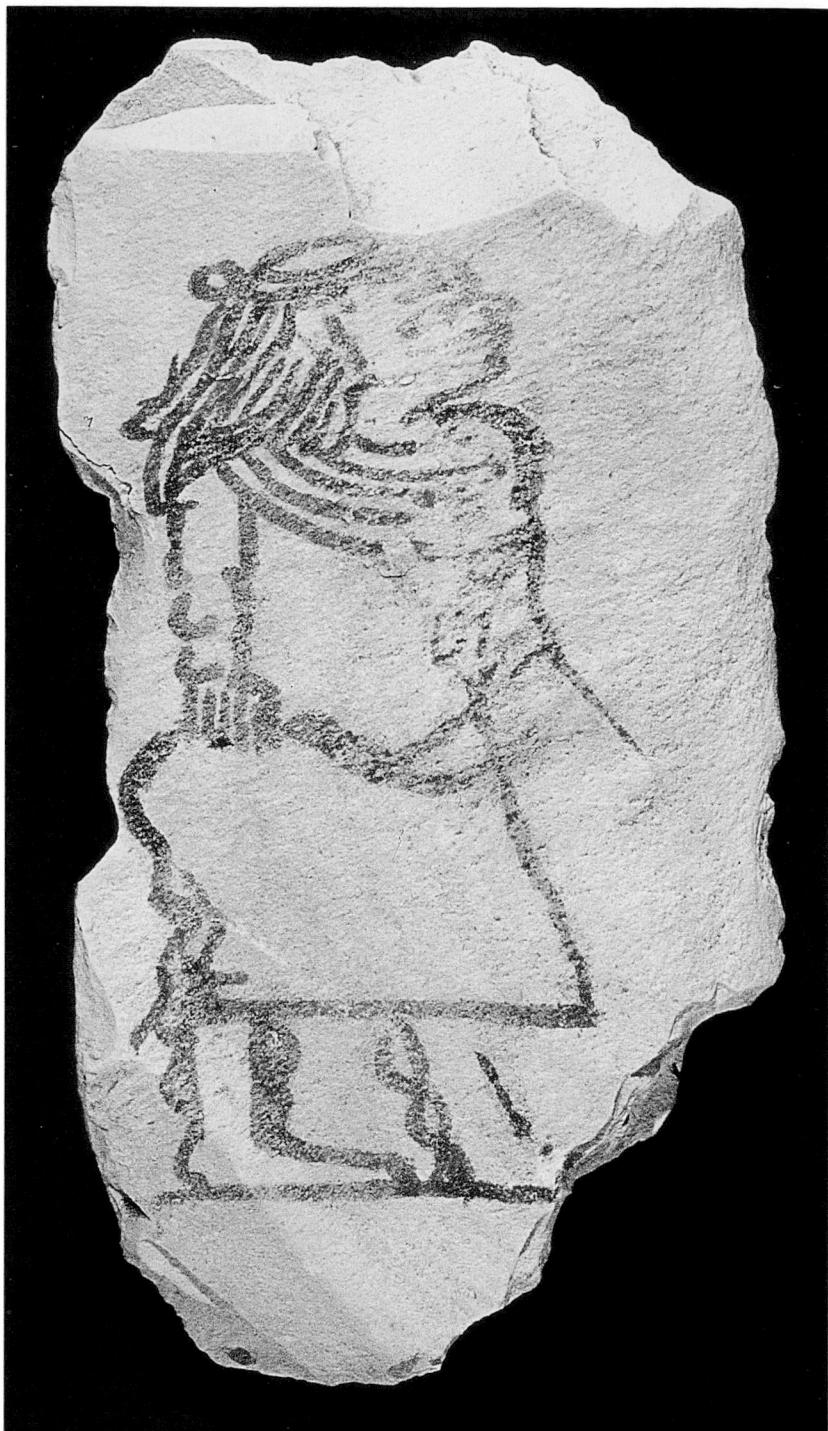

little detail, the eye and muzzle of the bull are noticeably emphasised. From a stylistic point of view, this small picture looks very much like some of the representations of bulls found at Deir el-Medina. This example therefore probably comes from that site or nearby.

Above the bull some hieroglyphic signs can be made out, with the word *pa-ian* ('the baboon'). Although this inscription bears no relation to the picture of the bull, it has been suggested that it is a name, perhaps

the name of the artist; or it may be just an exercise in writing.

The reverse side of the *ostracon* bears a rather clumsy drawing of an antelope. LL

Provenance: originally from Deir el-Medina (?); 1930, purchased Luxor

Bibliography: Werbrouck, 1952, p. 107; Werbrouck, 1953, pp. 100–1, fig. 17; Brunner-Trant, 1956, p. 107, n. 4

Queen of Punt

Egypt

20th Dynasty, c. 1150 BC

limestone

14 x 8 cm

Staatliche Museen zu Berlin, Preussischer Kulturbesitz, Ägyptisches Museum und Papyrussammlung, 21442

By far the most extensive account of Egypt's contact with the rest of Africa is presented in the reliefs and inscriptions in one of the colonnades of Queen Hatshepsut's temple at Deir el-Bahri in Thebes. This historical report relates in texts and pictures an expedition of Queen Hatshepsut (1479–1458 BC) to the land of Punt, which can be localised on the east African coast, probably modern Somalia.

The reliefs give a detailed illustration of housing, plants and animals, population and behaviour in this remote area of the world. Special attention is given to the representation of the royal couple of Punt. The queen is extremely obese and, with her short arms and legs and her steatopygeous bottom, appears reminiscent of the royal women of Karagwe in present-day north-west Tanzania.

This temple relief, carved c. 1470–1460 BC, excited the interest of artists at a much later date. The ostrakon, bearing the artist's sketch, was made by a Ramesside painter living and working in nearby Deir el-Medina. He did not copy the temple relief at Deir el-Bahri, but seems to have made his sketch from memory. Some iconographical details are his invention, but the characteristic features of this African queen had left a lasting impression on him DW

Provenance: 1913, Deir el-Medina, area D3 (Deutsche Orient-Gesellschaft, excavation no. 189)

Exhibition: Berlin 1967, no. 729

Bibliography: Brunner-Traut, 1956, pp. 75f., pl XXVIII, no. 76

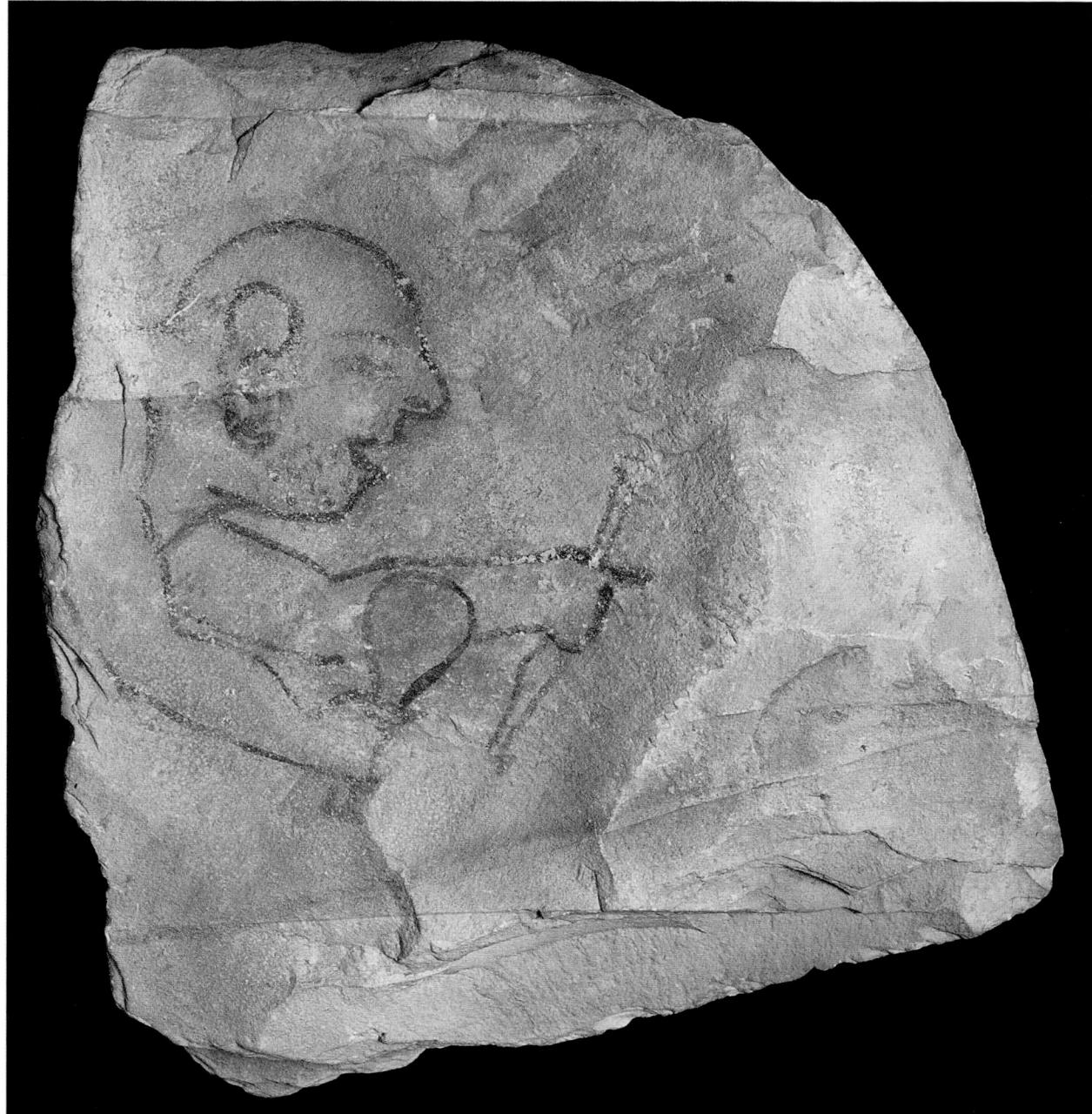

1.58

Decorated ostracon

Egypt

late 19th Dynasty–early 20th Dynasty, c. 1200–1153 BC

limestone

15 x 13.5 cm

Lent by the Syndics of the Fitzwilliam Museum, Cambridge, E.G.A. 43240. 1943

The extensive remains of the congested settlement at Deir el-Medina give some idea of the lives of the stone masons, artisans and workers who made the richly decorated tombs at Thebes. The bald stone mason or sculptor illustrated on this ostracon gripping the tools of his trade, the chisel and mallet, may have dwelt at this site.

A cheerful, brawny man with a short wide neck, shown correctly in profile view, a rare occurrence in Egyptian art, is bent at his task. The stone mason's beard is stippled; his open mouth might suggest that he is singing while at work. He is endowed with an over-large ear and bulbous nose with a prominent nostril. Despite the uncharacteristic subject and approach, the man's eye is elegantly drawn with a pencil-thin eyebrow, according to the Egyptian ideal of beauty.

The ostracon is decorated on the verso with a scene showing a kneeling figure before the snake goddess Meretseger with a line of dedicatory text below. The Egyptians worshipped

the subject of their fears, and snakes were a considerable worry to the workmen who made and decorated the royal and private tombs of western Thebes. It is not clear whether this drawing served as a practice model for a stele that was more permanently decorated in relief or whether this was the ultimate dedicated object which was subsequently irreverently decorated with the stone mason on the recto. EV

Provenance: 1943, given to the museum by R. G. Gayer-Anderson

Bibliography: Vassilika, 1995, no. 37

1.59

Tomb relief

Egypt

19th Dynasty, c. 1200 BC

painted sandstone

Staatliche Museen zu Berlin, Preussischer Kulturbesitz, Ägyptisches Museum und Papyrussammlung, 23731

Many aspects of everyday life in Ancient Egypt are known through representations in paintings, reliefs and three-dimensional models. The extremely rich iconography of tomb reliefs and paintings from the early Old Kingdom (c. 2700 BC) to the end of the dynastic period (c. 330 BC) is a manual of Egyptian civilisation through almost three millennia containing numerous details not reported in texts.

This relief fragment, made of stuccoed and painted sandstone, constitutes a small detail of a much larger scene of building activities. The building site is indicated by parts of a scaffolding of wooden beams tied together by ropes. Two carpenters are working at finishing this construction. The lower one holds an adze, the typical tool for woodwork. Several details of the head of the carpenter characterise him as belonging to the lower classes. His rough, uncombed hair and his stubby beard distinguish him from idealised representations of Egyptians of the upper orders. His orange-red, almost yellowish skin may be an indication of foreign origin, perhaps Syrian since these and other foreign workmen had been recruited in Nubia from the early Old Kingdom onwards. DW

Provenance: 1935, acquired by the museum

Exhibition: Berlin 1990, no. 52

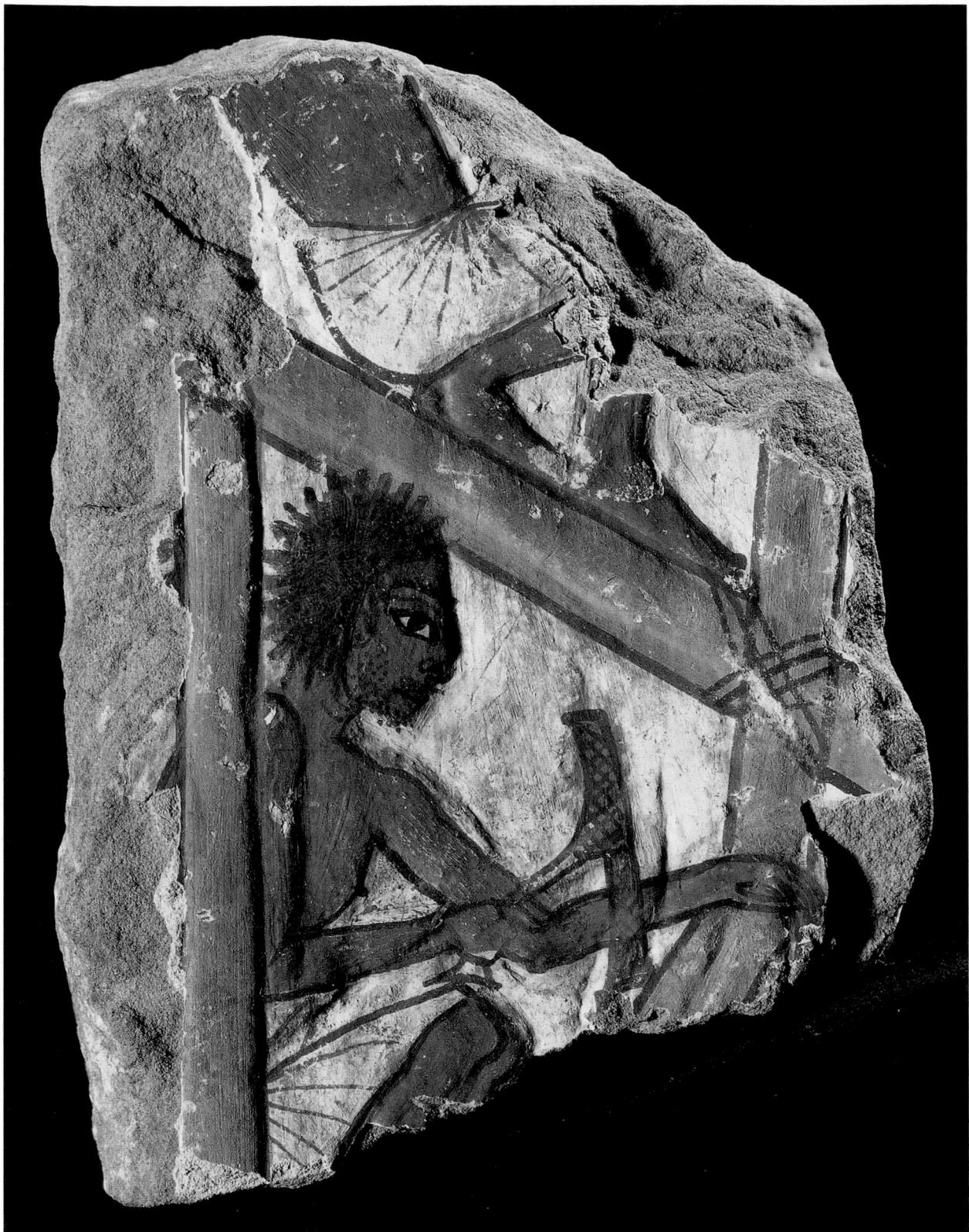

1.60

Relief

Egypt

late 25th Dynasty–early 26th Dynasty,
c. 670–650 BC

limestone

23.9 x 28.7 cm

The Brooklyn Museum

Charles Edwin Wilbour Fund, 48.74

Scenes of everyday life are among the most common themes in the decoration of Ancient Egyptian private tombs. The upper register of this fragmentary relief shows the partially preserved figures of two seated girls; the maiden on the left raises one leg, enabling her companion to extract a thorn embedded in her foot. The lower, more complete scene shows a woman with a child nestled in a sling wound around her body. She is a true ‘working mother’ who picks fruit from a tree while caring for her offspring.

The fragment came from the Theban tomb of Mentuemhat, Fourth Prophet of the god Amun at Thebes and mayor of that city. He lived during the troubled times bridging the transition from the 25th to the 26th Dynasty. Many artisans of this era sought inspiration from the art of earlier periods. The two vignettes on this relief were almost certainly appropriated from similar painted scenes in a nearby 18th-Dynasty tomb (Theban tomb 69, of a man named

Menena) that dates some seven-and-a-half centuries before Mentuemhat’s time.

Archaism, the conscious evocation of the style and iconography of an earlier era, was one of the most influential forces in Ancient Egyptian art. Throughout Egyptian history, but primarily in times of political and social uncertainty, artisans sought to recapture the spirit of bygone ‘classical’ ages. For example, in the first decades of the 18th Dynasty, following the expulsion of the detested Hyksos, royal sculptors carved images of kings reflecting the court style of the early 12th Dynasty, an era the Egyptians called the ‘repeating of births’ (i.e. ‘renaissance’).

Other examples of archaism are more idiosyncratic. A 26th-Dynasty official named Aba, for instance, had the walls of his Theban tomb decorated with scenes copied from the tomb of another Aba, who had lived approximately fifteen centuries earlier in the distant village of Deir-el-

Gebrawi. Perhaps the later Aba considered his much earlier namesake to be an ancestor, or else he was simply fascinated by the coincidence.

It is impossible to know why Mentuemhat’s artisans chose to borrow from an 18th-Dynasty tomb. What is certain, however, is that they did not slavishly copy the 18th-Dynasty model. Rather, they adapted the earlier images, changing certain details while working in a style far removed from the freehand sketchiness of Menena’s paintings.

JFR

Provenance: Thebes, tomb of Mentuemhat
Exhibitions: San Francisco 1975, no. 96a;
Berlin 1976, no. 68; Brussels 1976–7, no.
68; Tokyo et al. 1983–4, no. 59

Bibliography: Cooney, 1949, pp. 193–203;
Wolf, 1957, pp. 636, 640; Fazzini, 1972,
p. 60; Smith, 1981, pp. 411–12; Bianchi, in
Fazzini et al., 1989, no. 71; Der Manuelian,
1994, pp. 18–19; Russmann, 1994, pp.
13–14

1.61

Triad of Osorkon II

Egypt

22nd Dynasty, reign of Osorkon II,
c. 874–50 BCgold, lapis lazuli, glass
9 x 6.6 cm

Musée du Louvre, Paris

Rollin-Feuardent Collection, E 6204

This superb example of the goldsmith's art represents the god of the dead, Osiris, standing between his wife Isis and their son Horus, with his falcon head. Osiris is portrayed in an unusual position, squatting on a pillar of lapis lazuli, the dark blue of which contrasts strongly with the brilliant gold in which the divinities are cast. The costume details – hair, beard, loin cloth – are delicately chased. The wigs worn by Isis and Horus, no longer extant, were probably executed in lapis lazuli; contemporary texts refer to gold – the flesh of the gods – and to their lapis lazuli hair. On the slab of precious metal that forms the base of the plinth there is an inscription

placing King Osorkon II under the protection of Osiris. The cartouches, engraved on the pillar with a border of plant motifs, bear the name of the same king. The central statuette evidently represents Osorkon II under the aspect of the god of the dead, while Horus and Isis indicate their protection by their raised hands.

The squatting position of the main figure, and his small size, evoke the theme of the child appearing on the lotus flower, symbolising the recurring rebirth of the sun.

With its rich symbolism, typical of the 1st millennium, this precious group almost exactly echoes the triads carved for the Pharaoh Mycerinus over 1500 years earlier (cat. 1.50). CZ

Exhibition: Paris 1987, no. 46, pp. 172–3

Bibliography: Montet, 1960, p. 59; Stierlin-Ziegler, in Paris 1987, figs 107–10

1.62

Statuette of the god Ptah

Egypt

Late period, 26th Dynasty, c. 600 BC
bronze, partly blackened and inlaid with
gold and electrum
17.9 x 6.1 x 3.9 cmThe Visitors of the Ashmolean Museum,
Oxford, 1986.50

As a creator the god Ptah is often described in religious texts as 'forming' or 'sculpting' the bodies of other gods or the king, and he was the patron of all kinds of handicraft: his especial care for smiths and sculptors is appropriately recalled in this statuette, which is a masterpiece of bronze casting.

The god is shown in his canonical form as a standing figure enveloped in a wrap from which only his head and hands emerge. Around his neck is a broad bead collar, the counterpoise of which is a tasseled pendant that hangs over the back of his robe. He wears a close-fitting cap, the false beard exclusive to gods and kings, and bracelets. In his hands are the *ankh*-sign (or *crux ansata*) symbolic of 'life' and the forked *was* (sceptre) which terminates in the head of the animal of the god Seth – a fabulous beast for which various models have been suggested, including the wild pig, dog, okapi and ant eater.

The figure is a solid lost-wax cast in bronze with a high copper content. The sceptre has been cast separately in three parts. The rich colour of the metal has been enhanced by the blackening of specific areas and the addition of contrasting inlays – electrum for the whites of the eyes, and gold in the collar and bracelets. 'Black bronze' inlaid with gold or electrum is mentioned in Egyptian texts as a particularly prestigious material; the coloration of the metal could have been achieved with sulphides.

Small bronzes of human or animal divinities are a notable feature of the later stages of Egyptian culture. They mark a significant change in religious thought, when the major gods were no longer seen as remote beings with whom only the pharaoh could intercede: an individual might also place himself in the divine presence or sue for some personal benefit by dedicating a votive image, set on a base that would carry the donor's name and a dedicatory inscription.

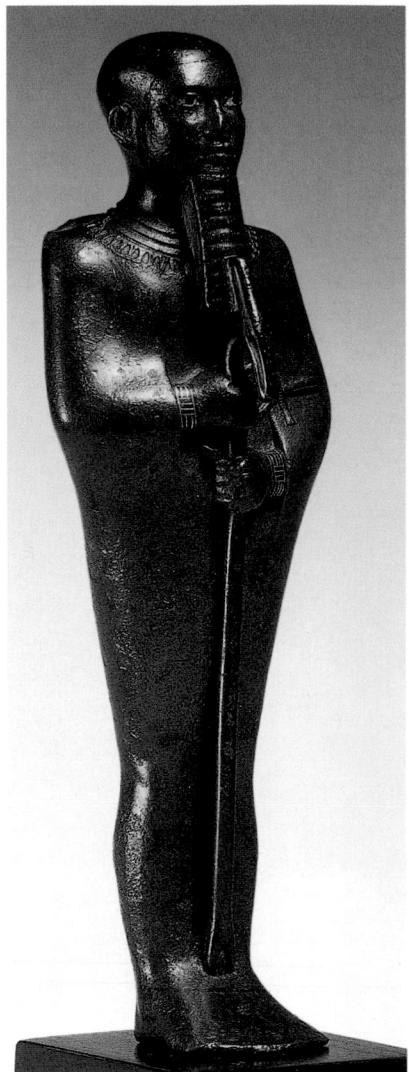

The presence of large numbers of such figures in shrines would have necessitated periodic clearances, hence the occasional discovery in temple precincts of caches of bronzes. The spare but subtle modelling of this figure, with the suggestion of the anatomy beneath the enveloping wrap, and the god's air of tranquil self-possession suggest a date in the 26th Dynasty. During this period there was a renewed interest in the cult of Ptah and his monuments at Memphis, and also a revival of the sculptural ideals of the Old Kingdom, when divine figures projected a timeless image of serene confidence. HW

Provenance: ex collection J. W. Trist; 1986, bequeathed to the museum by Miss M.R. Tomkinson

Bibliography: Trist and Middleton, 1887; Whitehouse, 1986; Penny, 1995, pp. 225–6, pl. 199

Figure of a jackal

Egypt

25th–26th Dynasty, c. 747–525 BC

wood (sycomore fig)

30 x 51.5 x 10 cm

The Trustees of the British Museum,
London, EA. 61517

The dogs and black jackals that frequented the cemeteries in the desert strip close to the banks of the Nile came to be associated in the minds of the Ancient Egyptians with deities who were believed to look after the dead and guide them on their journey into the west, the kingdom of the dead. The most prominent of these canine divinities was Anubis. According to mythology, he embalmed the murdered god Osiris and, by thus preserving his body, was instrumental in restoring him to life. Anubis was closely associated with mummification throughout the pharaonic period and continued to play a part in the Isis Cult of the Roman world. Beginning

in the New Kingdom (c. 1550–1069 BC), he was regularly depicted in tombs, on coffins and on funerary papyri completing the process of mummification, conducting the deceased to Osiris and supervising the weighing of the dead person's heart to determine whether or not his conduct on earth merited entry into the netherworld.

Wooden statues of recumbent Anubis jackals were sometimes included among funerary furnishings during the New Kingdom; examples have been found in the tombs of Tutankhamun and Horemheb in the Valley of the Kings, and others are known from non-royal burials, where they were mounted on the lid of the canopic chest (a box to contain the embalmed viscera of the deceased). In the late 8th century BC, wooden jackals were frequently placed on the vaulted tops of the rectangular outer coffins made for the more affluent members of Egyptian society, and a large number of them survive from

the necropolis of Thebes. The body and limbs of this example are carved from a single piece of wood, to which the separately made head and neck have been attached. The tail (now lost) was also originally a separate piece, fitting into a slot cut into the body. Examples which survive in a complete state show that the tail was meant to hang vertically over the end of the coffin. The shape of the face and paws, carved in a summary fashion, served as a basis for more detailed modelling in the gesso with which the entire figure was originally coated. This is now largely lost, together with all but the smallest traces of paint which show that the finished statuette was coloured black. The wood species was recently identified by Caroline Cartwright.
JHT

Provenance: ex collection Henry Salt
(probably found at Thebes)

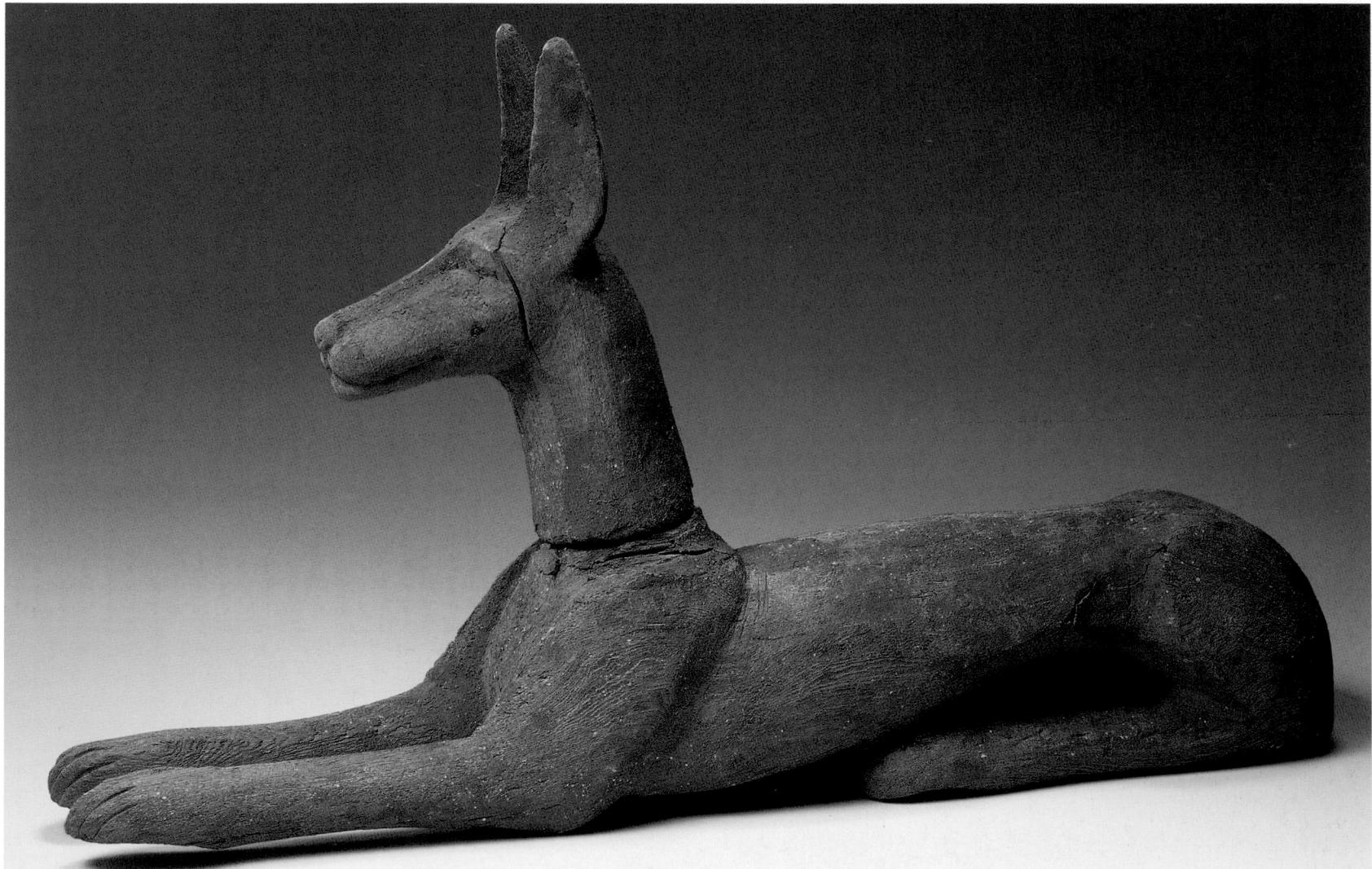

1.64

Anubis mask

Egypt

Late period, 6th–4th century BC or later

fired clay, paint

49 x 27 x 40 cm

Pelizaeus Museum, Hildesheim, 1585

This object, 8 kilograms in weight, of a delicate ceramic material, is without parallel in any collection, the only example of its kind to have survived the millennia.

Practical experiments have demonstrated that the functional designation ‘mask’ can indeed be applied to this item: the two semi-circular sections cut from the sides are large enough for very narrow shoulders, and it is possible to see and breathe through the two angular openings under the snout of the Anubis jackal. However, the weight and fragility of the material argue against practical use and raise the question of whether this might not rather be a model of a mask. It could have served as the prototype for the production of masks in a light, portable material such as painted linen or cartonnage. A solution to this problem will probably never be possible in the absence of parallels. The sole clear image in which an Anubis mask is worn dates no earlier than the Greco-Roman period.

The numerous scenes in tombs depicting a figure with the head of Anubis bending over a mummy are open to various interpretations. It is possible that they represent the god Anubis himself. However, they might instead depict a funerary priest who, with the help of the mask, has changed into Anubis and thus performs the embalming ritual as a substitute for the deity. In the ritual itself a priest carried out the ceremonies, but no textual evidence exists to determine whether the funerary priest remained in human guise in this role, or whether he disguised himself and ‘played’ the funerary god Anubis. At least in the case of the priest responsible for the preparation of the corpse, there would be a logical explanation for the latter interpretation. The preliminary stages of mummification involved the opening – and thus the violation – of the body, an action that only Anubis himself would have been entitled to perform. If the priest took

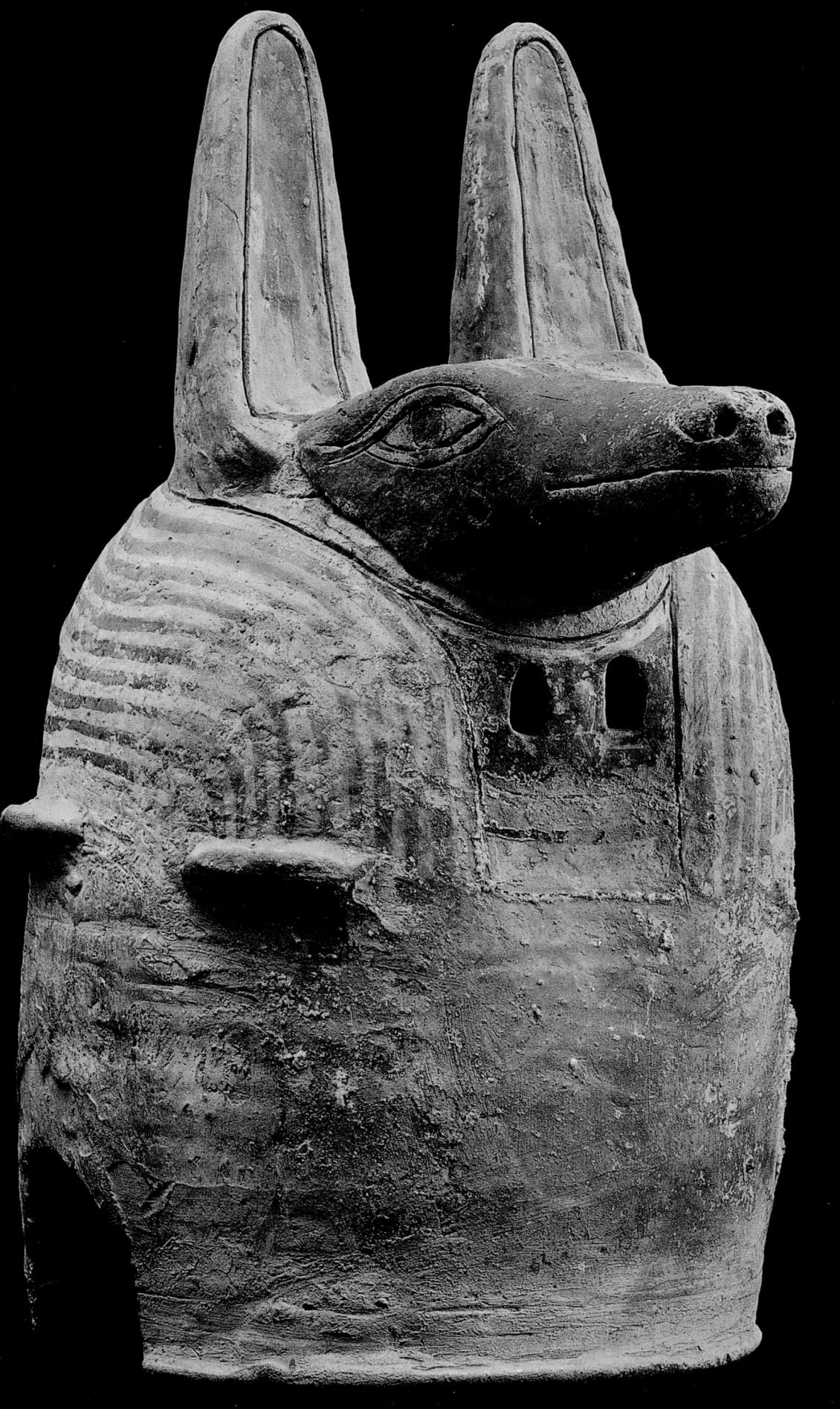

the form of Anubis, he would be magically raised to the status of the funerary god himself and thus receive the necessary legitimization for the treatment of the corpse.

The mask consists of two parts: the head section with the snout and eyes is a separately formed element, attached to the lower section by means of a tenon. It is made of fired and painted clay; the colours are now extremely faded. Nevertheless, the black hue of the skin remains clearly discernible; this does not correspond to the natural colour of the Anubis jackal but indicates in symbolic manner both the realm of the dead and survival for eternity. BS

Exhibitions: Linz 1989, no. 125;

Hildesheim and Mainz 1990, pp. 34f., T3

Bibliography: Roeder, 1921; Roeder and Ippel, pl. 127, fig. 49; Kayser, 1973, p. 103, fig. 74; Seeber, 1980; Eggebrecht, 1993, p. 87, fig. 84; Sweeney, 1993

1.65

Fragment of a female figure

Egypt

Ptolemaic period, c. 305–30 BC

faience

10.6 x 5.2 x 3.4 cm

The Brooklyn Museum

Charles Edwin Wilbour Memorial Fund, 64.198

Ancient Egyptian artisans lavished so much of their skill and attention on the modelling of faces that their proficiency at handling the human body is often overlooked by the modern viewer. For this reason, headless fragments such as this example can be particularly instructive. The female figure wears a sheer dress that clings tightly to her body, creating the illusion of nakedness. Unlike the slender women of earlier eras, this Ptolemaic example displays full firm breasts, a thick waist, a swollen fleshy stomach with pronounced navel, and broad hips. These features reflect the Egyptians' ideal female form in the last three centuries BC.

This full-figured treatment of the torso has two possible sources. Traditionally, scholars have interpreted it as evidence for Hellenistic Greek influence on Egyptian sculpture. They argue that the Ptolemaic 'ideal' differs so markedly from earlier Egyptian forms that it must owe its appearance to Hellenistic tastes.

Recently, however, it has been suggested that the Ptolemaic model of the perfect feminine body owes nothing to Greek inspiration: instead it is seen as an outgrowth of pharaonic artistic tradition. Each of the elements of the Ptolemaic female body – the ample breasts, the treatment of the lower abdomen etc. – can be found, in isolated examples, on earlier statuary. By incorporating these features into a single image, the Ptolemaic sculptor was creating something new that was based on Egyptian models.

This fragment is made of faience, a man-made compound consisting of ground quartz held together by an alkaline binder. Faience manufacture began in the predynastic period and continued in use well into the period of the Roman occupation of Egypt. Faience was either modelled or pressed into a mould and then fired in a kiln. Egyptian craftsmen almost always glazed their faience pieces. JFR

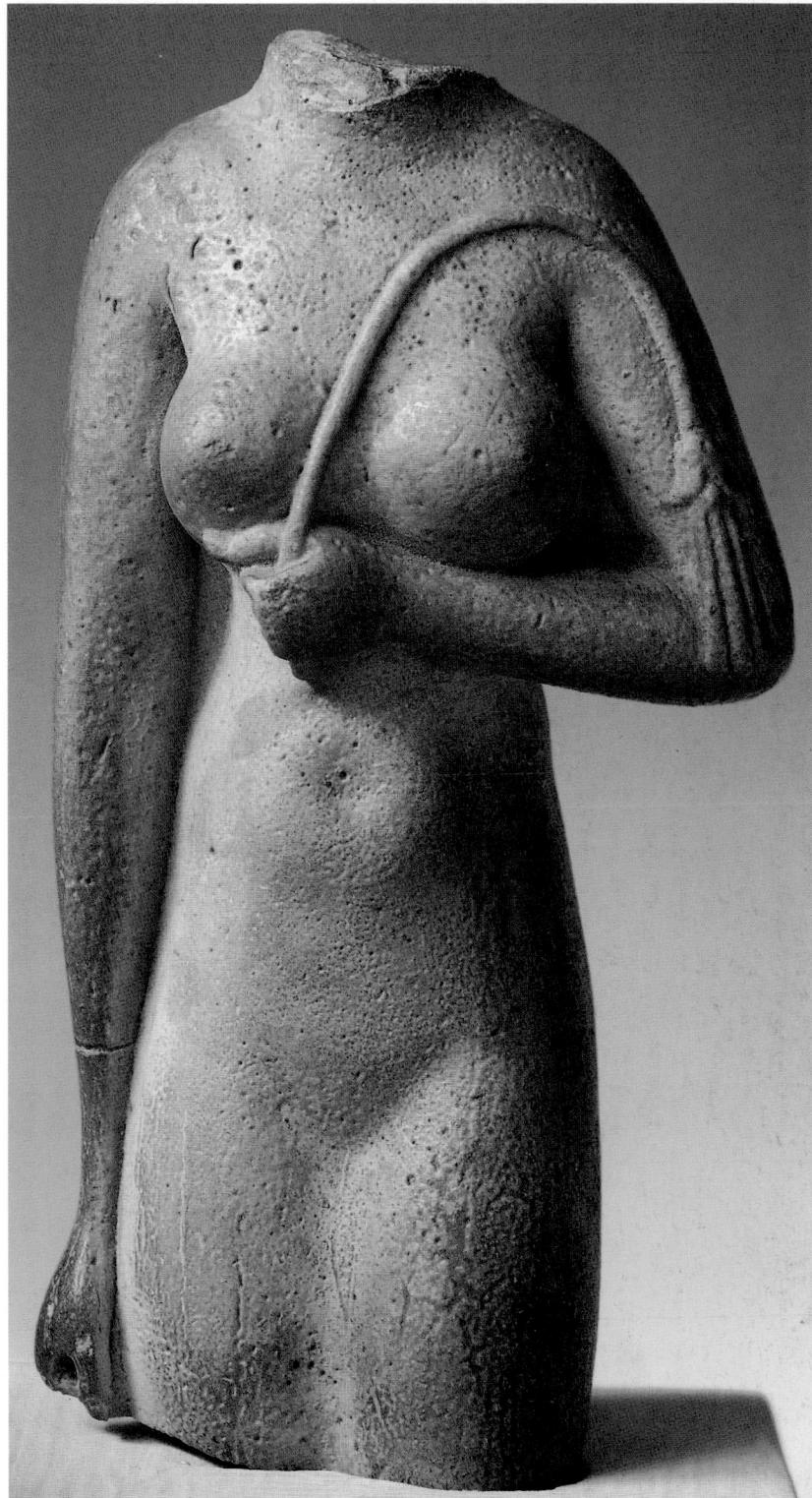

Provenance: ex collection Sir Bruce Ingram

Exhibitions: San Francisco 1975, no. 113; Berlin 1976, no. 80; Brussels 1976–7, no. 80; San Juan 1979, no. 35; Tokyo et al. 1983–4, no. 75

Bibliography: Riefstahl, 1968, pp. 72, 109, no. 72; Fazzini, in San Francisco 1975, no. 113; Fay, in Berlin 1976, no. 80; Quaegebeur, in Brussels 1976–7, no. 80; Bianchi, in San Juan 1979, no. 35; Quaegebeur, 1983, p. 119; Bianchi, in Tokyo et al. 1983–4, no. 75; Bianchi, in Fazzini et al., 1989, no. 83

Funerary bead-net

Egypt

Late period, after 600 BC

faience

116 x 43 cm

Musée du Louvre, Paris, E 13223

This funerary net covered the body of the deceased from shoulder to ankle; it is composed of tubular beads in blue faience, laid diagonally in regular lozenge shapes to form a very elegant mesh. The larger beads are joined together by means of smaller ones.

At chest height a dark blue faience scarab appears among the beads; its wings are formed from small, multi-coloured beads with flared ends, creating the effect of a lotus flower. On either side of this winged scarab, the solar symbol of rebirth, there are four mummiform figures in bright blue faience. These represent the four sons of Horus, protectors of the entrails placed in the canopic vases during mummification. Their iconography is standard: Duamouef has a dog's head, Imsety a human head, Qebeh-senuef a falcon's head and Hapy a monkey's head.

One of the earliest examples of funerary netting was found in Tanis, on the mummy of Sheshonk, a king of the 22nd Dynasty; the mesh was used with increasing frequency from the 25th Dynasty onwards. Such netting was designed to fit over the winding-sheet covering the mummy; it is generally composed of blue or green beads or, occasionally, beads made of gold or semi-precious stones. The network of beads fits round the funerary mask and bears symbols that will ensure the protection of the deceased. The winged scarab here replaces the usual heart-shaped scarab; the four sons of Horus are commonplace, as are other symbols such as the winged goddess Nut or the pillars of Djed (the symbol of stability). This wrapping technique was invented to offer maximum security to the mummy, enclosing it in a protective mesh to guarantee its survival; its use persisted until the Roman period.

PR

Bibliography: Marcq-en-Baroeul 1977, p. 33, no. 61; Andrews, 1984, p. 27, fig. 27; Boston and Dallas 1992, p. 175

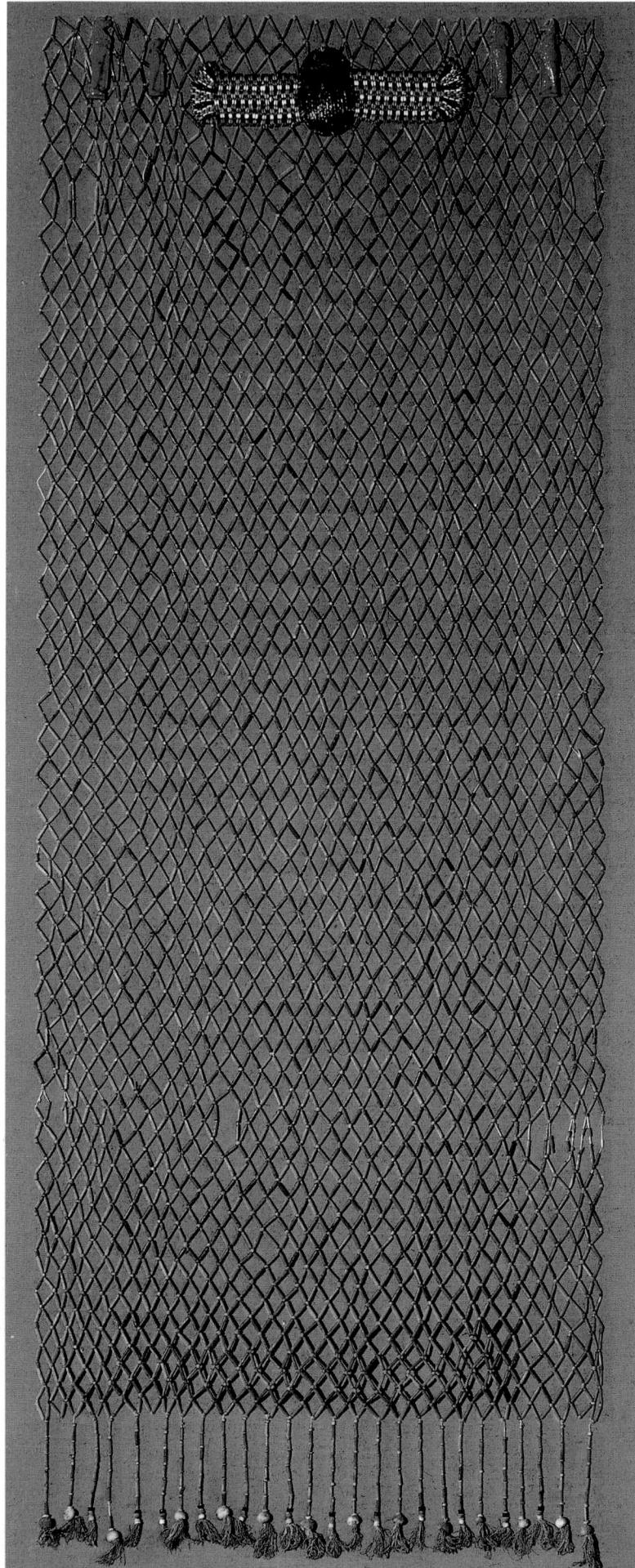

This full-length painted linen shroud, now missing its lower end, would have enveloped a mummified body, the painted portrait head positioned directly over the mummy's face. The scarab beetle that now appears to be suspended above the head would have been at the back of her head, its outstretched wings encircling and protecting it. The rows of deities on either side of the main figure (right side preserved) would have been at right angles to it, along the sides of the wrapped body.

The dead woman's regalia is identical to that of both Osiris, King of the Dead (shown in the upper right register), and Sokar, whose figure (now missing, with only the lower leg visible) is known from parallel examples. She holds (in the reverse order of the Osiris figure) the symbols of kingly power: crook and flail.

Flanking her head are the tutelary deities who protect a king: the goddesses Nekhbet and Edjo in the form of winged cobras, each wearing the crown of her respective domain (Upper and Lower Egypt).

Although the attributes of her costume are undeniably royal, the deceased may not here be emulating the funerary god Osiris, but the sun god Re. The scarab beetle whose wings enfolded the deceased's head is the young form of the sun god Khepri. In a famous representation of the 4th-Dynasty pharaoh Chaphren, the wings of the falcon god Horus embrace the king's head. Horus and the king together signify 'the god manifest in the person of the king' (Terrace and Fischer, 1970).

The intent may be: to identify the deceased with the reborn sun god.

The imagery that decorates the body field appears to imitate the horizontal registers of the painted, wrapped bodies of red-shrouded and of stuccoed portrait mummies. The upper scene depicts a mummy on the back of a lion (bed) flanked by human-headed *ba* (soul) birds. Above the mummy is the sun, whose energising rays revivify the lifeless corpse. The scene below also depicts a mummified body on a lion bed. A masked, jackal-headed priest, in imitation of the mortuary god Anubis, performs a funerary ritual to rejuvenate the limbs of the deceased. At the head and foot of the funerary bed the goddesses Isis and Nephthys

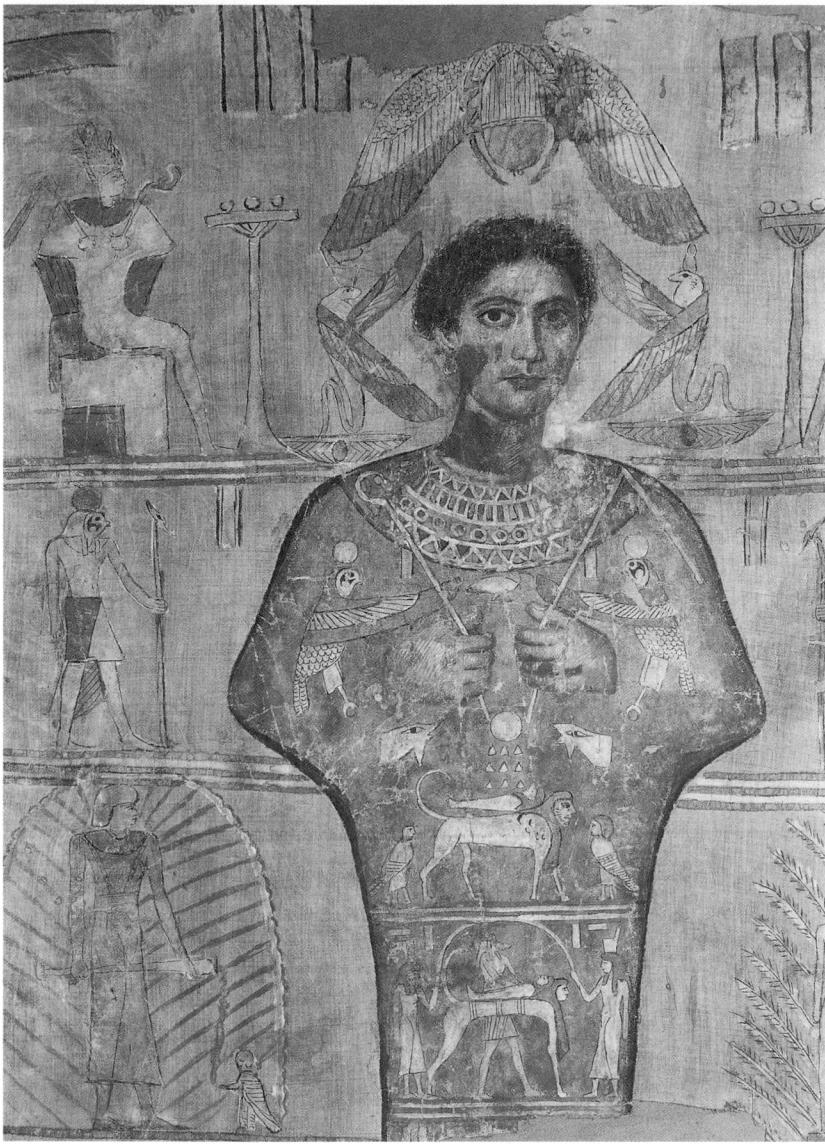

1.67

Funerary shroud

Akhmim (?)
Roman period, third quarter of
1st century AD
linen
115 x 88.5 cm
Museum of Fine Arts, Boston
Martha A. Wilcomb Fund, 1950, 50.650

1.68

Plaster head of a crocodile

Egypt
2nd–4th century
plaster, glass
18 x 43.5 x 19 cm
Staatliche Sammlung Ägyptischer Kunst,
Munich, 6809

Mummification of sacred animals was not uncommon in Ancient Egypt from the New Kingdom onwards. Venerated as living manifestations of god on earth, sacred animals were kept in temples, and after death they were buried in nearby cemeteries. Large catacombs at Sakkara contain the burials of bulls, cows and thousands of ibises, falcons, cats (cf. cat. 1.69) and baboons. Similar installations can be found at various other places. Mummified crocodiles have been excavated near temples of the god Sobek, in Kom Ombo in Upper Egypt and in Crocodilopolis in the Fayum oasis.

This life-size plaster head of a crocodile originally belonged to a crocodile mummy. It has been modelled in wet plaster over the head of the animal wrapped in linen strips. Impressions of these bandages are still visible inside the hollow head. The lively expression of the face results from the modelling of the teeth and the technique of the eyes with the pupil covered by a thin layer of glass. Thus the sacred animal retains its efficacy even after death. DW

hold a canopy above the scene. The disparity in artistic skill between the rendition of the portrait head and that of the mythological characters on the body field suggests that the two were executed by different artists. Perhaps the shroud was 'ready-made' and the portrait head commissioned at greater expense.

The deities arranged in horizontal registers at either side of the main figure (and beneath the enthroned figures of Osiris and Sokar) depict (at right) Re-Horakhty, and the tree goddess offering cool water to a human-headed *ba* bird. The registers at left are broken off. There would have been a striding figure to complement that of Re-Horakhty, and across from the tree goddess is a scene depicting the young Horus child hidden by his mother Isis amidst the rushes of Chemmis. None of the vertical bonds was ever inscribed.

The shroud was said to have been purchased at Akhmim. There are no similarly decorated pieces from the site; although it may well have been discovered in a cemetery there, typological factors suggest a Lower Egyptian provenance, possibly Sakkara. LHC

Exhibitions: Boston 1978, no. 5; Boston 1988, no. 153

Bibliography: Hermann, 1962; Parlasca, 1963; Parlasca, 1966; Terrace and Fisher, 1970; Parlasca, 1977; Ritner, 1985

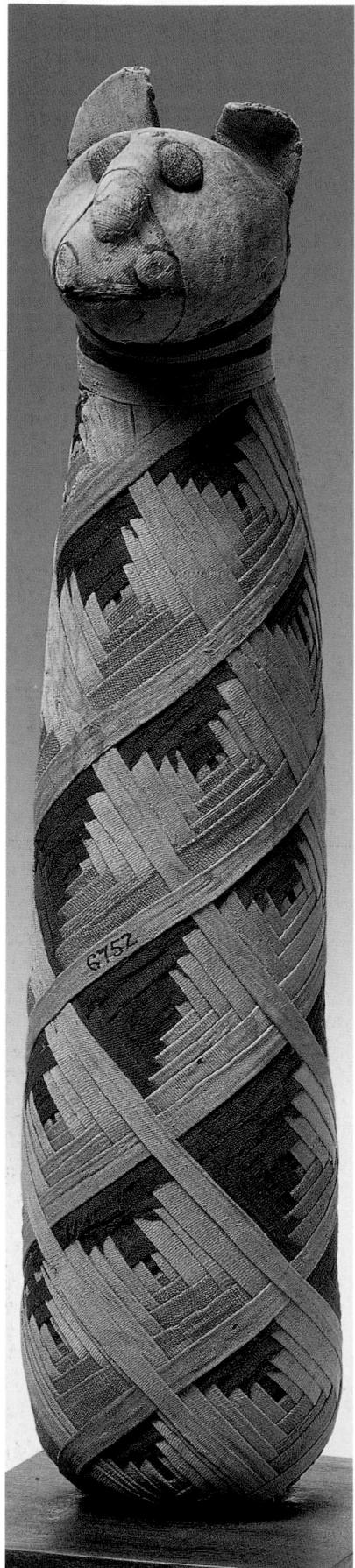

1.69a

Cat mummy

Egypt

Roman period, after 30 BC
bone, soft tissue, linen
h. 51 cm
The Trustees of the British Museum,
London, EA. 6752

1.69b

Cat mummy

Egypt

Roman period, after 30 BC
bone, soft tissue, linen
h. 45.5 cm
The Trustees of the British Museum,
London, EA. 55614

Animals were always highly regarded in Ancient Egypt and the cat in particular seems to have been revered from early times. During the Late period (664–332 BC) animal cults became increasingly important, reaching the peak of their popularity during the Ptolemaic period (332–30 BC). The Egyptians did not worship the animal itself but rather viewed each species as a representative of a particular god or goddess, believing that their deities could appear on earth in the form of their associated sacred animal. One of the most prominent animal cults was that of the cat, which was associated with the goddess Bastet at Bubastis in the Nile Delta. The intense religious significance attached to cats is reflected in Herodotus' account of Egypt (5th century BC) and in the large cemeteries designed to receive their embalmed bodies. Many thousands of mummified cats have been discovered at these sites. Recent radiological studies have revealed that some of these had been deliberately killed by having their necks broken, and the indications are that this occurred within two specific age ranges: between one and four months or between nine and twelve months. It is possible that those which had their necks broken before being mummified were temple cats bred specifically to become votive offerings. The mummified cats with intact neck vertebrae may have been household pets.

These two specimens illustrate the manner in which cat mummies were prepared. X-rays reveal that the larger mummy (cat. 1.69a) is that of an adult cat. The hind legs are pushed up against the pelvis and the forelegs

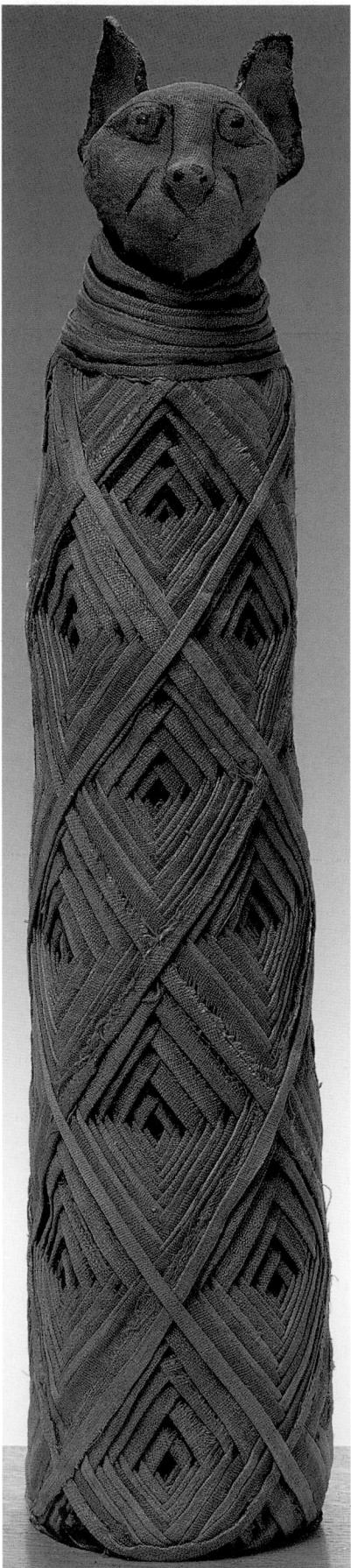

drawn down the body, producing a compact, elongated shape. All of the skeleton appears to be present and there is some indication of soft tissue. The smaller mummy is that of a kitten (cat. 1.69b). In this case, the hind legs have been pushed up on either side of the pelvis, with the forelegs again positioned in front. Most of the bones appear to be present, but the skeleton, measuring about 12 cm in width, occupies only about one-third of the package; X-rays show that the remaining two-thirds are filled with a dense mass, probably linen. The neck vertebrae of both cats are intact and show no signs of trauma.

Both cats are wrapped in strips of linen cloth of different colours, carefully applied in overlapping layers to create a repeating lozenge pattern. The elaborate arrangement of the outer wrappings imitates the appearance of human mummies of the Roman period, many of which were treated in a similar way. The representation of the features also parallels the practice followed in the embalming of humans, whereby an image of the face was either painted on the shroud or on a wooden panel, or modelled as a mask in cartonnage or plaster. The shape of the cats' faces and upturned ears have been skilfully modelled in linen; on the smaller mummy the features have been drawn in black paint. The larger specimen has been more elaborately fashioned; the eyes are represented by 'buttons' of coarse linen, while the corners of the mouth have been internally padded to give a raised appearance. The mouth itself and the whiskers are formed of linen threads and both the eyes and the mouth are outlined in brown. *JMF, JHT*

Exhibition: cat. 1.69a: Canberra and Melbourne 1990, no. 50

Bibliography: Armitage and Clutton-Brock, 1980, p. 187; Andrews, 1990², p. 65; Malek, 1993, pp. 73–6; Filer, in preparation

1.70

Shrine and skeletal figure

Egypt

Late period, 1st millennium BC

ebony, linen

h. 9 cm (shrine); 5.7 cm (figure)

Staatliche Museen zu Berlin, Preussischer Kulturbesitz, Ägyptisches Museum und Papyrussammlung, 20472

Several specimens of this strange kind of object are preserved. The small standing skeletal figure, originally wrapped in a piece of linen, belongs to a wooden shrine imitating the form of a chapel. The Egyptians believed that at the moment of physical death body and soul were separated. The soul took the shape of a human-headed bird, flying up from the body. The corpse had to remain in the tomb; through mummification it was transformed to an eternal entity. Despite the elaborate system of funerary beliefs, death remained a permanent threat. These skeletal figures may find their explanation in the following report by Herodotus (II, 78): 'At rich men's banquets, after dinner a man carried round a wood image of a corpse in a coffin, painted and carved in exact imitation, a cubit or two cubits long. This he shows to each of the company, saying "Drink and make merry, but look on this; for such shalt thou be when thou art dead." Such is the custom at their drinking-bouts.' This text corresponds to the Harper's Songs of the New Kingdom and reflects a deeply human attitude to death. DW

Provenance: 1912, acquired by the museum

Exhibitions: Berlin 1967, no. 956; Stuttgart 1984, no. 86

1.71

Rock engraving

Nubia

5th millennium BC

sandstone

20.5 x 27.5 cm

Staatliche Sammlung Ägyptischer Kunst, Munich, 5522

Besides the influences from the neighbouring Near East, the most important root of pharaonic Egypt's civilisation is north-eastern Africa. Before they reach the Egyptian Nile Valley, technological innovations such as the invention of pottery are first attested in the Sudan and in Nubia (including the Western Desert), signs of the transition from Late Palaeolithic to Early Neolithic.

The rock engraving of a long-horned cow comes from the desert north-west of Lower Nubia, from an area where cattle-breeding was practised by nomads living in the steppe while it was still humid enough to feed cattle.

Basic principles of Egyptian art are formulated in the representation of the cow. Its body is seen in profile; the horns are shown frontally. The combination of both views in one image constitutes the structure typical of reliefs and paintings of pharaonic times and analogous to experimental representations in modern art. DW

Provenance: Naga Kolofanda, north-west of Korosko, Nubia; given to the museum by Professor H. Stock

Bibliography: Munich 1972, p.17, no. 14

1.72

Figurine

Sudan
Neolithic, 4th millennium BC
Nubian sandstone
19.6 x 5 x 2 cm
Sudan National Museum, Khartoum,
SNM. 26.861

This representation of the human form is very stylised. The stone, dressed with a hammer and pick, has been polished all over. The sculptor has skilfully used the minimum of anatomical features, principally the sloping shoulders and the head, to leave no doubt that this is an anthropomorphic figure. From the shoulders the body tapers to a rounded base at one end and to the rounded head at the other. Two pairs of parallel incised grooves on the 'face' suggest the position of the eyes. These

extend up to a vertical groove which, together with another groove above the eyes, indicates the hairline. The front of the body is a smooth curve from head to foot, but on the back a marked change of direction at the point of maximum thickness suggests the transition from the buttocks to the thighs.

No close parallels to this figurine are known from the Nile Valley. It contrasts markedly with figurines such as cat. 1.73. Among the most characteristic features of these are their explicit female nature and their very broad hips. Cat. 1.72, although identified by the excavator as female, displays no obvious gender characteristics and is of totally different proportions, with the greatest width at the shoulders and no attempt to mark the position of the hips. It clearly relates to a totally different artistic tradition.

It was recovered from the grave of a man of more than 40 years of age in the northern Dongola Reach, 50 km south of the third cataract. The prominent location of this grave within the cemetery, together with the rich gravegoods which accompanied the burial, suggest that he was the chief of the community which buried its dead in this cemetery.

DAW

Provenance: 1986–9, Kadruka, cemetery 1, tomb 131 (Section Française de la Direction des Antiquités du Soudan, find no. KDK 1/131/8)

Exhibition: Lille 1994, no. 72

Bibliography: Reinold, 1991, p. 28, fig. 6; Reinold, 1994, pp. 96–7, fig. 7

1.73

Female figurine

Sudan
Neolithic, 4th millennium BC
fired clay
9 x 4 cm (max.)
Sudan National Museum, Khartoum,
SNM. 26.895

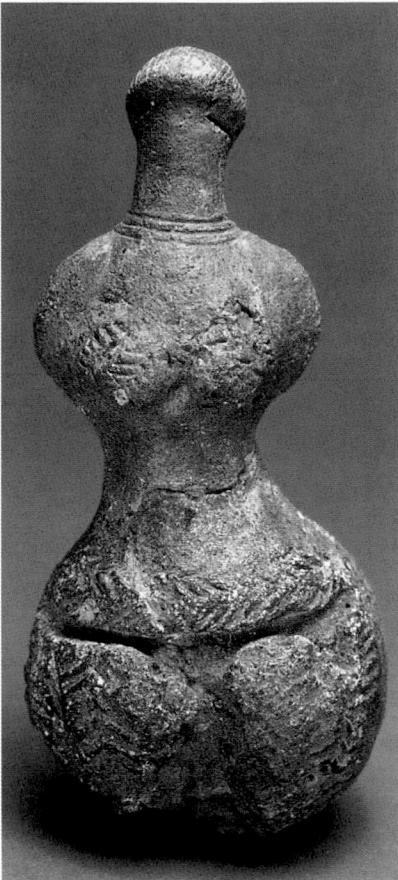

This steatopygous figure of a woman has a spherical lower body, with no indication of the legs apart from a T-shaped incision suggesting the position of the top of the thighs. The prominent hips give way to the narrow waist and to the ample bust. The arms are rounded stumps projecting a little from the shoulders. The only facial features provided are the eyes, indicated by two narrow slits; the neck is carried up to the hairline with an absence of a chin. The head sports hair tightly drawn back from the face, an abundant pigtail reaching to the small of the back. The pigtail is made from a separate piece of clay. The breasts and much of the body below the waist are covered in an incised herringbone decoration and three parallel grooves run around the base of the neck.

This is one of a number of similar figurines dating from the Neolithic to the late Meroitic periods which have been found on sites throughout Nubia, usually (although not invariably), in a funerary context. The basic steatopygous form of all these statuettes, although they differ in detail, testifies to the continuity of artistic tradition in Nubia over a period of several thousand years. On most examples there is incised decoration on the body, curvilinear, geometric or dotted. This is usually interpreted as representing tattooing rather than clothing. The grooves at the neck, however, may represent some type of necklace. It is assumed that these figurines had a religious significance.

The statuette was found in the grave of a child (five to seven years of age) within the cemetery at el-Kadada, 200 km downstream from Khartoum. It had been placed in front of the neck of the deceased. The cemetery contained graves of Neolithic, Meroitic and post-Meroitic date. DAW

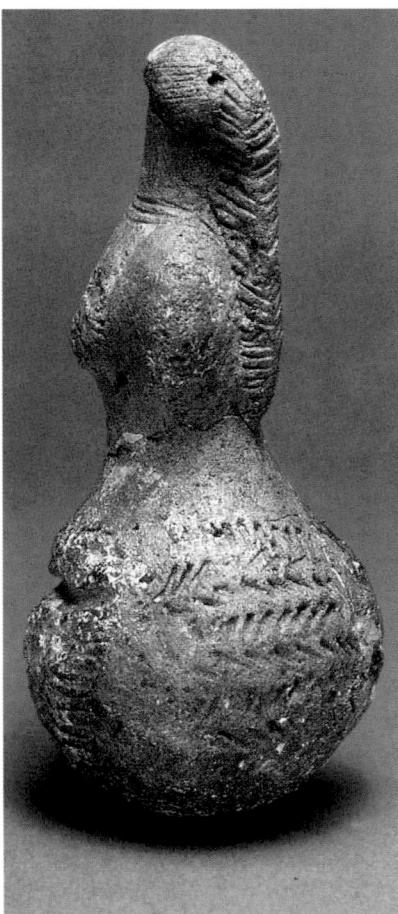

Provenance: 1976–83, el-Kadada, cemetery C, section 76, tomb 9 (Section Française de la Direction des Antiquités du Soudan, find no. KDD 76/9/2)

Exhibition: Lille 1994, no. 54

Bibliography: Reinold, 1987, p. 54, fig. 7

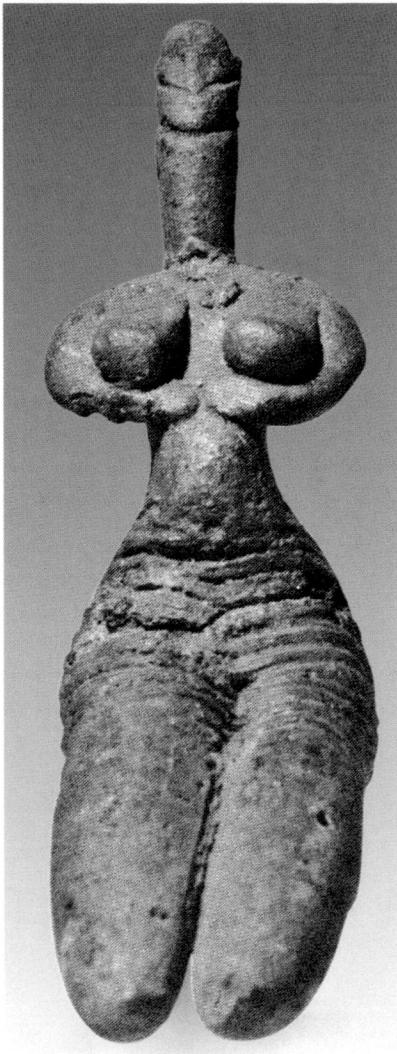

1.74

Female figurine

Sudan

Classic A-Group, c. 3100 BC

unfired clay

8.4 x 3.2 x 8.5 cm

Sudan National Museum, Khartoum,

SNM 13729

The torso of this steatopygous figurine of a naked woman, bent at the waist to suggest a sitting posture, is moulded in a naturalistic manner in contrast to the stylised legs and the head. The plump legs, divided by a deep cleft, stick straight out and taper a little towards the stumps, no attempt being made to indicate the ankles and feet. The long neck merges imperceptibly into the head where a deep gash, extending most of the way around it, marks the mouth. Two grooves angled downwards to their point of junction in the centre of the face represent the eyes with a slight ridge for the nose. The well-endowed lady has her arms hugging and lifting her breasts. Beginning immediately below the

navel and running in a swirl around each buttock and on to the inner thigh are several incised parallel grooves which are probably representations of tattoos, although they have also been identified as clothing and as folds of fat.

Steatopygous figures are a feature of the early cultures on the Middle Nile and continued to be produced as late as the Meroitic period. This figurine was found together with another of rather different form in the grave of an adult woman and child. The presence of these two figurines, one of an adult female, the other of a juvenile, parallels the human occupants of the grave. This led the excavator to suggest that the figures must represent the deceased and were buried in the grave to secure their eternal vitality, rather than being sexual partners for a deceased male or figures of fertility goddesses. *DAW*

Provenance: 1963–4, Halfa Degeim, Site 277, grave 16B (Scandinavian Joint Expedition, find no. 277/16 B:5)

Exhibit: Brooklyn 1978, no.1

Bibliography: Säve-Söderbergh, 1967–8, p. 228; Nordström, 1973, i, pp. 27, 127, ii, pls 56, 3, 197; Brooklyn 1978, p. 114

1.75

Beaker

Sudan

Neolithic, 4th millennium BC
fired clayh. 27.7 cm; diam. 25.4 cm
Sudan National Museum, Khartoum,
SNM. 26.899

The whole exterior and the interior as far as the waist of this hand-made vessel in the form of a calyx has a reddish-brown burnished surface. The exterior decoration is divided into panels by incised bands. Below the waist it is divided into four equal quarters by a vertical band. Above the waist it is again divided in the same way but the bands are offset from those in the lower part of the vessel. Each panel is filled with parallel scored lines in groups alternating to form a herringbone pattern. Three of the five triangles below the rim have the incised lines arranged vertically, the other two have two groups of lines, one group arranged vertically, the other obliquely.

This type of vessel is characteristic of the Neolithic in Sudan and examples have been found as far apart as el-Kadada and Kadruka; a related form is known from contemporary contexts in Egypt. Caliciform beakers have been recovered from funerary contexts only, suggesting that their function was intimately connected with funerary ritual. The quality of the vessels varies considerably, some being rather crude. Regional variations in the form have been noted, the markedly bulbous lower part of this vessel being a characteristic of the more southerly type.

This example was recovered together with three other vessels from a grave in the cemetery at el-Kadada. *DAW*

Provenance: 1978–9, el-Kadada, cemetery C, section 76, tomb 3 (Section Française de la Direction des Antiquités du Soudan, find no. KDD 76/3/59)

Exhibition: Lille 1994, no. 63

Bibliography: Geus, 1980, fig. 4, pl. VII

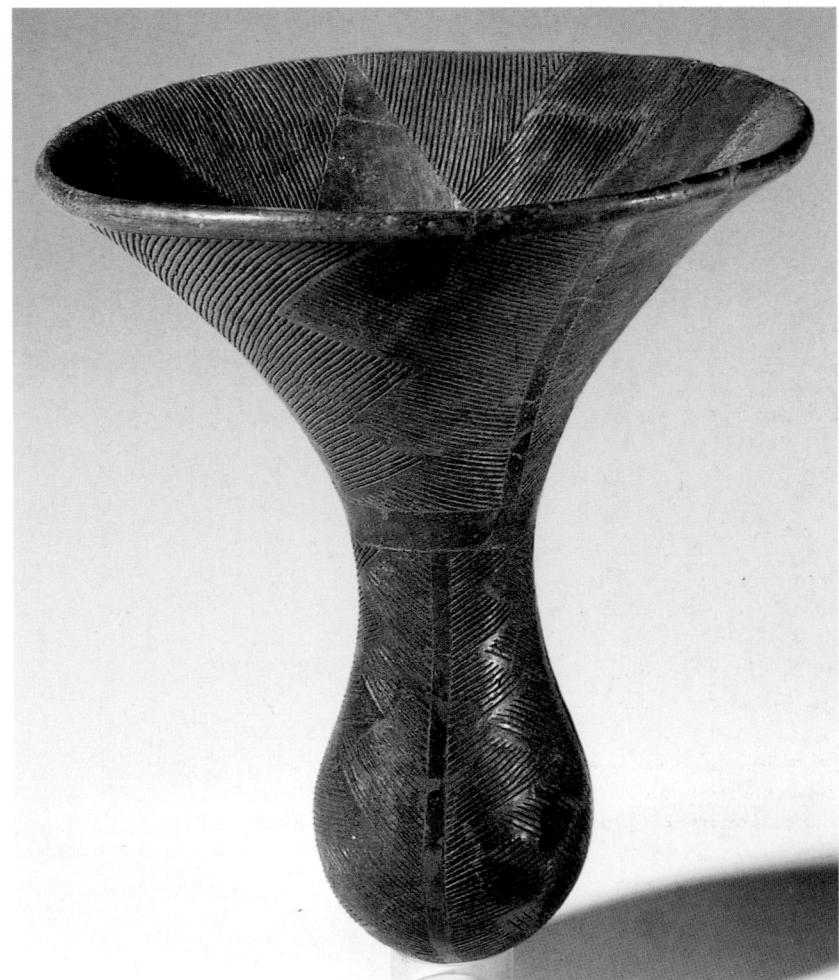

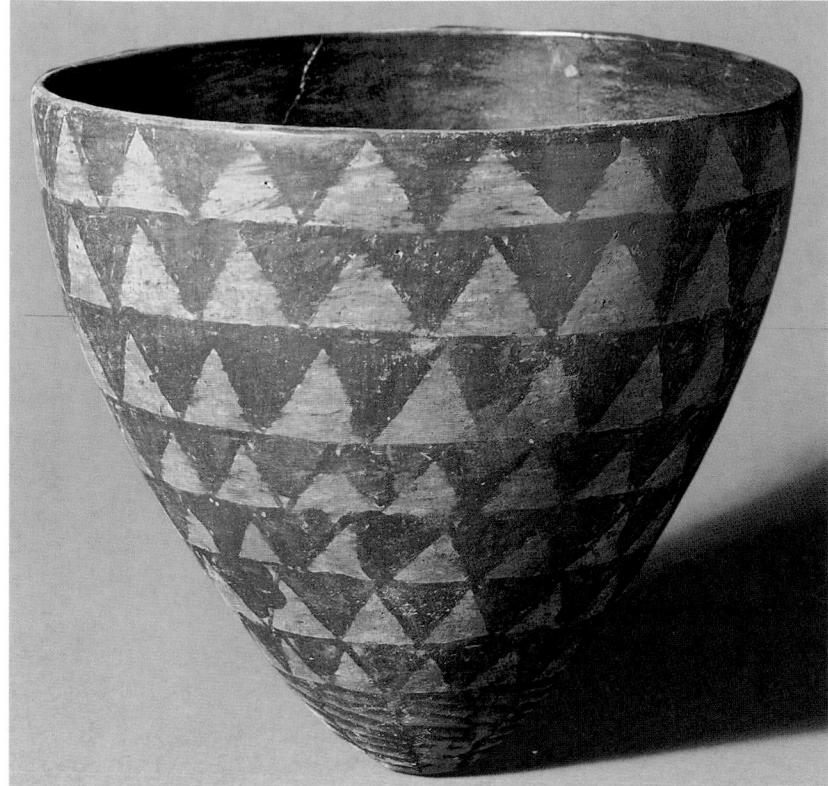

1.76

Bowl with dentelle decoration

Nubia

Classical A-Group culture, c. 3100 BC
fired Nile silt

h. 19.4 cm; diam. 20.6 cm

Lent by the Syndics of the Fitzwilliam Museum, Cambridge, E.G.A. 4668. 1943

This bowl represents the highest point in ceramic achievement of A-Group culture. The 'eggshell' ware is uniformly fine, with walls of about 3 mm in thickness. At the base, the pattern of triangles gives way to columns of horizontal lines, diminishing in length with the narrowing of the body of the bowl. The interior is painted black and polished.

The A-Group culture predominated in Lower Nubia and parts of Upper Nubia contemporary with the Naqada III period in Egypt and just before the unification of Egypt. At this time, c. 3100 BC, there was a dramatic change in the previous trade and exchange relationship between the two cultures. Objects from the A-Group are no longer found, and the Egyptian interest turns more to domination and control of Lower Nubia. The material remains of the A-Group suggest that the people were farmers and hunters and extracted gold at goldwashing sites. They made ivory combs, pins and pendants for personal adornment

and were buried in tumuli with places where offerings could be left for the dead. Though this may be due to Egyptian influence, their pottery combines Nubian and Naqadan elements to create individual and exquisite vessels.

This vessel is of pink fired clay. Its shape would have been formed by successive coils of clay, built up from the base and then smoothed together, perhaps through the use of a paddle and an anvil. Hardly any trace of the coils remains, owing to the skill of the potter and the quality of the local clay. The pattern was applied in a paint of red ochre before firing, a thin brush-like implement probably being used for the outlines. The paint within the triangles and the thicker lines of the base pattern was applied with a broader implement and with the fingers. The decoration at the base is in imitation of basketry, perhaps a pot-stand on which to place the bowl. The dentelle effect may also be derived from painted or specially woven baskets. The leather-hard surface was burnished with a smooth, well-rounded pebble or piece of leather to create the required lustre.

The fragility of the ware implies that it could not have been intended for everyday use. By imitating basketry, so much in daily use, the

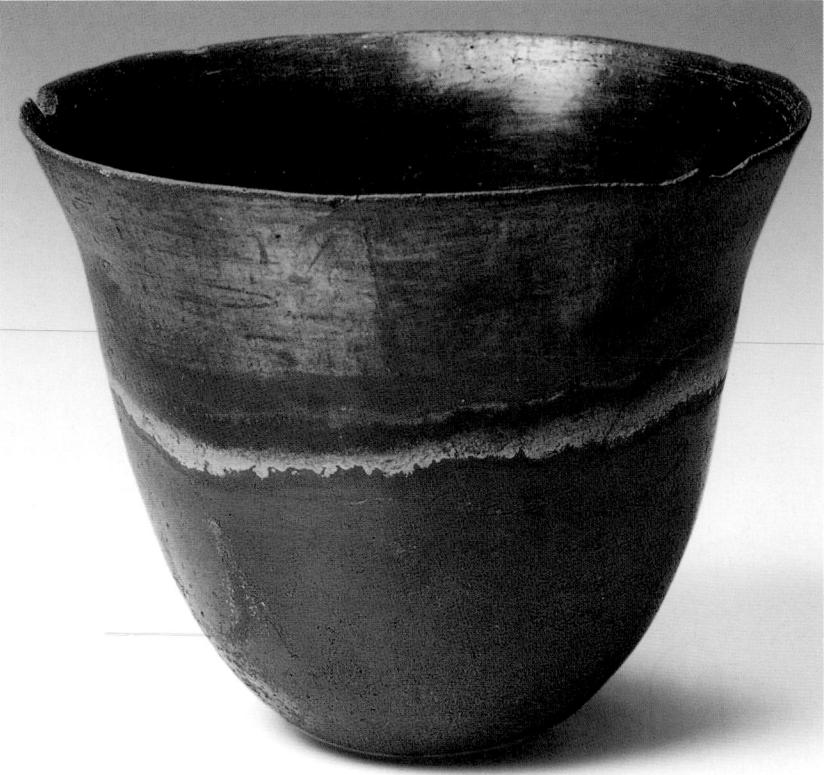

1.77

Beaker

Sudan

Classic Kerma, 1750–1550 BC

fired Nile silt

h. 14 cm; diam. (rim) 11.5 cm;

diam. (base) 4.9 cm

The Trustees of the British Museum, London, EA. 55424

This beaker has a cavetto profile rounding in to the small sagging base. The interior, the rim and the upper part of the exterior wall are covered in a lustrous black slip, the lower part of the exterior and the base in a red slip. Overlying the red-slipped zone and the point of junction of the red and black is a very pale grey stripe bounded by darker grey margins. The quality of execution is superb, and the vessel is extremely regular and fine with walls only 3 mm thick.

The caliciform beaker is a typical product of the Classic Kerma potters and vessels of this type are found throughout the kingdom, often in great profusion. These beakers are among the finest products of the potter's art to have been made in the Nile Valley at any period. The characteristic feature of the pottery of this period is the grey band, the idea for which may have come from observation of the accidentally produced grey spots noted on some pots of the immediately preceding period. It is not certain how the potters were able to produce the band as a consistent feature. This beaker was recovered from a funerary context, although the type is also a common find on occupation sites where they tend to be much less well preserved. It came from a subsidiary grave within one of the massive royal tumuli at Kerma (tumulus IV), where it was one of a stack of five beakers and a bowl placed close to the head of the individual in the north-east corner of the grave. DAW

Provenance: 1915–16, Kerma, Eastern Cemetery, Grave K451 (Harvard University – Museum of Fine Art Egyptian Expedition, Find no. 14.3–913)

Bibliography: Reisner, 1923, p. 239; Taylor, 1991, fig. 24; Quirke and Spencer, 1992, fig. 158

Leg of a chair, stool or bed

Egypt or Nubia
Napatan, 8th–7th century BC (?)
wood (*spina Christi*)
42.3 x 6.4–9 cm
The Trustees of the British Museum,
London, EA. 24656

The rectangular-sectioned, slightly tapering foot of this leg is decorated with shallow carved hieroglyphs. The inscription on the front face reads ‘all life, all power’ and on each side ‘all health, all joy’.

Upon this sits a human-headed sphinx wearing a collar with tear-drop beads hanging from its lower edge and with a scale pattern covering the chest and the forelegs to below the knee. The eyes were originally inlaid and the hair is represented by a smooth raised area upon which is a central forelock, a sidelock to left and right and long tresses running down the back of the head to the nape of the neck on either side of the ‘back pillar’. The top is rounded and pierced by rectangular mortise holes running right through the timber. The front face is decorated with an incised papyrus motif, the symbol of Lower Egypt, beneath the mortise and with a petal motif above. All the decoration is infilled with a white pigment.

The function of the two small circular holes that enter behind the left ear and in the left side of the lower abdomen and are angled towards the back of the piece is uncertain.

The treatment of the head with its round and fleshy face is characteristic of Kushite sculpture of the 25th Dynasty and can be paralleled, for example, on the *shabti* of Taharqo (cat. 1.79) from Nuri. Similar hairstyles with the hair gathered in four tufts are found on a number of Egyptian representations of Nubian girls and also occur on Egyptian faience female figures and female-headed sphinxes dated to the later Third Intermediate period and Late period. These have been associated with the rituals surrounding childbirth.

It is impossible to be certain whether this piece is the leg of a chair, stool or bed. Examples of these items of furniture from Egypt use legs of this type. Beds with rails tenoned into the four corner legs of this basic form are also common in Nubia from at least the Kerma period; known as

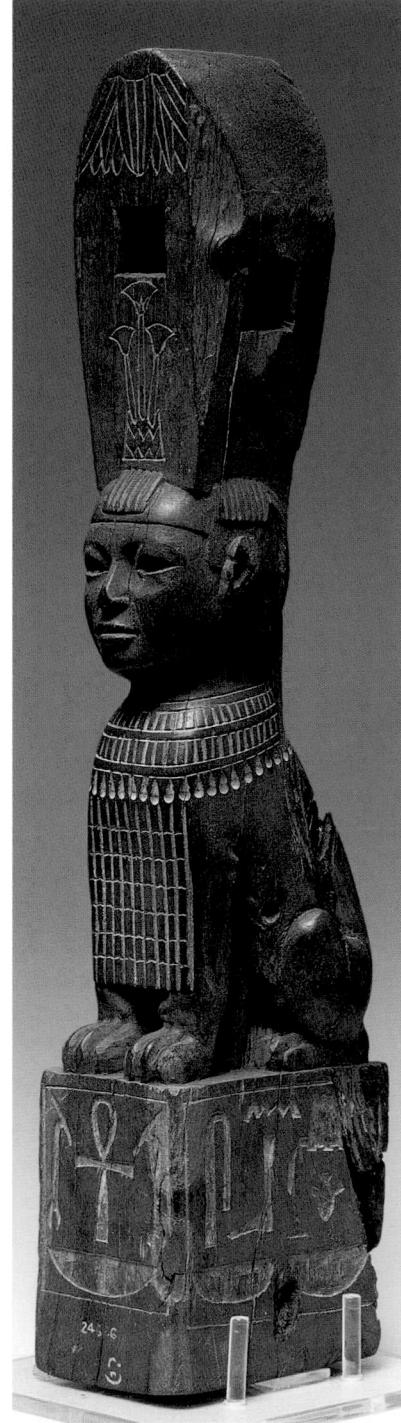

angereeb, they are still used today. They were frequently associated with burials, the deceased being placed upon them. SGQ, DAW

Bibliography: Quirke and Spencer, 1992, fig. 162; Killen, 1980, pls 38, 51–4; Boston 1982, p. 204, no. 239; Bulté, 1991, esp. pl. 28c

Shabti figure

Sudan
Napatan, c. 664 BC
stone, ankerite
h. 52.6 cm
The Trustees of the British Museum,
London, EA. 55485

The body of this mummiform figure of a male is entirely covered apart from the opposed hands which each hold a hoe and a cord. On the head is worn a *khat*-headcloth with a pigtail at the back and a single uraeus. The broad beard was probably curled at the end (in this piece broken off). The cord in each hand runs over the shoulder and carries a rectangular bag with a diamond lattice pattern.

At an early stage in the development of the kingdom the Napatan rulers adopted a number of features of Egyptian religious beliefs, kingship ideology and culture. In the realm of funerary religion it was Piye, who died around 716 BC, who adopted the Egyptian practice of providing *shabtis* in the grave. These were models of the king which would act as surrogate workers in the afterlife, hence the provision of the hoes and bags. In the tomb of Taharqo, the first of the Napatan kings to be buried at Nuri, 1070 complete and many fragmentary *shabtis*, of granite, green ankerite and calcite, were found, originally arranged in three rows along the wall of the chamber.

All bear texts from the Book of the Dead, chapter 6. The robust form of the *shabtis* and the choice of formulae from the Book of the Dead (by that time long obsolete in Egypt) are among many manifestations of the Napatans' predilection for Old, Middle and New Kingdom features, which they utilised in an eclectic manner. The facial features of these *shabtis* are typically Napatan and can be compared with the head of the sphinx on the wooden furniture leg (cat. 1.78).

The provision of a single uraeus on the Taharqo *shabti*s calls for comment. One of the distinctive features of representations of Napatan rulers is the presence of two uraei, their own way of illustrating their dominance over the lands of Upper and Lower Egypt. However, this iconography was by no means invariably used, and statues and reliefs showing rulers with one – as in this case – or no uraeus are known. DAW

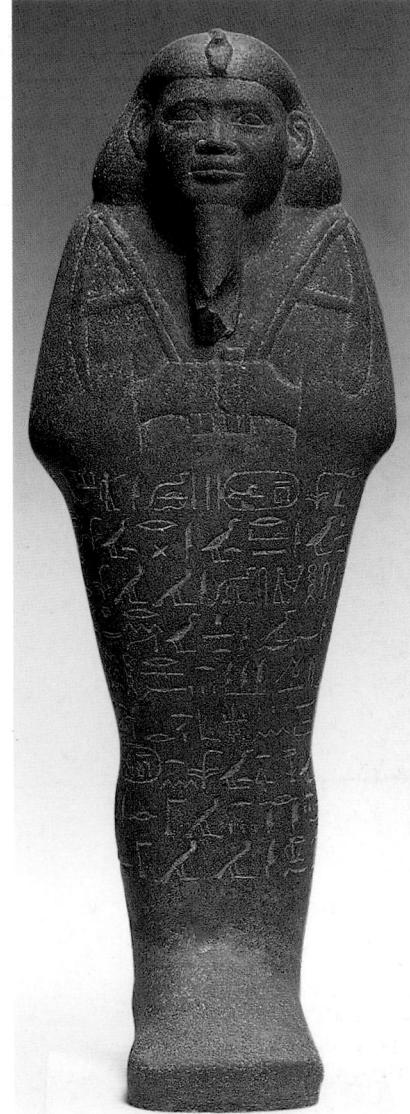

Provenance: 1916–17, Nuri, Tomb of Taharqo Nu. 1 (Harvard University – Museum of Fine Arts Egyptian Expedition)

Bibliography: Dunham, 1955, p. 10; Taylor, 1991, fig. 53

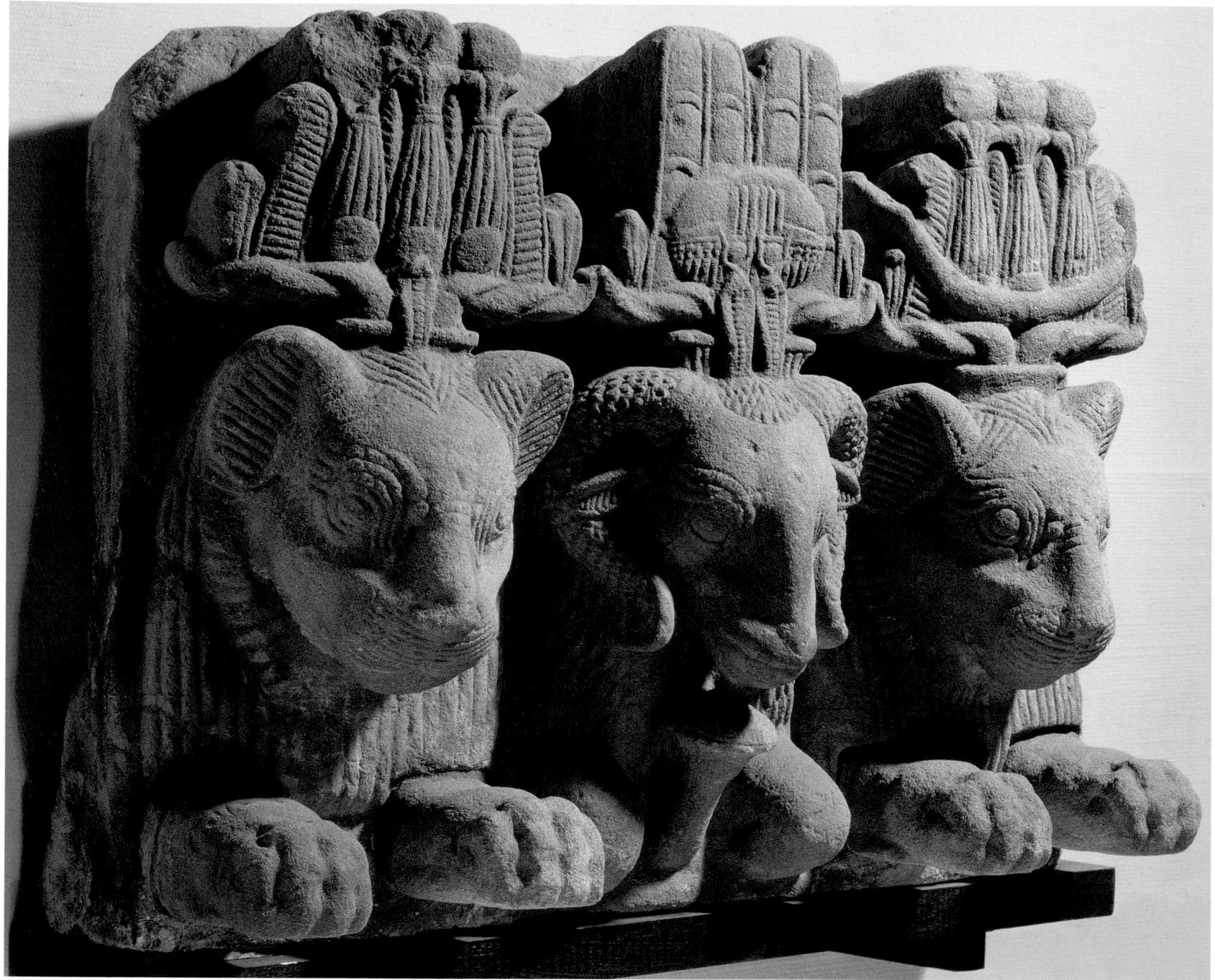

1.80

Divine triad

Sudan
Meroitic period, c. 200 BC
sandstone
64.3 x 88.3 x 36.6 cm

Staatliche Museen zu Berlin, Preussischer Kulturbesitz, Ägyptisches Museum und Papyrussammlung, 24300
Permanent loan from Humboldt Universität zu Berlin

Architectural sculpture was constantly used in Egypt from the beginning of the 3rd millennium BC onwards. Thresholds of palaces show the heads of foreigners (cf. cat. 1.24); gargoyles high up on temple walls

take the shape of apotropaic lion heads.

The central head shows a ram, combining in its horizontal horns and the horns winding around the ears of two different species of the animal sacred to Amun. Its crown is composed of uraei with sun-disks and cow horns, a huge sun-disk surrounded by a frieze of uraei and two falcon feathers flanked by two more uraei. Between the legs emerges a papyrus plant. Two lion heads flank the central motif: their crowns consist of horizontal ram horns, three bundle crowns with two sun-disks each, flanked by two ostrich feathers and two uraei. On the right

head a crescent is added above the horizontal ram horns.

The identification of these lion gods depends on the choice between Egyptian or Meroitic. In Egyptian iconography the two lions are Shu and Tefnut, the children of the primeval god Atum, representing sun and moon. In Meroitic iconography one of the most frequently represented gods is Apedemak, normally as a lion or a lion-headed man. The second lion could be the moon-god Khonsu, the son of Amun.

The triad combines purely pharaonic elements of religious iconography with typical Meroitic features.

The Lion Temple of Musawwarat es-Sufra where this block was excavated is one of the first examples of pure Meroitic style. Its founder, King Arnekhamani, contemporary of Ptolemy IV, extended the kingdom of Meroë to the southern border of Egypt at the first cataract near Assuan. DW

Provenance: 1960, Musawwarat es-Sufra, Lion Temple (Humboldt Universität zu Berlin Sudan Expedition, exc. no. IIC/24)
Exhibitions: Brooklyn 1978, no. 145; Berlin 1990, no. 159

Bibliography: Vandersleyen, 1975, fig. 435

Model of Gebel Barkal

Sudan

Meroitic period, 2nd century BC–2nd century AD
sandstone
h. 62.8 cm; diam. 59.2 cm
Museum of Fine Arts, Boston
Harvard-Boston Expedition, 21.3254

Once thought to be a shrine imitating the form of a traditional African hut, this hollow dome-like object of sandstone can now be identified quite confidently as a model of Gebel Barkal, the ‘Pure Mountain’ of Napata, which was the chief sanctuary and coronation centre of Kush and the site of the oracle of Amun, said to select each new king following the death of his predecessor. The object imitates in form the unique Napatan hieroglyphic symbol for Gebel Barkal, which appears several times in the stele of Nastasen (c. 335–315 BC) in Berlin. As a hieroglyph, the mountain is shown as a dome with a uraeus or cobra diadem (symbol of kingship) rising from one side and is used interchangeably for the ordinary ‘mountain’ hieroglyph in writings of the name ‘Amun of Napata’.

From the Egyptian New Kingdom onwards, Gebel Barkal was believed to be the residence of the southern (and primeval) form of the Theban god Amun, who was known as ‘Amun of Napata, dweller in the Pure Mountain’. Because of the curious 75-m-high pinnacle on the southern corner of Gebel Barkal, which in silhouette looks like a rearing uraeus, the mountain was not only identified as the dwelling-place of Amun, but was also identified by the Kushites as the true source of kingship in the Nile Valley, from which derived the legitimacy of the 25th Dynasty and their successors in the Sudan. In several ancient reliefs, the mountain is shown in cutaway section, with the god Amun enthroned within it, and with a giant uraeus rearing up before him from the mountain’s cliff. One can only speculate that the lost doorway of this model, probably of cast bronze, once had such a uraeus attached to its front.

The object is hollowed out on the inside, with a rectangular socket cut in the floor for the placement of a small seated statuette, now lost. Originally this statuette was hidden behind a door, made of a separate panel, which

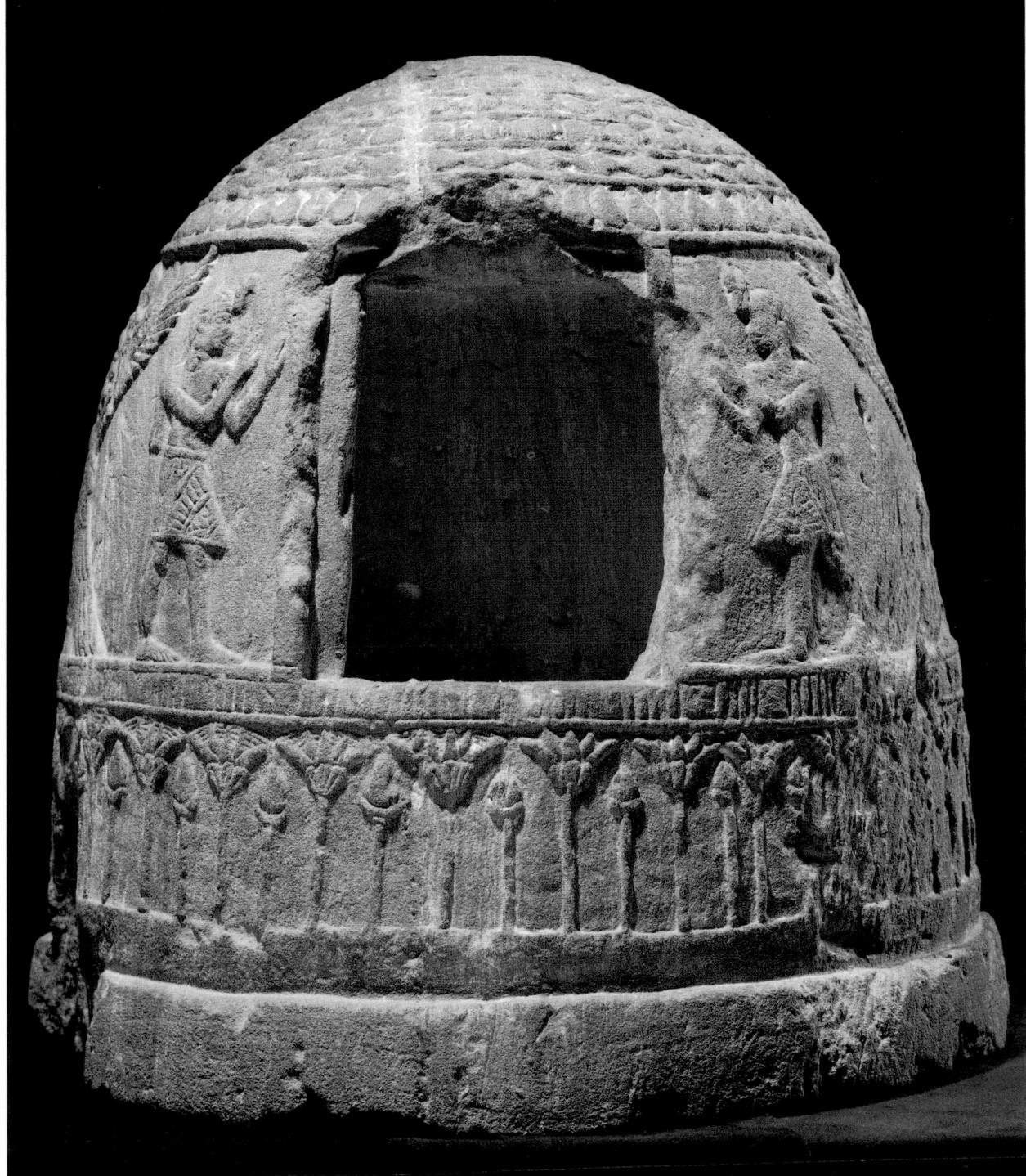

was sealed shut. Chips around the doorway reveal that this panel had been anciently prised open, probably by those who took the statue. The exterior surface is carved with three registers of relief. The lowest represents a stylised papyrus swamp, rendered as a series of parallel stems capped by alternating blossoms and buds. The upper border of this register forms the baseline for the doorway. On each side of the doorway are symmetrically carved rows of four figures facing it. Each row is led by a

king in short kilt, with arms upraised in adoration, followed by a winged goddess, followed in turn by a similar pair, except that the goddesses have alternating human and leonine heads. This register terminates at the rear with a double cartouche naming the royal donor, an otherwise unknown Meroitic king with the Egyptian throne name Neb-maat-Re. The upper register forms a necklace-like ornament of six bands of beads, the lowest being a series of drop-shaped pendants. A finial, now broken, once

projected from the summit, perhaps in the form of a ram’s head, the animal form of the Nubian Amun. The surface is grey-brown in colour, but was originally gessoed and still bears traces of red ochre pigment. TK

Provenance: Gebel Barkal, Great Temple of Amun (Room B 503), in debris
Exhibitions: Brooklyn, Seattle, New Orleans and The Hague 1978–9; Brockton, MA, and Providence, RI, 1981–4
Bibliography: Wenig, 1978, pp. 209–10; Kendall, 1982, pp. 58–9

1.82

Vessel in the form of a bound oryx

Sudan

Napatan, early 7th century BC
calcite (Egyptian alabaster)

8.2 x 17.5 x 6.5 cm

Museum of Fine Arts, Boston

Museum Expedition, 24.879

One of the richest early graves discovered at Mero was a rectangular pit burial, without superstructure, that contained the body of an adult female apparently lying on a bed. This burial had much in common with the contemporary tombs of the early 25th-Dynasty queens at El-Kurru. The deceased was surrounded by her funeral goods: toilet articles, jewellery, a pair of mirrors, pottery, nearly 30 bronze vessels and nine in calcite, of which three, like this one, were nearly identical and took the form of bound oryxes. Although no exact parallel for such vessels is known, the stone from which they were made derived from Egypt. Since many vessels of calcite are found in Kushite graves, it seems probable that they were made in Egypt and shipped to Nubia as containers for expensive oils and unguents.

The ovoid form of the animal's body approximates to that of the contemporary type of unguent vessel known as an *alabastron*. The normal alabastron rim has been altered to form the open-mouthed head of the

animal, made as a separate piece, while the expected lugs have been replaced by the bound legs, which form a convenient handle. The animal's mouth, which is the vessel's mouth, would evidently have been stoppered. The tail and ears are rendered in low relief, and the testicles are carved in the round. The eyes were once inlaid, and there was an inset triangle of reddish material on the forehead, of which traces survive. Two holes drilled at the top of the head held horns in another material, now lost. On the surviving original mate to this vessel in Khartoum the horns are made of carved slate, and the restored horns here duplicate these. TK

Provenance: Mero, West Cemetery, Tomb Beg. W. 609

Exhibitions: Brooklyn, Seattle, New Orleans and The Hague 1978–9; Brockton, MA, and Providence, RI, 1981–4

Bibliography: Wenig, 1978, p. 186; Kendall, 1982, p. 43

Jar

Sudan

Meroitic period, 1st century AD

fired clay

h. 31.7 cm; diam. (rim) 7.8 cm

The Trustees of the British Museum,
London, EA. 51561

This wheel-made jar has a globular body and a cylindrical neck. The whole of the exterior and the interior just over the rim is covered in an orange slip which shows clear traces of wipe marks. The decoration is painted in brown on the body. Beneath a horizontal line at the base of the neck is a single register of seven elements. Running clockwise around the pot from a tree is a giraffe facing right, a man facing left, a giraffe facing left, a tree, a giraffe facing left and finally another tree. Two lines run around the lower part of the body, the upper not continuously. The lower line acts as the ground on which the trees stand, while the figures all extend below this and each has its individual ground line. The trees are probably to be identified as date palms. The giraffes are all very similar, drawn in profile (apart from the pointed ears) with body, neck and legs featuring a crudely drawn diamond lattice. The tail is represented by a single line. The man is depicted in the typical Egyptian (and Meroitic) manner, the torso shown frontally, the rest of the figure in profile. On his head he wears a helmet with ear-flaps and a nose-guard held in place by a chin-strap. There is possibly some indication of clothing with a clear neckline and two arcs running from the centre under the arms. From the evidence of other similar representations, however, the arcs may represent the chest muscles.

Giraffes are a common motif in Meroitic art and are frequently painted on jars. There is considerable variation in the style of drawing, with some being rendered in a naturalistic manner and some almost as cartoon figures. This vessel can be closely related to a number of others from Faras where they were presumably made. The figure of the man and the giraffes are so similar to those on vessels painted by the so-called Prisoner Painter as to suggest that they are either by the same man or by a close associate.

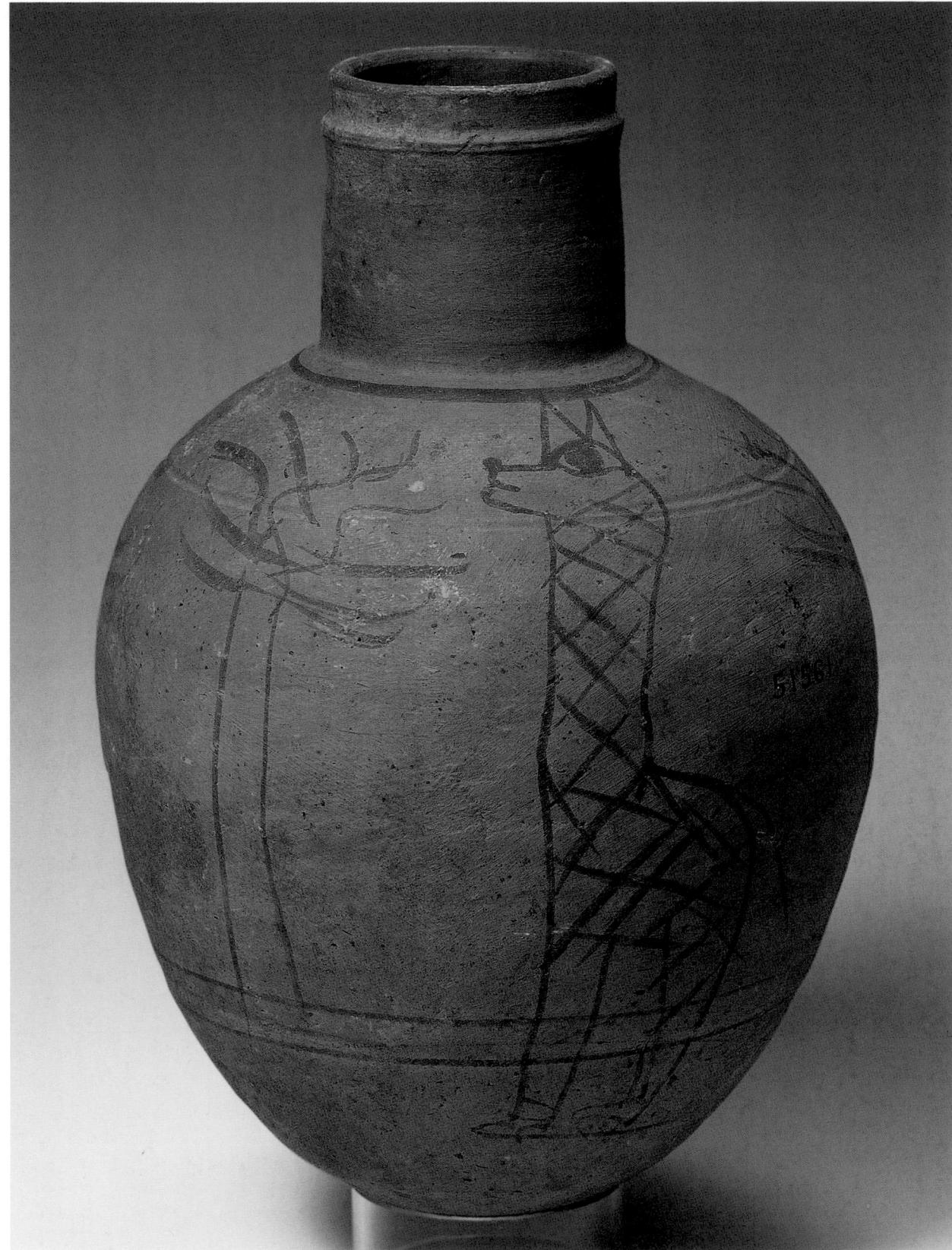

This pot came from the grave of an individual who was accompanied by several ceramic and copper-alloy vessels. His head rested on a wreath of leaves. *DAW*

Provenance: 1910–11, Faras, cemetery 1, grave 2006 (The Oxford Excavations in Nubia)

Bibliography: Griffith, 1925, p. 138; Brooklyn 1978, p. 290

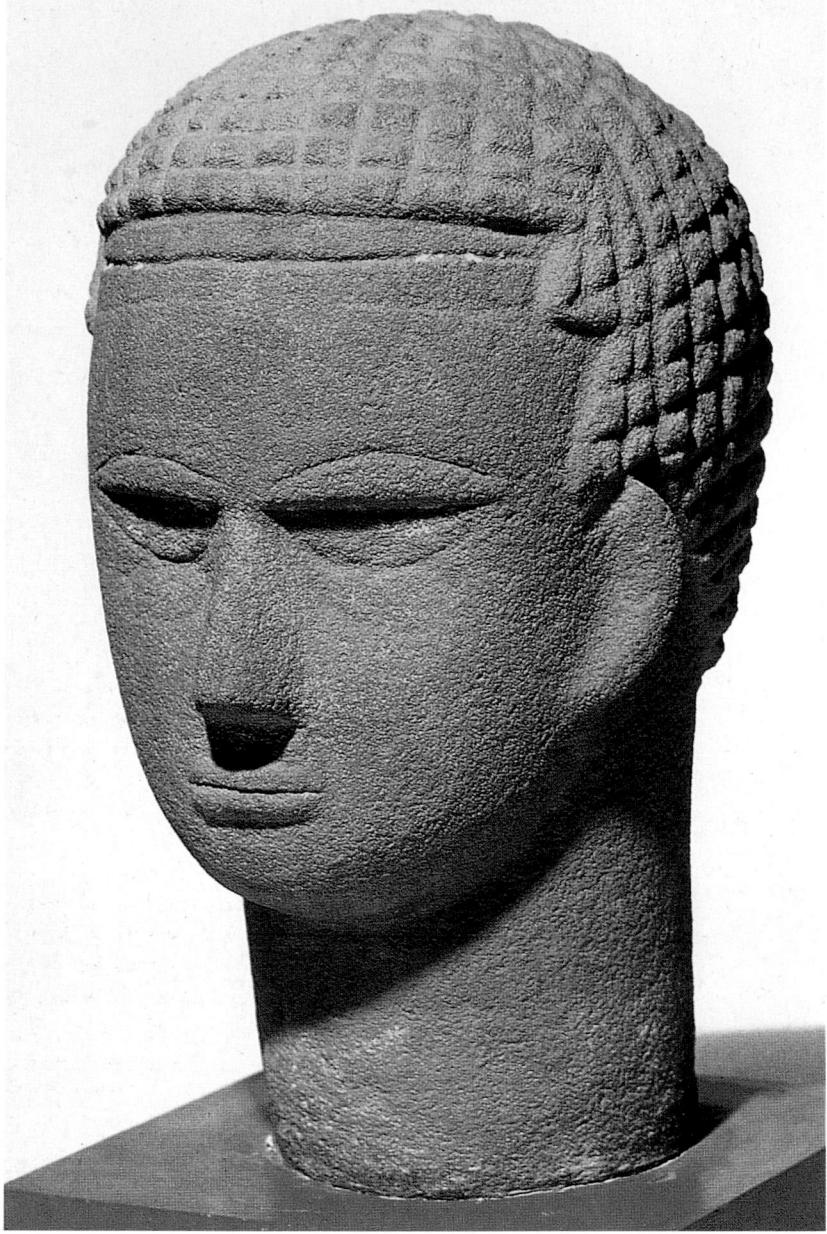

1.84

Male head

Sudan

Meroitic period, 2nd–3rd century AD
sandstone

26.7 x 15.5 x 18.4 cm

Sudan National Museum, Khartoum,
SNM. 13.365

Resting on a long columnar neck, this head of a man has a register of short vertical lines between two horizontal lines near its lower edge. The opening between the pouting lips is indicated by a straight narrow slit. There is little modelling of the long, pointed nose and no indication of nasal arches and nostrils. Slight depressions mark bags beneath the eyes. The upper lids are not indicated, their position being occupied by horizontal orbital ridges

cut back vertically to the eyeball. Towards the hairline the smooth brow has a shallow horizontal groove with another, much deeper groove above. The hair is close-cropped and represented by a square lattice on the top of the head and by a diamond lattice on the back and sides. The ears are simple protrusions without modelling. The skin was painted a reddish-brown and the hair was black. The eyelids, upper line on the brow and the neck bear traces of white paint.

The stylised form of this piece is highly unusual and it is difficult to find convincing parallels among the large number of human heads from northern Nubia that come from *ba* statues (cat. 1.85–6). These are all

much more naturalistic, with lentoed eyes delimited by upper and lower lids, arched orbital ridges and realistically modelled ears. However, a number of parallel details can be found on the *ba* statues, particularly the incised lines on the forehead, thought to represent cicatrices rather than a diadem. The register of decoration around the base of the neck is also a feature of several *ba* statues. By the treatment of the eyes the sculptor of this piece has been able to impart a powerful, brooding aspect to the head.

Significantly, the lower end of the neck has been dressed flat. This head thus falls into the category referred to as 'reserve heads' (cat. 1.25) rather than to that of the *ba* statue. It is thought that it may have taken the place of the more traditional *ba* statue in the pyramid chapels as a representation of the deceased. Reserve heads are rare in Nubia but another is known from Gemai, again with the diamond lattice pattern used to represent the hair but with the facial features executed in a very different manner. An interesting painted representation of reserve heads is to be found on a Meroitic jar from the cemetery at Nag Gamus in Egyptian Nubia. DAW

Provenance: 1963, Nelluah (South Argin), found near the surface between mastabas 26 and 27 (Spanish Archaeological Mission in the Sudan)

Exhibition: Brooklyn 1978, no. 160

Bibliography: Almagro et al., 1965, p. 87, pl. 14a–b; Almagro, 1965¹, pp. 62, 167, no. 17, pl. 39a–c; Leclant, 1976, p. 128, fig. 138; for the Gemai head see Bates and Dunham, 1927, pl. XXXVI; for the 'reserve heads' on the jar at Nag Gamus see Almagro, 1965², fig. 41

1.85

Head of a ba statue

Nubia

2nd–4th century AD
sandstone18.5 x 11 x 15.5 cm;
base 12.5 x 11 x 15.5 cmLent by the Syndics of the Fitzwilliam
Museum, Cambridge, E.12. 1910

Although the head is heavily weathered, it is clear that its modelling was never intended to be crisp. The face is long and narrow; the eyes are cursorily modelled and set so far apart that the outer corner of the preserved right eye wraps around the side of the face. The eyes bulge within a continuous hollowed-out orbital zone below the ridge of the forehead, presumably to emphasise the strong ridge of the brow. Only a faint hint of a rimmed contour survives around the eyes. The nose has completely weathered away, whereas the firmly pursed lips are emphatically drilled at the corners and set off from the flat plane of the chin. From the height of the head and the stepped contours above the face, this figure could be interpreted as wearing a helmet with a curved brim. Similar heads from Karanog are known, but with elements that look more like closely cropped natural hairlines

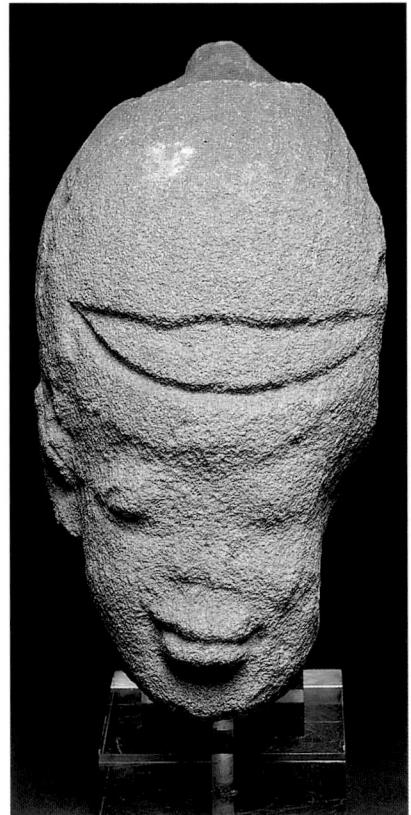

under a wig than brimmed helmets. At the back is a curved engaged strut which is broken off at the crown of the head. Perhaps this was a plume or some sort of (solar?) attribute now lost. Unusual are the three irregularly spaced, vertical scored marks at the right side of the head. The irregular break at the neck suggests that the head has broken off from a figure and was not sculpted as a 'reserve head' (cf. cat. 1.84).

This head is thought to come from a so-called '*ba*' statue, a bird sculpture with human head depicting the soul of a deceased (cf. cat. 1.86). The imagery is well represented in Egyptian New Kingdom tomb decoration and on coffin scenes of the mid-2nd and 1st millennium BC. The *ba* was believed to flutter about, often seeking repose in the shade of the sycamore trees planted beside small pools, where the sycamore goddess could pour a refreshing drink. In Meroitic Nubia of the 2nd to 4th centuries AD, *ba* statues representing the deceased could be positioned near tombs, often in close proximity to offering-tables where the living might set food and drink for the nourishment of the dead. The fact that these tables were decorated with foodstuffs and inscribed suggests that food and drink were magically provided for the *ba* statue after the living no longer came. EV

Provenance: F. W. Green, from Aniba

Bibliography: Mills, 1982, p. 56, pl. xc.6; Woolley and Randall-MacIver, 1910, nos 7048, 7069, 7070; Brooklyn, 1978, nos 151–60

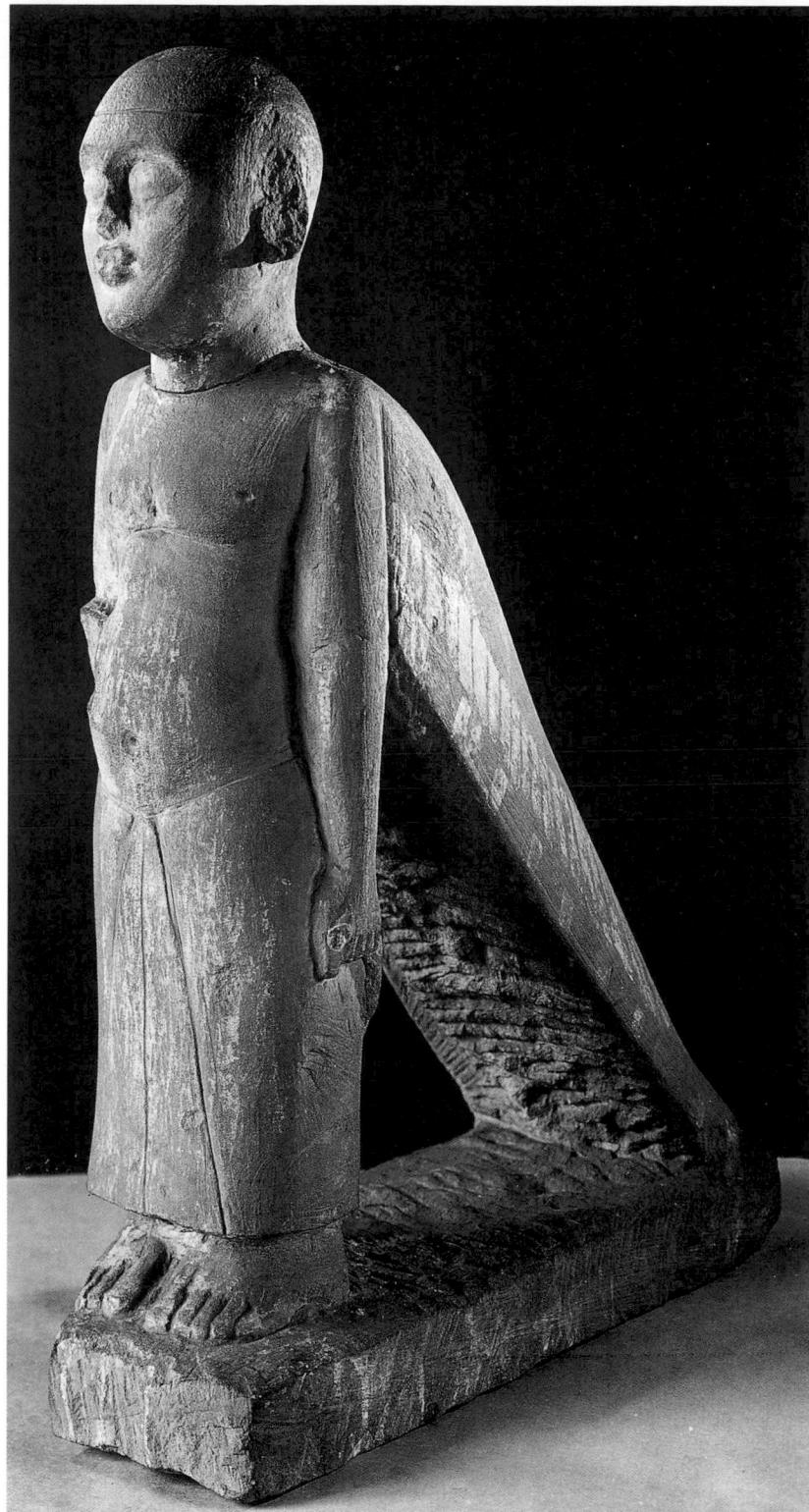

1.86

Ba statue

Lower Nubia

Meroitic period, c. 2nd–4th century AD
sandstone

69.9 x 20. x 49 cm

University of Pennsylvania Museum of Archaeology and Anthropology,
Philadelphia, E 7004

Meroitic '*ba*' statues' of Lower Nubia are a well-established genre. Normally, the statue combines a fully human figure with a pair of furred wings. Despite strong Egyptian influence upon Meroitic culture, this type of *ba* statue is not found in Egypt or around Meroe itself. In Egyptian belief, the *ba* was the mobile, transformational aspect of a dead person's personality, often represented as a human-headed

bird, while the *ka* (typically depicted in human form) was the embodied capacity of the deceased to absorb life and the nourishment needed to sustain it. Meroitic *ba* statues might in fact combine the notions of *ka* (the human figure) and *ba* bird (the attached wings); they typically also had a solar disc rising from the head, made separately and hence usually lost. *Ba* statues stood outside tombs as a focus for offering cults, but their exact location is uncertain (nearly all were found out of context).

This statue is allotted to Grave 133 in a cemetery at Karanog, Lower Nubia, perhaps incorrectly; the owner of this tomb was a woman, according to an inscription, and the statue is male. The head is schematically rendered, with simplified facial planes, unrealistically large eyes and protuberant, seemingly pursed lips. A hole in the top of the head supported the stem of a circular sun-disc, now gone. Traces of dark red paint, overlying a white ground, occur on the body, while the feather pattern on the wings was laid out in green, overlying a white ground. Stylistically, it can be seen as a provincial variation on the proportions and style of official divine and royal statuary of the period.

One arm extends down the side and grasps a piece of cloth (?); the other was once partially extended and has broken off. Like other *ba* statues, it may originally have held a cone-like object or a staff. The portly form (indicative of prosperity) wears a long kilt, with front panels; while the carefully delineated feet are bare. DO

Provenance: 1910, Karanog, Lower Nubia (E.B. Coxe, Jr. Expedition)

Bibliography: Woolley and Randall-MacIver, 1910, pp. 48, 134, pl. 16; Hoffmann, 1991, pp. 35–41; O'Connor, 1993, ch. 7

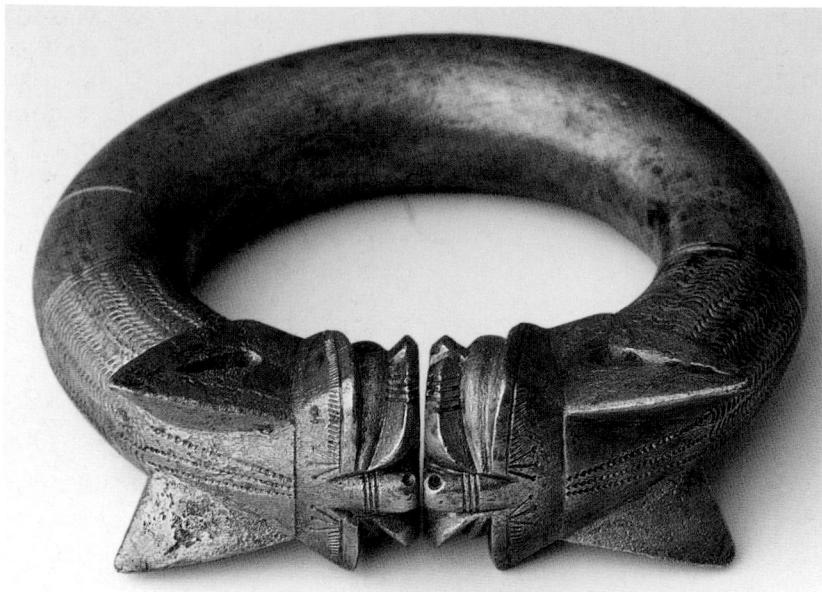

1.87

Bracelet

Nubia

X-Group, early 5th century AD

silver

external diam. 8.9 cm;

diam. of cross-section 2.7 cm

Museum of Egyptian Antiquities, Cairo,
JE 70296

This bracelet has terminals in the form of lions' heads. A number of similar bracelets were found in graves at Ballana and at the contemporary cemetery at Firka, a little upstream of the Dal Cataract. These are thought to be of Nubian manufacture. This piece was found, along with another of very similar type, *in situ* on the left wrist of a male buried within a burial pit at Ballana. On his head he wore a crown, anklets of leather with silver discs on the left leg and two silver toe-rings. An archer's silver brace lay by his right hand. Török suggests that this was the burial of a prince. DAW

Provenance: 1933, Ballana, tomb B6, burial C (Archaeological Survey of Nubia 1929–34, find no. B.6-23)

Exhibition: Brooklyn 1978, no. 270

Bibliography: Emery and Kirwan, 1938, p. 87, no. 23, p. 187, no. 19, pl. 39a; Török, 1988, p. 117, fig. 71, no. 23

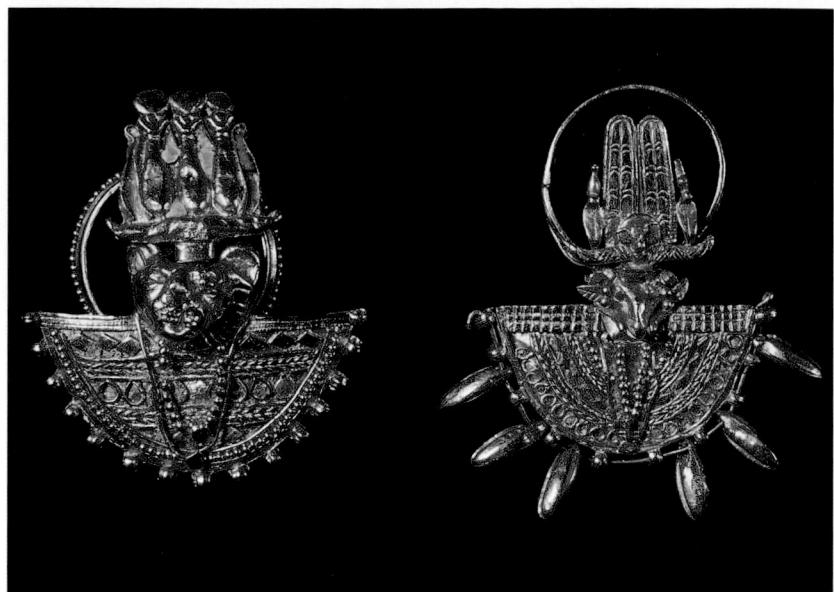

1.88

Two shield rings

Sudan

Meroitic period, c. 15 BC

gold, fused glass

h. 3.9 cm

Staatliche Museen zu Berlin, Preussischer Kulturbesitz, Ägyptisches Museum und Papyrussammlung, 22872

Shield rings are especially characteristic of Meroitic royal jewellery. Their formal structure is dominated by a semicircular necklace (or aegis) surrounding the head of a god or goddess. Consisting of a solid plate of gold, the aegis has on its reverse a gold ring fastened by a hinge. The divinities represented on these shield rings are a selection of those encountered in the reliefs of Meroitic temples and pyramid chapels, where Egyptian gods are mixed with typical Meroitic divinities: the lion-headed Apedamak, the anthropomorphic Sebiumeker and the foremost of the ram-headed gods. The latter group is the only one used in the iconography of these rings.

The ram head in the centre of this shield ring, made of solid gold, combines two different species: *ovis longipes*, with horizontal horns; and *ovis aries*, with horns winding around the ears. Its headdress consists of a sun-disk, a pair of falcon feathers and two uraeus snakes surmounted by the pharaonic crowns of Upper and Lower Egypt. A gold wire, passing through small loops at the outer rim of the aegis, supports six gold shells. Named after the Egyptian god Amun, these ram-headed gods are genuine Meroitic divinities. The Egyptian

Amun, originally represented in pure human form, assumes the shape of a ram only at a later date as a secondary manifestation whose origin clearly lies in the Upper Nubian culture of Kerma. Throughout the iconography of Amun, the Egyptian anthropomorphic figure is distinguished from the Nubian and Sudanese form of the ram.

These shield rings have been explained as functioning finger-rings. Their dimensions and fragility, however, tell against such a use. Shield rings can be found in relief figures of Meroitic queens as an ornament over the forehead, supported by a diadem or by a lock of hair. Similar ornaments do still exist in the oasis west of the Nile Valley. DW

Provenance: 1854, Begrawija (Meroe), Pyramid N5 of Queen Amanishakheto (Giuseppe Ferlini)

Exhibitions: Berlin 1990, no. 162; Berlin 1992, fig. 9b

Bibliography: Schäfer, 1910

Incense burner

Nubia

X-Group, late 4th–early 5th century AD
copper alloy
h. 25.7 cm; w. of pedestal 11.4 cm
Museum of Egyptian Antiquities, Cairo,
JE 70924

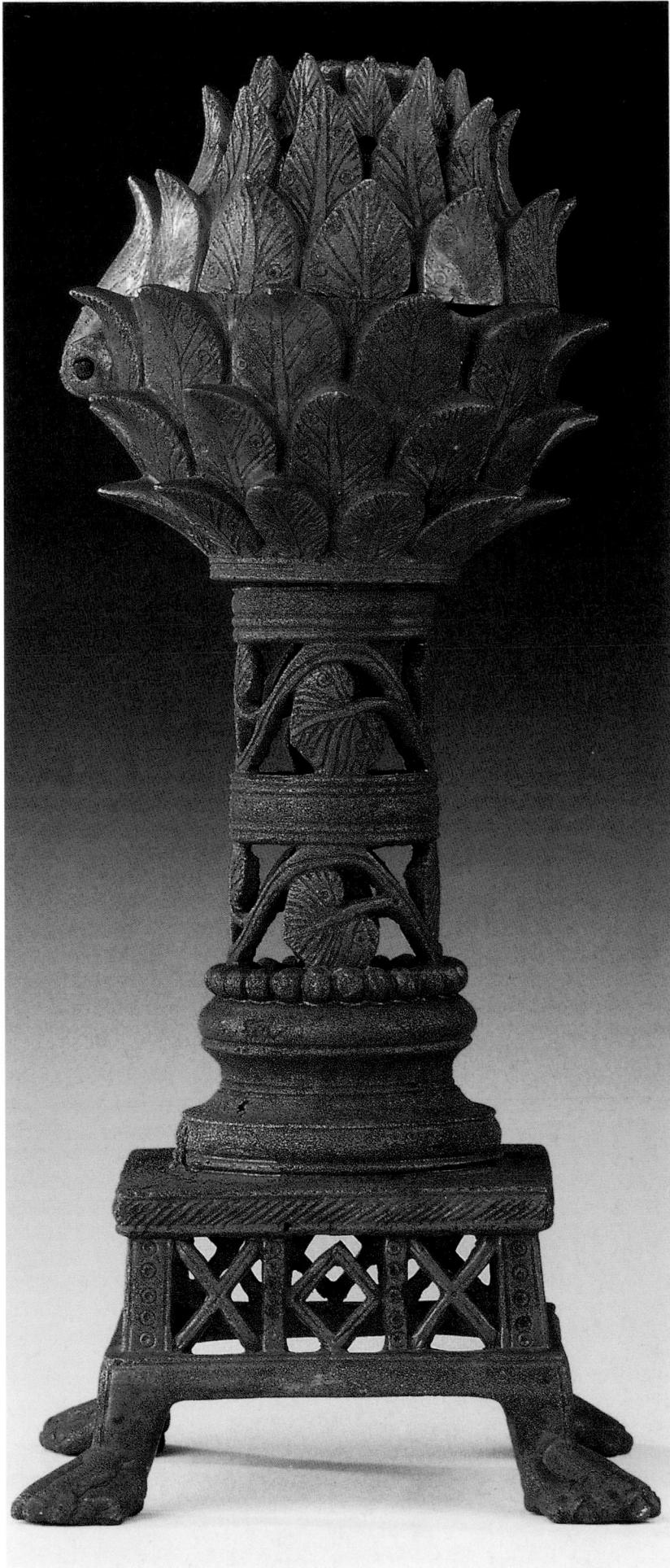

This incense burner is in the form of a pine cone. The scales on the upper half of the cone are tightly closed, those on the lower half are open. Each is decorated with a veined pattern and with small concentric circles. A lid on the top of the cone is hinged and pierced by a large hole and a row of smaller holes to allow the fumes to escape. The cone is supported on an openwork, slightly tapering cylinder decorated with two registers of a swirling leaf and tendril motif.

At the base of the cylinder a band of spherical beads masks the point of contact with the 'Attic' base. This sits on a square pedestal, the sides of which are decorated with an openwork floral pattern, as on the cylinder. Each panel is delimited by a vertical register at the corners of incised concentric circles and with a register of rope pattern above. *Ankh*-signs are incised in the top corners. The pedestal is supported by four lion's paws.

The character of this piece puts it firmly among the repertoire of the Late Antique period. There is some doubt as to its place of manufacture, whether it is a Nubian product or whether it was made in Egypt north of Aswan. Török has compared it with a similar piece, probably from Faiyum. There was certainly much imported material among the gravegoods found in the X-Group graves at Ballana and the nearby cemetery at Qustul. It was found lying on the floor adjacent to the burial of a female adult in the antechamber of the tomb, probably that of a queen. *DAW*

Provenance: 1932–4, Ballana, tomb 47 (Archaeological Survey of Nubia 1929–34, find no. B.47-10)

Exhibition: Brooklyn 1978, no. 275

Bibliography: Emery and Kirwan, 1938, p. 108, no. 10, pp. 362–3, no. 804, pl. 97A; Török, 1988, p. 123, fig. 81, no. 10, pl. XII

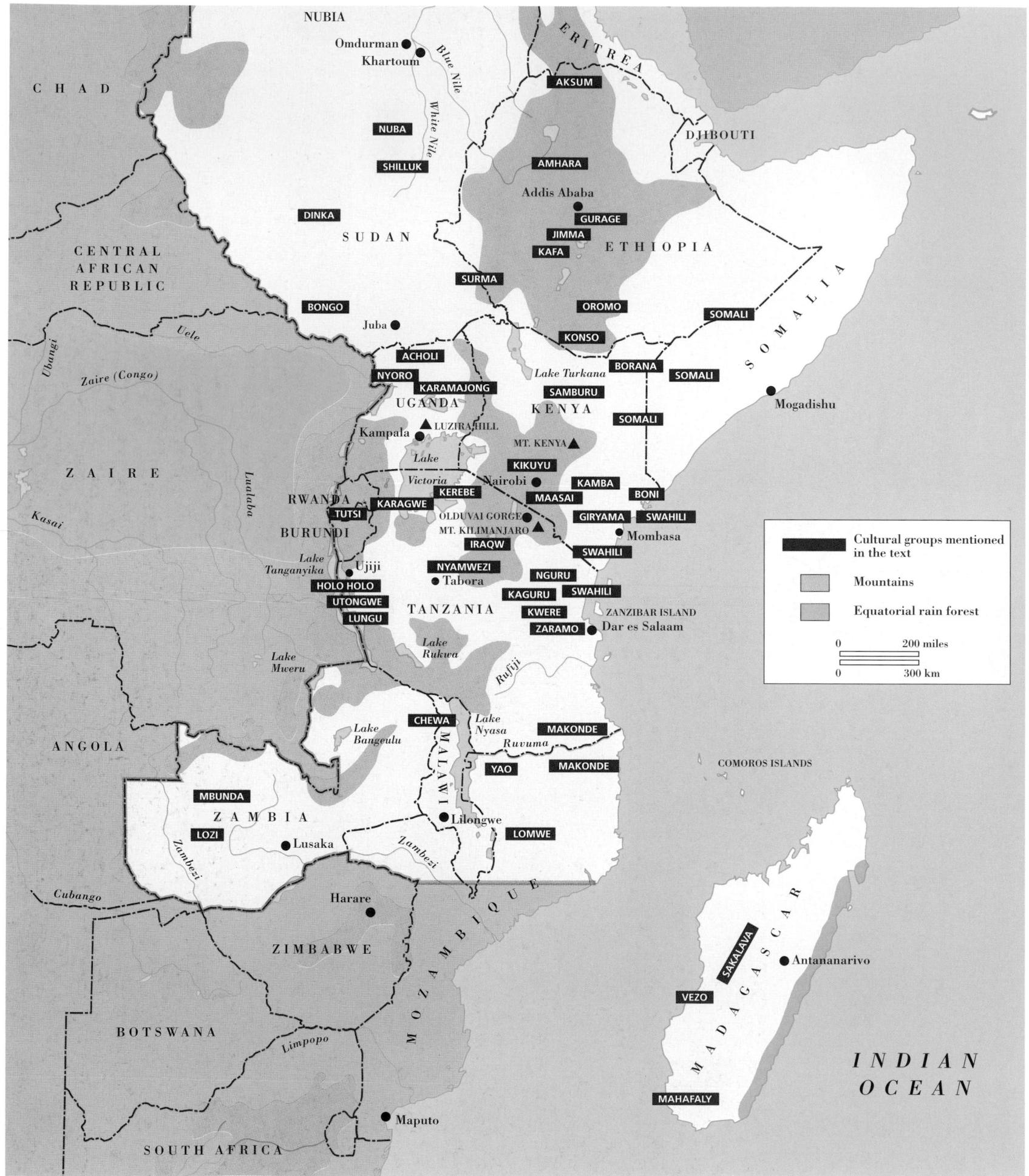

2 EASTERN AFRICA

John Mack

Eastern Africa provides the earliest evidence anywhere in the world of the development of distinctive human activity. The earliest of what might be termed 'cultural' objects were fashioned in those parts of the Rift Valley that run from the Olduvai Gorge in Tanzania to Lake Turkana in Kenya, including its extension into neighbouring Ethiopia. The area is also bordered along one side by the Indian Ocean, one of the more benign of seaways, which provides it with a maritime context comparable with that of Africa's Mediterranean and Red Sea shores. Given an area with such a long history of human occupation, and a hinterland that has proved relatively accessible both from within and beyond the continent's shores, its cultural and linguistic diversity is not unexpected; nor is overlap with other areas considered elsewhere in this catalogue and its accompanying exhibition.

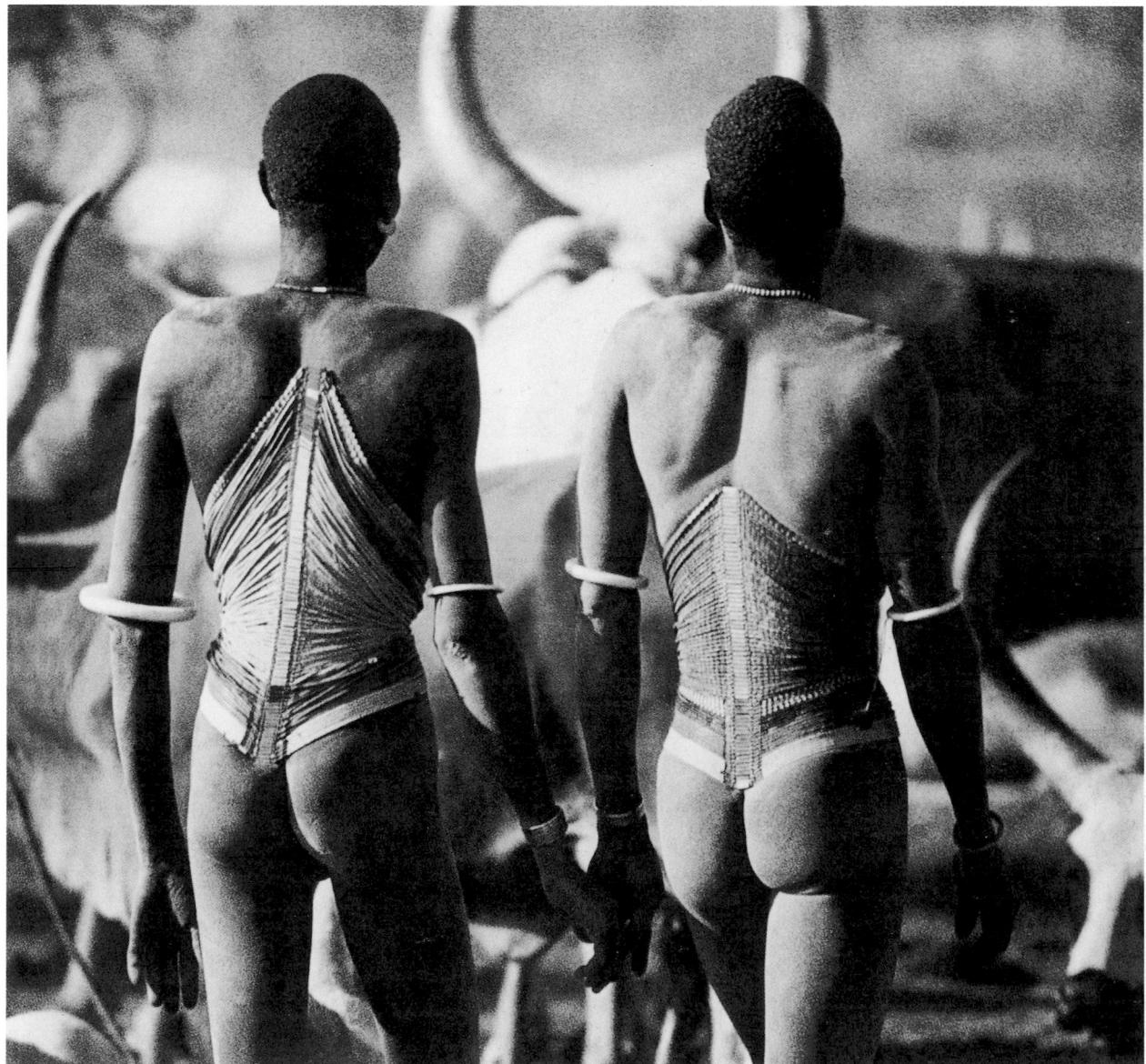

Fig. 1 Dinka men wearing beaded corsets, southern Sudan

Historical and geographical background

Regional definitions are, of course, always somewhat arbitrary. Two tendencies are evident in the familiar treatment of the eastern side of the continent. On the one hand, in the anglophone world, east Africa is often shrunk into the former British colonial entities that comprised the separately administered territories of Kenya, Tanganyika and Uganda, and perhaps Zambia and Malawi. Yet, most general surveys of African art embrace much more: they tend to consider together everything in sub-Saharan Africa that is not from the rich artistic heartlands of west and equatorial Africa; east Africa is taken as a kind of afterthought. Indeed, where sculpture has been found it is often presented as an overspill from the 'art-producing' areas on its borders. The tone of most discussions of art in eastern Africa is unremittingly apologetic. In this survey significant weight is accorded to this neglected area and to objects other than the figurative.

This is to be welcomed. However, the nature of the exhibition and its catalogue has necessitated a somewhat broader sweep than might have been ideal. The heart of the region extends from the coasts of Kenya and Tanzania across to the Ruwenzori Mountains and Lake Tanganyika. It takes in Uganda, Rwanda and Burundi, an area dominated by high plateau grasslands that in the north merge into areas of desert and arid scrub. To the south, Zambia, Malawi and parts of northern Mozambique are considered, as are the offshore islands – Zanzibar (now joined with Tanganyika in the modern state of Tanzania) and the large and environmentally varied island of Madagascar. Included also are the contrasting cultures of the north-east – Somalia and Ethiopia, and adjacent parts of the Sudan. Ethiopia, in particular, whose rugged highlands have effectively isolated it from wider contacts with other parts of the continent, is heir to a unique set of historical circumstances.

The present topography and vegetation of this region offers several possible modes of livelihood. Indeed, depending on circumstances, different peoples may be obliged to adopt a mix of strategies. Hunting and gathering as the sole means of sustenance is extremely rare in eastern Africa. It is the main activity of only a few small and isolated groups such as the Boni in Somalia and Kenya, the Hadza in Tanzania and the Mikea in south-west Madagascar. On the other hand, many of the peoples who occupy difficult environmental niches, or are subject to periodic drought conditions, often revert to a hunting and gathering livelihood when occasion arises. Most are otherwise cattle or, in northern Kenya, camel pastoralists driving their herds in search of distant water holes in the driest seasons. This sometimes gives rise to a dual system of material culture. There is often an emphasis on multi-functional, portable and replaceable objects for those following a periodic semi-nomadic existence, such as some of the headrests and stools illustrated here; a more stable and substantial set of objects is appropriate to those who remain in the permanent villages that pastoralists also usually maintain.

Just as at one extreme pastoralism shades off into hunting and gathering, so at the other it merges with mixed farming. Even those (e.g. the Dinka and related peoples in the southern Sudan) who conceptualise the world through their impressive herds of humped cattle do not rely uniquely on cattle products to sustain themselves; they also take advantage of the crops grown at their home villages. Mixed farming proper, however, involves a comprehensive range of such activities, from agriculture to animal husbandry. It is practised in some measure in all parts of the region, but predominates in northern and central Ethiopia, in western Kenya, Uganda and southwards, and in central Madagascar. Sorghum, millet and manioc are the main crops, as well as rice in Madagascar.

A third strategy is trade – and with trade the tendency towards urbanisation. Along the continent's eastern shores a series of trading centres arose in the early decades of the millennium, linking eastern Africa to the wider Indian Ocean. This maritime trade connected ports and islands from as far south as present-day Mozambique to southern Arabia and beyond. The main items imported into Africa appear to

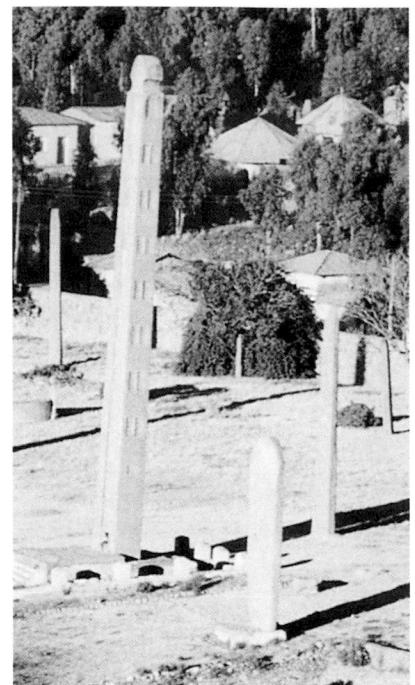

Fig. 2 View of Aksum showing standing stelae, some of the tallest monuments in the world

have been iron goods (though iron production was already established on a limited scale in eastern Africa by about AD 200) and glass. These were exchanged for gum, spices, ivory and horn. Mangrove swamps provided straight poles for building purposes. By about AD 800 this series of linked centres had become the instrument through which the Islamic faith spread along the coast. The first mosques were built and with them came the emergence of a distinctive Swahili culture at centres such as Lamu, Mombasa, Zanzibar and the Comoros. Here, a technique of chip-carving was applied to wooden doors and to other domestic objects, giving an interlaced geometric form of decoration that characterises the arts of the western Indian Ocean – as exemplified on the Swahili door shown here (cat. 2.27).

In northern Ethiopia another link to Arabia was similarly associated with moves towards urbanisation. As with the Swahili, the developments that took place were the result of a fusion of external and local tradition. Aksum, the centre of an elaborate kingdom, came to prominence in the 1st century AD. By the 4th century it had already become a Christian capital, predating the spread of Islam along the Indian Ocean coast. The influence of Aksum, which lies in the province of Tigray, stretched northwards to the modern state of Eritrea and the port of Adulis, which linked it in one direction with Rome and in another with India and Ceylon. The kings of Aksum even conquered parts of the Yemen – a reversal of the standard fate of continental Africa. Aksum, in addition to its monumental architecture and its series of dramatic tall stone stelae (fig. 2) – among the largest stone monuments ever created – retains a local tradition that it preserves the Ark of the Covenant reputedly carried there by Menelek, the son of King Solomon and the Queen of Sheba. By the 17th century the capital of the Christian kingdom had been established at Gondar, which in the 19th century emerged as the centre of a unified Empire in Ethiopia's northern and central highlands.

The linguistic map of eastern Africa is aligned in very broad terms with this distribution of economic strategies. Thus, the pastoralist tradition is largely associated with Nilotic populations, which include the main cattle-keeping groups in southern Sudan (fig. 1), the Turkana and related peoples in northern Kenya and Uganda, and the Maasai in Kenya and Tanzania. To the east of Lake Turkana and into adjacent areas of Ethiopia and Somalia the pastoralist tradition is maintained by Cushitic-speakers, who include the Somali and, more distantly, the Iraqw who are established in northern Tanzania. Northern Ethiopia is heir to a separate tradition of Semitic speakers, while the mixed farming areas of much of Uganda, Kenya and regions to the south of them are occupied by members of the different Bantu-speaking peoples who moved into and through the area from the early centuries after Christ. Swahili is also reckoned a Bantu tongue, though the Indian Ocean context of Swahili culture is evidenced in the extensive Arabic influences.

The oddity in the linguistic geography of the western Indian Ocean is the presence in Madagascar of a dominant language – Malagasy – which is of Malayo-Polynesian rather than African origin. The nearest cognate languages so far studied are found in central Borneo, 6400 km away across the Indian Ocean. The original occupation of this large island appears to be contemporary with the development of Islam and of the generation of Swahili culture on the east African coast about AD 800 or shortly before.

The most likely explanation of this situation is that groups from distant parts of the Indian Ocean were already established on the east African coast before the development of a distinctive Swahili culture. The disruption of their long-distance trade occasioned by competition from local traders with links to the Arabian Sea led to their occupation of the large and, until then, uninhabited island. A number of factors support this view. One is the mix in the affinities of the art styles within Madagascar. A second is the general comparability of some sculptural forms and, equally importantly, of their associated contexts of use between Madagascar and the immediate hinterland of the Swahili coast. The construction of cenotaphs at a distance from the graves of significant people, for instance, is paralleled in parts of Madagascar

and among the Giriama, Zaramo and others in the immediate hinterland on the continent. This suggests the hypothesis that the development of a Swahili wedge along the coast separated peoples who, if not at one time united, were at least once more closely in touch.

The 19th and 20th centuries

Most of the objects in this selection, and indeed most discovered in non-archaeological contexts, are inevitably of 19th- or 20th-century manufacture. No cast-metal works known to have been produced in eastern Africa have survived. A figurative casting found in excavations from the island of Manda off the Kenyan coast turned out to be of Indian origin. Equally, there are none of the impressive ceramics from the more distant past that characterise the archaeological cultures of parts of west Africa or the early Bantu presence in South Africa. A possible exception is the Luzira head and figure from Uganda (cat. 2.21), though this comes from an otherwise undocumented context and has never been securely dated. The suggestion is that it may be no more than a few centuries old. There are also rock paintings at a number of sites in the region, the most fully recorded being from Tanzania. Again, however, dating has proved difficult.

Unfortunately, many of the 19th-century sculptures are also poorly documented, at least by comparison with west and central African art and material culture. This, of course, goes hand in hand with the persistent representation of eastern Africa as being, with few exceptions, without art. Yet, there are extenuating circumstances that explain, even if they do not explain away, this overriding impression.

The first is that written texts concerning the interior of eastern Africa began to accumulate somewhat later than those for other parts of the continent. Early accounts, such as the *Periplus of the Erythraean Sea* (written in Greek by an anonymous traveller from Alexandria probably towards the end of the 1st century AD), deal almost entirely with the coastal region. Later Arab and Portuguese sources are likewise silent on the deeper interior of the continent. In effect the Swahili coast had few documented relations with the interior. Coastal trading stations were maintained in significant part by the gold trade established between Great Zimbabwe and the coast to the south of the region considered here, and carried on up and down the shipping routes. It was not until late into the second half of the 19th century that accounts of the more distant parts of the interior began to appear. After all, in 1871 Stanley's famous presumption about the identity of Dr Livingstone still seemed entirely reasonable to an outside world uninformed about the interior, and assuming it to be the ultimate in isolation.

None of this would matter greatly in terms of the understanding of the earlier chronology of the area if detailed oral histories were being systematically repeated locally and subsequently written down. Most societies in eastern Africa, however, have not had the kinds of 'keepers of tradition' (indigenous historians) whose knowledge is instrumental in confirming the legitimacy of ruling groups. It was not that the societies in question lacked history; rather, their unstable political character and generally small scale left them without the official historians whose recounting of traditions made possible the extensive reconstruction of lengthy dynastic genealogies like, say, those of the Asante, the state of Benin, the Kuba kingdom or – the main exception in the region under discussion – the chronicles of the Merina royalty in central Madagascar. In recent years historians and archaeologists, many of them from the region itself, have begun to fill this void. Where the general historical context of complex social and political events is less certain, the evolution and character of any associated aesthetic complex is more difficult to determine.

The period immediately before the advent of colonialism was one of profound change. Most of the populations that are now identified under particular 'tribal' names did not exist in that form until more recently. This is especially so in parts of what is now Tanzania, from which comes much of the major

sculpture included here. The area was criss-crossed in the second half of the 19th century by Swahili caravans seeking to exploit the interior of Africa for slaves and for ivory. Their dominion stretched across east Africa to Lake Tanganyika and deep into what is now eastern Zaire. It has been said that 'East Africa in 1870 is best defined as the economic hinterland of the commercial entrepot of Zanzibar' (Wright, 1985, p. 539). Yet, the impact of coastal populations on the interior varied considerably from area to area. Indeed, not all the major Swahili traders were themselves alike. In some cases weak chiefs were reduced in influence and power; elsewhere alliances were created and strong rulers continued to maintain a powerful and essentially peaceful influence over large areas. The net effect was that whereas some groups fared badly, others (the Nyamwezi, for instance) absorbed or acculturated surrounding groups. Those peoples living along the shores of Lake Tanganyika itself, especially at the major ports, such as Ujiji, were often able to benefit from their control of passages across the lake. Thus some groups are found in significant numbers on both sides, for example the Holoholo. Others, such as the ethnically diverse Jiji, were themselves greatly increased in numbers by incorporating outsiders and by buying into the slave trade. Ethnic affiliation was set on a course of flux that only the advent of colonialism halted.

These factors are an important background to the consideration of the distribution and significance of artworks in this area. Long-distance trade routes brought with them the possibility of a thoroughly mobile population, which, of course, included itinerant craftsmen. Thus, many of the works from central and western Tanzania are often identified as Nyamwezi. Most are from the turn of the century or earlier, by which time a Swahili community was established at Tabora in the heart of their territory. By then, there were also Nyamwezi established as far afield as Zanzibar, south-eastern Zaire and Zambia, often as agents or members of the Swahili–Arab caravans that were passing back and forth through Tabora. They were also to be found as ivory traders on Kerewe island in Lake Victoria, where they created work not only for their own use, but also for the Ukerewe who were the longer-term residents of the island (cat. 2.46–7). Figures carved here were also given as diplomatic gifts to more distant rulers, such as the Kabaka (or king) of Buganda. Similarly, Luba carvings have turned up among the Bemba in Zambia, and figures in a broadly south-eastern Zairean or Angolan style are known from the kingdom of the Lozi on Zambia's western borders. The so-called Wiko in Zambia maintain a tradition of carving and of masking that is evidence of their origins among the Chokwe in Angola. The Mbunda living among the Lozi in southern Zambia are the creators of the decorated lidded bowls (cat. 2.56) associated in innumerable catalogue captions with their host community.

In other words, the clients for artworks were not necessarily of the same tribal or ethnic background as their creators. Indeed, the clients for such works did not even have to possess a pre-existing tradition of plastic arts for itinerant carvers or traders to find a ready market. In the 20th century this situation has developed still further with the creation of works for a market that has increasingly included colonial officials and settlers, and nowadays tourists. Figure carvings include stereotyped images of the colonial period – the askari (i.e. the guards and servants of colonial properties), different tribal groups with their identifiable material culture, and portraits of colonial officials themselves and of members of different ethnic groups (cat. 2.25). The main creators of these works are often themselves the descendants of the traders and middlemen of the 19th century: the Kamba in Kenya or the Zaramo in Tanzania.

The function of artworks

But such set-piece carving for an external clientele was by no means the only motivation for the production of artworks. Another implication of the changing fortunes of leaders in the interior heartlands of eastern Africa was the general association of artworks with the more stable offices

of chieftaincy. The objects created often included such items as regalia or high-backed chiefly chairs, and on the Swahili coast this extended to the richly ornate architecture and furniture of the upper classes. For the peoples around Lake Tanganyika the use of chiefly thrones – and, associated with these, the carving of figures standing on stools (cat. 2.53), and even of figures seated on the shoulders of another figure – have a common conceptual source. Among many Bantu societies in Zaire and adjacent areas to the east and south there is a shared restriction on installed chiefs coming into direct contact with the earth: they are furnished with elaborate stools or chairs and, when passing over terrain where matting is not possible, may be carried on the back of a slave. This emphasises their status as greater than ordinary mortals.

Smaller sculpture is also often integral to other prestige objects. In the region this includes canes or swagger sticks that act as staffs of office, and – especially in Tanzania – the projections on musical instruments, which often have a head or full figure carved at the end. Many sculpted objects, however, are also associated with the possession of ritual expertise or with ritual paraphernalia. Thus the lids or stoppers of medicine containers and other parts of medicinal and magical apparatus are often carved in figurative form, particularly among the Mijikenda groups in Kenya and related peoples in Tanzania. Small, often highly stylised, dolls are also found in various parts of Tanzania and northern Zambia; these are carried by unmarried girls and women who have yet to bear children, rather like the *akuua' ba* of the Asante in Ghana. A link between these two objects, the medicine gourd whose medicinal contents bubble up causing the carved stopper to move when potent, and the images carried by those hoping to become pregnant, seems possible both conceptually and artistically.

Perhaps the most consistent events with which artworks are associated in eastern Africa (as more generally within the continent) are the procedures that take place at initiation of boys and of girls into adulthood. Sometimes such events are in the hands of secret societies who, in addition to overseeing initiation, are often involved with funerary procedures, and perhaps also are responsible for masking. This is so among groups in Zambia and Malawi and among the Makonde in Tanzania and Mozambique. The masks themselves are not necessarily as numerous as they are in some of the masking complexes of Zaire and adjacent areas of Angola, though the *nyau* society masks of the Chewa (fig. 3) and the *lipiko* masks of the Makonde (cat. 2.61) are often expressive of an eclectic range of subjects. The masks are worn principally by the members of the relevant secret society rather than necessarily by the initiates.

As in parts of Zaire, images are also produced in various places as a kind of teaching aid in conveying to initiation candidates the knowledge and behaviour appropriate to adulthood or to the next grade of the society. In many places clay images are made for this purpose, especially for female initiation. Usually they are left unfired. Indeed, few of these exist in either indigenous hands or museum collections, since most of the objects are made for use on specific occasions and are buried or otherwise destroyed when no longer required. Such ephemeral creations often escape mention, though like the arts of the body or of architecture, they are inevitable absentees in any exhibition of the artistic achievements of eastern Africa.

Of the larger sculpture produced in the region, much is intended for funerary purposes. In some instances this may be a figure placed directly on or beside a tomb, as occurs among such widely dispersed peoples as the Mahafaly in southern Madagascar (cat. 2.30), the Konso (cat. 2.12), Gato and Galla in Ethiopia and the Bongo (cat. 2.18) in southern Sudan. It is not, of course, everyone whose tomb is thus identified. Such sculpture is usually reserved for the tombs of royal or chiefly clans, and for the most significant individuals within them. In each case there seems to be little suggestion that portraiture is intended.

Tomb sculpture should not be confused with what are strictly cenotaphs – that is, sculpture set up as a memorial at some other site, though usually a place in a particular relationship to the cemetery (fig. 4). There may be several quite different reasons for this practice. In some cases cemeteries are not regarded

Fig. 3 Kasiya maliro, the eland mask, Chewa, Zambia. This *nyau yolemba* is believed to capture the spirit of the deceased person (photograph October 1984)

as proper places to be visited other than at times of burial. Death itself may be seen as a dangerous event, disorientating for descendants and disruptive of the community. Cemeteries are often seen as polluted grounds, frequented only by those set upon witchcraft. In parts of southern Madagascar, sculpture, standing stones and other devices are erected at a site distant from the graveyard and at a later date. This physical separation parallels the distinction between the potential for pollution from the recently deceased and the vitality to be derived from a properly and ritually consecrated ancestor. Among the Mijikenda (and especially their largest subgroup, the Giryama) in Kenya (cat. 2.26), and the Zaramo to the south in Tanzania, memorial posts are also associated with the spirits of the dead, in particular the deceased members of an influential society of male elders.

In these cases the sculpture is normally grouped at a particular site, just as the bodies of the dead are laid to rest together at the cemetery. Isolated sculpture (or some equivalent device), however, is also found, placed perhaps at the junction of a path and a road or at a crossroads. In such cases it is often to commemorate those who have died or are presumed dead but whose bodies have not been recovered: people lost in the bush or drowned. The sculpture substitutes for the missing body and incorporates the dead into the community of ancestors. Where sculpture intended for tombs is usually generalised, that placed at memorial sites is sometimes personalised, in which case the sculptural programme may refer to the circumstances of the death or to the main events in the life of the deceased. Examples are known primarily from Madagascar, but also occur in southern Sudan (and possibly elsewhere).

As in much of the continent, the arts of eastern Africa focus on those moments that mark major changes in the life of individuals or communities. Artistic endeavour, however defined, concentrates on festivals that themselves effect transition: art is associated with fertility and birth, with bad health or fortune and the possibility of restoration to vigour, with advancement to adulthood or installation to chieftaincy, and ultimately with death. The arts of death may seem the final phase in such acts (and arts) of transition. However, in conception, most funerary and commemorative images are also evocations of life: they both recollect the dead and assert the continuity of the living with the community of their ancestors. In the end human vitality is derived from the embodying of such continuity, whether literally in a physical birth, or artistically in a created image.

Fig. 4 Tanosy memorial site in south-eastern Madagascar. The sculpture records a group of canoeists drowned in a nearby harbour and was carved by the local sculptor Fesira in the 1930s

2.1

Oldowan core

Olduvai Gorge, Tanzania
c. 1.6–1.7 million BP
quartzite
h. 8.9 cm
Cambridge University Museum of Archaeology and Anthropology, 1934.1101 D

Human beings are not the only creatures that use tools, but coherent habits and traditions of tool-making are one of the definitions of humanity. Artefacts made of robust stone, the only material that survives over the very long term, are our main source of insight from the earliest times, well over a million years ago. Such objects as this mark the visible beginning of those human skills from which our artefacts and art, in

Africa and throughout the world, have developed their material complexity.

The earliest tradition of artefact-making known anywhere in the world was in eastern Africa. First recognised at Olduvai Gorge, in Tanzania, it is now known from other very ancient strata where the great Rift Valley cuts through the sediments of prehistoric lakes; this early African tradition was named 'Oldowan' (after the type-site of Olduvai) by the celebrated archaeologist Louis Leakey. This worked piece, technically a 'core', shows rough facets, now smoothed and rounded, where several flakes have been struck off. It was excavated by Leakey in 1931, many years before the early hominid fossils were found that made Olduvai and Leakey famous, from the

base of the site now known as HWK East.

Subsequent work has much expanded our knowledge of Oldowan, distinguishing an earlier phase from a later 'Developed Oldowan'. The Oldowan, confined to eastern Africa, precedes those later traditions of stone-working among hominids, spreading from their place of origin in Africa with other distinctive habits of tool-making.

Geological dating of volcanic ashes, among which the artefact-bearing beds are stratified, establishes the base of HWK East as some 1.6–1.7 million years old. CC

Provenance: 1931, excavated by Louis Leakey; 1934, presented to the museum

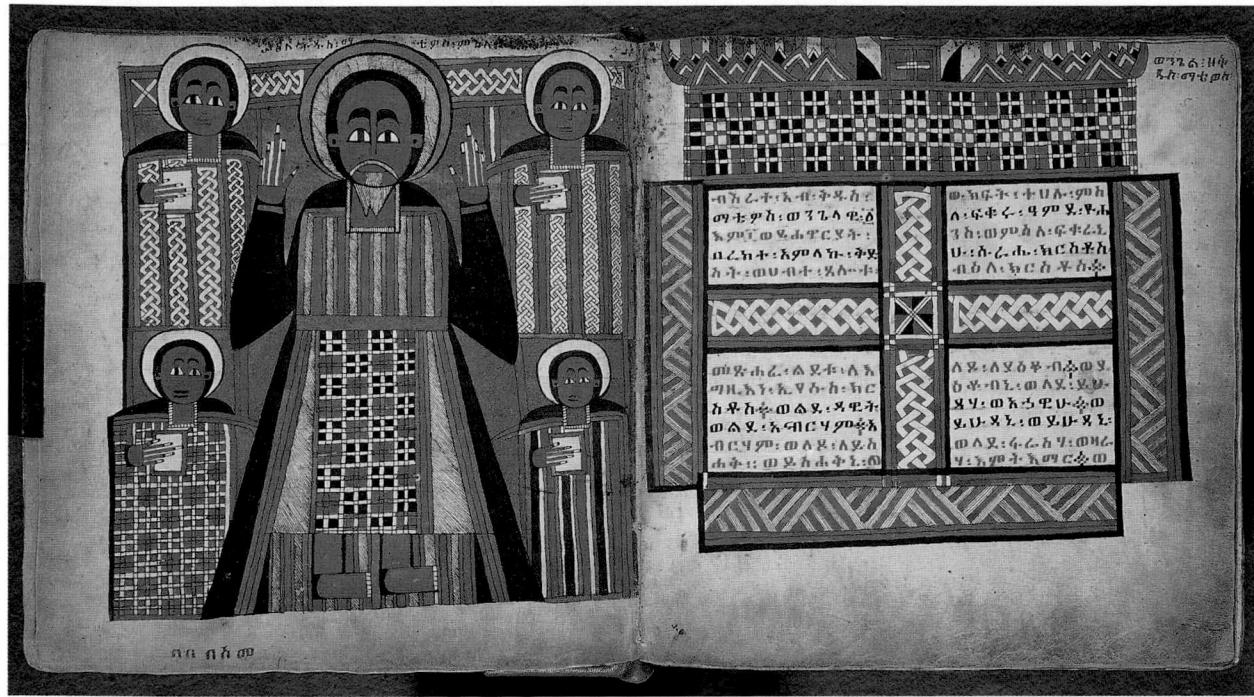

2.2

Four Gospels

Lasta
Ethiopia
17th century
parchment
26.8 x 24.9 cm

The British Library, London, Or. ms. 516

Christianity reached the old Ethiopian kingdom of Aksum from Alexandria in the 4th century and became widespread during the next two centuries with the missionary activities of the Nine Saints from Syria. As elsewhere in the Christian world, the Four Gospels dealing with the life and teachings of Christ must have played an important role in this conversion work. Initially, translations from Greek into the local language, Ge'ez, would have been used; with the arrival of the Nine Saints, translations from Syriac may well have been added. Writing materials and techniques too were probably introduced into Ethiopia at the time of the Nine Saints' arrival, because all the available evidence points to a widespread use of parchment there, rather than papyrus. No Ethiopic gospel manuscripts from before the 13th century survive, but some 500 later examples are known. Until the 10th century they were all produced in the same way, with goat, antelope, horse and gazelle skins as supports, and charcoal black and red ink for the writing. Pens were cut from reeds, and

powdered vegetable matter was used for colour – rose petals for reds and fruits of the *wäyra* plant (*Olea chrysophylla*) for blues – mixed with such binding agents as skin glues, sugar or resins. Mineral pigments were also used, like earth oxides for reds. Gold was not widely employed.

This illustration is taken from one of the many gospels produced in Ethiopia in the 17th century. The texts are introduced by full page portraits of the Evangelists linking the Word of God to its translators. The example selected depicts Matthew standing in the early Christian attitude of prayer. TT

Bibliography: Murphy, 1967; Ullendorf, 1968, pp. 34, 56–8; Galavaris, 1979, pp. 50 and 65; Medhin, 1980–2, pp. 219–22; Zuurmond, 1989, pp. 37–9; Heldman, in Baltimore et al. 1993–6, p. 247

2.3

Handcross

Ethiopia
17th century
wood
h. 33 cm
Staatliches Museum für Völkerkunde, Munich, 86-307629

The cross as an image of Christianity has been associated with Ethiopia since the Aksumite emperor Ezana adopted the new faith in the 4th century and issued coins engraved with the symbol that would spread his message. Several types of cross were used: large processional crosses (cf. cat. 2.4); with a hollow shaft mounted on a long wooden stick, which date back to the 12th century and are the property of churches and monasteries; staff crosses carried by pilgrims on their shoulders; pendant crosses worn on a long chain by women; neck-crosses worn by children and men; crosses used as paragraph signs in manuscripts and as protective devices in 'magic scrolls'.

Handcrosses large or small are the property of individual priests, who present them to the faithful for kissing whenever they meet and who use them for individual blessing. Made of metal (iron, bronze, brass), leather or, more commonly, heavy wood, they consist of the cross proper on top, often with additional decorative and/or symbolic elements; the handle, usually about 10–12 cm

long; and a rectangular, square or diamond-shaped base tablet at the end. Handcrosses connote a whole range of religious symbolism: the tablet base is said to symbolise Adam's tomb on Calvary, whereas the handle refers both to Christ as the 'New Adam' and to the notion that Christ's cross stemmed from the Tree of Life. Ethiopian priests also relate the tablet base to the *tabot* (Ark of the Covenant) and the alliance between God and man, while the handle is seen to carry the hope and life that accompany Christ's resurrection from the tomb. Such elaborate symbolism turns the handcross into a visual metaphor for theological concepts that were shared by the Eastern Fathers, including Athanasius and Cyril.

Anthropomorphic handles like the one exhibited, where the man-figure is seen to represent Adam carrying the cross, reinforce the idea that Christ, the second Adam, inaugurated a new humanity. TT

Bibliography: Moore, in Stuttgart 1973, pp. 67–87; Hecht, Benzing and Kidane, 1990, pp. 2–18; Heldman, in Baltimore et al. 1993–6, p. 132

Processional cross

Ethiopia
before 1868
metal
47 x 35 cm

The Trustees of the British Museum,
London, 1868. 10-1.16

For the Ethiopian church, the cross is not merely a symbol of Christ's suffering and death but, more importantly, a mark of his resurrection. The image of the cross is often portrayed in Ethiopian paintings in place of the Crucifixion, not only signifying respect for the dead Christ but also functioning as an icon that conveys the salvational and protective effect of averting evil. Such a function is clearly expressed in the prayer known as 'The Rampart of the Cross'. Cruciform decorative designs fill in the window openings of the 13th-century rock-hewn churches of Lalibela, one of which is itself shaped like a cross, and the cross can be seen on the roofs of churches, signalling the building's holy function.

The numerous processional crosses held by priests during religious services and ceremonies also powerfully establish a space of holiness and salvation, and act as symbolic markers pointing out the way for the faithful. Processional crosses are mostly made of metal – iron, copper, bronze, silver, rarely gold – or occasionally wood. The early processional crosses of the 12th and 13th centuries were mainly of copper and bronze, cast in the lost-wax method. Another technique involved the tracing of the desired cross image on to a sheet of metal, which was then cut or punched out. Iron staff crosses of the 17th and 18th centuries were cast and then hammered. To reinforce the Christological message of the Ethiopian church, designs were incised or stamped on the cross, communicating well-accepted truths and thus increasing the rhetorical power of these holy insignia. Their iconography included God the Father, the Archangels Gabriel and Michael and the Four Evangelists. The image of the Virgin and Child was also popular, particularly after Emperor Zara Yaqob bolstered her cult in the 15th century. In the example shown here the intricate interlocking design echoes decorative forms found on the screens and friezes of Ethiopian medieval churches. TT

Provenance: 1868, collected by R. R. Holmes

Bibliography: Mercier, 1979, p. 44; Hecht et al., 1990, p. 7; Lepage, in Paris 1992–3, pp. 62–70; Heldman, in Baltimore et al. 1993–6, p. 137

2.5

Head (Beta Israel)

Ethiopia
terracotta
8 x 4.5 x 7.5 cm
Private Collection

The Ethiopian 'Beta Israel' (House of Israel) is a Jewish group that speaks the Agaw language. Known by the dominant Ethiopian communities as Falashas (from the Ge'ez root *fälläsä*, 'to emigrate', 'to wander'), these people live north of Lake Tana in the provinces of Begemder and Semien. Their origin has been a matter of controversy, with scholars disagreeing on whether they descend from the Jewish diaspora community of Elephantine (Egypt) or if they are Ethiopians that were converted to Judaism through the influence of South Arabian Jews. What is certain is that some Jews did settle in Ethiopia, and eventually converted the Agaws. Apart from their religious practices, which derive from Old Testament prescriptions, they do not differ significantly from Ethiopian dominant groups. They do not speak Hebrew, and their sacred books – Genesis, Exodus, Leviticus, Numbers and Deuteronomy – are written in Ge'ez. Despite having been called *buda* ('evil eye') by the dominant society, and treated with fear and repugnance, they are a recognisably industrious and serious agriculture people, who are also skilled in many crafts. Their subjugation by the dominant Amharas took place in three stages. Between 1270 and 1632 several Ethiopian monarchs of the Solomonic and Gondarine periods

waged war against them and succeeded in depriving them of all political independence and of any rights to inheritable land. In the second stage (1632–1755), those of the Beta Israel living in the Gondar area became more respected, working as masons and soldiers. A few received higher-ranking titles, involving administrative duties, and were granted land rights. In the third stage, patterns of social and ideological separation became increasingly rigid, and the Beta Israel became a despised and feared occupational caste, with its own concepts of impurity reinforcing its separation from other groups. As the demand for masons and carpenters declined during this period, individuals reverted to their traditional occupations as blacksmiths, weavers and potters. Their unique ceramic statuary, produced by women and sold in markets, depicts family and religious life. It also portrays animals and people in small individual statuettes, like the head exhibited here. It is not clear how far back in time this tradition goes, nor how it started. The iconography of some of these pieces (for instance, representations of Jewish priests holding the Torah) clearly conveys a sense of 'Beta Israel' identity, and no doubt has contributed to reinforcing the group's perception of its unique social and cultural values. TT

Bibliography: Trimingham, 1952, pp. 19–22; Leslau, 1957, pp. 1–6, 53; Ullendorf, 1968, p. 117; Kidane and Wilding, 1976, p. 42; Quirin, 1979, pp. 133–43

2.6

Shield

Amhara
Ethiopia
19th century
gold, leather and textile mountings
h. 54.5; diam. 19 cm
Lords of the Admiralty

In 1632 a permanent capital of the Christian empire of the northern and central highlands of Ethiopia was established at Gondar. The actual power of the emperor was dictated by the allegiance shown to him by the rulers of numerous and, at times,

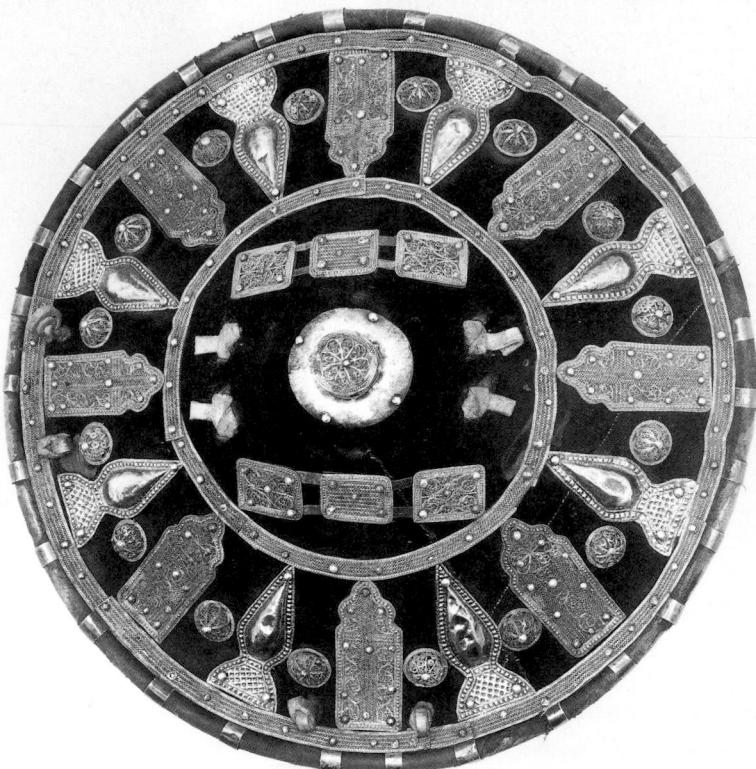

virtually independent kingdoms. It was not until the mid-19th century that the first of a succession of enlightened emperors began to unify the country. The increased internal stability brought about by this unification, together with an economy revolutionised by the widespread use of the Maria Theresa dollar, helped to stimulate a flowering of Ethiopian material culture during this period. Jewellery, textiles and elaborately embellished regalia and weaponry helped to define the complex hierarchy that existed in church, state and army. Shields were used as part of a complex etiquette of display that could be used to reinforce – or occasionally to question – this hierarchy.

Shields were made by pegging a section of untreated hide over a conical wooden mould upon which it would be oiled and shaped, its surface being decoratively embossed by means of specially designed hammers. Delicate metalwork might then be added before the shield was allowed to dry and harden. The possession of a fine, perfectly round shield, and the type of embellishment applied to its surface, were indications both of an Ethiopian's valour on the field of battle and of his standing in society. CS

Shields given as marks of distinction by the emperor to the *rases* (governors of provinces), and by the *rases* to their chiefs, would often be covered in velvet, and further embellished with silver or other metals. As with a warrior's other arms and accoutrements, his shield, covered in a red cotton cloth, was carried on his mule when he was on the march. An important man would employ a young boy to hold his shield behind him when he was engaged in any sort of important discussion, effectively to add weight to his argument. Shield attachments were also significant indications of a warrior's achievements, and often took the form of a lion's mane, tail or paw mounted on the boss of the shield. The significance of shields extended far beyond their functional capabilities, and they continued to be produced well into the 20th century, even though firearms were probably more widely used from an early date in Ethiopia than in any other part of Africa. CS

Bibliography: Pankhurst, 1990; Spring, 1995, pp. 99–100

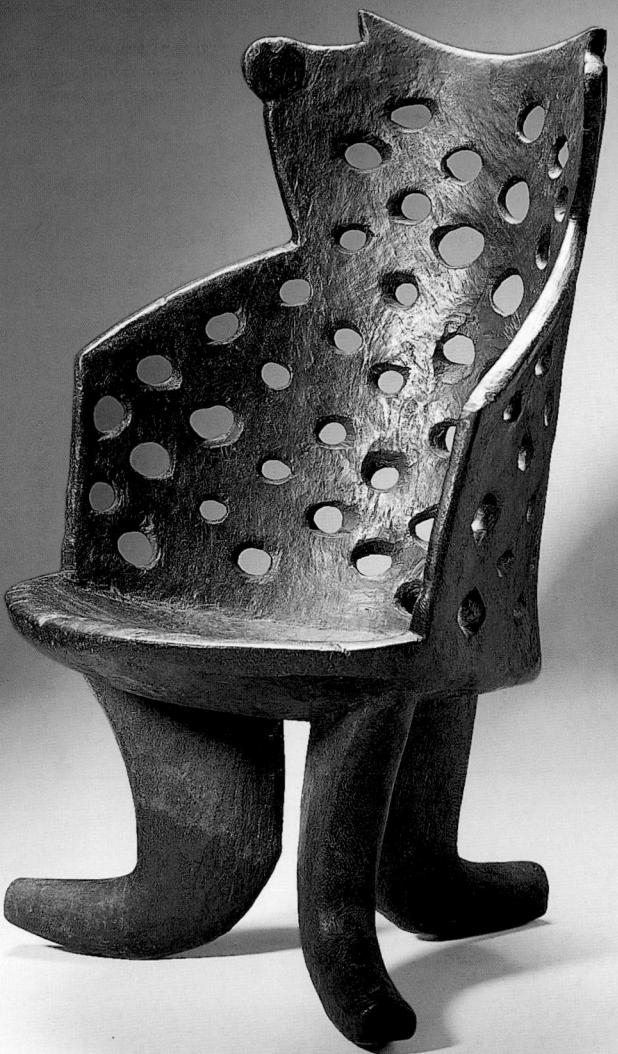

2.7a

High-backed stool

Jimma or Gurage
Ethiopia
wood
99 x 58.4 x 68.5 cm
Private Collection

2.7b

Stool

Kafa, Jimma or Oromo
Ethiopia (Malawi?)
wood
h. 13 cm; diam. 25 cm
Jonathan Lowen Collection

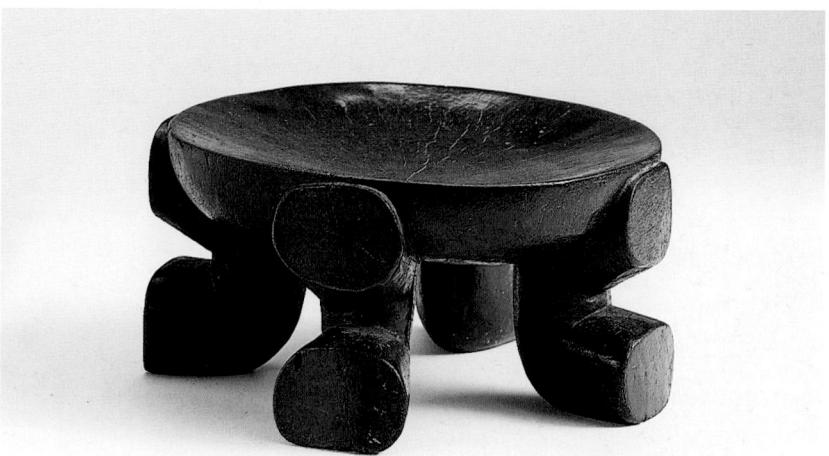

The style of the larger stool (cat. 2.7a) is common to a widespread region in eastern Africa. Ethiopia seems to have the most northerly examples of this type of stool construction in an area that extends southwards to Tanzania and westwards to the Tabwa of Zaire and Bemba of Zambia. They are used as political emblems as well as at the conclusion of female initiation ceremonies in Tanzania.

Throughout the region a stool-like form is used as a base; the artist then embellishes upon the idea by adding a backrest of some sort.

High-backed stools figure prominently in the installation of chiefs among the Gurage. The ritual installation of a new chief takes place at an earth shrine (belonging to a male deity) with an official of the female deity administrating. Despite their former renown for bravery in warfare, the chiefs have little political power and now act only as mediators in clan affairs. Chieftaincy is hereditary, passing from father to son, and on the death of a chief the heir is not permitted to enter the house of his deceased father until completing the installation ritual. The new chief is never allowed to touch the ground while going to the shrine and is then placed on the 'Chief's Seat'. He sits on this chair (described as an elaborately carved 'throne-like' seat of the three-legged type) for seven days, collecting gifts from his subjects before proclaiming himself king.

Although inherited from the chief's ancestors, the chair is not sacred and when broken can be replaced by the skilled 'caste' of woodcarvers known as the Fuga (cf. cat. 2.8). These are presumably part of the category of stools with backrests known as *wängyäba*, a highly elaborated form of the more common three-legged stools known as *bärcema*. The Gurage councils of elders also use such chairs. High-backed stools with perforated designs, often surmounted by a crescent form, come from the Jimma area. In what context and by whom they are used remains to be established. *WD*

Bibliography: Shack, 1966, pp. 152–4; Shack, 1974, p. 112; Roberts and Maurer, 1985; Felix, 1990; Nooter, 1994

The art of Ethiopia has only recently begun to gain much attention in African art historical studies. Information about Ethiopian headrests unfortunately remains meagre.

Many groups in southern Ethiopia make carved wooden headrests to enable people to sleep without interfering with their complicated coiffure. Hairstyles frequently declare their owner's age, gender, rank or status, and are often embellished and/or empowered by accoutrements and/or charms of a magico-religious nature. They then become signs, symbols and potent empowering devices that must be protected.

Some headrests look very much like those of the southern Ethiopians' pastoral neighbours in Kenya, Uganda, Somalia and Sudan. This is not surprising as the different peoples overlap political borders and headrest styles are often regionally rather than ethnically based. These two examples basically consist of a crescent-shaped head support on a conical base, a style that seems to come from the southwestern Ethiopian areas of Kafa and Gurage. There are often subtle differences in surface treatment, ranging from smooth surfaces to incised designs covering the base. One type, as in cat. 2.8b, has appendages curving down from the ends of the upper platform to the base of the cone.

Pankhurst and Ingrams illustrate two headrests from a 19th-century engraving with essentially the same conical base and crescent head support shape, while Huntingford declares the Kafa use wooden headrests of 'a similar Egyptian shape' (perhaps meaning a single tapered column). The same shape of headrest is also used among the Gurage, except that theirs usually have the surface of the conical portion covered with incised geometric decorations. These Gurage headrests, known as *gemma*, are carved by the Fuga, a 'caste' of woodcarvers (such classes of artists and artisans are a common feature of many Ethiopian societies). The importance of such people is illustrated by the words of Menjiya Tabata, a Fuga headrest carver: 'People generally call us Fuga, which is a term that means "despised". My people call themselves Gamas. We are not allowed to marry anyone from

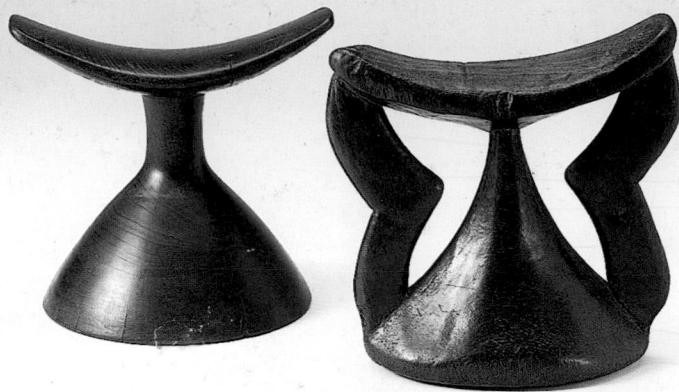

2.8a

HeadrestKafa or Gurage
Ethiopia
wood

18 x 17 x 10 cm

Jonathan Lowen Collection

2.8b

HeadrestKaficho (Kafa)
Ethiopia
wood

16 x 16 x 13 cm

Jonathan Lowen Collection

another clan, formerly [before 1974] we were not allowed to own land, and we cannot enter Gurage religious shrines. We are denied certain privileges ... but we have our religious beliefs, our own language, our own traditions. Fuga are important. We make things that Gurages cannot live without – most of the furniture and kitchen utensils found in the house, even the central supporting pole and roof beams of their houses are carved by the Fuga.' *WD*

Exhibition: East Lansing 1994

Bibliography: Huntingford, 1955, p. 128; Pankhurst and Ingrams, 1988, p. 128; Dewey, 1993, pp. 36–8; Abbink, 1994

Headrests with crescent-shaped upper platforms, small circular or oval bases and double, flat supporting columns, as in cat. 2.9a, are used by nomadic Somali in both southern Somalia and north-eastern Kenya. Very similar forms but with squatter proportions are made by the Boni of north-eastern Kenya and the extreme south of Somalia. Somali nomads also use another type of headrest with a single supporting column, often cylindrical or with vertical intertwining elements, as in cat. 2.9b. Whether the distribution of the two types always coincides is uncertain, but both types are found in some areas. Where this occurs it has been reported that the different styles were for men of different status, with the simpler variety being for young men, the double-column variety for elders.

The headrests are carved of a very fine-grained tough but lightweight wood. Acknowledged artists are sometimes commissioned to create them but any man can make his own. The double-column variety is made from a tree branch that has forked into equal sections: the basic shape is roughed out by cutting a hole through the centre; the shapes are then refined and the intricate surface patterns cut last. The wood is usually left its natural colour, but men occasionally paint their own red or black.

Somali headrests are used by both men and women. While the male type, such as those exhibited here, have relatively small bases and are thus somewhat unstable to sleep on, the examples used by women are more rectangular in form. Somali men carry the double-column headrests by slipping a wrist through the central hole, while the single-column type often has a leather loop attached for this purpose. Herders will sometimes rest by standing on one leg, placing the headrest on a shoulder and twisting their heads so as to rest their necks upon it. While the usual image is of nomadic herdsmen carrying their headrests, they are also used on the constructed raised beds on which Somalis sleep.

The headrests also function as symbols of vigilance. Young men charged with the care of their family's herds travel with them in their search for suitable grazing. Headrests with such small bases will soon tip, and the herders will unceremoniously be

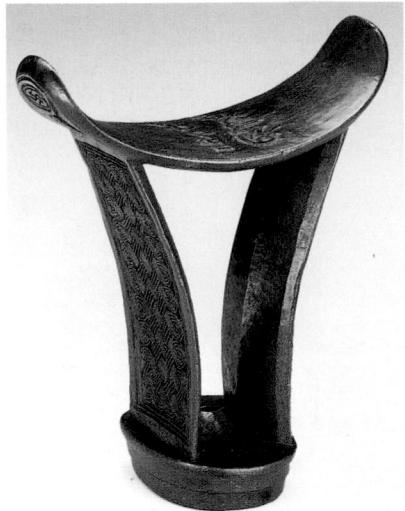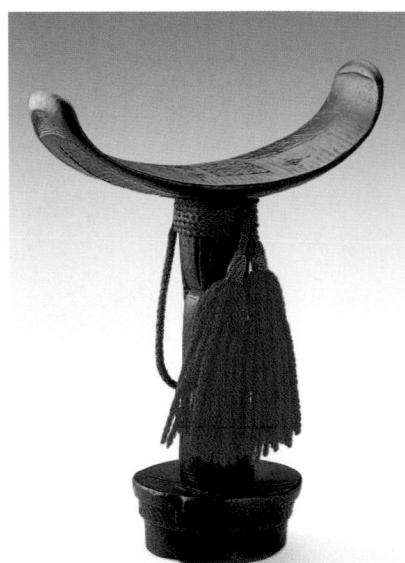

2.9a

Headrest (barkin)Somali or Boni
Somalia and Kenya
woodh. 17.1 cm
Gift of Blake Robinson, 87-3-1
National Museum of African Art,
Smithsonian Institution, Washington

2.9b

Headrest (barkin)Somali
Somalia
wood, fiberh. 20 cm
Gift of the Loughrans, 76-16-13
National Museum of African Art,
Smithsonian Institution, Washington

reminded of their responsibilities. The headrest also plays a role in nuptial ceremonies. The groom places currency for the defibulation price under his bride's headrest. The morning after the marriage is consummated, the bride may take this money, but only if she had been a virgin. She then uses it to buy an amber necklace, the symbol of her new status as a married woman.

The intertwine or guilloche pattern seen on the base and sides of the double-column headrest is typical and probably reflects extensive Islamic influence in the region. Images of snakes, scorpions and even lories are often incised on the surface of the upper platform. The idea is to portray sources of danger as a means of protection. Both figurative and guilloche patterns have been interpreted as 'a form of shorthand for a prayer' (Allen) to ensure God's protection for the sleeper. *WD*

Bibliography: Puccion, 1936, pp. 21–33, pl. V; Cerulli, 1959, pp. 92–3; Prins, 1965; Allen, 1976; Arnoldi, in Loughran et al., 1986, pp. 17–25; Dewey, 1993, pp. 40–1

2.10a

Covered milk vessel

Borana
Southern Ethiopia/Northern Kenya
20th century
twine, gourd, silver
h. 36 cm
Private Collection

2.10b

Covered milk vessel

Borana
Southern Ethiopia/Northern Kenya
20th century
twine, gourd, silver
h. 31 cm
Private Collection

Traditionally the Borana Galla are cattle-keeping pastoralists who now keep camels in the more arid parts of their territory. Their containers for liquids are firm, closely woven watertight baskets of wrapped twine. In size they range from large, urn-shaped vessels capable of holding three to six gallons to vessels, such as these, that have a smaller capacity. The former, contained in openwork wicker baskets, are used solely for the transport and storage of water; the latter rarely leave the home and are

used for milk and milk products. Smaller and more decorated vessels are generally reserved for visitors or the head of the household; they may be hung on the wall as decoration and rarely used. One is always filled with thick rich milk ready to be offered to honoured guests: they last from three to nine years.

The containers take three to nine months to complete, and all are made by women. Fibre from the roots of *Asparagus africanus* is preferred but *Commiphora*, *Acacia*, *Zizyphus* and

Hyphaene species may also be utilised. An awl and stick are used as weaving aids and the fibre is softened with water. New baskets may be waterproofed by being steeped in an infusion of acacia bark, smeared inside with melted fat or paste of sorghum flour or smoked with smouldering sticks which give off a resinous gum to coat the inside. *JB*

2.11

Phallic ornament (*kalaacha*)

Konso/Borana

Ethiopia

ivory, aluminium

5.7 x 4.9 x 9 cm

Jean and Noble Endicott

This phallic metal horn (*kalaacha*), worn vertically on the forehead, is an important emblem of the Gada system of generation sets and age grading common to the Konso and Borana and other Oromo (Galla) peoples of Ethiopia (cf. cat. 2.12). It is regarded as a sacred symbol because it is a replica of the great *kalaacha* found with the first ritual leader when God sent him to earth and revealed the basic values and institutions of society.

A generation set is named and recognised when its warrior members have each earned the right to wear a stiffened hair tuft by killing an enemy or a dangerous wild animal. As their set enter the system the set of their fathers takes office and the set of their grandfathers retires. The two most important stages in a man's life, when he reaches full adulthood (taking office and assuming ritual responsibility for maintaining the peace and prosperity of the nation) and when he retires from the system to enter a condition of sanctity, correspond with two of the Gada grades. The *kalaacha* is first worn when a man enters the Gada grade, and 'makes his head', i.e. he 'puts up' his *kalaacha*, which an eldest son

inherits from his father. Only the owner and his senior wife may touch the *kalaacha*. After his period in office, when his set continues in an advisory capacity, it is kept upturned in a full milkpot and worn only for ceremonies. Each man then allows his hair tuft to sag limply until a few years before the retirement ceremony, when he 'completes his head', i.e. he unravels his hair tuft, grows his hair into a halo style and 'puts up' his *kalaacha*, which is regarded as replacing the lost hair tuft. A *kalaacha* worn by such men serves to destroy evil influences and provides sanctuary to those who touch it. In some Galla groups the whole set wear the *kalaacha* at this time, in others it is worn only by ritual dignitaries, some of whom wear a two-horned variety. At the culminating ceremony the set retires from the system and a man 'takes down' his head, i.e. his hair (including his unravelled tuft) is shaved off and his *kalaacha* is removed.

Kalaacha were previously made of ivory or brass, sometimes of wood. Metal *kalaacha* are made by the lost-wax method. The Galla obtain them from smiths of other groups, such as the Konso, who often reside among them. JB

Bibliography: Jensen, 1936; Jensen, 1942; Jensen, 1954; Haberland, 1963; Brown, 1971; Hallpike, 1972; Baxter and Almagor, 1978

The Konso who produce these pole sculptures live in walled hilltop villages from which they practise intensive agriculture. The welfare of people and crops is believed to depend on the satisfactory functioning of the all-pervading Gada system and its rituals. Sexual activity is restricted to preserve masculinity. Hunting is a prestigious activity and bravery is highly regarded. Men who have killed an enemy or a dangerous wild animal are regarded as heroes.

When a hero is buried a phallic stone is placed over his grave. If he was also wealthy and of senior Gada grade, a group of carved figures (which only the wealthy can afford) is erected there some weeks or months later. A thatched roof stands over the group, which may be surrounded by a paved area delineated by a low wall. The group demonstrates the rank, wealth and lifetime achievements of the deceased.

The sculpture representing the hero himself occupies a central position flanked by representations of his wives and slain enemies. In front are carvings of the lion or leopard killed by the hero, the pet monkey or monkeys kept by him and stones representing the fields that he owned. The hero is portrayed as aggressively masculine with prominent erect penis. His hairstyle, phallic forehead ornament and bracelets denote his senior Gada rank and his status as a hero. The figures of his slain enemies are emasculated, it being the custom of the Konso to remove the genitalia of a slain enemy as a trophy.

These sculptures do not have legs, and the women and slain enemies are also armless, but the arms of the hero are carefully carved to show the bracelets. The figures, when new, are painted with red ochre, and have bone eyes and teeth and black painted eyebrows and beards.

Carved gravestones are erected by the neighbouring Borana and Sidamo Galla and grave posts are used by the Bongo of the Sudan (cat. 2.18); the closest analogy to Konso grave posts is in Kenya, where the coastal Mijikenda erect similar sculptures to their dead (cf. cat. 2.26). JB

Bibliography: Jensen, 1936; Jensen, 1942; Jensen, 1954; Nowack, 1954; Hallpike, 1972

2.12a

Grave figure (*waaga*)

Konso

Ethiopia

wood

h. 215 cm

Private Collection

2.12b

Grave figure (*waaga*)

Konso

Ethiopia

wood

h. 174 cm

Private Collection

2.12c

Grave figure (*waaga*)

Konso

Ethiopia

wood

h. 186 cm

Private Collection, Brussels

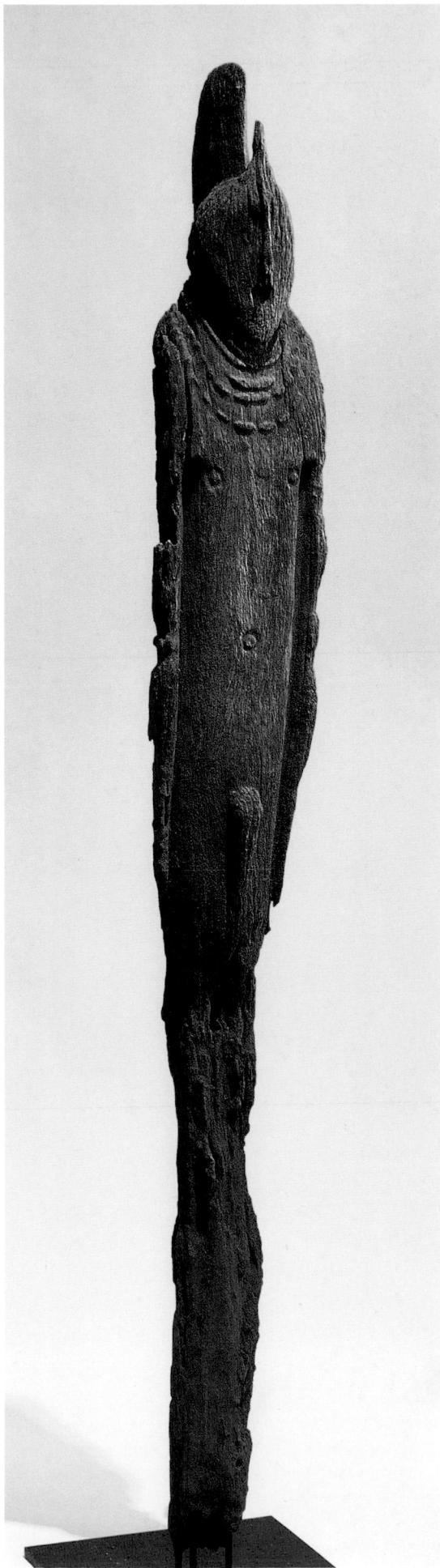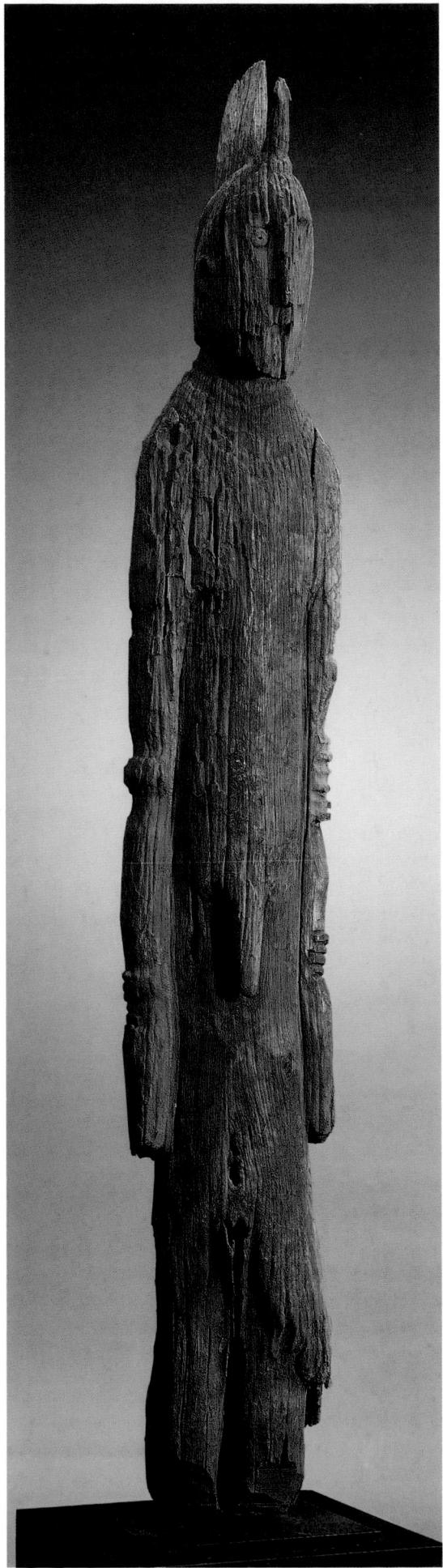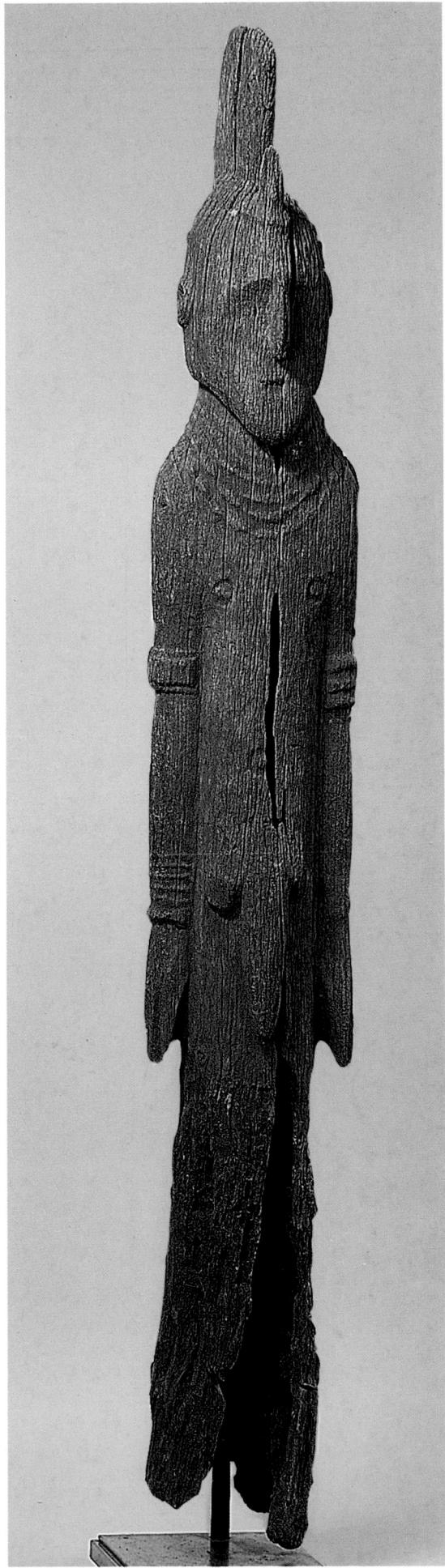

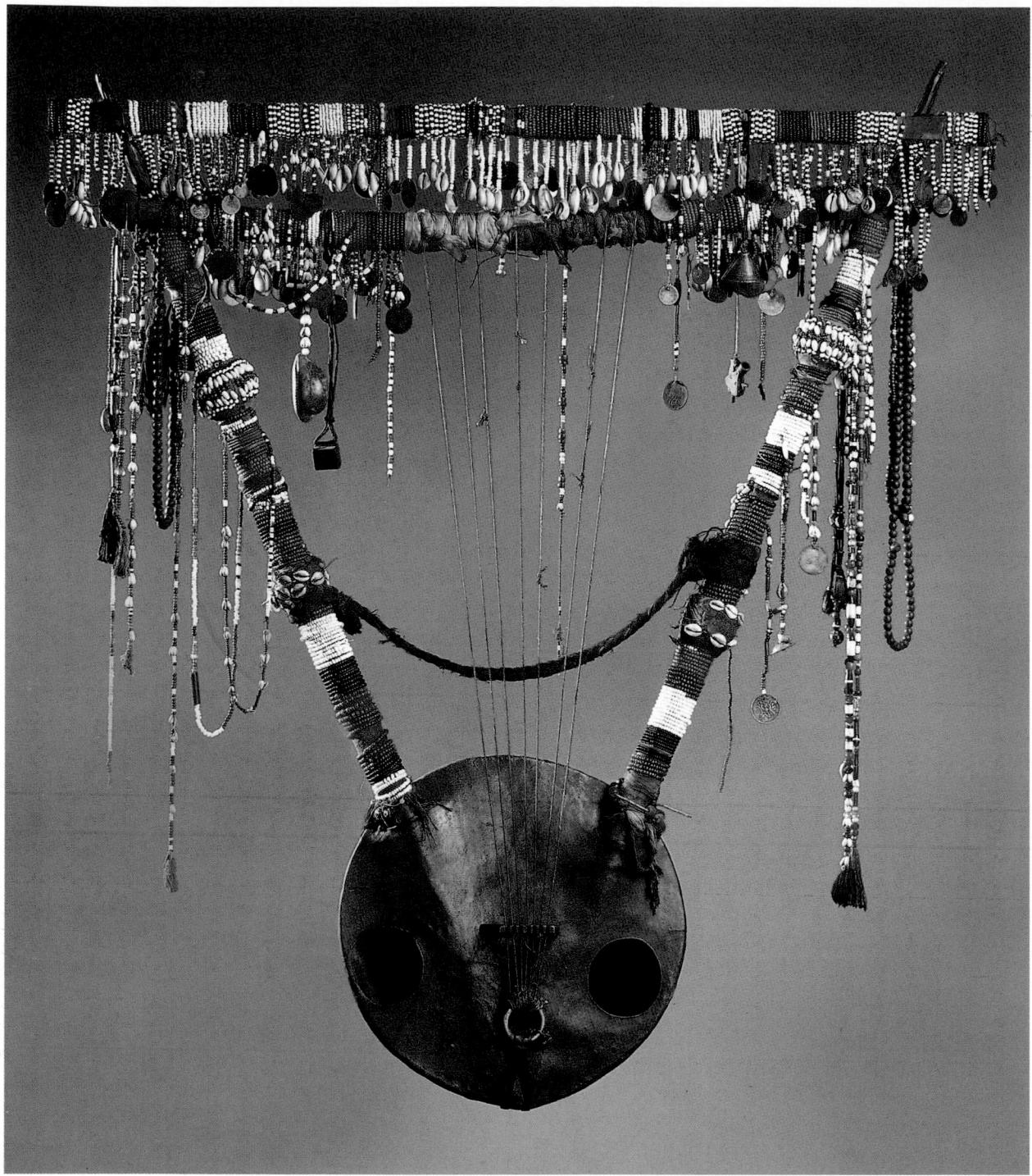

2.15

Lyre (*kissar*)

Nubia, Sudan
late 19th century
wood, leather, gut, glass, cowries
101 x 95 x 20 cm

The Trustees of the British Museum,
London, 1917. 4-11.1

Provenance: 1917, bequeathed to the
museum by Dr Southgate

Bibliography: Engel, 1864, p. 40; Musée
Royal du Congo belge, 1899, p. 132;
Metropolitan Museum of Art, 1902;
Jenkins, 1970

This lyre has a wooden hemispherical body. The skin soundtable displays its animal hair and contains two circular holes. Seven twisted gut strings run from the lower crossbar of the yoke, and pass over a wooden bridge to an iron ring. The wooden arms and the double crossbar are elaborately decorated with glass beads, cowries, amulets and rosaries, all of which are suspended from the upper bar. Both uprights and crossbars are wrapped with a loose weave cotton cloth over which strings of tiny coloured glass beads have been coiled. The arm-strap consists of bundles of plaited red cotton thread. Hundreds of pierced coins and cowrie shells hang on beaded strings from both upper and lower crossbar, and they ring and rattle when the instrument is moved. The coins are mostly Sudanese with Arabic inscriptions, and many of these are dated 1899 (1277 AH). Among them, however, are at least three coins of British origin: one a halfpenny dated 1861 with the head of Queen Victoria, and two other smaller coins dated 1832. There is also one coin from Sumatra dated 1804. Also hanging from the crossbars are several wooden prayer rosaries, a leather-bound Koranic amulet, two brass bells, the trigger mechanism from a gun(?), decorative mounts from a dagger, and a round key-hole escutcheon plate.

The instrument is used in *zar* ceremonies in Sudan. There is a belief that evil spirits can invade the body or mind of a person, and these can cause illness or pain and need to be exorcised. Sometimes the musician has special knowledge of curative rituals, and can use the instrument's sounds to call the evil spirits from the affected person. Ceremonies are carried on throughout the night and the singing and praying, accompanied by drumming, could often produce trance in the participants. During trance evil spirits are most easily exorcised.

Numerous necklaces of glass beads and cowrie shells are suspended from the crossbar. These are of various designs and it is probable that each time the instrument was used in a ceremony, the person receiving the rituals offered an item of personal adornment. NT

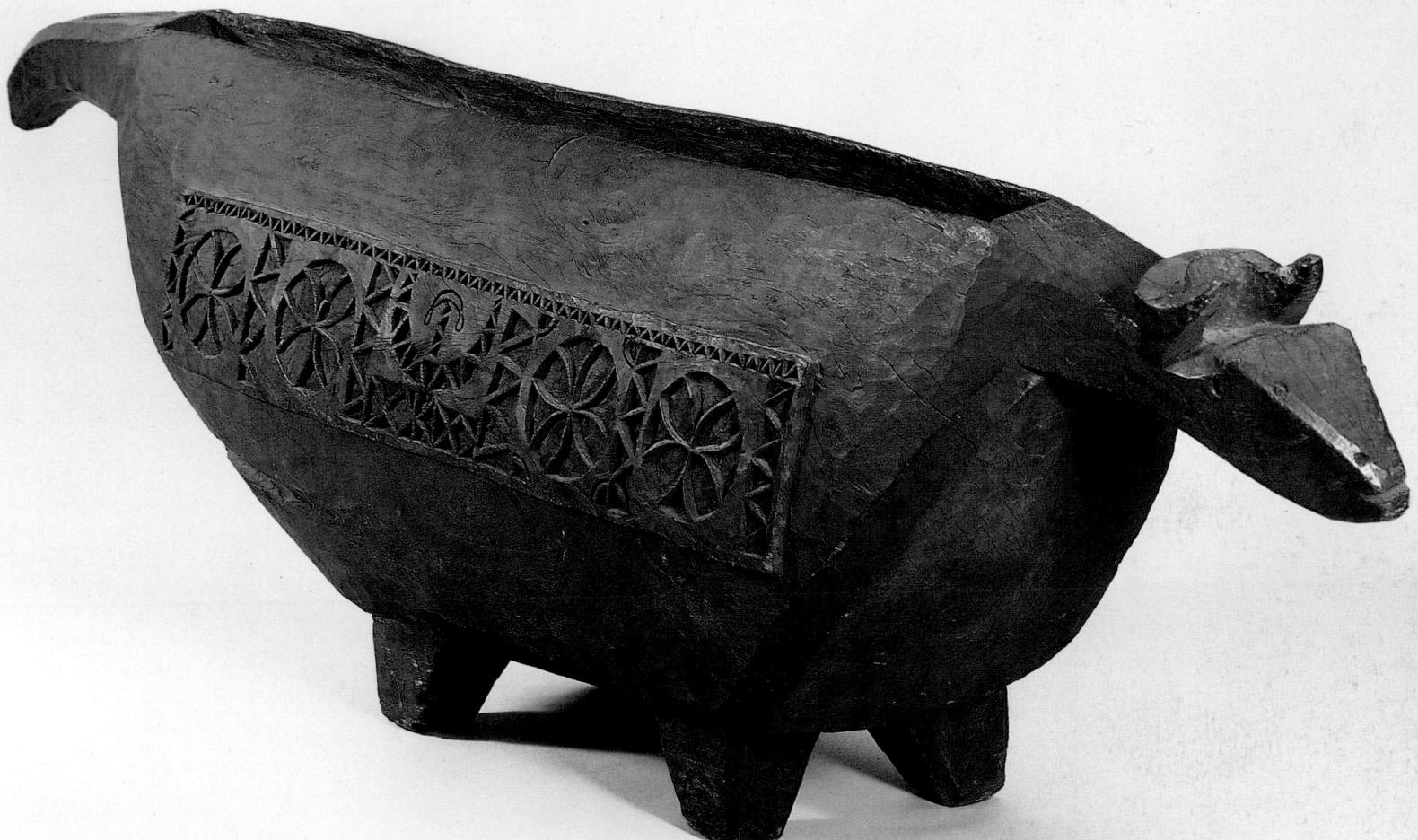

2.14

Slit drum

Bahr el-Ghazal, Omdurman

Sudan

19th century

wood

271 x 80 x 60 cm

The Trustees of the British Museum,
London, 1957. 11-8.1

Wooden slit drums like this have long been associated with prominent chiefs and leaders in the southern Bahr el-Ghazal region of Sudan and in neighbouring portions of the Central African Republic and Zaire. Massively conceived, such drums serve as voices of authority: they are 'tongues of chiefs' and their scale is dependent on the rank of their royal owners. The grand scale of this particular drum attests to its pivotal place in late 19th-century Sudanese history. Captured by

H. H. Kitchener, Commander of the Anglo-Egyptian forces, from the Khalifa Abdullahi, it acts as a memorial of the decisive British victory at the Battle of Omdurman in 1898. The defeat of the Khalifa brought to an end Sudanese resistance to British and Egyptian rule as well as the dream of Mohammed Ahmad, the self-proclaimed Mahdi or Messiah, of establishing an independent state based upon the principles of Islam.

The Holy War against the British Empire lasted nearly twenty years and left both sides exhausted. In triumph, the British returned home with ample evidence of the defeated foe – the sheer quantity of war trophies testifying to the epic dimensions of the struggle against the Mahdist's forces. Of the thousands of objects brought back from the Sudan, few can

compare with this impressive drum, presented by Kitchener to Queen Victoria. Apparently owned by Khalifa Abdullahi, who succeeded the Mahdi upon the latter's death on 22 June 1895, it had surely been used in order to lift the spirits of the Khalifa's troops.

It is distinguished not only by its size, but also by the incised designs carved along both flanks of the bullock. Slit drums in the form of cattle, goats or other animals from the Bahr el-Ghazal are typically not only smaller, but their bodies are sculpted smoothly and devoid of decorative effects. In this instance, however, mathematically precise floral patterns, a fretted crescent, meander patterns and a single reference to a long-bladed scimitar are carved in broad bands across the flank surfaces, their

geometric regularity and precision reminiscent of ancient Islamic shapes expressing God's unity and presence. It is assumed that the drum was probably originally carved in the distant non-Muslim parts of southern Sudan (or by someone from that region) and adapted to a militant Islamic context. A traditional southern Sudanese figurated drum, used in the service of the Khalifa and for fighting in the path of God, has been emblazoned with the signs and patterns of Muslim belief. *RAB*

Provenance: 1898, captured by Commander H. H. Kitchener, who presented it to Queen Victoria; 1937, given to the museum by H.M. King George V

Bibliography: Seligmann, 1911; Bravmann, 1983, pp. 48–57; Mack, in Schildkrout and Keim, 1990

2.15a

Replica throwing knife

Mahdist state
Sudan
late 19th century
iron with crocodile skin grip
30.6 x 3.2 cm

Manchester Museum, University of
Manchester, 0.8720

2.15b

Replica throwing knife

Mahdist State
Sudan
late 19th century
iron with crocodile skin grip
45.6 x 3.4 cm

Manchester Museum, University of
Manchester, 0.5036

The increasing unrest among the peoples of central and eastern Sudanic Africa during the 19th century culminated in the rebellion of 1881 in Kordofan Province, Sudan, led by Muhammad Ahmad, who declared himself Mahdi ('The Rightly Guided One'). By 1885 he had overthrown the corrupt Turco-Egyptian government in Khartoum and had established the Mahdist state. He died shortly after the fall of Khartoum and was succeeded by the Khalifa, who was committed to perpetuating the ideology of the Mahdiyya, a movement of ostensibly religious inspiration, but with revolutionary political and social aims. The Mahdist state was effectively dissolved following the battle of Omdurman in 1898, but Mahdism lived on and remains a vital political force in contemporary Sudan.

Peoples from a vast area of north-eastern and central Africa joined the

Mahdist armies, either of their own free will or as slaves. Workshops set up in towns such as Omdurman produced a range of artefacts, including regalia, weaponry and armour, which in one way or another reflected the Mahdist ideology, but which occasionally also displayed stylistic influences from much more diverse sources. Among such objects were these non-functional, replica throwing knives, cut out of sheet metal and covered with the acid-etched Arabic script known as *thuluth*, in which exhortations to the faithful from the Koran are written. However, these artefacts derived their distinctive form from the prestigious missile weapons of certain non-Islamic, central African peoples such as the Ngbaka, who lived many hundreds of miles to the south-west, and who were greatly diminished in number by the slave trade at this time.

It may be that throwing knives were gifts to the central African chiefs who assisted the slave raiders operating from Sudan in the late 19th century. However, it seems more likely that they were given as Islamicised (though still potent) status symbols to the leaders of those elements of the Mahdist armies that consisted mainly of central African slaves. There is evidence to suggest that other artefacts, slit-gongs for example, were transmuted in a similar way. CS

Bibliography: Zirngibl, 1983, pp. 48–9; Westerdijk, 1988, pp. 170–83; Spring, 1993, pp. 78–9

2.16a

Pot (*kadaru*)

Nuba Hills, Sudan
c. 1910
animal dung, paint
17.5 x 21 x 21 cm

Horniman Public Museum and Public Park Trust, London, NN 5456

2.16b

Pot (*kadaru*)

Nuba Hills, Sudan
c. 1910
animal dung, paint
21 x 24.8 x 24.3 cm
Horniman Public Museum and Public Park Trust, London, NN 5457

Such vessels as these bowls with footings are made of a paste of animal dung and water, shaped by hand, then painted with a thin layer of gum mixed with a red earth slip and left to dry in a cool place. The entire surface was slipped again with black colour, obtained from the soot outside a cooking-pot. Inside the vessel, however, the black was not applied to the whole surface and a reddish band was left. The inner design was carried out in white pigment. A white painted band of creeper-like design was made around the rim, and a sun-burst pattern was painted in the centre of the bowl.

The designs used on these vessels are similar in style to patterns on Nuba house walls, and to those used as part of male body decoration. The design is asymmetrical, but is symmetrically structured in bands picked out in white along the vessel walls. The patterns include chevrons, arrows and sun-bursts, described in a white paste made from chalky limestone and applied with a feather. There is some suggestion that the

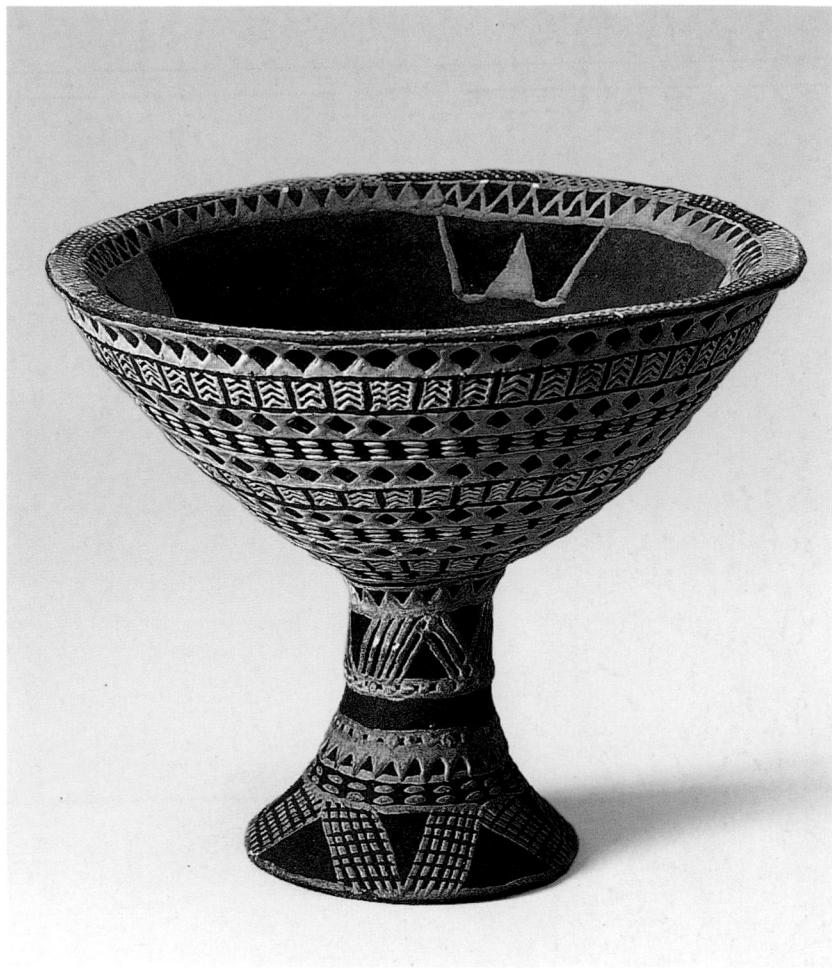

design is first traced onto the raw pot with a length of grass. The white decoration is made with a thick paste and is raised. Occasionally it is embellished with red pigment, possible haematite.

Both vessels are made of dung, possibly cow or donkey dung which is quite malleable when made into a paste. Vessels such as these are extremely fragile: unlike pottery, they can be consumed by fire, and they are less strong than a calabash since they can be destroyed by water. They are only air dried, and cannot be used in food preparation, though they could perhaps serve as storage bowls for dried foodstuffs. Hawkesworth suggests that they were an essential part of a girl's trousseau, and at a marriage ceremony were filled with wedding perfumes, flour and dried powdered vegetables. NT

Provenance: c. 1910, South Kordofan, collected by Sir Harold MacMichael

Bibliography: Hawkesworth, 1932; Faris, 1972, p. 62; Barley, 1994, p. 13

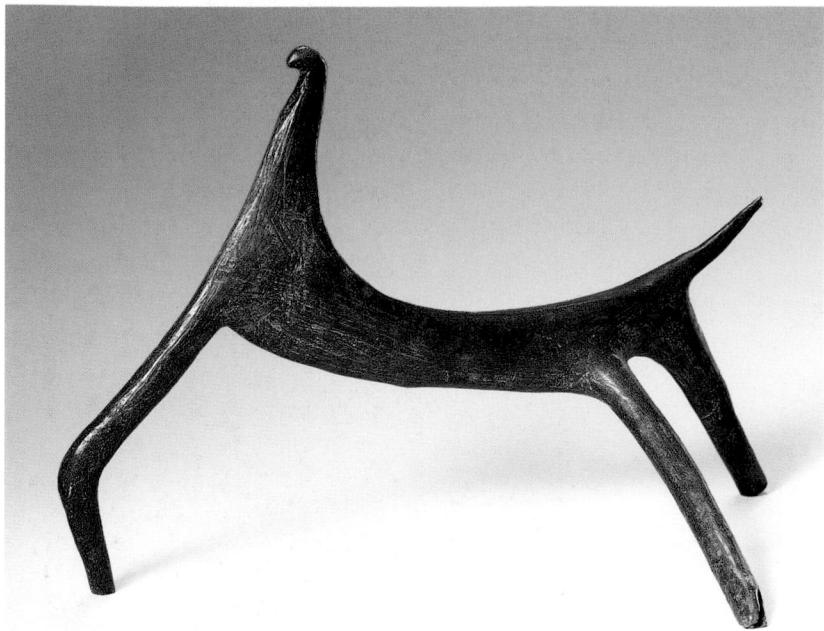

2.17a

Headrest

Dinka (Agar)

Sudan

wood

1. 52 cm

Staatliche Museen zu Berlin, Preussischer Kulturbesitz, Museum für Völkerkunde, III A 4172

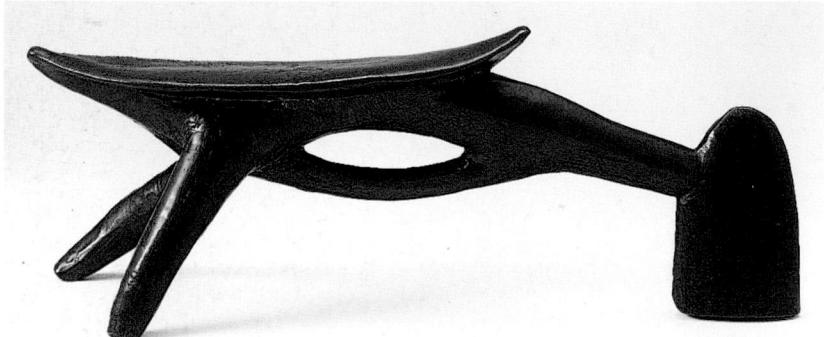

2.17b

Headrest

Shilluk

Sudan

wood

17.5 x 46 x 15 cm

Jonathan Lowen Collection

As many peoples of eastern Africa make headrests/stools, it is difficult to attribute these objects to specific groups unless they have been collected in the field. Most are three-legged with one side flattened. Mack and Coote aptly describe the carving process as 'opportunistic', going on to say: 'The simple forms produced by the Dinka and Nuer are often little more than the result of judicious pruning of a found branch to produce a three- or four-legged stool cum headrest. Zoomorphic features, such as a tail, are sometimes "brought out".' Riefenstahl shows a Shilluk warrior of the Sudan using one to protect his elaborate coiffure.

Among the Shilluk, Westermann noted that neckrests were used by men so that their hairstyles would not be spoilt during sleep. Many east African pastoralists regard coiffure primarily as an indicator of status. Among these groups a young man is entitled to begin wearing the distinctive coiffure that marks him as an adult only after he is initiated. As each member of the age set rises through the hierarchical society, changes in jewellery, hairstyle and feather decorations for the hair often mark each promotion. The use of headrests is often associated with this advancement and the headrests themselves become status symbols. Whether this pattern is true for the Shilluk and Dinka is unknown, but it certainly seems likely as Shilluk men still wear elaborate coiffures, and among the Dinka headrests/stools are primarily used by older men (Jeremy Coote, personal communication). The Dinka multi-purpose headrests/stools also provide a convenient place to sit as it is not considered proper for elderly men to sit directly on the ground.

No special skills were associated with the construction of headrests by the Shilluk and any man could make them alongside such activities as house-building and weapon-making. Headrests were made to resemble the forms of various animals, including ostriches and other birds. Cat. 2.17b perhaps could be interpreted as a bird, although it seems more like a stylised branch, while cat. 2.17a has the shape of an antelope or giraffe.

The symbolic importance of such objects is highlighted by the Shilluk belief that this headrest form was invented by Nyakang, their most

important ancestor, culture hero and the founder of the Shilluk dynasty. The Anuak held that if the king-elect was able to balance on a three-legged stool during his investiture ceremony he was acknowledged as the rightful heir. *WD*

Provenance: cat. 2.17a: collected by Konietzko

Bibliography: Westermann, 1912, pp. xxiv, xxxiii; Seligman and Seligman, 1932, p. 110; Riefenstahl, 1982, p. 229; Krieger, 1990, pls 13–6; Mack and Coote, in *The Dictionary of Art*, in preparation

2.18a

Grave figure

Bongo
Sudan
late 19th or early 20th century
wood, metal
h. 200 cm
Musée Barbier-Mueller, Geneva, 1027-1

2.18b

Grave figure

Bongo
Sudan
late 19th or early 20th century
wood
h. 132 cm
Private Collection, Belgium

The Bongo of the south-western Sudan are an agricultural central Sudanic-speaking people who suffered greatly from the depredations of slavery and the expansion of the Zande kingdoms in the 19th century. In the mid-19th century they may have numbered a quarter of a million or more, but by the 1870s their population was estimated at no more than 100,000 and by the 1920s at no more than 5000. By this time the remnant population was dispersed in a number of centres.

A category of tall, slim figure sculptures is attributed to the Bongo. These share a general pole-like form in which a human figure (apparently exclusively male) stands with flexed knees on a post and, generally, with arms held close to the body. Apart from facial features (including occasionally the inlaying of eyes with beads, as in cat. 2.18a), there is rarely any other sculptural detail. (At least in the 1920s some figures were painted, the face with blue commercial dye and the body with red ochre. The antiquity of this practice is not known.) These Bongo figures are often classified with the memorial figures of such east African peoples as the Konso and Gato of Ethiopia and the Girriama of Kenya. There are few formal similarities between them. It is the paucity to date of east African art scholarship that has led to these traditions being lumped together. Future historians might do better to look westwards to the traditions of the Zande and other Zairean and central African peoples for meaningful comparisons with Bongo art.

While there are detailed provenances for a number of grave figures in museums in Khartoum, little is known about the origins of most examples

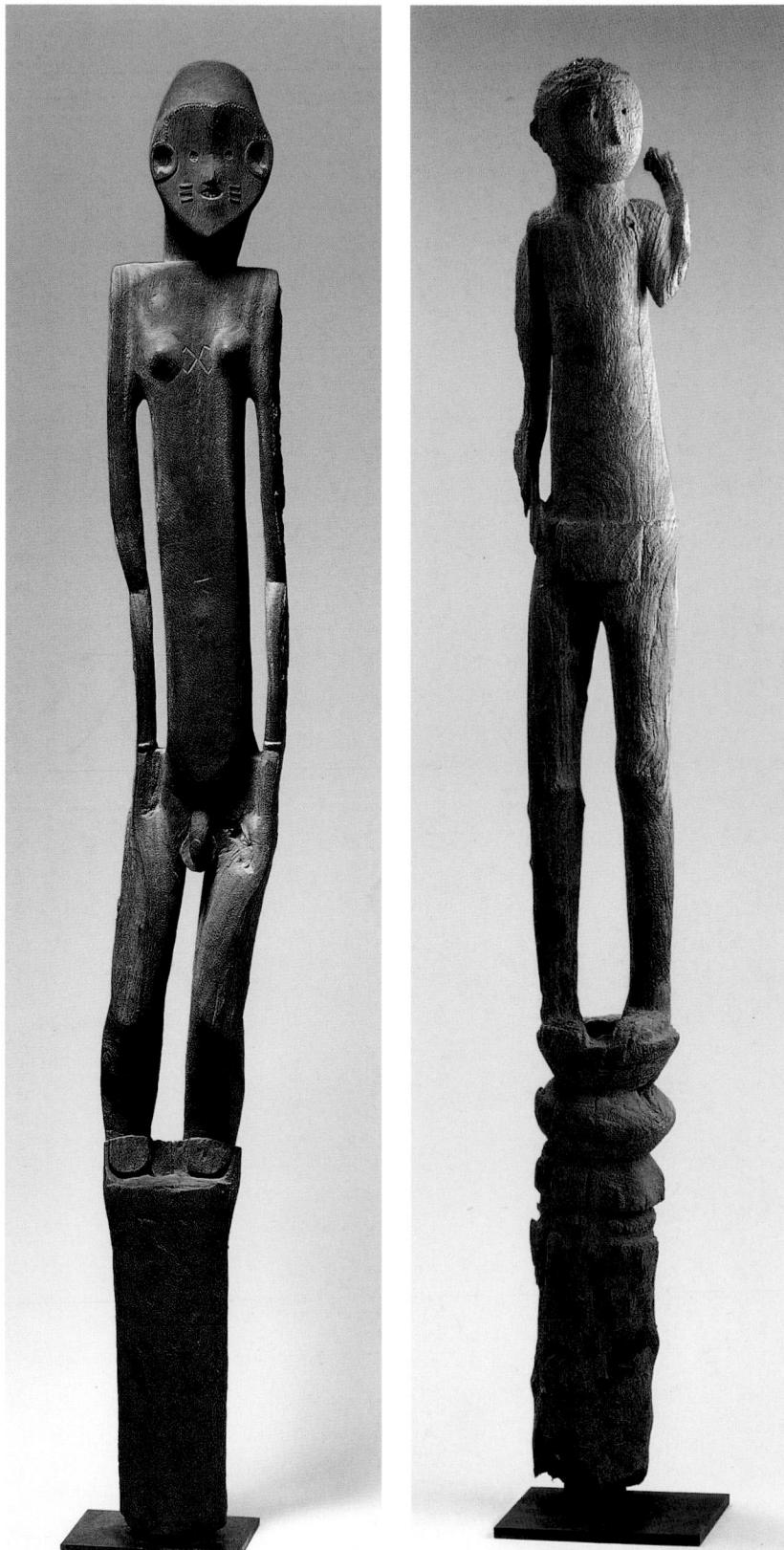

in European collections. Much of the published material is based on notoriously unreliable 19th-century accounts of travellers and explorers. It is not clear if figure sculpture was produced among all groups, nor is it clear that all figures identified as 'Bongo' were produced by them rather than by sculptors among such of their neighbours as the Belanda.

It was the practice among at least some Bongo groups to honour a deceased hunter-warrior by erecting on his grave a carved wooden effigy (*ngya*). This was done by his relatives at a feast held at the graveside a year or so after his death, the intention being to ensure for him a good place in the village of the dead. During his lifetime, a Bongo man could gain prestige and status through successfully hunting large animals and killing enemies in battle, as well as through performing meritorious feats. The effigies erected on graves were a reflection of title and rank achieved. They were often accompanied by notched posts that recorded the number of the deceased's successful kills and sometimes by effigies of his victims. Notches indicating successful kills were sometimes carved on the effigy post itself. The notches on the figure at cat. 2.18b would indicate that the deceased had killed four large animals (Evans-Pritchard).

It is not clear to what extent the effigies were supposed to resemble the features of the dead man, but in some cases at least the sculptor represented some of the deceased's personal adornments, such as scarification patterns and bracelets. It may well be that the scarification marks on cat. 31 – made by applying metal strips to the surface of the face – represent those borne in life by the deceased. The apron on cat. 2.18b may also have had a particular personal significance, though aprons were part of the everyday dress of Bongo men. The series of metal nails running from ear to ear across the brow of the figure may have formerly held in place a headdress, a possibility strengthened by the report that Bongo men and women wore feather headdresses at feasts and dances. It has also been reported, however, that the effigies of victims were represented with carved legs, so that cat. 2.18a may represent a victim. This possibility is strengthened by the fact that the face seems to

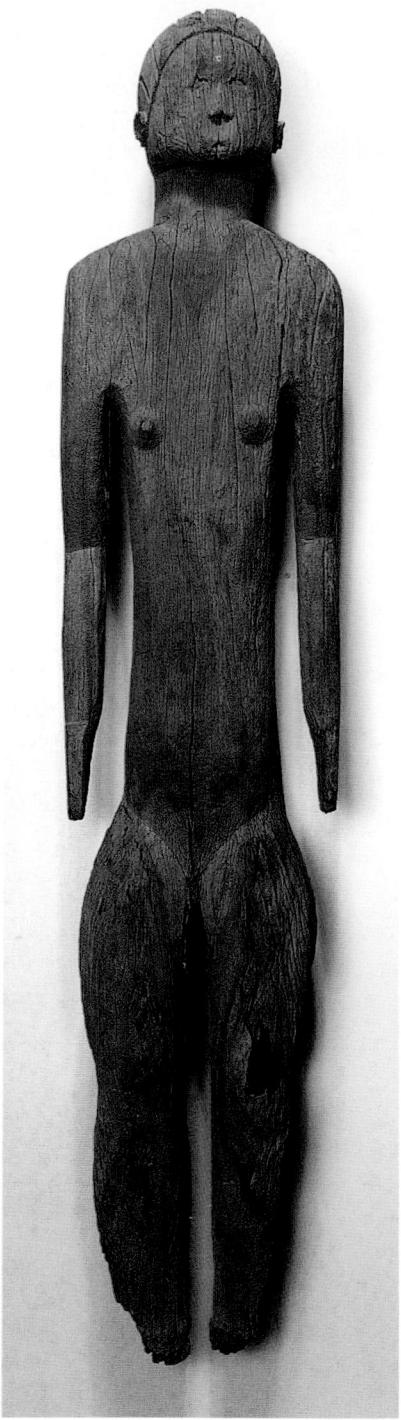

2.18c

Grave figure

Bongo
Sudan
late 19th or early 20th century
wood
145 x 30 cm

The Trustees of the British Museum,
London, 1973. AF. 35.1

represent a non-Bongo, at least to the extent that the inserted metal teeth do not obviously lack the lower incisors, which were extracted from all Bongo people when young. It is not clear how the Bongo regarded the removal of effigies from the graves of their ancestors. It seems that they received little if any attention after their erection and were left to the depredations of bush fires and the weather – as can be seen in the surface condition of cat. 2.18a, which presumably reached its present condition *in situ*. It must, however, be at least possible that they would have minded less about the removal of the effigies of victims, and that therefore at least some of the figures in European collections may be of his kind. JXC

Provenance: cat. 2.18c: 1973, acquired by the museum

Exhibitions: cat. 2.18a: Düsseldorf et al. 1988–9, no. 194; cat. 2.18b: Antwerp 1975; Brussels 1977, no. 119

Bibliography: Schweinfurth, 1873; Schweinfurth, 1875, pl. VIII; Evans-Pritchard, 1929; Kronenberg and Kronenberg, 1960; Kronenberg and Kronenberg, 1981

2.19

Lip plate

Surma peoples
Sudan/Ethiopia
20th century
wood
12 x 18 x 2 cm
Mimi Lipton

This is a challenging object to discuss in the context of an exhibition selected in large measure on aesthetic principles. It is challenging because the object itself – a lip plate – acts to alter dramatically the appearance of the wearer in ways that might be thought ‘aesthetic’; once in use, however, the plate becomes effectively invisible. To that extent it is arguably an instrument of broadly ‘aesthetic’ manipulation, rather than a consciously created aesthetic device in its own right.

In general it would rarely be seen as a separable object once created and inserted – rather like false teeth. This example has a suggestion of eyes and mouth, as if the plate were intended as a minimalist representation of a face. As such it is a striking object. This form, however, is not duplicated on other plates and may be either a fanciful interpretation on the part of the viewer or whimsy on the part of the creator.

Such plates are worn by women among the Surma-speaking peoples who occupy the Sudan/Ethiopia borders. While still young, women have a small wood splint inserted in

the lower lip; this incision is gradually enlarged by increasing the size of the splint until the lower lip is capable of holding a wood disc of greater dimension. Though there are photographs of women wearing such plates that go back at least to the 1930s (see, for example, the photographs by Dr John Bloss in the British Museum Ethnography Department archives), the ethnography of the area is limited and largely silent on the local understanding of this practice. Such speculation as there has been is largely confined to the observation that slavers in the 19th century were put off taking into captivity women wearing such plates. This, however, is also an explanation offered of the origin of the same practice elsewhere in Africa – for instance, among the Fali in Cameroon. Like much in indigenous explanation it seems calculated more to prevent further fatuous inquiry into essentially unanswerable questions than to present a solid factual account. In the end two contradictory explanations contest the interpretative ground: on the one hand the lip plate promotes beauty, on the other ugliness. JM

Bibliography: Nalder, 1937, p. 151; Lebeuf, 1953; Fisher, 1987, p. 216

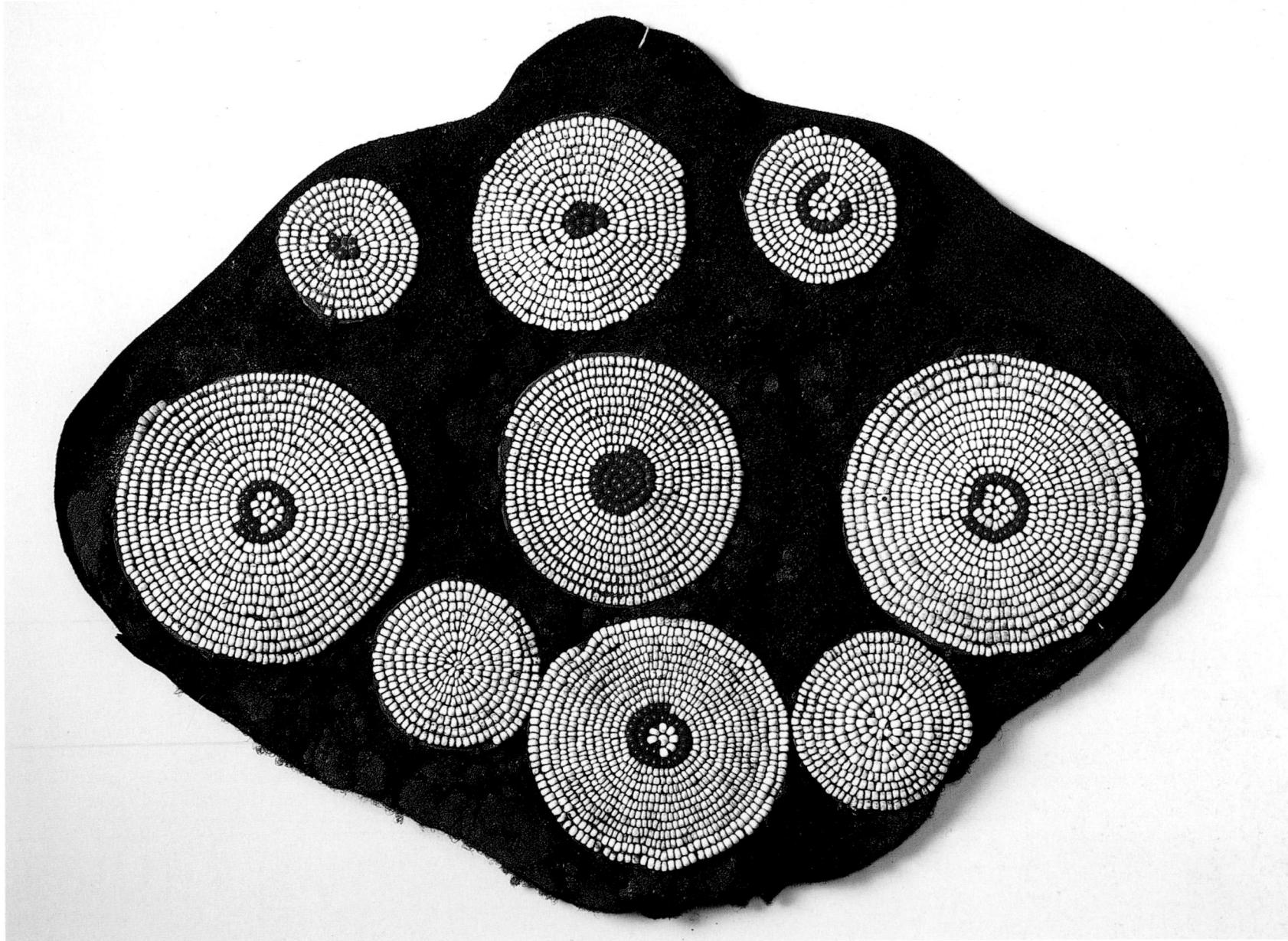

2.20

Bonnet

Acholi (?)
Uganda
human hair, beads
w. 33 cm
Museum für Völkerkunde, Leipzig,
MAF 8780

Among the cattle-keeping people along the borders of Uganda, southern Sudan and north-western Kenya, men have historically adopted a series of elaborate coiffures on initiation into the senior age grades associated with warriorhood. Frequently, as among the Karamajong of Uganda or the Turkana in Kenya, the hair is built up with mud and the resulting pack painted and set with feathers. An alternative is the creation of a large basin-shaped hairstyle

which is then decorated with discs of coloured beads. The best documented of these occur among the Didinga who occupy the hills on the borderlands of southern Sudan, where they were recorded and photographed by Powell-Cotton at the turn of the century. Although most of these hairstyles are built up as attached coiffures, some seem to have been made as separable objects; the circumstances in which this happened are not clear. In one case known to the author a separate headdress was created by prisoners from the hair shaved off when warriors were convicted and jailed.

This example is identified in the records of the museum from which it comes as of 'Schuli' (i.e. Acholi) origin. The Acholi are neighbours of

the Didinga and close trading partners. It is entirely possible that this object could have been collected in Acholi country, for the style is to some extent shared between Didinga and Acholi. In an area where material objects are all fabricated locally and easily replaced, styles are prone to change rapidly. These are not hierarchically organised societies with centralised institutions, but fluid groups among whom the expression of ethnic – as opposed to clan or age set – affiliation is of little significance. Most groups in this area, however, often incorporate clans with a generic name which in local dialect approximates to 'strangers'. Such strangers may retain elements of the groups with which they were formerly affiliated. Even among groups whose

warriors raid for cattle and who are otherwise enemies, the adoption of clans and of neighbouring material styles – even of trade – is not uncommon. *JM*

Bibliography: Powell-Cotton, 1904; Mack, 1982, pp. 111–30

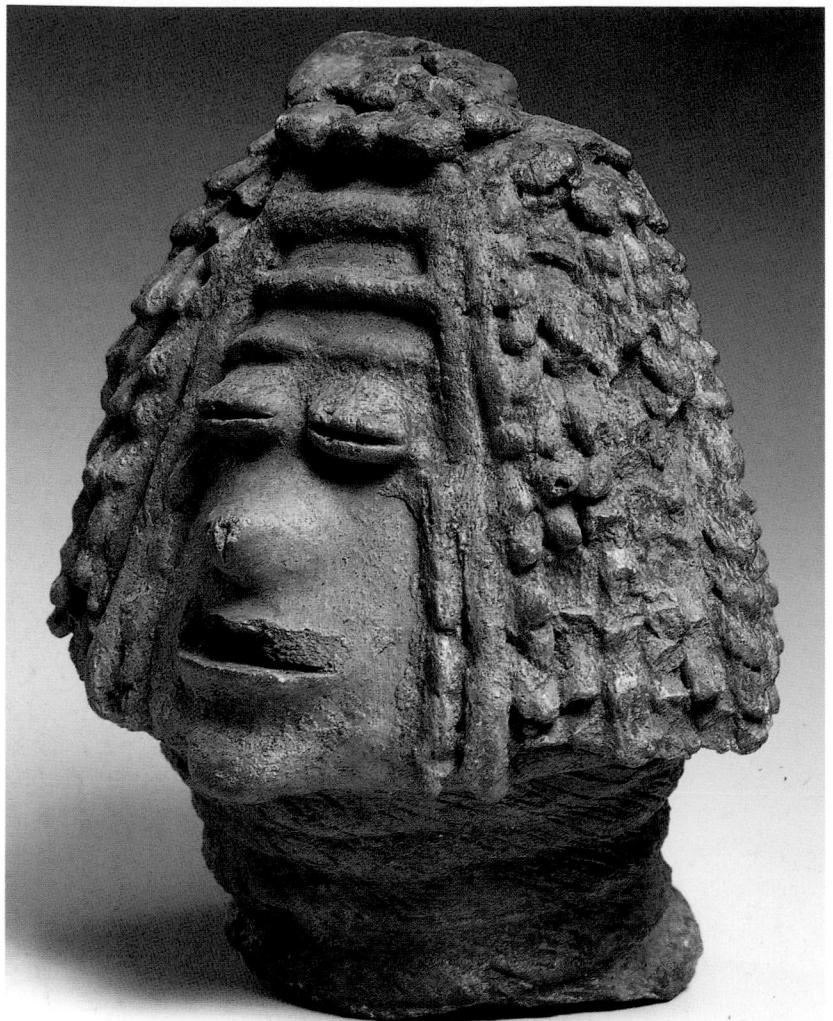

2.21

Luzira Head

Buganda

Uganda

before c. 1750

fired clay

20 x 17 x 17 cm (head),

22 x 16 x 16 cm (body)

The Trustees of the British Museum,

London, 1931. 1-5. 14/18

The Luzira Head consists of two pieces found in a collection of fourteen broken terracotta objects among some 150 pot shards. Plastic arts are a rarity in east Africa and there are no parallels to the Luzira Head in the whole area. Several reconstructions have been attempted, none of which is wholly convincing. An analysis of the fragments suggests that there were possibly four figures originally, which were broken before being placed in a pit. The associated ceramics, and part of a polished stone axe, locally known as thunderstones, suggest that the site was occupied for a long period, possibly from the early part of the 2nd millennium AD until the 19th century. There is at present no reliable indication of the exact age of the figures.

The head is hollow and was probably completed separately from the body. The decoration and all features were applied rather than being modelled on the figure. It is neither well fired nor burnished. The reconstructed pieces that comprise the figure are damaged, including the top of the head, the lips and the junctions between the head and body. The applied clay on the head represents either a wig or more probably hair dressed in clay, a not uncommon practice among priests or other ritual practitioners. Below the head there are five coils, which could possibly indicate a necklace of some kind, though probably not of beads. The lower solid section has rings that match those below the head. There are two strangely placed nipples. The arms are decorated with disc bracelets. The lower part of the trunk has what appears to be a small navel. There are indications of two small feet at the centre of the base of the trunk. The arms, terminating in schematically represented hands, rest on columns at the foot of which are further coils. Wayland originally suggested that the figure was a man. The nipples are small, but as no certain genitals are

indicated it is impossible to tell the gender.

Luzira was the site of a shrine whose guardians were of the Buganda Otter clan (Ng'onge), barkcloth makers to the royal household; a more modern shrine existed on the hill above. It is assumed that the figures were shrine furniture with the pots for offerings or belonging to the priest or priestess. Location of both the original and later shrine suggests that it was associated with the religion of nuclear Buganda around the lake where other shrines, mostly devoted to the original lake spirits or nature deities, were also located. The original shrine, as well as others, including that at Entebbe, where another enigmatic and anthropomorphic figure was found in 1964, was probably destroyed by followers of Kabaka Kamanya in the early 19th century during their attacks on the strongholds of the traditional Balubale. It would appear that the broken fragments were buried in the pit, but whether intentionally or as rubbish cannot now be ascertained. *MP*

Provenance: 1929, discovered during the building of a prison at Luzira on the shoreline of Lake Victoria near Kampala; later excavations by E. J. Wayland; 1931, given to the museum by E. J. Wayland

Bibliography: Wayland, 1930, p. 41; Wayland, Burkitt and Braunholz, 1933, pp. 25–9; Chaplin, 1967, pp. 195–210, 263–8; Posnansky and Chaplin, 1968, pp. 644–50

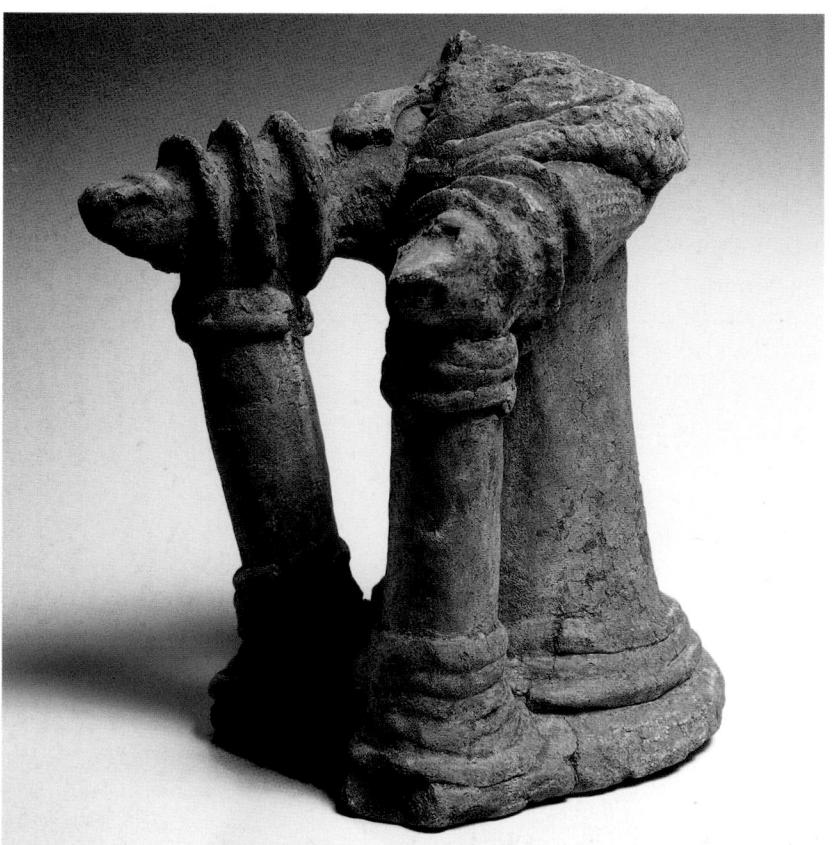

Headrests are indispensable items of the portable material culture of eastern Africa pastoralists, as are spears and other weapons. They are in effect more than just forms of pillow. Whether carried on the arm or in the hand by means of a leather thong, they indicate that their owners are warriors. They often have other small but essential items attached to them – tweezers, knives or chewing tobacco. When not required for sleeping they may just as easily provide an impromptu stool; whereas most examples, have a single column as support, cat. 2.22a is unusual in being furnished with three legs, making it equally useful for sitting or sleeping on.

These two examples in divergent styles are identified with the Karamajong of Uganda. In practice, however, either could just as readily have been attributed to other pastoralists, to the Turkana in Kenya, the Toposa in the southern Sudan or the Nyangatom and related peoples in the Omo Valley of Ethiopia. All share a somewhat similar material culture, and all – despite periodic outbursts of warfare – harbour within their midst clans of foreigners who have been displaced in the unpredictable search for water for their cattle. Such intermingling is reflected in the eclectic material styles found throughout the region. JM

Bibliography: Tornay, 1975; Fedders and Salvadori, 1977; Mack, 1982

2.22a

Headrest

Karamajong (or related people)
Uganda, Kenya, or neighbouring area
wood
18 x 14.5 x 14 cm
Jonathan Lowen Collection

2.22b

Headrest

Karamajong (or related people)
Uganda, Kenya, or neighbouring area
wood
13.5 x 19 x 9 cm
Jonathan Lowen Collection

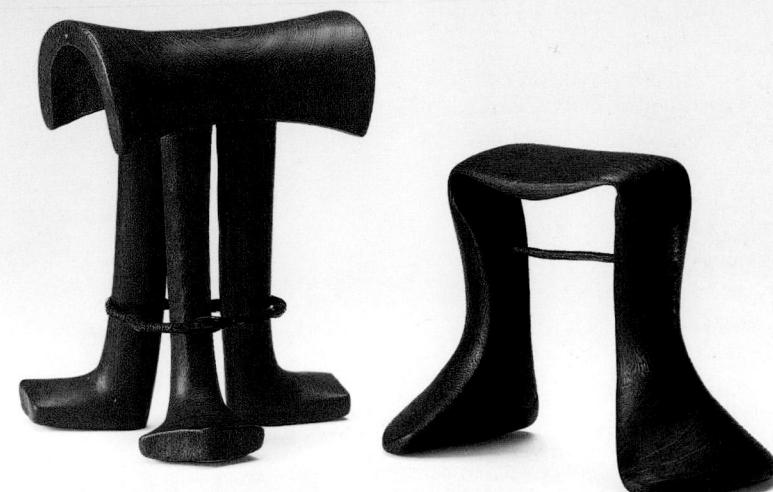

2.23

Milk-pot suspended in a string holder

Nyoro
Uganda
c. 1900–25
fired clay, graphite, vegetable fibre string
h. 16.5 cm, diam. 14 cm; carrier c. 114 cm
Manchester Museum, University of
Manchester

The group of peoples known as the 'Interlacustrine Bantu' are so called because they inhabit the area bounded by a series of lakes to the north and north-west of Lake Victoria. These peoples include the Ganda, Nyoro, Nkole, Soga, Toro and Hima of Uganda, and the Tutsi of Rwanda and Burundi. The cultures of these peoples had many features in common, and their artefacts are often very similar.

This pot is shaped like a wooden grooved milk-pot, although about two-thirds the size. The form is associated with a cattle-keeping culture such as that of the Nyoro or Hima of south-western Uganda bordering on Rwanda. Roscoe has described how the graphite, after mining, was powdered, and all the light-coloured stone removed. Usually the powder was mixed with water and the gelatinous juice of the *rukoma* shrub; this was painted on the unfired pot and left to dry. When 'leather hard', the pot was then well burnished with barkcloth scraps and a smooth stone. Alternatively, the graphite was mixed with butter and blood, and was made into balls that, when hard, were rubbed all over the unfired pot. When fully dry, it was fired, and when cool it was again polished with a smooth pebble to a lustrous silvery-black finish. This process had decorative and also practical value, since the burnishing compacted the outer surface of the pot, making it less permeable.

Graphite-burnished ware was reserved for the royal family and nobility. Roscoe illustrates a number of similar pots in slings hanging up in the dairy of the *Mukama* (king) of the Bakitara (also known as the *Nyoro*), and also a servant presenting the king with milk in a similar vessel. Graphite pottery was made by the Nyoro and not by the Ganda, although it could be exported; the main source of graphite was in Nyoro country.

While pottery in Africa is usually made by women, quality pots like this

are produced by men, and there are sanctions against women making pots or even approaching clay-pits and pottery workshop areas. 'Royal Potters', such as those working for the Kabaka of Buganda, have a special status and title, insignia, and privileges such as exemption from tax. A different type of pottery was used for beer-drinking, which was, and still is, an important element of social life, with special large drinking-vessels and finely plaited drinking-straws with filter ends for communal beer-drinking.

The sling, made of fibre cord, serves to hang the milk-pot up in the dairy. Netted slings made by women in a variety of patterns are found all over the Interlacustrine Bantu area. MC

Provenance: before 1926, F. H. Rogers
Bibliography: Johnston, 1904, p. 308;
Roscoe, 1925, pp. 225–8, pl. VIII; Trowell,
1941, pp. 56, 64; Trowell and Wachsmann,
1953, pp. 109, 117–18, 163, pls 17 A, 38

2.24a

Dance shield

Kikuyu
Kenya
early 20th century

wood
60 x 42 x 8 cm

Lucien van de Velde, Antwerp

Among the Kikuyu in central Kenya, as in many parts of Africa, initiation is – or has been – a significant spur to artistic activity. For boys, initiation is the prelude to entering the social status formerly associated with warriors; and indeed those initiated together in a particular territory once formed a unit within the wider age group for the execution of raids and the defence of villagers. Some aspects of the initiation process, such as the display of shields in initiation ‘dances’, make reference to this militaristic expectation of initiated men.

Initiation shields were of various kinds; unlike the war shields (*ngo*), which were crafted from animal hide, they were constructed of wood or bark. Those of the type shown here were usually carved from a solid piece of light wood by specialist craftsmen for a display of dance known as *muumburo*. As they have an armhole on the inner face of the shield, they can be manipulated by flexing the arm rather than being held in the hand.

All the wood shields were decorated with non-figurative motifs on the outer surface and usually on the inside as well. These designs were by no means arbitrary. The patterning had to be agreed in advance of successive initiations, which in some areas may have been annual, and was then applied to the new shields used on that particular occasion. Such pattern-

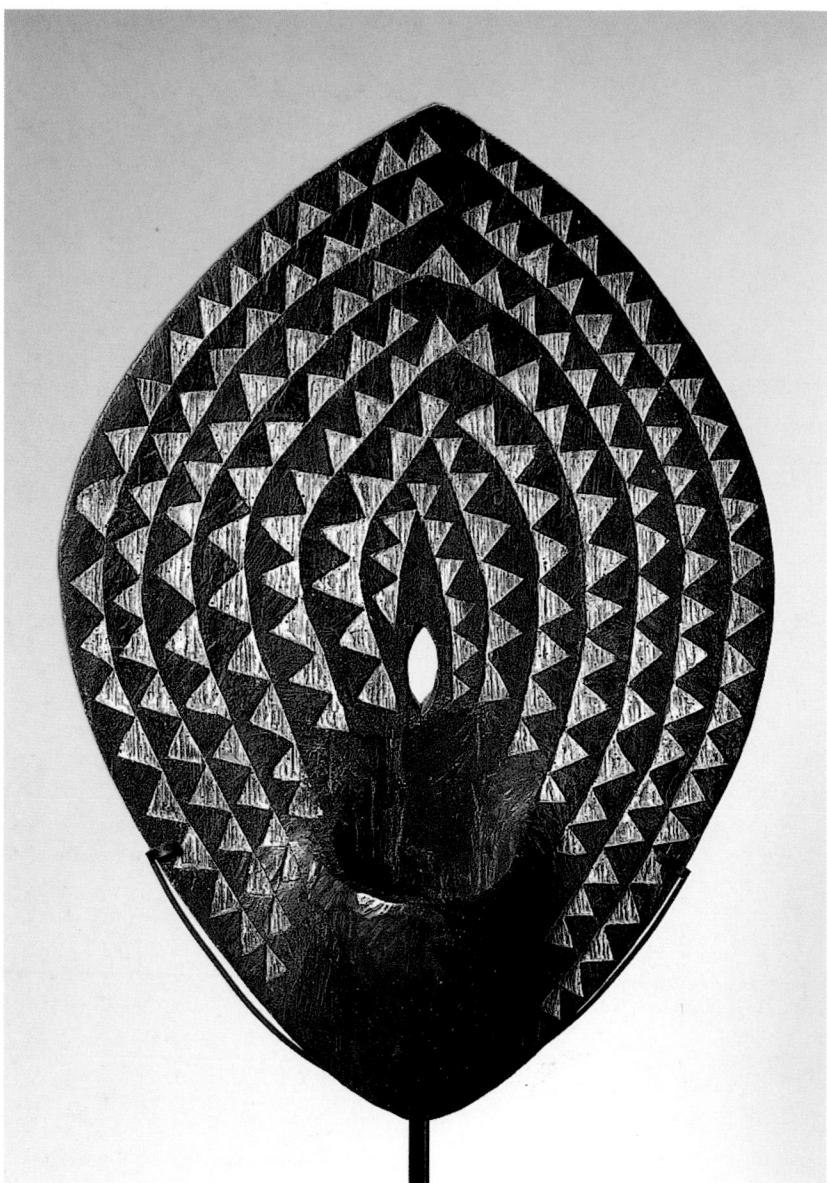

ing thus varied both by territorial unit and by initiation period. Shields used at the same initiation were not necessarily identical. Boys usually passed their dance shields on to their younger relatives. Many scraped off the old decoration, replacing it with the pattern agreed as the ‘insignia’ of their particular initiation group. Only when more than one boy from a family was to be initiated on the same occasion was a wholly new shield commissioned with a pattern selected for that year. Patterns were also applied to the back of the wooden shields – often in a form reminiscent of an eye and eyelid. SJMM

Provenance: cat. 2.24b: 1921, given to the museum by Mrs Selous

Bibliography: Routledge, 1910 (1968)

2.25

Figure

Kamba
Kenya
c. 1933
wood, metal, cloth
h. 21.3 cm
Bareiss Family Collection

The Kamba made their original home in the drought-prone scrub-lands of the eastern slopes of the Kikuyu highlands in southern Kenya. Rural Kamba keep livestock and farm along the banks of rivers and in the better watered depressions. In the 19th century they are known to have traded extensively with Arab and Swahili caravans. Today many Kamba are involved in a major trade in wood-carvings based on an industry that was initiated after World War I. Before the war the Kamba were skilled in working metal and carved utilitarian objects out of wood, including stools that were elaborately decorated with inlaid metal coil-work. They appear to have produced very little in the way of figurative wood carving, although a few examples of early anthropomorphic figures from Kambaland are to be found in European collections. Such figures were probably used in connection with the cult of the ancestors and may have represented clan founders and important elders. They are typically stocky with straight legs and their round heads are generally carved with pursed lips and protruding, S-shaped ears. Most are decorated with simple bead ornaments and inlaid metal eyes.

It is generally acknowledged among contemporary Kamba artists that the first person to begin carving figurative items intended exclusively for sale to Europeans was Mutisya Munge. Mutisya was a skilled carver of utilitarian objects who had served in the Carrier Corps in what was then Tanganyika during World War I. While in Tanganyika he had come into contact with Zaramo carvers involved in the production of figurative models of local styles of dress and ornament for the European market (which had apparently developed before 1914 with the encouragement of Lutheran missionaries). When he returned to his home village of Wamunyu after the war he took up figurative carving as a full-time occupation and the practice soon spread to other men in this area of Kambaland.

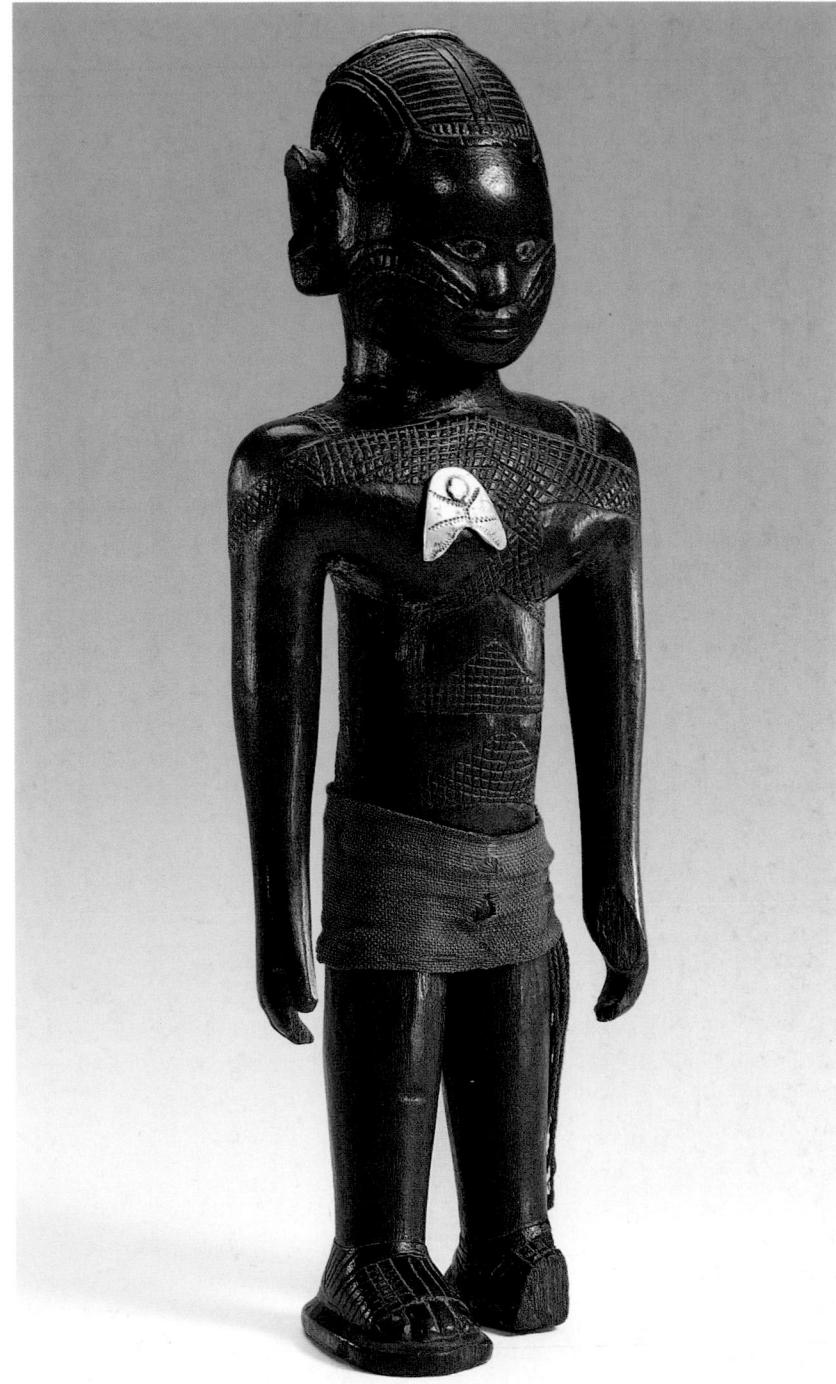

This figure depicts a Kamba man engraved with typical scarification marks of the early colonial period. In its stocky frame and straight legs it bears some resemblance to the form of early wooden figures used in connection with the ancestor cult. It is carved in a similar style to a fine figure of a Kamba woman in the British Museum that was evidently made for the European market and is recorded as having been collected in 1933. A number of remarkable carvings of this kind, often decorated with wire ornaments, metal inlay and pigment, appear to have been

produced by Kamba carvers during the inter-war period.

Finely carved figures such as this probably ceased being made after World War II when demand for Kamba carvings from overseas buyers began to outstrip the carvers' capacity for production, thus encouraging them to organise themselves into an efficient handicraft industry geared to fulfilling bulk orders for simpler, standardised figures. *ZK*

Bibliography: Lindblom, 1920; Elkan, 1958; Troughair, 1987; Felix, 1990

2.24b

Dance shield

Kikuyu
Kenya
early 20th century
wood
62 x 41 x 10 cm
The Trustees of the British Museum,
London, 1921. 10.28.12

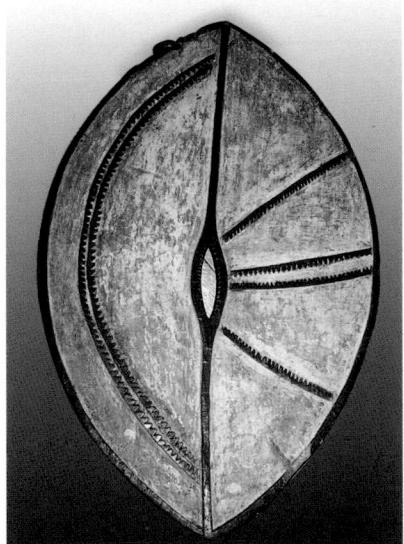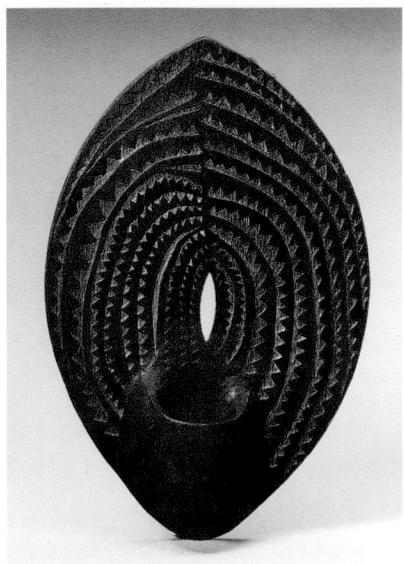

The *vigango* (sing. *kigango*) of the Giryama are not necessarily grave-markers, although there has been much confusion over this in the literature: *vigango* are sometimes placed on the site of graves, but normally not. Their role is not to indicate the location of physical remains but to provide a new abode – a new body, indeed – for the spirit of the deceased. Like the smaller and less elaborate *koma* pegs, together with which they form a sort of genealogical map for the household, *vigango* are erected some time after the death of an individual, usually only when the spirit of the deceased indicates discontent with its lack of a body by appearing in a dream to some living relative.

Among the Giryama (but perhaps less so among some neighbouring groups, such as the Jibana, Chonyi and Kauma, who also erect *vigango*) *koma* and *vigango* often stand in the men's conversation hut in a homestead, readily accessible to the elder male of the homestead, whose prerogative it is to pour palm wine into small coconut-shell cups set at the base of these ancestral memorials. This is done at regular intervals. If dreams or misfortune recommend it, the elder male may also slaughter a chicken or goat by the memorials, so that the blood goes to nourish the spirits. Generally, it is only the ancestors of the male head of the homestead who are so embodied within the homestead; his wife or wives will not usually have *vigango* or *koma* for their ancestors, and if they do these are not prominently placed.

There is some debate about the distinction between the *koma* pegs and these *vigango*, and what this signifies. Physically, the differences are readily apparent. *Koma* are small soft-wood pegs, standing only about 30 cm out of the ground, and carved in the most rudimentary way, with a slight waisting (possibly phallic) indicating that the *koma* is that of a male ancestor; they are occasionally 'dressed' with strips of cloth. *Vigango* are much taller, standing 130–200 cm out of the ground, and are carved from hardwood (which resists the attentions of termites); they are evidently anthropomorphic, usually decorated with incised triangles and often also originally painted with red, white and black. In the 19th century

some had silver dollars in place of eyes. They are much more expensive, elaborate and enduring. Although they are rather rarely made now, some relatively recent examples exist.

The difference – the fundamental question of to whom a *kigango* may be erected, and to whom only a *koma* – is partly one of gender: there seem to be no *vigango* for women. But not all men get them either. Some suggest that this has to do with membership of one of the several societies that structure Giryama life in important ways. *Vigango*, some would argue, are erected only for members of the *gohu* society, which is essentially concerned with the conspicuous consumption of wealth; admission to membership of it is similarly a sign of wealth. Even if they are not solely associated with *gohu* members, it would seem that only the wealthy would be likely to get *vigango*, as the rituals involved in the erection of a *kigango* are very much more costly than those for a *koma* peg. The very name *vigango*, which comes from a verbal root referring to 'binding, splicing', suggests the special power of wealthy elder males and the healing force which that power may have when used by the spirits of the deceased.

There are, however, suggestions that the difference between *koma* and *vigango* essentially relates to mobility (and perhaps reproducibility), and that there is a historical process of change. *Vigango* may be moved at most once from their original position, whereas *koma* may be more mobile, or may be replaceable (although there is some variation in practice over this). Since the early 19th century, the Giryama population has expanded both numerically and geographically: from being a relatively small group centred on the *kaya* ritual centre a little way inland from Mombasa, with a mixed farming economy that emphasised cattle pastoralism, the Giryama have multiplied and spread to areas some way north of the *kaya* and as far east as the coast, relying heavily on rather marginal maize farming and on involvement in the tourist economy of the Kenya coast. As part of this process, homesteads have tended to become smaller, as men leave those of their fathers rather earlier to establish their own – and therefore may seek to erect their own ancestral memorials. As the

population has expanded and dispersed, so it might be argued that *koma* have become more common than the more static *vigango*.

In either case, these wooden bodies for spirits have a limited period of use. Just as they are erected only when the spirits of the deceased make themselves remembered, so they are neglected once the spirits begin to be forgotten. This restricted sense of genealogy is emphasised by the fact that the Giryama alternate their names between generations, which tends to blur more distant ancestors into a stereotyped succession of names. Once an individual ancestor is forgotten, their *koma* or *vigango* are forgotten too – the soft-wood *koma* rot away, and after a time the more enduring *vigango* are left behind as homesteads move, no longer important because their spirits have faded from memory.

These four examples all have particularly carefully carved heads, whereas on many *vigango* the heads are essentially two-dimensional, and in some cases a geometric pattern is carved, no effort being made to represent human features. Two of them have the characteristic incised triangles, which perhaps represent human ribs, as well as the circular decorations that are common. The other two are predominantly incised with the rather less common rectilinear forms, and one is unusual in that the notches cut into the body serve as part of the pattern rather than terminating it.

While there are apparent similarities between these pieces and grave-markers of the Oromo, and some from Madagascar, no historical link has ever been demonstrated.

JW

Bibliography: Barrett, 1911; Champion, 1967; Hollis, 1909; Ngala, 1949; Wolfe, Parkin and Sieber, 1981

2.26a

Funerary post (*kigango*)

Giryama
Kenya
wood
h. 206 cm
Private Collection

2.26b

Funerary post (*kigango*)

Giryama
Kenya
wood
h. 145 cm
Private Collection

2.26c

Funerary post (*kigango*)

Giryama
Kenya
wood
h. 190 cm
Private Collection

2.26d

Funerary post (*kigango*)

Giryama
Kenya
wood
h. 130.5 cm
Private Collection

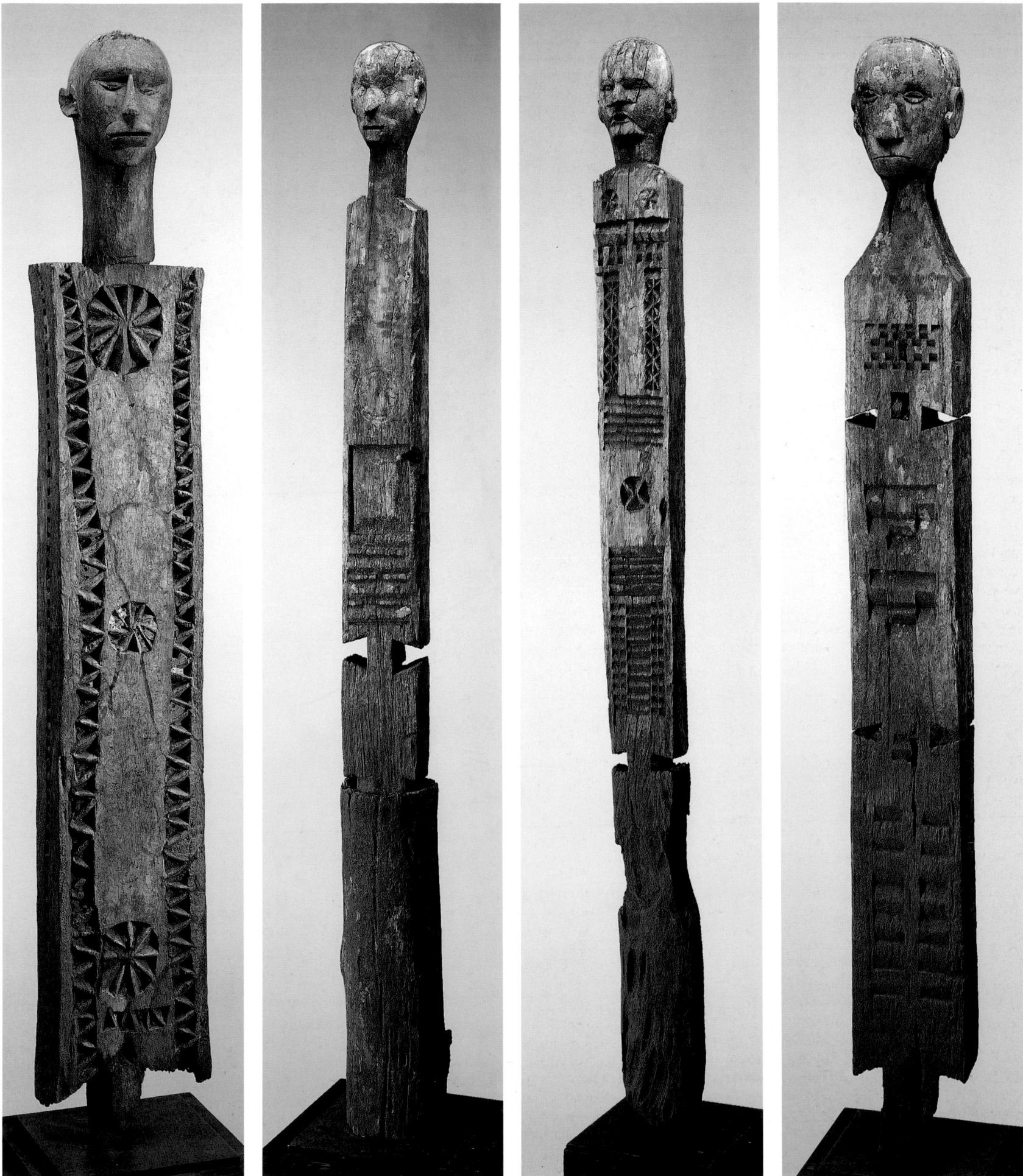

2.27

DoorSwahili
Tanzania

c. 1900

wood

h. 200 cm

Staatliche Museen zu Berlin, Preussischer
Kulturbesitz, Museum für Völkerkunde,
III E 8932

The carved doors of the east African coast, variously described as Swahili, Arab or Zanzibari, represent variants within an ancient and widespread tradition in the western Indian Ocean (the earliest reference is by the 16th-century Portuguese writer Barbosa, who described them as ‘well carved’). It declined after the Portuguese

invasion but revived in the 19th century. The largest concentrations of such doors occur in Zanzibar town (500), Lamu (200) and Mombasa (100).

The carved door, which consists of a number of interlocking members, is often the only striking external feature on an otherwise plain, white-

washed building. Its quality and size were an indication of the social status of the owner. All doors are double and open inwards from the centre. The most traditional Swahili-type doors occur at Siyu in the Lamu archipelago; these are engraved and painted in red rather than carved, and lack a central post. In Lamu they are simple with only the central post carved with rosettes or round geometric designs, ending with fish-scale decoration at top and bottom.

The tradition of carving doors reached its zenith in the 19th century when it was underpinned by the wealth flowing into Zanzibar and its subsidiary ports from commerce and clove production. The somewhat simpler carved doors in the smaller ports on the mainland, such as that illustrated here, were greatly elaborated in the doors of the ruling Omani élite in Zanzibar. The square-framed doors were carved with a variety of motifs: the fish and wavy lines point to an important source of livelihood for the Swahili; the chain is said to symbolise security; the rosette and the lotus suggest Indian influences; and the frankincense tree and date palm, which are indigenous to Somalia and Arabia, are said to denote wealth and plenty. Frequently these decorations centred upon a Koranic inscription in the middle of the lintel which may contain the date and name of the owner or artist. The leaves of the door were often decorated with rows of iron studs and fitted with a hasp and chain to lock the door from the outside.

Carved doors are one manifestation of the culture of the Indian Ocean region. Islam, the dhow trade and availability of timber and craftsmen provided the basis upon which the tradition flourished. There has been constant cultural interpenetration between the east African coast and the northern rim of the Indian Ocean. Some doors were imported into Oman from east Africa already carved, and probably exerted influence on the local craft. *AS*

Bibliography: Adie, 1952, pp. 114–16; Aldrick, 1990, pp. 1–18, pls 1–16; Bonnenfant and al-Harthi, 1977, pp. 128–30, pls XXVII, XL_a, b, XL_a–c, XL_b; Barbosa, in Freeman-Grenville, 1962, p. 131; Krieger, 1990, pl. 296, p. 45

2.28

Gameboard (bao)
Swahili
Zanzibar, Tanzania
20th century (?)
wood
90 x 36 x 4.7 cm
Peter Adler Collection

For centuries, the most popular boardgame along the east African coast has been *mankala*, a generic name for a family of boardgames akin to draughts and believed to be the oldest and most widely distributed in the world. It is played on boards with two, three or four rows of cuplike depressions or 'holes'. Two-row games are the most widely distributed in the world, while three- and four-row games are rarely found outside Africa. Africa is unique in being home to all three types.

The peoples of Kenya, Tanzania, Zanzibar and the Comoro Islands call the game *bao KiSwahili*, indicating a method of play that originated among the Swahili and Bajun Muslims of northern Kenya. It is played by two people on a *bao* (Swahili for 'board') containing four parallel rows of eight holes. Each player has 32 pieces and owns half of the board. The goal is to capture the opponent's pieces and redistribute them on one's own side of the board. This is done by sowing the pieces one by one in the appropriate inner and outer rows during the two stages of the game. A capture is made when a player's last piece falls into an occupied hole in his inner row. This hole must be opposite two occupied holes in the opponent's inner row. The hole in each inner row that is larger or of a different shape than the others is called *kuu* and houses accumulated pieces that may play a strategic role. Like chess, *bao KiSwahili* is a contemplative game of strategy. However, unlike chess, African *mankala* is played with great speed, requiring both mental and physical agility, and in the presence of a vocal audience.

The pieces are pebbles or inedible, hard, grey seeds from a thorny shrub. The *bao* may be simply holes scooped out of the ground or a board carved from a hardwood. In the past, decorated gameboards with a projecting storage hole at either end were prestige objects made by professional wood carvers. This one is decorated with carved geometrical designs reminiscent of those found on the doors of 19th-century Swahili houses in Zanzibar. *RAW*

Bibliography: Ingram, 1931, p. 257; Townshend, 1992, pp. 175–91; Nooter, 1984, pp. 34–9; Washington 1984; Aldrick, 1990, pp. 1–18; de Voogt, 1994, p. 3; Rollefson, 1992, pp. 1–6

2.29

Figures in intimate embrace
Mahafaly (?)
Madagascar
early 20th century
wood
h. 8 cm
Private Collection, Paris

This miniature panel showing two figures intimately entwined has been attributed to the Mahafaly of southern Madagascar. Its small scale suggests that it was carved as a virtuoso piece on its own or, more likely, as a panel for some small domestic object such as a comb. Mahafaly combs became more widely known when published between the wars, and the subject-matter of this piece also suggests a derivation in the colonial culture of Madagascar during the first part of the 20th century.

Sexually explicit sculpture is principally associated with the large-format carvings placed at the corners of Vezo graves (cat. 2.31b). These have become known among the Vezo themselves as *sary porno*, or pornographic images, not because their subject-matter was viewed locally as in any sense titillating, but because of the perceived interest of *vazaha* (white outsiders) who visited the funerary sites to photograph and eventually remove the sculpture. This, in its turn, led to the production of erotic sculpture purely for the amusement of a foreign clientele. Although the sculptors were generally of Sakalava or Vezo origin, carvers elsewhere picked up the theme, and sometimes reapplied it, as in this Mahafaly example, to objects intended for their own use. *JM*

Bibliography: Boudry, 1953, pp. 12–71; Université de Madagascar, 1963; Astuti, 1994, p. 112

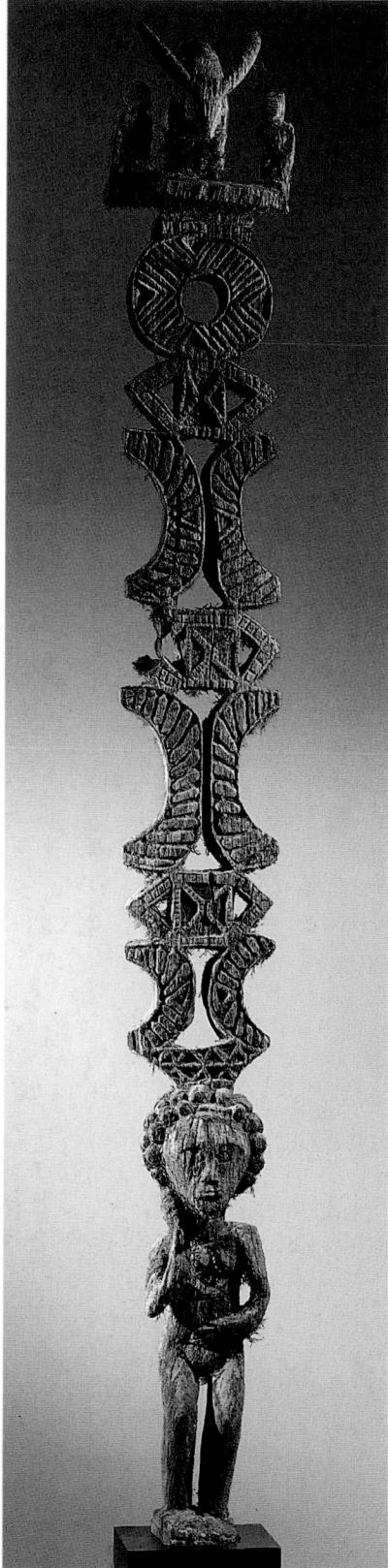

2.30a

Tomb sculpture (aloalo)

Mahafaly
Madagascar
wood
h. 193 cm
Private Collection

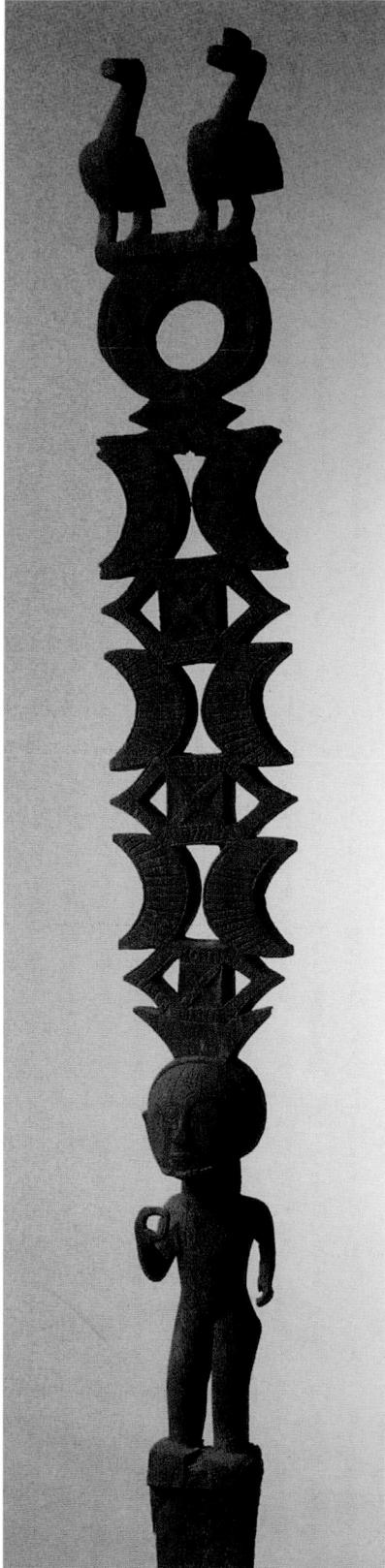

2.30b

Tomb sculpture (aloalo)

Mahafaly
Madagascar
wood
h. 226.6 cm
University of Pennsylvania Museum of Archaeology and Anthropology, Philadelphia, 62-4-1

The carving placed on tombs by the Mahafaly of south-western Madagascar are arguably the most familiar, yet the least understood of all the art forms produced on the island. Indeed, although the term by which the sculpture is known, *aloalo*, is now often applied to other unrelated types of object, the word itself remains inadequately translated.

The Mahafaly live in an extensive area of thorny semi-desert. They are predominantly cattle pastoralists, and the humped zebu cattle which are the basis of their livelihood also provide a leading theme in their figurative art, not least on *aloalo*. In visual terms the most prominent feature in their landscape are tombs, vast solid box-like structures of cut and natural stone which sit isolated in the countryside, often topped with a series of tall sculpted poles. As many as 30 such sculptures are recorded at single sites. Such graves are reserved to chiefly or royal lineages, one large tomb for each of the deceased of sufficient standing to be worthy of the expenditure involved in their creation.

The sculpture displayed on these stone platforms, though it has continued to evolve in form and content until today, retains an identifiable set of elements. The whole construction is generally carved from single pieces of wood, the lower part sometimes plain and sometimes with a standing figure. Above is an openwork structure of geometric forms, usually crescent shapes and circles which are conventionally interpreted as referring to the full and half moons. The image on the top of the whole sculpture shows the greatest variability. Humped cattle and birds are the most frequent subjects, cattle being sacrificed as part of funerary rites and the horns planted in the stone tomb alongside the *aloalo*. The birds are generally those which return at the end of the day to the same place, ducks or teal. This would seem to be a reference to the tomb as the new residence of the deceased. More recent *aloalo* also include groups of figures, aeroplanes, buses and other attributes of modern life which personalise the sculpture in a way not found on older versions.

At one level the sculpture, as the construction of the tomb itself, has a clearly honorific function. However, the term *aloalo* is normally inter-

preted as deriving from the word *alo*, a messenger or intermediary. They are distinguished from another category of Mahafaly carving known as *ajiba*, figurative sculpture in a different style erected away from sites as a form of cenotaph. This contrast tends to support speculation that the purpose of the *aloalo* is less that of a directly commemorative device than as an intercessor of some kind between the world of the living and that of the dead. As in many parts of Madagascar, the ancestors (*razana*) provide a point of reference in seeking to understand the tide of human affairs and a channel by which to influence their course.

Yet *alo* has a more general meaning. It is a word applied to situations which create linkage of any kind. In this sense it is sometimes used of techniques of weaving. In the case of Mahafaly funerary sculpture, it can refer to the interlocking geometry of circles and crescents which provide the central element of the sculpture, and which, by comparison with carving elsewhere on the island, is its distinctive feature. JM

Bibliography: Huntingdon and Metcalf, 1979; Mack, 1986, pp. 86–92

2.31a

Male funerary figure

Vezo
Madagascar
wood
h. 44 cm
Private Collection

2.31b

Female funerary figure

Vezo
Madagascar
wood
h. 57 cm
Private Collection

These two pieces are by an unknown Vezo artist whose sculptural intentions have been adapted by the abrasive action of sand. The objects seem to come from one of the nine or so funerary sites in the region of Morondava on Madagascar's western coast. The Vezo are a fishing population who should be distinguished from the surrounding Sakalava with whom they are often confounded and to whom Vezo funerary art is sometimes erroneously attributed. Vezo tombs are located in forests and sandy clearings distant from villages and are visited only for the purpose of burying the dead. The sculpture placed on tombs is to that extent largely invisible both to Vezo and to visiting ethnographers. Indeed, there is no unique indigenous term by which it is known, unlike the *aloalo* which surmount Mahafaly tombs.

A significant number of the carved figures were stolen in the post-war period from isolated Vezo cemeteries, mostly sawn from the poles which supported them (such pieces have been excluded from the selection in this exhibition). There is no tradition of re-erecting the tomb complexes which fall over and it would seem from the extensive abrasions on these pieces that they may have been removed at some unknown time, seemingly directly from the sand rather than from a standing monument.

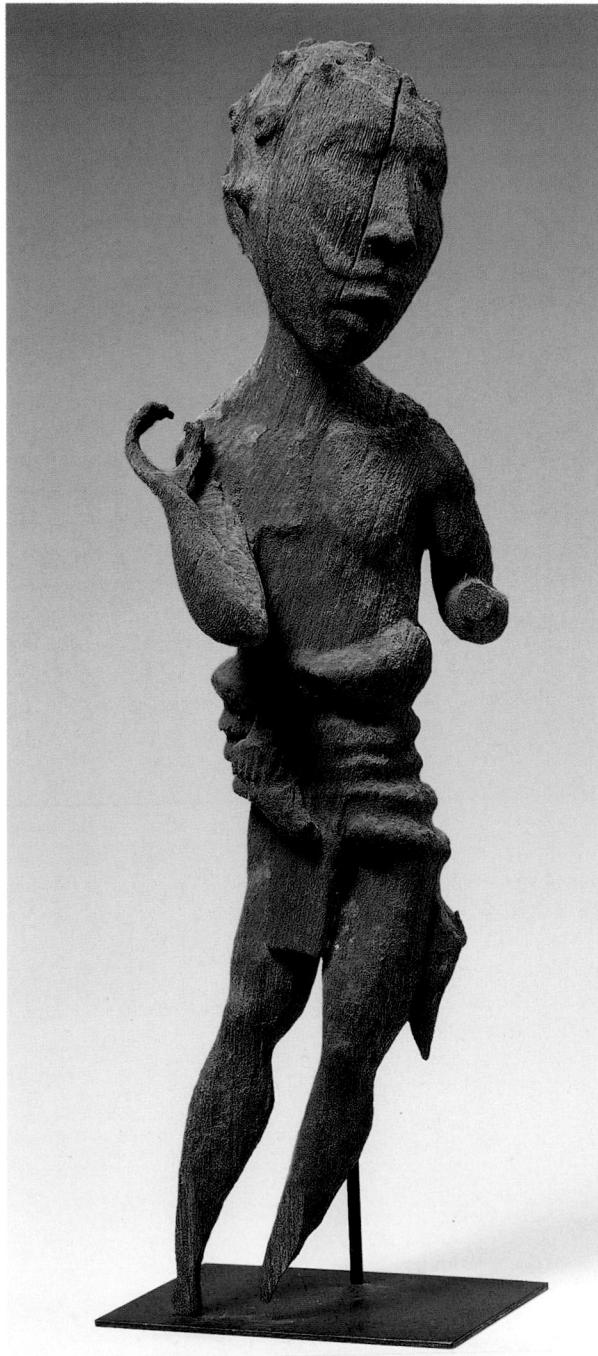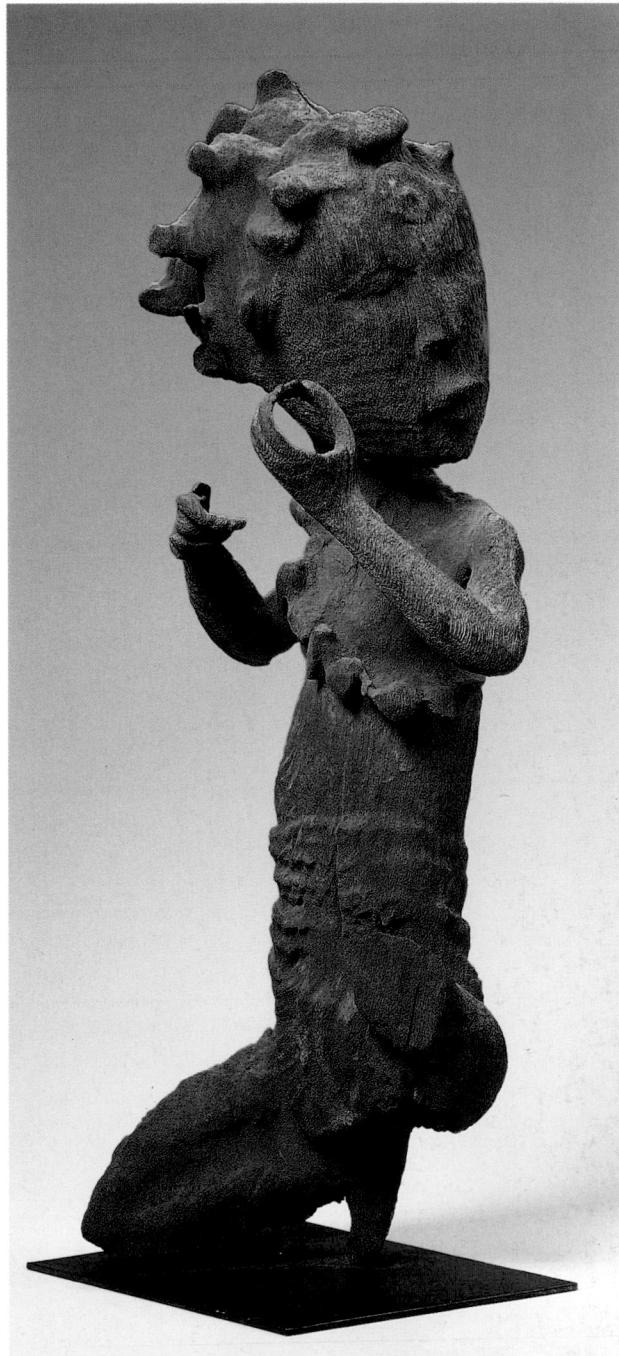

The two pieces here have been photographed in the past as if in intimate relationship. Some figures are carved in amorous embrace (as in the Mahafaly piece, cat. 2.29). It is, however, possible that, as with other Vezo tomb sculpture, they would originally have stood at opposite corners of a rectangular box-like wood structure. That at the sacred north-east corner would be male or female depending on the gender of the deceased. The north-east, the place where the sun rises, is associated both with dawn and with the most propitious of events: it is a good time to be born, the ideal moment for

circumcision, or for the removal of a corpse which has been laid out in a hut. It is a sacred ancestral direction. At the opposite, south-western corner would have stood his or her partner – a relationship in terms of direction which expresses the ideal union of people, and of destinies as calculated by the time and date of birth of individuals and applied to directions.

There are, however, features of these two pieces which are striking and unusual. Both are much more poised than is common; the tilt of the head and gesture of the hands contrast with the upright single figures which are more familiar. In

the end, however, it is difficult to say how far these attributes are fully representative of the original sculptural programme of the carver and how far they are the chance result of extensive weathering. JM

Bibliography: Oberle, n.d., pp. 134–42; Lombard, 1973; Mack, 1986, pp. 88–9; Astuti, 1994, pp. 111–22

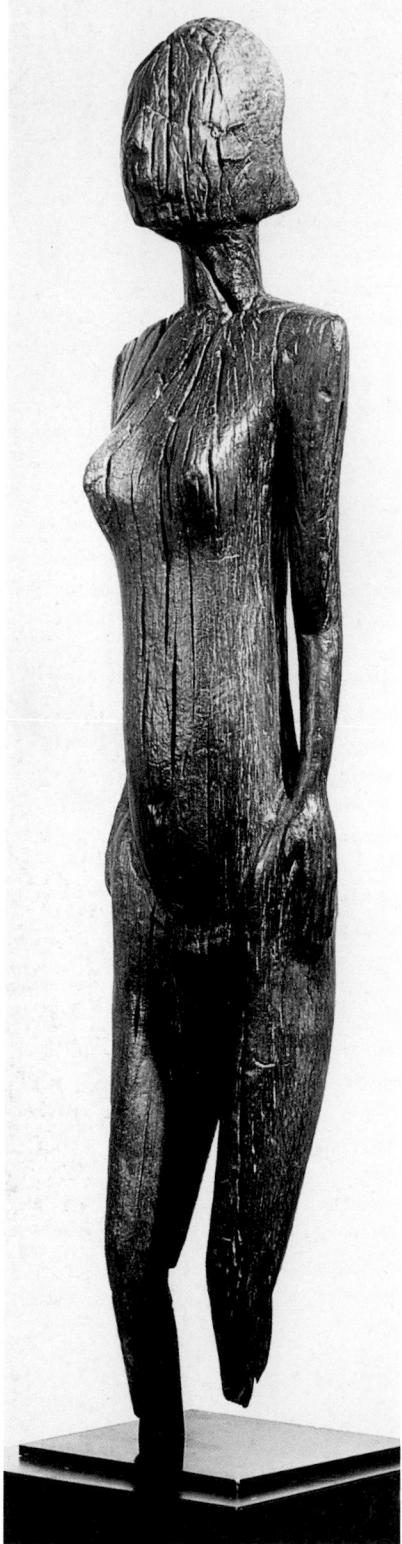

2.32

Female sculpture

Vezo (?)

Madagascar

wood

Private Collection

This sculpture is said to have been collected in Madagascar many years ago. Its general form and its glossy patination would seem to make both claims possible (and to suggest collection at a period predating the deliberate thefts from funerary sites on the island which have taken place since the 1970s). The patination, however, may not be original, for most Malagasy sculpture is created for exposure at ancestral sites outdoors and attains a highly weathered appearance. There is no handling, oiling, or other indigenous treatment of surfaces subsequent to completion as occurs in much of mainland Africa.

For Malagasy the ancestors (*razana*) in effect underwrite human existence. This is asserted in many actions: private, domestic and public. The most dramatic of these are ceremonies at which numbers of skeletal remains are taken for an afternoon from their tombs, rewrapped in new, preferably silk, shrouds and danced round the funerary site. Interestingly, there is no tradition of funerary or commemorative sculpture in central Madagascar where such ritual, with its direct contact with deceased ancestors, occurs. Rather, sculptural traditions are associated with the south and especially the south-west of the island. Here, it might be argued, the creation and erection of sculpture at tombs or at some nearby place, and the crucial ritual process which accompanies it, is equivalent to the rewrapping ceremonies. Both events serve to acknowledge the incorporation of the dead into the community of ancestors and to ensure the flow of vitality from the dead to the living which is the basis of life itself.

It is most likely that this figure is from the Vezo (as cat. 2.31a–b), though this is not the only possibility. In that case it is probable that it was not displayed singly but as part of a complex structure incorporating both male and female figures. It is very rare in Madagascar for female sculpture to be shown other than in relationship with a paired male figure (see also cat. 2.33). JM

Bibliography: Bloch, 1971; Mack, 1986

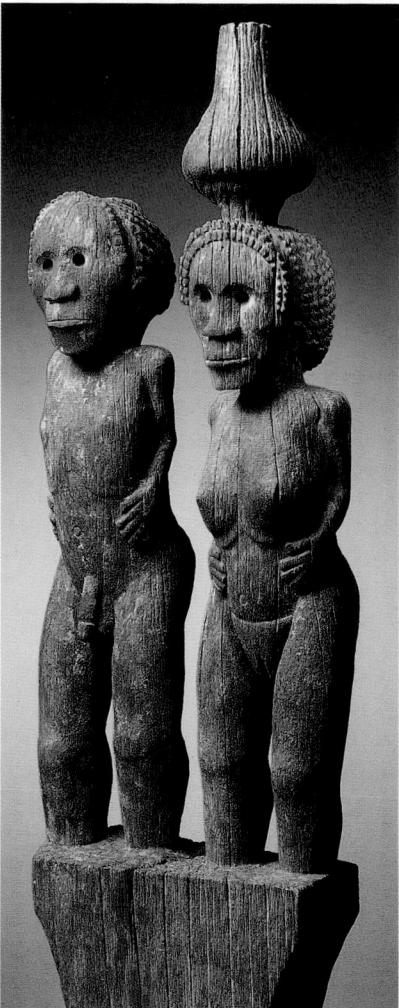

2.33

Mortuary post figure

Sakalava

Madagascar

19th century

wood

h. 99 cm

The Carlo Monzino Collection

Very few works of African sculpture from the eastern side of the continent have had much influence on Western art. This is one of the rare exceptions. It was originally in the collection of the sculptor Jacob Epstein and appears in photographs of his studio, prominently displayed on his mantelpiece. The piece might well have been the inspiration of a study in pencil and watercolour of a male and female pair completed by Epstein in 1913. A companion piece, probably by the same hand, is in the Musée de l'Homme. Yet the purpose and origins of both pieces remain confused.

The Musée de l'Homme example is a complete post, unlike this one, which is only the upper part, and is recorded as having been collected among the southern Sakalava. This provenance, however, has been disputed. The piece has been variously reattributed to the Betsileo and the Bara. Vogel describes it as one of up to twenty posts which surmount tombs; she thereby unwittingly implies a Mahafaly origin as they, and some neighbouring Antandroy, are the only people in Madagascar who erect poles in this way.

The main problem arises from the assumption that the piece has been intended for use in a funerary context, whether to be placed singly or in combination directly on a tomb or set up as a memorial. Urbain-Faublée's reattribution to the Bara is based on the observation that the Sakalava were at the time of collection too independent 'to accept the erection of a religious monument'. The tomb sculptures associated with the Sakalava (but in fact the work of the Vezo, an independent maritime group on Madagascar's western coast) have a restricted distribution and are generally slotted into the corners of large box-like wooden tombs. There is no evidence on the complete post of any such jointing.

There are reasons to think that the pieces are nonetheless of southern Sakalava origin, as the Musée de l'Homme records suggest. A field photograph in archives in Madagascar shows this post not in an isolated cemetery but with a dwelling directly behind it. It appears to have been taken in a village. A caption suggests that it is a *hazomanga*, that is a village post at which sacrifice and circumcision take place. JM

Bibliography: Bassani and McLeod, n. d., pp. 66–7; Leenhardt, 1947; Urbain-Faublée, 1963; Kent, 1970, p. 236; Vogel, 1985, pp. 190–2

Spoon with male figure

Southern Sakalava (?)

Madagascar
wood

l. 31 cm

The Trustees of the British Museum,
London, 1947. AF.18.103

This spoon is a puzzle. It entered the museum's collection from an undocumented source via the large and wide-ranging collection of Philip Smith. The suggestion that it might be from the island of Madagascar was probably made by William Fagg, the African curator of the day (an identification which has been tentatively followed in at least one publication: Mack, 1986, p. 65). Yet there would seem to be no other directly comparable spoons from the island that would confirm Madagascar as the unequivocal source. Indeed, a recent general survey of African spoons includes a somewhat similar example to this (though of a female figure) which is identified as Yaunde-Fang and from the Cameroon-Gabon borders.

That said, there are certainly many decorative spoons produced in Madagascar, particularly in the south and south-west. If correctly identified as of this origin, this one may be of southern Sakalava manufacture. Throughout Madagascar sculpted spoons are found in use for the serving of rice on ceremonial occasions. Rice itself is consumed in large quantities in Madagascar, and is regarded as an indispensable element in any meal. It is more than mere sustenance, however; it is seen as the source of life and of human vitality. Rice is a sacred substance (*masina*), the product of the toil of ancestors. So, too, the spoons with which it is presented at special events may be handed down in villages as an appropriate ancestral inheritance. *JM*

Provenance: ex collection Philip Smith
Bibliography: Falgayrettes et al., n.d.;
Mack, 1986; Homberger, 1991

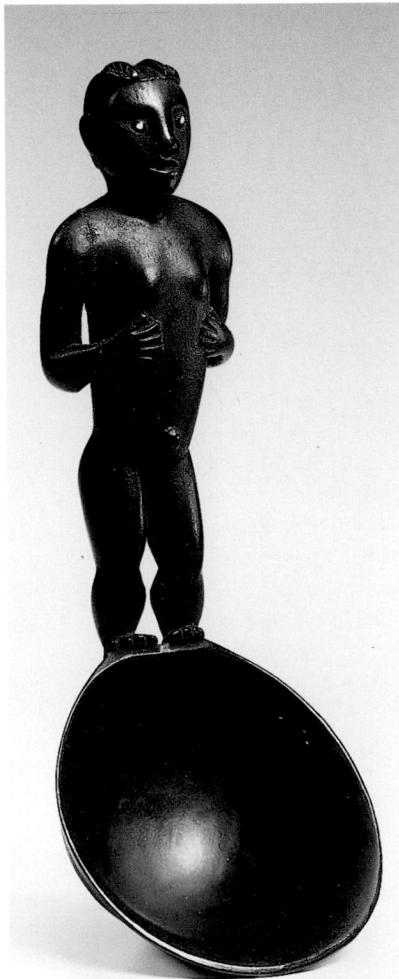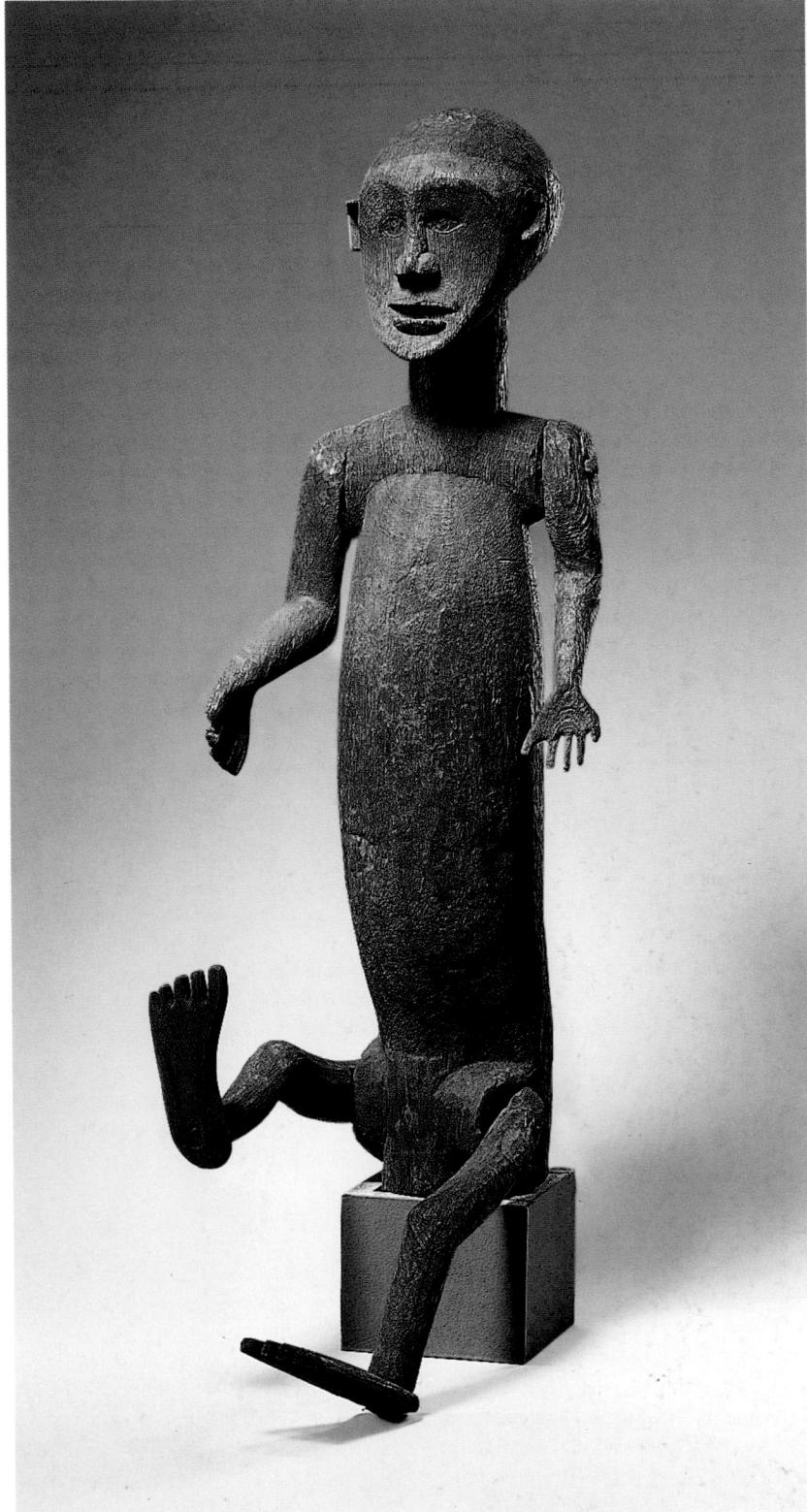**Funerary figure**Zaramo
Tanzania
late 19th century
woodh. 85 cm
Staatliche Museen zu Berlin, Preussischer Kulturbesitz, Museum für Völkerkunde,
III E 7260

The Zaramo was one of the first groups to be encountered by Europeans in east Africa yet, paradoxically, they remain little known. They live mainly in the coastal region of eastern Tanzania and are primarily dependent on cultivation of food crops, although fishing, cash crops and, in some areas, blackwood carving are also important economic activities. In pre-colonial

times the Zaramo had no centralised system of authority and leadership was held by lineage elders and by the heads of each autonomous village or village grouping (as was the case among most of the other related matrilineal peoples who inhabit eastern Tanzania). Village and matrilineage heads performed various judicial functions and conducted certain religious ceremonies, such as those intended to propitiate the ancestors or to purify the land. In the past some Zaramo leaders appear to have gained influence through their success in raiding Arab and Swahili caravans. Another way in which both men and women were able to achieve a degree of influence beyond their immediate matrilineage was by progressing through the ranks of a 'secret' association whose membership cut across kin and residential groups and whose highest ranks carried considerable prestige in the community. Initiation rites were staged in order to promote members and special rites were performed at the funerals of those of high rank.

Prominent Zaramo elders often had posts carved with anthropomorphic figures erected beside their graves and the figure illustrated here would appear to represent the top section of a rare form of Zaramo funerary monument of this kind. Very little is known about the circumstances that governed the erection of this particular form of funerary post but it would appear that such objects date from pre-colonial times. Based on the testimonies of two Zaramo informants, Felix suggests that this type of monument may have been constructed for prominent elders who died without leaving male offspring to praise them at the graveside. The figure would originally have been dressed in cloth and it was made with articulated limbs, apparently because the arms and legs were intended to be manipulated by a ritual expert at the burial ceremony. The ritual expert, who may have been a ventriloquist, made the figure move and talk as he sang the praises of the deceased elder. ZK

Provenance: 1899, collected by Stuhlmann
Bibliography: Beidelman, 1967; Felix,
1990, pp. 193-4

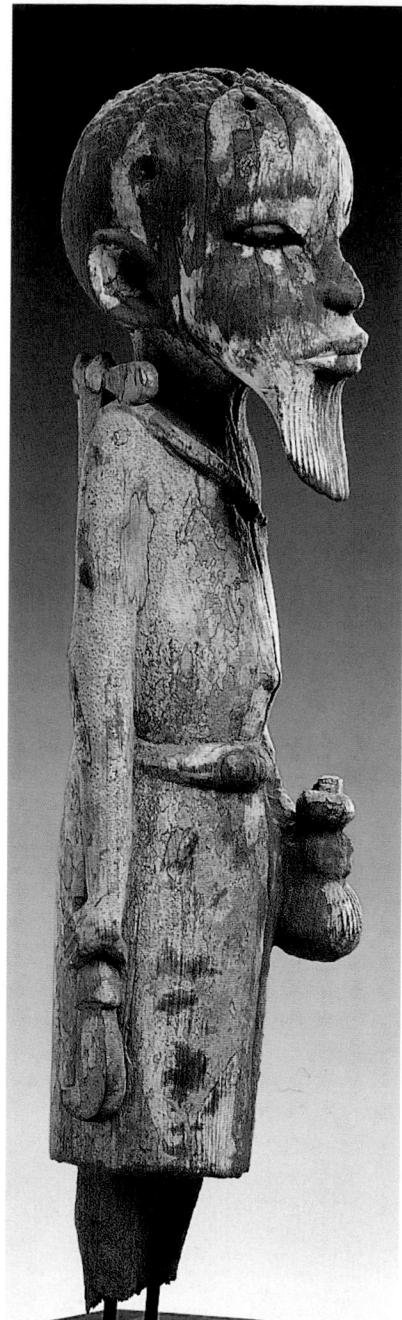

2.36

Funerary figure

Zaramo
Tanzania
19th century
wood
h. 36.8 cm
Musée Barbier-Mueller, Geneva, 1027-59

Zaramo commemorative monuments, erected over the graves of important elders, exhibit a variety of forms. Some examples are topped with sculpted heads, others are carved with full human figures, while a third category are carved with trunk-like (*Mwana hiti*) figures (see also funerary figure, cat. 2.35). Many of the more recent examples portray human

figures, carved in realistic style, which are thought to represent the individuals whom they are intended to commemorate. The grave monument figure illustrated here probably represents an elder who was a successful farmer because it portrays a bearded man carrying axe, bush-knife and water-gourd. The particular style in which this figure is carved recalls that of some of the finest Zaramo 'export' sculpture. This suggests that the well-developed mimetic skills of the carver, who would almost certainly have been involved in the creation of realistic wooden figures for foreign patrons, were called upon, in this instance, to serve the requirements of an indigenous sculptural practice. The figure may have been collected in the vicinity of Maneromango (a village about 64 km south of Dar es Salaam) where Lutheran missionaries first encouraged Zaramo carvers to begin producing realistic figures for European patrons before World War I. ZK

Bibliography: Elkan, 1958; Felix, 1990

2.37

Pole

Kwere/Zaramo
Tanzania
wood and metal
h. 128 cm
Private Collection

This unusual pole may be of a kind used in spirit possession ceremonies. Among the Zaramo, poles of this kind are called *mkomolo* or 'tree of recovery'. They are stood in the ground at the ritual site where they serve as a kind of backrest for the afflicted person. The staffs are carved with a hook from which gourds containing efficacious ritual substances are hung and they are decorated with strips of red and white material. The *mkomolo* is usually surmounted with a carved figure of a woman and child or with a stylised female trunk-like figure. This staff is unique for its tree-like, branching form surmounted by two large trunk-like female figures with a third, smaller, less stylised, bird-like figure below.

The trunk-like figure represents a core symbol in most of the matrilineal societies of north-eastern Tanzania. It combines both male and female iconography in that it takes the general form of a phallus yet is carved with breasts and represents a stylised, limbless female figure. Such figures may embellish a variety of culturally significant objects. The dual nature of the figure expresses the unity of life principles and it plays an especially important role in the female initiation rites. During her seclusion period a girl initiate is given a trunk-like figure which she ritually feeds and cares for in order to promote her growth, health and fertility.

Before primary spirit possession ceremonies, for example the *madagoli*, which is performed among the Zaramo, prayers are said and offerings made to the patient's ancestors, especially those who are known to have practised as possession cult healers. The ceremonial site is marked in a cleared space where the *mkomolo* staff (which represents the male life principle) is planted in the ground (which represents the female, regenerative life principle) in an act suggestive of copulation. The ceremony takes the form of a feast held in honour of the affecting spirit, which is called to participate and

which rises into the heads of patient and healer. The healer becomes possessed and is able to divine the spirit's wishes and also the identity of the particular ancestor who sent the spirit to afflict the patient. Once the ancestor is identified, the healer specifies the steps to be taken by the patient and his or her relatives to propitiate the offended ancestor. By emphasising the patient's links with the corporate kin group in this way, primary possession cults would seem to reinforce the unity and cohesion of the group and so reduce internal conflict between classes or factions.

ZK

Bibliography: Swantz, 1970;
Felix, 1990

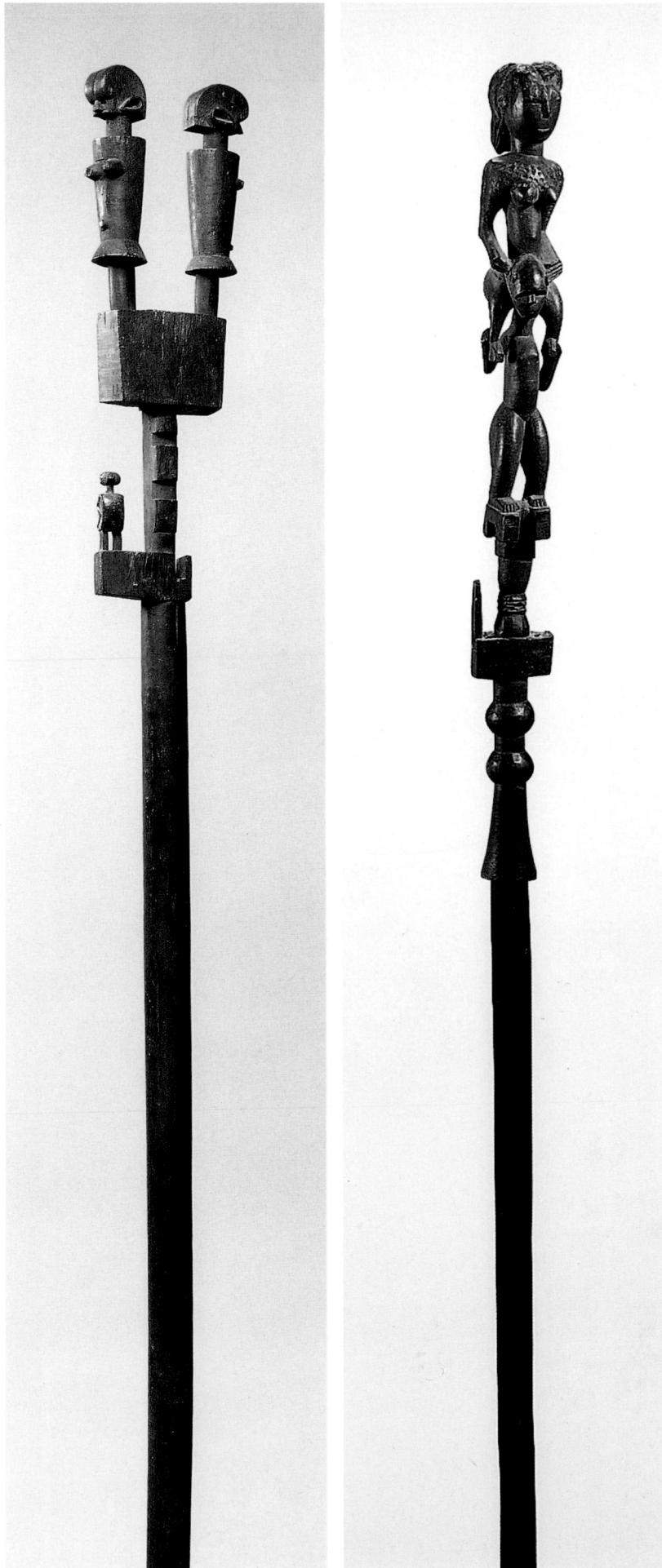

2.38

Staff

Kwere
Tanzania
early 20th century
wood
h. 142 cm
Felix Collection

The Kwere mainly inhabit the hinterland stretching inland from Bagamoyo town in north-eastern Tanzania. They have a predominantly agricultural economy and, as was the case with their southern neighbours, the Zaramo, had no centralised political organisation until an administrative hierarchy was imposed by European colonial powers in the late 19th century. The Kwere matrilineage was an autonomous political unit whose head was elected by the lineage elders; each village was also, to a large extent, autonomous and had its own head.

The rich cultural life of the Kwere includes elaborate ceremonial occasions. These are presided over by ritual specialists who may be lineage elders, leaders of spirit possession associations, diviners, healers or anti-witchcraft specialists. Ritual specialists were able to gain considerable social prestige and their influence sometimes extended well beyond their local kin and residential groups. Figurative staffs served to legitimate their special role and abilities and as tools in the ritual process. Staffs depicting the pickaback motif such as the one illustrated here were probably used in the context of male and female initiation rites, although they would also have been used in other contexts. They are carved with hooks on which gourds containing ritual substances were hung. Both male and female initiates are carried pickaback to the site where important rites in the initiation complex take place. In the male rites the initiates and their bearers are led to the ceremonial site by the ritual expert, who may carry a staff carved with the pickaback motif. According to Felix, staffs of this kind were sometimes also planted at the ceremonial ground and served to consecrate the site. ZK

Bibliography: Brain, 1962; Felix, 1990,
pp. 167–8

2.39

Mask

Kwere
Tanzania
early 20th century
wood
h. 50.5 cm
Fred Jahn Gallery

A variety of initiation associations or 'secret' societies existed among the Kwere and the other matrilineal peoples of eastern Tanzania during pre-colonial times. These were hierarchically organised institutions whose membership was drawn from a number of different lineages and villages. Both male and female associations existed and some may have permitted both men and women to become members. High ranking members held insignia in the form of objects such as figurative staffs (see cat. 2.38), animal tail whisks and bracelets. During the period of German rule initiation associations were instrumental in co-ordinating opposition against an oppressive colonial regime. They were therefore banned after the *maji-maji* uprisings of 1905, and by the beginning of World War I had largely died out.

Progress through the ranks was effected through the staging of special initiation ceremonies involving song and dance. Masked dancers also performed during special funeral rites for association members. Very few examples of Kwere masks have ever been collected and almost nothing is known about Kwere masquerade. According to evidence collected by Felix, however, the Kwere and the Zaramo may have used several types of mask including a 'war mask' and a mask danced at ceremonies connected with initiation. *ZK*

Bibliography: Felix, 1990, pp. 185–6

2.40

Pole

Kaguru
Tanzania
wood
215 x 20 x 22 cm
Felix Collection

The Kaguru inhabit the Itumba Mountains in north-eastern Tanzania, the plateau region to the north-west of the mountains and the lowland area to the east. They are predominantly agriculturalists. Social life traditionally centred primarily on the matrilineage, with male members of senior lineage segments generally inheriting ritual and jural authority.

Much of Kaguru ritual appears to have involved manipulation of symbols and ideas concerning the interplay of male and female life principles. Figurative poles and other objects (male symbols) were frequently carved with female imagery to create ritually powerful conjunctions of male and female symbols. Such artefacts were used in a variety of ceremonial contexts. Felix indicates that figurative poles were erected in meeting houses used by the 'secret' associations (now extinct). They were also erected outside Kaguru houses, often under thatched shelters, and served to protect the village from mystical dangers.

The pole illustrated here would originally have formed the central post of a Kaguru girls' initiation hut, although it is possible that similar poles may also have been used in the contexts mentioned above. The form of the pole is intended to represent an abstract female figure, as is suggested by the prominent breasts. The bifurcation at the top of the pole is thought to represent the traditional divided hairstyle which is a motif common to much of the figurative art of the matrilineal peoples of north-eastern Tanzania. Like certain other forms of ceremonial paraphernalia, including staffs and poles, formerly widely used during initiation rites in the region (and best known from Zaramo and Kwere examples), this pole may have served to help protect and ritually empower female initiates during their seclusion within the initiation hut. *ZK*

Bibliography: Beidelman, 1972, p. 41; Felix, 1990; Felix, in Berlin and Munich 1994, p. 223

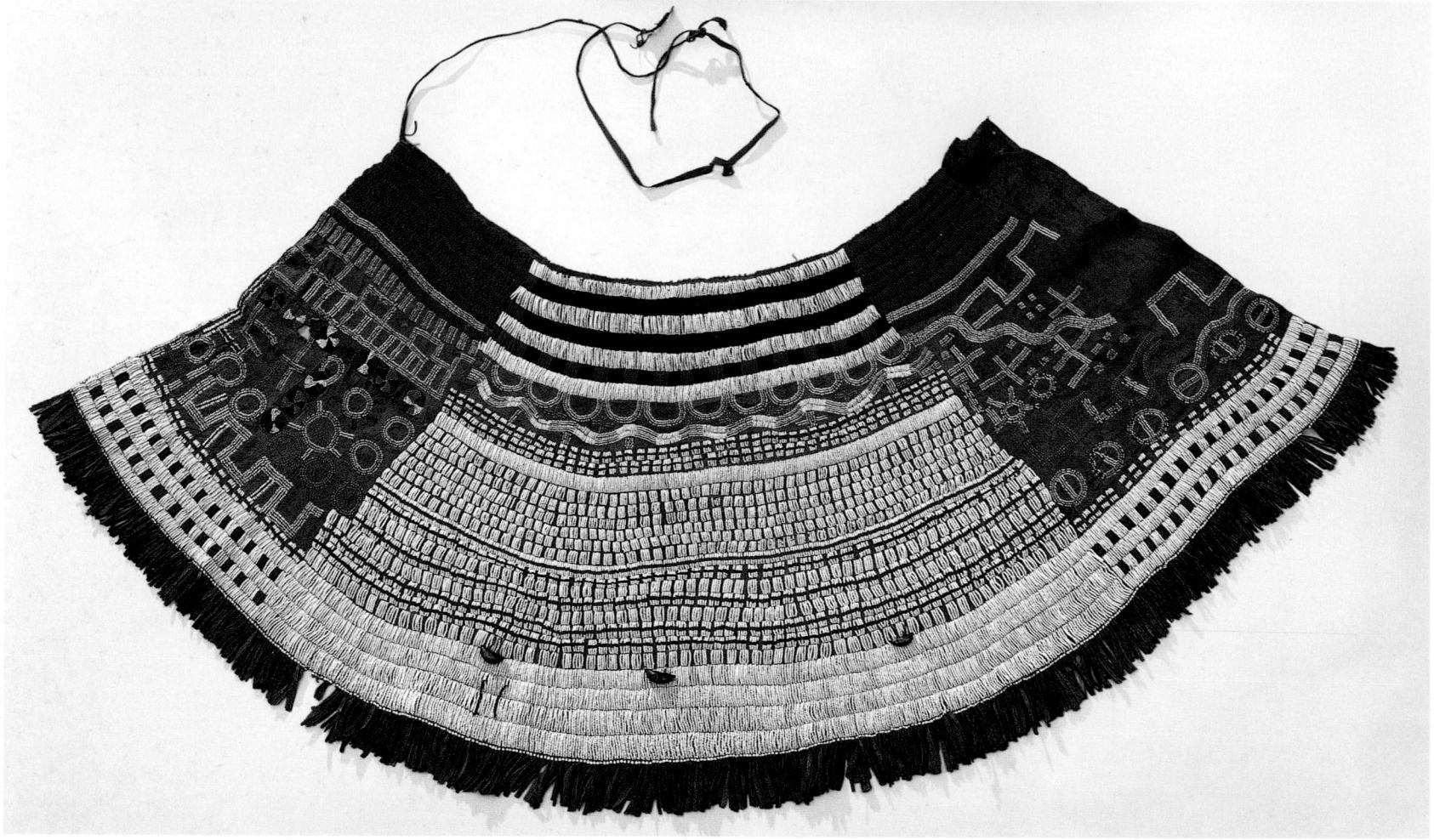

2.41

Skirt

Iraqw

Tanzania

early 20th century (?)

dressed animal skin, glass beads,
sinew thread, metal bells

170 x 70 cm

Commonwealth Institute, London,
T/TANZ/134

The Iraqw peoples, numbering today perhaps as many as 300,000 or more, inhabit the Arusha region of northern Tanzania. Although they are often said to be Southern Cushitic-speaking, the classification of their language remains disputed. The Iraqw keep livestock and grow crops on a plateau to the west of the Rift Valley. Their neighbours are the Maasai, Hadza, Barabaig and Gorowa, as well as several Bantu-speaking peoples. Their art and material culture have been little studied.

Iraqw beaded skirts are arguably the most elaborately decorated items of dress in eastern Africa, and this one is an excellent example of the tradition. It consists of four hide

panels, on which thousands of glass beads have been applied with a lazy-stitch to form a number of bands and geometric motifs. It is also adorned with three bells. The central panel was worn at the back, while in front the right edge was wrapped over the left, the two ends being tied. The skirt must be imagined wrapped around the waist of a young woman whose movements, whether walking or dancing, are constrained by the weight of the skirt (perhaps 15 kg or more) and emphasised by the swaying of the fringe and the tinkling of the bells. A fully dressed girl would also be adorned with anklets, wristlets, bracelets and necklaces, as well as having oiled and perfumed skin and specially dressed hair. The range of colours of the beads employed here – predominantly the basic contrasting colours white, red and black, with some dark blue and a little yellow – is typical of earlier eastern African beadwork; later examples incorporate a range of other, complementary colours, such as light green and light blue.

The history of this skirt before 1979 remains uncertain; any attempt to date it is speculative. The traditional context in which such skirts were made and used, the girls' initiation ritual Marmo, was abolished by the government-appointed chief, at least publicly, in 1930. In this rite of passage girls of the age of fourteen or so were secluded for a period of between six months to a year and underwent a symbolic death and rebirth: during this time they were fed rich foods so that they became fat; their bodies were oiled, perfumed and decorated; and they were taught sexual manners and the secrets of the exclusively female Marmo Society. The rite also seems to have had an important purifying aspect, so that the young girls were reborn with a new innocence and dignity. In addition, during this period each girl turned the leather cape with which she entered seclusion into an elaborately beaded skirt to her own design.

Despite its public abolishment, elements of Marmo have survived. Songs associated with the ritual

continue to be sung at ceremonies and beaded skirts to be worn. It is also possible that at least some women have continued to practise a version of Marmo, the secrets of which remain guarded by initiated Iraqw women; therefore, while it seems likely that the motifs decorating this and similar skirts have symbolic significance, their meanings are unknown to outsiders. In other contexts at least, however, the colour white (*awaak*) has associations with light, clarity, health, well-being, healing, curing and purification. It may be that the white beads that dominate this and other skirts symbolise in some way the new purity of the Marmo initiate. JXC

Provenance: by 1979, Commonwealth Institute, London

Exhibition: London and New York 1979–83

Bibliography: Wembah-Rashid, 1974, covers and p. 4; Perham, 1976, p. 95; Picton and Mack, 1979, p. 180; Thornton, 1980; Oliver and Crowder, 1981, p. 422; Wada, 1984; Carey, 1986, pp. 21–2, 26, fig. 17

2.42

Omusinga holder

Banyambo
Karagwe, Tanzania
18th–19th century
wrought iron
h. 72 cm
Marc and Denyse Ginzberg

Omusinga holders were used to hold sticks of the plant *Hibiscus fuscus*, a much-branched shrub growing to three metres. Clearly these holders were important items in the royal insignia as there were at least 50 of them, representing a considerable labour of highly skilled blacksmithing. Photographs of the Karagwe insignia taken in 1928 show a number of holders planted in the ground and holding long straight sticks which were named by a local informant as *omusinga*. And in 1966, when the former king, Rumanyika II, was visiting a village, he was presented with sticks of this plant. An oral tradition records that during new moon ceremonies the holders with sticks were placed in the ground to screen the royal drum *Nyabatama*. The fibrous quality of *omusinga* made it useful as a toothbrush, and it was also used to beat sour milk. But perhaps most significantly, its long straight sticks were used for spear shafts.

In this virtuoso example the seven-ply plaited iron shaft supports seven sockets; the distal end is pointed.
HS

Bibliography: Stanley, 1878, p. 473;
Stuhlmann, 1910, pp. 77–8, figs 41–5

2.43

Wrist guard (*igitembe*)

Tutsi
Burundi
first half 20th century
wood, copper
21.5 x 17.5 cm; thickness 10 cm
The Trustees of the British Museum,
London, 1948. AF. 30.5

There is very little written documentation about the wrist guards worn by bowmen. Normally functional, with no special claim to artistic merit, they are usually worn on the left wrist, to protect the archer's forearm from being bruised by the recoil of the bowstring. In the Western world a wrist guard is likely to be a leather gauntlet; in some parts of Africa a pad may be worn; in Rwanda the Tutsi used a thick bracelet made of a grass hoop covered with plaited grass in a chequer pattern of black and white.

A massive wooden wrist guard (*igitembe*) is a rare object. As described by Celis, this one comes from Burundi. There seems to be no other mention of such guards in the literature. This may in part be due to the fact that they do not look like archers' wrist guards, and may be taken for bracelets. The present example is heavy, penannular with a gap of only 28 mm; the central hole measures 55 mm at its greatest width. The wood is inlaid with thirteen small copper squares, three sunbursts of radiating lengths of copper wire and numerous small copper circles, making a balanced design. The copper

would have come from Katanga in Zaire, and the wire appears to be hand-drawn. Such a wrist guard would appear to belong to an archer of high rank, perhaps one of the royal bodyguard, as an insignia of office.
MC

Provenance: Daniel P. Biebuyck; purchased by the museum from M. de Beer, Brussels

Bibliography: Celis, 1970, p. 41; Sieber, 1972

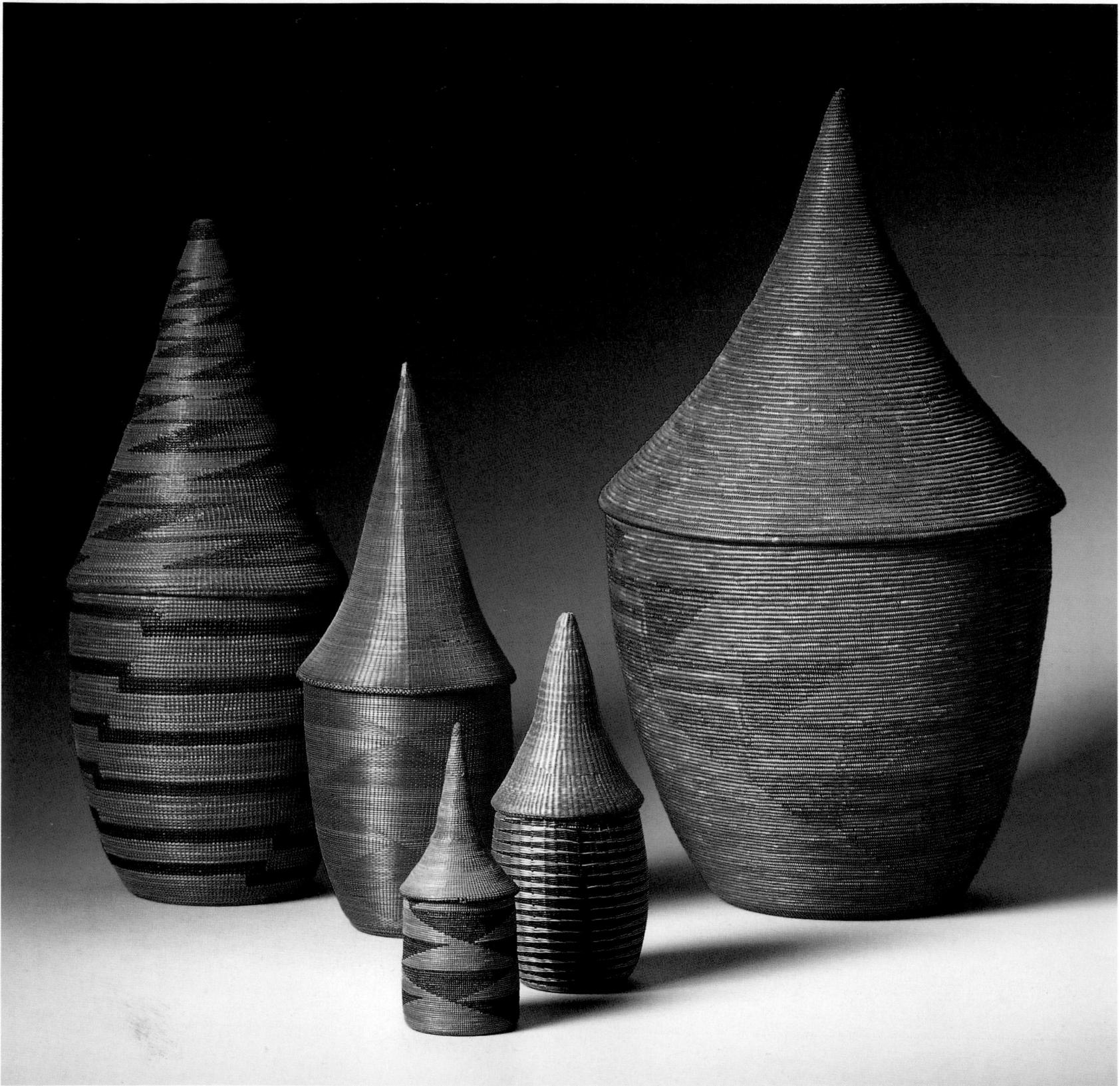

2.44a

Five miniature baskets

Tutsi

Rwanda and Burundi

first half 20th century

grass; black and red dye

h. 28 cm; 25 cm; 11 cm; 14 cm; 33 cm

Private Collection

Coil-sewn baskets (*agaseki*) with conical lids were made by Tutsi women of the aristocracy. The fine coil sewing and the precisely worked out spiral patterns, many of which have names, was time-consuming, and called for exact calculations in the stitching. Since the Tutsi were the ruling group in Rwanda, their women had the leisure they needed to perfect their skill in making these ultra-fine and elegantly patterned containers, which were often miniature marvels, some no more than 15 cm high overall. Small, flat, saucer-shaped basketry trays (*agakoko*) were made originally for presentation. The restrained colour palette and subtle variations of pattern, based on spiral lines and zigzags with triangles incorporated, make this among the world's most refined achievements in basketry.

2.44b

Two basketry trays

Tutsi
Rwanda
1940s
grass; orange, mauve and dark blue imported dyes
diam. 9.5 cm, 12 cm
The Trustees of the British Museum, London, 1948. AF. 8.422/1

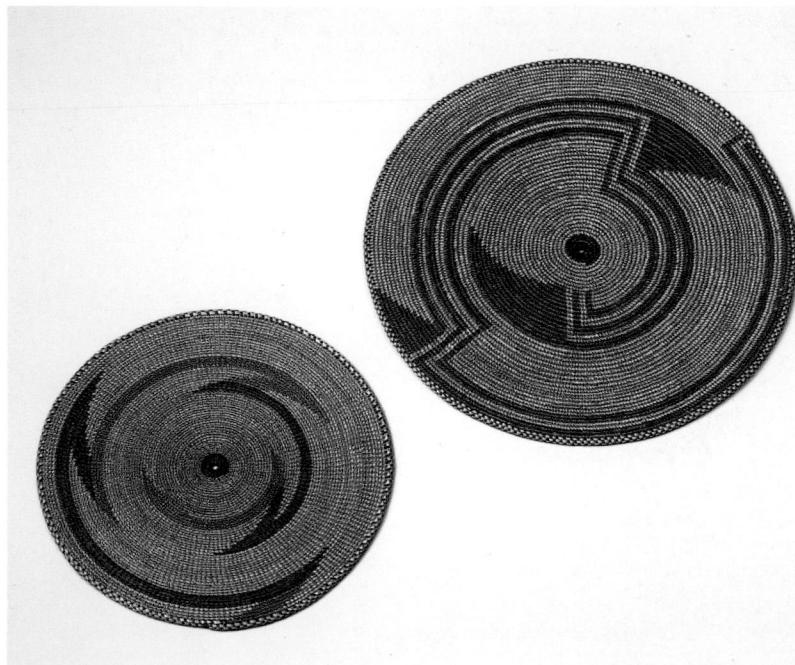

The traditional colours were the natural pale gold of the grass with the pattern in black or red. Black came from boiling banana flowers – the sap gave the black dye *inzero*. The red dye came from boiling the root and seeds of the *urukamgi* plant. By the 1930s imported dyes had expanded the range of available colours to include green, orange and mauve.

Earlier baskets, such as these lidded ones, show a delicacy of design that later examples, made at craft centres for sale to tourists, lack. Baskets made in Rwanda have a plain, undecorated lid; lids of those made in Burundi may be patterned. MC

Provenance: 1948, the larger tray collected for the museum, with documentation, by J. Lister

Bibliography: Trowell and Wachsmann, 1953, pp. 141–2, pl. 31A; Celis, 1970, pp. 40–2

2.45

Shield

Kerebe/Kara
Tanzania
wood, fibre and pigments
125 x 34 cm
Museum für Völkerkunde, Vienna, 60751

Bukerebe is a large fertile island in south-eastern Lake Victoria which supports dense banana groves and cultivation of millet and other crops. Originally settled by sections of Bantu-speaking clans from the mainland (including a large segment of the Jita group and a smaller section of the Kara) Bukerebe came under the control of Sese immigrants from the western lakeshore area whose ruling clan, the Silanga, established a chiefdom on the island in the 17th century. Sese power was concentrated in a chiefly court which appointed regional headmen from the Silanga clan. Before the colonial era and the deposition of chief Rukonge in 1895, Kerebe society was organised according to a strict ethnic hierarchy in which the majority Jita and Kara inhabitants held a subservient position with respect to the Sese. The activities of missionaries and European administration, along with the introduction of the cash economy, set in motion a process of 'democratisation' and a breakdown in the old order which has more or less continued to the present.

Although the shield illustrated here is typical of the kind found on Bukerebe and Bukara islands, similar shields also appear to have been used by Zinza people who inhabit the mainland south-west of the lake. The pattern of repeated isosceles triangles, carved in relief and painted, is a common form of decoration on shields from this area. The juxtaposition of white, red and black colours is a widespread motif in Bantu-speaking Africa and may relate to a common underlying element in the belief systems of these societies. However, the particular significance of these three colours as they are painted on the shield is not known. Shields of this kind would probably have ceased being made in the 1940s. ZK

Bibliography: Hartwig, 1969; Hartwig, 1976; Plaschke and Zirngibl, 1992, pp. 78–9

2.46

Presentation figure

Nyamwezi/Kerebe
Tanzania
wood
83 x 21 x 6 cm
Private Collection, London

This female figure represents something of an enigma. The Kerebe from the island of Bukerebe in south-eastern Lake Victoria are not known to have produced any figurative wood sculpture until some time after the deposition of 'Chief' Rukonge by the Germans in 1895 when a man called Buzuuya (who was originally a carver of shields for Rukonge) began making human figures mainly for the European market. The few available published illustrations of Buzuuya's work show that his figures were generally straight-limbed with short arms and large, somewhat spherical, heads. The long arms, bent limbs and more realistic head of the figure illustrated here would therefore indicate that it is not one of Buzuuya's works. The cross-hatched scarification marks which decorate the chest and abdomen of the piece also suggest that it is not the work of a Kerebe carver. In its posture and proportions the sculpture bears a certain resemblance to a *kigiilya* figure (cat. 2.47). The *kigiilya* figure was carved on Bukerebe island by a Nyamwezi member of an ivory trading expedition, and it would seem likely that the sculpture shown here is also the work of a Nyamwezi carver. The production and presentation of such figures probably represented one way in which Nyamwezi traders or trader emissaries were able to enhance their standing with powerful chiefs in the lake region. The *kigiilya* figure is known to have been used by the Kerebe chiefs Machunda and Rukonge in the exercise of power, although other figures of this kind appear to have been used only for show by their Kerebe recipients. ZK

Bibliography: Hartwig, 1969¹; Hartwig, 1976

The improbable tale which accompanies this sculpture is highly instructive about the nature of art history in eastern Africa. The story was unravelled by the late Gerald Hartwig. The comments which follow derive mainly from his detective work both in eastern Africa and in relevant museum archives elsewhere.

The first problem which arises concerns the identification of the piece. It is generally said to be of Kerewe (or better, Kerebe) origin, that is from the people who occupy the island of Bukerebe in the south-eastern corner of Lake Victoria; and indeed, the figure was certainly originally in the care of a Kerebe chief (*omukama*) called Rukonge. He had obtained it on inheritance of his title from his father Omukama Machunda. Furthermore, the piece was much respected in Kerebe society for its reputed powers. On the day of its completion Machunda's uncle died and the two events were inseparably linked. It became common knowledge that the man in question had not died but had mysteriously translated into the figure, and that Machunda himself had enabled this transformation. The event took place sometime before 1869, the year of Machunda's death. Until the figure was removed in a military mission in 1895, it was kept securely in the chiefly quarters and seen only by leading Kerebe and privileged visitors. It has thus an undeniable place in the context of Kerebe chiefly power in the second half of the 19th century.

Hartwig, however, was able to confirm that the work was not, in fact, created by a Kerebe carver, and indeed that there was no extensive tradition of Kerebe carving before this century. Bukerebe island was much frequented by the Nyamwezi who acted as emissaries of the Arab-Swahili trading outpost set up at Tabora, in what is now Tanzania. The figure, it seems, was created by a Nyamwezi carver who accompanied an ivory trading expedition to the island. Its naturalistic style and large format certainly bear little relationship to the figures from the eastern side of Lake Tanganyika which have more in common with Zairean traditions of carving.

A second figure in a similar style to this piece – this time of a female – is in the collections of the British

Museum. This piece was acquired by a well-known missionary, the Rev. John Roscoe, in Uganda; here it was said to have been created for the Ganda king (*kabaka*) Sana, who died in 1856. But Machunda and Sana were contemporaries and are known to have engaged in diplomatic exchanges. This second piece would seem to have been one example of such gift-giving. It is remembered by the Kerebe that the arm was broken when Kabaka Sana received the figure (a feature that still distinguishes it). It too is probably of Nyamwezi manufacture.

The sculpture illustrated here also had a chequered history once it left the keeping of Omukama Rukonge. It first fell into the hands of the resident White Fathers who used it to demonstrate the supposed perils of paganism. Its present battered appearance is testament to its treatment. The object was reputedly beaten with sticks, its eyes gouged and its sex organs removed – victim of acts of revenge against the Omukama and his people who had attacked a group of native converts. Thus this piece, like its companion sculpture in the British Museum, has been recontextualised at least twice within Africa itself before it ever reached a museum collection. JM

Bibliography: Fagg, 1965, p. 115; Hartwig, 1969

2.47

Presentation sculpture and power figure (*kigiilya*)

Nyamwezi/Kerebe
Tanzania/Lake Victoria
wood
h. 114 cm
Staatliche Museen zu Berlin, Preussischer
Kulturbesitz, Museum für Völkerkunde,
III E 5529

Nyamwezi

The people known as Nyamwezi are a large, loosely connected agrarian group with shared cultural traits but diverse origins who live in north-central Tanzania. Since the early 19th century they have been organised into small semi-autonomous chiefdoms, except for a period in the late 19th century when two strong chiefs, Mirambo and Nyungu ya Mawe, established separate hegemonies in extensive portions of Unyamwezi (the land of the Nyamwezi). At this time the Nyamwezi were increasingly involved in the caravan trade that crossed their territory, and many of them travelled between the Congo (now Zaire) and the Indian Ocean trading towns. It was on the coast that they were given the name 'Nyamwesi', meaning 'people of the west' (sometimes translated as 'people of the moon', because the new moon is visible only as it sets in the west).

Because of the extensive size and ethnic diversity of Unyamwezi the art from this area shows considerable variation in style, even though the principal art forms, such as discrete human figures and figured high-backed stools, are of similar type. Ancestors and chiefs have been of considerable importance in the belief system and socio-political structure of the Nyamwezi, and consequently most of their art relates to these themes: theirs is one of the richest art traditions in Tanzania. NIN

Bibliography: Murdock, 1959, p. 359; Abrahams, 1967, pp. 11–12; Were and Wilson, 1972, pp. 79–86

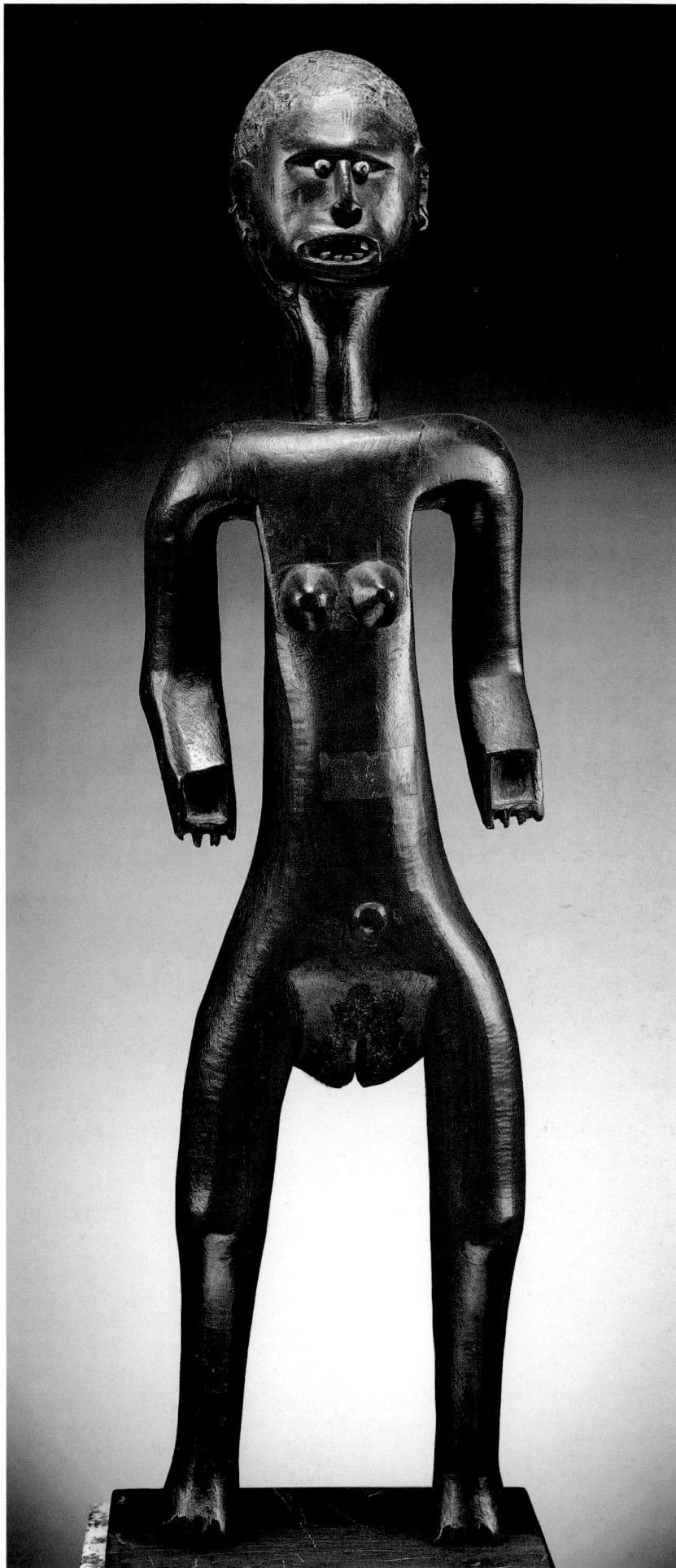

2.48

Female figure

Nyamwezi
Tanzania
c. 1900
wood
h. 74.5 cm
Private Collection

This figure exemplifies some of the finest qualities of Nyamwezi sculpture, seeming almost to burst with dynamism and exuberance. Its animated facial expression, enhanced by the beaded eyes and open mouth garnished with teeth, as well as its

taut and vigorous posture, are expressive of strong feeling and kinetic energy. Like the Nyamwezi high-backed stool (cat. 2.49) it has a compelling emotional quality.

The figure's grimacing countenance and the addition of hair and teeth suggest that it comes from an outlying area of Unyamwezi, probably influenced by the art traditions of an adjacent people to the east, such as the Sukuma who form part of the Nyamwezi group; similar features are sometimes seen on Sukuma masks or figures. While the central Nyamwezi style is usually characterised by a contained serenity of aspect and form, Sukuma art is more expressionistic and animated. Like virtually all free-standing sculptures of the Nyamwezi, this piece probably represents an ancestor. *NIN*

Provenance: 1900, collected in Tanzania

Bibliography: Holy, 1967, pp. 34–5; Gillon, 1984, p. 327; Leurquin and Meurant, 1990, pp. 19–20; Felix, Kecskési et al., 1994, pp. 233–4, 266–82, 408–13

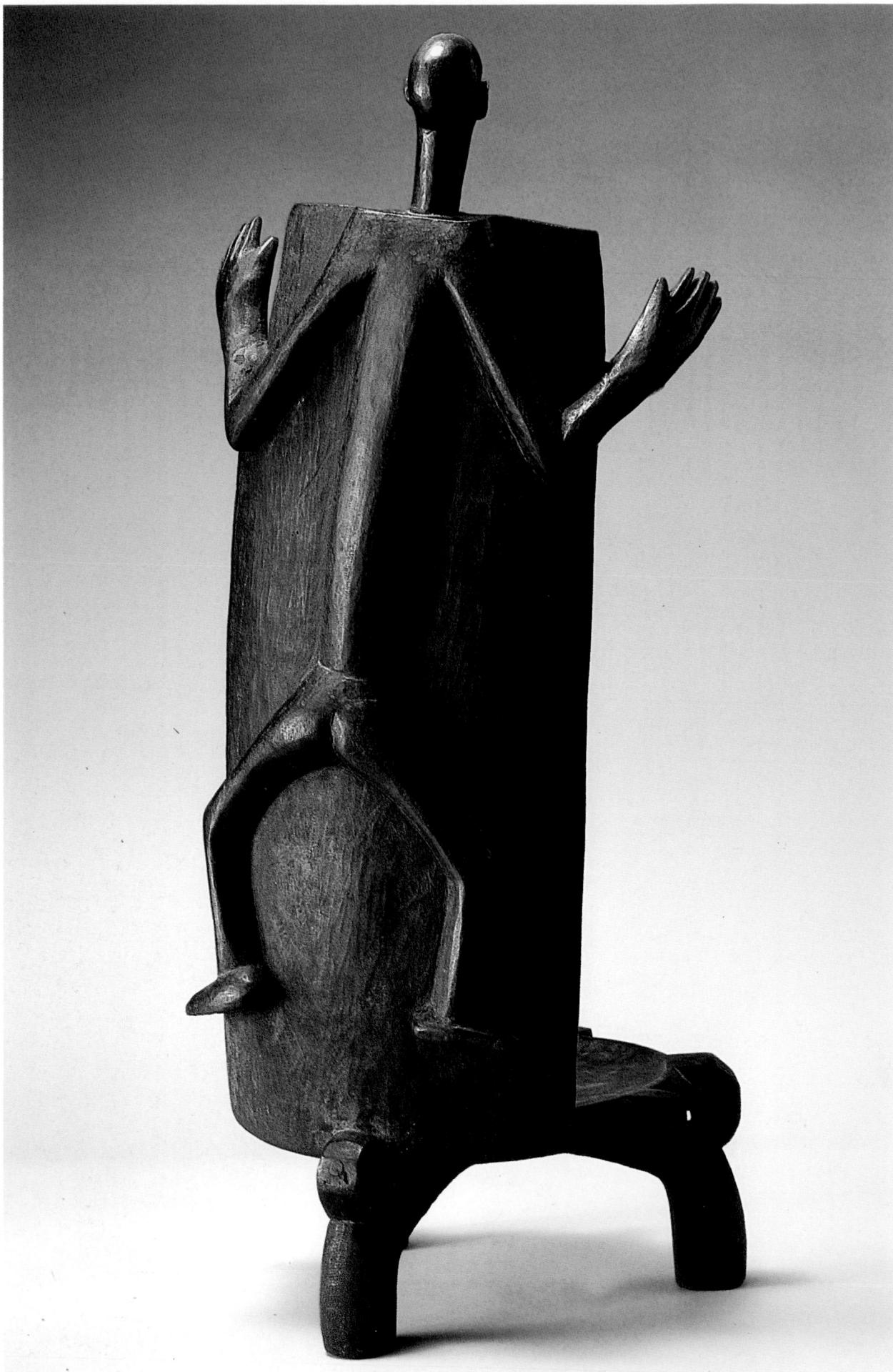

High-backed chief's stool

Nyamwezi
Tanzania
late 19th century
wood
h. 107 cm
Staatliche Museen zu Berlin, Preussischer Kulturbesitz, Museum für Völkerkunde, III E 6720

This is arguably the most famous piece of Nyamwezi art, known for both its history and its aesthetic qualities.

Collected by Lt von Grawert in 1898 from the Sultanate (or chiefdom) of Buruku in eastern Unyamwezi, this stool had been the property of the Sultan. The term Sultan, used in east Africa to designate chiefs along the Swahili coast, was also applied to important non-Arab chiefs who ruled in areas along the caravan trade routes that passed through the heart of Unyamwezi.

Stools with high carved backs were reserved for chiefs and sometimes used in pairs (one for the chief, the other for the consort), generally revealing male or female attributes. This example has a human figure carved on the dorsal side of the high back, with head and hands projecting from the edge of the backrest as if to embrace or protect the occupant of the throne. The head of the figure shows strong Nyamwezi characteristics, with beaded eyes, lean facial structure and prominent, pursed lips. But the object is most readily identified by the form of the stool base. The three convexly curved legs alternating with three protruding lugs are typical of Nyamwezi stool forms.
NIN

Provenance: 1898, collected by Lt. von Grawert from the Sultan of Buruku
Bibliography: Blohm, 1935, pp. 140–1; Fagg, 1965, p. 117; Wembah-Rashid, 1989; Krieger, 1990, p. 22, pls 102–5; Nooter, in Felix, Kecskési et al., 1994, pp. 294ff.

Female figure on stool

Nyamwezi
Tanzania
wood
h. 94 cm
Private Collection

Throughout Africa, stools signify status and rank. Figures shown seated or standing on stools are thus imbued with special meaning as expressions of spiritual or temporal power. This Nyamwezi figure probably represents a female ancestor, or refers to a chiefly lineage.

The tradition of using high-backed stools among chiefly societies in east Africa appears to have followed migration and trade routes. Similarly, stool-figures show patterns of occurrence on both sides of Lake Tanganyika among peoples governed by chiefs. In this part of the continent the most prolific expression of the convention has been found among the Tabwa people of south-eastern Zaire. It is known that there has long been communication between the Tabwa and groups across the lake in Tanzania, including the Nyamwezi.

This Nyamwezi stool-figure differs from Tabwa examples in several respects. The figure is female, whereas the illustrated Tabwa figures on stools are male. All Tabwa pieces are full figures, while the Nyamwezi is a trunk; only the head and torso are depicted. Its style conforms to that of the central Nyamwezi, with such features as an erectly held head, prominent ears, beaded eyes and pursed lips. The typically long and slender torso rises from a stool form that is prevalent in Unyamwezi. Even though other Tanzanian peoples are known to have stool-figures – for example, the Jiji figure in the Linden-Museum, Stuttgart, and the Tongwe figure (cat. 2.53) – their large number among the Tabwa suggests that the idea originated in Tabwaland and spread eastward to the (Tabwa-related) Jiji, the Tongwe, the Nyamwezi and others further east.
NIN

Bibliography: Hartwig, 1978, p. 64; Roberts and Maurer, 1985, pp. 106, 116, 122, 148, 246; Nooter, 1994, pp. 294–306

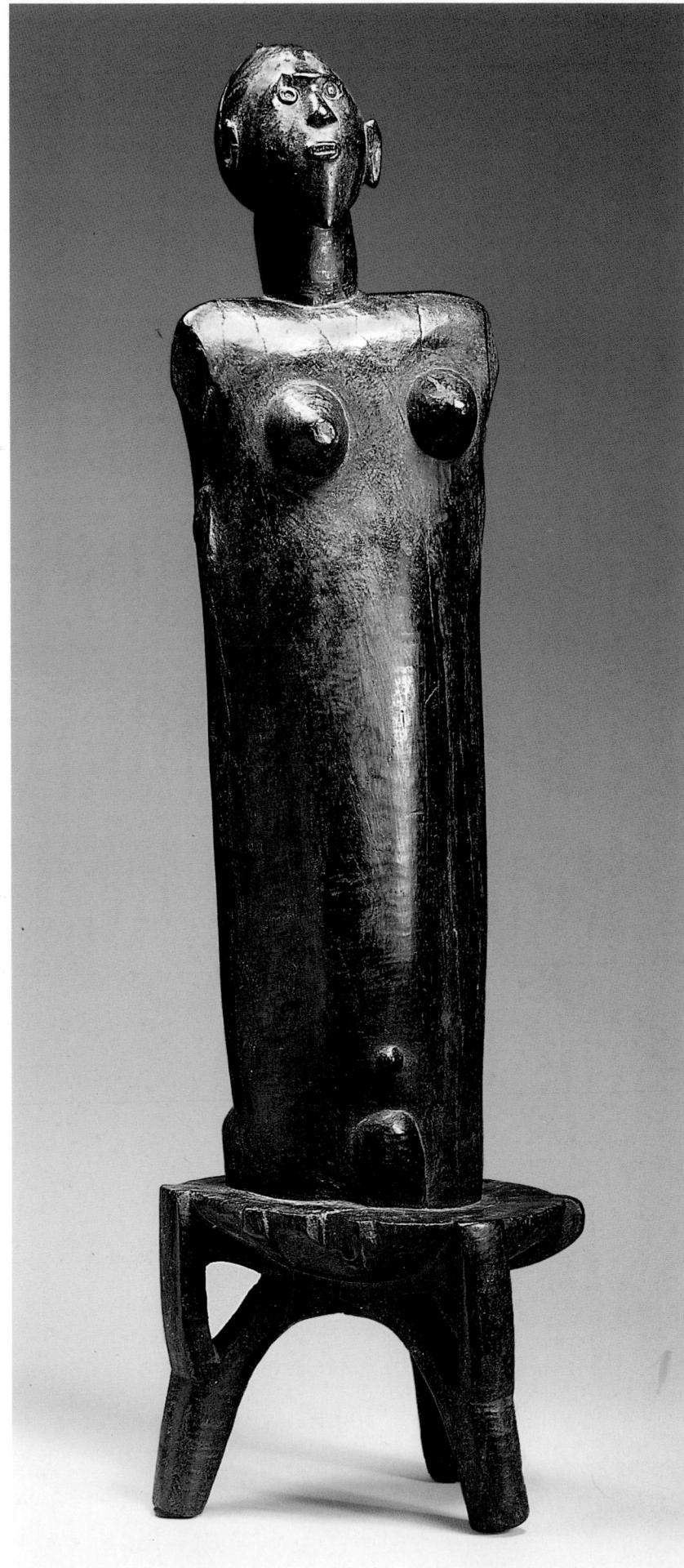

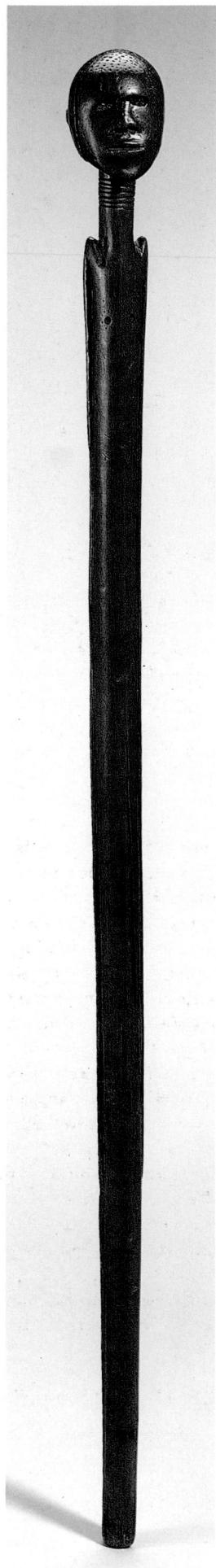

2.51

Staff

Nyamwezi
Tanzania
wood
h. 97.5 cm
Private Collection

In Africa, staffs have long had numerous and varied uses, ranging from their purely utilitarian function as walking-sticks to more exalted roles pertaining to spiritual, political or prestige matters. In addition, they sometimes communicate specific messages through their iconography, thus serving as documents whose sculpted forms can be understood as narratives. The degree of specialisation in the use of staffs by any group generally corresponds directly to the complexity of a staff's decoration.

This spare and elegant Nyamwezi staff probably served as the prestige emblem of a local chief. The integrity of its form and design does credit to the artist, who understood its role as both body support and statement of rank. The staff's overall structure and the delicate details of its carving are in artistic harmony, with facial features that are finely pared, strong, and enhanced by small pierced patterns indicating hair and beard. The notched shoulders and the arms rendered in relief along the sides of the staff are characteristic of its understated refinement. *NIN*

Bibliography: Felix, Kecskési et al., 1994, p. 262; M. N. Roberts, in A. F. Roberts, 1994², p. 24

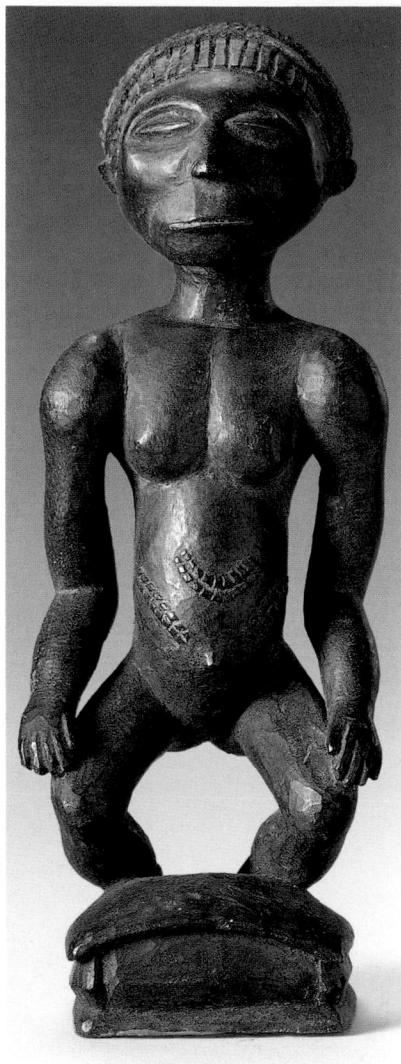

2.52

Female figure

Holoholo
Eastern Zaire/Tanzania
wood
h. 26 cm
Staatliche Museen zu Berlin, Preussischer Kulturbesitz, Museum für Völkerkunde, III E 12750

The Holoholo are a small group who occupy a portion of land on the western shore of Lake Tanganyika and some of whom have migrated to the Tanzanian side of the lake. They live in close proximity to the Hembra and Tabwa peoples, and fall within the Luba sphere of influence. Stylistic similarities to the art of these groups are very marked in this piece, as they are in other examples collected from the Holoholo at around the same time.

The matrilineal Holoholo are descended from the Baguha and other small ethnic groups of eastern Zaire. Although they now are governed by hereditary village chiefs and councils of elders, they maintained until the late 19th century a more stratified type of political organisation that is reflected in their early figural sculpture. Holoholo statuary known from this previous period bears the hallmarks of high social status, with elaborate coiffures, patterns of scarification, delicately rendered facial features and smoothly patinated surfaces, as are seen in this example. Balanced upon a base, with the feet only barely indicated by a single curved platform, this figure radiates confidence, serenity and strength. *NIN*

Provenance: collected in the former Belgian Congo (Zaire); 1907, donated to the museum by Schloifer

Bibliography: Schmitz, 1912, pp. 425–6; Murdock, 1959, pp. 296–300; Fagg, 1965, p. 104; Krieger, 1978, pl. 244, p. 115; Felix, 1989, pp. 201–3

2.53

Male figure on stool

Utongwe
Western Tanzania
wood
h. 78.5 cm
Bareiss Family Collection

The term Utongwe refers to the area or place of the Tongwe, a small group living among the Bende of western Tanzania on the central part of the eastern shore of Lake Tanganyika. Except for this object, virtually no art is known from the Tongwe, and very little has been discovered from the Bende who surround them.

Since the early 1900s chieftainship has been a strong institution in western Tanzania, largely influenced by the political system of the Interlacustrine kingdoms to the north. Therefore it is not surprising that figural art and chiefs' thrones from this general area relate to power and prestige.

This male figure from Utongwe eloquently expresses the qualities of dignity and leadership. Its carving bears stylistic similarities to that of the Jiji just to the north, who are an offshoot of the Tabwa people across Lake Tanganyika in Zaire, as it also does to the art of the Tabwa themselves. Allen Roberts points out that several groups, including the Bende and Tongwe, claim a common origin with the Tabwa. The facial features and elaborated coiffure of this figure show strong Tabwa influence, as does the convention of a human figure standing on a stool, which according to Evan Maurer is a sign of rank and status. These attributes suggest that the figure probably represents a chief.

NIN

Bibliography: Murdock, 1959, pp. 359–62; Fagg, 1965, p. 116; Holy, 1967, pl. 29, p. 45; Krieger, 1978, pls 104–7, pp. 22–3; Roberts and Maurer, 1985, pp. 116, 148, 161; Felix, Kecskési et al., 1994, pp. 359–60

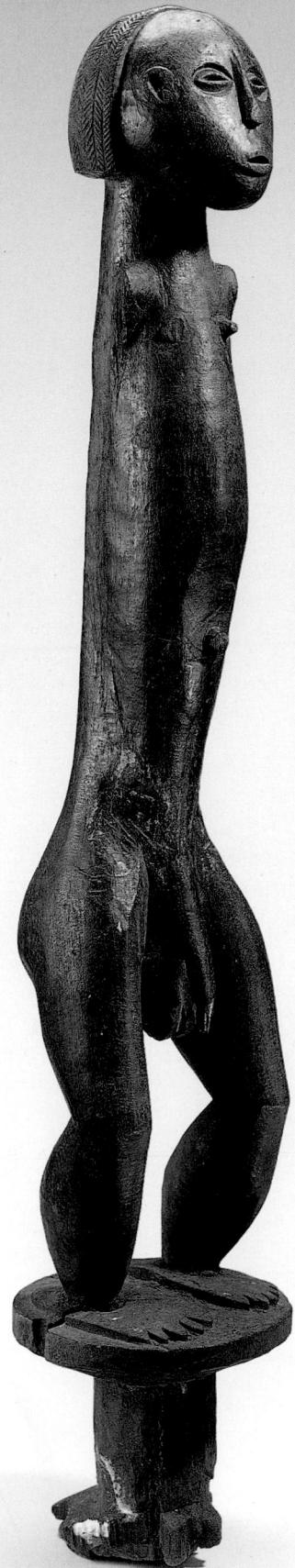

2.54

Mask

Lungu
Zambia or Tanzania
wood
h. 29.5 cm
Felix Collection

The Lungu (sometimes called Rungu) inhabit a broad area around the southern and south-eastern shores of Lake Tanganyika mainly in north-eastern Zambia and into south-western Tanzania. During the 19th century they were greatly reduced in number through the depredations of Ngoni, Arab and Bemba raiders.

The Lungu are predominantly horticulturalists with fishing constituting an important economic activity. They are divided into a number of dispersed, exogamous, patrilineal clans within a collection of chiefly districts headed by a titular paramount chief who appears to have had considerable ritual authority but little real power beyond the chiefly village. Although Lungu boys are not known to have undergone male initiation rites, the British missionary Swann, who visited the area in 1883,

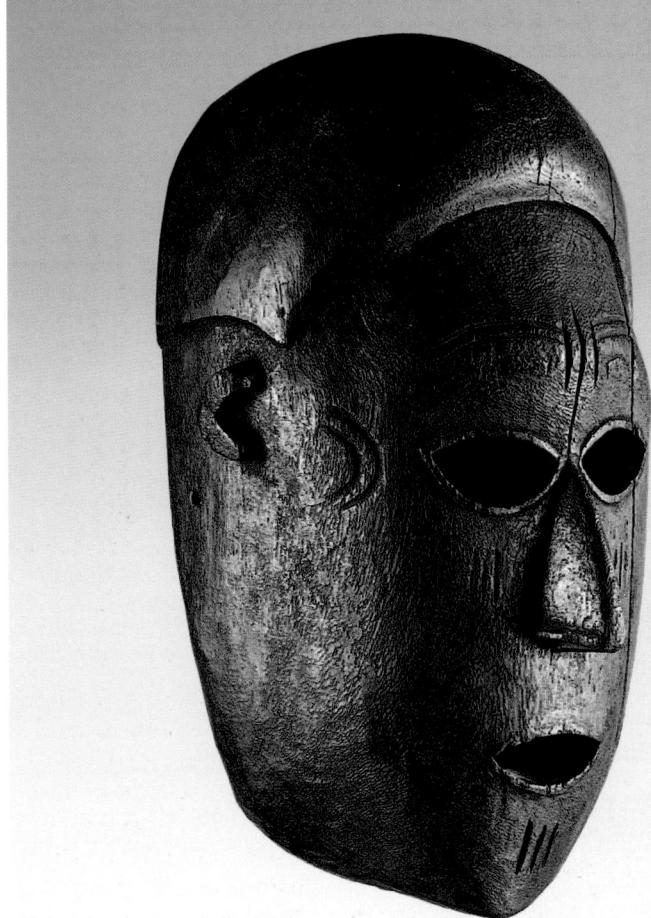

reports that Lungu girls were put through initiation rites characterised by 'extremely harsh discipline', during which they underwent a variety of painful and humiliating ordeals. These rites appear to have been aimed principally at preparing the girls for marriage, which took place at an early age and involved onerous obligations and duties. Masks of various kinds were worn by the initiators at a particular stage in the female initiation rites in order to terrify and impress. Masks, such as the one illustrated here, are very rare and no longer used during female rites among the Lungu. Thus nothing can be inferred about the ideology or ritual observances that may have accompanied their creation and use.

ZK

Bibliography: Swann, 1910, pp. 193–4; Willis, 1966

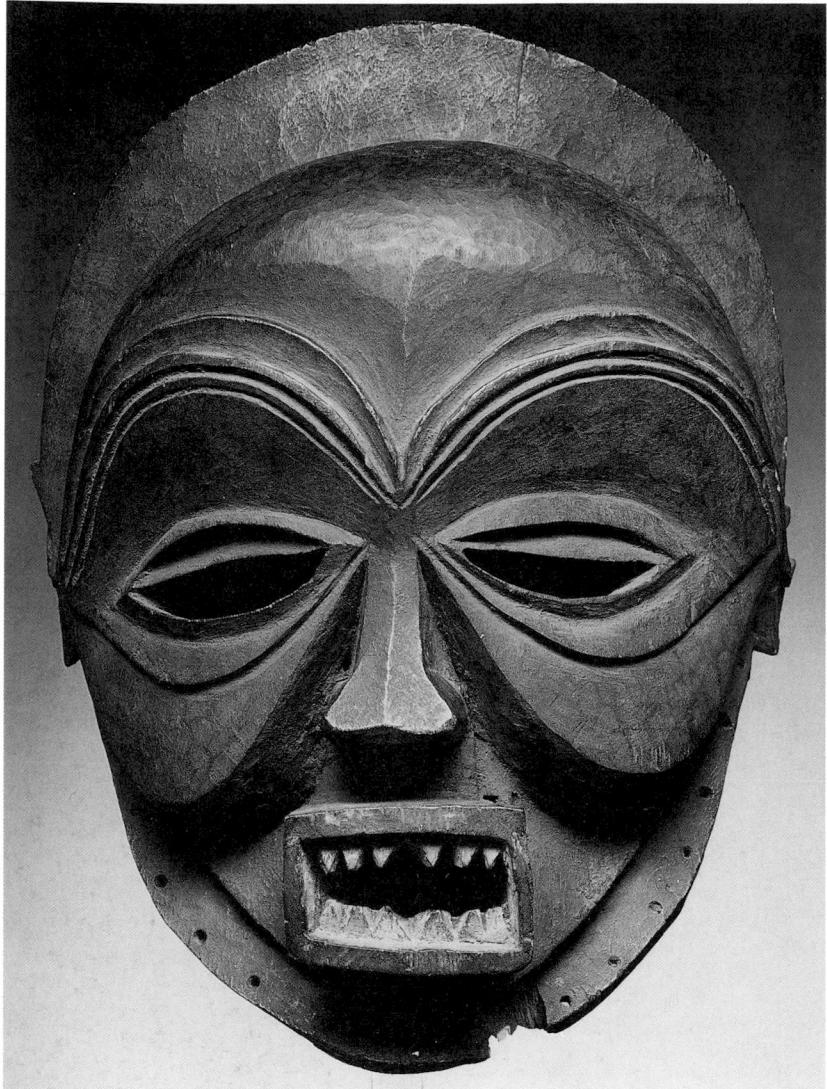

2.55

Mask (*samahongo*)

Mbunda
Zambia
19th century
wood
h. 45 cm

The Carlo Monzino Collection

The Mbunda people migrated from Angola into the area of the Lozi kingdom (Barotseland) during the 18th and 19th centuries and have become largely assimilated both culturally and politically by the Lozi. They are now scattered throughout the Western Province of Zambia.

Mbunda men enjoy the reputation of being expert at wood carving. This wooden mask is intended for use during the period of the boys' circumcision ceremony called *mukanda*. Among the Mbunda young boys who have reached puberty are secluded in a specially created circumcision camp for a period of between three and six months. During this time they are

circumcised and taught the behaviour and accomplishments necessary for adulthood. When they have recovered from the operation and are considered to have been sufficiently educated, *makisi* dancers, who are said to be the ancestral spirits of the boys, go to entertain the villagers, especially the women. Various types of *makisi* appear at this celebration. Many of them wear masks made of barkcloth; among them are *munguli* (hyena), *liveluvelu* (guinea fowl), *chizaluki* (chief), *kaluluwe* (hunter). Wooden masks, such as this one, are also used on the day following *makisi* dancing, when the boys are brought back to the village. Some *makisi* dancers are also invited to dance in the Lozi villages on other festive occasions.

The mask shown here used to be in the collection of the sculptor Jacob Epstein. Although there is no direct ethnographic information, the mask seems to be one of the type of mask called *samahongo*. *Samahongo* plays

the role of an old diviner. Common features are convex forehead and cheeks, and recessed eyes. In many of them, cheeks are inflated into two globular forms. In this mask, ridged arcs marking the cheek bones and the eyebrow surround the eyes with protruding eyelids; the eyes are situated in the middle of circular frames. This linear treatment of the eye area may suggest the carver's connection or familiarity with the style of the neighbouring Chokwe people. KY

Provenance: ex Jacob Epstein Collection
Exhibitions: London 1960, no. 42; New York 1984, no. 136; Florence 1989, no. 134
Bibliography: Fagg, 1960, no. 47; Fagg and Plass, 1964, p. 57; Pericot-Garcia et al., 1967, p. 180; Rubin, 1984, p. 145; Vogel, 1985, no. 136; Bassani, 1989, no. 134; Holy, 1971, p. 11; Papstein, 1994, pp. 152-5

The Lozi live in and around the flood plain of the Zambezi River in the Western Province of Zambia. Since the 18th century they have assimilated elements of many neighbouring ethnic groups including the Ndundulu, Kwangwa, Mbunda, Ila, Tonga, Lunda and Chokwe. The term 'Barotse' gained currency through usage by the Paris Evangelical Mission, and has been used to refer to the whole kingdom, of which the Lozi are the dominant group. In 1890 and 1900 a British Protectorate was established over Barotseland under treaties with the British South Africa Company which to a large extent endorsed the powers of the Lozi king. Even after the independence of Zambia in 1964, the political power of the Lozi king over the area has been substantially retained.

While the Lozi are noted for their fine basketry, they do not normally work in wood, except for making dug-out canoes. It is the carvers from several subjugated groups such as the Kwanga and Mbunba who meet the demand for wooden objects at the Lozi court. Among the best known objects are the lidded bowls used for meat and vegetables. The surface of the bowls is usually smooth, and the top knobs or handles of the lids form the main decorative element. In many examples, the handles are modelled into highly stylised figures. Bertrand (1898) provides one of the earliest illustrated records of this type of lidded bowl. He was given a bowl with an elephant carved on the lid by King Lewanika in 1895 and calls it a 'royal plate (*plat royal*)'.

It is worth noting that the figures are not only stylised but arranged in conformity with the shape of the bowls. For example, the oval shape of the bowl cat. 2.56a is repeated in the form of the ducks. KY

Bibliography: Sydow, 1932; Schmalenbach, 1955; Leuzinger, 1960; Leuzinger, 1972; Leuzinger, 1978; Bertrand, 1898

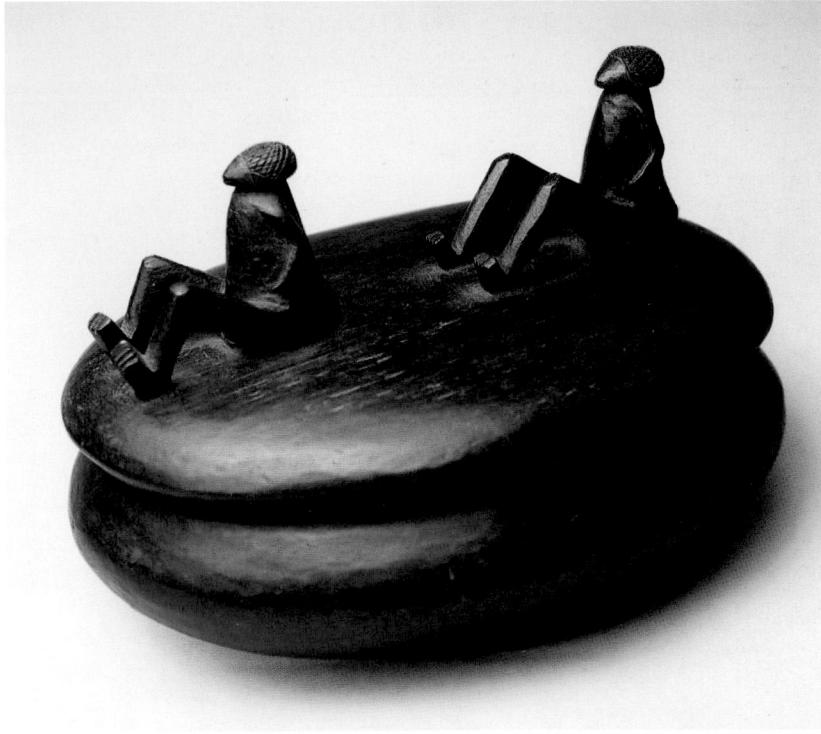

2.56a

Bowl with lid

Lozi (Barotse)
Zambia
wood
diam. 37 cm (bowl); 35 cm (lid)
Linden-Museum, Stuttgart, F50686

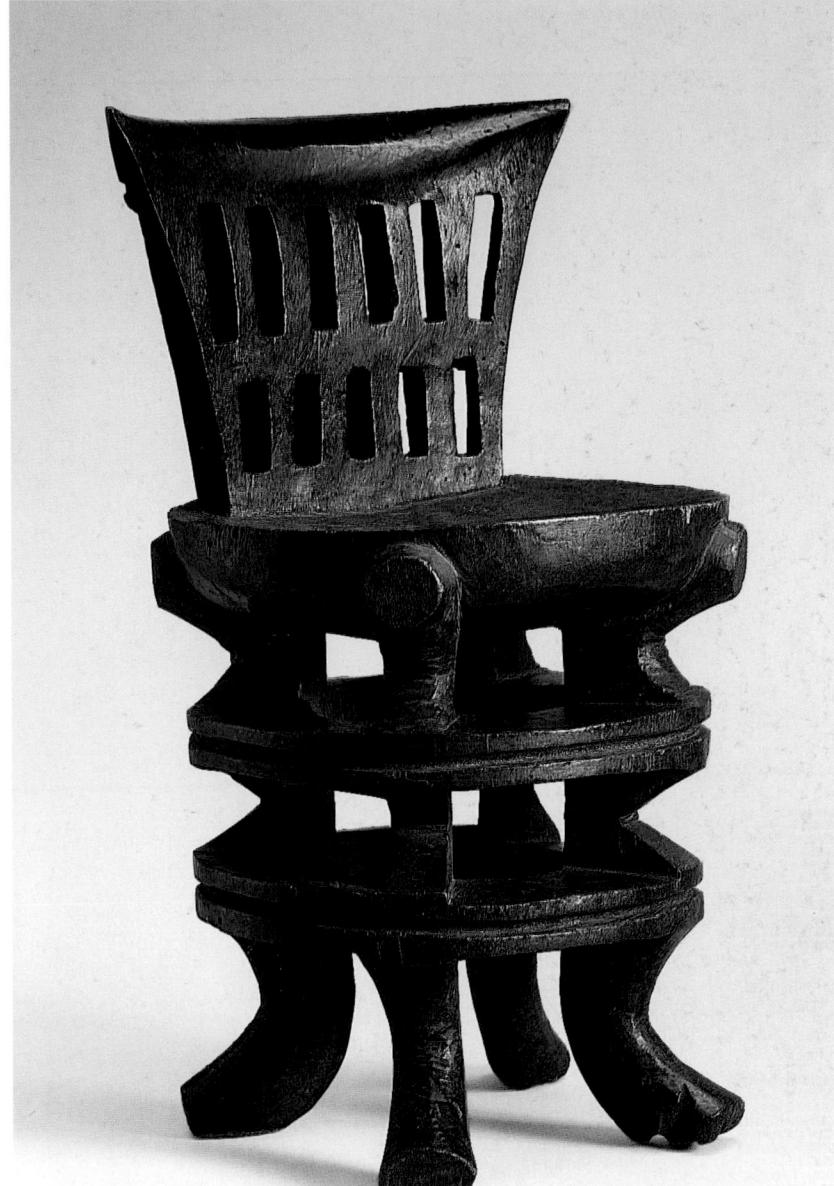

2.57

High-backed stool

possibly Chewa
Central Region, Malawi
wood
53.5 x 29.5 x 29.5 cm
Horniman Public Museum and Public Park Trust, London, 1981.150

Throughout Malawi woodcarvers have been able to hew mortars, gaming boards, large meat-trays, stools and even entire boats from the tall trees that grow in the higher altitudes throughout the country.

A traditional style of high-backed chair is unknown in Malawi. Typically, both royalty and commoners preferred to sit close to the ground, on a skin, a mat or a small stool. This spectacular chair reflects a blend of foreign and traditional influences

frequently found in prestige objects. Here, the carver has announced the high status of the owner by carving three separate tiers of a traditional-style four-legged stool, one stacked on top of the other. The legs are concave in shape, which gives a slightly zoomorphic look to each tier. The surface of the chair shows none of the delicate, zigzag decoration typical of most Swahili-inspired artwork, yet the pattern of rectangles that pierce the back support echoes grille-work patterns carved on the back of early Swahili chairs. MC

Bibliography: Pullinger, 1982; Allen, 1989, pp. 54–64

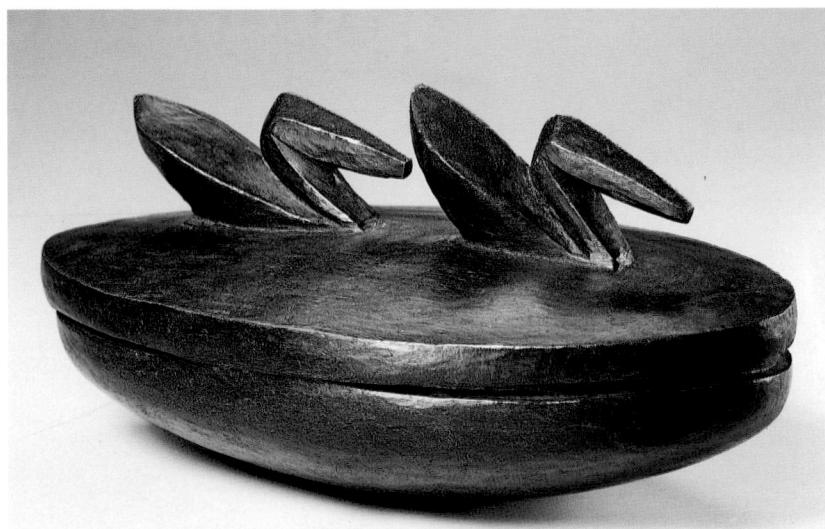

2.56b

Bowl with lid

Lozi (Barotse)
Zambia
wood
15.1 x 21.3 x 35 cm
Museum Rietberg, Zurich, RAF 1101

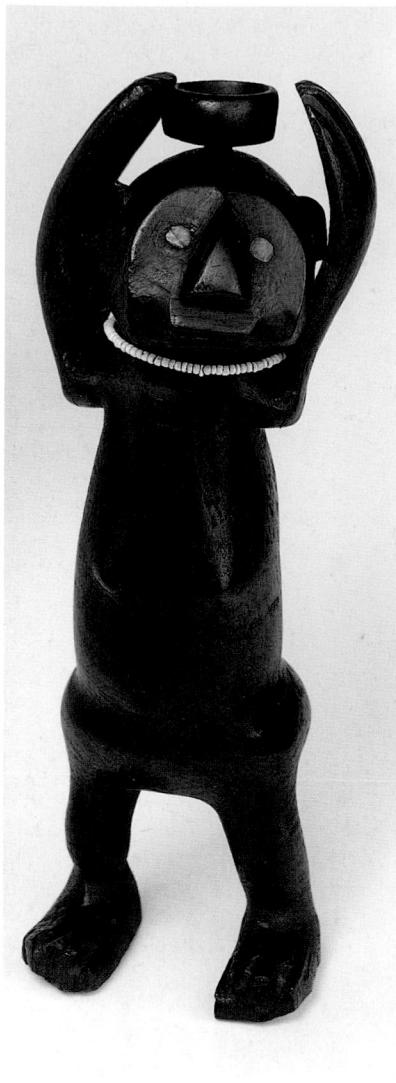

2.58a

Female figure

Malawi
wood, glass
27 x 7 x 5 cm
Museum für Völkerkunde, Vienna,
122.136

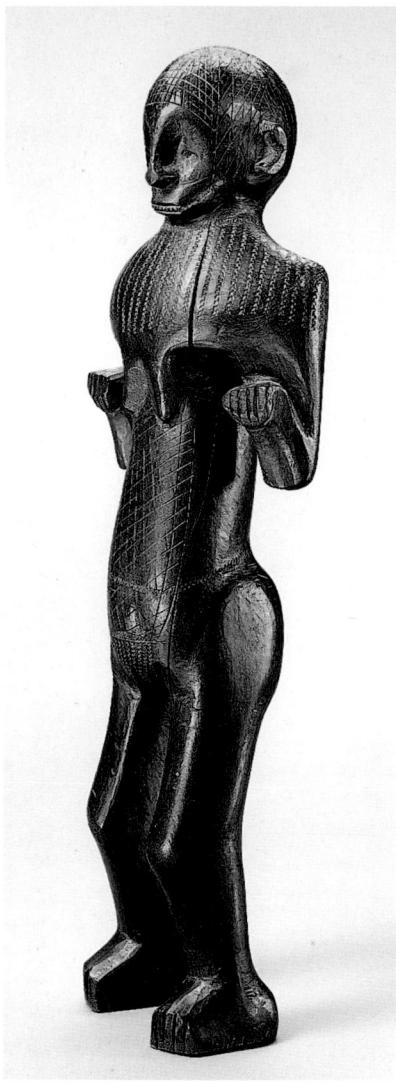

2.58b

Female figure with scarification

Malawi
wood
h. 48 cm
Bareiss Family Collection

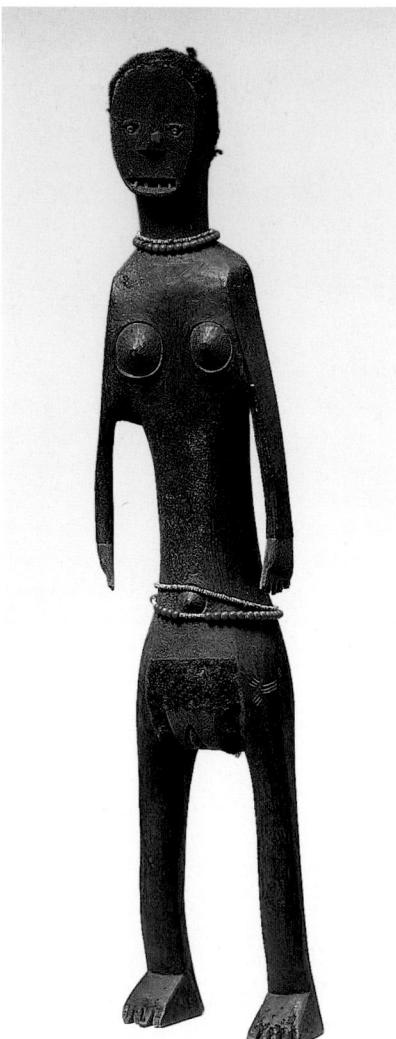

2.58c

Female figure

probably Yao
Malawi
1909
wood
76 x 18 x 11 cm
The Trustees of the British Museum,
London, 1909.24

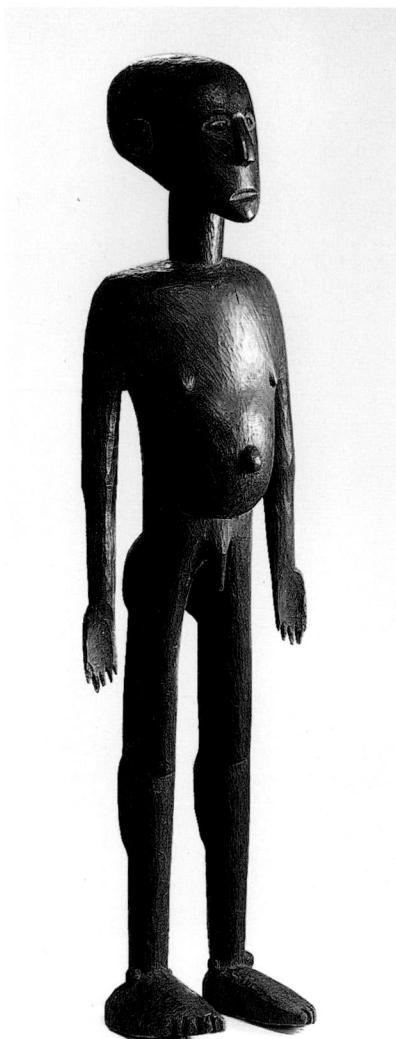

2.58d

Male figure

Malawi
wood
103 x 30 x 20 cm
Felix Collection

Artistically, the peoples of Malawi have been known only for their decorative utilitarian objects such as baskets, combs, bowls, snuffboxes, spoons, axes, pipes and mortars. Some personal items occasionally incorporated figurative elements, but free-standing sculpture was regarded as rare and idiosyncratic. Without specific ethnographic information relating to context, all figurative sculpture from this region had to be dismissed as the work of self-inspired artists responding to the demands of expatriates for African souvenirs.

However, so many new figures have come to light, some with early collection dates, that the issue must now be re-examined. The four pieces exhibited here, for example, draw upon canons of style too complex to be dismissed as spontaneous invention. 'Tourist' pieces are usually much more transparent in intent. Recent scholarship on pre-colonial educational systems suggests an educational purpose for some of these carvings – a function which would have been hidden from all but the most tenacious early visitor.

Secret, age-initiation schools (*unyago, chisungu*) were widespread in south-eastern Africa. They helped to instil traditional cultural values. Tangible objects, including masks, paintings, wooden and clay figurines, were used as didactic aids to inculcate important cultural information. Most were fragile and ephemeral. They were made to be discarded at the close of the initiation 'school'. However, other items, perhaps these wooden figures, would have been difficult and expensive to recarve. These would therefore be carefully preserved,

perhaps stored in caves until needed by the next 'class', or generation of initiates.

The female figure (cat. 2.58a) wears an *ngoti* on top of her head to facilitate carrying loads. The ethnic group from which it comes is not identified. The large, complex female figure (cat. 2.58c) portrays the classic cultural markers associated with the Yao – the nose-plug, a half-circle hairline, blue and white bead jewellery, and a distinctive pattern of parallel line scarification on the buttocks. Like other figures, this

sculpture may have once been used as a didactic aid, in this case to epitomise Yao ideals of beauty, deportment, and the social markings of a mature Yao woman. The fierce abstraction of the face, the figure's archetypal stance and its paddle-like hands link it to other Yao sculptures believed to have been used during initiation. Both boys and girls learned through initiation, but Yao girls were expected to undergo a more thorough and protracted series of classes, culminating in the initiation of First Birth. Consequently, most figures in this style depict the various conditions or stages of womanhood.

At the turn of the century both men and women customarily trimmed their hair, often in very stylish ways, yet the Yao would carefully remove all pubic hair. In this instance (cat. 2.58b) the presence of pubic hair around prominent female genitals (the Yao appreciated large, stretched labia) probably indicates pregnancy or ritual abstention from sexual congress. The Yao initiation master was responsible for managing the community of participants, for performing any surgical operations and for all didactic paraphernalia used in teaching. Therefore, any similarity in the form or style of some of these works may be a reflection of the patronage of the same initiation master rather than being in the hand of the same artist.

MWC

Provenance: cat. 2.58c: 1909, collected in Blantyre, Malawi; 1909, given to the museum by H. S. Stannus; cat. 2.58d: 1918, Private Collection, Germany

Bibliography: Werner, 1906; Stannus, 1922, pp. 229–372; Heckel, 1935; Harries, 1944; Cory, 1956; Mitchell, 1956; Richards, 1956; Rangeley, 1963, pp. 7–27; Dias, 1964; Alpers, 1966; Holy and Carey, 1967; Kubik, 1978¹, pp. 1–37; Kubik, 1978², pp. 37–51; Kecskési, 1982, pp. 52–6

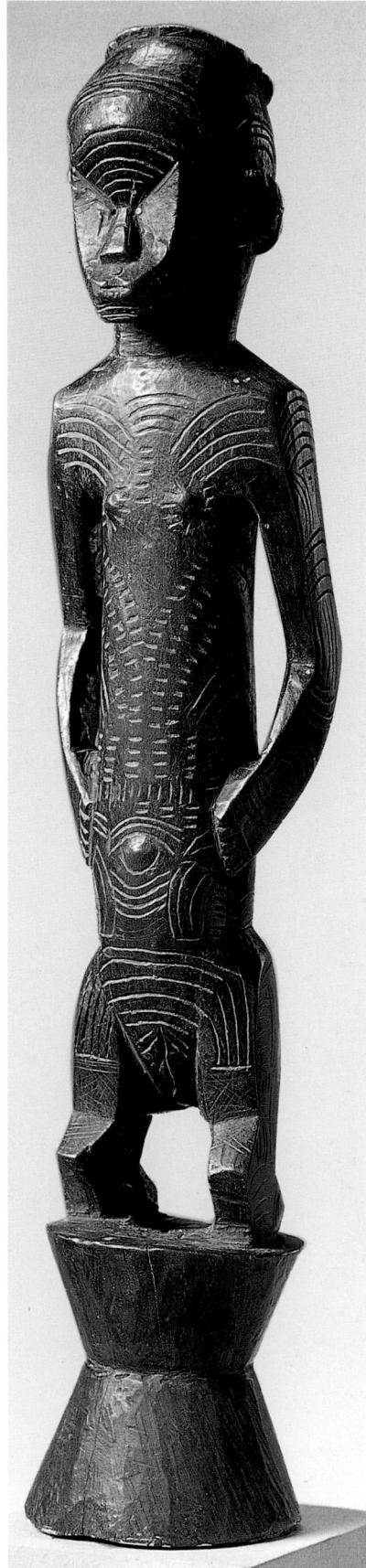

2.59

Female figure

Lomwe/Nguru
Malawi or Mozambique
1901
wood
h. 41 cm
Staatliche Museen zu Berlin, Preussischer Kulturbesitz, Museum für Völkerkunde, III E 9535

The Lomwe comprise a large number of related groups who live mainly in the fertile valley systems running north and south off the Namuli hills situated in northern Zambezia Province, northern Mozambique. Lomwe groups (called Nguru in official reports) also extend into southern Malawi, where they have lived since the famine of 1900 forced them to migrate into the area from further east. Ethnic boundaries are particularly difficult to draw with respect to the Lomwe, as many have intermixed with closely related neighbouring groups such as the Makua on their north-eastern frontier and the Yao on their western frontier. Like the Makua, the Yao and the Makonde, the Lomwe are primarily agriculturalists with a social organisation based on exogamous matrilineal clans.

In response to the upturn in the slave trade in the area during the 19th century some Yao and Lomwe groups became fully involved in the export of slaves and increased their ivory trade with the coast. The resultant acquisition of wealth and enlarged followings by local leaders contributed to the processes whereby the Lomwe developed a 'confederation' of independent territorial chiefdoms. These developments contrast with the situation of the Makonde, who retained a chiefless political organisation and whose response to the increase in the slave trade was to look to their defences on the Makonde plateau and reduce their involvement in trade with the coast.

Among the Lomwe different groups tattooed their bodies with distinctive markings. The type of motif as well as its position on the body indicate status. Persons of high status tended to be more profusely tattooed than others and their tattoos could be applied in various techniques. The elaborate pattern of engraved lines that decorates this figure is undoubtedly intended to represent

tattoo marks: the profusion of the lines and their complexity indicate high status. This conclusion is confirmed if one interprets the base of the sculpture to represent a stool. Figures carved seated or standing on a stool are common in many areas of eastern Africa and are frequently intended to represent leaders or others of high rank. The figure illustrated here may have the identifying marks of the ancestress of a particular chiefly matrilineage. It would probably have been used in the context of the chiefly ancestor cult, in which case it would originally have been kept in a shrine in the chief's house. Records of the Museum für Völkerkunde in Berlin indicate that the figure was collected from Mataka village on the shores of Lake Chirua (situated just within the border in south-eastern Malawi). ZK

Provenance: Wiese

Bibliography: O'Neill, 1883–4; Tew, 1950; Dias, 1964; Alpers, 1969; Schneider, 1973; Krieger, 1990, p. 66

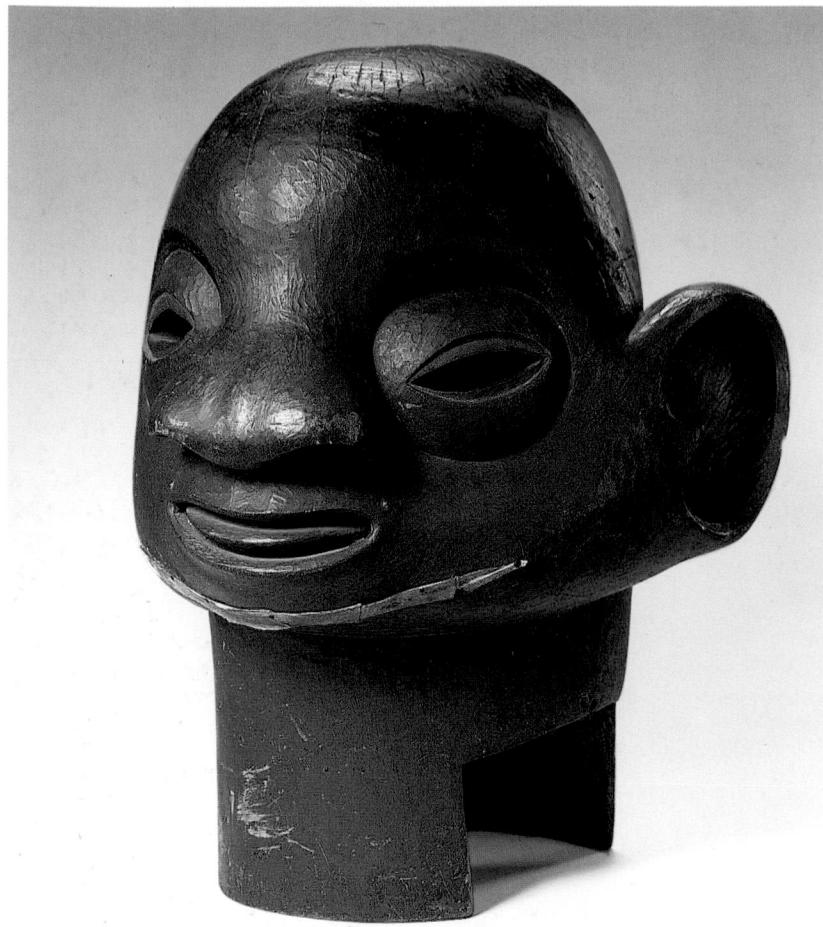

2.60

Mask

Makonde, Malaba
South-eastern Tanzania
early 20th century
wood, leather, pigment
h. 52 cm

Staatliche Museen zu Berlin, Preussischer Kulturbesitz, Museum für Völkerkunde,
III E 17810

This unusual helmet-like mask, apparently collected in the Lindi District, south-eastern Tanzania, cannot be assigned, on formal grounds, to any of the major categories of Makonde mask. Although at first glance it may appear to resemble the *lipiko* helmet mask (see cat. 2.61) of the Mozambican Makonde male masquerade association, it is stylistically anomalous. It has no bottom rim around which a cloth might be tied, as is the case with the *lipiko* mask, and its pedestal-like base with side sections cut out suggests that it was worn on the shoulders in a way that would have restricted any turning or nodding movements of the head. The mask displays certain stylistic affinities, notably in the way the eyes are carved,

with *midimu* masks of the Tanzanian Makonde collected in the same area but true *midimu* masks (see cat. 2.67) are invariably face masks, a classification to which this does not belong.

An intentional element of grotesque exaggeration, especially in the size and shape of the nose, makes the most likely explanation for its anomalous characteristics that it would have belonged to a comic masker. Comic masks are not true *mapiko* or *midimu* masks. They are usually owned, and often also made, by individual youths who take them along to perform, of their own accord, at initiation celebrations where they try to draw attention away from the main masquerade. They come in a great variety of forms that reflect, more than anything else, the individual creativity of their makers.

ZK

Provenance: Brink-Cronau, 1937
Bibliography: Wembah-Rashid, 1971;
Krieger, 1990

2.61

Helmet mask (*muti wa lipiko*)

Makonde
Mozambique/Tanzania
wood and human hair
22.3 x 36 cm
Bareiss Family Collection

This particular mask was apparently collected in southern Tanzania, which would suggest either that it was made by Mozambican Makonde migrants settled there or that it was traded from its place of origin. Before their conquest by Portuguese colonial troops in 1917 the Mozambican Makonde kept mainly to their plateau stronghold. During colonial times, however, a great many migrated across the Ruvuma River to work on sisal estates or farms in Tanzania. Many remained to settle on available agricultural land or to find work in urban areas. Wherever they have settled, Makonde migrants continue to hold initiation rites for boys and girls, and masquerade remains an important fixture at the public celebrations connected with these rites.

Lipiko (pl. *mapiko*) is the name that Mozambican Makonde men give to the masker of their masquerading association, who is brought from the bush into the village for initiation celebrations. The dances are accompanied by an orchestra of drummers. The 'head of the *lipiko*' (*muti wa lipiko*), or mask, is carved out of very light, balsa-like wood and fits over the masquerader's head like a helmet. It is always worn with a cloth tied around its bottom rim that falls loosely over the masquerader's shoulders, forming part of an elaborate costume designed to conceal completely his identity.

The mask is typically carved in a realistic style and its realism is often accentuated by the inclusion of human hair. Many of the older masks portray a Makonde woman complete with lip plug and decorated with the typical raised tattoos applied with beeswax. They are invariably carved with the face angled upwards, often with hooded eyes and with the ears positioned low, more or less level with the mouth. *Mapiko* masks in use today display greater stylistic diversity and tend to portray a variety of contemporary characters. The lip plug and the somewhat sunken features exhibited in the mask illustrated here suggest that it is intended to represent a woman elder. The form of the mask

is unusual in that the face displays a marked horizontal prognathism.

Makonde men conceal the true identity of their masker from the uninitiated and tell them that the *lipiko* is something non-human that has been conjured back from the dead. The secret, true identity of the masker is revealed only to Makonde boys during the male initiation rites, when they are forced to undergo a frightening ordeal in which they must overpower and unmask the *lipiko*.
ZK

Bibliography: Dias and Dias, 1970; Wembah-Rashid, 1971; Kingdon, 1994

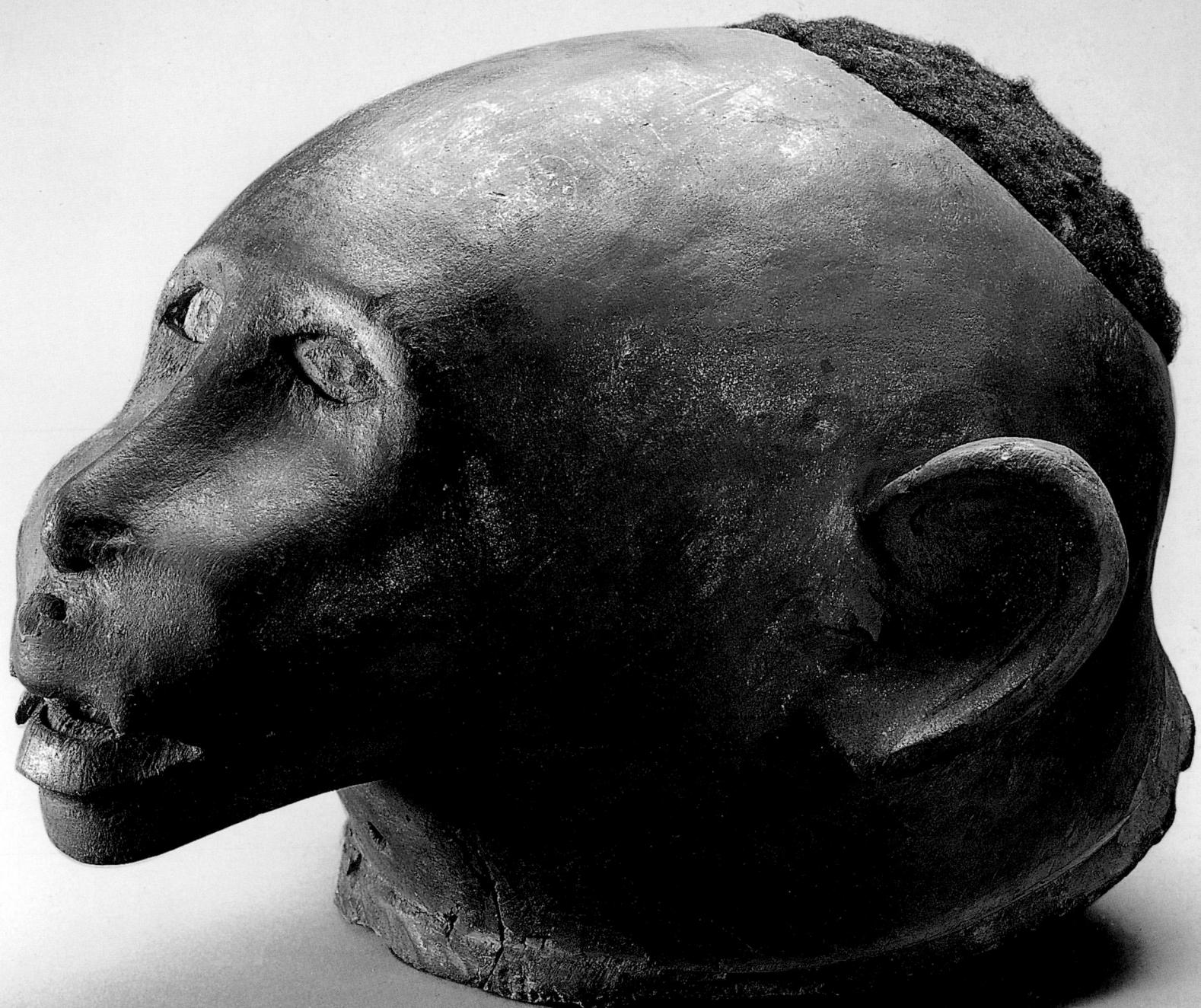

Initiation rites for boys and girls among the Mozambican Makonde are held during the dry season between May and November and must be begun at a time that the community considers to be auspicious. Several kin and residential groups co-operate in the organisation and sponsorship of the rites, and the various associated celebrations thus provide occasions on which members of different groups can come together in a festive atmosphere involving feasting, dance, music and masquerade. The celebrations associated with initiation rites provide the Makonde youth with opportunities to meet members of the opposite sex from marriageable groups. Young people dress up and adorn themselves in order to make an impression and stand out from the crowd. Rival *mapiko* (see cat. 2.61) groups vie with each other to put on the most accomplished masquerade performance and individuals compete for recognition of their style and abilities on the dance ground.

In previous decades Makonde men (and especially youths) would sometimes commission from a carver, or would make for themselves, decorative sticks called *disimbo* (sing. *simbo*), carved with figurative designs, which they used as dance accessories at initiation celebrations. In 1992 the late Chanuo Maundu (a blackwood carver originally from Ntoli village on the Makonde plateau in northern Mozambique) was shown a picture of the object illustrated here and immediately identified it as a *simbo* of this sort. He stated that this particular example was designed to balance comfortably on the arm of a person, facing outwards (the better to catch the attention of other participants at a dance).

The long, narrow nose and thick, flowing beard of the finely carved head that surmounts this *simbo* suggests that it is intended to represent a European. The words 'MIMIMA MAKAKA' conspicuously engraved on its shaft may be the name of its original owner. ZK

Provenance: 1954, donated to the museum by Mrs Webster Plass

Bibliography: Dias and Dias, 1970; Wembah-Rashid, 1971

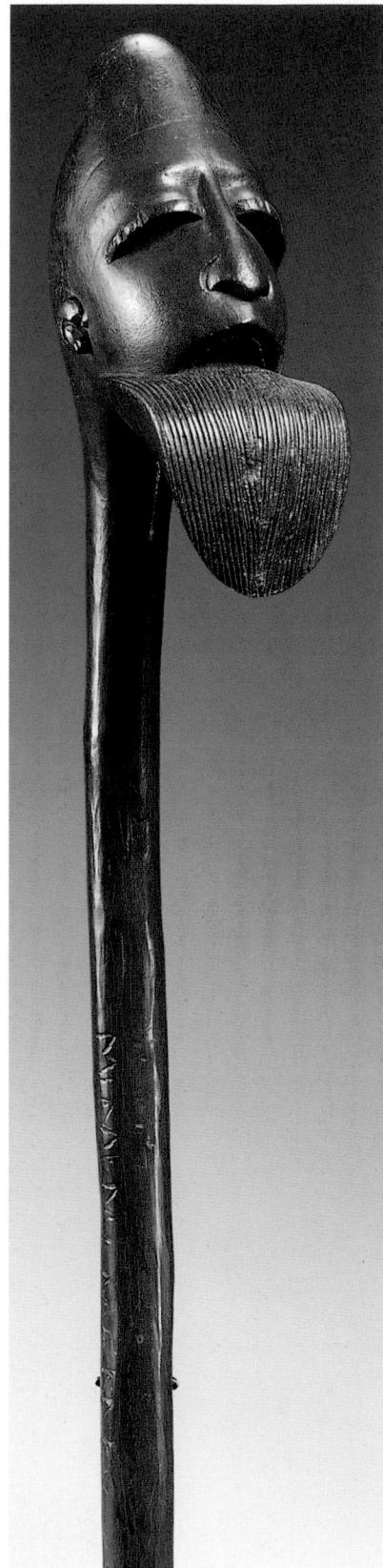

2.62

Dance accessory (*simbo*)

Makonde
Mozambique
wood

63 x 8 x 14 cm

The Trustees of the British Museum,
London, BM 1954. AF. 12.4

The Mozambican Makonde mainly inhabit the high plateau in Cabo Delgado Province. Their traditional way of life was augmented by hunting expeditions into the game-rich lowlands. Most aspects of Makonde social life were organised according to a kinship system based on exogamous matrilineal clans. In pre-colonial times the Mozambican Makonde had no chiefs as such and leadership was held by clan elders and an authoritative clan ritual specialist ('medicine man' or *humu*; pl. *vahumu*). They had a well-developed ancestor cult in which clan ancestresses and prominent elders who died very old and full of knowledge of *ntela* ('medicine') were venerated as minor divinities. The major life-cycle rituals continue to be staged in Makonde communities.

Wooden figurines called *masinamu* (sing. *lisinamu*) representing mythical clan ancestresses and deceased elders (now only to be found in museums) were apparently kept in the houses of village leaders and *vahumu* where they were probably associated with ancestor shrines. They were often painted and decorated with the Makonde raised tattoo marks. This double figure unique in that it depicts a female figure carrying a smaller figure (probably an initiated male from the indication of the painted facial scarification marks). Ethnographic accounts from the Ruvuma region indicate that boys and girls were carried pickaback at certain stages during the initiation rites, and it has been argued that the double figure may represent an initiate being carried. However, no evidence exists to indicate that Makonde boys were carried by women during the rites. Furthermore, there are no ethnographic records to suggest that sculptures of this kind may have been used in this context. Another explanation for this double figure may be that it expresses a special status relationship between two personages. It is possible that the sculpture would have been used in connection with the ancestor cult and it may have been intended to portray two deceased persons. ZK

Provenance: F. Schroder Collection

Bibliography: Dias, 1961; Dias and Dias, 1970; Kecskési, 1982

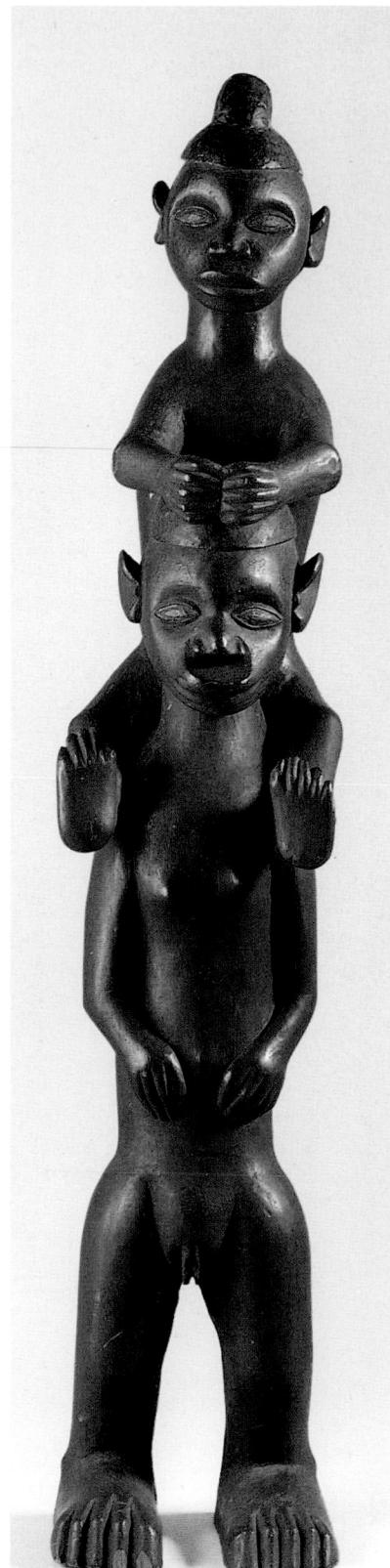

2.63

Double figure

Makonde
Mozambique
early 20th century
wood, pigment
h. 73.5 cm

Museum für Völkerkunde, Hamburg,
25.63.1

Water-pipe (*nyungwa*)

Makonde
Mozambique
terracotta, wood, coconut shell, beads
h. 27 cm
Private Collection

Tobacco has long been an important, high desirable commodity among the Makonde and it was widely exchanged for goods and services. It appears to have been regarded as a commodity associated with personal qualities such as generosity. Use of tobacco constituted one of the principal pleasures and privileges of elders. It was usually smoked or taken as snuff in a social context, especially by elderly men as they sat in the central men's house (*chitala*) conversing or reminiscing about the past.

The water-pipe exhibited here is characteristic of the finest Makonde utilitarian art in its inventiveness, in its witty suggestion of the human form and in its remarkable economy of design. Constructed from four detachable components, it is a masterpiece of suggestion. By sculpting a pair of lower legs to complete the N-shaped stem-holder-cum-stand, the maker (or makers) of this pipe created a form which subtly alludes to that of a seated human figure, with the bowl of the pipe representing the head and the coconut-shell reservoir representing the buttocks.

Figuratively elaborated and finely decorated water-pipes generally belonged to individuals of high status such as village or clan leaders and ritual experts. This example is unique in that it incorporates a terracotta stem-holder decorated with a delicate pattern of incised lines typical of some Makonde pottery. Modelling and potting in clay were women's arts in Makonde society and the virtuosity displayed in this rare piece suggests that it was made by an expert potter; the stems and bowl of the pipe were probably carved by a man, carving being a male art. The terracotta stem-holder includes a convenient carrying handle and its sculpted legs are decorated with miniature beadwork anklets. It may have been made for the potter's own use or she may have made it for another in exchange for other goods. In either case the pipe would have been intended to serve not only as an effective smoking apparatus but also as an object of display to be

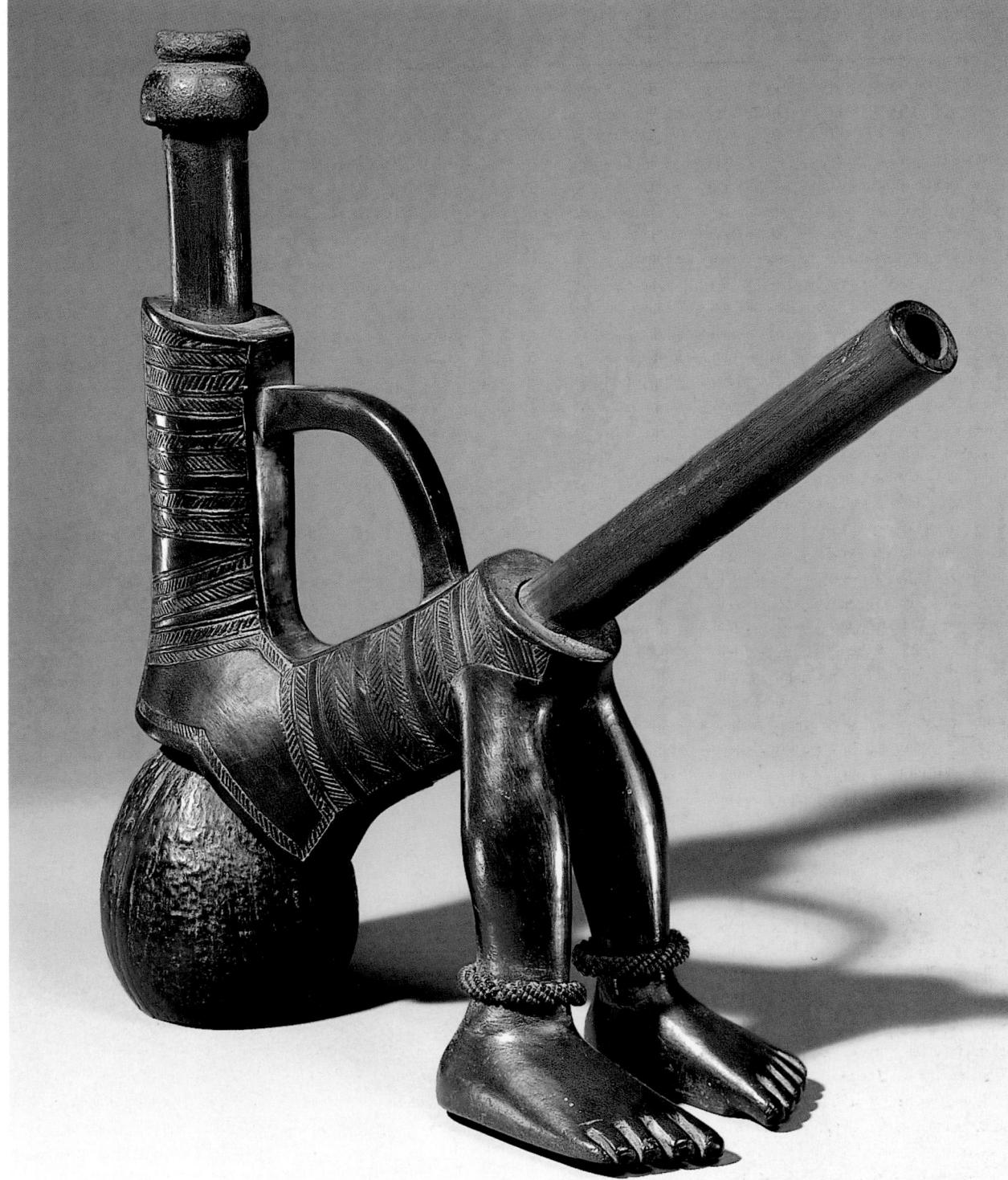

carried around, handled, admired and contemplated. It would have been closely linked with the identity of its owner and it represents one of the most intimate and treasured of Makonde personal objects. ZK

Bibliography: Dias and Dias, 1970;
Wanless, in Johannesburg 1991;
Washington 1991

2.65

Drum (*likuti*)

Makonde

Tanzania/Mozambique

late 19th or early 20th century

wood, leather, hair, copper nails

63 x 30 x 30 cm

W. and U. Horstmann Collection

The five or six distinct types of drum used by the Makonde to accompany their various dances and masquerade performances are not usually figuratively elaborated (although they are often carved with relief decorations). This unusual Makonde drum of the goblet-shaped variety (called *likuti* by the Mozambican Makonde) is carved with anthropomorphic legs and female imagery, suggesting that it would have served a special social function. The drum's imagery recalls that of wooden cult figures of lineage ancestresses now found only in museums. The tattoo marks, in the form of a vertical line of nested chevrons between two mirrored crescents carved in relief on the body of the drum, are common motifs found on ancestor figurines and also on body masks (see cat. 2.66) of the Tanzanian Makonde.

In pre-colonial times the Makonde groups who settled in the Ruvuma region were skilled in the arts of defence. They protected their villages against the attacks of enemy lineages, hostile external groups and wild animals by enclosing them within carefully maintained hedges of impenetrable thicket. The entrances to these villages were guarded by heavy gates, which were securely locked each evening. According to Kashimiri Matayo (a Makonde originally from Miula village on the Mozambican plateau) special drums of the *likuti* type were widely used by the Makonde in order to alert villagers and members of neighbouring settlements in the event of a threat.

Makonde warning drums continued to be used during colonial times and were typically sounded when a person had either been attacked by, or had wounded, a lion or leopard. At the sound of the drum beaten in a way that resembled, for example, the roar of a leopard, all the men of the local area would take up their weapons and assemble for a leopard hunt. ZK

Bibliography: O'Neill, 1885;
Blood, 1935, p. 12

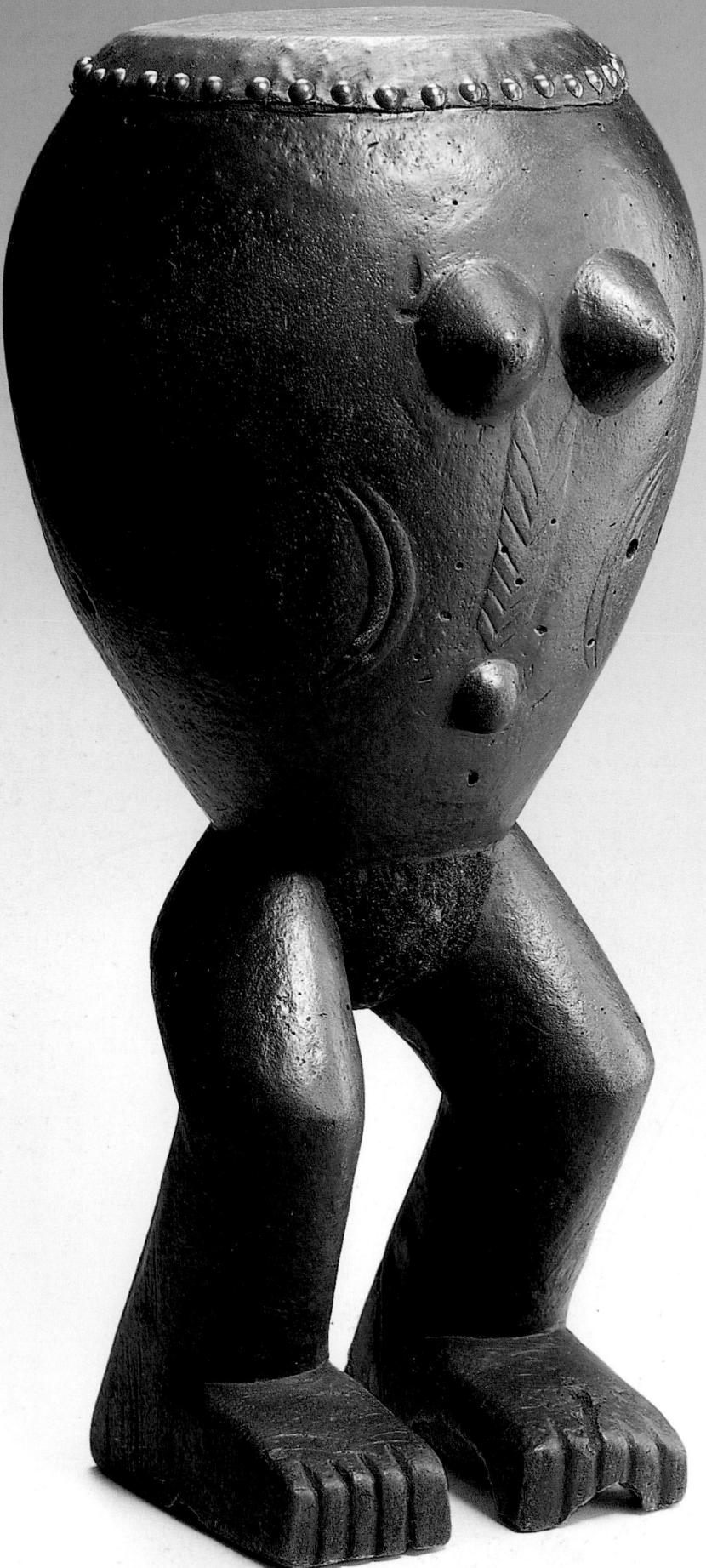

2.66

Body mask (*ndimu*)

Makonde

Southern Tanzania/Mozambique
late 19th century

wood

61.2 x 30.7 x 15 cm

Private Collection, London

Among the Makonde of south-eastern Tanzania initiation is still one of the most important ritual cycles. Both boys and girls must undergo a period of seclusion, generally six months, during which they learn songs and dances and are taught various practical activities. The initiation rites involve male circumcision and indoctrination into the secrets of gender. Everyone is taught the rules of adult behaviour, about sex and about the rights and obligations of married life. The celebrations that accompany the coming-out ceremonies involve feasting, dance and the masquerades of the *midimu* (sing. *ndimu*) spirit maskers.

The female body mask was part of the costume of a special *ndimu* masker called *amwalindembo* that was intended to represent a young pregnant woman. It was usually carved with a swollen abdomen decorated with the typical Makonde raised tattoos applied with beeswax (but in this case they are carved in relief) and was always worn by a male masquerader together with a matching female face mask. The *amwalindembo* performed a sedate dance, usually accompanied by a male *ndimu* masker, which dramatised the agonies of childbirth. Although the body mask is no longer in use today, dramatic scenes depicting various aspects of community life continue to be performed by masked or maskless performers during the celebrations.

ZK

Bibliography: Wembah-Rashid, 1971

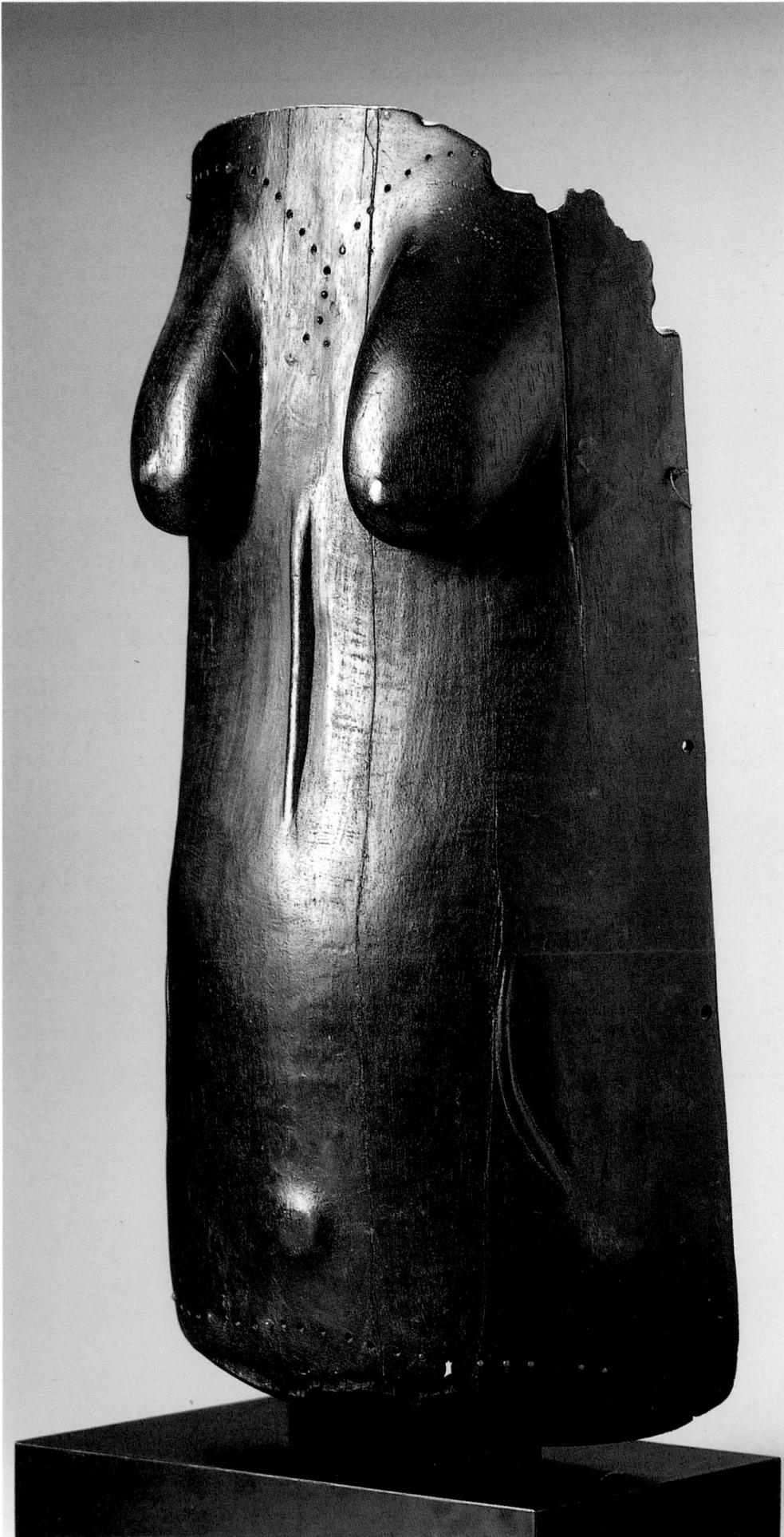

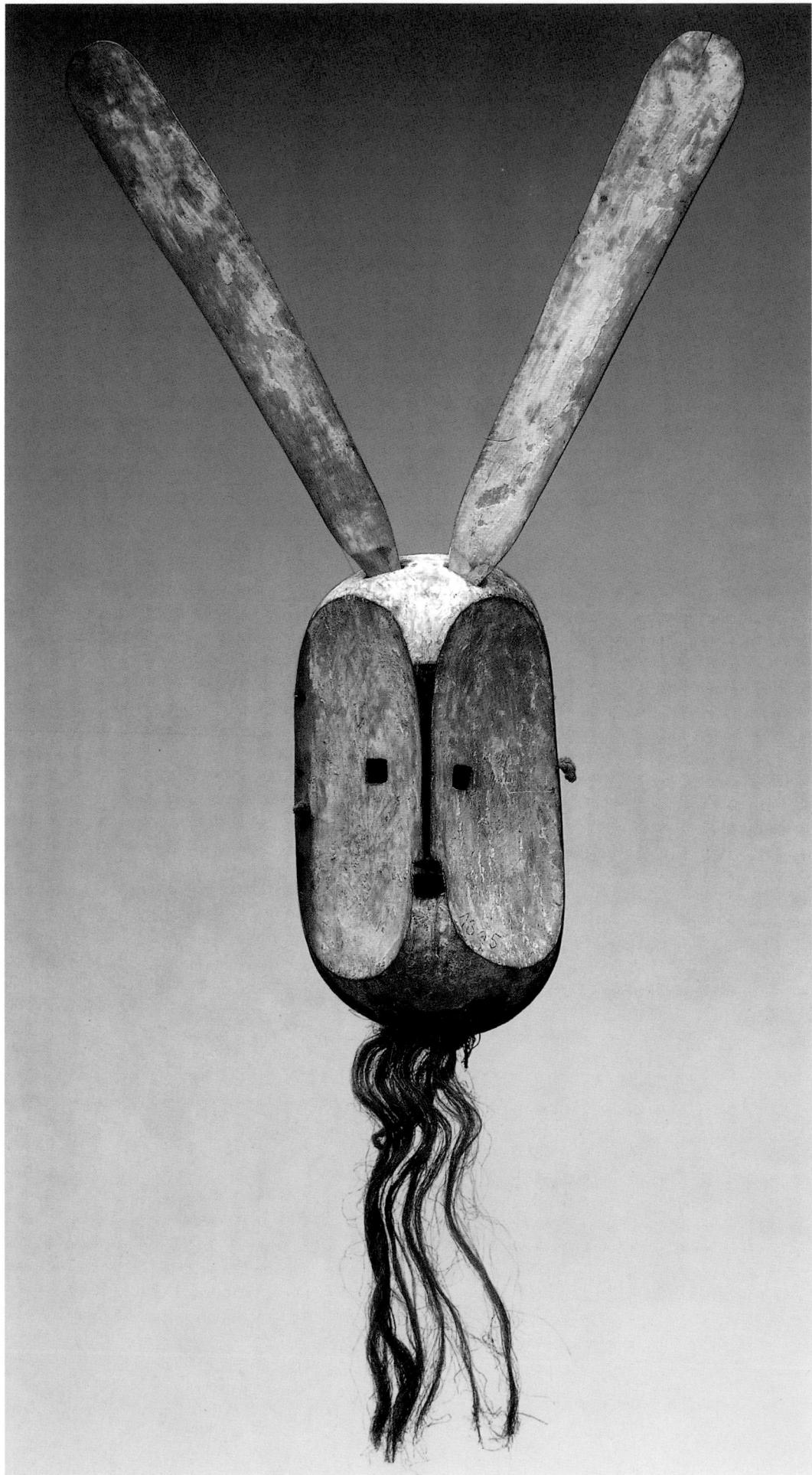

Face mask (*ndimu*)

Makonde
Southern Tanzania
early 20th century
wood, white pigment, vegetable fibre
h. 47 cm
Museum für Völkerkunde, Leipzig,
MAF 16593

The Makonde who now live in south-eastern Tanzania and those who remain in Mozambique have had to contend with different recent historical forces. Whereas the Mozambican Makonde were successfully able to repel all external invaders of their plateau stronghold until 1917 (when they were conquered by Portuguese colonial forces), the Tanzanian Makonde, in contrast, suffered enormous turmoil during the 19th century. An upturn in the slave trade, later aggravated by Ngoni raiders, led large numbers of people from several groups in the area to take refuge on the Newala plateau. These groups included sections of certain Yao and Makua clans whose continued presence on the plateau bears witness to a considerable interchange of peoples. This might have contributed to the diversity of styles and forms of the dancers of the Tanzanian Makonde, which contrast somewhat with the equivalent *lipiko* masquerading tradition of the Mozambican Makonde (see cat. 2.61). *Ndimu* (pl. *midimu*) is the generic name for all types of masker who impersonate spirits and wear wooden face masks. Both the face masks and the costumes of the *midimu* maskers (as well as their associated dances) vary according to the particular human- or animal-like spirits they are intended to personify. Some *midimu* can be divided into distinct categories, such as those which dance on stilts and those which incorporate a female body mask (see cat. 2.66). All are performed by members of the male masquerading associations during the coming-out celebrations for both male and female initiates.

The long spatula-shaped ears of the *ndimu* mask shown here were evidently carved separately and then attached. The length of the ears suggests that the mask is probably intended to represent a hare spirit.
ZK

Bibliography: Weule, 1909; Franz, 1969;
Wembah-Rashid, 1971; Clayton, 1993

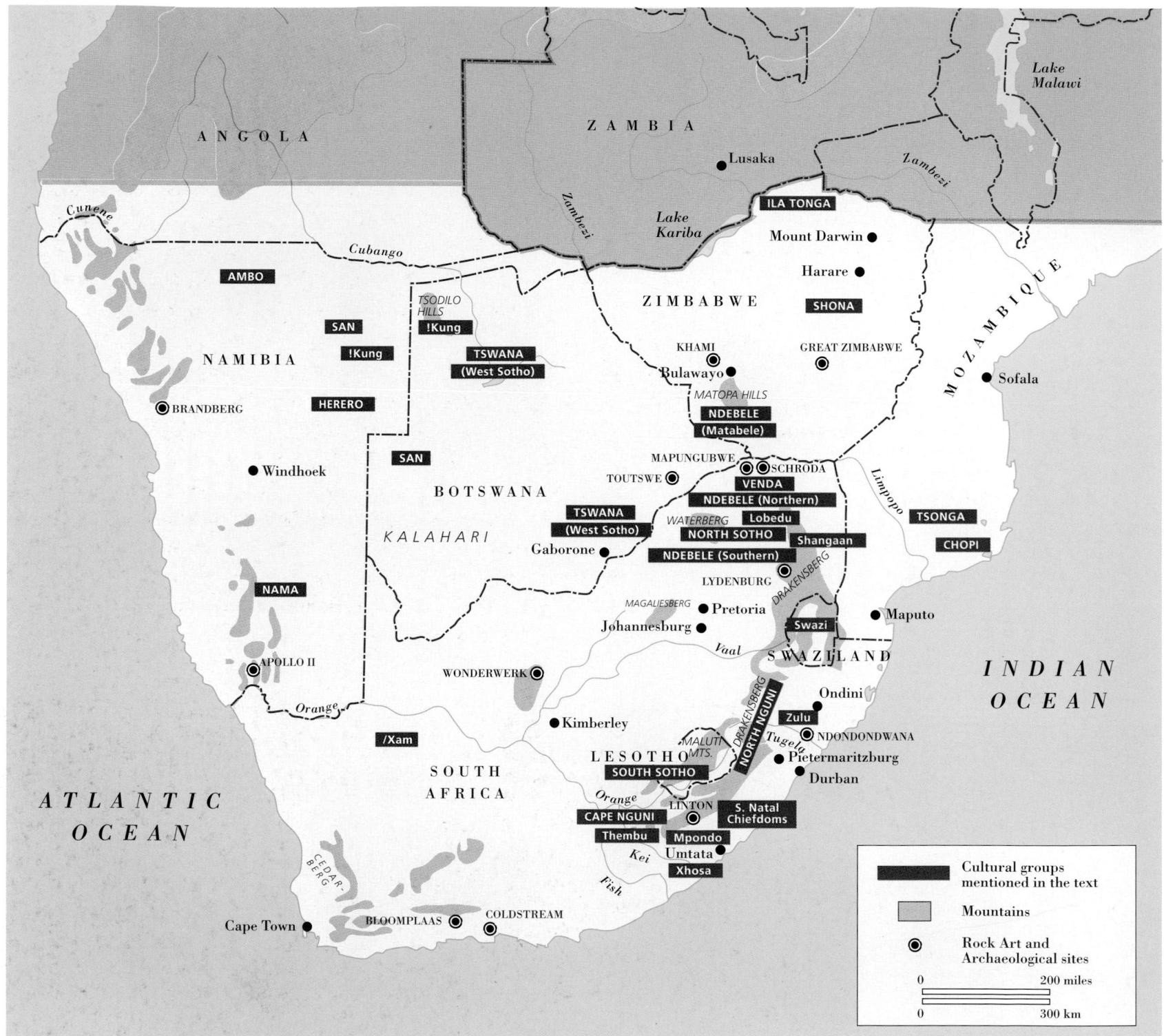

3 SOUTHERN AFRICA

Patricia Davison

Some of the oldest and most complex expressions of human creativity in Africa come from the areas south of the Zambezi and Cunene rivers. Nevertheless, the significance and range of art forms from this region have yet to be fully recognised. African art in southern Africa has a heritage of misunderstanding, arising from wider misconceptions regarding the history and culture of the subcontinent. During the colonial period African cultural identities were classified by outsiders, and complex historical relations among the inhabitants of the region tended to be reduced to a few well-worn categories that fast became stereotypes. Persistent lack of attention to historical detail has led to many works in collections being incorrectly attributed, misinterpreted and, with the notable exception of rock art, underrated within the field of 'African art'. Over the past two decades, however, both knowledge and appreciation of the arts of this area have been growing. In presenting a selection of significant works from southern Africa, together with art from the entire continent, this exhibition and its catalogue provides an unprecedented occasion for both reflection and celebration.

All the works selected for this exhibition once evoked other meanings, for other people, in other places. Although outside specialists have furthered an understanding of art in Africa, it is well to remember that African people themselves were the original keepers of the knowledge and beliefs that animate the history and material culture of the continent. Sensitivity to historical and social context enriches an understanding of art forms, but it must also be acknowledged that the sensory presence of a work of art can transcend historical context and move the viewer, even if it is not fully understood.

From another angle, some understanding of the processes by which works of art from one culture are given recognition in another can be illuminating. It is generally accepted that early 20th-century responses to art forms from Africa were shaped by preoccupations within European art practice, in particular the move away from naturalism, and were limited in certain respects by Western pre-

Fig. 1 Carved pole figures in the palisade surrounding the khôrô of Chief Modjadji's capital, 1960s

conceptions of what constituted 'art'. The absence, in most of southern Africa, of masking traditions comparable with those of west and central Africa, coupled with the fact that religious practices did not involve the use of carved ancestor figures, contributed to the relative neglect of this region by connoisseurs in the field that came to be known as 'African art'. As the works shown here affirm, aesthetic sensibility was certainly present but often in forms that integrated art and utility, and bridged the secular and sacred realms. Finely carved objects of everyday use, such as headrests and snuff containers, merged functional, symbolic and aesthetic attributes. Figurative carvings were produced but mainly for use in the secluded context of initiation schools. Such figures were hidden when not in use and, therefore, few found their way into private hands or museum collections. Furthermore, the ephemeral nature of objects made from organic materials reduced their archaeological visibility and limited their survival in collections. A tendency to draw rigid lines of distinction between the categories of fine art and applied art, a selective focus on durable sculptural forms and the paucity of reference works encouraged the misconception that art was rarely found south of the Zambezi River. Rock art commanded sustained attention but, in this case, sites were often inaccessible and known only to the relatively few specialists working in the field.

Since the 1970s a growing interest in the arts of southern Africa has been reflected in exhibitions and publications, both locally and abroad, as well as in the marketplace. Academic research has advanced considerably, and many objects housed in ethnographic collections have been reconsidered, now being regarded as both artefacts and works of art. In response to changing perceptions, art museums in several South African cities, led by Durban and Port Elizabeth, changed their collecting policies to include works that derived from local African traditions. Growing institutional collections have, in turn, stimulated interest and provided the basis for scholarly research. A notable moment in this process occurred in 1978 with the establishment of the Standard Bank Foundation of African Art at the University of the Witwatersrand. A more recent landmark was the exhibition in 1991 of the Brenthurst Collection at the Johannesburg Art Gallery, showing a wide range of accomplished works that had previously been in a private collection abroad. Coinciding with the return of many political exiles, this 'homecoming' exhibition proclaimed and celebrated the artistic heritage of southern Africa. Subsequent exhibitions at the South African National Gallery in Cape Town have underlined this message. Political transformation has been accompanied by an embrace of African culture and history, and a growing confidence in the artistic achievements of the subcontinent.

The earliest art in southern Africa

Unlike those art forms that have only recently been accorded the status of art, rock paintings and engravings, found throughout southern Africa, have been recognised as works of 'prehistoric' art for over a century. This did not, however, prevent them from being widely misinterpreted. Only in the last two decades has progress been made in understanding what the art meant for its creators, the early inhabitants of southern Africa, known in recent times as the Bushmen or San. (Both of these names have assumed negative connotations in certain historical contexts. 'San' is used here, as 'Bushman' continues to have derogatory connotations for some people.) The sheer number of sites, estimated at over 15,000, attests to the importance of rock art in San culture. Although pastoralists may have been responsible for some of the later art, and agriculturists are known to have depicted the layout of their settlements in engravings, these sites constitute a very small fraction of the entire body of rock art.

Painted shelters, some containing hundreds of individual paintings, are situated mainly, although not exclusively, in the mountainous regions of the subcontinent – the Matopo hills in Zimbabwe, the Tsodilo

Fig. 2 Skin of a small antelope made into a shoulder bag, used by /Xam hunter-gatherers in the Gordonia district of the Cape Province in the 19th century. Ovoid patterned areas, formed by removing the nap of the hide, recall the designs on ostrich eggshell flasks. Length 68 cm, South African Museum, Cape Town, AE 1546

hills in Botswana, the Namibian Brandberg, the Waterberg, Magaliesberg, Cedarberg and Drakensberg in South Africa, and the Maluti mountains of Lesotho, to name but the best-known regions. Engravings have a complementary distribution to the paintings, occurring mostly on exposed rocky outcrops and hillslopes or in the open veld of the inland plateau. They tend to depict individual animals, geometric patterns and occasionally human figures, while paintings range from single images to complex narrative compositions including people, animals, therianthropes (figures that combine animal and human features), scenes that appear to depict conflict and camp life, as well as enigmatic handprints and abstract forms.

White clay, black manganese or charcoal, and ochres shading from deep red, through vermillion to pale yellow (possibly mixed with blood, water or egg tempera) were used to produce arresting monochrome and bichrome images, as well as the shaded polychrome paintings that distinguish the most accomplished compositions. The clarity of line and detail in certain paintings suggests that quills, bone splinters or fine brushes of animal hair were used to execute these works. Over long periods of time, sites were revisited and acquired ritual significance. Many of the painted images are superimposed and connected to elements of earlier paintings and to features on the rock surface, as in the superb panel from the farm Linton in the Eastern Cape Province. Although incomplete – part of the panel remains in the shelter from which it was removed in 1918 – the composition and detail reveal both aesthetic sensibility and cognitive depth (cat. 3.4).

Paintings and engravings also occur on smaller stones, some of which have been excavated from archaeological deposits. Although less spectacular than large painted panels, stratified fragments are immensely valuable in that they can be dated if found in association with carbon remains. Unfortunately, when the painted stone from Coldstream (cat. 3.6) was excavated in 1911, isotopic dating methods had not yet been developed, so its age remains unknown. Painted stones excavated more recently from the southern Cape have been dated to between 2000 and 6000 years before the present (BP). Very much older, however, are the painted stones excavated from the Apollo 11 shelter in southern Namibia and dated by associated charcoal to 27,500 BP, making them the earliest dated rock paintings in Africa (cat. 3.3). This antiquity makes them far older than the painted sites of the Sahara and in the same time range as the rock art of Spain, southern France and Australia. Consequently, any suggestion that rock art spread from Europe to north Africa, the Sahara, east Africa and eventually south of the Zambezi cannot be sustained. It seems that these ancient aesthetic traditions developed independently.

After Apollo 11, the earliest dates for painted fragments come from two sites in Zimbabwe dated to about 10,000 BP. The earliest dated engravings, from Wonderwerk Cave in the northern Cape, span a period from about 10,000 to 4000 BP. The gap in time between Apollo 11 and the other dated sites is probably related to the need for more fieldwork rather than the absence of art production during the intervening period. It is well established that, about 30,000 years ago, nomadic hunter-gatherers were not only producing a range of fine stone and bone tools, but wearing ostrich eggshell beads and mollusc-shell pendants. Grinding-stones from this period may have been used to pound earth pigments for cosmetics or painting.

Artistic expression in the form of decorated ostrich eggshell vessels is known from 15,000 years ago in the eastern Cape. This art form, as well as the making of beads from ostrich eggshell, continued through the millennia to the 20th century (cat. 3.9), and ovoid forms that echo the designs on ostrich eggshell flasks are also found on bags made from animal skin (fig. 2). Bags like these were frequently depicted in rock paintings, which are known to have continued well into the colonial period. The final phase of painting, dating to the second half of the 19th century, includes depictions of ox-wagons and mounted colonists with rifles. Sadly, the rifles were too powerful for the artists. It is ironical that after the resistance

of hunter-gatherers had been quelled and they no longer posed a local threat to the colonists, their culture increasingly became the subject of intellectual discourse in the metropolitan centres of Europe. Evolutionist ideas prevailed; both the hunter-gatherers and their art were ranked low on the scale of civilisation. Fortunately, however, for the future understanding of rock art, the German philologist Wilhelm Bleek devoted his attention in the 1870s to understanding San languages and transcribing their oral literature. Eventually, over 12,000 pages of /Xam (southern San) folklore were recorded by Bleek and his sister-in-law, Lucy Lloyd. The evocative narratives of //Kabbo, Dia!kwain and /Han≠kass'o, who were serving prison sentences in Cape Town, have provided a key to the beliefs that animated rock art in San culture.

A century after Bleek had recognised the religious nature of San paintings, anthropologist David Lewis-Williams returned to the Bleek and Lloyd papers, to unravel the complex conceptual motivation of the art, and to refute the fallacy that it was simply a prosaic record of hunter-gatherer life. In essence, rock art depicts the rituals and experiences of healers who went into trance to harness supernatural potency for benevolent purposes, such as curing illness, preventing danger, attracting game or making rain. Certain animals were perceived as being potent sources of ritual energy. Elephant, giraffe, rhinoceros, zebra and lion were significant in particular contexts, but most powerful of all was the largest antelope, the eland. Depicted more frequently in most regions than any other animal, the eland evoked multiple meanings that mediated different realms of experience, as in the trance dance when the shaman 'died' like the eland to enter the spirit world, or when the eland dance was performed at girls' puberty rites. Visions experienced in trance were represented in the paintings, which then embodied spiritual power that could be invoked for ritual purposes.

Engravings, incised, scraped or pecked into the rock, were expressions of the same system of beliefs as the paintings. Grids, chevrons, circles and other abstract forms (cat. 3.8) are believed to depict hallucinatory entoptic phenomena seen during the early stages of trance, while many of the animals in engravings are associated with supernatural potency (cat. 3.7). The positioning of sites in the landscape, the angle of the sun, as well as the patina of the rock surface added to the impact of rock engravings in situ. When rock art is viewed in a gallery setting, however, the original ambience can only be imagined.

From about 2000 years ago, the presence of herders (later known as Khoikhoi) in the south-west is reflected in the archaeological remains of sheep and distinctive conical-based pottery. In other respects the material residues of herder sites were not markedly different from those of hunter-gatherers. Meanwhile, in the east and centre of the subcontinent, people who were both physically and culturally different from the hunters and herders were spreading southwards, bringing an economy and technology that was to transform the landscape. By about AD 300 these people, who lived in semi-permanent settlements, smelted and forged metal, produced distinctive pottery and cleared land to cultivate crops, had established themselves south of the Zambezi in present Zimbabwe, the eastern Transvaal and the subtropical coastal regions of Mozambique and Natal. Within the following two centuries they were also keeping herds of domestic cattle, and the importance of cattle grew beyond the economic realm to become of central cultural and symbolic significance.

The art of the southern African Iron Age

During the first millennium AD, known to archaeologists as the Early Iron Age, fine domestic pottery was ubiquitous, but by far the most important works from this period are the seven terracotta heads (cat. 3.10) from the eastern Transvaal site of Lydenburg, dated to between AD 500 and 700. Although the heads remain of unequalled quality, modelled figures from other sites in the Transvaal, Natal and Zimbabwe

suggest they were not unique. The 8th-century site of Ndondondwana on the Lower Tugela River in Natal has yielded fragments of a hollow ceramic sculpture, as well as modelled animal horns and human figures, and hundreds of figurines were recovered from the site of Schroda on the Limpopo. Many of these seem to be symbolic representations (cat. 3.11), possibly for use in initiation schools.

From about AD 800 very large settlements emerged in certain places, usually on hilltops or other elevated sites, and important centres were established near the confluence of the Limpopo and Shashi rivers. Toutswe and related sites in eastern Botswana reveal increased numbers of cattle, a growth of wealth and political stratification. The site known as K2 or Bambandanalo, adjacent to Mapungubwe on the Limpopo, yielded extensive evidence of ivoryworking, as well as ivory ornaments and large quantities of imported glass beads, indicative of links with trade networks on the east coast. This site declined as Mapungubwe rose to power around the year 1100 to become the capital of a trading empire. Gold replaced ivory as the most prestigious item traded for glass beads, cloth and Chinese celadon ware. Trade links extended to Sofala, Kilwa and indirectly to Arabia, India and China. The rulers of Mapungubwe lived and were buried on an élite hilltop area surrounded below by villages occupied by their subjects. The graves on Mapungubwe hill contained a large quantity of precious objects, including the remains of two small rhinoceroses, a bowl and a sceptre, all of which had been made of gold plates riveted to inner cores, probably of wood. The arms and neck of a human skeleton were found encircled by hundreds of gold-wire ornaments and beneath its head were pieces of curiously shaped gold plate, suggesting that they had adorned a wooden headrest. If this was so, it affirms that headrests have a long history of being regarded as intimate personal possessions that were buried with their owners. This practice continued among Shona and other southern African people to the early 20th century (cat. 3.20–1).

Mapungubwe was eventually succeeded by Great Zimbabwe in about 1250. For the next two centuries, Great Zimbabwe was the most important capital of a vast Shona kingdom that stretched between the Zambezi and Limpopo rivers (p. 31, fig. 1). From 1450 power shifted again, this time to Khami (near present Bulawayo) and to Mutapa (near Mount Darwin) in the north. Smaller Zimbabwe-like settlements extended southwards to the Zoutpansberg where cultural practices that have their origin in Zimbabwe traditions continue among the Venda people of the Northern Province of South Africa. Dry stone walling, in some places carefully patterned, is characteristic of all these sites but the magnificence and monumental scale of the stone architecture at Great Zimbabwe is unsurpassed. The site encompasses a hill complex, which was the residence of the ruler or mambo, the spiritual centre of the entire nation. The upper valley included a massive walled enclosure with inner walling and conical tower, while the lower valley was where the royal wives are believed to have lived. Six of the acclaimed soapstone birds (cat. 3.12) were found in the Eastern Enclosure of the hill complex, as were carved ceremonial bowls (cat. 3.13), monoliths and figurines. This is thought to have been a sacred place visited by the ancestral spirits of past rulers, who were commemorated symbolically by the birds.

The distinctive pillar with a crocodile carved below the bird came from the Lower Valley area associated with the royal wives, and possibly marked the ancestral shrine of the king's senior wife. Crocodiles were symbolically linked with chieftainship and wisdom, as well as the ancestral spirits by virtue of dwelling in deep pools. Both Shona and Venda divining implements (cat. 3.17) are inscribed with crocodile symbols, and the doors used by Venda chiefs are often carved with designs that have metaphorical associations with the crocodile (cat. 3.18a). Venda ethnography has been skilfully used by Thomas Huffman to suggest that the spatial arrangement and material remains of the Great Enclosure in the Upper Valley signify a site appropriate to girls' initiation ceremonies. The many stylised female and male figurines, as well as other unusual objects found in this area, are reminiscent of the figures known in recent times to have been used for teaching purposes in initiation schools. Although the scale

of building at Great Zimbabwe was exceptional, the underlying architectural layout was common to all Zimbabwe capitals, and similarities are still discernible in the present capitals of Venda chiefs. However, while the presence of pole figures (cat. 3.19; fig. 1) among the Lobedu people of the Transvaal lowveld may seem to echo the Zimbabwe birds, their positioning in the public court of the capital emphasises political rather than religious connotations.

The wealth of Great Zimbabwe, like that of Mapungubwe, hinged on control of the Indian Ocean gold trade, as well as local trade and tribute networks in tin, iron, copper, salt, cattle and grain. The reasons for the decline of Great Zimbabwe are not fully understood, but social and political factors, coupled with vastly diminished environmental resources, may have contributed to its demise. In the mid-15th century Great Zimbabwe was abandoned in favour of Khami and Mutapa, and by the early 16th century the Portuguese had taken control of the east coast trade.

In the south-eastern parts of southern Africa during the later part of the Iron Age a pattern of subsistence farming continued but between 1300 and 1600 settlement spread from the savanna areas into the unwooded grasslands. As in earlier times, the summer rainfall requirements of grain agriculture limited the geographical expansion of these early farmers. Regional differences in pottery styles and architecture became more pronounced and localised centres of metal production thrived in the wooded savanna regions – hoes, spears and other metal implements were traded to grassland communities. The arid western parts of the subcontinent were occupied predominantly by Khoisan hunter-gatherers and herders, but during the 16th century groups of Herero pastoralists and Ovambo agriculturists from the north-east moved into the area and settled on the fringes of the arid and semi-arid zones.

Cattle were important throughout. Ethnographic sources reveal that cattle were associated with patrilineal authority and the ancestral spirits. Among Nguni-speaking people this was emphasised by each homestead being arranged around a central cattle enclosure. In the concentrated Tswana settlements of the western highveld, cattle were kept in outposts but they remained of central cultural significance. Among Herero pastoralists, cattle were so strongly linked with the ancestral spirits that a sacred fire was kept alight continually beside the cattle byre in the centre of the homestead. Aesthetic sensibility was inseparable from cultural values, as is evident in the allusions to cattle in headrests and staffs (cat. 3.27a,c–d), as well as in the use of materials derived from cattle for making personal objects, such as snuff containers. Among predominantly agricultural communities, where beer brewed from sorghum or millet was the preferred offering to the ancestral spirits, vessels used for this purpose symbolised the link between everyday life and the spiritual realm. In general, women were precluded from cultural practices associated with cattle but were important in the domain of agriculture. They were also the potters and, in many parts of southern Africa, pottery vessels were symbolically associated with women and fertility.

From the late 18th century southern Africa was caught up in unprecedented processes of transformation. Although it would be incorrect to assume that interaction between groups was minimal before colonial contact or that traditional practices were unchanging, the dynamic of former historical relationships was completely altered by events that took place from the late 18th century onwards. The rise of military chiefdoms and the establishment of the Zulu kingdom (fig. 3) under Shaka in the early 19th century, the waves of migration that ensued, together with the advance of European colonists, the subsequent dispossession of land, and the undermining of chiefly authority irrevocably changed the cultural landscape of the subcontinent.

*Fig. 3 Mpande on his chair of state, from A. J. F. Angas, *The Kaffirs Illustrated*, 1849. The Zulu king is sitting on one of the four hand-carved chairs that he is known to have owned. The chair shown here is believed to have been made by the carver Mtomboti kaMangcengeza*

Impact of colonialism

Some of the most accomplished works of art had been produced for chiefs and rulers in tribute and in recognition of their elevated status (cat. 3.26, 40a, 46). Processes of colonisation changed both the nature of subject-ruler relationships and the material culture that was implicated in sustaining them. In some places access to raw materials was denied to craftsmen, and everywhere the introduction of taxation, a money economy and industrial goods had an impact on former cultural practices; as a result the production of hand-wrought metal artefacts declined. The migrant labour system undermined rural productivity and changed the balance of labour. In addition, missionaries set out to eradicate practices that were rooted in ancestor beliefs, and evolutionist theories had a negative effect on perceptions of African material culture.

As elsewhere on the continent, conquest resulted in the removal of significant cultural objects from southern Africa. Many colonial collections were enriched by insignia of office that had been appropriated from chiefs, and by trophies of war looted from battlefields. Reactions to conquest, however, were by no means passive or uniform. The case of the powerful Ndzundza Ndebele chiefdom, which was defeated by Boer forces in 1882, illustrates both cultural resilience and creative energy. The now famous mural art of the Ndebele people emerged in the 20th century in defiance of the threat to their cultural integrity when they were forced to disperse and live on white-owned farms. Significantly, both Ndebele wall-painting and beadwork, which predates the mural art, were developed by women drawing on traditions of the past with immaculate skill but also an openness to innovation (cat. 3.35). The earliest Ndebele beadwork goes back about a century, but the use of beadwork ornaments by Xhosa-speaking people in the eastern Cape is mentioned in records dating back to the 18th century.

The system used to classify both the people and the arts of the subcontinent derives in part from colonial processes of creating conceptual order in unknown territory. Standardising dialects and languages was a prerequisite for both effective government and mission work. Language classification then formed the basis of ethnographic classification. The African languages spoken in southern Africa form part of a large family of languages that stretches southwards from Cameroon and the Great Lakes of equatorial Africa. Although classificatory categories, such as 'Zulu', have often been misused in relation to cultural and stylistic attributions, it could be argued that even incorrect labels are part of the history of an object – part of its biography, as it were. From another viewpoint, however, both labels and stylistic classifications can mask historical relationships. For example, the presence of a heading, often taken to be diagnostically 'Zulu', may relate to a more complex historical situation in which headings were adopted by members of other groups. The early production of curio works further complicates the issue of classification and raises questions about the notion of authenticity.

It is perhaps pertinent to note in conclusion that, once objects are removed from their original contexts and reclassified, they acquire new connotations and values; they embody different narratives. These are as varied and cosmopolitan as the histories of individual works. Exhibitions such as this tell not only of the art on view but of the vision of the curators, and contemporary processes of selectivity. Rock art, however, has a history so long and is so embedded in the landscape that it seems to proclaim the creative human spirit of the continent. In drawing attention to the unique aesthetic heritage of southern Africa, this exhibition pays tribute to the artists, whose names are lost to us, and adds significantly to the continuing narrative of artistic expression in Africa.

Bibliographical note

A useful introduction to southern African rock art is found in Lewis-Williams (1983) and Lewis-Williams and Dowson (1989). Dowson (1992) provides a more detailed study of rock engravings, while the volume of essays edited by Lewis-Williams and Dowson (1994) covers current issues in rock art studies, including interpretations that emphasise gender relations in San society. Solomon (1992) discusses the issue of gender in rock art in some detail. Hall (1987) and Maggs (1984) cover the southern African Iron Age in general, while Huffman is concerned with the symbolic dimensions of the layout of Great Zimbabwe (1984) and has also written about the Zimbabwe birds (1985). A volume edited by Nettleton and Hammond Tooke (1989) contains essays that provide an introduction to historically known African art traditions, including studies of Venda and Lobedu art forms. The catalogue essays for the exhibitions held in Johannesburg, 1989 and 1991, cover the arts of the region, including essays on Ndebele beadwork, Venda art, figurative carving, pipes and snuff boxes and headrests.

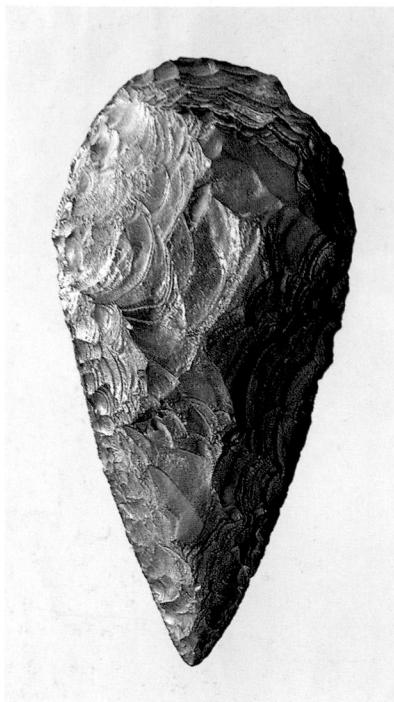

3.1

Handaxe

South Africa
c. 600,000 BP
banded ironstone
25 x 11.4 cm
McGregor Museum, Kimberley,
MMK 6538

Handaxes were all-purpose tools made in Africa by *Homo erectus* and archaic *Homo sapiens* during the Early Stone Age, between about one and a half million and 200,000 years ago. This fine example comes from Kathu Pan where an ancient sink-hole once provided access to artesian water in an arid area on the edge of the Kalahari. A small excavation, through eleven metres of layered sediments, yielded a few hundred thousand stone tools that came mainly from one level. The assemblage includes handaxes, cleavers, rare trimmed points, and a great variety of side and end scrapers, in addition to the debris resulting from their production. Most of the artefacts are made from locally available banded ironstone, but others are made from rocks that occur about 30 km away.

After they were discarded, many of these tools became coated with a shiny film of silica, which precipitated out at times when the alkaline groundwaters became saturated. These geochemical circumstances also resulted in faunal remains from the site being represented only by teeth,

which ranged from those of small springhares to those of an elephant species that became extinct in the African savannas about 600 millennia ago. It should be noted that this fact provides a minimum age for the associated tools.

Excavations at Wonderwerk Cave in the same region have yielded handaxes of similar age, together with evidence for the regular making of fire, discrete grass bedding areas, exotic pebbles or crystals, and red ochre that was presumably used for body decoration. These are among the earliest known traces of cultural patterns that reflect aesthetic sensibility. *PB*

Provenance: 1978–9, Kathu Pan, Site 1, Stratum 4b

Bibliography: Beaumont, 1990¹; Beaumont, 1990²

3.2

Handaxe

Namibia
Early Stone Age (Acheulean)
Rhyolite
34 x 13.5 x 8.5 cm
State Museum of Namibia, Windhoek,
B1419

The Pleistocene archaeology of Namibia is well represented by artefacts belonging to the Acheulean industrial complex, which first appeared more than a million years ago and lasted until approximately 200,000 years ago. Handaxes and cleavers, made by hammering on cobbles, blocks and flakes, are among the most characteristic of these artefacts and include examples of near perfect symmetry that exhibit complete mastery over the raw material.

Artefacts of wood, bone and other organic materials are extremely scarce and in Namibia the majority of Acheulean sites are open scatters in which only the stone artefacts survive. As a general rule, the artefacts are seldom found very far from the source of their raw material. Many such sites are located in saddles or gaps between hills where they may have formed part of communal game drives. Others are found on the margins of what would have been marshes or evaporation pans in the past, and it is conceivable that these locations also played a part in hunting strategies. The axes and cleavers, particularly, are thought to have been used in heavy woodworking and butchery of large animals, while a range of other artefacts including points, picks and scrapers reflect the variety of other

tasks. It is, however, arguable that workmanship of the handaxes and similar large pieces goes well beyond functional requirements. While it is not possible to attach to them any particular significance as, for example, prestige items, some apparently point to an aesthetic sense that is otherwise not well preserved in the archaeological record of the period.

Certainly, the middle Pleistocene in southern Africa coincided with major developments in human cultural and biological evolution, and these would have included the cognitive advances associated with art and language.

The example shown was collected from the surface in the vicinity of the Shambyu Roman Catholic Mission, near Rundu, on the Kavango River in northern Namibia. The site is exceptionally rich in Acheulean artefacts made of quartzite and rhyolite. The surface patina on the handaxe is mainly the result of polishing by the wind. Large numbers of the artefacts are cemented into a conglomerate outcrop that is partly submerged in the river. Similar outcrops occur elsewhere in the region and indicate the relatively young development of the river course relative to the Acheulean occupation. *JK*

Provenance: surface find, Shambyu Mission, Rundu, Okavango Province, north-eastern Namibia

Bibliography: Sampson, 1974; Jones, 1979, p. 836; Szabo and Butzer, 1979; Volman, 1984

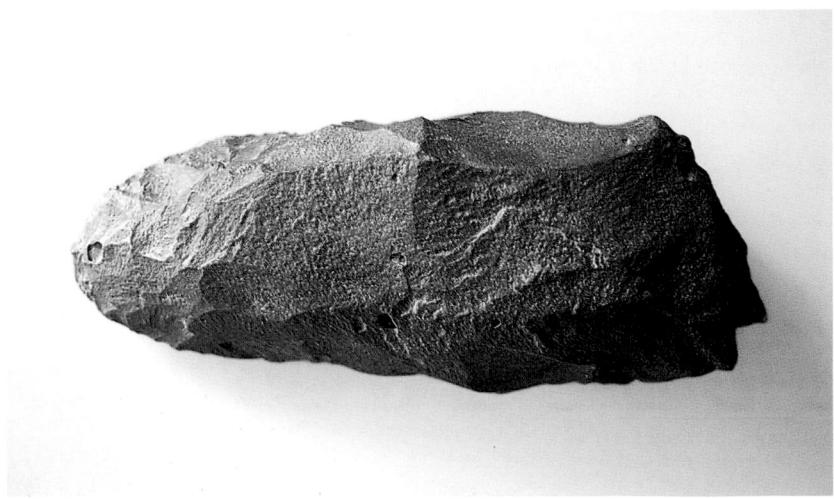

3.3a

Charcoal drawing of an antelope

Namibia

27,500–25,500 BP

charcoal and ochre on shale

9.5 x 12.5 x 1.5 cm

State Museum of Namibia, Windhoek,
B2104

3.3b

Charcoal drawing of animal-human figure (two pieces)

Namibia

27,500–25,500 BP

charcoal on shale

11 x 8 cm; 9 x 5 cm

State Museum of Namibia, Windhoek,
B2104

(illustrated p. 11)

Excavations at the Apollo 11 site have revealed an occupation sequence extending over the last 80,000 years, with a series of macrolithic, blade-dominated assemblages being replaced about 20,000 years ago by a series of increasingly microlithic assemblages and the eventual abandonment of the rock shelter in the last few centuries. Associated with the final macrolithic assemblage is a group of seven small slabs of rock showing traces of animal figures in charcoal, ochre and white. It is noteworthy that the rock slabs were apparently brought to the site from elsewhere; they are not spalls from paintings on the roof and walls of the rock shelter. The most remarkable of these is broken in two (cat. 3.3b), and bears what appears to be a feline creature with heavy head, deep chest and thin tapering legs. However, the two slightly curved horns and male genitalia are characteristic of bovid (cloven hooved herbivores). More interesting still, the drawing appears to have been retouched at some stage, with the possible alteration of the hind legs to resemble those of a human figure.

The other paintings are less complex, but they clearly belong to the same tradition. These include a headless antelope in charcoal, with a superpositioned line in red ochre (cat. 3.3a). The antelope is shown in an extended position and has the same tapering legs as the animal-human figure. A similar style is displayed by a third slab, bearing what appears to be a giraffe, or possibly a zebra. The short upright mane is found in both animals, as is the pronounced cheek,

but the body markings are a stylised chequer pattern of fine black and white lines. The remaining three slabs have very indistinct traces of charcoal lines, one possibly depicting a rhinoceros.

The same motifs are common among the surviving (and presumably much younger) paintings found in open rock shelters elsewhere in Namibia and southern Africa. Similarities in subject-matter and stylistic convention point to a remarkable continuity in the artistic tradition and in the religious beliefs to which it relates. Superpositioning, as shown by one of the Apollo 11 paintings (cat. 3.3a), is an important feature of the more recent rock art and reflects definite syntactical relations rather than disregard for earlier works. Furthermore, the combination of human and animal traits reflects the underlying beliefs of ritual healing practices of hunter-gatherers in which shamans employed the supernatural potency of particular

wild animal species. Details such as the long, tapering legs and the chequered body markings shown in the paintings are probably conventions for the depiction of physical symptoms experienced by shamans in trance. The rising sensation associated with the onset of trance is shown most suggestively in the depiction of the legs in the animal-human figure (cat. 3.3b), and the equally well-attested trance symptom of fractured vision probably influenced the body markings of the other animal paintings. In all likelihood, correspondence between the animals and the symptoms of ritual trance guided the artist's selection far more than their importance as quarry for the hunt.

The implication of this evidence is that southern African hunter-gatherer ritual and art remained stable for an extremely long period. However, the length of this period depends at present on the accuracy of the Apollo 11 dating. While attempts to date the art directly have so far proved incon-

clusive, there are promising new advances in the dating of extremely small samples from carbon-rich paintings. Although there are not many accurate radiocarbon dates available for stratified finds, the painted stones recovered from archaeological excavations in southern Africa appear relatively recent, dating to within the last 9000 years. The very much earlier dating of the Apollo 11 paintings, evidently Africa's oldest works of art and contemporary with some of the Upper Palaeolithic art of western Europe, is potentially of great significance.

It should be borne in mind that the painted slabs were found in a concentrated group, in the uppermost layer of the macrolithic blade-dominated assemblages, where they were dated to between 25,500 and 27,500 before the present (BP). The next layer, containing an essentially microlithic assemblage is dated to between 18,500 and 19,760 BP. While the younger dates currently provide a

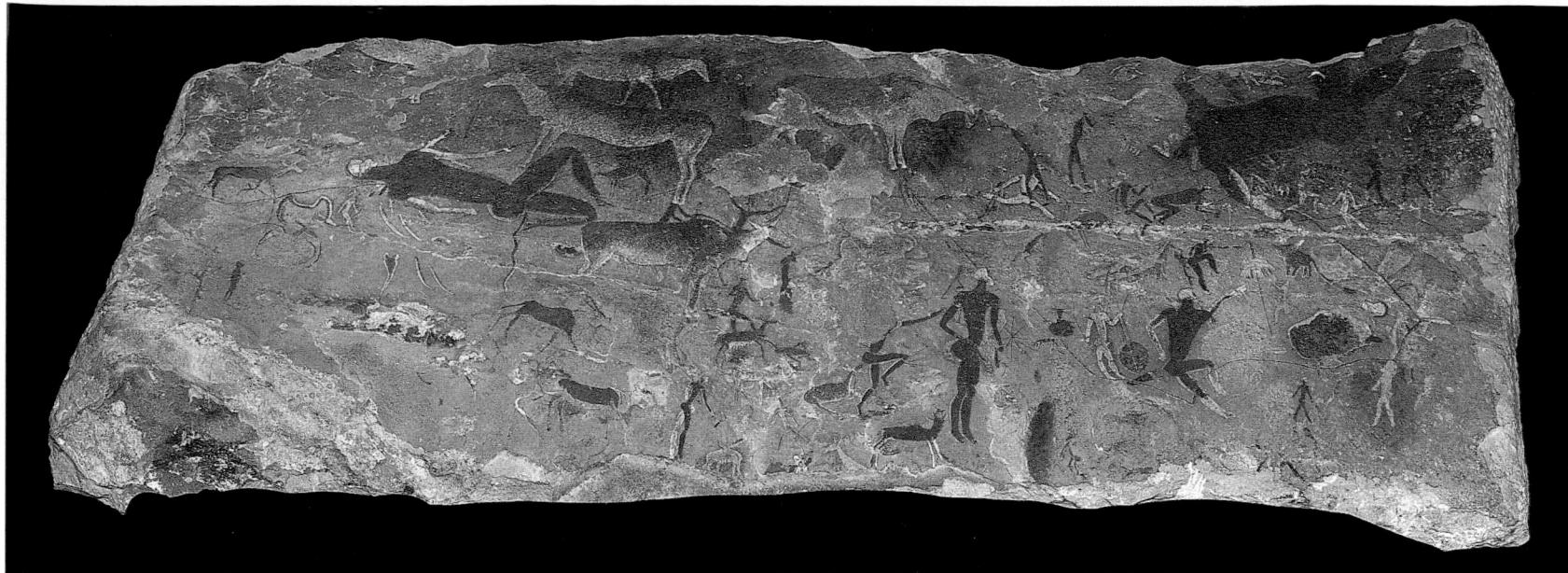

minimum age for the painted slabs, the excavation indicated that the association with the older dates was firm. Direct dating of the paintings themselves would resolve this ambiguity. JK

Provenance: 1969–72, Apollo 11 Cave, Huns Mountains, Karas Province, southern Namibia

Exhibition: Bonn 1991

Bibliography: Lewis-Williams, 1974; Wendt, 1974; Siegel, 1977; Rudner, 1983; Thackeray, 1983; Volman, 1984, p. 215; Kinahan, 1991

3.4

Linton panel

San

South Africa

possibly 18th or 19th century
stone, ochre and other pigments
85 x 205 x 20 cm

South African Museum, Cape Town,
SAM-AA 3185

The paintings of the Linton panel constitute an interconnected congeries of San religious symbols, metaphors of shamanic experience and depictions of shamanic hallucinations. Many of the images are connected by a bifurcating red line fringed with meticulously made white dots. This line, a common motif in the region, is thought to represent the route of shamanic travel or, perhaps simultaneously, the supernatural potency that permeated the San universe and that San shamans harnessed in order to enter the spirit world (trance), control the movements of animals, heal the sick, make rain and go on extracorporeal journeys in the form of animals. The southern San believed that this potency resided in certain large animals, chief of which was the eland (*Taurotragus oryx*), an animal that had, for the San, multiple symbolic associations. The depictions of eland in the Linton panel are symbols of this potency and, at the same time, ‘reservoirs’ of spiritual power on which San shamans, and possibly other people, could draw.

Depictions in the left part of the panel constitute a cluster of metaphors of shamanic trance experience.

The large supine figure depicts a shaman partly transformed into an animal; it has cloven hoofs rather than feet. The figure holds a fly switch, an artefact used almost exclusively in the trance, or medicine, dance. A key San metaphor, ‘death’ (entry into the spirit world), is represented by the antelope that impinges slightly upon one of the supine figure’s legs: it bleeds from the nose, as San shamans often did when they entered trance. ‘Death’ is also represented by the buck-headed snake that lies brokenly on its back; it too bleeds from the nose. The spotted rinkhals snake feigns death in this way and then springs to life. The fish that surround the supine figure and the eels below it represent another metaphor, the ‘underwater’ experience of which San shamans speak. A sense of weightlessness, difficulty in breathing, affected vision and hearing, and eventual unconsciousness are experienced by people underwater and by shamans entering trance.

Visual hallucinations experienced by shamans in trance are also depicted in the panel. A small dog-like creature with six legs is painted to the right of the central figure, which depicts a standing shaman. Just above this creature is an antelope head peering from a circle of paint that, like the red line, is marked with white dots. The spirit world was believed to lie behind the rock, and creatures of that world could be coaxed out of it by the application of paint. Further to the right, a human head, bleeding from the nose, also emerges from an area of paint.

The Linton panel was removed in 1918 from a rock shelter in the southern Drakensberg. Many associated paintings were destroyed in the process of removal. Those that were left in the rock shelter were subsequently severely damaged by natural weathering processes. The Linton panel probably comprises the richest and most complex set of rock paintings in any museum collection.
JDL-W

Provenance: 1918, removed from the farm Linton in the Eastern Cape Province, South Africa; 1918, South African Museum, Cape Town

Bibliography: Lewis-Williams, 1988; Lewis-Williams and Dowson, 1989

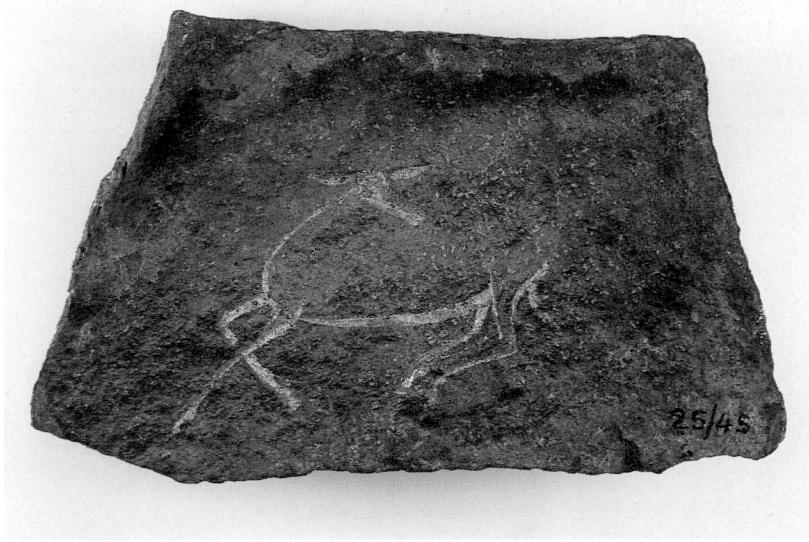

3.5

Rock painting

San
South Africa
age unknown
stone, paint
16 x 25 x 7 cm
University of the Witwatersrand,
Johannesburg, 25/45

This rock painting was removed in 1945 from the wall of a rock shelter in the Eastern Cape Province. It depicts a recumbent rhebuck (*Pelea capreolus*), painted in the shaded-polychrome technique. Its delicacy and the movement implied by its posture are typical of San art, but it is unique in that the central part of the body has been left unpainted. This was apparently an isolated image, but the San often painted animals in large groups that in size and sex ratios conform to herds as they are naturally constituted at different seasons of the year.

Animals had symbolic value for the San. Commenting on rock paintings of human figures with rhebuck heads, a 19th-century San man used a series of metaphors, some of which are depicted in the Linton rock paintings (cat. 3.4). He said that they were shamans who had 'died' and were then transformed in the 'underwater' spirit world and took on animal features.

The relationship between rhebuck and the spirit world is seen in the art in other ways as well. Sometimes 'spirit' rhebuck are depicted without legs and with trailing 'streamers'. In the region from which this painting comes, the number of paintings of

rhebuck is exceeded only by depictions of eland (*Taurotragus oryx*), the central, or key, symbol in San cosmology.

It has also been suggested that, because rhebuck live in small groups, they were conceptually associated with individual family groups among the San. Eland, on the other hand, were associated with larger aggregated San groups because eland herds amalgamate and break up into small groups seasonally, as do San communities. *JDL-W*

Provenance: 1945, removed from a rock shelter in the Eastern Cape Province, South Africa

Exhibition: Johannesburg 1995

Bibliography: Vinnicombe, 1976; Lewis-Williams, 1981; Lewis-Williams and Dowson, 1989; Lewis-Williams, 1990

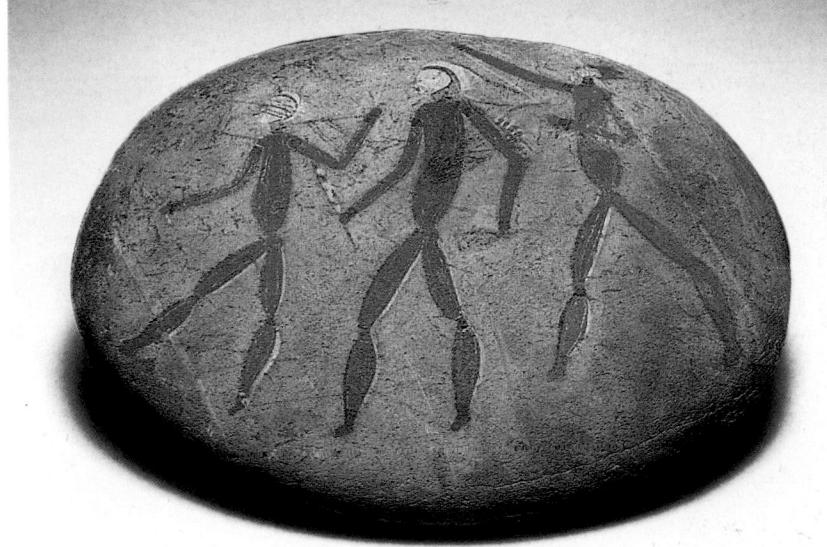

3.6

Coldstream stone

San
Southern Cape, South Africa
probably c. 2000 BP
quartzite, paint
24 x 30 x 7.1 cm
South African Museum, Cape Town,
SAM-AA 6008

This painted stone is one of the best-preserved and best-known pieces of southern African *art mobilier*. Some comparable painted stones from the same area have been dated to between 4000 and 2000 years ago; more recent examples have not been found.

The paintings depict three striding human figures. The right-hand figure has an arm raised in a gesture that is repeated in the rock paintings of the south-eastern mountains. The legs of all three figures are outlined partly in white, another feature found in paintings on the walls of rock shelters of the area. All three figures have some sort of decoration on their arms and legs. The first two figures from the left seem to be wearing some sort of white-edged caps; the figure on the right has a three-pointed red cap. They have the characteristic 'hooked' head with white face that is common in southern African rock art. It has been suggested that the lines painted on these faces may represent scarifications, but in some instances they clearly radiate from the nose, and therefore more probably depict nasal blood. When San shamans entered trance (the spirit world), they frequently bled from the nose. The central figure holds what may be a

feather and what seems to be a flat object. These items have led to the suggestion that it may depict a painter. Louis Péringuey thought that the black bars across the so-called 'feather' suggest that the object is a jackal's tail. While numerous figures in southern African rock art are depicted carrying animal-tail flywhisks, the object in the hand of the Coldstream figure is in fact extremely difficult to identify. A hunting bag from which a bow and arrows protrude is slung over this figure's shoulder. The stone was excavated in 1911 from a cave near the mouth of the Lottering river on the southern coast of South Africa. It was found, painted side up, lying on the shoulder of a skeleton. This suggests that it was implicated in funerary rituals. The excellent preservation of the paintings is remarkable and has led to suspicion that some of the natural ochres found in the excavation were used to touch up the images. Tests on the pigments have proved inconclusive. *JDL-W*

Provenance: 1911, excavated from Coldstream Cave, southern Cape coast, South Africa

Bibliography: Lewis-Williams, 1984; Wilson, van Rijssen and Gerneke, 1990

3.7

Rock engraving of giraffe

San
Namibia
1000–5000 BP
shale
70 x 66 x 45 cm
State Museum of Namibia,
Windhoek

The arid western Erongo Province of Namibia contains one of the largest concentrations of rock art in Africa, including many superbly painted rock shelters and extensive open-air engraving sites. While the paintings are dominated by human figures and the engravings by representations of animals, some subjects are common to both. Prominent among these is the giraffe, a species that also shows great variety in treatment, colour and style of execution.

Although naturalistic depiction is uncommon, and many examples show only the backline and profile, such paintings and engravings are not necessarily incomplete, for the rock art resonates with imagery and physical experiences associated with states of

altered consciousness. The belief of shamans in southern African hunter-gatherer communities, that the spinal column serves as a conduit for ritual potency, might explain the evident importance of the giraffe in the art. Indeed, paintings of serpents in Namibia are often identifiable as permutations of the giraffe, owing to the consistent presence of a small curve in exactly the position of the withers. Other features of the species that receive unusual emphasis include the pattern of the body markings and the short upright mane. The variegated markings of the giraffe are redolent of the fractured vision associated with the onset of trance, while the erect mane evokes one of the common physical symptoms of

game animals near to death. As a visual cue for the peculiar rising sensation in ritual trance, the extreme height of the giraffe would have further reinforced its ritual importance. Despite these suggestive associations, no specific meaning seems to have been attached to the giraffe in rock art, and in all likelihood it would have served as a general metaphor of the continuity between ritual, social life and the natural environment.

The engraving shown was produced by the pecking technique on a block of indurated shale, at the foot of the Dome ravine on the southern side of the remote Brandberg massif in western Namibia. The Dome ravine site is unusual in that it combines both paintings and engravings in an area containing more than 1000 painted sites. Although the site and the engraving are undated, archaeological surveys conducted in the same area have revealed evidence of intensive hunter-gatherer occupation over the last 5000 years. Many of the rock art sites were used repeatedly during this period as dry season refuges. While the giraffe engraving might not be as old as 5000 years, it is probably over 1000 years old, for in this area the hunting way of life, together with the ritual and rock art traditions, was rapidly displaced during the last millennium by the rise of nomadic pastoralism.
JK

Provenance: surface find, Dome ravine, Brandberg, Erongo Province, western Namibia

Exhibitions: Rotterdam 1993; Cambridge 1995

Bibliography: MacCalman, 1964; Pager, 1980; Lewis-Williams and Dowson, 1989; Kinahan, 1990, p. 5; Kinahan, 1991

Southern Africa's remarkable wealth of rock art is known not only for its extraordinary abundance, but also for its diversity. In addition to the famous paintings found mainly in rock shelters, there are the less widely appreciated engravings or petroglyphs, usually in open air settings on the interior plateau. These engravings manifest great variety in technique, content and history. For all their diversity, most of the engravings and paintings are believed to be linked within broadly similar Later Stone Age social and motivational contexts.

The oldest dated engravings go back about 12,000 years. On the other hand, oral history indicates that some rock art was made as recently as the 19th century. These two engravings were found near Kimberley in a region that is richly festooned with engraving sites. Animal and human images, as well as geometric or 'entoptic' forms such as these, occur in numbers ranging from just a few on hilltop boulders, to many hundreds or even thousands on the larger sites. A hard stone was used to form the images by chipping the outer crust of the rock.

The symbolism of San art is believed to be associated with religious beliefs and the experience of trance. The engravings may have been inspired by trance-induced visions, which were depicted on rocks at special places so that others could draw spiritual inspiration from them. Their palpable connection with landscape features, reflecting a 'topophilia', which is also revealed in some 19th-century San folklore, is one of the reasons why every effort is made today to preserve this art in its natural setting. *DM*

Bibliography: Wilman, 1933; Fock and Fock, 1979–89; Deacon, 1988; Morris, 1988; Beaumont and Vogel, 1989; Dowson, 1992

3.8a

Rock engraving

San
South Africa
c. 1000–2000 BP
Andesite rock
53 x 54 x 24 cm
McGregor Museum, Kimberley,
MMK RAC 28

3.8b

Rock engraving

San
South Africa
c. 1000–2000 BP
Andesite rock
48 x 50 x 12 cm
McGregor Museum, Kimberley,
MMK RAC 47

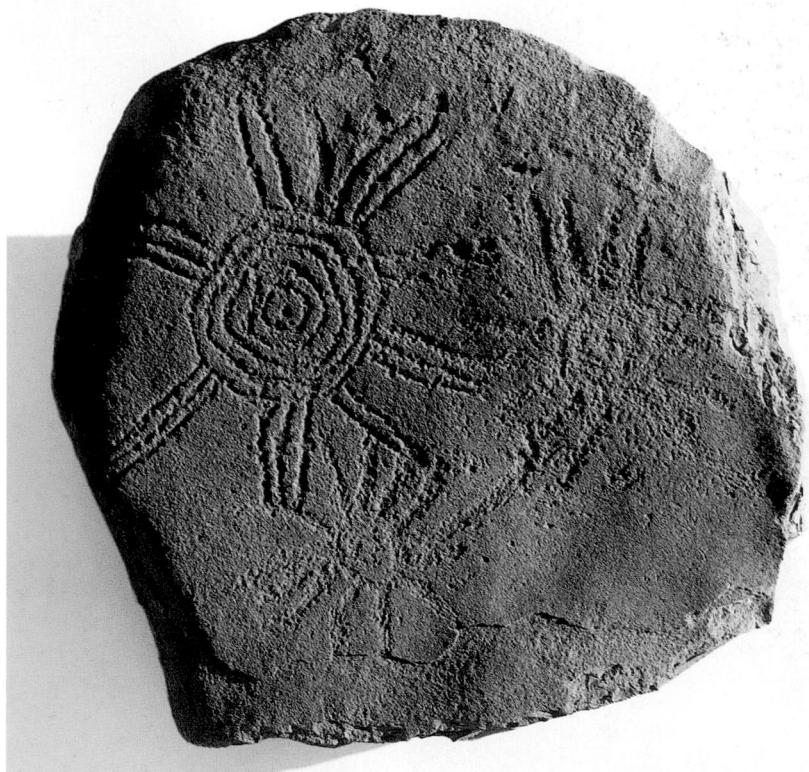

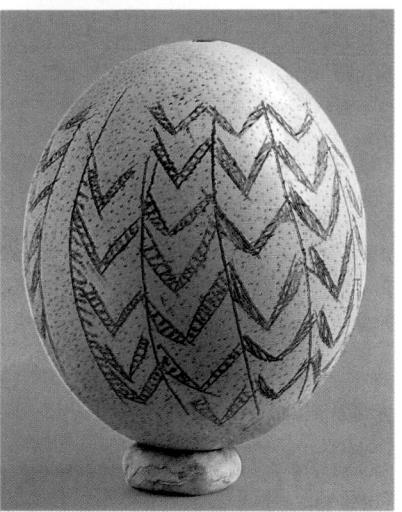

3.9a

Engraved ostrich eggshell flask

/Xam San
Griquatown, South Africa
1870s
ostrich eggshell
h. 15.5 cm; diam. 12.5 cm
Pitt Rivers Museum, Oxford, 1958.57.20

3.9b

Engraved ostrich eggshell flask

San
Windhoek, Namibia
early 20th century
ostrich eggshell
h. 14.8 cm; diam. 12.5 cm
South African Museum, Cape Town,
SAM-AE 1746

3.9c

Engraved ostrich eggshell flask

Masarwa
Molepolole, Botswana
early 20th century
ostrich eggshell
h. 15.4 cm; diam. 12.7 cm
University of Cape Town Collection at the
South African Museum, Cape Town,
UCT 58/46

3.9d

Engraved ostrich eggshell flask

San
Botswana
1920s
ostrich eggshell
190 x 110 x 112 cm
Natal Museum, Pietermaritzburg

Ostrich eggshells can remain well preserved for tens of thousands of years in archaeological deposits, and have been used as containers by hunter-gatherers, ancestors of the San, for at least 15,000 years. The oldest dated fragments of smoothed apertures, which indicate that eggshells were undoubtedly used as flasks, have been found in an archaeological context at Boomplaas Cave in the southern Cape region of South Africa. These are associated with Later Stone Age artefacts, though the practice of engraving patterns on eggshells is even older. Engraved fragments, but as yet without evidence for smoothed apertures, have been found at a small number of sites in South Africa and Namibia associated with Middle Stone Age artefacts more than 40,000 years old.

Until fairly recently, ostrich eggshell flasks were still used as water containers, particularly in areas where surface water was scarce. They were often buried for storage – caches of fifteen or more ostrich eggshell flasks have been found buried in the sand, and in the Kalahari several hundred eggshells, buried together, have been reported. In the 1960s Ju/'hoan in Botswana took about an hour to make a hole in an ostrich egg, remove the contents, clean the inside, and shape and smooth the aperture, which was most commonly at one end, but also found in the middle of the shell. When in use, the eggshells were sealed with a plug of beeswax or grass.

Engraving, done by both men and women, often took place over an extended period. Sharp stone flakes were the earliest tools, but metal implements were preferred when they became available. Charcoal or ochre was rubbed into the incisions to colour them black or red and to heighten the contrast and decorative impact. While very elaborate designs are seen, most cover only a portion of the surface. The designs are usually based on a 'ladder' or grid pattern, filling in triangles, parallel lines and curves. These patterns are also found in archaeological examples but both the fragments and the samples are too small to reveal any trend or change through time in pattern preferences. Some 20th-century engravers have taken advantage of the shape of the egg to design variations on an oval or ovoid form, while others focus designs

around the aperture. Naturalistic designs such as birds and antelope are known, but the majority are non-representational.

The flasks were not used exclusively for water. Records from the 19th and 20th centuries indicate that they were used for a variety of purposes, including the storage of ant larvae ('Bushman rice'), pieces of shell, as well as finely ground red ochre and powdered specularite, both used for cosmetic purposes. At least one finely engraved eggshell has been found with other grave goods in a Khoisan burial site.

Engraved decoration occurs on only a small percentage of ostrich eggshell flasks seen in use or recovered from abandoned caches. With little ethnographic knowledge on the special use of engraved eggshells, there is some disagreement among anthropologists as to whether the engraving had more than just a decorative purpose. Typically, old abandoned caches include only one or two decorated flasks, suggesting that engraving was relatively rare. Similarly, fragments of broken eggshells recovered at archaeological sites usually have only a small percentage of decorated pieces.

The highly decorated 20th-century examples on exhibition here could even reflect responses to the 'tourist' trade, which goes back several centuries. This is attested by an elaborately engraved eggshell obtained by the Swedish traveller Sparrman, who visited the Cape in the 1770s. Today, painted as well as engraved ostrich eggshells are available for sale throughout southern Africa.

The meaning of the 'traditional' patterns and motifs engraved on ostrich eggshell flasks has not been recorded. Although there is some similarity between the patterns of ladders, grids, parallel and zig-zag lines, chevrons and nested U-shapes used on ostrich eggshells and those in rock engravings and paintings, the religious metaphors, so evident in rock art, appear to be absent. The patterns on eggshells that have been used persistently for tens of thousands of years do not seem to have influenced the patterns in San beadwork (made only after glass trade beads were introduced from Europe in the last 400 years), nor the impressed designs

on clay pots made by some San groups in the last millennium.

The individualistic and seldom-repeated character of the designs has led to the assumption that their purpose was to indicate ownership. This has not been confirmed and the lack of agreement among Western observers probably stems from different perceptions of ownership. Anyone who has engraved an eggshell would be able to recognise his or her own work, but in traditional San society the engraver would not expect to have exclusive ownership or use of the eggshell and its contents. Instead, such items were widely shared and even exchanged within a *hxaro* network of gift-giving that established and maintained social relations and reduced risks. Designs assumed to imply ownership may have allowed an engraved flask to be recognised as the work of a particular individual, but would not have implied exclusive ownership either by the person who made it or by his or her social group. Irrespective of their possible meanings, however, engraved ostrich eggshell flasks manifest a combination of art and utility that has considerable antiquity. *JD*

Provenance: cat. 3.9a: Cape Town, c. 1932, from the Estate of E. J. Dunn; cat. 3.9b: 1913, donated to the South African Museum, Cape Town; cat. 3.9c: 1938, University of Cape Town Collection; since 1981, University of Cape Town Collection at the South African Museum

Bibliography: Bleek and Lloyd, 1911, pp. 261, 313; Dunn, 1931, pp. 95–6; Rudner, 1971; Marshall, 1976, p. 77; Lee, 1979, pp. 122–3, 276; Deacon, 1984, p. 237, table 11; Lee, 1984, pp. 97–102; Morris, 1994

3.9e

Engraved ostrich eggshell flask

San

Southern Africa (country of origin unknown)
ostrich eggshell
h. 15 cm; diam. 11 cm
The Trustees of the British Museum, London, 1910.363

3.9f

Engraved ostrich eggshell flask

San

Southern Africa (country of origin unknown)
ostrich eggshell
h. 15 cm; diam. 11.5 cm
Staatliche Museen zu Berlin, Preussischer Kulturbesitz, Museum für Völkerkunde, III D 3519

3.9g

Engraved ostrich eggshell flask

San

Southern Africa (country of origin unknown)
ostrich eggshell
h. 14 cm; diam. 12 cm
Staatliche Museen zu Berlin, Preussischer Kulturbesitz, Museum für Völkerkunde, III D 3513

3.10a

Lydenburg Head

Eastern Transvaal, South Africa

c. AD 500–700

clay; traces of white pigment and specularite

38 x 26 x 25.5 cm

University of Cape Town Collection at the South African Museum, Cape Town,
UCT 701/1

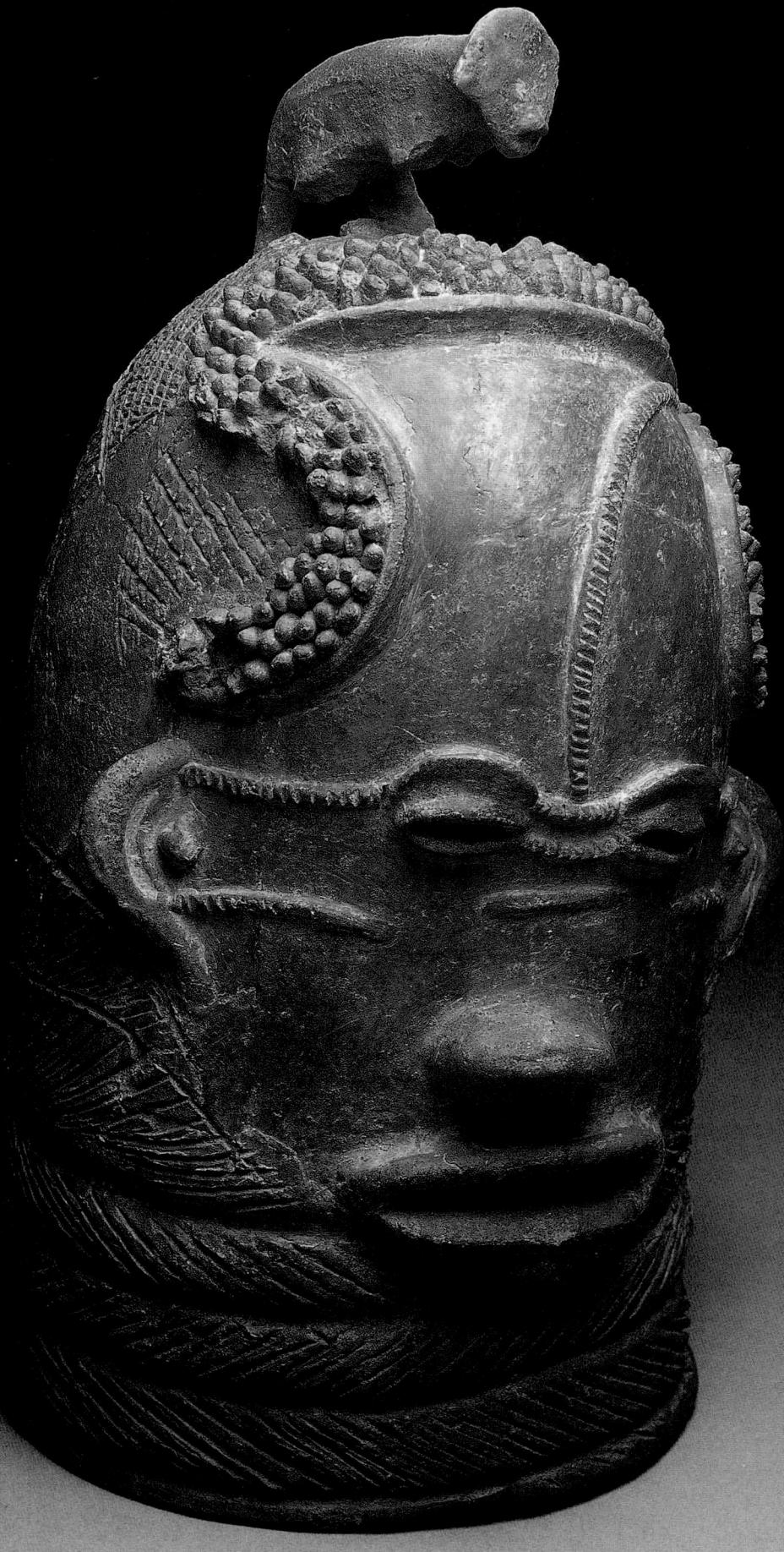

Seven terracotta heads, known as the 'Lydenburg Heads' after the site where they were found, have the distinction of being the earliest known forms of African sculpture in southern Africa. Fragments of the modelled heads, together with shards of domestic pottery, beads and metal ornaments, were found in an eroding gully, and charcoal from the site was later dated by the radiocarbon method to the 6th century AD. Later excavations confirmed this date and indicated that the heads had been buried in a pit, suggesting that they had been deliberately hidden when not in use.

Reconstruction of the fragments yielded seven fired earthenware heads, resembling inverted U-shaped vessels. Incised bands of diagonal hatching encircling the necks of the heads echo the characteristic decoration of domestic pottery from the site. Two of the heads are large enough to have been worn as helmet masks, and the smaller heads have a hole on either side of the neck that might have been used for attachment to a structure or costume. Distinctive facial features are formed by the application of modelled pieces of clay. All the heads have cowrie-like eyes, wide mouths, notched ridges that may represent cicatrisation, and raised bars across the forehead and temple to define the hairline. Panels of incised cross-hatching are found on the backs of all the heads. The large heads, however, differ from the others in having clay studs applied behind the hairline bar, and in being surmounted by modelled animal figurines. One of the small heads is atypical in having animal-like facial features (cat. 3.10b). Traces of white pigment and specularite are visible on all the heads.

Although the original function and significance of the heads remains elusive, archaeologists have suggested that they were possibly used in the performance of initiation rituals. If this was so, the heads would have been ceremonial objects used during the enactment of rites that marked the transition to a new social status, or membership of an exclusive group. The aesthetic power of the heads, enhanced by white slip and shimmering specularite, adds credence to the argument that they were used in a ritual drama to enthrall spectators, and mediate visually between the spirit world and that of everyday experience. Ultimately, the meaning of the heads remains enigmatic but they testify to a complex aesthetic sensibility among early agricultural communities in southern Africa, a millennium before the advent of European colonisation. *PD*

Provenance: late 1950s, discovered by K.L. von Bezing; 1960s, University of Cape Town; 1979, permanent loan to South African Museum. (In the 1970s the large head [cat. 3.10a] was restored by the British Museum)

Bibliography: Von Bezing and Inskeep, 1966, p. 102; Inskeep, 1971, p. 493; Inskeep and Maggs, 1975, pp. 114–38; Maggs and Davison, 1981, pp. 28–33; Evers, 1982, pp. 16–30

3.10b

Lydenburg Head

Eastern Transvaal, South Africa

c. AD 500–700

clay; traces of white pigment and specularite

24 x 12 x 18 cm

University of Cape Town Collection at the South African Museum, Cape Town, UCT 701/7

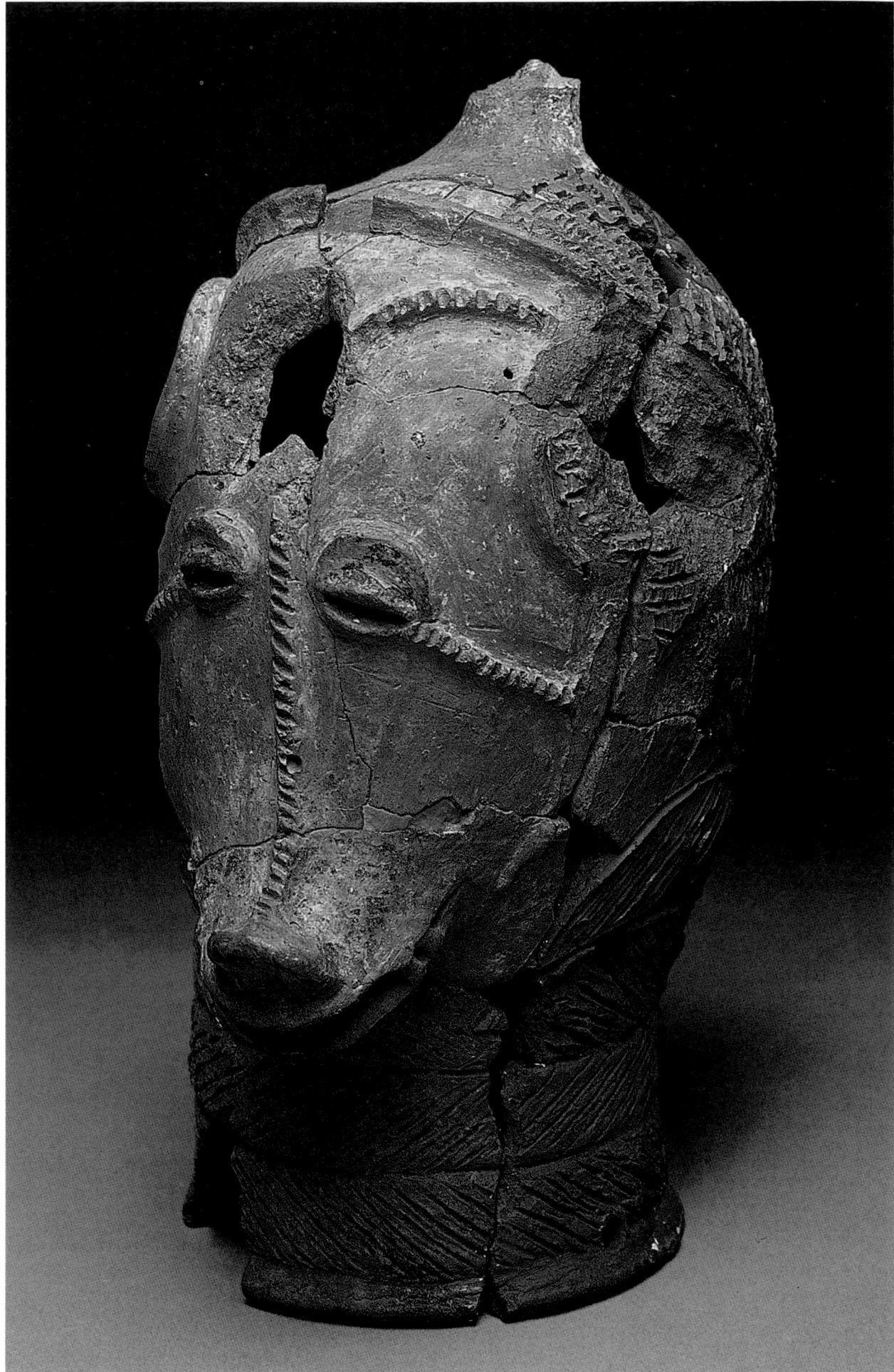

3.11a

Figurine

Northern Province, South Africa

9th century AD

clay

20 x 8.2 x 7 cm

On loan from the National Cultural History Museum, Pretoria, OHG 254

These three figurines form part of a much larger collection that was excavated on the farm Schroda, situated near the junction of the Shashi and Limpopo rivers. Fragments of modelled figurines occur throughout the site. A single cache, covered with potsherds, included over 400 fragments. The Schroda figurines may be divided broadly into three groups – realistic and stylised anthropomorphic (male and female), zoomorphic (including elephant, giraffe, cattle and birds) and mythological. Some have applied decorative features and were coloured with red ochre and graphite. Similar clay figurines have also been found at a number of other sites in the area.

The inhabitants of Schroda were able to exploit the vast herds of elephant in the Limpopo valley and the alluvial gold from the gold reefs in the south-west of present-day Zimbabwe. About the year 1000, Schroda was abandoned when a powerful group of newcomers settled in the vicinity and made their capital a few kilometres to the west at the site known as K2. This site became a wealthy trade centre, attested by the fact that more glass beads and ivory objects have been found at K2 than virtually all the previous settlements in the area put together.

Archaeological evidence shows that ritual activities were practised during the Early Iron Age even though they are not clearly understood. In particular, ceremonial sacrifice of animals is probably reflected by the pottery, ash and burnt bones that are often found in cattle enclosures. The best known artefacts indicating ritual behaviour in the Early Iron Age are the Lydenburg Heads (cat. 3.10) and the clay figurines from Schroda. Ethnographic sources suggest that collections of unusual figurines found within villages probably indicate the sites of former girls' initiation schools. As Schroda was a regional capital, occupied by between 300 and 500 people, large initiation schools were probably held there, explaining the profusion of these small clay sculptures. *JvS*

Provenance: 1976, excavated by E. Hanisch

Exhibitions: Pretoria 1982; Pretoria 1989

Bibliography: Richards, 1956; Hanisch,

1980, pp. 156–63; Grobler and Van

Schalkwyk, 1989, p. 70

3.11b

Figurine

Northern Province, South Africa

9th century AD

clay

18.5 x 8.5 x 6 cm

On loan from the National Cultural History Museum, Pretoria, OHG 252

(not illustrated)

3.11c

Figurine

Northern Province, South Africa

9th century AD

clay

21 x 10 x 6.5 cm

On loan from the National Cultural History Museum, Pretoria, OHG 251

Carved soapstone bird

Zimbabwe
13th–15th century
steatite
h. 100 cm
Groote Schuur Collection, Cape Town

Eight soapstone birds were found at Great Zimbabwe, the 13th–15th century capital of the Shona kingdom. All came from areas originally reserved for private and sacred functions. Seven came from the Hill Ruin, the secluded palace of a sacred leader. One of these stones was associated with the king's *chikuva*, or sanctuary, at the back of the Western Enclosure. The other six had apparently been mounted on low stone terraces in the Eastern Enclosure, a national ritual centre. The eighth bird was placed in a *chikuva* in the Philips Ruin or Lower Homestead, near where the king's pregnant wives were confined. These locations alone point to a religious significance.

Although each carved bird is different, they all have eagle mixed with human elements. The one from the Western Enclosure, for instance, has lips rather than a beak, and they all have four or five toes rather than three talons. Their meaning thus involves the roles of both birds and humans.

In Shona belief birds are messengers, and eagles, such as the bataleur, bring word from the ancestors.

Ancestral spirits in turn are supposed to provide health and success. Soaring like an eagle to heaven, the spirits of former leaders were supposed to intercede with God over national problems such as rain. Indeed, this ability to communicate directly with God was the essence of sacred leadership in the Zimbabwe culture. The carvings, then, were a stone metaphor for the intercessory role of royal ancestors.

Since each bird is unique, they probably represented specific leaders. Furthermore, their postures may have had gender significance. For example, the stone bird from the royal wives' area perches in a 'sitting' position, while the one associated with the king's *chikuva* is 'standing'. According to custom, the king's first wife, or *vahozi*, would have been in charge of the royal wives, and the sanctuary in

the Lower Valley was probably established to propitiate her ancestors. The most important woman in the capital, however, would have been the king's ritual sister, the senior woman of the ruling line and the great 'aunt' of the nation. The 'sitting' birds from the Hill Ruin probably signified the ancestral spirits of such women. The 'standing' birds of course symbolised the spirits of important male leaders.

Somewhat surprisingly, similar carved birds have not been found in other Zimbabwe culture settlements. This uniqueness may be due to the rise of Great Zimbabwe. When Great Zimbabwe became the capital, the supporting population was not familiar with sacred leadership because this feature had evolved 300 km away at Mapungubwe. To legitimise the new social organisation, the Zimbabwe leaders would have needed to glorify their ancestors. This would explain why all the birds from the Hill Ruin appear to have been carved by the same person. By the time Great Zimbabwe was abandoned, sacred leadership was widespread, and ideological justification of a new dynasty was no longer necessary.

TNH

Provenance: 1889, removed from the Eastern Enclosure of the Hill Ruin, Great Zimbabwe; 1889, sold by W. Posselt to Cecil John Rhodes

Bibliography: Bent, 1896, pp. 180–4; Hall, 1905, pp. 106–8; Posselt, 1924; Summers, 1961; Summers, 1963, pp. 70–4; Garlake, 1973, pp. 119–21; Huffman, 1985

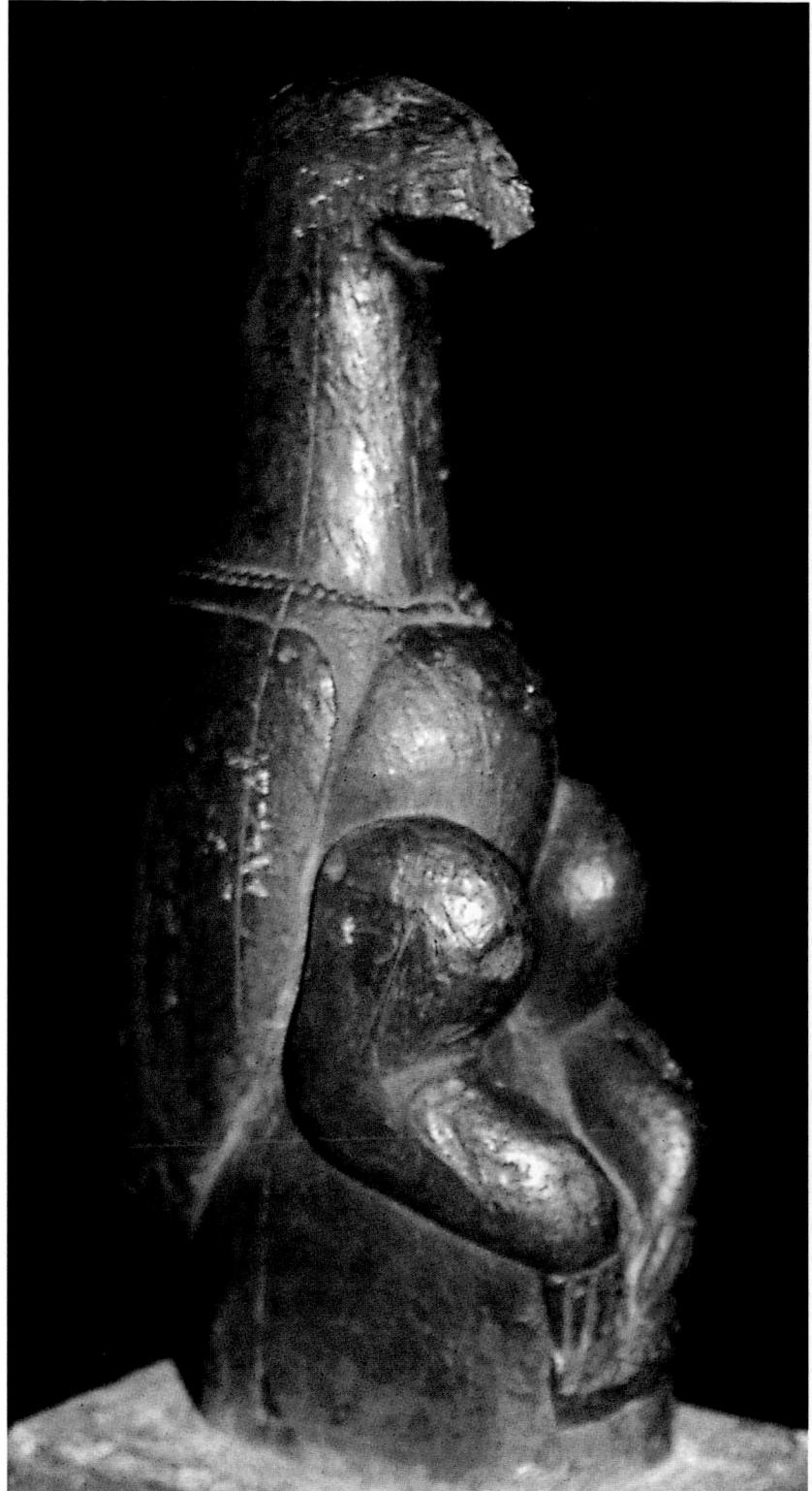

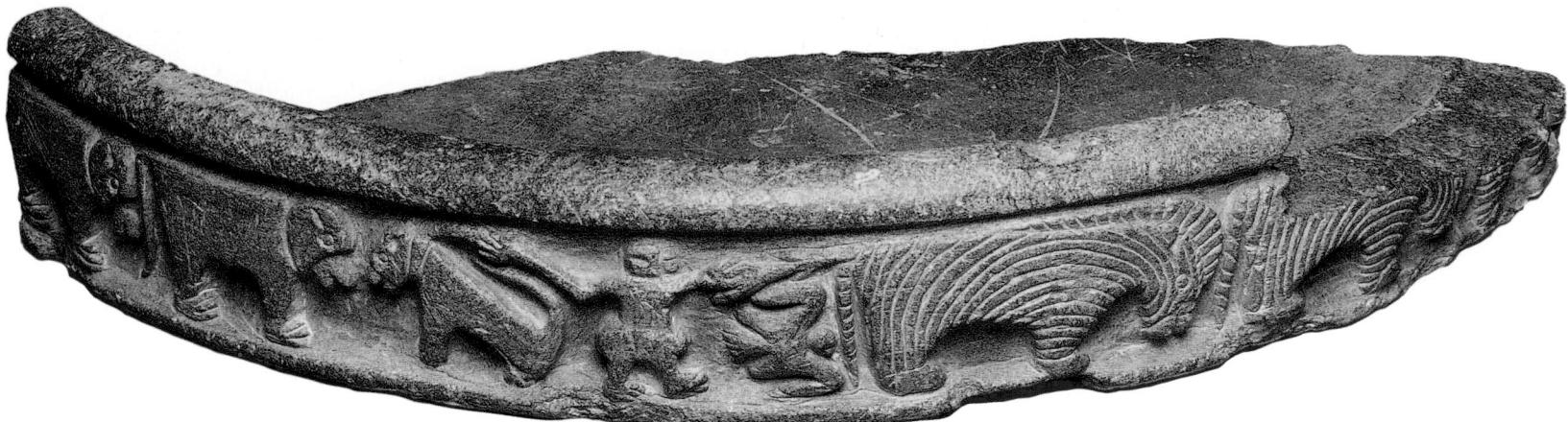

3.15

Fragment of carved soapstone bowl

Zimbabwe
13th–15th century
steatite

7.1 x 43.7 x 17.7 cm
South African Museum, Cape Town,
SAM-AE 7859

Soapstone bowls have been found in several areas at Great Zimbabwe. They were recovered from the Lower Valley (an area reserved for the king's wives), the Great Enclosure (a centre for initiations similar to the *domba* school of the Venda) and in the Hill Ruin (a palace complex that among other things provided ritual seclusion for the sacred leader).

The front (Western Enclosure) of the Hill Ruin was the more public compartment that contained the leader's audience chamber. The back (Eastern Enclosure) was a private and sacred area that housed some of the famous Zimbabwe birds (cat. 3.12) as well as soapstone bowls. Larger examples bear marks on the inside, possibly caused when cutting up meat: it seems that they may have been used in rituals that involved offerings to the ancestors.

The bowls vary from 30 to 60 cm in diameter with vertical sides 7 to 10 cm high. Usually the vertical sides have been carved with geometric designs such as hatching, cord and herringbone patterns. In the Zimbabwe culture, symbolic geometric designs usually represented crocodiles or snakes and were part of a complex of symbols that included mountains and pools, referring to protection. Thus a bowl with cord designs around the outside may have represented the 'snake of the water' that guarded female fertility.

Bowls with naturalistic designs are less common and more difficult to interpret. They are unlikely to have been divining bowls, because of their size and location of the designs. Most

divining bowls in southern Africa are marked along the rim rather than on the vertical walls, so that the designs can be easily seen. A soapstone bowl with a crocodile and bull carved on the walls was found in the Great Enclosure near a stone cairn that had been covered in burnt cattle bones. The primary function of all soapstone bowls, then, probably had to do with rituals propitiating ancestor spirits.

The carved fragment exhibited here has the most complex frieze on any bowl from Great Zimbabwe. It depicts a procession of zebra, followed by a bird and a human-like figure leading a dog, which faces a baboon. These symbols could have totemic significance but their meaning is not yet known. TNH

Provenance: 1891, discovered at Great Zimbabwe by T. Bent (possibly placed there in 1889 by W. Posselt)

Bibliography: Bent, 1896, pp. 195–203; Hall, 1905, pp. 108–10; Posselt, 1924; Summers, 1961, pp. 267–8; Blacking, 1969, pp. 251–5; Nettleton, 1984, pp. 226–31; Huffman, 1986

3.14

Khami figurine

Zimbabwe
15th–17th century
elephant ivory
h. 16.7 cm
Queen Victoria Museum,
Harare, Zimbabwe

Khami, near modern-day Bulawayo, was the capital of the Torwa dynasty after the abandonment of Great Zimbabwe. Established between 1420 and 1450, it was the largest settlement of the Zimbabwe culture until the Portuguese helped to destroy the palace in 1640.

The ivory figurine was found in the 1940s by K. R. Robinson during excavations in the Vlei Ruin above the court. It was among some large rocks towards the back of the ruin, embedded in a thin midden deposit along with bone fragments and broken pottery. It had, therefore, probably been discarded. The figurine appears to have been mounted on top of a staff, for the bottom 3 cm had been drilled to form a socket and the loop at the end was probably used for attachment. The figure itself appears to be a man sitting with his right arm flexed against his chest. Although the left forearm is missing, the left hand could have covered the pubic region.

The Vlei Ruin was probably the office of the second most important man in the capital, the king's brother. When a king came to power a brother was appointed with him. The brother became a legal expert and took charge of court proceedings after the previous legal expert had died. Typically, this brother's office was located on a low rise where he could overlook the court physically, a position that paralleled his official responsibilities.

Ivory objects in general are rare from Zimbabwe culture sites, while this kind of figurine is unique. Considering the extensive trade networks that would have included Khami, this object could have come from several sources outside the Zimbabwe culture area. TNH

Provenance: c. 1949, found by K. R. Robinson, Khami Ruins, Vlei (or No. 5) Ruin

Bibliography: Summers, 1949; Robinson, 1959, pp. 16–17, 156

3.15

Kenilworth Head

South Africa
19th century or earlier
stone
15.8 x 9.6 x 10.8 cm
McGregor Museum, Kimberley,
MMK 85

Siege Avenue, Kenilworth, in Kimberley, was under construction during the Anglo-Boer War (1899–1902) when road builders unearthed, from a depth of almost 2.5 m, a stone sculpture now known as the Kenilworth Head. A schist-like material has been carved to make a face – a wide nose, clearly defined almond-shaped eyes, slightly parted lips and small lobeless ears. Almost nothing is known of its original context but inferences can be made on the basis of comparison with other stone heads found in the area, in particular one that was recovered at Transvaal Road, a site quite close to Kenilworth.

The Transvaal Road head was found, along with five iron bracelets, in a burial disturbed during drainage excavations in 1946. Morphological research has established that the skeletal remains represent an individual with Negro/Khoisan features, and radiocarbon tests provide a probable date of 1650. This significantly predates colonial penetration of this area in the early 19th century, implying that these enigmatic carvings can be placed provisionally in an African context.

Another clue to understanding the head is a tantalising comment by Maria Wilman, former director of the McGregor Museum. She recalls that 'from an elderly Boer visitor to the museum we learned that, in his youth, the Bushmen on his father's farm... had a similar head, which they were in the habit of bringing out on festive occasions and dancing round'. This seems to confirm an indigenous use of stone heads and gives an indication of their significance. The northern Cape area has a wealth of petroglyphs, including rare small portable rock engravings, that are known to have had religious significance. It is not impossible that both portable engravings and carved stone heads were used in ceremonial contexts. However, in the absence of supporting evidence this must remain in the realm of speculation. DM, PB

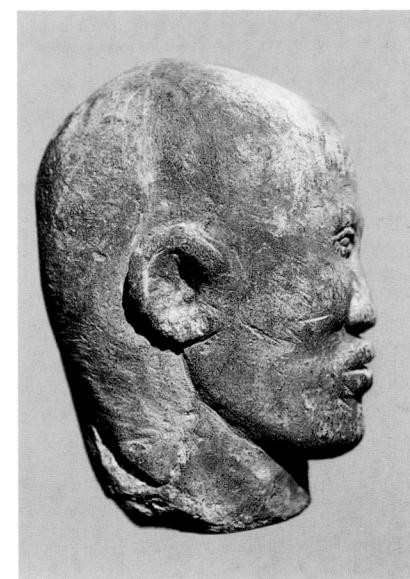

Provenance: 1908, presented to the McGregor Museum

Bibliography: Wilman, 1955, pp. 24–5; Power, 1951; Holm, 1963, pp. 52–4; Derricourt, 1974; Beaumont and Vogel, 1984, p. 86; Morris, 1990

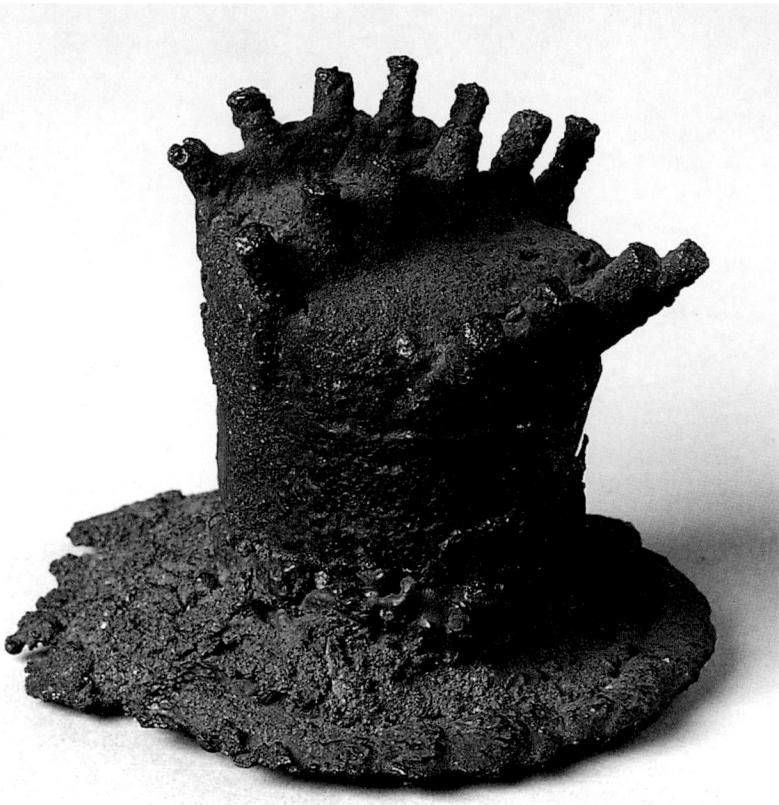

3.16a

Ingot (*musuku*)

Venda

Northern Province, South Africa
copper
h. c. 9.7 cm
Museum für Völkerkunde,
Frankfurt am Main, NS 35 283

3.16b

Ingot (*musuku*)

Venda

Northern Province, South Africa
copper
10 x 13 x 13 cm
U. and W. Horstmann Collection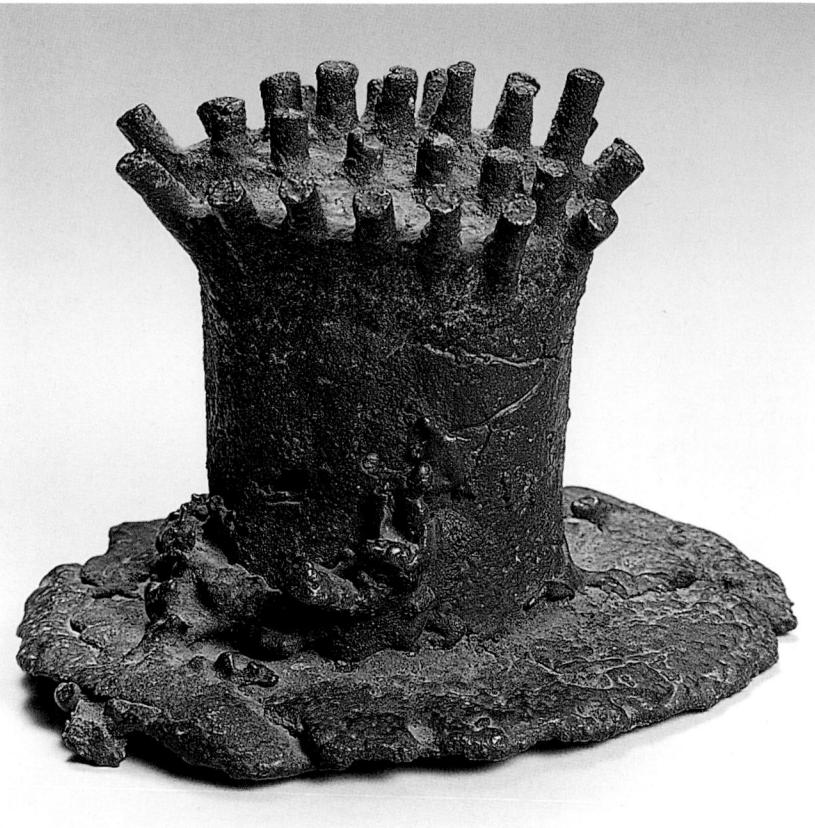

Musuku ingots are attributed to the Venda people of the Northern Province of South Africa and are historically associated with early copper mining at Messina. Another type of copper ingot, known as *lerale*, comes from the Phalaborwa area of the eastern Transvaal and differs from *musuku* ingots in having a distinctive rod-like shape. Both types of ingot usually have irregular projections extending from the body.

Musuku were probably cast in an impression made in sand, with the studs at the bottom. Successive layers of molten copper were poured into the mould, the overflow at the top forming the 'base' of the ingot. *Musuku* ingots vary considerably in size and weight, some weighing as much as several kilograms. Some *musuku* are hollow, others are solid, or filled with sand or slag, and some have been found on examination to contain something, such as a granite pebble. These ingots may have been ceremonial objects rather than currency or items of trade but there is uncertainty regarding their use. The significance of the projecting studs is also enigmatic.

The production of metal in southern Africa goes back to the 3rd century AD. Around the beginning of

the 11th century there is evidence of large-scale mining of copper and tin at centres like Messina and Rooiberg in the Transvaal. Generally, both copper and iron were used for personal ornaments, while iron was used for tools and weapons; tin ingots and gold are known to have been traded extensively. Mapungubwe and its neighbouring site, K2, in the Limpopo River valley were powerful trading centres and the earliest known southern African bronze artefacts have been found there.

Both *musuku* and *lerale* ingots probably date from the 16th century onwards when Sotho-Tswana speaking people had taken over many of the mining centres. From the amount of mining that was carried out in southern Africa in pre-colonial times, one would expect to find large numbers of ingots, or products derived from them. This is not the case, however, which suggests that many copper and tin ingots were exported via the east coast. The few *musuku* ingots still owned by Venda chiefs are revered as objects of authority and spiritual power. JvS

Bibliography: Stayt, 1931; Van Warmelo, 1940; Miller and Van der Merwe, 1994

Divining bowl (*ndilo*)

Venda

Northern Province, South Africa

19th century

wood, fibre and bone

h. 10 cm; diam. 32 cm

The Trustees of the British Museum,
London, 1946. AF. 4.1a

Divining bowls, *ndilo*, were made up to the end of the 19th century for use at the courts of Venda chiefs to divine witchcraft. Venda chiefs trace their ancestry back to the founding hero, Thoho ya Ndou, who is said to have led his people into the northern Transvaal from Zimbabwe. After founding his capital at Dzata in the Soutpansberg (c. 1700), Thoho ya Ndou is said to have disappeared into Lake Funduzi, and to remain there to this day presiding over a court beneath the water, which is a replica of those of living chiefs. These *ndilo* appear to depict this lake kingdom of the founding hero, while simultaneously being metaphors for the courts of living chiefs.

The subjects of the king were summoned to the central court of the capital, where they were seated according to their subgroups in concentric circles around the bowl and the diviner. The bowls were filled with water so that the crocodile on the bed of the bowl became immersed within a lake. The central mound, topped by a cowrie shell, was filled with magical substances: it projected above the water level, apparently referring to the mountains against which chiefs' capitals are built. Maize kernels were floated on this water and, as the bowl tipped or rocked on the bosses of its convex underside, the places in which they touched the rim were noted. Carved all around the rim are images representing animals which denote the different emblems of Venda subgroups, as well as designs drawn from Venda divining tablets, *thangu*. Thus the points at which the kernels touched the rim would indicate which subgroups the witches belonged to, as the divining tablet would shape their gender.

Any kernels which sank to the bed of the bowl would be interpreted according to which signs they touched there. These include two pronged shapes indicating the chief's wives, a semicircular enclosure indicating the cattle byre, a straight zigzag line

denoting both the path to the capital and lightning, and a bird-like form referring to the 'lightning bird' said to lay eggs at the point that lightning strikes.

The designs on the underside of the bowl further amplify this picture. Around part of the rim of the underside, the bowl is decorated with a further chevron pattern said to represent the python that writhes on the edges of pools and lakes. Concentric circle designs are called 'the eye of the crocodile' and interlace designs refer to its skin.

This particular bowl is one of the few that have survived and is an exceptionally elaborately carved example. It has attached to it other objects used by diviners. Bowls of this kind were counted among the *dzingoma* (mysteries/relics) of the chiefdom. AN

Provenance: 1946, given to the museum by D. Allan

Bibliography: Gieseke, 1930, pp. 257–310; Stayt, 1931, pp. 263–308; Van Warmelo, 1971, pl. 9; Nettleton, 1985, pp. 304–66

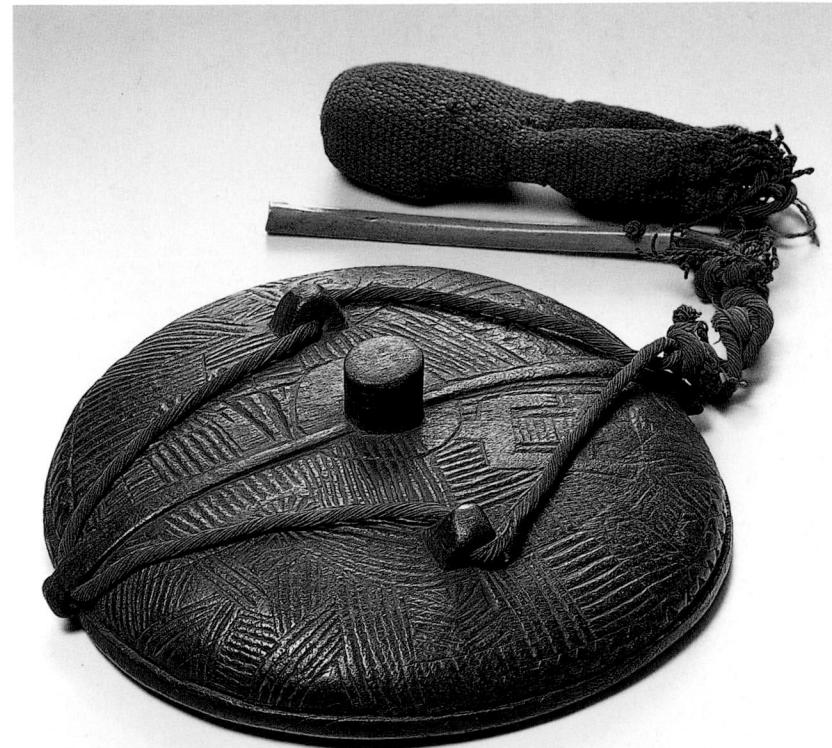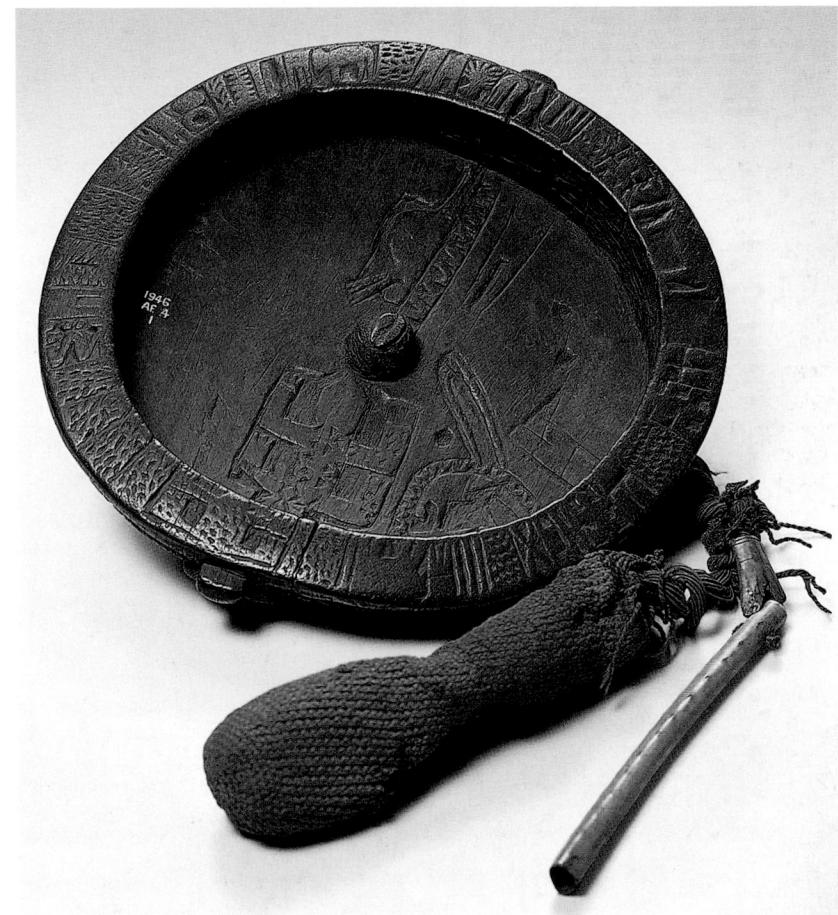

3.18a

Door (*vhothi/ngwena*)

Venda
Northern Province, South Africa
19th century
wood
154 x 50 x 5 cm
The National Cultural History Museum,
Pretoria, ET 1935/750

3.18b

Headrest

Venda
Northern Province, South Africa
19th century
wood
17 x 44 x 8 cm
The National Cultural History Museum,
Pretoria, ET 4570

Solid hung wooden doors were carved for high-ranking nobles and chiefs among the Venda. Doors with elaborately carved relief designs were, however, originally reserved for the most important chiefs of the houses of Ramabulana, Tshivhase and Mphaphuli. These doors were placed on the dwellings of the chiefs (*pfamo*) at the highest point of the capital, which was built on stone terraces against the southern sides of the Soutpansberg mountain ranges. They were thus not seen by most ordinary people during the chief's lifetime. At the death of the chief, a special burial hut might be erected with the carved door in place, used in succession disputes to give entrance only to the rightful heir to the chiefship.

The doors with elaborate carvings were called *ngwena* (crocodile) in the metaphorical speech used at chiefs' courts. Although no longer made and used, old examples are kept among the *dzingoma* (mysteries/relics) of one Venda chiefship where they are used in the initiation of young women. The sayings recited in this context give us more insight into 'meanings' generated by the forms of the door and its decoration.

The *harre* projections at the top and bottom of the door are referred to as the 'teeth', the holes at the centre of the door for the attachment of the leather thong to open and close the door are the 'nostrils', the interlace designs on the surface are the 'skin' and the concentric circles are the 'eyes' of the crocodile. Thus, while only one of the recorded doors bears a recognisable depiction of a crocodile, all the doors constitute generic images of crocodiles in their parts and design. When the door was closed, it was said that the 'crocodile bites', and when it was open, that the 'crocodile unbites'.

The relevant chiefs were themselves likened to the crocodile in his pool. Some were said to possess stuffed crocodiles in their dwellings which they used as pillows, and the same motifs as are found on the doors appear on the few known Venda headrests (cat. 3.18b). It was also maintained that, on their investiture, chiefs swallowed stones (*mmbe*) which had been taken from the stomach of a crocodile, and these the chief retained in his own stomach until he died.

Thus the doors on the chiefs' dwellings announced the presence of the immensely powerful chief/crocodile at the pinnacle of the Venda political and religious hierarchy. They were made by professional carvers, who were also responsible for the production of sacred drums, xylophones and divining bowls (cat. 3.17), all of which share the same decorative motifs and iconography. The last recorded instance of the use of such a door was at HaTshivhase in the 1950s. AN

Exhibition: cat. 3.18a: Pretoria 1982
Bibliography: Stayt, 1951, p. 55; Walton, 1954, pp. 43–6; Van Warmelo, 1971, pp. 361–5; Walton, 1974, pp. 129–30; Nettleton, 1985, pp. 252–50; Nettleton, 1989, pp. 70–6

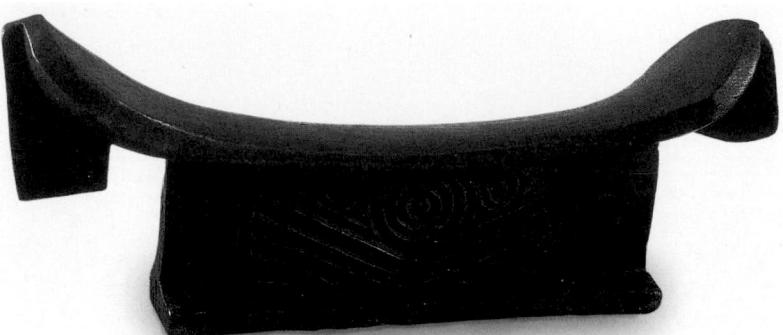

3.19a

Pole figure

Lobedu

Northern Province, South Africa
early 20th century
wood
h. 162.5 cm
South African Museum, Cape Town,
SAM-AE 9751

3.19b

Pole figure

Lobedu

Northern Province, South Africa
mid-20th century
wood
h. 164.8 cm
Johannesburg Art Gallery, JL-A-58

A palisade of carved poles is a distinctive feature of courts and places of authority among the Lobedu and related people. These two pole figures come from the palisade surrounding the court (*khoro*) of the Lobedu capital, situated in the wooded foothills of the Drakensberg. It is the residence of chief Modjadji, famed for her rain-making powers and ruler by ancestral right. The *khoro* is a circular arena that was formerly used for hearing court cases as well as for public gatherings and ceremonial performances. It was the domain of men, and the carved poles of the *khoro* were brought there by men from all the districts that owed allegiance to Modjadji. Skilled carvers produced individual poles that would distinguish their contribution to the *khoro* and acknowledge their obligation to the chief. Collectively the poles of the *khoro* expressed the solidarity of the disparate groups within Modjadji's realm; they were visual reminders of social and political ties and played a part in sustaining these relationships.

Pole figures follow the elongated shape of the pole itself, the carving being confined to the upper section. Each pole was carved by an individual, drawing on shared cultural references. Most poles had pointed or forked ends but some were carved in the form of utensils, weapons, stylised animals or human figures. The verticality of the poles suggests masculine symbolism but many of the poles depicted women and activities associated with them. An early 20th-century example (cat. 3.19a) represents a woman with the characteristic Lobedu hairstyle of a girl initiate. It could be inferred that

this pole acknowledged the importance of women and fertility, a recurrent theme during initiation rites and other ceremonies. A different interpretation is needed for the pole that represents a man wearing a headdress (cat. 3.19b), as this was not a customary practice among Lobedu men. This pole figure was probably carved by a Tsonga-Shangaan immigrant to Modjadji's territory. Its presence in the *khoro* reflects political inclusion but its style signifies cultural difference.

During the 1960s the traditional court system changed and a Western-style courthouse was built. Changes in administration and legal procedures undermined the political relationships that were formerly central to the *khoro* system. Not surprisingly, the aesthetic traditions associated with the *khoro* declined. PD

Provenance: cat. 3.19a: 1936–8, collected by E. J. and J. D. Krige from the Lobedu capital; cat. 3.19b: 1970s, collected from the Lobedu capital

Exhibition: cat. 3.19a: Cape Town 1978–92; cat. 3.19b: Johannesburg 1991

Bibliography: Krige and Krige, 1943, pp. 186–208; Davison, 1989, pp. 84–102

3.20a

Headrest (*mutsago*)

Shona
Zimbabwe
late 19th to early 20th century
wood
16 x 16.5 x 6 cm

The Trustees of the British Museum,
London, 1949. AF.46.813

3.20b

Headrest (*mutsago*)

Shona
Zimbabwe
late 19th to early 20th century
wood
14.3 x 15.6 x 6.1 cm
South African Museum, Cape Town,
UCT 50/2

3.20c

Headrest (*mutsago*)

Shona
Zimbabwe
late 19th to early 20th century
wood
15 x 18 x 6.5 cm
The Trustees of the British Museum,
London, 1921. 6-16.43

Headrests of this type with lobed bases, carved supports and horizontal platforms, all carved in one piece, are used with variations of design by a number of different southern African peoples. The examples which are conventionally classified as 'Shona' have supports which all vary to some extent in their composition, but which also demonstrate the persistent use of common motifs. These include two concentric circle motifs sandwiched between two triangles, the upper triangle being inverted vertically over the lower (cat. 3.20b). There is often a rectangular element placed either horizontally between the two circles or vertically from base to platform. In some cases two or more circular elements are inserted vertically piled up between the triangles (cat. 3.20a).

Headrests using these design elements have been claimed to be common to Shona-speaking peoples living in eastern, central and north-central Zimbabwe, i.e. among the Manyika, Zezuru, Korekore and possibly Karanga sub-groups. One of these headrests (cat. 3.20c) has further decoration in the form of engraved triangles on the upper surface of the platform, a feature which may be associated with the Manyika of the eastern regions of Zimbabwe. Many of these headrests have designs com-

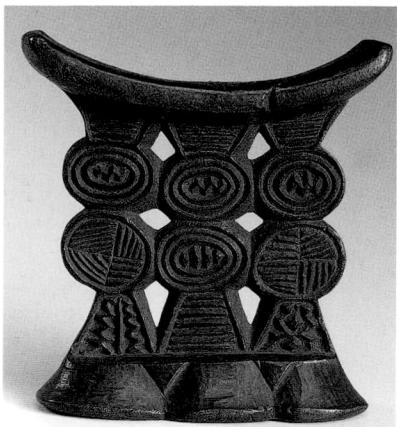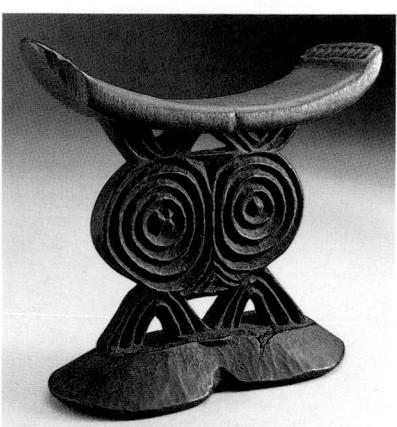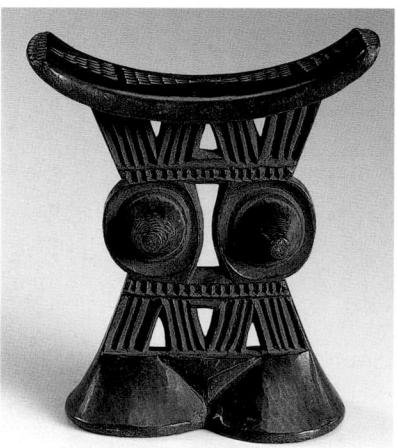

posed of chevrons or rows of keloid shapes along the upper edge of the short ends of their upper platforms.

Many commentators have remarked on how headrests of this style appear to represent a human figure with the upper platform as the shoulders, the vertical support as the torso and the base as the lower limbs, although the fixity of this identification has been challenged. One example illustrated here (cat. 3.20c) has very clearly delineated breasts where others have only concentric circle designs. There is further reference to the female in the

composition of the lobed bases with the central inverted triangular shape calling to mind the female genitals.

The designs on the headrests appear to have a semiotic multi-valence. For example, the concentric circle motifs may refer to the discs cut from the base of white conus-shells (*ndoro*) and thus bearing the ridges of the shell's spiral, which were worn as signs of status especially by chiefs and diviners. Another reference suggested for this motif has been the ripples in the pool made after a stone has been thrown into it, and, possibly by inference, the eyes of a crocodile, especially where such motifs appear on Shona divining apparatus (*hakata*). Pools are an important locus for many Shona groups in contacting their ancestors. The raised keloid shapes at the centres of some of these circular motifs make a clear reference to bodily scarification which used to be common among the Shona, but only for women. Such scarification patterns were often quite abstract, but there are records of patterns which depicted lizards or crocodiles on the abdominal regions of women, possibly linking the womb of the woman metaphorically to the ancestral realm envisaged as a pool.

All the decorative motifs on the headrests are called by the same name as scarifications, *nyora*, and have been claimed to indicate the patriclans from which their users come. Thus the designs, through their reference to scarifications (keloids, triangles and chevrons), to the ripples in pools and to *ndoro* shells (concentric circles), call to mind both the ancestors (*mudzi-mu/mhondoro*) of the lineage as well as the women who guarantee its fertility. As it was only women who were scarified in this fashion, with designs on the shoulders, lumbar region, chest, abdomen and around the pubis, this reference to *nyora* must indicate a feminine identity for the headrests.

Headrests were, however, used only by mature men among the Shona. When a man slept and dreamed he was said to be visiting his ancestors, the source of knowledge and prosperity. The headrests as female figures without heads further amplify this ancestral connection. When a man marries a woman the Shona say that he owns her body, but that her head (i.e. the seat of her ancestral 'being') belongs always to her father.

This clearly refers to the fact that, among the Shona, a woman's fertility is considered to be on loan to her husband's lineage, of which she never becomes a part, and thus the vast majority of the headrests do not have heads of their own. When a man sleeps on a headrest of this type, it is his head, his ancestral affiliation, which completes the human and specifically female image suggested by the headrest itself. When he died, this vehicle of ancestral communication, which also symbolised the reproductive potential of the wife (or wives) transferred to his lineage on his marriage, was buried with him or passed on to his descendants. Headrests of this type are also used today by Shona diviners as part of their symbolic paraphernalia linking them with the spirit world.

While very few such headrests are still being used today among the Shona, and even fewer are made, the tradition can be traced back to ancient ruins in Zimbabwe, including Khami and Danangombe (also known as Dhlo Dhlo), and possibly even Great Zimbabwe itself.

Headrests were personal items and appear to have been cherished by their owners. They were often carried on long journeys and were generally buried with their owners at death. Most of the older Shona headrests are carved in a hard wood and have acquired a deep dark brown patina and shiny surfaces from continual handling and use. A man using such a headrest would be able to protect his elaborate hairstyle, the wearing of which was common among Shona men until the end of the 19th century. In this way his head would be doubly adorned, both by the visible physical elevation afforded by the headrest and by the physical decorative elaboration afforded by the hairstyle. But, simultaneously, the female character of the headrest and its design would act as an affirmation of the importance of women in the social fabric of Shona life and in the perpetuation of lineages. AN

Provenance: cat. 3.20a: 1949, donated to the museum as part of the Oldman Collection; cat. 3.20b: 1921, given to the museum by Miss Hirst

Bibliography: Berlyn, 1968, p. 70; Nettleton, 1985, pp. 121–82; Nettleton, 1990, pp. 148–50; Dewey, 1993, pp. 98–133

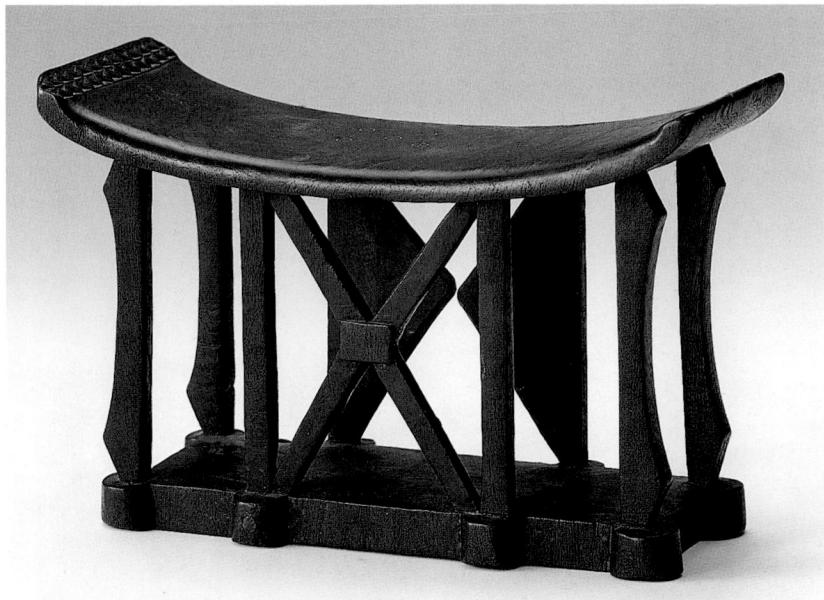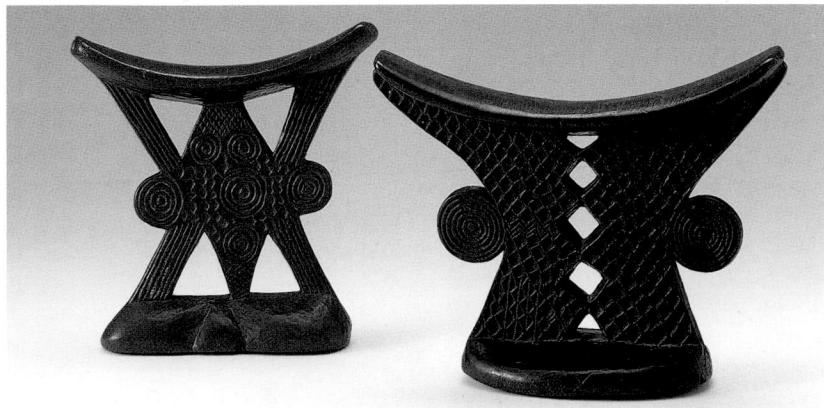

3.21a

Headrest (*mutsago*)

Shona
Zimbabwe
late 19th–20th century
wood
14 x 21 x 8.5 cm
Jonathan Lowen Collection

3.21b

Headrest (*mutsago*)

Shona
Zimbabwe
late 19th–20th century
wood
16.5 x 16 x 6 cm
Jonathan Lowen Collection

3.21c

Headrest (*mutsago*)

Shona
Zimbabwe
late 19th–20th century
wood
16.5 x 20.5 x 9 cm
Jonathan Lowen Collection

Headrests are made by the Shona-speaking peoples of Zimbabwe and Botswana in an array of different styles and motifs, with variations appearing for almost all of the canonical types that have been identified by scholars. This, together with the areas of overlap in both patronage and production with Tsonga-speakers in the eastern regions of Zimbabwe, makes classification according to narrow ethnic categories almost impossible. These three headrests show some elements which are not found on those conventionally associated with Shona-speakers.

In the case of one of the headrests (cat. 3.21a) only the upper platform suggests a Shona provenance, the base and supports being very close to forms more commonly made by Tsonga-speakers in Mozambique and the Transvaal. It appears further to incorporate forms derived from European furniture, this being especially visible in the way in which the columnar supports on the sides and

the scalloped supports on the ends have each been supplied with their own circular base, although these are in fact carved integrally with the rectangular base of the whole. The shape of the upper platform, particularly the treatment of the ends with their relief chevron patterns, complies with conventional Shona practice. The cross-shapes at the centres of the long sides also conform to the kinds of design used in headrests by the Karanga (south-east and central Zimbabwe) and Kalanga (south-west Zimbabwe and Botswana). The horizontal orientation and open design of this headrest are also similar to Tsonga-Shangaan examples collected by Swiss missionaries in the eastern Transvaal at the turn of the century. The absence of any decorative motifs, besides those on the upper platform, and the particular abstraction of the base, make it impossible to detect any symbolic content. This example throws into question many of the formal means of classification used to differentiate African art objects from one another, and also raises questions of change and adaptation of traditions in response to outside influences. It is clearly constructed from forms and ideas gleaned from a number of sources.

The other two headrests (cat. 3.21b–c) have been classified as Shona. Although they depart from generally accepted canonical norms of Shona headrest sculpture (as it is found in the northern, central and eastern regions of Zimbabwe) they nevertheless display many of the same elements. But the makers of these headrests, through a process of displacement of elements, create different relationships of motifs to one another, thus possibly effecting a different symbolic reading.

In both examples the circular elements have been shifted sideways so that they project outwards from the middle of the support. In one example (cat. 3.21b) the support itself is implicitly formed by the apical opposition of pairs of triangles, expressed in the triangles which pierce the thickness of the support itself. But in the other example the support has simply been treated as a single hourglass-shaped slab, with vertically superimposed diamonds penetrating the support along its central axis; such open-work effects

are common in the more canonical Shona subtypes. In both examples the upper platform is supported along its entire length without projecting beyond the support at the narrower ends. This arrangement is not common in most Shona headrest types and the non-canonical arrangement is repeated in the deployment of decorative motifs and in the compositions of their bases.

The concentric circles of cat. 3.21b have been used in relief decoration not only on the projecting circular forms on either side of the form, but also on the central diamond shape of the support. These are set against a background of simple spots hollowed out of the surface of the central shape, and the straight line decoration on the outer arms of the triangles. The concentric circles probably refer to the symbolic complex surrounding the use of white conus-shells. Among Shona-speakers, white is particularly linked with ancestors through a number of associations, but most relevant here is the special attention paid in the past to the droppings made by fish-eagles in pools: the pools were associated with the ancestral world, fish-eagles with powerful spirits, and their white droppings were considered a powerful substance used by many *n'anga* (healer/diviners). The concentric circles may thus well recall both pools and conus-shells.

In cat. 3.21c the concentric circles are confined to the circular projections from the support whose surface is covered with raised lines forming a carpet-like covering of diamond shapes. These diamonds, together with the diamond-shaped spaces, suggest female scarification patterns. But these designs are also very similar to the designs on Venda doors on which concentric circles are interpreted as crocodile eyes and the patterned surfaces as crocodile skin. The ruling groups of the Venda are an offshoot of the Shona and have retained many practices associated with their forebears: it is possible that such a headrest might denote a link with pool imagery and thus with the ancestors.

It may also be significant that in neither of these examples does the base conform to a type that denotes the human female through a rendering of her genital area. Cat. 3.21b has roughly formed pro-

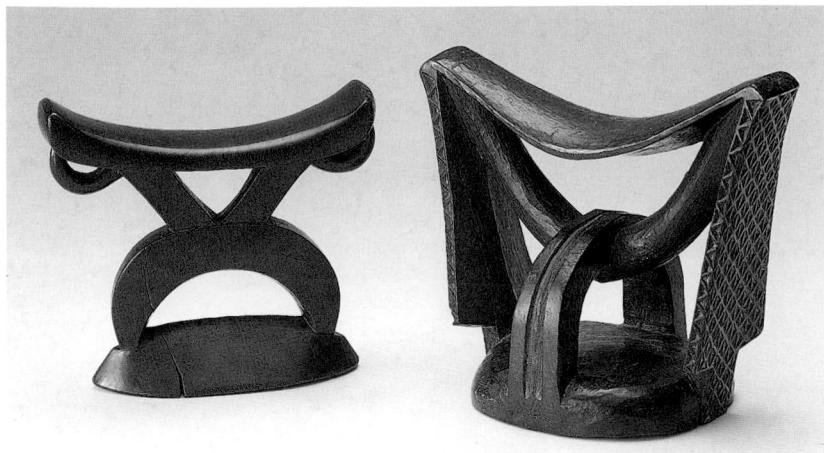

jections on the base, while cat. 3.21c has a simple oval-shaped and relatively thin base. It might thus be suggested that these headrests promote notions connected with the sources of ancestral power, while female imagery is underplayed. This also appears to be the case with most of the headrests apparently produced by southern Shona-speakers. AN

Bibliography: Nettleton, 1985, pp. 121–82; Becker and Nettleton, 1989, pp. 13–14; Nettleton, 1990, pp. 147–54; Becker, 1991, pp. 58–75; Dewey, 1993, pp. 98–133

3.22a

Headrest

probably Tsonga-related group
South Africa
wood
13.5 x 15 x 6.5 cm
Jonathan Lowen Collection

3.22b

Headrest

probably Tsonga-related group
South Africa
wood
14 x 11.5 x 7 cm
Jonathan Lowen Collection

3.22c

Headrest

probably Tsonga-related group
South Africa
wood
14 x 14 x 6 cm
Jonathan Lowen Collection

3.22d

Headrest

probably Tsonga-related group
South Africa
wood
14 x 16 x 16 cm
Jonathan Lowen Collection

3.22e

Headrest

probably Tsonga-related group
South Africa
wood
16.5 x 19 x 12 cm
Jonathan Lowen Collection

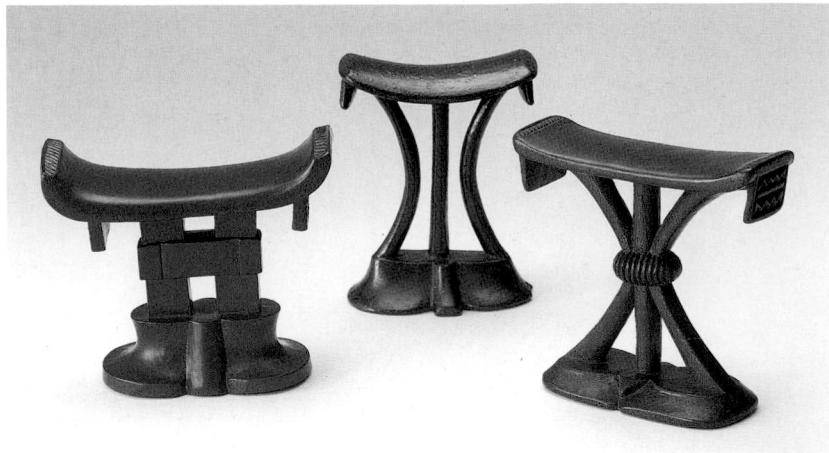

Although these headrests form a regional group, they show marked variation in the treatment of the base and the central support. Bases are either lobed, shaped, raised or chamfered and the central supports consist of combinations of curved vertical columns, upright beams and cross-bars. The shape of the central element, which reveals the greatest inventiveness, has provided the basis for formal classification undertaken by Jaques in the 1940s and more recently by Nettleton. The cross-bar, on which the head rests, is usually left undecorated except for single rows of small chevrons or triangles. A distinctive feature of the group is the presence of vertical lugs extending from both sides of the cross-bar. Another feature on two of the four headrests in this group is that the height exceeds the width, a relationship that differs from headrests found further south and west.

Headrests were utilitarian, protecting the hairstyle of the sleeper, but over extended periods of ownership and use they might become invested with complex spiritual associations. It is known that headrests were often buried with their owners, but in some cases they were retained as vehicles through which the late owner might be contacted in the ancestral realm.

Headrests have long been collectable objects. The large number that have survived tell of the removal of small portable objects by traders, soldiers, missionaries and others. Many headrests were removed from their places of origin without documentation, making it difficult to reconstruct particular histories. Moreover, attributing historical headrests to modern ethnic groupings, such

as Tsonga or Shangaan, is equally problematic. A regional grouping is more plausible.

The region from which these four headrests probably derive overruns modern political borders and includes south-eastern Zimbabwe, southern Mozambique and the north-eastern Transvaal. Waves of migration during the 19th century make this a culturally complex area, which demands an approach to art history that goes beyond single ethnic categories. RB

Bibliography: Kasfir, 1984; Nettleton, 1984, 1990, 1992; Dewey, 1986, 1993; Harries, 1988, 1989; Becker, 1991, Klopper, 1991, 1992

3.23

Headrest (*xiqamelo*)

Shangaan
Eastern Transvaal, South Africa
early 20th century
wood
15 x 20 x 9 cm
Johannesburg Art Gallery,
Jaques Collection, 1987.5.66

This is one of the most remarkable headrests from the southern African region. Its reputation is based on its quality and virtuoso carving, and on the fact that it is like no other known headrest from the area. Four tube-like forms rising from each corner of the base twist around each other, and around a central suspended knob, supporting the cross-bar. Within the confined space determined by the base and the cross-bar there is a sense of contained and compressed energy – a sense made all the more palpable when one realises that the headrest is

carved from one piece of wood. The base is a flat rectangular plane with a slight protrusion echoing the triangular protuberances of other headrests from within the Shona-Tsonga grouping (cat. 3.22b). The lugs, which could be considered a feature of Shangaan-Tsonga headrests, have been reduced to a simple double volume on the underside of the cross-bar. These understated extensions contrast with the vigour and complexity of the central section. The headrest appears to be unused and whether it was made for local consumption or for sale is not known.

The collector A. A. Jaques was a member of the Swiss Mission in South Africa. His documentation is incomplete and cannot be accepted uncritically. The names of owners and makers are not recorded, nor is there information on the age of the piece and where it was made. The attribution 'Shangaan' is a derivative of Soshangane, the Nguni chief who dominated what is now southern Mozambique from the 1820s to the 1850s. Following their defeat during the 1890s, the Shangaan fled to the eastern Transvaal where they settled among other people. RB

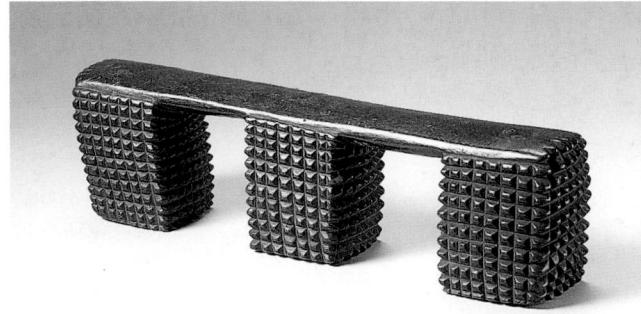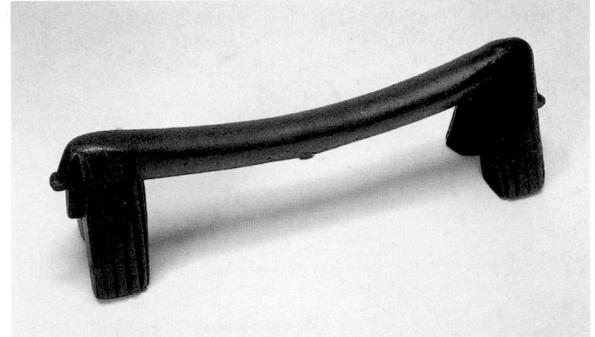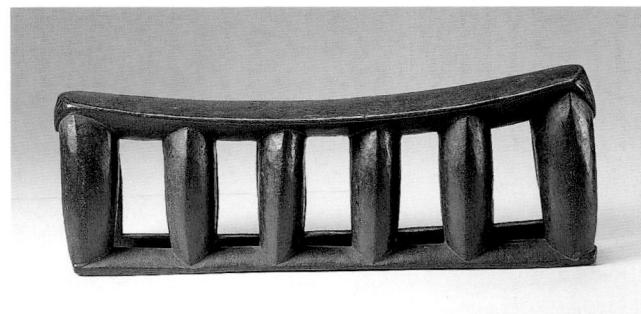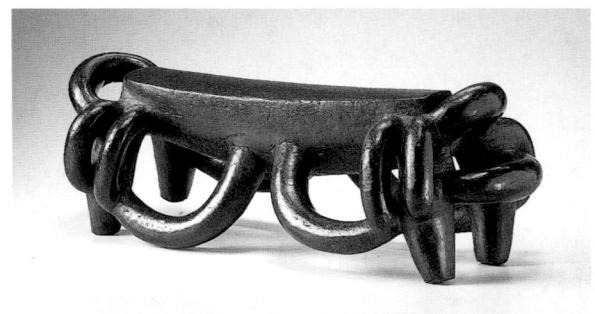

Provenance: 1925–40, collected by A.A. Jaques in the eastern Transvaal; 1940–59, Lemana Training College, near Elim, northern Transvaal; 1959–87, Africana Museum (now Museum Africa), Johannesburg; 1987, Johannesburg Art Gallery

Exhibitions: Johannesburg c. 1940; Johannesburg 1991, pl. 29

Bibliography: A.A. Jaques, c. 1941; L. Jaques, 1949; Wanless, 1987, p. 205; Becker, 1991

3.24a

Headrest (*isigqiki*)

Zulu

KwaZulu-Natal, South Africa
late 19th or early 20th century
wood

17 x 44 x 9 cm

The Trustees of the British Museum,
London, 1917. 11-3.3

3.24b

Headrest (*isigqiki*)

Zulu

KwaZulu-Natal, South Africa
late 19th or early 20th century
wood

12 x 42 x 8 cm

The Trustees of the British Museum,
London, 1917. 11-3.2

3.24c

Headrest (*isigqiki*)

Zulu

KwaZulu-Natal, South Africa
late 19th or early 20th century
wood

16 x 56 x 9.8 cm

Royal Albert Memorial Museum and
Art Gallery, Exeter City Museums,
3/1921.2

3.24d

Headrest

Nguni

South Africa

wood

19 x 55.5 x 21.5 cm

Kevin and Anna Conru

Headrests of Zulu manufacture are remarkably diverse both in form and in the extent to which they are decorated. Some examples have comparatively delicate, incised patterns both on their legs and at either end, while others, like those having the raised *amasumpa* motif (sometimes translated as 'warts'), suggest a boldly sculptural approach that is often echoed in the size and shape of the legs. Likewise, whereas most headrests have only two or three legs, some 19th-century examples have as many as six or even eight.

The reasons for this proliferation of styles remains unclear, but regional variations suggest that particular Zulu-speaking groups or 'clans' may have favoured particular forms and patterns. Certainly, there is considerable evidence to suggest that the *amasumpa* motif, found on headrests originating in the heartland of the Zulu Kingdom, may once have been reserved for people belonging to the royal family, and to the collateral groups through which it sought to extend its power.

What the majority of these headrests have in common is a covert or, more often than not, explicit allusion to the form of an animal, presumably a bull, ox or cow. Split legs and tails are not uncommon and some even have abstractly rendered bellies. Those with numerous pairs of legs probably were intended to invoke the idea of a large herd, which may

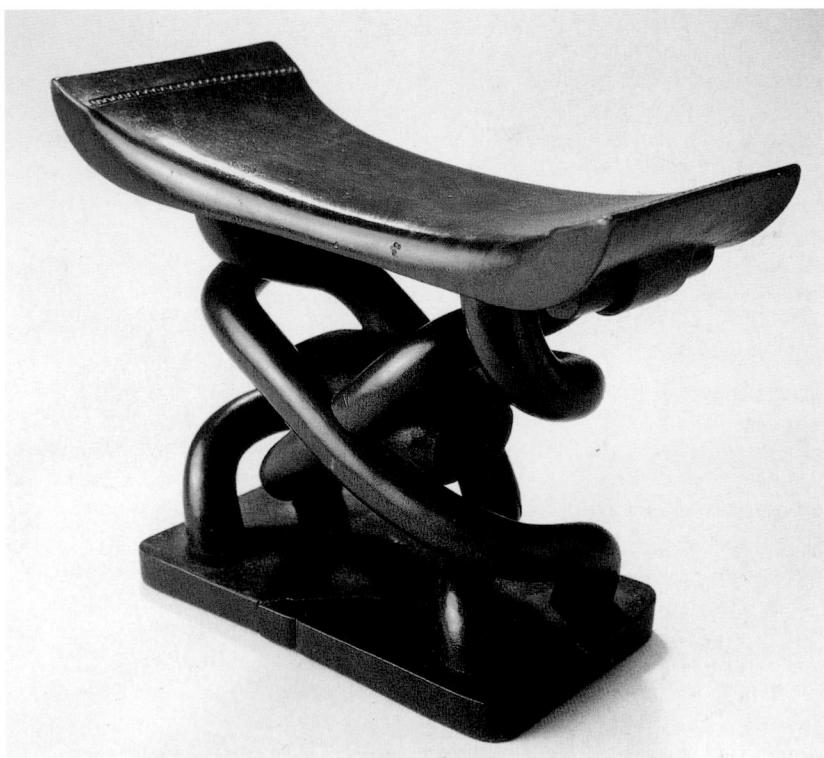

also be true of the *amasumpa* pattern. This reference to cattle is entirely understandable given that cattle are a major source of wealth and that it is through them that people maintain communication with their ancestors.

The use of cattle in bride wealth transactions may also be relevant in this regard. Historically, headrests formed part of the dowries young Zulu-speaking brides took with them to their husbands' homesteads. But today only ardent traditionalists still commission headrests for this purpose. SK

Provenance: cat. 3.24a–b: given to the museum by Dowager and Viscount Wolseley

Bibliography: Nettleton, 1990; Klopper, in Johannesburg 1991

3.25

Headrest

South-eastern Africa
South Africa, Swaziland, Zambia,
Zimbabwe, Mozambique, Malawi (?)
wood
h. 38 cm
Linden-Museum, Stuttgart, 116890

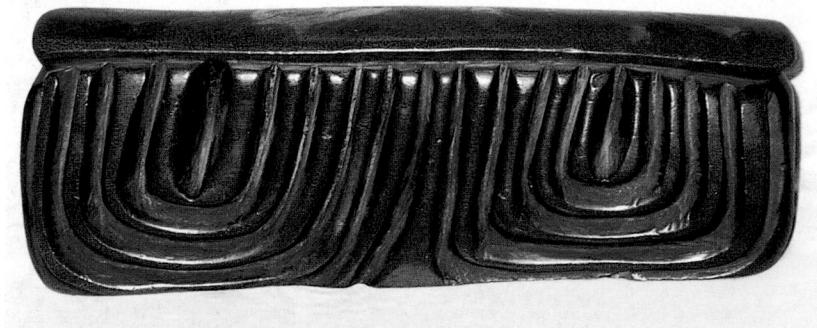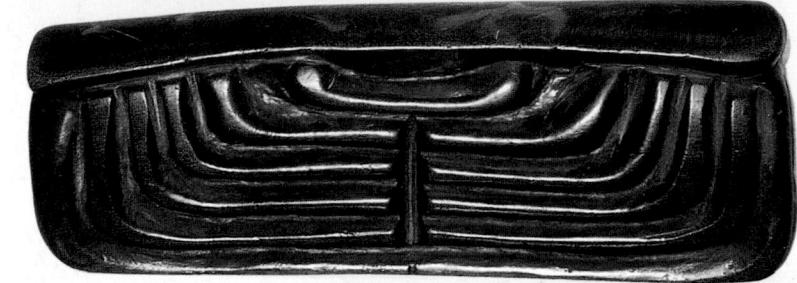

The Linden-Museum identifies this headrest as Zambezi. In the early part of this century, however, objects from anywhere in southern Africa were often labelled Zambezi. Complicating matters further, several Nguni-speaking groups from the north-east of southern Africa moved to the Zambezi River valley in the 19th century bringing their artistic traditions with them. The style of the Linden-Museum headrest seems closest to those from either the Swazi area or a neighbouring Nguni group and thus was probably made by one of the peoples from southern Africa or Swaziland or by one of the migrating Nguni groups who moved to the north.

In the south the Zulu- and Swazi-speaking groups have distinctive headrest styles which are easily distinguishable from those of their neighbours to the north, such as the Shona or Tsonga. While these latter groups typically make headrests with a base, central support and upper platform, the Zulu and Swazi headrests are usually made without a base and have a series of two to eight legs supporting a longer horizontal upper platform. In some headrests the legs have been turned into loops and the parallel loops carved on the side of the Linden-Museum headrest certainly mimic this style. In a few

examples the legs have been eliminated and the shape becomes an elongated rectangle like the Linden one. While there are many substyles, Zulu headrests as a general rule have horizontal ridges carved on the legs, while the Swazi ones mostly have vertical ridges. The Linden example has both.

During the period of intense war that engulfed much of southern Africa in the early 1800s, an Nguni-speaking group known as the Ngoni, originally from the Swaziland Transvaal area, left led by Zwangendaba. They moved northward through Mozambique and Zimbabwe to settle eventually in eastern Zambia, Malawi and southern Tanzania. Headrests that are very similar to the Swazi ones are found among both the Tanzania Ngoni (see Krieger) and the Malawi Ngoni.

Conner, who has studied the Jere and Maseko Ngoni of Malawi, reports that several known headrest styles relate to where a man or his ancestors lived before being assimilated into the Ngoni. He notes: 'Headrests, *chigogo*, were one of the many valuable personal objects which were normally broken and buried with their owner. Dreams were believed to be an important vehicle of communication with one's ancestors. Dreams were frequently acted upon. Perhaps to facilitate this valuable communication, headrest forms were conservative and usually replicated from father to son.'

Conner's observations of the Ngoni of Malawi illustrate how complicated ethnicity and style interaction can be. There, a single ethnic group uses headrests of various styles; one is 'Swazi-like', another is lakeside Tonga in form, and a third seems an adaptation of a north-eastern Shona style. The styles relate to the ethnicity of a man or his ancestors before being assimilated into the Ngoni. Without more exact collection information we can only say that there is a strong possibility that this headrest is from the Zambezi river area but made by an intrusive Nguni speaking group such as the Ngoni. WD

Bibliography: Krieger, 1980, figs 514–19; Conner and Peltine, 1983; Conner, 1991, p. 145; Johannesburg 1991, p. 33

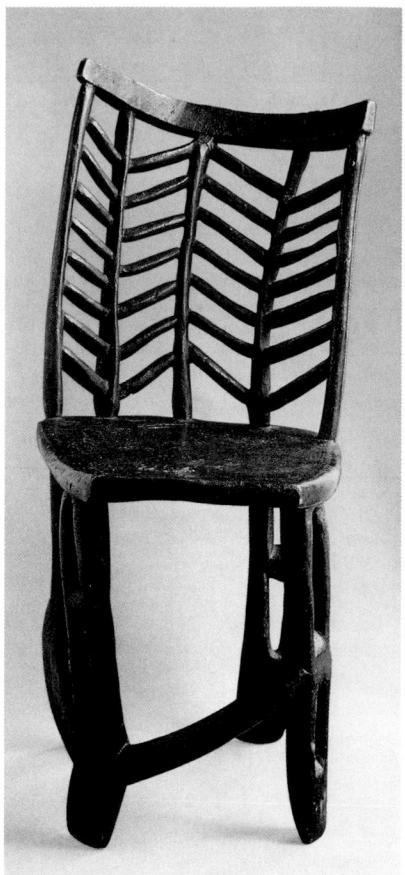

3.26

Carved chair

Zulu (Zulu Kingdom or Colony of Natal)
KwaZulu-Natal, South Africa
mid-19th century
wood
145 x 101 x 105 cm
Natal Museum, Pietermaritzburg

Carved chairs are known to have been produced throughout south-east Africa in the early to mid-19th century. This chair is one of at least two surviving said to have belonged to 19th-century Zulu kings. Like other examples in the genre (many of which are known only through illustrations and verbal descriptions) it is carved from a single piece of wood and is characterised by an asymmetrical treatment of the struts linking its legs. Despite these shared principles of design and execution, carved chairs from south-east Africa differed significantly one from another both in size and in the choice of motifs to decorate their backs and legs.

Probably inspired by European models acquired from Portuguese traders at Delagoa Bay, these chairs were reserved for the first Zulu king, Shaka, and his immediate successors. As such, they played an important role in affirming the king's political

authority over his subjects, none of whom were allowed to sit on chairs of any kind. But they certainly never acquired the ritual significance afforded the *inkatha*, which was used as a throne during the annual First Fruits ceremony when the king, dressed in a costume of natural fibres, affirmed his powers by renewing the fertility of the land. The *inkatha*, a large coil of grass containing body fluids from members of the king's regiments, was the quintessential symbol of Zulu unity.

By the mid-19th century the Zulu practice of using chairs as symbols of authority was being emulated by the leaders of neighbouring chiefdoms, some of whom appear to have bought chairs made by European craftsmen working in Natal (the British colony bordering on the Zulu kingdom) possibly with the aim of underlining the chief's wealth and status. In contrast, missionaries and other less affluent colonists who were unable to afford chairs of this kind appear to have bought comparatively inexpensive carved chairs made by local black craftsmen.

An inscription under the seat of this chair makes the questionable claim that it once belonged to King Cetshwayo, nephew of King Shaka and son of the third Zulu king, Mpande. Cetshwayo is said to have given it to the missionary the Rev. C. F. Mackenzie in 1858, but this is doubtful. Since Cetshwayo did not succeed his father until the 1870s, it is improbable that he himself actually owned any chairs or 'thrones' in the 1850s. Moreover, Mackenzie never actually visited the Zulu kingdom, and Cetshwayo is unlikely to have presented anyone with a gift of this kind, especially in the late 1850s when he was exceptionally suspicious of missionaries. Mackenzie probably acquired this chair from another source. SK

Provenance: 1916, donated to the museum by the great-niece of the Rev. C. F. Mackenzie, who was in Natal from 1855 to 1859

Bibliography: Angas, 1849, p. 55; Colenso, 1855, p. 124; Holden, 1866, pp. 252–3; Kotze, 1950, pp. 121, 158; Stuart and Malcolm, 1969, pp. 10–11; Webb and Wright, 1976, p. 44; Klopper, 1989; Delegorgue, 1990, p. 196

3.27a

Staff

Zulu (Zulu Kingdom or Colony of Natal)
KwaZulu-Natal, South Africa
19th century
wood, copper and brass wire
h. 143 cm; w. of ring 9 cm
Paarl Museum, Paarl, on loan to the
South African National Gallery,
PM 82/280

3.27b

Coiled snake staff

Natal chiefdoms
KwaZulu-Natal, South Africa
19th century
wood
h. 109.2 cm
Bowmunt Collection

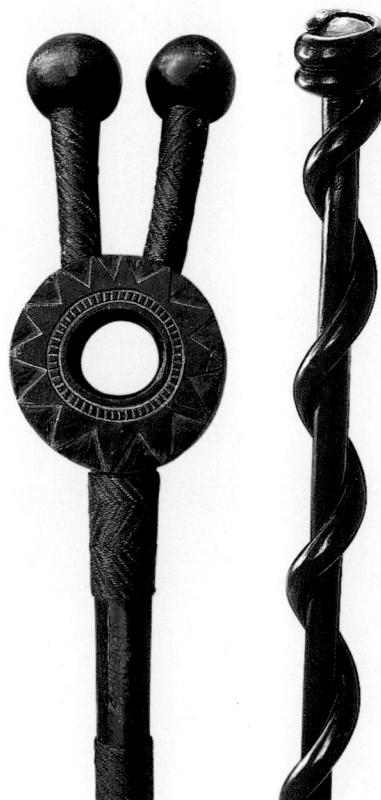

3.27c

Staff

Zulu (Zulu Kingdom)
KwaZulu-Natal, South Africa
19th century
wood
109.2 x 11.4 x 6.3 cm
Kevin and Anna Conru

Figurative and non-figurative staffs and clubs were produced throughout south-east Africa in the 19th and early 20th centuries. Many of these were made by carvers from Tsonga-speaking groups, who are known to have supplied the Zulu kingdom with staffs as part of the tribute they were forced to pay to Shaka and his successors. Tsonga-speaking migrants appear also to have produced figurative staffs for a non-indigenous market, like the example depicting a man with his legs bent up to his chest (cat. 3.27g). Among some Tsonga-speaking groups, figures on staffs may have prominent genitalia and were for probable use in initiation schools. Other staffs, surmounted either by strangely elongated heads or depictions of British soldiers wearing a variety of uniforms, seem to have been made by young men from the Colony of Natal, principally for their own use.

As this suggests, staffs were made for a variety of markets, even though most were evidently intended for use by chiefs. This latter category includes those with abstract or semi-abstract details like the two examples (cat. 3.27a,c) with horn-like projections and the generally very tall staffs surrounded by single or intertwining coiled snakes.

There is evidence to suggest that the style and iconography of the staffs used by chiefs varied considerably from one region to another. Thus, for example, in contrast to the coiled snake staffs, which appear to have been popular among groups in southern Natal, those featuring a variety of geometrically conceived motifs probably were associated only with important office bearers in the Zulu kingdom. Often surmounted by the horns of cattle (or similar motifs), staffs of this kind underline the importance of these animals as symbols of wealth and fertility and, perhaps more especially, as the means through which people maintained communication with royal and other ancestors. This is not to suggest that

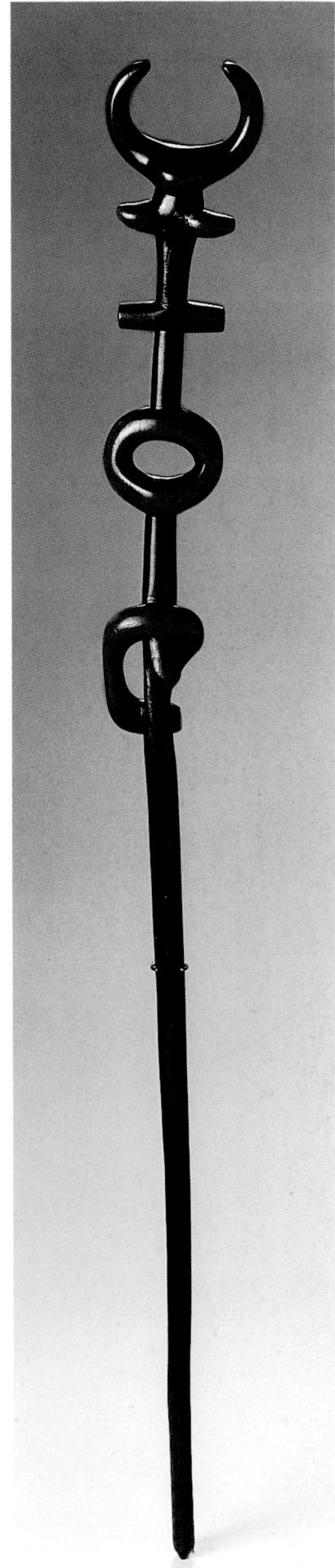

all motifs found on chief's staffs were carved with the intention of conveying specific meanings. On the contrary, staffs seem also to attest, quite simply, to an appreciation of the artist's ability to juxtapose carefully balanced shapes and forms, sometimes accentuated through the addition of wirework patterns.

Clubs with bulbous heads, some of which were also covered with complex wirework, suggest a similarly careful attention to shape and surface detail. Clubs made of rhino horn were reserved for chiefs as symbols of status. During the reigns of Shaka and Dingane in particular, comparatively heavy, hardwood clubs were said to have been used to execute offenders. But, more often than not, these clubs were used for hunting. SK

Bibliography: Webb and Wright 1976, pp. 63–4; Hooper, 1981, pp. 157–312; Nettleton, 1989; Klopper, in Johannesburg 1991; Maggs, 1991

3.27d

Club

Northern Nguni
Swaziland or KwaZulu-Natal,
South Africa
19th century?
rhinoceros horn
h. 90 cm; diam. 7.5 cm (head)
Jonathan Lowen Collection

3.27e

Club

Zulu (Zulu Kingdom or Colony of Natal)
KwaZulu-Natal, South Africa
19th century
wood, wire
60.9 x 8.8 x 8.8 cm
Bowmint Collection

3.27f

Club

Northern Nguni
Swaziland or KwaZulu-Natal,
South Africa
19th century
rhinoceros horn
49.5 x 10.1 x 10.1 cm
Bowmint Collection

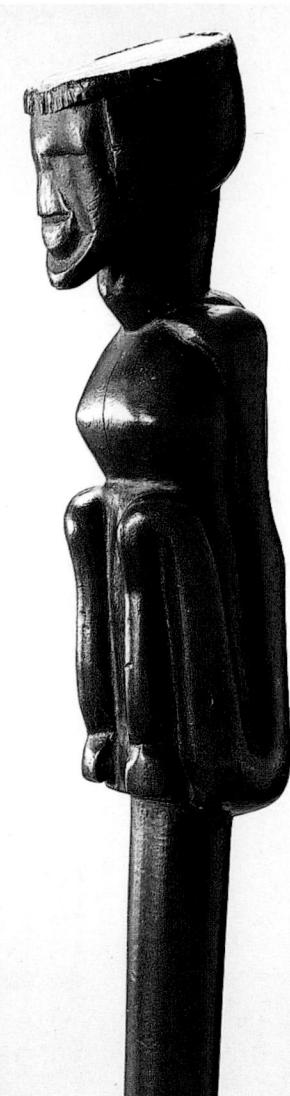

3.27g

Figurative staff

Presumably migrant Tsonga-speaking carver
KwaZulu-Natal, South Africa
late 19th or early 20th century
wood
22.8 x 6.3 x 6.3 cm
Bowmint Collection

3.28

Staff

Tsonga (?)
KwaZulu-Natal, South Africa
late 19th–early 20th century (?)
wood
106 x 10.1 x 6.3 cm
Kevin and Anna Conru

The Tsonga staff, while of an unusually stylised and sculpturally fluid form, exhibits the characteristics of classic Tsongan figural carving. The face has eyes with scorched pupils and brows, a broad triangular nose and the typically open oval mouth with the teeth carved in relief. The ears, beard and coiffure as well as the navel, breasts and ankles have been highlighted with pokerwork. He is wearing a conical headdress which has been decorated with alternating bands of natural wood and pokerwork, atypical because the majority of Nguni male figural works wear the married man's headring. Perhaps this represents an officer's helmet or another prestige insignia – a specimen in the Rijksmuseum voor Volkenkunde in Leiden wears a similar headdress. KC

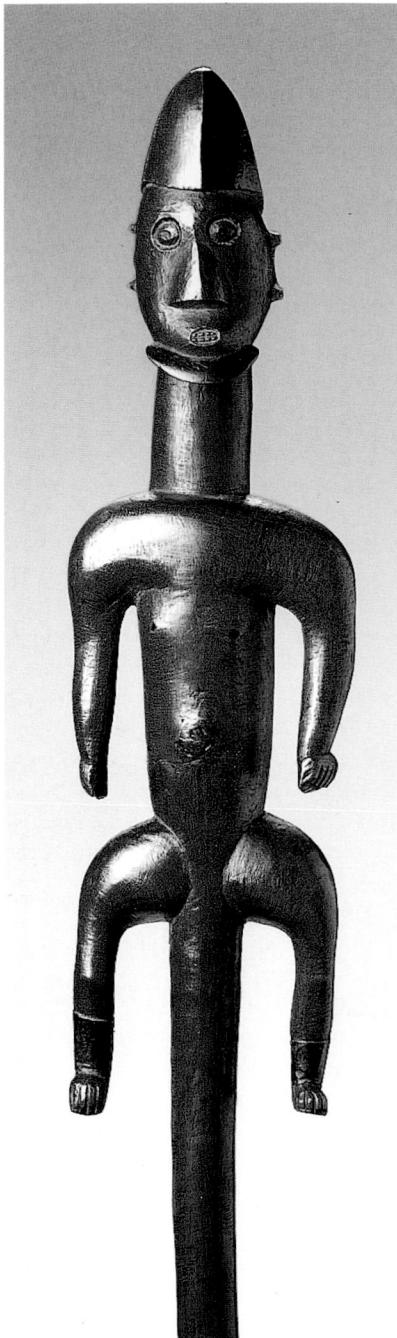

3.29a

Tobacco pipe

Thembu
South Africa
19th century
wood, metal inlay,
horn mouth piece
10.2 x 30.6 x 2.6 cm
Kevin and Anna Conru

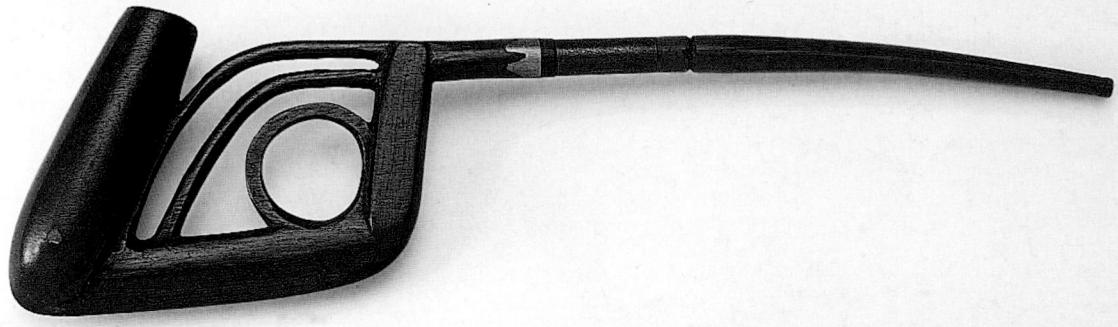

3.29b

Tobacco pipe

South Sotho or neighbouring
Cape Nguni
South Africa
wood
37 x 13.9 cm
National Museum of African Art,
Smithsonian Institution, Washington,
89-14-16

Carved tobacco pipes were widely used among Nguni-speaking people of the eastern Cape and their Sotho-speaking neighbours in Lesotho. Most pipes were made of a dense, dark wood; if the wood was light in colour, it tended to darken with the patina of use. Pipes were carved by men for use by both men and women. The length, style, decoration and size of a pipe were signifiers of social status, and pipes were often specifically displayed, either in use or when carried, as part of traditional dress. Smoking tobacco – as with the use of snuff – was an everyday activity but it was also associated with the power and generosity of individuals, as well as the ancestral spirits. Tobacco was often offered as a marriage gift and smoking was indirectly associated with fertility and procreation.

The two pipes exhibited here clearly illustrate two poles of aesthetic production. One (cat. 3.29a) is an example of the austere invention of shape; the rhythmical abstraction nevertheless plays itself out within the functional constraints of the pipe structure. The long bowl is typical of traditional eastern Cape pipes but invention emerges in the dramatic changes in the stem. Its shape in relation to the bowl creates a receptive space that is then bridged by thinly carved, arched forms and an open circle nestling against the curving stem. The sense of disjunction, the clarity of form, delicacy of placement and directionality of this pipe make it a striking object.

The other (cat. 3.29b) is a fine example of the figurative trend also found within the region. Here the

bowl of the pipe is literally a body with tapering cylindrical legs extending vertically downwards and ending in two tiny simplified feet. The bowl is fashioned into an elongated female torso, punctuated by a delicately carved pubic area, a navel and, culminating at the rim, two small breasts. The arms are thin and taut, and are clasped tightly against the side of the torso, cupping gently downwards towards the navel. The economy of this stylised human body is extraordinarily finely conceived and carved. The sheer stem of the pipe, which enters the lower back of the figure at an inclined angle, is in geometric contrast to the subtle figuration of the bowl. The absence of the head is often encountered in pipes of this type, and it is not certain if this example would originally have had a pipe cap in the form of a head or not. However, figurative pipes with delicately carved heads as stoppers are represented in South African museum collections.

Small personal objects like these pipes seem to have been passed on from hand to hand, family to family, linking clans and generations, and firmly binding the present to the past with all its ancestral significance and value. In addition, one senses in these carefully conceived objects the everyday pleasure given to maker, user and viewer. *KNe*

Exhibition: cat. 3.29b: Washington 1991
Bibliography: Shaw, 1938, pl. 95; Wanless, 1991, pl. 46

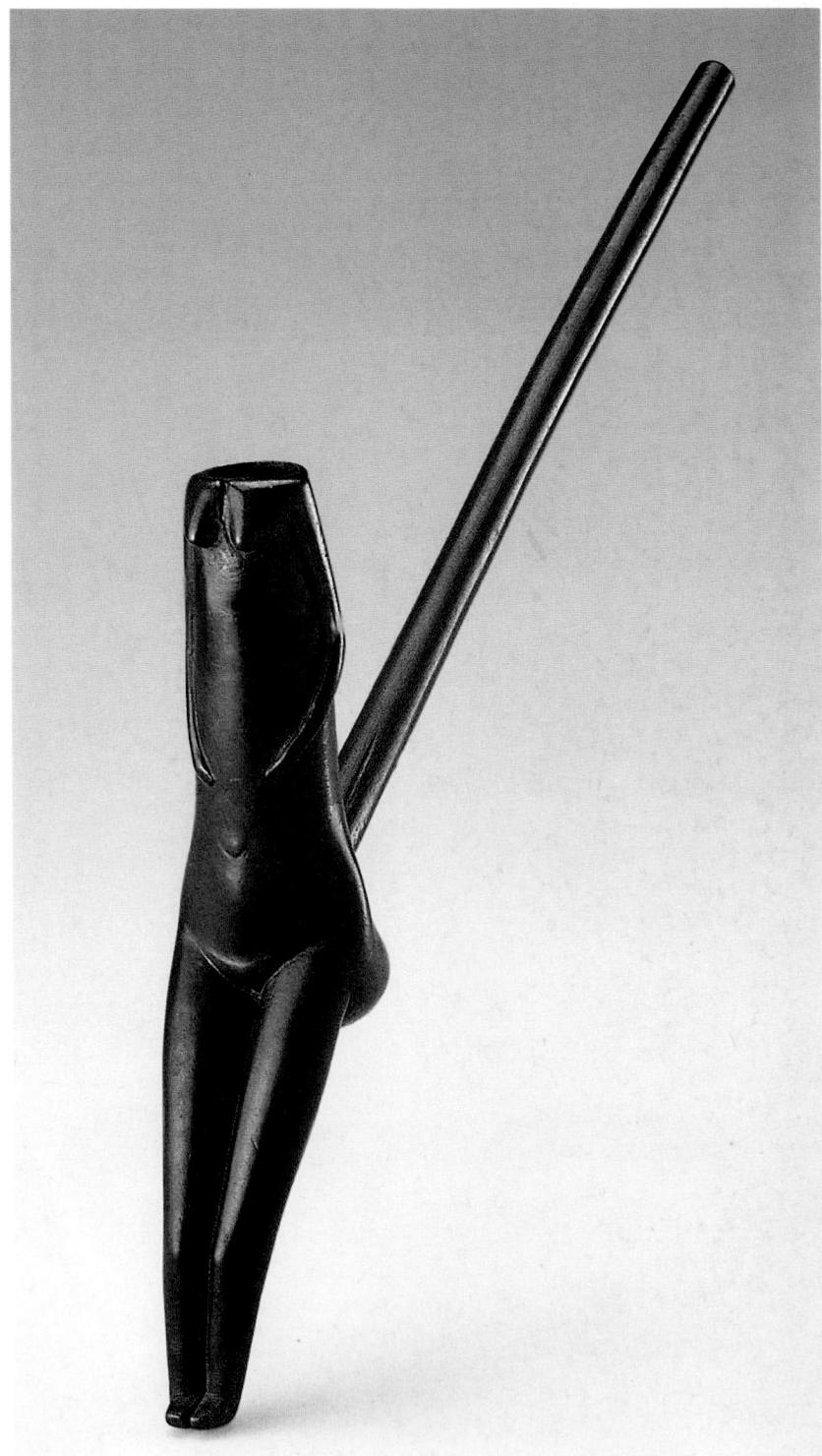

3.30a

Snuff container

Zulu
South Africa
horn
h. 36 cm
Staatliche Museen zu Berlin, Preussischer Kulturbesitz, Museum für Völkerkunde, III D 680

3.30c

Snuff container

South Sotho
Lesotho
horn
27.8 x 2.8 cm
Johannesburg Art Gallery, 406

3.30d

Snuff container

South Sotho
Lesotho
early 20th century
horn
59 x 3 cm
Johannesburg Art Gallery, 405

3.30e

Snuff container

Zulu
South Africa
horn
40.6 x 3.8 x 2.5 cm
Bowmint Collection

3.30b

Snuff container

Zulu
South Africa
horn
10.5 x 19.9 x 2.7 cm
Local History Museum, Durban, 95/248

While most snuff containers tend towards smallness and discretion, there is a group of extraordinary examples that, by the addition of long extensions or figurative attributes, break with the usual austerity of form and size. In cat. 3.30d these extensions from the base of the container have been fashioned into very long spatulate blades that follow the curve of the horn from which it was made, while in cat. 3.30c the tail-like extensions resemble long comb-like tines. These distinctive snuff containers made from cattle or antelope horn were carved by men with enormous skill and care. The horn seems to have been soaked, carved and heated so as to take on and retain complex, splayed forms. The regular twists of the streamers in cat. 3.30e seem to allude to the horns of a kudu, a large southern African antelope, which was formerly widespread in the region. The figurative representation of a human head in cat. 3.30a rests upon extensions shaped into an elongated double helix. The head itself, provided with rudimentary eyes, nose and mouth, is crowned by a headdress, a sign of age and status among Nguni-related groups.

These extravagant examples were probably 'show-off' pieces, designed and executed for chiefs and men of rank. Their scale and shape surely precluded them from being neatly tucked into an earlobe or worn from the neck or waist. Instead, it is likely that they would have to have been

carried ostentatiously, displaying the uniqueness of the object and denoting the importance of the owner. The fact that such prized possessions were made of cattle horn underlines the close connection between the wealth that cattle represent and the related associations with the use of snuff and tobacco.

A less exuberant example (cat. 3.30b) of this type of horn snuff container, visually striking in its own right, is characterised by long, curled, circular strap-like extensions. These possibly allowed for the container to be worn around an arm or attached to a bag. Another kind of horn snuff container, historically found in southern Lesotho and bordering areas, is characterised by figurative features (cat. 3.30f–g). These distinctive containers made use of the natural hollow of the horn, which was plugged from below to seal the cavity. A small mouth was then made by drilling a hole into the horn, and was fitted with a stopper. In the antelope-shaped example (cat. 3.30g) the natural curve of the horn gives an alertness to the implied body of the animal. The tapering body culminates in a starkly stylised head with sharp, splayed horns. In the finely carved example depicting a long-necked mother with child clinging to her back (cat. 3.30f) the natural curve of the horn suggests an elegant forward gait. In both it and its companion male figure fine details of scarification, clothing and facial features are played off against the stronger rhythmic angles of arms and legs, all precisely carved in low relief on the surface of the horn. KNe

Provenance: cat. 3.30c: 1980s, purchased for the Brenthurst Collection, Johannesburg, from Mr. J. Lowen, London
Exhibition: cat. 3.30c: Johannesburg 1991
Bibliography: Shaw, 1935, p. 29; Wanless, 1991, p. 132

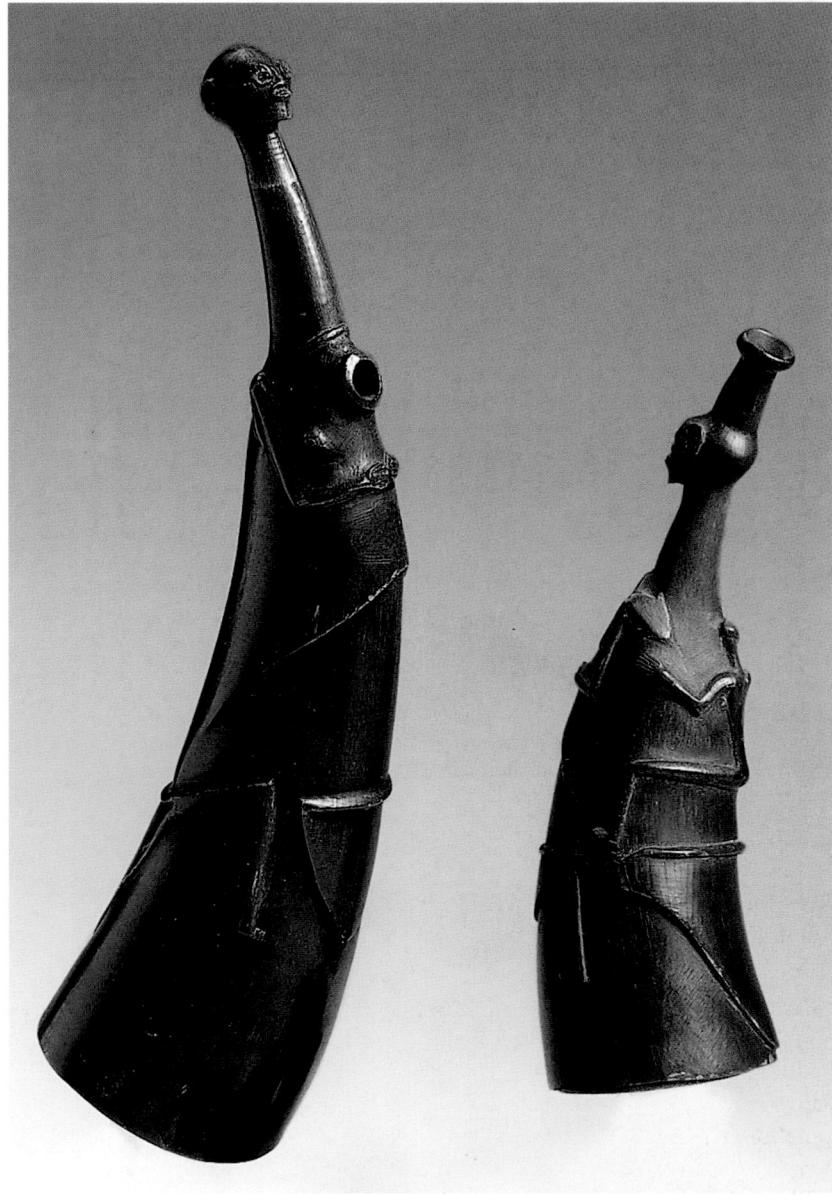

3.30f
Pair of snuff containers

South Sotho
Lesotho
horn
h. 17.5 cm (male), 12.5 cm (female)
Private Collection

3.30g
Snuff container

South Sotho
late 19th century
Lesotho
horn
19.2 x 4.3 x 4.5 cm
South African Museum, Cape Town,
SAM-AE 449

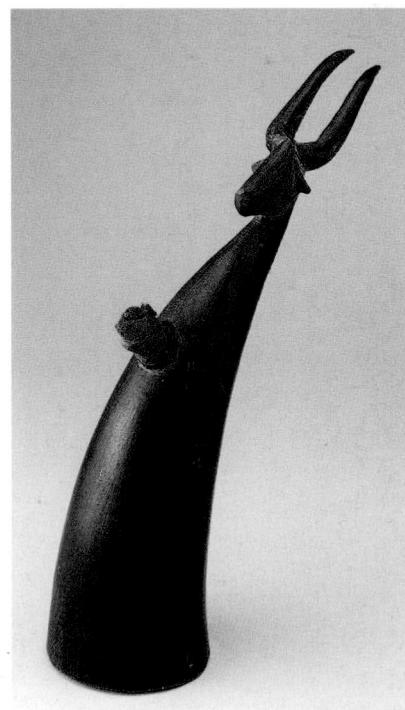

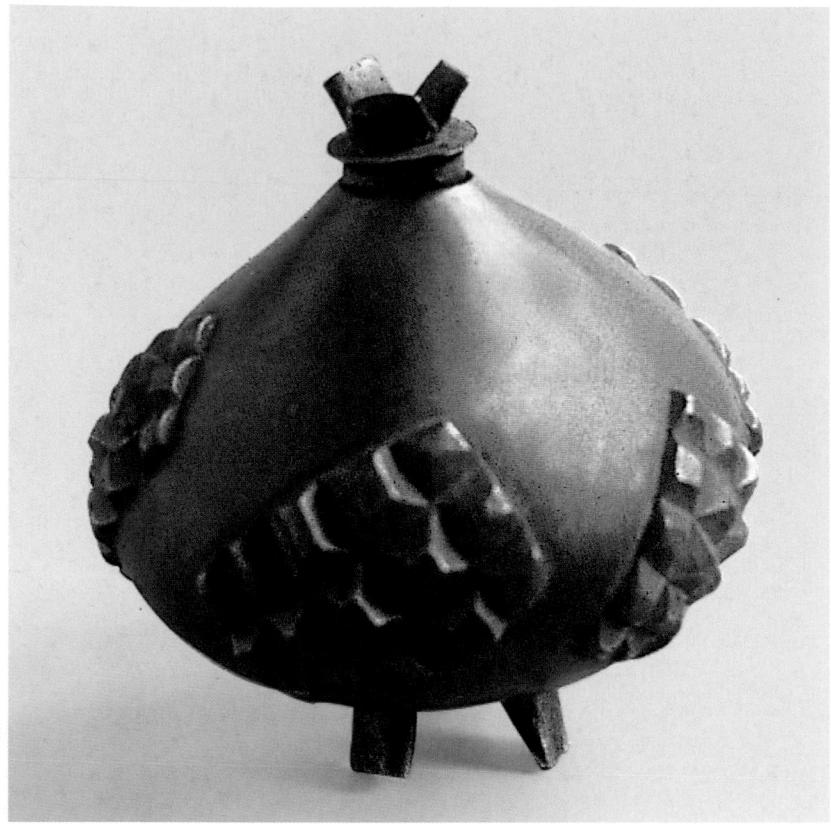

3.31a

Snuff container

Zulu
South Africa
rhinoceros horn, wood
7.5 x 6.2 x 6 cm
Natal Museum, Pietermaritzburg

3.31b

Snuff container

Zulu
South Africa
1880s
elephant ivory
12 x 9 x 8.8 cm
Natal Museum, Pietermaritzburg

3.31c

Snuff container

Tsonga
South Africa
wood
h. c. 18 cm; diam. c. 4 cm
Jonathan Lowen Collection

Throughout southern Africa the taking of snuff and smoking of tobacco are enjoyed, and valued as activities that help to sustain good social relationships. They also have highly significant associations with the ancestral world, with both virility and fecundity, and with the concomitant display of wealth, power and generosity. Snuff containers are among the smallest but most personal objects produced in southern Africa. Being discreet but portable tokens of status, receptacles for snuff were worn as accessories by both men and women. They adorned the waist, neck or arm and, among the Zulu, they were inserted through pierced earlobes. In addition, they were attached to cloaks or carried in bags.

Small as they are, snuff containers reflect the full range of aesthetic production, from abstract austerity and purity of line to figurative stylisations of human and animal form. References to cattle in shape and choice of material underscore the significance of cattle within a complex of beliefs associated with ancestral spirits, patriarchal authority and wealth.

The forms of snuff containers vary dramatically. Tiny gourds, calabashes or fruit-shells were often used, and the shape of a small gourd seems to have been the model for snuff containers carved from horn and ivory (cat. 3.31a–b). In a fine example exhibited here the bulbous body is raised on short legs. The use of rare materials, such as rhinoceros horn and elephant ivory, was the prerogative of chiefs and was associated with hunting prowess, as well as the regal power of these particular animals.

A pair of bulbous snuff containers

(cat. 3.31c) joined by a carved wooden chain is typical of those produced by the Tsonga people of the north-eastern Transvaal and Mozambique. These drop-like snuff containers have tapering stoppers, and are often found singly as well as in pairs. They are also frequently found attached to the ends of elaborate headrests. KNe

Provenance: cat. 3.31a–b; 19th century, Adams Loan to the museum

Bibliography: Davison, 1976, pp. 109–12, 145–6

A very distinctive type of snuff container, historically associated with Xhosa-speaking people in the eastern Cape, is made of a combination of hide scrapings mixed with blood and small amounts of clay. It has been suggested that these substances were collected from the hides of animals that had been offered to ancestors, thus giving the container a protective talismanic quality. The unusual mixture was worked over a clay core that was later removed when the modelled material had hardened to a stiff, leathery consistency. The outer surface of these particular snuff containers is usually spiky, the raised points having been made by lifting and stretching the surface membrane with a sharp implement while it was still malleable.

Many still have sharply pointed surfaces. This seems to indicate lack of wear; they might have been kept at home or safely within bags rather than being worn. These small sculpted forms were usually shaped like cattle or bulls with large horns. In an unusual example (cat. 3.32b) the upright form resembles a human figure, the container being the body and the stopper, with its spiky protrusions, a head with hair. However, the limbs point forward and, if placed on all fours, it resembles the cattle-like examples. In its subtle evocation of both animal and human features, this container recalls the relationship between humans and their domestic stock. The pervasive reference to cattle in this and many other forms of snuff container connects the social significance of snuff and tobacco with the spiritual power associated with these prized animals. *KNe*

Bibliography: Davison, 1976; Shaw and van Warmelo, 1988; Klopper, 1991; Wanless, 1991

3.32a

Snuff container

Cape Nguni
South Africa

hide scrapings, clay and blood mixture
10.1 x 6.3 x 11.4 cm
Bowmint Collection

3.32b

Snuff container

Cape Nguni
South Africa
19th century

hide scrapings, clay and blood mixture
13.6 x 6.6 x 4 cm
South African Museum, Cape Town,
SAM-AE 5934

3.33

Beaded apron

Southern Nguni
South Africa
19th century
hide, glass beads, sinew
50.2 (at centre) x 38.8 cm (at centre)
East London Museum, South Africa,
ELM ETH 1143

This striking apron follows the shape of the animal skin from which it was made, the hind legs forming extensions at its top for the attachment of ties, and the fore legs reduced to short flaps at the lower edge. The hide forms the base for beaded motifs in a range of colours, among which cobalt blue, white, pink and translucent yellow are most prominent.

Circular clusters of beads, arranged in irregular rows against a field punctuated with small raised loops, give the apron its distinctive appearance.

The collector did not record the context in which this garment was used, but it resembles the maternity aprons worn over the breasts and upper body by women in KwaZulu-

Natal. Considering that it was said to have been collected in adjacent Pondoland, it is not unlikely that the apron belonged to a woman who had northern Nguni cultural affinities. Maternity aprons were made from the skin of an animal offered to the paternal ancestors for protection of the unborn baby. Retaining the shape of the animal in the apron is an explicit reference to this ancestral propitiation, and wearing the apron was believed to bring health and good fortune to the child. The significance, if any, of the particular beaded motifs is not known. Beads in themselves, however, were indicators of prosperity and thus proclaimed the status of the wearer. After the birth of the child, maternity aprons were often used to carry the baby on the mother's back.

This piece, which pre-dates 1889, provides an interesting example of a 19th-century technique that could be described as beaded embroidery. Other styles of beadwork that diversified and became widespread in south-east Africa were unbacked and comprised a lace-like beadwork fabric. With increased availability of imported commodities during the 19th century, cloth replaced many garments formerly made of animal skins, but the symbolic significance of skin maternity aprons assured their continuity into the 20th century.

EMS, PD

Provenance: 1889, Emmerling Collection
Exhibition: Cape Town 1993, no. 176

Bibliography: Hooper, Davison and Klinghardt, 1989, pp. 327–9, 355; Morris and Preston-Whyte, 1994, p. 40

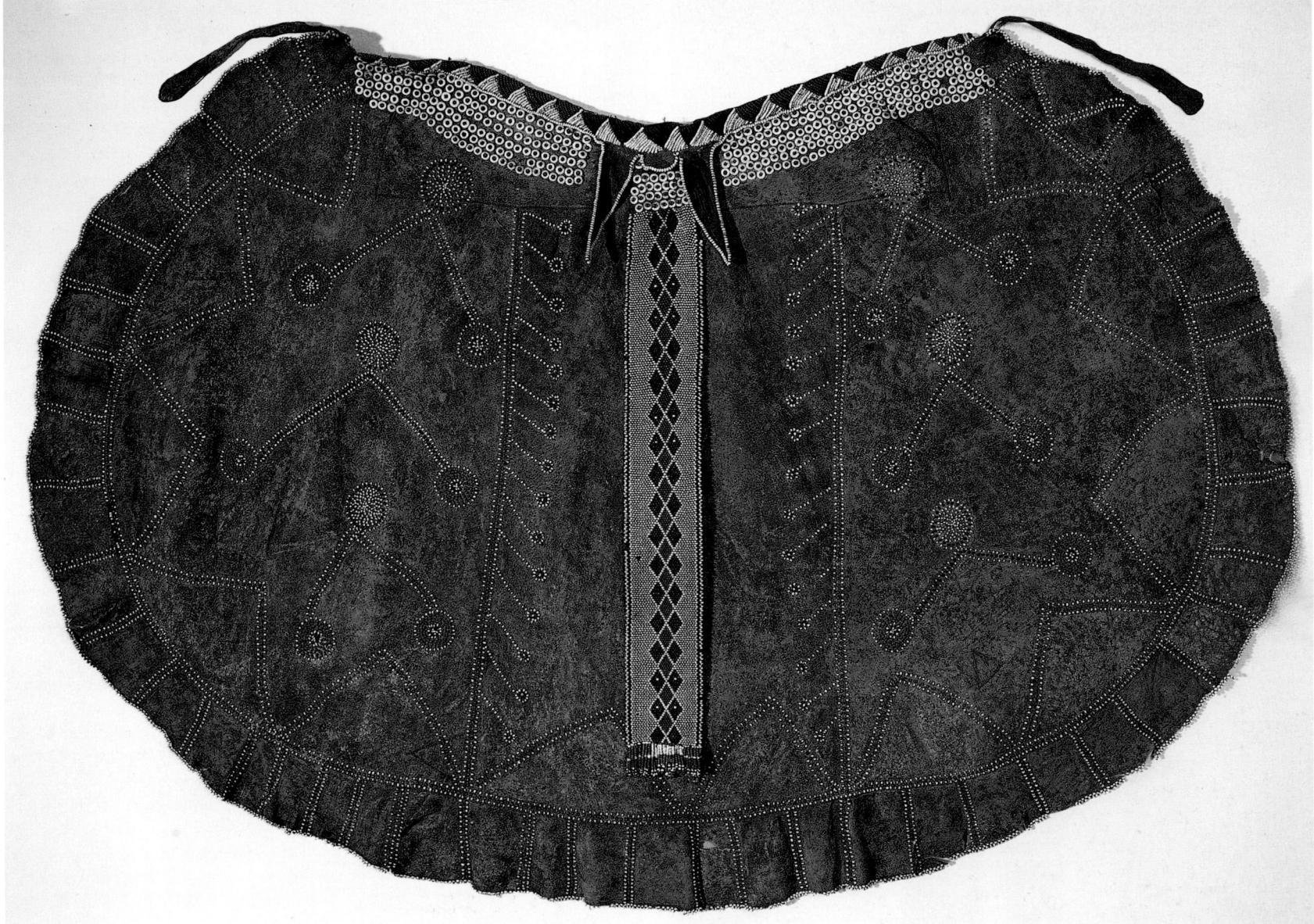

3.34

Cloak

Ndebele
South Africa
early 20th century
sheepskin, sinew, glass beads
h. 161 cm
Private Collection

Throughout southern Africa cloaks made of animal skins preceded the use of woollen blankets as wraps used for warmth and for display on ceremonial occasions. Among the Ndebele people sheepskin cloaks, associated with marriage, were worn by women on important occasions throughout their lives. Some months before the wedding, the bride's father prepared the skin that would be softened, cut and sewn into the characteristic semicircular shape of the cloak. There was considerable variation in beadwork ornamentation, ranging from beaded patterns covering the entire surface of the garment to a simple beaded band at the upper edge. Panels of beadwork hanging down the centre back were not uncommon. Photographs from the 1920s show brides wearing both

beaded and unbeaded cloaks. It is likely that beadwork was added to a cloak over a period of time. Although the shape of this cloak is characteristically Ndebele, the beadwork ornamentation is suggestive of that found among Sotho people, in particular the Ntswane, who are close neighbours of the Ndebele.

As a garment that simultaneously concealed and revealed, a cloak was invested with symbolic associations. During marriage ceremonies the cloak concealed the bride's body but revealed her new social status; when worn at the coming-out of a son's initiation school, it signified maternal status and pride; when worn by an elderly woman, it commanded respect for seniority. The cloak thus marked the passage of time and was valued highly by its owner. *PD*

Bibliography: Bruce, 1976, p. 145; Levy, 1990, pp. 56–7

3.35a

Beaded train (*nyoka*)

Ndebele
South Africa
before 1940
glass beads and cotton thread
168 x 19 cm
McGregor Museum, Kimberley,
MMK (E) 3064

3.35b

Beaded train (*nyoka*)

Ndebele
South Africa
before 1940
glass beads and cotton thread
172 x 26 cm
Private Collection, Johannesburg

3.35c

Beaded train (*nyoka*)

Ndebele
South Africa
before 1940
glass beads and cotton thread
187 x 19.7 cm
Standard Bank Collection of African Art,
University of the Witwatersrand,
Johannesburg, SBF 87.24.04

Long trains, made by Ndebele women from imported glass beads, are among the most accomplished examples of beadwork artistry in southern Africa. The conventional shapes of Ndebele beaded clothing and ornament have tended to remain fairly constant over the last century but colour and design choices have changed dramatically. The three *iinyoka* exhibited here are typical of the period before 1940 when Ndebele beadwork was predominantly white, interspersed with restrained geometric designs in a limited range of colours.

The term *nyoka* means 'snake' but there is no evidence to link beaded trains to fertility or to the ancestors whose presence is signalled by snakes. Speculation also surrounds the significance of the colour white, which often reflects states of social transition, separation or altered consciousness, but field research among the Ndebele has not provided evidence on this issue. From the 1950s onwards the use of colour became bolder and designs more exuberant, manifesting a proliferation of motifs, including letters, numbers and figurative images. Stylistic innovation became a feature of Ndebele beadwork. Some variations may have been the result of emerging regional styles but this has not been substantiated.

Ways of wearing *iinyoka* are varied and individual. Some are designed with a loop or headband attached so that they can hang from the neck or the head. Others are attached to the back of a sheepskin cloak, made by a bride's father for her to wear at her wedding. Sometimes only one *nyoka* is worn as a train but photographs from the 1920s show women wearing two *iinyoka*, one at the back and one in the front. Other images show two trains being worn, one from each shoulder. In the spirit of innovation, a modern bride may wear a Western-style veil together with her conventional beadwork.

Beadwork was used widely to delineate the social position of women. Changes in beaded apparel marked progress through successive stages of maturity and signified differing social responsibilities. Although in the past beadwork was worn every day, it is now reserved for important occasions, such as the coming-out ceremonies that follow initiation, weddings, funerals,

installations of age grade regiments, and parties for graduates who have completed college or university degrees. Old pieces of beadwork are unpicked and the beads recycled within the household, under the supervision of the senior women who decide what new items should be made, either for use by the family or for sale.

The Transvaal Ndebele originated among east-coast Nguni-speakers and moved into the area before or during the 17th century. Complex inter-relationships with Sotho-speaking groups of the central Transvaal occurred, resulting in varying degrees of shared custom and dress. Since the last decades of the 19th century, the Ndzungwa Ndebele, who have become prolific beadworkers, have suffered repeated social dislocation. They responded to these conditions of deprivation by reviving significant social institutions, such as men's initiation, and by developing ways of communicating their particular cultural identity. Women took on the task of re-establishing domestic cohesion; they developed existing skills and extended them in new directions. In the course of doing so, they achieved fame as highly acclaimed bead artists and mural designers. *NL*

Bibliography: Tyrrell, 1968, pp. 79–89; Levinsohn, 1984, pp. 112–27; Carey, 1986, pp. 136–8; Delius, 1989, pp. 227–58; Levy, 1990; Christopher, 1994, pp. 69–71

3.36a

Pair of earplugs (*iziqhaza*)

Zulu
South Africa
20th century
pierced wood and paint
diam. c. 6 cm
Jonathan Lowen Collection

3.36b

Pair of earplugs (*iziqhaza*)

Zulu
South Africa
20th century
wood, vinyl asbestos, glue
and panel pins
diam. c. 6 cm
Jonathan Lowen Collection

3.36c

Pair of earplugs (*iziqhaza*)

Zulu
South Africa
20th century
pierced wood and paint
diam. c. 6 cm
Jonathan Lowen Collection

3.36d

Pair of earplugs (*iziqhaza*)

Zulu
South Africa
20th century
wood, vinyl asbestos, glue and panel
pins
diam. c. 6 cm
Jonathan Lowen Collection

The development of earplugs is related to the custom of ear-piercing, still widely practised in south-east Africa, especially among Zulu-speaking people. Historically, it was an important ceremony performed on every Zulu child before puberty. It incorporated some of the features of the circumcision and initiation ceremonies which are still practised by many southern Nguni but which fell into disuse among the Zulu during the early 19th century. In Zulu practice the earlobe was pierced with a sharp piece of iron; thereafter small pieces from the top of a corn stalk were placed in the newly made holes. As the ear healed, larger and larger pieces were put into the hole until it was big enough for pieces of reed to be used. Early records mention conical earplugs made of polished ivory, horn or baked clay; they also note that snuff boxes shaped like slender barrels were worn in the ear.

By the second quarter of the 20th century much larger plugs made of

wood had come into fashion. Accordingly, the hole in the earlobe had to be distended considerably. Three sizes of plug (about 45 mm, 55 mm and 70 mm in diameter) were commonly encountered. The simplest and presumably earliest type consists of plain polished discs made from the wood of the red ivory tree (*Rhamnus zeyheri*), from which they took their name (*umnnini* or *umncaka*). They are often slightly convex and occasionally decorated with one or more metal studs. During the period from the 1930s to the mid-1940s, the relatively rare pierced and painted plugs were developed (cat. 3.36a,c).

Plugs of various woods with finely worked plastic mosaic overlays glued or nailed onto one or both sides had appeared by the late 1920s. Such plugs

(cat. 3.36b,d) reached their most intricate and sophisticated patterns (sometimes even incorporating letters of the alphabet) with the advent of vinyl asbestos as a flooring material around 1950. Most were made by Zulu craftsmen in Johannesburg for sale to fellow Zulu migrant workers. In the 1960s and 1970s vinyl asbestos was replaced by the thicker and more brittle perspex and occasionally by other plastics. As the new materials were more difficult to work, the designs became simpler, relying for their effect on larger bold areas of colour, a highly polished finish and, frequently, metal studs. They were usually overlaid on both sides and followed the regional patterns and colours of the Msinga district of KwaZulu, where many were produced. Finally, in the 1980s medium sized clip-on earplugs began to be made in Johannesburg. They consist typically of two 55 mm discs, connected in the centre by means of a tight rubber band. They have a perspex mosaic on one side and are painted white on the other.

The earplugs of the 1950s to 1970s tend to follow the colour conventions of regional beadwork. The colours available in vinyl asbestos closely resembled the colours of the glass beads traded in central KwaZulu at that time. They could be used to indicate the domicile of origin and possibly the clan affiliation of their owners, and certain colour combinations evoked associations with stages in the cycle of life. Most significantly, perhaps, the wearing of earplugs and the presence of conspicuously pierced earlobes identified a person as being Zulu.
FJ

Bibliography: Krige, 1936, pp. 81–7, 375; Bryant, 1949, p.141; Schoeman, 1968¹; Schoeman, 1968²; Jolles, 1994, pp. 52–9

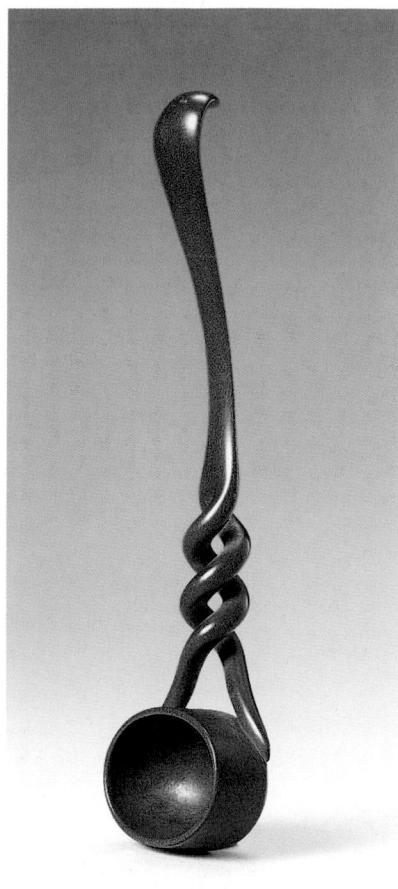

3.37

Spoon or ladle

probably Tsonga-related group
South Africa
wood
l. 20cm
W. and U. Horstmann Collection

Certain spoons, like many other African domestic objects, are aesthetically enhanced and exceed the function that is commonly assigned to them. In the south-eastern region of the subcontinent such elaboration is generally, but not exclusively, non-figurative and integrated into the form of the object. In this example, the subtly modelled handle curves gently, then becomes a double coil that eventually divides into two supports for a deep bowl. The bowl of the spoon, as well as the ornamental complexity of the handle, suggest it was used for serving rather than preparing food.

Historical references to spoons from south-eastern Africa go back to the early 18th century and they are illustrated in the accounts of many early travellers. Spoons embody many complex associations relating to ownership and are often linked to the

circumstances of their acquisition. Those that were regarded as personal property were usually buried with their owners, while those purchased by the husband as part of his bride-price (*lobola*) were returned to the wife's family on her death. Such symbolic acts tend to be associated with women. In rare cases this association is made explicit in figurative representations. *RB*

Exhibition: Johannesburg 1991

Bibliography: Junod, 1962, i, pp. 145, 193; Earthy, 1968, p. 163; Witt, 1991, pp. 87–103; Bouloré, 1992, pp. 85–6; Ravenhill, 1992, pp. 70–4; Jones 1994, p. 50

The final act in the British reduction of the Zulu Kingdom came on 4 July 1879, with the burning by Lord Chelmsford's troops of King Cetshwayo's capital, Ulundi/Ondini. Along with much war regalia that found its way into various collections, this vessel was taken as a trophy, either from an outlying garrison plundered along the advance or from the heart of the kingdom before its destruction. This type of pot (*uphiso*) was used for the transporting of sorghum beer from the brewing site to the regimental barracks or royal residence. It differed from the serving vessel in size and shape, having an almost spherical form to maximise volume, and a low collar to prevent spillage during transit.

'The perfection given in shape to all the Zulu pots', Bryant observed, 'was due to a natural ability in these people for describing the circle.' Zulu women handbuilt their ware by layering clay-rings, and after firing in a shallow pit, invariably finished it to a glossy jet black, using animal fat and a polishing pebble, with sifted soot and a special leaf-ash. The relief pattern of round studs is the most distinctive in the northern Nguni region, with variations seen today on carved wooden utensils. The studs may also be square or pyriform, and arrayed in either an unbroken chain

3.38

Beer vessel (*uphiso*)

Zulu
Zululand, South Africa
19th century
ceramic
37.50 x 39 x 39 cm
Local History Museum, Durban, NN90/39

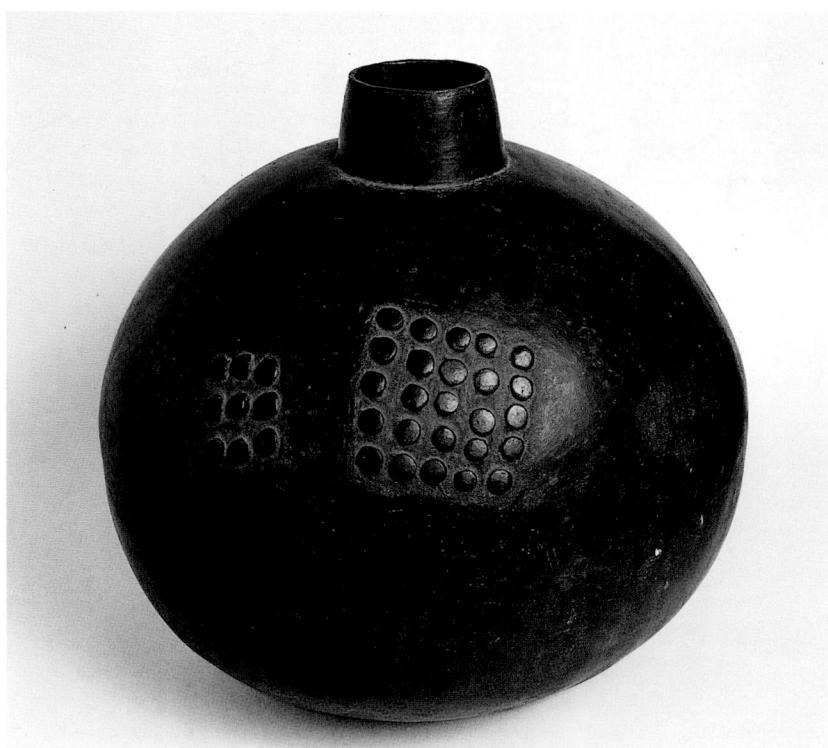

or zigzag, a succession of discrete squares or ovals, swallow-tails, circles, or large lozenges or diamonds (*izingxota*). The latter name was also given to the heavy brass gauntlets awarded to the Zulu Kingdom's men of distinction. Once the king had conferred the privilege of wearing these, they were taken to the royal smith for embellishment with one or other version of this pattern, against the gift of an ox. Thus the design probably carried the imprimatur of majesty, and indeed recent fieldwork has found it used most commonly by woodcarvers of the Emakhosini Valley, where the Zulu kings are buried – suggesting that it indeed originated in the area once dominated by the courts of Shaka's successors.

Elderly carvers assert that the clustered studs are a reference to wealth in cattle, which are not only central to Nguni cosmology and to relations between men and their ancestors, but also the chief form of bride-wealth. This makes it unsurprising that the pattern was produced not only *by* women but also *on* them: early photographs show that it was customary to beautify both wives and unmarried girls by cicatrising the belly, midriff, chest or upper arms in these various configurations. For this reason no doubt, the design is today known colloquially as *amasumpa* (warts), but this is probably a latter-day commoners' epithet for an emblem once exclusively the insignia of the ruling Zulu house, functioning above all as a symbol of royal patronage and power. In later years *amasumpa* possibly came to represent some aspect (not necessarily a head-count) of the groom's gift of cattle that to this day precedes every traditionalist Zulu-speaker's wedding. RP

Bibliography: Chubb, 1936, p. 185; Schofield, 1948, p. 188; Bryant, 1949, pp. 197, 401; Klopper, 1992, p. 125

3.39a

Earthenware vessel (*ukhamba*)

Zulu
KwaZulu-Natal, South Africa
clay
34 x 33 cm
Private Collection, Munich

3.39b

Earthenware vessel (*ukhamba*)

Zulu
KwaZulu-Natal, South Africa
clay
32.5 x 32 cm
Private Collection, Munich

Rimless pots made from fine brown or black clay are produced by women throughout the KwaZulu-Natal region. Pots of this kind are characterised by a smooth, glossy black finish achieved by refiring the already baked pots in a dry grass fire, before rubbing their surfaces with animal fat, usually with the aid of a small pebble. The use of incised lines or protruding mammillae to decorate such pots is widespread, although the practice of adding raised *amasumpa*, or 'warts', is by far the most common decorative technique adopted by Zulu potters. The patterns formed by these protrusions are known by different names, depending on how they are grouped. For example, *amasumpa* arranged in circles are known as *izidlubu*, while those forming a single continuous chain near the upper rim of the pot are called *uhanqu*. The design formed by wave-like zigzag bands of *amasumpa*, like that found on one of the pots shown here, is called *igwinci*. Pots of this kind are intended principally for serving and drinking a sorghum-based beer that is brewed in larger, comparatively roughly-made clay vessels. The drinking of this beer is associated, not only with the living, but also with the dead, to whom it is offered whenever ritual dictates that the ancestors must be remembered and appeased. Drinkers commonly spill small quantities of beer from their pots in what some people claim is an act of homage to their forebears.

Generally speaking, these beer pots are similar in style and decoration to the much smaller drinking-pots into which beer is sometimes decanted for individual consumption. But unlike the latter, their openings are usually covered with *izimbenge*, woven grass lids, many of which are decorated with beads. SK

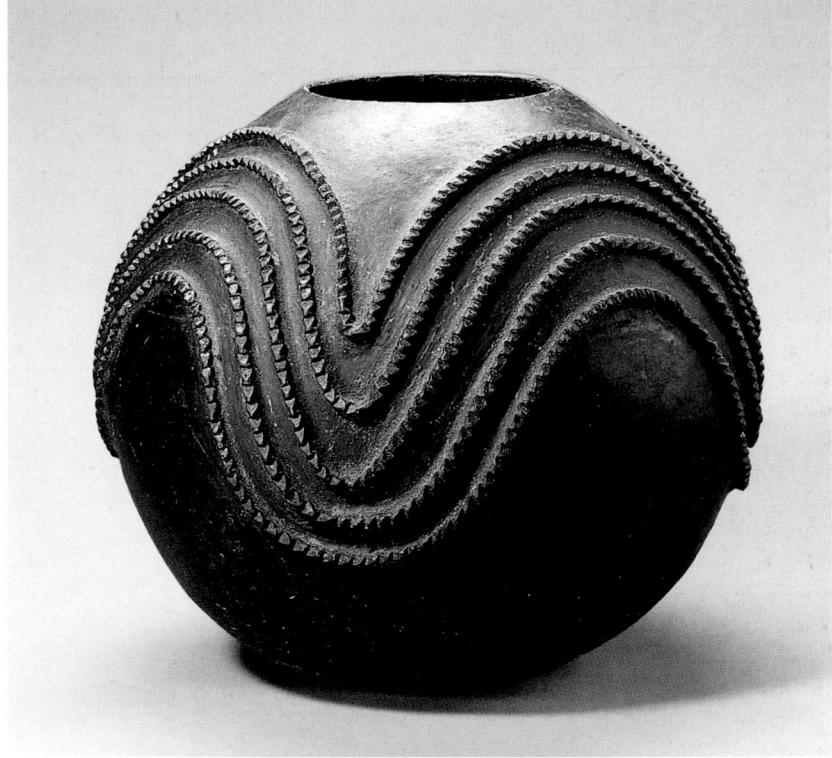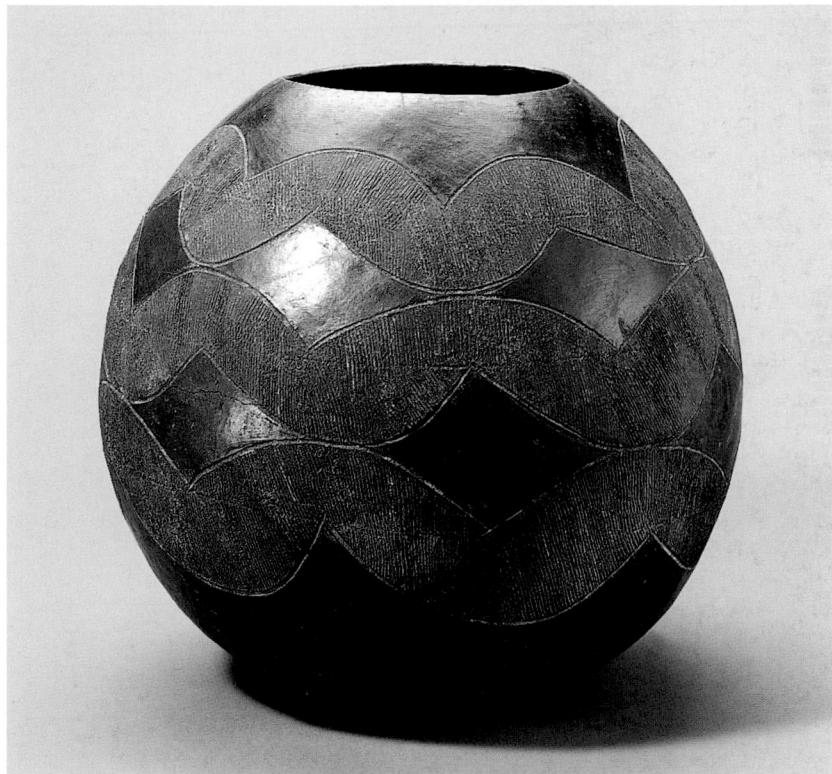

Bibliography: Bryant, 1949, pp. 398–401; Berglund, 1976; Levinsohn, 1983

5.40a

Lidded vessel

Northern Nguni
Swaziland or KwaZulu-Natal, South Africa
possibly late 19th century
wood
h. 39 cm (vessel); 14.5 cm (lid)
Linden-Museum, Stuttgart, 18438

5.40b

Lidded vessel

Northern Nguni
Swaziland or KwaZulu-Natal, South Africa
possibly late 19th century
wood
52 x 32 cm
The Trustees of the British Museum,
London, 1954.23.570

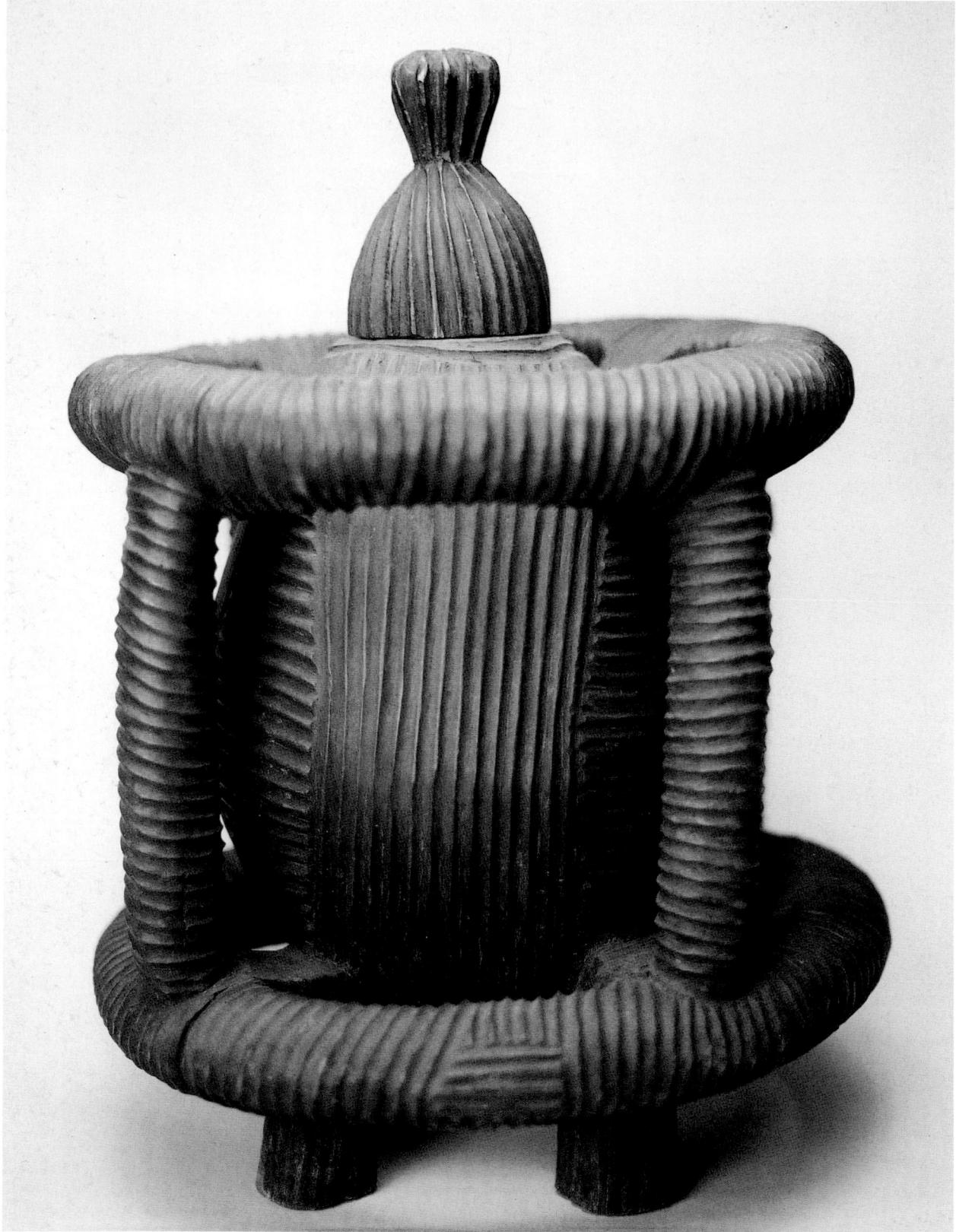

These lidded vessels are comparable with similar vessels in public collections in Europe and South Africa, all of which are decorated with broad bands of deeply incised lines. Each is carved from a single piece of wood. The robust virtuosity of these vessels (achieved in part through the patterns created by such ridges) is reinforced by their chunky proportions. Only some of the works in this genre, like the examples displayed here, are surrounded by exterior structures. But vessels of this kind are otherwise so consistent in style and execution that they may well have been produced by a single carver or workshop.

The decorations found on these vessels invoke comparison with the patterns used in certain headrest styles from the south-east African region. But since hardly anything is known about their history or possible functions, it is not even certain that they were produced for an indigenous, African market. Indeed most (if not all) of them appear never to have been used as receptacles for liquids or cooked foods, suggesting that they may have been sold as virtuous examples of African craftsmanship. An alternative but less probable explanation of their function is that they may have been commissioned by chiefs seeking to highlight their status through monumentally carved display objects. Unlike those owned by the heads of ordinary homesteads, the tall, slim milkpails commissioned by Zulu kings were generally lidded for fear that lightning might enter them. This tradition was probably linked to the belief that the king would never return as an ancestor if he drank milk thus affected. SK

Bibliography: Webb and Wright, 1976, p. 25; Berglund, 1976, pp. 37-42

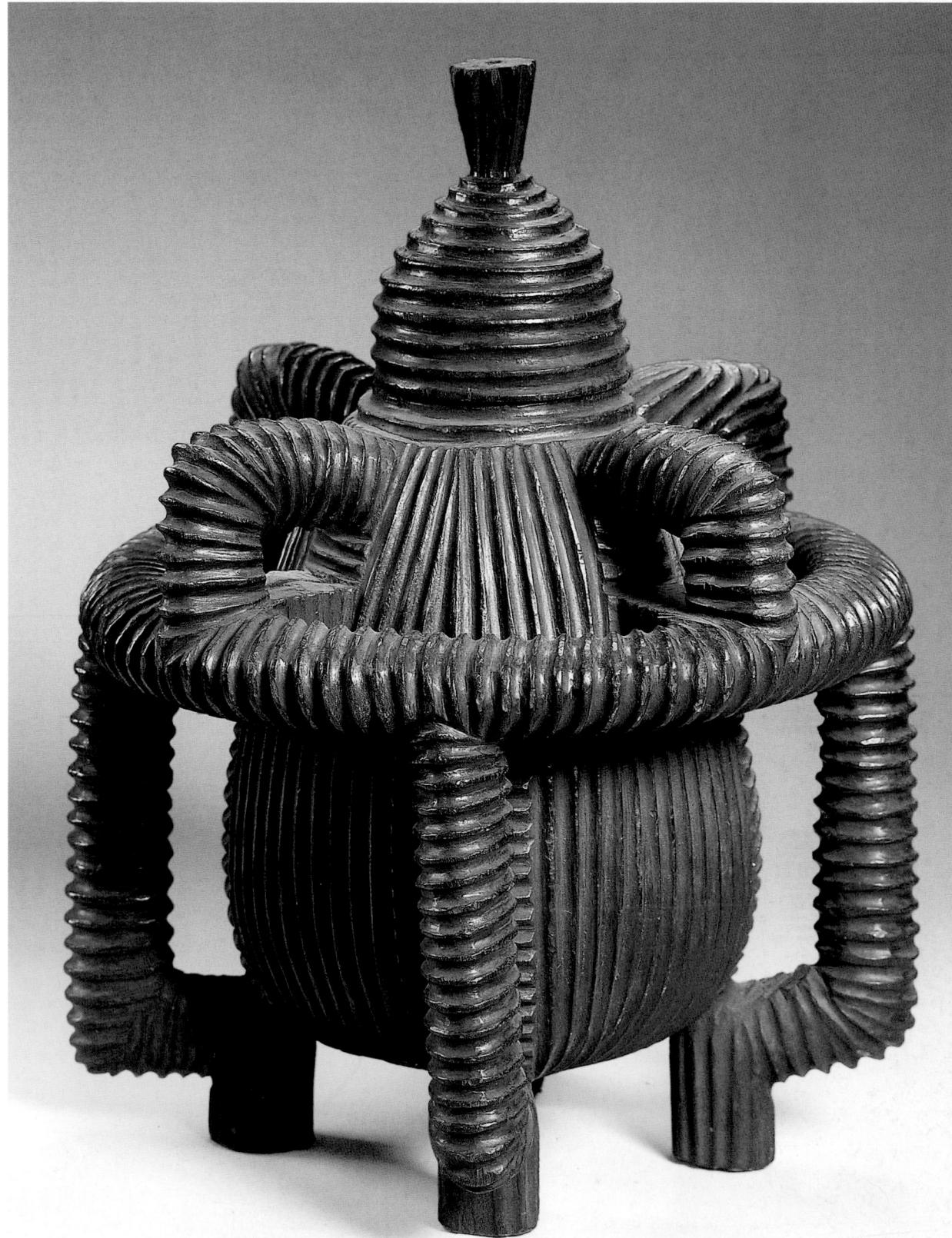

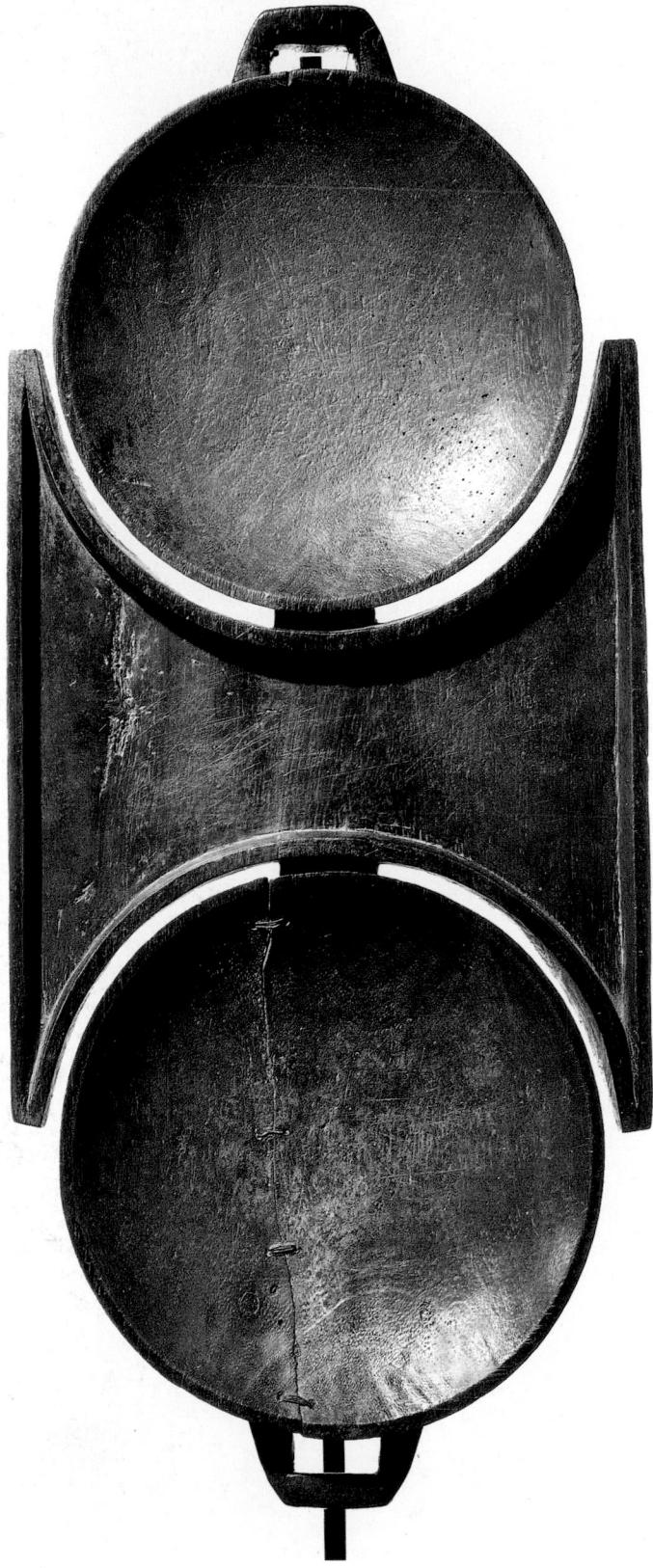

3.41a

Meat platter (*uggqoko*)

Zulu
KwaZulu-Natal, South Africa
wood
h. 80 cm
Private Collection

3.41b

Meat platter (*uggqoko*)

KwaZulu-Natal, South Africa
wood
l. 34 cm; w. 17 cm
W. and U. Horstmann Collection

Meat platters of various sizes, some of them big enough to hold large quantities of meat for communal distribution and consumption on special occasions, are still used throughout the area of present-day KwaZulu-Natal. Reserved for the roasted meat of ritually slaughtered goats or oxen, their widespread use underlines the continuing importance rural Zulu-speakers ascribe to their ancestors in securing the well-being of the living.

The styles of these platters vary considerably from one region to another, but unlike the two examples included in this exhibition, the majority are rectangular in shape, with rounded corners and two or four short legs. Most also have carefully executed decorative panels on the blackened underside of the bowl, probably because meat platters are often used to cover one another, partly to retain heat, partly to keep flies at bay.

Generally speaking, such platters are smeared with the fat of ritually slaughtered animals. This is done with the intention not only of sealing them against insect pests, but also because fat is commonly associated with the idea of ancestral protection. Most platters consequently acquire a deep patina that makes it very difficult to judge their age. Those with comparatively dusty surfaces, like the example with a 'head', breasts and womb-like bowl suggesting comparison with the female form, may well have been made for sale to European buyers. SK

Bibliography: Bryant 1949, p. 407; Indiana et al. 1980–1; Hooper, 1981, pp. 157–312; Klopper, in Johannesburg 1991

In these three figurines of indeterminate gender, presumably by the same carver, the treatment of such details as the hair, ear, facial features, arms, buttocks and legs is virtually identical.

In the late 19th and early 20th centuries numerous carvers from south-east Africa produced figurines for sale to a non-indigenous market. Most, but probably not all of these carvers appear to have been Tsonga-speaking migrants who left Mozambique for Natal in search of work. Many of them also made souvenir staffs or walking-sticks for the same market.

Typically, these figurines were sold as pairs, one male, one female, suggesting that they were inspired by the much larger figures some Tsonga-speaking carvers produced for use as didactic tools in male initiation ceremonies. But these differ from the initiation figures in several important respects. Perhaps, most obviously, they are generally stripped of the prominent genitalia found on initiation figures. Many also lack other important indicators not only of gender identity, but also of marital status, like headrings and topknots, although most of the female figurines either nurse or carry babies on their backs.

Partly because they are not paired in this way, the figurines shown here are quite unusual. Other differences between them and the paired figurines include the addition, to most of the latter, of poker-work details to accentuate certain features like beards. But they are similar to many of these figurines, and to souvenir figurative walking-sticks, in the treatment of their limbs, above all, the clear demarcation between the calves and thighs. SK

Bibliography: Nettleton, 1988; Klopper, in Johannesburg 1991; Nettleton, in Johannesburg 199

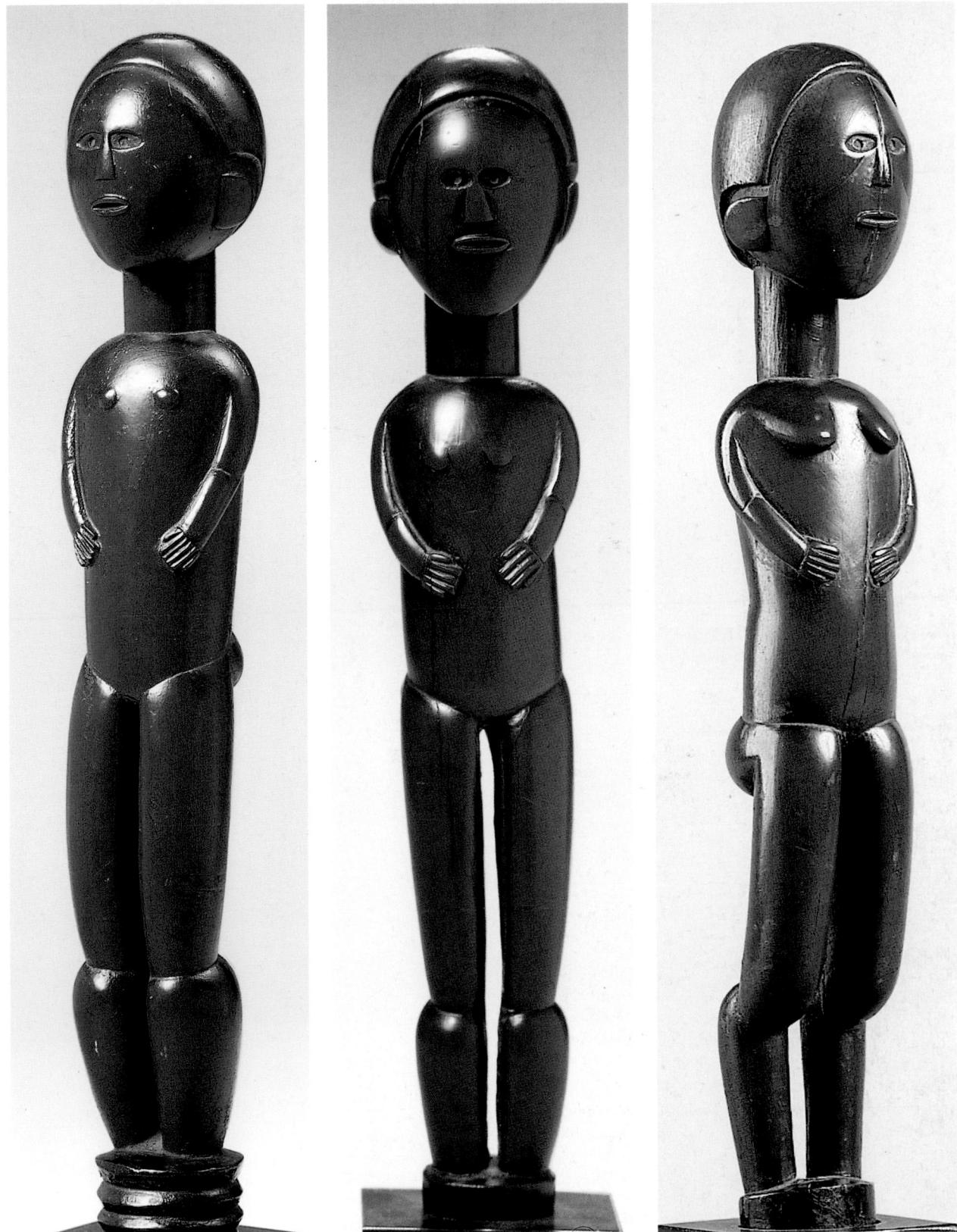

3.42a

Figurine

possibly Tsonga-related group
Mozambique or South Africa
probably late 19th or early 20th century
wood
h. 30 cm
Private Collection

3.42b

Figurine

possibly Tsonga-related group
Mozambique or South Africa
probably late 19th or early 20th century
wood
h. 29.5 cm
Musée Barbier-Mueller, Geneva, 1027.74

3.42c

Figurine

possibly Tsonga-related group
Mozambique or South Africa
probably late 19th or early 20th century
wood
30 x 4.8 x 5 cm
Private Collection, London

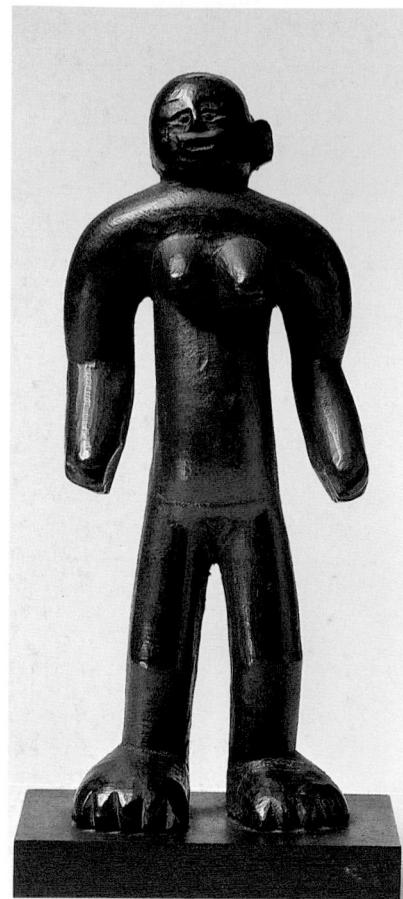

3.43

Figure

Tsonga (?)
South-east Africa
late 19th or early 20th century
wood
23 x 9.5 x 6 cm
Herman Collection

Figures of this kind are known from other collections in Europe, but very little is known of their origin. The style of carving has been defined as 'Zulu' by William Fagg, with one example from the Wellcome collection being provenanced to South Africa. This style is, however, unlike the only style of figurative carving that can securely be attributed to the Zulu-speakers of Natal, that of the baboon images carved on staffs. The very small head, the rough features and the treatment of the limbs are also unlike the carvings produced by the neighbouring Tsonga-speakers of Mozambique and the eastern Transvaal for use in initiations, but the treatment of the toes, the extreme enlargement of the feet and the horseshoe-shaped ear are concordant with stylistic features known from Tsonga-style carvings, both on

headrests and free-standing figures. A similar figure to this in the Museum für Völkerkunde in Vienna has a much more secure provenance, having been collected by Adolf Eppler in the 1880s among the 'Shangana Kaffirs', i.e. the Transvaal Tsonga. It was also one of a pair, pairs of male and female being typically produced for use in initiation ceremonies.

It might be suggested that this type of figure constitutes the output of a single, highly individualistic carver. The protuberant breasts and marked genitals suggest that this figure was not carved for European patrons, but for use in the community in which it was made. It was possibly made for use in initiation of young men among groups, such as the North Sotho, or of young women among the Venda-speakers, both of whose carving styles appear to have been quite diverse, and whose contacts with vassal Tsonga-speakers in the eastern Transvaal spanned over a century.

These groups used wooden figures as didactic aids in initiation schools, and the explicitness of this figure's genitalia suggest this as the most likely context for its use. It is also likely that, if such figures were made for indigenous use, they would have been clothed with cloth, leather or bead aprons to hide their genital areas when they were not in use, as is the case with many of the securely provenanced Tsonga and Venda figures.

Despite their small size and use of clothing, and contrary to popular belief and academic nomenclature, figures of this type were not used as 'dolls', i.e. as playthings. Moreover, as such figures have never been unambiguously provenanced to Natal, it does not make sense to perpetuate the myth of the notion of 'Zulu' figurative art, through attributing them to this, albeit famous, southern African political grouping. AN

Bibliography: Nettleton, 1988, pp. 48–51; Nettleton in Johannesburg 1991, pp. 32–47; Klopper, 1992, pp. 89–96

3.44

Carved milkpail (*ithunga*)

Zulu
KwaZulu-Natal, South Africa
wood
40 x 14 x 14 cm
W. and U. Horstmann Collection

The use of tall, slim milkpails has been common throughout the area of present-day KwaZulu-Natal since at least the mid-19th century. In most cases these milkpails are decorated with some delicately conceived motif on one or, more often, both sides. Usually, such motifs are situated well below the neck of the vessel, where they are said to serve as grips. Their primary function therefore seems to be to prevent the pail from slipping during the milking process.

Like this example, they sometimes have breast-like motifs carved near the neck of the vessel, thereby invoking associations with the female form, probably with the intention of suggesting lactation and hence, also, the idea of fertility. Women themselves are discouraged from touching their husbands' milkpails for the reason that these are associated with cattle and, through cattle, with their husbands' ancestors. This association also explains why, in the past, milkpails were regarded as heirlooms and passed on from one generation to another.

Milkpails of this kind are never used for storing milk, which is decanted into other containers, usually clay pots, wooden vessels shaped to look like the wide-bellied, narrow-mouthed clay pots commonly produced in the region, or calabash vessels. This milk is left to form sour milk, known as *amasi*. Once decanted, milkpails are placed upside down on a wooden pole, where they are left to drain and dry out between milking sessions. SK

Bibliography: Krige, 1936; Bryant, 1949; Raum, 1975, pp. 102, 515

Figure

Tsonga
Northern Province, South Africa
19th century
wood, beads
75 x 12.6 x 10.2 cm
University Art Galleries, University of the
Witwatersrand, Johannesburg, Standard
Bank Foundation of African Art
Collection, SBF 82.20

Many African groups in the northern Transvaal made figures of wood for use in initiation ceremonies. The Tsonga-speakers who migrated into this area in the early 19th century appear to have adopted this practice, but it is unknown among those in Mozambique. It appears that Tsonga-speakers both attended the initiations for men conducted by such north-Sotho-speaking groups as the Lobedu, Kgaga and Pedi, and adopted these ceremonies themselves. Figures such as these were used in the instruction of initiates, young men passing from youth into manhood. They were most often used in pairs, one male and one female, to illustrate teachings about sexual and social mores.

This figure is made in a style that is specifically associated with Tsonga-speakers, with a general pole-like formation, thin arms, and legs divided into two bulbous units. The jutting jawline, open oval mouth, striated hair and spatulate hands are also typical. The hips and chest of this example are clearly differentiated from the rest of the torso, a feature not commonly found in most other figures of this type. Also while most other examples have clearly delineated genitals, this one does not. Other extraordinary features include the black staining of the whole figure and its bead eyes.

On top of the head is a ring which was worn by adult men of the Shangaan subgroup of the Tsonga (descendants of the Nguni-speaking group who, under Shoshangane, had fled from Shaka in the early 19th century and settled in Mozambique). Their migration into the Transvaal was caused by succession disputes in the mid-19th century and later by conflict with the Portuguese in the late 19th century. They maintained many customs practised by northern Nguni speakers such as the Zulu and Swazi, among which was the wearing of a headdress (*isicoco*) by mature men. The headdress, made of grass

and wax, was sewn into the hair of a man who had reached maturity within his age-grade regiment. Figures such as this are reported to have been set up at the ceremony where the men of a regiment were given permission to wear the headdress and thus to marry. Thus the figures (with their female partners) would appear to have specific reference to Tsonga notions of maturity and manhood. By the end of the 19th century such figures were being sold to European travellers at Marabastad, and by 1910 examples were made specifically for this trade in curios. The lack of genitals in this example suggests either that they were removed after the figure was collected or that it was one of the earliest 'tourist' examples, later versions of which were carved with bases, spears and shields. AN

Bibliography: Nettleton, 1988, pp. 48–51; Becker and Nettleton, 1989, pp. 12–13; Nettleton, 1991, pp. 32–47

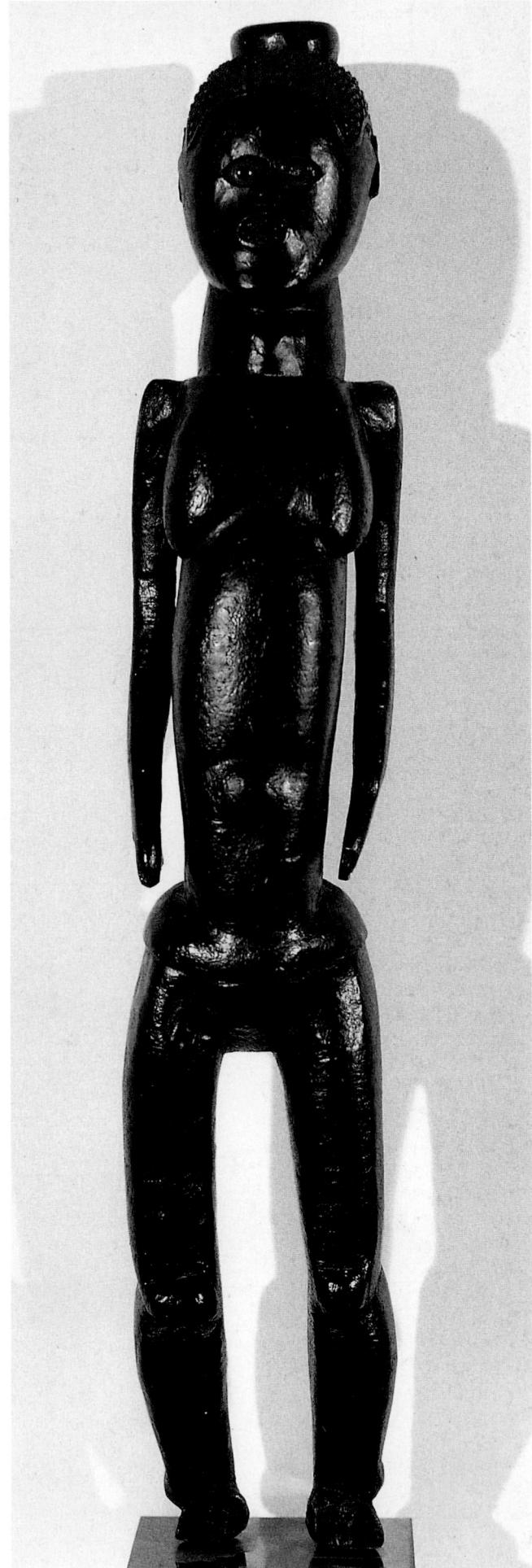

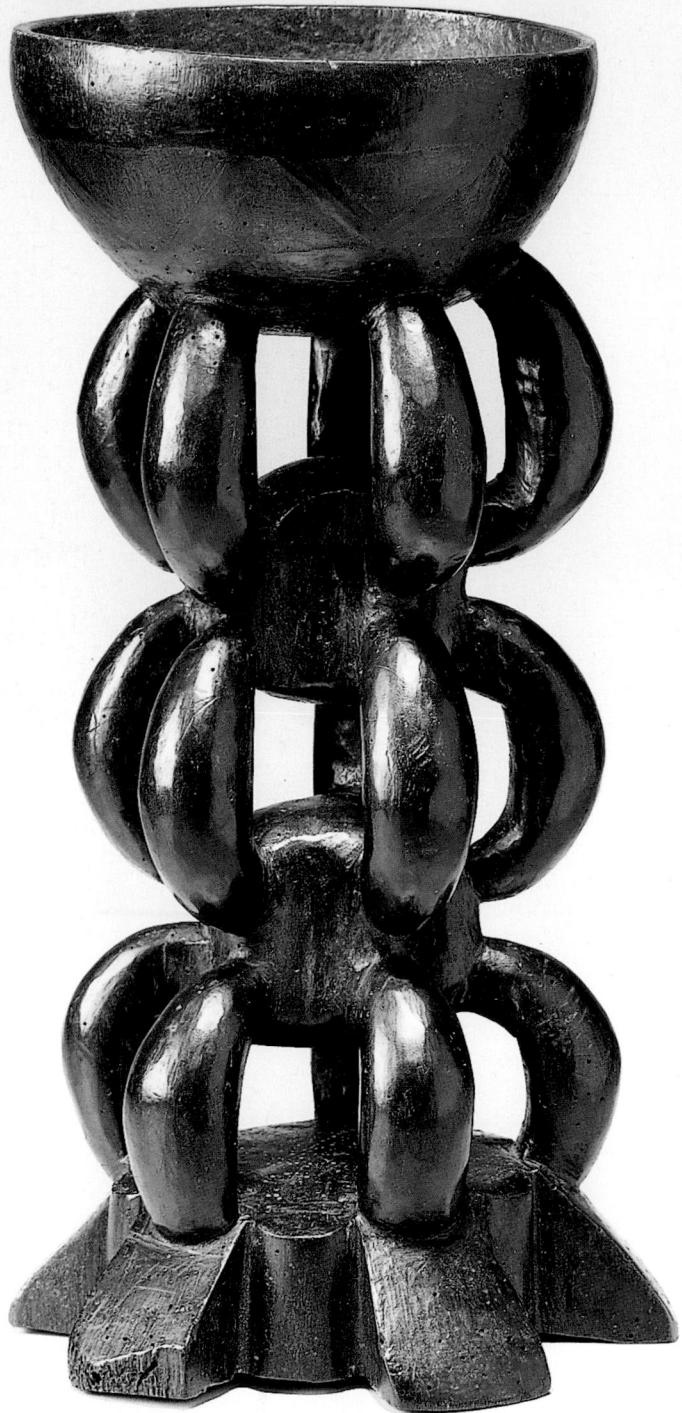

3.46

Bowl

possibly Tsonga, Shangaan,
Chopi or Lenge
South Africa
wood
h. 55 cm
Kevin and Anna Conru

A relatively small bowl is supported by intricately carved columns reminiscent of the chains and spirals found on spoons and sticks from this area. The columns bend and interweave in triple arches, each the height of the bowl. The purpose of the elaboration is not clear: such objects were not made for general use among the groups to which the piece could be attributed.

Round bowls with blackened surfaces and lighter triangular decorations, with no base or with small supports, are common in the Transvaal and Mozambique regions. In this region, as elsewhere, bowls were primarily functional but through relocation into the sphere of ritual they could transcend their utilitarian function. Among the Tsonga there are records of bowls being used for purification, and among the Lenge, because of the similarity of the triangular decoration on bowls with women's hairstyles, a bowl could be associated with the head and even represent it when turned upside down. The distinctive form of this bowl suggests a display of masterly skill.

The impetus to elaboration may have come from outside the carver's own social community. The piece may have been carved for exchange, for sale to a foreign visitor, or have been made to order by a colonial official. This might explain its eventual location in England. On the other hand it may have been a prestige object made to honour a local recipient. RB

Bibliography: Junod, 1962, ii, p. 150; Earthy, 1968, p. 50; Nettleton, 1991; Klopper, 1992

3.47

Dress ornaments (*omakipa*)

Ovambo
Namibia
c. 1937
leather, ivory, shell, glass beads
l. 27 cm (ANG. 1937.2207), 38 cm
(ANG. 1937.2325)
Powell-Cotton Museum, Birchington,
ANG.1937.2207/2325

Many Ovambo ivory clasp-buttons have recently appeared on the European and American markets where they have been without exception shown as individual objects rather than in any social context. They are a feature of women's prestige ceremonial dress in the area of Namibia on the Angolan border and among the Kwanyama in Angola itself.

They are perforated at the back in the manner of a toggle to admit leather thongs which bind them to belts or strands of beads. Early examples are found in conjunction with shell ornaments. In a Windhoek collection I have seen a complete harness of leather featuring about twenty-five *omakipa*.

The vocabulary of form is wide-ranging from narrow boat shapes through square pyramid to the more usual domed form sometimes culminating in a raised nipple in evident imitation of a breast.

They are usually made of elephant ivory softened by burial before working into the desired shape. Most are etched with conventional patterns of cross-hatching, though early examples can show more invention and less rigid formats. The etched marks are heightened by rubbing in various plant juices including one of a virulent crimson (sometimes almost purple). Some smaller *omakipa* are made from rhinoceros ivory while more recently bone has been used and even wood.

They are commissioned as gifts to the future bride by the groom. After marriage he will continue to add to his wife's collection which she wears on feast days to reflect his wealth. A full regalia would include loose straps also bearing these ivory clasps that swing freely in the dance.

Ironically a number of *omakipa* have recently found their way back to the world of female finery, made up as very expensive belts by a fashionable designer. TP

Bibliography: Lehuard, 1982, no. 42

3.48

Ritual bellows in the form of a buffalo

possibly Bayeyi
Botswana
late 18th century (?)
wood with copper
50 x 120 cm
National Museum Monuments and Art
Gallery, Gaborone, Botswana

This impressive animal was found in a rock shelter in the Chobe National Park in association with another bellows (in the form of an elephant) and some undecorated pottery.

Ritual bellows are found in many areas of Africa from areas as distant from Botswana as Northern Mali (Dogon) and the Gabon (Fang, Mitsugho). Many descriptions of forges and bellows in the literature describe complicated rituals associated with firing and a wealth of symbolic reference. Certainly the accomplished depiction of a buffalo would have had no mere ornamental function but formed part of a larger system of myth and sacred allegory.

Without its attendant pipes and bags the animal seems to be an autonomous piece of sculpture, yet examination reveals a complex

functional structure. The copper plates (fixed with copper nails) suggest the metal being worked. The stomach is hollowed out and on each side a row of holes indicate the position of the skin which was fixed over it. The pipe for the bellows travelled through the hollowed tail through which air passed with the operator sitting astride the animal to work the skin via handles. Such a fine and imposing bellows might perhaps have been reserved for ritual metal-working rather than the day to day activity of the forge.

The tentative dating and attribution is owed to Alec Campbell who supplied much of the information above. TP

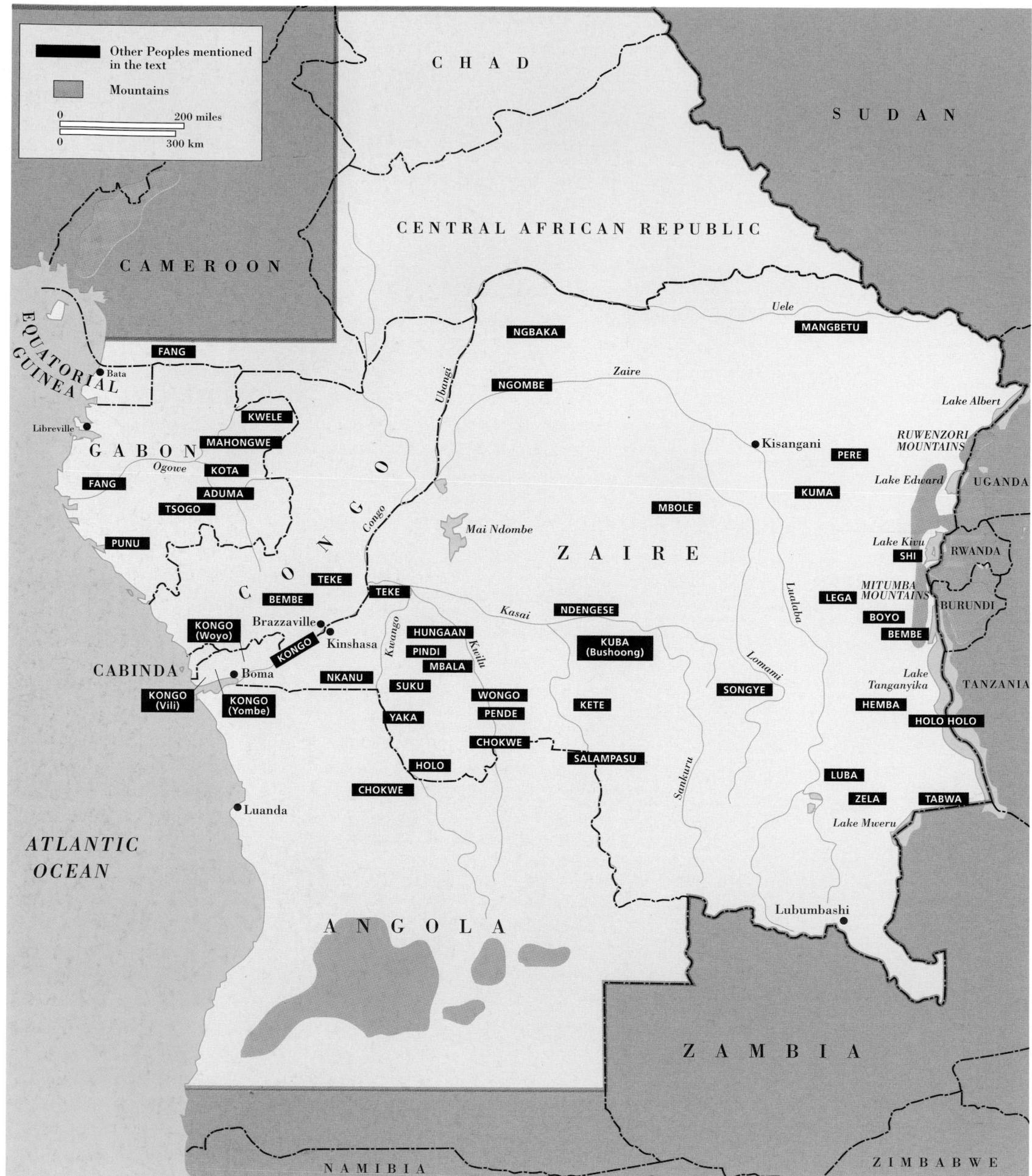

4 CENTRAL AFRICA

HISTORICAL AND CULTURAL ASPECTS OF CENTRAL AFRICA

Daniel Biebuyck

The central African region encompasses a vast area of rainforests, forest galleries, secondary forest formations and various types of open and wooded savannas. The region includes several countries, from southern Cameroon, Gabon, Equatorial Guinea (including Mbini), the Congo Republic and Cabinda to Zaire and northern Angola. There are cultural and historical overlappings between the populations inhabiting these countries and adjoining areas in the Central African Republic, the southern Sudan, Uganda, Rwanda, Burundi, Tanzania and Zambia. In numerous instances the national boundaries, as they were drawn up by the colonial powers, cut through the heartland of homogeneous cultural areas, such as Fang, Kongo, Cokwe, Luba, Lunda and Zande.

The majority of art-producing peoples in this region are Bantu-speakers (the Bantu languages constitute a large, highly differentiated subdivision within the Niger-Congo family of languages), the chief exceptions being found among ethnic groups straddling the boundaries of northern Zaire, the Central African Republic and the southern Sudan. Such ethnic groups as the Ngbandi, Ngbaka and Zande speak languages belonging to other subdivisions (called Adamava-Eastern) within the Niger-Congo family of languages.

The spread, differentiation and admixture of peoples and cultures in this region are the result of migrations extending over more than two millennia. Successive waves of population movements started in the south-western Grasslands of the Cameroon. At first they may have consisted of small-scale incursions from the savanna into the forest regions. Soon these early migrants were succeeded by groups taking several north-eastern and south-eastern routes, mostly circumventing the deep forest regions; subsequently there were crisscrossing movements in southern, north-western and western directions. In the course of these population shifts the immigrant groups encountered other nomadic and semi-nomadic hunters and gatherers, whose origins are uncertain, virtually all of whom were absorbed and assimilated by the newcomers. Archaeological and ethno-archaeological research in central Africa has revealed the existence of burial sites in the Upemba area of south-eastern Zaire dating back to the 6th century and offering in three different phases a complete Iron Age sequence. Moreover, these sites provide evidence of burial customs, pottery and basketry techniques that seem to anticipate the culture of historically known groups such as Luba. Early populations and their artistic activity are also evidenced by the pottery, axes and anvils in Katoto (south-eastern Zaire), the rock shelters with geometrical designs and other paintings in Lower Zaire, the famous wooden animal sculpture dating back to the 8th century found in central Angola and the stone tomb sculptures in south-western Zaire and Angola (cat. 4.1). Again many of these early artistic traditions were continued in the Luba and Kongo kingdoms and into modern times. The Pygmies (known under diverse names, such as Batwa, Bacwa, Bambuti), many of whom were until recently net and/or bow and arrow forest hunters and gatherers, are found in widely scattered areas throughout the region, and continue to exercise numerous privileged ritual and ceremonial rights with reference to the ownership of land and the enthronement of kings and chiefs. Even in those areas where they have disappeared or been completely absorbed, the memory of Pygmies is kept alive in oral narratives, genealogical recitations and ritual practices; their influences in music, song, dance techniques and even in dramatic performances are manifest everywhere (cat. 4.74).

The social and economic structures, the religious, philosophical and value systems of the peoples in the central African region vary widely in form and content, yet some important recurring patterns can

be discerned. Except for certain Pygmy groups, all populations in the region engage in some form of agriculture, based on the cultivation of bananas and plantains, root crops, cereals or a mixture of them all. All tend goats and sheep and keep chickens and dogs, but very few of the central African populations own cattle. Most groups fish (along the major rivers such as the Uele, Ubangi and Zaire specialist, semi-nomadic fishermen are found). Hunting game with dogs, nets, spears, bows and arrows, in collective battues, small groups or singly, and trapping using everything from snares and baited traps to pits and huge elephant crushers are still important subsistence activities in a large number of ethnic areas. The significance of hunting and trapping is deeply embedded in these peoples' ritual and world view regardless of whether there is game to hunt or not. Numerous important ceremonies and rites require collective battues, the search for particular animals and large-scale distribution of meat. Many durable parts of the animals are essential in the manufacture of artworks (cat. 4.29a,55).

The kinship and descent systems fall within the classic range of patrilineal and matrilineal organisations, the former being predominant in the north of this region, the latter among the southern groups. In some areas, particularly where the two systems meet, some populations adhere to more complex forms of organisation, such as bilineal (or double descent) and omnilineal (selective choices of tracing linkages through males and/or females) descent. As a general rule, the role of the father's group is significant in matrilineal population and of the mother's group (and extensions) in patrilineal societies. The different systems greatly influence the ways in which artworks are commissioned, used and transferred, but have little or no influence on the types and categories of art produced or the socio-ritual contexts in which it is used. In the rich artistic traditions of Zaire and overlapping areas, some of the ethnic groups who produce most art are found among the southern matrilineal populations, but this cannot be explained in terms of kinship and descent structures.

The range of political structures among the central African art-producing peoples is impressive. Although no major states rose to prominence through conquest, as they did in west or east Africa, several large kingdoms, some of them pluri-ethnic, have been recorded. Judging from the available evidence, some of these kingdoms flourished centuries ago and some, such as the Kuba, Luba and Lunda kingdoms, were still fully operative in colonial times and even survived to this century. Others, like the Kongo or Chokwe kingdoms, broke up into smaller, politically centralised or decentralised units at an early stage, either before or at the time of early contacts with the West. In many central African ethnic groups, however, the political organisation is of the petty state system (the ethnic group being divided into a number of small autonomous chiefdoms) or is conceived as a segmentary lineage system of interconnected larger and smaller kinship units. In some groups, political integration is loosely based on the alliance, kinship and territory of a few adjoining villages and hamlets. Unlike other regions in west Africa, only a very limited number of types of artwork, of the vast artistic output, are exclusively for the use of kings, queens and their retinue (cat. 4.46,49). Few artworks can be labelled 'royal', but many of diverse type are linked with politico-religious leadership, and were for the use of chiefs, royal initiators, village headmen, lineage heads and elders.

Throughout the region, initiation rites constitute elaborate systems of central importance in the life of the people. Among the mandatory initiations are those for boys and young men at various ages; these are generally collective, periodic, long-lasting and characterised by rites of passage, including circumcision, seclusion, physical hardship and intensive learning (values, songs, dances, use of artworks) (cat. 4.71). Among the peoples of southern Zaire and northern Angola in particular these youth initiations and the sophisticated hierarchical organisations they require make use of many diverse artworks (cat. 4.27). Analogous initiations for girls and young women (e.g. Kongo, Ngbandi, Ngbaka) exist in several areas, but they are not well documented (except for Bemba-related populations in south-eastern Zaire and Zambia)

and most are less elaborate. Other types of mandatory initiations are ‘vocational’ in nature; they involve kings, chiefs, headmen, ritual experts, healers and herbalists, diviners, blacksmiths, some categories of sculptors, singers and dancers. In the course of these, sometimes prolonged, initiations preceded by apprenticeships, the initiates learn the values and secrets linked with their offices. A considerable number of sometimes very secret and rare artworks are associated with these initiations.

So-called voluntary initiations form the basis of access to, and membership of, associations, sodalities, semi-secret and secret societies. These hierarchically structured associations, most exclusively for either men or women, although some are for men and women together (as married couples), are based on initiation rites held at various stages in a person’s life, possibly spanning a complete adult lifetime. Initiatory rites require the payment of fees and the distribution of gifts, food and goods, but also the large-scale participation of initiates. Based on specialised social, legal, moral, philosophical and artistic codes, these associations cut across socio-political structures, creating new forms of leadership, and frequently exercise an influence on the development of various exclusive and unique artworks.

Among the religious beliefs and practices that require the use of sculpture are the care and veneration of the dead, concerns about the destiny of the soul and life principles, ancestral cults, worship of nature spirits, divination and detection of evil-doers and witches, healing techniques, methods of inflicting and neutralising evil and sickness, consolidation of friendship and blood pacts, taking of oaths, personal and group protection and the enhancement of fertility. Among the few populations that have developed a pantheon of divinities, such as Shi, Hunde and Nyanga, artworks seem to be of little significance in their celebration. The most widespread and significant, if sometimes overrated, religious category is that of the ancestor cult (cat. 4.66). These cults of ‘the living dead’ take many forms and operate at several levels of the socio-political structures. In terms of art, the most important ancestral cults are addressed to founders of royal dynasties (cat. 4.37), clans and lineages, to kings and chiefs, to select founders and elders of lineages and villages and to their mothers or sisters.

The peoples of central Africa have a keen sense of beauty, although the canons on which the concepts of beauty are based are not always explicitly formulated. The embellishment of the human person through body adornment (dress, ornament, painting, cicatrisation, tattooing) and the enhancement of daily life through the use of refined objects (textiles, barkcloth, pots, cups, plates, baskets, mats, tools, utensils, weapons, various paraphernalia) (cat. 4.41–2) are central to the development of the visual arts.

In parts of eastern Zaire, Arab and Swahili raiders, infiltrating from east Africa, established control over many ethnic areas for many decades until the advent of the Belgian colonial forces. Whereas the presence of these external forces had a profound effect on various institutions and customs, the process of Islamisation in this part of Africa was limited mainly to areas along the western shore of Lake Tanganyika and parts of the hinterland, northwards to the area of Kisangani. In most of central Africa the colonial and missionary impact was not felt until the late 19th century, the major exceptions being those areas earlier affected by trade in slaves and ivory, and those near the Atlantic coast and the adjoining hinterland where Western contacts occurred as early as the 15th century. On the coast and in the hinterland, mainly inhabited by Kongo peoples and their offshoots, Christian influences manifested themselves in new forms of art made locally, such as crucifixes (cat. 4.2) and sculptures of the Virgin and St Anthony. Traces of Christian artistic concepts are apparent into the 20th century, particularly in some aspects of Kongo art (cat. 4.23). The actual dates of colonial contact and its intensity differed considerably from one ethnic territory to another, as did the responses of various ethnic groups. Colonial and missionary rule in some areas led to the severe repression of existing customs and institutions which were labelled ‘subversive’ or ‘against the civilising efforts’ of the colonial powers. In consequence some institutions and customs were modified and adapted to the changing conditions while others declined,

disappeared or functioned increasingly secretly. In a number of cases this had a drastic effect on artistic productivity. In other instances, in reaction to imposed legislation, reinvented protective and reactionary institutions emerged including new forms of secret societies new healing and anti-witchcraft organisations and prophetic and messianic cults. Some of the new-fashioned institutions were favourable to the existing arts, and even produced some additional forms of art, others were temporarily or permanently opposed to the arts, which came to be regarded as external symbols of backwardness.

Central African populations have produced many kinds of visual arts: painting on the body, on screens, on sculptures, on houses; drawings in the sand, on walls, on cloth; tattooing and cicatrisation of various parts of the body; body adornment in many forms (headdresses, necklaces, earrings, bangles, belts) (cat. 4.47–8,74–5); textiles and barkcloth (cat. 4.75); beadwork (cat. 4.45); calabash engraving and painting; metalwork (cat. 4.43,89); pottery (cat. 4.20,57,65); basketry; fibrework and plaiting; architecture in the form of dwellings, gathering houses, shrines and initiation lodges. They have created an abundantly rich variety of sculpture.

Bibliographical note

The early stylistic synthesis of Olbrechts, 1946, remains a useful classic. Specific analyses of the central African region and particular arts occur in the studies published by Bastin, Beumers and Koloss, Cornet, Herremans and Petridis, Lema, Neyt and Perrois. Advances in our understanding of central African arts very much depend on small-scale comparative studies (on a specific area or ethnic cluster) and monographs. Such field-, museum- and archive-based contributions are made by, among others, Bastin, Biebuyck, Bourgeois, Burssens, Ceyssens, Cornet, de Sousbergh, Hersak, Laburthe-Thomas, Lehuard, Lema, Neyt, Nooter, Perrois, Roberts, Thompson and Bahuchet. General linguistic data is covered by Greenberg, 1966, and Guthrie, 1967–71, historical material by Vansina, 1978, archaeological evidence in de Maret, 1974.

Sculptures are most often made from materials that are available locally. Some materials, such as metal and ivory, are employed for their symbolic meaning, supernatural properties, relative rarity or high value. Wood is the most common material. With the aid of an adze, the form is hacked out of a solid block, and further carved with a knife. As a rule, the sculpture is worked symmetrically and frontally. Colour, if it is to be applied, follows. For this, a variety of plant or animal dyes can be used. The colour may be transparent, mat or glossy. In some cases a mud bath and much polishing would produce a glossy surface ranging in colour from grey to black, covering the wood like a lacquer.

Small sculptures in ivory are found among only a small number of peoples. For example, they are made as finials for sceptres by the Kongo, as amulets by the Pende, the Hunga and the Luba. There are also the miniature ivory masks and figures used by the Lega in the closed *bwami* association.

A number of peoples make use of strips of copper to overlay a section of the sculpture, usually the face. The best known are the reliquary statues of the Kota (see below). With several of the Kongo peoples and also among the Teke, small sculptures are cast using a lost-form technique. Striking illustrations of this are the Christ figures (cat. 4.2), inspired by examples brought to Africa by missionaries, that were wrought by Kongo casters. Knives and spears were forged in iron. With the exception of the figural ceremonial axes of the Songye, where the representation of human bodies or faces is fashioned in openworked blades, depictions of men or animals in wrought iron are extremely rare. The iron anthropomorphic figure from the Kuba (cat. 4.43) is almost unique; together with a second example, it is described as the oldest figurative representation originating from central Africa. These figures would seem to date from the 17th century. The first was perhaps part of a depiction of a miniature house with figures, or a proa (flat boat) with oarsmen. The figure's maker has broken with traditional symmetry in representing the arms with large expressive hands to striking effect.

CONCERNING THE MORPHOLOGY, FUNCTION AND USE OF SOME IMPORTANT TYPES OF SCULPTURE IN CENTRAL AFRICA

Frank Herremans

The proportions of a sculpture do not as a rule coincide with actual anatomic proportions. Greatest attention is accorded the head; second in importance is the trunk. This hierarchy of emphasis reflects the importance accorded to those parts of the body: the head is the domicile of the soul, and the trunk – with representation of male and female organs – points to the significance of fertility, the guarantee of the community's continuing existence. In most cases, the arms and hands are fixed at the hips, with the legs short and carved with less attention to finish.

Reliquary figures among the Fang and the Kota

Although particular sculptures may have a similar function, their appearance may differ greatly. This is notably illustrated in the relic statuary of the different Fang groups (*nlo byeri*), and of the Kota and Mahongwe groups (*bwete*). They all use relic containers wherein the skulls of their prominent ancestors – chiefs, courageous warriors, village founders etc. – are kept. The preservation of relics in baskets or boxes is not limited to the Fang and the Kota; it is also encountered among a number of neighbouring peoples such as the Mitsogho and Masangho, the Punu and the Bandjabi. The Mbete, who claim to be descended from the Kota, also keep relics. However, they place them not in a basket or a box, but rather in an anthropomorphic statue, in the back of which is fashioned a cavity which serves as the relic recipient, and which may be closed with a cover.

The Fang live in an area that stretches from the south of Cameroon to the basin of the Ogooué, including Equatorial Guinea. Male or female protective figures are placed on top of their cylindrical relic containers, usually in a sitting position. As well as complete figures, there are also representations of human heads. These sculptures primarily serve to prevent the uninitiated from gaining access to the ancestral relics. They are also manipulated like marionettes, danced with and, as the ancestors' representatives, give audience to the descendants' complaints concerning the ancestors' neglect. Their design is very stylised, and differs according to their place of origin. Thus, the general composition of the northern statues is more taut and architectural than figures from further south. In the case of the latter, the muscles of the limbs – modelled in convex masses – are emphasised to a much greater degree. Still, in both cases we are probably seeing stylised representations of ideal beauty.

The Kota live mainly in the east of Gabon, and to a lesser extent in Congo (where the Mahongwe also live). In contrast to the Fang, who preserve their relics in boxes, the Kota and the Mahongwe use wickerwork baskets. The protective figures' lower ends are stuck into the relic containers, with the large

Fig. 1 Kota reliquary figures shown in their original setting. Engraving from *Tour du Monde* by P. S. de Brazza, 1887–8.

head and openwork lozenge shape below protruding from the basket's top (fig. 1). At first view their design differs considerably from the Fang statues, but, fabrication apart, closer inspection also reveals several similarities. The Kota reliquary figure is predominantly flat which emphasises its overall contour. Usually the elliptical face is decked with a painstakingly fashioned coiffure. A crowning element sits above, frequently in the shape of a crescent moon. The face is flanked by two planes, with sides generally rounded, which either follow the angle of descent or bend outwards at the bottom to finish in a point. The predominantly flat face may be modelled according to one of four variations: flat, concave, convex or concave-convex. The head sits upon a cylindrical neck, the lower part of which is an openworked lozenge shape. With Kota figures, this lozenge shape is represented frontally; with Mahongwe figures, however, it is in a crosswise position with respect to the face. The front of the wooden figure is covered in part or in whole by copper sheeting or strips. To this, iron sheeting is sometimes also applied. This possibly has a symbolic significance, though the explanation might also lie in the purely aesthetic satisfaction of colour contrast. Perhaps this holds as well for examples where brass and copper are used in combination. Eyes and mouth are also fashioned with copper wire and sheeting. Finally, one also encounters hammer-applied geometric patterns on the metal surface.

Exactly what is represented by the lozenge shape at the base of the figure is uncertain. One might advance the hypothesis of a stylised representation of the arms. Such a view might find support in a figure (cat. 4.90b) where the trunk is sculpted as a cylinder with a somewhat convex surface, and with the arms in low relief also forming a lozenge shape. A comparable representation, though somewhat more figurative than the previous example and with the arms carved away from the body, may be seen in a work from the eastern Kongo (cat. 4.28). One may posit the following hypothesis: head and arms (lozenge shape) represent only a part of the body. In use, the sculpture's lower end is stuck into the relic container, in this case a basket. In this way, the sculpture and relic container together form an entity, representing an entire human figure.

The same hypothesis may be applied to the case of the Fang: perhaps their sculpture, limited to reliquary heads, placed together with cylindrical relic containers, forms a complete figure. It has been proposed that the reliquary heads (cat. 4.91b, 92) are of an earlier date than the sculptures that represent the entire body (cat. 4.93–5).

As mentioned above, there are major morphological differences between the sculpture of the Fang and that of the Kota. Yet in the sculpting of the head there are a number of points of consonance. The major difference is that the Fang heads are fully rounded, though in the first place they must be approached from the front – something that accords with the general principle of frontality that marks all African sculpture. The flat rendering of the Kota reliquary figures makes this notion even more pronounced. In both cases particular attention is paid to the elaborate coiffure. The Fang nearly always use copper nails or small copper plates to fashion the eyes, a practice also seen in Kota and Mahongwe sculpture where the face is entirely covered by metal. Finally, among both the Fang and the Kota one may distinguish face-types where the facial plane runs, respectively, from concave to flat to convex. Moreover, there are also a number of representations of the face where the convex and concave parts are combined (for instance, the forehead convex to the eyebrows, with the remainder of the face concave).

These morphological differences and similarities are proper to each respective culture, but also bear witness to a past history where all manner of contacts led to an exchange of a variety of cultural elements, something also reflected in the form-language, or style, of the sculpture. This, though, should be set within a context much broader than one limited to the Fang and the Kota. Still, this example proves that, as with other elements of culture, a people's form-language forms part of the group's identity.

The ancestor figure: from the conceptual to realism

One of the major forms of veneration in central Africa is that of ancestors. The origin of this is to be found in the human need for the maintenance of the family, clan or ethnic group. To this end, appeal is made to the supernatural. The spirits deemed appropriate to serve as intermediaries are those ancestors from whom one stems. They provide a constant example to their descendants. Among a number of groups (such as the Fang and the Kota) ancestor relics may be approached and touched; believers maintain that this offers the most direct means of absorbing their fertility-granting potential. This direct physical contact with relics is, however, not a general practice. A large number of central African peoples bury the remains of their dead, and some – as, for example, the Luba with their leaders – do this at hidden locations. Behind this is the idea that the soul of the deceased becomes free from its mortal remains and can float around. Since this might have negative consequences, there arose the need to create designated places where the spirits could reside: waterfalls, rocks, trees etc. Among certain peoples, leaders have sculptures made of their own ancestors. These function for them as a ‘door to the supernatural’, through which the desires of their community may be communicated by means of prayer. Origins of leadership are often traced back to mythical ancestors, founders of the clan or culture-heroes of the particular people. Thus it is the king of the Kuba himself who incarnates the culture-hero *moshambwooy*: when masked he performs the myth of origin, telling of his incestuous relationship with his sister *ngady amwaash*. The manner by which the proto-ancestors are handled in mask performances is not unique; they usually appear at the bidding of a closed association or of the political leaders who use the masks to perpetuate their positions. The same also largely holds true for the various authority symbols, employed by the political élite, upon which ancestor figures are often represented. A number of these sculptures may represent the rising generation of leaders. Among the Hemba the importance of ancestor figures is most clearly made manifest. The leaders take up position amid these statues, by way of indicating to their subordinates the origin and legitimacy of their rule.

The ancestor statuary of the Chokwe, Luba, Hemba, Tabwa, Pre-Bembe groups, Bembe and Boyo undoubtedly belong to central Africa’s foremost representations of this sort. Most of these sculptures are symmetrical in composition and carved with the utmost care. Their expression is hieratic and often they exude a sense of tranquillity, wisdom and equilibrium. A number of elements, such as the representation of the coiffure, the headdress and other ornaments, serve to emphasise the figure’s status and identify the character portrayed. One may wonder whether the artists who created these works were themselves inclined, or urged by others, to give them a personal, individual character. In certain cases these figures were named after those they were to represent, whose souls were to occupy such statues. In his publication *La Grande Statuaire Hemba*, Neyt examined a number of statues from a single people, the Hemba. The facial morphology of these figures ranges from the highly idealised to the very realistic. My own view is that here one may already speak of portraiture, something which, for that matter, holds as well for the Hemba statues in this exhibition (cat. 4.66b,d–e). This hypothesis is confirmed by Neyt and de Strycker: ‘the Hemba artist often works with a model, whether a sculpture or a living person, generally the same person who is represented in the statue and, if that person is dead, the family would propose that member of the family who most resembles the deceased who is being honoured.’

Among the Chokwe, too, one encounters statues that represent former leaders, both male and female. It is interesting to compare these with the representations of the culture-hero Tshibinda Ilunga (fig. 2). Apart from stylistic differences dependent on their school of origin (the school of Moxico, the style of the land of origin, the school of Muzamba, and the style of the expansion period), one cannot rule out the notion that the representations of chiefs (cat. 4.36,38) have a more individualistic effect than the iconographic emphasis seen with the Tshibinda Ilunga.

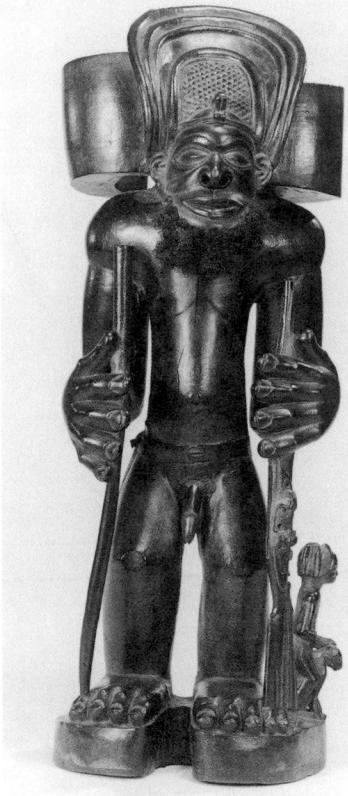

Fig. 2 Chokwe figure (h. 40 cm)
representing the culture-hero Tshibinda
Ilunga. Instituto de Antropologia 'Prof.
Mendez Correia', Porto

Power statues

In addition to reliquary figures and representations of ancestors and culture-heroes, a large number of central African peoples make use of objects – including sculptures – upon which or within which substances are applied that their users believe to contain supernatural properties. Among the Kongo peoples such ingredients are given the name *bilongo* (a term that we shall also use for other peoples). In the older literature these objects were termed ‘fetishes’. At present, they are called ‘power objects’ or, in the case of sculpture, ‘power statues’.

Power statues are frequently encountered among the peoples living in the region of the former Kongo Kingdom (cat. 4.6,7b), among the Teke, the Yaka and Suku, the Songye (cat. 5.93), and the Luba (cat. 4.63) and Tabwa. In some cases the presence of the *bilongo* is almost imperceptible, while in others it comprises an essential element in the sculpture’s overall design. One can surmise that the priest or healer – in Zaire, usually known as *nganga* – was expected to activate the *bilongo* by accurately executing ritual practices, with the aim of neutralising misfortune and adversity. Upon completion of the ritual, the client or patient expects to be relieved of the negative influences with which he has been beset. Such healing practices were previously described as magical. It is, however, difficult to draw a clear distinction between religious and magical practices, given that during the course of a ritual both elements are so closely interwoven. Thus, the priest may also conduct practices of a magical nature. This is why, perhaps, it might be useful to retain a distinction between the supplicating (religious) and the coercive (magical). Maintaining that magical practices always have a negative aim and religious ones a positive would not seem to be wholly accurate. Both forms of contact with the supernatural aim at a positive result, at least from the bidder’s point of view.

The nature of the components from which the *bilongo* is prepared may be quite diverse, but in the main consist of material of mineral, plant, animal or human origin. From the user’s point of view, the *bilongo* is more important than the statue itself. But from their design it often appears that attention was paid to the notion of statue and substances as integrated entity. Furthermore, in most of these cases one must speak of two makers: the sculptor who creates the statue, and the *nganga* who adds the *bilongo*.

Both among the various Kongo peoples and among the Teke the figures’ composition and modelling take into account the location in which the substances are to be placed (fig. 3). Thus, the arms are sometimes summarily treated, sometimes not at all, as this is where these ingredients are to be applied. The *bilongo* may also be an intrinsic component of the figure’s general form: the crowning of the head (coiffure or headdress), the abdomen or some other part of the body. Among the Kongo peoples a small container is usually attached to the statue in which the *bilongo* is placed, usually at the abdomen and sometimes on the back. These receptacles are closed with a mirror.

When during rituals the statue comes into use, its form may still be subject to modification and embellishment. Such is the case with the ‘nail figures’, named for the multitude of nails that are hammered all over their bodies. This treatment may be applied when, for example, two feuding groups have decided to bury the hatchet. By way of empowering the ceremony, nails are hammered into the statue. Such treatment is also used to activate the *bilongo* which has been applied to the statue for a specific purpose.

Most African sculpture owes its creation to religious, economic and social needs. The creator of such objects is not making art for art’s sake, but for use by the community or an individual as a medium for contact with the supernatural. Perhaps this is why the traditional African sculptor does not work directly from nature, rather basing his design on age-old tradition. His way of creating can thus be described as conceptual. Moreover, in many cases outside influences also play a role. These arose from a variety of circumstances, such as the migrations – voluntary or forced – of a particular group, the establishment

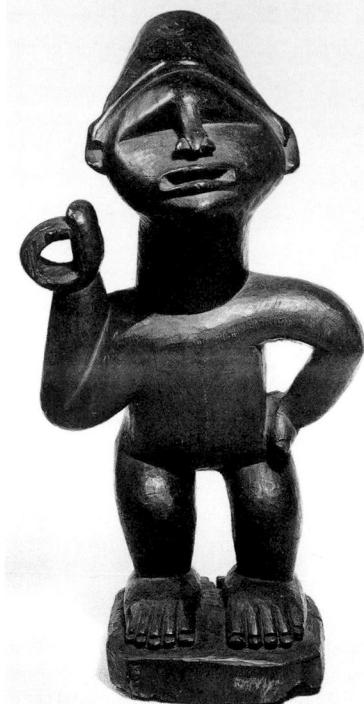

Fig. 3 Kongo figure (h. 37.8 cm) made to become a power statue but still missing the bilongo which should be added by the nganga. Museum of Ethnography, Antwerp, AE.714

of other peoples within another group's area, and the existence of trade contacts – all of which may be coupled with increased exposure to religious elements or currents from outside.

By the term 'conceptual', it is taken that the traditional African artist in the first place expresses that which he knows about things, rather than representing a direct reflection of that which he perceives visually. Statues, masks or other ritual objects must satisfy a number of requirements, and iconographic aspects must also be taken into account. All the same, this should not be over-stated, for one may recognise elements in the artistic representation which in fact make reference to reality – for example, coiffures, tattoos and prestige symbols such as headdresses and ornamentation in general.

Once the mask or statue is carved, it is consecrated and, thus endowed with ritual powers, is ready to function. Such sculpture becomes bound in an ambiguous relation with man: it is potentially both an ally and an enemy, and the powers it possesses must be courted with prayer and offerings. But these forces may also be compelled to do the bidding of the supplicant.

The plastic form-language of a culture contains a number of constantly recurring structural elements. This regularity is what one generally calls style. A second determining element in the creation of a sculpted work is the individual talent of the maker. The sculptor makes an object that optimally fulfils the demands required of it. The representation must answer to the iconographic norms that tradition sets for it. The sculptor must, at the same time, give expression to a number of spiritual, moral and other abstract principles which are associated with that which is represented. Believing in these, the sculptor will execute the work to the best of his ability, and his creation will acquire an artistic dimension.

In many cases the creative process does not end with the statue's or mask's fabrication and consecration. The subsequent ritual life of an object can alter its appearance, by the addition of offerings or the application of paraphernalia of diverse nature, in or on the sculpture. 'Charging' the object in this way is expected to induce the required function to begin or to increase its efficacy.

Bibliographical note

Brazza, 1887; Brazza, 1888; Fernandez, 1974; Neyt and de Strycker, 1974; Chaffin, 1979; Bastin, 1982; Perrois, 1985; Claerhout, 1988; Biebuyck, 1992; Fernandez, 1992; Neyt, 1995

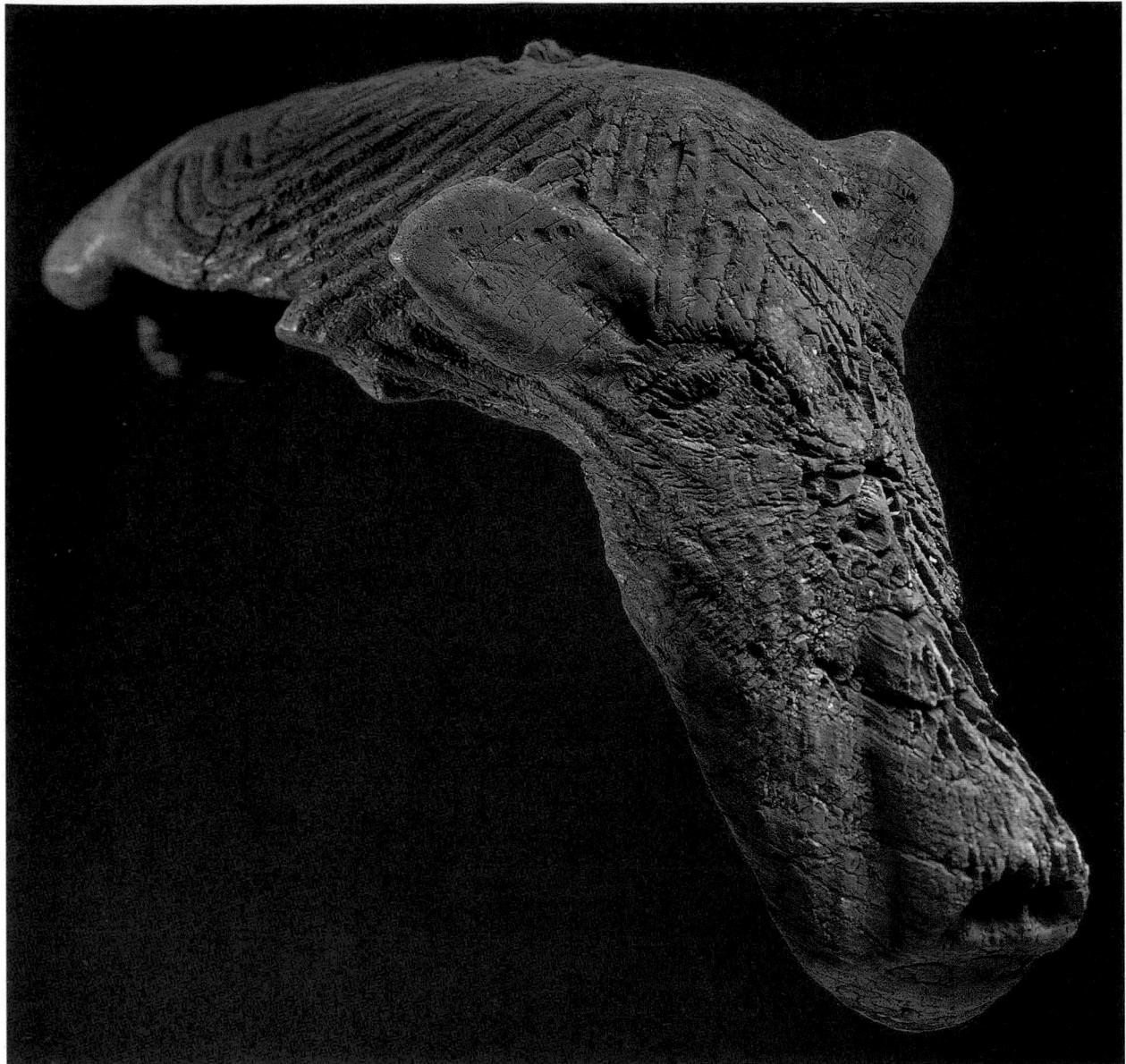

4.1

Zoomorphic head

Central Angola
8th–9th century
wood

50.5 x 15.5 cm
Royal Museum for Central Africa,
Tervuren, Belgium, MRAC 14796

This is probably the oldest wooden sculpture of central Africa, if not of sub-Saharan Africa. (A sample from it has been dated by carbon-14 analysis.) Its remarkable state of conservation is explained by the fact that it was 3.5 m under the water table when discovered in 1928.

Carved out of the trunk of a *Pterocarpus Angolensis* D.C. tree, it represents an animal with snout, eyes and small round ears. One can note two small holes, bored with a red-hot iron, on top of the head and at the

end of the tail. They were probably filled with hair-like fibres. It was most likely used as a horizontal mask or a headdress. The general shape of the head, with its broad muzzle, elongated snout and large nostrils, as well as the setting of the eyes, resemble closely the features of an aardvark (*Orycteropus*), the large solitary nocturnal insect eater. This pig-like animal is also suggested by the arched body, with its four legs and tail, as well as by the ripples on the body and forehead. As the ears of an aardvark are longer and more tubular, one cannot exclude that the figure may represent a zebra, a warthog, a hippopotamus or a composite imaginary animal. Originally, however, the ears may well have been bigger, so one can favour an aardvark identification.

Unfortunately, there is no ethnographic information on what the aardvark symbolises in this region, but the Tabwa of the southern Lake Tanganyika area are known to regard it as an animal especially ‘good to think’ since it evokes a wide range of essential oppositions (head/loins, closed/open, intellect/sexuality, culture/nature, human/animal, male/female, light/darkness, visible/invisible, good/evil). The burrowing abilities of this primordial creature are also considered important and it would not be surprising if this sculpture was buried on purpose.

PdeM

Provenance: 1928, discovered by C. Turlot in a bank of the Liavela River, central Angola

Bibliography: Van Noten, 1972; Roberts, 1985, pp. 24–5

4.2

Crucifix

Kongo
Zaire
18th–19th century
bronze, sheet metal, tacks, wood
29 x 19 cm
Bareiss Family Collection

According to oral traditions collected in the late 16th and early 17th centuries, the Kingdom of Kongo probably developed at the end of the 14th century as one of several modest states south of the River Zaire. Gradual expansion through alliances and military conquest made the capital, Mbanza Kongo, the centre of a large and powerful state. Portuguese sailors arrived there in 1483; at this time Portugal was a powerful mercantile nation, intent on establishing new commercial routes to the Indies. Its mercantile expansion was accompanied by a committed missionary spirit that actively sought to convert any peoples encountered to Catholicism. In 1499 Pope Alexander VI granted King Manuel I of Portugal patronage over all African lands that had been or were to be discovered by the Portuguese. In 1512 Manuel in turn sent a document to the king of Kongo, proposing a plan for the organisation of the Kongo state on the model of a Christian monarchy. Various local Kongo rulers were converted to Christianity, among them the king himself, who was baptised with the name of Alfonso I (1506–43). The process of conversion was visually reinforced by the widespread use of religious images, like the bronze figures of the Virgin Mary and the Portuguese-born Saint Anthony of Lisbon (also known as Saint Anthony of Padua), cast by Kongolese artists after Portuguese models, which became extraordinarily popular owing to the teaching of Capuchin priests.

Crucifixes played an equally important role in the elaborate ritual life of the Christian Kingdom of Kongo. Sometimes small orant figures are carved underneath Christ’s feet and/or placed at the top of the cross. Occasionally, the small orant figure at the bottom represented the Virgin Mary, indicating her role as mediator between Humankind and Divine Glory. But the Saviour is also often shown alone (as here). His decidedly African features, portrayed as such in numerous other known examples,

distinguish Kongo crucifixes from their European counterparts. They raise questions about the production and reception of artistic forms within diverse cultures, pointing to the inevitable shifts in meaning that would gradually remove the Catholic connotations of Kongo crucifixes, turning them into vehicles for the transmission of original local concepts and beliefs. In particular, as it had been perceived by the Kongo people before the arrival of Europeans, the cross was a visual analogy of their own relationship to their world, a crossroads between 'this world' (*nza yayi*) and 'the land of the dead' (*nsi a bafwa*). Such shifts in meaning have remained in use into the 20th century. They were visually reinforced by shifts in form, as in the choice of decorative elements of local tradition such as the round bosses in this example. TT

Bibliography: Thiel and Helf, 1984, p. 95; MacGaffey, 1986, pp. 45–6; New York 1988, pp. 43–7; Maastricht 1992, pp. 57, 310

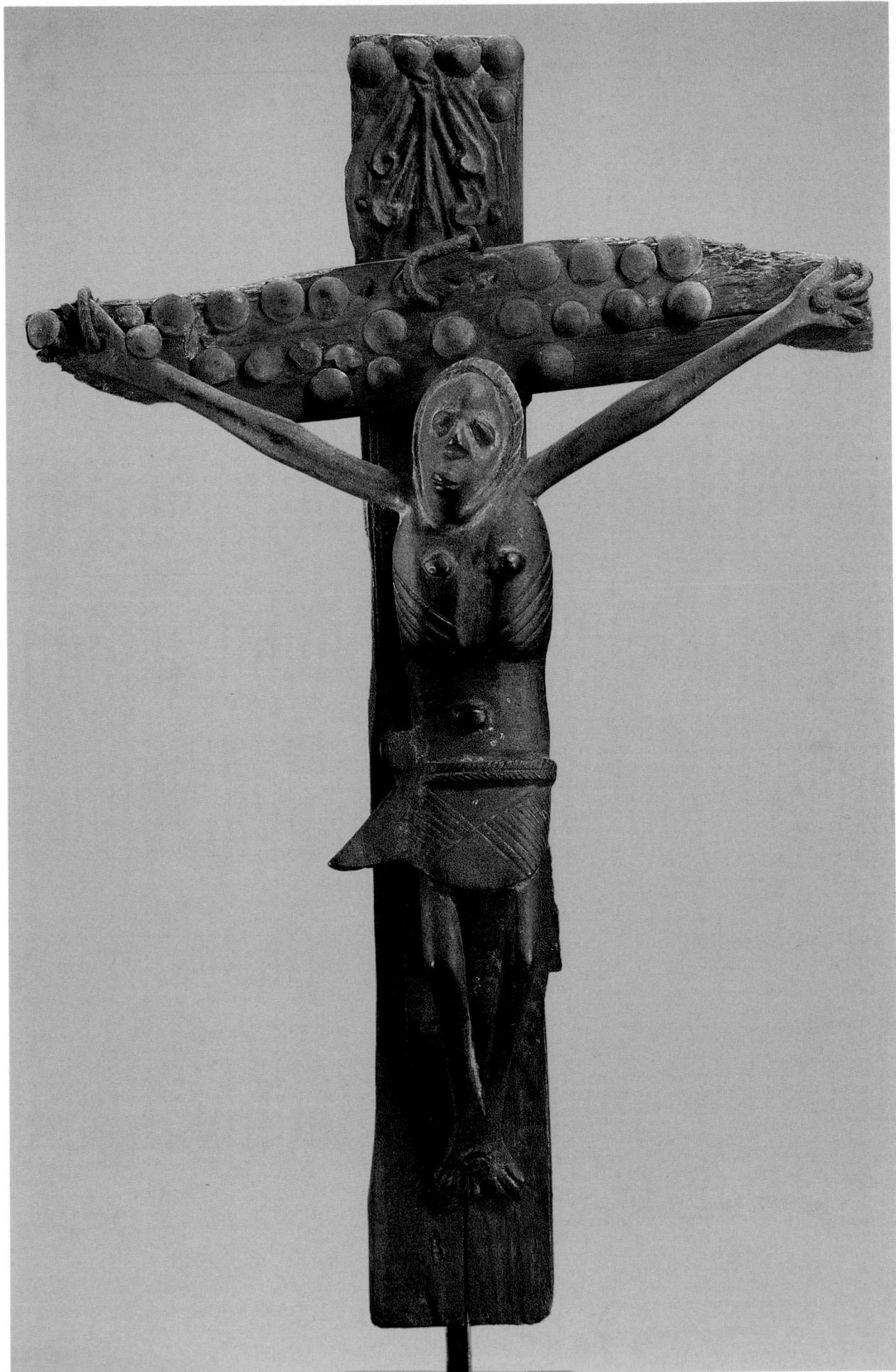

Staff handle (*mvuala*)

Solongo
Angola/Zaire
19th or 20th century
ivory
h. 11 cm
Private Collection, Brussels

According to Lehuard this is a Solongo piece. The Solongo people live on both sides of the Zaire estuary and along the Atlantic coast from Banana to Ambrizete.

The staff is the insignia of power. It is often presented to the future chief at his initiation ceremony, or is handed down from generation to generation. Possession of the staff permits its bearer to take part in political and legal proceedings.

This figure combines two well-known positions for this type of statuette: the head turning sideways (*kebo-kebo*: the turned head indicates a person keeping watch), and the kneeling position with hands on thighs (*ye mooko va bunda*). Generally speaking the kneeling position with both knees on the ground is characteristically female. It expresses deference and obedience; the hand on the thigh indicates waiting. The woman is frequently depicted squatting on her knees.

Carved sticks occur frequently in the art of Lower Zaire and the surrounding area (recently copies of antique sticks have pushed the number even higher). Ivory carving techniques have produced some exquisite works, indeed some masterpieces. JC

Bibliography: Lehuard, 1976; Lehuard, 1989, i, pp. 112, 610–15

Staff handle (*mvuala*)

Yombe
Zaire
19th century
ivory, patina
h. 15.5 cm
Private Collection

This handsome handle of a dignitary's staff comes from a known workshop. The Tervuren museum possesses a piece so similar that it has been suggested that both are by the same sculptor, as is the one in the Musée Barbier-Mueller in Geneva.

The handle shows a kneeling woman with her left hand on her thigh and the other placed against her cheek, signifying contemplation. The position is traditional, particularly on staffs belonging to chiefs. The elaborate hairstyle (*mpu*) indicates an importance shared with that of the chief. The naturalistic style of carving is typical of Kongo sculpture.

The copious scarification is characteristic of the Mayombe area. The women of the region of Lower Zaire had some of the most elaborate and elegant scarifications in all Africa. They were associated mainly with fertility. This pattern is based on a lozenge, also to be found in the decorative plaiting produced in this area; the plaits often illustrate proverbs (cf. cat. 4.17).

The staff symbolises the legitimacy of its bearer, or of the person entrusted with it. It connects his power with the power of his ancestors. It is not surprising that women should have such an important role in this type of artefact since it is their fertility that allows power to be passed on down the generations. JC

Bibliography: Lehuard, 1989, i; Tervuren 1995, no. 292

4.5a

Staff handle (*mvuala*)

Yombe

Zaire

19th–20th century

ivory

h. 14 cm

Private Collection

The theme of cat. 4.5a is motherhood. The founding-mother of the clan occupies a position of great respect; the art of Lower Zaire, with that of the Luluwa, is one of the richest in representations of mother-and-child groups.

The kneeling position is common in Kongo art. The therianthropic figure (cat. 4.5b) also features a similar cowrie necklace combining wealth and fertility. Sometimes there is only one kneeling figure. Generally both knees are on the ground and this position is called *mfunkama*. The groups often depict mother and child. 'The general impression conveyed by this type of sculpture, which is exquisitely detailed and finished, is that it stems from attitudes connected with submission – obedience, deference, devotion' (Lehuard).

In cat. 4.5a the mother holds her child without any expression of interest or affection, as is usual with such figures. The child is frequently missing. Even when both figures are carved with equal care the child is not regarded as essential. JC

Bibliography: Lehuard, 1976; Lehuard, 1989

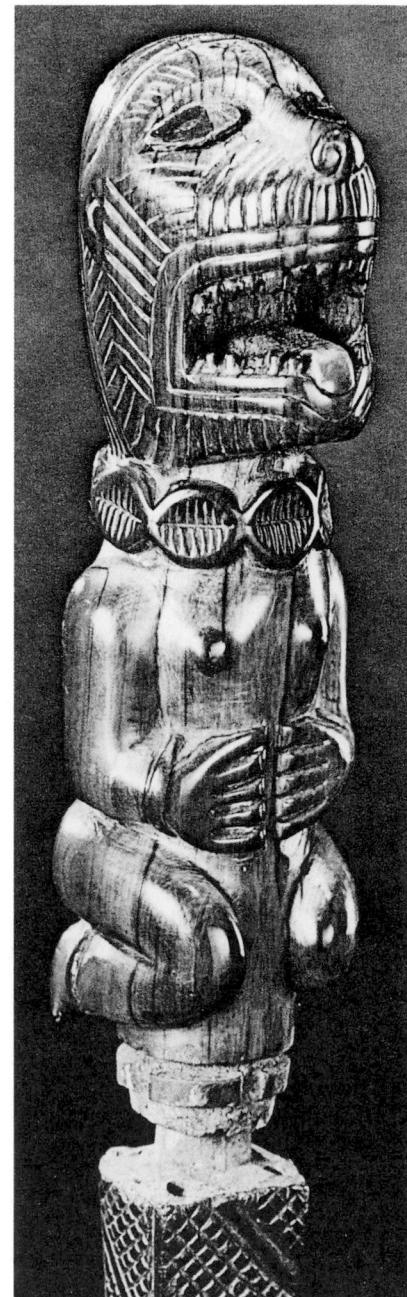

4.5b

Staff handle (*mvuala*)

Yombe

Zaire

ivory

19.6 x 6 x 6.9 cm

The Walt Disney-Tishman African Art Collection, Los Angeles, 1985. AF. 051.121

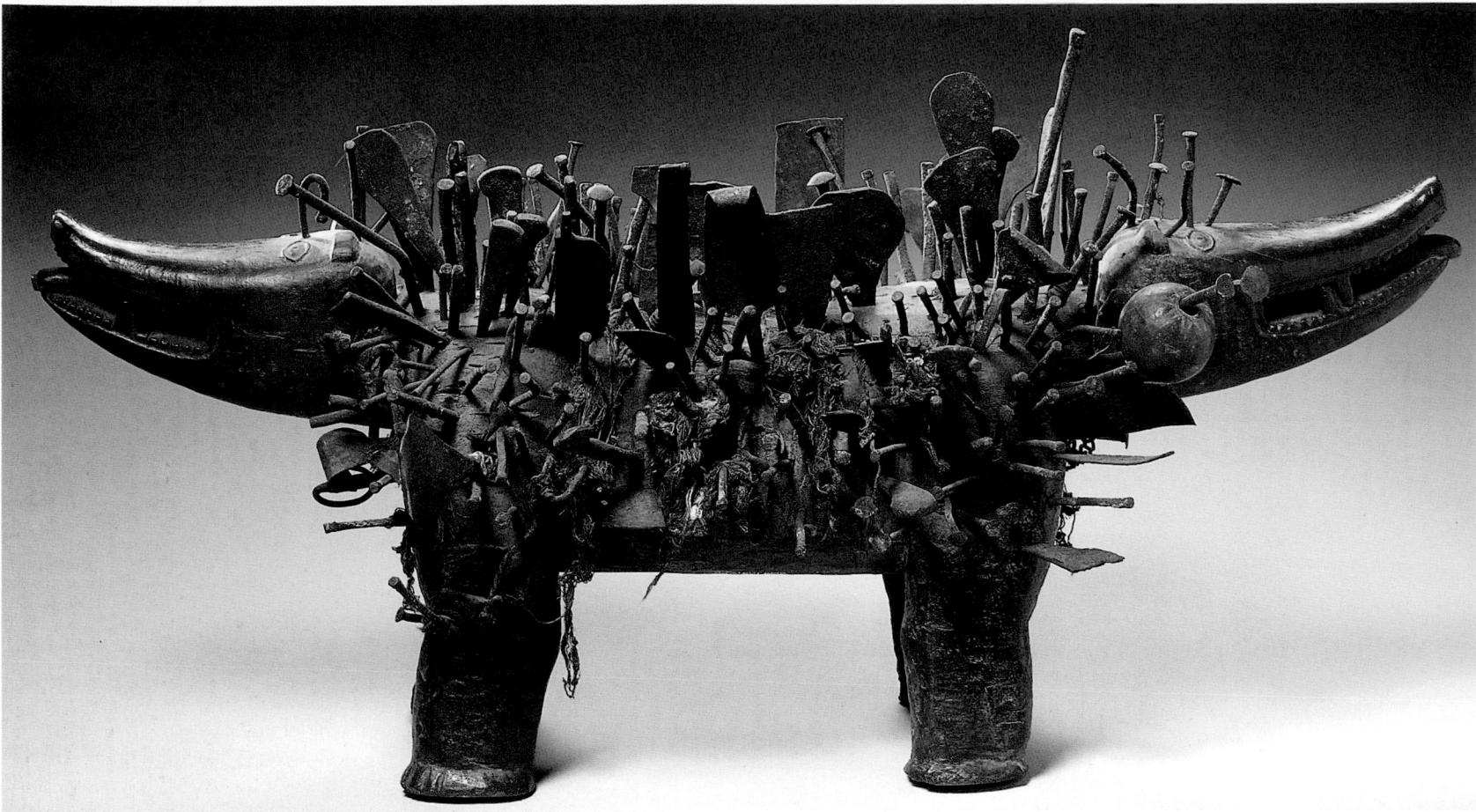

Kongo

Most of the objects widely admired as Kongo art fall into the category called *nkisi* (pl. *minkisi*), an untranslatable term. The Kongo, speakers of the Kikongo language, may number about three million people, distributed among the republics of Angola, Zaire and Congo on the Atlantic coast of central Africa. *Minkisi* are ritual procedures for dealing with problems ranging from public strife to theft and disease to the hope of seducing women and becoming wealthy. A *nkisi* as a ritual programme may include the *nganga*, the initiated expert who performs the ritual; his or her costume and other paraphernalia; the client; the prescribed songs to sing and rules to be observed; sacrifices, invocations, dancing, and drinking. *Minkisi* as found today in museums are no more than selected parts of the material apparatus necessary for the performance of rituals in pursuit of particular goals. Most of them date from between about 1880 and 1920. Colonial administrators repressed the use of *minkisi*, which, though they continue in active use to this day, no longer take the public and visually explicit forms of the past.

The basic idea of the *nkisi*-object is that of a container of forces directed to some desired end. The container held relics of the dead, or clay from the cemetery, which brought the powers of the dead into the *nkisi* and made it subject to a degree of control by the *nganga*. It also held *bilongo* (medicines), which metaphorically represented the uses to which this power was to be put. Other medicines were attached to the outside, where their function was to impress the public by their visual intricacy, suggesting the unusual capacities of such composite objects.

The outer attachments of some *minkisi* may consist of beautifully carved miniatures that serve as a reminder of their powers. Several of them represent in miniature the musical instruments that would be played during the activation of the *nkisi*, such as a slit-gong, a clapperless bell, and a double-ended wooden bell.

WM

Bibliography: MacGaffey, 1991

4.6

Nkisi nkondi (Kozo)

Kongo
Cabinda
before 1900
wood, iron
h. 67.5 cm
Musée Barbier-Mueller, Geneva, 1021-35

Not all varieties of *nkondi* were nailed figures, and of those that were, not all were anthropomorphic. The appearance of the figure was part of the metaphorical apparatus that indicated to knowledgeable viewers the purpose and abilities of the *nkisi*; it was not a sort of portrait of its animating spirit. In Kongo thought, the land of the dead lies 'across the water' or 'in the forest', where in fact cemeteries are located. Wild animals are the livestock of the dead. Dogs live with human beings in the village, but they are not eaten like other domestic animals and they help hunters kill game in the forest. They are thought of as mediating between the living and the dead, and thus between the seen and the unseen; it is said that dogs have 'four eyes', and that on the way to the land of the dead one passes through a village of dogs. Much respected on

the Cabinda coast in the 1880s, 'Kozo' was a retributive *nkisi* of *nkondi* type, in the form of a dog, but usually with two heads facing in opposite directions. The empowering medicines were usually contained in a pack bound with resin or clay, on the animal's back. The figure is a statement about hunting down unknown wrong-doers, about moving between the two worlds of invisible causes and visible effects. Kozo is said to have dealt with women's affairs and to have been paired with Mangaaka, an anthropomorphic *nkondi* also widely known and respected, which was for men's affairs, but the nature of their relationship is hidden from us. This example of Kozo has accumulated a particularly impressive collection of nails and hoe blades, each testifying to some bitter grievance. WM

Exhibition: Washington 1993, pp. 41-2

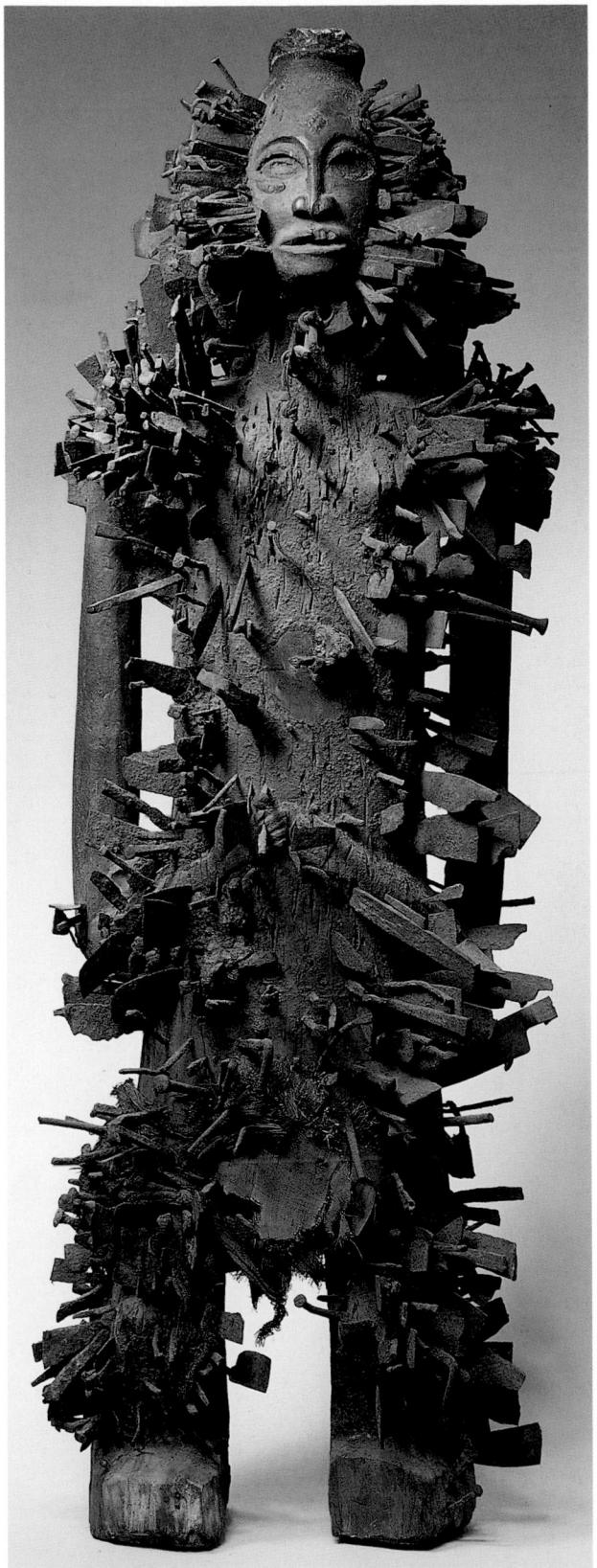

4.7a
Nkisi nkondi

Kongo
Zaire
late 19th century
wood, metal, pigment
h. 180 cm
The Trustees of the British Museum,
London, 1905.5.25.2

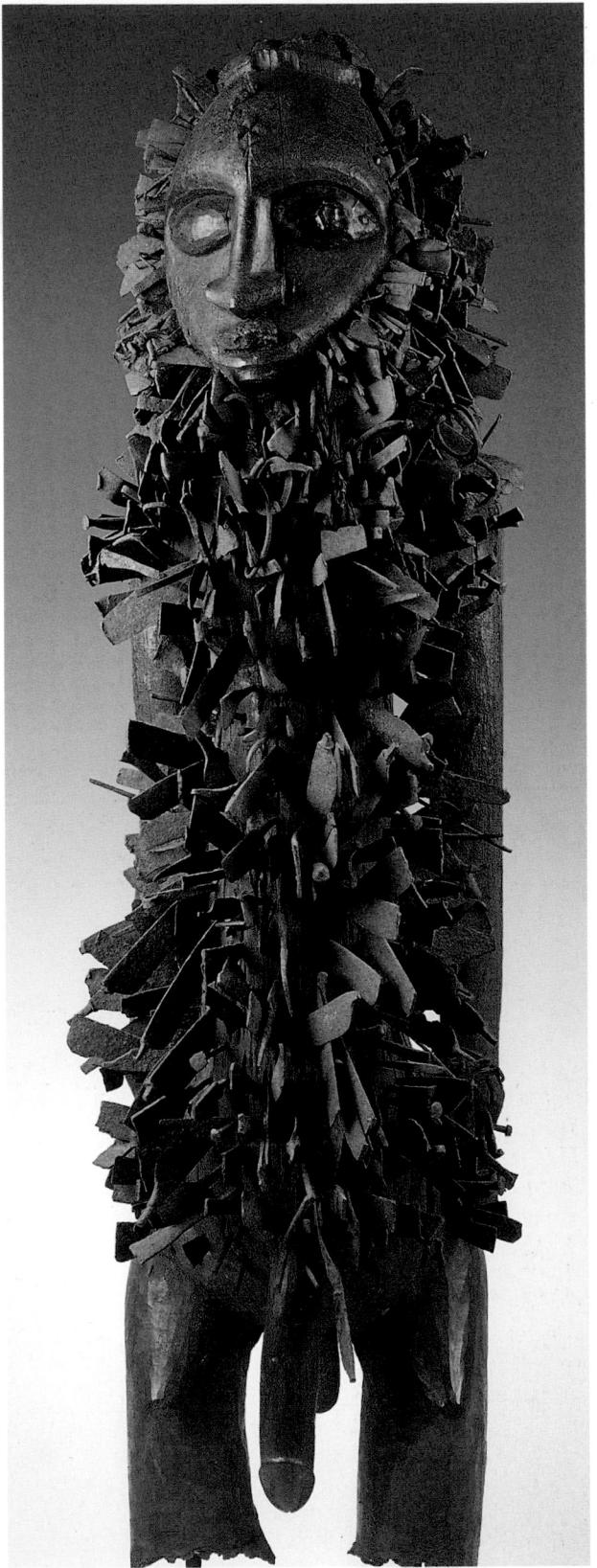

4.7b
Nkisi nkondi

Kongo
Zaire
late 19th century
wood, metal, pigment
h. 108 cm
Museo Preistorico Etnografico
'L. Pigorini', Rome, 84204

The extent to which a *nkisi nkondi* is covered with iron blades is an indication of its usage. Cat. 4.7a has only a small number of blades, while the other example is covered with iron blades more or less to the limit, indicating that it was well known and much resorted to by persons who felt a need for redress or relief. Cat. 4.7b is one of several similar long, thin figures, evidently produced by the same workshop in the Mayombe district of western Zaire. The top of its head once supported a resin-sealed pack of empowering medicines; others were probably contained in an accompanying bundle. In the centre of the forehead, the seat of intelligence and authority, the 'soul' of the *nkisi* is indicated by a lozenge shape, itself divided into four quadrants. The figure's left eye may once have been covered with realistic reflecting material, like the right, but may also have been intended to be 'blind'; this would mean that the *nkisi* had one eye for the things of this visible world and one for the nocturnal world of the occult. Whatever the case, the face is extraordinarily baleful; it seems both to surmount the bristle of metal advancing upon it and to threaten similar violence to designated enemies. The blades that crowd upon the body (most of them old hoe blades, but including a few European screws) carry relatively few of the tokens called 'dogs' (cf. cat. 4.8) that would have directed the *nkisi* to specific tasks.

Whereas the general appearance of cat. 4.7a is passive and suggests androgyny, cat. 4.7b is clearly male. The figure's exceptional genital endowment has nothing to do with fertility. Though there were many exceptions, *nkondi* were associated with virile symbols, since both hunting and justice were men's activities: most, male and female, were carved without genitals; those properly equipped would have worn a concealing cloth. For adults to expose their genitals is shocking and insulting, a supreme act of aggression. In the course of the ritual of activation specific to this *nkondi* the operator would have whipped off the cloth at appropriate moments, creating a calculated sensation. WM

Bibliography: MacGaffey, 1991, p. 136

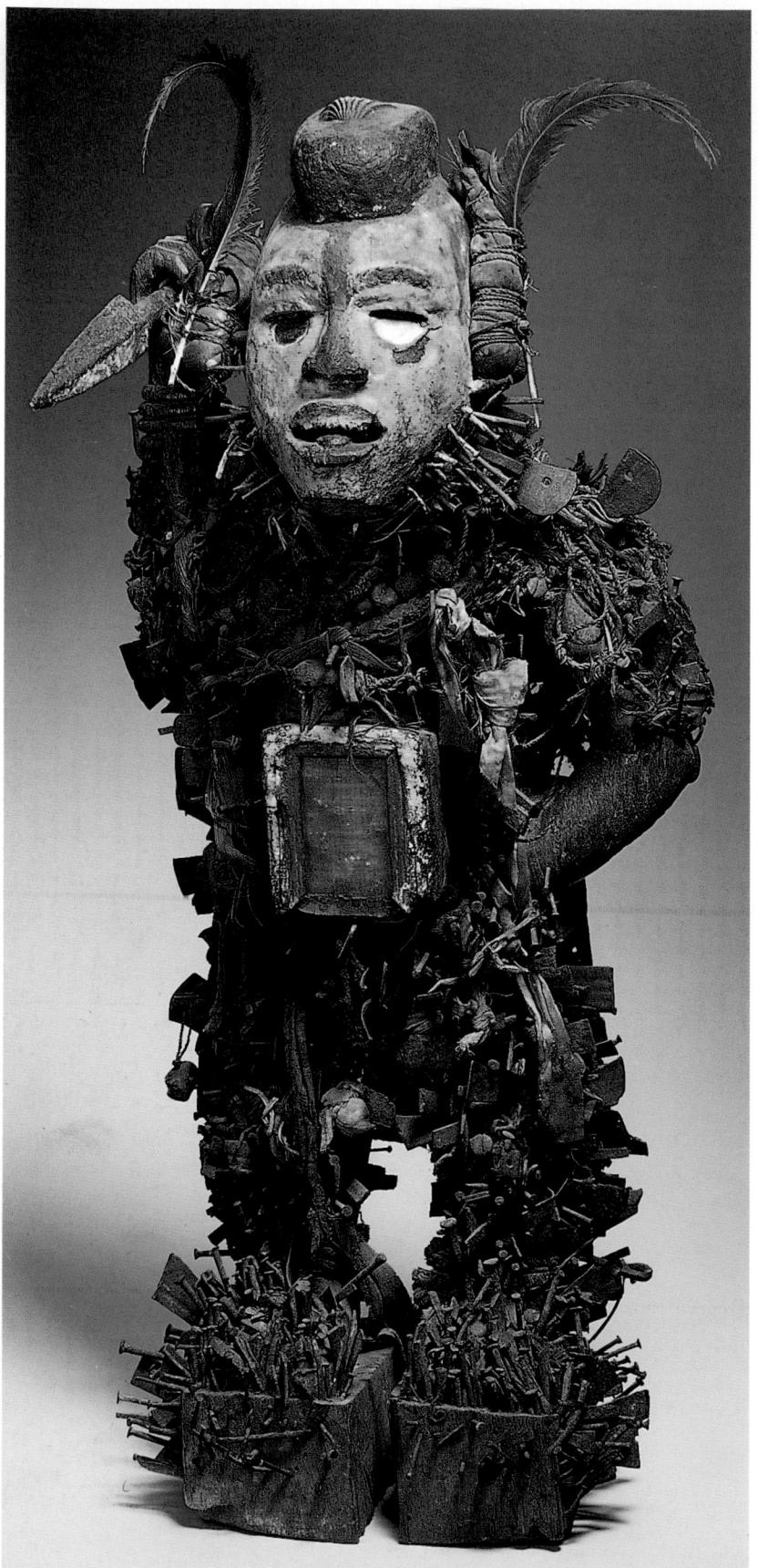

4.8

Nkisi nkondi

Kongo
Zaire
before 1878
wood, cord, iron, cloth
h. 85 cm
Royal Museum for Central Africa,
Tervuren, MRAC 22438

The most powerful, most spectacular and now (in the art world) the best-known Kongo *minkisi* belonged to the class called *nkondi*, a name which means 'hunter.' The business of *nkondi* was to identify and hunt down unknown wrong-doers, such as thieves and those who were believed to have caused sickness and death among their neighbours by occult means; *nkondi* could also punish those who swore false oaths and villages that broke treaties entered into under their supervision.

The container of *nkondi* found in museums is usually, as in this case, a wooden figure, to which medicines are added in one or more packets sealed with resin and located on the top of the head, on the belly, between the legs and elsewhere. The legs of this figure are wrapped in a miniature hunting net, to remind us that it hunts down its victims. Many other *nkondi* that did not attract the attention of collectors (and have therefore been lost) were contained in clay pots. To arouse the *nkisi* to go to work, it was both invoked and provoked. Invocations, often in extraordinarily bloodthirsty language, spelled out the problem, urging *nkondi* to punish the guilty party: 'Lord Mutinu! open your ears, be alert. The village, the houses, the people, do you not see us? My pig has disappeared, I can't hang on to a chicken, a goat, a pig, or any money in the house. The villagers, they have their animals, they have many children, they are content. I have not quarrelled with any one, man or woman. Mwene Mutinu, if anyone is angry with me and it is only a daylight matter, overlook it; but if it is witchcraft – proceed! Seize whoever is causing me harm, whether man or woman, young or old, plunder and strike! May his house and his family be destroyed, may they lose everything, do you hear?'

To provoke *nkondi*, gunpowder might be exploded in front of the container, insults might be hurled at it, but above all, in the case of a

wooden figure, nails, blades and other hardware were driven into it. Angered by these injuries, *nkondi* would mysteriously fly to the attack, inflicting on the wrong-doer similar harm. A few days later, if anyone in the village were to fall ill with pains in his chest, it would be said that *nkondi* had found him out and punished him. To make sure the *nkisi* knew just what was expected of it, bits of rag, hair of the stolen goat, or some other token, called a 'dog', would be attached to it, often to the nails, each time it was invoked. As time passed, the *nkisi* visibly accumulated the evidence of successful cursing, adding greatly to its fearsome appearance. Though we do not know its name or history, we can tell by looking at it that this piece, in its day, was undoubtedly feared far and wide. WM

Exhibition: Washington 1993

4.9

Nkisi nkondi (*fragment*)

Kongo
Congo
19th century
wood
31 x 12.5 x 12 cm
Royal Tropical Institute/Tropenmuseum,
Amsterdam, 3113-2

This weathered figure, with its suggestion of perdurable vitality in the face of adversity, had probably long been abandoned to the weather by its original owners. The wood has been worn by the rain and eaten by grubs, but some of the holes in the chest appear to be the result of nails or blades driven in. If so – and the aggressive expression of the face seems to confirm the hypothesis – this is the ‘ghost’ of a *nkisi nkondi*. The rotten remains of the figure were cut off by the collector in the manner of an antique Italian bust. The head once carried a medicine pack, and the eyes were probably filled in by a piece of glass backed with red cloth. It is a tribute to the skill of the sculptor that the object still appears vital, angry and energetic. Among the reasons for abandoning a *nkisi* were that the owner felt it was no longer effective, or that he had converted to Christianity. A *nkisi* could be aroused by driving nails into it, insulting it, comparing it unfavourably to a lump of wood, and threatening to throw it away in the bush. WM

Provenance: ex collection J. Brummer, Paris; Jacob Epstein, London

Exhibition: Paris 1989

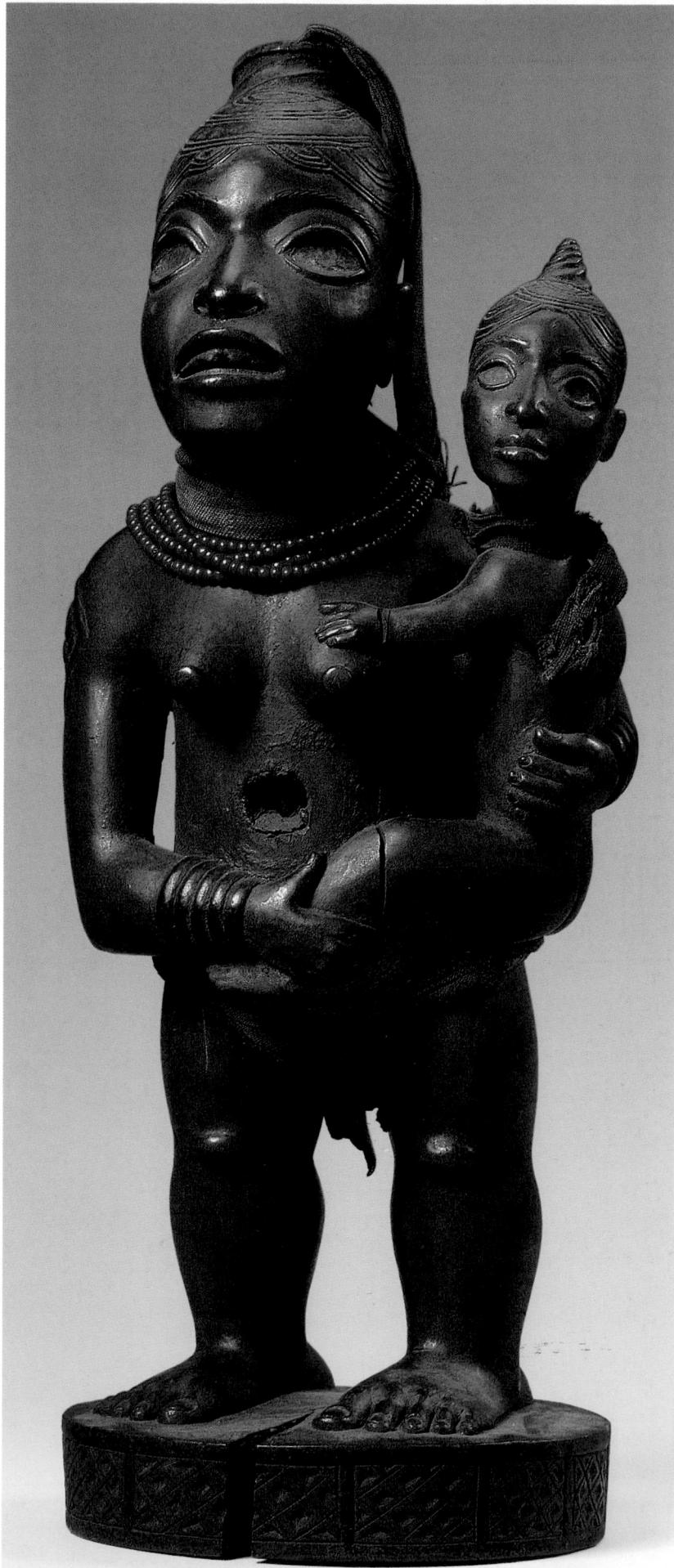

4.10

Nkisi nkondi (The wife of Mabyala)

Kongo

Cabinda

before 1900

wood, glass, cord, beads

h. 35.5 cm

National Museum of Ethnology, Leiden, 2668.2101

This exquisitely carved figure is one of at least two, both in the Leiden collection, that can be attributed to the same artist. The fine finish, the animated expression, the naturalistic pose, the delicate representation of the hair and the treatment of the nipples are distinctive. Most *minkisi* are anonymous, the collector not having bothered to record the name, but in this instance it is known that the figure is part of the material apparatus of a *nkisi nkondi* called Mabyala. At the end of the 19th century, along the coast from what is now Pointe Noire, in Congo, to Boma, in the estuary of the Zaire, Mabyala was one of the best known of the retributive *minkisi*, used to control crime and to sanction commercial relations. A number of named examples exist, but this is the only female one; she carries a child on her hip ‘to show that she is a married woman’. The pack of medicines once fastened to her belly has fallen off, so that the figure, like all *minkisi* now in museums, is no longer empowered. *Nkondi* were often represented as a pair, man and wife. As an indigenous text of the period puts it, ‘the powers of the male are more vigorous, but the female softens them; if they were two males, many houses would be burned by the lightning’ (*nkondi* controlled storms, and used them to attack recalcitrant villages). The male Mabyala who consorted with this woman has disappeared. In various museums, other items associated with Mabyala, though belonging originally to different ensembles, include a bag of medicines and a spectacular cap of red feathers for the *nganga*. WM

Exhibitions: Paris 1989; Washington 1993, pp. 32–9

4.11

Nkisi

Kongo

Cabinda (Ngoyo)

late 19th century

wood, red clay, other materials

27.5 x 16 cm

Museu Nacional de Etnologia, Lisbon,
AO-253 (1971)

This unusual and enigmatic *nkisi* is in the form of a boat-shaped container in which two anthropomorphic figures, probably male and female, lie side by side. On top of the figures is a broken piece of mirror, under which are presumably packed the medicines, whose name and function can only be guessed. A mirror serves a *nkisi* as its 'eyes', with which to see things concealed from normal view; it is not necessary that anything be literally visible in the mirror. A cord has been tacked to the wooden base by means of small nails; it gives the necessary appearance of forces under control or contained, and thus open to direction by the operator, the *nganga*.

This *nkisi* may be expected to cure some ailment, which, like all ailments, requires that contact be made with the land of the dead, thought of as across the water. Red is an appropriate colour for mediation. This interpretation is not incompatible with the possibility that the piece is related in some way to the slave trade. It comes from Ngoyo, the area of a kingdom of that name on the coast north of the mouth of the Zaire, which was actively engaged in the slave trade until 1865. Perhaps the model for this boat is a slave ship; the slave trade was, and is, thought of as a trade in souls taken prematurely to the land of the dead across the sea. WM

Provenance: collected by Dr E. Veiga de Oliveira

Exhibition: Lisbon 1994

Bibliography: Martin, 1994, p. 76

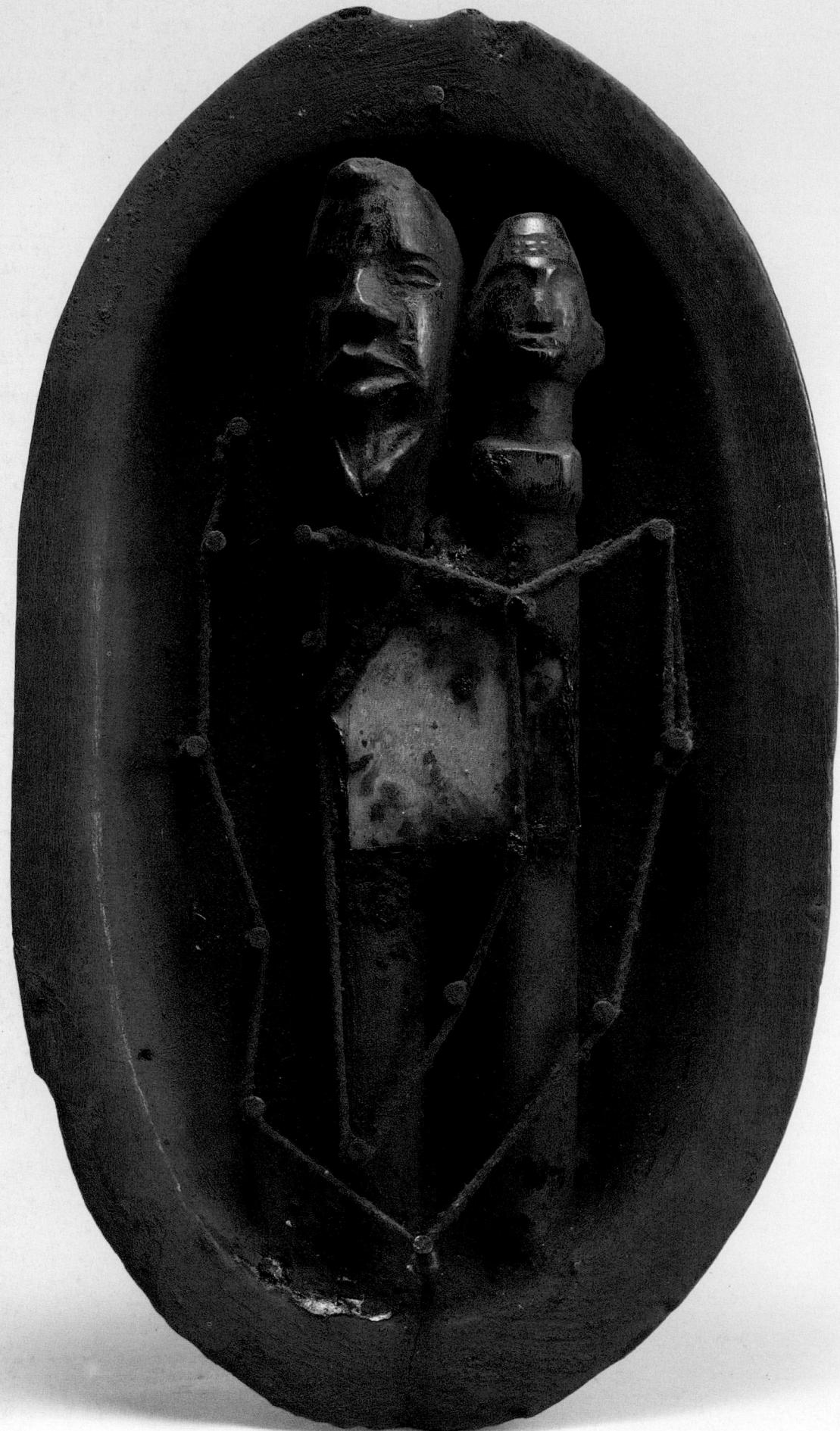

4.12

Devotional statue

Kongo (Vili)

Cabinda

19th century (?)

wood, glass

h. 44 cm

National Museum of Ethnology,
Leiden, 1354.47

This exceptional Kongo statue shows a kneeling woman holding a child (originally there were two more children, on her shoulders, of whom vestiges remain). Kongo sculptors were able to depict the most complex poses with a remarkable feeling for bodily ornamentation. The intricate details here in no way detract from the powerful presence of the figure, as the tilt of the head and the incisive detailing of eyes and mouth convey. The liveliness of the piece is due to the careful carving of the half-open mouth and the eyes; the latter have glass inserts with an etched circular pupil.

The hairstyle is exceptional. Pieces of this type normally have a conical hairstyle. In a few cases the point becomes a plait curving forwards, its end being bitten by a snake coming from behind the head. When seen from behind, the snake arises from the lower back.

The upper part of the chest, the shoulders and forearms are decorated with elaborate scarifications which pass under the richly decorated arm rings, the latter reminiscent of the metal bracelets that are abundant among the Kongo. On the thorax and lower thighs symbols of power increase the magical significance of the piece, placing it firmly in the category of mythological sculpture.
JC

Bibliography: Lehuard, 1989, i, pp. 220–31

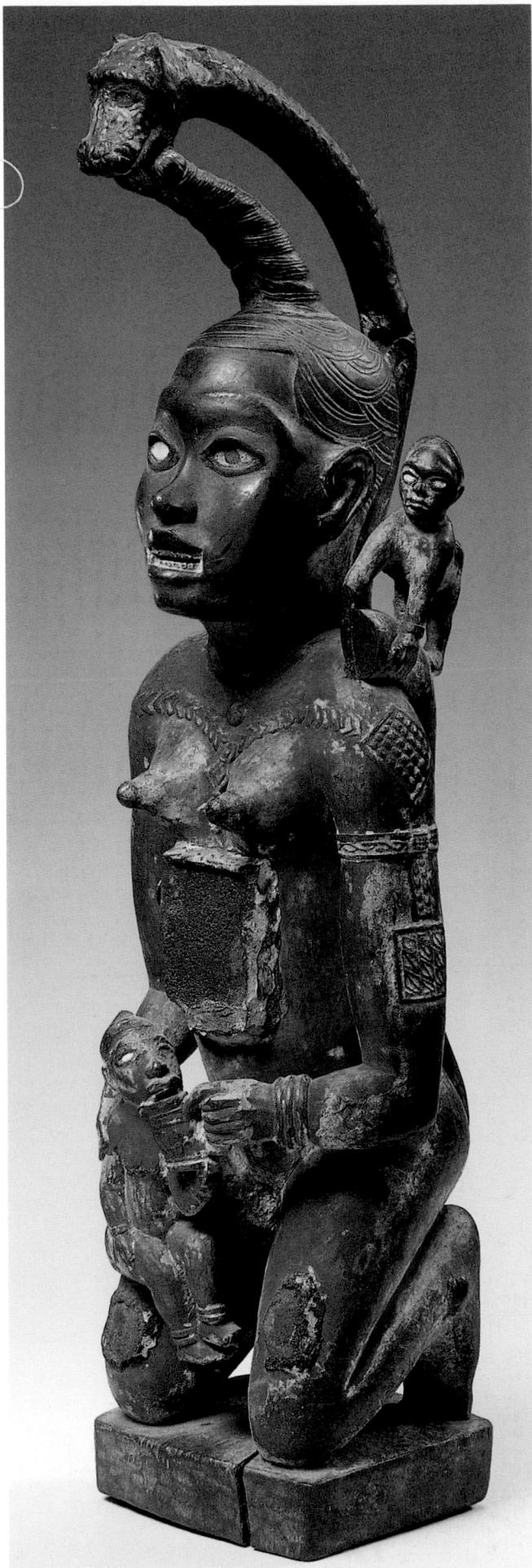

These two stone figures belong to a well-known and important group of works generally known under the term *ntadi* (pl. *mintadi*). The name derives from the descriptions of them by their discoverer, Robert Verly. There are, however, other and arguably more appropriate names which are applied to them locally. One such is *tumba*, a term which comes from the vocabulary applied to Portuguese tombs in the area. Stone figures are intended to adorn tombs and commemorate family members credited with remarkable achievements during their lifetime.

Sculptures of this kind may date back to as early as the 16th century; some – in particular some mother and child figures – may in fact be older still. They come from a relatively restricted area lying in the north of Angola on the left bank of the River Zaire in the area between Matadi and Boma. Technically this is the area of the Kongo or Boma. In neighbouring areas the tradition of stone funerary monuments is replaced by funerary ceramics which are themselves of considerable variety of form.

These two figures show some of the variations of posture and gesture which characterise the stone images, and indeed which are also found in wooden figures. Attempts have sometimes been made to interpret these as stereotypes of various kinds. Verly thought a contemplative figure represented a ‘thinker’, a chief concerned for the welfare of his people. Cat. 4.13a might give rise to somewhat similar speculation. It is not impossible, however, that posture is related rather to the social standing of the deceased or even to the circumstances of death. Certainly the gesture which involves chewing a plant stem (cat. 4.13b) recalls the act of a chief who spat out pieces of a sacred plant on the assembled company on ritual occasions. JC

Bibliography: Cornet, 1978¹

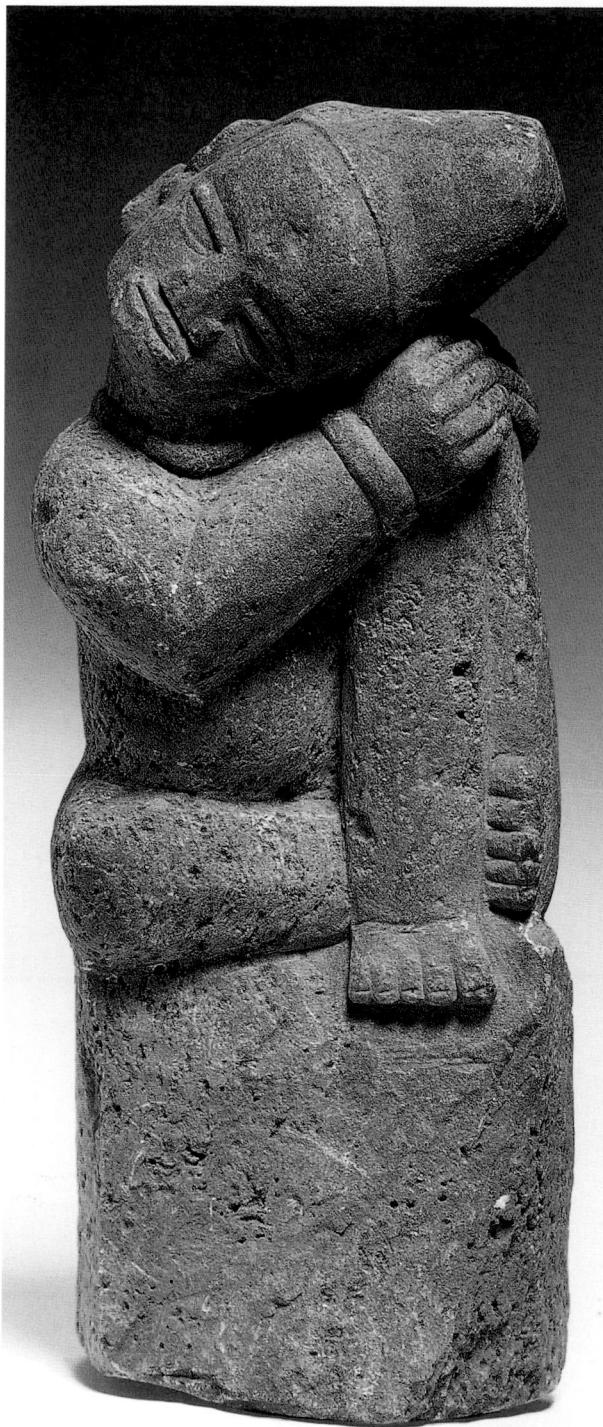

4.13a

Funerary monument (*tumba*)

Kongo
Boma, Zaire
19th–20th century
stone
38.2 x 15.2 cm
Royal Museum for Central Africa,
Tervuren, Belgium, MRAC 79.1.375

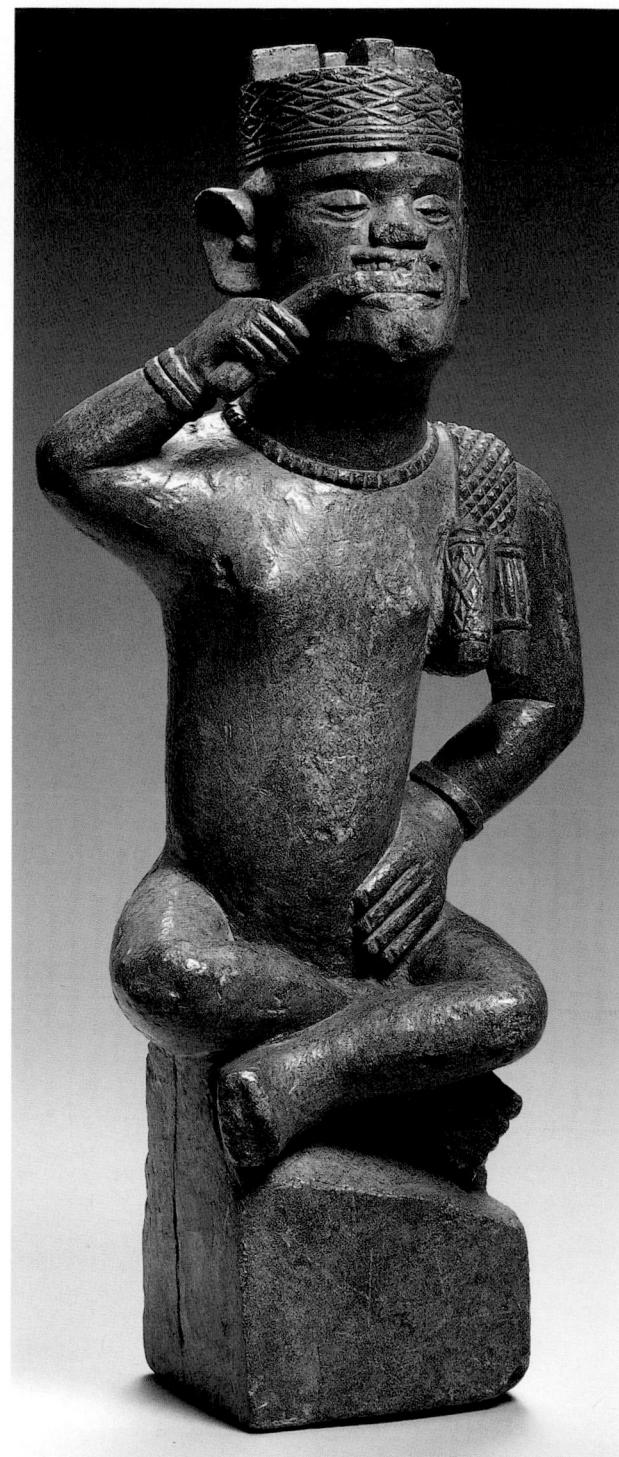

4.13b

Funerary monument (*tumba*)

Kongo
Boma, Zaire
19th–20th century
stone
h. 49 cm
Musée Barbier-Mueller, Geneva, 1021-17

4.14

Funerary monument (*ntadi*)

Kongo
Zaire
late 19th century
soapstone
h. 42 cm
The Trustees of the British Museum,
London, 1954.AF.13.1

Sculptures from this area depicting a

mother and child are usually known in the art world as *ntadi* (pl. *mintadi*), which may not have been the indigenous term for them. After the British began to enforce their ban on slave-trading after about 1825, the trade shifted from Ngoyo, on the coast, to the estuary of the River Zaire, where boats could hide among swamps and islands. The town of Boma became a centre of wealth. In quarries nearby, sculptors began to produce stone figures as items of conspicuous display for purchase by the wealthy, including traders who came from inland with slaves. Because *mintadi* were not produced for specific religious purposes, the sculptors were free to invent a great variety of forms, many of them related to items of European origin which were then becoming common in the area. Most were intended for display on graves in honour of the deceased and (*ntadi*, 'watchman') as witnesses to the dead. The modern expression, near the coast, is *tumba*, from the Portuguese for 'tombstone', but inland the usual term for a grave monument is *kinyongo*. Maternity was a common theme indicating that the deceased was female; other *mintadi* portrayed aspects of chiefship. They were usually painted; they were not *minkisi* unless, as happened sometimes, medicine packs were added to them. Several distinct sites and styles of production have been identified. *Mintadi* ceased to be produced in the 1920s. WM

Provenance: collected by R. Verly

Bibliography: Kinshasa 1978; Washington 1981

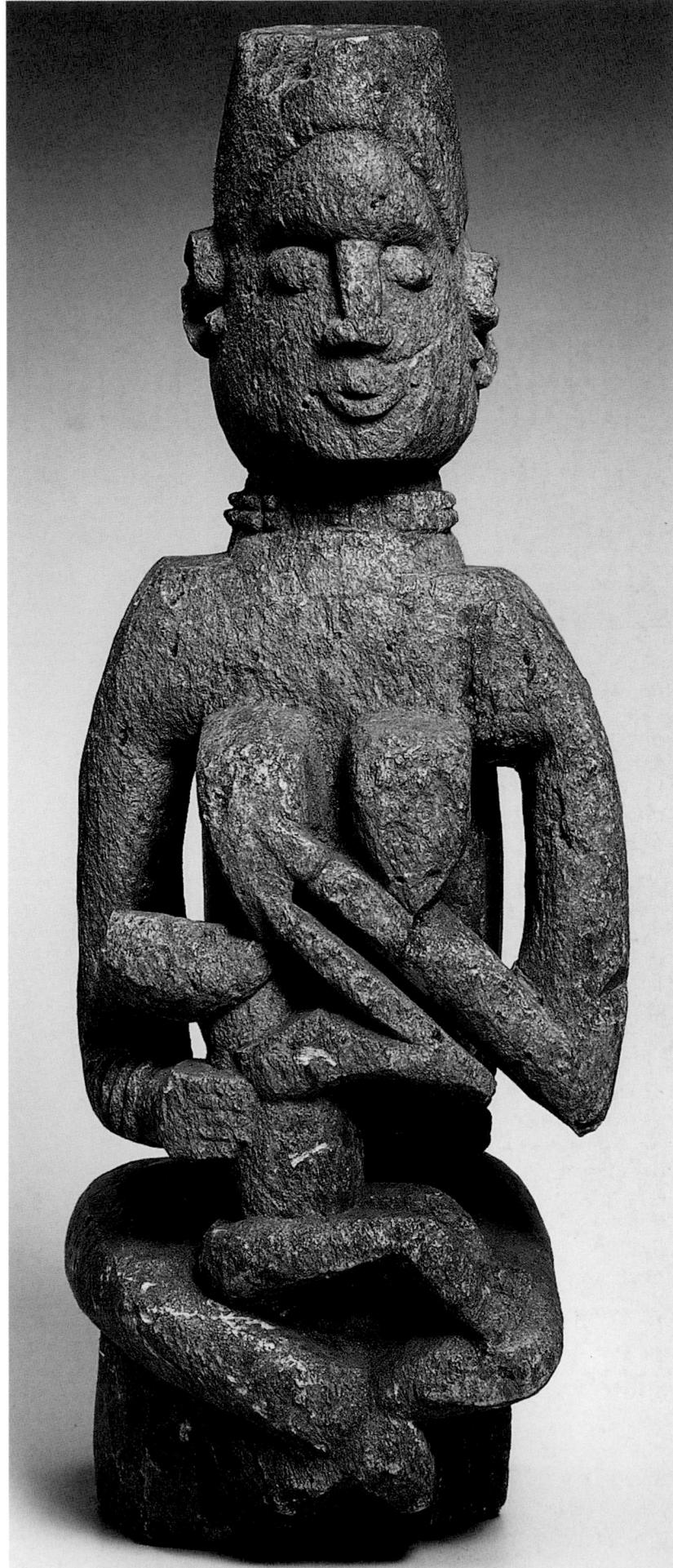

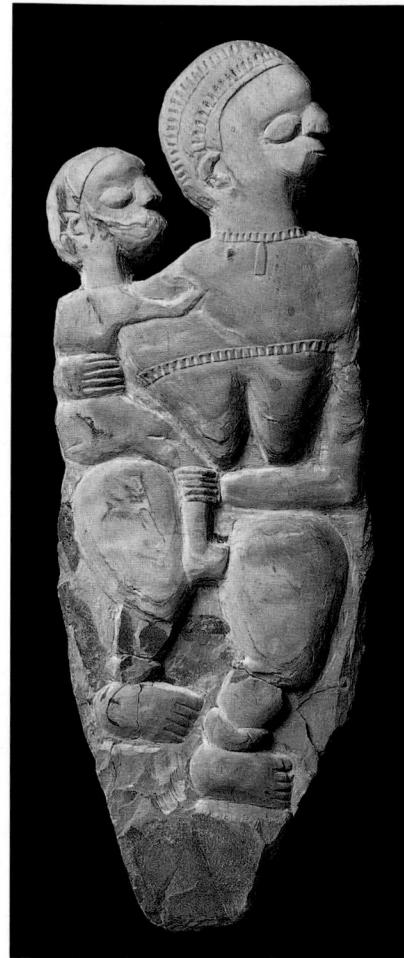

4.15

Stela

Solongo (?)
Zaire/Angola border
stone
61.5 cm x 21.5 cm
National Museum of Ethnology, Leiden,
RMV 2668-803

The hands of a few very individual artists can be recognised in the stelae from Angola and Zaire, of which several examples survive in European museums. The most common theme is that of a mother and child with the mother either carrying the infant or suckling it.

Outside Egypt and Nubia shallow carving (bas-relief) is relatively rare in Africa. Wherever it crops up inventive solutions are found to the problems of representation in (so to speak) two and a half dimensions (cat. 3.13, 5.133a). In these stelae the most frequent technique is one of articulating the body as a series of independent lines, though the present example is more fluid in execution than most.

Sandcast metal objects, which are essentially one-sided (like those of the Teke), exhibit similar characteristics,

whereas lost-wax castings in shallow-relief such as the Benin plaques (cat. 5.60b-e) develop quite a different language.

These particular stelae are the largest bas-relief stone carvings in Africa outside the ancient Nilotic cultures and they seem uniquely to have been made for funerary purposes. *TP*

Provenance: 1904, excavated by Brevié

Exhibition: Paris 1932

Bibliography: Camps-Fabrer, 1966;
Dembélé and Person, in Paris et al. 1993

4.16

Drum

Yombe
Cabinda
19th century
wood, hide
h. 77 cm
Museu Etnografico (Sociedade de
Geografia de Lisboa), Lisbon, AB-927

In the lower reaches of the River Zaire, in Mayombe, among the Woyo and neighbouring peoples, the varieties of drum (an essential accompaniment to life) exceeded the forms in general use in central Africa to include some less familiar shapes. Some of these are double-headed drums with exceptionally long bodies. In earlier times, particularly in Loango, there was another curious style in which the drum was like a mere accessory perched above a complex carved base with a human figure, carried on the back of an animal, sometimes accompanied by snakes. The piece shown here belongs to the latter category.

On a plinth with broad moulding an unidentifiable animal, with four sturdy legs, carries the shell of the drum. This type of support is symbolic; perhaps it is the endorsement of the chief's source of power. The rectangular soundbox, traditionally fastened with a fragment of mirror, also contains the insignia of power and has the same symbolic meaning. The design of snakes and tiny human figures is also intended to render this venerable instrument sacred. *JC*

Provenance: collected before 1885

Bibliography: Bastin, 1994, no. 43

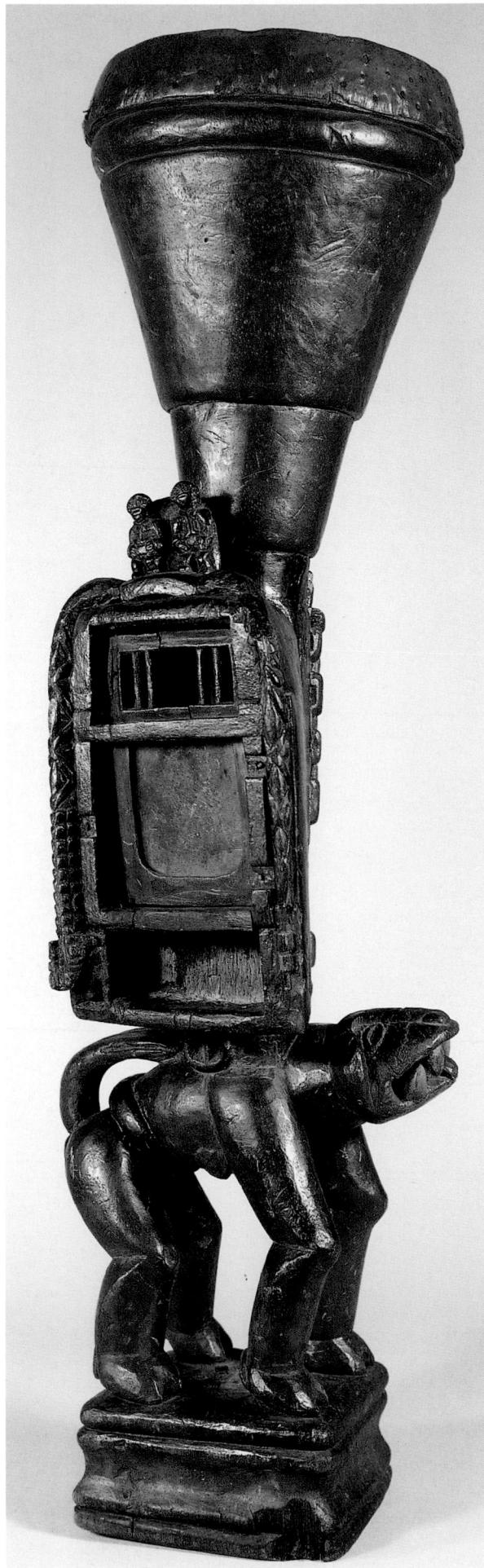

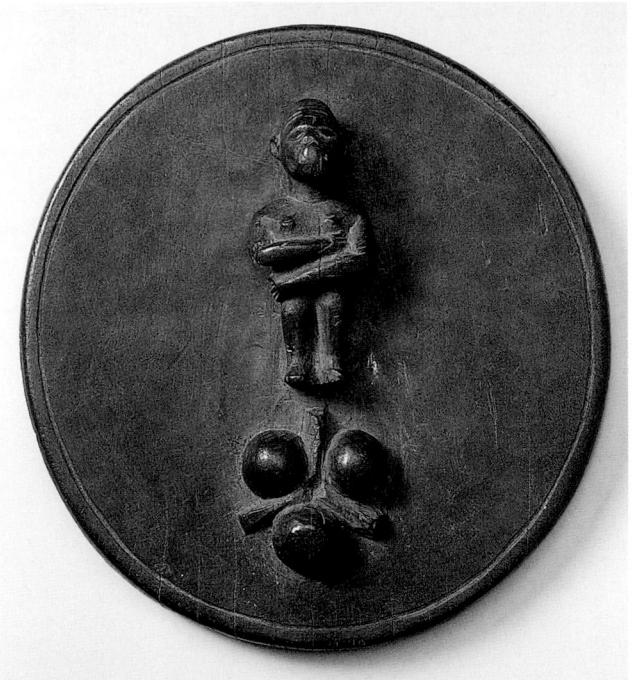

4.17a

**Lid with proverbial images
(taampha)**

Woyo
Zaire
19th or 20th century
wood
diam. c. 20 cm
National Museum of Ethnology,
Leiden, RMV 2966.18

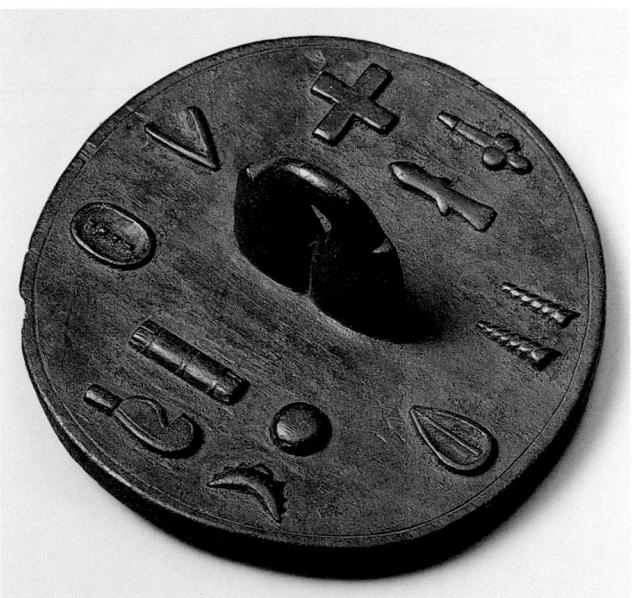

4.17c

**Lid with proverbial images
(taampha)**

Kongo
Cabinda
19th or 20th century
wood
diam. 20 cm
National Museum of Ethnology,
Leiden, RMV 2966.45

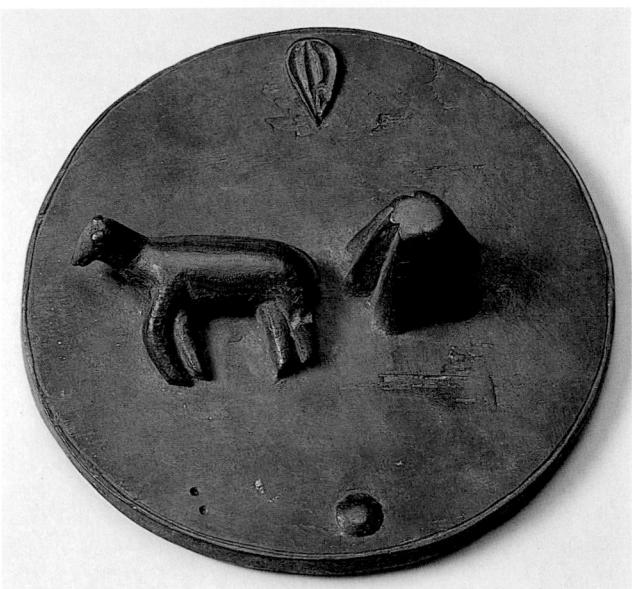

African popular speech makes wide use of proverbs, especially in the areas around the mouth of the River Zaire; one important feature of this culture is the visual representation of such proverbs. Such representations come in many forms: designs on the walls of houses, patterns in beadwork and, particularly, the carvings on wooden lids of pottery vessels. These lids were used as a means of communication, two types being especially popular: the first served to endorse the status of chiefs (cat. 4.17b), the second to restore peace during domestic quarrels. When meals were served to the people involved, the carvings on the lids of the storage vessels would either demand respect for the chief or chiefs who had been invited or advise on subjects of family conflict.

The proverbs were represented symbolically in a great variety of ways, from figures in high relief to representations of fruit, weapons, shells and different signs in low relief. There was no script, only images. The interpretation of these proverb lids is difficult because the wording varies from area to area, and the translation of each proverb into an image is influenced by local custom. The problem of interpretation is compounded when there is a hierarchy of several symbols on a single object. The most important elements are placed in the centre of the lid. These sometimes occur singly, but sculptors have a tendency to surround them with allusions to other proverbs that complete or elucidate the principal saying; in addition, signs whose meaning is less straightforward and more general are used to fill the space.

These lids are to be found among a number of peoples: the Vili in Mayombe and, most frequently, the Woyo, both those living in Zaire and those from the Cabinda enclave.

The replacement of traditional cooking utensils with objects made of aluminium or plastic has caused the virtual disappearance of such wooden lids, and consequently of this original method of presenting wisdom in the form of sculpture. JC

Bibliography: Cornef, 1980; Faïk-Nzuij, 1986

4.18

Androgynous figure

Teke

Republic of Congo
wood, earth, cowries
h. 84.5 cm
Private Collection

The Teke are found mainly in the Republic of Congo between the Franceville region of Gabon and the River Zaire, on both banks of the river as far as Kinshasa in the Republic of Zaire and beyond. They are farmers and hunters and live in an area of plateaux covered by savanna, in villages grouped under a district chief with a 'notable' at the head of each. They cohabit on the bilateral matrikinship principle, i.e. with the maternal family or its close connections; within this close-knit structure, however, there is great mobility.

The Teke system of belief is based on an invisible world ruled over by one god, Nziam, the creator. The deceased are reborn into this world. Nziam has tutelary spirits, the forces of nature, as henchmen. These spirits receive prayers and supplications, conveyed either by religious or magical means. The intermediaries in this prayer are often given a material presence; they are presented as a collection of various items that are either invested with magical powers or are assumed to contain a natural spirit or the spirit of the deceased. These objects (relics or fetishes) are kept in a container or receptacle attached to a sculpture representing the dead ancestor.

The statue exhibited here must surely be an ancestor. It would be interesting to know why the effigy is androgynous. Study of the face reveals a connection with the face of the statuette of a seated figure shown in Brussels in 1988.

Many theories have been advanced about the origins of this statuette. Is it Teke? Bembe? Bwende? The style in fact is Teke, from the left bank of the River Zaire. Sculptures in this style are to be found in Belgian collections.

The figure is standing in a traditional pose, legs bent, head erect; the eyes, made of glass beads, are close to the nose, the brow bulges, the mouth is prognathous and slightly open to show the teeth. A hole in the centre of the teeth suggests that a removable piece could be added to give concrete

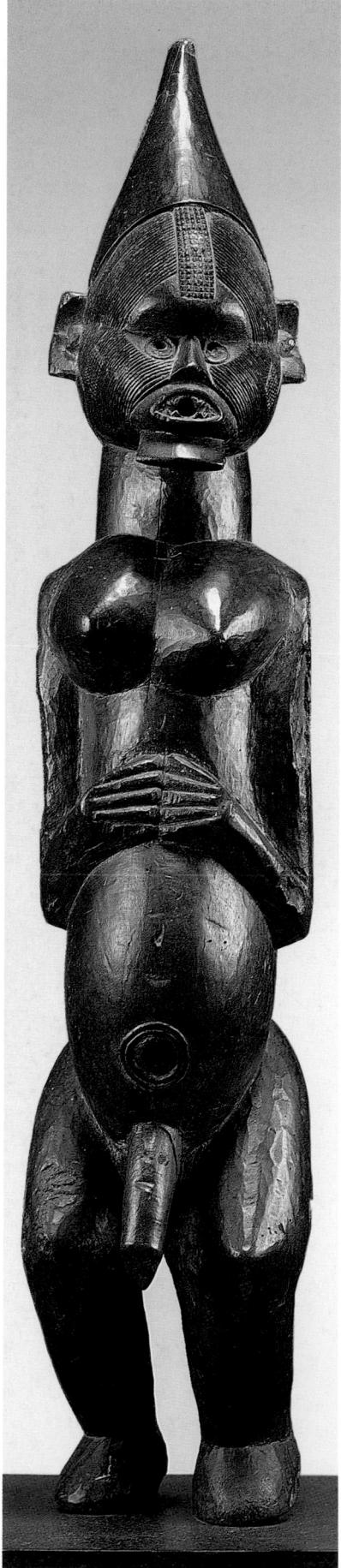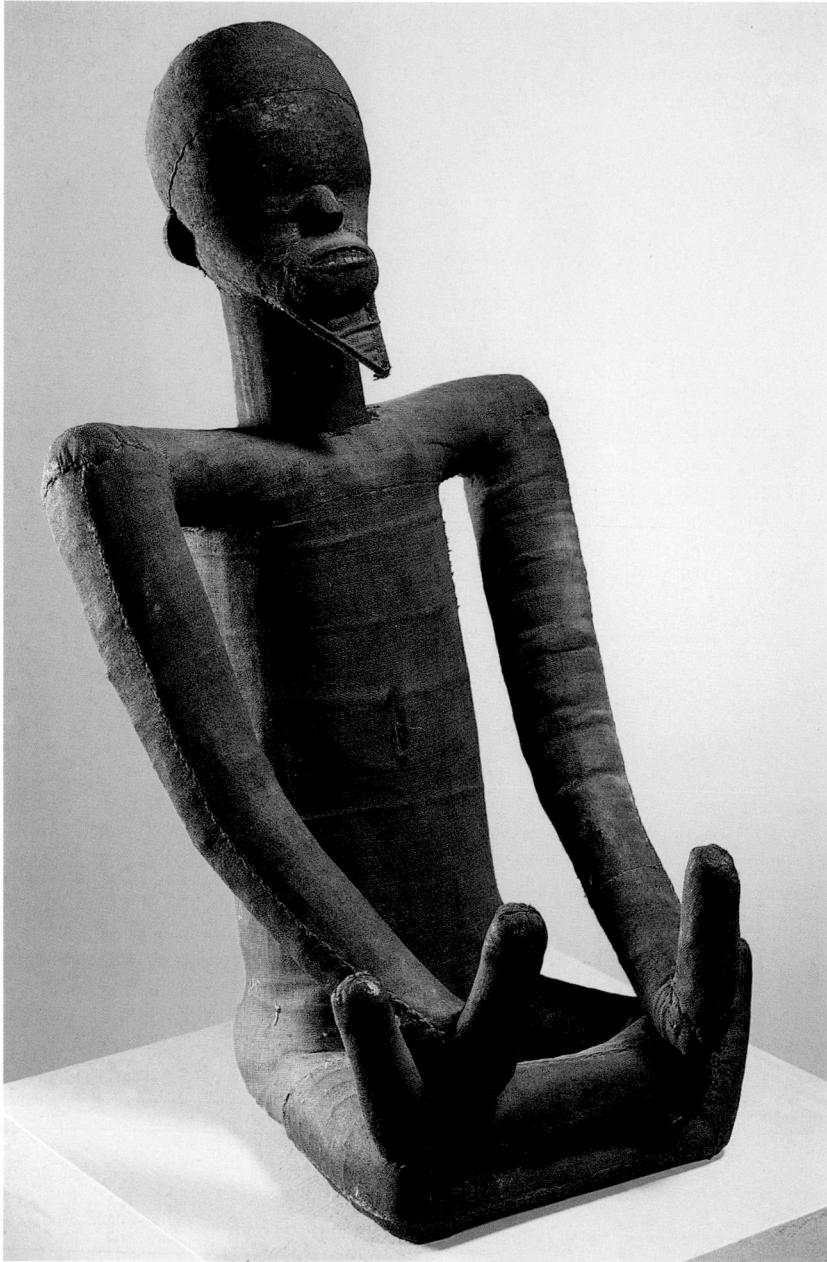

presence to the words of the ancestor. The area in the centre of the forehead bears a pattern of tattooed checks, indicating high office, and the forehead, temple and cheeks are densely covered with fine scarifications in specifically Teke patterns; the area around the eyes and mouth is not scarred. The ears are C-shaped, with the tragus in relief. The headdress worn by this person is reminiscent of the chignon of variable length worn by notables. LP

Exhibition: Brussels 1988, pl. XXVIII,
p. 96

4.19

Statuette of an ancestor

Bembe
Republic of Congo
19th century
fabric, wood, fibre
h. 46 cm
Private Collection

The Bembe once inhabited the Republic of Congo, near its border with Zaire. They were responsible for hundreds of small, beautifully carved sculptures that for years went unrecognised. Monumental statuary, however, is more scarce; the figures usually represent an ancestor squatting like a tailor, with minimised lower limbs. JC

Bibliography: Söderberg, 1975; Lehuard, 1989, i

4.20

Pot

Kongo

Zaire

20th century

fired clay

h. 11 cm; diam. 15 cm

The Trustees of the British Museum,
London, 1910.10.26.3

African pottery is characterised by the use of simple technology to produce objects of total utility and great beauty. The present pot is of a distinctive yellow clay and the striking and unusual decoration is achieved by splashing the surface with a very thick, resinous, vegetable decoction while it is still hot from baking.

The vegetable matter boils off rapidly, leaving an effect almost of wood grain. It is a technique used by a number of peoples around the mouth of the River Zaire.

African pots are largely hand made by women and baked at relatively low temperatures. The resulting terracotta is composed of comparatively large particles that are very resistant to thermal shock. This means that African pots can be placed directly on a fire without shattering, as would happen to pots made of finer clay and baked at a higher temperature. Because of the large particles, moisture can evaporate readily through the pot walls, so that pots used as water-containers keep their contents well below the temperature of their

surroundings. Where such porosity is not required, pots are often sealed by burnishing or applying vegetable decoctions. Western-style glazes could not be used at such low temperatures.
NB

Provenance: before 1910, collected by Rev. J. Weeks

Bibliography: De Haulleville and Coart, 1907, pls 6–7; Barley, 1994, p. 30

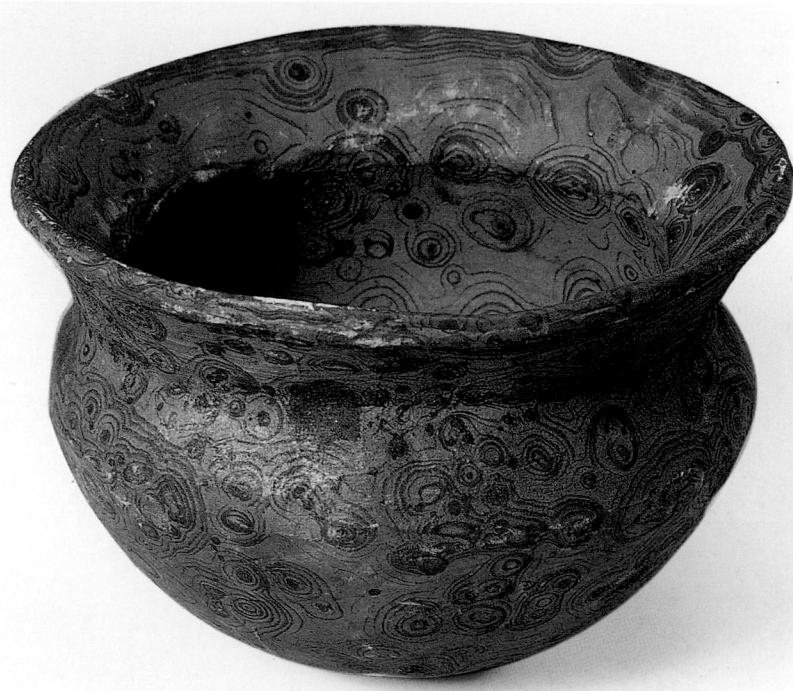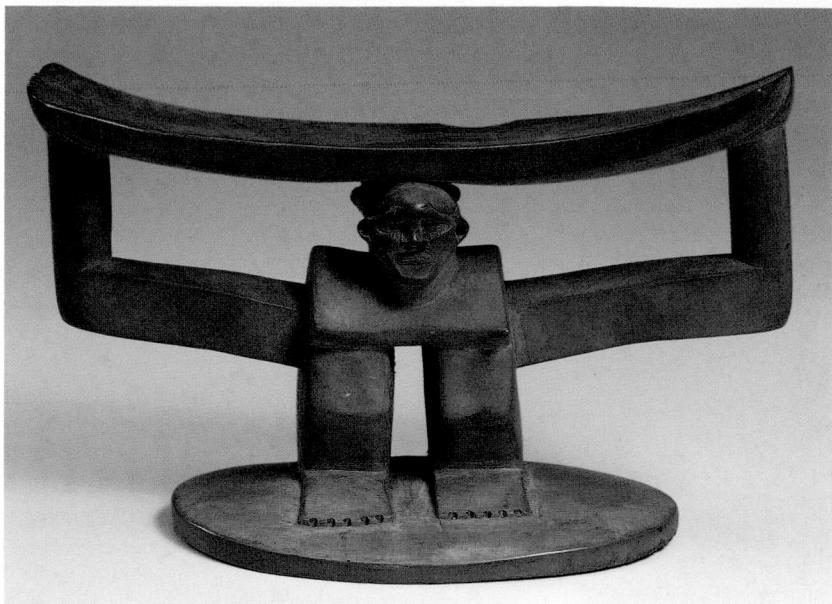

4.21

Headrest

Mbala

Zaire

c. 1900

wood

18 x 27 x 13 cm

The Trustees of the British Museum,
London, 1907. 5-28.13

Among the Mbala certain forms of headrest – and notably those with figurative supports – are known to have been reserved for chiefs. Such a restriction has been interpreted as reflecting the fact that chiefly authority rests upon the assent of the people, that the chief must listen to them as he does symbolically when he rests his head upon the headrest. An alternative interpretation, however, might be that the limitation to chiefs has less to do with the exercise of political wisdom and more with the nature of hierarchy: in other words, his authority is supreme, weighing down upon his subjects.

This particular example was collected by Torday in 1907 at the Mbala village of 'Mossonge', one of two he collected in a style identifiable with a single Mbala artist. Another, in the Tervuren museum (MRAC 20155), was collected among the more distant Teke before 1914, though said to have been of northern Mbala origin. It is possible that they are the work of a carver called Molime who was admired and befriended by Torday. A number of pieces in the British Museum's Torday Collection are known to be by this artist, though

the documentation does not confirm which. This, however, is so distinctive a style that the probability is that he is indeed the creator of the works. If, of course, the headrests were carved exclusively for chiefs this would also explain why they were collected in diverse places. *JM*

Provenance: 1907, acquired for the museum by Emil Torday

Bibliography: Biebuyck, 1985, p. 163

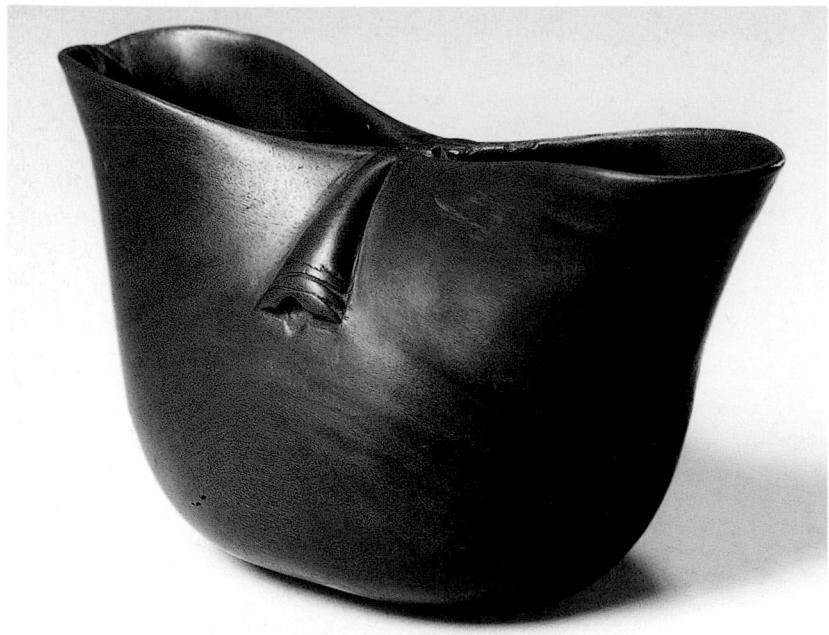

4.22

Drinking-vessel

Pindi or Suku
Zaire
c. 1904
wood
h. 9 cm
Staatliche Museen zu Berlin, Preussischer Kulturbesitz, Museum für Völkerkunde, III C 19806

This drinking-vessel has either been mistakenly labelled 'Bakuba' or is a Suku or Pindi trade article actually collected among the Kuba. Similar examples were collected by Frobenius among the Pindi. As a distinct sign of authority of a Suku headman or regional chief, the carved, double-mouthed drinking-vessel served for the ritual drinking of palm wine. The inviolability of the vessel was reinforced by the motifs featured on one or both sides of the vessel, which depicts either the image of an antelope horn as power-container, as in this example, or that of the *hemba* charm as a human face. The double-mouthed drinking-vessel originates in the gourd cup. The squat, pumpkin-shaped gourd, when vertically halved, results in two containers, the openings (joined in the middle) resembling a figure-of-eight. Carved from a single block of wood, Suku vessels measure an average of 9 cm in height by 11 cm in length; they generally have a rounded bottom. APB

Provenance: 1904, collected by Leo Frobenius

4.23

Door

Holo
Zaire
wood
160 x 45 cm
Private Collection

This double-panelled door presents Christian motifs in relief. A crucifix is featured on the left panel with a kneeling figure with hands held in a praying posture on the accompanying panel. Both motifs find their counterpart in Holo charm imagery in depictions of the enframed *nzambi* charm and hands-to-mouth posture in curative statuettes. APB

Relief panel

Pindi
 Zaire
 c. 1904
 wood, pigment
 h. 99 cm
 Museum für Völkerkunde, Hamburg

This panel, collected from the Pindi village of Kissala, was described as a 'door with moon, *kitekki* [charm figure] and two *kialu* [lizards]'. Other doors found among the neighbouring Mbala and Hungaan similarly have celestial symbols combined with reptile forms. The *kitekki* is distinctly related to the image found on a variety of Suku drinking-vessels. APB

Provenance: 1904, collected by Leo Frobenius

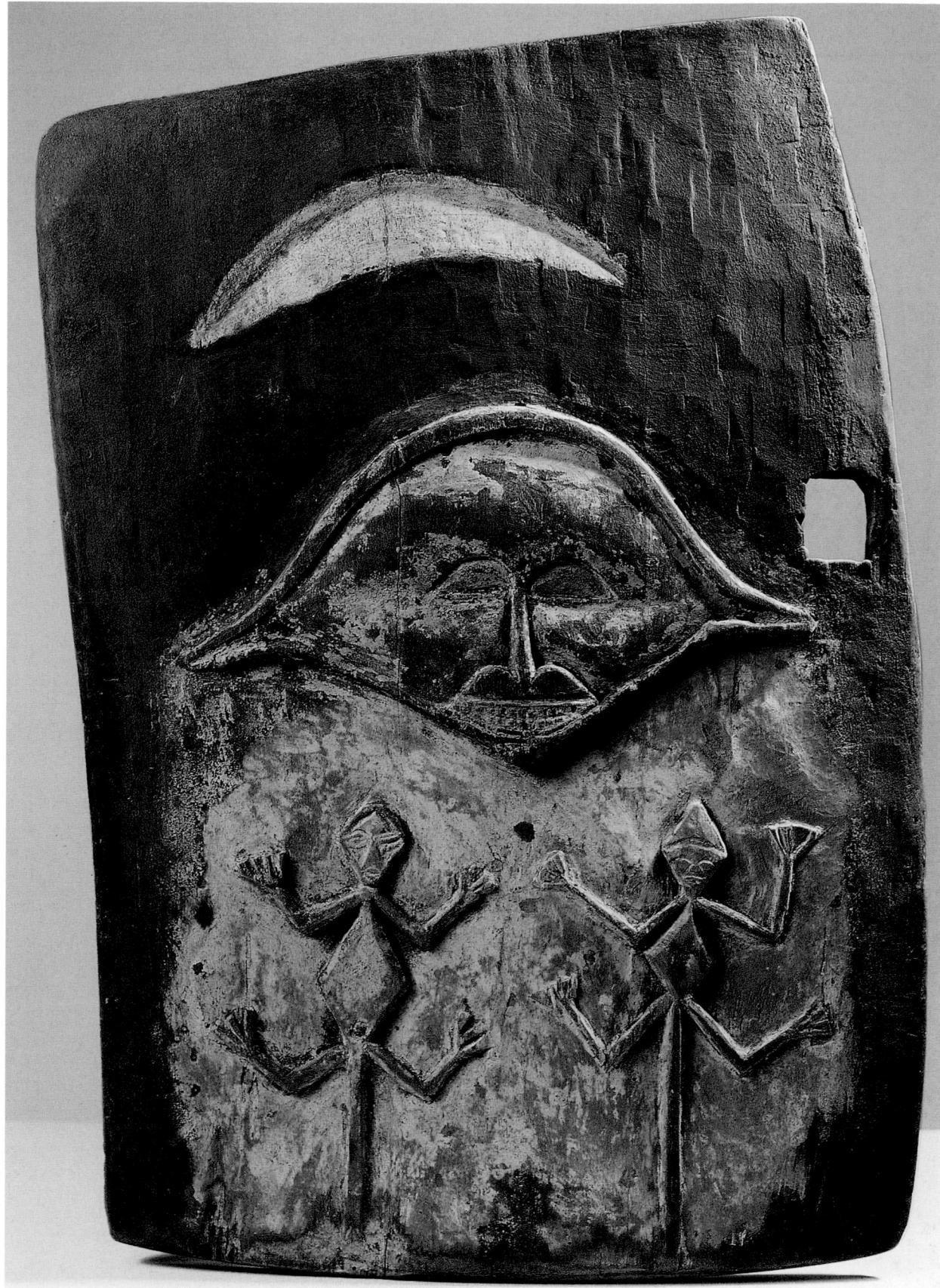

4.25

Panel

Hungaan

Kwenge Valley, Bandundu Province, Zaire

19th century

wood, pigment

99.2 x 45.3 cm

Museum für Völkerkunde, Hamburg,

5789.05

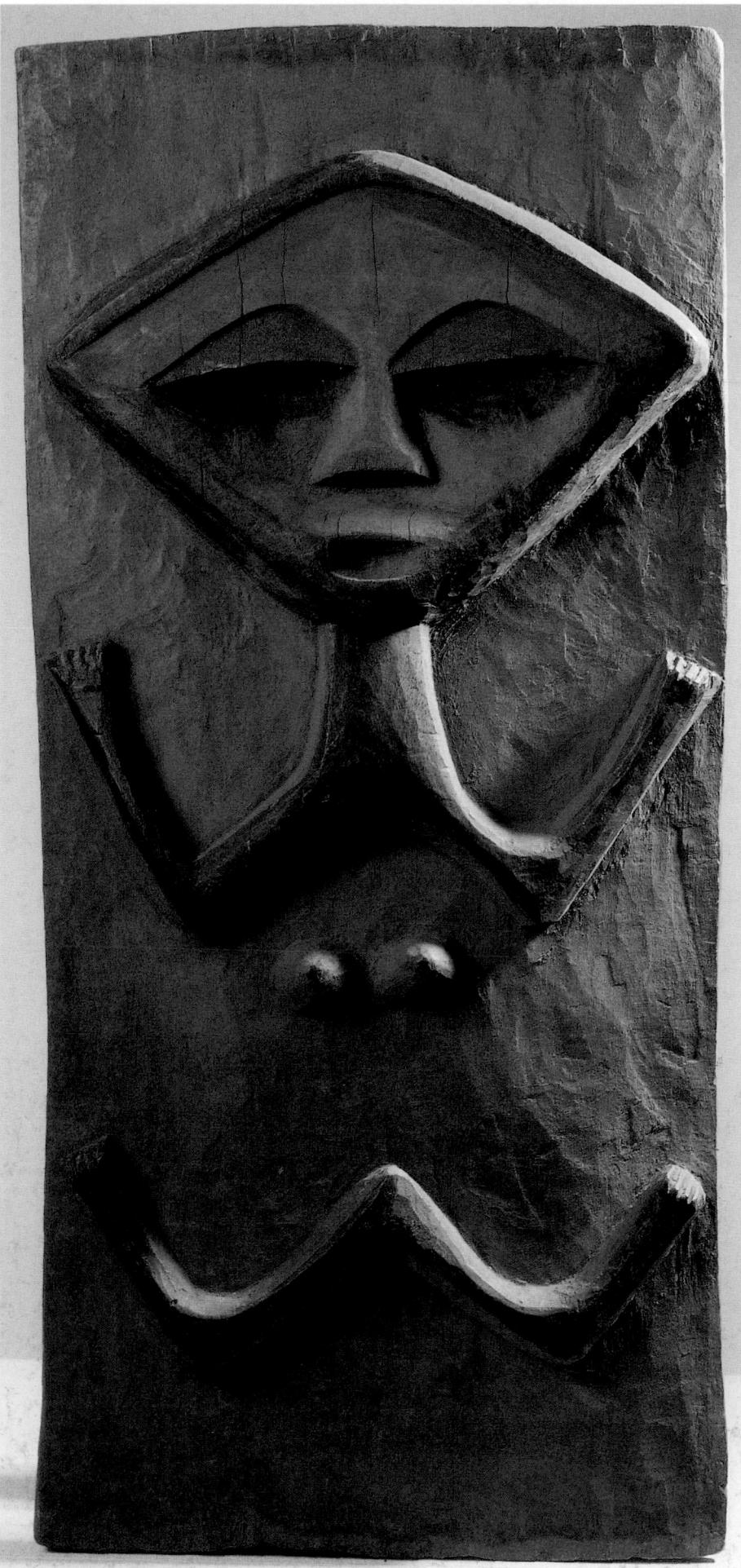

This panel exemplifies the 'displayed female motif' in which a figure is shown with splayed bent legs, exposing the genital area (see also cat. 4.26, 85). In daily life within certain regions of west central Africa, notably the Kwango River region of Zaire and the Ngunie River of Gabon, female modesty is characteristic; complete female nudity for an adult is non-existent in a public setting. The imagery, then, is a reference to something other than daily practice.

Appearances of the same motif could be shown from elsewhere in Africa, in sculptured lintels of the Mileke of Cameroon, Chokwe chair stretchers from Angola or the stools of Zula chiefs from Zaire. It is a universal theme whose earliest appearance can be found at Chatal Huyuk in Anatolia, probably in the 7th millennium BC.

The displayed female motif by no means ensures that the message is essentially about women. As the feminist theorist Laura Mulvey suggests in her book *Visual and Other Pleasures* (Bloomington, 1989, p. 11), the image of woman comes to be used as a sign, which does not necessarily signify the meaning 'woman' at all. Rather it springs from a male consciousness. Even within a ritual usage, males are communicating with other males via such imagery: it is not only a product of male carvers and commissioned by male dignitaries, but in the Kwango River region is also intended for the initiation of young males into responsible men.

Certainly there are implied elements of satisfying sexual curiosity, viewing the female as sexual object and the female role as bearer of children. There may even be hints of castration anxiety, fear of social inadequacy and rejection by one's peer group. Ultimately, however, in the context of male initiation the meaning of woman is sexual difference, which reinforces male solidarity.

This highly conventionalised example in relief consists of two 'W' forms, one supporting the lozenge-shaped head and the other suspended below leaving the two breasts emerging from the flat panel. According to Frobenius's ethnographic notes, the panel is from an old door and depicts a *kitekki*, or charm figure, which is given a personal name; the Hungaan placed such doors in a house where a sick person was being treated. Similar doors were collected by Frobenius among the Pindi and Mbala. While the head shown on this panel has stylistic affinity to Hungaan miniature ivory and bone pendant figurines, the pendants present a female in a squatting position whose knees nearly touch. Probably both served an apotropaic and protective function. APB

Provenance: 1905, collected by Leo Frobenius

Bibliography: Frobenius, ed. Klein, 1985, pp. 19–20; Biebuyck, 1985, i, p. 159; Biebuyck, 1987, pl. 17

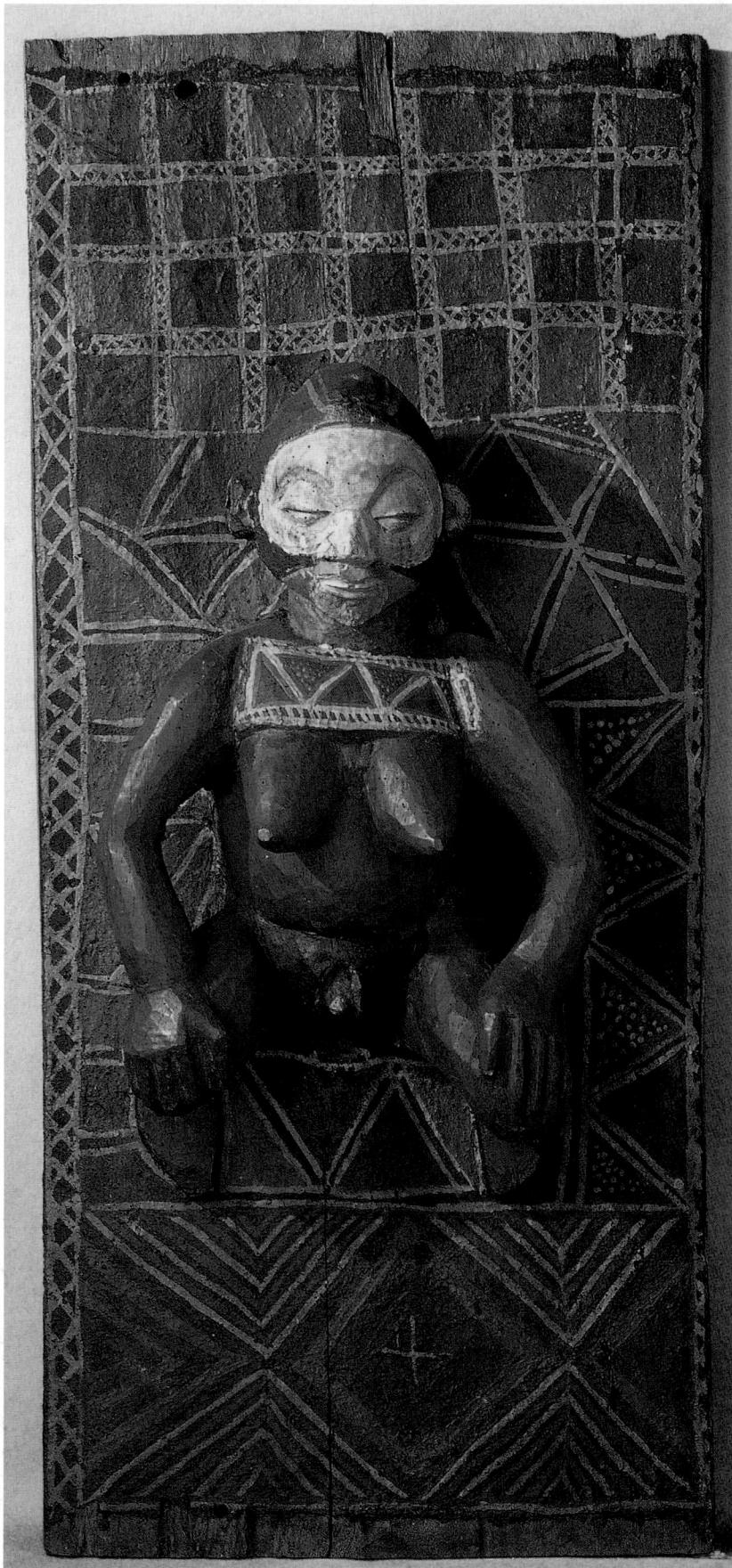

4.26

Panel

Nkanu

Zaire

wood, pigment

Laboratoire d'Ethnologie,
Musée de l'Homme, Paris, 32.15.11

Used in initiation to manhood ceremonies similar to *nkanda* of the Yaka, but here termed *kimeki*, Nkanu panels were exhibited in a special booth or hut with open front. This example shows a 'displayed female' (see cat. 4.25) in high relief seated at the centre, while the background is decorated with geometric shapes delineated within white cross-hatch zones. A beaded chest ornament is presented on this otherwise naked figure. Other examples show a male with large genitalia or a female giving birth as well as animal figures carved in relief. In comparison with similar depictions on Yaka masks, themes of sexuality and procreation dominate in this setting relating to male fertility and its protection. Sung verses and sexual depictions ridicule female attributes and celebrate sexual difference; male dominance is asserted and erotic indulgence given play. The initiate is led to identify himself in a dramatic and symbolic way with the human life cycle and with behaviour associated with its differing stages. In this context, male/female opposition is surpassed by an awareness of the importance of generational continuity for future life and well-being. APB

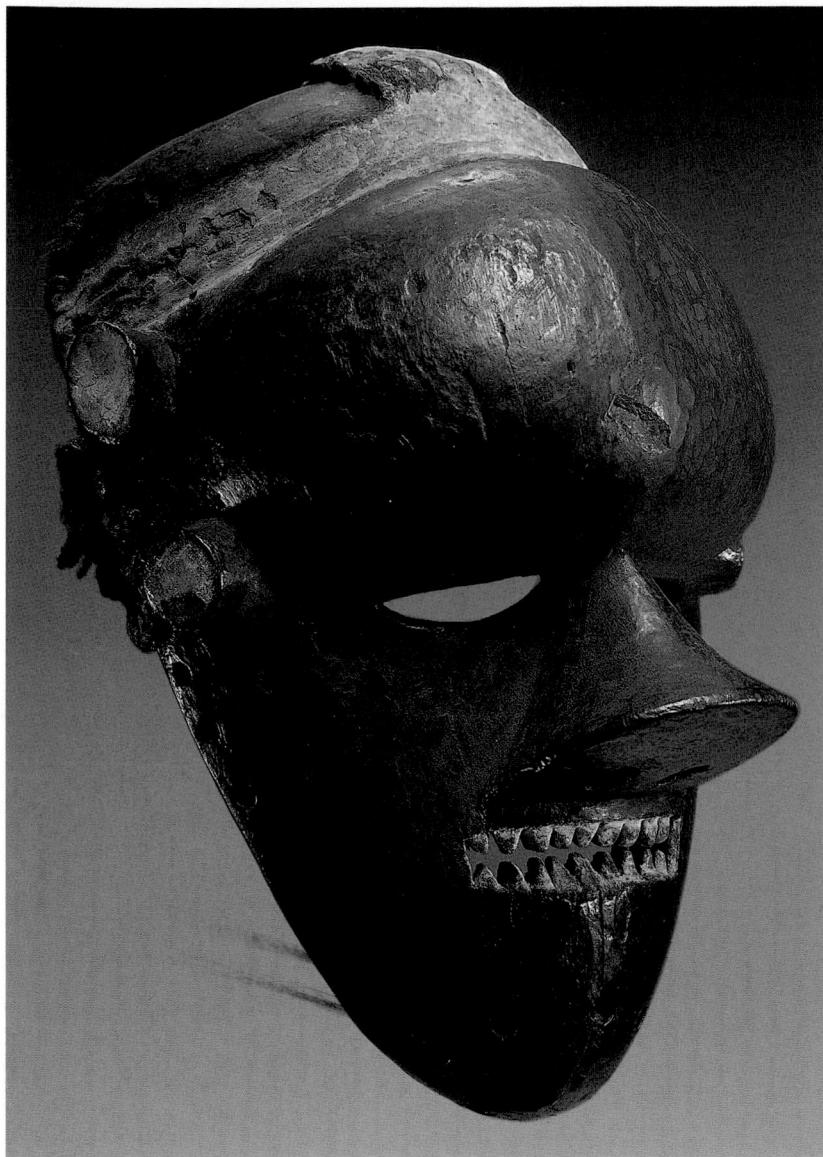

4.27

Mask (*kasangu*)

Sala Mpasu
Zaire
20th century
wood, pigment
32 x 22 x 24 cm
Felix Collection

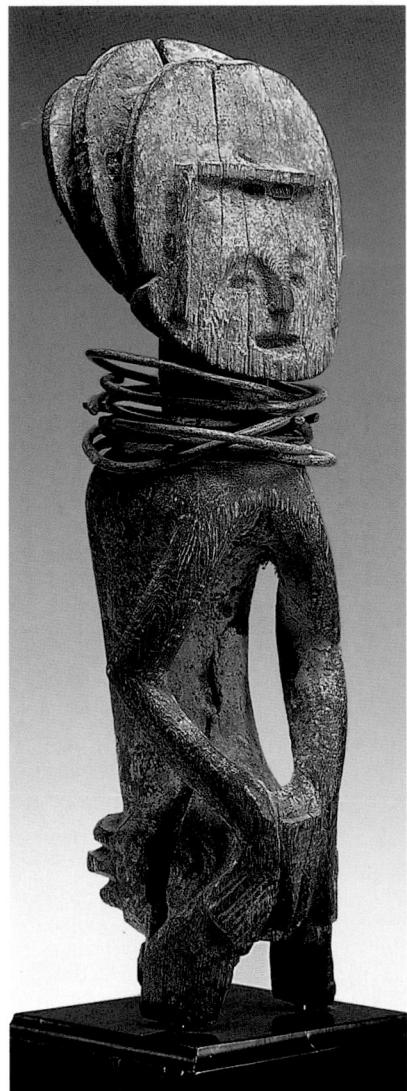

4.28

Female statuette

Eastern Kongo
Zaire or Angola
wood, metal
34 x 10 x 10 cm
Felix Collection

This kneeling figure in modified 'displayed female' stance, arms turned back with hands resting on hips, wears a dignitary's hat and bears a metal ring about the neck, yet lacks female breasts. Similar kneeling ring-necked statuettes showing a high degree of naturalism commonly derive from the Zombo plateau of northern Angola. Little is known regarding their precise ritual use although in comparison with statuettes of their neighbours they are presumed to serve both curative and apotropaic functions. APB

Before the turn of the century the Sala Mpasu were part of a small enclave of loosely connected peoples in Kasai Province, Zaire. Social organisation centred on three institutions: matrilineal clans (*mupanga*; pl. *mipanga*), settlements (*ikota*) built around 'rich men', and the warriors' society (*mungongo*; pl. *bangongo*). Sala Mpasu masks were integral parts of the warriors' society whose primary task was to protect this small enclave against invasions by outside kingdoms. Boys were initiated into the warriors' society through a circumcision camp, then rose through its ranks by gaining access to a hierarchy of masks. Earning the right to wear a mask involved performing specific deeds and large payments of livestock, drink and other material goods. Once a man 'owned' the mask, other 'owners' taught this new member particular

esoteric knowledge associated with it. Mask performances were open only to those having the right to wear the mask. Possessing many masks indicated not only wealth but knowledge.

Individual masks were obtained sequentially by a warrior to form a series of increasingly elaborate masks controlled by a society (*ndoge*) within the warriors' organisation. Basic wood masks (*kasangu*) are painted while the senior mask (*nukinka*) is copper-covered; some have pointed teeth. Filing teeth was part of the initiation process for both boys and girls designed to demonstrate the novices' strength and discipline.

Since the turn of the century the Sala Mpasu have undergone drastic economic, political and social changes that have directly affected their art forms and related institutions. Attempt-

ing to change their fierce reputation, the Sala Mpasu have disbanded the warriors' society. Masks, however, are still being danced as part of male circumcision ceremonies. ELC

Exhibition: San Diego 1992

Bibliography: Jobart, 1925; Clé, 1937; Clé, 1948; Bogaerts, 1950; Pruitt, 1973; Cameron, 1988

4.29a

Statuette

Hungaan
Zaire
wood
h. 57 cm
Museum für Völkerkunde, Hamburg,
5248.05

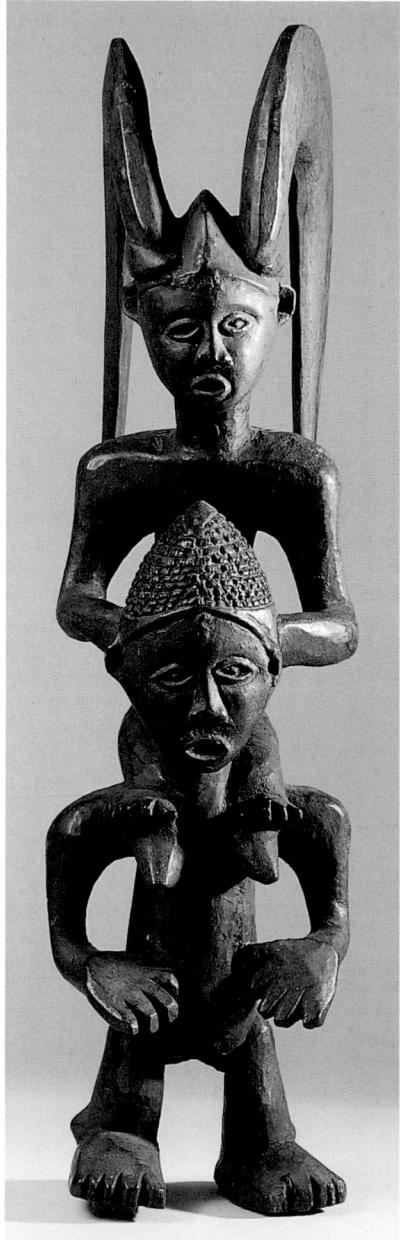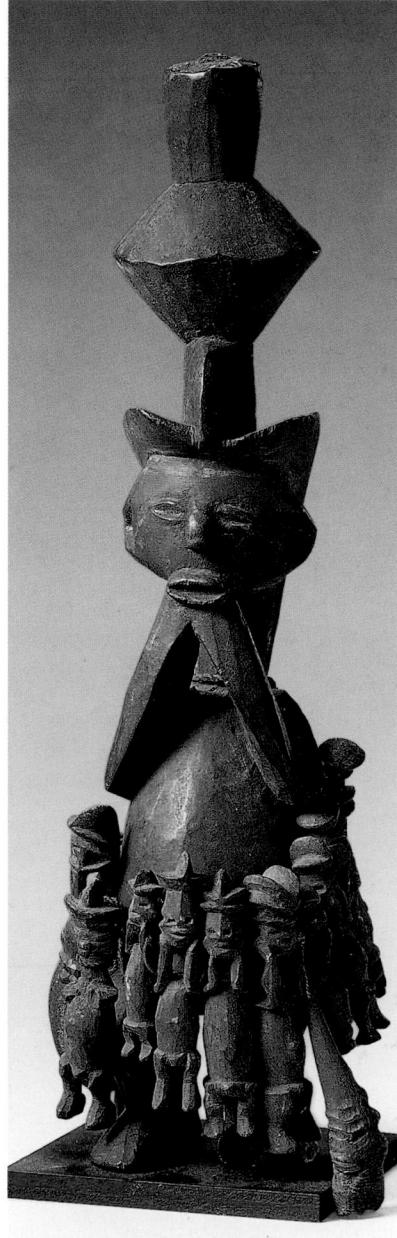

4.29b

Statuette

Hungaan
Zaire
wood, horn, cord
h. 47 cm
Staatliche Museen zu Berlin, Preussischer
Kulturbesitz, Museum für Völkerkunde,
III C 5310

4.29c

Statuette

Yaka
Zaire
wood
41 x 9 x 8.5 cm
Musée d'Art Moderne de la Ville de Paris,
Girardin bequest, D. 62.1.3, on loan to the
Musée National des Arts d'Afrique et
d'Océanie, Paris

The pickaback motif exemplified in cat. 4.29a is not that of a woman carrying a small child, but presumably a male dignitary, as indicated by the horned coiffure. Being carried on the shoulders is usually a part of some rite of passage in which the person must be kept off the ground or be treated like a newborn child. Hungaan statuettes with straight or bent horns refer to those of a stylised pangolin or aardvark and have their parallel in Hungaan masks said to be worn when a chief marries a wife. Among the neighbouring Mbala, with whom the Hungaan mix, horned statuettes are termed *malwambi*.

Collected in 1886 by the first Europeans to cross the Kwilu region, another Hungaan statuette (cat. 4.29b)

balances a vessel above its head and carries a dog bell, horn container and ten miniature figurines around its waist. Hungaan carvings were associated with ritual experts (*nga* or *nganga*) who specialised in protection, healing and divination according to a particular ritual institution. Larger figures were placed upon a high table within a house, and the largest were termed grandfather or grandmother *mukisi*. Those termed *nkonki* protected houses, gardens, animals, traps and nets, while others were worn by women and children as personal guardians or were hung over doorways. The miniatures attached to this charm appear to represent children of the main figure, though among neighbours of the Hungaan

supplementary carvings are frequently loaned out to individuals as an extension of the power assemblage.

The Yaka statuette (cat. 4.29c) is a lineage *biteki*, a charm used to contain and control evil influences or a hereditary disease; it may also be used to protect property and inflict injury on witches or other malefactors. Sculptural contrasts in the projection and recession of parts of the human body are vigorously expressed in this object. APB

Provenance: cat. 4.29b: 1886, collected by Richard Kund and Hans Tappenbeck
Bibliography: Frobenius, 1907, p. 91;
Kecskési, 1982; Biebuyck, 1985, i, p. 159;
Dewey, 1993

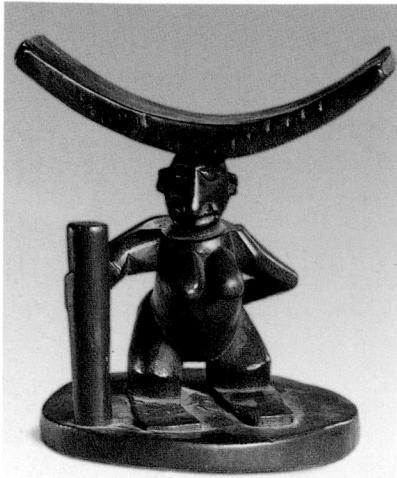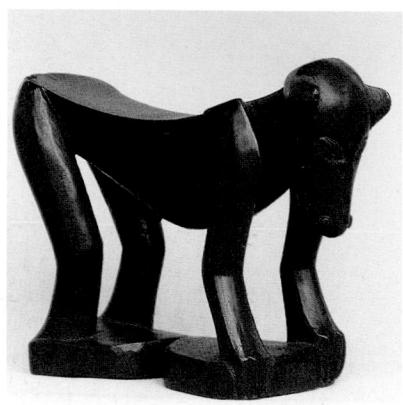

4.30a

Headrest

Yaka
Zaire
wood
19 x 16.5 cm

Museum Rietberg, Zurich, RAC 528

4.30b

Headrest

Yaka
Zaire
wood
19 x 16.5 cm
Private Collection, Paris

Headrests are items of furniture placed under one ear and along the side of the chin to support the head during sleep. They are positioned on sleeping mats in order to protect elaborate coiffures. Evidence of antecedents as remote as early pharaonic Egypt and as dispersed as the Bandiagara Cliffs of Mali and eastern Zaire in the Kisalian period attest to both the antiquity and the widespread use of this form of furnishing in Africa.

Cat. 4.30a has a female column as its central support and a rounded base. The figure grasps a large pestle, an item commonly used in conjunction with an hourglass-shaped mortar in the daily preparation of cassava (manioc) flour. Among the Yaka all tools partake of a gender-related topology. Even though the early morning sounds of women processing cassava at the mortar are ubiquitous, the pestle in certain ritual contexts displays an overt masculine significance. The overall referent here in the context of the prominently breasted and unclothed female appears to be sexual. Moreover, the mortar is not shown, as the Yaka do not permit allusion to sex during the preparation or eating of meals.

The headrest in the form of a quadruped with swayback as supporting platform may refer to diverse animals, including gazelles and felines. Cat. 4.30b appears to represent a dog. Among the Yaka, who term their headdresses *musawu*, canines are associated with the hunt (an exclusively male occupation and a source of male prestige) rather than being considered domestic pets. Although their keen sense of smell is linked metaphorically to the diviner's ability of clairvoyance, their sexual habits model the nocturnal promiscuity of sorcerers. APB

Bibliography: Dewey, 1993, pp. 16–17; Wassing, 1968, fig. 54; Zurich 1970, p. 282; Bastin, 1982, p. 10; Bourgeois, 1984, pp. 56–7; Devisch, 1993, p. 98

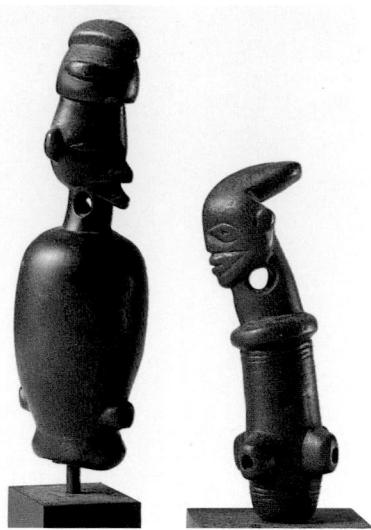

4.32

Pendant (gikhokho)

Central Pende
Zaire
ivory
6 x 4.5 x 2 cm
Private Collection

The Central Pende carve decorative pendants (sing. *gikhokho*, pl. *ikhokho*) in the form of miniature masks. Sculptors prefer elephant ivory when it is available because of its smooth, cool texture and because, if it is carved correctly, it does not crack with age. They also use the soft thigh bones of hippopotami. The latter can achieve much the same lustre and texture as ivory, but splits more easily and shows grooves from muscles and tendons that need to be disguised on the underside of the pendant. Some sculptors treat the ivory or bone first with special preparations to inhibit cracking and give the surface an enhanced slippery texture.

This lovely example shows a long history of use by its original owner that has shaped its appearance. The sculptors carve the pendants with the same sharply chiselled features as their wooden masks. The owners wear the pendants on cords or strings of beads around their necks, where in the course of the day they pick up sweat and (in the past) the red cam-wood powder used as a skin conditioner. Consequently, when the owners go to wash at the local stream, they scrub the pendants daily with abrasive fine sand to clean them and to preserve their colour. Although Westerners prize a golden patina,

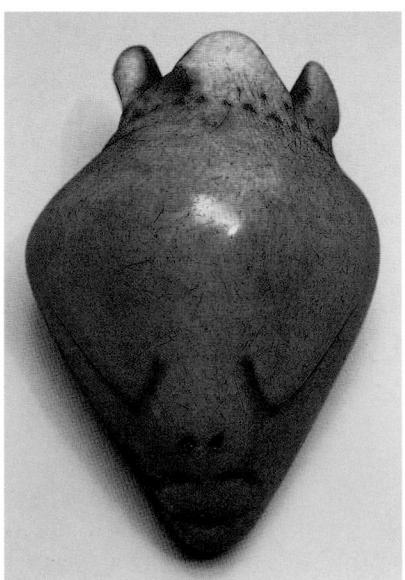

4.31a–c

Whistles

Pende
Zaire
wood
cat. 4.31a: 15 x 4.5 x 5 cm; cat. 4.31b: 11 x 3.5 x 3.5 cm; cat. 4.31c: h. 22 cm (not illustrated)
Herman Collection

It is often the case in the arts of Africa that the greatest refinement is found in the most utilitarian objects. The snuff bottles of the Zulu (cat. 3.30) are a case in point. A man or woman's essential possessions are seen by everyone; they become the focus for the greatest artistic inventions since prestige can be so easily (and daily) demonstrated. In other cultures the ubiquitous wristwatch can speak of wealth and sophistication. Forest people need whistles, which may become objects of personal adornment as well as giving pleasure in constant handling (which in turn makes them glow with wear and body oils).

Although as simple in musical structure as they are witty in style, the whistles of such peoples as the Pende or Teke are none the less capable (by means of half stopping the holes) of quite complicated utterances in the language of whistle-speech by which hunters can communicate across long distances. Two holes usually suffice to give the necessary range, and ears attuned to quarter-tones can detect a whole gamut of inflections from such limited means.

In many cultures (e.g. the Chokwe) the whistle is a prized possession whether in ivory or wood, and as a genre it is the netsuke of central Africa. TP

Pende clients worked to preserve the original white as long as possible. Even clients who kept their pendants for special occasions would have to scrub them from time to time with sand in order to keep the ivory or bone from darkening from house smoke.

This piece shows the effects of daily sand baths in the softening and blurring of its features. The extension of the nose and the eyelids are the first details to go. Comparison with works in the field indicates that this example received well over ten years of loving care that has resulted in the almost complete absorption of the features into the face.

There is some confusion in the literature about the role of these pieces. Recent fieldwork has clarified the issue. Although relatives and diviners sometimes made wood miniatures of masks for use in healing ceremonies, field associates stress that in contrast it was experienced sculptors who made the vast majority of pendants in ivory and hippopotamus bone as ornaments to embellish their clients' sense of beauty and style (*ginango*). ZSS

4.53

Male standing figure

Pindi (?)

Zaire

wood, pigment

h. 82.5 cm

Museum für Völkerkunde, Hamburg,
4490.05

Little is known about this unique piece. The Pindi (also called Pindji or Mpian) are an ethnic group dispersed in small groups between the Kwilu and Loange rivers in Zaire. They live peaceably intermixed with numerous other groups or in enclaves within Pende territory. Consequently, there is great diversity in their material artefacts, although they retain a distinct ethnic and linguistic identity. Frobenius acquired this piece in 1905 in Belo where Pindji, Hungaan and Mbala are in close proximity. The inscription to the Pindji is not certain as Belo may have been a collection point where individuals from the neighbourhood brought Frobenius material to sell.

Until recently, scholars have tended to avoid or underemphasise complex frontier cultures like this one in favour of large, centralised conglomerations or states. One can only generalise from Pende material that sculpture in the region tends to be used for decoration of the chief's house; for the creation of points of contact where individuals may pray to God through the intercession of the dead; and for personal power objects.

There are two indications that this figure was closely associated with the chief. The spotting is a ubiquitous reference to leopards and to the chief's metaphorical kinship to this beast. Apart from cunning and ferocity, there are thought to be parallels between a leopard stealing chickens and livestock and the chief's prerogative to collect taxes. The pattern on the cap is also one frequently associated with chiefs. The statue's condition and full-standing posture suggest that it was made to be kept indoors. The Pende used such figures within the chief's ritual house in order to fix a spirit for the chief's protection from his rivals.

The gesture of reaching up with both arms extended is unusual. The sculptor has formally enhanced its power and directionality by stretching out the arms and greatly elongating the neck and torso. Thompson records

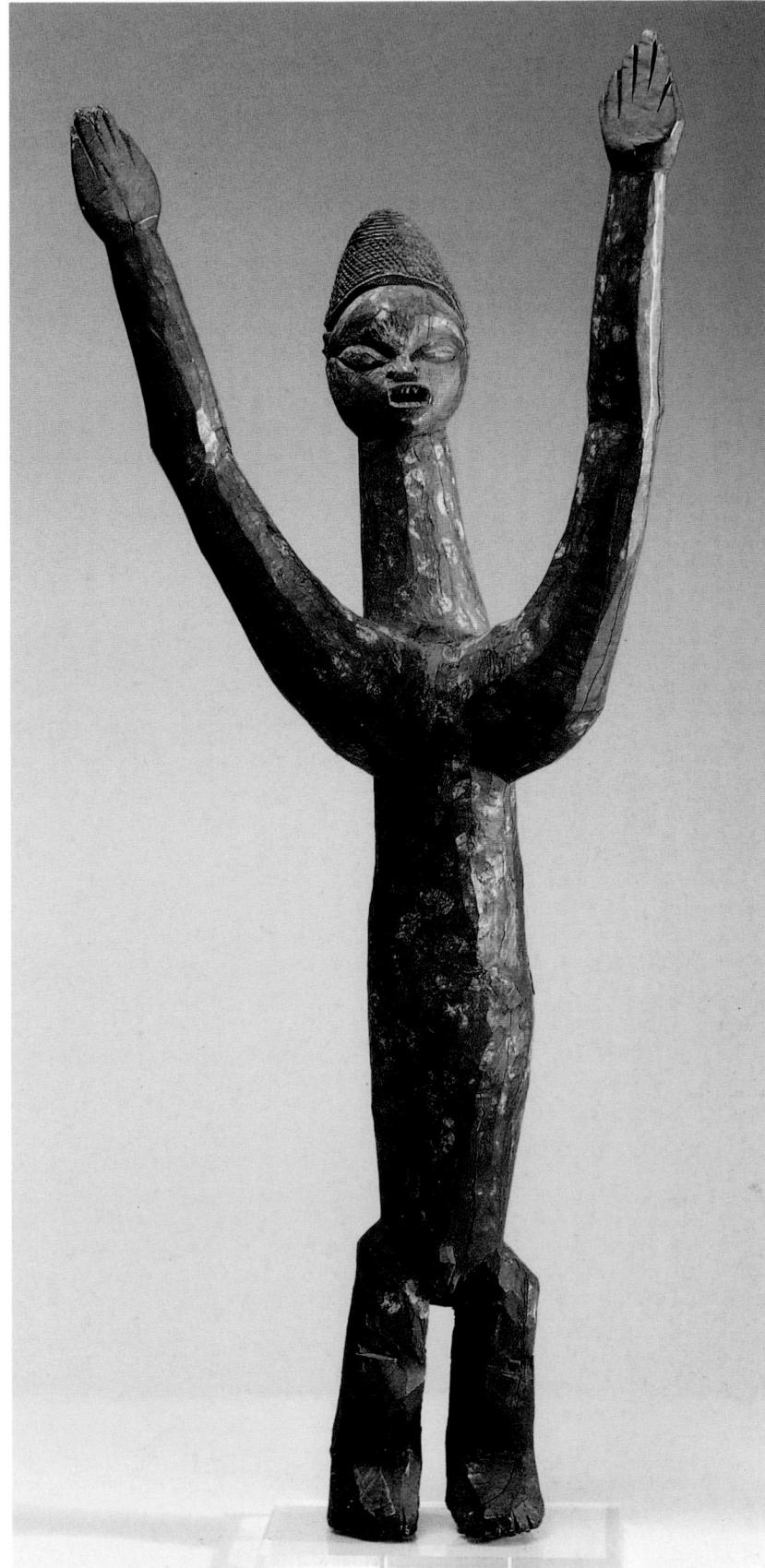

that the Kongo use a similar gesture with outstretched fingers (*yangalala*) to indicate joy and the shock of transcendent contact with the other world. Therein may lie a clue to the work's function. ZSS

Provenance: 1905, acquired in Belo by Leo Frobenius

Bibliography: Thompson, 1981, pp. 176–7; Biebuyck, 1985, pp. 150–2; Frobenius, 1985; Bourgeois, 1990, p. 123

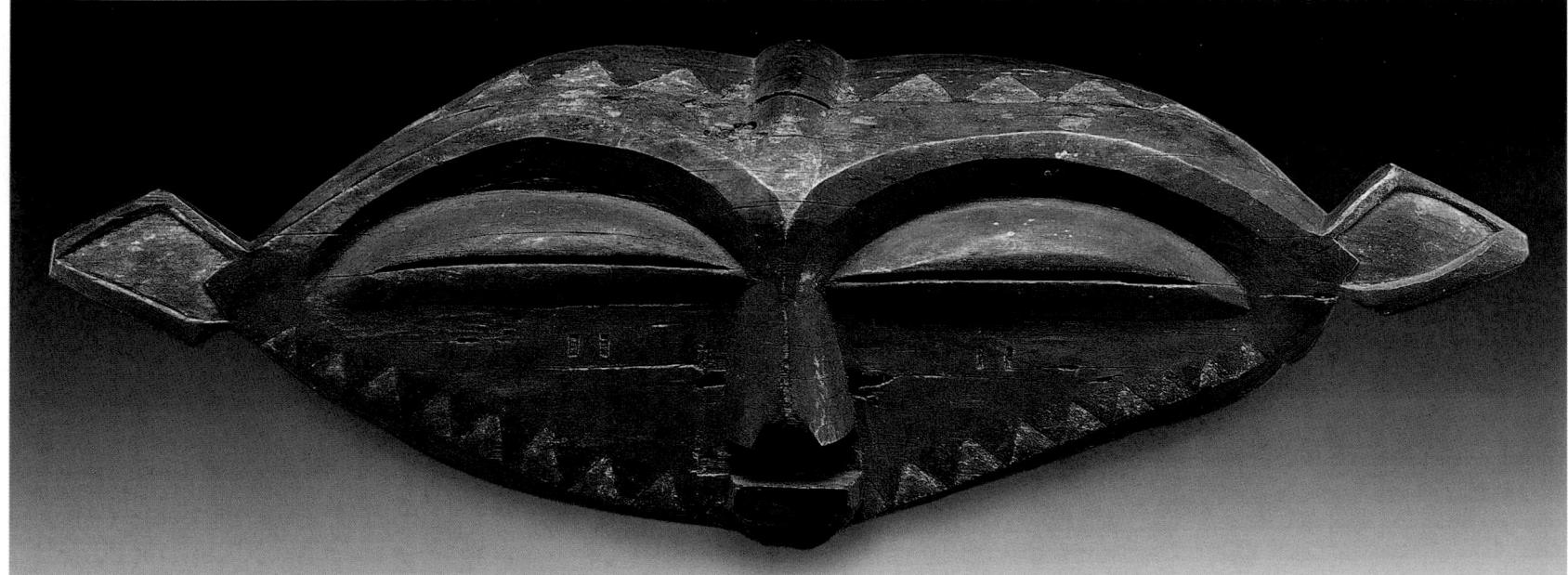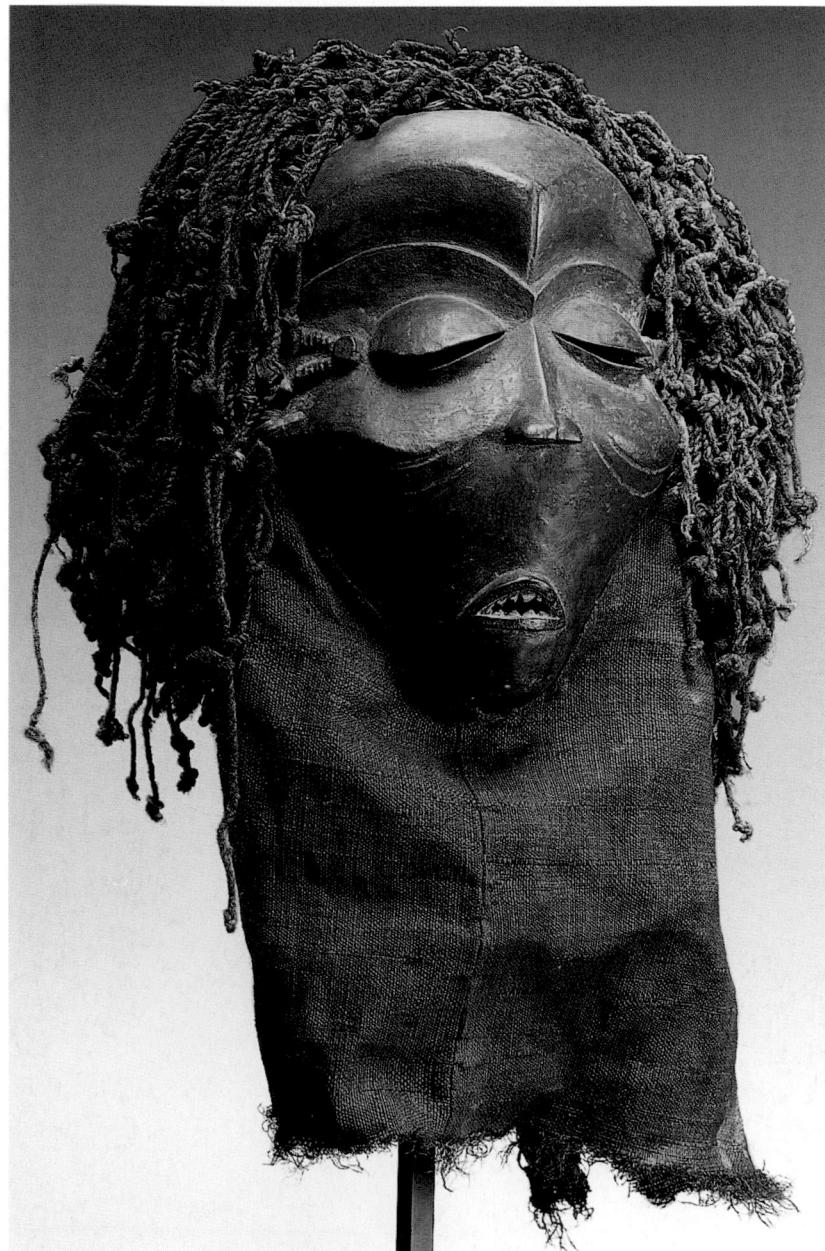

4.34

Mask (*Mbuya*)

Pende
Zaire
20th century
44 x 30 x 31 cm
wood, pigment, fibre, fabric
Felix Collection

The Pende are such sophisticated masqueraders that even their satirical masks (though in ritual there is no comedy without purpose) have a classical rigour. This mask belongs to the *travesti* tradition of men dressing as well-known feminine types (chief's wife, temptress, beauty queen etc.). This particular mask, probably the prostitute (*ngobo*), was danced in rites following boys' initiation. It was associated with a second initiation which traditionally would take place with a 'woman of the night'. The costume may be imagined covering the dancer and featuring large breasts of stuffed fibre.

In this mask the typical downcast eyelids of Pende sculpture, through whose narrow slit the dancer would see, are beautifully realised and the whole formal rhyme scheme echoes their seductive slant. This combined with the bold sweeping planes of the face creates a lofty formal rhythm seemingly at odds with the profane subject: such a paradox, even to the almost prim mouth, can also be found in the Japanese tradition and in Europe among the masks for the commedia dell'arte. TP

Bibliography: Petridis, 1993

4.35

Mask (*panya ngombe*)

Pende
Zaire
late 19th–early 20th century
wood
21.6 x 52.1 x 16.5 cm
The Detroit Institute of Arts
Founders Society Purchase, Eleanor Clay
Ford Fund for African Art, 79.37

Among the formidable range of Pende masks the human and animal are often linked, and in the West Kasai one particular type seems to share a masquerading and an architectural function. The lateral elongation of the *panya ngombe* mask relates to the wild cow/bull (or buffalo) which itself has chiefly associations and was danced by a masquerader in obviously regal dress, although this particular dancer (in a paradoxical role reversal that is to be expected in Pende masking traditions) is the one who collects offerings at the end of the initiation festivities.

Larger examples of this type of mask exist than the ritual itself would demand. These are referred to as *kenene* and served to decorate the lintels of major chiefs' houses. Here is one of the few cases in which absence of wear in a purportedly old mask should not arouse suspicion. TP

Statuette of a chief seated on a folding seat

Chokwe
Angola
before 1850
h. 45 cm (total); 29 x 17 x 19.5 cm (figure)
wood (*Crosopteryx febrifuga*), deep black patina;
hair, brass, beads, upholsterers' pins
Museu Etnografico (Sociedade de
Geografia de Lisboa), Lisbon, AB-924
S.G.L.

When one examines this complex piece of carving, it is difficult to believe that it is carved from a single log of wood; or that the sculptor had at his disposal only an adze, a small knife and a piece of red-hot metal wire to assist in the piercing of the openings.

The figure represents a local ruler (*mwanangana*), sitting on a Western type of chair that acts as a throne and clapping his hands in a gesture of greeting (*mwoyo*) in response to the homage paid to him by his subjects; he is wishing them a long life, health and prosperity. The traditional greeting was addressed to Kalunga, the Supreme Being, the All-Powerful, and is the equivalent of 'God bless you!'

The seat (or throne) is in the simplest of Western styles. The sculptor has shown more taste for opulence in other parts of the statue, although he was working within regional stylistic parameters, which have permitted attributions of this and similar creations to a single artist (or workshop) in the region of Moxico, south of the source of the Kasai. The small face, with its faint (but infectious) smile is surrounded with a finely plaited fringe decorated with a few red beads, the latter very unusual in Chokwe statuary. Lux, however, mentions this addition as being confined to the elders in his description of the hairstyles seen by him in the Songo area. An excellent photograph of four young Chokwe notables, each with a different hairstyle, taken by Fonseca Cardoso in 1904 in the region of Moxico, shows this style of fringe worn on the forehead by the man standing on the far left. Also very unusual are the great curved lashes supported at either end by the elliptical brass plate that emphasises each eye. The goatee beard, which has been dramatically shortened since 1985, used to be plaited and forked; it has lost the

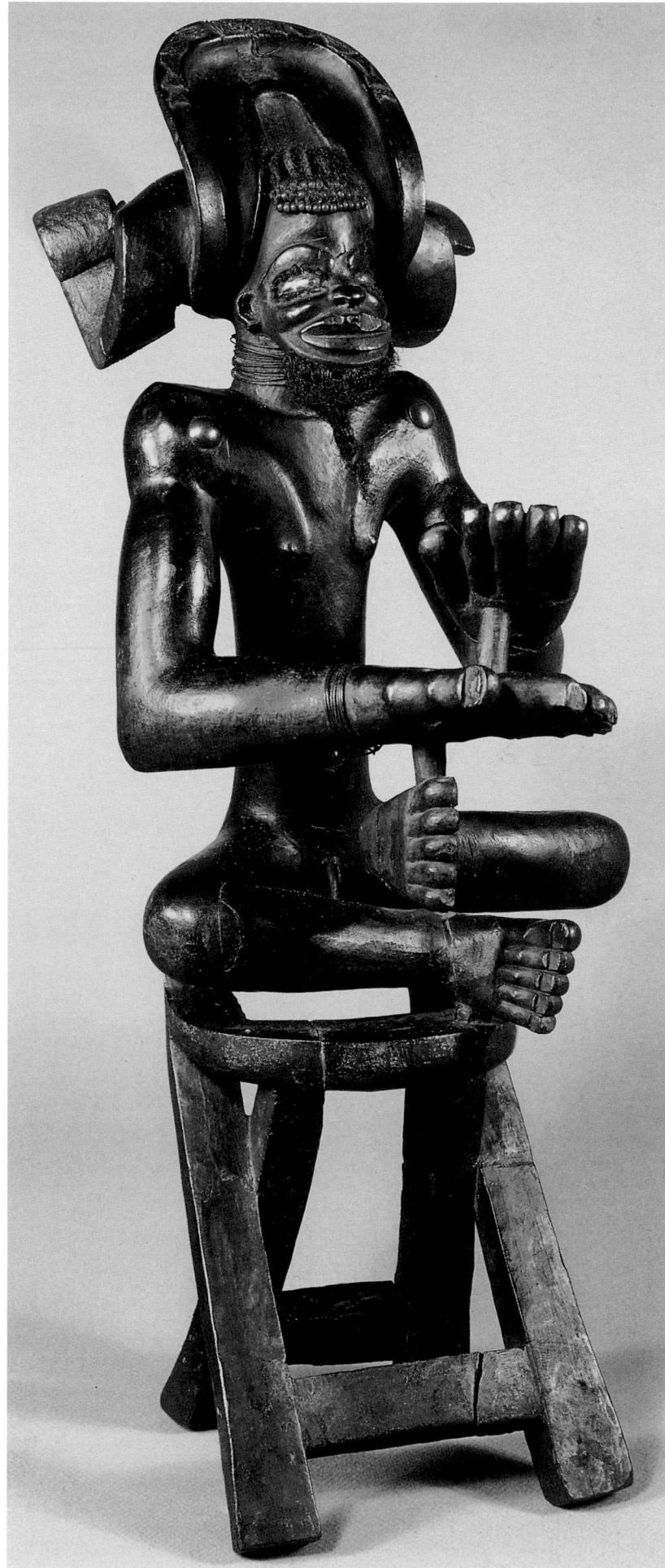

white and red beads that I saw threaded through its points in 1986. These details are not the only original features of this interesting sculpture. A border of interlocking triangles (*mapembe*) composed of fragments of brass wire carefully clipped together decorates the upper edge of the fan-shaped brim of the headdress. The usual curved side-wings appear originally to have been twisted into a spiral. *MLB*

Exhibitions: Rio de Janeiro 1922; Lisbon 1985, no. 115; Paris 1988, p. 79; Lisbon 1994, no. 116

Bibliography: Lux, 1880; Bastin, 1968, no. 8; Bastin, 1969, fig. 2; Bastin, 1981, fig. 11; Bastin, 1982, no. 64, pp. 130–1

Figure of the 'civilising hero'

Chibinda Ilunga

Chokwe

Angola/Zaire

before 1850

h. 39 cm

fine-grained wood, dark brown patina; hair, cotton, fibres, large yellow glass bead
Staatliche Museen zu Berlin, Preussischer Kulturbesitz, Museum für Völkerkunde, III C 1255 (1880)

Some time before 1956 a Namuyanga soothsayer in his eighties explained to me the identity of Chibinda Ilunga, the person commemorated in an ancient piece in the Museu do Dundo similar to this one (also undoubtedly of Chokwe manufacture); the entire Lunda people and anyone in their sphere of influence were already celebrating his memory. Victor W. Turner's *Lunda Love Story* (1955) gives a good résumé of the tale written down by H. Dias de Carvalho (1890) while staying at Musumba, near the River Kalanyi. It was Dr Paul Pogge, however, the first European officially to have reached the capital of the Mwata Yamvo empire in 1875, who made a record of this dynastic epic.

Chibinda Ilunga, the prince of 'sacred blood' (*mulpwe*), came from the eastern Luba lands ruled over by his father Kalala Ilunga. He was a passionate huntsman and, having crossed the Kalanyi-Bushimai, arrived in an area owned by the young female chieftain of the Lunda, Lweji. She was the keeper of the traditional symbol of authority, the bracelet or *lukano*, inherited from her father, Konde; the bracelet gives its possessor seniority over other lineages and pre-eminence at the Council of Elders. At that period the Lunda lands, between the Kalanyi and the Lulua, knew nothing of centralised power and their hunters still used only bludgeons and catapults. The noble stranger, raised in more sophisticated court circles and venerated by his retinue, used hunting weapons of metal, their efficacy reinforced by auspicious spells. Lweji, agreeably impressed by his gifts of game and attracted by his guest, welcomed Chibinda Ilunga enthusiastically to her domain; one day, after their marriage, she handed him the symbolic *lukano*. Her brothers and other important elders were displeased by

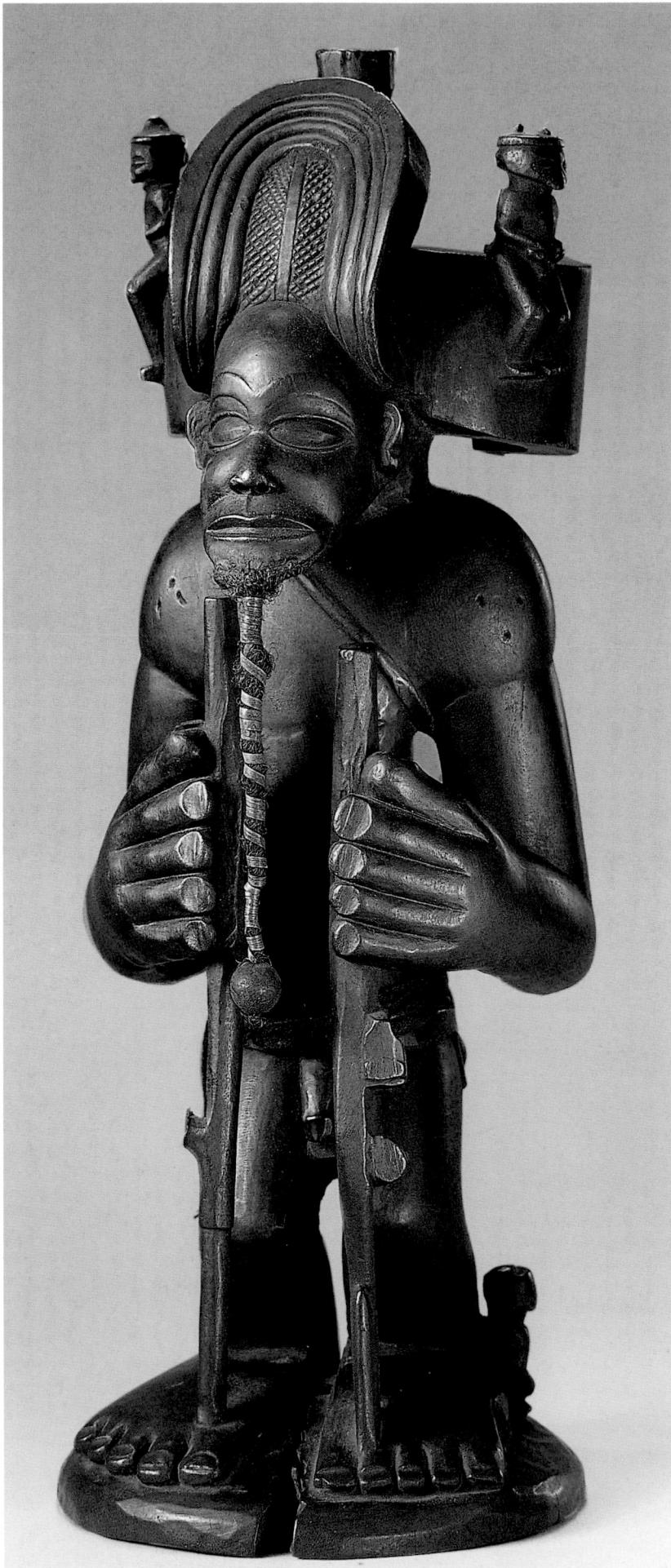

this seizure of power and left for the west, beyond the Kasai, in search of new lands. They took with them, however, some of their newly acquired customs and knowledge. These they transmitted to the people occupying the high wooded plateau, the fertile valleys, the sources of the Kasai and the Kwango, the land of the Chokwe or Uchokwe (also known as 'Tchiboco'), a land rich in game, favourable to the cultivation of cereals and vegetables, and where honey could be gathered in abundance.

Through an intricate series of marriages they became completely integrated into the local population which, as luck would have it, already had a long history of wood carving. Thus, as powerful chiefdoms were formed over the years, a court art developed in each one. Their rulers, wanting to commemorate this cultural hero of yore, commissioned their celebrated professional sculptors, or *songi*, to make images of Chibinda Ilunga. The prince was portrayed in full hunting regalia (including, from the end of the 18th or early 19th century, a flintlock rifle), and his due complement of charms. He was also shown proudly wearing the royal headdress of the Lord of the Chokwe (*mwanangana*).

This masterpiece returns the hero to his traditional role: he is a haughty and dignified figure, in spite of his powerful musculature and the exaggerated size of his extremities. His long, carefully tended beard emphasises his aristocratic origins. The miniature figures around him are tutelary spirits, vigilantes, looking out for game or a predator. *MLB*

Provenance: 9 November 1878, acquired from a Chokwe trader met by Otto H. Schütt on the road to Kimbundu, after the crossing of the River Loange

Exhibitions: Paris 1988, p. 72; Maastricht 1992, no. 90

Bibliography: Schütt, 1881, p. 151; Alexis, 1888, p. 233; Dias de Carvalho, 1890, pp. 50–112; Sydow, 1954, pl. 96–A; Bastin, 1961¹, fig. 1; Bastin, 1965, figs 9–11; Krieger, 1965, fig. 268; Leiris and Delange, 1967, fig. 55; Bastin, 1978, pls III–IV; Bastin, 1981, fig. 5; Bastin, 1982, no. 80

4.38

Female memorial effigy

Chokwe

Angola

before 1850

fine grained wood, dark reddish patina,
red ritual mud in eyes and mouth, hair
h. 35 cm

Staatliche Museen zu Berlin, Preussischer
Kulturbesitz, Museum für Völkerkunde,
1886, III C 2969

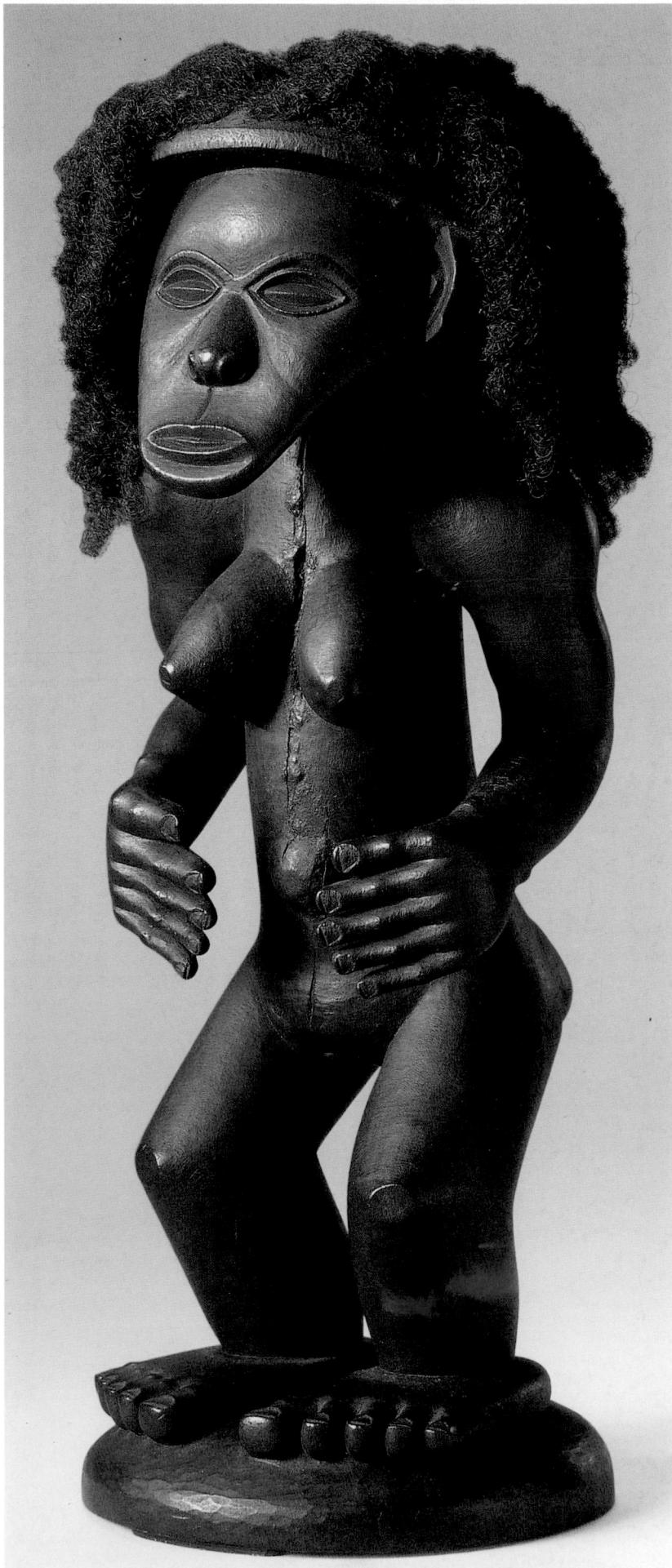

This powerful portrait probably represents the chief's leading wife (*namata*) or the queen mother (*mwanangana wa pwo*), both of whom had an important ritual position at court. In 1795 the caravan routes arrived at the upper reaches of the Zambezi, and this people, who lived in the interior at the sources of the Kwango, Kasai and Lungwe-Bungo rivers, were officially recognised in Benguela. The skill of their professional sculptors (*songi*) was recognised by all their neighbours, and indeed their renown must have reached the Atlantic coast, probably with the Ovimbundu as intermediary. This would explain how so much of their work was acquired from its country of origin by collectors in the last quarter of the 19th century.

Although modest in size, this piece is striking because of the extraordinarily vigorous way it projects itself into the three dimensions. Great care has been taken, nevertheless, with the carving of the face and the details of the hands and feet.

The stylisation of the face, projecting forwards in echo of the image traditionally depicted by the Chokwe in their masks, suggests categorisation of this effigy as belonging to the 'Muzamba school', at the source of the Kwango River.

Chokwe 'court art' is characterised by a certain naturalism, demonstrated in this exceptional example by the figure's opulent hairstyle. This is composed of real hair, plaited and fixed with pegs to the top of the head, behind a kind of diadem.

Baumann recorded oral testimony describing the composition of a court from an elderly notable whom he encountered at the source of the Kasai. The power of the local chief (*mwanangana*) was connected with the spiritual influence he wielded over the prosperity and fertility of his subjects; it was transmitted to him by ancestors of his dynasty at his enthronement. *MLB*

Provenance: before 1886, collected in Benguela by the explorer and diplomat Gustave Nachtigal

Exhibition: Berlin and Paris 1964

Bibliography: Sydow, 1926, pl. 25; Baumann, 1935, pp. 140–1; Fagg, 1964, fig. 76; Krieger, 1965, no. 306; Bastin, 1981, fig. 10; Bastin, 1962, ill. 97

4.39a–p

Divination figures

Chokwe
Angola
early 20th century
patinated wood, beads
h. 4–7.5 cm

Staatliches Museum für Völkerkunde, Munich, 33-30-3 (cat. 4.39a), 33-30-6 (cat. 4.39b), 33-30-2 (cat. 4.39c), 33-30-1 (cat. 4.39d), 33-30-7 (cat. 4.39e), 33-30-4 (cat. 4.39f), 33-30-8 (cat. 4.39g)

Staatliche Museen zu Berlin, Preussischer Kulturbesitz, Museum für Völkerkunde,

a III C 34687a (cat. 4.39h), III C 31775b (cat. 4.39i), III C 43841 (cat. 4.38j), III C 35680 (cat. 4.39k), III C 34687b (cat. 4.39l), III C 34687c (cat. 4.39m), III C 31775a (cat. 4.39n), Jean and Noble Endicott (cat. 4.39o–p)

Most of these small wooden carved objects were contained in a basket, called *ngombo ya cisuka*, used by the fortune-teller (*tahi*) of the Chokwe. This method of divination (*ngombo*), using a basket filled with a variety of symbolic objects which is shaken by the dignitary in charge (*kusuka*), is widespread among the Chokwe and was also adopted by some of their neighbours.

Divination is practised professionally only by a person designated and inspired by the spirit of *ngombo*. It takes place during a solemn public ritual. Normally a suppliant does not ask for prophecies about the future, but rather the causes of misfortune, sterility, illness, a death or even a scourge or epidemic afflicting a whole people.

The symbolic contents of the basket represent a diversity of items; they include carved wooden images of people, animals and objects, as well as vegetable and mineral subjects. Following a consultation, speedy atonement for the wrong done to

a person, or offence done to a spirit, can be imposed. When the influence of witchcraft is detected the 'eater of souls', who once would have been put to death, is nowadays permanently banned from the community.

The four *kalamba kuku wa lunga* figurines (cat. 4.39d,h,j,p), showing an ancestor squatting with his elbows on his knees and his hands on his head as

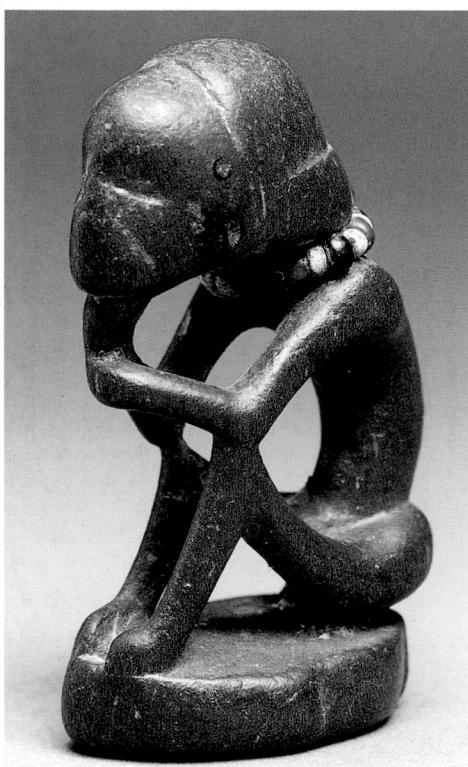

d

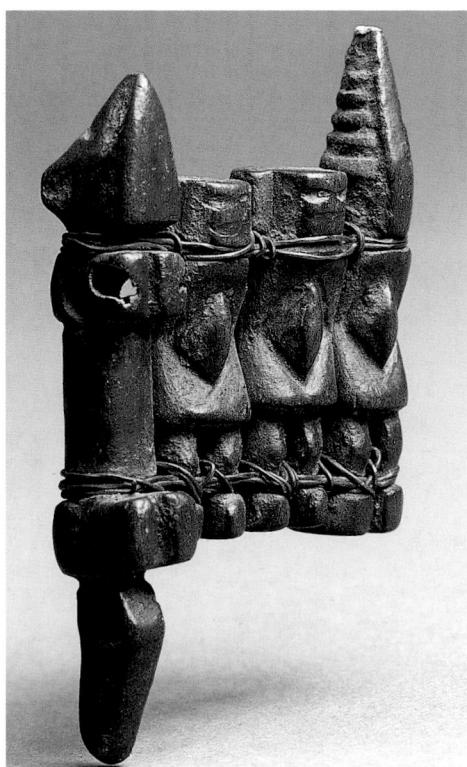

e

f

g

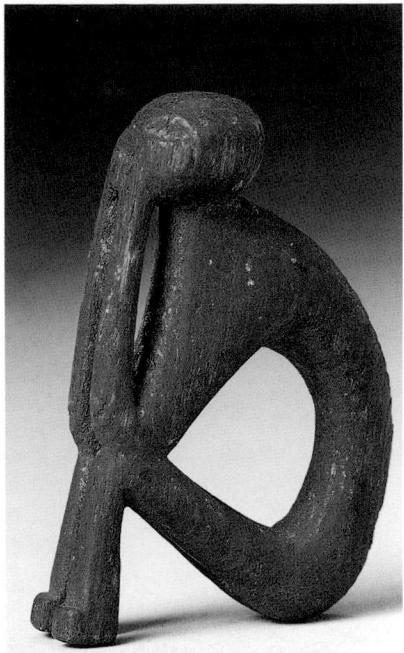

h

a sign of desolation (because his descendants have neglected their worship of him), illustrate the very individual way in which a sculptor can interpret a stereotype.

One important symbol evokes the spirit of *cikunza* (cat. 4.39c), auspicious for hunting and fertility. It is worn as an amulet on a gun or, by women, on a belt. It is personified in mask form (*mukishi*) during circumcision rituals, and is a benevolent patron of the initiation ceremonies performed when adolescents reach adulthood. This 'hunting amulet' is not really a divination figure, but Rodrigues illustrates three similar

objects collected in Angola for the collection of the Musée d'Ethnographie de Neuchâtel.

The female figurine *katwambimbi* (cat. 4.39a), the 'weeping woman', shown standing with her hands raised to her head, foretells an imminent death.

Cat. 4.39f shows a *mbata* man and woman coupling (*kumbata*: to get married); its meaning is highly complex, concerning the life of the couple as well as their relationship with their respective families.

Mufwaponde, the cripple (cat. 4.39n), denotes, according to Rodrigues, danger; if the head has been cut off (cat. 4.39l) the intervention of a sorcerer's black magic is to be feared.

The sorcerer, *cilowa* (cat. 4.39m), is carved schematically, his head being replaced by a ball of black wax, the surface of which is encrusted with the red and black fruit of the liquorice creeper. The small female figurine (cat. 4.39g) would seem to represent the spirit of *kakuka* (pl. *tukuka*) and relates to a sickness or possession suffered by women, to be cured or exorcised by an affliction ritual.

The figure of *kufu* (pl. *mufu*), a corpse, is usually represented by a fragment of wood (representing the bier pole) on which is hung a simulacrum of mortal remains (cat. 4.39b). Its presence at one side of the basket is a bad omen. It is most unusual for *mufu* to be evoked by such a complex scene as this – two men carrying the deceased, lying in a kind of palanquin (*tipoye*).

The four-footed animal (cat. 4.39k) appears to represent *muta*, the dog spirit, honoured in village sanctuaries by hunters and women seeking to become fertile. It is also represented on amulets, worn on a gun or at the waist. The example exhibited here is carved with exceptional suppleness.

The authors who have described the *ngombo ya cisuka* have never mentioned the small mask (female?) among the contents of the basket (cat. 4.39o). In fact it is only the Chokwe, neighbours of the Pende in Zaire, who have imitated their famous *ikhoko*, and this only since the turn of the century. The *ikhoko* is worn by men in memory of their initiation to adulthood, or for medicinal purposes.

These figures are usually made by the soothsayer or his assistants and are in no way considered works of art by the people using them. The contents are first consecrated by the professional soothsayer, then the configuration of objects obtained at the edge of the basket, at the 'eye' where the white clay (auspicious) meets the red clay (inauspicious), indicates the reply of the *ngombo* spirit that has been called up. It is a sensitive and diplomatic way of resolving private problems or conflict within the community. *MLB*

Bibliography: Krieger, 1969, figs 342–3; Rodrigues, 1985

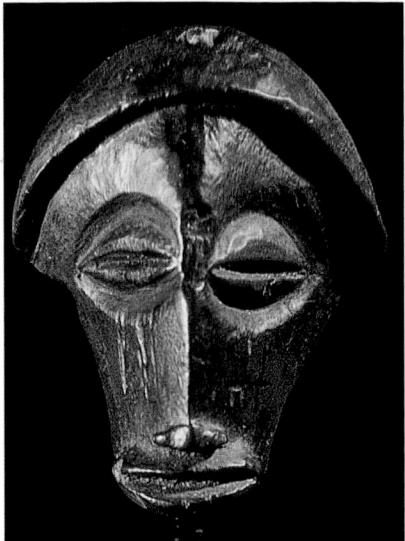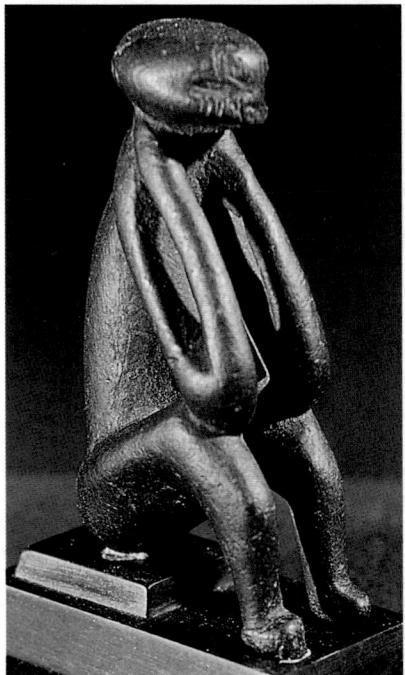

p

i

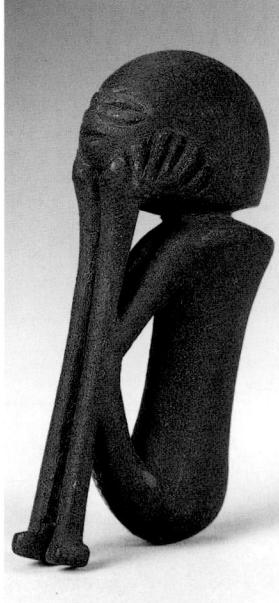

j

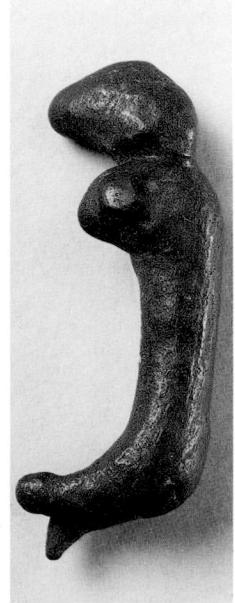

k

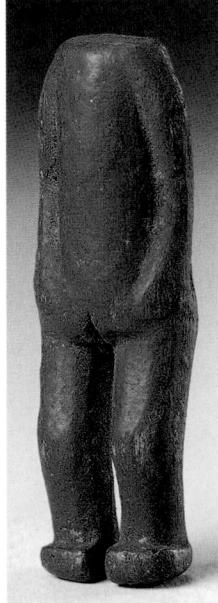

l

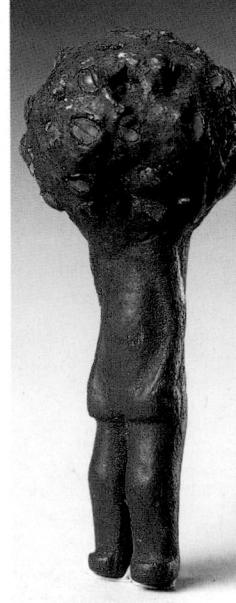

m

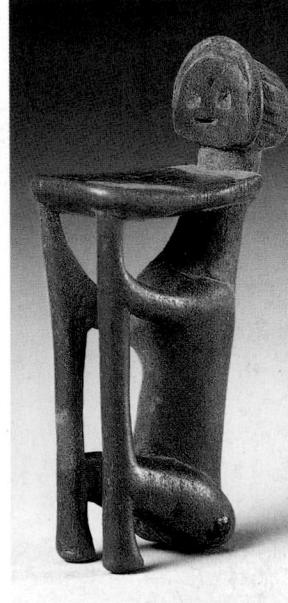

n

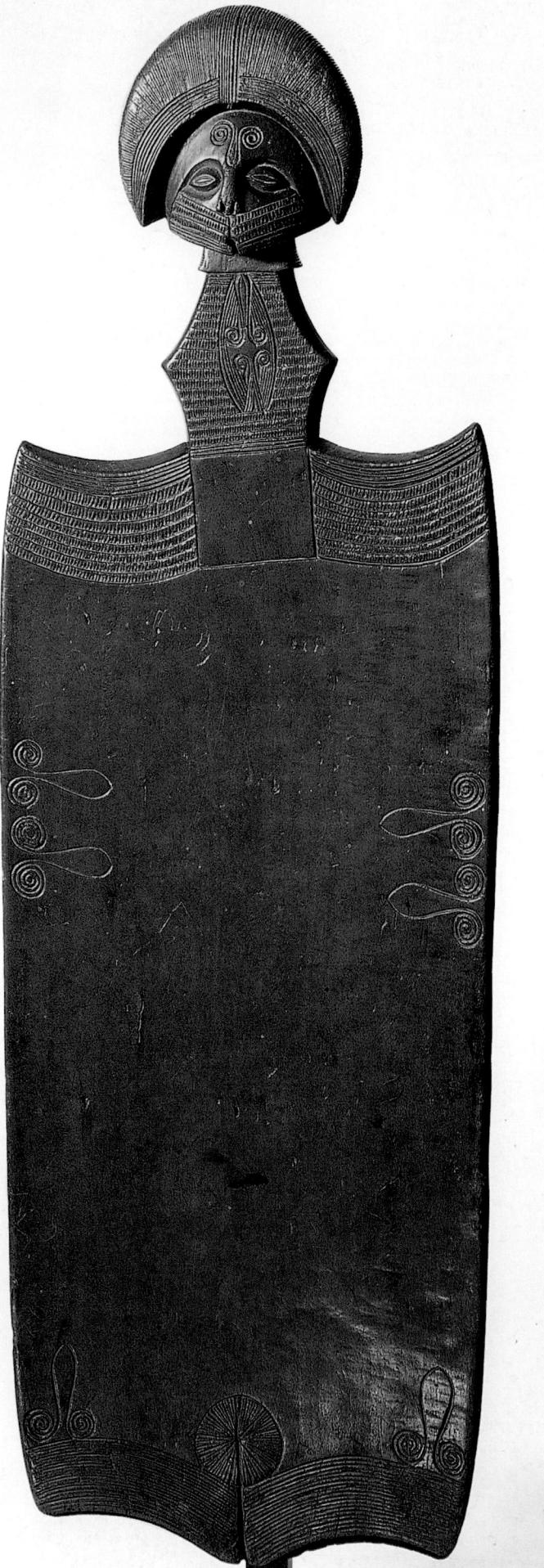

4.40

Bench or ceremonial bed

Chokwe

Angola

19th century

hardwood, chestnut brown patina

131 x 44 x 21 cm

Private Collection, Paris

The function of this unique piece, magnificently carved and bearing the patina of long years of use, is an enigma. It was certainly a ceremonial item, and seems to have belonged to a chief of the 19th century, when there was still an aura of splendour surrounding the 'ruler of the country' (*mwanangana*).

In 1985, when I came across it in a series of photographs sent me by its owner, I was able to confirm that there was good reason to think it was of Chokwe manufacture. The female hairstyle, although schematised in order to be presented in two dimensions, bears all the characteristics of the styles that had formerly been in fashion. The features were not far removed from those of the region. And the double spiral motif, *ukulungu*, abundantly repeated, exactly reproduced the classic earring design of the same name: this was a small item of female jewellery made of copper wire, skilfully coiled, also previously popular among the Chokwe.

The collector thought that this was a low table with four legs shaped like sawn-off cones, but no such piece of furniture was ever used by the Chokwe. Although for several decades tables were made on the (much enlarged) model of a four-legged stool with cross-pieces, covered in hide (already demonstrating Western influence dating back to the caravan trade of the mid-18th century), this novelty was introduced mainly to satisfy the demand of Europeans, particularly in Zambia.

The piece shown here is made of woven laths covered by a large mat which is often elegantly woven and decorated. In 1946, when he first began exploring the 'Tchibuco', the Uchokwe lands from which this people originally came, José Redinha de Saipes collected an item of furniture that was no less remarkable. This Portuguese ethnologist, formerly curator of the Museu do Dundo, entered the area where the Luachimo and Chiumbe rivers have their source and came upon the small chieftaincy

of Kalundjika (north of present-day Dala), where the Chokwe and the Lwena lived side by side. One particular worthy claimed to be descended from the celebrated Chinyama, brother of Queen Liveji of the Lunda; Chinyama went off on a mission of conquest some 500 years earlier in the direction of the Upper Zambezi and became chief of the Lwena (or Luva) people. Among the objects Redinha acquired is a handsome couch with a base of stretched hide and a small back-rest whose two uprights each bear a female head with headdresses consisting of a broad grilloche band (Museu Nacional de Antropologia, Luanda).

Given the dimensions of this handsome piece, no more than a metre long, and exceptional in every way, it is possible to think that it was used as a ceremonial bench on which the chief could sit comfortably while holding an audience. *MLB*

Exhibition: Paris 1988, p. 92

Bibliography: Redinha, 1953, p. 143; Bastin, 1961¹, fig. 77

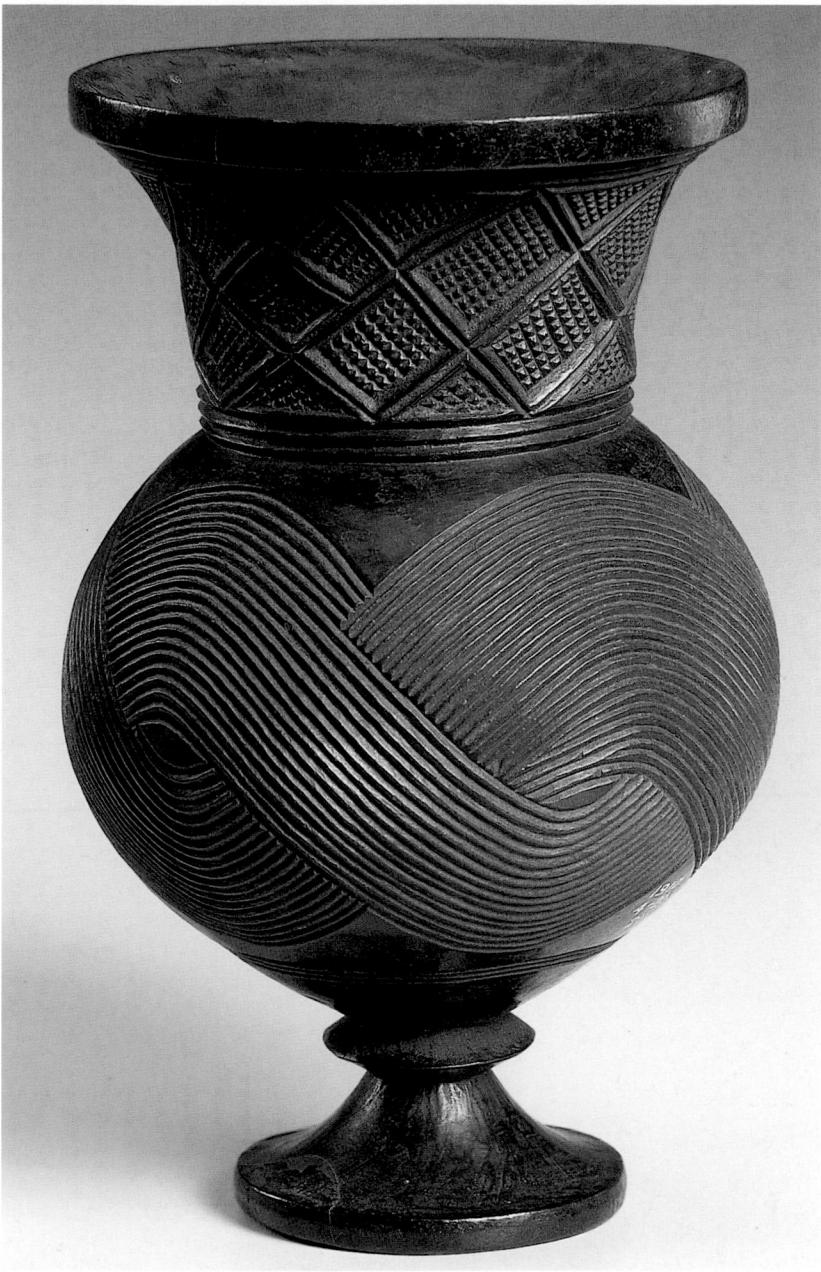

4.41

CupWongo
Zaire
wood

21 x 15 cm

The Trustees of the British Museum,
London, 1910. 4-20.21

This cup is one of several collected for the British Museum in 1909 by Emil Torday among the Wongo (confusingly he referred to them as the Bakongo). It probably comes from a Wongo village in the area of Kangala, otherwise a Pende chieftaincy between the Luana and Loange rivers. The cup is among those described several times in the associated documentation as 'quaintly carved' and 'remarkably skilful' in execution.

Torday 'noticed at once a similarity in the patterns with which these cups were ornamented and those which we found among the Bushongo' (that is, the Kuba), another piece of evidence to support his theory that these two peoples are nearly related. The Wongo are not formally part of the Kuba kingdom, though they share features of the cultural and artistic life of their neighbours to the east. Indeed Torday's passage through their country was encouraged by the reasonable reports he had received of the Wongo from the Kuba king himself.

The Wongo in fact, like many peoples in the region, make several styles of cup for drinking palm wine, including some in human form. The

symmetry of this example almost suggests that it has been turned on a lathe rather than carved directly with adze and knife as is the case. Its elegance is among the perplexing pieces of evidence to underline an emerging paradox of this period in the exploration of central Africa – that the most accessible and refined objects, from an external perspective, derived from the remotest and last explored parts of the continent. At a time in Europe when the so-called 'primitivist' movement was interested in the arts of coastal and riverine Africa, and especially in areas of French occupation, these 'sophisticated' pieces from deep in equatorial Africa challenged prevailing assumptions. Wongo country, after all, is not known to have been traversed by any European before Torday, and at the time the Wongo had a fearful reputation. Cups with this degree of accessible aesthetic quality were in sharp contrast to the image summoned up by rumours of cannibalism, treachery and aggression. JM

Provenance: 1909, collected by Emil Torday

Bibliography: Torday, 1925; Hilton-Simpson, 1911; Mack, 1990

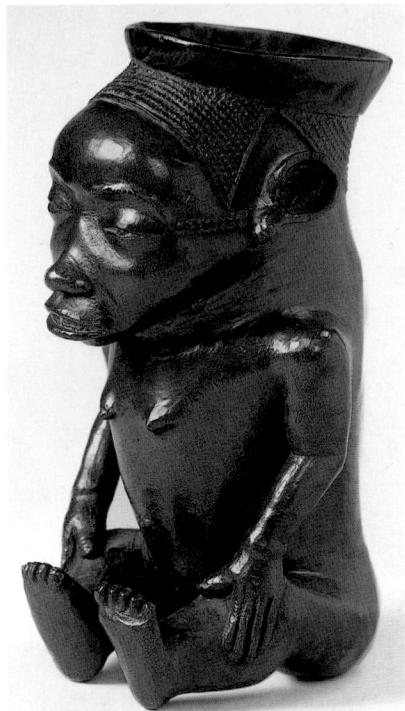

4.42

CupKuba
Zaire
wood

h. 19 cm

Private Collection, Paris

This cup is identified with the Kuba, though whether it is in fact from within the central groups of the Kuba kingdom itself or from one of the Kuba-related peoples, such as the Wongo or Lele, is not clear. Likewise it is not certain whether it was made for a local client or perhaps at the behest of missionaries or visitors. It represents an impressive sculptural achievement. Its form, however, that of a seated figure, is not replicated in

other clearly documented cups and seems to imply a degree of artistic licence and innovation suggestive of an expanded market.

In fact exercises in virtuosity which extend the canon of Kuba artistic expression are well enough known, even though the prevailing view of the 'tradition-bound' and 'formulaic' character of sub-Saharan African art tends to deny the possibility. After all, the famous Kuba king figures (not represented in this selection) appear to be the work of a limited number of innovative carvers. Cups in human form are known from many Kuba groups. Yet their very variety is already indicative of an exploratory approach. Vansina, for instance, speaks of a carver who, having created an image of a man riding an antelope, hollowed out the top and used it as a cup. Even if the cup here has indeed been created for an external market, its originality of conception is within the expectations of a Kuba court interested in virtuoso pieces. Indeed, it is arguable that the diversity of Kuba art was in fact greater in the 19th century than in more recent times – the impact of so-called tourist arts has contributed to standardising not expanding Kuba virtuosity. JM

Provenance: 1909, collected by Emil Torday

Bibliography: Vansina, 1968, pp. 12–27; Rosenwald, 1974, pp. 26–31; Vansina, 1978; Cornet, 1982

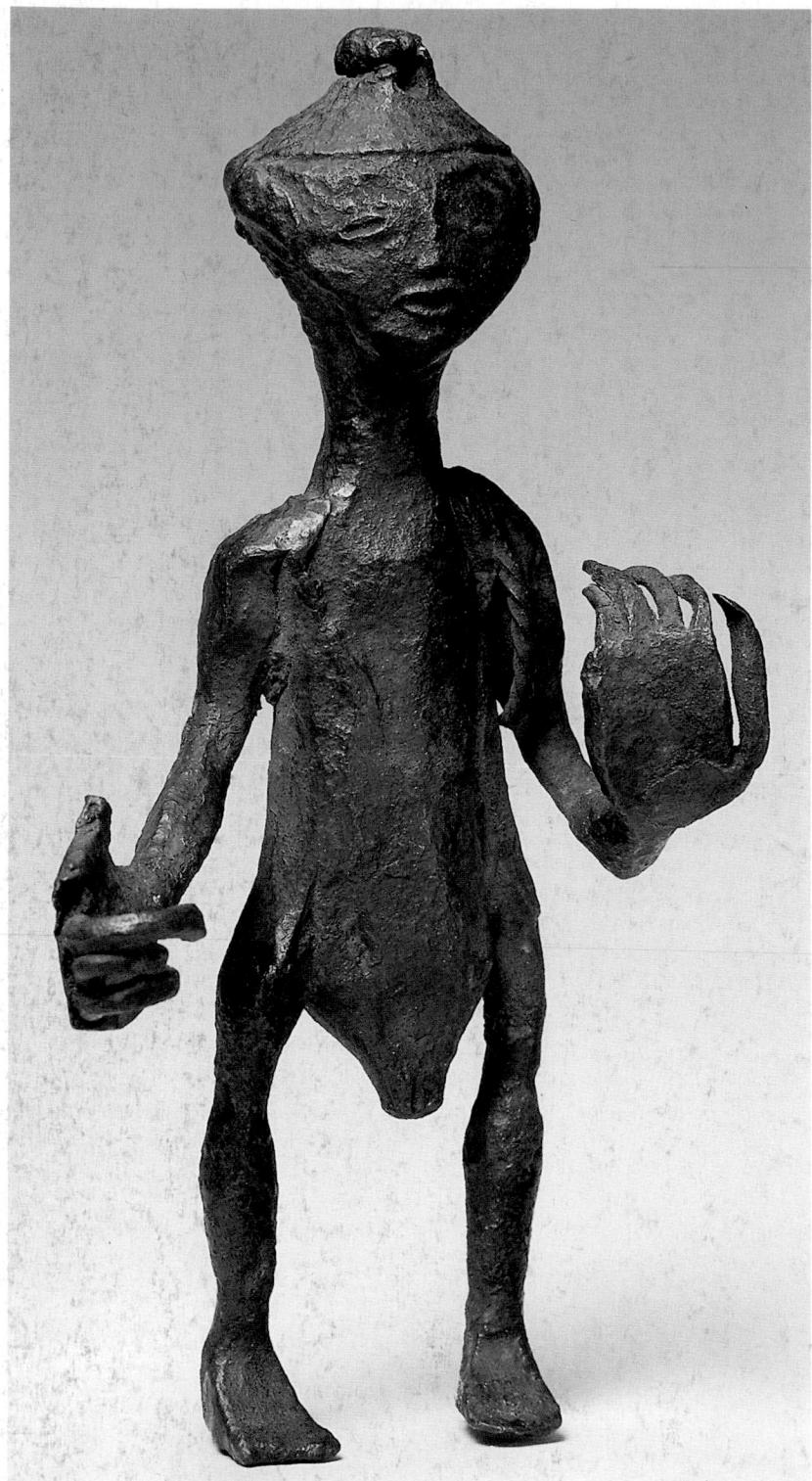

4.43

Statuette

Kuba
Zaire
18th century (?)
iron

h. 19.5 cm
Museum of Ethnography, Antwerp,
AE 773

This unusual statuette belongs to a pair of royal Kuba ornaments. Its companion piece is in the same museum. Other metal statues and some prestigious weaponry are attributed by the Kuba to one of their princes, Myeel, who must have lived in the 18th century.

This statuette depicts a man with a long neck and triangular head; his facial features are not very prominent. The hairline has the sharp angles

characteristic of the Kuba style. The body is powerfully modelled and stands on thin legs. The companion statue in the same style is prolonged by a kind of support that seems to prove that both figures were fixed to a base, possibly an item of royal display.

The Bushoong, the royal tribe of the Kuba kingdom, attribute every metal sculpture that shows talent to Myeel. Admiration for his work was increased during the reign of King Mbopey Mabiintsch ma-Kyeen, who died in 1969; he asked his blacksmiths to copy some ancient pieces, but their attempts met with no success. Legend has it that Prince Myeel was a first-class blacksmith. He should have succeeded to the throne but his difficult character caused him to be passed over by the dignitaries responsible for choosing a successor.
JC

Provenance: ex Pareyn Collection; 1920, acquired by the museum

Bibliography: Claerhout, 1976; Cornet, 1982

4.44

Figure

Ndengese
Zaire

wood, beads, copper
42.6 x 8.8 x 1.2 cm
Lent by the Metropolitan Museum of Art, New York
The Michael C. Rockefeller Memorial Collection, purchased by Nelson A. Rockefeller, 1978.412.618

The Ndengese are among the least prolific sculptors of west Africa. The quality of their royal figures, however, is such that the few examples that have survived are among the great treasures of the Tervuren and a handful of other museums. These have sumptuous body decoration in the style almost of the cloths made by their dominant near neighbours the Kuba. The serene faces of these statues are topped by an elaborate combination of coiffure and bonnet, the latter culminating in a projecting wooden cylinder. The Metropolitan Museum, as well as having such a figure, contains this variant which is seldom published. While possessing

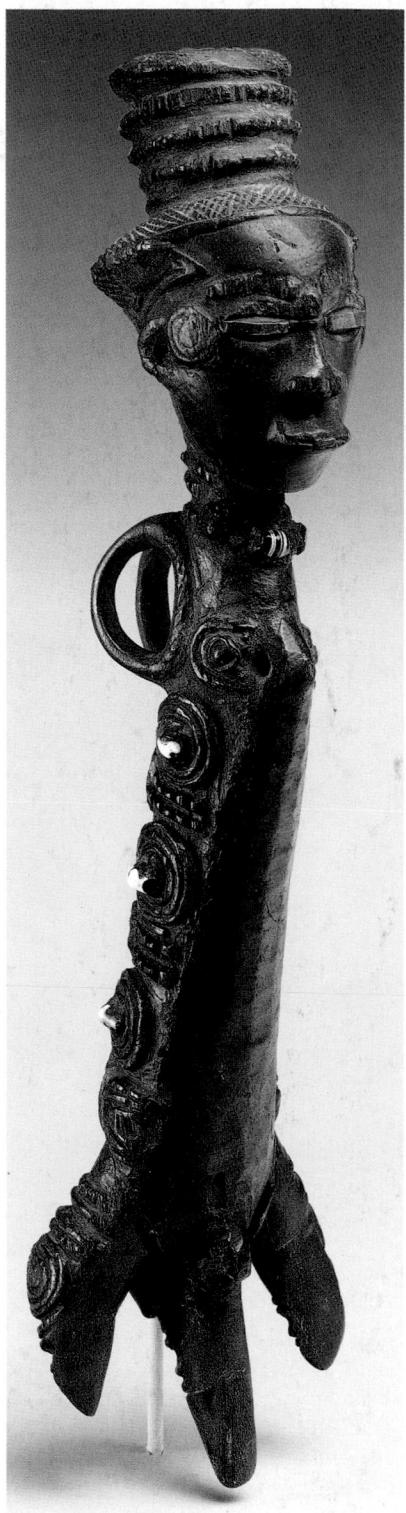

the characteristic scarifications, extended torso etc., it has an intensity which contrasts with the aloofness of the larger funeral effigies of notables (*totshi*). It bears many signs of ritual use and applications of palm oil. The presence of metal (copper) and beads also indicates its continuity of value to its original clientele. *TP*

Bibliography: Lewis and Delange, 1968

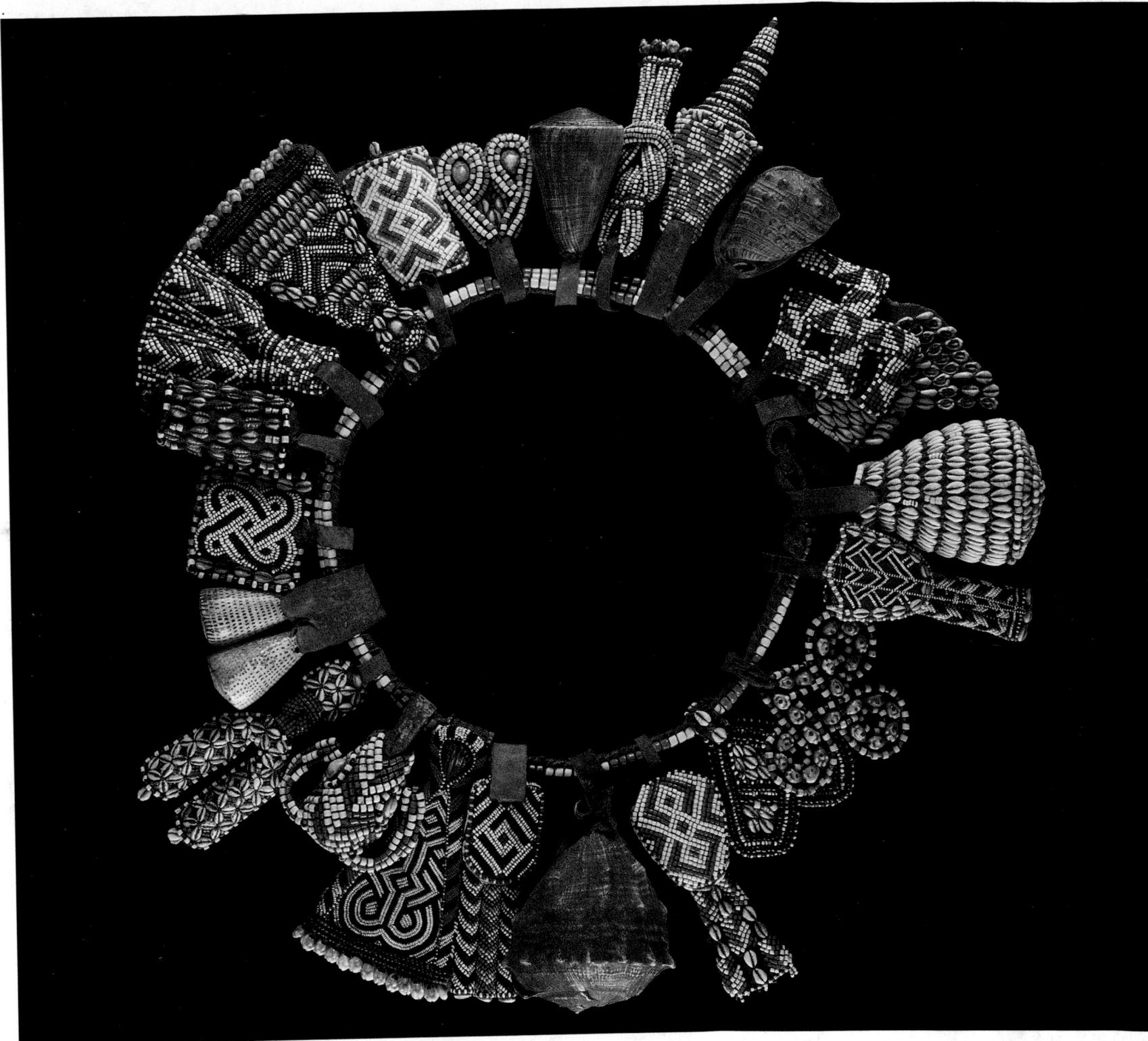

4.45

Beaded girdle

Kuba

Zaire

beads, shells, leather

The Minneapolis Institute of Arts
The Ethel Morrison Van Derlip Fund, 89.1

This superb girdle is a masterpiece of the inventive Kuba beadwork tradition. As so often in west and central Africa we find beadwork associated with, and being the

perquisite of, royalty, as is true of the Yoruba in Nigeria (cat. 5.85) and the kingdoms of Cameroon (cat. 5.80). In a sense this type of girdle (*yet*) is the apotheosis of the charm bracelet, consisting as it does of a collection (and additions are made up to a seeming record of 80 charms, in the *yet* of King Kot Mabiintsh ma Kyean) of traditional devices and signs realised in beadwork, together with shells that have a prestige value

because of rarity (i.e. that have come from distant seas).

Some of the elements can be easily read by the uninitiated like the knot and the animal head with horns: others include bells, leaves etc. The decorative devices recall both the figuring on wood sculpture, body scarification and other designs that are familiar from textiles (cat. 5.93). Cowries, as might be expected on a display object connected with wealth

and prestige, also figure largely, as they do in the exclusively royal belt (*nkap*) made of leopard fur. The *yet*, however, is the most flamboyant of all girdles and as can be seen in this example calls for design and bead application of the highest quality.
TP

Bibliography: Cornet, 1982

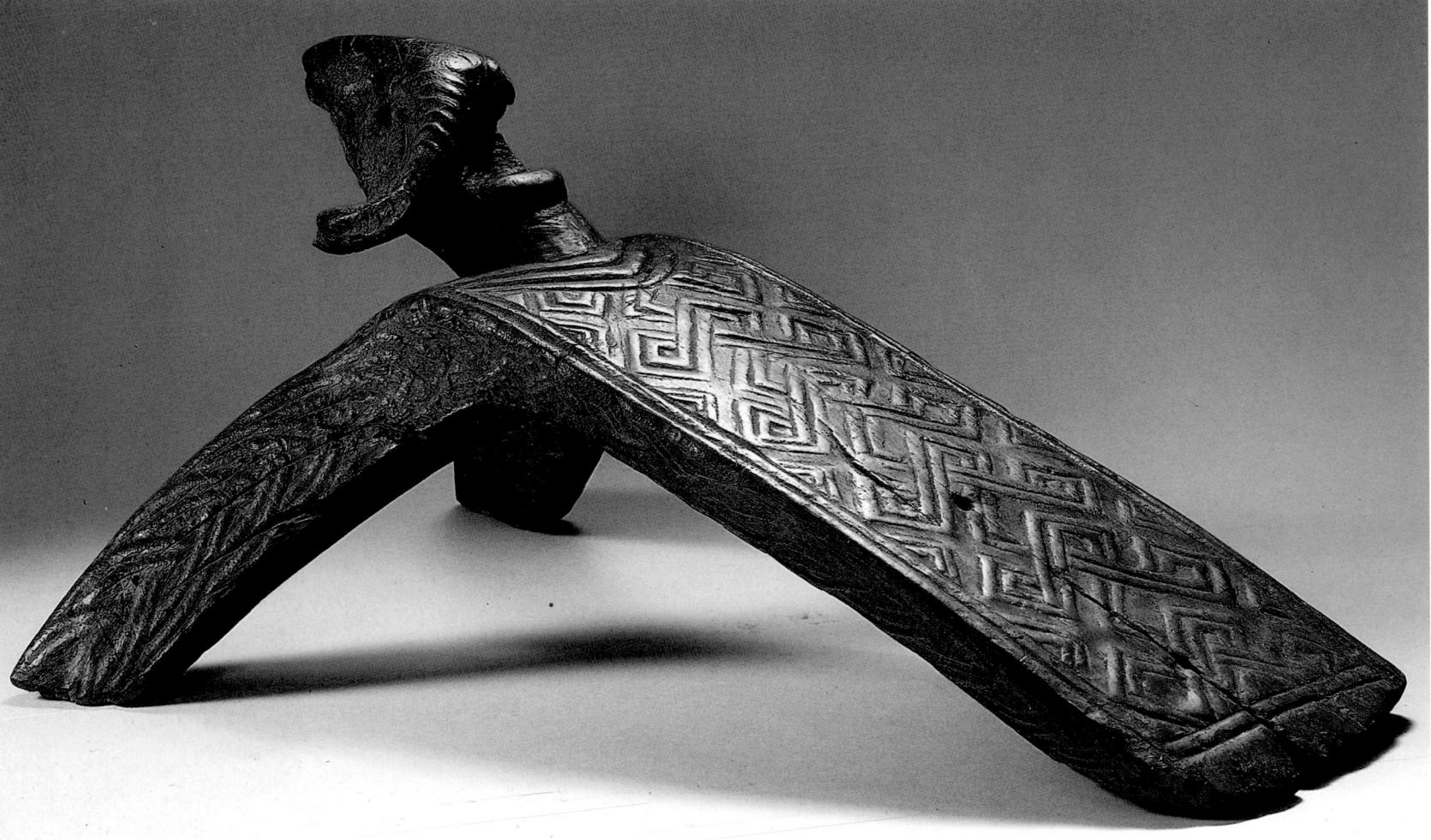

4.46

Backrest

Zaire
early 19th century
wood
36 x 50 x 85 cm

The Trustees of the British Museum,
London, 1909.5-13.9

This backrest is one of several acquired at the Kuba capital, Nsheng, in the opening decade of the century by Emil Torday. Others include an example of the carved tusks which were planted in the ground for the king to lean against. When all else failed he might sit on someone's back, as can be seen in an early photograph of the royal court. The divine character of the king is emphasised by the fact that he must not come directly in touch with the earth or sit directly upon it. The backrest illustrated here was apparently offered to Torday by a senior official at the court, though not by the king himself. The royal associations of the backrest are, however, apparent.

The most distinctive feature is the ram's head. The same motif also appears on beaded items of courtly regalia, and is associated with one form of mask. Although little is recorded on Kuba domestic economy in the otherwise extensive studies of their society, it does seem that flocks of sheep have been regarded as a royal preserve. This is not 'unexpected for

sheep appear to have been a relatively recent introduction. All such innovations, like items of material culture or new patterns, tend to be credited to royal inventiveness. The image of the ram connotes this royal attribute; at the same time it acts as one of a number of visual metaphors of the ideal relationship of the king to his people: powerful, dominant, the source of fertility. *JM*

Provenance: 1909, collected in Nsheng by Emil Torday

Bibliography: Vansina, 1978; Cornet, 1982, p. 301; Mack, 1990, p. 66

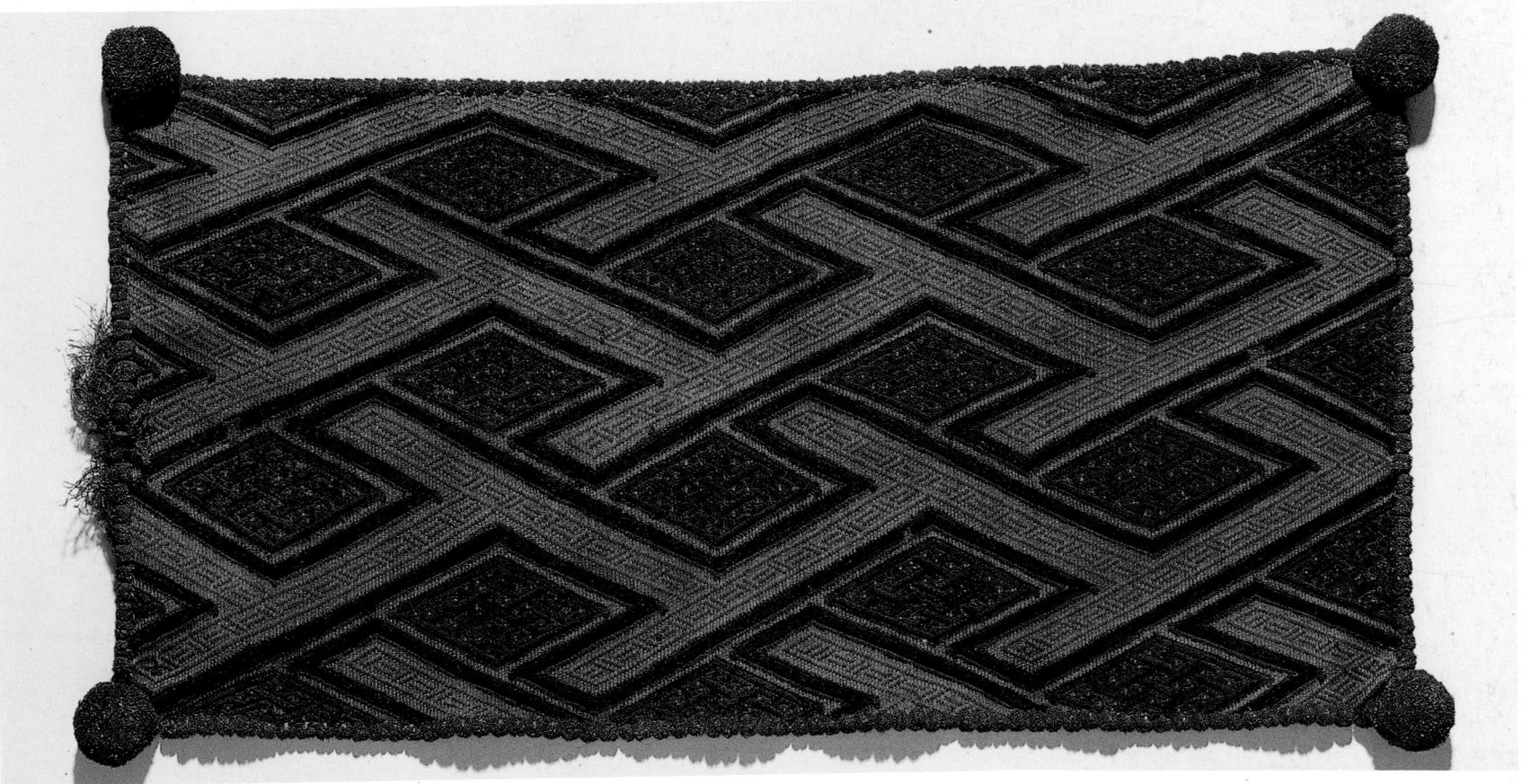

4.47

Cushion cover

Kongo
Zaire, Angola
early 17th century (?)
raffia, pigment
24 x 47 cm

Pitt Rivers Museum, Oxford, 1886.1.254.1

This is one of forty or so 17th-century raffia palm fibre cloths from the kingdom of the Kongo that survive in European collections. The history of this particular cloth cannot yet be established with certainty, but it seems likely that it is the 'table-cloth of grasse very curiously waved' that was listed by the botanists and collectors the John Tradescants (father and son) in the catalogue of their collection published in 1656.

It has often been reported that the raised patterns on these cloths were produced by a technique of 'cut pile' embroidery similar to that used in the late 19th and early 20th centuries in making the so-called 'Kasai-velvets' produced by the peoples of the Kuba kingdom some 1120 km to the north-east. Closer examination, however, reveals that a weaving technique was used to produce the patterns on this particular cloth. Although plain weave has been widely employed in Zaire, in

some areas weft floats have also been used to create geometrical patterns, generally lozenges and zigzag lines. (When only one colour is used the result is similar to European damask, but the pattern may also use a contrasting colour for the supplementary weft.) Among the Kongo, Mongo and Pende peoples a technique has been developed in which the weft floats have been cut and the ends of the cut thread have been rubbed so as to create a pile cloth. Although woven cut-pile and embroidered cut-pile cloths look similar, the design of a cut-pile weave is limited by the necessity of repeating simple patterns, whereas the design of an embroidered cut-pile cloth is freer and may, as in some Kuba cloths, consist of what seem like randomly scattered motifs. Clearly, the similarities in the general style of the two traditions suggest historical links, but the actual art-historical relationship between Kongo and Kuba cloths has yet to be established: that the techniques used are different makes this more difficult than it has seemed to some scholars.

This particular cloth is unusual because not all the weft floats are cut, resulting in a combination of damask-like areas and areas of cut-pile tufts.

Because weft floats reflect and cut tufts absorb light, this also results in variations in the basic tan colour. Here greater emphasis has been created by painting some tufts with black pigment. The use of an additional colour makes this piece apparently unique; all other known Kongo cloths are monochrome. For a whole Kongo cloth to be filled with an oblique interlaced design is also unusual, most other known cloths being made up of isolated designs enclosed in squares, repeated within an overall pattern. Only two others bear a similar design. The first is a cloth in the Danish National Museum, the second a cushion cover once in the collection of Manfred Sittala, Milan, and now known only from its appearance in a mid-17th-century watercolour by Cesare Fiore.

The name and significance of the pattern here are unknown, but are recognisably Kongo. As the indigenous weaving industry died out after the establishment of European contact, it is only the motifs used that link this early Kongo art visually with the body and sculptural arts that are well known from 19th- and 20th-century accounts and collections. The designs are the same on both sides of the

cloth, though the fact that they do not match at the edges suggests it was made from two cloths (probably two parts of one larger cloth) rather than from folding a single cloth. The decorative edging of small but intensely packed pom-poms, as well as the four large pom-poms at the corners, are also made of raffia and are a common feature of Zairean textiles.

Raffia cloths and mats formed part of the accoutrements of the Kongo nobility. The form of this cloth suggests that it is a cushion cover without a filling, though a possible additional (or alternative?) role as a bag or purse is suggested by the small opening at one end and by the fact that the Kongo king is said to have had a cushion in which to keep his jewels. JC, HvB

Provenance: by 1656, John Tradescant (the Younger); 1662, Hester Tradescant; 1678, Elias Ashmole; 1863, Ashmolean Museum, Oxford; 1886, Pitt Rivers Museum, University of Oxford

Exhibition: Oxford 1994

Bibliography: Tradescant, 1656, p. 53; Loir, 1935; Trowell, 1960, pl. XIX; Stritzl, 1971; Bassani, 1977; Williamson, 1983, pp. 339–40; Van Braeckel, 1993; Coote, 1995

4.48a

Woman's overskirt (*ncaka kot*)

Bushoong

Zaire

early 20th century

raffia

162 x 63 cm

The Trustees of the British Museum,
London, 1947.AE.11.1

4.48b

Woman's overskirt (*ncaka kot*)

Bushoong

Zaire

early 20th century

raffia

97 x 37 cm

The Trustees of the British Museum,
London, 1909.5.15.411

The elaborate surface decoration of woven raffia textiles is one of the most distinguishing features of Kuba arts of south-central Zaire. Kuba raffia textiles are celebrated for such decoration, which is achieved through dyeing, appliquéd and embroidery. Woman's overskirts, or skirt wrappers, like those exhibited here are made to be worn over longer, ceremonial skirts. They are worn by the Kuba for special occasions, for instance funerals, when raffia skirts and overskirts not only adorn the corpse but are worn by family and friends to celebrate the life of the deceased.

Weaving among the Kuba, as among other neighbouring groups, is gender-specific and men alone are responsible for all stages of the preparation of fibre and completion of weaving. The central panel of the overskirt is assembled from doubled sections of plain woven raffia cloth woven by men on a single-heddle loom. The garments are embroidered by women using plain woven raffia cloth as a foundation for both the central panels and borders.

The central panels in cat. 4.48a consist of embroidered and appliquéd motifs widely spaced across the central field. Black-dyed raffia thread is used for the embroidery on the undyed raffia cloth. This overskirt is an example of the early 20th-century Bushoong style in which there are a few randomly spaced motifs. Each motif is named – circle (*idingadinga*), tail of a dog (*ishina'mbuia*), leaves (*kash*) – to correspond to the shape it represents. This style of decoration parallels that of the long skirts known as *ncaka nsueha*, in which the entire

field of the design is covered with similar embroidered motifs. The borders, framing three sides of the skirt, usually combine overcast embroidery stitches and cut-pile designs which are overdye when the garment is finished. They are completed with a serpentine outer edge created by overstitching a twisted hank of raffia fibre to the outer edges.

Cat. 4.48b illustrates a Kuba embroidery style known from the 18th and 19th centuries. It is interesting to note that the intricate embroidered patterns share the same vocabulary of design as those found on Kuba woodcarving and mats. This Bushoong style of embroidery is distinguished by the use of twisted raffia fibre (*mishiing*). Such textiles are also known as *buuin bu mishiing* or designs sewn from 'strings'. The entire surface of the raffia cloth is densely embroidered with geometric designs. Overskirts embroidered in this style may be overdye with red or left undyed.

Cornet ascribes this type of embroidery to the Bushoong women living at the Kuba capital village of Nsheng. He proposes that this time-consuming work is the speciality of 'royal' women who are confined to their domestic compounds during pregnancy. Throughout the Kuba region, during periods of mourning (which may last from three to nine months), much time is also devoted to sewing and embroidery in order to replenish the supplies of ceremonial textiles which are used as gravegoods among the Kuba. PJD

Provenance: cat. 4.48b: 1907–9, Torday Congo Expedition

Bibliography: Torday and Joyce, 1910, pls VI, XXVIII; Torday, 1925, pp. 204–9; Adams, 1978, p. 30; Adams, in Vogel, 1981, pp. 232–3; Cornet, 1982, pp. 185–6, 194–7; Darish, 1989, p. 153; Zeidler and Hultgren, 1993, pp. 100–1

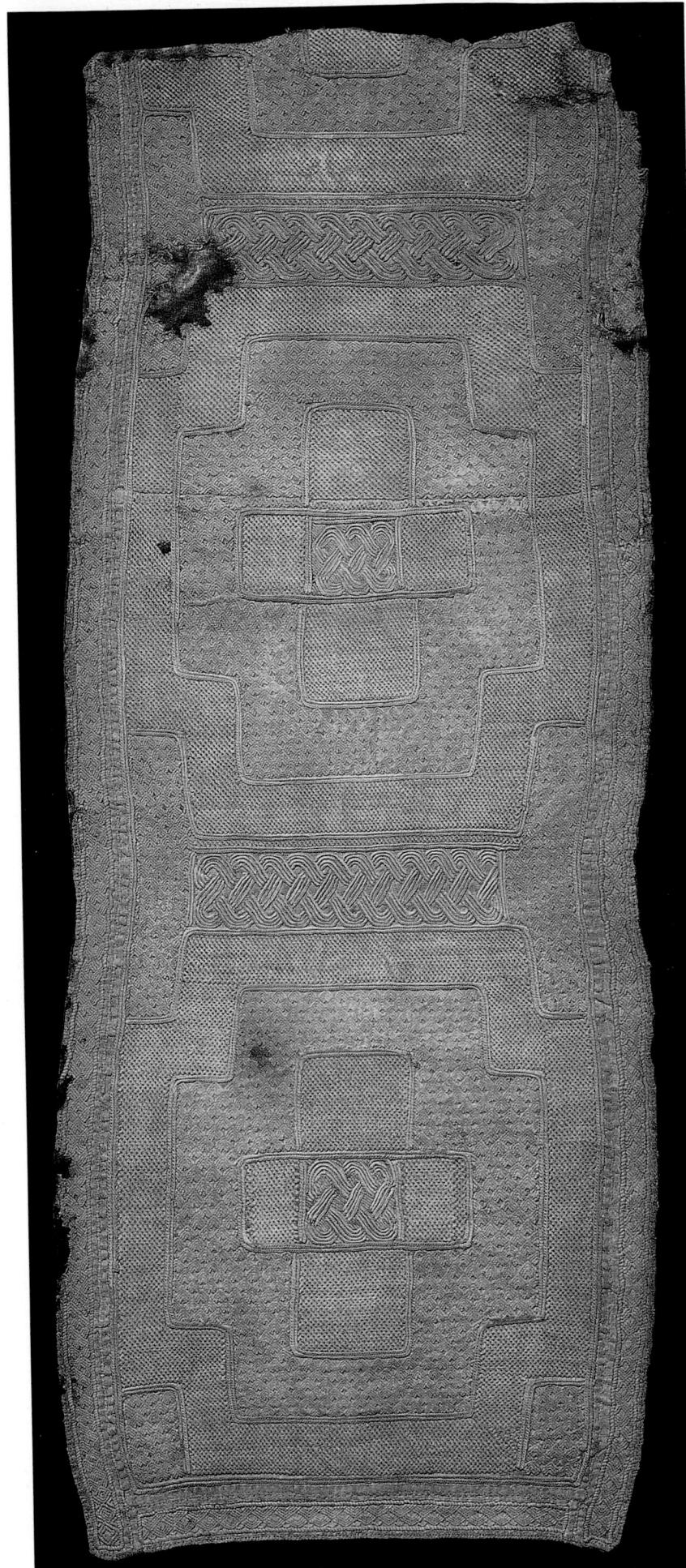

Mask (*ngady amwaash*)

Kuba

Zaire

wood, raffia cloth, beads, cowrie shells

1917 or earlier

58 x 43 x 20 cm

Peabody Museum of Archaeology and Ethnology, Harvard University, Cambridge, 17-41-50/B1909

The Kuba have a series of three masks that are used at public ceremonies, in initiation and at funerals. Each is in a quite distinctive style and has a characteristic range of behaviour associated with it.

The masks are 'royal' in several senses. Most obviously many of the events at which they perform, notably initiation, are under royal patronage. They also represent characters in mythic history with primordial associations or they express relationships determined by royalty. Thus two masks, *mwaash aMbooy* and *ngady mwaash aMbooy*, recall Woot, a Kuba equivalent to Adam, and Woot's sister-cum-wife, whose incestuous union created people. *Mwaash aMbooy* is sometimes worn by the king himself, establishing at one level an identity of authority between royalty and ancestral origins. The third mask, *bwoom*, is more complex: according to context or explanation of origin, it is variously a prince, a commoner, a pygmy or a subversive element at the royal court. The masks do not normally appear as a group, though *bwoom* and *ngady mwaash aMbooy* are sometimes understood to be competing for the affections of the female mask in the trio.

The example here is Woot's sister-consort, *ngady mwaash aMbooy*. Its feminine character is established less by its visual appearance – it lacks obvious determinants of gender such as the exuberant artificial breasts appended to some African masquerades – than by its mode of performance. As in so much of Kuba art and culture, the sense of visual and intellectual order is apparent. The court title *bulaam* at once comprises

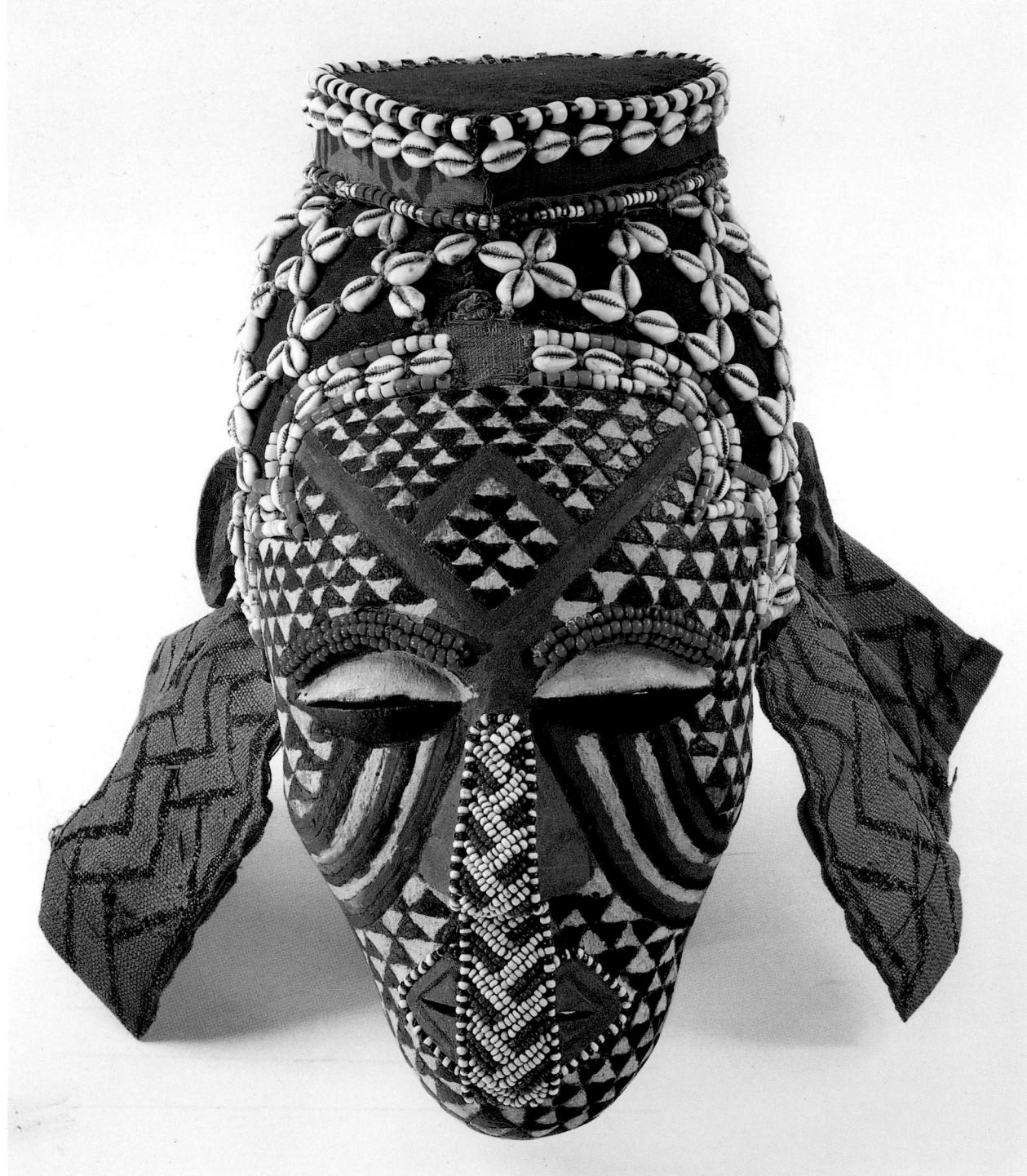

the role of oral historian and of dance instructor. The mask is associated with a mythic character; the dance steps that the mask duplicates are carefully choreographed to imitate those of women.

The motifs on the face of the mask include lines beneath the eyes said to represent tears, and distinctive triangular shapes picked out in contrasting colours. This latter motif is also encountered in several other contexts among which is a style of patchwork

barkcloth. An association with the mask motif is appropriate because barkcloth is regarded as an ancestral form of clothing and is still worn during periods of mourning. The identity of the mask with the primordial female ancestor is thus enhanced by what appears to be a carry-over from a motif associated with ancestral costume. JM

Bibliography: Vansina, 1955; Vansina, 1978; Cornet, 1982, pp. 250–70

4.50

Drum

Bena Luluwa
Zaire
19th century
wood, hide
h. 117.5 cm
Staatliche Museen zu Berlin, Preussischer
Kulturbesitz, Museum für Völkerkunde,
III C 2672

The drum is decorated with bands of engraved stripes and spots and bears a human mask; the sturdy body attached to the mask provides support for the drum.

The features are not typically Luluwa, and must have been influenced by a neighbouring style. The large eyes are those of Luluwa statues, however, further emphasised by white encircling lines. The nostrils are powerful. White occurs again on the teeth in the half-open mouth. The chin bears a small beard with three distinct spikes.

The navel is surrounded by circular scarified lines. The figure has his hand on his penis. This links the piece to a fertility cult, in the service of a family ruling over one of the many autonomous groups; this kind of organisation was typical of the Luluwa political system. JC

Provenance: 1885, collected from the Bena Luluwa tribe by Hermann von Wissman

Bibliography: Biebuyck, 1992

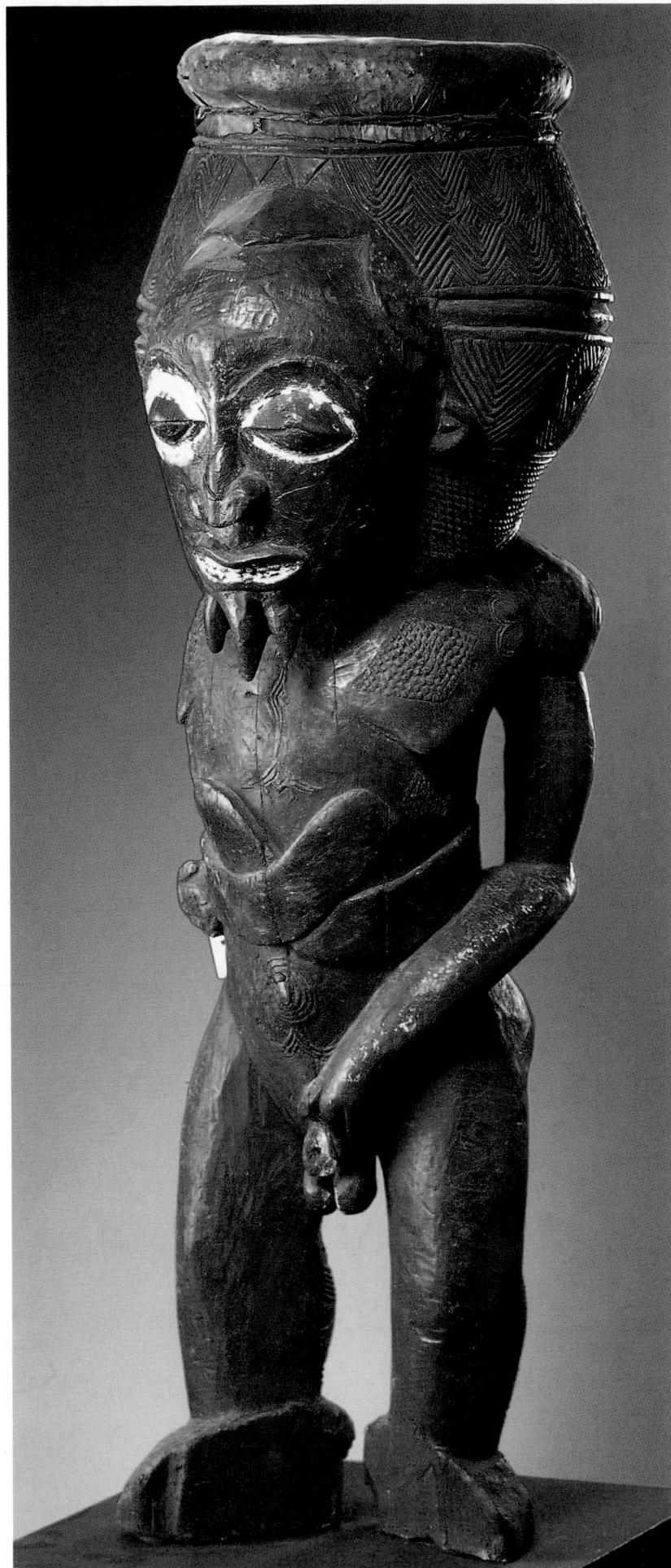

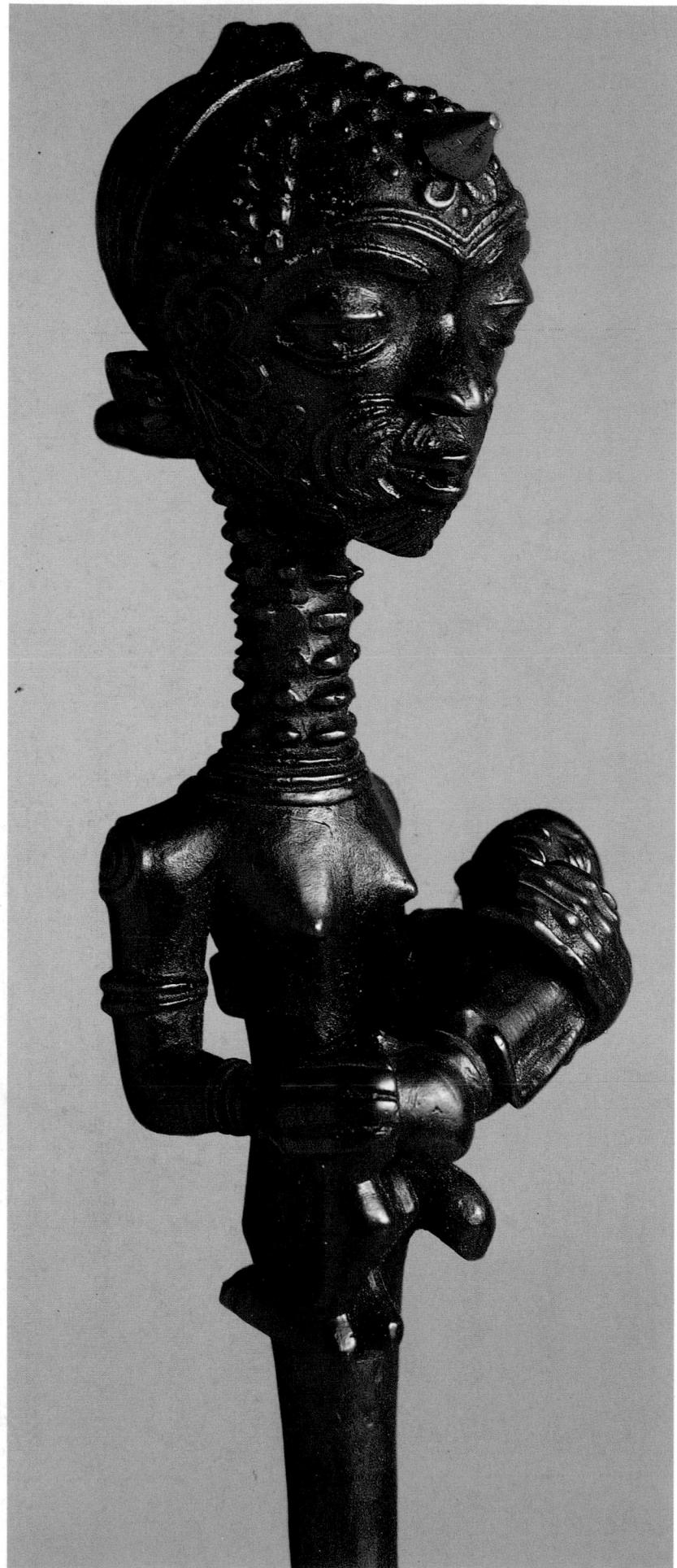

4.51

Statuette

Bena Luluwa
Zaire
19th–20th century
wood
35.5 x 8.5 cm
The Brooklyn Museum,
Museum Collection Fund, 50.124

Statues portraying mother and child are frequently to be found among the Bena Luluwa; they are linked to fertility cults, notably the *bwanga bwatshibola*. Although many statuettes show the complete figure, it is quite common for the body to taper to a point so that the object can be stuck into the sand. This figure has a large head on a very long neck, with much detailed decoration. The number of tattoos is remarkable, harking back to an ancient Luluwa custom, long since vanished and now known only from old drawings.

The figure bears a double message: status and fertility. On the one hand, the large Luluwa tribe was never politically united and therefore there were a large number of relatively autonomous chiefs, which meant that many local dignitaries had works of art dedicated to them. On the other hand, the statues belong to a fertility cult that is still extant.

Much of the ornamental detail is probably symbolic. The distended umbilical hernia, for example, refers to the line of succession and the dependence of successive generations on their ancestors. JC

Bibliography: Maesen, 1954; Petridis, 1995

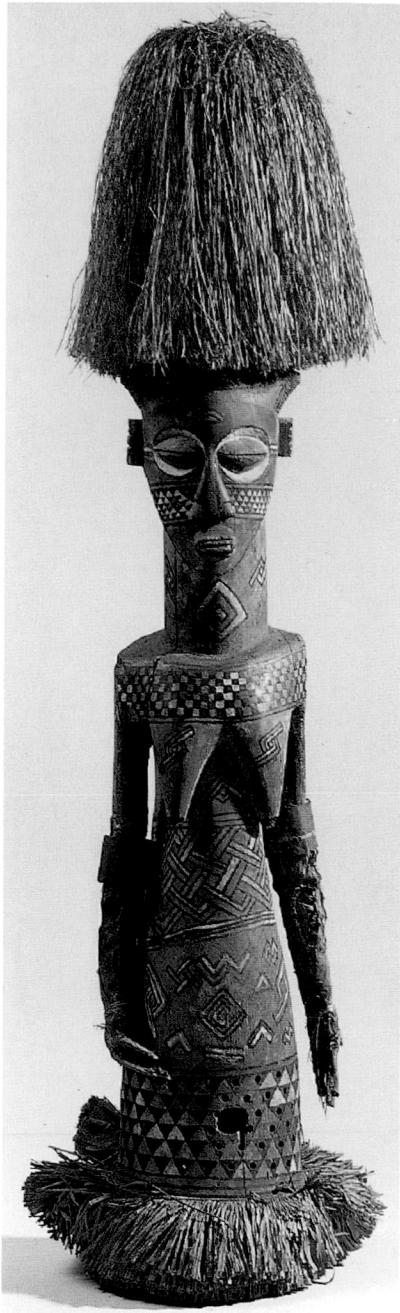

4.52

Mask

Kete
Zaire
19th century
wood, fibre, bark, paint
h. 154 cm
Museum für Völkerkunde, Hamburg,
4678.06

The Kuba kingdom was divided between three large peoples, the Bushoong (the royal tribe), the Ngende and the Ngongo, who were surrounded by about fifteen smaller (sometimes very small) groups. Of these, the Kete were the largest, but also the farthest from the royal centre of the kingdom.

mask was made by the Bena nika. More recent finds suggest such pieces are not exceptional. Examples of this type include single figures and women holding babies. They were made to be worn ceremonially. This one is thought to be connected with a rite of passage.

The scarifications on the stomach and the chequered design on the cheeks, on the belt around the shoulders, around the stomach and at the base of the mask would suggest that this piece belongs to a Kuba substyle. The base has a small vision hole cut in it. JC

Provenance: 1905, collected by Leo Frobenius

Bibliography: Zwerneemann and Lohse, 1985

4.53

Mask

Songye
Zaire
wood
h. 160 cm

The Trustees of the British Museum,
London, 1979. AF. 1.2397

The Tetela-Hamba of north Kasai (among whom I stayed in 1953 and 1954) do not use masks – neither the groups of the savanna nor the forest dwellers – despite a firm belief to the contrary held by art historians. The Sungu with whom he resided were located on the absolute southern periphery of the Tetela-Hamba areas, adjacent to the Songye. It is as good as certain that the so-called Sungu objects he collected at the beginning of this century belonged exclusively to the Songye culture. One mask was collected in Kasongo, ‘the nearest Sungu settlement to the Songye at Tempa on the Sankuru’ (Mack, 1990,

pp. 62–3). As it happens, it is also in Kasongo that ‘Major’ John White, who stayed at the Methodist mission of Minga from 1923 to 1926, acquired a mask that he ascribed to a Tetela witch doctor.

The location of Kasongo is, then, decisive. On a map of the territory of Lubefu acquired on site in 1953, this name appears as Kilolo Kasongo on the fifth parallel a few kilometres to the west of the Luedi River. This position corresponds precisely to an outpost called Mona Kassongo by Frobenius (1907, map no. 8). Mono Kassongo and Kilolo Kasongo are almost certainly one and the same. The village is actually situated in Songye country and not in Sungu country. Kilolo is a name meaning ‘notable’ in Songye (not in Tetela) and Kasongo is a proper name widespread only in Songye country. Furthermore, the term *moadi* (*mwadi*), attributed by Torday to the masks he collected in Kasongo, is also manifestly Songye in origin.

This remarkably beautiful mask with three fur horns is also unquestionably Songye, even though Torday designates it as Tetela. Indeed, the three-horn motif is found on a completely different type of mask that Torday does not hesitate to attribute to the Songye.

Another horned mask attributed to the Tetela is to be found in the Musée Barbier-Mueller in Geneva. Neyt’s attempts to justify this attribution by endeavouring to draw a parallel between the three-horn motif and certain Tetela beliefs are futile. This mask was to all appearances crafted like the others by the Sungu’s southern neighbours, the Tempa Songye of the former Lubefu territory, a population that remains unstudied. Three masks acquired in 1910 by the Royal Museum for Central Africa in Tervuren are formally ascribed to them. And, although they definitely differ from the British Museum mask exhibited here, Songye art – known principally through the works of the eastern regions – adheres to no strict canon. The myth of Tetela masks should now be laid to rest. LdeH

Bibliography: Frobenius, 1907; Torday and Joyce, 1922, pp. 29, 77; Hersak, 1986; Mack, 1990; Neyt, 1992; Hersak, 1995; de Heusch, 1995

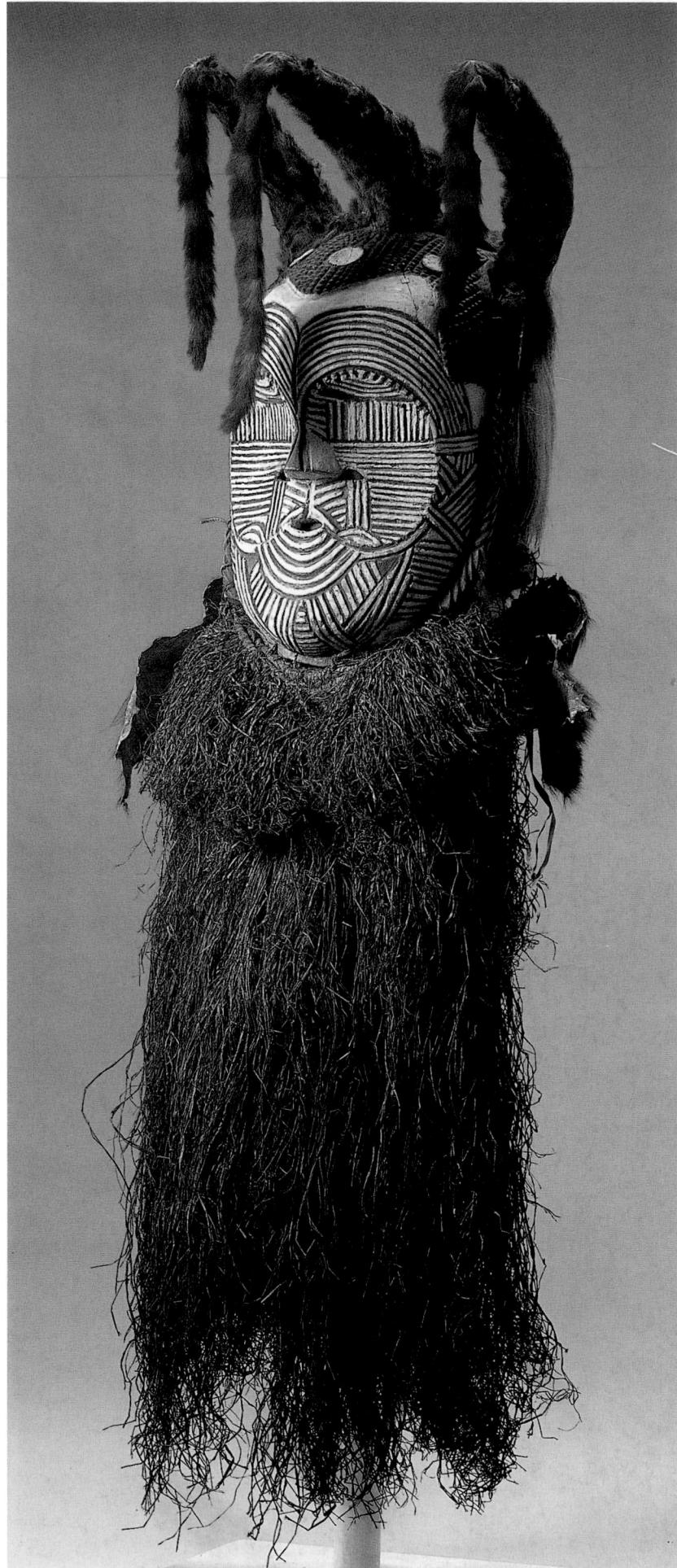

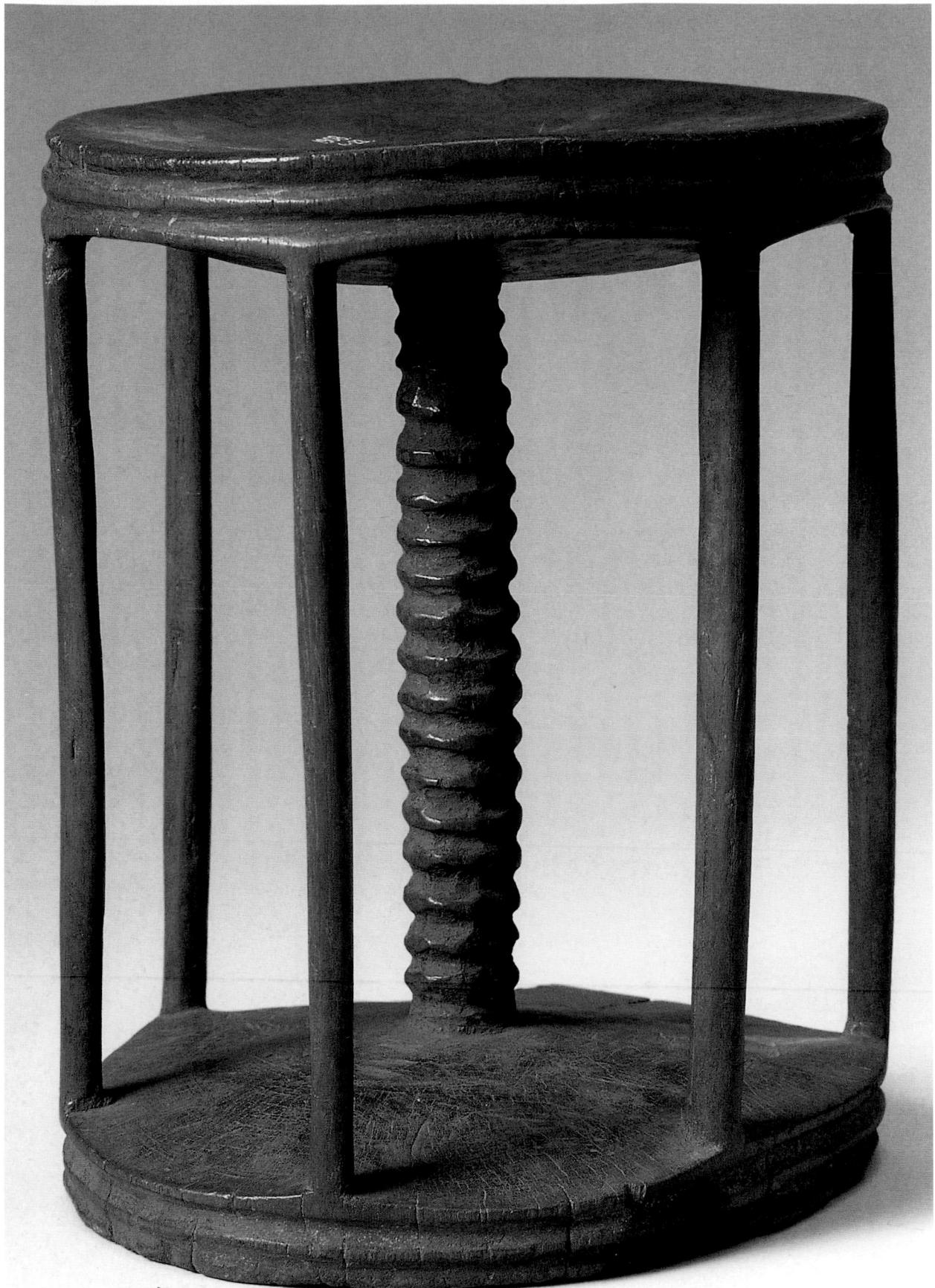

4.54

Stool

Songye-Sungu

Zaire

early 20th century

wood

24 x 29 x 17 cm

The Trustees of the British Museum,
London, 1908.6-22.67

This small wooden stool, like the large mask (cat. 4.53), comes from Mokunji, a village identified by its collector Emil Torday as Batetela-Sungu. Luc de Heusch argues in discussing the mask that this group should properly be identified as a western outlier of the Songye. While Torday's Tetela identification is wrong, it may be that this group of objects could be considered in terms of a Sungu ethnicity and art style. Certainly, both the mask form and this type of stool are unknown in Tetela art and culture and unusual in the context of Songye, though the case de Heusch makes is compelling enough.

The stool is extraordinary in the slender character of the outer and central supports. Indeed, it is more like a headrest in terms of size and of the kinds of weight it might be expected to support, yet its shape and the evidence of wear on the upper surface suggest that it was made to sit on. Carved from the solid, it has been extensively cut away. There is no documentation associated with the object that would indicate whether its use is delimited in any way. Certainly it would not appear to be of the scale of a chiefly stool. It may be that it was intended for use by women or children. *JM*

Provenance: 1907, collected by Emil Torday

Power figure (*nkisi*)

Songye

Zaire

wood, horn, metal
102 x 27 x 36 cmThe Trustees of the British Museum,
London, 1949. AF. 46.492

The term by which the Songye designate their magical figures – *nkisi* (pl. *mankisi*) – is encountered elsewhere in widely dispersed parts of central Africa. In southern Zambia, for instance, it is used by the Mbunda of their masks (cf. cat. 2.55). Equally, it is used among the Kongo on the Atlantic coast as a generic term with a wide range of reference: included here, however, are the magical figures that the Kongo, too, create (cat. 4.7). *Nkisi*, then, is a 'key word' deeply embedded in many different Bantu languages. Taken as a whole it becomes virtually untranslatable by reason of the very diversity of objects, substances and activities that it serves to designate. What all the various usages have in common, however, is that they serve to comprise an assemblage of objects and entities whose efficacy and capacity to influence the affairs of the living depend upon some external agency, usually identified with spirits or with ancestors.

Among the Songye it is only magical figures that are identified as *mankisi*. Masks, to which Songye figures are in some senses contrasted, are identified separately (see cat. 4.53) under the term *kifwebe* (pl. *bifwebe*) – though elsewhere in the Bantu world they, too, may be included in the reference of the term. There are two kinds of *nkisi*. One, which is much smaller in scale (and by far the more numerous), is personal in application and ownership: restricted to individuals or, at most, to households or nuclear families. The examples illustrated here, however, are much larger and, in their deliberate attempt to embody strength and power, more formidable in conception. They function on behalf of complete communities, and occasionally – where their powers are widely extolled – they may serve a more extensive constituency.

The efficacy of *mankisi* has several sources. Most important are the many different types of substance and paraphernalia applied to the figures.

Most of these are regarded as inherently powerful or aggressive – substances such as parts of lions, leopards, snakes, bees and birds of prey; the sexual organs of crocodiles and earth from the tracks of elephants; human elements taken from such exceptional categories of person as suicides, sorcerers, epileptics or twins. Items of regalia may also festoon the figure, recalling the typical attributes of chiefly dress or of the hunter. The figures themselves are always male and have a combination of characteristics that constitute a generalised reference to ancestors.

The most important and detailed study of Songye masks and figures to date is by Hersak. She notes that the efficacious substances listed above are thought of as having been contrived at the beginning of creation and were originally contained in horns and calabashes; the figures shown here have such containers attached to the object. In general, however, the head and the swollen abdomen of the figure hold the empowering concoctions, which – as in Kongo ideas about their magical figures – may themselves be regarded as in a sense 'containers', vehicles of mystical force. There is no prescribed formula or choice of elements unerringly adhered to in the creation of a magical figure: each is empowered by a variety of such substances, assembled in varying combinations according to the preferences and experience of the ritual specialist, the *nganga*, who 'creates' the object. It is significant that the carved properties of the figures are considered secondary. It is unquestionably the substances applied subsequently that are the critical element; indeed the *nganga* credited with the creation of the object may or may not also be its sculptor.

As a result of the individual treatments the object receives, each figure is seen as imbued with its own identity and even its individual name, often that of a renowned chief. This, in due course, is further embellished by its biography of accomplishments, of causes effectively resolved. It is also treated and attended to individually: it is fed, anointed and receives sacrifices in its honour. It is also individualised in the sense that it has its own particular life cycle. In the end it will itself suffer physical decay, for all that it is kept in a special hut and has its

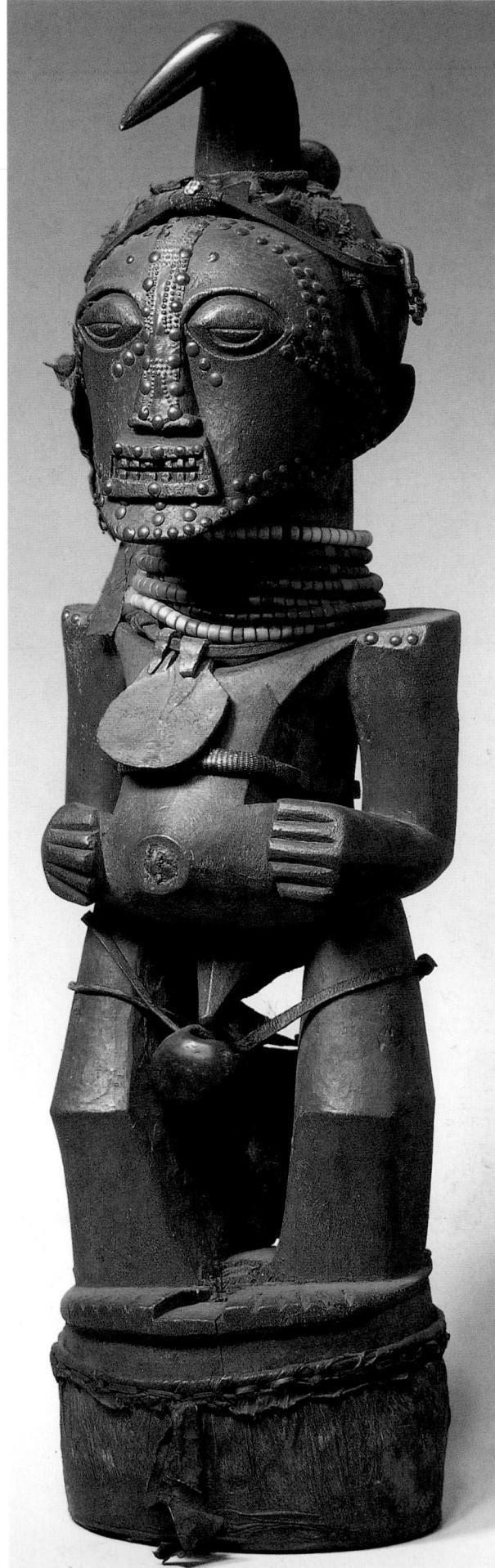

own designated guardian. Equally, should the *nganga* responsible for its existence himself die, its own powers are conceived as commensurately reduced and may come to be seen as in need of replacement.

Communal *mankisi* are used to achieve benign ends. The need of their magical intervention in human affairs may be signalled by such phenomena as persistent dreams of imminent danger among those charged with their care: premonitions expressed in visions of lightning and fire, or of deep ravines. To counteract these adverse signs the *nkisi* is brought out and manipulated by poles fitted into the holes that are carved under its arms. Like many things in the Bantu world associated with or identified as *nkisi*, the poles are retrieved from burial grounds. Each pole is held by a villager and the *nkisi* is walked through the village in public, attacking and challenging unseen yet threatening forces that may be present. Although dedicated to ensuring the health and welfare of the community, these figures are not exponents of the bedside manner but confrontational objects, objects with attitude. JM

Bibliography: Hersak, 1986, p. 118

4.56

Hilt of a knife with carved pommel

Songye
Zaire
19th century
metal, wood
h. 23 cm
Staatliche Museen zu Berlin,
Preussischer Kulturbesitz, Museum
für Völkerkunde, II C 4220

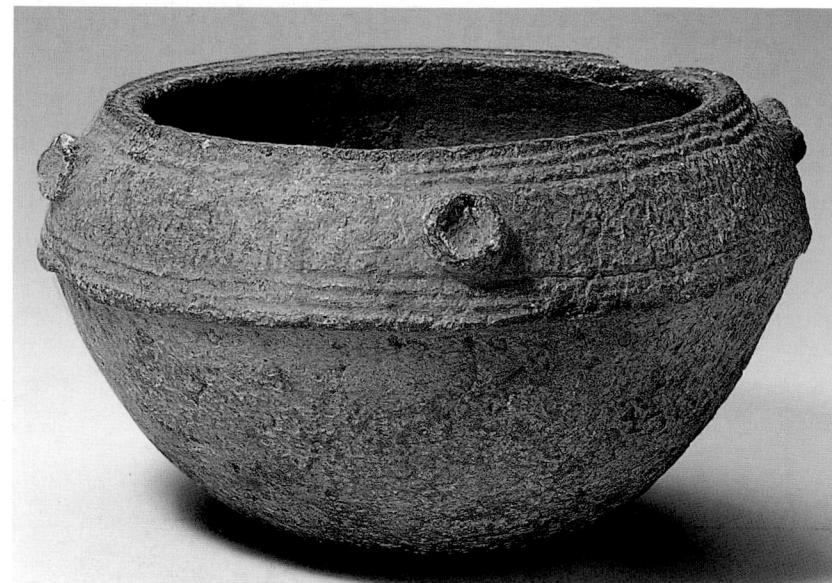

Figurative carvings such as the bearded head on the pommel of this ceremonial knife (its iron blade now missing) commonly appeared on the weaponry of the Songye and neighbouring Luba peoples. Chiefs and important men carried arms embellished in this way, including knives, axes, shields and, among the Luba, magnificent bowstands (cat. 4.62). Ornate parade knives, as well as symbolising the power and prestige of their owners, also acted as a visual means of declaring affiliation among the peoples of complex historical and ethnic background living in this region of southern Zaire.

The hilt of this knife is carved in a style associated with the western Songye. Heads of the type depicted on the pommel may represent benevolent ancestor figures, whereas those on the bosses of certain Songye shields represent the magical and malevolent figures which enforce the political and social control exercised by elders of the *kifwebe* secret society. Yet another representation of the human face may be found on the large, wrought-iron blades of axes made by the Nsapo, a people closely connected with the Songye, for use as symbols of power and prestige. In this instance, however, the heads are thought to represent subordinate peoples. CS

Bibliography: Hersak, 1985; Spring, 1993, pp. 84–93

4.57

Bowl

Classical Kisalian, 10th–14th century
Central Shaba, Zaire
terracotta
h. 17 cm; diam. 22 cm
Private Collection, Munich

The excavation of various sites in the Upemba depression, not far from the heartland of the Luba kingdom, revealed large burial sites with numerous gravegoods. Their study has made it possible to establish a complete sequence of occupation from the Early Iron Age to the present-day Luba peoples.

This fine bowl is typical of the gravegoods of the Classical Kisalian phase, dated by radiocarbon to between the 10th and the 14th centuries AD. Evidence of a hierarchical, hereditary society, starting with the Early Kisalian in the 8th–9th centuries, make this culture one of the early steps in the development of the powerful kingdoms of the savanna. The continuity and density of the occupation, as well as the persistence of certain customs from this time to the present, indicate that the Luba people have remained largely unchanged. PdeM

Bibliography: de Maret, 1985; de Maret, 1992

Divination board (*lukasa*)

Luba
Zaire
wood, beads, metal
27 x 14 x 4 cm
Felix Collection

The Luba works in this exhibition emphasise the role of art objects as texts, registers of knowledge, documents of history, ideology and culture. They served for the display of power, as historical documents, as a means of political validation, as instruments of prophecy and problem-solving, and as receptacles of spiritual vitality. The commission and production of Luba art flourished during the period of greatest political expansion, from the early 18th to late 19th centuries, when increasing numbers of rulers were installed as local manifestations of a broader concept of sovereignty. Works of art were used to forge alliances, to cement treaties and to settle debts (Reefe, 1981). Every object is a historical record of the dynamic cultural, artistic and ideological exchange and borrowing that has characterised the peoples of what is now south-eastern Zaire for several centuries.

Luba works of art are also concrete expressions of and vehicles for the ineffable dimensions of Luba ideology and religious belief. Insignia codify the secret precepts and principles of Luba government and spiritual authority, and many Luba insignia still serve as mnemonic devices, eliciting historical knowledge through their forms and iconography. Through oral narration and ritual performance, insignia serve both to conserve social values and to generate new values and interpretations of the past, as well as to effect social and political action.

For the Luba, the most prestigious historical pedigrees are those that can be traced to the founding ancestors. Although such stories might be considered 'myth' by Western historians, the Luba consider them the essence of truth: present events are legitimised by their relationship to the sacred past, as enshrined in the charters for kingship. These charters were sacred, to be guarded and disseminated by an association called Mbudye. Mbudye historians were rigorously trained 'men of memory' who could recite genealogies, lists of kings and all of the episodes in the founding charter

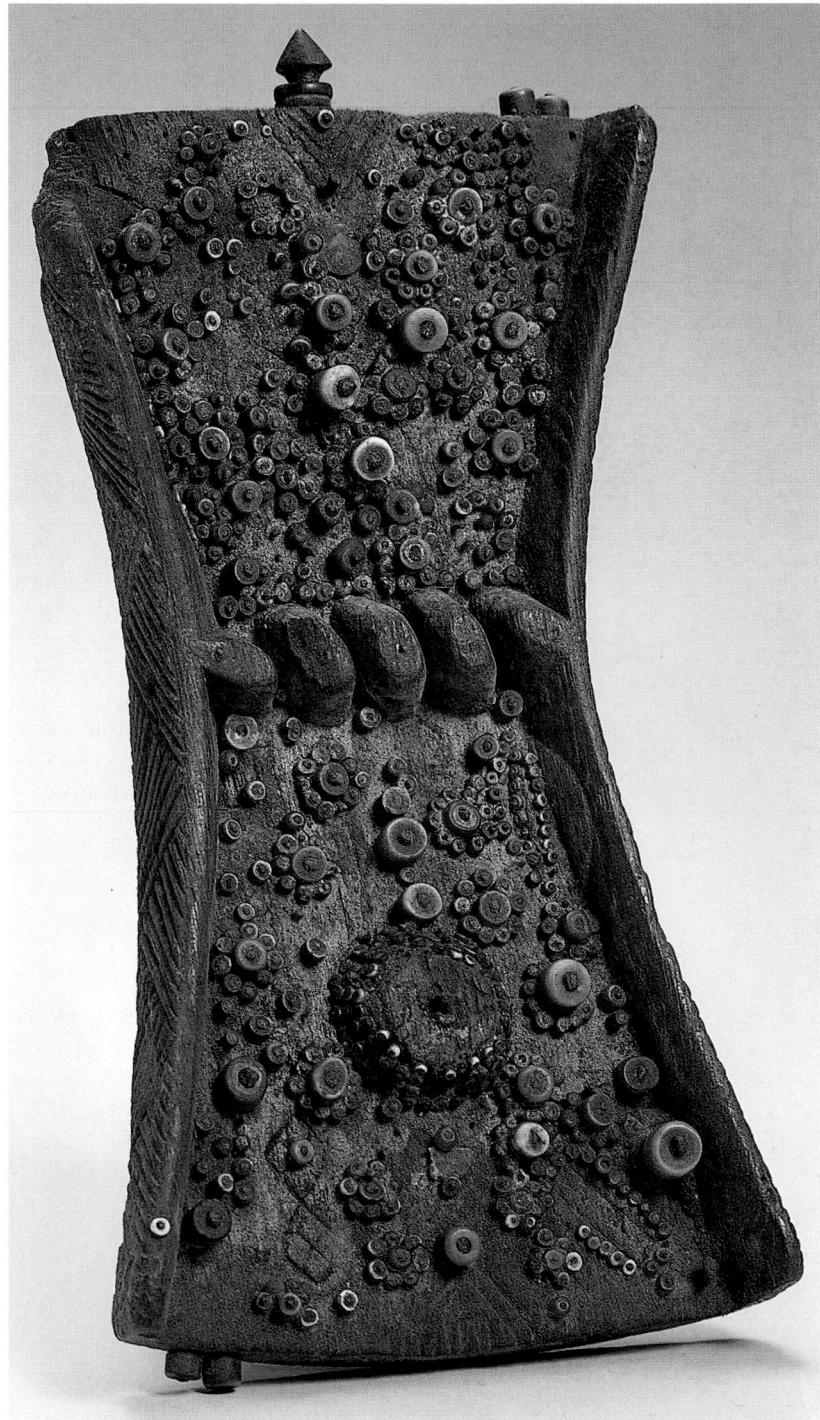

for kingship. Mbudye adepts created rituals for memory transmission in the 18th and 19th centuries, when the Luba kingdom was at its height. They also invented mnemonic devices to assist historical recitation (Reefe, 1977).

Principal among Luba memory devices is the *lukasa*, a hand-held, flat wooden object studded with beads and pins, or covered with incised or carved ideograms. During Mbudye rituals to induct rulers into office, a *lukasa* is used to teach sacred lore about culture heroes, clan migrations, and the

introduction of sacred rule; to suggest the spatial positioning of activities and offices within the kingdom or inside a royal compound; and to order the sacred prerogatives of the officials concerning contact with earth spirits and the exploitation of natural resources. Each *lukasa* elicits some or all of this information, but the narration varies with the knowledge and oratory skill of the reader.

Luba memory devices do not symbolise thought so much as stimulate it. They afford a multiplicity of meanings through their multi-

referential iconography. For example, coloured beads refer to specific culture heroes and the principal protagonists of Luba myth. Lines of beads refer to journeys, roads and migrations. A large bead surrounded by a circle of smaller ones refers to a chief encircled by his dignitaries. The iron pin refers to the king in whose honour the board is made, and the incised patterns encode royal secrets. Divided into male and female halves, the *lukasa* also encrypts historical information about genealogies and lists of clans and kings. Yet the reading of these visual 'texts' varies from one occasion to the next, depending on the contingencies of local politics, and demonstrates that there is not an absolute or collective memory of Luba kingship, but many memories and many histories. *MNR*

Bibliography: Fraser and Cole, 1972; Reeve, 1977, pp.48–50, 88; Reeve, 1981; Maret, 1985; Childs et al., 1989, pp. 54–9; Nooter, 1991; Dewey, in Los Angeles 1993; A. F. Roberts, 1993; Nooter and Roberts, forthcoming

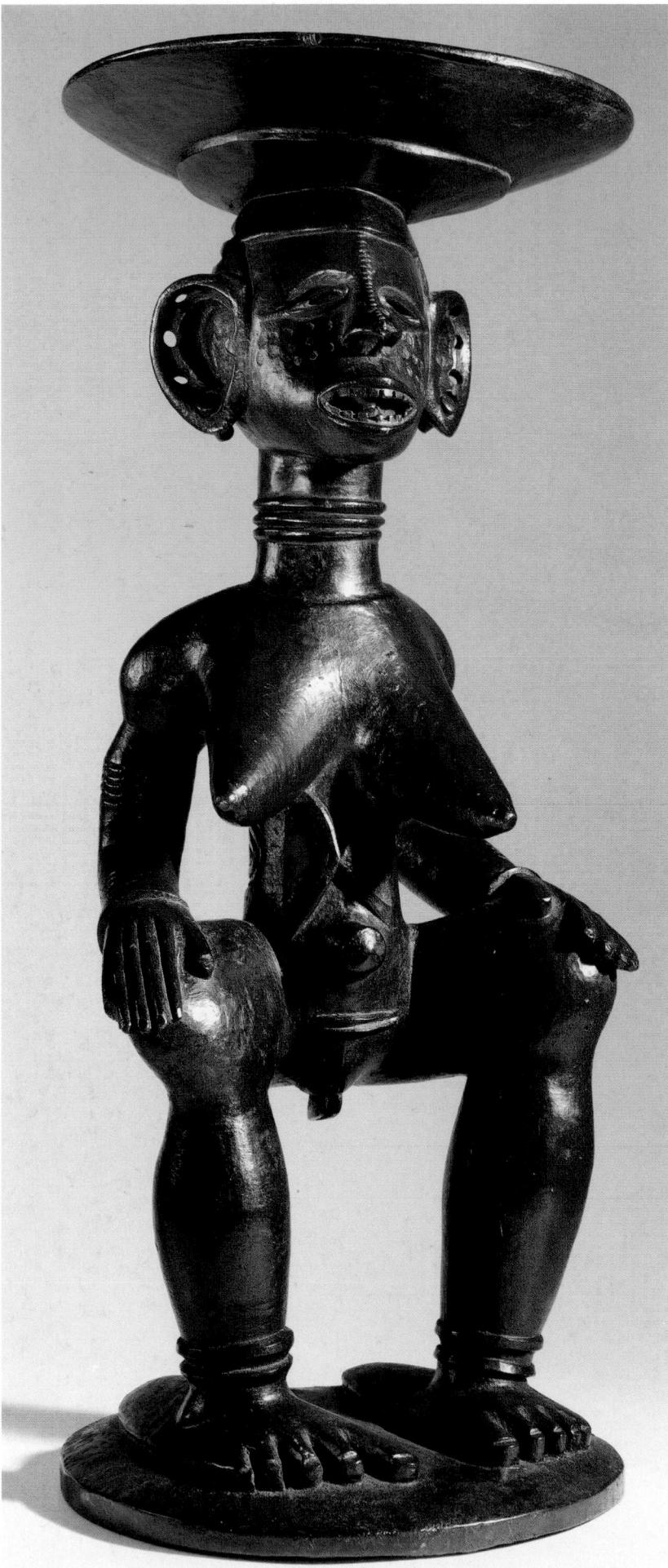

4.59

Stool

Luba/Maniema
Zaire (?)
wood
h. 52.5 cm
Private Collection

Luba and Luba-related stools used as thrones are often supported by a female caryatid. The stool shown here probably belonged to an east African chieftaincy, for while the overall conception of the stool is Luba, its execution and style are akin to pieces produced by groups as far east as the Makonde of Tanzania and Mozambique. Luba influence extended to lesser and greater degrees as far as Lake Tanganyika, on the border of eastern Zaire and western Tanzania, and many Luba works of art were collected in Tanzanian towns situated along the trade routes to east Africa, such as Tabora. Many groups borrowed Luba kingship ideology and practice, and copied their art forms. It is possible that this hybrid object represents the work of an east African artist emulating Luba style. Some stools depict the wives, sisters and mothers of chiefs, while others are more generic representations of women as the power behind the throne – a belief that is expressed in the Luba proverb ‘Men are chiefs in the daytime, but women are chiefs at night’.

Not only did women fulfil specific political roles in Luba history as councillors, advisers, ambassadors, emissaries and even chiefs, but they were also thought to have enhanced spiritual powers. The great twin tutelary spirits of Luba kingship were always represented by pairs of unmarried women who served as priestesses to guard the sanctuaries where the spirits reside. Paired female figures are often shown in Luba sculpture as the supports of headrests (see cat. 4.60) and surmounting staffs of office. *MNR*

Bibliography: Nooter, 1991, p. 236

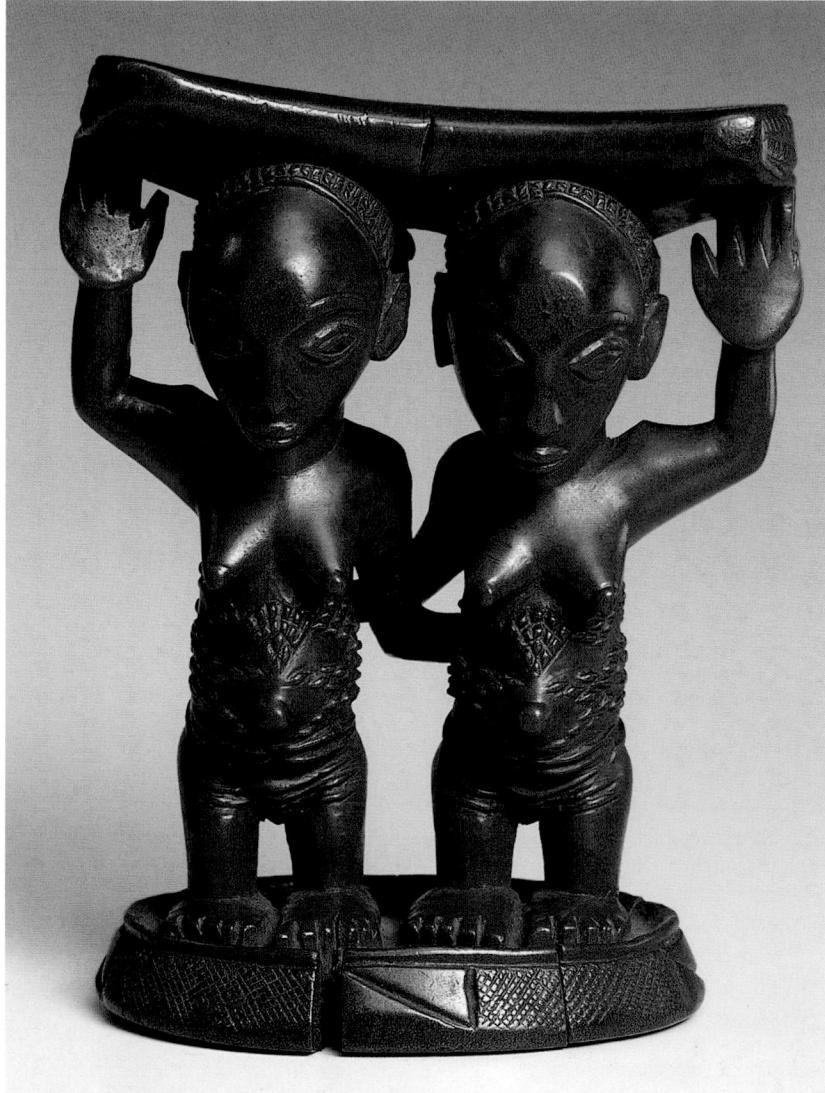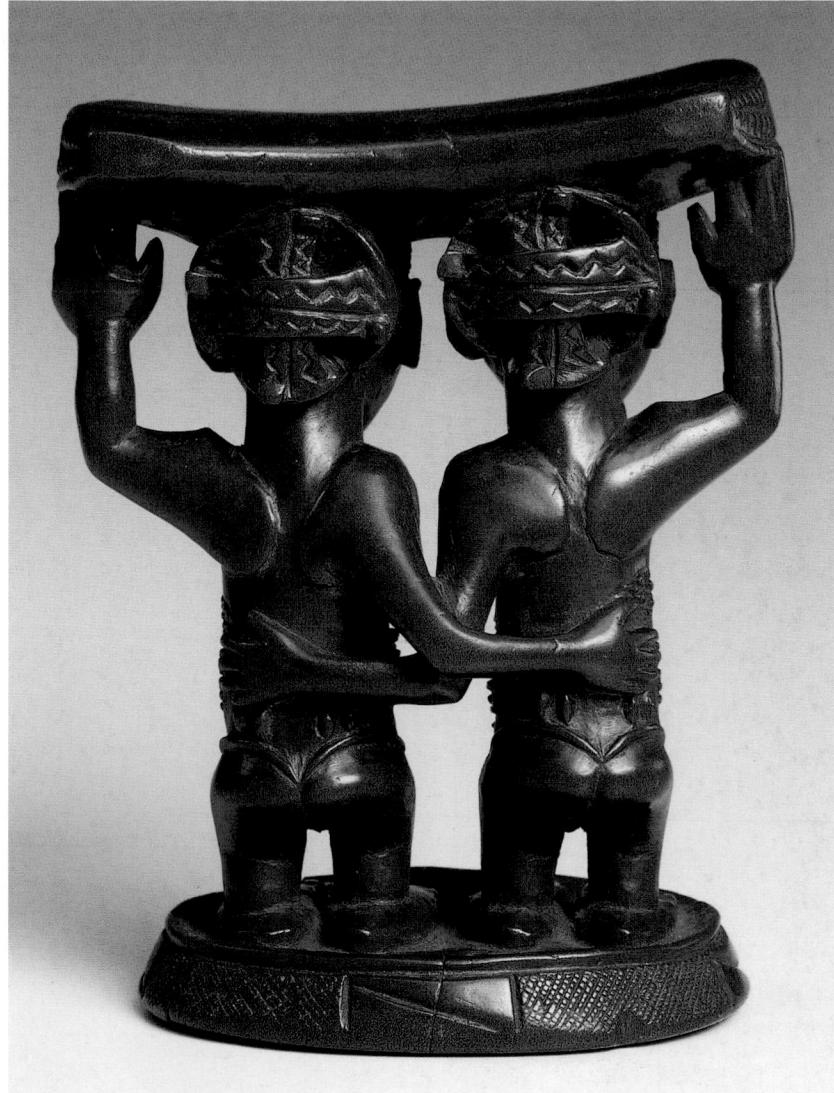

4.60

Headrest

Luba
Zaire
wood

17 x 13 x 9 cm

The Trustees of the British Museum,
London, 1956. AF. 27.270

A headrest serves as a pillow that is both cool and comfortable in a tropical climate, and protects elaborate hairstyles by raising the head above the surface of the bed. In addition to the great personal attachment that Luba people developed for their headrests, these were also seen as the seat of dreams. Luba consider dreams to be prophetic: dreams foretell important events, provide warnings and communicate messages from the other world. It is therefore fitting that headrests should be supported by the female priestesses who serve in real life as intermediaries and interlocutors for the spirits of the other world. The pairs of women on this headrest wear the two most popular hairstyles among the upper classes during the 19th century – the cruciform coiffure and the ‘step’ or ‘cascade’ style. These styles were not merely decorative; as with all Luba cosmetic adornments (scarification,

genital elongation, hairstyling), there is a spiritual dimension to beautification. Women are rendered ideal receptacles for the containment of spirit through the embellishment and ‘civilisation’ of their bodies and heads. *MNR*

Provenance: 1956, given to the museum by Mrs Webster Plass

Bibliography: Dewey, 1993

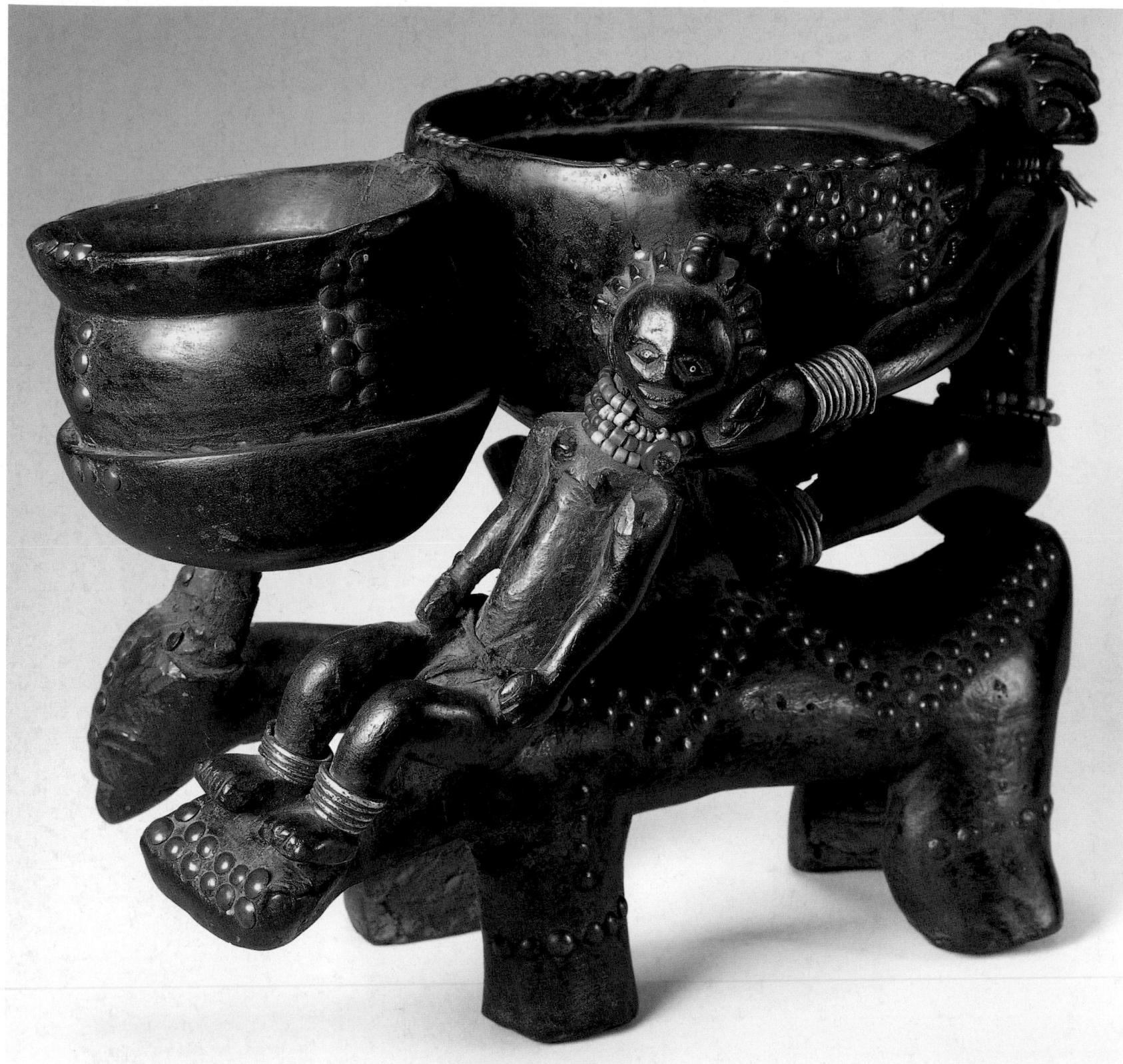

4.61a

Divination double-bowl

Luba

Zaire

wood, brass, beads, wire

32 x 42 x 26 cm

Felix Collection

Diviners are the master problem-solvers of Luba society, addressing crises and conflicts that threaten individual and communal well-being. Chiefs have personal diviners whom they consult, just as the first Luba king came to power through the clairvoyance of the first diviner, Mijibu Kalenga. Diviners use baskets, gourds and sculptures as mnemonic devices to remind them of certain general rubrics of Luba culture, through which they can classify specific behaviour. Among the most important of their instruments is the sculpted image of a woman holding a bowl. Diviners display such figures during consultations to honour the wives of their possessing spirits. The representation of the spirit's wife in sculptural form underscores the role of the diviner's actual wife as an intermediary in the process of invocation and consultation, and reinforces the Luba notion of women as spirit containers in both life and art.

Among its diverse powers, the bowl figure is known to have curative capacities. The diviner mixes a pinch

of kaolin from the figure's bowl with medicinal substances that will be administered to patients. The figure is reputed to have oracular powers: it serves as a mouthpiece for the spirit, and is capable of travelling from one place to another to gather evidence on suspected criminals. The bowl figure with two figures riding an antelope or a buffalo may be a specific reference to spirit possession: when the spirit takes possession of a diviner, it is said 'to mount the head', much as a rider mounts an animal. The founder of Luba kingship, Mbidi Kiluwe, is explicitly considered a hunting spirit who rides the lead animals of herds, directing them towards human hunters. It is likely that this sculpture was created to portray the founding hero. *MNR*

Bibliography: Roberts, 1993, p.74

4.61b

Bowl with small figure

Luba

Zaire

wood

h. 19.5 cm

Staatliche Museen zu Berlin, Preussischer Kulturbesitz, Museum für Völkerkunde, III C 19995

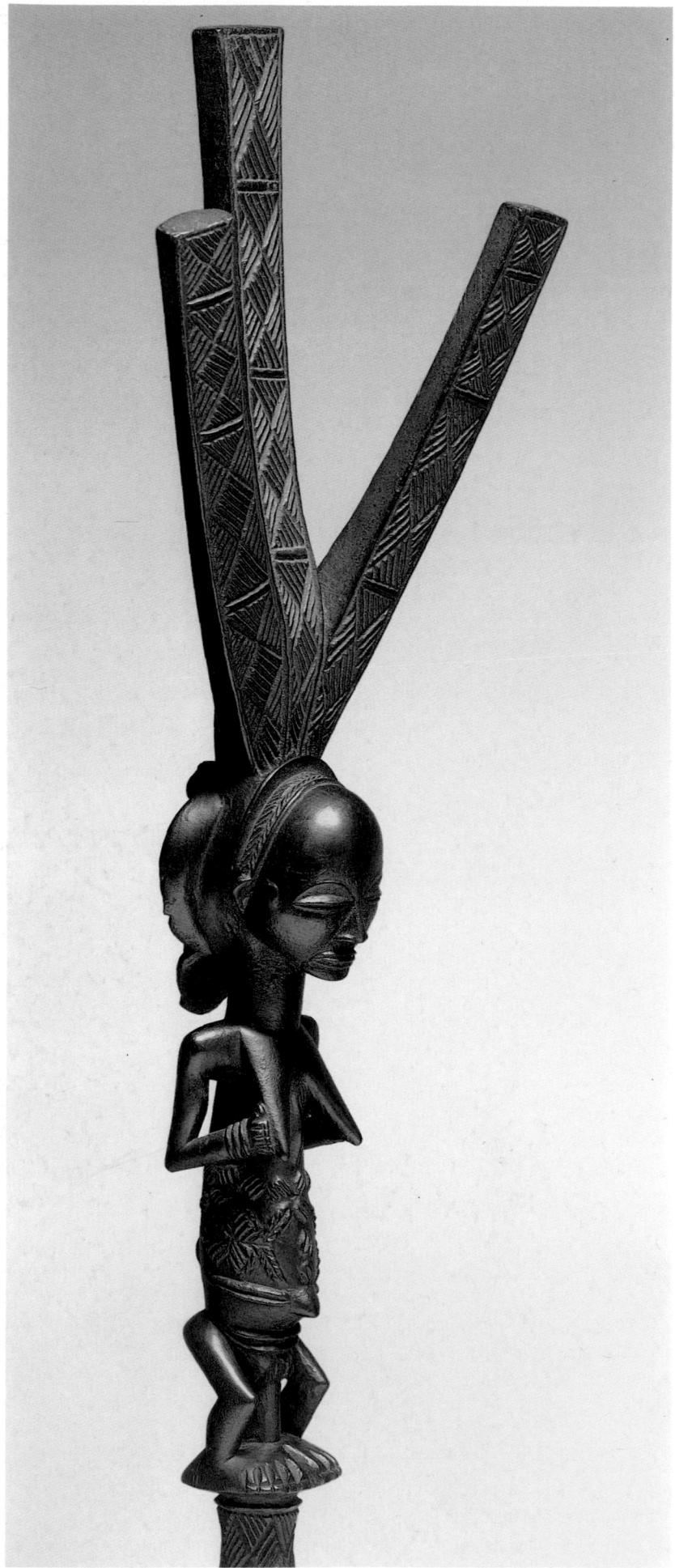

4.62

Bowstand

Luba
Zaire
wood
h. 120 cm
The Carlo Monzino Collection

Luba power was not centred in the hands of a single leader but was shared among specialists in various professions, most notably those of chiefs and titular officials, diviners and healers, and members of secret associations. Individuals in each of these institutions shared many of the same insignia, and were all initiated into the same basic body of sacred knowledge as taught through Mbudye initiations. Yet each also had its own special titles, roles and abilities as well as insignia.

Kings, client chiefs and certain high-ranking officials owned royal emblems in the form of stools, staffs, spears, weapons and bowstands. While these object types are seemingly utilitarian, Luba royal emblems have functions that surpass their original purpose: through their materials, forms and iconography, these works are symbolic of their owners' power and authority, wealth and worldliness. African arts of leadership are created as metaphorical extensions of a ruler's person, as aggrandisements of his or her presence. They extend the reach, expand the scope and elevate the stature of the leader.

Ironically, while it is often thought that royal emblems are highly visible and intended for public display and ceremony, many Luba insignia were seen rarely, if at all. Bowstands, for example, are among the most critical items in a Luba king's treasury and yet were never displayed in public. Rather, they were fastidiously guarded in the king's residence by a female dignitary named Kyabuta. For public ceremonies, the Kyabuta followed the chief with a simple bow held between her breasts (Maesen, personal communication, 1982). Within their protective enclosures, bowstands were regularly provided with prayers and sacrifices, and were subject to elaborate ritual and taboo.

Bowstands are owned by Luba kings in memory of the founder of Luba kingship, Mbidi Kiluwe, a renowned hunter and blacksmith who introduced advanced technologies in both arts. The formal development of

the bowstand can be traced from a simple hunting tool for the suspension of bows and arrows and animal carcasses to a sacred symbol of kingship. The bowstand encodes the memory of the origins of kingship, for Mbidi Kiluwe's sacred possession was his bow, and the bowstand has come to stand for the very essence of kingship itself.

Bowstands also commemorate actual women in Luba history. A bowstand made by the same artist and nearly identical with the one shown here is accompanied by documentation which states that it depicts the chief's mother, named Ngombe Madia, who led the migration of her people from the territories of east Africa to the region of the Luvua River, where they settled. Bowstands, then, like staffs, spears and stools, are commemorative, either honouring important women in Luba royal history or sometimes using a female figure to depict the king himself, since kings were incarnated in the body of a woman following death. *MNR*

Provenance: ex de Miré Collection; Lefèvre Collection; Mendès-France Collection; Pinto Collection

Exhibitions: New York 1986; Florence 1989

Bibliography: Fraser and Cole, 1972; Roberts, 1994

4.63

Six-headed healing figure

Luba
Zaire
wood, metal, fibre
h. 46 cm

The Trustees of the British Museum,
London, 1910.439

Diviners use an array of sculpted figures that serve as receptacles for medicinal substances. Called *bankishi*, some serve to catch thieves, others to retrieve lost articles; still others are for curing rites. By itself, the sculpted human figure is considered to be void, until charged with substances. These compounds, called *bijimba*, contain items thought to have rare and enhanced powers, such as human bones (life force) and the hair of twins (fertility). These are embedded into the cavities of horns, or simply wrapped in cloth and then inserted into a hole in the figure's head or stomach. Sometimes *bankishi* have multiple heads surrounding empowering substances. The many heads signal heightened powers of vision and clairvoyance, and the ability of the diviner to see in all directions simultaneously. MNR

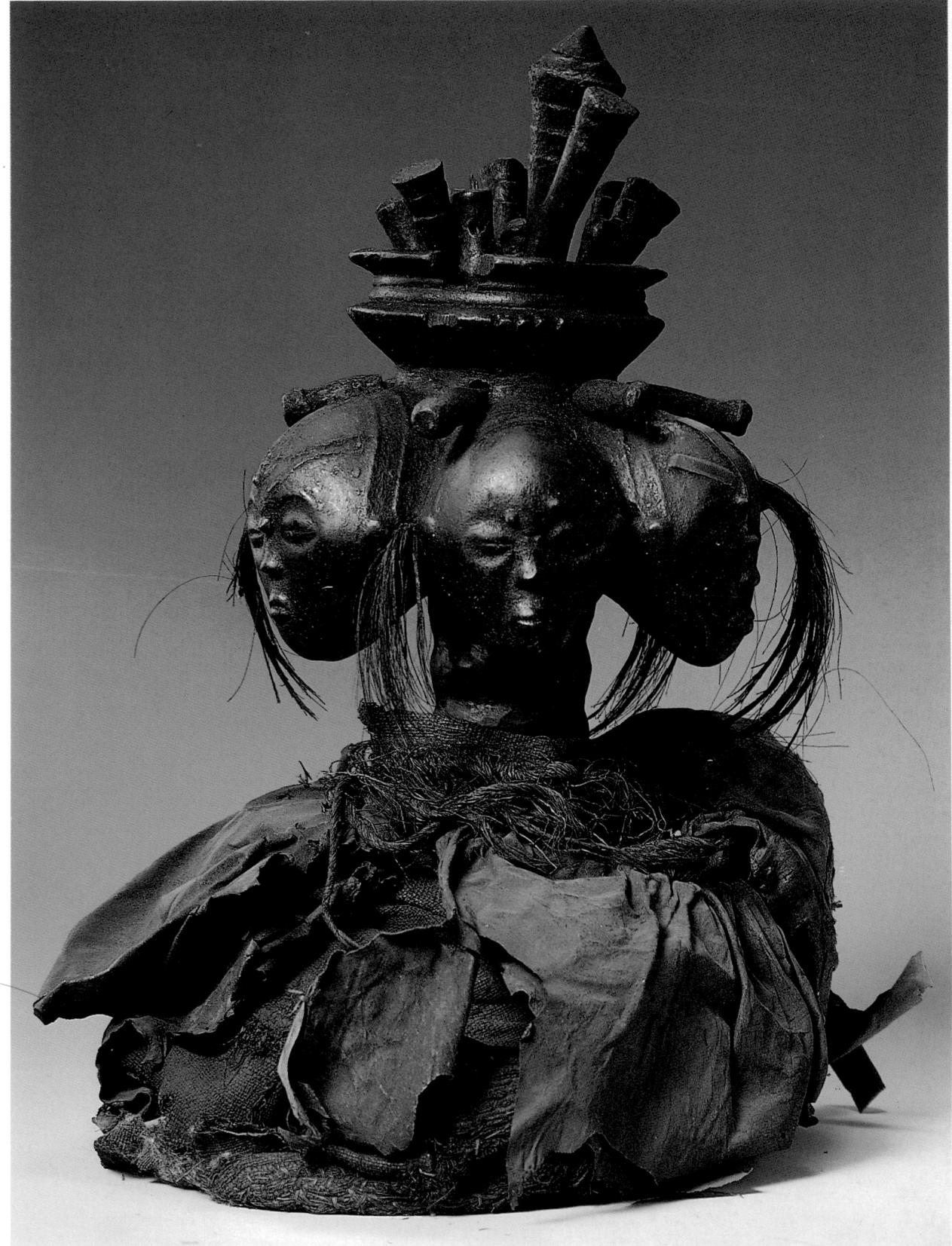

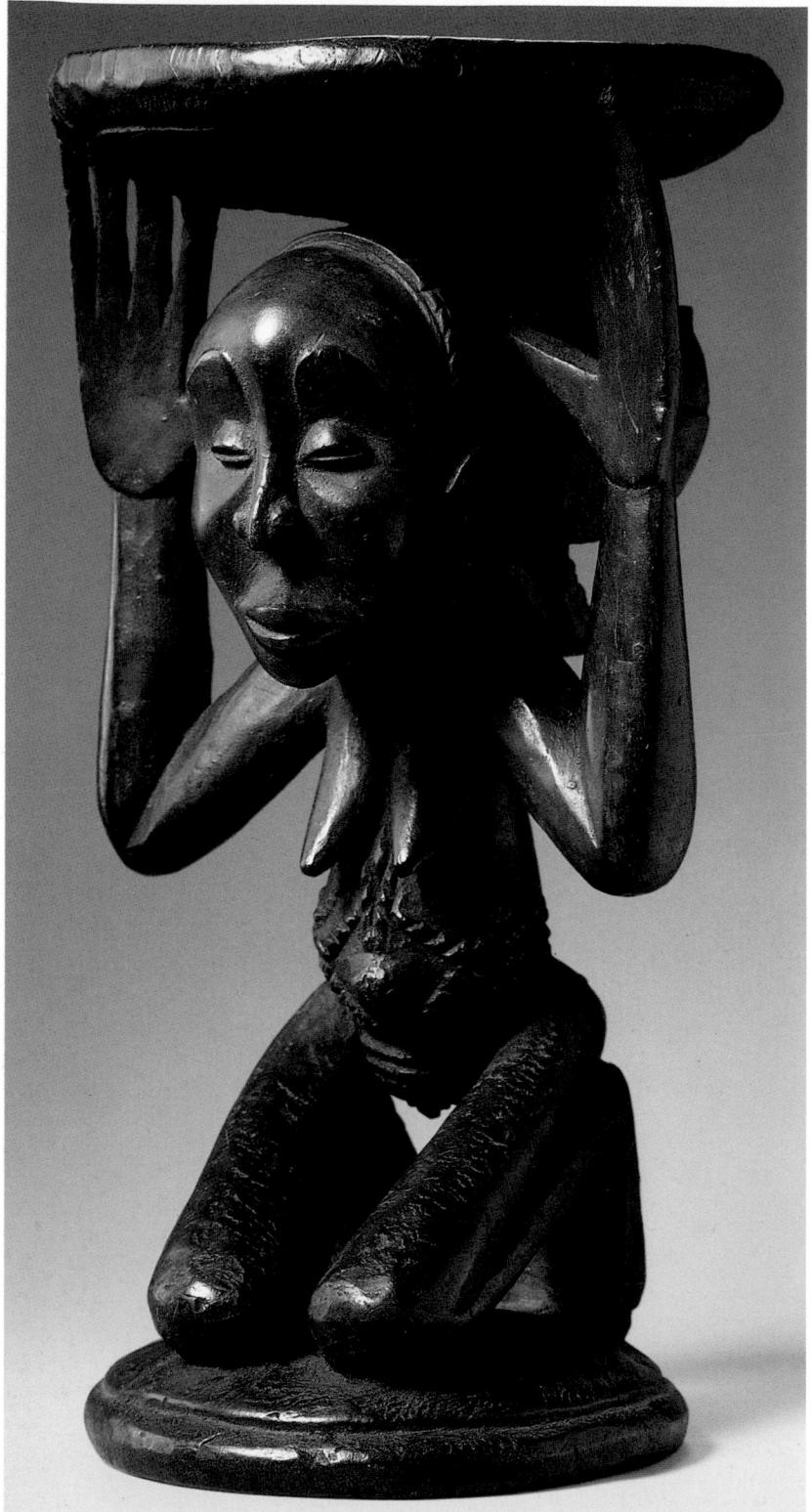

4.64

Stool

Hemba

Zaire

late 19th century

wood

52 x 27.5 x 22 cm

The Trustees of the British Museum,
London, 1905. 6-13-1

This famous stool is one of about twenty objects considered to be from the 'Buli' school, after a village in south-eastern Zaire near the confluence of the Luvua and Lukuga rivers where several objects of the style have been collected. These are lands associated with the Kunda clan, thought by some to be ancient residents and the progenitors of Luba royalty. The Luba culture heroes

Mbidi Kiliwe and Kalala Ilunga are said to be Kunda, as are several other important chiefs and kings of the region. During the colonial period, small clans and chiefdoms in the Buli area were attributed Hemba ethnicity. Hemba refers to the east, and anyone living in that direction from the Luba heartland along the Lualaba River may be called this. Nowadays, people in the area call themselves Hemba, as a convenient identity in national politics.

Neyt attributes this stool and another at the Metropolitan Museum of Art in New York to the hand of Ngongo ya Chintu, a man who once lived in Kateba village. Stools of the sort were possessed and used by chiefs and kings, especially among peoples who were either Luba themselves or who emulated Luba sacred rule. Objects of the distinctive Buli style were used across a broad area. Often those possessing stools such as ones commissioned from the Buli workshop were members of the Mbudye Society, the purpose of which was to extol a Luba model of power, refined behaviour and communication with the world of spirits. Stools are still used as seats of power and prestige, but they are also places of memory, situating power and memory in the past and present, and their subtle iconography can be read as sculptural narrative. Stools join other mnemonic devices used by people in this part of central Africa to remember what is right and glorious. In particular, a stool may be considered a *kitenta* or 'spirit capital' – that is, a place joining a chief and his people to the ancestors and other spirits seeking to guide everyday affairs. Stools are not for sitting, then, except in the most exceptional of circumstances, when a chief or king means to demonstrate his position as sacred intermediary between worlds. Vogel has suggested that the long face and aged stature of Buli figures, as opposed to the youth and exuberance of caryatids supporting earlier Luba stools, may reflect political disintegration at colonial conquest and the end of the age of sacred royalty. *MNR, AFR*

Bibliography: Olbrechts, 1947; Vogel, 1980; Neyt, 1994, p. 95; Roberts and Roberts, forthcoming

4.65

Pot

Luba (Zela)

Zaire

terracotta

40 x 58 x 34 cm

Private Collection, Munich

Luba art is well known for its royal arts and other sculptures in wood and metal, yet seldom are Luba ceramic arts exhibited or discussed. Pottery has played a central role in the critically important archaeological findings of the Luba region dating to the first millennium AD. Sequences of pottery types and styles have enabled archaeologists to identify periods and to establish the chronology of habitation and material culture in the area for a continuous span of 1500 years. Archaeological pots (e.g. cat. 4.57), while decorated with geometric patterns, do not possess figurative representation. A corpus of ceramics from the late 19th and early 20th century are, however, anthropomorphic and zoomorphic, with spouts sometimes formed in the shape of human heads. Cat. 4.65 shows an assortment of animals, including a tortoise and a lizard, encircling the body of the pot. *MNR*

Bibliography: de Maret, 1985; Childs et al., 1989

Luba

The ancestral statuary of the peoples living in the north of the province of Shaba (formerly Katanga) and in Maniema in the east of Zaire mainly appeared in Western museums and collections after the 1960s; the figures, with their characteristic cruciform plaited hairstyles, are both original and elegant. A few sculptures were known in Europe at the end of the 19th century, for instance the examples in the Museum für Völkerkunde in Berlin or the fine ancestral sculpture in the Museum of Ethnography in Antwerp (which entered the collections in 1931).

The later arrival of more than a hundred figures, collected from a clearly defined area of about 100 sq. km, revitalised understanding of the life and culture of these peoples. In former times this area was incorporated in the vast Luba culture that stretched from Kabongo, the capital, towards the Upemba depression and the region contained between the River Zaire and the lakes Tanganyika and Moero.

The Luba referred to people from the west as the 'Hemba', and this alluded to their way of pronouncing the language and to their manner of dress. Although the various ethnic groups living north of Lukuga professed to be 'Hemba', the complex social differences covered by the term need to be recognised. The southern groups, living in families, clans and chieftaincies, all traced their origins to a single place, the Hundu Mountains between Luama and Lulindi. These included the Niembo, the Honga, the Mambwe, the Nkuvu, the Muhona and many other groups. North of the Luika the Hemba groups mingle with others in a more complex fashion: the Zula, Bangubangu, Boyo and Bembi.

The veneration of ancestors is an important feature of life in large Hemba families. Fine statuary is ample evidence of this, but other ritual objects reflect an art that took many forms: the *kabeja*, a two-headed statuette connected with twins, and the *lagalla*, a large post in the shape of a head placed at the village boundary.

The statue with the ringed neck (cat. 4.66d) is a characteristic product of the workshops of the southern Niembo, around Mbulula. The figure

is admirably modelled, the curved torso setting off the shoulders and the belly that swells around the umbilical area. The ancestor's hands, placed on either side of his stomach, indicate that he is watching over his clan. The ovoid face is full and round, suggesting interior calm; the hair is dressed with a finely carved diadem in front, and with horizontal decorated plaits behind folding elegantly into the vertical plaits; these are supported by a square of raffia. This hairstyle is typical of one zone of the southern workshops, between the villages of Mbulula and Ilunga, in Honga country.

Cat. 4.66e comes from a village 130 km north of Makutano, in northern Hemba territory. The same general principles are observed: the ancestor has his hands on his stomach; he has a serene expression on his face, with half-closed eyes; and he has the same criss-cross hairstyle. The work is quite different from those of the south, however, in that this ancestor is of powerful, stocky build: the hair is built up high on the head; the ring of beard is prominent; and, on the back, a double-chevron motif echoes the motifs carved in crescent shapes on either side of a huge umbilical hernia.

Cat. 4.66b also comes from a village 130 km north of Makutano, but in Mambwe country, and is a product of the last of the southern styles made on the border with the south, near the Luika. The workshop is on the eastern side of the Hemba area. The face is more elongated, its eyes open, the flat cuts made by the chisel more in evidence. The less tangible signs of Hemba workmanship are nevertheless easy to spot.

The figure of an ancestor (cat. 4.66g), a magnificent carving of a dead chief, his eyes half-closed (to open no doubt on to another world), would lie in the half-light inside a hut. The conception of such figures was based on belief in an afterlife, as well as on the kinship system. Each ancestor is identified, assigned to a period and invoked; each confers on his owner a place in a branch of a carefully drawn-up genealogical tree relating the history of his family and the family's position on the land he inhabited. Large families among the Mambwe in the south would possess up to 20 statues, shared out among the dif-

4.66b
Ancestor figure
Mambwe
Zaire
wood
h. 65.5 cm
Private Collection

4.66a

Reliquary figure

Hemba

Zaire

ivory

h. 20 cm

Private Collection, Paris

ferent dwellings belonging to members of the same lineage.

The *lagalla*, guardian of the village, may be encountered several times in the same village. In Mambwe villages it always has two heads. The villagers make offerings to it. The exquisite cult statuette (cat. 4.66c) is evidence, at the northern limits of Hemba territory, of the survival of

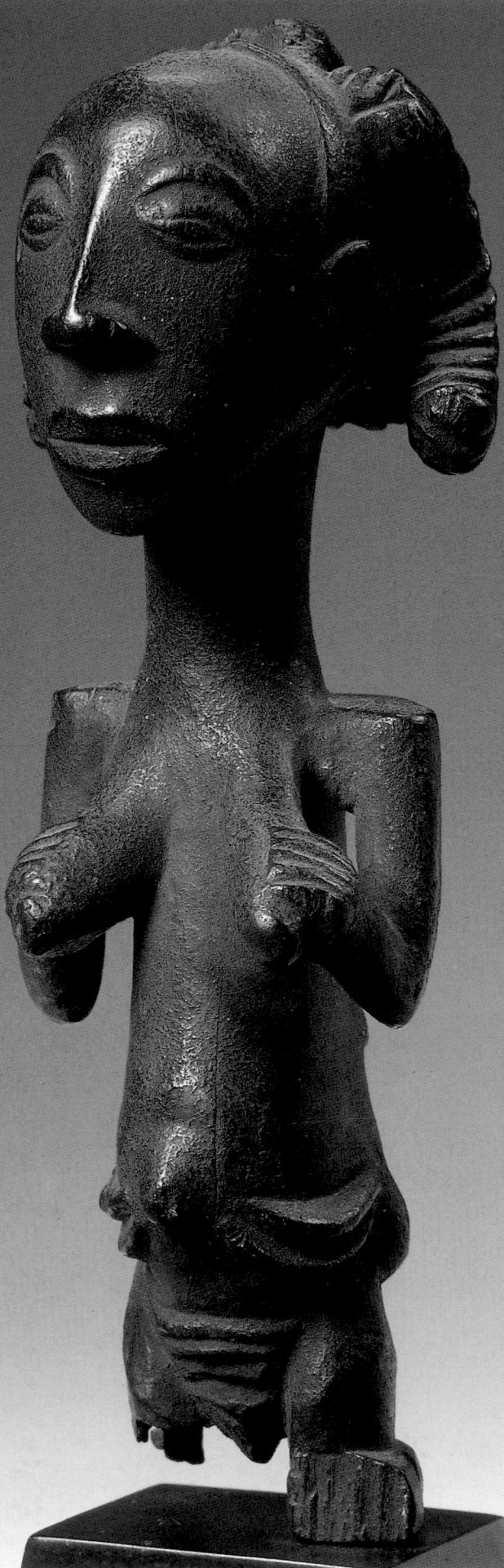

the great Luba culture that covered the whole region. This figure has plaited hair and holds her hands over her breasts. She reminds us of the importance of women in Luba culture as givers of life and nurture, and also of the gifts that transcend the visible and join the spirits of the natural world.

The astonishing figure from Frankfurt (cat. 4.66f) is carved from *Crossopteryx febrifuga*. On a cylindrical trunk, 54 cm high, a standing male figure is carrying another male on his shoulders; the upper figure has half-closed eyes and a diadem over a cruciform hairstyle. This kind of work is extremely rare among the Hembas, although other examples of people being carried can be found in Kusu country, on the left bank of the River Zaire, and further east, among the Tabwa and the Tumbwe, near Lake Tanganyika. This carving is generally described as a chief being carried by a slave, since it was customary for royal personages to avoid contact with the earth. This same tradition can be found among the Bemba in Zambia, in the Luba kingdom and elsewhere. In some cases a woman is carried by a man. Sometimes a fiancée would be carried in the same manner by her betrothed or by a member of the family. Whatever the truth of the matter, this piece of Hembas' sculpture seems to be of the head of an important family and the style suggests a Niembo chief, from the area near Mbulula where the southern style is at its purest.

FN

Provenance: cat. 4.66f: 1929, brought to the museum by A. Apeyer

Bibliography: Neyt and Strycker, 1975; Neyt, 1977, pp. 97–9, 296–7, 361, 499; Frankfurt 1983, pp. 24–5, 133; Maurer and Roberts, 1985, pp. 80, 88

4.66d

Ancestor figure

Niembo
Zaire
wood, raffia
h. 68 cm
Private Collection

4.66e

Ancestor figure

Northern Hembas
Zaire
wood
74 x 24 cm
Private Collection, Brussels

4.66c

Ancestor figure

Hembas
Zaire
wood
h. 25.5 cm
Private Collection

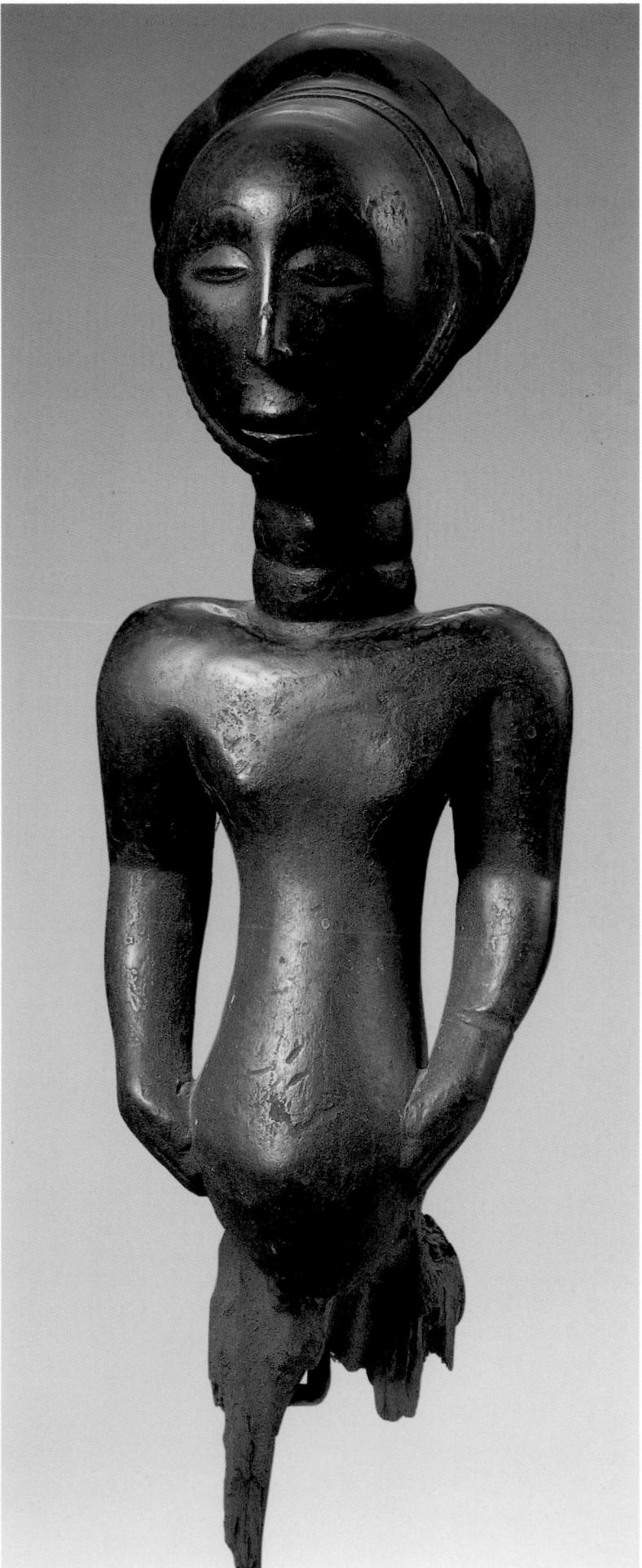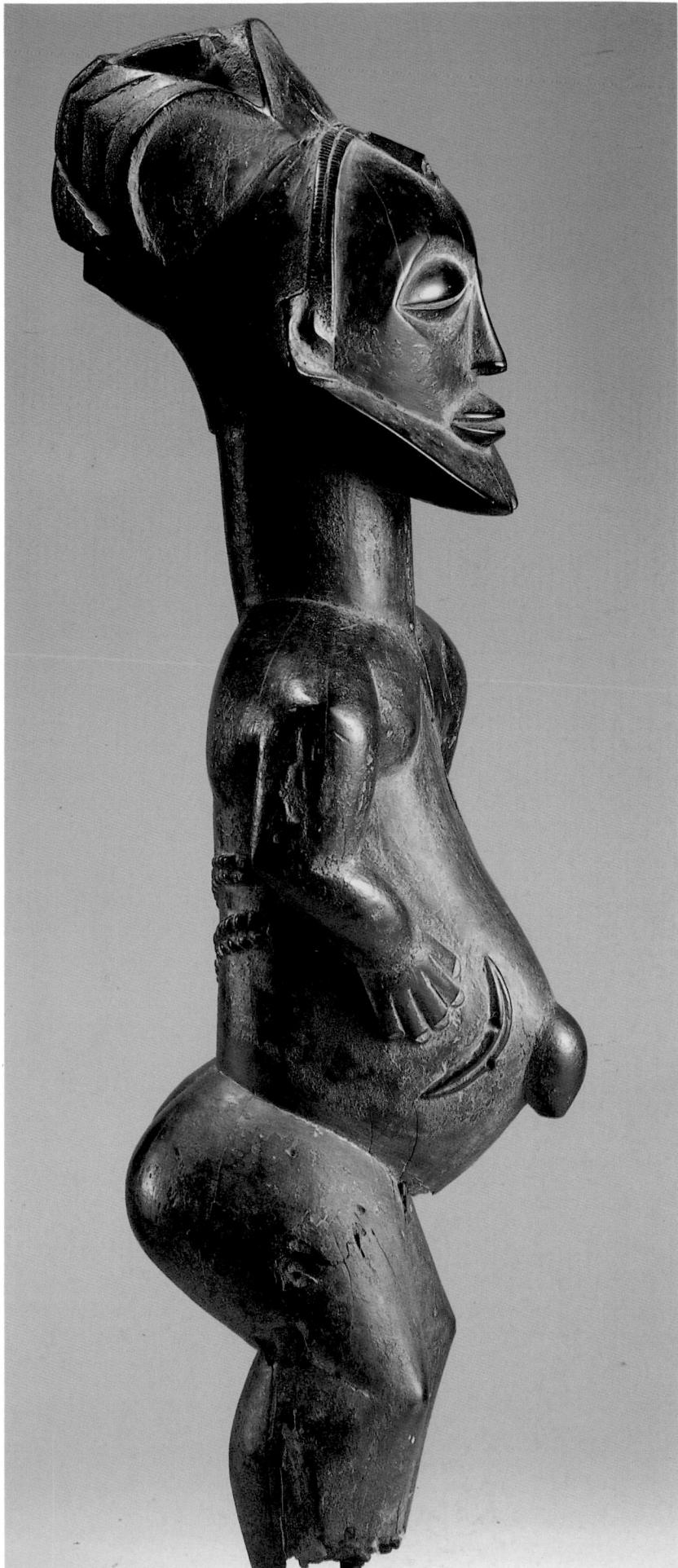

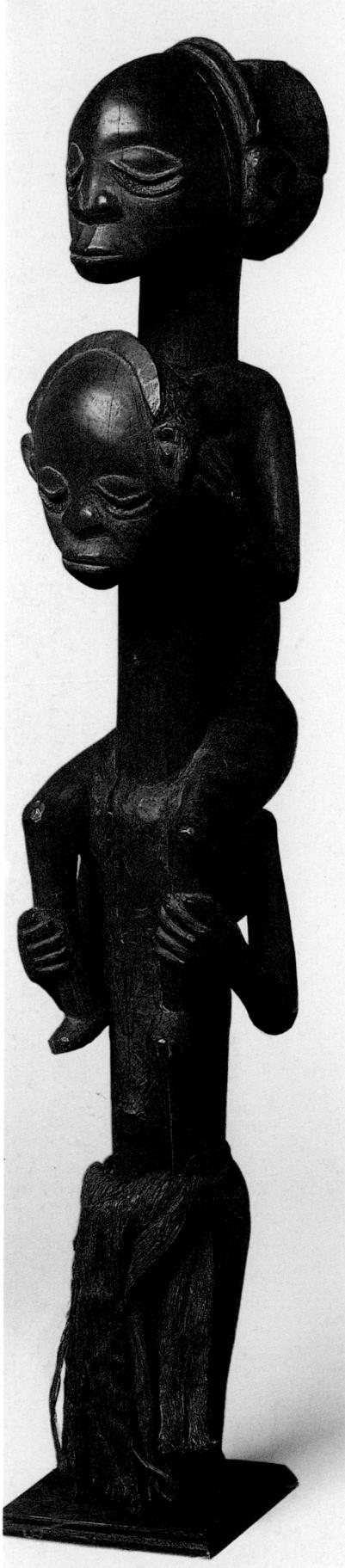

4.66f

Pickaback figure

Hemba

Zaire

wood, bark, fabric, fibre

h. 54 cm

Museum für Völkerkunde,
Frankfurt am Main, 26.543

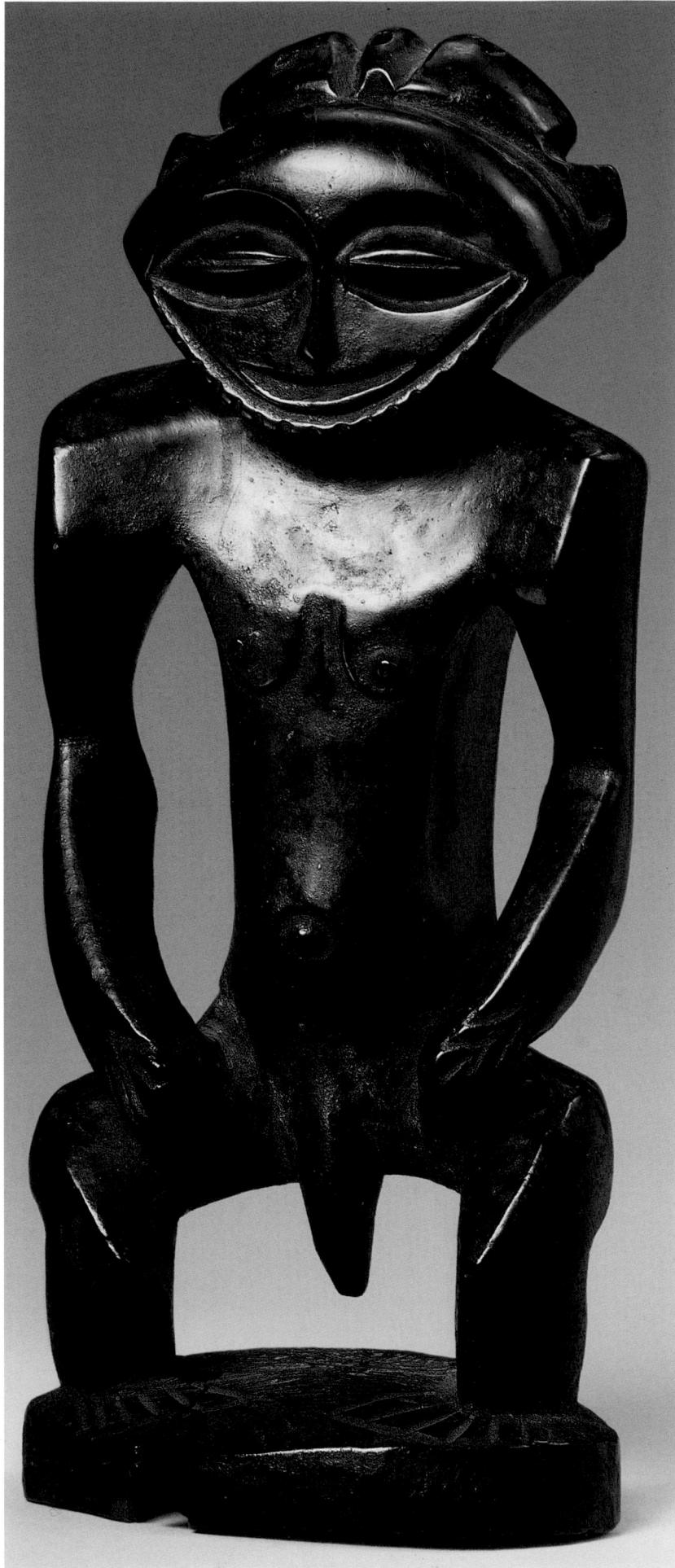

4.66g

Ancestor figure

Mambwe

Zaire

wood

h. 32 cm

Private Collection

whisk handle

o
ire
ood
.. 27.5 cm

Staatliches Museum für Völkerkunde,
Munich, 13.57.140

In the northern part of Maniema in Zaire, on the outskirts of Luama, live fragmented groups of people known by the Arabs as the Boyo or Buye. Among these, the Sumba are generally considered to be the best sculptors.

The beautiful fly whisk (cat. 4.67a) features an impressive figure, evoking the memory of an ancestor, on the handle. The serene face on the front is completed by a hairstyle with a curved pleat behind. The figure has its thorax thrust forward in a curious fashion, and a bulging stomach. It also has a backward thrust with a particularly curvaceous back. The hatched cuts, which possibly echo the spirals on the conus-shell worn by the chiefs, repeat the parallel curved lines on the thorax, the shoulder blades, above the hips and on either side of the legs, as if all blank areas needed to be covered. This piece, with its contrasting forms, expresses the ambiguous and sacred beauty of Boyo statuary better than anything written or spoken could do. How was H. Deininger allowed to bring this treasure to Europe in 1913? Very likely it was because it constituted only a minor portion of the chieftain's panoply.

The figure attributable to the Bembe people, who live in politically fragmented local settlements, is simpler, on a square base with angular sides (cat. 4.67b). The characteristic face has a high forehead and an almost vertical face, making a triangular shape with the nose in the centre. The simplified hairstyle is similar to the Boyo style; the shoulders curve right round the body as round a cylindrical trunk, with the arms folded (as here) over the chest. It is probably a work of funerary art, though this is known in only some of the Bembe groups. FN

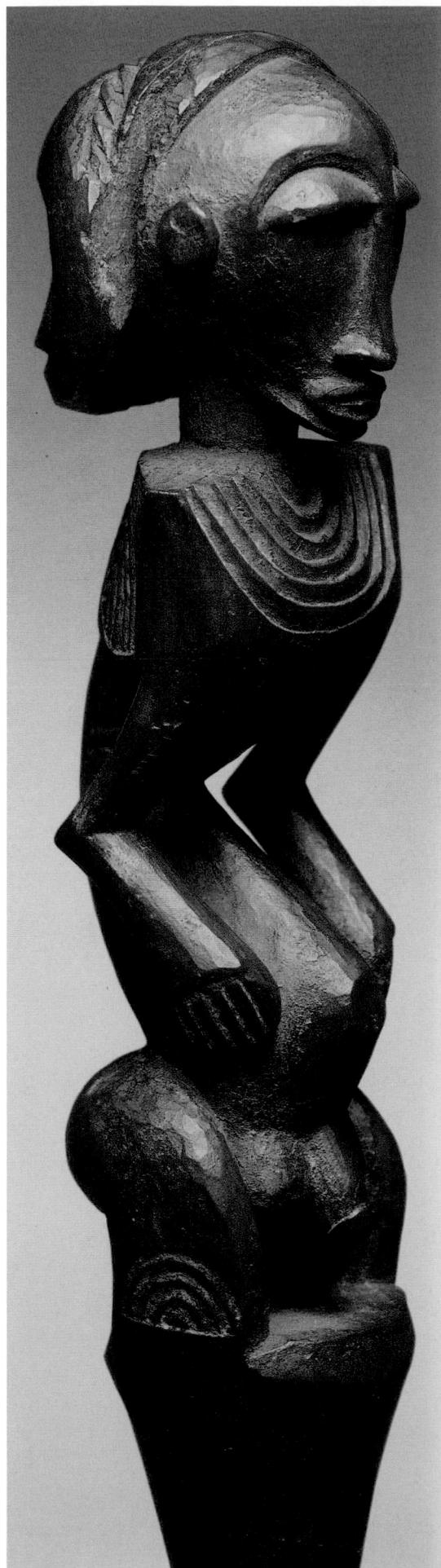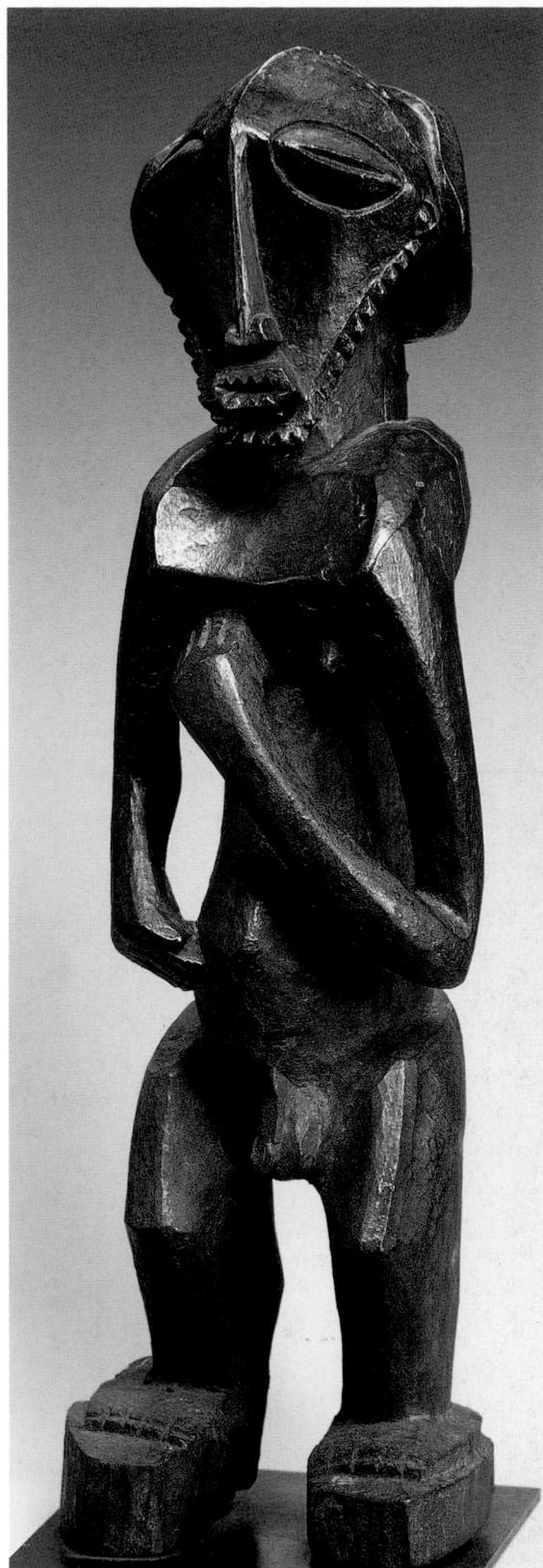

4.67b

Figure

Bembe
Zaire
wood
70 x 18 x 21 cm
Felix Collection

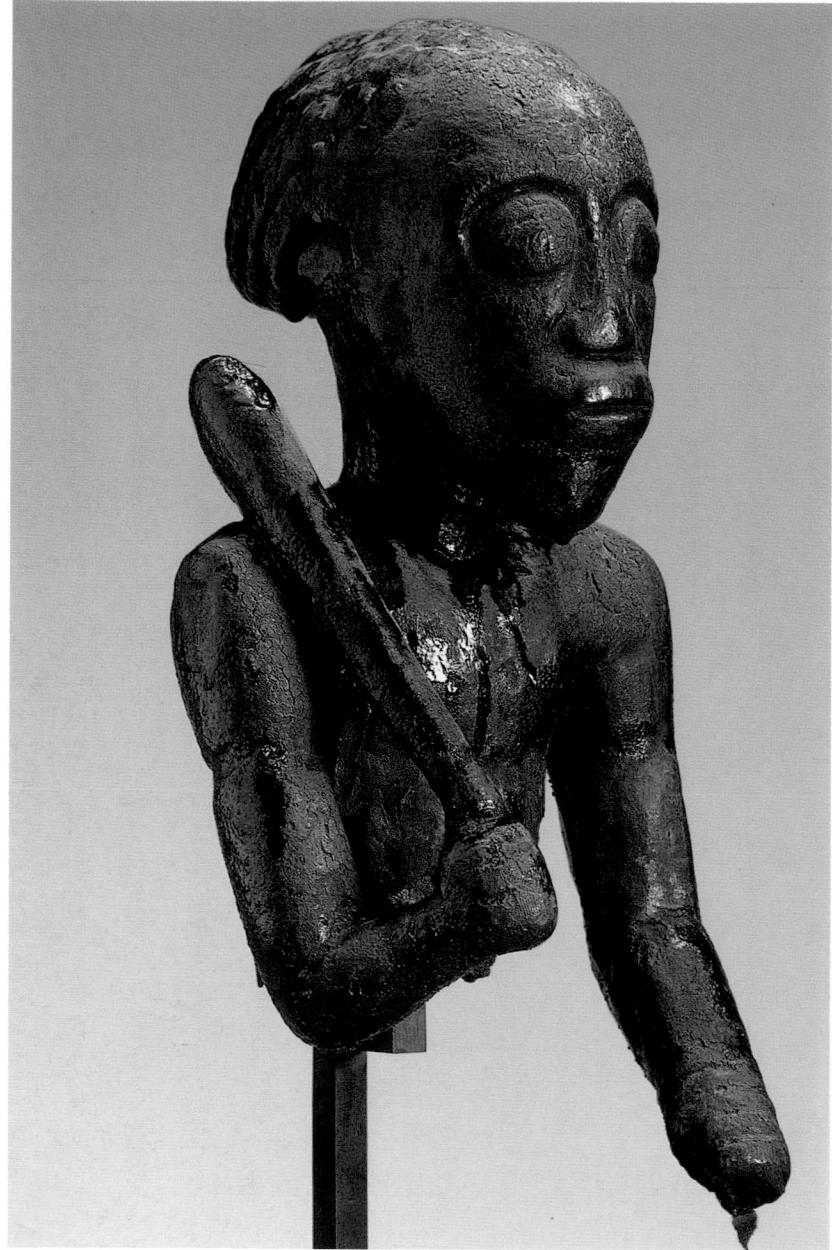

4.68

Bust

pre-Tabwa

Zaire

wood

h. 36 cm

Private Collection

This fragment is probably from people who once lived along the Lukuga River in south-eastern Zaire. It is an ancient object and, like several others to which it is stylistically related, may predate the arrival of current inhabitants of the region, who are of Tabwa ethnicity as followers of paramount chief Tumbwe. The figure is so similar in style to another fragment (Roberts and Maurer, 1985, pp. 102–3) that each object can be used to explain something of the other. Both have

strong, solemn faces, with forward-staring wide eyes and pursed lips suggesting determination. Both bear simple axes over the shoulders, of the sort carried by men throughout the region for their protection and utility. Chiefs usually possess more elaborate axes with carved handles and incised blades, but it is likely that such details were irrelevant to these sculptures.

More significant than the axe is what is left of the downward extended left arm. Rings around the wrist represent bracelets, probably of copper imported to the area from the nearby Copper Belt. The left arm of the figure not shown here is not quite so eroded, and its hand rests upon the head of a second figure carrying the first on his shoulders. Double figures

of the sort (cf. cat. 4.66f) are common to the region and much of central Africa, and generally they denote socio-political hierarchy. Kings, chiefs and title-holders might be carried on someone's shoulders, but so might brides and grooms during weddings, the victors of wrestling matches, young men and women emerging from initiation camps, or anyone else being offered momentary or pious respect. One can speculate that this figure represents a hereditary lineage chief carried on the back of a close kinsman. The chief is confident that he is being carried carefully (i.e. shown proper deference), and his resolute vision extends across lands with which he is identified. The glossy patina is probably from offerings of palm oil and beer, and years of soot from being stored in the thatched roof of a house. *AFR*

Bibliography: Kecskési, 1982; Roberts and Maurer, 1985, pp. 97–218

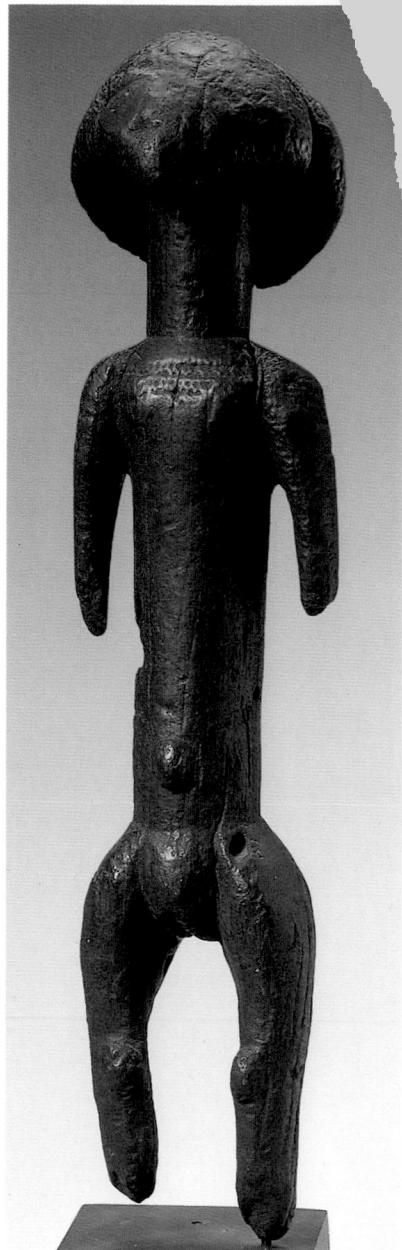

4.69

Figure

Tabwa (?)

Zaire (?)

early 20th century

wood

50.6 x 10.5 x 10 cm

Afrika Museum, Berg en Dal,

The Netherlands, 29–653

In the late 19th and early 20th centuries the Tabwa and surrounding peoples of south-eastern Zaire, north-eastern Zambia and south-western Tanzania carved small wooden figures to represent ancestors, great shamanistic healers and, perhaps occasionally, personified earth spirits. Called *mikisi*, such figures were kept by lineage elders in special buildings within their compounds, where the elders

sometimes slept to receive ancestral inspiration in their dreams. The figures had active powers to heal and protect, and many held charges of active magic. *Mikisi* might be placed near a sick person, or at the entrance to the village as a silent sentinel; they might be deployed in litigation, to ensure that a defendant told the truth, or placed near blacksmiths' forges or on hunting shrines, to keep evil forces from disrupting the transformative processes of work. Catholic missionaries considered such objects to be diabolical, and forbade their use. Most *mikisi* that still exist are in Western museums. *AFR*

Bibliography: Roberts, 1985

4.70a

Seated female figure

Tabwa
'Ujiji' style
Tanzania
late 19th century
wood, beads
85 x 38 x 36 cm
The Trustees of the British Museum,
London, 1954.23.3539

4.70b

High-backed stool

Tabwa
Zaire
late 19th century
wood
70 x 24 x 23 cm
The Trustees of the British Museum,
London, 1954.23.3196

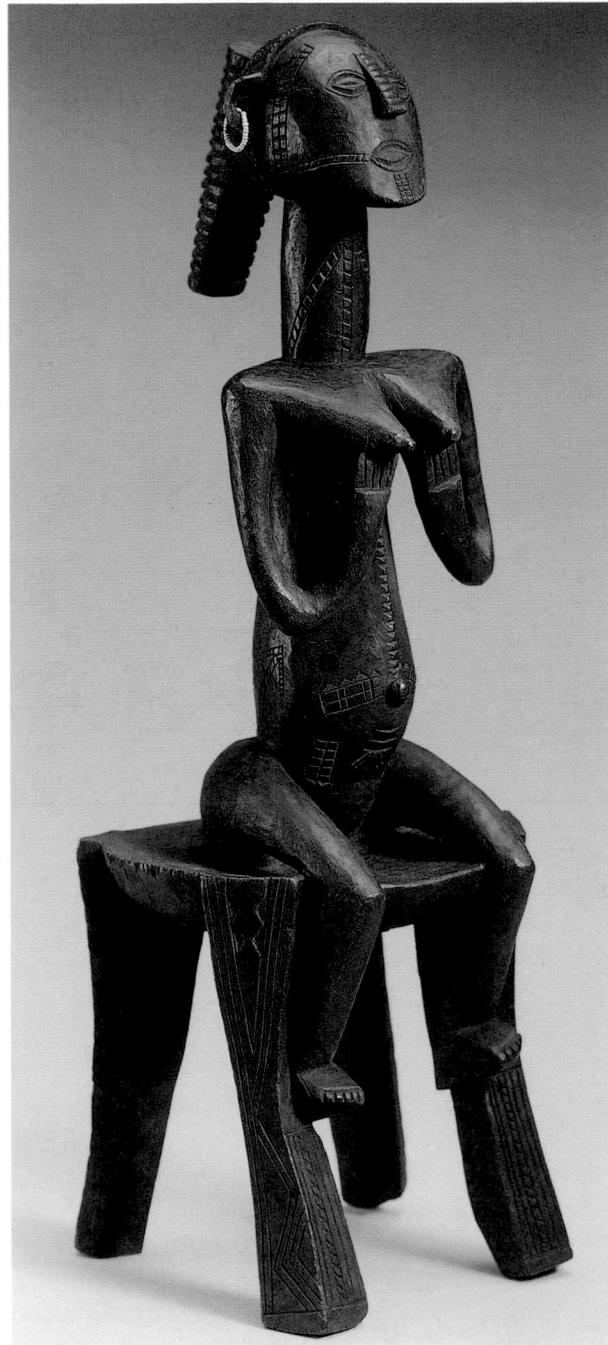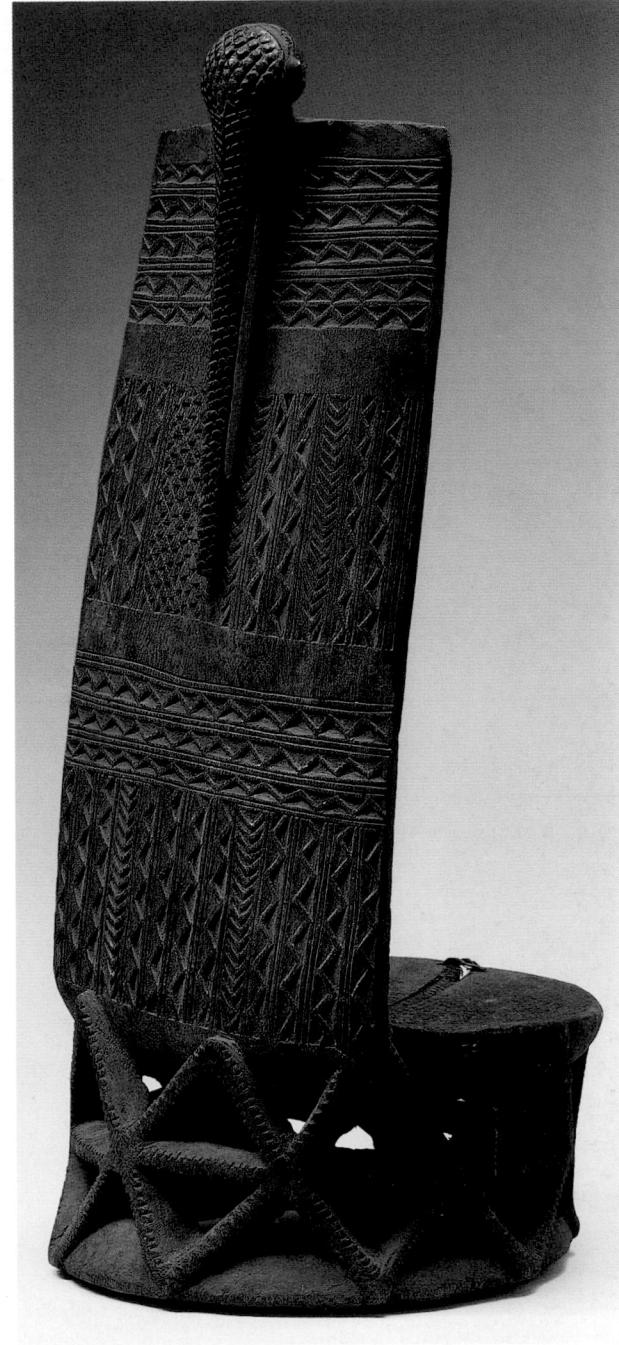

The style of the seated female figure (cat. 4.70a) is associated with the town of Ujiji, on the north-eastern shore of Lake Tanganyika. Around 1850 Ujiji became an important entrepot for caravan trade in slaves and ivory obtained west of the lake, in what is now Zaire. Local Ha and Tongwe formed a heterogeneous population with Luba, Tabwa, Bembe and others from the opposite shore, and the iconology and purposes of this figure reflect such an eclectic background. The treatment of the face, scarification and pendant coiffure are stylistically close to Tabwa sculpture. A number of Tabwa figures stand on stools, but are invariably male; while among Luba female figures commonly represent sacred kings. One other seated female figure is known from the same style area; it holds a bowl as a faint echo of Luba bowl-bearer figures. Similarly, by far the most common stance of both female and male Tabwa figures is with the hands placed either side of the navel, to stress the bonds with the mother's matrilineage; while Luba female figures often hold their breasts (as this figure does), where the secrets of sacred royalty are said to be held. A hypothetical purpose of this figure, then, is that it links the mixed populations around Ujiji with the glorious kingdoms west of Lake Tanganyika.

Stools such as the one upon which the figure sits are seats of power for Tabwa, Luba and related Zairian peoples. High-backed stools were once made by peoples across northern Tanzania, with the westernmost examples produced by Tabwa and Bisa (south-eastern Zaire and western

Zambia). The idea for such an artistic format was introduced to Tabwa by Nyamwezi ivory-hunters and slavers from central Tanzania. Only eight Tabwa high-backed stools are known. Four portray animals (three snakes and a Nile monitor lizard) associated with territorial spirits, linking the chief with the natural resources of his (or more rarely her) domain. The human figures or features on the other four stools refer to clan ancestors that 'embrace' the chief. The stool's back is decorated with the *balamwezi* motif, echoed in the triangular details of the openwork base. *Balamwezi* is Tabwa for 'the rising of a new moon',

and is a key metaphor: just as a new moon rises after several nights of utter obscurity, so will humans prevail over ignorance and 'dark' deceit, positive qualities that are embodied by the chief possessing such a stool.

The Tabwa created high-backed stools as 'statement art', in a conscious effort to invent traditions legitimising increased hegemony. As they participated in the late 19th-century ivory market and slave trade, certain Tabwa chiefs consolidated their political powers in imitation of neighbouring Luba, Bemba and Nyamwezi states. To this effect, they commissioned art and created ceremonies to confirm

their recently acquired 'royal' prerogative. Such arts flowered for a very short time, however, for by the mid-1880s European outposts in Tabwa lands had begun to stop the slave trade and, by the turn of the century, Tabwa 'royalty' was a moot issue.

AFR

Provenance: 1954, given to the museum by the Trustees of the Wellcome Historical and Medical Museum

Bibliography: Roberts, 1985; Roberts, 1994; Roberts and Maurer, 1985, pp. 246, 261–2, 277; Roberts and Roberts, forthcoming

4.71a

Spoon

Lega
Zaire
late 19th–early 20th century
ivory
23 x 53 x 39 cm

By courtesy of the Board of Trustees of the Science Museum, London

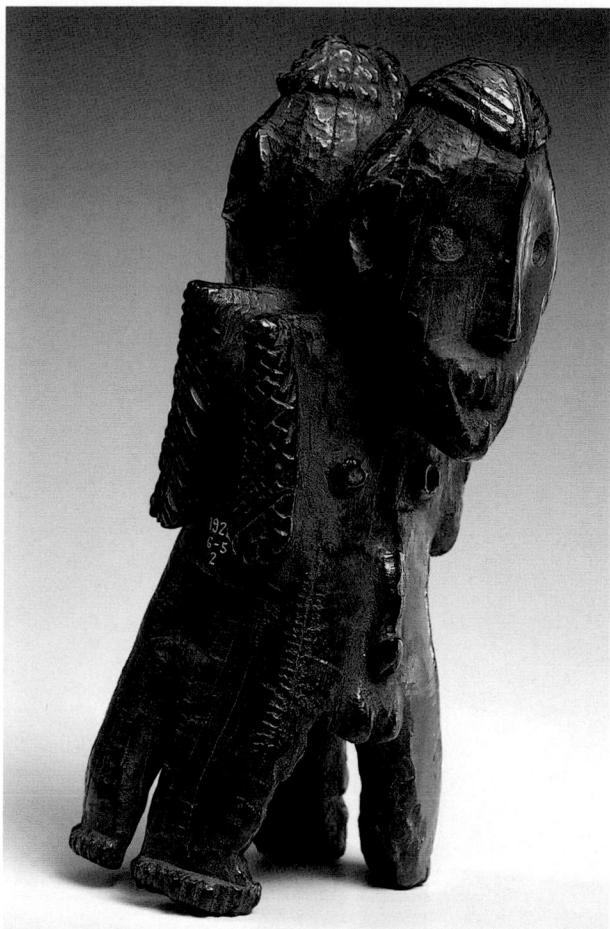

4.71b

Bifrontal figurine

Lega
Zaire
early 20th century
ivory
16 x 6.5 x 7.5 cm
The Trustees of the British Museum, London, 1929.6.5.2

The Lega inhabit the forest region in eastern Zaire. They are a Bantu-speaking group who practise a mixed economy involving agriculture, hunting and fishing. They do not possess a centralised political organisation, and both men and women aspire to moral authority by gaining high rank in the *bwami* initiation association. Membership of *bwami* cuts across the divisions between patrilineages and local residential groupings, and its graded initiations help to bind the generations through commemorative rituals which celebrate the virtues of deceased former members. The highest ranking members of the *bwami* association commission, own, use and interpret all Lega sculpture. Many categories of object are used in connection with the association's

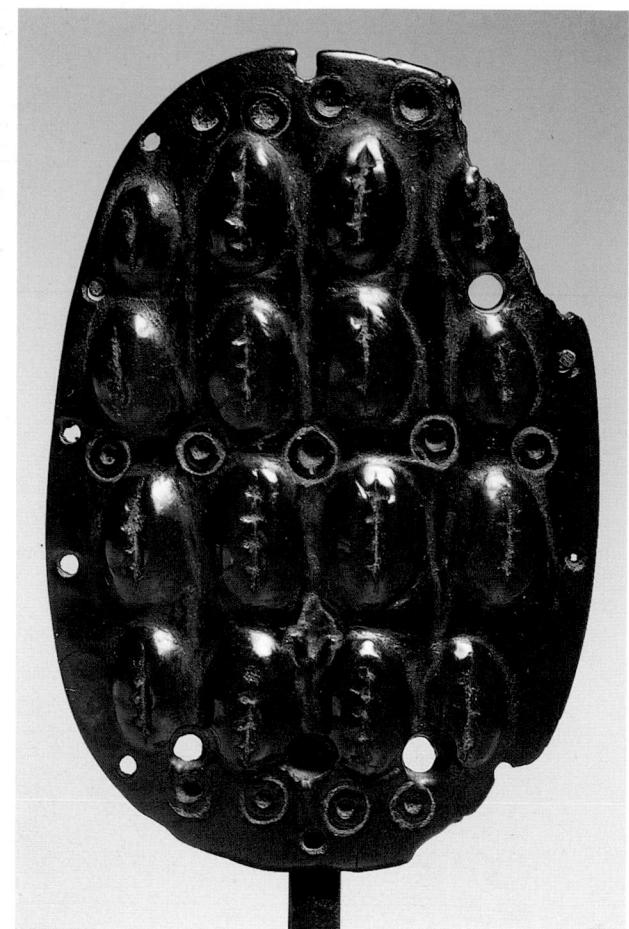

4.71c

Ritual ornament

Lega
Zaire
18th century (?)
ivory
h. 8.9 cm
Patricia Withofs Collection, London

activities, including anthropomorphic figurines of various kinds (e.g. cat. 4.71b), zoomorphic figurines, masks (cat. 4.71d–f), hats, spoons (cat. 4.71a), miniature implements, ornamental disks and chips (cat. 4.71c), animal parts and found objects.

The Lega call most anthropomorphic figurines *iginga*, which they define as 'objects that sustain the teachings and precepts of *bwami*'. Each figurine symbolically represents a named personage with particular moral qualities or defects that are expressed through dance and sung aphorisms during the most important stage in initiations to the highest grades of the association. Plurifrontal figurines (e.g. cat. 4.71b) exhibit a variety of forms and represent a distinct type of *iginga* named

Sakimatwemtwe ('Mr Many-Heads'). The saying that often goes with this type of figure when it is displayed by itself is: 'Mr Many-Heads has seen an elephant on the other side of the large river.' The saying alludes to the status of the high-ranking initiate who, having undergone many initiations, has witnessed great things and possesses enhanced powers of understanding. The mask with two faces exhibited here (cat. 4.71d) represents a variation of the plurifrontal motif, and it may have been used to illustrate some of the same characters and concepts as the related figures.

Among the numerous artefacts owned and worn by high-ranking *bwami* members are a variety of roughly ovoid bone or ivory chips. These may be strung together to form

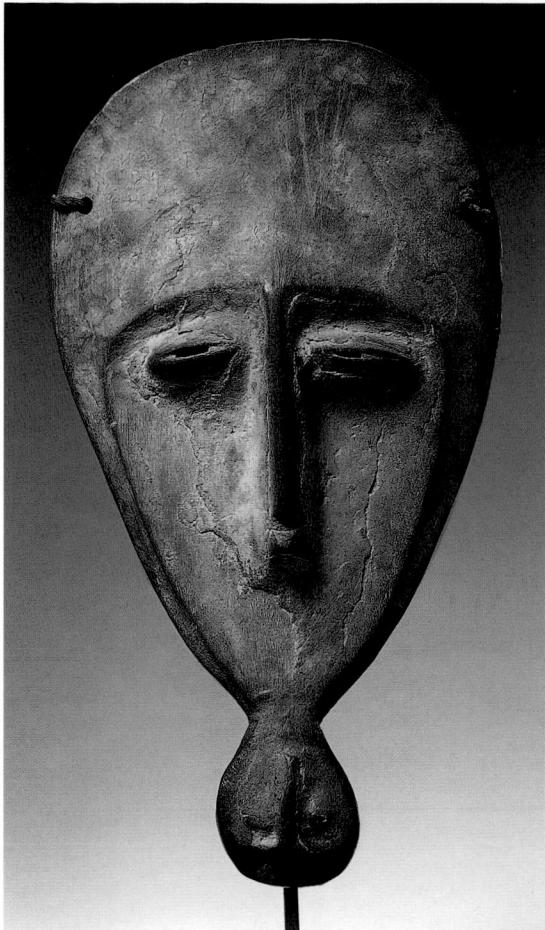

4.71d

Mask

Lega
Zaire
early 20th century
wood, pigment
28.5 x 15.5 x 4.5 cm
J. W. and M. Mestach

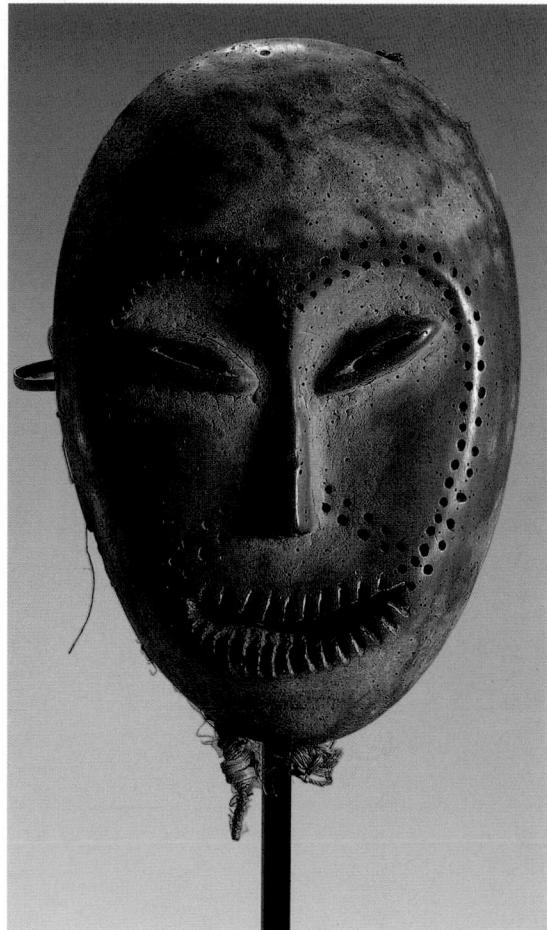

4.71e

Maskette (*lukwakongo*)
Lega
Zaire
wood, raffia, pigment
30 x 20 x 8 cm
Felix Collection

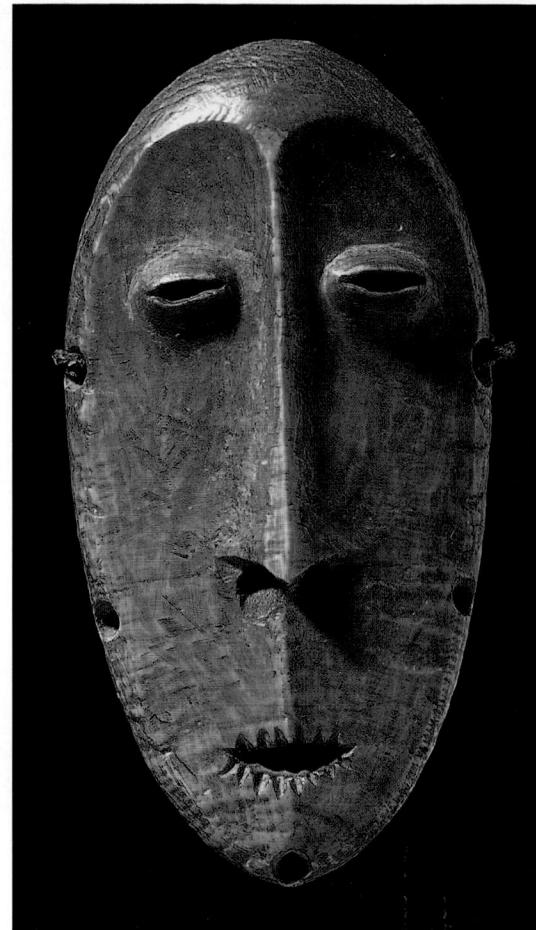

4.71f

Miniature mask (*idimu*)
Lega
Zaire
ivory
h. 10.5 cm
Private Collection

wristbands or they may be worn on necklaces as pectorals. Some are convex, as is the example exhibited (cat. 4.71c), and they are often decorated with the characteristic circle-dot motif. The example here is also decorated with an attractive cowrie shell design (strings of cowries are a standard item of exchange paid during all *bwami* initiations), and it may have served primarily as a prestige ornament. As a general rule, most of the simpler carved items and found objects used in *bwami* rituals serve mainly to illustrate ideas and principles rather than characters, as is the case with the masks and figurines.

Spoons carved in bone and ivory (cat. 4.71a) are prestige items owned by high-ranking *bwami* members and they are used during initiations to

convey a variety of ideas. Like the bone and ivory from which they are made, spoons may serve as symbols of continuity. In certain contexts they are used symbolically to feed masked preceptors in order to demonstrate the privileged status of old initiates who like to feast on soft delicacies.

Wooden, bearded maskettes with heart-shaped, concave faces painted with white pigment (cat. 4.71e) are owned, in some areas, by every male member of the most advanced level of the second highest grade (*yananio*) of the *bwami* association. The maskettes (called *lukwakongo*) are not worn over the face. Participants in most rites display their maskettes as a group in conjunction with particular dance movements and aphorisms which vary depending on the context in which

they are used. In some rites they may be held in the hand or dragged by their beards, in others they may be fixed to hats or arranged on a miniature palisade. An initiate will generally 'inherit' his maskette either from a deceased kinsman who was himself formerly a member of the top level of the *yananio* grade or from a living relative who has graduated to the highest ranking grade (*kindi*). The *lukwakongo* maskette is passed on to the initiate by his personal instructor during a rite of the same name. It serves as an emblem of the initiate's new rank and symbolises his links with other *bwami* association members and with deceased former members.

Of the four families of masks used in connection with *bwami* the *idimu* group (cat. 4.71f) embody the highest

authority. They are used in various ways during the most advanced rites of the highest ranking *bwami* grade and are always displayed attached to a miniature palisade surrounded by other types of mask. *Idimu* masks are not intended to represent spirits or ancestors in any way, and individual masks serve as the supreme figure-heads under which a collection of *bwami* communities rally. In the history of their use they embody a shared tradition and so help to validate the principles, rights and exchanges according to which the practices of the *bwami* association are structured. ZK

Bibliography: Biebuyck, 1973, p. 226; Biebuyck, 1985, p. 45; Biebuyck, 1986; Biebuyck, in Tervuren 1995, pp. 375–8

Panel with double faces

Shi
Zaire
wood, kaolin
h. 36 cm
Private Collection

This unusual piece is identified with the Shi who live in the vicinity of Lake Kivu in eastern Zaire. Their art and material culture is little documented, though at least one other object in this form is known (Felix, 1987, 1989). The same general style with a concave canoe-shaped base from which rise two heads in high relief also occurs among the neighbouring Komo. In no case, however, is the discussion of the significance and function of the carved panels conclusive.

Piecing together the little information (and indeed speculation) available, a number of observations arise. There is a general assumption that the panels and faces are somehow associated with primal ancestors (the two heads being assumed to be male and female) and with divination. In effect, this is a combination which in general terms goes readily together. On the one hand, ancestral authority, or the world of the spirits with which

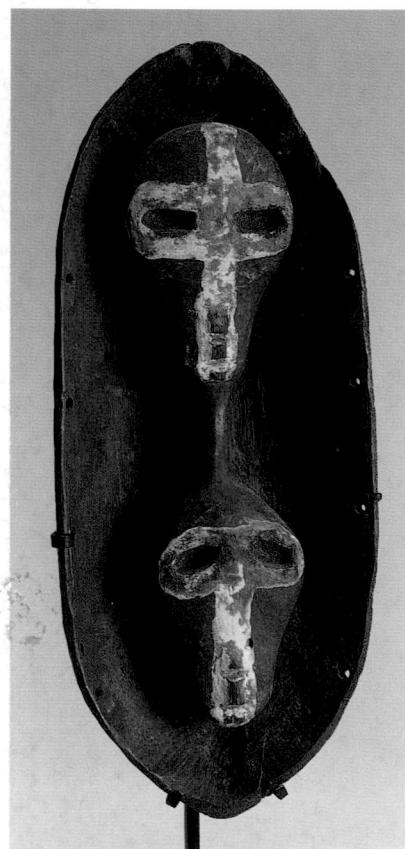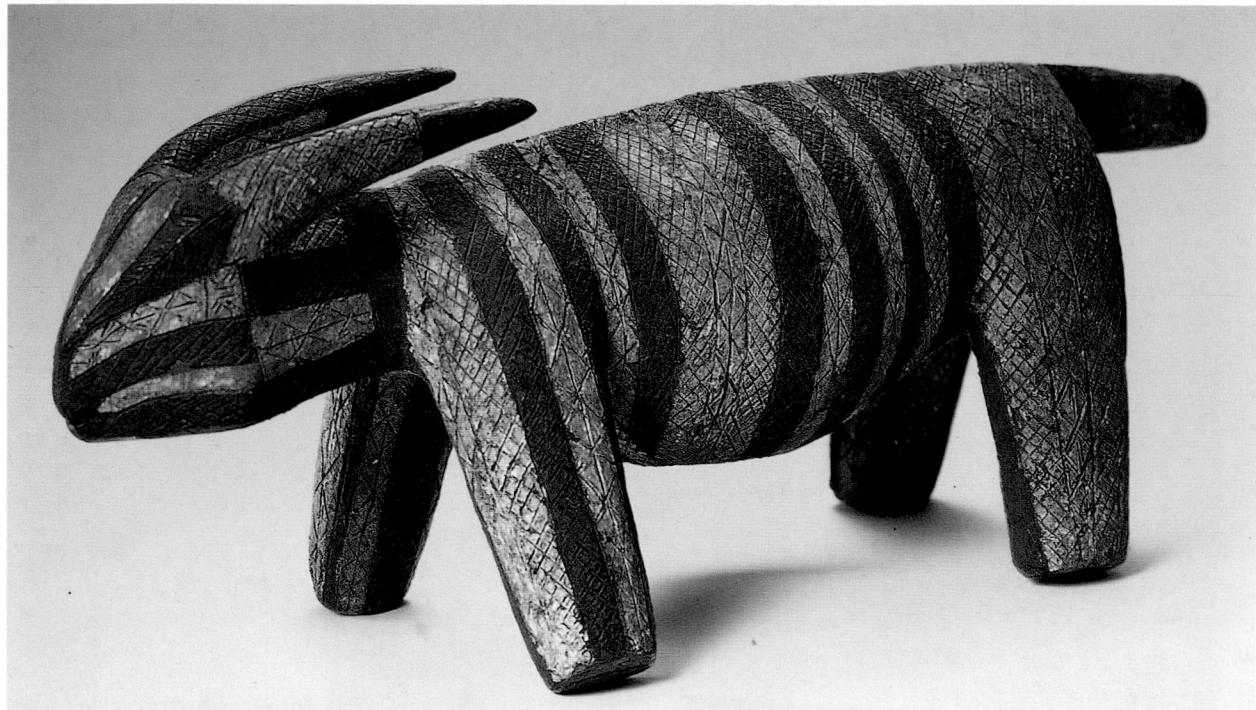

it is usually conflated, underlies much divinatory practice. On the other, the ancestors are not generally conceived as some remote and ineffectual point of reference but are usually seen as engaged in and having an oversight of everyday human affairs – an obvious point of contact with diviners and with their sources of special knowledge.

The use of white pigment to outline the eyes is also significant. In many parts of the Bantu world ocular vision is emphasised by outlining the eyes with white kaolin (cf. cat. 4.50). (A contrast with red is also characteristic of the symbolic colour spectrum of central Africa.) White is sometimes applied to the eyes of sculpture endowed with special powers, and also directly on the faces of diviners. All of this confirms the likely status of the objects, even if the precise ethnographic context remains to be confirmed. *JM*

Bibliography: Neyt, 1981, p. 37; Sieber et al., 1986, p. 139; Felix, 1987, p. 156; Felix, 1989, p. 264

4.73

Quadrupedal animal

Pere
Zaire
wood, pigments
27 x 69 x 24 cm
Felix Collection

The Pere, a group numbering only about 4000, are perhaps the least studied and least documented of all the peoples in equatorial Africa. Biebuyck provides summaries of what is recorded (see also Felix, 1987, for an equivalent piece to that exhibited here). The Pere claim historical links with the Komo, neighbours of the Shi (cat. 4.72), and with various Pygmy groups (cat. 4.74a). Indeed they have traditions of joint migration from Uganda with Pygmies to their present locations in north-eastern Zaire. None the less, their characteristic art forms show little indisputable linkage to those with whom they have the closest historical ties. The clearest connection is perhaps with the Lega, whose use of art objects in initiation as didactic references to social and moral conditions appears to be replicated among the Pere.

Whether this object may be a part of the initiatory complex is not at all certain. The only information about it indicates, somewhat vaguely, that it was used paired with another quadrupedal animal in ceremonies associated with hunting and fertility. Exactly how it might have been used

and to what effect is, however, unclear. Likewise, a cavity on the underside of the animal remains enigmatic. The most dramatic feature of the carving is the coloration on the flanks of the animal. This perhaps suggests a wild animal rather than a domesticated species and tends to support the speculative suggestion of a link to a hunting ritual. The only description of such rituals makes reference to the use of clay animal figurines in trapping elephants. Whether this figurine and its pair are part of the same complex remains for the present unclear; those reported appear to be crocodiles or iguanas. *JM*

Bibliography: Biebuyck, 1976, pp. 59–61; Biebuyck, 1986, pp. 246–9; Felix, 1987, p. 144, no. 9

4.74a

Barkcloth (*pongo*)

Ituri forager

Zaire

bark, pigment

90 x 58 cm

Private Collection, London

Women foragers of the Ituri Forest in north-eastern Zaire paint rhythmical, free, oscillating patterns on pieces of pounded inner bark which have been cut and hammered by men. Often working with a mixture of gardenia juice and carbon black, they employ the same rich repertory of motif and design that they apply in painting the bodies of their family and friends. In addition, women are the architects of the Ituri world. And they are the masters of the polyphonic, yodel-like style of singing special to Ituri foragers.

Ituri aesthetics links art and song. Both use polyphonic structures; contractions of intervals; macro-complications of structure in terms of successive passages; micro-complications of structure in terms of small motifs, modified at each repetition; staggered entrances and exits of line; and a strikingly playful multi-voiced mode of exposition.

These two barkcloths illustrate the spontaneity of Ituri painting. Shifting and contracting spaces between parallel lines build abstract rhythms and deliberate contrasts. At the left two different phrasings of tendril-like patterning about a narrow field of 'stars' and linear constructions lead the eye to an open field of parallel lines. Over these lines cross short parallel strokes, elegantly curved and flowing. Motifs vary at each repetition.

Cat. 4.74b nobly illustrates forager freedom of expression: the painter fills her space with interweaving, sapling-like lines, not unlike the trellis of sapling and vine with which she would make her home. Suddenly the design changes its mind. Lattice-like patterning evaporates. In its place emerge short, bisected rectangles of varying shape, length and positioning, like dominoes spilled or scattered on the ground. The artist has shown profound understanding of the realm of linear expression, moving from 'order' to 'chaos' and back again in one coherent composition.

The 'meaning' of this break-pattern art, eliding staggered accents

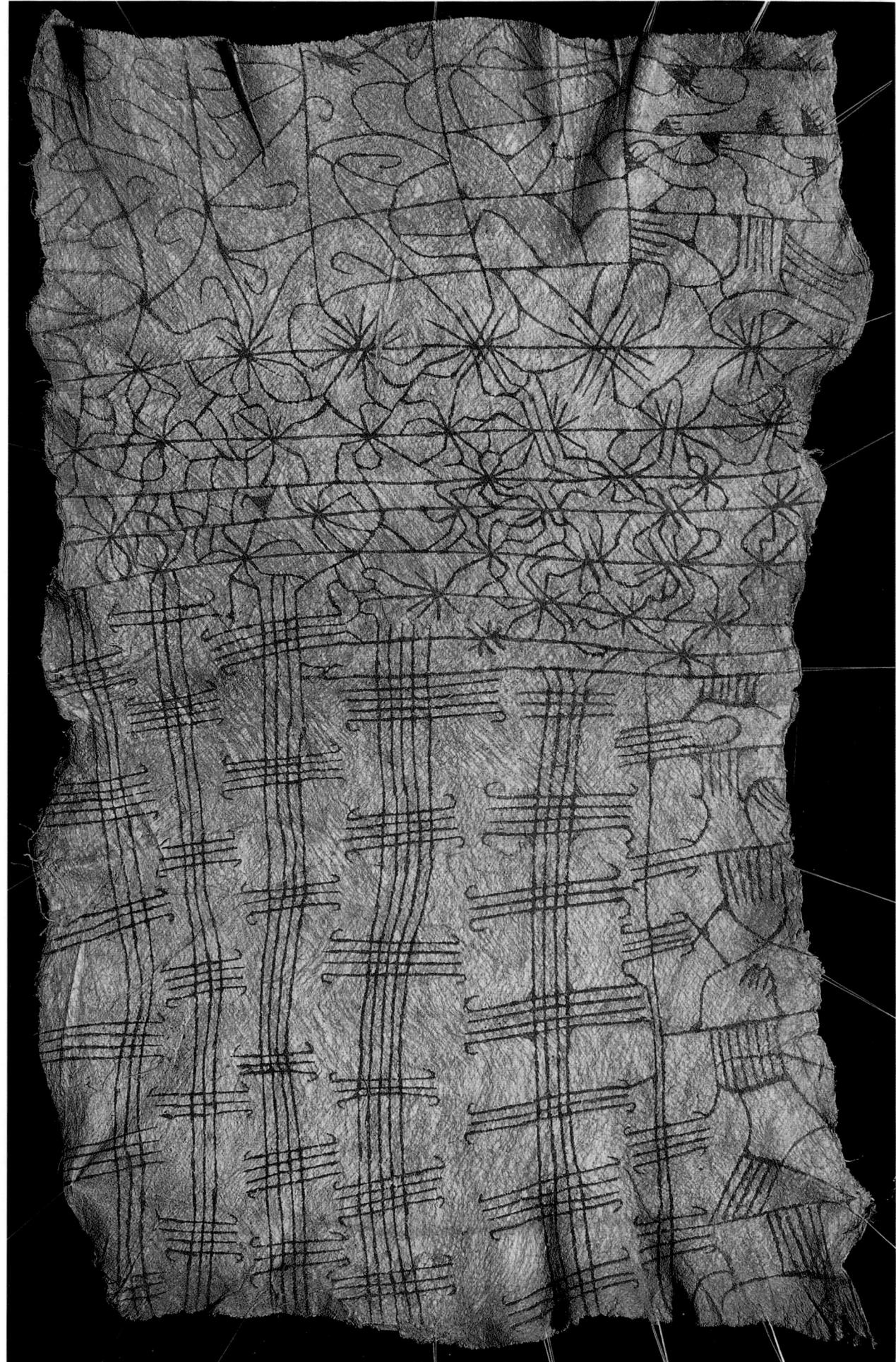

with stylised interlacing, is enigmatic. In ritual contexts it may encode a sylvan idiom, parallel, in its flowing rhythm, energy and abstraction, to polyphonic forest yodelling, the Ituri way of praising God.

Forager art has influenced painting in neighbouring Mangbetu, Lese-Karo and Komo villages. It is possible to see such influence reaching even further, to include women's art among the Shoowa and Kongo and, via forager pockets on the Cameroon Grasslands, women's inner-bark painting among the Ejagham and Bokyi. With these two *pongo*, then, we may sample an epicentre of women's style in the history of African art. *RFT*

Bibliography: Thompson and Bauchet, 1991; Thompson and Meurant, 1995

4.74b

Barkcloth (*pongo*)

Ituri forager

Zaire

bark, pigment

63 x 45.7 cm

Private Collection

Barkcloth

Mangbetu

Zaire

early 20th century

beaten bark, pigments

168 x 164 cm

Musée National des Arts d'Afrique et
d'Océanie, Paris, MNAN 1963.1116

Before the colonial era, barkcloth was the main item of men's and women's clothing in central Africa. The cloth was wrapped over a belt, passing under the legs when worn by men, and when worn by women simply draped over the belt in the front of the body. Women also carried small pieces of barkcloth and placed them over wooden stools.

This cloth is constructed of three separate pieces sewn together with raffia. The soft cloth is made from the bark of the fig tree (*Ficus roko* or *Urostigma ktshyana*) that has been beaten with a mallet made of ivory, bone or wood. Large pieces of cloth, such as this one, were used by men or by women of high status. Women did most of the painting on barkcloth, using a fibre brush and paint from the juice of the gardenia plant.

The designs on the cloth probably represent material objects, both flora and fauna, and manufactured objects. Much of the iconography remains undeciphered. Particular patterns are said to represent, for example, spiders, snakes, hairpins or houses. Pounding the bark to give it the soft and flat finish of cloth is done by both men and women. The painting closely resembles the designs used in women's body painting (also done with gardenia juice). Some of the geometric patterns found on barkcloth resemble designs incised on pottery or incised and burnished onto carved furniture. Irregular isolated patterns, as on this piece, have also been applied to wooden objects, such as on a Mangbetu painted shield.

This example of barkcloth is unusual in that the composition has been divided into four triangular sections, traced along the diagonals. The whole piece is enclosed by an unusual double-line border. While a division into sections is common, they are more often arranged in vertical or horizontal bands and the designs usually continue to the edges of the cloth with no outside border. Except for the border and the triangulation, the painting on this example combines design elements that have been associated with the aesthetics of both the Mangbetu and the Mbuti or Sua Pygmies (called Akka by the Mangbetu). Some scholars associate the free

and asymmetrical juxtaposition of patterns with a Pygmy aesthetic. Others note that in central Africa forest hunters and gatherers like the Akka and the Mbuti have lived in close social and economic collaboration with farmers like the Mangbetu. The techniques of bark-cloth manufacture and many of the designs are shared among several groups in the region and it is now difficult to specify ethnic affinities or origins for particular styles and designs. ES

Bibliography: Thompson and Bahuchet, 1991; Schildkrout and Keim, 1990

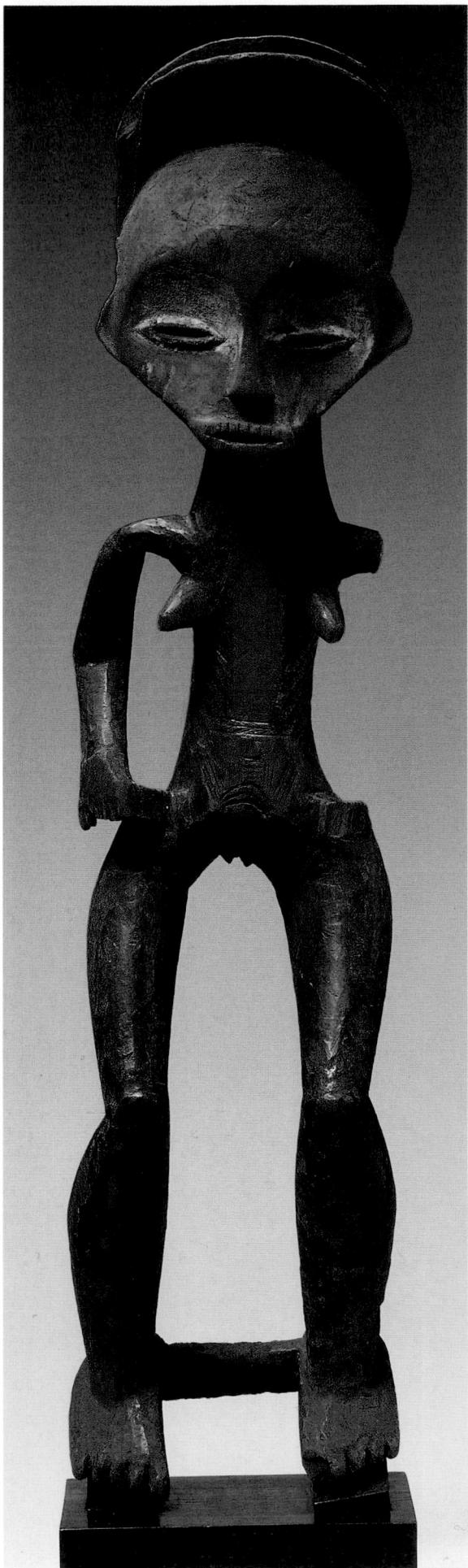

4.76

Hanging figure

Mbole
Zaire
wood
h. 69.5 cm
Museum of Ethnography, Antwerp,
AE 673

The artworks of the Mbole, who live along the Lomami River, are principally related to the activities of a pervasive and complex secret society known as *lilwa*. Although the exact role of the figures remains to be fully documented, it is clear that they evidence the juridical role of *lilwa* and represent those condemned to death by hanging. Their characteristic form with shoulders and arms hunched forward, in some examples with the feet pointing downwards, suggests a suspended posture. To that extent they are unique within the artistic canons of Africa, if we exclude the specifically Christian imagery developed in some places.

Death by hanging was the punishment for a variety of serious transgressions ranging from adultery to sorcery or murder, and was a dramatic public event. Normally the victims were men, though this is one of the rarer examples showing a woman. The condemned had a length of liana placed around the neck, and this in its turn was attached to a springy, bent tree. Once the tree was released, the condemned person's body was catapulted into the air. The sanction represented by this form of execution is emphasised by the hanging figures which are guarded by the same high-ranking initiate who acts as judge in cases which carry this punishment. The figures themselves bear the names of victims.

The figures are kept secretly. Initiates encounter them, often mounted on a litter, on a number of occasions during and after their initiation. Their first sighting occurs at the start of the initiation process when they are beaten with sticks and confronted with the images. Later they learn the circumstances in which the deceased came to be condemned and the figures act as a powerful warning against the transgression of social rules. Where an initiate's behaviour comes into question oaths may be sworn on the figures. JM

4.77

Five-seated stool

Ngombe area
Zaire
wood
197 x 20 x 11 cm
Peter Adler Collection

Across Africa people occasionally make headrests or chairs with multiple components, but it is not a common phenomenon. In west Africa the Nuna of Burkina Faso make double stools or headrests that are part of the diviner's equipment. The diviners presumably use these to dream on and consult with powerful nature spirits in order to solve clients' problems and predict the future. Among such widely dispersed peoples as the Tsonga and Shona of south-eastern Africa and the Somali of north-eastern Africa double headrests are made for married couples, as is the case with the Kuba and the Ngombe in central Africa. Among the Ngombe, Maes reports that when a married person dies the surviving spouse must sleep beside the corpse on the double headrest during the period before burial (when the body is displayed). The form of these Ngombe headrests, with strongly curved head platforms and columnar supports, however, is not at all like this five-part stool.

According to Felix, the faceting seen on the sides of this stool is typical of stool and figure carving in the Ngombe area. The function of the stool itself remains the subject of much conjecture: some say that judges would sit together on such stools while the accused were brought before them. The unity of the stools possibly symbolised the judges' unanimous decisions (an intriguing idea without any proven basis). The Ngombe have a warriors' society, Elombe, and the stool could perhaps have been used as a way of symbolically linking them to a common cause. WD

Bibliography: Biebuyck, 1976

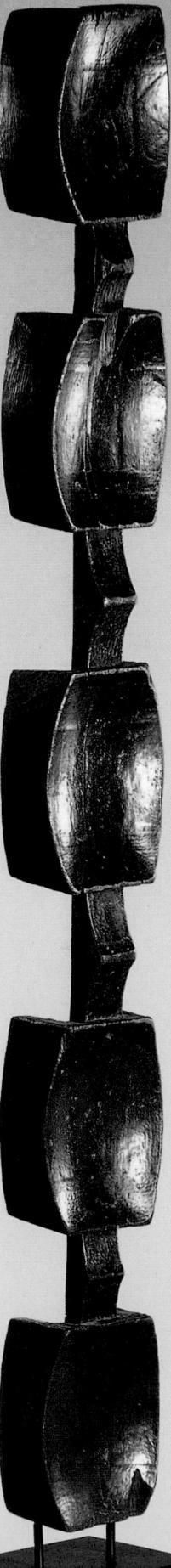

The Ekonda are one of the many Mongo-speaking peoples of central Zaire. As among related peoples, local authority was traditionally vested in a ritual chief (*nkumu*), a title conferred by village elders on a wealthy outsider who, in adopting the office, was obliged to pay for the authority invested in him. The past tense is likely to be appropriate here as Brown, who wrote the only extensive and accessible discussion of the *nkumu*, declared the office to have virtually died out 50 years beforehand.

The responsibilities of the *nkumu* included ceremonial, divination and the spiritual welfare of the community. He had the exclusive right to use several prestigious items of material culture, of which the pagoda-style hat (*botolo*) is the best known. Its fibre structure is tiered, and one or several brass plates are generally attached. The plates are made from beaten brass rods and are themselves a token of the wealth of the office-holder. Brass rods were a form of currency and quantities of them were handed over by the incoming *nkumu* as part of the installation ceremonies. Subsequently the hat worn in public on all occasions and at ritual events was often liberally smeared with a mixture of camwood and oil. JM

Bibliography: Brown, 1944; Arnoldi and Kraemer, 1995

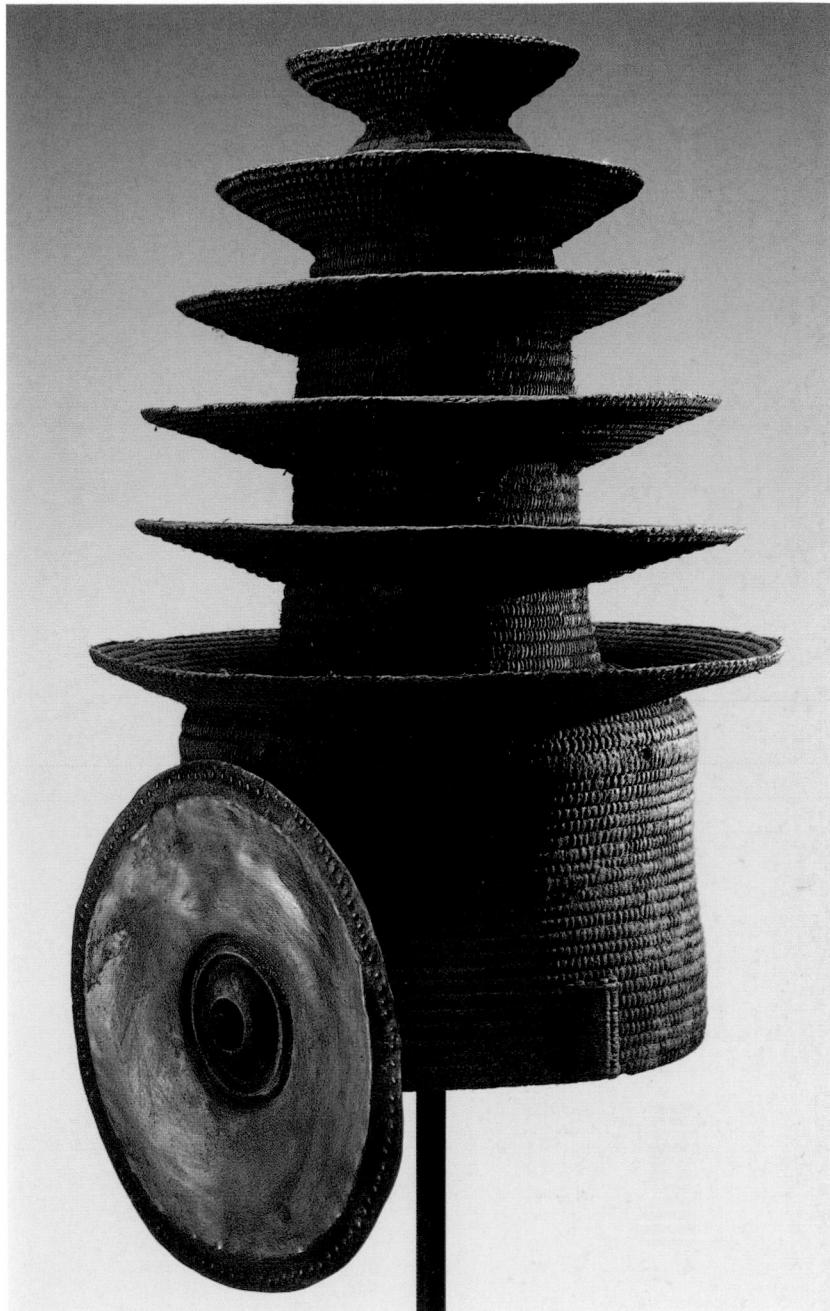

4.78

Hat (*botolo*)

Ekonda

Zaire

plant fibre, earth, brass

43.8 x 20.3 x 21 cm

The Museum of Fine Arts, Houston
Museum Purchase with funds provided
by Mr Frank J. Hevrdejs in honor of
Mr William James Hill at 'One Great
Night in November, 1992'

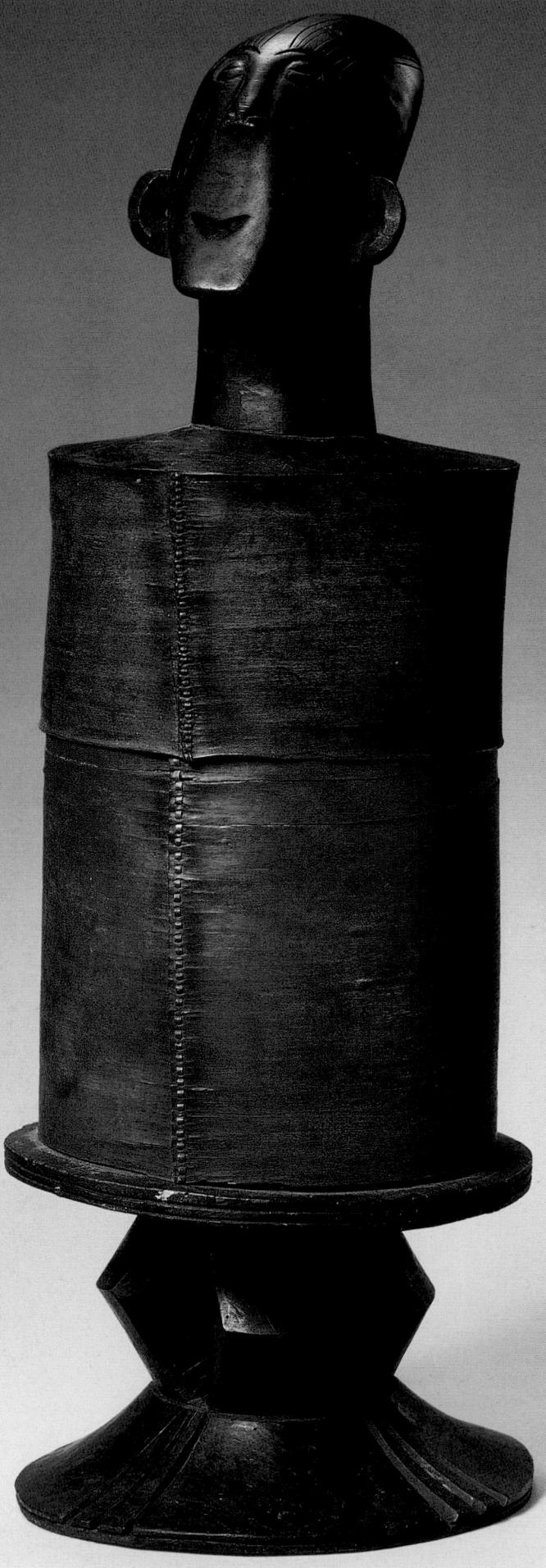

4.79

Box

Mangbetu

Zaire

wood, bark, fibre

h. 66 cm

Staatliche Museen zu Berlin, Preussischer Kulturbesitz, Museum für Völkerkunde, III C 19463

Wooden and bark boxes were commonly used in north-eastern Zaire for storing trinkets and medicines. This box was purchased in 1904 from Leo Frobenius; it is not known how Frobenius acquired it as he did not himself collect in this part of what was then the Congo Free State. Its large size may indicate that it was made for, or owned by, a chief or ruler. The wooden base, with an open-work central pedestal, is carved like a Mangbetu woman's stool, while the head is a typical stylised representation of a Mangbetu person with elongated head. The light and dark contrasting coloration is often found in this region and is sometimes said to have symbolic meaning, perhaps suggesting the two tones of the leopard.

In his description of travels in the 1870s through what is now the Sudan and Zaire, Schweinfurth described the Mangbetu court of King Mbunza as a centre for art, performance and the display of centralised power. Although the Mangbetu kingdom seems to have been considerably more fragmented than Schweinfurth believed, rulers like Mbunza did have large courts and a retinue of artists who made objects that were used and displayed in the court; these were given as gifts between rulers and, eventually, to visiting Europeans. By the beginning of Belgian colonial rule, which effectively reached north-eastern Congo in 1891, there were a number of competing chiefs in the Mangbetu-speaking regions, each with a court that echoed the form and style, if not the power, of Mbunza's. These rulers exchanged art objects as tribute and diplomatic gifts with other African leaders and with Europeans.

By the early 20th century dramatic changes had occurred in the arts of the area, partly because of the new markets and interest of foreign visitors. The beautiful Mangbetu villages, with their rows of large round houses covered with exterior murals, were photographed and

illustrated in European and American travel books. Working in wood, ivory and clay, as well as in wall paintings, artists increasingly turned to representational images, mainly of people, but also of animals and common objects of material culture. In the first two decades of the 20th century figurative art became much more prevalent, more stylised, and a form of portraiture developed.

The ruling class among the Mangbetu practised a form of head elongation and head wrapping, and the portrayal of this fashion came to typify the art of the area. Such utilitarian objects as boxes (made of bark and wood), pots, knives, ivory hairpins and musical instruments were increasingly adorned with representations of the wrapped elongated head and the women's fan-like coiffures. This genre built upon art forms that already existed in the area: the Bongo people in the Sudan made large wooden funerary trumpets surmounted by carved heads; the Azande of the Sudan and north-eastern Zaire made and played five-string harps, the necks of which were adorned with carved heads; and the Ngbaka played harps, not only with heads, but also with resonators, representing the human body, with projecting legs beneath representing the human form. *ES*

Provenance: 1904, purchased from Leo Frobenius

Exhibition: New York 1990, no. 58

Bibliography: Schweinfurth, 1875; Schildkrout and Keim, 1990

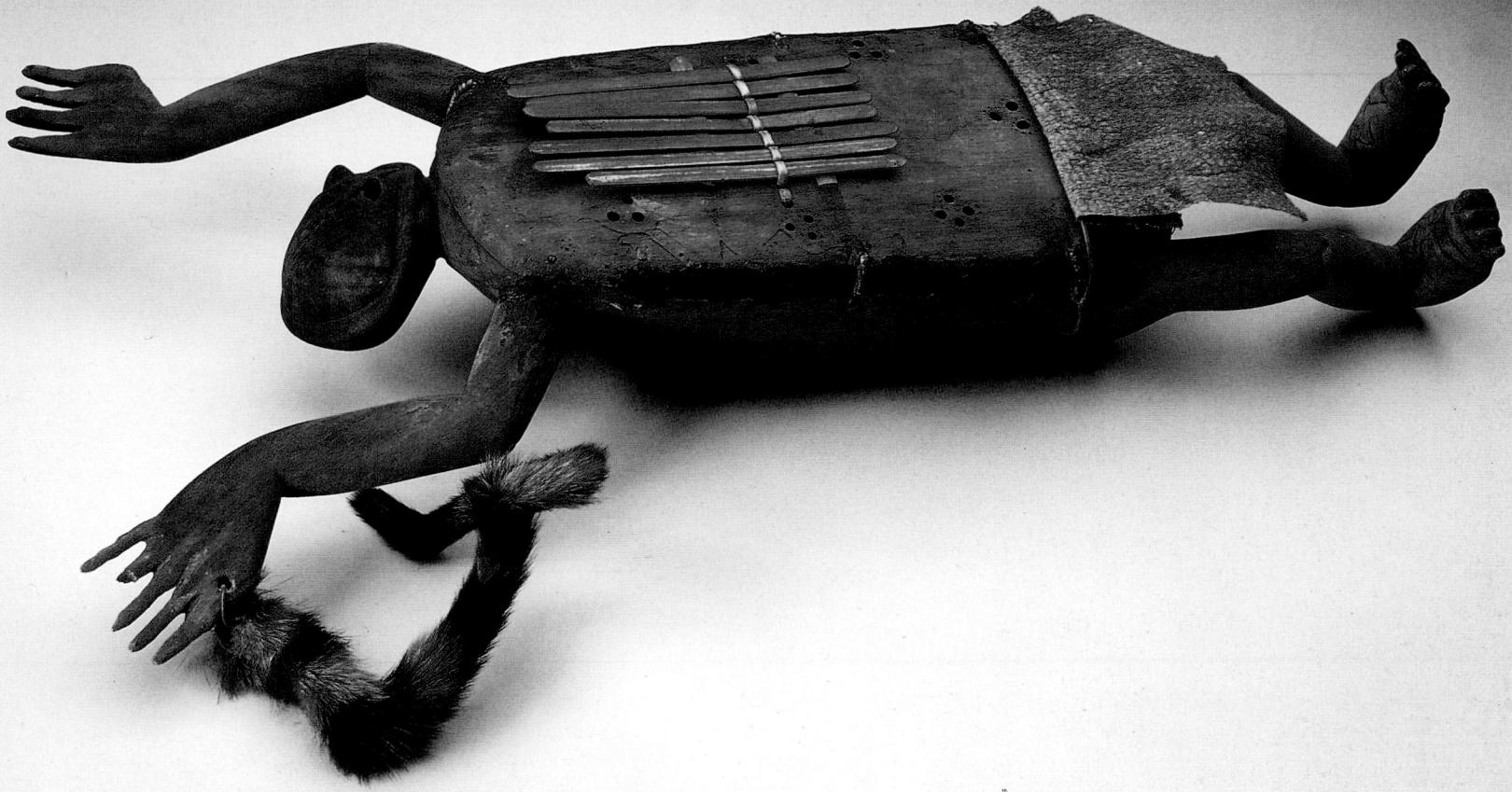

4.80

Mbira

Azande
Zaire
before 1914
wood, bamboo, barkcloth, animal tail,
brass
61.2 x 29.5 cm
American Museum of Natural History,
New York, AMNH 90.1/3317

The *mbira* (also known generically as *sanza* or lamellaphone or thumb piano) is a musical instrument played throughout sub-Saharan Africa. It generally consists of a hollow resonating chamber, over which are attached a single row, or multiple rows, of keys of different lengths; these are fitted at one end so that they can vibrate when plucked. This gentle and melodic instrument is usually played with the thumbs and sometimes the forefingers as an accompaniment to song. The musician, usually a man, would have used it to accompany ballads, particularly songs about personal experience. The *mbira* is not a court instrument, and would not have been played in ensembles. Many variations on this basic type of instrument are found, both in the number of keys and the material of which the keys are made (metal or wood); additional sound-producing elements that act as rattles are often incorporated.

This particular instrument was collected among the Azande people who live in the area that is now north-eastern Zaire and southern Sudan. The instrument represents a female,

possibly dancing, her arms, fingers and toes raised; her head is thrown back, and the expression on her face could be one of ecstasy. The sculptor has carved detailed genitalia that the clothing conceals.

This example was made by a Zande artist near Nala, a town in north-eastern Zaire. There are three other *mbira* in the same style, perhaps made by the same carver, in the Royal Museum for Central Africa at Tervuren, collected by Armand Hutereau in the same period. Unlike the others, however, the female represented in this example has a barkcloth skirt, a raffia back apron and carries a dance whisk. Her body is painted with small geometric designs surrounding holes in the resonating chamber. The traces of paint faintly indicate a style of body design that was popular among Mangbetu women at the turn of the century. The top of the resonating chamber has been sealed to the body cavity with pitch.
ES

Provenance: 1914, collected by Herbert Lang (American Museum of Natural History Congo Expedition, 1909–15)

Bibliography: Laurenty, 1962; Schmidt, 1989; Schildkrout and Keim, 1990

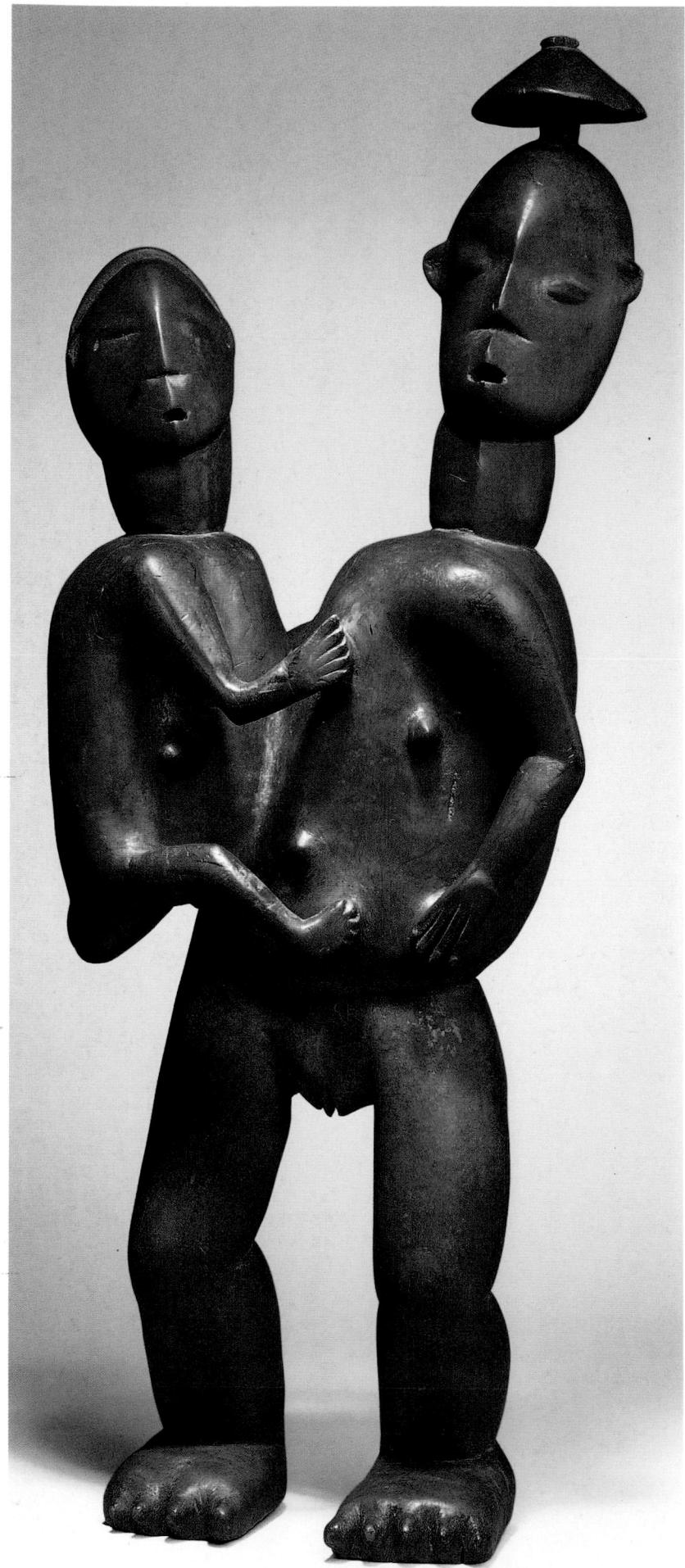

4.81

Mother and child

Azande

Zaire

c. 1914

wood

h. 60.2 cm

American Museum of Natural History,
New York, AMNH 90.1/3520

This mother and child figure is one of two such sculptures carved by an unknown Zande artist who was working at or near Nala around 1914. The same artist may have carved the *mbira* in this exhibition (cat. 4.80).

In the early colonial period the Azande of north-eastern Zaire and southern Sudan were organised into loosely confederated kingdoms, most of which were headed by members of the Avongara clan. Chiefs in some of the main centres seem to have employed artists who carved figures, some of which were given as gifts to other leaders, both African and European. The practice of using art as tribute encouraged the development of workshops in which rulers employed carvers who worked in distinctive styles. This work was usually made for secular rather than religious purposes.

Although the Azande sometimes carved figures for use on graves, there is no evidence that this piece was a funerary sculpture, or that it had any religious significance. It seems, rather, to be a rare and important example of a sculpture carved intentionally to be a work of art. No other mother and child figures in this particular style are known from the Azande, with the exception of one other made by the same artist. In this work the artist depicts the way in which mothers actually held their babies, straddling the sides of their bodies. Instead of depicting the waist band the mother would have used to hold the baby close to her side, the artist reveals the fusion of the bodies of the mother and baby. He also cleverly alters the conventional frontal posture of the female figure so that her body, which incorporates the body of the child, appears to be slightly turned towards the child. As in virtually all African sculpture, this composite figure still faces the viewer directly.

The mother's hairstyle shows the use of false hairpieces that were common among the peoples of north-eastern Zaire. Photographs of the

period show Azande and Mangbetu women wearing woven hairpieces, made with hair, raffia and cowrie shells, attached to their braided hair. Sometimes the hair was arranged into such a form without the use of a separate hairpiece. ES

Provenance: c. 1914, collected by Herbert Lang (American Museum of Natural History Congo Expedition, 1909–15)

Bibliography: Mack, in Schildkrout and Keim, 1990, pp. 217–31

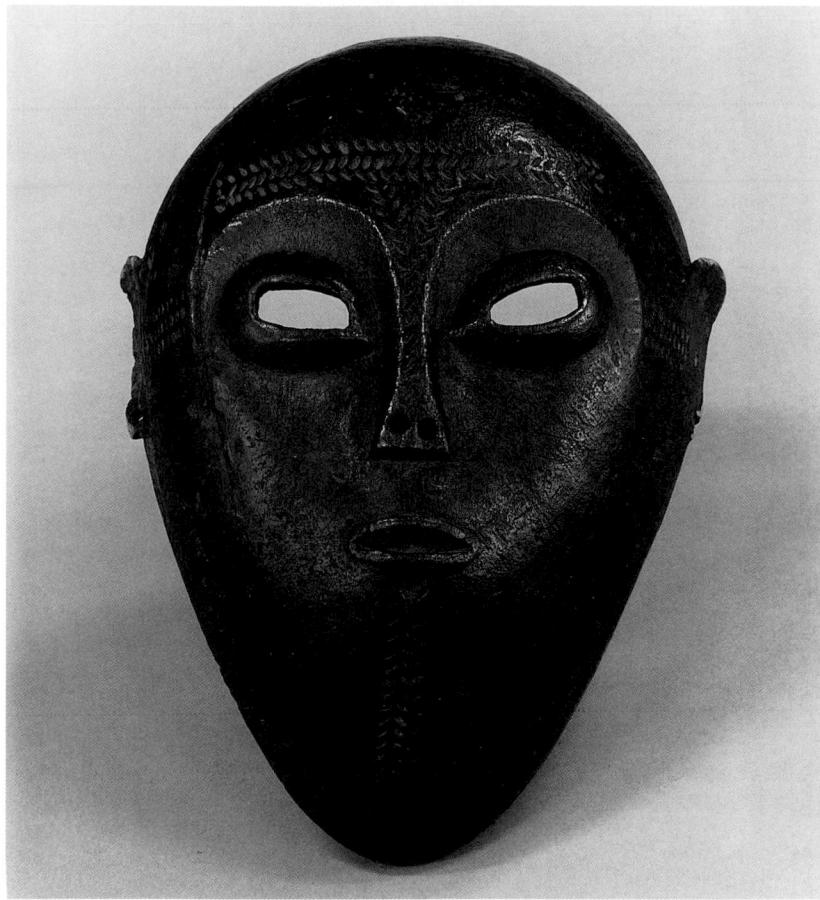

4.82

Mask

Ngbaka

Zaire

19th century

wood

33 x 25 cm

The Brooklyn Museum

Museum Expedition 1922, 22.1585

Robert B. Woodward Memorial Fund

Most masks from north-western Zaire are attributed to the Ngbaka (Bwaka, Ngbwaka). They were first seen in Europe in the early 1900s and the best-known style has a concave anthropomorphic face and scarification, as in that shown here. Most documented examples were worn at the festivals with which the extended male initiation rites ended.

Ngbaka masks present many art-historical problems. Their use was not widespread, and they were produced for purposes other than initiation ceremonies. Further, there were various mask styles among the Ngbaka and neighbouring groups. This diversity developed because northern Zaire was a zone of extreme cultural variety, a result of the intersection of two great ecological systems – the forest and grasslands – and several

great cultural traditions including Bantu, Sudanic, Chadian and Adamawan. Centuries of migration, wars, trade, intermarriage and cultural exchange produced a mosaic of societies organised on a relatively small scale and accustomed to frequent innovation and borrowing. Even where centralised societies such as the Zande and Mangbetu kingdoms existed at the time of the Belgian conquest (1890–c. 1920), they tended to be small, relatively recent in origin and composed of many heterogeneous peoples.

Customs appear to have varied widely among Ngbaka from different regions and many local groups show influences and borrowings from neighbouring cultures. Initiation masks such as this one seem to have been borrowed and adapted from the Mbanja (Banda), who live mostly to the north in the Central African Republic, but also among and around the Ngbaka. Evidence for this lies in the Mbanja-language songs that accompanied the masks and in the Mbanja names given to objects used in the initiations. It is even possible that Mbanja carvers were responsible for most mask production. In the late

1970s, masks of the sort shown here were still produced near Lake Kwada, but the few reports since then indicate the absence of mask use or, in some cases, the development of new mask styles.

Knowing the masks' provenance sheds little light on meaning and function, however. In none of the reported Ngbaka cases do the masks play the dramatic role which they occupy in some variants of the Mbanja initiation ritual. There the assembled initiates are first attacked and whipped by a masked older male and then ordered by the initiation director to fight off the masked attacker's assaults, seize him, strip and unmask him. The successful unmasking of the previous generation's masked representative is a condition for leaving the initiation camp.

Ngbaka borrowers use the masks differently and variably. In some accounts the director of the initiation dons the mask in order to announce the end of the seclusion of initiates in their bush camp; his appearance in the village simultaneously serves to frighten children and announce the beginning of post-initiatory celebrations. In other accounts the initiates themselves wear the masks, using them to entertain one another with laugh-provoking postures and antics. In still other accounts masks are worn by girls in the context of female initiation rites as they travel from house to house in their own and neighbouring villages, seeking gifts.

Thus the specific meaning and function of Ngbaka masks appears to vary depending on the group and its particular initiatory practice. While some attempts have been made to explain such variation in chronological terms, with 'serious' mask usages as anterior and sacred, and 'frivolous' usages as recent and profane, the frequent combination of serious and frivolous in well-documented African ritual practice casts doubt on this categorisation. Credible generalisations regarding the meaning and functions of these masks will be possible only as a result of more detailed local studies. CK, AA

Bibliography: Vergiat, 1936; Wolfe, 1955; Burssens, 1958¹; Burssens, 1958²; Katumba, 1983; Burssens, 1993

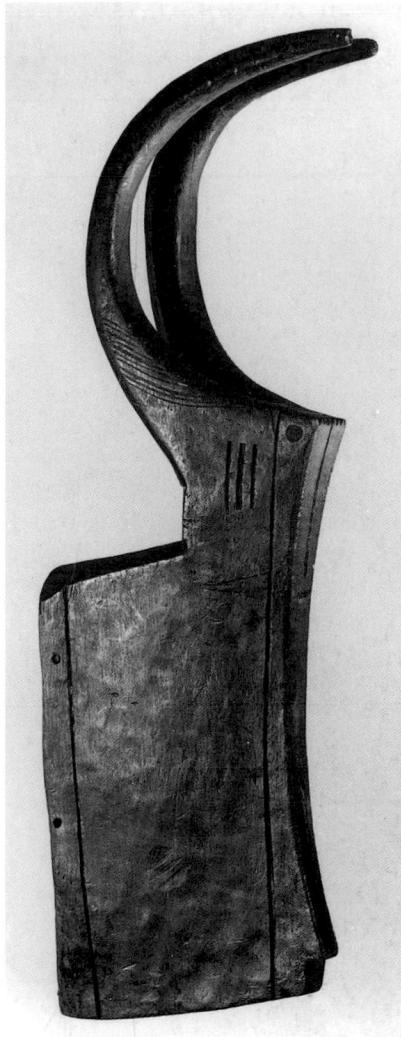

4.83

Animal head

Yangere

Chad

h. 55 cm

Laboratoire d'Ethnologie,
Musée de l'Homme, Paris, 04.17.19

The Kwele live in the northern part of Gabon, on the Congo border. They are to be found east of the Mekambo and in the Souanké region. Kwele culture – social organisation, way of life, beliefs, traditions – is still little understood, though Leon Siroto has contributed a number of articles on the subject. It is not known, for instance, why many of the masks bear very little sign of use. Kwele art can easily be identified by its characteristic treatment of the human face: the heart-shaped face is hollow or concave, with eyes that bulge slightly, surmounted by two elegant crescent-shaped eyebrows. The face is always white with a black background (forehead, cheeks).

As a contrast to their anthropomorphic masks, the Kwele also make zoomorphic masks (antelope, gorilla). The gorilla mask, known as *gou*, is one of the most spectacular.

The masks were created to strike terror into the hearts of the villagers; they were worn in the context of the activities of the initiation association, the *beete*, during ritual dances to ward off sorcery, to celebrate the circumcision of young men, at meetings connected with deaths in suspicious circumstances, and so forth. This type of mask has virtually the same ritual function as the *emboli* of the neighbouring MaHongwe in the region south of Mekambo: the same adult gorilla head shape is used, with its enormous sagittal crest. The Kwele *gou* mask is more naturalistic, with the roll of flesh below the eyes, the projecting jaw and the large canine teeth. The symbolism attached to the gorilla, which occurs particularly abundantly in the region of Djah, evokes the idea of the spirit of the bush in opposition to the men of the village; this is the force that regulates social and political life.

The *beete* rituals, when masks were used, died out around 1920 after concerted action by the French colonial administration and the Catholic missions. LP

Bibliography: Siroto, in Fraser and Cole, 1972

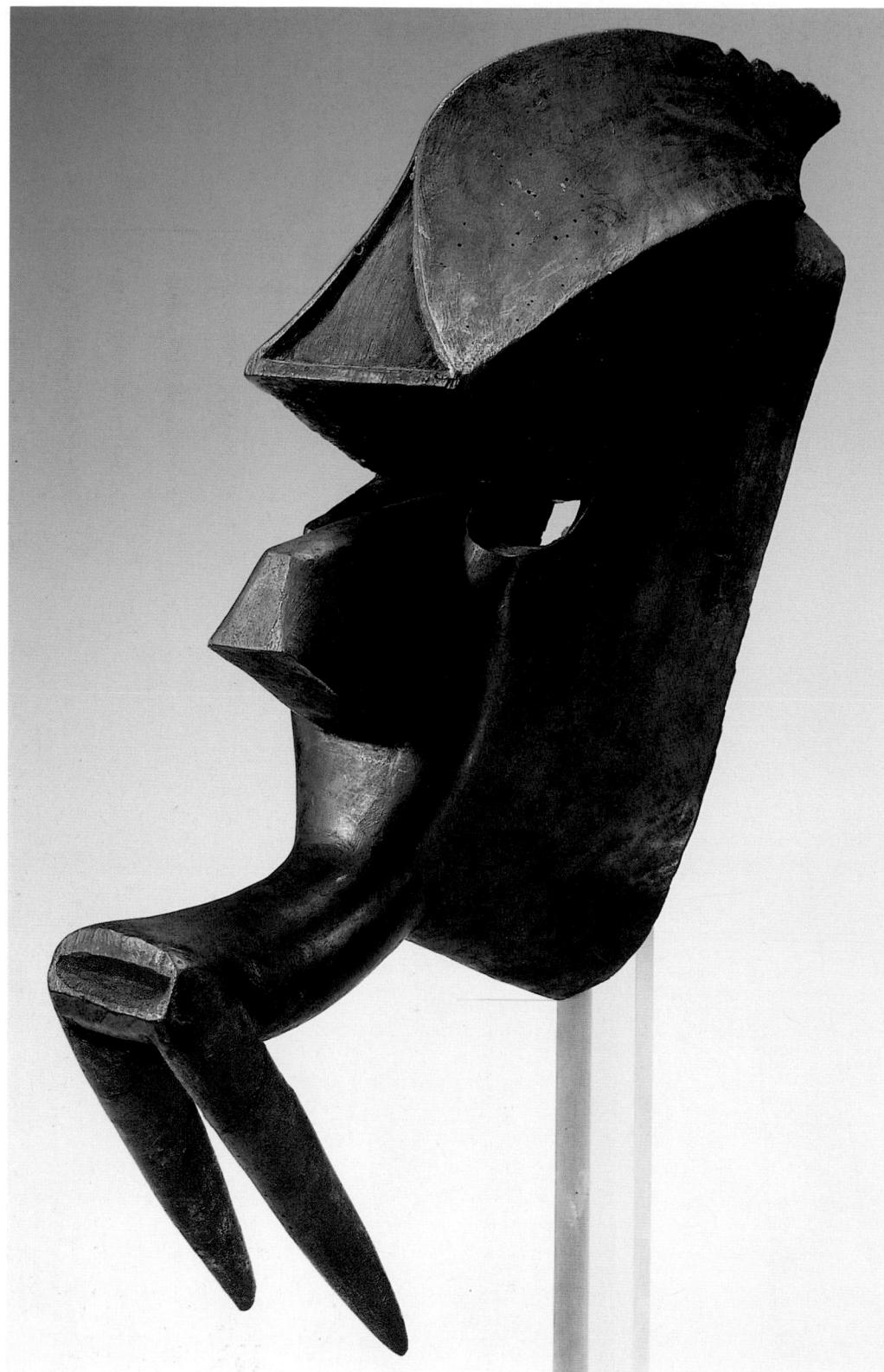

4.84

Mask

Kwele
Congo
early 20th century
wood, pigment

45 x 11 x 19 cm
Musée National des Arts d'Afrique et d'Océanie, Paris, MNAN 1963.189

Door

Punu
Gabon
19th century

wood
108 x 67 cm

Laboratoire d'Ethnologie, Musée de
l'Homme, Paris

This example of the 'displayed female motif' (cf. cat. 4.25) is decorated with an elaborate three-part coiffure, neck-ring and body scarification. Punu masks with a similar face were worn by costumed stilt dancers and said to represent the spirit of beautiful young women who returned from the dead to participate in village life. Similar free-standing statuettes of young females were attached to bags of human relics. The whitened figure in each instance makes reference not only to the dead, but also to anti-witchcraft techniques. Witches were believed to be most active and powerful at night, and whiteness refers to light and clarity, which stand in opposition to night and mystery. In Gabon and much of central Africa clairvoyants ring their eyes with white clay (kaolin) as a strategy for detecting witchcraft. APB

Bibliography: Griaule, 1947, fig. 51; Paris 1972, fig. 80; Perrois, 1979, fig. 276; Vogel and N'Diaye, 1985, fig. 61

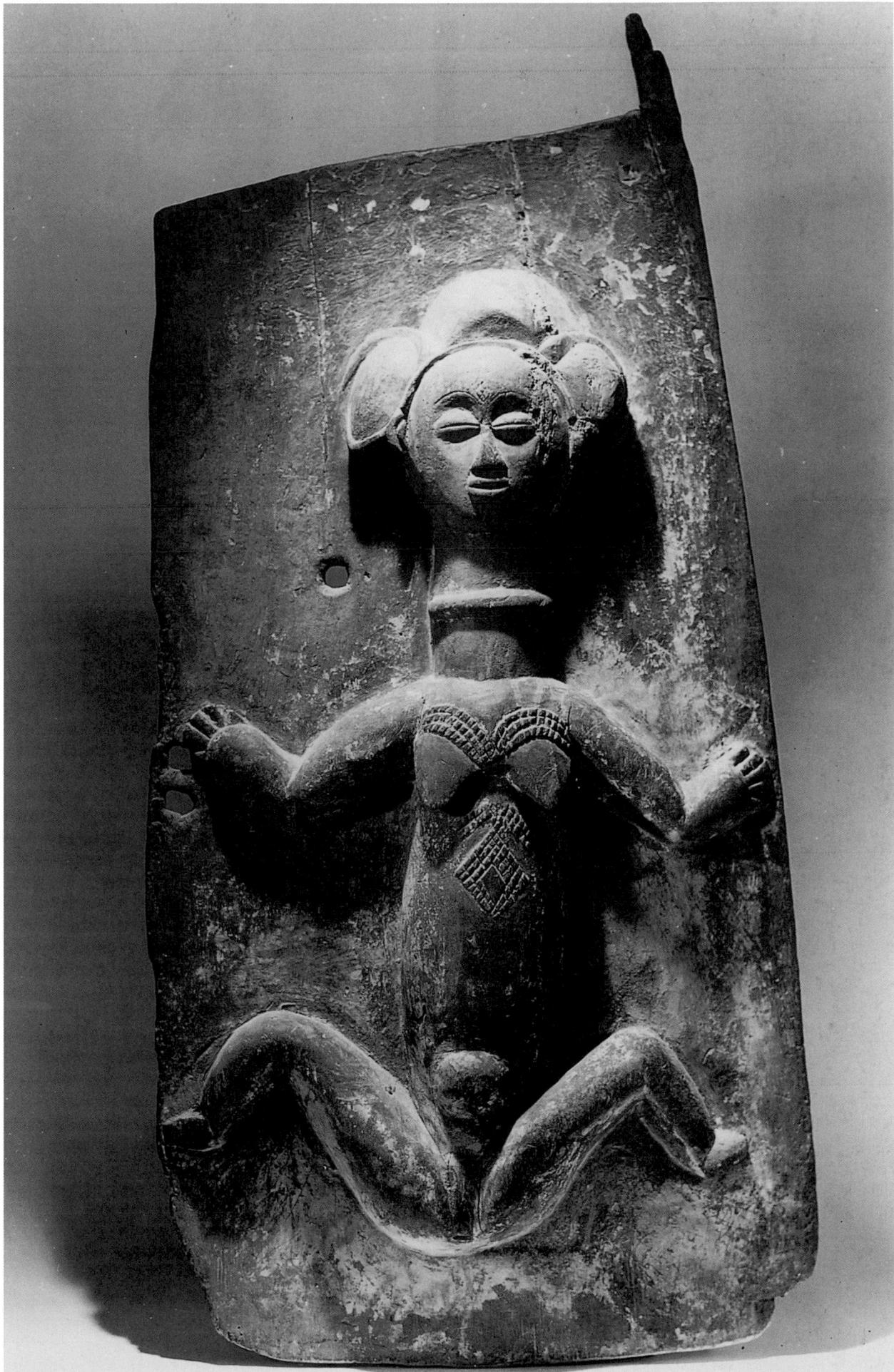

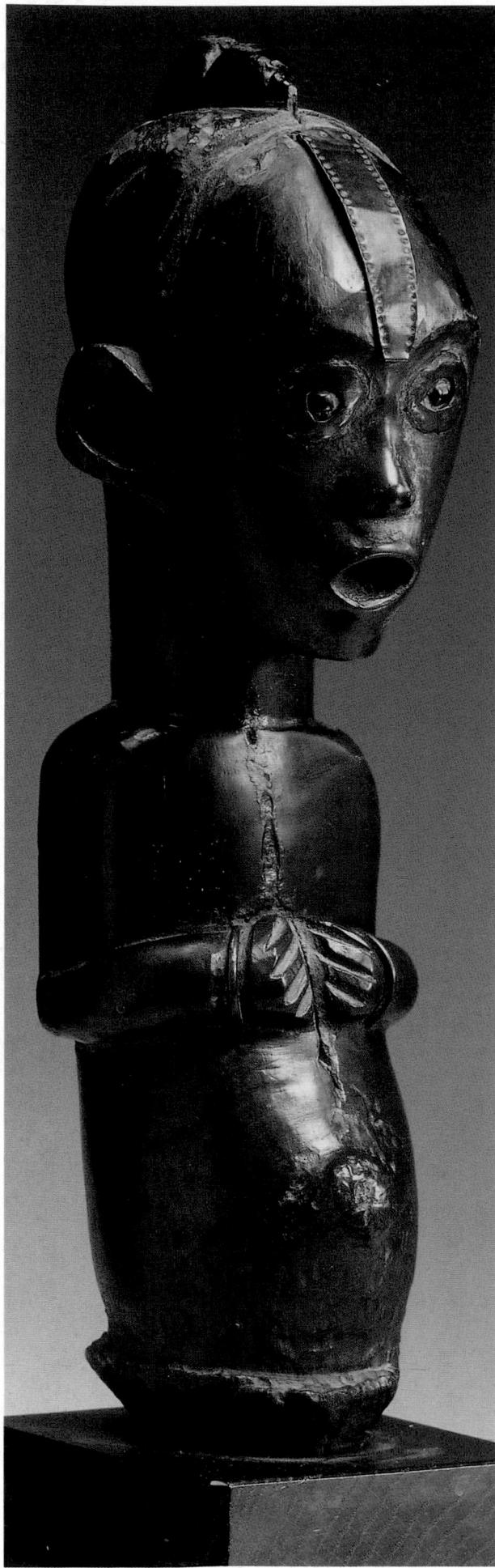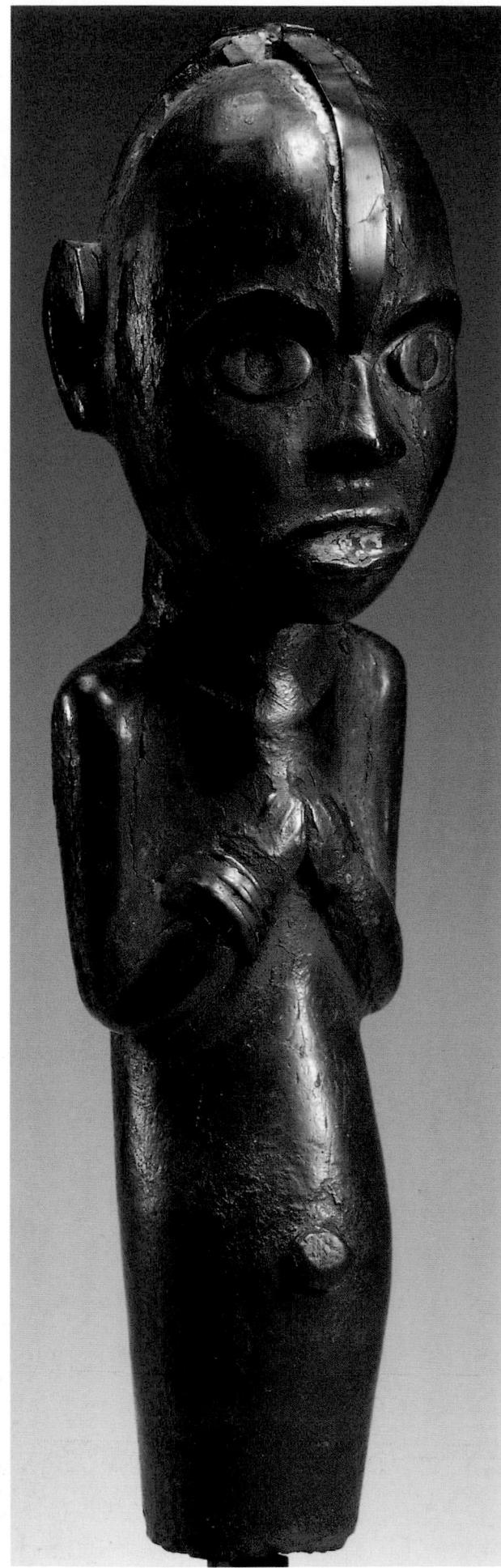

4.86a
Reliquary figure

Tsogo
Gabon
early 20th century
wood, pigment, metal
h. 33 cm
Private Collection

4.86b
Reliquary figure

Tsogo
Gabon
early 20th century
wood, pigment, metal, glass
42.5 cm
Private Collection

Tsogo sculpture is connected exclusively with initiation societies, the most important of which is the *bwiti*. The Tsogo lived a very isolated life until the 1930s in the remote, inaccessible area of Upper Ngoumé in Gabon, a small population in comparison with the large neighbouring groups. They were organised in matrilineal clans. The *bwiti* spread throughout central Gabon, then subsequently through the central Ogooué region as far as the estuary; it reached its peak among the Fang in a form that subsumed all others. Joining the *bwiti* involved an initiation through many long and painful stages, followed by regular rituals during which the *iboga*, a hallucinogenic plant, used constantly by the Tsogo but not habit-forming, was taken. Tsogo artists, including musicians, were not specialists but were simply initiates of the group who had tried their hand at these activities in their youth, with the aim of contributing to the group. This explains why Tsogo artefacts – architectural pieces, ritual objects, masks and statuettes – are usually poorly finished and have a somewhat rustic appearance.

Among the objects connected with worship, the *bwiti* reliquary busts, called *mumba bwiti*, had no particular importance. These sculptures, used to protect relics and for therapeutic purposes, stood in baskets containing 'magic' substances and fragments of human bone. Ancestor worship, or *mombe*, was one of the many rituals of the initiation societies.

Stylistically Tsogo sculpture is remarkably homogeneous in the large head, body shaped like a Greek urn, shoulders hunched forward and forearms held close to the chest. The face is organised around the double arch of the eyebrows and the arrow-shaped patch on the forehead.

Tsogo sculpture is characterised by simple, sturdy forms that express in wood the enduring concerns of the society and its initiates with their fondness for *iboga* and the supernatural. LP

Provenance: cat. 4.86a: ex Jacob Epstein Collection

4.87

Mask

Aduma

Gabon (Upper Ogooué)

19th century

wood, pigment

h. 54 cm

Laboratoire d'Ethnologie, Musée de l'Homme, Paris, 84.37.4

This is one of the oldest known masks of Equatorial Africa and Gabon, and more specifically of the Ogooué basin. Its attribution to the Aduma derives from the fact that these people (who were fine boatmen, often hired by Europeans in early explorations of that region) provided it; yet its precise origin remains unclear. In fact this type of mask, called *mvudi* all over eastern Gabon, but also called *mbudi*, *bodi*, *mvuri* and *yoyo*, has been documented among most of the ethnic groups of the region, where contacts and exchanges are frequent: Nzabi, Obamba (Ambama) and Ndassa, Wumbu, Kanigui and Teke.

Pierre Sallée (1975) has described another people of the region as follows: 'The Okande (who have now almost disappeared) are, with the Aduma, the great boatmen of the Ogooué; they are regarded, upstream and downstream, as having been responsible for transmitting and circulating the typical sculptural forms of the peoples of the Upper Ogooué (Aduma, Bawandji, Obamba). Their forms are characterised by the juxtaposition of solid mass and surface, by geometrical patches of colour, and by the projecting forehead, which creates very deep eye sockets separated by the vertical line of the bridge of the nose.'

For the last half-century these masks have been used for celebratory dances associated with the major social rituals. Their former role is less well documented.

The geometrical elements of the face can also be found in both surface and relief features (projecting forehead, nose) of some of the *mbulu-nngulu* reliquary figures. LP

Provenance: c. 1883, collected between Lastoursville and Franceville; 1884, Musée du Trocadéro, Paris

Bibliography: Sallée, 1975

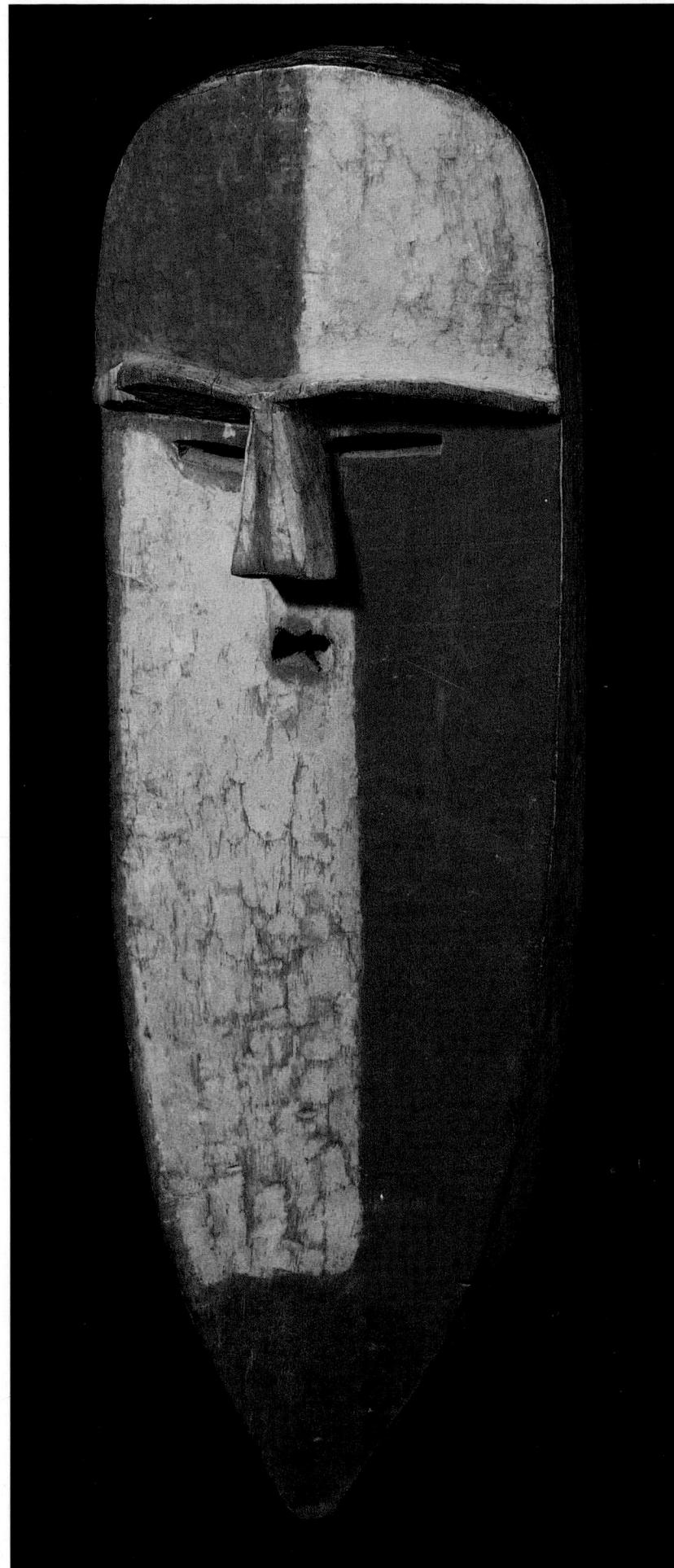

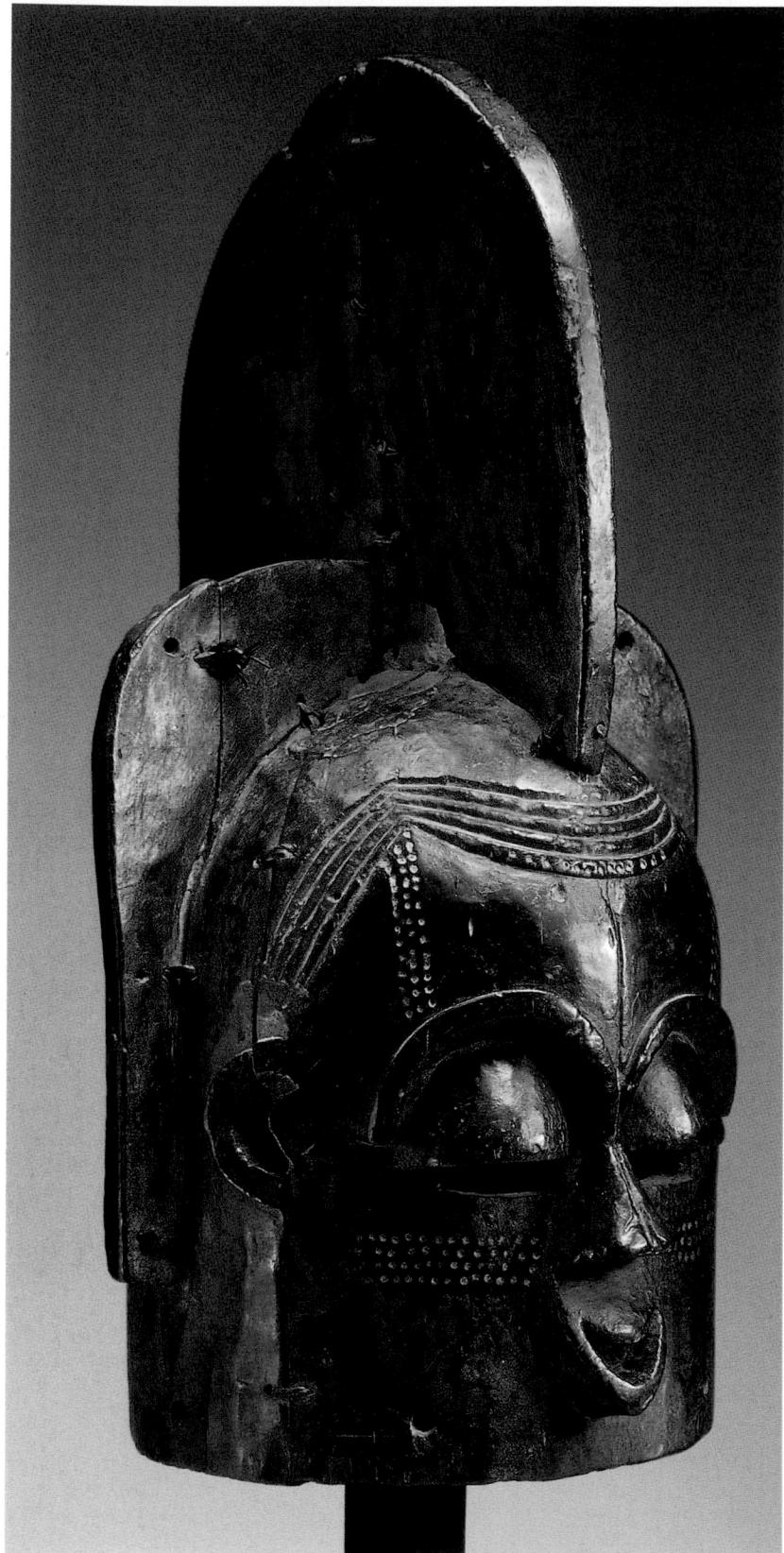

4.88

Helmet-mask

Kota
Gabon
19th century (?)
wood
h. 62 cm
Private Collection

Most of the helmet masks collected in Kota territory come from the province of Ogowe-Ivindo, near Makokou and Mekambo in the eastern part of Gabon. These masks, known variously as *emboli* or *mbuto*, measure between 40 and 80 cm. In Kota villages the mask is worn during dances in celebration of the initiation of adolescent boys; the high point of the ritual is circumcision (*satsi*). The candidates for *satsi* range from eight- to ten-year-olds or boys in their late teens, since the festivities are not organised on a regular basis. During the 'pedagogical' part of the ritual the elders demonstrate to the young men that the masks are not monsters but human beings like themselves. The mask is also worn during anti-sorcery séances or for psychotherapeutic purposes.

Stylistically and morphologically, two subtypes exist, one full and round, the other angular. The treatment of the subject is nevertheless the same in both types: the mask represents a human head with a crest similar to the sagittal crest of the gorilla.

The mask covers the dancer's face completely and is supported by a basketwork frame with a generous fringe. The wooden face has a convex (as in the one exhibited here) or concave forehead; the lower edge of the brow is formed by strongly arched eye sockets. The eyes have enormously heavy (sometimes tubular) lids, which give the mask a gaze that must be disturbing to the uninitiated. Like the Kwele of the Congo and the Fang in northern Gabon, the Kota give their masks a double-arched eyebrow. These arches join to form the nose, which projects and has a flat base. Unlike the angular masks, in which the planes are all somewhat exaggerated (brow, cheeks, the crest on the head), these rounded masks have a curious crescent-shaped mouth; the crescent motif is repeated at ear level. The face is decorated with dots and stripes to represent scarification. Some masks are painted white with red ochre and black spots to symbolise the panther (*ngoy*), which embodies male vitality and the warlike virtues of the Kota and the MaHongwe. It was in these villages of the upper Ivindo that groups of men-panthers persisted the longest (until the 1930s). LP

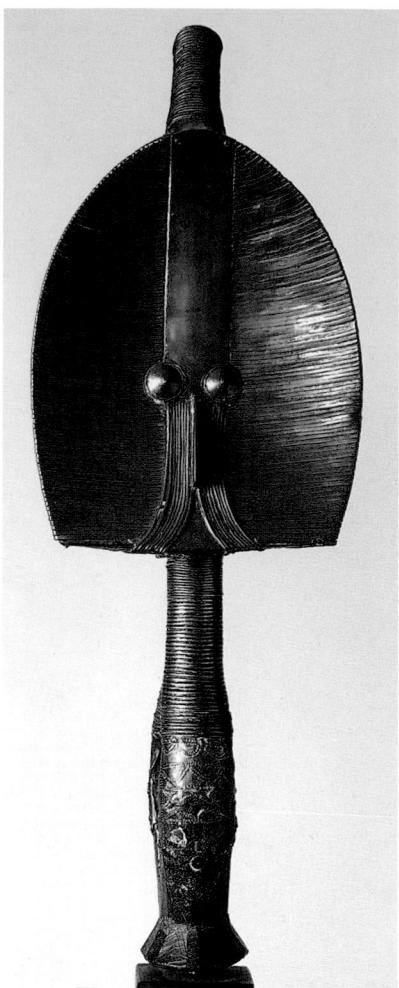

4.89

Reliquary figure

MaHongwe
Gabon
19th century
wood, metal
54.5 x 19 x 11 cm
Loed and Mia van Bussel Collection,
Amsterdam

It is nearly 30 years since it was realised that the reliquary figures inventoried as '*ossyeba*' should really be attributed to the MaHongwe in the extreme north-east of Gabon near the Congo border. These populations have links with the Kota and are themselves divided into subgroups, most notably the Bushamaye and the Bashake, who each produced objects in their own style. MaHongwe reliquary figures were placed over baskets containing relics of illustrious dead members of the lineage. The ancestor cult was called the *bwete*. The baskets would be preserved in temples within the village; they often had two figurines on top, one largish figure (about 50 cm high), the other much smaller (about 20 cm). The first was

supposed to represent the founder of the lineage and the second one of the descendants. The two figures were decorated very differently.

The large *bwete* figures of the sub-styles were invariably carved in the same fashion. One particularly remarkable feature is an abstract formulation of the anatomy of an extreme type. Although recognisably human because of its eyes and nose, the ancestor's face is severely formalistic: the face is pointed with a gentle hollowing from the brow to the mouth. The forehead has a broad metallic band across it and the cheeks are decorated with long curved moustaches made of narrow strips of metal, applied with great care. The skill with which the metal strips and patches are applied is one of the criteria by which the authenticity of these objects is assessed. This particular skill has been lost for nearly a century.

The hair tied at the back of the head has stylised plaits hanging from it; these are decorated with brass plaques, often bearing a design of punched holes.

The face of these *bwete* figures is certainly strange and highly conceptualised and in fact bears no relation to the Naja serpent head with which it is often compared. LP

Bibliography: Perrois, 1969

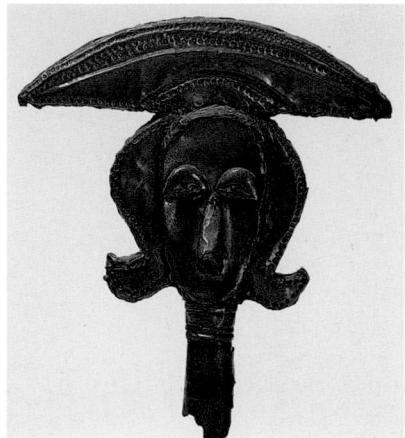

4.90a

Miniature reliquary figure

Kota
Gabon
early 20th century
wood, metal
23 x 18 x 6 cm
Herman Collection

4.90b

Reliquary figure on a stool

Kota
Gabon (Upper Ogowe)
19th century
wood, metal
h. 56 cm
Museum of Ethnography, Antwerp,
AE 60.51.3

The Kota of eastern Gabon, particularly those from the Upper Ogowe, have produced large quantities of statues of ancestors for ritual use; the statues are in wood decorated with a thin layer of copper or brass. Thanks to the diversity of these groups, scattered over a vast area covering the whole eastern part of Gabon and the regions bordering Congo in the south, a great variety of different styles has developed, some of them endogenous and some influenced by neighbouring styles. Ambete art, with its reliquary statues in painted wood (but without brass overlay), was thus probably responsible for inspiring Obamba and Ndassa sculptors.

The figure at cat. 4.90b, with his chest supported by a stool (*kwanga*), is reminiscent of Ambete pieces. Even the shape of the feet of the stool bears similarities with other stylised lower parts as made, for example, by the Fang. The figure appears to be masked, with a crest hairstyle of the same type as the hairstyle on classical reliquary figures. The face is simplified to a few lines and angles, with the brow projecting at right angles to the nose. This corresponds exactly to the *mvudi* masks from the same region (cf. cat. 4.87). The shape made by the arms, forming twin points on either side of the torso, is comparable to the lozenge-shaped torso of *mbulungulu* figurines. Reliquary figures on stools belong to a sculptural style that is midway between the flattened sculpture of the Obamba and the rounded shapes of the other local peoples. They are also to be found among the Kwele.

Miniature figures (e.g. cat. 4.90a) are extremely rare and the use to which they were put is not known. LP

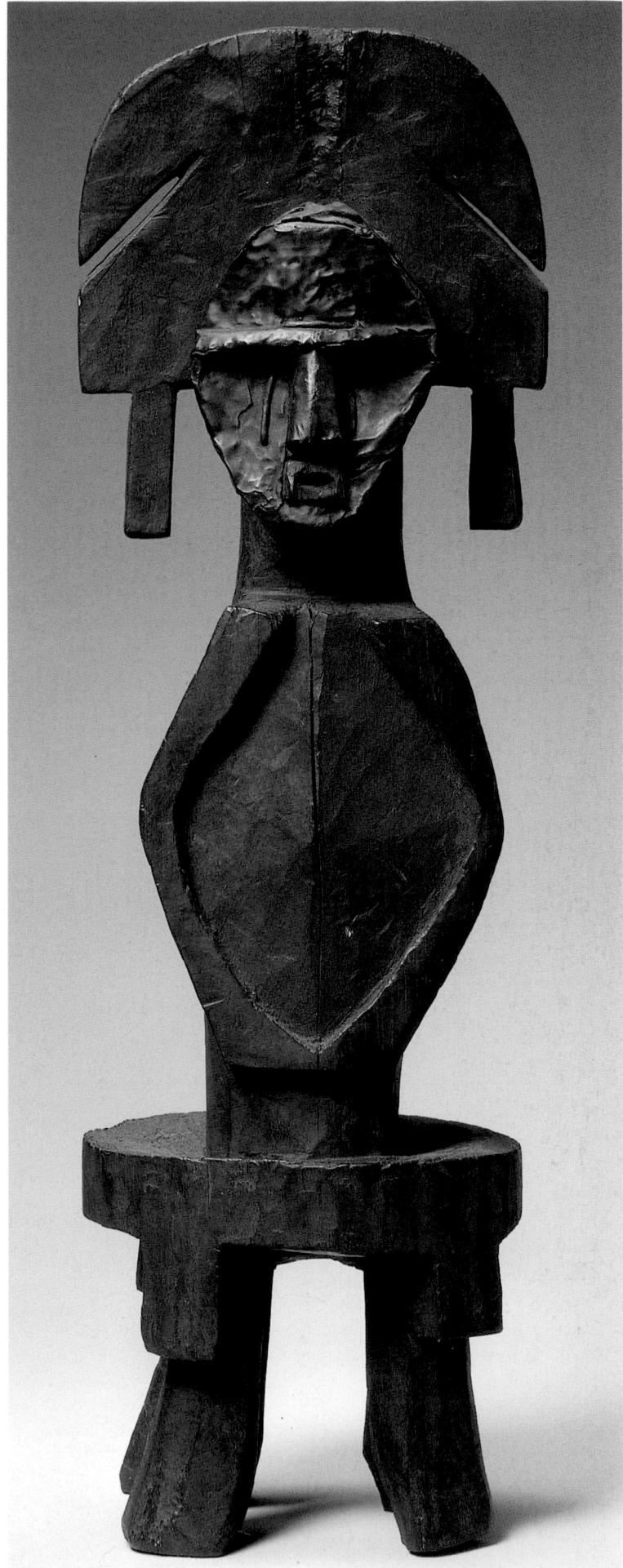

4.91a

Reliquary guardian figure

Fang
Gabon
19th century
patinated wood
34.9 x 19 cm
Private Collection

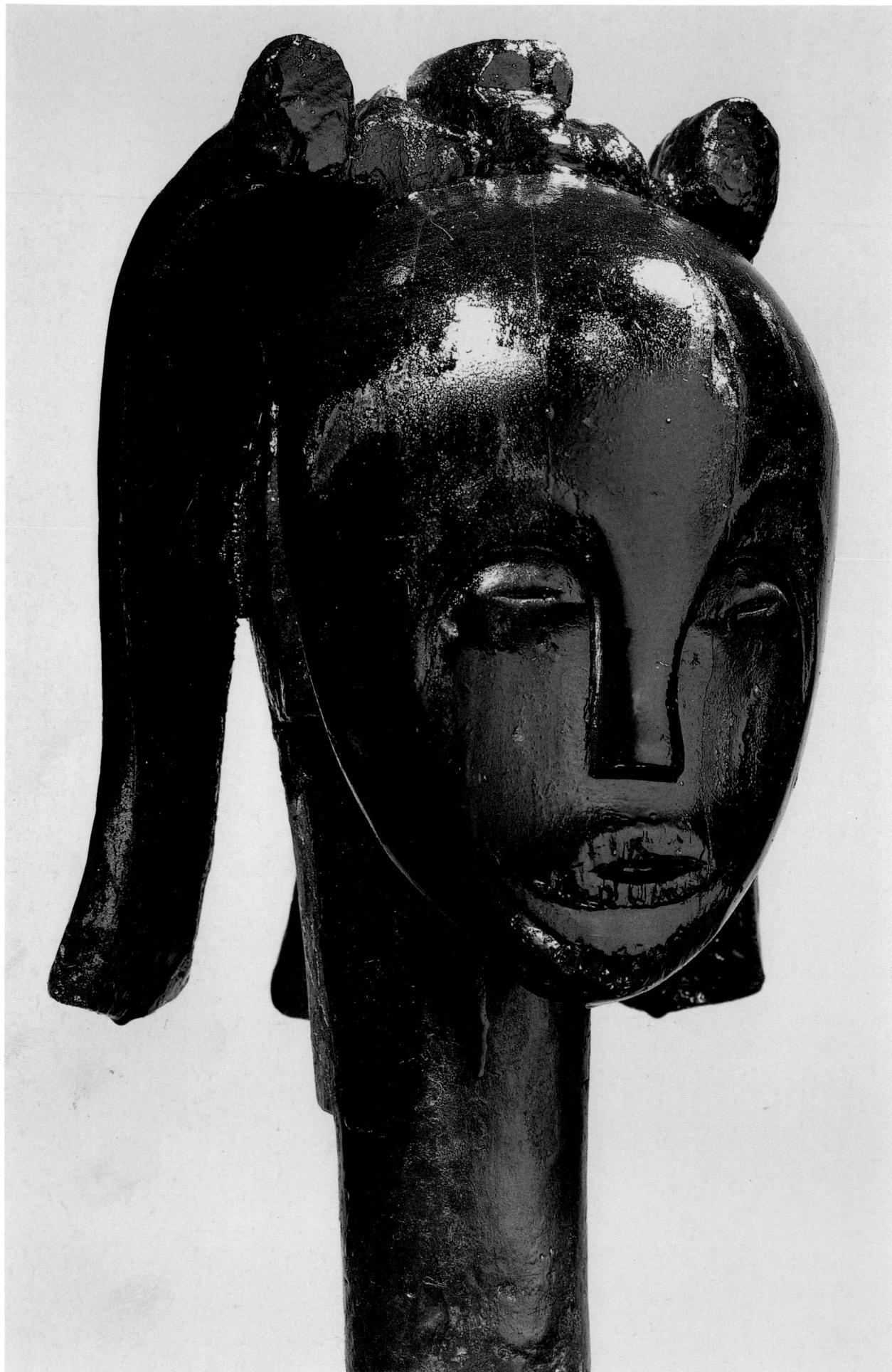

Fang reliquary chests, from southern Cameroon to the Ogowe Valley in Gabon, were generally surmounted by statuettes, but also sometimes by heads alone, particularly among the Ntumu (north-east of Rio Muni and the upper Woleu Valley) and the Betsi (Okano Valley and central Ogowe). The question of whether the style of the heads predates the style of the busts and erect statues was first raised by Tessmann (1913); in fact, the objects that were collected between 1880 and 1920 are not obviously any older than the statues. Because of their relative fragility (wood is difficult to preserve for any great length of time in an environment with a very unstable climate, where wood-eating insects are rife), they could be much scarcer than they actually are.

It is worth noting, however, that as far as representations related to the *byeri* (or cult of deceased ancestors of the lineage) are concerned, it appears from the relics still extant (mainly fragments of skull, or occasionally complete heads with jawbones) that the single head was the most common. It is also worth noting that during the theatrical ritual of the *melan* (one of the initiation rituals of the *byeri* during which the Fang 'reanimated' the deceased before calling them individually by name and presenting them to the young men being initiated) it was the statues that were used as puppets, not the single heads.

The *byeri* heads are stylistically very homogeneous, in contrast to the relative diversity of the whole figures. The only feature that varies is the hairstyle. Three different styles can be distinguished: the helmet-wig with multiple plaits (*ekuma*), the helmet with a central crest (*nlo-o-ngo*) and the transverse chignon. Fang hairstyles were always postiches made of hair, fibres and vegetable wadding, decorated with glass beads, cowries and metal chains. It is assumed that the heads with a chignon, where the hair itself was plaited close to the

scalp (high on the forehead and on the top of the head), represented females. The more richly decorated hairstyles, also plaited, are presumably masculine; they are significantly more common, which is to be expected in a patrilineal society.

The heads with transverse chignons are thought probably to be Betsi. The art of chignon-making and helmet hairstyles still survives among the women of Gabon: the Fang and the Myene women (particularly the Galoa and M'pongwe) amazed travellers with the originality of these creations in the mid-19th century. The heads made by the Ntumi and the Betsi are some of the most important artistic products of the Fang; the individual interpretation of the traditional model, in its finished form, reveals the quality of each artist.

The two heads exhibited here are among the most famous examples of classical Fang statuary. They have broad, admirably bulging brows, and the faces are carved in a soft heart-shape, with half-closed, almond-shaped eyes, a long, flattish nose and mouth pouting forwards. Minute differences in the treatment of the heads are perceptible: one artist has concentrated the face and brow into an ovoid shape, while his colleague has accentuated the flattened curves (a flat top to the skull) and elongated the face.

The delicacy of these carvings continues to surprise; they were produced in a village environment by people who had been constantly on the move since the beginning of the 19th century. This makes one wonder if the Fang statuary first discovered at the end of the 19th century is not the culmination of a long tradition, dating back to before the last migration of groups from the eastern savannas of Cameroon and central Africa. LP

Bibliography: Tessmann, 1913

4.91b

Reliquary guardian figure

Fang
Gabon
19th century
patinated wood
28.2 x 13.9 x 15.2 cm
Private Collection

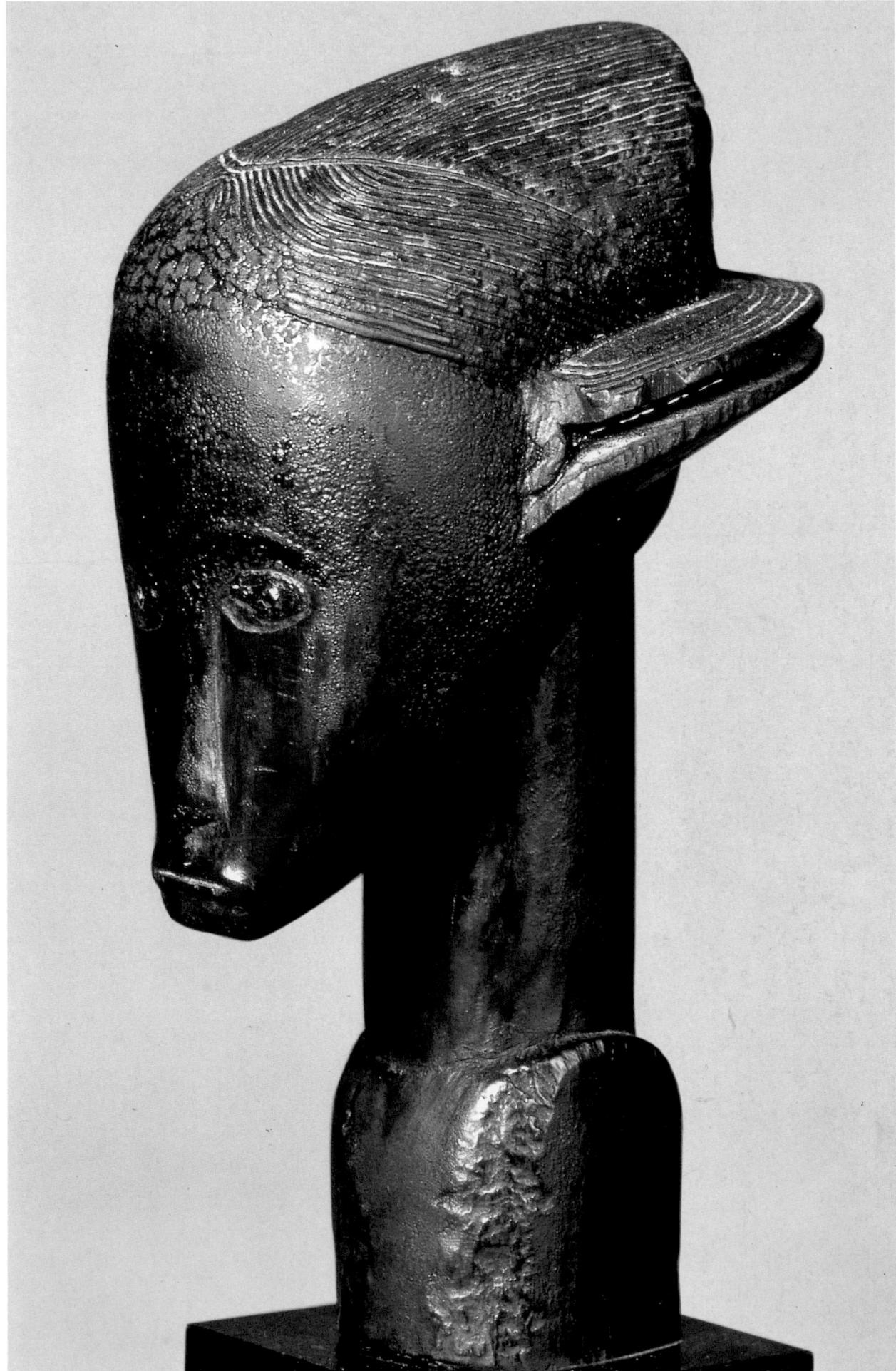

4.92

Reliquary head

Fang

Gabon (north of the Ogowe)

19th century

patinated wood

42.5 cm

Philadelphia Museum of Art,
1950, 134-202

The exaggeration of the projecting jaw of this Fang head, plus the very detailed rendering of the teeth, relate directly to its function as guardian of relics a century ago among Betsi families in northern Gabon. *Byeri* is the worship of illustrious dead members of the lineage (*ayon*) to elicit their indulgence – the dead are dangerous and must be kept at a distance from the living – and to beg for their grace, which will favour good fortune in this world. The present head, relatively large in size and massive, is typical of the sculpture of Fang groups living in the lower Ogowe Valley (and its tributaries from the right, the Okano and the Abanga) until the end of the 19th century. The head consists of a skull, effectively a sphere, placed on a cylindrical neck. The face projects far forward and is markedly convex between the elegantly curved brow and the jaw, the latter looking almost detached from the rest of the head.

The under part of the chin is also curiously hollowed out between the neck and the ears and on either side of the cheeks, although this cannot be observed from the front. It is not certain whether this hollowing out is original or whether some ritual use to which the head was put has caused this strange, misshapen result. The headdress is a simple bonnet enclosing the whole forehead and skull from one ear to the other and to the nape of the neck. The eyes are somewhat prominent, the pupils being decorated with inlaid brass patches, stuck on with resin. The double arch over the eye sockets, carved in a very smooth curve, is supported by a short, flat nose.

This striking piece presents a unique combination of originality and tradition, belonging as it does to a style that remained very homogeneous. Although the ancestral head conveys the required message, the slightly morbid interpretation of the usual Fang ‘pout’ transforms the face into a grimacing head of death. LP

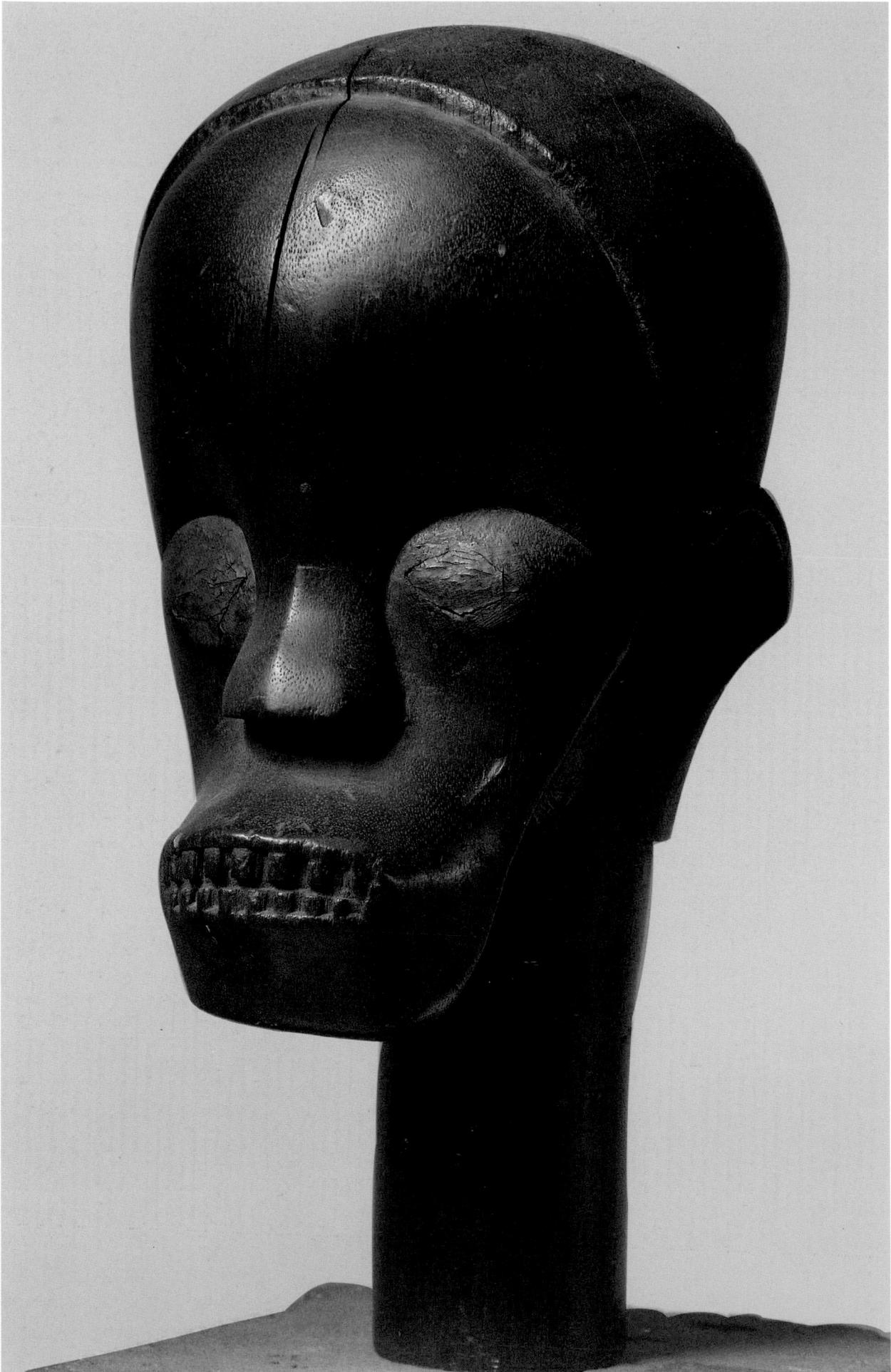

Pickaback figure

Fang (Ngumba)
Cameroon
19th century
wood
h. 55.8 cm
Private Collection

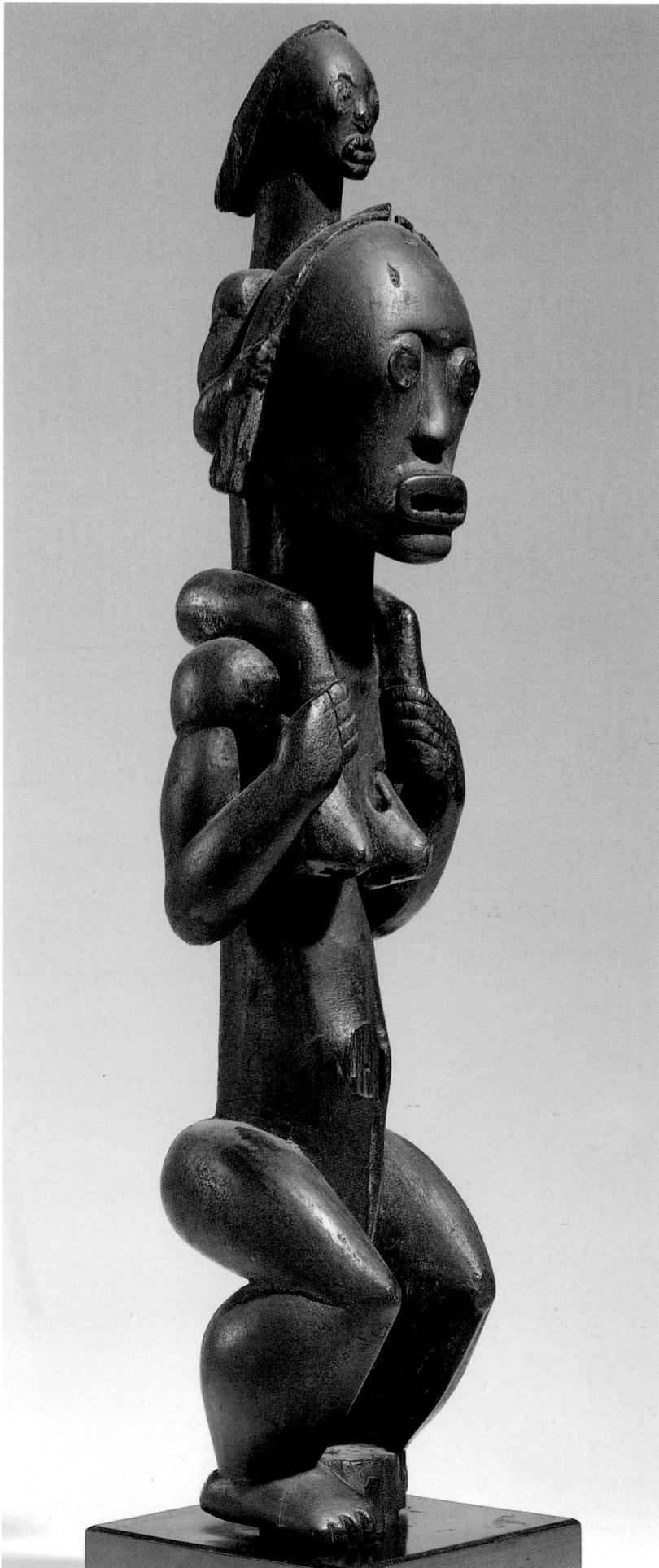

This exceptional statuette of a woman (mother?) and child has all the characteristics of the northern substyle of the Fang-Ngumba, first discovered at the end of the 19th century in the north of the Ntumu, in the area stretching from beyond Kribi to Bipindi and Lolodorf in the south of Cameroon.

Like many of the groups now part of the '*pahouin*' or Fang group, the Ngumba – who were Maka in origin and came from eastern Cameroon – intermarried with the Bulu, the Betsi and the Ntumu until finally they constituted a single group with its own identity, particularly as regards their arts and crafts. This cultural penetration must have taken place over more than a century during the great Fang migration which, by promoting a wave of lesser migrations from village to village, also caused a number of other groups to move from the north-west to the south-west of Atlantic equatorial Africa. Although it is not known whether or not the Fang came originally from Bahr el-Ghazal (as some traditions would have it), it has been ascertained that they emigrated from the savanna regions (in the north of Sanaga) to the rainforest. The Ngumba constitute a separate branch of the migration, distinct from the Nzaman and Betsi groups who made directly for Ogowe in Gabon.

The identifying feature of the Ngumba substyle is basically the elongation of the body (always represented naked) achieved by the contrast between short and massive legs (the thighs and calves particularly large), slightly bent, and a large head. Between the two the cylindrical body flares progressively from neck to stomach, supported by a very straight back. The shoulders and arms appear fixed to the torso. The child is carved separately (children in these parts are usually carried on the back, held in a band of cloth, or slung across the shoulder in a sort of small leather baby-carrier). LP

Provenance : ex G. de Miré Collection
Bibliography: Alexandre and Binet, 1958

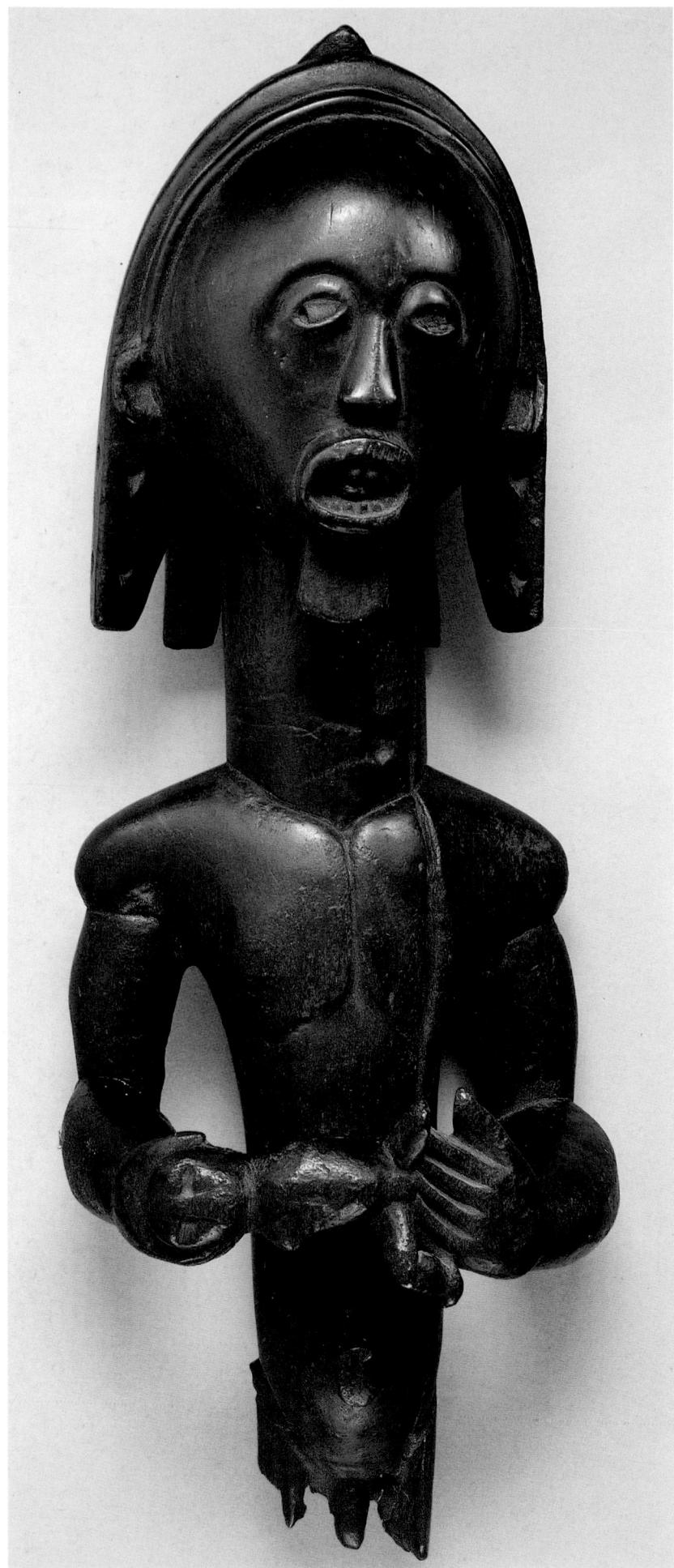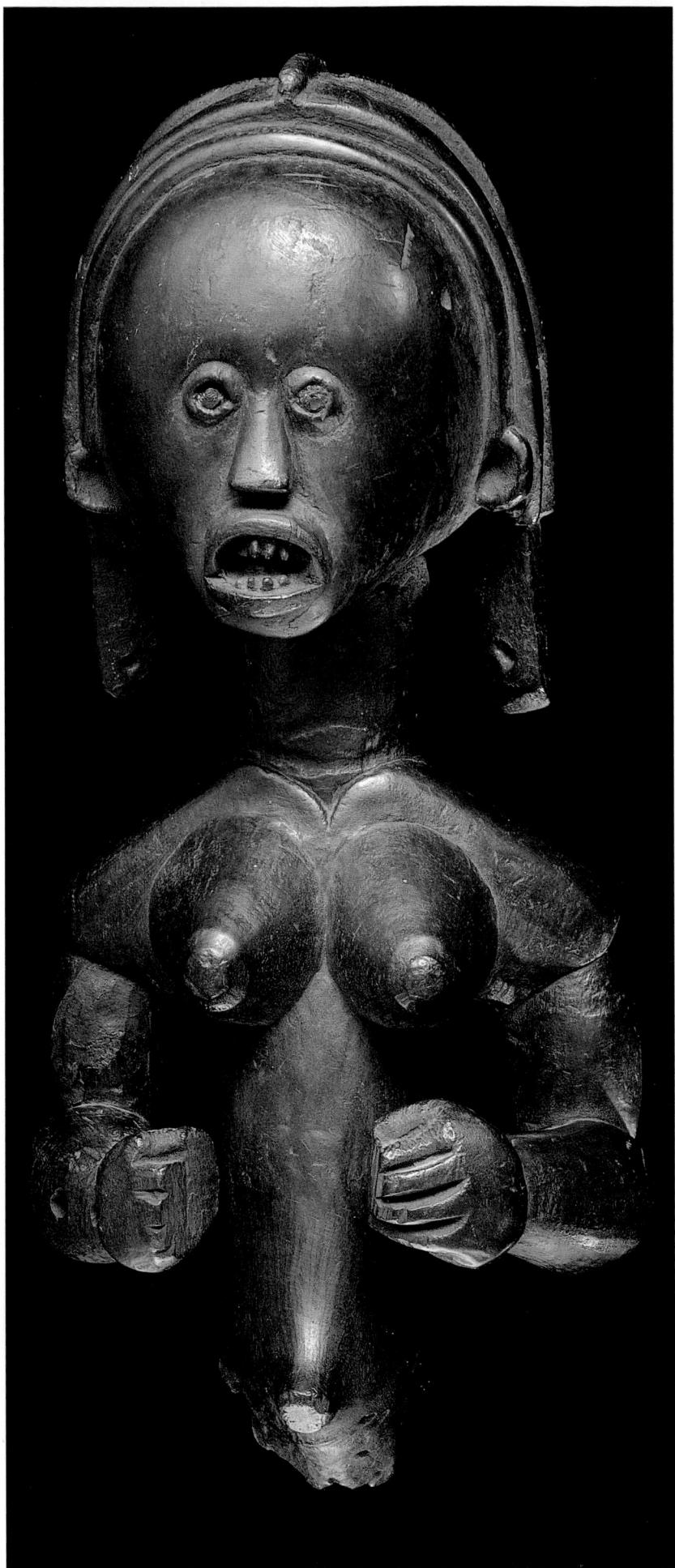

4.94a

Male figure holding a child

Fang (Ngumba)
Cameroon
19th century
wood, encrustation
57.2 x 22.9 x 17.8 cm
Peabody Museum of Archaeology and Ethnology, Harvard University, Cambridge, 30.2.50/B4974

4.94b

Female figure

Fang (Ngumba)
Cameroon
19th century
wood, metal
48.3 x 24.1 x 17.8 cm
Peabody Museum of Archaeology and Ethnology, Harvard University, Cambridge, 30.2.50/B4973

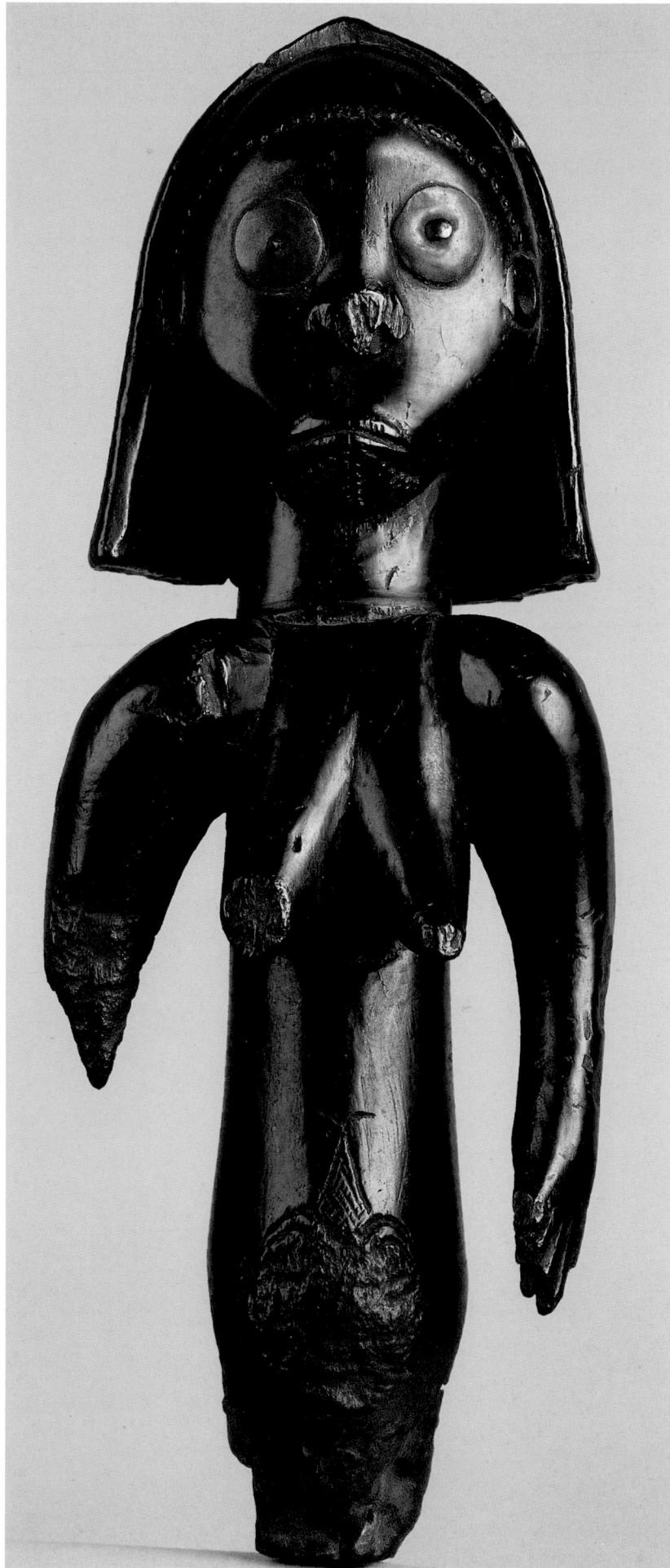

This pair of Fang-Ngumba statuettes from southern Cameroon, representing a man and a woman (now lacking their legs), is unique in including the sole surviving representation of a man holding a child. It is possible that the woman also originally held a child, as is suggested by the space between her hands. Another possibility is that the woman may have been holding an offering dish. It is quite common, when objects are collected, for portions with religious significance to be deliberately broken off, as with the *byeri* statues of the Fang. Ngumba stylistic features here are very clear: the structure of the face with its bulging brow and the head shaped like an inverted pear with the features fixed to the surface.

Unlike the Betsi figures, also from the south, with their concave, heart-shaped faces, Ngumba faces are full and rounded. The mouth in particular, with its thick lips thrust forward and slightly open to reveal pointed teeth, constitutes almost a separate element,

more or less rectangular in shape. The man wears a stylised beard, parallel-sided in shape. As in cat. 4.93, the heads of these two statuettes are on the large side, perched on a slender torso; this accentuates the elongated appearance of the body. The shoulders, simplified but with admirable fullness (like the arms and forearms), and the firm, round breasts of the young woman are extremely skilfully carved. The treatment of the eyes in each figure give them special prominence. The man's pupils are inlaid with fragments of glass, the woman's with metal nails. Interesting also are the holes for fixing feathers or glass bead necklaces, particularly at the base of the plaited hair. LP

4.95

Reliquary figure

Fang
Gabon
19th century
wood, copper
Private Collection, London

This hypnotic reliquary statue belongs to an identifiable school whose masterpiece is the large figure once owned by Epstein, which the present statue excels in grace though not in power. The large copper eyes fixed by a copper rivet give a baleful stare which in the original, dimly lit hut where reliquaries were kept was part of the guardianship of the sculptures. Traces of scarification around the umbilicus and the ridge of indentations over the forehead and chin also link this to the Epstein piece though the coiffure here is entirely individual. The balance of breasts and shoulders, making a double rhyme, forms a support like a fluted column for the head, which would otherwise seem out of proportion. TP

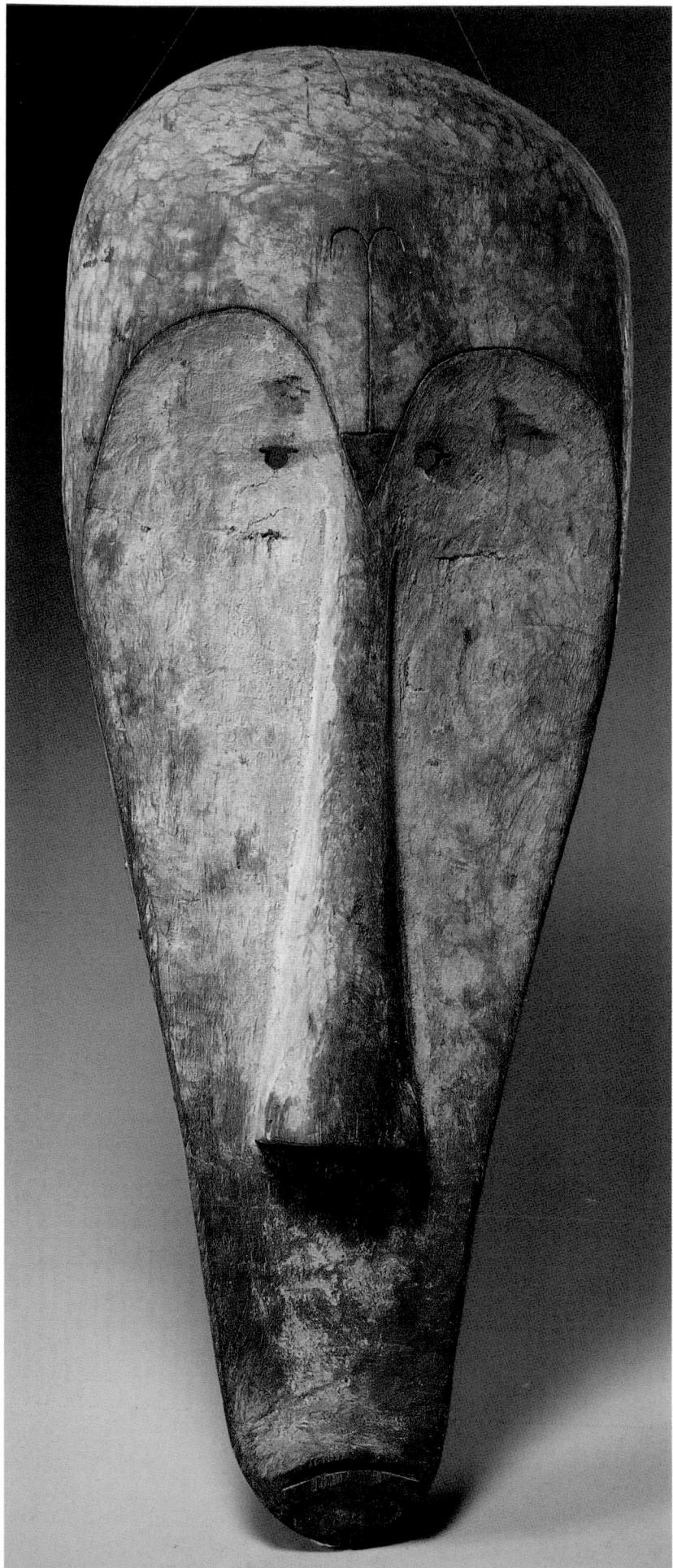

4.96a

Mask

Fang (Ntumu)
Rio Muni, equatorial Guinea
19th century
wood, pigment
h.78 cm

Staatliche Museen zu Berlin, Preussischer Kulturbesitz, Museum für Völkerkunde, III C 6000

4.96b

Mask

Fang
Gabon
19th century
wood, pigment
h. 65 cm
Laboratoire d'Ethnologie, Musée de l'Homme, Paris, 65.104.1

Fang masks connected with the society known as *ngil* continue to arouse tremendous interest because there are so few authentic, well-documented examples in existence. Reference works include the Berlin mask (cat. 4.96a), collected before 1895 probably among the Ntumu of Rio Muni and belonging stylistically to the same family as the mask in the Art Museum, Denver (collected in 1890). The Denver example was found quite near Libreville, in the region of the Monts de Cristal, in the territory of the Betsi, which at that time stretched as far as the estuary of the Gabon River.

The understated beauty of these masks, with their simple shape, has long fascinated collectors: the Berlin mask was a major feature of the exhibition at the Museum of Modern Art, New York, in 1935. It is regrettable that those travellers and anthropologists who saw the masks in use did not attempt to find out more about them. The descriptions left by early ethnographers attributed only a 'decorative' or playful role to them; detailing social ritual in all its complexity occupied their time fully enough. At the end of the 19th century the *ngil* was an association existing over and above the clan, wielding political and judicial powers; its activity is attested in all the southern parts of Fang territory, around the Gabon estuary and the Monts de Cristal, in the south and north-east of equatorial Guinea (Rio Muni), the upper Woleu Valley, among the Ntumu people in the east, the Okak in the west and the Betsi in the south.

The masters of the *ngil* could travel from village to village without danger because their role as peace-keepers was recognised; they were considered particularly useful in combating sorcery and evil practices, and in adjudicating between clans in conflict and rival villages. Rather than provoking any aesthetic feelings, the mask was a symbol of fear and retribution. The usual punishment for people convicted of sorcery was death. When the master of the *ngil* was summoned to a village he would arrive at night with a troop of followers, a kind of militia in the pay of the *ngengang*: master and judge arriving by the light of rush flares must have greatly enhanced the

dramatic effect of the masks. The *ngil*, for those more interested in participating in it than being subjected to it, involved a very strenuous initiation ceremony. Its therapeutic rituals were complementary to those of the *byeri* (cf. cat. 4.91).

The masks themselves, seen without their fibre ruff and without the dancers' clothing of raffia strips, give a false impression of serenity. The deliberate anatomical distortion is consistent with the need to personify a terrifying, semi-human being. The mask's job was to confound the sorcerer, hunt down the social deviant, punish the criminal.

The stylistic features typical of the Fang are all here: very broad, quarter-spherical forehead, double arch over the eye sockets, heart-shaped face, projecting mouth, headdress with a central crest (typical of the southern Fang), semicircular scarring on the brow and cheeks exaggerated to inspire fear.

White (kaolin wash) is the colour of the dead or of spirits. Created as weapons of terror, the masks still suggest the tripartite power of healer, man and ethereal spirit. LP

Provenance: cat. 4.96a: collected before 1895; cat. 4.96b: ex A. Lefèvre Collection; 1965, acquired by the museum

Exhibition: cat. 4.96a: New York 1935

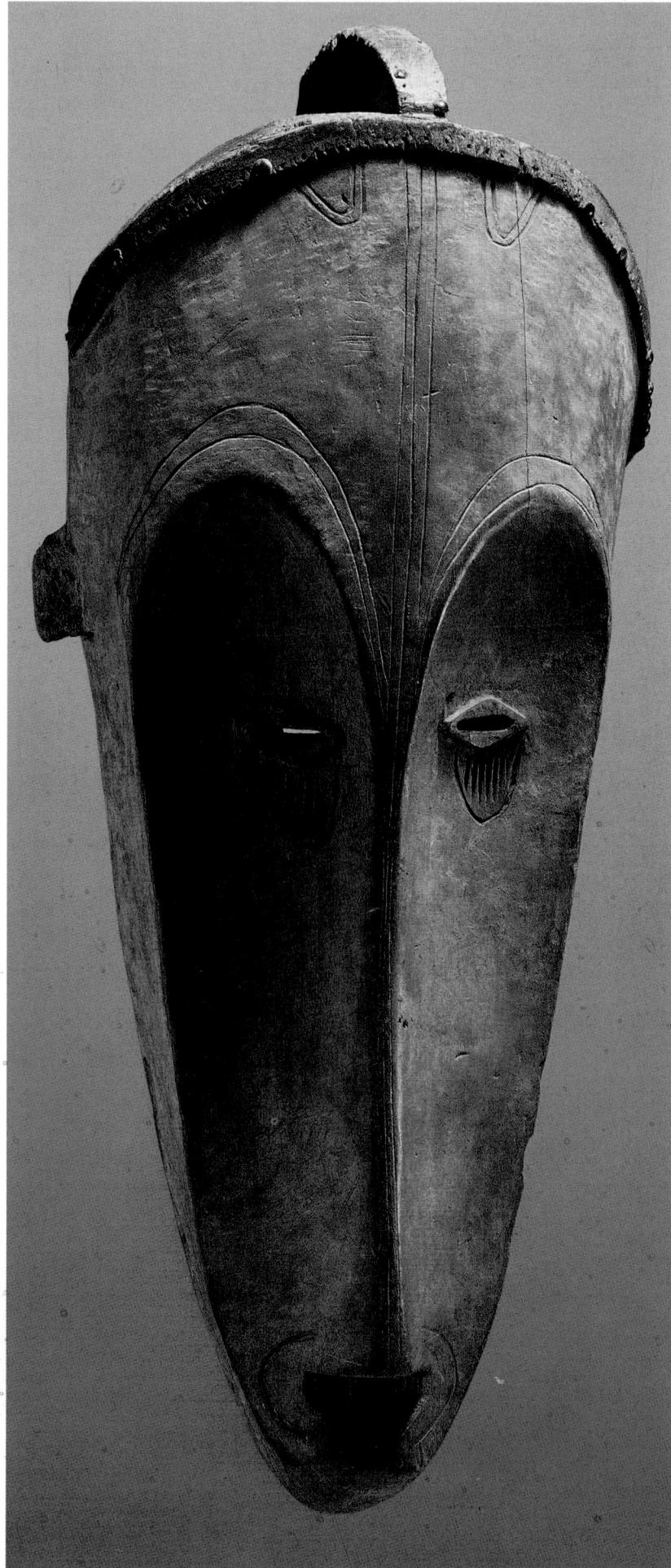

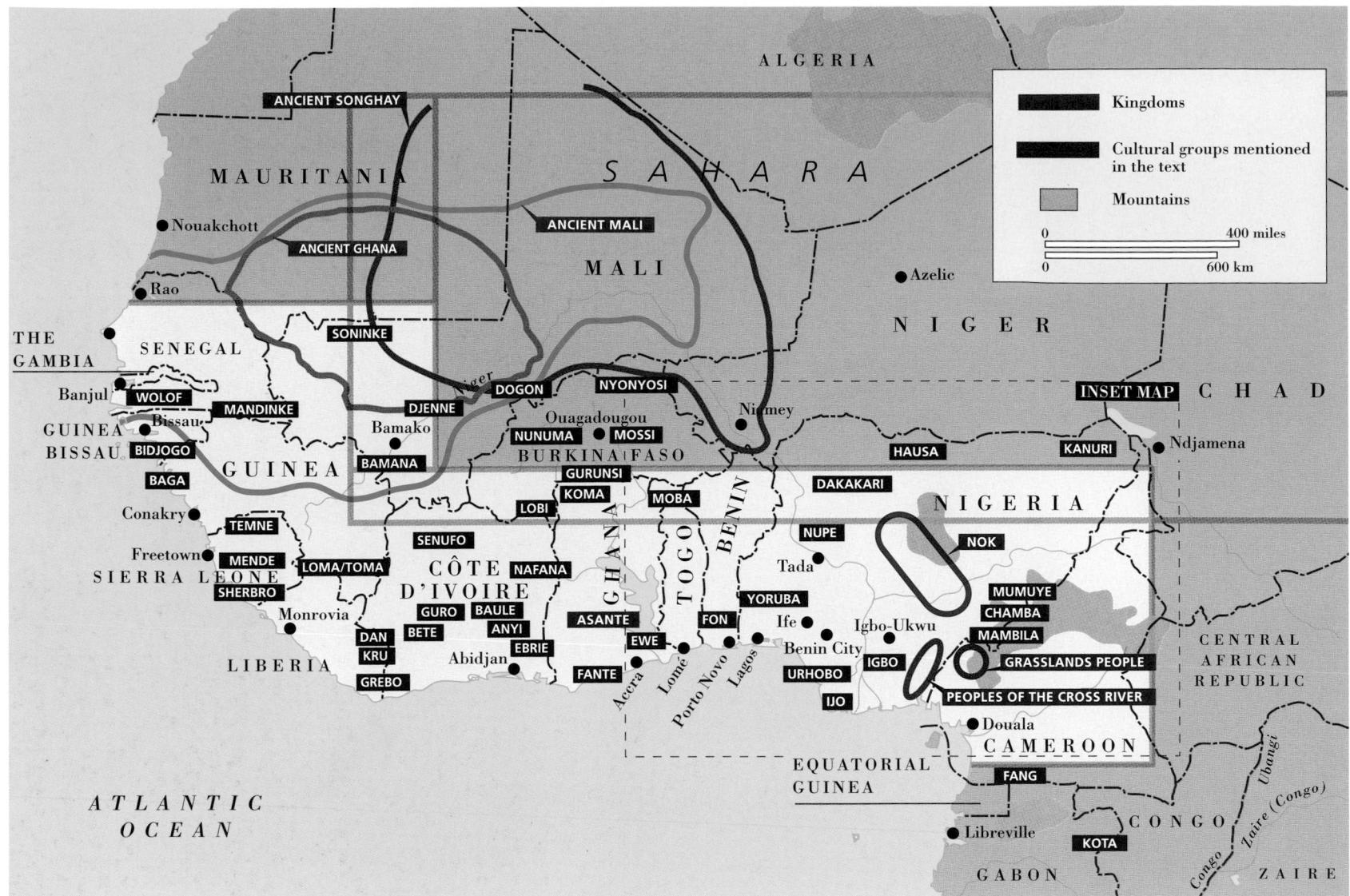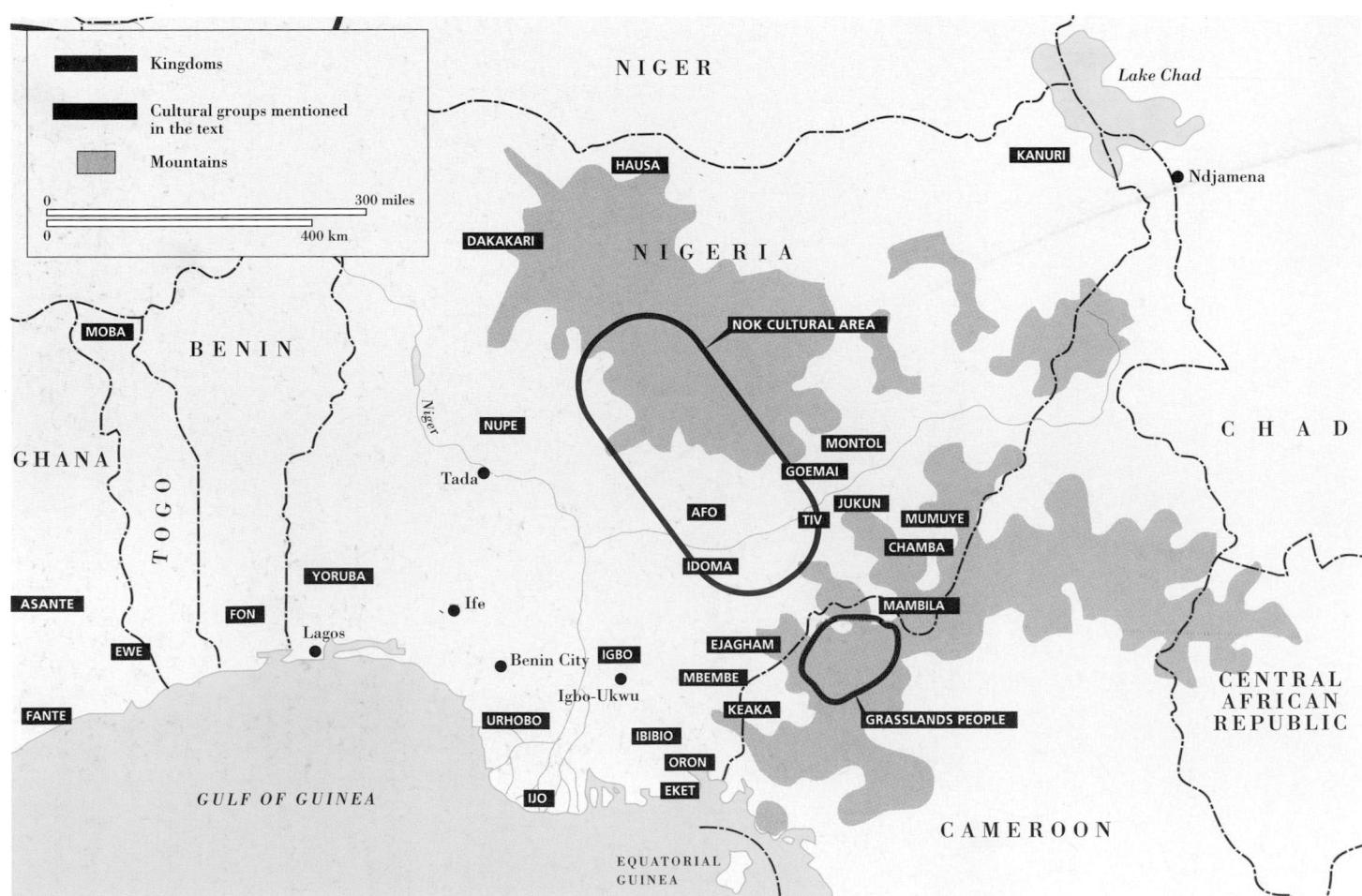

5 WEST AFRICA AND THE GUINEA COAST

John Picton

The conditions for a history of African art

Any introduction to the history of art in west Africa must take account of certain basic conditions. First, the sub-Saharan region of Africa has been substantially self-sufficient and innovative in regard to the inception of its pre-industrial technology, and, by implication, its visual arts. Second, west Africa is defined geographically by two episodes in prehistory: the formation of the Sahara, with its wide-ranging consequences, and the apparent dispersal of both the Bantu languages and an iron-working technology from what is now the Nigeria/Cameroon border region. Third, in this region the evolution of forms in local technology and tradition has often been contingent upon responses to the Mediterranean world and, after the 7th century AD, to Islam via trans-Saharan trade routes for as long as the Sahara has been a desert and to Europe via coastal trade from the late 15th century onwards; but these responses have been determined by local conditions. Fourth, any account of the history of art in sub-Saharan Africa is bound to seem rudimentary, given the extraordinary lack of data, especially when compared with what we know of European art; and very often the work of art itself is the only 'information' that we have about a given site or population.

Fig. 1 Oba Akenzua II, King of Benin, Nigeria, 1933–78, wearing coral and ivory regalia at one of the great ceremonial events

The reasons for this lack are not hard to discover: the scant archaeological coverage of the continent compounded by theft and illegal excavation, and the absence of written records compounded by inadequate assessment and incomplete collection of oral tradition. Moreover, most of the ‘classic’ works of sub-Saharan African art, unless they are the products of excavation, date from the late 19th and early 20th centuries, a period in which colonial rule was imposed upon Africa, a fact with implications for the assessment of the visual arts that we do not yet know how to contend with. Progress has been made: here and there information can be recovered about individual artists; and the very fact that one can write about west Africa in the terms set out here is a measure of the advances that have been made, particularly in our understanding of prehistory. Yet it is only in regard to the 20th-century visual arts of Africa that we can begin to gather the volume of data that would be considered the art-historical norm elsewhere.

Prehistory and technology

Several years ago, the archaeologist John Sutton proposed an ‘Aquatic Civilisation of Middle Africa’ composed of settled communities of fisher-people along the once fertile watercourse of what is now the southern Sahara/Sahel region, stretching more or less across the entire breadth of the continent. While the idea of a single civilisation was too simplistic, and while subsequent investigation suggests considerable regional diversity, the basic facts on which his argument was based still remain. There were populations dependent upon fishing and upon harvesting wild grain – probably wild species of sorghum – which had evolved distinctive fishing and ceramic technologies, with a pottery tradition immediately recognisable by a ‘dotted wavy line’ decorative patterning thought to have been made by using the spiny vertebrae of fish. For example, the central Sahara site of Amekni, dating from *c.* 6100 BC, provides evidence which suggests that pottery making began at that time and that its inception was independent of both Western Asia and Ancient Egypt (which evolved a ceramic technology later than both Western Asia and the Saharan region), among a population which, genetically, was closely akin to that now inhabiting sub-Saharan Africa.

At this time, the central Saharan region still supported a wide range of wild mammal species, as we can see in the earliest rock engravings. From about 4000 BC, perhaps in response to the gradual onset of the drying up of the Saharan region, there was a shift to a cattle-keeping pastoral economy in the central Sahara, and the paintings and engravings of this period in the Sahara – the period in which it became a desert – are dominated by scenes of cattle herding. Moreover, archaeological evidence proves that there was a gradual north-east to south-west movement of pastoralists through the Saharan region, with, it can be reasonably inferred, pressure on the resources, the fish and the wild grain, of the communities of the so-called ‘Aquatic Civilisation’. These climatic and demographic changes (which in the Nile Valley led to the inception of predynastic Egyptian civilisation) provided the conditions for people in the communities of what is now the Sahel region to start to domesticate plants in sub-Saharan Africa, a development that was independent of such changes elsewhere (including Ancient Egypt). Finally, it is probable that the border region between Nigeria and Cameroon was the area of dispersal, eastwards and southwards, of the Bantu languages and of an ironworking technology.

These are the episodes that define west Africa as a region, and define both its distinctive qualities and the period in which they were established. The period of the inception of metalworking in sub-Saharan Africa probably coincides with the period in which paintings and engravings of rock art of the Sahara frequently show horse-drawn wheeled chariots. Moreover, the distribution of these paintings and engravings, when plotted on a map, indicates the existence of routes across the Sahara that are uncannily like the western and central trade routes of medieval Islam as established from the 9th century onwards.

As to the origins of sub-Saharan metalworking, a technology essential to the practice of the visual arts, the presence of ceramic technology together with the evidence coming from the copperworking sites of Akjoujt (now in Mauritania) and Azelik (now in Niger) suggests that ironworking may have evolved locally and was not introduced by Phoenicians (via Carthage), Egyptians (via Meroë) or Arabians (via Aksum), as has been argued. It is well known that throughout sub-Saharan Africa the advent of iron-working was preceded by the continued use of stone tool technology without the intervention of a so-called Copper Age; whereas the discovery of copper smelting, for reasons of its lower melting point, is proven elsewhere to have been an essential prerequisite for the start of iron smelting. Thus it was assumed that this technology must have come to Africa from elsewhere, and discussion has revolved around the respective merits of the three possible sources just given, with Carthage and the trans-Saharan route as the most likely explanation. Yet, as the ability to control fire (the basis of both pottery and smelting) was already established late in the 7th millennium BC, and as there is evidence of early copper working sites in Akjoujt, Mauritania, and Azelik near Agadez in Niger from 2000 BC onwards, that entire discussion is rendered irrelevant and will remain so until we have some knowledge of the commodities of a trans-Saharan trade in its earliest beginnings. As yet we do not know if metals and/or the knowledge of metalworking figured in trade nor in which direction either might have passed.

Whatever one makes of these arguments, they are essential to an assessment of sites dated between 500 BC and AD 200 located across a wide area of what is now central Nigeria that provide unique evidence within west Africa for the existence of sculpture south of the Sahara. The medium of this sculpture is pottery, and though often referred to as 'terracotta', the clay fabric has the same coarse texture as most pottery, whether domestic or sculptural, in sub-Saharan Africa. But it should not be inferred that this is in some way a 'primitive' technology, notwithstanding the absence of both wheel and kiln. Coarse-textured clay was used in hand-building and bonfiring to create a pottery of a finely structured quality and of a utility adapted to the pre-industrial environment of Africa that cannot be matched by anything made with the wheel and the kiln. Moreover, these sculptures are not the rudimentary beginnings of an art but belong to a developed sculptural tradition. That they are its earliest evidence suggests a previous history yet to be discovered.

These sites, first identified by their pottery sculpture, are conventionally referred to as the Nok Culture, after the village on the southern escarpment of the Jos plateau close to the site where this sculpture was first described. Whether these sites represent a single population is open to question. In addition to the sculptures, Nok sites also provide the first clear evidence for iron smelting in the west African savanna. It was once suggested that the Nok Culture represented the very beginnings of ironworking, but it is now clear that, far from being unique, Nok Culture sites are only some of a series of sites across the savanna region south of the Sahara in east and west Africa dated to the last millennium BC, which provide early evidence for an ironworking technology. Nevertheless, Nok provides the earliest evidence yet available for a developed sculptural tradition in sub-Saharan Africa; and if the institutional arrangement whereby the potter is the wife of the smith, which still survives in many areas of sub-Saharan Africa, is of any antiquity (as the relationship between the two technologies suggests), then one might speculate that the earliest evidence for a developed sculptural tradition is also evidence of women working as sculptors. For, in addition to the simultaneous emergence of pottery sculpture and ironworking, at least some Nok sculptures are ring-built, a technique which is still used by women potters; and today potter-sculptors in the central Nigerian region are women.

Elsewhere, in Mali, at times comparable to Ife, we find more than one tradition of pottery sculpture, especially at the site of ancient Djenné (established as an urban centre in AD 800) in the inland Niger Delta, a site which also, possibly, provides the earliest evidence of urban living in sub-Saharan Africa.

These sculptures can be placed alongside those of Nok and Ife as evidence of the variety and wide distribution of pottery as a sculptural medium, but without suggesting any direct likeness, let alone continuity of style or influence. The later works in pottery, whether from archaeological sites, such as Koma in what is now northern Ghana, or Bankoni in southern Mali, or from the cemeteries characteristic of Akan communities in the more recent past, all suggest these same facts: that pottery is a medium widely used, and of considerable antiquity, yet neither ethnographic nor archaeological data yet exist whereby a history of art for this medium can be charted. The fact that this exhibition presents a broader selection of the material than has hitherto been brought together is in some part the result of illegal and undocumented excavations, the work of local entrepreneurs eager to satisfy the art-hungry savages of the Western world. From an art-historical point of view the tragedy is that one can know little or nothing of the original circumstances of this material, with the result that a history of art is reduced to a history of European engagement with it: all the rest is either circumstantial or imaginary. Ancient Djenne is simply not known in the manner of, for example, Ancient Egypt. Meanwhile, the loss of cultural property and the loss of ever knowing anything of its original circumstances is a double penalty for all the nation states of Africa.

Pottery sculpture is thus both ancient and widespread in west Africa, and it remains among the extant practices of the recent past that still, sometimes, survive. Its disappearance is less to do with changes in ritual practice than with technology. With few exceptions, pottery sculpture is the work of potters, almost invariably women, and as the use of ceramic wares has been superseded by recent industrial technology (most obviously the use of kerosene-burning cooking equipment and aluminium utensils, and the relatively higher costs of urban dependence upon wood as fuel) so the necessary skills are lost. Even when pottery has become a medium of education in the fine art curriculum of a school or university, the technical means are those of an industrialised society. Closely related to fired clay as a medium of sculpture is unfired clay, examples of which are widespread but largely uncollectable; within this tradition cement is frequently used for sculpture. However that may be, in the last millennium BC and the first millennium AD the smelting and forging of iron was practised throughout west and, indeed, the greater part of sub-Saharan Africa. During this same period the present-day distribution of languages was established throughout Africa together with, we can probably assume, the bases of the social and aesthetic traditions of the recent past. The final stage of that process is the spread of ironworking and Bantu languages from the region now identified as the Nigerian-Cameroon border through eastern, central and southern Africa. By the end of the first millennium, the city and the state were already established: by 800 the city of ancient Djenne in the inland delta of the River Niger is estimated to have contained some 10,000 people, and the medieval state of Ghana at the headwaters of the Upper Niger was known to the Islamic world. A local bronze-casting technology had evolved at the 9th-century site of Igbo-Ukwu. By 1000 we have the beginnings of the rise of Ife in the forests west of the Lower Niger, while in the 11th century Ghana was converted to Islam.

The rock art of the Sahara has thus provided evidence of changing human and animal populations in response to the climatic changes that turned it into a desert. It also seems to show that for as long as the Sahara has been desert, people have been going backwards and forwards across it. This suggests a network of trade routes of great antiquity, certainly dating from before Islam took control of the Mediterranean access to west Africa and India, and of their products (especially west African gold and Indian pepper) which was the reason for the 15th-century Portuguese exploration of the west African coast and beyond. This trade was hardly likely to have stopped at the Sahel, and one can suppose that it disseminated local African innovations further afield and eventually enabled the religion and culture of Islam to reach west Africa (notwithstanding the trans-Saharan brass-casting technology of Ife and the indigenous tradition of

Igbo-Ukwu; many Asante vessels are from north Africa, while the early weights for gold-dust almost certainly fitted a system of Islamic origin). The area was originally technically self-sufficient but later absorbed elements from beyond the Sahara and others from coastal trade. This in turn implies a factor fundamental to any understanding of the social and art-historical significance of trade: the importance of local traditions in shaping responses to these worlds beyond west Africa and in domesticating their products. Two examples will show this clearly: the melting down of European brass in 16th-century Benin to create the plaques that embellished the royal palace; and, in the early 18th century, the unravelling of Dutch silks by the Asante to make use of the yarn in their own textiles.

Languages

Today in west Africa some languages are spoken by populations of a few hundred and some by populations of several million. They represent three of the four great language families of Africa: Nilo-Saharan, Afro-Asiatic and Niger-Congo. (Khoi-San languages are located only in the southern half of the continent; and I also exclude Indo-European languages that have dominated the institutions of education in colonial and post-colonial times.) It is worth remembering that not only are the languages themselves different one from another (and we are talking of differences of the order of that between English and Chinese), but each presupposes a conceptual order that is equally different.

The 'Middle Africa' of Sutton's 'Aquatic Civilisation' discussed earlier in this essay, whose subsistence technology was so crucial to all subsequent developments in west Africa, as well as to the Nile Valley, is presumed to have been dominated by speakers of Nilo-Saharan languages; though if so, their present distribution suggests a subsequent rupture by Afro-Asiatic-speaking populations. Today in west Africa, Nilo-Saharan languages are found among riverine communities of the Middle Niger and in the Lake Chad region. The Afro-Asiatic language group, now thought to have originated in the Ethiopian region, includes the Arabic and Berber (e.g. Tifinagh, the language of the Tuareg) of desert pastoralists, and Hausa and related northern Nigerian languages (as well as Coptic and ancient Egyptian, Hebrew, Somali and the languages of Ethiopia). The greater part of west Africa is, therefore, dominated by the Niger-Congo languages, and these have been grouped into six branches: West Atlantic, Mande, Voltaic, Kwa, Adamawa and Benue-Congo (i.e. Bantu-related and Bantu, which, as already noted, have spread to dominate the greater part of eastern, central and southern Africa). Recent analysis, however, has extracted Dogon from Voltaic and Ijo from Kwa as sufficiently divergent to merit consideration as separate branches, while reclassifying Kwa within the Benue-Congo branch alongside the Bantu-related languages.

As the name implies, communities of people speaking West Atlantic languages often live at the very edge of the continent where they have been pushed by the expansion of their Mande-speaking neighbours. West-Atlantic-speaking communities and languages include Wolof in Senegal, Baga in Guinea, Bidyogo in Guinea Bissau and Sherbro of coastal Sierra Leone, whose ancestors were almost certainly the sculptors of *nomoli*, stone images for local use, and of ivory sculptures for sale to Europeans in the 16th century. The Fulani language is also within this group, spoken by pastoral cattle herders, communities of weavers around the inland delta of the Upper Niger and town-dwelling households. The latter often provided the leaders of Islamic reforming movements such as the early 19th-century Fulani jihad that swept through the area that is now northern Nigeria and established new aristocracies in the Hausa emirates. Fulani-speaking people are spread from Senegal to the Sudan Republic, scattered among speakers of almost the entire range of west African languages as a consequence of seasonal transhumant movements from north to south combined with a measure

of migratory drift over several centuries; whenever the pastoralists have moved on, so groups of town-dwelling Fulani remain.

Inland from these coastal communities, the Mande languages predominate, especially in the western forests and savannas. These include Mende in Sierra Leone, Dan across the Liberia-Guinea-Ivory Coast borders, and Bamana in Mali. To their east there are peoples speaking Voltaic languages, such as Dogon in Mali, Senufo in Ivory Coast, Mosi, Bwa and Bobo in Burkina Faso; and these are populations that have all proved themselves to be fine and prolific sculptors, weavers and builders. The great Kwa group dominates the savannas and forests of eastern Ivory Coast as far as the Cross River in south-eastern Nigeria. This comprises, among others, the Akan/Twi-speaking communities of southern Ivory Coast (e.g. Baule) and modern Ghana (e.g. Asante), through Ewe and Fon to Nigeria and Yoruba, Edo, Nupe, Igbo etc. The Adamawa branch (e.g. Chamba) stretches eastwards from the upper Benue area; and finally we meet the Bantu and Bantu-related languages of the Cross River area, the forests and grasslands of southern Cameroon, together with some of the communities of the Benue (Tiv, Jukun) and Middle Niger (Dakakari) regions of Nigeria.

The emergence of states and the metalworking arts

A powerful image of the place of west Africa within the medieval world is offered by Mansa Musa, emperor of Mali. In 1324, in the course of his pilgrimage to Mecca, he stayed in Cairo where he dispensed so much gold that, although everyone seemed to have benefited from his generosity, the value of gold, for a while, collapsed. At the time, and indeed until the discovery of the Americas, west Africa was the most important source of gold in Europe: English gold coins from the 14th century, for example, are of west African gold; and the Portuguese exploration of west Africa was intended to subvert the Moroccan control over European access to gold from Africa and pepper from India.

Both the empire of Ghana, the earliest-known state of sub-Saharan Africa, and that of Mali, founded by the mythic hero Sundiata at the end of the 12th century, were relatively well known to the Islamic travel writers of the time. The existence of these and later pre-colonial states, and their rise and fall, particularly in the western half of west Africa, appears to have been dependent upon Saharan salt, west African gold, trans-Saharan trade and access to the network of routes across west Africa. The major goldfields of Bambuk and Bure were located in what is now Senegal and Guinea, while the Akan gold-fields, essential to the formation in the late 17th/early 18th century of the Asante confederacy, are in modern Ghana. (In 1957 Nkrumah took Ghana, the name of the first state in sub-Saharan Africa, as the name of the first post-colonial independent nation.) Further east, in the region that is now Nigeria, the existence of the Hausa states, and the rise and fall of the Yoruba cities of Ife (11th–15th centuries) and Oyo (17th–19th centuries) cannot, however, be explained in terms of control over access to goldfields for the simple reason that there were none; but they were linked into the trans-west African/Saharan network via the Middle Niger.

One popular theory of how states are formed is that authority and wealth are concentrated at key points along trading routes and networks, and the transfer of wealth is controlled by an emergent élite class. This does not explain everything, partly because human history is always very much more complex than any theory will allow; and some of the most fruitful centres of art, such as Igbo-Ukwu, or the Opin villages of north-eastern Yoruba, are far from any well-beaten track. Moreover, one does not wish to perpetuate the notion that history is the history of states and kingdoms, as if there were no other forms of social and political order. Nevertheless, this theory does explain a good deal about the rise and fall of Ghana, Mali and their successors; and of Ife and Oyo. Added impetus was given to this process with the

Fig. 2 *Interior of the Friday Mosque, Zaria, Nigeria, built c. 1836 by Baban Gwani Mikhaila (Michael the Genius), the most famous of the Hausa architects*

appearance of Europeans at the coast: Robin Horton noted the emerging centralisation of authority in the 18th and 19th centuries in those Niger Delta communities that entered into trade with Europeans. Some states, for instance Asante and Oyo, were on both the coastal and the trans-Saharan trade networks.

By the time the empire of Ghana was destroyed by Sanhaja Berbers in the 11th century it was already an Islamic state, and trans-Saharan and long-distance west African trade routes were controlled by Muslims. Indeed, the widespread conversion to Islam throughout west Africa is the clearest and most long-lasting result of the trans-Saharan trade routes. The presence of Islam has had profound formal implications for developments in architecture (fig. 2), sculpture, masquerade, textiles and double-heddle weaving; and the decorative arts throughout the region and the diverse relationships between Islamic and local ritual practice must also be taken into account. In many ways the most significant consequence of trans-Saharan trade for the history of art was the importation of copper and brass (copper alloyed with zinc, and always with a little lead to improve the fluidity of the molten alloy) and, possibly, a lost-wax brass-casting technology. Copper and brass, whether as ingots or as vessels, were major imports into west Africa. (Sculpture in wrought iron is less widely found in west Africa than brass: the most notable examples occur

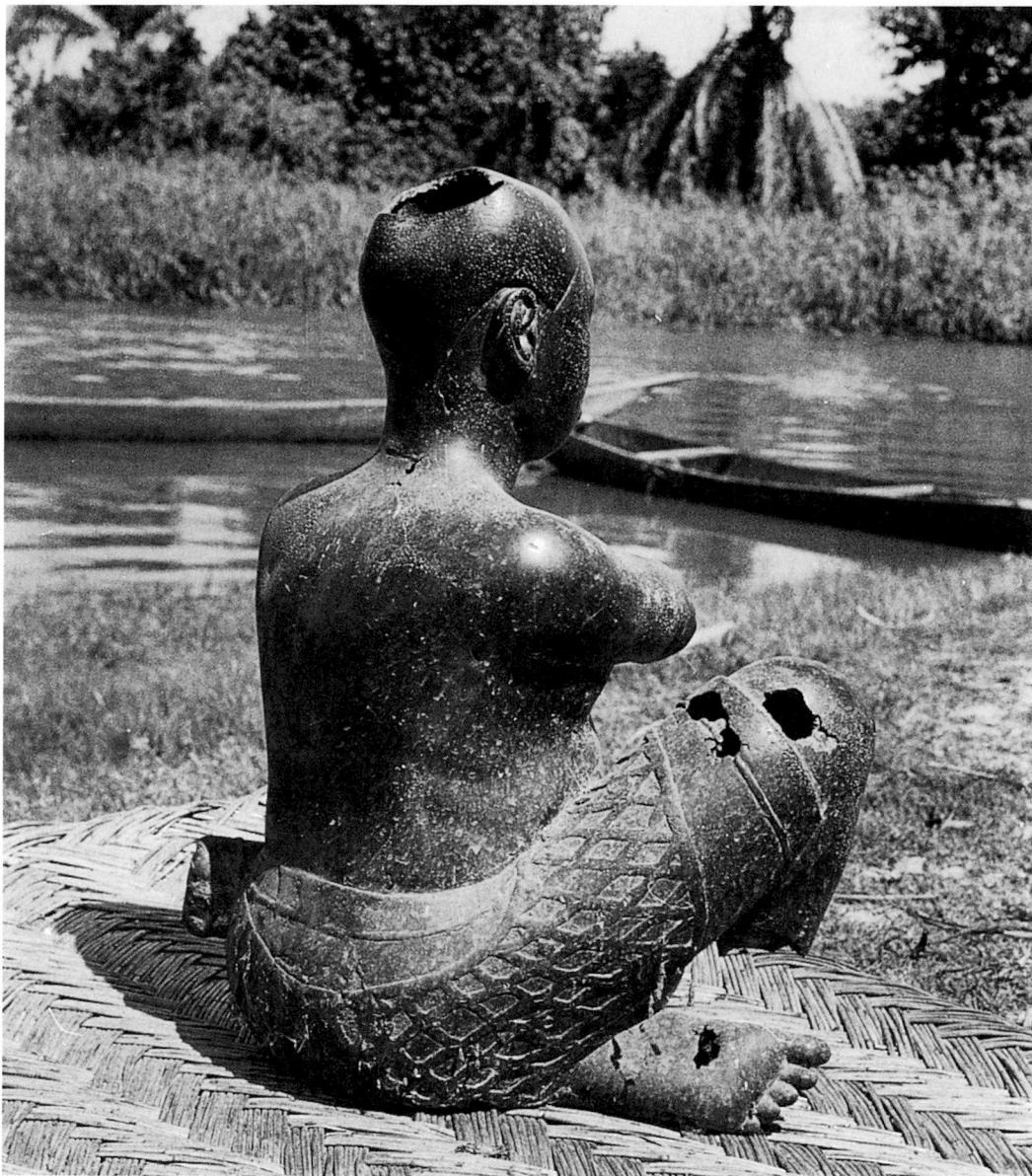

in Igbo, Edo, Yoruba and Fon communities in southern Nigeria and the adjacent Benin Republic, and in Bamana and Dogon communities in Mali. The linear and schematic qualities of this work are manifestly contingent upon the intractability of the medium.)

The art of Ife in particular, where the gods climbed down from heaven to make the Yoruba world, was developed first in pottery and then transferred to brass, using the lost-wax technique, in the course of its 'classic' period, the 11th to 15th centuries. The forms of Ife art owe nothing to an outside world, and the casting technology may or may not have been to hand; whereas the brass is certainly of trans-Saharan origin.

In contrast to Ife, the earlier (9th century) castings of Igbo-Ukwu are of a leaded bronze (an alloy of copper and tin, with lead) almost certainly of local derivation. The constituent metals were all available in the area (a fact hitherto overlooked) and the lost-wax method was employed in a manner that suggests it was an independent local invention. The very use of bronze at this date was unusual; elsewhere in the world brass was the most commonly used alloy (with bronze used only for specialist work). Why the castings of Igbo-Ukwu should appear where they do remains an enigma. One of the characteristic features of the region immediately to the west of the Lower Niger is the presence of settlements with walls or ramparts, indicating the need for protection from enemies. Ife was a substantial urban settlement

Fig. 3 The seated figure of Tada contemplating the River Niger. The apparent realism of the copper casting even records the rolls of fat characteristic of the middle-aged male waist

Fig. 4 Cast bronze figure of a hunter with antelope from an unknown Lower Niger site, probably pre-1500. The British Museum, London

with paved courtyards, forest and city shrines, a glass-making industry, and a royal palace. By contrast, to the east of the Lower Niger, neither settlements nor defensive structures are characteristic which suggests the settlements were sufficiently isolated not to require defence. This makes the Igbo-Ukwu bronzes the more inexplicable, particularly as they are the earliest sub-Saharan evidence for the use of copper alloys in art.

The rise of Ife, beginning in the 11th century, can be easily explained: its key location controlled access to forest products by way of the trading networks of west Africa, which were to be dominated by, and linked into, the trans-Saharan trade route via the Wangara, the Muslim Mande-speaking traders of the empire of Mali. The celebrated seated figure of Tada is a case in point (fig. 3). This casting in Ife style was kept (until its removal to the National Museum, Lagos) in the obscure riverine Nupe village of Tada, where it was emblematic of Tsoede, the founding hero of the pre-jihad dynasty of Nupe kings. It also has stylistic similarities to works discovered at Ife. However, not far away, upstream along the River Niger, there is an isolated group of communities of Mande-language speakers. That these could be a surviving remnant of the traders of the empire of Mali who served to link Ife into that wider trading network might account for the apparent dominance of Ife (in so far as art can provide such evidence) over access to the forests of the Lower Niger region. In that case Tada, located north of Ife on the Middle Niger,

might have been the point at which the agents of Ife connected with the Wangara of Mali, and the authority of the agents of Ife might in some manner have been legitimised by the presence of the cast figure.

This hypothesis, though the best we yet have, does not explain the other figures also once located at Tada, also associated with Tsoede and now in the Lagos museum, for these are manifestly not in the style of the seated figure and thus, it is to be assumed, not Ife works. Nor does it explain the magnificent pair of figures, also emblematic of Tsoede, that were once at Jebba, the Nupe community on an island upstream from Tada. One is of an archer (Lagos museum), the other, of a standing woman, was stolen from its house in Jebba some 25 years ago. All one can say of this diverse group of castings is that they indicate the existence of other, as yet unlocated, copper-alloy casting centres in the Middle and Lower Niger region.

A great many other castings support this proposition. These include figure sculptures, figurative bells and vessels, all categorised by William Fagg as the Lower Niger Bronze industries, though he insisted that this was a merely provisional grouping defined more in terms of our ignorance of their origins than in terms of style. Perhaps the most notable and certainly the best-known of these castings is the extraordinary figure of a hunter bearing an antelope (fig. 4). It is of bronze, rather than trans-Saharan brass, as are all those of the same group that have been tested, which suggests that indigenous casting technology was more widespread in the proto-historic period of the Lower Niger region than has been supposed. We know of several centres of brass-casting in the region to the west of the Lower Niger dating to the late 19th and early 20th centuries: for example, as well as Benin City, there were the Yoruba-speaking cities of Ijebu-ode (whence casting was transferred to Abeokuta) and Owo, and the north-east Yoruba villages of Obo-Ile and Obo-Ayegunle, none of which has been investigated in regard to casting. There is no evidence as yet of casting at either Ife or Igbo-Ukwu, other than the works themselves, in the sense that while some of the sculptures appear as isolated artefacts, others were excavated within ritual configurations; but none has yet been excavated from a workshop. (The present-day casting workshop in Ife is a latter-day introduction with no continuity with any period before this century.) It is, of course, true that there is no excavated evidence for casting in Benin City before the present century, but the context is quite different; it would be hard to deny a substantial measure of visual continuity between the castings of the 16th century and the ritual and ceremonial environment of the present. As to the origins and sources of copper-alloy-casting in Benin City, it is worth noting that while at least one tradition in Benin itself identifies Ife as the source of the lost-wax casting technology (as part of the mythic package legitimising the present dynasty of kings), the works themselves suggest otherwise; given the high status of the Benin corpus this will be explored below.

The technique of brass-casting was used in the recent past, and is still practised in many locations in west Africa. In Cameroon, Fumban is the major centre, which once produced tobacco-pipe bowls, bracelets and other decorative works, and today is still active, producing astonishing oversized replicas of Ife and Benin antiquities. In south-eastern Nigeria and in the Niger-Benue confluence there is evidence of casting traditions, not obviously derived from Igbo-Ukwu, that have not been studied. In Abomey, the capital of the Fon kingdom of Danhome, small-scale ornamental figurative castings have been produced since the introduction of the lost-wax technique by Akan casters in the 19th century. Akan (that is, Twi-speaking) casters are known for the brass weights for measuring gold and for covered vessels often incorporating human and animal tableaux. The same lost-wax technique was also employed for casting gold, whether as jewellery for chiefs or as figurative ornaments that encourage discourse in terms of proverbs or for state swords in the Asante confederacy. (Gold leaf applied to carved wood has also been used for chiefly regalia throughout the Akan region, in particular umbrella

finials, the tops of staffs for chiefs' spokesmen, and stools.) In the north of modern Ghana and in the adjacent regions of Ivory Coast and in Burkina Faso there is a complex of figurative and decorative casting traditions that include Frafra-, Mosi-, Dyula- and Senufo-speaking peoples. Of particular interest are the often complex metaphysical connotations of apparently commonplace artefacts. Further west, figurative brass-casting traditions exist among the Dan, Bamana and Dogon people, and castings are now coming to light that appear to have some temporal relationship with the pottery sculptures of ancient Djenné. The fact that such discoveries appear to be made largely in the context of a thieving that runs counter to archaeological investigation is, of course, a tragedy for historical understanding. Meanwhile, the works of art remain the only evidence of a people and a social and aesthetic context that we yet know little about.

The fact that in all the latter-day traditions a copper-zinc alloy is used may indicate that the technique originated from a trans-Saharan source, with the obvious exception of Igbo-Ukwu. Substantial quantities of brass were exported across the Sahara as rods or as ready-made vessels. On the other hand, the Lower Niger hunter is cast in bronze; the most plausible hypothesis is that it comes from an as yet unidentified early Yoruba-speaking casting centre other than Ife; and as far as we know all latter-day Yoruba casting employs brass. This suggests the possibility that the casting technology was an indigenous invention that in due course made use of sources of metal that rendered the technologies of mining, smelting and alloying obsolete (similar considerations explain the demise of the mining and smelting of local iron ore in the present century). Discussion of the early period castings of Benin also has to take into account the implications of alloy content. In any case, brass was an important export to west Africa in the coastal trade initiated by the Portuguese in the late 15th century; and the brass in common use at the present time, as in the recent past, is largely European scrap (or, of course, old castings).

Gold, in contrast, is a metal seemingly far less valued in art than copper and its alloys. Indeed, it was because of information to that effect garnered by the Portuguese from their military conquest of Morocco in the 15th century that they carried copper and brass manillas as a medium of trade in their explorations of the African coast, metal that helped the innovative developments in 16th-century Benin, in particular the development of the plaque form (cat. 5.60b–e). In the Asante confederacy, however, gold was a metal of social and political consequence in the casting of jewellery and regalia (cat. 5.103), in its imitation in yellow silk (cat. 5.93), and in its use as currency with the attendant casting of weights in brass (cat. 5.103–7). In mythic terms, the most significant artefact is the Golden Stool, conjured from the sky on a Friday in c. 1700 by Anokye the priest, thereby initiating the Asante confederacy and confirming Osei Tutu as its high king.

The history of art in Benin City

It is evident from oral tradition, and from the fragmentary reportage of European visitors to Benin from 1485–6 onwards, that the city, kingdom and empire experienced two major periods of economic and political growth. The first is centred on the late 15th-century king Ewuare, who is said to have wrestled with the god of the sea to obtain the coral beads essential to royal and chiefly regalia, who introduced the red barathea (a felted textile) a crucial element of ceremonial dress, and who instituted and defined the present orders of chiefly titles. Ewuare was succeeded by a series of warrior kings, the last of whom reigned in the latter half of the 16th century. The 17th century was a time of gradual decline until the fortunes of Benin were revived in the early 18th century by Akenzua. There followed another period of gradual decline ending with the destruction of much of Benin City and the exile of its king by the British in 1897. A subsequent revival started with the re-institution of kingship in 1914

(fig. 1). Probably there is now as much casting in Benin City as there ever was, a development as yet undocumented.

Much of the history of Benin seems to be represented in brass-casting, although there is no precise coincidence between art and politics; William Fagg categorised Benin art within three periods. For example, the early 18th-century resurgence of Benin is associated in oral tradition with the inception of new forms of casting which are also marked by stylistic developments that Fagg regarded as ushering in a late period. Fagg's middle period is likewise defined by innovation in form, in particular the rectangular plaques that were mounted on wooden pillars in the verandas of the royal palace until it was apparently rebuilt around or soon after 1700. The inception of the plaque form can be assigned to the period of the advent of Europeans for at least two reasons: first, because the imagery of the plaques includes the Portuguese themselves, who were not seen in Benin City until 1485–6 (and one could argue that the plaque form offered Benin artists the possibilities of an indigenous representation of their own art forms and ceremonial in art); and, second, because the plaques manifest an expansion of the brass-casting industry that can only be attributed to the availability of vast quantities of copper alloy.

In the course of twenty months in 1505–7, the last Portuguese agent as Ughoton expended 12,750 manillas (bracelets) in trade with Benin, and by this time the people of Benin preferred brass to copper manillas. Moreover, the demand for manillas increased so much that by 1516–17 a single ship was recorded carrying 13,000 in one voyage to Benin. In other words, the proposition is that the vast quantities of brass bracelets that the Portuguese used to trade with Benin found their way to the casters, thereby enabling the inception and casting of this form. Whether one can attribute the source of the essentially two-dimensional form of the plaque to a Portuguese source, such as illustrations in books (which can be proven as a source of much of the ivory-carving made in Benin in the early 16th century for the Portuguese) is a possibility that remains unproven.

The plaques seem to develop from an experimental phase, illustrated by the plaque of the Portuguese leopard hunters (Berlin), to an increasingly hieratic form of composition, which imposed a character on the art of Benin from which it never really escaped. The best illustration of this is the late period figure of a Portuguese musketeer (British Museum). The Portuguese monopoly of trade with Benin came to an end in the 1530s, and this figure is in early 16th-century dress. His musket, however, can be dated to the late 17th or early 18th century; and the alloy from which the casting is made, because of its high percentage of zinc, can be dated to the late 18th or early 19th century (fig. 5).

The early period castings are thought to predate the advent of European contact; and one group of cast heads displays a degree of naturalism uncharacteristic of castings that can fairly certainly be dated after the advent of Europeans. Dating these works is not simple. The famous ivory costume masks (British Museum and Metropolitan Museum of Art, New York) display an early period naturalism, with a row of bearded long-haired Portuguese heads around the top. In Benin today, these masks are said to represent Idia, the mother of Esigie, the early 16th-century king who, among other things, instituted the office, title and cult of the Queen Mother. Again, in Benin today these early period heads are regarded as trophies representing the decapitated heads of enemies in war. Art-historically they are probably the prototype of the memorial heads known from the middle period onwards and placed upon the altars dedicated to deceased kings. As to the composition of the alloys from which they have been cast, those early period heads that have been examined indicate a leaded gunmetal, that is, copper, tin and zinc, with a small amount of lead to improve the flow of the molten alloy; and, given that both local and trans-Saharan alloys might have been available, this fact alone suggests a greater complexity than the dynastic myths of Ife derivation would allow.

Fig. 5 Portuguese soldier in 16th-century dress, with early 18th-century musket, cast in brass no earlier than 1800. The British Museum, London

Sculptures, textiles, architecture, masquerade

Wood is by far the best-known sculptural medium of art in west Africa, as it is elsewhere in the sub-Saharan region. However, there is no real evidence to suppose that this represents anything other than a European predilection, rather than African taste, bearing in mind, first, the great variety of forms and styles of art in other materials, whether two- or three-dimensional, and, second, the traditional dependence of European and American connoisseurs upon the collected artefact and the manner in which this material has been placed within ready-made categories of 'art' and 'craft' (the latter taken to be of a lesser aesthetic status, a conclusion that flies in the face of what little we actually know of local values). Nevertheless, the range of forms achieved in addressing a block of wood with an adze (with few exceptions the fundamental carving tool of west Africa) never fails to astonish: one need only compare the fulsome works of the Grasslands of Cameroon with the schematic four-square Kalabari forms of the Niger Delta.

Compared with pottery and metalwork, wood is a relatively ephemeral medium, subject to the destructive effects of warfare, fire, rainwater and insects; and often objects have been preserved only by their removal from their original context to an art collection (there is, after all, a positive aspect, directly and indirectly, to the work of 'the art-hungry savages of the Western world'). Throughout much of the 19th century the Yoruba-speaking region, perhaps the most prolific single region in which sculpture has been produced, was ravaged by wars, one kingdom fighting against another. As a result, partly through destruction and partly through social disruption, there are very few extant sculptures in wood dating from earlier than the latter half of the 19th century, and no memory of sculptors other than those occasionally enshrined in the mythic praise-poetry of the gods and heroes. Sometimes the ephemerality of wood sculpture is institutionalised as in the Akoko-Edo communities (to the north of the Benin kingdom) where a set of monumental masks denoting age grades is produced once every seven years and abandoned in a forest grove following the celebrations at which a new set of elders abandons its youth.

The earliest wood sculptures that survived in their original circumstances at the turn of the present century (though now largely in museums) seem to be those ancestral memorials for which secure genealogical evidence suggests dates in the late 18th century, the ancestral figure sculptures of Oron at the mouth of the Cross River in south-east Nigeria (cat. 5.43), and the memorial screens of Kalabari house heads in the eastern Niger Delta. Claims for far greater antiquity have been made for material supposedly the work of the Tellem predecessors of the Dogon inhabitants of the Bandiagara cliffs of Mali (cat. 6.17–18), though the accuracy and status of such claims is uncertain.

One of the consequences of all this is that we can discern little of a history, in the sense of a narrative of developing forms in relation to and as part of inevitably changing contexts of ideas and practices. On the other hand, we know a good deal about such contexts as are extant at the present time, which permit inferences about the recent past. The commemoration of ancestors, whether from a relatively recent (Oron, Kalabari) or a mythic past (Dogon) has already been mentioned. Sometimes, however, figure sculptures are for display and advertisement, as in the processional *tye kpa* sculptures commissioned by Senufo women of the Ivory Coast; contrasted with these are the figures commissioned by Senufo *sandogo* diviners, also women, to represent the spirit familiars that grant them powers of divination. Closely related (conceptually) is the tradition of images of spirit spouses commissioned by Akan peoples in Ivory Coast and Ghana following divination. Then there are the Fon *vodun* (cat. 5.91c) or Bamana *boli* (cat. 6.7) traditions in which figurative images are compounded from materials that serve as tropes of energies that are actualised in ritual. Bangwa portrait statues of kings carved by professional sculptors can be contrasted with images carved by amateurs, steeped in magical medicines intended to damage thieves, for example, showing the cancerous swollen abdomen with which the thief will be afflicted who steals from the house where they are kept (hence the apparently pregnant male figures

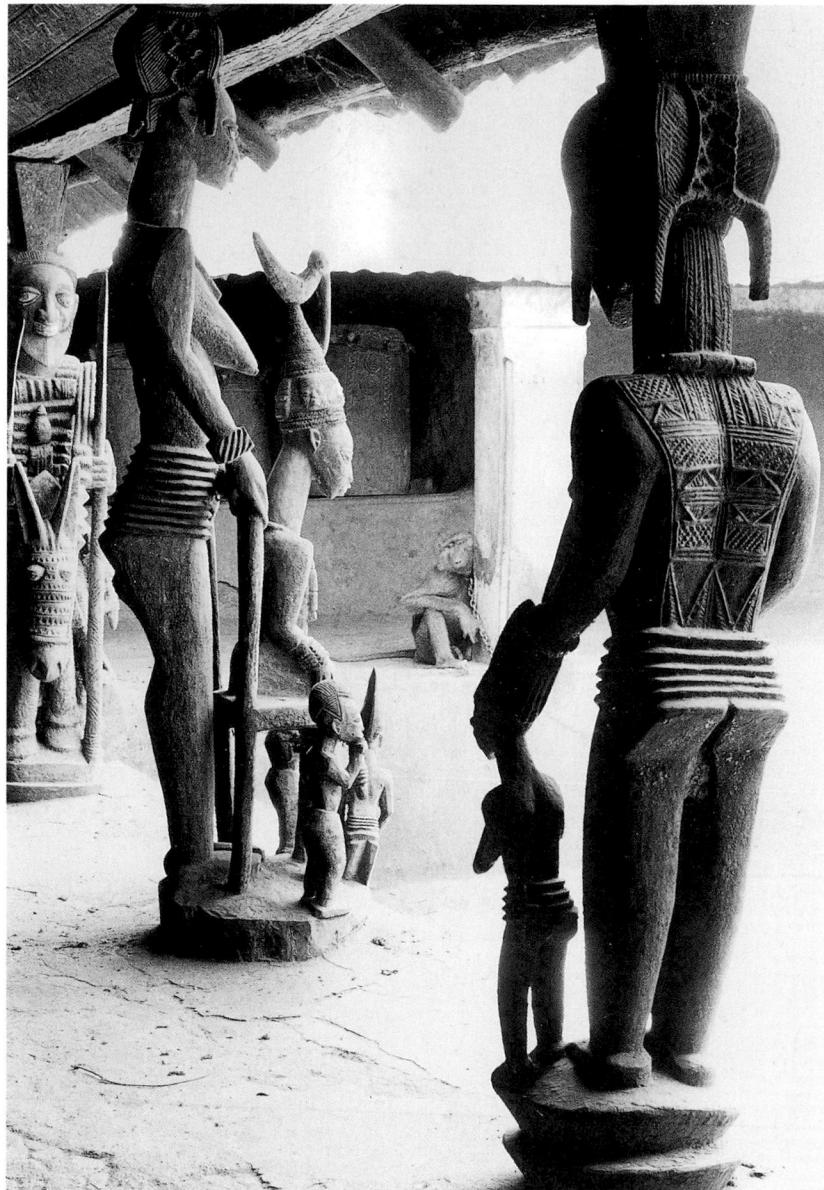

Fig. 6 Veranda posts carved c. 1915 by Oloue of Ise-Ekiti for the palace of the Ogoga of Ikere. The posts are now in the USA

from the Cameroon Grasslands; cat. 5.6). Figurative sculpture in the veranda posts of eastern Yoruba (Ekiti) kings (fig. 6) and other well-to-do men is essentially decorative, whereas central Yoruba shrine images mediate between deities and devotees who place sacrificial food upon their lips, and throughout most of the Yoruba-speaking region small figures are carved to replace twins that die in infancy.

Thus, there are images as real ancestors, mythic heroes, twins, advertisements and decorative embellishments, spirit familiars and spouses, vehicles of energy and points of mediation. Whatever the institutional and functional bases of these traditions, it is also possible that the images can serve as a stimulus for the articulation of other social concerns.

As to the makers of these images, though there are a few reports of women sculptors working in wood (for example, women carving Dan masks in Liberia), for the most part sculptors in wood are men, sometimes trained by a formal process of apprenticeship, sometimes self-taught. These contrast with metal-workers, on the one hand, for whom the complexities of the technical procedures demand professional specialisation; and potters, on the other, whose skills are passed on informally in the domestic space of women's activities. In a few areas, research has demonstrated the links between style and individual artistry: this is true of the identifiable master-sculptors of the Opin and Ekiti regions of the Yoruba-speaking area; and also of Dan sculptors in Liberia.

Sculpture in ivory is usually closely related to wood-carving, since the same craftsmen work in both materials, though ivory is a much more intractable medium. Indeed, the close-grained hardness of ivory makes for the execution of the finest detail, as evidenced in the first African art objects to reach Europe, the ivories carved in coastal Sierra Leone, Benin City and the Kingdom of Kongo sold in the early 16th century to Portuguese traders (cat. 5.132). Mende, Yoruba and Edo sculptors of the more recent past have continued to work in this medium. Stone is another related medium. It may be soft, as in the schist used especially in pre-16th-century Sierra Leone (cat. 5.133), and for the sculptures found at the Yoruba-speaking village of Esie (cat. 5.71–2); or hard, as in the sculptures of Ife, or in the most extensive grouping of sculptures in stone, the ancestral and chiefly commemorative sculptures in the forests of the middle Cross River in south-east Nigeria.

The earliest evidence of textile manufacture is provided in the 9th century at Igbo-Ukwu where small fragments of unpatterned bast-fibre cloth were excavated, preserved by their close contact with copper in an archaeological site. The assumption is that they were woven on an upright single-heddle loom of the kind that continues to be used by women in Nigeria. Elsewhere, textile fragments in cotton, and wool, using indigo dye, have been found at 11th/12th-century funerary sites in the Tellem caves in Mali. The relatively narrow web suggests that they were probably woven on a horizontal double-heddle loom as used mostly, though no longer exclusively, by male weavers throughout west Africa.

Cotton, wool, wild silk, raffia and bast are all indigenous to particular regions of west Africa, with cotton by far the most widely used. Local dye colours were available from vegetables, and, occasionally, minerals, with indigo, of which there are several plant species, pre-eminent. However, developments in pattern and design in west Africa have been substantially enhanced from at least the early 18th century onwards by the availability of imported ready-dyed silk and cotton yarns, and, later, rayon, viscose and lurex, to provide colours and textures not available within the range of local dyes. In some areas hand-spun, locally dyed cloths continue to be woven alongside factory-spun or dyed yarns; elsewhere the latter have supplanted the former. Nevertheless, the beauties of Asante (cat. 5.93) and Ewe (cat. 5.92) textiles in 19th- and 20th-century Ghana would not have been possible without novel yarns and colours, the use of which was enhanced by the innovative use of two pairs of heddles. Very different developments occurred along the coastal region from Guinea Bissau to Senegal, in and around the inland Niger Delta, and in the Yoruba-speaking region of Nigeria, but all to a greater or lesser degree contingent upon distinctive usages of imported yarns and colours within local traditions of weave structure and design.

Architecture, the other dominant feature of the west African visual environment, cannot be transferred to a gallery. Earthen buildings are particularly well adapted to the west African climate (in a way that cement, its usual ‘modern’ replacement, is not: with its lack of heat resistance, cement is the most unsuitable building material for the tropics). The forms were generally modular, composed and built up of small units, rectangular in the forests and circular in the savanna. With the appearance of Islam monumental rectangular forms, whether designed as palaces or mosques, dominate the urban savanna. Buildings provide scope for mural decoration whether moulded, impressed or excised in high or low relief, or painted, formerly applied in water-based earth colours but now in industrially manufactured paint. This is an art that is largely passed over for reasons of its uncollectability, yet mural painting by Yoruba women in shrines and palaces exhibits a diversity that is the equal of other Yoruba visual art forms, but it is essentially ephemeral given the use of water-based colours. In many areas, north-east Ghana for example, buildings, mural painting (again by women) and textile design are the dominant features of the visual environment.

Masquerade brings together performance, textiles and other fabrics, wood sculpture and assemblage.

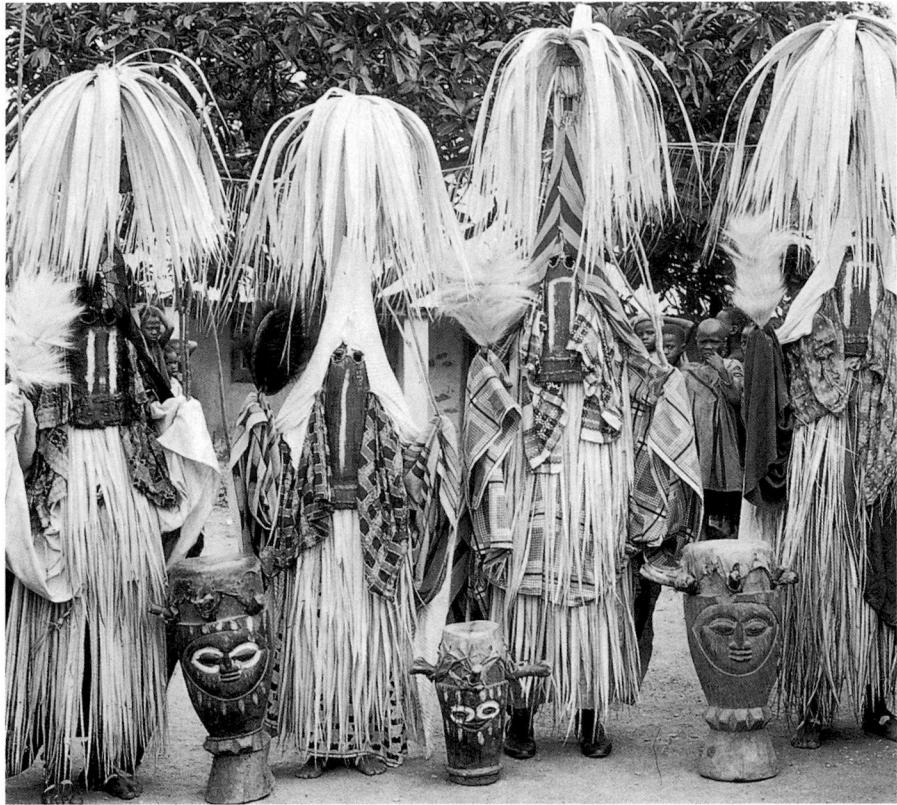

Yet perhaps more than any other medium it is difficult to encapsulate within a European museum: buildings can at least be photographed and drawn. One can admire the disembodied pieces, and some masks are complete in themselves as sculptures and as presumed vehicles of energy; yet the empty costume is just that. In masquerade it is the event, the performance that is paramount. Wooden masks are well known and frequently collected but there is a greater variety of masks made of insubstantial and often ephemeral materials that make little sense disembodied in a glass case (fig. 7). Moreover, masking is by no means a unified phenomenon, and the status of a mask within its local context must be taken into account.

In all performance traditions, masks are used for their strategic value in creating social distance, thereby enhancing dramatic impact within small-scale communities where everyone knows everyone else. Sometimes, however, the mask can become the literal embodiment of a metaphysical presence and energy; the performer is the mere animator of its progress within a community. Clearly, the issue of secrecy in regard to the identity of the performer is irrelevant in these examples; and even when there is talk of secrecy, this may simply be part of a distancing strategy without entailing any substantial ritual penalty for its breach. Secrecy is, in contrast, paramount in those masked institutions in which masks in effect deny human agency, when the 'official' story is that the mask hides a presence, wild or ancestral, that is too dangerous to see. In other words, the mask protects those outside from what is within; but the converse is also possible, for example south-western Yoruba *efe-gelede* masks which, far from denying the agency of the performer or embodying a metaphysical presence, protect the wearers from the gaze of the witches for whose entertainment they perform.

As to the overt social purposes served by masquerade, while there may be some dominant theme (e.g. entertaining, healing, judging, legitimising, executing, purging a community from thieves, initiating into adult status, reconciling people to the loss of an elder, and so forth), it is important to recognise the wide range of subsidiary social concerns also addressed through masked performances. The location of authority is a case in point; and so too is gender, for women do not participate in masked performance

Fig. 7 Masks of bark, palm fronds and cloth, worn at the festival of Ogun, god of iron, Ijero district, Ekiti-Yoruba, Nigeria

(other than in the mythic past in many traditions, and in the Sande women's initiation organisation of Mende (cat. 5.136), Gola and other peoples of Sierra Leone and Liberia). Masquerades in some shape or form are almost ubiquitous throughout west Africa: the Asante confederacy is the one most obvious exception. Even in regions dominated by Islam masked performers entertain during the night feasts of Ramadan.

This account, essentially concerned with the status of works of art as contexts (the 'weaving together' of ideas-and-practices), reveals little or nothing of the relationship between aesthetic and social categories, let alone its development within the life histories of communities. This remains perhaps the most tantalising problem in west African art history, and it is to this that the discussion must now turn.

Categories and identities

It has been traditional in the Eurocentric documentation of the visual arts of west Africa to divide the region into the 'Western Sudan' and the 'Guinea Coast', a division that approximately conforms to the climatic/vegetational zones, and to place 'tribal' categories of style in one zone or the other; and occasionally authors shift works from one tribe to another, and tribes from one zone to another. This kind of listing of things according to possibly arbitrary and certainly externally-derived categories has fulfilled some useful purpose, but now the discussion must be moved on to take account of local histories and sensibilities.

Forms and styles vary from place to place, and it matters that we can locate them as originating in one place or another. On the other hand, a categorisation of this variability according to 'tribe' is at best oversimplistic, first, because the notion of 'tribe' is substantially a colonial fiction, and second, because the placing of differences in form and style is very much more complex than 'tribal' classification will allow. Of course individuals and communities manifest a sense of identity with others in groupings that may vary from a few hundred, as in the Akoko-Edo region north of the Benin kingdom, to fifteen or twenty million, as with the Yoruba-speaking peoples. Senses of identity and difference may be located variously in language, traditions of mythic origin, political affiliation, kinship, trading relationships, occupation, common inhabitance of an area of land; and the boundaries of that identity and difference may or may not be the same for each of these factors, thus imparting to that identity a potentially complex and multi-dimensional character (that must now also take into account the realities of national identities). Modern senses of ethnic identity have often come into existence in the contesting of colonial rule, and it is the exception rather than the norm to find isolated (whether socially or geographically) communities that fit within the idea of 'tribe'. The real work now, therefore, is to understand the processes of negotiating identity from within communities and the place of works of art therein. Differences of form and style can signify social categories: lineage, elder/junior, male/female, the cult of a deity, masking association, region (within the same language area), non-smiths/smiths, high or low rank media, artist, city/countryside, pastoral/sedentary, and so on, perhaps even signifying the differences between speakers of different languages; this work has hardly begun.

As with form so, in a sense, with vegetation, which, as one proceeds northwards from the Atlantic coast, changes from mangrove swamp to forest to open woodland to grassland to steppe to desert (except in the coastal region from Accra to Porto Novo where there is a break in the forest, and the savanna meets the Atlantic). Yet a 'Guinea Coast/Western Sudan' categorisation is, once again, an over-simplification, partly because of the different qualities of savanna, partly because persistent swidden farming has had the effect of turning forest into savanna, and partly because over several thousand years there have been environmental changes with successive wet and dry phases that have defined west Africa.

It will be obvious that whatever the organisational convenience of considering west African art according to climatic and vegetational zones, the fact is that we are not thereby dealing with aesthetic categories manifest in material itself; and it would be absurd to impose an environmental determinism on art. The tempting supposition that schematisation is characteristic of the savanna-sahel and naturalism of the forests is difficult to maintain when faced with the material itself. Quite apart from our complete lack of knowledge of local perceptions and the fact that what we contrast as naturalistic and as schematic pertains only to sculpture, naturalism and schematisation are each found throughout west Africa, as the material in this exhibition makes clear. Not only do 'Guinea Coast' and 'Western Sudan' not exist as discrete vegetational zones, neither are they coherent entities in historical, sociological or aesthetic terms.

Indeed, the key to any understanding of west Africa (whether art-historical or otherwise) lies precisely in the interaction of people, communities and forms across vegetational zones, language groupings, pre- and post-colonial states, masking and cult associations, and so forth. The facts of trading networks, among other kinds of relationship, whether local or longer-distance, east to west, north to south, along the Niger and Benue, among other rivers, or wherever (but ultimately mediating relationships between the different regions of west Africa, including the fact that links between different forest regions were invariably mediated via the savanna prior to the advent of European coastal trade), taken together with the continuities and disjunctions discussed in regard to Nok, Ife, Yoruba, Nupe, Igbo etc., all serve to set aside any residual usefulness of vegetational/climatic classifications of west African art. Long-distance trade routes, languages and technologies each provide a kind of structure and system to west Africa, and as such ultimately link the Sahara and beyond to the coast; but the mapping of these structures and systems will not bring them to coincide either with each other or with climate and vegetation.

Tradition and the 20th century

Art in west Africa did not somehow come to an end in the 20th century, and, whatever the form or medium of present-day art, the sense of tradition is as important as ever, enabling post-independence artists to work productively within a contemporary sense of national identity. In any case, popular misconceptions aside, west Africa was never the locus of static tradition, in which nothing changed until the local wars and European colonisations, and their attendant developments, in the 19th and 20th centuries. Although these developments are beyond the scope of this exhibition they merit attention if only to correct yet another absurdly simplistic division of west African art into the 'traditional' and the 'modern', or even worse, the 'contemporary'. The realities of material and social change cannot, of course, be denied; yet the persistence of many traditions inherited from the past alongside novel developments now institutionalised within the modern nation-states of west Africa is familiar.

The concept of tradition as such is not the problem, for without a handing on there is neither art nor society: rather it is through the external imposition of the category 'traditional' that problems arise. We no longer talk about 'primitive art', but, as we have noted, its auction-house substitute, 'tribal' art, is almost as problematic though for different reasons; and so 'traditional' art comes into being as the latest sanitised replacement. Yet, when, as is indeed the case, masked performers and art-school-trained painters inhabit the same city and period, what is the value of a categorisation that seeks to separate the 'traditional' from the 'contemporary'? In reality it prevents any understanding of a local sense of tradition, while defining as 'traditional' a bogus sense of authenticity located essentially in the past, as if Africa had no proper place in the century the rest of the world inhabits.

In any case, with certain obvious exceptions, the greater number of works in most museum collections, as in this exhibition, unless they are the products of excavation, are likely to have been made no earlier than the mid-19th century, and often much later, i.e. within the period of colonial rule. In the contemporary juxtaposition of forms inherited from the past and new developments in the present we find the formation of 20th-century ethnic identities. The development of school and university education, literacy, mission Christianity, the rise of a purified Islam, the new technologies and novel political institutions: each has had its effect with the demise of some traditions, the continuity of others and the inception of yet others. Moreover, the work of challenging colonial rule fell largely to a Muslim and Christian intelligentsia and this too had its art forms. Colonial rule was challenged in the writing of grammar books and histories by that local intelligentsia, and in the painting of pictures that even the most philistine colonial governor could recognise as art; and it was also challenged from within the traditions surviving from the past in images of ridicule and subversion. In the first decade of this century, the Nigerian painter Aina Onabolu (1882–1963) taught himself European-style painting and began his campaign for the establishment of art education within the colonial school system, though it was not until 1927 that a teacher was appointed, and even then it was a European (Kenneth Murray, later to found what is now the National Commission for Museums and Monuments in Nigeria). By the 1960s, when the countries of west Africa gained their independence, a survey of the visual arts would have included fine art and design departments at universities, self-taught sign painters, masked performers, potters, weavers, dyers, and sculptors in various media. In Nigeria there was a reaction against the kind of genre subject-matter encouraged in the art colleges at that time, in favour of a return to the traditions inherited from the past as a legacy of forms with which to represent a variety of identities, all Nigerian. In due course these developments would lead to the formation of artistic ‘schools’ based upon local design forms, the diversity nevertheless continuing to celebrate a Nigerian identity. The particular ritual and decorative needs of Christianity and Islam have also proved significant as sources of subject-matter and patronage. In the 1960s, too, ‘summer schools’ were started at which anyone with or without formal education could practise art. The best-known of these continues at Oshogbo in Nigeria. In general the various lines of development established in the contesting of colonial rule have continued to flourish and develop in the post-independence period, with enhanced state patronage, and the inception of national and private collections and galleries.

The point with which to conclude this essay, therefore, is not reiteration of slipshod notions of the demise of an ‘authentic’ African art, but rather emphasis on the vigour and variety of contemporary practice. Let us also remember how we persistently impose alien categories on the art and artists of west Africa: this tribe/that tribe, forest/savanna, art/craft, traditional/contemporary, and so on. Instead, let us attend to the manner in which individuals and communities place themselves in relation to the works of art of their choice. Let us listen to local artists, critics and patrons while there is still time (their patience cannot be taken for granted forever). Then we might learn to sense a little more than we do now of local perceptions of form, tradition and history; surely this is worth doing.

Bibliographical note

- Willett, 1967; Ryder, 1969; Williams, 1974; Cole and Ross, 1977; Garlake, 1978; Shaw, 1978; Barley, 1984; Herbert, 1984; Vansina, 1984; Craddock and Picton, 1986; Picton and Mack, 1989; Picton, 1992; Dmochowski, 1990; Shaw et al., 1993; Picton, 1994^a; Picton, 1994^b; Picton 1994^c; Willett, 1994

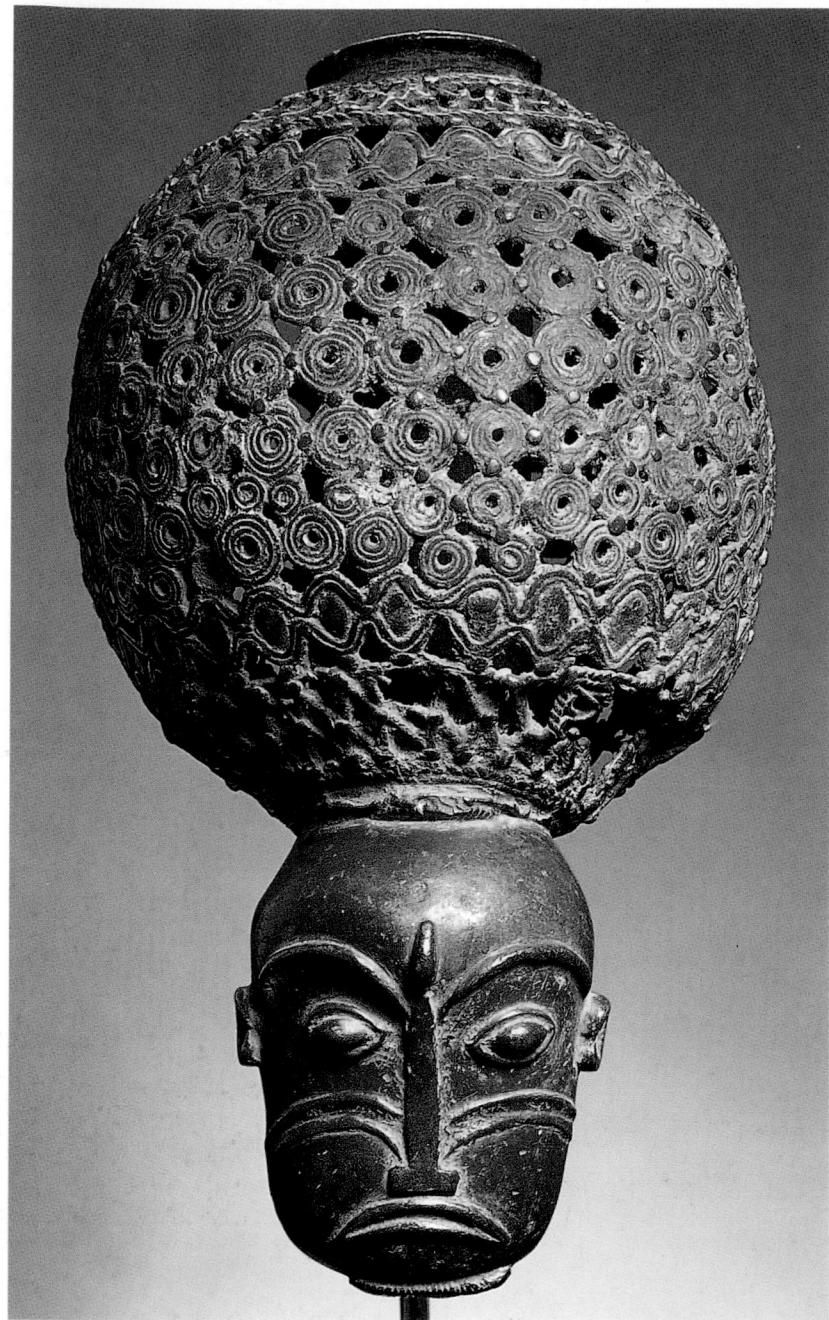

5.1

Pipe bowl

Western Cameroon
19th–20th century
bronze

38 x 19 x 21 cm
Afrika Museum, Berg-en-Dal,
The Netherlands, 564.1

In overall form this item has the appearance of a ceremonial tobacco-smoking pipe bowl from the Cameroon Grasslands, but the style of the face is not of this area. Copper-alloy objects were used as regalia of office, and were traded in restricted quantity from the markets of Bali, Bafoussan and Bamum. The technique of lost-wax casting is believed to have

originated among the Tikar of the Upper Mbam Valley, east of the Grasslands. In fact the Tikar, who do little, if any, casting today, believe themselves to be ancestors of the Bamum and certain other peoples of the Bamenda Highlands, whose metal crafts are well known.

Among many of the small kingdoms of the Cameroon Grasslands, including the Bamum, masks of carved wood or cast brass and ceremonial pipes of brass or pottery are often shown with large circular or hemispherical superstructures representing the crown of the Fon. This form of helmet mask, used in the Nia Festival, is shown in a photo-

graph taken at Foumban, the capital of Bamum, by Oldenburg in 1912–13. An illustration of an early Bamum king at Foumban wearing a large circular headdress has been published. Such masks with depictions of royal headgear, decorated with special materials such as beads, cowrie shells, sheet brass and bells, were worn widely by retainers at palace festivals.

The piece shown here is of uncertain origin. It does not have the broad nose, bulging cheeks, open mouth and apparently smiling or laughing countenance which is associated with the large, elaborate prestige headgear or coiffure characteristic of so much Bamum mask and pipe sculpture. Its face bears little stylistic relationship to the Bamum as it has a down-curving mouth (the arch of which is echoed by that of the eyebrows and cicatrization marks on the cheeks) and a sharply angled nose resembling an inverted 'T'; the central forehead bears the representation of a keloid; and the ears do not project prominently. It is none the less a remarkable piece, not least because of the very large filigree superstructure, decorated with coil, stud and undulating line motifs. At top and bottom of the superstructure the filigree pattern resembles the abstracted spider motif, a dominant element in Grasslands iconography. KN

Bibliography: Schädler, 1973, p. 295; Joseph, 1974, pp. 46–52; Lamb and Lamb, 1981; Northern, 1984

5.2

Cup

Duala

Cameroon

ivory, horn

105 x 69 x 54 cm

By courtesy of the Board of Trustees of the Science Museum, London, A 641447

The style of this piece is highly unusual within the corpus of African ivory carving. The cup, with its sensitive curves, nestles in a series of slim buttresses that converge in a stubby handle, raising the suspicion of its having been cut down. Inevitably, the basic shape recalls the art form for which the Duala are best known, the elaborately carved canoe prows, *tange*, that they produce to this day.

The cup is said to have belonged to 'the King of the Dualas' and to have been used for taking 'medicine'. Given the ambiguity of this term in pidgin, its uses can only be guessed at, while Duala kingship was long divided between warring factions and so offers little hope of pinning down the cup's source.

In modern Cameroon the Duala people live mostly in and around the principal port of Douala, and until recently have been unjustly neglected by art historians as 'corrupted' by Western contact. Douala is documented as a source of raw ivory from the 18th century onwards, but very little is known of ivories working by them. NB

Bibliography: Wilcox, 1992, p. 263, no. 9

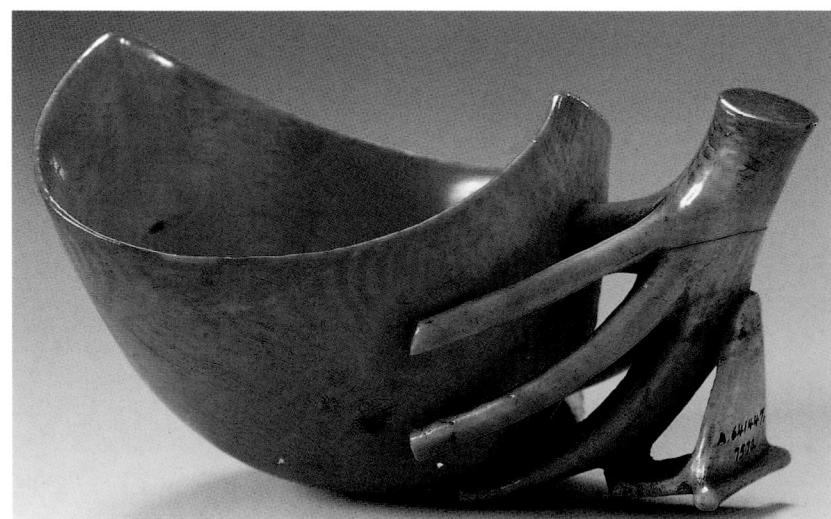

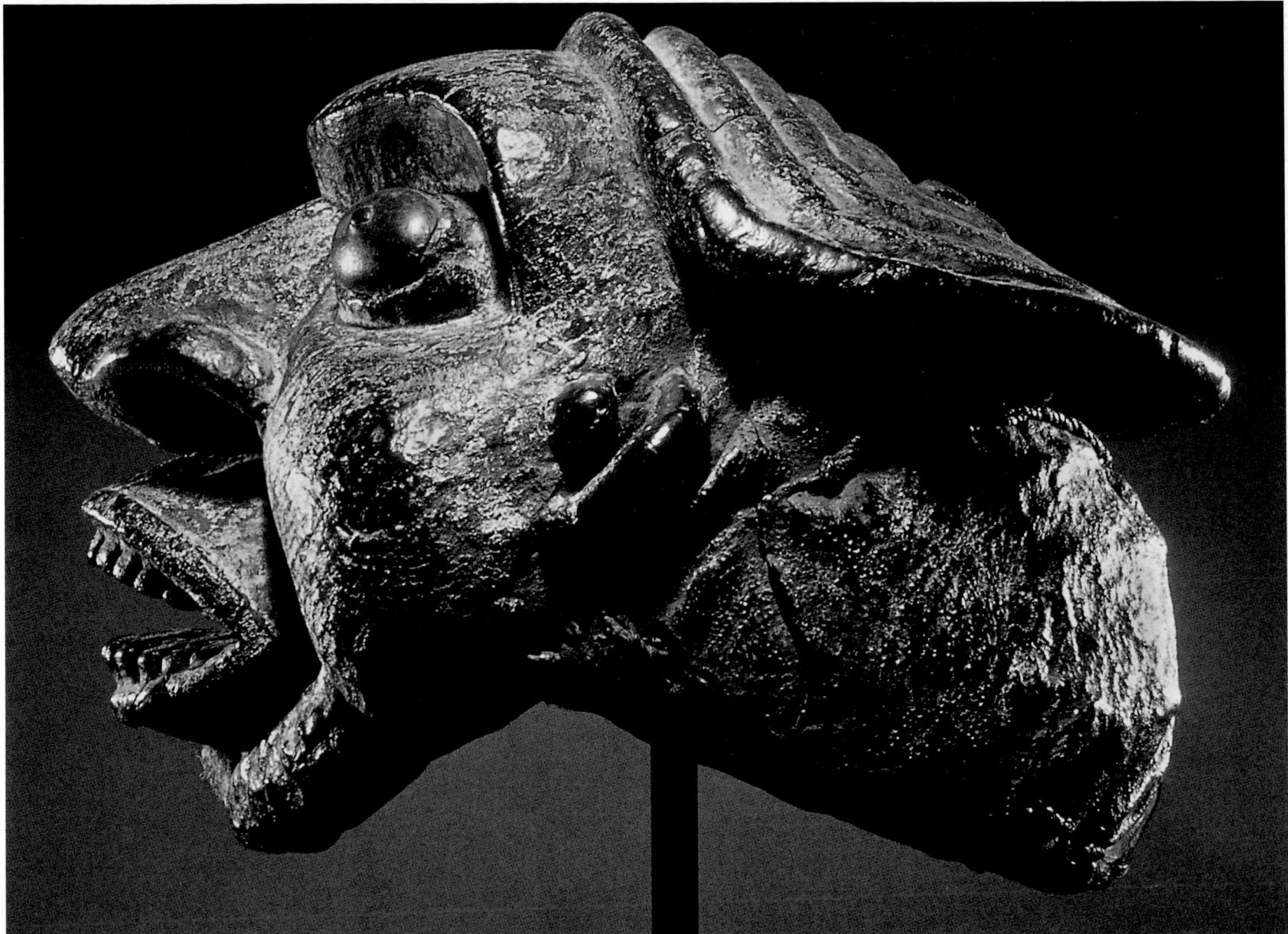

5.3

Anthropomorphic mask

Wum

North-western Province, Cameroon
wood

24 x 21 x 33 cm

Charles and Kent Davis

The Bamum and Bamileke cultures of the central Grassland region have been studied in considerable detail; the densely populated region of north-western Cameroon, however, with its high plateaux and luxuriantly wooded extinct volcanoes, also has a rich artistic heritage, divided by scholars into five stylistic sub-groups. This mask is a fine example of the stylistic area between Wum and Fungom in the west.

In the Wum villages there are a large number of masks known as *juju*, which are brought out for the successive festivals, to celebrate the sorghum harvest in the dry season, or the great *ibinilumé* festival in December, or for the funerals of important people. This helmet mask carved from very hard wood is typical of the Wum style with

its compact, geometrical shape, its wide open mouth, and its dilated nostrils and bulging eyes, the latter devoid of all expression. EF

5.4

Standing male figure

Kundu

Western Cameroon

late 19th–early 20th century

wood, pigment

h. 190 cm

Staatliche Museen zu Berlin, Preussischer Kulturbesitz, Museum für Völkerkunde, III C 10026

This piece is said to be from the Kundu of south-west Cameroon, whose art is little known. A fairly naturalistic face is contained at the centre of a diamond-shaped frame, and at the back of the head is a large rectangular structure with rounded corners. The right hand is raised as if to point a projectile such as a spear, or possibly a staff. The body is naked; light and dark pigment divide the frontal view of the trunk vertically.

The flat structure at the rear of the head is reminiscent of the stylised European sea captain's hat of the days of sail on the Guinea Coast, which is worn by masked performers of the Cross River leopard spirit cult, Ekpe. This cult is diffused widely in eastern Nigeria and western Cameroon and lodges are found throughout forest and savanna zones. Such a 'hat', however, would normally be worn with a netted string or cloth costume covering the entire body, including face, which is clearly not the case here.

Although most settlements in the Rumpi Hills of south-west Cameroon forestland possess lodges for the Ngbe (leopard spirit society; cf. cat. 5.35), there are remnants of all-male regulatory societies which existed before the adoption of Ngbe. One such institution is the Kundu Musongo society, which employed small wooden carvings in the administering of oaths to establish a person's guilt or innocence. Larger figures, of which the present piece appears to be an example, were used to enforce dispute settlements within the community, and on ceremonial occasions carried on member's backs in dance and procession. KN

Bibliography: Northern, 1984, pp. 186–7; Nicklin, 1991², pp. 3–18

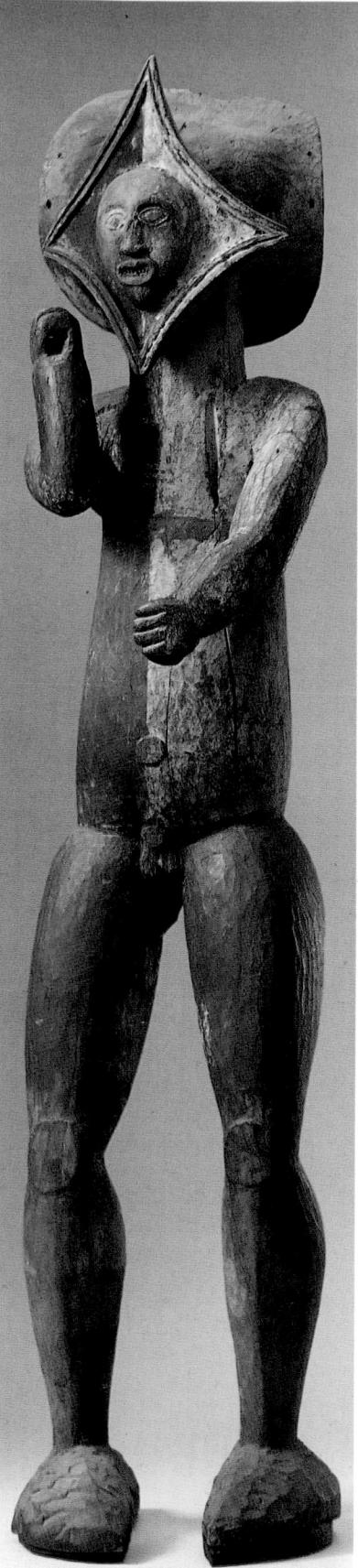

5.5

Mask

Keaka

Cameroon

wood

h. 125.7 cm

Private Collection

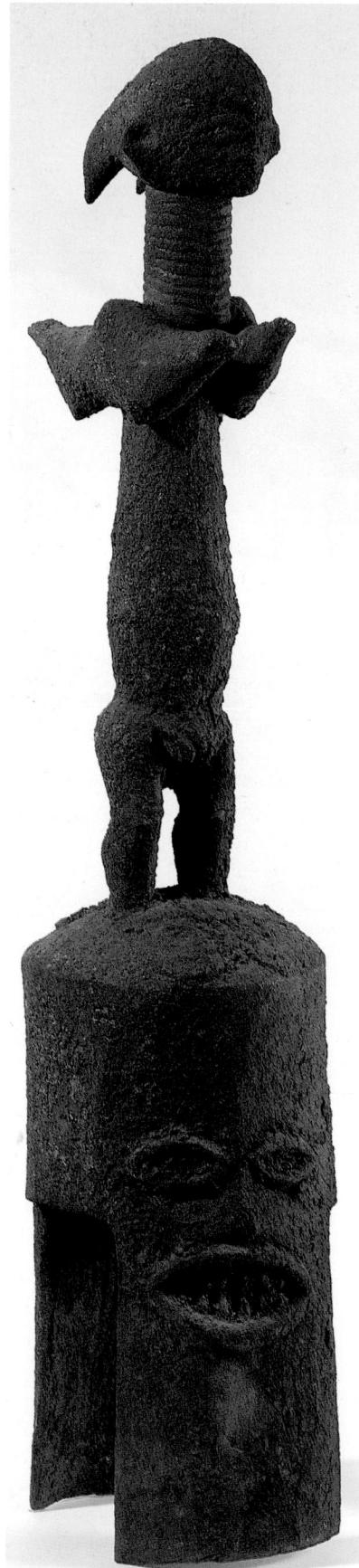

Like their neighbours the Anyang and the Banyangi, on the border between Nigeria and Cameroon, the Keaka are related to the Ejagham (also called the Ekoï), who are renowned for their wooden masks covered in antelope hide. The Keaka have developed a rustic kind of sculpture which, stylistically, marks the transition between Igbo sculpture and the art of the Grasslands. For initiation rites and funerals they produce masks (to date little studied and badly represented in public collections) of the type of the rare example shown here. This consists of a helmet representing a human face with an open mouth and almond eyes, surmounted by a female statuette with rings round its neck and, here, broken arms. EF

Male figure

Bamileke
Cameroon
wood
h. 125 cm
Staatliche Museen zu Berlin, Preussischer
Kulturbesitz, Museum für Völkerkunde,
III C 21121

The most striking feature of this large wooden seated figure is the swollen belly that contrasts with the stick-like arms and the rudimentary feet, possibly fastened to the earth. In a smaller figure from the Cameroon Grasslands, this would indicate that it was involved in the (causing and) curing of diseases of the belly.

Figures of this style and size are usually identified as commemorative figures, representing a local ruler and commissioned at the time of his enthronement (cf. cat. 5.14). The present piece would seem to come from one of the southern kingdoms. Thereafter, the figures may enter into all manner of ceremonial and cult activities that vary widely from one fonship to another. Similar large female figures exist and it seems that male and female are to be viewed as pairs, but female statues are more variable in their attribution. They are often depicted as pregnant.

While male commemorative figures are usually carved with swollen bellies, the extent of distension in the present case is unusual. There seems no need to see this as an implied hermaphroditism, however, but more as regal embonpoint with a metaphysical dimension. *NB*

Bibliography: Harter, 1986, p. 54

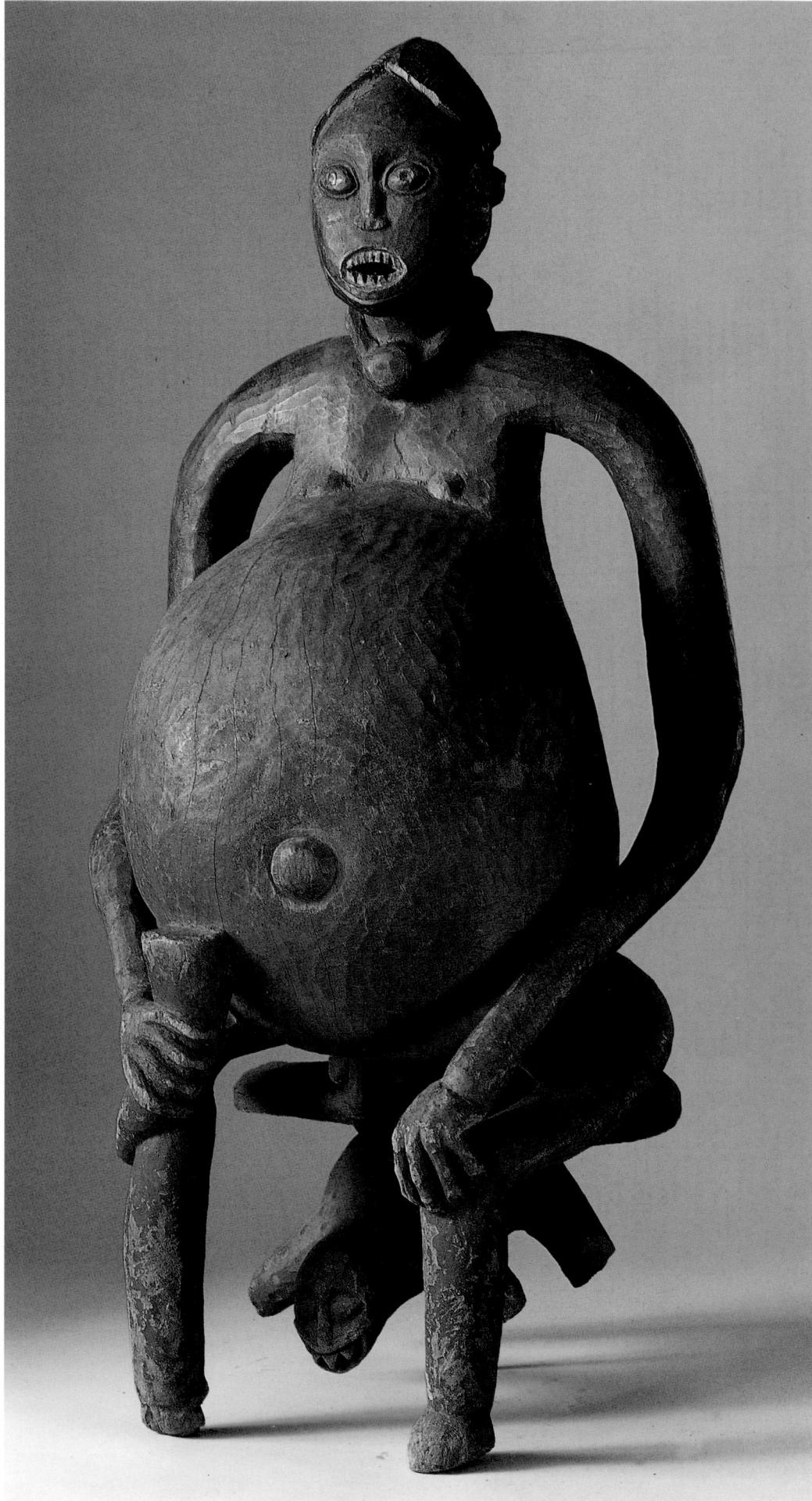

5.7

Royal throne with caryatid

Bamileke, Chiefdom of Banka
Bafang region, Cameroon

wood
h. 51 cm

Staatliche Museen zu Berlin, Preussischer Kulturbesitz, Museum für Völkerkunde, III C 22793

This throne was collected in the early 20th century by a German officer in Banka, a small kingdom founded in the 17th century south of the Bamileke plateau, in the Bafang region. The back of the throne, carved from a single piece of wood, represents a seated king with his genitals conspicuously on view, his hands on his knees and a royal diadem, richly embroidered or beaded, on his head. The panel surrounding him is decorated with a motif that recurs frequently in the arts of the Grasslands area – the so-called ‘chicken’s intestine’ motif – and rests on a caryatid representing either a panther, symbol of royalty (here with a human face) or a vanquished chief wearing heavy bracelets round his wrists, or alternatively a synthesis of these two allegories. A relief pattern of diamonds suggests the markings of a panther skin. This type of throne can be found all over the Bamileke country and is an important element of royal furnishing, often more ceremonial than functional. The caryatid represents power with various symbols (panther, serpent, elephant), while the back usually commemorates a deceased prince. Some thrones, variously painted or covered with glass paste beads, are up to two metres high (as at Bandjoun). The treatment of this powerful piece is reminiscent of the style of Batié, a big centre for Bamileke sculpture a little further to the north. EF

Provenance: 1909, collected by Gnügge in Banka

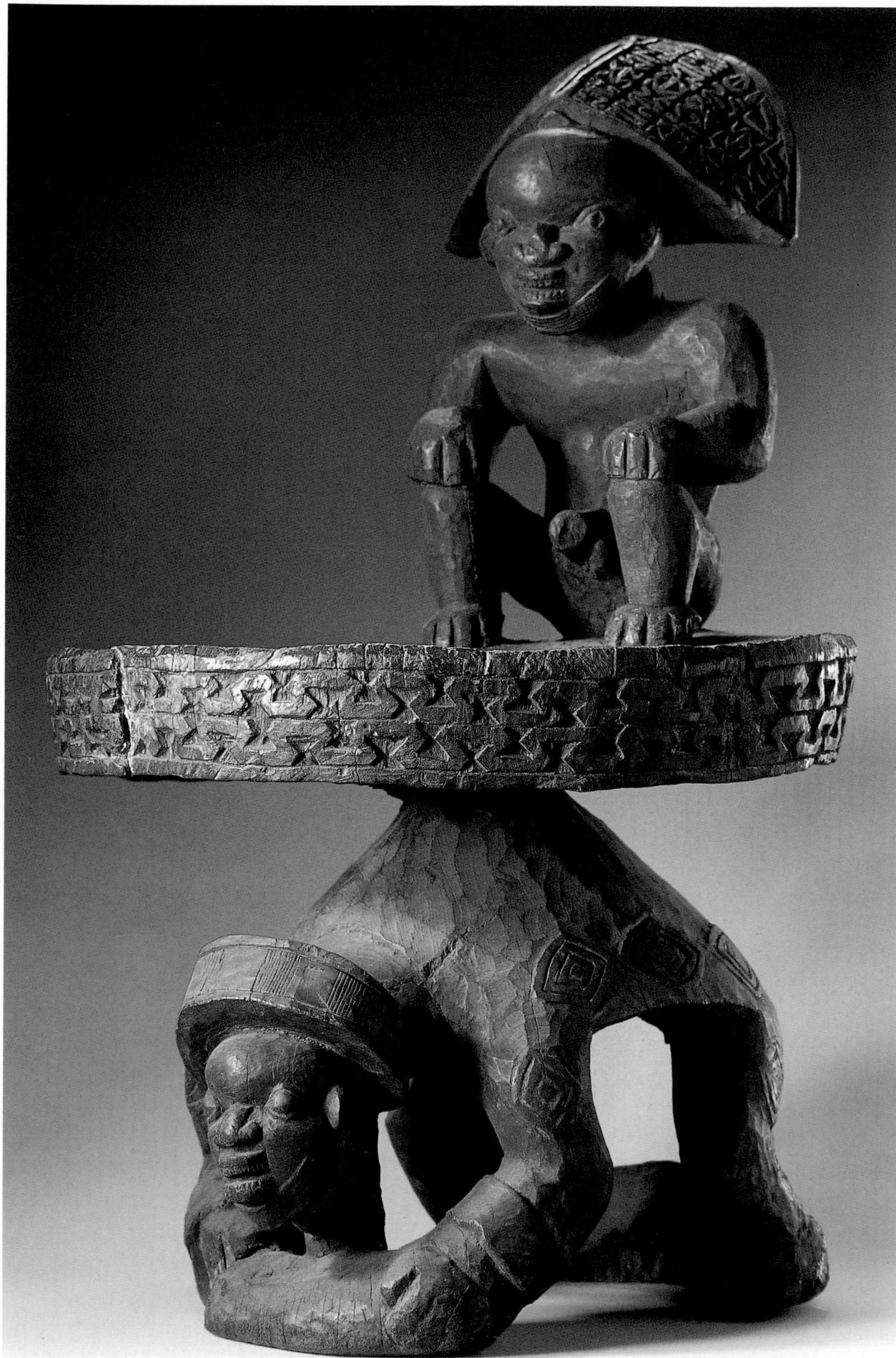

Royal mask representing an elephant

Bamileke, Chiefdom of Bafu-Fondong
Western Province, Cameroon
last quarter of 19th century
wood

46.5 x 58 x 90 cm
Musée National des Arts d'Afrique et d'Océanie, Paris, AP 92-50

The elephant (known to the Bamileke as *so*), with the panther, is the symbol of royal power and is an important element of the arts of the Grasslands, particularly in the north and west of the Bamileke plateau: it appears on masks, drums, stools, seats, pipes and staffs. Masks, which can be made either of wood or of beaded fabric, appear at important royal ceremonials, at the funerals of kings, queens and dignitaries and at the harvest or spring festivals. They are used during a very dramatic dance, the *nso* or *nzen*, an elephant dance executed within the royal enclosure (the *tsa*) by princes and the nobility of the chiefdom who are members of powerful secret societies such as the Kwosi, the Kemjyeh or the Manjong.

This massive head is a stylised version of an elephant with its broad, round ears, slanting eyes, short trunk and elegantly curved tusks. It comes from the chiefdom of Bafu-Fondong, near Dschang to the west of the Bamileke plateau. For years Bafu-Fondong was in thrall to the neighbouring chiefdom of Baleveng; it won its independence in the 18th century with an uprising led by Prince Ndaptchu. Tradition holds this to have been carved in the last quarter of the 19th century, during the reign of Fon Kana I. EF

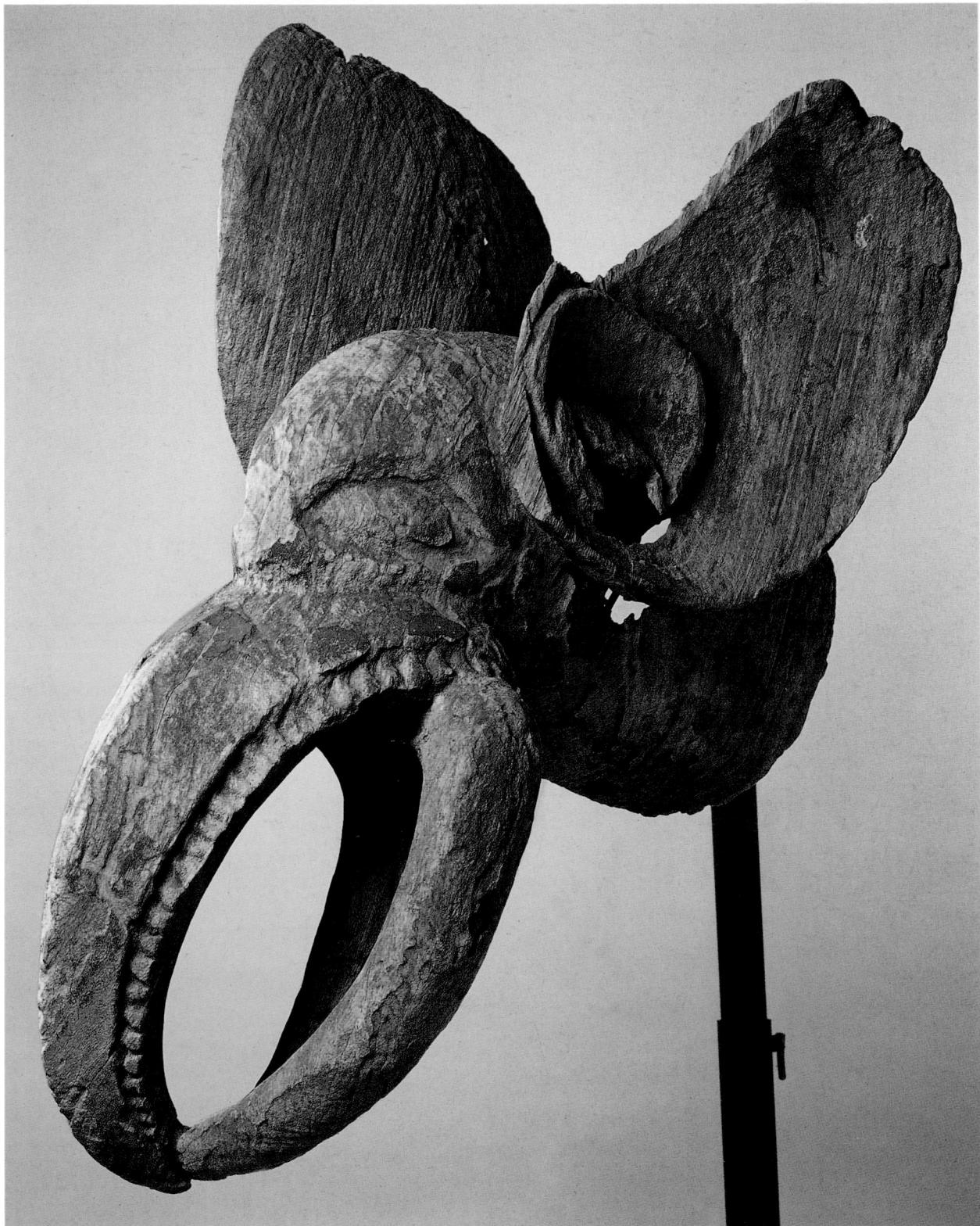

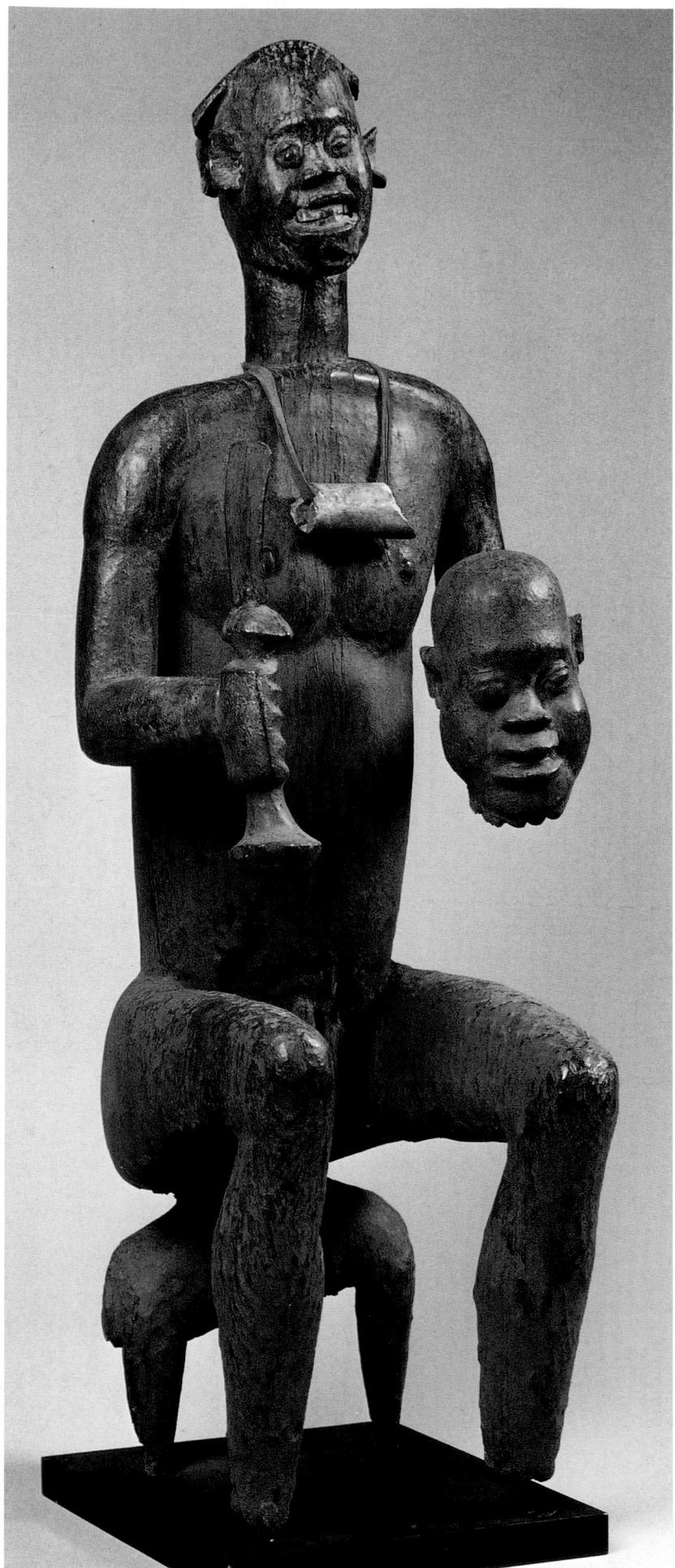

5.9

Bafum king returning from victory

Bafum area (Bafum-Katse kingdom, Ide/Esu)

Cameroon

early 19th century (?)

wood, hair, ivory, bone, bead, cloth

113 x 31.7 x 45.7 cm

The Walt Disney-Tishman African Art Collection, Los Angeles, 1984.AE051.110a,b

Few narrative sculptures in the art of west Africa need as little working out as this triumphant figure of a king of the old Bafum-Katse chiefdom. He has returned from battle and his upheld sword plus the severed head of an important (judging from its relative and significant size) enemy tell their tale of victory as does the expression of proud glee on his face. He sits on an animal that may be a leopard (its fragmentary state allows us only to guess) and wears round his neck a large Venetian bead of a chevron type (that is still sought after for prestige necklaces and is already much faked for market traders all over sub-Saharan Africa).

Human hair still clings to his chin and the whole effect of his expression is heightened by the band of implanted teeth engraved in ivory. Hyper-realistic touches such as this, plus the incontestable quality of the carving, have led the piece to be associated with an almost legendary artist of the beginning of the 19th century, one of the anonymous but famous masters that intrigue and frustrate the students of African art history. *TP*

Provenance: ex Tishman Collection

Bibliography: Hasterin, 1981

5.10

Basketry bowl

Oku

Cameroon Grasslands

20th century

plant fibre, pigment

h. c. 12 cm

Staatliche Museen zu Berlin, Preussischer Kulturbesitz, Museum für Völkerkunde, III C 24980

In West Cameroon, especially in the Grasslands region, a wide variety of basketry products is made for utilitarian and ceremonial purposes, especially for use as containers.

The upper part of the present specimen is constructed from coiled basketry. In some localities the coils are so tightly wrapped and stitched that the basket can be used to hold liquids, notably palm wine. In this case the ascending coil which forms the bowl is decorated with oversewn needlework, and the tall pedestal is faced with alternate bands of light and dark coloured cordage.

This basket is from the Oku of the north-western Grasslands, whose neighbours to the south-west are the Babungo, and to the south-east the Bansom. It was probably used for food storage. The social structure of the Cameroon Grasslands is hierarchical. Had such a pedestal basket been intended for palace use, it would have been adorned with cowrie shells or beads. Pedestal baskets were often equipped with a lid that could be secured with a string. *KN*

Bibliography: Gebauer, 1979; Northern, 1984

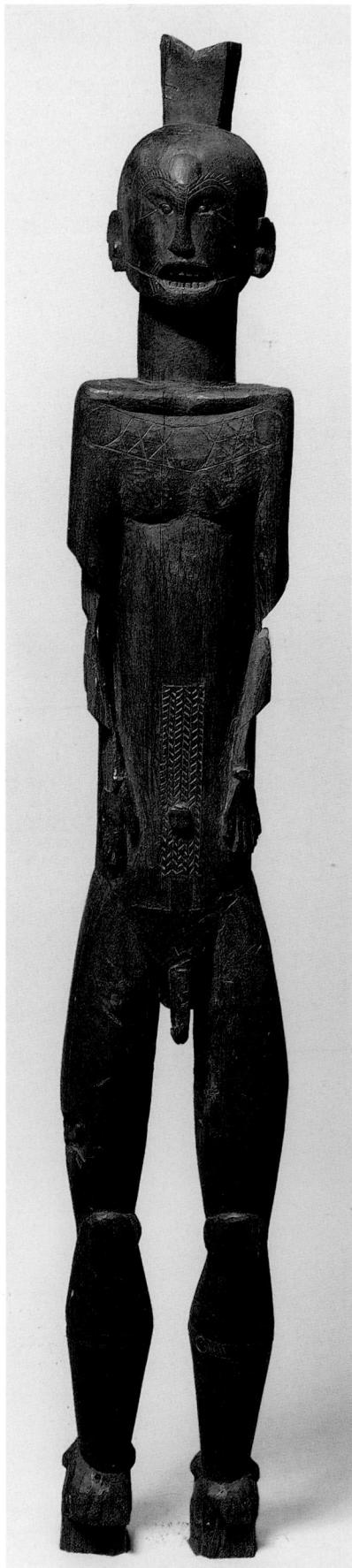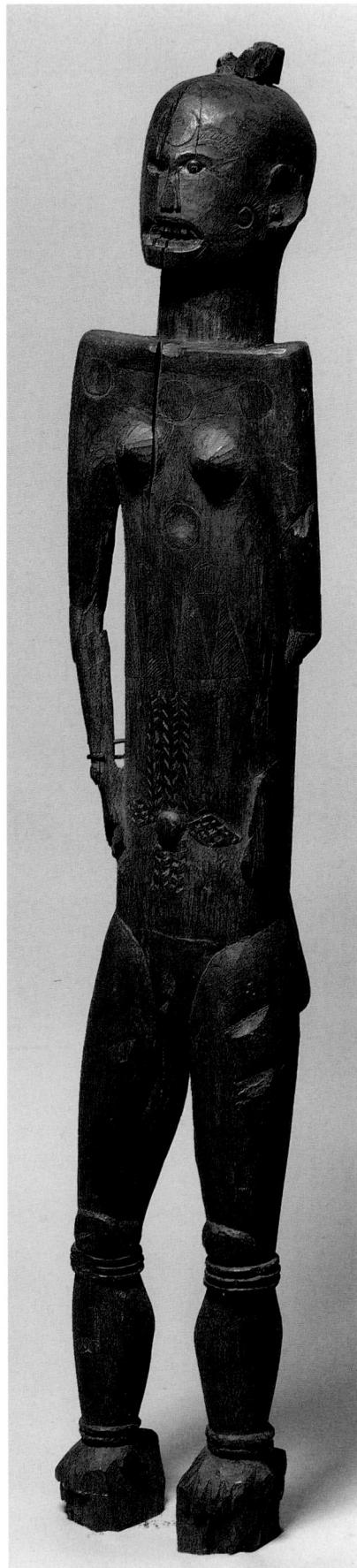

5.11a–b

Pair of figures

Koko
Cameroon
wood (with glass beads)

161 cm, 130.5 cm
Staatliches Museum für Völkerkunde,
Munich, 95.6/7

This remarkable pair of figures has been in Europe for over a century. Later sculpture from the Koko lack their grandeur and severity. To say that these are pole figures deprives them of their dynamism by implication, yet this is the general type (widespread in Africa) to which they belong. The damage inflicted on the arms of each figure is evidently not accidental. Whether they were hacked in this way by the Koko themselves in order to destroy their potency is not known. Similar damage was done to Igbo standing figures by warring groups this century. If their ritual power was thereby forfeited their aesthetic quality remains. The formal certainty of their making, with sharp accents for the shoulders and powerful faces reminiscent of Cross River figures, is offset by delicate scarification motifs and, on the back of the female, a pattern of spots that may have some association with a leopard cult. These two figures with their remaining shafts below the feet and weightbearing headpieces probably served as flanking (?) supports for the inner entrance to a sanctuary.

The eyes are represented by glass beads (unusually for the art of Cameroon) but this factor is consistent with the eclectic style of the pieces about whose earlier history one would wish to know more. *TP*

Provenance: 1895, acquired by the museum from E. Zimmerer

Exhibition: New York 1987

Bibliography: Darminik, 1902; Bernatzik, 1947; Kecskési, 1987

5.12

Royal mask

Bamum, Kingdom of Fumbam
Western Province, Cameroon
wood, copper, plant fibres, glass-paste
beads, cowries
h. 93 cm
Laboratoire d'Ethnologie, Musée de
l'Homme, Paris, Gift of Charles Ratton
35-6-1

This monumental helmet mask, carved from a single piece of wood, represents a human head wearing an openwork diadem decorated with lizards and crocodiles, somewhat reminiscent of the tiara surmounting the large *tukah* mask collected by Pierre Harter in the Bamileke chiefdom of Bamendou (cat. 5.16). The face has fine sheets of copper pinned all over it. The lizards in the diadem are decorated with beads and cowries stitched on to a woven raffia backing. These spectacular masks were worn during the annual ceremonies to celebrate the first rains (*ndja*), or the bringing in of the second harvest in November–December. This mask would not have been worn by the king because of its great weight but would have been carried by one of his servants. Along with the other masks and equipment for political, administrative, legal or dramatic ceremonial, it would have been kept in a special area inside the royal enclosure. EF

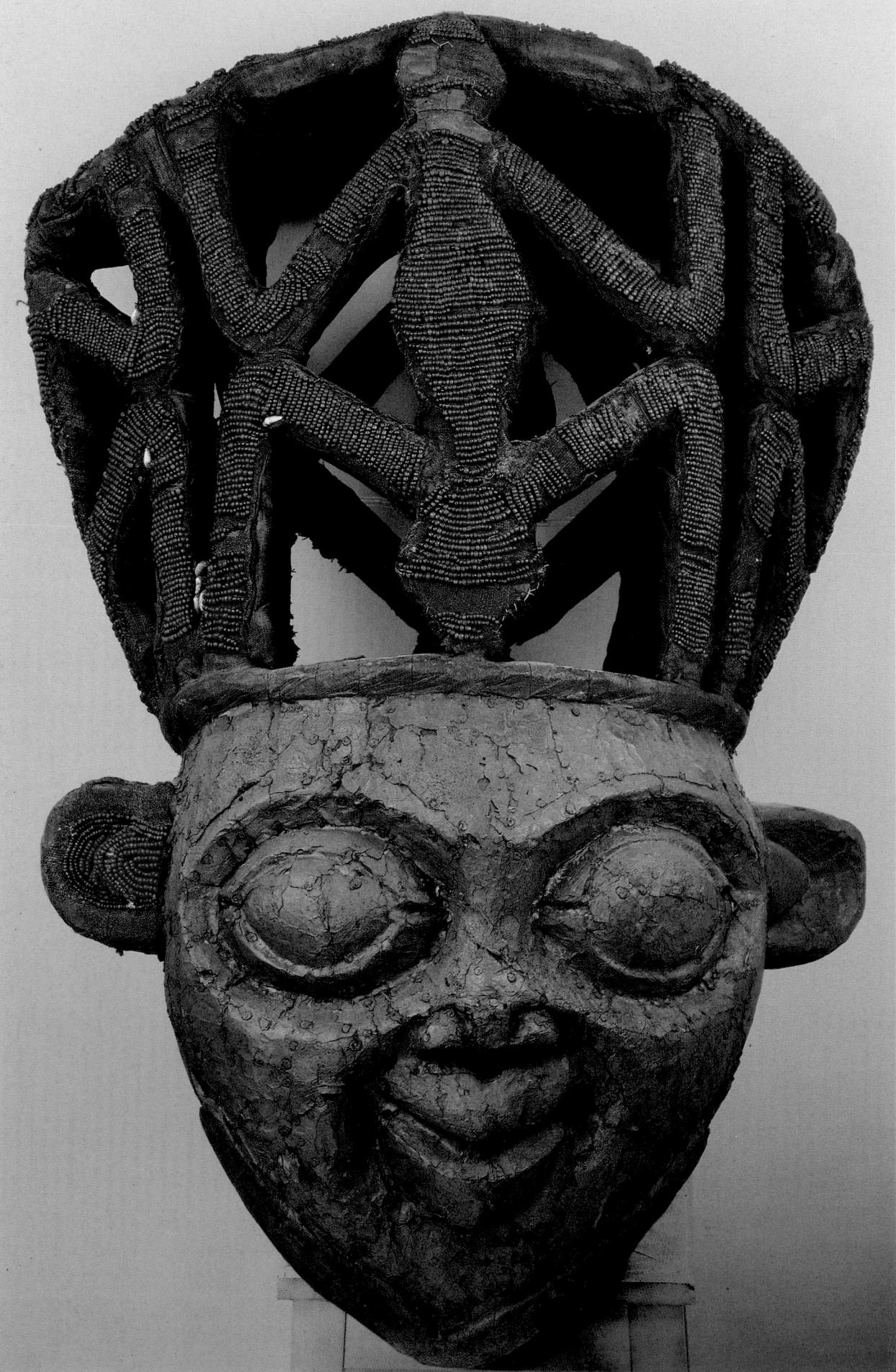

5.13

Buffalo mask

Bamum
Western Province, Cameroon
wood, fibre, glass-paste beads
63.5 x 28 x 15.2 cm
Maureen and Harold Zaremba

Large animal masks were frequently worn during masked ceremonials in the Grasslands. The most popular forms were elephants, monkeys, goats and cattle; leopards, crocodiles, dogs and birds were also occasionally represented. The animals are not always easily recognisable, particularly when the representations are intentionally hybrid. The masks

have to be studied in conjunction with animal mythology and symbolism. Horned masks occur among the Bamum, less frequently among the Bamileke. The commonest of all, the buffalo, represents strength, courage and power. Hunters were legally obliged to present the heads of all buffalos killed to the ruler; among the Bamum failure to comply with this could carry the death penalty. Buffalo heads were traditionally hung over the doorways of dwellings, or were attached to the posts supporting the roof awning, like the skulls of the enemy killed in combat; alternatively they might be used as seats. The horns were used as drinking-vessels and were decorated with carved patterns.

This handsome wooden mask is carved from a single piece of wood and is wrapped in a woven raffia fabric on to which are stitched small glass-paste beads, using a technique particular to the bead artists of the Grasslands. The beads are trading beads, and the old-fashioned blue and red tubular beads predominate.

EF

5.14

Royal stool

Bamum

Cameroon

wood, glass beads, cowries

175 x 50 cm

Museum für Völkerkunde, Vienna,
171.471

The connection between stool and power, especially when the stool incorporates a figure, will have already become apparent thus far in catalogue and exhibition. 'Enstoolment' is the term used among the Akan (and in other parts of west Africa) for enthronement of a chief. The announcement of this tendency in terms of artistic splendour reaches its peak among the kingdoms of Cameroon. Each court has its treasury where ritual goods are kept. Some of these can be of warehouse proportions and are filled with regalia, weapons and sculpture. The items which add most to the prestige of a Fon (more a king than a chief) are the often elaborate beadworked figures and stools. These are brought out on ceremonial occasions and even a minor visiting dignitary might see ranged before the

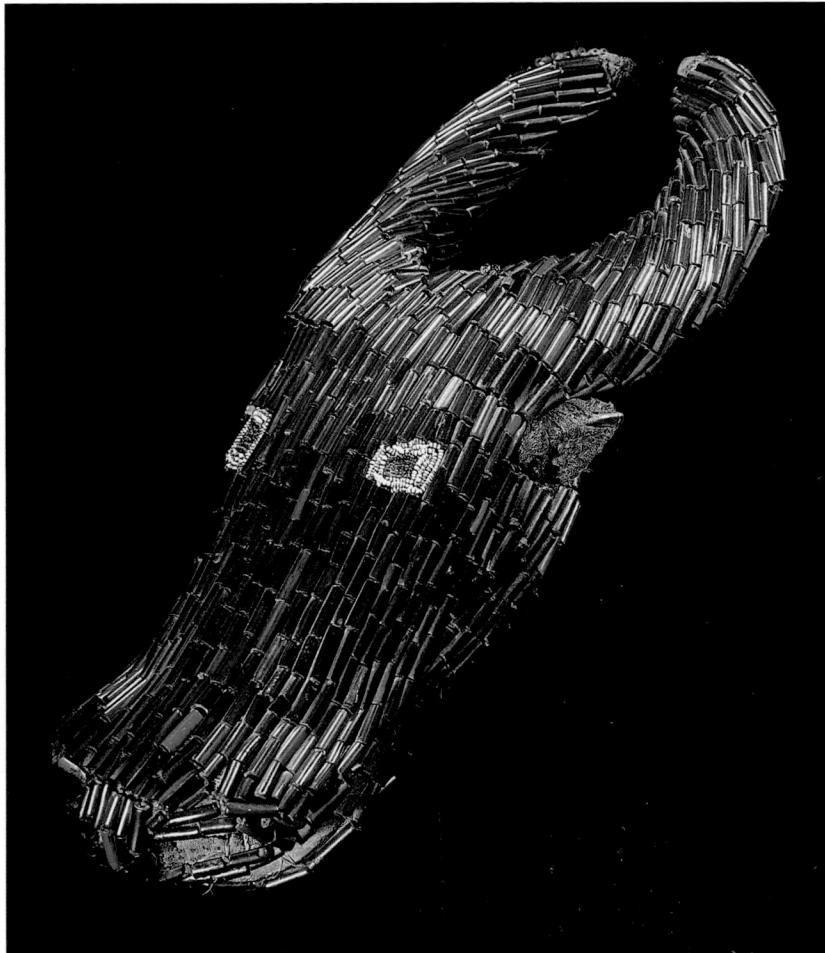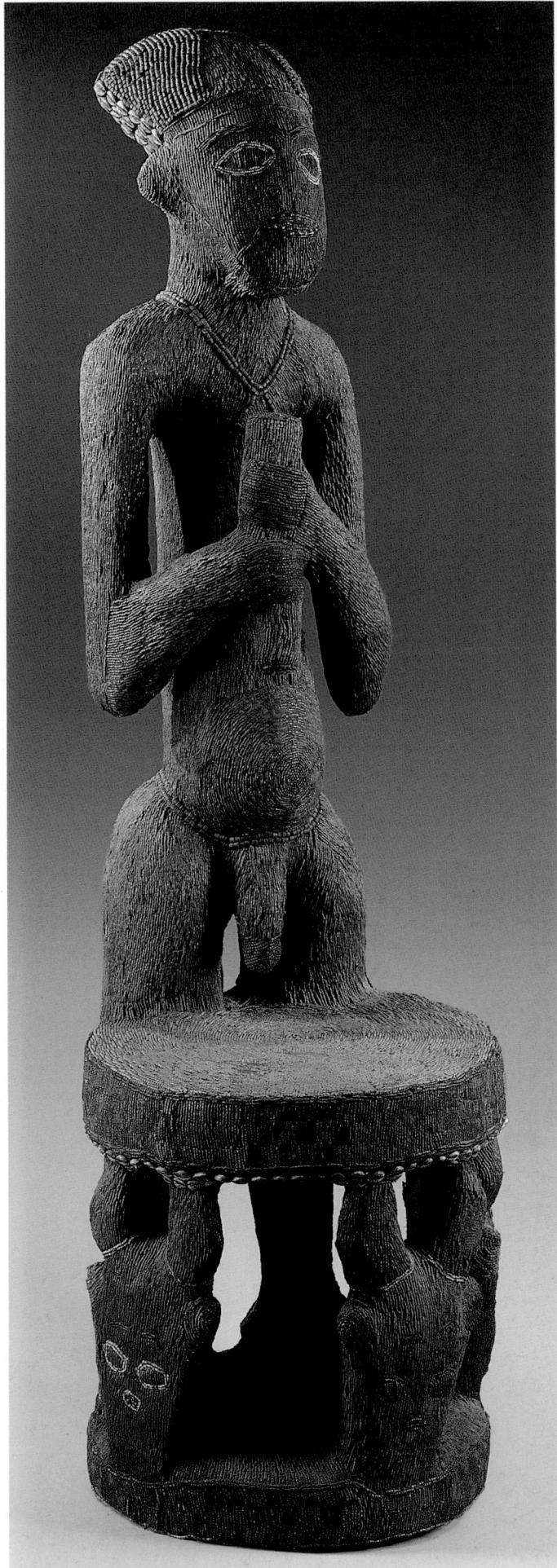

palace itself an impressive array of beaded sculpture, some of it dating back to the middle of the last century. The bright colours of imported beads (the role of Czechoslovakia and Italy, for example, is not to be underestimated in the history of African art) are used at maximum brilliance and brought together with the greatest impact of contrast. In African light this can be dazzling, whereas in the sobriety of a European museum the effect is somewhat strident, like bright Bermuda shorts on a British beach.

In this particular example from the Bamum in the north-east savanna region the artist (and here one need not hesitate to use the word since court artist is a highly regarded and non-hereditary role earned by merit; he is a professional) has used the tens (or probably hundreds) of thousands of beads, together with wealth-indicating cowries, with unusual fluency and subtlety. The small size of beads used usually indicates a date of manufacture after the beginning of this century: ancient beaded work usually features the longer beads seen in cat. 5.13.

This type of figured stool occurs throughout the Grassland kingdoms and is symbolic rather than practical. Costly and elaborate items of beadwork are the prerogative or in the gift of the Fon himself, and the presence of beadwork even in lesser objects would indicate royal connections, as is the case with the Yoruba (cf. cat. 5.85). Kaiser Wilhelm II, for example, received tribute in the form of beadwork stools from Fon Njoya of the Bamum in the early years of this century; the crafting of these examples helps to date the present stool as near that period. TP

5.15

Fragment of a pillar representing King Tita Gwenjang (Fonyonga II)

By the sculptor Njinerat

Kingdom of Bali-Nyong
North-Western Province, Cameroon
c. 1904-5
wood, pigment
143.5 x 36 x 22 cm
Musée National des Arts d'Afrique et d'Océanie, Paris, Pierre Harter Bequest, AP 92-32

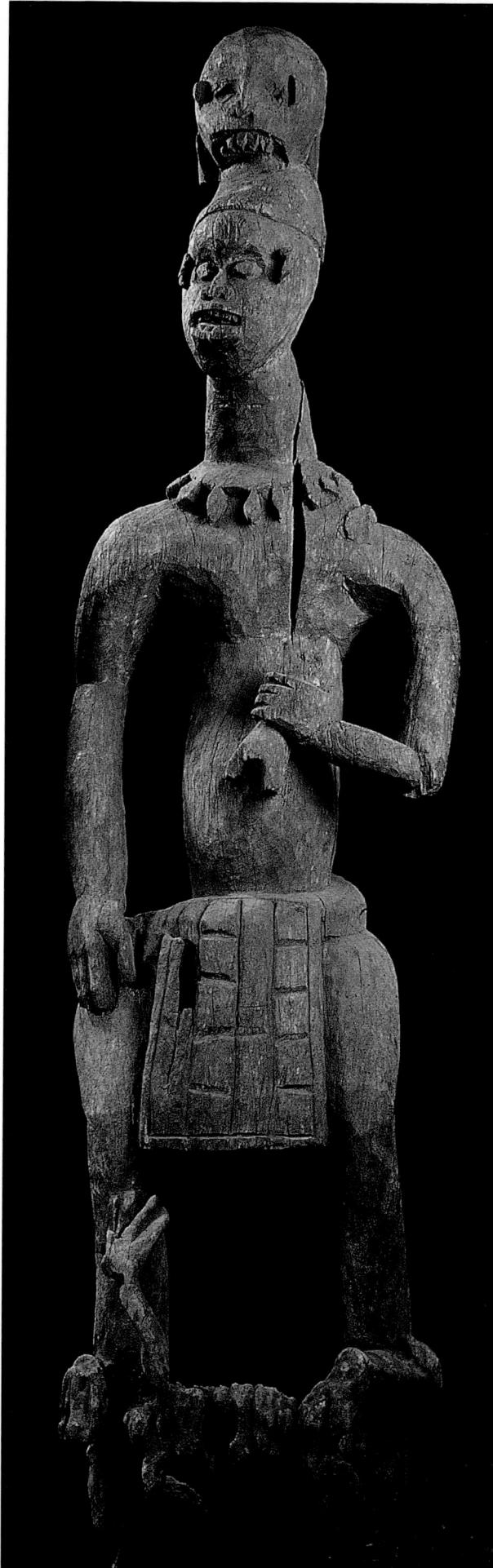

This figure is one of the carved columns of the peristyle that supported the roof of the former royal palace of Bali-Nyong, demolished in the 1950s during the reign of Garega II when a new stone palace was built; fortunately there are some photographs of it taken in 1943. The columns usually consisted of three figures, one on top of the other, with their backs to the door frame. They were taken down, sawn into three pieces and dispersed; some portions can now be seen in the museum in Bamenda. Pierre Harter acquired three fine fragments; this one was the lower part of a pillar immediately to the left of the entrance to the palace. It represents a Fon of Bali named Tita Gwenjang (Fonyonga II) who ruled in about 1870. He is wearing a necklace of panther teeth and holding a sword of which only the hilt remains; under his feet lies the corpse of an enemy. The royal headdress bears a skull that was originally between the feet of the person higher up on the column, his older brother and predecessor, Tita Nji. At the top there stood another figure (also saved by Harter), a warrior or servant, with arms akimbo. The chiefs of Bali are descendants of Chamba conquerors, a tribe of horsemen from northern Cameroon and Nigeria. They subjugated a large number of villages on the plain of Ndop on the borders of Bamenda. The Bali colonnade illustrated these military achievements; taking its inspiration from the traditional architecture and sculpture of the region it also confirmed the desire of local people to establish their chiefs from other parts of the country more securely. This particular column was apparently carved, with others, by a sculptor named Njinerat c. 1904-5. It bears the characteristic features of Grassland sculpture, particularly of Bamileke carving: the expressionist, almost grotesque treatment of the figures has the heads, shoulders, bodies and limbs sticking out awkwardly in all directions, with no attempt at symmetry. EF

Bibliography: Gebauer, 1943

Royal mask of the Kah Society

Bamileke, Chiefdom of Bamendou
Western Province, Cameroon
wood

85.7 x 69.5 x 53.5 cm
Musée National des Arts d'Afrique et
d'Océanie, Paris, Pierre Harter Bequest,
AP 92-15

This exceptional mask, carved from a single piece of wood, is the jewel of the Pierre Harter collection. In *Arts anciens du Cameroun*, Harter wrote: 'The royal treasure of Bamendou was one of the most impressive collections of the Grassfield. This is a monumental mask with an openwork hairstyle, named *tukah*, held in the possession of the Kah society, which was the equivalent of the council of ministers of the chiefdom. It carried considerable symbolic weight and combined various attributes. The transience of life is alluded to by the six lizards in the headdress, their sinuous outlines being contained within the lobes, each of which, in turn, terminates in the curl of the lizards' tails.

The continual renewal of the chiefdom is symbolised by various fertility symbols. The protuberant brow bulges like a pregnant stomach, and the two bloated cheeks like breasts swollen with milk; these two attributes also refer to the powerful twin forces of alliance and allegiance. The sacred act of procreation is evoked by the nose which appears to penetrate the cheeks (spread wide as female thighs) like an erect male organ. Finally, the perfect equilibrium of the whole, with its combination of spherical and ovoid masses, conveys a sense of the universal and the eternal.... According to the tenth Fon, Dongmo (1955–1976), *tukah* represented the power, the nobility and the endurance of the Bamendou through several generations. It was said to have been carved from a tree in the sacred wood planted by Jeugman, the founder, an émigré from Fodjomo (in the Bamenda region). The mask was displayed during a slow-moving quinquennial procession connected with the classes of the Majong. The weight and power of the mask meant that it was never worn on the head. It was carried at arm's length by the *wala*, who took turns at leading the parade, two by two, moving very slowly, and making frequent stops; it would take several hours to cover the few hundred

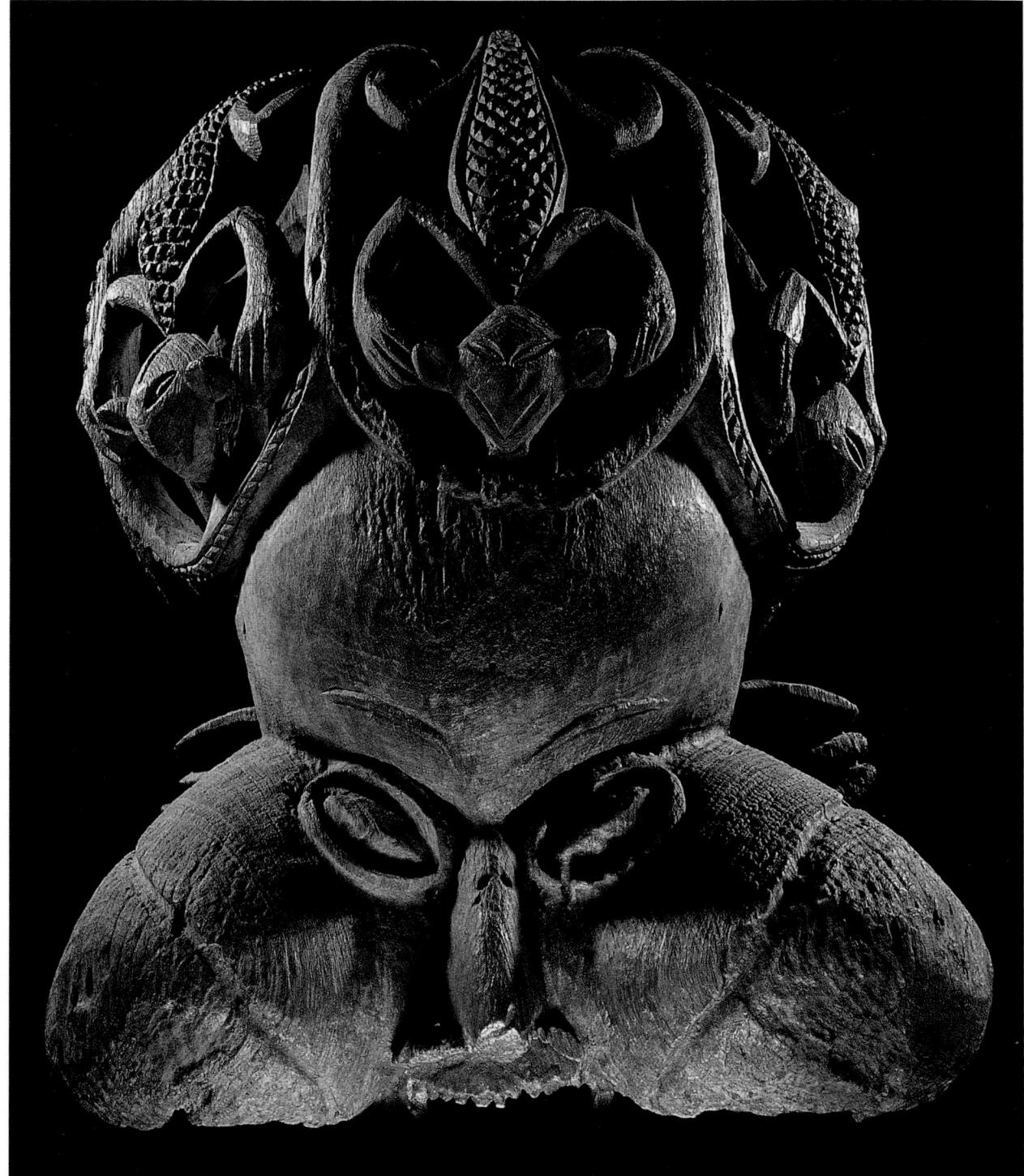

metres between the dance floor and the hut where the mask in 1957 was guarded round the clock. When we came across the mask in 1957 it had been abandoned for years under the rubble of a deserted hut which no one dared to approach.'

This mask is reminiscent of the massive and even more stylised masks used by the Bamileke of Batcham and Bandjoun, known by the name of *tsesah*. EF

Provenance: 1957, collected by Pierre Harter in the chiefdom of Bamendou, between Dschang and Bafoussam

Bibliography: Harter, 1986

5.17

Calabash stand

carved by Kamteu (*d.* 1915)
Bamileke, Chiefdom of Foto
Dschang Region, Cameroon
c. 1910
wood
127 x 50.7 x 66.5 cm
Musée National des Arts d'Afrique et
d'Océanie, Paris, AP 92.39

This large statue of a seated queen once stood by the throne in the royal dwelling; in its arms the figure held a removable calabash containing ritual objects (a pipe and other personal items) belonging to the Bamileke ruler of Foto. The figure rests her arms on a stylised elephant's head: seen from the side, the feet of the stool and the queen's legs combine to make a convincing silhouette of an elephant, and this lends the group exceptional solidity and strength. Like other items of royal furniture, it was probably originally designed to be covered with small glass paste beads stitched to a framework of woven raffia, which would explain the absence of facial features. The sculptor knew that the features would be outlined in beads.

The torso is completely hollow; this may have been to make it lighter, or to form a receptacle for relics or charms or to act as a sound box so that a servant hidden behind the stand could make the sculpture 'speak' during a ritual performance. It was carved by Kamteu (*d.* 1915), who was celebrated in the neighbourhood of Banjout. EF

Provenance: 1975, presented to Pierre Harter by the fon of Foto, Soffack

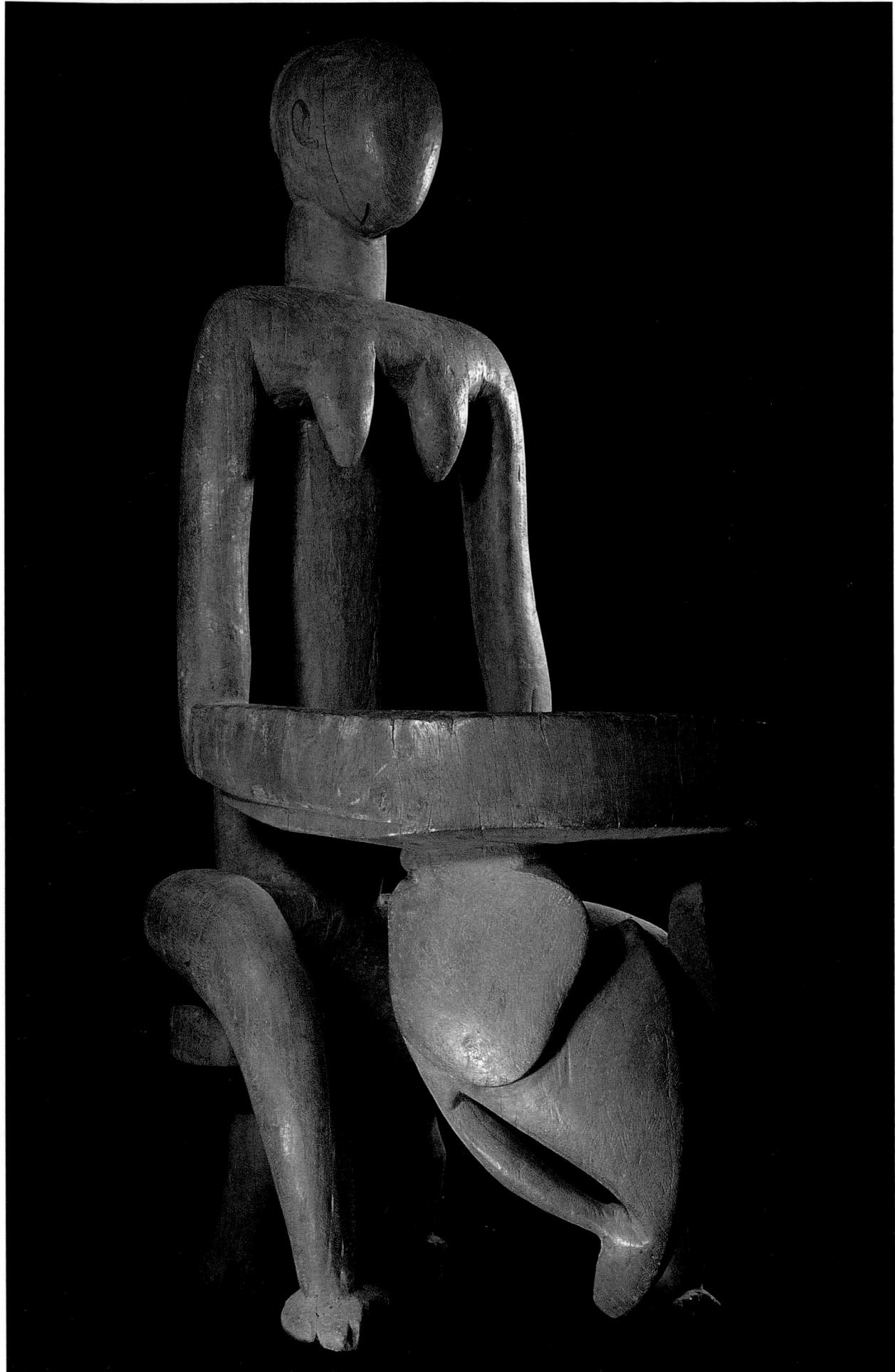

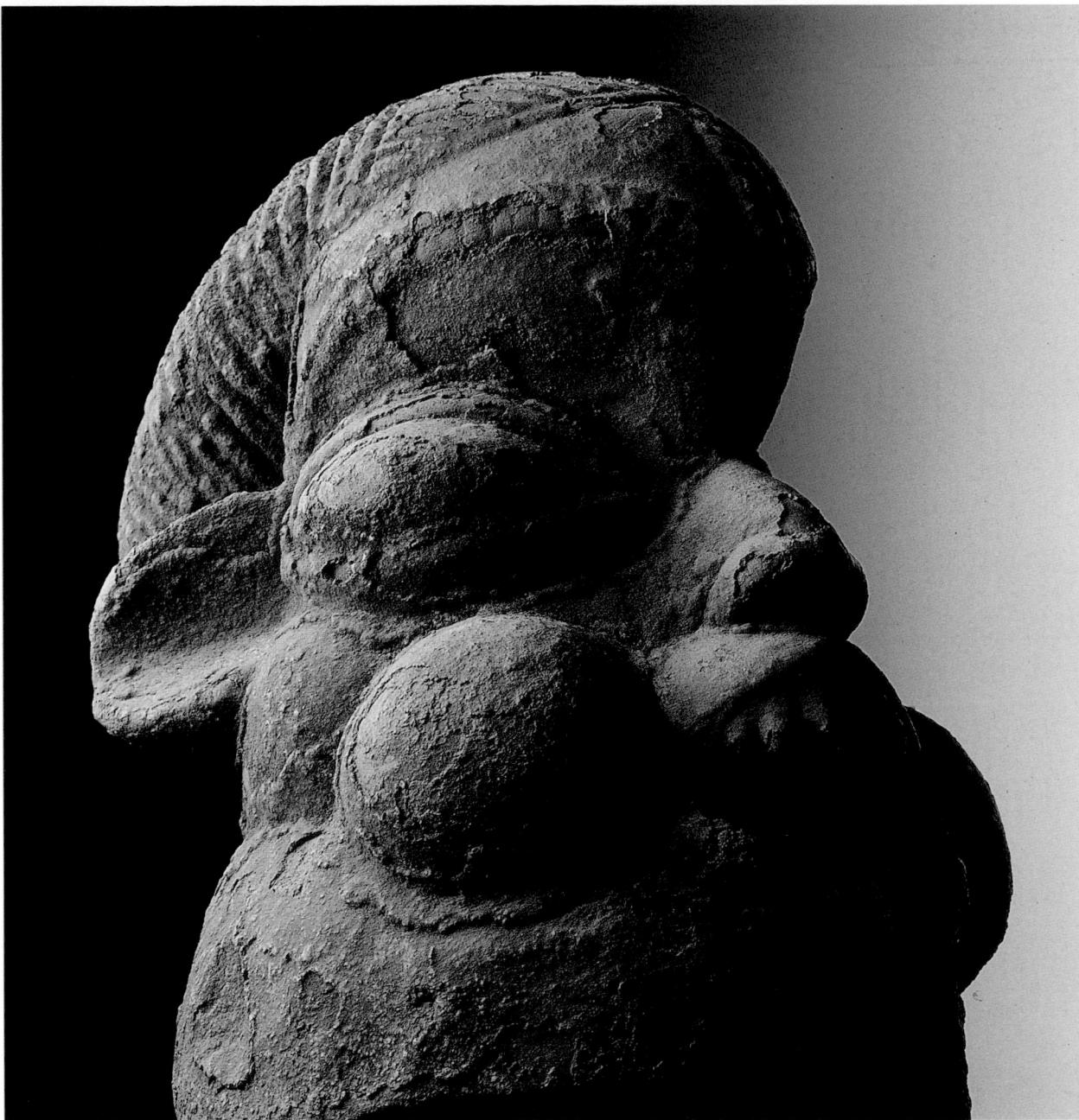

5.18

Mask of the Troh Society

Bangwa, Chiefdom of Foretia Fontem region
Western Province
Cameroon
wood with a blackish crusty patina
27 x 19.7 x 27.5 cm
Musée National des Arts d'Afrique et d'Océanie, Paris, AP 92-52

Among the Bangwa people of the Fontem region, the secret society of Troh (known as a 'night society') consists of a council of nine notables; this kind of politico-religious institution is found all over the Grasslands, the society in the neighbouring Bamileke country being known as Kamvuu. The grand master of the society is

the chief himself (the *fwa*), the other members being the heirs of the nine companions of the founder of the dynasty. These nine notables are the guardians of tradition whose duty it is to supervise the selection of a new chief, his enthronement and his funeral. This helmet type of mask is worn exclusively by the members of the Troh, and is handed down by them from father to son. Theoretically, therefore, each chieftancy possesses only nine masks. This one comes from Foretia, just north of Fontem. Harter studied more than 50 of these masks, some of them with two or more faces. He noticed two distinct styles, a Bangwa style, formalist in tendency, and a naturalistic style

influenced by the Bamileke. This Bangwa example represents a man's face, grimacing slightly, his mouth open to show filed teeth, wearing a pointed headdress with the point thrown backwards; the mask is made up of a series of spherical shapes for the brow, eyes, cheeks and so on. The thick patina is the result of years of ritual fumigation and libation, and is a testimony to the mask's great age; a member of the Troh has guarded this symbol of his power with great care. EF

Bibliography: Harter, 1986

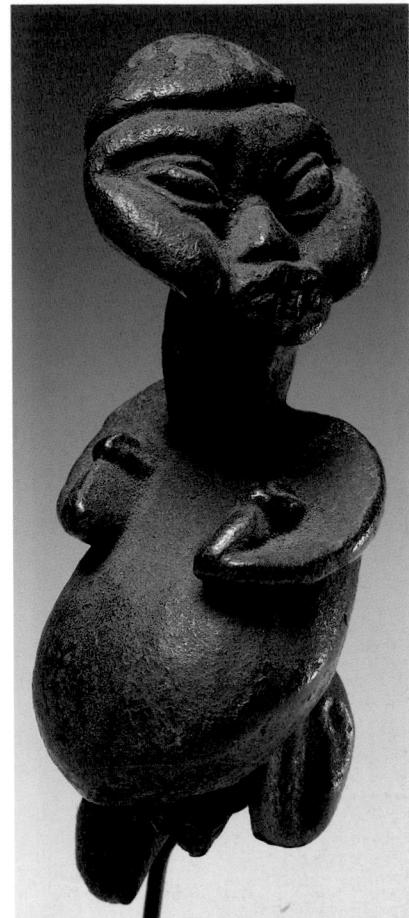

5.19

Statuette (*mu po*)

Bamileke, Chiefdom of Bangangté Western Province, Cameroon
wood
15 x 5.5 x 5.5 cm
Private Collection

Bamileke healers and soothsayers used small wooden statuettes to represent the patients in their magical-medical practices; the patients would be treated at a distance. Sometimes the statuettes have a cavity in the back into which magical substances would be placed and the cavity closed with a band of leather or cloth. Some of them, made of wood, ivory or a softish stone, would be carried by mask-wearing members of the Kun'gan secret society during their big rituals.

The statuettes measure between 10 and 40 cm in height; they are called *mu po* in Bandjoun, *pu pueh* in Bafang and *meu boun* in Bangangté and generally depict a pregnant woman with her hands on her chest or under her chin. This symbol of maternity occurs frequently in the arts of the Grasslands, relating to the fertility of the group and of the lands belonging to the chiefdom. EF

5.20

Standing male figure

Mambila
Nigeria/Cameroon border
late 19th century (?)
wood
45 x 18 x 18 cm
Private Collection

Several stylistic conventions in this figure suggest that it might come from a group of small communities to the north of the Tikar Grasslands around the Nigerian/Cameroon border: the 'dished' rendering of the face; the gesture of hand or hands to chin or beard; the way in which the lower limbs are represented, with accentuated thigh, much reduced lower leg and large feet similar in form to the thighs; and the conical rendering of the stomach. Several peoples in this area produce such sculptures, including the Mfunte, Mbum, Kaka and not least the Mambila who occupy the plateau of that name.

Such figures are commonly described as ancestor figures, a description which is challenged. The gesture of the left hand or both hands to chin in Mambila sculpture is characteristic of *tadep* figures connected with a healing association called Suaga. The ritual paraphernalia were kept in granary-like storehouses adorned with painted screens (*baltu*). Two types of carved anthropomorphic figure were displayed in front of the storehouse: *kike* made from raffia palm pith, and *tadep* carved from wood. Both types were often made as a male-female pair and usually painted with black, red and white pigments. The style of the former is generally more abstracted than that of the latter. Larger *tadep* were also kept inside the storehouses. Although the Suaga complex remains central to the religious system of the Mambila, most figures and masks have been removed owing to their popularity among Western art collectors.

The style of this figure is indicative of that attributed to the Mambila, but the realism of the extended belly and the rounded structure on top of the head (reminiscent of the type of headgear worn by Cameroon Grassland elephant masqueraders to the south) are not typical. KN

Bibliography: Schneider, 1955; Fagg, 1968; Gebauer, 1979; Zeitlyn, 1994, pp. 38–47; Schwartz, n.d.

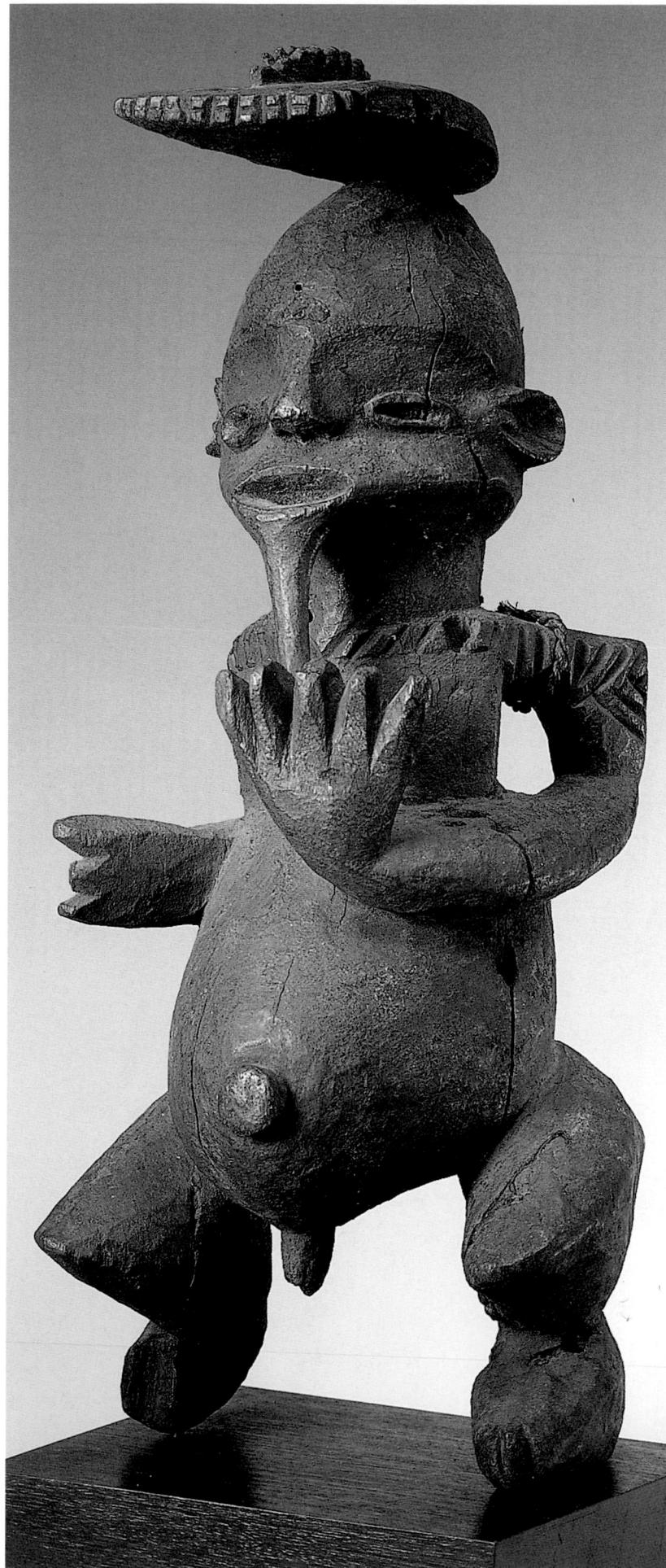

5.21

Double statuette

Mambila
Nigeria
stone
30 x 9.5 x 7.5 cm
Galerie Michael Werner, Cologne and New York

The Mambila, who inhabit the region between Nigeria and Cameroon, are famous for the originality of their sculpture. This consists mainly of wooden statues, frontal and very heavy; the figures invariably have big, expressionist heads, with hair often dotted with small wooden pegs and zoomorphic helmet masks in polychrome wood. The protruding eyes of the masks are reminiscent of the sculpture of the Grasslands. Also produced are less well-known sculptures in fired clay or soft stone, often of volcanic origin. This curious figure belongs to the latter type. It represents two people with their feet interlocked, a man and a woman in the coital position. Their heads, with very prominent features, are typical of the Mambila style. EF

5.22

Standing female figure

Chamba

Nigeria

wood

51 x 16.5 x 13 cm

Fritz Koenig Collection

Chamba figures are less well-known than the often ungainly buffalo helmet masks that they share with their neighbours the Dakka in east Nigeria south of the Benue river. It was here that they migrated in the 17th century from the mountains on the Cameroon border, and remained in the face of Fulani invasions in the 19th century. The smaller wooden figures are a defence against snake poison and are stuck into the ground by means of an iron spike.

Larger figures are rarer and this fine example with the characteristic crest is one of the largest known. Other figures are typically found in the form of a joined pair with, so to speak, two legs between them. This particular sculpture is in the most reductive of Chamba styles, pared down in detail and concentrating with masterly success on relationships of volume. Like the double figures it seems to have been apotropaic in function. *TP*

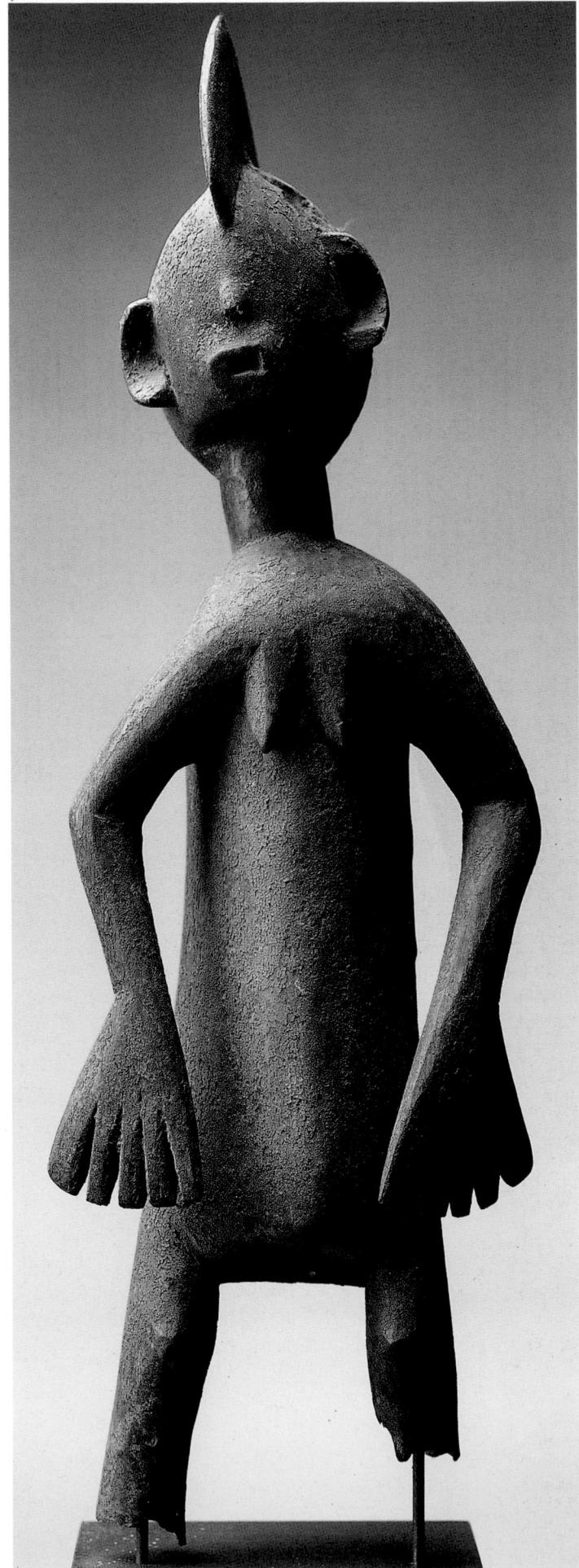

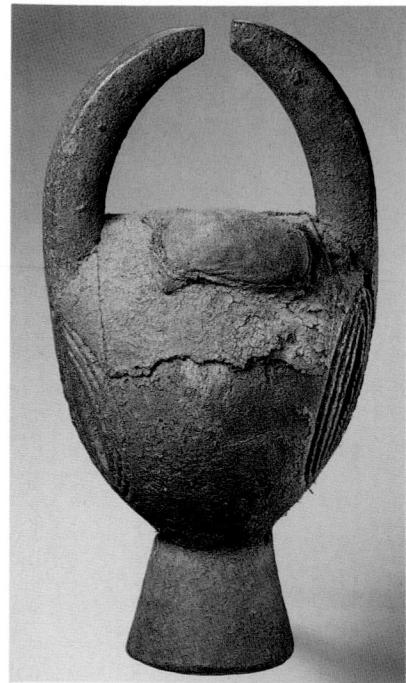

5.23

Composite horizontal headdress

Kantana/Mama
Northern Nigeria
20th century
wood
52.7 x 27.5 x 19 cm
Musée Barbier-Mueller, Geneva, 1003-16

This abstract headdress is composed of three shapes: a central dome with two curved projections recalling animal horns at one end and an angular flange at the opposite end. Instead of placing it vertically over his face, the performer affixed it on top of his head. It was thus perceived horizontally, the way most people imagine and depict animals. A generous ruff of plant fibre hung from the lower edges and hid the upper body of the wearer. Thus the horizontal headdress functions as a mask. This example should be assigned to the Kantana people (known earlier as the Mama) of northern Nigeria where wild buffalo roam the bush. The Kantana employ several kinds of abstract horned headdresses at their ceremonies for crop fertility. A packet of symbolic medicines and traces of offering materials on this wooden carving indicate the intensity of their appeals.

The Kantana horizontal mask belongs to a group of headdress forms that have remarkably wide distribution mainly in west Africa. These exhibit a blunt elongated mouth, a cranium and pointed shapes, such

as horns or feathers, extending back from the head. McNaughton has listed over 80 ethnic groups who include this kind of mask in their repertory. These groups extend over 3000 miles of territory, occupy diverse physical environments, belong to eight linguistic groupings and diverge in local culture. The variety of these horizontal masks within the basic tripartite format is a tribute to the artistic creativity of the carvers. Examples vary from minimal abstract forms, such as this one, to elaborate figurative examples, in which we can recognise a long crocodile snout, a human-shaped nose and brow on the cranium, and identifiable antelope or buffalo horns for the third element. This combination refers to the environment in which the performances take place, by alluding to the powerful creatures of water and of land closely linked to the human presence. References to the surrounding world are made by a variety of other creatures such as snakes, hyenas, chameleons, elephants, hippopotami and birds. In articulating this imagery, local carvers have also imagined many gradations of realism and abstraction, thus producing a remarkably varied corpus of artistically devised objects.

This mask, which so prominently features creatures of the wild, appears in public on the head of a performer wearing a huge costume of fibre strands taken from the bush or forest, confirming the identity frequently assigned by its owners as a bush spirit. Often the masker carries two staffs which serve as animal forelegs. These animalistic apparitions are designed to bring the vitality of the outside world into the village in order to regenerate crops and increase the birth of children. Their typical behaviour includes extremely energetic, even threatening movements, which may be restrained through cords held by attendants or through man-made rhythms of drumming and song. This ritual suggests that the masquerader conveys the powerful non-human energies of the surrounding environment which however must come under control in order to benefit the community. *MA*

Bibliography: Fraser, 1962, pp. 38–52; Sieber and Ververs, 1974, fig. 14; McNaughton, 1991, pp. 40–55

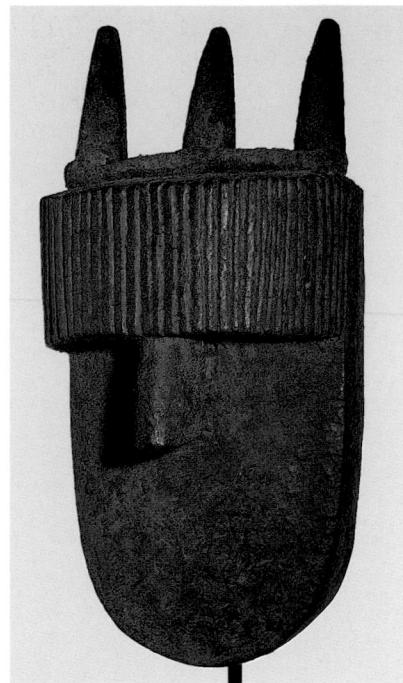

5.24

Mask

Loma (or Toma)
Liberia
20th century
wood
h. 79 cm
Rosemary and George Lois Collection

The Loma are one of the numerous Mande-speaking populations who descended from the northern savanna region into the forested band of west Africa during the turbulent conditions of the later days of the Malian Empire (1230–1670). In recent times the majority (numbering 150,000) have occupied the hilly forested region of northern Liberia. In the past their most notable sculptural forms were long wooden masks that combined human and animal features. Only men wore these masks, which were fitted over the wearer's head horizontally. All functioned within the major men's association generally known as Poro. This association usually regulates land use, organises work groups and enforces regulations regarding initiation, marriage, trade and comportment.

The largest Loma mask was 1.82 m in height, with a long, movable, crocodile-toothed maul extending in front, a mid-section of human-like face with exaggerated nose and forehead, and a huge bunch of feathers of birds of prey stretching out at the back. For the Loma and their neighbours, the Bandi, this frightening image rep-

resented the major forest spirit (Dandai or Landa, Landai) which made manifest the power of Poro; one of its duties was symbolically to devour boys during initiation in order to give them rebirth as men.

While these huge masks are rare in collections, one encounters numerous examples of a mask that early reports identified as Nyangbai, the wife of the great forest spirit. Like the example shown here, this kind is of smaller dimensions and, lacking the extended maul, seems less threatening. It is worn directly over the male wearer's face. The upper part usually exhibits simplified (cattle or antelope) horn shapes and a rounded forehead overhanging a short, abstractly shaped nose and large, flat facial planes. Usually such female partners to big male masks help out at periods of initiation and make an appearance only at important funerals or crises. *MA*

Bibliography: Germann, 1933, pp. 118, 121; Eberl-Elber, 1957, pp. 42–5; Van Damme, 1987, pp. 9–12

Mumuye

The Mumuye are probably an amalgam of seven originally separate peoples who retreated under pressure to the rocky hills south of the Benue River.

These three works reflect the diversity of style within the Mumuye figure tradition. Few were known before the 1960s and were usually misidentified as Chamba (as was cat. 5.25a). The Chamba are southern neighbours of the Mumuye and were one of the invading groups that drove the ancestors of the present Mumuye to their present home. Cat. 5.25a is one of the earliest recorded examples and is unusual for the open, stool-like central area.

Despite the large variety of sub-styles, all figures tend to be elongated, ranging in size from 20 to 160 cm. The legs are usually angular, and ribbon-like arms wrap around the torso with elbows clearly marked.

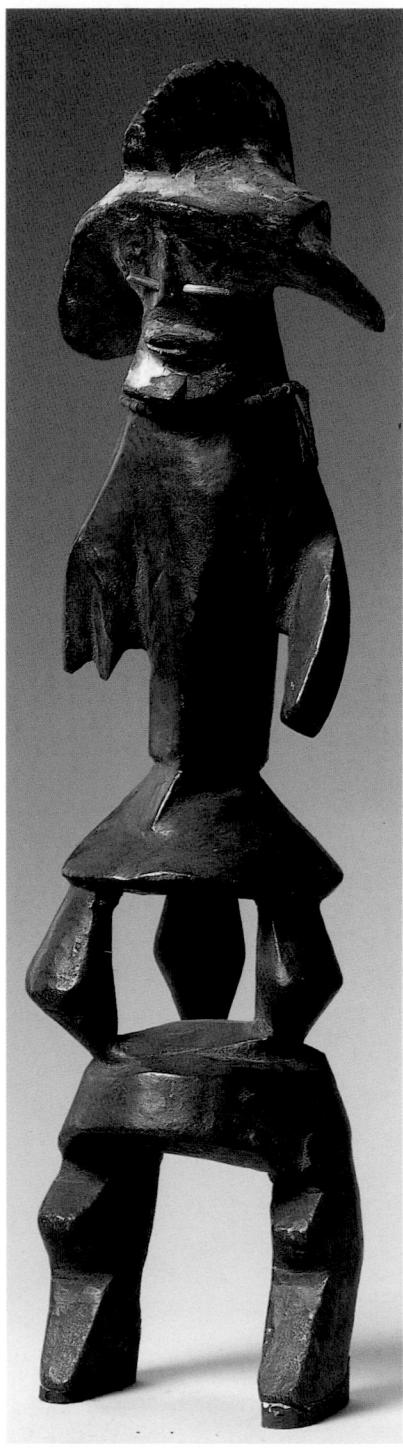

5.25a

Standing figure

Mumuye
Nigeria
wood
h. 30.4 cm
The Trustees of the British Museum,
London, 1922. 6.10.3

The heads may display a coiffure in the form of a crest. Scarification on face and body is delineated and the nasal septum is perforated for the insertion of a short section of a stalk of Guinea corn. Both scarification and nasal septum ornamentation reflect local custom.

A number of such sculptures have large ears with pierced and distended earlobes for the insertion of plugs, a practice visible in some Jukun figures from neighbouring areas. The Mumuye distinguish the gender of the figures on the basis of the shape of the ears; only Mumuye women distend their earlobes. In sculptures where secondary sex characteristics are absent or difficult to identify this may be the only clue to determining the gender of a figure.

The Mumuye occasionally used their figures for divination and healing, as did the north-western neighbours, the Montol and Goemai. Other figures, indistinguishable in form and style, reinforced the status of important elders, served as house guardians and/or were used to greet rainmakers' clients. BH, RS

Provenance: cat. 5.25a: 1922, acquired by the museum; cat. 5.25b: ex collection Jack Naiman

Bibliography: Fagg, 1963, pl. 158b; Rubin, 1969, figs 174–80; Fry, 1970, pp. 14, 89; Rubin, in Fry, 1978, pp. 106–8; Rubin, in Vogel, 1981, pp. 155–8; Sieber and Walker, 1987, pl. 35, p. 78; Robbins and Nooter, 1989, pl. 152

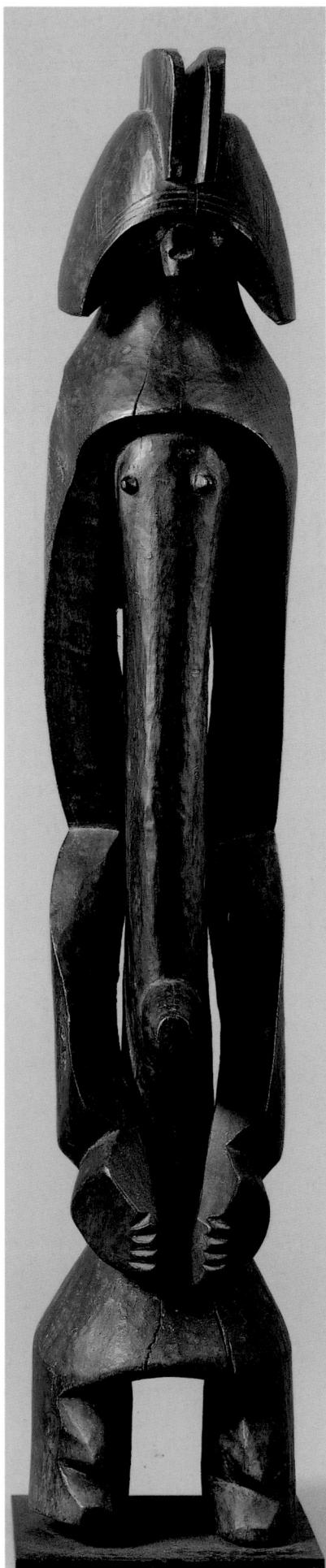

5.25b

Standing figure

Mumuye
Nigeria
wood
h. 99 cm
Beyeler Collection, Basle

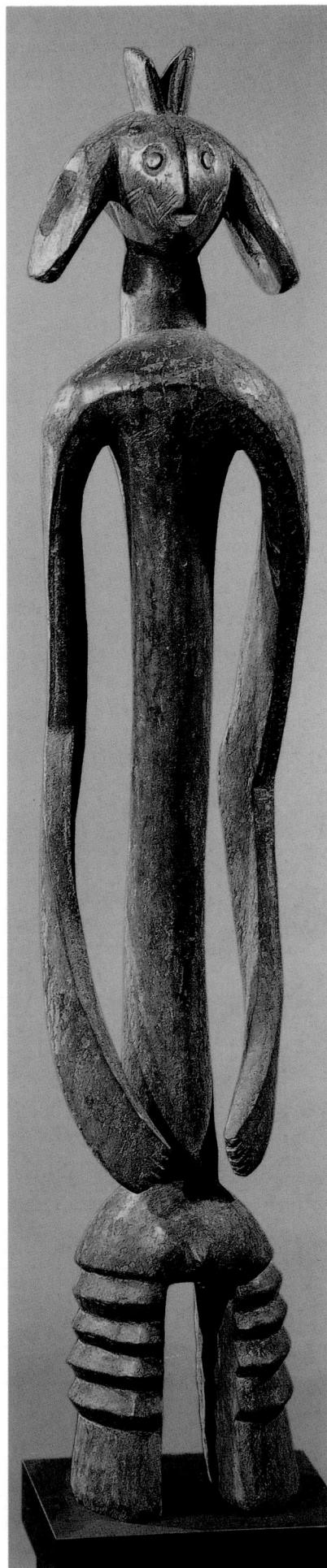

5.25c

Standing figure

Mumuye
Nigeria
wood
h. 110 cm
Private Collection, Paris

5.26

Figure

Benue to Cross River region
Nigeria
wood
100 x 11.5 cm
The National Commission for Museums
and Monuments, Lagos, 721.1246H

All we seem to have for this figure is a location somewhere from the middle Benue to the Cross rivers, a region of diverse social environments with many uses for figure sculpture as other entries make abundantly clear. It is an area, moreover, in which one passes rapidly from places where there is a well-developed stylistic configuration, invariably mediated by institutions of apprenticeship, to places where neither a defined style nor the means to inculcate it are present. Nevertheless, whether to satisfy a ritual need or for mere playfulness (and one cannot tell from the sculpture itself), men take to carving the human figure often having had no training in the use of a knife or an adze. Indeed, their only experience of the effect of a sharp blade on a piece of wood may well have been watching a smith prepare the haft for a tool he has wrought. As a result a series of highly idiosyncratic schematisations come into existence which, in the absence of secure data, defy attempts at precise geographical location. *JWP*

5.27

Headrest

Jukun
Nigeria
bronze
63 x 90 x 50.5 cm
The National Commission for Museums
and Monuments, Jos, Nigeria

Two of these unusual headrests exist, one of them in a damaged state: both are in the Jos museum. Attribution to the Jukun seems certain. Although their great wooden figures are justly well known despite the fact that only a dozen or so have survived (of which cat. 5.28 is the finest), they were also accomplished smiths and casters though not so prolific as their neighbours the Tiv. The Tiv however seem never to have produced an object so technically difficult as this hollow-cast headrest whose bronze walls are as thin as the early Benin heads.

What is particularly interesting in the survival of this piece is that unlike the Tiv, the Jukun identify their origins in the Sudan and their casting knowledge from the area of the Sao culture (cat. 6.60) near Lake Chad after its dispersal. The height of Jukun influence was in the 16th century when its long vanished capital Kwororafa thrived, which suggests connections with other Nigerian bronze-casting traditions. Metallurgical analysis may yet provide more clues. The extraordinary saddle-like form of this impressive headrest which may date from near the time of Jukun power (perhaps a 17th-century date is likely since the crotals which

hang from it are of an appropriate type) has northern associations and it should be remembered that the Jukun were early converts to Islam.

It is objects such as this, which occupy a place of transition both in time and geography, that with the future sophistication of the analysis of alloys as well as stylistic studies will provide the key to the complex web of influence and achievement in the ever absorbing story of Nigerian bronzes in particular and those of Africa in general. *TP*

Bibliography: Williams, 1974

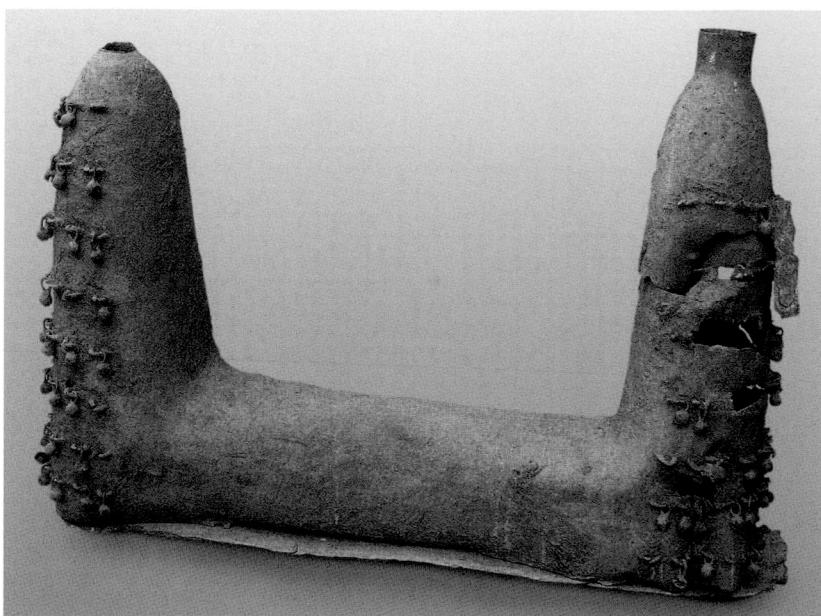

Female figure

Jukun
Nigeria
late 19th–early 20th century
wood
59.7 x 20 x 22 cm
The Menil Collection, Houston,
71-05 DJ

The Jukun live both north and south of the River Benue, dispersed across a wide swath of the middle belt of northern Nigeria. Distinctive to Jukun culture is the institution of divine kingship and the maintenance of cults providing access between the living and their ancestors. Figurative sculpture is made primarily by the northeastern Jukun, especially those living between the towns of Pindiga and Kona. Figures occur mostly in pairs, designated as husband and wife and often representing a deceased chief and his consort. These sculptures often had ancestral connotations, facilitating contact between living chiefs and their predecessors, who were enlisted to maintain community well-being or to avert disaster.

This female figure relates to the examples Rubin observed among the Jukun subgroup called the Wurbo, who live scattered along the banks of the River Taraba. Such figures were not specifically ancestral but were used in a possession cult called Mom which was instrumental in treating a variety of personal illnesses or in alleviating community crises like epidemic disease or crop failure. They were used to incarnate spirits, to whom offerings were made. Like other Wurbo figures, especially those Rubin saw in the village of Wurbo Daudu, this piece is carved of heavy hardwood and is distinguished by a pronounced facial overhang, distended earlobes with cylindrical ear plugs, sharply conical breasts, long arms bent forward and ending in large hands with deep gouges suggesting fingers, and rudimentary legs and feet. The surface details on this particularly striking female figure also reveal elements of Jukun regalia and body decoration: incised carving around the upper arm, forearm and waist represent cast brass ornaments, some with the openwork designs typical of Jukun craftsmanship; the deeply carved loaf-shaped projection from the top of the head captures an elaborate coiffure; and the markings at the sides of the face and across the chest depict patterns of scarification. Absent here, but typical of the genre, are small metal plugs inset in the eyes. *MCB*

Bibliography: Meek, 1931; Rubin, 1969, pp. 78–93; Rubin, 1973, pp. 221–31; Gillon, 1984; Rubin and Berns, in preparation

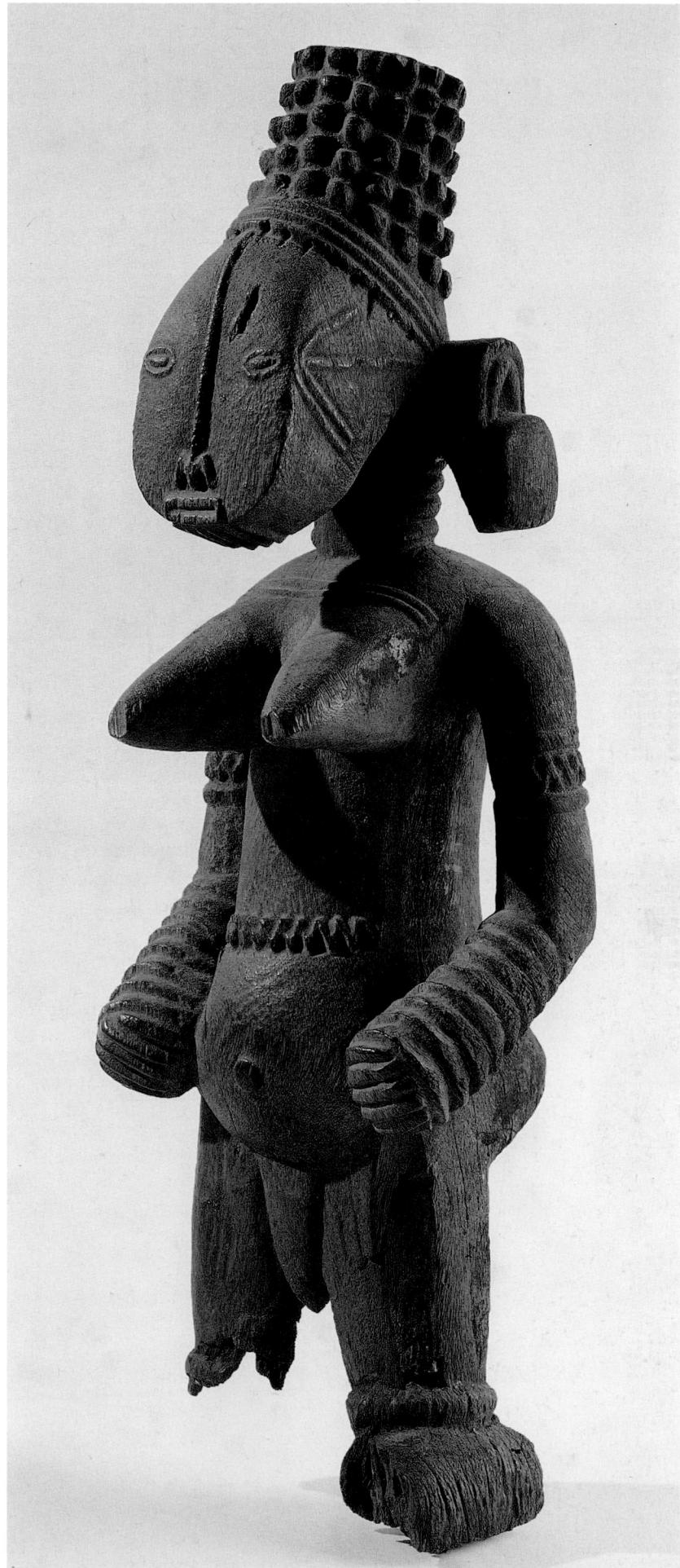

Male figure

Montol
Nigeria
20th century
wood
44.5 x 12.5 x 9.5 cm
Courtesy of the Trustees of the National Museums of Scotland, Edinburgh,
A.1953.99

The Montol live in the region of central Nigeria which is dominated by the Jos Plateau. They are one of a cluster of small Chadic-speaking groups living within this rugged terrain. They and their neighbours – the Goemai, Tarok, Ngas and others – share the practice of producing small figurative sculpture for men's societies concerned with healing. The Montol call this society Komtin (known as Kwompten among the Goemai and Tarok), and its members employ carved wooden figures in healing rituals or in determinations of the cause of illness. Like this example, Montol figures have a squat, chunky system of proportions, with body parts rendered geometrically. Torsos are columnar with broad chests and hips; the arms typically hang unarticulated at the sides of the body and the short legs emerge from the hips in an open-stanced, inverted 'U' formation. The schematic, triangular head has abstract features. Deep gouges in the upper torso and face are rudimentary references to body scarification patterns practised by the Montol and other groups in the area.

Little information has been published on these Montol healing figures. *MCB*

Exhibition: Purdue University 1974

Bibliography: Isichei, 1982, pp. 1–57;
Rubin and Berns, in preparation

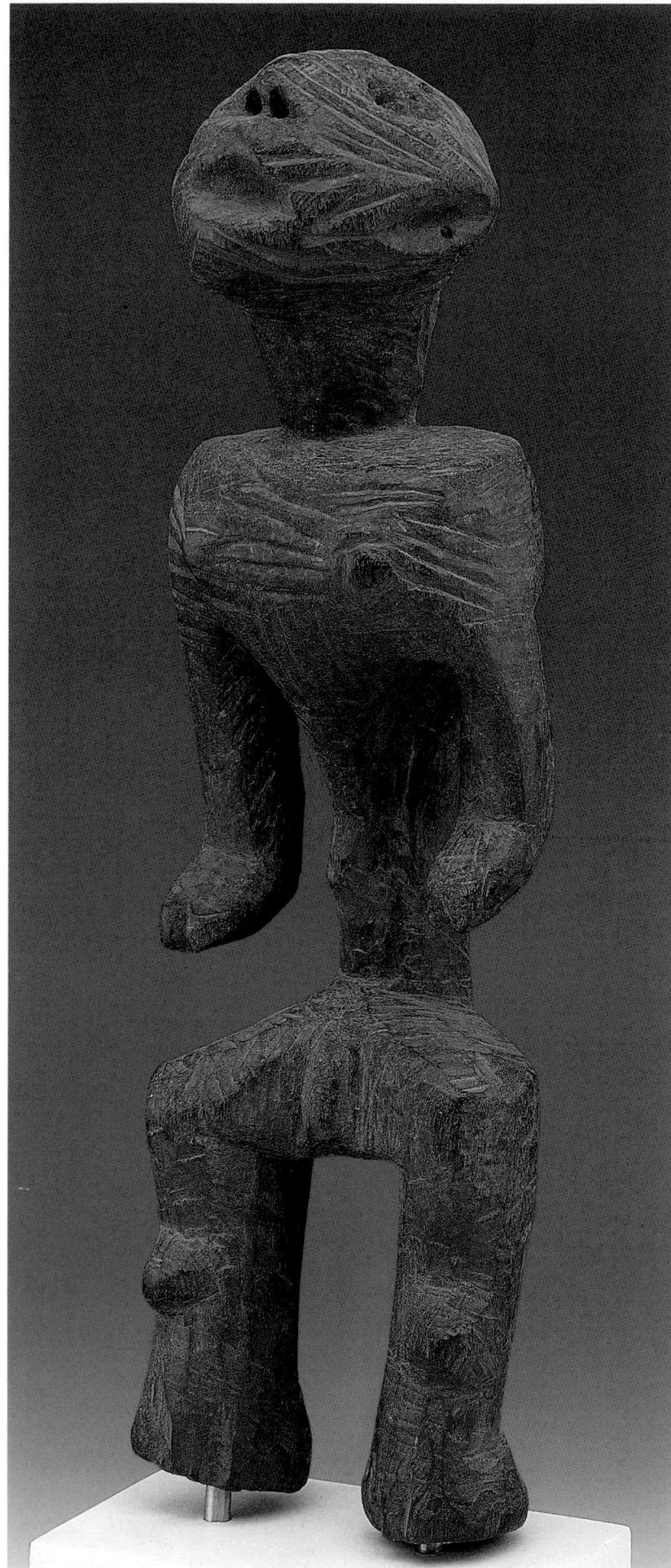

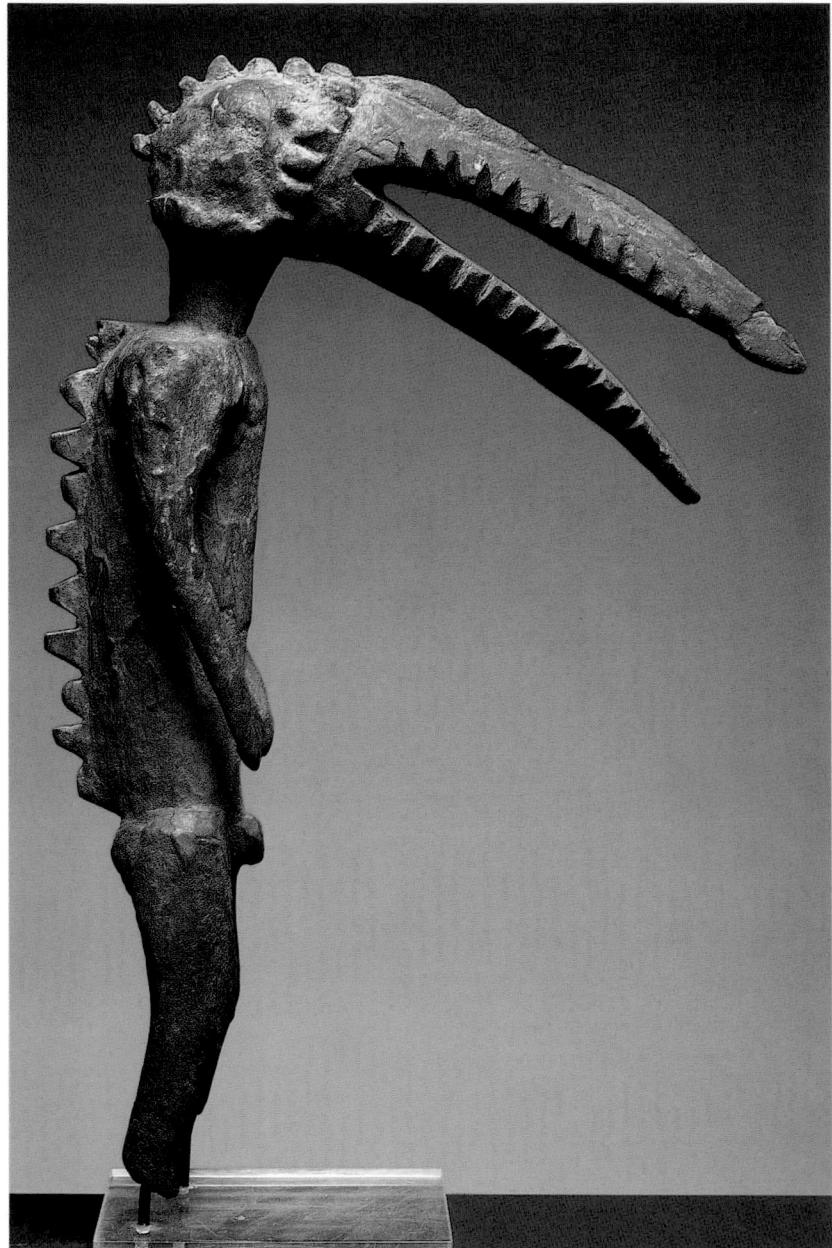

5.30

Standing figure

Goemai
Nigeria
wood
62 x 15 x 45 cm
Fritz Koenig Collection

The Goemai live to the north of the Benue River, opposite the Jukun. Their land is bisected by the Shemanker, a tributary of the Benue. Of the masks found among the Goemai one type is of particular interest because it relates to this figure and may be of an older, indigenous form that is shared by the Montol, northern neighbours of the Goemai. Called *gugwom* by both the Goemai and Montol, it is a horizontal mask with elongated crocodile-like jaws. It officiates at the installation and burial of chiefs and has a strong ancestral association; it is also used during the dry season and is associated with the success of agriculture.

Gugwom masks resemble the head of this figure and of several others

photographed in 1957 by Robin Jagoe, a British colonial officer (published by Sieber). The latter are quite unlike other Goemai examples, which lack the zoomorphic head and are used by diviners in healing ceremonies. They had appeared at a harvest ceremony near Shendam, the capital of the Goemai. It was probably also an ancestral rite, for the ceremony took place near the graves of deceased Long Goemais (paramount chiefs of the Goemai).

This may be the only figure of its type outside Nigeria that resembles the figures in Jagoe's photographs. In the absence of other data it may be considered to have ancestral and agricultural significance to the Goemai and be related to the celebration of deceased chiefs.
BH, RS

Bibliography: Sieber, 1961, figs 7, 29, 31; Klever, 1975, p. 225, fig. 101; Schaedler, 1992, p. 157, fig. 124

A wide range of bracelets, lip plugs, bells, pendants, beads, tobacco pipes, snuff bottles and other forms have been associated with prestige, coming-of-age and leadership. Unfortunately, almost no information about precise origin, use or meaning has been published.

It has been suggested that this figure comes from the Verre at the far eastern border of Nigeria or from the Tiv around the middle of the Benue valley. There exists no close parallel in the known corpus of works from either group. However, a number of aspects would suggest a Tiv origin, for instance the pose of the figure and the crotals hanging from what appear to be bangles. The precise origin of the metal figure tradition(s) of the Benue valley might never be established for the following reasons: the works have emerged without field data and it is too late to retrieve them; an unrecorded origin of the casting tradition may lie outside the Benue valley, either toward Lake Chad or to the south-east; or the casters may have been itinerant artisans.
BH, RS

Bibliography: Abraham, 2/1940, pls 6, 7B, 12A; Bohannan, 1957, pl. XIIa-c; Rubin, 1973, pls X, XI; Rubin, 1982, pl. H5

5.31

Figure

Tiv (?)
Nigeria
copper alloy
h. 44.7 cm
Private Collection

Copper alloy figures from northern Nigeria are extremely rare, although castings with human elements, usually heads, occur among the far more frequent ornamental or utilitarian forms. Found along most of the Benue River valley many have been recorded among or attributed to the Egbira, Idoma, Tiv, Jukun, Abakwariga, Verre and several small groups in north-eastern Nigeria and the adjacent Cameroon Highlands.

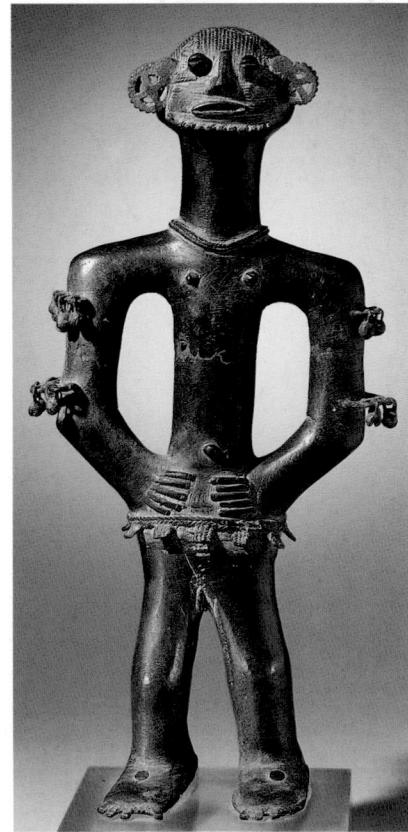

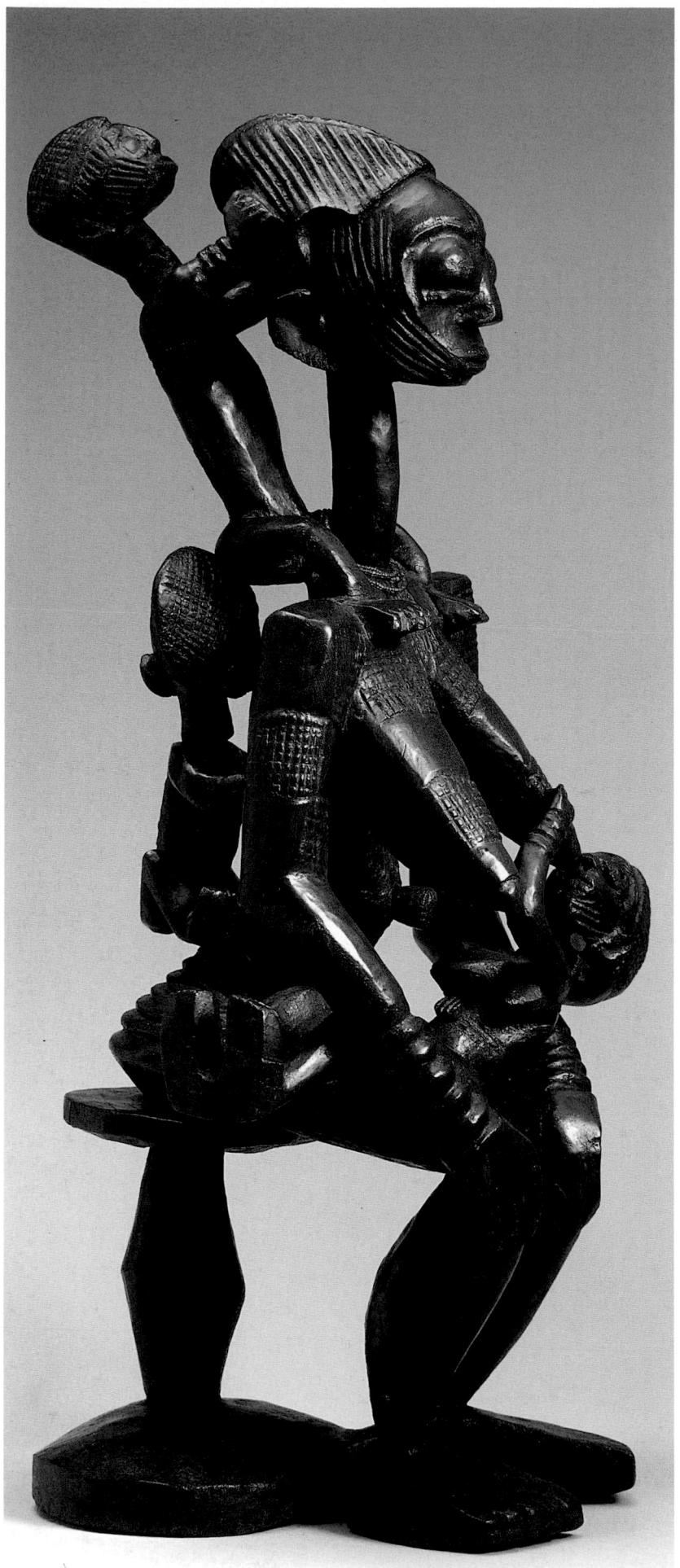

5.32a

Maternity figure

Afo (?)

Nigeria

19th century

wood

70 x 30 x 31 cm

Horniman Public Museum and Public Park Trust, London, 31.42

Both of these sculptures are now generally attributed to the Afo (cat. 5.32a was for a time assigned to the Yoruba, and cat. 5.32b to the Jukun, although it is quite unlike other Jukun figure carvings).

The maternity figure (cat. 5.32a) is unusual not only because there are three infants (rather than one) but because instead of being carved from a single block of wood, several pieces of wood were pegged in its construction. William Fagg suggested that Afo maternity figures represent an ancestral mother. Tschudi notes that 'every community of any size possesses ... a carved statuette representing a pregnant woman with a child on her back. This is worshipped in ceremonies by the men of the village praying for the preservation of fertility in their wives.' More generally it may be ancestral and attend to the well-being and health of the villagers.

In the early 1960s Rubin photographed a caryatid stool at the Jukun village of Gidan Yaka on the south bank of the Benue River about 20 miles from Wukari. In 1958 Sieber photographed one among the Goemai across the Benue River from the Jukun. Although a number of examples in related styles have been attributed to the Afo, none has field provenance. Some are figures, others are caryatids supporting a disc or a bowl on top of the head. All known instances are formally related and represent a female figure, often with an infant on her back. Many exhibit facial and body scarification and a large herniated navel, in which respect they resemble cat. 5.32b. However, facial scars similar to both figures are found on Jukun and Igala masks indicating that the Afo are not alone in using this form of scarification.

It seems that the stools were not cult objects. Rubin describes the stool he saw as 'an oath image used in cases of theft, and prayed to in certain crisis situations, such as drought'. Further, he notes that there was an 'earlier intimate association with a powerful and revered ancestor'. None the less, 'the figure appears to stand outside more usual ... channels of access to the ancestor involved, such as masks or figures'. The stool Sieber photographed was used as a seat for a masked dancer to rest on; no other association was offered.

Despite the formal and stylistic parallels for this type of object, it may be too easy to attribute all examples to the Afo. Kasfir notes that the 19th-century Fulani jihad 'scattered many of the [Benue] north-bank populations, and with them their cults and cult sculpture'. The result, she suggests, is 'a pantribal genre of mixed provenance, rather than a single point of diffusion'. The result may well be a style that evolved along both banks of the Benue from near its confluence with the Niger upriver for some 40 km.
BH, RS

Provenance: cat. 5.32a: early 20th century, collected by Major FitzHerbert Ruxton; 1931, acquired by the museum; cat. 5.32b: 1904, collected by Capt. Glaunig in Wukari (capital of the Jukun)

Bibliography: Underwood, 1947, fig. 21; B. Fagg, 1948, p. 125 and pl. K; B. Fagg, 1958; Sieber, 1958; Fagg, 1963, fig. 143b; Krieger, 1969, no. 231, pl. 230; Rubin, 1969, i, pp. 91–3, ii, figs 161–4; Tschudi, 1969–70, pp. 84, 95; Kasfir, in Vogel, 1981, p. 163; Sieber and Walker, 1987, cover, p. 39

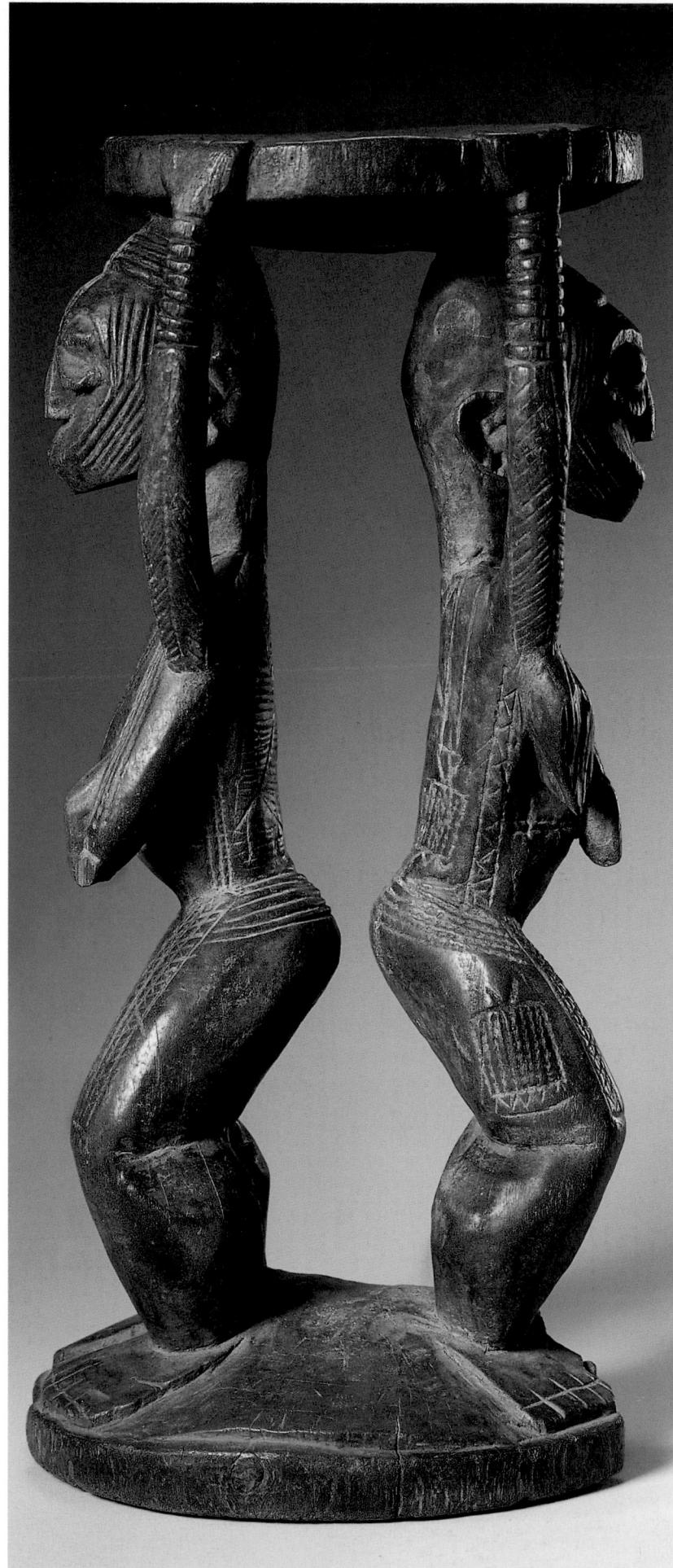

5.32b

Double caryatid stool

Afo (?)

Nigeria

19th century

wood

h. 57 cm

Staatliche Museen zu Berlin, Preussischer Kulturbesitz, Museum für Völkerkunde, III C 18455

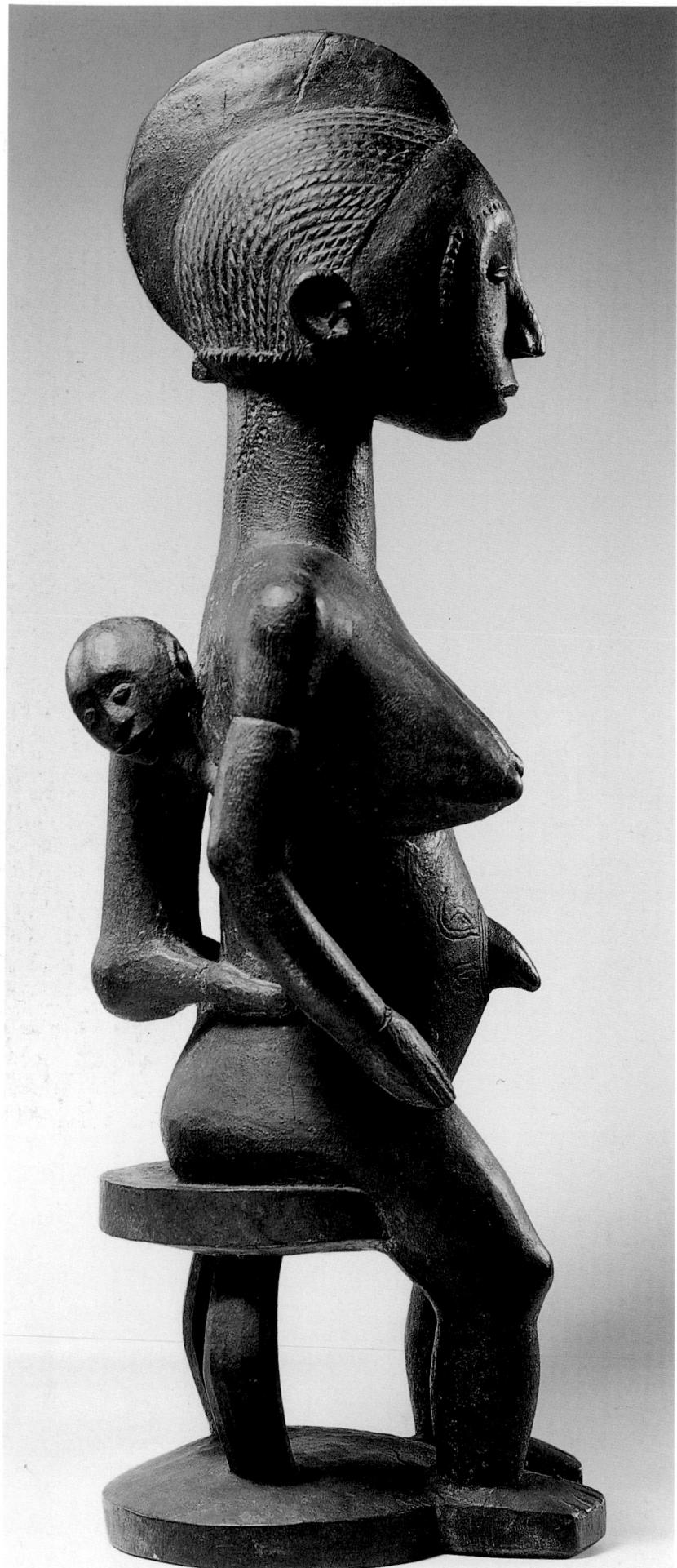

5.33

Female figure with child (*ekwotame*)

Idoma or Tiv

Nigeria

19th century

wood

h. 68.5 cm

Dr Laurence R. Goldman, Brisbane

Fewer than half a dozen figures in this style by at least two hands are known. One example was photographed by Sieber in the Idoma village of Oturkpo-Icho in 1958, resulting in a provisional attribution to the Idoma, the eastern neighbours of the Tiv; it is apparently by the same hand as this piece, which was formerly in the Epstein Collection. The name *ekwotame* ('image with breasts') may well be local. No other example has field data, precise origin, name or use. According to Kasfir, members of the family who owned the Oturkpo-icho figure stated that it was purchased in a Tiv village by the present owner's great-uncle about 1870; Sieber's informant (from the same family) reported that it was owned by his grandfather at least 50 years earlier, but did not mention a Tiv origin. Possibly the carving workshop was Tiv. The scarification around the herniated navel and on the face are characteristic of the Tiv; the work may have been carved by an Idoma artist active in a Tiv borderland.

There is some confusion with regard to the function of the sculpture. Sieber was firmly told that the piece he recorded was not a juju, but was placed next to the bodies of old men at their funerals. Kasfir reports that she was told that it was 'a very powerful "juju"' and has by accretion incorporated wealth, fertility, luck and protection functions'. BH, RS

Provenance: ex collection Jacob Epstein

Bibliography: Sieber, 1961, fig. 5, pp. 8-9; Kasfir, 1979, pp. 337 ff., figs 94-100; Bassani and McLeod, 1989, fig. 230, p. 106

Large carvings made from a single piece of wood, often sculpted from a considerable portion of a tree, were widespread in the Middle Cross River region of south-east Nigeria, especially among such groups as the Bahumuno, Yakur and Mbembe of the Obubra area. A few free-standing carved pillars can still be seen among the Yakur. These usually serve to define ward territory within typically compact village settlements, the sites of annual ceremonies connected with the agricultural cycle. During the 1970s some communities around Obubra also possessed drums with finials carved in the round in either animal (e.g. monkey) or human form, representing the head or full body, the latter often seated. Given that these sculptures are carved from the same piece of timber as the slit drum itself, unusually for African carvings, the grain of the wood is horizontal - opposite to the axis of the head or figure in upright position.

Large slit drums were generally the property of the community or a specific male association such as the leopard spirit society (cf. cat. 5.35) or an age-set. They were used to summon able-bodied men to tackle an emergency such as fire or (formerly) slave-raiding forays or to inform communities (for drum language can carry over many miles) of important news, especially the death of a prominent person.

During the Nigerian Civil War of 1967-70, it is said that Biafran soldiers caused fear and confusion among the enemy by using giant slit drums to imitate artillery fire. Sadly, during the war and its aftermath, many pillars and drums in this area had portions lopped off them in order to satisfy the demands of the international art market, so that by the 1970s relatively few remained intact.

Both the Mbembe pieces shown here are weathered, having been exposed to tropical rainfall in the context of their original use. Such weathering serves to enhance rather than detract from the aesthetic quality and is probably indicative of a late 19th-century date. KN

Provenance: cat. 5.34a: ex collection Kamer

Bibliography: Forde, 1964; Harris, 1965; Eyo, 1977, pp. 220-2; Nicklin, 1981, pp. 259-60

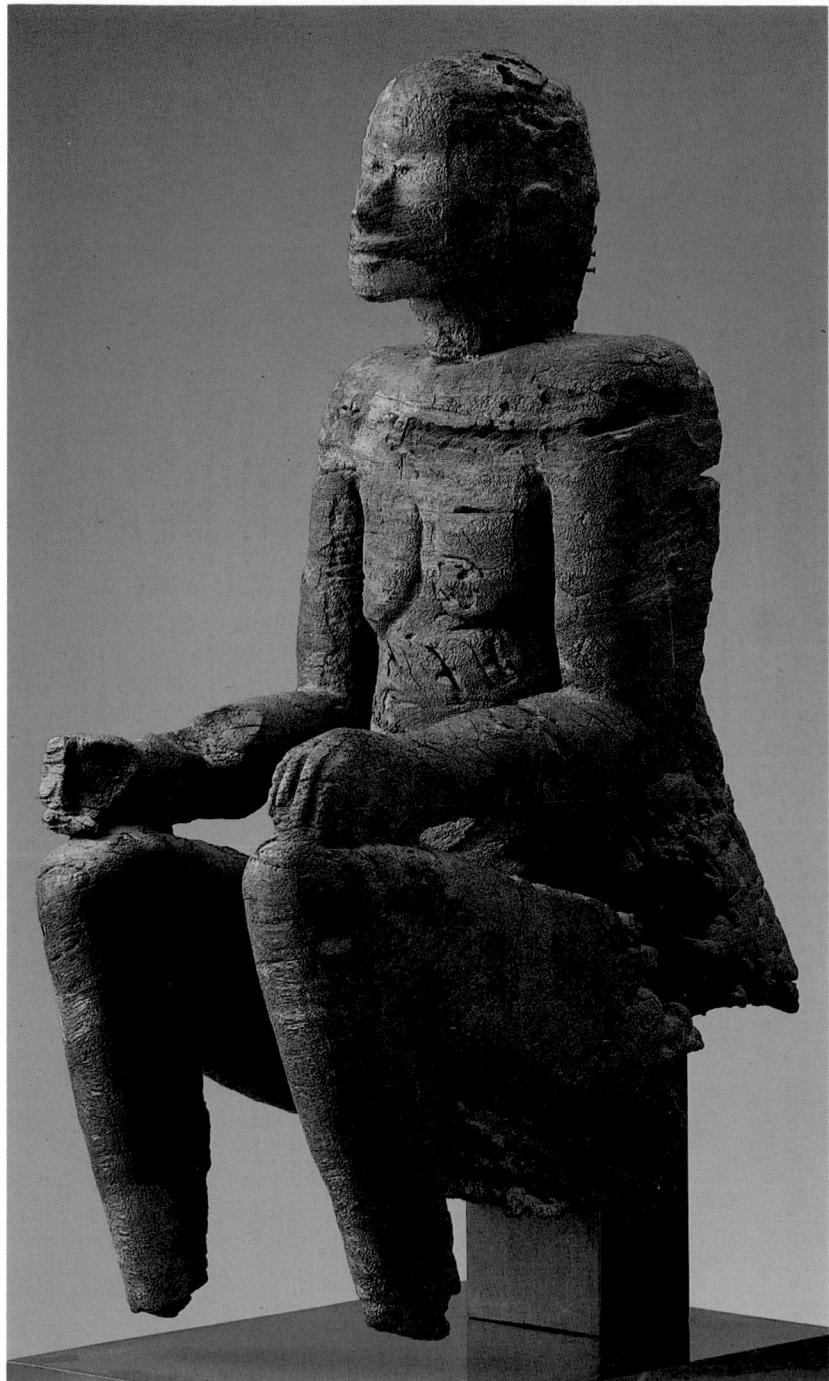

5.34a

Drum finial: seated figure

Mbembe
south-east Nigeria
late 19th century
wood
h. 80 cm
Private Collection

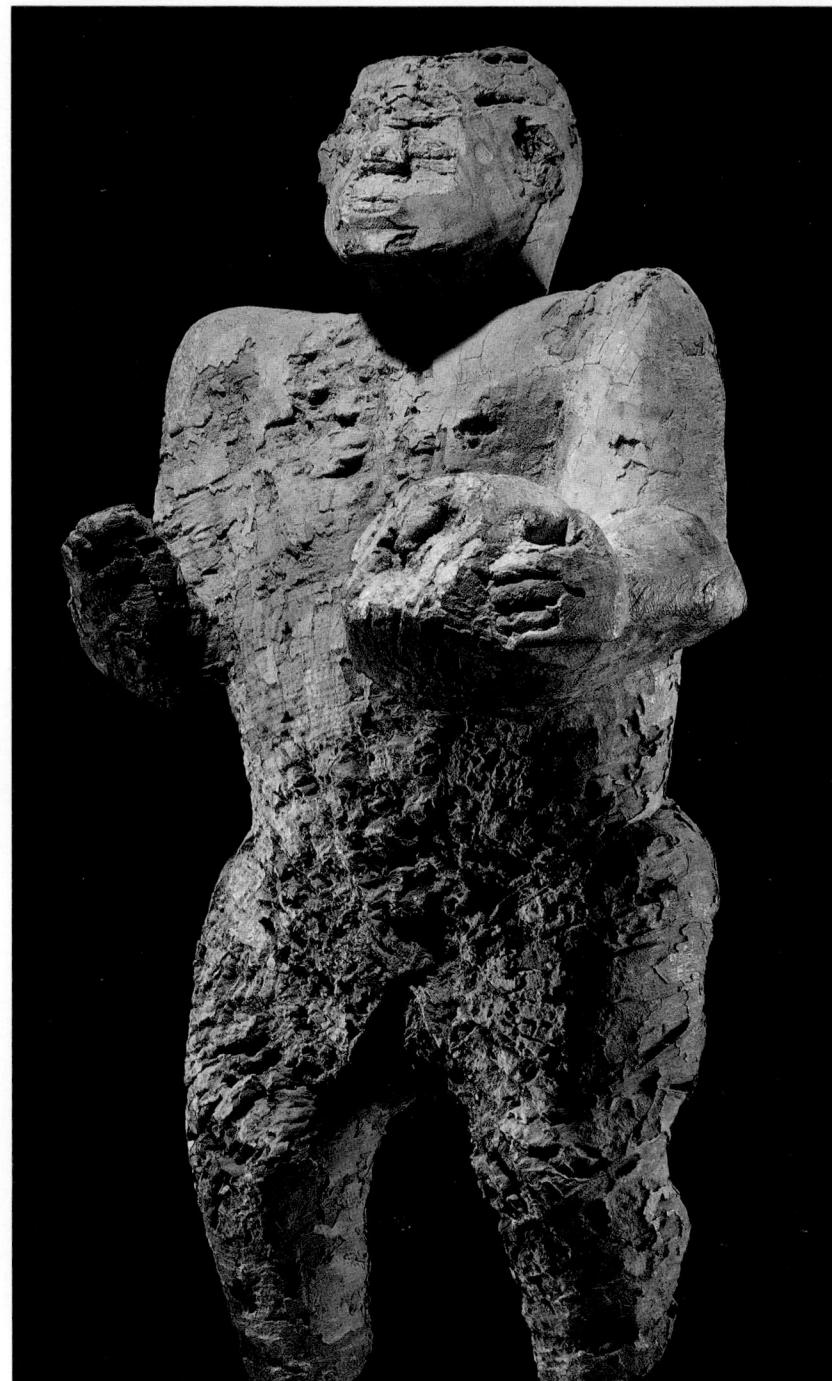

5.34b

Standing figure

Mbembe
South-east Nigeria
wood
h. 85 cm
Private Collection

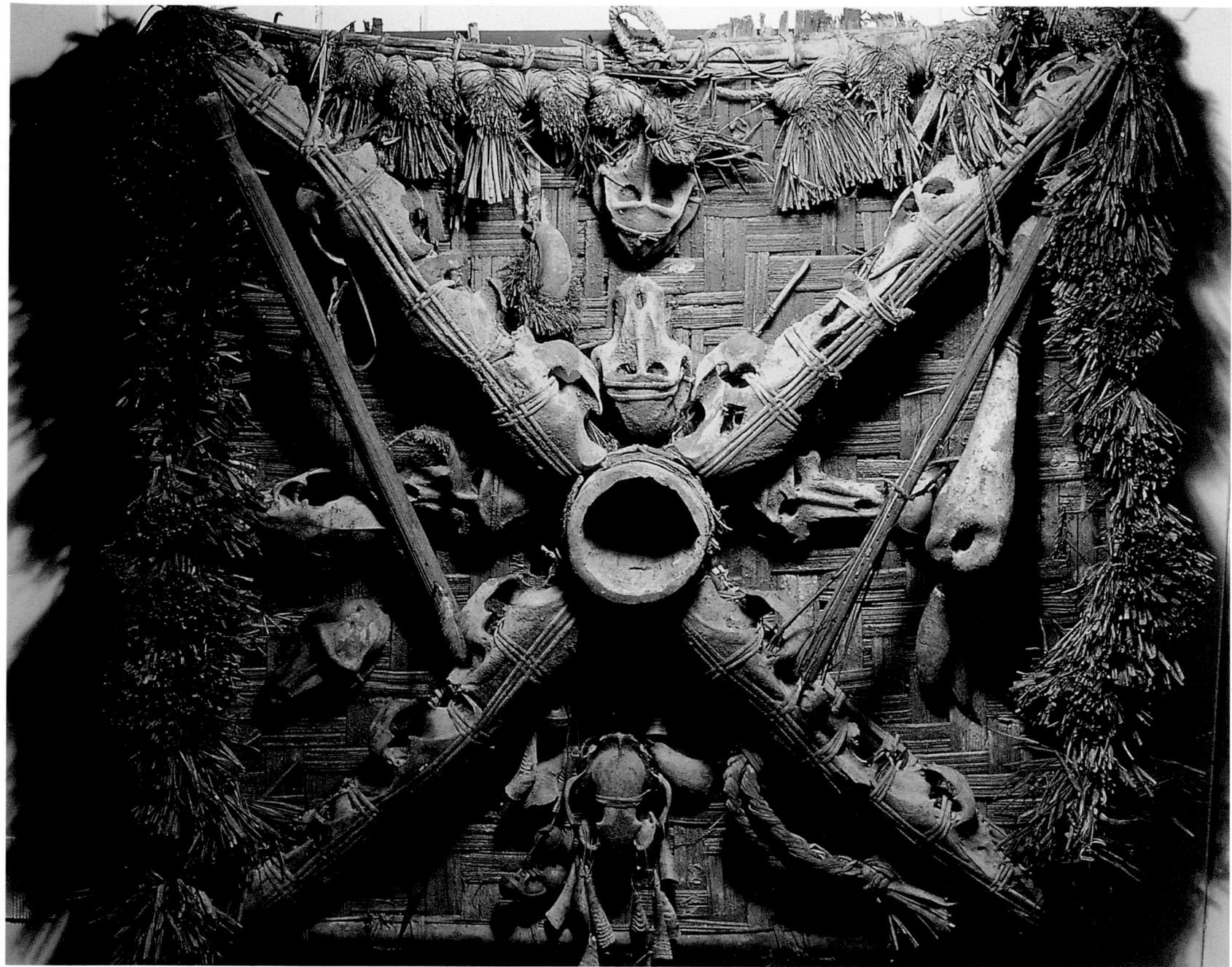

5.35

Emblem of the leopard spirit society

Ejagham

South-east Nigeria/south-west Cameroon
20th centurycane, wood, animal skulls, fibre
127 x 132 x 16 cm
Charles and Kent Davis

This is a fine example of an emblem of the Ngbe (leopard spirit society) of the Cross River borderlands of south-east Nigeria/south-west Cameroon. Talbot (1912) recorded such items for the Ejagham, and Ruel described those of the Banyang.

Ngbe, a major regulatory society of the Cross River region and its adjacent

territories, may be seen either as a federation of distinctive sub-associations or as a graded unitary society. After initiation into the most junior echelon of Ngbe, often in childhood or adolescence, a man proceeds to join some or all of the sections of this all-male society, which have varying degrees of prestige and distinctive bodies of lore. Membership is granted by senior elders of the cult, upon payment of customary fees in cash and kind, in return for esoteric knowledge and, sometimes, regalia.

As well as having their own forms of masquerade costume, song and dance, sub-associations of Ngbe

sometimes have their own emblem which is adorned with the skulls and horns of beasts consumed at the foundation feast. The Banyang screen (*nkpa*) described by Ruel was the property of the Bekundi sub-association of Ngbe. The basic structure of the *nkpa* is that of a mat, usually woven from palm leaves or palm-leaf midrib bark, strengthened at the edges with lengths of palm midrib decorated with raffia tufts. The specimen in question is equipped with a suspension loop, by which means it would have been attached either to the central pillar of the Ngbe lodge, or the wall behind which lay the inner sanctum.

Most Ngbe emblems have at the centre one or more membrane drums. Not only is such a drum essential to all Ngbe performances, but it is used by the society's crier in making announcements, and is thus a symbol of its legislative authority. The circular structure at the centre of the present specimen is probably the wooden body of such a drum, with its membrane missing. A more remarkable feature, however, is the lines of skulls, firmly secured with cane, which radiate from the centre, as diagonals, possibly an expression of the 'four quarter' motif painted on some Ngbe drum heads. Between the four quarters of the screen are several

skulls, of baboons, cows and canine animals, as well as goat and/or antelope skulls and horns. The overall configuration of the lines of skulls is reminiscent of certain motifs of the type associated in the Cross River region with a pictographic script called Nsibidi, and with a form of sacred calligraphy known as Anaforuana among Cuban members of Abakua (a form of Ngbe which found expression among the descendants of Cross River victims of the trans-Atlantic slave trade).

Other items incorporated into the screen include a baton-like staff, a palm-fibre broom and two loops of rope. Ceremonial brooms convey a number of meanings among Cross River peoples: they may be used in extending sign-language expressions or be carried in procession as devices to sweep away hostile 'medicines'. Among the Banyang of Cameroon, loops of cordage are employed by Bekundi initiates as signs which bar entry or deter theft. KN

Bibliography: Talbot, 1912, p. 264; Talbot, 1926, pp. 346–783; Ruel, 1969, pp. 220–1; Cabrera, 1970; Cabrera, 1975; Thompson, 1983, p. 241; Rubin, 1984, p. 68; Nicklin, 1991¹, pp. 3–5

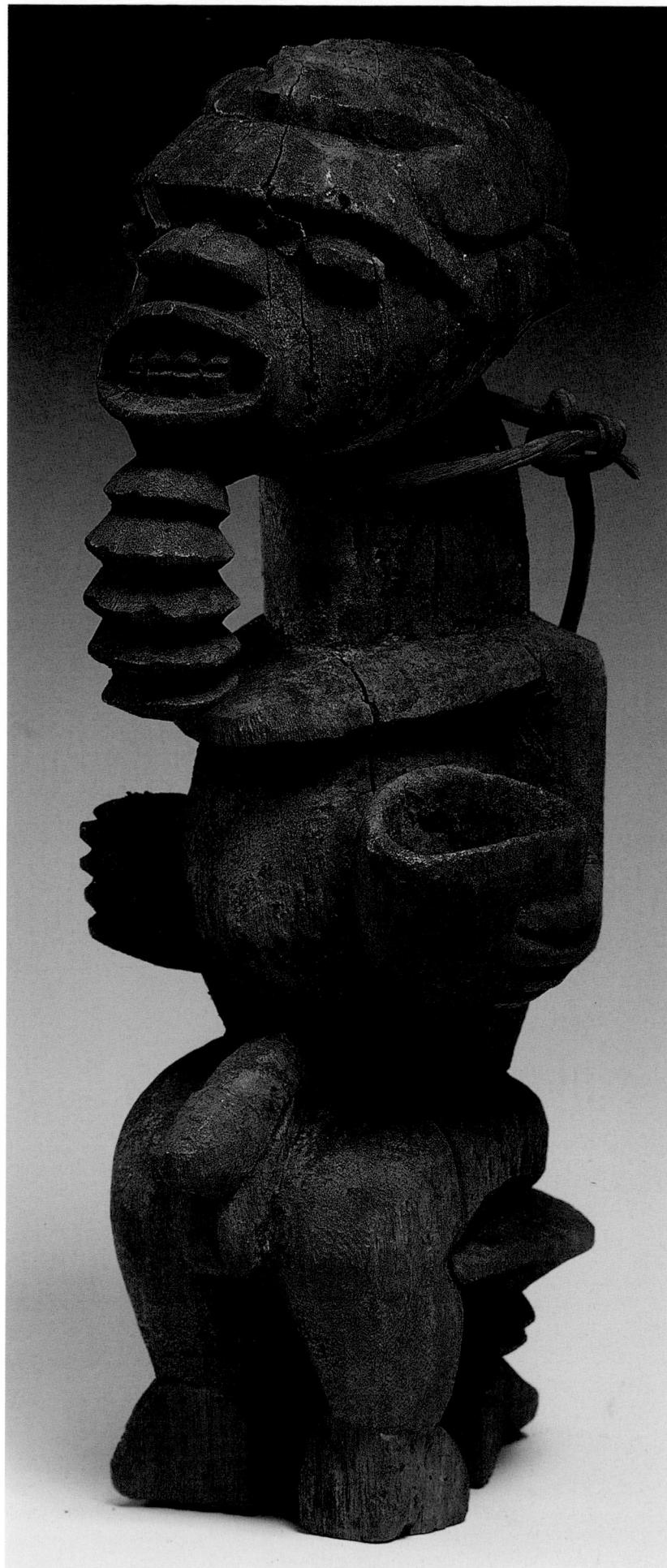

5.36

Seated male figure

Bangwa (?)

Western Cameroon

late 19th century (?)

wood

35 x 14 x 16 cm

The Trustees of the British Museum,
London, 1920.11-6.5

Although this fine piece is given an Ekoi (Ejagham) attribution by William Fagg, there is little about the style of carving to confirm this. The mode of depiction of the coiffure/cap, brows, open mouth with prominent teeth and plaiting of the beard in segmented fashion are all reminiscent of western Grasslands style and specifically suggestive of masks and figures of the Bangwa, a Bamilike people at the western limit of distribution, adjacent to the forest-dwelling Banyang and Ejagham. The figure's seated posture is similar to that of carving styles even further to the west, for example among the Ibibio, Annang and Ogoni of south-east Nigeria. According to the museum's records it is from 'Nikim ... Befun country'.

It is possible that this is a Bangwa ancestral figure carved by an artist influenced by styles to the west, the dominant axis of overland trade routes leading to the port of Calabar in the lower reaches of the Cross River. Some Bangwa artists are known to have travelled long distances to work for distant patrons. KN

Bibliography: Fagg and Plass, 1964, p. 51;
Brain and Pollock, 1971; Brain, 1980

Carved monolith (*atal*)

Bakor, Ekoi (Ejagham)
 Cross River, Nigeria
 16th century (?)
 basaltic stone
 h. 114 cm
 Musée Barbier-Mueller, Geneva, 1015.9

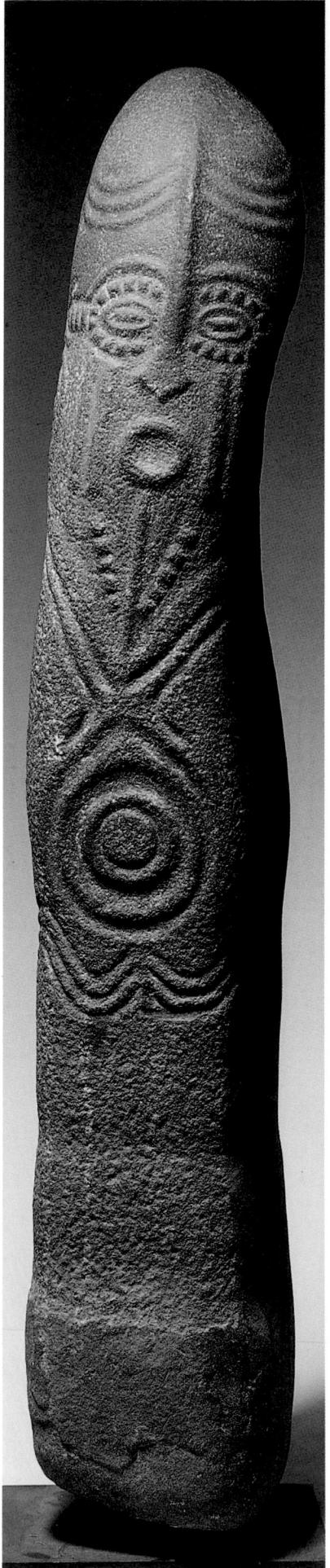

The deeply grooved features on cat. 5.37a depict an individual wearing a stocking cap commonly used today by village heads and other titled individuals in many parts of eastern Nigeria. The figure may therefore represent a chief or a titled official. He is shown with an elongated nose and segmented eyelids that encircle the almond-shaped eyes. On either side of the eyes are horizontal keloids, representing the raised tattoo marks that can still be seen today on the faces of elder men and women of the area. The mouth is a simple circle, while the navel is formed by equally simple concentric circles. Spirals on both sides of the body represent coiled manillas used as currency in the past. The curvilinear style of rendering the human features is peculiar to the monoliths of the Abanyom, Agba and Nnam groups of villages, particularly the Nnam.

This style is distinct from the more sculptural style seen, for example, in cat. 5.37b, which is peculiar to the Nta, Nde and Nselle groups of villages. The depiction of human form in this example approaches the sculptural in that an attempt has been made to separate the head from the torso with a deep, broad groove. The round eyes set under heavy eyebrows, the open mouth with the tongue sticking out, and the bearded, austere face all indicate the role of the individual portrayed. This figure is known as Ebiabu and stands for the society of that name, which was responsible for carrying out death sentences. The monolith was recorded *in situ* at Etingnta, the main village of the Nta group. A similar monolith, also called Ebiabu, has been recorded at Nna Orokpa, another Nta village.

These columnar basaltic stones on which human features were carved come from the basin of the Cross River or its tributaries. They are found almost exclusively within the five village groups of Nnam, Nselle, Abanyom, Nde and Akaju, who inhabit an area of over 900 sq. km in the middle of the Cross River area. Together, these groups of villages form a homogeneous linguistic group known as 'Bakor'. The Bakor language is a sub-dialect of the larger linguistic group known as Ekoi or Ejagham. The Ekoi or Ejagham are found in the easternmost part of southern Nigeria and in the contiguous area of the west-

ern Cameroon Republic. They are hoe agriculturists and their main crops are yam, cocoyam and maize. The men are hunters, but help in clearing the bush for women to farm. The unity of the 'Bakor' linguistic group, despite its former internecine warfare, has now been politically expressed in the joint celebration of the annual New Yam Festivals into which the carved monoliths are incorporated. Because these monoliths are almost exclusively found in the Bakor linguistic area, the term 'Bakor' is used here to refer to them (rather than 'Ekoi' or 'Cross River', terms that are too imprecise because they refer to a much wider and more diffuse geographical area than is relevant to these stones).

These monoliths were first described by a British District Officer, Charles Partridge, in 1905, who noted that at the Alok village of the Nnam group the monoliths were painted and offerings were made to them during the New Yam Festival. In 1968 Philip Allison made a comprehensive documentation of the monoliths, which number over 300 and which range in height from 90 to 180 cm. They are found mostly in abandoned village sites arranged in perfect, near perfect and segmented circles. When found in present-day villages, the monoliths are usually arranged in clusters of several stones or individually beside a big tree in the middle of the village. It seems that most of the monoliths found in the present-day villages were removed from old village sites and brought to the new settlements when the community moved. In their original setting the monolith circles enclosed areas that were used as a marketplace and as a community playground during the day and occasionally at night for secret ritual activities. Through historical reconstruction Allison dated the monoliths of Nta to the 16th century, when trade with Europeans in Calabar at the mouth of the Cross River brought prosperity to the inland peoples of the Cross River. This dating seems to be supported by a recent carbon-14 from Alok, but another carbon-14 date from Emangabe gave the date of around AD 200.

Allison gave the name *akwanshi* to the carved monoliths and it has since been widely used. Recent studies have revealed that the use of the term is incorrect. '*Akwanshi*' is used only by the Nta and Nselle groups to designate

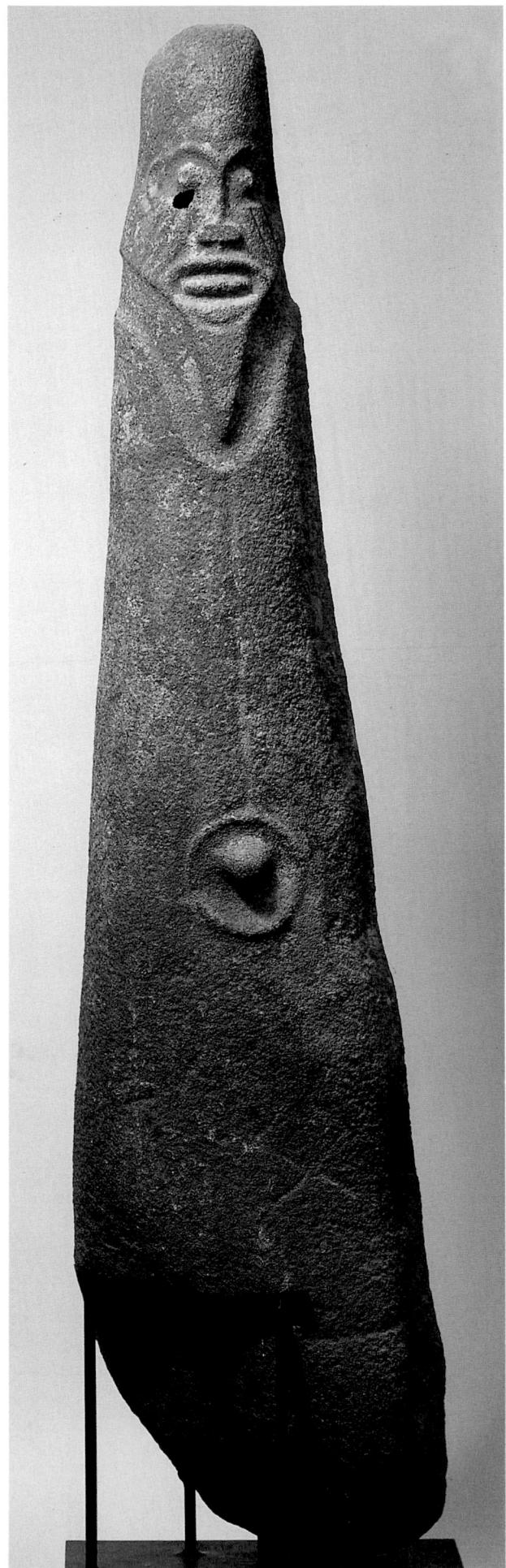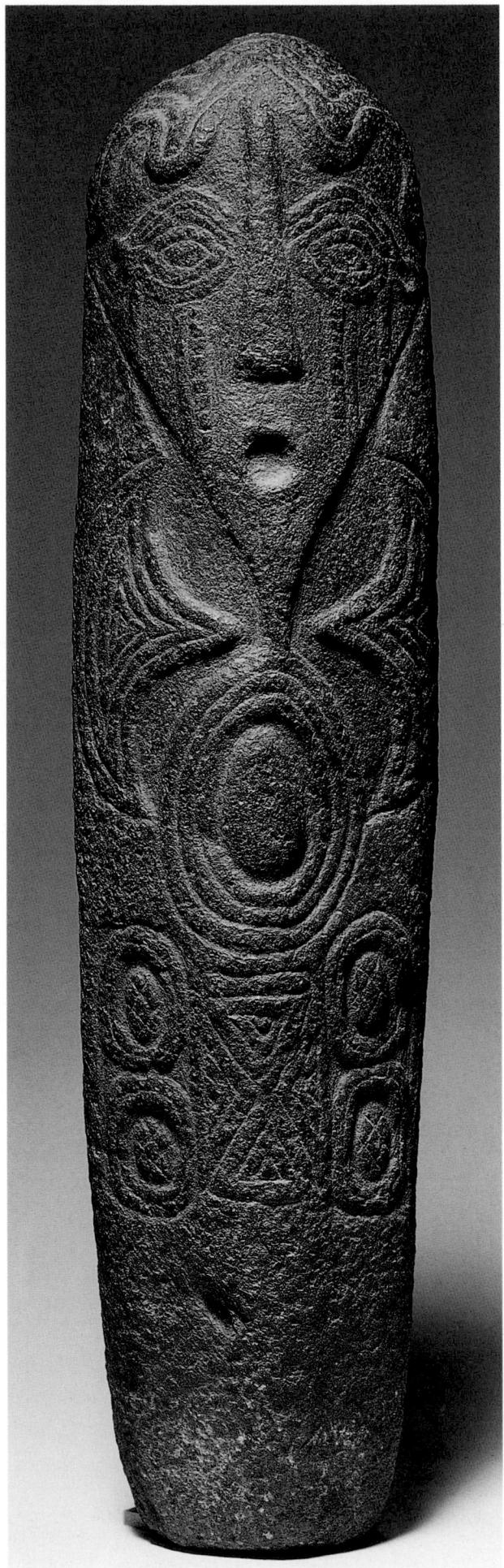

small uncarved stones representing dead ancestors of the family or lineage; they range in height from 7.5 to 15 cm. They are usually piled in a heap in the compound of the family or lineage head and sometimes within the circle of the village's larger monoliths. Among the Nnam, Abanyom and Akaju these small uncarved stones are known as *akuku*. On the other hand, the Nta group use the word *netal* to refer to the large carved monoliths for which the Nselle term is *alapatal* and the Nnam and Akaju term is *atal*. Although these large carved stones also represent dead ancestors, they refer more specifically to dead legendary figures linked to memorable events. For example, the carved monoliths may represent famous hunters or warriors, the personification of the very beautiful or the very ugly. Special functionaries in the society were also represented, for example, the figure of Ebiabu mentioned above. Hence, instead of the term *akwanshi*, the shortest version of all the designations of the carved monoliths is adopted here: *atal* (used by the Nnam, Abanyom and Akaju), also because it is cognate with the Nta *netal* and the Nselle *alapatal*. EE

Bibliography: Partridge, 1905; Allison, 1962; Allison, 1968; Eyo, 1984

5.37b

Carved monolith (*atal*)

Bakor, Ekoi (Ejagham)
Cross River, Nigeria
16th century (?)
basaltic stone
h. 174 cm
Private Collection, Brussels

5.37c

Carved monolith (*atal*)

Bakor, Ekoi (Ejagham)
Cross River, Nigeria
16th century (?)
basaltic stone
h. 84 cm
Private Collection, London

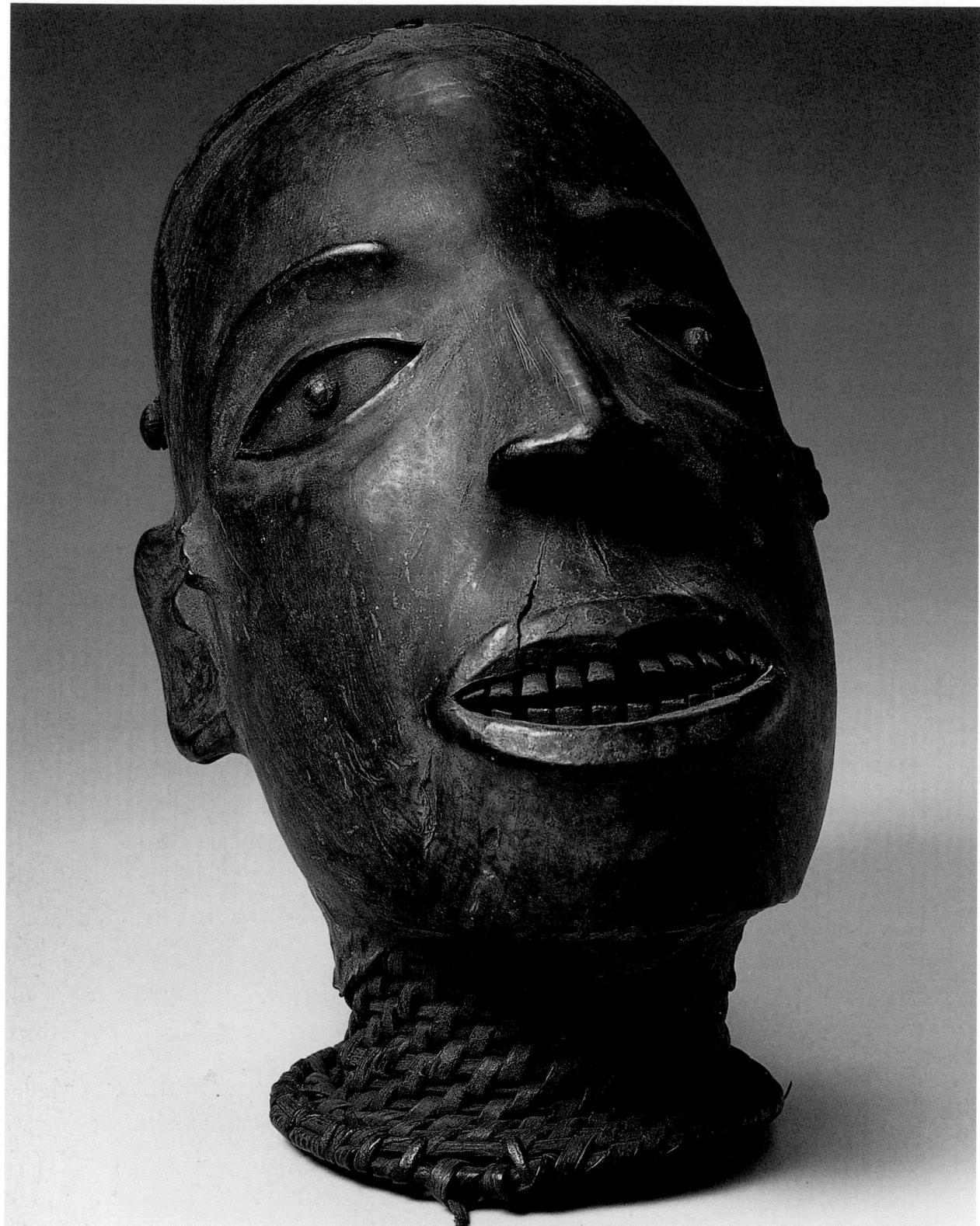

5.58

Skin-covered cap mask

Ejagham
Cameroon
19th century
wood, animal (?) skin, cane
h. 21.5 cm
Museum für Völkerkunde, Leipzig,
MAF 8705

This is a cap mask or headdress carved from wood, covered with skin and with a base of woven basketry for attachment to the head of the masquerader. Although there are authenticated cases of human skin being used to cover such masks, which are typical of the Cross River rain forests of the southern Nigeria/Cameroon borderland, the use of

carefully de-haired and softened antelope skin is much more frequent. The techniques used in the production of skin-covered masks are more complex than those of most other African mask sculpture, as the subtractive process of carving is followed by an additive one involving not only the attachment of the skin to the wooden surface, but also inserts of metal or

cane to represent the eyes and teeth; the pupils of the eye consist of a metal or wooden nail or peg.

Creases and folds in the skin covering of this piece, especially around the mouth, suggest either insufficient technical mastery or the artist's intention not to produce a smooth surface. The latter may reflect context of use, for skin-covered masks are often employed in pairs, a rather ugly and often aggressive male character or the 'Beast' (as probably represented in the present piece) interacting with a gracefully moving female character or 'Beauty'. The upward tilt of the head is characteristic of the former category of mask, often with those that most closely resemble a real human head carried above the performer's head. The bodies of both dancers would normally be entirely covered by a long gown, formerly of string netting, more recently of cotton cloth.

The patina of this cap mask indicates a lengthy period of use; between performances it was probably carefully wrapped in bark cloth or woven screw pine matting and stored in rafters near a continually smouldering hearth. It was customary to rub the mask with palm oil and to place it in gentle sunlight before use, so that the skin retained some flexibility and often achieved a degree of glossiness as this example has at its lips and the tip of the nose.

Masquerade performances generally took place at the initiation or funerals of members of the associations that owned them, and also at periodic rites connected with agriculture. Thompson suggested that the skin covering of a mask served as a magical agent to invoke ancestral spirits, thus eroding the barrier between living and dead participants in communal rituals.

The naturalistic style of this headdress, especially the careful delineation of the lips and eyes, indicates Middle rather than Upper Cross River origin, probably from one of the smaller Ejagham-speaking groups of people on the Cameroon side of the border, such as the Keaka. KN

Bibliography: Mansfeld, 1908; Nicklin, 1974, pp. 8–15, 67–8; Nicklin, 1979, pp. 54–9; Thompson, 1981, pp. 175–6; Nicklin, 1983, pp. 125–7

Cap mask

Ejagham/Anyang

Cameroon

19th century (?)

wood, pigment, fibre

h. 29 cm

Private Collection, Paris

It is usual for mask makers of the Cross River region to enhance the realism of their work by applying a layer of animal skin and then painting it with plant dye to accentuate facial features. There is some evidence in this piece of black or dark brown pigment having been applied to the face and head for this purpose, though directly on to the wood. Other modes of decoration normally associated with skin-covered mask art are also to be seen, for example the remains of pegs, representing coiffure; and a metal inset to form the eye, pierced by a wooden peg depicting the pupil. A vertical row of copper studs represents scarification marks on the temples. The headdress does not, however, have a basketry base of the type often associated with skin-covered cap masks.

William Fagg wrote on a mask (in the Museum für Völkerkunde, Frankfurt am Main, and described by de Rachewiltz as a 'Girl's head in wood, with a wig') that is in the same style and possibly by the same hand as this example. He correctly asserted that 'the subtlety of the artist's hand was such that the addition of skin could only have weakened the effect' of its superb naturalism.

The colour and finish of the headdress indicate that it was once repeatedly rubbed with palm oil. Unlike certain classes of African mask that were allowed to decay after use, cap masks and helmet masks were often looked after with great care in periods between masquerades. They were regarded as valuable property by the age-sets, warriors' and hunters' groups who owned them. Nevertheless, this piece has suffered some termite damage. It is probably from a master carver of the Anyang, a small Ejagham-speaking group in southwest Cameroon. KN

Bibliography: Fagg, 1965; de Rachewiltz, 1966; Nicklin, 1974, pp. 8-15, 67-8; Nicklin, 1979, pp. 54-9

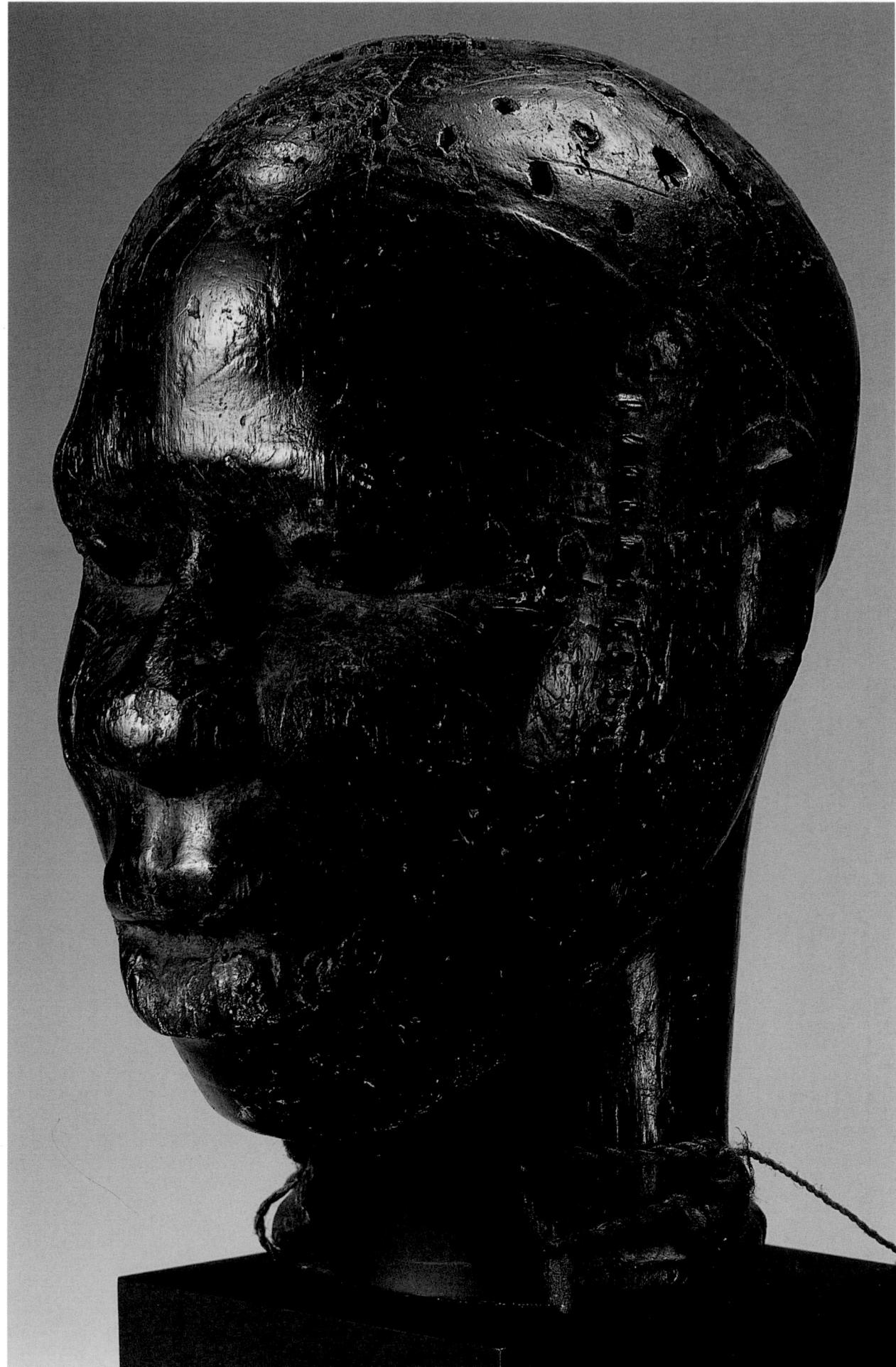

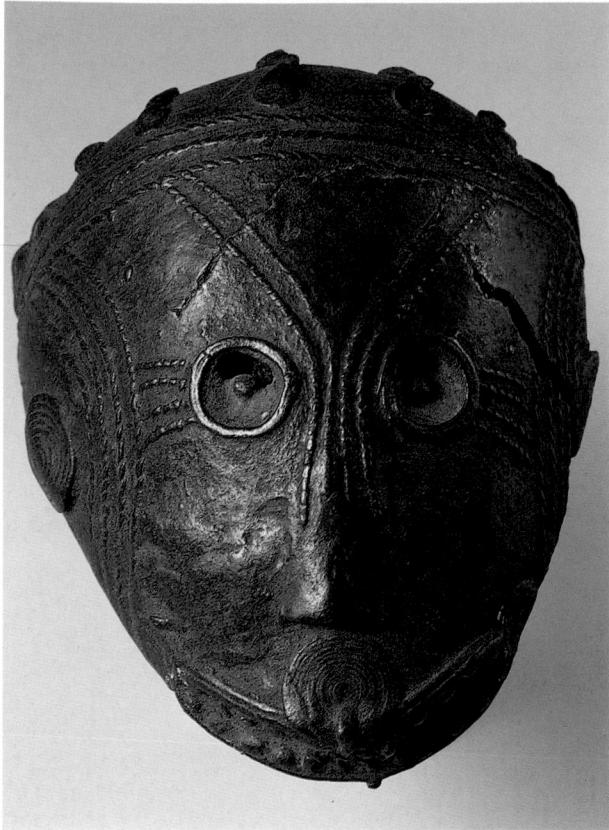

5.40

Head

Cross River
South-east Nigeria
18th century (?)
copper alloy, clay core
15 x 12 x 10 cm
Private Collection

This almost ovoid therianthropic object appears to possess human features combined with those of a fish or snake, probably a python. Rather than eyes, there are two eye sockets, ridged on the inside, and the upper and lower jaws have a series of projections, both pointed and curved, which look barbel- rather than tooth-like. At either side of the mouth, at the centre of the lip and on both temples are spiral motifs of a kind common to the decorative repertoire of Cross River metal and stone sculpture. Such motifs were executed on the human body and face until the later 19th century. Bands of skeuomorphic stitchwork decoration run across the top of the forehead between eye and temple and also traverse the face from top of forehead to nose. The knobs and elongated projections towards the back of the head are reminiscent of a manner of representing plaited coiffure in some Cross River mask sculpture.

5.41

Zoomorphic head

Cross River, Nigeria
16th–17th century
copper alloy
h. 17 cm
Private Collection, London

This fragment of a copper-alloy sculpture depicts a zoomorphic head, perhaps that of a sheep. Its open mouth is bordered by a ropework pattern also used to form concentric circles around the disproportionately large, open eyes. The rope pattern is also employed horizontally in the nose area of the head and in criss-crossing the area between the nose and the eyes. This pattern is widely used on copper-alloy art objects from the Cross River, for example, on the therianthropic head (cat. 5.40). It can also be seen on some of the famous leaded bronzes from Igbo Ukwu (9th–10th centuries).

There is no known copper-alloy casting centre in the Cross River area comparable to Ife, Benin or Igbo Ukwu. Yet numerous copper-alloy artefacts have been found in the region, primarily in shrines. It has been suggested that the bells and other items were brought here through trade by itinerant Igbo metal smiths, but the possibility of a small-scale casting industry in the Cross River area itself should not be overlooked. For example, Keith Nicklin has recorded a site at Mbak Itam on the western bank of the Cross River as perhaps 'a major iron smelting and brass casting archaeological site'. It is believed that with the importation into eastern Nigeria of manillas, copper rods and twisted copper wires (including the *chittem* by European traders to be used as currency from the 16th century) some could have been melted down and used for the casting of such objects. EE

Bibliography: Forde, 1964; Nicklin and Fleming, 1980, pp. 104–5; Fleming and Nicklin, 1982, pp. 53–7; Nicklin, 1982

Face mask

Middle Cross River
South-east Nigeria
20th century (?)
wood
h. 32.5 cm
Private Collection

This face mask is remarkable for the pronounced and protruding lips, for the area of the eye sockets in the form of an upper and lower rounded rectangle, as well as for a series of prominent vertical bars on the forehead. The teeth are roughly rendered in the large mouth. The overall impression is that of a man/ape, the latter characteristics derived from the mandrill (*Papio sphinx*), a species of west African baboon hunted for food in the Cross River rain forest.

Among various peoples of the Middle Cross River region of Ikom and Ogoja, age-sets and other groups perform masquerades involving a female 'Beauty' and a male 'Beast' (cf. cat. 5.38). While the female wears a wooden cap or helmet mask (sometimes skin-covered) and a long cloth gown, the male is dressed in a shaggy, net fibre costume, with or without a carved face mask. The latter typically behaves in an aggressive, lewd manner associated with ape behaviour. Such performances occur at funerary ceremonies and first fruit or 'New Yam' festivals connected with the beginning of the agricultural cycle.

The artistic treatment of the mouth of this face mask and the deeply scored brow is comparable with that of some Janiform helmet masks of the Middle Cross River. KN

Bibliography: Nicklin, 1981, pp. 170-1; Neyt, 1985, pp. 110-11

5.43a

Ancestor figure (*ekpu*)

Oron

South-east Nigeria

19th century

wood

104.5 x 30 x 26.5 cm

The National Commission for Museums
and Monuments, Lagos

All three of these Oron ancestor figures from the Cross River estuary of the Palm Belt region of south-east Nigeria strongly display stylistic features characteristic of this genre: headgear appropriate for an elder (appearing to balance rather precariously on top of the head); plaited beard; abdomen in the shape of an elongated onion with depiction of scarification; a stylised representation of a short skirt worn below the navel; relatively small genitals and short legs. The arms are close to the body, the elbows bent at right angles, and the hands hold carved horn-like objects believed to be representations of palm-wine drinking-horns or symbols of senior lineage office. Scarification is shown in the temple area on both sides of the head.

Formerly, when an elder died, a length of hardwood such as camwood (*Pterocarpus*) was carved to represent him and joined others in the men's meeting-house (*obio*) of the village. Here, they were offered sacrifices and libations and appealed to for the well-being of the community and to avert disaster, especially the loss of fishing crews and canoes. As time went by and further carvings were added they came to symbolise lineage identity and the rights of their owners, or 'records in wood' as Nsugbe expressed it. They thus served to validate the authority of living village elders.

Nigeria's first Surveyor of Antiquities, the late Kenneth Murray, was appalled by the poor condition of many of the *ekpu* carvings owing to the decline of indigenous beliefs in the face of Christian proselytisation during the early years of the 20th century. In 1947 he published the first detailed description of the genre, upon which the above account is based. Since the Oron elders refused permission for any carvings to be removed from clan territory, he advocated the establishment of a museum at Oron in which to preserve the *ekpu* figures. Originally a small earth building was allocated by the

colonial authorities for this purpose, but owing to the danger of fire and a series of thefts in the late 1950s (which allowed a number of ancestor figures to reach collections in Europe and the USA), a proper museum was eventually built and opened to the public around the time of Nigerian independence in 1960.

At the outbreak of the Nigerian Civil War in 1967 there are believed to have been well over 600 *ekpu* sculptures arranged in impressive open storage at the Oron museum, but by the cessation of hostilities in 1970 only just over 100 pieces remained, many of the best examples having been looted or burnt as firewood in a refugee camp at Umuahia. The remnant of the Oron collection formed the core of a permanent exhibition opened at the rehabilitated National Museum, Oron, in April 1977.

Originally, Oron *ekpu* figures were held by the Nigerian Department of Antiquities on trust, a receipt being issued to the owners at the time of removal from the original site. The owners, usually represented by a lineage head or other senior elder, retained the right to conduct traditional ritual observances at the museum in honour of the deceased persons commemorated by the *ekpu* carvings. In practice, however, this rarely, if ever, took place. The process of placing the *ekpu* figures in a museum destroyed their traditional spiritual value.

However, as a principal component of the rehabilitated museum at Oron, the *ekpu* figures played an important part in the nation-building process instituted by the Nigerian Federal Government after the Biafran War, therefore acquiring a new and unexpected spiritual value. Today, many members of the Oron community are proud of the *ekpu* figures displayed at the waterside museum site, and appreciate them as unique expressions of their own cultural identity. (The people of Oron have a history of fear of exploitation and suppression by neighbouring groups such as the Eket to the west and Ibibio to the north).

Despite the fact that the *ekpu* figures as a whole are a relatively homogeneous group, significant stylistic variation does occur within the genre, as illustrated by the present selection. Note the unusually broad,

squat appearance of cat. 5.43a, with its elaborate high relief decoration, and the attenuated character of cat. 5.43c in which the formal lines of the sculpture are not lost despite missing portions of the limbs and beard. Cat. 5.43b is in a particularly good state of preservation and shows how crisply all the forms are realised and how their totemic vertical pile is effectively organised. These are all representative examples of what Fagg described as 'one of the finest and oldest styles of wood-carving which are still to be seen [in Nigeria]'.

Cat. 5.43c is from Eke Ebung in the *afaha* of Enwang, and was said to have been carved in honour of Anwana Odung Anko. KN

Bibliography: Murray, 1946, pp. 112–14; Murray, 1947, pp. 310–14; Fagg and Plass, 1964; Nsugbe, 1961, pp. 354–65; Eyo, 1977; Nicklin, 1977; Nicklin, 1990; Nicklin, in preparation

5.43b

Ancestor figure (*ekpu*)

Oron
South-east Nigeria
19th century
wood
135 x 19 x 18 cm
The National Commission for Museums and Monuments, Lagos

5.43c

Ancestor figure (*ekpu*)

Oron
South-east Nigeria
19th century
wood
136 x 19.5 cm
The National Commission for Museums and Monuments, Lagos, PD/69.U.5

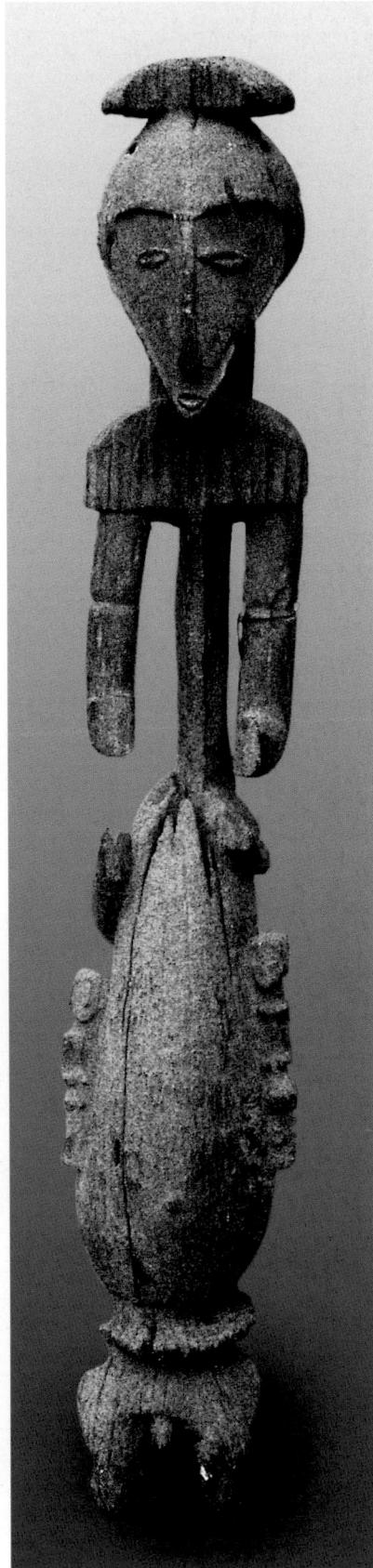

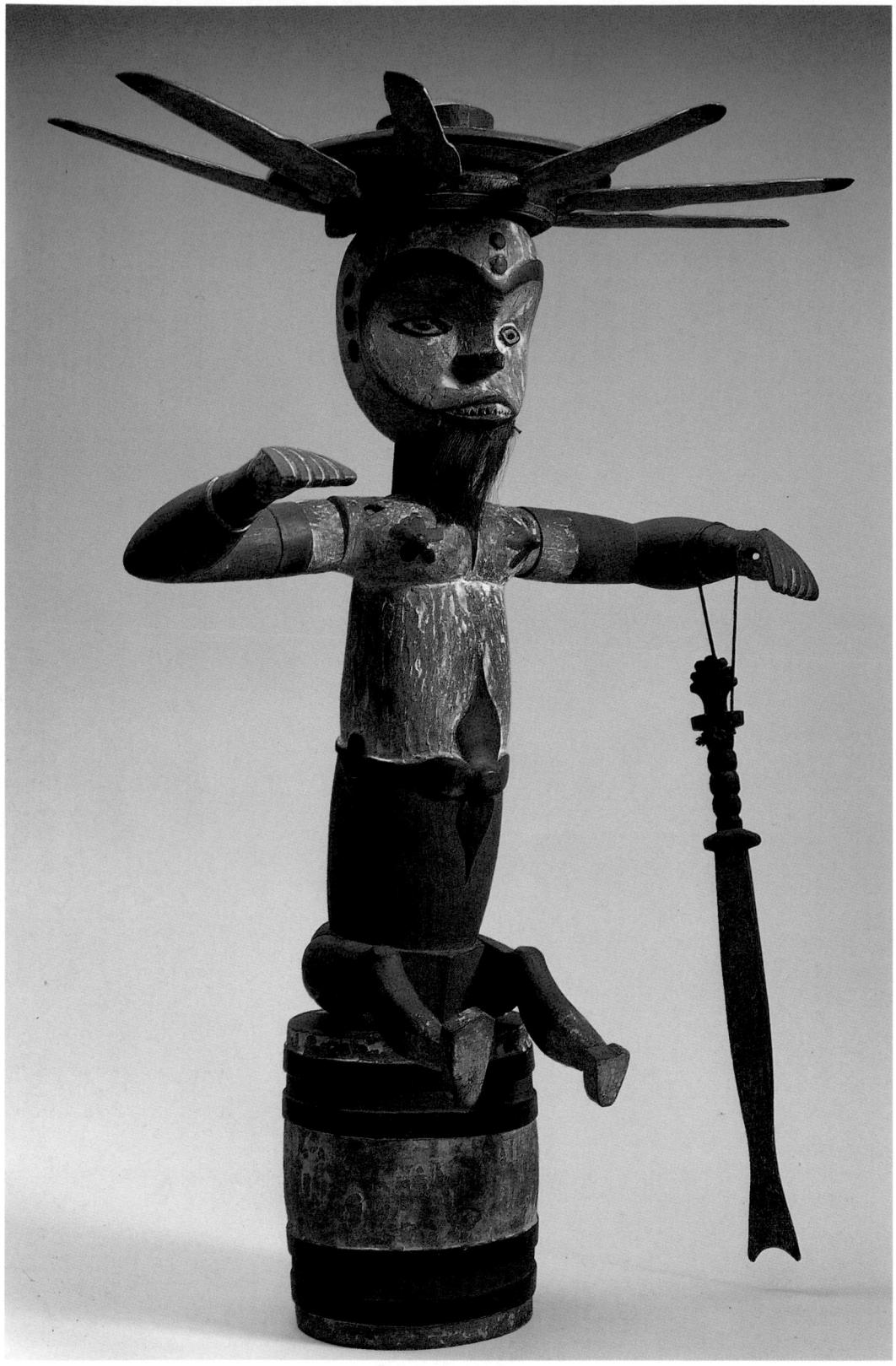

5.44

Male figure seated on a barrel

Ibibio

South-east Nigeria

19th century

wood, pigment

87 x 57 x 44 cm

Horniman Public Museum and Public

Park Trust, London, Crowther-Benyon

Collection, 37-48

This figure of a bearded man with feather headdress, seated on a barrel, is from the Eket area of coastal Ibibioland. It is probably from a memorial shrine (*ngwomo*) for a deceased head of a village (or village group) of the type shown in a photograph by the former colonial officer P. Amaury Talbot. The Horniman Museum also possesses a carved wooden shrine post similar to that in Talbot's photograph.

That the figure represents an elder is indicated by the addition to the carving of a goatee beard of ram's hair. The headdress, carved from wood and pigmented, is worn as a circlet beneath a representation of a 19th-century French sailor's hat, reflecting contact between the inhabitants of the coastal Ibibio area and European sailing ships in that period. The feathers represented here are those of the fish eagle, and the wearing of such a headdress is confined to initiates of one of the most exclusive of all Ibibio titles, *Inam*. The holder of *Inam* had to be at least 70 years old, wealthy and of impeccable moral rectitude. When he died he was believed to have the right to sit beside the creator god in the council of the underworld or afterlife.

At the centre of the forehead are two circular marks, one above the other, representing one of the modes of scarification formerly practised by the southern Ibibio. A further three marks on either temple are similarly arranged. The floral or leaf-like decoration of the abdomen is likely to represent body painting of the type known to have been executed for such occasions as initiation or burial.

Suspended from one hand of the figure is a representation of a bifurcated knife, an important part of the official's regalia. The arms and legs of the figure have been carved separately, and the manner in which the arms, in particular, are mortised to the trunk probably reflects the influence of European carpentry techniques. Similar influences are seen in the case of ancestor screens (*duein fubara*; cat. 5.57) made in the same period by the nearby Kalabari people of the Niger Delta. KN

Bibliography: Talbot, 1923; Fagg, 1963, pp. 124-5; Nicklin and Salmons, 1978, pp. 30-4; Neyt, 1979, pp. 15-22; Salmons, 1980, pp. 119-41; Barley, 1988; Nicklin, 1993

5.45a

Head pendant

Igbo (?)
Nigeria
10th century
bronze
h. 7.6 cm; diam. 4.8 cm
The National Commission for Museums
and Monuments, Lagos, 39.1.19

5.45b

Head pendant

Igbo (?)
Nigeria
10th century
bronze
8 x 4.5 x 5.5 cm
The Trustees of the British Museum,
London, 1956. AF. 15.p

These pendant masks form a pair from a large collection of remarkable bronze castings found at Igbo-Ukwu in south-eastern Nigeria, 40 km south-east of Onitsha on the River Niger. A number of bronze artefacts were found accidentally in digging a cistern shortly before the outbreak of World War II. Excavations at the site in 1959–60 revealed further bronzes and laid bare the manner of their deposition. They were spread out at no great depth in a rectangular area in such a manner as to suggest they had been protected by a lightly made shelter. For some reason they were abandoned in ancient time, the shelter fell down, the bush grew over it and the spot was forgotten.

As well as vessels and ornaments cast in bronze, there were objects made in copper, pottery vessels and over 63,000 glass and carnelian beads. There were calabashes with copper handles attached, and the objects cast in bronze included a number of weapon-scabbards and highly ornate attachments for ceremonial staffs. This collection comprised objects of a ritual and ceremonial nature. They probably represent the regalia of a dignitary who performed the function of both king and priest. There is still such a functionary in that part of Igboland, known as the *Eze-Nri*. He is the head of the title-taking system, in which, in place of hereditary chieftaincies and sub-chieftaincies there is a hierarchy of men who have earned their positions by merit, as a result of hard work and service to the community, and having reached a financial position to be able to pay the fees necessary for each grade. Some titled men are distin-

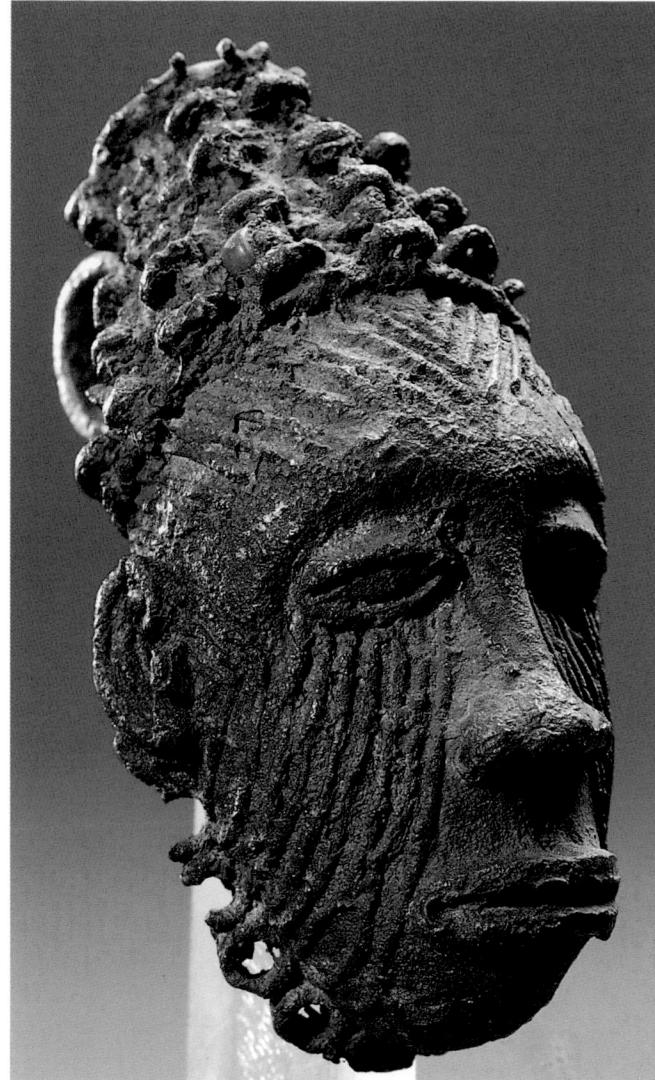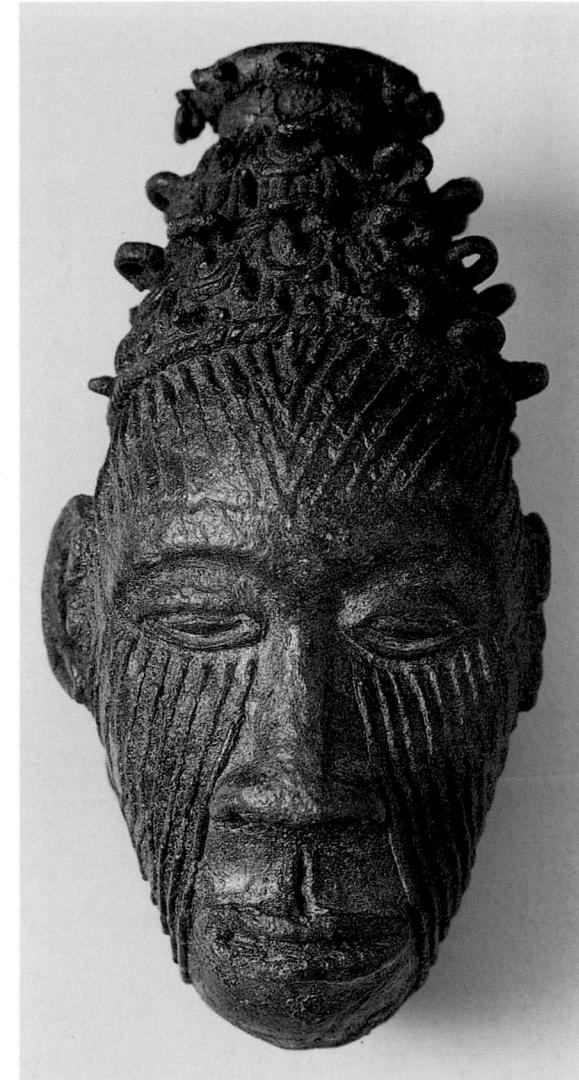

guished by facial scarifications of the kind portrayed on these little face masks. They were probably worn attached to a dignitary's regalia, for they have each a large loop at the back for the insertion of a thong. The back also has a number of much smaller loops, doubtless for the attachment of copper chains in the manner shown in cat. 5.47 for hanging beads and crotals. There is a fair-sized opening at the back for the extraction of the clay core on which the wax (or latex) was shaped in manufacture by the lost-wax process. All the objects from Igbo-Ukwu that have been shown by analysis to be alloys of copper and tin (usually with the addition of some lead) were cast by this method, whereas the objects made of almost pure copper were fashioned by hammering, bending, twisting and chasing. There were no objects of brass, as there were no alloys containing significant amounts of zinc.

During the investigations of 1959–60, near the repository of regalia, a kingly burial chamber was discovered, the floor of which was nearly 3.5 metres below the surface of the ground. In this wooden-lined vault a man of distinction had been interred, propped up on a copper-studded stool and dressed in all his regalia. Various rich objects were included, such as three elephant tusks; these were too badly preserved to ascertain whether they were carved or made into horns. There were over 102,000 glass and carnelian beads. A third site at Igbo-Ukwu was excavated in 1965. Here, a quantity of ceremonial objects had been intentionally disposed of, buried in a pit dug for the purpose. A cluster of radio carbon dates places these sites in the 9th–10th centuries, and such a date is confirmed by analysis of the metal content of the bronzes. Thus the Igbo-Ukwu materials are the manifestation of an indigenous technical and artistic flowering some

five centuries before this area had any contact with Europe. TS

Provenance: cat. 5.45a: 1959, bought and presented to the Lagos Museum by John Field; cat. 5.45b: 1959, excavated by Isaiah Anozie; 1956, given to the British Museum by F. W. Carpenter

Bibliography: Shaw, 1970, p. 142, pls. III, 270–1; Shaw, 1975

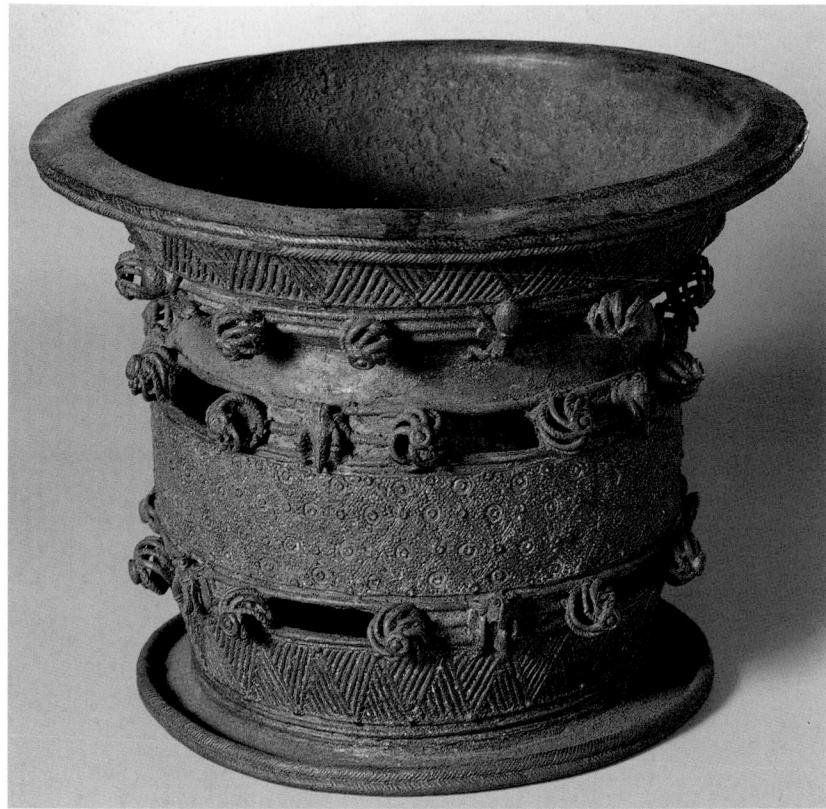

5.46

Bowl with integral stand

Igbo (?)
Nigeria
10th century
bronze
h. 20.5 cm
The National Commission for Museums and Monuments, Lagos, 1939.1.1

A number of the Igbo-Ukwu bronze castings show signs of being skeuomorphically related to objects previously made in other materials. So it is with this bowl on its own pedestal base, which almost certainly largely copies a ceramic original; a number of pottery bowls joined to their own pottery pedestal bases were found in the excavation. The two zones of hatched triangles on the bronze at the top and bottom of the stand can be matched in pottery vessels. Separate copper handles for calabashes were also found, and were the prototypes for the handles cast integrally with bronze bowls imitating the shape of calabashes. There are many other examples of skeuomorphs in the Igbo-Ukwu material.

This specimen may have been cast in two or more pieces, which were subsequently joined together with additional molten metal. That this is what was done in the cast of another large vessel from Igbo-Ukwu has been

proved by means of sectioning it across the join – but such an investigation has not been carried out on this particular bowl.

Stylistically, ‘the strange rococo, almost Fabergé-like virtuosity’ of the full range of Igbo-Ukwu work makes it ‘justly famous for a fragile, jewel-like aesthetic of a delicacy to be compared only with Roman pieces imported at the Nabataean capital at Faras’ (Williams, 1974, p. 118). The Igbo-Ukwu work makes the famous brass heads of Ife seem less arresting, and the later brasses of Benin seem less brilliant, although Benin works are much better known on account of their quantity and because of a hundred years of exposure to European and American scrutiny. However, the uniqueness of Igbo-Ukwu art presents a tremendous problem – what were its antecedents and its successors? Out of what tradition did it grow? What became of the style and standards it embodied? There is a challenge to set Igbo-Ukwu art in a wider geographical and chronological context than the isolation it at present enjoys. TS

Provenance: 1939, excavated by Isaiah Anozie; 1939, purchased and presented to the Lagos Museum by John Field
Bibliography: Shaw, 1970, pp. 112–13, pl. 5; Williams, 1974; Shaw, 1977

5.47

Double-egg pendant with beaded chains

Igbo (?)
Nigeria
10th century
bronze, copper, glass
h. 21.6 cm; l. 30 cm
The National Commission for Museums and Monuments, Lagos, 79.R.5 (IS 367)

This object was discovered at Igbo-Ukwu in the excavations of 1959–60. The bronze double-egg pendant is matched by a similar one recovered in the cistern-digging some 20 years earlier, but that example did not have the attached chains, beads and crotals. The double-egg with thong-loop at the back is generically similar to the masks with the facial scarifications (cat. 5.45). Other pendants in this category include four elephant heads, two (very different) ram heads and a leopard head. These all have small loops for the attachment of copper chains of beads, but the chains and beads themselves are now missing; it was only the excavated example that revealed the use to which the small loops on the castings were put.

The surface of each egg is smooth, but bears three representations of flies, and there are four on the arch that connects the two eggs. The symbolism and significance of this fly motif, which occurs (along with other insects) on some of the other bronze castings, are difficult to fathom.

Lying between the two eggs is a representation of a large bird, with prominent bulbous eyes and its wings curved back underneath its tail; feathers are represented by raised lines grouped concentrically in arches. The crotals at the end of the chains are small, clapperless jingle ornaments, and are cast in bronze. TS

Provenance: 1960, excavated by Thurstan Shaw, on behalf of the Nigerian Federal Department of Antiquities

Bibliography: Shaw, 1970, pp. 143–4, pls 276–7

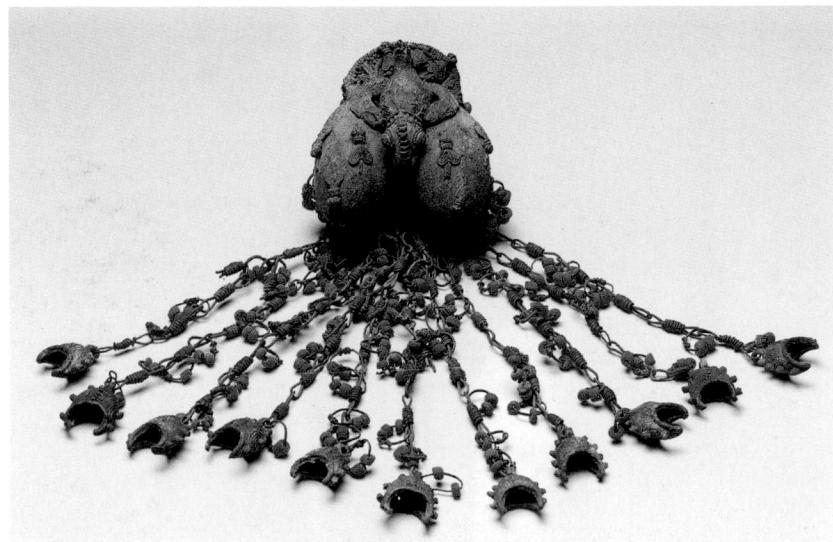

Globular ceramic vessel with everted rim

Igbo
Nigeria
10th century
fired clay
h. 40.6 cm
Department of Archaeology and Anthropology, University of Ibadan, IJ 650

The body is globular below a widely-everted flat rim, making a wide-mouthed vessel with comparatively little constriction at the neck. Five heavy strap handles, placed equidistantly, joined the rim and the shoulder, but one of the handles is now missing. The outer surface of each handle is decorated with six or seven transverse ridges, crossed by oblique grooving, slanting in different directions on adjacent ridges, arranged in such a way as to be reminiscent of basketry. A wide deep groove runs round the outer edge of the rim, and a smaller, much less pronounced one, upon the upper surface of the rim just inside the edge. The neck is decorated with a heavy cordon bearing bold finger-tip impressions set slightly obliquely. Below this the whole of the upper half of the globular part of the pot is elaborately decorated. The groundwork of this decoration is made up of a system of concentric grooving, and with bosses below each handle. Part of the infill between the concentric circles, or parts of them, is made up of panels of straight parallel grooves or of small shallow pitting; the lower edge of the decorated area is bounded by four parallel grooves running right round the pot, but only approximately horizontally; they terminate some 12.7 cm apart by making the two inner grooves, and the top and bottom grooves, join in a round-ended fashion. The intervening space is filled with an exactly similar short stretch of four parallel grooves with rounded ends. Above this, in a space between two of the handles, is modelled a quadruped, which gives the impression of being superimposed on the other decoration, although it is in fact arranged integrally with it. This animal, with its spinal crest, coiled tail, opposed digits and body marked with triangular panels of fine cross-hatching, is believed to represent a chameleon; the body is humped up away from the body of the pot (which underneath it is plain), the animal

being attached only by the head, feet and tail. There is a similar applied figure in each of the other four spaces between the handles. To the right of the chameleon is a ram's head, with long downward-curving horns; to the right of this a coiled snake, with the back of the body decorated with a segmented pattern. To the right again is a curious, inanimate-looking, rectangular slab, covered all over with cross-hatching, and humped up in the middle away from the wall of the pot; what it represents is not known. Below it the ground pattern contains a sixth groove-surrounded boss, slightly smaller than the ones below the handles.

The fifth space between the handles is occupied by a coiled snake similar to the other except that the segmented pattern is carried right over the head to the mouth instead of stopping at the neck. The style of decoration, with deep concentric grooves and raised conical bosses, also ridged and grooved, is typical of ancient Igbo-Ukwu ware. Such pottery occurred plentifully on all three Igbo-Ukwu sites. Rouletting, common today in Nigeria and at Ife and Benin, does not occur on ancient Igbo-Ukwu pottery.

This specimen was found, almost upside down, in the disposal pit. It is likely that it was used for ceremonial purposes by a high-ranking man; at his death it was buried in the pit, along with all his other ritual trappings, since no one else would be entitled to use them. TS

Provenance: 1964, excavated by Thurstan Shaw, on behalf of the University of Ibadan

Bibliography: Shaw, 1970, pp. 215–16, pls 468–72

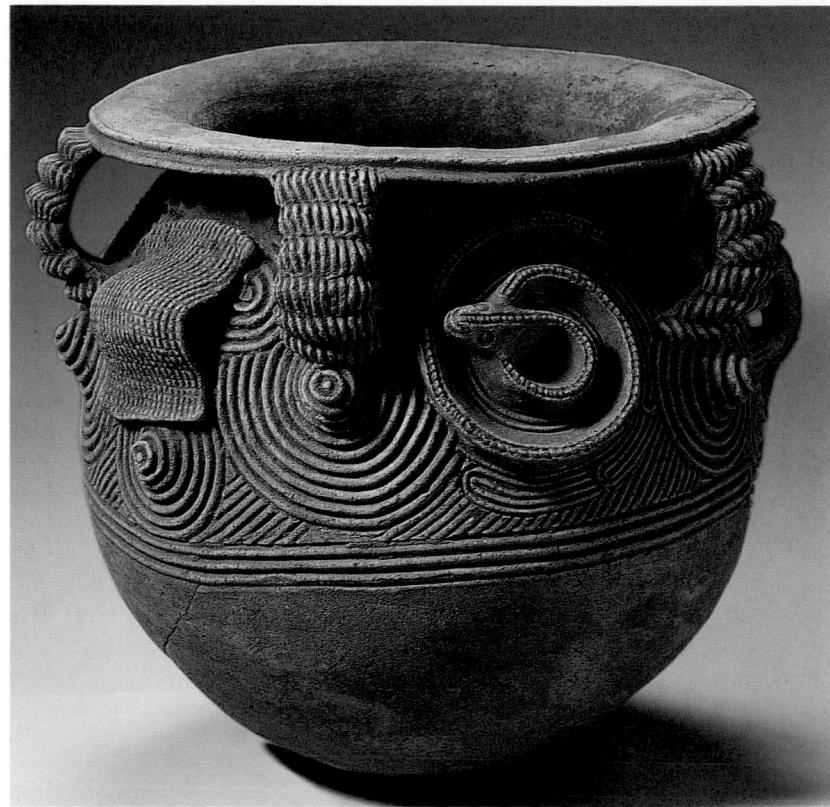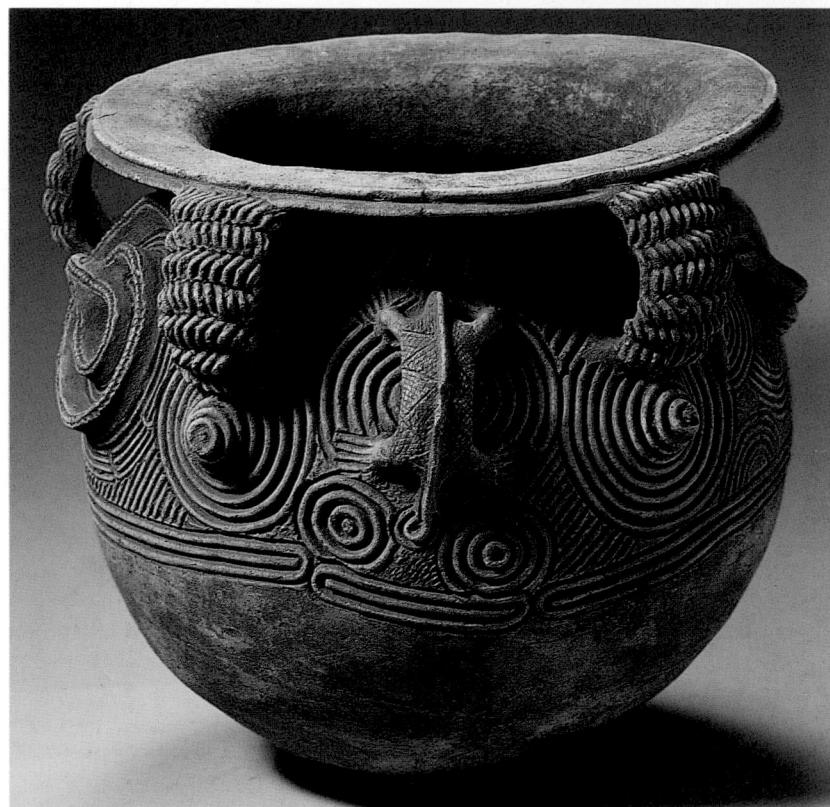

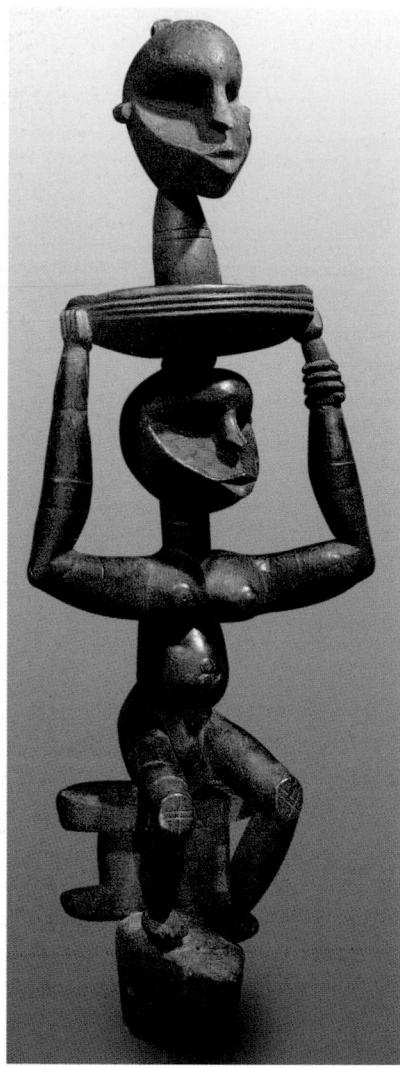

5.49

Headdress

Igbo
Ogbom, Nigeria
wood

82 x 31 x 21.9 cm
The National Commission for Museums
and Monuments, Lagos, LG.33

Only scanty data survives on headdresses called *ogbom* and on the dances associated with them, which were apparently last performed before 1940. These fine carvings were attached to basketry caps and were used in dance by men in festivals honouring Ala, the Igbo earth deity. Most *ogbom* headdresses celebrate fertile young women with ample breasts, as on this example, and the dances appear to have called attention to Ala's role in both human and agricultural fertility and increase. G.I. Jones reported that at one point women entered the arena to dance around the *ogbom* carrier, while Murray's account indicates that the

dance helped to make women fertile, with men enjoined to marry if the local population appeared to have declined since *ogbom* was last performed.

This specimen features a disembodied head-on-neck being carried by the seated young female on a plate or circular platform. Apparently a trophy head, from an Igbo area once known for headhunting, this iconography would appear to refer (at least indirectly) to the role of the heads of slain enemies in bringing power and increase to the receiving community. In this regard it is perhaps notable that an origin myth, found by Jeffries among the Nri Igbo, refers to the planting of heads from which, subsequently, grew yams, the favoured food of most Igbo people. HMC

Bibliography: Murray, 1941; Cole and Aniakor, 1984, pp. 15, 174–6; Jones, 1984

5.50a

Deity figure

Igbo
Nigeria
wood

130 x 24.5 cm
The National Commission for Museums
and Monuments, Lagos, 80.5.328

5.50b

Deity figure

Igbo
Nigeria
wood, paint, metal
h. 180 cm
Private Collection

The religious beliefs and practices of Igbo-speaking peoples identify a constellation of tutelary deities known as *alusi* or *agbara*. As the children or deputies of the high god Chukwu (lit. *chi*: 'god' or 'spirit'; *ukwu*: 'great'), they are accessible to human petition and sacrifice. These unseen, proximate deities (encompassing places, principles and people) include the earth, rivers and other prominent features of the landscape, markets (and the days on which they are held), war,

remote founding ancestors and legendary heroes. Overall the deities and their cults are considered responsible for the health, prosperity and general well-being of the people and the productivity of field and stream; they uphold the moral, social and ecological order. Each major cult has a priest and other attendants who pour libations weekly, offer blood sacrifices periodically and oversee an annual festival honouring the gods.

Such supernaturals are often symbolised by hardwood figures varying from about 45 cm in height to over life size. They are carved in conventionalised, symmetrical, rather static poses, and are given the attributes of titled individuals. They exist in several regional styles, and in any given area as many as a dozen or more are housed together as generic 'families' in more or less elaborate shrines usually at the centre of each village group, often adjacent to markets or dance grounds. Their shrine buildings or compounds are sometimes large and well decorated, especially in the north-central Onitsha/Awka region, but everywhere minor gods may also be housed

in domestic compounds. Without collection data it is impossible to determine which deity is represented by any one figure, for the many hundreds of known figures conform to generic types lacking deity-specific attributes. While male sculptors are invariably the creators of these figures, many different hands can be recognised in each style area. Women normally paint the images with celebratory pigments.

The standing figure (cat. 5.50b) probably comes from the Onitsha region. It is typical of figures from the still larger north-central area. Its size suggests that it may have been a principal deity, as 'family members' were normally smaller. Incised scarification patterns on the body are similar to those anyone could have as an indication of personal beauty and fully socialised status. Shrine figures were redecorated by women supplicants of the cult before its annual festival. These cosmetic, beautifying pigments of orange-red camwood and/or white chalk were also affected by worshippers. In the north-central region deity 'families' were often displayed publicly during such festivities; they were lined up on the edge of a dance ground, where they received such presents as kola nuts, money and chalk from villagers. The assembly would also be given larger sacrificial offerings by cult officials along with prayers of thanks and petitions for a large harvest and prosperity. Elaborate meals were prepared and consumed and worshippers danced in the gods' honour.

The figure in cat. 5.50a is in the style of the Owerri/Mbaise region, where there is an emphasis on rectilinear, squared off forms in contrast to the more rounded styles of Onitsha/Awka to the north. The arm position with hands held as if begging is interpreted as indicating the deity's readiness to receive sacrificial offers as well as its open-handedness and honesty. The incised body and facial scars indicate titled status. HMC

Bibliography: Cole, 1969; Cole and Aniakor, 1984, pp. 89–100

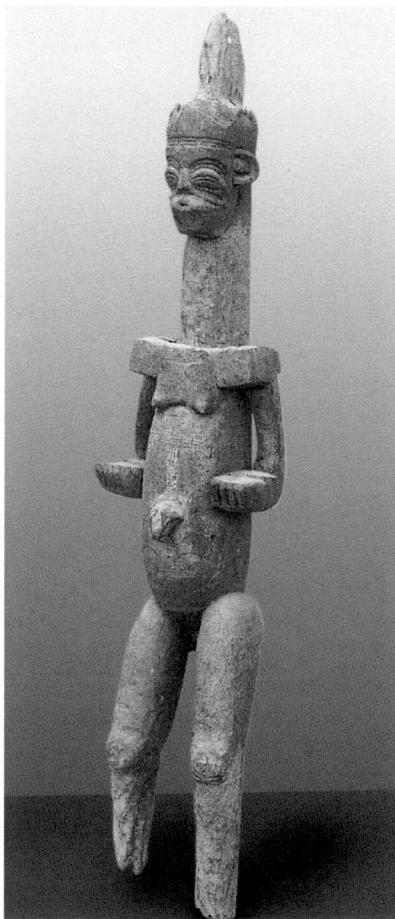

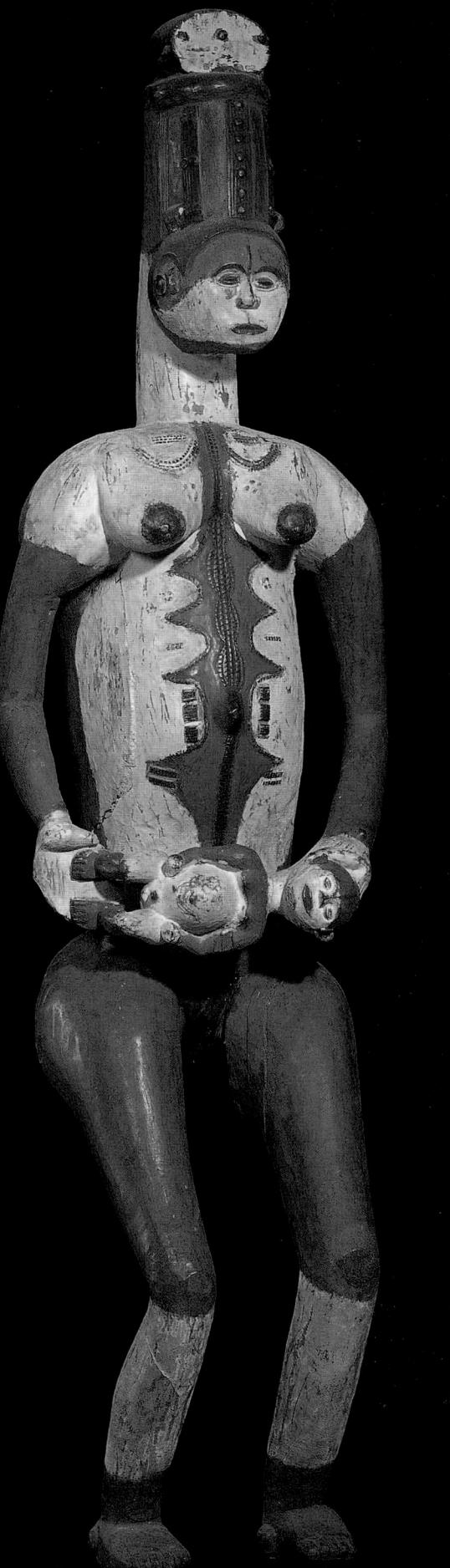

5.51

Women seated on a stool

Northern Igbo/southern Idoma (?)
East central Nigeria
19th century (?)
wood, pigment
74 x 26 x 24 cm
Kathy van der Pas and Steven van de Raadt

This female figure, seated upon a stool, is elaborately adorned with representations of ivory bangles at wrist and ankle (the latter worn over brass leg bangles) and strings of large beads around the neck. A bell with clapper is worn at the waist, above a representation of a girdle, suspended by a bead shoulder-loop. Coiffure is also intricate, with tightly coiled braids in the form of reversed spirals covering much of the scalp, surmounted by an arched structure. Hands clasped at the front hold a smoking or musical pipe to the mouth. Complex scarification marks are shown on the face and body, notably a vertical row of cross-hatched round keloids on either temple and upper arm.

The sculptural style of the face is reminiscent of that of some masks from the transitional northern Igbo and Benue Valley areas of eastern central Nigeria. The facial features are characteristic of the domed face masks of the northern Igbo maiden spirit masquerade (*mmuo*). What remains of the representation of a carved wooden stool strongly resembles that associated with title-taking by élite men and women, especially in northern central Igbo country. These are often portrayed in representations of seated figures owned by lineage segments in respect of the Ikenga cult.

The prominent buttocks and markedly upright back are characteristic of seated female figures connected with concepts of fertility and lineage among several Benue Valley groups, including the Igala, Afo, Idoma, Tiv and Igedde. Often these are maternity figures, though this is not the case here. This piece probably represents a female ancestor, and would have been employed in funeral ceremonies connected with the matrilineage, an institution called Ekwotame by the Idoma. KN

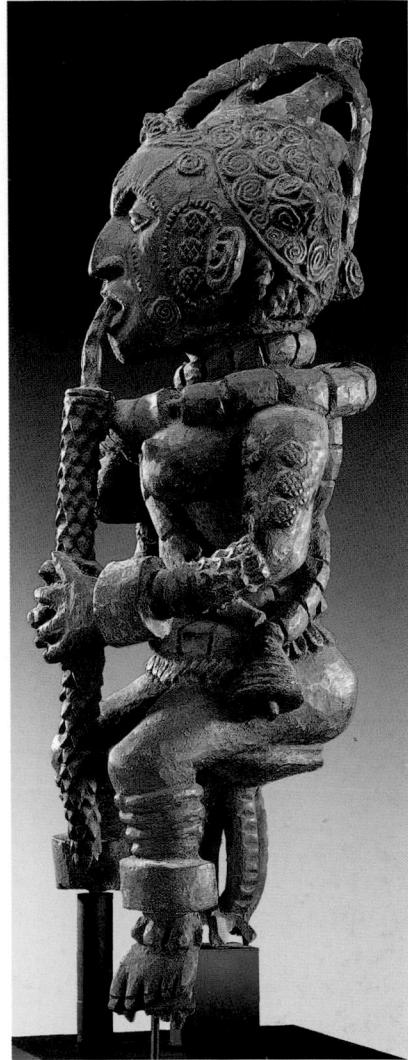

Bibliography: Boston, 1977, pp. 62–3; Wittmer, 1978, pp. 17–25; Cole and Aniakor, 1984, pp. 120–5; Jones, 1984, pp. 61–4; Neyt, 1985, pp. 101–8, 141–51

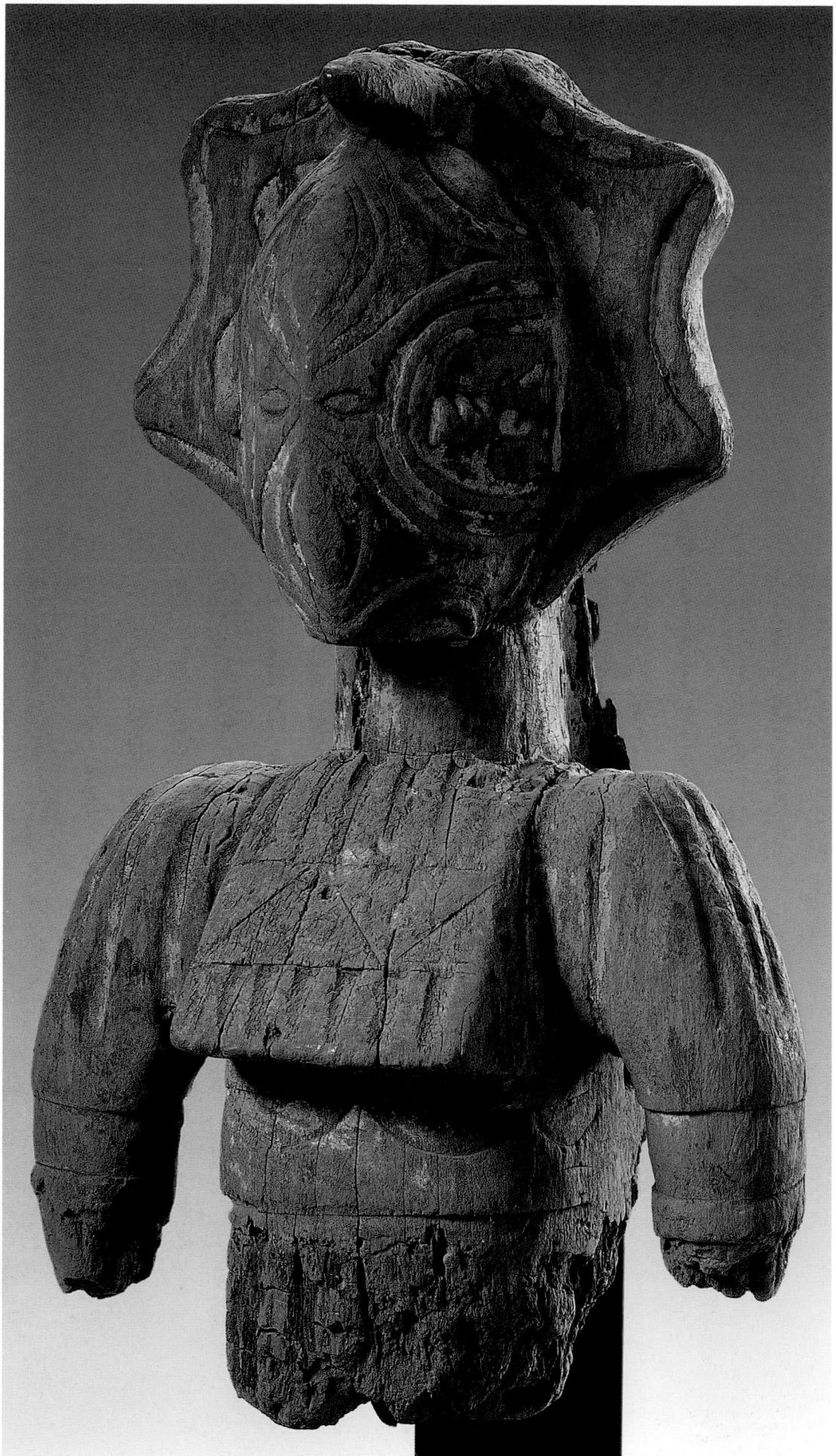

5.52

Torso

Igbo
Afikpo/Ohafia (?), Nigeria
wood
h. 66 cm
Private Collection

This fragmentary sculpture, consisting of a masked head on a torso, was more than likely part of an ensemble of life-size painted wood figures that embellished a men's meeting-house in Ohafia. A similar one, which is preserved as a national monument by the Nigerian Department of Antiquities, still stands in the Obu Nkwu ('House of Images') in Asaga Ohafia. The head appears to be wearing a calabash mask of the sort documented by Ottenberg in Afikpo villages, but analogous masks were also worn in Ohafia, Abiriba and other eastern Igbo communities, probably in connection with the Ekpe cult. In this example the neck of the calabash projects slightly over the forehead, and the mask face is incised in curvilinear patterns that were guidelines for pigments (now lacking because of weathering).

These shrines and meeting-houses once contained numerous figures (there are 22 at Asaga Ohafia of legendary ancestors, local gods, their servants, warriors, masqueraders and genre figures). More than a family, the group suggests part of an idealised community, somewhat like the sculptural programme of elaborate *mbari* houses in the Owerri region. Around the turn of the century there were many such shrine meeting-houses among eastern Igbo groups; most of them have long since been dismantled and their sculptures dispersed, although some have been rebuilt in cement block, with modern carvings or cement figures lining the walls, as in Asaga. *HMC*

Bibliography: Jones, 1937; Cole and Aniakor, 1984, pp. 95–7, pl. 18

5.53

Door

Igbo
Nigeria
wood

112 x 43 x 4 cm

The Trustees of the British Museum,
London, 1950.AF.45.545

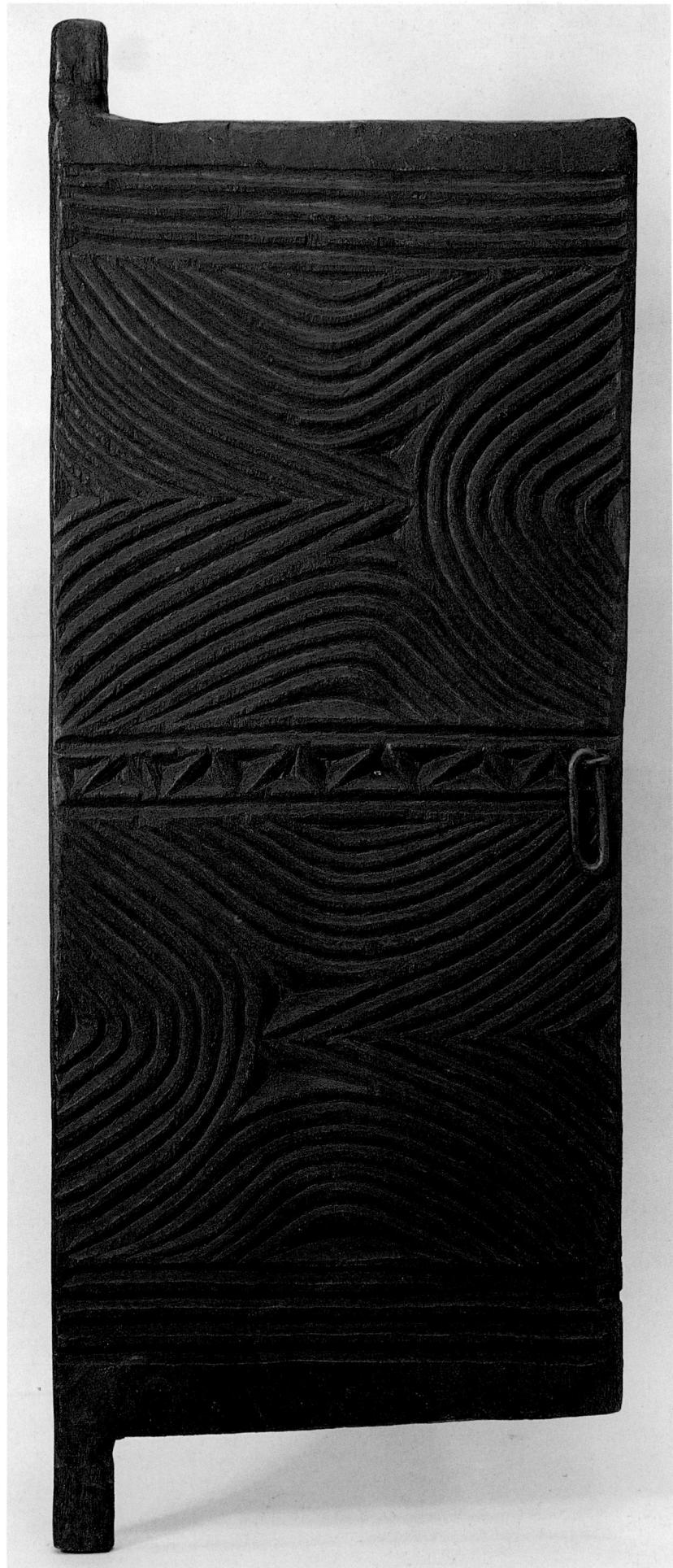

Igbo doors are normally carved in hardwood – which is considered ‘male’ – including African oak (*Chlorophora excelsia*), for which the Igbo word is *oji* or *iroko*. Most embellished doors were used at main entrance portals of domestic compounds, typically those housing families of titled men and women. They may also adorn the compounds of tutelary deities, especially in the north-central Igbo region. Such fine portals are called ‘doors of honour’ (*mgbo ezi*).

Carved doors are generally associated with the Awka area, well known for its geometric style, usually referred to as ‘chip carving’; but since similarly embellished doors are known from many Igbo subgroups, an Awka provenance is often unwarranted unless collection data indicate a specific place of origin. The curvilinear style of this door suggests that it might come from the area between Okigwi and Owerri rather than Awka. These patterns, carved by men, relate closely to women’s styles of wall and body painting. While non-figurative, the motifs are usually named after similar designs found either in nature or on artefacts. Although it is true that the motif names betray something of the Igbo world view, individual door designs are rarely specifically symbolic.

Among the Igbo, as in most cultures, a decorated, elaborate portal serves to signal elevated status, relative wealth and good taste, while separating the more profane world of the outside, the village, from the family sanctuary, the dwelling areas and shrines within. Many such Igbo doors were further decorated with locally obtained white, orange-red and black pigments, adding brightness and thus visibility to compound entrances that from the outset were intended as visual magnets drawing attention to the habitations of prominent families or gods. *HMC*

Provenance: 1950, given to the museum by P. A. Talbot

Bibliography: Cole, 1969; Neaher, 1981; Cole and Aniakor, 1984, pp. 68–71

Yam altar

Igbo

Nigeria

fired clay

h. 40 cm

Trustees of the National Museums of Scotland, Edinburgh, 1905.8

Fired clay altars or shrines with elaborate figural tableaux were made in the Ukwani Igbo region west of the River Niger during the 19th and early 20th centuries. Only a handful of such ceramics are known. Early reports indicate their use in the yam cult (yams being the main prestige crop among most Igbo groups). This sculpture appears to depict a male chief and family head holding a decorated

drinking-horn in one hand, a fan in the other, one or both of which were most likely titled attributes in the area. He is flanked by two pregnant females (probably intended to represent his wives), who are heavily scarified, finely coiffed and are also holding fans. In front sits a child (or servant) with a double gong, along with a fowl, presumably a sacrifice for the yam deity, Ifejioku, and in the centre, a cylindrical *ikenga* of the western Igbo type. An *ikenga*, seen here as a 'shrine within a shrine', typically received such offerings as farm produce and prayers to the physical power – the power of the right hand and arm. As a whole the group would appear to illuminate the

centrality of the family in Igbo culture along with the importance of generous yam harvests to the family's success and therefore its status.

Women were the ceramic sculptors in this region, as they were potters and clay workers in most of tropical Africa. This highly accomplished sculptural group rises out of a hollow ceramic base with a textured surface; at the back it is attached to a kind of openwork screen with several decorative loops. *HMC*

Bibliography: Cole and Aniakor, 1984, p. 80; Washington 1987, p. 96

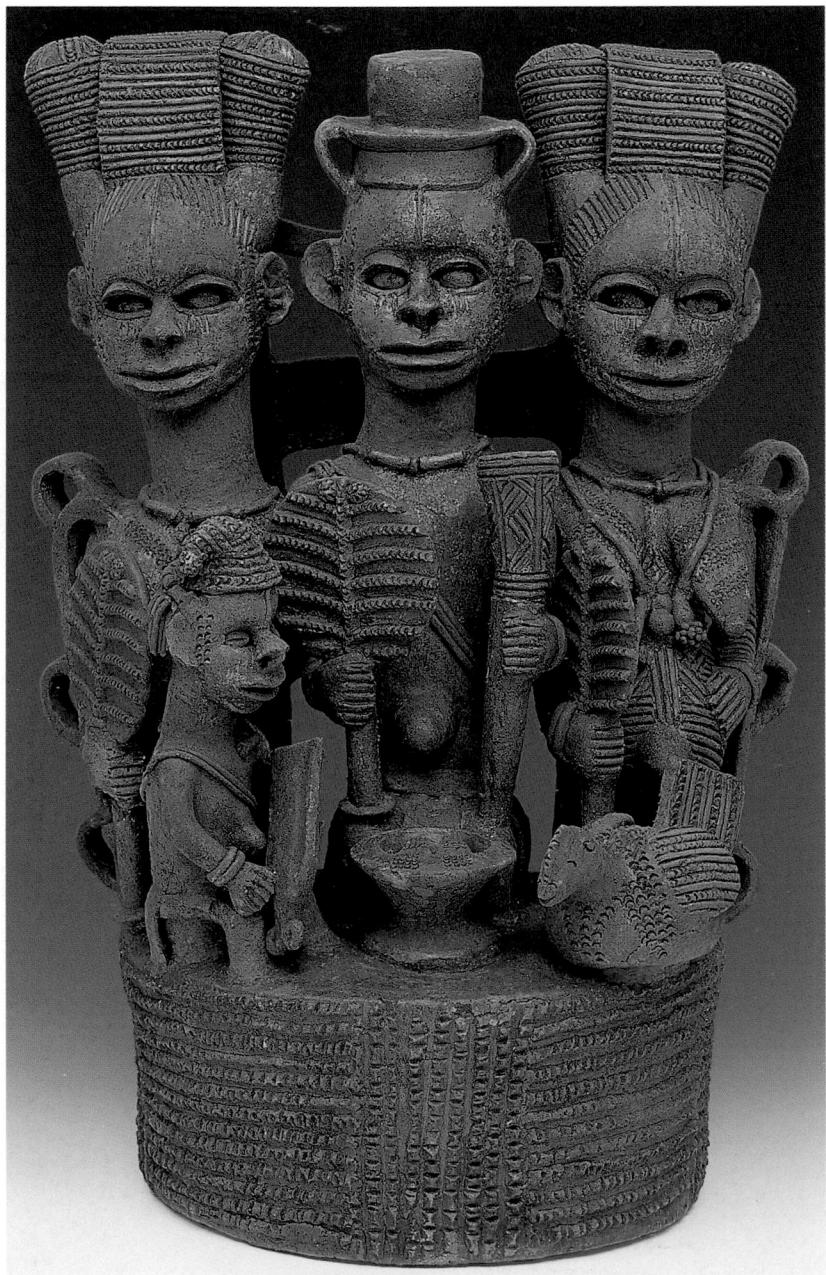

5.55

Cap mask

Ogoni or Abua (?)

Niger Delta

20th century

wood

54 x 17 x 17 cm

J. W. and M. Mestach

At first glance this splendid piece would appear to be 'a bird with wings hanging by its sides and a broad tail depending from the torso' (Maurer). However, although it is probable that the carver intended to suggest bird-like features, the overall form could also represent a human torso, while the central portion of the work closely resembles the head of a ram or he-goat and the lower section might depict a fish tail. Such an intriguing form is typical of that used by a certain masquerade group living in the Niger Delta, who are often called upon to represent the close interdependence of man and creatures in this particular eco-system.

The Ogoni, who live on the periphery of the eastern Delta, use face masks representing goats, sheep, antelope and other animals, often with elaborate up- or down-curving horns, for a youths' acrobatic dance called *karikpo*. However, as no eye holes pierce this mask, it could not have been used as a face mask.

A number of holes at the back of

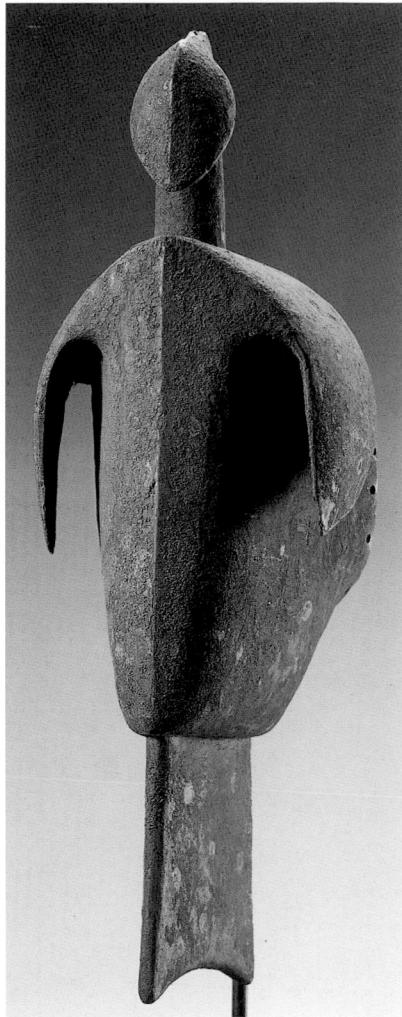

the main face or torso indicate that the mask would have been worn on top of the head, horizontally, attached to a costume covering the body and head of the performer.

The human head finial and fish-tail projection are characteristic of the headdresses employed by the Ijo and their neighbours in their periodic masquerades held in honour of the water spirits (*owu*). As these are believed to be capable of passing between the earthly and spiritual realm, and between land and water, their masquerades will often combine human, animal and fish attributes, as in this mask. Although the head is depicted in abstract form, it is not carved in the geometric style usual for the Ijo. It is therefore probable that it comes from one of the neighbouring Delta groups, such as the Ogoni or Abua. *KN*

Bibliography: Horton, 1965, pp. 68–71; Jones, 1984, pp. 159ff.; Nicklin and Salmons, in preparation

Ceremonial staff

Ijo

Niger Delta

17th–18th century (?)

ivory, pigment traces

78 x 8 x 8.5 cm

Charles and Kent Davis

This sculpture depicts a maternity figure seated on a stool or chest above a kneeling male figure. The woman is shown wearing bracelets and large anklets, and the man bears a flintlock pistol, with trigger-guard and flashpan clearly visible. The gourd-like container which is suspended by a thong from the right shoulder of the male figure could be interpreted as a medicine container, but in the context of southern Nigeria strongly suggests a powder-and-shot flask for recharging a muzzle-loading firearm.

The finial at the upper end of the staff gives the impression of a multi-layered or segmented hat, which, together with the prominent bangles and 'enthroned' position, suggests high social status. This extravagant headgear would appear to represent a headdress of the type worn by senior members of the Kalabari Ekinne (water spirit society). Depictions of such headdresses occur in a large proportion of ancestral screens (*duien fubara*; cat. 5.57). The kneeling posture of the male, and lesser personal adornment, is indicative of the status of armed retainer. A remarkable feature of both figures is the depiction of a wide flat necklace or ruff, with hexagonal motifs (perhaps representing a line of beads) carved in high relief at the rim.

The facial features of both figures project from the flat surface of the background face. The eyes are cylindrical; the nose has a prominent bridge and bulging nostrils, and its base forms a straight, sharp line traversing much of the face. Mouths of figures are open, and the jaw of the female slightly prognathic. Such facial treatment gives this piece a definite Ijo attribution. This aesthetic convention is associated with the masks of the Ijo water spirit, Owu, generally comprising horizontal structures carried on top of the head with representations of the human face directed skywards. In fact the lateral projection on either side of the head of the male figure is stylistically reminiscent of the flat structure of

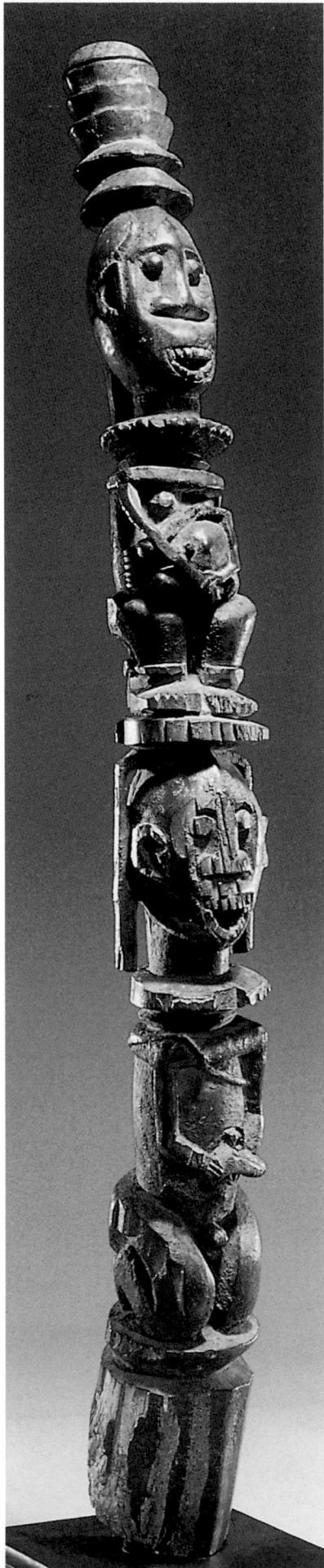

the typical Owu headdress upon which upward-facing human heads are carved.

However, the style of the faces of the ivory staff is most directly comparable with that of headdresses used by the Igbile water-spirit cult at Ughoton or Guratto, the old river port of Benin. In addition to close stylistic affinity, these are vertically aligned, and bear evidence of influence from the Ilage Yoruba area, whence the Igbile cult derives. Fagg compares these 'cone-head' Igbile masks to bronze bell-heads of the western portion of the Niger Delta; the style of rendering the bodies of the ivory staff figures is reminiscent of some of the finest of all Lower Niger bronze figures, notably the 'fluid' artistic treatment of both the slender upper limbs and the much fuller lower limbs, especially in the kneeling position.

Carved elephant tusks occur in a wide variety of contexts in southern Nigeria, most notably those placed on top of commemorative brass heads of Benin palace altars and side-blown horns which are part of the chiefly regalia of the Ibibio-speaking area and some inland forest communities in south-east Nigeria/south-west Cameroon. High-relief decoration is characteristic of these respective genres. Much less common is in-the-round carving of the whole or greater part of the tusk, as seen here. This compares with the tradition of the wooden ancestor figure (*ekpu*) of the Oron on the west bank of the Cross River estuary. Perhaps the best-known form of ancestral staff is the *ukhurne* of the Oba of Benin, which symbolises his 'power' as head of the royal line, and his incarnation of divine ancestors.

This ceremonial staff is unique among the known corpus of Ijo sculpture in any medium, remarkable for its attention to the detail of the two figures, especially the realism of the gun held by the male. Although most certainly Ijo, this piece presents an impressive amalgam of artistic influences reflecting its probable origin at the westernmost edge of the Delta. Its age and authenticity are attested by the smoothness and colour of the ivory, a chestnut tree of the kind imparted by repeated applications of palm oil in the past, and a smoke-blackened patina. The remaining part

of the base of the staff is friable, suggesting that it was kept for much of its existence in an upright position on the ground, presumably in a shrine. The top of the head of the nursing infant, though incomplete, shows no sign of fracture. Rather, it presents a smooth surface as though caused by the gradual shaving away of small amounts of substance over a period of time, conceivably for ritual purposes connected with fertility. KN

Bibliography: Talbot, 1926, fig. 178; Fagg and Plass, 1964, p. 147; Horton, 1965; Willett, 1971, p. 105; Plubin, 1976; Dean, 1985, p. 42, pl. 10; Eicher and Erekosima, 1987; Barley, 1989, pp. 25, 62 ff.; Nicklin, 1989, p. 40; Ross, 1992, pp. 226–7, pl. E.

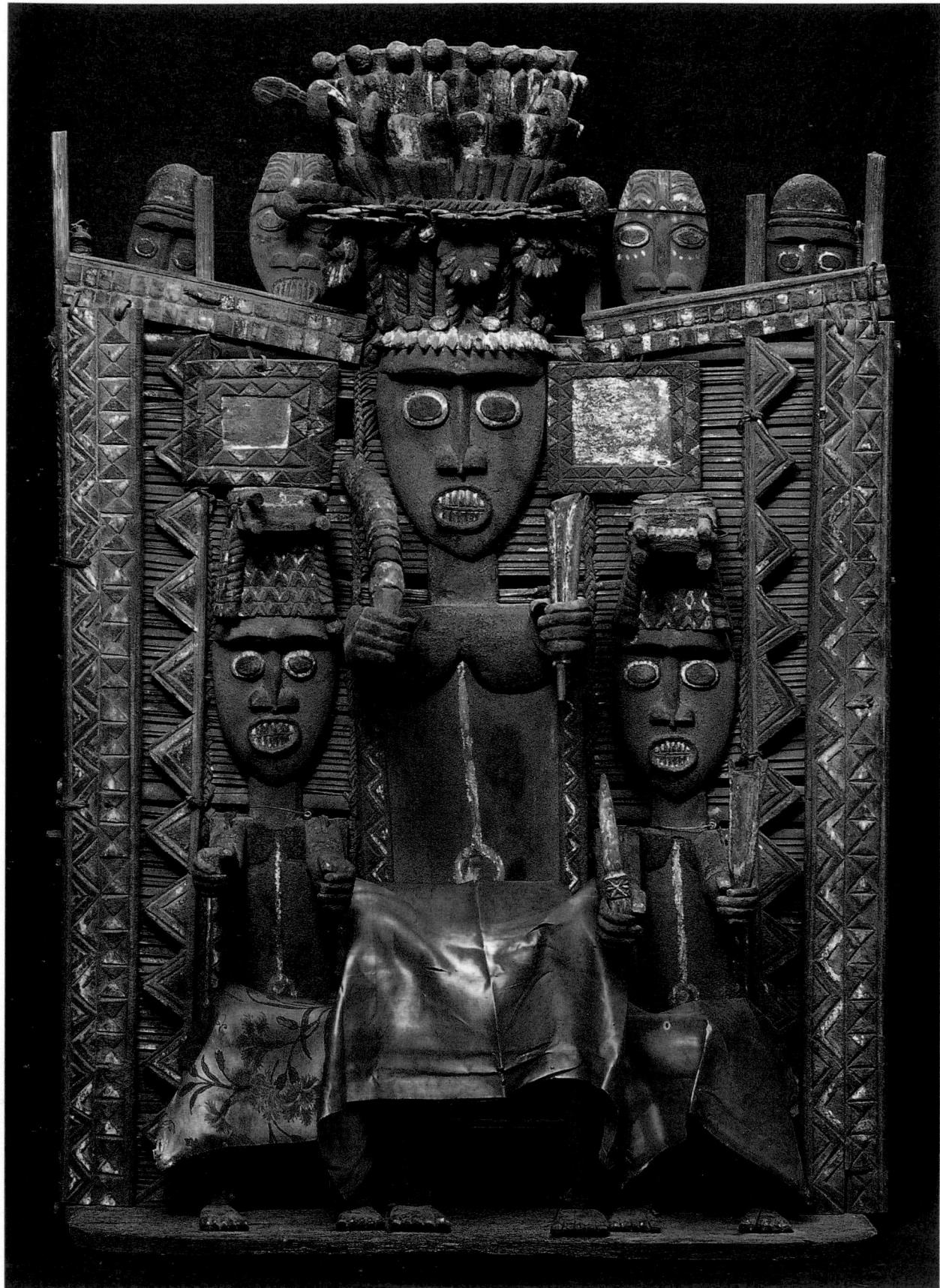

5.57

Funerary screen (*ndnen fubara*)

Kalabari

Nigeria

19th century (?)

wood, cane, raffia, natural pigment

127 x 94 x 40.5 cm

The Trustees of the British Museum,
London, 1950, AF.45.331

From the 15th century onwards, the Kalabari were important middlemen of the Atlantic trade. Through their hands passed exports of slaves, ivory, palm oil and pepper and imports of brassware, gunpowder, alcohol and other Western luxuries. Trade was controlled by rival houses. Members of the trading houses of slave origin rose to positions of prominence and in the late 18th century the dynamic Amachree I assumed the kingship itself. He was the first to be commemorated by a screen of this form.

As a foreigner, Amachree would be denied access to traditional Kalabari objects of power. Since Kalabari culture has repeatedly used imported objects as signs of identity, it seems likely that these new shrines were based on European two-dimensional images, prints and paintings – imported screens for imported people.

The screens were made by the family that provided pilots for European vessels and so were able to observe European reverential attitudes towards religious and royal images. The screens were kept in the meeting house that was the headquarters of the trading group and the spirits of the dead were held to return to them at least once every eight days to receive offerings and be apprised of the affairs of the house.

Each screen depicts a particular ancestor displayed in a masquerade outfit, in this case the feathered headdress of Alagba. The masquerader holds an Alagba knife and a carved tusk. Flanking figures wear headpieces of the Otoba (hippopotamus) masquerade, coral beads and imported satin or floral textiles. The square shapes attached to the back screen probably represent mirrors that were used to embellish headpieces. NB

Provenance: 1916, collected and donated to the museum by P. A. Talbot.

Bibliography: Horton, 1965; Barley, 1988

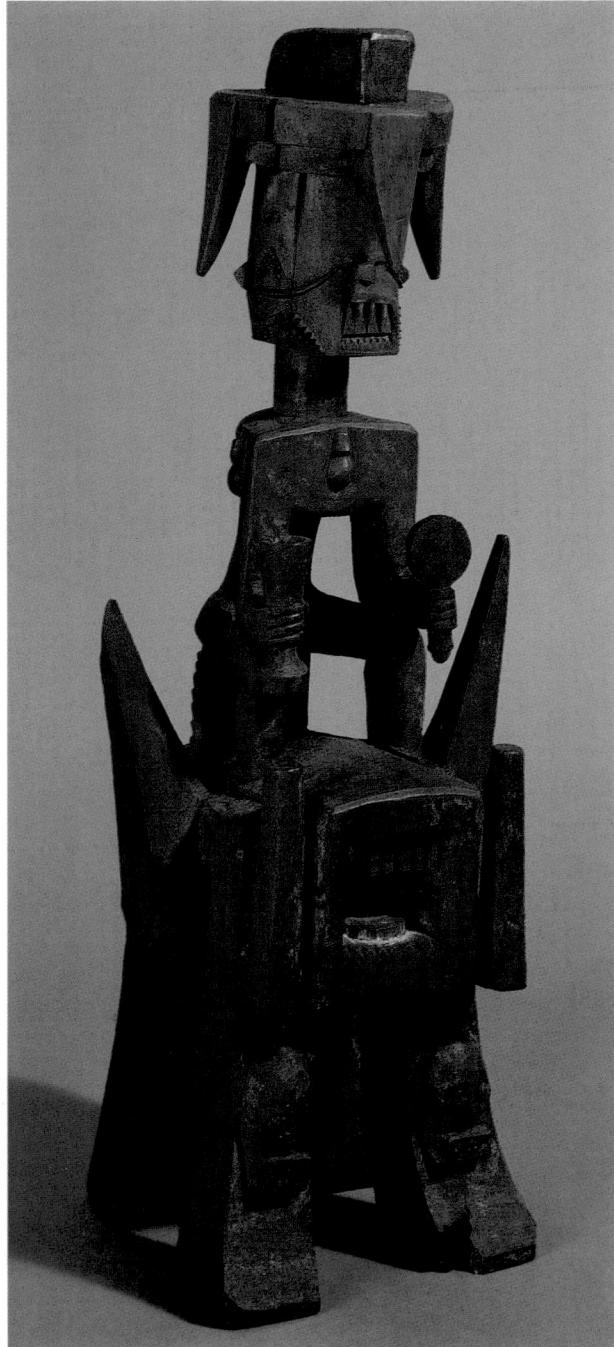

5.58a
Carved figure (efri)
 Ijo
 Nigeria
 19th century?
 wood
 99 x 36 x 42 cm
 The Trustees of the British Museum,
 London, 1949.AF.46.188

5.58b
Carved figure (ivwri)
 Urhobo
 Nigeria
 19th century (?)
 wood, pigment
 70 x 27 x 26 cm
 The Trustees of the British Museum,
 London, 1954.AF.25.428

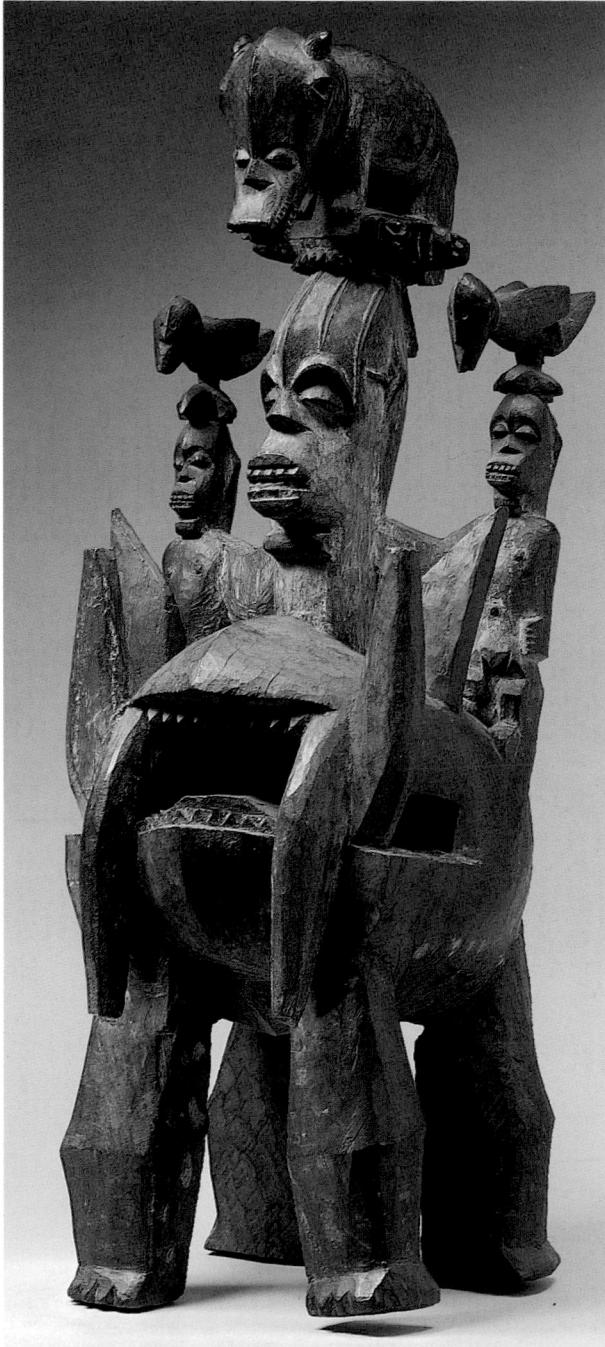

The powerful Urhobo sculpture (cat. 5.58b) combines human, animal and bird-like qualities in a single complex figure. It stands on four massive legs that support a creature that is little more than a vast, gaping mouth, with great, curving incisors and rows of sharp teeth. The whole of this element arguably constitutes the stomach of the human figure that surmounts it. He, in turn, grasps two lesser figures, surmounted by birds, separately carved, and is himself supporting an elephant trampling heads under its feet. All the figures have prominent teeth and facial scarification and that in the centre

wears a coral (?) bead at the neck as an indication of wealth and status.

Urhobo *ivwri* sculptures are associated with human aggression. The gaping mouth is seen as the focal point. The figures are involved in self-defence from outside attack and the focusing of individual hostility on external enemies. Relatively large sculptures such as this one might be expected to be owned by a whole group, who look to them for protection. Oral histories of individual pieces typically relate the bringing of an *ivwri* to the foundation of a new settlement. It is normally associated with a particular, successful and

aggressive male warrior whose descendants take over the care of the piece. Such works accumulate dangerous powers that are controlled only with difficulty. The possession of such an object is an assertion of status. In previous centuries success was primarily measured in terms of the loss and gain of individuals through the operations of the slave trade, so that *ivwri* remain conceptually linked to slaving.

As part of a larger household shrine, the figure is merely the central element of a much more complex work. In use, such carvings would incorporate a separate triangular screen of slatted cane or wood, attached at the rear of the central figure. Among the Urhobo such an element is known as a 'wing' to empower the object to work at a distance. Fronds of feathery raffia may be hung from the 'wing'. Since this element is much more fragile than the centre sculpture, it has been lost in most museum pieces and indeed is regularly replaced in use. Although usually kept in semi-darkness on a shrine, in at least one case an *ivwri* is recorded as being placed on the head of a performer who dances with it.

The corresponding sculpture from the Ijo (cat. 5.58a) is a similar conception yet is different in so many particulars that the pieces read like the same statement in two different dialects. The Urhobo *ivwri* rounds out its forms wherever possible, while the Ijo *efri* squares all its shapes off. The function of the piece is the same as that of the Urhobo and exhibits the same aggression. Nowhere can the stylistic differences between neighbouring peoples be better demonstrated.

Although works of this kind are typically interpreted as handling impersonal forces, ritual objects in southern Nigeria frequently externalise parts of the human body – so that movements of the head, hand etc. may have strong moral implications and so make the parts of the body subject to control. The stomach can be seen as a symbol of personal greed and acquisitiveness and this sculpture directs and moderates its excesses.
NB

Bibliography: Foss, 1975

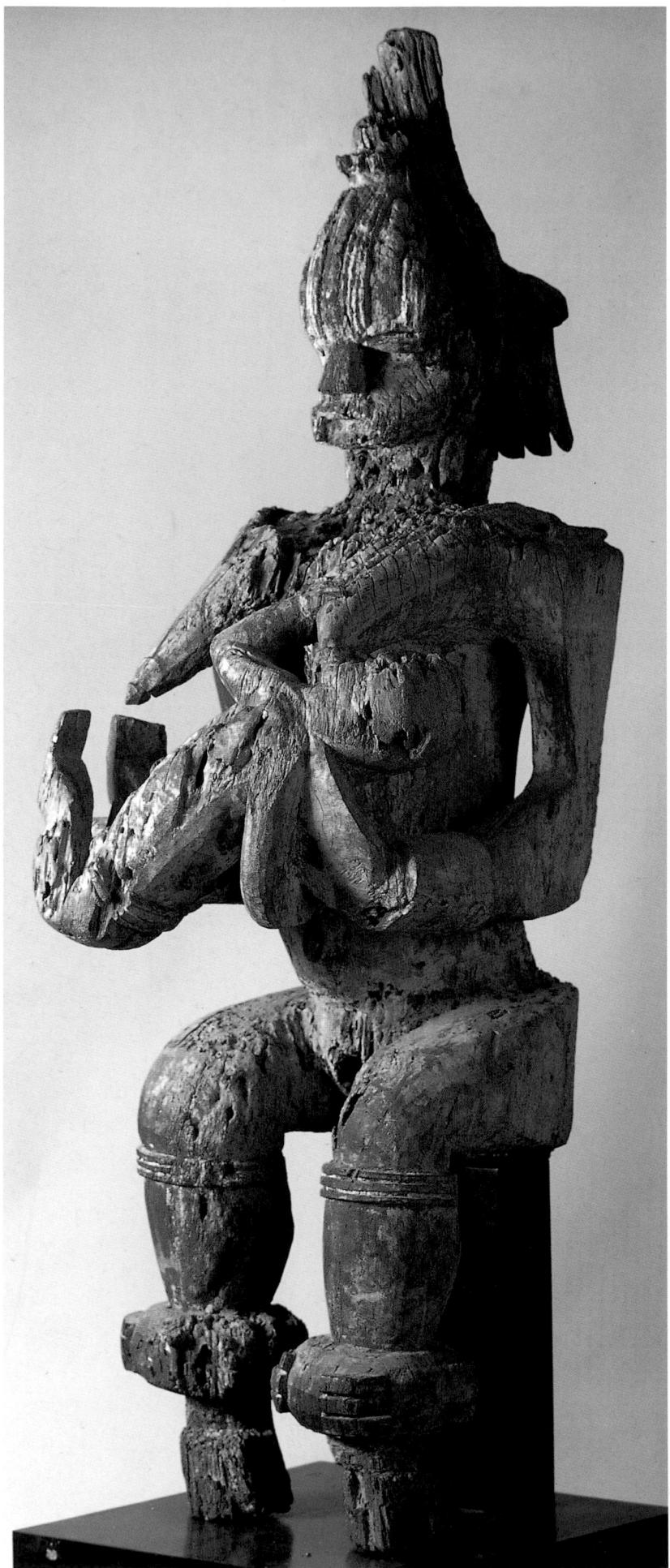

5.59

Carved figure (*edjo re akare*)

Urhobo

Nigeria

19th century (?)

wood

h. 142 cm

Musée Barbier-Mueller, Geneva

The Urhobo of southern Nigeria distinguish between the figures of spiritual beings and those of named ancestors and have different styles for each. This maternity figure is clearly in the former (*edjo*) style with its relative naturalism and rounded, non-geometric general forms. It assumes a characteristic half-seated pose and would have been supported against the mud wall of a shrine, with the posts below the feet embedded in the earth. Much abraded, it would once have been heavily encrusted with white chalk as a mark of spiritual purity and power. The lower limbs would have been wrapped in a white cloth and so less subject to erosion. The head bears the remains of raised facial scars and a complex peaked coiffure, *igbeton*, worn by women of high rank. A necklace curves over the shoulders and on the legs are hollow brass manillas that might be stuffed with aromatic leaves.

Figures of this kind were mainly associated with water-spirits or settlement founders; female carvings seem to have been kept on the fringes of the village near water while male figures were centrally located.

The suckling pose does not necessarily imply that the powers of the spirit were concerned exclusively with child-bearing. In African sculpture maternity is often seen as completing female identity and nurturing may be metaphorically applied more generally to relations between spiritual powers and life on earth. *NB*

Bibliography: Foss, 1975; Foss, 1976

5.60a

Head of a queen mother

Benin
Nigeria
16th century
brass
h. 55 cm

The Board of Trustees of the National
Museums and Galleries on Merseyside
(Liverpool Museum), 27.11.99.08

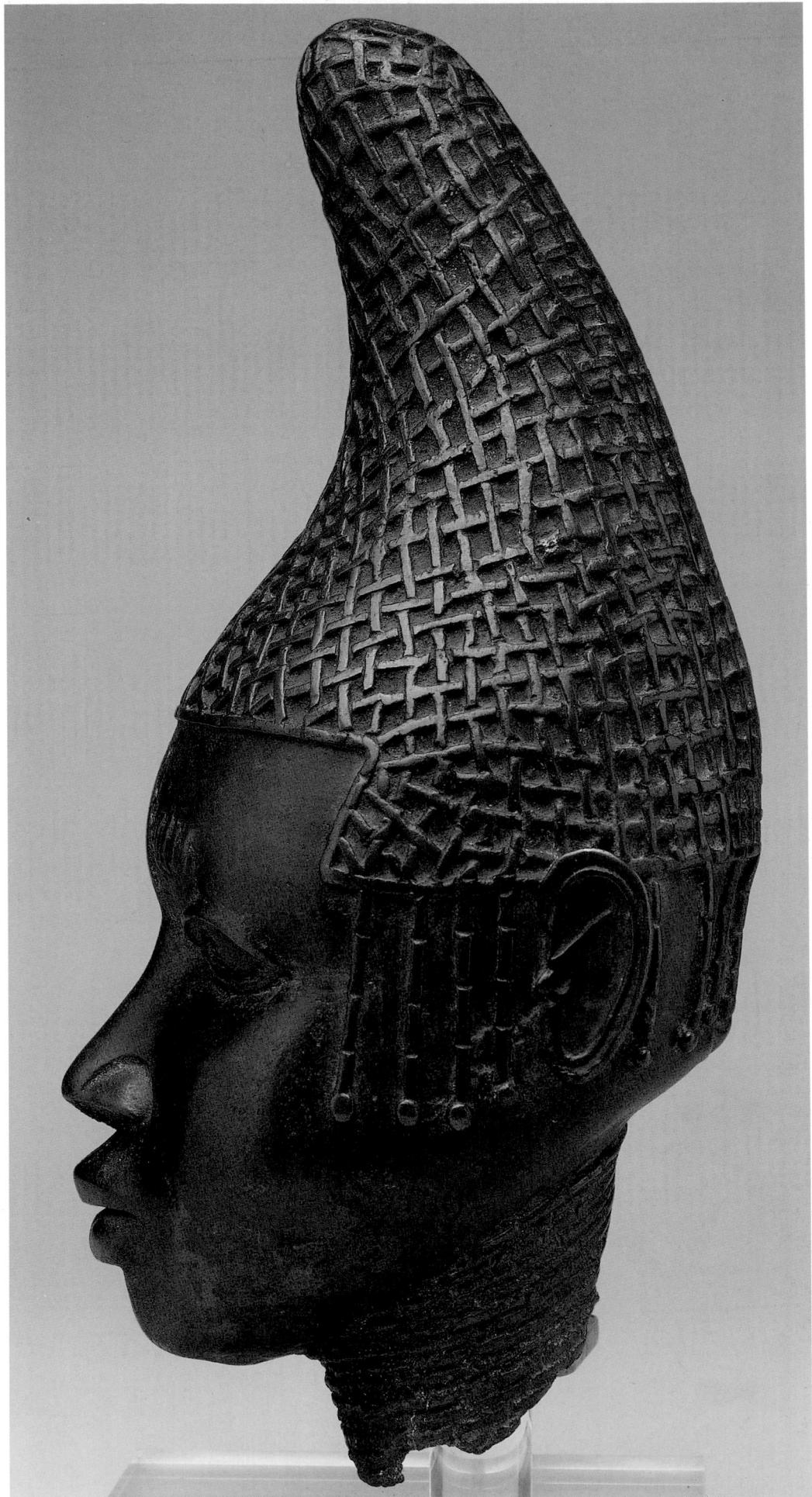

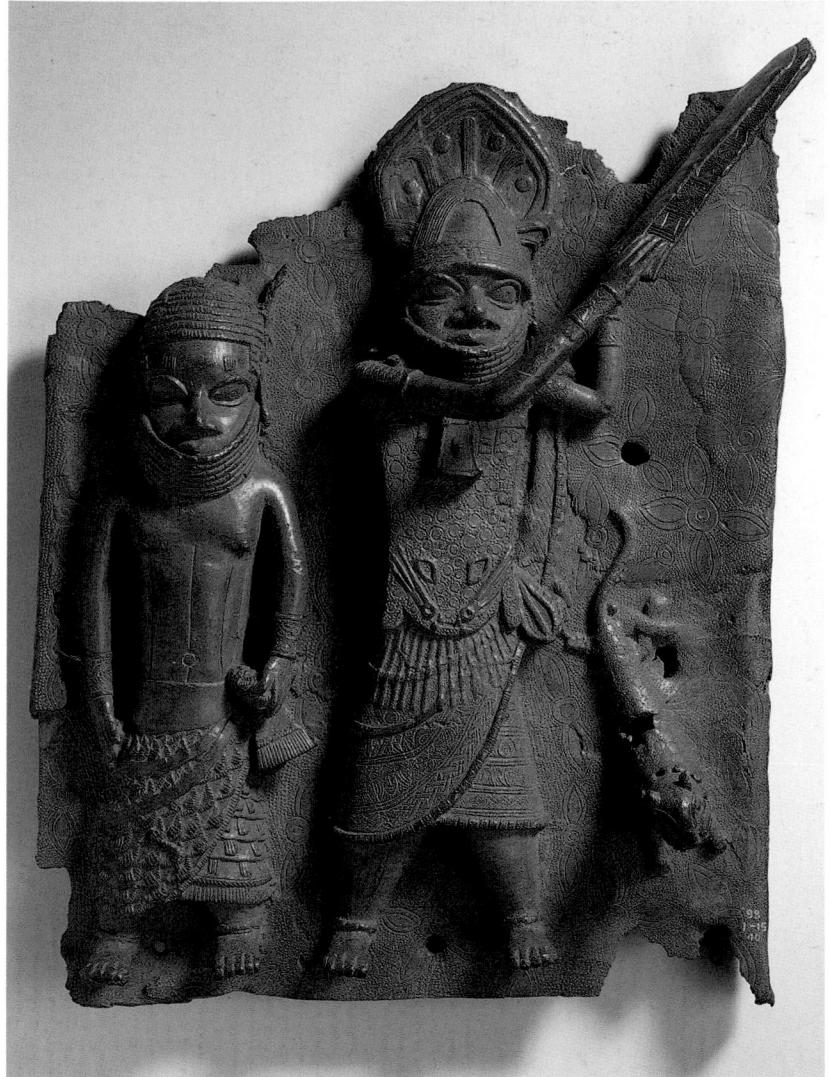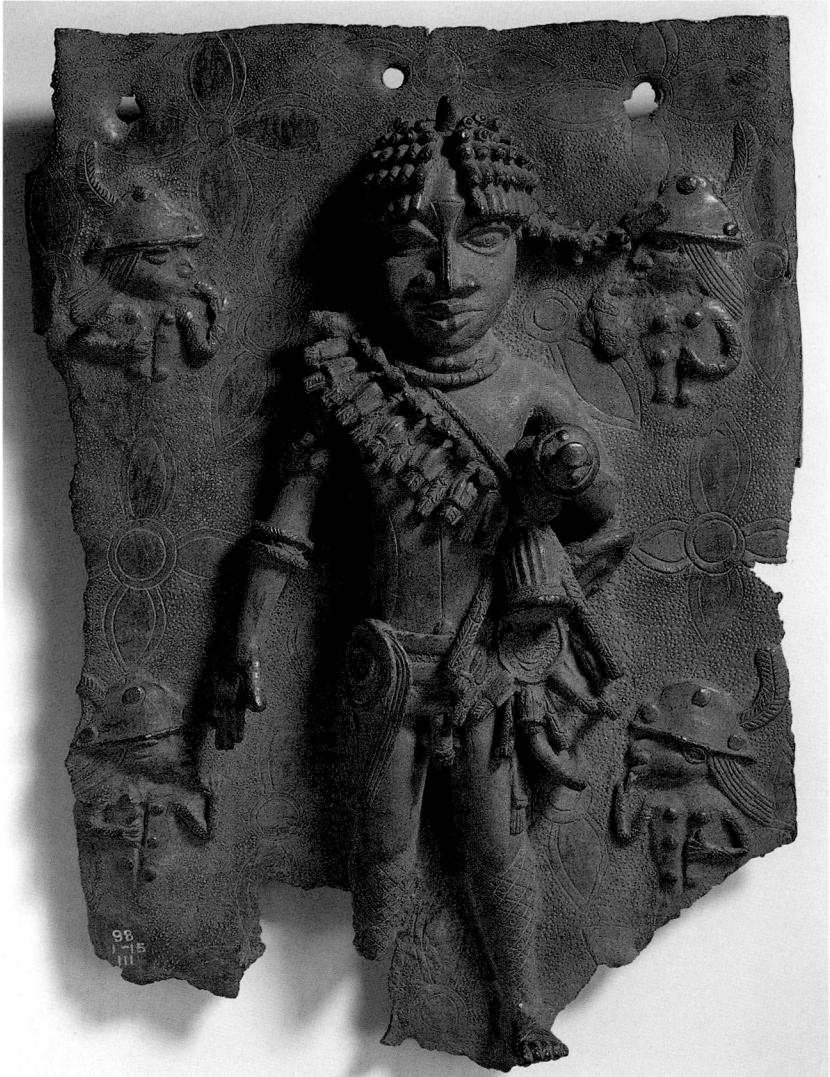

5.60b-e

Plaques

Benin
Nigeria
16th century
brass

50 x 37.5 cm; 44 x 32 cm; 45 x 39 cm;
50 x 40 cm

The Trustees of the British Museum,
London, 1988. 1-15.173; 1-15.111;
1-15.121; 1-15.40

When British forces entered Benin City in 1897 they were surprised to find large quantities of cast brass objects. The technological sophistication and overwhelming naturalism of these pieces contradicted many 19th-century Western assumptions about Africa in general and Benin – regarded as the home of ‘fetish’ and human sacrifice – in particular. Explanations were swiftly generated to cover the epistemological embarrassment. The objects must, it was supposed, have been made by the Portuguese, the Ancient Egyptians, even the lost tribes of Israel. Subsequent research has tended to stress the indigenous origins of west African metallurgy. Yet it was the naturalism that proved decisive. After some hesitation between the categories of ‘curio’ and ‘antiquity’, these objects became unequivocally ‘art’. Their status was marked by the establishment of the resonant term ‘Benin bronzes’, despite their being largely of brass, the noble

material locating them firmly within the tradition of Western art studies.

Since then, a great deal of archaeological, historical, scientific and anthropological enquiry has been undertaken. Works have been classified by period according to the familiar art-historical terms Early, Middle and Late, with the last implying a tailing-off in quality. Controlled production, exclusively for the court and within a guild system, might seem to favour relatively simple models of development. Yet the precise chronology of much of the Benin corpus and its relationship to other African casting traditions remain open to question. Present datings depend largely on the acceptance that Benin casting traditions were derived from the naturalism of neighbouring Ife and on the direct connection (or at least as straight a line of descent as possible) of these to the ‘stylised’ forms of the late 19th century, bolstered here

and there with outsider descriptions of the Benin court, oral histories, thermoluminescent datings of clay cores and metal analyses. Whether differences of style are exclusively explicable in terms of date rather than difference of function or origin, however, remains problematic. As the capital of a centralised empire with fluctuating boundaries, Benin City had long disseminated regalia to vassal kingdoms and attracted both craftsmen and objects of power to the centre. Scholars have frequently attempted, on the basis of rather tenuous evidence, to repunctuate the corpus of works found in Benin City to create a classic genealogy in line with Western assumptions and exclude the rest.

The queen mother head (cat. 5.60a) is normally ascribed, on stylistic grounds, to the 16th century, i.e. the end of the Early period (Fagg, 1963). The title of queen mother was apparently introduced to Benin by the Oba

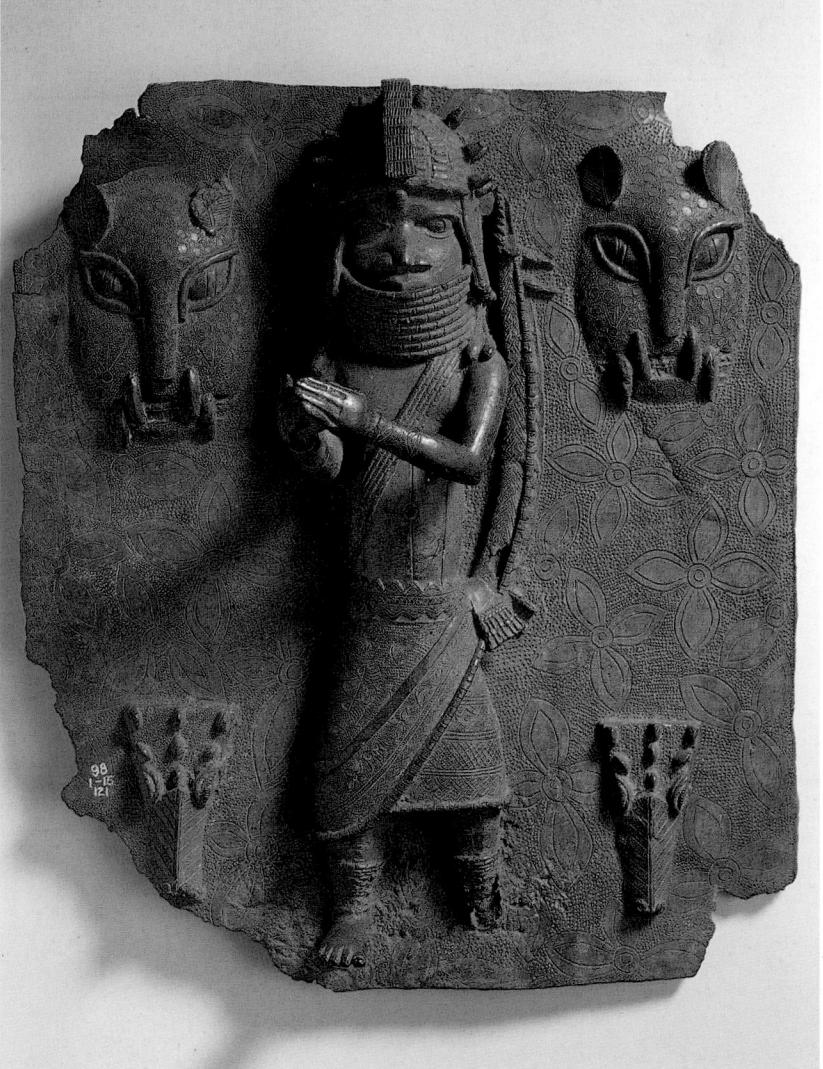

Esigie about the beginning of the 16th century to honour his own mother, Idia; the first brass memorial heads of this form are assigned to this period. The peaked headdress of coral beads is peculiar to the queen mother and, according to one version, is termed 'the chicken's beak'. While the Oba was associated with powerful aggressive animals such as the leopard, queen mothers had a special link with the cockerel, representations of which appeared on altars. This head was presumably kept on those same altars in the queen mother's palace at Uselu, outside the capital, Benin City. It seems generally to be the case that brass heads served as bridges between the spirit and the ordinary worlds but that no tradition of personal portraiture was known.

The positive images of Benin formed by early European visitors make much of the order and imposing architecture of Benin City. Among the features that strongly impressed West-

erners were the palace towers, surmounted by huge birds and ornamented with large brass pythons that zigzagged down the roofs to terminate in great heads with open jaws.

The python head (cat. 5.60g) is one of the finest examples of the genre. A box in the Berlin museum, in the form of a palace building, shows the serpent as continuing over the ridge of the roof and down the other side to end in a tail. Holes around the neck are for the attachment of the rest of the body; the tongue, lost in most examples of this kind, has survived. While many snake heads are entirely covered in scale-like marks, in this piece they are limited to a line four deep around the jaws, giving it considerable elegance. The python, as a creature moving both in the trees and under the ground, was one of the many animals believed by the people of Benin to operate as a messenger of the god Olokun, with whom the Oba specially identified.

At the end of the 17th century the pillars that supported the palace were of wood covered with brass plaques. Like coral and ivory, brass was a material with royal connotations and its use was strictly controlled. By the end of the 19th century and possibly long before that, the plaques had been abandoned in favour of a palace entirely of metal and were mostly dumped in a ruinous storehouse. Many have holes showing where nails were hammered through, and the plaques often seem to have been broken while being wrenched from the pillars. Their production is conventionally dated to the second half of the 16th century; indeed, Fagg refers to them as 'the sheet anchor' of the whole system of Benin chronology. This has not, however, made them immune to challenge.

Although plaques are nowadays normally interpreted in Benin City by analogy with photographs, it seems that most showed recurrent scenes of

ritual rather than unique events. Many can no longer be precisely identified.

The first (cat. 5.60b) deals globally with the place of the leopard within the Benin court. One of the praise-names of the Oba was 'The Leopard of the Town' and he alone was allowed to slay leopards as part of his ritual duties. Leopards would be captured as cubs to be raised within the palace and so tamed in preparation for their immolation. The leopard here is tame, as is shown by its collar. It is shaded with a shield, another prerogative of the Oba within the palace precincts, which strengthens the link between the ruler of the city and the ruler of the forest. The main human figure wears a cuirass, probably of felt and leather; it terminates in a leopard's head and a collar of leopard's teeth, emphasising the warrior's role as a shedder of blood. On his left hip the cloth is raised up into an unusual high 'tail'.

5.60f

Head of a dwarf

Benin
Nigeria
14th century
brass
h. 14.5 cm
Staatliche Museen zu Berlin, Preussischer Kulturbesitz, Museum für Völkerkunde, III C 12514

5.60g

Head of a python

Benin
Nigeria
18th century
brass
h. 42 cm
Staatliche Museen zu Berlin, Preussischer Kulturbesitz, Museum für Völkerkunde, III C 8514

Particularly striking is the rendering of the leopard, which is shown lying with its back legs crossed over each other; but the whole figure is arranged unforeshortened, from top to bottom within the conceptual frame.

The second plaque (cat. 5.60c) shows a single figure with elaborate coiffure. The braid that seems to be flying is unusual in the rather static idiom of Benin art and may not have been deliberate. A tasseled belt crosses the chest, supporting a sword and an unusual bag (?) and bell hang from the waist. The legs are painted or tattooed up to the knees in a fashion otherwise seen on naked pages; although this figure is dressed, his genitals are exposed, suggesting that he too may be a page. In Benin, in an idiom of overstatement, pages – like all unmarried youths – went naked until the Oba ‘made them men’ by giving them land, rich clothes and wives. The corners bear images of European heads, hatted and bearded with hands to their lips in a pose common elsewhere on the plaques. In other, clearer renditions they appear to be touching their beards in a gesture of respect.

The third plaque (cat. 5.60d) shows another court figure with the unusual high ‘tail’ rising from the point at which his cloth is tied over the left hip. In his hands he bears an enigmatic object that may be a musical instrument. A similar figure appears on the ivory sistrum (cat. 5.60n; see below), suggesting he may belong to the same ceremonial context, the Emobo ceremony that cleanses the city of evil forces. In the upper corners of the plaque are leopard heads, images of the Oba, while in the bottom are those of the crocodile, another messenger of the god Olokun.

The last plaque (cat. 5.60e) shows a heavily stylised palm-tree, possibly a Borassus palm in fruit. Two fallen leaves are arranged symmetrically on either side. A Benin informant suggested that some of the plaques illustrate proverbs but was unable to identify clearly which proverb might be involved here.

Dapper’s famous 17th-century description of Benin City includes an engraving of the Oba processing with leopards and dwarfs. Both were apparently represented on the altars as aspects of the palace (the collec-

tions in Vienna and Berlin contain images of dwarfs). The head of a dwarf depicted here (cat. 5.60f) has been interpreted variously as male or female but the gender is not clear. The top and back are lacking and cracks in the chin and the roughness of the surface suggest that some of this may derive from unsuccessful casting. The face is strongly prognathous and the hair is only slightly suggested. Unusually, the nostrils are not pierced and the features weakly modelled. The neck ends in a necklace and is pierced as though for attachment.

A number of large standing figures are known from Benin, representing the Oba, attendants and European soldiers. Female figures of brass are comparatively scarce. That from Berlin (cat. 5.60h) immediately challenges notions of a classical Benin corpus. A closely similar one (in the Lagos collection) has a stand in a form normal in Benin works dated to the late 17th century. In common with many of the plaques, the arms are cast solid, without clay core. The necklace, crossed baldric, facial and body scarification are features all well known from classic Benin works but the style here is greatly at variance with these. The bulbous eyes and tubular legs, the extraordinary modelling of the hair and the square feet all recall a vast and heterogeneous corpus of southern Nigerian bronze castings that have not been assigned to any particular centre and are reduced to a spurious order by calling them the Lower Niger Bronze Industry. Attempts to identify the casting with figures of Benin myth and history remain speculative. Meanwhile, ‘Benin’ continues to spawn an increasingly numerous and dubious progeny – Owo, Ijebu etc. derived from vassal cities of the Benin empire – as a means of explaining its substyles in terms of outside influence.

Another piece in the same indeterminate position is the Berlin mudfish-headed figure (cat. 5.60i). It stands on massive, ill-formed feet, pierced at the front. The skirt extends to the left in the familiar Benin fashion, with two tabs hanging down. Large beads form a necklace and bandolier. The figure holds remnants of a snake in both hands. The ‘whiskers’ of the mudfish have been so modelled as to resemble

5.60h

Figure of a woman

Benin
Nigeria
17th–18th century (?)
brass

h. 48 cm

Staatliche Museen zu Berlin, Preussischer Kulturbesitz, Museum für Völkerkunde, III C 10864

hair. European hair is similarly represented in Benin figures.

Mudfish were, like Europeans, regarded as messengers of the god Olokun who sent both wealth and children from over the sea. It is the distinguishing feature of such fish to retreat into the mud as a watercourse dries up. At the first rain they reappear, vibrant with life. They are thus suitable images of intermediaries between the realms of the living and the dead. The portrayal of the Oba as a semi-mudfish is common in Benin, though more usually it is the legs that are assimilated with 'whiskers'. It is even related that the 14th-century Oba Ohen explained a stroke that made him lame in terms of this transformation.

Some time before 1907 a man digging a water-hole at Apapa, Lagos, accidentally discovered a ram's head pectoral (cat. 5.60j) at a depth of about three metres, along with a large hoard of other brass objects. It is a work of striking elegance, strongly modelled and with subdued ornamentation. The central, semicircular panel has been edged in cast plait-work, while a simple geometric design has been punched into its flat surface. Large crotals are attached with wire. The horns of the ram have been spread to frame the hollow head that is surmounted by a suspension hoop, also in plaitwork. Stylistically, it recalls the Benin ram aquamaniles and the casting has a similar thinness and accomplished lightness.

Inevitably, its discovery in Lagos has encouraged speculation on more exotic origins. While the use of ram images is very common in many parts of southern Nigeria, it has been associated with influence from Ancient Egypt or the Yoruba kingdom of Owo. Yet tradition has it that Lagos

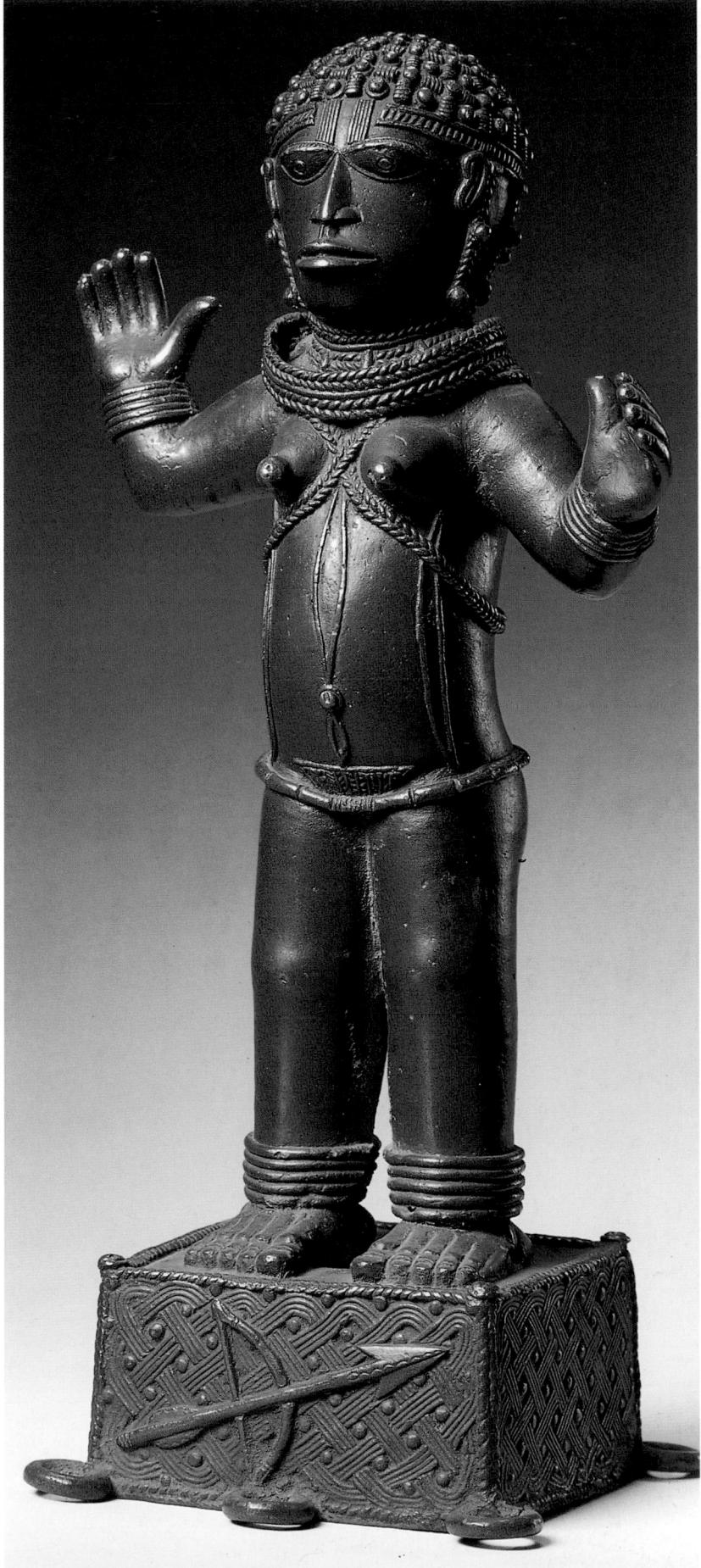

was a vassal of the Benin empire in the mid-16th century and the pectoral may well have been made at that time. As belligerent, domineering animals, rams were associated in Benin with male notables and were a favoured beast of sacrifice.

The small costume mask in the form of a human face (cat. 5.60k) is another non-canonical piece, so it is sometimes regarded as 'Lower Niger' rather than truly 'Benin'. It combines a headdress recalling Ife brass castings with scarification redolent of Benin. The use of iron to mark the pupils of the eyes is typically Benin, yet their form is unusual, as are the slits underneath. These are known both from Ife brasswork and Benin ivorywork. The presence of loops at either side instead of at the back suggests that this mask may have been worn around the neck rather than on the left hip, as was more customary in Benin.

The manilla bracelet (cat. 5.60l) was presumably far too big to have ever been worn. Apart from being body decoration, manillas acted also as a reserve of value, as a ritual currency and as religious paraphernalia. It is of ridged cross-section with flared ends and incised geometric markings. It demonstrates many of the problems involved in attributing items of southern Nigerian metalwork. Together with many other manillas of varied forms, it was part of the contents of a shrine in the Andoni Creeks (i.e. in Ibibio country, southern Nigeria) destroyed by the British administration in 1904 following allegations of manslaughter. This collection of metal material included bracelets apparently of Ijaw manufacture, Lower Niger figure sculpture, swords of an almost Art Nouveau style (otherwise undocumented), a Dutch ship's bell, bronze leopard skulls and a length of drainpipe. Metal analysis shows the bracelet to be a genuine bronze, not brass, indeed to be almost of pure copper. All the shrine material seems to have been painted with stripes of white kaolin, a common mark of sacrality. The very diversity of the hoard is likely to have been part of its power.

The large iron staff (*osun ematon*; cat. 5.60p) forms part of the equipment of a Benin Osun priest, a specialist who uses the power of leaves and forest plants. Made of iron, it has a branching, tree-like form that ends

5.60i

Figure with mudfish head

Benin
Nigeria
brass
h. 38 cm
Staatliche Museen zu Berlin, Preussischer Kulturbesitz, Museum für Völkerkunde, III C 10873

5.60j

Ram's head pectoral

Apapa, Lagos
Nigeria
16th century
brass
h. 43 cm
The Trustees of the British Museum, London, 1930. 4-23.1

in representations of flame and sharp, piercing objects, such as animal horns and weapons. When complete, it would be surmounted by a grey heron, the lord of the witches. Planted in the earth, it is an important ritual object in the fight against witchcraft and held to be hot with power. Particularly effective is the chameleon represented on it, whose changing skin can be used at night by the Osun specialist to take photographs of the witches.

Benin art contains many skeuomorphs, objects habitually made in one material that are occasionally executed in others. The ivory and copper leopard (cat. 5.60q) is one such. One of a pair sent to Queen Victoria by Admiral Rawson, the commander of the British Punitive Expedition of 1897, its form recalls that of the brass aquamaniles, jugs used to contain water for royal ritual ablutions.

Made from five principal pieces of ivory fitted together, it could not be used as a water container and the 'lid' just in front of the tail does not open. It has been convincingly argued that

the older brass leopards themselves were inspired by medieval European models that happily fitted into Benin political symbolism. The spots are executed in copper and are said to be made from 19th-century percussion caps used for the detonation of rifles. The eyes contained fragments of imported mirror. In this, the Benin artistic corpus reverses the received orthodoxies not merely about naturalism in African art but also about patterns of trade. In defiance of the 'imperial model', whereby raw materials were supposed to be taken from Africa for conversion into manufactures in the metropolitan heartland, Benin usually imported European products that were pulped to make finished goods of interest to the Oba and court. Most of the Benin 'bronzes' were, after all, made from European metal.

The ivory sistrum (cat. 5.60n) is a *tour de force* of the ivory carver's art. It is a musical instrument, containing two bells of different size, producing a dry, tapping sound when struck.

5.60k

Mask in human form

Benin
Nigeria
brass
15.5 x 9.5 x 6 cm
The Trustees of the British Museum, London, 1962. AF. 13.1

5.60l

Manilla bracelet

Lower Niger
Nigeria
bronze, kaolin
15 x 20 cm
The Trustees of the British Museum, London, 1905.4-13.2

5.60m

Carved door

Benin (?)
Nigeria
wood
121 x 38.5 x 184 cm
The National Commission for Museums
and Monuments, Lagos, 74.I.422

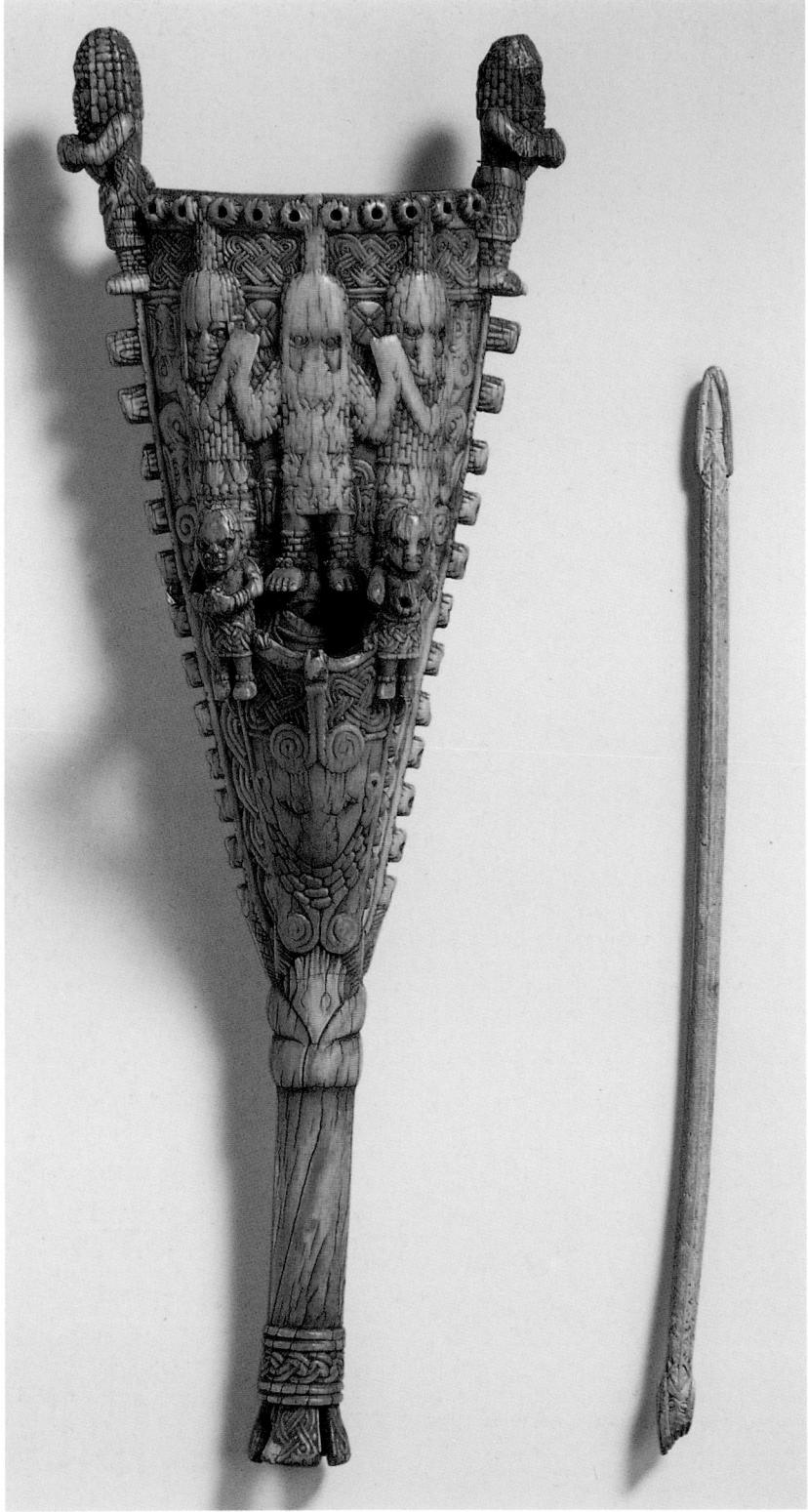

5.60n

Sistrum

Benin
Nigeria
16th century (?)
ivory
h. 36 cm
The Trustees of the British Museum,
London, 1963: AF. 4.1

5.60o

Striker

Benin
Nigeria
16th century (?)
h. 28 cm
The Trustees of the British Museum,
London, 1964: AF. 7.1

5.60p

Staff (*osun ematon*)

Benin
Nigeria
iron
h. 180 cm
Staatliche Museen zu Berlin,
Preussischer Kulturbesitz, Museum für
Völkerkunde, III C 8506

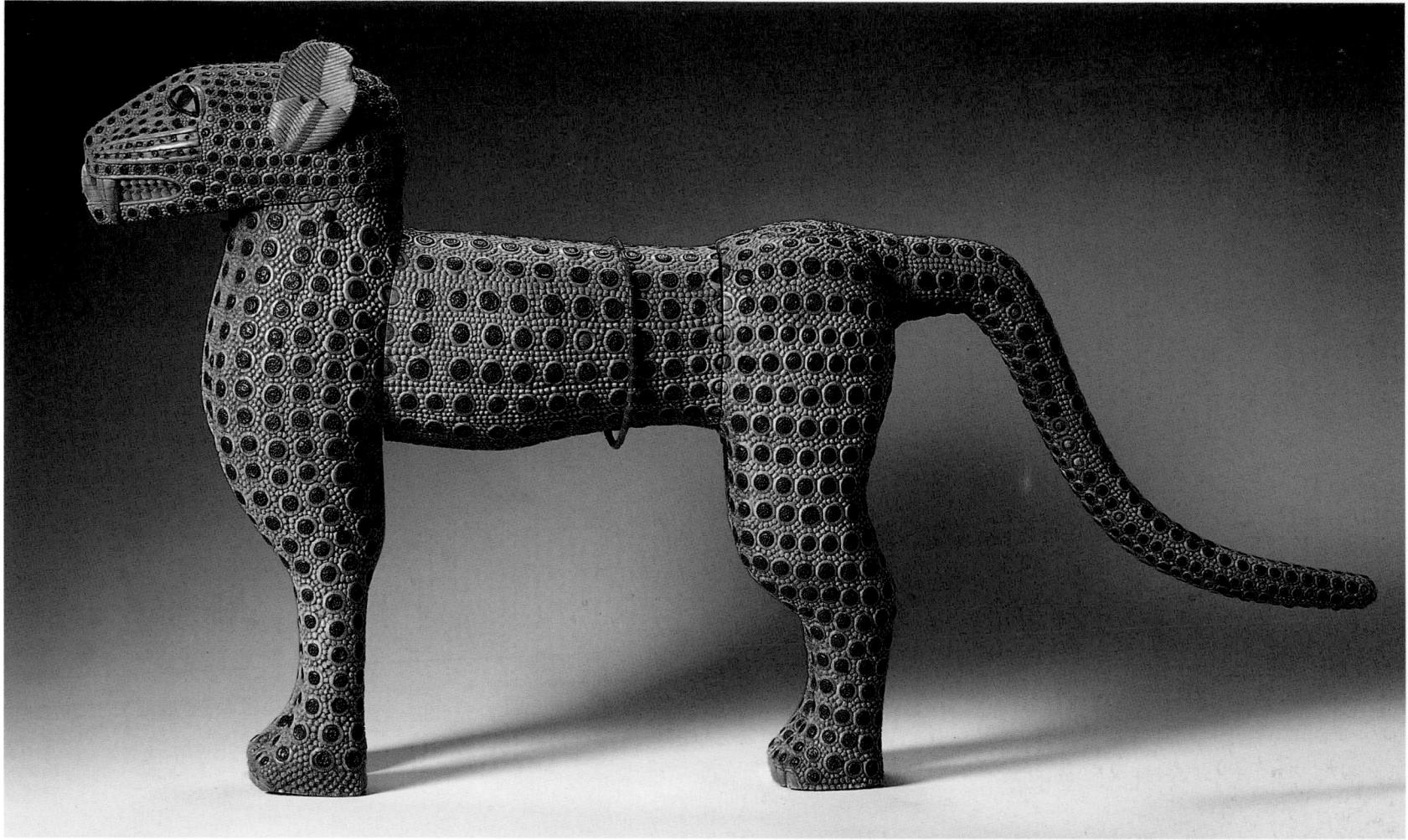

5.60q

Leopard

Benin
Nigeria
19th century
ivory and copper
47 x 88 cm

Lent by Her Majesty The Queen

On one side the Oba is depicted in human form, supported by two retainers. On the other, he incarnates the god Olokun with mudfish legs and a swinging crocodile in each hand. Human musicians mark the extremities of both vessels, which are edged with hollowed crenellations. Apart from the shaft of the handle, the surface is completely covered with fine, worn carving. The guilloche pattern of the end of the handle is repeated in various parts of the main vessels, fitted between representations of human faces, mudfish, snakes and – unusually – turtles, all recalling Olokun and his messenger animals. It shows the familiar ‘chaining’ technique whereby objects blend into each other. So the penis of the Oba becomes a hand that grips a bat. The Oba grasps a crocodile whose jaws, in turn, become another hand. The striker (cat. 5.60o) shows signs of having been completely covered with a criss-cross pattern, now greatly abraded, while its ends are again in the form of mudfish

heads. An instrument of this kind is used nowadays by the Oba at a ceremony to drive evil forces from Benin City.

It has been argued that the tradition of ivory carving in Benin differs from that of royal brass casting in that a separate guild is responsible for it, one that also undertakes woodcarving. Carving of wood and ivory was less affected than casting by the decline in the Late period, so that even 19th-century works such as the leopard (cat. 5.60q) and the carved Benin door (cat. 5.60m) are of relatively high quality. In the absence of clear information concerning provenance, the latter is hard to place. While elaborate doors were common in Benin City, and in Africa generally are part of a concern with status and the symbolic importance of thresholds, this particular door bears none of the motifs normally associated with Benin. *NB*

Provenance: cat. 5.60b–e: 1988, given to the museum by the Secretary of State for Foreign Affairs; cat. 5.60l: 1905, given to the museum by the British administration for southern Nigeria; cat. 5.60n: 1963, given to the museum by Mrs Webster Plass; cat. 5.60o: 1964, given to the museum by Lady Epstein; cat. 5.60q: 1897, given to Queen Victoria by Admiral Rawson

Bibliography: Fagg, 1960, pp. 33, 38; Fagg, 1963; Babatunde Lawal, 1975, p. 238; Dark, 1975, p. 40; Poyner, 1978, p. 193; Tunis, 1978; Ben-Amos, 1980, p. 53; Tunis, 1985

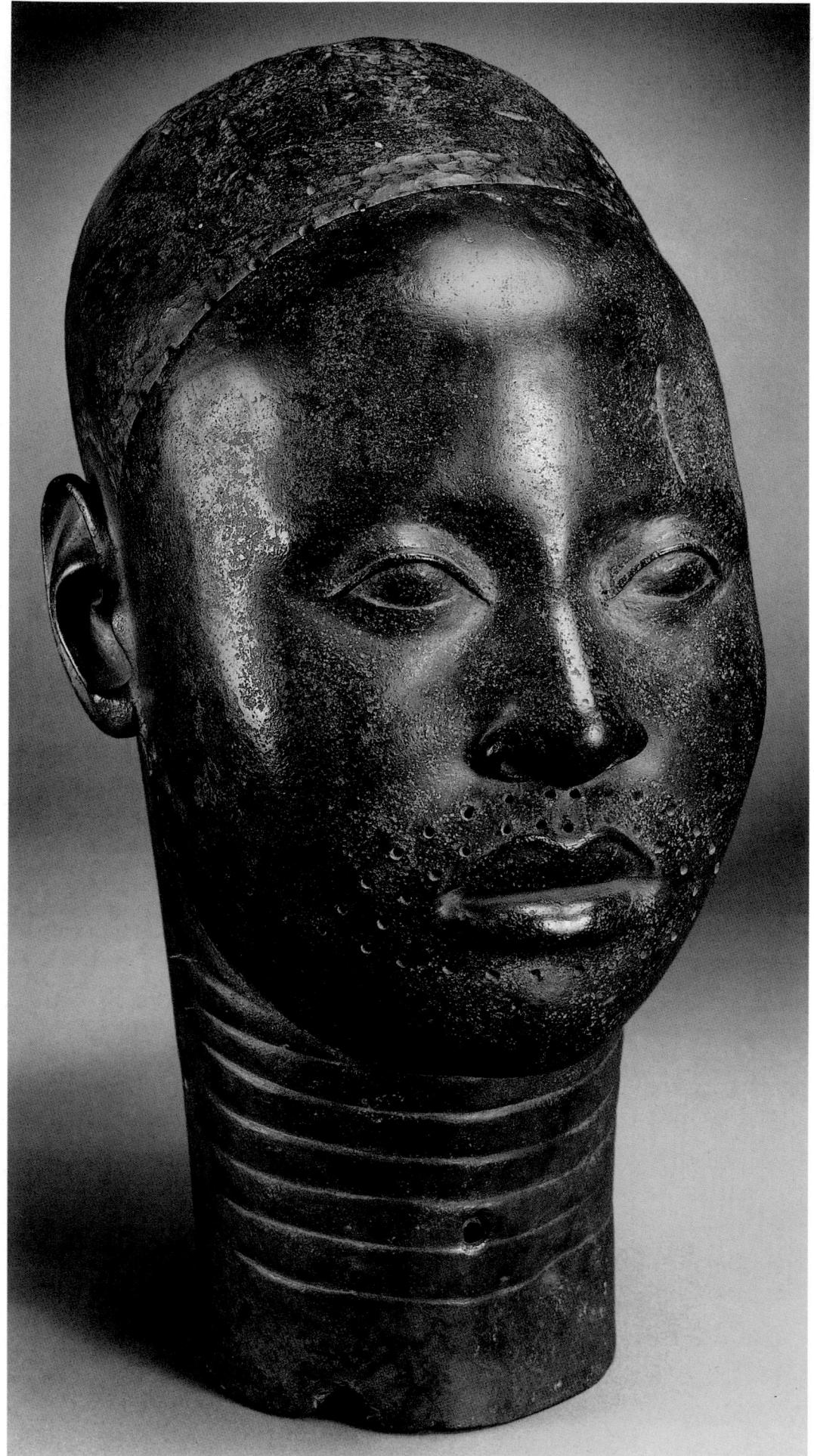

5.61

Head

Yoruba

Ife, Nigeria

12th–15th century

zinc-brass

51 x 9.5 cm

The National Commission for Museums
and Monuments, Ife, Nigeria, 11

In 1938 ground was being dug to construct a house in Wunmonije Compound, now immediately behind the palace in Ife, but formerly within the enclosing palace wall. The workers found two groups of castings. Most were of life-size heads like this one, two were smaller than life size and wore crowns and there was the upper part of a figure that closely resembles that of an Ooni found in 1957 at Ita Yemoo. Their portrait-like naturalism astounded the Western art world despite the fact that the German explorer and ethnographer Leo Frobenius had called attention to this art in 1910 when he found a crowned metal head and a score of terracotta sculptures. It was not considered in 1938 any more than in 1910 that this could really be the work of African sculptors unless they had worked under a European master. Soon after World War II, William Fagg argued persuasively that they were indeed made by Africans before Europeans first landed on the Guinea Coast. The Western critics were still astonished in 1982 when this head and others similar were shown in the exhibition *Treasures of Ancient Nigeria*.

The head has been cast from a wax original over a clay core. The top of the head has been cut back on the wax before casting to make it fit an existing crown. Holes have been provided in the neck to allow it to be attached either to a column or more likely to a wooden body. It is not clear how these heads were used. Perhaps they carried the crown and other emblems of office of a dead ruler in a second burial ceremony to show that, though the incumbent had died, the office continued, or they may have been used in annual rites of purification and renewal for the ruler and his people. FW

Exhibition: Detroit et al. 1980–3, no. 39

Bibliography: Fagg, 1963; Willett, 1967, pl. II; Shaw, 1978

Mask head

Yoruba

Ife, Nigeria

12th–15th century

copper

33 x 19 cm

The National Commission for Museums
and Monuments, Lagos, IFE.17

This life-size mask is reputed to have been kept on an altar in the palace at Ife ever since it was made. It is said to represent the early Ooni of Ife Obalufon II, who is credited with having introduced the art of bronze casting. It is a masterpiece of the bronzesmith's art for it is completely flawless despite being cast in pure copper without any addition of zinc, tin or lead to help it to flow in the enclosed mould. Molten copper oxidises on exposure to air, forming a thick skin that prevents it from flowing in the narrow confines of the mould, a fact that was known to the smiths at Igbo-Ukwu in the 9th or 10th century. The Ife smiths seem to have hit on the idea of excluding the air by joining the mould to the crucible and inverting the whole lot when the metal was fluid enough. The rough patches above the hairline are where channels were provided in the mould to permit the metal to enter and gases to leave. They would have been partially filled with metal and then cut off. The holes above the hairline were probably to carry a crown. As in the life-size head, the surface has been cut away over the ears so that the crown could fit. The holes round the mouth and jaw carried a veil of beads, as is shown in a very similar terracotta piece found at the Obalufon shrine and sadly stolen from the Archaeology Department of the Obafemi Awolowo University in Ife. The flange at the back of the face has holes to allow it to be attached to a costume. Clearly this is a mask intended to be worn in a representation of a king, but what the performance was remains a mystery. *FW*

Bibliography: Willett, 1967, pl. I; Shaw, 1978, pl. 83; Eyo and Willett, 1982, no.41

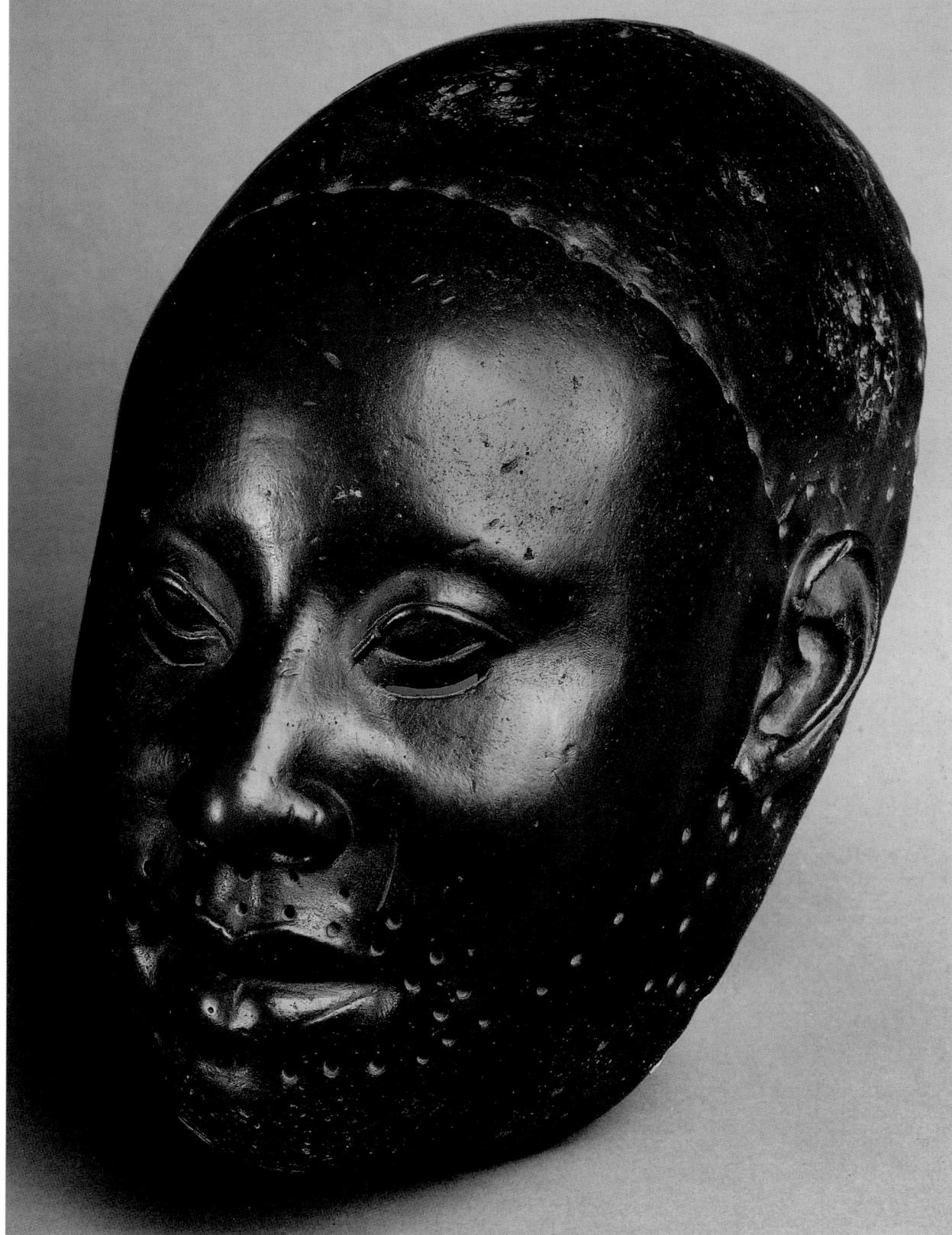

5.63

Figure of an Ooni

Yoruba
Nigeria
Ita Yemoo, Ife
12th–15th century
zinc-brass
47.1 x 17.3 x 16.3 cm
The National Commission for Museums
and Monuments, Lagos, 79.R.12

This is one of a group of sculptures found in 1957 by workmen levelling the ground to build the headquarters of the Ife Co-operative Produce Marketing Union. According to the Ooni (King) of Ife at the time, it represents the Ooni in the costume worn for his coronation. The left hand holds an animal horn that is filled with a powerful medicine. The right hand holds a wooden staff covered with bead-embroidered cloth; this is replaced after the coronation by the *irukere* (lit. 'ram's beard'), the beaded cow-tail flywhisk that is widely recognised in Africa as a symbol of authority. Being complete, this figure has proved invaluable in interpreting the many hundreds of fragments of terracotta sculpture in the Ife Museum. Crowns show considerable variety, but all have some form of conical boss over the forehead with a rising element above it. The one worn here is the most common form with a plaitwork riser ending in a pointed tip. The heavy collar with globular beads along the inner edge is also typical, as are the pair of beaded badges, shaped like a bow-tie, which hang on the chest. All the features represented here – the mass of strings of beads covering most of the chest, the longer rope of much heavier beads, with a loop of beads at their lowest point; the beaded cuffs on the forearms and lower legs, accompanied by narrow bracelets and anklets – are regularly represented in the terracotta sculptures. FW

Bibliography: Willett, 1967, pl. 6;
Eyo and Willett, 1982, no. 44

5.64

Seated figure

Yoruba
Tada, Nigeria
13th–14th century
copper
55.7 x 34.5 x 36 cm
The National Commission for Museums
and Monuments, Lagos, 79.R.18

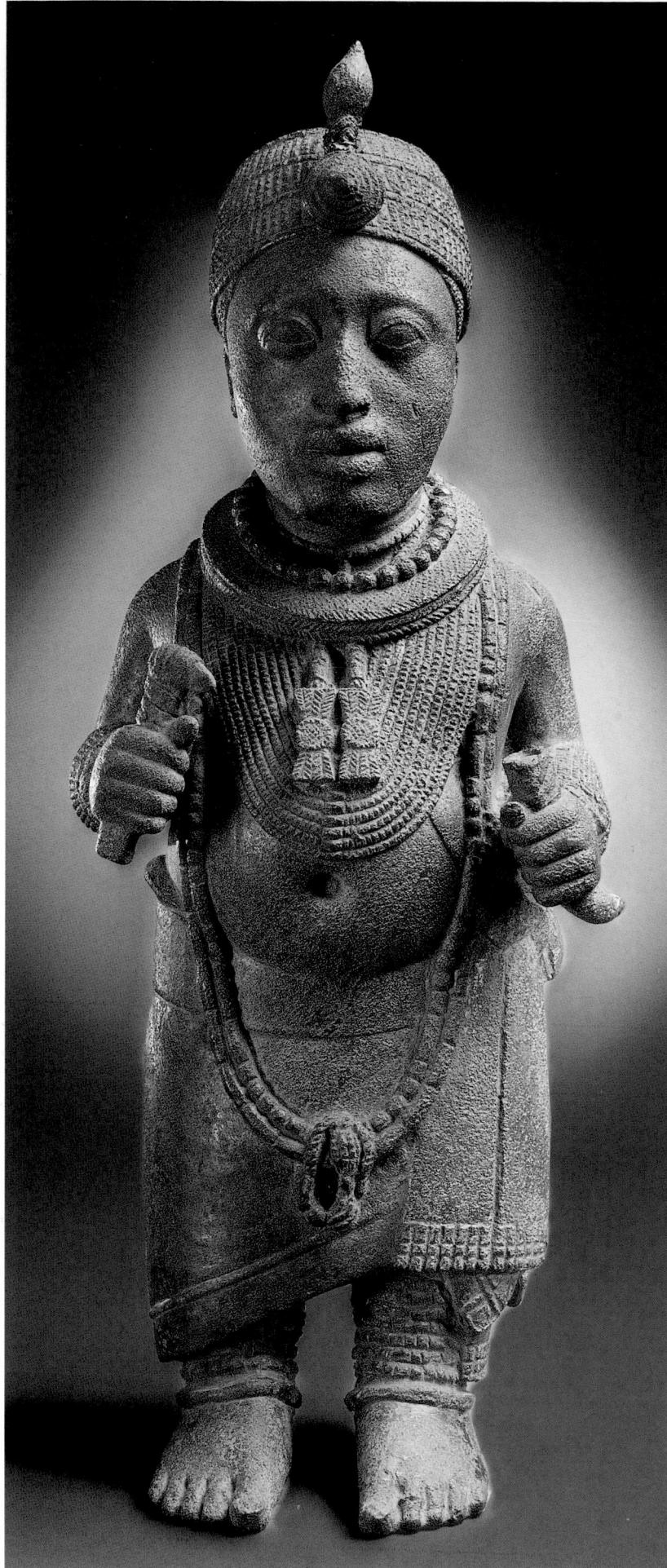

This is without doubt the supreme masterpiece of the Ife smiths' art. Its proportions are naturalistic, whereas normally the head is a quarter or more of the height of the figure. The limbs are usually the torso are generally no more than cylinders, but here the legs and remaining parts of the arms are very lifelike. The figure wears a wrapper that is overlain with a net of beads. On the left hip a sash is tied round a folded cloth, perhaps the corners of the wrapper. (There is a similar hip ornament in terracotta from a life-size figure from the Iwinrin Grove.) Originally the right foot may have projected below the level of the base, which prompted William Fagg to suggest that it might have been intended to sit on a round stone throne (as cat. 5.66).

The metal used to cast this piece was almost pure copper. This sculpture, weighing in its broken state and without the enclosing mould about 18 kg, was too heavy to cast by joining the mould to the crucible, so it was probably cast by partly burying the mould in the ground and melting the metal in several sealed crucibles. When ready these would have been taken to the mould, their tops knocked off and the metal poured in. One can distinguish on the back of the figure the lines separating the different pourings of metal, as it chilled when running into the mould and did not fuse completely. Until recently this piece was kept in a shrine in the Nupe village of Tada on the River Niger 192 km north of Ife, where the villagers took it down to the river every Friday (they are good Muslims) and scrubbed it with river gravel to ensure the fertility of their wives and of the fish on which they live. This accounts for its smoothed appearance. Bernard Fagg persuaded the villagers that they were destroying the sculpture and with it the fertility they were trying to promote. He provided them with special cloths to keep it bright. By 1956 the cloths had worn out and the habit had been lost. The figure was already developing its dark protective patina.

It is not clear why this piece and several others were found so far north. It may well be that its location indicates the ancient northern frontier of the kingdom of Ife. FW

Bibliography: Willett, 1967, pl. 8

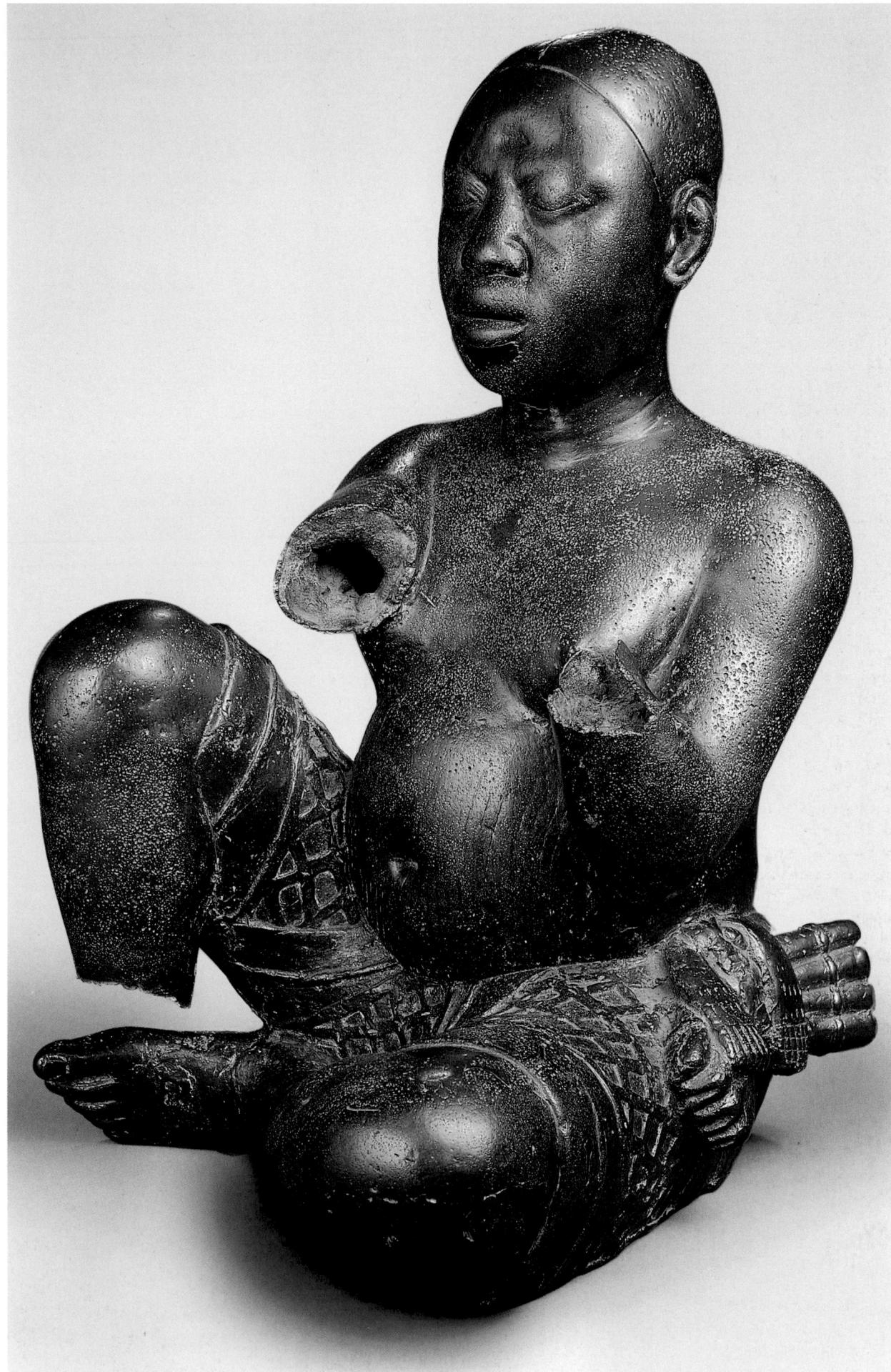

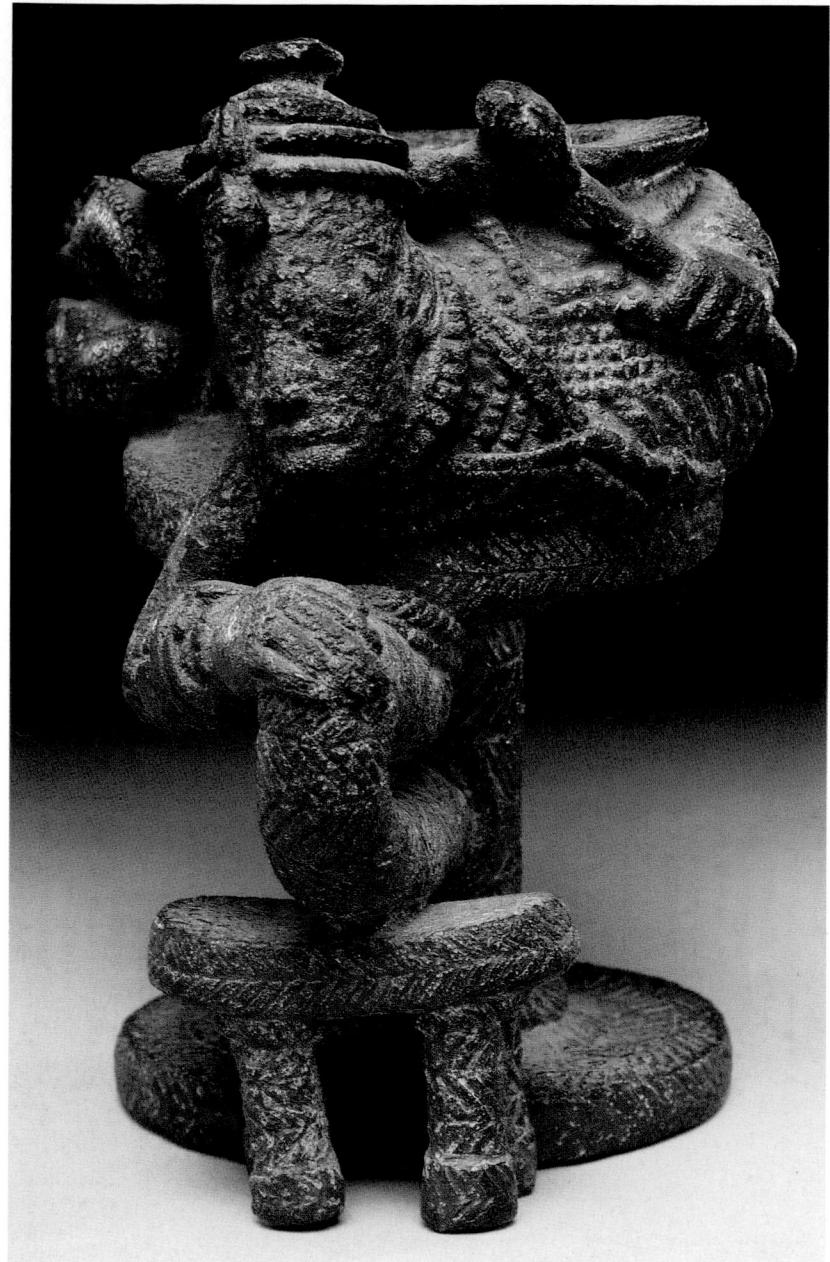

5.65

Vessel

Yoruba
Nigeria
Ita Yemoo, Ife
12th–15th century
zinc-brass
12.4 x 10.5 cm
The National Commission for Museums
and Monuments, Lagos, L.192.58

Like the brass figure of an Ooni (cat. 5.63), this object, which the finders called an ash-tray, was found by accident. It is a solid, flawless casting and was cast upside-down. It represents a queen wearing the usual flanged crown, heavy beaded collar, a mass of necklaces over the chest with a heavy rope of beads outside them and the beaded badges

of office on the chest. She wears the usual beaded cuffs, bracelets and anklets. Her body is curved around an open bowl, which stands on top of a typical Ife throne; this is composed of two discs separated by a column from which projects a loop that curves back to join the lower side of the top disc (cat. 5.66). The surface is covered with herringbone decoration. The figure supports herself on the loop with her left arm. In her right hand she holds a staff with a human head like two that were found with this piece. On one example the head was gagged. It is impossible to tell whether the head on the queen's staff was gagged. There were also two staff-heads, each with two gagged human heads. It would appear that these castings were used

in a very important cult in which the highest form of sacrifice was offered. The bowl was probably intended to be a receptacle for a liquid, possibly of snail juice (used as an antiseptic when children are scarified), kept on certain shrines in modern Yorubaland. FW

Bibliography: Willett, 1967, pl. 9;
Eyo and Willett, 1982, no. 46

5.66

Throne

Yoruba
Nigeria
Ile Oluorogbo, Ife
12th–15th century
quartz
h. 53 cm
The Trustees of the British Museum,
London, 1896. 11.22.1

This is one of three stools made from vein quartz (one like this but with the loop broken off and the third a matching four-legged stool) that were given by the Ooni of Ife, Adelekan Olubushe, in 1896 to Captain Bower. They came originally from the shrine of Oluorogbo, who is said to be the messenger between earth and heaven and to have known the art of writing.

Veins of quartz outcrop around Ife. It is a very hard crystalline substance that fractures along the crystal faces. This makes it unsuitable for working by striking with hammer and chisel, so this elaborate shape must have been achieved very laboriously by abrasion, probably by rubbing with moist sand applied with blocks of wood. The mouldings around the top and bottom of the central column and at each end of the loop are almost circular in section (rather than being quadrants, as one would expect to find on worked stone). This led the sculptor Leon Underwood to suggest that the form had been created by a bronzesmith in whose craft it would be natural to apply a roll of wax to form such a moulding. However, it has been shown that the prototype of these stools was in wood and bark; the form was copied in terracotta, in which such a shape of moulding would be as easy to achieve as it would be in wax. FW

Provenance: 1896, given by the Ooni of Ife to Captain Bower, who passed it on to Sir Gilbert Carter; 1896, given to the museum by Sir Gilbert Carter

Bibliography: Willett, 1967, pl. 77

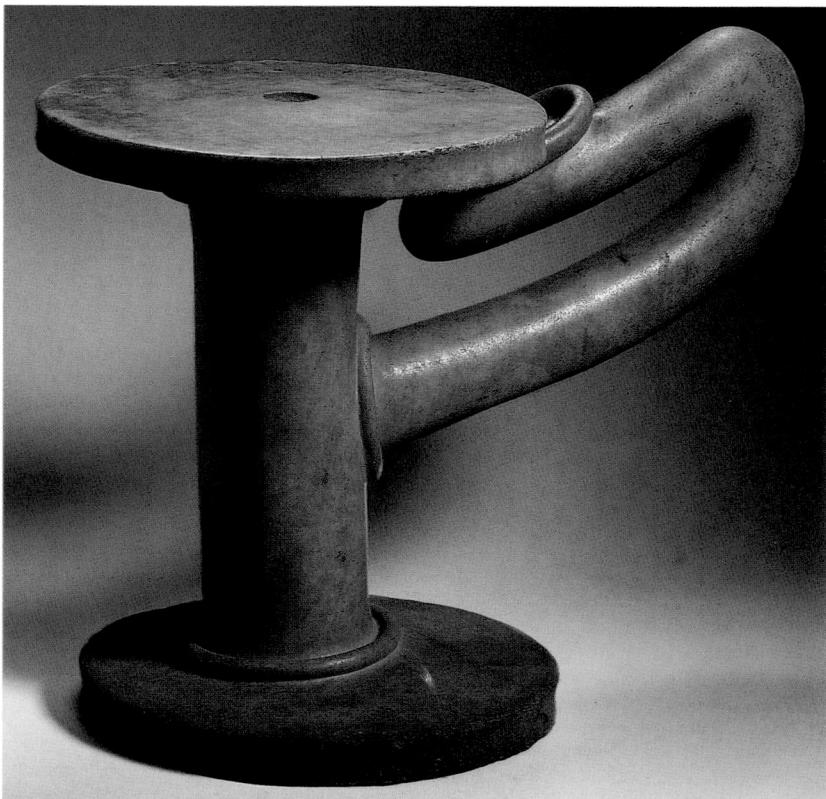

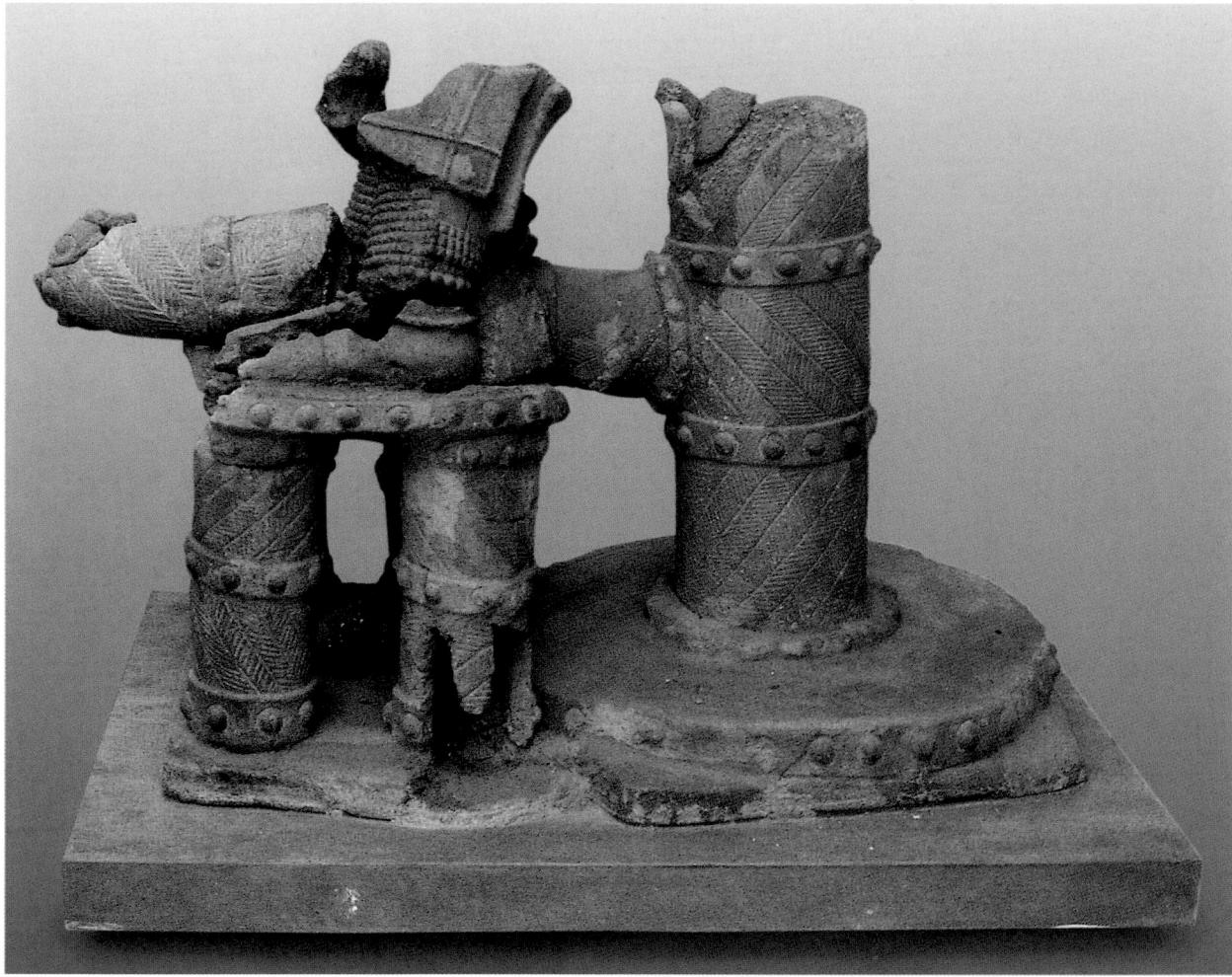

5.67

Throne group

Yoruba
Nigeria
Iwinrin Grove, Ife
12th–15th century
terracotta
60 x 55.5 x 85 cm
The National Commission for Museums
and Monuments, Ife, Nigeria, 49.1.25

The Iwinrin Grove contained a number of life-size terracotta figures, now sadly fragmentary, some of which appear to have been intended to stand on each side of this piece holding the clothing of the seated figure. It represents a throne composed of a rectangular four-legged stool supporting the loop of the spectacular looped form of seat unique to Ife (cat. 5.66, 68). A cloth was draped over the seat and the incumbent sat with his/her feet astride the loop, resting on the four-legged stool. The form of the looped seat appears to be derived from a wide cylindrical box made of bark with wooden ends that is used in present-day Ife to store ritual objects and to serve as a seat for the priest during

ceremonies. The two parts are often joined together with a loop of bark, and the box/stool is commonly painted. Copies in stone of this form are known with the decoration rendered in relief. Excavations conducted in the Iwinrin Grove at different times by Bernard Fagg and Frank Willett recovered not only some of the shards incorporated into the present sculpture, including the loins of the figure seated on it, but also glass studs set in a strip of copper, which must be the prototype of the bands of decoration shown by the present piece. The figure was about two-thirds life size. The head, wearing a beaded cap swathed with cloth that matches the herringbone pattern of the stool, was stolen from the Ife Museum in April 1993. The incised herringbone decoration resembles that of the group of brass stools from Ita Yemoo, and occurs on some of the other terracotta representations of these thrones. The successful firing of such large sculptures in an open fire – for they had no kilns – reflects the very high degree of technical skill of

the Ife sculptors. Since in modern Yorubaland both domestic and ritual pottery is made by women, it may well be that they made these terracotta sculptures. FW

Bibliography: Willett, 1967, pl. 76

5.68

Stool

Yoruba
Nigeria
Igbo Apere Oro, Ife
12th–15th century
granite-gneiss
34.5 x 14 x 29 cm
The National Commission for Museums
and Monuments, Ife, Nigeria, 58.1.5

This is one of two stools from Igbo Apere Oro ('the grove of the stools for the bullroarer'). It is complete and is the most elegant surviving simplification of the four-legged stool, grooves having been fashioned in the ends to give the impression that the legs are longer than they really are. This feature also has the effect of making the stool look less massive.

The Oro Society is very powerful. To it the execution of criminals used to be delegated. It no longer fulfils this role, but it still employs the bullroarer – an oval piece of wood at the end of a long twisted cord that is whirled round so that the piece of wood rotates through the air to produce a very eerie sound, intended to scare away the uninitiated from its secret night-time ceremonies. FW

Bibliography: Willett, 1967, pl. 78

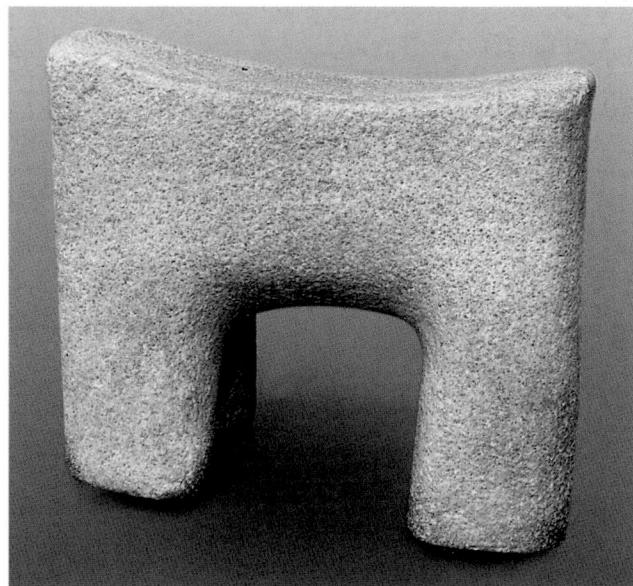

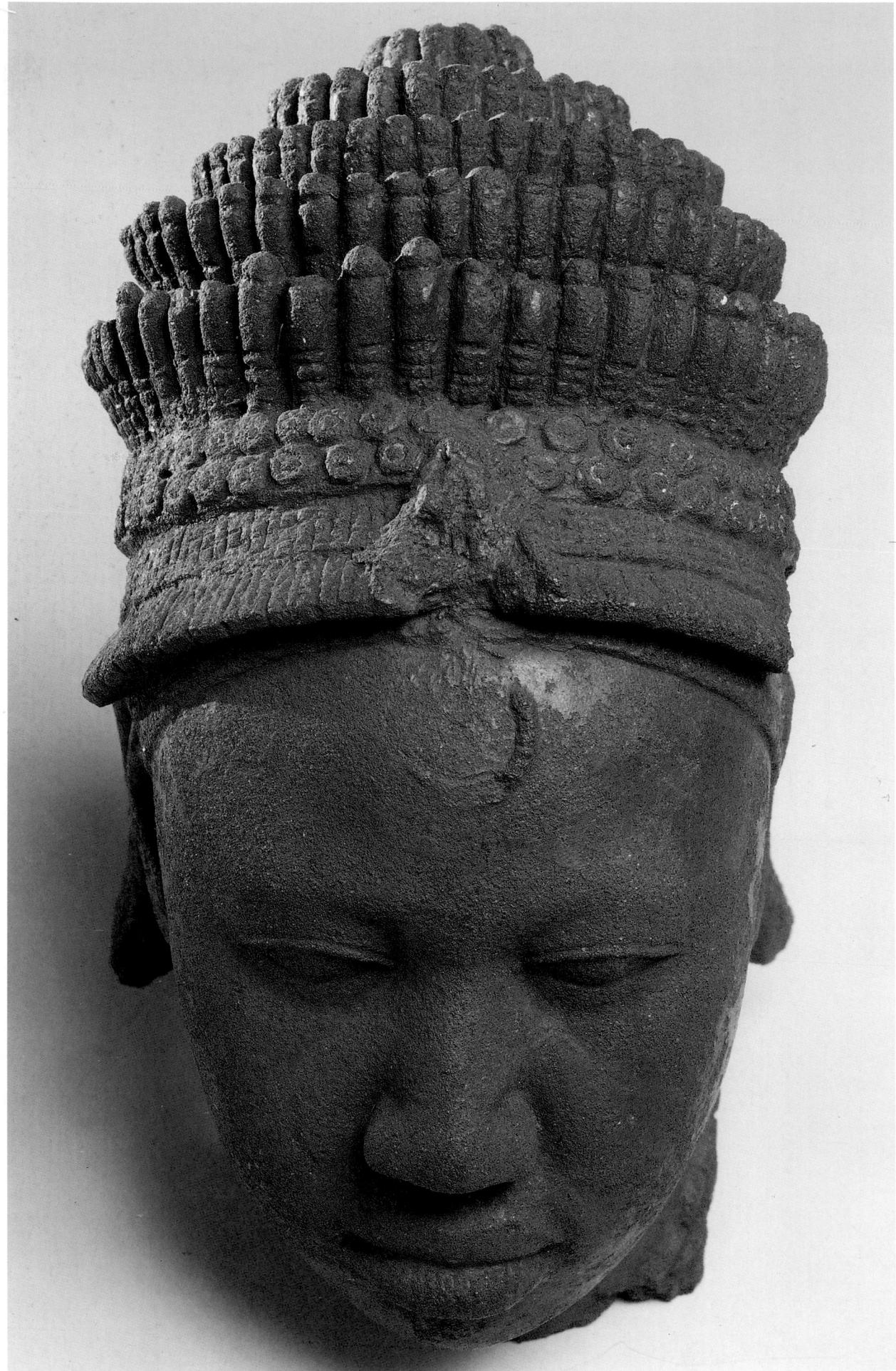

5.69

Head of a queen

Yoruba

Nigeria

Ita Yemoo, Ife

12th–13th century

terracotta

h. 25 cm; diam. 17 cm

The National Commission for Museums
and Monuments, Ife, Nigeria, 79.R.7

The accidental discovery of the cast figures at Ita Yemoo in 1957 led to excavations on the site. During the first season the remains of a shrine, composed largely of worn-out grindstones with terracotta sculptures, were discovered. Four heads were found, but as there were seven left feet there must have been at least that number of figures originally. Most had been dug away and incorporated into the walls of two nearby houses. One has been demolished and has contributed pieces that could be joined on to those excavated. Two of the four heads were without headdresses of any kind and are thought to have been figures of attendants. They are about two-thirds life size. The other two wore crowns and were three-quarters or more life size. The flanged crown appears to indicate that the wearer is a queen. It has been possible to reconstruct the front of a female body from the excavated fragments but they do not fit this head. It appears that at least two queens were represented on the shrine. Originally this head had a crest on the front of the crown like that worn by the brass figure of an Ooni from the same site. FW

Bibliography: Willett, 1967, pl. IX;
Eyo and Willett, 1982, no. 50

5.70

Woman carrying two horns

Yoruba

Nigeria

Ife

12th–15th century

terracotta

24.9 x 10.5 cm

The National Commission for Museums
and Monuments, Lagos

There are a number of small figures from Ife that appear to have originally been parts of tableaux or groupings of figures on a single support. None of them survives intact. This piece (apparently unfinished), with its head turned to one side and its back flat, is likely to have been part of such a group. The face is delicately striated to represent a scarification that is typical of the art of Ife (although long unused). The wrapper extends from the armpits to the ankles, which indicates that the figure is a woman. In the Classical art of Ife, male figures wear wrappers from the waist down, while women keep their breasts covered; only in later works are women represented with their breasts uncovered. She carries a pair of buffalo horns in her hands. Similar pairs of horns appear on ritual pots in Ife and there is a fragment of terracotta from Owo that represents a pair of horns apparently being rubbed against each other. (They are still used in this way, in the Ekiti area of Yorubaland, as a ceremonial musical instrument.) Buffalo horns are associated nowadays with the cult of Oya, goddess of the River Niger and also of the powerful wind that precedes a thunderstorm. Her temperament is thought to resemble that of a buffalo, one of the most feared of west African animals because of its unpredictability. The rubbing together of buffalo horns may well be thought also to represent the sound of rolling thunder.

This piece was seized by the Nigerian authorities as it was about to be exported. It seems to have been dug illicitly from the site of Obalara's Land, which was being excavated at the time by Peter Garlake. FW

Bibliography: Eyo and Willett, 1982,
no. 590

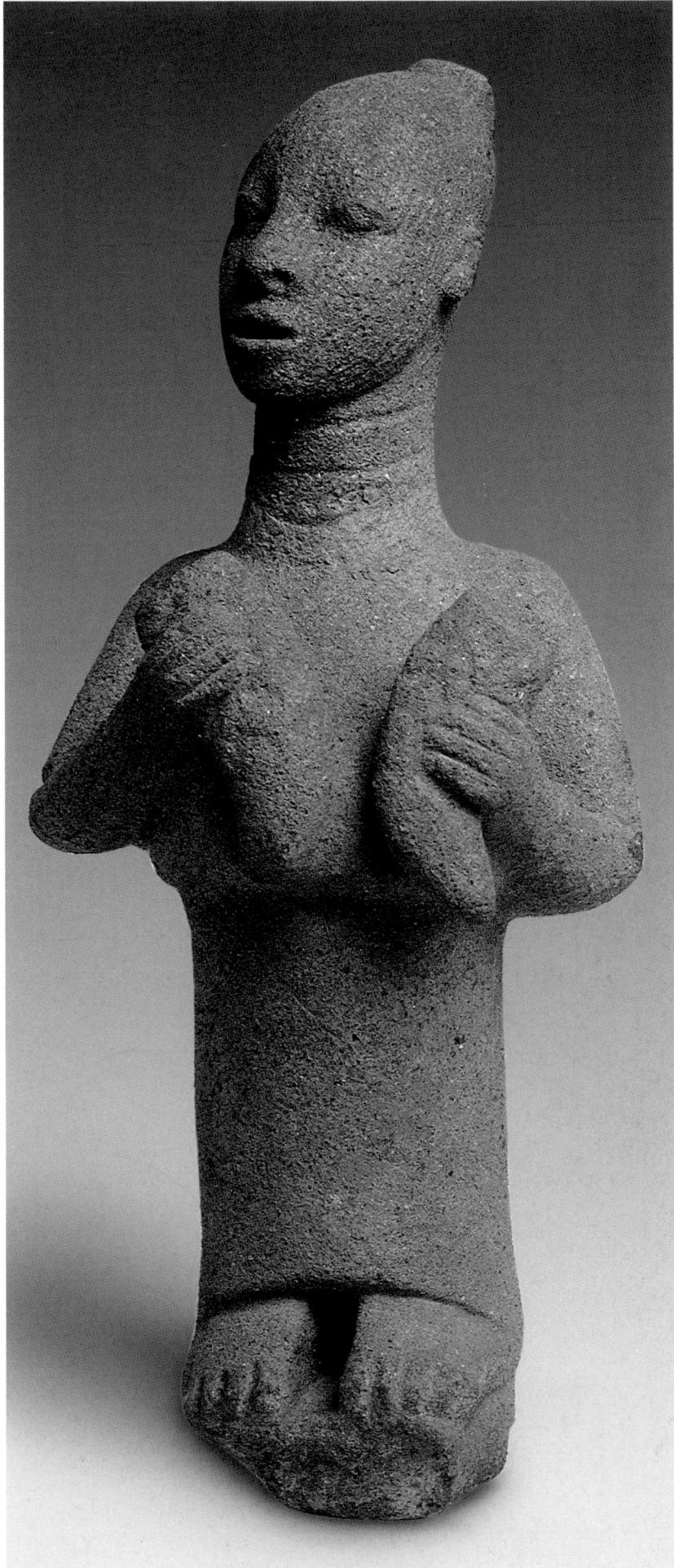

Seated male figure

Esie
Nigeria
12th–15th century
soapstone (talc schist)
67 x 30 cm

The National Commission for Museums and Monuments, Lagos, HT.260

Esie stone carvings remain one of the unsolved mysteries in the history of Yoruba art. For centuries, thousands of fragments and a few sculpted figures lay in a grove in the present Igbomina Yoruba town of Esie. The scene gave the impression of deliberate destruction, if not desecration. In 1912 Frobenius called attention to similar stone sculptures in neighbouring towns, but dismissed them as 'poor and degenerate in form'. The images in Esie remained relatively undisturbed until the 1930s, when Ranshaw and then Murray appealed for their preservation and conservation. It was not until 1973–4 that Phillips Stevens, Jr, undertook the cataloguing and photographing of the entire collection.

Esie oral traditions relate that settlers from Old Oyo 'met' the stone

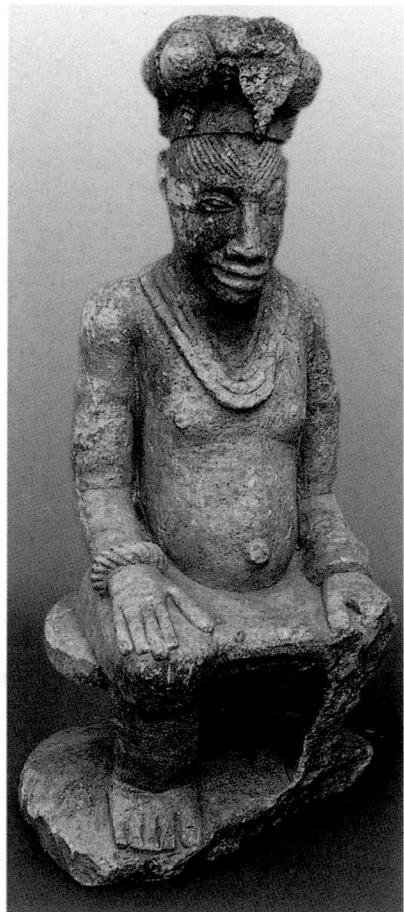

sculptures when they arrived in the 15th (or 16th) century. Other oral and ritual traditions appear to confirm that the sculptures and their mutilation predate the ancestral memory of the present inhabitants of Esie. The disarray of the primary site, vandalism over the years, and the nature of the material itself has made archaeological research difficult. At another site, known as the Iwoto Grove, thermoluminescent tests on pottery found adjacent to soapstone carvings (apparently unfinished works) suggest dates ranging from the 10th to the 18th centuries.

The quality of the artistry and the distinct style indicates that the Esie sculptures were once associated with the flourishing culture that required and could afford the celebration of social roles in visual art. Archaeological evidence of iron smelting and paved roads in the general vicinity of Esie clearly indicate that an early and well-developed culture existed in the area. Oral histories (*itan*) in neighbouring Igbomina towns frequently refer to 'the people of Oba' who no longer exist. Whether the Esie carvings are to be associated with the Oba culture is far from resolved, but seems to be the most promising line of inquiry.

This seated male figure is clearly a portrait of one with authority. His headdress (a type found on several Esie figure sculptures) consists of a cluster of twelve snail shells. He wears a necklace consisting of three strands of large beads and bracelets of varying design on his wrists. His forehead is scarified with a V-shaped pattern of ten or eleven lines. As with all of the Esie seated figures, he sits on a stool consisting of two circular platforms connected by a cylinder. It is a type of stone stool reserved for royalty in ancient Ife, although there is little else that suggests an Ife association with these sculptures.

It is not only social position that the artist depicts, it is dignity, composure, age and authority that characterise the subject of the sculpture. One senses the once powerful body and is made aware of the weight of the flesh in the slight protrusion of the abdomen and the hips. In spite of areas of damage, the viewer recognises in this work the high level of artistic achievement by Esie carvers. *JP III*

Provenance: 1930s, first brought to scholarly attention by British colonial administrators and educators; permanent loan to the National Museum in Lagos
Bibliography: Daniel, 1957; Clark, 1958, p. 196; Frobenius, 1968, i, p. 318; Obayemi, 1974, p. 14; Stevens, 1978, pp. 1–87; Afolayan, 1989, pp. 3–4, 8; Hambolu, 1989; Onabajo, 1989, pp. 5, 7; Pemberton, in Drewal, Pemberton and Abiodun, 1989, pp. 77–89

Seated male figure

Esie
Nigeria
12th–15th century
soapstone (talc schist)
88 x 30 cm

The National Commission for Museums and Monuments, Lagos, HT.68

Very few undamaged figures exist among the thousands of stone carvings found in the 1930s in a forest grove in Esie, a small Igbomina Yoruba town 100 km north of Ile Ife. They appear to have been deliberately destroyed and thrown together as an act of desecration. As a consequence, archaeological evidence of their age and origin is extremely difficult to determine. An analysis of oral

histories (*itan*) in Esie and surrounding Igbomina towns and recent archaeological excavations suggest dates between the 12th and 15th centuries.

The carvings indicate a cultural context of stability and a degree of social and political organisation in which a high level of artistry and a distinctive style developed. Both male and female figures are depicted – for the most part persons of rank, although there are images of slaves. This seated male figure is depicted wearing a plain, round cap that does not completely cover his hair. As on a few other Esie sculptures, he has a short, pointed beard that slightly elongates the face and forms a counterpoint to the shape of the cap and is echoed in the rows of beads draped around the neck, showing a concern for the play of forms.

As in the ancient art of Ife (of approximately the same period) the head forms one third of the total sculpture. While there is no evidence, archaeological or stylistic, for suggesting a link between Ife and Esie sculpture, the convention of the prominence of the head and face in Yoruba figures is found over the centuries and among diverse Yoruba subgroups.

The social status and authority of the figure is indicated by the staff held in the left hand, bracelets on each wrist, the skirt or loin-cloth knotted in the front, the gesture of the right hand to the stomach, and the seated position. The Esie stone sculptures are a celebration of social rank and roles. Male figures wear a variety of caps and females have elaborate hairstyles. Both male and female figures hold daggers on their laps or in a raised position against their right shoulder: a fragment of a sheath is at the left hip of this figure. Other sculptures depict men with quivers of arrows on their backs or cutlasses held at their side. At the very least one receives the impression of a warrior community and an equality of leadership roles among men and women. *JP III*

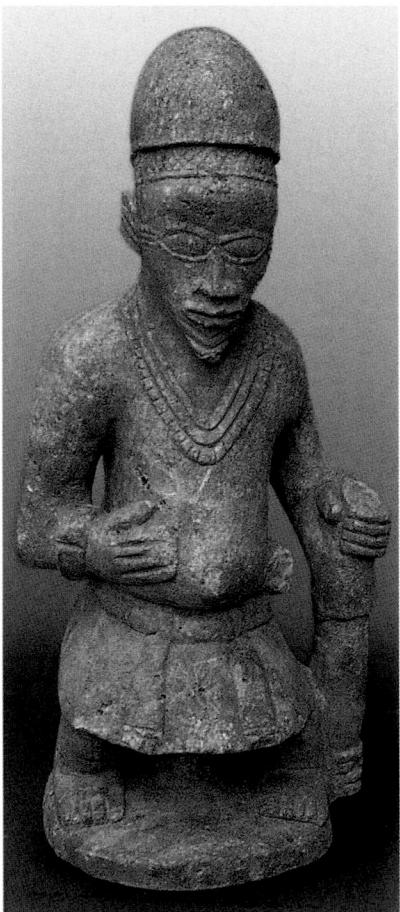

Provenance: 1930s, first brought to scholarly attention by British colonial administrators and educators; permanent loan to the National Museum in Esie, Nigeria
Bibliography: Stevens, 1978, pp. 1–87; Pemberton, in Drewal, Pemberton and Abiodun, 1989, pp. 77–89

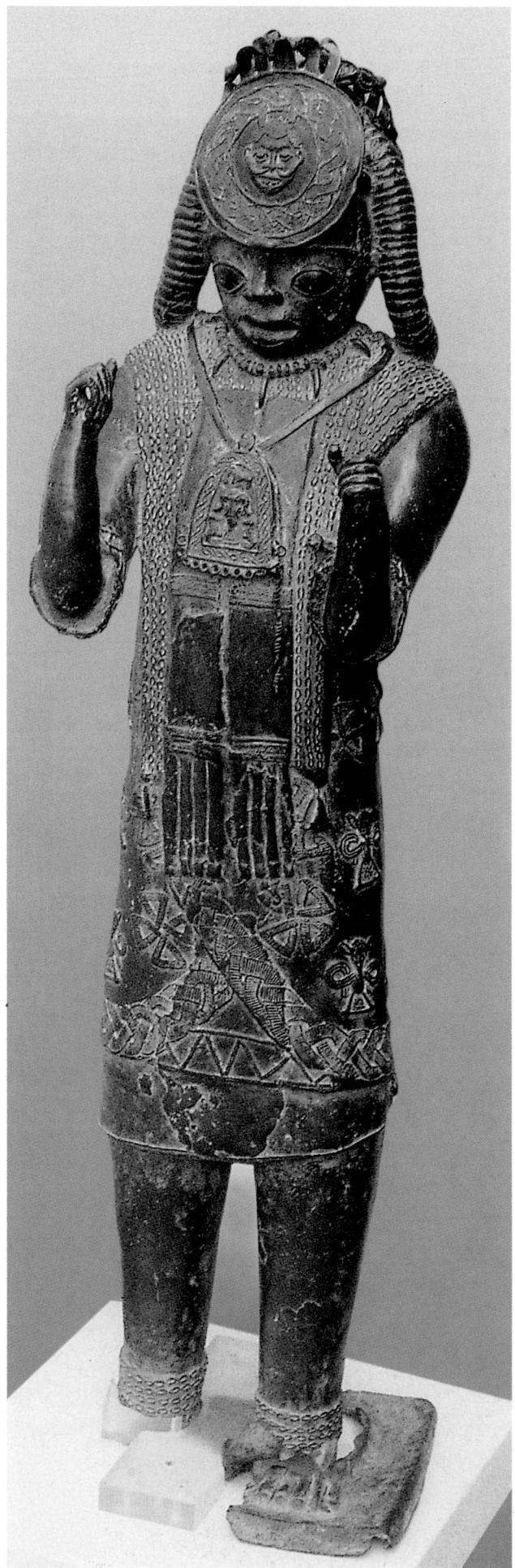

5.73a

Figure of a man

Tada village, Kware State, Nigeria
early 14th century (?)
tin-bronze
115 x 26 cm
The National Commission for Museums
and Monuments, Lagos, 79.R.3

5.73b

Figure of a bird

Tada village, Kware State, Nigeria
early 14th century (?)
tin-bronze
157 x 24.5 x 82.5 cm
The National Commission for Museums
and Monuments, Lagos, 90.R.17

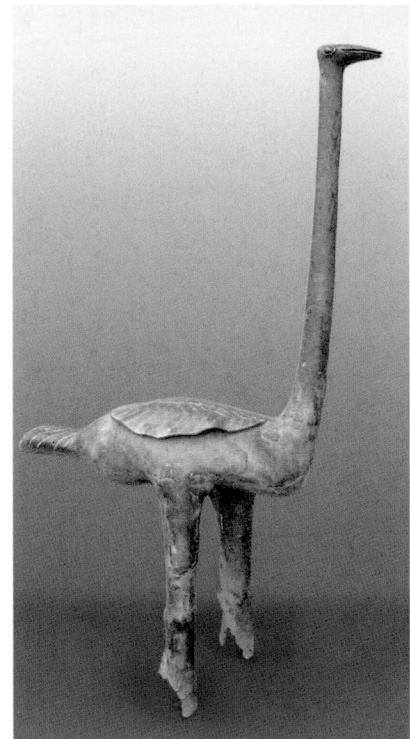

These are two of nine copper-alloy castings once in the Nupe village of Tada on the south bank of the Middle Niger. In 1969, after the theft of one of the two bronze figures at Jebba, an island village in the Niger upstream from Tada, they were removed to the Lagos museum. The other castings at Tada are a seated cast-copper figure in the style of Ife (cf. cat. 5.64), two smaller standing figures, another long-necked bird and an elephant. The Jebba castings were both standing figures, one an archer, the other (which was stolen) a woman. All are said to have been deposited at Tada and Jebba by Tsodee, founding hero of the Nupe kingship.

The standing figure shows a man wearing a richly embroidered or appliquéd tunic, draped with a cloth (?) hung with bells and cowry shells. Around his neck he wears a pectoral ornament of a ram's head and a necklace of leopard's teeth. His headgear features a pair of discs, and a horned human head with snakes coming out of the nostrils, surmounted by a row of birds. The significance of all this is unknown, though each element can be found elsewhere, in the arts of Ife, Owo and Benin.

Although these figures come from the Nupe-speaking region of what is now Nigeria, they also belong to the casting traditions of the Lower Niger region, including Igbo-Ukwu, Ife and Benin. Other scholars have proposed that they come from Old Oyo and Owo and while the figures are evidence of an important casting centre, probably within the Yoruba-speaking area, we have no idea of its location. The fact that the standing figure is of tin-bronze (almost certainly of local rather than trans-Saharan origin) confirms that it dates from before the

first contact with Europeans and before coastal trade with Europeans brought in zinc-brass which was otherwise available through trans-Saharan trade. This dating is confirmed by measuring the thermoluminescence of the cores. The technical quality of the casting is not always of the highest and there is evidence that a series of burn-in repairs were made to complete the work. *JWP*

Bibliography: Shaw, 1973, pp. 233-8; Williams, 1974; Willett and Flemming, 1976, pp. 135-46; Eyo and Willett, in Detroit et al. 1980

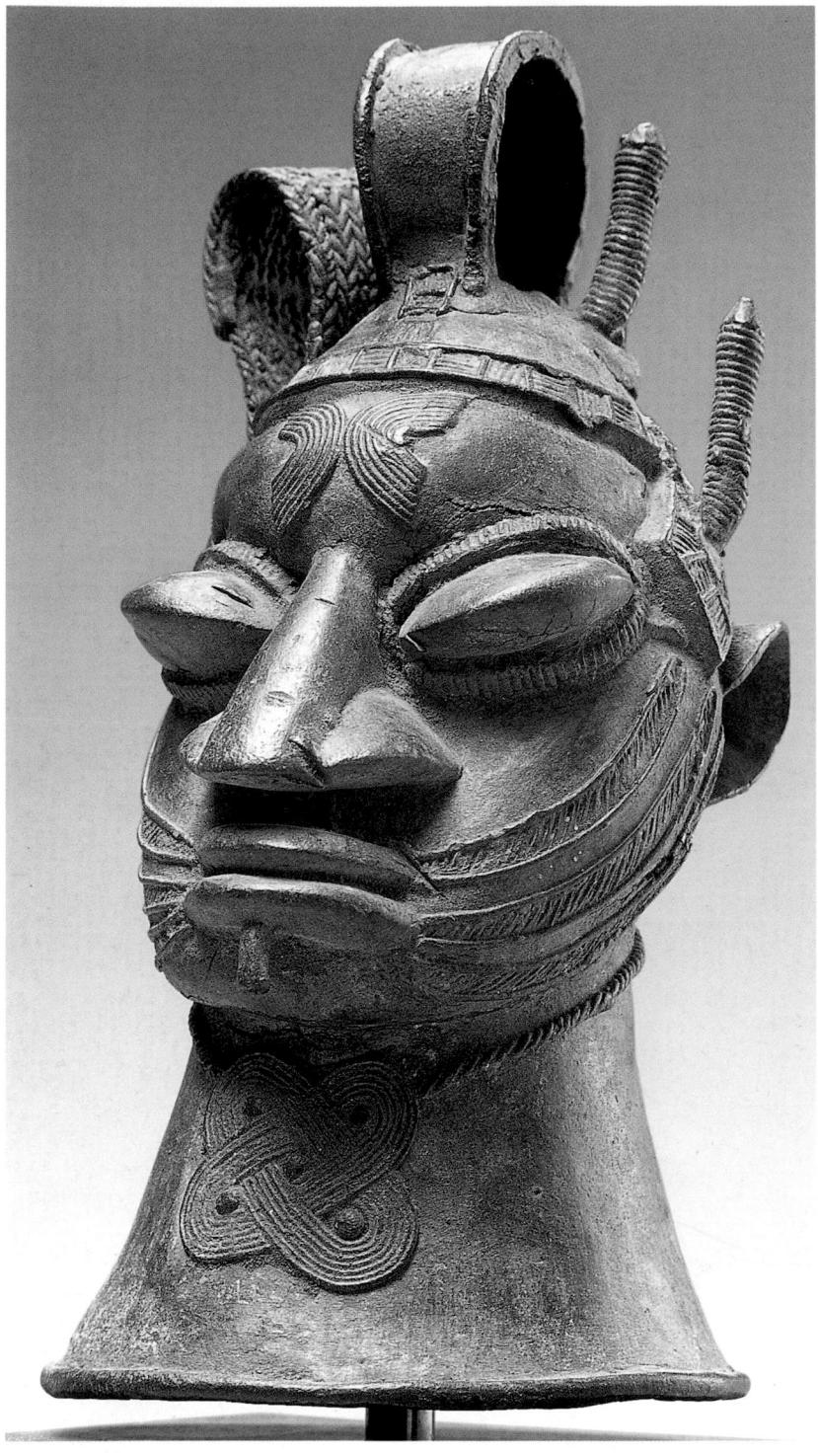

5.74

Face bell (*omo*)Ijebu-Yoruba
Nigeria
18th or 19th centurybronze
25 cm
W. and U. Horstmann Collection

Brass face bells (*omo*) are owned by the Olisa and other prominent chiefs in Yorubaland, particularly among the Ijebu-Yoruba. Special sounds announce the presence of powerful persons. These chiefs, whose titles

may have come from the Edo kingdom at Benin, participate in enthronement rites. The paramount ruler of the Ijebu-Yoruba, the Awujale, may also have such a bell.

Worn on a sash over the right shoulder so as to hang down at the left hip, the face bell is associated with transitions and the transfer of power, each occupant casting one for his successor. Almost all examples of such face bells have three long striations (with or without textured patterns between them) that curve

outwards from the corners of the mouth around the sides of the full face to the ears. This pattern occurs in relief faces on an Ijebu bronze stool that served in enthronement rites. The double crescent marks on the forehead appear most frequently in the arts of the Osugbo Society (cat. 5.77), whose members supervise the selection and installation of rulers. These same crescent marks also occur on the bronze stool. The wrapped projections that rise on the left side of the head and the long braided loop that descends on the right may refer to *itagbe*, woven cloths with wrapped tassels often draped on the head or shoulder during ceremonies. These cloths are owned by titled Osugbo elders and other prominent chiefs among the Ijebu-Yoruba. The interlace pendant necklace may symbolise the complexity and eternity of the life cycle of birth, life, afterlife and reincarnation. *HJD*

Bibliography: Thompson, 1970; Thompson, 1971, ch. 6; Fagg, 1981, p. 104; Fagg and Pemberton, 1982, pp. 38–9, pls 9, 39; Drewal, Pemberton and Abiodun, 1989, pp. 120–6

This exhibition does not seek to be a round-up of canonical masterpieces and is content to ask questions where they arise and present enigmas where they occur (as with cat. 7.16 for example). A group of at least three stone figures that have an origin among the Yoruba and are said to come from a region in the Ife area and to have been found at abandoned shrines, do not seem at first to fit into a known pattern. Since their age is not known they are described by the rather loose term pre-Yoruba: a conjectured date might be in the region of 300 to 400 years ago.

The massive conception and skill of their carving, however, commands our attention. The protruding eyes placed almost at the sides of the head recall other Nigerian works including some variant twin figures (*ibejì*) whose stance they share. Early African stone and terracotta artefacts from the Nomoli of the Kissi (cat. 5.134) to the statuettes from Komaland (cat. 6.32) are all relevant in the attempt to place this (as yet) anomalous work in at least a stylistic territory. *TP*

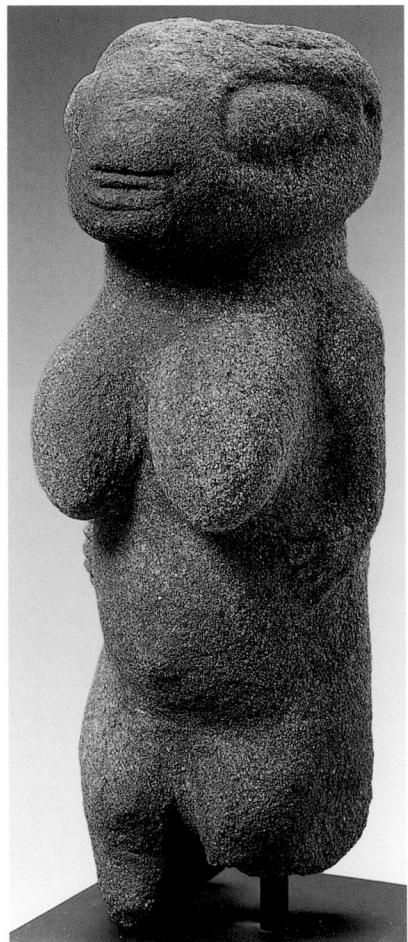

5.75

Female figure(Proto) Yoruba (?)
Nigeria
stone
53 x 16 x 22 cm
W. and U. Horstmann Collection

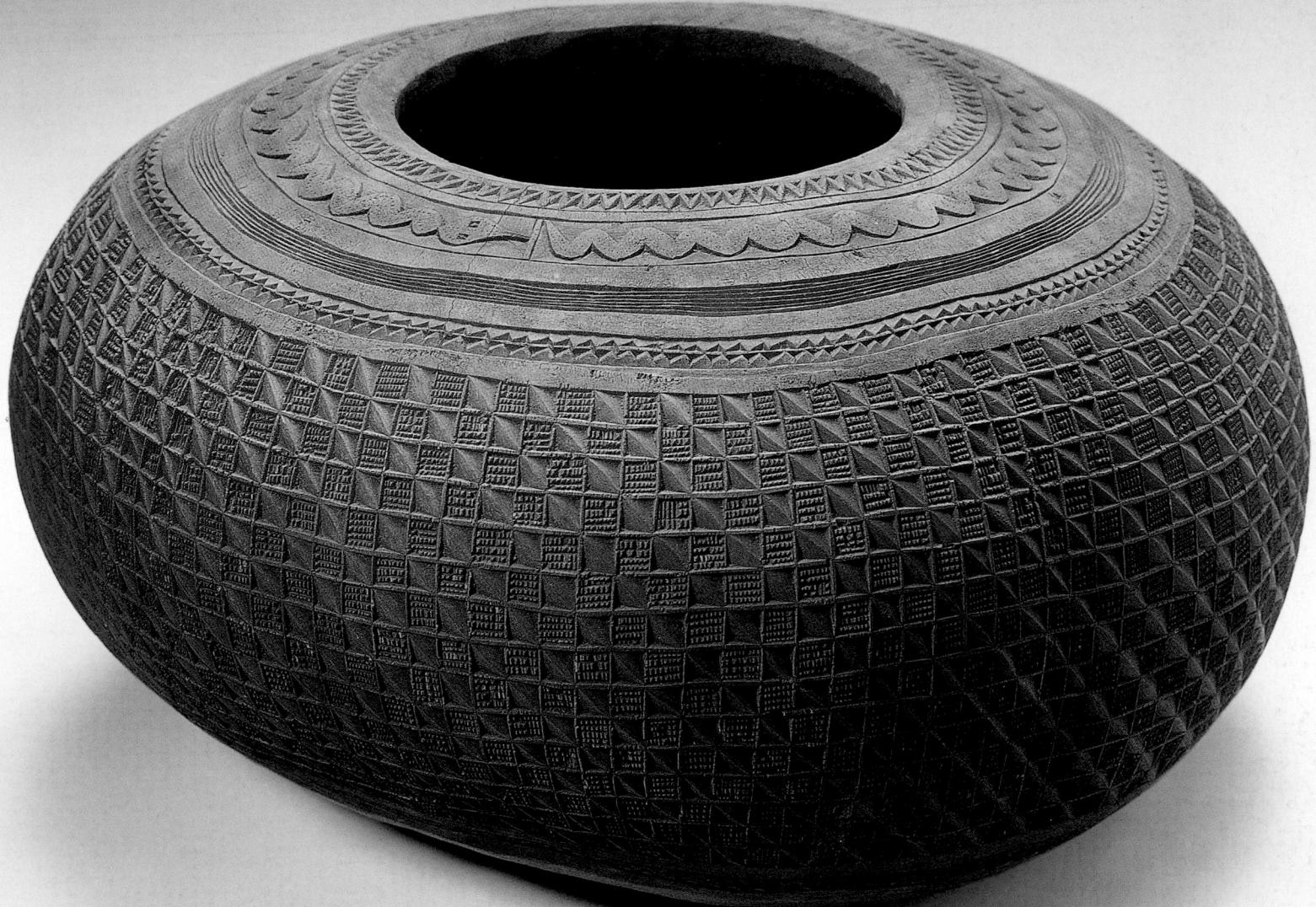

5.76

Gourd vessel

Yoruba (?)
Nigeria
19th century (?)
gourd
h. 35 cm, diam. 61 cm
The Trustees of the British Museum,
London, 1979. AF. 1.446

Calabash gourds of the *Cucurbitaceae* family are prevalent throughout sub-Saharan Africa, occurring in a great diversity of shapes and sizes. Naturally spherical, tubular and bottle-shaped fruits may all be further varied by tying the growing gourd.

The present gourd has a variable thickness that, in places, exceeds 4 cm, and the artist has exploited this for decorative effect. Except around the aperture, where a snake and various zigzag motifs are preserved in the outer integument, the smooth exterior has been completely removed. A chequerboard design of alternating bevelled diamonds and raised squares has been used to cover the entire surface of the vessel. To maintain the formal rigour of the pattern, the artist has had to vary the size of each motif and the depth to which it is cut to

accommodate the irregularities of the vessel.

Carving within the depth of a gourd is a common Yoruba technique. Sometimes chalk may be rubbed into the design to accentuate the perception of depth, but there is no sign of this in the present piece.

Gourds vary enormously in the uses to which they are put. Large gourds form a prominent part of the altars of the Yoruba god of thunder, Sango, and it is not impossible that a work of such consummate artistry had such a role. NB

Bibliography: Trowell, 1960, pp. 47-51

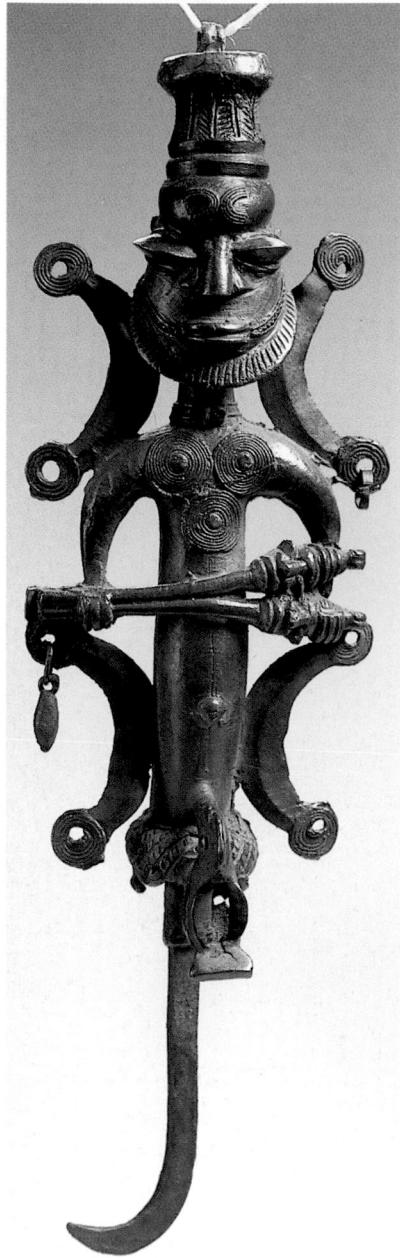

5.77a

**Ogboni/Osugbo sceptre
(*edan Osugbo*)**

Ijebu-Yoruba
Nigeria
late 19th century
brass, iron, bronze
h. 60 cm

By courtesy of the Board of Trustees of
the Science Museum, London, A 10465

The Ogboni Society (or Osugbo as it is known among the Ijebu-Yoruba) is one of the most important institutions of Yoruba-speaking peoples. Consisting ideally of the eldest and wisest male and female elders in a community, the society decides the most serious judicial matters and metes out punishment for all criminals condemned to death. It also controls the selection and installation as well as the abdications and funerals of rulers, thus serving a wide variety of crucial political, judicial and religious functions.

Ogboni paired castings placed on iron shafts (straight or curved) and joined by a chain at the top are known as *edan*. Consisting of male and female figures, *edan* symbolises the original founding couple of a community, the witnessing presence of the guardians of ancient law (female and male ancestors), the female and male membership of the Ogboni lodge and, by extension, all men and women in the society. The theme of female/male co-operation and union is central to Ogboni ideology and practice. Opposed crescents on foreheads of Ogboni works are an ideogram for the themes of duality, complementarity and doubling.

Edan is cast upon the initiation of Ogboni members and serves a variety of important purposes. It is a public emblem of the omnipotence and omnipresence of the Ogboni Society in all community matters and, being portable, is carried by an Ogboni member as a sign of office, a message and a protective amulet. When worn by Ogboni members, it is draped around the neck and suspended down the chest. Those with curved or looped shafts (like cat. 5.77a) may have been used to carry things or as a ritual poker.

The visual emphasis given to sexual identity in *edan*, as well as the theme

of the couple, convey the mystical powers of procreation. The genitals of both male and female *edan* figures are often dramatically displayed, a reference to momentous oaths.

According to some Yoruba, the most powerful curse or invocation a woman (or man) can utter is pronounced while naked. Even when *edan* have heads on stems (like those being held by the male in cat. 5.77a), female and male genitals may appear – a visual reminder of the importance of the couple. In initiation rites the unclothed novice is washed by a titled elder in the presence of other members who are themselves naked. Similar procedures continue today, whereby all Ogboni members and guests remove footwear and bare their chests or shoulders before entering the

lodge. Such acts connote honesty, openness, humility and reverence for the sacred. They affirm that no secrets will be kept among the membership and, at the same time, that no secrets will be revealed to outsiders.

Posture and gesture in *edan* evoke the solemnity of Ogboni ritual. Ogboni iconography portrays members performing ritual acts as part of their sacred governmental obligations. Large, bifaceted eyes, a distinctive and dramatic feature of Ijebu bronzes (e.g. cat. 5.74), may be the artist's way of suggesting the 'inner eye' or insight (*oju-inu*) of wise Ogboni elders who see and know about everything in the society.

The four arcs that frame the figure of cat. 5.77a may be abstractions of birds in profile, for these often flank

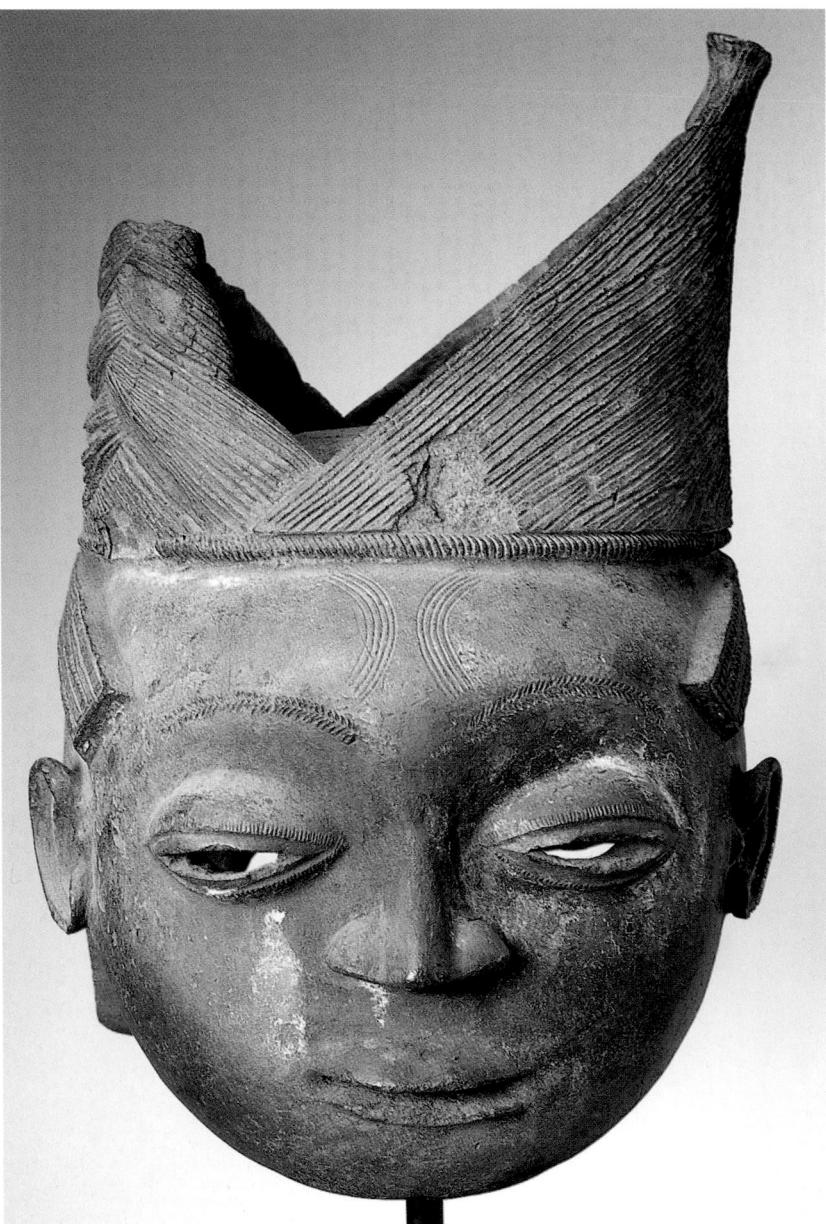

5.77b

Ogboni/Osugbo head

Ijebu-Yoruba
Nigeria
18th or 19th century (?)
terracotta
h. 38 cm
Private Collection, Brussels

figures in Ijebu *edan*. The arcs also echo the crescents on the forehead and the shape of the realistic bird at the base of the penis.

The terracotta head (cat. 5.77b) is possibly a fragment from a full female figure, one of a rare corpus of earthen sculptures used to decorate the inner courtyard of Ogboni Society lodges or *iledi*. An example of a complete figure of a kneeling woman (half of a male/female couple) is now in the Afrika Museum at Berg-en-Dal. The elaborate coiffure frequently appears in other Ogboni artworks and is a widespread and important hairstyle for the Ijebu-Yoruba, among whom it is associated with priests and priestesses of the gods, queens and other high-ranking women. Like the pairing of male and female imagery in *edan*, the mixing of media (iron and brass) and the use of clay in Ogboni art seem to express the central theme of uniting gendered entities – iron, symbolic of maleness, with brass, associated with femaleness, and earth as the abode of both female and male ancestors.

HJD

Bibliography: Morton-Williams, 1960; Ogunba, 1964; Williams, 1964; Atanda, 1973; Williams, 1974; Drewal, 1981, pp. 90–1; Fagg, 1981, p. 104; Witte, 1988; Drewal, 1989a; Drewal, Pemberton and Abiodun, 1989, pp. 136–43

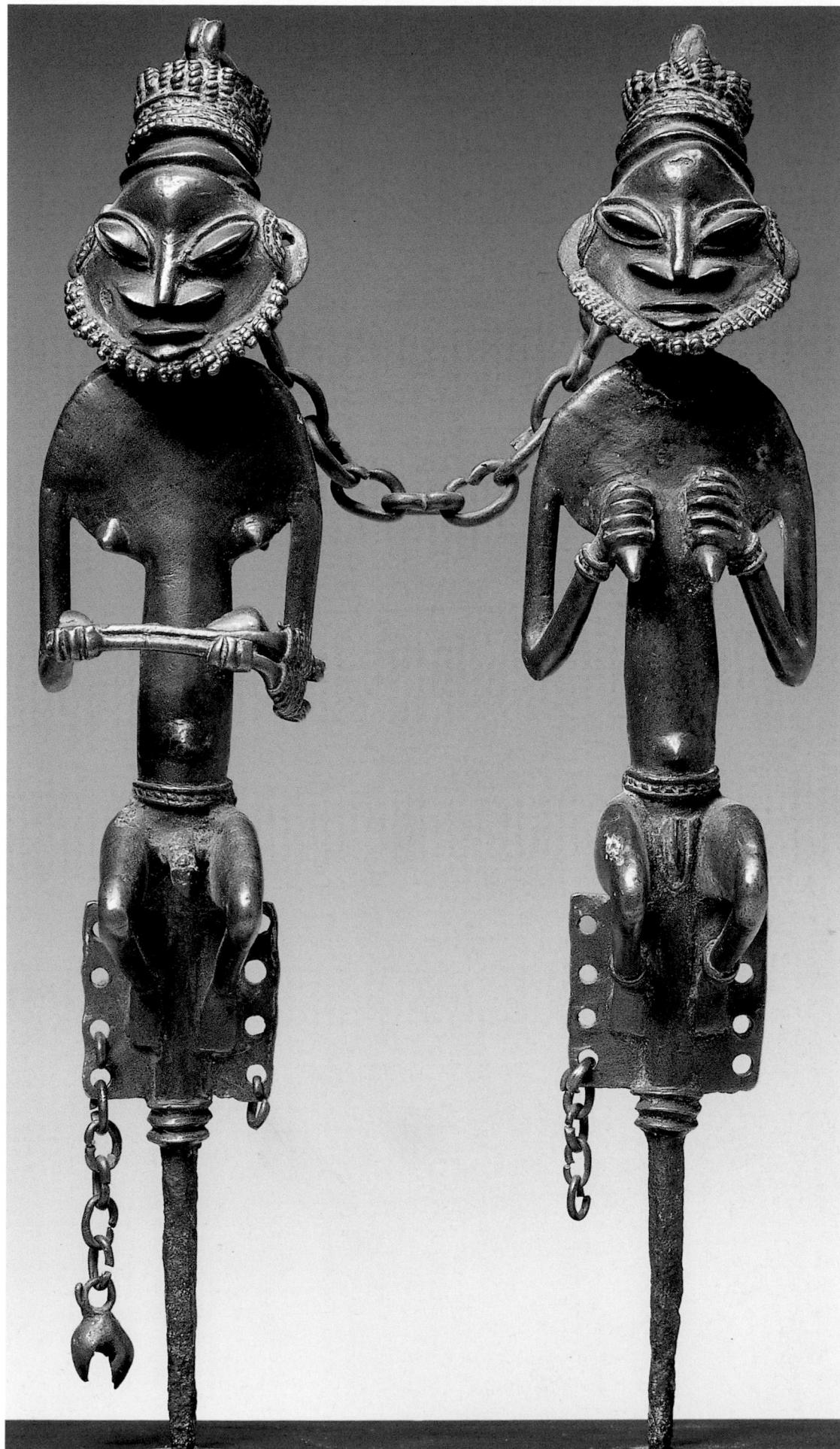

5.78a

Ogboni couple

Yoruba
Nigeria
19th century
bronze
h. 78.5 cm
Private Collection

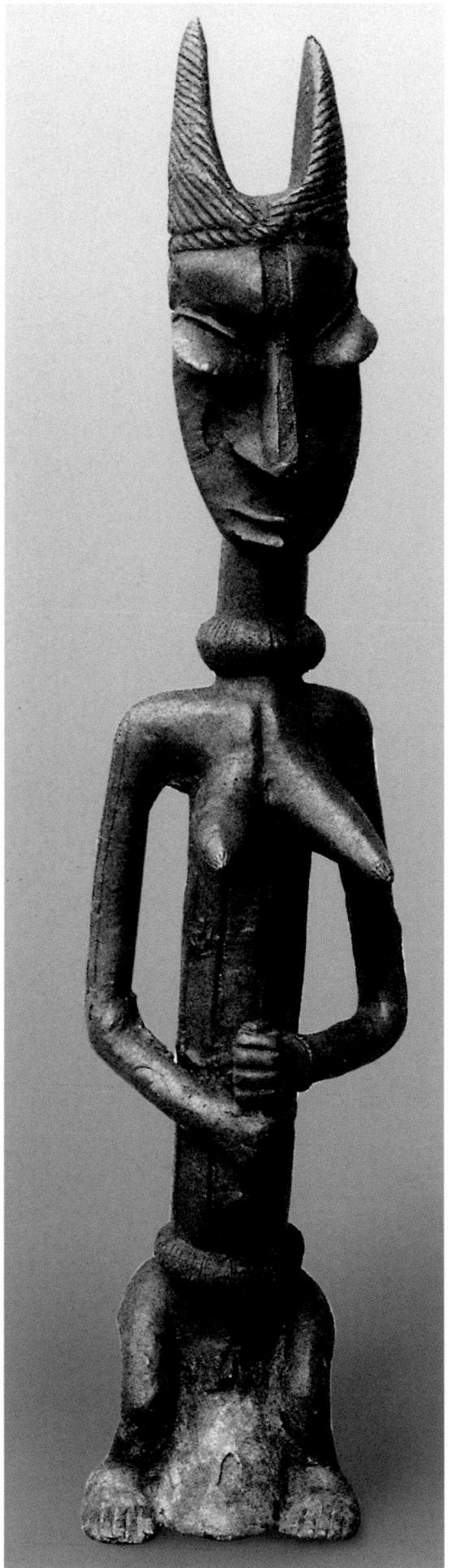

5.78b

Female Ogboni altar figure (*onile*)

Yoruba

Nigeria

18th–19th century
brass

106 x 20 x 16 cm

The National Commission for Museums
and Monuments, Lagos, 65.4.53

The Ogboni Society (also called Osugbo) wields considerable religious and political power among the Yoruba because of its role as the vital link between a given community and the earth that sustains it. The Yoruba personify the earth (*Ile*) as an ambivalent mother. For the same earth goddess who nurtures humanity like a child also receives the body of the dead at interment. Without the goddess's benevolence there will be no peace and happiness in the world. All members of the Ogboni regard themselves as *Omo Iya*, 'the children of the (same) mother', partly because of their closeness to the goddess whom they venerate and partly because they regulate the social order on her behalf. In pre-colonial times the Ogboni functioned as a town council, law court and electoral college, punishing antisocial elements and rewarding outstanding citizens by recommending them to the king for deferential titles. The most popular emblem of the Ogboni is *edan* – a pair of male and female brass figures usually joined at the top by an iron chain (cat. 5.78a). Bigger, free-standing versions of the *edan* pair, called *onile* (owner of the House), occupy special altars inside the Society's lodge, mediating between the Ogboni and the goddess. That the pair represents the ambivalent nature of the goddess is evident not only in the perception of the male and female figures as one object, but also in the reference to them as '*Iya*' (Mother). Apart from alluding to the interdependence of the sexes in the procreative process (among others), the male figure alludes to the 'hard', negative aspect of the goddess, and the female to her 'soft', positive one – a dualism also evident in the iconography of other Yoruba deities such as Esu (the divine messenger) and Oro (the collective power of the ancestral dead). This phenomenon is implied in popular sayings such as '*Tako, tabo, ejiwapo*' ('Male and female go together') and '*Tibi, tire, ejiwapo*'

('Good and evil go together'). Some scholars have questioned the gender status of the earth because they could not find any reference to an earth goddess in the *Odu Ifa*, a body of sacred myths on Yoruba history, culture and religion.

This female *onile* was one of a pair originally housed in the Ogboni lodge of Owu, a town destroyed during the Yoruba civil wars of the 19th century. The pair was removed from the lodge shortly before the fall of Owu: one was taken to Ede and the other (cat. 5.78b) to Apomu, where the Nigerian National Museum acquired it. This example symbolises the enigma of the maternal principle in the Yoruba universe. The vertical thrust of the figure echoes one of the praise-chants (*oriki*) of the earth goddess hailing her as being 'As succulent and erect as the *odundun* (medicinal) shrub'; it also recalls the uprightness and firmness expected of an Ogboni adherent. The full breasts and longish neck with choker evoke maternal support, beauty and grace. The placing of the left fist on the right one (with the thumb concealed) – a ritual salute of the Ogboni – welcomes members to the lodge, where the goddess as *onile* provides an abode for both the living and the dead. The exposed genitals signify the procreative power with which she renews life at the physical and metaphysical levels. The schematised pose, enlarged head and pronounced facial features allude to her transcendence: she is the invisible third party to the deliberations of the Ogboni, enforcing confidentiality, loyalty, equity, justice and self-discipline. The horned coiffure identifies her as a strong-willed goddess who will visit her full wrath on traitors and on all those engaged in acts detrimental to the social order. Hence the popular Yoruba saying '*Eni da Ile, a ba Ile lo*' ('Whoever betrays the earth will be overwhelmed by her'). BL

Bibliography: Biobaku, 1952, p. 38; Beier, 1959, p. 2; Morton-Williams, 1960, pp. 362–74; Williams, 1964, pp. 139–65; Daramola and Jeje, 1967, pp. 132–3; Ojo, 1973, p. 51; Eyo, 1977, p. 180; Adeoye, 1989, pp. 340–4, 356–8; Drewal, 1989a, pp. 151–74; Drewal, 1989b, pp. 117–45; Lawal, 1974, p. 243; Lawal, 1995, pp. 36–49

Lintel

carved by Olowe of Ise-Ekiti (d. 1938)
 Yoruba
 Ikere-Ekiti, Nigeria
 wood
 h. 127 cm
 The Trustees of the British Museum,
 London, 1925. N/N

African artists are rarely identified by name, yet traditional African art is not anonymous. The artists' names were known to their patrons and townspeople. If their art was highly regarded, they were known beyond the place where they lived. Their names are unknown to us because early collectors failed to ask, 'Who made this?'

The carver of this lintel is Olowe of Ise-Ekiti. He was born, probably around 1873, in Efon-Alaiye, one of the sixteen pre-colonial Ekiti-Yoruba kingdoms now located in the modern state of Ondo, Nigeria. While still a youth, Olowe was sent to the town of Ise to serve as a messenger in the palace of the Arinjale (King). At some point, Olowe demonstrated an aptitude for carving wood and *oju-onu*, an 'eye for design', and was subsequently apprenticed to a master carver.

Eventually, Olowe left his master to establish an atelier of his own.

Olowe served the Arinjale of Ise as a court artist. As his fame grew, he was given large commissions by several other Yoruba kings and wealthy families within a wide radius of Ise. He enhanced the prestige of their palaces with doors and elaborately carved posts to support the roofs of the verandas surrounding the courtyards as well as containers, drums and other objects.

Olowe carved an ensemble of a pair of doors and a lintel for the palace of the Ogoga at Ikere. In 1924 they were installed at the entrance to the exhibition in the Nigerian Pavilion at the British Empire Exhibition at Wembley. Olowe's style so impressed the British Museum that it attempted to buy the carvings from the African king. The Ogoga refused to sell the doors, but agreed to exchange them for a British-made throne. This was done, and the sculptures remained in England. Olowe, who was still alive, carved another set of doors and lintel as replacements.

Olowe's style is unique among Yoruba and other African carvers of

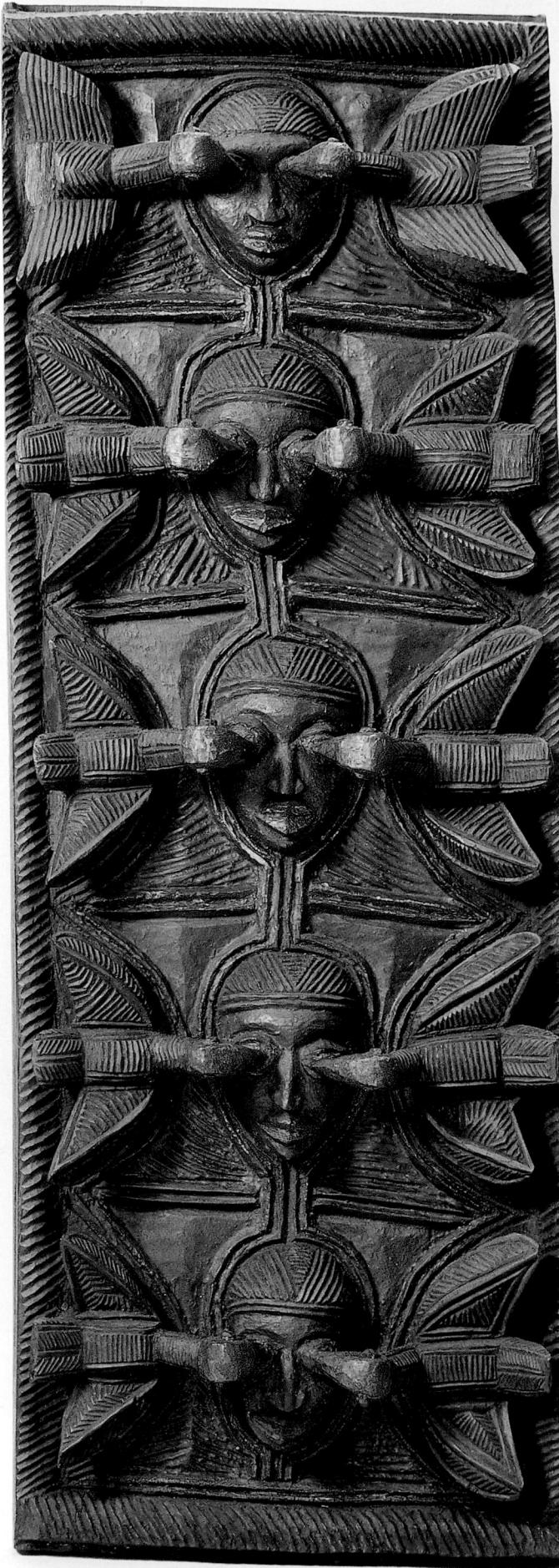

any period. Other sculptors carved figures on doors and lintels in low and even relief. Olowe's figures are not static and frontal, but appear to be active. In addition, Olowe carved with rich textures and vivid colours.

This lintel depicts five faces positioned between pairs of birds pecking at the eyes. This is a scene of human sacrifice. The birds are not just vultures, but sacred messengers of the gods. In Yoruba ritual, sacrifice is a means of communication between humans and the deities. Before the 19th century such acts were committed only on occasions of utmost communal importance, such as festivals honouring the iron god, Ogun, or in rites connected with installing a new king. Human beings were the rarest and most precious type of sacrifice. The depiction of vultures in the feeding posture is a positive image that represents the divine acceptance of a sacrifice. *RAW*

Bibliography: Lawrence, 1924, pp. 12–14; Allison, 1944, pp. 49–50; Allison, 1952, pp. 100–15; Idowu, 1963, pp. 118–20; Fagg, 1969, p. XX; Awolalu, 1979, pp. 138–42; Walker, 1994, pp. 91–106

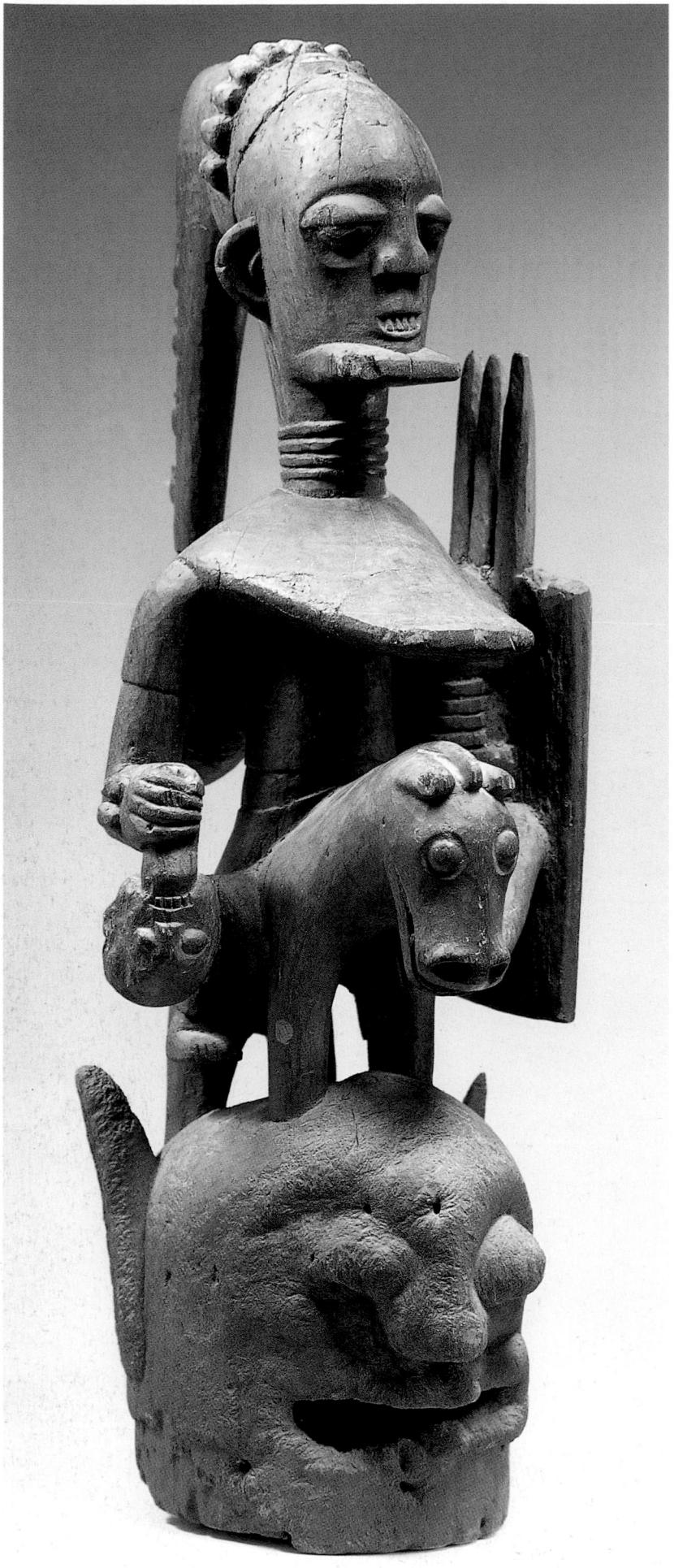

5.80

Helmet mask

Ekiti (Yoruba)

Nigeria

late 19th century (?)

wood

103 x 35 x 42 cm

The Trustees of the British Museum,
London, 1924.12-20.2

The north-eastern kingdoms and communities of the Yoruba speakers constitute a region of considerable institutional diversity in which the familiar 'classic' forms of Yoruba civilisation become increasingly rare as one proceeds east. In mask and in cult local forms often proliferate, and neither forms, nor the names of forms, nor the cults in which those forms are used, have a consistent distribution, even when some continuities persist, such as Ifa divination, the descent of kings – if they have them – from Oduduwa of Ife, and the cult status of iron.

The helmet mask with a superstructure carved from a single block of wood is known as an *epa*-type given the frequency of the generic term *epa*, but also as *elefon*, or *aguru*, depending upon local usage. Both *epa* and *elefon* are sometimes found in the same community as distinct mask forms. Sometimes the generic term for any mask form is *egigun*, sometimes *imale*, and there is a widespread belief that to carve an image or a mask and to sacrifice to it is to create a metaphysical presence.

The cult status of the masks is very varied, and the various usages are not mutually exclusive. Some are objects of display worn by young men to celebrate their transfer to a higher grade; some are used at the post-burial rites of deceased titled men; some masks are sacrificed to because of their inherent energy as *imale*; some masks attract a cult following because of their proven efficacy in healing; and some are displayed in public as part of the rites of an otherwise secret association. Some masks celebrate Ogun, the iron-wielding mythic hero, the focus of whose cult is in the central Ekiti village of Ire. (The feast of Ogun in many communities of central Ekiti is the major annual celebration, often at the height of the rainy season. New yams are harvested and sacrificed to Ogun prior to general consumption.)

The present mask is carved in a style characteristic of the village of Oye-Ekiti, close to Ire, from which it can be inferred that it would probably have been performed during the feast of Ogun. It came to the museum in 1924, at a time when sculptors were still actively producing such work in this area. The eroded state of the face would be due to successive applications of sacrificial blood and palm wine (the only reason for suggesting it dates from the late 19th century). The figure surmounting the mask is a warrior on horseback with shield and spears in one hand and a severed head in the other; he wears the long cap in which hunters keep their powder dry. This is appropriate given the character of Ogun, although it is in any case one of the standard images carved on masks of this sort irrespective of cult status (others include mothers and children, leopards, dogs and rams). Identification of this mask as Ogun is, in other words, contingent upon its place of origin. The equestrian imagery does not derive from local warfare, but from the cavalry used by the Oyo kingdom and empire (the 'classic' models of Yoruba civilisation, which until the mid-20th century were the only Yoruba group consistently to use the term Yoruba of themselves) that dominated the region from the Middle Niger to the coast from the 17th to the 19th centuries, and by the emirate of Ilorin established in north-central Yoruba in the early 19th century by the Fulani jihad. Cavalry was of little practical use in the rocky terrain of Ekiti, but the images persist, embodying memories of the 19th-century intra-Yoruba wars in which Ekiti was trapped on one side or another in various shifting alliances. In these circumstances, the figure is an apt representation of energy and authority. *JWP*

Bibliography: Carroll, 1967; Ojo, 1978; Picton, 1994¹; Picton, 1994²; Picton, in preparation

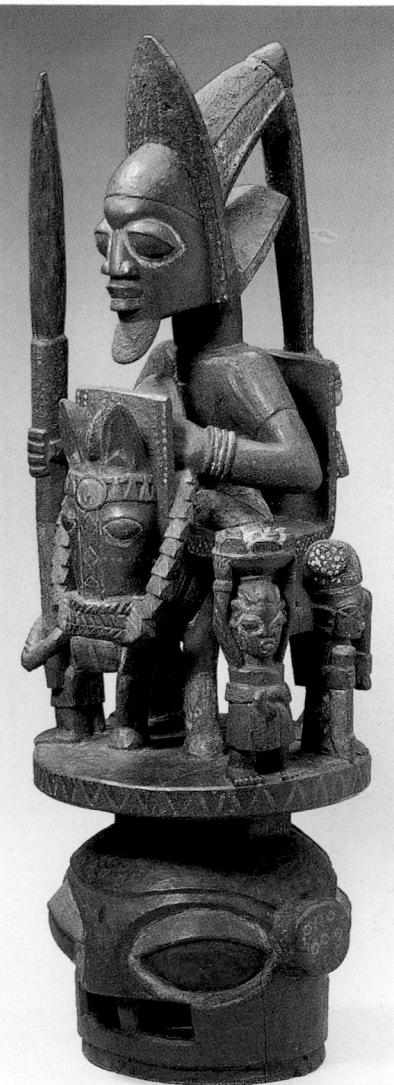

5.81

Helmet mask

possibly carved by Bambose of Osi-Ilorin
Opin (Yoruba)
Nigeria
late 19th century (?)
wood
117 x 40 x 43 cm
The Trustees of the British Museum,
London, 1964.AF.2.1

Opin originally consisted of a group of twelve villages to the north of Ekiti, within a radius of five miles from Osi-Ilorin (so-called because unlike Osi-Ekiti to the south, it had been brought into the Ilorin emirate in the 1850s with all the other Opin communities). In Opin, *aguru* masks such as this were used in the post-burial rites of titled men whose status was based upon personal achievement rather than on lineage. They were carried by the young men of a given age grade who in the course of their performance were expected to leap,

wearing the mask, to the top of a mound sometimes 8 feet high.

Opin is notable in the history of African and Yoruba art as one of the very few locations where it is sometimes possible, within the traditions inherited from the pre-colonial era, to study the corpus of work of known artists, to assess their place within a particular tradition and even to chart the development of an individual artist's work, at least since c. 1850 when the area was absorbed into the Ilorin empire. This mask was collected before 1910 and is very possibly the work of Bambose of Osi-Ilorin. In his day, Bambose was the leader of the Opin sculptors' guild, and his house was a meeting place for sculptors to discuss their work. He was the teacher of the better-known master, Areogun (c. 1880–1954), the dominant artist of Opin and northern Ekiti during the first half of the 20th century.

The leather helmet of the warrior on horseback identifies him as local rather than a soldier of Ilorin, who would have worn a turban surmounted by a basketry hat. But this detail makes little difference to the significance of the mask, just as the names sometimes given can include 'Warrior-Don't-Fight' (i.e. us), and 'Warrior-Help-Us-to-Fight' (i.e. them). The generic image of the warrior transcends the detail of whose warrior is fighting whom. *JWP*

Provenance: before 1910, collected by Churchill Bryant in Osi-Ilorin

Bibliography: Carroll, 1967; Ojo, 1978, pp. 455–70; Picton, 1994¹, pp. 46–59, 101–2; Picton, in preparation

5.82

Presentation box in the shape of a woman kneeling with a cockerel

Yoruba
Nigeria
early 20th century
wood, kaolin
53 x 25 x 37 cm
Robert B. Richardson

The supplicant woman approaching a priest or diviner with an offering is one of the three most common images in the eastern Yoruba sculptural traditions of the Ekiti kingdoms. In this example, the woman wears the hairstyle of the new bride. The body of the cockerel is carved to form a box which itself is used in the presentation of gifts whether to an honoured visitor or to a deity. The back of the

cockerel, with its head and tail, is missing. The sculptor cannot as yet be identified, but he clearly belongs to the same school as Ayantola of Odo-Ehin in the Ijero-Ekiti kingdom, a sculptor who was still working in the 1960s. It is uncertain whether this piece is by Ayantola himself, made earlier in his career when his skills were greater than they were in his later years, or by his father. *JWP*

Bibliography: Carroll, 1967; Ojo, 1978, pp. 455–70; Picton, 1994¹, pp. 1–34; Picton, 1994², pp. 46–59, 101–2; Picton, in preparation

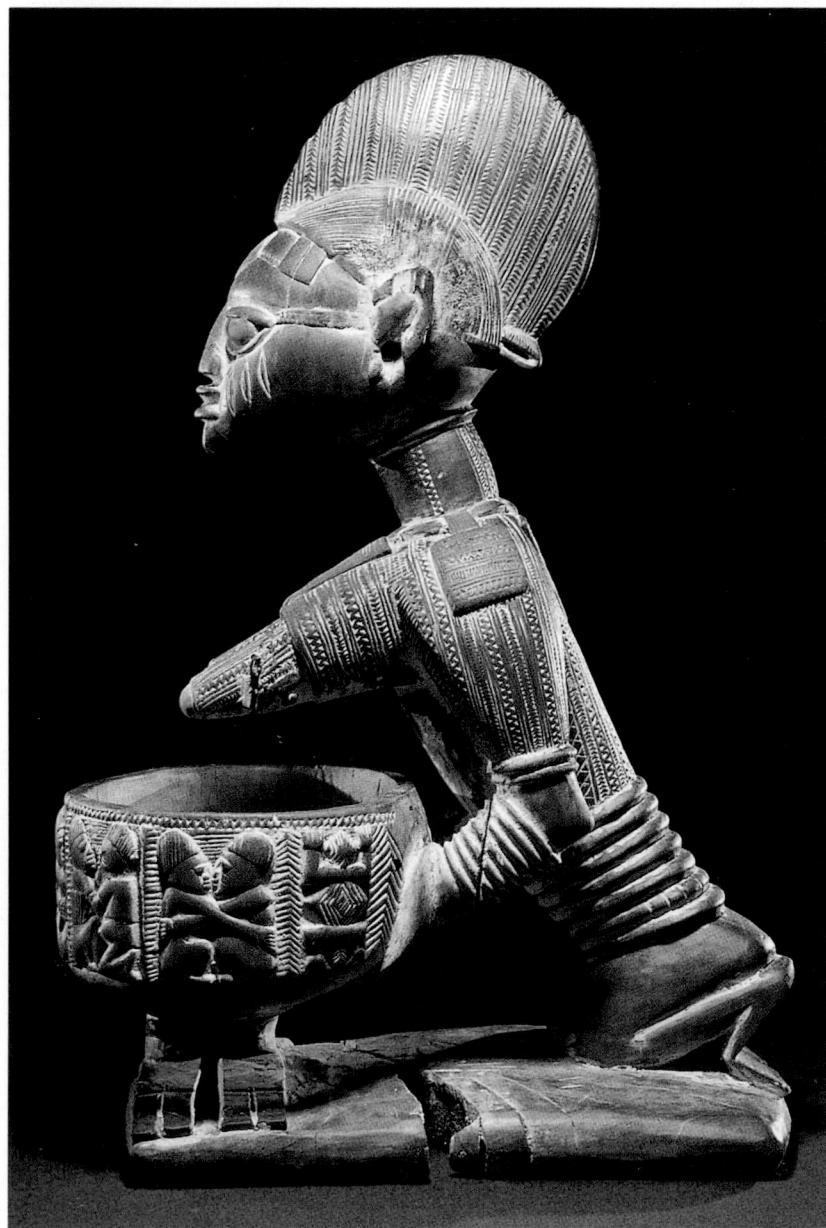

Sango shrine figure with musicians

Yoruba
Nigeria
early 20th century
wood
h. 73.5 cm
Ian Auld Collection

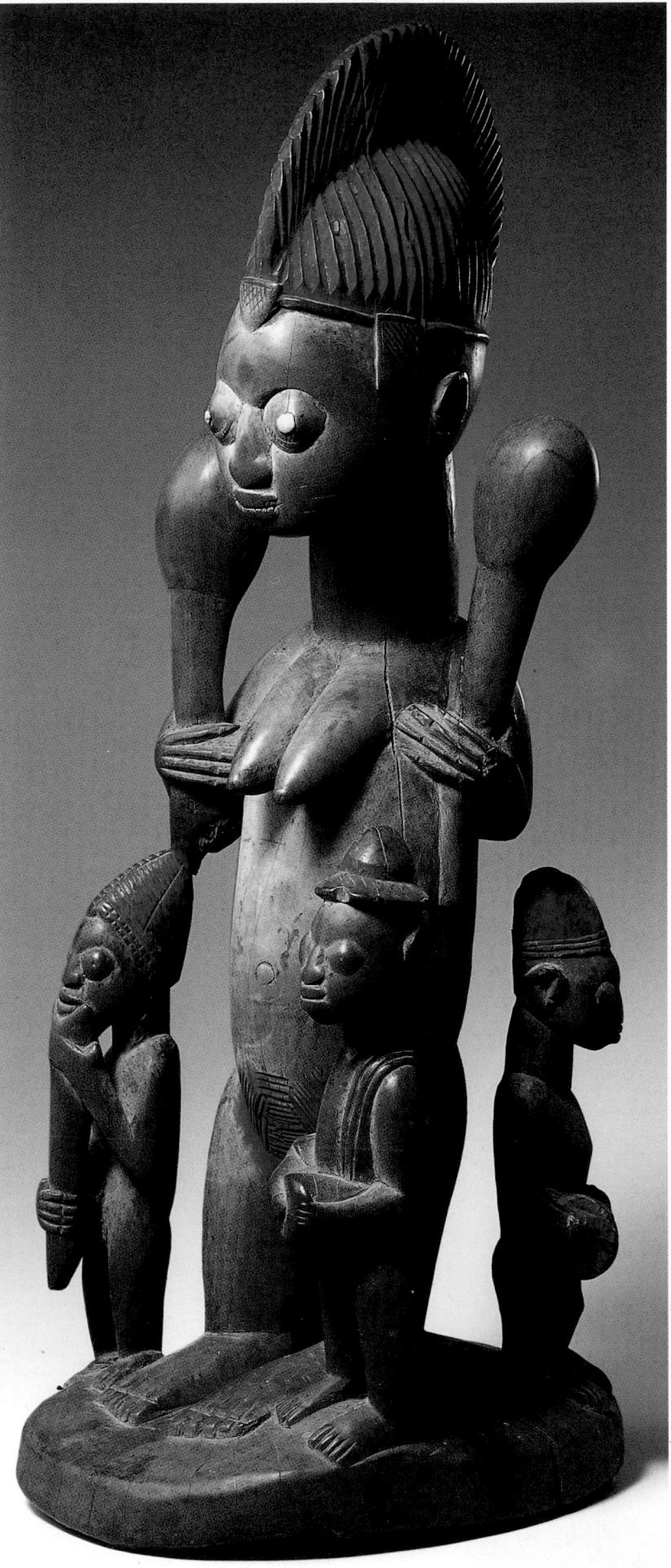

The devotees of Sango, the Yoruba deity (*orisa*) of thunder and lightning, place these carvings (*ere*) on altars dedicated to him. Yoruba oral traditions often identify Sango as one of the early kings (*Alaafin*) of Oyo-Ile. He is described as a strange and unpredictable character: violent, temperamental and vindictive, yet handsome, loving, caring and generous. He was a great warrior and magician who had the power to attract lightning, with which he vanquished his enemies on the battlefield. The circumstances surrounding Sango's death and deification are not clear. Some stories claim that he voluntarily abdicated the throne after a long reign in the 15th or 16th century and disappeared through a hole in the ground as a sign of his transformation into an *orisa*. Others allege that his subjects forced him to abdicate after becoming tired of his political intrigues and military escapades. In the end, he committed suicide. But shortly after, according to one legend, Oyo-Ile experienced a series of unprecedented and devastating thunderstorms that the king's former subjects interpreted as a manifestation of his retributive justice and wrath. As a result, they dedicated shrines not only to pacify him, but also to harness his power for communal benefit. Since his military successes reportedly laid the foundation for the political ascendancy and economic prosperity of Oyo-Ile, Sango worship was a state religion from the 17th to the early 19th centuries, when the kingdom was at the apex of its power.

As the controller of rainfall, Sango represents the dynamic, fecund principle in nature. This explains the emphasis on the female in Sango art and rituals. Initiation into the priesthood symbolically converts a devotee, regardless of gender, into a female medium subject to possession by Sango, thus providing an appropriate receptacle for the virile and fertilising power of the deity. During possession, a devotee becomes Sango incarnate, performing acrobatic dances and magical feats, speaking with the voice of the deity and praying for the well-being of the society.

The standing female figure (cat. 5.83a) represents a priestess, shaking rattle-gourds (*sere*) in praise of Sango, accompanied by musicians. Worn by male and female priests, the high-

crest coiffure (*agogo*) identifies her as a medium (*adosu*) awaiting the descent of Sango. Intended to beautify the carving, the blue dye (made by Reckitt's) on the coiffure and pelvis of the figure as well as the headdresses of the musicians is a modern substitute for indigo blue – a colour highly valued by the Yoruba because of its association with coolness. The composition, with its remarkable craftsmanship, complements the imagery of Sango in his praise-chants (*oriki*) as a lover of art, music and beautiful women. Ulli Beier photographed this particular carving at Illobu (near Osogbo) in the 1950s during the annual Festival of Images (Odun Ere) in the town when sculptures from different shrines were displayed in public and carried in a dancing procession honouring all the *orisa*. However, in Beier's photograph, the dominant female figure was adorned with head-ties and beaded necklaces, while the musicians had their head-gear painted white instead of blue. The change of colour reflects the constant and honorific renovations attending the use of sculpture in Yoruba religion. In style, pose and composition the carving is strikingly similar to a Sango altar figure in Illobu, also photographed by Beier in the 1950s. The resemblance is so close (except that the drummer here wears a pith helmet instead of a dog-eared cap) that the two pieces would seem to have come from the same workshop, if not from the same hand. Beier identified the carver of the Illobu piece as Maku of Erin, who died about 1955.

The kneeling figure with a bowl (cat. 5.83b) shares many stylistic elements with carvings from the Illobu-Erin-Osogbo triangle. The double-axe motif on the coiffure is a metaphor for the thunderbolt (in the form of a polished stone axe) that, according to popular belief, Sango hurls down from the sky during thunderstorms. It also signifies the male–female interaction in Sango symbolism, recalling the stage during initiation ceremonies when a novitiate has a polished stone axe tied to his/her head to symbolise the union of the human and superhuman. The kneeling pose communicates respect, worship and supplication. The bowl carried by the figure is a 'give-and-take' symbol, obliging Sango to reciprocate the sacrifices

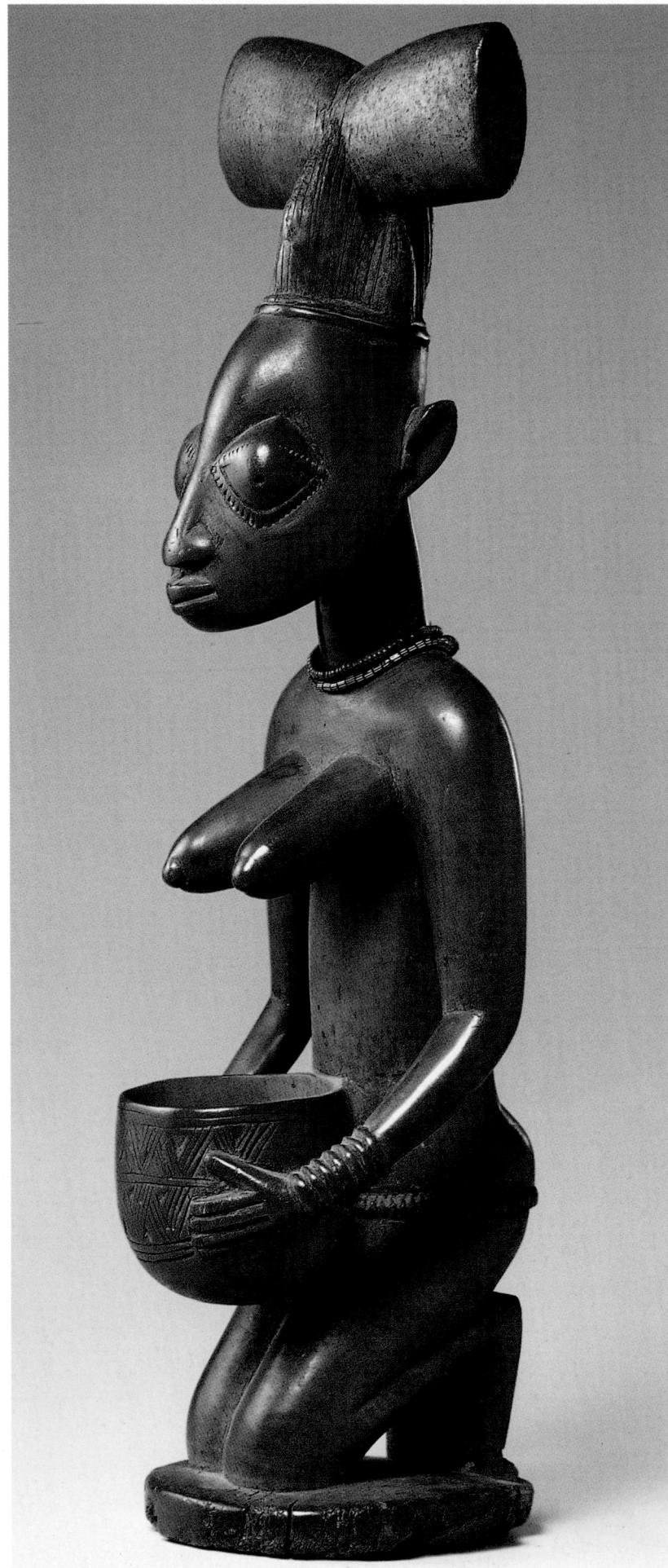

offered to him by showering the devotee with all the desirable things of life.

The stylised double-axe staff held by the kneeling female with a child on the back (cat. 5.83c) identifies her as a devotee of Sango. The child on the back signifies the protection and nurture expected from the deity. In some cases women who have had children after offering sacrifices place such sculptures in Sango shrines both as an expression of thanks and to implore the deity to protect the supplicant and her child. Because it is stylistically similar to the carvings of Abogunde of Ede, John Pemberton has suggested that this piece might have been carved by the same master.
BL

Bibliography: Beier, 1954, pp. 14–20; Beier, 1957, pl. 20; Beier, 1960, pls 5, 7; Lawal, 1971; Pemberton, 1982, pl. 53; Pemberton, 1989, pl. 161

5.83b

Sango shrine figure with bowl

Yoruba
Nigeria
early 20th century
wood
h. 52 cm
Ian Auld Collection

5.83c

Sango shrine figure with child

Yoruba
Nigeria
late 19th century
wood
h. 56 cm
Ian Auld Collection

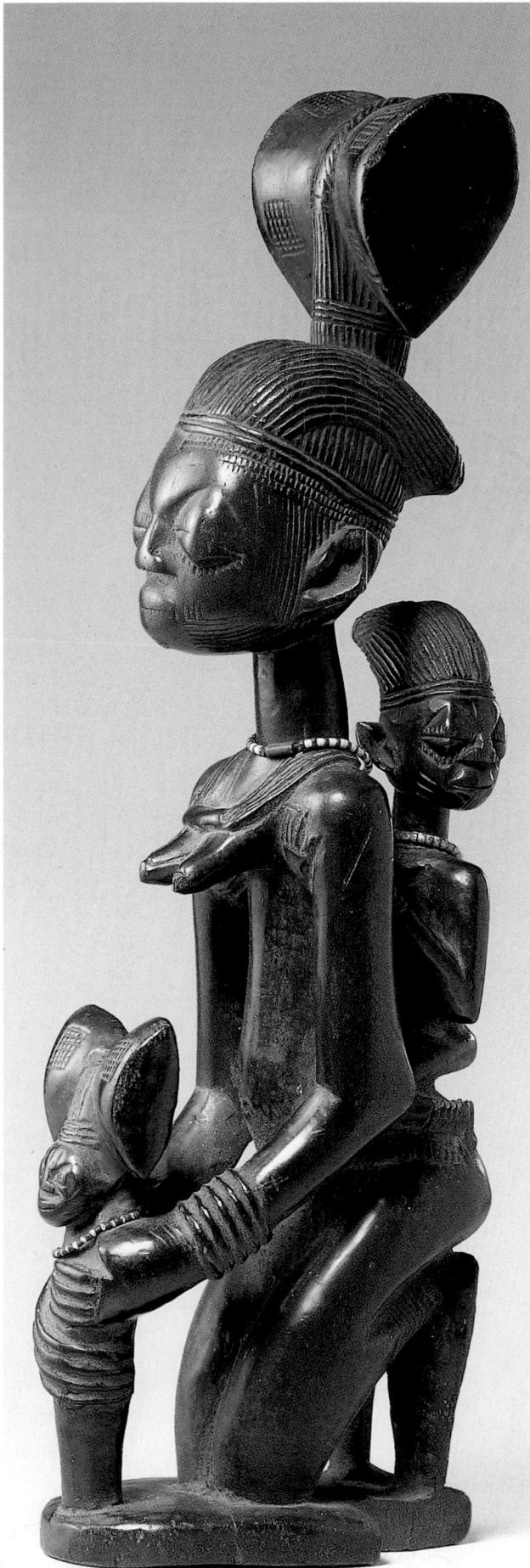

5.84

Shrine figure with child

Yoruba
Nigeria
late 19th century
wood
h. 60 cm
Ian Auld Collection

Although the original context of this shrine figure is uncertain, the high-rise coiffure of the female is characteristic of carvings found in shrines dedicated to Oya, Sango's favourite wife and the goddess of tornado and the River Niger. Indeed, the figure is so close, stylistically and iconographically, to two carvings from an Oya shrine in Ilobu (photographed by Ulli Beier in the 1950s) that it might have been carved in Ilobu by the same artist. In popular imagination Oya is the gale accompanying the thunderstorm, felling trees, demolishing houses and catapulting roofs from one end of the town to another, heralding the thunderous majesty of Sango. Because of the collaboration between the pair, Oya's sacred symbol (a pair of buffalo horns) can be found on many shrines, while Sango's thunderbolts or carved double-axes adorn Oya's shrines. Like her husband, Oya is temperamental, and hence must be wooed with the same degree of emotional intensity. Mother and child figures on Oya's shrines have virtually the same significance as they do on Sango's.

BL

Bibliography: Beier, 1959, pl. 26;
Pemberton, 1982, pl. 34

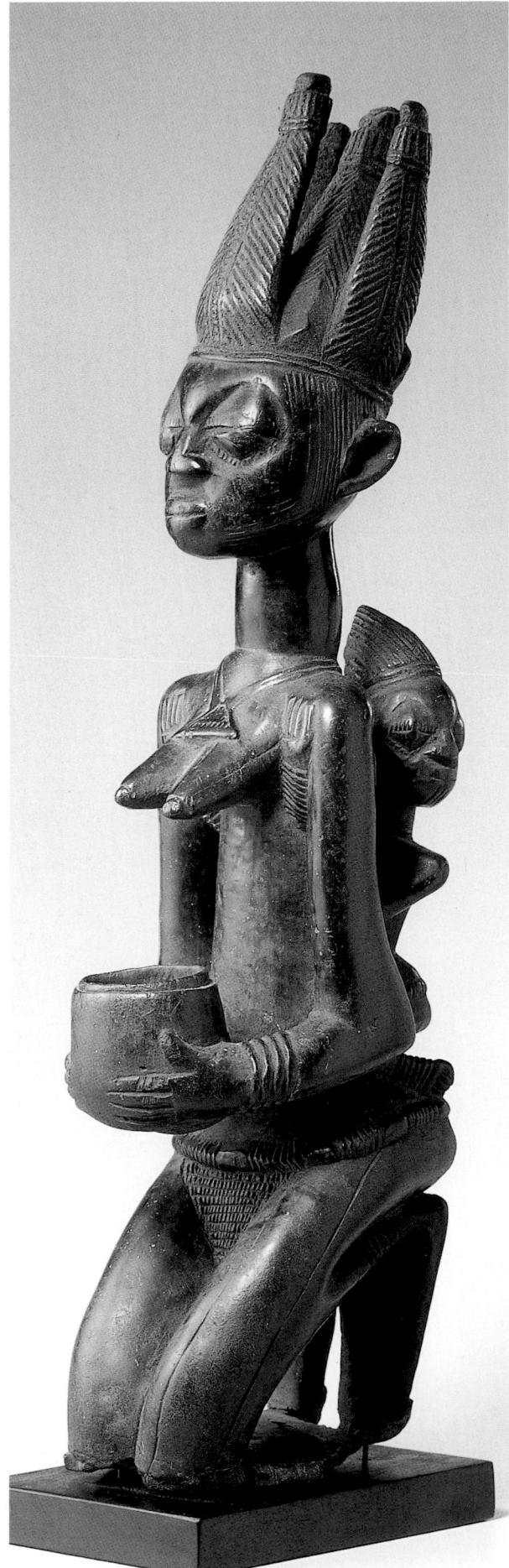

This extraordinary Yoruba display piece is said to have been commissioned by the Ogoga, the Oba (ruler) of Ikere, and given by him to a British envoy. As an expression of royal authority, beaded artwork was an appropriate gift from an Oba to the envoy of another kingdom.

The prominent female figure with a child on her back holds an offering bowl surmounted by a small bird. Four female servants surround her, their elaborate cockscomb hairstyles echoing that of the larger figure. Three hold bundles, and one kneels in front with the bowl resting on her head. The body of the central figure surmounts a conical form resembling an Oba's crown. Four male figures holding guns surround the base.

Among the Yoruba beads were the privilege of rulers and others who held positions of authority, such as Ifa divination priests. The conical beaded crown with a veil of beads (*adenla*) is the principal symbol of royal authority. On every crown a stylised human face appears at the front and sometimes on four sides or in a pattern of sixteen faces covering the entire crown. When a Yoruba ruler wears the crown, his head (*ori ode*) is covered, his face hidden by the veil of beads. His inner head, or personal destiny (*ori inu*), is inextricably related to the sacred authority (*ase*) of the crown and of all who have worn it. The peak usually features a bird, an image associated with the power of women, often referred to as 'our mothers', that is, the secret, hidden procreative power of women.

The display piece is an expression of the interrelationship of male and female powers underlying royal authority. The power of men is overt; they carry guns. The power of women is covert; women give birth, which is to say sacrifice, which is loss and gain. Without the power of 'the mothers', kings could not rule. In this example prominence is given to the woman. Her essential nature (*iwa*) and physical beauty (*ewa*) are conveyed through the child that she carries on her back, her elaborate hairstyle and the fullness of her breasts. It is, however, through the artistry of the beadwork, the rich and almost indiscriminate use of colour and pattern, that the sculpture conveys its sense of energy. From the bottom of the group of figures, the colours change from darker shades

of blue and green, accented with touches of white, gold and silver, through brighter shades of blue, red, yellow and green to a more extensive use of gold and silver. The indigo blue in the crown of the woman's coiffure echoes the darker colours in the base of the work. In the hierarchical structure of the sculpture and controlled use of colour and patterns the artist shows what the Yoruba would call *oju-onu* ('eye for design') as well as *oju-inu* ('insight'), his understanding of his subject. JP III

Provenance: 1924, bought from Ogoga of Ikerre-Ekiti by the British Empire Exhibition

Bibliography: Fagg, 1980; Cole, 1989, pp. 50-1; Drewal et al., 1989, pp. 166-9; Abiodun et al., 1991, pp. 20, 25

5.85

Display piece

Yoruba
Ekiti, Nigeria
early 20th century
cloth, basketry, beads, fibre
106 x 26 x 28 cm
The Trustees of the British Museum,
London, 1924.136

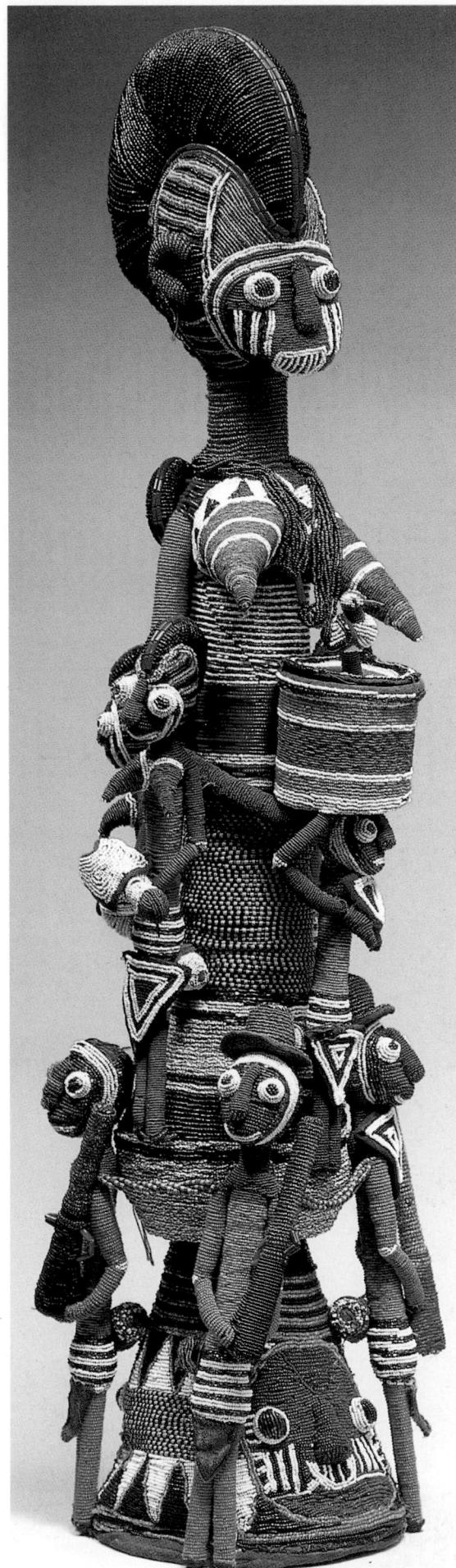

Headress (ere Gelede)

Anago-Yoruba
Republic of Benin
late 19th/early 20th century
wood, traces of pigment
35 x 18.5 x 21 cm
Private Collection, Brussels

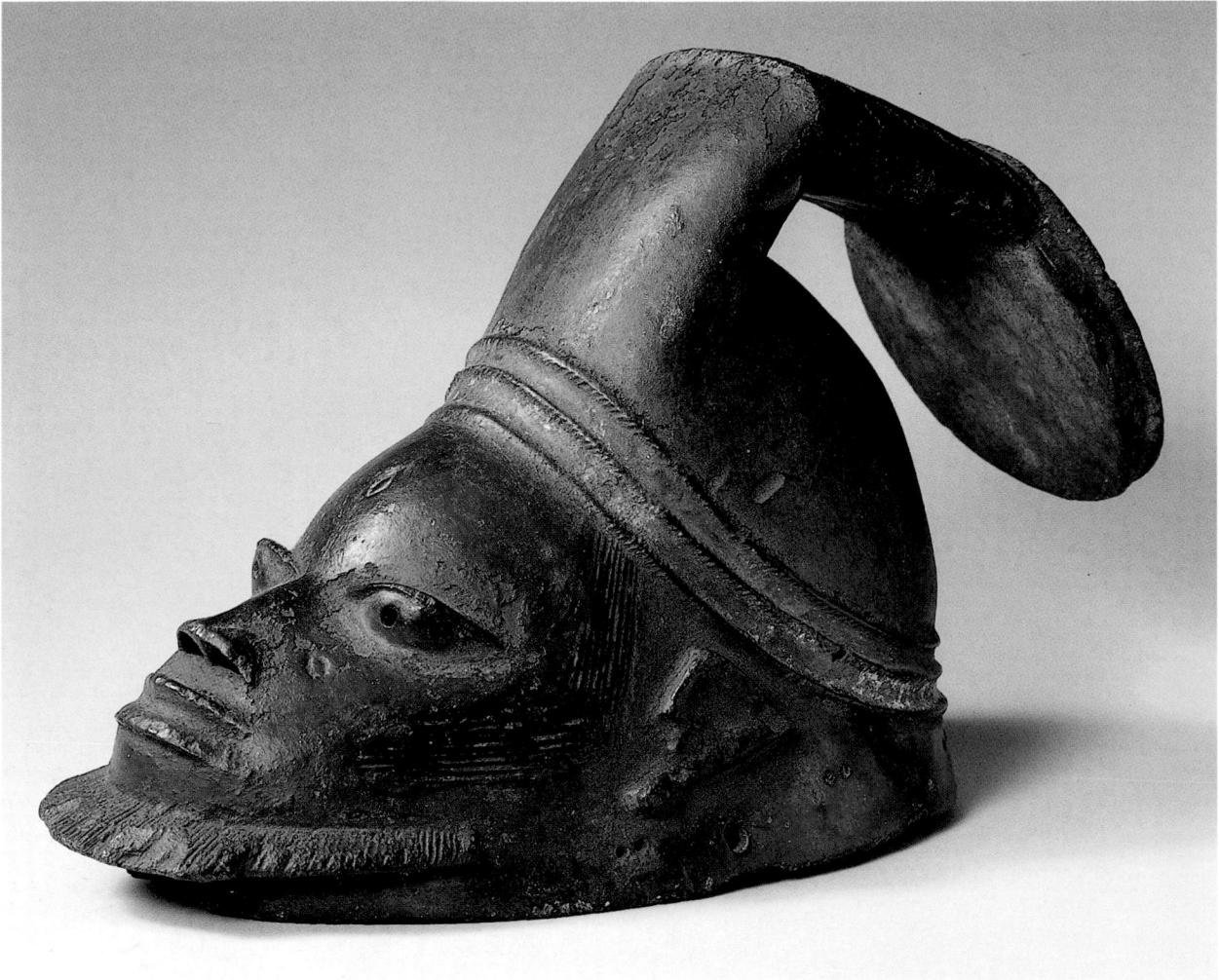

This Gelede society headdress, from the Anago-Yoruba who straddle the present border between Nigeria and the Republic of Benin, comes from the hand of an unnamed master who perhaps worked in the vicinity of Ifonyin. A mark of his distinctive style is the angularity of the ears. The mask depicts a northern (probably Oyo) Yoruba Muslim with boldly incised marks of ethnicity, his beard, and stylishly folded cloth cap. The artist has skilfully captured the fluid qualities of cloth. In a wonderful way he has played with, and reversed, a Yoruba saying about a person who dresses improperly as 'one who wears cloth like wood' (*o nro aso l'igi*). Here the master sculptor has used wood convincingly to evoke cloth.

Gelede pays homage to the spiritual powers of women, especially elderly ones, known affectionately as 'our mothers', *awon iya wa*. The powers possessed by such women, comparable with those of gods (*orisa*), spirits (*oro*) or ancestors (*osi*), may be used for the benefit or the destruction of society.

When manifesting their destructive side, such women are called *aje*. If angered, they can bring down individuals and communities. Gelede masking performances entertain and enlighten the community and 'our mothers', pleasing, placating and thus encouraging them to use their extraordinary powers for the well-being of society. Hence the performances are a sacrifice, an appeal to forces in the world using the aesthetic power of sculpture, costume, song and dance. They offer explicit commentary on social and spiritual matters, helping to shape society in constructive ways.

The themes in Gelede imagery may be grouped broadly into three categories: role recognition; satire; and concerns about the workings of various cosmic forces. These categories are often not mutually exclusive. In the first, individuals and/or groups are praised and honoured for their contributions to society. The second does just the opposite – it ridicules and damns anti-social persons or

groups. The third, by both explicit depictions or metaphoric allusions, treats cosmic forces affecting the community.

This mask focuses on the presence and impact of Muslims in Yoruba culture. It may have honoured their contributions as traders and leaders or satirised their attempts to eradicate indigenous religious beliefs and practices (such as Gelede itself). In the absence of specific details of this mask's 'life history', the precise intentions of its maker and users must remain open to speculation. *HJD*

Bibliography: Thompson, 1971, ch. 14; Drewal, 1981, pp. 114–16; Fagg and Pemberton, 1982, pls 2, 5, 29, 49; Drewal and Drewal, 1983; Drewal, Pemberton and Abiodun, 1989, ch. 8, fig. 251; Abiodun, Drewal and Pemberton, 1991, pp. 29–33

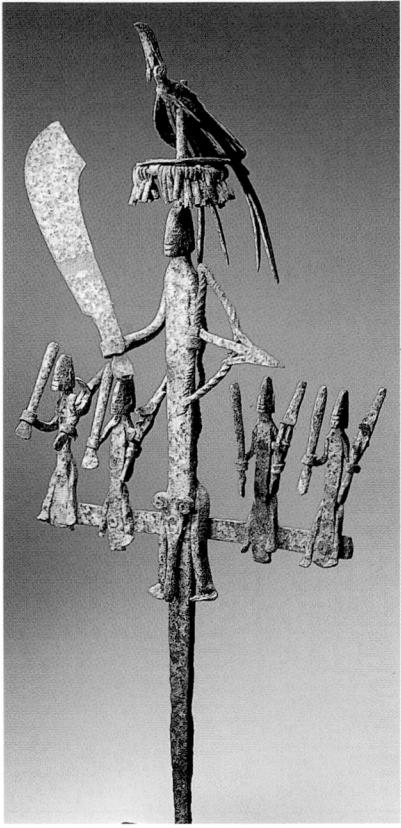

5.87

StaffYoruba
Nigeria20th century (?)
wrought iron
73.5 x 33 x 19 cm

Ian Auld Collection

The best-known Yoruba wrought ironwork forms are those of Osanyin and Ifa, the gods of medicine and divination respectively. For Osanyin, the typical form is a substantial iron spike surmounted by a bird, with sixteen birds radiating out from the centre. The number sixteen refers to the Ifa divination system in which the diviner seeks to identify which of 256 ($= 16 \times 16$) chapters in the memorised corpus of divinatory texts is appropriate to a supplicant's problems. The grouping of texts into 256 chapters also provides for the classification of medicinal plants and magical substances according to the particular character of each chapter. For Ifa, the typical form is a staff of the kind carried by a diviner in procession, surmounted by one or two birds. In both cases the birds refer to that metaphysical domain in which the resolution and healing of affliction occurs. Some wrought works take the form of the Osanyin spike, but the central bird is surrounded by images of tools used by a smith rather than by miniature birds. It is uncertain if this is for some other cult, or determined by some unusual conjunction of Osanyin and Ogun. The present example is puzzling in that the human figure bears no resemblance to the more usual works in this medium, but is rather closer to the cult ironwork of Danhome. Moreover, the presence of the miniature bow and arrow suggests a hunting deity, Oshoosi, whose cult is found especially in the south-west Yoruba region. *JWP*

Bibliography: Williams, 1974; Drewal, Pemberton and Abiodun, 1989

5.88

Divination bowl (*aqere ifa*)Yoruba
Nigeria
wood
28.5 x 21.5 cm
Private Collection

This superb carved and patinated Yoruba bowl, *aqere ifa*, is supported by a horseman and flanked by soldiers, giving an impression of great lightness and strength. The size of retainers, horse and central figure are carefully balanced. Details of dress and equipment are rendered with great attention in a manner reminiscent of Abeokuta style. The mouth of the vessel is incised with a star-shaped pattern that focuses attention on the central source of power. It is used in the cult of Ifa divination as a fitting receptacle for the sixteen palm nuts and other equipment used by the practitioner and stored on an altar.

NB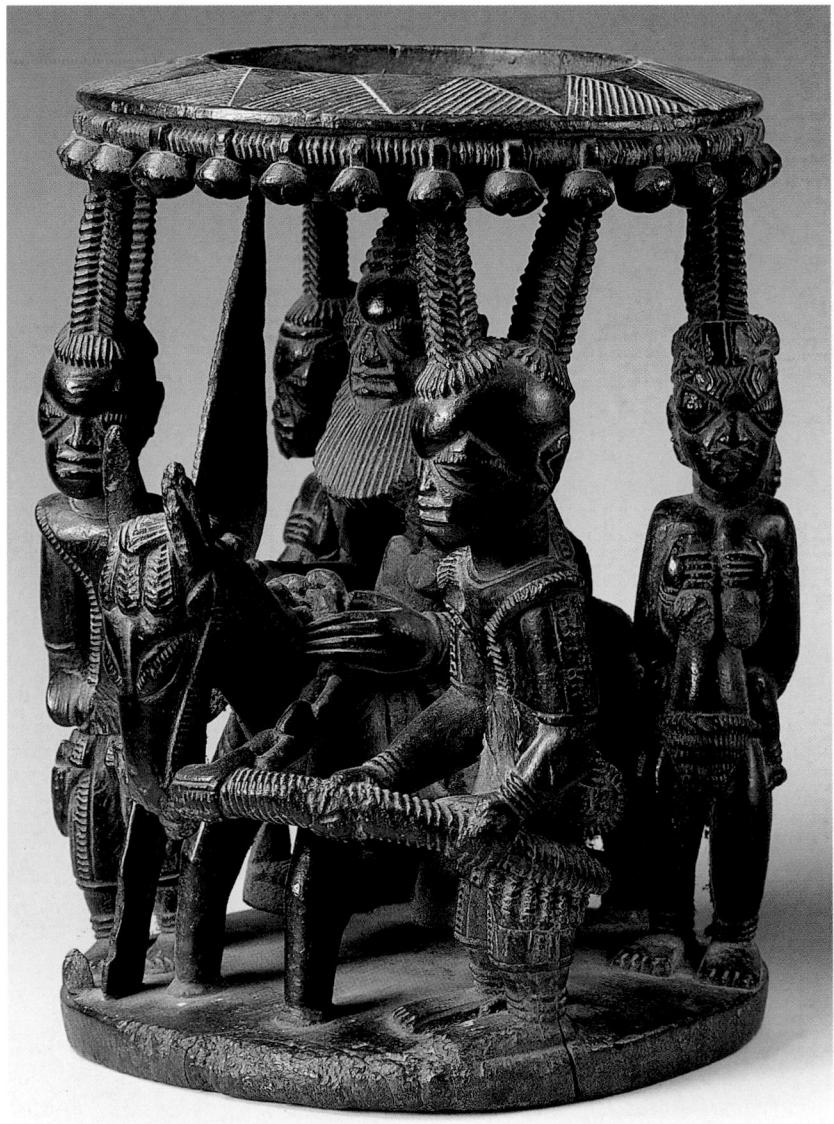

5.89

Ring

Yoruba
Nigeria
copper alloy
diam. 19 cm

National Museum of African Art,
Smithsonian Institution,
Washington, 89.17.1

This is one of a group of rings of a type that came on the market in the mid-1970s, reportedly having been found together in an illicit excavation in Ife. Their condition certainly suggests that they had been buried in the ground for some time. This piece shows a Yoruba ruler, intended to be seen as standing, although represented in high relief lying on the surface of the ring. The swelling of the chest suggests that this may be a queen rather than a king. A small crown is worn in the form of a truncated cone with decorative elements overhanging the ears on each side. This is not the type of crown usually represented in Ife art, which has a ring of large globular beads at the inner edge, and it lacks the pair of badges, shaped like a bow-tie, generally worn by royal figures in Ife. The crossed baldrics of beads are uncommon, though not unknown, in Ife. On the forehead are the addorsed crescents that indicate, in the Ijebu area of Yorubaland, member-

ship of the Oshugbo Society (known elsewhere as the Ogboni Society), a mark that is worn by both men and women. The right hand holds a short staff with a discoidal head.

At the feet of the principal figure lies a gagged human head, with the headless body of the victim lying face down, arms tied behind his back at the elbows. Long lines of scarification run up the spine and down each arm. Another gagged head lies at the victim's feet. A vulture pecks at the neck of a second victim, and a third head and victim bring us back to the main figure, beside whom, on the outer side of the ring, lie a tortoise and a pair of ceremonial staffs of the Oshugbo/Ogboni Society. Sacrificial victims used to be gagged to prevent them cursing their executioner, for such a curse would prove fatal. These objects might have been made to record the installation of Yoruba kings and been sent to Ife to demonstrate their allegiance. If so they would appear to be later than the other copper-alloy castings from Ife, since none of them shows the crown that is typical of Ife works of the Classical period. This one appears to have been cast in Ijebu. FW

Bibliography: Vogel, 1985

5.90

Torque

Yoruba
Nigeria
17th–18th century (?)
bronze
diam. 40 cm
Private Collection

Several of these elegant torques have emerged in recent years. In terms of massive casting they are feats in themselves and their working also commands admiration. Their ideal form is evidently as near a perfect circle as possible with the two pointed finials meeting with, so to speak, a kiss. Many fail or join with limited success: this particular example with its slender points achieves the intuited goal on both counts.

An initial analysis of the brass alloy suggests a date around the 18th century (though this is based only on two samples). It is possible that the function of such torques caused them to be made over a long period.

By the time of Ibn Battuta's famous tour (1354) stone moulds existed for making ingots and many elaborately twisted ingots are extant. This torque however is cast in its curved form rather than bent. The trade manilla

with its currency associations is evidently the root reference for such a piece and there can be no doubt that only the wealthy could afford an object of this weight (some are over 4 kilos); yet it seems to have had other functions than that of a financial indicator, being worn by women in a ritual dance involving cutlasses. This seems unlikely when one picks up the torque but it can easily be demonstrated that it sits well around the neck and could be worn in dance rituals even by a young girl.

Variants of the heavy cast torque are seen in ones or twos, but this form appears to have endured since many have been found buried in caches. Too much attention has perhaps been paid to the figurative castings of the Yoruba at the expense of their rich range of 'abstract' bronzes and of virtuoso brass castings such as this perfectly conceived and executed work. TP

Bibliography: Williams, 1974

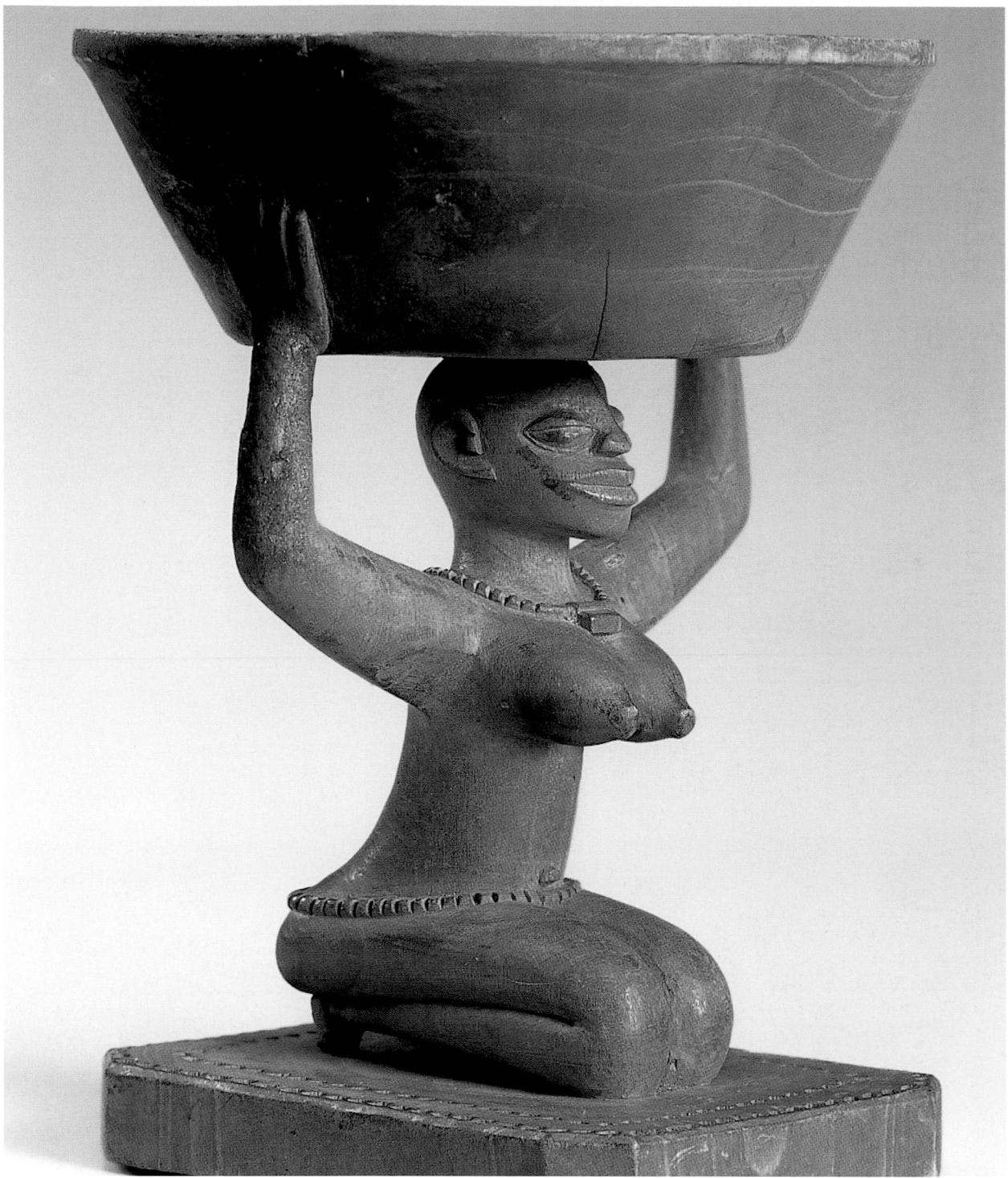

5.91a

Caryatid figure with offering

Fon
Republic of Benin
wood
h. 18 cm
The Trustees of the British Museum,
London, 1886. 7.17.5

South Benin woodcarving seems to be mainly concerned with human figure representation in various heights and forms. Those carvings are all known as *bocio*, a term difficult to translate, even if most people agree that it is an association of *bo* (charm) and *cio* (corpse). They are also named *atin vle gbedo* (wood resembling a human being). A *bocio* is considered to link the visible to the invisible: the end of the generally pole-shaped figure is stuck into the ground so as to emerge from the earth upon which

man (*gbedo*, i.e. master of the cosmos) has entire authority. The goal of a *bocio* is merely to capture the very essence (*yé*) of whatever it represents. It has no pretension to verisimilitude and should not be looked at as portraiture chasing a likeness.

The *bocio* is ubiquitous in Fon culture. It lies in front or at the rear of houses, next to shrines, in the middle of courtyards and in any other place where human beings can be present. One might also find it in the remote bush, clad in rags and tatters

or proudly exhibiting brand new garments, depending on who is to be imitated. The primary function of a *bocio* figure is to dispel or trap evil that might mistake a sculpture for a real person's presence. The direction in which the figure looks is the one from which evil might come. The *bocio* delineates the frontier between the tamed forces of civilisation dwelling in the boundaries of a human settlement and the unbridled forces of the wilderness not so far away.

Although most *bocio* figures are found in Fon country and can be considered as cultural and ethnic markers, they are also carved by Yoruba or Yoruba-trained artists. This is not surprising since Yoruba influence is found throughout Fon art. The various wars between Fon and Yoruba helped such influences to take root through the arrival and maintenance of Yoruba artists and diviners in the Fon Kingdom of Abomey, where they played a significant role at the royal court.

Some of the carvings display this influence through themes such as caryatid bowl figures (cat. 5.91a) traditionally designed to contain offerings to Orunmila, the god who animates the Ifa animation system, to whom all human beings must submit regardless of beauty or fortune. Ifa is a geomancy that originated in Ife in Nigeria. Both Yoruba and Fon consider this city as their religious capital.

Bocio figures are relatively little known, and most of the time it is difficult to relate such figures to history. However, one of those exhibited here (cat. 5.91d) was brought back as war booty in 1893. It was found in the Royal Palace of Abomey together with two other gigantic figures. All three were said to be royal portraits, this one being of Ghezo (1818–58). Its red painted body covered with sharp iron ties and smeared with sacrificial remains suggests, however, that it more probably represents Gu, the god of iron, who assures success in battle. This linkage to war is also suggested by the lost cutlass it formerly held in its raised arm and by the protective arm and waist belts.

Bocio are also a frequent embodiment of extraordinary beings called *aziza*; half-way between man and beast, they alone may be endowed

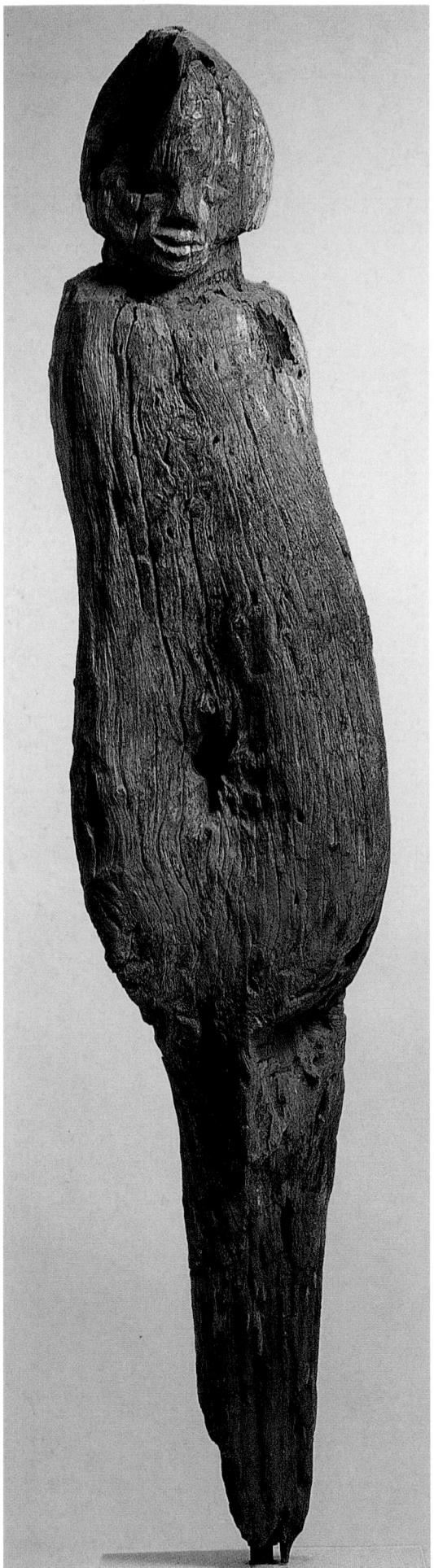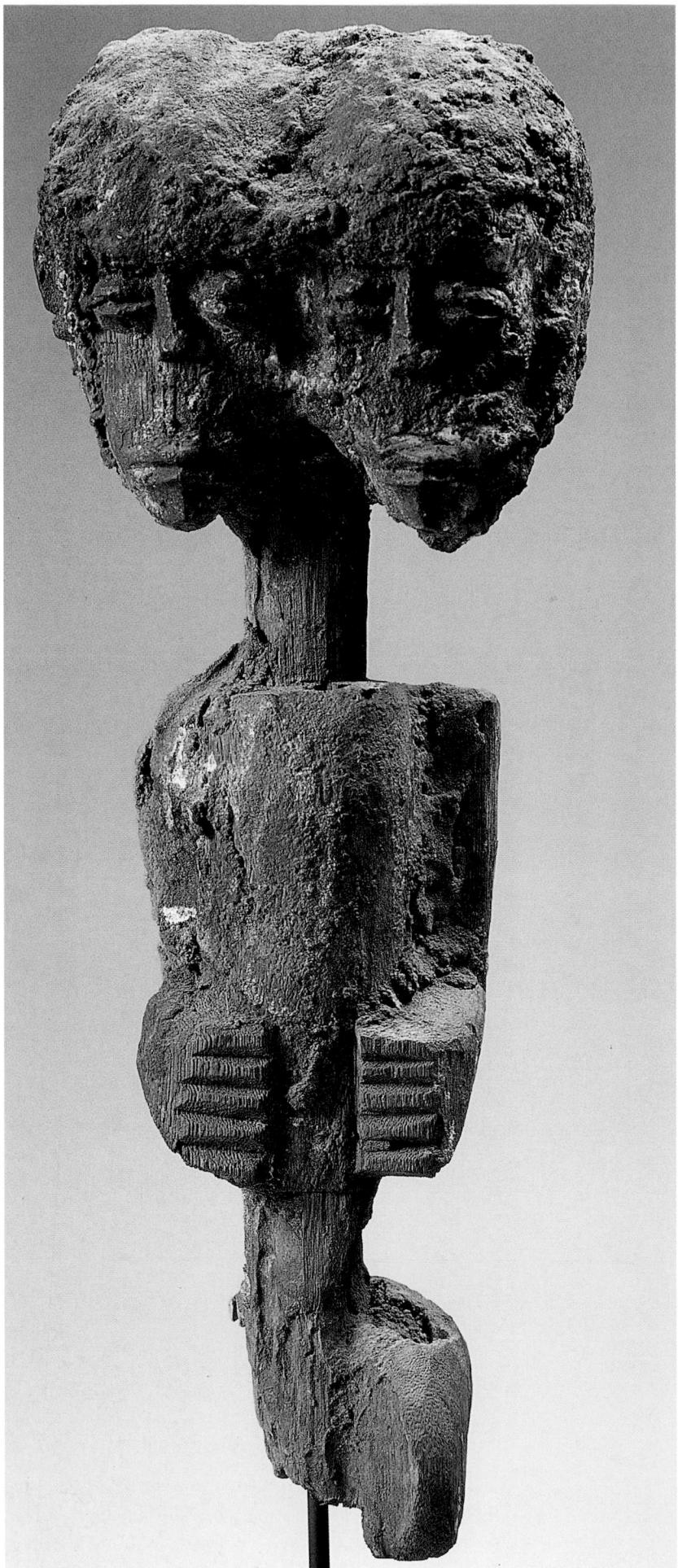

with double or triple faces on a single trunk. They are usually met by hunters who learn from them secrets of medical herbs, for instance. They are said to be dwarfs, hence the need to portray them as short and imposing.

Bocio can be just a minimal transformation of a log, and all the accidents linked to the growing of a tree can be animated by the carver, for whom nature itself affords whatever is necessary to representation. Permanent exposure to the elements continues the carving process, thus contributing to the appearance of being half-way between real and unreal. CJA

Provenance: cat. 5.91a: 1886, given to the museum by Mrs A. Turnbull; cat. 5.91d: Royal Palace of Abomey; 1893, taken to France as booty by Captain Founsgrievs

Bibliography: Merlo, 1966; Adande, 1994; Blier, 1995

5.91b

Bocio

Fon
Republic of Benin
wood
h. 132 cm
Private Collection, Paris

5.91c

Bocio

Fon
Republic of Benin
wood
h. 44 cm
Private Collection, Paris

5.91d

Bocio

Fon
Republic of Benin
19th century
wood, iron
h. 168 cm
Laboratoire d'Ethnologie,
Musée de l'Homme, Paris

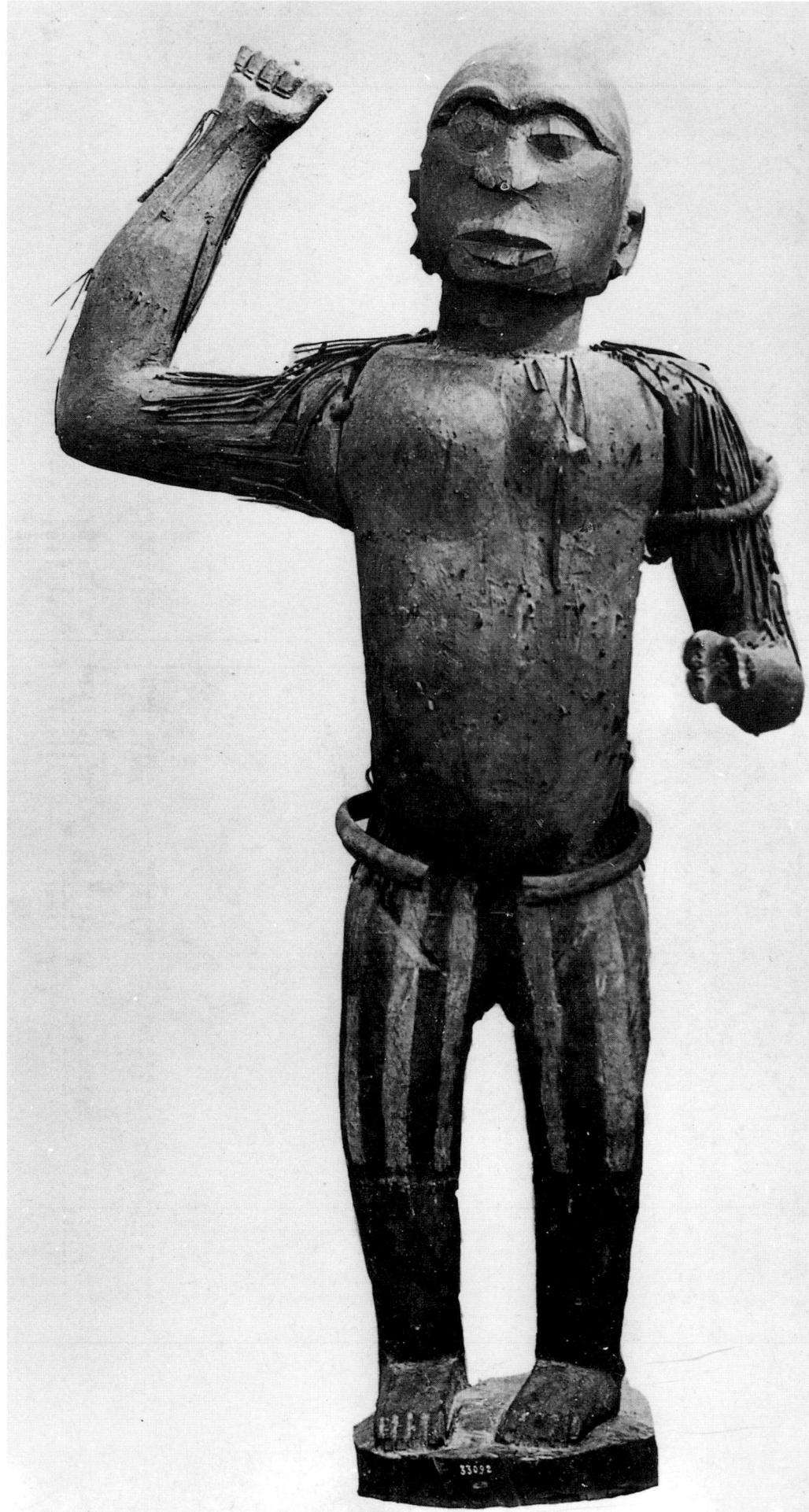

5.92

Cotton textile

Ewe
Ghana
early 20th century (?)
cotton
370 x 212 cm
Peter Adler Collection

Ewe weavers use the same type of loom as Asante weavers, with two pairs of heddles, making it possible to alternate warp-faced and weft-faced patterning within the 4-inch-wide format; as with Asante textiles, the weaving is planned so that when the woven strip is cut and sewn together edge to edge a regular design emerges. In this cloth (for which the generic term is *odanudo*, literally 'skilled cloth'), almost certainly woven at Kpetoe, one of a number of Ewe weaving centres (each with its range of styles), the warp-faced and weft-faced areas are more or less equally spaced, permitting the regular alternation of blocks of colour; in designs such as this one can grasp the logic of the narrow-strip format. The juxtaposition of colour and design achieved here is impossible to replicate on a broader loom without evolving a more complex double-warp structure. The one point at which the differing blocks are aligned rather than alternated suggests that a strip is missing at the centre of this cloth.

Comparison with the Asante *adwinasa* textile (cat. 5.93) illustrates the characteristic differences of the two traditions. Ewe weavers employ figurative motifs in the float-weave embellishments and they habitually ply cotton yarn of two colours to weave the weft-faced areas; Asante weavers do neither of these things. Ewe weavers also make greater use of imported machine-spun cotton, in a wider range of ready-dyed colours than Asante weavers, although they also make use of silk yarn (and its latter-day substitutes: rayon was in use in Asante by the turn of the 20th century). They often imitated Asante designs in order to make the most of the demand for '*kente*' (a word of uncertain derivation) among the élite in Ghana after its independence when President Nkrumah had popularised this cloth as a form of national dress. There are other differences: unlike Asante, the commissioning of highly patterned cloth was not limited to members of an Ewe chiefly élite.

In any case, Ewe weavers worked more for the market than on commission, and employed a wider variety of styles associated with different weaving centres but also with patterns intended to supply outside demand, such as the 'Popo' cloth woven for sale in the Niger Delta, or the 'Kongo' cloths intended for even further afield.

JWP

Bibliography: Menzel, 1972; Lamb, 1975; Picton and Mack, 1989; 2nd edn, 1992

5.93

Silk textile (*adwinasa*)

Asante
Ghana
19th century (?)
silk
200 x 110 cm
Private Collection, London

The Asante confederacy was a group of Akan kingdoms acknowledging the authority of Kumasi that came into being in the late 17th century with the mythic conjuring of the Golden Stool down from the sky on a Friday by Okomfo Anokye for Osei Tutu, the first Asantehene. Asante people dominated the trade networks linking savanna and coast in this part of west Africa, and throughout the 18th and 19th centuries their prestige, influence, wealth and authority steadily increased. This, together with the restriction on the use of silk to chiefly hierarchies and their courts, seems to have prompted the weavers to make formal experiments within the limits of their technical apparatus. Textiles known as *adwinasa* represent the high point of achievement among the weavers of Bonwire, which was (and still is) the centre of all Asante silk weaving.

In the past much Asante cloth was woven of cotton locally hand-spun to a fine quality unequalled elsewhere, and dyed in indigo to create a seemingly endless variety of striped patterns. In the early 19th century Asante weavers were first reported to be unravelling European silk cloths in order to

use the yarn in their own textiles; the use of silk, and the alternation of warp-faced and weft-faced plain weave within a single length of cloth (made possible by means of the addition to the loom of a second pair of heddles), are among the more characteristic features of Asante weaving. At first, silk may have been used sparingly in the weft-faced and float-weave patterning, but in due course it became normal to weave the entire cloth in silk. Yellow silk replicates the Asante court taste for gold ornament and the use of gold dust and nuggets as currency (otherwise rare in west Africa), though other colours are used. Silk textiles were woven only on commission from members of the royal and chiefly élite and were never sold in the marketplace (unless a piece was rejected: weaving in lengthy but narrow strips, which are then cut and sewn together edge to edge to form the completed textile, is generally characteristic of west Africa).

In the case of *adwinasa*, a term that means 'fullness of ornament' (*adwini*), the weft-faced banding is reduced to the minimum required to provide a formal structure within which the entire face of the cloth can be embellished with float-weave patterns. Each element in the design varies in scale, configuration and colour to ensure, in the finest *adwinasa* of the late 19th century, that no two pieces are ever the same. The motifs, whose significance varies, include items of weaving apparatus, chiefly regalia, and symbolic representations of proverbs and historical references. In this case the emphasis is on visual pleasure in formal elaboration within the context of chiefly authority. *JWP*

Bibliography: Menzel, 1972; Lamb, 1975; Picton and Mack, 1989; 2nd edn, 1992

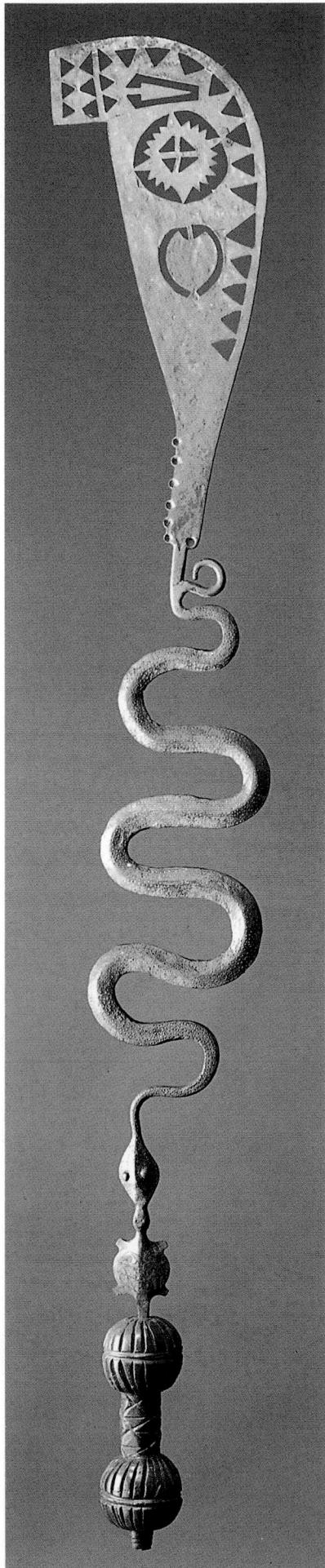

5.94

Ceremonial sword

Asante
Ghana
19th century
metal
150 x 26 cm
The Trustees of the British Museum,
London, 1896.5-19.4

This Asante iron ritual sword, *afanatene*, was primarily an item of display. It would presumably once have had a wooden handle, possibly representational, covered in gold leaf. From this rises a tortoise that becomes the head of a snake whose sinuous body supports the blade itself. Such blades commonly show openwork representations of proverbial animals and, in the present case, geometric motifs.

Swords of many different kinds occurred within the Asante empire, conferring status on their possessors but also acting as a means of expressing centralised authority. The Asantehene himself, when seated in state, would be flanked by a three-pronged version of such a weapon.
NB

Bibliography: McLeod, 1981, p. 91

5.95a

Kuduo

Asante/Akan
Ghana
19th century
copper alloy
h. 12 cm; diam. 18 cm
Private Collection

5.95b

Kuduo

Asante/Akan
Ghana
18th or 19th century(?)
copper alloy
h. 18.5 cm; diam. 15 cm
Private Collection

These two circular vessels with figuratively elaborated lids show the extent to which Asante and other Akan peoples developed remarkably diverse *kuduo* containers cast of copper alloys. Both vessels rest upon separately cast openwork lattice rings, distinguished by the fineness of their execution, which have been carefully fused to the *kuduo* themselves. On the lid of the first container is a triad of three-dimensional cast figures: a seated, bearded man flanked by two much smaller figures, representing musicians who are also seated and playing side-blown trumpets. Leg irons and a farmer's hoe complete this enigmatic composition, suggestive of the strong sense of social and political hierarchy found within Asante and other Akan cultures. The lid of cat. 5.95a is dominated by a bold low-relief rendering of a crocodile, its body splayed across the lid's diameter; the handle is worked in exquisite detail, echoing the design along the edge of the lid and at various points on the body of the vessel itself.

Kuduo were used in many ways by the Asante and Akan. They held gold dust and other valuables, but could also be found in important political and ritual contexts. Some *kuduo* were buried with their owners, while others were kept in the palace shrine rooms that housed the ancestral stools of deceased state leaders. Life and the afterlife, the present and the past, were enhanced and made more meaningful by the presence of these elegant prestige vessels. *RAB*

Bibliography: Mcleod, 1981; Brincard, 1983; Silverman, 1983; Garrard, 1983; Schadler, 1993, pl.66

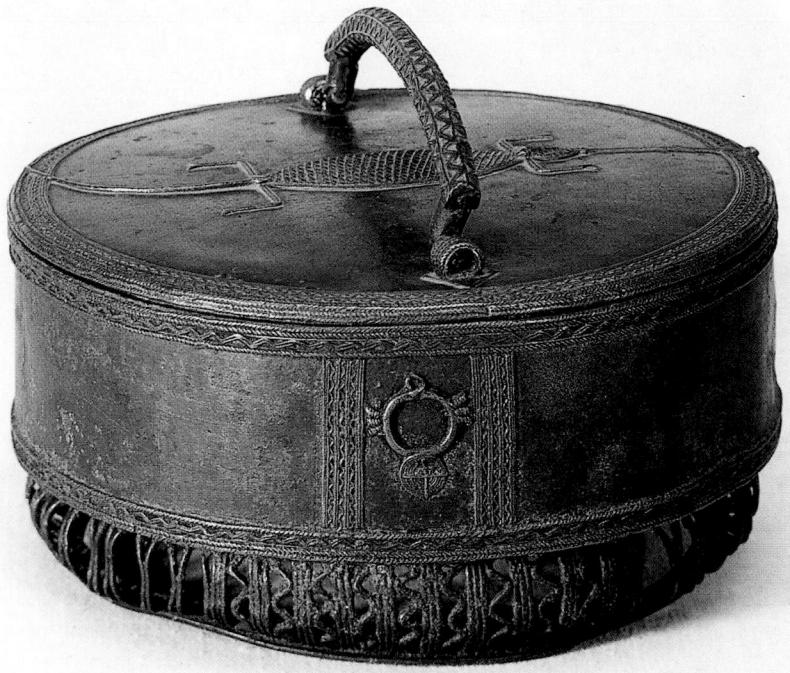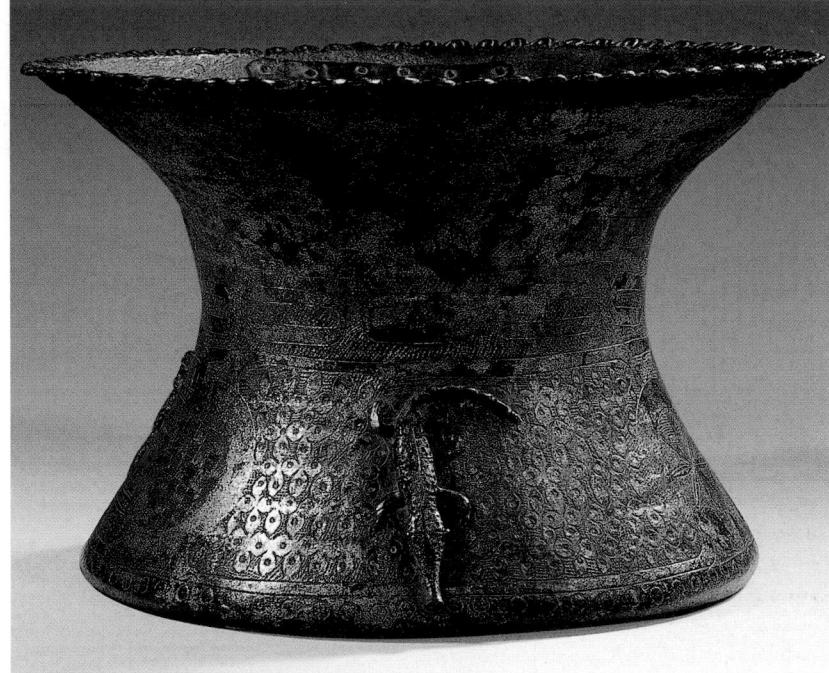

5.96

Kuduo

Asante
Ghana
18th or 19th century (?)
gilded copper alloy
h. 17.8 cm
George Ortiz Collection

The Asante culture has long been at the vortex of historical events that tie it not only to the European presence on the coast of Ghana, but also to an ancient network of trade ascending from Muslim north Africa to the heart of the Ghanaian forest. The Asante people have themselves been active historical agents; their artists have always gladly accepted items imported from the wider world, assimilating and transforming them in a continuing search for new and more fully realised Asante cultural forms.

Inspired by 14th- and 15th-century Arabic-inscribed basins from Mameluk Egypt (six of which survive in varying states of disrepair within greater Asante) and other imported Islamic bowl, goblet and cup forms, Asante metalcasters also drew upon European trade wares in the creation of luxury containers for this highly class-conscious society. Over generations the Asante artistic imagination was to reshape these models, resulting in a remarkable range of containers

known as *kuduo*, vessels cast of various copper alloys.

One of the most elegant is this fine example, an open-mouthed vessel with flared sides and a delicately scalloped rim, which blends the purity of medieval Islamic design with Asante creative ingenuity. Its silhouette is time-honoured among Muslim craftsmen, and containers of this shape, known as *tish*, are still a popular item in the *souks* of north Africa. The measured and densely worked bands of designs and the medallions containing rosette patterns that encircle this *kuduo* clearly echo Islamic prototypes. The Asante artist has enhanced this container, however, by including three crocodile figures and adding gold leafing to its surface. *RAB*

Bibliography: Mcleod, 1981; Brincard, 1983, pl. G6, p. 114; Silverman, 1983; Garrard, 1983

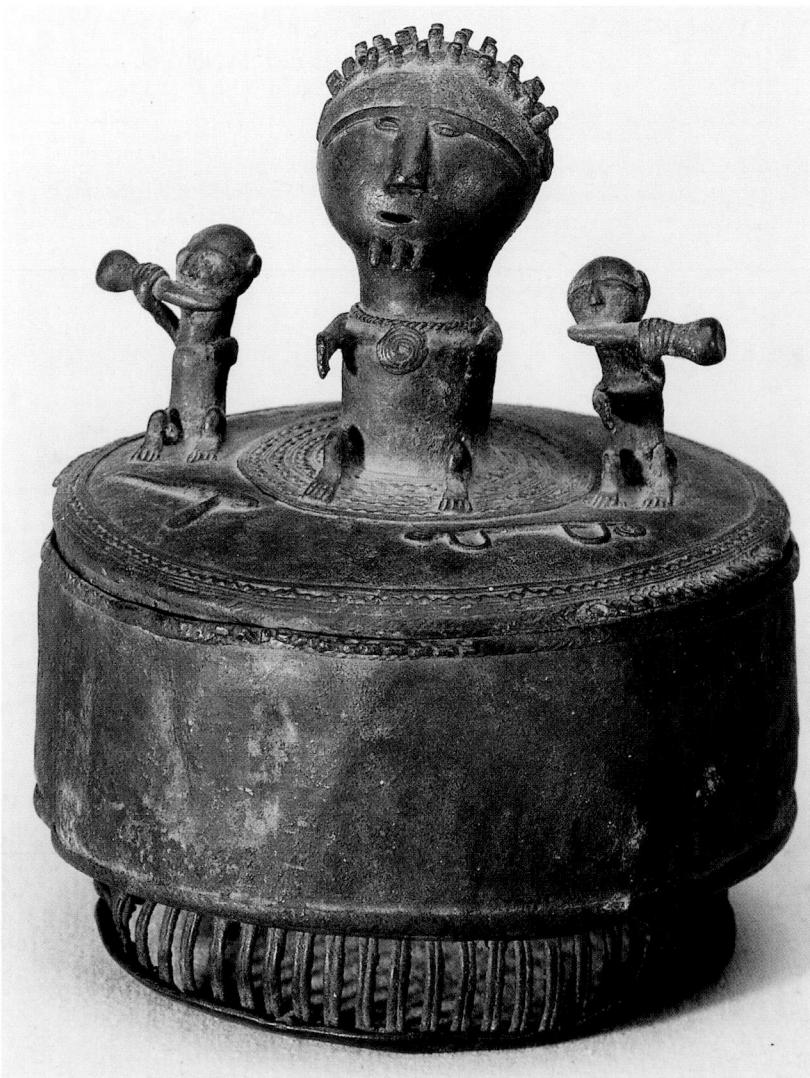

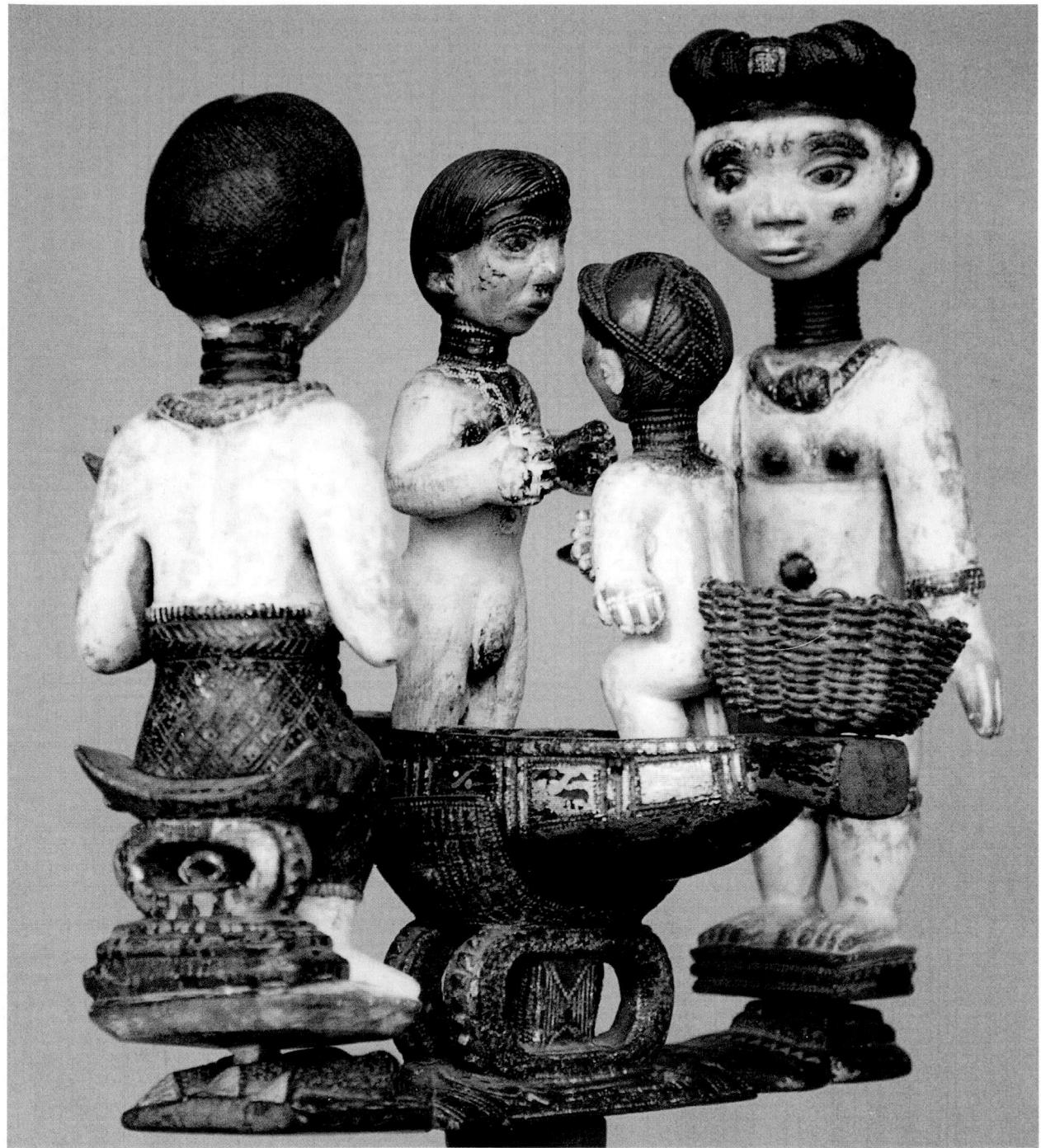

5.97

Staff with painted figures

Fante
Ghana
20th century
wood, paint, glass
h. 220 cm
Dr. E. Wachendorff Collection

In most Akan societies the linguist plays an important role. Even today, in quite a small village, it would be discourteous to speak to the chief directly in the first person: he is to be addressed through his linguist who will not necessarily pass the message on but will be, as it were, the micro-

phone through which you pay respects to his dignity or make any kind of negotiation. The linguist's staff of office marks him out in any gathering and is often, as here, decorated with various motifs including hands and snakes. The top of this example consists of a figure group of some complexity (though not untypically elaborate) which no doubt incorporates one of the proverbs of which the linguist must keep a store. In earlier times this might well have been covered in gold leaf (or simulation of such) as is still the custom among the Asante, Baule etc (cat. 5.117), but the

present piece is of quite recent manufacture and is painted with brilliant oil-based paints.

Two figures occupy a boat (the Fante are grouped in the coastal regions south of Asante territories) which itself is placed upon a clan stool; two figures look on, one of them enthroned. An enigmatic basket completes the scene. The lively group in its fresh, frank and direct style will perhaps remind visitors to the exhibition of the recently publicised Asafo flags which also transmit narrative messages in clear colours.

TP

5.98

Drum

Fante
Ghana
c. 1940
wood
h. 87 cm
Private Collection, Paris

This anthropomorphic female drum is seated on the back of a lion with the feet of the drum resting on top of a much smaller elephant. The instrument was once the lead drum in an Akan popular band that performed at a variety of occasions including puberty celebrations, marriages and funerals. Special events aside, the primary motivation for this continuing tradition is social and recreational, with evening entertainments at the core of a community's leisure activities. Similar to their Euro-American counterparts, traditional Ghanaian bands are a product of frequently changing tastes in music and dance. The principal drum is the visual and musical focus of the group. Additional instruments in these primarily percussion ensembles may include clappers, gourd and metal rattles, gongs, other drums and human voices. Each style of music and dance has its own name. This drum is quite likely from one of the Fante groups called *ompe*, which has been translated as 'who doesn't like it'.

The elaborately carved 'master' drums of these bands are invariably female and are often referred to as the 'queen mother' of the ensemble. Despite this royal allusion and the regal presence of the lion and elephant, these drumming and dancing groups function as voluntary musical ensembles independent of Akan court structures. Nevertheless, drums like the present example borrow heavily from Akan royal notions about the art of being seated. Of all African peoples, the Akan probably have the most sophisticated vocabulary of stool and chair types, with a wealth of distinctive meanings and contexts of use. The scale of the drum figure relative to the two royal animals that support it obviously aggrandises the importance of the drum itself. Among the Asante, lion stools were once the exclusive prerogative of the Asantehene, and foot rests of any type were reserved for high ranking chiefs. The state treasury of Adanse Fomena still

holds two brass elephants of European manufacture that serve as foot rests for the paramount chief. These concepts of elevation and enthronement have been borrowed by the drumming group to enhance their theatrical presentation.

The importance of the drum, and therefore of the group that once owned it, is further emphasised by the relief carving around the torso. Each distinct motif illustrates part of the conventionalised oral literature of the Akan – from praise names, proverbs and folk tales to riddles, boasts and insults. While some of these motifs may celebrate the prowess of the band, most are aphorisms that comment on the everyday life of the Fante. For example, to the left of the breasts a leopard confronts a tortoise, which illustrates the maxim: 'When the leopard catches the tortoise it turns it over and over in vain.' This common saying argues against aberrant behaviour and against challenging the natural order of things. In the same vein, at the back of the drum is a cat with a small bag around its neck facing a mouse. This motif warns: 'It is a foolish mouse that tries to steal from the cat.' *DHR*

Bibliography: Nketia, 1963; Cole and Ross, 1977; Ross, 1988; Ross, 1989

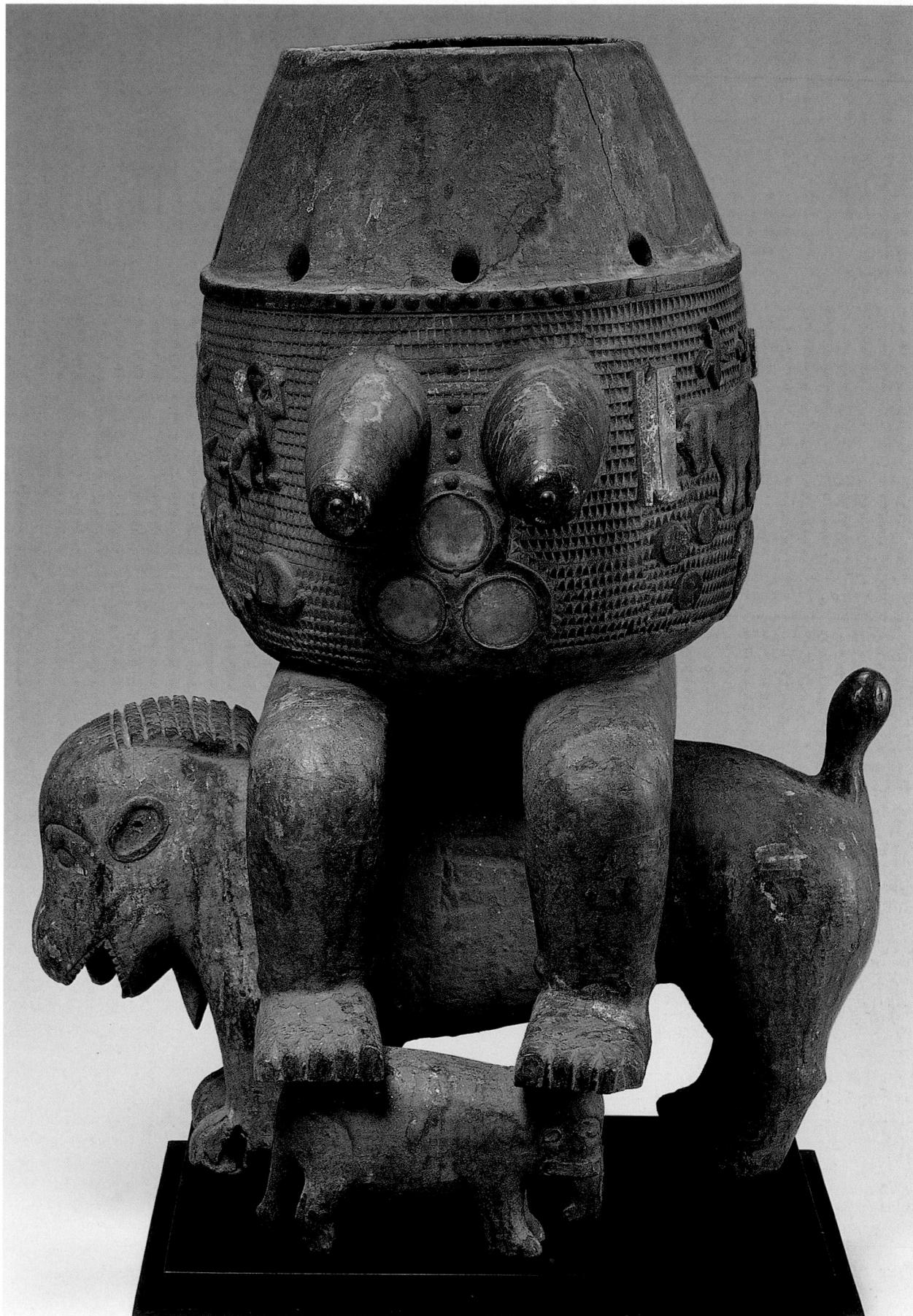

5.99a

Memorial head

Akan
Ghana
17th–19th century
terracotta
51 x 14 x 15 cm
Private Collection

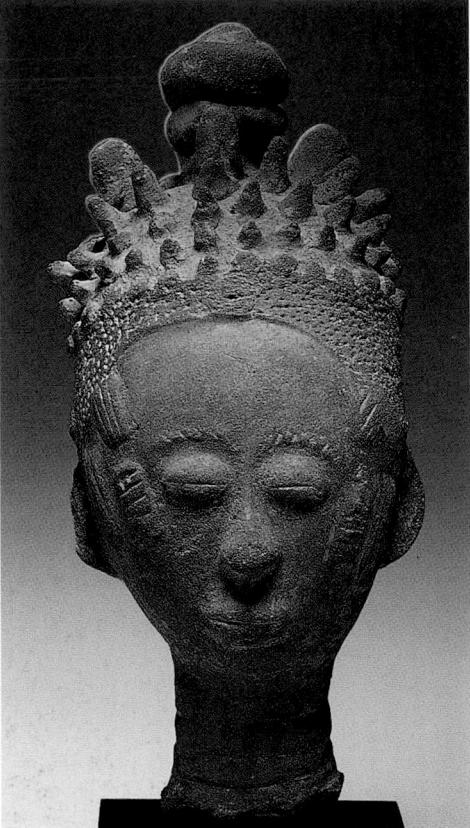

5.99b

Memorial head

Akan
Ghana
17th–19th century
grey terracotta
25 x 17 x 19 cm
Private Collection, Munich

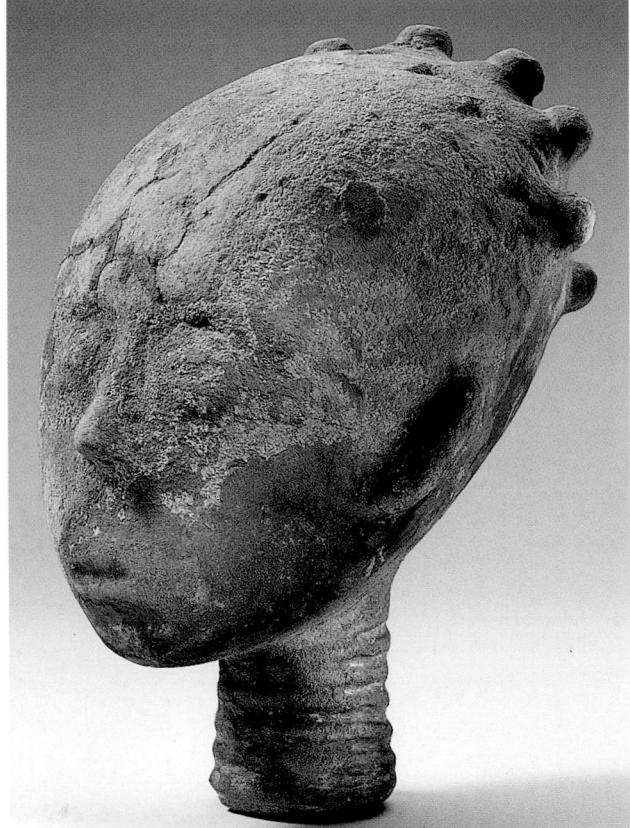

5.99c

Memorial head

Akan
Ghana
17th–19th century
red terracotta
27 x 16 x 11 cm
Private Collection, Munich

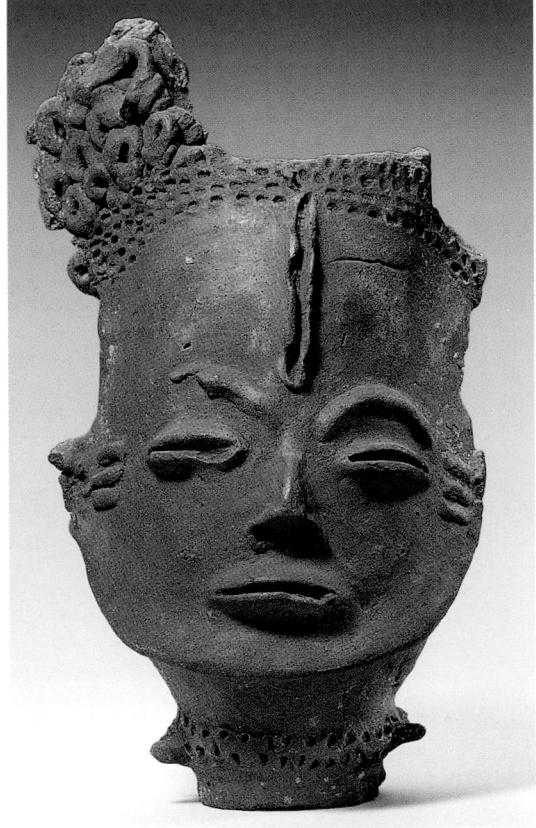

Although it is common for many of these terracottas to be labelled Asante, the vast majority are southern Akan, with the most northerly concentration of sculpture coming from Adanse Fomena. In scale the heads of the terracottas vary widely from small solid pieces two or three inches high to nearly life-size sculptures. Free-standing heads coexist with full figures, and styles range from abstract to highly naturalistic. While facial features may be simply modelled, considerable attention is paid to scarification patterns and to details of coiffure. Some terracottas are left unpainted while others have been painted with black or other colours. Years of exposure have removed much evidence of surface pigment.

Terracotta funerary sculpture has at least a 400-year history among the Akan in what is now southern Ghana. Pieter de Marees (1602) wrote of the burial of a chief: 'All his possessions,

such as his weapons and clothes, are buried with him, and all his nobles who used to serve him are modelled from life in earth, painted and put in a row all around the grave, side by side.' Thermoluminescent tests confirm that a number of such sculptures date from at least as early as this account, although most fall within a 17th- to 19th-century span. The tradition continued in a few areas until the 1970s.

Probably the most detailed description of an ensemble of Akan funerary figures comes from the 19th-century missionary Brodie Cruickshank: 'They also mould images from clay, and bake them. We have seen curious groups of these in some parts of the country. Upon the death of a great man, they make representations of him, sitting in state, with his wives and attendants seated around him. Beneath a large tree in Adjumacon, we once saw one of these groups, which had a very

natural appearance. The images were some jet black, some tawny-red, and others of all shades of colours between black and red, according to the complexion of the original, whom they were meant to represent. They were nearly as large as life, and the proportions between the men and women, and boys and girls, were well maintained. Even the soft and feminine expressions of the female countenance were clearly brought out. The cabocer and his principal men were represented smoking their long pipes, and some boys upon their knees were covering the fire in the bowls, to give them a proper light.'

Memorial terracottas were created by female artists to honour deceased chiefs and other important elders, both male and female. As is clear from the above quotation, surviving members of the chief's entourage or family members of the deceased were also represented. The ensemble of

sculptures was not typically positioned on the grave, but rather at a sacred grove close to the cemetery where rituals were performed with libations, and offerings of food and prayers. In addition, a rich variety of ceramic vessels was assembled at the site to receive the offerings. In certain locales, selected pots were ornamented with elaborate figural or other representational motifs. Some of the smaller terracotta heads in collections may have been broken off such pots.

It is clear that Akan terracottas did not function exclusively as ancestral memorials in static funerary contexts. Fired clay sculptures have also been documented as processional figures and in shrine and stool rooms. *DHR*

Bibliography: De Marees, 1602, p. 185; Cruickshank, 1853, ii, pp. 270–1; Field, 1948; Sieber, 1972, pp. 173–83; Cole and Ross, 1977; Coronel, 1979, pp. 28–35

5.99d

Memorial head

Akan
Ghana
17th–19th century
terracotta
53 x c. 19 x c. 18 cm
Private Collection

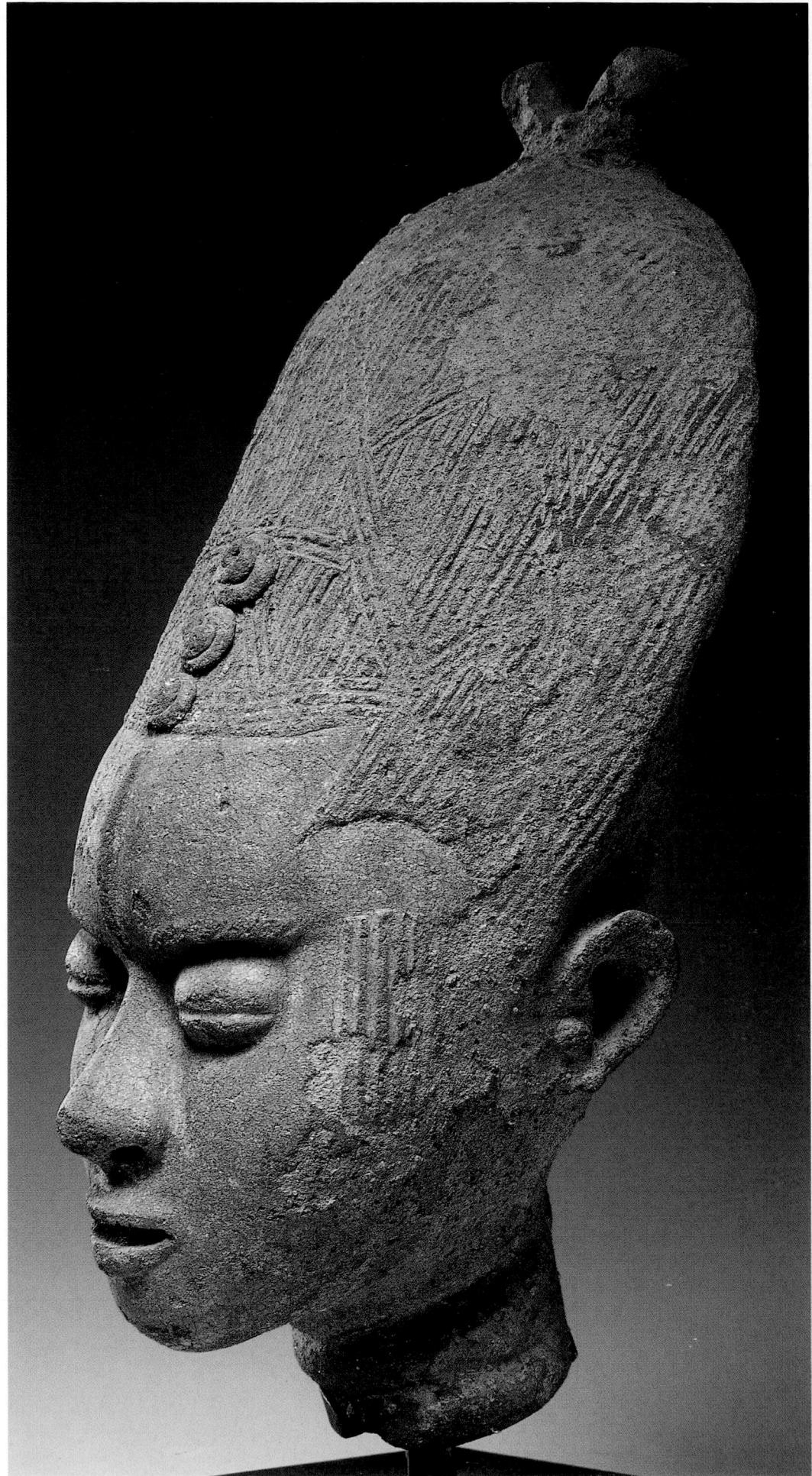

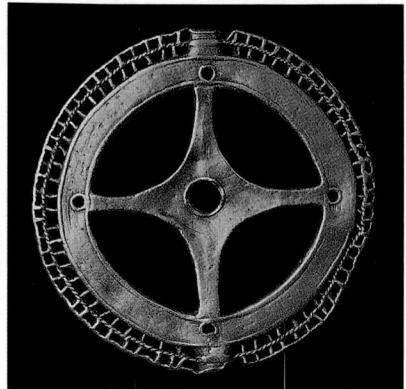

5.100

Pectoral disc

Akan (perhaps Asante)

Ghana

19th century

gold

diam. 8.5 cm

The Detroit Institute of Arts, 81.701

This jewel belongs to the varied class of disc-shaped gold ornaments which includes some of the most beautiful examples of Akan goldwork from Ghana. Usually such discs were worn as pectorals, suspended over the chest by a white cord. But usage varied, and sometimes they were attached to a cap, or used as the centrepiece of a necklace. In other instances they might be tied to the hair, or even worn around the ankle.

Such discs are usually referred to in the literature as 'soul-washer's badges' (*akrafokonmu*). Many served as pectorals worn to indicate the status of the chief's *okra*, a young official who 'washed' or purified the chief's soul. But in reality these discs were multi-purpose objects which could function in a wide variety of contexts. Some were worn as the insignia of a royal messenger; others as that of a herald, linguist, war-leader, sub-chief or even a junior official. Occasionally they might be displayed by the chief himself. In the past they were sometimes worn by girls at puberty ceremonies, and today, in Asante, they can indicate the principal mourner at a funeral (being then referred to as *awisiado* rather than *akrafokonmu*).

In this example the absence of surface ornament serves to fix attention dramatically on the central motif, four arms radiating from a focal point. This is probably the Akan symbol of a crossroads (*nkwantan*). It has proverbial significance, indicating the power and authority of the

chief: 'the chief is like a crossroads, all paths lead to him'.

Several factors combine to suggest that this pectoral disc dates from the 19th century. During the 20th century the size of such discs has tended to increase, while their standard of workmanship has declined. The present example is relatively small. It is also of exquisite workmanship. In particular, it retains traces of an old and curious technique (abandoned in the 20th century): in the original wax model, the flat parts of the design were not cut out from a sheet of wax but rather built up from thin wax threads, which were laid side by side and subsequently smoothed.

Another detail is significant. The four small circular holes in the design, as well as the central hole, have not simply been punched in the wax model. Each hole has been most carefully reinforced by an applied circlet of wax thread. This superlative attention to detail recurs in a number of other early castings. It is found, for instance, in a series of magnificent crocodile heads cast in silver, which were almost certainly produced in the royal workshops of Asante before the fall of Kumasi in 1874. This raises the possibility that the pectoral disc is not merely of 19th-century date, but indeed part of the extensive loot which the British obtained from Kumasi at that time. *TFG*

Bibliography: Garrard, 1989, pp. 66–9, 225

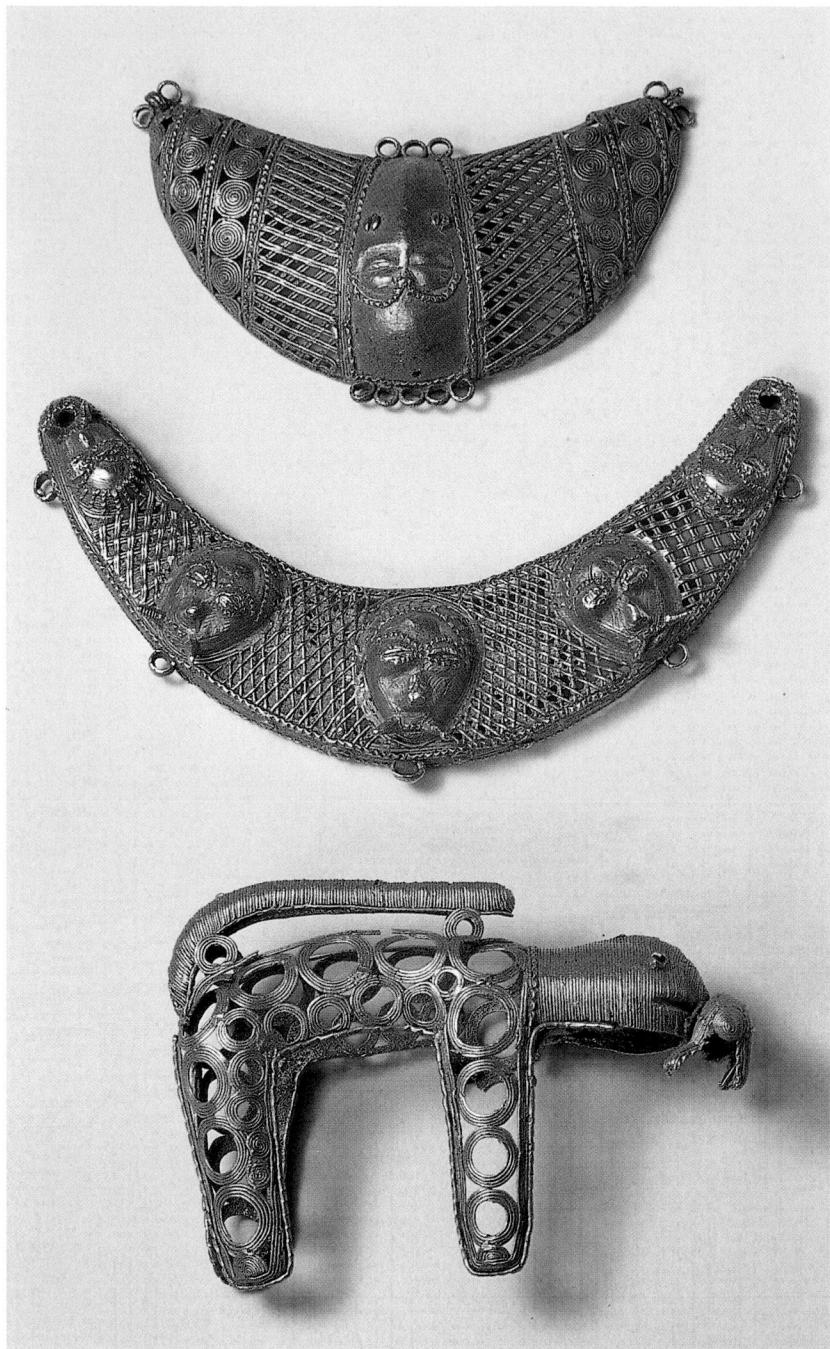

5.102a–c

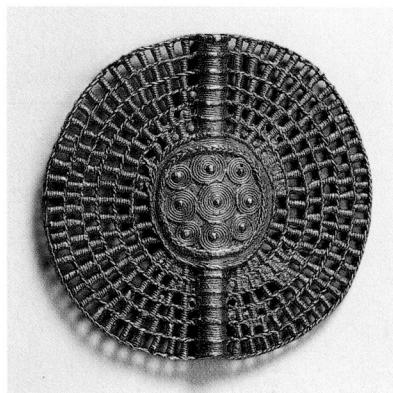

5.101a–b

Two pectoral discs

Akan

Ghana

gold

a: diam. 6 cm; b: diam. 10.8 cm

The Trustees of the British Museum,
London, 1818.11-14.6 and 1900.4-27.23

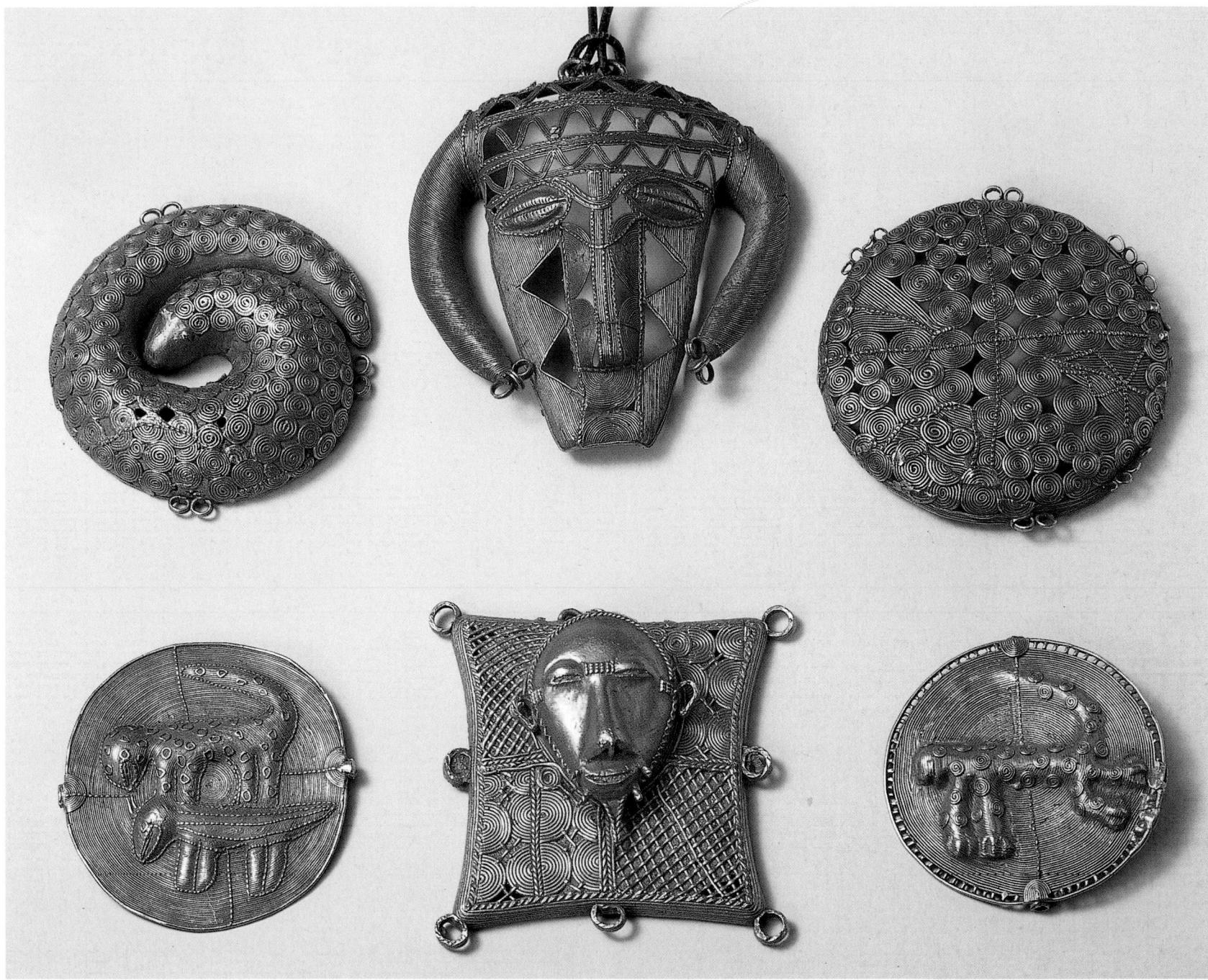

5.102d-i

5.102a-i

Gold ornaments

Lagoons region and Baule
Ivory Coast
19th–20th century
gold
h. c. 6–15 cm
Private Collection

For several centuries in southern Ivory Coast, gold ornaments such as these have been worn at public festivals. They were common to the Akan and Akan-related peoples of the Lagoons region and the Baule living further inland. Usually such jewels were attached to the hair, being provided with small loops for suspension through which threads were passed. Some could also be worn on a chain around the neck, for instance the crescent with five heads shown here (cat. 5.102b). Chiefs and dignitaries also attached such ornaments to the velvet of their crowns and caps, while disc-shaped ornaments were

sometimes used to embellish wooden stools.

The art of making this jewellery was introduced to the Ivory Coast centuries ago by Akan goldsmiths coming from Ghana (formerly known as the Gold Coast). Each ornament was initially modelled in fine wax threads over a charcoal core, and then invested in a clay mould and cast by the lost-wax process. This technique is still used today, though the modern products do not bear comparison with those made a few generations ago.

Human heads were a popular motif, as were crescent forms, snakes, tortoises, crabs, leopards, rams' heads,

and a great variety of other shapes. In the Lagoons region, wealthy persons used these gold ornaments to increase their status in the community, holding lavish ceremonies at which their accumulated treasure was publicly displayed. Even today, such ceremonies are reported from time to time, and as many as a hundred such ornaments may be exhibited, laid out on tables in the street. *TFG*

Bibliography: Garrard, 1989, pp. 100–8

i-vi

Akan goldweights

Akan weights, in their immense diversity, served for weighing gold-dust over a period of about five centuries, from 1400 to 1900. They were used by all the various Akan and Akan-related peoples of southern Ghana and the neighbouring regions of the Ivory Coast.

From about the late 14th century gold mined in the Akan forest began to be traded northwards. It passed first to the towns of the west African Sahel, and thence across the Sahara desert to north Africa. To meet the needs of this trade the Akan began to make weights equivalent to those of their Sahelian trading partners. These weights were of two series, one based on an Islamic ounce used in the trans-Saharan trade, and the other on the *mithqal* of gold-dust (about 4.5 grams, or one-sixth of an Islamic ounce).

When the Portuguese began trading along the west African coast from the 1470s, the Akan made further weights to the standard of the Portuguese ounce. After 1600, when the Dutch introduced the heavier troy ounce, this series too was assimilated by the Akan. Thus the Akan eventually had four series of weights for trade with all their external partners. Over the centuries these became merged into one long traditional table of about 60 different units of weight, their origins being forgotten. Up to 1900 goldweights were made to all of these units.

As if the great variety of cast brass weights was not enough, the Akan also used seeds, pottery discs, European nest-weights and many scraps of European metal as aids in the weighing process. There was also a complex array of other apparatus including scales, spoons, shovels, sieves, god-dust boxes, brushes, touchstones and small cloth packets. In the Akan world the weighing of gold was a complicated and time-consuming art. *TFG*

vii-xvi

5.105/i-xvi

Geometric goldweights

Akan
Ghana
15th–19th century
brass, some with copper plugs
h. c. 2–4 cm each
Private Collection, London

The first Akan goldweights were various geometric forms, which became increasingly diverse and elaborate over the centuries. They are by far the most common of Akan goldweights.

Of the weights exhibited here, nos i to viii are conventionally ascribed to the Early period (15th–17th century). No. viii, a truncated bicone, was a type common in the Roman and Arab worlds, and also in the Sahel region of west Africa, immediately south of the Sahara. The Akan initially traded their gold to this region, and the truncated bicone was probably one of the earliest, if not the earliest, type of weight that they adopted as the gold trade began.

Other early geometric forms made by the Akan characteristically have notched or indented edges and, very often, an incised or engraved surface decoration of fine lines, dots and punch-marks (nos ii to vi). Some are further embellished by inset copper plugs (no. vi). This technique of decorating cast brass was known in the Middle Niger region, for instance at ancient Djenne, and its reappearance among the Akan suggests that they may have had contact, at a very

early period, with goldsmiths from the Middle Niger region.

From about the 16th century onwards many early geometric weights had a raised surface decoration, often of bars and swastikas (no. iii). Some were more elaborate; no. i is a superb large weight from a chief's treasury, probably of the 17th century. It comes from coastal Ghana and bears the symbol of a European key, perhaps representing some such proverb as 'Death has the key to open the miser's chest'. It represents the Akan unit of five *pereguan* (about 352 grams).

Late period weights of the 18th and 19th centuries took innumerable forms. Some are variations on the motif of the ram's horn (no. iv), signifying force and courage. Even more remarkable are the three-dimensional 'puzzle-weights' (nos viii–ix, xiii–xiv, xvi), whose fantastic forms reflect the imaginative genius of the Akan goldsmith.

All these various geometric weights continued to be used up to about 1900, when goldmining in the region was brought under European control, and the gold-dust currency replaced by colonial coinage. *TFG*

Bibliography: Garrard, 1980, pp. 274–87

i-ii

iii-v

5.104/i-x

Goldweights representing human figures

Akan
Ghana
17th–19th century
brass
h. c. 2–4 cm each
Private Collection, London

By the 17th century, if not before, Akan goldsmiths extended the range of their weight forms to include representations of human figures, animals, plants and seeds, man-made artefacts, etc. Such weights were still intended for practical use, being made to the correct weight standards. But they had a wider significance. Primarily they represented Akan proverbs, serving as a mnemonic device to call to mind a particular proverb or saying. It is even said that

they were occasionally sent from one person to another as 'messages'. They also played an important role as objects for display and ostentation; many of the finest were made for chiefs' treasuries, but by the 19th century they seem to have come into general use among the population. The examples exhibited include the following:

No. i. Man tapping palm wine. Weights in this style may be 17th–18th century.

No. ii. Couple in sexual embrace. Although modern copies of this theme abound, genuine old examples are exceedingly rare, for the goldsmiths were reluctant to depict such a personal and private act. Probably 18th century.

No. iii. Two persons seated on a single chair, one with hand to mouth. This may represent the proverbial friends Amoaku and Adu, who met after many years' separation.

No. iv. Woman on stool, regarding her face in a mirror.

No. v. Man seated on stool, holding a parasol. Probably 17th century.

No. vi. Man playing *fontomfrom* drums. This would represent a proverb such as 'Firamon says he won't have anything to do with the drums: yet when they beat the talking drums they say "Condolences, Firamon".'

No. vii. Man playing an ivory side-blown trumpet.

No. viii. Man carrying palm-wine pots on his head. This weight was

cast by one of the most gifted 19th-century Kumasi goldsmiths; two other examples of his work are in the Museum of Mankind, London.

No. ix. Man on horseback carrying a spear. This may depict a warrior from the northern savanna. It is in the best style of the Asante region and dates from the 19th century.

No. x. Woman carrying a bowl on her head and a child on her back. This weight, in the Asante style of the 19th century, represents the proverb 'It is the hard-working woman who carries her child on her back and a load at

the same time' (Everyone admires an industrious worker who is prepared to take on another burden). TFG

Bibliography: Garrard, 1980, pp. 297–9; Garrard, 1982, pp. 60–2

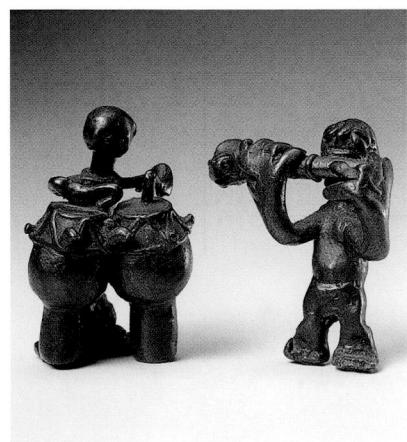

vi-vii

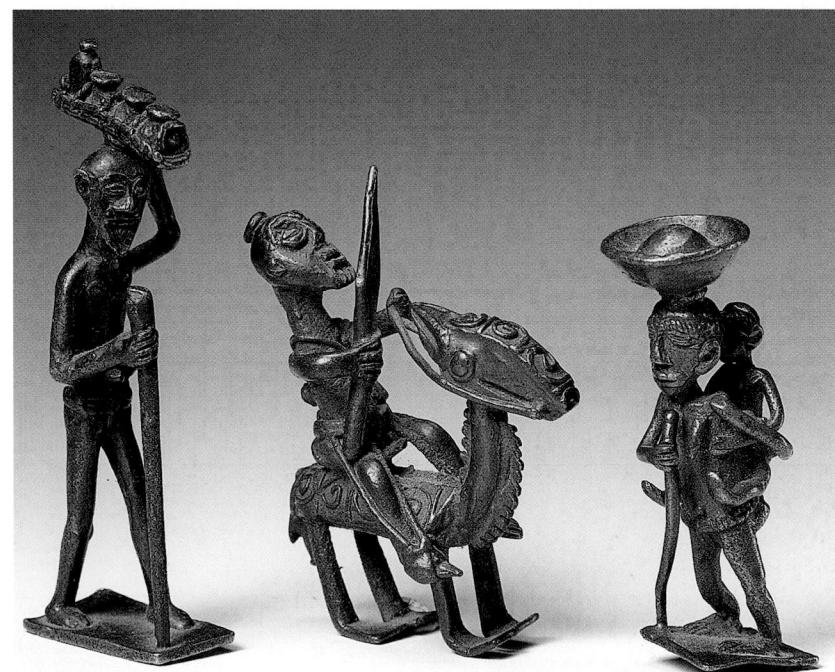

viii-x

5.105/i-xii

Goldweights representing animals

Akan

Ghana, Ivory Coast
17th–19th century

brass

h. c. 2–4 cm each

Private Collection, London

The fauna of the west African forest is generously represented among Akan proverb weights, with many kinds of birds, mammals, reptiles, fish and arthropods being depicted. There were often several proverbs that could apply to a given weight. The present examples include the following:

No. i. Crocodile. A well-known proverb has it that 'The old crocodile swallows a pebble when the year ends' (Misfortunes are inescapable and we must accept them as a part of life).

No. ii. Antelope head. This may be a Baule casting from the Ivory Coast.

No. iii. Crocodile. This example, from the coastal region of southern Ghana, was cast without a tail. It may date from the 17th century (Early period).

No. iv. Scorpion. Among several applicable proverbs is the following: 'If the scorpion bites a good mother's child, the pain lasts until the hearth grows cold' (If there is a troublesome person in the house, you will have no peace until he leaves).

No. v. Flat-bodied fish with long fins.

No. vi. Pangolin (?). This could represent the Asante proverb 'Don't sell me pangolin meat for I have no onions' (Don't bring me unnecessary trouble).

No. viii. Elephant. This animal was often used as a symbol for a chief or powerful man, in proverbs such as the following: 'If you follow an elephant you don't lose your way' (If you follow an important man you are protected).

No. x. Bird with a serpentine neck.

No. xi. Bird with a swastika design on its back. This casting is contemporaneous with the Early period geometric weights showing the swastika motif and dates probably from the 17th century.

No. xii. Leopard standing on another leopard. TFG

Bibliography: Garrard, 1980, pp. 292–6, 302–13

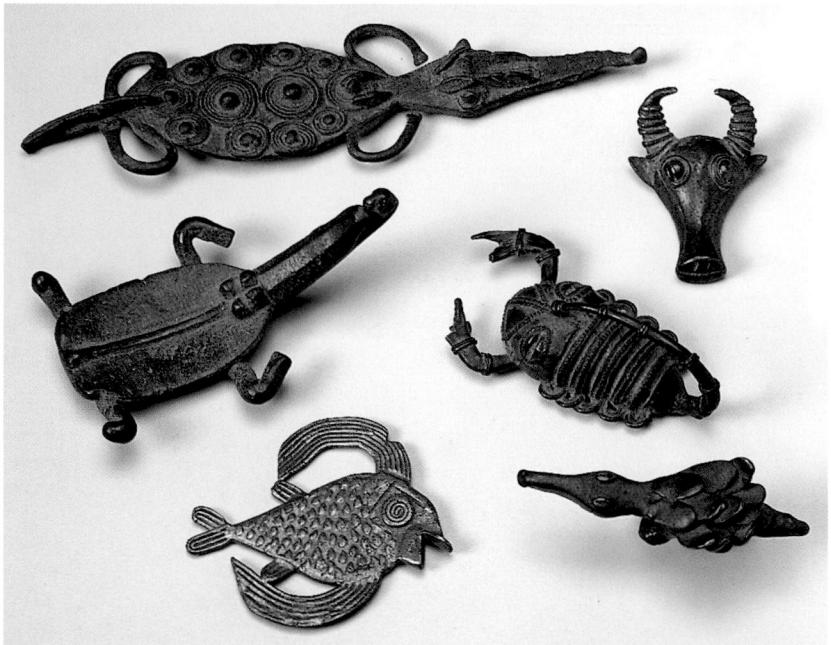

i-vi

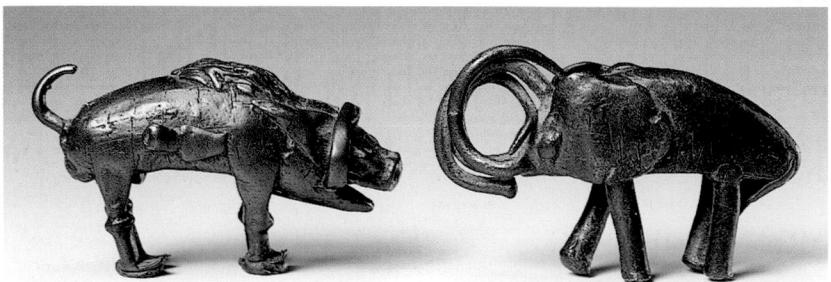

vii-viii

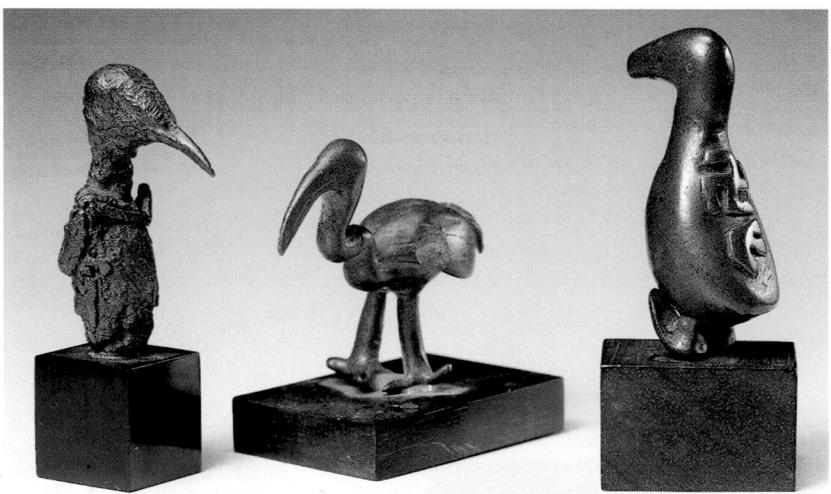

ix-xi

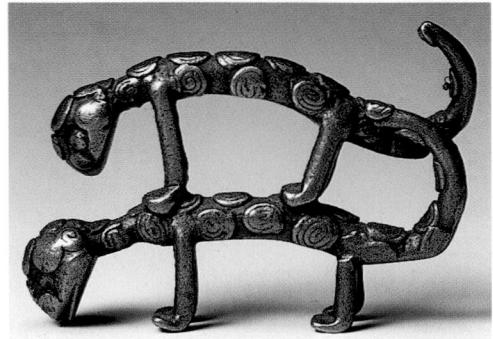

xii

**Goldweights representing
artefacts**

Akan
Ghana, Ivory Coast
17th–19th century
brass
h. c. 2–4 cm each
Private Collection, London

This group of weights provides unique evidence of the range of artefacts used by the Akan in past centuries. It includes domestic furniture, items of culinary equipment, weapons and tools (some based on European originals), implements for use in agriculture and hunting, and an extraordinary range of objects connected with the paraphernalia of chieftaincy. The following small selection is included in the exhibition:

No. i. Woodcutter's axe.

No. ii. European padlock. Often associated with magical practices and sorcery.

No. iii. Stylised triangular padlock.

No. iv. Elephant-tail whisk. These were symbols of high status, used only by chiefs and important fetish priests. An appropriate proverb would be the following: 'The elephant's tail is short, but it whisks off flies with it' (Make use of what you have).

No. v. Hide shield with attached iron bells. Such shields were formerly used in warfare. This splendid weight would represent the proverb 'Though the covering of a shield wears out, its framework still remains' (The family head may die but the family endures).

No. vi. Horse-tail fan. These were carried in procession by certain attendants of the chief, whose duty it was to drive away evil spirits from before him.

No. vii. Ladder. This commonly represented the proverb 'The ladder of death is not climbed by one man alone' (We are all mortal).

No. viii. Load of kola nuts on a carrying rack. Kola nuts, transported in this fashion, were an extremely important item of trade between the Akan forest region and the savanna to the north.

No. ix. Akan stool.

No. x. Akan stool.

No. xi. Carved wooden board for the game of *Oware*. Among several applicable proverbs is the following: 'A stranger does not play *oware*' (Do not interfere in other people's affairs).

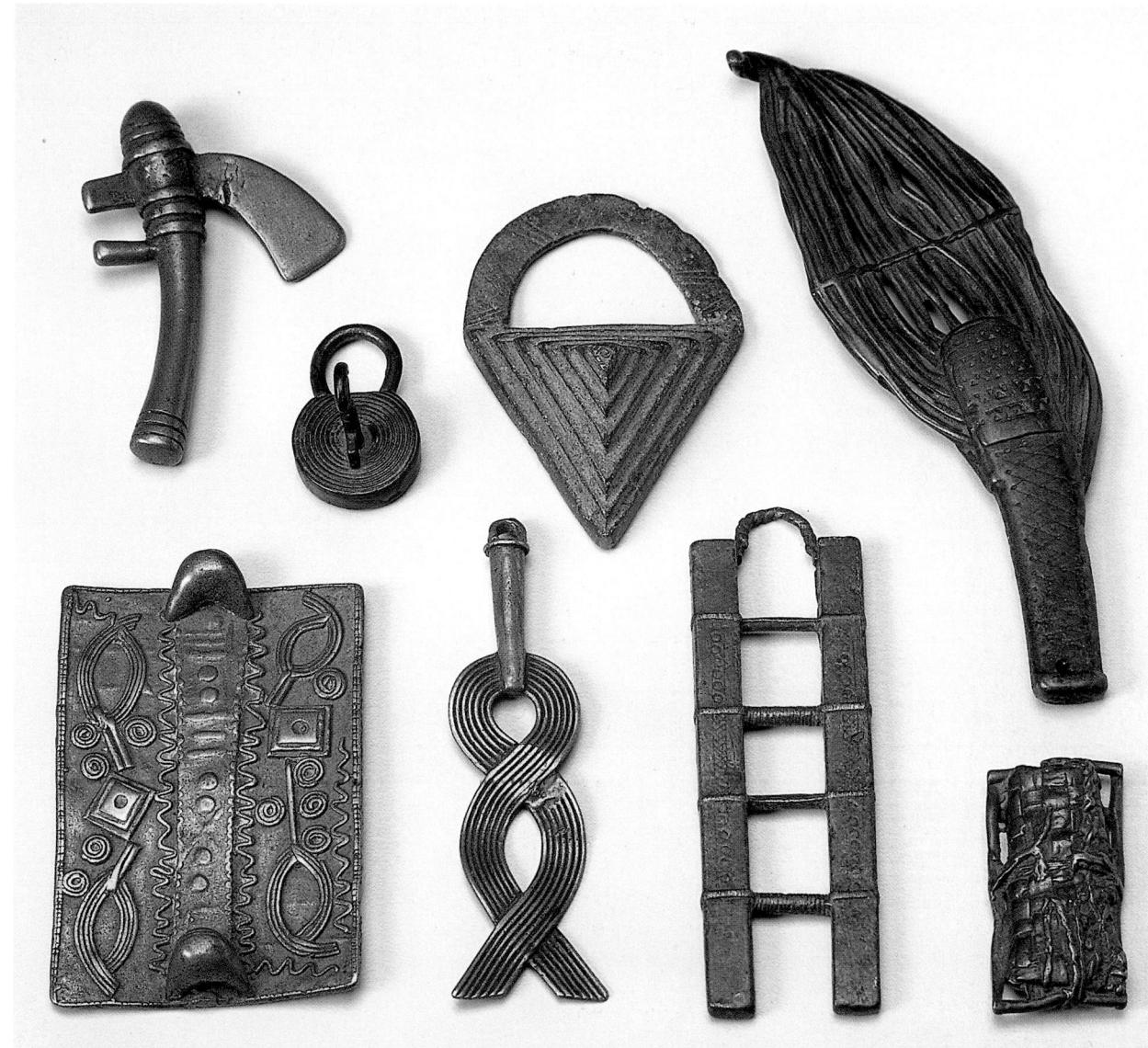

i–viii

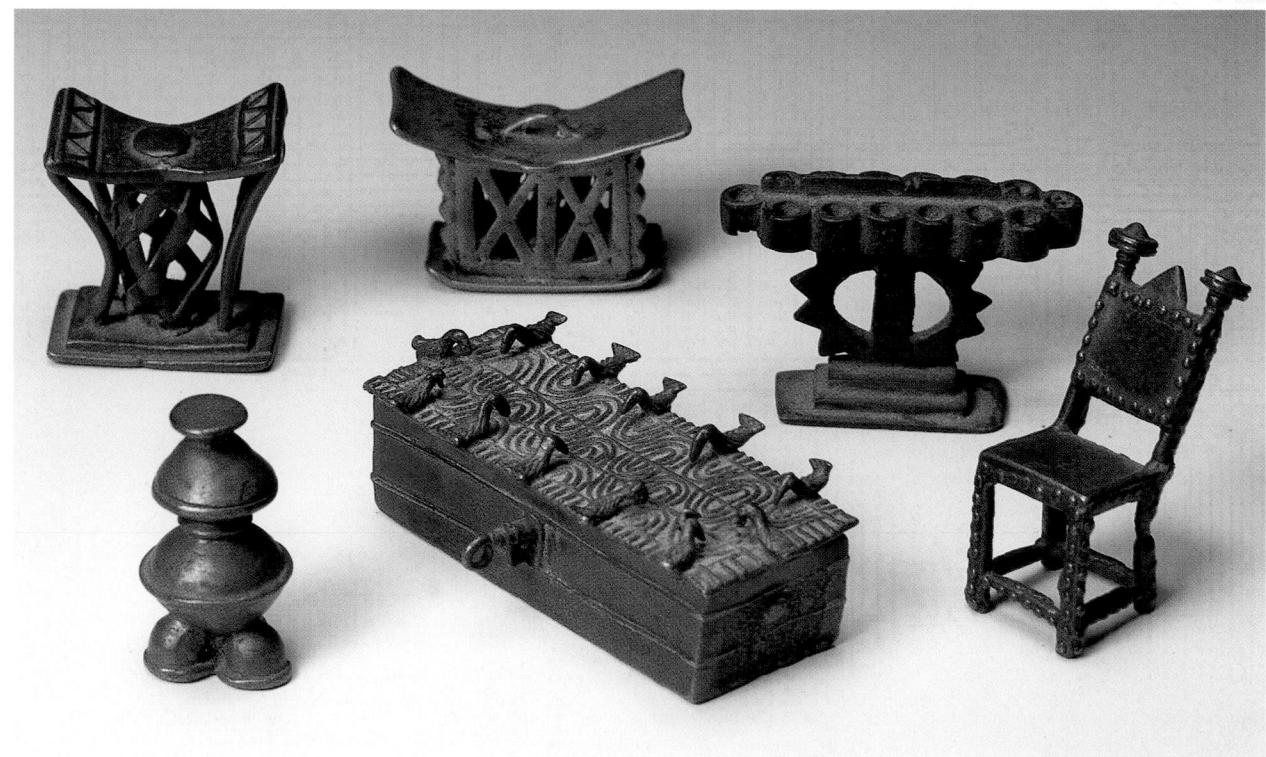

ix–xiv

No. xii. A cooking-pot superimposed on another pot, which rests on three hearthstones. An appropriate proverb might relate that the pot above cannot come to the boil until the one beneath has done so (stressing that we are all dependent on others).

No. xiii. Gold-dust chest or box (*adaka*), the lid decorated with twelve birds. Large wooden chests were found in a chief's treasury; small portable brass boxes were owned by many adults to hold gold-dust. In some cases the brass boxes were made to a specific weight standard, and could thus themselves be used as goldweights.

No. xiv. Upright chair (*asipim*). This kind of chair, highly prized by the Akan, was based on a 17th-century European original. *TFG*

Bibliography: Garrard, 1980, pp. 292–6, 302–15

5.107/i–xviii

Goldweights cast directly from nature

Akan

Ghana, Ivory Coast
17th–19th century
brass

h. c. 2–4 cm each
Private Collection, London

In the 16th century certain goldsmiths of Padua and Nuremberg developed a technique of casting directly from nature, by replacing the usual wax model with an actual animal such as a lizard or snake. The same technique has long been known in west Africa, where it was doubtless invented independently. The Akan goldsmith exploited this technique to the full, producing some very remarkable castings. These direct castings served as goldweights in the usual way, and were associated with traditional proverbs.

The following selection is shown:

No. i. Grasshopper.

No. ii. Small lizard with front legs tied to its tail. The significance of this gruesome weight is unclear, but the tied limbs suggest a prisoner.

No. iii. Two joined roots.

No. iv. Chrysalis.

No. v. Maize leaf tied into a knot. This represents the proverb 'If there

i–viii

ix–xvii

xviii

is trouble in a wise man's house, he ties it into a knot'.

No. vi. Water snail.

No. vii. Groundnut (peanut) pod.

No. viii. Winged seed.

No. ix. Chicken foot.

No. x. Pod of kola seeds.

No. xi. Cluster of seven immature plantain fruits. A well-known proverb for this weight was 'The plantain's descendants are without end' (said of a fruitful person).

No. xii. Bird's skull, including beak.

No. xiii. Crab claw.

No. xiv. Small, very sweet berry used in sauce.

No. xv. Group of three small water snails.

No. xvi. Okra fruit.

No. xvii. Beetle.

No. xviii. Corn cob. This old and massive casting of 469 grams may have been intended to represent a rare Akan weight unit equivalent to 16 Portuguese ounces (459 grams). *TFG*

Bibliography: Garrard, 1980, pp. 122, 290–1

5.108

Female figure

Bete

Ivory Coast
20th century
wood
h. 46.5 cm
Private Collection

Until recently sculpture by Bete carvers received little attention in the art world (no examples were published as being of Bete origin until 1964). A few dozen male and (mostly) female figures in the range of 80–100 cm in height were collected in the 1930s, but changes in Bete society after the 1920s diminished the production and use of objects associated with earlier religious rites.

This decline was partly due to the popularity of a syncretist cult that advocated destruction of such imagery and partly to the increasing commercialisation of agriculture. From the 1930s onwards the Bete focused on expanding coffee and cocoa plantations and developed large urban trading centres at Gagnoa in the eastern region and Daloa in the west.

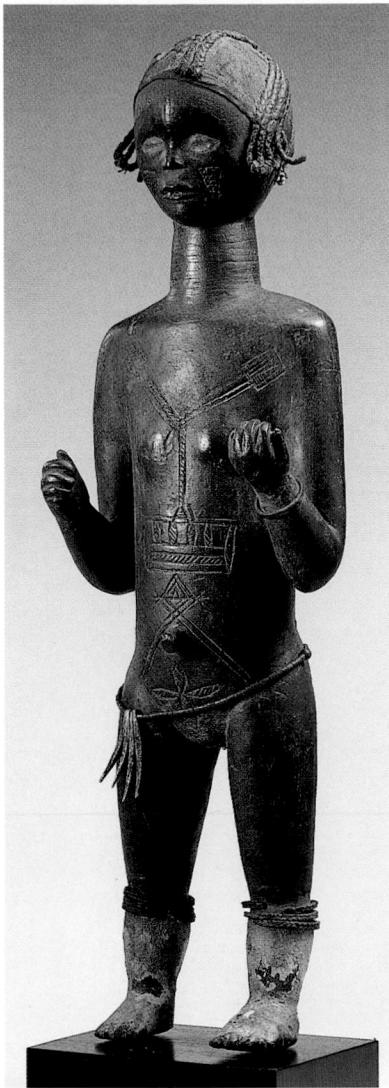

5.109

Female torso

Attie
Ivory Coast
ivory
h. 14.5 cm
Private Collection

This elegant female torso in well-patinated ivory is pierced at the bottom and hollow, and was probably carved as a staff-finial or flywhisk handle for a chief.

The hair is pulled up into a tight topknot. The head is bulbous and inclined at an angle. Arms and breasts are reduced to vestigial bumps resulting in a simple tubular form with flowing lines that would fit easily in the hand. Face, neck and sides of the chest show raised scarification. The pattern round the abdomen may be a beaded belt that preserves modesty.

This piece is attributed to the Attie (Ankye), one of the so-called Lagoon peoples of Ivory Coast, who use similar incised decorative patterns. It is rather different from the elaborately detailed style of the better known male figures in Western dress from this area but may have served a similar function as an object of adornment and exchange. NB

Bibliography: Visona, 1983

5.110

Female statuette (*nkpasopi*)

Lagoons region
Ivory Coast
20th century
wood, metal, glass
h. 24.5 cm
Musée Barbier-Mueller, Geneva, 1007.12

This finely sculpted statuette with its rigid pose, bulbous limbs and cupped hands is in a style typical of the lagoons region of the south-eastern Ivory Coast. As is commonly the case in this region, it has been beautified by the addition of glass waist-beads and a necklace of small disc-shaped metal beads of Baule origin. The figurine could have served in a variety of contexts. It may have been owned by a diviner, for use in conveying messages to the spirit world, or it may have been prescribed by the diviner for a client. Alternatively, it could have been intended to represent (and house) a man's 'spirit lover' from the other world, or it may have been displayed at certain traditional dances. Statuettes of similar form were put to all of these varied uses.

It is not practicable to attribute this carving to a particular ethnic group. The lagoons region, though relatively small, contains a mosaic of peoples speaking some fifteen languages, many of them established there since remote antiquity. Living in close proximity to each other, they have long used, copied and been influenced by each other's art forms, and also those of their northern neighbours, the Baule and Anyi. Statuettes of this form have been attributed to the Ebrie (Kyaman) and the Atie (Akye), but they were also known to the Gwa and Abe. Until such time as the ethnic identity of their carvers has been established, it is preferable not to assign a precise label to such works. TFG

Provenance: before 1939, Collection Josef Mueller

Bibliography: Visona, in Schmalenbach, 1988, p. 133; Visona, in Barbier, 1993, i, p. 371, ii, p. 170

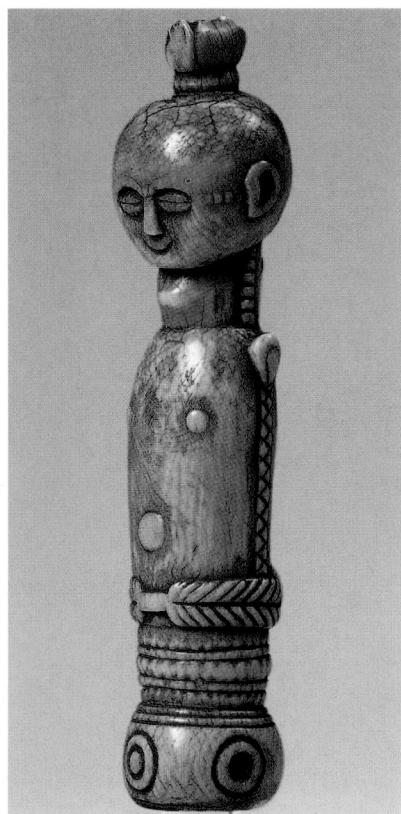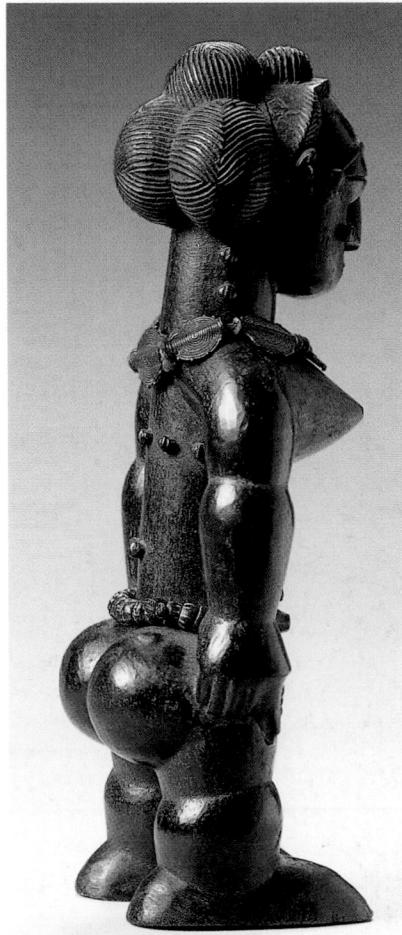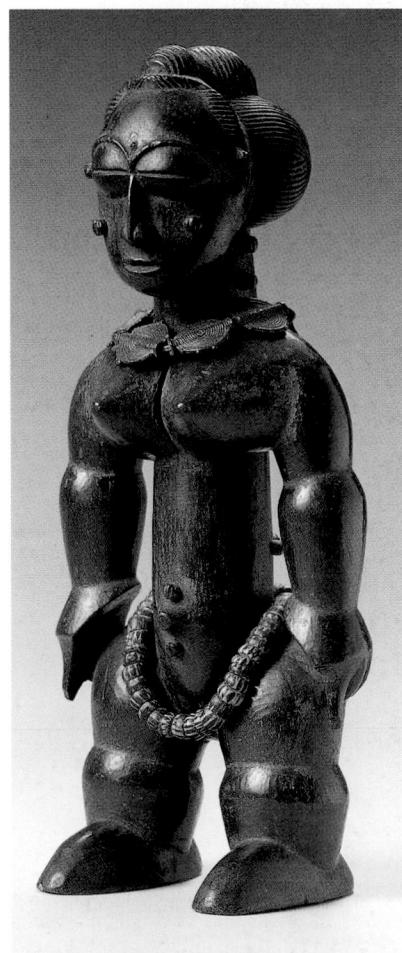

This division marks a difference in their early style of masks and figures: the eastern carvings show some similarity to the styles of their Guro neighbours, while the few known western sculptures bear a degree of resemblance to those of the Wè (Guéré) to the west. Bete figures exhibit a variety of simple hand positions, which are difficult to interpret, as well as touches of white pigment, as in the figure shown here.

From foreigners' brief comments on the figural sculptures collected in villages, it seems that a tall pair of male and female figures were preserved in a shelter to represent the founders of the site and community. This practice of honouring the ancestral founders who first cleared the forest or bush is known also in a number of other west African agricultural communities. MA

Bibliography: Herold, 1985, pp. 124–6; Fischer, 1989, pp. 46–7

5.111

Seated female figure

Akye
Ivory Coast
early 20th century
wood
h. 64 cm
Musée National de la Côte d'Ivoire,
Abidjan, 42.3.517(A11)

The unique style of this sculpture identifies it as a work from the region inhabited by the Akye (Atie), a lagoon people. It represents a woman, her hair dressed into four cones, seated on a stool of Akan form. The sculpture is in blackened wood, and the arms have been carved separately and then attached.

Figures of this kind are said to represent a spirit or ancestor, and to have been used in a cult called *logbu*. Little is known about them, however, for they went out of use quite rapidly between about 1910 and 1930. In 1914 the renowned Liberian prophet William Harris arrived in the Ivory Coast, and by the fervour of his preaching induced whole populations – particularly in the lagoons region – to abandon their statues and traditional religious cults. In consequence great quantities of sculptures from the lagoons were destroyed, and relatively few examples survive in museums and private collections.

The present statue is one of several examples now in the Abidjan museum, which came from the collections formed by Bédiat and Modeste in the 1930s and '40s. TFG

Exhibitions: Vevey 1969; Paris 1989

Bibliography: Vevey 1969, pp. 206–7;
Paris 1989, pp. 52–5

5.112

Female figure with anklets

Bondoukou region
Ivory Coast
late 19th–early 20th century
wood
h. 46 cm
National Museum of African Art,
Smithsonian Institution,
Washington, 85.8.5

This very beautiful figure is carved in a series of voluptuous interrelated curves. The hair is neatly dressed in a helmet shape with a crest running from front to back; there are raised scarifications at the sides and front of the body; and further scarification is shown beside each eye in the form of three vertical strokes. The tiny arms are held beneath the breasts, while the hands and feet are rudimentary. The figure wears a pair of large elliptical anklets or foot-rings. In 1968 William Fagg published another female statue unquestionably in the same style, but by a different hand. Though outside the norms of Baule and Anyi statuary, this figure has features reminiscent of it, notably the treatment of the face and abdomen. Fagg concluded that it could plausibly be attributed to the Anyi, and certainly to one of the smaller Akan groups of whom they are the most important. He added in a footnote that two larger figures in the same style had just entered the collection; they were said to have been collected at Wenchi, a northern Akan town in the Brong region of Ghana.

A number of rare and remarkable sculpture styles existed in the region surrounding the Ivory Coast–Ghana border. These statues, with their hints of Anyi or Baule influence, are probably to be attributed to the Bondoukou region, which has long been an artistic melting-pot. Within a radius of 60 km from Bondoukou are found a variety of ethnic groups living in close proximity, some of Akan origin (Abron, Anyi, Domaa) and some of Senufo and Voltaic origin (Nafana, Fantera, Kulango). The present statue could have been made by, or for, any one of these groups. It should be noted too that Wenchi, where the two largest statues in this style are said to have been collected, lies only 75 km to the east along the main road from Bondoukou. TFG

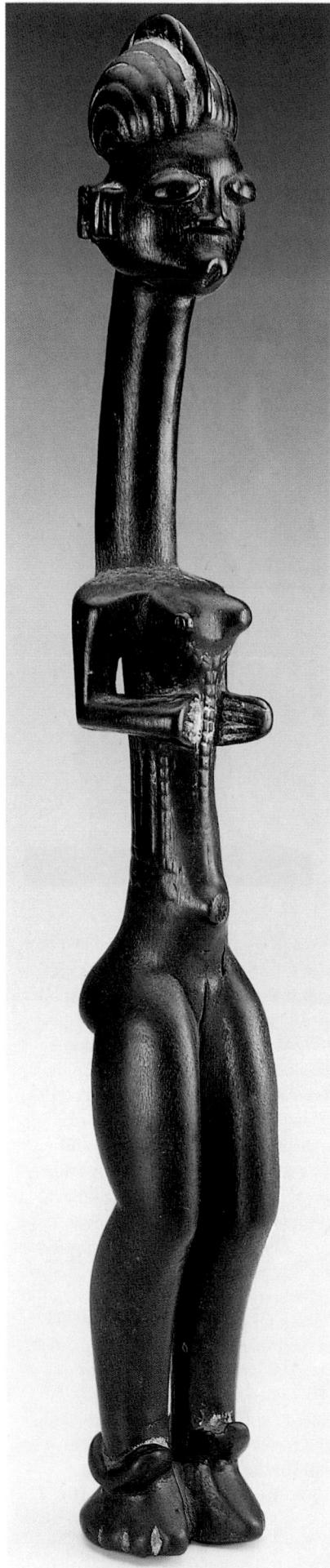

Bibliography: Fagg, 1968, fig. 91

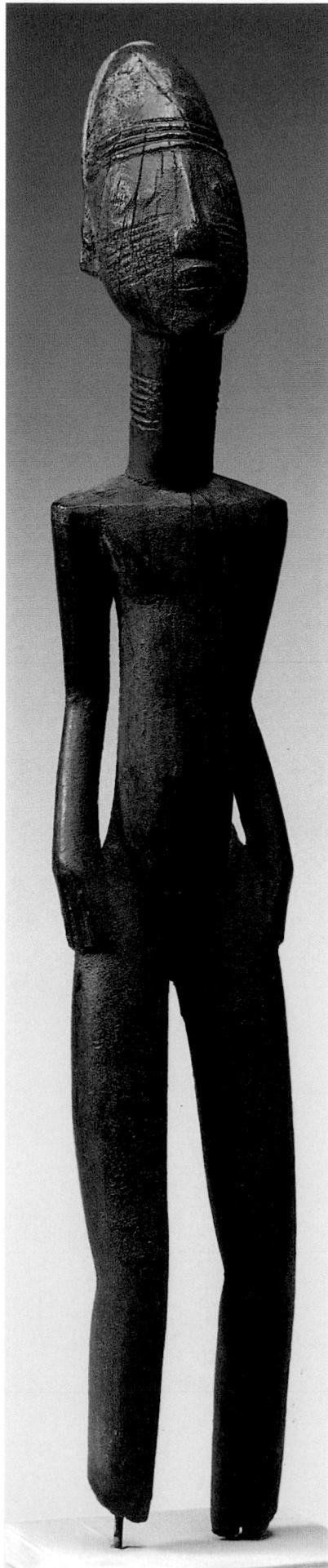

5.113

Male figure

Gurunsi or Dagara (?)
Burkina Faso
19th–20th century
wood
65 x 10.8 x 7 cm
Musée National des Arts d'Afrique et d'Océanie, Paris, MNAN 79.2.2

This male statue of rare elegance has a long tapering form, with a deliberate exaggeration in the length of the head, neck and thighs. Its cheeks and neck carry panels of about seven incised horizontal scarifications. The shoulders are square and slight, the arms held loosely to the sides, and the fingers are summarily indicated on the spade-shaped hands.

No close parallels seem to be known for this sculpture. Its attribution to the Kulango need not be taken seriously. The lower two-thirds of the statue (i.e. minus the head and neck) are found to be 'almost Lobi'. Among the myriad substyles of Lobi statuary parallels can be found for the squared shoulders, slight arms, abdomen, buttocks and elongated legs of this statue. It is the tall, forward-slanting neck and the equally tall, backward-slanting head which diverge most markedly from Lobi style.

One is tempted to conclude that if this is not a work by a brilliantly idiosyncratic Lobi sculptor, it must come from one of the peoples in close proximity. Those peoples include the Dagara/Dagari/Dagaaba, who live to the north-east but in part share the same territory as the Lobi. Even further north-east are the various ethnic groups who fall under the umbrella-term 'Gurunsi': the Pwa (Pugula), Sisaala, Kasena, Nuna, Nunuma, Ko and others. A Nuna shrine-figure strangely reminiscent of the present statue, though not in the same style, is in the Musée Barbier-Mueller. This enigmatic statue doubtless belongs to the rich but largely unexplored tradition of shrine sculpture in southern Burkina Faso.
TFG

Exhibition: Paris 1989 (attributed to the Kulango)

Bibliography: Roy, 1987, pp. 252–3; Roy, in Schmalenbach, 1988, p. 76; Féau, in Paris 1989, p. 94

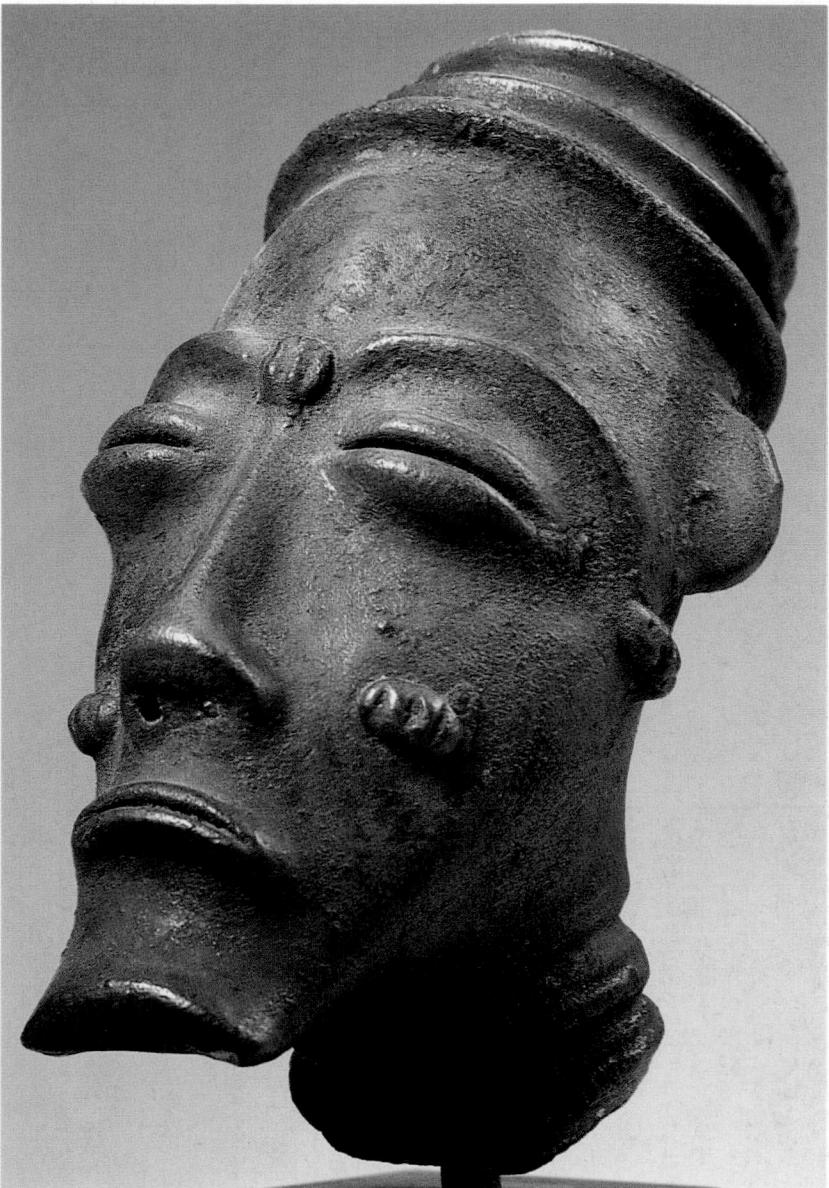

5.114

Funerary head

Sanwi
Ivory Coast
19th–early 20th century
fired clay
h. 18 cm
Private Collection

This terracotta head depicts a woman of high status with her hair elaborately dressed in three superimposed rings. It may originally have been attached to a short rudimentary body. Its style identifies it as coming from the region of Krinjabo, the capital of the Sanwi people (an Akan subgroup), in the south-eastern Ivory Coast. Statuettes in the Krinjabo style often retain their original smooth surface finish, and some show traces of painting. They were collected by French officials at least as early as

1904, and may have been made shortly before that time.

Such heads and figurines were widely used in cults of the dead by various Akan peoples of the south-eastern Ivory Coast and southern Ghana. They were regarded as an actual 'portrait' of the defunct personage. The Sanwi and some Ghanaian groups give these statuettes the collective name *mma*, meaning children or little people.

The Akan have made funerary sculptures in terracotta for at least four centuries. Originally this was done to honour a deceased king or queen mother, who would be depicted surrounded by elders and officials. By the 19th century the custom had become more general, and such figurines were made for any notable man or woman whether or not of

royal blood. The whole assemblage of statuettes, representing the deceased with attendants (who sometimes numbered dozens), would be set out, not in the cemetery itself but in a secluded part of the forest nearby. The shrine so constituted was known as a *mmaso*. Here at certain times reverence was paid to the deceased, offering of food and drink being made to his or her spirit accompanied by prayers. TFG

Bibliography: Duchemin, 1946, pp. 13–14; Amon d'Aby, 1960, pp. 67, 70–2; Garrard, 1984, pp. 167–90; Féau, in Paris 1989, pp. 55–9

5.115

Female figure (*blolo bla* or *asie usu*)

Baule
Ivory Coast
20th century
wood
h. 50 cm
Private Collection, New York

The Baule of central Ivory Coast are justly famous for their visual art traditions, especially figurative sculpture and masks. Baule figures have mistakenly been referred to as 'ancestor figures', but in fact they represent two types of spirit: spirit mates in the other world or bush spirits who inhabit nature beyond the edge of human settlements. Both types of figure are similar in form, and each type is referred to by the Baule as a 'person in wood' (*waka sran*). Unless collected *in situ*, the actual function of a figure cannot readily be determined.

The Baule believe that each person has a mate of the opposite sex who lives in the 'other world' (*blolo*); a man has an 'other-world woman' (*blolo bla*) and a woman has an 'other-world man' (*blolo bian*). The existence of this other-world partner is usually revealed through divination following a crisis of young adult life, such as inability to conceive or a problem related to marriage. To resolve the problem, one commissions the carving of a figure as a stand-in for the other-world mate and one typically spends one night a week alone to receive this person in dream visits; on the following day offerings are placed in a small bowl at the feet of the figure.

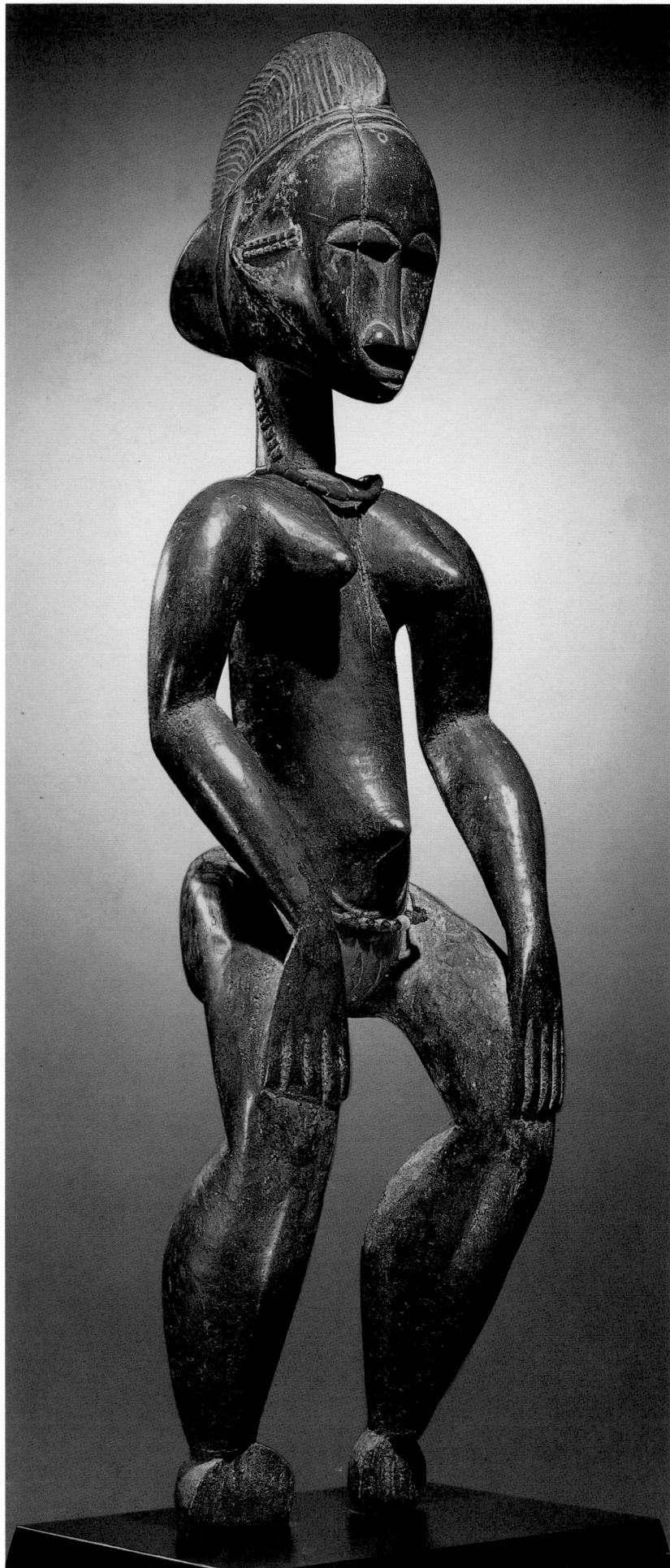

Figures are also carved as intermediaries to bush spirits who may intervene in a person's life to cause madness or to confer clairvoyance, thus enabling one to divine through trance dances. When they function to localise a troublesome spirit, these figures may receive libations and develop an encrusted surface. The figures used by diviners, however, are usually handled with care and often a figure is displayed near the diviner during a public performance.

This unusually strong female figure presents many characteristics of Baule figurative aesthetics: the head has a finely depicted coiffure and a composed face with downcast eyes, set off from the body by a strong neck; and the torso, with high, small breasts and gently swelling abdomen, is set off from the lower body by the aesthetically important, curving iliac crest of the pelvis that is further emphasised by the added hip beads. It is the artist's treatment of the limbs, however, that captures our attention: frontally, the emphatically long arms, which lead to the hands in a position of rest just above the knees, frame the torso and create a strong vertical axis to the figure; in profile, the long arms and legs reveal, in their flexed tension, not only a sense of composure but a sense of movement and power – an identity and character that makes communication possible. PR

Bibliography: Vogel, 1977; Ravenhill, 1980; Vogel, 1980; Ravenhill, 1994

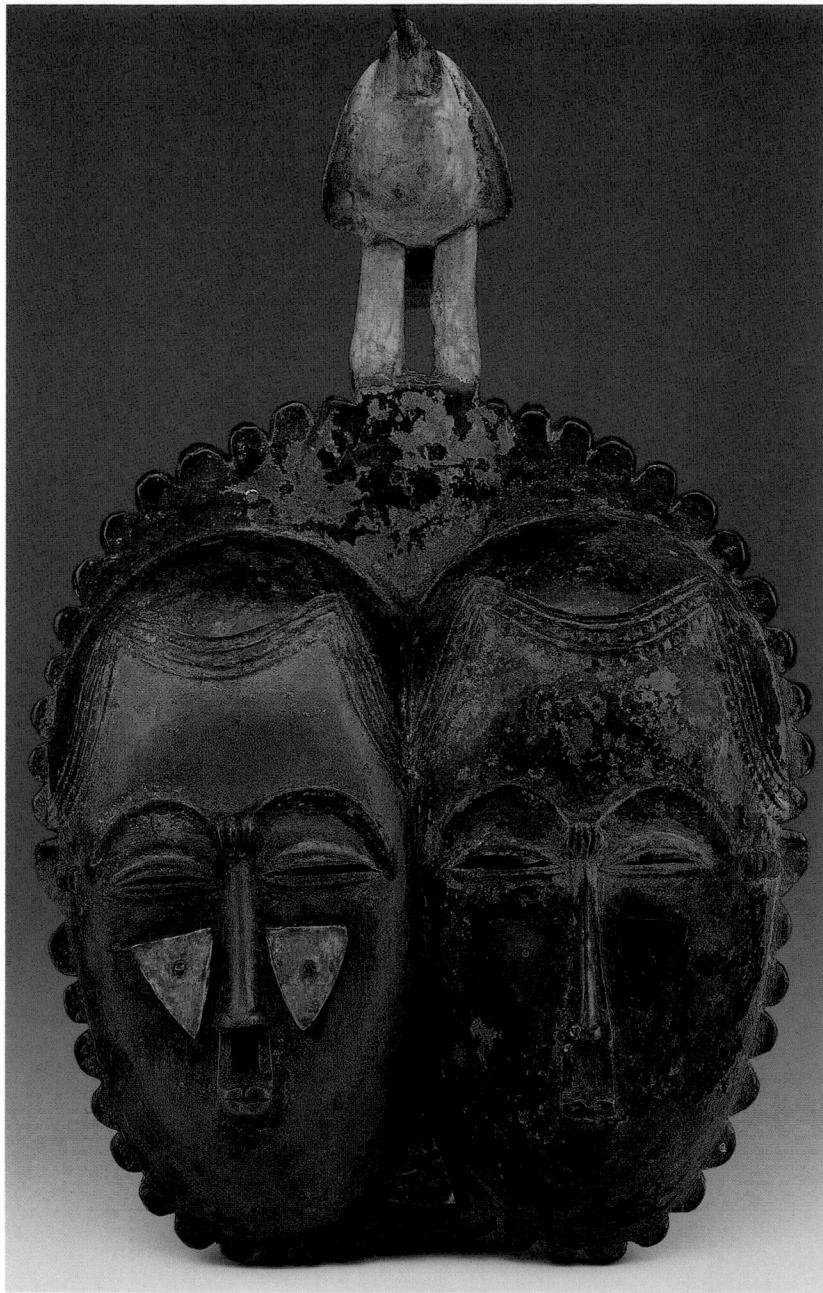

5.116

Double face mask

Yaure, Baule or Guro

Ivory Coast

19th century

wood, metal

27.5 x 10.2 x 11 cm

Trustees of the National Museums of Scotland, Edinburgh, 1907.272

Unlike the large helmet masks of often ferocious form, which are not supposed to be seen by Baule women, the small anthropomorphic or zoomorphic face masks that the Baule call *ngblo* can loosely be considered entertainment masks. They are worn by male dancers who perform in public theatres or who dance for funerals. The masks appear in suites, with ani-

mal forms, both domestic (e.g. sheep or goats) and wild (elephant), preceding human face masks. These masks represent social roles or may be inspired by the beauty of real people and hence be like portraits. Human face masks, as in this example, are often surmounted by a zoomorphic decorative element that demonstrates the artist's creativity and skill.

In central Ivory Coast there is considerable stylistic overlap between Baule, Yaure and Guro face masks, and it is difficult to ascertain actual attributions and distributions. The three separate ethnic 'styles' are principally a convenience covering attributions that codify supposed characteristics, such as the rick-rack

beard of masks attributed to the Yaure, into systematic distinctions that may be more imagined than real. What the supposedly different styles have in common is an emphasis on smooth, 'classic' beauty of the face as framed by a (usually) elaborate and textured coiffure; and an exploration of artistic creativity in the super-structural element(s). PR

Bibliography: Vogel, 1977; Ravenhill, 1980; Vogel, 1980; Ravenhill, 1994

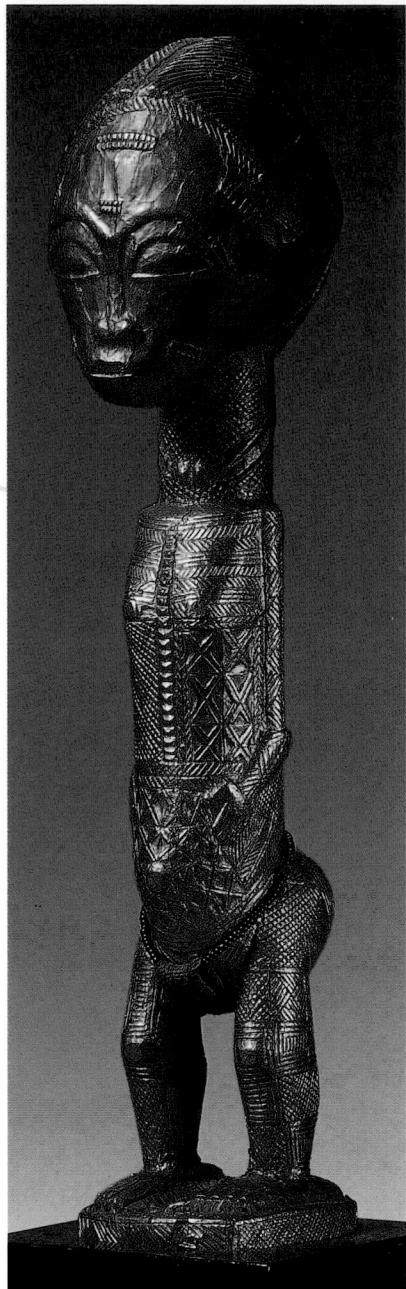

5.117

Gilded male figure

Baule

Ivory Coast

20th century

wood, gold foil

h. 26 cm

Private Collection, Paris

Wood sculptures covered in gold, called *sika blawa*, are made and used by the Baule as prestige items for public display. Most often the surface of the sculpture is carved with cross-hatching, striations and geometric patterns in order to create a faceted surface that, when covered with gold foil, gives rise to an interesting play of light. Figures, flywhisks and staffs are used as regalia to call attention to the

power of chiefs or the social standing of a family when used in public display on ceremonial occasions.

The gold-covered figure, apart from its surface decoration, clearly follows Baule conventions of an artistic idealisation of the human form. The importance of facial aesthetics in appreciating personal beauty leads to an emphasis on the head, making it out of scale to the proportions found in nature. The composure of the body conveys a sense of being that is also found in the artist's interpretations of the gaze, the gaze of a sentient being, a 'person in wood' or *waka sran*. PR

Bibliography: Vogel, 1977; Vogel, 1980; Ravenhill, 1994

5.118

Door

Baule
Ivory Coast
19th–20th century
wood
h. 146 cm
Musée Barbier-Mueller, Geneva, 1007.3

Many of the most famous forms of Baule art, such as masks and figures, were not highly visible in their original context. Figures were often placed in private shrines in private homes, and masks appeared on relatively rare occasions, and then only briefly. In traditional Baule society, however, there were a number of art forms that were intended to enjoy high visibility, with the weaver's heddle pulley being the publicly displayed work of art *par excellence*. Doors carved with low-relief figurative or abstract decoration were another form of public art, although today they are no longer made.

After the crocodile or the monitor lizard, the most common animal depicted on Baule doors is the fish, though the portrayal of two large fish on this door is unusual. Representations of fish on Baule doors tend to be orientated vertically and most commonly a single large fish is carved with its head to the top and with a small prey in its mouth. The artist who carved this door created a dynamic composition of two plump fish that seem to evoke complementarity and similar movement. The different angles of placement combine with a relatively high relief for the fish and a low-relief planar background framed by semicircles, producing a three-dimensional work that *in situ* would have been further emphasised by the frame of a doorway and the play of raking sunlight. PR

Provenance: before 1939, acquired for Josef Mueller Collection

Bibliography: Holas, 1953; Vogel, 1993, p. 16

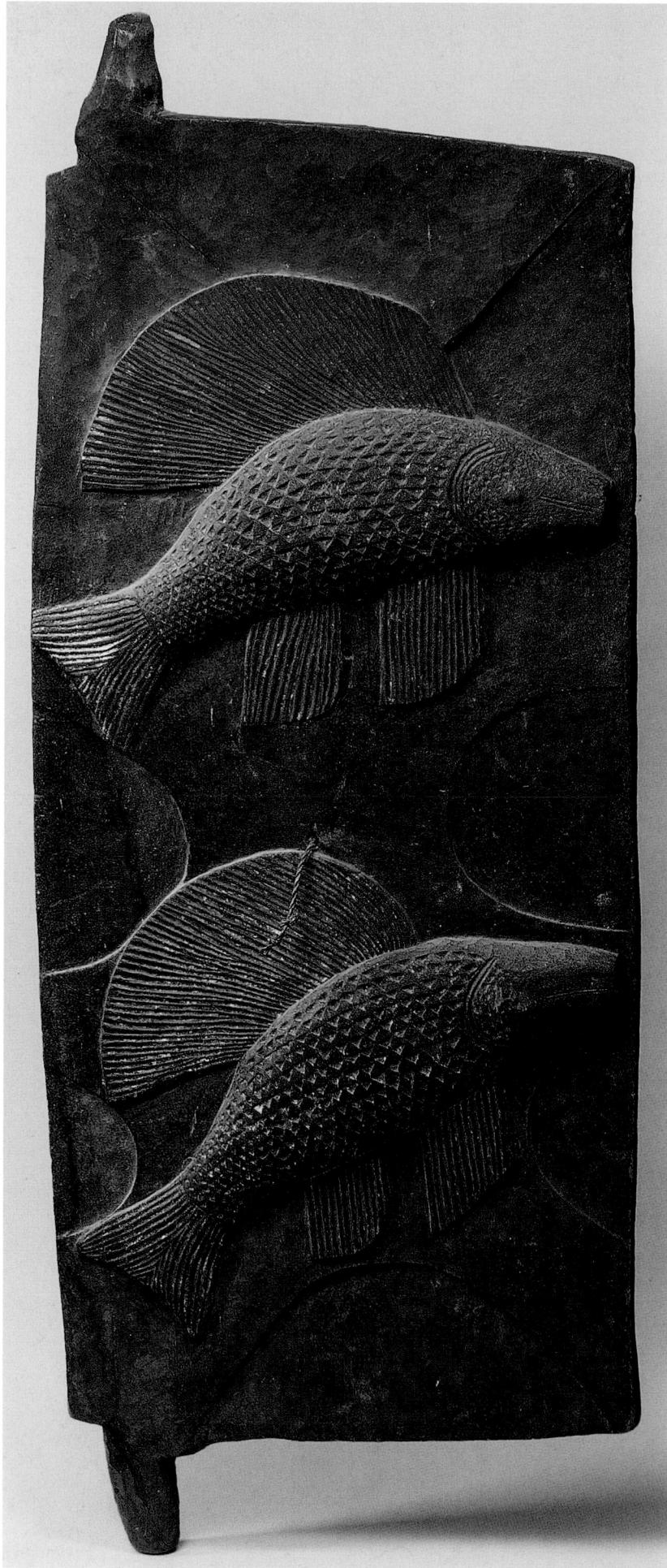

5.119

Mask (*sakrobundi*)

Nafana
Bondoukou District, Ivory Coast
19th century
wood, pigments
h. 146 cm
The Trustees of the British Museum, London, 1934.2

This impressively sculpted and painted face mask is one of the treasures of African art in the British Museum. Collected at the very end of the 19th century by Captain Sir Cecil Armitage, it was acquired at a critical juncture in British and French relations on the west African coast. Both powers were seeking to extend their spheres of influence inland, and competition between the two was intense. Each dispatched numerous official missions to the interior between 1879 and 1889 in the hope of establishing diplomatic and commercial ties with Ardjoumani, the powerful Abron ruler of Jaman. Of particular interest to both was Bondoukou (Bontuku), the principal town of the kingdom and an ancient Mande commercial emporium, for they were not only aware of its economic stature, but also recognised its strategic position as the gateway to the north and to Islamic territories that were believed to stretch to the Mediterranean. After nearly ten years Ardjoumani accepted the French flag, signed a treaty and opened the trade routes between his kingdom and the French post at Krinjabo on the coast.

It is from this period that the earliest accounts of *sakrobundi* emerge. R.A. Freeman, a medical officer and member of the British Mission from Cape Coast to Bondoukou in 1888–9, encountered *sakrobundi* in two communities in the Gold Coast interior: at the Bron town of Odumase and in the Nafana village of Duadaso, only ten miles east of the French frontier at Bondoukou. He recorded his impressions and sketched for posterity 'the Great Inland Fetish', a masked presence concealed in a full-length raffia costume. Thirteen years later Delafosse documented the paramount shrine of *sakrobundi* in the Nafana community of Oulike, north-east of Bondoukou, illustrating the mud reliefs of a *sakrobundi* mask with a coiled snake and staff on the walls of the shrine. *Sakrobundi*, at this time, was clearly a powerful spiritual

presence in Jaman and adjacent portions of the Gold Coast, and especially in Nafana villages within the shadow of Bondoukou (which was under the spiritual leadership of Imam Malik Timitay, the Muslim authority of the city).

Sakrobundi was to retain its influence, despite the growing colonial presence, well into the 1930s, when it was suppressed by French and British missionaries. Their assaults drove the masquerade itself out of existence, but the tutelary spirit survived and was still functioning in the 1960s. As the public face of a cult noxious to colonial sensibilities, the *sakrobundi* was retired or, as the Nafana elders of Oulike said, 'it was put to rest'. This *sakrobundi* mask from Jaman in the British Museum is a vivid example of the evanescence of masking traditions under duress. In its time this large, flat, oval-faced mask, crowned with horns and richly painted in red, white and black patterns, was undoubtedly a powerful spiritual presence. RAB

Provenance: collected by Sir Cecil Armitage

Bibliography: Underwood, 1953, fig. 20; Fagg, 1969, no. 128; Bravmann, 1974, pp. 102–6; Bravmann, 1979, pp. 46–7

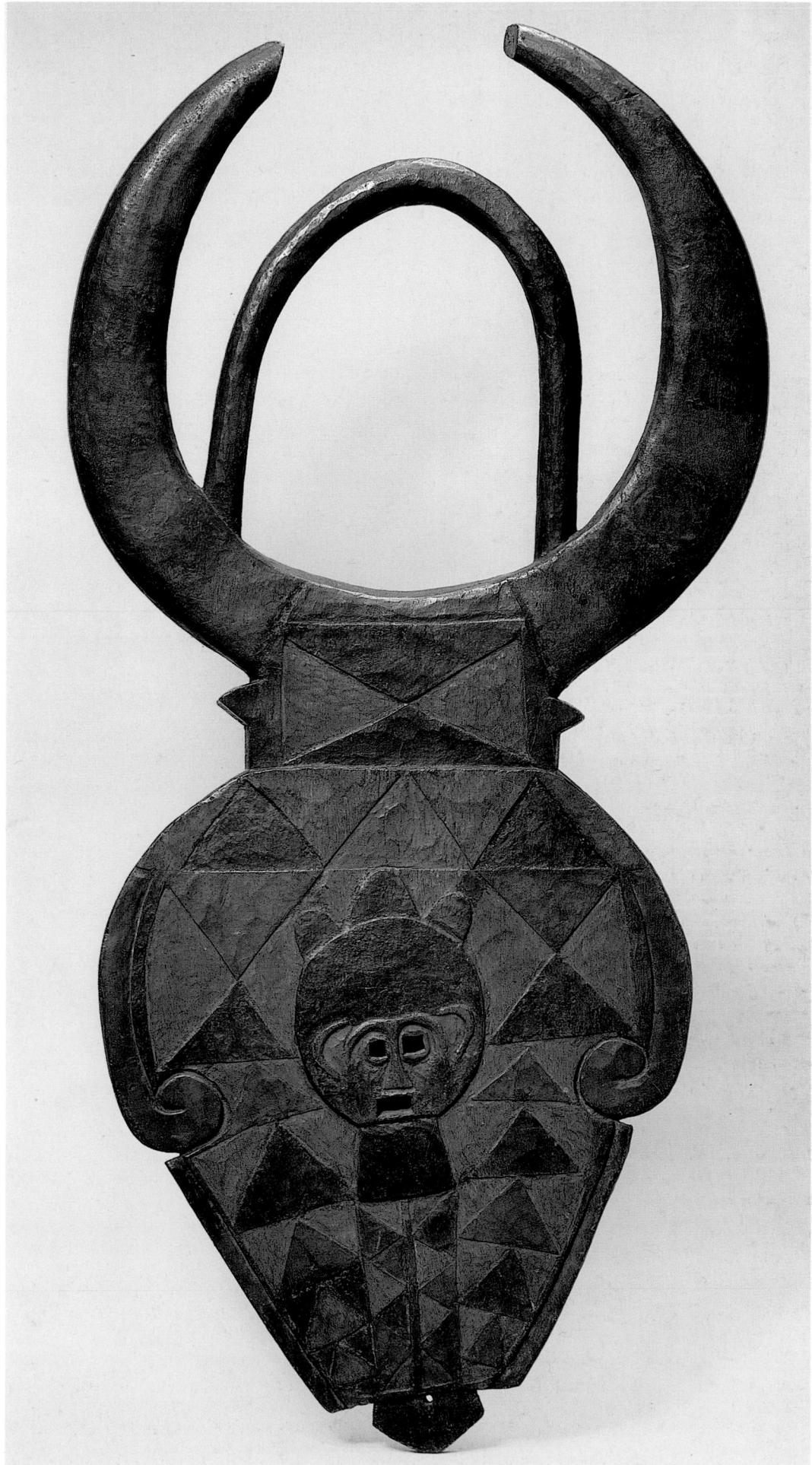

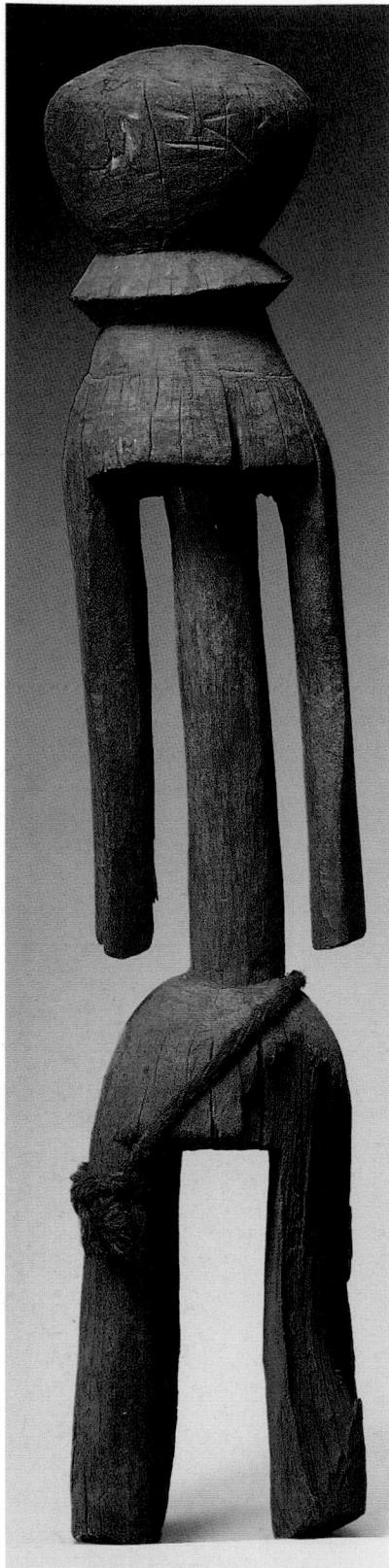

5.120

Shrine figure (*tchitcheri sakwa*)

Moba

Togo

19th century

wood

h. 125 cm

Museum für Völkerkunde, Leipzig

Among the Moba of northern Togo wooden figures called *tchitcheri* (sing. *tchitcherik*) are prescribed by diviners to enhance the efficacy of personal, household and village shrines. Carved of a single piece of wood, *tchitcheri* are rendered abstractly in human form. This figure conforms to broad stylistic conventions common among Moba figures: the ovoid head, neck ring, broad chest and flaring hips stand in marked contrast to the elongated, recessed torso and the vertical axis of the figure. As with many Moba figures, facial features are absent and the hands and feet are minimally carved. In some examples gender is evidenced by a carved penis, a vertical incision suggesting the vagina or small protruding breasts.

The large, broad size of this particular shrine figure probably characterises it as belonging to the category called *tchitcheri sakab* (sing. *tchitcherik sakwa*; *sakab* means 'old men'). In most field contexts these impressive statues are planted in the ground at least to groin level and sometimes to mid-waist. Some are embellished with a cotton smock or straw hat, or carry a hoe. They represent and are named after the ancient founding clan ancestors, or their children. They are associated with earth shrines, called *tingban*, maintained by particular families who serve as custodians to shrines dedicated to the earth.

Given the association of these images with founding ancestors, the general belief among the Moba is that the figures are 200 years old or more; thus, there is no contemporary tradition for carving new or replacement *tchitcheri sakab*. CMK

Provenance: 1900–1, collected by Dr H. Gruner

Bibliography: Zech, 1904; Frobenius, 1913, p. 430; Zwernemann, 1967, p. 118; Kreamer, 1987, pp. 52–5, 82–3

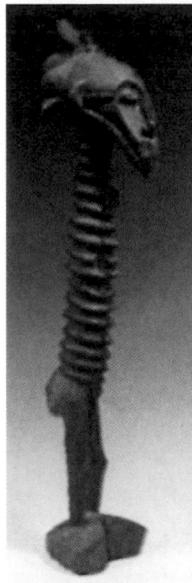

5.121

Pair of helmet mask crests

Senufo

Ivory Coast

early 20th century

wood, fibres

h. 76 cm and 73 cm

Musée National de la Côte d'Ivoire, Abidjan, A 1535/6

These two figures are the surviving crests from a pair of helmet masks that would originally have been about 100 cm high. Only a very small number of such helmet masks are known. The figures are carved without arms (in a few cases also without legs), and their bodies are dramatically reduced to a column of two-faceted rings.

Although these helmet masks come from the region inhabited by the Tyebara, a Senufo dialect group, they were neither made nor used by them. My enquiries in 1990 confirmed that they were used uniquely by the Fodonon, another Senufo dialect group, at the villages of Lataha and Seridjakaha. The Fodonon, however, had no sculptors, and therefore commissioned these masks from a third Senufo subgroup, the Kulebele, who were professional sculptors. The Kulebele carved these masks for the Fodonon at Koko, a quarter of Korhogo (about 15 km from Lataha), where the Belgian ethnographer Maesen collected the first known pair in 1939.

Pairs of such helmet masks were owned by the Fodonon men's secret societies known as 'Ponno' (the equivalent of the Poro societies of the

Tyebara). Each society kept one male-female pair in its sacred forest.

There were formerly seven men's Ponno societies at Lataha, though they have today been reduced to three by amalgamation. The masks came out at night for the funeral rites of a Ponno member, held some time after the actual interment. They also appeared at the great communal funeral commemorations held every few years. They were worn by initiates walking in procession around the village, and followed by others who struck each other with whips or bare hands or even threw burning straw on each other.

Around 1950 the practitioners of a new cult known as Massa arrived at Lataha and demanded that the Ponno societies abandon their sacred statuary. In the ensuing panic the sacred forests were emptied of their major statues, but by good fortune these, including the present crests, were rescued and preserved by French missionaries.

In 1990 the Ponno initiates of Lataha offered a convincing explanation for the ring-like bodies of these crests, and the absence of arms. At the commemorative funeral, which can take place long after the actual interment, the corpse is represented symbolically by a white cloth twisted into a rope and tied at each end. An initiate dances with this at the funeral rites; it is then carried to the cemetery and thrown on to the grave. All present then run back to the village without looking behind them. The ringed body of the sculpture is said to depict this twisted white cloth representing the corpse. TFG

Exhibition: Paris 1989

Bibliography: Clamens, 1953, pp. 78–9; Goldwater, 1964, pp. 21–2, figs 80–4; Förster, 1988, pp. 60–1; Diarrassouba, in Paris 1989, pp. 90–1; Koloss and Förster, 1990, pp. 14–16, 40; Convers, 1991, pp. 24–34; Glaze, in Barbier, 1993, ii, p. 14

5.122a

Dance-mask, female (*gu*)

northern Guro
Ivory Coast
wood
30 x 14 x 13 cm
Herman Collection

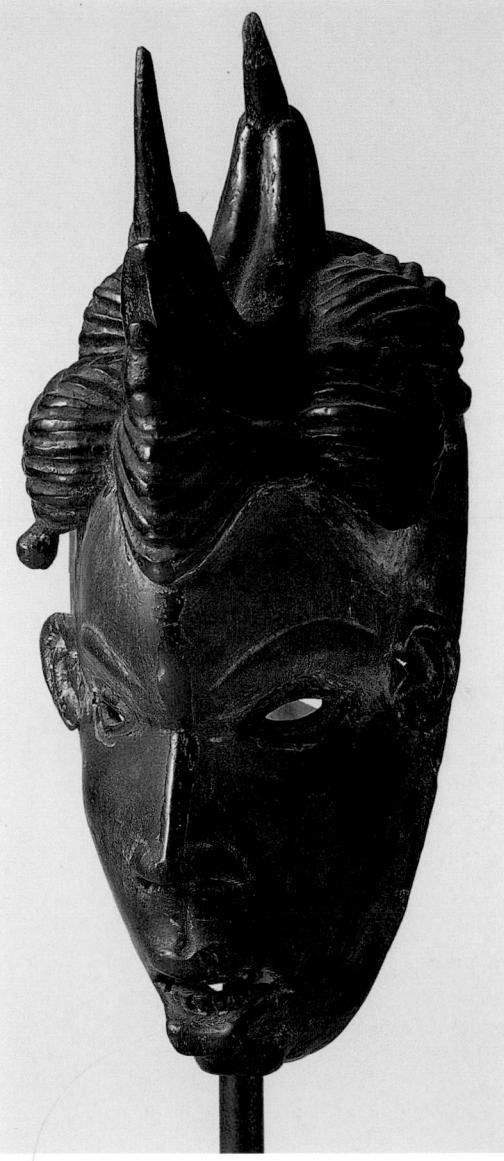

5.122b

Dance-mask, male (*zaouli*)

northern Guro
Ivory Coast
wood, fibres
27 x 16 x 10 cm
Musée National des Arts d'Afrique et d'Océanie, Paris, MNAN 1963.184

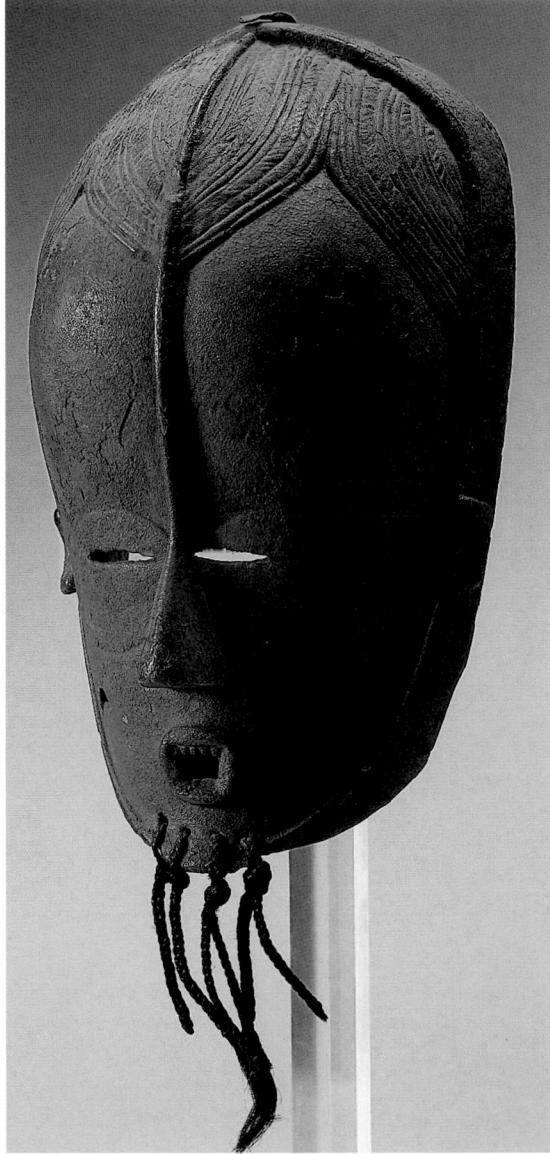

5.122c

Dance-mask

Guro
Ivory Coast
wood
h. 35 cm
Museum Rietberg, Zurich
Collection Baron E. Von der Heydt,
RAF 510

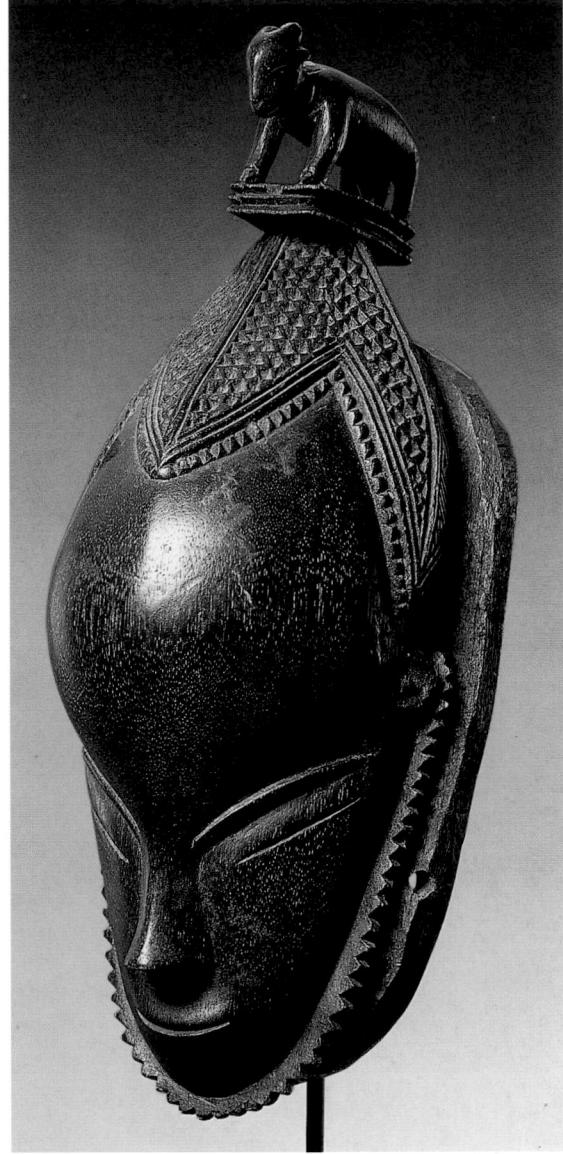

These dance-masks are examples of the refined styles found among the Guro of central Ivory Coast, whose sculpture is notable for its elegance and meticulous detail. They probably come from villages in the region of Zuenoula, among the northern Guro.

Such masks are used in a well-known village masquerade which generally has a 'cast' of three characters. One, known as *gu* (cat. 5.122a), is a beautiful young woman, her hair dressed in a series of plaits some of which combine to form a central crest.

Another is *zaouli* (cat. 5.122b), an elderly man whose beard in this example is depicted by a fringe of short cords attached to the chin. The third character, *zamble* (not represented here), is an antelope, sometimes identified as the bushbuck (*Tragelaphus scriptus*), a species common in the region.

From time to time dance competitions are held between neighbouring villages at which these masks perform. Sometimes *zamble* appears with *zaouli*, in which case the

antelope is taken to be the sister or wife of the old man. Alternatively *zamble* dances with *gu*, in which case the antelope is the husband and the beautiful young woman his wife. At the close of the competition, the *gu*-mask representing the wife of the victorious *zamble* appears and together with him dances around the whole village.

Such masquerades in various forms are a popular entertainment in central Ivory Coast. They exist not only among the Guro, a Mande group,

but also among their eastern neighbours, the Yaure and Baule. All these peoples have produced sculptors of exceptional talent, and their dance-masks rank among the finest in west Africa. TFG

Exhibitions: cat. 5.122b: Le Havre 1965; Paris 1972, no. 75

Bibliography: Damman, 1966; Neauzé, 1967, p. 170

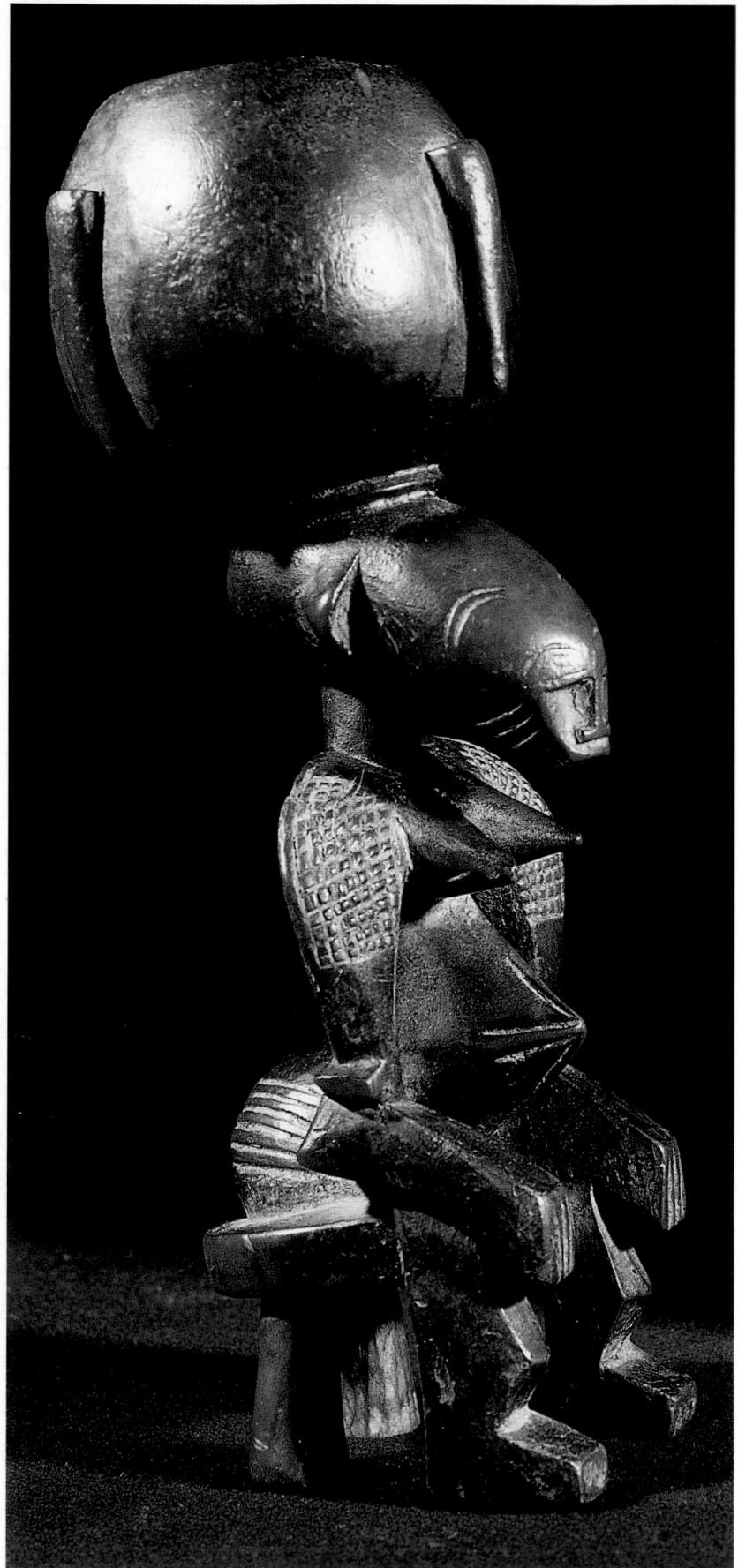

5.123

Diviner's figure

Senufo
Ivory Coast
20th century
wood
h. 29 cm

Jean and Noble Endicott

This small female statue, seated on a four-legged Senufo stool and bearing a bowl on her head, is a representation of a bush spirit. It would originally have had a female partner, depicted either free-standing or seated on a horse. Such a pair forms part of the essential equipment of the diviner or soothsayer (*sandoo*); the statuettes both represent and serve as the abode for the pair of bush spirits who are believed to be in communication with the diviner.

The practice of divination is universal among the Senufo, and practitioners of the art are to be found in every village. They consult the spirit in order to help a client resolve problems and obtain better fortune. Most diviners are women, though the calling is also open to men.

The statuettes are set out with other paraphernalia in the tiny consulting room, and the diviner plies them with a long stream of questions in the course of the séance. In 1934 the missionary Father Knops noted an instance where a female figure of this kind, bearing a bowl on its head, was brought out into the open and danced around by all the members of the *sandogo*, the village divination society.

The bush spirits, variously called *mandeo*, *ndeо* or *tugu* (pl. *mandebele*, *ndebele*, *tugubele*), form the subject of a great quantity of Senufo sculpture. In addition to the diviner's personal statuettes mentioned above, it is common for a diviner to prescribe that the client himself obtain a pair of such statuettes to keep in his house. This is particularly the case where a client claims to have seen such a spirit in the bush, or in dreams, or where the diviner learns that a bush spirit is seeking to follow, befriend or trouble the client. The statuettes purchased by the client are in most cases a simple pair of matching, free-standing figures; the more elaborate figures, seated on horseback or bearing a pot on the head, are almost exclusively reserved for the diviner. *TFG*

Bibliography: Goldwater, 1964, pp. 24–5; Glaze, 1981, pp. 54–69; Förster, 1988, pp. 87–8; Glaze, in Schmalenbach, 1988, p. 81

Standing bird

Senufo
Ivory Coast
19th–early 20th century
wood
h. 149 cm
The Berggruen Collection, London

In former times many of the men's secret Poro societies in the Senufo region owned a large standing sculpture of a bird. This statue, kept in the sacred forest, was used in the rites for the admission of initiates to the final phase of training. It generally had a hollowed base, which permitted it to be carried on the head of an initiate. Some examples also have holes in the wings, through which cords were passed to steady the bird when carried.

The identification of this bird is uncertain. Its large curved beak suggests a species of hornbill, but there is no unanimity among the Senufo informants, who identify it variously as a hornbill, crow, vulture, eagle or buzzard. Older Senufo, however, usually name it as *sejen* or *fijen* (according to dialect), a term that simply means 'the bird'.

The significance of this bird is indicated more clearly by two other names. It is sometimes called *kasingele*, 'the first ancestor', which may refer either to the mythological founder of the human race or to the ancestral founder of the sacred forest.

Alternatively, it is named *poropia nong*, which means literally 'mother of the Poro child'. The statue is thus a primary symbol of the Poro leadership, indicating the authority of its elders. In the language of Poro these elders are collectively known as *katyleeo*, 'the old woman', since they stand in the position of 'mother' to the junior initiates. The juniors themselves are called *poro piibele*, 'children of Poro'. TFG

Bibliography: Goldwater, 1964, p. 28, figs 148–9; Förster, 1988, p. 75; Bochet and Garrard, in Barbier, 1993, ii, p. 31

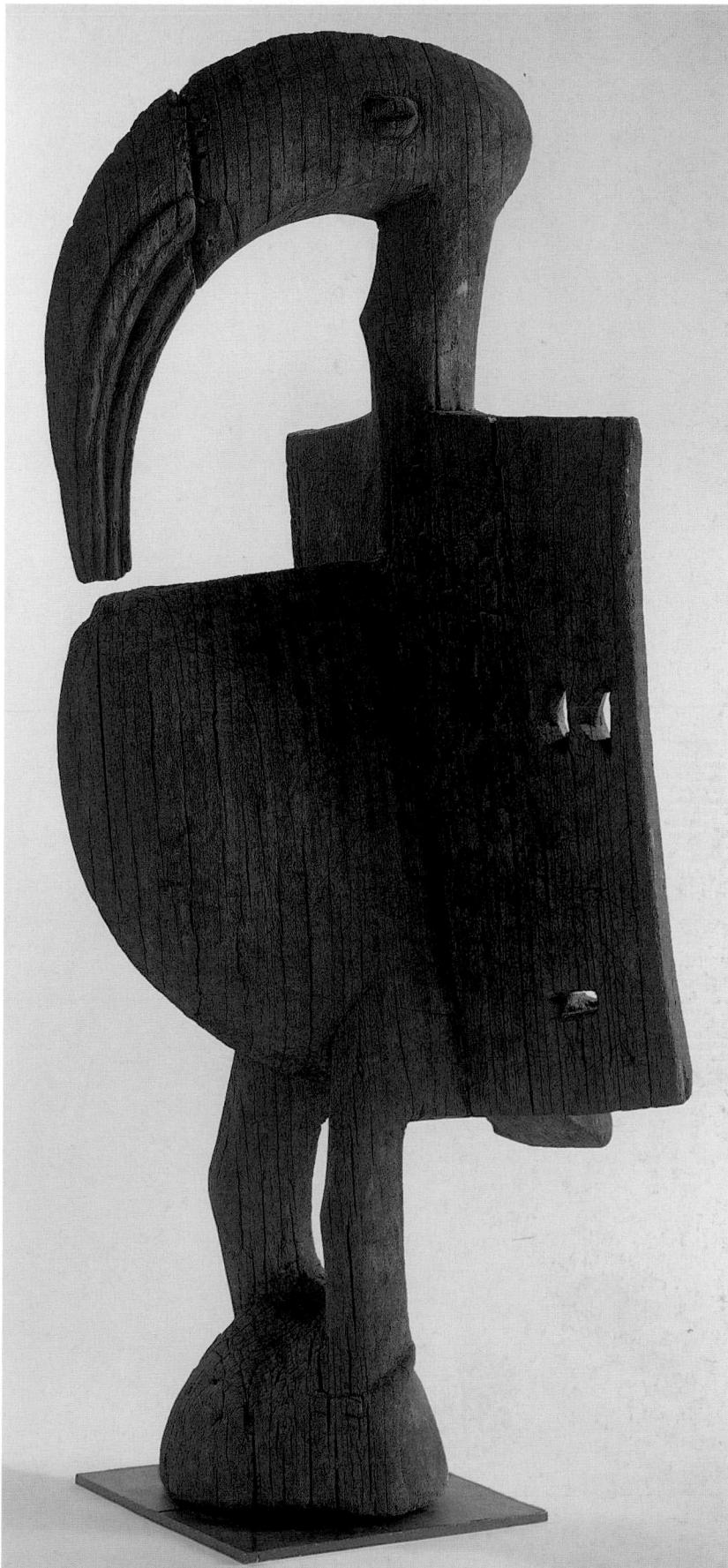

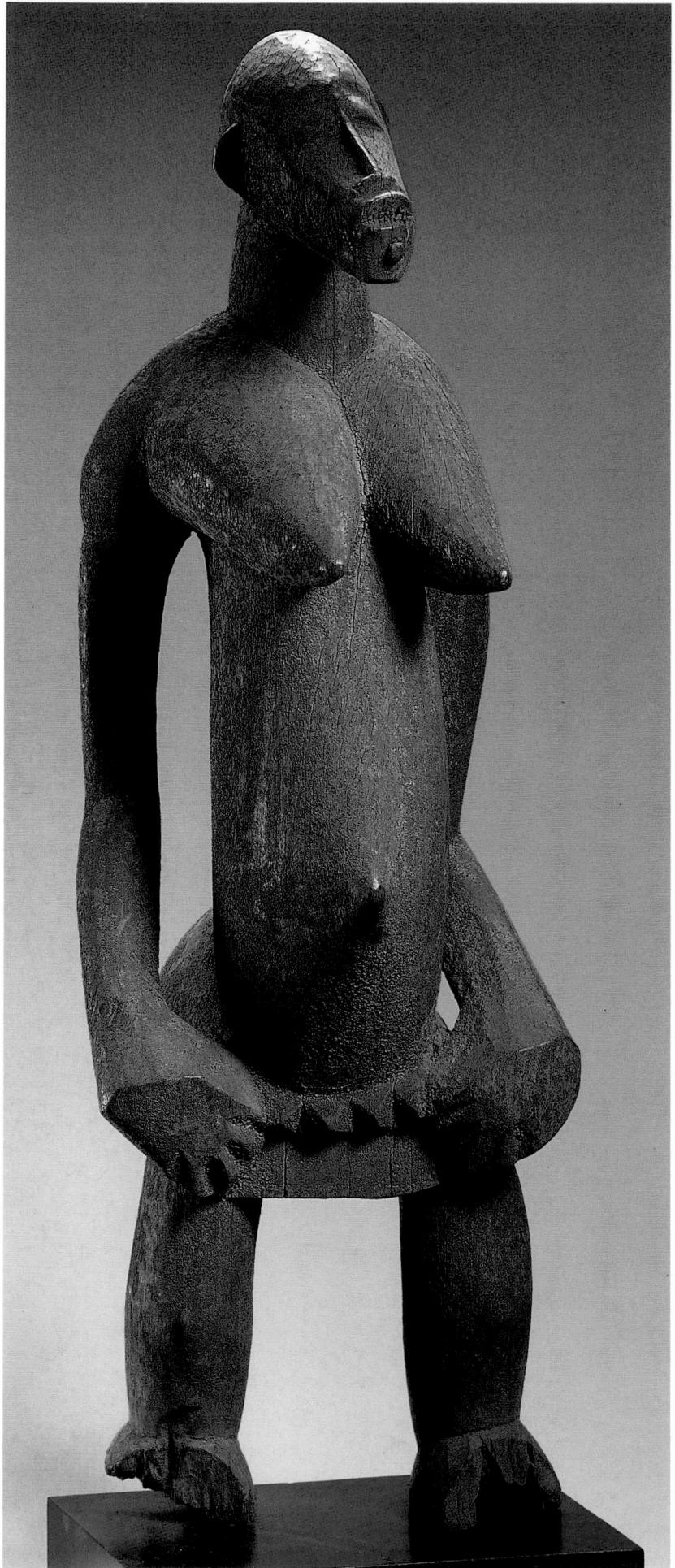

5.125

Female figure

Senufo

Ivory Coast

early 20th century

wood

h. 78.5 cm

Royal Tropical Institute/Tropenmuseum,
Amsterdam, 4133.29

While the Senufo blacksmiths and professional sculptors carved countless small statues, generally under 30 cm in height, those of larger size are relatively rare. This fine example of the larger category could have been used in a number of ways, but has no particular distinguishing features or attached ornaments that might enable its precise context of use to be established. Nevertheless its badly eroded feet suggest that it was used for display in a permanent fixed position, standing on the ground, and probably indoors rather than outdoors since the rest of the body is relatively well conserved.

Such large-scale statuary was occasionally commissioned in the past by the male Poro societies and by their female equivalent, the Tyekpa. In the case of the Poro, a pair of large statues was sometimes placed on public display at the wooden shelter where the initiates gathered to celebrate funerals, a custom now abandoned owing to frequent theft of the statues. The societies sometimes commissioned statues to be carried in procession on the heads of the initiates, or placed on the ground to serve as a focal point for dancing.

The present statue, on the other hand, is more likely to have been carved for the owner of a *yasungo*, a large 'fetish', shrine or power object on which sacrifices are made. Such shrines were often located indoors, away from public view. The nature of the *yasungo* shrines varied and in the absence of precise documentation it is difficult to say what role this statue may have played.

It may be noted that, while some pairs of statues are said to represent the 'first ancestor' (*kasingele*), the concept of portraying in sculpture an actual named ancestor seems to have been unknown. In the same way, the idea of sculptural portrayals of a living person fills the Senufo with horror. It was regarded as a dangerous and threatening act, inviting a curse on the head of the person depicted or,

in the case of a woman, rendering her sterile. The sculptors say that if such a statue was made, it would be to harm a person. They add that if a girl tried to refuse them in marriage, they would retaliate (but only in jest) by threatening to carve a statue of her. *TFG*

Bibliography: Goldwater, 1964, pp. 23–5; Glaze, in Barbier, 1993, ii, p. 24

Ritual pounder

Senufo
Ivory Coast
early 20th century
wood
h. 95 cm
Museum Rietberg, Zurich, RAF 301

Among the finest of Senufo sculptures are the large ritual pestles or pounders carved as a male or female figure. These were formerly owned by many Poro societies both in the Ivory Coast and in Mali. Initially carved as pairs, it sometimes happened that one broke or decayed to the point of being unusable, in which case a replacement would be commissioned, often from a different carver. It could thus happen that a functional 'pair' kept in the sacred forest was in fact by two different carvers.

The present example is one of the eight pounders removed from the various sacred forests of Lataha about 1950 on the orders of the Massa cult. It was no longer in use, having lost its base, and two male pounders were also badly damaged; but the five others were intact. A man from Lataha who was an initiate at the time recently identified the present pounder as coming from Kofile ('white forest'), one of the three sacred forests still existing in the village.

These sculptures were used mainly (but not exclusively) in the various rituals that took place before and after the burial of a deceased Poro elder. They are carried by initiates who visit the house of the deceased. One is sometimes placed beside the corpse in its shroud at the public ceremonies that follow. They then accompany the corpse to its burial place, swung and pounded on the ground in time to the solemn music of the Poro orchestra. When the interment is complete and the soil rapidly heaped over the grave – which occurs shortly before nightfall – a male initiate may, in a final and decisive gesture, leap into the grave with a pounder and beat the soil seven times. This pounding ensures that the spirit of the deceased person does not linger in the vicinity, but passes on its way to the 'village of the dead'. The pounders may also be used in supplementary rituals on the ensuing days.

In the Fodonon dialect spoken at Lataha the ritual pounder is called

ponno shon ('person of Poro') or *pon pia* ('child of Poro'). It is also known as *denge* or *madengo* ('bush spirit'). Analogous names are given in the Tyebara dialect of Korhogo. In the literature the pounder has almost always been called a '*déblé*'; this is a corrupt rendering of the plural of the Tyebara name for a bush spirit – *ndeo* (pl. *ndebele*). Elsewhere, in dialect areas west of Korhogo, the carved pounder is simply known as *dol* (pl. *dogele*), a pestle. TFG

Provenance: ex collection Emil Storrer
Exhibitions: New York 1964; Zurich 1988; Berlin 1990

Bibliography: Clamens, 1953, pp. 78–9; Goldwater, 1964, pp. 22–3, fig. 94; Förster, 1988, pp. 68–70; Diarrassouba, in Paris 1989, p. 87; Koloss and Förster, 1990, pp. 14–20; Convers, 1991, pp. 31–4; Glaze, in Barbier, 1993, ii, p. 22

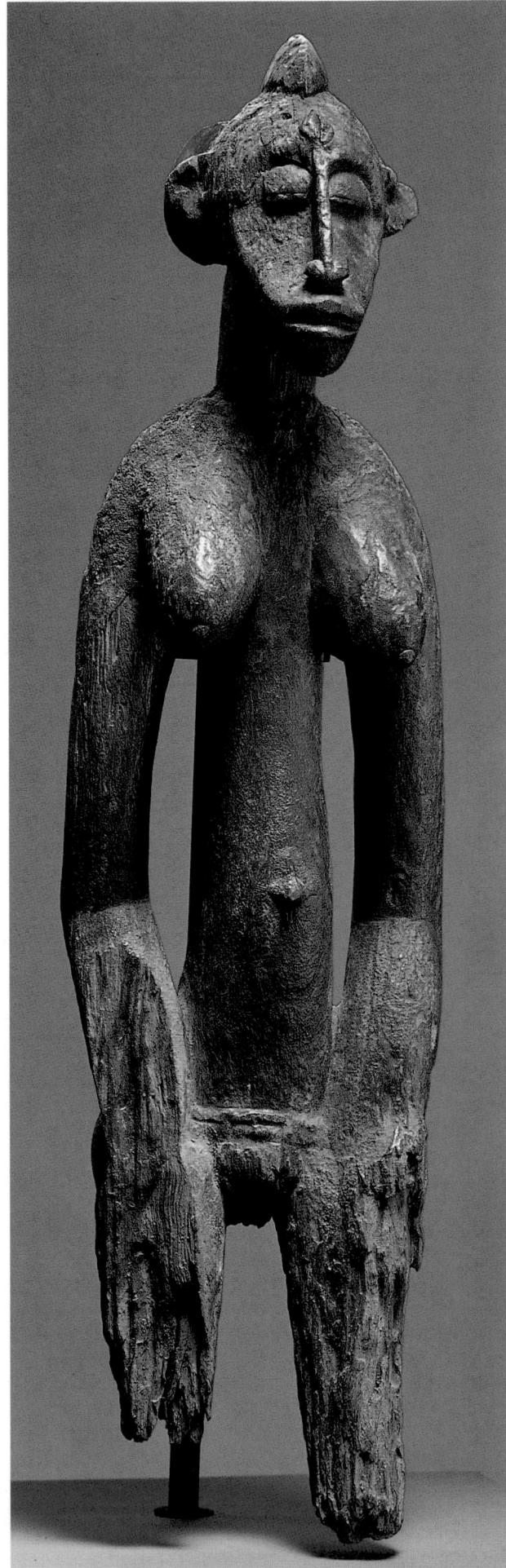

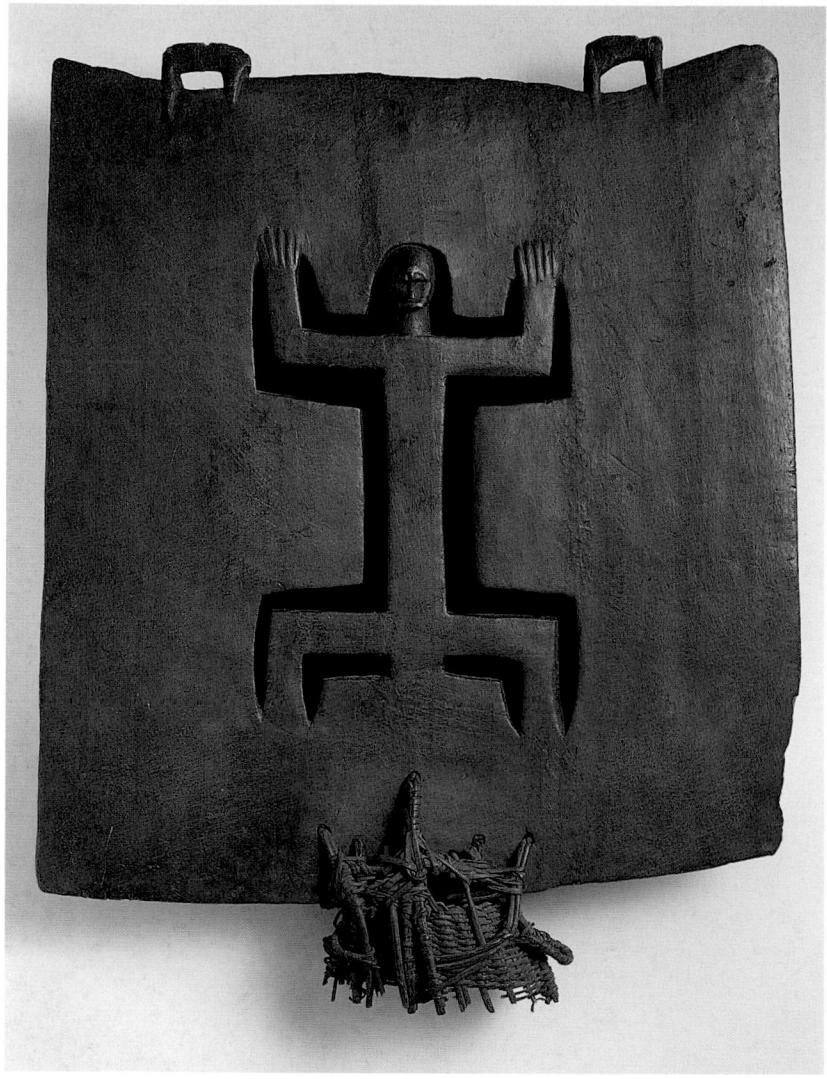

5.127

Ceremonial headdress

Senufo
Ivory Coast
20th century
wood, fibres
h. 98 cm
Musée National des Arts d'Afrique et d'Océanie, Paris, MNAN 65.1.4

The Senufo Poro (a male initiation society) is not a monolithic organisation but a multitude of independent village societies whose customs and artistic traditions vary quite considerably, not only from one region to another, but even within the same dialect group. The present headdress provides a good illustration of this tendency. It takes the form of a rectangular plank carved with a stylised human figure, and supported on a wicker headpiece. Ceremonial headdresses of this kind were unknown to the Poro societies of the Tyebara and Fodonor, but were apparently confined to the Nafara in the region of

Sinematiali, some 30 km east of Korhogo.

These headdresses were displayed by the initiates at a great public festival held to mark the conclusion of the intermediate period of Poro training, known as *kwonro*. After the festival the initiates entered the sacred forest to undergo a ritual death and rebirth; this qualified them for the final seven-year period of training (*tyologo*) in the initiation cycle.

For their public appearance the headdresses were painted with polychrome designs of squares or spots in natural pigments.

The custom of using them fell into abeyance some decades ago. In the literature they have been named both as *kwonro* and as *dagu*. TFG

Bibliography: Goldwater, 1964, pp. 20–1, figs 75–9; Knops, 1980, pp. 144, 199; Förster, 1988, pp. 17–19; Féau, in Paris 1990, p. 162; Koloss and Förster, 1990, p. 43; Glaze, in Barbier, 1993, ii, p. 18

Group of small masks

Miniature masks replicate the forms of the much-admired face masks well known from Liberia and the Ivory Coast. For the peoples of this forested region, the Dan, Mano and Wenion, masks too small to be worn are powerful charms. They are kept hidden, destined for personal protection or enhancement, in contrast to the face masks worn by performers on public occasions for communal benefit. All masks, no matter how delicate, comic or crude their form or behaviour, are invested with the powerful vitality of the forest, a vitality that fosters well-being and protection against harm. This identification with the forest imbues masks with such importance that even tiny versions possess power.

Because performing with a wooden face mask and costume was a widespread practice until the 1960s, there were tens of thousands of masks to be found in the forest zone. The variety of these regional masks is enormous, although never departing from the frontal facial form. The inhabitants themselves class these performers and their face masks into general social categories such as male, female and unusual or deviant types. Small Dan masks modelled after these three categories are included here: male, female and distorted.

People of this region also categorised masks according to social functions, such as adjudicator, debt collector, warrior, dancer, singer, actor, hunter and delinquent. In practice, before the 1960s there was hardly a social activity that lacked the involvement of an active masker: enlisting workers to clear paths, recalling a runaway wife, entertaining women cultivators, snatching feast food to distribute to children, spying on clandestine projects. These performance masks were inspired by dreams sent to men by forest spirits who wished to be manifested and honoured in the human community.

Each face mask had its own name, which alluded to its specific nature or powers, and its own porter, a male, who performed in it. At his death, the mask passed on to another member of his family indicated by spirit-inspired signs. In spite of the link between a mask and its performer, masks belonging to members of a lineage were considered the possession of that

lineage and performances were supervised by lineage elders.

One of the major motivations for creating small masks derives from a strict rule that protects the public persona of the masked performer spirit but denies acclaim to the wearer. The human porter must never identify himself as the mask wearer or utter a public statement on his relationship to a mask. He or a lineage elder are, however, entitled to commission a hand-sized model (13–15 cm), keep it as a private altar and make sacrifices to it to advance their interests in an undertaking or to counter witchcraft, thus gaining a personal advantage. Their frequent sacrifices over this mask-altar with bits of food, sauces, blood and oil produce an encrusted surface, as in the Mano example (cat. 5.128h). Another way to enhance the porter's importance is for him silently to display a small model within the councils of men, especially on visits to other communities. This identifies him as a mask porter or as a member of a powerful lineage.

In the forest region the uses of small masks are almost as varied as for the larger versions. As sacred objects they function within the rites of men's secret societies. For example, at Dan secret society initiations small masks are placed on the path that leads to the meeting place and aspiring members must pay to have them removed; along with other talismans they are displayed on a tray to members as representations of the benevolent masked spirits of the area. A circumciser may wipe a small mask with his knife to purify the blade of harmful forces. Boys in the Dan circumcision camp try their hand at carving small hand-sized masks and this may lead to spirit-inspired dreams of becoming a masked singer or dancer.

Among the Mano masks that share most closely the styles and functions of the Dan are miniatures used by feminine style performers who carry out tasks such as seeking food in the village for the boys and girls in the initiation camps or entertaining at festivals. Other small Mano forms, such as cat. 5.128o, which may have been carved in commemoration of powerful men or women of the family or lineage, are kept at personal altars. A stylistic variation occurs among the northern Mano in the use of face

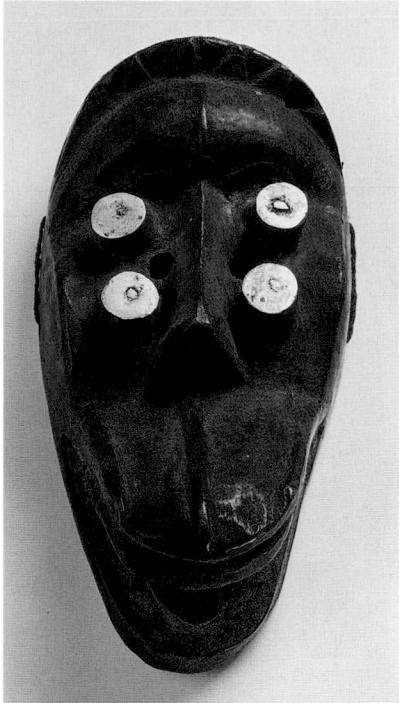

5.128a
Dan (Yacuba, Gio, Geh)
Liberia, Ivory Coast
20th century
wood
h. 15.5 cm
Museum für Völkerkunde, Vienna,
155.162

5.128b
Dan
Liberia, Ivory Coast
20th century
wood
h. 13.7 cm
Jean and Noble Endicott

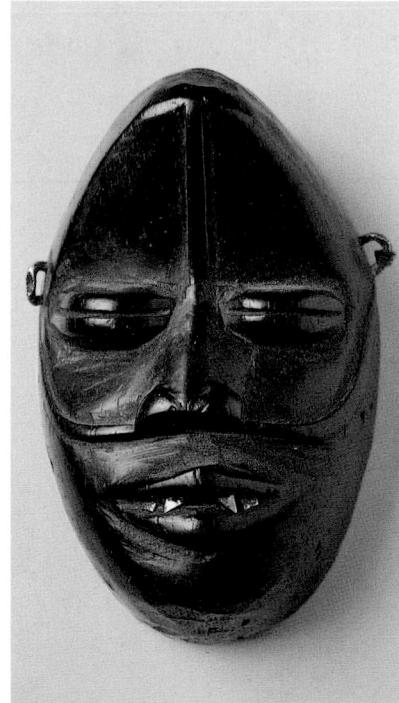

5.128c
Wenion (Wè, Guéré)
Liberia, Ivory Coast
20th century
wood
h. 10.7 cm
Private Collection

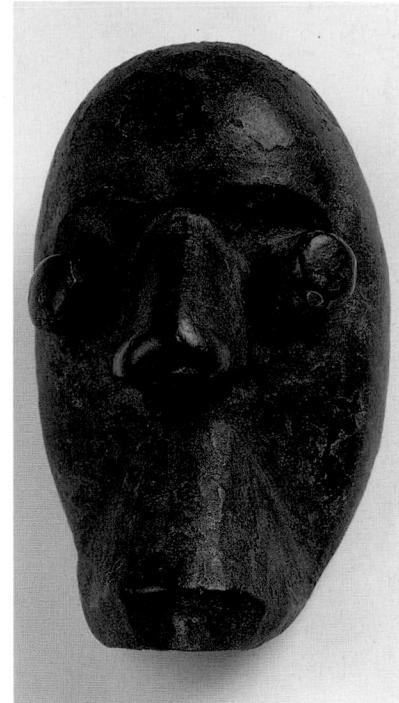

5.128d
Dan (Yacuba, Gio, Geh)
Liberia, Ivory Coast
20th century
wood
h. 13.5 cm
Museum für Völkerkunde, Vienna,
126.166

5.128e
Dan (Yacuba, Gio, Geh)
Liberia, Ivory Coast
20th century
wood
h. 12 cm
Museum für Völkerkunde, Vienna,
126.168

5.128f
Dan (Yacuba, Gio, Geh)
Liberia, Ivory Coast
20th century
wood, vegetable fibre, copper
h. 17 cm
Musée National des Arts d'Afrique et
d'Océanie, Paris, A 83.1.2

5.128g
Dan (Yacuba, Gio, Geh)
Liberia, Ivory Coast
20th century
wood, cloth
12 x 7 cm
Herman Collection

5.128h
Mano
Liberia, Ivory Coast
20th century
wood, encrustation
h. 13.1 cm
Jean and Noble Endicott

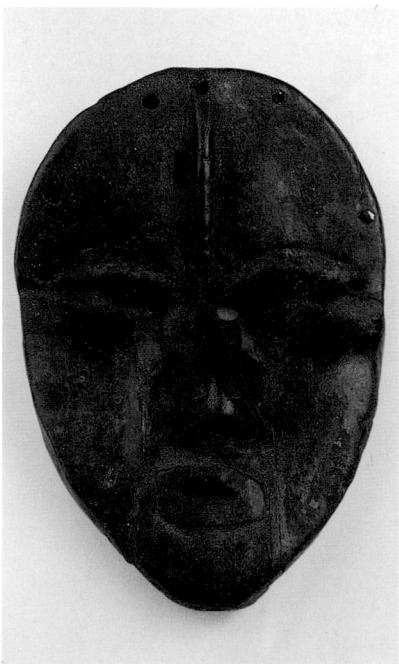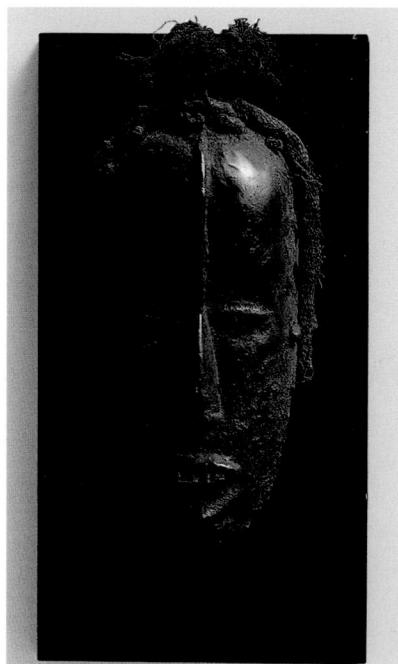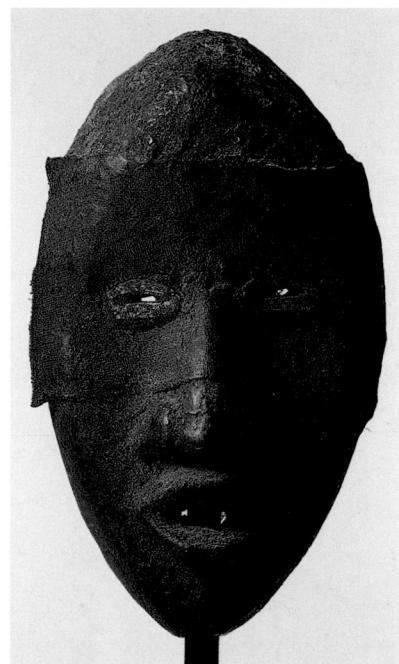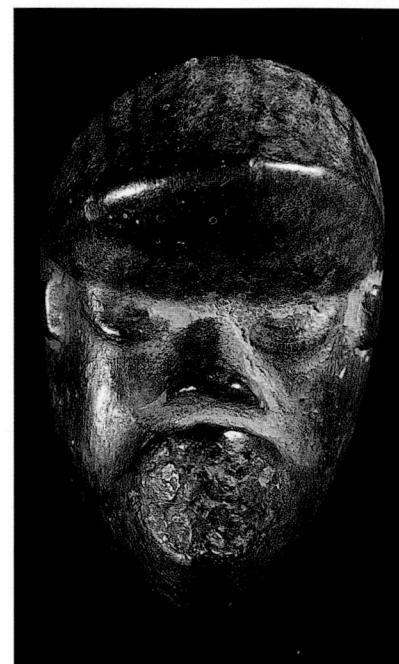

masks combining human and bird-beak features. These are associated with the ceremonies of the men's secret initiation society (*ge bon*). The reduced version shown here (cat. 5.128w) is not to be worn, but is placed in the initiation camp or field hut as a guardian against harmful spirits or theft.

Diviners initiate the commissioning of small masks for various purposes. For men seeking protection during forest work, travel or other risky situations, the diviner may recommend carrying a hand-sized feminine style of mask wrapped under their garments. On the diviner's advice a tiny mask form (5–6 cm) may be hung in a bag on a child's body to prevent or cure illness. Treated with sacrificial oil, these masks develop a glossy patina. Although women are prohibited from possessing performance masks, a woman from a Dan family owning such a mask may commission a miniature to take with her when moving to her husband's household. After consecration and sacrifices the tiny mask is hidden in her basket of personal possessions, thus preserving contact with its powers.

Miniature models showing exaggerated masculine features are fairly rare in contemporary collections. The majority of small masks are in a pointed oval style with feminine facial features. An example of each kind from the Dan, cat. 5.128d and 5.128e, was collected in Liberia in 1936. Two of the earliest Dan examples shown here (acquired 1868) were hand-sized models decorated with beards of plaited fibre or monkey hair, bone tubes, beadwork and animal skin, with a black gummy substance in the hollow of the backs. (The substance is probably the remains of magical medicines.) These elaborations are rarely found in collections of miniature examples, perhaps because of collectors' taste for sculptural form. Cat. 5.128f, which exhibits an elegant reserve similar to carvings by the Guro who live east of the Dan, shows traces of a cotton and fibre headdress around the mask. Various surface effects result from offerings of masticated kola nuts (a stimulant) and palm oil, rubbed on the wood surfaces in order to maintain contact and obtain spiritual power for the owner's endeavours. The red-

dish cloth across the face of cat. 5.128g corresponds to its use on larger versions, the colour indicating the vitality that protects the owner and threatens enemies.

The small Wenion masks illustrate typical variations known and used currently. Cat. 5.128r, with its slit eyes and cylindrical projections ('cheekbones'), exaggerated features and palm-fibre beard, is readily recognisable as a model of the youthful warrior masquerader who does not engage in the overtly threatening behaviour of the 'fighting warriors' but displays remarkable spurts of energetic dancing. The other two Wenion examples (cat. 5.128c,m) exhibit a thick-featured, bearded feminine form favoured for dancers and entertainers. The raised welts on cat. 5.128c running upward from the nostrils represent a facial scar that used to be given to both men and women of the southern forest zone. Other kinds of feminine-style Wenion masks resemble fine-featured Dan masks.

The many small masks exhibited here illustrate the diversity of personal styles among Dan, Mano and Wenion carvers and possibly those from other forest zone populations such as the Konor, Mau or Tura to the north of the Dan and the Bete to the east. MA

Bibliography: Becker-Donner, 1940, pp. 94, 97; Schwab, 1947, pp. 277–8, 364–5; Holas, 1952, pp. 125–7; Fagg, 1955, pp. 160–2; Himmelheber, 1960, pp. 161–2; Girard, 1967, p. 155, pl. VII; Verger-Fèvre, 1980, pls 22, J6, Jll; Gnonsoa, 1983; Fischer and Himmelheber, 1984, p. 107; Herold, 1985, pp. 142–6; Adams, 1988; Verger-Fèvre, 1989, pp. 123–4.

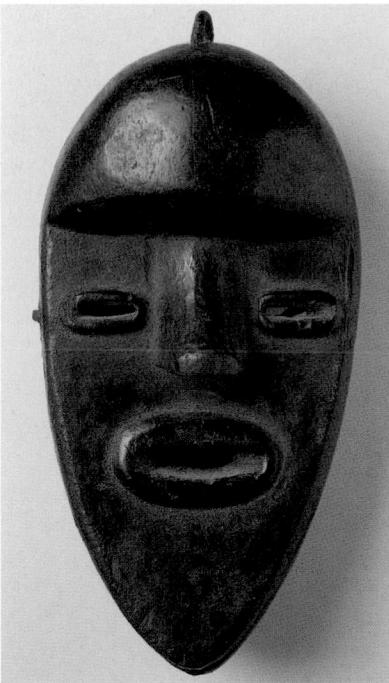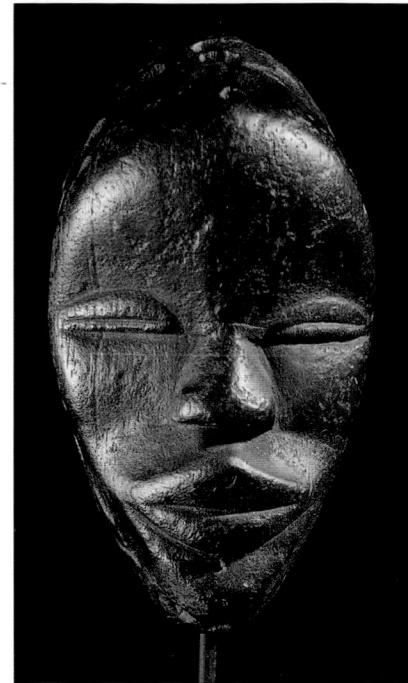

5.128i
Dan (?)
Liberia, Ivory Coast
20th century
wood
h. 14.6 cm
Private Collection

5.128j
Dan
Liberia, Ivory Coast
20th century
wood
h. 13.7 cm
Jean and Noble Endicott

5.128k
Dan (Yacuba, Gio, Geh)
Liberia, Ivory Coast
20th century
wood
h. 10.1 cm
Private Collection

5.128l
Dan
Liberia, Ivory Coast
20th century
wood
h. 10.1 cm
Private Collection

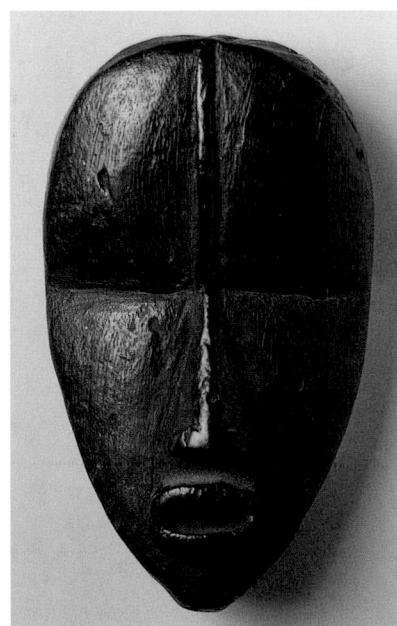

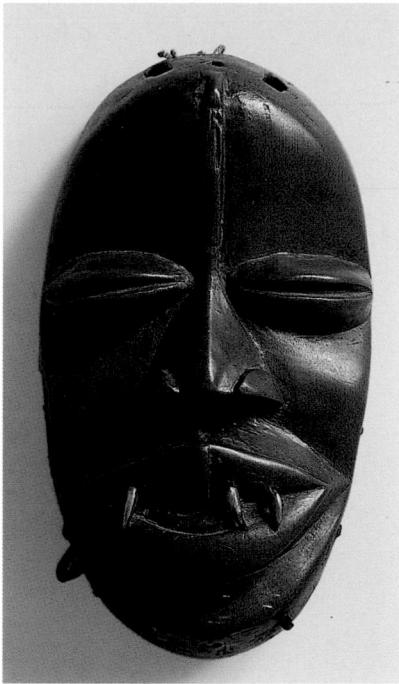

5.128m
Wenion (Wè, Guéré)
Liberia, Ivory Coast
20th century
wood, bone
h. 13.7 cm
Musée National des Arts d'Afrique et d'Océanie, Paris, A 85.1.2

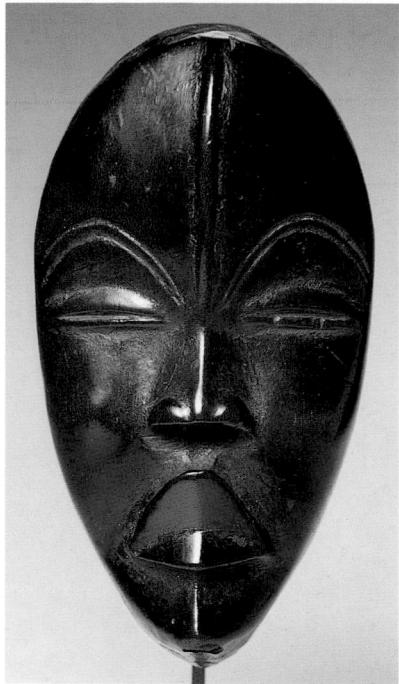

5.128n
Dan
Liberia, Ivory Coast
20th century
wood
h. 14 x 7 x 3 cm
Private Collection, Paris

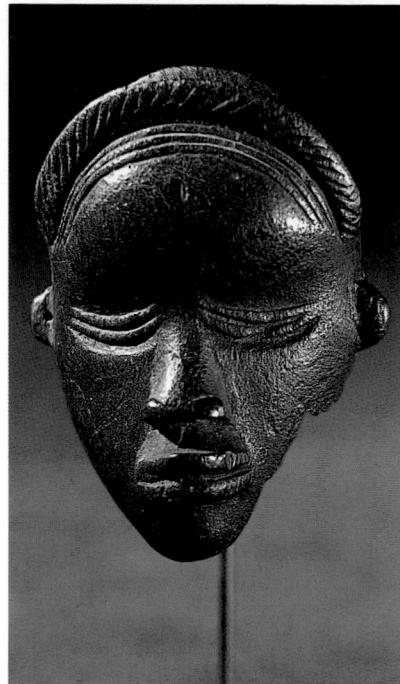

5.128o
Mano
Liberia, Ivory Coast
20th century
wood
h. 23 cm
Jean and Noble Endicott

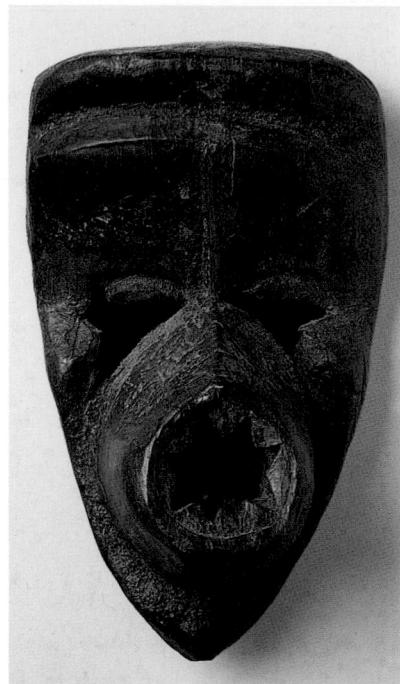

5.128p
Dan (Yacuba, Gio, Geh)
Liberia, Ivory Coast
20th century
wood
h. 12.7 cm
Private Collection

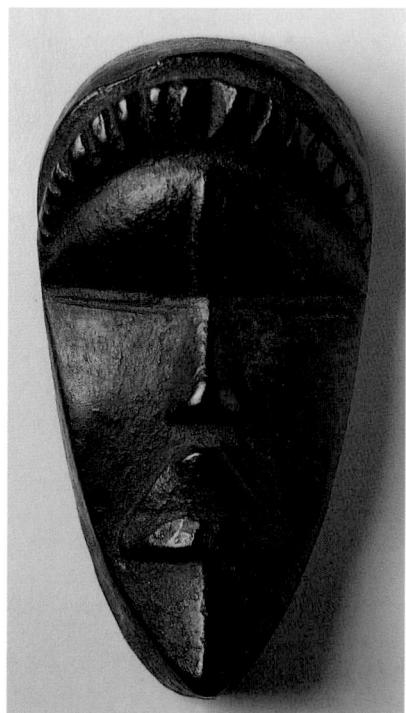

5.128q
Mano
Liberia, Ivory Coast
20th century
wood
h. 10.7 cm
Private Collection

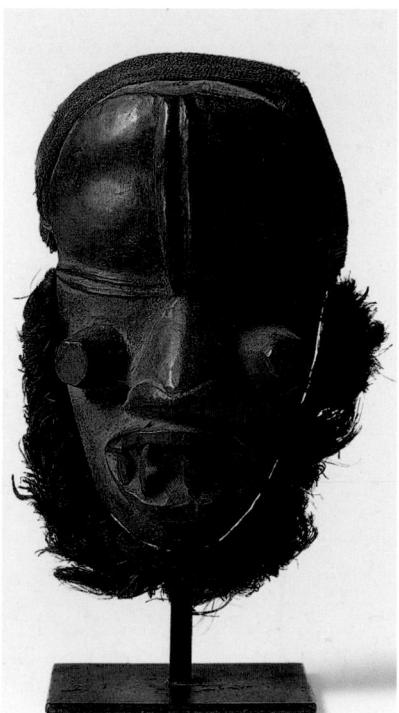

5.128r
Wenion (Wè, Guéré)
Liberia, Ivory Coast
20th century
wood
h. 17 cm
Herman Collection

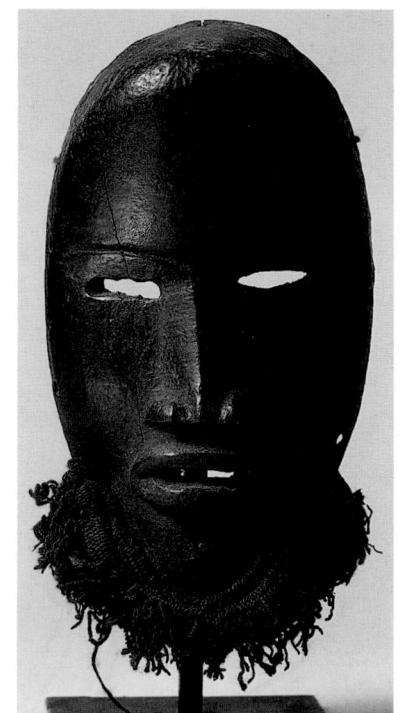

5.128s
Dan
Liberia, Ivory Coast
20th century
wood
h. 18 cm
Herman Collection

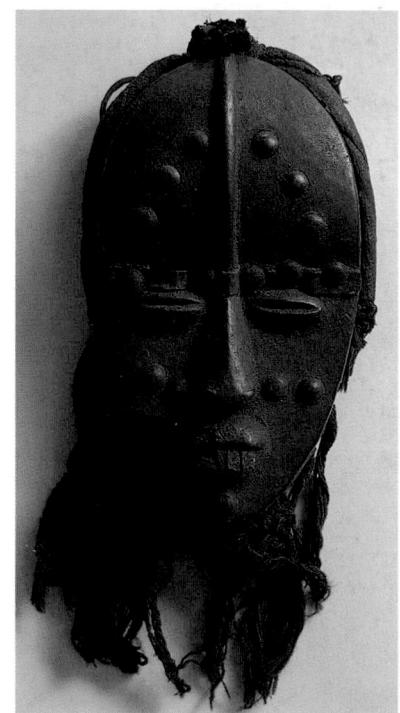

5.128t
Dan
Liberia, Ivory Coast
20th century
wood, cotton, iron
h. 15 cm
Musée National des Arts d'Afrique et d'Océanie, Paris, A 67.1.8

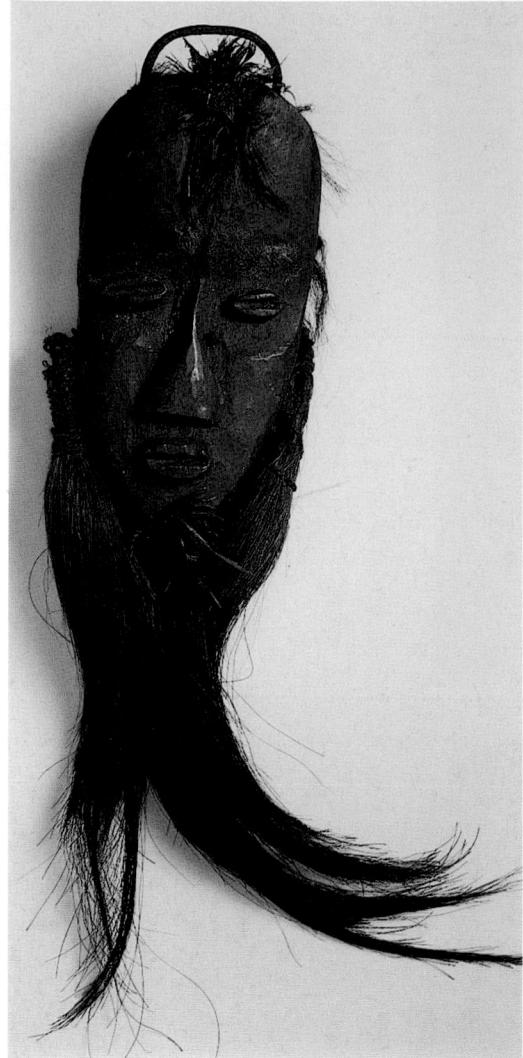

5.128u

Dan
Liberia, Ivory Coast
c. 1868
wood, fibre, animal skin, bone, beads,
gummy residue
37 x 9 x 5 cm
The Trustees of the British Museum,
London, 4572

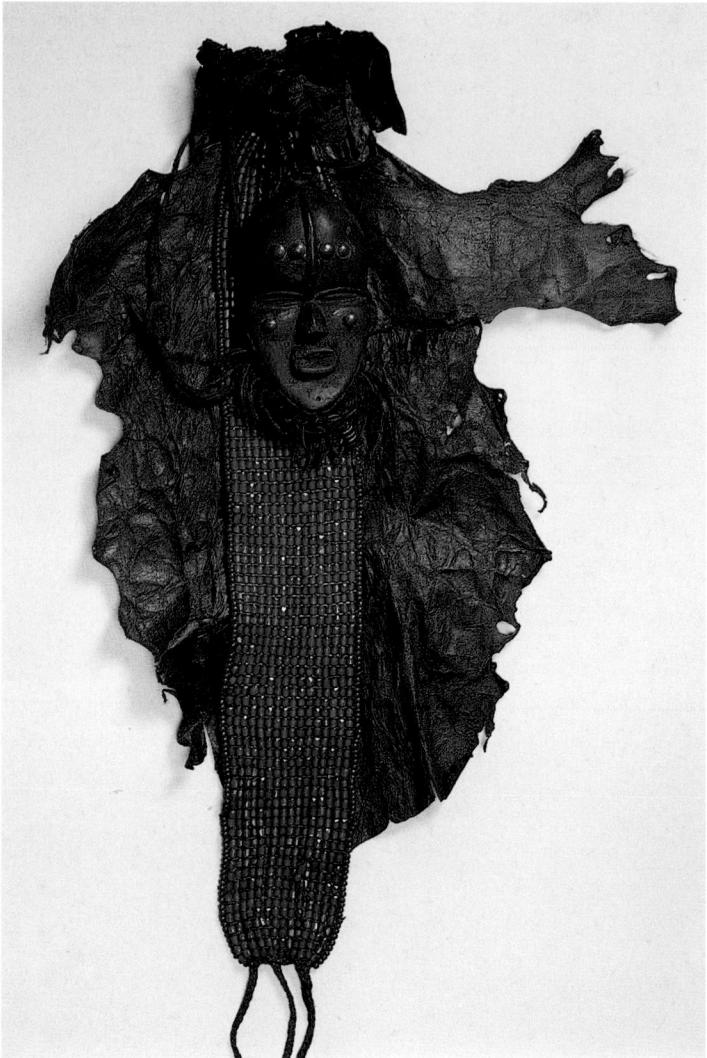

5.128v

Dan
Liberia, Ivory Coast
c. 1868
wood, fibre, animal skin, bone, beads,
gummy residue
63 x 46 x 6 cm
The Trustees of the British Museum,
London, 4572

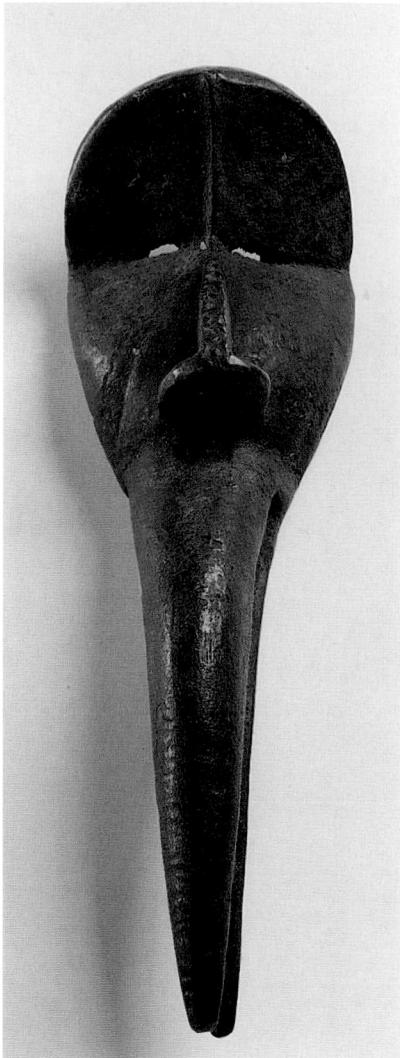

5.128w

Mano
Liberia, Ivory Coast
20th century
wood, metal
h. 23 cm
Museum für Völkerkunde, Vienna,
126.169

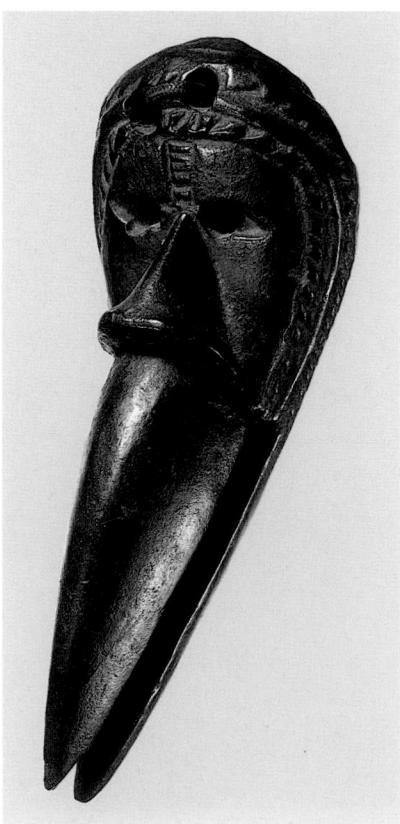

5.128x

Dan
Liberia, Ivory Coast
20th century
wood
h. 16.5 cm
Rosemary and George Lois Collection

Many-eyed mask

Kru
Ivory Coast
20th century
wood, vegetable fibre
42 x 16 x 21 cm
Musée Ethnographique de Dakar,
CI, 55-1-52, on loan to the Musée National
des Arts d'Afrique et d'Océanie, Paris,
67.1.7

This spectacular mask with two rows of tubular eyes is a rare object and information about it is just as rare.

Its unique feature is the exaggerated number of projecting cylindrical eye forms that elongate the facial planes. In a number of west African communities the phrase 'four eyes' refers to a person such as a seer or a witch to whom is attributed the power of seeing (with the extra pair of eyes) into realms and forces invisible to normal social beings. This metaphor may have inspired the multiplication of eye forms for masks, considering that masqueraders in numerous other communities are held to have such powers. Small holes for actual vision are punched alongside the nostrils.

Scholars now assign this mask to the Kru, a small population inhabiting the western coastal region of the Ivory Coast. The Kru are known to have produced a few other masks resembling this one, with a flattened base, one or more pairs of tubular eyes, a thin nasal ridge and a rectangular mouth with projecting parallel lips. The mask is carved from a single piece of wood, a practice that is typical of sub-Saharan African sculpture, although on some Kru masks the cylindrical eyes and other details are added.

In the coastal region masks were painted typically with irregular triangular or round areas of ochre and white pigment from local sources and laundry blue from markets. The dark surface of the mask seems to be the result of a coating of redwood powder and a vinyl glue, applied in a misguided effort to seal the many insect holes. The beard is attached to a fibre strand held by hooks on either side, but there are no holes along the sides for the attachment of a costume to hide the porter of the mask.

Masking was not a prominent institution among the Kru. No one has reported seeing this particular

kind of long flat mask in use.

In addition to this rare form, there are two other varieties of the abstractly featured Kru mask: one with a wooden disc or carved horns extending beyond the face; the other, with or without extensions, adds a massive forehead that projects over the face. The latter kind includes the two Kru masks owned by Picasso, undoubtedly collected in the Ivory Coast and attributed to the 'Grebo' as a general term covering the Kru and their neighbours in eastern Liberia.

Worn vertically, Kru masks were, according to reports, danced to celebrate fighting prowess or to mime a communal story. In one account the mask form was not destined for the dance, but with a small hollow in the back for protective medicines, it was set up in front of the chief's house as a mark of his office. Judging by photographs of masks collected from the coastal region in the 1890s and a few scenes of performance since 1960, a Kru mask when worn was fitted below a huge headdress consisting of an arc-shaped fibre framework covered with a band of cloth and trimmed with a stiff fringe of palm-leaf strips and long waving feathers (to spectacular effect). Otherwise the mask was obscured by being fastened within a panel of painted, plaited palm fibres that was set on top of the performer's head or attached in front of a conical bonnet, leaving the face visible. This method of attachment may account for the lack of holes on a number of Kru masks. It is possible, however, that some early 20th-century examples were made without holes for sale to French sailors who then traded their African 'antiquities' at the docks in Paris.

Seen vertically, the flat base and abstracted features of Kru masks may seem unique, but a consideration of Kru history makes it plausible that the origin of this unusual form lies in the contacts between the Kru and the Ijo peoples in southern Nigeria. For centuries the coastal Kru people have been favoured to work with European traders along the coast. Widely known as '*krumen*' (a linguistic coincidence), they were sought after as cargo-loaders and sailors. In the second half of the 19th century they worked for English shippers in the palm-oil trade all the way to the Niger Delta region and beyond.

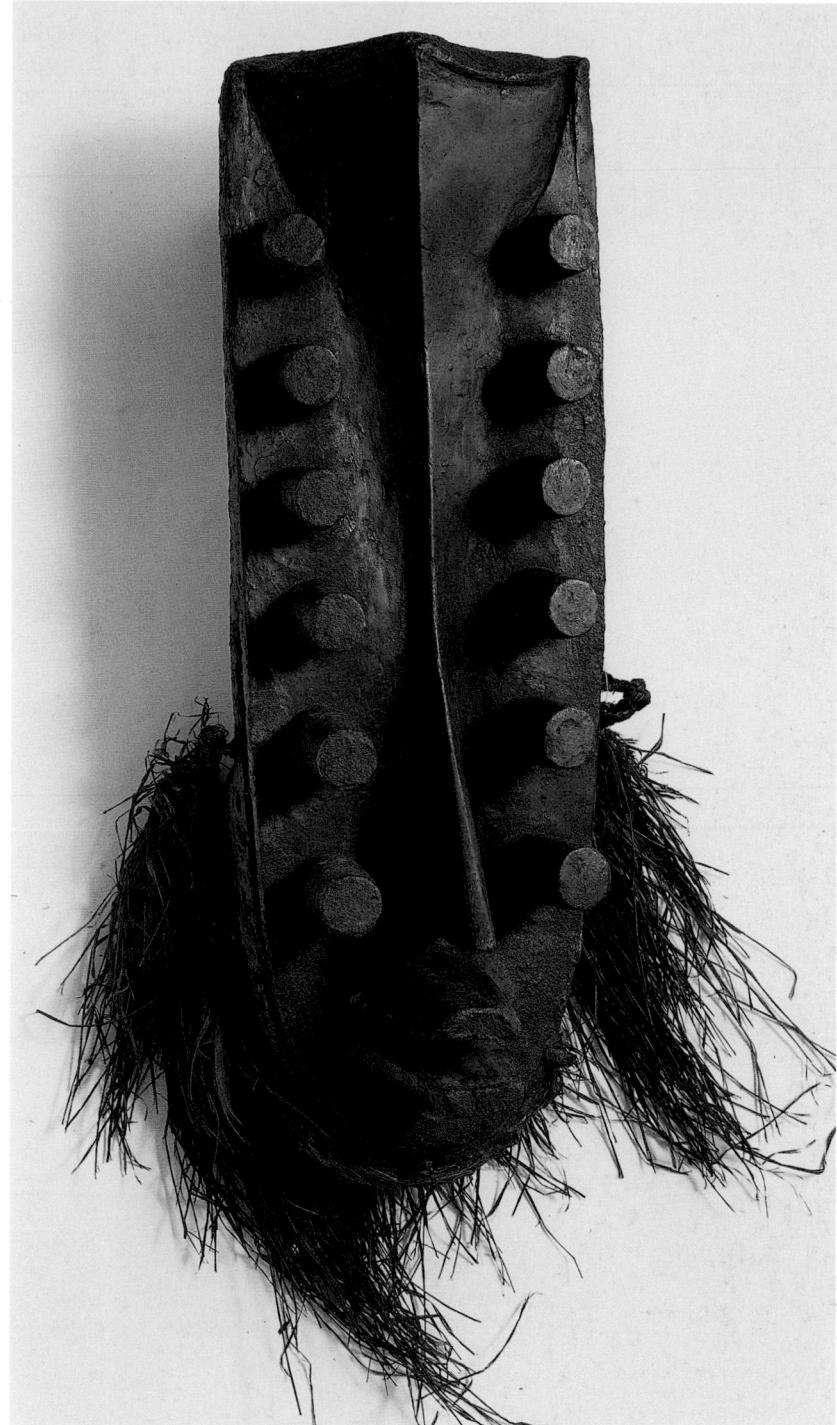

In this work they came in contact with the Ijo. Through handling transport and trade between the Niger Delta and inland markets, the Ijo, like the Kru, were accustomed to life on boats, and were also active in the English palm-oil trade. For their major cult of water spirit performances, the Ijo created severely abstract wooden masks that exhibit a structure comparable to those of the Kru. This kind of mask was placed on top of the performer's head and obscured with various forms of palm-leaf fibre ruffs or drapery; that is, the masks were

worn horizontally rather than vertically. Because of the quantity of Ijo masks, their integration into a major cult and their greater visual elaboration, it is reasonable to consider them the inspiration for the abstract Kru masks. MA

Bibliography: Frobenius, 1898, pl. XI, figs 110–14; Vandenhoutte, 1948, pl. XVI, p. 48; Krieger, 1960, fig. 16; Horton, 1965, pls 46, 68, 70; Brooks, 1972, p. 35; Holas, 1976, p. 70; Holas, 1980, cover, pls ff. p. 256; Verger-Fèvre, 1980, pl. H-4; Jones, 1984, pp. 160–3; Rubin, 1984, i, pp. 20–1, 260, 305; Herter, 1991, pp. 58–71; Verger-Fèvre, 1995, pp. 1–2

Human figure

Kru (?)
Liberia
19th century
wood, pigment
h. 107 cm
Staatliche Museen zu Berlin, Preussischer Kulturbesitz, Museum für Völkerkunde, III C 28582

This statue is one of the oldest carvings from the coastal regions of Liberia. It was purchased by the Berlin museum in 1913 from a respected English dealer, with the following information: 'Kru, Liberia. A very old specimen. Brought to England before 1865.' No other known figure is covered with incised designs and coloured with red and black pigments as this one is.

The sculpture of the Kru of Liberia is little studied, and no information is available on the use of this statue. One might suppose – in view of the way Kru men in the first half of the 19th century travelled as itinerant labourers for European shipping trade as far away as Gabon and regularly to the West Indies – that this statue was brought from some other region than west Africa. This is unlikely for two reasons. First, human figures, although not common, were used among other peoples of western Liberia, both coastal and interior. For example, at the entrance to a village, travellers frequently encountered a carved post of this height with a human head at the top. Less visible was the statue attached to a post marking the headman's house altar. Second – and more indicative of a local origin – are the features that recur in regional statuary, such as the projecting brow, thin ridged nose and oval, pointed face, and the rhythm of the incised designs. The way in which the carver sets up a repeating rhythm of striped rectangular units at the shoulders and then changes the interior shapes, sizes and angle of placement further down the column is a fine example of a style of visual design characteristic of artists' work on two-dimensional surfaces in west Africa. It forsakes symmetry for the benefit of variety and individuality. MA

Provenance: before 1865, in England; 1913, purchased by the museum

Bibliography: Krieger, 1965, 1, pl. 18, p. 24; Adams, 1989, pp. 35–43; Siegmann, 1995

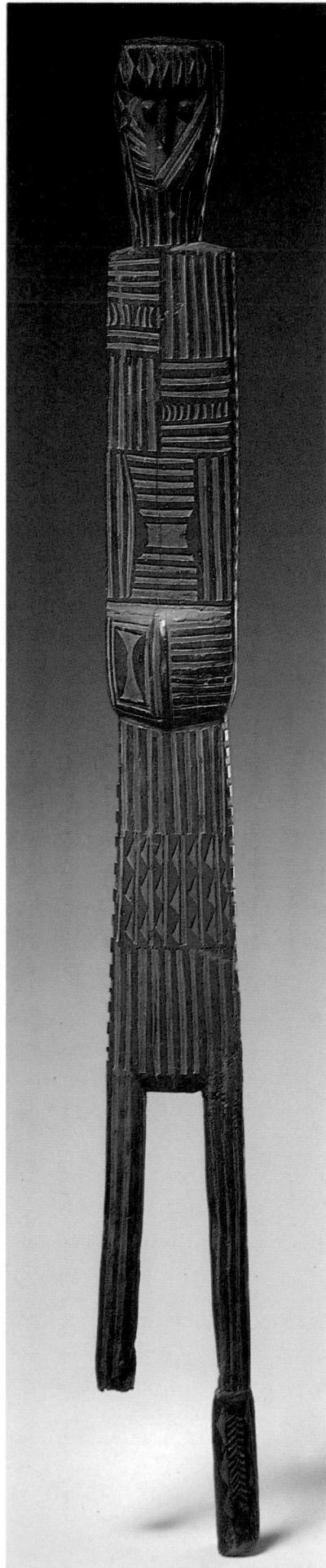**Standing female figure**

Bete
Ivory Coast
20th century
wood
h. 74.9 cm
Maureen and Harold Zaremba

This forthright and well carved figure is difficult to identify precisely, and that makes it an interesting object to examine. One of the features typical of known Bete figures is not apparent here, that is, the angled joining of the legs at the groin. The figure may, nevertheless, be a product of a Bete carver's hand because style regions did not have rigid boundaries. Usually around the borders there would be some interpenetration of neighbouring carving styles. In addition, for lack of research, we do not know how much variation in carving styles occurred within the Bete region.

To add to the difficulty, the introduction of colonial administration in the first half of this century changed many ways of life in west Africa, including carving styles. Especially from the second quarter of the 20th century, there were more opportunities for travel and interchange of visits and ideas. The result was that carvers could more readily take on commissions from distant chiefs and stay for weeks at a chief's expense while completing an order of masks, figures and other carvings. The Dan people who live to the west of the Bete were noted as skilful carvers. Their sculptors were especially likely to circulate on invitation and certainly their works became even more widely known among their neighbours than in earlier times.

These complex interactive situations may account for the numerous Dan-like features on this Bete figure, such as the straight vertical stance with arms symmetrically posed. The proportions of the major body parts, that is, head, neck and torso size with short legs, are also more like Dan forms than Bete. In spite of the Dan-like features, the head and facial contours do not follow Dan models.

The arms on this figure are exceptionally long. On Dan figures in general the arms occasionally extend up to or slightly beyond the hip-line. This in itself is unusual because a consistent characteristic of figural carving in the sub-Saharan region

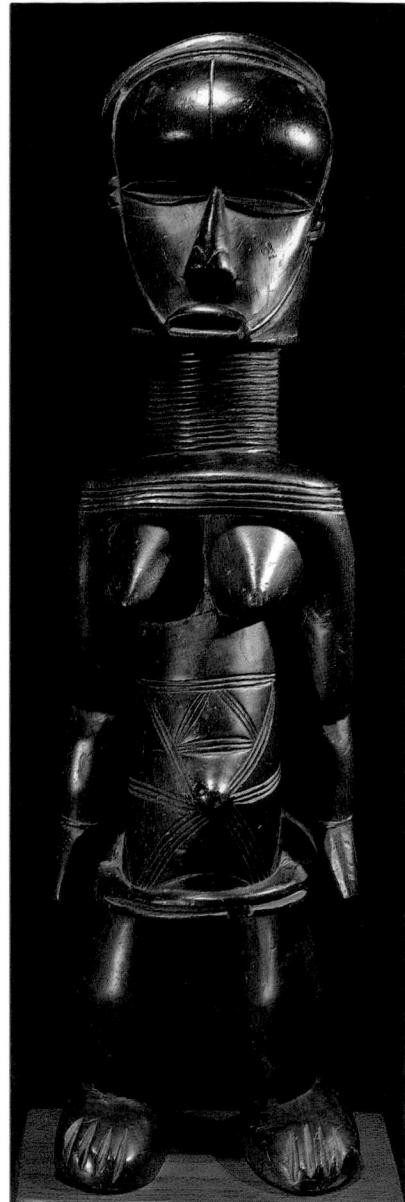

is separation of body parts, achieved notably through shortening the arms, so that they do not link the torso and hip mass.

The visual interest in this statuette lies in the fine formal rhythm; there is a play between the shaping of the body parts and the repetition of strong horizontals seen in the indentation at eye level, the straight chin and squared shoulders. These horizontal forms are enlivened by small surface effects such as the simple shape of the eyes and mouth, neck striations, shoulder banding and hip rings. MA

Bibliography: Fischer and Himmelheber, 1984, figs 110–11, 153–7; Herold, 1985, figs 21–6

Salcellar

Master of the Symbolic Execution

Sapi-Portuguese
 Sierra Leone
 16th century
 ivory
 h. 42 cm
 Museo Preistorico Etnografico
 'L. Pigorini', Rome, 1973, 104.079

The neologism 'Afro-Portuguese ivories', first used by William Fagg, designates a group of refined ivory works of art (saltcellars, pyxides, spoons, forks, dagger handles and oliphants) created between the end of the 15th century and the mid-16th by African Sapi artists of Sierra Leone and Yoruba or Edo artists of Benin, to be exported to Europe. The ivories show, in their shape and decoration, a perfect fusion of African and European figurative elements, the latter evidently suggested by Portuguese clients and therefore useful for dating works. The specimens from Sierra Leone were identified through convincing analogies between the ivories and early carvings in soft stone from the same region.

References to such saltcellars go back to the records of the treasurer of the Casa de Guiné (1504–5, the only book to escape the Lisbon earthquake of 1755), which mentions the collection of a tax of 25 per cent on 'saleiros' and 'colhares' of ivory imported from Africa to Portugal. The word 'salyros' also occurs in a report (1506–10) by Valentim Fernandes, who wrote that the inhabitants of Sierra Leone 'are black and very talented in manual art, that is [they create] ivory saltcellars and spoons. They carve in ivory any work which we draw for them'. This draws attention to the fact that designs were submitted to African carvers by European clients.

The Sapi-Portuguese saltcellars may be divided broadly in two main categories: those with a conical base and others with an openwork, cylindrical base. The specimen here is of the second type, which normally shows fewer European elements than the first, both in shape and decoration.

The spherical lidded bowl resting on a platform might have been inspired by a container (gourd or terracotta) supported by a caryatid stool. The scene carved on the lid,

a multiple execution, seems to refer to a practice of the country described in early chronicles. The executioner, however, and the two men seated on the base (next to two women showing scarifications) wear codpieces. The decoration is mainly of rows of beads alternating with straight lines and is typical of Manueline architecture, so called after Emanuel I, King of Portugal from 1495 to 1521. The head of the victim, the hand of the executioner and the improbable axe are recent restorations.

The gigantic size of the executioner compared with the victims suggests a symbolic representation of a great chief endowed with the power of life and death – hence the naming of the creator of the saltcellar as the 'Master of the Symbolic Execution'. He was a great, sophisticated and inventive artist, able to combine elegance with a high degree of compositional skill. Two equally perfect saltcellars can probably be attributed to him. EB

Exhibition: Washington 1991, no. 67

Bibliography: Fyfe, 1964; Ryder, 1964; Mota, 1975; Bassani and Fagg, 1988; Bassani, 1994

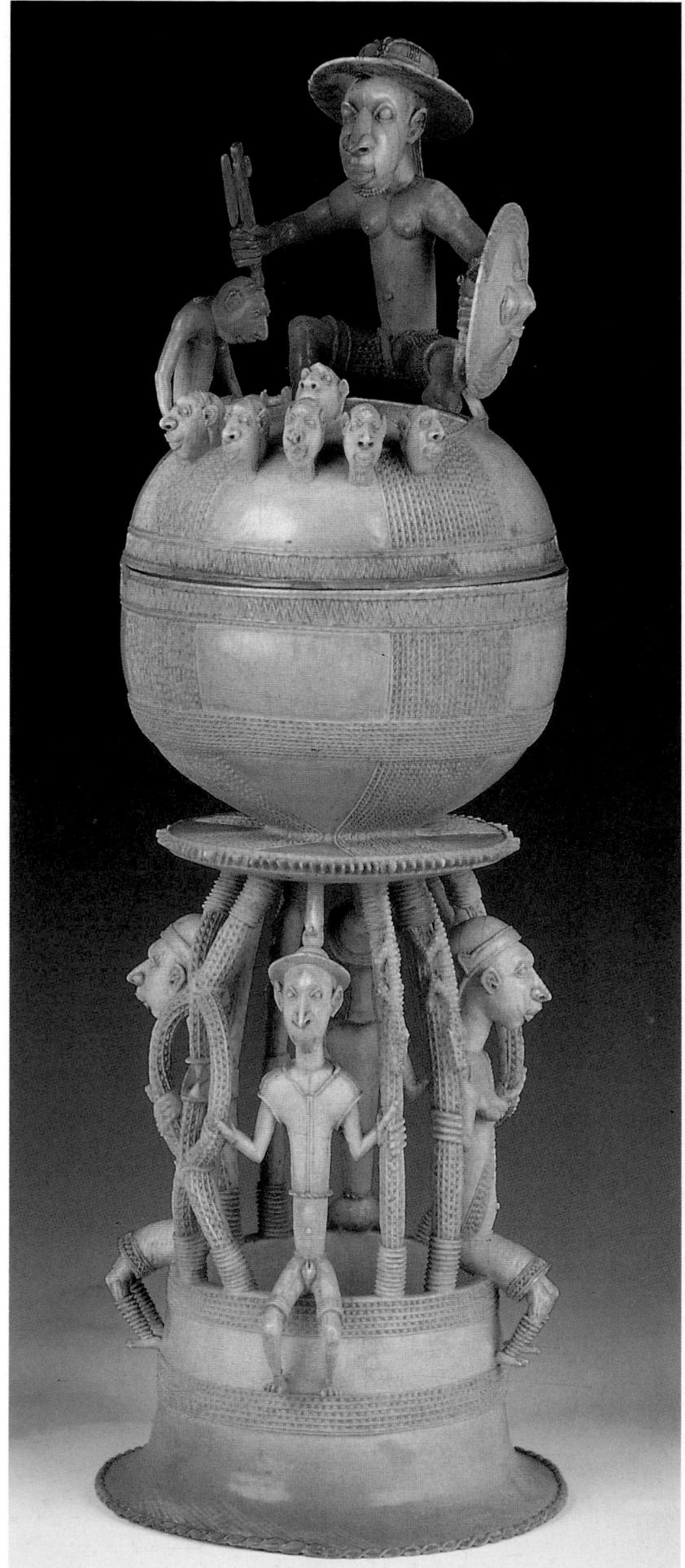

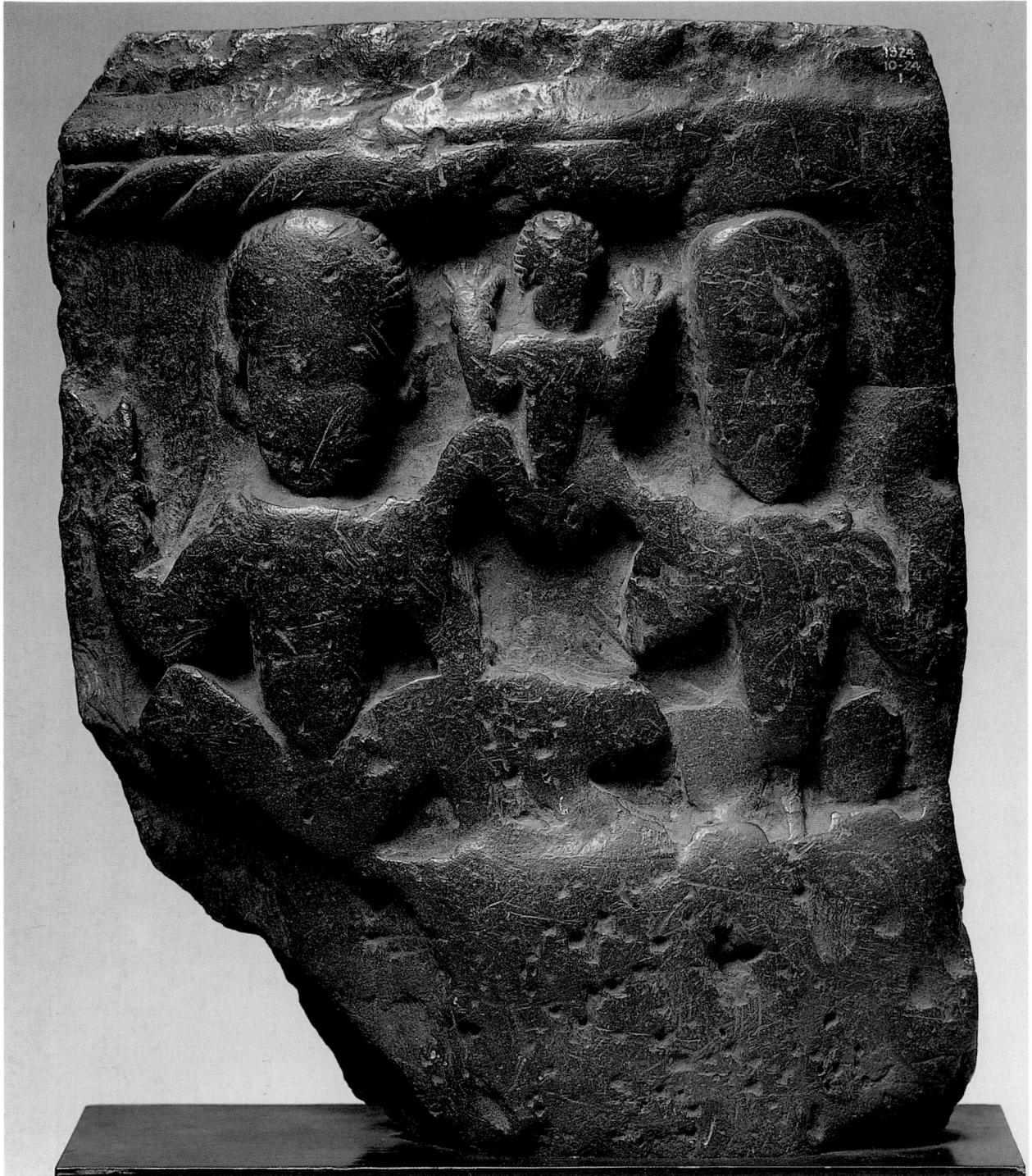

5.133a

Sculpted tabletSierra Leone
soapstone

43 x 31 cm

The Trustees of the British Museum,
London, 1924. 10.24.1

A small area of the Upper Guinea Coast, embracing adjacent parts of the modern states of Guinea, Sierra Leone and Liberia, is one of the few places in sub-Saharan Africa where people have carved in stone. The material used was usually steatite or soapstone, whose relative softness allows it to be carved with tools and techniques similar to those used in woodcarving. The sculptures made were for the most part human figure carvings between 7.5 and 15 cm in height; but there were also a significant number

of sculpted heads, near life-size, on pedestal-like necks, some examples of sculpted animal figures, and at least one enigmatic sculpted stone slab.

Those found in south-eastern Sierra Leone close to the Atlantic coast are generally referred to today by the Mende term *nomoli* (pl. *nomolisia*) and are characterised by large rounded heads projected forwards from the neck, protruberant eyes, a fleshy nose with flaring nostrils, and full lips. A stylistically more varied group, found further inland, is nowadays

referred to by the Kissi term *pomdo* (pl. *pomda/pomta*), even where the sculptures are known to have been found outside present Kissi homelands. These vary from simple columns on which a semblance of a human face has been roughly scratched to elaborate sculptures involving multiple figures and/or considerable descriptive detail.

It seems likely that the great majority of these sculptures are centuries old. The present inhabitants of the area find them buried in the soil or in watercourses in the course of preparing their farms, fishing or digging for diamonds. The Mende people believe that they were made by previous inhabitants or by spirits; they regard them as 'rice gods' and make offerings to them to increase their harvests. The Kissi for their part look upon them as manifestations of their deceased ancestors and place them in ancestral shrines. (There are a few instances of more recent stone carvings, but these seem generally to be regarded by local people as quite different from the ancient works.)

Scholars have concluded that these sculptures were probably made by ancestors of the present Kissi, Krim and Bullom peoples who originally occupied the areas where they are now found. Since most of these areas are today occupied by the Kono and Mende peoples, it is also argued that they must have been made before the latter settled in their current homelands. The date when this occurred is, however, still a matter of controversy.

There is no evidence that sculpting in stone was still being carried on in Upper Guinea when the Portuguese made their first contacts with the coast c.1460. Contemporary Portuguese descriptions of this part of west Africa make no reference to stone sculpture, and, despite some rather fanciful claims made in the past, no surviving examples of stone sculpture show features definitely derived from European models or definitely representing European dress or artefacts. It is, therefore, probable that the stone sculptures predate the mid-15th century, and some may be much older.

The Upper Guinea stone sculptures cannot be convincingly related to any other stonemasonry tradition, in Africa or elsewhere. Their only close affinities are with sculptures in other

materials that are found in adjacent parts of Upper Guinea. A few rare examples of ancient woodcarvings that stylistically mirror the differences between the *nomoli* and *pomdo* figures have come to light within the last 20 years. So, too, have a few clay heads and figures. However, the major carving tradition that can be related to the stone sculptures consists in some 100 or so hybrid works of ivory sculpture made for the Portuguese by African craftsmen in Sierra Leone in the late 15th and early 16th centuries: the so-called Sapi-Portuguese ivories. (Sapi was the name the Portuguese gave to a number of peoples speaking related languages along the Upper Guinea Coast, including the Baga, the Temne and the Bullom; cf. cat. 5.137–8).

The function of these stone sculptures is not certain. A number of figures (and the pedestal heads) seem to show personages wearing ornaments (rings, bracelets), astride animals and carrying weapons, all of which are most probably indications of rank. It has been plausibly suggested that the persons represented are dead chiefs or notables. However, until stone figures have been discovered in the course of a properly conducted archaeological excavation, there is no means of putting this hypothesis to the test. The differences between certain of the stone carvings are in any case so great that it is unlikely that there was any single function that they were meant to fulfil. *WH*

Provenance: cat. 5.133b: 1909, given to the museum by Major G. Anderson

Bibliography: Thompson, 1852; Rutimeyer, 1901; Rutimeyer, 1908; Person, 1961; Dittmer, 1967; Tagliaferri and Hammacher, 1974; Lamp, 1983; Tagliaferri, 1989; Hart and Fyfe, 1995

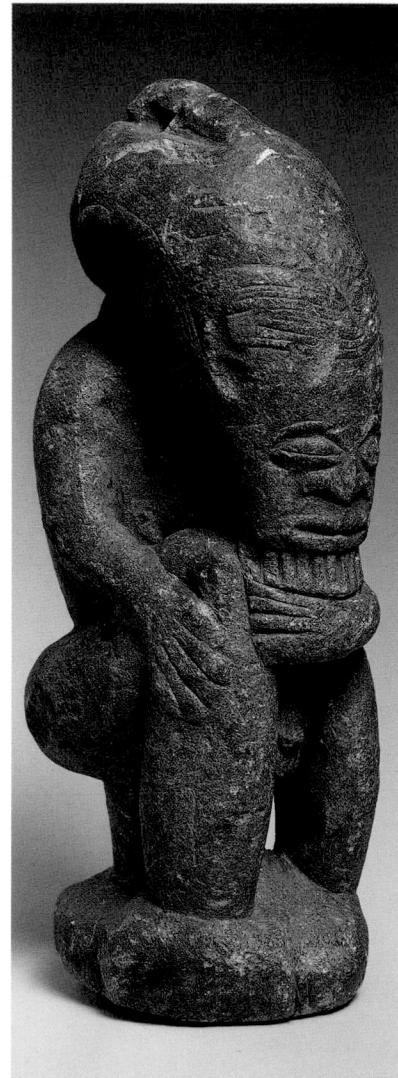

5.133b

Figure

Sapi
Sierra Leone
soapstone
h. 50 cm

The Trustees of the British Museum,
London, 1909. 2-20.1

5.133c

Reclining Figure

Sapi
Sierra Leone
soapstone
h. 36 cm
The Trustees of the British Museum,
London, 1904. 4-15.1

5.133d

Figure

Guinea
soapstone
h. 26 cm
Laboratoire d'Ethnologie,
Musée de l'Homme, Paris, 52.13.1

5.133e

Head

Sherbro
Sierra Leone
stone
h. 24 cm
Musée Barbier-Mueller,
Geneva, 1002-1

5.135f

Figure

Sapi
Sierra Leone
soapstone
h. 14 cm
The Trustees of the British Museum,
London, 1906. A. 5-25.2

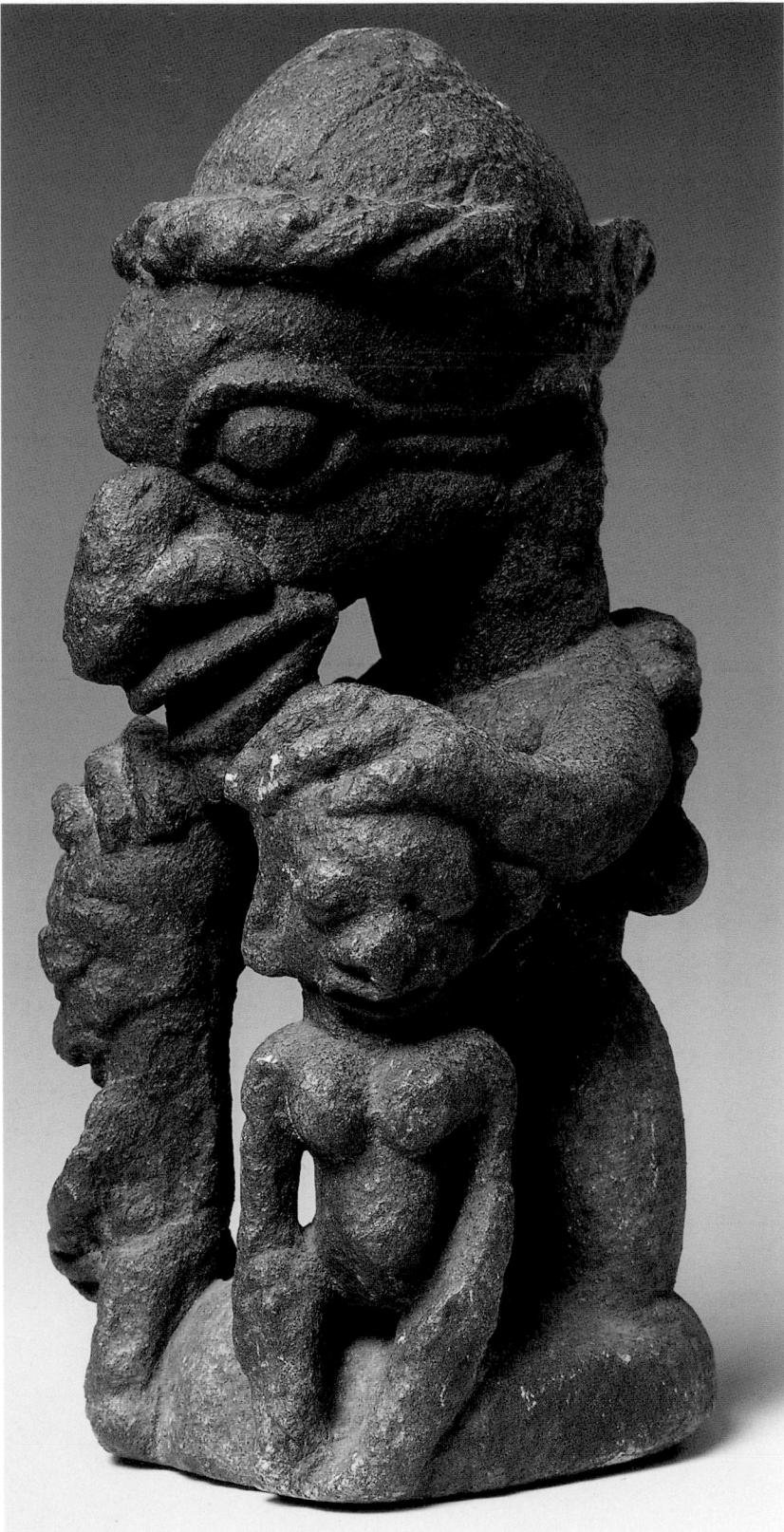

5.135g

Figure

Sapi
Sierra Leone
soapstone
h. 18 cm
Pitt Rivers Museum, Oxford, 1934.24.2

In recent years a few extremely weathered wooden figures have come to light which seem stylistically to match the ancient stone sculptures dug up in Sierra Leone, Guinea and Liberia. It seems probable, therefore, that they are of similar age. One such figure has been carbon-dated to the period 1190–1394, the earliest dating for any work of art from this area. However, in the absence of any known archaeological context, this result must be treated with caution.

The two figures displayed here illustrate this stylistic matching. The stone figure (cat. 5.134a) is an unusually well-preserved example of the style of sculpture found among the Kono of eastern Sierra Leone and the Kissi of Guinea. Beneath a hooked nose the edges of the mouth are drawn back to reveal pointed teeth. There are well-defined body markings on the chest and around the projecting navel. This pointing of the teeth and body scarification were described among the Temne and Bullom in the 16th century, and are additional evidence linking the sculptures to the Sapi peoples. The squatting or kneeling posture of the figure is echoed in that of the wooden figure (cat. 5.134b), although the erosion of the surface of the latter means that little of the finer detail, if there was any, has survived. They show similar conventions in the representation of the head and face. The austerity of the carving style makes it uncertain whether the two figures are wearing a cap with a high crest running front to back or whether this represents a way of dressing the hair. *WH*

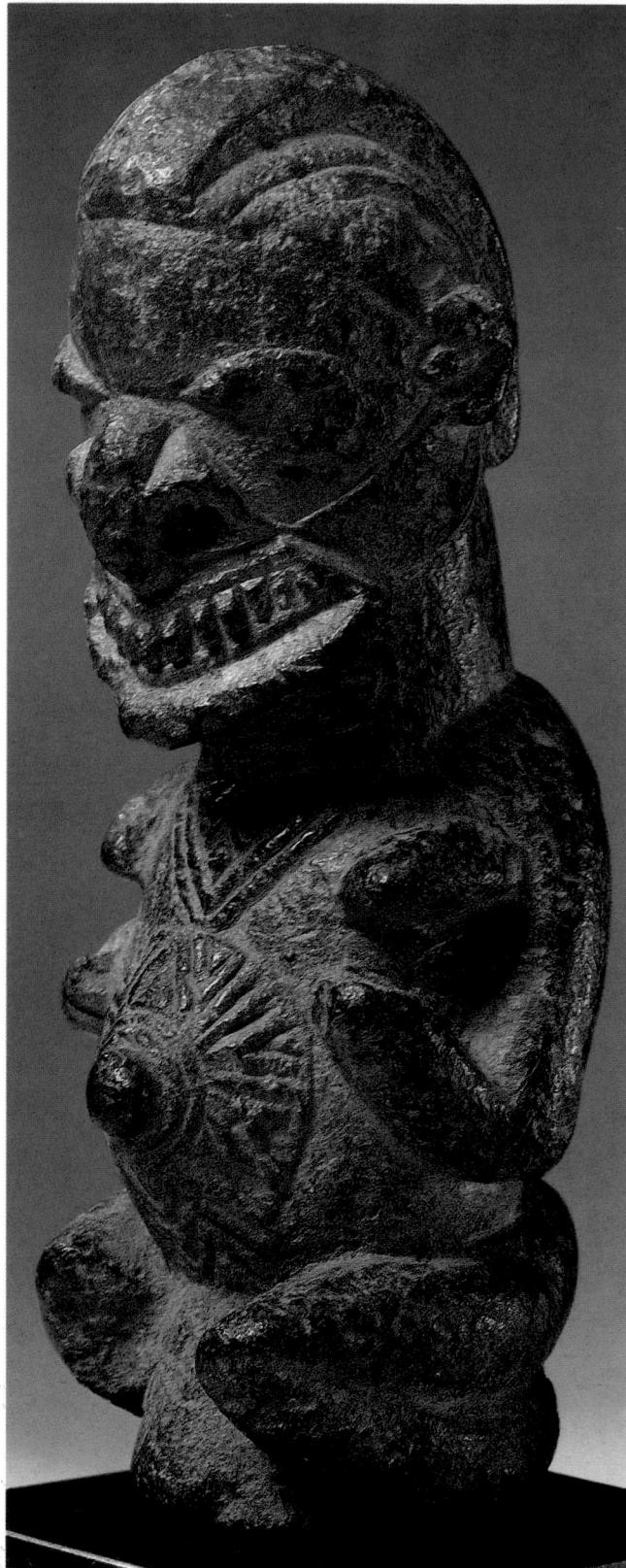

5.134a

Figure

Kissi, Guinea
c. 15th–16th century
soapstone
16.2 x 4.5 x 6 cm
L. Lanfranchi Collection, Milan

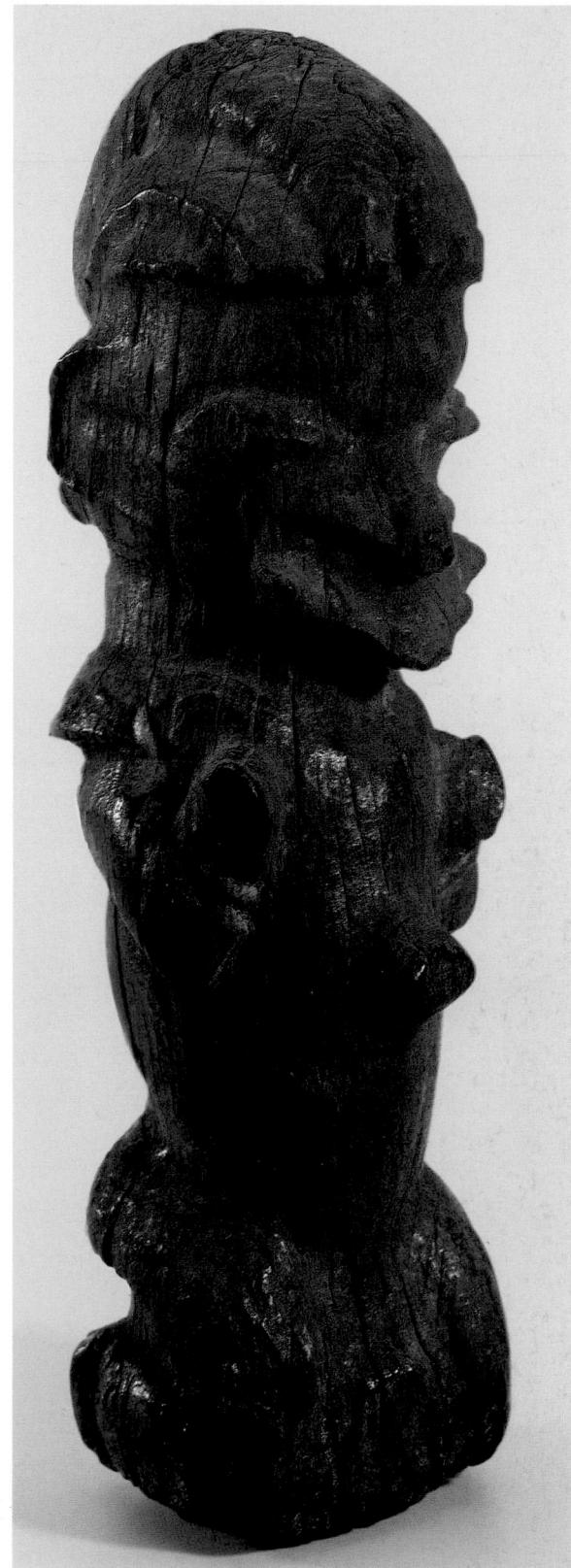

5.134b

Figure

Kissi, Guinea
c. 15th–16th century
wood
24.5 x 7 x 8.5 cm
Vittorio Mangiò

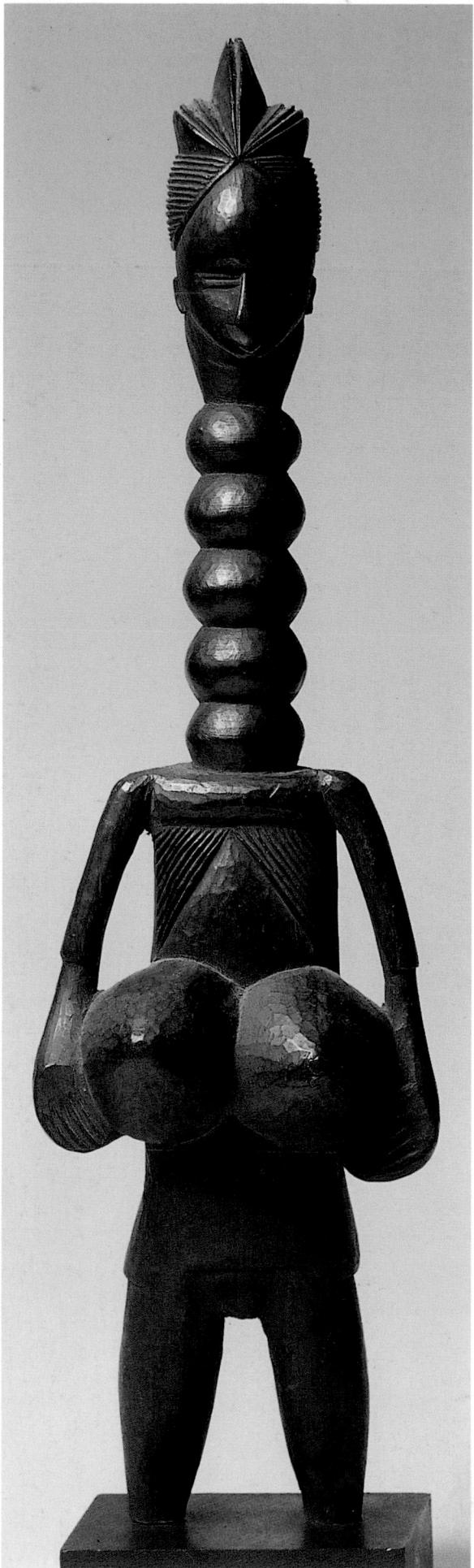

5.135

Female standing figure

Mende
Sierra Leone
20th century
wood
43.5 x 12 x 12 cm
Herman Collection

The large Mende population comprises numerous kinds of social structure, such as firmly marked kin groups, political hierarchies and societies for diverse purposes: training boys and girls in appropriate behaviour, protection against enemies or curing illnesses. Most bodily ills are believed to result from transgressions against the rules of conduct laid down by one sodality or another. The Njaye society of the Kpa Mende region, open to both men and women, offers a typical example. Its particular concerns are the treatment of mental illness and the means of increasing one's personal magnetism and fertility. The society possesses a secret 'medicine' that is the source of its power to enforce its rules on the community. Such medicines consist of natural substances such as plant materials and rocks, manipulated so as to be imbued with invisible powers.

The various sodalities employ sculpted figures as guardians and as curative agents. The majority represent the female figure, either seated or standing, with the hands touching the body and the arms held slightly apart from the torso. The statues are usually dressed with beaded or cloth aprons and bead necklaces. Such figures are placed in or near the sodality's processions when the society officials appear in public.

The statue could have been used in ritual or for prestige. Full-length figures with hands placed at or on the breasts were part of the curing ritual of the Sando society. All over the Mende region (except in Bonthe district) carved figures could serve as house ornaments. The possession of carvings of persons or animals 'to dress the house' added to the prestige of prosperous men. Between 1930 and 1961, British district officers encouraged regular displays of carvings at district meetings of paramount chiefs. It was a competitive display, and the winner received a money prize which was passed on to the carver. In Mende society any young male may apprentice or set himself up as

a carver. Until he earns a virtuoso reputation, the carver works intermittently or travels to find clients. Nowadays carvers produce pieces at home which itinerant traders carry throughout the region and to international markets. *'MA'*

Bibliography: Hommel, 1974; Phillips, 1979, pp. 104-9

5.136

Helmet mask

Mende
Sierra Leone
20th century
wood
45 x 23 x 23 cm
Private Collection

In sub-Saharan Africa only men are normally permitted on ritual occasions to wear wooden masks. This black helmet mask is worn exclusively by women. The practice of women wearing masks seems to have been brought to several populations of Sierra Leone and Liberia, such as the Temne, Gola and Vai,

by the Mende and Mande-speaking people from the northern savanna. Because of the similarity of mask styles and the itinerant pathways of noted carvers, it is difficult to assign some masks to a particular ethnic group.

In the 19th century the Mende were organised into independent chiefdoms; families and individuals were ranked according to their land-use rights. Industrious rice farmers, the Mende number approximately two million people. The rituals of their women's society, called Sande, require the appearance of masked figures. Within such a large population there are many variations in local practices and carving styles, but there is broad agreement on the nature of the mask itself.

The mask presents an ideal of feminine beauty admired by the Mende: elaborate hairstyle, full forehead and small facial features. The gleaming surface signifies healthy, glowing skin. This particular mask is unusual because it lacks the swelling fleshy rolls alternating with deep incised lines at the neck or back of the head. These effects are considered marks of beauty and a promise of fecundity. The neck is broad to fit over the head of the woman who will wear it. Sande officials commission male carvers to produce the mask in secret. The surface is smoothed with the rough leaves of the ficus tree, then dyed black with a concoction made of leaves. Before use, it is anointed with palm oil to make it shine. (Modern carvers use black shoe polish.)

With this confining mask, the wearer (who has to be a good dancer and an official of the Sande) puts on a thick cotton costume covered with heavy fibre strands dyed black. Her dances may last for over two hours. The sacredness of the mask lies in its deeper meaning as a representation of the long deceased founder of Sande society. In pre-colonial times women could hold the position of chief of a village cluster; until the 1970s women politicians continued to use the Sande society to support and further their careers in modern government. With increasingly rigorous Islamisation, however, the Sande society is being seriously modified or even disbanded. *MA*

Bibliography: Phillips, 1979; Phillips, 1985

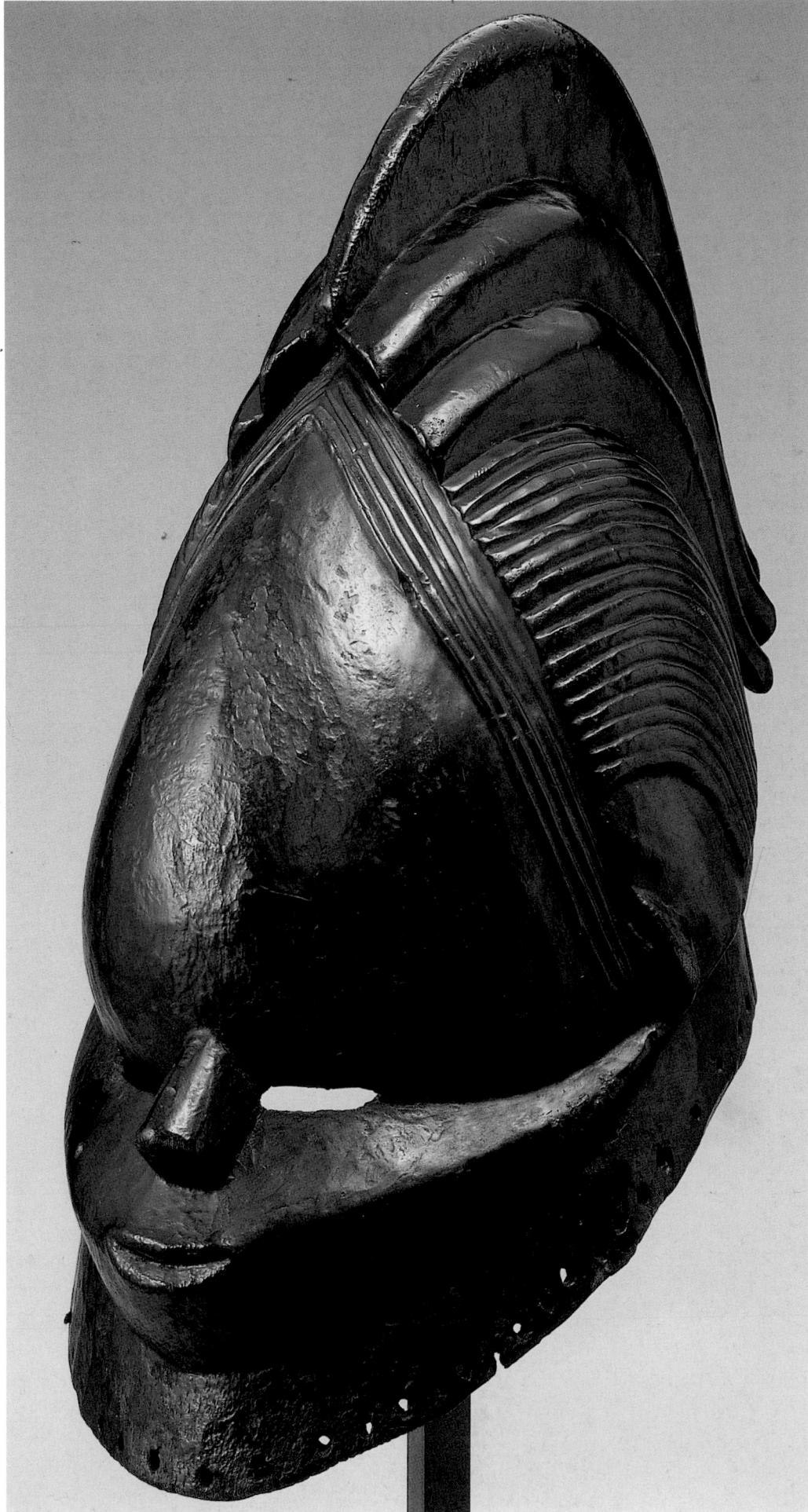

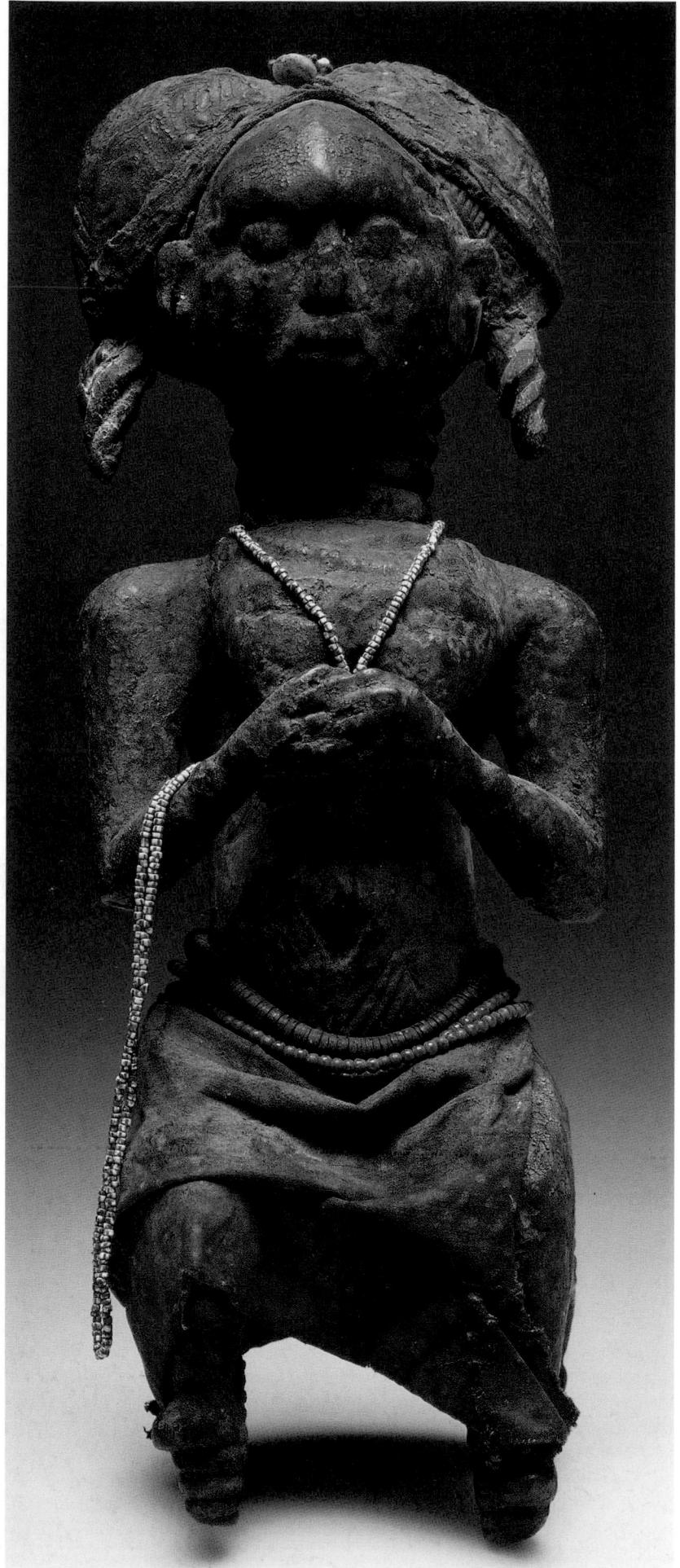

5.137

Seated female figure

Temne

Sierra Leone

early 20th century

wood, cloth, beads, cowrie shells, button, fibre

h. 45.5 cm

Museum of Ethnology, Rotterdam, 58629

The female figure seated on a stool is rare in Sierra Leone, where it is found only among the Temne, and used by the officials (*an-Digba*) of the women's Bondo association. The head of the local chapter may keep such a figure among her prized ritual possessions, hidden in her private room. It would be brought out in public on only one occasion, at the girls' initiation to adulthood.

Bondo is a universal association for women among the Temne, related to Sande among the Mende people to the south. The leadership has a hierarchy of five essential ranks: Soko, the highest, who wears a red cloth; a group of titled Digbas; Sampa, the dancer who wears a red mitred cap; several technicians in internship; and the 'Chimpanzees' (*ta-Wotho*), the Digbas in basic training. Initiation is usually held every three or four years, alternating with the initiation for boys, called Poro. Girls may be as young as six, or in their late teens, but are usually about thirteen, as the year-long initiation ritual serves as the principal marriage ceremony.

At the first ceremonies, when the girls are led to a sacred grove at the riverside, the figure may be carried by the Soko at the head of the procession, dressed in the costume of the well-known Bondo spirit, Nöwo (or Sowo). This is a quiet ceremony, not for public view, in which the girls file to the river for a ritual bathing and then proceed to a forest grove where they will receive a clitoridectomy, and retire for two weeks before the public opening ceremonies of initiation begin. The carrying of the figure ahead of the procession is meant to provide a model of feminine perfection available only through Bondo training, and to inspire the girls, who are naturally apprehensive about the unknown proceedings ahead.

The figure is called So-Nyande, the 'Beautiful So(ko)', combining Temne and Mende wording. She is an image of both a woman of high Bondo rank

and her inherited official line, and seated as an initiate appears at the final ceremonies. The graduating Bondo girl is provided with a chair or stool, lavishly spread with cloths. Exquisitely coiffured, adorned with beads and a waist-cloth, and rubbed thoroughly with oil to enhance her black brilliance, she, like the figure, is an object of adoration.

This figure is very similar to another known carving by an artist working in the 1930s. While that figure is painted and polished black, this figure is thoroughly encrusted, indicating varying modes of ritual maintenance for the same type of object. *FL*

5.138

Shrine figure headdress

Baga or Bulunits

Guinea

19th century

wood, ram horns, encrustation

h. 40 cm

Laboratoire d'Ethnologie,
Musée de l'Homme, Paris,
33.40.86

This type of object was used principally as a shrine figure and also as a dance headdress. It was known among the northern Baga of the Sitemu subgroup as *a-Tshol*, meaning 'medicine'. Alternative names include *elek*. It takes the form of a head with an exceptionally long beak and a long neck inserted into a base structure.

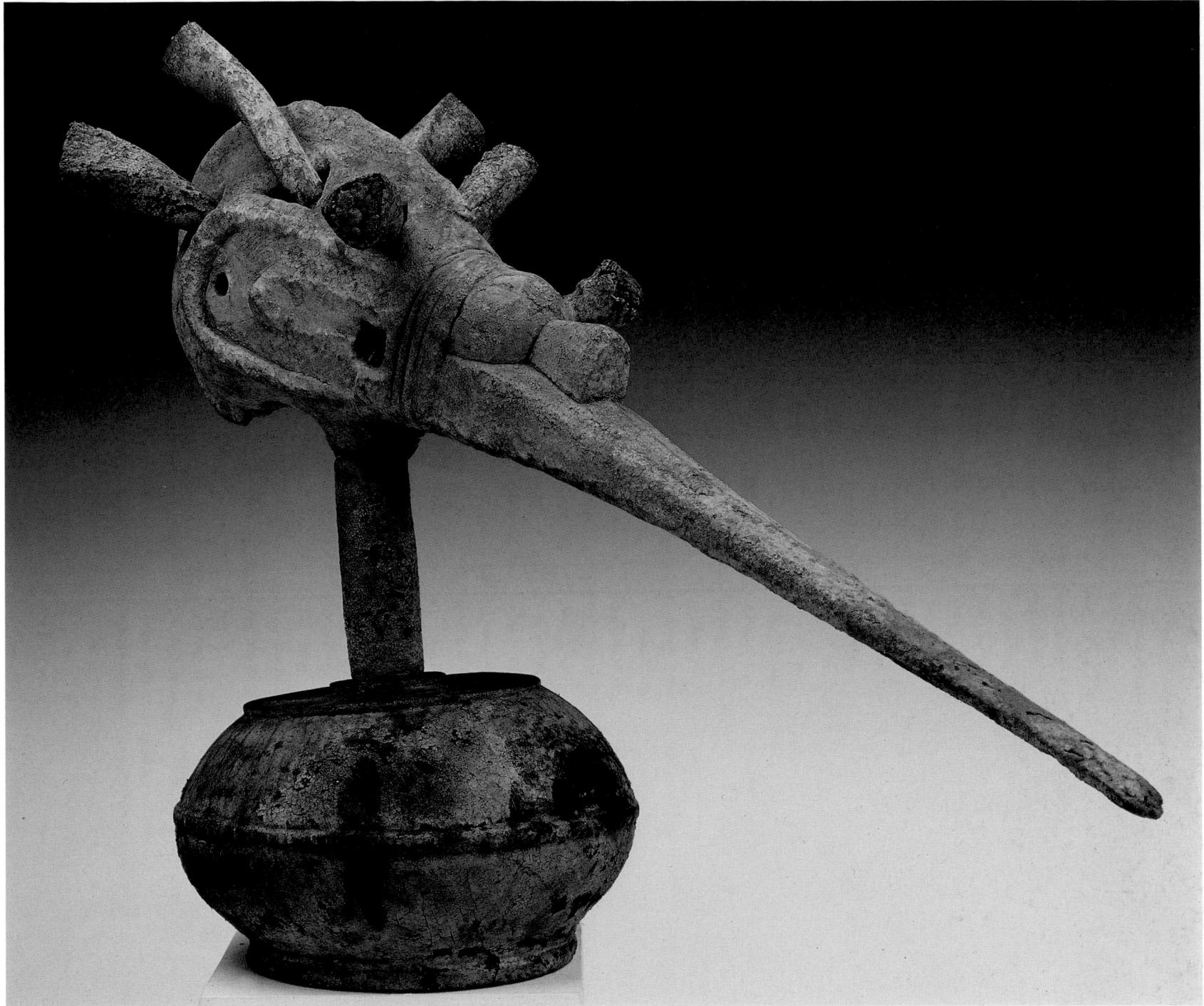

The head also has anthropomorphic aspects, such as a coiffure, ears, forehead and nose.

A-Tshol figures were placed in the young men's sacred grove as guardians during initiation. They were instrumental in rituals of healing, divination and the pursuit of justice. The use of the word 'medicine' throughout this region of Africa applies to any substance that is known to have powers of healing or protection, including horns, shells, bark and leaves. The *a-Tshol* shrine could hold a collection of these

materials and/or the wooden avian figure.

The *a-Tshol* was under the control of the eldest male member of a family as a symbolic incarnation of the lineage. It was used as an instrument of spiritual power in determining the cause of misfortune in the family or the community at large, generally attributed to the evil collusion of antisocial persons with malevolent spiritual forces. Through ritual performed at the shrine the elder was able to identify the evildoer and to prescribe retribution

for his acts, thus bringing an end to the misfortune.

Bearing the *a-Tshol* on top of the head in dance, the dancer wore normal clothing; a palm frond was attached to the base of the figure. The headdress was not attached to the dancer's head but was left to balance itself. It was said to take control and to guide the dancer's movements. Most of the larger examples, such as this one, are carved in two separate pieces joined by inserting the long neck into the spherical or cylindrical base. This suggests that the head

may have swivelled during dance. The dancer carried a knife in each hand and was surrounded in dance by devotees often going into trance.

This *a-Tshol* was collected in the Bulunits village of Monchon. The Bulunits are unrelated linguistically to the Baga, but they closely share a ritual culture with the contiguous Baga Sitemu and Pukur, and these three groups see themselves as a cultural unit. *FL*

Provenance: 1932, collected from Monchon by Prof. Henri Labouret

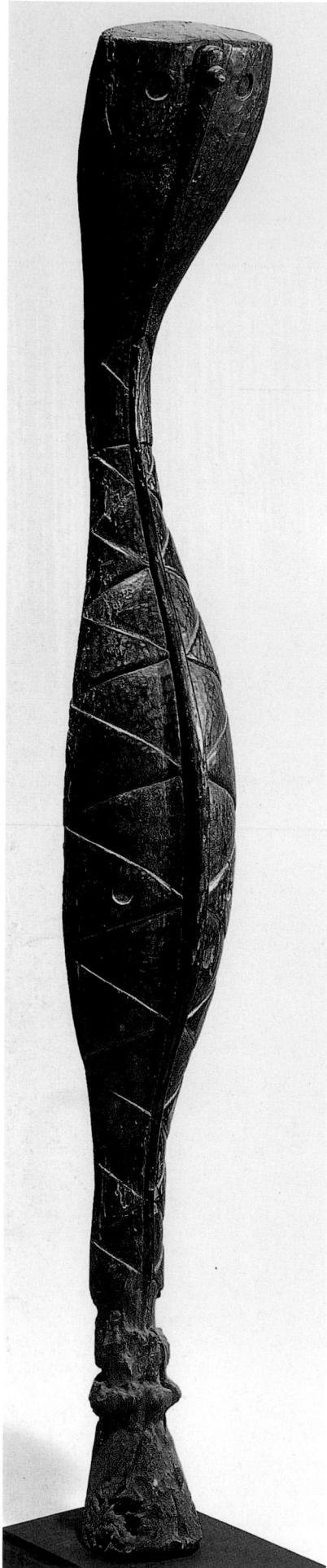

5.139

Sculpture in the form of a stylised serpent (*bansonyi*)

Baga
Guinea
wood, pigment
l. 210 cm
Private Collection, Paris

In Western museums Baga carved serpents are normally exhibited as static sculpture in a way that gives little idea of their traditional function as dance headdresses. In use they tower above a light framework that is borne on the shoulders and body of a dancer concealed beneath a raffia covering who moves rapidly amid cries and the firing of guns, shaking and twirling the structure to show off the bells, feathers and cloths attached to it. Confusion, agitation and motion are the keynotes of the performance, reflected somewhat mutedly in the curves and coloured zigzag markings of the residual sculpture and its balanced triangular head.

There is a certain confusion in the literature on these snakes, probably from a misplaced attempt to reduce the varied usages of fragmented and loosely related peoples to a single pattern, though African masquerades often have very broad portfolios. The serpent headdress is attested as involved in protecting boys at circumcision, curing droughts and appearing at funerals. Sometimes it appears in groups, it may be male or female and it has been interpreted by the cosmologically-minded as reconciling the spirit of the water with that of the bush. *NB*

Bibliography: Delange, 1962, pp. 3–23; Lamp, 1986, pp. 64–7

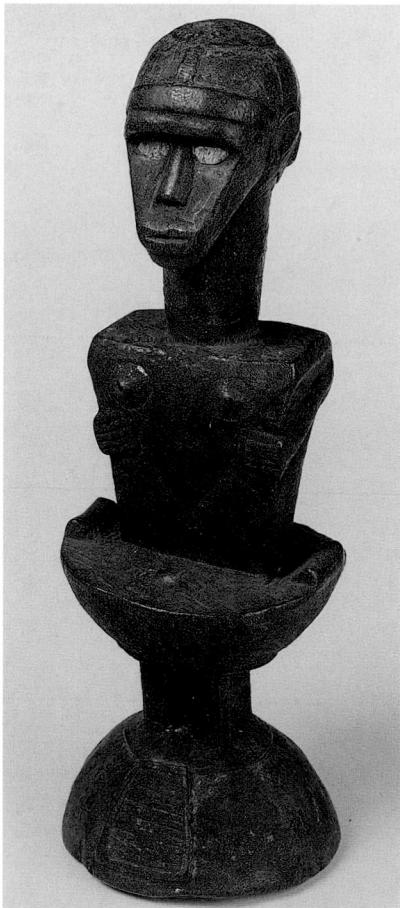

5.140

Altar figure

Bijogo
Bissagos Islands, Guinea Bissau
wood
h. 40 cm
Museum für Völkerkunde, Vienna,
136.066

The Bijogo recognise a large class of objects known as *iran* that act as locations for divinity. These may be of a variety of materials and forms including pots and wooden sculptures of either or both sexes. This altar figure, *iran otibango* (civilised spirit), with its prominent brow and brooding geometric features, is in a style typical of the island of Carache. A common component of these carvings is a stool that subsumes the lower half of the figure. In this case, the body tattooing that is the mark of full initiation is transferred to the stool while the figure wears a medallion around its neck. Such sculptures are usually associated with fertility and successful agriculture and kept in village shrines. *NB*

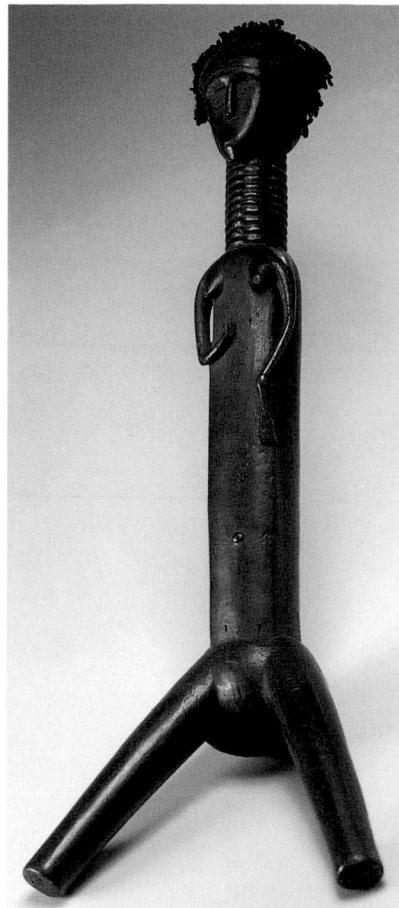

5.141

Dance doll

Bijogo
Bissagos Islands, Guinea Bissau
wood, human hair
54 x 21 x 50 cm
By courtesy of the Board of Trustees of the Science Museum, London, A 655925

Like many 'doll' figures of African children's sculpture, those from the Bissagos have been variously interpreted. They may be seen as educational toys, anticipating motherhood, as fecundity figures, augmenting natural fertility, and funerary figures, replacing dead children. Dolls of the present form, always female, with splayed legs, rudimentary breasts and reduced arms are seen principally as objects of play and dance props. Girls carry them on the hip as they would a young child. Rings of fat around the neck are a common attribute of beauty and the human hair on the head is cut as for a girl undergoing initiation.

It may be questioned how far this division corresponds to a Bijogo view. These sculptures apparently feature in the dances of female initiation, a period that conflates many roles. While the whole event seems to con-

tradict easy generalisations about African masquerade and drumming as exclusively male, it must be noted that girls undergo initiation on behalf of boys who have died before puberty. They are simultaneously identified with such boys and also viewed as their virgin wives. Only through possession of female bodies and the blurring of such lines can the boys complete all the necessary stages of existence in this world and re-enter the regular cycle of life. It is therefore unlikely that the dolls represent any single named person or concept but are more likely to be instruments of multiple identification. Such wooden figures are nowadays typical of the eastern end of the Bissagos archipelago. *NB*

Bibliography: Gallois Duquette, 1976, pp. 26–43; Gallois Duquette, 1983, pp. 132–4

5.142

Swordfish mask

Bijogo
Bissagos Islands, Guinea Bissau
wood, pigment
h. 127 cm
Private Collection

The Bijogo are known from early chroniclers' accounts for their daring raids on shipping along the African coast using huge canoes. Martial virtues were cultivated by an age-set system that associated young men with powerful beasts of the sea and land; masquerades had an important role. While young boys might wear calf and fish masks, older uninitiated youths wear those depicting wild bulls, sharks, hippopotami and swordfish. Their dances are unpredictable and violent to accord with the character of the animal represented and their own undomesticated nature. They spend much of their time grooming, dancing in various villages and developing love affairs.

This mask would be worn with the proboscis pointing forward, the hollow at the rear resting on top of the head and fastened with ties of green raffia. Unlike a bull mask it would not cover the face. Typically, the dancer would also wear a large wooden dorsal fin attached to the middle of his back and would carry a shield and stick with bells while swooping and ducking in performance. Masquerade headdresses such as this are best known from the island of Uno. *NB*

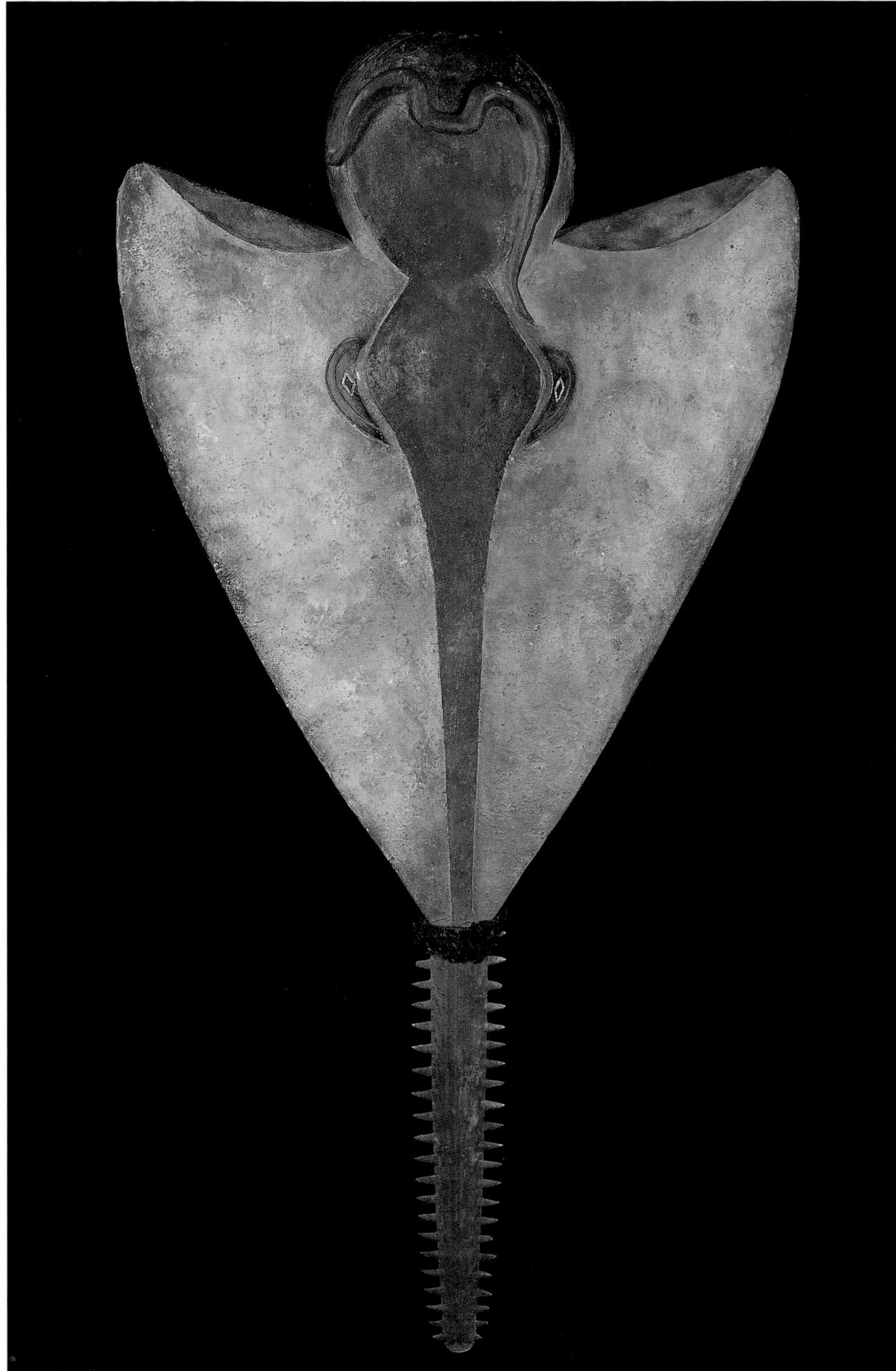

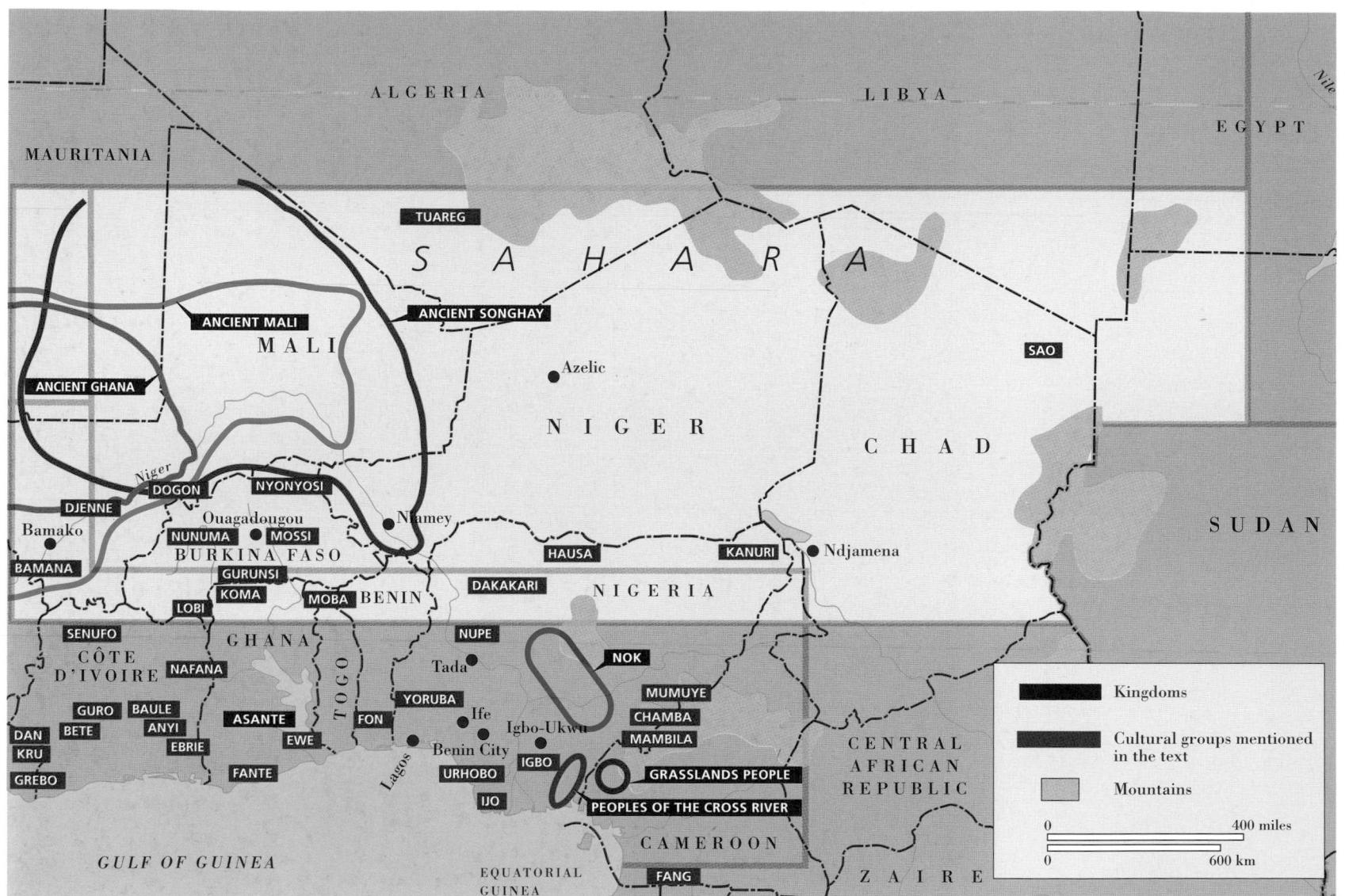

6 THE SAHEL AND SAVANNA

René A. Bravmann

Stretching across the continent, from the Atlantic to the Gulf of Aden, is the geographical zone known as the Sahel/Savanna. On maps it appears as a broad undifferentiated band lying between the Sahara and tropical forests, a vast land of steppes and tree-covered plains. In fact this apparent unity is an illusion, for the Sahel/Savanna is a rich mosaic of ecosystems that contain, in whole or in part, some of the great rivers of the continent – the Senegal, Niger, Volta and the upper stretches of the Nile. To move south from the desert's fringe is to begin a dramatic journey across a variety of ecological zones, from the stark aridity and fragility of sub-Saharan steppe to the relative moistness of woodlands and savanna. Along the Sahara's southern fringe only the heartiest of herders, people like the cattle-raising Fulani or Tuareg camel-breeders, have managed to overcome the rigours of this difficult land. The savanna and woodlands, on the other hand, are endowed with an abundance of plant and animal life that supports cereal and root agriculture and the raising of livestock, as well as providing considerable resources for hunting and fishing. Every few hundred miles there are environmental shifts signalled by tilled fields of crops, ranging from sorghum and millet in the north to yams in the moist southern savanna. Archaeological evidence suggests that this is the area where African rice, bullrush millet and sorghum were first domesticated and that it has been home to some of Africa's earliest cities.

The Sahel/Savanna from Senegal and Mauritania to Lake Chad is distinguished by its place in the historical consciousness of Europe and the Muslim world. The accounts of travellers, geographers and men of letters, written in Arabic, shed light on the Sahel/Savanna from the 10th to the 17th centuries; these writings are particularly important in assessing the region's past. The earliest extant writings are those of al Masudi and Ibn Haukal; there is also the famous early 16th-century history of Africa by

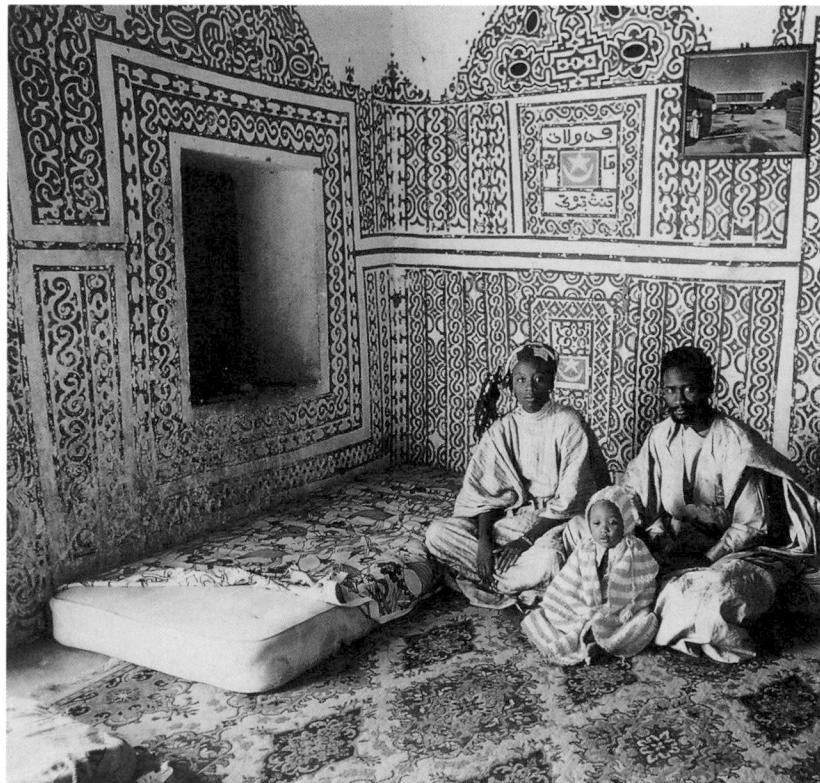

Fig. 1 The home of the mayor of Walata, Mauritania, with painted wall decoration

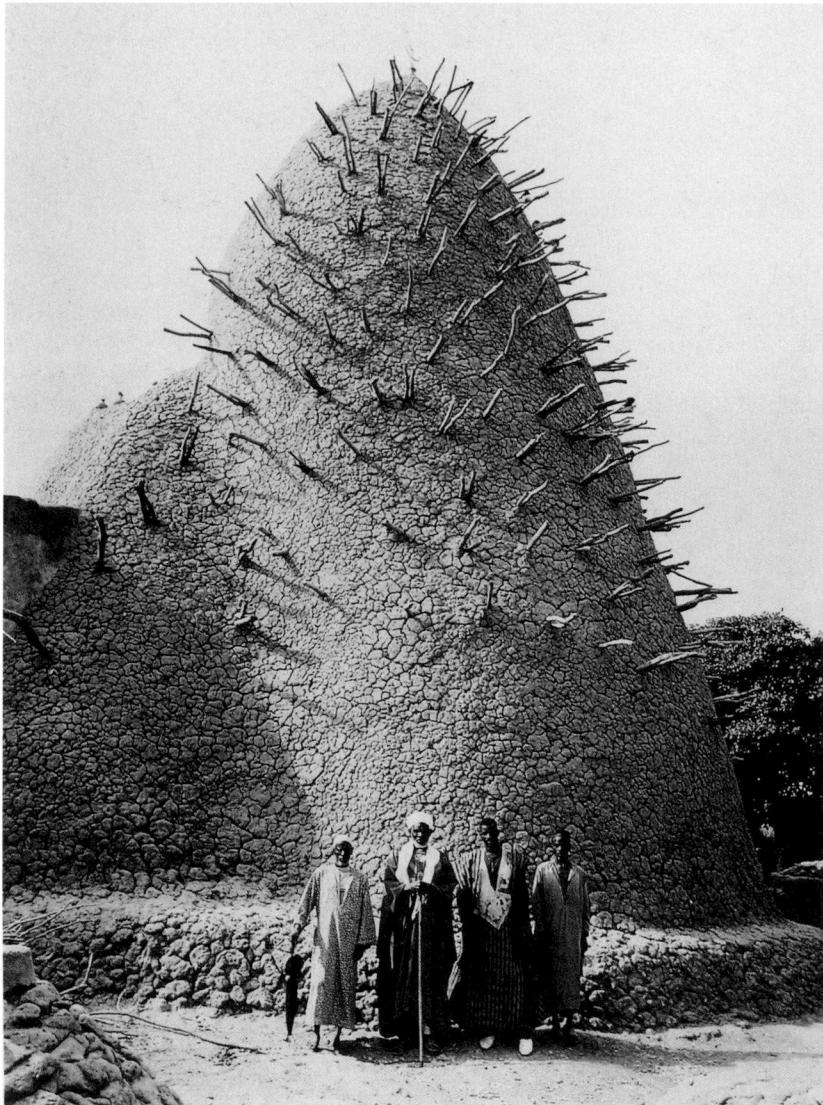

Leo Africanus that was translated into French and English within a generation of its appearance in Latin. These sources, together with later European accounts and oral traditions, have enabled historians to reconstruct the broad outlines of Sahel/Savanna history over the last 1100 years, from the empires of ancient Ghana and medieval Mali in the west to the states of Hausaland and Bornu in the east. It is, one could say, history on a grand scale, based on the rise and fall of powerful political entities and of kingdoms and cities linked by trade routes stretching to north Africa, the Mediterranean world and the Near East. Nothing brings home the character of this zone better than the etymology of the term *sahel*: Levzion tells us it derives from the Arabic word *sahil* meaning shore ‘which is well understood if the desert is compared to a sea of sand, and the camel to a ship’. Hence, the towns which developed in the Sahel ‘may be regarded as ports. These towns became both commercial entrepôts and political centres.’ Into these Sahelian ports, places such as Koumbi Saleh, Timbuktu, Gao and Kano, flowed the luxury goods of the Islamic world – brassware, copper, textiles, ceramics and precious Saharan salt in exchange for gold, ivory and other products from the Sahel/Savanna. In Arabic this zone is called the *bilad al sudan*, the land of the blacks, and it is here that Islam and African societies were to meet. While one cannot discount the European colonial presence or the broader impact of the West on the area (a historical phase effectively only a century old) these pale by comparison to the much more profound influence that Islam has had over the last millennium. Conversion to Islam in this region began at the end of the 10th century when the Sarakholle, a Mande people also known as the Soninke who lived in what is present-day

Fig. 2 Part of the mosque at Dougouba, Mali

Mauritania, were converted by Muslim Sanhaja Berbers to the faith. Within a generation, Sarakholle converts spread the message of Islam into the Senegal River Valley, and shortly afterwards their religious zeal was felt as far away as the Niger River, in the areas of Takrur and Massina. From the 11th to the 17th centuries Muslim traders and clerics, the true propagators and cultivators of Islam, would introduce the religion to every major kingdom and state between the Atlantic and Lake Chad, and in some cases among more localised cultures as far south as the west African forest. The Islamic presence was dramatic. Political and economical institutions not only took on a decided cast, but much of life itself – the tone of daily existence and the arts and architecture – assumed the trappings of Islam. Intellectual life was also deeply affected, and important towns like Djenné, Timbuktu, Gao and Kano became vital centres of Islamic scholarship and learning. Famous Muslim leaders such as Mansa Musa of Mali, Askia Muhammad of Songhay and Idris Alooma of Bornu (whose merits and deeds are kept alive by contemporary praise singers and authors) ruled over large and complex states that were known throughout north Africa and the Near East.

The Islamic presence can be seen and felt throughout this region, but African societies were not merely passive recipients of the faith: they actively shaped and moulded the religion in order to fit its calling within local circumstances. Everywhere in the Sahel/Savanna a synthesis developed between the message and requirements of Islam and traditional beliefs, values and sensibilities. There is no surer way of apprehending this African Islamic reality than by looking at the art and architecture of the region; the mosque, for example, the supreme architectural statement of a Muslim community, and usually constructed of the noblest and finest materials, has undergone a most dramatic restatement. Along the Niger River, in such places as Djenné, Mopti, Goundam and Timbuktu, mosques are built of the humblest materials, such as sun-baked mud (what the French call *pisé* and the Spanish *adobe*), yet in the hands of skilled masons such mosques have resulted in some of the most remarkable sculptural and architectural expressions of the faith (fig. 2). Built like fortresses, with battlemented walls and towers bristling with spikes, these mosques, with gently sloping minarets, have walls and buttresses pierced with projecting beams that serve as permanent scaffolding and help relieve their overall massiveness and horizontality.

Even in those areas farthest removed from the vital urban centres of Islam, and among the most traditional of peoples, the Muslim presence asserts itself in both dramatic and more subtle ways. Dogon art and culture, for example, long hailed as exemplars of traditional Sudanic civilisation, cannot be fully understood or appreciated without acknowledging the impact of Muslim mystical texts like the Kabbe, written early in the 20th century by the Fulani cleric and scholar Cerno Bokar of Bandiagara, and utilised in many Dogon rituals today. Songhay spirit possession, known as Ghimbala, so prevalent throughout the inland Niger Delta of eastern Mali, can ultimately make sense only if we acknowledge how it was re-shaped during the 19th century by the Muslim reformer Sheikh Hamadu of Massina. Ghimbala itself is now the result of extraordinary accommodations, of a blending of Quranic and Songhay invocations, of sacrificial acts that are prescribed by the Quran and sanctioned by the traditional spirits that have always inhabited this Songhay-dominated portion of the Niger River. Possession ceremonies, the *batous*, follow an ancient calendar cycle but out of deference to Islam, especially the fundamentalist strain that has emerged in recent years in Mali, they are no longer held during Ramadan, the month of the fast. Likewise, we cannot really understand the historical complexities of Sahel/Savanna textile and clothing traditions if we fail to recognise the strong Muslim north African influences upon various techniques and an entire grammar of Islamic decorative designs.

Another distinctive feature of the artistic and cultural life of this region is the pervasiveness of ‘castes’, endogamous artisan populations that have long plied their skills over much of the area. They are found among many of the most prolific art-producing societies represented in this exhibition: Mande peoples

like the Bamana and Malinke; the Dogon, Senufo, Minianka, and among virtually all Tuareg, Fulani and Moorish populations. These artists are also exceedingly important in Bobo, Bwa and Kulango communities and their influence has been noted as far south as the forests of Liberia and Ivory Coast, where they reside among the Dan, Nafana and Abron. A minority, rarely exceeding ten per cent of their host populations, these ironworkers, sculptors, weavers, potters, leather-workers etc. have secured a place for themselves that defies their numbers. Socially situated between those of noble or freeborn status and the descendants of former slaves and servile peoples, they are generally described as virtual pariahs, feared and despised, which does not explain the vital roles they play. While we still know very little about their history, how they came into being and what political and cultural forces were responsible for their social segregation, it would be safe to say that they have occupied a critical place in Sahel/Savanna creativity for centuries. A recent study on the development of these 'castes' based on medieval Arabic sources, the 17th-century Timbuktu chronicles known as the *Ta'rikh al-Fattash* and the *Ta'rikh al Sudan*, and a scattering of European accounts confirms that at least some of these artisan groups were an important component of 14th-century Malinke society. By 1500 they had spread among neighbouring Wolof and Soninke, and as far east as Songhay and various Fulani populations. That such specialised artisans existed at an even earlier date is strongly suggested by recent archaeological evidence from various sites within the inland Niger Delta and in Mauritania. Ancient Jene-Jeno, a flourishing urban centre by the middle of the first millennium AD, was most likely home to many artisans working in iron, gold and copper alloys. At Tegdaoust in the Mauritanian desert, tentatively identified with the historical trading centre of Awdaghust, impressive filigree gold jewellery and a cache of gold and silver dating from the 11th century have been uncovered, confirmation of the artistic sophistication of this early commercial centre.

If the historical particulars of these artisan families elude us, we are on much firmer ground when it comes to an understanding of their place within Sahel/Savanna societies in the more recent past and today. These groups were deemed so crucial by their hosts that they were almost never obligated to serve in the army and could not be enslaved, a fate that even the mightiest of nobles was not altogether certain of avoiding. These people were never members of castes in the classic sense of that term, for they were never defined as members of a particular social class by their hosts or by themselves. What distinguished them from others, most fully, was not their social status but the fact that they were people free to pursue their creative skills. They apparently always married among themselves, but beyond this they were rarely subjected to those forms of social segregation and discrimination commonly found in true caste systems. It might be more appropriate, therefore, to describe these artists as members of historic guilds who carried out specific creative activities within certain institutional frameworks, albeit loosely organised, that allowed them to control artistic production and encouraged high aesthetic standards.

How these guilds were able to maintain themselves and their autonomy over time is particularly intriguing. Many of the guilds and their members were attracted to the courts of chiefs and kings. They never themselves sought power, and could not by definition occupy positions of authority. That they worked for and supported those in authority and often served as the most trusted of political and spiritual advisers is certainly the case, but they not only remained aloof from struggles for political power, they would normally withdraw their services under such circumstances. Members of these guilds also demonstrated a degree of mobility that helped foster a strong sense of independence; they took their skills and knowledge from capital cities to commercial centres and villages, from one chiefdom to another, and at times from one host culture to others. Regarded as 'different', indeed often viewed with ambivalence, they could not be treated with disrespect or be subject to abuse for they could (and did) refuse to work, literally going on strike against repressive patrons or entire communities. In the end they were able to

Fig. 3 The house of a marabout, Segou, Mali

preserve their autonomy because they remained productive artists, passing their skills on to subsequent generations. So long as they continued to work at their professions, neither their knowledge nor expertise could be taken from them.

What ultimately strikes the eye and mind as one looks at the many objects from the Sahel/Savanna brought together in this exhibition is the remarkable variety of artistic techniques they honour and the time range of creativity they reveal. The history of ceramic sculpture from this region has been totally revised in the last 25 years and is well represented by a number of anthropomorphic terracottas from the area of Djenne that are provisionally dated to the 11th to 15th centuries, from Bankoni also in Mali and dated between the 14th and 16th centuries, and from Komaland in northern Ghana, c. 13th–16th century. The sculptural sophistication of these pieces is stunning and they have much to teach us about variations in style and shifts in taste. Since most, however, have been collected under the most dubious of circumstances and thus without provenance, their ultimate value as objects of history is severely compromised.

Metalworking, in the form of a sophisticated filigree gold pectoral disc (13th–14th century) from one of the many tumuli in the area of Rao in north-western Senegal, the lively postured cast copper figurines from medieval Djenne, an unusual bronze cast helmet from Komaland (16th–17th century) and the 18th–19th century miniature equestrian figure attributed to Kotoko in Chad, extend our vision of Sahel/Savanna metallurgy. Much has been learned about the dynamic trade in metals, especially copper and copper alloys, from archaeological investigations in Mauritania and Niger and by revisiting Arabic sources, suggesting that a mastery of widely divergent techniques, from hammering to casting in the lost-wax process, was already achieved by the end of the first millennium AD. The remarkable 14th-century Djenne bronze and iron figure, a figurated Dogon staff of unknown date and an enigmatic Lobi figurine are three of the iron sculptures that stand as testaments to the vitality of an ancient ironworking tradition that was found throughout much of the region.

Of the stone sculpture, particularly impressive is the delicately worked monolith from Tondidarou in Mali dated to the 12th century, one of numerous such sculptures found in conjunction with pre-Islamic burial mounds. Two Kurumba stone sculptures from Burkina Faso, the smaller one said to be 18th–19th century and the more fully figural example dated by Schweeger-Hefel, on the basis of oral traditions, to the 14th century, attest the long history of Kurumba settlement in the region of Lurum.

Finally there is a variety of vital wood sculpture from the region – masks, imaginative figurative forms, accumulative sculptures of mud, blood and wood that served as sacred altars, and a range of domestic items such as stools and pillow supports. Many come from the most prolific art-producing societies today, including the Bamana, Dogon, Mossi and Lobi.

Bibliographical note

McIntosh and McIntosh, n. d., pp. 215–18; Mauny, 1961; Levzion, 1973; Meillassoux, 1975; Camara, 1976; Picton and Mack, 2nd edn, 1989; Richter, 1980; Diop, 1981; Glaze, 1981; Hopkins and Levzion, 1981; Schweeger-Hefel, 1981; Sutton, 1982, pp. 291–315; Herbert, 1984; Vansina, 1984; Prussin, 1986; McNaughton, 1988; Tamari, 1991, pp. 221–50; Fibbal, 1994

6.1a

Monolith

Tondidarou region, Mali

c. 7th century

sandstone

h. 80 cm

Laboratoire d'Ethnologie,
Musée de l'Homme, Paris, 32.40.61

Northern Mali is rich in megalithic sites which often took the form of large clusters of standing stones, though most of these have either now fallen of their own accord or been disturbed. Many of the stones are simple phallic shapes and quite roughly hewn while some are elaborate in marking and reference with highly worked formal elements. The language of the engraved lines that appear on the more complex examples has much in common with other Saharan stone sculptures, the stelae from Morocco (cat. 7.14–15).

What is known as the first megalithic site in Tondidarou has yielded the finest group of these stones and probably constitutes the richest ensemble in Africa outside the Ekoi region of Nigeria, where what used to be known as Akwanshi stones (cat. 5.37) stand in abundance. The resemblance to these of the monoliths under discussion is remarkable (if coincidental) and many engraved motifs are common to both. Whether there is some connection between these designs and the entoptic phenomena discussed by Lewis-Williams in his examination of San rock art (cat. 3.4–5) in southern Africa has yet to be explored. That a common experience rather than a stylistic influence is the cause of this artistic congruence would certainly be the more likely explanation.

The huge umbilicus in association with a general phallic form of cat. 6.1b reminds one again of the economy of Neolithic sculpture so perfectly exemplified by the round-boss from Chad (cat. 6.58).

The name Tondidarou itself reflects the prominence of the local megaliths in the landscape since it is formed from the Songhay *tondi* (stone) and *dari* (standing). An interesting example of cultural appropriation (and a curious sidelight on the idea of context) is that the stones are now sometimes said to be people petrified by God because they opposed Islam.

The hard sandstone that is worked to make these objects suggests the use of metal tools, of which there have been associated finds in the region.

TP

6.1b

Monolith

Tondidarou region, Mali

c. 7th century

sandstone

h. 152 cm

Laboratoire d'Ethnologie,
Musée de l'Homme, Paris, 32.40

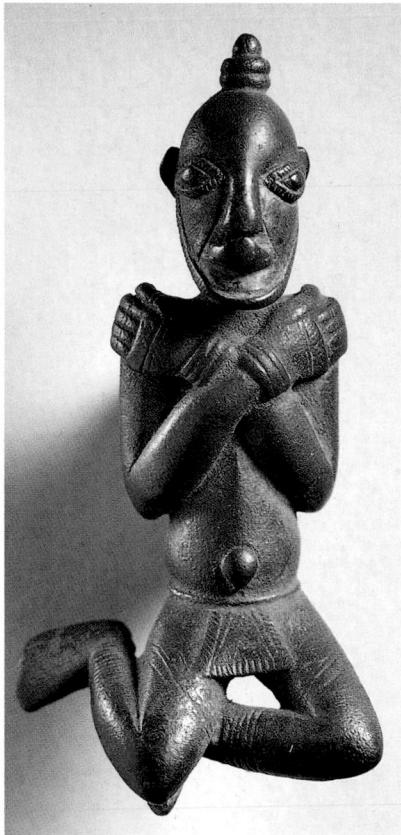

6.2a

Pendant figure

Djenne
Mali
bronze
h. 9.6 cm
Musée Barbier-Mueller, Geneva,
1004.125

6.2b

Kneeling figure

Djenne/Dogon
Mali
bronze
h. 6 cm
Private Collection

6.2c

Pendant figure

Djenne
Mali
bronze
7.5 x 4 cm
Private Collection

Djenne metalwork

The many hundreds of ancient sites in the region of the inland delta of the Niger have yielded an extraordinary harvest of metal objects. The first of these came to light early in this century, in a small excavation conducted by Lieutenant Desplagnes at Kili. More have been found in official archaeological excavations during the past 30 years. By far the greatest number, however, have emerged from the illicit pillaging of sites on a massive scale. This last activity is doubly harmful: it not only removes the objects concerned but also conceals or destroys the evidence as to their exact provenance, age, context, authorship and historical associations.

The objects obtained from official excavations include bracelets, earrings, small pendants, bells, parts of horse trappings, and small cuprous alloy figurines of a bird and a reptile. Those from clandestine digging are much more impressive, with an astonishing quantity of chains, necklaces, horse ornaments and finger-rings, as well as a variety of human figure amulets and pendants, equestrian figures, small animals and reptiles, complex pectoral ornaments, and even small pendants depicting masks or heads. Many of these are cast in cuprous alloys (brass and 'bronze'), others fashioned from iron, and in rare instances two or more metals are combined in the same work.

This metalwork is far from homogeneous, revealing disparate styles and techniques. At one extreme are tiny stick-like miniature figures, both human and equestrian, said by the looters to come from the region of Guimbala. Apparently found buried in pots, these began turning up in large numbers a few years ago. At the other extreme are superbly modelled small amulets in the form of crouching or kneeling human figures, in the classic style which has come to be labelled 'Djenne' or 'Dogon'. Between these extremes are the many bracelets and other body ornaments, horse trappings and the like, in a variety of styles and substyles. The looters attribute some of these to the region of Niafounke. Lacking the guidance of controlled archaeological excavation, or even scientific collecting, we cannot delimit the provenance of each style even in

general terms, nor can we assign firm dates. It is true that some pendants in the 'Djenne' style so closely resemble the Djenne terracotta figurines that they may well be contemporaneous, dating from the same general period, the 12th to the 16th century. It is also true that much looted metalwork may come from sites at which tobacco pipes are not found, and which therefore date from before the 17th century. But these arguments are not particularly strong. Even if Djenne terracottas stopped being made at some particular point in time, this would not necessarily prevent the brass casters from continuing to make pendant figurines in similar style for some generations to come. And if, as seems likely, many looted items of metalwork come from burials, the absence of tobacco pipes need have no particular significance.

Thus, while some items – particularly the finer works in the Djenne style – may date from around the 12th to the 16th century, there seems no reason why some of the great mass of other objects could not be more recent: from the 17th, 18th or even 19th century. This is to be expected if, as seems likely, cuprous metals became increasingly available during this later period.

It has become customary to speak of a 'Dogon' style of art, with reference to wood sculptures and small 'bronzes', and a 'Djenne' style with reference to certain terracottas. Now that an increasing corpus of small 'bronzes' is known from the Djenne region, together with a few miraculous survivals in wood sculpture, it becomes apparent that this division is unrealistic. If we take several dozen of the small 'bronze' human figurines, for instance, we find some which conform to our preconceptions of what is Djenne and what is Dogon, but a whole spectrum of others in between. These castings cannot convincingly be divided into two groups. Rather, we seem to be confronted with works from a single broad 'style area', which embrace a variety of workshop and personal substyles extending no doubt over several generations or even centuries. We can observe the same phenomenon among spirit figure amulets from the wider Senufo region (southern Mali, northern Ivory Coast and western Burkina Faso).

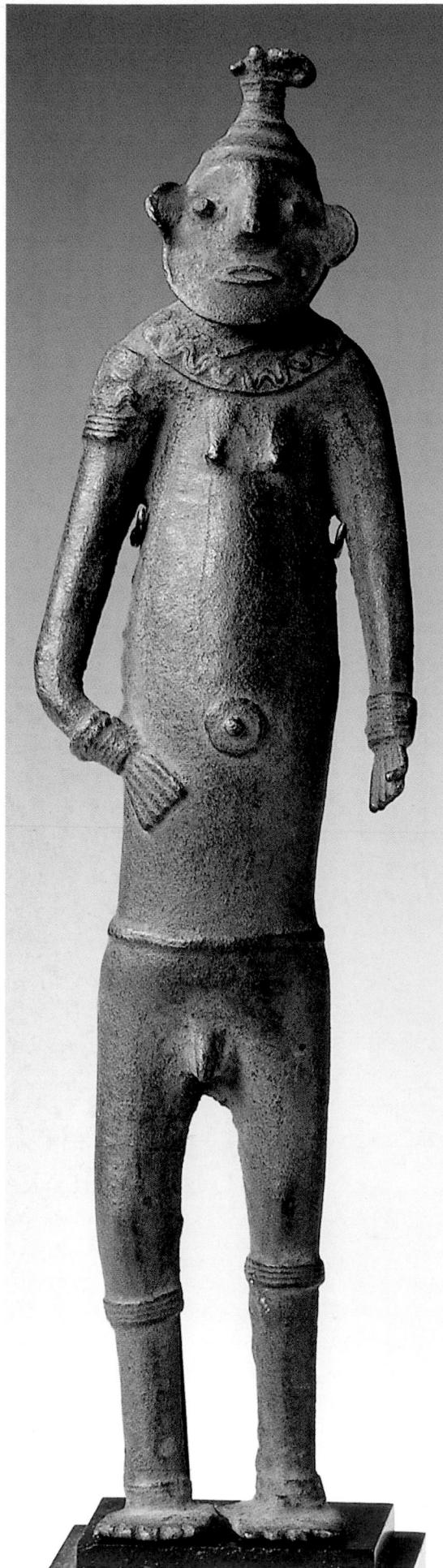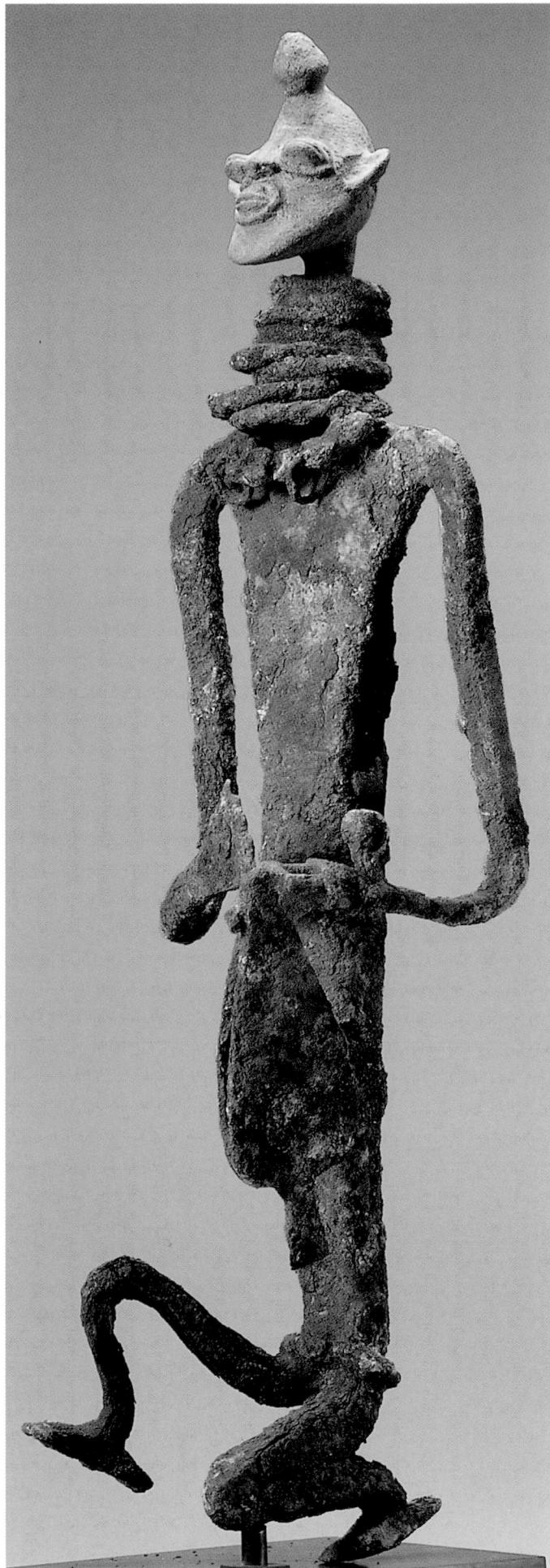

6.2d
Standing figure
Djenne
Mali
bronze
h. 24 cm
Private Collection

6.2e
Male figure
Djenne
Mali
iron, bronze
h. 49.5 cm
Private Collection

It need not be a matter of surprise that the metal arts of the Djenne and Dogon peoples prove to be inextricably linked, if not actually the same. In a very real sense the Dogon country was the hinterland of Djenne. The two are geographically close, and even today Dogon peasants and traders come regularly to the market in Djenne.

Misconceptions readily arise in the study of African art. We are impressed by the differences between the urbanised, Islamicised, mercantile Djenne people with their dramatic Sahelian architecture and the animist Dogon farmers with their separate language and their world of small huts and granaries. The two being so unlike, we may assume that their metal arts must spring from different sources. The reality may be otherwise. It seems more likely that there was a single specialist group of metal casters (ethnic identity unknown), who had workshops throughout the region and served both the Djenne and the Dogon.

Again we can draw a parallel with the Lorhon brass-casters of Burkina Faso and Ivory Coast. Their clients included not only the animist Lobi, Kulango and Senufo but also the Muslim Diula of Kong. Many of the brass castings commonly attributed to these four ethnic groups may not have been made by them, but rather by this separate artisan group, the Lorhon, and their descendants, who established workshops over a wide area.

It is even possible that the brass castings made for the citizens of ancient Djenne may ultimately prove to be ancestral to those made more recently for the Dogon, Senufo, Lobi, Kulango and other Voltaic peoples such as the Toussian. A remarkable Djenne human figurine published by Blandin, for instance, shows at the same time affinities with Dogon amulets and Kulango and Senufo spirit figures. It is conceivable that different branches of the far-flung Lorhon artisan clan may originally have been responsible for introducing brass casting among all these different peoples. Time and distance may not entirely have effaced the links which connect the brassworking styles of these peoples with the culture of ancient Djenne. *TFG*

Bibliography: Blandin, 1988, p. 33, fig. 1

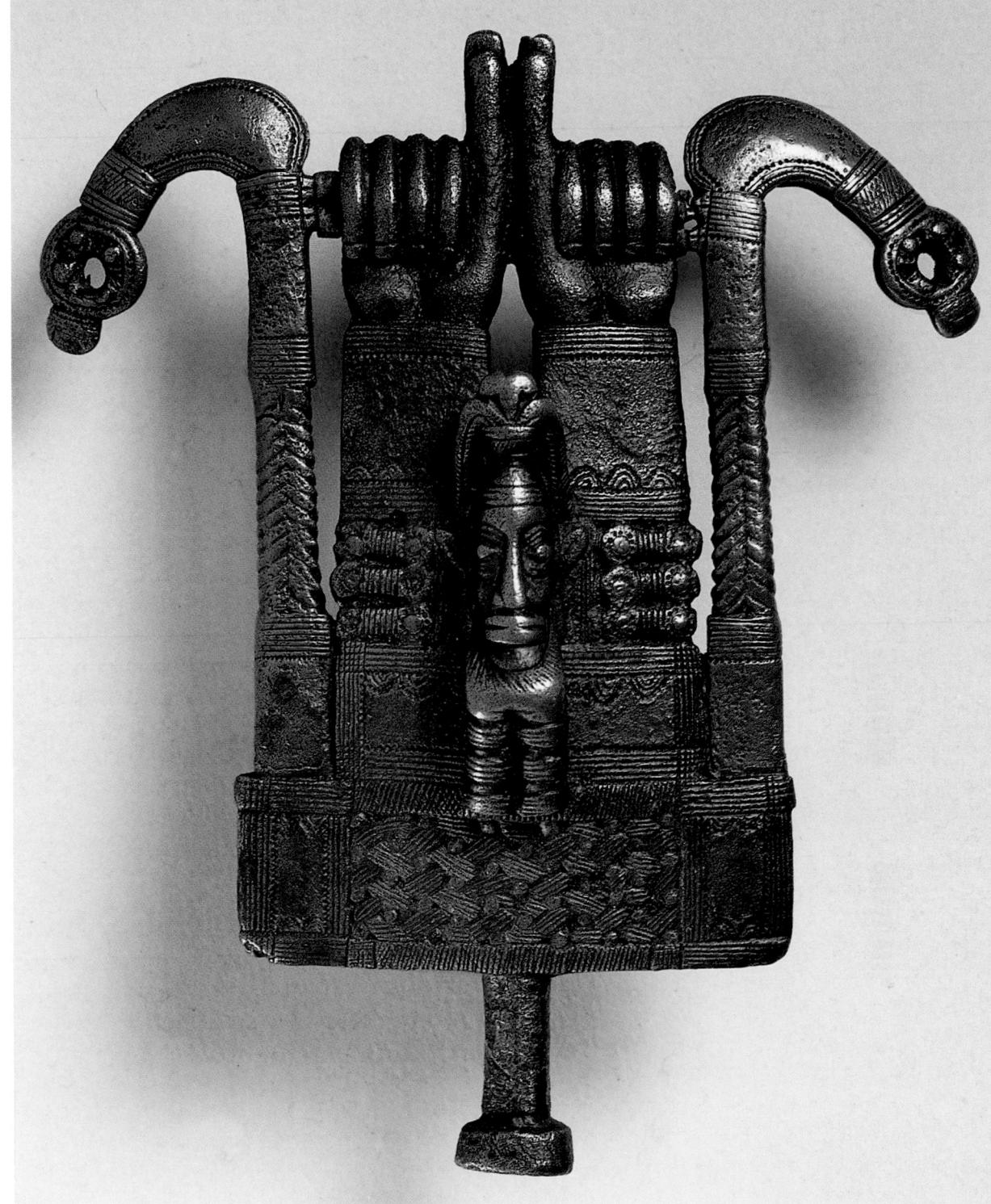

6.2f

Royal ornament

Djenne
Mali
copper, brass
h 11.4 cm

Musée Barbier-Mueller, Geneva, 1004-185

6.3

Neck-ring

Djenne

Mali

copper alloy

43 x 23 cm

W. and U. Horstmann Collection

There are two neck-rings known like this one. The owner was told that it came from Djenne where it is so far without parallel. Unfortunately, almost all artworks originally from Djenne were looted so that very little is known about their provenance. The other known neck-ring, which is practically identical, was found in Ife around 1936 together with the granite head of a ram in the churchyard of St Philip's Missionary Society Church in Aiyetoro, during the digging of the grave of Samuel Oki. No closely similar neck-ring is represented in the art of Ife, so it is quite possible that it was imported from Djenne, for both

cities flourished at the same time.

Moreover the composition of the Ife piece would be unique in the Ife body of metal castings. Typical Ife pieces are either of copper with only traces of other elements or of zinc-brass, usually with a substantial amount of added lead. The Ife neck-ring, by contrast, is a tin-bronze (with 9.4 per cent of tin, whereas 4.8 per cent is the highest amount of tin recorded from the other Ife pieces) with no detectable zinc at all. Very few copper-alloy artefacts from Djenne have been analysed. They show a wide variety of compositions, none corresponding to the Ife analysis. FW

Exhibition: New York 1992

Djenne terracottas

During the period of French colonial rule, fragments of terracotta figures occasionally came to light on the sites of the long-abandoned villages scattered throughout the inland Niger Delta. At first little attention was paid to them. Nothing concrete was known of their function or context of use, and estimates of their age were guesswork. Within the last twenty years, however, carefully controlled scientific excavations, notably at Djenne-Jeno (the site of the ancient city of Djenne), have yielded more figures *in situ*. Thermoluminescence dates show that these were made over a period of several centuries, up to about the 16th century.

Unfortunately, the success of the official excavations led to an epidemic of pillaging by the local population. Hundreds, probably thousands, of ancient sites were ransacked and severely damaged. This activity brought to light an astonishing quantity of terracotta sculpture, often of superb quality, much of it intact or nearly so. This material adds a wholly new dimension to the terracotta arts of Africa, hitherto mainly known through the works of Nok and Ife in Nigeria.

The Malian terracottas occur over a vast region and in a number of distinct regional styles. Human figures predominate, sometimes of large size, and represented either singly or occasionally as a couple. There is also a series of magnificent equestrian figures representing warriors or hunters. Animals, and particularly snakes, were also depicted; small terracottas of coiled snakes are quite common. In the region of Djenne itself these terracottas are modelled in elaborate detail, and in a highly distinctive style. The human figures show a wealth of jewellery and body ornaments, as well as items of clothing. Body surfaces are sometimes ornamented with impressed stamps, or drawn lines or even with raised bumps suggestive of some dreadful disease. Elsewhere, notably to the far west towards Bamako, occur terracottas of much simpler style, in which body decoration is kept to a minimum or omitted altogether. This has been named the 'Bankoni style', after the region where many such works are said to have been found.

The function of this extraordinary statuary is not entirely clear, but appears to have been primarily religious. Medieval Arabic sources speak disapprovingly of the animist cults and idolatry then prevalent in the region. It may have been the spread of Islam, notably following the Moroccan invasion of the region in 1591, that led to the abandonment

6.4a

Equestrian figure

Djenne

Mali

wood

h. 71.7 cm

The Minneapolis Institute of Arts, 83.168

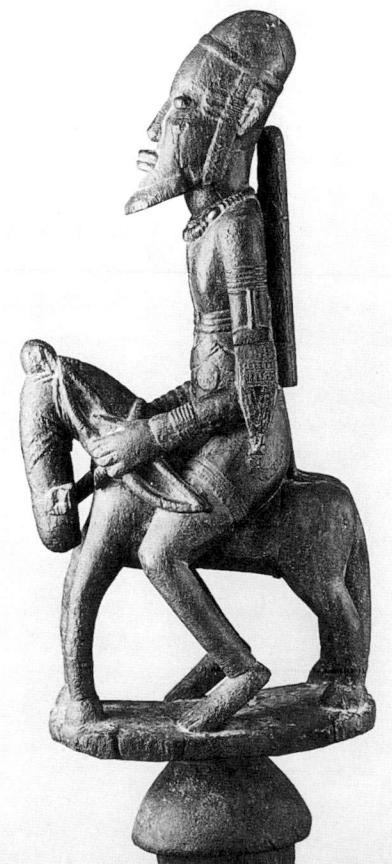

6.4b

Seated figure

Region of Segou

Mali

terracotta

h. 44.3 cm

Musée Barbier-Mueller, Geneva, 1004-13

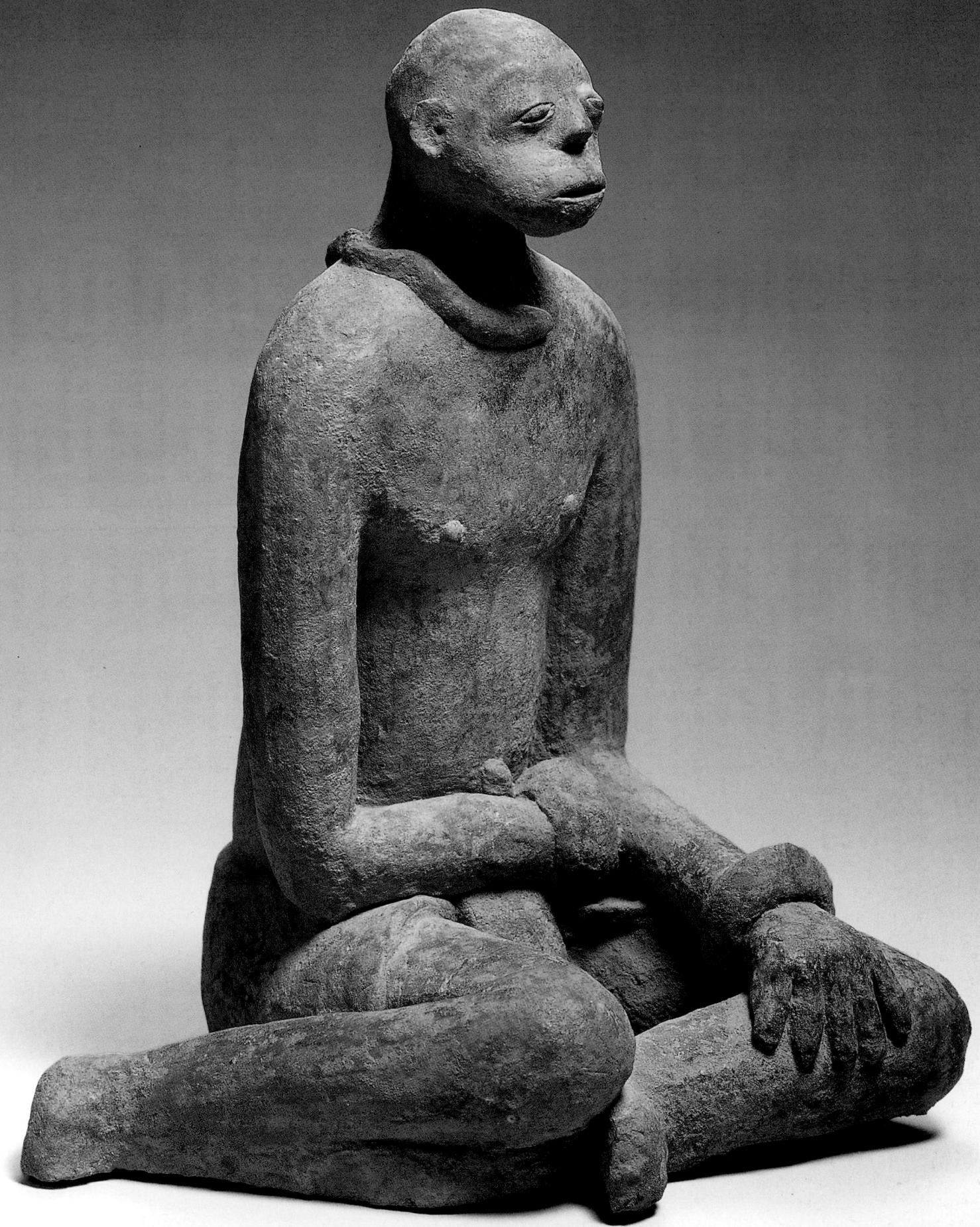

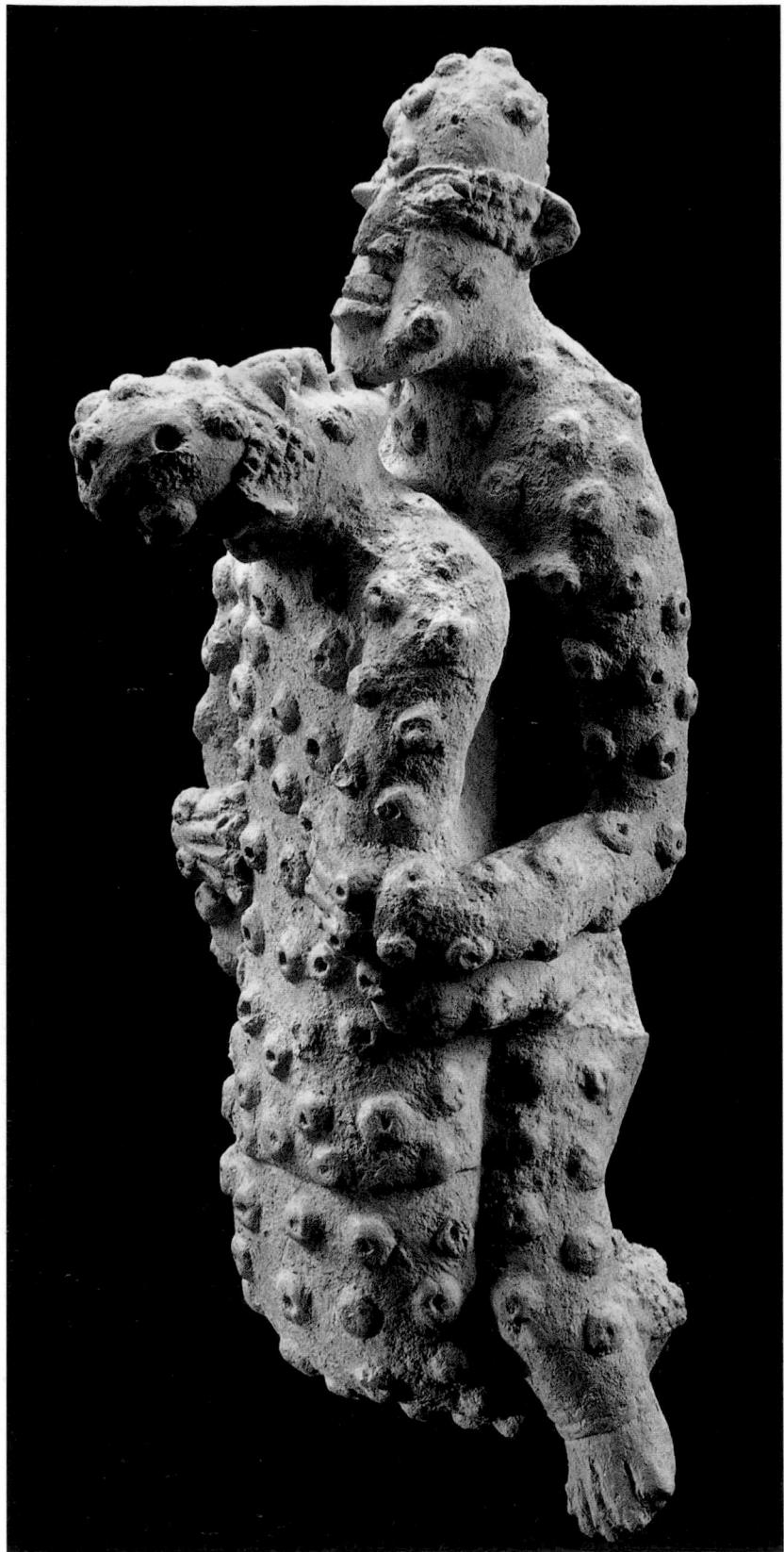

6.4c

Embracing couple

Djenne

Mali

terracotta

h. c. 40 cm

Private Collection

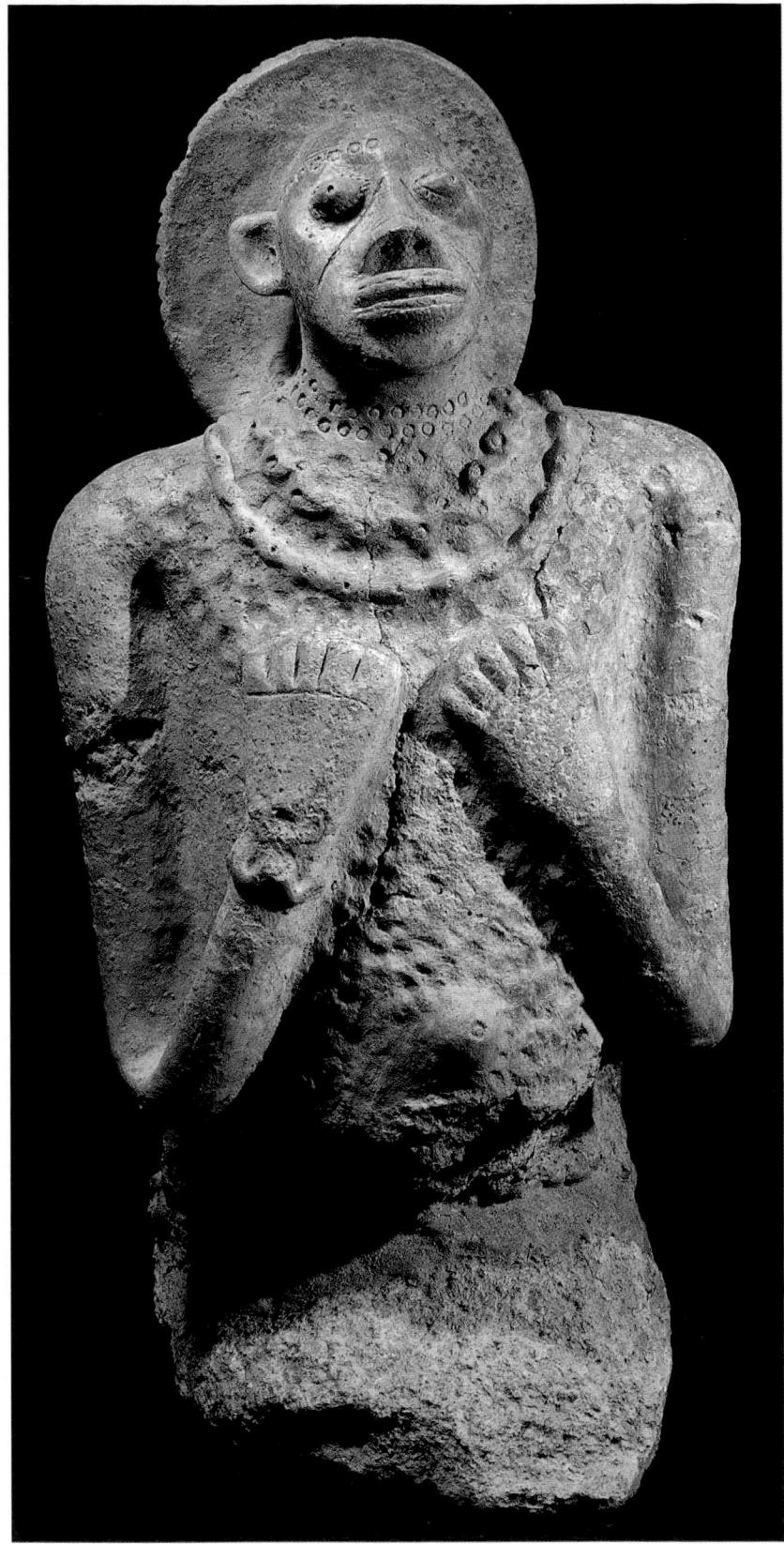

6.4d

Kneeling figure

Djenne

Mali

terracotta

55.2 x 30.4 x 28.5 cm

Maureen and Harold Zaremba

of these statues and the cults and practices associated with them.

A variety of explanations can be proposed, ranging from guardian figures, spirit images and commemorative figures of the dead to depictions of traditional legends. Some of the human figures appear to be in attitudes of adoration. The wealth of serpent imagery suggests that snake cults were widely known, and these reptiles occupy a prominent place in the myths and folklore of the region.

The simple potter's art was also practised in Mali to a degree of excellence rarely achieved elsewhere in west Africa. From the Djenne region come countless small pots, jars and flasks in shapes of extraordinary delicacy and beauty. There are also larger vessels for grain and water storage, as well as for medicinal use, and some of the largest were used for human burials. All these come from the same sites as the terracotta figurines. Further west, the Bankoni region has yielded a series of unique long-necked zoomorphic pots. Until recently the wood sculpture of ancient Djenne was totally unknown. It was assumed that all such sculpture had perished centuries ago, although its existence could be inferred from certain comments in the medieval Arabic sources. Now, however, several examples of ancient Djenne wood sculpture have come to light.

They are masterly works, carved with meticulous attention to detail and unmistakably in the same general style as the Djenne terracottas. The circumstances of their preservation and finding are not known to me, but since they seem virtually undamaged they could scarcely have come from the exposed sites of the delta itself. I have heard it said that they must have been hidden in caves in the Dogon country, and this seems the most likely explanation, for Dogon and Tellem statues have been found in such caves, preserved for centuries against destruction. The Djenne sculptures appear to date from the 15th or 16th century, and they could have been hidden in Dogon country by citizens of Djenne fleeing from the Moroccan invasion of 1591.

The wood sculptures of ancient Djenne also bear much resemblance to those of the Dogon themselves, and this is perhaps not surprising, Djenne, situated on the edge of the desert, is

likely to have produced little wood suitable for sculpture, and supplies would have come from the nearest available source, probably the Dogon region. This being so, it is entirely feasible that the statues were actually carved by sculptors from the Dogon country. There is a need to re-evaluate the relationship between the Djenne peoples and the Dogon, as evidenced by the survival of these remarkable wood sculptures. *TFG*

6.4e
Female figure
Djenne
Mali
terracotta
45 x 16.5 x 18 cm
Private Collection

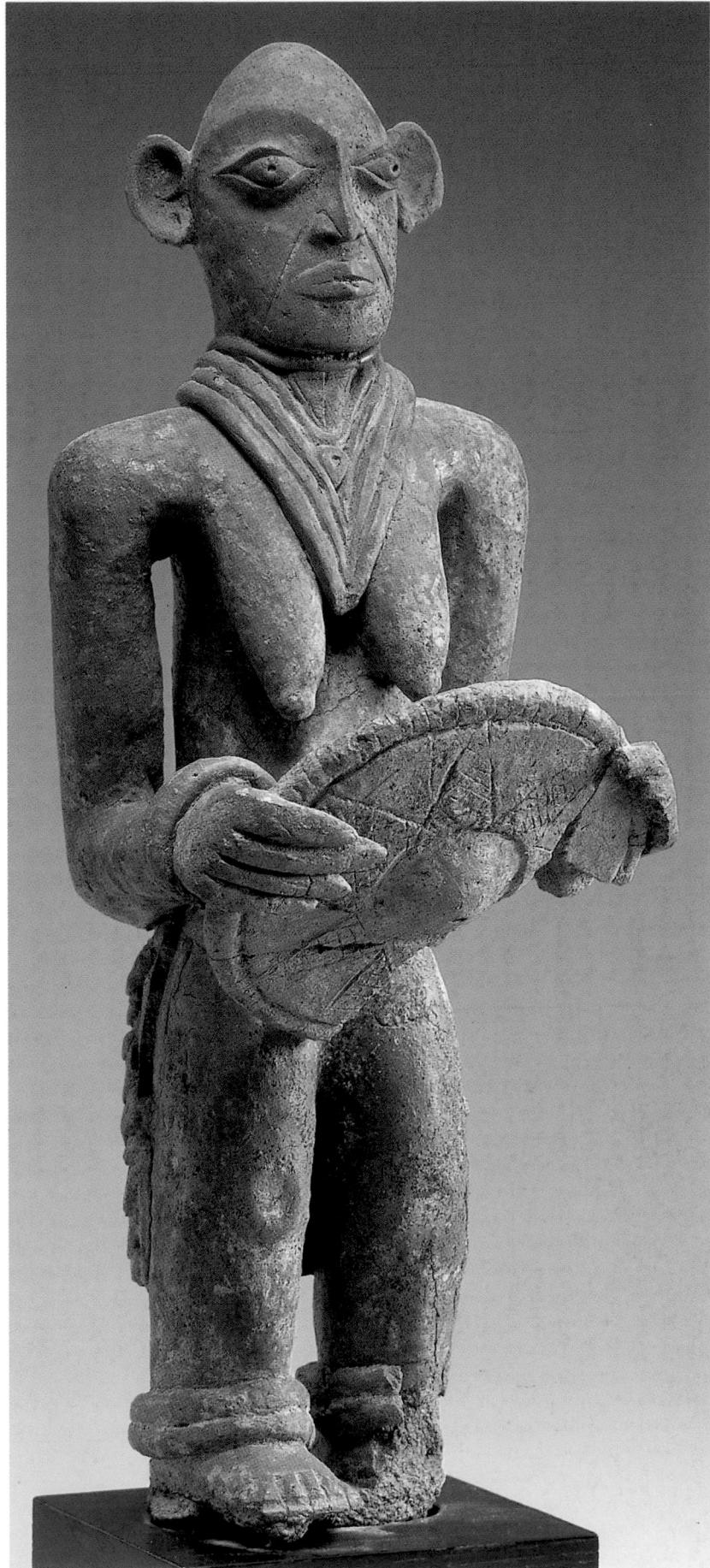

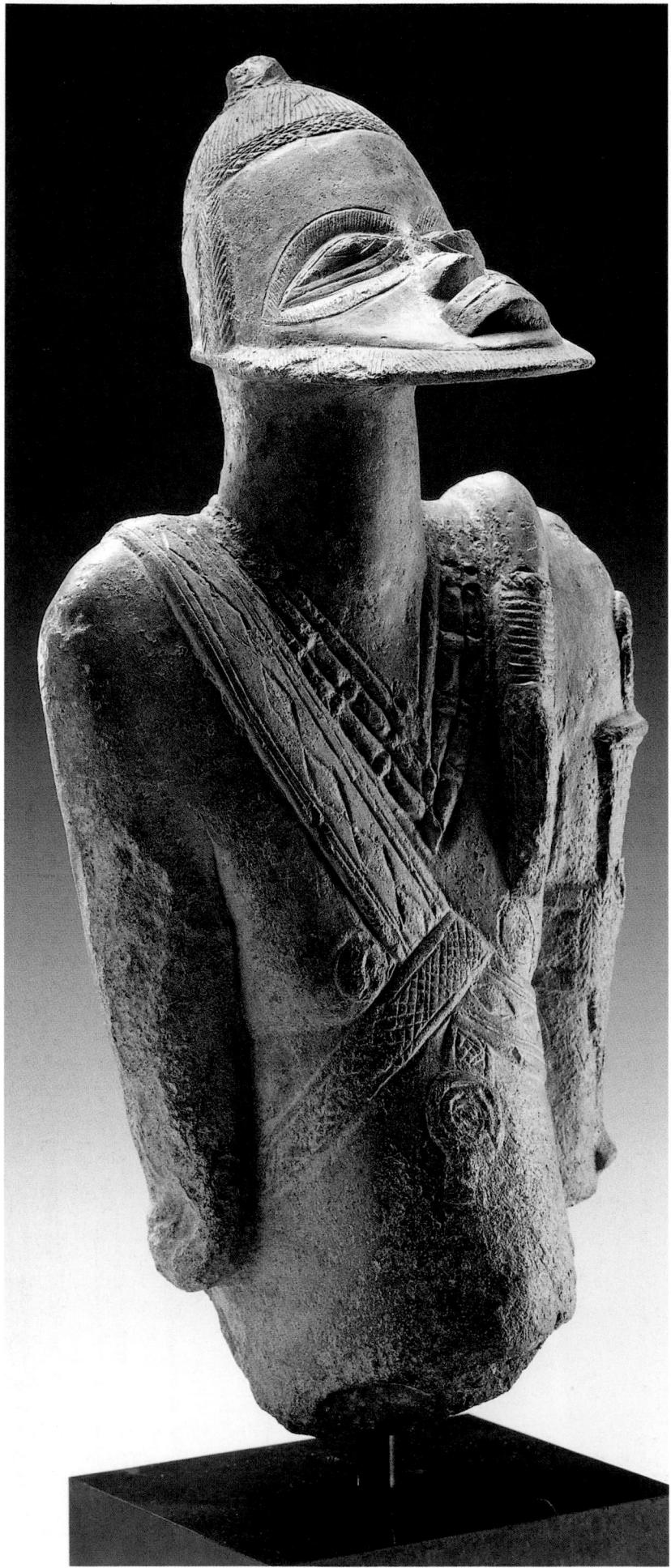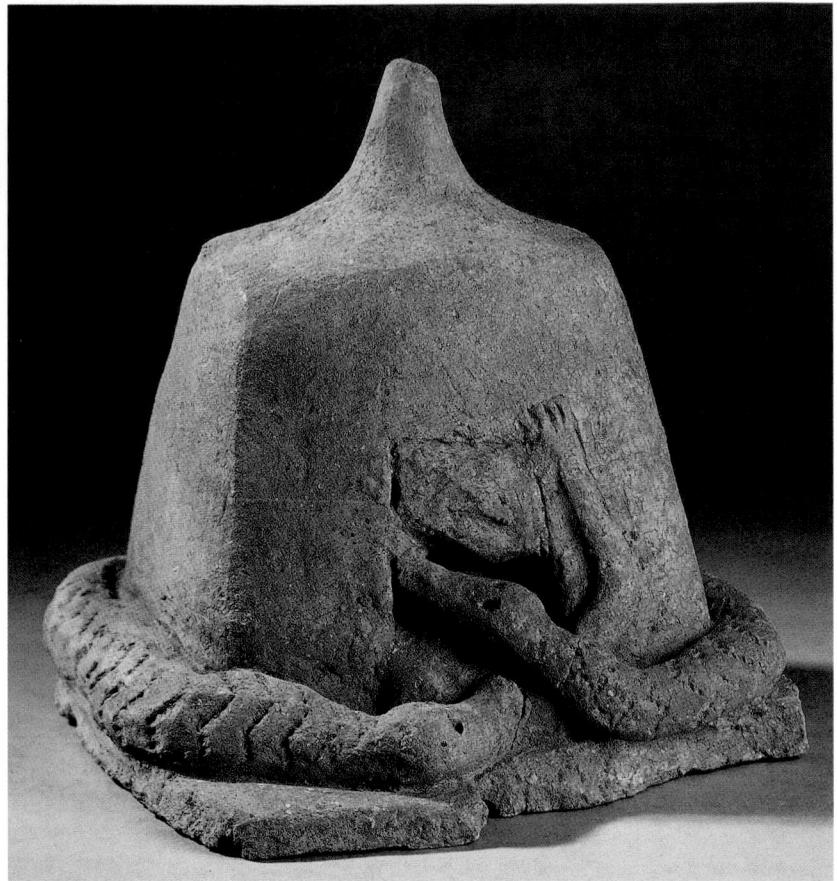

6.4f

Bearded figure (fragment)

Djenne

Mali

terracotta

h. 38.1 cm

The Detroit Institute of Arts

Founders Society, Eleanor Clay Ford Fund
for African Art, 78.32

6.4g

Shrine sculpture

Djenne

Mali

terracotta

22.7 x 22.2 x 22.7 cm

New Orleans Museum of Art

Museum Purchase, Robert P. Gordy Fund,
90.196

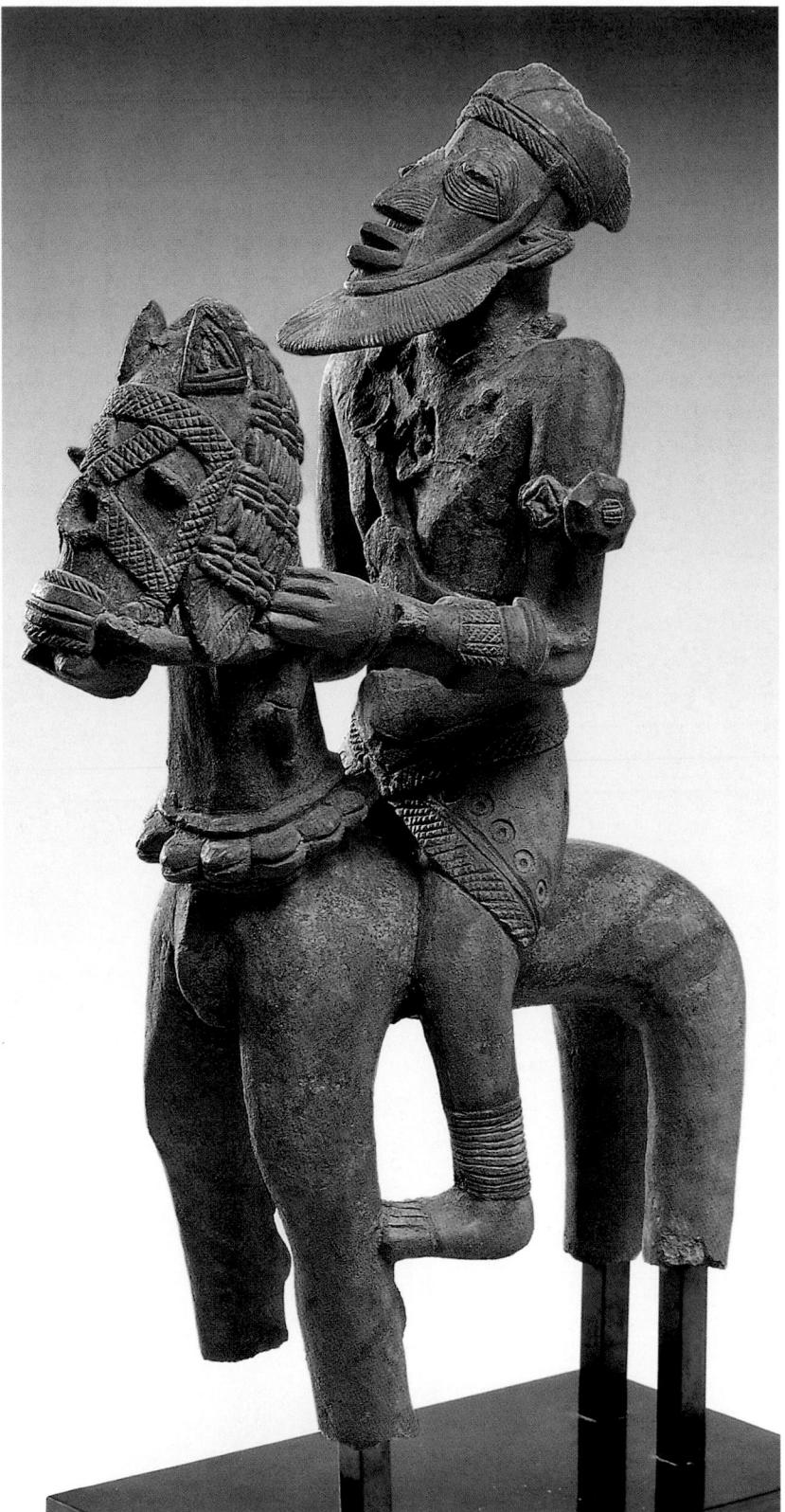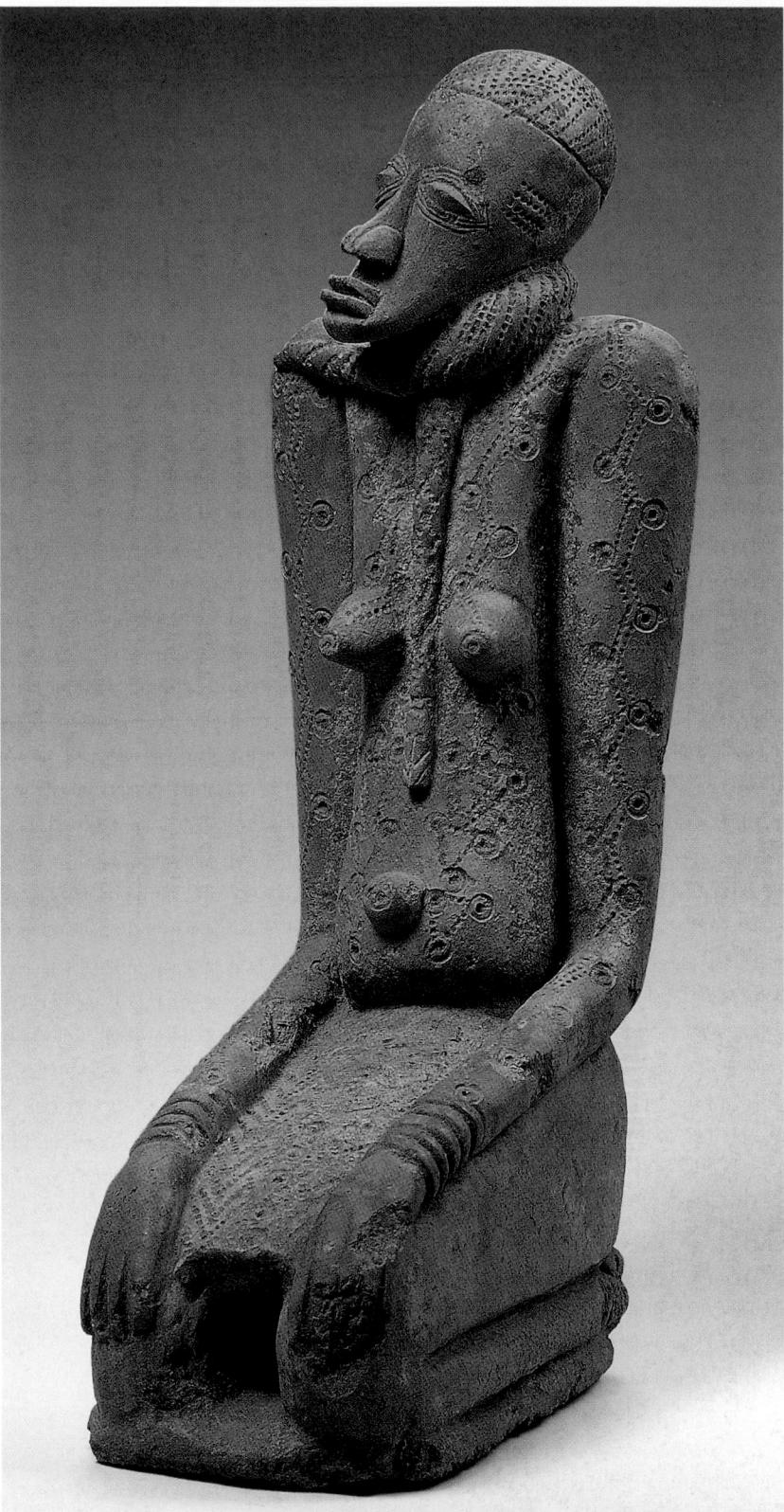

6.4h

Horse and rider

Djenne
Mali
terracotta
44 x 17 x 30 cm
Private Collection

6.4i

Kneeling figure with snake

Djenne
Mali
terracotta
h. 57 cm
Private Collection

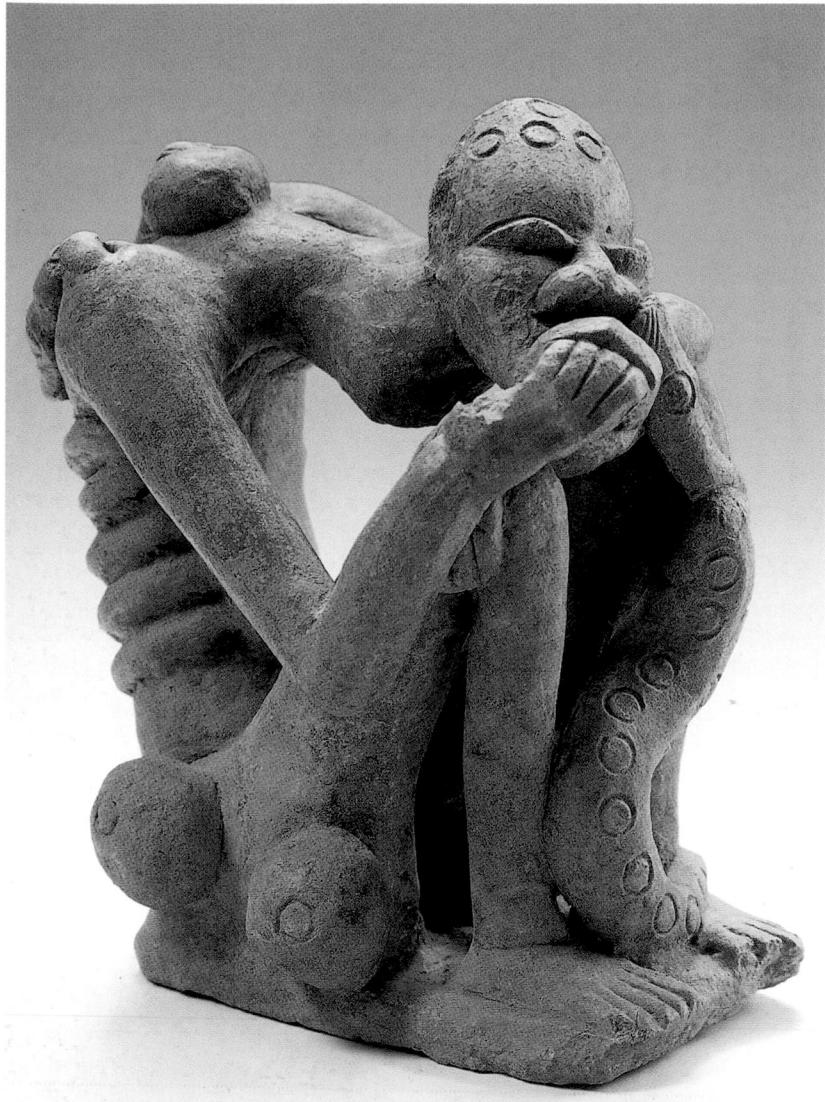

6.4j

Figure

Djenne
Mali
terracotta
h. 29.5 cm
Private Collection

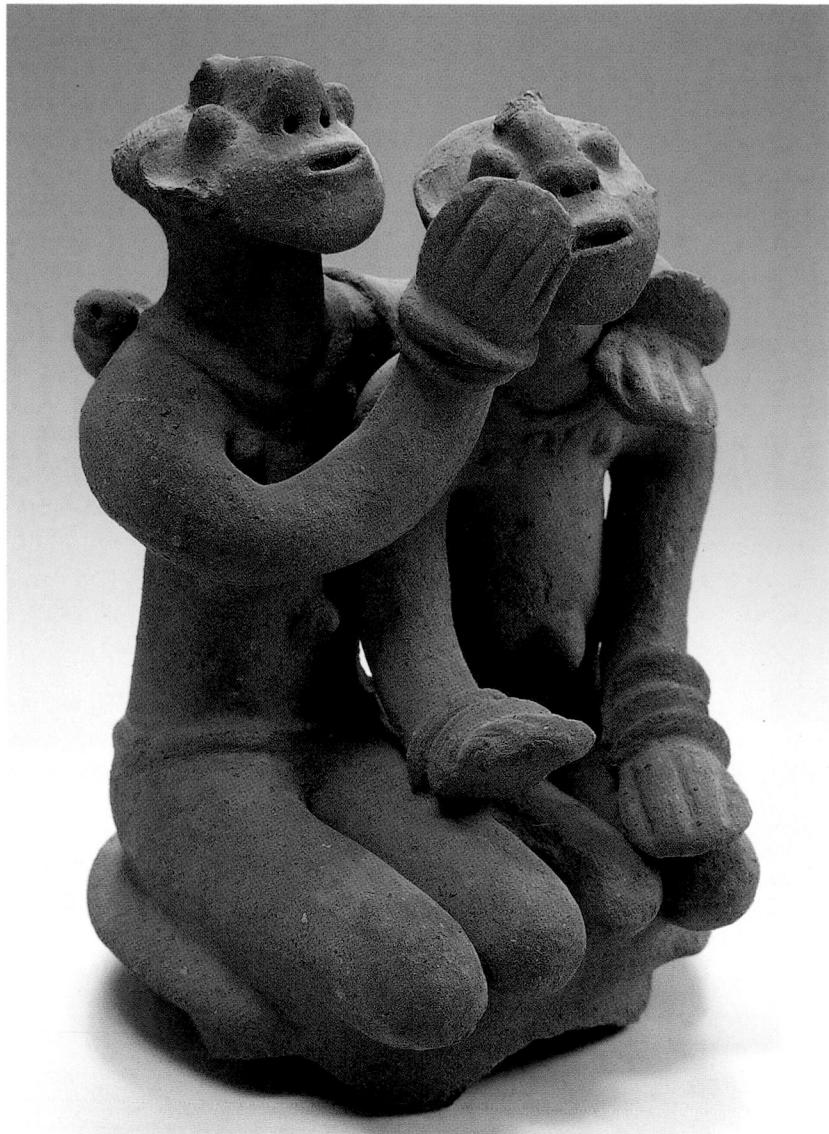

6.4k

Pair of figures

Bankoni
Mali
terracotta
h. 33.8 cm
Private Collection

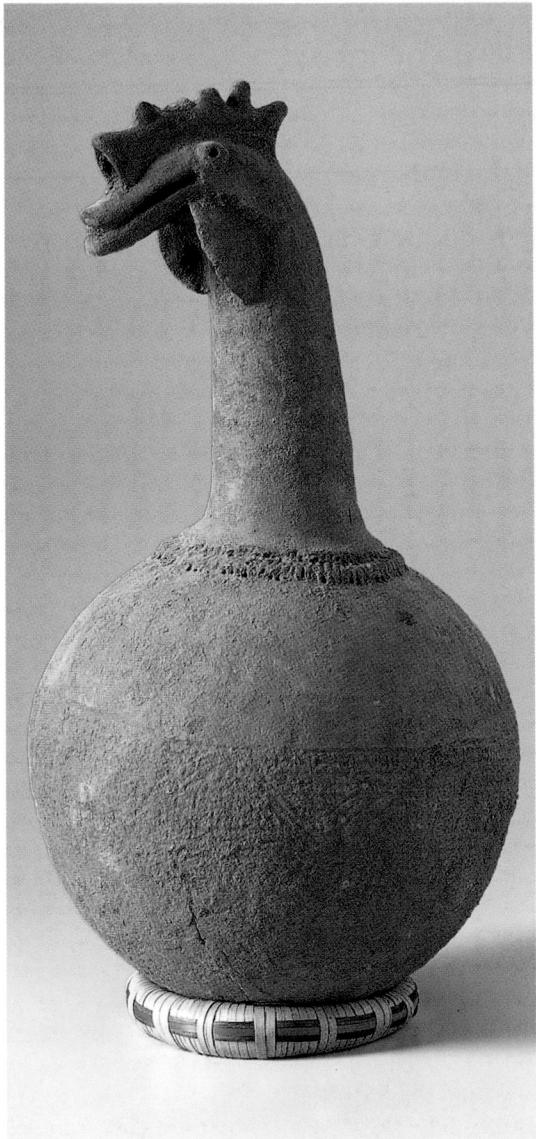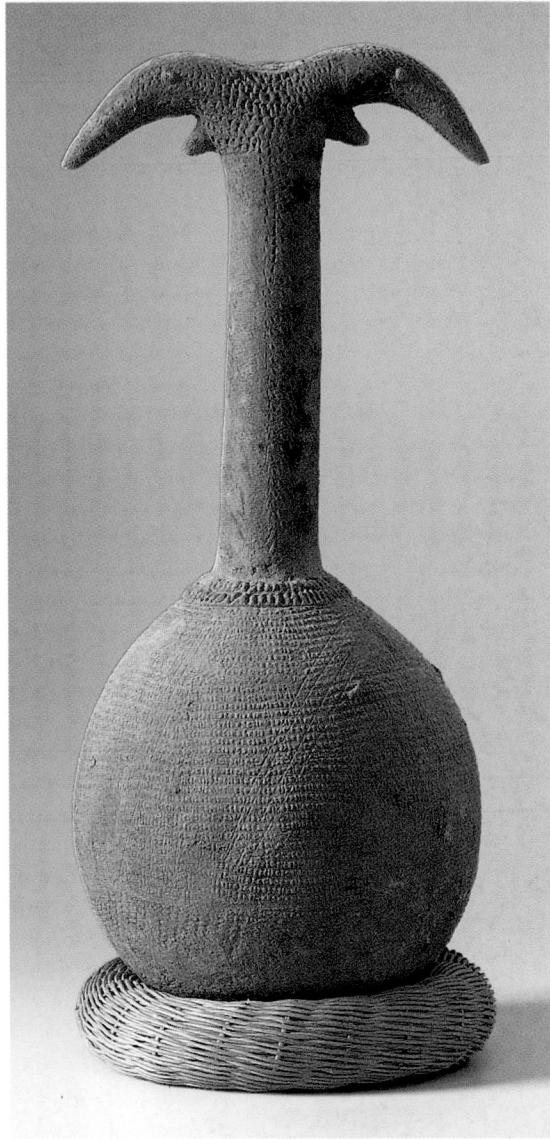

6.41

Three pots

Bankoni
Mali
terracotta
c. 54 x 22 x 22 cm
Private Collection

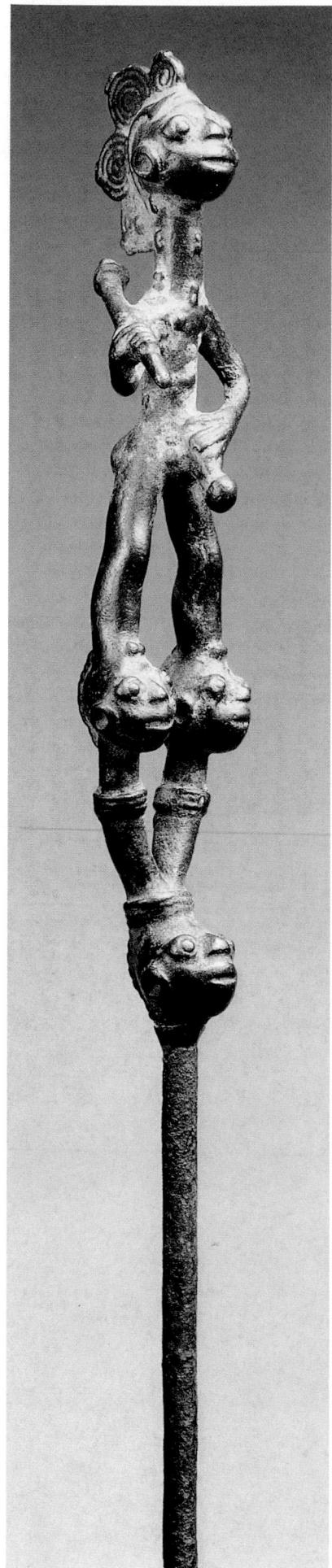

6.5a

Staff (*sono*)

Beafada, Badyaranke, Maninka or Fula
Guinea and Guinea Bissau
19th–20th century
copper alloy
69.9 x 4.1 x 3.8 cm
Lent by The Metropolitan Museum of
Art, New York
The Michael C. Rockefeller Memorial
Collection, Bequest of Nelson A.
Rockefeller, 1979.206.212

6.5b

Staff (*sono*)

Beafada, Badyaranke, Maninka or Fula
Guinea and Guinea Bissau
19th–20th century
copper alloy
h. 135 cm
Musée Barbier-Mueller, Geneva, 1001–32

Brass and iron staffs, called *sono*, form part of what may be one of the oldest continuous traditions of art in west Africa. The bottom is often a spear blade. In the central shaft, typically, forged iron is thrust at regular intervals into brass collars made by the lost-wax casting technique and embellished with geometric patterns. The brass collars often include angular extensions that create a cage effect, or a pair of hook shapes that sweep down, out and up again, ending in small replicas of human heads. The top of the staff is capped with a brass finial, generally consisting of an elaborately decorated cone or globe upon which figures or animals are mounted. These may include equestrian figures with attendants, some female and carrying containers upon their heads, some male with exaggerated genitalia. Many of these males carry staffs or weapons, and may be warriors. The brass casting is fine enough for horses' reins and people's hairstyles to be wonderfully articulated.

These staffs, which have mistakenly been attributed to the Soninke, seem to possess a complex and somewhat confusing genealogy. They are most directly attributable to the Beafada (or Biafada), Badyaranke (or Pajadinca), Maninka (or Malinké) and Fula (or Peul), all of whom have lived in the area we know as the Republic of Guinea and Guinea Bissau. To the north in Senegal the ancient Mande kingdom of Kabu used similar staffs, and the same may well be true of other states founded by Mande colonists between the Gambia

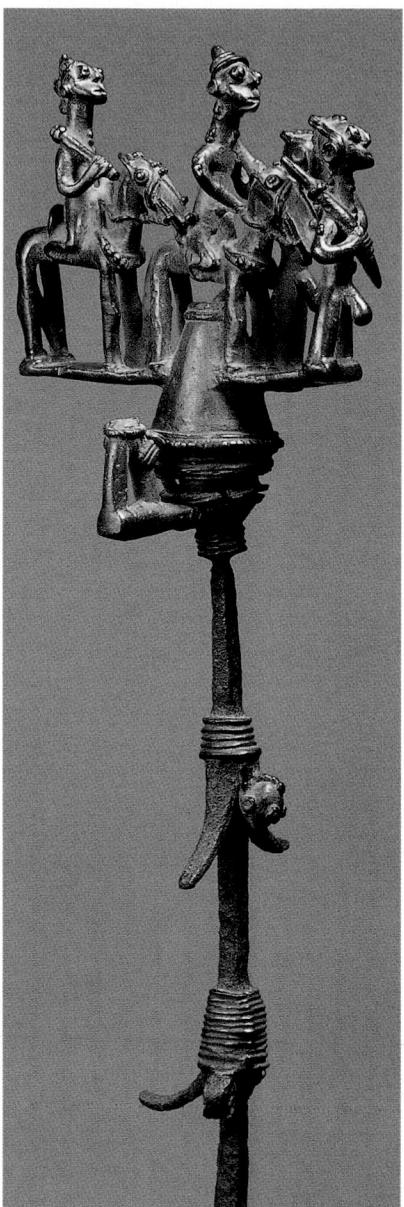

and Corubal rivers described in 16th-century Portuguese accounts. Still further north in The Gambia, closely related staffs called *chono* were found that featured more abstract compositions and emphasised iron but often included brass, as well as silver. They were still being used in the mid-20th century by Mandinka groups along the Gambia River, the descendants of 13th-century Mande imperialists who mixed with local populations and founded a cluster of Mande expansionist states.

South-east of the Beafada and Badyaranke, along the coast in Sierra Leone, late 17th-century Portuguese traders seem to have carried a number of brass and iron staffs very much like the present examples as gifts to Bulom leaders in the area known as Ro-Ponka. And further east in the Ivory Coast,

some Senufo seem also to have used brass and iron staffs.

Inland, similar staffs, usually made entirely of iron, have been used up to the present by heartland Mande groups such as the Bamana, Bozo and Maninka. Many scholars feel that this is the area where the staff originated. The tradition could be as old as the Mali empire.

The most plausible hypothesis is that as early as the 13th century such staffs were carried west and south by groups of military leaders and entrepreneurs who were pursuing the Mali empire's expansionist policies.

The staffs from the Gambia River have been used as insignia of leadership and political power. It seems likely that over all the centuries they were viewed as vehicles to associate their owners with the power and historical glory of the Mali empire and its leaders, even as the hinterland kingdoms manoeuvred for independence and distance from any tangible subordination.

Both Mande heartland peoples, such as the Bamana, and Mande-speaking peoples abroad in the hinterlands have had very long-standing interest in making art from metal. Mande have worked hard to be centrally involved in west African mining and trading of gold since at least as early as the ancient Ghana empire (which was flourishing by the 8th century). Sculptures and ornaments of all kinds, and in tremendous abundance, were recorded by early Arab visitors to the courts of the Ghana empire and the subsequent Mali empire (early 13th to the late 16th centuries), and oral traditions credit many of this vast area's greatest heroes as having been members of famous metal-smithing families.

The staffs also symbolise and embody the occult powers articulated in the spiritual beliefs of the area. Metal is an excellent medium for storing and harnessing enormous amounts of energy, because smiths can transfer it to the staffs during their creation. They were used as crucial religious objects in non-Islamic cults. In the Republic of Guinea and Guinea Bissau, for example, they would be stuck into the side of sacred trees, where they could amplify the powers of their owners by influencing the invisible forces constantly at work.

in the natural and social worlds. They were also used as soothsaying devices and consulted before any dangerous undertaking, such as war. Chono versions along the Gambia River were intended to protect the kingdom and its capital, and even today medicines and amulets may be hung on the hooks to protect political office-holders.

Their symbolism remains largely unexplained, and it could well be that it was quite flexible. Equestrian imagery may invoke wealth and power, and refer to leadership or even particular rulers. Possessing a horse was a clear indication of power and wealth. The spear blade bottoms also suggest power generally and military prowess specifically.

In the more complex example (cat. 6.5b) the standing figures form an apparent entourage, an indication of status and prestige for the mounted figures.

Human heads at the ends of the hooks that sweep out from the iron shaft are almost ubiquitous on these brass and iron staffs. The simpler example (cat. 6.5a) features an assertively articulated male figure carrying a staff or weapon and standing upon two human heads which are themselves set on top of one another. This composition could well refer to dominance over a population or even over a defeated enemy. The heads could also refer, however, to a supporting population upon whom a leader depends for power. *PMcN*

Bibliography: Pereira, 1956–8 (1956); Koroma, 1959, pp. 25–8; Mota, 1960, pp. 625–62; Lampreia, 1962, nos 412–17; Mota, 1965, pp. 149–54; Weil, 1973; Bassani, 1979, pp. 44–7; Weil, 1981

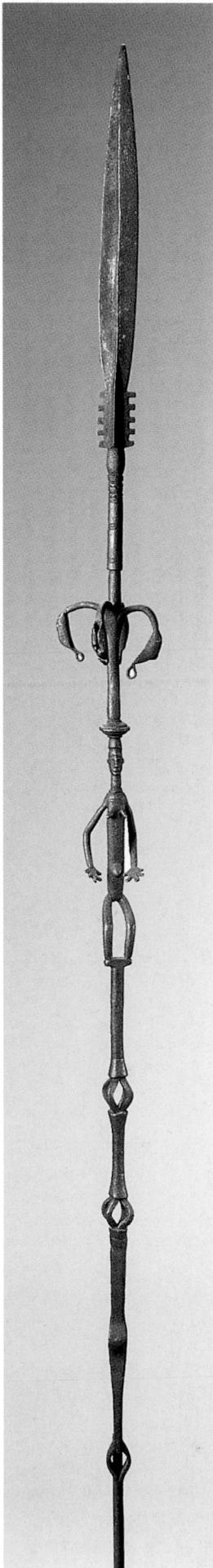

6.6

Staff with female figure (nege muso)

Bamana (Bambara)
Mali
iron
h. 161 cm
Private Collection

Staffs of this type are the most technically difficult of all the artworks Bamana and other Mande sculptors make. These sculptors are almost invariably members of the blacksmiths' clan. Typically, the shaft is forged out of several pieces, which are joined by inserting the top of one into a socket formed from the bottom of the next, and then heated and hammer-welded together. Frequently the shaft is expanded into cage-like protrusions, and on most examples hooks sweep down, out and up from the shaft, usually at the sockets. The hooks end in rounded knobs, which may be reminiscent of the little brass heads on the similar staffs called *sono* (cat. 6.5). Less frequently, as in this example, the sweeping hooks are inverted, and end in little iron rattles or bells, much like many Dogon staffs. Many of these staffs end in a spear blade at the base, but the creator of this piece has moved the blade from the bottom to the top (again like many Dogon examples) and embellished it with groups of five tooth-shaped extensions. The cages, inverted hooks and embellished spear blade work exquisitely together to create a powerful composition that frames and helps to highlight the marvellously sculpted female figure in the middle.

The figures on most staffs are standing women or equestrian men, and they are generally placed at the top, unlike our example. Here the figure carries a container on her head. The elongated limbs and flexed knees are typical, but the overall articulation and embellishment of this piece is masterly.

Mande blacksmiths overflow with the same spiritual energy (called *nyama*) that is said to animate the universe and allow for every action in it. This is the energy that makes amulets effective, and these staffs become amulets themselves, because as smiths forge them they also infuse them with *nyama*. They may also add additional power through secret recipes (cat. 6.8) that combine science and ritual.

These staffs were used in many situations: they could be set on top of the tombs of leaders and town founders, or in front of family residences to help honour ancestors. Some chiefs apparently used them as family insignia, and also used their power as amulets to enhance their own leadership abilities. Some staffs were considered so powerful that they could be employed to turn away attacking armies.

The Bamana secret initiation associations also used the staffs around their altars, or put them near or even in sacred trees. The beauty of the staffs was said to make the altars more powerful, as was the power embedded in the iron. This power strengthened the association, but the beauty of the staffs also enhanced funerals, when they were carried in procession, or regular business meetings, when members danced with them.

Symbolism, as in much Bamana sculpture, is ambiguous and subject to various interpretations. That is particularly true of the forged figures. They may be ancestors or characters from Mande legend, such as Muso Koroni, the first woman on earth, semi-divine, and bringer of tremendous chaos; or (if male) Ndomajiri, the world's first blacksmith and bringer of stability and medicines. The hat worn by this figure resembles those worn by hunters and sorcerers, and its presence on a woman signals awesome occult power. The spear symbolises power in the more tangible world of aggressive military deeds. *PMcN*

Bibliography: Imperato, 1983;
McNaughton, 1988

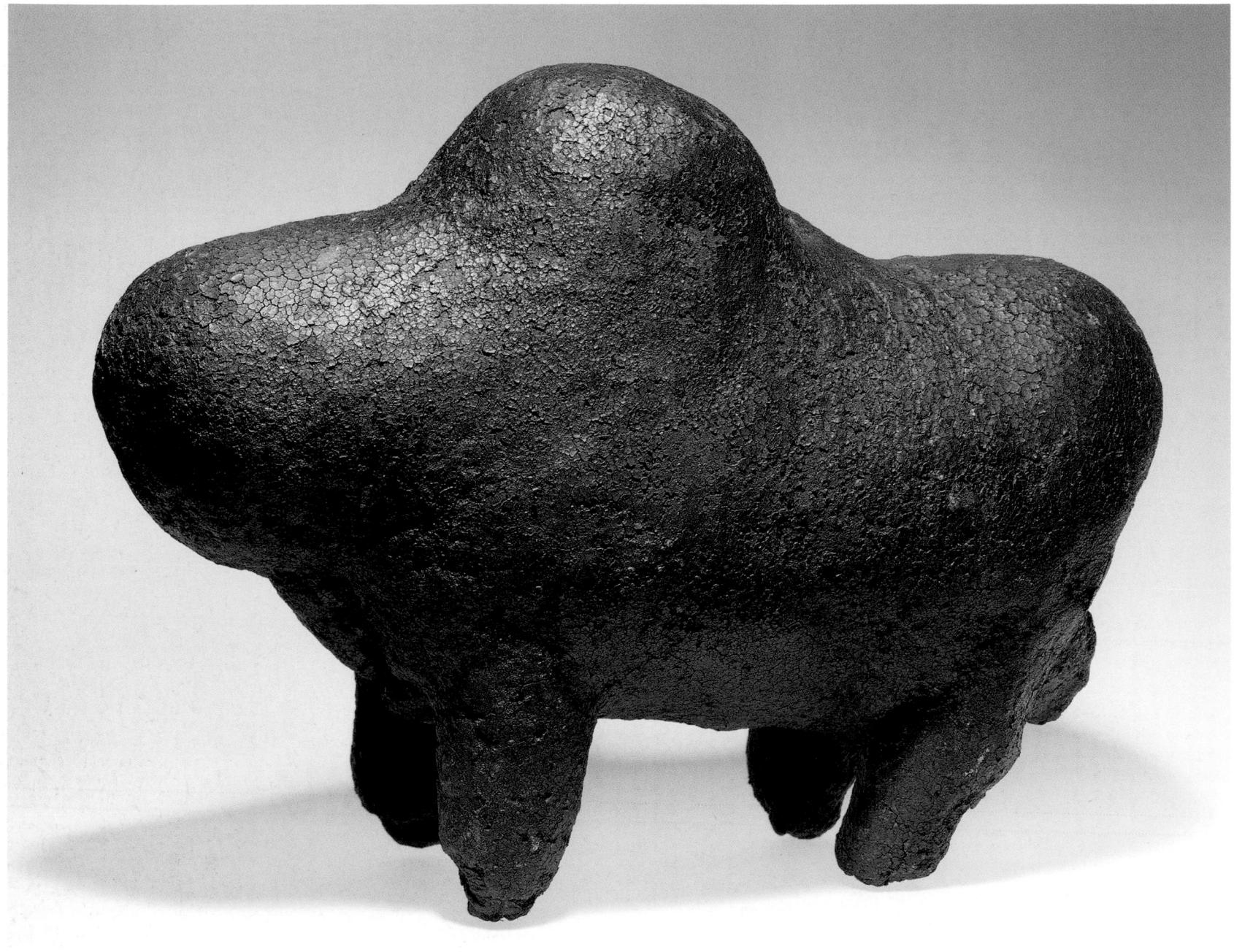

6.7

Altar figure (*boli*)

Bamana (Bambara)

Mali

wood, encrustation

Laboratoire d'Ethnologie,

Musée de l'Homme, Paris, 31.74.1091

Boliw (sing. *boli*) have become widely known in the West although ironically they are considered by Mande people to be secret objects. They are used by the Bamana secret initiation associations and harbour huge quantities of energy (*nyama*) that can be activated by the association priests and members to help accomplish goals (such as destroying anti-social sorcerers). They also serve as symbols of the Bamana universe, and association

members help make them by bringing together a wide range of often esoteric ingredients, including animal bones, vegetable matter, honey and pieces of metal. Some colonial era authors claimed that human body parts were included. The surfaces are hard, with thick coatings of earth, impregnated with sacrificial materials such as the blood of chickens or goats, chewed and expectorated kola nuts, alcoholic beverages and millet. Both surfaces and interiors are created by enacting a complex array of the power recipes called *daliluw* (cat. 6.8), with the result that these objects are considered to be among the most potent of all Mande sculptures.

Many *boliw* seem to depict animals such as hippopotami or cows, and some are shaped like human beings. Sometimes, however, it is impossible to suggest what they might be. This fits with the Mande principle that very powerful things are opaque to general human understanding, and only the initiated will understand them. For others, the lack of understanding is ominous, and the murky ambiguity articulated in the shapes serves as a warning to stay away or risk great personal danger. Only skilled professionals are capable of engaging the powers contained in these instruments.

Some Mande feel they are devices to be used for the good of association

members and the community. Others find them loathsome and fearsome, with too much power that dominates the members of the associations. Still others consider them to be just one more element in their social and spiritual landscapes, sometimes to be used, sometimes to be treated with caution.

Placement of these objects is not entirely clear. When the *ci wara* (cat. 6.10) association used them, they were kept in baskets, and association officials danced with them on their heads during meetings. PMcN

Bibliography: Dieterlen, 1951, pp. 92–5; Imperato, 1970; McNaughton, 1979; Brett-Smith, 1983; McNaughton, 1988

Mask in the shape of an animal head

Bamana (Bambara)

Mali

wood, encrustation

47 x 25 x 22 cm

Museum Rietberg, Zurich, RAF 206

Baron E. von der Heydt Collection

This mask is designed in the helmet configuration and horizontal alignment typical of Mande youth association masks or those of the secret initiation associations that specialise in the manipulation of occult power. Youth association masks do not possess sacrificial surfaces, however, so this example certainly belonged to a power association. Komo, Kono and Nama are the three best known. Kono is an unlikely candidate, because to our knowledge their masks are greatly elongated, so that they usually measure a metre or more from ear to snout. Komo masks can be up to a metre long, but they are generally around half that size, while Nama masks are most frequently even smaller. By size, then, this mask could be Komo or Nama.

Komo masks are renowned for their enormous and threatening mouths, while this mask's mouth is not quite so ferocious. Nama masks, on the other hand, are frequently articulated as birds' heads. In this example the overall configuration of the head is reminiscent of the wild boars that inhabit the Malian countryside. It therefore falls outside the most common range of imagery for either Komo or Nama. But, as in the case of other Bamana art forms (e.g. cat. 6.6), personal experiences, expertise and imagination can generate works that are decidedly out of the ordinary.

There are other Bamana power associations that are unknown to strangers, being very local or even one-of-a-kind branches in a single community. These come into being and continue to exist through the efforts of capable, convincing and often charismatic spiritual experts. The expertise involved is grounded in the power recipes, in what the Mande call *jiri don*, the science of trees, an ever-expanding and changing body of herbal knowledge that views the natural world both scientifically and ritually. While many people who possess the highly secret knowledge accept what they learn with no

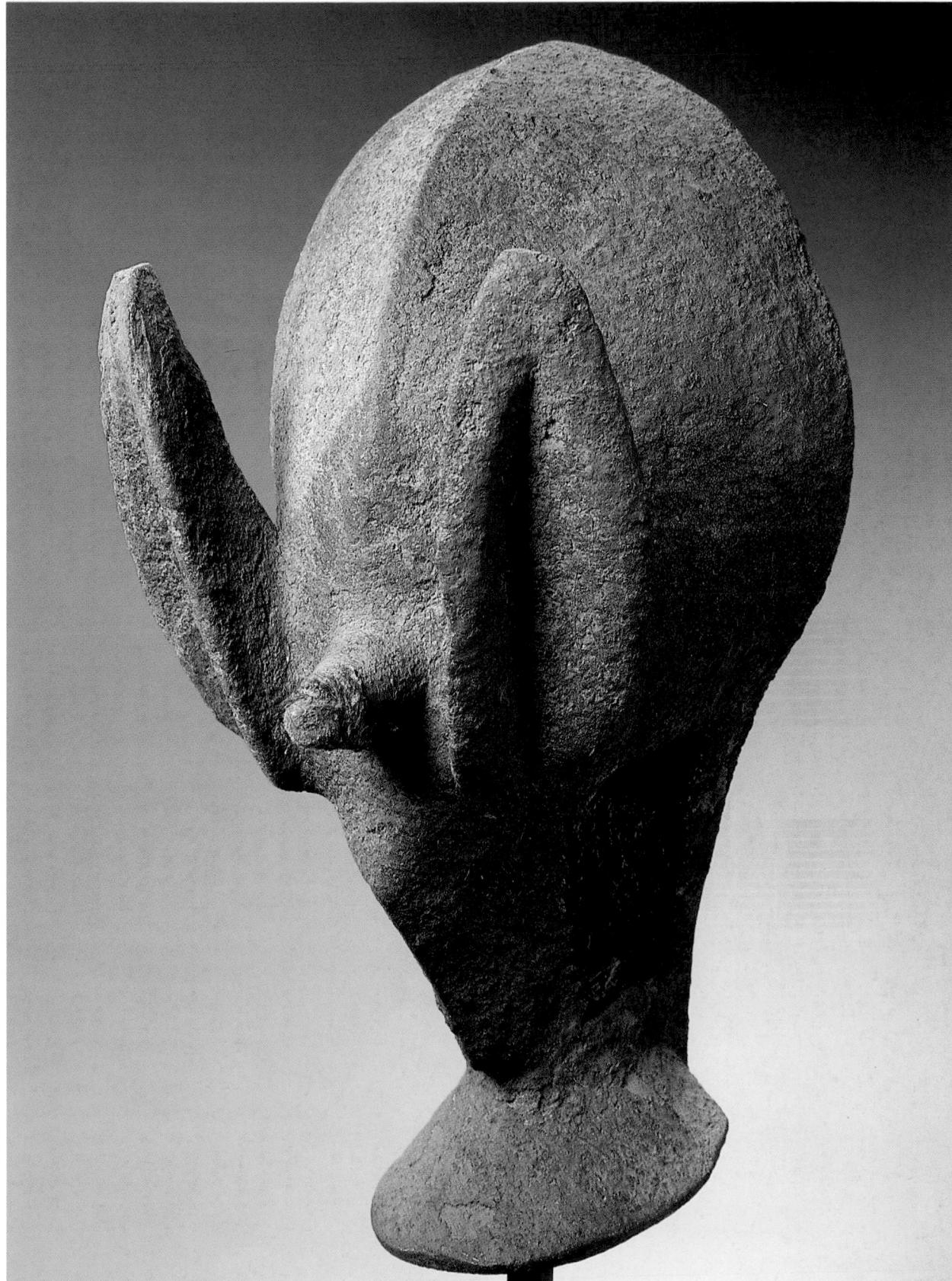

desire for alteration, others are very experimental with it. This leads to idiosyncratic sculpture.

In general, the power associations solved problems and did good works for their members and their com-

munities. Much depends upon the effectiveness of officials, however, including the leader or assistant who dances the mask at association meetings. *PMcN*

Bibliography: Zurich 1963, no. 7; McNaughton, 1979; MacNaughton, 1988; McNaughton, 1991; McNaughton, 1992

6.9a

Female figure (*nyeleni*)

Bamana (Bambara)

Mali

wood, iron, oil

h. 71 cm

Private Collection

6.9b

Female figure with container

(*jomogoniw* or *gwanden*)

Bamana (Bambara)

Mali

wood, oil

h. 130 cm

Private Collection

These two sculptures are associated with the initiation associations called Jo and Gwan in southern Mali. The most widely known uses for such figures are as memorials for deceased twins and insignia of initiation in the Jo association branches. Twin sculptures tend to be smaller, typically ranging up to about 50 cm in height, and they depict either males or females, depending on the gender of the deceased. Jo association figures tend to be a little larger, usually not less than 50 cm high; they always depict women, generally standing on a circular base. But there is so much room for overlap that often a particular figure cannot be attributed with any certainty. The smaller piece shown here (cat. 6.9a) is most likely a Jo association sculpture.

The Mande associations, known generally as Jow (sing. Jo), offer general social guidance and teach modes of behaviour. These associations were arranged in a hierarchical order of initiation, and increasingly complex and esoteric levels of knowledge were provided as members moved up the hierarchy. This hierarchy was disrupted by first the Tukulor in the late 19th century and then the French. But even before Tukulor domination these associations very likely exhibited considerable variation and flexibility.

In the southern Bamana area, within a rough triangle formed by the towns of Bougouni to the west, Dioila to the north and Sikasso to the east, the Bamana secret initiation associations are reduced to two, Jo and Gwan, which express their own forms of variation, such as having joint female and male membership.

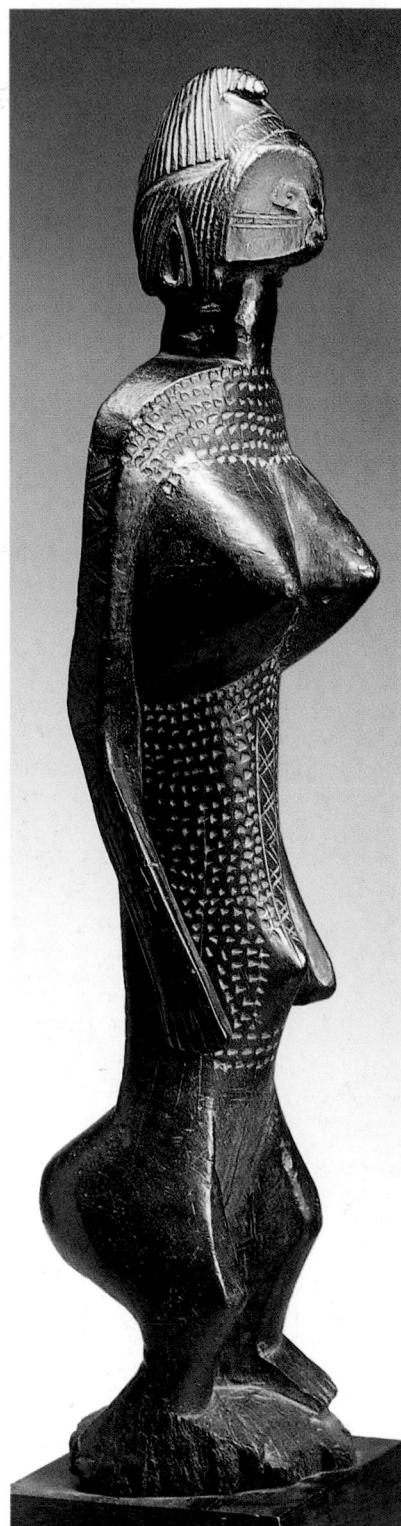

Blacksmiths generally form their own group within the Jo and it is they who use figures such as cat. 6.9a when they tour and perform after their initiation. They hold them or set them in the performance arena as they sing and dance. The sculptures are called *jonyeleni* or *nyeleni*, which means 'little Nyele', a name often given to first-born daughters, which means 'pretty little one'. These sculptures are oiled and often embellished with clothes and jewellery, and they are carved to emphasise ideal attributes of feminine beauty. They may serve to express interest in and concern about the institution of marriage, in which newly initiated single men will soon be involved. They also help to make the blacksmith performances the most successful and entertaining of all the performing groups within the Jo.

Much larger sculptures, such as the second example shown here (cat. 6.9b) were also used, where they were called *jomogoniw*, 'little people of the Jo'. They were also used in the Gwan association (and called *gwanden*, 'children of the Gwan'), a special division concerned with issues of fertility and childbirth.

These larger figures are cared for by senior members of the associations, and are displayed during their annual celebrations. They are washed to remove extraneous matter, re-oiled and adorned with clothing, and then sacrifices are made on the entrance to the house where they are kept. Ezra says people refer to the sculptures as 'marvellous things' (*kaba ko*), and 'things that could be looked at without limit'.

The annual Jo celebrations generally involve only two sculptures, depicting a man and women. The Gwan celebrations involve more elaborate groupings of up to seven. A seated woman with child (*gwandusu*) and a male (*gwantigi*), often seated, were the most important. The other figures were called companions, and each had its own name. They included a woman carrying a container on her head (as at cat. 6.9b), and a woman holding up her breasts in a gesture of nurturing. Often the women's stomachs swell gracefully, suggesting pregnancy or fertility. The display group was considered a kind of theatre, representing the nature and activities of the association. PMcN

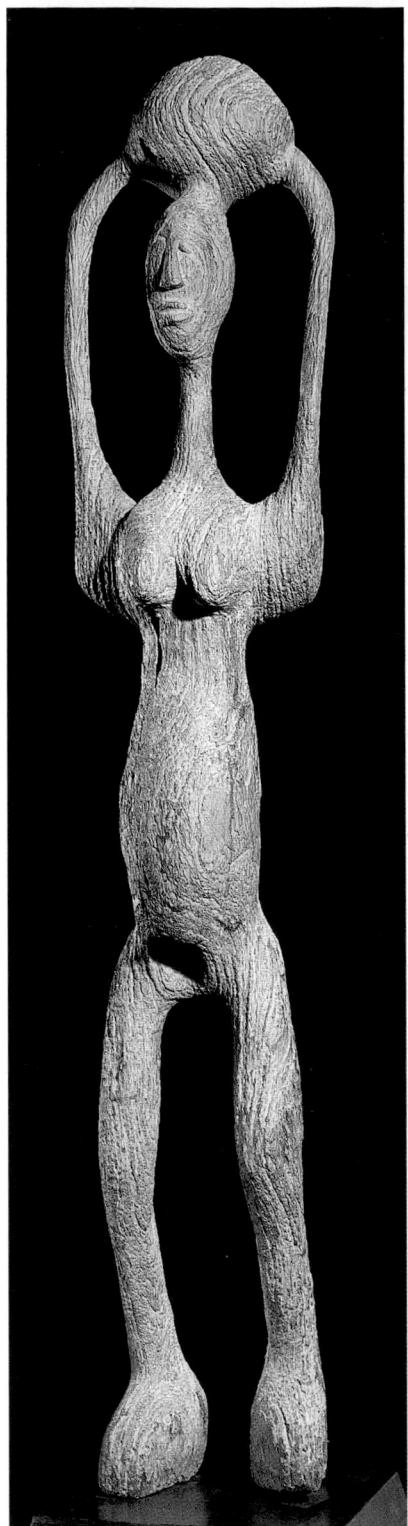

Bibliography: Páques, 1954; Zahan, 1960; Imperato, 1974, nos 66, 97; Imperato, 1975; Ezra, 1983; Imperato, 1983; Ezra, 1986

6.10 a–b

Two antelope headdresses

Bamana (Bambara) or Wasulka

Mali

20th century

wood

a: h. 55 cm; b: h. 80 cm

Private Collection, London

Carved wood antelope headdresses such as these are among the most widely known and greatly appreciated Mande types of art in the West.

In fact, few types of art from anywhere in Africa have received more Western attention. They are used by the Bamana agricultural associations; the best known is called *ci wara*, the lesser known *gonyon*. In both, the headdresses are called *ci wara* ('farmiy anind', 'farming beat'). Similar sculptures are called *sogoni kun* and are used by the Wasuluka youth association (*jon*) during farming festivals. Goldwater popularised a regional system of attribution for these headdresses. Carved headdresses that extend upwards in a large curve with openwork carving to represent the antelope's neck and mane belong to the 'vertical style' associated with the eastern Bamana. Smaller headdresses with pronounced horizontal extension, which are sometimes carved more naturalistically, belong to the 'horizontal style' associated with northern Bamana. Examples such as these, that emphasise tremendous variation, great ingenuity of form and often extreme abstraction, belong to the 'abstract style' generally associated with southern Bamana and Wasuluka. Here anteaters and aardvarks may also be included in the sculpted compositions and frequently the formal elements are so stylised that it becomes difficult to sort them out. As in many other types of Mande sculpture, the creativity and expertise of sculptors play prominent roles.

The *ci wara* association began as a secret male initiation association that taught agricultural skills and sought to maintain the blessing of the supernatural being (also called *ci wara*) that first taught people to farm. Dances were held in the fields and, instead of masks, dancers put part of their *boli* (cat. 6.7) in a basket and set it on top of their heads. Later the carved antelope headdresses were invented and danced in male-female pairs. Gradually the performances became less secret so that ultimately entire

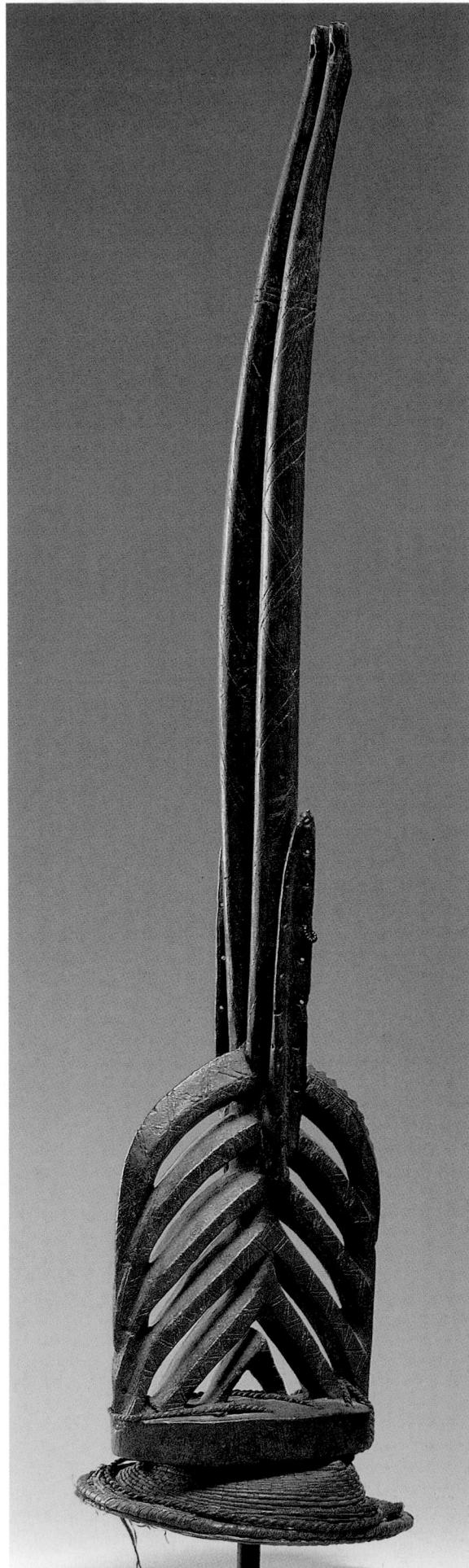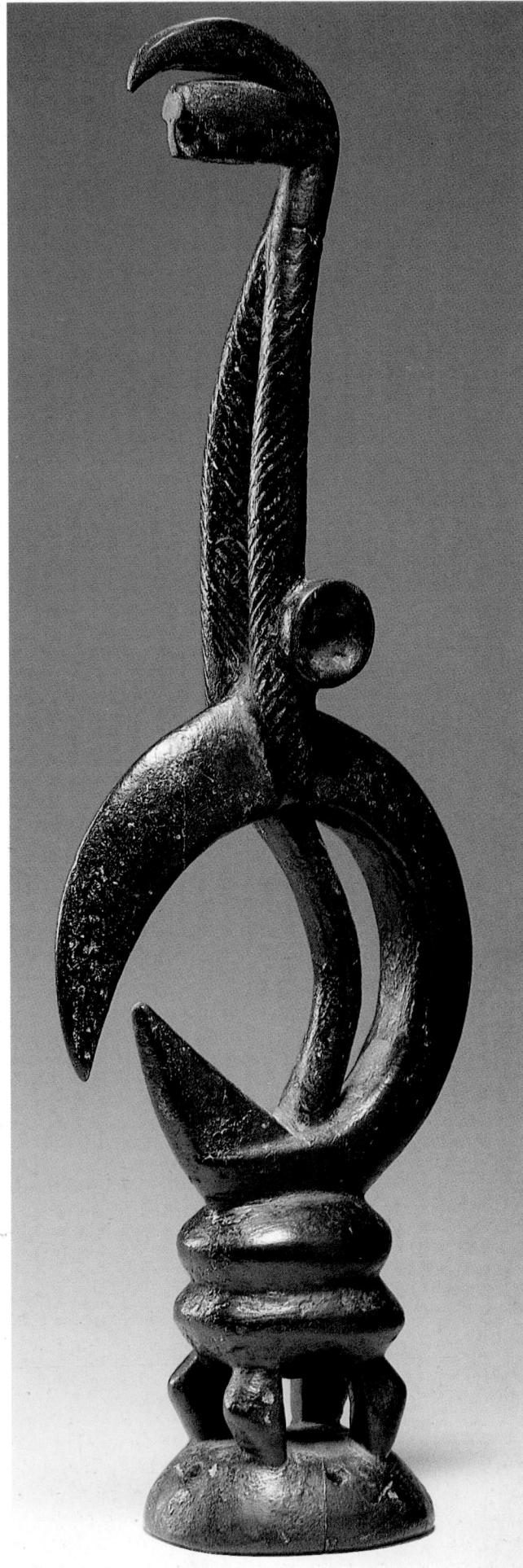

communities could attend, and the association became best known for its annual farming contests and accompanying performances.

The Mande often use animals in metaphors that comment upon social life and the human condition. Roan and dwarf antelopes are considered graceful and strong; aardvarks are determined and conscientious. These are values associated with farming, where strength, stamina, patience and foresight are all necessary to do a good job. In this regard another use of the phrase *ci wara*, which means 'farming animal' or 'farming beast', is important as praise for good farmers, for it likens the prowess of a person to the prowess of creatures that survive in the ultimate of difficult environments, the wilderness. *PMcN, DA*

Bibliography: Ganay, 1947; Ganay, 1949; Goldwater, 1960; Imperato, 1970; Imperato, 1974, pp. 19–21; Zahan, 1980; Brink, 1981, pp 24–5; Zahan, 1981, pp. 22–4; McNaughton, 1994, p 35

6.11

Pair of masks

Bamana (Bambara)

Mali

wood, organic matter, cotton fibre
25 x 17 x 12 cm (male);
37 x 16 x 11 cm (female)

Charles and Kent Davis

These masks are clearly carved in a Bamana style. The nose, mouth and the planes of the face all suggest that they come from areas where the initiation associations called Jo and Gwan are found. They bear a striking resemblance to the faces of the large carved wooden figures used by both of those associations. Although information on these masks is extremely limited, we may tentatively surmise that they belong to the Jo association, and possibly to the Gwan as well.

The Jo association is divided internally into several age grades, the most senior of which can be entered at the age of 36 when an applicant has successfully acquired the knowledge and moved through the process of formal initiation that mark passage upward in the association. Association leaders are picked

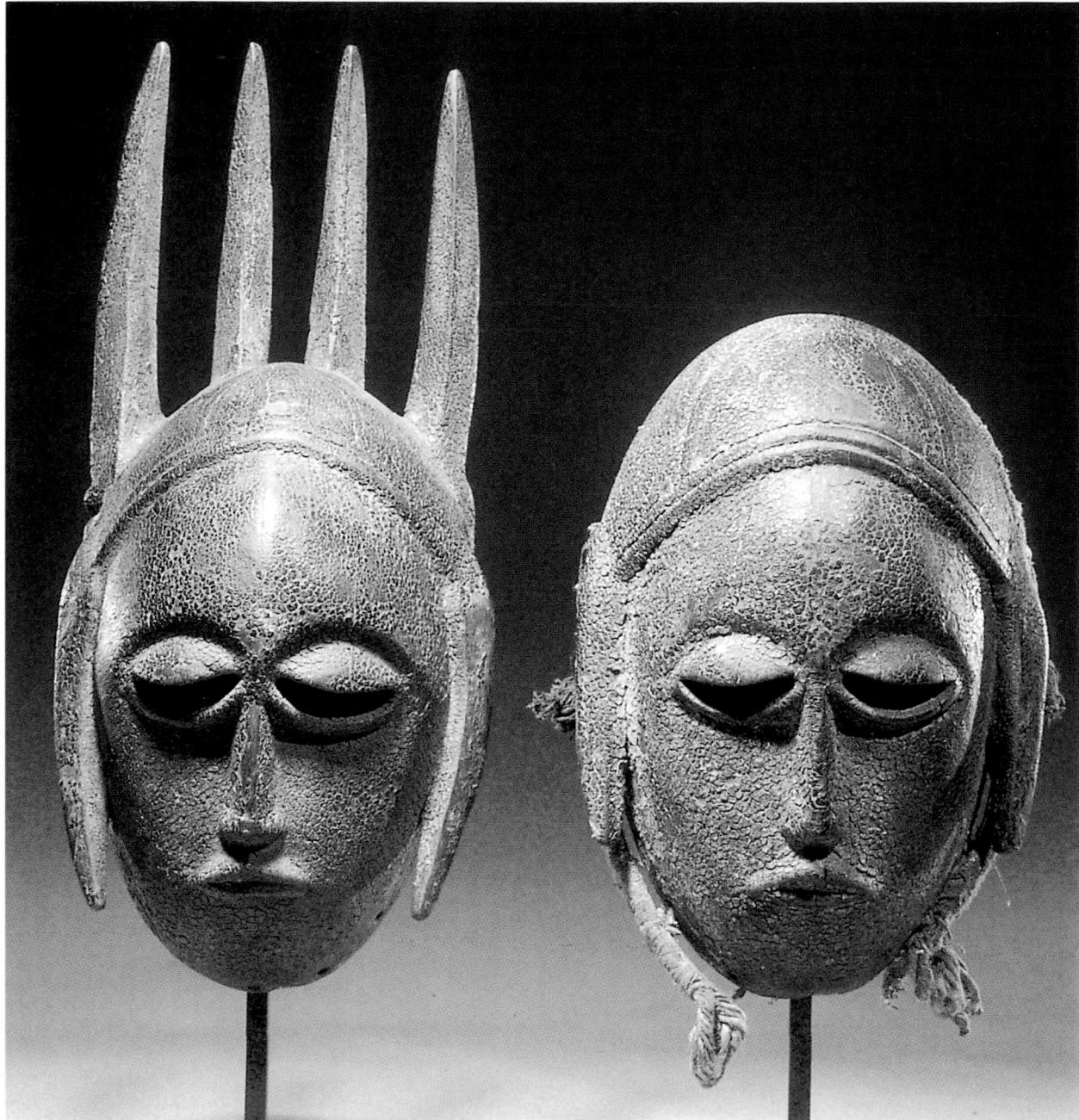

from the senior age group, and one of the most important leaders is *Nanfiri* which is also the name of an esoteric ritual object in his charge.

The ritual object, though small enough to be stored in a gourd, possesses tremendous supernatural power, and is used for swearing oaths. The official called *Nanfiri* is also very important: he has ritual roles at funerals, including the funeral of the head of the Jo, and he oversees and protects new initiates into the association during their induction ceremonies.

The Jo is one of the Bamana initiation associations that undertakes public performances, and when they

do the *Nanfiri* is a prominent dancer, so much so that he is called 'decoration' for the association. When dancing the *Nanfiri* wore a cotton cloth costume dyed red with painted designs in black. A hood with eye holes topped with porcupine quills and feathers covered his head. Similar cotton cloth costumes and hoods are fairly widespread in the general region of west Africa, extending south into Ivory Coast and north into Beledougou plains north of the Niger River.

In the 1980s Charlie Davis, a New Orleans dealer, told Ezra about wooden masks from southern Mali, which he understood to be called *Nanfiri* and to be part of the Jo and Gwan associations. It is possible that

certain branches of the associations decided to create masks for their *Nanfiri* office holders. Such a change would be consistent with the creativity that many Bamana people manifest. The organic materials on these masks could be sacrificial. One (described as female) has the row of horns quite common on Ntomo masks, which belong to another of the well-known Bamana associations. If as surmised these masks belong to the Jo and Gwan associations, and if they are a pair, we do not know who, besides the *Nanfiri* office holder, wore one. *PMcN*

Bibliography: Ezra, 1983, pp. 68–75; Ezra, 1995

Dogon

Dogon statuary is among the most discussed and least understood in Africa. A number of factors have contributed to this state of affairs. First, there is the obvious fact that the Dogon do not in any simple sense 'exist', having been defined and created as a convenience of colonial administration. Then there is the difference between anglophone and francophone styles of field enquiry, the former traditionally functionalist, the latter intellectualising and systematising, each perhaps saying more about the ethnographer than about the Dogon. There is also the matter of specialist as opposed to generalised exegesis in a culture where knowledge cannot be assumed to be equally shared by all so that varying interpretations may not be seen simply as contesting. Complicating the enquiry is the stern disavowal of knowledge that often follows on from conversion to Islam. Behind it all lurks the reality or otherwise of the Tellem, responsible for a supposedly ancient substyle but whose name seems to mean simply 'we found them'. The status of the works as art has inevitably become entangled with their ability to be unpacked into cosmic messages so that a style of exegesis has developed that sees Dogon sculpture as largely expressive of myth and constituting a form of congealed cosmology.

The statues themselves vary enormously in size, form and surface patination. This is not to say that art critics have not sought to establish rigorous styles and historical watersheds, but the value of such attempts is at best to impose a somewhat arbitrary order on a mass of ill-digested data so that 'transitional forms' abound. It remains the case that we have very little reliable information on what Dogon statuary was used for and by whom, a fact that has certainly entered into the way in which it has been used to bolster arguments for the universality of art. Interpretations home in on 'ancestral' figures and those involved in rainmaking. *NB*

Bibliography: Griaule, 1965; Laude, 1973; De Mott, 1979; Bedaux and Lange, 1983, pp. 5–59; Van Beek, 1991, pp. 139–67; Leloup, 1995

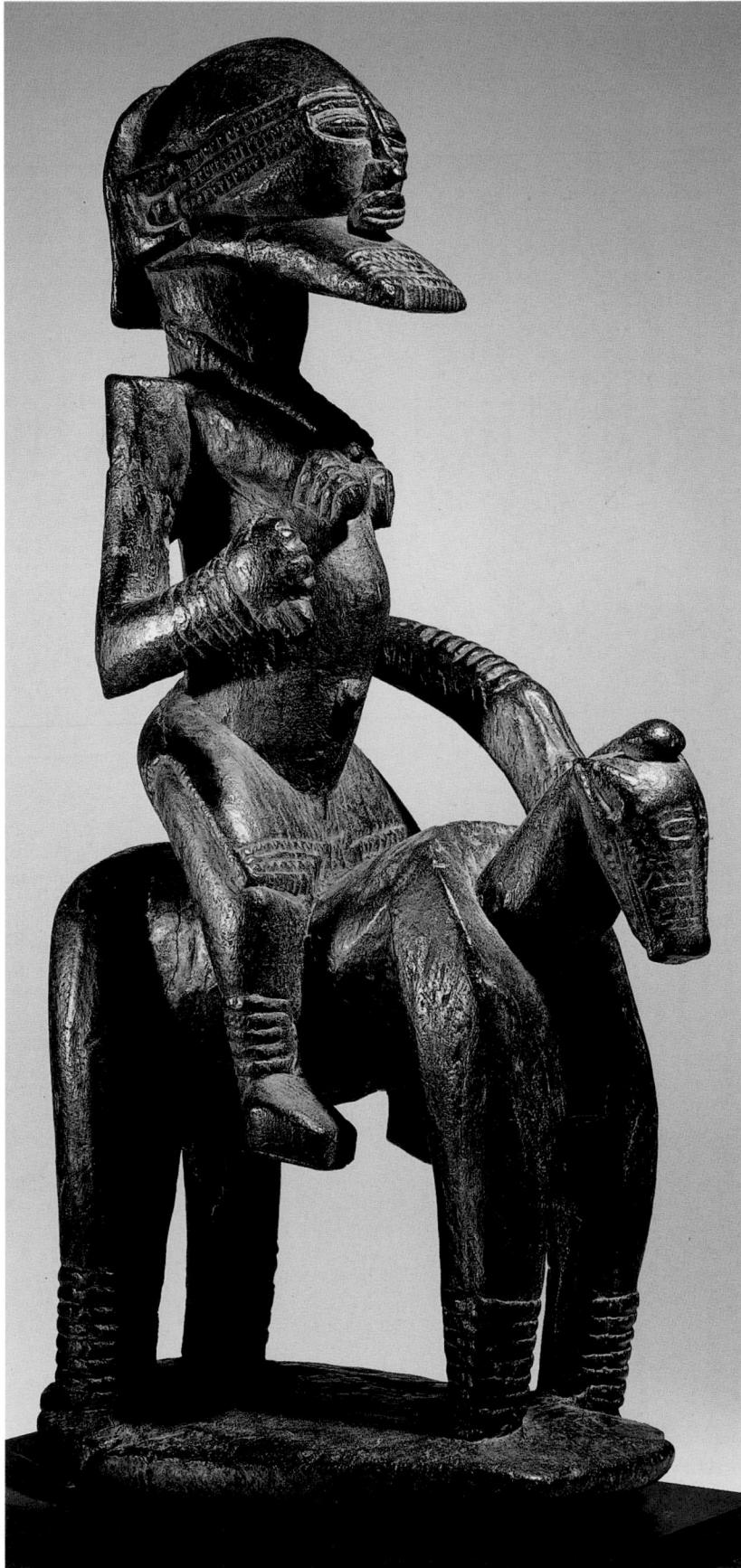

6.12

Equestrian figure

Dogon
Mali
18th century (?)
wood
h. 50 cm
Private Collection

The chronicles of Muslim travellers throughout the Sahara and Sahel tell of the existence of the horse in Mali's ancient empires. From the mid-11th century, royalty is known to have displayed its authority, and kingdoms to have flourished their military might, with the aid of equestrian prowess. This equestrian figure exhibits such characteristics. Larger even than his powerful mount, the rider sits proudly upright, his feet secured in stirrups, his left hand holding the reins. His beard indicates that he has earned respected elder status, the scarification marking his temples suggests affiliation with or initiation into a particular social group. The jewellery that adorns his neck, arms and ankles – a motif repeated on the lower legs of the horse – denotes personal achievement and wealth.

Among today's descendants of Mali's historic inhabitants are the Dogon: a society with neither the royalty nor the military of early empires, but whose sculpted equestrian figures remain an adapted, and continually adaptable, sign of privilege and power. Riders may represent warriors, invaders or emissaries from afar, respected deceased leaders of the local community, bush spirits that appear to passers-by, or the spiritual supremacy of the village priest or *hogon*, each of whom possesses a link to ancestral realms and has the means to own a horse and the power to discipline it to his will. *RH*

Bibliography: Law, 1980, p. 15; Ezra, in New York 1988, p. 40; Van Beek, 1988, p. 63; Cole, in Washington 1989, p. 121

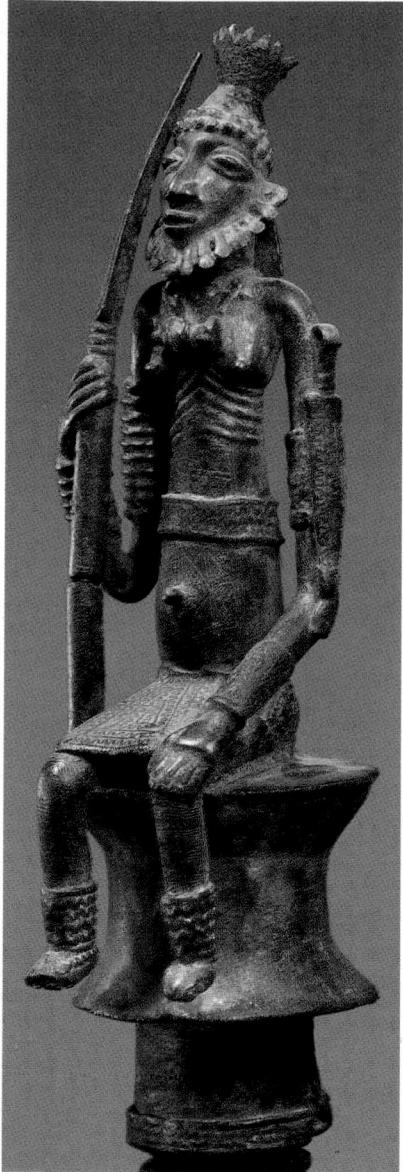

6.13

Staff

Dogon
Mali
copper alloy
h. 75 cm

Lent by The Metropolitan Museum of Art, New York
Edith Perry Chapman Fund, 1975.306

6.15

Kneeling female figure

Dogon
Mali
wood
Private Collection

The kneeling figure (male or female) is a motif often found among Dogon figurative sculpture and may be representative of a long history of trade in ideas and subjects among the varied inhabitants of the region reaching from Mopti and Djenné to the Bandiagara escarpment. This example exhibits features of such historic sculpture as well as characteristics considered highly desirable in a Dogon woman. She kneels devotionally; her eyes are cast deferentially downwards; her head is held high but modestly bowed on top of a slender neck. Her youthful breasts and rounded belly offer the potential of childbearing. Her scars suggest an ability to embrace the responsibilities that come with membership of adult society, and her coiffure – its carved motif visually echoing her scars – accentuates a head that is outwardly well tended and inwardly properly educated. Her powerful thighs support a strong body, and her fingers point toward the female earth. Although her posture and comportment have been linked visually to terracotta figures associated with early Inland Niger Delta civilisations (and the repetition of the kneeling pose found among a number of historic and contemporary figures suggests ritual significance), we fully understand neither the significance of the pose nor the linkage between historic and contemporary figures of this kind.

RH

Bibliography: de Grunne, 1988, pp. 50–5,
92

6.16

Mask

Dogon
Mali
wood
h. 58 cm
Private Collection

This unusual mask features elements which, although common to Dogon sculpture, are not generally combined in one piece. This kneeling female may be associated with Satimbe, the ancestral female who discovered masking and from whom masking was appropriated for use within the male domain. The figure may also depict Yasigine, older sister of masks, who has become synonymous with the women's groups that provide food, drink and other sustenance for masquerade dancers during ritual performances. Masks such as this are danced during Dama, a post-interment funerary rite mounted by villages every several years, and Sigi, a multi-village event undertaken every 60 years. The imagery may be female, but masks are danced by men. The rites affirm the village as living and distinguish it as a realm separate from the spirits of the deceased.

In most known examples of the Satimbe mask, the female figure stands or sits, with arms raised, at the crown of a mask that most often represents an antelope. In this example, the figure kneels, arms at her sides, above a mask with a decidedly human face. She may once have been adorned with beads and have worn a raffia skirt, serving both as a reminder of the wilds where masking was discovered, and to cover her lower body, the sight of which is prohibited to men. RH

Bibliography: Griaule, 1958, pp. 266–78

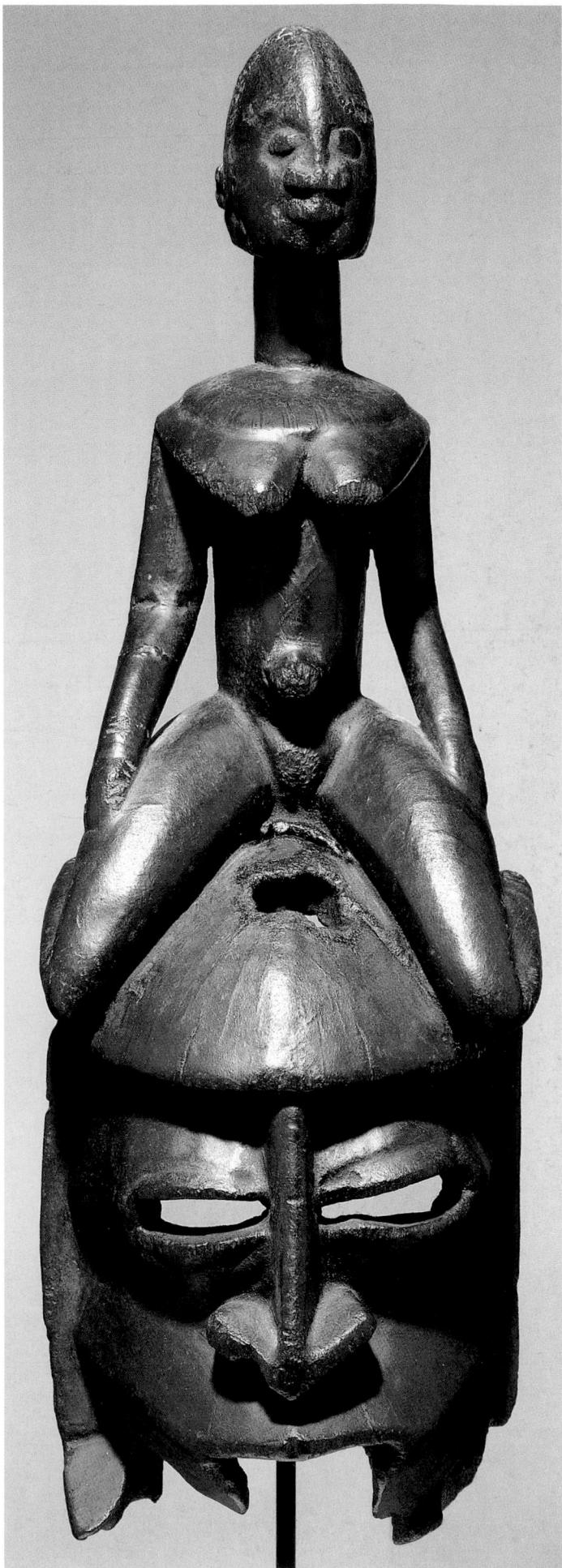

Plank figure

Dogon

Mali

16th–17th century
wood, encrustation
h. 45 cmMusée Dapper, Paris
Lester Wunderman Collection

This sculpture is recognisable as the human form even though severely reduced to emphasise its essential significance. The body is conceived as a solid plank, carved in wood with its important relief features comprising a head and the suggestion of genitalia on the front, a smaller human figure on the back, and two arms ending in hands defined apart from the plank and raised above the head. The head is the seat of wisdom; genitalia are associated with procreation and continuity; the figure on the back may represent an infant, thus suggesting the plank figure is female, even though she lacks breasts. The raised arm motif is found in many contexts in Dogon art. Like kneeling figures whose hands on their thighs may denote supplication, the convention of hands raised into the air may indicate entreaty, especially for rain.

The surface patina is composed of accumulated layers of additive materials, suggesting the object is of a certain age and has been used in sacrifices. As a shrine figure, the object might be dedicated to familial ancestors who are praised and ritually fed throughout the year, but particularly at the beginning of the agricultural season. *RH*

Bibliography: Ezra, 1988, p. 59; Leloup, 1994

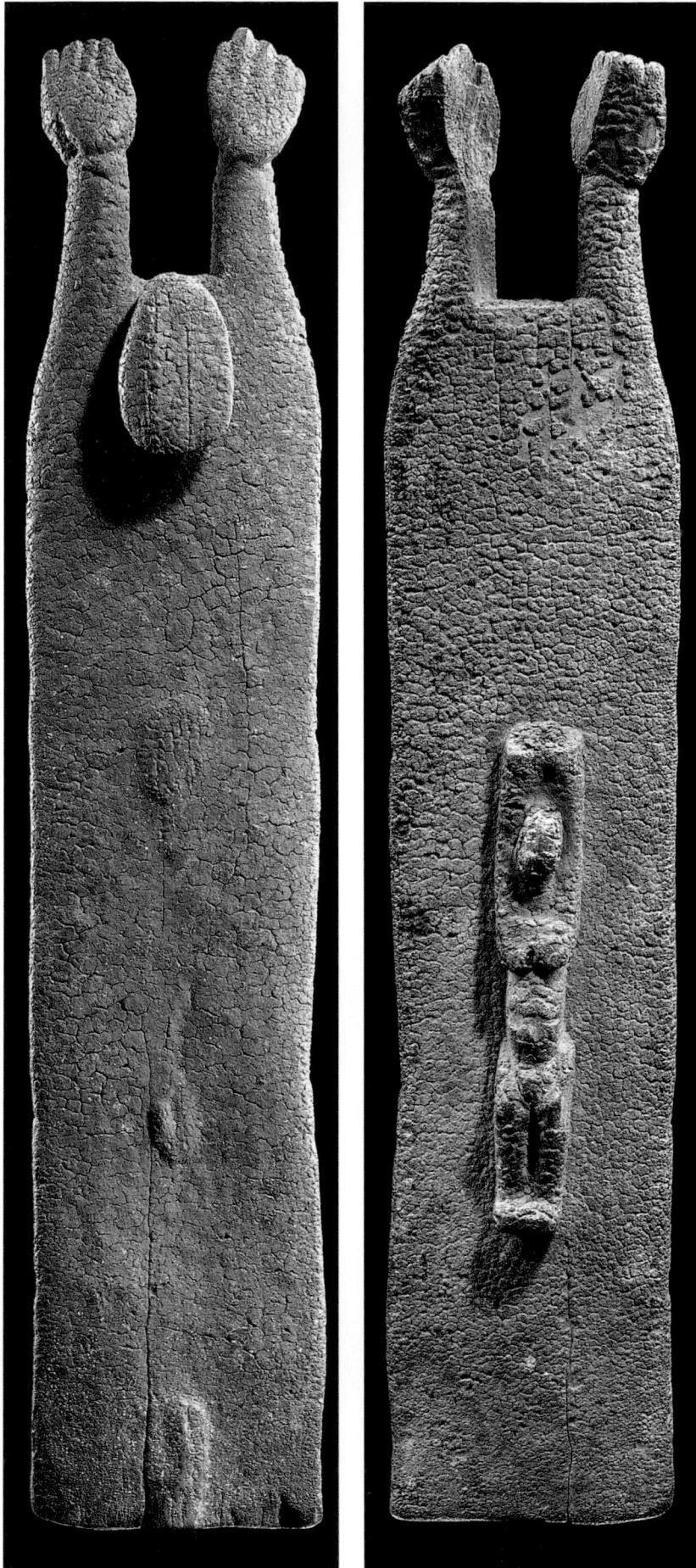

The supreme god, Amma, sent to earth four mythological beings to serve as ancestors to the Dogon people. Because these beings were lonely, and so that they might procreate, Amma bestowed a female twin on each of the four males, thus creating eight ancestors for the Dogon. Our figures represent these ancestors, or Nommo. Cat. 6.18c, a female figure, stands alone. In cat. 6.18b two figures stand side by side, complementary male and female physical bodies symbolic of lineage, procreation and continual increase. A thick encrustation of sacrificial material obscures most of the individualising characteristics carved into the wood substructures. Arms reach upwards, variously suggesting engagement in ritual purification or linkage between earth and sky.

The female figure (cat. 6.18c) stretches her arms upwards, and her hands meet above her head. Her legs extend downwards from planks that run along her sides. She stands on a disc which may have terminated in a single dowel, the figure intended to lean against a wall or to be planted in the floor of a shrine.

The Nommo pair exhibit similar characteristics: cylindrical bodies, arms raised, stylised and reduced features. The male has a beard, associating him with age and wisdom. The female wears a labret, or lip plug, to simulate a beard. The torsos are attenuated. The legs are disproportionately short and bent at the knee in a fashion common to Nommo. *RH*

Provenance: cat. 6.18c: 1956, given to the museum by Mrs Webster Plass

Bibliography: Leiris, 1933, pp. 26–30; Griaule and Dieterlen, 1986, p. 381; Zahan, 1988, pp. 56–7

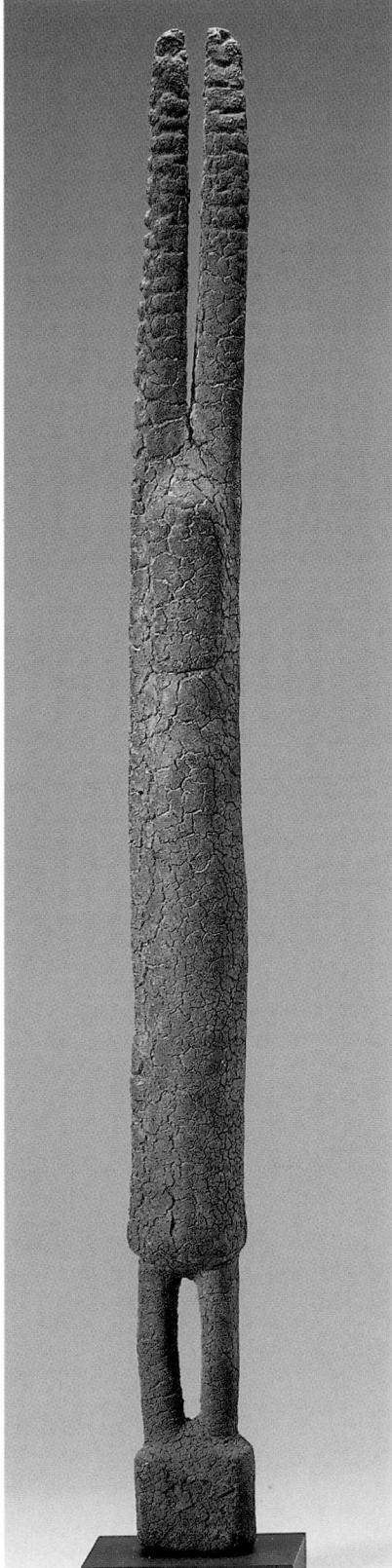

6.18a

Figure

Tellem
Mali
wood
h. 84 cm
Private Collection

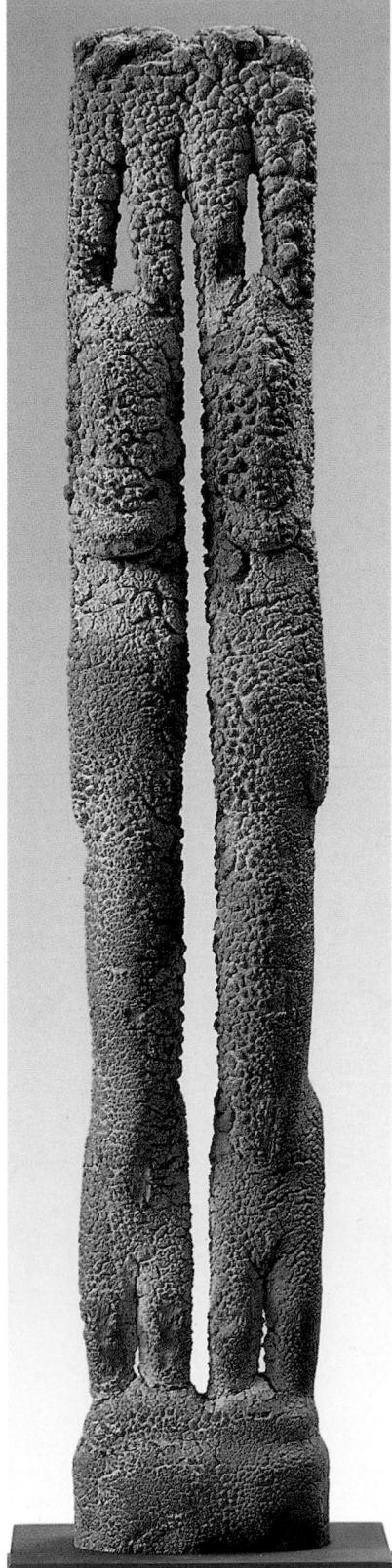

6.18b

Couple with raised arms (*nommo*)

Dogon
Mali
wood, encrustation
h. 42 cm
Private Collection, Paris

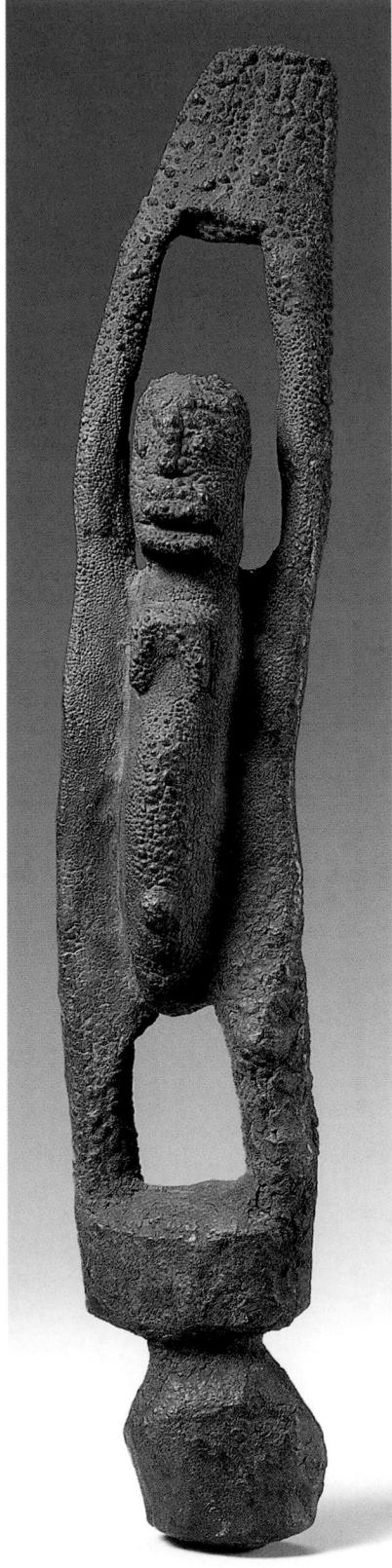

6.18c

Figure with raised arms (*nommo*)

Dogon
Mali
wood, encrustation
50 x 9 x 6 cm
The Trustees of the British Museum,
London, 1956.AE.27.1

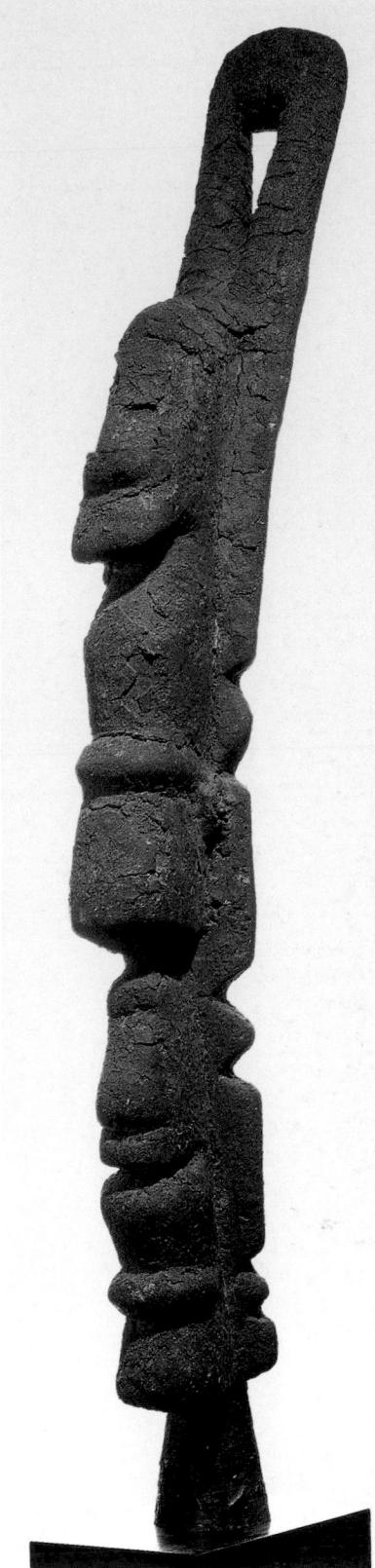

6.18d

Figure

Tellem
Mali
wood
h. 62 cm
Private Collection

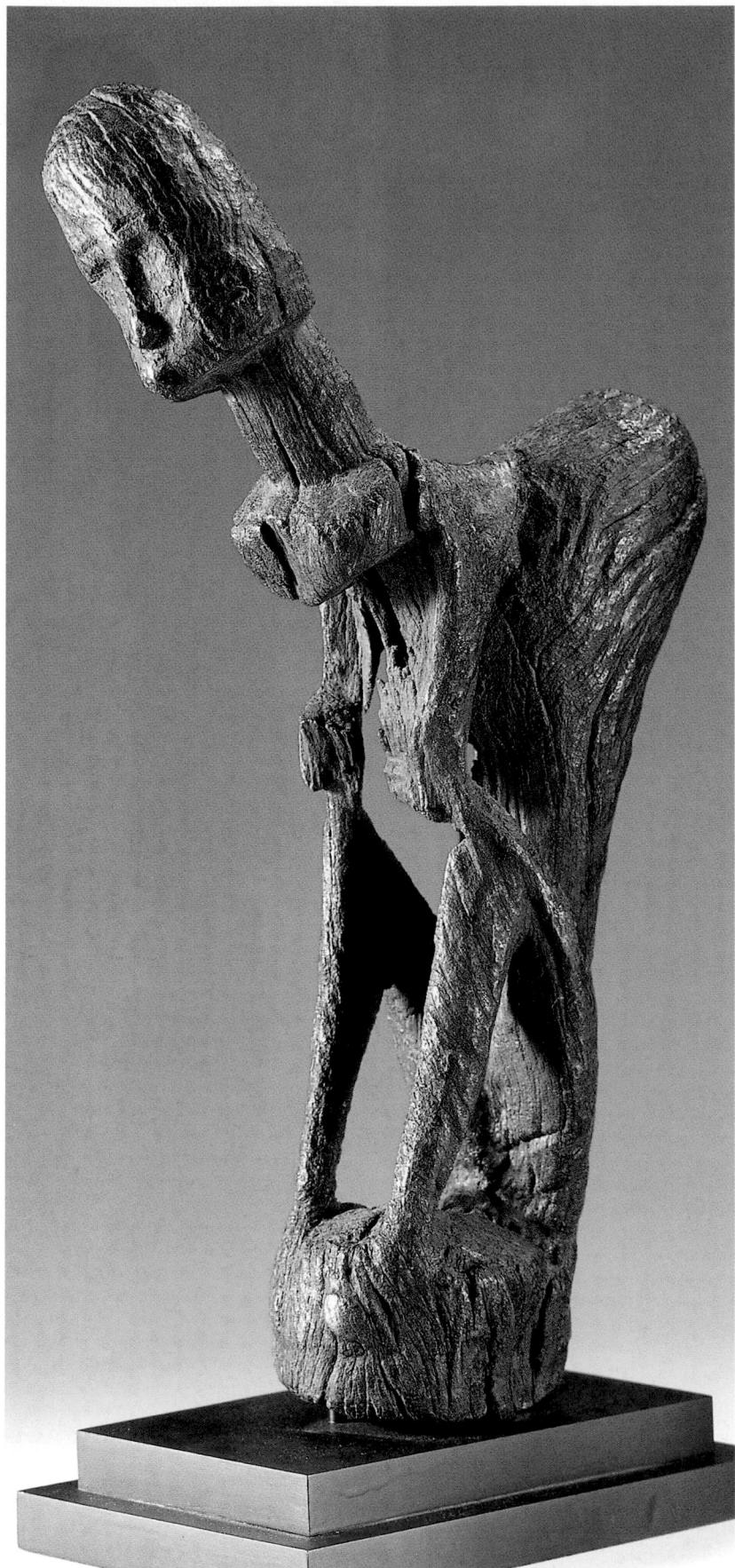

6.19

Hunchback figure

Dogon

Mali

wood

h. 45 cm

Private Collection, Paris

This figure is puzzling. Carved in a style reminiscent of many known Nommo sculptures, it portrays not a twin, but someone with a physical deformity. As is often the case with Nommo sculpture, the figure is carved from one piece of wood: a branch of a tree, sometimes with the physical imperfection of a crook, elbow or knot which is incorporated into the sculptural design. Here, arboreal imperfection translates into human malformation.

The figure is seated, elbows hyperextended and resting on raised knees. The face is looking off to the right. The extremities are vestigial, although the feet and buttocks form three points on a contiguous drum-shaped base. The hump on the figure's back is the visual focal point. It exerts a pull on all areas of the form, drawing the viewer's eye away from the figure's face.

The entire surface is distressed. Cracks have appeared, perhaps through exposure to the elements in combination with the natural drying process of the wood. In places that project outwards, however subtly, the surface is shiny with oils – added through handling the piece or the addition of sacrificial materials; in grooves and recesses the surface has a light accumulation of oils and other matter which dulls the patina. *RH*

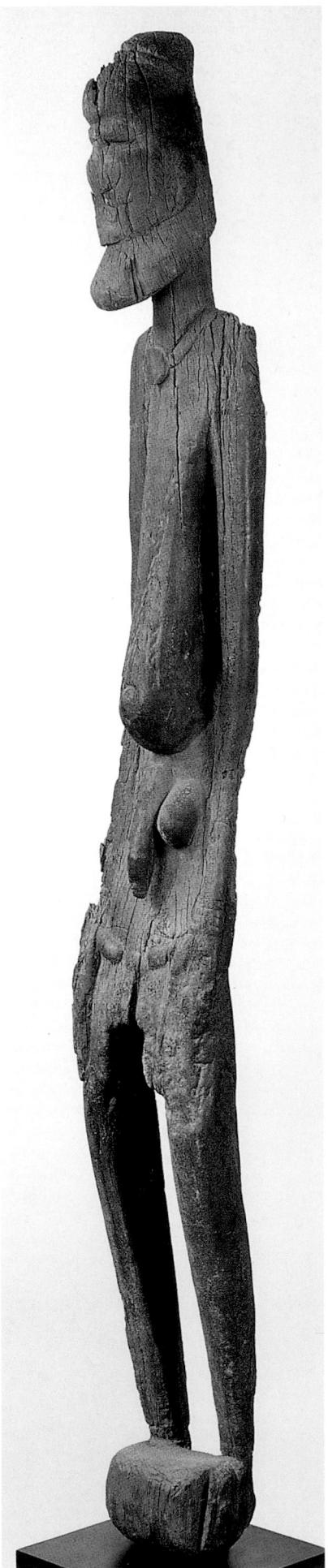

6.20

Male figure

Dogon
Mali
wood
h. 167 cm
Marc and Denyse Ginzberg

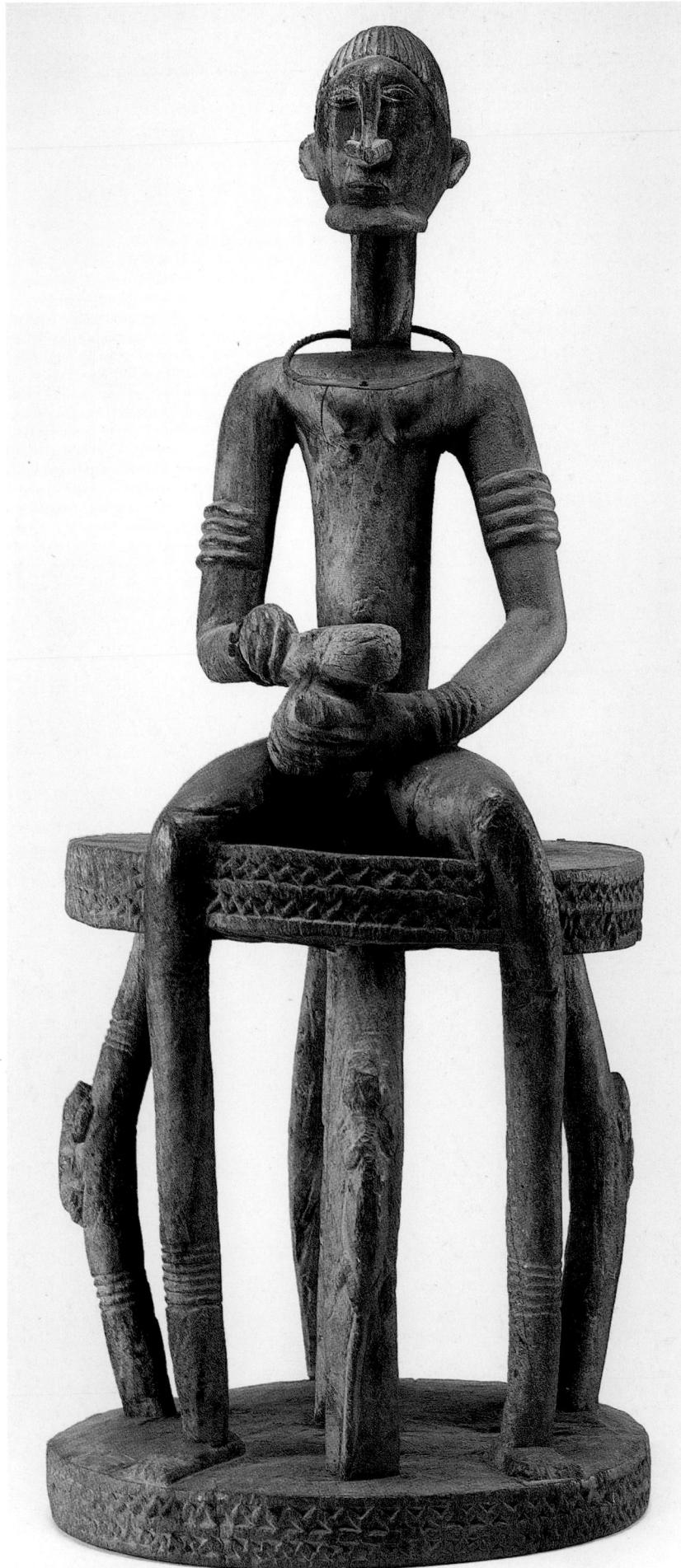

6.21

Seated male figure

Dogon
Mali
wood, iron
73 x 29 x 32 cm
Lent by The Metropolitan Museum of Art, New York
The Michael C. Rockefeller Memorial Collection, Given by Nelson A. Rockefeller in 1965, 1978.412.455

An interpretation of Dogon cosmology suggests that the universe is composed of two discs – the earth and the sky – connected by a tree at the centre. In addition to the tree, if we were to span the discs at each of the four cardinal points with relief carvings of ancestors, and seat a *hogon*, a village priest of high authority, on top of the upper disc, the configuration would resemble this carving and could be read as an *imago mundi*, a primer on fundamental Dogon social and belief structures.

The object is carved from a single piece of wood. The discs are incised at their perimeters with motifs suggesting the path of Lèbè Serou, the ancestor incarnated as a serpent and associated with the *hogon*'s power. The discs are connected at the centres by a straight unadorned cylinder – the tree – and at the edges by four bowed cylinders carved on their exteriors with reliefs of human figures. These figures, kneeling and standing, may portray the four original Nommo who mediate between the two realms. The seated figure is the *hogon*, the elder whose knowledge of both spiritual and temporal affairs accords him great local authority. RH

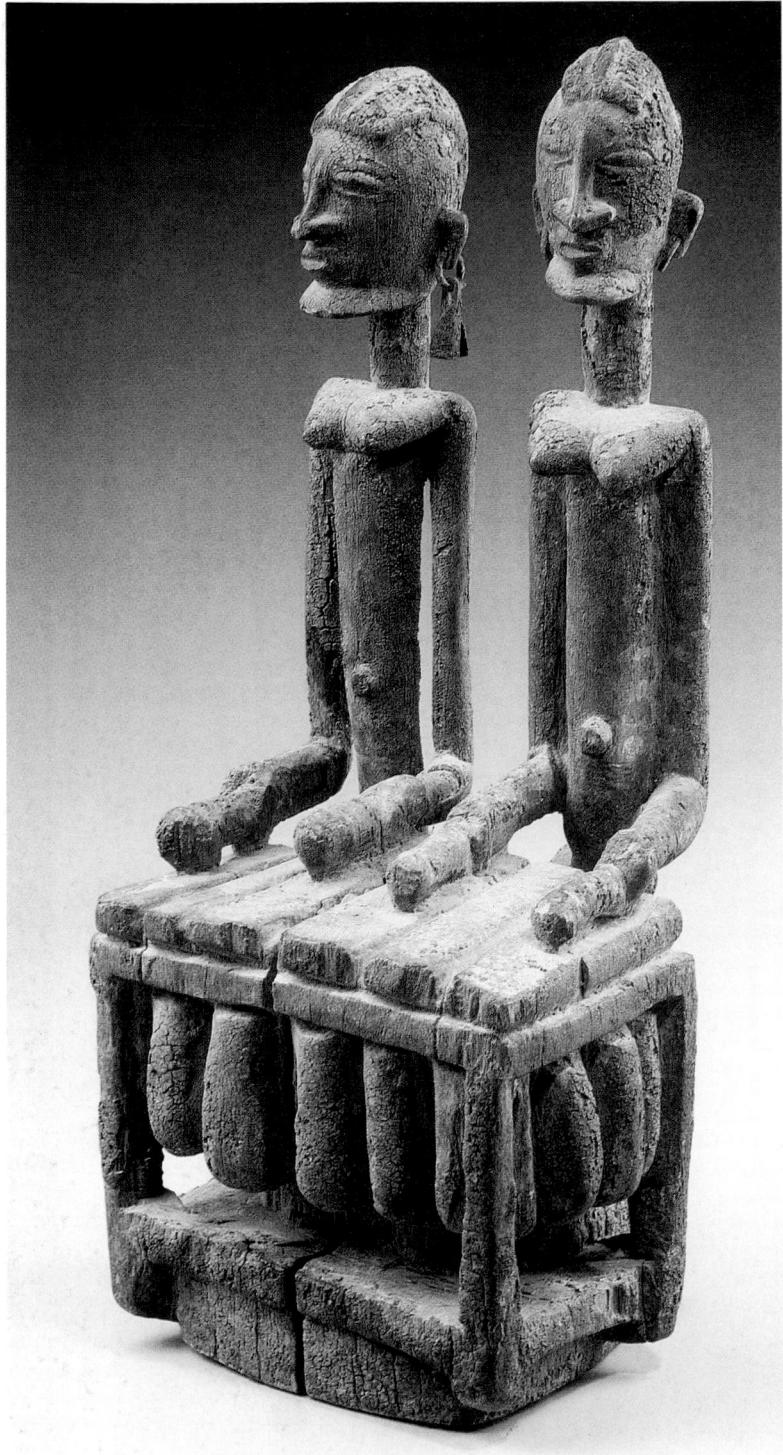

6.22

Balafon players

Dogon
Mali
wood
h. 44 cm
Private Collection

The *balafon* players sit side by side engaged in light popular entertainment. The figures retain visual characteristics that easily identify them as Dogon: the arrow-shaped nose, the trimmed beard at the jaw, the long gently swelling neck on top

of severe shoulders and torso, and hips that seem in some ways disjointed. The surface of this wooden sculpture appears to have accumulated the kind of patina that usually results from the addition of sacrificial material. In this case, however, age and storage conditions may be responsible.

A *balafon* consists of planks of wood of varying lengths and thicknesses tied to an oblong frame; dried gourds, also graded, are fastened to the planks. As the *balafon* player

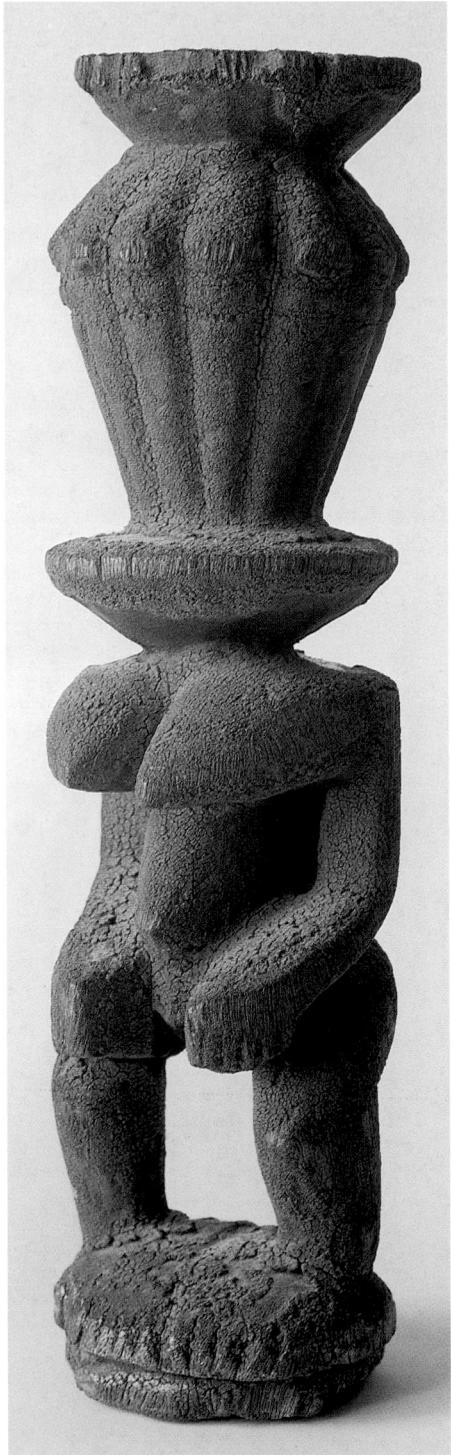

6.23

Female figure

Dogon
Mali
wood, encrustation
29.8 x 8.5 x 7.6 cm
The Menil Collection, Houston, X 053

'One cannot always pray ... at the altar, but a statue can' (Van Beek, 1988, p. 60). This female figure, with its coat of sacrificial material, is perhaps what is termed a *dege*, a protective statue, that doubles for an individual in a devotional context. In this sense, the *dege* is not an ancestral figure, but one representative of the living.

The figure is chunky in appearance. Its square shoulders, protruding breasts, hips and flexed knees all correspond to conventions of human anatomy as conceived by the Dogon sculptor. Likewise, its hands appear vestigial, and its feet are completely subsumed by the base on which the figure stands. The dual disc configuration of the head and the cluster of standing figures (barely visible through the sacrificial material) which form it and connect the two discs may be a reference to the two cosmological plateaux of heaven and earth (cf. cat. 6.21).

Our knowledge of Dogon figurative sculpture is limited. For the present, we can say with some confidence that this standing female figure, thick with accumulated sacrificial material, was most likely used as a substitute for its owner in a shrine context. RH

6.24

Double figure

Dogon
Mali
wood
h. 87 cm
Private Collection, Paris

According to a Dogon creation myth, the first human beings to come into the world were twins, and twins born today among the Dogon are considered to be endowed with significant quantities of *nyama* (power and energy) that makes all life possible. Twins born into a family constitute a special blessing, auguring a future of plenty, fertility and continuity of existence.

The sculpture is made from a single piece of wood and carved in patterns of angles and open-work. From the front, the figures are stacked

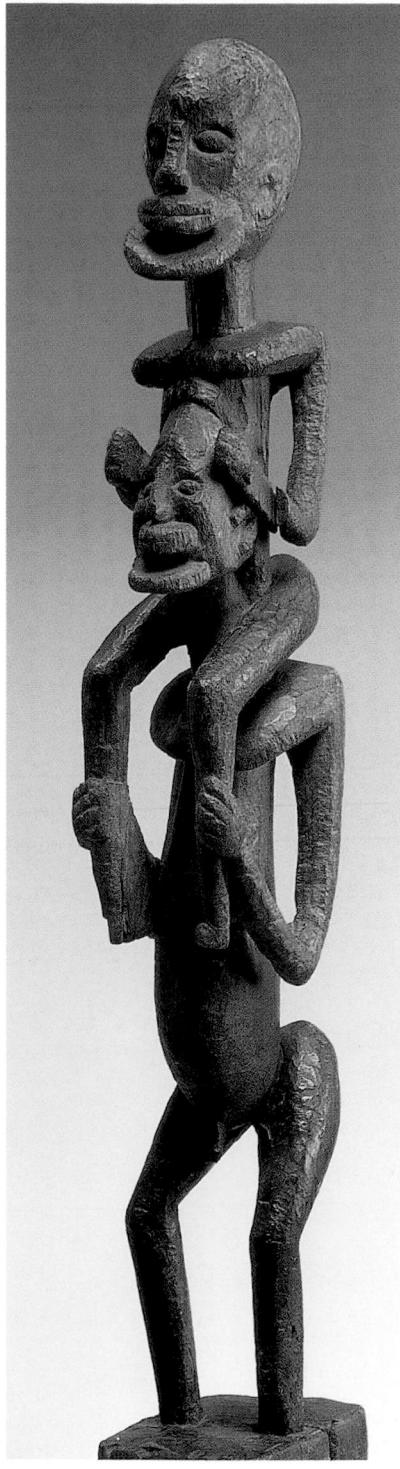

vertically. From the side, the two figures' limbs, torsos and buttocks zigzag down the bodies.

With one figure pickaback on the other, this piece may represent the phenomenon of twins as conceived both in spiritual and in earthly realms, leaving open the possibility of several interpretations. As Nommo, original ancestral twins, the double figure seems to match the myth; the four original Nommo were male, as are these two. As an earthly phenomenon, the figure portrays very practical

characteristics of twinning. Although twins are individual beings, they are connected forever through the fact of a single birth, giving them a single identity. Each, at times throughout his life, will carry the other – a lesson and metaphor not only for twins but for the entire extended family and village. RH

Bibliography: New York 1988, p. 48

6.25

Post (*togu na*)

Dogon

Mali

wood

601 x 68 x 12 cm

Fritz Koenig Collection

At least one *togu na*, or great shelter, can be found in every Dogon village. Most family compounds contain a *togu*, or sheltered meeting place. The *togu na* is built as a meeting place for the male elders of the village. It is an open structure with vertical elements that support a thatched roof. Near the cliffs, the vertical elements may be mud brick. In most cases they are carved posts that ideally number eight: three along the east and west sides and two in the interior. They are conceived as sequential, coiling in plan in the form of a snake. The roof is low so that the men inside must remain seated in discussion. The thatch, ideally composed of eight tiers layered at 90 degrees, helps keep the interior cool; the tiers refer, as do the posts, to the eight ancestral Nommo.

In its official capacity as a meeting house, the *togu na* is the site of government, arbitration, village business and cordial banter. It is the domain of men, but its vertical posts often exhibit female, androgynous or sexual imagery. Our example portrays a highly stylised, relief-carved, copulating couple. The female, standing on her head, has her arms raised in Nommo fashion. The dominant male stands on top of the female's feet and their exaggerated genitalia meet in symbolic union. The upper left fork of the post displays a snake in low relief. The snake refers to Lebe, one of the Nommo, whose domain is speech – which is the express purpose of the *togu na*. RH

Bibliography: Griaule, 1965, p. 98; Huet, 1988, pp. 34–6, 91

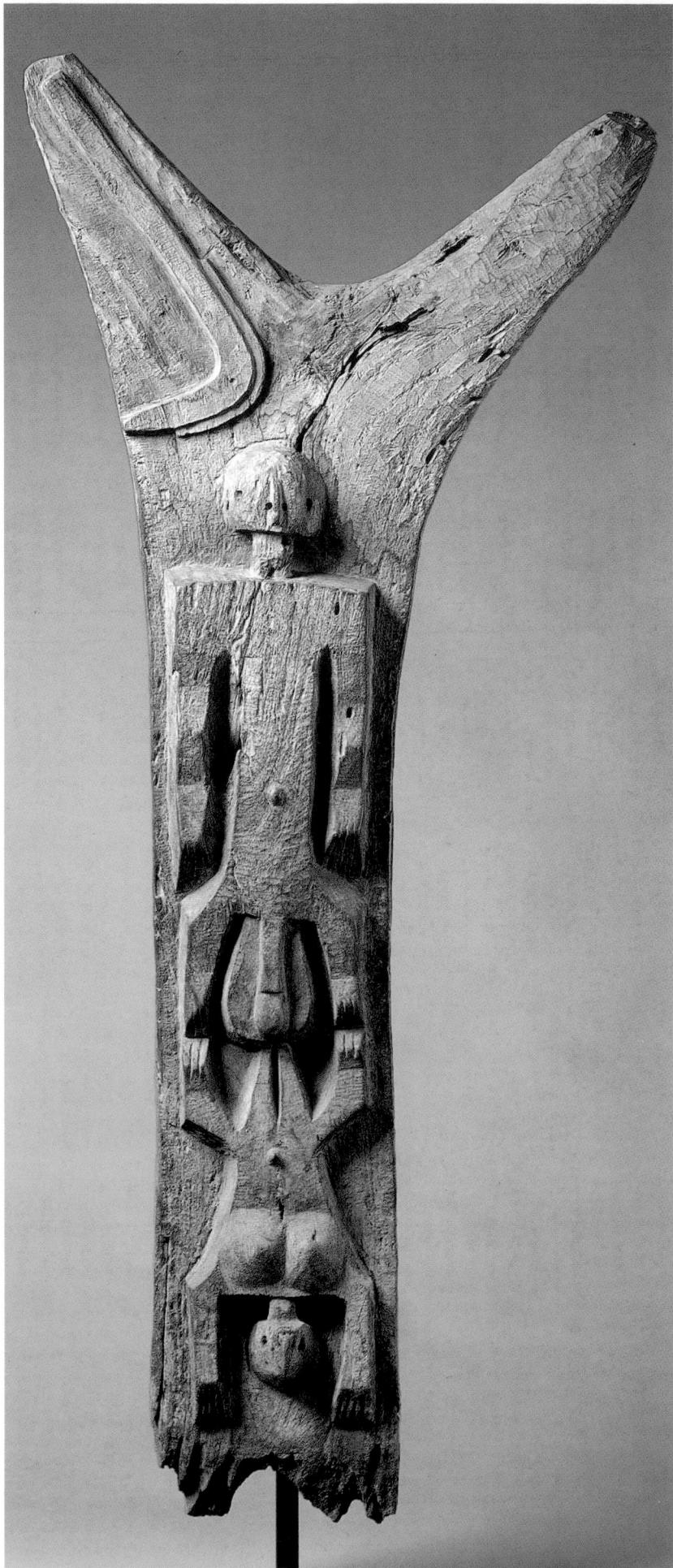

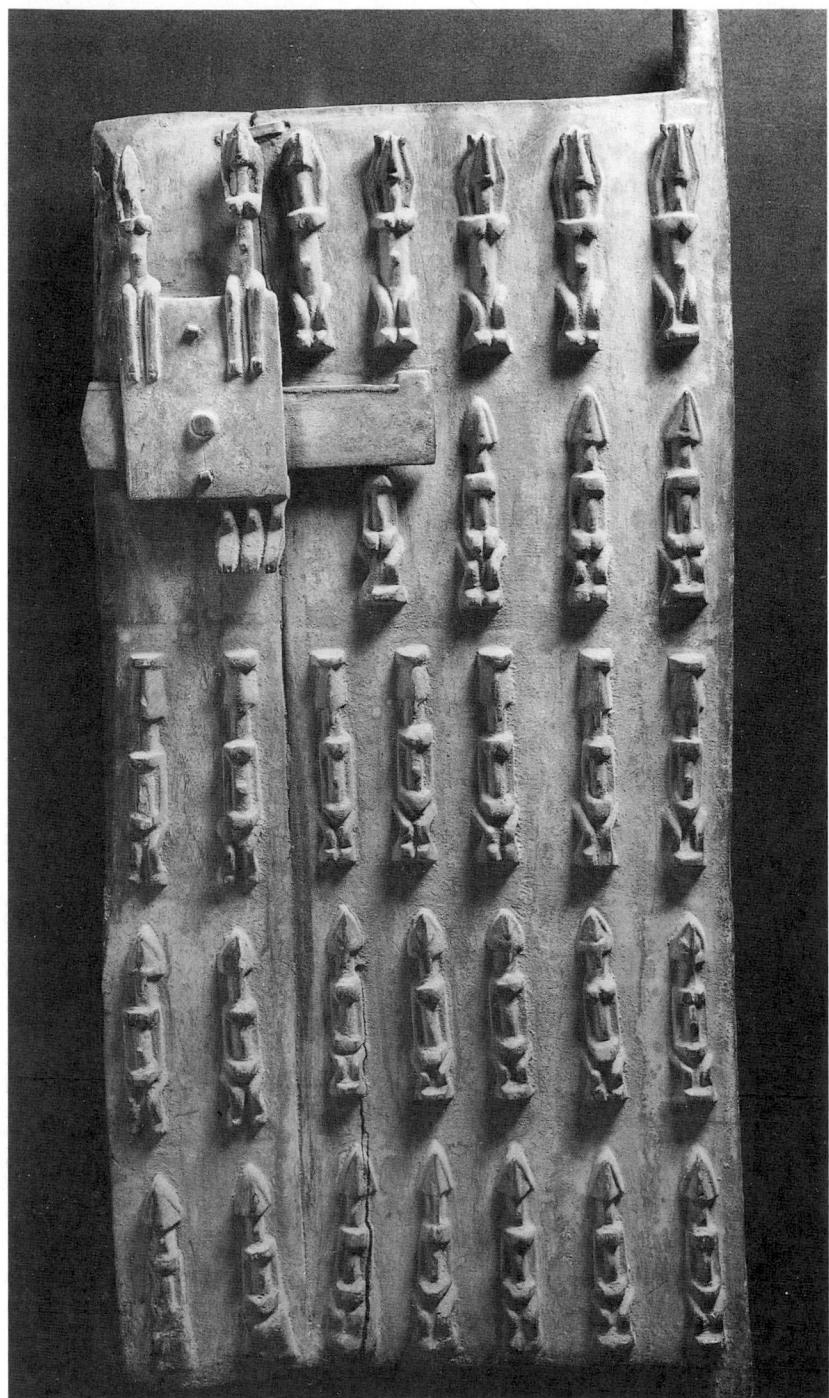

6.26

Door with lock

Dogon
Mali
wood
h. 98.5 cm
Private Collection

6.28

Staff

Dogon
Mali
iron
81 x 10 x 13 cm
Fritz Koenig Collection

Central to Dogon mythology are the ancestral figures called Nommo (cf. cat. 6.18b-c). The seventh Nommo, the blacksmith, stole blistering hot iron and a piece of the sun, then slithered down the rainbow to earth. During his descent, other Nommo hurled lightning bolts at the blacksmith, bolts which he repelled with his bellows. The blacksmith's earthly landing was so violent that the impact shattered his body, the breaks becoming the human joints which permitted human beings to work and dance.

This iron staff probably illustrates the first part of this myth: the seventh Nommo holding the bellows in his left hand (signified by his shield) and, in his right hand, either a lightning bolt or the crooked staff of the ritual thief. His form is reduced to its geometric essentials. His body and limbs are cylinders, his shield is a disc, his head is a modified cone. The projection from his chin suggests a beard and therefore the status of an elder.

Historically, in most locales among the Dogon the smelting of iron has been an activity limited to a special class of smiths, the *jemo*. Today, few smiths continue to smelt their own iron. Iron is available commercially and although *jemo* continue to work the forge, almost all purchase iron from the Bandiagara or Mopti markets. RH

6.27

Rock painting

Dogon
Mali
painted rock
h. 30 cm
Laboratoire d'Ethnologie,
Musée de l'Homme, Paris

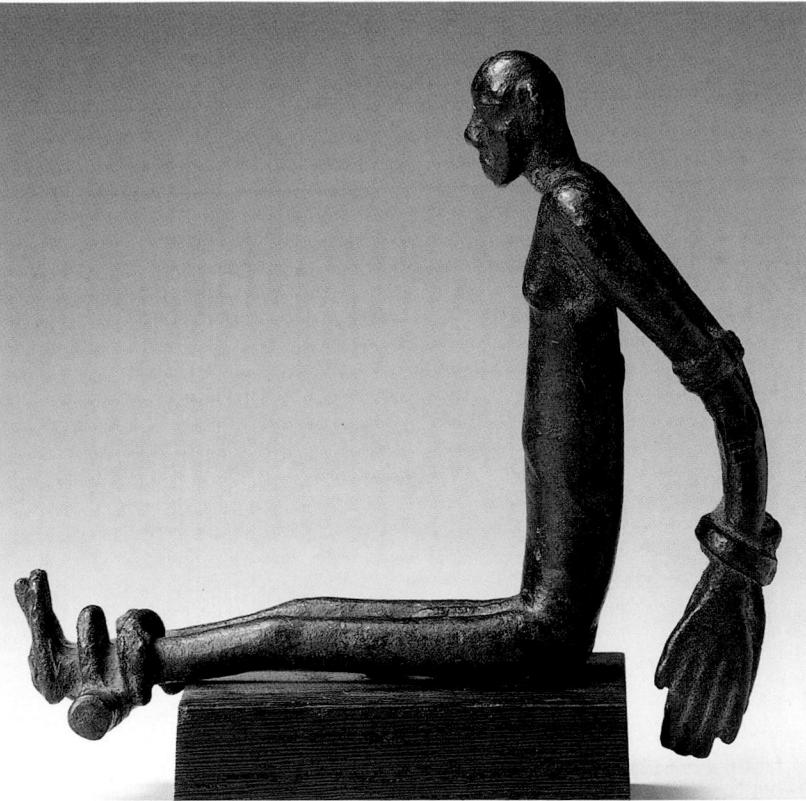

6.29a

Pendant of seated prisoner

Dogon
Mali
bronze
4.5 x 3 cm
Private Collection

6.29b

Pendant of two riders

Dogon
Mali
bronze
h. 9 cm (with base 11 cm)
Private Collection

Small cast bronze or copper objects are known to have been worn as pendants, primarily by the village *hogon*. Although visually different from one another, the objects subtly express a common theme of subjugation and power.

To ride a horse, the rider must be more powerful than the horse. The two together, rider and horse, fuse human intelligence with animal strength and create a presence greater than the sum of its parts. Cat. 6.29b portrays two figures – flattened and frontal – apparently riding side-saddle on an over-burdened horse.

To take a prisoner means the taker is the mightier of the combatants. During the past 1000 years, the Inland Niger Delta region has been the site of violent rises and falls of empires, and the taking of, and trade in, slaves. Cat. 6.29a,c both show a man with ankles shackled and hands bound behind his back. The features and body are relatively naturalistic in contour and, unlike the equestrian figure, may be intended to be viewed in the round.

As articles of personal adornment, small cast metal objects have a lengthy history in the Inland Delta region. Copper may have arrived via early trans-Saharan trade; the archaeological site of Djenne has turned up objects in copper and is only 100 miles from the Bandiagara cliffs, current Dogon country. As early as the 11th century an exchange of ideas, technologies and goods is likely to have occurred between Inland Delta peoples and the historic inhabitants of Bandiagara. RH

Bibliography: New York 1988, p. 110;
Washington 1989, p. 116

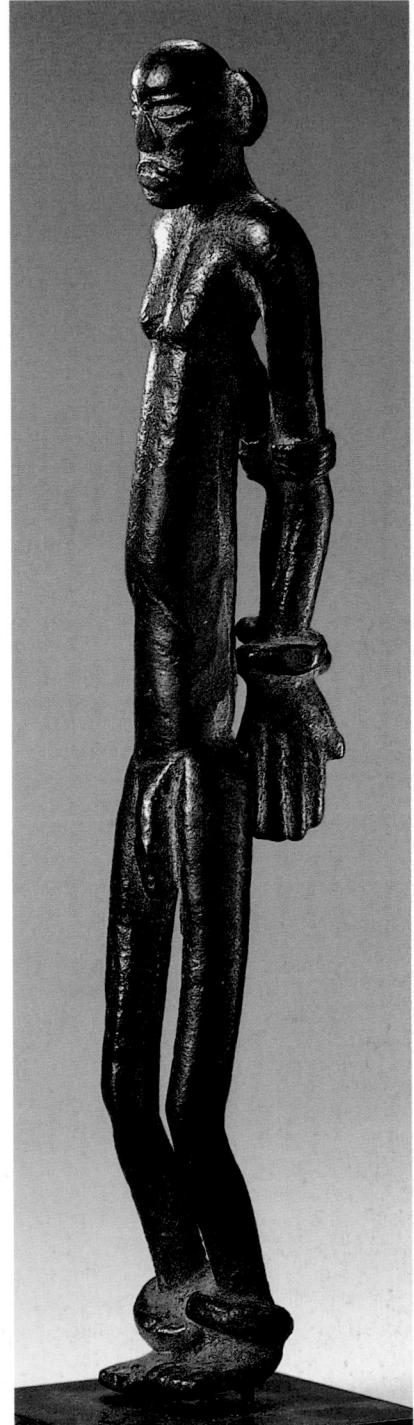

6.29c

Standing figure

Dogon
Mali
bronze
h. 21.8 cm
Musée Barbier-Mueller, Geneva, 1004-129

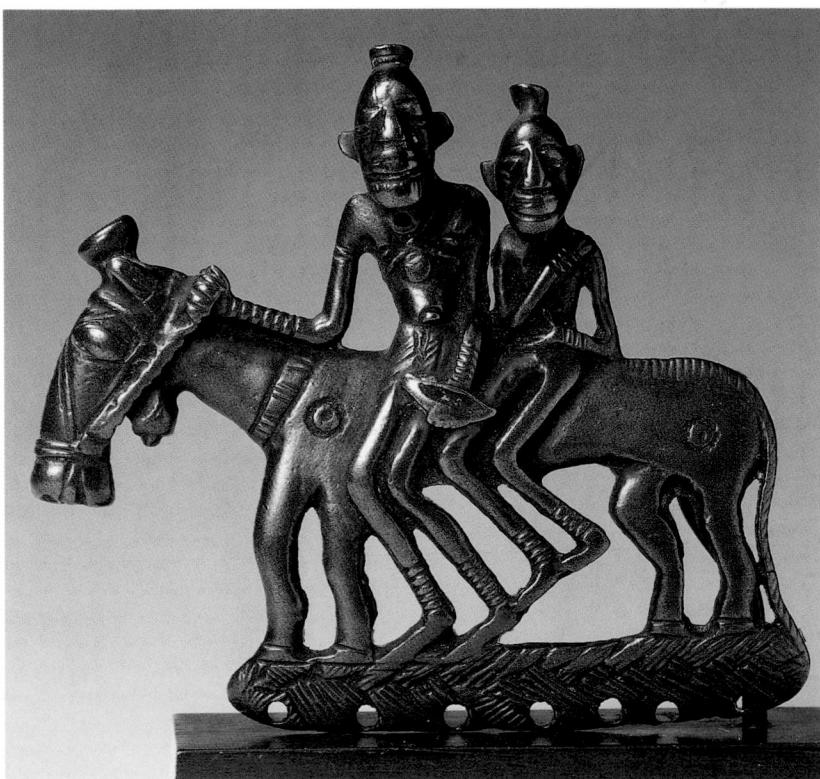

6.50

Shelter post

Mossi
Burkina Faso
20th century (?)
wood
262 x 23 x 16 cm
Private Collection

The fork at the top of this post indicates that it is a support post from one of the large sun-shelters beneath which Mossi chiefs meet with officials of their court and the members of their communities to hear pleas and to issue decisions about the affairs of the community. The figure represents a young woman who is offered as a wife by the chief to a deserving man in the community as a reward for loyalty and service. The first-born daughter of every such union is in turn offered to the chief to give in marriage, thus strengthening political ties in the community.

The posts are arranged in rows of three with from three to five rows of posts each about two metres apart, in the courtyard, or *samande*, of the chief's official residence. The central posts are paired, male and female, to represent the chief as the ideal ruler of all his people without regard to gender. The forks at the top held horizontal beams that in turn supported large bundles of straw, millet stalks and other fodder for animals. A few decades ago it was common to find decorated posts, but now, although the sun-shelters are common, almost all figurative posts have been collected by dealers and sold on the antiquities market. Even in towns where there is no chief such shelters are erected so that the people of the village can sit in their shade and work while they exchange news. Similar shelters are common among all Voltaic-speaking peoples, including the Kurumba in northern Burkina Faso and the Dogon in Mali (cat. 6.25) and Burkina who call them *togu na*. *CDR*

Bibliography: Roy, 1987, pp. 170–4

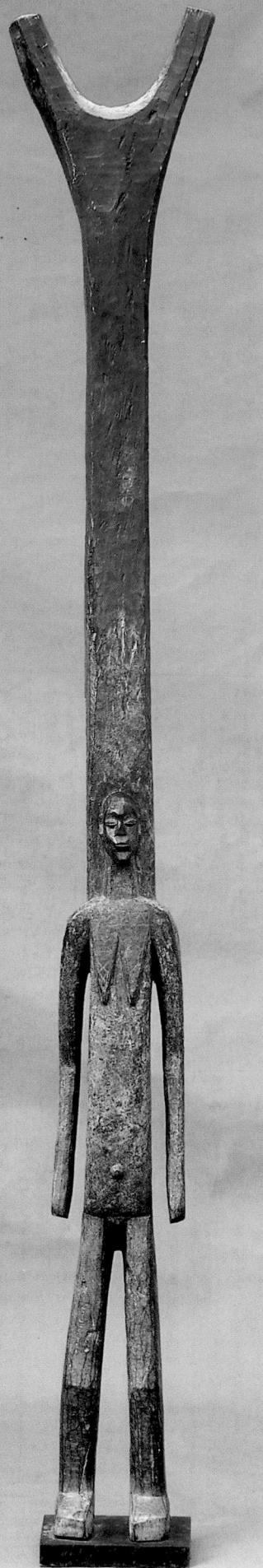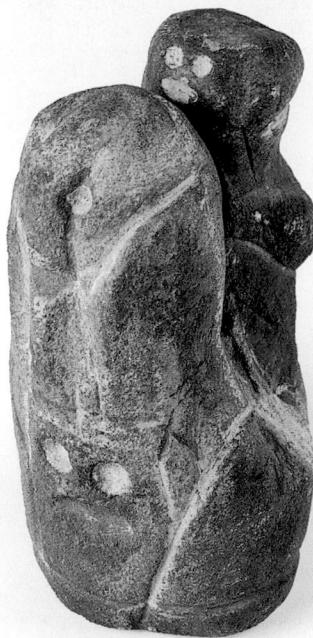

6.31a

Double figure

Mossi (*nyonyose*)
Burkina Faso
stone
15.2 x 9.2 cm
Museum für Völkerkunde, Vienna,
156.281

The Mossi people came into being in the early 15th century when a group of horsemen from northern Ghana rode into the valley of the White Volta River and conquered several farming peoples, including the Nuna and Lela in the west, the Dogon in the north-west and the Kurumba in the north. Some of these farming peoples fled ahead of the Mossi cavalry, notably the Dogon who fled to Bandiagara, while others remained behind and were integrated into a new society called Mossi (*mogho*, world; *moaga*, person; *mosse*, people). The conquering élite became rulers and belong to the social class called *nakomse*, while the conquered farmers became commoners called *nyonyose* or 'the ancient ones' in reference to their position as first owners of the land. The *nyonyose* hold a great deal of supernatural power which they have used to manipulate the forces of nature against their enemies. Thus all *nyonyose* are Mossi, but not all Mossi are *nyonyose*. In the far north the *nyonyose* in Lurum, Ouré, Bourzanga, Kongoussi, Tikare and

Seguénega are descended from the ancient Kurumba, inhabitants of the region before 1500. These two stone objects are said to have been given to the prominent Sawadogo family by nature spirits (*kinkirsi*) before the Mossi conquest.

The large anthropomorphic figure is from the town of Ouré and was used by local women to aid conception. A woman might offer prayers and sacrifices to the figure, then carry it on her back. If she is not strong enough to perform this feat, she will not be able to bear children. If she bears a child successfully she must offer thanks and sacrifices to the figure.

The smaller stone figure is a grindstone in the shape of paired phalluses, which are in turn incised with the features of a mother and child. There are deep grooves and a hole that might permit the figure to be worn suspended around the neck, and signs of extensive wear and handling in the places where one's hand naturally falls indicate very great age. In addition there are incised graphic patterns, including the 'X' which is ubiquitous on the masks of Voltaic peoples. *CDR*

Provenance: collected by Annmarie Schweeger-Hefel

Bibliography: Schweeger-Hefel, 1981, pp. 8, 54

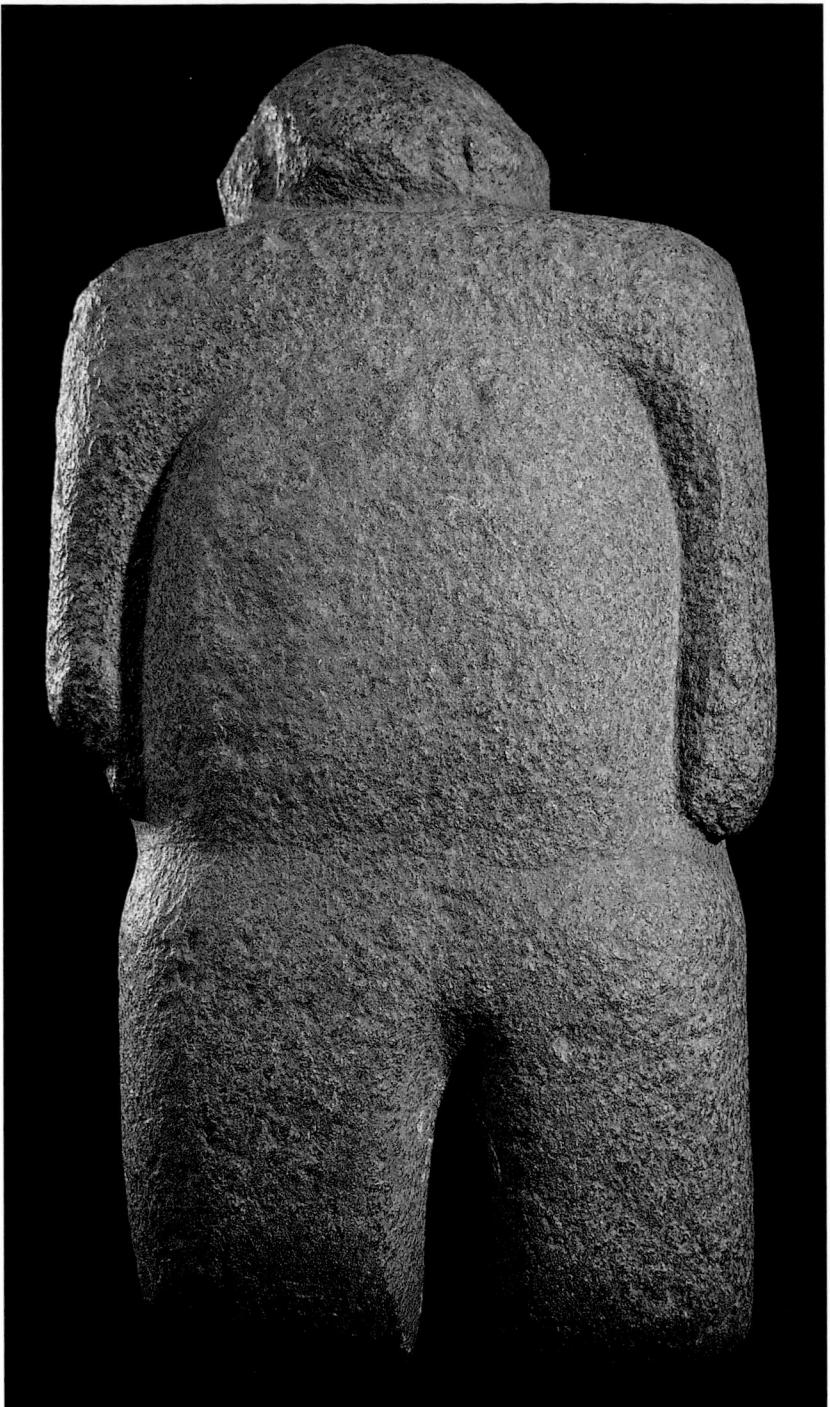

6.31b

Anthropomorphic figure

Mossi (*nyonyose*)
village of Ouré, Burkina Faso
15th century (?)
stone
45 x 24 x 13 cm
Private Collection

6.32

Figure

Komaland
Ghana
15th–16th century
terracotta
28 x 8.5 x 10 cm
Private Collection

Komaland in northern Ghana has yielded up thousands of small terracotta sculptures mostly of small size from burial sites. Some of the small figures are in a rough and ready style which seems to replicate itself in monstrous fashion as if on a production line. There is, however, as in the present piece, a hint of the existence of a more refined tradition, more hieratic and austere. The wrap-around features of the present figure would be difficult without precedent to identify as African (similar difficulties are presented by the pre-Yoruba stone figure cat. 5.75) and the face alone would be a challenge in a visual quiz (in which most would think of South America) yet the pose recalls certain Djenne figures (cat. 6.4i for example) and seems to link this sculpture with the group of ancient civilisations of the valleys of the Niger, a connection that can only be supposition until further research is done. This connection is further endorsed by the prominent necklaces and wrist ornaments. The quiet dignity of the present figure which sits on a terracotta base which allows one to imagine the missing legs is in marked contrast to the wide-eyed and open-mouthed figurines that form the bulk of Koma material: the long span of time that the Koma culture endured before its enigmatic end suggests there are various stylistic periods: whatever the case, this piece must represent a 'high' style that is also testified to by some of the surviving bronzes, for all that they appear to be in general of later manufacture (cat. 6.2d). TP

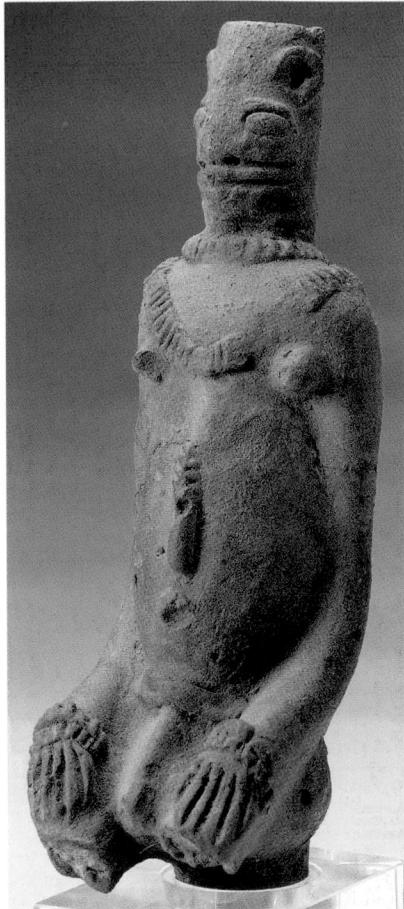

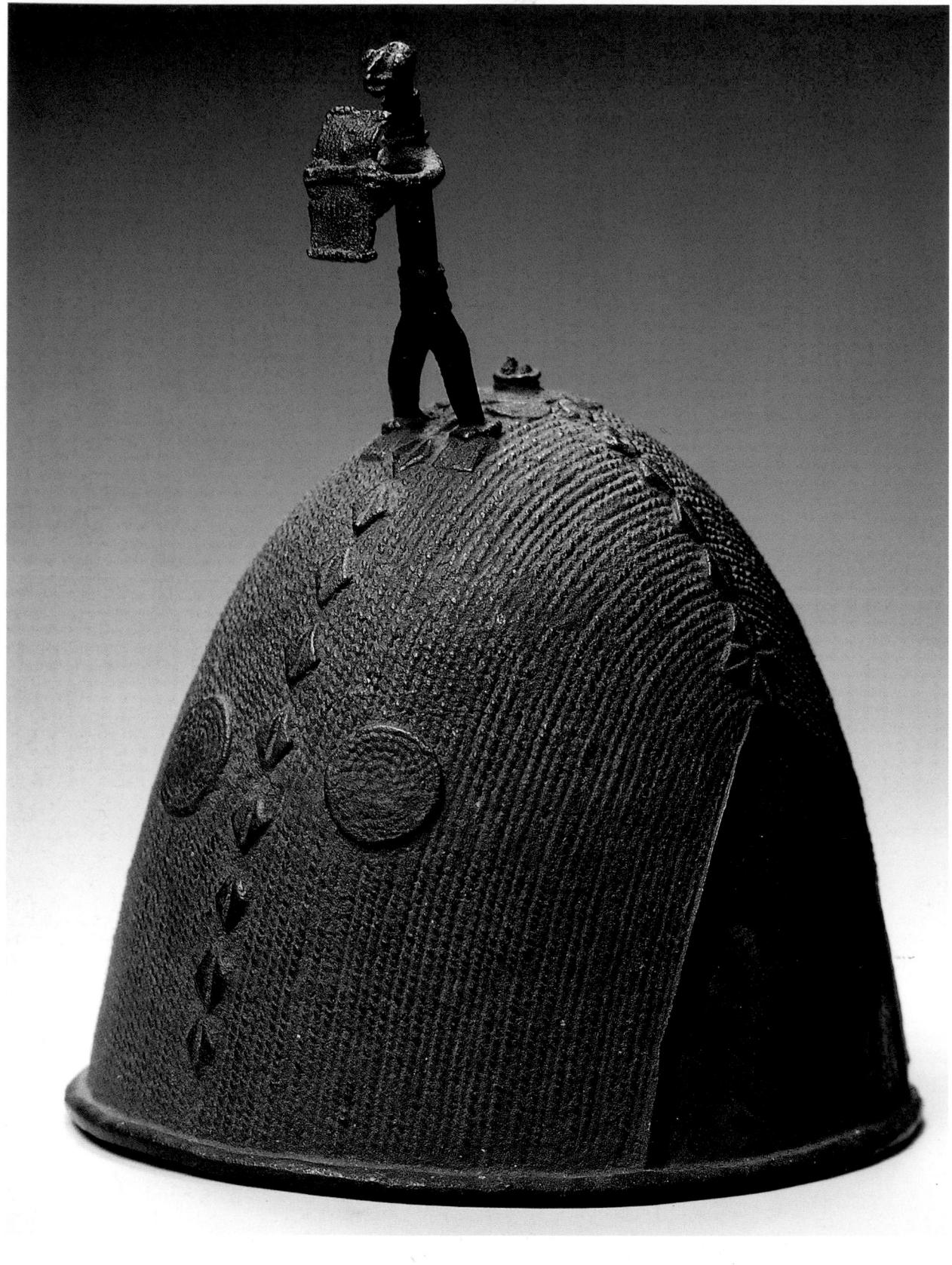

6.33

Helmet surmounted by figure

Koma-Builsa

Ghana

bronze

h. 25 cm

W. and U. Horstmann Collection

Artefacts of this type originate from Iron Age burial sites attributed to ancestors of the modern Koma-Builsa people, a sub-group of Mole-Dagbani-speaking people of northern Ghana. The Koma-Builsa occupy farming settlements in the valleys of the rivers Kulpawn and Sisili, tributaries of the

White Volta. Over 40 Iron Age sepulchral sites are distributed over an area of about 90 by 100 km. Each site contains scores of tombs. The Iron Age bearers of the Koma-Builsa culture buried their dead in tombs surmounted by earthen superstructures each circumscribed by a

circle of stones. The burial mounds, which vary in dimension and range between 4 and 30 metres in diameter, probably represent a hierarchy reflecting the social, political or economic status of the occupants.

The burials are associated with domestic animal bones, the remains of the pre-interment parting feasts that were held at the mausolea by living clan members to honour the departed relations. Other associated material remains are milling stones, domestic pottery, iron and copper implements, weapons and ornaments, cowrie shell 'money', terracotta and cast metal sculptures.

The artefacts that constitute the most striking aspect of the culture feature human activities, domestic and wild animals, stools and amulets, and anthropomorphic elements (circumcised male genitals portrayed separately). According to Koma-Builsa ethno-histories the ancient artefacts were functionally related to totemic observances and ancestral veneration customs (the Builsa word *koma* or *kwoba* means father or ancestor).

The modern Koma-Builsa still make and use cultural objects which feature in the ancient sites either as actual objects or as motifs and icons on artworks. For instance, housewives own and use a bridal calabash helmet called *zuk-chin*, decorated all over with cowrie shells, which is also worn by male hunters.

This cast bronze helmet is probably a stylised cowiform variety of the *zuk-chin*. Others include human portrait heads, 'janus' heads, multiple heads and whole-bodied winged figures. Thermoluminescence indicates that the Iron Age Koma-Builsa culture flourished between the 13th and 19th centuries. This chronology is supported by the presence in the tombs of Indian Ocean cowrie shells and equestrian terracottas with motifs depicting horse-riding accoutrements (saddle, stirrup, double reins, bit and horseshoe), features introduced via the trans-Saharan trade routes after the 8th century. JA

Bibliography: Anquandah and Van Ham, 1985; Anquandah, 1987¹; Anquandah, 1987²; Anquandah, n.d.

Mask

Nunuma
Burkina Faso
19th century
wood, pigment
123 x 48 x 23 cm
Musée des Arts Africains, Océaniques et Amérindiens Vieille Charité, Marseilles,
991-001-001

Just to the west of the Mossi plateau live the Nunuma, one of the many small Voltaic cultures commonly referred to in the literature as 'Gurunsi'. Historically buffeted by the Mossi kingdom, who raided them for slaves and to whom they had to pay tribute, and subject to the rising power of Islam in the early 19th-century Holy War and the establishment of the state of Ouahabou by the Mande Dafing cleric and reformer Al-Hajji Mahmud, the Nunuma appeared to have emerged from these events intact. While Islam was to flourish in major Dafing communities such as Douroula, Safane, Boromo and Ouahabou, Nunuma villages organised along segmentary lineage principles continued to maintain cherished cultural and artistic traditions.

That this is still the case today is strongly suggested by Roy's investigation of the arts at Tissé and in other Nunuma villages, although why the Nunuma were so little touched by either Islam or the Mossi presence is not explained. It may be that neither Islam nor the Mossi could really supplant those basic values which have always guided Nunuma existence – the inward-looking nature of these villages, strongly centred upon notions of family, the ancestors, farming and masquerades. 'Decentralised' and 'stateless' are terms often used with reference to people like the Nunuma; leadership here is based upon the guiding wisdom of lineage priests and ritual specialists. Millet farming is crucial for it not only sustains and defines this world of villages, but its cyclical nature allows the Nunuma time to pursue other activities – carving, painting, building and firing pots – and to devote themselves to the creation of elaborate masquerades.

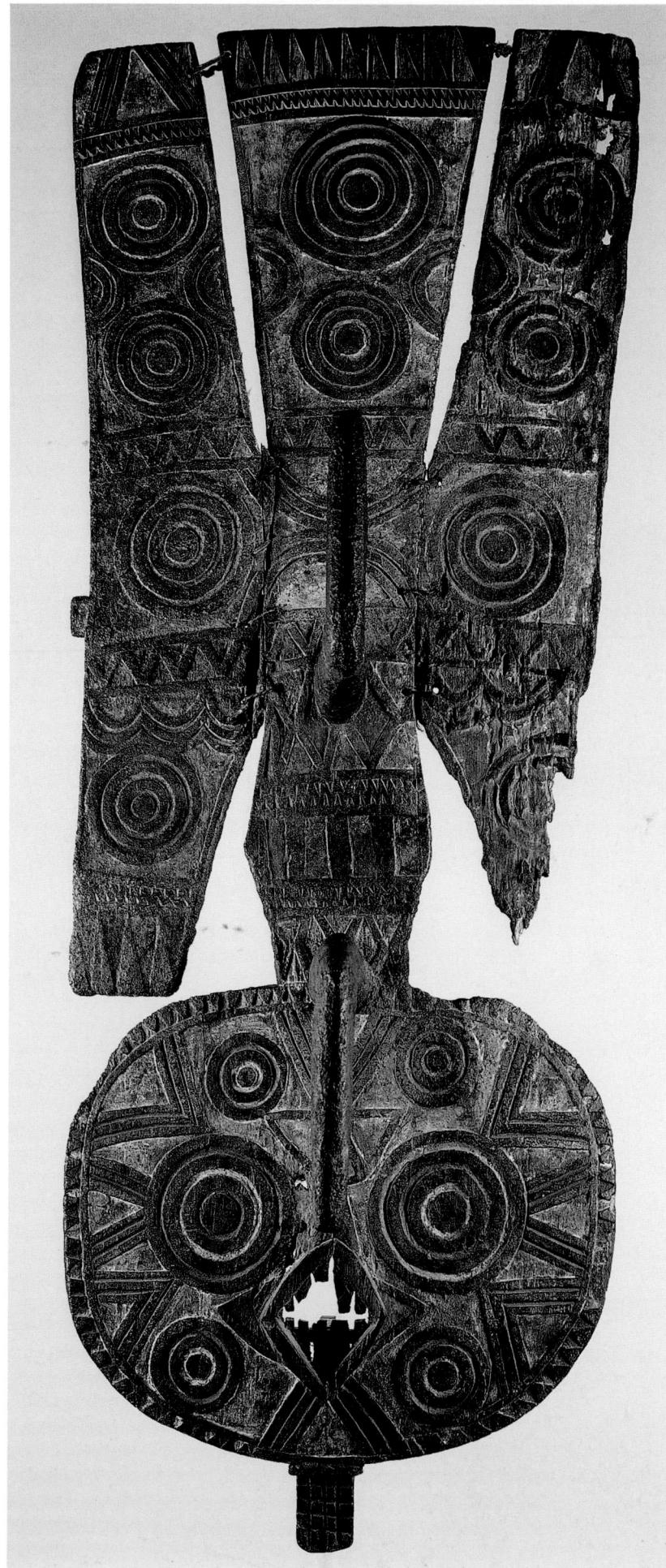

A particularly splendid Nunuma mask, this spiritual presence ensured a community's health and shielded it from destructive forces. Danced to the sounds of flutes and drums, such a mask would have infused those about it with its own special potency. While faintly reminiscent in its form of a mask named *Budu*, this old and frequently repaired example is a classic statement of Voltaic masking. The exquisite balance achieved between the face itself and the superstructure, the strong projecting bent beaks, and the sensitively rendered surface designs commonly found in Gurunsi masks are elegantly brought together in this masterpiece. *RAB*

Bibliography: Kamer, 1973; New York 1978; Roy, 1987, pp. 204–49, fig. 195

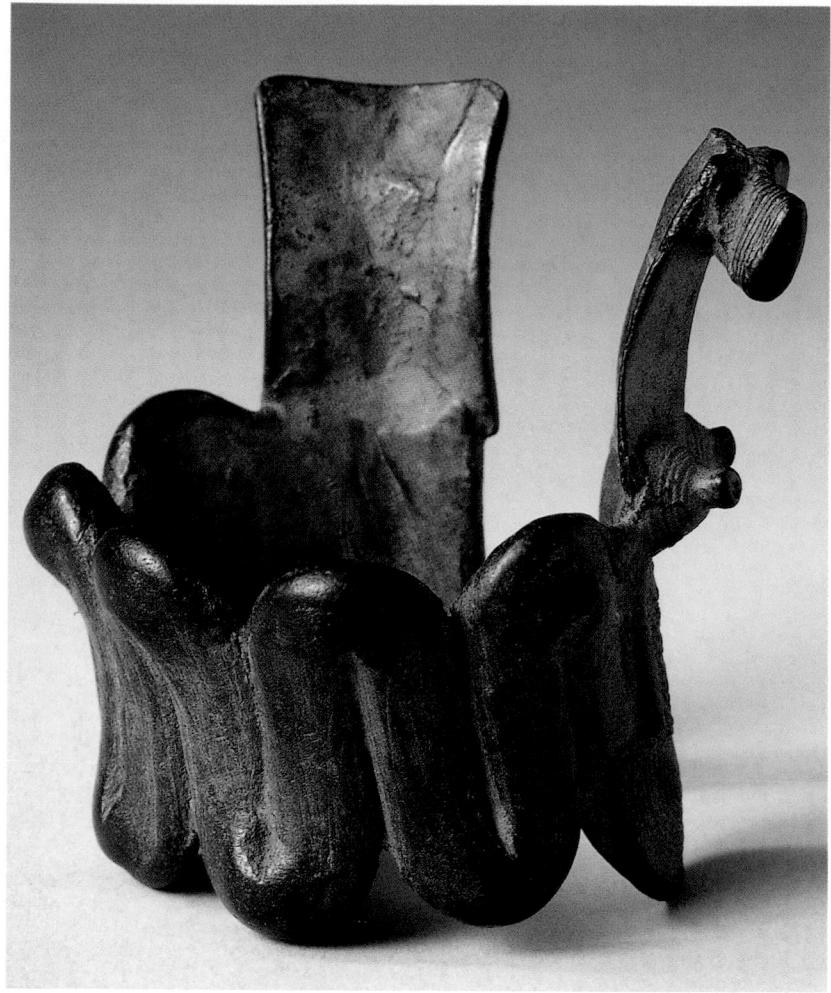

6.35a

Bracelet

Lorhon
Burkina Faso/Ivory Coast
18th century (?)
copper alloys
8 x 6.5 cm
Private Collection

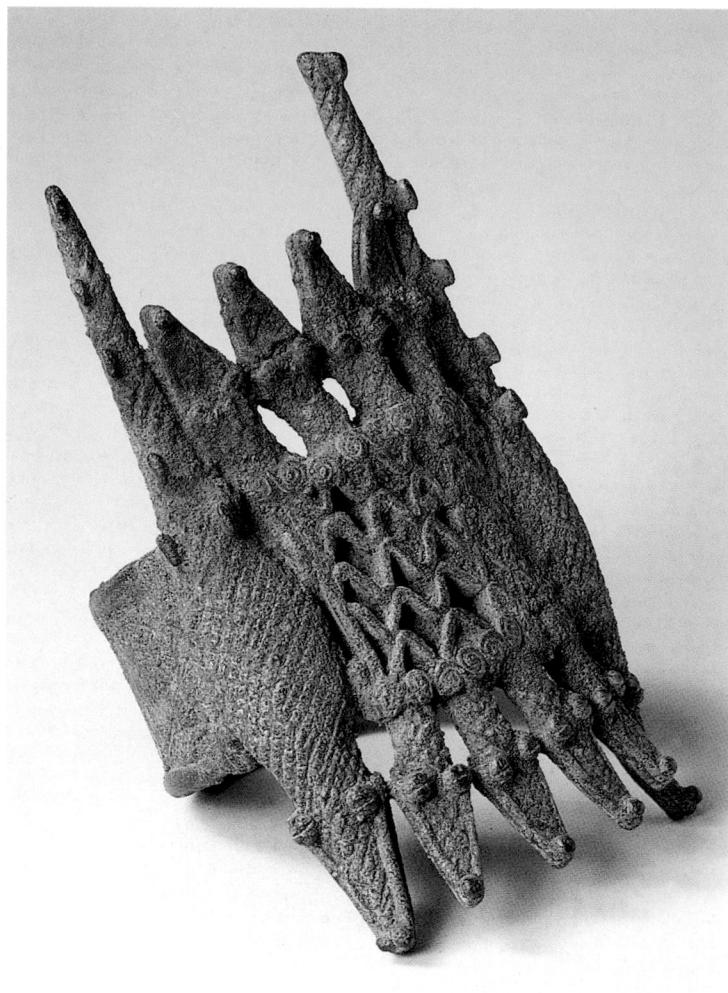

6.35b

Bracelet with ten crocodile heads

Lorhon
Burkina Faso/Ivory Coast
18th century (?)
copper alloys
15.5 x 6 cm
Private Collection

6.35c

Armlet (?)

Lorhon
Burkina Faso/Ivory Coast
18th century (?)
copper alloys
diam. 23 cm
Private Collection

6.35d

Sceptre

Lorhon
Burkina Faso/Ivory Coast
18th century (?)
copper alloys
42 x 22.5 cm
Private Collection

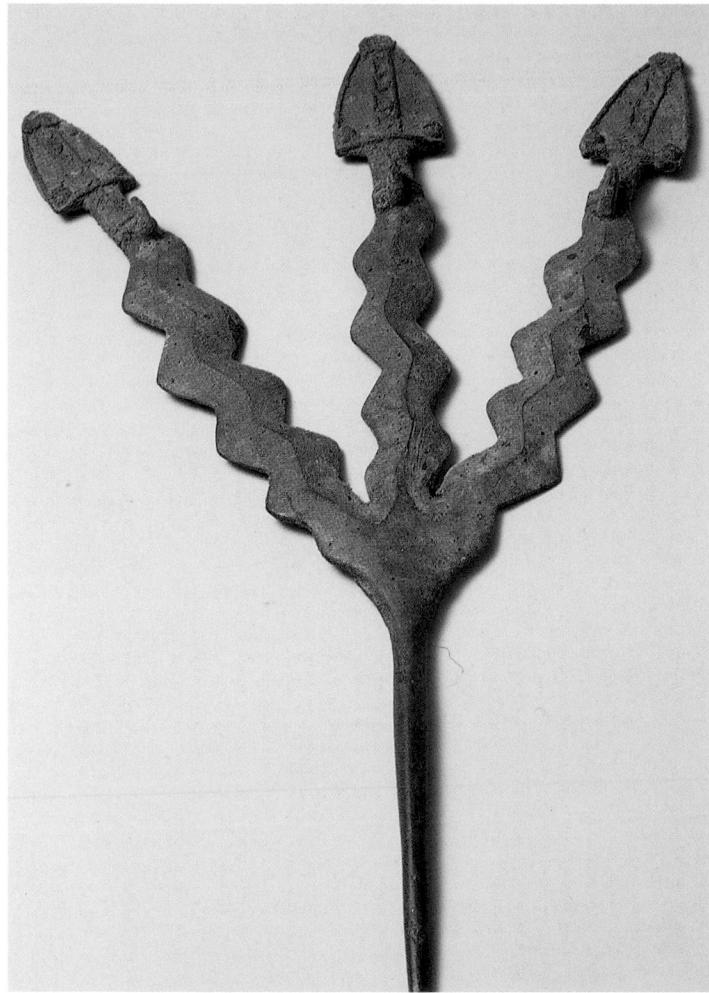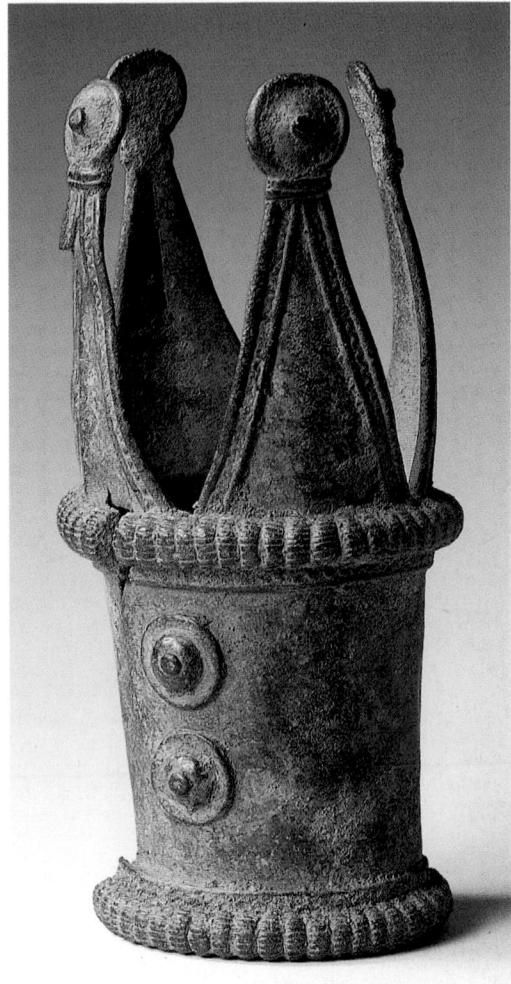

6.35e

Bracelet with crocodile head

Lorhon
Burkina Faso/Ivory Coast
18th century (?)
copper alloys
h. 17 cm; diam. 9.5 cm
Private Collection

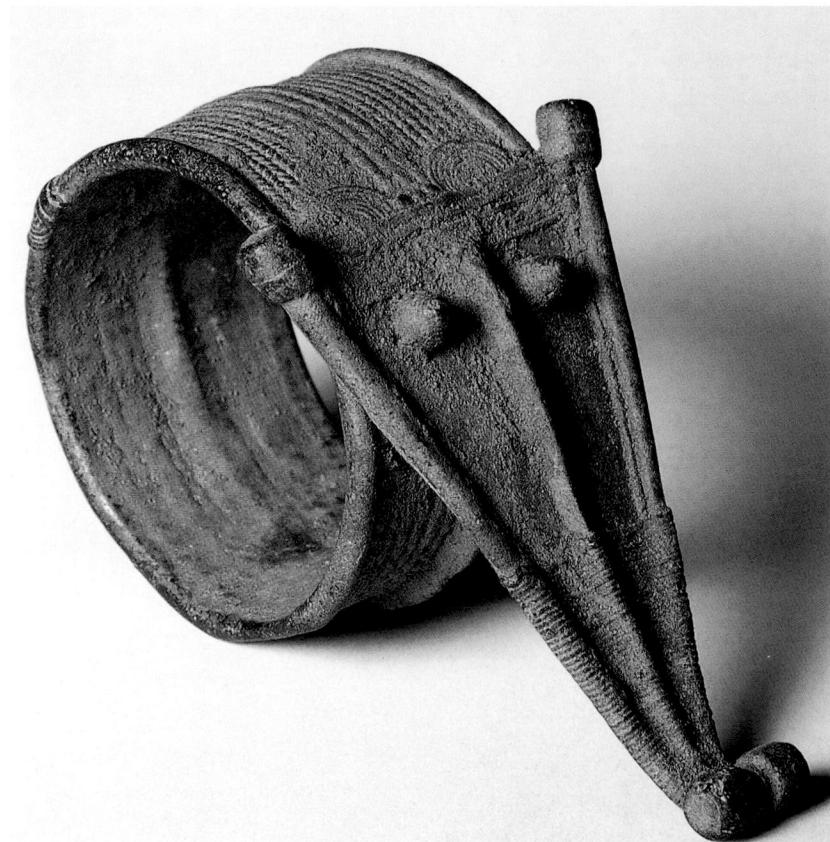

Just west of the Black Volta River, between Gaoua and Bouna, lie the remains of many stone buildings and associated pits or shafts cut deeply and with great precision into the lateritic soil, first noted by Delafosse in 1902. In 1913, while conducting brief surface excavations at Oyono, Labouret found a number of intriguing and finely cast copper objects and other items, but was unable to determine who might have been responsible for them. He suggested that this must have been an important and early goldmining area. On the basis of his data and a rereading of Leo Africanus's account of the flourishing gold trade in 16th-century Gao, Mauny later identified the area as the Lobi goldfields. While in the absence of sustained archaeological research little more can safely be said about the Lobi goldfields, I would suggest that this particular region appears to be yet another place where goldmining and a high degree of artistry in copper have been found side by side.

Labouret also describes the Lorhon or Nabe, an impressive group of artisans and renowned metalworkers living between Gaoua and the Kulango state of Bouna in north-eastern Ivory Coast. Supplied with copper rods by Dyula traders, and enjoying the patronage of both the Lobi and Kulango, the Lorhon were pre-eminent in the field of metal-casting, a position they have maintained to the present. The quality of these two bracelets and of the armlet (?) suggests Lorhon workmanship. The bracelet with a large single projecting snake head, elegantly balanced by a group of six small snakes, is a *tour de force* of casting. *RAB*

Bibliography: Delafosse, 1912; Labouret, 1920; Labouret, 1931; Mauny, 1961; Meyer, 1981; Scanzi and Delcourt, 1987

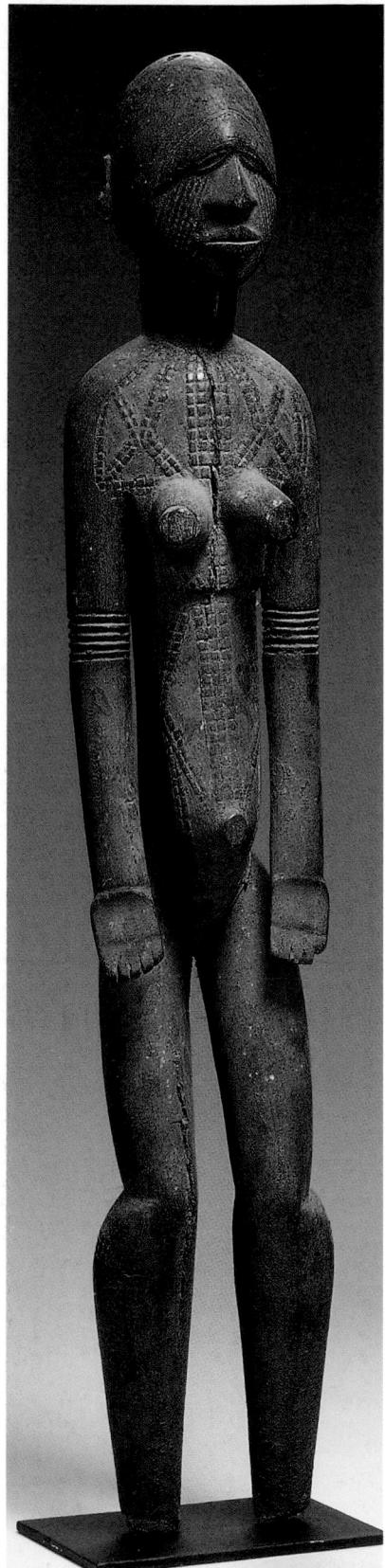

6.36

Diviner's figure (*dimbien*)

Nuna

Burkina Faso

20th century (?)

wood

h. 85 cm

Musée Barbier-Mueller, Geneva, 1005.4

This large and impressive figure was used by a religious specialist or diviner (*vuru*) among the Nuna people in south-central Burkina Faso to represent a spirit from the wilderness with which he could communicate and whose supernatural power he could control for the benefit of his clients. Such figures are kept together with non-figurative objects, including jars, bottles and stones, on shrines in dark corners of the diviner's home where they become covered with a thick crust of offering material, especially millet porridge, beer and chicken blood. All of that material has been long-since cleaned from this figure. It was collected near the Nuna town of Leo in southern Burkina Faso in the early 1970s by the (then) director of the national museum.

The Nuna are one of several peoples in Burkina Faso whose communities are formed around the worship of nature spirits, which in turn establish religious laws that control the moral and ethical conduct of life in the communities. There are traditionally no chiefs or other representatives of secular power in these communities, although the French attempted to create such centralised power during the colonial period.

Such figures serve the same function as the spectacular masks from the same peoples; they make the invisible nature spirits concrete and permit the congregation to offer their prayers and offerings. The geometric scarification patterns on the chest and back are part of a large body of graphic patterns that are used by the Nuna and their neighbours to communicate visually religious laws and moral values. Such patterns also appear on their masks, on human bodies and on pottery and the clay walls of buildings. CDR

Provenance: ex Henri Kamer

Bibliography: Kamer, 1973, pp. 136–7; Roy, 1987, pp. 246–9, 252–3; Schmalenbach, 1988, p. 76

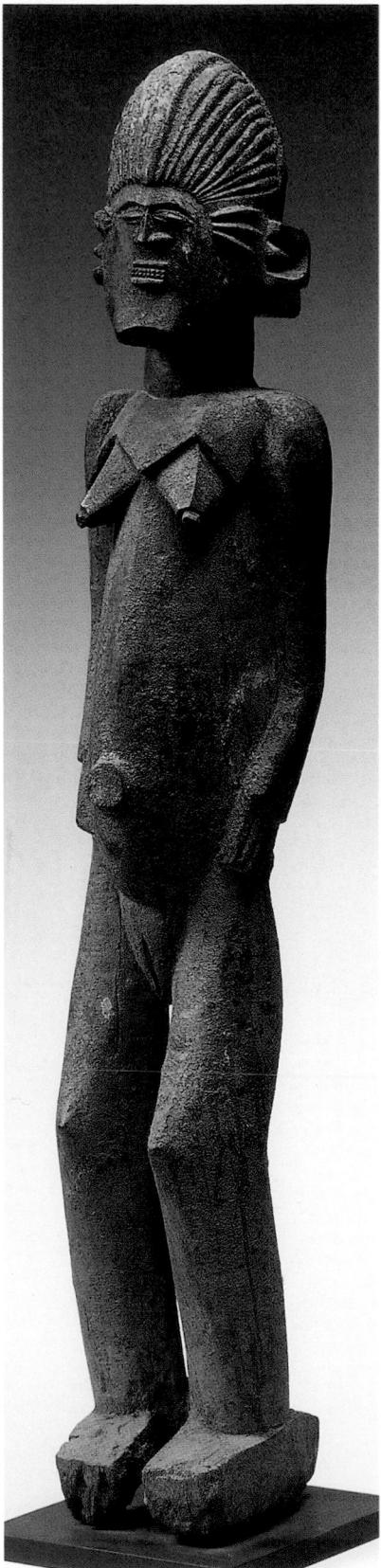

6.37

Standing female figure

Lobi

Burkina Faso/north-eastern Ivory Coast

20th century

wood

78 x 15.8 x 12.5 cm

Musée National des Arts d'Afrique et d'Océanie, Paris, MNAN 66.17.1

In every Lobi house a small shrine room (*thil du*) is set apart for the worship of ancestral spirits. Here are placed a variety of wooden statues, some of large size, together with an assortment of clay sculptures, iron staffs, bottles, pots and the like. Frequent sacrifices are made at these shrines to ensure the goodwill of the ancestors, and to avoid illness and misfortune.

This large female figure doubtless came from such a shrine. It is carved in a dramatic and unusual style; it could come from either north or south of the international boundary between Burkina Faso and Ivory Coast. The statue bears traces of sacrificial blood and chicken feathers. Of unknown significance are the three raised scarification marks on each temple of the figure. Such marks are not normally depicted on Lobi statues, and may suggest a foreign origin either for the maker of the figure or for the woman depicted. TFG

Exhibition: Zurich 1981

Bibliography: Meyer, 1981, p. 76

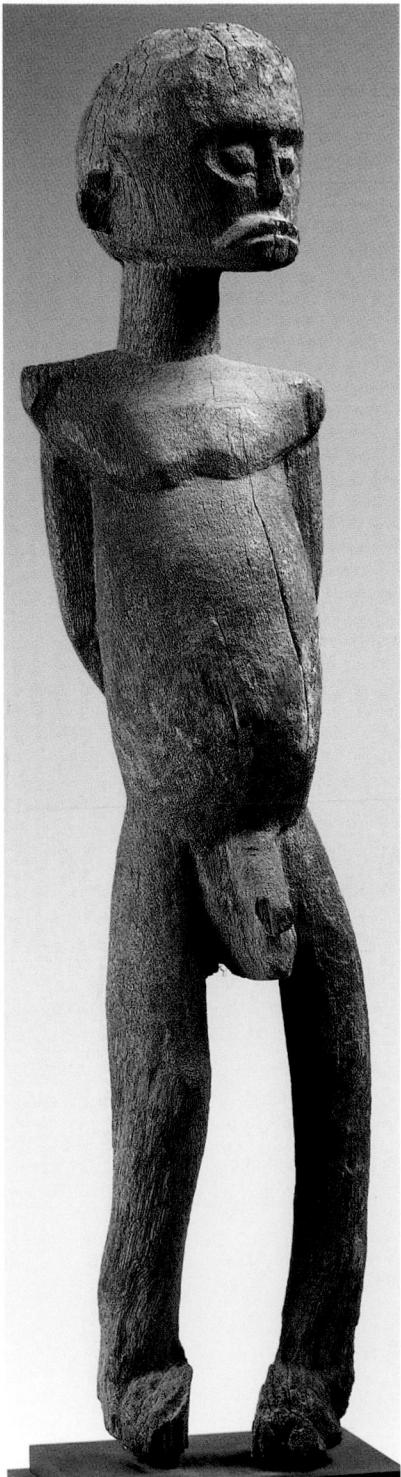

6.38

Male figure (*bateba*)

Lobi

Burkina Faso/north-eastern Ivory Coast
20th century
wood
h. 59 cm
Private Collection, Paris

In the corpus of Lobi statues (*bateba*) there is a distinct group which depicts gestures such as shock, despair or sadness: for instance one or both hands to the chin or the mouth, one or both arms crossed over the chest, or up-raised, or held behind the back. Meyer names this group *bateba yadawora*, 'unhappy *bateba*'. It was explained to him that when a man became deeply unhappy for any reason, for example if he had suffered a bereavement, the statue would be unhappy or mourn in place of him, or take his misfortune away. The present statue evidently belongs to this class, having its hands behind its back and a particularly woebegone expression. *TFG*

Bibliography: Meyer, 1981, pp. 104–6

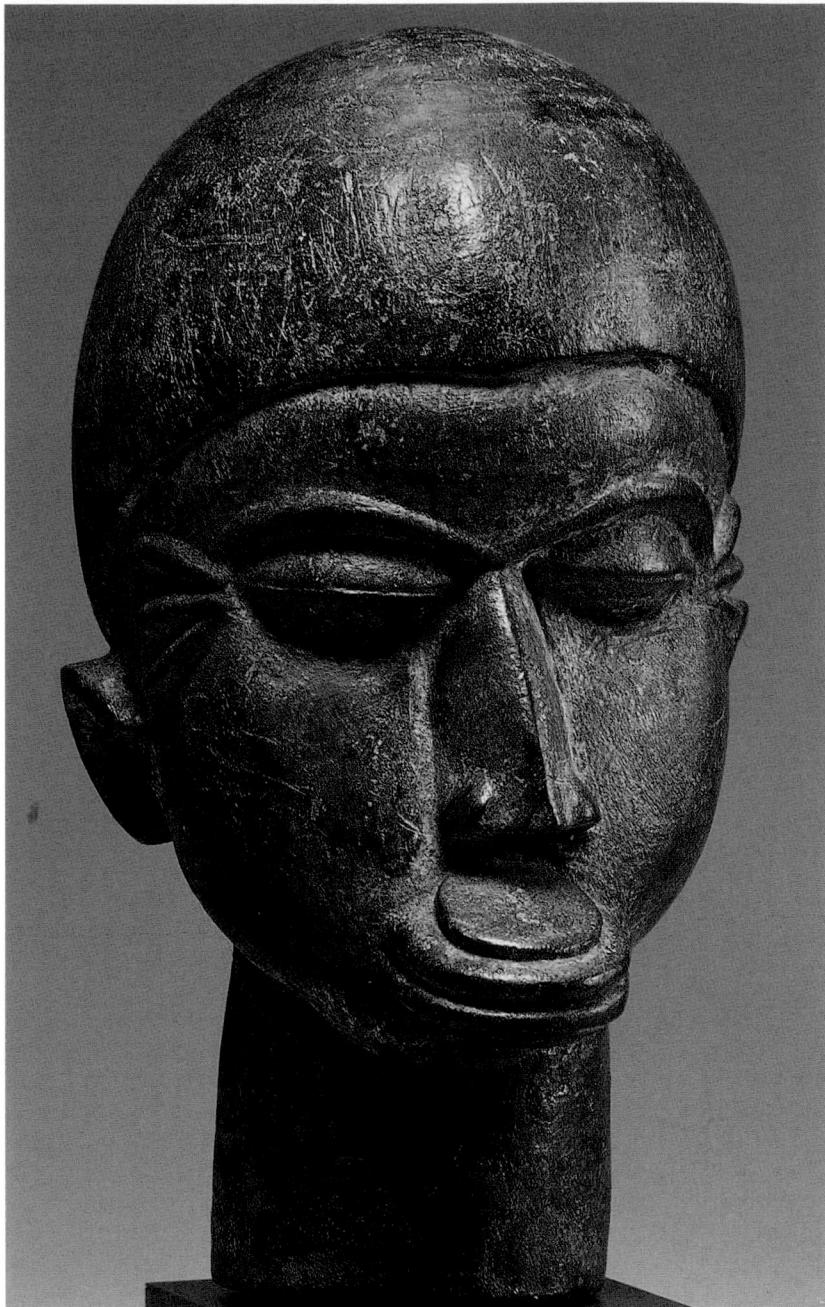

6.39

Head on post

Lobi

Burkina Faso/north-eastern Ivory Coast
20th century
wood
h. 51 cm
Private Collection, Paris

Large heads depicted on a post or stake form a unique category of Lobi sculpture. They are found on both sides of the international boundary which runs through Lobi territory. Many examples are sculpted with great care and attention to detail, and, unlike the full-bodied figures, they often show a triple scarification at the temple. The present example also depicts a lip plug. Until a genera-

tion ago the women of the region commonly wore lip plugs of wood or quartz, and these can still occasionally be seen.

These sculpted heads were fixed into the ground at various shrines, both in the shrine room and in the open air. They are also found with their spike set into the top of an external wall, where they served as guardians of the house. For this reason the end of the spike is often eroded, and in the present example it seems to have been cut away. *TFG*

Bibliography: Meyer, 1981, pp. 27–8, 35, 100–2

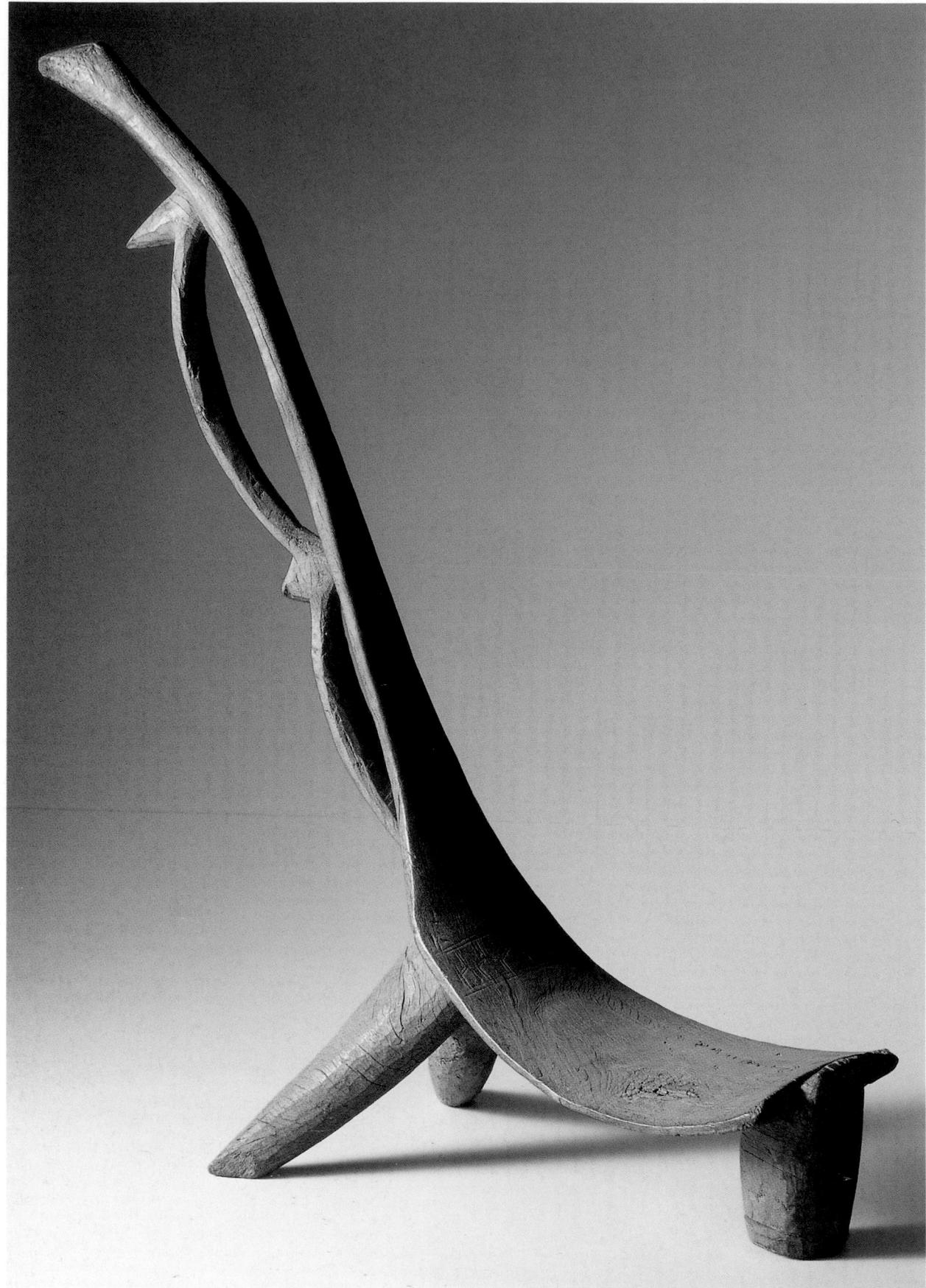

6.40

Chair

Nuna

Burkina Faso

20th century (?)

wood

81 x 67 x 28.5 cm

Musée de l'IFAN, Dakar, D. 67.1.16

On loan to Musée National des Arts d'Afrique et d'Océanie, Paris

In remote villages in Burkina Faso it is still possible to come across elderly men reclining on stools such as this one, smoking their pipes. Women also have personal stools which invariably have four legs, while men's stools have three, for the numbers four and three are associated with the female and male genders in much of Africa.

Among the Nuna large stools are passed from generation to generation until their legs wear away. Among the Lobi, who live just to the west of the Nuna, such large stools, as well as other personal property including headrests, pipes and spoons, become intimately associated with the spirit of the owner after decades of use, so that when the owner dies as a respected elder his (or her) stool is placed on the family ancestral shrine as a vehicle for communication from one generation to the next. Neither the Nuna nor the Lobi carve ancestor figures, but such heirlooms stand in the place of such figurative portraits. This graceful stool comes equipped with a handle that projects from the back and whose surface gives evidence of decades of use. *CDR*

Bibliography: Roy, 1987, p. 62

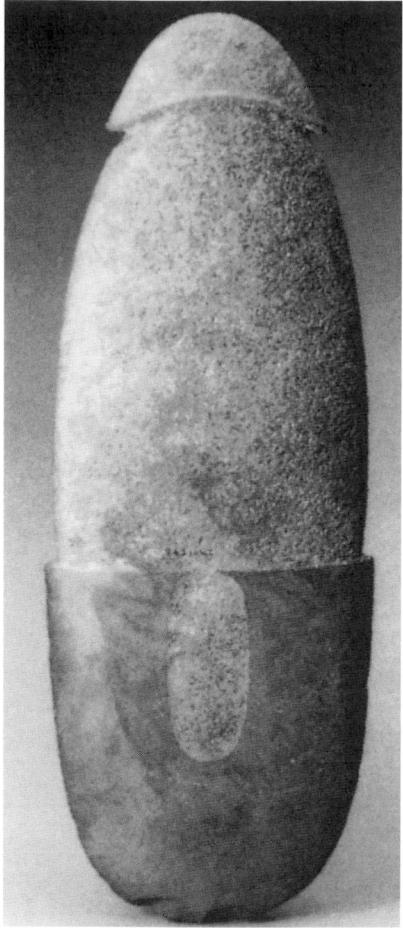

6.43

Polished stone axe

River Kilenge, Wuro Daudu, Adamawa, Nigeria
schist
h. 32 cm

The National Commission for Museums and Monuments, Jos, Nigeria, 64.J.161.2

This polished stone axe was found with a similar specimen under 6 feet of deposit near the River Kilenge at Wuro Daudu in Song District of Adamawa. The lower or blade end is highly polished, the remainder of the stone being fashioned by a delicate 'pocking' technique. Apparently never utilised, this remarkably well made implement could scarcely have been intended for ordinary use, and was in all probability a ceremonial object.

Polished stone axes occur throughout Nigeria and are frequently found re-used in secondary contexts, even incorporated on shrines in Benin. Neolithic in origin, they appear to have survived well into the Iron Age of west Africa. None, however, has been quite so beautifully crafted as the two Wuro Daudu specimens with their attenuated profiles, although larger, less refined examples have

been reported from the Jos Plateau in the savanna region of Nigeria and the forested countryside around Benin.

AF

Provenance: found near the River Kilenge at Wuro Daudu, Song District of Adamawa, northern Nigeria; presented to the museum by the Lamido of Adamawa

Exhibition: Paris et al. 1993

Bibliography: B. Fagg, 1946, pp. 48–55; Shaw, 1978, p. 44; Devissé, in Paris et al. 1993–4, p. 572

6.44

Gourd-shaped vessel

Nupe
Central Nigeria
late 19th–early 20th century
terracotta, brass fittings
38 x 32 cm
Private Collection, Munich

The Nupe live along the northern and southern banks of the middle Niger River in Nigeria. During the 19th century, they were conquered by Muslim Fulani who took over the leadership role of the Nupe ruling élite and incorporated the Nupe into the Islamic state called the Sokoto Caliphate. Nupe craftsmen work a wide variety of materials including wood, cloth, metal and ceramics. This ceramic vessel represents a collaborative effort on the part of a female potter and a male brass smith.

Pottery centres are located throughout Nupe country, especially at riverine sites where the finest sources of clay are found. Large gourd-shaped ceramic vessels like this one are produced in pottery centres, including the town of Muregi near the confluence of the Kaduna and Niger rivers. With a globular body and narrow funnel-like neck that terminates in a small bowl, these pots are among the most distinctive products of the Nupe pottery industry. Similar vessels are also made by Nupe and Gwari potters in the Kakanda, Bassa Nkwomo and Bassange regions located near the confluence of the Niger and Benue rivers. The vessels were an important commodity in the Nupe canoe trade from Jebba Island to the Niger–Benue river confluence. The widespread distribution of this

distinctive vessel form suggests that it is a hallmark of the middle Niger River ceramic style.

Such vessels are used as storage containers for palm wine and water. The potter starts the base of the pot using a convex mould technique and after the base dries to a leather-hard state, she continues to build the walls with a pull-coil and scraping technique. The smaller bowl that forms the top of the pot is begun in the same way. A hole is cut in the bottom of the leather-hard smaller pot, which is then joined to the mouth of the larger pot by coils of clay to form the neck. The entire surface of the pot is textured with a stippled pattern made by rolling a roulette. The pot is then subdivided into several rows articulated by horizontal bands incised with a small stick. The surface has irregular small, smooth, burnished patches placed around the pot.

The vast majority of gourd-shaped vessels have a russet colour due to an oxygenated firing process. In some regions, however, the pot is basted

with a locust-pod slip immediately after the firing which imparts a glossy brown sheen to the surface. In the past, after purchasing a ceramic storage vessel from the market place, a wealthy patron who wished to transform the pot into a prestige container would take it to a Bida brassworker, who dressed it with hammered brass fittings that were decorated with *repoussé* and *pointillé* designs. This ceramic vessel, whose lip, neck and belly are elaborately dressed with a series of brass bosses and fan- and canoe-shaped fittings, is similar in appearance to the most prestigious hammered brass vessels formerly produced by Bida brass smiths – the gourd-shaped *mange* vessel. Brass *mange* water jars were formerly purchased by the Fulani king of Bida, the Etsu Nupe, for his daughter's dowry and as gifts to members of the Fulani political élite. JP

Bibliography: Perani, 1973; Stossel, 1981

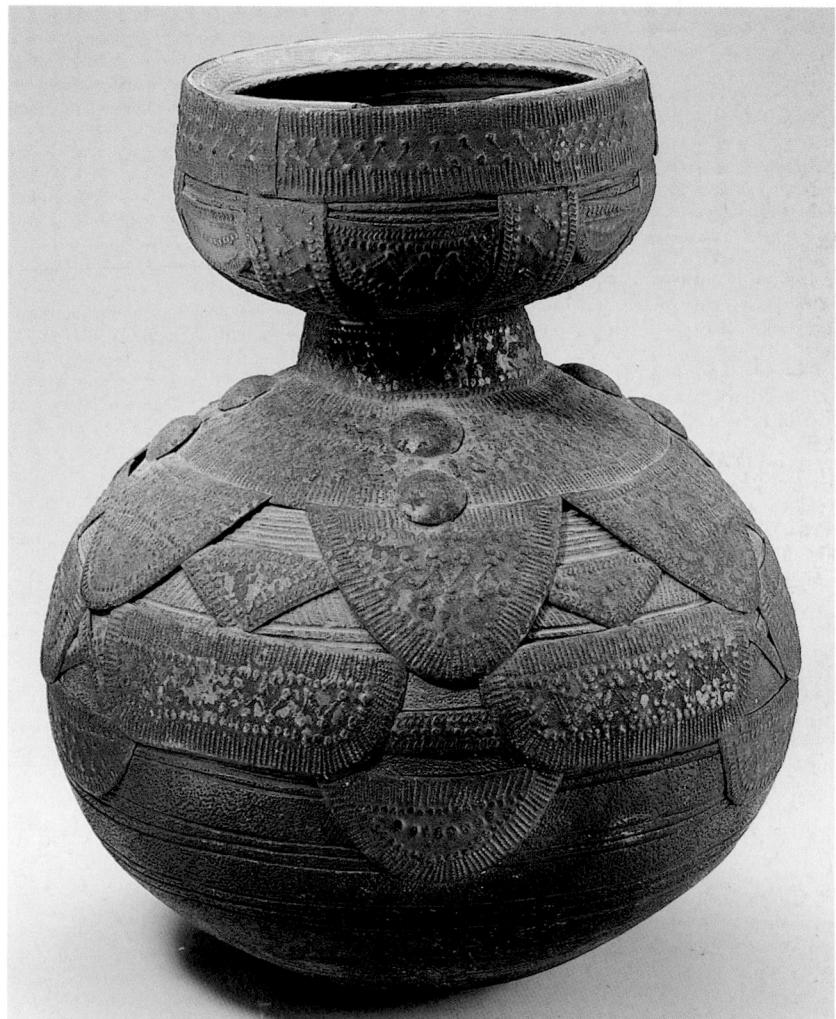

6.43

Figure

Borgu Division, Ilorin, Nigeria
c. AD 100–700
fired clay, red slip
20.5 x 10.5 x 8 cm
The National Commission for Museums and Monuments, Kaduna, Nigeria, KD 89.R.240

This is an unusual terracotta figure with a surface finish of red slip. The body is hollow, swelling at the shoulders, at the midriff (where there is a protruding navel) and at the hips. The limbs are solid, but each one is perforated by a small hole. The head has a large circular hole or mouth, above and below which are additional holes of similar size to those on the limbs. Much of the head is covered by cord roulette impressions probably indicating hair. This is the only part of the figure not covered in red slip.

This specimen was one of only two examples (the other was incomplete) of red-slipped stylised figures. They were excavated from a tell site on the west bank of the River Niger about a quarter of a mile upstream of the southern tip of Rofia Island. The site, known only as RS 63/32, yielded numerous fragments of other figurines but none executed in the same 'abstract' style.

Radio carbon dates indicate that this tell site was occupied from about AD 100 to 700, and the stratigraphic evidence suggests that there was continuous occupation throughout that period. Domestic pottery, stone beads, ear or lip plugs, and bracelets together with numerous iron objects (rings, bracelets, arrow-heads, spearheads, axes, knives) and the absence of any defensive structures suggest this was a small, peaceful, riverside settlement with an agricultural economy supplemented by hunting and fishing.

The role of the figures in this riverine community has never been established but their position in the art history of Nigeria later than much of the Nok material but earlier than Ife has been discussed in detail by Willett. AF

Bibliography: Priddy, 1970, p. 24; Eyo, 1977, p. 35; Willett, 1984, pp. 87–100

6.44

Grave sculpture

Dakakari
North-western Nigeria
late 19th–early 20th century
terracotta
77 x 23.5 cm
The National Commission for Museums and Monuments, Lagos, 2.19

The Dakakari reside in the hilly region north of Kontagora in north-western Nigeria. Dakakari ceramic grave sculpture belongs to a broad-based west African fired clay-earth-funerary-ancestral worship complex. Some of the better documented traditions include the ceramic sculpture of the Inland Niger Delta region of Mali and the Akan region of Ghana. For these and for the Dakakari, the earth where the deceased are buried is the source of clay used to make funerary sculpture.

Dakakari women produce utilitarian ceramic vessels for cooking and storage purposes. These are also used to mark the earthen tombs of ordinary men and women. However, for prominent men such as a lineage head, priest, renowned hunter, wrestler or skilled warrior, who have distinguished themselves by their exceptional accomplishments within

524 SAHEL AND SAVANNA

The hollow-ware figurative sculptures are supported on spherical ceramic bases that are inserted into the earth and include stylised representations of standing humans, equestrian images and animals, especially antelopes and elephants. The sculptures representing elephants are spherical forms supported by four legs and trimmed on top with a wide comb shape that may derive from the silver haircombs worn by married Dakakari women. Elephant sculptures are the most expensive and prestigious of the grave markers and are associated with the graves of family heads and hunters.

This example belongs to a category of non-figurative Dakakari pagoda grave sculptures, which is characterised by an architectonic quality.

Pagoda grave sculpture was more common during the 19th and early 20th century; visitors to the region in the 1940s noted that pagoda grave markers were disappearing. Pagoda grave markers are based on a stack of utilitarian pedestal storage pots that have been elaborated and rendered non-utilitarian by sealing the lid of the top pot. In a domestic context this type of pedestal pot would be used for storing honey or beer. Each vessel form in the stack is embellished with rows of raised ridges patterned with notched incisions that are identical to the decorative bands found on Dakakari elephant grave sculpture. It is in this category of non-figurative ceramic grave sculpture that the boundaries between utilitarian ceramic vessels and ritual ceramic sculpture become blurred. Generally, Dakakari graves are marked by an ensemble of ceramic forms that might include both figurative and non-figurative sculpture along with utilitarian pots. Each time a family member is buried, a pot or ceramic sculpture is added to the funerary ensemble. JP

Bibliography: Harris, 1938; Fitzgerald, 1944; Bassing, 1973; Berns, 1993

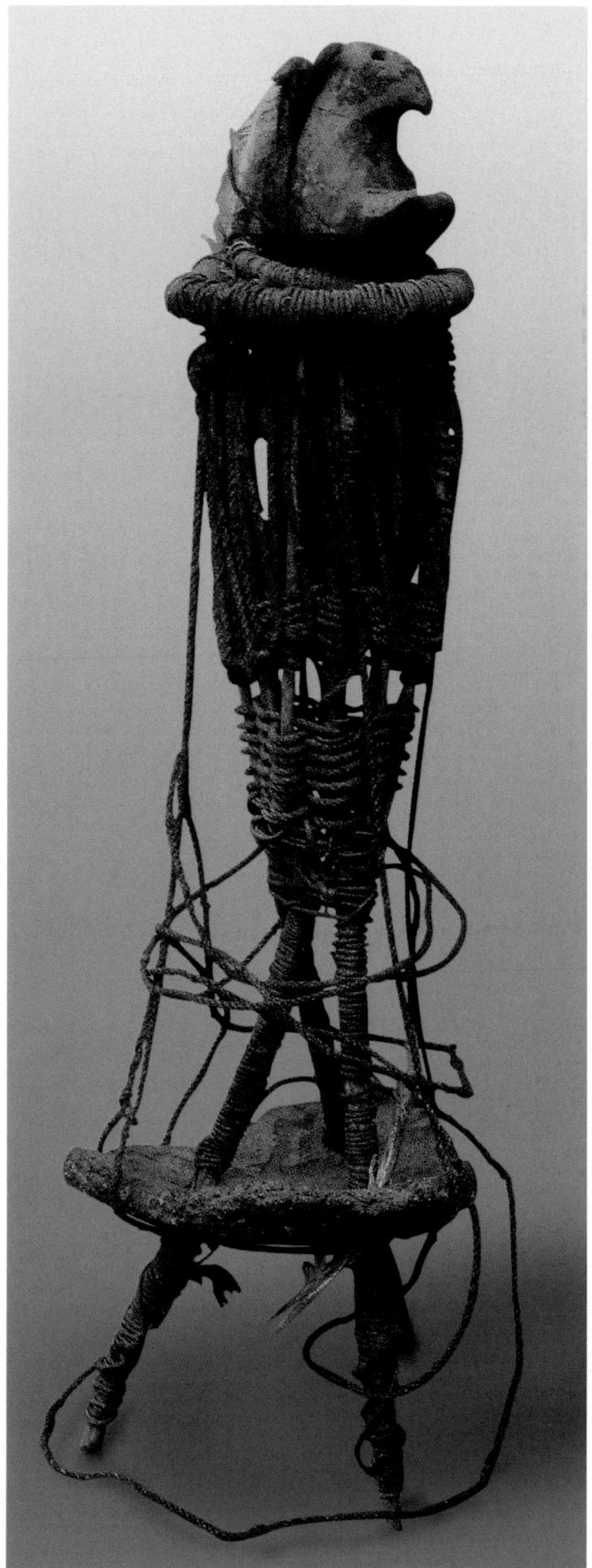

6.45

Tripod power object used for healing

Nok district

Nigeria

20th century

cane, string, feathers, animal parts,
terracotta

67 x 27 cm

The National Commission for Museums
and Monuments, Jos, Nigeria

From the Nok region, though we cannot know whether or not it is connected with the ancient civilisation that takes its name from the village of Nok, comes this extraordinary and elaborate construction whose ingenious structure is masked at first sight by its haphazard look. Described by the curator of the Jos museum as a fetish (a term now so general as to hold little meaning), it has more the appearance of an oracular device in which the attached wooden animal plays some part. The root of the edifice is an apparently broken piece of a pot through which some of the sticks pass. The choice of such an object for an aesthetically based exhibition not only indicates the expansionist tendency of art and its embrace but shows, as Collam so provocatively put it 50 years ago, 'how the African past is always one step ahead of the European present'. *TP*

archaeological investigation it becomes impossible to assess the role and function of these strange and intriguing works of art. A similar tragedy has befallen the terracotta sculptures of the Middle Niger basin. The terracotta works of art collectively referred to as the Nok Culture occur in central Nigeria, a country that has had controls restricting the export of antiquities across its borders since 1939. Associated with these exceptional figures are fragments of stone querns and ornaments, iron tools and quantities of broken pots and bowls. Soil conditions do not appear conducive to the preservation of much organic material and in the absence of skeletal remains much of what is known about those who lived at the time of Nok is derived from the evidence of the figures themselves. They favoured elaborate hairstyles, exploiting the sculptural qualities of African hair, arrayed themselves with necklaces, armlets, bangles and anklets, and appear in some fragments to be wearing some form of cloth.

Excavations at Taruga have confirmed that the makers of the Nok terracottas were not only users but smelters of iron. Their skills in making domestic pots and bowls were equal to the skills displayed in the making of the figures and they appeared to work stone into ornaments with equal ease. Accomplished representations of animals, human ailments and mythical beings all feature. They are remarkable for their humour, sense of caricature and sophisticated sculptural quality, echoes of which, in various media, can be found in later works such as those at Tada, Ife, Benin and among the Yoruba.

Radio carbon and thermoluminescent dating have confirmed that the early estimates of age based on geological and stratigraphic grounds are broadly correct, placing the Nok culture in the latter half of the first millennium BC and the first few centuries AD. Further precision in assessing the age of the Nok cultural material now depends on future archaeological research. *AF*

Bibliography: B. Fagg, 1977; Bitiyoung, in Paris et al. 1993–4, pp. 393–414; A. Fagg, 1994

Nok

Some of the most enigmatic and dramatic of terracottas which reflect the Nok iconography have appeared in private collections outside Nigeria. Some of these are seen here for the first time. These objects bear mute witness to an archaeological catastrophe equal to the looting of Cycladean statues and the tombs of the pharaohs, for without detailed

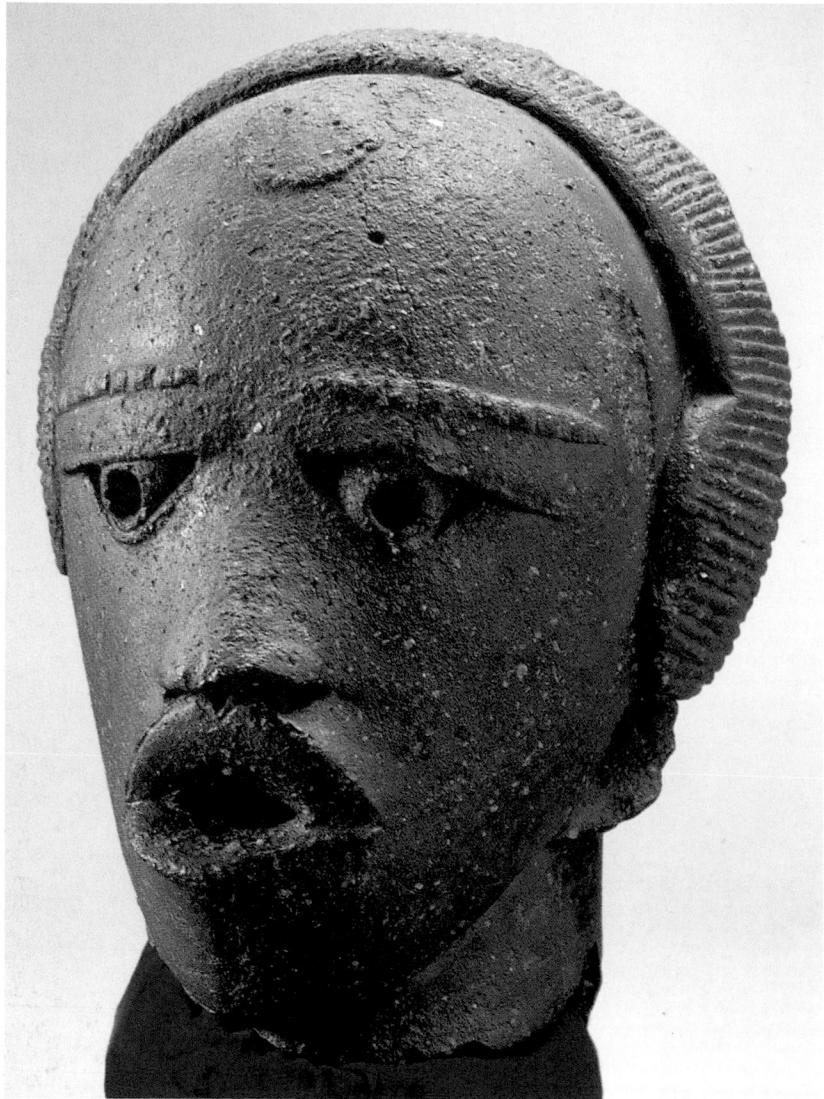

6.46

The Jemaa Head

Jemaa, Kaduna State, Nigeria

c. 500 BC

fired clay

25 x 17.5 cm

The National Commission for Museums
and Monuments, Lagos, 79.R.2

This near life-size terracotta head, discovered in the course of mining for tin in the Jemaa area, and then used as a scarecrow for over a year in a mineworker's farm, was reported in 1944. The head had been found in alluvial tin-bearing deposits under 25 feet of sedimentary sands and gravels. The aesthetic accomplishment of the piece was obvious. The stylised treatment of the face and the technical expertise evident in the Jemaa Head were mirrored in the terracotta monkey's head from Nok (Fagg, 1956). A visit to Nok to study the site of the discovery of the monkey's head yielded another terracotta human

head and associated figurine fragments in the same artistic tradition. This group of fragmentary terracotta figures formed the core of the corpus of material known as the Nok Culture. It was suggested on geological grounds that these figures occurring in stratigraphically similar deposits were some 2000 years old, but it was not until 1970 that a thermoluminescence analysis of the Jemaa Head itself suggested a date of about 500 BC. *AF*

Exhibition: Detroit et al. 1980–3

Bibliography: B. Fagg, 1945; Fagg, 1956;
B. Fagg and Fleming, 1970, pp. 53–5;
B. Fagg, 1977, p. 1

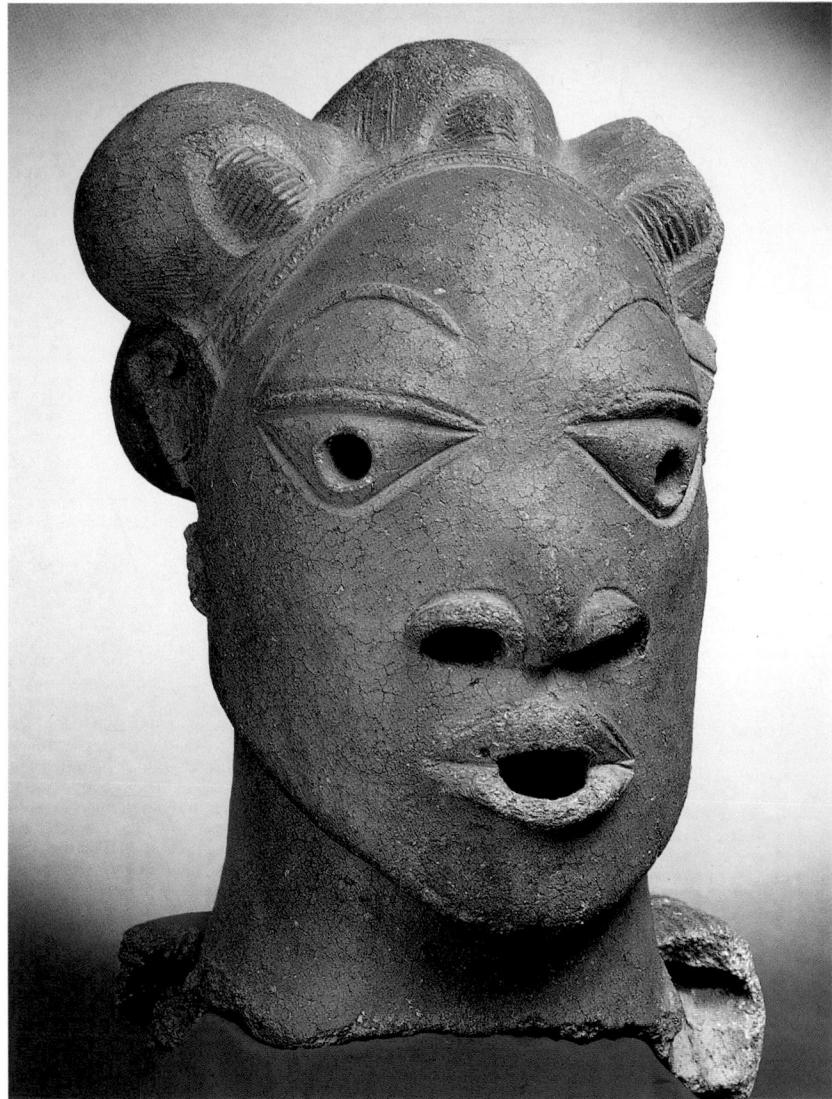

6.47

The Dinya Head

Nok Valley, Kaduna State, Nigeria

c. 500 BC–AD 200

fired clay

36 x 22.5 cm

The National Commission for Museums
and Monuments, Lagos, 79.R.1

Discovered in 1954 face down in a narrow channel in the bedrock, overlain by some 3.80 metres of alluvial deposits, this spectacular life-size terracotta head from the Nok Valley is characteristic of the Nok style. Broken at the neck, it appears to have been part of a figure which when complete would probably have been at least 1.50 metres high. Fingermarks of the maker are visible on the interior but the exterior has been tooled to a fine surface finish. While its striking countenance is impressive today, originally, as part of a complete figure, it must have been awe-inspiring. The buns of hair plaited at

intervals round the face are perforated, but why this is so remains a mystery. This is the largest complete Nok head to have been recovered and preserved in Nigeria's museums, although parts of even larger heads exist, often too fragmentary to exhibit.

The Dinya Head was nearly destroyed when unearthed by a tin-miner's pickaxe but, fortunately, was saved by the quick-witted actions of a labourer who had worked part-time for the Nigerian Antiquities Service. The miner's destructive impulse was probably due to the fact that these terracottas often appeared in pockets of the tin-bearing deposits when the tin was running out. *AF*

Exhibition: Detroit et al. 1980–3

Bibliography: B. Fagg, 1956, p. 95;
B. Fagg, 1977, p. 13; Eyo and Willett, 1982,
p. 50

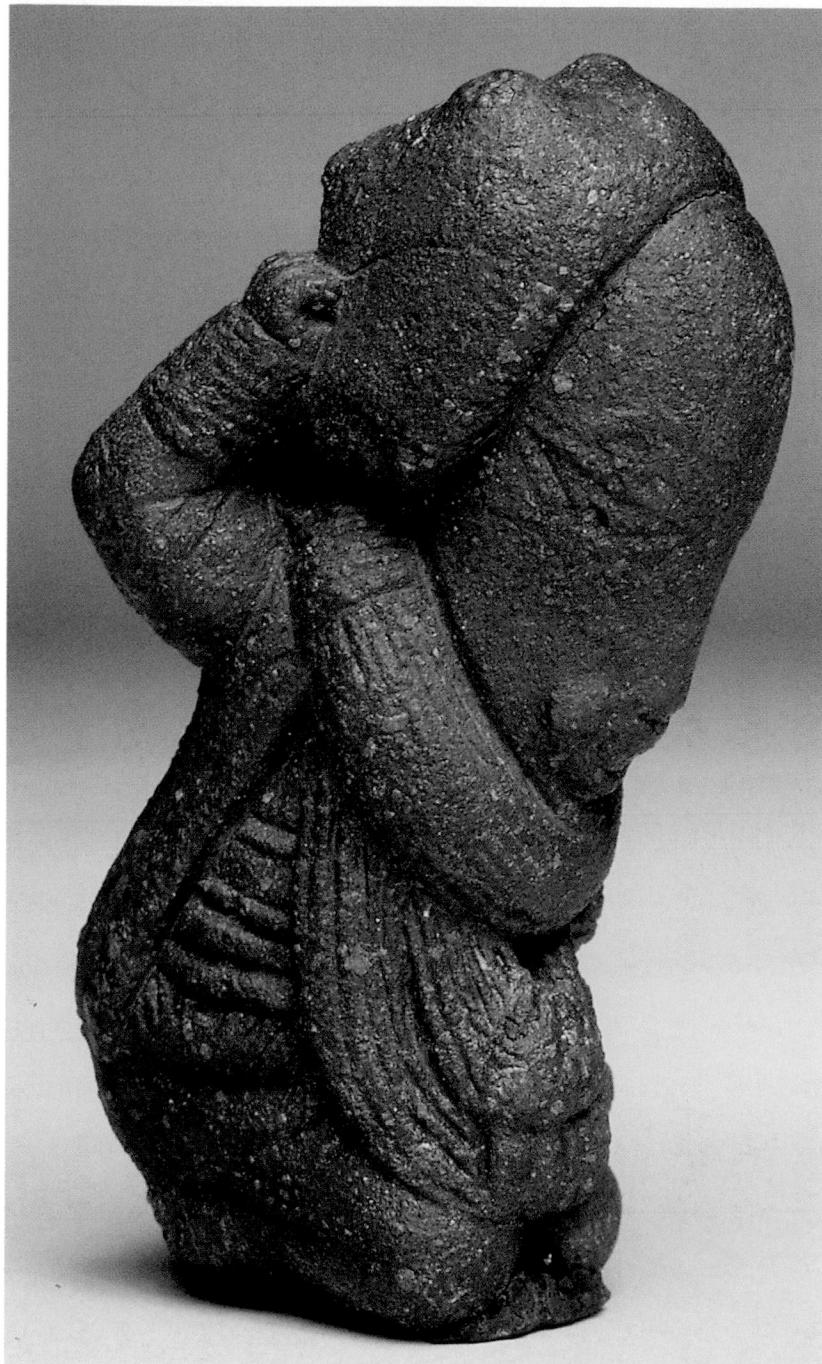

6.48

Figure

Bwari, near Suleja (formerly Abuja), central Nigeria

c. 500 BC–AD 200

burnt clay

10.6 x 6.2 cm

The National Commission for Museums and Monuments, Lagos, 60.J.2

This beautiful figure was recovered from the banks of the Makobolo River. From the crown of the head to the soles of its feet the detail is meticulous. A mere 10.5 cm high, this little figure has a tactile quality, like Japanese ivory netsuke. Adorned with necklaces, bangles and anklets, this

remarkably well-preserved complete Nok terracotta is unique in complexity, although fragmentary examples of similar size have been recovered from the Nok Valley and elsewhere.

Unlike larger examples of the Nok artistic tradition the Bwari figure is sculpted in solid clay. With a delicately moulded beard and what appear to be tufts of hair at the corners of the mouth (a feature present in a number of other figures) this male figure adopts a subservient posture in marked contrast to some of the larger, clearly female, Nok sculptures. The elaborate stylisation of the hair with six buns and what seem to be tresses hanging

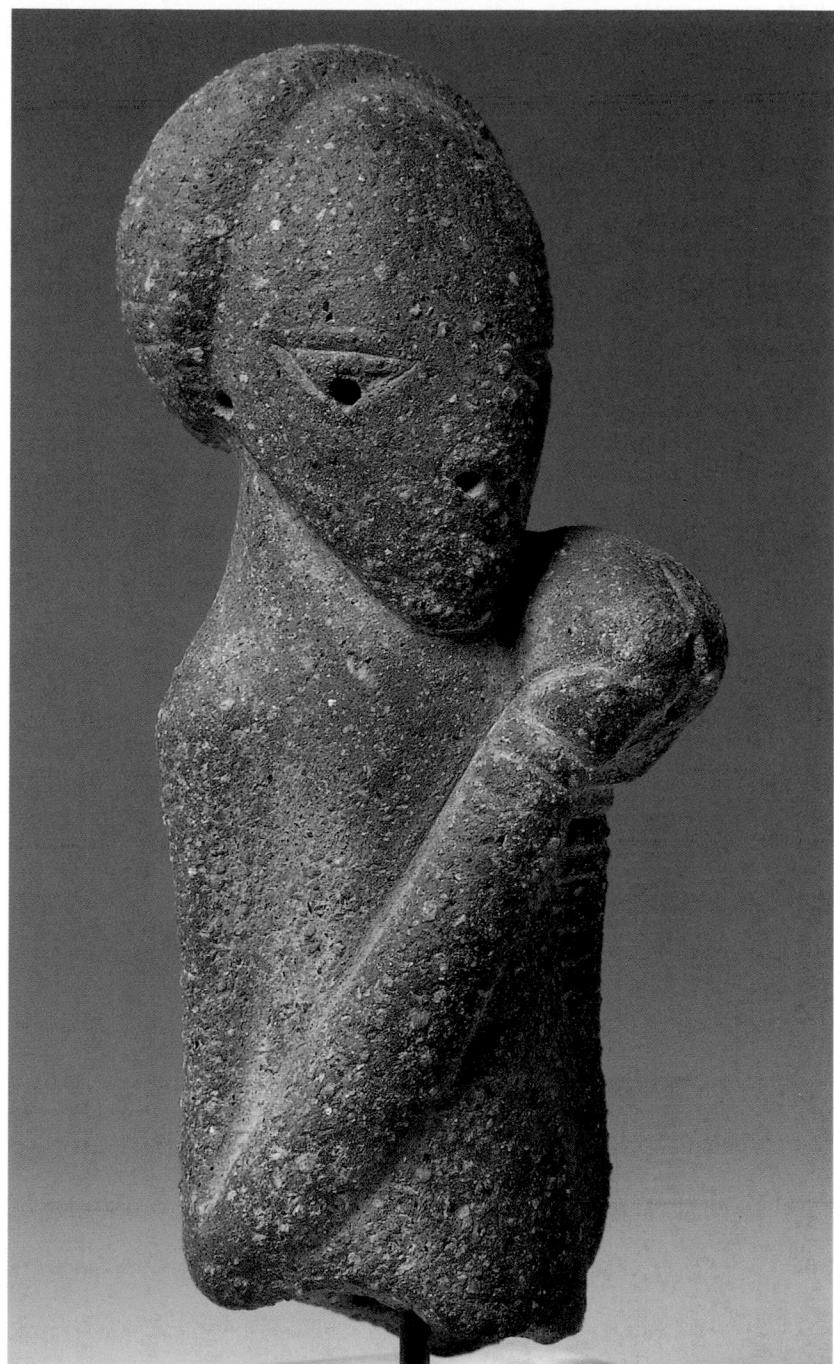

down the back of the neck are characteristic of many of the Nok terracottas regardless of gender.

Circumstances surrounding the discovery of this piece indicate an age comparable to that of the Jemaa and Dinya heads (cat. 6.46–7). AF

Provenance: 1960, recovered on the banks of the Makobolo River during mining operations

Exhibition: Detroit et al. 1982–3

Bibliography: B. Fagg, 1960; B. Fagg, 1977, p. 15; Eyo and Willett, 1982, p. 59

6.49

Figure

Nok
Nigeria

terracotta

16.5 x 6 x 8 cm

Ian Auld Collection

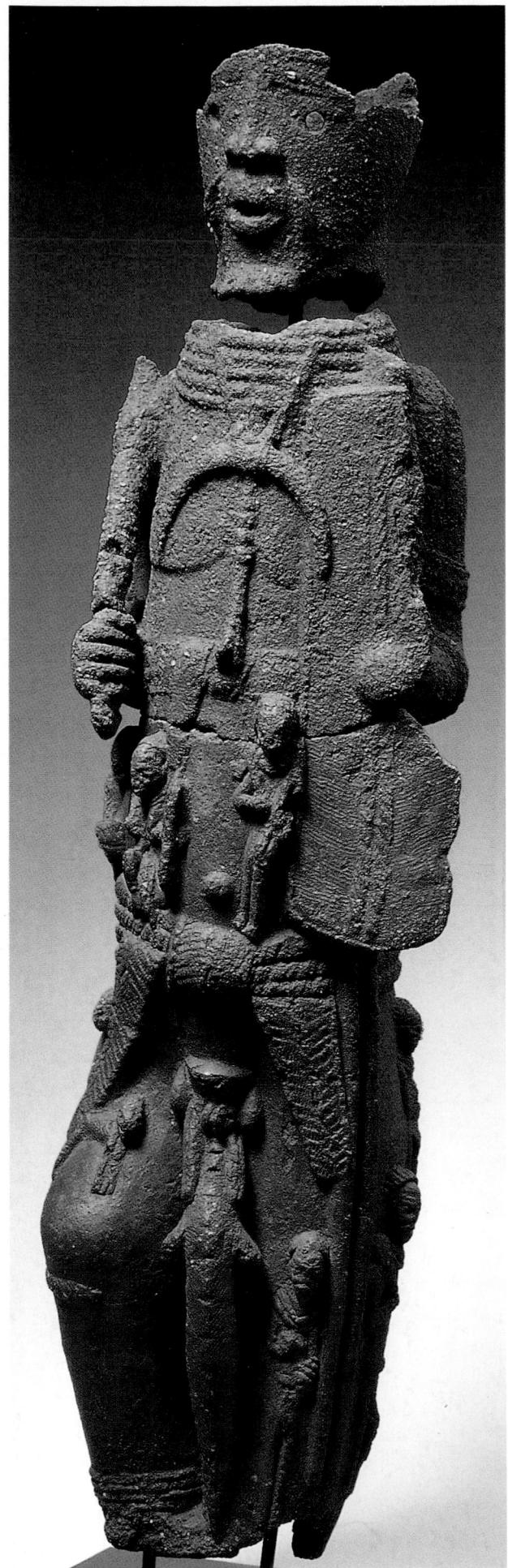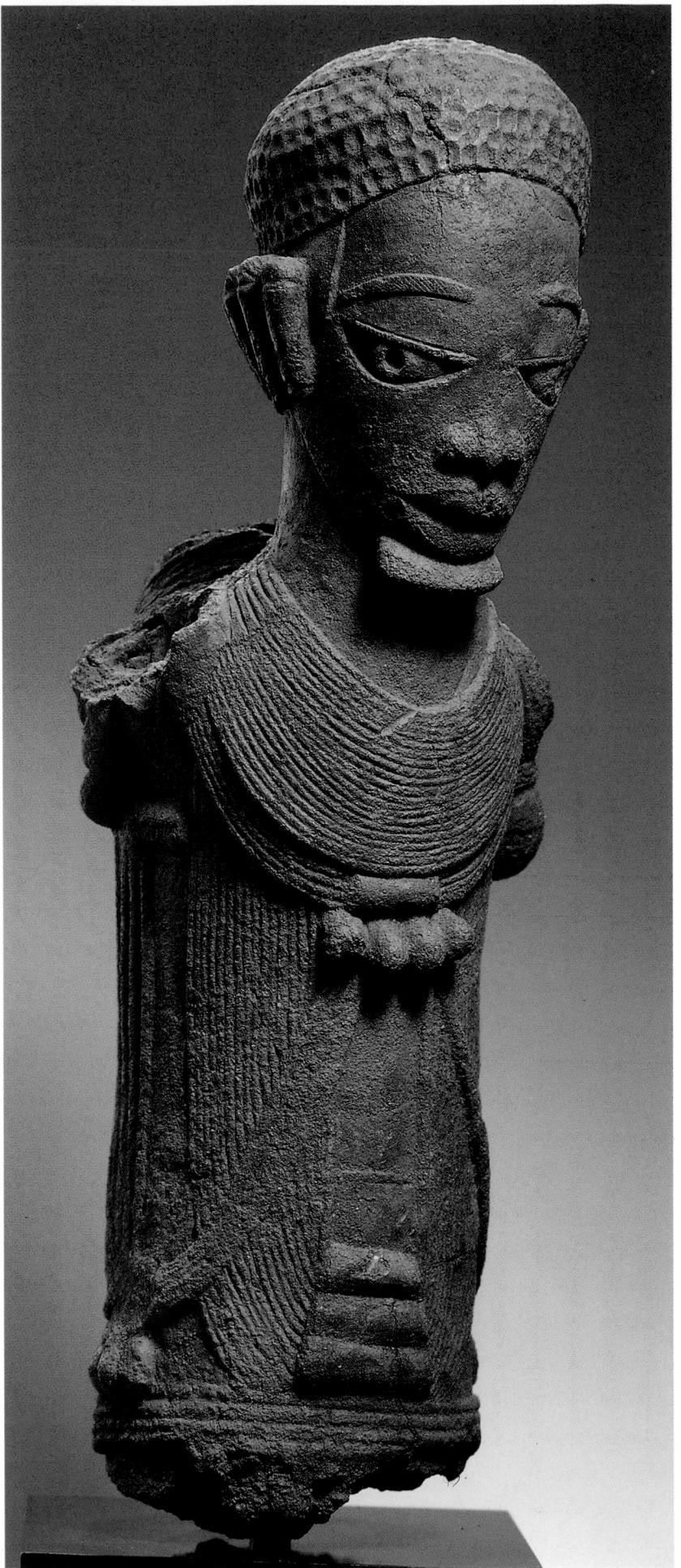

6.50

Warrior figure

Nok
Nigeria
terracotta
88 x 23 x 20 cm
De Meulder Collection

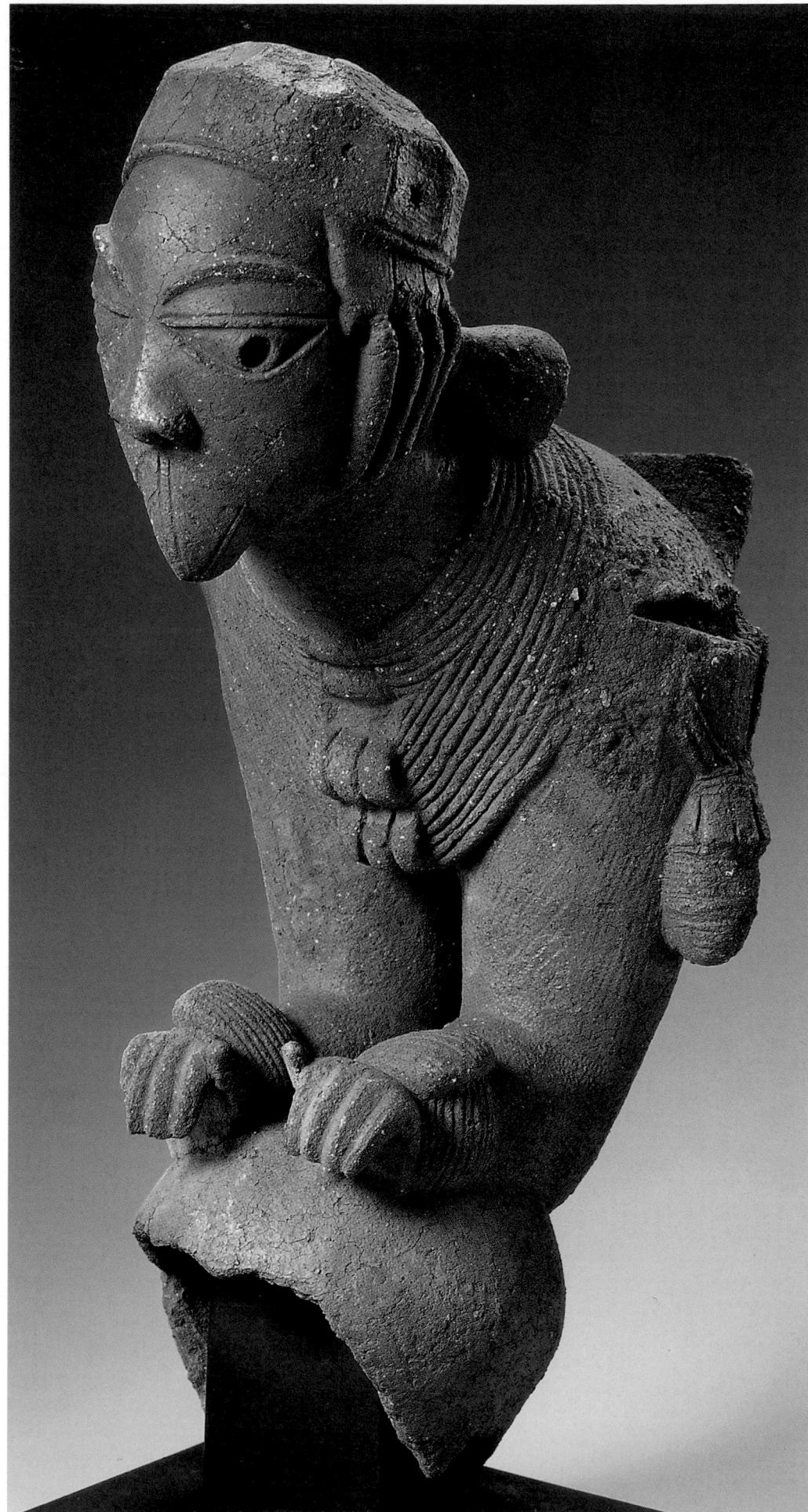

6.51

Two-headed fragment

Nok
Nigeria
terracotta
h. 66 cm
Private Collection, London

6.52

Human/bird figure

Nok
Nigeria
terracotta
47 x 20 x 22 cm
Private Collection

6.53

Kneeling male figure

Nok
Nigeria
terracotta
65.5 x 19 x 25 cm
Private Collection

6.54

Seated female figure

Nok
Nigeria
terracotta
58 x 25 x 19 cm
Private Collection

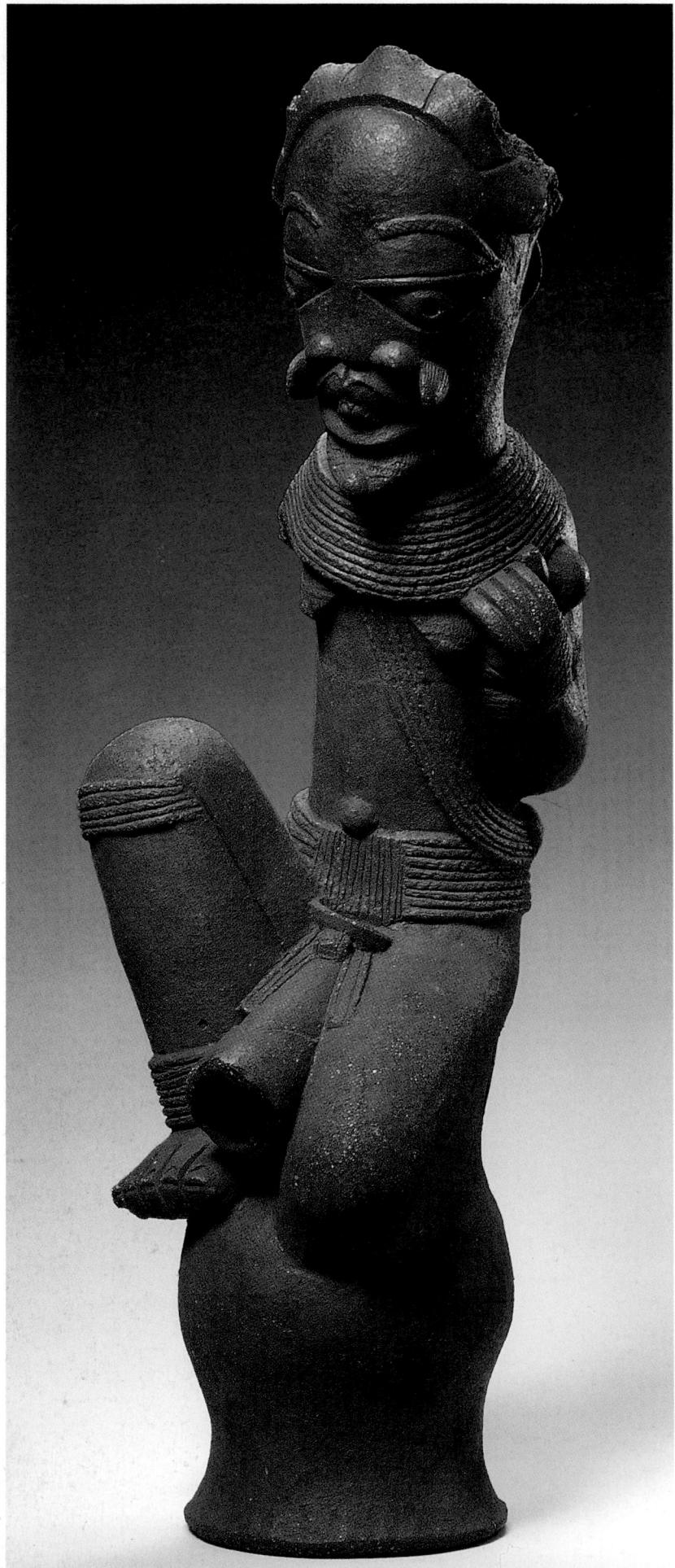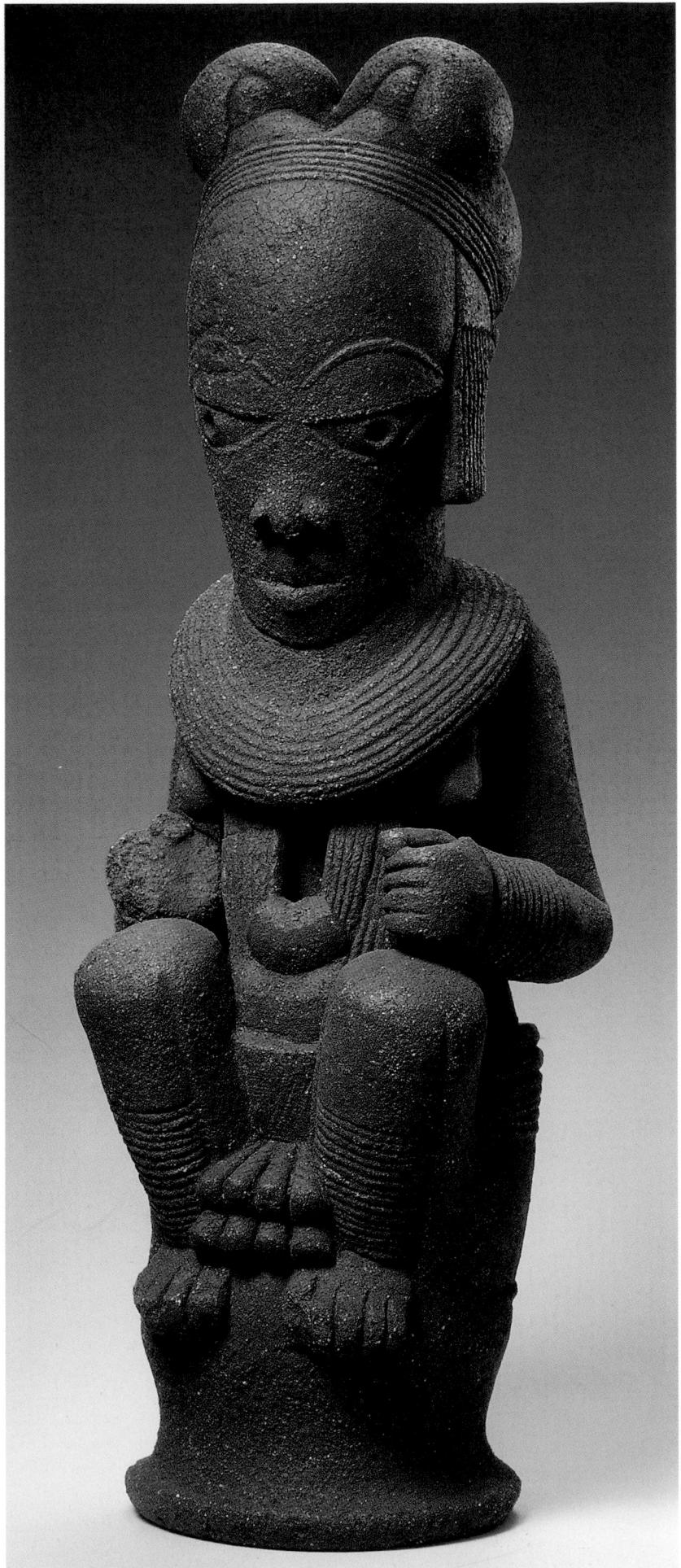

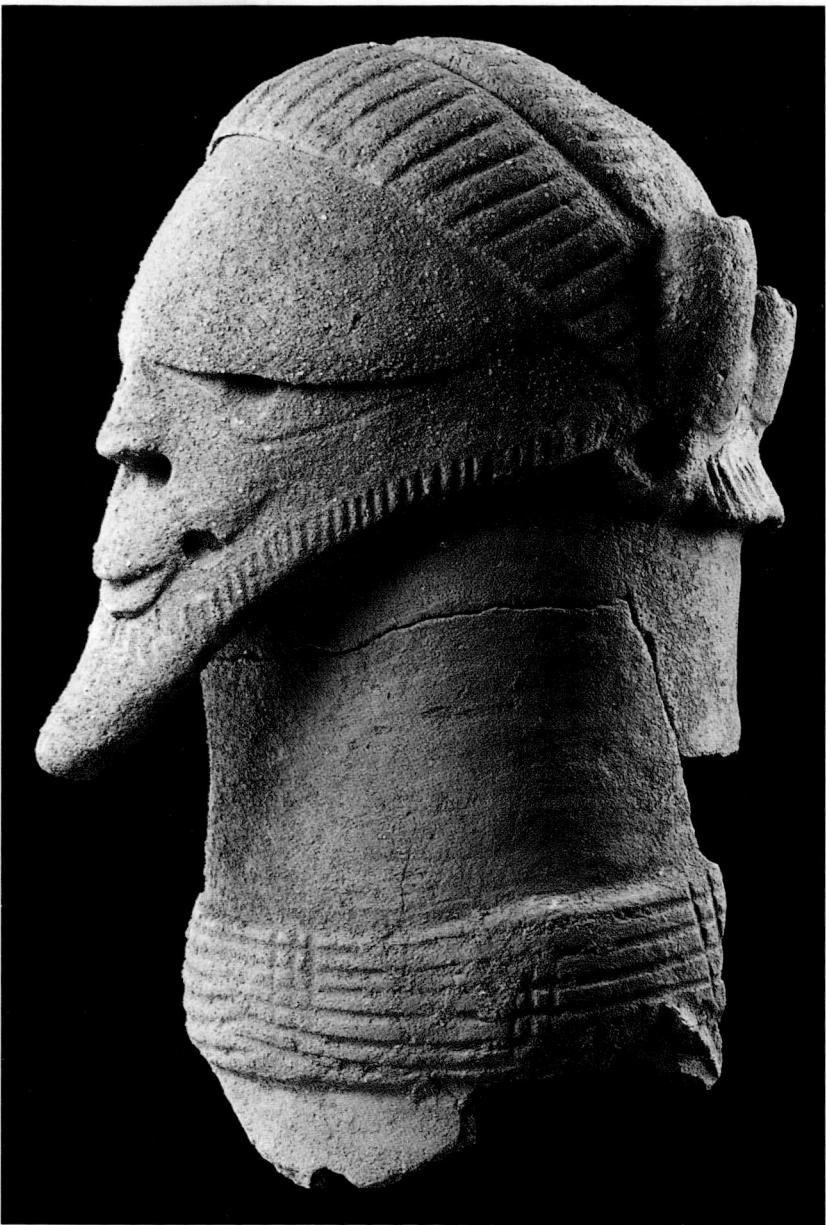

6.55
Head
 Sokoto
 Nigeria
 c. 200 BC–AD 200
 terracotta
 Private Collection

In the north-west of Nigeria, north of Yelwa and the Dakakari (cat. 6.44), is the Sokoto region, another part of the great Niger Valley complex whose archaeological riches have been the focus of so much debate. Sokoto itself is at the confluence of ancient trade routes. Chance finds in the area have included terracottas whose thermoluminescence datings point to a period of a century or two earlier than the average estimate for the Nok figures.

Those sculptures that have emerged range from crude statuettes, some of

warriors (which seem like those of Nok to have surmounted inverted pots), to large almost life-size busts in a distinctive austere style of which the present example is typical. ‘Sokoto’ terracottas seem to lack the ornate trappings associated with larger Nok works and some figures are bare of any ornament. The heavy brow and delicate features combined with a fine beard have a severe aspect in comparison with which Nok heads on a similar scale appear even sensual. The thin pottery walls of this head attest to a highly developed technique. It is to be hoped that properly conducted excavations will one day give us enough information to assess the connection between these two seemingly isolated cultures.

TP

6.56

Quiver

Fulani
 Nigeria
 early 20th century
 leather, wood, iron
 h. 75 cm
 Royal Tropical Institute/Tropenmuseum,
 Amsterdam, 2404-10a/i

The Fulani, whether following a pastoral lifestyle or practising a mixed economy of cattle-raising and agriculture, depend upon specialist groups of artisans to provide them with many of the essentials of life. Blacksmiths (*waylube*) furnish them with hoes, axes, knives and arrows while the *lawbe*, or workers in wood, create the mortars, pestles, bowls and milk urns that all Fulani families use. Although as herdsmen they make their own sandals out of cowhide, all other leather articles, which are invariably beautifully embellished, are made by the *gargasaabe*, leather-working professionals who have always worked for Fulani patrons. Even the most humble object, such as this quiver, is distinguished by quiet elegance, a delicate balancing of form and utility through the use of leather strips, bands of varying cuts of dyed hide and brass tacking. RAB

Bibliography: Urvoy, 1955; Dupire, 1962; Beckwith and Van Offelen, 1981

6.57

Cushion support (*ehel*)

Tuareg
 Niger
 early 20th century
 wood
 129 x 25 cm
 Drs Nicole and John Dintenfass

Among the Tuaregs of Niger elegantly sculpted cushion supports are important items in any well-appointed household. They were carved by members of the guild known as Enaden, literally meaning ‘the other’, blacksmiths who have been instrumental in the creation of precisely those things that have forever distinguished the upper classes of this society (the *imochar* or warriors and the *insilimen* or religious teachers) from the many vassal populations of the Tuareg world. Tuareg terminology fully expresses the

betwixt and between status of this artisan guild, a black population that, although regarded as culturally important, has always been socially marginalised. While the Enaden are primarily blacksmiths, they are also carvers and, more rarely, weavers. Whatever their medium, the products of the Enaden are among the most potent of hegemonic symbols – for in sitting and reclining upon the pillows and *ehel*, Tuareg nobles literally sit and lean upon these artists, dramatically re-enacting the historical relationship between themselves and the members of this guild. To observe a dignified, fully robed and turbaned Tuareg sitting in his tent is to witness the fullness of his authority and to realise that he is filled with a sense of personal superiority that cannot be wrested from him.

Ehel such as this example form part of the basic furnishing found in any upper-class Tuareg's tent, itself a hemisphere shaped of exquisitely woven and embroidered mats (*asaber* or *shitek*), dominated by geometric bands of subtle colour gradations and highlighted with carefully embroidered designs of dyed twine and leather. The Tuareg living-space appears almost to flaunt its beauty in the face of the desolate Sahel, to represent a private domain imbued with an aura of grace and refinement that defies its natural surroundings. Within these sparkling domes, *ehel* are used to pin the mat-woven walls against the exterior tent-poles. Like the interior roof props (calabash supports) and bed, *ehel* are carefully carved and often inlaid or embossed with delicate silver and copper detailing. In this particular specimen, the entire surface of the *ehel* has been opened up, creating a stunning set of patterns. RAB

Bibliography: de Gironcourt, 1914; Killian, 1934; Lhote, 1947; Gabus, 1958, i, pp. 89–95, ii, pp. 255–60; Bernus, 1981; Etienne-Nugue and Saley, 1987

6.58

Engraved boss

Chad

stone

h. 19 cm

Laboratoire d'Ethnologie,
Musée de l'Homme, Paris, 60.154.3

This small but impressive stone sculpture, found in the north-central Saharan area of Chad in the Bourkon region, now has the resonant title of the Omphalos of Edrichinga, because of its navel-like appearance. In many of the surviving stone sculptures and monoliths of the Sahara the navel is emphasised (cat. 6.1). Here, however, we have a conflation of the generative and nurturing elements since the nipple-like top makes the entire piece a stylised breast while the ridge running round the circumference makes an unambiguous phallic reference. The other markings are of a more enigmatic nature though their parallels are found in stelae from distant parts of north Africa (cat. 1.14, 7.8a) which date from the Neolithic to the Bronze Age. Since all other markings on the piece have evident sexual connotations one is tempted to read the vertical pair of grooves as a vaginal symbol. To suggest so much in such an austere and economical fashion is a feat of metaphorical compression making what is after all less than 500 cubic centimetres of worked stone have a charge of weight and density quite out of proportion to its size. TP

6.59

Beaker

Chad

ceramic

14.8 x 13.2 cm

Laboratoire d'Ethnologie,
Musée de l'Homme, Paris, 979.37.1

Discovered in Korotoro in the Sahara north of Chad, this painted beaker from the beginning of the Iron Age bears witness to the fact that Africa is not divided into east and west as it is represented in schematic maps (and, perforce, in the arrangement of exhibitions). The constant seepage, and occasional sweep, of trade and influence from side to side of the continent is less focused in history than relations between north and central Africa or east and south.

In decoration and even more particularly in form this vessel shows direct affinities with Nilotc ware, especially that of Ancient Nubia. The technique closely resembles that of Kerma pottery (cat. 1.77) which shares the characteristics of thin walls and slightly flared top, though Kerma ware shows a higher degree of refinement. The decorative elements seem to hark back to even earlier Nubian vessels of the A-Group (cat. 1.76) although they recur as well in much later times in the Sudan. TP

Provenance: given to the museum by Françoise Treinan-Claustre

6.60a

Horse and rider

Sao

Chad

bronze

11 x 11 x 3 cm

Private Collection

6.60b

Figure

Sao
Chad
terracotta
43 x 14.5 cm
Laboratoire d'Ethnologie,
Musée de l'Homme, Paris, 49.3.30

6.60c

Mask-like figure

Sao
Chad
terracotta
13.7 x 8.9 x 6.4 cm
The Menil Collection, Houston, X 065

The very term 'Sao' indicates the vagueness of our knowledge of a complex of cultures once situated at the south-western shore of Lake Chad. It means in a pejorative Moslem usage 'pagans'. People from the north settled here from the 5th century onwards but the great epoch of Sao culture, characterised by walled cities and elaborate funerary rites, was from the 10th to the 16th centuries. From this time date the many thousands of mostly ceramic objects that have yet to be coherently interpreted.

Animal references abound and apart from a number of small incontrovertibly human heads in terracotta the majority of artefacts take on some animal or fish characteristics.

The scale of such objects is represented here by two sculptures of baked clay. The flat head (cat. 6.60c) in a style that is typical of the variations on a theme characteristic of Sao sculpture is, enigmatically, a human head with incised references to other creatures rather than to scarification patterns. Perhaps even the gills of fish are referred to. These have been called 'pebble heads' because of their resemblance to flat stones. Too many explanations of their use (maskoids, protective amulets, ritual weights for fishing nets etc.) have been evinced for it to be useful to pursue the matter of function.

Flat ceramic heads occur in other cultures of the valleys of the Niger but these are more stable in their descriptive style; the Sao maskoids seem in some way to be a language of markings, almost a shorthand of zoomorphic reference.

Characteristic of a larger and later style of what can easily be described

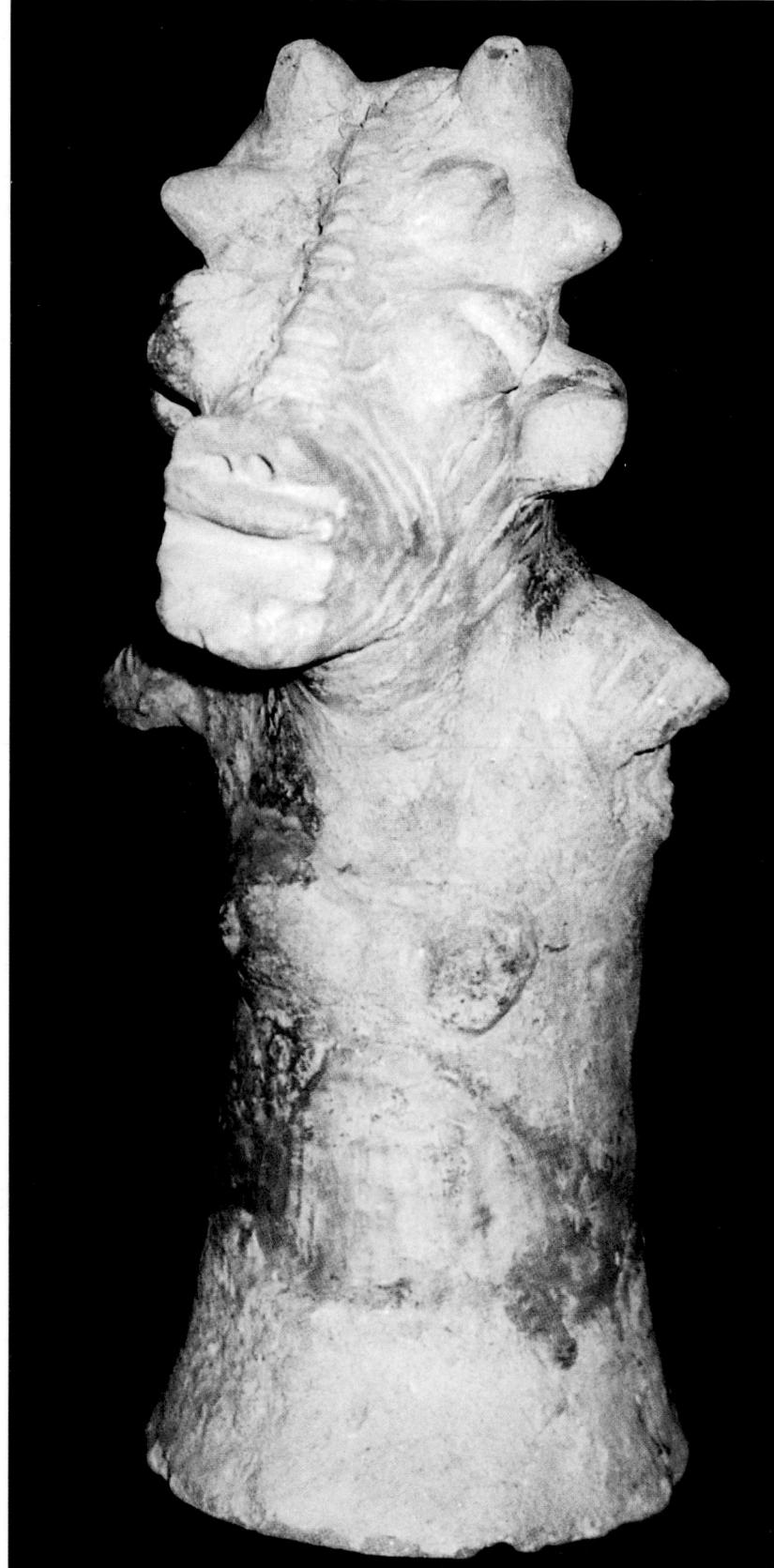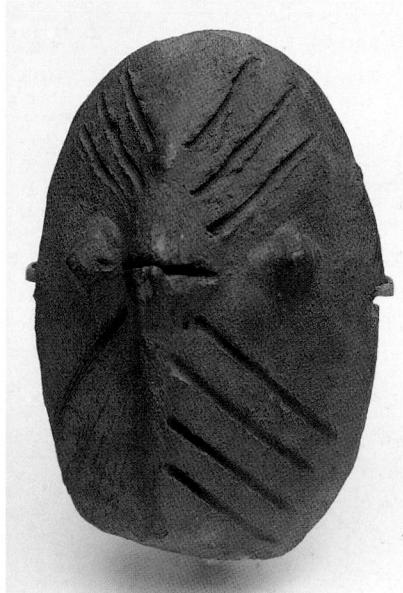

From what seems to be the end of Sao culture comes a group of brass equestrian figures, of varying size, found in the area. Cat. 6.60a is a characteristic example but of exceptional size. TP

Provenance: excavated by Lebeuf

Bibliography: Sinoto, n.d.; Lebeuf, 1971; Jansen and Gauthier, 1973

by the conveniently vague term 'cult figure' is the therantrropic statue from Tago (cat. 6.60b). The sculpture may or may not represent a figure wearing a mask or even be intentionally ambiguous. The eyes made from impressed pellets of clay are standard

in Sao representations of man and beast and perhaps too little is known about the culture for us to lay too heavy interpretative hands on it. The piece was found in association with more obviously human figures in the central shrine at Tago.

7 NORTHERN AFRICA

PREHISTORIC NORTH-WEST AFRICA

Timothy A. Insoll and
M. Rachel MacLean

Geographically, north-west Africa has three distinct ecological zones: the coastal strip, bounded to the west by the Atlantic Ocean and to the north by the Mediterranean Sea; the characteristic Maghribian tell country; and the true desert of the Sahara. These three zones provide very different environments, and have evidence of cultural links with very different areas: the Mediterranean to the north; sub-Saharan Africa to the south; and the Nilotc Sudan to the east. These factors resulted in distinctive cultural adaptation and development, reflected in the archaeological record of the region throughout the prehistoric period, and particularly clearly in that of the Neolithic. It is during this era that artistic expression truly matured and flourished, leaving behind a wealth not only of enduring rock art but also of portable artefacts.

The Neolithic, which developed from the Palaeolithic or Old Stone Age (50,000–7000 BC), is characterised by a major change in subsistence strategy (the beginnings of domestication of both food crops and animals) and by other related changes in permanency of settlement and modification of technology. In north-west Africa the process of 'Neolithisation' was a very gradual one, Neolithic traits being only slowly adopted, from the 7th millennium BC, into the existing Epi-Palaeolithic way of life. In the last millennium BC the appearance of copper and bronze metallurgy heralds the beginning of the Bronze Age.

As a result of the distance in time and the variable preservation conditions existing in the region, the surviving objects – particularly the art objects – are predominantly of stone, though ceramic and bone also survive. Stone polishing was widespread, and drilling technology was highly developed, employing abrasives, needles and drills – techniques that survive today. Axes, hoes, adzes and beads were produced, which in the Sahara were made from semi-precious stones such as amazonite,

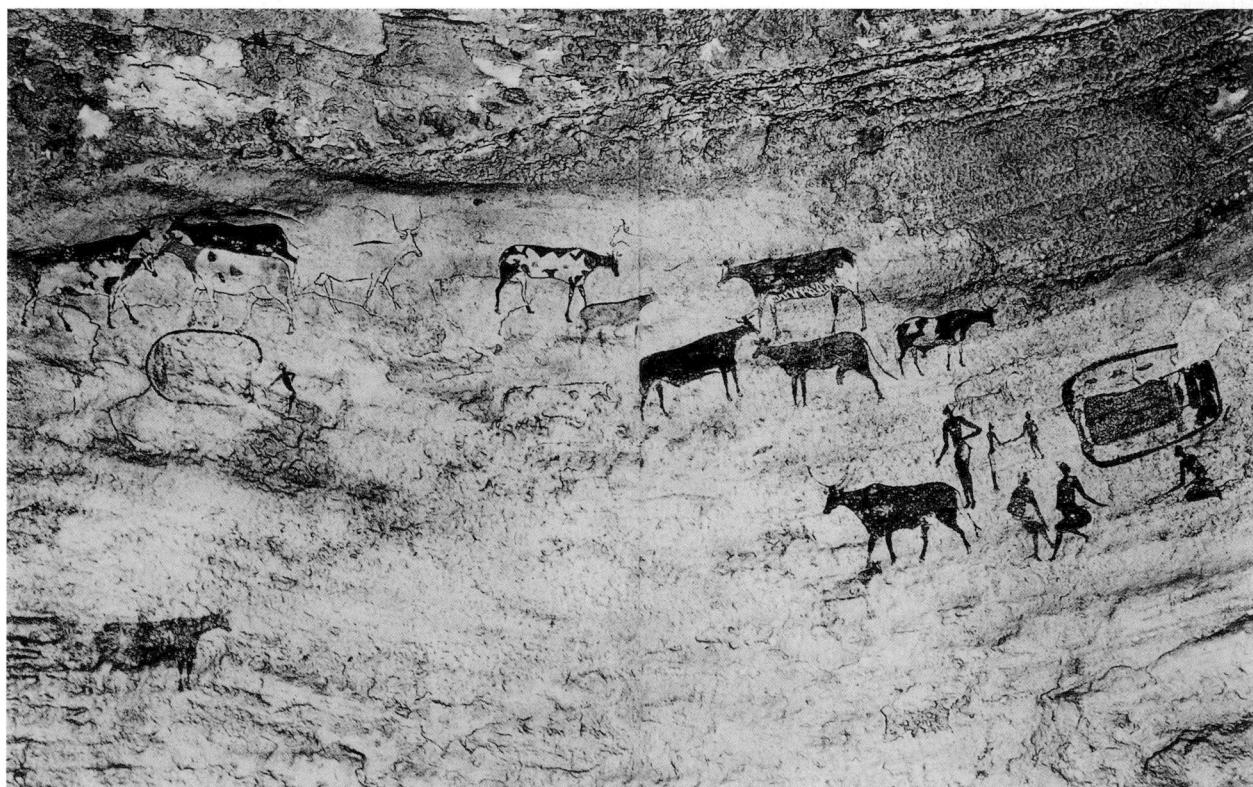

Fig. 1 Men with a shelter and herd of cattle, showing the Sahara before it became desert, rock painting in red-brown and white paint, the cattle c. 30 cm long, Cattle period, Sefar, Tassili-n'Ajjer

chalcedony and cornelian (as with the exceptional Saharan example, cat. 7.5). Pecked and polished hardstone bowls were also produced (cf. cat. 7.6a from the Moroccan coast and cat. 7.6b from the Tassili-N'Ajjer), which were used as mortars for grinding grains, berries and – importantly within the artistic context – for the production of vegetable dyes and the grinding of ochre for both rock and body painting.

It is, however, highly probable that artistic expression was not restricted to these materials alone, and that organic materials were also used. Indeed, it is likely that the human body itself may have functioned as an element for cultural artistic expression, as is indicated by certain depictions of individuals in regional rock paintings where tattooing and body painting are shown at Ouan Bender, Azzer and Ouan Derbaouen in Algeria/Niger. The extensive evidence for the grinding of pigments and ochres may be a result of this practice.

Groups in the Maghribian tell country developed a remarkable descriptive art tradition, portraying animals on engraved stone plaques and ostrich eggshells. In the Atlas Mountains rock engravings are found in the same style, often on a very large scale, depicting both humans and animals and, as a result of the stylistic similarity, it is presumed these are also of a Neolithic date.

In the Sahara a great flourishing of rock engravings and paintings (fig. 1) occurred during the Neolithic period, which have become one of the most studied artistic phenomena of the region. Related to this rock art, a truly magnificent tradition of stone sculpture developed: 38 animal sculptures and anthropomorphic cult figurines, carved from hard rock, such as basalt, dolerite and gneiss, have been recovered so far (the two idols from Tabelbalet, cat. 7.3, and the ram's head from Tadjentourt, cat. 7.4, are famous examples). This stylistic tradition based on bilateral symmetry and the absence of all unnecessary high relief is also characteristic of other more utilitarian stone objects.

With the Bronze Age, increasing desertification of the Sahara resulted in a restriction of settlement within the southern region and a realignment with the Mediterranean world. A concentration of archaeological material is found in the coastal regions and High Atlas, and is associated with a distinctive change in rock art style. Stylised representations of man and his material goods become the focus of these engravings, replacing the realistic portrayal of the natural world that characterised the Neolithic period, perhaps representative of a shift in man's conceptualisation of his environment, and his place within the wider world.

CARTHAGINIAN, NUMIDIAN AND ROMAN

R. J. A. Wilson

Certainly by the 8th century BC, and possibly earlier too, groups of Phoenician traders from what is now Lebanon had begun to settle suitable harbour sites along the coast of north Africa. One of these, Carthage, near present-day Tunis, was to grow into the leading Phoenician colony in north Africa and later into one of the greatest cities of the Roman world. The traditional foundation date given by the ancient sources is 814 BC, but the earliest archaeological material from both cemeteries and habitation sites at Carthage is not earlier than c. 725 BC, although it is possible that the earliest settlement and the oldest burials still elude discovery. The expansion of Carthage was rapid, and the city was soon founding settlements of its own; in time it came to dominate the whole of the north

African littoral from Morocco to western Libya, and controlled parts of Spain, Sardinia and Sicily as well. Yet despite the enormous commercial and military success of the Carthaginian state right down to its fatal encounters with Rome in the 3rd and 2nd centuries BC, it never developed a highly distinctive art of its own. Carthaginian artefacts of the 8th and 7th centuries BC are virtually indistinguishable from those of the Phoenician homeland, so that it is often difficult to separate the imported from the locally made (cat. 7.13). Then, from the 6th century BC, increasing Greek influence on Carthaginian art is detectable, for the most part via Greek Sicily, reaching a peak during the Hellenistic period before the destruction of Carthage by Rome in 146 BC. Throughout, Carthaginian iconography was also influenced by Egyptian art. The outcome was an amalgam rather than a truly original and distinctive Carthaginian style. There were, of course, some items which can be said to be characteristically Carthaginian, even if they occur elsewhere, such as the grotesque clay masks used as apotropaic symbols, especially in tombs (cf. cat. 7.9), or the elegant copper-alloy razors, often finely engraved, which are common in Carthage between the 6th and 3rd centuries BC: since Carthaginian men generally wore beards and they are found in women's graves as well as men's, their function may well also have been to ward off the evil eye. Also very distinctive, both in Carthage and elsewhere in its sphere of influence, are the limestone votive slabs (*stelae*), usually with simple but striking sculpture in low relief. Many display also the symbol of the supreme Carthaginian goddess, Tanit, indicated by a triangle surmounted by horizontal bar and a circular disc representing the sun (cat. 7.14–15).

Carthaginian civilisation also had a far-reaching impact on the indigenous peoples of the interior of the Maghrib, known collectively as the Numidians. Kings like Masinissa (who ruled 203–146 BC), a noted linguist, philosopher, and the father of 44 children, encouraged settled agriculture rather than nomadism and adopted Punic (Carthaginian) rather than Libyan as the language of court. Little is known archaeologically of Numidian settlements, but their funerary architecture, such as the great circular stone-built mausolea at Le Medracen and near Tipasa (in Algeria) or the square ones at El Khroub (Algeria), Dougga (Tunisia) and elsewhere show an eclectic taste, with a mixture of Greek, Carthaginian and Egyptian elements.

Under Roman rule the north African provinces flourished, largely as a result of efficient agricultural production. The amount of land under cultivation greatly increased, in some cases helped by extensive irrigation schemes, and the resulting African capacity for creating vast surpluses of grain and olive oil for export overseas, as well as other produce in lesser quantities (such as wine and figs), laid the foundations for Romano-African prosperity. The exotic fauna of north Africa, where elephants, lions and tigers roamed north of the Sahara, were rounded up for butchery in the amphitheatres of Italy and elsewhere. The much-prized yellow marble of Simitthus (Chemtou) was exported for prestige building projects, and even the pottery industry, producing huge quantities of rather ordinary red tableware from the 2nd century AD onwards, eventually captured markets the length and breadth of the Mediterranean. Other notable exports from Africa included fish-sauce (*garum*); wood, especially for furniture making, from the Mahgrib; and dyes, for which the island of Mogodor off western Morocco was famous.

The wealth generated by the landed élite expressed itself in the construction of both public buildings and of private houses and villas. Not only were the old Carthaginian settlements totally rebuilt in due course with buildings in the new idiom of Roman architecture – the fora, theatres, baths, aqueducts and amphitheatres found in most self-respecting Roman towns across the Empire – but towns also took root in areas of the interior where there had been little urban development in pre-Roman times. Some were formal foundations of retired Roman legionaries (*coloniae*), such as

the almost completely excavated towns of Cuicul (Djemila) and Timgad in Algeria; others were spontaneous creations of the new socio-economic order. The splendidly preserved remains of these and the temples on the forum at Sufetula (Sbeitla), the amphitheatre at Thysdrus (El Djem) or the building complexes erected at Lepcis Magna in Libya by that city's most distinguished son, the Emperor Septimius Severus (ruled 193–211), provide vivid testimony to the architectural sophistication of Romano-African civilisation.

In this climate of wealthy patronage it is not surprising that the arts also flourished (fig. 2). Vigorous local schools of sculptors working in both limestone and marble were established, turning out highly competent pieces both in relief and in the round; but a distinctive Romano-African style, characterised by somewhat flat, two-dimensional stylised relief sculpture, is best seen in votive dedications in sanctuaries. Good examples are the numerous *stelae* in honour of Saturn, who was worshipped in Roman Africa as a thinly disguised version of the Phoenician god Baal: in Africa religious conservatism died hard. The legacy of Carthage can also be seen by the continued use, even to the time of Saint Augustine in the late 4th century, of Punic (Carthaginian) as the principal spoken language in many districts. Artistically, however, the most significant and distinctive African contribution was made by the many mosaic workshops (*officinae*), which responded freely to the demand of their patrons for elaborate figured mosaics, especially from the later 2nd century onwards when African prosperity reached new heights. Rejecting the black and white style then favoured by Italian mosaicists, they adopted an original and creative approach to mosaic design which employed a rich and varied polychromy, and used the entire surface of a floor to create a decorative ensemble. Sometimes entirely ornamental patterns were used, but often figures were incorporated within the panels. These designs were soon joined by all-over figured compositions with ambitious scenes depicting the pastimes and triumphs of the patrons who commissioned them, from the amphitheatre and the circus, or from hunting or country life (cf. cat. 7.10). Processions of marine creatures, often whimsical and fantastic, were also common, but mythological scenes as such were rare. By the 4th century this highly popular and successful approach had been adopted by mosaicists working in Italy and several other provinces; in some cases, indeed, it seems certain that African mosaicists travelled abroad to fulfil specific commissions. After the adoption of Christianity, which spread gradually throughout much of north Africa in the course of the 3rd century, their abundant talents were also turned to the benefit of Christian patrons, in mosaic-paved churches and baptisteries alike.

Fig. 2 Bust of a young man, possibly a portrait of Juba II (25 BC–AD 19), bronze, Musée d'Archéologie, Rabat

Islam and the Arabic language have influenced north African art and culture since the 7th century AD (1st century AH) when, despite their small numbers, the Muslim armies of Arabia were able to dislodge the Byzantine Empire in north Africa. However, the Arabisation of north Africa was gradual and never complete; the indigenous peoples continue to this day to speak the local Berber languages (of Hamitic, not Semitic origin), although they practise Islam. It is this assimilation of Arab, Berber and (to some extent) sub-Saharan African cultures that gives Islamic north Africa its particular character.

THE ISLAMIC PERIOD

Nadia Erzini

Although north-west Africa, known in Arabic as the Maghrib, and including modern Algeria, Tunisia, Morocco and Mauritania, was initially subject to the central government at Damascus and Baghdad, independent dynasties soon emerged, such as the Idrisids (789–926) with their new capital at Fez, and the Aghlabids (800–909) at Kairouan. The Fatimids (909–1171) conquered most of north Africa, but were also replaced by local Berber dynasties, such as the Zirids. The invasions of the Bedouin tribes from Arabia in the 11th century further extended Islam and Arabic influence into the hinterland, and the Berbers retreated into the remote Atlas, Rif and Kabylie mountain regions and the Sahara Desert.

In the 11th to 13th centuries, two great religious reform movements, the Almoravids (1056–1147) and the Almohads (1130–1269), led by Berber tribes from the western Sahara and the Atlas Mountains, reunited the Maghrib under a single rule from Marrakesh. These dynasties extended their rule into the Iberian peninsula, and the highly developed Hispano-Muslim or Andalusian art and architecture flourished in north Africa from this period onwards. The Marinid and Saadian dynasties of Morocco were particularly to benefit from the influx of Andalusian immigrant artisans and architects during and after the Catholic reconquest of Spain. The peculiarly conservative nature of north African art can be felt especially in the art of Morocco, where medieval and Andalusian forms have been reproduced faithfully until recent times, and are still part of the currency of decorative art. While Morocco remained in relative political and cultural isolation under the Alawi dynasty (founded in 1631), Algeria and Tunisia became part of the Ottoman Empire in the 16th century, and their art forms combine provincial Turkish and local north African elements. French and Spanish colonial occupation has dominated the region in recent centuries.

A major source of wealth for the Islamic dynasties in the pre-colonial period was the gold of west Africa, which was traded for north African manufactured goods (leather, textiles, arms and metalwork) and Saharan salt, through the towns of Timbuktu, Gao and Djenné. The western Sudan was conquered by the Moroccan dynasties of the Almoravids and Saadians, in the 11th and 16th century respectively. The Islamic arts of calligraphy and architecture spread into west Africa through trade and the foundation of religious fraternities.

The Muslim kingdoms of the western Sudan also expanded northwards into the western Sahara. Slaves from the western Sudan region were traded in north Africa until recent times, and certain peoples, such as the Gnawa in Morocco, with their traditional cowrie-shell ornaments, represent the continuity of the sub-Saharan artistic tradition in north Africa. Yet, it is difficult, to pinpoint precise examples of the influence of sub-Saharan Africa on north African art.

While the medieval entrepôts of north Africa and the western Sudan prospered from the trans-Saharan trade, much of that trade was carried out by Saharan nomads: the Arabic-speaking ‘Moors’ of the western Sahara and the Berber Tuareg of the central and southern Sahara. The introduction of the camel as a means of transport at the end of the Roman period made this arduous life possible.

The three main cultural traditions of north Africa are covered by this exhibition: the complex urban industries of Arab, Berber and Andalusian origin, with their emphasis on architecture and calligraphy as well as the decorative arts; the more primitive rural arts of the agriculturalist and pastoralist Berber peoples of the mountain and desert regions, which although of ancient origin, are limited by ethnographic documentation to a late 19th- and 20th-century date, and the portable artefacts of the nomadic peoples of the western and central Sahara, closely linked to their dependence on cattle and camels.

It is ironic that more imagination is needed to conjure up a picture of material culture produced 500 years ago in Egypt than under the pharaohs some 3000 years earlier. The spectacular tomb finds of pharaonic times dominate any view of the artistic production of Egypt. In contrast, Islam has no tradition of burying treasured items with the dead and so medieval gold and silverwork has been melted down, pottery and glass has shattered, gems have been reset and silks have decayed. Yet the medieval period, particularly between the 10th and 15th centuries, when Egypt was independent and Cairo was one of the greatest cities of the world, was another glorious interlude in the history of Egyptian art.

The buildings of medieval Cairo still evoke the splendour of these centuries, although they are badly in need of restoration and protection from the effects of earthquakes and modern pollution. Objects preserved in religious institutions and foreign treasuries are augmented by chance finds and excavations, especially at Fustat, the first Islamic capital of Egypt which later became a rubbish dump for the inhabitants of Cairo. These vessels and fragments of inlaid brass; lustred, gilded or enamelled glass; lustre or blue and white pottery; carved rock crystal and painted ivory; jewellery made from fine gold filigree with enamel insets; scraps of polychrome silk or embroidered muslin; and pieces of carved stone and carved or inlaid woodwork, all hint at a luxurious lifestyle for the wealthy of Cairo. But they are pale shadows of the treasures described in contemporary accounts of Egypt and in the vivid stories of the Arabian Nights, which are set in Baghdad in the Abbasid period but were written in 14th-century Cairo and mirror the high and low life of that city.

After the Arab invasion in 642, Egypt was absorbed into the growing Islamic Empire. For more than 300 years it was to remain a province ruled by a governor and forced to submit an annual tribute to the caliph. A fast turnover of governors stopped them from becoming seriously involved in patronage of art and architecture and the tribute demanded by the caliphate reduced the money available for major projects. During these centuries the Islamisation of Egypt was slow. Objects bearing Arabic inscriptions were probably made for the ruling class, but patronage by the local Coptic and Jewish communities ensured that earlier forms and styles continued to be produced. Many of the objects described as Coptic should probably be dated well after the Arab invasion.

A brief period of Egyptian independence, under Ahmad ibn Tulun and his successors (868–905), is marked by a surge of building activity, including the large congregational mosque which remains a landmark in Cairo (fig. 3). Palaces from this period have not survived but descriptions suggest that they were extremely opulent, with large gardens inhabited by exotic animals and grand reception halls with idiosyncratic features such as pools of quicksilver.

The triumphant arrival of the Fatimids in 969 and their foundation of a new capital, Cairo (Arabic: al-Qahira, ‘the Victorious’), marks the beginning of five and a half centuries of independence, wealth and lavish patronage of the arts in Egypt. The Fatimids were a Shiite dynasty from north Africa who claimed descent from *'Ali*, fourth Caliph and son-in-law of the Prophet Muhammad. They proclaimed themselves the true caliphs and set themselves up in direct opposition to the Sunni caliphate based in Baghdad. They exploited the geographical position of Egypt, which links Africa and Asia, the Mediterranean world and the East via the Red Sea. They established an immensely profitable trading network which brought, among other things, rock crystal and ivory from the eastern coast of Africa, gold from Nubia, spices and exotica from India and porcelain from China.

A number of mosques survive from the Fatimid period in Cairo and in towns on the main trading routes through Egypt. The finest of these have façades decorated with shell niches, foliated Kufic inscriptions and interlace ornament in carved stone. The Fatimids also introduced the practice of

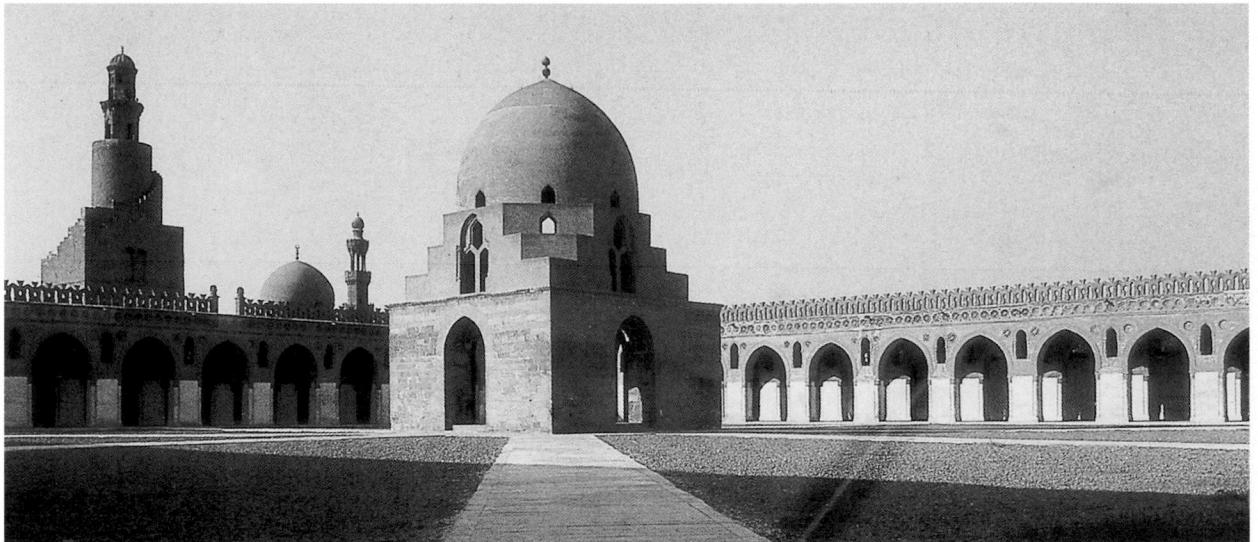

Fig. 3 Courtyard (sahn) of the congregational mosque built by Ibn Huhun (AD 868–84). The central domed fountain was added by the Mamluk Sultan Lajin in 1296

building monuments to holy men. These ‘cities of the dead’, housing estates of mausolea in vast graveyards which were (and remain) places for picnics and processions, were to become a feature of Egyptian religious architecture.

The luxury of the Fatimid court in Cairo was legendary. The caliphs built splendid palaces with gardens featuring pavilions of gilded marble. Their walls were decorated with frescos of hunting scenes, dancing girls, processions and other courtly activities. Some idea of how these may have looked is given by the cycle of courtly scenes on the painted wooden ceiling of the Cappella Palatina in Palermo, which was probably painted by a Fatimid artist in the middle of the 12th century.

Descriptions of the contents of Fatimid palaces survive: gold trees with mechanical singing birds and other automata, thrones of gold engraved with hunting scenes, pierced gold screens, enamelled gold jewellery, carved ivory hairpins, gem-encrusted mirrors, thousands of vessels in gold, silver, rock crystal, porcelain and rooms full of fine textiles. Some examples of Fatimid treasures have been preserved. These carved rock crystals (cat. 7.50), ivories (cat. 7.49) and embroidered textiles (cat. 7.51) confirm the quality of art produced in Fatimid Egypt. Other objects also reveal an interest in the details of everyday life. Among the scenes depicted on carved wood and ivory panels, lustre pottery or paper are a cockfight, a girl dancing with scarves, a reclining lady musician with her attendants, labourers bringing in the harvest, and a naked woman tattooed all over her body. Some images are blatantly Christian in their iconography (cat. 7.46), which suggests that the Coptic community continued to play an important role in patronage of the arts.

The Ayyubid ruler Saladin, famous in Europe for his defeat of the Crusaders, was also responsible for ousting the Fatimids from Egypt in 1171 and the restoration of Sunni Islam as the state religion. Later Ayyubid rule was weakened by internecine power struggles that prepared the way for a military takeover of Egypt by their Mamluk troops and the foundation of the Mamluk dynasty (1250–1517). The fall of Baghdad to the Mongols in 1258 and the subsequent installation of the caliphate in Cairo established Cairo as the spiritual, intellectual and political centre of the Islamic world.

Mamluk palaces have not survived, but a large number of religious buildings, almost all of them in Cairo, indicate the splendour and quality of architecture during this period (fig. 4). The Mamluks perverted the Fatimid tradition of erecting mausolea for holy men by building them for themselves. Religious institutions were built alongside on the understanding that they employed and supported the descendants of the founder after the inevitable confiscation of his wealth and possessions on his

Fig. 4 Carved stone dome of the mosque in the mausoleum complex built by Sultan Qa'itbay, Cairo, AD 1472–4

death or fall from power. Their desire to make a public statement of piety and power encouraged the Mamluk sultans and officers to site these buildings in the centre of Cairo. Urban overcrowding tested the ingenuity of their architects as they wrestled with the problem of creating a grand façade and majestic interior within an irregular and usually small plot of land on a dark and narrow street.

These buildings were richly decorated in the style of the time: walls faced with different coloured marbles, granites and mother-of-pearl; enormous doors of pierced or inlaid brass or of carved wood inlaid with ivory; ceilings of painted wood; stone window screens pierced to let light through intricate geometric patterns. They were also provided with furniture and objects, often of elaborate workmanship; a carved or inlaid wood *minbar* (cat. 7.67), enamelled glass lamps (cat. 7.62), brass chandeliers (cat. 7.59), gold, silver or brass candlesticks, Qurans as well as inlaid brass or wooden chests to contain them and bookrests to support them when used.

Of all Islamic religious objects, Qurans, the visible word of Allah, are closest in spirit and prestige to the altarpieces of medieval Europe and they attracted the same critical attention from contemporaries. Mamluk Qurans are particularly fine. The famous seven-volume Quran ordered by the Mamluk Amir Baybars al-Jashnaqir was described by Ibn Iyas, a 16th-century historian, as one of the wonders of the age (cat. 7.55). Written in gold by Cairo's leading calligrapher, Shaykh Sharaf al-Din ibn al-Wahid, and decorated by the most skilled illuminators available, it took more than a year to complete and cost 1700 dinars.

As the wealthiest members of society, the Mamluk military élite dominated patronage of the arts, although merchants and court officials (Coptic, Muslim and Jewish) were often rich enough to buy fine objects. Buildings and artefacts commissioned by the sultan or his amirs are easily distinguished by the titular inscriptions and personal blazons which they used to decorate their possessions. Inlaid brass and enamelled glass vessels bearing their titles and blazons have survived in some quantity but

inventories indicate that gold and silver vessels were preferred and that rich individuals sometimes owned several thousand precious metal vessels. Not one of these has survived.

The Mamluks, like the Fatimids, derived much of their wealth from trade, especially spices from India which were sold to Europe at considerable profit. Their lucrative monopoly of the East-West trade via the Red Sea was undermined in the later 15th century when the Portuguese rounded Cape Horn and provided an alternative sea route between Europe and the East. The advance of the Ottomans in 1517 found a weakened regime which was no match for their superior fire-power. Egypt was subsumed into the Ottoman Empire and retained provincial status until the 19th century. Egyptian art and architecture became a pale reflection of fashions at the Ottoman court in Istanbul, although traditional skills, such as stone and wood carving, gave an Egyptian identity.

Cairo (like its predecessor Fustat) was the centre of the patronage and production of art and architecture throughout the Islamic period in Egypt. As the capital of a succession of wealthy dynasties and home to a large percentage of the Egyptian population, including almost all the most privileged members of society, that is not surprising. The geography of Egypt also encourages centralisation. The Nile creates a corridor of habitation and transport so that all roads, literally, lead to Cairo. Merchants travelled that corridor regularly, supplying local customers with goods from the capital on their way to more distant destinations.

Cairo's main rival as a centre of artistic production was Damascus, second city of the empire and capital of Syria, which had well-established workshops for metalwork, pottery, glass and other media. The Mamluks are known to have ordered special objects from Damascus – inlaid brass candlesticks, decorated wax candles, enamelled glass vessels. This makes the attribution of portable objects difficult, even those objects bearing the names of individuals known to have been resident in Cairo. Contemporary accounts and the objects themselves, however, testify to a steady migration of craftsmen from Syria to Cairo in response to the large market for luxury goods to be found there; it is therefore likely that most objects destined for the court were made locally in Cairo, especially those in delicate materials such as glass, which might have been damaged during a long journey.

The cosmopolitan character of Cairo strongly affected the art produced in the city. Rulers of Egypt, the most important patrons of art and architecture, included black Africans, north Africans, Arabs, Turks, Mongols, even, briefly, a woman (although she was reduced to marrying a second-rate general to consolidate her position). Court officials showed a similar racial mix. They often brought artistic notions with them from abroad: Ibn Tulun's mosque (fig. 4) reflects the great congregational mosque in Samarra. The Fatimids brought a well-developed architectural style with them from north Africa. The wealth of Cairo attracted craftsmen from across the Islamic world and even beyond. Individual craftsmen and architects usually remain nameless but occasionally there is a reference to Persian tilemakers or Armenian architects; or the name on a signed object indicates a craftsman's hometown in Mosul, Basra or Tabriz. Objects made in China, Iran, Europe and elsewhere circulated in the Cairo markets. Styles and techniques introduced by these foreign patrons, craftsmen and objects ensured that Cairo remained abreast of the latest artistic fashions. Equally, innovations conceived in Cairo radiated out to the numerous countries with which it had trading links.

Although the puzzle may be incomplete, the material and literary evidence from Islamic Egypt can be pieced together to create a picture of a sophisticated, urban culture that was admired throughout the Islamic world and beyond. As the 14th-century Tunisian historian Ibn Khaldun remarked in his monumental work on history and civilisation, *The Muqaddimah*: 'Today no city has a more abundant sedentary culture than Cairo. It is the mother of the world, the great centre of Islam and the mainspring of the sciences and the craft.'

Two poles for hanging leather bags

Arab nomads or 'Moors'
Mauritania or western Sahara
20th century
wood
h. 134 and 136 cm
Linden-Museum, Stuttgart, A 39150/1

After leather, wood is perhaps the most important material in Saharan daily life, and is used for the poles and beams of the nomads' tents on which are hung bags, saddles, bows and whips, as well as bed frames, dishes, cups, milking bowls, spoons, mortars and pestles. Various types of wood are available, despite the encroaching desertification of the oases. Along with tent poles, beds are the most elaborately decorated wooden items in the life of the nomads. When in use these beds are covered with two or three mats woven of grass and leather strips. They are light enough to transport, upside down

but in one piece, on the back of a camel.

The Tuareg bed frame (cat. 7.1d) is decorated with silver, strips of copper sheet and bronze studs. Metal is used very little among the Tuareg, generally only for their arms, of iron inlaid with copper. Copper is used sparingly for ornamentation on wood, and rarely for whole items such as cups or pots. There is a small population of nomadic artisans (often of black sub-Saharan origin) among the Tuareg, who specialise as blacksmiths and arms-makers. Berber Jews, on the other hand, primarily settled in the oases of the northern Sahara such as the M'zab in Algeria and the Dades Valley in Morocco, supply silver jewellery and coppersmithing. It is curious that the elaborate wooden objects are carved and turned by the iron- and coppersmiths.

The bed frame consists of six poles, 2 metres in length, carried on two transverse beams. Both the transverse supports and the feet end in large

discs. This type is thought to recall pharaonic Egyptian bed frames, especially the finials in the form of lotus flowers. The same lotus flower finials and the decoration with strips of copper sheet are also found on Tuareg poles for various purposes.

Two types of tent are found in the Sahara: the more common has one or two central columnar supports, and the Tuareg in the southern Sahara have a barrel-vaulted tent on a semi-circular frame. All the furnishings of these tents are decorated, such as the two poles for hanging leather bags (cat. 7.1a) and the pole with three prongs for holding a gourd or leather container (cat. 7.1b). Each pole is sharpened to a point for standing upright in a nomadic encampment, and the upper half is elaborately carved and pierced with semicircles and triangular and cruciform shapes. These pieces are from the nomadic 'Moors' of Mauritania, but could equally be Tuareg. The sculptural, almost totemic, quality of the carving recalls sub-Saharan sculpture.

Ceramics are little used in the Sahara, and eating vessels are more often made of wood. The wooden bowl shown here (cat. 7.1c), used for food or milk, is also from the 'Moors' of Mauritania but exactly similar shapes and decoration are also found among the Tuareg. The bowl is of turned wood, and the decoration is quite fine, the parallel lines probably executed mechanically on the lathe. Larger examples have iron handles, and old wooden vessels that dry out and crack are repaired with rivets of copper, as in the exhibited piece.

When milk is heated in one of these wooden bowls, the vessel is not placed over the fire, but instead heated stones from the hearth are placed in the milk. The Tuareg are said to appreciate the taste of burning in the milk, and the taste is also said to keep away evil spirits. NE

Bibliography: Kilian, 1954, pp. 148–9, 152–3 and illustrations; Meunié, 1961; Nicolaisen, 1963, p. 268, fig. 195a–b; Du Puigardeau, 1967–70

7.1b

Pole for holding a gourd or leather container

Arab nomads or 'Moors'
Oualata, Mauritania
20th century
wood
h. 181 cm (total)
Linden-Museum, Stuttgart,
A 32629La/b

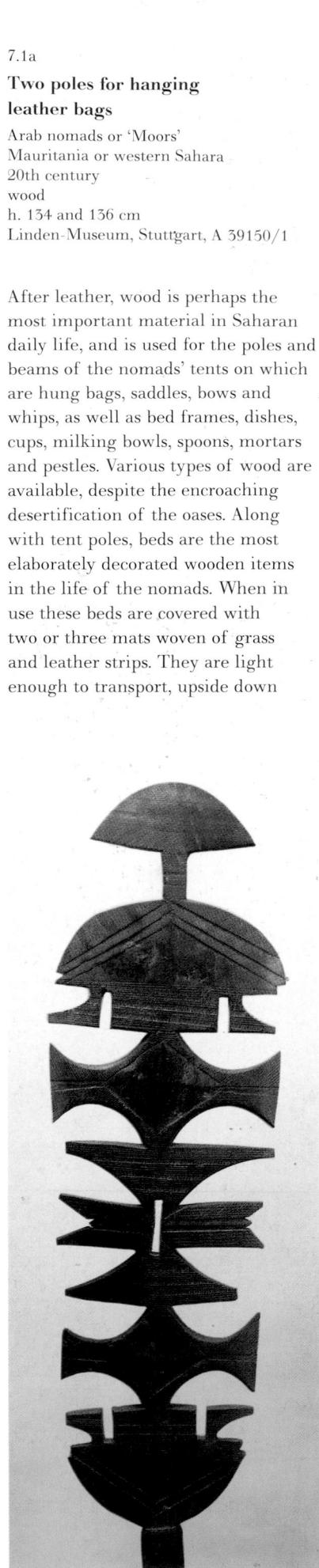

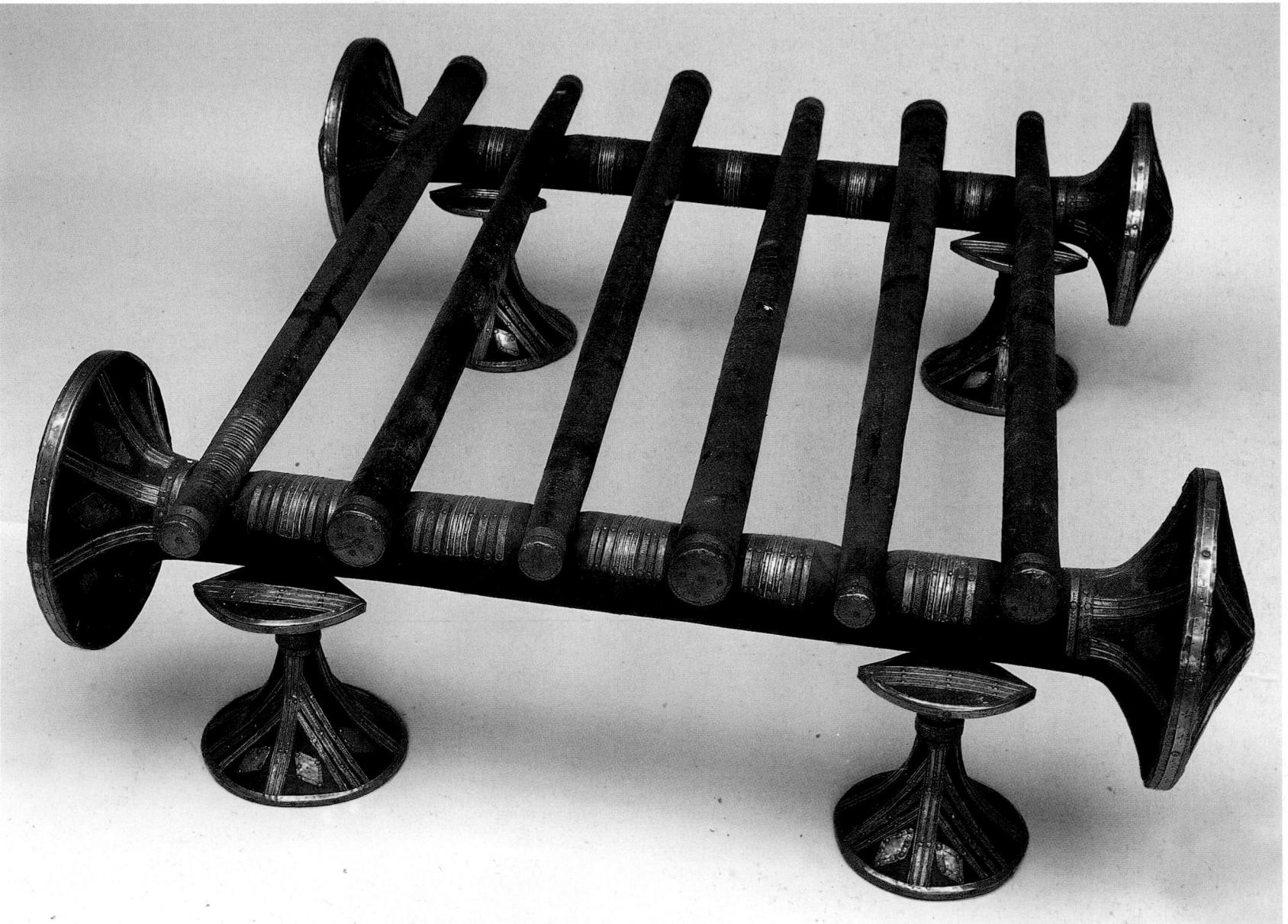

7.1c

Bowl

Arab nomads or 'Moors'
Mauritania or western Sahara
20th century (?)
wood
h. 20 cm; diam. 25 cm
Linden-Museum, Stuttgart, A 39152

7.1d

Bed frame (*tedabut*)

Tuareg
Sahara
20th century
wood, bronze, silver, copper
50 x 176 x 153 cm
Private Collection

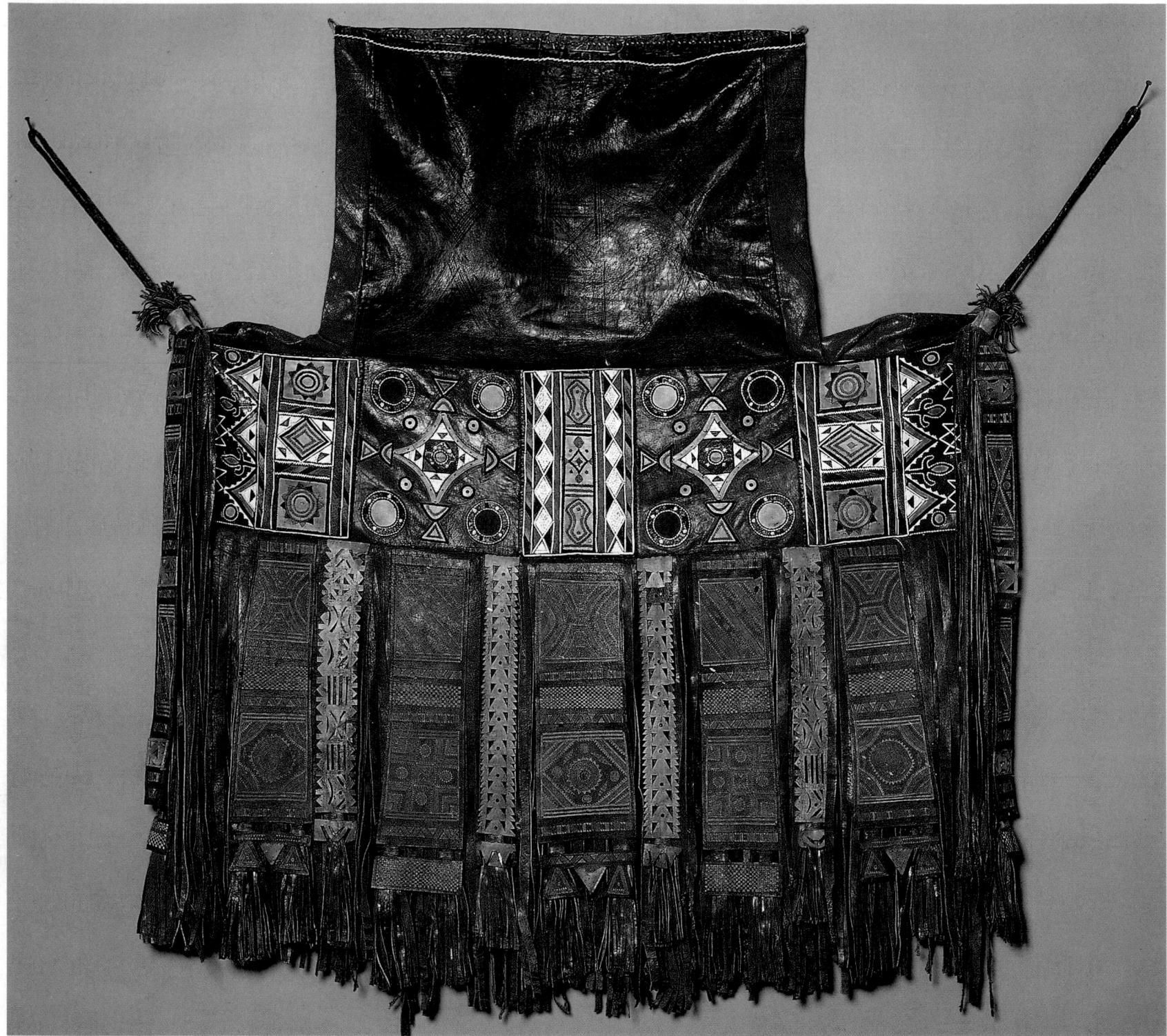

7.2a

Bag

Tuareg
Sahara
mid-20th century
leather
115 x 100 cm
Bert Flint

The modern populations of the Sahara can be divided into two geographic groups, the Berber-speaking Tuareg who inhabit the central and southern Sahara (modern Algeria, Libya, Chad, Mali, Niger, Burkina Faso and Nigeria), and the Arabic-speaking 'Moors' who inhabit the western Sahara, Mauritania, Mali and western Algeria. They lead a nomadic life, herding camel, goat and sheep and conducting trade between

north and sub-Saharan Africa, although during the 20th century there has been increasing settlement. In Mauritania a number of ancient medieval oasis towns, such as Oulata, Chengiti and Tindouf, have been settled by the Moors, and in Algeria, Libya and Chad there are oases populated by agriculturalists and artisans, mostly from the black minority among the Tuareg. In the Tibesti region of southern Libya and

northern Chad there are whole populations of black settlers, known as the Tedda, who probably originated in the western Sudan. A system of slavery or vassalage of black peoples is still practised by the Tuareg and Moors.

Apart from a small minority population of metalworkers, the Tuareg are self-sufficient, and produce their own utensils, predominantly of leather. They do not weave cloth, but import cotton cloth and wool from

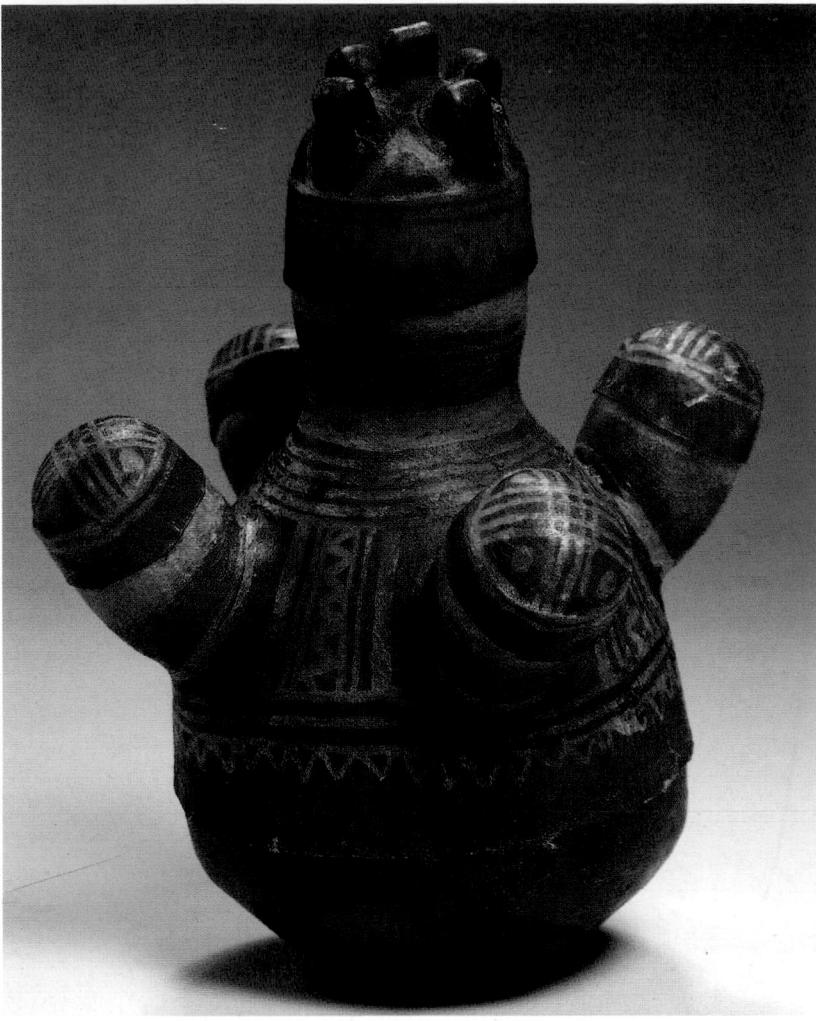

7.2b

Container (*botta*)

Tedda

Tibesti region, southern Libya and northern Chad

20th century

leather

h. 23 cm; diam. 11 cm

Royal Tropical Institute/Tropenmuseum, Amsterdam, 2760-140

cross-hatching and zigzags, which are scraped off the surface of the leather.

Cat. 7.2c is an example of a more utilitarian leather object, a butter jar, from the 'Moors' of Mauritania.

Among the Tuareg such containers are made of camel skin covered with goat leather, with leather stoppers and goat-hair rope. Aside from the important role of milk in the nomadic diet, butter is also used as a cosmetic, applied to skin and hair, to counteract the harsh desert climate. NE

Bibliography: Kilian, 1954, p. 148 and illustrations; Nicolaisen, 1963, p. 93, fig. 161a-d; Prussin, 1986, p. 139, fig. 5.25a-b; Sijelmassi, 1986, pp. 76, 78-9

7.2c

Butter jar

Arabic nomads or 'Moors'

Mauritania or western Sahara

20th century

leather, rope

h. 40 cm

Linden-Museum, Stuttgart, A 37289A/b

sub-Saharan or north Africa. Goat hair is used for making rope. Leather is obtained primarily from goats and sheep, and sometimes camels, and is worked by women of the ruling Tuareg and artisan class. Leather is essential for the walls of their tents, some articles of clothing, harnesses and all types of container.

A large number of different types are made to hold clothes and provisions. The shapes of leather bags vary but the most common are very long, with the top part folding over to make a closing flap, a type used by men in north Africa as far north as the Mediterranean. The shape of the bag (cat. 7.2a), in which the body is wider than the neck and opening, can be identified with Tuareg women's travelling bags.

Blue is the favourite colour for leather, as well as for the robes and veils of the Tuareg, known as the 'blue men' for the indigo that rubs off on their skin. The blue-dyed leather is often applied in openwork cut-out designs on a background of brown

or black leather, and is painted or embroidered with white, red and black thread or leather thongs. There is a taste for long flaps and fringes. The leather can have a mat or polished surface. The decorative motifs, as in cat. 7.2a, are all geometric: chequerboard, lozenge net, equilateral triangle, circle, six-point star, zigzag, spiral and the so-called 'Tuareg cross'. This decoration resembles that of Moroccan Berber and sub-Saharan Hausa textiles, and contrasts with the more complex repertoire of the towns of north Africa.

Among the Tuareg, goat and sheep leather is also moulded to make small boxes for jewellery, make-up, perfume, butter containers etc. The leather container in the form of a bottle with five necks and lids (cat. 7.2b) is from the Tibesti people of the Tedda, or the eastern extreme of the Tuareg region, but exactly the same form and decoration is found among the Air or Ayr Tuareg of the southern Sahara. The decoration consists of simple

7.3

Two anthropomorphic monoliths

Tabelbalet (Tassili-N'Ajjer)

Algeria

Neolithic

sandstone

Le Bardo, Musée National de Préhistoire et d'Anthropologie Culturelle, Algiers

These sculptures were found in the Tabelbalet region of Algeria among nine similar sandstone objects.

Minimum detail is used to create a stylised representation of human figures: an oval relief line gives contour to the face, with accentuated, curved eyebrows beginning at the nose. Mouths are absent from all nine figures. The emphasis upon eyebrows and nose has led some scholars to interpret these sculptures as stylised owls. Within the Tabelbalet area, other items have also been recovered: arrowheads of chalcedony and a fine yellow-red flint, polished stone axes, inscribed fragments of ostrich eggshell, and ceramics, which had been either basket-moulded or incised with a sharp point. The figures are rep-

resentative of the flowering of stylised stone sculpture during the Neolithic period in the Saharan region. Among the 38 animal and human figurines to have been recovered, the greatest concentration occurs in the Tassili-N'Ajjer. In addition to humans, various animals are represented, including sheep, antelopes or rodents. All these sculptures observe strict stylistic rules: the use of bilateral symmetry, the absence of high relief and an emphasis on anatomical detail. The characteristics and techniques of this tradition are repeated on more utilitarian stone objects, such as axes, grindstones and pestles.

Of the group of nine figurines recovered from Tabelbalet, two were noticeably larger than the others, one with a conical base, and the example shown here with a flat base, rounded at the edges. The finishing of these bases has been interpreted as indicating that they were intended to be driven into the ground, or supported by rocks, as tomb markers. The other figures, including the smaller example

shown here, have been cut down or deliberately broken. It is thought that these sculptures are anthropomorphic cult figures, perhaps linked with totemic and animistic beliefs. Before the arrival of Christianity and Islam during the course of the 1st millennium AD, it is known that the local Berber held such beliefs. Interestingly, Tuareg (Berber) women in the region have been recently recorded clumsily painting in the carved relief lines and adding facial features to these monoliths which suggests that they have a symbolic significance today.

TAI, MRM

Bibliography: Bouyssonie, 1956, pl. CVII; Balout, 1958, p. 157; Forde-Johnston, 1959, p. 47; Camps-Fabrer, 1966, pp. 282–5; Camps, 1982, pp. 581–2

7.4

Ram's head

Tadjentourt (Hoggar)

Algeria

Neolithic

basalt

h. 26.5 cm

Laboratoire d'Ethnologie, Musée de l'Homme, Paris, E 74.1382.493

This stylised ram's head, oval in section and broken at one end, is made from a very dark basalt. The design has been flattened, and all detail perceived as unnecessary has been removed, creating the impression of a ram or antelope with only minimal design elements. This is an outstanding example of the Neolithic sculpture tradition of the Saharan region, which produced both stylised animal and human figurines in this distinctive restrained style, with its emphasis on bilateral symmetry. Of the 38 examples of these carved stone objects recovered from the Sahara, this head has been variously interpreted, being seen as a ram, an antelope, a fish, or an idol similar to the examples from Tabelbalet (cf. cat. 7.3); the twist of the horns found on the front of the figurine, however, suggests that it is probably a sheep or goat. Similar examples have been recovered, including an ante-

lope's head from Imakassen in the Tassili-N'Ajjer and the head of a bull carved in diorite from Tisnar in the Admer Erg. A second ram's head has been recovered from Tamentit, near Touat. As with the anthropomorphic figurines, which form part of this tradition, it is probable that the animal heads may have functioned as totemic objects. TAI, MRM

Bibliography: Bouyssonie, 1956, pl. CX; Camps-Fabrer, 1966, pp. 271–2; Camps, 1982, pp. 574–82

7.5

Polished stone axe

Sahara
Neolithic
greenstone
20 x 7.5 x 5 cm

Dr Klaus-Jochen Krüger

This Neolithic axe, the exact provenance of which is unknown, is a particularly striking example of a polished stone axe, an artefact found not only in this region but also throughout Europe and much of Africa. It is the choice of the material used rather than the quality of the workmanship displayed that gives this example its outstanding beauty. Axes manufactured in north-west Africa show great variety in both form and size: cylindrical axes are the most common form, while flat and rectangular axes are less frequent. Great variety is also seen in the material, both hard stone, such as granite, and more exotic semi-precious stones being selected. An entire tool-kit in green jasper, including flaked and partially polished stone axes, was found at the site of Ténéré in Niger.

While axes manufactured from the less attractive and more common materials were probably used as tools, it is highly unlikely that this was the function of the rare examples manufactured in exotic materials, such as this one. It is believed that these were objects of intrinsic value, perhaps used as items for prestige exchange. In Europe extensive exchange routes of polished stone axes have been traced, using axes manufactured from materials with very limited distribution, and individual items have been seen to travel considerable distances. It is probable that this example represents a high aesthetic, social and symbolic value.
TAI, MRM

Bibliography: Forde-Johnston, 1959; Hugot, 1981, p. 599; Whittle, 1985

7.6a

Stone bowl

Skhirat
Morocco
Neolithic
stone
h. 12.4 cm
Musée d'Archéologie, Rabat, 89.5.3.2

7.6b

Stone bowl

Tassili-N'Ajjer
Algeria
Neolithic
stone
h. 10 cm
Laboratoire d'Ethnologie, Musée de l'Homme, Paris, C 64.365.493

Stone bowls dating to the Neolithic period are found throughout north-west Africa, as these two examples, from the Moroccan coast and the central Sahara respectively, testify. The site of Skhirat, which is located on the road which joins Rabat and Casablanca, is better known for its Palaeolithic assemblages, though two fragmentary polished stone axes, a Neolithic development, were also found at this site. Although little is known about these bowls, they are representative of the high quality of stoneworking techniques developed at

the beginning of this period. Drilling equipment was perfected, utilising specialist tools – burins, needles and drills, and abrasive powders of fine sand and resins, these being used in conjunction with polishing and pecking to achieve a very high standard of craftsmanship. Stone bowls are frequently polished, the greater polish often found on the interior surface being interpreted as a result of use. In addition to stone bowls, an extensive range of polished stone tools was produced, including axes (see cat. 7.5), scrapers, hammers, grinding-stones, pestles and mortars, adzes and polishers or burnishers, objects both beautiful and functional.

Traces of ground ochres have been identified in the base of some bowls, indicating that they may have been used for the preparation of ochres for rock or body painting, or other decor-

ative purposes. Neolithic rock paintings from the Tassili-N'Ajjer clearly depict tattooing or painting on both male and female figures, and pieces of ochre and traces of other mineral pigments (zinc sulphide and galena having been found at many sites) have been interpreted as evidence of widespread bodypainting. They also appear to have been used for grinding wild berries, grains, dried grasses, vegetable dyes and medicines. It has further been suggested that these vessels were used for storage purposes, though the nature of the products stored is controversial.
TAI, MRM

Bibliography: Forde-Johnston, 1959; Souville, 1973, p. 118; Hugot, 1981, p. 597; Camps, 1982

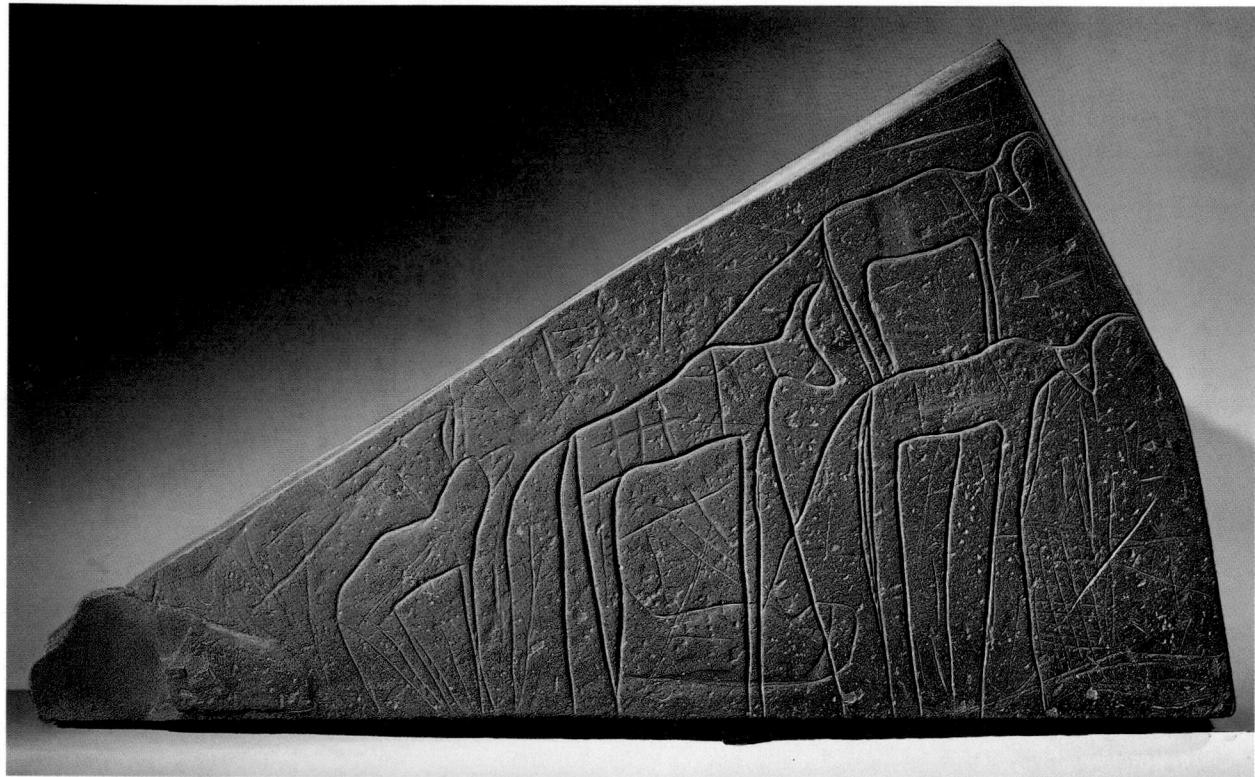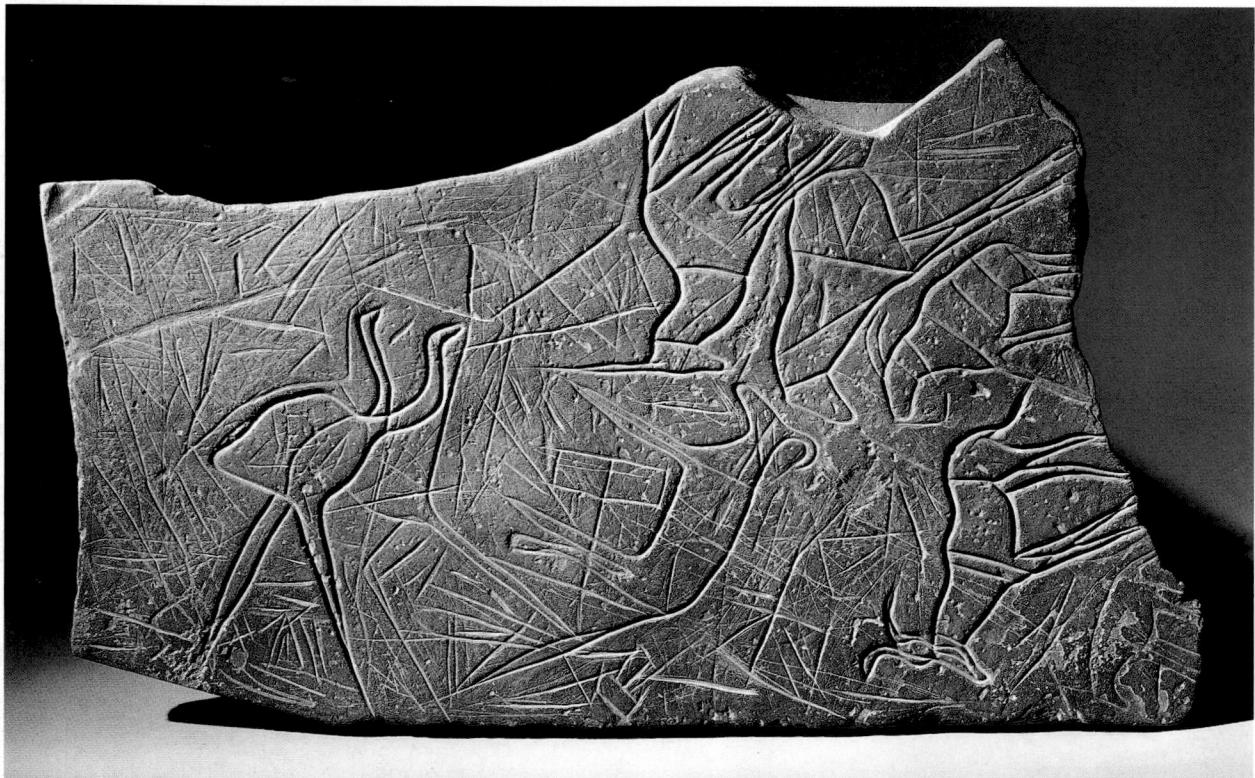

7.7a

Rock engraving

Lemcaiteb (Saquia el-Hamra)
Western Sahara/Morocco

Neolithic
stone

h. c. 84 cm
Museum für Völkerkunde, Basle,
III.21.319

7.7b

Rock engraving

Lemcaiteb (Saquia el-Hamra)
Western Sahara/Morocco

Neolithic
stone

h. 84 cm
Museum für Völkerkunde, Basle,
III.11.976

These are examples of the wider Neolithic engraving tradition found throughout this region, in both the Sahara and the Atlas Mountains. Such engravings are executed in a remarkably naturalistic style, depicting both man and animals on small stone plaques and ostrich eggshells, and, on a much larger scale, on rock faces. The technique used in most of them is the smooth U- or V-shaped incision. Cat. 7.7b depicts, on the left-hand side, a striding ostrich in outline and, on the right-hand side, six four-legged animals, four with horns. Scholars have interpreted the species represented as including oryx, other antelope, sheep, goat and hyena. It has also been suggested that certain of the geometric designs on the plaque, including the V-shaped marks between the legs of the ostrich and the rectangular pattern in the centre of the plaque, are later additions, since they do not display the same degree of patination.

The realism of these images has made them useful in the study of wild fauna in the Saharan and tell regions during the Neolithic, and as a source of information on domestication of animals in the region. The Sahara was not, at the beginning of the Neolithic period, the desert that it is today.

Concentrations of wildlife occurred at the large lakes then in the region, and included animals now found only well to the south of the Sahara. An extensive flora, including willow, hazel and ash, supported animal and human populations. These animal species, which are abundantly represented in the rock and ostrich eggshell engravings, were to disappear from the Sahara in the 1st millennium BC. *TAI, MRM*

Exhibition: Basle 1977

Bibliography: Haas, in Basle 1977, pp. 8–9; Hugot, 1981, p. 601; Camps, 1982, pp. 608–9

Stone stela

N'Kheila
Casablanca Region, Morocco
Bronze Age
stone
84 x 54 x 11 cm
Musée d'Archéologie, Rabat, 89.5.2.3

The concern with the depiction of wildlife, and of man's relationship with both wild and domestic animals, central to the art of the Neolithic period, disappears in the Bronze Age. People and their manufactured goods become the focus of rock engravings and carvings, and this change is linked with the appearance of geometric designs and schematic symbols, which serve further to remove them from the naturalistic settings of the former period. These three objects reflect this, with their use of circular and geometric decoration and a central preoccupation with stylised human figures, and clearly contrast with the Neolithic engraved stone plaque from Lemcaiteb (cat. 7.7b). On the first stela (cat. 7.8a) a sexless naked body is separated from the circular motifs typical of the Bronze Age by two sinuous borders. The circular and geometric motifs employed here have frequently been interpreted in other contexts (e.g. Australian Aboriginal rock art and that of the San in southern Africa) as the images perceived while in a trance-like state, possibly drug-induced (cf. cat. 3.8). As can be seen, the rock engraving (cat. 7.8c) employs similar roundels, and what may possibly be interpreted as a highly stylised figure of a (shamanistic?) dancer. The second stela (cat. 7.8b) has previously been given a Neolithic date, but the design elements used, circular and sinuous relief, appear to have a greater affinity with the characteristic Bronze Age motifs illustrated on the other items. It is possible that it may represent a transitional stage between these two distinct periods.

This has been interpreted as reflecting a dramatic shift in conceptual system, and a re-evaluation of the relationship between man and his world, evidence perhaps of increasing socio-political complexity associated with significant technological change. The end of the humid period in the mid-3rd millennium BC, and the resultant desertification of the Sahara,

led to the concentration of the Bronze Age population in Saharan oases and along the coastline of the Maghrib. The unity of Africa which had existed throughout the Neolithic period was now disrupted and the Bronze Age population along the coastal strips became isolated. Links between these groups and the Iberian peninsula in the west and Sicily, Malta, Sardinia

and southern Italy in the east grew stronger, a fundamental change that may also have influenced artistic styles. *TAI, MRM*

Bibliography: Souville, 1973, p. 294; Desanges, 1981, pp. 425–6; Camps, 1982, pp. 612–61

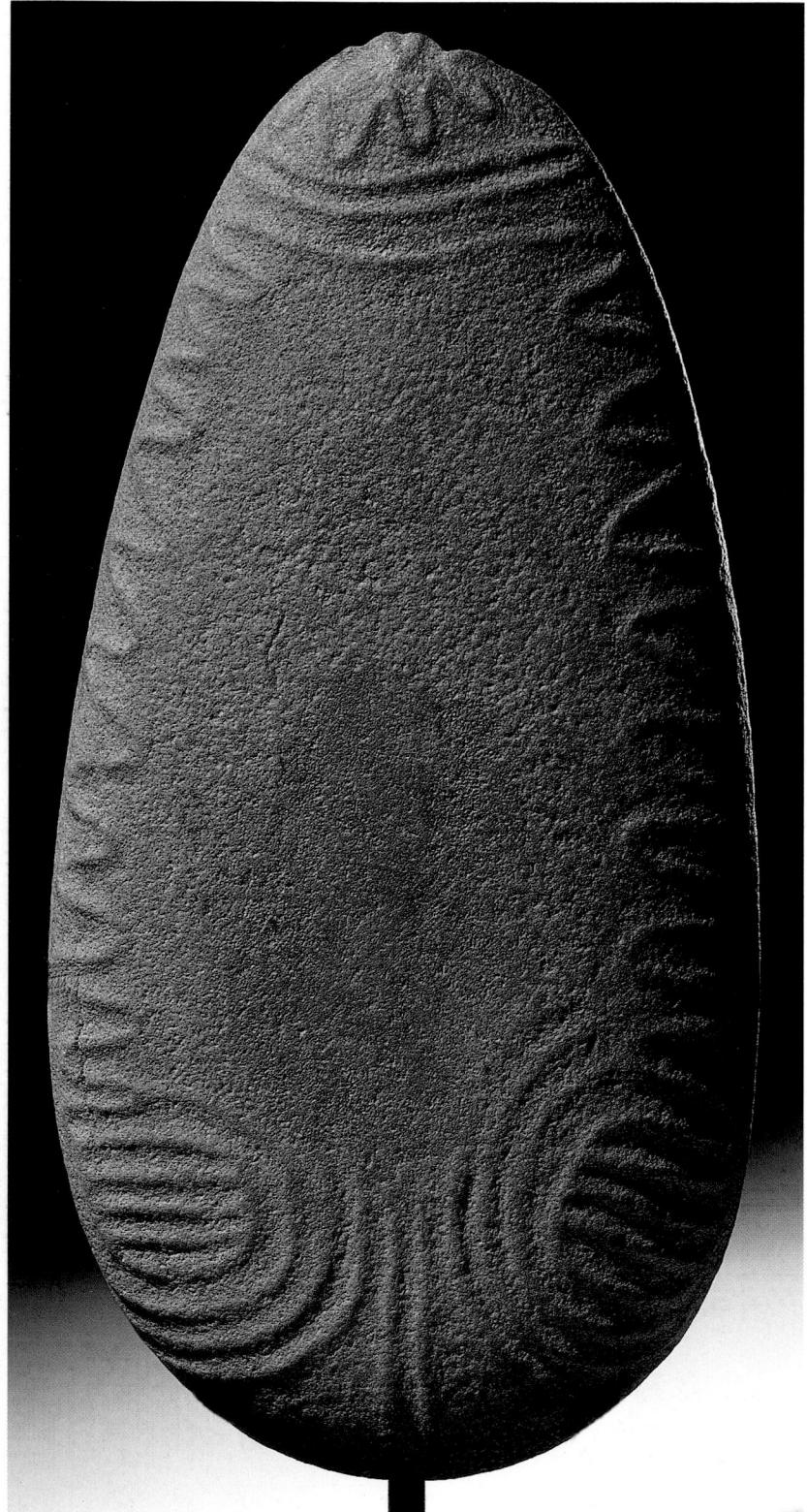

7.8b

Stone stela

Sahara
Bronze Age (?)
stone

59 x 30 x 2.4 cm
Dr Klaus-Jochen Krüger

7.8c

Rock engraving

Morocco
Bronze Age
stone
h. 52 cm

Musée d'Archéologie, Rabat, 89.5.1.5

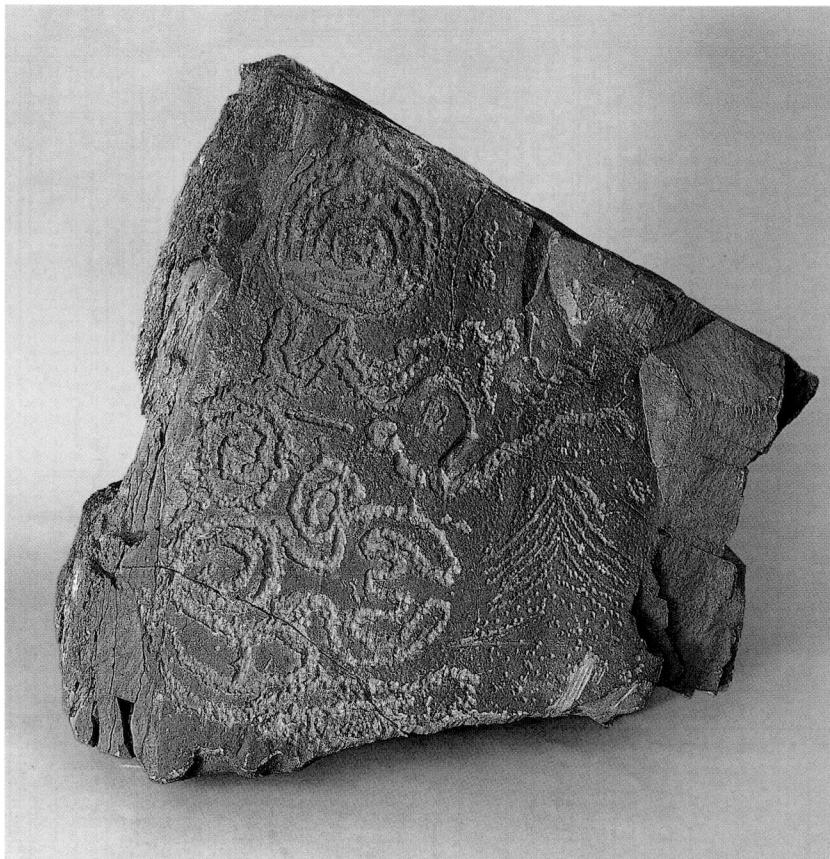

7.9a

Mask with negroid features

Tunisia
late 7th or early 6th century BC
terracotta
21 x 15.5 x 11 cm
Musée National du Bardo, Le Bardo,
Tunisia

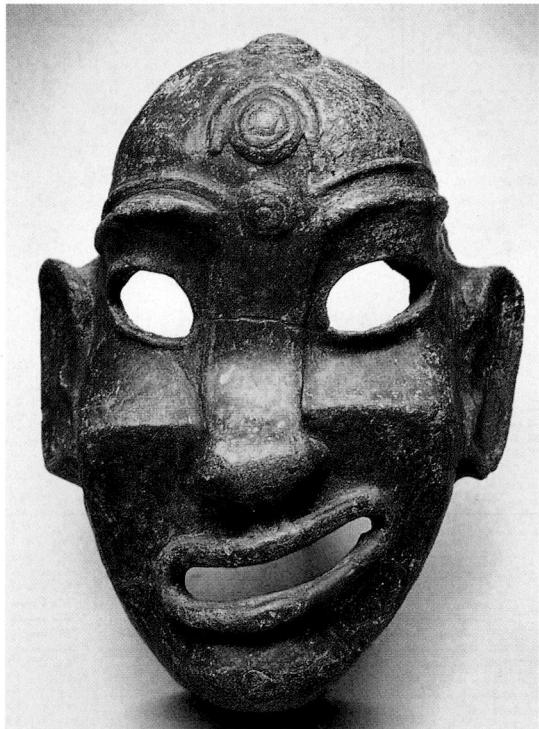

7.9b

Grimacing mask

Tunisia
late 6th or early 5th century BC
terracotta
16 x 13 x 10 cm
Musée National du Bardo, Le Bardo,
Tunisia

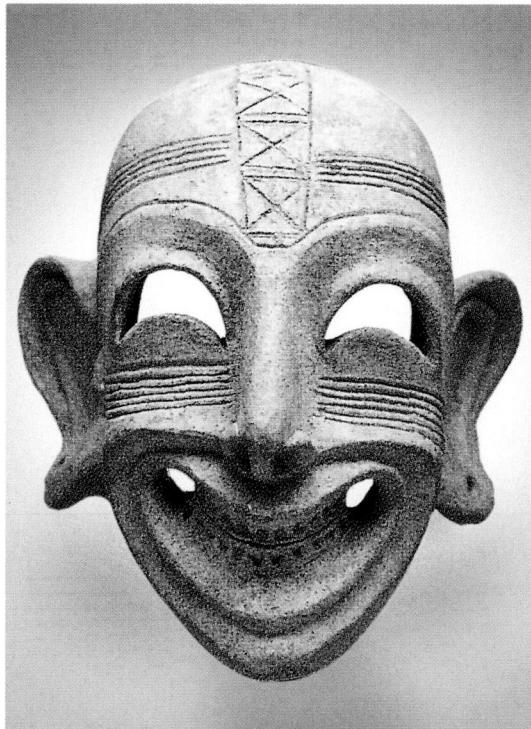

7.9c

Mask of a bearded man

Tunisia
c. 500 BC
terracotta
20 x 14.5 x 8.5 cm
Musée National du Bardo, Le Bardo,
Tunisia

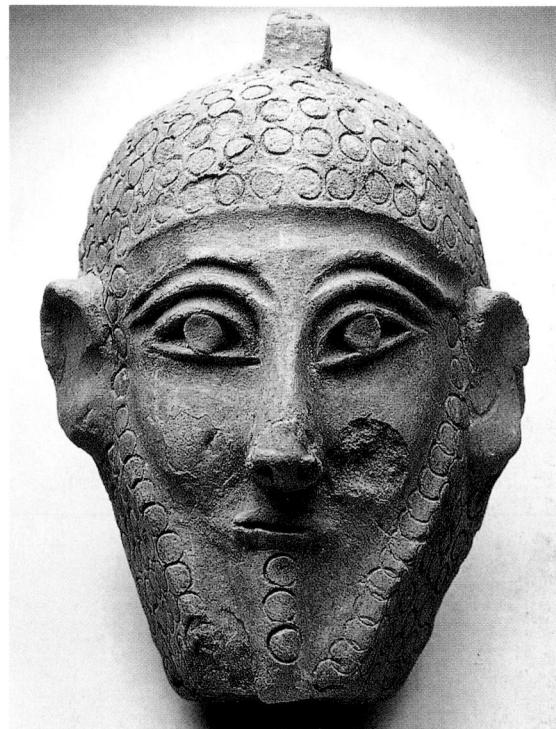

These masks are good examples of a type of artefact widespread in the Phoenician settlements of north Africa. The earliest come from the Phoenician homelands of the eastern Mediterranean (Lebanon, Syria) and date to the 11th and 10th centuries BC; thereafter the masks have a long history of use to the 2nd century BC. Most western examples come from tombs and clearly have an apotropaic function, possessing magical properties to frighten off evil spirits from the tomb; they have also been found in sanctuaries. It has been suggested that the grotesque image represents a specific deity, such as the demon Humbaba of Mesopotamian origin, but this is not certain. The life-size masks may have been worn by worshippers in religious processions, the eye holes allowing visibility. On the Sicilian island of Mozia (the Phoenician colony of Motya) they seem to have been used to cover the faces of the human sacrificial victims in the sanctuary where this

rite was carried out (*tophet*). Most masks, however, are smaller than life-size and may have been used to cover statuettes and other effigies. In view of the fact that the vast majority of these masks come from tombs, most may have been made specifically as gravegoods. Cat. 7.9a belongs to the earliest type known from the cemeteries of Carthage, with apparently negroid features: there is a large flat nose, protruding ears, prominent almond-shaped eyes sloping downwards towards the nose, and a mouth with only one side turned up, giving the face an awkward leer. The division between the upper and lower parts of the face is marked by a sharp change of plane (carination), as commonly on such masks; there are three raised button-like knobs (warts?), made up of concentric circles, on the central axis of the head between the crown and the eyebrows, the middle one being surmounted by a crescent design.

Cat. 7.9b is a rather later version of the type of mask with negroid

features. The grinning face is typical, an effect produced by giving the mouth a distinct U-shape and turning up its corners. This differs from cat. 7.9a in having crescent-shaped eyes and a raised and pointed rather than a flattened nose; teeth are also shown, and the mask bears decoration in the form of horizontal scored lines.

Also decorative is the upright rectangular scored panel with three crosses, extending from the crown of the head to the bridge of the nose. As with cat. 7.9a, its principal function was apotropaic. Virtually identical masks with the same scored pattern of decoration are known from elsewhere at Carthage and also from San Sperate in Sardinia.

The terracotta mask of a bearded man (cat. 7.9c), with staring eyes, prominent nose and ears, triangular chin and perfunctory mouth, is placed somewhat off centre. The hair and the beard are indicated by a series of impressed open circles, in the case of the beard sometimes overlapping with

each other; in addition there are three further circles shown below the mouth. A suspension hole projects from the top of the head. This striking terracotta is another example of the apotropaic mask designed to ward off evil spirits; this example, however, differs from most in displaying no grimace and in having solid rather than hollow eyes. *RJAW*

Provenance: cat. 7.9a: 1890s, Carthage, Dermech district, from a burial; cat. 7.9b: Carthage, from a burial; cat. 7.9c: Carthage, south slope of Byrsa Hill

Exhibitions: cat. 7.9a: Venice 1988, no. 231; Paris 1995, p. 45; cat. 7.9b: Paris 1995, p. 45; cat. 7.9c: Paris 1995, p. 37

Bibliography: cat. 7.9a: Gauckler, 1915, pl. CXCVIII; Picard, 1965–6, pp. 11–12, pl. I.1; Yacoub, 1970, fig. 10; Ciasca, in Venice 1988, pp. 356–9; Lancel, 1995, p. 61, fig. 37; cat. 7.9b: Picard, 1965–6, very similar is Paris 1982–3, no. 45; cat. 7.9c: Picard, 1964, p. 67, pl. 24; Picard, 1965–6, 19–20, no. 23 with pl. V.19; Moscati, 1973, pl. 24; Lancel, 1995, p. 62, fig. 38

Mosaic panel showing a woman dancing

Tunisia
c. AD 400
limestone, marble
201 x 154 cm
Musée de Carthage

This mosaic panel shows a young woman, naked from the hips up, with a shawl over her left arm; she wears a necklace, two armlets and a pair of bracelets. She is shown dancing or lightly stepping to the left; both the direction of her gaze, over her left shoulder, and the gesture of her left hand suggest that she is not alone. On her head she carries a basket from which roses are falling; a further basket of roses, with handles, stands in the lower left corner of the mosaic. In the background, behind a curved high fence, is a thicket of rose bushes. The border of the panel shows a simple ribbon pattern.

The panel is one of four at the corners of a cold room (*frigidarium*) in a richly appointed detached bath building in a rural location 30 km south of Carthage. Of the other three corner panels, there is one almost identical to that shown here, and the other two depict half-naked girls pouring water from an uplifted jug. Interpretation is uncertain. It has been suggested that the four represent the seasons, but then different attributes would be depicted in each panel, not two pairs of two almost identical scenes. The centre of the pavement in the *frigidarium* depicted a marine procession with Neptune and Amphitrite, along with nereids and tritons, disporting themselves on the backs of a wide variety of often fantastical marine creatures. The main scene of the floor is therefore unrelated to the subject of the four corner panels. It seems certain that the bath building was located on a private villa estate and belonged to a wealthy landowner, but the whereabouts of the main villa building awaits discovery. Figured mosaics are very common in north Africa; the mosaic industry flourished in response to the demands of wealthy landowners who wanted to invest the profits they had made from agriculture in ostentatiously decorated dwellings in town and country alike. North Africa was particularly prosperous in the late Empire, and this

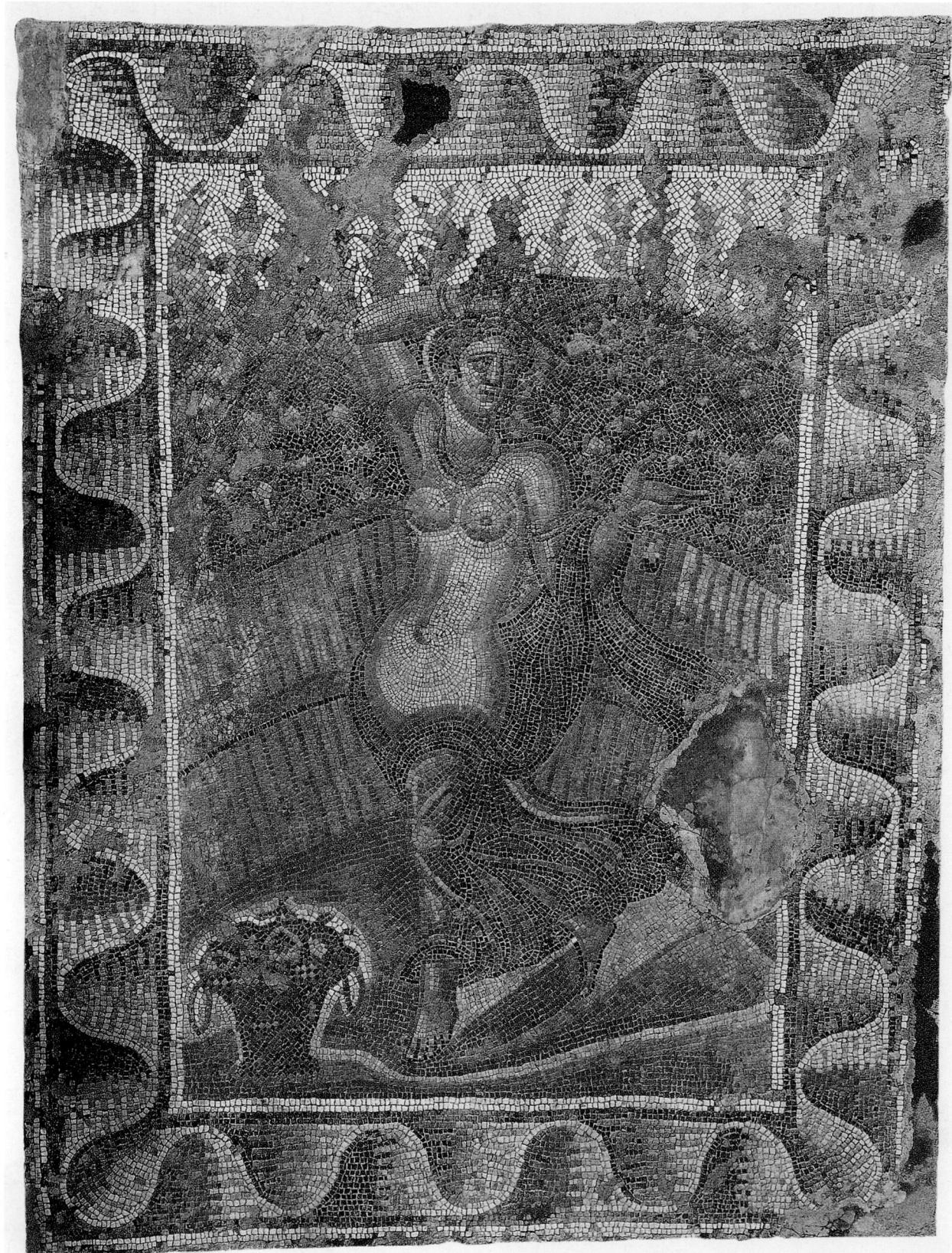

mosaic dates from just before the end of a particularly active period of demand for such floors, which declined sharply with the Vandal control of the central part of north Africa (Tunisia and eastern Algeria) from the 420s. *RJAW*

Provenance: 1980s, Sidi Ghrib, from the cold room (*frigidarium*) of a bath building
Exhibition: Paris 1995, p. 309
Bibliography: Ennabli, 1986, p. 42, pl. XIII

7.11

Head of a priest

Egypt

2nd century BC

black basalt

19.5 x c. 14.5 x 17.5 cm

Württembergisches Landesmuseum,
Stuttgart, 1.26

This head of a bearded man, with broad forehead, heavy eyelids and prominent nose, is typical of sculpted heads in Ptolemaic Egypt; in particular the neat coiffure, sitting like a cap on its wearer's head (rather than rising naturally from the contour of the scalp), is paralleled on numerous heads of this period, and represents a fashion in Egyptian sculpture that can be traced back to the Old Kingdom. The man can be identified as a priest both by the diadem with perfunctory rosettes which he wears in his hair, and also by the sculpted panel on the rear side of the head. This depicts two divinities, one lion-headed and crowned by the sun-disc, the other falcon-headed with a double crown; they face right towards a priest, who raises both hands in adoration. The gods, who lack specific attributes, must be Horus and Uto, who were worshipped in the temple at Buto where the head was found. The priest is shown on the panel as shaven-headed in time-honoured priestly fashion, in contrast to the head itself which portrays him in secular style with close-cropped curly beard. The wearing of beards did not become fashionable in Egypt until the 2nd century BC. *RJAW*

Provenance: Kom el Far'in-Buto (Delta)

Exhibition: Stuttgart 1984, no. 110

Bibliography: Brunner-Traut and Brunner, in Stuttgart 1984, p. 139

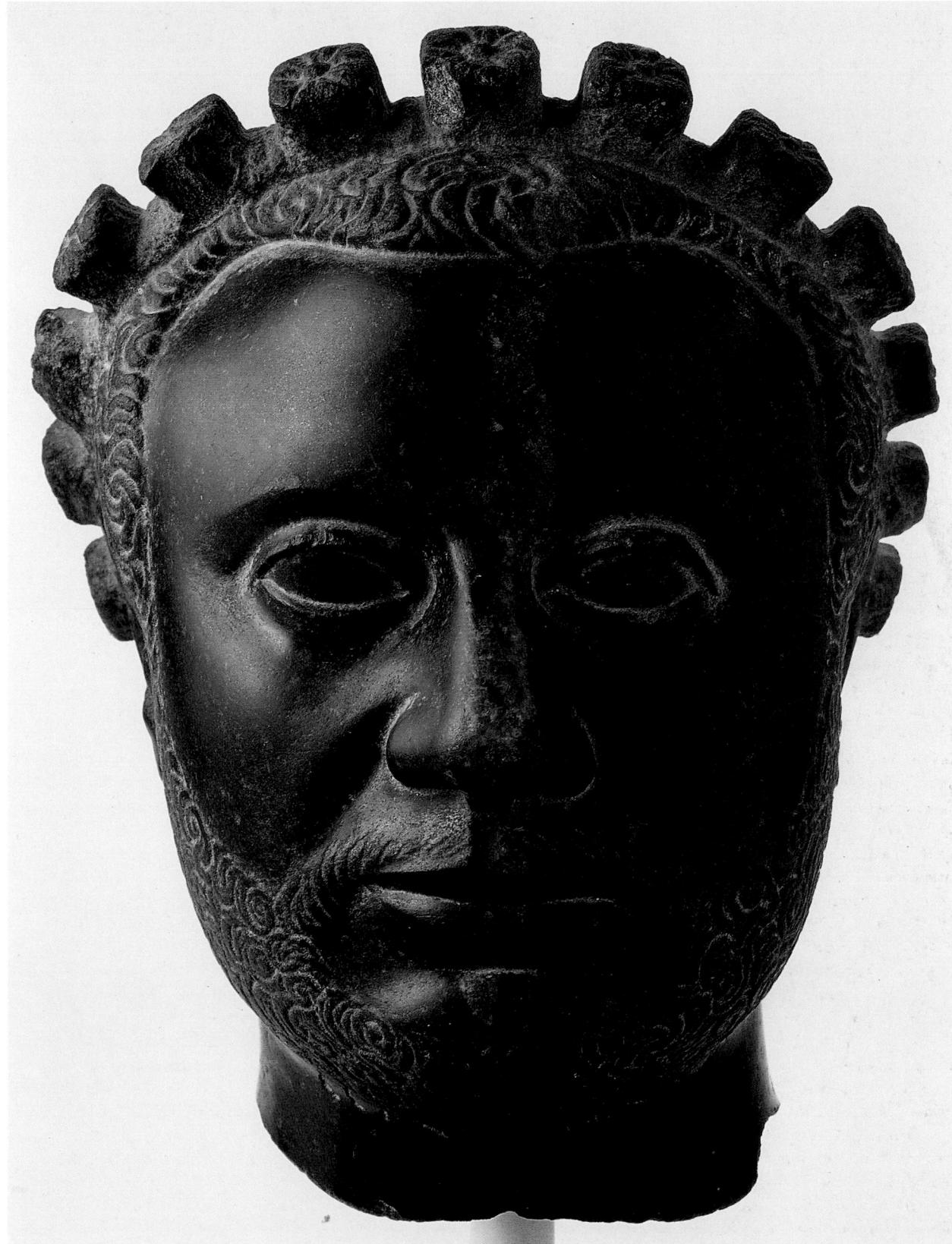

7.12

Statue of a lion-headed goddess

Tunisia

1st century AD

terracotta

150 x 46 x 36.5 cm

Musée National du Bardo, Le Bardo,

Tunisia

This remarkable terracotta statue shows a standing female figure in a full-length robe, the lower part of which is swathed with a pair of bird's wings. In place of a human head is that of a lion (rather than a lioness), with staring, fierce expression. The goddess holds an item of uncertain identification (now damaged) in her left hand. The statue is one of a number of distinctive large-scale terracottas to come from a sanctuary site at Bir Bou Rekba dedicated to the principal deities of the Carthaginian pantheon, Baal and Tanit, and to their Roman successors and equivalents, Saturn and Caelestis. The open-air sanctuary is of unusual type, consisting of three terraced courts with altars, votives and tiny chapels to house the cult image (but no full-scale temple). The iconography of the goddess is ultimately borrowed from that of the Egyptian lioness-headed goddess Sekhmet, a symbol of solar force; but the identity of the figure exhibited here as an unusual symbol of Africa itself can be established on the basis of a Roman silver coin (a *denarius*) of 47/6 BC, where a very similar lion-headed figure is named as the *genius terrae Africae*, the 'protective spirit of the land of Africa'. The figure on the coin is shown holding the symbol of Tanit, a triangle surmounted by a horizontal line and a circle. This lion-headed version of the *genius terrae Africae* is known only from two other representations, at Tiddis and Bir-Dirbal, both in Algeria. The personification of Africa in antiquity was more usually shown as a woman whose head is surmounted by an elephant's trunk and tusks.

RJAW

Provenance: 1908, Bir Bou Rekba, near Hammamet

Exhibitions: Venice 1988, no. 215; Paris 1995, p. 103

Bibliography: Merlin, 1910, pp. 44–7; LeGlay, 1961, pp. 97–100; Yacoub, 1970, fig. 26; Bisi, in Venice 1988, pp. 332–3

7.13

Statuette of a seated goddess

Tunisia

c. 700 BC

terracotta

25 x 9.5 x 10 cm

Musée National du Bardo, Le Bardo, Tunisia

This statuette represents a mother goddess seated on a high-backed throne. She holds her right hand across her enlarged belly and her breasts are prominent; she is clearly represented as pregnant. She wears a long robe down to her feet, which also envelops her head, leaving only her ears and forearms bare. Her hair is arranged in great tresses falling either side of the head, a style ultimately of Egyptian origin. Her robe is decorated with black lines, her ears are painted red, and there are other traces of blue and red paint as well: originally the entire surface would have been highly painted. The terracotta, from one of the early graves at Carthage, is identical to examples from the homeland of the Phoenicians (in what is now Lebanon), the people who settled Carthage. This example is almost certainly either a Phoenician import

brought by an early settler, or made in Carthage by an artist who had got hold of a Phoenician mould for making such terracottas. The pregnant mother goddess probably represents the Phoenician goddess Astarte, goddess of love and fecundity.

RJAW

Provenance: 1902, Carthage, necropolis in the Dermech district, tomb 310

Exhibitions: Paris 1982–3, no. 30; Paris 1995, p. 102

Bibliography: Gauckler, 1915; Cintas, 1970, pl. XIII, fig. 51; Lancel, 1995, p. 65, fig. 41 (identical to Venice 1988, no. 38, from Phoenicia, in Musée du Louvre, Paris)

7.14

Stela in honour of Tanit and Baal

Tunisia

3rd–2nd century BC

limestone

59 x 33.5 x 16 cm

Musée de Carthage

This stela and cat. 7.15 come from the *tophet* of Salammbô at Carthage. The *tophet* was an open-air sanctuary covering 6000 square metres in which were deposited cinerary urns containing the remains of new-born infants and young children, sacrificed in honour of the all-powerful goddess of the Carthaginians, Tanit, and her consort Baal-Hammon. The urn was sealed at the top with a stone pillar, replaced from the 6th century BC onwards by a stone slab. This example belongs to the final phase of Carthage before its destruction by Rome in 146 BC, at a time when Hellenistic Greek culture was exerting a powerful influence on Carthaginian art.

Underneath a central gable with flanking projections is a stylised Ionic capital, with the customary volutes on either side and the egg and dart decoration (*ovolo*) in between. Below it is the symbol of Tanit, consisting of a triangle surmounted by a horizontal bar (here hooked at the ends, perhaps to suggest hands) and a small circle. Above it is a crescent moon; Tanit is queen of heaven as well as earth. The Tanit symbol is flanked by a pair of wands with entwined snakes at the top, and a ribbon tied to the middle. This *caduceus* is the symbol usually associated with the Greek god Hermes (the Roman Mercury), messenger of the gods and conductor of souls to the underworld. The inscription, in neo-

Punic script, reads: ‘To the Lady, to Tanit, Face of Baal, and to the Lord, to Baal Hammon; vowed by Himilco, son of Abmelqart, son of Baalhannon, son of Baalamasos’. Just as modern Christian names are sometimes chosen from Biblical names, so Carthaginian personal names often incorporate the names of their deities: the last two here refer to Baal, and Abmelqart alludes to another Carthaginian deity Melqart, the equivalent of Heracles (the Roman Hercules). RJAW

Provenance: Carthage, the sanctuary known as the *tophet*

Exhibition: Paris 1995, p. 109

Bibliography: CIS I.3, no. 5589, with pl. XXVI, 14

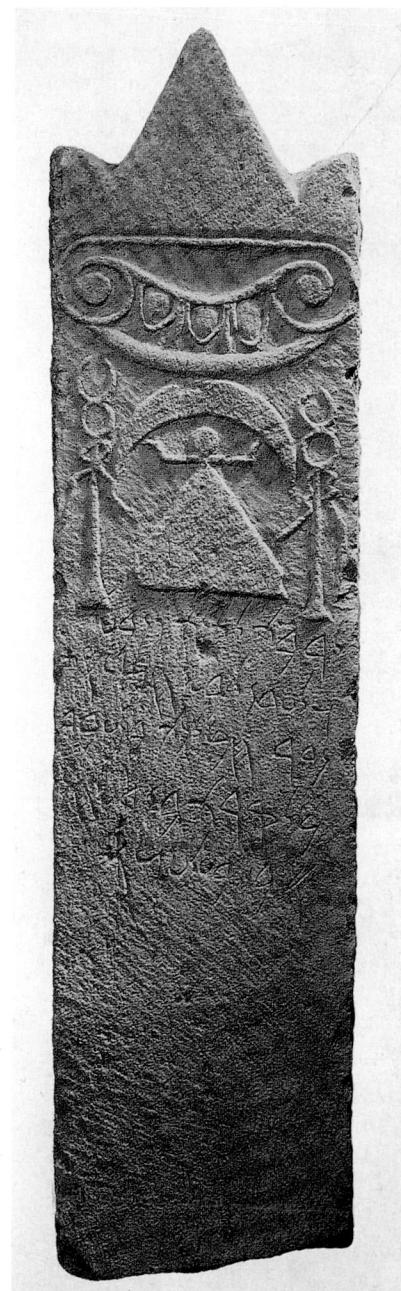

7.15

Stela in honour of Tanit and Baal

Tunisia

4th century BC

limestone

79 x 19 x 15.5 cm

Musée de Carthage

This stone slab comes from the *tophet* of Salammbô at Carthage (cf. cat. 7.14). In a central rectangular recessed panel is sculpted a simple representation of the Tanit symbol, a solid triangle surmounted by a horizontal bar and a circle, with a crescent moon above. The inscription, in neo-Punic script, reads: ‘To the Lady, to Tanit, Face of Baal, and to the Lord, to Baal Hammon; vowed by Bodmilquart, son of Hanno, son of Milkyaton, son of Bery,

son of Ty.' Over 6000 stelae have been found in the *tophet* (and over 20,000 cinerary urns), giving some idea of the extent of the popularity of the worship of the supreme Carthaginian deities which continued unabated from the late 8th century BC to the destruction of Carthage in 146 BC. The cremated remains were not always of humans: animals were sometimes substituted from the start, and constitute as much as 30 per cent of 7th- and 6th-century burials; but this practice declined in the late period, when human sacrifices account for 88 per cent of cremated offerings. The Romans prohibited human sacrifice, but it may have continued in some parts of north Africa into the third century AD: Tanit and Baal continued to be worshipped, but in a new, thinly Romanised guise as Caelestis and Saturn. *RJAW*

Provenance: Carthage, the sanctuary known as the *tophet*

Exhibition: Paris 1995, p. 109

Bibliography: CIS i.3, no. 5507 (text); Lapeyre and Pellegrin, 1942, pl. II (photograph of the stele *in situ*); Hours-Miedan, 1950, pl. Vle (sketch); on the *tophet*, Stager, 1980 (incl. earlier bibliography); Aubet, 1993, pp. 212–17

7.16

Cut metal figure

Volubilis, Morocco
metal

Musée d'Archéologie, Rabat

The attractive archaeological museum at Rabat houses many masterpieces, some of which are shown in this exhibition (notably cat. 7.8a, 19).

One of the main displays consists of the finds at the site of Volubilis which show a range of Roman objects from fine imported sculpture to the most humdrum utensil and give a good picture of life in Roman Africa. Anomalous among these are some votive images which have a local and uncolonial flavour, cut in metal, well crafted and in a direct, expressive style. They do not have the air of a debased provincial Roman style but a vivacity all their own. This particular example, for all its missing forearm, sums up the essence of these unusual artefacts which seem to have more in common with rock-painting silhouettes in the region than with outside influences.

7.17

Relief of eight divinities

Tunisia
probably 2nd or 1st century BC
limestone
65 x 159 x 28 cm
Musée National du Bardo, Le Bardo, Tunisia

This unusual stone has a recessed rectangular panel in its upper half in which are depicted seven men and one woman in flat relief. The male figures are identical, with stylised wig-like hair; they are bearded, and wear long-sleeved garments pinned by a circular brooch on one shoulder. The female figure, fourth from the right, has similar wig-like hair, but she also wears drop earings and armlets as well as a band or diadem in her hair. The relief almost certainly depicts the indigenous deities of the Numidian peoples of the interior of north Africa, and in the absence of the slightest trace of Roman influence in the relief's iconography or style, it probably predates Roman control of north Africa, belonging to the period when the Numidian kingdoms were at their height in the 2nd and 1st centuries BC. If so it is a rare surviving example of Numidian relief sculpture. Chemtou (Simithu), near which this relief was found, was an important Numidian settlement, and its famous quarries of yellow marble (*giallo antico*) were then being exploited for the first time. That the worship of these multiple divinities in the Chemtou region continued into the Roman period is shown by a rough cut relief, also showing eight divinities, still visible

in the Roman quarries at Chemtou. Neither cat. 7.17 nor the quarry carving is inscribed, but Latin inscriptions elsewhere in north Africa normally refer to these indigenous deities as the *dii Mauri* ('the Moorish gods'). The inscription on a 3rd century AD relief from Béja in northern Tunisia, about 70 km from Chemtou, names the seven deities it depicts as Macurtam, Macurgum, Vihina, Bonchor, Varsissima, Matilam and Lunam, names which are certainly native Libyan in origin (only Bonchor may owe something to the Carthaginian world). Since these names are unknown elsewhere, it is impossible to say if any of these gods are represented on this relief; indeed another pantheon of five, known collectively as the *dii Magifae* and carrying the quite different names of Masiden, Thiliva, Suggan, Lesdan and Masiddica, is documented near Tébessa in eastern Algeria; while another clutch of godlings, also in Algeria, delight in the names of the *dii Ingitozoglezim*. We know little about these indigenous cults in pre-Roman and Roman north Africa; the Chemtou panel provides a rare glimpse of one such pantheon. *RJAW*

Provenance: 1965, found at Borj Helal, near Chemtou, north-west Tunisia

Exhibition: Paris 1995, p. 193

Bibliography: Bénabou, 1976, pp. 187–330; Fentress, 1978; Horn and Rüger, 1979, pl. 24; Fantar, 1986, p. 137, no. II.123

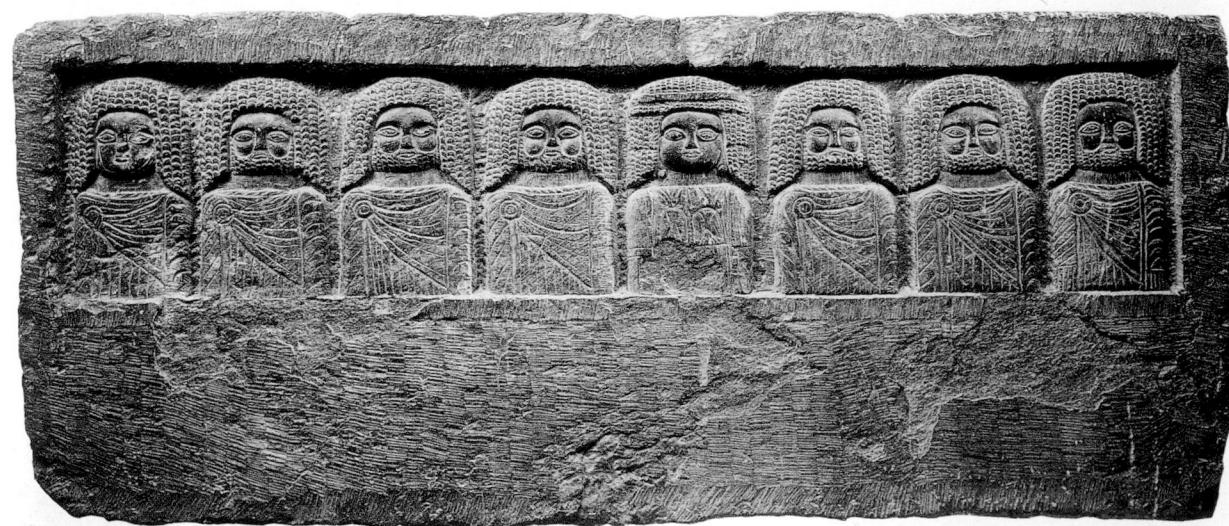

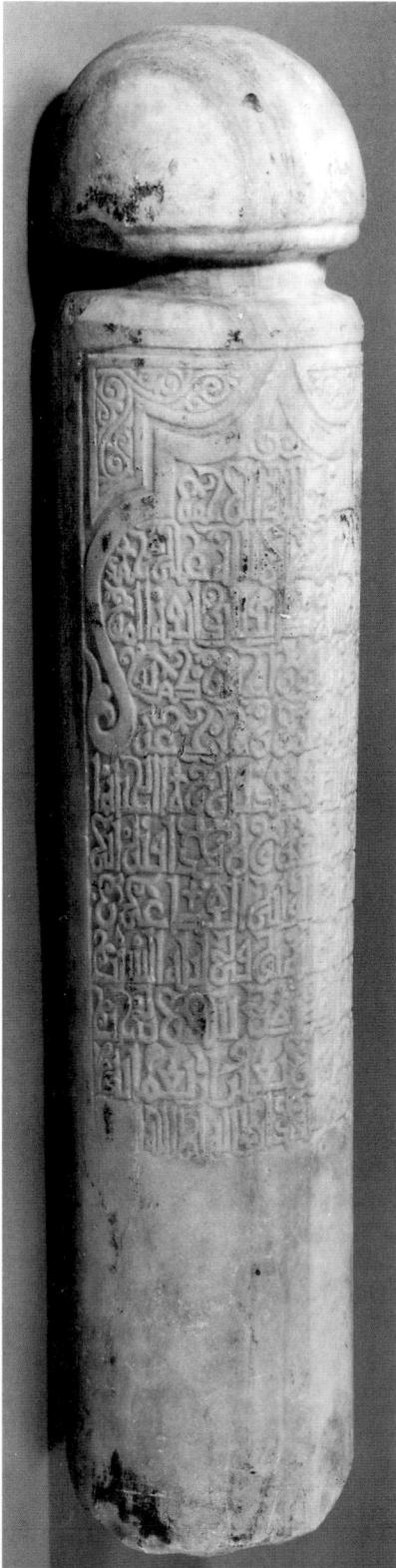

7.18

Gravesstone

Kairouan, Tunisia
AD 1052 (444 AH)
marble
h. 114 cm
Musée des Arts d'Afrique et d'Océanie,
Paris, A.94.5.2

Although the Quran specifies that the dead should be buried immediately after death in the desert under an unmarked stone, funeral art developed in Tunisia as it did throughout Islam. This gravestone comes from the cemetery of Ganah al Ahdar, Suqrn, Kairouan. It is a monolithic column surmounted by a turban, phallic in shape and reminiscent of a number of gravestones to be found in sub-Saharan Africa, for instance in Tandidarou. In later centuries, funeral stones were purely geometric in shape.

The epitaph is beautifully written in a flowery Kufic script; it consists of twelve lines sculpted in relief in a multi-lobed niche. Two scutcheons decorated with foliage adorn the upper part of the niche and a three-petaled flower the lower.

The inscription begins with the *bismillah*, 'In the name of Allah the Merciful', and the *tasliya*, 'that the Blessing of Allah fall on Mohammed and his kin'; it continues with verse 182 from the Sourate III, verse 182: 'Every soul must taste death. A man only gains the Day of Judgement through his deeds...he who is shifted from below the underworld and who enters Paradise may reckon that he has gained Life and the whole world...life is but a...'. The inscription ends with the name of the deceased: 'this tomb belongs to Abu Baker Ali al-Lawati-al-Kusa'i, may the Blessing of Allah be upon him...he died on Friday 11 Rajab 444 (6 November 1052)'. MFV

Provenance: Private Collection, Paris

7.19

Gravestone (*mashhada*) of the Marinid sultan Abu Ya'qub Yusuf

Chellah, near Rabat

Morocco

1307

marble

81 x 51 x 14 cm

Musée Archéologique, Rabat, 89.5.2.4

This gravestone was discovered at Chellah, the necropolis of the Marinid dynasty of Morocco, outside Rabat, in 1881. It reuses a Roman stela with a dedication in Latin to a governor of Betica (southern Spain) of the 3rd or 4th century. The Arabic inscription identifies it as the gravestone of the Marinid sultan Abu Ya'qub Yusuf (r. 1286–1307); the cursive inscription of the main panel refers to him as the just ruler, the warrior for religion, the martyr, the prince of believers and the defender of the faith. A quotation from the Quran, in angular Kufic script, runs around the frame.

This is one of the finest artefacts preserved from late medieval north

Africa. Its composition, with a blind cusped arch on columns, and a delicate arabesque scroll and shells in the spandrels, is typical of a gravestone (*mashhada*) current in north Africa and Spain by the 11th century. These stelae were intended to stand upright at the head and foot of a grave, or were embedded in walls, and were often used in conjunction with a long prismatic gravestone that covered the actual tomb (*mqabriyya*). Several other tombstones of both types have been preserved that were made for other members of the Marinid court at Fez. The quality of the marble and of the carving of this royal tombstone can also be matched in the gravestones of the Nasrid dynasty of Granada, today in the Museo Nacional de Arte Hispanomusulmán in the Alhambra. NE

Provenance: 1881, discovered at the necropolis of Chellah, near Rabat

Bibliography: Paris 1990, p. 20

7.20

Mosaic panel (*zallij*)

Fez

Morocco

glazed earthenware

h. 150 cm

Musée Dar al-Batha, Fez

Glazed ceramic tiles as well as glazed vessels were introduced into north Africa with the Islamisation of this area; the earliest known tiles date to the 9th century. The technique of cutting monochrome tiles into smaller pieces and producing mosaic panels of different colours seems to date from the 12th century, when it appeared in north Africa and Islamic Spain, probably developed as an alternative to expensive glass and stone mosaic (cf. cat. 7.63). It also provided an alternative to polychrome tiles, whose lead glaze had a tendency to run, and did not allow several colours on one tile, a technique perfected in the Islamic east. Cut-tile mosaic is known in Morocco as *zallij*, meaning glazed or vitrified, and this Arabic word is probably the source of the Spanish *azulejo*, meaning tile. Fez was intermittently the capital of Morocco from the 8th century to the 20th, and few other towns in north Africa have such a continuous tradition of medieval urban culture and crafts. The industries of architectural decoration are synonymous with this sophisticated urban life, and were essential for the mosques and luxurious houses of Fez, some of which survive from the 14th century. Many of the *zallij* panels in the Musée Dar al-Batha come from medieval houses since demolished; other panels can be enjoyed *in situ* as pavements and dadoes of the buildings of Fez and other towns. The most famous panels are perhaps those of the Alhambra palace in Granada. The complex geometry attained in medieval *zallij* panels was usually based on stellar designs, with the numbers of the points of the stars based on multiples of eight, and necessitated an virtuosity of tile-cutting and laying. This restrained example uses only square pieces to make a chequerboard design. NE

Bibliography: Marçais, 1954; Paccard, 1980, i, pp. 349–493; Damluji, 1992

7.21

Two folios from a Quran manuscript

Tunisia
late 10th century
parchment, inks, gold leaf
13.5 x 20 cm

The al-Sabah Collection, Dar al-Athar al-Islamiyyah, Kuwait, LNS 65 MS (a, g)

These parchment folios belong to a fragmentary Quran codex with 93 leaves, each with seven lines to a page. Representative of the Quran manuscripts produced in Kairouan, the text is written in broken cursive or curvilinear Kufic with red and green diacritics. The verse stops are indicated by gold rosettes, and the mark for the fifth verse is the Arabic letter for 'h'.

The folio illustrated above contains verses from the Quran (VI: 1-2), with the chapter title written in gold. A gold palmette with touches of white, blue and green extends from the title into the margin. The folio illustrated below is the left half of either a double frontispiece or finis-

piece and was conceived as an oblong with a palmette extension. The geometric design in the rectangle consists of interlacing circles and squares painted in gold and accentuated by green, blue, brown and black. The floral elements in the border link the geometric composition and marginal extension.

Bibliography: New York et al. 1995

7.22

Illuminated pages from the 'Dala'il al-Khairat' ('Guide to Blessings')

(one illustrated)

Algeria
AD 1655 (1066 AH)
paper, gilding, inks, watercolour
17 x 12 cm each
Musée National des Arts d'Afrique et d'Océanie, Paris, M.1962.1488.1/2

During the Abbasid, Timurid and Safavid periods (13th–16th centuries), numerous artistic centres flourished from Merat to Tabriz, producing collections of poetry and chronicles.

This copy of the *Dala'il al-Khairat* is dedicated to Abu Abdallah Muhammad Ben Rahmuni, the Husayni Sharif, and to those chosen by God afterwards. In this town of Algiers, Allah's Protectorate, in the year 1066. This collection of prayers is written in north African cursive script, *maghribi*

These two pages are illuminated on both sides. The recto bears a picture of the Mosque at Mecca, with the Kaaba at the centre (towards which the prayers of the whole of the Muslim world are directed), a stylised version of the *minbar* (pulpit) and the Zamzam well. The verso bears a text about the first mosque in Medina.

On the recto of the second page are drawings of the tombs of the Prophet and his two companions, Umar and Abu Bakr. The dimensions of the chamber are given, as well as the place where the Angel Gabriel appeared. On the verso is a labyrinth with a genealogy of the Prophet descending from Adam and Eve. In the centre a multi-lobed arch surmounts the golden lamp flanked by two rose windows. Below this are written the names of Adam and Eve.

Maghribi script developed in Andalusia but found its true flowering in north Africa from the 12th century onwards. It became the official script of north Africa. MFV

Provenance: 1946, given to the museum by Mme Denan

Exhibition: Venissieux 1982

Bibliography: Berque, 1959

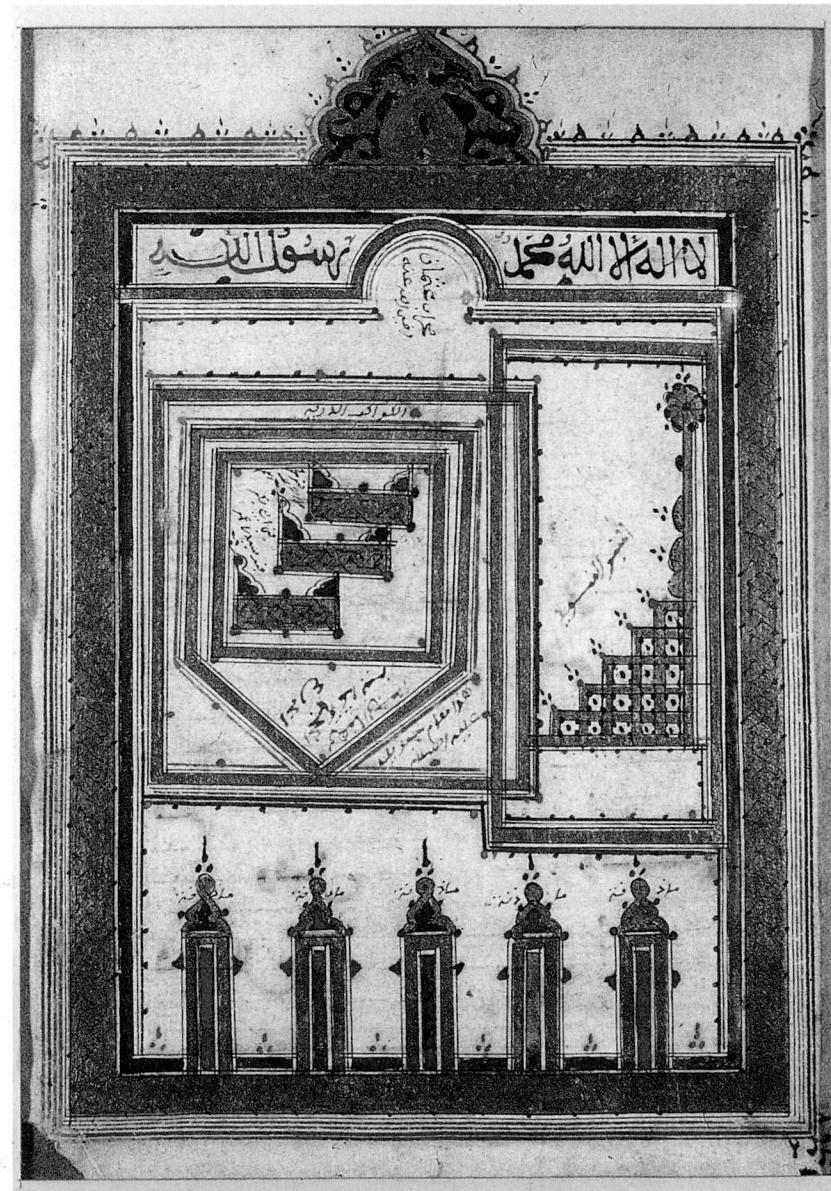

7.23

**Four segments of a necklace
(*qannuta*) (two illustrated)**

Moknine
Tunisia
17th century (?)
gold, filigree and *cloisonné* enamel
4 x 2 cm each
Musée National des Arts d'Afrique et d'Océanie, Paris, MNAM 1968.5.27.1/4

Tunisian jewellers were working with precious metals well before the Christian era. The quality of their techniques (filigree, chasing, *cloisonné*, engraving, etching, *repoussé*) was famous all over the Mediterranean. The arrival of Jews and Muslims expelled from Andalusia between the 14th and 17th centuries meant that the art of the court of Granada (especially jewellery) survive.

These bobbin-like elements, resembling small tubular containers, are intended to hold the scrolls of the Torah; this would have given them a religious significance, in fact would have made them into little talismans. They are reminiscent of 14th- and 15th-century jewellery from Granada, particularly the elements found in necklaces of the Nasrid dynasty, which were also called *qannuta*. Some scholars think that these are derived from ancient forms – Greek, Roman or Byzantine – handed down from generation to generation from the Caliphate of Cordoba to the Maghrib. *MFV*

Provenance: ex collection Paul Eudel, Paris

Exhibitions: Lons-le Saunier 1970; Paris 1971; Paris 1977; Paris 1995

Bibliography: Sugier, 1968, p. 151; Gargouri-Sethom, 1983; González, 1994, p. 189

7.24

Lady's belt (*hzam*)

Fez
Morocco
19th century
silk lampas
323 x 41 cm
Musée National des Arts d'Afrique et d'Océanie, Paris, M.70.4.14

The art of silk weaving has existed in Morocco at least since the 14th century. Ibn Khaldun mentions it in his *Muqaddimah*. Garments and belts of woven silk and gold were made in Fez according to a traditional method that came from Spain but originated in Byzantium, and was adopted in Baghdad before spreading through the western provinces of the medieval Muslim world. The craftsmen of Fez used traditional 'drawlooms', from which modern looms are directly descended. One of the most remarkable workshops of Fez belonged to the Ben Sherif family, active since the second half of the 19th century. These silk belts, ornamented with gold, were worn by women on special occasions, over a matching kaftan; they would be folded in two except by women belonging to families descended from the Prophet, who wore them full-width. They were also used as gifts among the aristocracy, following the

form and style of the ancient *tiraz* (see cat. 7.51).

The oldest type of belt (16th and 17th century) is straight, relatively short and very soft; from the 18th century on, however, and particularly in the 19th century, belts were broader and longer, and were coated with a kind of size that made them very stiff. Their decoration was extremely varied, combining Byzantine, Hispano-Moresque and Ottoman elements with paisley patterns or with 19th-century European motifs as used in the silk mills of Lyons or the velvet workshops of Genoa. Prophylactic designs – the hand, Solomon's seal or the *mihrab* – are also common, epigraphic designs less so. These designs have been compared to the heraldic devices of Granada. Floral patterns came into their own in the 19th century.

These showy belts were fashionable at court until the end of the 19th century. *MFV*

Provenance: ex collection Colonel and Mme Bernard, Paris; 1970, given to the museum by Mme Bernard
Exhibition: Paris 1977

Bibliography: Vogel, 1920; Golvin, 1950; Ricard, 1950, pp. 41–8; Bernès, 1974

7.25a

Blue and white dish

probably Fez
Morocco

19th or early 20th century
glazed earthenware
diam. 46 cm

The Brooklyn Museum, 74.2
Anonymous gift in honour of
Charles K. Wilkinson

7.25b

Green and white bowl

Tamgrout
Southern Morocco
early 20th century
glazed earthenware
diam. 30 cm

Musée Majorelle d'Art Islamique,
Marrakesh

Glazed ceramic vessels and tiles have been a feature of north African town life since the early Islamic period. Moroccan examples took on a particular character in the 17th and 18th centuries, owing in part to the political and cultural isolation of the Saadian and 'Alawi dynasties that ruled in this period. Techniques, decoration and shape easily distinguish Moroccan from the contemporary ceramics of the rest of the Islamic world, in particular from those of the rest of north Africa (Algeria and Tunisia), under Ottoman Turkish domination at this time. Moroccan

vessels such as these dishes were kitchen wares, for eating from or storing food, as well as being enjoyed for their ornamental value. Glazed ceramic dishes in this tradition are still produced and commonly used in Moroccan cuisine today, for cooking as well as presenting food. The potting of the earthenware body is often heavy, with the decoration applied freehand, since these Moroccan dishes were produced rapidly and in large numbers.

The glazed ceramic industry was in the main limited to the towns of Fez, Meknes and Tetouan, and later in the 19th and early 20th centuries to Safi and Rabat as well as the small centres of Tamgrout and Ouarzazate in the south of Morocco. In the rural areas, on the other hand, only unglazed ceramics were produced. The common glazed ceramic vessels fall into four groups: blue and white; polychrome (blue, green, black, purple, yellow and white); monochrome (usually green-glazed); and bichrome (green and white or green and yellow).

Although the use of the interlace of blue band inset with panels of fine floral decoration is well known, the

blue and white dish (cat. 7.25a) has an unusually dynamic composition. It forms a part of a group of Moroccan ceramics decorated with the paisley motif, taken (as the name implies) from imported textiles.

The green and white bowl (cat. 7.25b) is also unusual with its exceptionally daring and simple composition – half of the vessel merely dipped into the green glaze. This design is identified with the relatively recent production at Tamgrout, a small oasis town in southern Morocco, with an important *zawiya* or religious fraternity and library. NE

Bibliography: Sijelmassi, 1986, pp. 96–8, 206, 218–19; Vossen and Ebert, 1986, p. 494; Hakenjos, 1988, figs 92, 96–8, 141

7.26

Coffer (*sanduq*)

Morocco, probably Fez
14th–16th century
wood with iron fixtures, traces of red and yellow paint

87 x 45.5 x 61 cm
Musée National des Arts d'Afrique et d'Océanie, Paris, m. 87.8.1

This wooden coffer is luxuriously carved with Arabic inscriptions and architectural motifs in a style that is otherwise known only from wooden architectural elements in Fez. It is difficult to date otherwise than to the 14th–16th century. The square ends and tendrils of the Kufic inscriptions on the box appear to be benedictory and do not assist in the identification of the piece. The shape of the pyramidal cover resembles those of the ivory caskets of medieval Islamic Spain and Sicily. The large size of this wooden chest suggests, however, a different use from that of the ivory caskets, perhaps to store books or documents in a mosque or clothes and furnishings in a house.

Bibliography: Cambazard-Amahan, 1989; Paris 1990, n. 418

7.27a

Couscous dish

Ait Smail, Halouane or Ijebbareen village
Grande Kabylie, Algeria
early 20th century
terracotta, paint
diam. 39 cm
Musée National des Arts d'Afrique et
d'Océanie, Paris, M.1972.3.2

7.27b

Couscous dish

Maatka (?)
Grande Kabylie, Algeria
early 20th century
terracotta, paint
diam. 44 cm
Musée National des Arts d'Afrique et
d'Océanie, Paris, M.1972.3.3

Rural pottery is made throughout the Maghrib, and has developed very little since prehistoric times. This pottery is related to the antique pottery found in the burial grounds of Sicily and Greece; stylistic influences brought to this part of the world by the Phoenicians can be found in fragments unearthed in Gouraya, Tiddis, Rokina or Bou-Nora. Although the forms have undergone a gradual process of refinement and the decoration has become increasingly rich, the techniques used by women modelling clay today in Kabylie or Aurès have scarcely altered since Neolithic times.

Apart from some isolated centres in the Sahara, Algerian pottery is made in places along the country's west-east axis, following the mountain ranges.

The most interesting moulded pots, with the shapeliest curves, the purest lines, the most harmonious and original forms (multiple jugs, oil lamps), come from Kabylie. The village women who made them adopted simple, functional and beautiful forms. They took their decorative motifs from the world around them – symbols and magic signs to protect them from misfortune.

Making pots has always been the work of women: they make them annually, selling any items that are surplus to requirements in the local market to augment the family income. Each stage of manufacture has its own ritual, from the choice of a propitious day for each operation (choosing, soaking and kneading the clay, then modelling, drying, polishing and painting) until the final firing. The decoration, usually carried out after firing, is done with a rudimentary brush and natural pigments: kaolin, iron oxides, decoctions of *lentiscus*, century plant and juniper. In certain villages the pottery is painted with a resinous varnish immediately after firing; this gives a yellow colour and ensures that the pot is watertight. A piece of leather is used to burnish the varnished surface. Firing takes place over an open fire of fig branches and cow dung mixed with straw, formed into cakes and dried in the sun. These cakes (*tichichines*) burn slowly, producing excellent embers. MFV

Provenance: ex collection Sorensen, Algiers, and collection Olagnier-Riottot, Paris; given to the museum by Mme Olagnier-Riottot

Exhibitions: cat. 7.27a: Bourges 1977; Venissieux 1982; cat. 7.27b: Evreux 1974

Bibliography: Van Gennep, 1911; Bel, 1939; Camps, in Lybica, 1955; Balfet, 1956; Moreau, 1976; Sned, 1982

7.28

Ceramic 'milk jug'

Bani Ouarain tribe, Rif Mountains
North-eastern Morocco
20th century
terracotta, paint
52 x 50 x 32 cm
Yvette Wiener

The Berber regions of Morocco fall into three large cultural and linguistic groups: the Rif Mountains in the north; the Middle and High Atlas Mountains; and the Anti Atlas Mountains and the Sus Valley in the far south. Many of the tribal languages or dialects are mutually incomprehensible, and the tribes are further distinguished by their dress, jewellery and other artefacts.

Although glazed and unglazed ceramic vessels were produced in towns all over Morocco, only unglazed ceramics were produced in the rural Berber-speaking areas. To this day, only women manufacture pottery in the Rif, while men dominate the urban industries of Fez, Asfi etc. Historically, the only rural pottery produced came from northern Morocco. Moroccan Berber pottery is sometimes painted with simple rectilinear designs, but its main aesthetic interest lies in its sculptural forms. Some of the forms, such as the two-handled amphora with a pointed base, appear to have a Classical precedent, as does some of the painted and burnished decoration (cat. 7.27), and indeed the extent of Berber ceramic production roughly coincides with the area of Phoenician, Greek and Roman influence in north Africa.

This vessel has a bulbous ovoid body with a tall tapering neck and two handles. Its decoration is painted in brown or manganese between the first and second firing. The simple linear painted design is closely related to tattoos given to women in Rif and other Berber areas, often on the chin, forehead, hands and feet, as well as to the linear decoration found on some Berber carpets.

Some of the Rif Berbers are subsistence farmers, and others semi-nomadic pastoralists, herding sheep and goats. If indeed this vessel served as a milk jug or butter jar, presumably its distinctive shape would have been useful for transportation by donkey. Equally the handles and horizontal body would have permitted the vessel to be hung and shaken back and forth

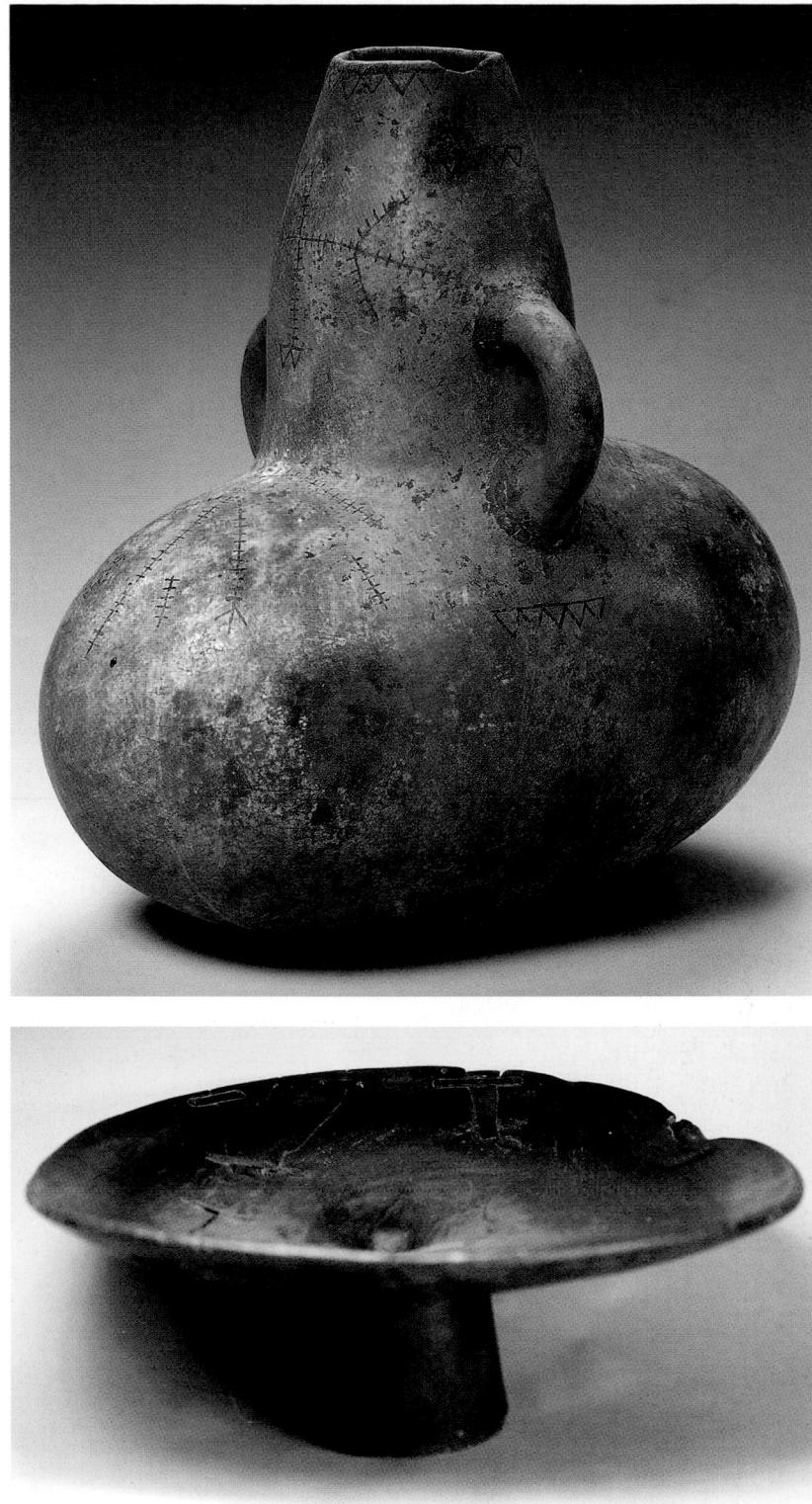

for making butter. This shape is one of the most characteristic of the artefacts of the Bani Quarain tribe, Taounate province, in the region of Taza. NE

Bibliography: Hakenjos, 1988, fig. 234

7.29

Couscous bowl

southern Morocco
early 20th century
wood, earthenware
25 x 65 cm
Linden-Museum, Stuttgart, A36337

Dishes used for the day-to-day preparation and serving of food in northwest Africa are generally made of a robust ceramic, frequently glazed in red and brown. This wooden vessel is a good example of such a common eating dish, which, though dating from the earlier part of this century, is equally representative of traditional wood and ceramic types today. The bowl shown is intended for the serving of couscous, the national dish of Morocco, its simple design and plain colours contrasting with the exotic nature of many couscous dishes. Couscous, which is made from granulated wheat, can be coloured bright yellow with turmeric or saffron, and is served piled high with colourful steamed vegetables and spiced meats. Eating is an important communal experience throughout Africa, and the large size of this dish reflects this common cultural attitude to the sharing of food. Indeed, the serving of couscous at the end of a meal symbolises the total satisfaction of the guest through the generosity of the host. Culinary influences, and hence influences on food vessel types, have passed in both directions, south from the Maghrib and north across the Sahara, and have contributed to the richness of the cuisine throughout these regions. TAI, MRM

Bibliography: Ministère de l'Economie Nationale, 1958; Carrier, 1987; Wolfert, 1989, p. 107

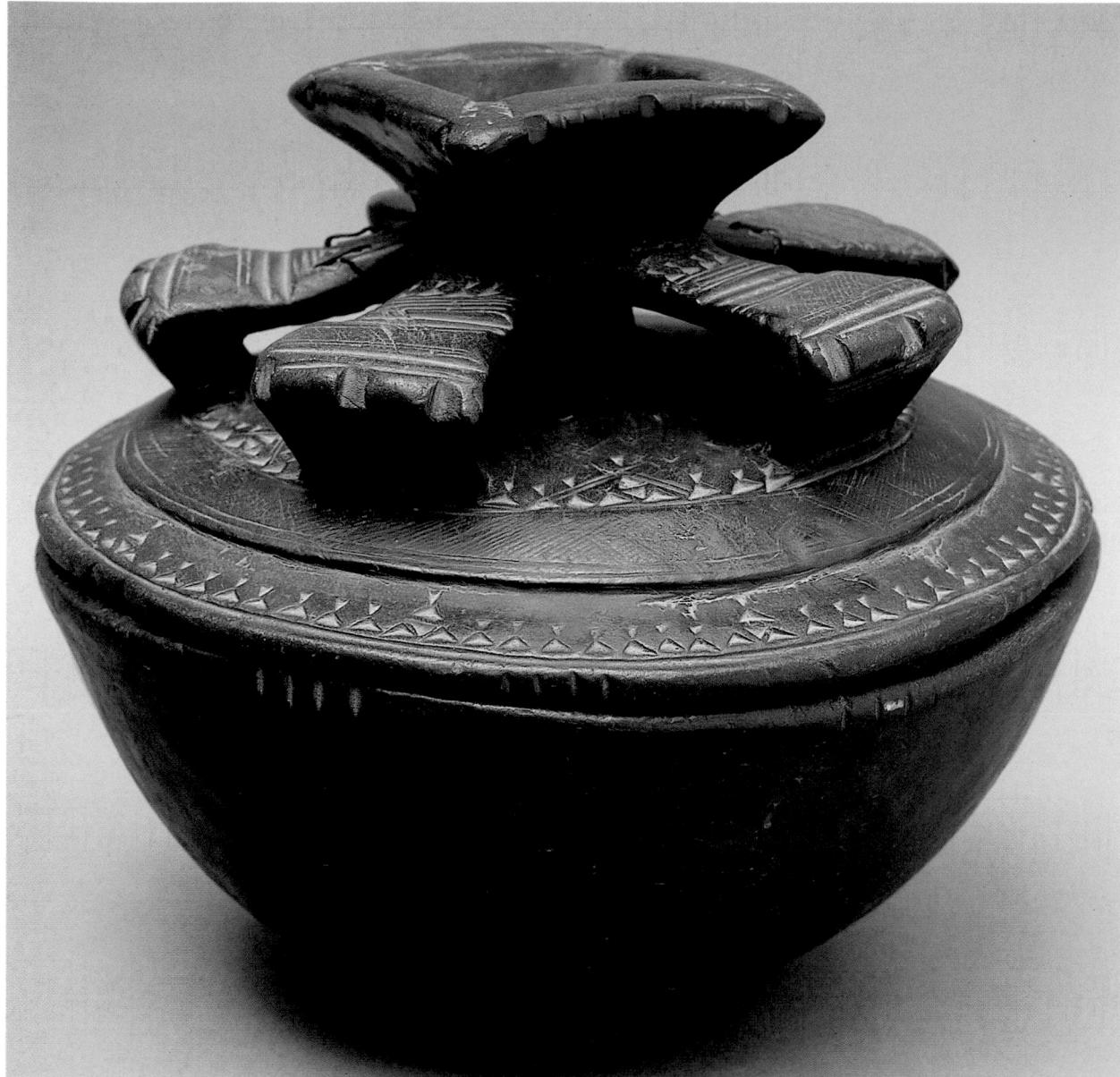

7.30

Dish with lid

Algeria
early 20th century
wood
25 x 29 cm
Bert Flint

Clear parallels for this wooden bowl have been difficult to find, and, while certain elements in its design appear to be typically Moroccan, it could also be thought to have affinities with the material culture of nomadic groups, such as the Tuareg, who inhabit areas further to the south, and more distantly, with that of sub-Saharan sedentary groups. Wooden containers, along with leather-work, basketry and metal, are preferred by those whose transhumant lifestyle precludes the use of less durable materials, such as ceramics. The low relief carving which has been used to decorate the surface of this vessel is, however, a recurrent theme in the Islamic world, where an intermittent antipathy to representational art-forms has led to a development of often complex geometric patterns. The intricate

carving of the raised handle indicates that this vessel was the work of an accomplished craftsman, able to conceive and execute a three-dimensional design which incorporates both simple surface patterns and more complex structural elements. Interestingly, similar structural elements can be seen in wooden vessels used by the Tuareg which exhibit influences from the sedentary sub-Saharan groups, those termed '*de style nègre*'. The combination of elements from these three distinct areas and cultures in this one vessel is of particular interest.

TAI, MRM

Bibliography: Gabus, 1958, p. 152;
Ettinghausen, 1976, pp. 62–3; Cribb, 1991

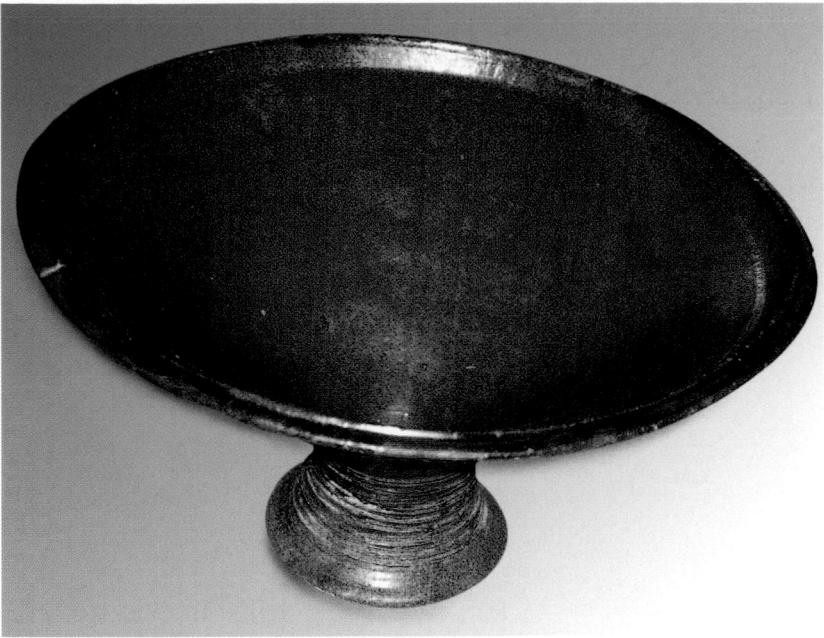

7.31

Bowl for dried fruit

Tamgrout
Morocco
early 20th century
glazed earthenware
diam. 50 cm
Musée Majorelle d'Art Islamique,
Marrakesh

This fruit platter is made of a robust ceramic and is glazed in an olive green. Very similar green glazes were being used throughout the Occidental Muslim world as early as the medieval period, and the use of greens and browns in ceramic decoration, to the exclusion of other colours, is characteristic of the work of these Islamic craftsmen. The distinctive olive-green glaze is created by mixing varying amounts of ferric oxide with copper, usually with a lead glaze, which permits a much greater range of colours to be used than alkaline glazes, the other basic glaze type. The pedestal and rim of the dish shown are decorated with simple horizontal channelling. As with couscous dishes (cf. cat. 7.29), the basic simplicity of the design and decoration of this dish contrasts with the variety of colours and shapes of the fruit it is used to display, and the large size of the vessel indicates its communal function. Traditionally Moroccan meals are finished with the presentation of a large platter piled high with carefully arranged fruits, fresh in summer and dried in winter. The pedestal dish used for the presentation of items such as fresh fruit is a common vessel type found throughout the modern Islamic world.

TAI, MRM

Bibliography: Robert-Chaleix, 1983, p.280; Wolfert, 1989, p. 236; al-Hassan and Hill, 1992, pp. 166–8

7.32

Stool

Morocco
wood
h. 26 cm

Museum für Völkerkunde, Leipzig

Carved from a single piece of wood, this stool reflects in its design the shape of the tree trunk from which it has been manufactured. Gently waisted, the central decorative bosses are restricted by the maximum diameter of the trunk and hence echo the top and base to create a balanced design. The production of this item in a Moroccan context is particularly interesting, as the use of stools in this area is not common, seating traditionally being upon mats and cushions or low divans. The use of wooden stools is, however, extremely common in sub-Saharan Africa and is seen throughout the continent, where

any man of status will have his own wooden stool, either inherited from his ancestors or acquired personally. The tradition of carving in the round could also be said to be more typical of sub-Saharan Africa; though the technique is used in Morocco, the employment of low relief carving, often embellished with inlays of various materials (e.g. bone or ivory), is more common. The shape of the stool is highly reminiscent of the hollow tree-trunk drums which are made throughout the continent, the central bosses resembling the wooden pegs to which the drum skin, stretched tight across the upper opening, is attached, possibly reflecting a distant relationship.

TAI, MRM

Bibliography: Ministère de l'Economie Nationale, 1958; Willett, 1971

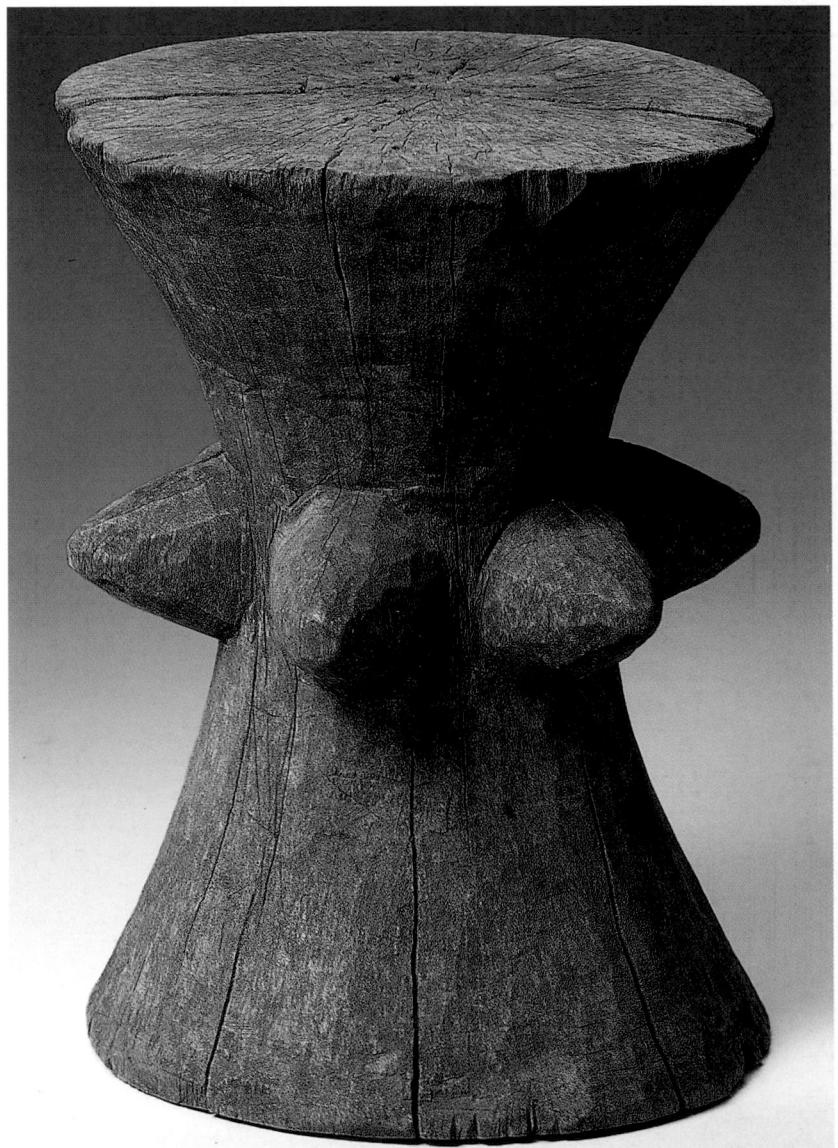

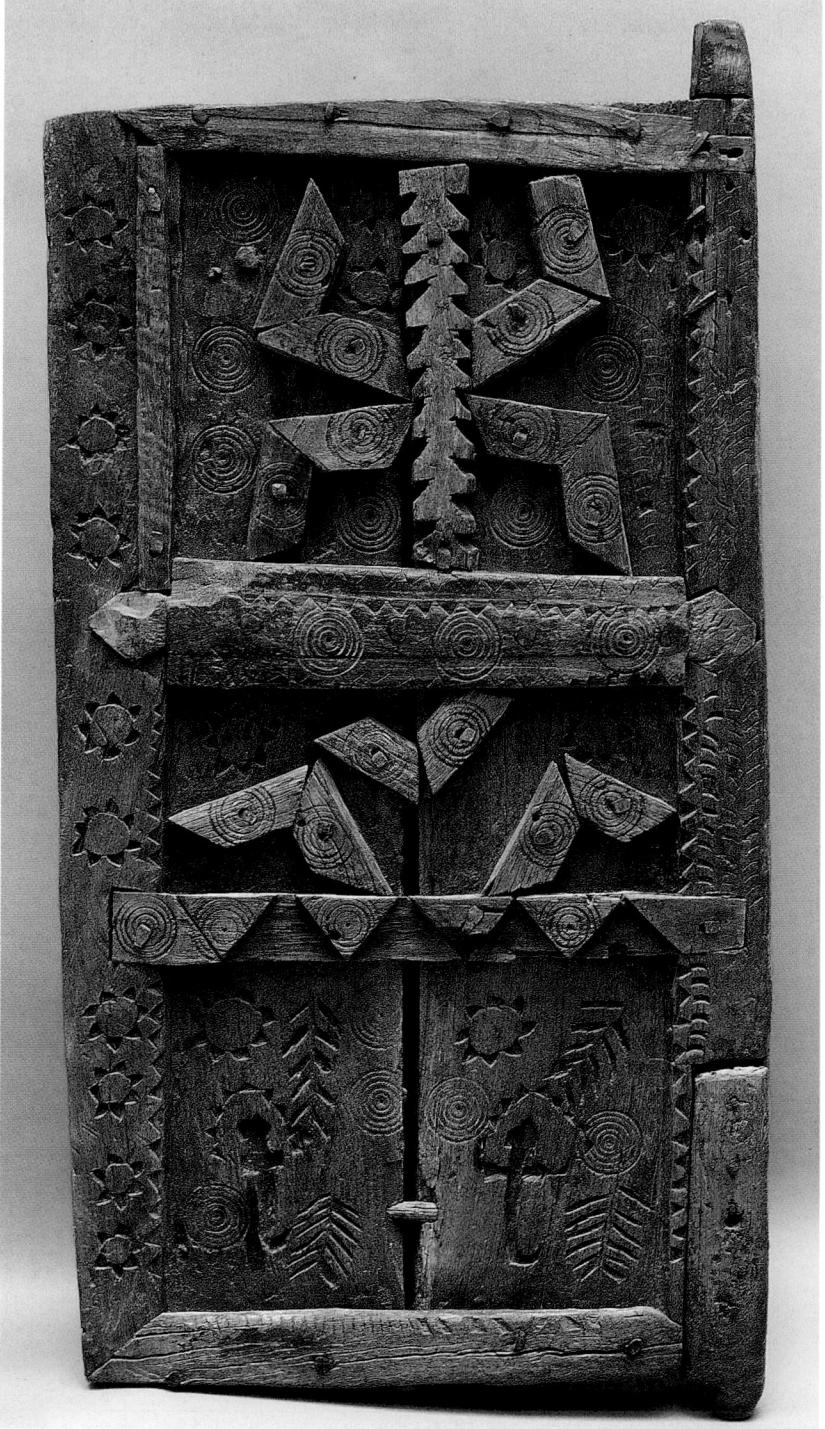

7.33a

Granary door

Berber
High Atlas, Morocco
early 20th century
wood
160 x 58 x 9 cm
Bert Flint

7.33b

Door

Berber
Middle Atlas, Morocco
late 19th century
wood
187 x 66 x 4 cm
Bert Flint

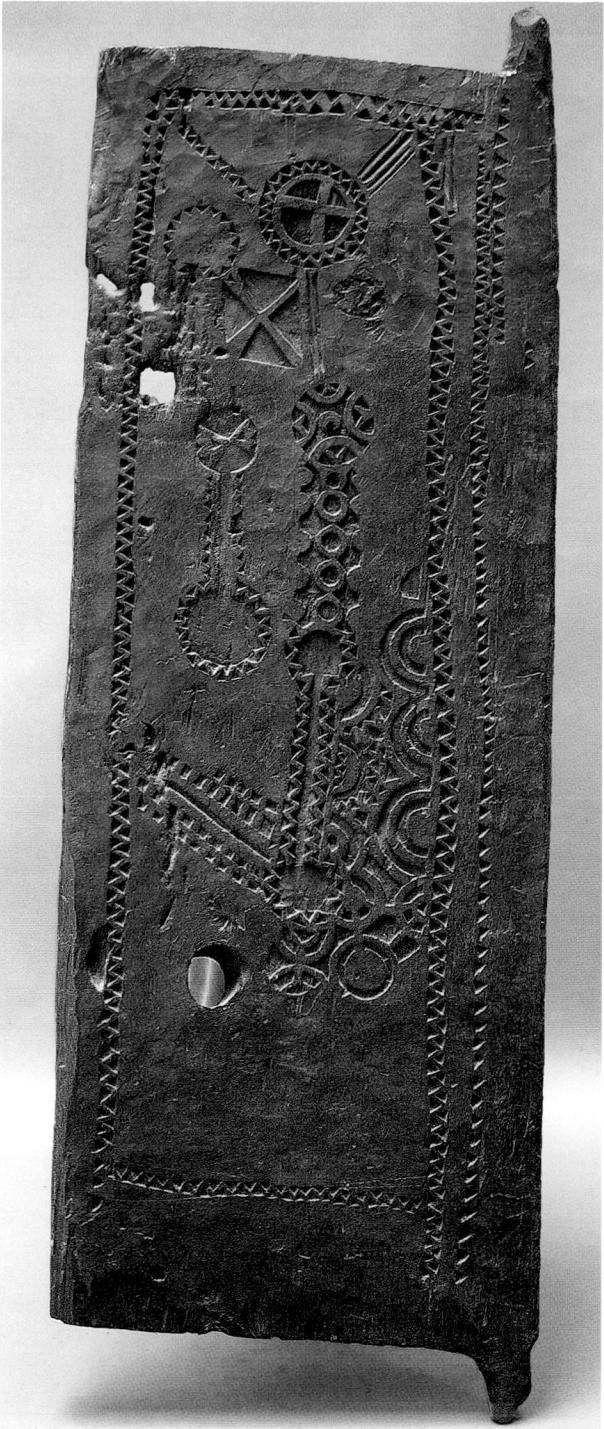

These doors come from Berber buildings in southern Morocco, an area with a remarkable architectural tradition, particularly to be seen in the *qasbas* or forts of the Anti-Atlas and Saharan oases. These buildings are constructed of mudbrick and *pisé* or adobe, and despite the technical handicaps of this material, reach impressive size and height. Additional visual impact is given by the tall corner towers with crenellations and other simple decoration in brick. The immediate visual similarity with

the vernacular architecture of the Yemen and Afghanistan has been remarked, but there is no evidence for any other than a local source for this tradition, whose architectural influence can be felt in the monumental *pisé* mosques of Mali. The ephemeral nature of mudbrick ensures that none of the existing structures can be dated to earlier than the 19th century, although this tradition is much older. The military exteriors of a variety of buildings – not only forts, but whole fortified villages, fortified granaries,

single houses or castles – reflect a time when central government had little control in these areas and raiding and banditry between tribes was common. These constructions vary enormously in size; some have a square outline and an orthogonal plan, while others appear to have grown organically.

There is little decoration except on the entrances and doors. Urban influence from nearby Marrakesh can be seen in the use of pointed horseshoe arches with surrounding moulding frames and friezes of brick decoration on the main entrances of the *qasbas*.

These two doors are from a granary (cat. 7.33a) and the interior of a house (cat. 7.33b is a leaf from a double door). They turn on wooden pegs set in stone and metal gudgeons, but their latches and locks are of wood, and their construction and decoration are comparatively simple. Superficially, they resemble other Berber wooden artefacts, such as the famous Kabyle chests of Algeria. However, a single homogeneous culture cannot be suggested, as the only similarity between the different Berber areas lies in the simplicity of the geometric designs used.

The granary door, with its representation of a frog and a snake, serves to protect the harvest from both natural and supernatural enemies. The frog is traditionally believed to embody a *jinn*, or otherworldly spirit, and should be avoided or appeased. The snake has an ancient history as the protector of homes, and as such is often left offerings of food and encouraged to stay in the foundations of a house. Apotropaic animals such as snakes, lizards, centipedes and scorpions are also to be found on Berber silver jewellery of southern Morocco. The representation of animals (indeed of any living thing) is very rare in north African art, as it is not permitted according to the strict interpretation of Islamic law, but here the animal representation reflects the pre-Islamic practices that survive among the Muslim Berbers. NE

Bibliography: Paris 1925, pp. 27–30, nos 33–51; Meunié, 1962, pl. 11; Paccard, 1980, i, pp. 28–39; Curtis, 1983; Sijelmassi, 1986, p. 253

7.34

Interior door

Fez (?)

18th or 19th century
carved and painted wood with iron fixtures
239 x 130 x 7 cm
Fage Art, London

The architectural traditions of medieval Islamic Spain and north Africa were preserved with extraordinary faithfulness in Moroccan cities such as Fez, Meknes, Marrakesh, Rabat-Salé and Tetuan. Of the three decorative industries of tilework, wood and stucco, woodwork is perhaps the most conservative and most difficult to date. Thus this door could have been made any time in recent centuries. The form and decoration have changed little since the medieval period; there are two main door leaves and two smaller wicket gates cut out of the main leaves, the latter lacking in this example. The main doors turn on wooden pegs set in stone and metal gudgeons. The doors can be closed from the interior and exterior of the rooms with an iron bolt, missing in this example. Both sides are usually decorated, and in this case the 16-pointed star predominates. The floral motif on the outer borders confirms the post-medieval, 18th- or 19th-century date.

This is a door to a room of an important house, said to be from Fez, but which could equally well be from any other town. The type of door is inextricably linked with the plan and elevation of these urban houses: rooms were grouped around a courtyard and often the only source of light and ventilation for the rooms was through the tall doors. The extreme height of the doors corresponds to the height of the rooms. At different seasons and times of day, either the main doors or the wicket gates could be opened. As elsewhere in Islamic society, women in Morocco were segregated from men who did not belong to their immediate family. However, as Moroccan houses were not equipped with harems or different areas for men and women, so these doors also served to screen women from view when male visitors were present.

Bibliography: Barrucand, 1978; Paccard, 1980, i, p. 231, ii, pp. 224, 274, 280–1, 426–51; Revault et al., 1985, 1989, 1992

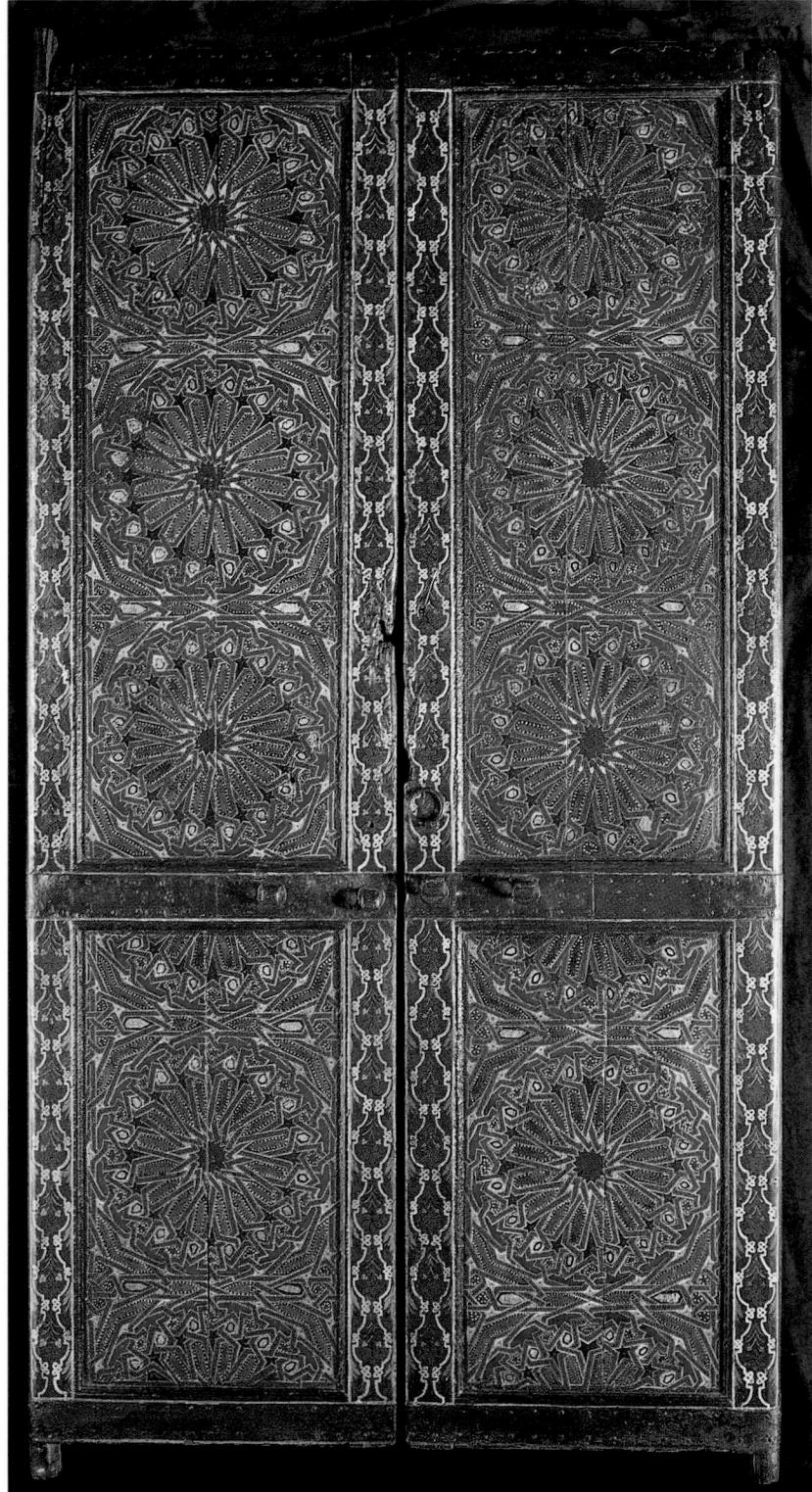

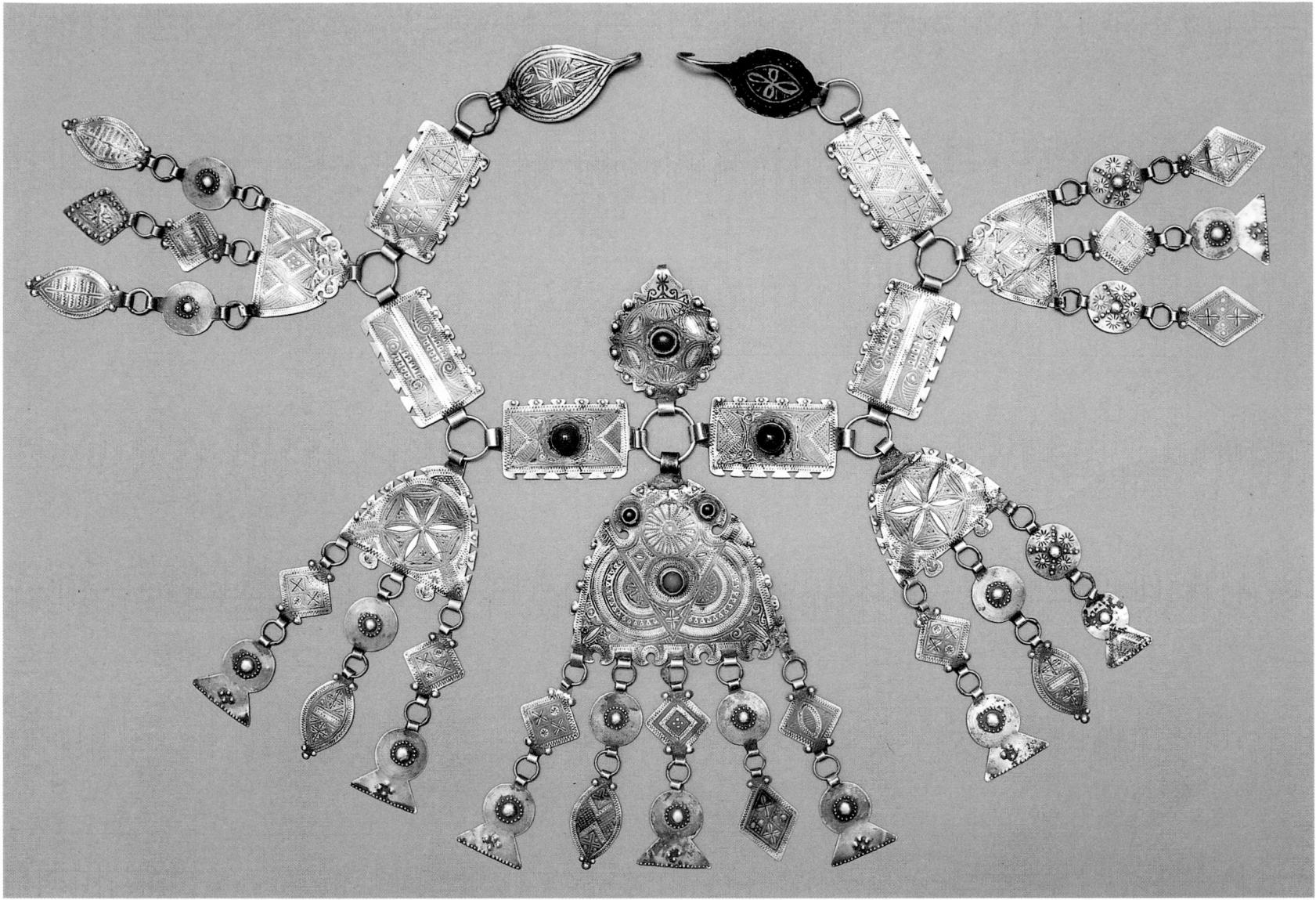

7.35a

Pectoral or head ornament

Berber groups of Anti-Atlas Mountains
Taroudant region, southern Morocco

20th century
silver, niello, glass
19 x 45 cm
Bert Flint

7.35b

Fibulae (*bzayim*) with connecting chain and central ovoid bead (*taghmut*)

Berber groups of Anti-Atlas Mountains,
Ait Ouaouzguite

20th century
silver, *cloisonné* enamel, glass
h. 147 cm

Musée Barbier-Mueller, Geneva, 1000-35

'Berber' is the general name given to the indigenous peoples of north Africa, whose cultures have survived in remote mountain and desert regions, despite the Arabisation of the plains following the Islamic conquest. The Berber languages are completely different from those of the Semitic family, although many Berbers today speak both Berber and Arabic. Most Berbers are Muslims, but there is a small Jewish minority. Their traditional material culture is easily distinguished from the Arab and Andalusian culture of the towns. In Morocco this Berber culture is particularly rich and varied, and the inability of the central government based in Fez, Meknes, Marrakesh or Rabat to control the mountain peoples ensured that it flourished in relative isolation until the French and Spanish colonial domination of the 20th century.

While jewellery in the cities was often made of gold inset with precious stones, Berber jewellery is characteristically made of silver decorated with niello and *cloisonné* enamel, and set with glass or semi-precious stones. Both in cities and in Berber regions, the jewellers were often Jews. The jewellery was worn exclusively by women (Islamic strictures about the wearing of precious metals seem not to have curtailed its use), usually given as part of their bride-price.

The pectoral or head ornament (cat. 7.35a) probably comes from the Ida or Ndif people near Taroudant in southern Morocco. It consists of various plaques of thin sheet silver, inlaid with niello, decorated with granulation and inset with red glass cabochons.

The two fibulae with a connecting chain and a central ovoid bead (cat. 7.35b) are used by Berber women

to hold a cloak or loose garment at the shoulder. These fibulae have ancient Classical and early medieval prototypes, but their striking triangular shape is characteristic of Berber jewellery of the Anti-Atlas Mountains. Both the triangular form and the ovoid shape of the bead are understood as symbols of female fertility. The elaboration of the silver engraving and the enamel make this a particularly fine example. NE

Exhibition: Paris 1977, no. 559

Bibliography: Besancenot, 1953, nos 124-8, 155; Jacques-Méunier, 1960-1; Sijelmassi, 1986, pp. 151, 153, 158-9, 166; Rouach, 1989, p. 174, fig. 290

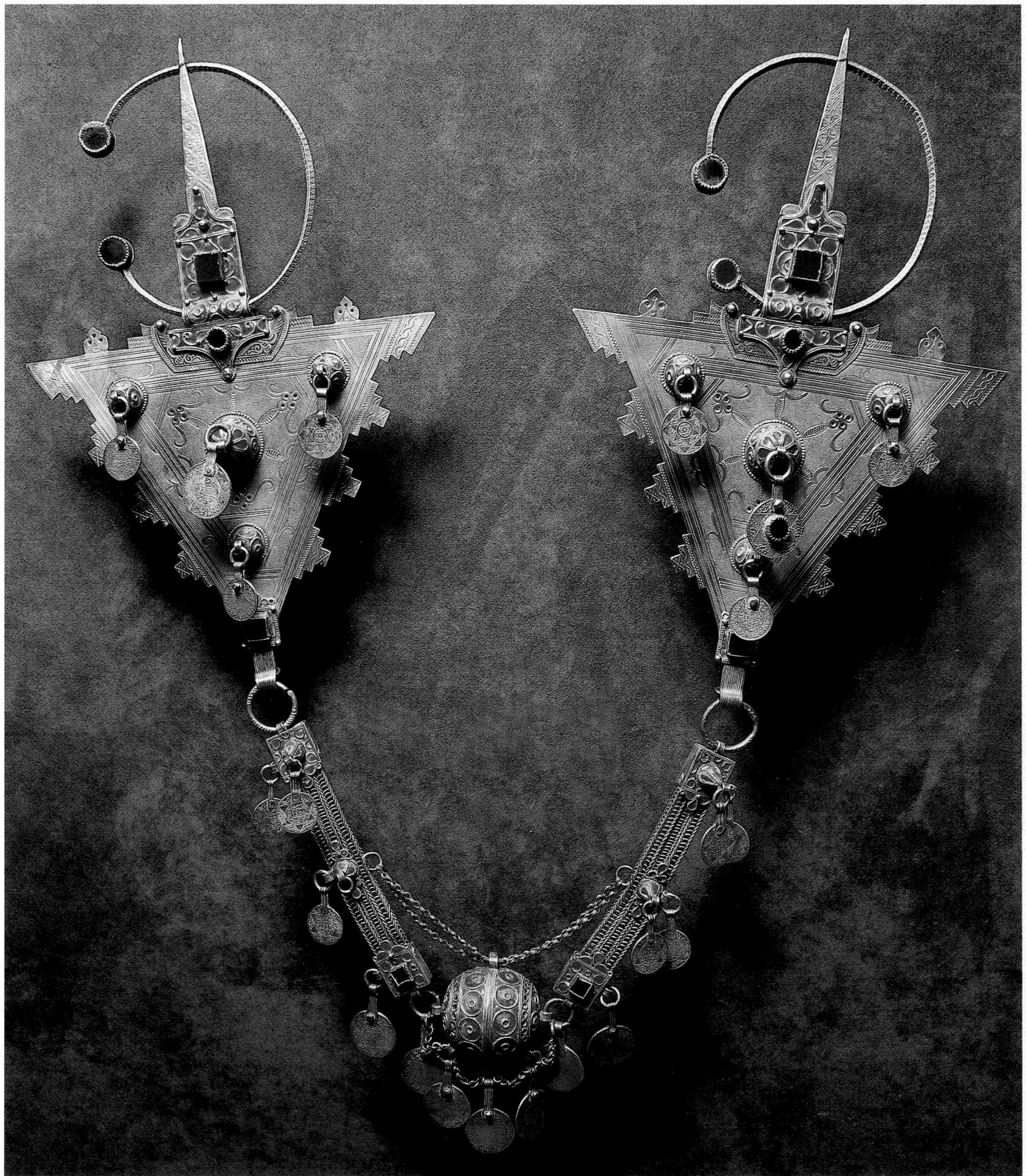

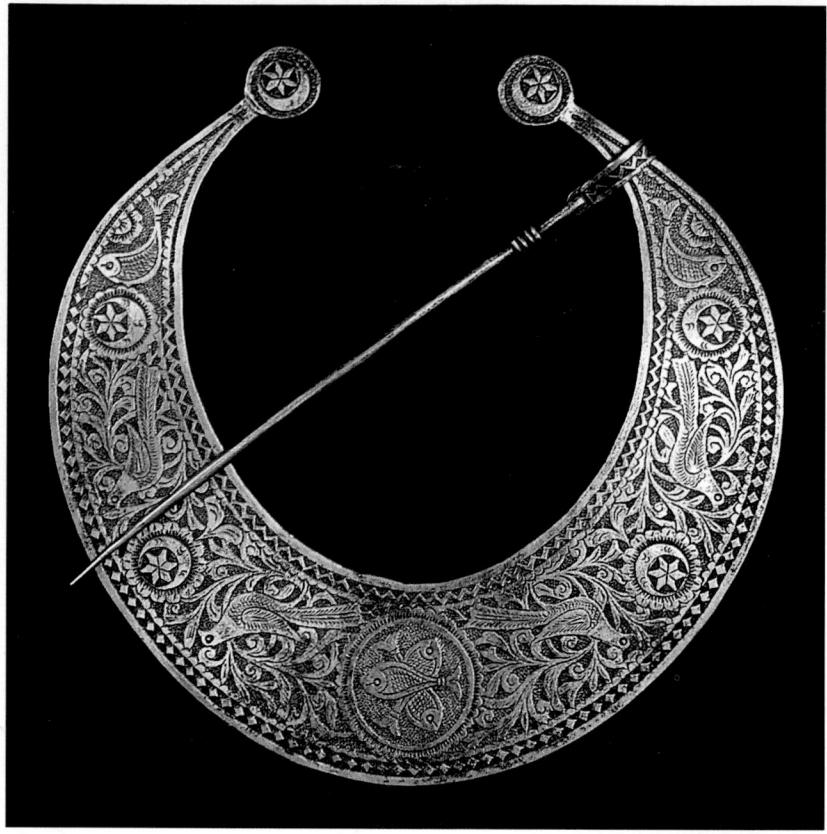

7.36

Fibula (*hål*)

Medenine, Tataounine

Tunisia

late 19th century

silver

diam. 17.4 cm; w. 4.4 cm

Musée National des Arts d'Afrique et d'Océanie, Paris, MNAM 66.7.13

Rural jewellery, often in solid silver, chased, moulded or engraved, and decorated with cornelians, coral, lapis lazuli or glass, is striking for its unusual curved forms, the rhythm of its concentric geometrical designs and the diversity of its decorative themes. In southern Tunisia the jewellery is often impressively large and heavy, reminiscent of that from Libya.

This fibula is designed to fasten a draped garment; it is crescent-shaped, with a silver ball fashioned from a cube with cut corners at either end. The design, chased on a matt background, consists of foliage with lively birds on either side of a flower formed from a crescent and a star. At the centre of the fibula there are three intertwined fish, carved in a circle with great freshness. The same motif can be found on wooden marriage chests painted in the 18th century and, in slightly different

form, on an Egyptian cup of the 18th Dynasty.

The crescent motif comes from ancient oriental astronomical designs used in Carthage in Punic times, either separately or in association with the star. Islam has kept both motifs, both for their design qualities and because they were associated with beneficent popular beliefs. The Ottomans took the crescent and star as their emblem and Husayn Bey, Bey of Tunis in 1824, adopted it as the emblem of Islam itself. The fish motif is very popular in this land of sailors; it is associated with the idea of fertility and with protection against the evil eye, hence its appearance on all wedding garments. The bird appears in innumerable stories and embodies the notion of rebirth.

MFV

Provenance: ex collection Renié, Paris

Exhibitions: Lons-le-Saunier 1970; Paris 1977; Paris 1995

Bibliography: Eudel, 1906, p. 181; Sugier, 1967; Gargouri-Sethom, 1983

The Berber carpets made in the plains and mountain areas of north Africa constitute a rich and varied group of pile and flat-woven textiles. Each Berber group has distinctive compositions, motifs, techniques and colours on its carpets. Berber rugs are woven by women on vertical heddle looms. The rugs form part of the traditional furnishings of the house or tent, where they cover a damp floor or are used as mattresses or blankets, wall-hangings or prayer rugs. The raw material is usually black or white sheep's wool; sometimes goat hair is used. The wool may be left its natural colour or dyed with plants or minerals. In the Atlas Mountains ochres made from metallic oxide are quite common; in the plains of Marrakesh the madder that grows along the banks of the River Tensift produces some astonishing reds. The wool is washed, sorted, combed, carded and dyed before being woven. The setting up of the warp on the loom is a complicated procedure that needs the skill of an older woman, but younger women are not allowed to escape this chore.

The most interesting Moroccan carpets are produced in three areas: by Berber transhumants of the Middle Atlas Mountains; by the Berber farmers of the High Atlas Mountains to the south; and by the Arabic-speaking farmers of the plains around Marrakesh and the central Atlantic plains. The carpets of the Middle Atlas are represented by examples from two tribes: the Zemmour and the Bani M'Guild.

The Zemmour are nomads on the plateaux that lie to the north and west of the Middle Atlas; the land is favourable to crop-growing and grazing. The Zemmour weave rugs whose smooth, velvety surface owes much to the even regularity of the knotting; their pile is shorter than that of the rugs woven by the groups living in the higher regions.

The Zemmour carpet (cat. 7.37a) has a red background and features two kinds of knot: the Ghordes knot over three threads, and the Berber knot over four threads. The design of diamonds, triangles, chevrons and checks, in yellow, pale green and blue, is organised on vertical lines. The 'x' motif, used by the Berber tribes to identify their possessions, is used extensively, in highly elaborate forms. The patterned area of the carpet has

no border, which helps give the impression of a limitless design.

Another carpet from the Middle Atlas Mountains (cat. 7.37b) is Bani M'Guild in origin, from the area to the south of Meknes. The carpet is flat-woven, and the colours are predominantly dark red with white, orange, yellow and pink motifs. The composition creates an interesting juxtaposition of horizontal and vertical panels, inset with panels of lozenges and triangles. The motifs in white appear to be embroidered but are in fact woven into the design.

The carpets of the settled Berber farmers of the High and Anti-Atlas are represented by an example from the Ait Ouaouzquite or the Glawa (cat. 7.37c). Its formal composition suggests an inspiration in urban carpets, perhaps those of Rabat. It is a pile carpet, using a variety of colours: purple, green, blue and white on a red background.

Carpets from the plains around Marrakesh and the Atlantic coastal plains, which are populated by sedentary Arabic-speaking tribes, are represented by two examples (cat. 7.37d–e). The area between Marrakesh and Essaouira, populated by nomadic Arab tribes who may have come from Egypt to set up their camps along the River Tensift in the 16th century, is heavily influenced by nearby Berber culture and carpetmaking in particular. The carpets woven in this area are known as 'Chichaoua carpets' after a former market.

The free, asymmetrical designs of some of the carpets of this region differ dramatically from the rigid geometric patterns of other regions. The motifs include wavy lines, triangles, diamonds and chevrons symbolising running water; unusually, they may also represent humans and animals – stylised fish, serpents, centipedes, scorpions and snakes, as well as houses, tents, teapots and rivers. The patterns are sometimes grouped around a central lozenge-shaped medallion. Their symbolism is not always clear, but some have suggested that the carpets document the transformation of tribal existence from a nomadic to a sedentary life.

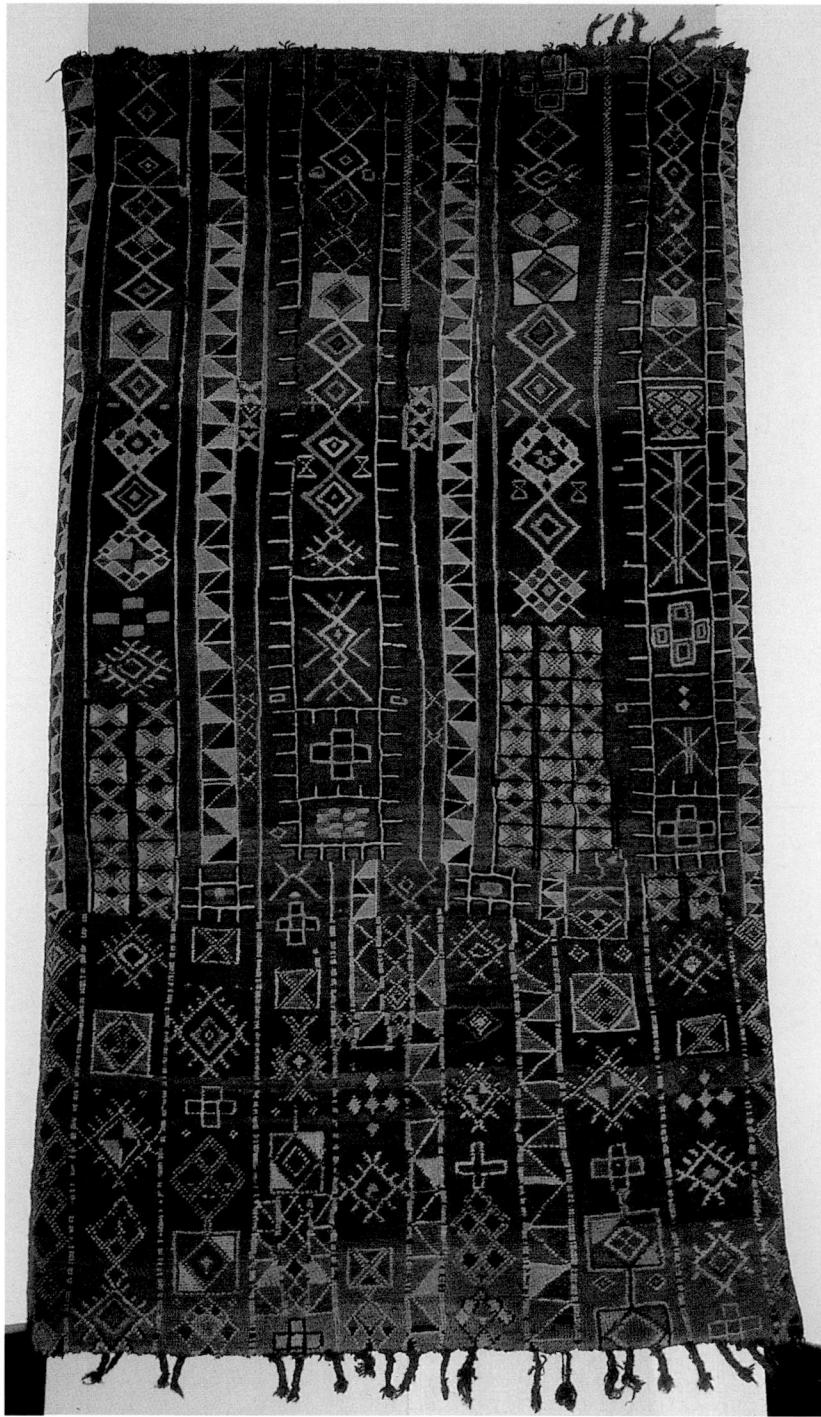

7.37a

Carpet (zerbiya)

Berber, Zemmour
Middle Atlas Mountains, Morocco
early 20th century
wool
290 x 160 cm
Musée National des Arts d'Afrique et
d'Océanie, Paris, M.77.4.7

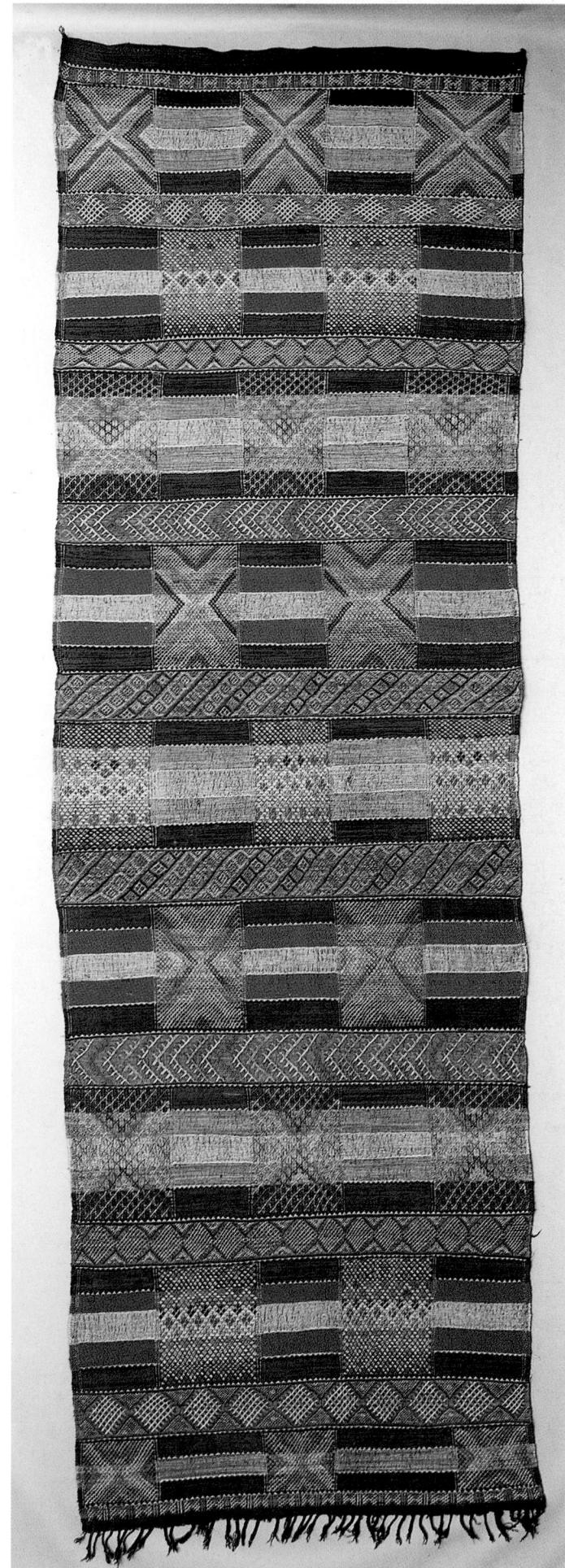

7.37b

Carpet (zerbiya)

Berber, Bani M'Guild
Middle Atlas Mountains, Morocco
20th century
wool, cotton
150 x 480 cm
Bert Flint

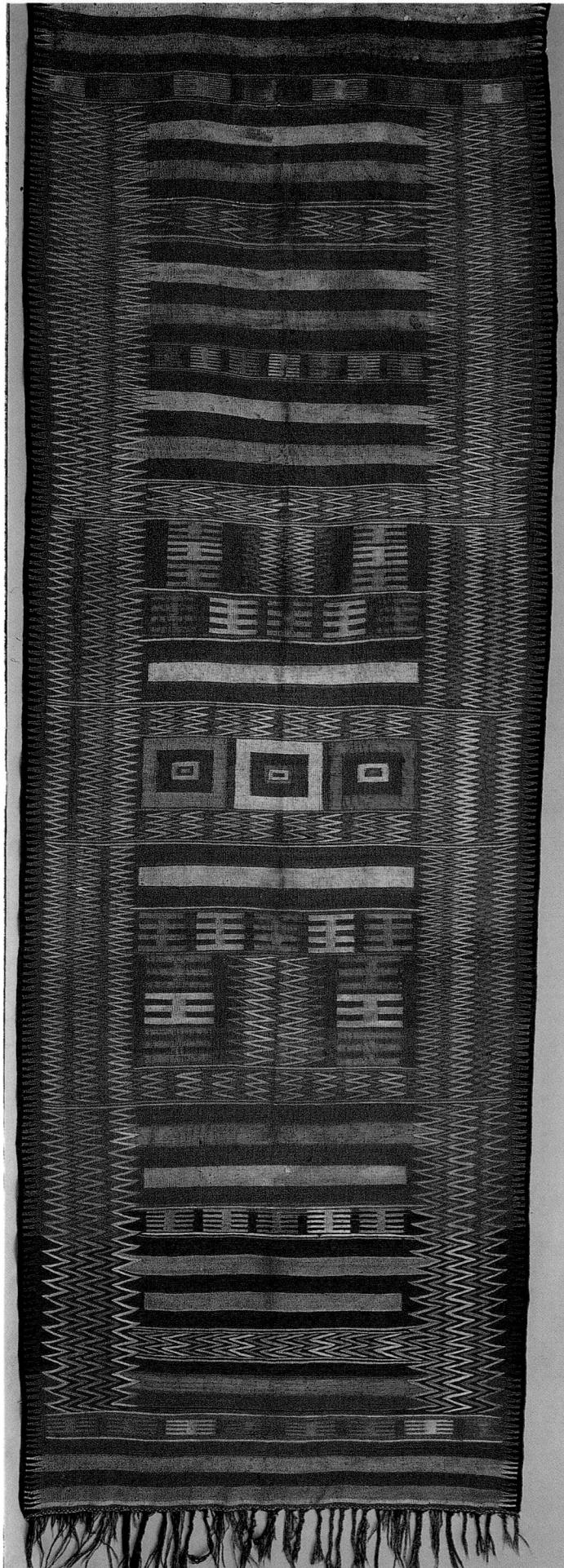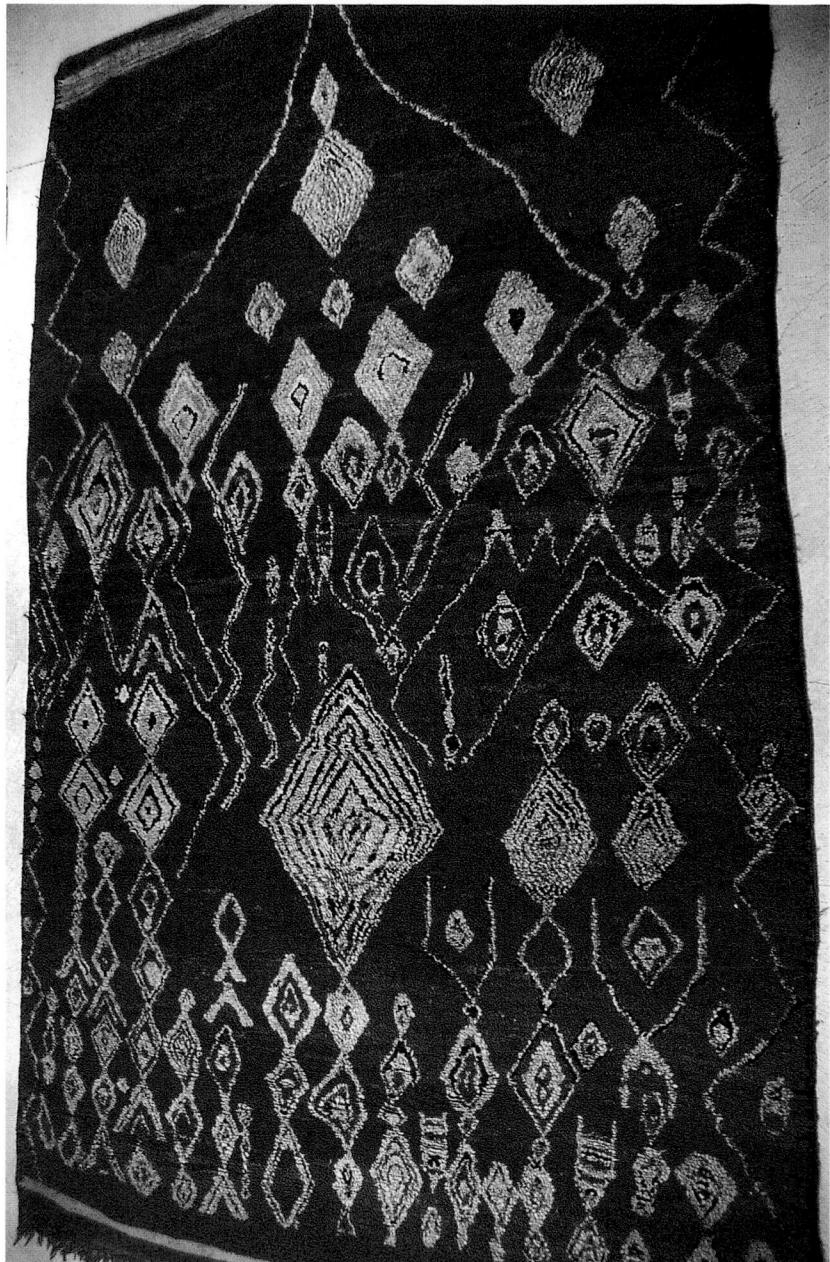

7.37c

Carpet (zerbiya)

Berber, Bani Ouaouzguite
High Atlas Mountains, Morocco
20th century
wool
Musée Dar si Said, Marrakesh

7.37d

Carpet (zerbiya)

Chiadma
Plains of Marrakesh, Morocco
early 20th century
wool
344 x 204 cm
Musée National des Arts d'Afrique et d'Océanie, Paris, M.88.1.1

Others have seen the influence of the western Sudan in the compositions and the bright colours.

White, yellow, green, blue and black designs are used on a red ground, but the colours tend to vary in tone and intensity more than in other regions. These two carpets from the plains of Marrakesh, like most of the rugs of this region, are woven with a pile. The Chiadma carpet-makers always used vegetable dyes: madder for the reds, pomegranate skin for the yellow, henna for the orange and indigo for the blue. These carpets are large in size, with big, tightly packed Ghiordes knots; the lacy black edges are made of a mixture of sheep's wool and goat hair, which makes them very strong. This type of carpet is no longer

7.40a–b

Two kohl pots

Coptic
Egypt
4th–5th century
ivory
h. c. 7 cm each
Museum of Coptic Art, Cairo, 1076, 7600

These two small bottles are containers for kohl, a black lead ore used as make-up for the eyes. They may also have been used as perfume or oil bottles. Cat. 7.40a is cylindrical; it has a lid and two small handles on the sides of the body. The surface of the body is decorated with engraved parallel lines. The lid is conical with a small handle on its top and an engraved line on its upper part. Cat. 7.40b has a bulbous body and a long neck; the lower part of the neck is engraved with three incised parallel lines. The surface of the body is decorated with three bands of incised decoration separated by two parallel incised lines. The pots probably belonged to a rich owner: ivory was expensive, even if widely used, and oil and perfumes were luxury items. CM

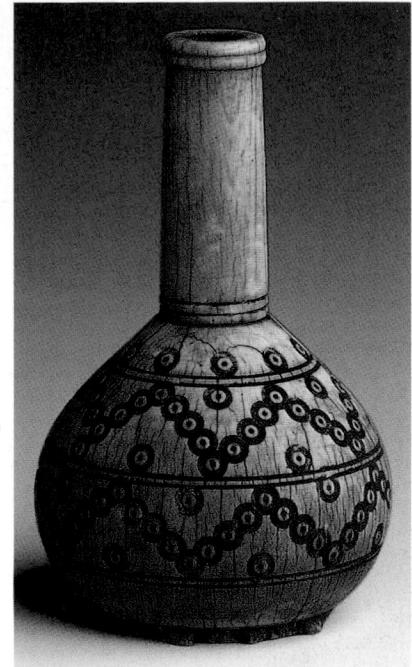

Bibliography: Badawy, 1978; Atiya, 1991

7.41

Beaker with animal handle

Coptic
Egypt
bronze
h. c. 12 cm; diam. 10 cm
Museum of Coptic Art, Cairo, 5086

This cylindrical vessel, used as a drinking-cup, has four small flat feet and a handle in the shape of a stylised feline; there is no decoration on the body of the beaker. The animal on the handle is in a vertical position with the legs attached to the body of the vessel. The head is inclined towards the rim; the mouth is open, the eyes are carved and the ears are shown in relief. The form of the vessel is sober, yet the feline handle gives it an elegance typical of Coptic metalwork. In Coptic Egypt metal-workers took their ideas from Rome, Byzantium and later from the Muslim world. It is difficult to determine whether the object is Christian or not: not all craftsmen were Christian. The Coptic era embraces the end of paganism, the conversion to Christianity and the beginning of the Islamic period. CM

Bibliography: Gayet, 1902; Strzygowski, 1904; Atiya, 1991, v; Benazeth and Gabra, 1992

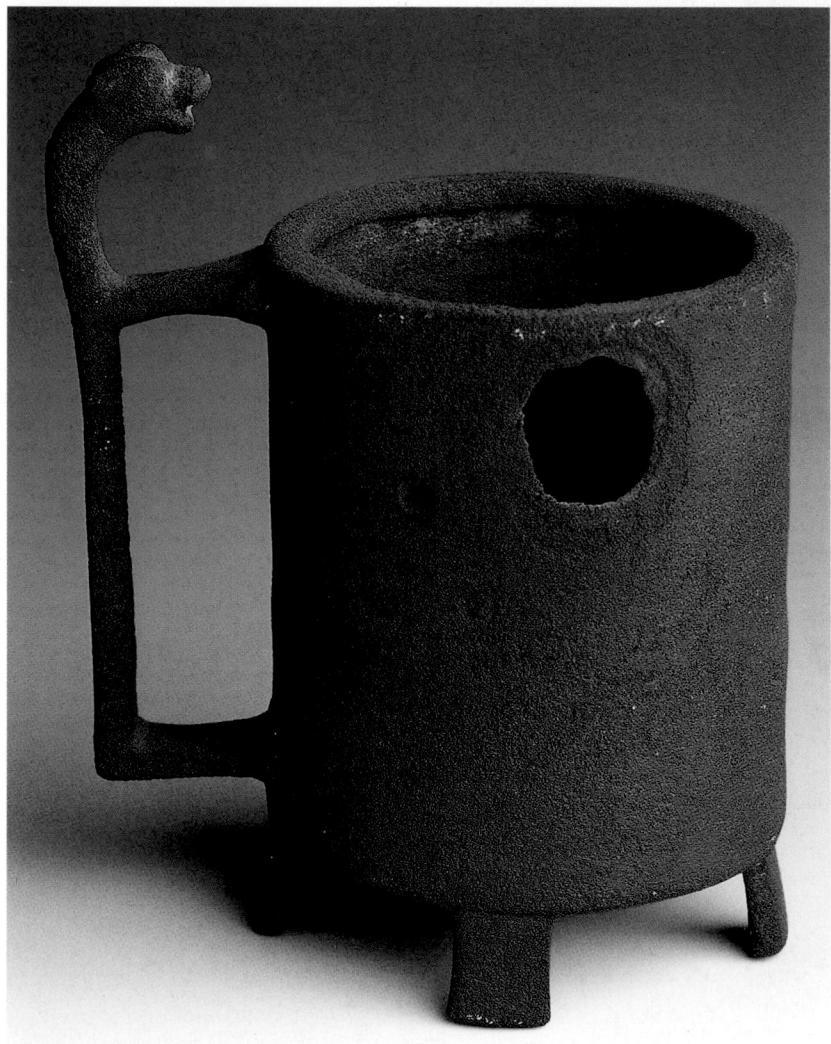

7.42

Two ostraka

Coptic
Egypt
7th–8th century
limestone
10 x 10 cm each
Museum of Coptic Art, Cairo, 4661, 4748

These two ostraka were probably used to try out various geometrical patterns and letters. The smaller ostrakon, drawn in black ink and painted with a fine brush, bears the Star of David inscribed inside a stylised flower and a rosette on the right; the remaining space is filled with letters, perhaps the names of the monks or craftsmen responsible. The larger piece has a more complex decorative pattern: the three interlacing bands in black ink are probably a trial design for a manuscript or painting, and the letters may be signatures or practice script.

Ostraka are found throughout Egypt from the New Kingdom to the Coptic period. The word is derived from the Greek for pottery fragment: in ancient Greece votes were cast on pot-shards on the banishment of citizens (hence 'ostracise') but the meaning has been extended to include shards bearing marks, drawings and inscriptions of various kinds. The use of ostraka for such inscriptions was a result of the high price of papyrus and parchment and of an obsessive need to write everything down.

Ostraka began to be used even for important documents such as official contracts. In some Egyptian monasteries the libraries were filled with ostraka of official letters and literary texts. CM

Bibliography: Atiya, 1991, vi

7.43

Panel

Coptic
Egypt
5th century
limestone
c. 60 x 100 x 60 cm
Museum of Coptic Art, Cairo, 7061

This is a fragment of a larger decorative panel, probably a pediment or a niche-head. It represents Daphne being transformed into a tree. She is naked, with her hair arranged in a Greek coiffure and both arms raised, holding two symmetrical and stylised foliated stems. Figures from pagan mythology, such as Venus, Dionysus, the Nereids, and Leda and the Swan, mainly taken from the Hellenistic repertoire, are found in Coptic sculpture throughout Egypt. Owing to the syncretism of Coptic Christianity, Coptic artists were able to depict nude pagan figures, their font of inspiration in a country imbued with such a heterogeneous cultural heritage, without fear of causing offence. The sculpture is in the so-called 'Ahnas Style', which was not confined to Ahnas (a major centre at the entrance to the Fayum oasis from the valley) but influenced sculpture throughout Egypt. The manner of representing Daphne may be termed 'soft', with a smoothness of carving in the shape of the body, stylised facial features and vivacity of movement (as opposed to the 'hard' style, with more static characteristics). CM

Provenance: Ahnas

Bibliography: Gayet, 1902; Beckwith, 1963; Badawy, 1978

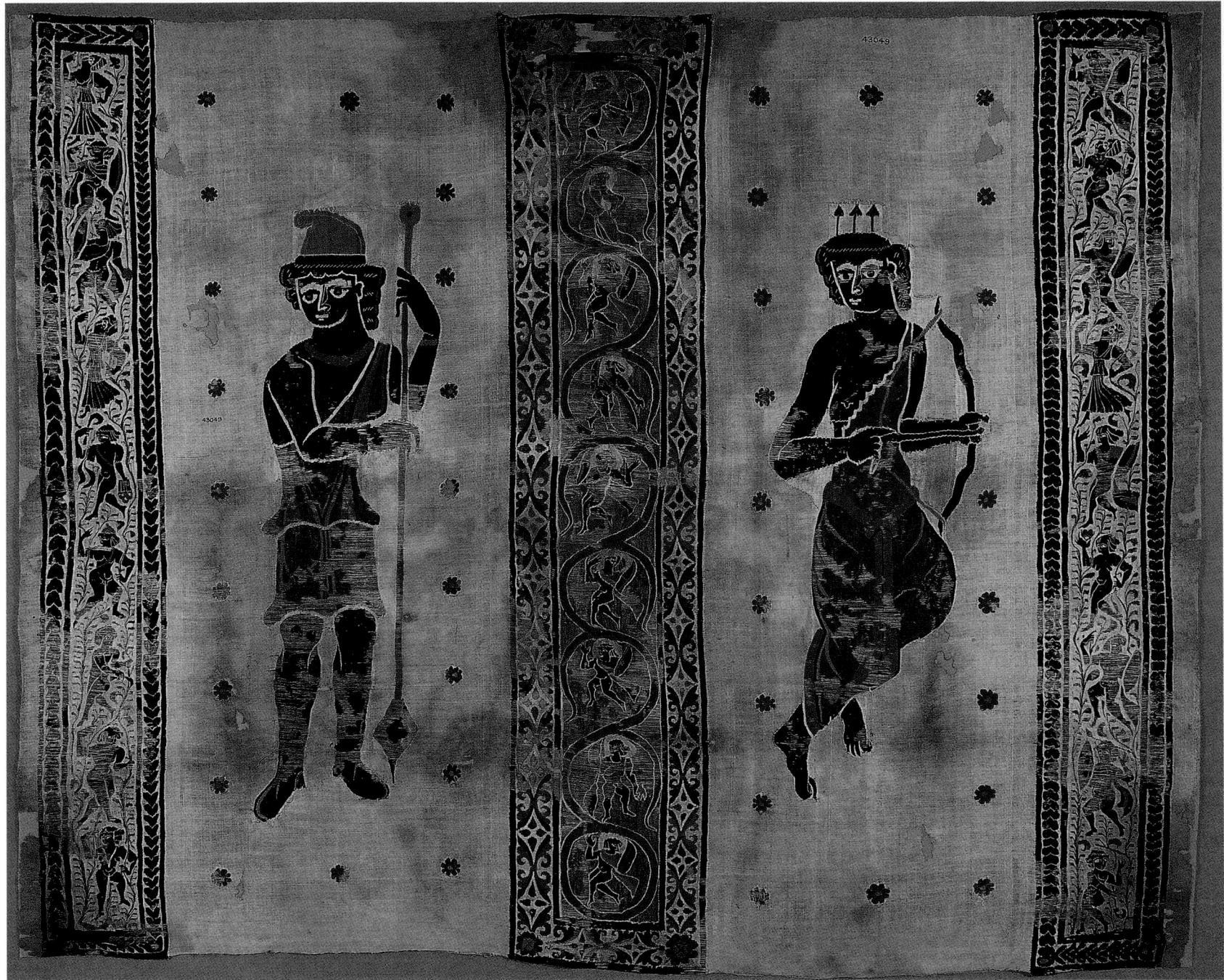

7.44

Textile

Coptic
Egypt
4th–5th century
linen

147.3 x 183 cm
The Trustees of the British Museum,
London, EA.43049

This large tapestry in coloured wools and undyed linen is decorated with three vertical bands and two large human figures. The vertical bands show dancing male and female figures. In the side bands the female figures wear long pleated dresses and the males flying cloaks. The dancers are on a background of vine tendrils;

the border of both bands is composed of heart-shaped motifs. The central band has a formalised floral border; inside a scroll pattern there are male dancing figures, each with a cloak. The left side of the tapestry features a standing male figure holding a reversed spear; he is dressed in a short green skirt, partly covered by a cloak fastened on the left shoulder, and wears a necklace and a pointed hat (the latter probably of western Asiatic origin). The spear and the hat probably indicate that he is of divine or heroic stature. The female figure on the right is drawing a bow. A quiver with three arrows is slung on her

back. Both figures have a border composed of stylised red flowers. The dress and posture of the figures suggest that they represent Artemis and one of the hunters associated with her – Actaeon, Orion or Meleager.

The treatment of the figures and the stressed whites of the eyes, heavy eyebrows and stylised hair marks the divergence of Coptic art from classical, Greco-Roman forms. The vertical bands with added roundels became a typical feature of Coptic textiles in later periods and the mythical figures turned into the saints and angels of the following centuries.
CM

Provenance: Akhmim (?)

Bibliography: Badawy, 1978; Quirke and Spencer, 1992

7.45

Panel

Coptic
Egypt
limestone

5th–7th century
31.2 x 62.4 cm

The Trustees of the British Museum,
London, EA.1531

This limestone panel is engraved with three circles, each formed by six swastikas; the swastikas further to the right and left of the central circle are also part of the two side circles. Different subjects are engraved in the centre of each circle: the one on the left is filled with a rosette of petals and lancet-like leaves; the middle one has a hexagon with a central relief boss; and the one on the right features a dove with its head turned backwards. The panel is not finished on either side. It belonged to a longer decorative frieze, which may be identified by the position of the bird as having been horizontal; given its heaviness and format, it probably comes from a wainscot. The intricate motifs carefully carved in a refined technique confirm the *horror vacui* of Coptic sculptors. During the 7th and 8th centuries AD Coptic art, and especially sculpture, reached stylistic independence. Although there are still elements of Greco-Roman motifs and iconography, these have been absorbed and modified by local artists. While the provenance of this piece is uncertain, a convincing parallel may be cited from Saqqara. CM

Provenance: Saqqara, Monastery of Apa Jeremias (?)

Bibliography: Quibell, 1912; Duthuit, 1931; Badawy, 1978

Panel

Coptic
Egypt
4th–5th century
limestone
h. 40 cm
Staatliche Sammlung Ägyptischer Kunst,
Munich, AS 5528

This panel represents a naked kneeling youth with short curly hair and both arms raised; he is carved within an arch and hands and legs are badly damaged. It may represent the New Testament story of the man cured of paralysis, a theme symbolising salvation in early Christian art and found in other Coptic sculptures.

The posture, with both hands raised probably carrying a bed, distantly recalls the figure of the pharaonic god Shu carrying the sky.

It is difficult to date this work precisely, but the 4th–5th century would seem likely. In their earliest attempts to represent Christian subjects the Egyptians drew on late Hellenistic, Roman and ancient Egyptian iconography. Coptic artists reused motifs they had seen throughout Egypt, left by previous artists, or reinterpreted motifs seen by the artisans in the nearest countries of the Mediterranean. Motifs, including mythological subjects, Egyptian gods and goddesses and animals, that did not have too manifestly pagan connotations were adopted to serve the Christian creed. The clearest example is Isis suckling Horus, interpreted as the forerunner of all later statues and paintings of the Madonna and Child.

CM

Bibliography: Beckwith, 1963; Badawy, 1978

7.47

Carved panel

Egypt
second half of 9th century
wood
58 x 45 cm

Museum of Islamic Art, Cairo, VII 13173

This arched panel, made from a thick block of a local type of wood called *aziza*, is carved with a design based on the heads and necks of two geese, ending in floral designs of stylised leaves. The carving is in the 'bevelled' style in which the carved edges of one design slope into the next, leaving no space behind the designs. The *horror vacui* aesthetic of this style was to become one of the main characteristics of Islamic art. The style originated during the 9th century in Samarra, capital of the Abbasid Caliphate on the Tigris in Iraq, and was used for wall decorations in both stucco and wood. The bevelled style became popular in Egypt during the reign of Ahmad ibn Tulun (868–884), a great patron of art and architecture, who employed builders, stucco carvers, carpenters and even musicians to make his capital equal to Samarra.

AY

Exhibition: London 1976, no. 437,
pp. 282–3

7.48

Panel from a cenotaph

Made for the grave of Muhammad b. Fatik Ashmuli (?)
Cairo
AD 967 (356 AH)
marble
39 x 75 cm
The Trustees of the British Museum,
London, OA.1975.4-15, 1

This rectangular marble panel from a cenotaph is carved on both sides with Arabic inscriptions. The inscription on the outer side consists of the beginning of the *basmala*, 'in the name of God the Merciful'; that on the inner side again begins with the *basmala*, followed by the name of the deceased, Muhammad b. Fatik Ashmuli (?) and the date of his death in the month of Jumada II AD 967 (356 AH). The inscriptions are both in the angular Kufic script but they are markedly different in style. The ornamental Kufic on the outer surface creates a monumental effect. It is carved in high relief with rounded letter forms, several terminating in leafy forms, within a raised frame. The simpler but elegant Kufic on the inner surface is incised into the stone and ornament is limited to the barbed tops of the letters.

The bevelled sides and the incomplete outer inscription indicate that this panel would have been at the head of a low screen or open cenotaph erected around the grave. Three other panels, two adjoining to form the long side of a similar cenotaph and another short side, are in the Islamic Museum in Cairo. Their outer surfaces are carved with parts of chapter CXII from the Quran. This panel probably formed the beginning of the same or a similar Quranic quotation.

Differences in epigraphy suggest that these panels come from three different cenotaphs but they must have been produced in the same workshop over a short period of time in the mid-10th century. Another long panel in the Gayer Anderson Museum in Cairo is closer in style and may have been part of the same sarcophagus. It is missing its lower part but the inscription ends *al-hamdu lillah* ('praise be to God'), which occurs many times in the Quran. RW

Exhibition: London 1976, p. 302, no. 477

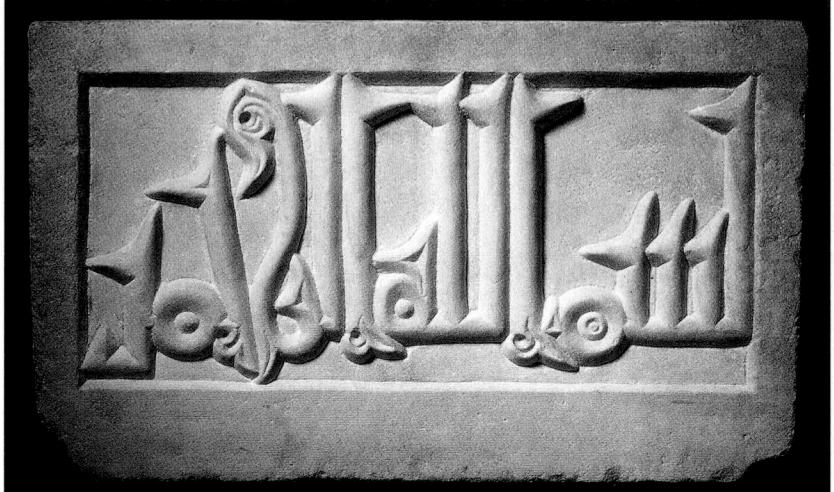

7.49

Four chess pieces

Egypt (?)
10th–11th century
ivory
The Trustees of the British Museum,
London
(a) King or Queen, 1856.6-12.4
h. 3.8 cm
(b) King or Queen, 1862.8-9.2
h. 5.6 cm; diam. 5.1 cm
(c) King or Queen, 1877.8-2.8
h. 3.8 cm
(d) Knight, 1881.7-19-47
h. 5.4 cm; diam. 3 cm

It is generally accepted that the game of chess as we know it originated in India. From there it reached Persia during the Sassanian period (c. 6th century), and became very popular during the Islamic period. References to chess in Arabic literature appear as early as the 8th century (Umayyad period), and treatises on chess and

names of great masters (such as al-Adli) start to appear in the mid-9th century; a testimony to the popularity of the game. From the Arab world the game passed to the West: examples of abstract pieces based on Islamic models include the 10th/11th-century Venafro chessmen, probably of Italian manufacture.

Contadini (1995) has divided ivory chess pieces of the Islamic period into two categories. The first includes pieces with human or animal shapes. The second consists of abstract pieces, in two different styles: style set A, which was especially popular during the 10th to 12th centuries; and style set B, which came to the fore in the 13th century.

The pieces exhibited here are wonderful examples of style set A. In this style the King and Queen have an identical shape variously inter-

preted as a stylised human figure on a throne or a ruler on a throne on top of an elephant's back. The Queen is always smaller than the King, but given that the pieces in question come from different sets (judging from their relative sizes, and the type of ivory and decoration) it is impossible to distinguish them. The Knight has a protuberance reminiscent of a horse's head (as opposed to the Bishop, which has two protuberances, reminiscent of an elephant's tusks).

The pieces are decorated with incised concentric circles, dots and lines. This type of decoration is frequently found on Islamic abstract chess pieces, dice and draughtsmen, and also appears on Roman draughtsmen and dice. *AC*

Provenance: (a): 1856, purchased by the museum from J. Webb; (b): 1862, purchased by the museum from Baron von Estorf; (c): 1877, purchased by the museum from Rev. Greville J. Chester, who had acquired it in Catania, Sicily; (d): 1881, purchased by the museum from Rev. Greville J. Chester

Bibliography: Dalton, 1909, pl. XLVIII, nos 225–8; Contadini, 1995, fig. 47

7.50

Ewer

Egypt
Fatimid
last quarter of 10th century
rock crystal
h. 18 cm; diam. c. 12.5 cm (at base);
thickness of crystal c. 2.5 mm;
thickness of relief c. 0.5 mm
Tesoro della Basilica di San Marco,
Venice, 80

Rock crystal occurs in crystals of hexagonal form, some only tiny specks, others as long as a metre. Because of its purity, beauty and permanence, it has been fashioned into objects of particular rarity from quite early times. The art of carving rock crystal reached a peak in the central lands of the Islamic world between the 8th and 11th centuries. This Fatimid jug is a fine example of a group of six precious rock crystal ewers with a relief-cut decoration made in Egypt in the 10th and early 11th century. The object has been carved from one piece of rock crystal and decorated by means of a bow drill by artisans who specialised in the carving of precious stones. The decoration, a pair of lions in heraldic posture, one on either side of the jug and separated by scrolls of interlaced branches and palmettes, is extremely fine. The thumb rest is in the form of a ram. The object is of particular importance because it bears a Kufic inscription around the shoulder with

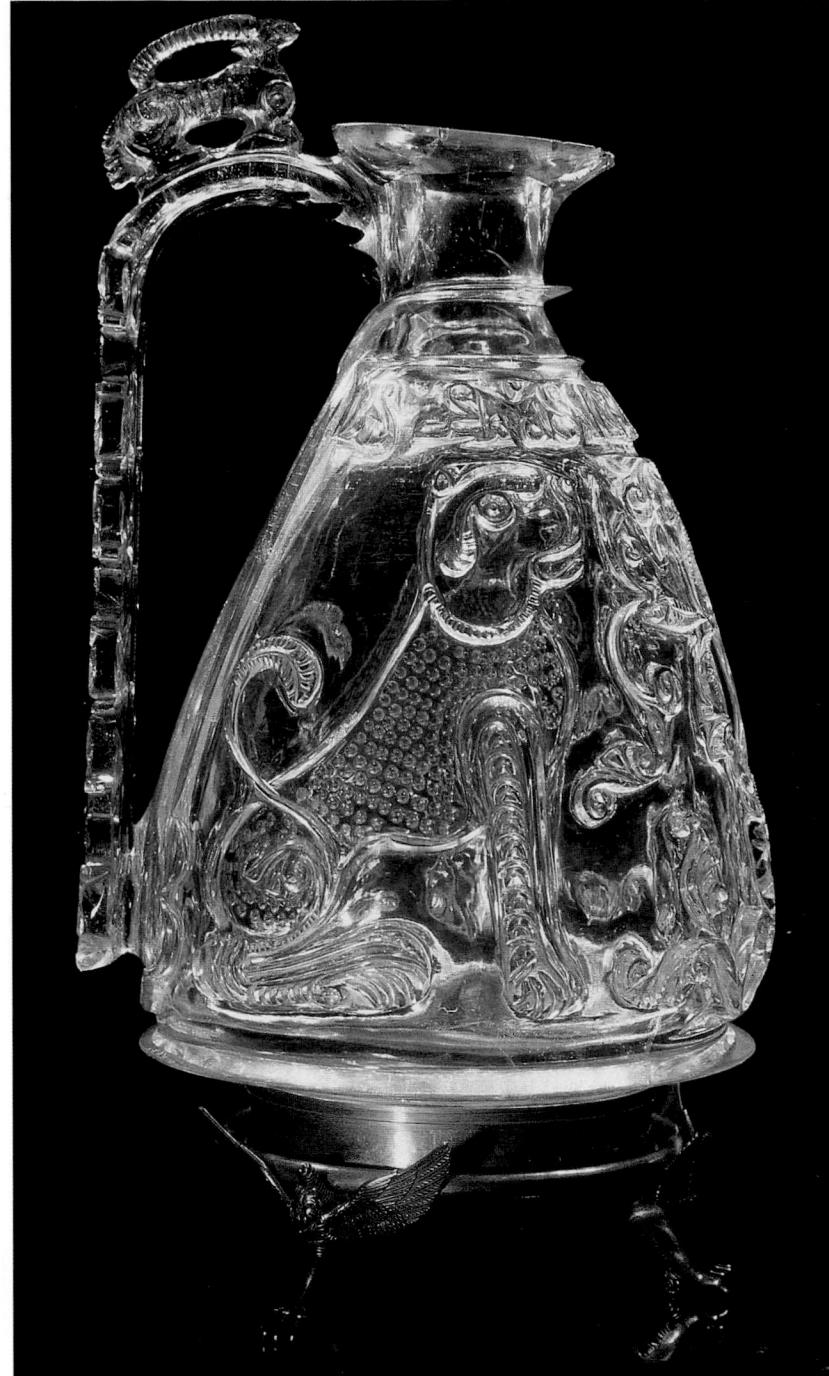

the name of the Fatimid caliph al-Aziz, who reigned between 975 and 996. It is therefore securely dated to the last quarter of the 10th century and can be used as a point of reference for dating other rock crystal objects. The inscription reads *baraka min Allah lil-Imam al-Aziz bi-llah* ('May the blessing of God be on the Imam al-Aziz bi-llah'). The piece is mounted with a gold and enamel European mount of the 16th century or later.

About 180 such Islamic rock crystals survive. Many of these are now in royal and church treasuries of western

Europe, some having arrived as early as the 10th century; others were found in archaeological excavations, notably those at Fustat. *AC*

Exhibitions: London 1984, pp. 224–9, no. 31; Berlin 1989, p. 194, fig. 215; Venice 1993–4, p. 153, no. 61

Bibliography: Lanci, 1845–6, ii, pp. 133–4, iii, pl. XLIV, fig. 3; Lamm, 1929–30, i, pp. 192–3, ii, pl. 67, no. 1; Erdmann, in Hahnloser, 1971, pp. 112–13, no. 124, pls XCIX–XCIX

7.51

Textile with embroidered calligraphic band

Egypt
Fatimid
10th–early 11th century
linen and silk
17.8 x 49.7 cm
The Trustees of the British Museum, London, 1901.3-14.20

This textile belongs to a special type known as *tiraz*. This is a general term for embroidery, but it is also used more specifically to refer to calligraphic or decorative bands found on garments for both men and women. Although the term *tiraz* ultimately refers to embroidered decoration, it is applied freely to bands created by other techniques, including weaving, painting and printing. In fact, the term *tiraz* is so imprecise that it is also used to designate the whole fabric industry.

During the Fatimid period the production of *tiraz* was a state monopoly, continuing earlier trends. According to Ibn Khaldun, writing in the 14th century, under the Umayyads and the Abbasids the cloth mills that supplied the royal wardrobe were housed in the palace and called *dar al-tiraz*. But under the Abbasids there was already a state-controlled *tiraz* workshop in Egypt. Most surviving examples, including this one, are from the Fatimid period. They mainly come from burial sites in Egypt.

The textile shown here is a splendid early Fatimid calligraphic *tiraz*. It is a yellowish, linen fabric decorated with an embroidered epigraphical band in blue silk. The inscription is in Kufic (angular) script and repeats *al-mulk lillah*, or 'sovereignty is God's'. AC

Provenance: 1901, entered the museum as part of the Major W. J. Myers Collection

7.52

Carved panel

Egypt
11th century
wood
28 x 255 cm
Museum of Islamic Art, Cairo, VII 4063

This wood panel is carved with hunting, dancing and music scenes and was originally painted in red, turquoise, black and white. It is one of several which decorated the reception hall in the residential apartment of Sayyida al-Mulk, the sister of the Fatimid Caliph al-Hakim (966–1021), in the western Fatimid palace built by the Caliph al-Aziz (975–996).

The wood panels were later reused in the hospital (*maristan*) built by Sultan Qalawun in the 13th century. There are other examples of wood being reused in different contexts in Cairo as Egypt has little native wood and imported wood was expensive. In the hospital they were placed upside down, probably because the figural designs were considered impious at that time. The courtly scenes depicted on this and the other panels evoke aristocratic life during the Fatimid period. Genre scenes of this type have a long history in Egypt, from the Pharaonic period to the Islamic era. AY

Exhibition: Cairo 1969, no. 220, p. 232
Bibliography: Herz, 1913, pp. 169–74, pls XXVIII–XXIX; Wiet, 1930, no. 21; Pauty, 1931, pp. 48–50, pl. XLVI; Marçais, 1935–40, pp. 240–57; Lamm, 1935–6, pp. 69–80; Hasan, 1956, no. 343, p. 442

7.53

Bowl

Egypt
Fatimid
first half of 12th century
white earthenware painted in lustre on a white glaze
h. 9.6 cm; diam. 22.3 cm
The Board of Trustees of the Victoria and Albert Museum, London, C.49-1952

The bowl has a high cylindrical footring, convex sides and a slightly out-turned lip. Inside, framed by two broad bands, is painted a figure traditionally identified as a 'Coptic priest', swinging a censer suspended by chains from his extended right hand. Beside him, to the right, is a cypress. Inner markings are everywhere scratched through the lustre, forming spiral designs.

The technique of lustre painting seems to be an Islamic invention. It appears on glassware as early as the 8th century and on pottery by the 9th century. The effect is achieved by applying a mixture of silver and copper oxides over the glaze and refiring it in a reduction kiln which extracts oxygen from the oxides and reduces them to a metallic state.

On the outside of this bowl a band of lustre is painted around the lip, and the inscription *sa'ad* in Kufic characters is written twice as a mirror inscription (and not with characters written in reverse, as is often stated). The inscription has long puzzled scholars. Butler thought that it was the 'attempt of a Copt in early Muslim days to render in Arabic the original Greek for prior or abbot'. But the bowl is now generally accepted as belonging to a group of vessels so inscribed, although the use of a mirror inscription remains unexplained. There has been much debate whether *sa'ad* is the name of a specific potter or painter; whether it should be interpreted literally as 'good luck' (a perfectly reasonable possibility, although the good-luck formula found on other contemporary objects is usually *sa'ada*, 'happiness, prosperity'); or whether *sa'ad* is the name of a workshop. This last hypothesis is the

one I think most likely. The relatively large amount of material with *sa'ad* inscriptions is so varied in type, style and iconography that it is unlikely to be the work of a single person.

Even during Islamic times the Copts were famous for their work in metal, their textiles and pottery, and there was a large Coptic community in Fustat (old Cairo), where the kilns were situated. It is hardly surprising, therefore, to find Christian imagery in luxury pottery which could well have been made by or for a Copt. Another striking example is provided by a shard painted in lustre with the head of Christ surrounded with a crossed nimbus. AC

Provenance: found near Luxor (?); ex Dikram Garabed Kelekian Collection

Bibliography: Kelekian, 1910, pl. 6; Butler, 1926, p. 54, pl. XI; Lane, 1947, pp. 22–3, pl. 26A; Caiger-Smith, 1975, p. 37, pl. B; Féhervari, 1985, p. 105

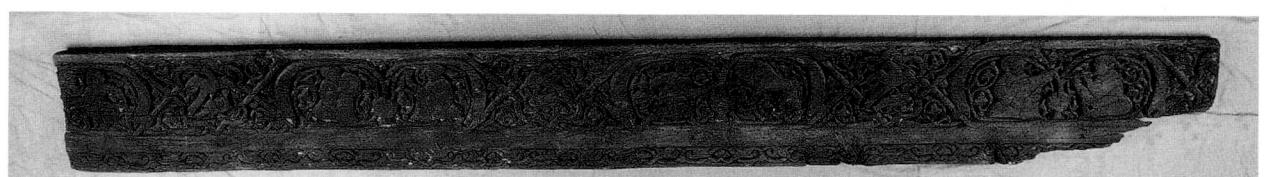

Water jar and stand (*kilga*)

Cairo

12th century and later
alabaster (jar), marble (stand)
h. 97 cm (jar and stand);
47 x 27.5 x 65 cm (stand)

Manchester City Art Galleries, 1934.235

Carved from a single block of marble, the *kilga*, or jar stand, consists of a rectangular open-topped base on four legs with a projecting basin. The exterior of the *kilga* is finely carved with a variety of flutes and arcades. Two female figures decorate the corners, two lion heads jut out above the basin and an Arabic benedictory inscription in Kufic script of the 12th century runs around the outer edge of the stand.

Originally the *kilga* would have held an unglazed earthenware jar (*zir*) which both cooled the water inside through condensation and cleaned it as it slowly filtered through the low-fired, porous body. The inhabitants of medieval Cairo used water polluted by local refuse and sewage. Ibn Ridwan, chief physician at the Fatimid court and author of a medical topography of Cairo written in the early 11th century, describes the purification of contaminated water: 'The best thing is not to use this water until it has been purified several times [by boiling and filtering] . . . the purified part is placed in a jar; only what seeps through the porosities of the jar will be used.'

Many *kilgas* were later furnished with stone jars. The jar associated with this *kilga* has a pointed base and was therefore always intended for suspension in a stand. Cups or ladles would have been attached to the rim so that water could be scooped out; the stone would have kept the water cool but would not have allowed it to permeate through into the basin and so the original function of the *kilga* would have been annulled.

Kilgas often demonstrate an unusual combination of Muslim and Coptic iconography. Here figures of seated females with hands raised, the traditional pose of a Christian at prayer, are combined with Arabic benedictory inscriptions. RW

Provenance: 1934, bequeathed to the galleries by John Yates

Bibliography: Ibrahim, 1978; Knauer, 1979, p. 71

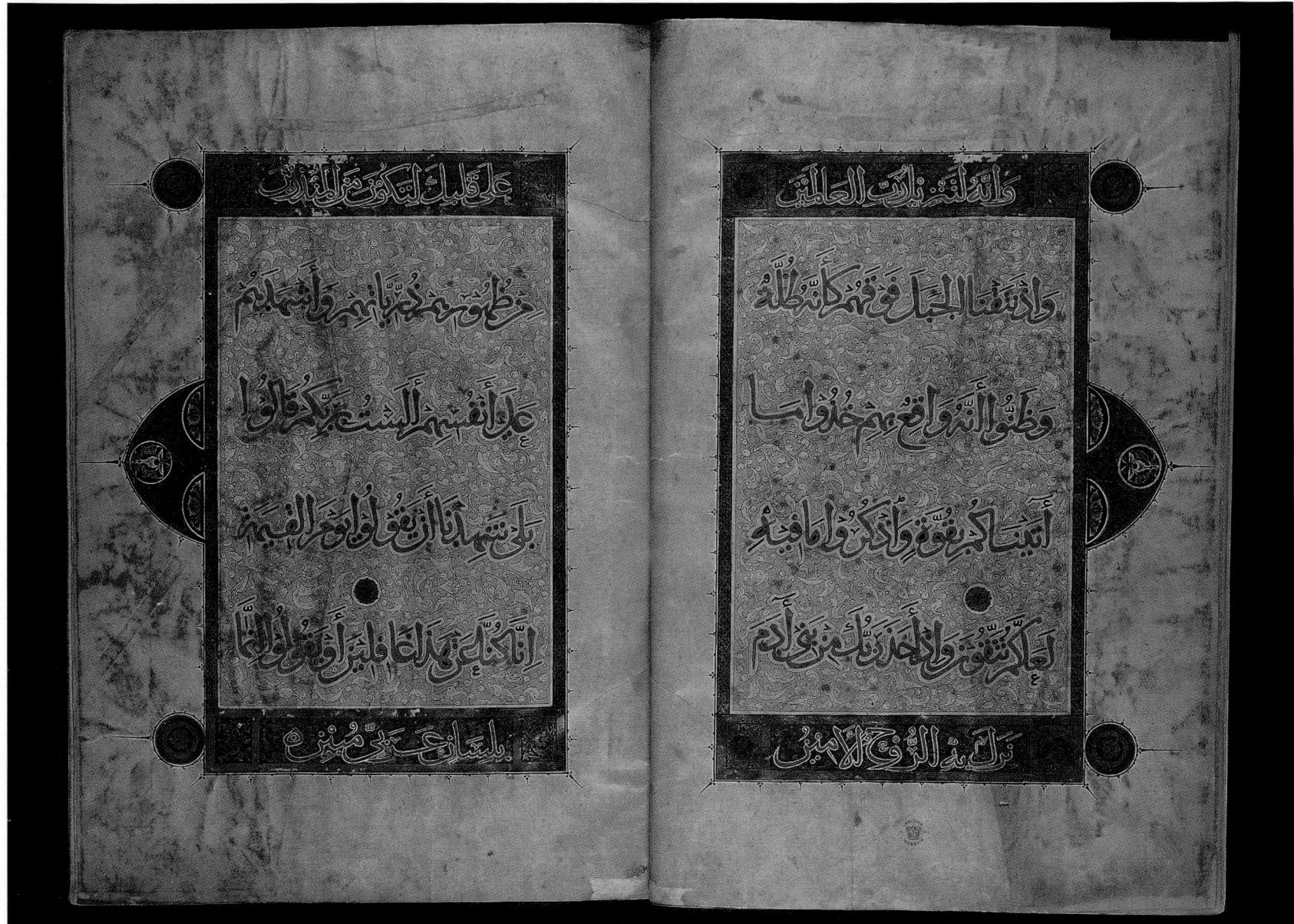

7.55

Volume of a seven-part Quran

Cairo
Egypt
AD 1305 (705 AH)
47 x 32 cm

The British Library, London, Add. 22408

This is volume three of a large Quran in *asba'* (seven divisions), written in *thuluth-ash'ar* script with a double page frontispiece and fine illumination throughout. It was copied by Shaykh Sharaf al-Din Muhammad ibn al-Wahid and illuminated by Abu Bakr, known as Sandal, for the Mamluk amir Rukn al-Din Baybars al-Jashnaqir (later Sultan al-Muzaffar Baybars 1309–10).

This is the earliest dated Mamluk Quran; it stands at the beginning of an exceptionally rich period of Quran production and is one of the finest of

them all. The writing of the Quran is recorded by several Mamluk historians. The fullest description is given by Ibn Iyas: 'In that year [AD 1305–6 (705 AH)] the *atabak* Baybars al-Jashnaqir began to build his *khanqah* which is in the square of Bab al-'Id opposite Darb al-Asfar. It is said that when the building was completed, Shaykh Sharaf al-Din ibn al-Wahid wrote a copy of the Quran in seven parts for the *atabak* Baybars. It was written on paper of Baghdadi size, in *ash'ar* script. It is said that Baybars spent 1600 dinars on these volumes so that they could be written in gold. It was placed in the *khanqah* and is one of the beauties of the age.' (James, 1988).

The calligrapher Ibn al-Wahid (*d.* 1311) was one of the best calligraphers of the 14th century and his

Qurans attained high prices. This one is written in gold outlined with a fine black line, a technique which was usually reserved for *sura* (chapter) headings.

The illumination of this and two other volumes was the work of Sandal, who signs this volume in the marginal medallion of the final colophon page. Sandal was also highly regarded by his contemporaries. The double frontispiece in this volume has a central star-polygon surrounded by interlocking geometric shapes which is characteristic of his style. RW

Exhibitions: London 19761, nos 66–9; London 19762, no. 527

Bibliography: Lane-Poole, 1886, pp. 225–6; Lings and Safadi, in London 19761, no. 62; Atil, 1981, p. 23; James, 1984, pp. 147–57; James, 1988, no. 1, pp. 34–75, 220

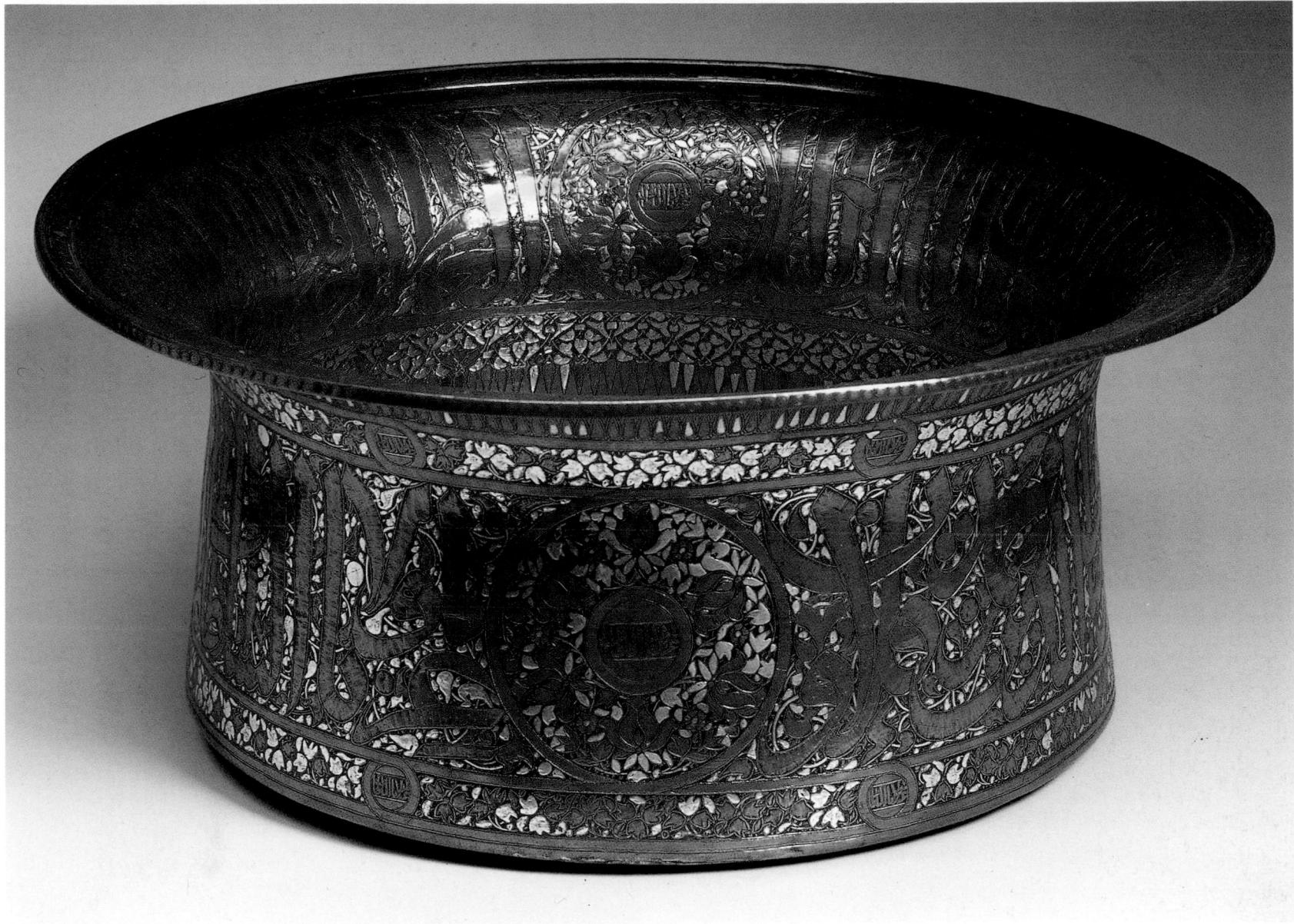

7.56

Basin

made for Sultan al-Nasir Muhammad ibn Qala'un, c. 1320–41

Cairo or Damascus
c. 1320–41

brass, gold, silver

h. 22.7 cm; diam. 54 cm.

The Trustees of the British Museum,
London, OA.1851. 1-4, 1

Majestic inscriptions in Mamluk *thuluth* script, originally inlaid with gold, decorate the interior and exterior of this large basin. They give the name and titles of the Mamluk Sultan al-Nasir Muhammad ibn Qala'un, who ruled between 1293 and 1341: 'Glory to our master the Sultan al-Malik al-Nasir the wise, the efficient, the warrior, the champion of the faith, the defender Nasir al-Dunya wal-Din Muhammad

ibn Qala'un, may his victory be glorious.'

Small medallions containing the epigraphic blazon of the sultan ('glory to our master the Sultan') are at the centre of the floral roundels which punctuate the inscriptions and are repeated in the narrow leafy borders on the exterior of the basin. The base is decorated with a large roundel filled with swimming fish.

Large basins like these were among the most prestigious of Mamluk metalworkers' productions. The fish in the base confirm that they functioned primarily as ablution vessels but their size and shape made them appropriate for a number of other uses also. The historian al-Jazari (1260–1338) describes a circumcision ceremony organised by Sultan Khalil for his brother Muhammad (before he

became sultan) at which each amir had to throw as many gold dinars as he had mamluks into a basin. The 14th-century Italian pilgrim Sigoli describes wedding festivities in Cairo during which women guests put gifts into a large basin placed by the side of the bride.

The long reign of Sultan al-Nasir Muhammad coincided with a period of prosperity and relative stability in the Mamluk empire. The sultan was responsible for making peace with his Mongol neighbours in Iran, after nearly a century of war between the two empires; this encouraged trade between Iran and Egypt and introduced a range of Chinese and Persian luxuries to the Mamluk court. The effect of these can be seen here in the lively lotus flower design in the main roundels, probably inspired by

roundels on Chinese textiles. The sultan was an active patron of art and architecture. He and his officers were responsible for commissioning many other inlaid brass vessels and were probably largely responsible for the blossoming of the Mamluk fine metalworking industry during the 14th century. *RW*

Provenance: 1851, acquired by the museum

Exhibition: Washington 1981, no. 26, pp. 88–91

Bibliography: Lane-Poole, 1886, pp. 227–8, 190; Migeon, 1907, ii, p. 206, fig. 164; Migeon, 1927, ii, pp. 76–7, fig. 253; Ross, 1931, p. 318; Wiet, 1932, appx no. 183; Sigoli, 1948, pp. 167–8; al-Jazari, 1949, pp. 28–9; Barrett, 1949, p. xviii, pl. 28; Zaki, 1956, nos 508–9, figs 508–9; Aslanapa, 1977, p. 76, fig. 9; Ward, 1993, p. 111, fig. 88

7.57

Incense burner

Egypt

14th century

brass inlaid with silver and gold

h. 20.5 cm; diam. 14 cm

Museum of Islamic Art, Cairo, VII 15129

This brass incense burner has a cylindrical body on three legs surmounted by a separate domed top and inlaid with silver and gold designs in bands, mostly containing floral ornament. The fastening of the domed lid with its tiny floral decoration appears to be a later addition. It may have been added at the same time as the second smaller dome which has a cross inside, suggesting that these later additions may have been an attempt to convert the vessel to Christian use. *AY*

Provenance: ex Ralph Harari Collection

7.58

Perfume sprinkler (*qumqum*)

Egypt

middle of 14th century

brass inlaid with silver and gold

h. 22.5 cm; diam. 7.6 cm

Museum of Islamic Art, Cairo, VII 15111

This brass perfume sprinkler (*qumqum*) has a pear-shaped body with a flaring foot and long tapering neck (the neck is a later replacement). The surface of the vessel is inlaid with silver and gold inscriptions and designs, the latter including lozenge patterns, *chinoiserie* floral scrolls, flying birds, geometric motifs and arabesques. The underside of the base is decorated with an embossed nine-petalled rosette with a foliate scroll in the recessed surround. The main inscription frieze contains the name and titles of Sultan Hasan: 'Glory to our lord the Sultan al-Malik al-Nasir Nasir al-Dunya wal-Din al-Malik al-Nasir Hasan.' The radial inscriptions in the three large medallions contain shorter versions of the same inscription. Small roundels in the frieze above and below the main inscription contain the sultan's epigraphic blazon 'al-Malik al-Nasir'. *AY*

Exhibitions: Cairo 1969, no. 79; London 1976, no. 255

Bibliography: Wiet, 1932, appx no. 255, p. 217; Mostafa, 1958, no. 70, fig. 29; Mostafa, 1961, pp. 48–9, fig. 42; Atil, 1981, no. 31, p. 98

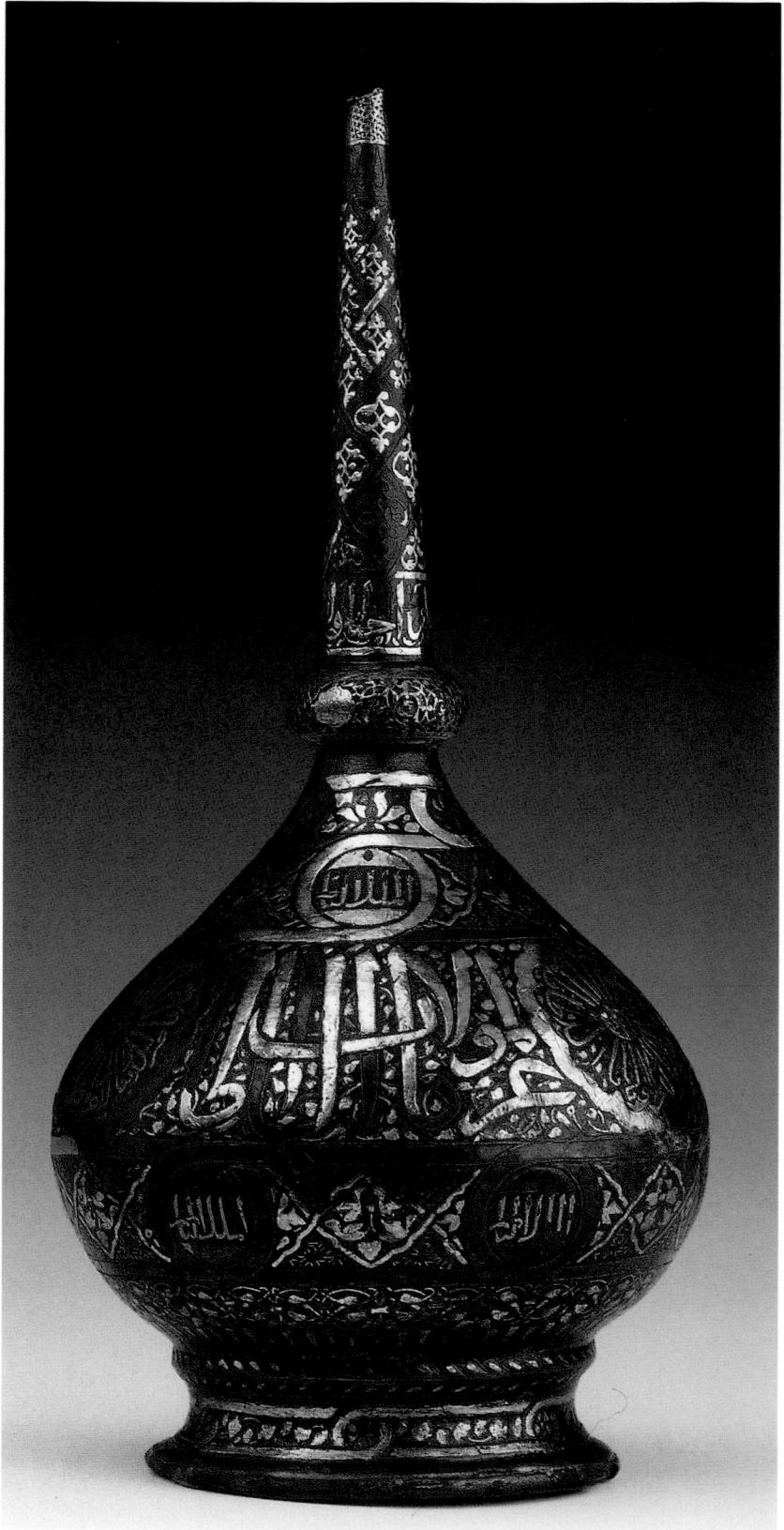

Chandelier

Egypt

c. 1360

brass

h. 220 cm; diam. 65 cm

Museum of Islamic Art, Cairo,
VII MIA 92

This octagonal brass chandelier is constructed in three tiers; with a domed top and eight legs, it has pierced and engraved decoration. Four shelves with crenellated edges around the chandelier have holes in which to insert glass oil lamps. Six more lamps would have been inserted into the cross-shaped holders above the dome. The chandelier would have been suspended from the ceiling but its legs enabled it to be placed securely on the floor while the lamps were being filled.

The fine *thuluth* inscription featured in the central section of the chandelier was engraved on a separate sheet of brass before being fixed in place. It contains the name and titles of Sultan al-Nasir Hasan (1347–51 and 1354–61): ‘Glory to our lord the Sultan al-Malik al-Nasir, the learned, the reformer, the just, the conqueror, defender of the faith, defender of castles and frontiers, the helper, the victorious, sultan of Islam and all Muslims, killer of unbelievers and polytheists, reviver of justice among peoples, defender of the world and faith, Hasan son of Sultan al-Malik al-Nasir, the defender of the world and faith Muhammad, son of al-Malik al-Mansur Qalawun, may his victory be glorious.’ AY

Provenance: found at the madrasa of Sultan Hasan, Cairo

Bibliography: Wiet, 1930, no. 54; Wiet, 1932, pp. 1–7, pl. XII

7.60

Glass beaker

Cairo

1300–20

glass, gilding, enamel

h. 11 cm; diam. (rim) 7.1 cm

The Trustees of the British Museum,
London, OA.79.5-22, 68

This cylindrical glass beaker with flaring rim is decorated with fish and eels in red enamel and gilded. Glass vessels with decoration were among the most sought-after products of Mamluk craftsmen. Many bear the official titles and blazon of the sultan or one of his officers. Others were decorated in a less specific style and sold to wealthy Egyptians or exported

across the world – to China, Europe, the Middle East, Arabia and other parts of Africa.

Delicate glass beakers such as this one provided a luxurious alternative to heavy, thick-walled, pottery drinking vessels. Filled with red wine, they are

shown in contemporary paintings held by sultans and courtiers, sometimes with a matching glass decanter placed nearby. Fish often feature in the decoration of these beakers as a pun on their function. Eels are rarer; they may have been intended to add a note of local realism as eels are plentiful in the Nile. The sight of fish and eels frolicking in red wine would have reminded the drinker of marine life seen through the muddy waters of the Nile.

The beaker was acquired in Quft (Koptos), 10 km north of Qus in Upper Egypt. During the Mamluk period, Qus was the administrative centre of the area and the third city of Egypt (after Cairo and Alexandria). Its strategic position on the Nile where it bends close to the Red Sea made it an important trading post for merchants travelling between Cairo and east Africa, Arabia or the Indian Ocean and its markets were renowned. Local Copts filled many of the administrative posts in the area, working under Mamluk governors and officials appointed by the sultan in Cairo. The lack of Mamluk titles decorating this vessel suggests that it was owned by a wealthy member of the Coptic community of Quft, but it was probably made in Cairo. RW

Provenance: 1879, bought by the museum from the Rev. Greville Chester who had acquired it in Quft (Koptos) in Upper Egypt

Bibliography: Schmoranz, 1899, fig. 29; Read, 1902, p. 222, figs 2–3; Dillon, 1907, p. 163; Honey, 1927, p. 290; Lamm, 1930, p. 343, pl. 138.1; Tait, 1979, p. 19, fig. E

7.61

Mosaic panel

Egypt

14th or early 15th century
marble, mother of pearl
26 x 101 cm

Museum of Islamic Art, Cairo, VII 3075

This panel has different coloured marbles and mother-of-pearl set into plaster to form a series of four semi-circular arches surrounded by geometric designs. It would originally have been set into the wall as part of a dado. It has been suggested that it came from the mausoleum of Barsbay (1422–38). Stone mosaic panels were frequently used as architectural decoration during the Mamluk period in Egypt. The composition of this one, particularly the semicircular arches made from bands of different coloured stones, reflects the use of *ablaq* (polychrome stone) in contemporary architecture. The use of different colours in architectural panels such as this one demonstrates the preoccupation of Mamluk craftsmen with polychrome decoration – seen in the enamelled glass, painted pottery and inlaid metalwork of the period. AY

Bibliography: Herz, 1906, p. 57, no. 23; Herz, 1907, p. 54, no. 23; Wiet, 1950, no. 15; Mostafa, 1961, p. 54, fig. 7; Atil, 1981, no. 107, pp. 212–13, no. 1

7.62a

Mosque lamp

made for the Mamluk Amir Sayf al-Din
Shaykhu
Cairo
c. 1350–5
glass, gilding, enamel
h. 35 cm
The Trustees of the British Museum,
London, OA.G.1985.497

7.62b

Mosque lamp

made for the Mamluk Amir Sayf al-Din
Shaykhu
Cairo
c. 1350–5
glass, gilding, enamel
h. 35 cm
The Trustees of the British Museum,
London, OA.S.333 (OA+521)

Enamelled and gilded glass lamps were commissioned in large numbers for the many mosques built in Cairo by the Mamluk sultans and their amirs. These lamps, in the shape of a footed vase with wide body, flaring neck and handles for suspension, follow a type known in both metal and glass since the 6th century. In Byzantium suspended lamps of this shape were sometimes used as a symbol of a holy place and this practice was continued during the Islamic period. The symbolism of the lamp was made more potent by a verse in the Quran (xxiv, 35) in which the light of a lamp is compared to the light of God. Many Mamluk mosque lamps, including these three examples, are inscribed with part or all of this verse: ‘God is the Light of the heavens and the earth; /the likeness of His Light is as a niche wherein is a lamp/(the lamp in a glass,/the glass as it were a glittering star)/kindled from a Blessed Tree,/an olive that is neither of the East nor of the West/ whose oil well-nigh would shine,/ even if no fire touched it.’

Two lamps (cat. 7.62a–b) are also decorated with a bold inscription frieze containing the name and titles of Sayf al-Din Shaykhu al-Nasiri: ‘By order of the noble and high excellency, the lord, the well-served Sayf al-Din Shaykhu al-Nasiri, may God make his victory glorious.’ Shaykhu’s blazon of a red cup on a gold ground with red upper field and dark blue lower field appears in the centre of the roundels on the neck and the underside of each lamp.

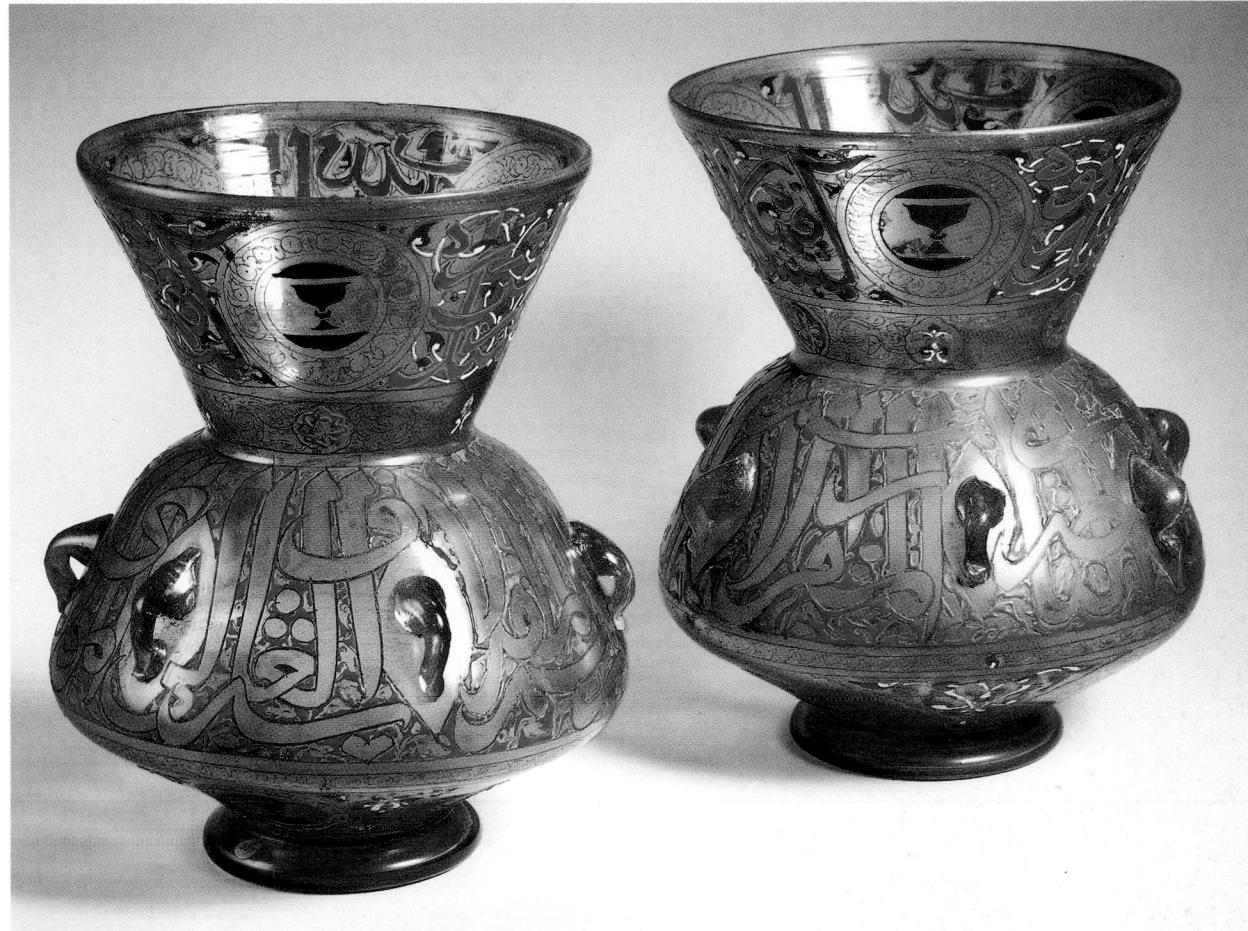

Shaykhu was a mamluk of Sultan al-Nasir Muhammad ibn Qala'un, but rose to prominence during the 1340s. After he helped to put Sultan al-Nasir Hasan on the throne for his second reign in 1354 he was effectively ruler of the Mamluk empire until he was murdered at court in 1357. Shaykhu's wealth and influence made him an important patron of art and architecture in Cairo; more than eleven mosque lamps inscribed with his name, titles and blazon have survived. A fragment of one of these is known to have come from Shaykhu's mosque at the foot of the citadel, which was completed in 1349; that is likely to be the origin of the present examples too. The mosque was considered to be one of the finest of its time. In 1355 he built a *khanqah* (Sufi monastery) opposite, and these two remain important architectural landmarks in Cairo. He also commissioned inlaid brass objects, including a fine tray inscribed with his name and titles in gold and silver.

The third lamp (cat. 7.61c) bears the titles of Sultan al-Zahir Barquq (1382–99). He was the first in a long line of Circassian sultans after more

than a century of rule by Sultan Qala'un and his descendants. In 1386 his madrasa, built next to the complex of Sultan Qala'un and the mosque of his son Sultan al-Nasir Muhammad and intended to outshine them both, was completed. He furnished this building with numerous enamelled glass lamps, many of which are preserved in the Museum of Islamic Art in Cairo. This lamp is typical of the group and probably came from the same building. RW

Provenance: cat. 7.62a: 1983, given to the museum by the descendants of F. Ducane Godman; cat. 7.62b: 1868, given to the museum by Felix Slade's executors

Bibliography: cat. 7.62a: Godman, 1901, p. 72, pl. 72; Lamm, 1930, pl. 192.10; cat. 7.62b: Franks, 1862, no. 4966, p. 388; Nesbitt, 1871, no. 333, p. 61 and pl. VIII; Nesbitt, 1878², pl. LXV, p. 57; Garnier, 1884, i, p. 295; Lane-Poole, 1886, pp. 216–17; Schmoranz, 1899, p. 48; Migeon, 1907, p. 355; Migeon, 1927, ii, p. 135; Wiet, 1929, appx. no. 60, p. 165; Tait, 1979, p. 155, fig. 168

7.62c

Mosque lamp

made for the Mamluk Sultan al-Malik al-Zahir Barquq
Cairo
c. 1386
glass, gilding, enamel
h. 30cm
Austrian Museum of Applied Arts, Vienna,
GL 3034

Mosaic panel

Egypt

14th or 15th century
stone, marble, plaster
28 x 28 x 1.6 cm

University of Pennsylvania Museum
of Archaeology and Anthropology,
Philadelphia, NEP 58

This wall panel is made up of cut stone in different colours, creating a 'square Kufic' inscription within a geometric border. The inscription reads: 'There is no God but Allah, Muhammad is the messenger of Allah, may Allah bless him.'

Mosaics of cut stone of contrasting colours were popular in Mamluk Egypt. They were used particularly as surrounds to fountains and, as here, panels to be set into walls. The earliest example of a square Kufic mosaic panel in Cairo is in the mausoleum of Sultan Qala'un (1285) but during the 14th and 15th centuries they became very popular and can still be seen on the walls of Mamluk buildings, such as the grand portal to the mosque of Sultan Hasan (1556).

The term 'square Kufic' is used to describe inscriptions contained within a square or rectangle where the verticals and horizontals of individual letters are aligned with the outer border. Square Kufic has been compared with Chinese seals, in which the character is also inscribed within a square, but the format may have evolved independently on Islamic coins. From an early period Islamic coins bear inscriptions arranged in a square, sometimes even framed by one, and it was a natural step to move from that to square Kufic in which the inscription is read clockwise around the square as the coin is turned in the hand.

The same inscription, arranged in an identical format, appears on a series of coins minted at Tabriz by the Il-Khanid ruler Abu Sa'id (1317–35). This direct quotation from an Il-Khanid coin is one of many examples of Mongol influence on Mamluk art after Abu Sa'id and the Mamluk Sultan al-Nasir Muhammad made peace in the 1320s, after nearly a century of war between their empires.

RW

7.64

Panel with inscription

Egypt
Ottoman period, 18th century
wood
30 x 77 cm
Museum of Islamic Art, Cairo, VII 11758

This wooden panel is carved with a religious inscription in square Kufic script in three lines. The inscription is in praise of God and calls upon the reader to depend upon him, but it is slightly ambiguous in places and may be missing a fourth line. This type of script became popular in Egypt in the 13th century and continued in use into the 18th century. Its angular forms are particularly suitable for architectural settings and it was widely used to decorate buildings throughout the Islamic world. Another panel from the same donation to the Cairo museum (no. 11742) is also inscribed in square Kufic with part of a verse from the Quran (LXI,13): 'Help from God and a nigh victory.' AY

Provenance: 1933, given to the museum through the endowment of ex-Prince Kamal al-Din Hussein

7.65

Panel in the name of Sultan

Qa'itbay
Egypt
1468–96
ivory set in wood
9.2 x 35.8 x 1.5 cm
Museum of Islamic Art, Cairo, VII 2334

The carved ivory panel bears an elegant *thuluth* inscription which can be translated as: '[Glory to] our lord the Sultan al-Malik al-Ashraf Qa'itbay, may his victory be glorious.' Sultan Qa'itbay, who ruled from 1468 to 1496, was a discerning patron of art and architecture. He commissioned several buildings in Cairo and would have provided them all with the necessary furniture and fittings. This panel is said to be from the madrasa of Qa'itbay completed in 1472–4. It would probably have been fixed to a wooden *minbar* (cat. 7.67) or to a door. AY

Exhibitions: Cairo 1969, no. 41; London 1976, no. 155

Bibliography: Wiet, 1950, no. 39; Atil, 1981, no. 105, pp. 210–11164

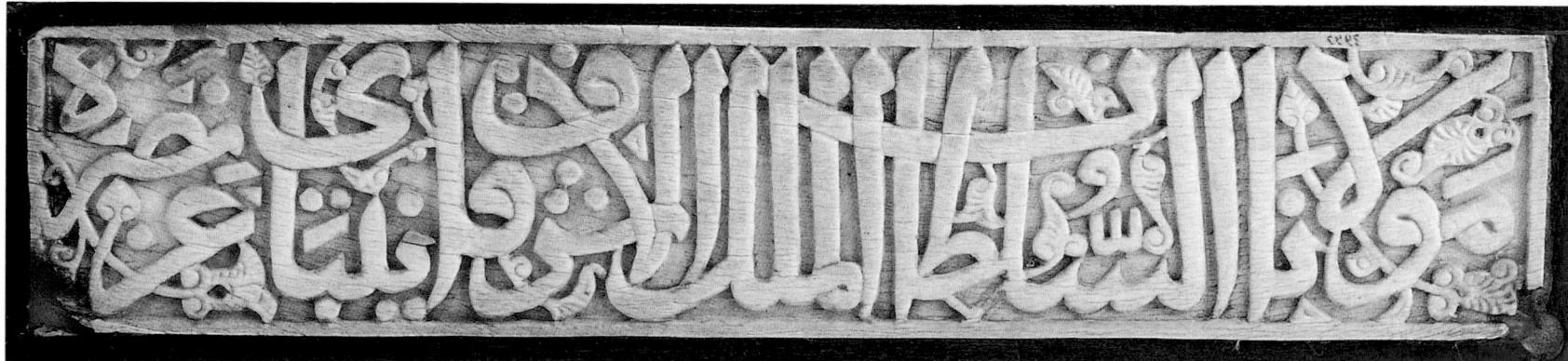

7.66

Carpet

Mamluk

Egypt

15th–16th century

wool

265 x 240 cm

Austrian Museum of Applied Arts,
Vienna, T 8346

This is a typical example of a large group of luxury carpets thought to have been produced in Egypt in the late 15th or early 16th century. Except for one example entirely in silk, Mamluk carpets are woven from a lustrous wool and this, together with the density of the knotting and the intricacy of the designs, gives them a characteristic sheen. The range of colours is invariably restricted; vermillion, brilliant blue and green predominate. In most cases kaleidoscopic designs are organised around three octagonal medallions or (as here) one central medallion. The borders feature alternating

cartouches and rosettes, while the field between the border and the central octagon is filled with complex designs based on eight-pointed stars and eight-lobed rosettes as well as characteristically Egyptian papyrus and lancet motifs.

Mamluk carpets are among the most controversial objects in Islamic art history. These exquisite textiles seem to have no real precursors in medieval Egypt and there is hardly any relevant textual evidence. There is no consensus about where the carpets were made, when they were made or why. Although many scholars believe that they were woven in Cairo

under the patronage of the Mamluk sultans, others have argued that they may have been produced in north Africa, Syria or Anatolia. Again, while many believe that production started in the 15th century under the patronage of the Mamluk Sultan Qa'itbay (and his heraldic blazon does feature on one surviving fragment), others argue that these carpets were not produced until after the Ottoman conquest of Egypt in 1517. Although it is possible that such luxury objects were produced for the ruling Circassian and Turkish military élite in Egypt, it is also possible that the carpets were chiefly made for export to the West. The squarish shape of this and other examples might indicate that they were made to be spread over European tables. The geometric design does, however, look characteristically Mamluk and has parallels in wood-work, book illumination and other media, but there is much debate about its meaning (if any). The central octagonal medallion has been interpreted as a stylised representation of a royal sunburst, of a central Asian mandala, of the Dome of the Rock in Jerusalem, of a courtyard fountain, or as the reflection of a coffer-vaulted ceiling beneath which the carpet would be spread. RI

Provenance: ex Imperial Hapsburg Collection

Exhibition: London 1983, p. 62, no. 22

Bibliography: Sarre and Trenkwald, 1926–7, i, pl. 47; Erdmann, 1962, pp. 14–15

Minbar for the Sultan Qa'itbay

Egypt
Mamluk
end of 15th century
wood inlaid with ivory
612 x 304 x 113 cm

The Board of Trustees of the Victoria and Albert Museum, London, 1050-1869

The *minbar* (pulpit) is one of the main furnishings of a Friday (congregational) mosque. It is placed to the right of the *mihrab* (the niche which gives the direction to Mecca), and is used by the imam leading the prayers or delivering the sermon.

The wooden *minbar* shown here bears the name and titles of the Mamluk Sultan Qa'itbay, who reigned between 1468 and 1496, but it is not known from which mosque it comes. It is sometimes reported in the literature to come from Qa'itbay's madrasa at Qal'at al-Kabsh in Cairo, but a *minbar* exists there still. As Lane-Poole put it: 'As one Sultan would sometimes place a pulpit in the mosque of another, and Kait Bey was especially generous in this kind of restoration, it is possible that the pulpit did not come from any of his own mosques'. This *minbar* consists of seven steps leading to a small landing, surmounted by an onion-shaped dome with a *mugarnas* (stalactite) decoration around its base. At the top of the dome there is a finial of three small spheres surmounted by a crescent, as found in Mamluk architecture, for example on top of the dome and minaret of the Qa'itbay complex in Cairo. The *minbar* has a door with two wings surmounted by a *mugarnas* decoration which shows traces of painting representing flowers and leaves in red and green. The triangular sides are decorated with a pattern of grooved strapwork radiating from sixteen-point stars, the various sections of which are filled with small, finely carved ivory tiles. The balustrades consist of rectangular panels decorated in a similar way; in their geometrical organisation they are reminiscent of full-page illuminations in Mamluk Qurans. A wooden *minbar* obviously based on the one shown here is that made in 1480 for the mosque of Qajmas al-Ishaqi, one of Qa'itbay's amirs; it remains *in situ* and is almost identical in shape and decoration. Qa'itbay's *minbar* is possibly one of the last examples of Mamluk wood-

work to use ivory inlay; that of Qajmas al-Ishaqi has bone inlay, reflecting the current economic need to use inexpensive materials.

The word *minbar* is often pronounced, and therefore transcribed, as *mimbar*, but it comes from the root 'n-b-r' which in Arabic means 'high, elevation, stand'; it is more probably a loan-word from the Ethiopic, with the sense of 'seat, chair'. The *minbar* was primarily the throne of the Prophet in his capacity as a ruler, for the proclamation of important announcements. It is reported that the Prophet's *minbar* consisted of two steps and a seat. It was portable and indispensable for later rulers when they wished to make a public appearance. The *minbar* was used by early Islamic rulers or their governors as a seat from which to address the Muslims at the Friday worship, in keeping with the additional use of mosques in the Umayyad period as places of political assembly. Its function as a purely religious pulpit seems to have been established towards the end of the Umayyad period, and by the 8th century it had started to become a standard item of mosque furniture throughout the Islamic world.

As a symbol of authority the *minbar* was an important feature not only of the mosque, but also of the community. Muslim towns could be categorised according to whether or not they had a *minbar*; cities with more than one being considered prosperous.

The shape of the present *minbar*, with a domed canopy, a doorway and decorative elements consisting of stars and polygons made up of carved pieces of wood, became standard in Egypt, Syria and Turkey from the Fatimid period onwards. During the Mamluk period elaborate inlay of ivory, mother-of-pearl and various types of wood began to be used. The *minbar* on exhibition is a superb example of this late Mamluk type.
AC

Provenance: from the Meymar Collection; 1869, purchased by the museum

Exhibition: Paris 1867

Bibliography: Lane-Poole, 1886, pp. 113-15, fig. 34; Sourdel-Thomine and Spuler, 1973, no. 309; Blair and Bloom, 1994, pp. 109-10, fig. 141

BIBLIOGRAPHY

- ABBINK, 1994 J. Abbink, 'Review of Sleeping Beauties', *Museum Anthropology*, 18 (3), 1994, pp. 81–2
- ABIODUN, DREWAL and PEMBERTON, 1991 R. Abiodun, H. J. Drewal and J. Pemberton, *Yoruba Art and Aesthetics*, Zurich, 1991
- ABRAHAM, 1940 R. C. Abraham, *The Tiv People*, London, 1934, 2nd edn 1940
- ABRAHAMS, 1967 R. G. Abrahams, *Peoples of Greater Uyamwezi, Tanzania*, London, 1967
- ABRAHAMS, 1981 R. G. Abrahams, *The Nyamwezi Today: A Tanzanian People in the 1970s*, Cambridge, 1981
- ADAMS, 1974 B. Adams, *Ancient Hierakonpolis*, Warminster, 1974
- ADAMS, 1977 W. Y. Adams, *Nubia, Corridor to Africa*, London, 1977
- ADAMS, 1978 M. Adams, 'Kuba Embroidered Cloth', *African Arts*, 12 (1), 1978, pp. 24–59, 106–7
- ADAMS, 1988¹ V. Adams, *Predynastic Egypt*, Aylesbury, 1988
- ADAMS, 1988² M. Adams, 'Double Perspectives: Masking Among the Wé/Guére, Ivory Coast', *College Art Journal*, 47 (2), 1988, pp. 95–102
- ADAMS, 1989 M. Adams, 'Beyond Symmetry in Middle African Design', *African Arts*, 25 (1), 1989, pp. 35–45, 102–3
- ADANDE, 1994 C. Adande, 'Le Bochio: Une sculpture de rien qui cache tout', in *Mélanges Jean Pliya*, Cotonou, 1994, pp. 111–34
- ADEOYE, 1989 C. L. Adeoye, *Igbagbo ati Esin Yoruba*, Ibadan, 1989
- ADIE, 1952 J. J. Adie, 'Zanzibar Doors', *Guide to Zanzibar*, Zanzibar, 1952, pp. 114–16
- AFOLAYAN, 1989 F. S. Afolayan, 'The Esie Lithic Culture: Perspectives from the Igbo-minna Tradition', paper presented at the Seminar on Material Culture, Monuments and Festivals in Kwara State, National Museum, Esie, Nigeria, 1989
- AGIRI, 1972 B. A. Agiri, 'The Ogboni among the Oyo-Yoruba', *Lagos Notes and Records*, 3 (2), 1972, pp. 50–9
- AL-HASSAN and HILL, 1992 A. Y. Al-Hassan and D. R. Hill, *Islamic Technology: An Illustrated History*, Cambridge, 1992
- AL-JAZARI, 1949 Al-Jazari, *La chronique de Damas d'al-Jazari*, trans. J. Sauvaget, Paris, 1949
- ALDRED, 1971 C. Aldred, *Jewels of the Pharaohs*, London, 1971
- ALDRED, 1975 C. Aldred, *Akhenaton and Nefertiti*, Brooklyn Museum, New York, 1975
- ALDRED, 1979 C. Aldred, in *Le temps de pyramides*, ed. J. Leclant, Paris, 1979
- ALDRED, 1980¹ C. Aldred, *Egyptian Art*, New York and Toronto, 1980
- ALDRED, 1980² C. Aldred, *Egyptian Art in the Days of the Pharaohs, 3100–320 B.C.*, London, 1980
- ALDRED, 1988 C. Aldred, *Akhenaten, King of Egypt*, London, 1988
- ALDRICH, 1990 J. Aldrich, 'The Nineteenth-century Carved Wooden Doors of the East African Coast', *Azania*, 25, 1990, pp. 1–18, pls 1–16
- ALEXANDRE and BINET, 1958 P. Alexandre and J. Binet, *Le groupe dit Pahouin*, Paris, 1958
- ALEXIS, 1888 M. Alexis, *Le Congo belge illustré*, Liège, 2/1888
- ALLDRIDGE, 1901 T. J. Alldrige, *The Sherbro and its Hinterland*, London, 1901, pp. 144–9
- ALLEN, 1976 J. Allen, 'A Somali Headrest', *MILA Institute of African Studies, University of Nairobi*, 5 (2), 1976, pp. 42–58
- ALLEN, 1989 J. de Vere Allen, 'The Kiti Cha Enzi and other Swahili Chairs', *African Arts*, 22 (3), 1989, 54–64
- ALLISON, 1944 P. A. Allison, 'A Yoruba Carver', *Nigerian Magazine*, 22, 1944, pp. 49–50
- ALLISON, 1952 P. A. Allison, 'Travelling Commissioners of the Ekiti Country', *Nigerian Field*, 17, 1952, pp. 100–15
- ALLISON, 1962 P. Allison, 'Carved Stone Figures in the Eko County of the Middle Cross River', *Man*, 15, 1962
- ALLISON, 1968 P. Allison, *Cross River Monoliths*, Lagos, 1968
- ALMAGRO, 1965¹ M. Almagro, *La Necrópolis Meroítica de Nellua*, Madrid, 1965
- ALMAGRO, 1965² M. Almagro, *La Necrópolis Meroítica de Nag Gamus*, Madrid, 1965
- ALMAGRO et al., 1965 M. Almagro et al., 'Excavations by the Spanish Archaeological Mission in the Sudan, 1962–3 and 1963–4', *Kush*, 13, 1965, pp. 78–95
- ALPERS, 1966 E. A. Alpers, 'The Role of the Yao in the Development of Trade in East Central Africa, 1698–ca. 1850', diss., University of London, 1966
- ALPERS, 1969 E. Alpers, 'Trade, State and Society Among the Yao in the Nineteenth Century', *Journal of African History*, 10, 1969, pp. 405–20
- AMON D'ABY, 1960 F. J. Amon D'Abey, *Croyances religieuses et coutumes juridiques des Agni de la Côte d'Ivoire*, Paris, 1960
- ANDREWS, 1984 C. Andrews, *Egyptian Mummies*, London, 1984
- ANDREWS, 1990¹ C. Andrews, *Ancient Egyptian Jewellery*, London, 1990
- ANDREWS, 1990² C. Andrews, *Egyptian Mummies*, London, 1990
- ANDREWS, 1994 C. Andrews, *Amulets of Ancient Egypt*, London, 1994
- ANGAS, 1849 G. F. Angas, *The Kafirs Illustrated*, London, 1849
- ANQUANDAH, 1987¹ J. Anquandah, 'L'art du Komaland. Une découverte récente au Ghana septentrional', *Arts d'Afrique Noire*, 62, 1987, pp. 11–18
- ANQUANDAH, 1987² J. Anquandah, 'The Stone Circle Sites of Komaland: Northern Ghana in West African Archaeology', *African Archaeological Review*, 5, 1987
- ANQUANDAH, n. d. J. Anquandah, 'Komabuilsa – its Art and Archaeology' [unpublished MS]
- ANQUANDAH and VAN HAM, 1985 J. Anquandah and L. van Ham, *Discovering the forgotten 'civilisation' of Komaland, Northern Ghana*, Rotterdam, 1985
- ANTWERP 1975 *Afrikaanse beeldhouwkunst nieuw zicht op een erfgoed / Sculptures africaines nouveau regard sur un héritage*, exh. cat. ed. P. Guimot, Antwerp, 1975
- ARBERRY, 1955 A. J. Arberry, *The Koran Interpreted*, London, 1955
- ARMITAGE and CLUTTON-BROCK, 1980 P. L. Armitage and J. Clutton-Brock, 'An Investigation of the Mummified Cats held by the British Museum (Natural History)', *Museum of Applied Science Centre for Archaeology Journal*, Mummification Supplement, 1 (6), 1980, pp. 185–8
- ARNOLDI, 1986 M. J. Arnoldi, 'The Artistic Heritage of Somalia', in *Somalia in Word and Image*, ed. K. S. Loughran et al., Washington, 1986
- ARNOLDI and KRAEMER, 1995 M. J. Arnoldi and C. M. Kraemer, *Crowning Achievements: African Arts of Dressing the Head*, Los Angeles, 1995
- ARUNDALE, BONOMI and BIRCH, 1840 *Gallery of Antiquities Selected from the British Museum*, 1840
- ASLANAPA, 1977 O. Aslanapa, *Yüzyıllar Boyuncu Türk Sanatı*, Ankara, 1977
- ASSELBERGHHS, 1961 H. Asselberghs, *Chaos en Beheersing: Documenten uit Aeneolitisch Egypte*, Leiden, 1961
- ASTUTI, 1994 R. Astuti, 'Invisible Objects: Mortuary Rituals among the Vezo of Western Madagascar', *RES*, 25, 1994, pp. 111–22
- ATANDA, 1975 J. A. Atanda, 'The Yoruba Ogboni Cult: Did it exist in Old Oyo?', *Journal of the Historical Society of Nigeria*, 6 (4), 1975, pp. 365–72
- ATIL, 1981 E. Atil, *Renaissance of Islam: Art of the Mamluks*, exh. cat., Washington, 1981
- ATIYA, 1991 A. S. Atiya, *The Coptic Encyclopedia*, New York, 1991
- AUBET, 1993 M. E. Aubet, *The Phoenicians and the West*, trans. M. Turton, Cambridge, 1993 [Tiro y las colonias fenicias de Occidente, 1987]
- AWOLALU, 1979 O. J. Awolalu, *Yoruba Beliefs and Sacrificial Rites*, London, 1979
- AYRTON et al., 1904 E. R. Ayrton et al., *Abydos*, iii, London, 1904
- BADAWY, 1978 A. Badawy, *Coptic Art and Archaeology: The Art of the Christian Egyptians from the Late Antique to the Middle Ages*, London, 1978
- BAGINSKI and TIDHAR, 1980 A. Baginski and A. Tidhar, *Textiles from Egypt 4th–13th Centuries*, 1980
- BAINES, 1975 J. Baines, 'Ankh-sign, Belt and Penis Sheath', *Studien zu altägyptischer Kultur*, 3, 1975, pp. 1–24
- BAINES and MALEK, 1980 J. Baines and J. Malek, *Atlas of Ancient Egypt*, Oxford, 1980
- BAKRY, 1969 H. S. K. Bakry, *Zeitschrift der deutschen morgenländischen Gesellschaft*, suppl. 1, 1969, p. 21
- BAKRY, 1971 H. S. K. Bakry, *Mitteilungen des deutschen archäologischen Instituts, Abteilung Kairo*, 27, 1971, pp. 158–9, pls 30–1
- BALDAOUI, 1942 J. Baldaoui, *Les tapis*, 1942
- BALFET, 1956 H. Balfet, 'Les poteries modelées d'Algérie', in *Libyca*, Algiers, 1956
- BALOUT, 1958 L. Balout, *L'Algérie préhistorique*, Paris, 1958
- BALTIMORE et al. 1993–6 *African Zion: The Sacred Art of Ethiopia*, exh. cat. by M. Heldman with R. Grierson and S. C. Munro-Hay, Walters Art Gallery, Baltimore et al., 1993–6
- BALTY et al., 1988 J. C. Balty, H. de Meulenaere, D. Homes-Frédéricq, L. Limme, J. Strybol and L. Vandenberghe, *Musées royaux d'art et d'histoire. Bruxelles. Antiquité*, Musea Nostra 11, Brussels, 1988
- BARBIER, 1993 J. P. Barbier, ed., *Art of Côte d'Ivoire from the Collections of the Barbier-Mueller Museum*, 2 vols, Geneva, 1993
- BARLEY, 1984 N. Barley, 'Placing the West Africa Potter', in *Earthenware in Asia and Africa*, ed. J. Picton, London, 1984
- BARLEY, 1988 N. Barley, *Foreheads of the Dead: An Anthropological View of Kalabari Ijaw Ancestral Screens*, Washington, 1988
- BARLEY, 1989 N. Barley, *Native Land*, London, 1989
- BARLEY, 1994 N. Barley, *Smashing Pots: Feasts of Clay from Africa*, London, 1994
- BARRETT, 1911 W. E. H. Barrett, 'Notes on the Customs of the Wa-Giriamá', *Journal of the Royal Anthropological Institute*, 41, 1911, pp. 20–8
- BARRETT, 1949 D. Barrett, *Islamic Metalwork in the British Museum*, London, 1949

- BARRUCAND, 1978 M. Barrucand, 'Structures et décors des charpentes alauoides à partir d'exemples de Meknès', *Bulletin d'archéologie marocaine*, 11, 1978, pp. 115–56
- BASLE 1977 *Als die Sahara grün... Würfelsbilder aus der Saguia el-Hamra*, exh. cat. by S. Haas, Museum für Völkerkunde, Basle, 1977
- BASSANI, 1976 E. Bassani, 'I Mintadi del Museo Pigorini', *Critica d'Arte*, 1976, pp. 49–64
- BASSANI, 1977 E. Bassani, 'Oggetti africani in antiche collezioni italiane', *Critica d'arte*, 42 (151), 1977, pp. 151–82
- BASSANI, 1979 E. Bassani, 'Sono from Guinea Bissau', *African Arts*, 12 (4), 1979, pp. 44–7, 91
- BASSANI, 1989 E. Bassani, *La grande scultura dell'Africa Nera*, Florence, 1989
- BASSANI, 1994 E. Bassani, 'Additional Notes on the Afro-Portuguese Ivories', *African Arts*, 27 (3), 1994, pp. 34–45
- BASSANI, E. Bassani, 'Les sculptures Vallisnieri', *Africa-Tervuren*, 14 (1), pp. 15–22
- BASSANI and FAGG, 1988 E. Bassani and W. Fagg, *Africa and the Renaissance*, New York, 1988
- BASSANI and McLEOD, 1989 E. Bassani and M. M. McLeod, *Jacob Epstein Collector*, Milan, 1989
- BASSING, 1973 A. Bassing, 'Grave Monuments of the Dakakari', *African Arts*, 6 (4), 1973, pp. 36–9
- BASTIN, 1961¹ M.-L. Bastin, *Art décoratif Tshokwe*, Lisbon, 1961
- BASTIN, 1961² M.-L. Bastin, 'Quelques œuvres Tshokwe de musées et collections d'Allemagne et de Scandinavie', *Africa-Tervuren*, 7 (4), 1961, pp. 101–5
- BASTIN, 1965 M.-L. Bastin, 'Tshibinda Ilunga: à propos d'une statuette de chasseur ramenée par Otto H. Schütt en 1880', *Baessler-Archiv*, new series, xiii, 1965, pp. 501–37
- BASTIN, 1968 M.-L. Bastin, 'L'art d'un peuple d'Angola i, Tshokwe', *African Arts*, 2 (1), 1968, pp. 40–6, 60–4
- BASTIN, 1969 M.-L. Bastin, 'Quatre statuettes anciennes de chef Tshokwe', *Africa-Tervuren*, 15 (1), 1969, pp. 1–8
- BASTIN, 1976 M.-L. Bastin, 'Les styles de la sculpture Tshokwe', *Arts d'Afrique Noire*, 19 (3), 1976, pp. 16–35
- BASTIN, 1978 M.-L. Bastin, *Statuettes Tshokwe du héros civilisateur Tshibinda Ilunga*, Arnouville, 1978
- BASTIN, 1981 M.-L. Bastin, 'Quelques œuvres Tshokwe: une perspective historique', *Antologia di Belle Arti*, 17–18, 1981, pp. 83–104
- BASTIN, 1982 M.-L. Bastin, *La sculpture Tshokwe*, Meudon, 1982
- BASTIN, 1984 M.-L. Bastin, *Introduction aux arts d'Afrique noire*, Arnouville, 1984
- BASTIN, 1988 M.-L. Bastin, 'Les Tshokwe du pays d'origine', in *Art et Mythologie, Figurines tshokwe*, Paris, 1988, pp. 49–68
- BASTIN, 1992 M.-L. Bastin, 'The Mwanangana Chokwe Chief and Art (Angola)', in *Kings of Africa: Art and Authority in Central Africa*, Maastricht, 1992, pp. 64–70
- BASTIN, 1994 M.-L. Bastin, *Sculpture angolaise. Mémorial de cultures*, exh. cat., Lisbon, 1994
- BATES and DUNHAM, 1927 O. Bates and D. Dunham, 'Excavations at Gemai', *Harvard African Studies*, 7, 1927, pp. 1–122
- BAUMANN, 1935 H. Baumann, *Lunda. Bei Bauern und Jägern in Inner-Angola*, Berlin, 1935
- BAUMGARTEL, 1955 E. Baumgartel, *The Cultures of Prehistoric Egypt*, i, London, 1955
- BAUMGARTEL, 1960 E. Baumgartel, *The Cultures of Predynastic Egypt*, ii, Oxford, 1960
- BAUMGARTEL, 1970¹ E. J. Baumgartel, *Petrie's Naqada Excavation: A Supplement*, London, 1970
- BAUMGARTEL, 1970² E. J. Baumgartel, 'Some Additional Remarks on the Hierakonpolis Ivories', *Journal of the American Research Centre in Egypt*, 7, 1970, pp. 7–14
- BAXTER and ALMAGOR, 1978 P. J. W. Baxter and U. Almagor, eds, *Age, Generation and Time*, London, 1978
- BEAUMONT, 1990¹ P. B. Beaumont, 'Kathu Pan', in P. Beaumont and D. Morris, *Guide to archaeological sites in the Northern Cape*, Kimberley, 1990
- BEAUMONT, 1990² P. B. Beaumont, 'Wonderwerk Cave', in P. Beaumont and D. Morris, *Guide to archaeological sites in the Northern Cape*, Kimberley, 1990
- BEAUMONT and VOGEL, 1984 P. B. Beaumont and J. C. Vogel, 'Spatial Patterning of the Ceramic Later Stone Age in the Northern Cape Province, South Africa', in *Frontiers: Southern African Archaeology Today*, ed. M. Hall et al., BAR International Series 207, Oxford, 1984, pp. 80–95
- BEAUMONT and VOGEL, 1989 P. B. Beaumont and J. C. Vogel, 'Patterns in the Age and Context of Rock Art in the Northern Cape', *South African Archaeological Bulletin*, 44, 1989, pp. 73–81
- BECKER 1991 R. L. Becker, 'Headrests: Tsonga Types and Variations', in *Art and Ambiguity: Perspectives on the Brendhurst Collection of Southern African Art*, exh. cat., Johannesburg, 1991, pp. 58–76
- BECKER and NETTLETON, 1989 R. Becker and A. Nettleton, 'Tsonga-Shangana Beadwork and Figures', in *Ten Years of Collecting: The Standard Bank Foundation Collection of African Art*, exh. cat., Johannesburg, 1989, pp. 9–15
- BECKER-DONNER, 1940 E. Becker-Donner, 'Kunst und Handwerk in No-Liberia', *Baessler-Archiv*, 23 (2/3), 1940
- BECKWITH, 1965 J. Beckwith, *Coptic Sculpture*, London, 1965
- BECKWITH and VAN OFFELEN, 1983 C. Beckwith and Van Offelen, *Nomads of Niger*, New York, 1983
- BEDAUX, 1977 R. Bedaux, *Tellem*, Berg en Dal, 1977
- BEDAUX and LANGE, 1983 R. Bedaux and A. Lange, 'Tellem, reconnaissance archéologique d'une culture de l'Ouest africain au Moyen Âge: La poterie', *Journal de la Société des Africistes*, 53, 1983, pp. 5–59
- BERIDELMAN, 1967 T. O. Beidelman, *The Matrilineal Peoples of Eastern Tanzania*, London, 1967
- BERIDELMAN, 1971 T. O. Beidelman, *The Kaguru: A Matrilineal People of East Africa*, New York, 1971
- BEIER, 1954 U. Beier, 'Festival of the Images', *Nigeria*, 45, 1954, pp. 14–20
- BEIER, 1957 U. Beier, *The Story of Sacred Wood Carvings from One Small Yoruba Town*, Lagos, 1957
- BEIER, 1959 U. Beier, *A Year of Sacred Festivals in One Yoruba Town*, Lagos, 1959
- BEIER, 1960 U. Beier, *Art in Nigeria*, Cambridge, 1960
- BEL, 1959 M. Bel, *Les arts indigènes féminins en Algérie*, Algiers, 1959
- BELEPE BOPE MABINTSH, 1978 'Les œuvres plastiques africaines comme documents historiques', Likundoli, 1978 [unpublished MS]
- BELEPE BOPE MABINTSCH, 1988 *La triade des masques Bwoom Mosh'ambooy et Ngady a muuash*, 1988
- BELZONI, 1820 G. Belzoni, *Narrative of the Operations and Recent Discoveries within the Pyramids, Temples, Tombs and Excavations in Egypt and Nubia*, London, 1820
- BEN-AMOS, 1980 P. Ben-Amos, *The Art of Benin*, London, 1980
- BÉNABOU, 1976 M. Bénabou, *La résistance africaine à la romanisation*, Paris, 1976
- BENAZETH and GABRA, 1992 D. Benazeth and G. Gabra, *L'art du métal au début de l'ère chrétienne*, Paris, 1992
- BENT, 1896 J. T. Bent, *The Ruined Cities of Mashonaland*, London, 1896
- BERGLUND, 1976 A.-I. Berglund, *Zulu Thought-Patterns and Symbolism*, Cape Town, 1976
- BERLIN 1974 *Frühe Stufen der Kunst: Propyläen Kunsgeschichte*, 13, ed. M. Mellink and J. Filip, Berlin, 1974, p. 244, pl. XXXI
- BERLIN 1976 Ägyptische Kunst aus dem Brooklyn Museum, exh. cat. ed. J. S. Karig and K.-T. Zauzich, Ägyptisches Museum der Staatlichen Museen, Preussischer Kulturbesitz, Berlin, 1976
- BERLIN 1989 *Europa und der Orient, 800–1900*, exh. cat. ed. G. Sievernich and H. Budde, Martin-Gropius-Bau, Berlin, 1989
- BERLIN and MUNICH 1994 *Tanzania: Meisterwerke Afrikanischer Skulptur*, exh. cat. with introductory text by M. Felix and M. Kecskés and contributions by G. Blesse et al., Haus der Kulturen der Welt, Berlin, 1994; Städtische Galerie im Lenbachhaus, Munich, 1994
- BERLYN, 1968 P. Berlyn, 'Some Aspects of the Material Culture of the Shona People', *Native Affairs Department Annual*, 9 (5), 1968, pp. 68–73
- BERNATZIK et al., 1947 H. A. Bernatzik et al., *Afrika: Handbuch der angewandten Völkerkunde*, Innsbruck, 1947
- BERNES, 1974 J. P. Berne, *Brocart et soieries de Fès en Maroc: Costumes, broderies, brocarts*, Paris, 1974, pp. 26–50
- BERNS, 1993 M. C. Berns, 'Art, History and Gender: Women and Clay in West Africa', *African Archaeological Review*, 11, 1993, pp. 129–48
- BERNUS, 1981 E. Bernus, *Touaregs Nigériens*, Paris, 1981
- BERQUE, 1959 J. Berque, *Les Arabes*, Paris, 1959, cover illus.
- BERTRAND, 1898 Bertrand, *Au pays des Ba-Rotsi*, 1898
- BESANCENOT, 1953 J. Besancenot, *Bijoux arabes et berbères du Maroc*, Casablanca, 1953
- BEUMERS and KOLOSS, 1992 E. Beumers and H. J. Koloss, eds, *Kings of Africa*, exh. cat., Maastricht, 1992
- BIEBUYCK, 1975 D. P. Biebuyck, *Lega Culture: Art, Initiation and Moral Philosophy among a Central African People*, Berkeley, 1975
- BIEBUYCK, 1976 D. P. Biebuyck, 'Sculpture from the Eastern Zaire Forest Regions: Mbole, Yela and Pere', *African Arts*, 10 (1), 1976, pp. 54–61
- BIEBUYCK, 1981¹ D. P. Biebuyck, 'Plurifrontal Figurines in Lega Art (Zaire)', in *The Shape of the Past: Studies in Honour of Franklin D. Murphy*, ed. G. Buccellati and C. Speroni, Berkeley, 1981, pp. 115–27
- BIEBUYCK, 1981² D. P. Biebuyck, *Statuary of the pre-Bembe Hunters*, Tervuren, 1981
- BIEBUYCK, 1985 D. Biebuyck, *The Arts of Zaire: Southwestern Zaire*, Berkeley, 1985
- BIEBUYCK, 1986 D. P. Biebuyck, *The Arts of Zaire: Eastern Zaire, The Ritual and Artistic Context of Voluntary Associations*, Berkeley, 1986
- BIEBUYCK, 1987 D. P. Biebuyck, *The Arts of Central Africa: An Annotated Bibliography*, Boston, 1987
- BIEBUYCK, 1992¹ D. Biebuyck, *Kings of Africa*, Maastricht, 1992, p. 315
- BIEBUYCK, 1992² D. P. Biebuyck, 'Religie in Central-Afrika', in Maastricht 1992, pp. 29–31
- BIOBAKU, 1952 S. O. Biobaku, 'An Historical Sketch of Egba Traditional Authorities', *Africa*, 22 (1), 1952, pp. 35–49
- BIOBAKU, 1956 S. O. Biobaku, 'Ogboni, the Egba Senate', in *Proceedings of the Third International West African Conference, Ibadan, December 12–21, 1949*, Lagos, 1956, pp. 257–63
- BITIYONG, 1993–4 Y. Bitiyong, 'Culture Nok, Nigeria', in *Vallées du Niger*, exh. cat. ed. J. Devisse, Paris, 1993–4
- BLACKING, 1969 J. Blacking, 'Songs, Dances, Mimes and Symbolism of Venda Girls' Initiation School, Part 4: The Great Dombe Song', *African Studies*, 28, 1969, pp. 215–66
- BLACKING, 1985 J. Blacking, 'The Great Enclosure and Dombe', *Man*, 20, 1985
- BLAIR and BLOOM, 1994 S. Blair and J. Bloom, *The Art and Architecture of Islam 1250–1800*, New Haven, 1994
- BLANDIN, 1988 A. Blandin, *Afrique de l'Ouest: Bronzes et autres alliages*, Louvain, 1988
- BLANDIN, 1992 A. Blandin, 'Fer Noir' d'Afrique de l'Ouest, Salon-de-Provence, 1992

- BLEEK and LLOYD, 1911 W. H. I. Bleek and L. C. Lloyd, *Specimens of Bushman Folklore*, London, 1911
- BLIER, 1995 P. S. Blier, *Vodun: Art, Psychology and Power*, Chicago, 1995
- BLOCH, 1971 M. Bloch, *Placing the Dead: Tombs, Ancestral Villages and Kinship Organizations in Madagascar*, London, 1971
- BLOCH, 1982 M. Bloch, *Death and the Regeneration of Life*, Cambridge, 1982
- BLOHM, 1953 W. Blohm, *Die Nyamwezi: Gesellschaft und Weltbild*, Hamburg, 1953
- BLOOD, 1935 A. Blood, *The Dawn of a Diocese*, London, 1935
- BOGAERTS, 1950 H. Bogaerts, 'Bij de Basala Mpasu, de Koppensnellers van Kasai', *Zaire*, 4 (4), 1950, pp. 379–419
- BOHANNAN, 1957 P. Bohannan, 'Artist and Critic in an African Society', in *The Artist and Critic in Tribal Society*, ed. M. H. Smith, New York, 1957, pp. 85–94
- BONNENFANT, BONNENFANT and AL-HARTHI, 1977 P. and G. Bonnenfant and S. H. S. al-Harthi, 'Architecture and Social History at Mudayrib', *Journal of Oman Studies*, 5 (2), 1977, pp. 107–35, pls XXVII, XIa–b, XIa–c, XIa–d
- BONNET, 1990 C. Bonnet, ed., *Kerma, royaume de Nubie*, Geneva, 1990
- BONTINCK, F. Bontinck, 'La provenance des sculptures Vallisnierié', *Africa-Tervuren*, 25 (4), pp. 88–91
- BOONE, 1986 S. Boone, *Radiance from the Waters*, New Haven, 1986
- BOSCH, 1950 Rev. P. Fr. Bosch, *Les Banyamwezi: Peuple de l'Afrique Orientale*, Munster, 1950
- BOSTON, 1977 J. S. Boston, *Ikenga Figures among the Northwest Igbo and the Igala*, London, 1977
- BOSTON, 1982 *Egypt's Golden Age: The Art of Living in the New Kingdom 1558–1085 BC*, exh. cat. ed. E. Brovarski, S. Dolland, R. Freed, Museum of Fine Arts, Boston, 1982
- BOSTON and DALLAS, 1992 *Mummies and Magic: The Funerary Arts of Ancient Egypt*, exh. cat. by S. d'Auria, P. Lacovara, C. M. Roehrig, Museum of Fine Arts, Boston, Dallas Museum of Art, 1992
- BOTHMER, 1948 B. V. Bothmer, 'A Pre-dynastic Egyptian Hippopotamus', *Bulletin of the Museum of Fine Arts*, Boston, 265, 1948, p. 69
- BOTHMER, 1949 B. V. Bothmer, 'The Dwarf as Bearer', *Bulletin of the Museum of Fine Arts*, Boston, 47, 1949, p. 9 ff
- BOTHMER, 1979 B. V. Bothmer, 'Ancient Nubia and the Northern Sudan: A New Field of Art History', *Meroitica*, 5, 1979, pp. 177–80
- BOTHMER, 1982 B. V. Bothmer, 'On Realism in Egyptian Funerary Sculpture of the Old Kingdom', *Expedition*, 24 (1), Winter 1982, pp. 27–39
- BOUDRY, 1953 R. Boudry, 'L'art décoratif malgache', *Revue de Madagascar*, pp. 12–71
- BOUKOBZA, 1974 A. Boukobza, *La poterie marocaine*, Casablanca, 1974
- BOULORÉ, 1992 V. Bouloré, 'Review Cuillers-Sculptures', *African Arts*, 25 (1), 1992, pp. 85–6
- BOURGEOIS, 1984 A. Bourgeois, *Art of the Yaka and Suku*, Meudon, 1984
- BOURGUET, 1968 P. du Bourguet, *L'art copte*, Paris, 1968
- BOURRIAU, 1981 J. D. Bourriau, ed., *Umm el-Ga'ab: Pottery from the Nile Valley before the Arab Conquest*, exh. cat., Fitzwilliam Museum, Cambridge, 1981
- BOURRIAU, 1985 J. Bourriau, 'Technology and Typology of Egyptian Ceramics', in *Ancient Technology and Modern Science*, ed. W. D. Kingery, *Ceramics and Civilization*, i, Columbus, OH, 1985, pp. 27–42
- BOURRIAU, 1987 J. Bourriau, 'Pottery Figure Vases of the New Kingdom', *Cahiers de la céramique égyptienne*, i, 1987, pp. 81–96
- BOUYSSONIE, 1956 J. Bouyssonie, *Collections préhistoriques: Musée d'Ethnographie et de Préhistoire du Bardo (Alger)*, Album 1, Paris, 1956
- BRAIN, 1962 J. Brain, 'The Kwere of the Eastern Province', *Tanganyika Notes and Records*, 58–9, 1962, pp. 231–41
- BRAIN, 1972 R. Brain, *Bangwa Kinship and Marriage*, Cambridge, 1972
- BRAIN and POLLACK, 1971 R. Brain and A. Pollack, *Bangwa Funerary Art*, London, 1971
- BRAVMANN, 1974 R. A. Bravmann, *Islam and Tribal Art in West Africa*, Cambridge, 1974
- BRAVMANN, 1979 R. A. Bravmann, 'Gur and Manding Masquerades in Ghana', *African Arts*, 13 (1), 1979, pp. 44–51
- BRAVMANN, 1983 R. Bravmann, *African Islam*, Washington, 1983
- BRAZZA, 1887–8 S. de Brazza, '3 explorateurs dans l'Ouest Africain', *Le Tour du Monde*, 1887–8
- BRETT-SMITH, 1985 S. C. Brett-Smith, 'The Poisonous Child', *Res*, 6, Autumn 1985, pp. 47–64
- BRINCARD, 1982 M. T. Brincard, ed., *The Art of Metal in Africa*, New York, 1982
- BRINK, 1981 J. T. Brink, 'The Antelope Headdress (Chi Wara)', in *For Spirits and Kings: African Art from the Tishman Collection*, ed. S. Vogel, New York, 1981
- BRITISH MUSEUM guide, 1909 British Museum, *A Guide to the Egyptian Galleries (Sculpture)*, London, 1909
- BROOKLYN 1978 *Africa in Antiquity: The Arts of Ancient Nubia and the Sudan*, exh. cat. by S. Wenig, Brooklyn Museum, Brooklyn, 1978
- BROOKS, 1972 G. Brooks, *The Kru Mariner in the Nineteenth Century*, Newark, DE, 1972
- BROVARSKI et al., 1982 E. Brovarski et al., eds, *Egypt's Golden Age: The Art of Living in the New Kingdom 1558–1085 BC*, exh. cat., Boston, 1982
- BROWN, 1944 H. D. Brown, 'The Nkumu of the Tumba: Ritual Chieftainship on the Middle Congo', *Africa*, 14, 1944, pp. 451–47
- BROWN, 1971 J. Brown, 'Borana Kalacha Cire Perdue Casting', *Kenya Past and Present*, 1 (1), 1971
- BRUCE, 1976 H. J. Bruce, 'The arts and crafts of the Transvaal Ndebele', in *Africana Byways*, ed. A. H. Smith, 1976, pp. 135–50
- BRUNNER-TRAUT, 1956 E. Brunner-Traut, *Die altägyptischen Scherbenbilder (Bildostrak) der deutschen Museen und Sammlungen*, Wiesbaden, 1956
- BRUNTON, 1927 G. Brunton, *The Badarian Civilization*, British School of Archaeology in Egypt, xlvi, Cairo, 1927
- BRUNTON and CATON-THOMPSON, 1928 G. Brunton and G. Caton-Thompson, *The Badarian Civilization and the Predynastic Remains near Badari*, London, 1928
- BRUSSELS 1976–7 *Égypte éternelle: Chefs d'œuvre du Brooklyn Museum/Egypte's Glorie: Meesterwerken van het Brooklyn Museum*, exh. cat. ed. H. De Meulenaere and L. Limme, Palais des Beaux-Arts, Brussels, 1975–6
- BRUSSELS 1977 *Arts premiers d'Afrique noire*, exh. cat. by P. Guimot, Studio 44, Brussels, 1977
- BRUSSELS 1988 *Des animaux et des hommes: témoignages de la Préhistoire et de l'Antiquité*, exh. cat., Crédit Communal, Brussels, 1988
- BRUSSELS 1992 *Beauté fatale. Armes d'Afrique centrale*, exh. cat. by J. Cornet et al., Crédit Communal, Brussels, 1992
- BRUYÈRE, 1937 B. Bruyère, *Rapport sur les fouilles de Deir-el-Medineh (1934–35)*, Fouilles de l'Institut Français Archéologique de l'Orient du Caire, XV, 2: *La nécropole de l'Est*, Cairo, 1937
- BRYANT, 1949 P. T. Bryant, *The Zulu People, as they were before the White Man Came*, Pietermaritzburg, 1949
- BUDGE, 1904 E. A. W. Budge, *British Museum: A Guide to the Third and Fourth Egyptian Rooms*, London, 1904
- BULTÉ, 1991 J. Bulté, *Talismanes Égyptiens d'heureuse maternité*, Paris, 1991
- BURSSENS, 1958¹ H. Burssens, 'La fonction de la sculpture traditionnelle chez les Ngbaka', *Brouse*, Leopoldville, 1958, pp. 10–28
- BURSSENS, 1958² H. Burssens, *Les peuplades de l'entre Congo-Ubangi (Ngbandi, Ngbaka, Mbandja, Ngombe et Gens d'Eau)*, Tervuren, 1958
- BURSSENS, 1962 H. Burssens, *Yanda-beeld en Mani-sekte bij de Zande*, Tervuren, 1962
- BURSSENS, 1993 H. Burssens, 'Mask Styles and Mask Use in the North of Zaire', in F. Herremans and C. Petridis, eds, *Face of the Spirits. Masks from the Zaire Basin*, Ghent, 1993
- BURSSENS and GUISSON, 1992 H. Burssens and A. Guisson, *Mangbetu. Art de cour africain de collections privées belges*, Brussels, 1992
- BURSTEIN, 1993 S. M. Burstein, 'The Hellenistic Fringe: The Case of Meroe', in *Hellenistic History and Culture*, ed. P. Green, Berkeley, Los Angeles and Oxford, 1993, pp. 38–54
- BURTON, 1860 R. F. Burton, *The Lake Regions of Central Africa*, 2 vols, London, 1860
- BUTLER, 1926 A. J. Butler, *Islamic Pottery: A Study Mainly Historical*, London, 1926
- CABRERA, 1970 L. Cabrera, *La Sociedad secreta Abakua narrada por viejos adeptos*, Miami, 1970
- CABRERA, 1975 L. Cabrera, *Anaforuana ritual y simbolo de la iniciacion en la sociedad secreta Abakua*, Madrid, 1975
- CAIGER-SMITH, 1973 A. Caiger-Smith, *Tin-Glaze Pottery in Europe and the Islamic World*, London, 1973
- CAIRO 1969 *Exhibition of Islamic Art in Egypt 969–1517 AD*, exh. cat., The United Arab Republic, Ministry of Culture, Cairo, 1969
- CAMARA, 1976 S. Camara, *Gens de la parole*, Paris, 1976
- CAMBАЗАРД-АМАХАН, 1989 C. Cambazard-Amahan, *Le décor sur bois dans l'architecture de Fès*, Paris, 1989
- CAMBRIDGE 1981 *Umm el-Ga'ab: Pottery from the Nile Valley before the Arab Conquest*, exh. cat. by J. Bourriau, Fitzwilliam Museum, Cambridge, 1981
- CAMBRIDGE and LIVERPOOL 1988 *Pharaohs and Mortals: Egyptian Art in the Middle Kingdom*, exh. cat. by J. Bourriau, Fitzwilliam Museum, Cambridge and Liverpool, 1988
- CAMERON, 1988 E. L. Cameron, 'Sala Mpasu Masks', *African Arts*, 22 (1), 1988, pp. 54–45
- CAMPS, 1955 G. Camps, 'Recherches sur l'antiquité de la céramique modelée et peinte en Afrique du Nord', in *Libyca*, III, Algiers, 1955
- CAMPS, 1982 G. Camps, 'Beginnings of Pastoralism and Cultivation in North-West Africa and the Sahara: Origins of the Berbers', in *The Cambridge History of Africa*, ed. J. D. Clark, i, Cambridge, 1982, pp. 548–623
- CAMPS-FABRER, 1966 H. Camps-Fabrer, 'Matière et art mobilier dans la préhistoire Nord-Africaine', *Mémoire centre de recherches anthropologiques, préhistoriques et ethnographiques*, Algiers, 1966
- CANBERRA and MELBOURNE 1990 *Civilisation: Treasures of the British Museum*, exh. cat., Australian National Gallery, Canberra, 1990; Museum of Victoria, Melbourne, 1990
- CAPART, 1905 J. Capart, *Primitive Art in Egypt*, trans. A. S. Griffith, London, 1905
- CAPART, 1909 J. Capart, 'Vase préhistorique à décor incisé', *Bulletin des Musées royaux d'art et d'histoire*, 2 (2), 1909, p. 8
- CAPE TOWN 1995 *Ezakwantu. Beadwork from the Eastern Cape*, exh. cat. ed. E. Bedford, South African National Gallery, Cape Town, 1995
- CAREY, 1986 M. Carey, *Beads and Beadwork of East and South Africa*, London, 1986
- CARRIER, 1987 R. Carrier, *Taste of Morocco*, London, 1987
- CARROLL, 1967 K. Carroll, *Yoruba Religious Carving*, London, 1967
- CELIS, 1970 G. Celis, 'The Decorative Arts in Rwanda and Burundi', *African Arts*, 4 (1), 1970, pp. 40–2
- CERULLI, 1959 E. Cerulli, *Scritti vari editi ed inediti*, Rome, 1959
- CEYSSENS, 1984 J. H. Ceyssens, *Pouvoir et parenté chez les Kongo-Dinga du Zaïre*, Nijmegen, 1984

- CHAFFIN, 1980 A. Chaffin, 'Complément d'information sur "L'Art Kota"', French/English, *Arts Afrique Noire*, 33, 1980, pp. 42–3
- CHAFFIN and CHAFFIN, 1979 A. and F. Chaffin, *L'Art Kota; les figures de reliquaire*, Meudon, 1979
- CHAMPION, 1967 A. Champion, *The Agiryana of Kenya*, London, 1967
- CHANTREAUX, 1945 G. Chantreaux, 'Les tissages décorés chez les Beni-Guild', *Hespéris*, 32, 1945, pp. 19–33
- CHAPLIN, 1967 J. H. Chaplin, *The Prehistoric Art of the Lake Victoria Region*, diss., Makerere University College, Kampala, 1967
- CHIKWENDU et al., 1989 V. E. Chikwendu et al., 'Nigerian Sources of Copper, Lead and Tin for the Igbo-Ukwu Bronzes', *Archaeometry*, 31 (1), 1989, pp. 27–36
- CHILDSD et al., 1989 S. T. Childs et al., 'Iron and Stone Age Research in Shaba Province, Zaire: An Interdisciplinary and International Effort', *Nyame Akuma*, 32, 1989, pp. 54–9
- CHRISTOPHE, 1959 L. Christophe, 'La statue de Ramsès Ier', *La Revue du Caire*, 22^e année, xlii (226), June 1959
- CHRISTOPHER, 1994 A. J. Christopher, *The Atlas of Apartheid*, Johannesburg, 1994
- CHUBB, 1936 E. C. Chubb, 'The Zulu Brass Armlet "Ingzota": A Badge of Distinction', *Man: a Monthly Record of Anthropological Science*, 36, 1936, pp. 251–69
- CINTAS, 1970 P. Cintas, *P. Manuel d'archéologie punique*, Paris, 1970
- CLAERHOUT, 1988 A. Claerhout, *The Ethnographic Museum Antwerpen*, Tielt, 1988
- CLAERHOUT, A. Claerhout, 'Two Kuba Wrought-Iron Statues', *African Arts*, 9 (4), pp. 60–4
- CLAMENS, 1953 C. Clamens, 'Notes d'Ethnologie Sénooufo', *Notes africaines*, 59, 1953, pp. 76–80
- CLARK, 1958 J. D. Clark, 'The Stone Figures of Esie', *Nigerian Magazine*, 14, 1958, pp. 106–8
- CLAYTON, 1993 A. Clayton, *Christianity and Islam: A Study of Religious Appropriation among Makonde*, diss., Manchester University, 1993
- CLÉ, 1957 C. Clé, 'Faits divers chez les Basala Mpasu', *Missions de Scheut*, 8, 1957, pp. 247–9
- CLÉ, 1948 C. Clé, 'Les Basala Mpasu: Quelques aspects de leur vie', *Missions de Scheut*, 1948, 5, pp. 120–2; 6, pp. 143–7; 10, pp. 246–9; 11, pp. 269–71
- COLE, 1969 H. M. Cole, 'Art as a Verb in Igboland', *African Arts*, 3 (1), 1969, pp. 34–41
- COLE, 1989 H. M. Cole, *Icons: Ideals and Power in the Art of Africa*, Washington, 1989
- COLE and ANIAKOR, 1984 H. M. Cole and C. C. Aniakor, *Igbo Arts: Community and Cosmos*, Los Angeles, 1984
- COLE and ROSS, 1977 H. M. Cole and D. H. Ross, *The Arts of Ghana*, Los Angeles, 1977
- COLENSO, 1855 J. W. Colenso, *Ten Weeks in Natal*, Cambridge, 1855
- COLLECTIF, 1982 *À la rencontre de la poterie modelée en Algérie*, Algiers, 1982
- COLLETT et al., 1992 D. P. Collett, A. E. Vines and G. E. Hughes, 'Dating and chronologies of the Valley Enclosures: Implications for the interpretation of Great Zimbabwe', *African Archaeological Review*, 10, 1992
- CONNER, 1991 M. W. Conner, *The art of the Jere and Maseko Ngoni of Malawi, 1818–1964*, diss., Indiana University, 1991
- CONNER and PELRINE, 1983 M. W. Conner and D. Pelrine, *The Geometric Vision: Arts of the Zulu*, West Lafayette, 1983
- CONTADINI, 1995 A. Contadini, 'Gli scacchi di Venafro', in *Eredità dell'Islam – Arte Islamica in Italia*, exh. cat., Milan, 1993, no. 6, pp. 71–2
- CONTADINI, 1994 A. Contadini, 'A figurative Islamic ivory chess piece', *Scacchi e scienze applicate*, 12, 1994, pp. 3–4
- CONTADINI, 1995 A. Contadini, 'Islamic Ivory Chess Pieces, Draughtsmen and Dice in the Ashmolean Museum', *Islamic Art in the Ashmolean Museum: Oxford Studies in Islamic Art*, Oxford, 1995
- CONVERS, 1991 M. Convers, 'L'aventure de Massa en Pays Sénoufo', *Primitifs*, 6, 1991, pp. 24–4
- COONEY, 1949 J. D. Cooney, 'Royal Sculptures of Dynasty VI', *Actes du XXI^e Congrès International des Orientalistes (Paris – 23–31 Juillet 1948)*, Paris, 1949
- COOTE, 1995 J. Coote, 'A Table-Cloath of Grasse Very curiously Waved', *Pitt Rivers Museum News*, no. 5 (Summer 1995)
- CORNET, 1972 J. Cornet, *Art de l'Afrique noire au pays du fleuve Zaire*, Brussels, 1972
- CORNET, 1978¹ J. Cornet, *Pierres Sculptées du Bas-Zaire*, exh. cat., Institut des Musées Nationaux, Kinshasa, 1978
- CORNET, 1978² J. Cornet, *A Survey of Zairian Art, The Bronson Collection*, Raleigh, NC, 1978
- CORNET, 1980 J. Cornet, *Pictographies Woyo*, Milan, 1980
- CORNET, 1982 J. Cornet, *Art Royal Kuba*, Milan, 1982
- CORNET, 1993 J. Cornet, 'Masks among the Kuba Peoples', in *Face of the Spirits: Masks from the Zaire Basin*, Antwerp, 1993, pp. 128–43
- CORONEL, 1979 P. C. Coronel, 'Aowin terracotta sculpture', *African Arts*, 13 (1), 1979, pp. 28–35
- CORY, 1956 H. Cory, *African Figurines*, New York
- COSTA, 1988 B. Costa, 'Preparazione per un Corpus dei Poggiatesta nell'Antico Egitto: classificazione tipologica', *Egitto e Vicino Oriente*, xi, 1988, pp. 39–50
- CRADDOCK and PICTON, 1986 P. Craddock and J. Picton, 'Mediaeval copper alloy production and West African bronze analysis: part II', *Archaeometry*, XXVIII (1), 1986
- CRIBB, 1991 R. Cribb, *Nomads in Archaeology*, Cambridge, 1991
- CRUICKSHANK, 1853 B. Cruickshank, *Eighteen Years on the Gold Coast of Africa*, London, 1853
- CUNARD, 1970 N. Cunard, ed., *Negro*, abridged with introduction by H. Ford, New York, 1970, p. 431 [1st edn 1934]
- CURTIS, 1983 W. Curtis, 'Berber Collective Dwellings of the Northwest Sahara', *Mugarnas*, 1, 1983, pp. 181–209
- DALTON, 1909 O. M. Dalton, *Catalogue of the Ivory Carvings of the Christian Era, with Examples of Mohammedan Art and Carvings in Bone in the Department of British and Medieval Antiquities and Ethnography of the British Museum*, London, 1909
- DAMLUJI, 1992 S. Damluji, ed., *Zillij: The Art of Moroccan Ceramic*, Reading, 1982
- DAMMANN, 1966 E. Dammann, 'Albert Schweitzer', *Tribus*, 15, 1966, pp. 7–10
- DANIEL, 1957 F. de F. Daniel, 'The Stone Figures of Esie, Ilorin Province, Nigeria', *Journal of the Royal Anthropological Institute*, 67, 1957, pp. 43–9
- DARAMOLA and JEJE, 1967 O. Daramola and A. Jeje, *Awon Asa ati Orisa Ile Yoruba*, Ibadan, 1967
- DARISH, 1989 P. Darish, 'Dressing for the next Life: Raffia Textile Fabrication and Display among the Kuba of south-central Zaire', in *Cloth and Human Experience*, ed. A. Weiner and J. Schneider, Washington, 1989, pp. 117–40
- DARK, 1975 P. Dark, 'Benin Bronze Heads: Styles and Chronology', in *African Images: Essays in African Iconology*, ed. D. McCall and E. Bay, New York and London, 1975
- DASEN, 1993 V. Dasen, *Dwarfs in Ancient Egypt and Greece*, Oxford, 1993
- DAVIES, 1991 W. V. Davies, ed., *Egypt and Africa: Nubia from Prehistory to Islam*, London, 1991
- DAVIS, 1989 W. Davis, *The Canonical Tradition in Ancient Egyptian Art*, Cambridge, 1989
- DAVISON, 1976 P. Davison, 'Some Nguni Crafts: The Use of Horn, Bone and Ivory', *Annals of the South African Museum*, 70 (2), 1976, pp. 79–155
- DAVISON, 1989 P. Davison, 'The Art of the Lobedu', in *African Art in Southern Africa: from Tradition to Township*, ed. A. Nettleton and D. Hammond Tooke, Pretoria, 1989
- DE HAULLEVILLE and COART, 1907 A. de Hauleville and M. Coart, 'La céramique', in *Notes Analytiques sur les Collections Ethnographiques*, 2 (1), 1907
- DE MAREES, 1987 P. de Marees, *Description and Historical Account of the Gold Kingdom of Guinea*, 1602, trans. A. Van Danzig and A. Jones, Oxford, 1987
- DE MARET, 1971–92 P. de Maret, Jean Hiernoux et al., *Fouilles archéologiques dans la vallée du Haut-Lualaba*, Zaire, Musée Royale de l'Afrique Centrale, Tervuren, 1971–92
- DE MARET, 1974 P. de Maret, *Fouilles archéologiques dans la vallée du Haut-Lualaba*, Zaire: *Sanga et Katongo*, Tervuren, 1974
- DE MARET, 1985¹ P. de Maret, *Fouilles archéologiques dans la vallée du Haut-Lualaba, Zaire: II. Sanga et Katongo*, 1974, Tervuren, 1985
- DE MARET, 1985² P. de Maret, *Fouilles archéologiques dans la vallée du Haut-Lualaba, Zaire: III. Kamilamba, Kikulu et Malemba-Nkulu*, 1975, Tervuren, 1985
- DE MORGAN, 1895 J. De Morgan, *Fouilles à Dahchour, Mars-Juin 1894*, Vienna, 1895
- DE MORGAN, 1905 J. De Morgan, *Fouilles à Dahchour, en 1894–5*, Vienna, 1905
- DE MOTT, 1979 B. de Mott, *Dogon Masks: A Structural Study of Form and Meaning*, Ann Arbor, 1979
- DE RACHEWILTZ, 1966 B. de Rachewiltz, *Introduction to African Art*, London, 1966
- DE VOOGT, 1994 A. J. de Voogt, 'Review of Bao (Mankala): The Swahili Ethic in African Idiom', *The Capteyn*, May 1994
- DEACON, 1984 J. Deacon, 'Later Stone Age People and their Descendants in Southern Africa' in *Southern African Prehistory and Palaeoenvironments*, ed. R. G. Klein, Rotterdam, 1984, pp. 221–528
- DEACON, 1988 J. Deacon, 'The Power of Place in Understanding Southern San Rock Engravings', *World Archaeology*, 20, 1988, pp. 129–40
- DELAFOSSÉ, 1912 M. Delafosse, *Haut-Sénégal-Niger*, Paris, 1912
- DELEGORGUE, 1990 A. Delegorgue, *Travels in Southern Africa*, i, Pietermaritzburg, 1990
- DELIUS, 1989 P. Delius, 'The Ndzundza Ndebele: Indenture and the Making of Ethnic Identity', in *Holding Their Ground: Class, Locality and Culture in Nineteenth and Twentieth Century South Africa*, ed. T. Lodge et al., Johannesburg, 1989
- DEMEL, 1932 H. Demel, 'Ein ägyptisches Salbengefäß aus dem Alten Reich', *Jahrbuch der Kunsthistorischen Sammlungen in Wien*, new series, 1932, pp. 3–8, figs 1–4
- DEMEL, 1947 H. Demel, *Ägyptische Kunst*, Vienna, 1947
- DENBOW, 1986 J. R. Denbow, 'Patterns and Processes: A new look at the later prehistory of the Kalahari', *Journal of African History*, 27 (1), 1986
- DENIS, 1974 W. Denis, *Icon and Image*, London, 1974
- DER MANUELIAN, 1994 P. der Manuelian, *Living in the Past: Studies in Archaism of the Egyptian Twenty-sixth Dynasty*, London, 1994
- DERRICOURT, 1974 R. M. Derricourt, 'A Soap Stone Sculpture from Rhodesia', *South African Archaeological Bulletin*, 29, 1974, pp. 38–40
- DESANGES, 1981 J. Desanges, 'The Proto-Berbers', in *General History of Africa*, ii: *Ancient Civilisations of Africa*, ed. G. Mokhtar, London, 1981, pp. 425–40
- DETROIT et al. 1980–3 *Treasures of Ancient Nigeria*, exh. cat. by E. Eyo and F. Willett, Detroit Institute of Arts et al., 1980–3
- DEVISCH, 1993 R. Devisch, *Weaving the Threads of Life*, Chicago, 1993

- DEWEY, 1986 W. J. Dewey, 'Shona Male and Female Artistry', *African Arts*, 19 (3), 1986, pp. 64–7, 84
- DEWEY, 1993 W. J. Dewey, 'Declarations of Status and Conduits to the Spirits: A Case Study of Shona Headrests', in *Sleeping Beauties: The Jerome L. Joss Collection of African Headrests at UCLA*, exh. cat., Fowler Museum of Cultural History, Los Angeles, 1993, pp. 98–135
- DIAS, 1961 J. Dias, *Portuguese Contributions to Cultural Anthropology*, Johannesburg, 1961
- DIAS and DIAS, 1964–70 A. J. Dias and M. Dias, *Os Macondes de Moçambique*, 3 vols, Lisbon, 1964–70
- DIAS DE CARVALHO, 1890 H. Dias de Carvalho, *Expedição portuguesa ao Muatiânuva (1884–1888). Ethnographia e história tradicional dos povos da Lunda*, Lisbon, 1890
- DICK-READ, 1964 R. Dick-Read, *Sanamu: Adventures in Search of African Art*, London, 1964
- DIETERLEN, 1951 G. Dieterlen, *Essai sur la religion Bambara*, Paris, 1951
- DILLON, 1907 E. Dillon, *Glass: The Connoisseur's Library*, London, 1907
- DINKLER, 1970 E. Dinkler, ed., *Kunst und Geschichte Nubiens in christlicher Zeit*, Recklinghausen, 1970
- DIOP, 1981 A. B. Diop, *La société Wolof: Tradition et changement*, Paris, 1981
- DITTMER, 1967 K. Dittmer, 'Bedeutung, Datierung und kulturhistorische Zusammenhänge der „prähistorischen“ Steinfiguren aus Sierra Leone und Guinée', *Baessler Archiv*, 40, 1967, pp. 183–238
- DMOCHOWSKI, 1990 Z. R. Dmochowski, *The Traditional Architecture of Nigeria*, i–iii, London, 1990
- DORF, in preparation S. Dorf, 'The Hierakonpolis Door-socket: A New Study', in preparation
- DOWSON, 1992 T. A. Dowson, *Rock Engravings of Southern Africa*, Johannesburg, 1992
- DRENKHahn, 1986 R. Drenkhahn, *Elfenbein im Alten Ägypten*, Erbach, 1986
- DREWAL, 1981 H. J. Drewal, 'Staff (Edan Oshugbo)' and 'Mask (Gelede)', in *For Spirits and Kings: African Art from the Tishman Collection*, ed. S. Vogel, New York, 1981, pp. 90–1, 114–16
- DREWAL, 1989¹ H. J. Drewal, 'Artists of the Western Kingdoms', in H. J. Drewal, J. Pemberton and R. Abiodun, *Yoruba: Nine Centuries of African Art and Thought*, New York, 1989, pp. 212–31
- DREWAL, 1989² H. J. Drewal, 'Meaning in Osugbo Art: A Reappraisal', in *Man Does Not Go Naked: Textilien und Handwerk aus afrikanischen und anderen Ländern*, ed. B. Engelbrecht and B. Gardi, Basle, 1989, pp. 151–74
- DREWAL, 1989³ H. J. Drewal, 'Art and Ethos of the Ijebu', in H. J. Drewal, J. Pemberton and R. Abiodun, *Yoruba: Nine Centuries of African Art and Thought*, New York, 1989, pp. 117–145
- DREWAL and DREWAL, 1983 H. J. and M. T. Drewal, *Gelede: Art and Female Power among the Yoruba*, Bloomington, 1983
- DREWAL, PEMBERTON and ABIODUN, 1989 H. J. Drewal, J. Pemberton and R. Abiodun, *Yoruba: Nine Centuries of African Art and Thought*, New York, 1989
- DU PUIGARDEAU, 1967–70 O. Du Puigardeau, 'Arts et coutumes de Maures', *Hespéris-Tamuda*, 8, 1967, pp. 111–250; 9, 1968, pp. 329–458; 11, 1970, pp. 5–82
- DUCHEMIN, 1946 G. J. Duchemin, 'Tête en terre cuite de Krinjabo (Côte d'Ivoire)', *Notes africaines*, 29, 1946, pp. 15–14
- DUNHAM, 1955 D. Dunham, *The Royal Cemeteries of Kush II: Nuri*, Boston, 1955
- DUNN, 1951 E. J. Dunn, *The Bushman*, London, 1951
- DUPIRE, 1962 M. Dupire, *Peuls Nomades: Étude descriptive des WoDaabe du Sahel Nigérien*, Paris, 1962
- DÜSSELDORF et al. 1988–9 *Afrikanische Kunst aus der Sammlung Barbier Mueller, Genf*, exh. cat. ed. W. Schmalenbach, Düsseldorf, Kunstsammlung Nordrhein-Westfalen et al., 1988–9 [also published in French and English edn]
- DUTHUIT, 1951 G. Duthuit, *La sculpture copte*, Paris, 1951
- EARTHY, 1968 E. D. Earthy, *Valenge Women: The Social and Economic Life of the Valenge Women of Portuguese East Africa*, London, 1968 [1st edn 1953]
- EAST LANSING 1994 *Ethiopia: Traditions of Creativity*, exh. cat. by R. Silverman, Michigan State University Museum, East Lansing, 1994
- EBERL-ELBER, 1959 R. Eberl-Elber, 'Die Masken der Männerbünde in Sierra Leone', *Ethnos*, 2 (2), 1959, pp. 38–46
- EDWARDS, 1978 I. E. S. Edwards, *The Pyramids of Egypt*, London, 1978
- EGGEBRECHT, 1993 A. Eggebrecht, ed., *Pelizaeus-Museum Hildesheim: Die Ägyptische Sammlung*, Mainz, 1993
- EICHER and EREKOSIMA, 1987 J. B. Eicher and T. V. Erekosima, 'Kalabari funerals: celebration and display', *African Arts*, 21 (1), 1987
- ELKAN, 1958 W. Elkan, 'The East African Trade in Wood Carvings', *Africa*, 57 (2), 1958, pp. 314–25
- EMERY and KIRWAN, 1958 W. B. Emery and L. P. Kirwan, *The Royal Tombs of Ballana and Oustul*, Cairo, 1958
- ENGEL, 1864 C. Engel, *Music of the Most Ancient Nations*, London, 1864
- ENNABLI, 1986 A. Ennabli, 'Les thermes du thiase marin de Sidi Ghrib (Tunisie)', *Fondation Eugène Piot: Monuments et Mémoires*, 68, 1986, pp. 1–59
- ERDMANN, 1962 K. Erdmann, *Europa und der Orientteppich*, Berlin, 1962
- ESSEN, 1961 see Vienna 1961
- ETIENNE-NUGUE and SALEY, 1987 J. Etienne-Nugue and M. Saley, *Artisanats Traditionnels Niger*, Dakar, 1987
- ETTINGHAUSEN, 1992 R. Ettinghausen, 'The Man-made Setting', in *The World of Islam*, ed. B. Louis, London, 1992, pp. 57–72
- EUDEL, 1902 P. Eudel, *L'orfèvrerie algérienne et tunisienne*, Algiers, 1902
- EUDEL, 1906 P. Eudel, *Dictionnaire des bijoux de l'Afrique du Nord*, Paris, 1906
- EVANS-PRITCHARD, 1929 E. E. Evans-Pritchard, 'The Bongo', *Sudan Notes and Records*, 12 (1), 1929, pp. 1–61
- EVERS, 1982 T. M. Evers, 'Excavations at the Lydenburg Heads Site, Eastern Transvaal, South Africa', *South African Archaeological Bulletin*, 57, 1982, pp. 16–50
- EYO, 1977 E. Eyo, *Two Thousand Years of Nigerian Art*, Lagos, 1977
- EYO, 1984 E. Eyo, 'Alok and Emangabe Stone Monoliths, Ikrom', in *Arte in Africa*, Florence, 1984
- EYO and WILLETT, 1982 see Detroit et al. 1980–5
- EZRA, 1983 K. Ezra, 'Figure Sculptures of the Bamana of Mali', diss., Northwestern University, 1983
- EZRA, 1986 K. Ezra, *A Human Ideal in African Art: Bamana Figurative Sculpture*, Washington, 1986
- FAGG, A., 1994 A. Fagg, 'Thoughts of Nok', *African Arts*, 27 (3), 1994, pp. 79–85
- FAGG, B., 1945 B. Fagg, 'A Preliminary Note on a New Series of Pottery Figures from Northern Nigeria', *Africa*, 15 (1), 1945, pp. 21–2
- FAGG, B., 1946 B. Fagg, 'Archaeological Notes from Northern Nigeria', *Man*, 1946, pp. 48–55
- FAGG, B., 1948 B. Fagg, in *Man*, November 1948, p. 140
- FAGG, B., 1956¹ B. Fagg, 'A Life-size Terracotta Head from Nok', *Man*, 1956, p. 95
- FAGG, B., 1956² B. Fagg, 'The Nok Culture', *West African Review*, 1956
- FAGG, B., 1958 B. Fagg, personal communication, 1958
- FAGG, B., 1977 B. Fagg, *Nok Terracottas*, Lagos, 1977, 2/1990
- FAGG, B. and FLEMING, 1970 B. Fagg and S. J. Fleming, 'Thermoluminescent dating of a terracotta of the Nok Culture', *Archaeometry*, 12 (1), 1970, pp. 55–5
- FAGG, 1949 W. B. Fagg, *Traditional Art of the British Colonies*, London, 1949
- FAGG, 1955 W. B. Fagg, 'Two Early Masks from the Dan Tribes in the British Museum', *Man*, 55, 1955, pp. 160–2
- FAGG, 1960¹ W. B. Fagg, *The Epstein Collection*, London, 1960
- FAGG, 1960² W. B. Fagg, *Nigerian Tribal Art*, London, 1960
- FAGG, 1963 W. B. Fagg, *Nigerian Images: the Splendor of African Sculpture*, London and New York, 1963
- FAGG, 1964 W. B. Fagg, *Afrique. 100 tribus – 100 chefs-d'œuvre*, Paris, 1964
- FAGG, 1964 W. B. Fagg, *African Sculpture: an anthology*, London, 1964
- FAGG, 1965 W. B. Fagg, *Tribes and Forms in African Art*, New York and London, 1965
- FAGG, 1968 W. B. Fagg, *African Tribal Images*, Cleveland, 1968
- FAGG, 1969 W. B. Fagg, *African Sculpture*, Washington, 1969
- FAGG, 1969 W. B. Fagg, 'The African Artist', in *Traditions and Creativity in Tribal Art*, ed. D. Biebuyck, Berkeley, 1969, pp. 42–57
- FAGG, 1980 W. B. Fagg, introduction to *Yoruba Beadwork. Art of Nigeria*, by John Pemberton III, exh. cat., New York, 1980
- FAGG, 1981 W. B. Fagg, 'Figure of an Ogboni or Oshugbo Chief', in *For Spirits and Kings: African Art in the Tishman Collection*, ed. S. Vogel, New York, 1981, p. 104
- FAGG, and PEMBERTON, 1982 W. B. Fagg and J. Pemberton, *Yoruba Sculpture of West Africa*, New York, 1982
- FAGG, and PLASS, 1964 W. B. Fagg and M. Plass, *African Sculpture*, London, 1964
- FAIK-NZUJI, 1986 'Lecture d'un taampha, planchette à proverbe des Woyo', *Arts d'Afrique Noire*, 1986
- FALGAYRETTES et al., n. d. C. Falgayrettes et al., *Cuillers-Sculptures*, Musée Dapper, Paris, n. d.
- FANTAR, 1986 M. Fantar, ed., *30 ans au service du patrimoine*, Tunis, 1986
- FANTAR, 1995 M. H. Fantar, *Carthage: la cité punique*, Paris, 1995
- FARIS, 1972 J. C. Faris, *Nuba Personal Art*, London, 1972
- FAZZINI, 1972 R. A. Fazzini, 'Some Egyptian Reliefs in The Brooklyn Museum', in *Miscellanea Wilbouriana*, i, Brooklyn, 1972, pp. 53–70
- FAZZINI et al., 1989 R. A. Fazzini et al., *Ancient Egyptian Art in The Brooklyn Museum*, Brooklyn, 1989
- FEDDERS and SALVADORI, 1977 A. Fedders and C. Salvadori, *Turkana, Pastoral Craftsmen*, Nairobi, 1977
- FÉHÉRVARI, 1985 G. Fehérvari, *La ceramica islamica*, Milan, 1985
- FELIX, 1987 M. L. Felix, *100 Peoples of Zaire and their Sculpture*, Brussels, 1987
- FELIX, 1989 M. Felix, *Maniema: An Essay on the Distribution of the Symbols and Myths Depicted on the Masks of Greater Maniema*, Munich, 1989
- FELIX, 1990 M. L. Felix, *Mwana Hiti: Life and Art of the Matrilineal Bantu of Tanzania*, Munich, 1990
- FELIX, KECSKÉSI et al., 1994 M. Felix, M. Kecskési et al., *Tanzania: Meisterwerke Afrikanischer Skulptur*, ed. J. Jahn, Munich, 1994
- FENTRESS, 1978 E. Fentress, 'Dii Mauri and Dii Patrii', *Latomus*, 37, 1978, pp. 507–16
- FERBER et al., 1988 L. S. Ferber et al., *Masterpieces in The Brooklyn Museum*, Brooklyn, 1988

- FERNANDEZ, 1974 J. W. Fernandez, 'La Statuaire Fan-Gabon', *African Arts*, 8 (1), 1974, pp. 76–7
- FERNANDEZ, 1992 J. W. Fernandez, 'Met andere ogen: een beschouwing bij een collectie draagbare kunst van de Fang (en Kota) (Gabon)', in Maastricht 1992, pp. 32–6
- FIELD, 1948 M. J. Field, *Akim Kotoku: An Oman of the Gold Coast*, London, 1948
- FILER, in preparation J. M. Filer, 'Attitudes to Death with Reference to Cats in Ancient Egypt', *Proceedings of The Archaeology of Death in the Ancient Near East*, in preparation
- FINKENSTAEDT, 1980 E. Finkenstaedt, 'Regional Painting Style in Prehistoric Egypt', *Zeitschrift für Ägyptische Sprache und Altertumskunde*, 107, 1980, pp. 118–19, fig. 5
- FISCHER, 1989 E. Fischer, 'Bété', in *Corps sculptés, corps parés, corps masqués*, ed. E. Féau and Y. Savané, Paris, 1989, pp. 46–7
- FISCHER and HIMMELHEBER, 1984 E. Fischer and H. Himmelheber, *The Arts of the Dan in West Africa*, trans. A. Biddle, Zurich, 1984 [*Die Kunst der Dan*, 1976]
- FISHER, 1987 A. Fisher, *Africa Adorned*, London, 1987
- FITZGERALD, 1944 R. T. D. Fitzgerald, 'Dakarai Grave Pottery', *Journal of the Royal Anthropological Institute*, 1944, pp. 45–57
- FLEMING and NICKLIN, 1982 S. J. Fleming and K. W. Nicklin, 'Analysis of two bronzes from a Nigerian Asunaja Shrine', *Museum of Applied Science Centre for Archaeology Journal*, 2 (2), 1982, pp. 55–7
- FLINT, 1974 B. Flint, *Formes et symboles dans les arts maghrébins*, ii: *Tapis et tissages*, Tangier, 1974
- FLINT, 1987 B. Flint, *Tapices marroquines*, exh. cat., Seville, 1987
- FOCK and FOCK, 1979–89 G. J. Fock and D. M. L. Fock, *Felsbilder in Südafrika*, 3 vols, Cologne, 1979–89
- FORDE, 1964 D. Forde, *Yako Studies*, London, 1964
- FORDE-JOHNSTON, 1959 J. Forde-Johnston, *Neolithic Cultures of North Africa*, Liverpool, 1959
- FÖRSTER, 1988 T. Förster, *Die Kunst der Senoufo*, Zurich, 1988
- FOSS, 1975 W. Foss, 'Images of Aggression: Ivuri Sculpture of the Urhobo', in *African Images: Essays in African Iconology*, ed. D. McCall and E. Bay, New York and London, 1975
- FOSS, 1976 W. Foss, 'Urhobo Statuary for Spirits and Ancestors', *African Arts*, 9 (4), 1976, pp. 12–23
- FRANKFURT AM MAIN 1983 *Luba Hemba*, exh. cat., Museum für Völkerkunde, Afrika-Sammlung 1, Frankfurt am Main, 1983
- FRANKS, 1862 A. W. Franks, 'Glass', *Catalogue of the Special Exhibition of Works of Art on Loan at the South Kensington Museum, June 1862*, exh. cat. ed. J. C. Robinson, London, 1862, pp. 381 ff.
- FRANZ, 1969 M. Franz, 'Traditional Masks and Figures of the Makonde', *African Arts*, 3 (1), 1969, pp. 42–5
- FRASER, 1962 D. Fraser, 'The Legendary Ancestor Tradition in West Africa', in *African Art as Philosophy*, ed. D. Fraser, New York, 1962, pp. 58–55
- FRASER and COLE, 1972 D. Fraser and H. M. Cole, *African Art and Leadership*, Madison, 1972
- FREEMAN-GRENVILLE, 1962 G. S. P. Freeman-Grenville, *The East African Coast*, Oxford, 1962
- FRISHMAN and HASAN-UDDIN, 1994 M. Frishman and K. Hasan-Uddin, eds, *The Mosque: History, Architectural Development and Regional Diversity*, London, 1994
- FROBENIUS, 1898 L. Frobenius, *Die Masken und Geheimbünde Afrikas*, Halle, 1898
- FROBENIUS, 1907 L. Frobenius, *Im Schatten des Kongostaates*, Berlin, 1907
- FROBENIUS, 1913 L. Frobenius, *Und Afrika sprach*, 3 vols, Berlin, 1913
- FROBENIUS, 1968 L. Frobenius, *The Voice of Africa*, 2 vols, New York, repr. 1968
- FROBENIUS, 1985 L. Frobenius, *Ethnographische Notizen aus den Jahren 1905 und 1906*, ed. H. Klein, Stuttgart, 1985
- FRY, 1970 P. Fry, 'Essay sur la statuaire mumuye', in *Objets et Mondes: La revue du Musée de l'Homme*, X (1), 1970, pp. 5–28
- FRY, 1978 J. Fry, ed., *Twenty-five African Sculptures*, Ottawa, 1978
- FYFE, 1964 C. S. Fyfe, *Sierra Leone Inheritance*, London, 1964
- GABRA, 1995 G. Gabra, *Cairo: the Coptic Museum and Old Churches*, Cairo, 1995
- GABUS, 1958 J. Gabus, *Au Sahara: Arts et Symboles*, Neuchâtel, 1958
- GALAVARIS, 1979 G. Galavaris, *The Illustrations of the Prefaces in Byzantine Gospels*, Vienna, 1979
- GALLOIS DUQUETTE, 1976 D. Gallois Duquette, 'Informations sur les arts plastiques des Bidyogo', *Arts d'Afrique Noire*, 18, 1976, pp. 26–45
- GALLOIS DUQUETTE, 1985 D. Gallois Duquette, *Dynamique de l'art bidjogo*, Lisbon, 1985
- GANAY, 1947 S. de Ganay, 'Un jardin d'essay et son autel chez les Bamana', *Journal de la Société des Africanistes*, 17, 1947, pp. 57–63
- GANAY, 1949 S. de Ganay, 'Aspects de mythologie et de symbolique Bambara', *Journal de psychologie normale et pathologique*, 41 (2), 1949, pp. 181–201
- GÄNSICKE, 1994 S. Gänsicke, 'King Aspelta's Vessel Hoard from Nuri in the Sudan', *Journal of the Museum of Fine Arts*, Boston, 6, 1994, pp. 14–40
- GARGOURI-SETHOM, 1986 S. Gargouri-Sethom, *Le bijou traditionnel en Tunisie*, Aix-en-Provence, 1986
- GARLAKE, 1973 P. S. Garlake, *Great Zimbabwe*, London, 1973
- GARLAKE, 1974 P. S. Garlake, 'Excavations at Obalar's Land, Ife: An interim report', *West African Journal of Archaeology*, 4, 1974
- GARLAKE, 1977 P. S. Garlake, 'Excavations on the Woye Asiri family land in Ife, Western Nigeria', *West African Journal of Archaeology*, 7, 1977
- GARLAKE, 1978¹ P. Garlake, *Kingdoms of Africa*, London, 1978
- GARLAKE, 1978² P. S. Garlake, 'Pastoralism and zimbabwe', *Journal of African History*, 19 (4), 1978
- GARLAKE, 1982 P. S. Garlake, 'Prehistory and ideology in Zimbabwe', *Africa*, 52 (3), 1982
- GARLAKE, 1995 P. S. Garlake, *The Hunter's Vision*, London, 1995
- GARNIER, 1884 E. Garnier, 'Collections de M. Spitzer. La Verrerie', *Gazette des Beaux-Arts*, 1884, pp. 293 ff
- GARRARD, 1980 T. F. Garrard, *Akan Weights and the Gold Trade*, London, 1980
- GARRARD, 1982 T. F. Garrard, 'Erotic Akan Goldweights', *African Arts*, 15 (2), 1982, pp. 60–2, 88
- GARRARD, 1983 T. Garrard, 'A Corpus of 15th to 17th Century Akan Brass Castings', in *Akan Transformations: Problems in Ghanaian Art History*, Los Angeles, 1983, pp. 30–53
- GARRARD, 1984 T. F. Garrard, 'Figurine Cults of the Southern Akan', *Iowa Studies in African Art*, Iowa City, 1984, pp. 167–90
- GARRARD, 1989 T. F. Garrard, *Gold of Africa*, Munich, 1989
- GARSTANG, 1907 J. Garstang, 'Excavations at Hierakopolis, at Esna, and in Nubia', *Annales du Service des Antiquités de l'Égypte*, 8, 1907, pp. 152–48
- GARSTANG, 1928 J. Garstang, 'An Ivory Sphinx from Abydos', *Journal of Egyptian Archaeology*, 14, 1928
- GAUCKLER, 1915 P. Gauckler, *Nécropoles puniques de Carthage*, Paris, 1915
- GAYET, 1902 A. Gayet, *L'art copte*, Paris, 1902
- GEBAUER, 1979 P. Gebauer, *Art of Cameroon*, New York, 1979
- GERMANN, 1933 P. Germann, *Die Völkerstämme im Norden von Liberia*, Leipzig, 1933
- GEUS, 1980 F. Geus, *Rapport annuel d'activité*, 1978–79, Lille, 1980
- GEUS, 1984 F. Geus, 'Excavations at el Kadada and the Neolithic of the Central Sudan', in *Origin and Early Development of Food-Producing Cultures in North-eastern Africa*, ed. L. Krzyzaniak and M. Kobusiewicz, Poznan, 1984, pp. 361–72
- GIBBAL, 1994 J. M. Gibbal, *Genii of the River Niger*, trans. B. F. Raps, Chicago, 1994
- GIESSEKE, 1930 E. D. Giesecke, 'Wahr-sagerei bei den BaVenda', *Zeitschrift für EingeborenenSprache*, 21 (1) 1930, pp. 257–310
- GILBERT, 1989 M. Gilbert, 'Akan terracotta heads: gods or ancestors?' *African Arts*, 22 (4), 1989, 34–45
- GILLON, 1984 W. Gillon, *A Short History of African Art*, London and New York, 1984
- GIRARD, 1967 J. Girard, *Dynamique de la société ouobé: loi des masques et coutume*, Paris, 1967
- GLAZE, 1981 A. J. Glaze, *Art and Death in a Senoufo Village*, Bloomington, 1981
- GNONSOA, 1983 A. Gnonsoa, *Masques de l'Ouest Ivoirien*, Abidjan, 1983
- GODMAN, 1901 F. D. Godman, *The Godman Collection of Oriental and Spanish Pottery and Glass*, London, 1901
- GOLDWATER, 1960 R. Goldwater, *Bambara Sculpture from the Western Sudan*, New York, 1960
- GOLDWATER, 1964 R. Goldwater, *Senoufo Sculpture from West Africa*, New York, 1964
- GOLLNHOFER et al., 1975 O. Gollnhofer, *Art et artisanat tsogho*, Paris, 1975
- GOLVIN, 1950 L. Golvin, 'Le "Métier à la Tire" des fabricants de brocarts de Fès', *Hespérés*, XXXVII, 1950, pp. 21–52
- GONZÁLEZ, 1994 V. González, *Émaux d'Al Andalus et du Maghreb*, Aix-en-Provence, 1994
- GRANT, 1864 J. A. Grant, *A Walk across Africa*, Edinburgh, 1864
- GREENBERG, 1966 J. Greenberg, *The Languages of Africa*, Bloomington, 1966
- GRIAULE, 1958 M. Griaule, *Masques Dogons*, Paris, 1958
- GRIAULE, 1947 M. Griaule, *Descente du troisième verbe chez les Dogons du Soudan*, Paris, 1947 [repr. from *Psyché*, 2, pp. 13–14]
- GRIAULE, 1965 M. Griaule, *Conversations With Ogotemméli: An Introduction to Dogon Religious Ideas*, 1965
- GRIAULE and DIETERLEN, 1986 M. Griaule and G. Dieterlen, *The Pale Fox*, 1986
- GRIFFITH, 1911 F. L. Griffith, *Karanog: the Meroitic Inscriptions of Shablu and Karanog*, University Museum, Philadelphia, 1911
- GRIFFITH, 1925 F. L. Griffith, 'Oxford Excavations in Nubia', *Liverpool Annals of Archaeology and Anthropology*, 12 (3–4), 1925, pp. 57–172
- GROBLER and VAN SCHALKWYK, 1989 E. Grobler and J. A. van Schalkwyk, *Reflection of a Collection*, Pretoria, 1989
- GRUNNE, 1988 B. de Grunne, 'Ancient Sculpture of the Inland Niger Delta and Its Influence on Dogon Art', *African Arts*, 21 (4), 1988, pp. 50–5, 92
- GULLIVER, 1959 P. H. Gulliver, 'A Tribal Map of Tanganyika', *Tanganyika Notes and Records*, 52, 1959
- GUTHRIE, 1967–71 M. Guthrie, *Comparative Bantu: An Introduction to the Comparative Linguistics and Prehistory of the Bantu Languages*, 4 vols, London, 1967–71
- HABERLAND, 1965 E. Haberland, *Galla Süd-Äthiopiens. Völker Süd-Äthiopiens. Ergebnisse der Frobenius Expedition 1950–52, und 1954–56*, 1965
- HÄGG, 1987 T. Hägg, ed., *Nubian Culture: Past and Present*, Stockholm, 1987

- HAHNLOSER, 1971 H. R. Hahnloser, ed., *Il Tesoro di San Marco: Il Tesoro e il Museo*, ii, Florence, 1971
- HAKENJOS, 1988 B. Hakenjos, *Marokkanische Keramik*, Stuttgart and London, 1988
- HALL, 1905 M. Hall, *Great Zimbabwe*, London, 1905
- HALL, 1958 R. de Z. Hall, 'A Tribal Museum at Bweranyange, Bukoba District', *Tanganyika Notes and Records*, 5, 1958, pp. 1–4
- HALL, 1987 M. Hall, *The Changing Past: Farmers, Kings and Traders in Southern Africa, 200–1860*, Cape Town, 1987
- HALLPIKE, 1972 C. R. Hallpike, *The Konso of Ethiopia: A Study of the Values of a Cushitic People*, Oxford, 1972
- HAMBOLU, 1989 H. M. Hambolu, 'An Archaeological Up-date on the Mystery of the Esie Stone Figures', paper presented at the Seminar on Material Culture, Monuments and Festivals in Kwara State, National Museum, Esie, Nigeria, 1989
- HANISCH, 1980 E. O. M. Hanisch, 'An Archaeological Interpretation of Certain Iron Age Sites in the Limpopo/Shashi Valley', diss., University of Pretoria, 1980
- HARLEY, 1941 G. Harley, 'Notes on the Poro in Liberia', *Papers of the Peabody Museum*, Cambridge, MA, 19 (2), 1941
- HARLEY, 1950 G. Harley, 'Masks as Agents of Social Control', *Papers of the Peabody Museum*, Cambridge, MA, 32 (2), 1950
- HARRIES, 1944 L. Harries, *The Initiation Rites of the Makonde Tribe*, iii, Livingstone, 1944
- HARRIES, 1988 P. Harries, 'The Roots of Ethnicity: Discourse and the Politics of Language Construction in South-East Africa', *African Affairs*, 346, 1988, pp. 25–52
- HARRIES, 1989 P. Harries, 'Exclusion, Classification and Internal Colonialism: The Emergence of Ethnicity among the Tsonga-speakers of South Africa', in *The Creation of Tribalism in Southern Africa*, ed. L. Vail, London, 1989
- HARRIS, 1938 P. G. Harris, 'Notes on the Dakarari People', *Journal of the Royal Anthropological Institute*, 1938, pp. 114–53
- HARRIS, 1965 R. Harris, *The Political Organisation of the Mbembe, Nigeria*, London, 1965
- HART, 1984 W. A. Hart, 'So-called Minserah Figures from Sierra Leone', *African Arts*, 18 (1), 1984, pp. 84–6
- HART, 1990 G. Hart, *Eyewitness Guides: Ancient Egypt*, London, 1990
- HART, 1993 W. A. Hart, 'Sculptures of the Njayezi Society among the Mende', *African Arts*, 26 (1), 1993, p. 46
- HART and FYFE, 1993 W. A. Hart and C. Fyfe, 'The Stone Sculptures of the Upper Guinea Coast', *History in Africa*, 20, 1993, pp. 71–87
- HARTER, 1986 P. Harter, *Arts Anciens du Cameroun*, supplement to *Arts d'Afrique Noire*, XL, Arnouville, 1986
- HARTLE, 1970 D. Hartle, 'Preliminary Report of the University of Ibadan's Kainji Rescue Archaeology Project 1968', *West African Archaeological Newsletter*, 12, 1970, pp. 7–19
- HARTWIG, 1969¹ G. Hartwig, 'A Historical Perspective of Kerebe Sculpturing – Tanzania', *Tribus*, 18, 1969, pp. 85–102
- HARTWIG, 1969² G. Hartwig, 'The Role of Plastic Art Traditions in Tanzania', *Baessler-Archiv*, 17, 1969
- HARTWIG, 1976 G. Hartwig, *The Art of Survival in East Africa: The Kerebe and Long-Distance Trade, 1800–1895*, New York, 1976
- HARTWIG, 1978 G. Hartwig, 'Sculpture in East Africa', *African Arts*, 11 (4), 1978
- HASAN, 1956 Z. M. Hasan, *Atlas al-funun al-zukhrifiyya wa'l tasawir al-islamiyya*, Cairo, 1956
- HAWKESWORTH, 1932 G. Hawkesworth, 'A Note on the Making of Kadaru Pottery', letter to Sir Harold MacMichael, 1932, archives of the Horniman Museum and Public Park Trust, London
- HAYES, 1955 W. C. Hayes, *The Scepter of Egypt*, i, 1955
- HECHT et al., 1990 D. Hecht, B. Benzing and G. Kidane, *The Handcrosses of the IES Collection*, Addis Ababa, 1990
- HECKEL, 1935 B. Heckel, *The Yao Tribe: Their Culture and Education*, iv, London, 1935
- HELCK, 1977 W. Helck, 'Fremdvölkerdarstellung', *Lexikon der Ägyptologie*, ed. W. Helck and W. Westendorf, ii, Wiesbaden, 1977, cols 315–21
- HENDRICKX, 1992 S. Hendrickx, 'Une scène de chasse dans le désert sur le vase pré-dynastique Bruxelles, M. R. A. H. E. 2631', *Chronique d'Égypte*, 67, 1992, pp. 5–27
- HENDRICKX, 1994 S. Hendrickx, *Antiquités préhistoriques et protodynastiques d'Égypte*, Guides du département égyptien, 8, Musées Royaux d'Art et d'Histoire, Brussels, 1994
- HERBERT, 1984 E. Herbert, *The Red Gold of Africa*, Madison, 1984
- HEROLD, 1985 E. Herold, 'Traditional Sculpture of the Bete Tribe, Ivory Coast', *Annals of the Náprstek Museum*, 15, 1985, pp. 81–165
- HERREMAN, 1985 F. Herreman, *De Wenteling om de Aslija: Mumuye-beeldhouwwerken uit Nigeria*, Ga-maart, 1985
- HERREMAN and PETRIDIS, 1993 F. Herreman and C. Petridis, eds, *Face of the Spirits: Masks from the Zaire Basin*, Antwerp, 1993
- HERSAK, 1986 D. Hersak, *Songye Masks and Figure Sculpture*, London, 1986
- HERSAK, 1995 D. Hersak, 'Colours, Stripes and Projection: Revelations on Fieldwork Findings and Museum Enigmas', in *Object Signs of Africa*, ed. L. de Heusch, Ghent, 1995
- HERTER, 1991 P. Herter, 'Les peuples Krou de la Frontière Eburreo-Libérienne', *Primitifs*, 6, 1991, pp. 58–71
- HERTER, 1993 P. Herter, 'Wè Masks', *Art of Côte d'Ivoire*, ed. J.-P. Barbier-Muller, i, Geneva, 1993, pp. 184–219
- HERZ, 1906 M. Herz, *Catalogue raisonné des monuments exposés dans le Musée National de l'Art Arabe*, Cairo, 1906
- HERZ, 1907 M. Herz, *Descriptive Catalogue of the Objects Exhibited in the National Museum of Arab Art*, Cairo, 1907
- HERZ, 1913 M. Herz, 'Boiseries fatimides aux sculptures figurales', *Orientalisches Archiv*, 3 (4), Leipzig, 1913, pp. 169–74
- HEUSCH, 1995 L. de Heusch, 'Beauty is Elsewhere: Returning a Verdict on Tetela Masks', in *Object Signs of Africa*, ed. L. de Heusch, Ghent, 1995
- HILDESHEIM 1985 *Nofret – Die Schöne: Die Frau im Alten Ägypten*, exh. cat. ed. B. Schmitz, Roemer- und Pelizaeus-Museum, Hildesheim, 1985
- HILDESHEIM and MAINZ 1990 *Suche nach Unsterblichkeit: Totenkult und Jenseitsglaube im alten Ägypten*, exh. cat., Hildesheim and Mainz, 1990
- HILTON-SIMPSON, 1911 W. H. Hilton-Simpson, *Land and Peoples of the Kasai*, London, 1911
- HIMMELHEBER, 1960 H. Himmelheber, *Negerkunst und Negerkünstler*, Brunswick, 1960
- HIMMELHEBER, 1966 H. Himmelheber, 'Masken der Guéré II', *Zeitschrift für Ethnologie*, 91 (1), 1966, pp. 100–8
- HINTZE et al., 1971 F. Hintze, K. H. Priese, S. Wenig and C. Onasch, *Musauwarat es Sufra*, i, 1–2, *Der Löwentempel*, Berlin, 1971, 1993
- HOFFER, 1973 C. Hoffer, 'Mende and Sherbro Women in High Office', *Canadian Journal of African Studies*, 6 (2), 1973, pp. 151–64
- HOFFMANN 1991 Hoffmann, *Steine für die Ewigkeit: meroitische Opferfächer und Totenstein*, Vienna, 1991
- HOLAS, 1952 B. Holas, *Les masques Kono*, Paris, 1952
- HOLAS, 1955 B. Holas, *Portes sculptées du Musée d'Abidjan*, Dakar, 1955
- HOLAS, 1976 B. Holas, *Civilisations et arts de l'Ouest Africain*, Paris, 1976
- HOLAS, 1980 B. Holas, *Traditions Krou*, Paris, 1980
- HOLDEN, 1866 W. C. Holden, *Past and Future of the Kaffir Races*, London, 1866
- HOLLIS, 1909 A. C. Hollis, 'A Note on the Graves of the Wa-Nyika', *Man*, 9, 1909, p. 145
- HOLM, 1963 E. Holm, 'Sfinks', *Tydskrif vir geesteswetenskappe*, March 1963, pp. 47–54
- HOLMES, 1992 D. Holmes, 'Chipped Stone-working Craftsmen, Hierakonpolis and the Rise of Civilization in Egypt', in *The Followers of Horus*, ed. R. Friedman and B. Adams, Oxford, 1992, pp. 37–44
- HOLY, 1967 L. Holy, *The Art of Africa: Masks and Figures from Eastern and Southern Africa*, London, 1967
- HOLY, 1971 L. Holy, *Zambian Traditional Art*, NECZAM, 1971
- HONEY, 1927 W. B. Honey, 'A Syrian glass goblet', *Burlington Magazine*, June 1927, p. 289
- HOOPER, 1983 L. Hooper, 'Some Nguni Crafts. Part 5: Woodcarving', *Annals of the South African Museum*, 70 (3), 1983
- HOOPER, DAVISON and KLINGHARDT, 1989 L. Hooper, P. Davison and G. Klinghardt, 'Some Nguni crafts: skin-working technology', *Annals of the South African Museum*, 70 (4), 1989, pp. 313–404
- HOPE, 1987 C. A. Hope, *Egyptian Pottery*, London, 1987
- HOPKINS and LEVTZION, 1981 J. F. P. Hopkins and N. Levzion, *Corpus of Early Arabic Sources for West African History*, New York, 1981
- HORN and RÜGER, 1979 H. G. Horn and C. B. Rüger, eds, *Die Numider*, Reiter und Könige nördlich der Sahara, Bonn, 1979
- HORNBURGER, 1991 L. Hornberger, ed., *Spoons in African Art*, Zurich, 1991
- HORTON, 1965 R. Horton, *Kalabari Sculpture*, Lagos, 1965
- HORTON, 1987 M. Horton, 'The Swahili corridor', *Scientific American*, 257, 1987
- HOULIHAN and GOODMAN, 1986 P. Houlihan and S. Goodman, *The Birds of Ancient Egypt*, Cairo, 1986
- HOURS-MIEDAN, 1951 M. Hours-Miedan, 'Types de décor des stèles de Carthage. Les représentations figurées sur les stèles de Carthage', *Cahiers de Byrsa*, 1, 1951, pp. 15–76
- HUET, 1988 J. C. Huet, 'The Togu Na of Tenyu Ireli', *African Arts*, 21 (4), 1988, pp. 54–6, 91
- HUFFMAN, 1984 T. N. Huffman, 'Expressive Space in the Zimbabwe Culture', *Man*, 19, 1984, pp. 593–612
- HUFFMAN, 1985 T. N. Huffman, 'The Soapstone Birds from Great Zimbabwe', *African Arts*, 18 (3), 1985, pp. 68–73
- HUFFMAN, 1986 T. N. Huffman, 'Iron Age Settlement Patterns and the Origins of Class Distinction in Southern Africa', in *Advances in World Archaeology* 5, ed. F. Wendorff and E. Close, New York, 1986, pp. 291–358
- HUGOT, 1981 H. J. Hugot, 'The Prehistory of the Sahara', in *General History of Africa*, i: *Methodology and African Prehistory*, ed. J. Ki-Zerbo, London, 1981, pp. 585–610
- HULTGREN and ZEIDLER, 1995 M. L. Hultgren and J. Zeidler, *A Taste for the Beautiful: Zairian Art from the Hampton University Museum*, Hampton, VA, 1995
- HUNTINGDON and METCALF, 1979 W. R. Huntingdon and P. Metcalf, *Celebration of Death: The Anthropology of Mortuary Ritual*, Cambridge, 1979
- HUNTINGFORD, 1955 G. W. B. Huntingford, *The Galla of Ethiopia. The Kingdoms of Kafa and Janjero*, London, 1955
- IBRAHIM, 1978 L. A. Ibrahim, 'Clear fresh water in Cairene houses', *Islamic Archaeological Studies*, i, Cairo, 1978, pp. 1–26
- IDOWU, 1963 E. B. Idowu, *Olodomare, God in Yoruba Belief*, New York, 1963
- IMPERATO, 1970 P. J. Imperato, 'The Dance of the Tyi Wara', *African Arts*, 4 (1), 1970, pp. 8–15, 71–80
- IMPERATO, 1974 P. J. Imperato, *The Cultural Heritage of Africa*, Chanute, 1974
- IMPERATO, 1975 P. J. Imperato, 'Bamana and Mininka Twin Figures', *African Arts*, 8, 1975, pp. 55–60

- IMPERATO, 1983 P. J. Imperato, *Buffoons, Queens and Wooden Horsemen: The Dyo and Gouan Societies of the Bambara of Mali*, New York, 1983
- INDIANAPOLIS 1980–1 *African Furniture and Household Objects*, exh. cat. by R. Sieber, Indianapolis Museum of Art, Indianapolis, 1980–1
- INGRAM, 1931 W. Ingram, *Zanzibar: Its History and its People*, London, 1931
- INSKEEP, 1971 R. R. Inskeep, 'Terracotta Heads', *South African Journal of Science*, 67, 1971, pp. 492–5
- INSKEEP and MAGGS, 1975 R. R. Inskeep and T. M. Maggs, 'Unique Art Objects in the Iron Age of the Transvaal South Africa', *South African Archaeological Bulletin*, 50, 1975, pp. 114–38
- ISICHEI, 1982 E. Isichei, *Studies in the History of Plateau State, Nigeria*, London, 1982
- JACQUES-MEUNIÉ, 1951 D. Jacques-Meunié, *Greniers citadelles au Maroc*, Paris, 1951
- JACQUES-MEUNIÉ, 1960–1 D. Jacques-Meunié, 'Bijoux et bijouteries du Sud Marocain', *Cahiers des arts et techniques d'Afrique du Nord*, 6, 1960–1, pp. 57–72
- JACQUES-MEUNIÉ, 1961 D. Jacques-Meunié, *Cités anciennes de Mauritanie, provinces de Tagannt et du Hodh*, Paris, 1961
- JACQUES-MEUNIÉ, 1962 D. Jacques-Meunié, *Architecture et habitats du Dadès*, Paris, 1962
- JAHN, 1994 J. Jahn, ed., *Tanzania: Meisterwerke Afrikanischer Skulptur*, Munich, 1994
- JAMES, 1974 T. G. H. James, *Corpus of Hieroglyphic Inscriptions in The Brooklyn Museum, i: From Dynasty I to the End of Dynasty XVIII*, Wilbour Monographs, vi, Brooklyn, 1974
- JAMES, 1984¹ D. James, 'Some observations on the calligrapher and illuminators of the koran of Rukn al-Din Baybar al-Jashnagir', *Muqarnas*, ii, 1984, pp. 147–57
- JAMES, 1984² T. G. H. James, *Egyptian Painting*, London, 1984
- JAMES, 1988 D. James, *Qur'ans of the Mamluks*, London, 1988
- JAMES and DAVIES, 1983 T. G. H. James and W. V. Davies, *Egyptian Sculpture*, London, 1983
- JANSEN and GAUTHIER, 1973 G. Jansen and J. G. Gauthier, *Ancient Art of the Northern Cameroons: Sao and Fali*, Oosterhout, 1973
- JAQUES, 1940 A. A. Jaques, 'Carved Headrests of the Shangaans', *Sunday Times*, 9 April 1940
- JAQUES, c. 1941 A. A. Jaques, 'Shangaan Head-rests', lecture delivered to the Fine Arts Society of Johannesburg, c. 1941
- JAQUES, 1949 L. Jacques, 'Art indigène et appuis-tête', *Bulletin de la Mission suisse dans l'Afrique du Sud*, 49 (635), 1949, pp. 333–40
- JAROŠ-DECKERT, 1987 B. Jaroš-Deckert, *Statuen des Mittleren Reichs und der 18. Dynastie*, Vienna, 1987
- JENKINS, 1970 J. Jenkins, *Music of Eritrea*, iii, 1970, record no. TGM103
- JENSEN, 1936 A. E. Jensen, *Im Lande des Gada*, Stuttgart, 1936
- JENSEN, 1942 A. E. Jensen, 'Das Gada-System der Konso und die Altersklassensysteme der Niloten', *Ethnos*, 19, 1942, pp. 1–22
- JENSEN, 1954 A. E. Jensen, 'Elementi della cultura dei Conso', *Rassegna di studi etiopici*, 2, 1954, pp. 217–59
- JOBART, 1925 A. Jobart, 'Chez les Bassalam Pasu du Haut kasai', *Bulletin de la Société Belge d'Études Coloniales*, 82, 1925, pp. 280–92
- JOHANNESBURG 1989 *Ten Years of Collecting: The Standard Bank Foundation Collection of African Art*, exh. cat., ed. D. Hammond-Tooke and A. Nettleton, University of the Witwatersrand Art Galleries, Johannesburg, 1989
- JOHANNESBURG 1991 *Art and Ambiguity: Perspectives on the Brendhurst Collection of Southern African Art*, exh. cat. by P. Davison et al., Johannesburg Art Gallery, Johannesburg, 1991
- JOHNSTON, 1904 H. Johnston, *The Uganda Protectorate*, London, 1904
- JOLLES, 1994 F. Jolles, 'Messages in Fixed Colour Sequences? Another Look at Msinga Beadwork', in *Oral Tradition and its Transmission, the Many Forms of Message*, ed. E. Sienraert, M. Cowper-Lewis and N. Bell, Durban, 1994, pp. 47–62
- JONES, 1937 G. I. Jones, 'Ohafia Obu Houses', *Nigerian Field*, 6 (4), 1937, pp. 169–71
- JONES, 1979 P. R. Jones, 'Effects of raw materials on biface manufacture', *Science*, 204, 1979, pp. 835–6
- JONES, 1984 G. I. Jones, *The Art of Eastern Nigeria*, Cambridge, 1984
- JONES, 1994 A. Jones, 'A Collection of African Art in Seventeenth-century Germany: Christopher Weickmann's Kunst- und Naturkammer', *African Arts*, 27 (2), 1994, pp. 28–5, 92
- JOSEPH, 1974 M. B. Joseph, 'Dance Masks of the Tikar', *African Arts*, 7 (3), 1974, pp. 46–52
- JUNOD, 1962 H. A. Junod, *The Life of a South African Tribe*, 2 vols, New York, 1962 [1st edn 1912]
- KAMER, 1973 H. Kamer, *Haute-Volta*, Brussels and Paris, 1973
- KAMER, 1974 H. Kamer, *Ancêtres Mbembé*, Paris, 1974
- KANTOR, 1944 H. J. Kantor, 'The Final Phase of Predynastic Culture: Gerzean or Semainean?', *Journal of Near Eastern Studies*, 3, 1944, pp. 110–36
- KANTOR, 1948 H. J. Kantor, 'A Predynastic Ostrich Egg with Incised Decoration', *Journal of Near Eastern Studies*, 7, 1948, pp. 46–51
- KASFIR, 1979 S. L. Kasfir, *The Visual Arts of the Idioma of Central Nigeria*, diss., School of Oriental and African Studies, London, 1979
- KASFIR, 1984 S. L. Kasfir, 'One Tribe, One Style? Paradigms in the Historiography of African Art', *History in Africa*, 11 (1), 1984, pp. 163–95
- KATUMBA, 1985 N. B. M. Katumba, 'La circoncision chez les Ngbaka', *Africa: Revista do Centro de Estudos Africanos da USP (São Paulo)*, 6, 1985, pp. 3–53
- KAYSER, 1973 H. Kayser, 'Die ägyptischen Altertümer im Roemer-Pelizaeus-Museum in Hildesheim', *Wissenschaftliche Veröffentlichung Pelizaeus-Museum*, 8, Hildesheim, 1973
- KECSKÉSI, 1982¹ M. Kecskési, 'The Pickaback Motif in the Art and Initiation of the Rovuma Area', *African Arts*, 16 (1), 1982, pp. 52–5
- KECSKÉSI, 1982² M. Kecskési, *Kunst aus dem Alten Afrika*, Munich, 1982
- KEIMER, 1949 L. Keimer, *Bibliotheca Orientalis*, 6, 1949, p. 139, n. 10
- KELEKIAN, 1910 *Kelekian Collection of Persian and Analogous Potteries*, Paris, 1910
- KELLY, 1977 J. N. D. Kelly, *Early Christian Doctrines*, London, 5/1977
- KELTERBORN, 1984 P. Kelterborn, 'Toward Replicating Egyptian Predynastic Flint Knives', *Journal of Archaeological Science*, 11, 1984, pp. 453–53
- KEMP, 1989 B. J. Kemp, *Ancient Egypt: Anatomy of a Civilization*, London and New York, 1989
- KENDALL, 1982 T. Kendall, *Kush: Lost Kingdom of the Nile*, Brockton, MA, 1982
- KENDALL, 1994 T. Kendall, 'Le Djebel Barkal: Le Karnak de Koush', *La Nubie (Les Dossiers d'Archéologie*, 196), 1994, pp. 46–53
- KENT, 1970 R. Kent, *Early Kingdoms in Madagascar: 1500–1700*, New York, 1970
- KERCHACHE, 1993 J. Kerchache, *Art of Africa*, New York, 1993
- KIDANE and WILDING, 1976 G. Kidane and R. Wilding, *The Ethiopian Cultural Heritage / L'Héritage Culturel Ethiopien*, Addis Ababa, 1976
- KILLIAN, 1954 C. Killian, 'L'art des Touareg', *La Renaissance*, 1 (7–9), 1954, pp. 147–55
- KILLEN, 1980 G. Killen, *Ancient Egyptian Furniture*, i, 4000–1300 BC, Warminster, 1980
- KINAHAN, 1990 J. Kinahan, 'Four thousand years at the Spitzkoppe: changes in settlement and land use on the edge of the Namib Desert', *Cimbebasia*, 12, 1990, pp. 1–14
- KINAHAN, 1991 J. Kinahan, *Pastoral nomads of the Central Namib Desert: The people history forgot*, Windhoek, 1991
- KINGDON, 1994 Z. Kingdon, *A Host of Devils: The History and Context of the Modern Makonde Carving Movement*, diss., University of East Anglia, 1994
- KINSHASA 1978 *Pierres sculptées du Bas-Zaire*, exh. cat. by J. Cornet, Institut des Musées Nationaux, Kinshasa, 1978
- KLEVER, 1975 U. Klever, *Brückmann's Handbuch der afrikanischen Kunst*, Munich, 1975
- KLOPPER, 1989 S. Klopper, 'Carvers, Kings and Thrones in Nineteenth-century Zululand', in *African Art in Southern Africa: From Tradition to Modernism*, ed. A. Nettleton and D. Hammond-Tooke, Johannesburg, 1989
- KLOPPER, 1991 S. Klopper, 'Zulu' Headrests and Figurative Carvings', in *Art and Ambiguity: Perspectives on the Brendhurst Collection of Southern African Art*, exh. cat., Johannesburg, 1991, pp. 80–105
- KLOPPER, 1992 S. Klopper, *The Art of Zulu-speakers in Northern Natal-Zululand: An Investigation of the History of Beadwork, Carving and Dress from Shaka to Inkatha*, diss., University of the Witwatersrand, Johannesburg, 1992
- KNAUER, 1979 E. R. Knauer, 'Marble Jar-Stands from Egypt', *Metropolitan Museum Journal*, 14, 1979, pp. 67–102
- KNOPS, 1980 P. Knops, *Les anciens Senufo 1923–35*, Berg en Dal, 1980
- KOLOSS and FÖRSTER, 1990 H. J. Koloss and T. Förster, *Die Kunst der Senufo, Elfenbeinküste*, Berlin, 1990
- KOROMA, 1959 V. H. Koroma, 'The Bronze Statuettes of Ro-Ponka, Kafu Bolom', *Sierra Leone Studies*, 22, 1959, pp. 25–28
- KOTZE, 1950 D. J. Kotze, ed., *Letters of the American Missionaries, 1835–1838*, Cape Town, 1950
- KOZLOFF, 1985 A. P. Kozloff, 'Symbols of Egypt's Might', *Bulletin of the Egyptological Seminar*, 5, 1985, pp. 61–6
- KOZLOFF and BRYAN, 1992 A. P. Kozloff and B. M. Bryan, *Egypt's Dazzling Sun: Amenhotep III and his World*, Cleveland, OH, 1992
- KREAMER, 1987 C. M. Kreamer, 'Moba Shrine Figures', *African Arts*, 20 (2), 1987, pp. 52–5, 82–3
- KRIEGER, 1960 K. Krieger, *Westafrikanische Masken*, Berlin, 1960
- KRIEGER, 1965–9 K. Krieger, *Westafrikanische Plastik*, i–iii, Berlin, 1965–9
- KRIEGER, 1978, 1990 K. Krieger, *Ostafrikanische Plastik*, Museum für Völkerkunde, Berlin, 1978, 2nd edn 1990
- KRIGE, 1988 E. K. Krige, *The Social System of the Zulus*, Pietermaritzburg, 1988 [1st edn 1936]
- KRIGE and KRIGE, 1945 E. J. Krige and J. D. Krige, *The Realm of a Rain-Queen: A Study of the Pattern of Lovedu Society*, London, 1945
- KRONENBERG and KRONENBERG, 1960 A. and W. Kronenberg, 'Wooden Carvings in the South Western Sudan', *Kush*, viii, 1960, pp. 274–81, pls XL–LII
- KRONENBERG and KRONENBERG, 1981 W. and A. Kronenberg, *Die Bongo Bauern und Jäger im Südsudan*, Wiesbaden, 1981
- KUBIK, 1978¹ G. Kubik, 'Boys' Circumcision School of the Yao: A Cinematographic Documentation at Chief Makanjila's Village in Malawi, 1967', *Review of Ethnology*, 6 (1–7), 1978, pp. 1–37
- KUBIK, 1978² G. Kubik, 'Nzondo – Girls' Initiation Ceremony among the Yao at Makanjila's Village in Malawi, 1967', *Review of Ethnology*, 6 (1–7) 1978², pp. 37–51
- KÜHNEL, 1971 E. Kühnel, *Die islamischen Elfenbeinskulpturen: VIII.–XIII. Jahrhundert*, 2 vols, Berlin, 1971
- KUNSTHISTORISCHES MUSEUM, 1988 Kunsthistorisches Museum, *Führer durch die*

- Sammlungen, museum guidebook, Egyptian and Near Eastern section by E. Haslauer and H. Satzinger, Vienna, 1988
- LABOURET, 1920 H. Labouret, 'Le mystère des ruines du Lobi', *Revue d'ethnographie et des traditions populaires*, i, 1920, pp. 178–96
- LABOURET, 1931 H. Labouret, *Les tribus du Rameau Lobi*, Paris, 1931
- LABURTHE-TOLRA and FALGAYRETTES-LEVEAU, 1991 P. Laburthe-Tolra and C. Falgayrettes-Leveau, *Fang*, Paris, 1991
- LAMB, 1975 V. Lamb, *West African Weaving*, London, 1975
- LAMB and LAMB, 1981 V. and A. Lamb, *Au Cameroun: weaving-tissage*, Douala, 1981
- LAMM, 1929–30 C. J. Lamm, *Mittelalterliche Gläser und Steinschnitterarbeiten aus dem Nahen Osten*, 2 vols, Berlin, 1929–30
- LAMM, 1935–6 C. J. Lamm, 'Fatimid Wood-work, its Style, and Chronology', *Bulletin de l'Institut d'Égypte*, 18, 1935–6, pp. 69–80
- LAMP, 1985 F. Lamp, 'House of Stones: Memorial Art of Fifteenth Century Sierra Leone', *Art Bulletin*, 65, 1983, pp. 219–37
- LAMPREIA, 1962 J. D. Lampreia, *Catálogo-inventário da Secção de Etnografia do Museu da Guiné Portuguesa*, Lisbon, 1962
- LANCEL, 1995 S. Lancel, *Carthage, A History*, trans. A. Nevill, Oxford, 1995 [1st edn, *Carthage*, 1992]
- LANCI, 1845–6 M. Lanci, *Trattato delle simboliche rappresentanze arabiche e della varia generazione de' musulmani caratteri sopra differenti materie operati*, 2 vols, Paris, 1845–6
- LANDSTROM, 1970 B. Landstrom, *Ships of the Pharaohs*, London, 1970
- LANE, 1947 A. Lane, *Early Islamic Pottery*, London, 1947
- LANE-POOLE, 1886 S. Lane-Poole, *The Art of the Saracens in Egypt*, London, 1886
- LANGLOIS, 1954 P. Langlois, *Arts soudanais: Tribus dogons*, Brussels, 1954
- LANSING, 1934 A. Lansing, 'The Burial of Hepy', *Bulletin of The Metropolitan Museum of Art*, xxix, 1934, pp. 27–41
- LAPEYRE and PELLEGRIIN, 1942 G.-C. Lapeyre and A. Pellegrin, *Carthage punique (814–146 avant J-C)*, Paris, 1942
- LAUDE, 1975 J. Laude, *African Art of the Dogon: The Myths of the Cliff Dwellers*, New York, 1975
- LAURENTY, 1962 J.-S. Laurenty, *Les Sanza du Congo*, Tervuren, 1962
- LAW, 1980 R. Law, *The Horse in West Africa*, London, 1980
- LAWAL, 1970 B. Lawal, *Yoruba Sango Sculpture in Historical Retrospect*, diss., Indiana University, 1970
- LAWAL, 1974 B. Lawal, 'Some Aspects of Yoruba Aesthetics', *The British Journal of Aesthetics*, 14 (3), 1974, pp. 239–49
- LAWAL, 1975 B. Lawal, 'Yoruba-Shango Ram Symbolism: From Ancient Sahara or Dynastic Egypt?', in *African Images: Essays in African Iconology*, ed. D. McCall and E. Bay, New York and London, 1975
- LAWAL, 1995 B. Lawal, 'À YÀ GBÓ, À YÀ TÓ: New Perspectives on Edan Ogboni', *African Arts*, 28 (1), 1995, pp. 36–49, 98–100
- LAWRENCE, 1924 C. T. Lawrence, 'Report on the Nigerian Section, British Empire Exhibition', *West Africa*, 1212, 1924, pp. 12–16
- LEAKEY, 1977 L. S. B. Leakey, *The Southern Kikuyu before 1903*, 3 vols, London, 1977
- LEBEUF, 1953 J. P. Lebeuf, 'Lebrets et greniers des Falis', *Bulletin de l'Institut Français de S. Afrique*, 15, 1953, pp. 1321–8
- LECLANT, 1976 J. Leclant, 'Kushites and Meroites: Iconography of the African Rulers on the Ancient Upper Nile', in *The Image of the Black in Western Art*, i, New York, 1976, pp. 89–132
- LEE, 1979 R. B. Lee, *The !Kung San: Men, Women and Work in a Foraging Society*, Cambridge, 1979
- LEE, 1984 R. B. Lee, *The Dobe !Kung*, New York, 1984
- LEFEVRE and VAN RINSVELD, 1990 F. Lefebvre and B. van Rinsveld, *L'Égypte: Des Pharaons aux Coptes*, Brussels, 1990
- LEGESSE, 1975 A. Legesse, *Gada: Three Approaches to the Study of African Society*, 1975
- LEGLAY, 1961 M. LeGlay, *M. Saturne africain: Monuments* i, Paris, 1961
- LEHUARD, 1974 R. Lehuard, *Statuaire du Stanley-Pool*, Arnouville, 1974
- LEHUARD, 1976 R. Lehuard, *Les Phembas du Mayombe*, Arnouville, 1976
- LEHUARD, 1982 R. Lehuard, 'Omakipa', *Arts d'Afrique Noire*, 42, 1982, pp. 20–5
- LEHUARD, 1989 R. Lehuard, *Art Bakongo, les Centres de Style*, 2 vols, Arnouville, 1989
- LEHUARD, 1995 R. Lehuard, *Art Bakongo: les masques*, Arnouville, 1995
- LEIBOVITCH, 1959 J. Leibovitch, 'Étuis à fard zoomorphes de l'Ancien Empire égyptien', *Atiqot*, 2, 1959, pp. 118–20
- LEIRIS, 1995 M. Leiris, 'Objets rituels dogon', *Minotaure*, 2, 1953, pp. 26–30
- LEIRIS and DELANGE, 1967 M. Leiris and J. Delange, *Afrique noire. La création plastique*, Paris, 1967
- LEMA GWETE, 1980 Lema Gwete, *Kunst aus Zaire. Masken und Plastiken aus der Nationalssammlung*, Bremen, 1980
- LESLAU, 1957 W. Leslau, *Coutumes et croyances des Falaches (Juifs d'Abyssinie)*, Paris, 1957
- LEURQUIN and MEURANT, 1990 A. Leurquin and G. Meurant, 'Tanzanie méconnue', *Arts d'Afrique Noire*, 73 and 75, 1990
- LEUZINGER, 1960 E. Leuzinger, *The Art of the Negro Peoples*, London, 1960
- LEUZINGER, 1972 E. Leuzinger, *The Art of Black Africa*, London, 1972
- LEUZINGER, 1978 E. Leuzinger, ed., *Afrikanische Skulpturen*, Zurich, 1978
- LEVINSOHN, 1983 R. Levinsohn, 'Amacunu Beverage Containers', *African Arts*, 16 (3), 1983, pp. 53–6
- LEVINSOHN, 1984 R. Levinson, *Art and Craft of Southern Africa: Treasures in Transition*, Johannesburg, 1984
- LEVITZION, 1975 N. Levzion, *Ancient Ghana and Mali*, London, 1975
- LEVY, 1990 D. Levy, 'Continuities and Change in Ndebele Beadwork: c. 1885 to the Present', diss., University of the Witwatersrand, Johannesburg, 1990
- LEWIS-WILLIAMS, 1974 J. D. Lewis-Williams, 'The syntax and function of the Giant's castle rock paintings', *South African Archaeological Bulletin*, 27, 1974, pp. 49–65
- LEWIS-WILLIAMS, 1981 J. D. Lewis-Williams, *Believing and Seeing: Symbolic Meanings in Southern San Rock Paintings*, London, 1981
- LEWIS-WILLIAMS, 1983 J. D. Lewis-Williams, *The Rock Art of Southern Africa*, Cambridge, 1983
- LEWIS-WILLIAMS, 1984 J. D. Lewis-Williams, 'Ideological Continuities in Prehistoric Southern Africa: The Evidence of Rock Art', in *Interfaces: The Relationship of Past and Present in Hunter-gatherer Studies*, ed. C. Schrire, New York, 1984, pp. 225–52
- LEWIS-WILLIAMS, 1988 J. D. Lewis-Williams, 'The World of Man and the World of Spirit: An Interpretation of the Linton Rock Paintings', *Margaret Shaw Lecture*, 2, 1988, pp. 1–16
- LEWIS-WILLIAMS, 1990 J. D. Lewis-Williams, *Discovering Southern African Rock Art*, Cape Town, 1990
- LEWIS-WILLIAMS and DOWSON, 1989 J. D. Lewis-Williams and T. A. Dowson, *Images of Power: Understanding Bushman Rock Art*, Johannesburg, 1989
- LEWIS-WILLIAMS and DOWSON, 1994 J. D. Lewis-Williams and T. A. Dowson, eds, *Contested Images: Diversity in Southern African Rock Art Research*, Johannesburg, 1994
- LILLE, 1994 *Nubie. Les cultures antiques du Soudan*, ed. B. Gratien and F. le Saout, Lille, 1994
- LINDBLOM, 1920 G. Lindblom, *The Akamba in British East Africa*, Uppsala, 1920
- LINGS, 1976 M. Lings, *Qur'anic art of illumination and calligraphy*, London, 1976
- LINGS and SAFADI, 1976 M. Lings and Y. Safadi, eds, *The Qur'an: A British Library Exhibition*, exh. cat., London, 1976
- LINZ, 1989 Ägypten: Götter, Gräber und die Kunst: 4000 Jahre Jenseitsglaube, exh. cat., Linz, 1989
- LISBON, 1994 Sculpture angolaise. Mémorial de cultures, exh. cat. by M.-L. Bastin, Museo Nacional de Etnología, Lisbon, 1994
- LOIR, 1935 H. Loir, *Le tissage du raphia au Congo Belge*, Brussels, 1935
- LOMBARD, 1975 J. Lombard, 'Les Sakalavamenabe de la côte Ouest: La société et l'art funéraire', in *Malgache, qui es-tu?*, Neuchâtel, 1975
- LONDON, 1862 Catalogue of the Special Exhibition of Works of Art on Loan at the South Kensington Museum, exh. cat. ed. J. C. Robinson, London, 1862
- LONDON, 1976 *The Arts of Islam*, exh. cat., Hayward Gallery, London, 1976
- LONDON, 1976 *The Qur'an: A British Library Exhibition*, World of Islam Festival, London, 1976
- LONDON, 1981 *Asante: Kingdom of Gold: The Power and Splendour of a Great Nineteenth-Century West African Kingdom*, exh. cat. by M. McLeod, Museum of Mankind, London, 1981
- LONDON, 1982 see Detroit et al. 1980–3
- LONDON, 1983 *The Eastern Carpet in the Western World from the 15th to the 17th century*, exh. cat. ed. D. King and D. Sylvester, Arts Council of Great Britain, Hayward Gallery, London, 1983
- LONDON, 1984 *The Treasury of San Marco Venice*, exh. cat., British Museum, London, 1984
- LONDON AND NEW YORK, 1979–85 *African Textiles: Looms, Weaving and Design*, exh. cat. by J. Picton and J. Mack, Museum of Mankind/British Museum, London, 1979–82; American Museum of Natural History, New York, 1983; London, 1979, rev. edn 1989
- LORENZ, 1991 H. Lorenz, ed., *Spoons in African Art*, Museum Rietberg, Zurich, 1991
- LORQUIN, 1992 A. Lorquin, *Les tissus coptes*, Paris, 1992
- LOS ANGELES, 1993 *Sleeping Beauties: The Jerome L. Joss Collection of Headrests at UCLA*, exh. cat. by W. Dewey, Fowler Museum of Cultural History, University of California, Los Angeles, 1993
- LOUGHAN, 1986 K. S. Loughran et al., eds, *Somalia in Word and Image*, Washington, 1986
- LOVICONI, 1991 A. Loviconi, *Regards sur la faïence de Fès*, Paris 1991
- LUXOR MUSEUM, 1979 *Catalogue*, Luxor Museum of Ancient Egyptian Art, Cairo, 1979
- MAASTRICHT, 1992 *Kings of Africa: Art and Authority in Central Africa*, exh. cat. ed. by E. Beumers and H.-J. Koloss, Foundation Kings of Africa, Maastricht, 1992
- MACCALMAN, 1964 H. R. MacCalman, 'Grosse Domschlucht Brandberg: A new discovery of prehistoric rock art in South West Africa', *IPEK*, 21, 1964, pp. 91–5
- MACGAFFEY, 1986 W. MacGaffey, *Religion and Society in Central Africa: The Ba-Kongo of Lower Zaire*, Chicago and London, 1986
- MACGAFFEY, 1991 W. MacGaffey, *Art and Healing of the BaKongo: Commented by Themselves*, Stockholm, 1991
- MACGAFFEY and HARRIS, 1993 W. MacGaffey and M. D. Harris, *Astonishment and Power*, Washington, 1993
- MACK, 1982 J. Mack, 'Material Culture and Ethnic Identity in Southeastern Sudan', in *Culture History in the Southern Sudan*, ed. J. Mack and P. Robertshaw, Nairobi, 1982, no. 8, pp. 111–50

- MACK, 1986 J. Mack, *Madagascar: Island of the Ancestors*, London, 1986
- MACK, 1990 J. Mack, *Emil Torday and the Art of the Congo, 1900–1909*, London, 1990
- MACK and COOTE, in preparation J. Mack and J. Coote, 'East Africa: Domestic and other arts', in *The Dictionary of Art*, London, in preparation
- MACK, SCHILDKROUT and KEIM, 1990 J. Mack, E. Schildkrout and C. A. Keim, *African Reflections: Art from Northeastern Zaire*, New York and Washington, 1990
- MCINTOSH and MCINTOSH S. K. McIntosh and R. J. McIntosh, 'Current Directions in West African Prehistory', *Annual Review of Anthropology*, 12, pp. 215–58
- MCLEOD, 1981 M. McLeod, *The Asante*, London, 1981
- MCNAUGHTON, 1979 P. R. McNaughton, *Secret Sculptures of Komo: Art and Power in Bamana (Bambara) Initiation Associations*, Philadelphia, 1979
- MCNAUGHTON, 1982 P. R. McNaughton, 'Language, Art, Secrecy and Power: The Semantics of Dalilu', *Anthropological Linguistics*, 24 (4), 1982, pp. 487–505
- MCNAUGHTON, 1988 P. R. McNaughton, *The Mande Blacksmiths: Knowledge, Power and Art in West Africa*, Bloomington, 1988
- MCNAUGHTON, 1991 P. McNaughton, 'Is there History in Horizontal Masks? A Preliminary Response to the Dilemma of Form', *African Arts*, 24 (2), 1991, pp. 40–53, 88–9
- MCNAUGHTON, 1992 P. R. McNaughton, 'From Mande Komo to Jukun Akuna: Approaching the Difficult Question of History', *African Arts*, 25 (2), 1992, pp. 76–85, 99–100
- MCNAUGHTON, 1994 P. R. McNaughton, 'Antelope Headdress', in *Vision of Africa: The Jerome L. Joss Collection of African Art at UCLA*, ed. D. Ross, Los Angeles, 1994
- MAES, 1929 J. Maes, *Les appuis-tête du Congo Belge*, Annales du Musée Royal du Congo Belge, ser. VI (i) 1, Tervuren, 1929
- MAESEN, 1954 A. Maesen, 'Statuaire et culte de fécondité chez les Luluwa du Kasai (Zaïre)', *Quaderni Poro*, 1954, 3, pp. 49–58
- MAESEN, 1959 A. Maesen, *Arte del Congo*, Rome, 1959
- MAESEN, 1960 A. Maesen, *Umbangu. Art du Congo au Musée de Tervuren*, Brussels, 1960
- MAGGS, 1984 T. Maggs, 'The Iron Age South of the Zambezi', in *Southern African Prehistory and Palaeoenvironments*, ed. R. G. Klein, Rotterdam, 1984, pp. 329–60
- MAGGS, 1991 T. Maggs, 'Metalwork from Iron Age Hoards as a Record of Metal Production in the Natal Region', *South African Archaeological Bulletin*, 46, 1991, pp. 131–6
- MAGGS and DAVISON, 1981 T. Maggs and P. Davison, 'The Lydenburg Heads and the Earliest African Sculpture South of the Equator', *African Arts*, 14 (2), 1981, pp. 28–33
- MALEK, 1986 J. Malek, *In the Shadow of the Pyramids*, London, 1986
- MALEK, 1993 J. Malek, *The Cat in Ancient Egypt*, London, 1993
- MANSFELD, 1908 A. Mansfeld, *Urwald-Dokumente*, Berlin, 1908
- MARCAIS, 1935–40 G. Marcais, 'Les figures d'hommes et de bêtes dans les bois sculptés d'époque Fatimite', *Mélanges Maspéro III (Orient Islamique)*, Cairo, 1935–40, pp. 240–57
- MARCAIS, 1954 G. Marcais, *L'architecture musulmane d'occident*, Paris, 1954
- MARcq-EN-BAROEUL, 1977 *L'Égypte des pharaons*, Marcq-en-Baroeul, 1977
- MARSEILLES, 1990 *L'Égypte des millénaires obscurs*, exh. cat., Musées de Marseille, Marseilles, 1990
- MARSHALL, 1976 L. Marshall, *The Kingdom of Nyae Nyae*, Cambridge, MA, 1976
- MAUNY, 1961 R. Mauny, *Tableau géographique de l'ouest Africain au Moyen Âge*, Dakar, 1961
- MAURER, n. d. E. M. Maurer, *The Intelligence of Forms: An Artist Collects African Art*, Minneapolis, n. d.
- MAURER and ROBERTS, 1985 E. Maurer and A. F. Roberts, eds, *Tabwa. The Rising of a New Moon: A Century of Tabwa Art*, Ann Arbor, 1985
- MAYES, 1959 S. Mayes, *The Great Belzoni*, London, 1959
- MEAUXÉ, 1968 P. Meauxé, *African Art*, London, 1968
- MEDHIN, 1980–2 T. W. Medhin, 'La préparation traditionnelle des couleurs en Éthiopie', *Abbay*, 11, 1980–2, pp. 219–24
- MEEK, 1931 C. K. Meek, *A Sudanese Kingdom: An Ethnographical Study of the Jukun-speaking Peoples of Nigeria*, London, 1931
- MEILLASSOUX, 1975 C. Meillassoux, ed., *L'esclavage en Afrique précoloniale*, Paris, 1975
- MENZEL, 1972 B. Menzel, *Textilien aus Westafrika*, Berlin, 1972
- MERCIER, 1979 J. Mercier, *Ethiopian Magic Scrolls*, New York, 1979
- MERLIN, 1910 A. Merlin, *Le sanctuaire de Baal et de Tanit près de Siagu*, Notes et Documents, iv, Paris, 1910
- MERLO, 1966 C. Merlo, *Un chef-d'œuvre d'art Nègre: Le buste de la Prêtresse*, Anvers-sur-Oise, 1966
- METROPOLITAN MUSEUM OF ART, 1902 *Handbook no. 13, Musical Instruments of all Nations*, iii, New York, 1902
- MEURANT, 1986 G. Meurant, *Shoowa motieven. Afrikaans textiel van het Kuba-rijk*, Brussels, 1986
- MEYER, 1981 P. Meyer, *Kunst und Religion der Lobi*, Zurich, 1981
- MICHALOWSKI, 1974 K. Michalowski, *Faras: Die Wandbilder in den Sammlungen des Nationalmuseums zu Warschau*, Warsaw and Dresden, 1974
- MIDANT-REYNES, 1987 B. Midant-Reynes, 'Contribution à l'étude de la société prédynastique: Le cas du couteau "Ripple-Flake"', *Studien zur altägyptischen Kultur*, 14, 1987, pp. 185–224
- MOTA, 1960 T. da Mota, 'Descoberta de bronzes antigos na Guiné Portuguesa', *Boletim Cultural da Guiné Portuguesa*, 15, 1960, pp. 625–32
- MOTA, 1965 T. da Mota, 'Bronzes antigos da Guiné', *Actas do Congresso Internasional de Etnografia*, 4, 1965, pp. 149–54
- MOTA, 1975 A. T. Mota, 'Gli avori africani nella documentazione dei secoli XV–XVII', *Africa*, 50 (4), 1975, pp. 580–9
- MIDDLETON and KERSHAW, 1972 J. Middleton and G. Kershaw, *The Central Tribes of the North-Eastern Bantu*, London, 1972
- MIGEON, 1907 G. Migeon, *Manuel d'art musulman*, Paris, 1907
- MIGEON, 1927 G. Migeon, *Manuel d'art musulman*, Paris, 1927
- MILLER and VAN DER MERWE, 1994 D. E. Miller and N. J. Van der Merwe, 'Early Metal Working in Sub-Saharan Africa: A Review of Recent Research', *Journal of African History*, 35, 1994, pp. 1–36
- MILLS, 1982 A. J. Mills, *The Cemeteries of Qasr Ibrim*, London, 1982
- MINISTÈRE DE L'ÉCONOMIE NATIONALE, 1958 Ministère de l'Économie Nationale, *L'Artisanat au Maroc*, Casablanca, 1958
- MITCHELL, 1956 J. C. Mitchell, *The Yao Village: A Study in the Social Structure of a Nyasaland Tribe*, Manchester, 1956
- MONNERET DE VILLARD, 1923 U. Monneret de Villard, *La scultura ad Ahnas: Note sull'origine dell'arte copta*, Milan, 1923
- MONTET, 1960 P. Montet, *La nécropole royale de Tanis*, iii: *Les constructions et le tombeau de Chechang II*, Paris, 1960
- MOREAU, 1976 J. B. Moreau, *Les grands symboles méditerranéens de la poterie algérienne*, Algiers, 1976
- MORRIS, 1988 D. Morris, 'Engraved in Place and Time: A Review of Variability in the Rock Art of the Northern Cape and Karoo', *South African Archaeological Bulletin*, 43, 1988, pp. 109–21
- MORRIS, 1990 D. Morris, 'Sculptured Stone Heads from the Kimberley Area and the Western Orange Free State', in P. B. Beaumont and D. Morris, *Guide to Archaeological Sites in the Northern Cape*, Kimberley, 1990
- MORRIS, 1994 D. Morris, 'An Ostrich Eggshell Cache from the Vaalbos National Park, Northern Cape', *Southern African Field Archaeology*, 3 (1), 1994, pp. 55–8
- MORRIS and PRESTON-WHYTE, 1994 J. Morris and E. Preston-Whyte, *Speaking with Beads. Zulu Arts from Southern Africa*, London, 1994
- MORTON-WILLIAMS, 1960 P. Morton-Williams, 'The Yoruba Ogboni Cult in Oyo', *Africa*, 30 (4), 1960, pp. 362–74
- MOSCATI, 1973 S. Moscati, *The World of the Phoenicians*, trans. A. Hamilton, London, 1973 [Il mondo dei Fenici, 1966]
- MOSTAFA, 1958 M. Mostafa, *Unity in Islamic Art*, Cairo, 1958
- MOSTAFA, 1961 M. Mostafa, *The Museum of Islamic Art: A Short Guide*, Cairo, 1961
- MOTA, 1960 T. da Mota, 'Descoberta de bronzes antigos na Guiné Portuguesa', *Boletim Cultural da Guiné Portuguesa*, 15, 1960, pp. 625–32
- MOTA, 1965 T. da Mota, 'Bronzes antigos da Guiné', *Actas do Congresso Internasional de Etnografia*, 4, 1965, pp. 149–54
- MOTA, 1975 A. T. Mota, 'Gli avori africani nella documentazione dei secoli XV–XVII', *Africa*, 50 (4), 1975, pp. 580–9
- MURDOCK, 1959 G. P. Murdock, *Africa: Its Peoples and their Culture History*, New York, 1959
- MURPHY, 1967¹ R. T. A. Murphy, 'Luke, Evangelist, St.', *New Catholic Encyclopedia*, viii, New York, 1967, pp. 1066–7
- MURPHY, 1967² R. T. A. Murphy, 'Luke, Gospel according to St.', *New Catholic Encyclopedia*, viii, New York, 1967, pp. 1067–72
- MURRAY, 1911 M. A. Murray, 'Figure Vases', in *Historical Studies*, 1910, British School of Archaeology in Egypt Studies, ii, London, 1911, pp. 40–6
- MURRAY, 1941 K. C. Murray, 'Ogbom', *Nigerian Field*, 12 (2), 1941, pp. 127–31
- MURRAY, 1946 K. C. Murray, 'The Wood Carvings of Oron. The Need for a Museum', *Nigeria Magazine*, 25, 1946, pp. 112–4
- MURRAY, 1947 K. C. Murray, 'Ekpu: the ancestor figures of Oron, Southern Nigeria', *Burlington Magazine*, 89, 1947, pp. 310–4
- MUSCARELLA, 1974 O. W. Muscarella, *Ancient Art: The Norbert Schimmel Collection*, Mainz, 1974
- MUSÉE ROYAL DU CONGO BELGE, 1899 Musée royale du Congo Belge, *Annales*, i, 1899
- MUSEUM RIETBERG, 1978 Museum Rietberg, *Afrikanische Skulpturen*, Zurich, 1978
- NALDER, 1937 L. F. Nalder, *A Tribal Survey of Mongala Province*, London, 1937
- NEAHER, 1976 N. C. Neaher, *Bronzes of Southern Nigeria and Igbo Metallurgy*, diss., Stanford University, Stanford, 1976
- NEAHER, 1981 N. Neaher, 'An Interpretation of Igbo Carved Doors', *African Arts*, 15 (1), 1981, pp. 49–55, 88
- NEEDLER, 1984 W. Needler, *Predynastic and Archaic Egypt in the Brooklyn Museum*, New York, 1984
- NESBITT, 1871 A. Nesbitt, *Catalogue of the Collection of Glass Formed by Felix Slade*, London, 1871
- NESBITT, 1878¹ A. Nesbitt, *A Descriptive Catalogue of the Glass Vessels in the South Kensington Museum*, London, 1878
- NESBITT, 1878² A. Nesbitt, *Glass*, London, 1878
- NETTLETON, 1984 A. Nettleton, *The Traditional Figurative Woodcarving of the Shona and Venda*, diss., University of the Witwatersrand, Johannesburg, 1984
- NETTLETON, 1985 A. Nettleton, *The Figurative Woodcarving of the Shona and Venda*, diss., University of the Witwatersrand, Johannesburg, 1985
- NETTLETON, 1988 A. Nettleton, 'History and the Myth of Zulu Sculpture', *African Arts*, 21 (3) 1988, pp. 48–51
- NETTLETON, 1989 A. Nettleton, 'The Not-so-new: "Transitional Art" in Historical Perspective', in *Diversity and Interaction: Proceedings of the Fifth Annual Conference of the South African Association of Art Historians*, Durban, 1989

- NETTLETON, 1989¹ A. Nettleton, 'The Crocodile Does not Leave the Pool: Venda Court Arts', in *Art of Southern Africa: From Tradition to Township*, ed. A. Nettleton and D. W. Hammond-Tooke, Johannesburg, 1989, pp. 67–83
- NETTLETON, 1989² A. Nettleton, 'Venda Art', in *Ten Years of Collecting: The Standard Bank Foundation Collection of African Art*, exh. cat., University of the Witwatersrand Art Galleries, Johannesburg, 1989, pp. 5–8
- NETTLETON, 1990 A. Nettleton, "Dream Machines": Southern African Headrests', *Southern African Journal of Art and Architectural History*, 1 (4), 1990, pp. 147–54
- NETTLETON, 1991 A. Nettleton, 'Tradition, Authenticity, and Tourist Sculpture in 19th and 20th Century South Africa', in *Art and Ambiguity: Perspectives on the Brenturst Collection of Southern African Art*, exh. cat., Johannesburg, 1991, pp. 32–7
- NETTLETON, 1992 A. Nettleton, *Headrests of Southern, East and Central Africa*, report submitted to the CSD, Pretoria, 1992
- NETTLETON and HAMMOND-TOOKE, 1989 A. Nettleton and D. Hammond-Tooke, eds, *Art of Southern Africa: From Tradition to Township*, Johannesburg, 1989
- NEW YORK 1978 *Traditional Sculpture from Upper Volta*, exh. cat. by N. Skougstad, African-American Institute, New York, 1978
- NEW YORK 1980 *Yoruba Beadwork. Art of Nigeria*, exh. cat. by John Pemberton III, introduction by W. B. Fagg, Pace Gallery, New York, 1980
- NEW YORK 1988¹ *Art of the Dogon: Selections from the Lester Wunderman Collection*, exh. cat. by K. Ezra, The Metropolitan Museum of Art, New York, 1988
- NEW YORK 1988² *Africa and the Renaissance: Art in Ivory*, exh. cat. by E. Bassani and W. B. Fagg, ed. S. Vogel, Center for African Art, New York, 1988
- NEW YORK 1990 *Africa Explores: 20th Century African Art*, exh. cat. by S. Vogel and I. Ebong, Center for African Art, New York, 1990
- NEYT, 1977 F. Neyt, *La grande statuaire hemba du Zaïre*, Louvain-la-Neuve, 1977, 2nd edn 1995
- NEYT, 1979 F. Neyt, *L'Art Eket: Collection Azar*, Paris, 1979
- NEYT, 1981 F. Neyt, *Arts traditionnels et histoire au Zaïre. Cultures forestières et royaumes de la savane*, Louvain-le-Neuve, 1981
- NEYT, 1985¹ F. Neyt, *The Arts of the Benue: to the Roots of Tradition*, 1985
- NEYT, 1985² F. Neyt, 'Tabwa Sculpture and the Great Traditions of East-Central Africa', in E. M. Maurer and A. F. Roberts, *Tabwa, the Rising of a New Moon: A Century of Tabwa Art*, Seattle, 1985, pp. 65–89
- NEYT, 1992 F. Neyt, 'Les masques tetela existent-ils?', in *Art tribal*, Geneva, 1992
- NEYT, 1993 F. Neyt, *Luba. Aux sources du Zaïre*, Paris, 1993
- NEYT, 1994 F. Neyt, *Luba: To the Sources of the Zaïre*, Paris, 1994
- NEYT, 1995 F. Neyt, *La grande statuaire Hemba*, Louvain-la-Neuve, 1995
- NEYT and STRYCKER, 1974 F. Neyt and L. de Strycker, *Approche des arts Hemba*, Villiers-le-Bel, 1974
- NEYT and DE STRYCKER, 1975 F. Neyt and L. de Strycker, 'Approche des arts hemba', *Arts d'Afrique noire*, supp. to vol. 11, Villiers-le-Bel, 1975
- NGALA, 1949 R. Ngala, *Nchi na Desturi za Wagirama*, Nairobi, 1949
- NICKLIN, 1974 K. Nicklin, 'Nigerian Skin-covered Masks', *African Arts*, 7 (3), 1974, pp. 8–15; 67–8
- NICKLIN, 1977 K. Nicklin, *Guide to the National Museum, Oron*, Lagos, 1977
- NICKLIN, 1979 K. Nicklin, 'Skin-covered masks of Cameroon', *African Arts*, 12 (1), 1979
- NICKLIN, 1980¹ K. Nicklin, 'Archaeological Sites in the Cross River Region', *Nyame Akuma*, 16, 1980
- NICKLIN, 1980² K. Nicklin, 'The Cross River Bronzes', in *The Art of Metal in Africa*, ed. M.-T. Brincard, New York, 1980, pp. 47–50
- NICKLIN, 1981 K. Nicklin, 'Rape and restitution: the Cross River region considered', *Museum (Unesco)*, 53 (4), 1981
- NICKLIN, 1982 K. Nicklin, 'An anthropomorphic bronze from the Cross River region', *Tribal Art Bulletin: Musée Barbier-Mueller*, 16, 1982
- NICKLIN, 1989 K. Nicklin, 'A Lower Niger Bronze Female Figure', in *Important Tribal Art*, London, 1989
- NICKLIN, 1990 K. Nicklin, 'The epic of the Ekpu: ancestor figures of Oron, South East Nigeria', in *Politics of the Past*, ed. P. Gathercole and D. Lowenthal, London, 1990
- NICKLIN, 1991¹ K. Nicklin, 'An Ejagham emblem of the Ekpe Society', *Tribal Art Bulletin: Barbier-Mueller Museum*, 1991
- NICKLIN, 1992² K. Nicklin, 'Ekpe in the Rio del Rey', *Tribal Art Bulletin: Barbier-Mueller Museum*, Geneva, 1991
- NICKLIN, 1993 K. Nicklin, 'Celui qui voulait être Dieu', *Arts d'Afrique Noire*, 85, 1993
- NICKLIN, in preparation K. Nicklin, *Ekpu: The Oron Ancestor figures. Southeastern Nigeria*, in preparation
- NICKLIN and FLEMING, 1980 K. Nicklin and S. J. Fleming, 'A bronze "Carnivore Skull" from Oron, Nigeria', *Museum of Applied Science Center for Archaeology Journal*, 1 (4), 1980
- NICKLIN and SALMONS, 1978 K. Nicklin and J. Salmons, 'S. J. Akpan of Nigeria', *African Arts*, 11 (1), 1978
- NICKLIN and SALMONS, 1984 K. Nicklin and J. Salmons, 'Cross River art styles', *African Arts*, 18 (1), 1984
- NICKLIN and SALMONS, in preparation K. Nicklin and J. Salmons, 'Arts of Southeastern Nigeria', in *Arts of Nigeria*, ed. E. Eyo, in preparation
- NICOLAISEN, 1965 J. Nicolaisen, *Ecology and Culture of the Pastoral Tuareg with Particular Reference to the Tuareg of Ahaggar and Ayr*, Copenhagen, 1965
- NKETIA, 1965 J. H. K. Nketia, *Drumming in Akan Communities in Ghana*, London, 1965
- NOOTER, 1984 N. I. Nooter, 'Zanzibar Doors', *African Arts*, 17 (4), 1984, pp. 34–59, 94
- NOOTER, 1991 M. H. Nooter, *Luba Art and Statecraft: Creating Power in a Central African Kingdom*, diss., Columbia University, New York, 1991
- NOOTER, 1994 N. I. Nooter, 'Ostafrikanische hochlehnige Hocker: Eine transkulterelle Tradition', in *Tanzania: Meisterwerke Afrikanischer Skulptur*, ed. J. Jahn, Munich, 1994
- NORDSTRÖM, 1973 H. A. Nördstrom, *Neolithic and A-Group Sites*, Stockholm, 1973
- NORTHERN, 1984 T. Northern, *The Art of Cameroon*, Washington, 1984
- NOWACK, 1954 E. Nowack, *Land und Volk der Konso*, Bonn, 1954
- NSUGBE, 1961 P. O. Nsugbe, 'Oron Ekpu figures', *Nigeria Magazine*, December 1961, pp. 357–65
- PAPSTEIN, 1994 R. Papstein, ed., *The History and Cultural Life of the Mbunda Speaking Peoples*, Lusaka, 1994
- PÂQUES, 1954 V. Pâques, 'Bouffons sacrés du cercle de Bougouni (Soudan français)', *Journal de la Société des Africanistes*, 24, 1954, pp. 625–52
- PARIS, 1925 A. Paris, *Documents d'architecture berbère sud de Marrakesh*, Paris, 1925
- PARIS 1977 *Islam dans les collections nationales*, exh. cat., Grand Palais des Champs Elysées, Paris, 1977
- PARIS 1982–3 *De Carthage à Kairouan: 2000 ans d'art et d'histoire en Tunisie*, exh. cat., Musée du Petit Palais, Paris, 1982–3
- PARIS 1987 *Tanis: L'or des pharaons*, exh. cat., Galeries Nationales du Grand Palais, Paris, 1987
- PARIS 1989¹ *Corps sculptés, corps parés, corps masqués: Chefs-d'œuvre de Côte-d'Ivoire*, exh. cat., Galeries Nationales du Grand Palais, Paris, 1989
- PARIS 1989² *Objets interdits*, exh. cat., Fondation Dapper, Musée Dapper, Paris, 1989
- PARIS 1990 *De l'Empire romain aux villes impériales: 6000 ans d'art au Maroc*, exh. cat., Musée du Petit Palais, Paris, 1990
- PARIS 1992–3 *Le roi Salomon et les maîtres du regard: Art et médecine en Éthiopie*, exh. cat. ed. J. Mercier and H. Marchal, Musées Nationaux/Musée National des Arts d'Afrique et d'Océanie, Paris, 1992
- PARIS 1995 *Carthage: L'histoire, sa trace et son écho*, exh. cat., Musée du Petit Palais, Paris, 1995
- PARIS and MILAN 1989–90 *L'Égypte copte en Égypte-Égypte: Chefs-d'œuvre de tous les temps*, exh. cat. ed. D. Benazeth and G. Gabra, Paris and Milan, 1989–90
- PARIS et al. 1993–4 *Vallées du Niger*, exh. cat. ed. J. Devissé, Paris, 1993–4
- PARTRIDGE, 1905 C. Partridge, *Cross River Natives*, London, 1905
- PAUTY, 1931 E. Pauty, *Le bois sculpté jusqu'à l'époque Ayyoubide*, general cat., Museum of Islamic Art, Cairo, 1931
- PAYNE, 1993 J. C. Payne, *Catalogue of the Predynastic Collection in the Ashmolean Museum*, Oxford, 1993
- PEDLEY, 1980 J. G. Pedley, ed., *New Light on Ancient Carthage*, Ann Arbor, 1980

- PEMBERTON, 1982 J. Pemberton, 'Shango Shrine Sculpture' and 'Figure with Bowl', in W. Fagg and J. Pemberton, *Yoruba: Sculpture of West Africa*, New York, 1982, pls 34, 55
- PEMBERTON, 1989 J. Pemberton, 'The Oyo Empire', in H. J. Drewal, J. Pemberton and R. Abiodun, *Yoruba: Nine Centuries of African Art and Thought*, New York, 1989, pp. 146–87
- PENNY, 1993 N. Penny, *The Materials of Sculpture*, New Haven and London, 1993
- PERANI, 1977 J. Perani, *Nupe Crafts: The Dynamics of Change in Nineteenth and Twentieth Century Weaving and Brassworking*, diss., Indiana University, Bloomington, IN, 1977
- PÈRE, 1988 M. Père, *Les Lobi: Tradition et changement: Burkina Faso*, 2 vols, Paris, 1988
- PEREIRA, 1956 D. P. Pereira, *Esmeraldo du Situ Orbis. Côte occidentale d'Afrique du Sud Marocain au Gabon (1506–1508)*, trans. R. Mauny, Bissau, 1956
- PERHAM, 1976 M. Perham, *East African Journey: Kenya and Tanganyika 1929–30*, London, 1976
- PERICOT-GARCÍA et al., 1967 L. Pericot-García et al., *Prehistoric and Primitive Art*, New York, 1967
- PERROIS, 1969¹ L. Perrois, *Gabon: culture et techniques*, general cat., Musée des Arts et Traditions de Libreville, Paris
- PERROIS, 1969² L. Perrois, *Aspects de la sculpture traditionnelle du Gabon: Anthropos*, St-Augustin, ill., 1969
- PERROIS, 1972 L. Perrois, *Statuaire fang*, Paris, 1972
- PERROIS, 1977 L. Perrois, *Sculpture traditionnelle du Gabon*, Paris, 1977
- PERROIS, 1979 L. Perrois, *Arts du Gabon. Les arts plastiques du Bassin de l'Ogooué*, Paris 1979
- PERROIS, 1985 L. Perrois, *Art ancestral du Gabon*, Geneva, 1985
- PERROIS and DELAGE, 1990 L. Perrois and M. S. Delage, *Art of Equatorial Guinea. The Fang Tribes*, New York, 1990
- PERSON, 1961 Y. Person, 'Les Kissi et leurs statuettes de pierre dans le cadre de l'histoire ouest-africaine', *Bulletin de l'Institut Français de l'Afrique Noire*, 23B, 1961, pp. 1–59
- PETRIDIS, 1995 C. Petridis, *Trésors d'Afrique. Musée de Tervuren*, 1995, pp. 330–5
- PETRIE, 1917 W. M. F. Petrie, *Tools and Weapons*, London, 1917
- PETRIE, 1927 W. M. F. Petrie, *British School of Archaeology in Egypt: Objects of Daily Use*, London, 1927
- PETRIE, 1939 W. M. F. Petrie, *The Making of Egypt*, London, 1939
- PETRIE, 1953 W. M. F. Petrie, *Ceremonial Slate Palettes*, London, 1953
- PETRIE, n. d. W. H. F. Petrie, MSS Notebook no. 137, n. d.
- PETRIE and QUIBELL, 1896 W. M. F. Petrie and J. E. Quibell, *Naqada and Ballas 1895*, British School of Archaeology in Egypt, i, London, 1896
- PHILLIPS, 1978 R. Phillips, 'Masking in Mende Sande Society Initiation Rituals', *Africa* (London), 48 (3), 1978, pp. 265–76
- PICARD, 1964 G. C. Picard, *Carthage*, trans. M. and L. Kochan, London, 1964 [*Le Monde de Carthage*, 1956]
- PICARD, 1965–6 G.-C. Picard, 'Sacra punica: Étude sur les masques et rasoirs de Carthage', *Karthago*, 13, 1965–6, pp. 1–115
- PICARD and PICARD, 1968 G.-C. and C. Picard, *The Life and Death of Carthage*, trans. D. Collon, London, 1968 [*Vie et mort de Carthage*, 1968]
- PICTON, 1992¹ J. Picton, 'Desperately seeking Africa', New York 1992, *Oxford Art Journal*, XV(2), 1992
- PICTON, 1992² J. Picton, 'Technology, tradition and lurex', in *History, Design and Craft in West African Stripwoven Cloth*, Smithsonian Institution, Washington, 1992
- PICTON, 1994¹ J. Picton, 'Art, identity and identification: a commentary on Yoruba art historical studies', in *The Yoruba Artist*, ed. H. J. Drewal, J. Pemberton III, Washington, 1994, pp. 1–34
- PICTON, 1994² J. Picton, 'Sculptors of Opin', *African Arts*, 27 (3), pp. 46–59, pp. 101–2
- PICTON, 1994³ J. Picton, 'A tribute to William Fagg', *African Arts*, XXVII (5), 1994
- PICTON, in preparation J. Picton, 'The horse and its rider in Yoruba art: images of conquest and possession', in *Cavaliere dell'Africa: Storia, Iconografia, Simbolismo*, Milan, in preparation
- PICTON and MACK, 1979 J. Picton and J. Mack, *African Textiles*, London, 2nd edn, 1989
- PINDER-WILSON, 1973 R. Pinder-Wilson with C. Brooke, 'The Reliquary of St. Petroc and the Ivories of Norman Sicily', *Archeologia* (Society of Antiquaries of London), 1973, pp. 168–243
- PLASCHKE and ZIRNGIBL, 1992 D. Plaschke and M. Zirngibl, *African Shields: Graphic Art of the Black Continent*, Munich, 1992
- POGGE, 1880 P. Pogge, *Im Reiche des Muata Jamvo*, Berlin, 1880
- PORADA, 1980 E. Porada, 'A Lapis Lazuli Figurine from Hierakonpolis in Egypt', *Iranica Antiqua*, 15, 1980, pp. 175–81
- PORTER and MOSS, 1964–81 B. Porter and R. Moss, eds, *Topographical Bibliography of Ancient Egyptian Hieroglyphic Texts, Reliefs and Paintings*, i (2), iii (1–2), Oxford, 1964–81
- POSNANSKY and CHAPLIN, 1968 M. Posnansky and J. H. Chaplin, 'Terracotta Figures from Entebbe, Uganda', *Man*, 5 (4), 1968, pp. 644–50
- POSSELT, 1924 W. Posselt, 'The Early Days of Mashonaland and a Visit to the Zimbabwe Ruins', *National Affairs Department Annual*, 2, 1924, pp. 70–6
- POWELL-COTTON, 1904 P. H. G. Powell-Cotton, *In Unknown Africa*, London, 1904
- POWER, 1951 J. H. Power, 'Two Sculptured Heads in the McGregor Museum, Kimberley', *South African Archaeological Bulletin*, 6, 1951, pp. 54–5
- POYNER, 1978 R. Poyner, *The Ancestral Arts of Owo Nigeria*, diss., University of Indiana, Bloomington, IN, 1978
- PRIDDY, 1970 A. J. Priddy, 'RS 63/32: An Iron Age Site near Yelwa, Sokoto Province: Preliminary Report', *West African Archaeological Newsletter*, 12, 1970, pp. 20–52
- PRIESE, 1977 K. -H. Priese, 'Eine verschollene Bauinschrift des frühmeroitischen Königs Aktisanes (?) vom Gebel Barkal', in *Ägypten und Kusch*, Berlin, 1977, pp. 359 ff.
- PRINS, 1965 A. H. J. Prins, 'A Carved Headrest of the Cushitic Boni: An Attempted Interpretation', *Man*, 221, 1965, pp. 189–91
- PRUITT, 1975 W. Pruitt, *An Independent People: A History of the Sala Mpasu of Zaire and their Neighbours*, diss., Northwestern University, 1975
- PRUSSIN, 1986 L. Prussin, *Hatumere. Islamic Design in West Africa*, Berkeley and London, 1986
- PUCCIONI, 1936 N. Puccioni, *Antropologia e ethnografia della genti della Somalia*, Bologna, 1936 [English trans., 1960]
- PULLINGER and KITCHIN, 1982 J. S. Pullinger and A. M. Kitchin, *Trees of Malawi: with some Shrubs and Climbers*, Malawi, 1982
- QUAEGBEUR, 1983 J. Quaegebeur, 'Trois statues de femme d'époque ptolémaïque', in *Artibus Aegypti: Studia in honorem Bernardi V. Bothmer a Collegis Amicis Discipulis Conscripta*, ed. H. De Meulenaere and L. Limme, Brussels, 1983, pp. 109–27
- QUIBELL, 1900 J. F. Quibell, *Hierakonpolis*, i: *Plates of Discoveries in 1898*, London, 1900
- QUIBELL, 1912 J. E. Quibell, 'Excavations at Saqqara', *The Monastery of Apa Jeremias*, Cairo, 1912
- QUIBELL and GREEN, 1902 J. E. Quibell and F. W. Green, *Hierakonpolis*, ii, London, 1902
- QUIRIN, 1979 J. Quirin, 'The Beta Israel (Falasha) and the Process of Occupational Caste Formation, 1270–1868', *Proceedings of the Fifth International Conference on Ethiopian Studies*, Chicago, 1979, pp. 135–45
- QUIRKE and SPENCER, 1992 S. Quirke and J. Spencer, *The British Museum Book of Ancient Egypt*, London, 1992
- RANDALL-MACIVER and MACE, 1902 D. Randall-MacIver and A. C. Mace, *El Amrah and Abydos*, London, 1902
- RANGELEY, 1963 W. H. J. Rangeley, 'The Ayao', *Nyasaland Journal*, 16 (1), 1963, pp. 7–27
- RANKE, 1980 H. Ranke, 'The Egyptian Collections of the University Museum', *University Museum Bulletin*, 15 (2–3), 1980, pp. 26, 30, fig. 14
- RAUM, 1975 O. F. Raum, *The Social Functions of Avoidances and Taboos among the Zulu*, Berlin, 1975
- RAVENHILL, 1980 P. Ravenhill, *Baule Statuary Art: Meaning and Modernization*, Philadelphia, 1980
- RAVENHILL, 1992 P. L. Ravenhill, 'Preview: The Art of the Personal Object', *African Arts*, 25 (1), 1992, pp. 70–5
- RAVENHILL, 1994 P. Ravenhill, *The Self and the Other: Personhood and Images among the Baule*, Côte d'Ivoire, Los Angeles, 1994
- READ, 1902 C. H. Read, 'On a Saracen Goblet of Enamelled Glass of Medieval Date', *Archaeologia*, 58 (1), 1902, pp. 217 ff.
- REDINHA, 1953–5 J. Redinha, *Campanha Etnográfica ao Tchiboco (Alto-Tchicapa)*, i–ii, Lisbon, 1953–5
- REEFE, 1977 T. Reeve, 'Lukasa: A Luba Memory Device', *African Arts*, 10 (4), 1977, pp. 48–50, 88
- REEFE, 1981 T. Reeve, *The Rainbow and the Kings*, Berkeley, 1981
- REEVES, 1985 C. N. Reeves, 'Tutankamun and his Papyri', *Göttinger Misellen*, 88, 1985
- REEVES, 1990 C. N. Reeves, *Valley of the Kings: The Decline of a Necropolis*, London, 1990
- REINISCH, 1865 S. Reinisch, *Die aegyptischen Denkmäler in Miramar*, Vienna, 1865
- REINOLD, 1987 J. Reinold, 'Rapports préliminaires des campagnes 1984–85 and 1985–6', *Archéologie du Nil Moyen*, 2, 17–67, 1987
- REINOLD, 1991 J. Reinold, 'Néolithique soudanais: les coutumes funéraires', *Egypt and Africa*, ed. W. V. Davis, London, 1991, pp. 16–29
- REINOLD, 1994 J. Reinold, 'Le Cimetière Néolithique KDK. 1 de Kadruka (Nubie Soudanaise)', in *Études Nubiennes*, ii, ed. C. Bonnet, Geneva, 1994, pp. 93–100
- REISNER, 1915 G. A. Reisner, 'Accessions to the Egyptian Department during 1914', *Bulletin of the Museum of Fine Arts*, Boston, 13, 1915, p. 32, figs 10, 34
- REISNER, 1925 G. A. Reisner, 'Excavations at Kerma. Parts I–III', *Harvard African Studies*, 5, Cambridge, MA, 1925
- REISNER, 1931 G. A. Reisner, *Mycerinus: the Temple of the Third Pyramid at Giza*, Cambridge, MA, 1931
- REVAULT et al., 1985–92 J. Revault et al., *Palais et demeures de Fès*, 3 vols, Paris, 1985–92
- RICARD, 1927–34 P. Ricard, *Corpus des tapis marocaines*, 4 vols, Paris, 1927–34
- RICARD, 1932 P. Ricard, *Les tapis marocains*, 1932
- RICARD, 1934 P. Ricard, *Corpus des tapis marocaines*, iv, Paris, 1934
- RICARD, 1950 P. Ricard, 'Une lignée d'artisans: Les Ben Cherif de Fès', in *Hespérès*, 1950, pp. 41–8
- RICHARDS, 1956 A. I. Richards, *Chisungu: A Girls' Initiation Ceremony among the Bemba of Northern Rhodesia*, London, 1956
- RICHTER, 1980 D. Richter, *Economics and Change: The Kulelele of Northern Ivory Coast*, La Jolla, CA
- RIEFENSTAHL, 1982 L. Riefenstahl, *Vanishing Africa*, New York, 1982 [trans. from German original by K. Talbot]
- RIEFENSTAHL, 1968 E. Riefenstahl, *Ancient Egyptian Glass and Glazes in The Brooklyn Museum*, Wilbour Monographs, i, Brooklyn, 1968

- ROBBINS and NOOTER, 1989 W. M. Robbins and N. I. Nooter, *African Art in American Collections*, Washington, 1989
- ROBERT-CHALEIX, 1983 D. Robert-Chaleix, 'Céramiques découverts à Tegdaoust', in J. Devissé et al., *Tegdaoust III*, Paris, 1983, pp. 245–94
- ROBERTS, 1985 A. F. Roberts, 'Social and Historical Contexts of Tabwa Art', in *The Rising of a New Moon: A Century of Tabwa Art*, ed. A. Roberts and E. M. Maurer, Seattle, 1985, pp. 1–48
- ROBERTS, 1993 A. F. Roberts, 'Insight: or Not Seeing is Believing', in *Secrecy: African Art that Conceals and Reveals*, ed. M. H. Nooter, New York, 1993
- ROBERTS, 1994¹ A. F. Roberts, 'Formenverwandtschaft: Ästhetische Berührungs punkte zwischen Völkern West-Tanzanias und Südost-Zaires/Usanifu sawa katiya watu wa Tanzania ya Magharibi na watu wa kusini mashariki ya Zaire/A Sharing of Forms: Ästhetic Commonalities among Peoples of Western Tanzania and Southeastern Zaire', in *Tanzania: Meisterwerke Afrikanischer Skulptur/Sanaa za Mabingwa wa Kufrika*, ed. J. Jahn, Munich, 1994, pp. 350–70
- ROBERTS, 1994² A. F. Roberts, ed., *Staffs of Life: Rods, Staffs, Scepters and Wands from the Coudron Collection of African Art*, Iowa City, 1994
- ROBERTS, forthcoming A. F. Roberts, *Memory: Luba Art and the Making of History*, New York, forthcoming
- ROBERTS, M. N., 1994 M. N. Roberts, 'Sculpted Narratives of Luba Staffs of Office', in *Staffs of Life*, ed. A. F. Roberts, Iowa City, 1994
- ROBERTS and MAURER, 1985 A. Roberts and E. Maurer, eds, *The Rising of a New Moon: A Century of Tabwa Art*, Seattle and Ann Arbor, 1985
- ROBINS, 1986 G. Robins, *Egyptian Painting and Relief*, Aylesbury, 1986
- ROBINSON, 1959 K. R. Robinson, *Khami Ruins*, Cambridge, 1959
- RODRIGUES de AREIA, 1985 M. L. Rodrigues de Areia, *Les symboles divinatoires. Analyse socio-culturelle d'une technique de divination des Cokwe de l'Angola (ngrombo ya cisuka)*, Coimbra, 1985
- ROEDER, 1921 G. Roeder, 'Der Priester als Anubis an der Mumie', in *Alt-Hildesheim*, 3, Hildesheim, 1921, pp. 31–5
- ROEDER and IPPEL, 1921 G. Roeder and A. Ippel, *Die Denkmäler des Pelizaeus-Museums zu Hildesheim*, Berlin and Hildesheim, 1921
- ROEHRIG, 1992 C. H. Roehrig in *MMAAB*, Spring 1992, pp. 32–3
- ROLLEFSON, 1992 G. O. Rollefson, 'A Neolithic Game Board from Ain Ghazal, Jordan', *Bulletin of the American Schools of Oriental Research*, 286, 1992, pp. 1–6
- ROSCOE, 1911 J. Roscoe, *The Baganda*, London, 1911
- ROSCOE, 1925 J. Roscoe, *The Bakitara or Banyoro*, Cambridge, 1925
- ROSENWALD, 1974 J. B. Rosenwald, 'Kuba king figures', *African Arts*, 7, pp. 26–31
- ROSS, 1931 E. D. Ross, *The Art of Egypt through the Ages*, London, 1931
- ROSS, 1988 D. H. Ross, 'Queen Victoria for Twenty-Five Pounds: The Iconography of a Breasted Drum from Southern Ghana', *Art Journal*, 47 (2), 1988, pp. 114–20
- ROSS, 1989 D. H. Ross, 'Master Drums from Akan Popular Bands', in *Sounding Forms: African Musical Instruments*, exh. cat. by M.-T. Brincard, American Federation of Arts, Washington, 1989, pp. 78–81
- ROSS, 1992 D. H. Ross, ed., *Elephant. The Animal and its Ivory in African Culture*, Los Angeles, 1992
- ROUACH, 1989 D. Rouach, *Bijoux berbères au Maroc dans la tradition judéo-arabe*, Paris, 1989
- ROUTLEDGE and ROUTLEDGE, 1968 U. S. Routledge and K. Routledge, *Vital and Prehistoric People: The Akikuyu of British East Africa*, London, 1968
- ROUTLEDGE S. Routledge, *The Akikuyu*, London, 1910
- ROY, 1987 C. Roy, *Art of the Upper Volta Rivers*, Paris, 1987
- ROY, 1992 C. Roy, *Art and Life in Africa: Selections from the Stanley Collection, Exhibitions of 1985 and 1992*, Iowa City, 1992
- RUBIN, 1969 A. Rubin, *The Arts of the Jukun-speaking Peoples of Northern Nigeria*, diss., Indiana University, Bloomington, 1969
- RUBIN, 1973 A. Rubin, 'Bronzes of the Middle Benue', *West African Journal of Archaeology*, 3, 1973, pp. 221–31
- RUBIN, 1982 A. Rubin, 'Bronzes of Northeastern Nigeria', in *The Art of Metal in Africa*, ed. M.-T. Brincard, New York, 1982, pp. 45–6
- RUBIN, 1984¹ W. Rubin, ed., 'Modernist Primitivism', in 'Primitivism' in 20th Century Art, i, 1984, pp. 1–79
- RUBIN, 1984² W. Rubin, ed., 'Primitivism' in 20th Century Art, New York, 1984
- RUBIN and BURNS, in preparation A. Rubin and M. C. Burns, eds, *The Arts of the Benue River Valley*, Los Angeles, in preparation
- RUDNER, 1971 J. Rudner, 'Ostrich Eggshell Flasks and Soapstone Objects from the Gordon District, North-western Cape', *South African Archaeological Bulletin*, 26 (105–4), 1971, pp. 139–42
- RUDNER, 1983 I. Rudner, 'Paints of the Khoisan Rock Artists', *South African Archaeological Society, Goodwin Series*, 4, 1983, pp. 14–20
- RUEL, 1969 M. Ruel, *Leopards and Leaders: Constitutional Politics among a Cross River People*, London, 1969
- RUSILLON, 1912 H. Rusillon, *Une culte dynastique avec évocation des morts chez les Sakalaves de Madagascar, 'le tromba'*, Paris, 1912
- RUSSMANN, 1989 E. R. Russmann, *Egyptian Sculpture: Cairo and Luxor*, Austin, TX, 1989
- RUSSMANN, 1994 E. R. Russmann, 'Relief Decoration in the Tomb of Mentuemhat (TT 34)', *Journal of the American Research Center in Egypt*, 31, 1994, pp. 1–19
- RUSSMANN, 1995 E. R. Russmann, 'A Second Style in Egyptian Art of the Old Kingdom', *Mitteilungen des Deutschen Archäologischen Instituts, Abteilung Kairo*, 51, 1995, pp. 94–5
- RÜTIMEYER, 1901 L. Rütimeyer, 'Über westafrikanische Steinidole', *Internationales Archiv für Ethnographie*, 14, 1901, pp. 195–205
- RÜTIMEYER, 1908 L. Rütimeyer, 'Weitere Mitteilungen über westafrikanische Steinidole', *Internationales Archiv für Ethnographie*, 18, 1908, pp. 167–78
- RYDER, 1964 A. F. C. Ryder, 'A Note on the Afro-Portuguese Ivories', *Journal of African History*, 5, 1964, pp. 565–5
- RYDER, 1969 A. F. C. Ryder, *Benin and the Europeans*, London, 1969
- SALEH and SOUROUZIAN, 1987 M. Saleh and H. Sourouzian, *Official Catalogue: The Egyptian Museum Cairo*, Mainz, 1987
- SALMONS, 1980 J. Salmon, 'Funerary shrine cloths of the Annang Ibibio, South-east Nigeria', in *Textiles of Africa*, ed. K. G. Ponting and D. Idiens, Bath, 1980
- SAMAIN, n. d. A. Samain, *La langue Kisonge*, Brussels, n. d.
- SAMPSON, 1974 C. G. Sampson, *The Stone Age Archaeology of Southern Africa*, New York, 1974
- SAN DIEGO 1992 *Reclusive Rebels: An Approach to the Sala Mpasu and their Masks*, exh. cat. by E. L. Cameron, San Diego Mesa College, San Diego, 1992
- SAN FRANCISCO 1975 *Images for Eternity: Egyptian Art from Berkeley and Brooklyn*, exh. cat. by R. A. Fazzini, M. H. de Young Memorial Museum, San Francisco, 1975
- SAN JUAN 1979 *Escultura del Antiguo Egipto del Museo de Brooklyn*, exh. cat. by R. S. Bianchi, Museo de la Fundación Arqueológica Anthropológica e Histórica, Puerto Rico, 1979
- SARRE and TRENKWALD, 1926–7 F. Sarre and H. Trenkwald, *Old Oriental Carpets*, 2 vols, Leipzig and Vienna, 1926–7
- SATZINGER, 1987 H. Satzinger, *Ägyptisch-Orientalische Sammlung: Kunsthistorisches Museum Wien*, Munich, 1987
- SATZINGER, 1994 H. Satzinger, *Das Kunsthistorische Museum in Wien: Die Ägyptisch-Orientalische Sammlung*, Zaberns Bildbände zur Archäologie 14, Mainz, 1994
- SATZINGER, in preparation H. Satzinger, 'Eine Pavianstatue mit Königsfigur (Wien ÄS Inv. Nr. 5782)', *Beihefte, Studien zur alt-ägyptischen Kultur/Acts of IVth International Congress of Egyptologists, Munich 1987*, in preparation
- SÄVE-SÖDERBERGH, 1967–8 T. Säve-Söderbergh, 'Preliminary Report of the Scandinavian Joint Expedition, Archaeological Investigations between Faras and Gemmai – November 1963–March 1964', *Kush*, XV, 211–50
- SCANZI, 1993 G. F. Scanzi, *L'art traditionnel Lobi*, Bergamo, 1993
- SCANZI and DELCOURT, 1987 G. F. Scanzi and J.-P. Delcourt, *Potomo Waka*, Milan, 1987
- SCHAEDLER, 1973 K. F. Schaedler, *African Art in Private German Collections*, Munich, 1973
- SCHAEDLER, 1992 K. F. Schaedler, *Gods, Spirits, Ancestors: African Sculpture from Private German Collections*, Munich, 1992
- SCHAEDLER, 1993 K. F. Schaedler, *Gods, Spirits, Ancestors – African Sculpture from Private German Collections*, Munich, 1993
- SCHARFF, 1928 A. Scharff, 'Some Prehistoric Vases in the British Museum and Remarks on Egyptian History', *Journal of Egyptian Archaeology*, 14, 1928, pp. 261–76
- SCHARFF, 1929 A. Scharff, *Die Altertümer der Völker und Frühzeit Ägyptens*, ii, Staatliche Museen zu Berlin, Mitteilungen aus der Ägyptischen Sammlung 5, Berlin, 1929
- SCHILDKROUT and KEIM, 1990 E. Schildkrout and C. A. Keim, *African Reflections: Art from Northeastern Zaire*, New York, Washington, 1990
- SCHMALENBACH, 1953 W. Schmalenbach, *Die Kunst Afrikas*, Basle, 1953
- SCHMALENBACH, 1988 W. Schmalenbach, *African Art from the Barbier-Mueller Collection*, Geneva, Munich, 1988
- SCHMIDT, 1981 P. R. Schmidt, *The Origins of Iron Smelting in Africa: A Complex Technology in Tanzania*, Providence, RI, 1981
- SCHMIDT, 1989 C. E. Schmidt, 'African Mbirea as Musical Icons', in *Sounding Forms: African Musical Instruments*, ed. M.-T. Brincard, New York, 1989, pp. 73–9
- SCHMITZ, 1913 R. Schmitz, *Les Baholoholo*, Brussels, 1913
- SCHMORANZ, 1899 G. Schmoranz, *Old Oriental Gilt and Enamelled Glass Vessels*, Vienna and London, 1899
- SCHNEIDER, 1955 G. Schneider, 'Mambila Album', *Nigerian Field*, 20, 1955, pp. 112–32
- SCHNEIDER, 1973 B. Schneider, 'Body Decoration in Mozambique', *African Arts*, 6 (2), 1973, pp. 26–31
- SCHOEMAN, 1968¹ H. S. Schoeman, 'A preliminary report of traditional beadwork in the Mkhwanazi area of the Mtunzini district, Zululand', *African Studies*, 27 (2), 1968, pp. 57–82
- SCHOEMAN, 1968² H. S. Schoeman, 'A preliminary report of traditional beadwork in the Mkhwanazi Area of the Mtunzini District, Zululand', *African Studies*, 27 (3), 1968, pp. 107–34
- SCHOLFIELD, 1948 J. F. Scholfield, *Primitive Pottery: an Introduction to South African Ceramics, Prehistoric and Protohistoric*, Handbook Series No. 3, South African Archaeological Society, 1948
- SCHULZ, 1992 R. Schulz, *Die Entwicklung und Bedeutung des kuboiden Statuentytypus: Eine Untersuchung zu den sogenannten Würfelhockern*, 2 vols, Hildesheim, 1992
- SCHUTT, 1881 O. H. Schutt, *Reisen im Sudwestlichen Becken des Congo*, Berlin, 1881
- SCHWAB, 1947 G. Schwab, 'Tribes of the Liberian Hinterland', *Papers of the Peabody Museum*, Cambridge, MA, 31, 1947 [with contributions by G. Harley]

- SCHWARTZ, 1971 A. Schwartz, *Tradition et changements dans la société Guéré*, Paris, 1971
- SCHWARTZ, n. d. N. Schwartz, 'Mambilla – Art and Material Culture', *Milwaukee Public Museum/Publications in Primitive Art*, 4, n. d.
- SCHWEEGER-HEFEL, 1981 A. Schweeger-Hefel, *Steinskulpturen der Nyonyose aus Ober-Volta*, Munich, 1981
- SCHWEINFURTH, 1873 G. Schweinfurth, *Im Herzen von Afrika*, Leipzig, 1873 [also published in English]
- SCHWEINFURTH, 1875 G. Schweinfurth, *Artes Africanae: Illustrations and Descriptions of Productions of the Industrial Arts of Central African Tribes*, Leipzig and London, 1875
- SCHWEITZER, 1948 U. Schweitzer, *Löwe und Sphinx im Alten Ägypten*, Ägyptologische Forschungen, 15, Glückstadt and Hamburg, 1948
- SEEBER, 1980 C. Seeber, 'Maske', in *Lexikon der Ägyptologie*, iii, Wiesbaden, 1980, pp. 1196–9
- SEIDEL and WILDUNG, 1975 M. Seidel and D. Wildung, in *Das alte Ägypten: Propyläen Kunstgeschichte*, xv, ed. C. Vandersleyen, Berlin, 1975
- SEIPEL, 1983 W. Seipel, *Bilder für die Ewigkeit: 3000 Jahre ägyptischer Kunst*, Heidelberg, 1983
- SELIGMAN, 1911 C. G. Seligman, 'An Ausumwa Drum', *Man*, 11, 1911, p. 7
- SELIGMAN, 1917 C. G. Seligman, 'A Bongo Funerary Figure', *Man*, XVIII, 67
- SELIGMAN, 1980 T. Seligman, 'Animism and Islam: A Mask from North-East Liberia', *Apollo*, 111 (216–7), 1980, pp. 63–5
- SELIGMAN and SELIGMAN, 1932 C. G. and B. Seligman, *Pagan Tribes Of The Nilotic Sudan*, London, 1932
- SETTGAST and GEHRIG, 1978 J. Settgast and U. Gehrig, *Von Troja bis Amarna: The Norbert Schimmel Collection*, New York, Mainz, 1978
- SHACK, 1966 W. A. Shack, *The Gurage: A People of the Ensete Culture*, London, 1966
- SHACK, 1972 W. A. Shack, *The Central Ethiopians: Amhara, Tigrina and Related Peoples*, London, 1972
- SHAW, 1935 M. Shaw, 'Some native snuff-boxes in the South African Museum', *Annals of the South African Museum*, 24 (3), 1935, pp. 141–62, pls 24–31
- SHAW, 1938 M. Shaw, 'Native pipes and smoking in South Africa', *Annals of the South African Museum*, 24, 1938, pp. 277–302, pls 86–99
- SHAW, 1970 T. Shaw, *Igbo-Ukuw: An Account of Archaeological Discoveries in Eastern Nigeria*, London, 1970
- SHAW, 1973 T. Shaw, 'Note on trade and the Tsoede bronzes', *West African Journal of Archaeology*, 3, pp. 233–8
- SHAW, 1975 T. Shaw, 'Those Igbo-Ukuw Radiocarbon Dates: Facts, Fictions and Probabilities', *Journal of African History*, 16 (4), 1975, pp. 503–17
- SHAW, 1977 T. Shaw, *Unearthing Igbo-Ukuw*, Ibadan, 1977
- SHAW, 1978 T. Shaw, *Nigeria*, London, 1978
- SHAW, 1990 R. Shaw, *Early Pastoralists of South-Western Kenya*, Nairobi, 1990
- SHAW T. Shaw, 'The Nok Sculptures of Nigeria', *Scientific American*, 244 (2), pp. 154–66
- SHAW et al., 1993 T. Shaw, P. Sinclair, B. Andah, A. Okpoko, eds, *The Archaeology of Africa*, London, 1993
- SHAW and VAN WARMELO, 1988 E. M. Shaw and N. J. Van Warmelo, 'The Material Culture of the Cape Nguni', *Annals of the South African Museum*, 58 (4), 1988, pp. 447–949
- SIEBER, 1958 R. Sieber, unpublished field photographs, K2–4, 5, 1958
- SIEBER, 1961 R. Sieber, *Sculpture of Northern Nigeria*, New York, 1961
- SIEBER, 1972¹ R. Sieber, 'Kwahu Terracottas: Oral Traditions and Ghanaian History', *African Art and Leadership*, ed. D. Fraser and H. Cole, Madison, 1972, pp. 173–83
- SIEBER, 1972² R. Sieber, *African Textiles and Decorative Arts*, New York, 1972
- SIEBER, 1980 R. Sieber, *African Furniture and Household Objects*, Bloomington, 1980
- SIEBER and VERVERS, 1974 R. Sieber and T. Ververs, *Interaction: The Art Styles of the Benue River Valley and East Nigeria*, Indianapolis, 1974
- SIEBER and WALKER, 1987 R. Sieber and R. A. Walker, *African Art in the Cycle of Life*, Washington, 1987
- SIEBER, NEWTON and COE, 1986 R. Sieber, D. Newton and M. D. Coe, *African Pacific and Pre-Columbian Art in the Indiana University Art Museum*, Indianapolis, 1986
- SIEGEL, 1977 R. K. Siegel, 'Hallucinations', *Scientific American*, 257, 1977, pp. 132–40
- SIEGMANN, 1995 W. Siegmann, verbal communication to M. J. Adams, 7 April 1995
- SIGOLI, 1948 S. Sigoli, 'Pilgrimage of Simone Sigoli to the Holy Land', trans. T. Bellorini and E. Hoade, in *Publication of the Studium Franciscanum*, 6, 1948, pp. 157–201
- SIJELMASSI, 1986 M. Sijelmassi, *Les arts traditionnels au Maroc*, Paris, 1986
- SILVERMAN, 1983 R. A. Silverman, 'Akan Kuduo: Form and Function', in *Akan Transformations: Problem in Ghanaian Art History*, Los Angeles, 1983, pp. 10–29
- SIMPSON, 1977 W. K. Simpson, *The Face of Egypt: Permanence and Change in Egyptian Art*, Katonah, 1977
- SMITH, 1949 W. S. Smith, *A History of Egyptian Sculpture and Painting in the Old Kingdom*, Boston, 1949
- SMITH, 1981 W. S. Smith, *The Art and Architecture of Ancient Egypt*, rev. with additions by W. K. Simpson, Harmondsworth and New York, 1981
- SNOEK, 1981 M. A. Snoek, *Les arts décoratifs Mangbetu: Negue et Roko*, Brussels, 1981
- SÖDERBERG, 1975 B. Söderberg, 'Les figures d'ancêtres chez les Babembe', *Arts d'Afrique Noire*, 13–14, 1975, pp. 14–37
- SOURDEL-THOMINE and SPULER, 1973 J. Sourdel-Thomine and B. Spuler, *Die Kunst des Islam*, Berlin, 1973
- SOUROUZIAN, 1991 H. Sourouzian, 'A Bust of Amenophis II at the Kimbell Art Museum', *Journal of the American Research Centre in Egypt*, 28, 1991, pp. 55–74
- SOUVILLE, 1973 G. Souville, *Atlas préhistorique du Maroc*, i: *Maroc Atlantique*, Paris, 1973
- SPEKE, 1863 J. H. Speke, *Journal of the Discovery of the Source of the Nile*, Edinburgh, 1863
- SPENCER, 1980 A. J. Spencer, *Catalogue of Egyptian Antiquities in the British Museum*, V: *Early Dynastic Objects*, London, 1980
- SPENCER, 1993 A. J. Spencer, *Early Egypt: The Rise of Civilization in the Nile Valley*, London, 1993
- SPEYER et al. 1993–4 Götter, Menschen, Pharaonen/Dioses, Hombres, Faraones/Das Vermächtnis der Pharaonen, exh. cat. ed. W. Seipel, Kunsthistorisches Museum, Vienna, 1993–4
- SPRING, 1993 C. Spring, *African Arms and Armour*, London, 1993
- STAGER, 1980 L. E. Stager, 'The rite of child sacrifice at Carthage', in *New Light on Ancient Carthage*, ed. J. G. Pedley, Ann Arbor, 1980, pp. 1–11
- STAHL, 1986 A. Stahl, 'Early food production in West Africa: Rethinking the role of the Kintampo culture', *Current Anthropology*, 27, 1986
- STANLEY, 1878 H. M. Stanley, *Through the Dark Continent*, 2 vols, London, 1878
- STANNUS, 1922 H. S. Stannus, 'The Wayao of Nyasaland', *Varia Africana III, Harvard African Studies, the African Department of the Peabody Museum of Harvard University*, 3, 1922, pp. 229–372
- STAYT, 1931 H. A. Stayt, *The Bavenda*, Oxford, 1931
- STEVENS, 1978 P. J. Stevens, *The Stone Images of Esie, Nigeria*, Ibadan, 1978
- STOCKHOLM 1961 5000 år egyptisk konst, exh. cat., National Museum of Ethnology, Stockholm, 1961
- STÖRK, 1984 Contribution to *Lexikon der Ägyptologie*, Wiesbaden, 1984, pp. 257–63
- STOSSEL, 1981 A. Stossel, *Nupe Kakanda Basa-Nge*, Munich, 1981
- STRITZL, 1971 A. Stritzl, *Raffiaplüsch aus dem Königreich Kongo* [with English summary], Vienna, 1971
- STRZYGOWSKI, 1904 J. Strzygowski, *Koptische Kunst*, Vienna, 1904
- STUART and MALCOLM, 1969 J. Stuart and D. Malcolm, eds, *The Diary of Henry Francis Fynn*, Pietermaritzburg, 1969
- STUHLMANN, 1910 F. Stuhlmann, *Handwerk und Industrie in Ostafrika*, Hamburg, 1910
- STUTTGART 1975 Religiöse Kunst Äthiopiens – Religious Art of Ethiopia, exh. cat., Institut für Auslandsbeziehungen, Stuttgart, 1975
- STUTTGART 1984 Osiris, Kreux und Halbmond: Die drei Religionen Ägyptens, exh. cat. ed. E. Brunner-Traut and H. Brunner, Stuttgart Landesmuseum, Mainz-am-Rhein, 1984
- SUGIER, 1968 C. L. Sugier, 'Les bijoux de la mariée à Moknine', *Cahiers des A. T. P.*, Tunis, 1968, p. 151
- SUGIER, 1977 C. L. Sugier, *Bijoux tunisiens: Formes et symboles*, Tunis, 1977
- SUMMERS, 1949 R. Summers, 'An Ancient Ivory Figurine from Khami Ruins', *Man*, 49, 1949, p. 96
- SUMMERS, 1961¹ R. Summers, 'Excavations in the Great Enclosure', *Occasional Papers of the National Museums of Southern Rhodesia*, 5 (23A), 1961, pp. 236–88
- SUMMERS, 1961² R. Summers, 'The Zimbabwe Bird', *Rhodesian Countryman*, 1(3), 1961, pp. 2–4
- SUMMERS, 1963 R. Summers, *Zimbabwe: A Rhodesian Mystery*, Cape Town, 1963
- SUTTON, 1982 J. E. G. Sutton, 'Archaeology in West Africa: A review of recent work and a further list of radiocarbon dates', *Journal of African History*, 23 (3), 1982, pp. 291–313
- SWANN, 1910 A. Swann, *Fighting the Slave Hunters in Central Africa*, London, 1910
- SWANTZ, 1970 A. Swantz, *Ritual and Symbol in Transitional Zaramo Society*, Uppsala, 1970
- SWEENEY, 1993 D. Sweeney, 'Egyptian Masks in Motion', in *Göttinger Miszellen*, 135, 1993, pp. 101–4
- SYDOW, 1926 E. von Sydow, *Kunst und Religion der Naturvölker*, Oldenburg, 1926
- SYDOW, 1954 E. von Sydow, *Afrikanische Plastik*, Berlin, 1954
- SZABO and BUTZER, 1979 B. J. Szabo and K. W. Butzer, 'Uranium series dating of lacustrine limestones from pan deposits with Final Acheulean assemblages at Rooidam, Kimberley District, South Africa', *Quaternary Research*, 11, 1979, pp. 257–60
- TAGLIAFERRI, 1989 A. Tagliaferri, *Stili del potere*, Milan, 1989
- TAGLIAFERRI and HAMMACHER, 1974 A. Tagliaferri and A. Hammacher, *Fabulous Ancestors*, New York, 1974
- TAIT, 1979 H. Tait, ed., *The Golden Age of Venetian Glass*, London, 1979
- TALBOT, 1912 P. A. Talbot, *In the Shadow of the Bush*, London, 1912
- TALBOT, 1923 P. A. Talbot, *Life in Southern Nigeria*, 4 vols, London, 1923
- TAMARI, 1991 T. Tamari, 'The Development of Caste Systems in West Africa', *Journal of African History*, 32 (2), 1991, pp. 221–50
- TAYLOR, 1978 M. Taylor, *The Lewis Chessmen*, London, 1978
- TAYLOR, 1991 J. H. Taylor, *Egypt and Nubia*, London, 1991
- TERRACE, 1968 E. Terrace, *Connoisseur*, September 1969, pp. 49–56

- TERRASSE, 1958 H. Terrasse, *Kasbas berbères de l'Atlas et des oasis*, Paris, 1958
- TERVUREN 1995 *Treasures from the African-Museum*, exh. cat., Royal Museum for Central Africa, Tervuren, 1995
- TESSMANN, 1913 G. Tessmann, *Die Pangwe*, 2 vols, Berlin, 1913
- TEW, 1950 M. Tew, *Peoples of the Lake Nyasa Region*, London, 1950
- THACKERAY, 1983 A. I. Thackeray, 'Dating the Rock Art of Southern Africa', *South African Archaeological Society, Goodwin Series*, 4, 1983, pp. 21–6
- THIEL and HELF, 1984 J. F. Thiel and H. Helf, *Christliche Kunst in Afrika*, Berlin, 1984
- THOMPSON, 1852 G. Thompson, *Thompson in Africa*, New York, 1852
- THOMPSON, 1970 R. F. Thompson, 'The Sign of the Divine King: An Essay on Yoruba Bead Embroidered Crowns with Veil and Bird Decoration', *African Arts*, 3 (3), 1970, pp. 8–17, 74–80
- THOMPSON, 1971 R. F. Thompson, *Black Gods and Kings: Yoruba Art at UCLA*, Los Angeles, 1971
- THOMPSON, 1981 R. F. Thompson, 'Headdress', in *For Spirits and Kings. African Art from the Paul and Ruth Tishman Collection*, ed. S. Vogel, New York, 1981
- THOMPSON, 1983 R. F. Thompson, *Flash of the Spirit. African and Afro-American Art and Philosophy*, New York, 1983
- THOMPSON and BAHUCHET, 1991 R. F. Thompson and S. Bahuchet, *Pygmées? Peintures sur écorce battue des Mbouti (Haut-Zaire)*, Paris, 1991
- THOMPSON and CORNET, 1981 R. F. Thompson and J. Cornet, *The Four Moments of the Sun: Kongo Art in two Worlds*, Washington, 1981
- THOMPSON and MEURANT, forthcoming R. F. Thompson and G. Meurant, *Mbuti Design: Painting by Women of the Ituri Forest*, London, forthcoming
- THORNTON, 1980 R. J. Thornton, *Space, Time and Culture among the Iraquw of Tanzania*, New York, 1980
- TOKYO et al., 1983–4 *Nefert net Kemit : Egyptian Art from The Brooklyn Museum*, exh. cat. by R. A. Fazzini et al., Isctan Museum of Art et al., 1983–4
- TORDAY, 1925 E. Torday, *On the Trail of the Bushongo*, Philadelphia, 1925
- TORDAY and JOYCE, 1910 E. Torday and T. A. Joyce, *Notes ethnographiques sur les peuples communément appelés Bakuba ainsi que les peuplades apparentées: les Bushongo*, Brussels, 1910
- TORDAY and JOYCE, 1922 E. Torday and T. A. Joyce, *Notes ethnographiques sur les peuplades habitant les bassins du Kasai et du Kwango oriental: peuplades de la forêt, peuplades des prairies*, Tervuren, 1922
- TORNAY, 1975 S. Tornay, 'La culture matérielle Nyangatom', *Ethiopie d'aujourd'hui*, Paris, 1975
- TÖRÖK, 1970 L. Török, 'On the Chronology of the Ahnas Sculpture', *Acta Archaeologica Academiae Scientiarum Hungaricae*, 22, Budapest, 1970
- TÖRÖK, 1988 L. Török, *Late Antique Nubia*, Budapest, 1988
- TÖRÖK, 1995 L. Török, *The Birth of An Ancient African Kingdom: Kush and her Myth of the State in the First Millennium BC*, Lille, 1995
- TÖRÖK, in preparation L. Török, *Meroe City: an Ancient African Capital. John Garstang's Excavations in the Sudan*, London, in preparation
- TOWNSHEND, 1992 P. Townshend, 'Bao (Mankala): The Swahili Ethic in African Idiom', *Paideuma*, 28, 1992, pp. 175–91
- TRADESCANT, 1656 J. Tradescant, *Museum Tradescanticum, Or a Collection of Rarities Preserved at South-Lambeth near London by John Tradescant*, London, 1656 [The Tradescant Collection, facs. repr., London, 1980]
- TRAORE, 1965 D. Traore, *Comment le noir se soigne-t-il? Ou médecine et magie africaines*, Paris, 1965
- TRIESTE 1986 *Massimiliano: Da Trieste al Messico*, exh. cat. ed. L. R. Loseri, Trieste, 1986
- TRIMINGHAM, 1952 J. S. Trimingham, *Islam in Ethiopia*, Oxford, 1952
- TRIST and MIDDLETON, 1887 J. W. Trist and J. H. Middleton, in *Proceedings of the Society of Antiquaries*, 2nd ser., 11, 1887, pp. 335–5
- TROUGHEAR, 1987 A. Troughear, 'Kamba Carving: Art or Industry?', *Kenya Past and Present*, 19, 1987, pp. 15–25
- TROWELL, 1941 M. Trowell, 'Some Royal Craftsmen of Buganda', *Uganda Journal*, 8 (2), 1941, pp. 47–64
- TROWELL, 1960 M. Trowell, *African Design*, London, 1960
- TROWELL and WACHSMANN, 1953 M. Trowell and K. P. Wachsmann, *Tribal Crafts of Uganda*, Oxford, 1953
- TSCHUDI, 1969–70 J. Tschudi, 'The Social Life of the Afo, Hill Country of Nasarawa, Nigeria', *African Notes*, 6 (1), 1969–70, pp. 87–99
- TUNIS, 1978 I. Tunis, 'The Enigmatic Lady', *Baessler-Archiv*, xxvi, 1978, pp. 57–89
- TUNIS, 1983 I. Tunis, 'A Note on Benin Plaque Termination Dates', *Tribus*, 32, 1983, pp. 45–53
- TURNER, 1955 V. W. Turner, 'A Lunda love story and its consequences: selected texts from traditions collected by H. Dias de Carvalho at the court of Mwatiwanwa in 1887', *Rhodes-Livingstone Journal*, 19, 1955, pp. 1–26
- TYRRELL, 1968 B. Tyrrell, *Tribal Peoples of Southern Africa*, Cape Town, 1968
- UCKO, 1965 P. J. Ucko, 'Anthropomorphic Ivory Figurines from Egypt', *Journal of the Royal Anthropological Institute*, 95, 1965, pp. 214–39
- UCKO, 1968 F. J. Ucko, *Anthropomorphic Figurines of Predynastic Egypt and Neolithic Crete with Comparative Material from the Prehistoric Near East and Mainland Greece*, Royal Anthropological Institute Occasional Paper 24, London, 1968
- UCKO, 1970 P. J. Ucko, 'Penis Sheaths: A Comparative Study. The Curl Lecture 1969', *Proceedings of the Royal Anthropological Society 1969*, London, 1970, pp. 27–67
- UCKO and HODGES, 1963 P. Ucko and H. W. M. Hodges, 'Some Predynastic Egyptian Figures, Problems of Authenticity', *Journal of the Warburg and Courtauld Institutes*, 26, 1963
- ULLENDORFF, 1968 E. Ullendorff, *Ethiopia and the Bible: The Schweich Lectures*, Oxford, 1968
- UNDERWOOD, 1947 L. Underwood, *Figures in Wood of West Africa*, London, 1947
- UNDERWOOD, 1952 L. Underwood, *Masks of West Africa*, London, 1952
- UNIVERSITÉ DE MADAGASCAR, 1963 Université de Madagascar, *Art Sakalava*, Antananarivo, 1963
- URBAIN-FAUBLÉE, 1963 M. Urbain-Faublée, *L'art malagache*, Paris, 1963
- URVOY, 1955 Y. Urvoz, *L'art dans le territoire du Niger. Études nigériennes*, xi, Niamey, 1955
- VAJDA, 1955 L. Vajda, 'Human and Animal Plastic Figures from the Kilimanjaro Region', *Nepazzi ereteticz*, 37, 1955, pp. 181–90
- VALLOGGIA, 1980 M. Valloggia, 'Deux objets théiomorphes découverts dans le mastaba V de Balat', *Livre du centenaire de l'Institut français d'archéologie orientale, Mémoires de l'Institut Français d'Archéologie Orientale du Caire*, 114, 1980, pp. 145–51, pls. xi–xviii
- VAN BEEK, 1988 W. E. A. van Beek, 'Functions of Sculpture in Dogon Religion', *African Arts*, 21 (4) 1988, pp. 58–65, 91
- VAN BEEK, 1990 W. E. A. van Beek, 'Enter the Bush: A Dogon Mask Festival', in *Africa Explores: 20th Century African Art*, exh. cat. by S. Vogel and I. Ebong, Center for African Art, New York, 1990, pp. 56–73
- VAN BEEK, 1991 W. E. A. van Beek, *Dogon Restudied: A Field Evaluation of the Work of Marcel Griaule*, 1991
- VAN BRAECKEL, 1993 H. van Braeckel, 'Versieringstechnieken op Kuba-textiel', in *African Majesty*, exh. cat., Antwerp, 1993, pp. 20–39
- VAN DAMME, 1987 A. van Damme, *De Maskensculptuur binnen het Poro-Genootschap van de Loma*, Ghent, 1987
- VAN GENNEP, 1911 A. van Gennep, *Études d'Ethnographie algérienne*, Paris, 1911
- VAN NOTEN, 1972 F. van Noten, 'La plus ancienne sculpture sur bois de l'Afrique centrale?', *Africa-Tervuren*, 18, 1972, pp. 153–6
- VAN WARMELLO, 1952 N. J. van Warmelo, *Contributions towards Venda History, Religion and Tribal Ritual*, Pretoria, 1952
- VAN WARMELLO, 1940 N. J. van Warmelo, *The Copper Miners of Musina and the Early History of the Zoutpansberg*, Pretoria, 1940
- VAN WARMELLO, 1971 N. J. van Warmelo, 'Courts and Court Speech in Venda', *African Studies*, 30 (3), 1971, pp. 355–70
- VANDENHOUTE, 1948 P. Vandenhoute, *Classification stylistique du masque Dan et du masque Guéré de la Côte d'Ivoire*, A. O. F., Medelingen van het Rijksmuseum voor Volkenkunde, Leiden, no. 4, 1948
- VANDERSLEYEN, 1975 C. Vandersleyen, ed, *Das alte Ägypten: Propyläen Kunsts geschichte*, xv, Berlin, 1975, pl. 1302
- VANDIER, 1952 J. Vandier, *Manuel d'archéologie égyptienne*, i: *Les épôques de formation: Les trois premières dynasties*, Paris, 1952
- VANDIER, 1958 J. Vandier, *Manuel d'archéologie égyptienne*, iii: *Les grandes époques: La statuaire*, Paris, 1958
- VANLATHEM, 1983 M.-P. Vanlathem, *Cercueils et momies de l'Egypte Ancienne*, Brussels, 1983
- VANSINA, 1955 J. Vansina, 'Initiation Rituals of the Bushong', *Africa*, 25, pp. 138–55
- VANSINA, 1964 J. Vansina, 'Les noms personnels et structure sociale chez les Tyo (Téké)', *BSARSOM*, 4, 1964, pp. 794–804
- VANSINA, 1966 J. Vansina, *Introduction à l'ethnographie du Congo*, Kinshasa, 1966
- VANSINA, 1968 'Kuba Art in its Cultural Contexts', *African Forum*, 3, 4, pp. 12–27
- VANSINA, 1973 J. Vansina, *The Tio Kingdom of the Middle Congo, 1880–1892*, London, 1973
- VANSINA, 1978 J. Vansina, *The Children of Woot, A History of the Kuba Peoples*, Madison, 1978
- VANSINA, 1984 J. Vansina, *Art History in Africa*, Harlow, 1984
- VANSINA, 1990 J. Vansina, *Paths in the Rainforest*, Madison, 1990
- VASSILIKI, 1995 E. Vassilika, *Egyptian Art*, Cambridge, 1995
- VENICE 1988 *The Phoenicians*, exh. cat. ed. S. Moscati, Palazzo Grassi, Venice; Milan, 1988
- VENICE 1993–4 *Eredità dell'Islam: Arte Islamica in Italia*, exh. cat. ed. G. Curatola, Doge's Palace, Venice, 1993–4; Milan, 1993
- VERGER-FÈVRE, 1980 M. N. Verger-Fèvre, *Masques faciales de l'ouest de la Côte d'Ivoire dans les collections publiques françaises*, ii, Mémoire École du Louvre, Paris, 1980
- VERGER-FÈVRE, 1989 M. N. Verger-Fèvre, 'Dan', in *Corps sculptés, corps parés, corps masqués*, ed. E. Féau and Y. Savané, Paris, 1989
- VERGER-FÈVRE, 1995 M. N. Verger-Fèvre, letter to M. J. Adams, 25 April 1995
- VERGIAT, 1936 A. M. Vergiat, *Les rites secrets des primitifs de l'Oubangui*, Paris, 1936
- VEVEY 1969 *Die Kunst der Elfenbeinküste*, exh. cat., Musée des Beaux-Arts, Vevey, 1969
- VIAL, 1980 G. Vial, *Ceintures marocaines du 16ème au 19ème siècle*, exh. cat., Bern Riggisberg, 1980
- VIENNA et al. 1961 *5000 Jahre Ägyptische Kunst*, exh. cat. ed. Egon Komorzyński et al., Kunsthistorisches Museum, Vienna, 1961
- VIENNA 1992 *Gott Mensch Pharaon: Viertausend Jahre Menschenbild in der Skulptur des alten Ägypten*, exh. cat. by W. Seipel et al., Kunsthistorisches Museum, Vienna, 1992

- VIENNA 1994 *Pharaonen und Fremde: Dynastien im Dunkel*, exh. cat. by S. Quirke, Historisches Museum, Vienna, 1994
- VIENNA MUSEUM GUIDE, 1988
see Kunsthistorisches Museum, 1988
- VINNICOMBE, 1976 P. Vinnicombe, *People of the Eland: Rock Paintings of the Drakensberg Bushmen as a Reflection of their Life and Thought*, Pietermaritzburg, 1976
- VINSON, 1994 S. Vinson, *Egyptian Boats and Ships*, Princes Risborough, 1994
- VISONA, 1983 M. Visona, *Art and Authority among the Ayke of the Ivory Coast*, diss., University of California, Santa Barbara, 1983
- VOGEL, 1920 S. Vogel, *Soieries marocaines*, Paris, 1920
- VOGEL, 1977 S. Vogel, *Baule Art as the Expression of a World View*, Ann Arbor, 1977
- VOGEL, 1980¹ S. Vogel, *Beauty in the Eyes of the Baule*, Philadelphia, 1980
- VOGEL, 1980² S. Vogel, 'The Buli Master and Other Hands', *Art in America*, 68 (5), 1980, pp. 153–42
- VOGEL, 1981 S. Vogel, ed., *For Spirits and Kings: African Art from the Paul and Ruth Tishman Collection*, New York, 1981
- VOGEL, 1983 S. Vogel, 'Rapacious Birds and Severed Heads: Early Bronze Rings from Nigeria', *Art Institute of Chicago Centennial Lectures: Museum Studies* 10, Chicago, 1983, pp. 330–57
- VOGEL, 1985 S. Vogel, *African Aesthetics: The Carlo Monzino Collection*, Milan, 1985
- VOGEL, 1988 S. Vogel, ed., *ART/artifact*, Munich, 1988
- VOGEL, 1993 S. Vogel, 'Door', in *Art of Côte d'Ivoire*, ii, Geneva, 1993
- VOGEL and N'DIAYE, 1985 S. Vogel and F. N'Diaye, *African Masterpieces from the Musée de l'Homme*, exh. cat., Center for African Art, New York, 1985
- VOLMAN, 1984 T. P. Volman, 'Early Prehistory of Southern Africa', in *Southern African Prehistory and Palaeoenvironments*, ed. R. G. Klein, Rotterdam, 1984
- VON BEZING and INSKEEP, 1966 K. L. von Bezing and R. R. Inskeep, 'Modelled Terracotta Heads from Lydenburg, South Africa', *Man*, 1 (1), 1966, p. 102
- VON BISSING, 1900 F. W. von Bissing, *Ein Thebanischer Grabfund aus dem Anfang des Neuen Reichs*, Berlin, 1990
- VOSSEN and EBERT, 1986 R. Vossen and W. Ebert, *Marokkanische Töpferei*, Bonn 1986
- WADA, 1984 S. Wada, 'Female Initiation Rites of the Iraqw and the Gorowa', *Senri Ethnological Studies*, no. 15 (Africa 3), 1984, pp. 187–96
- WALKER, 1994 R. A. Walker, 'Anonymous Has a Name: Olowe of Ise', in *The Yoruba Artist*, ed. R. Abiodun, H. J. Drewal and J. Pemberton III, Washington and London, 1994
- WALTON, 1954 J. Walton, 'Carved Wooden Doors of the Bavenda', *Man*, 54, 1954, pp. 43–6
- WALTON, 1975 J. Walton, 'Art and Magic in the Southern African Vernacular Architecture', in P. Oliver, *Shelter, Sign and Symbol*, London, 1975, pp. 117–34
- WANLESS, 1987 A. Wanless, 'Headrests in the Africana Museum. Part 5', *Africana Notes and News*, 27 (5), 1987, p. 203
- WANLESS, 1991 A. Wanless, 'Public Pleasures: Smoking and Snuff-taking in Southern Africa', in *Art and Ambiguity: Perspectives on the Brethurst Collection*, exh. cat. by P. Davison et al., Johannesburg Art Gallery, Johannesburg, 1991, pp. 125–45
- WARD, 1995 R. Ward, *Islamic Metalwork*, London, 1995
- WASHINGTON 1980 *From the Far West: Carpets and Textiles of Morocco*, exh. cat., Textile Museum, Washington, 1980
- WASHINGTON 1981¹ *The Four Moments of the Sun: Kongo Art in Two Worlds*, exh. cat. by R. F. Thompson and J. Cornet, National Gallery of Art, Washington, 1981
- WASHINGTON 1981² *Renaissance of Islam: Art of the Mamluks*, exh. cat. by E. Attil, Washington, 1981
- WASHINGTON 1984 *African Mankala*, exh. brochure by R. A. Walker, National Museum of African Art, Smithsonian Institution, Washington, 1984
- WASHINGTON 1987 *African Art in the Cycle of Life*, exh. cat. by R. Sieber and R. A. Walker, National Museum of African Art, Smithsonian Institution, Washington, 1987
- WASHINGTON 1989 *Icons: Ideals and Power in the Art of Africa*, exh. cat. by H. M. Cole, National Museum of African Art, Washington, 1989
- WASHINGTON 1991¹ *Exploring African Art, The Art of the Personal Object*, exh. cat. by P. Ravenhill, National Museum of African Art, Smithsonian Institution, Washington, 1991
- WASHINGTON 1991² *The Art of the Personal Object*, exh. cat. by P. Ravenhill, National Museum of African Art, Washington, 1991
- WASHINGTON 1991⁵ *Circa 1492: Art in the Age of Explorations*, exh. cat. ed. J. A. Levenson, National Gallery of Art, Washington, 1991
- WASHINGTON 1993 *Astonishment and Power*, exh. cat. by W. MacGaffey and M. D. Harris, National Museum of African Art, Washington, 1993
- WASSING, 1968 R. Wassing, *African Art: Its Background and Traditions*, New York, 1968
- WAYLAND, 1930 E. J. Wayland, *Annual Report of the Uganda Geological Survey*, Entebbe, 1930
- WAYLAND, BURKITT and BRAUNHOLZ, 1933 E. J. Wayland, M. C. Burkitt and H. J. Braunholz, 'Archaeological Discoveries at Luzira', *Man*, 33, 1933, pp. 25–9
- WEBB and WRIGHT, 1976 C. de B. Webb and J. Wright, eds, *The James Stuart Archive*, i, Pietermaritzburg, 1976
- WEIL, 1973 P. M. Weil, 'The Chono: Symbol and Process in Authority Distribution in Mandinka Political Entities of Senegambia', unpublished paper, 1973
- WEIL, 1981 P. M. Weil, personal communication, 1981
- WEMBAH-RASHID, 1971 J. A. R. Wembah-Rashid, 'Isinyago and Midimu: Masked Dancers of Tanzania and Mozambique', *African Arts*, 4 (2), 1971, pp. 38–44
- WEMBAH-RASHID, 1974 J. A. R. Wembah-Rashid, ed., *Introducing Tanzania through the National Museum*, Dar es Salaam, 1974
- WEMBAH-RASHID, 1989 J. A. R. Wembah-Rashid, personal communication, Nairobi, 1989
- WENDT, 1974 W. E. Wendt, 'Art mobilier' aus der Apollo 11 Grotte in Südwest-Afrika, die ältesten datierten Kunstwerke Afrikas', *Acta Praehistorica et Archaeologica*, 5 (1), 1974, pp. 1–42
- WENIG, 1978 S. Wenig, *Africa in Antiquity: The Arts of Ancient Nubia and the Sudan*, Brooklyn, 1978
- WERBROUCK, 1932 M. Werbrouck, 'Ostraca à figures', *Bulletin des Musées Royaux d'Art et d'Histoire*, 4, 1932, pp. 106–9
- WERBROUCK, 1953 M. Werbrouck, 'Ostraca à figures', *Bulletin des Musées Royaux d'Art et d'Histoire*, 25, 1953, pp. 93–111
- WERE and WILSON, 1968 G. Were and D. A. Wilson, *East Africa through a Thousand Years: A History of the Years A.D. 1000 to the Present Day*, London, 1968
- WERNER, 1906 A. Werner, *The Natives of British Central Africa*, London, 1906
- WEST LAFAYETTE 1974 *Interactions: The Art Styles of the Benue River Valley and East Nigeria*, exh. cat. by R. Sieber and T. Vevers, Creative Arts Department, Purdue University, West Lafayette, 1974
- WESTERDIJK, 1988 P. Westerdijk, *The African Throwing Knife*, Utrecht, 1988
- WESTERMANN, 1912 D. Westermann, *The Shilluk People and their Language and Folklore*, Philadelphia, 1912
- WEULE, 1909 K. Weule, *Native Life in East Africa*, trans. A. Werner, London, 1909
- WHITEHOUSE, 1987 H. Whitehouse, 'A Statuette of Ptah the Creator, "Beautiful of Face"', *The Ashmolean*, 12, Summer–Autumn 1987, pp. 6–8
- WHITTLE, 1985 A. Whittle, *Neolithic Europe: A Survey*, Cambridge, 1985
- WIET, 1929 G. Wiet, *Catalogue général du Musée Arabe du Caire: Lampes et bouteilles en verre émaillé*, Cairo, 1929
- WIET, 1930 G. Wiet, *Album du Musée Arabe du Caire*, Cairo, 1930
- WIET, 1932 G. Wiet, *Catalogue général du Musée Arabe du Caire: Objets en cuivre*, Cairo, 1932
- WILCOX, 1992 R. Wilcox, 'Elephants, Ivory and Art: Duala Objects of Persuasion', in *Elephant: The Animal and its Ivory in African Culture*, ed. D. Ross, Los Angeles, 1992
- WILKINSON, 1943 C. K. Wilkinson, 'Chessmen and Chess', *Bulletin of the Metropolitan Museum of Art* N. S. I, 1943, pp. 271–9
- WILKINSON, 1971 A. Wilkinson, *Ancient Egyptian Jewellery*, London, 1971
- WILLETT, 1967 F. Willett, *Ifé in the History of West African Sculpture*, London, 1967
- WILLETT, 1971¹ F. Willett, *African Art*, London, 1971
- WILLETT, 1971² F. Willett, *African Art. An introduction*, Thames & Hudson, London, 1971
- WILLETT, 1984 F. Willett, 'A Missing Millennium? From Nok to Ife and beyond', in *Arte in Africa*, ed. E. Bassani, Florence, 1984
- WILLETT, 1994 F. Willett, *African Art*, 2nd edn., London, 1994
- WILLETT and FLEMING, 1976 F. Willett and S. Fleming, 'Catalogue of some important Nigerian copper-alloy castings dated by thermoluminescence', *Archaeometry*, 18 (2), pp. 155–46
- WILLIAMS, 1964 D. Williams, 'The Iconology of the Yoruba Edan Ogbon', *Africa*, 34 (2), 1964, pp. 139–65
- WILLIAMS, 1974 D. Williams, *Icon and Image: A Study of Sacred and Secular Forms in African Classical Art*, New York, 1974
- WILLIAMS, 1988¹ B. Williams, *Decorated Pottery and the Art of Nagada III*, Münchner Ägyptologische Studien 45, Munich, 1988
- WILLIAMS, 1988² B. Williams, 'Narmer and the Coptos Colossi', *Journal of the American Research Centre in Egypt*, 25, 1988, pp. 55–59
- WILLIAMSON, 1983 L. Williamson, 'Ethnological Specimens in the Pitt Rivers Museum attributed to the Tradescant Collection', in *Tradescant's Rarities: Essays on the Foundation of the Ashmolean Museum 1683 with a Catalogue of the Surviving Early Collections*, ed. A. MacGregor, Oxford, 1983, pp. 338–45
- WILLIS, 1966 R. Willis, *The Fipa and Related Peoples of South-West Tanzania and North-East Zambia*, London, 1966
- WILLOUGHBY and STANTON, 1988 K. L. Willoughby and E. B. Stanton, eds, *The First Egyptian*, Columbia, SC, 1988
- WILMAN, 1935 M. Wilman, *The Rock Engravings of Griqualand West and Bechuanaland, South Africa*, Cambridge, 1935
- WILSON, VAN RIJSSEN and GERNEKE, 1990 M. L. Wilson, W. R. R. Van Rijssen and D. A. Gerneke, 'An Investigation of the "Coldstream Stone"', *Annals of the South African Museum*, 99, 1990, pp. 187–215
- WITT, 1991 J. Witt, 'Spoons in Southeast Africa', in *Spoons in African Art. Cooking – Sewing – Eating: Emblems of Abundance*, exh. cat., Zurich, 1991, pp. 87–103
- WITTE, 1988 H. A. Witte, *Earth and the Ancestors: Ogboni Iconography*, Amsterdam, 1988
- WITTMER, 1978 M. K. Wittmer, *Three Rivers of Nigeria: Art of the Lower Niger, Cross and Benue; from the collection of William and Robert Arnott*, Atlanta, 1978
- WOLF, 1957 W. Wolf, *Die Kunst Aegyptens: Gestalt und Geschichte*, Stuttgart, 1957
- WOLFE, 1955 A. W. Wolfe, 'Art and the Supernatural in the Ubangi district' *Man*, 55 (76) 1955, pp. 65–7
- WOLFE, PARKIN and SIEBER, 1981 E. Wolfe, D. Parkin and R. Sieber, *Vigango: The Commemorative Sculpture of the Mijikenda of Kenya*, Bloomington, 1981

- WOLFERT, 1989 P. Wolfert, *Good Food from Morocco*, London, 1989
- WOODS, 1974 W. Woods, 'A Reconstruction of the Triads of King Mycerinus', *JEA*, 60, 1974, pp. 82–93
- WOOLLEY and RANDALL-MACIVER, 1910 C. L. Woolley and D. Randall-MacIver, *Karanog: The Romano-Nubian Cemetery*, iii, iv, Philadelphia, 1910
- YACOUB, 1970 M. Yacoub, *Le Musée du Bardo: musée antique*, Tunis, 1970
- ZAHAN, 1960 D. Zahan, *Sociétés d'initiation Bambara: le N'domo, le Koré*, Paris, 1960
- ZAHAN, 1980 D. Zahan, *Antilopes du soleil: arts et rites agraires d'Afrique noire*, Vienna, 1980
- ZAHAN, 1981 D. Zahan, 'Antelope Headdress Female (Chi Wara)', in *For Spirits and Kings: African Art from the Tishman Collection*, ed. S. Vogel, New York, 1981
- ZAHAN, 1988 D. Zahan, 'The Boat of the World as a Pendant', *African Arts*, 21 (4), 1988, pp. 56–7
- ZAKI, 1956 M. H. Zaki, *Atlas al-funun al-zukhrifiya wa'l tasawir al-islamiya*, Cairo, 1956
- ZANGRIE, 1947–50 Zangrie, 'Les institutions, la religion et l'art des Ba Buye; Groupes Ba Sumba du Ma Nyema (Congo Belge)', *Ethnographie*, 45, 1947–50, pp. 54–80
- ZECH, 1904 G. Zech, 'Land und Leute an der Nordwestgrenze von Togo', *Mitteilungen von Forschungsreisenden und Gelehrten aus den deutschen Schutzgebieten*, 17, 1904, pp. 107–35
- ZEITLYN, 1994 D. Zeitlyn, 'Mambila Figurines and Masquerades', *African Arts*, 27 (4), 1994, pp. 38–47
- ZETTERSTROM, 1976 K. Zetterstrom, *The Yamein Mano of Northern Liberia*, Uppsala University Occasional Papers, vi, Uppsala, 1976
- ZETTERSTROM, 1980 K. Zetterstrom, 'Poro of the Yamein Mano, Liberia', in *Ethnologische Zeitschrift Zürich*, i, ed. M. J. Adams, 1980, pp. 41–59
- ZIRNGIBL, 1983 M. Zirngibl, *Rare African Short Weapons*, Grafenau, 1983
- ZURICH 1961 see Vienna 1961
- ZURICH 1963 *African Sculpture*, exh. cat. by E. Leuzinger, Museum Rietberg, Zurich, 1963
- ZURICH 1991 *Spoons in African Art. Cooking – Serving – Eating: Emblems of Abundance*, exh. cat. ed. L. Homberger, Museum Rietberg, Zurich, 1991
- ZUURMOND, 1989 R. Zuurmond, *Novum Testamentum Aethiopicum: The Synoptic Gospels*, Stuttgart, 1989
- ZWERNEMANN, 1967 J. Zwernemann, 'Remarques sur des statuettes des Gurma au Nord du Togo', *Notes africaines*, 116, 1967, p. 118
- ZWERNEMANN and LOHSE, 1985 J. Zwernemann and W. Lohse, *Aus Afrika: Ahnen – Geister – Götter*, Hamburg, 1985

LENDERS TO THE EXHIBITION

ALGERIA	Fred Jahn Gallery Fritz Koenig Collection Dr Klaus-Jochen Krüger Museum für Völkerkunde, Leipzig Estate of Dr Bernd Mittelsten-Scheid Staatliches Museum für Völkerkunde, Munich Staatliche Sammlung Ägyptischer Kunst, Munich Linden-Museum, Stuttgart Württembergisches Landesmuseum, Stuttgart Dr E. Wachendorff Collection	University of the Witwatersrand, Johannesburg McGregor Museum, Kimberley Karel Nel Paarl Museum, Paarl Natal Museum, Pietermaritzburg The National Cultural History Museum, Pretoria	Horniman Public Museum and Public Park Trust, London Petrie Museum of Egyptian Archaeology, University College, London The Science Museum (by courtesy of the Board of Trustees), London The Board of Trustees of The Victoria and Albert Museum, London Lords of the Admiralty Jonathan Lowen Collection Manchester City Art Galleries Manchester Museum, University of Manchester The Visitors of The Ashmolean Museum, Oxford Pitt Rivers Museum, Oxford Yvette Wiener Patricia Withofs Collection
AUSTRALIA	Dr Laurence R. Goldman, Brisbane	SUDAN	Sudan National Museum, Khartoum
AUSTRIA	Kunsthistorisches Museum, Vienna Museum für Völkerkunde, Vienna Austrian Museum of Applied Arts, Vienna	SWITZERLAND	Musée Barbier-Mueller, Geneva Museum für Völkerkunde, Basle Beyeler Collection, Basle W. and U. Horstmann Collection The Carlo Monzino Collection George Ortiz Collection Museum Rietberg, Zurich
BELGIUM	Museum of Ethnography, Antwerp Musées Royaux d'Art et d'Histoire, Brussels Felix Collection Pierre Loos Collection J. W. and M. Mestach De Meulder Collection Royal Museum for Central Africa, Tervuren Lucien van de Velde, Antwerp	ITALY	L. Lanfranchi Collection, Milan Vittorio Mangiò Museo Preistorico Etnografico 'L. Pigorini', Rome Tesoro della Basilica di San Marco, Venice
BOTSWANA	National Museum, Monuments and Art Gallery, Gaborone	IVORY COAST	Musée National de la Côte d'Ivoire, Abidjan
EGYPT	Museum of Coptic Art, Cairo Museum of Egyptian Antiquities, Cairo Museum of Islamic Art, Cairo Museum of Ancient Egyptian Art, Luxor	KUWAIT	The al-Sabah Collection, Dar al-Athar al-Islamiyyah
FRANCE	Musée Guimet, Lyons Musée des Arts Africains, Océaniques et Amérindiens Vieille Charité, Marseilles Musée Dapper, Paris Musée de l'Homme, Paris Musée du Louvre, Paris Musée National des Arts d'Afrique et d'Océanie, Paris	MOROCCO	Bert Flint Musée Dar al-Batha, Fez Musée Dar Si Said, Marrakesh Musée Majorelle d'Art Islamique, Marrakesh Musée d'Archéologie, Rabat
GERMANY	Bareiss Family Collection Staatliche Museen zu Berlin, Preussischer Kulturbesitz, Ägyptisches Museum und Papyrussammlung Staatliche Museen zu Berlin, Preussischer Kulturbesitz, Charlottenberg Museum Staatliche Museen zu Berlin, Preussischer Kulturbesitz, Museum für Spätantike und Byzantinische Kunst Staatliche Museen zu Berlin, Preussischer Kulturbesitz, Museum für Völkerkunde Galerie Michael Werner, Cologne and New York Museum für Völkerkunde, Frankfurt am Main Museum für Völkerkunde, Hamburg Pelizaeus Museum, Hildesheim	NAMIBIA	State Museum of Namibia, Windhoek
PORUGAL	Department of Archaeology and Anthropology, University of Ibadan The National Commission for Museums and Monuments	NIGERIA	The Provost and Fellows of Eton College, The Myers Museum Egee Art, London Royal Albert Memorial Museum and Art Gallery, Exeter City Museums Her Majesty The Queen Herman Collection Mimi Lipton The Board of Trustees of the National Museums and Galleries on Merseyside (Liverpool Museum) The British Library, Oriental and India Office Collections The Trustees of the British Museum, London Commonwealth Institute, London
SOUTH AFRICA	Bowmint Collection Groote Schuur Collection, Cape Town South African Museum, Cape Town South African National Gallery, Cape Town East London Museum Local History Museum, Durban Johannesburg Art Gallery	TUNISIA	Musée de Carthage Musée National du Bardo, Le Bardo
		UNITED KINGDOM	Peter Adler Collection Ian Auld Collection The Berggruen Collection, London Powell-Cotton Museum, Birchington The Syndics of the Fitzwilliam Museum, Cambridge Cambridge University Museum of Archaeology and Anthropology Kevin and Anna Conru Trustees of the National Museums of Scotland, Edinburgh The Provost and Fellows of Eton College, The Myers Museum Egee Art, London Royal Albert Memorial Museum and Art Gallery, Exeter City Museums Her Majesty The Queen Herman Collection Mimi Lipton The Board of Trustees of the National Museums and Galleries on Merseyside (Liverpool Museum) The British Library, Oriental and India Office Collections The Trustees of the British Museum, London Commonwealth Institute, London
		ZIMBABWE	Queen Victoria Museum, Harare
			and other lenders who wish to remain anonymous

PHOTOGRAPHIC CREDITS

All works of art are reproduced by kind permission of the owners. Specific acknowledgements are as follows:

Maurice Aeschimann, Geneva, cat. 5.96
 Dick Beaulieux, Brussels, cat. 2.54
 Gérard Bonnet, Marseilles, cat. 6.34
 Margarete Büsing, cat. 1.5, 69
 Margaret Carey, fig. 2, p. 118
 Mario Carrieri, Milan, cat. 2.33, 55
 © Dirk Bakker, cat. 5.45a, 46–7, 61–5, 69; 6.46–8
 © Museum für Völkerkunde, Basle, cat. 7.7a–b, photos by Peter Horner
 © 1995 Museum of Fine Arts, Boston. All rights reserved. Cat. 1.8, 25, 46–7, 67, 81–2
 © Illustrative Options, Botswana. All rights reserved. Cat. 5.48
 © of the Fitzwilliam Museum, University of Cambridge, cat. 1.17, 49, 58, 76, 85
 © S. A. Cultural History Museum, Cape Town, cat. 3.12, photo by Cecil Kortje
 Professor M. H. Day, fig. 11, p. 18
 © Kathrin Doeppner, cat. 7.5, 88
 © The Detroit Institute of Arts, 1995, cat. 4.35; 5.102
 Z. R. Dmochowski, fig. 2, p. 335
 © Trustees of the National Museums of Scotland, Edinburgh, cat. 5.29, 55, 116
 William Fagg, fig. 1, p. 327, fig. 5, p. 334, fig. 6, p. 340
 © P. A. Ferrazzini, Musée Barbier-Mueller, Geneva, cat. 5.133e
 © Rheinländer, Hamburg, cat. 2.63; 4.24–5, 29b, 33, 52
 © President & Fellows of Harvard College 1990. All Rights Reserved. Photos by Hillel Burger, cat. 4.49, 94a–b
 © Hickey & Robertson, (Houston), cat. 5.28, (Texas), cat. 6.25
 © Alan Keohane/Impact, London, cat. 7.2a, 35a, 37b–c
 © National Museum of Ethnology, Leiden, photo by Ben Grishaaver, cat. 4.15
 © Museum für Völkerkunde, Leipzig, cat. 5.38, 120, 7.32, photos by Heini Schneebeli
 © The British Museum, London, cat. 5.58b
 © The British Museum, London, cat. 1.1, 3, 7, 12a–b, 18, 35–6, 50–1, 53, 63, 71a–b, 77–9, 83; 2.4, 13–14, 18c, 21, 24b, 34, 43, 44b–c, 58c, 62; 3.9e, 17, 20a, 20c, 24a–b, 40b; 4.7a, 14, 20–1, 41, 46, 48a–b, 53–5, 60, 63–4, 70a–b, 71b; 5.25a, 36, 45b, 53–4, 58a, 60b–e, 60j–l, 60n–o, 66, 76, 79–81, 85, 91a, 94, 101a–b, 119, 128v–w, 133a–c, 135f; 6.18c; 7.44–5, 48–9, 51, 56, 60, 62a–b; fig. 13, p. 20, photos by Heini Schneebeli
 © Science Museum, London, cat. 5.2, 71a, 77a, 141, photos by Heini Schneebeli
 © Manchester City Art Galleries, cat. 7.54, photo by Peter Burton

© Manchester Museum, cat. 2.15a–b, 23
 © Staatliches Museum für Völkerkunde, Munich, cat. 4.39a–g, 67a; 5.11a–b, photos by Swantje Autrum-Mulzer
 © 1994 Christie's, New York, cat. 4.91b
 © 1995 The Metropolitan Museum of Art, New York, cat. 1.31, 48; 4.44; 6.5a, 13, 21
 © 1992 Dr Gerald Newlands, Alberta, Canada, fig. 1, p. 11
 © 1995 Pitt Rivers Museum, Oxford, cat. 3.9a; 4.47; 5.133g, photos by Heini Schneebeli
 © Musée de l'Homme, Paris, cat. 4.26, 85; 5.91d; 6.1a–b, 27, 58–9, 60b; 7.3–4, 6b
 © Musée de l'Homme, Paris, cat. 6.7, photo by D. Destable & C. Lemzaouda
 © Musée de l'Homme, Paris, cat. 5.12, 138, photos by B. Hatala
 © Musée de l'Homme, Paris, cat. 4.87, photo by C. Lemzaouda
 © Musée de l'Homme, Paris, cat. 4.96b; 5.135d, photos by D. Ponsard
 © R. M. N., Paris, cat. 7.18, 24
 © R. M. N., Paris, cat. 7.36, photo by A. Chuzeville
 © R. M. N., Paris, cat. 7.23, photo by J. Cuenot
 © R. M. N., Paris, cat. 7.22, 26, 57a, 57d, photos by A. Emont
 © R. M. N., Paris, cat. 7.27a–b, photos by Heini Schneebeli
 © R. M. N., Paris, cat. 5.8, 17, photos by H. Lewandowski
 © R. M. N., Paris, cat. 5.15–16, 18, photos by N. Mathéus
 © Museum of Ethnology, Rotterdam, cat. 5.137
 © 1995 John Bigelow Taylor, N.Y.C., cat. 1.14; 2.64; 3.41a; 4.59, 71f, 91a, 93; 5.5, 25, 31, 34b, 50b, 115, 128i, 142; 6.12, 16, 18a, 57, 96
 Claudio Elia, Rome, cat. 4.7b; 5.132
 Angela Fisher, fig. 1, p. 117
 Lynton Gardiner, cat. 2.24; 6.20
 Jean-François Gout, cat. 1.72–3, 75
 Gilbert Graham, Florida, cat. 2.11; 4.39o–p; 5.123, 128b, 128h, 128j, 128o
 Karlheinz Grünke, Hamburg, cat. 4.72
 George Hart, fig. 1, p. 41, fig. 2, p. 42
 Mike Harvey Photography, cat. 3.47
 Ferry Herrebrugh, cat. 5.51
 Pelizaeus Museum, Hildesheim, cat. 1.64
 George Hixon, Houston, cat. 6.60c
 Barry Iverson, cat. 1.28–30, 32–5, 34a–b, 41, 45, 87, 89; 7.38a–b, 39, 40a–b, 41–3, 47, 52, 57–9, 61, 64–5
 Bernd-Peter Keiser, Braunschweig, cat. 2.12b, 26a–d, 48; 4.18–19
 Timothy Kendall, fig. 6, p. 50
 Franko Khoury, cat. 2.9a–b; 3.29b; 5.89, 112
 Jürgen Liepe, cat. 1.2, 59, 80, 88
 By permission of The British Library, London, cat. 2.2; 7.55
 Green and Russell, London, cat. 2.46; 5.42c; 4.95
 Courtesy of the Board of Trustees of the Victoria and Albert Museum, London, cat. 2.6; 7.55, 67; fig. 10, p. 17
 John Mack, fig. 4, p. 123
 Angelo Mariazzi, Milan, cat. 5.134a
 H. O. Mönnig, fig. 1, p. 179
 George Meister, Munich, cat. 2.25, 38–9, 51, 53, 58, 61; 5.39a–c; 2.2, 57, 65; 5.99b–c; 6.42
 Courtesy Dept. of Library Services, American Museum of Natural History, New York, cat. 4.80–1, photos by Lynton Gardiner
 Objectif 31, Nyon, cat. 1.39
 Bernard O'Kane, fig. 3, p. 541, fig. 4, p. 542
 University of Pennsylvania Museum, Philadelphia, cat. 1.24, 86; 2.50a; 7.63
 John Picton, fig. 7, p. 342
 Marc Laurent Rivière, cat. 4.30b
 Heini Schneebeli, London, cat. 1.4, 9–11, 15, 16a–b, 19, 20a–c, 21–3, 37, 40, 45–4, 52, 54a–b, 55–6, 61–2, 66; 2.7a–b, 8a–b, 10a–b, 12a, 12c, 16a–b, 17a–b, 18a–b, 19–20, 22a–b, 24, 27–9, 31a–b, 35–7, 40–1, 44a, 47, 49–50, 52, 56–7, 58d, 59–60, 65–7; 5.9f–g, 16b, 21a–c, 22a–e, 24d, 27b–g, 28, 29a, 30a–b, 30f, 31c, 32a, 34, 36a–d, 37, 41b, 42a–b, 43–4, 46; 4.1, 3–6, 8–11, 15a, 17a–c, 22–3, 27–8, 29a, 29c, 30a, 31b, 32, 34, 37–8, 39, 40, 42–3, 50, 56, 58, 61a–b, 66a–d, 66g, 67b, 68–9, 71c–e, 73, 74a, 75–7, 79, 84, 86a–b, 88–9, 90a–b, 96a; 5.4, 6–7, 10, 19–20, 24, 32a–b, 35, 34a, 37a–c, 39–42, 44, 48, 51–2, 56, 59, 60f–i, 60m, 60g, 74–5, 77b, 78a, 85a–c, 84, 86–8, 91b–c, 92, 98, 99a, 99d, 100, 105–10, 113–14, 117–18, 122a–c, 125–7, 128c, 128f–g, 128k–n, 128r–t, 129–30, 135e, 135–6, 139; 6.2a–f, 3, 4e, 4h–k, 5b, 6, 8, 9a, 10a–b, 14, 18b, 18d, 19, 24, 29a–b, 30, 31b, 35, 35a–f, 36–41, 46l, 49, 51, 53–4, 56, 60a; 7.1d, 2b, 28, 34, 35b; figs 2–3, p. 12, fig. 4, p. 15, figs 6–8, p. 15
 Lothar Schnept, Cologne, cat. 5.21
 Paolo Vandrasch, Milan, cat. 4.62
 Atelier Frankenstein, Vienna, cat. 7.66
 Derek Welsby, fig. 4, p. 48
 Kenji Yoshida, fig. 3, p. 122
 National Archives, Zimbabwe, photo by Mrs Bent, fig. 1, p. 31

FRIENDS OF THE ROYAL ACADEMY

Sponsors

Mrs Denise Adeane
Mr M. R. Anderson
Mr P.F.J. Bennett
Mrs D. Berger
Mr David Berman
Mrs J. Brice
Mr Jeremy Brown
Mrs Susan Burns
Mrs L. Cantor
The Carroll Foundation
Mr Christopher Cates
Mrs Elizabeth Corob
Mr and Mrs S. Fein
Mr M. J. Fitzgerald (Occidental International Oil Inc.)
Mr and Mrs R. Gapper
Mr and Mrs Robert Gavron
Mr and Mrs Michael Godbee
Lady Gosling
Mr Peter G. Goulandris
Lady Grant
Mr Harold Joels
Mrs G. Jungels-Winkler
Mr J. Kirkman
Dr Abraham Marcus
Mrs Catherine Martineau
The Oakmoor Trust
Ocean Group p.l.c. (PH. Holt Trust)
Mr Godfrey Pilkington (Piccadilly Gallery)
The Worshipful Company of Saddlers
Mr and Mrs David Shalit
The Stanley Foundation
Mrs Paula Swift
Mr Robin Symes
Mrs Edna S. Weiss
Sir Brian Wolfson

Associate Sponsors

Mr Richard B. Allan
Mrs Meg Allen
Mr Richard Alston
Mr Ian F.C. Anstruther
Mrs Ann Appelbe
Mr John R. Asprey
Lady Attenborough
Mr J.M. Bartos
Mr N.S. Bergel
Mrs J. L. Berger
Mrs Susan Besser
Mrs Linda Blackstone
Mrs C.W.T. Blackwell
Mr Peter Boizot
C.T. Bowring (Charities Trust) Ltd
Mrs J.M. Bracegirdle
Mr Cornelius Broere
Lady Brown
Mr P.J. Brown Jr
Mr T. M. Bullman
Mrs A. Cadbury
Mr and Mrs P.H.G. Cadbury
Mr and Mrs R. Cadbury
Mrs C.A. Cain
Miss E.M. Cassin
Mr R.A. Cernis
Mr. S. Chapman
Mr W.J. Chapman
Mr. M. Chowen
Mrs J.V. Clarke
Mr John Cleese
Mrs D. Cohen
Mrs R. Cohen
Mr C. Cotton
Mrs Saeda H. Dalloul
Mr and Mrs D. de Laszlo
Mr John Denham
Mr Richard Dobson
The Marquess of Douro
Mr D.P. Duncan
Mrs J. Edwards
Mr Kenneth Edwards
Mrs K.W. Feesey MSc
Mr J.G. Fogel
Mr Graham Gauld
Mr Stephen A. Geiger
Mrs P. Goldsmith
Mr Gavin Graham
Mrs O. Grogan

Mr J.A. Hadjipateras
Mr B. R. H. Hall
Mr and Mrs D. Hallam-Peel
Mr and Mrs Richard Harris
Miss Julia Hazandras
Mr Malcolm Herring
Mrs P. Heseltine
Mrs K. S. Hill
Mr R.J. Hoare
Mr Reginald Hoe
Mr Charles Howard
Mrs A. Howitt
Mr Christopher Hull
Mr Norman J. Hyams
Mr David Hyman
Mrs Manya Igel
Mr C.J. Ingram
Mr S. Issern-Feliu
The Rt. Hon. The Countess of Iveagh
Mrs I. Jackson
Lady Jacobs
Mr and Mrs S.D. Kahn
Mr D.H. Killick
Mr P.W. Kininmonth
Mrs L. Kosta
Mrs E. Landau
Mr and Mrs M.J. Langer
Mrs J.H. Lavender
Mr Morris Leigh
Mr J. R. A. Leighton
Mr Owen Luder
Mrs G.M.S. McIntosh
Mr Peter I. McMean
The Hon. Simon Marks
Mr and Mrs V.J. Marmion
Mr B.P. Marsh
Mr and Mrs J.B.H. Martin
Mr R.C. Martin
Mr and Mrs G. Mathieson
Mr R. Matthews
Mr J. Menasakanian
Mr J. Moores
Mrs A. Morgan
Mrs A. Morrison
Mr A.H.J. Muir
Mr David H. Nelson
Mrs E.M. Oppenheim-Sanderson
Mr Brian R. Oury
Mrs J. Palmer
Mr J.H. Pattison
Mrs M.C.S. Philip

Mrs Anne Phillips
Mr Ralph Picken
Mr G.B. Pincus
Mr G.A. Pitt-Rivers
Mr W. Plapinger
Mrs J. Rich
Mr Clive and Mrs Sylvia Richards
Mr F.P. Robinson
Mr D. Rocklin
Mrs A. Rodman
Lady Rootes
Mr and Mrs O. Roux
The Hon. Sir Stephen Runciman CH
Sir Robert Sainsbury
Mr G. Salmanowitz
Mr Anthony Salz
Lady Samuel
Mrs Bernice Sandelson
Mrs Bernard L. Schwartz
Shell UK Ltd
Mr Mark Shelmerdine
Mr R.J. Simmons
Mr John H.M. Sims
Mrs M. C. Slawson
Mr and Mrs M.L. Slotover
Mr and Mrs R. Slotover
The Spencer Wills Trust
Mr J.A. Tackaberry
Mr N. Tarling
Mr G.C.A. Thom
Mr H.R. Towning
Mrs Andrew Trollope
Mr E. Victor
Mr A.J. Vines
Mrs C.H. Walton
Mr D.R. Walton Masters
Mr Neil Warren
Miss J. Waterous
Mrs J.M. Weingarten
Mrs C. Weldon
Mr Frank S. Wenstrom
Mrs I. Wolstenholme
Mr W.M. Wood
Mr R.M. Woodhouse
Mr and Mrs E.S. Worms

ROYAL ACADEMY TRUST

Benefactors

H.M. The Queen
Mr and Mrs Russell B. Aitken
American Airlines
The Annie Laurie Aitken Charitable Trust
American Associates of the Royal Academy Trust
American Express Company
Mrs John W. Anderson II
The Andor Family
The Hon. and Mrs Walter H. Annenberg
Mr Walter Archibald
Marilyn B. Arison
The Hon. Anne and Mr Tobin Armstrong
Asprey
AT & T
AT & T (UK) Ltd
The Bank of England
Barclays Bank plc
The Baring Foundation
B.A.T. Industries plc
Mr Tom Bendham
Benihana Group
Mr and Mrs James Benson
Mrs Brenda Benwell-Lejeune

In Memoriam: Ida Rose Biggs
Charlotte Bonham-Carter Charitable Trust
Denise and Francis Booth
Bowen of New York City
Mr Peter Bowring
British Gas plc
The British Petroleum Company plc
BP America
British Steel plc
Mr Keith Bromley
The Brown Foundation Inc.
BT
Bunzl plc
Iris and B. Gerald Cantor
The Rt. Hon. the Lord Carrington
The Trustees of the Clore Foundation
The John S. Cohen Foundation
The Cohen Family Charitable Trust
The Colby Trust
Commercial Union Assurance Company PLC
The Ernest Cook Trust
Mrs Jan Cowles
Crabtree & Evelyn
Credit Suisse First Boston
The Hon. and Mrs C. Douglas Dillon

Sir Harry and Lady Djanogly
In Memoriam: Miss W.A. Donner
The Dulverton Trust
Alfred Dunhill Limited
Miss Jayne Edwardes
The John Ellerman Foundation
English Heritage
Esso UK PLC
The Esme Fairbairn Charitable Trust
Lord and Lady Faringdon
Mr and Mrs Eugene V. Fife
Mr and Mrs Donald R. Findlay
Mr. D. Francis Finlay
Mr Walter Fitch III
Mrs Henry Ford II
The Henry Ford II Fund
The Late John Frye Bourne
The Garfield Weston Foundation
Gartmore plc
The Gatsby Foundation
The Getty Grant Program
The J. Paul Getty Jr Trust
The Lady Gibson
Glaxo Wellcome plc
Mrs Mary Graves

The Jack Goldhill Charitable Trust
Maurice and Laurence Goldman
The Horace W. Goldsmith Foundation
The Worshipful Company of Goldsmiths
The Gosling Foundation Ltd
The Greentree Foundation
Mr Lewis Grinnan Jr
The Worshipful Company of Grocers
The Worshipful Company of Haberdashers
The Paul Hamlyn Foundation
The Late Dr and Mrs Armand Hammer
Mrs Sue Hammerson
Philip and Pauline Harris Charitable Trust
The Hayward Foundation
The Howser Foundation
Mr and Mrs Randolph Hearst
Klaus and Belinda Hebben
The Hedley Foundation
Mrs Henry J. Heinz II
The Henry J. and Drue Heinz Foundation
Drue Heinz Trust
The Heritage of London Trust
IBM United Kingdom Limited
The Idlewild Trust
The Inchcape Charitable Trust

The Worshipful Company of Ironmongers
 Mr and Mrs Ralph Isham
 The J.P. Jacobs Charitable Trust
 Jerwood Foundation
 Mr and Mrs Donald P. Kahn
 Mrs D. King
 KPMG Peat Marwick
 Irene and Hyman Kreitman
 The Kresge Foundation
 The Kress Foundation
 Mr and Mrs Sol Kroll
 Ladbrooke Group Plc
 Mr D.E. Laing
 The Kirby Laing Foundation
 The Maurice Laing Foundation
 The Landmark Trust
 The Lankelly Foundation
 Mr John S. Latsis
 The Leche Trust
 The Leverhulme Trust
 Mr Leon Levy and Ms Shelby White
 Mr J.H. Lewis
 Lex Service Plc
 The Linbury Trust
 The Ruth and Stuart Lipton Charitable Trust
 Sir Sydney and Lady Lipworth
 Lloyds Bank PLC
 Mr John Madejski
 Mrs T.S. Mallinson
 The Manifold Trust
 The Stella and Alexander Margulies Charitable Trust
 Mr and Mrs John L. Marion
 Mrs W. Marks
 Marks & Spencer
 Mrs Jack C. Massey
 M. J. Meehan & Company
 Paul Mellon KBE
 The Anthony and Elizabeth Mellows Charitable Trust
 The Mercers' Company
 The Henry Moore Foundation
 Museums and Galleries Improvement Fund
 National Westminster Bank PLC
 Mr Stavros S. Niarchos
 Orrin Charitable Trust
 Otemae College
 The Peacock Charitable Trust
 Mr and Mrs Frank Pearl
 The Pennycress Trust
 In Memoriam: Mrs Olive Petit
 The P.F. Charitable Trust
 The Pilgrim Trust
 Mr A.N. Polhill
 The Hon. and Mrs Leon B. Polsky
 The Hon. and Mrs Charles H. Price II
 Provident Financial plc
 Prudential Assurance Company Ltd
 The Radcliffe Trust
 The Rayne Foundation
 The Regent Hotel
 Mr and Mrs Laurance S. Rockefeller
 The Ronson Charitable Foundation
 The J. Rothschild Group Charitable Trust
 Rothschilds Inc
 The RTZ Corporation Plc
 The Late Dr Arthur M. Sackler

Mrs Arthur M. Sackler
 The Sainsbury Family Charitable Trusts
 Mrs Jean Sainsbury
 Mrs Basil Samuel
 Mrs Louisa Sarofim
 Save & Prosper Educational Trust
 Sea Containers Limited
 Shell UK Ltd
 The Archie Sherman Charitable Trust
 Mr and Mrs James C. Slaughter
 The Late Mr Robert Slaughter
 Pauline Denyer Smith and Paul Smith CBE
 The Spencer Charitable Trust
 Miss K. Stalnaker
 Mr and Mrs Stephen Stamas
 The Starr Foundation
 Mr and Mrs Robert K. Steel
 Bernard Sunley Charitable Foundation
 John Swire and Son
 Mr and Mrs A. Alfred Taubman
 Mr and Mrs Vernon Taylor Jr.
 Texaco Inc
 G. Ware and Edythe Travelstead
 The TSB Foundation for England and Wales
 Seiji Tsutsumi
 The Douglas Turner Charitable Trust
 The 29th May 1961 Charitable Trust
 Unilever PLC
 Mr Alexander Von Auersperg
 The Henry Vyner Charitable Trust
 S.G. Warburg Limited
 Dorothy, Viscountess Weir
 The Weldon UK Charitable Trust
 Mr and Mrs Keith S. Wellin
 The Welton Foundation
 Westminster City Council
 Mr and Mrs Garry H. Weston
 Mr Anthony Whishaw RA
 Mr Frederick B. Whittemore
 The Hon. and Mrs John C. Whitehead
 Mrs John Hay Whitney
 Mr and Mrs Wallace S. Wilson
 Mr A. Witkin
 The Wolfson Foundation
 The Late Mr Charles Wollaston
 The Late Mr Ian Woodner
 Mr and Mrs William Wood Prince

CORPORATE MEMBERS

Alliance & Leicester Building Society
 Arthur Andersen & Andersen Consulting
 Ashurst Morris Crisp
 Atlantic Plastics Limited
 A.T. Kearney Limited
 Bankers Trust
 Banque Indosuez
 Barclays de Zoete Wedd
 BAT Industries plc
 BP Chemicals
 British Aerospace plc
 British Alcan Aluminium plc
 British Gas plc

British Petroleum
 BT
 Bunzl plc
 Capital International Ltd
 Christie's
 Chubb Insurance Company
 Cookson Group plc
 Coopers & Lybrand
 Courage Limited
 C.S. First Boston Group
 The Daily Telegraph plc
 Datastream International
 Department of National Heritage
 The Diamond Trading Company (Pty) Limited
 The First National Bank of Chicago
 Robert Fleming & Co. Limited
 French Railways Ltd.
 Gartmore plc
 Glaxo Wellcome plc
 Goldman Sachs International Limited
 Grand Metropolitan plc
 Guinness PLC
 Hay Management Consultants Ltd
 Hill Samuel Bank Limited
 Hillier Parker May & Rowden
 ICI
 Industrial Bank of Japan, Limited
 Jaguar Cars Ltd
 John Laing plc
 Leading Guides Limited
 Lehman Brothers International
 Lloyds Private Banking Limited
 E.D. & F. Man Limited Charitable Trust
 Marks & Spencer
 Merrill Lynch Europe Ltd
 McKinsey's
 Midland Group
 MoMart plc
 J.P. Morgan
 Morgan Stanley International
 Newton Investment Management Limited
 The Peninsular and Oriental Steam Navigation Co
 The Reader's Digest Association
 Republic National Bank of New York
 Reuters
 Rothmans International p.l.c.
 Rothmans International Tobacco (UK) Ltd
 Royal Bank of Scotland plc
 The RTZ Corporation PLC
 Salomon Brothers
 Santa Fe Exploration (U.K.) Limited
 Sea Containers Ltd.
 Silhouette Eyewear
 SmithKline Beecham
 Smith & Williamson
 Société Générale
 Société Générale de Belgique
 Southern Water plc
 TI Group plc
 Tractebel
 Trafalgar House Construction Holdings Ltd
 Unilever PLC
 Union Minière
 Visa International Europe, Middle East, Africa Region

CORPORATE ASSOCIATES
 AT & T
 Bass PLC
 BMP DDB Needham
 BMW (GB) Ltd
 The BOC Group
 Booker plc
 Bovis Construction Limited
 Cable and Wireless plc
 Charterhouse plc
 CJA (Management Recruitment Consultants) Limited
 Clifford Chance
 Coutts & Co
 Credit Lyonnais Laing
 The Dai-Ichi Kangyo Bank Limited
 Dalgleish & Co
 De La Rue plc
 Durrington Corporation Limited
 Enterprise Oil plc
 Fina plc
 Foreign & Colonial Management Ltd
 General Accident plc
 The General Electric Company plc
 Guardian Royal Exchange plc
 Hamilton Oil Company Ltd
 Heidrick & Struggles Int.
 H.J. Heinz Company Limited
 IBM UK Ltd
 S.C. Johnson
 Kleinwort Benson Limited
 Lex Service PLC
 Linklaters & Paines
 John Lewis Partnership plc
 Lloyds Bank plc
 Macfarlanes
 Mars G.B. Limited
 Nabarro Nathanson
 Nat West Investment Management
 NEC (UK) Ltd
 Northern Telecom Europe Ltd
 Ove Arup Partnership
 Pearson plc
 Pentland Group plc
 The Rank Organisation Plc
 Reliance National Insurance Company (UK) Ltd
 Royal Insurance Holdings plc
 Sainsbury's PLC
 Save & Prosper Educational Trust
 Schroder Investment Management Ltd
 J. Henry Schroder Wag & Co Limited
 Sears plc
 Sedgwick Group plc
 Slough Estates plc
 Smith System Engineering
 Sony United Kingdom Limited
 Sotheby's
 Sun Life Assurance Society plc
 Tate & Lyle Plc
 Tomkins PLC
 Toyota Motor Corporation
 United Biscuits (UK) Ltd
 Vistech International Ltd

SPONSORS OF PAST EXHIBITIONS

The Council of the Royal Academy thanks sponsors of past exhibitions for their support. Sponsors of major exhibitions during the last ten years have included the following:

ALITALIA
 Italian Art in the 20th Century 1989
 AMERICAN EXPRESS FOUNDATION
 Je suis le cahier: The Sketchbooks of Picasso 1986
 ARTS COUNCIL OF GREAT BRITAIN
 Peter Greenham 1985
 THE BANQUE INDOSUEZ GROUP
 Pissarro: The Impressionist and the City 1993

BANQUE INDOSUEZ AND W.I. CARR
 Gauguin and The School of Pont-Aven: Prints and Paintings 1989
 BBC RADIO ONE
 The Pop Art Show 1991
 BECK'S BIER
 German Art in the 20th Century 1985
 BMW 8 SERIES
 Georges Rouault: The Early Years, 1905-1920 1995

ROBERT BOSCH LIMITED
 German Art in the 20th Century 1985
 BOVIS CONSTRUCTION LTD
 New Architecture 1986
 BRITISH ALCAN ALUMINIUM
 Sir Alfred Gilbert 1986
 BRITISH PETROLEUM PLC
 British Art in the 20th Century 1987

BT
 Hokusai 1991
 CANARY WHARF DEVELOPMENT
 New Architecture 1986
 THE CAPITAL GROUP COMPANIES
 Drawings from the J. Paul Getty Museum 1993
 THE CHASE MANHATTAN BANK
 Cézanne: The Early Years 1988

CHILSTONE GARDEN ORNAMENTS
The Palladian Revival: Lord Burlington and his House and Garden at Chiswick 1995

CANTOR FITZGERALD
From Manet to Gauguin: Masterpieces from Swiss Private Collections

CLASSIC FM
Goya: Truth and Fantasy, The Small Paintings 1994
The Glory of Venice: Art in the Eighteenth Century 1994

THE DAI-ICHI KANGYO BANK LIMITED
22nd Summer Exhibition 1990

THE DAILY TELEGRAPH
American Art in the 20th Century 1993

DEUTSCHE BANK AG
German Art in the 20th Century 1985

DIGITAL EQUIPMENT CORPORATION
Monet in the '90s: The Series Paintings 1990

THE DRUE HAINZ TRUST
The Palladian Revival:
Lord Burlington and his House and Garden at Chiswick

THE DUPONT COMPANY
American Art in the 20th Century 1993

THE ECONOMIST
Igno Jones Architect 1989

EDWARDIAN HOTELS
The Edwardians and After: Paintings and Sculpture from the Royal Academy's Collection, 1900–1950 1990

ELECTRICITY COUNCIL
New Architecture 1986

ELF
Alfred Sisley 1992

ESSO PETROLEUM COMPANY LTD
220th Summer Exhibition 1988

FIAT
Italian Art in the 20th Century 1989

FINANCIAL TIMES
Igno Jones Architect 1989

FIRST NATIONAL BANK OF CHICAGO
Chagall 1985

FONDATION ELF
Alfred Sisley 1992

FORD MOTOR COMPANY LIMITED
The Fauve Landscape: Matisse, Derain, Braque and their Circle 1991

FRIENDS OF THE ROYAL ACADEMY

Peter Greenham 1985
Sir Alfred Gilbert 1986

GAMLESTADEN
Royal Treasures of Sweden, 1550–1700 1989

JOSEPH GARTNER
New Architecture 1986

J. PAUL GETTY JR CHARITABLE TRUST
The Age of Chivalry 1987

GLAXO HOLDINGS PLC
From Byzantium to El Greco 1987
Great Impressionist and other Master Paintings from the Emil G. Bührle Collection, Zurich 1991
The Unknown Modigliani 1994

THE GUARDIAN
The Unknown Modigliani 1994

GUINNESS PLC
Twentieth-Century Modern Masters: The Jacques and Natasha Gelman Collection 1990
225th Summer Exhibition 1991
224th Summer Exhibition 1992
225th Summer Exhibition 1993
226th Summer Exhibition 1994
227th Summer Exhibition 1995

GUINNESS PEAT AVIATION
Alexander Calder 1992

HARPERS & QUEEN
George Rouault: The Early Years, 1905–1920 1993
Sandra Blow 1994

THE HENRY MOORE FOUNDATION
Henry Moore 1988
Alexander Calder 1992

HOECHST (UK) LTD
German Art in the 20th Century 1985

THE INDEPENDENT
The Art of Photography 1859–1989 1989
The Pop Art Show 1991

THE INDUSTRIAL BANK OF JAPAN
Hokusai 1991

INTERCRAFT DESIGNS LIMITED
Igno Jones Architect 1989

JOANNOU & PARASKEVAIDES (OVERSEAS) LTD
From Byzantium to El Greco 1987

THE KLEINWORT BENSON GROUP
Igno Jones Architect 1989

LLOYDS BANK
The Age of Chivalry 1987

LOGICA
The Art of Photography, 1859–1989 1989

LUFTHANSA
German Art in the 20th Century 1985

THE MAIL ON SUNDAY
Royal Academy Summer Season 1992
Royal Academy Summer Season 1993

MARTINI & ROSSI LTD
The Great Age of British Watercolours, 1750–1880 1995

MARKS & SPENCER PLC
Royal Academy Schools Premiums 1994
Royal Academy Schools Final Year Show 1994

MELITTA
German Art in the 20th Century 1985

PAUL MELLON KBE
The Great Age of British Watercolours, 1750–1880 1995

SIEGENS
German Art in the 20th Century 1985

SEA CONTAINERS LTD.
The Glory of Venice: Art in the Eighteenth Century 1994

SILHOUETTE EYEWEAR
Egon Schiele and His Contemporaries: From the Leopold Collection, Vienna 1990
Wisdom and Compassion: The Sacred Art of Tibet 1992
Sandra Blow 1994

SOCIÉTÉ GÉNÉRALE DE BELGIQUE
Impressionism to Symbolism: The Belgian Avant-Garde, 1880–1900 1994

SPERO COMMUNICATIONS
Royal Academy Schools Final Year Show 1992

SWAN HELLENIC
Edward Lear 1985

TEXACO
Selections from the Royal Academy's Private Collection 1991

THE TIMES
Old Master Paintings from the Thyssen-Bornemisza Collection 1988
Wisdom and Compassion: The Sacred Art of Tibet 1992
Drawings from the J. Paul Getty Museum 1993
Goya: Truth and Fantasy, The Small Paintings 1994

TRACTEBEL
Impressionism to Symbolism: The Belgian Avant-Garde, 1880–1900 1994

TRAFALGAR HOUSE
Elisabeth Frink 1985

TRUSTHOUSE FORTE
Edward Lear 1985

UNILEVER
Frans Hals 1990

UNION MINIERE
Impressionism to Symbolism: The Belgian Avant-Garde, 1880–1900 1994

Sir Christopher Wren and the Making of St Paul's 1991

REPUBLIC NATIONAL BANK OF NEW YORK
Sickert: Paintings 1992

ARTHUR M. SACKLER FOUNDATION
Jewels of the Ancients 1987

SALOMON BROTHERS
Henry Moore 1988

THE SARA LEE FOUNDATION
Odilon Redon: Dreams and Visions 1995

SIEMENS
German Art in the 20th Century 1985

SEA CONTAINERS LTD.
The Glory of Venice: Art in the Eighteenth Century 1994

SILHOUETTE EYEWEAR
Egon Schiele and His Contemporaries: From the Leopold Collection, Vienna 1990
Wisdom and Compassion: The Sacred Art of Tibet 1992
Sandra Blow 1994

SOCIÉTÉ GÉNÉRALE DE BELGIQUE
Impressionism to Symbolism: The Belgian Avant-Garde, 1880–1900 1994

SPERO COMMUNICATIONS
Royal Academy Schools Final Year Show 1992

SWAN HELLENIC
Edward Lear 1985

TEXACO
Selections from the Royal Academy's Private Collection 1991

THE TIMES
Old Master Paintings from the Thyssen-Bornemisza Collection 1988
Wisdom and Compassion: The Sacred Art of Tibet 1992
Drawings from the J. Paul Getty Museum 1993
Goya: Truth and Fantasy, The Small Paintings 1994

TRACTEBEL
Impressionism to Symbolism: The Belgian Avant-Garde, 1880–1900 1994

TRAFALGAR HOUSE
Elisabeth Frink 1985

TRUSTHOUSE FORTE
Edward Lear 1985

UNILEVER
Frans Hals 1990

UNION MINIERE
Impressionism to Symbolism: The Belgian Avant-Garde, 1880–1900 1994

OTHER SPONSORS

Sponsors of events, publications and other items in the past two years:

Academy Group Limited
Air Namibia
Air Seychelles
Air UK
Alitalia
American Airlines
Arthur Andersen
Athenaeum Hotel and Apartments
Austrian Airlines
Berggruen & Zevi Limited
British Airways
British Mediterranean Airways
British Midland
Bulgari Jewellery
Cable & Wireless
Chilstone Garden Ornaments
Christies International plc
Citibank N.A.
Columbus Communications
Condé Nast Publications

Brenda Evans
Fina Plc
Forte Plc
The Four Seasons Hotels
Ghana Airways Corporation
Häagen-Dazs
Tim Harvey Design
Hyundai Car (UK) Ltd
IBM United Kingdom Limited
Inter-Continental Hotels
Intercraft Designs Limited
Jaguar Cars Limited
John Lewis Partnership plc
A.T. Kearney Limited
Kenya Airways
KLM
The Leading Hotels of the World
Lonrho Hotels
Magic of Italy
Martini & Rossi Ltd

May Fair Inter-Continental Hotels
Mercury Communications Ltd
Merrill Lynch
Midland Bank Plc
Anton Mosimann
NK
Novell U.K. Ltd
Patagonia
Penshurst Press Ltd
Percy Fox and Co
Polaroid (UK) Ltd
The Regent Hotel
The Robina Group
Royal Mail International
Sears Plc
Swan Hellenic Ltd
Mr and Ms Daniel Unger
Kurt Unger
Venice Simplon-Orient-Express
Vista Bay Club Seychelles

Vorwerk Carpets Limited
Louis Vuitton Ltd
Warner Bros.
White Dove Press
Winsor & Newton
Mrs George Zakhem

HAVERING COLLEGE OF F & H E

5083

WITHDRAWN

The Elements

CHEMICAL ELEMENTS

CHART OF THE ELEMENTS

Name	Symbol	Atomic Number	Atomic Mass*	Name	Symbol	Atomic Number	Atomic Mass*
Actinium	Ac	89	(227)	Mendelevium	101	(256)	
Aluminum	Al	13	26.98	Mercury	Hg	80	200.6
Americium	Am	95	(243)	Molybdenum	Mo	42	95.94
Antimony	Sb	51	121.8	Moscovium	Mc	115	(288)
Argon	Ar	18	39.95	Neodymium	Nd	60	144.2
Arsenic	As	33	74.92	Neon	Ne	10	20.18
Astatine	At	85	(210)	Neptunium	Np	93	(244)
Barium	Ba	56	137.3	Nickel	Ni	28	58.70
Berkelium	Bk	97	(247)	Nihonium	Nh	113	(284)
Beryllium	Be	4	9.012	Niobium	Nb	41	92.91
Bismuth	Bi	83	209.0	Nitrogen	N	7	14.01
Bohrium	Bh	107	(267)	Nobelium	No	102	(253)
Boron	B	5	10.81	Oganesson	Og	118	(294)
Bromine	Br	35	79.90	Osmium	Os	76	190.2
Cadmium	Cd	48	112.4	Oxygen	O	8	16.00
Calcium	Ca	20	40.08	Palladium	Pd	46	106.4
Californium	Cf	98	(249)	Phosphorus	P	15	30.97
Carbon	C	6	12.01	Platinum	Pt	78	195.1
Cerium	Ce	58	140.1	Plutonium	Pu	94	(242)
Cesium	Cs	55	132.9	Polonium	Po	84	(209)
Chlorine	Cl	17	35.45	Potassium	K	19	39.10
Chromium	Cr	24	52.00	Praseodymium	Pr	59	140.9
Cobalt	Co	27	58.93	Promethium	Pm	61	(145)
Copernicium	Cn	112	(285)	Protactinium	Pa	91	(231)
Copper	Cu	29	63.55	Radium	Ra	88	(226)
Curium	Cm	96	(247)	Radon	Rn	86	(222)
Darmstadtium	Ds	110	(281)	Rhenium	Re	75	186.2
Dubnium	Db	105	(262)	Rhodium	Rh	45	102.9
Dysprosium	Dy	66	162.5	Roentgenium	Rg	111	(272)
Einsteinium	Es	99	(254)	Rubidium	Rb	37	85.47
Erbium	Er	68	167.3	Ruthenium	Ru	44	101.1
Europium	Eu	63	152.0	Rutherfordium	Rf	104	(263)
Fermium	Fm	100	(253)	Samarium	Sm	62	150.4
Flevorium	Fl	114	(289)	Scandium	Sc	21	44.96
Fluorine	F	9	19.00	Seaborgium	Sg	106	(266)
Francium	Fr	87	(223)	Selenium	Se	34	78.96
Gadolinium	Gd	64	157.3	Silicon	Si	14	28.09
Gallium	Ga	31	69.72	Silver	Ag	47	107.9
Germanium	Ge	32	72.61	Sodium	Na	11	22.99
Gold	Au	79	197.0	Strontium	Sr	38	87.62
Hafnium	Hf	72	178.5	Sulfur	S	16	32.07
Hassium	Hs	108	(277)	Tantalum	Ta	73	180.9
Helium	He	2	4.003	Technetium	Tc	43	(98)
Holmium	Ho	67	164.9	Tellurium	Te	52	127.6
Hydrogen	H	1	1.008	Tennesseine	Ts	117	(294)
Indium	In	49	114.8	Terbium	Tb	65	158.9
Iodine	I	53	126.9	Thallium	Tl	81	204.4
Iridium	Ir	77	192.2	Thorium	Th	90	232.0
Iron	Fe	26	55.85	Thulium	Tm	69	168.9
Krypton	Kr	36	83.80	Tin	Sn	50	118.7
Lanthanum	La	57	138.9	Titanium	Ti	22	47.88
Lawrencium	Lr	103	(257)	Tungsten	W	74	183.9
Lead	Pb	82	207.2	Uranium	U	92	238.0
Lithium	Li	3	6.941	Vanadium	V	23	50.94
Livermorium	Lv	116	(293)	Xenon	Xe	54	131.3
Lutetium	Lu	71	175.0	Ytterbium	Yb	70	173.0
Magnesium	Mg	12	24.31	Yttrium	Y	39	88.91
Manganese	Mn	25	54.94	Zinc	Zn	30	65.41
Meitnerium	Mt	109	(268)	Zirconium	Zr	40	91.22

*All atomic masses are given to four significant figures. Values in parentheses represent the mass number of the most stable isotope.

Silberberg ~ Amateis

CHEMISTRY

The Molecular Nature of Matter and Change

8e

A diagram illustrating an electron shell. It consists of a central point surrounded by eight wavy lines radiating outwards, representing the orbital paths of eight electrons.

Mc
Graw
Hill
Education

CHEMISTRY: THE MOLECULAR NATURE OF MATTER AND CHANGE, EIGHTH EDITION

Published by McGraw-Hill Education, 2 Penn Plaza, New York, NY 10121. Copyright © 2018 by McGraw-Hill Education. All rights reserved. Printed in the United States of America. Previous editions © 2015, 2012, and 2009. No part of this publication may be reproduced or distributed in any form or by any means, or stored in a database or retrieval system, without the prior written consent of McGraw-Hill Education, including, but not limited to, in any network or other electronic storage or transmission, or broadcast for distance learning.

Some ancillaries, including electronic and print components, may not be available to customers outside the United States.

This book is printed on acid-free paper.

1 2 3 4 5 6 7 8 9 LWI 21 20 19 18 17

ISBN 978-1-259-63175-7
MHID 1-259-63175-3

Chief Product Officer, SVP Products & Markets: *G. Scott Virkler*
Vice President, General Manager, Products & Markets: *Marty Lange*
Vice President, Content Design & Delivery: *Betsy Whalen*
Managing Director: *Thomas Timp*
Director: *David Spurgeon, Ph.D.*
Brand Manager: *Rose Koos*
Director, Product Development:
Associate Director of Digital Content: *Robin Reed*
Marketing Manager: *Matthew Garcia*
Market Development Manager: *Shannon O'Donnell*
Director of Digital Content: *Shirley Hino, Ph.D.*
Digital Product Developer: *Joan Weber*
Director, Content Design & Delivery: *Linda Avenarius*
Program Manager: *Lora Neyens*
Content Project Managers: *Laura Bies, Tammy Juran & Sandy Schnee*
Buyer: *Sandy Ludovissy*
Design: *David W. Hash*
Content Licensing Specialists: *Ann Marie Jannette & Lorraine Buczek*
Cover Image: © Don Farrall/Photographer's Choice RF/Getty Images
Compositor: *Aptara®, Inc.*
Printer: *LSC Communications*

All credits appearing on page or at the end of the book are considered to be an extension of the copyright page.

Library of Congress Cataloging-in-Publication Data

Names: Silberberg, Martin S. (Martin Stuart), 1945- | Amateis, Patricia.
Title: Chemistry : the molecular nature of matter and change / Martin S. Silberberg, Patricia G. Amateis, Virginia Tech.
Description: Eighth edition. | New York, NY : McGraw-Hill Education, [2018] | Includes index.
Identifiers: LCCN 2016040017 | ISBN 9781259631757 (alk. paper) | ISBN 1259631753 (alk. paper)
Subjects: LCSH: Chemistry—Textbooks.
Classification: LCC QD33.2 .S55 2018 | DDC 540—dc23 LC record available at <https://lccn.loc.gov/2016040017>

The Internet addresses listed in the text were accurate at the time of publication. The inclusion of a website does not indicate an endorsement by the authors or McGraw-Hill Education, and McGraw-Hill Education does not guarantee the accuracy of the information presented at these sites.

To Ruth and Daniel, with all my love and gratitude.

MSS

To Ralph, Eric, Samantha, and Lindsay:
you bring me much joy.

PGA

BRIEF CONTENTS

Preface xx

Acknowledgments xxxii

- 1 Keys to Studying Chemistry: Definitions, Units, and Problem Solving 2**
- 2 The Components of Matter 42**
- 3 Stoichiometry of Formulas and Equations 94**
- 4 Three Major Classes of Chemical Reactions 144**
- 5 Gases and the Kinetic-Molecular Theory 204**
- 6 Thermochemistry: Energy Flow and Chemical Change 256**
- 7 Quantum Theory and Atomic Structure 294**
- 8 Electron Configuration and Chemical Periodicity 330**
- 9 Models of Chemical Bonding 368**
- 10 The Shapes of Molecules 404**
- 11 Theories of Covalent Bonding 442**
- 12 Intermolecular Forces: Liquids, Solids, and Phase Changes 470**
- 13 The Properties of Mixtures: Solutions and Colloids 532**
- 14 Periodic Patterns in the Main-Group Elements 584**
- 15 Organic Compounds and the Atomic Properties of Carbon 632**
- 16 Kinetics: Rates and Mechanisms of Chemical Reactions 690**
- 17 Equilibrium: The Extent of Chemical Reactions 746**
- 18 Acid-Base Equilibria 792**
- 19 Ionic Equilibria in Aqueous Systems 842**
- 20 Thermodynamics: Entropy, Free Energy, and Reaction Direction 894**
- 21 Electrochemistry: Chemical Change and Electrical Work 938**
- 22 The Elements in Nature and Industry 996**
- 23 Transition Elements and Their Coordination Compounds 1036**
- 24 Nuclear Reactions and Their Applications 1072**

Appendix A Common Mathematical Operations in Chemistry A-1

Appendix B Standard Thermodynamic Values for Selected Substances A-5

Appendix C Equilibrium Constants for Selected Substances A-8

Appendix D Standard Electrode (Half-Cell) Potentials A-14

Appendix E Answers to Selected Problems A-15

Glossary G-1

Index I-1

DETAILED CONTENTS

© Fancy Collection/SuperStock RF

CHAPTER

1

Keys to Studying Chemistry: Definitions, Units, and Problem Solving 2

- 1.1 Some Fundamental Definitions 4**
The States of Matter 4
The Properties of Matter and Its Changes 5
The Central Theme in Chemistry 8
The Importance of Energy in the Study of Matter 8
- 1.2 Chemical Arts and the Origins of Modern Chemistry 10**
Prechemical Traditions 10
The Phlogiston Fiasco and the Impact of Lavoisier 11

- 1.3 The Scientific Approach: Developing a Model 12**
- 1.4 Measurement and Chemical Problem Solving 13**
General Features of SI Units 13
Some Important SI Units in Chemistry 14
Units and Conversion Factors in Calculations 18
A Systematic Approach to Solving Chemistry Problems 19
Temperature Scales 25
Extensive and Intensive Properties 27

- 1.5 Uncertainty in Measurement: Significant Figures 28**
Determining Which Digits Are Significant 29
Significant Figures: Calculations and Rounding Off 30
Precision, Accuracy, and Instrument Calibration 32
- CHAPTER REVIEW GUIDE 33
PROBLEMS 37

CHAPTER

2

The Components of Matter 42

- 2.1 Elements, Compounds, and Mixtures: An Atomic Overview 44**
- 2.2 The Observations That Led to an Atomic View of Matter 46**
Mass Conservation 46
Definite Composition 47
Multiple Proportions 49
- 2.3 Dalton's Atomic Theory 50**
Postulates of the Atomic Theory 50
How the Theory Explains the Mass Laws 50
- 2.4 The Observations That Led to the Nuclear Atom Model 52**
Discovery of the Electron and Its Properties 52
Discovery of the Atomic Nucleus 54
- 2.5 The Atomic Theory Today 55**
Structure of the Atom 55

- Atomic Number, Mass Number, and Atomic Symbol 56
Isotopes 57
Atomic Masses of the Elements 57
- TOOLS OF THE LABORATORY: MASS SPECTROMETRY 60**
- 2.6 Elements: A First Look at the Periodic Table 61**
- 2.7 Compounds: Introduction to Bonding 64**
The Formation of Ionic Compounds 64
The Formation of Covalent Substances 66
- 2.8 Compounds: Formulas, Names, and Masses 68**
Binary Ionic Compounds 68
Compounds That Contain Polyatomic Ions 71

- Acid Names from Anion Names 74
Binary Covalent Compounds 74
The Simplest Organic Compounds: Straight-Chain Alkanes 76
Molecular Masses from Chemical Formulas 76
Representing Molecules with Formulas and Models 78
- 2.9 Mixtures: Classification and Separation 81**
An Overview of the Components of Matter 81
- TOOLS OF THE LABORATORY: BASIC SEPARATION TECHNIQUES 83**

- CHAPTER REVIEW GUIDE 84
PROBLEMS 86

Source: NASA

CHAPTER**3*****Stoichiometry of Formulas and Equations 94*****3.1 The Mole 95**

Defining the Mole 95
Determining Molar Mass 96
Converting Between Amount, Mass, and Number of Chemical Entities 97
The Importance of Mass Percent 102

3.2 Determining the Formula of an Unknown Compound 104

Empirical Formulas 105
Molecular Formulas 106

CHAPTER**4*****Three Major Classes of Chemical Reactions 144*****4.1 Solution Concentration and the Role of Water as a Solvent 145**

The Polar Nature of Water 146
Ionic Compounds in Water 146
Covalent Compounds in Water 150
Expressing Concentration in Terms of Molarity 150
Amount-Mass-Number Conversions Involving Solutions 151
Preparing and Diluting Molar Solutions 152

4.2 Writing Equations for Aqueous Ionic Reactions 155

The Key Event: Formation of a Solid from Dissolved Ions 157

CHAPTER**5*****Gases and the Kinetic-Molecular Theory 204*****5.1 An Overview of the Physical States of Matter 205**

Measuring Gas Pressure: Barometers and Manometers 208
Units of Pressure 209

5.3 The Gas Laws and Their Experimental Foundations 210

The Relationship Between Volume and Pressure: Boyle's Law 211
The Relationship Between Volume and Temperature: Charles's Law 212
The Relationship Between Volume and Amount: Avogadro's Law 214
Gas Behavior at Standard Conditions 215

Chemical Formulas and Molecular Structures; Isomers 110

3.3 Writing and Balancing Chemical Equations 111

Calculating Quantities of Reactant and Product 116
Stoichiometrically Equivalent Molar Ratios from the Balanced Equation 116

Reactions That Occur in a Sequence 120
Reactions That Involve a Limiting Reactant 122

Theoretical, Actual, and Percent Reaction Yields 127

CHAPTER REVIEW GUIDE 130

PROBLEMS 135

Predicting Whether a Precipitate Will Form 157

Stoichiometry of Precipitation Reactions 162

4.4 Acid-Base Reactions 165

The Key Event: Formation of H_2O from H^+ and OH^- 167

Proton Transfer in Acid-Base Reactions 168

Stoichiometry of Acid-Base Reactions: Acid-Base Titrations 172

4.5 Oxidation-Reduction (Redox) Reactions 174

The Key Event: Movement of Electrons Between Reactants 174

Some Essential Redox Terminology 175

Using Oxidation Numbers to Monitor Electron Charge 176

Stoichiometry of Redox Reactions: Redox Titrations 179

4.6 Elements in Redox Reactions 181

Combination Redox Reactions 181
Decomposition Redox Reactions 182
Displacement Redox Reactions and Activity Series 184
Combustion Reactions 186

4.7 The Reversibility of Reactions and the Equilibrium State 188

CHAPTER REVIEW GUIDE 190

PROBLEMS 196

The Ideal Gas Law 216

Solving Gas Law Problems 217

5.4 Rearrangements of the Ideal Gas Law 222

The Density of a Gas 222

The Molar Mass of a Gas 224

The Partial Pressure of Each Gas in a Mixture of Gases 225

The Ideal Gas Law and Reaction Stoichiometry 228

5.5 The Kinetic-Molecular Theory: A Model for Gas Behavior 231

How the Kinetic-Molecular Theory Explains the Gas Laws 231

Effusion and Diffusion 236

The Chaotic World of Gases: Mean Free Path and Collision Frequency 238

**CHEMICAL CONNECTIONS TO ATMOSPHERIC SCIENCE:
HOW THE GAS LAWS APPLY TO EARTH'S ATMOSPHERE 239**

5.6 Real Gases: Deviations from Ideal Behavior 241

Effects of Extreme Conditions on Gas Behavior 241

The van der Waals Equation: Adjusting the Ideal Gas Law 243

CHAPTER REVIEW GUIDE 244

PROBLEMS 247

© Maya Kruchankova/Shutterstock.com

CHAPTER 6

Thermochemistry: Energy Flow and Chemical Change 256

6.1 Forms of Energy and Their Interconversion 257

Defining the System and Its Surroundings 258
Energy Change (ΔE): Energy Transfer to or from a System 258
Heat and Work: Two Forms of Energy Transfer 258
The Law of Energy Conservation 261
Units of Energy 261
State Functions and the Path Independence of the Energy Change 262
Calculating Pressure-Volume Work (PV Work) 263

6.2 Enthalpy: Changes at Constant Pressure 265

The Meaning of Enthalpy 265
Comparing ΔE and ΔH 265
Exothermic and Endothermic Processes 266

6.3 Calorimetry: Measuring the Heat of a Chemical or Physical Change 268

Specific Heat Capacity 268
The Two Major Types of Calorimetry 269

6.4 Stoichiometry of Thermochemical Equations 273

6.5 Hess's Law: Finding ΔH of Any Reaction 275

6.6 Standard Enthalpies of Reaction (ΔH_{rxn}°) 277

Formation Equations and Their Standard Enthalpy Changes 277
Determining ΔH_{rxn}° from ΔH_f° Values for Reactants and Products 279

CHEMICAL CONNECTIONS TO ENVIRONMENTAL SCIENCE: THE FUTURE OF ENERGY USE 281

CHAPTER REVIEW GUIDE 285
PROBLEMS 288

CHAPTER

7

Quantum Theory and Atomic Structure 294

7.1 The Nature of Light 295

The Wave Nature of Light 296
The Particle Nature of Light 299

7.2 Atomic Spectra 302

Line Spectra and the Rydberg Equation 302
The Bohr Model of the Hydrogen Atom 303
The Energy Levels of the Hydrogen Atom 305

TOOLS OF THE LABORATORY:

SPECTROMETRY IN CHEMICAL ANALYSIS 308

7.3 The Wave-Particle Duality of Matter and Energy 310

The Wave Nature of Electrons and the Particle Nature of Photons 310
Heisenberg's Uncertainty Principle 313

7.4 The Quantum-Mechanical Model of the Atom 314

The Atomic Orbital and the Probable Location of the Electron 314

Quantum Numbers of an Atomic Orbital 316
Quantum Numbers and Energy Levels 317

Shapes of Atomic Orbitals 319
The Special Case of Energy Levels in the Hydrogen Atom 322

CHAPTER REVIEW GUIDE 323

PROBLEMS 325

CHAPTER

8

Electron Configuration and Chemical Periodicity 330

8.1 Characteristics of Many-Electron Atoms 332

The Electron-Spin Quantum Number 332
The Exclusion Principle 333
Electrostatic Effects and Energy-Level Splitting 333

8.2 The Quantum-Mechanical Model and the Periodic Table 335

Building Up Period 1 335
Building Up Period 2 336
Building Up Period 3 338

Building Up Period 4: The First Transition Series 339

General Principles of Electron Configurations 340
Intervening Series: Transition and Inner Transition Elements 342
Similar Electron Configurations Within Groups 342

8.3 Trends in Three Atomic Properties 345

Trends in Atomic Size 345

Trends in Ionization Energy 348
Trends in Electron Affinity 351

8.4 Atomic Properties and Chemical Reactivity 353

Trends in Metallic Behavior 353
Properties of Monatomic Ions 355

CHAPTER REVIEW GUIDE 361

PROBLEMS 363

© Chip Clark/Fundamental Photographs, NYC

CHAPTER

9

Models of Chemical Bonding 368

9.1 Atomic Properties and Chemical Bonds 369

The Three Ways Elements Combine 369
Lewis Symbols and the Octet Rule 371

9.2 The Ionic Bonding Model 372

Why Ionic Compounds Form:
The Importance of Lattice Energy 373
Periodic Trends in Lattice Energy 375
How the Model Explains the Properties of Ionic Compounds 377

9.3 The Covalent Bonding Model 379

The Formation of a Covalent Bond 379
Bonding Pairs and Lone Pairs 380
Properties of a Covalent Bond:
Order, Energy, and Length 380

How the Model Explains the Properties of Covalent Substances 383

TOOLS OF THE LABORATORY: INFRARED SPECTROSCOPY 384

9.4 Bond Energy and Chemical Change 386

Changes in Bond Energy: Where Does ΔH_{rxn}° Come From? 386
Using Bond Energies to Calculate ΔH_{rxn}° 386
Bond Strengths and the Heat Released from Fuels and Foods 389

9.5 Between the Extremes: Electronegativity and Bond Polarity 390

Electronegativity 390

Bond Polarity and Partial Ionic Character 392

The Gradation in Bonding Across a Period 394

9.6 An Introduction to Metallic Bonding 395

The Electron-Sea Model 395
How the Model Explains the Properties of Metals 396

CHAPTER REVIEW GUIDE 397

PROBLEMS 399

CHAPTER

10

The Shapes of Molecules 404

10.1 Depicting Molecules and Ions with Lewis Structures 405

Applying the Octet Rule to Write Lewis Structures 405
Resonance: Delocalized Electron-Pair Bonding 409
Formal Charge: Selecting the More Important Resonance Structure 411
Lewis Structures for Exceptions to the Octet Rule 413

10.2 Valence-Shell Electron-Pair Repulsion (VSEPR) Theory 417

Electron-Group Arrangements and Molecular Shapes 418
The Molecular Shape with Two Electron Groups (Linear Arrangement) 419

Molecular Shapes with Three Electron Groups (Trigonal Planar Arrangement) 419

Molecular Shapes with Four Electron Groups (Tetrahedral Arrangement) 420

Molecular Shapes with Five Electron Groups (Trigonal Bipyramidal Arrangement) 421

Molecular Shapes with Six Electron Groups (Octahedral Arrangement) 422

Using VSEPR Theory to Determine Molecular Shape 423

Molecular Shapes with More Than One Central Atom 426

10.3 Molecular Shape and Molecular Polarity 428

Bond Polarity, Bond Angle, and Dipole Moment 428
The Effect of Molecular Polarity on Behavior 430

CHEMICAL CONNECTIONS TO SENSORY PHYSIOLOGY: MOLECULAR SHAPE, BIOLOGICAL RECEPTORS, AND THE SENSE OF SMELL 431

CHAPTER REVIEW GUIDE 432

PROBLEMS 437

© Richard Megna/Fundamental Photographs, NYC

CHAPTER

11

Theories of Covalent Bonding 442

11.1 Valence Bond (VB) Theory and Orbital Hybridization 443

The Central Themes of VB Theory 443
Types of Hybrid Orbitals 444

11.2 Modes of Orbital Overlap and the Types of Covalent Bonds 451

Orbital Overlap in Single and Multiple Bonds 451
Orbital Overlap and Rotation Within a Molecule 455

11.3 Molecular Orbital (MO) Theory and Electron Delocalization 455

The Central Themes of MO Theory 455
Homonuclear Diatomic Molecules of Period 2 Elements 458
Two Heteronuclear Diatomic Molecules: HF and NO 462
Two Polyatomic Molecules: Benzene and Ozone 463

CHAPTER REVIEW GUIDE 464

PROBLEMS 466

CHAPTER

12

Intermolecular Forces: Liquids, Solids, and Phase Changes 470

12.1 An Overview of Physical States and Phase Changes 471

Heat Involved in Phase Changes 475
The Equilibrium Nature of Phase Changes 478
Phase Diagrams: Effect of Pressure and Temperature on Physical State 482

12.3 Types of Intermolecular Forces 484

How Close Can Molecules Approach Each Other? 484
Ion-Dipole Forces 485
Dipole-Dipole Forces 485
The Hydrogen Bond 486

Polarizability and Induced Dipole Forces 487
Dispersion (London) Forces 488

12.4 Properties of the Liquid State 490

Surface Tension 491
Capillarity 491
Viscosity 492

12.5 The Uniqueness of Water 493

Solvent Properties of Water 493
Thermal Properties of Water 493
Surface Properties of Water 494
The Unusual Density of Solid Water 494

12.6 The Solid State: Structure, Properties, and Bonding 495

Structural Features of Solids 495

TOOLS OF THE LABORATORY: X-RAY DIFFRACTION ANALYSIS AND SCANNING TUNNELING MICROSCOPY 502

Types and Properties of Crystalline Solids 503
Amorphous Solids 506
Bonding in Solids: Molecular Orbital Band Theory 506

12.7 Advanced Materials 509

Electronic Materials 509
Liquid Crystals 511
Ceramic Materials 514
Polymeric Materials 516
Nanotechnology: Designing Materials Atom by Atom 521

CHAPTER REVIEW GUIDE 523

PROBLEMS 525

© amnat11/Shutterstock.com

CHAPTER 13

The Properties of Mixtures: Solutions and Colloids 532

13.1 Types of Solutions: Intermolecular Forces and Solubility 534

Intermolecular Forces in Solution 534
Liquid Solutions and the Role of Molecular Polarity 535
Gas Solutions and Solid Solutions 537

13.2 Intermolecular Forces and Biological Macromolecules 539

The Structures of Proteins 539
Dual Polarity in Soaps, Membranes, and Antibiotics 541
The Structure of DNA 542

13.3 Why Substances Dissolve: Breaking Down the Solution Process 544

The Heat of Solution and Its Components 544

The Heat of Hydration: Dissolving Ionic Solids in Water 545

The Solution Process and the Change in Entropy 547

13.4 Solubility as an Equilibrium Process 549

Effect of Temperature on Solubility 549
Effect of Pressure on Solubility 551

13.5 Concentration Terms 552

Molarity and Molality 552
Parts of Solute by Parts of Solution 554
Interconverting Concentration Terms 556

13.6 Colligative Properties of Solutions 557

Nonvolatile Nonelectrolyte Solutions 558

Using Colligative Properties to Find Solute Molar Mass 563

Volatile Nonelectrolyte Solutions 564
Strong Electrolyte Solutions 564
Applications of Colligative Properties 566

13.7 The Structure and Properties of Colloids 568

CHEMICAL CONNECTIONS TO ENVIRONMENTAL ENGINEERING: SOLUTIONS AND COLLOIDS IN WATER PURIFICATION 570

CHAPTER REVIEW GUIDE 572

PROBLEMS 576

CHAPTER

14

Periodic Patterns in the Main-Group Elements 584

14.1 Hydrogen, the Simplest Atom 585

Where Hydrogen Fits in the Periodic Table 585

Highlights of Hydrogen Chemistry 586

14.2 Trends Across the Periodic Table: The Period 2 Elements 587

14.3 Group 1A(1): The Alkali Metals 590

Why the Alkali Metals Are Unusual Physically 590

Why the Alkali Metals Are So Reactive 592

14.4 Group 2A(2) 592

How the Alkaline Earth and Alkali Metals Compare Physically 593

How the Alkaline Earth and Alkali Metals Compare Chemically 593

Diagonal Relationships: Lithium and Magnesium 595

14.5 Group 3A(13): The Boron Family 595

How the Transition Elements Influence This Group's Properties 595

Features That First Appear in This Group's Chemical Properties 595

Highlights of Boron Chemistry 597

Diagonal Relationships: Beryllium and Aluminum 598

14.6 Group 4A(14): The Carbon Family 598

How Type of Bonding Affects Physical Properties 598

How Bonding Changes in This Group's Compounds 601

Highlights of Carbon Chemistry 601

Highlights of Silicon Chemistry 603

Diagonal Relationships: Boron and Silicon 604

14.7 Group 5A(15): The Nitrogen Family 604

The Wide Range of Physical Behavior 606

Patterns in Chemical Behavior 606

Highlights of Nitrogen Chemistry 607

Highlights of Phosphorus Chemistry 610

14.8 Group 6A(16): The Oxygen Family 612

How the Oxygen and Nitrogen Families Compare Physically 612

How the Oxygen and Nitrogen Families Compare Chemically 614

Highlights of Oxygen Chemistry: Range of Oxide Properties 615

Highlights of Sulfur Chemistry 615

14.9 Group 7A(17): The Halogens 617

Physical Behavior of the Halogens 617

Why the Halogens Are So Reactive 617

Highlights of Halogen Chemistry 619

14.10 Group 8A(18): The Noble Gases 622

How the Noble Gases and Alkali Metals Contrast Physically 622

How Noble Gases Can Form Compounds 624

CHAPTER REVIEW GUIDE 624

PROBLEMS 625

© Miroslav Hlavko/Shutterstock.com

CHAPTER 15 *Organic Compounds and the Atomic Properties of Carbon* 632

15.1 The Special Nature of Carbon and the Characteristics of Organic Molecules 633

The Structural Complexity of Organic Molecules 634
The Chemical Diversity of Organic Molecules 634

15.2 The Structures and Classes of Hydrocarbons 636

Carbon Skeletons and Hydrogen Skins 636
Alkanes: Hydrocarbons with Only Single Bonds 639
Dispersion Forces and the Physical Properties of Alkanes 641
Constitutional Isomerism 641
Chiral Molecules and Optical Isomerism 642
Alkenes: Hydrocarbons with Double Bonds 644

Restricted Rotation and Geometric (*cis-trans*) Isomerism 645

Alkynes: Hydrocarbons with Triple Bonds 646

Aromatic Hydrocarbons: Cyclic Molecules with Delocalized π Electrons 647

Variations on a Theme: Catenated Inorganic Hydrides 648

TOOLS OF THE LABORATORY: NUCLEAR MAGNETIC RESONANCE (NMR) SPECTROSCOPY 649

15.3 Some Important Classes of Organic Reactions 651

Types of Organic Reactions 651
The Redox Process in Organic Reactions 653

15.4 Properties and Reactivities of Common Functional Groups 654

Functional Groups with Only Single Bonds 654

Functional Groups with Double Bonds 659

Functional Groups with Both Single and Double Bonds 662

Functional Groups with Triple Bonds 666

15.5 The Monomer-Polymer Theme I: Synthetic Macromolecules 668

Addition Polymers 668
Condensation Polymers 669

15.6 The Monomer-Polymer Theme II: Biological Macromolecules 670

Sugars and Polysaccharides 670
Amino Acids and Proteins 672
Nucleotides and Nucleic Acids 674

CHEMICAL CONNECTIONS TO GENETICS AND FORENSICS: DNA SEQUENCING AND FINGERPRINTING 679

CHAPTER REVIEW GUIDE 681

PROBLEMS 683

CHAPTER 16 *Kinetics: Rates and Mechanisms of Chemical Reactions* 690

16.1 Focusing on Reaction Rate 691

16.2 Expressing the Reaction Rate 694

Average, Instantaneous, and Initial Reaction Rates 694
Expressing Rate in Terms of Reactant and Product Concentrations 696

16.3 The Rate Law and Its Components 698

Some Laboratory Methods for Determining the Initial Rate 699
Determining Reaction Orders 699
Determining the Rate Constant 704

16.4 Integrated Rate Laws: Concentration Changes over Time 707

Integrated Rate Laws for First-, Second-, and Zero-Order Reactions 708

Determining Reaction Orders from an Integrated Rate Law 709

Reaction Half-Life 711

16.5 Theories of Chemical Kinetics 715

Collision Theory: Basis of the Rate Law 715

Transition State Theory: What the Activation Energy Is Used For 718

16.6 Reaction Mechanisms: The Steps from Reactant to Product 721

Elementary Reactions and Molecularity 721

The Rate-Determining Step of a Reaction Mechanism 723

Correlating the Mechanism with the Rate Law 724

16.7 Catalysis: Speeding Up a Reaction 727

The Basis of Catalytic Action 728
Homogeneous Catalysis 728
Heterogeneous Catalysis 729
Kinetics and Function of Biological Catalysts 730

CHEMICAL CONNECTIONS TO ATMOSPHERIC SCIENCE: DEPLETION OF EARTH'S OZONE LAYER 732

CHAPTER REVIEW GUIDE 733

PROBLEMS 736

© hxdbzxy/Shutterstock.com

CHAPTER **17**

Equilibrium: The Extent of Chemical Reactions 746

17.1 The Equilibrium State and the Equilibrium Constant 747

17.2 The Reaction Quotient and the Equilibrium Constant 750

The Changing Value of the Reaction Quotient 750

Writing the Reaction Quotient in Its Various Forms 751

17.3 Expressing Equilibria with Pressure Terms: Relation Between K_c and K_p 756

17.4 Comparing Q and K to Determine Reaction Direction 757

17.5 How to Solve Equilibrium Problems 760

Using Quantities to Find the Equilibrium Constant 760

Using the Equilibrium Constant to Find Quantities 763

Problems Involving Mixtures of Reactants and Products 768

17.6 Reaction Conditions and Equilibrium: Le Châtelier's Principle 770

The Effect of a Change in Concentration 770

The Effect of a Change in Pressure (Volume) 773

The Effect of a Change in Temperature 775
The Lack of Effect of a Catalyst 777
Applying Le Châtelier's Principle to the Synthesis of Ammonia 779

CHEMICAL CONNECTIONS TO CELLULAR METABOLISM: DESIGN AND CONTROL OF A METABOLIC PATHWAY 781

CHAPTER REVIEW GUIDE 782

PROBLEMS 785

CHAPTER **18**

Acid-Base Equilibria 792

18.1 Acids and Bases in Water 794

Release of H⁺ or OH⁻ and the Arrhenius Acid-Base Definition 794

Variation in Acid Strength: The Acid-Dissociation Constant (K_a) 795

Classifying the Relative Strengths of Acids and Bases 797

18.2 Autoionization of Water and the pH Scale 798

The Equilibrium Nature of Autoionization: The Ion-Product Constant for Water (K_w) 799

Expressing the Hydronium Ion Concentration: The pH Scale 800

18.3 Proton Transfer and the Brønsted-Lowry Acid-Base Definition 803

Conjugate Acid-Base Pairs 804

Relative Acid-Base Strength and the Net Direction of Reaction 805

18.4 Solving Problems Involving Weak-Acid Equilibria 808

Finding K_a Given Concentrations 809

Finding Concentrations Given K_a 810

The Effect of Concentration on the Extent of Acid Dissociation 811

The Behavior of Polyprotic Acids 813

18.5 Molecular Properties and Acid Strength 816

Acid Strength of Nonmetal Hydrides 816

Acid Strength of Oxoacids 816

Acidity of Hydrated Metal Ions 817

18.6 Weak Bases and Their Relation to Weak Acids 818

Molecules as Weak Bases: Ammonia and the Amines 818

Anions of Weak Acids as Weak Bases 820

The Relation Between K_a and K_b of a Conjugate Acid-Base Pair 821

18.7 Acid-Base Properties of Salt Solutions 823

Salts That Yield Neutral Solutions 823

Salts That Yield Acidic Solutions 823

Salts That Yield Basic Solutions 824

Salts of Weakly Acidic Cations and Weakly Basic Anions 824

Salts of Amphiprotic Anions 825

18.8 Generalizing the Brønsted-Lowry Concept: The Leveling Effect 827

18.9 Electron-Pair Donation and the Lewis Acid-Base Definition 827

Molecules as Lewis Acids 828

Metal Cations as Lewis Acids 829

An Overview of Acid-Base Definitions 830

CHAPTER REVIEW GUIDE 831

PROBLEMS 834

© Joe Scherschel/Getty Images

CHAPTER 19

Ionic Equilibria in Aqueous Systems 842

19.1 Equilibria of Acid-Base Buffers 843

What a Buffer Is and How It Works: The Common-Ion Effect 843
The Henderson-Hasselbalch Equation 848
Buffer Capacity and Buffer Range 849
Preparing a Buffer 851

19.2 Acid-Base Titration Curves 853

Strong Acid–Strong Base Titration Curves 853
Weak Acid–Strong Base Titration Curves 855
Weak Base–Strong Acid Titration Curves 859
Monitoring pH with Acid-Base Indicators 860

Titration Curves for Polyprotic Acids 862

Amino Acids as Biological Polyprotic Acids 863

19.3 Equilibria of Slightly Soluble Ionic Compounds 864

The Ion-Product Expression (Q_{sp}) and the Solubility-Product Constant (K_{sp}) 864
Calculations Involving the Solubility-Product Constant 865
Effect of a Common Ion on Solubility 868
Effect of pH on Solubility 869
Applying Ionic Equilibria to the Formation of a Limestone Cave 870
Predicting the Formation of a Precipitate: Q_{sp} vs. K_{sp} 871

Separating Ions by Selective Precipitation and Simultaneous Equilibria 874

CHEMICAL CONNECTIONS TO ENVIRONMENTAL SCIENCE: THE ACID-RAIN PROBLEM 875

19.4 Equilibria Involving Complex Ions 877

Formation of Complex Ions 877
Complex Ions and the Solubility of Precipitates 879
Complex Ions of Amphibolic Hydroxides 881

CHAPTER REVIEW GUIDE 883

PROBLEMS 887

CHAPTER

20

Thermodynamics: Entropy, Free Energy, and Reaction Direction 894

20.1 The Second Law of Thermodynamics: Predicting Spontaneous Change 895

The First Law of Thermodynamics Does Not Predict Spontaneous Change 896
The Sign of ΔH Does Not Predict Spontaneous Change 896
Freedom of Particle Motion and Dispersal of Kinetic Energy 898
Entropy and the Number of Microstates 901
Entropy and the Second Law of Thermodynamics 901
Standard Molar Entropies and the Third Law 901
Predicting Relative S° of a System 902

20.2 Calculating the Change in Entropy of a Reaction 906

Entropy Changes in the System: Standard Entropy of Reaction (ΔS_{rxn}°) 906
Entropy Changes in the Surroundings: The Other Part of the Total 908
The Entropy Change and the Equilibrium State 910
Spontaneous Exothermic and Endothermic Changes 911

20.3 Entropy, Free Energy, and Work 912

Free Energy Change and Reaction Spontaneity 912
Calculating Standard Free Energy Changes 913

The Free Energy Change and the Work a System Can Do 915
The Effect of Temperature on Reaction Spontaneity 916

Coupling of Reactions to Drive a Nonspontaneous Change 920

CHEMICAL CONNECTIONS TO BIOLOGICAL ENERGETICS: THE UNIVERSAL ROLE OF ATP 921

20.4 Free Energy, Equilibrium, and Reaction Direction 922

CHAPTER REVIEW GUIDE 928
PROBLEMS 931

© Griffin Technology

CHAPTER **21** *Electrochemistry: Chemical Change and Electrical Work* **938**

21.1 Redox Reactions and Electrochemical Cells **939**

A Quick Review of Oxidation-Reduction Concepts 939
Half-Reaction Method for Balancing Redox Reactions 940
An Overview of Electrochemical Cells 944

21.2 Voltaic Cells: Using Spontaneous Reactions to Generate Electrical Energy **945**

Construction and Operation of a Voltaic Cell 946
Notation for a Voltaic Cell 948
Why Does a Voltaic Cell Work? 949

21.3 Cell Potential: Output of a Voltaic Cell **950**

Standard Cell Potential (E_{cell}°) 950
Relative Strengths of Oxidizing and Reducing Agents 953

Using $E_{\text{half-cell}}^{\circ}$ Values to Write Spontaneous Redox Reactions 954
Explaining the Activity Series of the Metals 958

21.4 Free Energy and Electrical Work **959**

Standard Cell Potential and the Equilibrium Constant 959
The Effect of Concentration on Cell Potential 961
Following Changes in Potential During Cell Operation 963
Concentration Cells 964

21.5 Electrochemical Processes in Batteries **968**

Primary (Nonrechargeable) Batteries 968
Secondary (Rechargeable) Batteries 969
Fuel Cells 970

21.6 Corrosion: An Environmental Voltaic Cell **972**

The Corrosion of Iron 972
Protecting Against the Corrosion of Iron 973

21.7 Electrolytic Cells: Using Electrical Energy to Drive Nonspontaneous Reactions **974**

Construction and Operation of an Electrolytic Cell 974
Predicting the Products of Electrolysis 976
Stoichiometry of Electrolysis: The Relation Between Amounts of Charge and Products 980

CHEMICAL CONNECTIONS TO BIOLOGICAL ENERGETICS: CELLULAR ELECTROCHEMISTRY AND THE PRODUCTION OF ATP **982**

CHAPTER REVIEW GUIDE 984

PROBLEMS 987

CHAPTER **22** *The Elements in Nature and Industry* **996**

22.1 How the Elements Occur in Nature **997**

Earth's Structure and the Abundance of the Elements 997
Sources of the Elements 1000

22.2 The Cycling of Elements Through the Environment **1002**

The Carbon Cycle 1002
The Nitrogen Cycle 1004
The Phosphorus Cycle 1005

22.3 Metallurgy: Extracting a Metal from Its Ore **1008**

Pretreating the Ore 1009
Converting Mineral to Element 1010
Refining and Alloying the Element 1012

22.4 Tapping the Crust: Isolation and Uses of Selected Elements **1014**

Producing the Alkali Metals: Sodium and Potassium 1014
The Indispensable Three: Iron, Copper, and Aluminum 1015

Mining the Sea for Magnesium 1021
The Sources and Uses of Hydrogen 1022

22.5 Chemical Manufacturing: Two Case Studies **1025**

Sulfuric Acid, the Most Important Chemical 1025
The Chlor-Alkali Process 1028

CHAPTER REVIEW GUIDE 1029

PROBLEMS 1030

© PjrStudio/Alamy

CHAPTER 23

Transition Elements and Their Coordination Compounds 1036

23.1 Properties of the Transition Elements 1037

- Electron Configurations of the Transition Metals and Their Ions 1038
- Atomic and Physical Properties of the Transition Elements 1040
- Chemical Properties of the Transition Elements 1042

23.2 The Inner Transition Elements 1044

- The Lanthanides 1044
- The Actinides 1045

23.3 Coordination Compounds 1046

- Complex Ions: Coordination Numbers, Geometries, and Ligands 1046
- Formulas and Names of Coordination Compounds 1048
- Isomerism in Coordination Compounds 1051

23.4 Theoretical Basis for the Bonding and Properties of Complex Ions 1055

- Applying Valence Bond Theory to Complex Ions 1055
- Crystal Field Theory 1056

CHEMICAL CONNECTIONS TO NUTRITIONAL SCIENCE: TRANSITION METALS AS ESSENTIAL DIETARY TRACE ELEMENTS 1063

CHAPTER REVIEW GUIDE 1065

PROBLEMS 1067

CHAPTER

24

Nuclear Reactions and Their Applications 1072

24.1 Radioactive Decay and Nuclear Stability 1073

- Comparing Chemical and Nuclear Change 1074
- The Components of the Nucleus: Terms and Notation 1074
- The Discovery of Radioactivity and the Types of Emissions 1075
- Modes of Radioactive Decay; Balancing Nuclear Equations 1075
- Nuclear Stability and the Mode of Decay 1079

24.2 The Kinetics of Radioactive Decay 1083

- Detection and Measurement of Radioactivity 1083
- The Rate of Radioactive Decay 1084
- Radioisotopic Dating 1087

24.3 Nuclear Transmutation: Induced Changes in Nuclei 1090

- Early Transmutation Experiments; Nuclear Shorthand Notation 1090
- Particle Accelerators and the Transuranium Elements 1091

24.4 Ionization: Effects of Nuclear Radiation on Matter 1093

- Effects of Ionizing Radiation on Living Tissue 1093
- Background Sources of Ionizing Radiation 1095
- Assessing the Risk from Ionizing Radiation 1096

24.5 Applications of Radioisotopes 1098

- Radioactive Tracers 1098
- Additional Applications of Ionizing Radiation 1100

24.6 The Interconversion of Mass and Energy 1101

- The Mass Difference Between a Nucleus and Its Nucleons 1101
- Nuclear Binding Energy and Binding Energy per Nucleon 1102

24.7 Applications of Fission and Fusion 1104

- The Process of Nuclear Fission 1105
- The Promise of Nuclear Fusion 1109

CHEMICAL CONNECTIONS TO COSMOLOGY: ORIGIN OF THE ELEMENTS IN THE STARS 1110

CHAPTER REVIEW GUIDE 1112

PROBLEMS 1114

- Appendix A** Common Mathematical Operations in Chemistry A-1
Appendix B Standard Thermodynamic Values for Selected Substances A-5
Appendix C Equilibrium Constants for Selected Substances A-8

- Appendix D** Standard Electrode (Half-Cell) Potentials A-14
Appendix E Answers to Selected Problems A-15

- Glossary G-1**
Index I-1

LIST OF SAMPLE PROBLEMS (*Molecular-scene problems are shown in color.*)**Chapter 1**

- 1.1 Visualizing Change on the Atomic Scale 6
- 1.2 Distinguishing Between Physical and Chemical Change 7
- 1.3 Converting Units of Length 20
- 1.4 Converting Units of Volume 21
- 1.5 Converting Units of Mass 22
- 1.6 Converting Units Raised to a Power 23
- 1.7 Calculating Density from Mass and Volume 24
- 1.8 Converting Units of Temperature 27
- 1.9 Determining the Number of Significant Figures 29
- 1.10 Significant Figures and Rounding 32

Chapter 2

- 2.1 Distinguishing Elements, Compounds, and Mixtures at the Atomic Scale 45
- 2.2 Calculating the Mass of an Element in a Compound 48
- 2.3 Visualizing the Mass Laws 51
- 2.4 Determining the Numbers of Subatomic Particles in the Isotopes of an Element 57
- 2.5 Calculating the Atomic Mass of an Element 58
- 2.6 Identifying an Element from Its Z Value 62
- 2.7 Predicting the Ion an Element Forms 66
- 2.8 Naming Binary Ionic Compounds 69
- 2.9 Determining Formulas of Binary Ionic Compounds 70
- 2.10 Determining Names and Formulas of Ionic Compounds of Metals That Form More Than One Ion 71
- 2.11 Determining Names and Formulas of Ionic Compounds Containing Polyatomic Ions (Including Hydrates) 73
- 2.12 Recognizing Incorrect Names and Formulas of Ionic Compounds 73
- 2.13 Determining Names and Formulas of Anions and Acids 74
- 2.14 Determining Names and Formulas of Binary Covalent Compounds 75
- 2.15 Recognizing Incorrect Names and Formulas of Binary Covalent Compounds 75
- 2.16 Calculating the Molecular Mass of a Compound 77
- 2.17 Using Molecular Depictions to Determine Formula, Name, and Mass 77

Chapter 3

- 3.1 Converting Between Mass and Amount of an Element 98
- 3.2 Converting Between Number of Entities and Amount of an Element 99
- 3.3 Converting Between Number of Entities and Mass of an Element 99
- 3.4 Converting Between Number of Entities and Mass of a Compound I 100
- 3.5 Converting Between Number of Entities and Mass of a Compound II 101
- 3.6 Calculating the Mass Percent of Each Element in a Compound from the Formula 102
- 3.7 Calculating the Mass of an Element in a Compound 104
- 3.8 Determining an Empirical Formula from Amounts of Elements 105
- 3.9 Determining an Empirical Formula from Masses of Elements 106
- 3.10 Determining a Molecular Formula from Elemental Analysis and Molar Mass 107
- 3.11 Determining a Molecular Formula from Combustion Analysis 108
- 3.12 Balancing a Chemical Equation 114

- 3.13 Writing a Balanced Equation from a Molecular Scene 115
- 3.14 Calculating Quantities of Reactants and Products: Amount (mol) to Amount (mol) 118
- 3.15 Calculating Quantities of Reactants and Products: Amount (mol) to Mass (g) 119
- 3.16 Calculating Quantities of Reactants and Products: Mass to Mass 120
- 3.17 Writing an Overall Equation for a Reaction Sequence 121
- 3.18 Using Molecular Depictions in a Limiting-Reactant Problem 123
- 3.19 Calculating Quantities in a Limiting-Reactant Problem: Amount to Amount 125
- 3.20 Calculating Quantities in a Limiting-Reactant Problem: Mass to Mass 125
- 3.21 Calculating Percent Yield 128

Chapter 4

- 4.1 Using Molecular Scenes to Depict an Ionic Compound in Aqueous Solution 148
- 4.2 Determining Amount (mol) of Ions in Solution 149
- 4.3 Calculating the Molarity of a Solution 150
- 4.4 Calculating Mass of Solute in a Given Volume of Solution 151
- 4.5 Determining Amount (mol) of Ions in a Solution 151
- 4.6 Preparing a Dilute Solution from a Concentrated Solution 153
- 4.7 Visualizing Changes in Concentration 154
- 4.8 Predicting Whether a Precipitation Reaction Occurs; Writing Ionic Equations 159
- 4.9 Using Molecular Depictions in Precipitation Reactions 160
- 4.10 Calculating Amounts of Reactants and Products in a Precipitation Reaction 162
- 4.11 Solving a Limiting-Reactant Problem for a Precipitation Reaction 163
- 4.12 Determining the Number of H⁺ (or OH⁻) Ions in Solution 166
- 4.13 Writing Ionic Equations for Acid-Base Reactions 167
- 4.14 Writing Proton-Transfer Equations for Acid-Base Reactions 171
- 4.15 Calculating the Amounts of Reactants and Products in an Acid-Base Reaction 172
- 4.16 Finding the Concentration of an Acid from a Titration 173
- 4.17 Determining the Oxidation Number of Each Element in a Compound (or Ion) 177
- 4.18 Identifying Redox Reactions and Oxidizing and Reducing Agents 178
- 4.19 Finding the Amount of Reducing Agent by Titration 180
- 4.20 Identifying the Type of Redox Reaction 187

Chapter 5

- 5.1 Converting Units of Pressure 210
- 5.2 Applying the Volume-Pressure Relationship 217
- 5.3 Applying the Volume-Temperature and Pressure-Temperature Relationships 218
- 5.4 Applying the Volume-Amount and Pressure-Amount Relationships 218
- 5.5 Applying the Volume-Pressure-Temperature Relationship 219
- 5.6 Solving for an Unknown Gas Variable at Fixed Conditions 220
- 5.7 Using Gas Laws to Determine a Balanced Equation 221
- 5.8 Calculating Gas Density 223
- 5.9 Finding the Molar Mass of a Volatile Liquid 225
- 5.10 Applying Dalton's Law of Partial Pressures 226
- 5.11 Calculating the Amount of Gas Collected over Water 228

- 5.12 Using Gas Variables to Find Amounts of Reactants or Products I 229
 5.13 Using Gas Variables to Find Amounts of Reactants or Products II 230
 5.14 Applying Graham's Law of Effusion 236

Chapter 6

- 6.1 Determining the Change in Internal Energy of a System 262
 6.2 Calculating Pressure-Volume Work Done by or on a System 264
 6.3 Drawing Enthalpy Diagrams and Determining the Sign of ΔH 267
 6.4 Relating Quantity of Heat and Temperature Change 269
 6.5 Determining the Specific Heat Capacity of a Solid 270
 6.6 Determining the Enthalpy Change of an Aqueous Reaction 270
 6.7 Calculating the Heat of a Combustion Reaction 272
 6.8 Using the Enthalpy Change of a Reaction (ΔH) to Find the Amount of a Substance 274
 6.9 Using Hess's Law to Calculate an Unknown ΔH 276
 6.10 Writing Formation Equations 278
 6.11 Calculating ΔH_{rxn}° from ΔH_f° Values 280

Chapter 7

- 7.1 Interconverting Wavelength and Frequency 297
 7.2 Interconverting Energy, Wavelength, and Frequency 301
 7.3 Determining ΔE and λ of an Electron Transition 307
 7.4 Calculating the de Broglie Wavelength of an Electron 311
 7.5 Applying the Uncertainty Principle 313
 7.6 Determining Quantum Numbers for an Energy Level 317
 7.7 Determining Sublevel Names and Orbital Quantum Numbers 318
 7.8 Identifying Incorrect Quantum Numbers 318

Chapter 8

- 8.1 Correlating Quantum Numbers and Orbital Diagrams 337
 8.2 Determining Electron Configurations 344
 8.3 Ranking Elements by Atomic Size 347
 8.4 Ranking Elements by First Ionization Energy 350
 8.5 Identifying an Element from Its Ionization Energies 351
 8.6 Writing Electron Configurations of Main-Group Ions 356
 8.7 Writing Electron Configurations and Predicting Magnetic Behavior of Transition Metal Ions 358
 8.8 Ranking Ions by Size 360

Chapter 9

- 9.1 Depicting Ion Formation 372
 9.2 Predicting Relative Lattice Energy from Ionic Properties 376
 9.3 Comparing Bond Length and Bond Strength 382
 9.4 Using Bond Energies to Calculate ΔH_{rxn}° 389
 9.5 Determining Bond Polarity from EN Values 393

Chapter 10

- 10.1 Writing Lewis Structures for Species with Single Bonds and One Central Atom 407
 10.2 Writing Lewis Structures for Molecules with Single Bonds and More Than One Central Atom 408
 10.3 Writing Lewis Structures for Molecules with Multiple Bonds 409
 10.4 Writing Resonance Structures and Assigning Formal Charges 412
 10.5 Writing Lewis Structures for Octet-Rule Exceptions 416
 10.6 Examining Shapes with Two, Three, or Four Electron Groups 425
 10.7 Examining Shapes with Five or Six Electron Groups 426

- 10.8 Predicting Molecular Shapes with More Than One Central Atom 427
 10.9 Predicting the Polarity of Molecules 429

Chapter 11

- 11.1 Postulating Hybrid Orbitals in a Molecule 449
 11.2 Describing the Types of Orbitals and Bonds in Molecules 454
 11.3 Predicting Stability of Species Using MO Diagrams 457
 11.4 Using MO Theory to Explain Bond Properties 461

Chapter 12

- 12.1 Finding the Heat of a Phase Change Depicted by Molecular Scenes 477
 12.2 Applying the Clausius-Clapeyron Equation 480
 12.3 Using a Phase Diagram to Predict Phase Changes 483
 12.4 Drawing Hydrogen Bonds Between Molecules of a Substance 487
 12.5 Identifying the Types of Intermolecular Forces 489
 12.6 Determining the Number of Particles per Unit Cell and the Coordination Number 497
 12.7 Determining Atomic Radius 500
 12.8 Determining Atomic Radius from the Unit Cell 501

Chapter 13

- 13.1 Predicting Relative Solubilities 537
 13.2 Calculating an Aqueous Ionic Heat of Solution 546
 13.3 Using Henry's Law to Calculate Gas Solubility 552
 13.4 Calculating Molality 553
 13.5 Expressing Concentrations in Parts by Mass, Parts by Volume, and Mole Fraction 555
 13.6 Interconverting Concentration Terms 556
 13.7 Using Raoult's Law to Find ΔP 559
 13.8 Determining Boiling and Freezing Points of a Solution 561
 13.9 Determining Molar Mass from Colligative Properties 563
 13.10 Depicting Strong Electrolyte Solutions 565

Chapter 15

- 15.1 Drawing Hydrocarbons 637
 15.2 Naming Hydrocarbons and Understanding Chirality and Geometric Isomerism 646
 15.3 Recognizing the Type of Organic Reaction 652
 15.4 Predicting the Reactions of Alcohols, Alkyl Halides, and Amines 658
 15.5 Predicting the Steps in a Reaction Sequence 661
 15.6 Predicting Reactions of the Carboxylic Acid Family 665
 15.7 Recognizing Functional Groups 667

Chapter 16

- 16.1 Expressing Rate in Terms of Changes in Concentration with Time 697
 16.2 Determining Reaction Orders from Rate Laws 701
 16.3 Determining Reaction Orders and Rate Constants from Rate Data 705
 16.4 Determining Reaction Orders from Molecular Scenes 707
 16.5 Determining the Reactant Concentration After a Given Time 708
 16.6 Using Molecular Scenes to Find Quantities at Various Times 712
 16.7 Determining the Half-Life of a First-Order Reaction 713
 16.8 Determining the Energy of Activation 717
 16.9 Drawing Reaction Energy Diagrams and Transition States 720
 16.10 Determining Molecularities and Rate Laws for Elementary Steps 722
 16.11 Identifying Intermediates and Correlating Rate Laws and Reaction Mechanisms 725

Chapter 17

- 17.1 Writing the Reaction Quotient from the Balanced Equation 752
 17.2 Finding K for Reactions Multiplied by a Common Factor or Reversed and for an Overall Reaction 754
 17.3 Converting Between K_c and K_p 757
 17.4 Using Molecular Scenes to Determine Reaction Direction 758
 17.5 Using Concentrations to Determine Reaction Direction 759
 17.6 Calculating K_c from Concentration Data 762
 17.7 Determining Equilibrium Concentrations from K_c 763
 17.8 Determining Equilibrium Concentrations from Initial Concentrations and K_c 763
 17.9 Making a Simplifying Assumption to Calculate Equilibrium Concentrations 766
 17.10 Predicting Reaction Direction and Calculating Equilibrium Concentrations 768
 17.11 Predicting the Effect of a Change in Concentration on the Equilibrium Position 772
 17.12 Predicting the Effect of a Change in Volume (Pressure) on the Equilibrium Position 774
 17.13 Predicting the Effect of a Change in Temperature on the Equilibrium Position 776
 17.14 Determining Equilibrium Parameters from Molecular Scenes 778

Chapter 18

- 18.1 Classifying Acid and Base Strength from the Chemical Formula 798
 18.2 Calculating $[\text{H}_3\text{O}^+]$ or $[\text{OH}^-]$ in Aqueous Solution 800
 18.3 Calculating $[\text{H}_3\text{O}^+]$, pH, $[\text{OH}^-]$, and pOH for Strong Acids and Bases 802
 18.4 Identifying Conjugate Acid-Base Pairs 805
 18.5 Predicting the Net Direction of an Acid-Base Reaction 807
 18.6 Using Molecular Scenes to Predict the Net Direction of an Acid-Base Reaction 807
 18.7 Finding K_a of a Weak Acid from the Solution pH 809
 18.8 Determining Concentration and pH from K_a and Initial $[\text{HA}]$ 810
 18.9 Finding the Percent Dissociation of a Weak Acid 812
 18.10 Calculating Equilibrium Concentrations for a Polyprotic Acid 814
 18.11 Determining pH from K_b and Initial $[\text{B}]$ 819
 18.12 Determining the pH of a Solution of A^- 822
 18.13 Predicting Relative Acidity of Salt Solutions from Reactions of the Ions with Water 824
 18.14 Predicting the Relative Acidity of a Salt Solution from K_a and K_b of the Ions 826
 18.15 Identifying Lewis Acids and Bases 830

Chapter 19

- 19.1 Calculating the Effect of Added H_3O^+ or OH^- on Buffer pH 846
 19.2 Using Molecular Scenes to Examine Buffers 850
 19.3 Preparing a Buffer 851
 19.4 Finding the pH During a Weak Acid–Strong Base Titration 857
 19.5 Writing Ion-Product Expressions 865
 19.6 Determining K_{sp} from Solubility 866
 19.7 Determining Solubility from K_{sp} 867
 19.8 Calculating the Effect of a Common Ion on Solubility 869
 19.9 Predicting the Effect on Solubility of Adding Strong Acid 870

- 19.10 Predicting Whether a Precipitate Will Form 871
 19.11 Using Molecular Scenes to Predict Whether a Precipitate Will Form 872
 19.12 Separating Ions by Selective Precipitation 874
 19.13 Calculating the Concentration of a Complex Ion 878
 19.14 Calculating the Effect of Complex-Ion Formation on Solubility 880

Chapter 20

- 20.1 Predicting Relative Entropy Values 905
 20.2 Calculating the Standard Entropy of Reaction, $\Delta S_{\text{rxn}}^\circ$ 907
 20.3 Determining Reaction Spontaneity 909
 20.4 Calculating $\Delta G_{\text{rxn}}^\circ$ from Enthalpy and Entropy Values 913
 20.5 Calculating $\Delta G_{\text{rxn}}^\circ$ from ΔG_f° Values 915
 20.6 Using Molecular Scenes to Determine the Signs of ΔH , ΔS , and ΔG 917
 20.7 Determining the Effect of Temperature on ΔG 918
 20.8 Finding the Temperature at Which a Reaction Becomes Spontaneous 919
 20.9 Exploring the Relationship Between ΔG° and K 923
 20.10 Using Molecular Scenes to Find ΔG for a Reaction at Nonstandard Conditions 924
 20.11 Calculating ΔG at Nonstandard Conditions 926

Chapter 21

- 21.1 Balancing a Redox Reaction in Basic Solution 942
 21.2 Describing a Voltaic Cell with a Diagram and Notation 948
 21.3 Using $E_{\text{half-cell}}^\circ$ Values to Find E_{cell}° 951
 21.4 Calculating an Unknown $E_{\text{half-cell}}^\circ$ from E_{cell}° 953
 21.5 Writing Spontaneous Redox Reactions and Ranking Oxidizing and Reducing Agents by Strength 956
 21.6 Calculating K and ΔG° from E_{cell}° 961
 21.7 Using the Nernst Equation to Calculate E_{cell}° 962
 21.8 Calculating the Potential of a Concentration Cell 966
 21.9 Predicting the Electrolysis Products of a Molten Salt Mixture 977
 21.10 Predicting the Electrolysis Products of Aqueous Salt Solutions 979
 21.11 Applying the Relationship Among Current, Time, and Amount of Substance 981

Chapter 23

- 23.1 Writing Electron Configurations of Transition Metal Atoms and Ions 1040
 23.2 Finding the Number of Unpaired Electrons 1045
 23.3 Finding the Coordination Number and Charge of the Central Metal Ion in a Coordination Compound 1049
 23.4 Writing Names and Formulas of Coordination Compounds 1050
 23.5 Determining the Type of Stereoisomerism 1054
 23.6 Ranking Crystal Field Splitting Energies (Δ) for Complex Ions of a Metal 1059
 23.7 Identifying High-Spin and Low-Spin Complex Ions 1061

Chapter 24

- 24.1 Writing Equations for Nuclear Reactions 1078
 24.2 Predicting Nuclear Stability 1080
 24.3 Predicting the Mode of Nuclear Decay 1082
 24.4 Calculating the Specific Activity and the Decay Constant of a Radioactive Nuclide 1085
 24.5 Finding the Number of Radioactive Nuclei 1086
 24.6 Applying Radiocarbon Dating 1089
 24.7 Calculating the Binding Energy per Nucleon 1103

ABOUT THE AUTHORS

Martin S. Silberberg received a B.S. in Chemistry from the City University of New York and a Ph.D. in Chemistry from the University of Oklahoma. He then accepted a position as research associate in analytical biochemistry at the Albert Einstein College of Medicine in New York City, where he developed methods to study neurotransmitter metabolism in Parkinson's disease and other neurological disorders. Following six years in neurochemical research, Dr. Silberberg joined the faculty of Bard College at Simon's Rock, a liberal arts college known for its excellence in teaching small classes of highly motivated students. As head of the Natural Sciences Major and Director of Premedical Studies, he taught courses in general chemistry, organic chemistry, biochemistry, and liberal-arts chemistry. The small class size and close student contact afforded him insights into how students learn chemistry, where they have difficulties, and what strategies can help them succeed. Dr. Silberberg decided to apply these insights in a broader context and established a textbook writing, editing, and consulting company. Before writing his own texts, he worked as a consulting and development editor on chemistry, biochemistry, and physics texts for several major college publishers. He resides with his wife Ruth in the Pioneer Valley near Amherst, Massachusetts, where he enjoys the rich cultural and academic life of the area and relaxes by traveling, gardening, and singing.

Patricia G. Amateis graduated with a B.S. in Chemistry Education from Concord University in West Virginia and a Ph.D. in Analytical Chemistry from Virginia Tech. She has been on the faculty of the Chemistry Department at Virginia Tech for 31 years, teaching General Chemistry and Analytical Chemistry. For the past 16 years, she has served as Director of General Chemistry, responsible for the oversight of both the lecture and lab portions of the large General Chemistry program. She has taught thousands of students during her career and has been awarded the University Sporn Award for Introductory Teaching, the Alumni Teaching Award, and the William E. Wine Award for a history of university teaching excellence. She and her husband live in Blacksburg, Virginia and are the parents of three adult children. In her free time, she enjoys biking, hiking, competing in the occasional sprint triathlon, and playing the double second in Panjammers, Blacksburg's steel drum band.

PREFACE

Chemistry is so crucial to an understanding of medicine and biology, environmental science, and many areas of engineering and industrial processing that it has become a requirement for an increasing number of academic majors. Furthermore, chemical principles lie at the core of some of the key societal issues we face in the 21st century—dealing with climate change, finding new energy options, and supplying nutrition and curing disease on an ever more populated planet.

SETTING THE STANDARD FOR A CHEMISTRY TEXT

The eighth edition of *Chemistry: The Molecular Nature of Matter and Change* maintains its standard-setting position among general chemistry textbooks by evolving further to meet the needs of professor and student. The text still contains the most accurate molecular illustrations, consistent step-by-step worked problems, and an extensive collection of end-of-chapter problems. And changes throughout this edition make the text more readable and succinct, the artwork more teachable and modern, and the design more focused and inviting. The three hallmarks that have made this text a market leader are now demonstrated in its pages more clearly than ever.

Visualizing Chemical Models—Macroscopic to Molecular

Chemistry deals with observable changes caused by unobservable atomic-scale events, requiring an appreciation of a size gap of mind-boggling proportions. One of the text's goals coincides with that of so many instructors: to help students visualize chemical events on the molecular scale. Thus, concepts are explained first at the macroscopic level and then from a molecular point of view, with pedagogic illustrations always placed next to the discussions to bring the point home for today's visually oriented students.

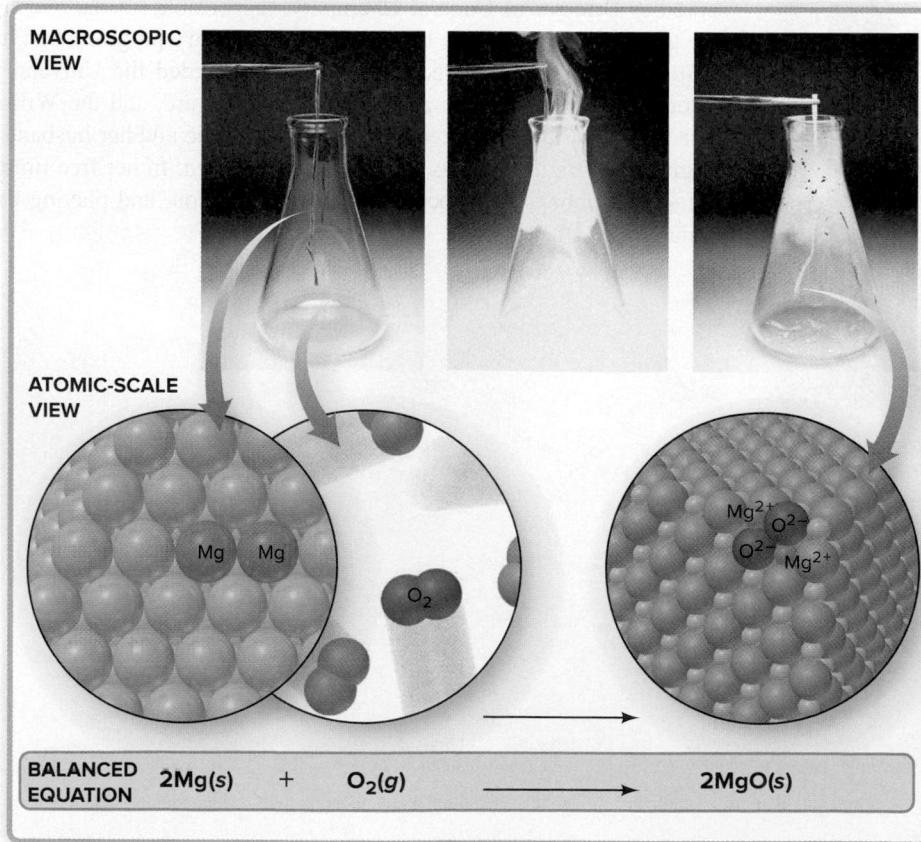

Thinking Logically to Solve Problems

The problem-solving approach, based on the four-step method widely accepted by experts in chemical education, is introduced in Chapter 1 and employed *consistently* throughout the text. It encourages students to *plan* a logical approach to a problem, and only then proceed to *solve* it. Each sample problem includes a *check*, which fosters the habit of “thinking through” both the chemical and the quantitative reasonableness of the answer. Finally, for *practice* and reinforcement, each sample problem is followed immediately by *two* similar follow-up problems. And, *Chemistry* marries problem solving to visualizing models with molecular-scene problems, which appear not only in homework sets, as in other texts, but also in the running text, where they are worked out stepwise.

SAMPLE PROBLEM 2.3

Visualizing the Mass Laws

Problem The scenes below represent an atomic-scale view of a chemical reaction:

Which of the mass laws—mass conservation, definite composition, and/or multiple proportions—is (are) illustrated?

Plan From the depictions, we note the numbers, colors, and combinations of atoms (spheres) to see which mass laws pertain. If the numbers of each atom are the same before and after the reaction, the total mass did not change (mass conservation). If a compound forms that always has the same atom ratio, the elements are present in fixed parts by mass (definite composition). If the same elements form different compounds and the ratio of the atoms of one element that combine with one atom of the other element is a small whole number, the ratio of their masses is a small whole number as well (multiple proportions).

Solution There are seven purple and nine green atoms in each circle, so mass is conserved. The compound formed has one purple and two green atoms, so it has definite composition. Only one compound forms, so the law of multiple proportions does not pertain.

FOLLOW-UP PROBLEMS

2.3A The following scenes represent a chemical change. Which of the mass laws is (are) illustrated?

2.3B Which sample(s) best display(s) the fact that compounds of bromine (*orange*) and fluorine (*yellow*) exhibit the law of multiple proportions? Explain.

SOME SIMILAR PROBLEMS 2.14 and 2.15

Determining an Empirical Formula from Masses of Elements

Problem Analysis of a sample of an ionic compound yields 2.82 g of Na, 4.35 g of Cl, and 7.83 g of O. What are the empirical formula and the name of the compound?

Plan This problem is similar to Sample Problem 3.8, except that we are given element *masses* that we must convert into integer subscripts. We first divide each mass by the element's molar mass to find the amount (mol). Then we construct a preliminary formula and convert the amounts (mol) to integers.

Solution Finding amount (mol) of each element:

$$\text{Amount (mol) of Na} = 2.82 \frac{\text{g Na}}{22.99 \frac{\text{g Na}}{\text{mol}}} = 0.123 \text{ mol Na}$$

$$\text{Amount (mol) of Cl} = 4.35 \frac{\text{g Cl}}{35.45 \frac{\text{g Cl}}{\text{mol}}} = 0.123 \text{ mol Cl}$$

$$\text{Amount (mol) of O} = 7.83 \frac{\text{g O}}{16.00 \frac{\text{g O}}{\text{mol}}} = 0.489 \text{ mol O}$$

Constructing a preliminary formula: $\text{Na}_{0.123}\text{Cl}_{0.123}\text{O}_{0.489}$

Converting to integer subscripts (dividing all by the smallest subscript):

The empirical formula is NaClO_4 ; the name is sodium perchlorate.

Check The numbers of moles seem correct because the masses of Na and Cl are slightly more than 0.1 of their molar masses. The mass of O is greatest and its molar mass is smallest, so it should have the greatest number of moles. The ratio of subscripts, 1/1/4, is the same as the ratio of moles, 0.123/0.123/0.489 (within rounding).

FOLLOW-UP PROBLEMS

of an unknown compound is found to contain 1.23 g of H, 12.64 g of O. What is the empirical formula and the name of the compound?

Iron metal M reacts with sulfur to form a compound with the formula of M reacts with 2.88 g of S, what are the names of M and M_2S_3 ? [Hint: convert (mol) of S, and use the formula to find the amount (mol) of M.]

PROBLEMS 3.42(b), 3.43(b), 3.46, and 3.47

Applying Ideas to the Real World

As the most practical science, chemistry should have a textbook that highlights its countless applications. Moreover, today's students may enter emerging chemistry-related hybrid fields, like biomaterials science or planetary geochemistry, and the text they use should point out the relevance of chemical concepts to such related sciences. The *Chemical Connections and Tools of the Laboratory* boxed essays (which include problems for added relevance), the more pedagogic margin notes, and the many applications woven into the chapter content are up-to-date, student-friendly features that are directly related to the neighboring content.

CHEMICAL CONNECTIONS TO ENVIRONMENTAL ENGINEERING

Solutions and Colloids in Water Purification

TOOLS OF THE LABORATORY

Nuclear Magnetic Resonance (NMR) Spectroscopy

Water Treatment Plants
Treating water involves several steps (Figure B13.1):

- Step 1. Screening and settling.** As water enters the facility, screens remove debris, and settling removes sand and other particles.
- Step 2. Coagulating.** This step and the next two remove colloids. These particles have negative charges that repel each other. Added aluminum sulfate [cake alum; $\text{Al}_2(\text{SO}_4)_3$] or iron(III) chloride (FeCl_3), which supply Al^{3+} or Fe^{3+} ions that neutralize the charges, coagulates the particles through intermolecular forces.
- Step 3. Flocculating and sedimenting.** Mixing water and flocculating agents in large basins causes a fluffy floc to form. Added carbon dioxide (CO₂) forms thin bridges between floc particles, which grow bigger and float into other basins, where they form a sediment and are removed. Some plants use dissolved air flotation (DAF) instead; bubbles forced through the water attach to the flocs, and the floating mass is skimmed off.
- Step 4. Filtering.** Various filters remove remaining particles. In slow sand filters, the water passes through sand and/or gravel of increasing particle size. In rapid sand filters, the sand is back-washed with water, and the colloid mass is removed. Membrane filters (not shown) with pore sizes of 0.1–10 µm are small tubes bundled together inside a vessel. The water is forced into these tubes, and the colloid mass is strained out. Membrane filters are resistant to disinfectants.

Figure B13.1 The water treatment facility at the Orange County Water District in California.

Step 5. Disinfecting. Water sources often contain harmful microorganisms that are killed by one of three agents:

- Chlorine, as aqueous bleach (ClO_4^-) or Cl_2 , is most common, but carcinogenic chlorinated organic compounds can form.
- UV light emitted by high-intensity fluorescent tubes disinfects by disrupting microorganisms' DNA.
- Ozone (O_3) gas is a powerful oxidizing agent.

Sodium fluoride (NaF) to prevent tooth decay and phosphate salts may be added to remove these dissolved particles.

Step 6 (not shown). Adsorbing onto granular activated carbon (GAC). Petroleum and other organic contaminants are removed by adsorption. GAC is a highly porous agent formed by "activating" wood, coal, or coconut shells with steam: 1 kg of GAC has a surface area of 275 acres!

Water Softening via Ion Exchange

Water with large amounts of Ca^{2+} and Mg^{2+} ions, such as hard water. Combined with fatty-acid anions in soap, these cations form solid deposits on clothes, washing machines, and sinks:

$$\text{Ca}^{2+}(aq) + 2\text{C}_8\text{H}_{17}\text{COONa}(aq) \longrightarrow \text{CaCO}_3(s) + \text{CO}_2(g) + \text{H}_2\text{O}(l)$$

When a large amount of HCO_3^- is present, the cations form scale, a carbonate deposit in boilers and hot-water pipes that interferes with the transfer of heat:

$$\text{Ca}^{2+}(aq) + 2\text{HCO}_3^-(aq) \longrightarrow \text{CaCO}_3(s) + \text{CO}_2(g) + \text{H}_2\text{O}(l)$$

Figure B13.2 Ion exchange to remove hard-water cations.

Membrane Processes and Reverse Osmosis

Membranes with 0.0001–0.01 µm pores can remove unwanted ions from water. Recall that solutions of different concentrations separated by a semipermeable membrane create osmotic pressure. If a semipermeable membrane is placed in a solution and pressure is applied to the more concentrated solution, force water back through the membrane and filter out ions. In homes, toxic heavy-metal ions, such as Pb^{2+} , Cd^{2+} , and Hg^{2+} , are removed this way. On a large scale, reverse osmosis is used for desalination, which can convert seawater (40,000 ppm of ions) to drinking water (400 ppm) (Figure B13.3).

Wastewater Treatment

Wastewater, used domestic or industrial water, is treated in several ways before being returned to a natural source:

- In **primary treatment**, the water enters a settling basin to remove particles.
- In **biological treatment**, bacteria metabolize organic compounds and are then removed by settling.
- In **advanced treatment**, a process is tailored to remove a specific pollutant. For example, ammonia, which causes excessive growth of plants and algae, is removed in two steps:
 - Nitrification.** Certain bacteria oxidize ammonia (electron donor) with O_2 (electron acceptor) to form nitrate ion: $\text{NH}_3 + 2\text{O}_2 \longrightarrow \text{NO}_3^- + 2\text{H}^+ + \text{H}_2\text{O}$
 - Denitrification.** Other bacteria oxidize an added compound like methanol (CH_3OH) using the NO_3^- : $\text{CH}_3\text{OH} + 6\text{NO}_3^- \longrightarrow 3\text{N}_2 + 5\text{CO}_2 + 7\text{H}_2\text{O} + 6\text{OH}^-$

Thus, the process converts NH_3 in wastewater to N_2 , which is released to the atmosphere.

Problems

B13.1 Briefly answer each of the following:

- Why is cake alum [$\text{Al}_2(\text{SO}_4)_3$] added during water purification?
- Why is water that contains large amounts of Ca^{2+} and Mg^{2+} difficult to use for cleaning?
- What is the meaning of "reverse" in reverse osmosis?
- Why might a water treatment plant use ozone as a disinfectant instead of chlorine?
- How passing a saturated NaCl solution through a "spent" ion-exchange resin regenerate the resin?

B13.2 Wastewater discharge from a sugar refinery contains 3.55 g of sucrose ($\text{C}_12\text{H}_{22}\text{O}_11$) per liter. A government-sponsored study is testing the feasibility of removing the sugar by reverse osmosis. What pressure must be applied to the wastewater solution at 20 °C to produce pure water?

Figure B15.1 The basis of ^1H spin resonance.

Figure B15.2 The $^1\text{H-NMR}$ spectrum of acetone.

Figure B15.3 The $^1\text{H-NMR}$ spectrum of dimethoxymethane.

(continued)

A Purple Mule, Not a Blue Horse and a Red Donkey

A mule is a genetic mix, a hybrid, of a horse and a donkey; it is not a horse one instant and a donkey the next. Similarly, the color purple is a mix of red and blue, not red one instant and blue the next. In the same sense, a resonance hybrid is one molecular species, not one resonance form this instant and another resonance form the next. The problem is that we cannot depict the actual species, the hybrid, accurately with a single Lewis structure.

Reinforcing through Review and Practice

A favorite feature, the section summaries that conclude every section restate the major ideas concisely and immediately (rather than postponing such review until the end of the chapter).

A rich catalog of study aids ends each chapter to help students review the content:

- **Learning Objectives**, with section and/or sample problem numbers, focus on the concepts to understand and the skills to master.
- **Key Terms**, boldfaced and defined within the chapter, are listed here by section (with page numbers), as well as being defined in the *Glossary*.
- **Key Equations and Relationships** are highlighted and numbered within the chapter and listed here with page numbers.
- **Brief Solutions to Follow-up Problems** triple the number of worked problems by providing multistep calculations at the end of the chapter, rather than just numerical answers at the back of the book.

CHAPTER REVIEW GUIDE

Learning Objectives

Relevant section (S) and/or sample problem (SP) numbers appear in parentheses.

Understand These Concepts

- The quantitative meaning of solubility (§13.1)
- The major types of intermolecular forces in solution and their strengths (§13.1)
- How the like-dissolves-like rule depends on intermolecular forces (§13.1)
- Why gases have relatively low solubilities in water (§13.1)
- General characteristics of solutions formed by various combinations of gases, liquids, and solids (§13.1)
- How intermolecular forces stabilize the structures of proteins, the cell membrane, and DNA (§13.2)
- The essential components of a solution cycle and their effect on ΔH_{soln} (§13.3)
- The dependence of ΔH_{soln} on ionic charge density and the factors that determine whether ionic solvation processes are exothermic or endothermic (§13.3)
- The meaning of entropy and how the balance between the change in enthalpy and the change in entropy governs the solution process (§13.3)
- The distinctions among saturated, unsaturated, and supersaturated solutions, and the equilibrium nature of a saturated solution (§13.4)
- The relation between temperature and the solubility of solids (§13.4)
- Why the solubility of gases in water decreases with a rise in temperature (§13.4)
- The effect of gas pressure on solubility and its quantitative expression as Henry's law (§13.4)
- The meaning of molarity, molality, mole fraction, and parts by mass or by volume of a solution, and how to convert among them (§13.5)
- The distinction between electrolytes and nonelectrolytes in solution (§13.6)

Key Terms

Page numbers appear in parentheses.

- alloy (538)
amino acid (539)
boiling point elevation (ΔT_b) (559)
charge density (545)
colligative property (557)
colligative property (557)
desalination (571)
dipole-induced dipole force (535)
force (535)
double helix (543)
electrolyte (557)
entropy (S) (547)
fractional distillation (564)
- freezing point depression (ΔT_f) (561)
hard water (570)
heat of hydration (ΔH_{hydr}) (545)
heat of solution (ΔH_{soln}) (544)
Henry's law (551)
hydration shell (534)
ideal solution (558)
ion exchange (570)
ionic atmosphere (565)
ion-induced dipole force (534)
like-dissolves-like rule (534)
lipid bilayer (542)

- mass percent (% w/w)) (554)
miscible (534)
molality (m) (553)
mole fraction (X) (554)
mole-to-mole ratio (543)
nonelectrolyte (557)
nucleic acid (542)
osmosis (562)
hydration shell (534)
ideal solution (558)
ion exchange (570)
ionic atmosphere (565)
ion-induced dipole force (534)
like-dissolves-like rule (534)
lipid bilayer (542)
- soap (541)
solubility (S) (534)
solute (534)
solvent (534)
supersaturated solution (549)
suspension (568)
Tyndall effect (569)
protein (539)
vapor pressure lowering (ΔP) (558)
reverse osmosis (571)
saturated solution (549)
semipermeable membrane (562)
- water softening (570)

Key Equations and Relationships

Page numbers appear in parentheses.

- 13.1 Dividing the general heat of solution into component enthalpies (544):

$$\Delta H_{soln} = \Delta H_{lattice} + \Delta H_{solvent} + \Delta H_{mix}$$

- 13.2 Dividing the heat of solution of an ionic compound in water into component enthalpies (545):

$$\Delta H_{soln} = \Delta H_{lattice} + \Delta H_{hydr}$$

Summary of Section 9.1

- Nearly all naturally occurring substances consist of atoms or ions bonded to others. Chemical bonding allows atoms to lower their energy.
- Ionic bonding occurs when metal atoms transfer electrons to nonmetal atoms, and the resulting ions attract each other and form an ionic solid.
- Covalent bonding is most common between nonmetal atoms and usually results in individual molecules. Bonded atoms share one or more pairs of electrons that are localized between them.
- Metallic bonding occurs when many metal atoms pool their valence electrons into a delocalized electron "sea" that holds all the atoms in the sample together.
- The Lewis electron-dot symbol of a main-group atom shows valence electrons as dots surrounding the element symbol.
- The octet rule says that, when bonding, many atoms lose, gain, or share electrons to attain a filled outer level of eight (or two) electrons.

13.3 Relating gas solubility to its partial pressure (Henry's law) (551):

$$S_{gas} = k_H \times P_{gas}$$

13.4 Defining concentration in terms of molarity (552):

$$\text{Molarity (M)} = \frac{\text{amount (mol) of solute}}{\text{volume (L) of solution}}$$

13.5 Defining concentration in terms of molality (553):

$$\text{Molality (m)} = \frac{\text{amount (mol) of solute}}{\text{mass (kg) of solvent}}$$

13.6 Defining concentration in terms of mass percent (554):

$$\text{Mass percent [\% (w/w)]} = \frac{\text{mass of solute}}{\text{mass of solution}} \times 100$$

13.7 Defining concentration in terms of volume percent (554):

$$\text{Volume percent [\% (v/v)]} = \frac{\text{volume of solute}}{\text{volume of solution}} \times 100$$

13.8 Defining concentration in terms of mole fraction (554):

$$\text{Mole fraction (X)} = \frac{\text{amount (mol) of solute}}{\text{amount (mol) of solute} + \text{amount (mol) of solvent}}$$

13.9 Expressing the relationship between the vapor pressure of solvent above a solution and its mole fraction in the solution (Raoult's law) (558):

$$P_{solvent} = X_{solvent} \times P^o_{solvent}$$

13.10 Calculating the vapor pressure lowering due to solute (558):

$$\Delta P = X_{solute} \times P^o_{solvent}$$

13.11 Calculating the boiling point elevation of a solution (560):

$$\Delta T_b = K_b m$$

13.12 Calculating the freezing point depression of a solution (561):

$$\Delta T_f = K_f m$$

13.13 Calculating the osmotic pressure of a solution (562):

$$\Pi = \frac{n_{soln}}{V_{soln}} RT = MRT$$

BRIEF SOLUTIONS TO FOLLOW-UP PROBLEMS

- 13.1A (a) 1-Butanol has one $-OH$ group/molecule, while 1,4-butenediol has two $-OH$ groups/molecule. 1,4-Butenediol is more soluble in water because it can form more H bonds.
(b) Chloroform is more soluble in water because of dipole-dipole forces between the polar $CHCl_3$ molecules and water. The forces between nonpolar CCl_4 molecules and water are weaker dipole-induced dipole forces, which do not effectively replace H bonds between water molecules.

- 13.1B (a) Chloroform dissolves more chlorothomethane due to similar dipole-dipole forces between the polar molecules of these two substances. CH_3Cl molecules do not exhibit H bonding and so do not effectively replace H bonds between methanol molecules.
(b) Hexane dissolves more pentanol due to dispersion forces between the hydrocarbon chains in each molecule.

- 13.2A From Equation 13.2, we have

$$\Delta H_{soln} \text{ of } KNO_3 = \Delta H_{lattice} \text{ of } KNO_3 + (\Delta H_{hydr} \text{ of } K^+ + \Delta H_{hydr} \text{ of } NO_3^-)$$

$$34.89 \text{ kJ/mol} = 685 \text{ kJ/mol} + (\Delta H_{hydr} \text{ of } K^+ + \Delta H_{hydr} \text{ of } NO_3^-)$$

$$\Delta H_{hydr} \text{ of } K^+ + \Delta H_{hydr} \text{ of } NO_3^- = 34.89 \text{ kJ/mol} - 685 \text{ kJ/mol} = -650 \text{ kJ/mol}$$

- 13.2B From Equation 13.2, we have

$$\Delta H_{soln} \text{ of NaCN} = \Delta H_{lattice} \text{ of NaCN} + (\Delta H_{hydr} \text{ of } Na^+ + \Delta H_{hydr} \text{ of } CN^-)$$

$$12.21 \text{ kJ/mol} = 766 \text{ kJ/mol} + (-410 \text{ kJ/mol} + \Delta H_{hydr} \text{ of } CN^-)$$

$$\Delta H_{hydr} \text{ of } CN^- = 12.21 \text{ kJ/mol} - 766 \text{ kJ/mol} + 410 \text{ kJ/mol} = -355 \text{ kJ/mol}$$

- 13.3A The partial pressure of N_2 in air is the volume percent divided by 100 times the total pressure (Dalton's law, Section 5.4):

$$P_{N_2} = 0.78 \times 1 \text{ atm} = 0.78 \text{ atm}$$

$$S_{gas} = k_H \times P_{gas}$$

$$S_{N_2} = (7 \times 10^{-2} \text{ mol/L} \cdot 0.78 \text{ atm})$$

$$= 5 \times 10^{-4} \text{ mol/L}$$

- 13.3B In a mixture of gases, the volume percent of a gas divided by 100 times the total pressure equals the gas's partial pressure (Dalton's law, Section 5.4):

$$P_{gas} = 0.40 \times 1.2 \text{ atm} = 0.48 \text{ atm}$$

$$k_H = \frac{S_{gas}}{P_{gas}} = \frac{1.2 \times 10^{-2} \text{ mol/L}}{0.48 \text{ atm}} = 2.5 \times 10^{-2} \text{ mol/L} \cdot \text{atm}$$

- 13.4A Convert mass (g) of ethanol to kg, multiply by the molality to obtain amount (mol) of glucose, and then multiply amount (mol) of glucose by the molar mass to obtain mass of glucose.

Amount (mol) of glucose

$$= 563 \text{ g ethanol} \times \frac{1 \text{ kg}}{10^3 \text{ g}} \times \frac{2.40 \times 10^{-2} \text{ mol glucose}}{1 \text{ kg ethanol}}$$

$$= 1.35 \times 10^{-2} \text{ mol glucose}$$

- Mass (g) glucose = $1.35 \times 10^{-2} \text{ mol C}_2H_5O_2 \times \frac{180.16 \text{ g C}_2H_5O_2}{1 \text{ mol C}_2H_5O_2}$
 $= 2.43 \text{ g glucose}$

- 13.4B Convert mass (g) of I_2 to amount (mol) and amount (mol) of $(CH_3CH_2)_2O$ to mass (kg). Then divide moles of I_2 by kg of $(CH_3CH_2)_2O$.

$$\text{Amount (mol) of } I_2 = 15.20 \text{ g } I_2 \times \frac{1 \text{ mol }}{253.8 \text{ g } I_2} = 5.989 \times 10^{-2} \text{ mol } I_2$$

Mass (kg) of $(CH_3CH_2)_2O$

$$= 1.33 \text{ mol } (CH_3CH_2)_2O \times \frac{74.16 \text{ g } (CH_3CH_2)_2O}{1 \text{ mol } (CH_3CH_2)_2O} \times \frac{1 \text{ kg }}{10^3 \text{ g }}$$

$$= 9.86 \times 10^{-2} \text{ kg } (CH_3CH_2)_2O$$

$$\text{Molality (m)} = \frac{5.989 \times 10^{-2} \text{ mol }}{9.86 \times 10^{-2} \text{ kg }} = 0.607 \text{ m}$$

Finally, an exceptionally large number of qualitative, quantitative, and molecular-scene problems end each chapter. Four types of problems are presented—three by chapter section, with comprehensive problems following:

- Concept Review Questions** test qualitative understanding of key ideas.

- Skill-Building Exercises** are grouped in similar pairs, with one of each pair answered in the back of the book. A group of similar exercises may begin with explicit steps and increase in difficulty, gradually weaning the student from the need for multistep directions.

- Problems in Context** apply the skills learned in the skill-building exercises to interesting scenarios, including realistic examples dealing with industry, medicine, and the environment.

- Comprehensive Problems**, mostly based on realistic applications, are more challenging and rely on material from any section of the current chapter or any previous chapter.

PROBLEMS

Problems with **colored** numbers are answered in Appendix E and worked in detail in the Student Solutions Manual. Problem sections match those in the text and give the numbers of relevant sample problems. Most offer Concept Review Questions, Skill-Building Exercises (grouped in pairs covering the same concept), and Problems in Context. The Comprehensive Problems are based on material from any section or previous chapter.

Depicting Molecules and Ions with Lewis Structures (Sample Problems 10.1 to 10.5)

Concept Review Questions

10.1 Which of these atoms *cannot* serve as a central atom in a Lewis structure: (a) O; (b) He; (c) F; (d) H; (e) P? Explain.

10.2 When is a resonance hybrid needed to adequately depict the bonding in a molecule? Using NO_2 as an example, explain how a resonance hybrid is consistent with the actual bond length, bond strength, and bond order.

10.3 In which of these structures does X obey the octet rule?

10.4 What is required for an atom to expand its valence shell? Which of the following atoms can expand its valence shell: F, S, H, Al, Se, Cl?

Skill-Building Exercises (grouped in similar pairs)

10.5 Draw a Lewis structure for (a) SiF_4 ; (b) SeCl_2 ; (c) COF_2 (C is the central atom).

10.6 Draw a Lewis structure for (a) PH_4^+ ; (b) C_2F_4 ; (c) SbH_3 .

10.7 Draw a Lewis structure for (a) PF_3 ; (b) H_2CO_3 (both H atoms are attached to O atoms); (c) CS_2 .

10.8 Draw a Lewis structure for (a) CH_4S ; (b) S_2Cl_2 ; (c) CHCl_3 .

10.9 Draw Lewis structures of all the important resonance forms of (a) NO_2^+ ; (b) NO_2^- (N is central).

10.10 Draw Lewis structures of all the important resonance forms of (a) HNO_3 (HONO_2); (b) HAsO_4^{2-} (HOAsO_3^{2-}).

10.11 Draw Lewis structures of all the important resonance forms of (a) N_3^- ; (b) NO_2^- .

10.12 Draw Lewis structures of all the important resonance forms of (a) HCO_2^- (H is attached to C); (b) HBrO_4 (HOBrO_3).

10.13 Draw the Lewis structure with lowest formal charges, and determine the charge of each atom in (a) IF_5^- ; (b) AlH_4^- .

10.14 Draw the Lewis structure with lowest formal charges, and determine the charge of each atom in (a) OCS ; (b) NO .

10.15 Draw the Lewis structure with lowest formal charges, and determine the charge of each atom in (a) CN^- ; (b) ClO_4^- .

10.16 Draw the Lewis structure with lowest formal charges, and (a) CINO .

The form of each ion will depend on the charges, and (b) SO_3^{2-} .

10.18 Draw a Lewis structure for a resonance form of each ion with the lowest possible formal charges, show the charges, and give oxidation numbers of the atoms: (a) AsO_4^{3-} ; (b) ClO_2^- .

10.19 These species do not obey the octet rule. Draw a Lewis structure for each, and state the type of octet-rule exception: (a) BH_3 (b) AsF_4^- (c) SeCl_4

10.20 These species do not obey the octet rule. Draw a Lewis structure for each, and state the type of octet-rule exception: (a) PF_6^- (b) ClO_3 (c) H_3PO_3 (one P—H bond)

10.21 These species do not obey the octet rule. Draw a Lewis structure for each, and state the type of octet-rule exception: (a) BrF_3 (b) ICl_7^- (c) BeF_2

10.22 These species do not obey the octet rule. Draw a Lewis structure for each, and state the type of octet-rule exception: (a) O_5^- (b) XeF_2 (c) SbF_4^-

Problems in Context

10.23 Molten beryllium chloride reacts with chloride ion from molten NaCl to form the BeCl_2^{2-} ion, in which the Be atom attains an octet. Show the net ionic reaction with Lewis structures.

10.24 Despite many attempts, the perbromate ion (BrO_4^-) was not prepared in the laboratory until about 1970. (In fact, articles were published explaining theoretically why it could never be prepared!) Draw a Lewis structure for BrO_4^- in which all atoms have lowest formal charges.

10.25 Cryolite (Na_3AlF_6) is an indispensable component in the electrochemical production of aluminum. Draw a Lewis structure for the AlF_6^{3-} ion.

10.26 Phosgene is a colorless, highly toxic gas that was employed against troops in World War I and is used today as a key reactant in organic syntheses. From the following resonance structures, select the one with the lowest formal charges:

Valence-Shell Electron-Pair Repulsion (VSEPR) Theory

(Sample Problems 10.6 to 10.8)

Concept Review Questions

10.27 If you know the formula of a molecule or ion, what is the first step in predicting its shape?

10.28 In what situation is the name of the molecular shape the same as the name of the electron-group arrangement?

10.29 Which of the following numbers of electron groups can give rise to a bent (V shaped) molecule: two, three, four, five, six? Draw an example for each case, showing the shape classification (AX_mE_n) and the ideal bond angle.

10.30 Name all the molecular shapes that have a tetrahedral electron-group arrangement.

Comprehensive Problems

2.119 Helium is the lightest noble gas and the second most abundant element (after hydrogen) in the universe.

(a) The radius of a helium atom is 3.1×10^{-11} m; the radius of its nucleus is 2.5×10^{-15} m. What fraction of the spherical atomic volume is occupied by the nucleus (V of a sphere = $\frac{4}{3}\pi r^3$)?

(b) The mass of a helium-4 atom is 6.64648×10^{-24} g, and each of its two electrons has a mass of 9.10939×10^{-28} g. What fraction of this atom's mass is contributed by its nucleus?

2.120 From the following ions (with their radii in pm), choose the pair that forms the strongest ionic bond and the pair that forms the weakest:

Ion: Mg^{2+} K^+ Rb^+ Ba^{2+} Cl^- O^{2-} I^-
Radius: 72 138 152 135 181 140 220

2.121 Give the molecular mass of each compound depicted below, and provide a correct name for any that are named incorrectly.

OPTIMIZING THE TEXT

The modern chemistry student's learning experience is changing dramatically. To address the changes that students face, a modern text partnered with a suite of robust digital tools must continue to evolve. With each edition, students and instructors alike have been involved in refining this text. From one-on-one interviews, focus groups, and symposia, as well as extensive chapter reviews and class tests, we learned that everyone praises the pioneering molecular art, the stepwise problem-solving approach, the abundant mix of qualitative, quantitative, and applied end-of-chapter problems, and the rigorous *and* student-friendly coverage of mainstream topics.

Global Changes to Every Chapter

Our revision for the eighth edition focused on continued optimization of the text. To aid us in this process, we were able to use data from literally thousands of student responses to questions in LearnSmart, the adaptive learning system that assesses student knowledge of course content. The data, such as average time spent answering each question and the percentage of students who correctly answered the question on the first attempt, revealed the learning objectives that students found particularly difficult. We utilized several approaches to present these difficult concepts in a clearer, more straightforward way in the eighth edition of *Chemistry: The Molecular Nature of Matter and Change*.

Making the concepts clearer through digital learning resources. Students will be able to access over 2,000 digital learning resources throughout this text's SmartBook. These learning resources present summaries of concepts and worked examples, including over 400 videos of chemistry instructors solving problems or modeling concepts that students can view over and over again. Thus, students can have an "office hour" moment at any time.

NEW! Student Hot Spot

We are very pleased to incorporate real student data points and input, derived from thousands of our LearnSmart users, to help guide our revision. LearnSmart Heat Maps provided a quick visual snapshot of usage of portions of the text and the relative difficulty students experienced in mastering the content. With these data, we were able to both hone our text content when needed and, for particularly challenging concepts, point students to the learning resources that can elucidate and reinforce those concepts. You'll see these marginal features throughout the text. Students should log into Connect and view the resources through our SmartBook.

50 CHAPTER 2 Atoms, Molecules, and Ions

2.4 The Periodic Table

More than half of the elements known today were discovered between 1800 and 1900. During this period, chemists noted that the physical and chemical properties of certain groups of elements were similar to one another. These similarities, together with the need to organize the large volume of available information about the structure and properties of elemental substances, led to the development of the *periodic table*, a chart in which elements having similar chemical and physical properties are grouped together. Figure 2.10 shows the modern periodic table in which the elements are arranged by atomic number (shown above the element symbol) in horizontal rows called *periods* and in vertical columns called *groups* or *families*. Elements in the same group tend to have similar physical and chemical properties.

The elements can be categorized as metals, nonmetals, or metalloids. A **metal** is a good conductor of heat and electricity, whereas a **nonmetal** is usually a poor conductor of heat and electricity. A **metalloid** has properties that are intermediate between those of metals and nonmetals. Figure 2.10 shows that the majority of known elements are metals; only 17 elements are nonmetals, and fewer than 10 elements are metalloids. Although most sources, including this text, designate the elements B, Si, Ge, As, Sb, and Te as metalloids, sources vary for the elements Po and At. In this text, we classify both Po and At as metalloids. From left to right across any period, the physical and chemical properties of the elements change gradually from metallic to nonmetallic.

Elements are often referred to collectively by their periodic table group number (Group 1A, Group 2A, and so on). For convenience, however, some element groups have been given special names. The Group 1A elements, with the exception of H (i.e., Li, Na, K, Rb, Cs, and Fr), are called **alkali metals**, and the Group 2A elements (Be, Mg, Ca, Sr, Ba, and Ra) are called **alkaline earth metals**. Elements in Group 6A (O, S, Se, Te, and Po) are sometimes referred to as the **chalcogens**. Elements in Group 7A (F, Cl, Br, I, and At) are known as **halogens**, and elements in Group 8A (He, Ne, Ar, Kr, Xe, and Rn) are called **noble gases**, or rare gases. The elements in Group 1B and Groups 3B–8B collectively are called the **transition elements or transition metals**.

The periodic table is a handy tool that correlates the properties of the elements in a systematic way and helps us to predict chemical behavior. At the turn of the twentieth century, the periodic table was deemed "the most predictive tool in all of science." We will take a more detailed look at this keystone of chemistry in Chapter 7.

Mass (kg) of uranium = mass (kg) of pitchblende $\times \frac{\text{mass (kg) of uranium in pitchblende}}{\text{mass (kg) of pitchblende}}$

$$= 102 \text{ kg pitchblende} \times \frac{71.4 \text{ kg uranium}}{84.2 \text{ kg pitchblende}} = 86.5 \text{ kg uranium}$$

Converting the mass of uranium from kg to g:

$$\text{Mass (g) of uranium} = \text{mass (kg) of pitchblende} \times \frac{1000 \text{ g}}{1 \text{ kg}} = 8.65 \times 10^4 \text{ g uranium}$$

Finding the mass (in kg) of oxygen in 102 kg of pitchblende:

$$\text{Mass (kg) of oxygen} = \text{mass (kg) of pitchblende} - \text{mass (kg) of uranium}$$

$$= 102 \text{ kg} - 86.5 \text{ kg} = 15.5 \text{ kg oxygen}$$

Converting the mass of oxygen from kg to g:

$$\text{Mass (g) of oxygen} = 15.5 \text{ kg oxygen} \times \frac{1000 \text{ g}}{1 \text{ kg}} = 1.55 \times 10^5 \text{ g oxygen}$$

Check The analysis showed that most of the mass of pitchblende is due to uranium, so the large mass of uranium makes sense. Rounding off to check the math gives

$$\sim 100 \text{ kg pitchblende} \times \frac{70}{85} = 82 \text{ kg uranium}$$

FOLLOW-UP PROBLEMS

2.2A The mineral "fool's gold" does not contain any gold; instead it is a compound composed only of the elements iron and sulfur. A 110.0-g sample of fool's gold contains 51.2 g of iron. What mass of sulfur is in a sample of fool's gold that contains 86.2 g of iron?

2.2B Silver bromide is the light-sensitive compound coated onto black-and-white film. A 26.8-g sample contains 15.4 g of silver, with bromine as the only other element. How many grams of each element are on a roll of film that contains 3.57 g of silver bromide?

SOME SIMILAR PROBLEMS 2.22–2.25

Student Hot Spot

Student data indicate that you may struggle with using mass fraction to calculate the mass of an element in a compound. Access the Smartbook to view additional Learning Resources on this topic.

Applying ideas with enhanced problems throughout the chapters. The much admired four-part problem-solving format (plan, solution, check, follow-up) is retained in the eighth edition, in both data-based and molecular-scene *Sample Problems*. Two *Follow-up Problems* are included with each sample problem, as well as a list of *Similar Problems* within the end-of-chapter problem set. *Brief Solutions* for all of the follow-up problems appear at the end of each chapter (rather than providing just a numerical answer in a distant end-of-book appendix, as is typical). The eighth edition has over 250 sample problems and over 500 follow-up problems. In almost every chapter, several sample and follow-up problems (and their brief solutions) were revised in this edition with two goals in mind. We sought to provide students with a variety of problems that would clearly elucidate concepts and demonstrate problem solving techniques, while giving students the opportunity to be challenged and gain competence. We also included more intermediate steps in the solutions to both sample and follow-up problems so that students could more easily follow the solutions.

Re-learning ideas with annotated illustrations. The innovative three-level figures and other art that raised the bar for molecular visualization in chemistry textbooks is still present. Several existing figures have been revised and several new ones added to create an even better teaching tool. We continue to streamline figure legends by placing their content into clarifying annotations with the figures themselves.

Mastering the content with abundant end-of-chapter problem sets. New problems were added to several chapter problem sets, providing students and teachers with abundant choices in a wide range of difficulty and real-life scenarios. The problem sets are more extensive than in most other texts.

Content Changes to Individual Chapters

In addition to the general optimization of concept explanations and problem solutions throughout the text, specific improvements were made to most chapters:

- **Chapter 1** has a revised table of decimal prefixes and SI units to make conversion among SI units clearer, a revised discussion on intensive and extensive properties, and a revised sample problem on density.
- **Chapter 2** includes revised sample problems on mass percent and naming of compounds.
- **Chapter 3** has several new end-of-chapter problems: one new problem on the determination of a molecular formula, two new problems on writing a balanced reaction and determining the limiting reactant from molecular scenes, and two new stoichiometric problems involving limiting reactants.
- **Chapter 4** includes a new figure illustrating the activity series of the halogens. Sample problems on stoichiometry in precipitation and acid-base reactions were revised to include reactions that do not have 1:1 mole ratios.
- **Chapter 5** has two revised sample problems that provide students with additional opportunities for pressure unit conversions and stoichiometry calculations for gas reactions.
- **Chapter 6** has a clearer and more detailed discussion on pressure-volume work and a revised sample problem on the calorimetric determination of heat of combustion. Also included are new end-of-chapter problems on the calculation of enthalpy change for an aqueous reaction and determination of heat of combustion with bomb calorimetry.
- **Chapter 7** contains a new table summarizing the relationships between the quantum numbers and orbitals for the first four main energy levels.
- **Chapter 8** contains a new figure on electron spin; orbital diagrams have been added to the solutions of several sample problems.
- **Chapter 9** has improvements to several figures, a more detailed discussion of relationship between difference in electronegativity and ionic character, and some new follow-up problems.
- **Chapter 10** includes more detailed examples of depicting molecules with double bonds and ions with Lewis structures. Sample and follow-up problems have been revised to provide more opportunities to calculate formal charges and use those to evaluate resonance structures.
- **Chapter 11** has new art to illustrate formation of sigma and pi bonds and a new figure to show the placement of lone pairs in hybrid orbitals.
- **Chapter 12** includes additional information about viscosity and intermolecular forces.
- **Chapter 13** includes a more challenging sample problem on Henry's law, as well as revisions to several follow-up problems. There are new problems on the calculation of molar mass from freezing point depression.
- **Chapter 15** incorporates new art to make nomenclature clearer and a revised figure to show the key stages in protein synthesis.
- **Chapter 16** has a revised sample problem using the first-order integrated rate law, a revised figure on reaction mechanisms, and a new molecular scene problem on first-order reactions.
- **Chapter 17** contains a revised table on concentration ratios in an equilibrium system and two new sample problems, one on finding the equilibrium constant for an overall reaction, and the other on converting between K_p and K_c .
- **Chapter 18** has a new table on magnitude of K_a and percent dissociation and two revised sample problems.
- **Chapter 19** has a revised sample problem on buffer pH that reflects a more realistic lab procedure, a new molecular scene problem involving buffer solutions, a clearer

presentation of pH calculations during acid-base titrations, and revised figures of pH titration curves. The section on acid-base indicators has been expanded, including the addition of a new figure about choosing an indicator for each type of acid-base titration. The discussion of aqueous solutions of metal sulfides was simplified.

- **Chapter 20** incorporates a new table that summarizes Q , K , ΔG , and reaction spontaneity.
- **Chapter 21** has several revised follow-up problems.
- **Chapter 23** has a new figure illustrating chelate complex ions and several revised figures. A new equation for calculating the charge of the metal ion in a complex ion has been added.
- **Chapter 24** has a new table summarizing changes in mass and atomic numbers during radioactive decay; a table on stability of even vs. odd numbers of nucleons has been revised. The discussion about mode of decay and neutron/proton ratio has been expanded.

Innovative Topic and Chapter Presentation

While the topic sequence coincides with that used in most mainstream courses, built-in flexibility allows a wide range of differing course structures:

For courses that follow their own topic sequence, the general presentation, with its many section and subsection breaks and bulleted lists, allows topics to be rearranged, or even deleted, with minimal loss of continuity.

For courses that present several chapters, or topics within chapters, in different orders:

- Redox balancing by the oxidation-number method (formerly covered in Chapter 4) has been removed from the text, and the half-reaction method is covered with electrochemistry in Chapter 21, but it can easily be taught with Chapter 4.
- Gases (Chapter 5) can be covered in sequence to explore the mathematical modeling of physical behavior or, with no loss of continuity, just before liquids and solids (Chapter 12) to show the effects of intermolecular forces on the three states of matter.

For courses that use an atoms-first approach for some of the material, Chapters 7 through 13 move smoothly from quantum theory (7) through electron configuration (8), bonding models (9), molecular shape (10), VB and MO bonding theories (11), intermolecular forces in liquids and solids (12), and solutions (13). Immediate applications of these concepts appear in the discussions of periodic patterns in main-group chemistry (Chapter 14) and in the survey of organic chemistry (Chapter 15). Some instructors have also brought forward the coverage of transition elements and

coordination compounds (23) as further applications of bonding concepts. (Of course, Chapters 14, 15, and 23 can just as easily remain in their more traditional placement later in the course.)

For courses that emphasize biological/medical applications, many chapters highlight these topics, including the role of intermolecular forces in biomolecular structure (12), the chemistry of polysaccharides, proteins, and nucleic acids (including protein synthesis, DNA replication, and DNA sequencing) (15), as well as introductions to enzyme catalysis (16), biochemical pathways (17), and trace elements in protein function (23).

For courses that stress engineering applications of physical chemistry topics, Chapters 16 through 21 cover kinetics (16), equilibrium in gases (17), acids and bases (18), and aqueous ionic systems (19) and entropy and free energy (20) as they apply to electrochemical systems (21), all in preparation for coverage of the elements in geochemical cycles, metallurgy, and industry in Chapter 22.

create™

McGraw-Hill Create™ is another way to implement innovative chapter presentation. With Create, you can easily rearrange chapters, combine material from other content sources, and quickly upload content you have written, such as your course syllabus or teaching notes. Find the content you need in Create by searching through thousands of leading McGraw-Hill textbooks. Create even allows you to personalize your book's appearance by selecting the cover and adding your name, school, and course information. Order a Create book, and you'll receive a complimentary print review copy in 3–5 business days or a complimentary electronic review copy (eComp) via e-mail in minutes. Go to www.mcgrawhill-create.com today and register to experience how McGraw-Hill Create empowers you to teach *your* students *your* way.
www.mcgrawhillcreate.com

Tegrity®

McGraw-Hill Tegrity® records and distributes your class lecture with just a click of a button. Students can view it anytime and anywhere via computer, iPod, or mobile device. Tegrity indexes as it records your PowerPoint® presentations and anything shown on your computer, so students can use key words to find exactly what they want to study. Tegrity is available as an integrated feature of McGraw-Hill Connect® Chemistry and as a stand-alone product.

McGraw-Hill Connect® Learn Without Limits

Connect is a teaching and learning platform that is proven to deliver better results for students and instructors.

Connect empowers students by continually adapting to deliver precisely what they need, when they need it, and how they need it, so your class time is more engaging and effective.

73% of instructors who use Connect require it; instructor satisfaction increases by 28% when Connect is required.

Connect's Impact on Retention Rates, Pass Rates, and Average Exam Scores

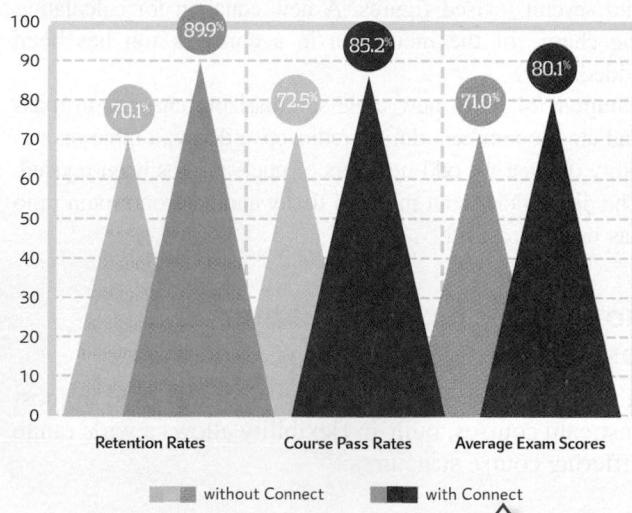

Using Connect improves retention rates by **19.8%**, passing rates by **12.7%**, and exam scores by **9.1%**.

Analytics

Connect Insight®

Connect Insight is Connect's new one-of-a-kind visual analytics dashboard that provides at-a-glance information regarding student performance, which is immediately actionable. By presenting assignment, assessment, and topical performance results together with a time metric that is easily visible for aggregate or individual results, Connect Insight gives the user the ability to take a just-in-time approach to teaching and learning, which was never before available. Connect Insight presents data that helps instructors improve class performance in a way that is efficient and effective.

Impact on Final Course Grade Distribution

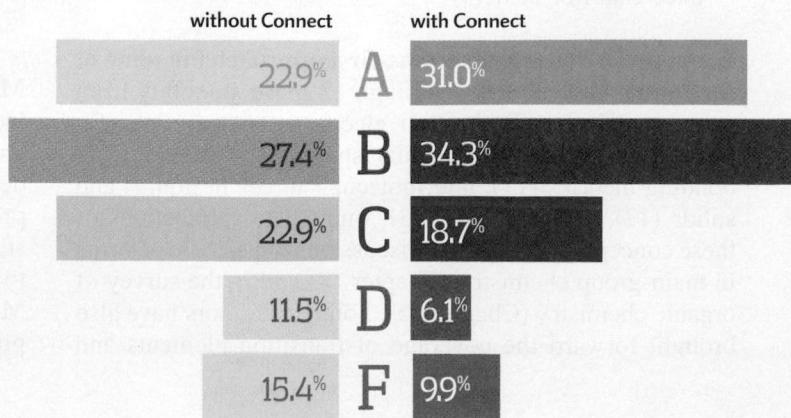

Adaptive

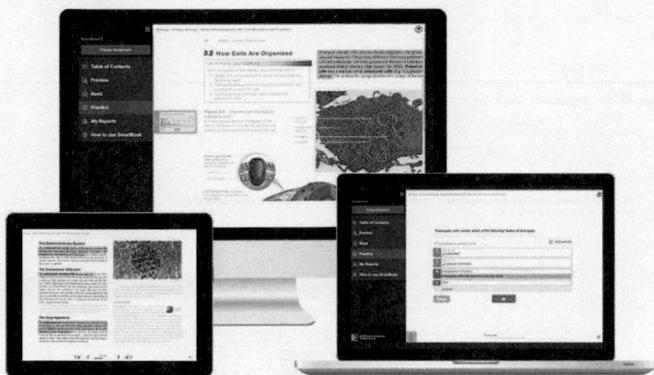

More students earn **A's** and **B's** when they use McGraw-Hill Education **Adaptive** products.

SmartBook®

Proven to help students improve grades and study more efficiently, SmartBook contains the same content within the print book, but actively tailors that content to the needs of the individual. SmartBook's adaptive technology provides precise, personalized instruction on what the student should do next, guiding the student to master and remember key concepts, targeting gaps in knowledge and offering customized feedback, and driving the student toward comprehension and retention of the subject matter. Available on tablets, SmartBook puts learning at the student's fingertips—anywhere, anytime.

Over **8 billion questions** have been answered, making McGraw-Hill Education products more intelligent, reliable, and precise.

www.mheducation.com

THE ADAPTIVE READING EXPERIENCE DESIGNED TO TRANSFORM THE WAY STUDENTS READ

of students reported SmartBook to be a more effective way of reading material.

of students want to use the Practice Quiz feature available within SmartBook to help them study.

of students reported having reliable access to off-campus wifi.

of students say they would purchase SmartBook over print alone.

of students reported that SmartBook would impact their study skills in a positive way.

Mc
Graw
Hill
Education

*Findings based on 2015 focus group results administered by McGraw-Hill Education

ADDITIONAL INSTRUCTOR AND STUDENT RESOURCES FOR YOUR COURSE!

MCGRAW-HILL CONNECT CHEMISTRY

A robust set of questions, problems, and interactive figures are presented and aligned with the textbook's learning goals. The integration of **ChemDraw by PerkinElmer**, the industry standard in chemical drawing software, allows students to create accurate chemical structures in their online homework assignments. As an instructor, you can edit existing questions and write entirely new problems. Track individual student performance—by question, assignment, or in relation to the class overall—with detailed grade reports. Integrate grade reports easily with Learning Management Systems (LMS), such as WebCT and Blackboard—and much more. Also available within Connect, our adaptive SmartBook has been supplemented with additional learning resources tied to each learning objective to provide point-in-time help to students who need it. To learn more, visit www.mheducation.com.

Instructors have access to the following instructor resources through Connect.

- Art** Full-color digital files of all illustrations, photos, and tables in the book can be readily incorporated into lecture presentations, exams, or custom-made classroom materials. In addition, all files have been inserted into PowerPoint slides for ease of lecture preparation.
- Animations** Numerous full-color animations illustrating important processes are also provided. Harness the visual impact of concepts in motion by importing these files into classroom presentations or online course materials.
- PowerPoint Lecture Outlines** Ready-made presentations that combine art and lecture notes are provided for each chapter of the text.
- Computerized Test Bank** Over 2300 test questions that accompany *Chemistry: The Molecular Nature of Matter and Change* are available utilizing the industry-leading test generation software TestGen. These same questions are also available and assignable through Connect for online tests.
- Instructor's Solutions Manual** This supplement, prepared by Mara Vorachek-Warren of St. Charles Community College, contains complete, worked-out solutions for *all* the end-of-chapter problems in the text.

The screenshot shows a web-based interface for a chemistry problem. At the top, it says "Sec. Ex. 4B - Resonance structures of sulfate anion". Below this, there are two chemical structures of the sulfate anion (SO_4^{2-}) separated by a double-headed arrow, indicating resonance. The first structure has a central sulfur atom bonded to four oxygen atoms, with single bonds and partial negative charges (:O^-). The second structure shows a double bond between sulfur and one oxygen, and single bonds from sulfur to the other three oxygens. A "window space" button is visible below the structures. On the right side of the screen, there is a "ChemDraw Communication - Google Chrome" window titled "ezto.mheducation.com/wwtb/viewer/tools/chemdraw". This window shows a drawing tool interface with various chemical symbols and a workspace where a partial chemical structure is being drawn. The workspace has a "Don't forget to save! To avoid losing your work, be sure to save before leaving this window." message at the bottom. Buttons for "reset...", "save", and "save & exit" are at the bottom right of the ChemDraw window.

Fueled by LearnSmart—the most widely used and intelligent adaptive learning resource—**LearnSmart Prep** is designed to get students ready for a forthcoming course by quickly and effectively addressing gaps in prerequisite knowledge that may cause problems down the road. By distinguishing what students know from what they don't, and honing in on concepts they are most likely to forget, LearnSmart Prep maintains a continuously adapting learning path individualized for each student, and tailors content to focus on what the student needs to master in order to have a successful start in the new class.

The screenshot shows a mobile application interface for "General Chemistry". At the top, it says "A Particle Description of the Phases of Matter". On the left, there is a text box with a portrait of a person and some descriptive text about the three phases of matter: solid, liquid, and gas. It mentions that the image shows a microscopic or particulate view of each phase. Below this, there is a diagram showing three containers representing different phases: a solid (represented by a dense packing of black spheres), a liquid (represented by a medium packing of black spheres), and a gas (represented by a sparse packing of black spheres with many empty spaces). At the bottom, there are buttons for "GIVE FEEDBACK" and "CONTINUE". The progress bar at the bottom indicates "PROGRESS: Structure of Matter 1%".

THE VIRTUAL LAB EXPERIENCE

Based on the same world-class, superbly adaptive technology as LearnSmart, **McGraw-Hill LearnSmart Labs** is a must-see, outcomes-based lab simulation. It assesses a student's knowledge and adaptively corrects deficiencies, allowing the student to learn faster and retain more knowledge with greater success. First, a student's knowledge is adaptively leveled on core learning outcomes: questioning reveals knowledge deficiencies that are corrected by the delivery of content that is conditional on a student's response. Then, a simulated lab experience requires the student to think and act like a scientist: recording, interpreting, and analyzing data using simulated equipment found in labs and clinics. The student is allowed to make mistakes—a powerful part of the learning experience! A virtual coach provides subtle hints when needed, asks questions about the student's choices, and allows the student to reflect on and correct those mistakes. Whether your need is to overcome the logistical challenges of a traditional lab, provide better lab prep, improve student performance, or make students' online experience one that rivals the real world, LearnSmart Labs accomplishes it all.

COOPERATIVE CHEMISTRY LABORATORY MANUAL

Prepared by Melanie Cooper of Clemson University, this innovative manual features open-ended problems designed to simulate experience in a research lab. Working in groups, students investigate one problem over a period of several weeks, so they might complete three or four projects during the semester, rather than one preprogrammed experiment per class. The emphasis is on experimental design, analytic problem solving, and communication.

STUDENT SOLUTIONS MANUAL

This supplement, prepared by Mara Vorachek-Warren of St. Charles Community College, contains detailed solutions and explanations for all problems in the main text that have colored numbers.

ACKNOWLEDGMENTS

It would be nearly impossible to put together a more professional, talented, and supportive publishing team than our colleagues at McGraw-Hill Education: Managing Director Thomas Timp, Director of Chemistry David Spurgeon, Ph.D., Associate Director of Digital Content Robin Reed, Program Manager Lora Neyens, Content Project Manager Laura Bies, Designer David Hash, Marketing Manager Matthew Garcia, and Director of Digital Content Shirley Hino. It is a pleasure to work with them; their leadership, knowledge, and encouragement have helped to make this latest edition a reality.

Mara Vorachek-Warren of St. Charles Community College provided a thorough accuracy check of all the new

sample problems, follow-up problems, and end-of-chapter problems as part of her superb preparation of both the Student and Instructor's Solutions Manuals.

The following individuals helped write and review learning goal-oriented content for **LearnSmart for General Chemistry**: Margaret Ruth Leslie, Kent State University and Adam I. Keller, Columbus State Community College.

Several expert freelancers contributed as well. Jane Hoover did her usual excellent job in copyediting the text, and Lauren Timmer and Louis Poncz followed with meticulous proofreading. And many thanks to Jerry Marshall, who patiently researched new stock and studio photos.

CHEMISTRY

1

Keys to Studying Chemistry: Definitions, Units, and Problem Solving

1.1 Some Fundamental Definitions

States of Matter
Properties of Matter and Its Changes
Central Theme in Chemistry
Importance of Energy

1.2 Chemical Arts and the Origins of Modern Chemistry

Prechemical Traditions
Impact of Lavoisier

1.3 The Scientific Approach: Developing a Model

1.4 Measurement and Chemical Problem Solving

Features of SI Units
SI Units in Chemistry
Units and Conversion Factors
Systematic Problem-Solving Approach

Temperature Scales
Extensive and Intensive Properties

1.5 Uncertainty in Measurement: Significant Figures

Determining Significant Digits
Calculations and Rounding Off
Precision, Accuracy, and Instrument Calibration

Source: © Fancy Collection/SuperStock

- › exponential (scientific) notation (Appendix A)

Maybe you're taking this course because chemistry is fundamental to understanding other natural sciences. Maybe it's required for your medical or engineering major. Or maybe you just want to learn more about the impact of chemistry on society or even on your everyday life. For example, does the following morning routine (described in chemical terms) sound familiar? You are awakened by the buzzing of your alarm clock, a sound created when molecules align in the liquid-crystal display of your clock and electrons flow to create a noise. You throw off a thermal insulator of manufactured polymer (blanket) and jump in the shower to emulsify fatty substances on your skin and hair with purified water and formulated detergents. Next you adorn yourself in an array of pleasant-smelling pigmented gels, dyed polymeric fibers, synthetic footwear, and metal-alloy jewelry. After a breakfast of nutrient-enriched, spoilage-retarded carbohydrates (cereal) in a white emulsion of fats, proteins, and monosaccharides (milk) and a cup of hot aqueous extract containing a stimulating alkaloid (coffee), you abrade your teeth with a colloidal dispersion of artificially flavored, dental-hardening agents (toothpaste), grab your portable electronic device containing ultrathin, microetched semiconductor layers powered by a series of voltaic cells (laptop), collect some objects made from processed cellulose and plastic, electronically printed with light- and oxygen-resistant inks (books), hop in your hydrocarbon-fueled, metal-vinyl-ceramic vehicle, electrically ignite a synchronized series of controlled gaseous explosions (start your car), and take off for class!

But the true impact of chemistry extends much farther than the commercial products of daily life. The truth is that the most profound biological and environmental questions ultimately have chemical answers: How does an organism reproduce, grow, and age? What are the underlying explanations for health and disease? How can we sustain a planetary ecosystem in which plant, animal, and human populations thrive? Is there life on other worlds?

So, no matter what your reason for studying chemistry, you're going to learn some amazing things. And, this course comes with a bonus for developing two mental skills. The first, common to all science courses, is the ability to solve problems systematically. The second is specific to chemistry, for as you comprehend its ideas, you begin to view a hidden reality, one filled with incredibly minute particles moving at fantastic speeds, colliding billions of times a second, and interacting in ways that allow your brain to translate fluxes of electric charge into thoughts and that determine how all the matter inside and outside of you behaves. This chapter holds the keys to unlock and enter this new world.

IN THIS CHAPTER . . . We discuss some central ideas about matter and energy, the process of science, units of measurement, and how scientists handle data.

- › We begin with fundamental concepts about matter and energy and their changes.
- › A brief discussion of chemistry's origins, including some major missteps, leads to an overview of how scientists build models to study nature.
- › We examine modern units for mass, length, volume, density, and temperature and apply systematic chemical problem solving to unit conversions.
- › We see that data collection always includes some uncertainty and examine the distinction between accuracy and precision.

1.1 SOME FUNDAMENTAL DEFINITIONS

A good place to begin our exploration of chemistry is by defining it and a few central concepts. **Chemistry** is the scientific study of matter and its properties, the changes that matter undergoes, and the energy associated with those changes. **Matter** is the “stuff” of the universe: air, glass, planets, students—anything that has mass and volume. (In Section 1.4, we discuss the meanings of mass and volume in terms of how they are measured.) Chemists want to know the **composition** of matter, the types and amounts of simpler substances that make it up. A **substance** is a type of matter that has a defined, fixed composition.

The States of Matter

Matter occurs commonly in three physical forms called **states**: solid, liquid, and gas. On the macroscopic scale, each state of matter is defined by the way the sample fills a container (Figure 1.1, flasks at top):

- A **solid** has a fixed shape that does not conform to the container shape. Solids are *not* defined by rigidity or hardness: solid iron is rigid and hard, but solid lead is flexible, and solid wax is soft.
- A **liquid** has a varying shape that conforms to the container shape, but only to the extent of the liquid’s volume; that is, a liquid has *an upper surface*.
- A **gas** also has a varying shape that conforms to the container shape, but it fills the entire container and, thus, does *not* have a surface.

On the atomic scale, each state is defined by the relative positions of its particles (Figure 1.1, circles at bottom):

- In a *solid*, the particles lie next to each other in a regular, three-dimensional pattern, or *array*.
- In a *liquid*, the particles also lie close together but move randomly around each other.
- In a *gas*, the particles have large distances between them and move randomly throughout the container.

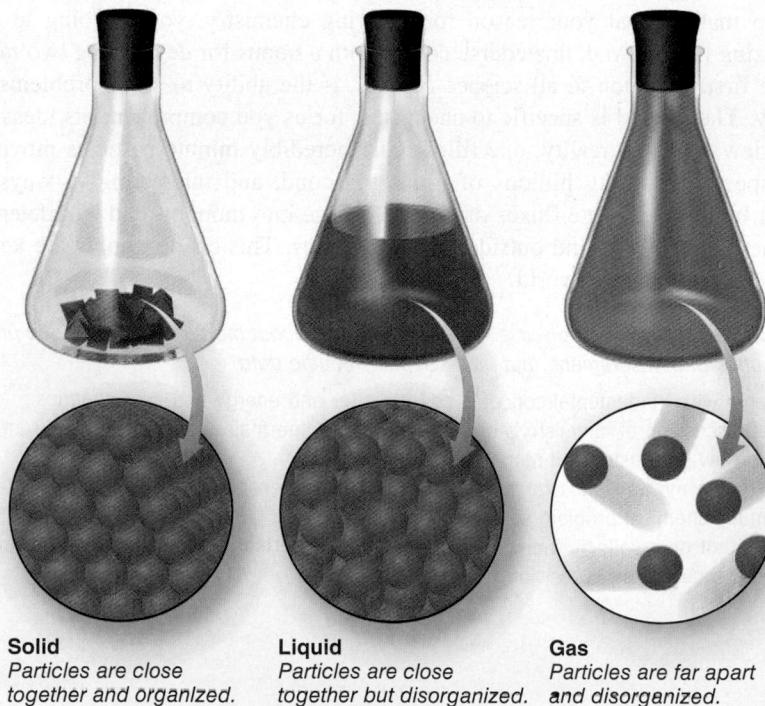

Figure 1.1 The physical states of matter.

The Properties of Matter and Its Changes

We learn about matter by observing its **properties**, *the characteristics that give each substance its unique identity*. To identify a person, we might observe height, weight, hair and eye color, fingerprints, and, now, even DNA pattern, until we arrive at a unique identification. To identify a substance, we observe two types of properties, physical and chemical, which are closely related to two types of change that matter undergoes.

Physical Change: No Change in Composition Physical properties are characteristics a substance shows *by itself, without changing into or interacting with another substance*. These properties include color, melting point, electrical conductivity, and density. A **physical change** occurs when a substance *alters its physical properties, not its composition*. For example, when ice melts, several physical properties change, such as hardness, density, and ability to flow. But the composition of the sample does *not* change: it is still water. The photograph in Figure 1.2A shows what this change looks like in everyday life. The “blow-up” circles depict a magnified view of the particles making up the sample. In the icicle, the particles lie in the repeating pattern characteristic of a solid, whereas they are jumbled in the liquid droplet; however, *the particles are the same* in both states of water.

Physical change (same substance before and after):

All changes of state of matter are physical changes.

Chemical Change: A Change in Composition Chemical properties are characteristics a substance shows *as it changes into or interacts with another substance (or substances)*. Chemical properties include flammability, corrosiveness, and reactivity with acids. A **chemical change**, also called a **chemical reaction**, occurs when *one or more substances are converted into one or more substances with different composition and properties*. Figure 1.2B shows the chemical change (reaction) that occurs when you pass an electric current through water: the water decomposes (breaks down) into two other substances, hydrogen and oxygen, that bubble into the tubes. The composition *has changed*: the final sample is no longer water.

Chemical change (different substances before and after):

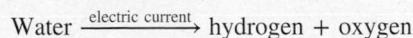

Let's work through a sample problem that uses atomic-scale scenes to distinguish between physical and chemical change.

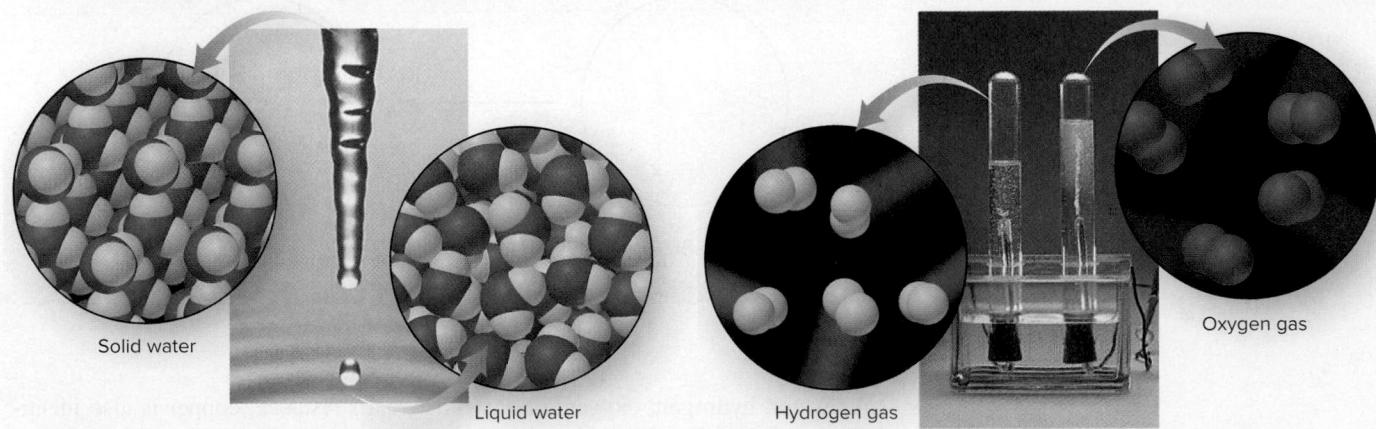

A Physical change:

Solid state of water becomes liquid state.
Particles before and after remain the same,
which means composition did **not** change.

B Chemical change:

Electric current decomposes water into different substances
(hydrogen and oxygen). Particles before and after are different,
which means composition **did** change.

Figure 1.2 The distinction between physical and chemical change.

Source: (A) © Paul Morrell/Stone/Getty Images; (B) © McGraw-Hill Education/Stephen Frisch, photographer

SAMPLE PROBLEM 1.1**Visualizing Change on the Atomic Scale**

Problem The scenes below represent an atomic-scale view of a sample of matter, A, undergoing two different changes, left to B and right to C:

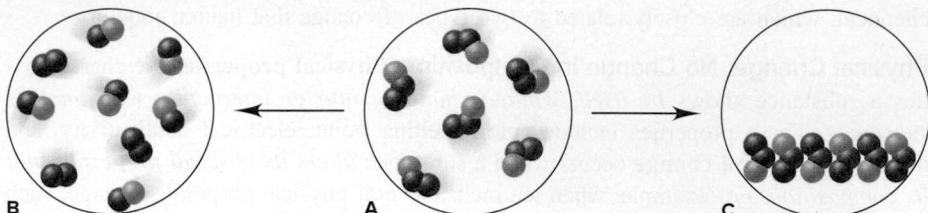

Decide whether each depiction shows a physical or a chemical change.

Plan Given depictions of two changes, we have to determine whether each represents a physical or a chemical change. The number and colors of the little spheres that make up each particle tell its “composition.” Samples with particles of the *same* composition but in a different arrangement depict a *physical* change, whereas samples with particles of a *different* composition depict a *chemical* change.

Solution In A, each particle consists of one blue and two red spheres. The particles in A change into two types in B, one made of red and blue spheres and the other made of two red spheres; therefore, they have undergone a *chemical change* to form different particles. The particles in C are the same as those in A, but they are closer together and arranged in a regular pattern; therefore, they have undergone a *physical change*.

FOLLOW-UP PROBLEMS

Brief Solutions for all Follow-up Problems appear at the end of the chapter.

1.1A Is the following change chemical or physical?

1.1B Is the following change chemical or physical?

SOME SIMILAR PROBLEMS 1.1 and 1.84

Like water, hydrogen, oxygen, or any other real substance, copper is also identified by *its own set* of physical and chemical properties (Table 1.1).

Temperature and Changes in Matter Depending on the temperature and pressure of the surroundings, many substances can exist in each of the three physical states and undergo changes in state as well. For example, as the temperature increases, solid water melts to liquid water, which boils to gaseous water (also called *water vapor*).

Table 1.1 Some Characteristic Properties of Copper

Physical Properties	Chemical Properties
Easily hammered into sheets (malleable) and drawn into wires (ductile)	Slowly forms a blue-green carbonate in moist air
Can be melted and mixed with zinc to form brass	Reacts with nitric or sulfuric acid
Density = 8.95 g/cm ³ Melting point = 1083°C Boiling point = 2570°C	Slowly forms deep-blue solution in aqueous ammonia

Source: (copper) © McGraw-Hill Education/Mark Dierker, photographer; (candlestick) © Ruth Melnick; (copper carbonate, copper reacting with acid, copper and ammonia) © McGraw-Hill Education/Stephen Frisch, photographer

Similarly, as the temperature drops, water vapor condenses to liquid water, and with further cooling, the liquid freezes to ice:

In a steel plant, solid iron melts to liquid (molten) iron and then cools to the solid again. And, far beyond the confines of a laboratory or steel plant, lakes of molten sulfur (a solid on Earth at room temperature) lie on Jupiter's moon Io (see photo), which is capped by poles of frozen hydrogen sulfide, a gas on Earth.

The main point is that *a physical change caused by heating can generally be reversed by cooling*. This is *not* generally true for a chemical change. For example, heating iron in moist air causes a chemical reaction that yields the brown, crumbly substance known as rust. Cooling does not reverse this change; rather, another chemical change (or series of them) is required.

The following sample problem provides practice in distinguishing some familiar examples of physical and chemical change.

SAMPLE PROBLEM 1.2

Distinguishing Between Physical and Chemical Change

Problem Decide whether each of the following processes is primarily a physical or a chemical change, and explain briefly:

- (a) Frost forms as the temperature drops on a humid winter night.
- (b) A cornstalk grows from a seed that is watered and fertilized.
- (c) A match ignites to form ash and a mixture of gases.
- (d) Perspiration evaporates when you relax after jogging.
- (e) A silver fork tarnishes slowly in air.

Plan The basic question we ask to decide whether a change is chemical or physical is, "Does the substance change composition or just change form?"

Many substances that are common on Earth occur in unusual states on other worlds.

Source: JPL-NASA

Solution (a) Frost forming is a physical change: the drop in temperature changes water vapor (gaseous water) in humid air to ice crystals (solid water).

(b) A seed growing involves chemical change: the seed uses water, substances from air, fertilizer, and soil, and energy from sunlight to make complex changes in composition.

(c) The match burning is a chemical change: the combustible substances in the match head are converted into other substances.

(d) Perspiration evaporating is a physical change: the water in sweat changes its state, from liquid to gas, but not its composition.

(e) Tarnishing is a chemical change: silver changes to silver sulfide by reacting with sulfur-containing substances in the air.

FOLLOW-UP PROBLEMS

1.2A Decide whether each of the following processes is primarily a physical or a chemical change, and explain briefly:

(a) Purple iodine vapor appears when solid iodine is warmed.

(b) Gasoline fumes are ignited by a spark in an automobile engine's cylinder.

(c) A scab forms over an open cut.

1.2B Decide whether each of the following processes is primarily a physical or a chemical change, and explain briefly:

(a) Clouds form in the sky.

(b) Old milk turns sour.

(c) Butter is melted to use on popcorn.

SOME SIMILAR PROBLEMS 1.6 and 1.7

The Central Theme in Chemistry

Understanding the properties of a substance and the changes it undergoes leads to the central theme in chemistry: *macroscopic-scale* properties and behavior, those we can see, are the results of *atomic-scale* properties and behavior that we cannot see. The distinction between chemical and physical change is defined by composition, which we study macroscopically. But composition ultimately depends on the makeup of substances at the atomic scale. Similarly, macroscopic properties of substances in any of the three states arise from atomic-scale behavior of their particles. Picturing a chemical event on the molecular scale, even one as common as the flame of a laboratory burner (*see margin*), helps clarify what is taking place. What is happening when water boils or copper melts? What events occur in the invisible world of minute particles that cause a seed to grow, a neon light to glow, or a nail to rust? Throughout the text, we return to this central idea:

We study observable changes in matter to understand their unobservable causes.

The Importance of Energy in the Study of Matter

Physical and chemical changes are accompanied by energy changes. **Energy** is often defined as *the ability to do work*. Essentially, all work involves moving something. Work is done when your arm lifts a book, when a car's engine moves the wheels, or when a falling rock moves the ground as it lands. The object doing the work (arm, engine, rock) transfers some of the energy it possesses to the object on which the work is done (book, wheels, ground).

The total energy an object possesses is the sum of its potential energy and its kinetic energy.

- **Potential energy** is *the energy due to the position of the object relative to other objects.*
- **Kinetic energy** is *the energy due to the motion of the object.*

Methane and oxygen form carbon dioxide and water in the flame of a lab burner. (Carbon is black, oxygen red, and hydrogen blue.)

Let's examine four systems that illustrate the relationship between these two forms of energy: a weight raised above the ground, two balls attached by a spring, two electrically charged particles, and a fuel and its waste products. Two concepts central to all these cases are

1. When energy is converted from one form to the other, it is *conserved*, not destroyed.
2. Situations of lower energy are more stable and are favored over situations of higher energy, which are less stable.

The four cases are

- A weight raised above the ground (Figure 1.3A). The energy you exert to lift a weight against gravity increases the weight's potential energy (energy due to its position). When you drop the weight, that additional potential energy is converted to kinetic energy (energy due to motion). The situation with the weight elevated and higher in potential energy is *less stable*, so the weight will fall when released, resulting in a situation that is lower in potential energy and *more stable*.
- Two balls attached by a spring (Figure 1.3B). When you pull the balls apart, the energy you exert to stretch the relaxed spring increases the system's potential energy. This change in potential energy is converted to kinetic energy when you release the balls. The system of balls and spring is less stable (has more potential energy) when the spring is stretched than when it is relaxed.
- Two electrically charged particles (Figure 1.3C). Due to interactions known as electrostatic forces, opposite charges attract each other, and like charges repel each other. When energy is exerted to move a positive particle away from a negative one, the potential energy of the system increases, and that increase is converted to

A A gravitational system. Potential energy is gained when a weight is lifted. It is converted to kinetic energy as the weight falls.

B A system of two balls attached by a spring. Potential energy is gained when the spring is stretched. It is converted to the kinetic energy of the moving balls as the spring relaxes.

C A system of oppositely charged particles. Potential energy is gained when the charges are separated. It is converted to kinetic energy as the attraction pulls the charges together.

D A system of fuel and exhaust. A fuel is higher in chemical potential energy than the exhaust. As the fuel burns, some of its potential energy is converted to the kinetic energy of the moving car.

Figure 1.3 Potential energy is converted to kinetic energy. The dashed horizontal lines indicate the potential energy of each system before and after the change.

kinetic energy when the particles are pulled together by the electrostatic attraction. Similarly, when energy is used to move two positive (or two negative) particles together, their potential energy increases and changes to kinetic energy when they are pushed apart by the electrostatic repulsion. Charged particles move naturally to a more stable situation (lower energy).

- A fuel and its waste products (Figure 1.3D). Matter is composed of positively and negatively charged particles. *The chemical potential energy of a substance results from the relative positions of its particles and the attractions and repulsions among them.* Some substances are higher in potential energy than others. For example, gasoline and oxygen have more chemical potential energy than the exhaust gases they form. This difference is converted into kinetic energy, which moves the car, heats the interior, makes the lights shine, and so on. Similarly, the difference in potential energy between the food and air we take in and the wastes we excrete enables us to move, grow, keep warm, study chemistry, and so on.

› Summary of Section 1.1

- › Chemists study the composition and properties of matter and how they change.
- › Matter exists in three physical states—solid, liquid, and gas. The behavior of each state is due to the arrangement of the particles.
- › Each substance has a unique set of *physical* properties (attributes of the substance itself) and *chemical* properties (attributes of the substance as it interacts with or changes to other substances). Changes in matter can be *physical* (different form of the same substance) or *chemical* (different substance).
- › A physical change caused by heating may be reversed by cooling. But a chemical change caused by heating can be reversed only by other chemical changes.
- › Macroscopic changes result from submicroscopic changes.
- › Changes in matter are accompanied by changes in energy.
- › An object's potential energy is due to its position; an object's kinetic energy is due to its motion. Energy used to lift a weight, stretch a spring, or separate opposite charges increases the system's potential energy, which is converted to kinetic energy as the system returns to its original condition. Energy changes form but is conserved.
- › Chemical potential energy arises from the positions and interactions of a substance's particles. When a higher energy (less stable) substance is converted into a more stable (lower energy) substance, some potential energy is converted into kinetic energy.

Figure 1.4 Alchemical apparatus.

Source: © SSPL/The Image Works

1.2 CHEMICAL ARTS AND THE ORIGINS OF MODERN CHEMISTRY

This brief overview of early breakthroughs, and a few false directions, describes how the modern science of chemistry arose and progressed.

Prechemical Traditions

Chemistry had its origin in a prescientific past that incorporated three overlapping traditions—alchemy, medicine, and technology:

1. *The alchemical tradition.* Alchemy was an occult study of nature that began in the 1st century AD and dominated thinking for over 1500 years. Originally influenced by the Greek idea that matter strives for “perfection,” alchemists later became obsessed with converting “baser” metals, such as lead, into “purer” ones, such as gold. The alchemists’ names for substances and their mistaken belief that matter could be altered magically persisted for centuries. Their legacy to chemistry was in technical methods. They invented distillation, percolation, and extraction and devised apparatus still used routinely today (Figure 1.4). But perhaps even more important was that alchemists encouraged observation and experimentation, which replaced the Greek approach of explaining nature solely through reason.

2. *The medical tradition.* Alchemists also influenced medical practice in medieval Europe. And ever since the 13th century, distillates and extracts of roots, herbs, and other plant matter have been used as sources of medicines. The alchemist and physician Paracelsus (1493–1541) considered the body to be a chemical system and illness an imbalance that could be restored by treatment with drugs. Although many early prescriptions were useless, later ones had increasing success. Thus began the alliance between medicine and chemistry that thrives today.

3. *The technological tradition.* For thousands of years, pottery making, dyeing, and especially metallurgy contributed greatly to people's experience with materials. During the Middle Ages and the Renaissance, books were published that described how to purify, assay, and coin silver and gold, how to use balances, furnaces, and crucibles, and how to make glass and gunpowder. Some of the books introduced quantitative measurement, which was lacking in alchemical writings. Many creations from those times are still marveled at throughout the world. Nevertheless, the skilled artisans showed little interest in *why* a substance changes or *how to predict* its behavior.

The Phlogiston Fiasco and the Impact of Lavoisier

Chemical investigation in the modern sense—*inquiry into the causes of changes in matter*—began in the late 17th century. At that time, most scientists explained **combustion**, the process of burning a material in air, with the *phlogiston theory*. It proposed that combustible materials contain *phlogiston*, an undetectable substance released when the material burns. Highly combustible materials like charcoal were thought to contain a lot of phlogiston, and slightly combustible materials like metals only a little. But inconsistencies continuously arose.

Phlogiston critics: Why is air needed for combustion, and why does charcoal stop burning in a closed vessel?

Phlogiston supporters: Air “attracts” phlogiston out of the charcoal, and burning stops when the air in the vessel is “saturated” with phlogiston.

Critics also noted that when a metal burns, it forms a substance known as its *calx*, which weighs more than the metal, leading them to ask,

Critics: How can the *loss* of phlogiston cause a *gain* in mass?

Supporters: Phlogiston has negative mass.

As ridiculous as these responses seem now, it's important to remember that, even today, scientists may dismiss conflicting evidence rather than abandon an accepted idea.

The conflict over phlogiston was resolved when the young French chemist Antoine Lavoisier (1743–1794) performed several experiments:

1. Heating mercury calx decomposed it into two products—mercury and a gas—whose *total mass equaled the starting mass of the calx*.
2. Heating mercury with the gas reformed the calx, and, again, *the total mass remained constant*.
3. Heating mercury in a measured volume of air yielded mercury calx and left four-fifths of the air remaining.
4. A burning candle placed in the remaining air was extinguished.

Lavoisier named the gas *oxygen* and gave metal calxes the name *metal oxides*. His explanation of his results made the phlogiston theory irrelevant:

- Oxygen, a normal component of air, combines with a substance when it burns.
- In a closed container, a combustible substance stops burning when it has combined with all the available oxygen.
- A metal calx (metal oxide) weighs more than the metal because its mass includes the mass of the oxygen.

This new theory triumphed because it relied on *quantitative, reproducible measurements*, not on strange properties of undetectable substances. Because this approach is at the heart of science, many propose that the *science* of chemistry began with Lavoisier.

› Summary of Section 1.2

- › Alchemy, medicine, and technology placed little emphasis on objective experimentation, focusing instead on mystical explanations or practical experience, but these traditions contributed some apparatus and methods that are still important.
- › Lavoisier overthrew the phlogiston theory by showing, through quantitative, reproducible measurements, that oxygen, a component of air, is required for combustion and combines with a burning substance.

1.3 THE SCIENTIFIC APPROACH: DEVELOPING A MODEL

Our prehistoric ancestors survived through *trial and error*, gradually learning which types of stone were hard enough to use for shaping other types, which plants were edible and which poisonous, and so forth. Unlike them, we employ the *quantitative theories* of chemistry to understand materials, make better use of them, and create new ones: specialized drugs, advanced composites, synthetic polymers, and countless others (Figure 1.5).

To understand nature, scientists use an approach called the **scientific method**. It is not a stepwise checklist, but rather a process involving creative proposals and tests aimed at objective, verifiable discoveries. There is no single procedure, and luck often plays a key role in discovery. In general terms, the scientific approach includes the following parts (Figure 1.6):

- **Observations.** These are the facts our ideas must explain. The most useful observations are quantitative because they can be analyzed to reveal *trends*. Pieces of quantitative information are **data**. When the same observation is made by many investigators in many situations with no clear exceptions, it is summarized, often in mathematical terms, as a **natural law**. The observation that mass remains constant during chemical change—made by Lavoisier and numerous experimenters since—is known as the law of mass conservation (Chapter 2).
- **Hypothesis.** Whether derived from observation or from a “spark of intuition,” a hypothesis is a proposal made to explain an observation. A sound hypothesis need not be correct, but it must be *testable by experiment*. Indeed, a hypothesis is often the reason for performing an experiment: if the results do not support it, the hypothesis must be revised or discarded. *Hypotheses can be altered, but experimental results cannot.*
- **Experiment.** A set of procedural steps that tests a hypothesis, an experiment often leads to a revised hypothesis and new experiments to test it. An experiment typically contains at least two **variables**, quantities that can have more than one value. A well-designed experiment is **controlled** in that it measures the effect of one variable on another while keeping all other variables constant. Experimental results must be *reproducible* by others. Both skill and creativity play a part in experimental design.

Figure 1.5 Modern materials in a variety of applications. **A**, High-tension polymers in synthetic hip joints. **B**, Specialized polymers in clothing and sports gear. **C**, Liquid crystals and semiconductors in electronic devices. **D**, Medicinal agents in pills.

Source: (A) © George Haling/Science Source; (B) © Javier Soriano/AFP/Getty Images; (C) © Alexey Boldin/Shutterstock.com; (D) © Didecs/Shutterstock.com

- **Model.** Formulating conceptual models, or **theories**, based on *experiments* that test *hypotheses* about *observations* distinguishes scientific thinking from speculation. As hypotheses are revised according to experimental results, a model emerges to explain how a phenomenon occurs. A model is a *simplified*, not an exact, representation of some aspect of nature that we use to *predict* related phenomena. Ongoing experimentation refines the model to account for new facts.

Lavoisier's overthrow of the phlogiston theory demonstrates the scientific method of thinking. *Observations* of burning and smelting led to the *hypothesis* that combustion involved the loss of phlogiston. *Experiments* showing that air is required for burning and that a metal gains mass during combustion led Lavoisier to propose a new *hypothesis*, which he tested repeatedly with quantitative *experiments*. Accumulating evidence supported his developing *model (theory)* that combustion involves combination with a component of air (oxygen). Innumerable *predictions* based on this theory have supported its validity, and Lavoisier himself extended the theory to account for animal respiration and metabolism.

Figure 1.6 The scientific approach to understanding nature. Hypotheses and models are mental pictures that are revised to match observations and experimental results, *not* the other way around.

› Summary of Section 1.3

- › The scientific method is a process designed to explain and predict phenomena.
- › Observations lead to hypotheses about how a phenomenon occurs. When repeated with no exceptions, observations may be expressed as a natural law.
- › Hypotheses are tested by controlled experiments and revised when necessary.
- › If reproducible data support a hypothesis, a model (theory) can be developed to explain the observed phenomenon. A good model predicts related phenomena but must be refined whenever conflicting data appear.

1.4

MEASUREMENT AND CHEMICAL PROBLEM SOLVING

Measurement has a rich history characterized by the search for *exact, invariable standards*. Measuring for purposes of trade, building, and surveying began thousands of years ago, but for most of that time, it was based on standards that could vary: a yard was the distance from the king's nose to the tip of his outstretched arm, and an acre was the area tilled in one day by a man with a pair of oxen. Our current system of measurement began in 1790 in France, when a committee, of which Lavoisier was a member, developed the *metric system*. Then, in 1960, another committee in France revised the metric system and established the universally accepted **SI units** (from the French Système International d'Unités).

General Features of SI Units

The SI system is based on seven **fundamental units**, or **base units**, each identified with a physical quantity (Table 1.2, *next page*). All other units are **derived units**, combinations

Table 1.2 SI Base Units

Physical Quantity (Dimension)	Unit Name	Unit Abbreviation
Mass	kilogram	kg
Length	meter	m
Time	second	s
Temperature	kelvin	K
Amount of substance	mole	mol
Electric current	ampere	A
Luminous intensity	candela	cd

of the seven base units. For example, the derived unit for speed, meters per second (m/s), is the base unit for length (m) divided by the base unit for time (s).

For quantities much smaller or larger than the base unit, we use decimal prefixes and exponential (scientific) notation (Table 1.3). For example, the prefix *kilo-* (symbolized by k) indicates that the unit is one thousand times larger than a base unit, and the prefix *milli-* (m) indicates that the unit is one-thousandth the size of a base unit:

$$1 \text{ kilosecond (1 ks)} = 1000 \text{ seconds} = 1 \times 10^3 \text{ seconds}$$

$$1 \text{ millisecond (1 ms)} = 0.001 \text{ second} = 1 \times 10^{-3} \text{ second}$$

Note that a mathematically equivalent statement of the second relationship is
 $1000 \text{ milliseconds (ms)} = 1 \text{ second}$

Because the prefixes are based on powers of 10, SI units are easier to use in calculations than English units. (If you need a review of exponential notation, see Appendix A.)

Some Important SI Units in Chemistry

In this chapter, we discuss units for length, volume, mass, time, density, and temperature; other units are presented in later chapters. Table 1.4 shows some SI quantities for length, volume, and mass, along with their English-system equivalents.

Table 1.3

Common Decimal Prefixes Used with SI Units*

Prefix*	Symbol	Conventional Notation	Exponential Notation	Example [using gram (g) [†] or meter (m) [‡]]
tera	(T)	1,000,000,000,000	1×10^{12}	1 teragram (Tg) = 1×10^{12} g
giga	(G)	1,000,000,000	1×10^9	1 gigagram (Gg) = 1×10^9 g
mega	(M)	1,000,000	1×10^6	1 megagram (Mg) = 1×10^6 g
kilo	(k)	1000	1×10^3	1 kilogram (kg) = 1×10^3 g
hecto	(h)	100	1×10^2	1 hectogram (hg) = 1×10^2 g
deka	(da)	10	1×10^1	1 dekagram (dag) = 1×10^1 g
—	—	1	1×10^0	
deci	(d)	0.1	1×10^{-1}	1 decimeter (dm) = 1×10^{-1} m
centi	(c)	0.01	1×10^{-2}	1 centimeter (cm) = 1×10^{-2} m
milli	(m)	0.001	1×10^{-3}	1 millimeter (mm) = 1×10^{-3} m
micro	(μ)	0.000001	1×10^{-6}	1 micrometer (μm) = 1×10^{-6} m
nano	(n)	0.000000001	1×10^{-9}	1 nanometer (nm) = 1×10^{-9} m
pico	(p)	0.000000000001	1×10^{-12}	1 picometer (pm) = 1×10^{-12} m
femto	(f)	0.000000000000001	1×10^{-15}	1 femtometer (fm) = 1×10^{-15} m

*The prefixes most frequently used by chemists appear in bold type.

[†]The gram is a unit of mass.

[‡]The meter is a unit of length.

Table 1.4**Common SI-English Equivalent Quantities**

Quantity	SI Units	SI Equivalents	English Equivalents	English to SI Equivalent
Length	1 kilometer (km)	1000 (10^3) meters	0.6214 mile (mi)	1 mile = 1.609 km
	1 meter (m)	100 (10^2) centimeters	1.094 yards (yd)	1 yard = 0.9144 m
	1 meter (m)	1000 millimeters (mm)	39.37 inches (in)	1 foot (ft) = 0.3048 m
	1 centimeter (cm)	0.01 (10^{-2}) meter	0.3937 inch	1 inch = 2.54 cm (exactly)
Volume	1 cubic meter (m^3)	1,000,000 (10^6) cubic centimeters	35.31 cubic feet (ft^3)	1 cubic foot = 0.02832 m^3
	1 cubic decimeter (dm^3)	1000 cubic centimeters	0.2642 gallon (gal)	1 gallon = 3.785 dm^3
	1 cubic decimeter (dm^3)	1000 cubic centimeters	1.057 quarts (qt)	1 quart = 0.9464 dm^3
	1 cubic centimeter (cm^3)	0.001 dm^3	0.03381 fluid ounce	1 fluid ounce = 29.57 cm^3
Mass	1 kilogram (kg)	1000 grams (g)	2.205 pounds (lb)	1 pound = 0.4536 kg

Length The SI base unit of length is the **meter (m)**. In the metric system, it was originally defined as 1/10,000,000 of the distance from the equator to the North Pole, and later as the distance between two fine lines engraved on a corrosion-resistant metal bar. More recently, the first exact, unchanging standard was adopted: 1,650,763.73 wavelengths of orange-red light from electrically excited krypton atoms. The current standard is exact and invariant: 1 meter is the distance light travels in a vacuum in 1/299,792,458 of a second.

A meter is a little longer than a yard (1 m = 1.094 yd); a centimeter (10^{-2} m) is about two-fifths of an inch (1 cm = 0.3937 in; 1 in = 2.54 cm). Biological cells are often measured in micrometers (1 $\mu\text{m} = 10^{-6}$ m). On the atomic scale, nanometers (10^{-9} m) and picometers (10^{-12} m) are used. Many proteins have diameters of about 2 nm; atomic diameters are about 200 pm (0.2 nm). An older unit still in use is the angstrom ($1\text{\AA} = 10^{-10}$ m = 0.1 nm = 100 pm).

Volume In chemistry, the significance of length appears when a sample of matter is measured in three dimensions, which gives its **volume (V)**, the amount of space it occupies. The derived SI unit of volume is the **cubic meter (m^3)**. Since the volume of some objects can be calculated using the relationship length \times width \times height, a length unit cubed (meters \times meters \times meters = m^3) is a unit of volume. In chemistry, we often use non-SI units, the **liter (L)** and the **milliliter (mL)** (note the uppercase L), to measure volume. Physicians and other medical practitioners measure body fluids in cubic decimeters (dm^3), which are equivalent to liters:

$$1 \text{ L} = 1 \text{ dm}^3 = 10^{-3} \text{ m}^3$$

And 1 mL, or $\frac{1}{1000}$ of a liter, is equivalent to 1 cubic centimeter (cm^3):

$$1 \text{ mL} = 1 \text{ cm}^3 = 10^{-3} \text{ dm}^3 = 10^{-3} \text{ L} = 10^{-6} \text{ m}^3$$

A liter is slightly larger than a quart (qt) (1 L = 1.057 qt; 1 qt = 946.4 mL); 1 fluid ounce ($\frac{1}{32}$ of a quart) equals 29.57 mL (29.57 cm^3).

Figure 1.7 (next page) is a depiction of the two 1000-fold decreases in volume from 1 dm^3 to 1 cm^3 and then to 1 mm^3 . The edge of a 1-m³ cube would be just a little longer than a yardstick.

Figure 1.8A (next page) shows some laboratory glassware for working with volumes. Erlenmeyer flasks and beakers are used to contain liquids. Graduated cylinders, pipets, and burets are used to measure and transfer them. Volumetric flasks and pipets have a fixed volume indicated by a mark on the neck. Solutions are prepared quantitatively in volumetric flasks, and specific amounts are put into cylinders, pipets, or burets to transfer to beakers or flasks for further steps. In Figure 1.8B, an automatic pipet transfers liquid accurately *and* quickly.

Some volume equivalents:

1 m^3	$= 1000\text{ dm}^3$
1 dm^3	$= 1000\text{ cm}^3$
	$= 1\text{ L} = 1000\text{ mL}$
1 cm^3	$= 1000\text{ mm}^3$
	$= 1\text{ mL} = 1000\text{ }\mu\text{L}$
1 mm^3	$= 1\text{ }\mu\text{L}$

Figure 1.7 Some volume relationships in SI: From cubic decimeter (dm^3) to cubic centimeter (cm^3) to cubic millimeter (mm^3).

Figure 1.8 Common laboratory volumetric glassware. **A**, From left to right are two graduated cylinders, a pipet being emptied into a beaker, a buret delivering liquid to an Erlenmeyer flask, and two volumetric flasks. **Inset**, In contact with the glass neck of the flask, the liquid forms a concave meniscus (curved surface). **B**, An automatic pipet delivers a given volume of liquid to each test tube.

Source: (A) © McGraw-Hill Education/Stephen Frisch, photographer; (B) © BrandTech Scientific, Inc.

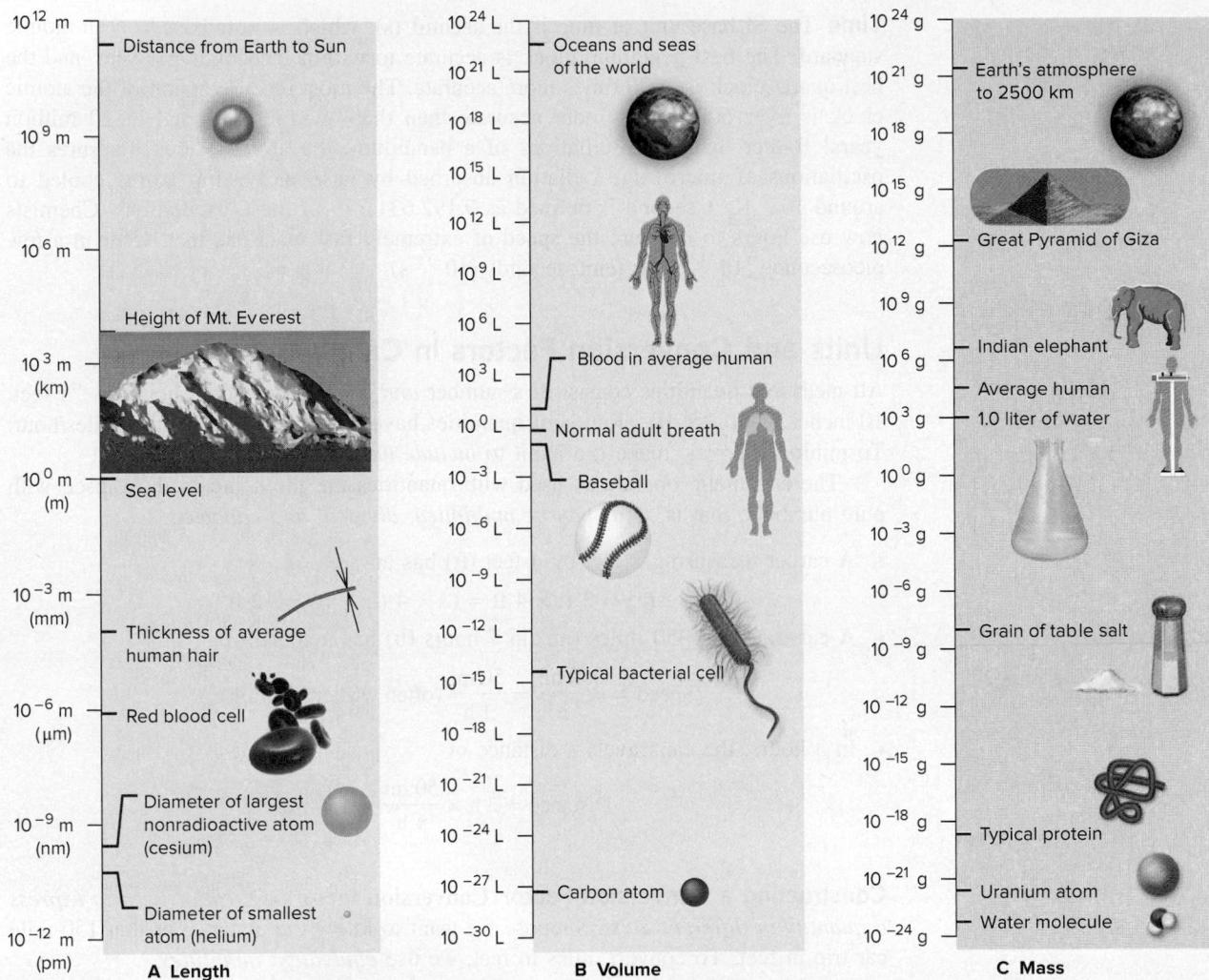

Figure 1.9 Some interesting quantities of length (A), volume (B), and mass (C). The vertical scales are exponential.

Mass The quantity of matter an object contains is its **mass**. The SI unit of mass is the **kilogram (kg)**, the only base unit whose standard is an object—a platinum-iridium cylinder kept in France—and the only one whose name has a prefix.*

The terms *mass* and *weight* have distinct meanings:

- **Mass is constant** because an object's quantity of matter cannot change.
- **Weight is variable** because it depends on the local gravitational field acting on the object.

Because the strength of the gravitational field varies with altitude, you (and other objects) weigh slightly less on a high mountain than at sea level.

Does this mean that a sample weighed on laboratory balances in Miami (sea level) and in Denver (about 1.7 km above sea level) give different results? No, because these balances measure mass, not weight. (We actually “mass” an object when we weigh it on a balance, but we don’t use that term.) Mechanical balances compare the object’s mass with masses built into the balance, so the local gravitational field pulls on them equally. Electronic (analytical) balances generate an electric field that counteracts the local field, and the current needed to restore the pan to zero is converted to the equivalent mass and displayed.

Figure 1.9 shows the ranges of some common lengths, volumes, and masses.

*The names of the other base units are used as the root words, but for units of mass we attach prefixes to the word “gram,” as in “microgram” and “kilogram”; thus, we say “milligram,” never “microkilogram.”

Time The SI base unit of time is the **second (s)**, which is now based on an atomic standard. The best pendulum clock is accurate to within 3 seconds per year, and the best quartz clock is 1000 times more accurate. The most recent version of the atomic clock is over 6000 times more accurate than that—within 1 second in 20 million years! Rather than the oscillations of a pendulum, the atomic clock measures the oscillations of microwave radiation absorbed by gaseous cesium atoms cooled to around 10^{-6} K: 1 second is defined as 9,192,631,770 of these oscillations. Chemists now use lasers to measure the speed of extremely fast reactions that occur in a few picoseconds (10^{-12} s) or femtoseconds (10^{-15} s).

Units and Conversion Factors in Calculations

All measured quantities consist of a number *and* a unit: a person's height is "5 feet, 10 inches," not "5, 10." Ratios of quantities have ratios of units, such as miles/hour. To minimize errors, make it a habit to *include units in all calculations*.

The arithmetic operations used with quantities are the same as those used with pure numbers; that is, *units can be multiplied, divided, and canceled*:

- A carpet measuring 3 feet by 4 feet (ft) has an area of

$$\text{Area} = 3 \text{ ft} \times 4 \text{ ft} = (3 \times 4)(\text{ft} \times \text{ft}) = 12 \text{ ft}^2$$

- A car traveling 350 miles (mi) in 7 hours (h) has a speed of

$$\text{Speed} = \frac{350 \text{ mi}}{7 \text{ h}} = \frac{50 \text{ mi}}{1 \text{ h}} \text{ (often written } 50 \text{ mi}\cdot\text{h}^{-1}\text{)}$$

- In 3 hours, the car travels a distance of

$$\text{Distance} = 3 \text{ h} \times \frac{50 \text{ mi}}{1 \text{ h}} = 150 \text{ mi}$$

Constructing a Conversion Factor **Conversion factors** are *ratios used to express a quantity in different units*. Suppose we want to know the distance of that 150-mile car trip in feet. To convert miles to feet, we use *equivalent quantities*,

$$1 \text{ mi} = 5280 \text{ ft}$$

from which we can construct two conversion factors. Dividing both sides by 5280 ft gives one conversion factor (shown in blue):

$$\frac{1 \text{ mi}}{5280 \text{ ft}} = \frac{5280 \text{ ft}}{5280 \text{ ft}} = 1$$

And, dividing both sides by 1 mi gives the other conversion factor (the inverse):

$$\frac{1 \text{ mi}}{1 \text{ mi}} = \frac{5280 \text{ ft}}{1 \text{ mi}} = 1$$

Since the numerator and denominator of a conversion factor are equal, multiplying a quantity by a conversion factor is the same as multiplying by 1. Thus, *even though the number and unit change, the size of the quantity remains the same*.

To convert the distance from miles to feet, we choose the conversion factor with miles in the denominator, because it cancels miles and gives the answer in feet:

$$\text{Distance (ft)} = 150 \text{ mi} \times \frac{5280 \text{ ft}}{1 \text{ mi}} = 792,000 \text{ ft}$$

Choosing the Correct Conversion Factor It is easier to convert if you first decide whether the answer expressed in the new units should have a larger or smaller number. In the previous case, we know that a foot is *smaller* than a mile, so the distance in feet should have a *larger* number (792,000) than the distance in miles (150). The conversion factor has the larger number (5280) in the numerator, so it gave a larger number in the answer.

Most importantly, the *conversion factor you choose must cancel all units except those you want in the answer*. Therefore, set the unit you are converting *from* (beginning unit) in the *opposite position in the conversion factor* (numerator or denominator) so that it cancels and you are left with the unit you are converting *to* (final unit):

$$\text{beginning unit} \times \frac{\text{final unit}}{\text{beginning unit}} = \text{final unit} \quad \text{as in} \quad \text{mi} \times \frac{\text{ft}}{\text{mi}} = \text{ft}$$

Or, in cases that involve units raised to a power:

$$(\text{beginning unit} \times \text{beginning unit}) \times \frac{\text{final unit}^2}{\text{beginning unit}^2} = \text{final unit}^2 \quad \text{as in} \quad (\text{ft} \times \text{ft}) \times \frac{\text{mi}^2}{\text{ft}^2} = \text{mi}^2$$

Or, in cases that involve a ratio of units:

$$\frac{\text{beginning unit}}{\text{final unit}_1} \times \frac{\text{final unit}_2}{\text{beginning unit}} = \frac{\text{final unit}_2}{\text{final unit}_1} \quad \text{as in} \quad \frac{\text{mi}}{\text{h}} \times \frac{\text{ft}}{\text{mi}} = \frac{\text{ft}}{\text{h}}$$

Converting Between Unit Systems We use the same procedure to convert between one system of units and another, for example, between the English (or American) unit system and the International System. Suppose we know that the height of Angel Falls in Venezuela (the world's highest) is 3212 ft; we can find its height in miles as

$$\text{Height (mi)} = 3212 \text{ ft} \times \frac{1 \text{ mi}}{5280 \text{ ft}} = 0.6083 \text{ mi} \quad \text{ft} \Rightarrow \text{mi}$$

Now, we want its height in kilometers (km). The equivalent quantities (see Table 1.4) are

$$1.609 \text{ km} = 1 \text{ mi}$$

Because we are converting *from* miles *to* kilometers, we use the conversion factor with miles in the denominator in order to cancel miles:

$$\text{Height (km)} = 0.6083 \text{ mi} \times \frac{1.609 \text{ km}}{1 \text{ mi}} = 0.9788 \text{ km} \quad \text{mi} \Rightarrow \text{km}$$

Notice that kilometers are *smaller* than miles, so this conversion factor gave us an answer with a *larger* number (0.9788 is larger than 0.6083).

If we want the height of Angel Falls in meters (m), we use the equivalent quantities 1 km = 1000 m to construct the conversion factor:

$$\text{Height (m)} = 0.9788 \text{ km} \times \frac{1000 \text{ m}}{1 \text{ km}} = 978.8 \text{ m} \quad \text{km} \Rightarrow \text{m}$$

In longer calculations, we often string together several conversion steps:

$$\text{Height (m)} = 3212 \text{ ft} \times \frac{1 \text{ mi}}{5280 \text{ ft}} \times \frac{1.609 \text{ km}}{1 \text{ mi}} \times \frac{1000 \text{ m}}{1 \text{ km}} = 978.8 \text{ m} \quad \text{ft} \Rightarrow \text{mi} \Rightarrow \text{km} \Rightarrow \text{m}$$

The use of conversion factors in calculations is also referred to as the factor-label method, or **dimensional analysis** (because units represent physical dimensions). We use this approach throughout the text.

A Systematic Approach to Solving Chemistry Problems

The approach used in this book to solve problems emphasizes reasoning, not memorizing, and is based on a simple idea: plan how to solve the problem *before* you try to solve it, then check your answer, and practice with similar follow-up problems. In general, the sample problems consist of several parts:

1. **Problem.** This part states all the information you need to solve the problem, usually framed in some interesting context.

Student Hot Spot

Student data indicate that you may struggle with conversion factors. Access the Smartbook to view additional Learning Resources on this topic.

2. **Plan.** This part helps you *think* about the solution *before* juggling numbers and pressing calculator buttons. There is often more than one way to solve a problem, and the given plan is one possibility. The plan will
 - Clarify the known and unknown: what information do you have, and what are you trying to find?
 - Suggest the steps from known to unknown: what ideas, conversions, or equations are needed?
 - Present a road map (especially in early chapters), a flow diagram of the plan. The road map has a box for each intermediate result and an arrow showing the step (conversion factor or operation) used to get to the next box.
3. **Solution.** This part shows the calculation steps in the same order as in the plan (and the road map).
4. **Check.** This part helps you check that your final answer makes sense: Are the units correct? Did the change occur in the expected direction? Is it reasonable chemically? To avoid a large math error, we also often do a rough calculation and see if we get an answer “in the same ballpark” as the actual result. Here’s a typical “ballpark” calculation from everyday life. You are in a clothing store and buy three shirts at \$14.97 each. With a 5% sales tax, the bill comes to \$47.16. In your mind, you know that \$14.97 is about \$15, and 3 times \$15 is \$45; with the sales tax, the cost should be a bit more. So, your quick mental calculation is in the same ballpark as the actual cost.
5. **Comment.** This part appears occasionally to provide an application, an alternative approach, a common mistake to avoid, or an overview.
6. **Follow-up Problems.** This part presents similar problems that require you to apply concepts and/or methods used in solving the sample problem.
7. **Some Similar Problems.** This part lists a few more problems (found at the end of each chapter) for practice.

Of course, you can’t learn to solve chemistry problems, any more than you can learn to swim, by reading about it, so here are a few suggestions:

- Follow along in the sample problem with pencil, paper, and calculator.
- Try the follow-up problems as soon as you finish the sample problem. A very useful feature called Brief Solutions to Follow-up Problems appears at the end of each chapter, allowing you to compare your solution steps and answers.
- Read the sample problem and text again if you have trouble.
- The end-of-chapter problems review and extend the concepts and skills in the chapter, so work as many as you can. (Answers are given in Appendix E in the back of the book for problems with a colored number.)

Let’s apply this systematic approach in some unit-conversion problems. Refer to Tables 1.3 and 1.4 as you work through these problems.

Road Map

SAMPLE PROBLEM 1.3

Converting Units of Length

Problem To wire your stereo equipment, you need 325 centimeters (cm) of speaker wire that sells for \$0.15/ft. How much does the wire cost?

Plan We know the length of wire in centimeters (325 cm) and the price in dollars per foot (\$0.15/ft). We can find the unknown cost of the wire by converting the length from centimeters to inches (in) and from inches to feet. The price gives us the equivalent quantities (1 ft = \$0.15) that allow us to convert from feet of wire to cost in dollars. The road map starts with the known quantity of 325 cm and moves through the calculation steps to the unknown.

Solution Converting the known length from centimeters to inches: The equivalent quantities beside the road map arrow are needed to construct the conversion factor.

We choose 1 in/2.54 cm, rather than the inverse, because it gives an answer in inches:

$$\begin{aligned}\text{Length (in)} &= \text{length (cm)} \times \text{conversion factor} \\ &= 325 \text{ cm} \times \frac{1 \text{ in}}{2.54 \text{ cm}} = 128 \text{ in}\end{aligned}$$

Converting the length from inches to feet:

$$\begin{aligned}\text{Length (ft)} &= \text{length (in)} \times \text{conversion factor} \\ &= 128 \text{ in} \times \frac{1 \text{ ft}}{12 \text{ in}} = 10.7 \text{ ft}\end{aligned}$$

Converting the length in feet to cost in dollars:

$$\begin{aligned}\text{Cost (\$)} &= \text{length (ft)} \times \text{conversion factor} \\ &= 10.7 \text{ ft} \times \frac{\$0.15}{1 \text{ ft}} = \$1.60\end{aligned}$$

Check The units are correct for each step. The conversion factors make sense in terms of the relative unit sizes: the number of inches is *smaller* than the number of centimeters (an inch is *larger* than a centimeter), and the number of feet is *smaller* than the number of inches. The total cost seems reasonable: a little more than 10 ft of wire at \$0.15/ft should cost a little more than \$1.50.

Comment 1. We could also have strung the three steps together:

$$\text{Cost (\$)} = 325 \text{ cm} \times \frac{1 \text{ in}}{2.54 \text{ cm}} \times \frac{1 \text{ ft}}{12 \text{ in}} \times \frac{\$0.15}{1 \text{ ft}} = \$1.60$$

2. There are usually alternative sequences in unit-conversion problems. Here, for example, we would get the same answer if we first converted the cost of wire from \$/ft to \$/cm and kept the wire length in cm. Try it yourself.

FOLLOW-UP PROBLEMS

1.3A A chemistry professor can walk a mile in 15 minutes. How many minutes will it take the professor to walk 10,500 meters (m)? Draw a road map to show how you planned the solution.

1.3B The rhinovirus, one cause of the common cold, has a diameter of 30 nm. How many of these virus particles could line up side by side on a line that is 1.0 in long? Draw a road map to show how you planned the solution.

SOME SIMILAR PROBLEMS 1.26–1.29

SAMPLE PROBLEM 1.4

Converting Units of Volume

Problem The volume of an irregularly shaped solid can be determined from the volume of water it displaces. A graduated cylinder contains 19.9 mL of water. When a small piece of galena, an ore of lead, is added to the cylinder, it sinks and the volume increases to 24.5 mL. What is the volume of the piece of galena in cm^3 and in L?

Plan We have to find the volume of the galena from the change in volume of the cylinder contents. The volume of galena in mL is the difference before (19.9 mL) and after (24.5 mL) adding it. Since mL and cm^3 represent identical volumes, the volume in mL equals the volume in cm^3 . We then use equivalent quantities ($1 \text{ mL} = 10^{-3} \text{ L}$) to convert mL to L. The road map shows these steps.

Solution Finding the volume of galena:

$$\text{Volume (mL)} = \text{volume after} - \text{volume before} = 24.5 \text{ mL} - 19.9 \text{ mL} = 4.6 \text{ mL}$$

Converting the volume from mL to cm^3 :

$$\text{Volume (cm}^3\text{)} = \text{volume (mL)} \times \text{conversion factor} = 4.6 \text{ mL} \times \frac{1 \text{ cm}^3}{1 \text{ mL}} = 4.6 \text{ cm}^3$$

Converting the volume from mL to L:

$$\text{Volume (L)} = \text{volume (mL)} \times \text{conversion factor} = 4.6 \text{ mL} \times \frac{10^{-3} \text{ L}}{1 \text{ mL}} = 4.6 \times 10^{-3} \text{ L}$$

Road Map

Check The units and magnitudes of the answers seem correct, and it makes sense that the volume in mL would have a number 1000 times larger than the same volume in L.

FOLLOW-UP PROBLEMS

1.4A Within a cell, proteins are synthesized on particles called ribosomes. Assuming ribosomes are spherical, what is the volume (in dm^3 and μL) of a ribosome whose average diameter is 21.4 nm (V of a sphere = $\frac{4}{3}\pi r^3$)? Draw a road map to show how you planned the solution.

1.4B During an eruption, the famous geyser Old Faithful in Yellowstone National Park can expel as much as 8400 gal of water. What is this volume in liters (L)? Draw a road map to show how you planned the solution.

SOME SIMILAR PROBLEMS 1.36 and 1.37

SAMPLE PROBLEM 1.5

Converting Units of Mass

Road Map

Problem Many international computer communications are carried by optical fibers in cables laid along the ocean floor. If one strand of optical fiber weighs 1.19×10^{-3} lb/m, what is the mass (in kg) of a cable made of six strands of optical fiber, each long enough to link New York and Paris (8.84×10^3 km)?

Plan We have to find the mass (in kg) of a known length of cable (8.84×10^3 km); we are given equivalent quantities for mass and length of a fiber (1.19×10^{-3} lb = 1 m) and for number of fibers and a cable (6 fibers = 1 cable), which we can use to construct conversion factors. Let's first find the mass of one fiber and then the mass of cable. As shown in the road map, we convert the length of one fiber from km to m and then find its mass (in lb) by converting m to lb. Then we multiply the fiber mass by 6 to get the cable mass, and finally convert lb to kg.

Solution Converting the fiber length from km to m:

$$\text{Length (m) of fiber} = 8.84 \times 10^3 \text{ km} \times \frac{10^3 \text{ m}}{1 \text{ km}} = 8.84 \times 10^6 \text{ m}$$

Converting the length of one fiber to mass (lb):

$$\text{Mass (lb) of fiber} = 8.84 \times 10^6 \text{ m} \times \frac{1.19 \times 10^{-3} \text{ lb}}{1 \text{ m}} = 1.05 \times 10^4 \text{ lb}$$

Finding the mass of the cable (lb):

$$\text{Mass (lb) of cable} = \frac{1.05 \times 10^4 \text{ lb}}{1 \text{ fiber}} \times \frac{6 \text{ fibers}}{1 \text{ cable}} = 6.30 \times 10^4 \text{ lb/cable}$$

Converting the mass of cable from lb to kg:

$$\text{Mass (kg) of cable} = \frac{6.30 \times 10^4 \text{ lb}}{1 \text{ cable}} \times \frac{1 \text{ kg}}{2.205 \text{ lb}} = 2.86 \times 10^4 \text{ kg/cable}$$

Check The units are correct. Let's think through the relative sizes of the answers to see if they make sense: The number of m should be 10^3 larger than the number of km. If 1 m of fiber weighs about 10^{-3} lb, then about 10^7 m should weigh about 10^4 lb. The cable mass should be six times as much as that, or about 6×10^4 lb. Since 1 lb is about $\frac{1}{2}$ kg, the number of kg should be about half the number of lb.

FOLLOW-UP PROBLEMS

1.5A An intravenous nutrient solution is delivered to a hospital patient at a rate of 1.5 drops per second. If a drop of solution weighs 65 mg on average, how many kilograms are delivered in 8.0 h? Draw a road map to show how you planned the solution.

1.5B Nutritional tables give the potassium content of a standard apple (about 3 apples per pound) as 159 mg. How many grams of potassium are in 3.25 kg of apples? Draw a road map to show how you planned the solution.

SOME SIMILAR PROBLEMS 1.32 and 1.33

SAMPLE PROBLEM 1.6**Converting Units Raised to a Power**

Problem A furniture factory needs 31.5 ft^2 of fabric to upholster one chair. Its Dutch supplier sends the fabric in bolts that hold exactly 200 m^2 . How many chairs can be upholstered with 3 bolts of fabric?

Plan We are given a known number of fabric bolts (3 bolts) which can be converted to amount of fabric in m^2 using the given equivalent quantities (1 bolt = 200 m^2 fabric). We convert the amount of fabric from m^2 to ft^2 and use the equivalent quantities (31.5 ft^2 of fabric = 1 chair) to find the number of chairs (see the road map).

Solution Converting from number of bolts to amount of fabric in m^2 :

$$\text{Amount } (\text{m}^2) \text{ of fabric} = 3 \text{ bolts} \times \frac{200 \text{ m}^2}{1 \text{ bolt}} = 600 \text{ m}^2$$

Converting the amount of fabric from m^2 to ft^2 : Since $0.3048 \text{ m} = 1 \text{ ft}$, we have $(0.3048)^2 \text{ m}^2 = (1)^2 \text{ ft}^2$, so

$$\text{Amount } (\text{ft}^2) \text{ of fabric} = 600 \text{ m}^2 \times \frac{1 \text{ ft}^2}{(0.3048)^2 \text{ m}^2} = 6460 \text{ ft}^2$$

Finding the number of chairs:

$$\text{Number of chairs} = 6460 \text{ ft}^2 \times \frac{1 \text{ chair}}{31.5 \text{ ft}^2} = 205 \text{ chairs}$$

Check Since $1 \text{ ft} = 0.3048 \text{ m}$, 1 ft is a little less than $\frac{1}{3}$ of a meter, which means that 3.3 ft is about the same as 1 m. We are using squared length units, and $(3.3 \text{ ft})^2$, or 11 ft^2 , is about the same as 1 m^2 . Multiplying the amount of fabric in m^2 by 11 gives 6600 ft^2 of fabric. Each chair requires about 30 ft^2 of fabric, so 6600 ft^2 will upholster 220 chairs, a number close to our answer.

Comment When using conversion factors raised to a power, be certain to raise *both* the number *and* unit to that power. In this problem,

Correct: $0.3048 \text{ m} = 1 \text{ ft}$

so $(0.3048)^2 \text{ m}^2 = (1)^2 \text{ ft}^2$ or $0.09290 \text{ m}^2 = 1 \text{ ft}^2$

Incorrect: $0.3048 \text{ m}^2 = 1 \text{ ft}^2$ (squaring only the units and not the numbers)

FOLLOW-UP PROBLEMS

1.6A A landowner wants to spray herbicide on a field that has an area of 2050 m^2 . The herbicide comes in bottles that hold 16 fluid ounces (fl oz), and 1.5 fl oz mixed with 1 gal of water will treat 300 ft^2 . How many bottles of herbicide will the landowner need? Draw a road map to show how you planned the solution.

1.6B From 1946 to 1970, 75,000 kg of mercury was discharged into a lake in New York. The lake has a surface area of 4.5 mi^2 and an average depth of 35 ft. What mass (in g) of mercury is contained in each mL of lake water in 1970? Draw a road map to show how you planned the solution.

SOME SIMILAR PROBLEMS 1.30, 1.31, and 1.34**Road Map**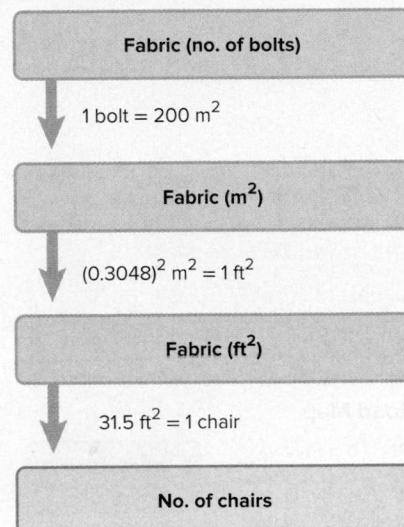

Density: A Combination of Units as a Conversion Factor Derived units, combinations of two or more units, can serve as conversion factors (previously we mentioned that speed is length/time). In chemistry, a very important example is **density (d)**, the mass of a sample of a substance divided by its volume (mass/volume ratio):

$$\text{Density} = \frac{\text{mass}}{\text{volume}} \quad (1.1)$$

We isolate each of these variables by treating density as a conversion factor:

$$\text{Mass} = \text{volume} \times \text{density} = \text{volume} \times \frac{\text{mass}}{\text{volume}}$$

$$\text{or,} \quad \text{Volume} = \text{mass} \times \frac{1}{\text{density}} = \text{mass} \times \frac{\text{volume}}{\text{mass}}$$

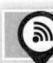**Student Hot Spot**

Student data indicate that you may struggle with the conversion of units raised to a power. Access the Smartbook to view additional Learning Resources on this topic.

Table 1.5

Densities of Some Common Substances*

Substance	Physical State	Density (g/cm ³)
Hydrogen	gas	0.0000899
Oxygen	gas	0.00133
Grain alcohol	liquid	0.789
Water	liquid	0.998
Table salt	solid	2.16
Aluminum	solid	2.70
Lead	solid	11.3
Gold	solid	19.3

*At room temperature (20°C) and normal atmospheric pressure (1 atm).

Because volume can change with temperature, so can density. But, at a given temperature and pressure, the *density of a substance is a characteristic physical property and, thus, has a specific value.*

The SI unit of density is kilograms per cubic meter (kg/m³), but in chemistry, density has units of g/L (g/dm³) or g/mL (g/cm³) (Table 1.5). The densities of gases are much lower than the densities of liquids or solids (see Figure 1.1).

Road Map

(a)

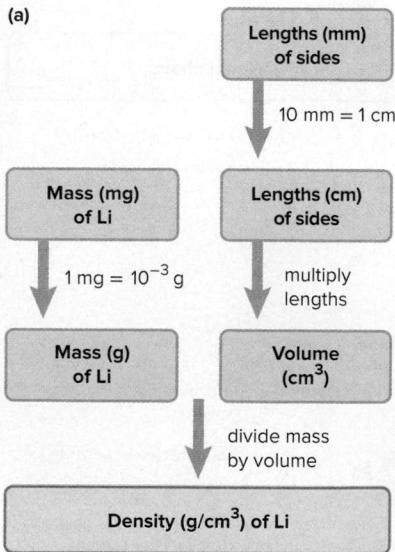

(b)

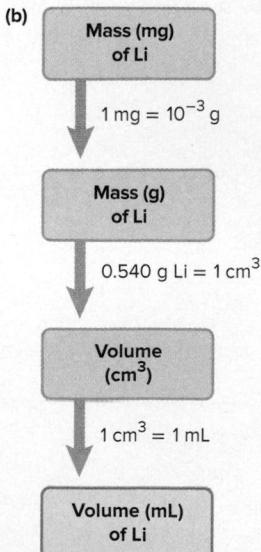

SAMPLE PROBLEM 1.7

Calculating Density from Mass and Volume

Problem (a) Lithium, a soft, gray solid with the lowest density of any metal, is a key component of advanced batteries, such as the one in your laptop. A slab of lithium weighs 1.49×10^3 mg and has sides that are 20.9 mm by 11.1 mm by 11.9 mm. Find the density of lithium in g/cm³. (b) What is the volume (in mL) of a piece of lithium with a mass of 895 mg?

Plan (a) To find the density in g/cm³, we need the mass of lithium in g and the volume in cm³. The mass is 1.49×10^3 mg, so we convert mg to g. We convert the lengths of the three sides from mm to cm, and then multiply them to find the volume in cm³. Dividing the mass by the volume gives the density (see the road map). (b) We have a known mass of lithium (895 mg); we convert mg to g and then use the density from part (a) as a conversion factor between the mass of lithium in g and its volume in cm³. Finally, we convert cm³ to mL (see the road map).

Solution (a) Converting the mass from mg to g:

$$\text{Mass (g) of lithium} = 1.49 \times 10^3 \text{ mg} \left(\frac{10^{-3} \text{ g}}{1 \text{ mg}} \right) = 1.49 \text{ g}$$

Converting side lengths from mm to cm:

$$\text{Length (cm) of one side} = 20.9 \text{ mm} \times \frac{1 \text{ cm}}{10 \text{ mm}} = 2.09 \text{ cm}$$

Similarly, the other side lengths are 1.11 cm and 1.19 cm.

Multiplying the sides to get the volume:

$$\text{Volume (cm}^3\text{)} = 2.09 \text{ cm} \times 1.11 \text{ cm} \times 1.19 \text{ cm} = 2.76 \text{ cm}^3$$

Calculating the density:

$$\text{Density of lithium} = \frac{\text{mass}}{\text{volume}} = \frac{1.49 \text{ g}}{2.76 \text{ cm}^3} = 0.540 \text{ g/cm}^3$$

(b) Converting the mass from mg to g:

$$\text{Mass (g) of lithium} = 895 \text{ mg} \times \frac{10^{-3} \text{ g}}{1 \text{ mg}} = 0.895 \text{ g}$$

Converting the mass of lithium to volume (mL):

$$\text{Volume (mL)} = 0.895 \text{ g} \times \frac{1 \text{ cm}^3}{0.540 \text{ g}} \times \frac{1 \text{ mL}}{1 \text{ cm}^3} = 1.66 \text{ mL}$$

Check (a) Since $1 \text{ cm} = 10 \text{ mm}$, the number of cm in each length should be $\frac{1}{10}$ the number of mm. The units for density are correct, and the size of the answer ($\sim 0.5 \text{ g/cm}^3$) seems correct since the number of g (1.49) is about half the number of cm^3 (2.76). Also, the problem states that lithium has a very low density, so this answer makes sense. (b) Since the density of lithium is 0.540 g/cm^3 or 0.540 g/mL , about 0.5 g of lithium has a volume of 1 mL. Therefore, a mass of about 0.9 g would have a volume of about 1.8 mL.

FOLLOW-UP PROBLEMS

1.7A The density of Venus is similar to that of Earth. The mass of Venus is $4.9 \times 10^{24} \text{ kg}$, and its diameter is 12,100 km. Find the density of Venus in g/cm^3 . The volume of a sphere is given by $\frac{4}{3}\pi r^3$. Draw a road map to show how you planned the solution.

1.7B The piece of galena in Sample Problem 1.4 has a volume of 4.6 cm^3 . If the density of galena is 7.5 g/cm^3 , what is the mass (in kg) of that piece of galena? Draw a road map to show how you planned the solution.

SOME SIMILAR PROBLEMS 1.38–1.41

Temperature Scales

Temperature is a frequently measured quantity in chemistry; there is a noteworthy distinction between temperature and heat:

- **Temperature (T)** is a measure of how hot or cold one object is relative to another.
- **Heat** is the energy that flows from an object with a higher temperature to an object with a lower temperature. When you hold an ice cube, it feels like the “cold” flows into your hand, but actually, heat flows from your hand to the ice.

In the laboratory, we measure temperature with a **thermometer**, a graduated tube containing a fluid that expands when heated. When the thermometer is immersed in a substance hotter than itself, heat flows from the substance through the glass into the fluid, which expands and rises in the thermometer tube. If a substance is colder than the thermometer, heat flows to the substance from the fluid, which contracts and falls within the tube.

We'll consider three temperature scales: the Celsius ($^\circ\text{C}$, formerly called centigrade), the Kelvin (K), and the Fahrenheit ($^\circ\text{F}$) scales. The SI base unit of temperature is the **kelvin (K)** (note that no degree sign is used with the symbol for this unit). Figure 1.10 shows some interesting temperatures in the Kelvin scale, which is preferred in scientific work (although the Celsius scale is still used frequently). In the United States, the Fahrenheit scale is used for weather reporting, body temperature, and so forth.

The three scales differ in the size of the unit and/or the temperature of the zero point. Figure 1.11 on the next page shows the freezing and boiling points of water on the three scales.

- The **Celsius scale** sets water's freezing point at 0°C and its boiling point (at normal atmospheric pressure) at 100°C . Thus, the size of a Celsius degree is $\frac{1}{100}$ of the difference between the freezing and boiling points of water.

Student Hot Spot

Student data indicate that you may struggle with using density as a conversion factor. Access the Smartbook to view additional Learning Resources on this topic.

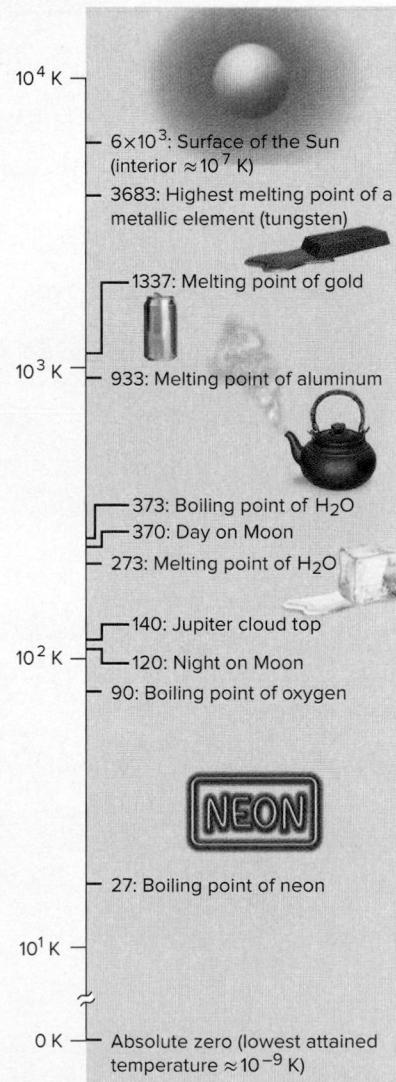

Figure 1.10 Some interesting temperatures.

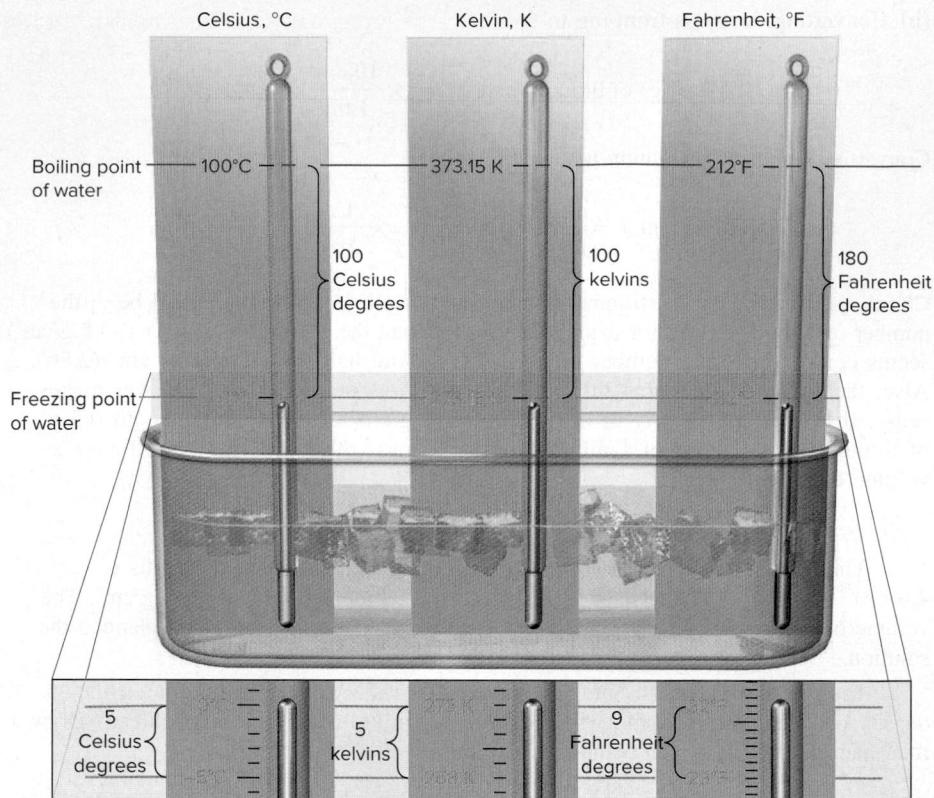

Figure 1.11 Freezing and boiling points of water in the Celsius, Kelvin (absolute), and Fahrenheit scales. At the bottom of the figure, a portion of each of the three thermometer scales is expanded to show the sizes of the units.

- The **Kelvin (absolute) scale** uses the *same size degree* as the Celsius scale; the difference between the freezing point (+273.15 K) and the boiling point (+373.15 K) of water is again 100 degrees, but these temperatures are 273.15 degrees higher on the Kelvin scale because it has a *different zero point*. Absolute zero, 0 K, equals -273.15°C . Thus, on the Kelvin scale, *all temperatures are positive*.

We convert between the Celsius and Kelvin scales by remembering the different zero points: $0^{\circ}\text{C} = 273.15\text{ K}$, so

$$T \text{ (in K)} = T \text{ (in } ^{\circ}\text{C)} + 273.15 \quad (1.2)$$

And, therefore,

$$T \text{ (in } ^{\circ}\text{C)} = T \text{ (in K)} - 273.15 \quad (1.3)$$

- The Fahrenheit scale differs from the other scales in its zero point *and* in the size of its degree. Water freezes at 32°F and boils at 212°F . Therefore, 180 Fahrenheit degrees ($212^{\circ}\text{F} - 32^{\circ}\text{F}$) represents the same temperature change as 100 Celsius degrees (or 100 kelvins). Because 100 Celsius degrees equal 180 Fahrenheit degrees,

$$1 \text{ Celsius degree} = \frac{180}{100} \text{ Fahrenheit degrees} = \frac{9}{5} \text{ Fahrenheit degrees}$$

To convert a temperature from $^{\circ}\text{C}$ to $^{\circ}\text{F}$, first change the degree size and then adjust the zero point ($0^{\circ}\text{C} = 32^{\circ}\text{F}$):

$$T \text{ (in } ^{\circ}\text{F)} = \frac{9}{5} T \text{ (in } ^{\circ}\text{C)} + 32 \quad (1.4)$$

To convert a temperature from $^{\circ}\text{F}$ to $^{\circ}\text{C}$, do the two steps in the opposite order: adjust the zero point and then change the degree size. In other words, solve Equation 1.4 for T (in $^{\circ}\text{C}$):

$$T \text{ (in } ^{\circ}\text{C)} = [T \text{ (in } ^{\circ}\text{F)} - 32] \frac{5}{9} \quad (1.5)$$

Table 1.6 The Three Temperature Scales

Scale	Unit	Size of Degree (Relative to K)	Freezing Point of H ₂ O	Boiling Point of H ₂ O	T at Absolute Zero	Conversion
Kelvin (absolute)	kelvin (K)	—	273.15 K	373.15 K	0 K	to $^{\circ}\text{C}$ (Equation 1.2)
Celsius	Celsius degree ($^{\circ}\text{C}$)	1	0 $^{\circ}\text{C}$	100 $^{\circ}\text{C}$	-273.15 $^{\circ}\text{C}$	to K (Equation 1.3) to $^{\circ}\text{F}$ (Equation 1.4)
Fahrenheit	Fahrenheit degree ($^{\circ}\text{F}$)	$\frac{5}{9}$	32 $^{\circ}\text{F}$	212 $^{\circ}\text{F}$	-459.67 $^{\circ}\text{F}$	to $^{\circ}\text{C}$ (Equation 1.5)

Table 1.6 compares the three temperature scales.

SAMPLE PROBLEM 1.8

Converting Units of Temperature

Problem A child has a body temperature of 38.7 $^{\circ}\text{C}$, and normal body temperature is 98.6 $^{\circ}\text{F}$. Does the child have a fever? What is the child's temperature in kelvins?

Plan To see if the child has a fever, we convert from $^{\circ}\text{C}$ to $^{\circ}\text{F}$ (Equation 1.4) and compare it with 98.6 $^{\circ}\text{F}$. Then, to convert the child's temperature in $^{\circ}\text{C}$ to K, we use Equation 1.2.

Solution Converting the temperature from $^{\circ}\text{C}$ to $^{\circ}\text{F}$:

$$T \text{ (in } ^{\circ}\text{F)} = \frac{9}{5} T \text{ (in } ^{\circ}\text{C)} + 32 = \frac{9}{5}(38.7 \text{ } ^{\circ}\text{C}) + 32 = 101.7 \text{ } ^{\circ}\text{F} \quad \text{Yes, the child has a fever.}$$

Converting the temperature from $^{\circ}\text{C}$ to K:

$$T \text{ (in K)} = T \text{ (in } ^{\circ}\text{C)} + 273.15 = 38.7 \text{ } ^{\circ}\text{C} + 273.15 = 311.8 \text{ K}$$

Check From everyday experience, you know that 101.7 $^{\circ}\text{F}$ is a reasonable temperature for someone with a fever. In the second step, we can check for a large error as follows: 38.7 $^{\circ}\text{C}$ is almost 40 $^{\circ}\text{C}$, and 40 + 273 = 313, which is close to our answer.

FOLLOW-UP PROBLEMS

1.8A Mercury melts at 234 K, lower than any other pure metal. What is its melting point in $^{\circ}\text{C}$ and $^{\circ}\text{F}$?

1.8B The temperature in a blast furnace used for iron production is 2325 $^{\circ}\text{F}$. What is this temperature in $^{\circ}\text{C}$ and K?

SOME SIMILAR PROBLEMS

1.42 and 1.43

Extensive and Intensive Properties

The variables we measure to study matter fall into two broad categories of properties:

- **Extensive properties** are *dependent* on the amount of substance present; mass and volume, for example, are extensive properties.
- **Intensive properties** are *independent* of the amount of substance; density is an intensive property.

Thus, a gallon of water has four times the mass of a quart of water, but it also has four times the volume, so the density, the *ratio* of mass to volume, is the same for both samples; this concept is illustrated for copper in Figure 1.12. Another important example concerns heat, an extensive property, and temperature, an intensive property: a vat of

The mass and volume of the three cubes of copper are different; mass and volume are extensive properties.

For these three cubes of copper,

$$\text{density} = \frac{8.9 \text{ g}}{1.0 \text{ cm}^3} = \frac{71 \text{ g}}{8.0 \text{ cm}^3} = \frac{240 \text{ g}}{27.0 \text{ cm}^3} \approx 8.9 \text{ g/cm}^3$$

The density remains the same regardless of sample size; density is an intensive property.

Figure 1.12 Extensive and intensive properties of matter.

boiling water has more heat, that is, more energy, than a cup of boiling water, but both samples have the same temperature.

Some intensive properties, like color, melting point, and density are characteristic of a substance, and thus, are used to identify it.

› Summary of Section 1.4

- › The SI unit system consists of seven base units and numerous derived units.
- › Exponential notation and prefixes based on powers of 10 are used to express very small and very large numbers.
- › The SI base unit of length is the meter (m); on the atomic scale, the nanometer (nm) and picometer (pm) are used commonly.
- › Volume (V) units are derived from length units, and the most important volume units are the cubic meter (m^3) and the liter (L).
- › The *mass* of an object—the quantity of matter in it—is constant. The SI unit of mass is the kilogram (kg). The *weight* of an object varies with the gravitational field.
- › A measured quantity consists of a number and a unit.
- › A conversion factor is a ratio of equivalent quantities (and, thus, equal to 1) that is used to express a quantity in different units.
- › The problem-solving approach used in this book has four parts: (1) plan the steps to the solution, which often includes a flow diagram (road map) of the steps, (2) perform the calculations according to the plan, (3) check to see if the answer makes sense, and (4) practice with similar, follow-up problems and compare your solutions with the ones at the end of the chapter.
- › Density (d), a characteristic physical property of a substance, is the ratio of the mass of a sample to its volume.
- › Temperature (T) is a measure of the relative hotness of an object. Heat is energy that flows from an object at higher T to one at lower T .
- › Temperature scales differ in the size of the degree unit and/or the zero point. For scientific uses, temperature is measured in kelvins (K) or degrees Celsius ($^{\circ}\text{C}$).
- › Extensive properties, such as mass, volume, and energy, depend on the amount of a substance. Intensive properties, such as density and temperature, do not.

1.5 UNCERTAINTY IN MEASUREMENT: SIGNIFICANT FIGURES

All measuring devices—balances, pipets, thermometers, and so forth—are made to limited specifications, and we use our imperfect senses and skills to read them. Therefore, we can *never* measure a quantity exactly; put another way, every measurement includes some **uncertainty**. The device we choose depends on how much uncertainty is acceptable. When you buy potatoes, a supermarket scale that measures in 0.1-kg increments is acceptable:

Measured mass: $2.0 \pm 0.1 \text{ kg} \longrightarrow$ actual mass: between 1.9 and 2.1 kg

The “ $\pm 0.1 \text{ kg}$ ” term expresses the uncertainty in the mass. Needing more certainty than that to weigh a substance, a chemist uses a balance that measures in 0.001-kg increments:

Measured mass: $2.036 \pm 0.001 \text{ kg} \longrightarrow$ actual mass: between 2.035 and 2.037 kg

The greater number of digits in this measurement means we know the mass of the substance with *more certainty* than we know the mass of the potatoes.

We *always estimate the rightmost digit* of a measurement. The uncertainty can be expressed with the \pm sign, but generally we drop the sign and *assume an uncertainty of one unit in the rightmost digit*. The digits we record, both the certain and the uncertain ones, are called **significant figures**. There are four significant figures

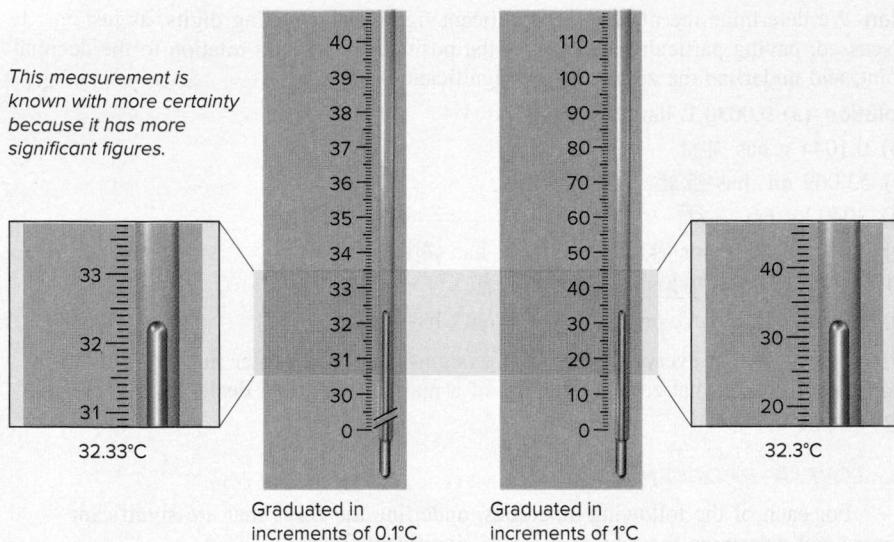

Figure 1.13 The number of significant figures in a measurement.

in 2.036 kg and two in 2.0 kg. *The greater the number of significant figures, the greater is the certainty of a measurement.* Figure 1.13 shows this point for two thermometers.

Determining Which Digits Are Significant

When you take a measurement or use one in a calculation, you must know the number of digits that are significant: *all digits are significant, except zeros used only to position the decimal point.* The following procedure applies this point:

1. Make sure the measurement has a decimal point.
2. Start at the left, and move right until you reach the first nonzero digit.
3. Count that digit and every digit to its right as significant, including zeros between nonzero digits.

Thus, 2.033 has four significant figures, and 0.000562 has only three because a leading zero is never significant and the other three zeros are used only to position the decimal point.

A complication can arise when zeros end a number:

- If there *is* a decimal point and the zeros lie either after or before it, they *are* significant: 1.1300 g has five significant figures and 6500. has four.
- If there *is no* decimal point, we assume that the zeros are *not* significant, unless exponential notation clarifies the quantity: 5300 L is *assumed* to have two significant figures, but 5.300×10^3 L has four, 5.30×10^3 L has three, and 5.3×10^3 L has two.
- A terminal decimal point indicates that zeros are significant: 500 mL has one significant figure, but 500. mL has three (as do 5.00×10^2 mL and 0.500 L).

SAMPLE PROBLEM 1.9

Determining the Number of Significant Figures

Problem For each of the following quantities, underline the zeros that are significant figures (sf) and determine the total number of significant figures. For (e) to (g), express each quantity in exponential notation first.

- | | | |
|--------------------------------|------------------|---------------|
| (a) 0.0030 L | (b) 0.1044 g | (c) 53,069 mL |
| (d) 3040 kg | (e) 0.00004715 m | (f) 57,600. s |
| (g) 0.0000007160 cm^3 | | |

Plan We determine the number of significant figures by counting digits, as just discussed, paying particular attention to the position of zeros in relation to the decimal point, and underline the zeros that are significant.

Solution (a) 0.0030 L has 2 sf

(b) 0.1044 g has 4 sf

(c) 53.069 mL has 5 sf

(d) 3040 kg has 3 sf

(e) 0.00004715 m, or 4.715×10⁻⁵ m, has 4 sf

(f) 57,600. s, or 5.7600×10⁴ s, has 5 sf

(g) 0.000007160 cm³, or 7.160×10⁻⁷ cm³, has 4 sf

Check Be sure that every zero counted as significant comes after nonzero digit(s) in the number. Recall that zeros at the end of a number *without* a decimal point are not significant.

FOLLOW-UP PROBLEMS

1.9A For each of the following quantities, underline the zeros that are significant figures and determine the total number of significant figures (sf).

(a) 31.070 mg (b) 0.06060 g (c) 850.°C

1.9B For each of the following quantities, underline the zeros that are significant figures and determine the total number of significant figures (sf). Express each quantity in exponential notation first.

(a) 200.0 mL (b) 0.0000039 m (c) 0.000401 L

SOME SIMILAR PROBLEMS 1.52 and 1.53

Significant Figures: Calculations and Rounding Off

Measuring several quantities typically results in data with differing numbers of significant figures. In a calculation, we keep track of the number in each quantity so that we don't have more significant figures (more certainty) in the answer than in the data. If we do have too many significant figures, we must **round off** the answer.

The general rule for rounding is that *the least certain measurement sets the limit on certainty for the entire calculation and determines the number of significant figures in the final answer*. Suppose you want to find the density of a new ceramic. You measure the mass of a piece of it on a precise laboratory balance and obtain 3.8056 g; you measure the volume as 2.5 mL by displacement of water in a graduated cylinder. The mass has five significant figures, but the volume has only two. Should you report the density as 3.8056 g/2.5 mL = 1.5222 g/mL or as 1.5 g/mL? The answer with five significant figures implies more certainty than the answer with two. But you didn't measure the volume to five significant figures, so you can't possibly know the density with that much certainty. Therefore, you report 1.5 g/mL, the answer with two significant figures.

Rules for Arithmetic Operations The two rules in arithmetic calculations are

1. *For multiplication and division.* The answer contains the same number of significant figures as there are in the measurement with the *fewest significant figures*. Suppose you want to find the volume of a sheet of a new graphite composite. The length (9.2 cm) and width (6.8 cm) are obtained with a ruler, and the thickness (0.3744 cm) with a set of calipers. The calculation is

$$\text{Volume (cm}^3\text{)} = 9.2 \text{ cm} \times 6.8 \text{ cm} \times 0.3744 \text{ cm} = 23.422464 \text{ cm}^3 = 23 \text{ cm}^3$$

No. of significant figures: 2 2 4 2

Even though your calculator may show 23.422464 cm³, you report 23 cm³, the answer with two significant figures, the same as in the measurements with the lower

number of significant figures. After all, if the length and width have two significant figures, you can't possibly know the volume with more certainty.

2. *For addition and subtraction.* The answer has the same number of *decimal places* as there are in the measurement with the *fewest decimal places*. Suppose you want the total volume after adding water to a protein solution: you have 83.5 mL of solution in a graduated cylinder and add 23.28 mL of water from a buret. The calculation is shown in the margin. Here the calculator shows 106.78 mL, but you report the volume as 106.8 mL, because the measurement with fewer decimal places (83.5 mL) has one decimal place (*see margin*).

Note that the answer, 106.8 mL, has four significant figures, while the volume of the protein solution, 83.5 mL, has only three significant figures. In addition and subtraction, the number of significant figures is determined by the number of decimal places, not the total number of significant figures, in the measurements.

Rules for Rounding Off You usually need to round off the final answer to the proper number of significant figures or decimal places. Notice that in calculating the volume of the graphite composite, we removed the extra digits, but in calculating the total volume of the protein solution, we removed the extra digit and increased the last digit by one. The general rule for rounding is that *the least certain measurement sets the limit on the certainty of the final answer*. Here are detailed rules for rounding off:

1. If the digit removed is *more than 5*, the preceding number increases by 1: 5.379 rounds to 5.38 if you need three significant figures and to 5.4 if you need two.
2. If the digit removed is *less than 5*, the preceding number remains the same: 0.2413 rounds to 0.241 if you need three significant figures and to 0.24 if you need two.
3. If the digit removed is *5*, the preceding number increases by 1 if it is odd and remains the same if it is even: 17.75 rounds to 17.8, but 17.65 rounds to 17.6.
If the 5 is followed only by zeros, rule 3 is followed; if the 5 is followed by non-zeros, rule 1 is followed: 17.6500 rounds to 17.6, but 17.6513 rounds to 17.7.
4. *Always carry one or two additional significant figures through a multistep calculation and round off the final answer only.* Don't be concerned if you string together a calculation to check a sample or follow-up problem and find that your answer differs in the last decimal place from the one in the book. To show you the correct number of significant figures in text calculations, *we round off intermediate steps*, and that process may sometimes change the last digit.

Note that, unless you set a limit on your calculator, it gives answers with too many figures and you must round the displayed result.

Significant Figures in the Lab The measuring device you choose determines the number of significant figures you can obtain. Suppose an experiment requires a solution made by dissolving a solid in a liquid. You weigh the solid on an analytical balance and obtain a mass with five significant figures. It would make sense to measure the liquid with a buret or a pipet, which measures volumes to more significant figures than a graduated cylinder. If you do choose the cylinder, you would have to round off more digits, and some certainty you attained for the mass value would be wasted (Figure 1.14). With experience, you'll choose a measuring device based on the number of significant figures you need in the final answer.

Exact Numbers **Exact numbers** have no uncertainty associated with them. Some are part of a unit conversion: by definition, there are exactly 60 minutes in 1 hour, 1000 micrograms in 1 milligram, and 2.54 centimeters in 1 inch. Other exact numbers result from actually counting items: there are exactly 3 coins in my hand, 26 letters in the English alphabet, and so forth. Therefore, unlike measured quantities, *exact numbers do not limit the number of significant figures in a calculation*.

$$\begin{array}{r} 83.5 \text{ mL} \\ + 23.28 \text{ mL} \\ \hline 106.78 \text{ mL} \end{array}$$

Answer: Volume = 106.8 mL

Figure 1.14 Significant figures and measuring devices. The mass measurement (6.8605 g) has more significant figures than the volume measurement (68.2 mL).

Source: (both) © McGraw-Hill Education/Stephen Frisch, photographer

SAMPLE PROBLEM 1.10

Significant Figures and Rounding

Problem Perform the following calculations and round the answers to the correct number of significant figures:

$$(a) \frac{16.3521 \text{ cm}^2 - 1.448 \text{ cm}^2}{7.085 \text{ cm}} \quad (b) \frac{(4.80 \times 10^4 \text{ mg}) \left(\frac{1 \text{ g}}{1000 \text{ mg}} \right)}{11.55 \text{ cm}^3}$$

Plan We use the rules just presented in the text: (a) We subtract before we divide. (b) We note that the unit conversion involves an exact number.

$$\text{Solution (a)} \frac{16.3521 \text{ cm}^2 - 1.448 \text{ cm}^2}{7.085 \text{ cm}} = \frac{14.904 \text{ cm}^2}{7.085 \text{ cm}} = 2.104 \text{ cm}$$

$$(b) \frac{(4.80 \times 10^4 \text{ mg}) \left(\frac{1 \text{ g}}{1000 \text{ mg}} \right)}{11.55 \text{ cm}^3} = \frac{48.0 \text{ g}}{11.55 \text{ cm}^3} = 4.16 \text{ g/cm}^3$$

Check Note that in (a) we lose a decimal place in the numerator, and in (b) we retain 3 sf in the answer because there are 3 sf in 4.80. Rounding to the nearest whole number is always a good way to check: (a) $(16 - 1)/7 \approx 2$; (b) $(5 \times 10^4/1 \times 10^3)/12 \approx 4$.

FOLLOW-UP PROBLEMS

1.10A Perform the following calculation and round the answer to the correct number of significant figures:

$$\frac{25.65 \text{ mL} + 37.4 \text{ mL}}{73.55 \text{ s} \left(\frac{1 \text{ min}}{60 \text{ s}} \right)}$$

1.10B Perform the following calculation and round the answer to the correct number of significant figures:

$$\frac{154.64 \text{ g} - 35.26 \text{ g}}{4.20 \text{ cm} \times 5.12 \text{ cm} \times 6.752 \text{ cm}}$$

SOME SIMILAR PROBLEMS 1.56–1.59, 1.66, and 1.67

Precision, Accuracy, and Instrument Calibration

We may use the words “precision” and “accuracy” interchangeably in everyday speech, but for scientific measurements they have distinct meanings. **Precision**, or *reproducibility*, refers to how close the measurements in a series are to each other, and **accuracy** refers to how close each measurement is to the actual value. These terms are related to two widespread types of error:

1. **Systematic error** produces values that are *either* all higher or all lower than the actual value. This type of error is part of the experimental system, often caused by a faulty device or by a consistent mistake in taking a reading.
2. **Random error**, in the absence of systematic error, produces values that are higher *and* lower than the actual value. Random error *always* occurs, but its size depends on the measurer’s skill and the instrument’s precision.

Precise measurements have low random error, that is, small deviations from the average. *Accurate measurements have low systematic error and, generally, low random error*. In some cases, when many measurements have a high random error, the average may still be accurate.

Suppose each of four students measures 25.0 mL of water in a preweighed graduated cylinder and then weighs the water *plus* cylinder on a balance. If the density of water is 1.00 g/mL at the temperature of the experiment, the *actual* mass of 25.0 mL of water is 25.0 g. Each student performs the operation four

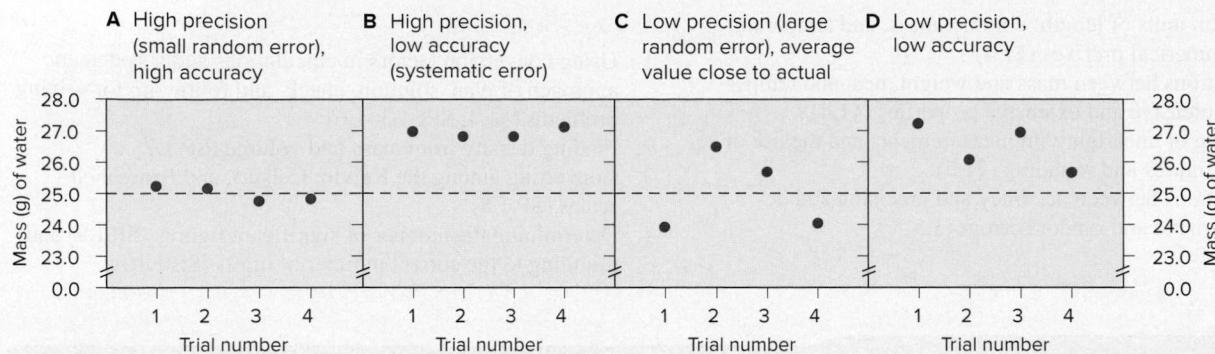

Figure 1.15 Precision and accuracy in a laboratory calibration.

times, subtracts the mass of the empty cylinder, and obtains one of four graphs (Figure 1.15):

- In graph A, random error is small; that is, precision is high (the weighings are reproducible). Accuracy is high as well, as all of the values are close to 25.0 g.
- Random error is also small and precision high in graph B, but accuracy is low; there is systematic error, with all of the weighings above 25.0 g.
- In graph C, random error is large and precision is low. But since the average of the scattered values is close to the actual value, systematic error is low.
- Graph D also exhibits large random error, but note that there is also significant systematic error in this case, resulting in low accuracy (all the values are high).

Systematic error can be taken into account through **calibration**, comparing the measuring device with a known standard. The systematic error in graph B, for example, might be caused by a poorly manufactured cylinder that reads “25.0” when it actually contains about 27 mL. If that cylinder had been calibrated, the students could have adjusted all volumes measured with it. The students also should calibrate the balance with standardized masses.

› Summary of Section 1.5

- The final digit of a measurement is always estimated. Thus, all measurements have some uncertainty, which is expressed by the number of significant figures.
- The certainty of a calculated result depends on the certainty of the data, so the answer has as many significant figures as in the least certain measurement.
- Excess digits are rounded off in the final answer according to a set of rules.
- The choice of laboratory device depends on the certainty needed.
- Exact numbers have as many significant figures as the calculation requires.
- Precision refers to how close values are to each other, and accuracy refers to how close values are to the actual value.
- Systematic errors give values that are either all higher or all lower than the actual value. Random errors give some values that are higher and some that are lower than the actual value.
- Precise measurements have low random error; accurate measurements have low systematic error and low random error.
- A systematic error is often caused by faulty equipment and can be compensated for by calibration.

CHAPTER REVIEW GUIDE

Learning Objectives

Relevant section (§) and/or sample problem (SP) numbers appear in parentheses.

Understand These Concepts

- The defining features of the states of matter (§1.1)
- The distinction between physical and chemical properties and changes (§1.1; SPs 1.1, 1.2)

- The nature of potential and kinetic energy and their interconversion (§1.1)
- The process of approaching a phenomenon scientifically and the distinctions between observation, hypothesis, experiment, and model (§1.3)

5. The common units of length, volume, mass, and temperature and their numerical prefixes (§1.4)
6. The distinctions between mass and weight, heat and temperature, and intensive and extensive properties (§1.4)
7. The meaning of uncertainty in measurements and the use of significant figures and rounding (§1.5)
8. The distinctions between accuracy and precision and between systematic and random error (§1.5)

Master These Skills

1. Using conversion factors in calculations and a systematic approach of plan, solution, check, and follow-up for solving problems (§1.4; SPs 1.3–1.6)
2. Finding density from mass and volume (SP 1.7)
3. Converting among the Kelvin, Celsius, and Fahrenheit scales (SP 1.8)
4. Determining the number of significant figures (SP 1.9) and rounding to the correct number of digits (SP 1.10)

Key Terms

Page numbers appear in parentheses.

accuracy (32)	derived unit (13)	liter (L) (15)	scientific method (12)
base (fundamental) unit (13)	dimensional analysis (19)	mass (17)	second (s) (18)
calibration (33)	energy (8)	matter (4)	SI unit (13)
Celsius scale (25)	exact number (31)	meter (m) (15)	significant figures (28)
chemical change (chemical reaction) (5)	experiment (12)	milliliter (mL) (15)	solid (4)
chemical property (5)	extensive property (27)	model (theory) (13)	state of matter (4)
chemistry (4)	gas (4)	natural law (12)	systematic error (32)
combustion (11)	heat (25)	observation (12)	temperature (<i>T</i>) (25)
composition (4)	hypothesis (12)	physical change (5)	thermometer (25)
controlled experiment (12)	intensive property (27)	physical property (5)	uncertainty (28)
conversion factor (18)	Kelvin (absolute) scale (26)	potential energy (8)	variable (12)
cubic meter (m ³) (15)	kelvin (K) (25)	precision (32)	volume (<i>V</i>) (15)
data (12)	kilogram (kg) (17)	property (5)	weight (17)
density (<i>d</i>) (23)	kinetic energy (8)	random error (32)	
	liquid (4)	round off (30)	

Key Equations and Relationships

Page numbers appear in parentheses.

1.1 Calculating density from mass and volume (23):

$$\text{Density} = \frac{\text{mass}}{\text{volume}}$$

1.2 Converting temperature from °C to K (26):

$$T \text{ (in K)} = T \text{ (in } ^\circ\text{C)} + 273.15$$

1.3 Converting temperature from K to °C (26):

$$T \text{ (in } ^\circ\text{C)} = T \text{ (in K)} - 273.15$$

1.4 Converting temperature from °C to °F (26):

$$T \text{ (in } ^\circ\text{F)} = \frac{9}{5} T \text{ (in } ^\circ\text{C)} + 32$$

1.5 Converting temperature from °F to °C (27):

$$T \text{ (in } ^\circ\text{C)} = [T \text{ (in } ^\circ\text{F)} - 32] \frac{5}{9}$$

BRIEF SOLUTIONS TO FOLLOW-UP PROBLEMS

1.1A Chemical. The red-and-blue and separate red particles on the left become paired red and separate blue particles on the right.

1.1B Physical. The red particles are the same on the right and on the left, but they have changed from being close together in the solid state to being far apart in the gaseous state.

1.2A (a) Physical. Solid iodine changes to gaseous iodine.

(b) Chemical. Gasoline burns in air to form different substances. (c) Chemical. In contact with air, substances in torn skin and blood react to form different substances.

1.2B (a) Physical. Gaseous water (water vapor) changes to droplets of liquid water.

(b) Chemical. Different substances are formed in the milk that give it a sour taste. (c) Physical. Solid butter changes to a liquid.

1.3A The known quantity is 10,500 m; start the problem with this value. Use the conversion factor 1 mi/15 min to convert distance in miles to time in minutes.

Time (min)

$$= 10,500 \text{ m} \times \frac{1 \text{ km}}{1000 \text{ m}} \times \frac{1 \text{ mi}}{1.609 \text{ km}} \times \frac{15 \text{ min}}{1 \text{ mi}} = 98 \text{ min}$$

See Road Map 1.3A.

1.3B Start the problem with the known quantity of 1.0 in; use the conversion factor 1 virus particle/30 nm to convert from length in nm to number of virus particles.

No. of virus particles

$$= 1.0 \text{ in} \times \frac{2.54 \text{ cm}}{1 \text{ in}} \times \frac{1 \times 10^7 \text{ nm}}{1 \text{ cm}} \times \frac{1 \text{ virus particle}}{30 \text{ nm}} \\ = 8.5 \times 10^5 \text{ virus particles}$$

See Road Map 1.3B.

Road Map 1.3A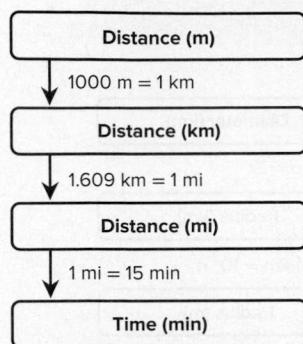**Road Map 1.3B**

1.4A Radius of ribosome (dm) = $\frac{21.4 \text{ nm}}{2} \times \frac{1 \text{ dm}}{10^8 \text{ nm}}$
 $= 1.07 \times 10^{-7} \text{ dm}$

Volume of ribosome (dm³) = $\frac{4}{3}\pi r^3 = \frac{4}{3}(3.14)(1.07 \times 10^{-7} \text{ dm})^3$
 $= 5.13 \times 10^{-21} \text{ dm}^3$

Volume of ribosome (μL)

$$= (5.13 \times 10^{-21} \text{ dm}^3) \left(\frac{1 \text{ L}}{1 \text{ dm}^3} \right) \left(\frac{10^6 \mu\text{L}}{1 \text{ L}} \right)$$
 $= 5.13 \times 10^{-15} \mu\text{L}$

See Road Map 1.4A.

1.4B Volume (L) = 8400 gal $\times \frac{3.785 \text{ dm}^3}{1 \text{ gal}} \times \frac{1 \text{ L}}{1 \text{ dm}^3}$
 $= 32,000 \text{ L}$

See Road Map 1.4B.

Road Map 1.4A**Road Map 1.4B**

1.5A Start the problem with the known value of 8.0 h. The conversion factors are constructed from the equivalent quantities given in the problem: 1 s = 1.5 drops; 1 drop = 65 mg.

Mass (kg) of solution

$$= 8.0 \text{ h} \times \frac{60 \text{ min}}{1 \text{ h}} \times \frac{60 \text{ s}}{1 \text{ min}} \times \frac{1.5 \text{ drops}}{1 \text{ s}}$$
 $\times \frac{65 \text{ mg}}{1 \text{ drop}} \times \frac{1 \text{ g}}{10^3 \text{ mg}} \times \frac{1 \text{ kg}}{10^3 \text{ g}}$
 $= 2.8 \text{ kg}$

See Road Map 1.5A.

1.5B Start the problem with the known quantity of 3.25 kg of apples. The conversion factors are constructed from the equivalent quantities given in the problem: 1 lb = 3 apples; 1 apple = 159 mg potassium.

$$\text{Mass (g)} = 3.25 \text{ kg} \times \frac{1 \text{ lb}}{0.4536 \text{ kg}} \times \frac{3 \text{ apples}}{1 \text{ lb}} \times \frac{159 \text{ mg potassium}}{1 \text{ apple}} \times \frac{1 \text{ g}}{10^3 \text{ mg}}$$
 $= 3.42 \text{ g potassium}$

See Road Map 1.5B.

Road Map 1.5A**Road Map 1.5B**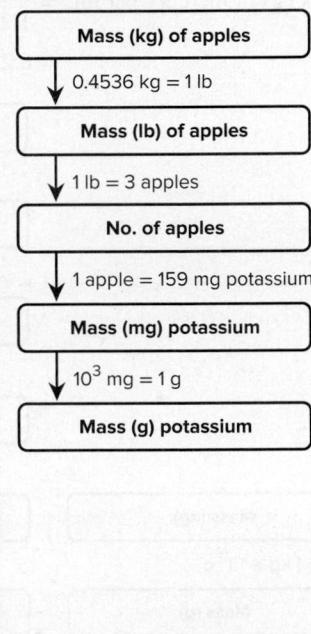

1.6A Start the problem with the known value of 2050 m². The conversion factors are constructed from 300 ft² = 1.5 fl oz and 16 fl oz = 1 bottle.

$$\text{No. of bottles} = 2050 \text{ m}^2 \times \frac{1 \text{ ft}^2}{(0.3048)^2 \text{ m}^2} \times \frac{1.5 \text{ fl oz}}{300 \text{ ft}^2} \times \frac{1 \text{ bottle}}{16 \text{ fl oz}}$$
 $= 7 \text{ bottles}$

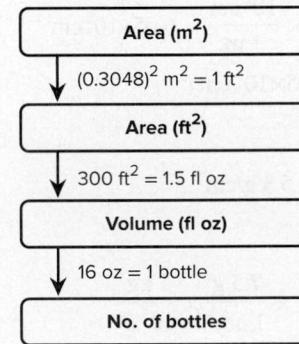

BRIEF SOLUTIONS TO FOLLOW-UP PROBLEMS

(continued)

1.6B Mass (g) = $75,000 \text{ kg} \times \frac{1000 \text{ g}}{1 \text{ kg}} = 7.5 \times 10^7 \text{ g}$

$$\begin{aligned} \text{Volume (mL)} &= 4.5 \text{ mi}^2 \times \frac{(5280)^2 \text{ ft}^2}{1 \text{ mi}^2} \times 35 \text{ ft} \times \frac{0.02832 \text{ m}^3}{1 \text{ ft}^3} \\ &\quad \times \frac{1 \times 10^6 \text{ cm}^3}{1 \text{ m}^3} \times \frac{1 \text{ mL}}{1 \text{ cm}^3} \\ &= 1.2 \times 10^{14} \text{ mL} \end{aligned}$$

$$\begin{aligned} \text{Mass (g) of mercury per mL} &= \frac{7.5 \times 10^7 \text{ g}}{1.2 \times 10^{14} \text{ mL}} \\ &= 6.2 \times 10^{-7} \text{ g/mL} \end{aligned}$$

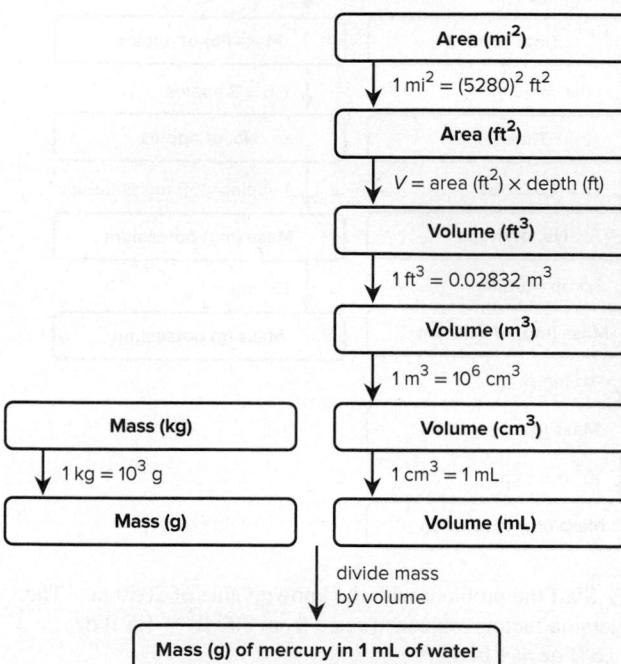

1.7A Mass (g) = $4.9 \times 10^{24} \text{ kg} \times \frac{10^3 \text{ g}}{1 \text{ kg}} = 4.9 \times 10^{27} \text{ g}$

$$\text{Radius (cm)} = \frac{12,100 \text{ km}}{2} \times \frac{10^3 \text{ m}}{1 \text{ km}} \times \frac{10^2 \text{ cm}}{1 \text{ m}} = 6.05 \times 10^8 \text{ cm}$$

$$\begin{aligned} \text{Volume (cm}^3\text{)} &= \frac{4}{3}\pi r^3 = \frac{4}{3}(3.14)(6.05 \times 10^8 \text{ cm})^3 \\ &= 9.27 \times 10^{26} \text{ cm}^3 \end{aligned}$$

$$\text{Density (g/cm}^3\text{)} = \frac{4.9 \times 10^{27} \text{ g}}{9.27 \times 10^{26} \text{ cm}^3} = 5.3 \text{ g/cm}^3$$

See Road Map 1.7A.

1.7B Mass (kg) of sample = $4.6 \text{ cm}^3 \times \frac{7.5 \text{ g}}{1 \text{ cm}^3} \times \frac{1 \text{ kg}}{10^3 \text{ g}}$

$$= 0.034 \text{ kg}$$

See Road Map 1.7B.

Road Map 1.7A

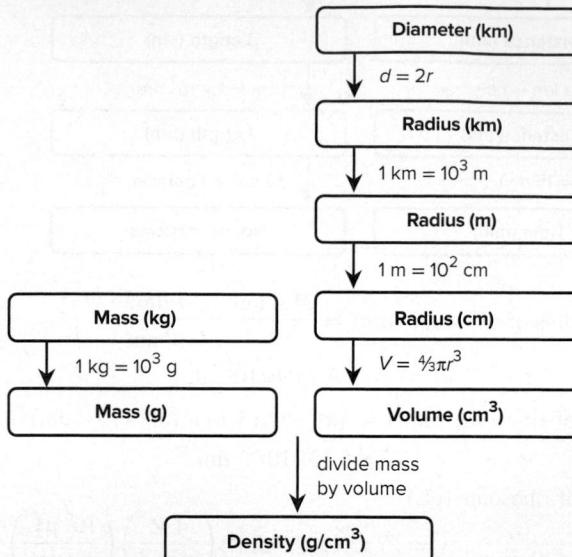

Road Map 1.7B

1.8A $T \text{ (in } ^\circ\text{C)} = 234 \text{ K} - 273.15 = -39^\circ\text{C}$
 $T \text{ (in } ^\circ\text{F)} = \frac{9}{5}(-39^\circ\text{C}) + 32 = -38^\circ\text{F}$

Answers contains two significant figures (see Section 1.5).

1.8B $T \text{ (in } ^\circ\text{C)} = (2325^\circ\text{F} - 32) \frac{5}{9} = 1274^\circ\text{C}$
 $T \text{ (in } ^\circ\text{K)} = 1274^\circ\text{C} + 273.15 = 1547 \text{ K}$

- 1.9A** (a) 31.070 mg, 5 sf
 (b) 0.06060 g, 4 sf
 (c) 850.°C, 3 sf

- 1.9B** (a) 2.000 × 10² mL, 4 sf
 (b) 3.9 × 10⁻⁶ m, 2 sf
 (c) 4.01 × 10⁻⁴ L, 3 sf

1.10A $\frac{25.65 \text{ mL} + 37.4 \text{ mL}}{73.55 \text{ g} \left(\frac{1 \text{ min}}{60 \text{ g}} \right)} = 51.4 \text{ mL/min}$

1.10B $\frac{154.64 \text{ g} - 35.26 \text{ g}}{4.20 \text{ cm} \times 5.12 \text{ cm} \times 6.752 \text{ cm}} = 0.823 \text{ g/cm}^3$

PROBLEMS

Problems with **colored** numbers are answered in Appendix E and worked in detail in the Student Solutions Manual. Problem sections match those in the text and give the numbers of relevant sample problems. Most offer Concept Review Questions, Skill-Building Exercises (grouped in pairs covering the same concept), and Problems in Context. The Comprehensive Problems are based on material from any section.

Some Fundamental Definitions

(Sample Problems 1.1 and 1.2)

Concept Review Question

1.1 Scenes A–D represent atomic-scale views of different samples of substances:

- (a) Under one set of conditions, the substances in A and B mix, and the result is depicted in C. Does this represent a chemical or a physical change?
- (b) Under a second set of conditions, the same substances mix, and the result is depicted in D. Does this represent a chemical or a physical change?
- (c) Under a third set of conditions, the sample depicted in C changes to that in D. Does this represent a chemical or a physical change?
- (d) After the change in part (c) has occurred, does the sample have different chemical properties? Physical properties?

Skill-Building Exercises (grouped in similar pairs)

1.2 Describe solids, liquids, and gases in terms of how they fill a container. Use your descriptions to identify the physical state (at room temperature) of the following: (a) helium in a toy balloon; (b) mercury in a thermometer; (c) soup in a bowl.

1.3 Use your descriptions from Problem 1.2 to identify the physical state (at room temperature) of the following: (a) the air in your room; (b) tablets in a bottle of vitamins; (c) sugar in a packet.

1.4 Define *physical property* and *chemical property*. Identify each type of property in the following statements:

- (a) Yellow-green chlorine gas attacks silvery sodium metal to form white crystals of sodium chloride (table salt).
- (b) A magnet separates a mixture of black iron shavings and white sand.

1.5 Define *physical change* and *chemical change*. State which type of change occurs in each of the following statements:

- (a) Passing an electric current through molten magnesium chloride yields molten magnesium and gaseous chlorine.
- (b) The iron in discarded automobiles slowly forms reddish brown, crumbly rust.

1.6 Which of the following is a chemical change? Explain your reasoning: (a) boiling canned soup; (b) toasting a slice of bread; (c) chopping a log; (d) burning a log.

1.7 Which of the following changes can be reversed by changing the temperature: (a) dew condensing on a leaf; (b) an egg turning hard when it is boiled; (c) ice cream melting; (d) a spoonful of batter cooking on a hot griddle?

1.8 For each pair, which has higher potential energy?

- (a) The fuel in your car or the gaseous products in its exhaust
- (b) Wood in a fire or the ashes after the wood burns

1.9 For each pair, which has higher kinetic energy?

- (a) A sled resting at the top of a hill or a sled sliding down the hill
- (b) Water above a dam or water falling over the dam

Chemical Arts and the Origins of Modern Chemistry

Concept Review Questions

1.10 The alchemical, medical, and technological traditions were precursors to chemistry. State a contribution that each made to the development of the science of chemistry.

1.11 How did the phlogiston theory explain combustion?

1.12 One important observation that supporters of the phlogiston theory had trouble explaining was that the calx of a metal weighs more than the metal itself. Why was that observation important? How did the phlogistonists respond?

1.13 Lavoisier developed a new theory of combustion that overturned the phlogiston theory. What measurements were central to his theory, and what key discovery did he make?

The Scientific Approach: Developing a Model

Concept Review Questions

1.14 How are the key elements of scientific thinking used in the following scenario? While making toast, you notice it fails to pop out of the toaster. Thinking the spring mechanism is stuck, you notice that the bread is unchanged. Assuming you forgot to plug in the toaster, you check and find it is plugged in. When you take the toaster into the dining room and plug it into a different outlet, you find the toaster works. Returning to the kitchen, you turn on the switch for the overhead light and nothing happens.

1.15 Why is a quantitative observation more useful than a non-quantitative one? Which of the following is (are) quantitative? (a) The Sun rises in the east. (b) A person weighs one-sixth as much on the Moon as on Earth. (c) Ice floats on water. (d) A hand pump cannot draw water from a well more than 34 ft deep.

1.16 Describe the essential features of a well-designed experiment.

1.17 Describe the essential features of a scientific model.

Measurement and Chemical Problem Solving

(Sample Problems 1.3 to 1.8)

Concept Review Questions

1.18 Explain the difference between mass and weight. Why is your weight on the Moon one-sixth that on Earth?

1.19 When you convert feet to inches, how do you decide which part of the conversion factor should be in the numerator and which in the denominator?

1.20 For each of the following cases, state whether the density of the object increases, decreases, or remains the same:

- A sample of chlorine gas is compressed.
- A lead weight is carried up a high mountain.
- A sample of water is frozen.
- An iron bar is cooled.
- A diamond is submerged in water.

1.21 Explain the difference between heat and temperature. Does 1 L of water at 65°F have more, less, or the same quantity of energy as 1 L of water at 65°C?

1.22 A one-step conversion is sufficient to convert a temperature in the Celsius scale to the Kelvin scale, but not to the Fahrenheit scale. Explain.

1.23 Describe the difference between intensive and extensive properties. Which of the following properties are intensive: (a) mass; (b) density; (c) volume; (d) melting point?

Skill-Building Exercises (grouped in similar pairs)

1.24 Write the conversion factor(s) for

- | | |
|---------------------------------------|---|
| (a) in ² to m ² | (b) km ² to cm ² |
| (c) mi/h to m/s | (d) lb/ft ³ to g/cm ³ |

1.25 Write the conversion factor(s) for

- | | |
|---|---------------------------------------|
| (a) cm/min to in/s | (b) m ³ to in ³ |
| (c) m/s ² to km/h ² | (d) gal/h to L/min |

1.26 The average radius of a molecule of lysozyme, an enzyme in tears, is 1430 pm. What is its radius in nanometers (nm)?

1.27 The radius of a barium atom is 2.22×10^{-10} m. What is its radius in angstroms (\AA)?

1.28 What is the length in inches (in) of a 100.-m soccer field?

1.29 The center on your school's basketball team is 6 ft 10 in tall. How tall is the player in millimeters (mm)?

1.30 A small hole in the wing of a space shuttle requires a 20.7-cm² patch. (a) What is the patch's area in square kilometers (km²)? (b) If the patching material costs NASA \$3.25/in², what is the cost of the patch?

1.31 The area of a telescope lens is 7903 mm². (a) What is the area in square feet (ft²)? (b) If it takes a technician 45 s to polish 135 mm², how long does it take her to polish the entire lens?

1.32 Express your body weight in kilograms (kg).

1.33 There are 2.60×10^{15} short tons of oxygen in the atmosphere (1 short ton = 2000 lb). How many metric tons of oxygen are present in the atmosphere (1 metric ton = 1000 kg)?

1.34 The average density of Earth is 5.52 g/cm³. What is its density in (a) kg/m³; (b) lb/ft³?

1.35 The speed of light in a vacuum is 2.998×10^8 m/s. What is its speed in (a) km/h; (b) mi/min?

1.36 The volume of a certain bacterial cell is 2.56 μm^3 . (a) What is its volume in cubic millimeters (mm³)? (b) What is the volume of 10^5 cells in liters (L)?

1.37 (a) How many cubic meters of milk are in 1 qt (946.4 mL)? (b) How many liters of milk are in 835 gal (1 gal = 4 qt)?

1.38 An empty vial weighs 55.32 g. (a) If the vial weighs 185.56 g when filled with liquid mercury ($d = 13.53$ g/cm³),

what volume of mercury is in the vial? (b) How much would the vial weigh if it were filled with the same volume of water ($d = 0.997$ g/cm³ at 25°C)?

1.39 An empty Erlenmeyer flask weighs 241.3 g. When filled with water ($d = 1.00$ g/cm³), the flask and its contents weigh 489.1 g. (a) What is the volume of water in the flask? (b) How much does the flask weigh when filled with the same volume of chloroform ($d = 1.48$ g/cm³)?

1.40 A small cube of aluminum measures 15.6 mm on a side and weighs 10.25 g. What is the density of aluminum in g/cm³?

1.41 A steel ball-bearing with a circumference of 32.5 mm weighs 4.20 g. What is the density of the steel in g/cm³ (V of a sphere = $\frac{4}{3}\pi r^3$; circumference of a circle = $2\pi r$)?

1.42 Perform the following conversions:

- 68°F (a pleasant spring day) to °C and K
- 164°C (the boiling point of methane, the main component of natural gas) to K and °F
- 0 K (absolute zero, theoretically the coldest possible temperature) to °C and °F

1.43 Perform the following conversions:

- 106°F (the body temperature of many birds) to K and °C
- 3410°C (the melting point of tungsten, the highest for any metallic element) to K and °F
- 6.1×10^3 K (the surface temperature of the Sun) to °F and °C

Problems in Context

1.44 A 25.0-g sample of each of three unknown metals is added to 25.0 mL of water in graduated cylinders A, B, and C, and the final volumes are depicted in the circles below. Given their densities, identify the metal in each cylinder: zinc (7.14 g/mL), iron (7.87 g/mL), or nickel (8.91 g/mL).

1.45 The distance between two adjacent peaks on a wave is called the *wavelength*.

- The wavelength of a beam of ultraviolet light is 247 nanometers (nm). What is its wavelength in meters?
- The wavelength of a beam of red light is 6760 pm. What is its wavelength in angstroms (\AA)?

1.46 Each of the beakers depicted below contains two liquids that do not dissolve in each other. Three of the liquids are designated A, B, and C, and water is designated W.

(a) Which of the liquids is (are) more dense than water and less dense than water?

(b) If the densities of W, C, and A are 1.0 g/mL, 0.88 g/mL, and 1.4 g/mL, respectively, which of the following densities is possible for liquid B: 0.79 g/mL, 0.86 g/mL, 0.94 g/mL, or 1.2 g/mL?

1.47 A cylindrical tube 9.5 cm high and 0.85 cm in diameter is used to collect blood samples. How many cubic decimeters (dm^3) of blood can it hold (V of a cylinder = $\pi r^2 h$)?

1.48 Copper can be drawn into thin wires. How many meters of 34-gauge wire (diameter = 6.304×10^{-3} in) can be produced from the copper in 5.01 lb of covellite, an ore of copper that is 66% copper by mass? (Hint: Treat the wire as a cylinder: V of cylinder = $\pi r^2 h$; d of copper = 8.95 g/cm³.)

Uncertainty in Measurement: Significant Figures

(Sample Problems 1.9 and 1.10)

Concept Review Questions

1.49 What is an exact number? How are exact numbers treated differently from other numbers in a calculation?

1.50 Which procedure(s) decrease(s) the random error of a measurement: (1) taking the average of more measurements; (2) calibrating the instrument; (3) taking fewer measurements? Explain.

1.51 A newspaper reported that the attendance at Slippery Rock's home football game was 16,532. (a) How many significant figures does this number contain? (b) Was the actual number of people counted? (c) After Slippery Rock's next home game, the newspaper reported an attendance of 15,000. If you assume that this number contains two significant figures, how many people could actually have been at the game?

Skill-Building Exercises (grouped in similar pairs)

1.52 Underline the significant zeros in the following numbers:
(a) 0.41; (b) 0.041; (c) 0.0410; (d) 4.0100×10^4 .

1.53 Underline the significant zeros in the following numbers:
(a) 5.08; (b) 508; (c) 5.080×10^3 ; (d) 0.05080.

1.54 Round off each number to the indicated number of significant figures (sf): (a) 0.0003554 (to 2 sf); (b) 35.8348 (to 4 sf); (c) 22.4555 (to 3 sf).

1.55 Round off each number to the indicated number of significant figures (sf): (a) 231.554 (to 4 sf); (b) 0.00845 (to 2 sf); (c) 144,000 (to 2 sf).

1.56 Round off each number in the following calculation to one fewer significant figure, and find the answer:

$$\begin{array}{r} 19 \times 155 \times 8.3 \\ 3.2 \times 2.9 \times 4.7 \end{array}$$

1.57 Round off each number in the following calculation to one fewer significant figure, and find the answer:

$$\begin{array}{r} 10.8 \times 6.18 \times 2.381 \\ 24.3 \times 1.8 \times 19.5 \end{array}$$

1.58 Carry out the following calculations, making sure that your answer has the correct number of significant figures:

$$(a) \frac{2.795 \text{ m} \times 3.10 \text{ m}}{6.48 \text{ m}}$$

$$(b) V = \frac{4}{3}\pi r^3, \text{ where } r = 17.282 \text{ mm}$$

$$(c) 1.110 \text{ cm} + 17.3 \text{ cm} + 108.2 \text{ cm} + 316 \text{ cm}$$

1.59 Carry out the following calculations, making sure that your answer has the correct number of significant figures:

$$(a) \frac{2.420 \text{ g} + 15.6 \text{ g}}{4.8 \text{ g}} \quad (b) \frac{7.87 \text{ mL}}{16.1 \text{ mL} - 8.44 \text{ mL}}$$

$$(c) V = \pi r^2 h, \text{ where } r = 6.23 \text{ cm} \text{ and } h = 4.630 \text{ cm}$$

1.60 Write the following numbers in scientific notation:
(a) 131,000.0; (b) 0.00047; (c) 210,006; (d) 2160.5.

1.61 Write the following numbers in scientific notation:
(a) 282.0; (b) 0.0380; (c) 4270.8; (d) 58,200.9.

1.62 Write the following numbers in standard notation. Use a terminal decimal point when needed.

$$(a) 5.55 \times 10^3; (b) 1.0070 \times 10^4; (c) 8.85 \times 10^{-7}; (d) 3.004 \times 10^{-3}.$$

1.63 Write the following numbers in standard notation. Use a terminal decimal point when needed.

$$(a) 6.500 \times 10^3; (b) 3.46 \times 10^{-5}; (c) 7.5 \times 10^2; (d) 1.8856 \times 10^2.$$

1.64 Convert the following into correct scientific notation:
(a) 802.5×10^2 ; (b) 1009.8×10^{-6} ; (c) 0.077×10^{-9} .

1.65 Convert the following into correct scientific notation:
(a) 14.3×10^1 ; (b) 851×10^{-2} ; (c) 7500×10^{-3} .

1.66 Carry out each calculation, paying special attention to significant figures, rounding, and units (J = joule, the SI unit of energy; mol = mole, the SI unit for amount of substance):

$$(a) \frac{(6.626 \times 10^{-34} \text{ J} \cdot \text{s})(2.9979 \times 10^8 \text{ m/s})}{489 \times 10^{-9} \text{ m}}$$

$$(b) \frac{(6.022 \times 10^{23} \text{ molecules/mol})(1.23 \times 10^2 \text{ g})}{46.07 \text{ g/mol}}$$

$$(c) (6.022 \times 10^{23} \text{ atoms/mol})(1.28 \times 10^{-18} \text{ J/atom}) \left(\frac{1}{2^2} - \frac{1}{3^2} \right),$$

where the numbers 2 and 3 in the last term are exact

1.67 Carry out each calculation, paying special attention to significant figures, rounding, and units:

$$(a) \frac{4.32 \times 10^7 \text{ g}}{\frac{4}{3}(3.1416)(1.95 \times 10^2 \text{ cm})^3} \text{ (The term } \frac{4}{3} \text{ is exact.)}$$

$$(b) \frac{(1.84 \times 10^2 \text{ g})(44.7 \text{ m/s})^2}{2} \text{ (The term 2 is exact.)}$$

$$(c) \frac{(1.07 \times 10^{-4} \text{ mol/L})^2 (3.8 \times 10^{-3} \text{ mol/L})}{(8.35 \times 10^{-5} \text{ mol/L})(1.48 \times 10^{-2} \text{ mol/L})^3}$$

1.68 Which statements include exact numbers?

- (a) Angel Falls is 3212 ft high.
- (b) There are 8 known planets in the Solar System.
- (c) There are 453.59 g in 1 lb.
- (d) There are 1000 mm in 1 m.

1.69 Which of the following include exact numbers?

- (a) The speed of light in a vacuum is a physical constant; to six significant figures, it is $2.99792 \times 10^8 \text{ m/s}$.
- (b) The density of mercury at 25°C is 13.53 g/mL.
- (c) There are 3600 s in 1 h.
- (d) In 2016, the United States had 50 states.

Problems in Context

1.70 How long is the metal strip shown below? Be sure to answer with the correct number of significant figures.

1.71 These organic solvents are used to clean compact discs:

Solvent	Density (g/mL) at 20°C
Chloroform	1.492
Diethyl ether	0.714
Ethanol	0.789
Isopropanol	0.785
Toluene	0.867

(a) If a 15.00-mL sample of CD cleaner weighs 11.775 g at 20°C, which solvent does the sample most likely contain?

(b) The chemist analyzing the cleaner calibrates her equipment and finds that the pipet is accurate to ± 0.02 mL, and the balance is accurate to ± 0.003 g. Is this equipment precise enough to distinguish between ethanol and isopropanol?

1.72 A laboratory instructor gives a sample of amino-acid powder to each of four students, I, II, III, and IV, and they weigh the samples. The true value is 8.72 g. Their results for three trials are I: 8.72 g, 8.74 g, 8.70 g II: 8.56 g, 8.77 g, 8.83 g
III: 8.50 g, 8.48 g, 8.51 g IV: 8.41 g, 8.72 g, 8.55 g

(a) Calculate the average mass from each set of data, and tell which set is the most accurate.

(b) Precision is a measure of the average of the deviations of each piece of data from the average value. Which set of data is the most precise? Is this set also the most accurate?

(c) Which set of data is both the most accurate and the most precise?

(d) Which set of data is both the least accurate and the least precise?

1.73 The following dartboards illustrate the types of errors often seen in measurements. The bull's-eye represents the actual value, and the darts represent the data.

(a) Which experiments yield the same average result?

(b) Which experiment(s) display(s) high precision?

(c) Which experiment(s) display(s) high accuracy?

(d) Which experiment(s) show(s) a systematic error?

Comprehensive Problems

1.74 Two blank potential energy diagrams appear below. Beneath each diagram are objects to place in the diagram. Draw the objects on the dashed lines to indicate higher or lower potential energy and label each case as more or less stable:

(a) Two balls attached to a relaxed or a compressed spring

(b) Two positive charges near or apart from each other

1.75 The scenes below illustrate two different mixtures. When mixture A at 273 K is heated to 473 K, mixture B results.

(a) How many different chemical changes occur?

(b) How many different physical changes occur?

1.76 Bromine is used to prepare the pesticide methyl bromide and flame retardants for plastic electronic housings. It is recovered from seawater, underground brines, and the Dead Sea. The average concentrations of bromine in seawater ($d = 1.024$ g/mL) and the Dead Sea ($d = 1.22$ g/mL) are 0.065 g/L and 0.50 g/L, respectively. What is the mass ratio of bromine in the Dead Sea to that in seawater?

1.77 An Olympic-size pool is 50.0 m long and 25.0 m wide.

(a) How many gallons of water ($d = 1.0$ g/mL) are needed to fill the pool to an average depth of 4.8 ft? (b) What is the mass (in kg) of water in the pool?

1.78 At room temperature (20°C) and pressure, the density of air is 1.189 g/L. An object will float in air if its density is less than that of air. In a buoyancy experiment with a new plastic, a chemist creates a rigid, thin-walled ball that weighs 0.12 g and has a volume of 560 cm³.

(a) Will the ball float if it is evacuated?

(b) Will it float if filled with carbon dioxide ($d = 1.830$ g/L)?

(c) Will it float if filled with hydrogen ($d = 0.0899$ g/L)?

(d) Will it float if filled with oxygen ($d = 1.330$ g/L)?

(e) Will it float if filled with nitrogen ($d = 1.165$ g/L)?

(f) For any case in which the ball will float, how much weight must be added to make it sink?

1.79 Asbestos is a fibrous silicate mineral with remarkably high tensile strength. But it is no longer used because airborne asbestos particles can cause lung cancer. Grunerite, a type of asbestos, has a tensile strength of 3.5×10^2 kg/mm² (thus, a strand of grunerite with a 1-mm² cross-sectional area can hold up to 3.5×10^2 kg). The tensile strengths of aluminum and Steel No. 5137 are 2.5×10^4 lb/in² and 5.0×10^4 lb/in², respectively. Calculate the cross-sectional areas (in mm²) of wires of aluminum and of Steel No. 5137 that have the same tensile strength as a fiber of grunerite with a cross-sectional area of 1.0 μm^2 .

1.80 Earth's oceans have an average depth of 3800 m, a total surface area of 3.63×10^8 km², and an average concentration of dissolved gold of 5.8×10^{-9} g/L. (a) How many grams of gold are in the oceans? (b) How many cubic meters of gold are in the oceans? (c) Assuming the price of gold is \$1595/troy oz, what is the value of gold in the oceans (1 troy oz = 31.1 g; d of gold = 19.3 g/cm³)?

1.81 Brass is an alloy of copper and zinc. Varying the mass percentages of the two metals produces brasses with different properties. A brass called yellow zinc has high ductility and strength and is 34–37% zinc by mass. (a) Find the mass range (in g) of copper in 185 g of yellow zinc. (b) What is the mass range (in g) of zinc in a sample of yellow zinc that contains 46.5 g of copper?

1.82 Liquid nitrogen is obtained from liquefied air and is used industrially to prepare frozen foods. It boils at 77.36 K. (a) What

is this temperature in $^{\circ}\text{C}$? (b) What is this temperature in $^{\circ}\text{F}$? (c) At the boiling point, the density of the liquid is 809 g/L and that of the gas is 4.566 g/L. How many liters of liquid nitrogen are produced when 895.0 L of nitrogen gas is liquefied at 77.36 K?

1.83 A jogger runs at an average speed of 5.9 mi/h. (a) How fast is she running in m/s? (b) How many kilometers does she run in 98 min? (c) If she starts a run at 11:15 am, what time is it after she covers 4.75×10^4 ft?

1.84 Scenes A and B depict changes in matter at the atomic scale:

- (a) Which show(s) a physical change?
- (b) Which show(s) a chemical change?
- (c) Which result(s) in different physical properties?
- (d) Which result(s) in different chemical properties?
- (e) Which result(s) in a change in state?

1.85 If a temperature scale were based on the freezing point (5.5°C) and boiling point (80.1°C) of benzene and the temperature difference between these points was divided into 50 units (called $^{\circ}\text{X}$), what would be the freezing and boiling points of water in $^{\circ}\text{X}$? (See Figure 1.11.)

1.86 Earth's surface area is $5.10 \times 10^8 \text{ km}^2$; its crust has a mean thickness of 35 km and a mean density of 2.8 g/cm^3 . The two most abundant elements in the crust are oxygen ($4.55 \times 10^5 \text{ g/t}$, where t stands for "metric ton"; 1 t = 1000 kg) and silicon ($2.72 \times 10^5 \text{ g/t}$), and the two rarest nonradioactive elements are ruthenium and rhodium, each with an abundance of $1 \times 10^{-4} \text{ g/t}$. What is the total mass of each of these elements in Earth's crust?

2

The Components of Matter

2.1 Elements, Compounds, and Mixtures: An Atomic Overview

2.2 The Observations That Led to an Atomic View of Matter

Mass Conservation

Definite Composition

Multiple Proportions

2.3 Dalton's Atomic Theory

Postulates of the Theory

Explanation of the Mass Laws

2.4 The Observations That Led to the Nuclear Atom Model

Discovery of the Electron

Discovery of the Nucleus

2.5 The Atomic Theory Today

Structure of the Atom

Atomic Number, Mass Number, and Atomic Symbol

Isotopes

Atomic Masses

2.6 Elements: A First Look at the Periodic Table

2.7 Compounds: Introduction to Bonding

Formation of Ionic Compounds

Formation of Covalent Substances

2.8 Compounds: Formulas, Names, and Masses

Binary Ionic Compounds

Compounds with Polyatomic Ions

Acid Names from Anion Names

Binary Covalent Compounds

Straight-Chain Alkanes

Molecular Masses

Formulas and Models

2.9 Mixtures: Classification and Separation

An Overview of the Components of Matter

Source: © M. Shcherbyna/Shutterstock.com; © Raul Gonzalez/Science Source

Concepts and Skills to Review Before You Study This Chapter

- › physical and chemical change (Section 1.1)
- › states of matter (Section 1.1)
- › attraction and repulsion between charged particles (Section 1.1)
- › meaning of a scientific model (Section 1.3)
- › SI units and conversion factors (Section 1.4)
- › significant figures in calculations (Section 1.5)

Look closely at almost any sample of matter—a rock, a piece of wood, a butterfly wing—and you'll see that it's made of smaller parts. With a microscope, you'll see still smaller parts. And, if you could zoom in a billion times closer, you'd find, on the atomic scale, the ultimate particles that make up all things.

Modern scientists are certainly not the first to wonder what things are made of. The philosophers of ancient Greece did too, and most believed that everything was made of one or, at most, a few elemental substances (elements), whose hotness, wetness, hardness, and other properties gave rise to the properties of everything else. Democritus (c. 460–370 BC), the father of atomism, took a different approach, and his reasoning went something like this: if you cut a piece of, say, aluminum foil smaller and smaller, you must eventually reach a particle of aluminum so small that it can no longer be cut. Therefore, matter is ultimately composed of indivisible particles with nothing but empty space between them. He called the particles *atoms* (Greek *atomos*, “uncuttable”) and proclaimed: “According to convention, there is a sweet and a bitter, a hot and a cold, and ... there is order. In truth, there are atoms and a void.” But, Aristotle, one of the greatest and most influential philosophers of Western culture, said it was impossible for “nothing” to exist, and the concept of atoms was suppressed for 2000 years.

Finally, in the 17th century, the English scientist Robert Boyle argued that, by definition, an element is composed of “simple Bodies, not made of any other Bodies, of which all mixed Bodies are compounded, and into which they are ultimately resolved,” a description remarkably close to our idea of an element, with atoms being the “simple Bodies.” The next two centuries saw rapid progress in chemistry and the development of a “billiard-ball” image of the atom. Then, an early 20th-century burst of creativity led to our current model of an atom with a complex internal structure.

IN THIS CHAPTER . . . We examine the properties and composition of matter on the macroscopic and atomic scales.

- › We relate the three types of observable matter—elements, compounds, and mixtures—to the atoms, ions, and molecules they consist of.
- › We see how the defining properties of the types of matter relate to 18th-century laws concerning the masses of substances that react with each other.
- › We examine the 19th-century atomic model proposed to explain these laws.
- › We describe some 20th- and 21st-century experiments that have led to our current understanding of atomic structure and atomic mass.
- › We focus on the general organization of the elements in the periodic table and introduce the two major ways that elements combine.
- › We derive names and formulas of compounds and calculate their masses on the atomic scale.
- › We examine some of the ways chemists depict molecules.
- › We classify mixtures and see how to separate them in the lab.
- › We present a final overview of the components of matter.

2.1 ELEMENTS, COMPOUNDS, AND MIXTURES: AN ATOMIC OVERVIEW

Based on its composition, matter can be classified into three types—elements, compounds, and mixtures. Elements and compounds are called **substances**, matter with a *fixed* composition; mixtures are not substances because they have a variable composition.

1. Elements. An **element** is the *simplest type of matter with unique physical and chemical properties*. It consists of only one kind of atom and, therefore, cannot be broken down into a simpler type of matter by any physical or chemical methods. Each element has a name, such as silicon, oxygen, or copper. A sample of silicon contains only silicon atoms. The *macroscopic* properties of a piece of silicon, such as color, density, and combustibility, are different from those of a piece of copper because the *submicroscopic* properties of silicon atoms are different from those of copper atoms; that is, *each element is unique because the properties of its atoms are unique*.

In nature, most elements exist as populations of atoms, either separated or in contact with each other, depending on the physical state. Figure 2.1A shows atoms of an element in its gaseous state. Several elements occur in molecular form: a **molecule** is an independent structure of two or more atoms bound together (Figure 2.1B). Oxygen, for example, occurs in air as *diatomic* (two-atom) molecules.

2. Compounds. A **compound** consists of two or more different elements that are bonded chemically (Figure 2.1C). That is, the elements in a compound are not just mixed together: their atoms have joined in a chemical reaction. Many compounds, such as ammonia, water, and carbon dioxide, consist of molecules. But many others, like sodium chloride (which we'll discuss shortly) and silicon dioxide, do not.

All compounds have three defining features:

- *The elements are present in fixed parts by mass* (have a fixed mass ratio). This is so because *each unit of the compound consists of a fixed number of atoms of each element*. For example, consider a sample of ammonia. It is 14 parts nitrogen by mass and 3 parts hydrogen by mass *because* 1 nitrogen atom has 14 times the mass of 1 hydrogen atom, and each ammonia molecule consists of 1 nitrogen atom and 3 hydrogen atoms:

Ammonia gas is 14 parts N by mass and 3 parts H by mass.

1 N atom has 14 times the mass of 1 H atom.

Each ammonia molecule consists of 1 N atom and 3 H atoms.

- *A compound's properties are different from the properties of its elements.* Table 2.1 shows a striking example: soft, silvery sodium metal and yellow-green, poisonous chlorine gas are very different from the compound they form—white, crystalline sodium chloride, or common table salt!
- *A compound, unlike an element, can be broken down into simpler substances—its component elements—by a chemical change.* For example, an electric current breaks down molten sodium chloride into metallic sodium and chlorine gas.

Figure 2.1 Elements, compounds, and mixtures on the atomic scale. The samples depicted here are gases, but the three types of matter also occur as liquids and solids.

A Atoms of an element

B Molecules of an element

C Molecules of a compound

D Mixture of two elements and a compound

Table 2.1**Some of the Very Different Properties of Sodium, Chlorine, and Sodium Chloride**

Property	Sodium	+	Chlorine	→	Sodium Chloride
Melting point	97.8°C		-101°C		801°C
Boiling point	881.4°C		-34°C		1413°C
Color	Silvery		Yellow-green		Colorless (white)
Density	0.97 g/cm ³		0.0032 g/cm ³		2.16 g/cm ³
Behavior in water	Reacts		Dissolves slightly		Dissolves freely

Source: (Sodium, Chlorine, Sodium chloride) © McGraw-Hill Education/Stephen Frisch, photographer

3. Mixtures. A **mixture** consists of two or more substances (elements and/or compounds) that are physically intermingled, **not** chemically combined. Mixtures differ from compounds as follows:

- The components of a mixture **can** vary in their parts by mass. A mixture of the compounds sodium chloride and water, for example, can have many different parts by mass of salt to water.
- A mixture **retains many of the properties of its components**. Saltwater, for instance, is colorless like water and tastes salty like sodium chloride. The component properties are maintained because on the atomic scale, a mixture consists of the individual units of its component elements and/or compounds (Figure 2.1D).
- Mixtures, unlike compounds, can be separated into their components by physical changes; chemical changes are not needed.** For example, the water in saltwater can be boiled off, a physical process that leaves behind solid sodium chloride.

The following sample problem will help you to differentiate these types of matter.

SAMPLE PROBLEM 2.1

Distinguishing Elements, Compounds, and Mixtures at the Atomic Scale

Problem The scenes below represent atomic-scale views of three samples of matter:

Describe each sample as an element, compound, or mixture.

Plan We have to determine the type of matter by examining the component particles. If a sample contains only one type of particle, it is either an element or a compound; if it contains more than one type, it is a mixture. Particles of an element have only one kind of atom (one color of sphere in an atomic-scale view), and particles of a compound have two or more kinds of atoms.

Solution (a) Mixture: there are three different types of particles. Two types contain only one kind of atom, either green or purple, so they are elements, and the third type contains two red atoms for every one yellow, so it is a compound.

(b) Element: the sample consists of only blue atoms.

(c) Compound: the sample consists of molecules that each have two black and six blue atoms.

FOLLOW-UP PROBLEMS

Brief Solutions for all Follow-up Problems appear at the end of the chapter.

2.1A Does each of the following scenes best represent an element, a compound, or a mixture?

2.1B Describe the following representation of a reaction in terms of elements, compounds, and mixtures.

SOME SIMILAR PROBLEMS 2.3, 2.4, and 2.9

› Summary of Section 2.1

- › All matter exists as either elements, compounds, or mixtures.
- › Every element or compound is a substance, matter with a fixed composition.
- › An element consists of only one type of atom and occurs as a collection of individual atoms or molecules; a molecule consists of two or more atoms chemically bonded together.
- › A compound contains two or more elements chemically combined and exhibits different properties from its component elements. The elements occur in fixed parts by mass because each unit of the compound has a fixed number of each type of atom. Only a chemical change can break down a compound into its elements.
- › A mixture consists of two or more substances mixed together, *not* chemically combined. The components exhibit their individual properties, can be present in any proportion, and can be separated by physical changes.

2.2 THE OBSERVATIONS THAT LED TO AN ATOMIC VIEW OF MATTER

Any model of the composition of matter had to explain three so-called mass laws: the *law of mass conservation*, the *law of definite (or constant) composition*, and the *law of multiple proportions*.

Mass Conservation

The first mass law, stated by Lavoisier on the basis of his combustion experiments, was the most fundamental chemical observation of the 18th century:

- **Law of mass conservation:** *the total mass of substances does not change during a chemical reaction.*

The *number* of substances may change and, by definition, their properties must, but the *total amount* of matter remains constant. Figure 2.2 illustrates mass conservation because the lead nitrate and sodium chromate solutions (*left*) have the same mass as the solid lead chromate in sodium nitrate solution (*right*) that forms after their reaction.

Figure 2.2 The law of mass conservation.

Source: © McGraw-Hill Education/Stephen Frisch, photographer

Even in a complex biochemical change, such as the metabolism of the sugar glucose, which involves many reactions, mass is conserved. For example, in the reaction of, say, 180 g of glucose, with oxygen, we have

Mass conservation means that, based on all chemical experience, *matter cannot be created or destroyed*.

To be precise about it, however, we now know, based on the work of Albert Einstein (1879–1955), that the mass before and after a reaction is not *exactly* the same. Some mass is converted to energy, or vice versa, but the difference is too small to measure, even with the best balance. For example, when 100 g of carbon burns, the carbon dioxide formed weighs 0.000000036 g ($3.6 \times 10^{-8} \text{ g}$) less than the sum of the carbon and oxygen that reacted. Because the energy changes of *chemical* reactions are so small, for all practical purposes, mass *is* conserved. Later in the text, you'll see that energy changes in *nuclear* reactions are so large that mass changes are easy to measure.

Definite Composition

The sodium chloride in your salt shaker is the same substance whether it comes from a salt mine in Pakistan, a salt flat in Argentina, or any other source. This fact is expressed as the second mass law:

- **Law of definite (or constant) composition:** *no matter what its source, a particular compound is composed of the same elements in the same parts (fractions) by mass.*

The **fraction by mass (mass fraction)** is the part of the compound's mass that each element contributes. It is obtained by dividing the mass of each element in the compound by the mass of the compound. The **percent by mass (mass percent, mass %)** is the fraction by mass expressed as a percentage (multiplied by 100):

$$\text{Mass fraction} = \frac{\text{mass of element X in compound A}}{\text{mass of compound A}}$$

$$\text{Mass percent} = \text{mass fraction} \times 100$$

For an everyday example, consider a box that contains three types of marbles: yellow ones weigh 1.0 g each, purple 2.0 g each, and red 3.0 g each. Each type makes up a fraction of the total mass of marbles, 16.0 g. The *mass fraction* of yellow marbles is their number times their mass divided by the total mass:

$$\begin{aligned} \text{Mass fraction of yellow marbles} &= \frac{\text{no. of yellow marbles} \times \text{mass of yellow marbles}}{\text{total mass of marbles}} \\ &= \frac{3 \text{ marbles} \times 1.0 \text{ g / marble}}{16.0 \text{ g}} = 0.19 \end{aligned}$$

Figure 2.3 The law of definite composition. Calcium carbonate occurs in many forms (such as marble, top, and coral, bottom).

Source: (top): © Punchstock RF; (bottom): © Alexander Cherednichenko/Shutterstock.com

Road Map

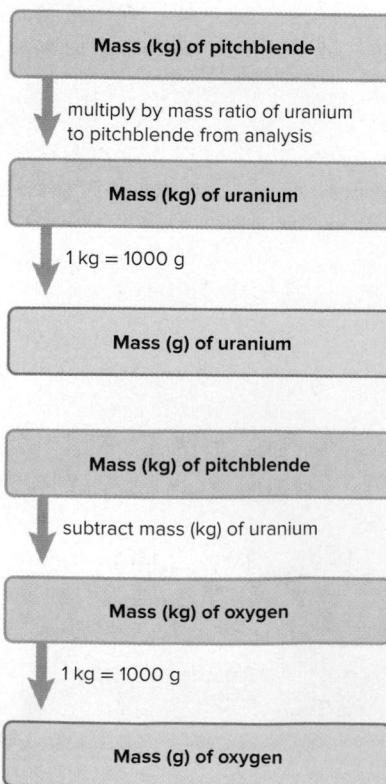

The *mass percent* (parts per 100 parts) of yellow marbles is $0.19 \times 100 = 19\%$ by mass. Similarly, the purple marbles have a mass fraction of 0.25 and represent 25% by mass of the total, and the red marbles have a mass fraction of 0.56 and represent 56% by mass of the total.

In the same way, each element in a compound has a *fixed* mass fraction (and mass percent). For example, calcium carbonate, the major compound in seashells, marble, and coral, is composed of three elements—calcium, carbon, and oxygen. The following results are obtained from a mass analysis of 20.0 g of calcium carbonate:

Analysis by Mass (grams/20.0 g)	Mass Fraction (parts/1.00 part)	Percent by Mass (parts/100 parts)
8.0 g calcium	0.40 calcium	40% calcium
2.4 g carbon	0.12 carbon	12% carbon
9.6 g oxygen	0.48 oxygen	48% oxygen
20.0 g	1.00 part by mass	100% by mass

The mass of each element depends on the mass of the sample—that is, more than 20.0 g of compound would contain more than 8.0 g of calcium—but the *mass fraction is fixed no matter what the size of the sample*. The sum of the mass fractions (or mass percents) equals 1.00 part (or 100%) by mass. The law of definite composition tells us that pure samples of calcium carbonate, no matter where they come from, always contain 40% calcium, 12% carbon, and 48% oxygen by mass (Figure 2.3).

Because a given element always constitutes the same mass fraction of a given compound, we can use that mass fraction to find the actual mass of the element in any sample of the compound:

$$\text{Mass of element} = \text{mass of compound} \times \text{mass fraction}$$

Or, more simply, we can skip the need to find the mass fraction first and use the results of mass analysis directly:

Mass of element in sample

$$= \text{mass of compound in sample} \times \frac{\text{mass of element in compound}}{\text{mass of compound}} \quad (2.1)$$

For example, knowing that a 20.0-g sample of calcium carbonate contains 8.0 g of calcium, the mass of calcium in a 75.0-g sample of calcium carbonate can be calculated:

$$\text{Mass (g) of calcium} = 75.0 \text{ g calcium-carbonate} \times \frac{8.0 \text{ g calcium}}{20.0 \text{ g calcium-carbonate}} = 30.0 \text{ g calcium}$$

SAMPLE PROBLEM 2.2

Calculating the Mass of an Element in a Compound

Problem Pitchblende is the most important compound of uranium. Mass analysis of an 84.2-g sample of pitchblende shows that it contains 71.4 g of uranium, with oxygen the only other element. How many grams of uranium and of oxygen are in 102 kg of pitchblende?

Plan We have to find the masses (in g) of uranium and of oxygen in a known mass (102 kg) of pitchblende, given the mass of uranium (71.4 g) in a different mass of pitchblende (84.2 g) and knowing that oxygen is the only other element present. The mass ratio of uranium to pitchblende in grams is the same as it is in kilograms. Therefore, using Equation 2.1, we multiply the mass (in kg) of the pitchblende sample by the ratio of uranium to pitchblende (in kg) from the mass analysis. This gives the mass (in kg) of uranium, and we convert kilograms to grams. To find the mass of oxygen, the only other element in the pitchblende, we subtract the calculated mass of uranium (in kg) from the given mass of pitchblende (102 kg) and convert kilograms to grams.

Solution Finding the mass (kg) of uranium in 102 kg of pitchblende:

$$\text{Mass (kg) of uranium} = \text{mass (kg) of pitchblende} \times \frac{\text{mass (kg) of uranium in pitchblende}}{\text{mass (kg) of pitchblende}}$$

$$= 102 \text{ kg pitchblende} \times \frac{71.4 \text{ kg uranium}}{84.2 \text{ kg pitchblende}} = 86.5 \text{ kg uranium}$$

Converting the mass of uranium from kg to g:

$$\text{Mass (g) of uranium} = 86.5 \text{ kg uranium} \times \frac{1000 \text{ g}}{1 \text{ kg}} = 8.65 \times 10^4 \text{ g uranium}$$

Finding the mass (in kg) of oxygen in 102 kg of pitchblende:

$$\begin{aligned}\text{Mass (kg) of oxygen} &= \text{mass (kg) of pitchblende} - \text{mass (kg) of uranium} \\ &= 102 \text{ kg} - 86.5 \text{ kg} = 15.5 \text{ kg oxygen}\end{aligned}$$

Converting the mass of oxygen from kg to g:

$$\text{Mass (g) of oxygen} = 15.5 \text{ kg oxygen} \times \frac{1000 \text{ g}}{1 \text{ kg}} = 1.55 \times 10^4 \text{ g oxygen}$$

Check The analysis showed that most of the mass of pitchblende is due to uranium, so the large mass of uranium makes sense. Rounding off to check the math gives

$$\sim 100 \text{ kg pitchblende} \times \frac{70}{85} = 82 \text{ kg uranium}$$

FOLLOW-UP PROBLEMS

2.2A The mineral “fool’s gold” does not contain any gold; instead it is a compound composed only of the elements iron and sulfur. A 110.0-g sample of fool’s gold contains 51.2 g of iron. What mass of sulfur is in a sample of fool’s gold that contains 86.2 g of iron?

2.2B Silver bromide is the light-sensitive compound coated onto black-and-white film. A 26.8-g sample contains 15.4 g of silver, with bromine as the only other element. How many grams of each element are on a roll of film that contains 3.57 g of silver bromide?

SOME SIMILAR PROBLEMS 2.22–2.25

Student Hot Spot

Student data indicate that you may struggle with using mass fraction to calculate the mass of an element in a compound. Access the Smartbook to view additional Learning Resources on this topic.

Multiple Proportions

It's quite common for the same two elements to form more than one compound—sulfur and fluorine do this, as do phosphorus and chlorine and many other pairs of elements. The third mass law we consider applies in these cases:

- **Law of multiple proportions:** if elements A and B react to form two compounds, the different masses of B that combine with a fixed mass of A can be expressed as a ratio of small whole numbers.

Consider two compounds of carbon and oxygen; let's call them carbon oxides I and II. These compounds have very different properties: the density of carbon oxide I is 1.25 g/L, whereas that of II is 1.98 g/L; I is poisonous and flammable, but II is not. Mass analysis shows that

Carbon oxide I is 57.1 mass % oxygen and 42.9 mass % carbon

Carbon oxide II is 72.7 mass % oxygen and 27.3 mass % carbon

To demonstrate the phenomenon of multiple proportions, we use the mass percents of oxygen and of carbon to find their masses in a given mass, say 100 g, of each compound. Then we divide the mass of oxygen by the mass of carbon in each compound to obtain the mass of oxygen that combines with a fixed mass of carbon:

	Carbon Oxide I	Carbon Oxide II
g oxygen/100 g compound	57.1	72.7
g carbon/100 g compound	42.9	27.3
g oxygen/g carbon	$\frac{57.1}{42.9} = 1.33$	$\frac{72.7}{27.3} = 2.66$

If we then divide the grams of oxygen per gram of carbon in II by that in I, we obtain a ratio of small whole numbers:

$$\frac{2.66 \text{ g oxygen/g carbon in II}}{1.33 \text{ g oxygen/g carbon in I}} = \frac{2}{1}$$

The law of multiple proportions tells us that in two compounds of the same elements, the mass fraction of one element relative to that of the other element changes in *increments based on ratios of small whole numbers*. In this case, the ratio is 2/1—for a given mass of carbon, compound II contains 2 *times* as much oxygen as I, not 1.583 times, 1.716 times, or any other intermediate amount. In the next section, we'll discuss the model that explained the mass laws on the atomic scale and learn the identities of the two carbon oxides.

› Summary of Section 2.2

- › The law of mass conservation states that the total mass remains constant during a chemical reaction.
- › The law of definite composition states that any sample of a given compound has the same elements present in the same parts by mass.
- › The law of multiple proportions states that, in different compounds of the same elements, the masses of one element that combine with a fixed mass of the other can be expressed as a ratio of small whole numbers.

2.3 DALTON'S ATOMIC THEORY

With over 200 years of hindsight, it may be easy to see how the mass laws could be explained by the idea that matter exists in indestructible units, each with a particular mass and set of properties, but it was a major breakthrough in 1808 when John Dalton (1766–1844) presented his atomic theory of matter.

Postulates of the Atomic Theory

Dalton expressed his theory in a series of postulates, presented here in modern terms:

1. All matter consists of **atoms**, tiny indivisible units of an element that cannot be created or destroyed. (This derives from the “eternal, indestructible atoms” proposed by Democritus more than 2000 years earlier and reflects mass conservation as stated by Lavoisier.)
2. Atoms of one element *cannot* be converted into atoms of another element. In chemical reactions, the atoms of the original substances recombine to form different substances. (This rejects the alchemical belief in the magical transmutation of elements.)
3. Atoms of an element are identical in mass and other properties and are different from atoms of any other element. (This contains Dalton’s major new ideas: *unique mass and properties* for the atoms of a given element.)
4. Compounds result from the chemical combination of a specific ratio of atoms of different elements. (This follows directly from the law of definite composition.)

How the Theory Explains the Mass Laws

Let's see how Dalton's postulates explain the mass laws:

- *Mass conservation.* Atoms cannot be created or destroyed (postulate 1) or converted into other types of atoms (postulate 2). Therefore, a chemical reaction cannot possibly result in a mass change because atoms are just combined differently.
- *Definite composition.* A compound is a combination of a *specific* ratio of different atoms (postulate 4), each of which has a particular mass (postulate 3). Thus, each element in a compound must constitute a fixed fraction of the total mass.
- *Multiple proportions.* Atoms of an element have the same mass (postulate 3) and are indivisible (postulate 1). The masses of element B that combine with a fixed mass of element A must give a small, whole-number ratio because different numbers of B atoms combine with each A atom in different compounds.

The *simplest* arrangement consistent with the mass data for carbon oxides I and II in our earlier example is that one atom of oxygen combines with one atom of carbon in compound I (carbon monoxide) and that two atoms of oxygen combine with one atom of carbon in compound II (carbon dioxide):

Let's work through a sample problem that reviews the mass laws.

SAMPLE PROBLEM 2.3

Visualizing the Mass Laws

Problem The scenes below represent an atomic-scale view of a chemical reaction:

Which of the mass laws—mass conservation, definite composition, and/or multiple proportions—is (are) illustrated?

Plan From the depictions, we note the numbers, colors, and combinations of atoms (spheres) to see which mass laws pertain. If the numbers of each atom are the same before and after the reaction, the total mass did not change (mass conservation). If a compound forms that always has the same atom ratio, the elements are present in fixed parts by mass (definite composition). If the same elements form different compounds and the ratio of the atoms of one element that combine with one atom of the other element is a small whole number, the ratio of their masses is a small whole number as well (multiple proportions).

Solution There are seven purple and nine green atoms in each circle, so mass is conserved. The compound formed has one purple and two green atoms, so it has definite composition. Only one compound forms, so the law of multiple proportions does not pertain.

FOLLOW-UP PROBLEMS

2.3A The following scenes represent a chemical change. Which of the mass laws is (are) illustrated?

2.3B Which sample(s) best display(s) the fact that compounds of bromine (*orange*) and fluorine (*yellow*) exhibit the law of multiple proportions? Explain.

SOME SIMILAR PROBLEMS 2.14 and 2.15

› Summary of Section 2.3

- › Dalton's atomic theory explained the mass laws by proposing that all matter consists of indivisible, unchangeable atoms of fixed, unique mass.
- › Mass is conserved during a reaction because the atoms retain their identities but are combined differently.
- › Each compound has a fixed mass fraction of each of its elements because it is composed of a fixed number of each type of atom.
- › Different compounds of the same elements exhibit multiple proportions because they each consist of whole atoms.

2.4 THE OBSERVATIONS THAT LED TO THE NUCLEAR ATOM MODEL

Dalton's model established that masses of elements reacting could be explained in terms of atoms, but it did not account for why atoms bond as they do: why, for example, do two, and not three, hydrogen atoms bond with one oxygen atom in a water molecule?

Moreover, Dalton's "billiard-ball" model of the atom did not predict the existence of subatomic charged particles, which were observed in experiments at the turn of the 20th century that led to the discovery of *electrons* and the atomic *nucleus*. Let's examine some of the experiments that resolved questions about Dalton's model and led to our current model of atomic structure.

Effect of electric charges.

Source: © McGraw-Hill Education/Bob Coyle, photographer

Discovery of the Electron and Its Properties

For many years, scientists had known that matter and electric charge were related. When amber is rubbed with fur, or glass with silk, positive and negative charges form—the same charges that make your hair crackle and cling to your comb on a dry day (*see photo*). Scientists also knew that an electric current could decompose certain compounds into their elements. But they did not know what a current was made of.

Cathode Rays To discover the nature of an electric current, some investigators tried passing it through nearly evacuated glass tubes fitted with metal electrodes. When the electric power source was turned on, a "ray" could be seen striking the phosphor-coated end of the tube, which emitted a glowing spot of light. The rays were called **cathode rays** because they originated at the negative electrode (cathode) and moved to the positive electrode (anode).

Figure 2.4 shows some properties of cathode rays based on these observations. The main conclusion was that *cathode rays consist of negatively charged particles*.

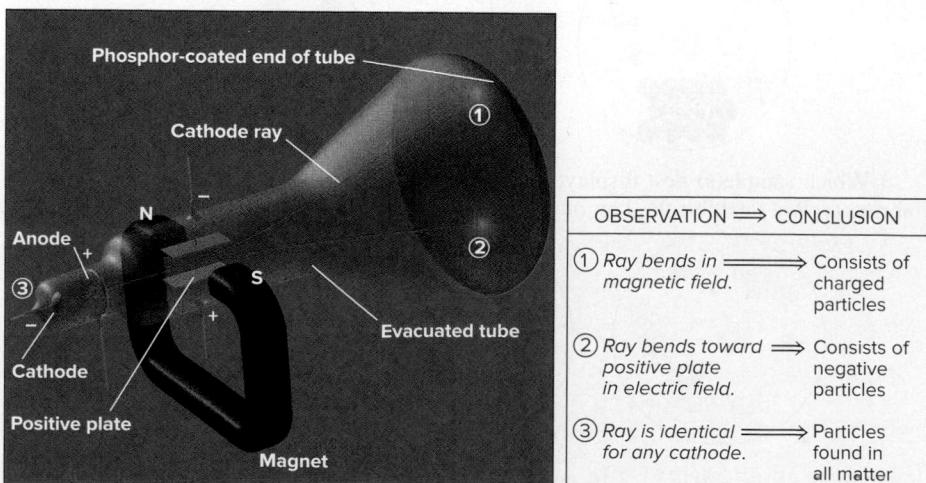

Figure 2.4 Observations that established the properties of cathode rays.

found in all matter. The rays become visible as their particles collide with the few remaining gas molecules in the evacuated tube. Cathode ray particles were later named *electrons*. There are many familiar cases of the effects of charged particles colliding with gas particles or hitting a phosphor-coated screen:

- In a “neon” sign, electrons collide with the gas particles in the tube, causing them to give off light.
- The aurora borealis, or northern lights (*see photo*), occurs when Earth’s magnetic field bends streams of charged particles coming from the Sun, which then collide with gas particles in the atmosphere to give off light.
- In older televisions and computer monitors, the cathode ray passes back and forth over the phosphor-coated screen, creating a pattern that we see as a picture.

Mass and Charge of the Electron Two classic experiments and their conclusion revealed the mass and charge of the electron:

1. *Mass/charge ratio.* In 1897, the British physicist J. J. Thomson (1856–1940) measured the ratio of the mass of a cathode ray particle to its charge. By comparing this value with the mass/charge ratio for the lightest charged particle in solution, Thomson estimated that the cathode ray particle weighed less than $\frac{1}{1000}$ as much as hydrogen, the lightest atom! He was shocked because this implied that, contrary to Dalton’s atomic theory, *atoms contain even smaller particles*. Fellow scientists reacted with disbelief to Thomson’s conclusion; some even thought he was joking.

2. *Charge.* In 1909, the American physicist Robert Millikan (1868–1953) measured the *charge* of the electron. He did so by observing the movement of tiny oil droplets in an apparatus that contained electrically charged plates and an x-ray source (Figure 2.5). X-rays knocked electrons from gas molecules in the air within the apparatus, and the electrons stuck to an oil droplet falling through a hole in a positively charged plate. With the electric field off, Millikan measured the mass of the now negatively charged droplet from its rate of fall. Then, by adjusting the field’s strength, he made the droplet slow and hang suspended, which allowed him to measure its total charge.

After many tries, Millikan found that the total charge of the various droplets was always some *whole-number multiple of a minimum charge*. If different oil droplets picked up different numbers of electrons, he reasoned that this minimum charge

Aurora borealis display.

Source: © Roman Crochuk/Shutterstock.com

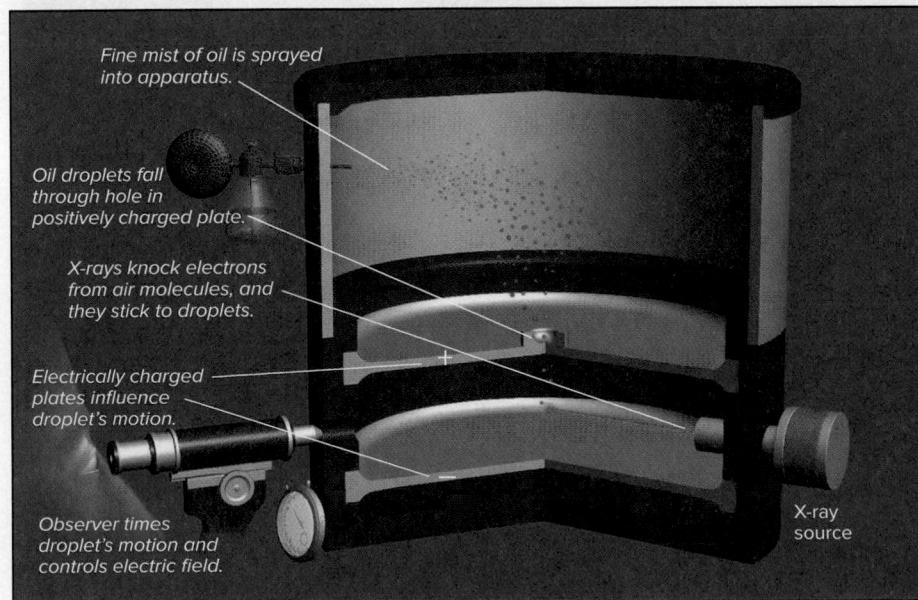

Figure 2.5 Millikan’s oil-drop experiment for measuring an electron’s charge. The total charge on an oil droplet is some whole-number multiple of the charge of the electron.

must be the charge of the electron itself. Remarkably, the value that he calculated over a century ago was within 1% of the modern value of the electron's charge, -1.602×10^{-19} C (C stands for *coulomb*, the SI unit of charge).

3. Conclusion: calculating the electron's mass. The electron's mass/charge ratio, from work by Thomson and others, multiplied by the value for the electron's charge gives the electron's mass, which is *extremely* small:

$$\begin{aligned}\text{Mass of electron} &= \frac{\text{mass}}{\text{charge}} \times \text{charge} = \left(-5.686 \times 10^{-12} \frac{\text{kg}}{\text{C}} \right) (-1.602 \times 10^{-19} \text{ C}) \\ &= 9.109 \times 10^{-31} \text{ kg} = 9.109 \times 10^{-28} \text{ g}\end{aligned}$$

Discovery of the Atomic Nucleus

The presence of electrons in all matter brought up two major questions about the structure of atoms. Matter is electrically neutral, so atoms must be also. But if atoms contain negatively charged electrons, what positive charges balance them? And if an electron has such a tiny mass, what accounts for an atom's much larger mass? To address these issues, Thomson proposed his "plum-pudding" model—a spherical atom composed of diffuse, positively charged matter with electrons embedded in it like "raisins in a plum pudding."

In 1910, New Zealand–born physicist Ernest Rutherford (1871–1937) tested this model and obtained a very unexpected result (Figure 2.6):

- 1. Experimental design.** Figure 2.6A shows the experimental setup, in which tiny, dense, positively charged alpha (α) particles emitted from radium are aimed at gold foil. A circular, zinc-sulfide screen registers the deflection (scattering angle) of the α particles emerging from the foil by emitting light flashes when the particles strike it.
- 2. Hypothesis and expected results.** With Thomson's model in mind (Figure 2.6B), Rutherford expected only minor, if any, deflections of the α particles because they

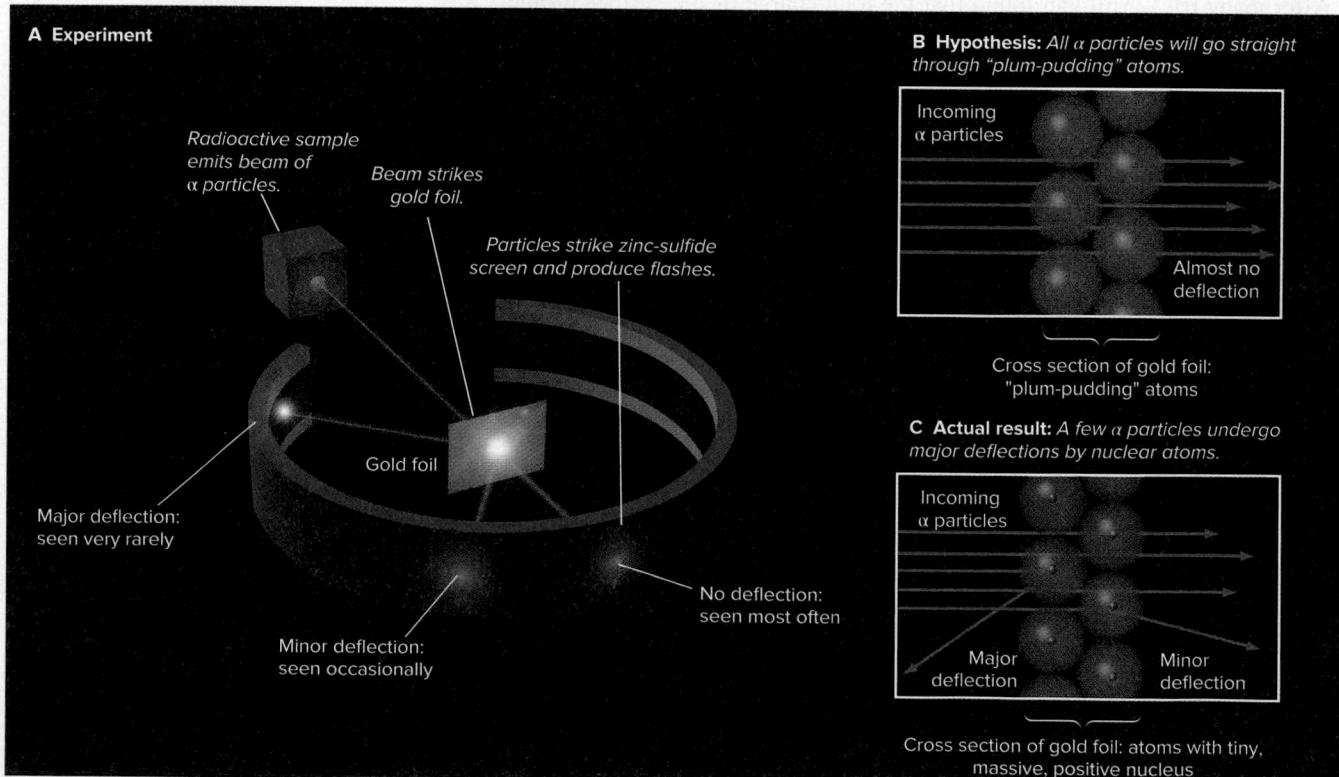

Figure 2.6 Rutherford's α -scattering experiment and discovery of the atomic nucleus.

should act as bullets and go right through the gold atoms. After all, he reasoned, an electron should not be able to deflect an α particle any more than a Ping-Pong ball could deflect a baseball.

3. *Actual results.* Initial results were consistent with this hypothesis, but then the unexpected happened (Figure 2.6C). As Rutherford recalled: “I remember two or three days later Geiger [one of his coworkers] coming to me in great excitement and saying, ‘We have been able to get some of the α particles coming backwards . . .’ It was quite the most incredible event that has ever happened to me in my life. It was almost as incredible as if you fired a 15-inch shell at a piece of tissue paper and it came back and hit you.” The data showed very few α particles deflected at all and only 1 in 20,000 deflected by more than 90° (“coming backwards”).
4. *Rutherford’s conclusion.* Rutherford concluded that these few α particles were being repelled by something small, dense, and positive within the gold atoms. Calculations based on the mass, charge, and velocity of the α particles and the fraction of these large-angle deflections showed that
 - An atom is mostly space occupied by electrons.
 - In the center is a tiny region, which Rutherford called the **nucleus**, that contains all the positive charge and essentially all the mass of the atom.
 He proposed that positive particles lay within the nucleus and called them *protons*.

Rutherford’s model explained the charged nature of matter, but it could not account for all the atom’s mass. After more than 20 years, in 1932, James Chadwick (1891–1974) discovered the *neutron*, an uncharged dense particle that also resides in the nucleus.

› Summary of Section 2.4

- › Several major discoveries at the turn of the 20th century resolved questions about Dalton’s model and led to our current model of atomic structure.
- › Cathode rays were shown to consist of negative particles (electrons) that exist in all matter. J. J. Thomson measured their mass/charge ratio and concluded that they are much smaller and lighter than atoms.
- › Robert Millikan determined the charge of the electron, which he combined with other data to calculate its mass.
- › Ernest Rutherford proposed that atoms consist of a tiny, massive, positively charged nucleus surrounded by electrons.

2.5 THE ATOMIC THEORY TODAY

Dalton’s model of an indivisible particle has given way to our current model of an atom with an elaborate internal architecture of subatomic particles.

Structure of the Atom

An *atom* is an electrically neutral, spherical entity composed of a positively charged central nucleus surrounded by one or more negatively charged electrons (Figure 2.7, *next page*). The electrons move rapidly within the available volume, held there by the attraction of the nucleus. (To indicate their motion, they are often depicted as a cloudy blur of color, darkest around a central dot—the nucleus—and becoming paler toward the outer edge.) An atom’s diameter ($\sim 1 \times 10^{-10}$ m) is about 20,000 times the diameter of its nucleus ($\sim 5 \times 10^{-15}$ m). The nucleus contributes 99.97% of the atom’s mass, but occupies only about 1 quadrillionth of its volume, so it is incredibly dense: about 10^{14} g/mL! ›

An atomic nucleus consists of protons and neutrons (the only exception is the simplest nucleus, that of hydrogen, which is just a proton). The **proton** (p^+) has a positive charge, and the **neutron** (n^0) has no charge; thus, the positive charge of the nucleus results from its protons. The *magnitudes* of the charges possessed by a proton and by an **electron** (e^-) are equal, but the *signs* of the charges are opposite. An atom is neutral because the number of protons in the nucleus equals the number

The Tiny, Massive Nucleus

A few analogies can help you grasp the incredible properties of the atomic nucleus. A nucleus the size of the period at the end of a sentence would weigh about 100 tons, as much as 50 cars! An atom the size of the Houston Astrodome would have a nucleus the size of a green pea that would contain virtually all the stadium’s mass. If the nucleus were about 1 cm in diameter, the atom would be about 200 m across, or more than the length of two football fields!

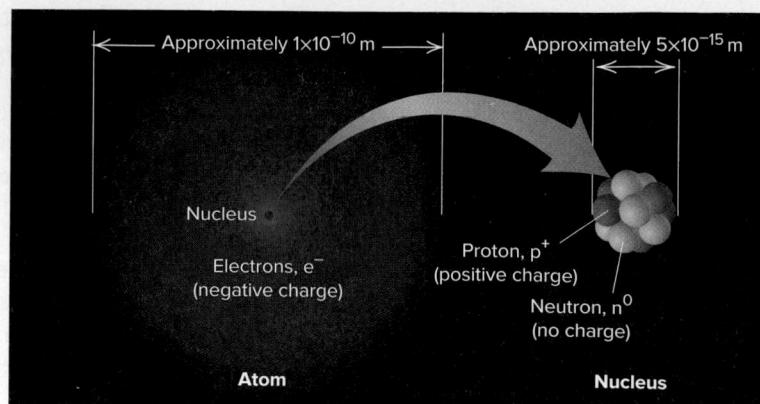

Figure 2.7 General features of the atom.

of electrons surrounding the nucleus. Some properties of these three subatomic particles are listed in Table 2.2.

Atomic Number, Mass Number, and Atomic Symbol

The **atomic number (Z)** of an element equals the number of protons in the nucleus of each of its atoms. *All atoms of an element have the same atomic number, and the atomic number of each element is different from that of any other element.* All carbon atoms ($Z = 6$) have 6 protons, all oxygen atoms ($Z = 8$) have 8 protons, and all uranium atoms ($Z = 92$) have 92 protons. There are currently 118 known elements, of which 90 occur in nature and 28 have been synthesized by nuclear scientists.

The **mass number (A)** is the total number of protons and neutrons in the nucleus of an atom. Each proton and each neutron contributes one unit to the mass number. Thus, a carbon atom with 6 protons and 6 neutrons in its nucleus has a mass number of 12, and a uranium atom with 92 protons and 146 neutrons in its nucleus has a mass number of 238.

The **atomic symbol** (or *element symbol*) of an element is based on its English, Latin, or Greek name, such as C for carbon, S for sulfur, and Na for sodium (Latin *natrium*). Often written with the symbol are the atomic number (Z) as a left *subscript* and the mass number (A) as a left *superscript*, so element X would be ${}^A_Z X$ (Figure 2.8A). Since the mass number is the sum of protons and neutrons, the number of neutrons (N) equals the mass number minus the atomic number:

$$\text{Number of neutrons} = \text{mass number} - \text{atomic number}, \quad \text{or} \quad N = A - Z \quad (2.2)$$

Thus, a chlorine atom, symbolized ${}^{35}_{17}\text{Cl}$, has $A = 35$, $Z = 17$, and $N = 35 - 17 = 18$. Because each element has its own atomic number, we also know the atomic number from the symbol. For example, instead of writing ${}^{12}_6\text{C}$ for carbon with mass number 12, we can write ${}^{12}\text{C}$ (spoken “carbon twelve”), with $Z = 6$ understood. Another way to name this atom is carbon-12.

Table 2.2

Properties of the Three Key Subatomic Particles

Name (Symbol)	Charge		Mass		Location in Atom
	Relative	Absolute (C)*	Relative (amu)[†]	Absolute (g)	
Proton (p^+)	1+	$+1.60218 \times 10^{-19}$	1.00727	1.67262×10^{-24}	Nucleus
Neutron (n^0)	0	0	1.00866	1.67493×10^{-24}	Nucleus
Electron (e^-)	1-	-1.60218×10^{-19}	0.00054858	9.10939×10^{-28}	Outside nucleus

*The coulomb (C) is the SI unit of charge.

[†]The atomic mass unit (amu) equals 1.66054×10^{-24} g; discussed later in this section.

Isotopes

All atoms of an element have the same atomic number but not the same mass number. Isotopes of an element are atoms that have different numbers of neutrons and therefore different mass numbers. Most elements occur in nature in a particular isotopic composition, which specifies the proportional abundance of each of its isotopes. For example, all carbon atoms ($Z = 6$) have 6 protons and 6 electrons, but only 98.89% of naturally occurring carbon atoms have 6 neutrons ($A = 12$). A small percentage (1.11%) have 7 neutrons ($A = 13$), and even fewer (less than 0.01%) have 8 ($A = 14$). These are carbon's three naturally occurring isotopes— ^{12}C , ^{13}C , and ^{14}C . A natural sample of carbon has these three isotopes in these relative proportions. Five other carbon isotopes— ^9C , ^{10}C , ^{11}C , ^{15}C , and ^{16}C —have been created in the laboratory. Figure 2.8B depicts the atomic number, mass number, and symbol for four atoms, two of which are isotopes of the element uranium.

A key point is that the chemical properties of an element are primarily determined by the number of electrons, so all isotopes of an element have nearly identical chemical behavior, even though they have different masses.

SAMPLE PROBLEM 2.4

Determining the Numbers of Subatomic Particles in the Isotopes of an Element

Problem Silicon (Si) is a major component of semiconductor chips. It has three naturally occurring isotopes: ^{28}Si , ^{29}Si , and ^{30}Si . Determine the numbers of protons, electrons, and neutrons in an atom of each silicon isotope.

Plan The mass number (A ; left superscript) of each of the three isotopes is given, which is the sum of protons and neutrons. From the List of Elements on the text's inside front cover, we find the atomic number (Z , number of protons), which equals the number of electrons. We obtain the number of neutrons by subtracting Z from A (Equation 2.2).

Solution From the elements list, the atomic number of silicon is 14. Therefore,

$$\begin{aligned} {}^{28}\text{Si} &\text{ has } 14\text{p}^+, 14\text{e}^-, \text{ and } 14\text{n}^0(28 - 14) \\ {}^{29}\text{Si} &\text{ has } 14\text{p}^+, 14\text{e}^-, \text{ and } 15\text{n}^0(29 - 14) \\ {}^{30}\text{Si} &\text{ has } 14\text{p}^+, 14\text{e}^-, \text{ and } 16\text{n}^0(30 - 14) \end{aligned}$$

FOLLOW-UP PROBLEMS

2.4A Titanium, the ninth most abundant element, is used structurally in many objects, such as electric turbines, aircraft bodies, and bicycle frames. It has five naturally occurring isotopes: ^{46}Ti , ^{47}Ti , ^{48}Ti , ^{49}Ti , and ^{50}Ti . How many protons, electrons, and neutrons are in an atom of each isotope?

2.4B How many protons, electrons, and neutrons are in an atom of each of the following, and which elements are represented by Q, R, and X? (a) ${}_{11}^{\text{Q}}$ (b) ${}_{20}^{\text{R}}$ (c) ${}_{53}^{\text{X}}$

SOME SIMILAR PROBLEMS 2.39–2.42

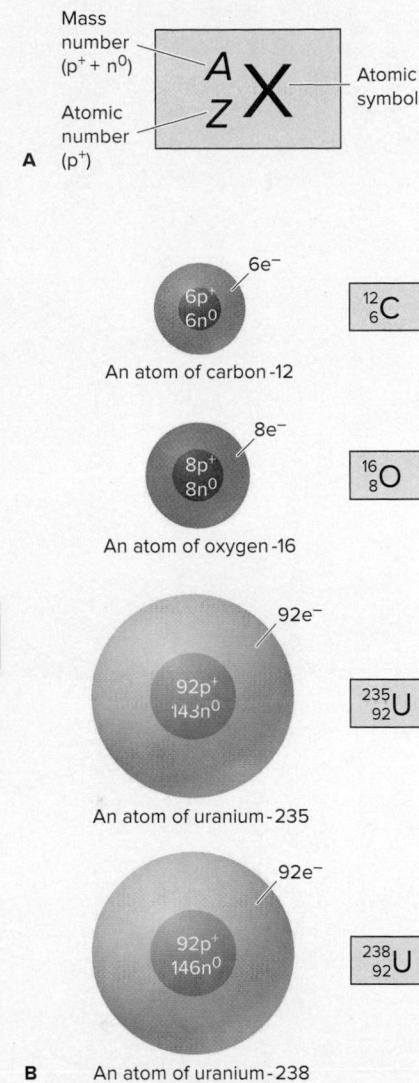

Figure 2.8 Atom notation. **A**, The meaning of the ${}_{Z}^A X$ notation. **B**, Notations and spherical representations for four atoms. (The nuclei are not drawn to scale.)

Atomic Masses of the Elements

The mass of an atom is measured relative to the mass of an atomic standard. The modern standard is the carbon-12 atom, whose mass is defined as exactly 12 atomic mass units. Thus, the **atomic mass unit (amu)** is $\frac{1}{12}$ the mass of a carbon-12 atom. Based on this standard, the ^1H atom has a mass of 1.008 amu; in other words, a ^{12}C atom has almost 12 times the mass of an ^1H atom. We will continue to use the term *atomic mass unit* in the text, although the name of the unit has been changed to the **dalton (Da)**; thus, one ^{12}C atom has a mass of 12 daltons (12 Da, or 12 amu). The atomic mass unit is a relative unit of mass, but it is equivalent to an absolute mass of 1.66054×10^{-24} g.

Finding Atomic Mass from Isotopic Composition The isotopic composition of an element is determined by **mass spectrometry**, a method for measuring the relative masses and abundances of atomic-scale particles very precisely (see the Tools of the Laboratory essay at the end of this section). For example, using a mass spectrometer, we measure the mass ratio of ^{28}Si to ^{12}C as

$$\frac{\text{Mass of } ^{28}\text{Si atom}}{\text{Mass of } ^{12}\text{C standard}} = 2.331411$$

From this mass ratio, we find the **isotopic mass** of the ^{28}Si atom, the mass of this silicon isotope relative to that of ^{12}C :

$$\begin{aligned}\text{Isotopic mass of } ^{28}\text{Si} &= \text{measured mass ratio} \times \text{mass of } ^{12}\text{C} \\ &= 2.331411 \times 12 \text{ amu} = 27.97693 \text{ amu}\end{aligned}$$

Along with the isotopic mass, the mass spectrometer gives the relative abundance as a percentage (or fraction) of each isotope in a sample of the element. For example, the relative abundance of ^{28}Si is 92.23% (or 0.9223), which means that 92.23% of the silicon atoms in a naturally occurring sample of silicon have a mass number of 28.

From such data, we can obtain the **atomic mass** (also called *atomic weight*) of an element, the *average* of the masses of its naturally occurring isotopes weighted according to their abundances. Each naturally occurring isotope of an element contributes a certain portion to the atomic mass. For instance, multiplying the isotopic mass of ^{28}Si by its fractional abundance gives the portion of the atomic mass of Si contributed by ^{28}Si :

$$\begin{aligned}\text{Portion of Si atomic mass from } ^{28}\text{Si} &= 27.97693 \text{ amu} \times 0.9223 = 25.8031 \text{ amu} \\ &\quad (\text{retaining two additional significant figures})\end{aligned}$$

Similar calculations give the portions contributed by ^{29}Si with a relative abundance of 4.67% ($28.976495 \text{ amu} \times 0.0467 = 1.3532 \text{ amu}$) and by ^{30}Si with a relative abundance of 3.10% ($29.973770 \text{ amu} \times 0.0310 = 0.9292 \text{ amu}$). Adding the three portions together (rounding to two decimal places at the end) gives the atomic mass of silicon:

$$\begin{aligned}\text{Atomic mass of Si} &= 25.8031 \text{ amu} + 1.3532 \text{ amu} + 0.9292 \text{ amu} \\ &= 28.0855 \text{ amu} = 28.09 \text{ amu}\end{aligned}$$

Thus, the average atomic mass of an element can be calculated by multiplying the mass of each naturally occurring isotope by its fractional abundance and summing those values:

$$\text{Atomic mass} = \Sigma(\text{isotopic mass})(\text{fractional abundance of isotope}) \quad (2.3)$$

where the fractional abundance of an isotope is the percent natural abundance of the isotope divided by 100.

The atomic mass is an average value; that is, while no individual silicon atom has a mass of 28.09 amu, in the laboratory, we consider a sample of silicon to consist of atoms with this average mass.

SAMPLE PROBLEM 2.5

Calculating the Atomic Mass of an Element

Problem Silver (Ag; Z = 47) has 46 known isotopes, but only two occur naturally, ^{107}Ag and ^{109}Ag . Given the following data, calculate the atomic mass of Ag:

Isotope	Mass (amu)	Abundance (%)
^{107}Ag	106.90509	51.84
^{109}Ag	108.90476	48.16

Plan From the mass and abundance of the two Ag isotopes, we have to find the atomic mass of Ag (weighted average of the isotopic masses). We divide each percent abundance by 100 to get the fractional abundance and then multiply that by each isotopic mass to find the portion of the atomic mass contributed by each isotope. The sum of the isotopic portions is the atomic mass (Equation 2.3).

Solution Finding the fractional abundances:

$$\text{Fractional abundance of } {}^{107}\text{Ag} = 51.84/100 = 0.5184; \text{ similarly, } {}^{109}\text{Ag} = 0.4816$$

Finding the portion of the atomic mass from each isotope:

$$\begin{aligned}\text{Portion of atomic mass from } {}^{107}\text{Ag} &= \text{isotopic mass} \times \text{fractional abundance} \\ &= 106.90509 \text{ amu} \times 0.5184 = 55.42 \text{ amu}\end{aligned}$$

$$\text{Portion of atomic mass from } {}^{109}\text{Ag} = 108.90476 \text{ amu} \times 0.4816 = 52.45 \text{ amu}$$

Finding the atomic mass of silver:

$$\text{Atomic mass of Ag} = 55.42 \text{ amu} + 52.45 \text{ amu} = 107.87 \text{ amu}$$

Or, in one step using Equation 2.3:

$$\begin{aligned}\text{Atomic mass of Ag} &= (\text{isotopic mass of } {}^{107}\text{Ag})(\text{fractional abundance of } {}^{107}\text{Ag}) \\ &\quad + (\text{isotopic mass of } {}^{109}\text{Ag})(\text{fractional abundance of } {}^{109}\text{Ag}) \\ &= (106.90509 \text{ amu})(0.5184) + (108.90476 \text{ amu})(0.4816) \\ &= 107.87 \text{ amu}\end{aligned}$$

Check The individual portions seem right: $\sim 100 \text{ amu} \times 0.50 = 50 \text{ amu}$. The portions should be almost the same because the two isotopic abundances are almost the same. We rounded each portion to four significant figures because that is the number of significant figures in the abundance values. This is the correct atomic mass (to two decimal places); in the List of Elements (inside front cover), it is rounded to 107.9 amu.

FOLLOW-UP PROBLEMS

2.5A Neon, a gas found in trace amounts in air, emits light in the visible range when electricity is passed through it. Use the isotopic abundance data from the Tools of the Laboratory essay at the end of this section and the following isotopic masses to determine the atomic mass of neon: ${}^{20}\text{Ne}$ has a mass of 19.99244 amu, ${}^{21}\text{Ne}$ has a mass of 20.99385 amu, and ${}^{22}\text{Ne}$ has a mass of 21.99139 amu.

2.5B Boron (B; Z = 5) has two naturally occurring isotopes. Find the percent abundances of ${}^{10}\text{B}$ and ${}^{11}\text{B}$ given these data: atomic mass of B = 10.81 amu, isotopic mass of ${}^{10}\text{B}$ = 10.0129 amu, and isotopic mass of ${}^{11}\text{B}$ = 11.0093 amu. (*Hint:* The sum of the fractional abundances is 1. If x = abundance of ${}^{10}\text{B}$, then $1 - x$ = abundance of ${}^{11}\text{B}$.)

SOME SIMILAR PROBLEMS 2.47–2.50

The Atomic-Mass Interval From the time Dalton proposed his atomic theory through much of the 20th century, atomic masses were considered constants of nature, like the speed of light. However, in 1969, the International Union of Pure and Applied Chemistry (IUPAC) rejected this idea because results from more advanced mass spectrometers showed consistent variations in isotopic composition from source to source.

In 2009, IUPAC proposed that an *atomic-mass interval* be used for 10 elements with exceptionally large variations in isotopic composition: hydrogen (H), lithium (Li), boron (B), carbon (C), nitrogen (N), oxygen (O), silicon (Si), sulfur (S), chlorine (Cl), and thallium (Th). For example, because the isotopic composition of hydrogen from oceans, rivers, and lakes, from various minerals, and from organic sediments varies so much, its atomic mass is now given as the interval [1.00784; 1.00811], which means that the mass is greater than or equal to 1.00784 and less than or equal to 1.00811. It's important to realize that *the mass of any given isotope of an element is constant, but the proportion of isotopes varies from source to source*.

Road Map

Mass spectrometry is a powerful technique for measuring the mass and abundance of charged particles from their mass/charge ratio (m/e). When a high-energy electron collides with a particle, say, an atom of neon-20, one of the atom's electrons is knocked away and the resulting particle has one positive charge, Ne^+ (Figure B2.1). Thus, its m/e equals the mass divided by 1+.

Figure B2.2, part A, depicts the core of one type of mass spectrometer. The sample is introduced (and vaporized if liquid or solid), then bombarded by high-energy electrons to form positively charged particles, in this case, of the different neon isotopes. These are attracted toward a series of negatively charged plates with slits in them. Some particles pass through the slits into an evacuated tube exposed to a magnetic field. As the particles enter this region, their paths are bent, the lightest particles (lowest m/e) are deflected most and the heaviest particles (highest m/e) least. At the end of the magnetic region, the particles strike a detector, which records their relative positions and abundances (Figure B2.2, parts B and C).

Mass spectrometry is now employed to measure the mass of virtually any atom, molecule, or molecular fragment. The technique is being used to study catalyst surfaces, forensic materials, fuel mixtures, medicinal agents, and many other samples, especially proteins (Figure B2.2, part D); in fact, John B. Fenn and Koichi Tanaka shared part of the 2002 Nobel Prize in chemistry for developing methods to study proteins by mass spectrometry.

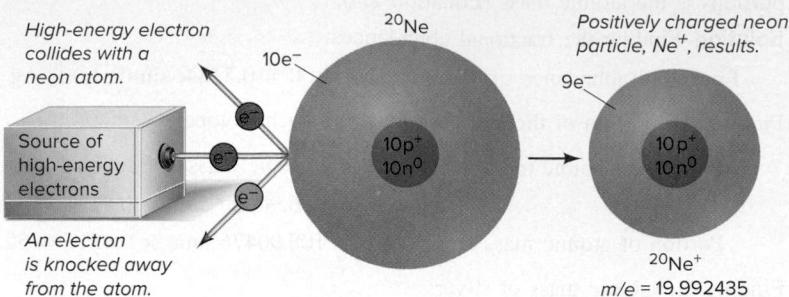

Figure B2.1 Formation of a positively charged neon particle (Ne^+).

PROBLEMS

B2.1 Chlorine has two naturally occurring isotopes, ^{35}Cl (abundance 76%) and ^{37}Cl (abundance 24%), and it occurs as diatomic (two-atom) molecules. In a mass spectrum, peaks are seen for the molecule and for the separated atoms.

- How many peaks are in the mass spectrum?
- What is the m/e value for the heaviest particle and for the lightest particle?

B2.2 When a sample of pure carbon is analyzed by mass spectrometry, peaks X, Y, and Z are obtained. Peak Y is taller than X and Z, and Z is taller than X. What is the m/e value of the isotope responsible for peak Z?

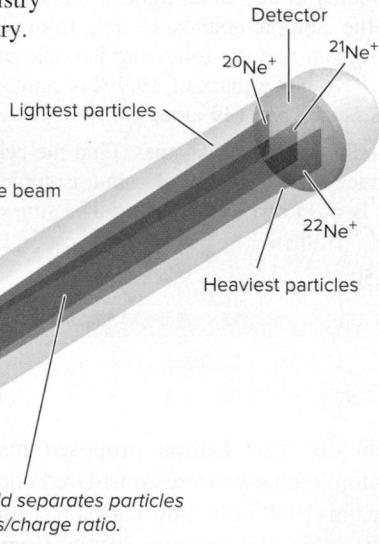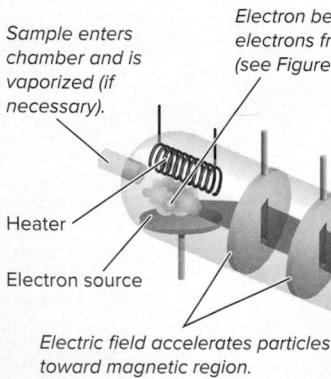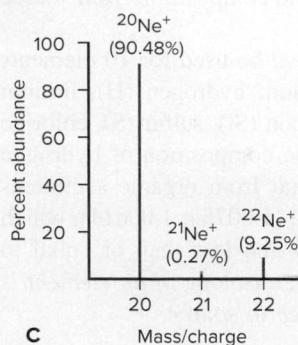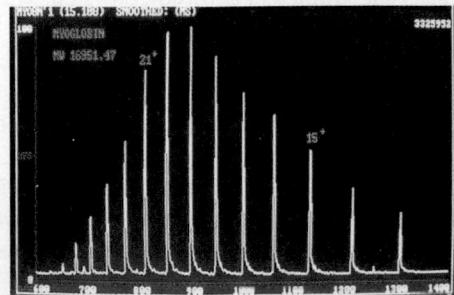

The atomic-mass interval is important for very precise work, but because this text uses four significant figures for atomic masses in calculations—for example, 1.008 amu for the atomic mass of H—the change does not affect our discussions (see the List of Elements inside the front cover). Also, such small differences in composition do not overturn the basic idea of the law of definite composition: elements occur in a fixed proportion by mass in a compound, no matter what the source (Section 2.2).

› Summary of Section 2.5

- › An atom has a central nucleus, which contains positively charged protons and uncharged neutrons and is surrounded by negatively charged electrons. An atom is neutral because the number of electrons equals the number of protons.
- › An atom is represented by the notation ${}^A_Z X$, in which Z is the atomic number (number of protons), A the mass number (sum of protons and neutrons), and X the atomic symbol.
- › An element occurs naturally as a mixture of isotopes, atoms with the same number of protons but different numbers of neutrons. Each isotope has a mass relative to the ${}^{12}\text{C}$ mass standard.
- › The atomic mass of an element is the average of its isotopic masses weighted according to their natural abundances. It is determined using a mass spectrometer.

2.6 ELEMENTS: A FIRST LOOK AT THE PERIODIC TABLE

At the end of the 18th century, Lavoisier compiled a list of the 23 elements known at that time; by 1870, 65 were known; by 1925, 88; today, there are 118! By the mid-19th century, enormous amounts of information concerning reactions, properties, and atomic masses of the elements had been accumulated. Several researchers noted recurring, or *periodic*, patterns of behavior and proposed schemes to organize the elements according to some fundamental property.

In 1871, the Russian chemist Dmitri Mendeleev (1836–1907) published the most successful of these organizing schemes as a table of the elements listed by increasing atomic mass and arranged so that elements with similar chemical properties fell in the same column. The modern **periodic table of the elements**, based on Mendeleev's version (but arranged by *atomic number*, not mass), is one of the great classifying schemes in science and an indispensable tool to chemists—and chemistry students.

Organization of the Periodic Table One common version of the modern periodic table appears inside the front cover and in Figure 2.9 (*next page*). It is formatted as follows:

1. Each element has a box that contains its atomic number, atomic symbol, and atomic mass. (A mass in parentheses is the mass number of the most stable isotope of that element.) The boxes lie, from left to right, in order of *increasing atomic number* (number of protons in the nucleus).
2. The boxes are arranged into a grid of **periods** (horizontal rows) and **groups** (vertical columns). Each period has a number from 1 to 7. Each group has a number from 1 to 8 and either the letter A or B. A newer system, with group numbers from 1 to 18 but no letters, appears in parentheses under the number-letter designations. (The text uses the number-letter system and shows the newer group number in parentheses.)
3. The eight A groups (two on the left and six on the right) contain the *main-group elements*. The ten B groups, located between Groups 2A(2) and 3A(13), contain the *transition elements*. Two horizontal series of *inner transition elements*, the lanthanides and the actinides, fit *between* the elements in Group 3B(3) and Group 4B(4) and are placed below the main body of the table.

MAIN-GROUP ELEMENTS

1A (1)	TRANSITION ELEMENTS																		8A (18)
1 H 1.008	2 A (2)	3 Li 6.941	4 Be 9.012	5 B 10.81	6 C 12.01	7 N 14.01	8 O 16.00	9 F 19.00	10 Ne 20.18										
11 Na 22.99	12 Mg 24.31	3B (3)	4B (4)	5B (5)	6B (6)	7B (7)	(8)	(9)	(10)	1B (11)	2B (12)	13 Al 26.98	14 Si 28.09	15 P 30.97	16 S 32.06	17 Cl 35.45	18 Ar 39.95		
19 K 39.10	20 Ca 40.08	21 Sc 44.96	22 Ti 47.87	23 V 50.94	24 Cr 52.00	25 Mn 54.94	26 Fe 55.85	27 Co 58.93	28 Ni 58.69	29 Cu 63.55	30 Zn 65.38	31 Ga 69.72	32 Ge 72.63	33 As 74.92	34 Se 78.96	35 Br 79.90	36 Kr 83.80		
37 Rb 85.47	38 Sr 87.62	39 Y 88.91	40 Zr 91.22	41 Nb 92.91	42 Mo 95.96	43 Tc (98)	44 Ru 101.1	45 Rh 102.9	46 Pd 106.4	47 Ag 107.9	48 Cd 112.4	49 In 114.8	50 Sn 118.7	51 Sb 121.8	52 Te 127.6	53 I 126.9	54 Xe 131.3		
55 Cs 132.9	56 Ba 137.3	57 La 138.9	72 Hf 178.5	73 Ta 180.9	74 W 183.8	75 Re 186.2	76 Os 190.2	77 Ir 192.2	78 Pt 195.1	79 Au 197.0	80 Hg 200.6	81 Tl 204.4	82 Pb 207.2	83 Bi 209.0	84 Po (209)	85 At (210)	86 Rn (222)		
87 Fr (223)	88 Ra (226)	89 Ac (227)	104 Rf (265)	105 Db (268)	106 Sg (271)	107 Bh (270)	108 Hs (277)	109 Mt (276)	110 Ds (281)	111 Rg (280)	112 Cn (285)	113 Nh (284)	114 Fl (289)	115 Mc (288)	116 Lv (293)	117 Ts (294)	118 Og (294)		

INNER TRANSITION ELEMENTS

6 Lanthanides	58 Ce 140.1	59 Pr 140.9	60 Nd 144.2	61 Pm (145)	62 Sm 150.4	63 Eu 152.0	64 Gd 157.3	65 Tb 158.9	66 Dy 162.5	67 Ho 164.9	68 Er 167.3	69 Tm 168.9	70 Yb 173.1	71 Lu 175.0
7 Actinides	90 Th 232.0	91 Pa (231)	92 U 238.0	93 Np (237)	94 Pu (244)	95 Am (243)	96 Cm (247)	97 Bk (247)	98 Cf (251)	99 Es (252)	100 Fm (257)	101 Md (258)	102 No (259)	103 Lr (262)

Figure 2.9 The modern periodic table.

Classifying the Elements One of the clearest ways to classify the elements is as metals, nonmetals, and metalloids. The “staircase” line that runs from the top of Group 3A(13) to the bottom of Group 6A(16) is a dividing line:

- The **metals** (three shades of blue in Figure 2.9) lie in the large lower-left portion of the table. About three-quarters of the elements are metals, including many main-group elements and all the transition and inner transition elements. They are generally shiny solids at room temperature (mercury is the only liquid) that conduct heat and electricity well. They can be beaten into sheets (are malleable) and wires (are ductile).
- The **nonmetals** (yellow) lie in the small upper-right portion of the table (with the exception of the nonmetal hydrogen in the upper-left corner). They are generally gases or dull, brittle solids at room temperature (bromine is the only liquid) and conduct heat and electricity poorly.
- The **metalloids** (green; also called **semimetals**), which lie along the staircase line, have properties between those of metals and nonmetals.

Figure 2.10 shows examples of these three classes of elements.

Two major points to keep in mind:

- In general, elements in a group have *similar* chemical properties, and elements in a period have *different* chemical properties.
- Despite the classification of elements into three types, in reality, there is a gradation in properties from left to right and top to bottom.

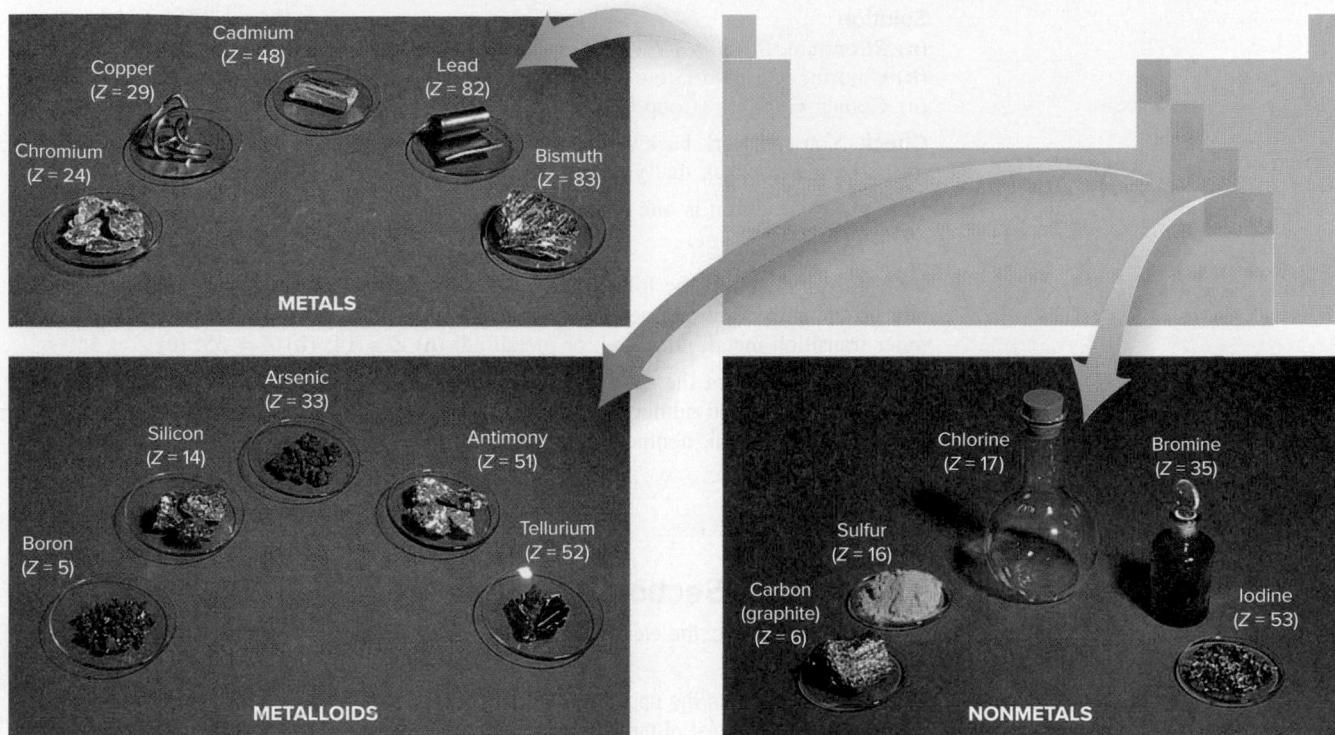

Figure 2.10 Some metals, metalloids, and nonmetals. Source: © McGraw-Hill Education/Stephen Frisch, photographer

It is important to learn some of the group (family) names:

- Group 1A(1) (except for hydrogen)—*alkali metals* (reactive metals)
- Group 2A(2)—*alkaline earth metals* (reactive metals)
- Group 7A(17)—*halogens* (reactive nonmetals)
- Group 8A(18)—*noble gases* (relatively nonreactive nonmetals)

Other main groups [3A(13) to 6A(16)] are often named for the first element in the group; for example, Group 6A(16) is the *oxygen family*.

Two of the major branches of chemistry have traditionally been defined by the elements that each studies. *Organic chemistry* studies the compounds of carbon, specifically those that contain hydrogen and often oxygen, nitrogen, and a few other elements. This branch is concerned with fuels, drugs, dyes, and the like. *Inorganic chemistry*, on the other hand, focuses on the compounds of all the other elements and is concerned with catalysts, electronic materials, metal alloys, mineral salts, and the like. With the explosive growth in biomedical and materials sciences, the line between these branches has, in practice, virtually disappeared.

SAMPLE PROBLEM 2.6

Identifying an Element from Its Z Value

Problem From each of the following Z values, give the name, symbol, and group and period numbers of the element, and classify it as a main-group metal, transition metal, inner transition metal, nonmetal, or metalloid: (a) Z = 38; (b) Z = 17; (c) Z = 27.

Plan The Z value is the atomic number of an element. The List of Elements inside the front cover is alphabetical, so we look up the name and symbol of the element. Then we use the periodic table to find the group number (top of the column) and the period number (left end of the row) in which the element is located. We classify the element from the color coding in the periodic table.

Solution

- (a) Strontium, Sr, is in Group 2A(2) and Period 5, and it is a main-group metal.
 (b) Chlorine, Cl, is in Group 7A(17) and Period 3, and it is a nonmetal.
 (c) Cobalt, Co, is in Group 8B(9) and Period 4, and it is a transition metal.

Check You can work backwards by starting at the top of the group and moving down to the period to check that you get the correct Z value.

Comment Strontium is one of the alkaline earth metals, and chlorine is a halogen.

FOLLOW-UP PROBLEMS

2.6A Identify each of the following elements from its Z value; give the name, symbol, and group and period numbers, and classify it as a main-group metal, transition metal, inner transition metal, nonmetal, or metalloid: (a) $Z = 14$; (b) $Z = 55$; (c) $Z = 54$.

2.6B Identify each of the following elements from its Z value; give the name, symbol, and group and period numbers, and classify it as a main-group metal, transition metal, inner transition metal, nonmetal, or metalloid: (a) $Z = 12$; (b) $Z = 7$; (c) $Z = 30$.

SOME SIMILAR PROBLEMS 2.56 and 2.57

› Summary of Section 2.6

- › In the periodic table, the elements are arranged by atomic number into horizontal periods and vertical groups.
- › Nonmetals appear in the upper-right portion of the table, metalloids lie along a staircase line, and metals fill the rest of the table.
- › Elements within a group have similar behavior, whereas elements within a period have dissimilar behavior.

2.7

COMPOUNDS: INTRODUCTION TO BONDING

Aside from a few exceptions, *the overwhelming majority of elements occur in nature in compounds combined with other elements*. Only a few elements occur free in nature. The noble gases—helium (He), neon (Ne), argon (Ar), krypton (Kr), xenon (Xe), and radon (Rn)—occur in air as separate atoms. In addition to occurring in compounds, oxygen (O), nitrogen (N), and sulfur (S) occur in their most common elemental form as the molecules O₂, N₂, and S₈, and carbon (C) occurs in vast, nearly pure deposits of coal. And some metals—copper (Cu), silver (Ag), gold (Au), and platinum (Pt)—are also sometimes found uncombined.

Elements combine in two general ways, and both involve *the electrons of the atoms of interacting elements*:

1. *Transferring electrons* from atoms of one element to atoms of another to form **ionic compounds**
2. *Sharing electrons* between atoms of different elements to form **covalent compounds**

These processes generate **chemical bonds**, the forces that hold the atoms together in a compound. This section introduces compound formation, which we'll discuss in much more detail in later chapters.

The Formation of Ionic Compounds

Ionic compounds are composed of **ions**, charged particles that form when an atom (or small group of atoms) gains or loses one or more electrons. The simplest type of ionic compound is a **binary ionic compound**, one composed of ions of two elements. It typically forms *when a metal reacts with a nonmetal*:

- Each metal atom *loses* one or more electrons and becomes a **cation**, a positively charged ion.
- Each nonmetal atom *gains* one or more of the electrons lost by the metal atom and becomes an **anion**, a negatively charged ion.

In effect, the metal atoms *transfer electrons* to the nonmetal atoms. The resulting large numbers of oppositely charged cations and anions attract each other by *electrostatic forces* and form the ionic compound. A cation or anion derived from a single atom is called a **monatomic ion**; we'll discuss *polyatomic ions*, those derived from a small group of atoms, later.

The Case of Sodium Chloride All binary ionic compounds are solid arrays of oppositely charged ions. The formation of the binary ionic compound sodium chloride, common table salt, from its elements is depicted in Figure 2.11. In the electron transfer, a sodium atom loses one electron and forms a sodium cation, Na^+ . (The charge on the ion is written as a right superscript. For a charge of 1+ or 1-, the 1 is not written; for charges of larger magnitude, the sign is written *after* the number: 2+.) A chlorine atom gains the electron and becomes a chloride anion, Cl^- . (The name change when the nonmetal atom becomes an anion is discussed in Section 2.8.) The oppositely charged ions (Na^+ and Cl^-) attract each other, and the similarly charged ions (Na^+ and Na^+ , or Cl^- and Cl^-) repel each other. The resulting solid aggregation is a regular array of alternating Na^+ and Cl^- ions that extends in all three dimensions. Even the tiniest visible grain of table salt contains an enormous number of sodium and chloride ions.

Coulomb's Law The strength of the ionic bonding depends to a great extent on the net strength of these attractions and repulsions and is described by *Coulomb's law*, which can be expressed as follows: *the energy of attraction (or repulsion) between two particles is directly proportional to the product of the charges and inversely proportional to the distance between them.*

$$\text{Energy} \propto \frac{\text{charge 1} \times \text{charge 2}}{\text{distance}}$$

In other words, as is summarized in Figure 2.12 (next page),

- Ions with higher charges attract (or repel) each other more strongly than do ions with lower charges.
- Smaller ions attract (or repel) each other more strongly than do larger ions, because the charges are closer to each other.

Predicting the Number of Electrons Lost or Gained Ionic compounds are neutral because they contain equal numbers of positive and negative charges. Thus, there are equal numbers of Na^+ and Cl^- ions in sodium chloride, because both ions are singly charged. But there are two Na^+ ions for each oxide ion, O^{2-} , in sodium oxide because it takes two 1+ ions to balance one 2- ion.

Can we predict the number of electrons a given atom will lose or gain when it forms an ion? For A-group elements, we usually find that metal atoms lose electrons and nonmetal atoms gain electrons to *form ions with the same number of electrons as in an atom of the nearest noble gas* [Group 8A(18)]. Noble gases have a stability that is related to their number (and arrangement) of electrons. Thus, a sodium atom ($11e^-$) can attain the stability of a neon atom ($10e^-$), the nearest noble gas, by losing one electron. Similarly, a chlorine atom ($17e^-$) attains the stability of an argon atom ($18e^-$), its nearest noble gas, by gaining one electron. Thus, in general, when an element located near a noble gas forms a monatomic ion,

- *Metals lose electrons:* elements in Group 1A(1) lose one electron, elements in Group 2A(2) lose two, and aluminum in Group 3A(13) loses three.
- *Nonmetals gain electrons:* elements in Group 7A(17) gain one electron, oxygen and sulfur in Group 6A(16) gain two, and nitrogen in Group 5A(15) gains three.

Figure 2.11 The formation of an ionic compound. **A**, The two elements as seen in the laboratory. **B**, The elements on the atomic scale. **C**, The electron transfer from Na atom to Cl atom to form Na^+ and Cl^- ions, shown schematically. **D**, Countless Na^+ and Cl^- ions attract each other and form a regular three-dimensional array. **E**, Crystalline NaCl occurs naturally as the mineral halite. Source: A(1-2), E: © McGraw-Hill Education/Stephen Frisch, photographer

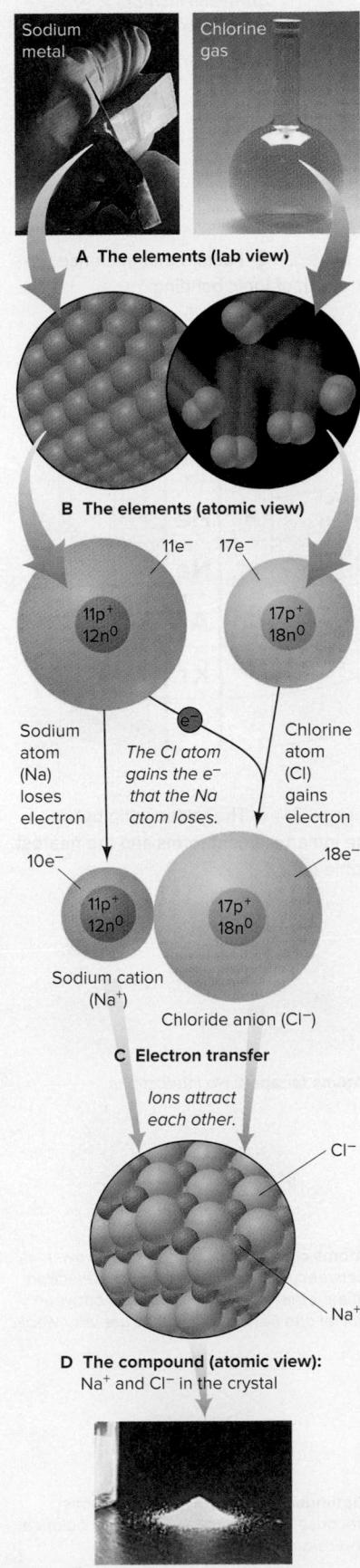

E The compound (lab view):
NaCl crystals

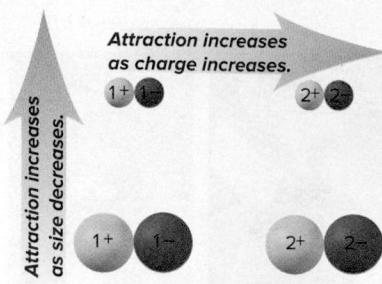

Figure 2.12 Factors that influence the strength of ionic bonding.

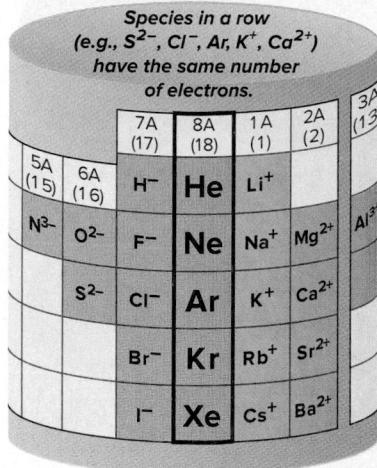

Figure 2.13 The relationship between the ion an element forms and the nearest noble gas.

Atoms far apart: No interactions.

Atoms closer: Attractions (green arrows) between nucleus of one atom and electron of the other increase. Repulsions between nuclei and between electrons are very weak.

Optimum distance: H_2 molecule forms because attractions (green arrows) balance repulsions (red arrows).

Figure 2.14 Formation of a covalent bond between two H atoms.

In the periodic table in Figure 2.9, it looks like the elements in Group 7A(17) are “closer” to the noble gases than the elements in Group 1A(1). In truth, both groups are only one electron away from having the number of electrons in the nearest noble gas. Figure 2.13 shows a periodic table of monatomic ions that has the left and right sides joined so that it forms a cylinder. Note that fluorine ($F; Z = 9$) has one electron fewer than the noble gas neon ($Ne; Z = 10$) and sodium ($Na; Z = 11$) has one electron more; thus, they form the F^- and Na^+ ions. Similarly, oxygen ($O; Z = 8$) gains two electrons and magnesium ($Mg; Z = 12$) loses two to form the O^{2-} and Mg^{2+} ions and attain the same number of electrons as neon. In Figure 2.13, species in a row have the same number of electrons.

SAMPLE PROBLEM 2.7

Predicting the Ion an Element Forms

Problem What monatomic ions would you expect the following elements to form?
 (a) Iodine ($Z = 53$) (b) Calcium ($Z = 20$) (c) Aluminum ($Z = 13$)

Plan We use the given Z value to find the element in the periodic table and see where its group lies relative to the noble gases. Elements in Groups 1A, 2A, and 3A lose electrons to attain the same number as the nearest noble gas and become positive ions; those in Groups 5A, 6A, and 7A gain electrons and become negative ions.

Solution (a) I^- Iodine ($_{53}I$) is in Group 7A(17), the halogens. Like any member of this group, it gains 1 electron to attain the same number as the nearest Group 8A(18) member, in this case, $_{54}Xe$.

(b) Ca^{2+} Calcium ($_{20}Ca$) is in Group 2A(2), the alkaline earth metals. Like any Group 2A member, it loses 2 electrons to attain the same number as the nearest noble gas, $_{18}Ar$.

(c) Al^{3+} Aluminum ($_{13}Al$) is a metal in the boron family [Group 3A(13)] and thus loses 3 electrons to attain the same number as its nearest noble gas, $_{10}Ne$.

FOLLOW-UP PROBLEMS

2.7A What monatomic ion would you expect each of the following elements to form:
 (a) $_{16}S$; (b) $_{37}Rb$; (c) $_{56}Ba$?

2.7B What monatomic ion would you expect each of the following elements to form:
 (a) $_{38}Sr$; (b) $_{8}O$; (c) $_{55}Cs$?

SOME SIMILAR PROBLEMS 2.70 and 2.71

The Formation of Covalent Substances

Covalent substances form when atoms of elements share electrons, which usually occurs between nonmetals.

Covalent Bonding in Elements and Some Simple Compounds The simplest case of electron sharing occurs not in a compound but in elemental hydrogen, between two hydrogen atoms ($H; Z = 1$). Imagine two separated H atoms approaching each other (Figure 2.14). As they get closer, the nucleus of each atom attracts the electron of the other atom more and more strongly. As the separated atoms begin to interpenetrate each other, repulsions between the nuclei and between the electrons begin to increase. At some optimum distance between the nuclei, the two atoms form a **covalent bond**, a pair of electrons mutually attracted by the two nuclei. The result is a hydrogen molecule, in which each electron no longer “belongs” to a particular H atom: the two electrons are *shared* by the two nuclei. A sample of hydrogen gas consists of these diatomic molecules (H_2)—pairs of atoms that are chemically bound, each pair behaving as a unit—not separate H atoms. Figure 2.15 shows other nonmetals that exist as molecules at room temperature.

Atoms of *different* elements share electrons to form the molecules of a covalent compound. A sample of hydrogen fluoride, for example, consists of molecules in

Figure 2.15 Elements that occur as molecules.

which one H atom forms a covalent bond with one F atom; water consists of molecules in which one O atom forms covalent bonds with two H atoms:

Distinguishing the Entities in Covalent and Ionic Substances There are two key distinctions between the chemical entities in covalent substances and those in ionic substances.

1. *Most covalent substances consist of molecules.* A cup of water, for example, consists of individual water molecules lying near each other. In contrast, under ordinary conditions, *there are no molecules in an ionic compound.* A piece of sodium chloride, for example, is a continuous array in three dimensions of oppositely charged sodium and chloride ions, *not* a collection of individual sodium chloride “molecules.”
2. *The nature of the particles attracting each other in covalent and in ionic substances is fundamentally different.* Covalent bonding involves the mutual attraction between two (positively charged) nuclei and the two (negatively charged) electrons that reside between them. Ionic bonding involves the mutual attraction between positive and negative ions.

Polyatomic Ions: Covalent Bonds Within Ions Many ionic compounds contain **polyatomic ions**, which consist of two or more atoms bonded *covalently* and have a net positive or negative charge. For example, Figure 2.16 shows that a crystalline form of calcium carbonate (*left*) occurs on the atomic scale (*center*) as an array of polyatomic carbonate anions and monatomic calcium cations. The carbonate ion (*right*) consists of a carbon atom *covalently* bonded to three oxygen atoms, and two additional electrons give the ion its 2– charge. In many reactions, the polyatomic ion stays together as a unit.

Figure 2.16 The carbonate ion in calcium carbonate.

Source: (calcium carbonate crystals)
© papa1266/Shutterstock.com

› Summary of Section 2.7

- › Although a few elements occur uncombined in nature, the great majority exist in compounds.
- › Ionic compounds form when a metal *transfers* electrons to a nonmetal, and the resulting positive and negative ions attract each other to form a three-dimensional array. In many cases, metal atoms lose and nonmetal atoms gain enough electrons to attain the same number of electrons as in atoms of the nearest noble gas.
- › Covalent compounds form when elements, usually nonmetals, *share* electrons. Each covalent bond is an electron pair mutually attracted by two atomic nuclei.
- › Monatomic ions are derived from single atoms. Polyatomic ions consist of two or more covalently bonded atoms that have a net positive or negative charge due to a deficit or excess of electrons.

2.8 COMPOUNDS: FORMULAS, NAMES, AND MASSES

In a **chemical formula**, element symbols and, often, numerical subscripts show the type and number of each atom in the smallest unit of the substance. In this section, you'll learn how to write the names and formulas of ionic and simple covalent compounds, how to calculate the mass of a compound from its formula, and how to visualize molecules with three-dimensional models. To make learning the names and formula of compounds easier, we'll rely on various rules, so be prepared for a bit of memorization and a lot of practice.

Binary Ionic Compounds

Let's begin with two general rules:

- For *all* ionic compounds, *names and formulas give the positive ion (cation) first and the negative ion (anion) second.*
- For all *binary* ionic compounds, *the name of the cation is the name of the metal, and the name of the anion has the suffix -ide added to the root of the name of the nonmetal.*

For example, the anion formed from bromine is named *bromide* (*brom+ide*). Therefore, the compound formed from the metal calcium and the nonmetal bromine is named *calcium bromide*.

In general, if the metal of a binary ionic compound is a main-group element (A groups), it usually forms a single type of ion; if it is a transition element (B groups), it often forms more than one. We discuss each case in turn.

Compounds of Elements That Form One Ion The periodic table presents some key points about the formulas of main-group monatomic ions (Figure 2.17):

- Monatomic ions of elements in the same main group have the same ionic charge; the alkali metals—Li, Na, K, Rb, Cs, and Fr—form ions with a $1+$ charge; the halogens—F, Cl, Br, and I—form ions with a $1-$ charge; and so forth.
- For cations, ion charge equals A-group number: Na is in Group 1A and forms Na^+ , Ba is in Group 2A and forms Ba^{2+} . (Exceptions in Figure 2.17 are Sn^{2+} and Pb^{2+} .)
- For anions, ion charge equals A-group number minus 8; for example, S is in Group 6A ($6 - 8 = -2$) and thus forms S^{2-} .

Try to memorize the A-group monatomic ions in Table 2.3 (all except Ag^+ , Zn^{2+} , and Cd^{2+}) according to their positions in Figure 2.17. These ions have *the same number of electrons as an atom of the nearest noble gas*.

Because an ionic compound consists of an array of ions rather than separate molecules, its formula represents the **formula unit**, which contains the *relative* numbers of cations and anions in the compound. The compound has zero net charge, so the positive charges of the cations balance the negative charges of the anions. For

	1A (1)											7A (17)	8A (18)		
Period	H ⁺	2A (2)											H ⁻		
1	Li ⁺											N ³⁻	O ²⁻	F ⁻	
2															
3	Na ⁺	Mg ²⁺	3B (3)	4B (4)	5B (5)	6B (6)	7B (7)	8B (8) (9) (10)			1B (11)	2B (12)	Al ³⁺	S ²⁻	Cl ⁻
4	K ⁺	Ca ²⁺				Cr ²⁺ Cr ³⁺	Mn ²⁺	Fe ²⁺ Fe ³⁺	Co ²⁺ Co ³⁺		Cu ⁺ Cu ²⁺	Zn ²⁺			Br ⁻
5	Rb ⁺	Sr ²⁺									Ag ⁺	Cd ²⁺	Sn ²⁺ Sn ⁴⁺	I ⁻	
6	Cs ⁺	Ba ²⁺										Hg ²⁺ Hg ²⁺	Pb ²⁺ Pb ⁴⁺		
7															

example, calcium bromide is composed of Ca²⁺ ions and Br⁻ ions, so two Br⁻ balance each Ca²⁺. The formula is CaBr₂, not Ca₂Br. In this and all other formulas,

- The subscript refers to the element symbol preceding it.
- The subscript 1 is understood from the presence of the element symbol alone (that is, we do not write Ca₁Br₂).
- The charge (without the sign) of one ion becomes the subscript of the other:

- The subscripts are reduced to the smallest whole numbers that retain the ratio of ions. Thus, for example, for the Ca²⁺ and O²⁻ ions in calcium oxide, we get Ca₂O₂, which we reduce to the formula CaO.*

The following two sample problems apply these rules. In Sample Problem 2.8, we name the compound from its elements, and in Sample Problem 2.9, we find the formula.

SAMPLE PROBLEM 2.8

Naming Binary Ionic Compounds

Problem Name the ionic compound formed from the following pairs of elements:

- Magnesium and nitrogen
- Iodine and cadmium
- Strontium and fluorine
- Sulfur and cesium

Plan The key to naming a binary ionic compound is to recognize which element is the metal and which is the nonmetal. When in doubt, check the periodic table. We place the cation name first, add the suffix *-ide* to the nonmetal root, and place the anion name second.

Solution (a) Magnesium is the metal; *nitr*- is the nonmetal root: magnesium nitride.

(b) Cadmium is the metal; *iod*- is the nonmetal root: cadmium iodide.

(c) Strontium is the metal; *fluor*- is the nonmetal root: strontium fluoride. (Note the spelling is fluoride, not flouride.)

(d) Cesium is the metal; *sulf*- is the nonmetal root: cesium sulfide.

*Compounds of the mercury(I) ion, such as Hg₂Cl₂, and peroxides of the alkali metals, such as Na₂O₂, are the only two common exceptions to this step: reducing the subscripts for these compounds would give the incorrect formulas HgCl and NaO.

Common Monatomic Ions*

Charge	Formula	Name
Cations		
1+	H ⁺	hydrogen
	Li ⁺	lithium
	Na ⁺	sodium
	K ⁺	potassium
	Cs ⁺	cesium
	Ag ⁺	silver
2+	Mg ²⁺	magnesium
	Ca ²⁺	calcium
	Sr ²⁺	strontium
	Ba ²⁺	barium
	Zn ²⁺	zinc
	Cd ²⁺	cadmium
3+	Al ³⁺	aluminum
Anions		
1-	H ⁻	hydride
	F ⁻	fluoride
	Cl ⁻	chloride
	Br ⁻	bromide
	I ⁻	iodide
2-	O ²⁻	oxide
	S ²⁻	sulfide
3-	N ³⁻	nitride

*Listed by charge; those in **boldface** are most common.

FOLLOW-UP PROBLEMS

2.8A Name the ionic compound formed from the following pairs of elements:

- (a) Zinc and oxygen
- (b) Bromine and silver
- (c) Lithium and chlorine
- (d) Sulfur and aluminum

2.8B Name the ionic compound formed from the following pairs of elements:

- (a) Potassium and sulfur
- (b) Iodine and barium
- (c) Nitrogen and cesium
- (d) Sodium and hydrogen

SOME SIMILAR PROBLEMS 2.84–2.87

SAMPLE PROBLEM 2.9**Determining Formulas of Binary Ionic Compounds**

Problem Write formulas for the compounds named in Sample Problem 2.8.

Plan We write the formula by finding the smallest number of each ion that gives the neutral compound. These numbers appear as *right subscripts* to the element symbol.

- Solution** (a) Mg²⁺ and N³⁻; three Mg²⁺ ions (6+) balance two N³⁻ ions (6-): Mg₃N₂
 (b) Cd²⁺ and I⁻; one Cd²⁺ ion (2+) balances two I⁻ ions (2-): CdI₂
 (c) Sr²⁺ and F⁻; one Sr²⁺ ion (2+) balances two F⁻ ions (2-): SrF₂
 (d) Cs⁺ and S²⁻; two Cs⁺ ions (2+) balance one S²⁻ ion (2+): Cs₂S

Comment 1. The subscript 1 is understood and so not written; thus, in (b), we do *not* write Cd₁I₂.

2. Ion charges do *not* appear in the compound formula; thus, in (c), we do *not* write Sr²⁺F₂⁻.

FOLLOW-UP PROBLEMS

2.9A Write the formula of each compound named in Follow-up Problem 2.8A.

2.9B Write the formula of each compound named in Follow-up Problem 2.8B.

SOME SIMILAR PROBLEMS 2.84–2.87

Compounds of Metals That Form More Than One Ion As noted earlier, many metals, particularly the transition elements (B groups), can form more than one ion. Table 2.4 lists some examples; see Figure 2.17 for their placement in the periodic table. Names of compounds containing these elements include a *roman numeral within parentheses* immediately after the metal ion's name to indicate its ionic charge. For example, iron can form Fe²⁺ and Fe³⁺ ions. Iron forms two compounds with chlorine: FeCl₂, named iron(II) chloride (spoken “iron two chloride”), which contains Fe²⁺; and FeCl₃, named iron(III) chloride, which contains Fe³⁺.

We are focusing here on systematic names, but some common (trivial) names are still used. In common names for certain metal ions, the Latin root of the metal is followed by either of two suffixes (see Table 2.4):

- The suffix *-ous* for the ion with the lower charge
- The suffix *-ic* for the ion with the higher charge

Thus, iron(II) chloride is also called ferrous chloride and iron(III) chloride is ferric chloride. (Memory aid: there is an *o* in *-ous* and *lower*, and an *i* in *-ic* and *higher*.)

Table 2.4**Some Metals That Form More Than One Monatomic Ion***

Element	Ion Formula	Systematic Name	Common (Trivial) Name
Chromium	Cr^{2+}	chromium(II)	chromous
	Cr^{3+}	chromium(III)	chromic
Cobalt	Co^{2+}	cobalt(II)	
	Co^{3+}	cobalt(III)	
Copper	Cu^+	copper(I)	cuprous
	Cu^{2+}	copper(II)	cupric
Iron	Fe^{2+}	iron(II)	ferrous
	Fe^{3+}	iron(III)	ferric
Lead	Pb^{2+}	lead(II)	
	Pb^{4+}	lead(IV)	
Mercury	Hg_2^{2+}	mercury(I)	mercurous
	Hg^{2+}	mercury(II)	mercuric
Tin	Sn^{2+}	tin(II)	stannous
	Sn^{4+}	tin(IV)	stannic

*Listed alphabetically by metal name; the ions in **boldface** are most common.

SAMPLE PROBLEM 2.10**Determining Names and Formulas of Ionic Compounds of Metals That Form More Than One Ion**

Problem Give the systematic name for the formula or the formula for the name:

- (a) Tin(II) fluoride (b) CrI_3 (c) Ferric oxide (d) CoS

Solution (a) Tin(II) ion is Sn^{2+} ; fluoride is F^- . Two F^- ions balance one Sn^{2+} ion: tin(II) fluoride is SnF_2 . (The common name is stannous fluoride.)

(b) The anion is I^- , iodide, and the formula shows three I^- . Therefore, the cation must be Cr^{3+} , chromium(III) ion: CrI_3 is **chromium(III) iodide**. (The common name is chromic iodide.)

(c) **Ferric** is the common name for iron(III) ion, Fe^{3+} ; oxide ion is O^{2-} . To balance the charges, the formula is Fe_2O_3 . [The systematic name is iron(III) oxide.]

(d) The anion is sulfide, S^{2-} , which requires that the cation be Co^{2+} . The name is **cobalt(II) sulfide**.

FOLLOW-UP PROBLEMS

2.10A Give the systematic name for the formula or the formula for the name:

- (a) lead(IV) oxide (a component of car batteries); (b) Cu_2S ; (c) FeBr_2 ; (d) mercuric chloride

2.10B Give the systematic name for the formula or the formula for the name:

- (a) copper(II) nitride; (b) PbI_2 ; (c) chromic sulfide; (d) FeO

SOME SIMILAR PROBLEMS 2.88 and 2.89

Student Hot Spot

Student data indicate you may struggle with formulas of ionic compounds that include Roman numerals. Access the Smartbook to view additional Learning Resources on this topic.

Compounds That Contain Polyatomic Ions

Many ionic compounds contain polyatomic ions. Table 2.5 on the next page lists some common polyatomic ions. Remember that *the polyatomic ion stays together as a charged unit*. The formula for potassium nitrate is KNO_3 ; each K^+ balances one NO_3^- . The formula for sodium carbonate is Na_2CO_3 ; two Na^+ balance one CO_3^{2-} . *When two or more of the same polyatomic ion are present in the formula unit, that ion appears in parentheses with the subscript written outside.* For example, calcium nitrate contains

Table 2.5 Common Polyatomic Ions*

Formula	Name
Cations	
NH_4^+	ammonium
H_3O^+	hydronium
Anions	
CH_3COO^- (or $\text{C}_2\text{H}_3\text{O}_2^-$)	acetate
CN^-	cyanide
OH^-	hydroxide
ClO^-	hypochlorite
ClO_2^-	chlorite
ClO_3^-	chlorate
ClO_4^-	perchlorate
NO_2^-	nitrite
NO_3^-	nitrate
MnO_4^-	permanganate
CO_3^{2-}	carbonate
HCO_3^-	hydrogen carbonate (or bicarbonate)
CrO_4^{2-}	chromate
$\text{Cr}_2\text{O}_7^{2-}$	dichromate
O_2^-	peroxide
PO_4^{3-}	phosphate
HPO_4^{2-}	hydrogen phosphate
H_2PO_4^-	dihydrogen phosphate
SO_3^{2-}	sulfite
SO_4^{2-}	sulfate
HSO_4^-	hydrogen sulfate (or bisulfate)

*Boldface ions are the most common.

one Ca^{2+} and two NO_3^- ions and has the formula $\text{Ca}(\text{NO}_3)_2$. Parentheses and a subscript are *only* used if *more than one* of a given polyatomic ion is present; thus, sodium nitrate is NaNO_3 , not $\text{Na}(\text{NO}_3)$.

Families of Oxoanions As Table 2.5 shows, most polyatomic ions are **oxoanions** (or *oxyanions*), those in which an element, usually a nonmetal, is bonded to one or more oxygen atoms. There are several families of two or four oxoanions that differ only in the number of oxygen atoms. The following naming conventions are used with these ions.

With two oxoanions in the family:

- The ion with *more* O atoms takes the nonmetal root and the suffix *-ate*.
- The ion with *fewer* O atoms takes the nonmetal root and the suffix *-ite*.

For example, SO_4^{2-} is the sulfate ion, and SO_3^{2-} is the sulfite ion; similarly, NO_3^- is nitrate, and NO_2^- is nitrite.

With four oxoanions in the family (a halogen bonded to O) (Figure 2.18):

- The ion with the *most* O atoms has the prefix *per-*, the nonmetal root, and the suffix *-ate*.
- The ion with *one fewer* O atom has just the root and the suffix *-ate*.
- The ion with *two fewer* O atoms has just the root and the suffix *-ite*.
- The ion with the *least (three fewer)* O atoms has the prefix *hypo-*, the root, and the suffix *-ite*.

For example, for the four chlorine oxoanions,

ClO_4^- is perchlorate, ClO_3^- is chlorate, ClO_2^- is chlorite, ClO^- is hypochlorite

Hydrated Ionic Compounds Ionic compounds called **hydrates** have a specific number of water molecules in each formula unit. The water molecules are shown after a centered dot in the formula and named with a Greek numerical prefix before the word *hydrate* (Table 2.6). To give just two examples,

Epsom salt: $\text{MgSO}_4 \cdot 7\text{H}_2\text{O}$ magnesium sulfate *heptahydrate*
(seven water molecules in each formula unit)

Washing soda: $\text{Na}_2\text{CO}_3 \cdot 10\text{H}_2\text{O}$ sodium carbonate *decahydrate*
(ten water molecules in each formula unit)

The water molecules, referred to as “waters of hydration,” are part of the hydrate’s structure. Heating can remove some or all of them, leading to a different substance. For example, when heated strongly, blue copper(II) sulfate pentahydrate ($\text{CuSO}_4 \cdot 5\text{H}_2\text{O}$) is converted to white copper(II) sulfate (CuSO_4).

No. of O atoms ↑	Prefix	Root	Suffix
	per	root	ate
		root	ate
		root	ite
	hypo	root	ite

Figure 2.18 Naming oxoanions. Prefixes and suffixes indicate the number of O atoms in the anion.

Copper(II) sulfate pentahydrate

Copper(II) sulfate

Source: © McGraw-Hill Education/Charles Winters/Timeframe Photography, Inc.

SAMPLE PROBLEM 2.11**Determining Names and Formulas of Ionic Compounds Containing Polyatomic Ions (Including Hydrates)**

Problem Give the systematic name for the formula or the formula for the name:

- (a) $\text{Fe}(\text{ClO}_4)_2$ (b) Sodium sulfite (c) $\text{Ba}(\text{OH})_2 \cdot 8\text{H}_2\text{O}$

Solution (a) ClO_4^- is perchlorate, which has a $1-$ charge, so the cation must be Fe^{2+} .

The name is iron(II) perchlorate. (The common name is ferrous perchlorate.)

(b) Sodium is Na^+ ; sulfite is SO_3^{2-} , and two Na^+ ions balance one SO_3^{2-} ion. The formula is Na_2SO_3 .

(c) Ba^{2+} is barium; OH^- is hydroxide. There are eight (*octa*-) water molecules in each formula unit. The name is barium hydroxide octahydrate.

FOLLOW-UP PROBLEMS

2.11A Give the systematic name for the formula or the formula for the name:

- (a) cupric nitrate trihydrate; (b) zinc hydroxide; (c) LiCN .

2.11B Give the systematic name for the formula or the formula for the name:

- (a) ammonium sulfate; (b) $\text{Ni}(\text{NO}_3)_2 \cdot 6\text{H}_2\text{O}$; (c) potassium bicarbonate.

SOME SIMILAR PROBLEMS 2.90 and 2.91**Numerical Prefixes for Hydrates and Binary Covalent Compounds*****Table 2.6**

Number	Prefix
1	mono-
2	di-
3	tri-
4	tetra-
5	penta-
6	hexa-
7	hepta-
8	octa-
9	nona-
10	deca-

*It is common practice to drop the final *a* from the prefix when naming binary covalent oxides (see the Comment in Sample Problem 2.14).

SAMPLE PROBLEM 2.12**Recognizing Incorrect Names and Formulas of Ionic Compounds**

Problem Explain what is wrong with the name or formula at the end of each statement, and correct it:

- (a) $\text{Ba}(\text{C}_2\text{H}_3\text{O}_2)_2$ is called barium diacetate.
 (b) Sodium sulfide has the formula $(\text{Na})_2\text{SO}_3$.
 (c) Iron(II) sulfate has the formula $\text{Fe}_2(\text{SO}_4)_3$.
 (d) Cesium carbonate has the formula $\text{Cs}_2(\text{CO}_3)$.

Solution (a) The charge of the Ba^{2+} ion *must* be balanced by *two* $\text{C}_2\text{H}_3\text{O}_2^-$ ions, so the prefix *di*- is unnecessary. For ionic compounds, we do not indicate the number of ions with numerical prefixes. The correct name is barium acetate.

(b) Two mistakes occur here. The sodium ion is monatomic, so it does *not* require parentheses. The sulfide ion is S^{2-} , not SO_3^{2-} (which is sulfite). The correct formula is Na_2S .

(c) The roman numeral refers to the charge of the ion, *not* the number of ions in the formula. Fe^{2+} is the cation, so it requires one SO_4^{2-} to balance its charge. The correct formula is FeSO_4 . [$\text{Fe}_2(\text{SO}_4)_3$ is the formula for iron(III) sulfate.]

(d) Parentheses are *not* required when only one polyatomic ion of a particular kind is present. The correct formula is Cs_2CO_3 .

FOLLOW-UP PROBLEMS

2.12A State why the formula or name at the end of each statement is incorrect, and correct it:

- (a) Ammonium phosphate is $(\text{NH}_3)_4\text{PO}_4$.
 (b) Aluminum hydroxide is AlOH_3 .
 (c) $\text{Mg}(\text{HCO}_3)_2$ is manganese(II) carbonate.

2.12B State why the formula or name at the end of each statement is incorrect, and correct it:

- (a) $\text{Cr}(\text{NO}_3)_3$ is chromic(III) nitride.
 (b) $\text{Ca}(\text{NO}_2)_2$ is cadmium nitrate.
 (c) Potassium chlorate is $\text{P}(\text{ClO}_4)$.

SOME SIMILAR PROBLEMS 2.92 and 2.93**Student Hot Spot**

Student data indicate that you may struggle with writing formulas of ionic compounds containing polyatomic ions. Access the Smartbook to view additional Learning Resources on this topic.

Acid Names from Anion Names

Acids are an important group of hydrogen-containing compounds that have been used in chemical reactions since before alchemical times. In the laboratory, acids are typically used in water solution. When naming them and writing their formulas, we consider acids as anions that have one or more hydrogen ions (H^+) added to them to give a neutral compound. The two common types of acids are binary acids and oxoacids:

1. *Binary acid* solutions form when certain gaseous compounds dissolve in water. For example, when gaseous hydrogen chloride (HCl) dissolves in water, it forms hydrochloric acid, which is named as follows:

Prefix *hydro-* + nonmetal *root* + suffix *-ic* + separate word *acid*
 hydro + chlor + ic + acid

or *hydrochloric acid*. This naming pattern holds for many compounds in which hydrogen combines with an anion that has an *-ide* suffix.

2. *Oxoacid* names are similar to those of the oxoanions, except for two suffix changes:

- *-ate* in the anion becomes *-ic* in the acid
- *-ite* in the anion becomes *-ous* in the acid

Thus, following this pattern:

Oxyanion root + suffix *-ic* or *-ous* + separate word *acid*

IO_2^- is iodite, and HIO_2 is iodous acid.

NO_3^- is nitrite, and HNO_3 is nitric acid.

The oxoanion prefixes *hypo-* and *per-* are retained:

BrO_4^- is perbromate, and $HBrO_4$ is perbromic acid.

Note that the prefix *hydro-* is *not* used when naming oxoacids.

SAMPLE PROBLEM 2.13

Determining Names and Formulas of Anions and Acids

Problem Name each of the following anions, and give the name and formula of the acid derived from it: (a) Br^- ; (b) IO_3^- ; (c) CN^- ; (d) HSO_4^- .

Solution (a) The anion is bromide; the acid is hydrobromic acid, HBr.

(b) The anion is iodate; the acid is iodic acid, HIO_3 .

(c) The anion is cyanide; the acid is hydrocyanic acid, HCN.

(d) The anion is hydrogen sulfate; the acid is sulfuric acid, H_2SO_4 . (In this case, the suffix is added to the element name *sulfur*, not to the root, *sulf-*.)

FOLLOW-UP PROBLEMS

2.13A Write the formula and name for the anion of each acid: (a) chloric acid; (b) hydrofluoric acid; (c) acetic acid; (d) nitrous acid.

2.13B Name each of the following acids, and give the name and formula of its anion:

(a) H_2SO_3 (two anions); (b) $HBrO$; (c) $HClO_2$; (d) HI.

SOME SIMILAR PROBLEMS 2.94 and 2.95

Binary Covalent Compounds

Binary covalent compounds are typically formed by the combination of two nonmetals. Some are so familiar that we use their common names, such as ammonia (NH_3), methane (CH_4), and water (H_2O), but most are named systematically:

- The element with the lower group number in the periodic table comes first in the name. The element with the higher group number comes second and is named with its root and the suffix *-ide*. For example, nitrogen [Group 5A(15)] and fluorine

[Group 7A(17)] form a compound that has three fluorine atoms for every nitrogen atom. The name and formula are nitrogen trifluoride, NF_3 . (*Exception:* When the compound contains oxygen and any of the halogens chlorine, bromine, or iodine, the halogen is named first.)

- If both elements are in the same group, the one with the higher period number is named first. Thus, one compound that the Group 6A(16) elements sulfur (Period 3) and oxygen (Period 2) form is sulfur dioxide, SO_2 .
- Covalent compounds use Greek numerical prefixes (see Table 2.6) to indicate the number of atoms of each element. The first element in the name has a prefix *only* when more than one atom of it is present; the second element *usually* has a prefix.

SAMPLE PROBLEM 2.14**Determining Names and Formulas of Binary Covalent Compounds**

- Problem** (a) What is the formula of carbon disulfide?
 (b) What is the name of PCl_5 ?
 (c) Give the name and formula of the compound whose molecules each consist of two N atoms and four O atoms.

- Solution** (a) The prefix *di-* means “two.” The formula is CS_2 .
 (b) P is the symbol for phosphorus; there are five chlorine atoms, which is indicated by the prefix *penta-*. The name is phosphorus pentachloride.
 (c) Nitrogen (N) comes first in the name (lower group number). The compound is dinitrogen tetroxide, N_2O_4 .

Comment Note that, as the first elements in the name, carbon in (a) and phosphorus in (b) do not have the prefix *mono-*. In (c), the *a* at the end of the Greek prefix is dropped when the prefix is added to *-oxide*. Similarly, “hexa-oxide” becomes *hexoxide*, “deca-oxide” becomes *decoxide*, and so forth.

FOLLOW-UP PROBLEMS

- 2.14A** Give the name or formula for (a) SO_3 ; (b) SiO_2 ; (c) dinitrogen monoxide;
 (d) selenium hexafluoride.
- 2.14B** Give the name or formula for (a) SCl_2 ; (b) N_2O_5 ; (c) boron trifluoride;
 (d) iodine tribromide.

SOME SIMILAR PROBLEMS 2.98 and 2.99**SAMPLE PROBLEM 2.15****Recognizing Incorrect Names and Formulas of Binary Covalent Compounds**

Problem Explain what is wrong with the name or formula at the end of each statement, and correct it:

- (a) SF_4 is monosulfur pentafluoride.
 (b) Dichlorine heptoxide is Cl_2O_6 .
 (c) N_2O_3 is dinitrotioxide.

Solution (a) There are two mistakes. *Mono-* is not needed if there is only one atom of the first element, and the prefix for four is *tetra-*, not *penta-*. The correct name is sulfur tetrafluoride.

- (b) The prefix *hepta-* indicates seven, not six. The correct formula is Cl_2O_7 .
 (c) The full name of the first element is needed, and a space separates the two element names. The correct name is dinitrogen trioxide.

FOLLOW-UP PROBLEMS

- 2.15A** Explain what is wrong with the name or formula at the end of each statement, and correct it:
 (a) S_2Cl_2 is disulfurous dichloride.
 (b) Nitrogen monoxide is N_2O .
 (c) BrCl_3 is trichlorine bromide.

2.15B Explain what is wrong with the name or formula at the end of each statement, and correct it:

- (a) P_4O_6 is tetraphosphorous hexaoxide.
- (b) SF_6 is hexafluorosulfide.
- (c) Nitrogen tribromide is NiBR_3 .

SOME SIMILAR PROBLEMS 2.100 and 2.101

Table 2.7

The First 10
Straight-Chain
Alkanes

Name (Formula)	Model
Methane (CH_4)	
Ethane (C_2H_6)	
Propane (C_3H_8)	
Butane (C_4H_{10})	
Pentane (C_5H_{12})	
Hexane (C_6H_{14})	
Heptane (C_7H_{16})	
Octane (C_8H_{18})	
Nonane (C_9H_{20})	
Decane ($\text{C}_{10}\text{H}_{22}$)	

The Simplest Organic Compounds: Straight-Chain Alkanes

Organic compounds typically have complex structures that consist of chains, branches, and/or rings of carbon atoms that are also bonded to hydrogen atoms and, often, to atoms of oxygen, nitrogen, and a few other elements. At this point, we'll name just the simplest organic compounds. Rules for naming other organic compounds are provided in Chapter 15.

Hydrocarbons, the simplest type of organic compound, contain *only* carbon and hydrogen. *Alkanes* are the simplest type of hydrocarbon; many function as important fuels, such as methane, propane, butane, and the mixture that makes up gasoline. The simplest alkanes to name are the *straight-chain alkanes* because the carbon chains have no branches. Alkanes are named with a *root*, based on the number of C atoms in the chain, followed by the suffix *-ane*.

Table 2.7 gives names, molecular formulas, and space-filling models (discussed shortly) for the first 10 straight-chain alkanes. Note that the roots of the four smallest alkanes are new, but those for the larger ones are the same as the Greek prefixes shown in Table 2.6 (with the final *-a* dropped).

Molecular Masses from Chemical Formulas

In Section 2.5, we calculated the atomic mass of an element. Using the periodic table and the formula of a compound, we calculate the **molecular mass** (also called the *molecular weight*) of a molecule or formula unit of the compound as the sum of the atomic masses:

$$\text{Molecular mass} = \text{sum of atomic masses}$$

(2.4)

The molecular mass of a water molecule (using atomic masses to four significant figures from the periodic table) is

$$\begin{aligned}\text{Molecular mass of } \text{H}_2\text{O} &= (2 \times \text{atomic mass of H}) + (1 \times \text{atomic mass of O}) \\ &= (2 \times 1.008 \text{ amu}) + 16.00 \text{ amu} = 18.02 \text{ amu}\end{aligned}$$

Ionic compounds don't consist of molecules, so the mass of a formula unit is sometimes called the **formula mass** instead of *molecular mass*. For example, for calcium chloride, we have

$$\begin{aligned}\text{Formula mass of } \text{CaCl}_2 &= (1 \times \text{atomic mass of Ca}) + (2 \times \text{atomic mass of Cl}) \\ &= 40.08 \text{ amu} + (2 \times 35.45 \text{ amu}) = 110.98 \text{ amu}\end{aligned}$$

We can use atomic masses, not ionic masses, because electron loss equals electron gain, so electron mass is balanced.

To calculate the formula mass of a compound with a polyatomic ion, *the number of atoms of each element inside the parentheses is multiplied by the subscript outside the parentheses*. For barium nitrate, $\text{Ba}(\text{NO}_3)_2$,

$$\text{Formula mass of } \text{Ba}(\text{NO}_3)_2$$

$$\begin{aligned}&= (1 \times \text{atomic mass of Ba}) + (2 \times \text{atomic mass of N}) + (6 \times \text{atomic mass of O}) \\ &= 137.3 \text{ amu} + (2 \times 14.01 \text{ amu}) + (6 \times 16.00 \text{ amu}) = 261.3 \text{ amu}\end{aligned}$$

In the next two sample problems, the name or molecular depiction is used to find a compound's molecular or formula mass.

SAMPLE PROBLEM 2.16**Calculating the Molecular Mass of a Compound**

Problem Using the periodic table, calculate the molecular (or formula) mass of

- Tetraphosphorus trisulfide
- Ammonium nitrate

Plan We first write the formula, then multiply the number of atoms (or ions) of each element by its atomic mass (from the periodic table), and find the sum.

Solution

- (a) The formula is P_4S_3 .

$$\begin{aligned}\text{Molecular mass} &= (4 \times \text{atomic mass of P}) + (3 \times \text{atomic mass of S}) \\ &= (4 \times 30.97 \text{ amu}) + (3 \times 32.06 \text{ amu}) \\ &= 220.06 \text{ amu}\end{aligned}$$

- (b) The formula is NH_4NO_3 . We count the total number of N atoms even though they belong to different ions:

Formula mass

$$\begin{aligned}&= (2 \times \text{atomic mass of N}) + (4 \times \text{atomic mass of H}) + (3 \times \text{atomic mass of O}) \\ &= (2 \times 14.01 \text{ amu}) + (4 \times 1.008 \text{ amu}) + (3 \times 16.00 \text{ amu}) \\ &= 80.05 \text{ amu}\end{aligned}$$

Check You can often find large errors by rounding atomic masses to the nearest 5 and adding: (a) $(4 \times 30) + (3 \times 30) = 210 \approx 220.06$. The sum has two decimal places because the atomic masses have two. (b) $(2 \times 15) + 4 + (3 \times 15) = 79 \approx 80.05$.

FOLLOW-UP PROBLEMS

2.16A What is the molecular (or formula) mass of each of the following?

- Hydrogen peroxide
- Cesium carbonate

2.16B What is the molecular (or formula) mass of each of the following?

- Sulfuric acid
- Potassium sulfate

SOME SIMILAR PROBLEMS 2.104 and 2.105

SAMPLE PROBLEM 2.17**Using Molecular Depictions to Determine Formula, Name, and Mass**

Problem Each scene represents a binary compound. Determine its formula, name, and molecular (or formula) mass.

- sodium
- fluorine
- nitrogen

Plan Each of the compounds contains only two elements, so to find the formula, we find the simplest whole-number ratio of one atom to the other. From the formula, we determine the name and the molecular (or formula) mass.

Solution (a) There is one brown sphere (sodium) for each yellow sphere (fluorine), so the formula is NaF. A metal and nonmetal form an ionic compound, in which the metal is named first: sodium fluoride.

$$\begin{aligned}\text{Formula mass} &= (1 \times \text{atomic mass of Na}) + (1 \times \text{atomic mass of F}) \\ &= 22.99 \text{ amu} + 19.00 \text{ amu} = 41.99 \text{ amu}\end{aligned}$$

(b) There are three yellow spheres (fluorine) for each blue sphere (nitrogen), so the formula is NF₃. Two nonmetals form a covalent compound. Nitrogen has a lower group number, so it is named first: nitrogen trifluoride.

$$\begin{aligned}\text{Molecular mass} &= (1 \times \text{atomic mass of N}) + (3 \times \text{atomic mass of F}) \\ &= 14.01 \text{ amu} + (3 \times 19.00 \text{ amu}) = 71.01 \text{ amu}\end{aligned}$$

Check (a) For binary ionic compounds, we predict ionic charges from the periodic table (see Figure 2.13). Na forms a 1+ ion, and F forms a 1– ion, so the charges balance with one Na⁺ per F[–]. Also, ionic compounds are solids, consistent with the picture. **(b)** Covalent compounds often occur as individual molecules, as in the picture. Rounding in (a) gives 25 + 20 = 45; in (b), we get 15 + (3 × 20) = 75, so there are no large errors.

FOLLOW-UP PROBLEMS

2.17A Determine the name, formula, and molecular (or formula) mass of the compound in each scene below:

2.17B Determine the name, formula, and molecular (or formula) mass of the compound in each scene below:

SOME SIMILAR PROBLEMS 2.108 and 2.109

Representing Molecules with Formulas and Models

In order to represent objects too small to see, chemists employ a variety of formulas and models. Each conveys different information, as shown for water:

- A *molecular formula* uses element symbols and, often, numerical subscripts to give the *actual* number of atoms of each element in a molecule of the compound. (Recall that, for ionic compounds, the *formula unit* gives the *relative* number of

each type of ion.) The molecular formula of water is H_2O : there are two H atoms and one O atom in each molecule.

- A *structural formula* shows the relative placement and connections of atoms in the molecule. It uses symbols for the atoms and either a pair of dots (*electron-dot formula*, left) or a line (*bond-line formula*, right) to show the bonds between the atoms. In water, each H atom is bonded to the O atom, but not to the other H atom.

In models shown throughout this text, colored balls represent atoms.

- A *ball-and-stick model* shows atoms as balls and bonds as sticks, and the angles between the bonds are accurate. Note that water is a bent molecule (with a bond angle of 104.5°). This type of model doesn't show the bonded atoms overlapping (see Figure 2.14) or their accurate sizes, so it exaggerates the distance between them.

- A *space-filling model* is an accurately scaled-up image of the molecule, so it shows the relative sizes of the atoms, the relative distances between the nuclei (centers of the spheres), and the angles between the bonds. However, bonds are not shown, and it can be difficult to see each atom in a complex molecule.

Every molecule is minute, but the range of molecular sizes, and thus molecular masses, is enormous. Table 2.8 on the next page shows the two types of formulas and models for some diatomic and small polyatomic molecules, as well as space-filling models of portions of two extremely large molecules, called *macromolecules*, deoxyribonucleic acid (DNA) and nylon.

	Hydrogen, H		Phosphorus, P
	Carbon, C		Sulfur, S
	Nitrogen, N		Chlorine, Cl
	Oxygen, O		Group 8A(18), e.g., neon, Ne
	Group 1A(1), e.g., lithium, Li		

› Summary of Section 2.8

- An ionic compound is named with cation first and anion second: metal name nonmetal root + *-ide*. For metals that can form more than one ion, the charge is shown with a roman numeral: metal name(charge) nonmetal root + *-ide*.
- Oxoanions have suffixes, and sometimes prefixes, attached to the root of the element name to indicate the number of oxygen atoms.
- Names of hydrates have a numerical prefix indicating the number of associated water molecules.
- Acid names are based on anion names.
- For binary covalent compounds, the first word of the name is the element farther left or lower down in the periodic table, and prefixes show the numbers of each atom.
- The molecular (or formula) mass of a compound is the sum of the atomic masses.
- Chemical formulas give the number of atoms (molecular) or the arrangement of atoms (structural) of one unit of a compound.
- Molecular models convey information about bond angles (ball-and-stick) and relative atomic sizes and distances between atoms (space-filling).

Table 2.8 Representing Molecules

Name	Molecular Formula (Molecular Mass, in amu)	Bond-Line Formula	Ball-and-Stick Model	Space-Filling Model
Carbon monoxide	CO (28.01)	C≡O		
Nitrogen dioxide	NO ₂ (46.01)	O=N=O		
Butane	C ₄ H ₁₀ (58.12)	 H H H H H—C—C—C—C—H H H H H		
Aspirin (acetylsalicylic acid)	C ₉ H ₈ O ₄ (180.15)			
Deoxyribonucleic acid (DNA) (~10,000,000 amu)				
Nylon-66 (~15,000 amu)				

2.9 MIXTURES: CLASSIFICATION AND SEPARATION

In the natural world, *matter usually occurs as mixtures*. A sample of clean air, for example, consists of many elements and compounds physically mixed together, including O₂, N₂, CO₂, the noble gases [Group 8A(18)], and water vapor (H₂O). The oceans are complex mixtures of dissolved ions and covalent substances, including Na⁺, Mg²⁺, Cl⁻, SO₄²⁻, O₂, CO₂, and of course H₂O. Rocks and soils are mixtures of numerous compounds, including calcium carbonate (CaCO₃), silicon dioxide (SiO₂), aluminum oxide (Al₂O₃), and iron(III) oxide (Fe₂O₃). And living things contain thousands of substances—carbohydrates, lipids, proteins, nucleic acids, and many simpler ionic and covalent compounds.

There are two broad classes of mixtures:

- A **heterogeneous mixture** has one or more visible boundaries among the components. Thus, its composition is *not* uniform, but rather varies from one region of the mixture to another. Many rocks are heterogeneous, having individual grains of different minerals. In some heterogeneous mixtures, such as milk and blood, the boundaries can be seen only with a microscope.
- A **homogeneous mixture** (or **solution**) has no visible boundaries because the components are individual atoms, ions, or molecules. Thus, its composition *is* uniform. A mixture of sugar dissolved in water is homogeneous, for example, because the sugar molecules and water molecules are uniformly intermingled on the molecular level. We have no way to tell visually whether a sample of matter is a substance (element or compound) or a homogeneous mixture.

Although we usually think of solutions as liquid, they exist in all three physical states. For example, air is a gaseous solution of mostly oxygen and nitrogen molecules, and wax is a solid solution of several fatty substances. Solutions in water, called **aqueous solutions**, are especially important in chemistry and comprise a major portion of the environment and of all organisms.

Recall that mixtures differ from compounds in three major ways:

1. The proportions of the components of a mixture can vary.
2. The individual properties of the components in a mixture are observable.
3. The components of a mixture can be separated by physical means.

The difference between a mixture and a compound is well illustrated using iron and sulfur as components (Figure 2.19). Any proportions of iron metal filings and powdered sulfur form a mixture. The components can be separated with a magnet because iron metal is magnetic. But if we heat the container strongly, the components will form the compound iron(II) sulfide (FeS). The magnet can then no longer remove the iron because it exists as Fe²⁺ ions chemically bound to S²⁻ ions.

Chemists have devised many procedures for separating a mixture into its components, and the Tools of the Laboratory essay at the end of this section describes some common ones.

An Overview of the Components of Matter

Understanding matter at the observable and atomic scales is the essence of chemistry. Figure 2.20 on the next page is a visual overview of many key terms and ideas in this chapter.

› Summary of Section 2.9

- › Heterogeneous mixtures have visible boundaries among the components.
- › Homogeneous mixtures (solutions) have no visible boundaries because mixing occurs at the molecular level. They can occur in any physical state.
- › Components of mixtures (unlike those of compounds) can have variable proportions, can be separated physically, and retain their properties.
- › Separation methods are based on differences in physical properties and include filtration (particle size), crystallization (solubility), distillation (volatility), and chromatography (solubility).

Figure 2.19 The distinction between mixtures and compounds. **A**, A mixture of iron and sulfur consists of the two elements. **B**, The compound iron(II) sulfide consists of an array of Fe²⁺ and S²⁻ ions.
Source: © McGraw-Hill Education/Stephen Frisch, photographer

Figure 2.20 The classification of matter from a chemical point of view.

Some of the most challenging laboratory procedures involve separating mixtures and purifying the components. All of the techniques described here depend on the *physical properties* of the substances in the mixture; no chemical changes occur.

Filtration is based on *differences in particle size* and is often used to separate a solid from a liquid, which flows through the tiny holes in filter paper as the solid is retained. In vacuum filtration, reduced pressure below the filter speeds the flow of the liquid through it. Filtration is used in the purification of tap water.

Crystallization is based on *differences in solubility*. The *solubility* of a substance is the amount that dissolves in a fixed volume of solvent at a given temperature. Since solubility often increases with temperature, the impure solid is dissolved in hot solvent and when the solution cools, the purified compound solidifies (crystallizes). A key component of computer chips is purified by a type of crystallization.

Distillation separates components through *differences in volatility*, the tendency of a substance to become a gas. *Simple distillation* separates components with *large* differences in volatility, such as water from dissolved ionic compounds (Figure B2.3). As the mixture boils, the vapor is richer in the more volatile component, in this case, water, which is condensed and collected separately. *Fractional distillation* (discussed in Chapter 13) uses many vaporization-condensation steps to separate components with small volatility differences, such as those in petroleum.

Chromatography is also based on *differences in solubility*. The mixture is dissolved in a gas or liquid, and the components

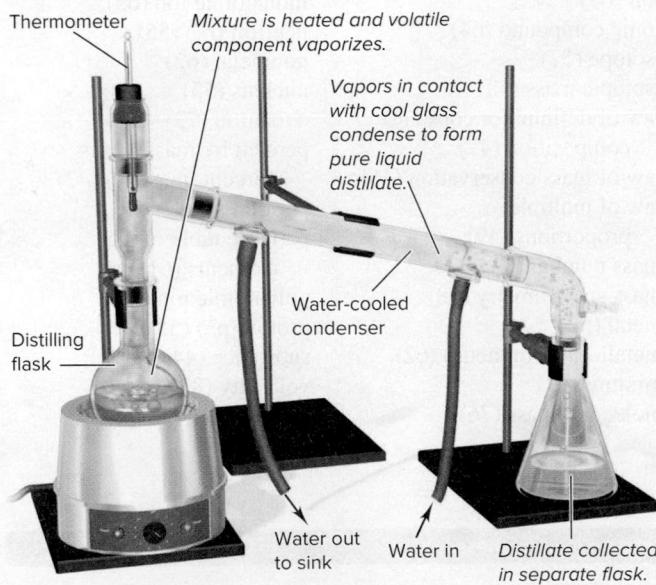

Figure B2.3 Distillation.

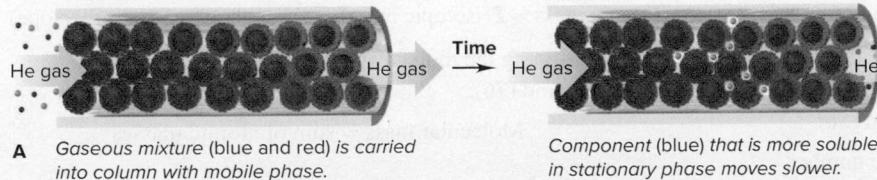

Figure B2.5 Principle of gas-liquid chromatography (GLC). The stationary phase is shown as a viscous liquid (gray circles) coating the solid beads (yellow) of an inert packing.

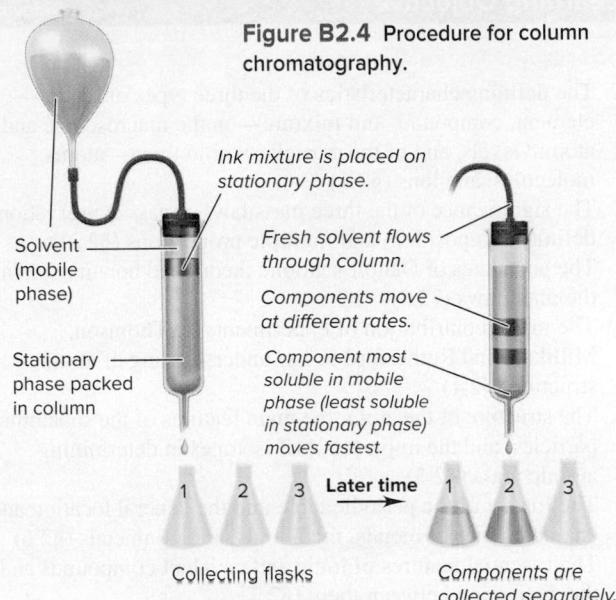

Figure B2.4 Procedure for column chromatography.

are separated as this solution, called the *mobile phase*, flows through a solid (or viscous liquid) called the *stationary phase*. A component with lower solubility in the stationary phase moves through it faster than a component with a higher solubility. Figure B2.4 depicts the separation of inks by *column chromatography*.

In a related technique called *gas-liquid chromatography (GLC)*, the mobile phase is an inert gas, such as helium, that carries a gaseous mixture of components into a long tube packed with the stationary phase (Figure B2.5, part A). The components emerge separately and reach a detector. A chromatogram has numerous peaks, each representing the amount of a specific component (Figure B2.5, part B). *High-performance (high-pressure) liquid chromatography (HPLC)* is similar to GLC, but the mixture need not be vaporized, so more heat-sensitive components can be separated.

Problem

- B2.3** Name the technique(s) and briefly describe the procedure for separating each of the following mixtures into pure components: (a) table salt and pepper; (b) drinking water contaminated with soot; (c) crushed ice and crushed glass; (d) table sugar dissolved in ethanol; (e) two pigments (chlorophyll *a* and chlorophyll *b*) from spinach leaves.

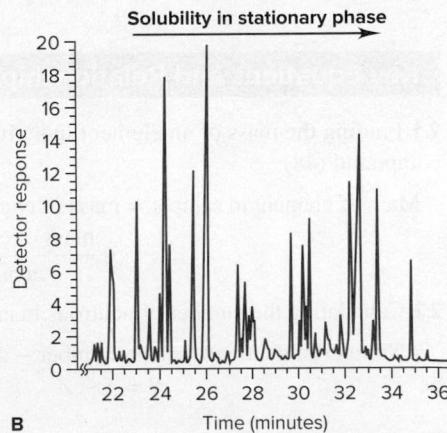

B

CHAPTER REVIEW GUIDE

Learning Objectives

Relevant section (§) and/or sample problem (SP) numbers appear in parentheses.

Understand These Concepts

- The defining characteristics of the three types of matter—element, compound, and mixture—on the macroscopic and atomic levels, and of the particles within them—atoms, molecules, and ions (§2.1)
- The significance of the three mass laws—mass conservation, definite composition, and multiple proportions (§2.2)
- The postulates of Dalton's atomic theory and how it explains the mass laws (§2.3)
- The major contribution of experiments by Thomson, Millikan, and Rutherford to our understanding of atomic structure (§2.4)
- The structure of the atom, the main features of the subatomic particles, and the importance of isotopes in determining atomic mass (§2.5)
- The format of the periodic table and the general location and characteristics of metals, metalloids, and nonmetals (§2.6)
- The essential features of ionic and covalent compounds and the distinction between them (§2.7)
- The types of mixtures and their properties (§2.9)

Master These Skills

- Distinguishing elements, compounds, and mixtures at the atomic scale (SP 2.1)
- Using the mass ratio of element to compound to find the mass of an element in a compound (SP 2.2)
- Visualizing the mass laws (SP 2.3)
- Determining the numbers of subatomic particles in the isotopes of an element (SP 2.4)
- Calculating an atomic mass from isotopic composition (SP 2.5)
- Identifying an element from its Z value (SP 2.6)
- Predicting the ion an element forms (SP 2.7)
- Naming and writing the formula of an ionic compound formed from the ions in Tables 2.3–2.5 (SPs 2.8–2.12, 2.17)
- Naming and writing the formula of an acid and its anion (SP 2.13)
- Naming and writing the formula of a binary covalent compound (SPs 2.14, 2.15, 2.17)
- Calculating the molecular or formula mass of a compound (SP 2.16, 2.17)

Key Terms

Page numbers appear in parentheses.

anion (64)	covalent bond (66)	hydrate (72)	molecule (44)
aqueous solution (81)	covalent compound (64)	ion (64)	monatomic ion (65)
atom (50)	crystallization (83)	ionic compound (64)	neutron (n^0) (55)
atomic mass (58)	dalton (Da) (57)	isotope (57)	nonmetal (62)
atomic mass unit (amu) (57)	distillation (83)	isotopic mass (58)	nucleus (55)
atomic number (Z) (56)	electron (e^-) (55)	law of definite (or constant) composition (47)	oxoanion (72)
atomic symbol (56)	element (44)	law of mass conservation (46)	percent by mass (mass percent, mass %) (47)
binary covalent compound (74)	filtration (83)	law of multiple proportions (49)	period (61)
binary ionic compound (64)	formula mass (76)	mass number (A) (56)	periodic table of the elements (61)
cathode ray (52)	formula unit (68)	mass spectrometry (58)	polyatomic ion (67)
cation (64)	fraction by mass (mass fraction) (47)	metal (62)	proton (p^+) (55)
chemical bond (64)	group (61)	metalloid (semimetal) (62)	substance (44)
chemical formula (68)	heterogeneous mixture (81)	mixture (45)	volatility (83)
chromatography (83)	homogeneous mixture (solution) (81)	molecular mass (76)	
compound (44)			

Key Equations and Relationships

Page numbers appear in parentheses.

2.1 Finding the mass of an element in a given mass of compound (48):

$$\text{Mass of element in sample} = \text{mass of compound in sample} \times \frac{\text{mass of element in compound}}{\text{mass of compound}}$$

2.2 Calculating the number of neutrons in an atom (56):

$$\text{Number of neutrons} = \text{mass number} - \text{atomic number}$$

or

$$N = A - Z$$

2.3 Calculating the average atomic mass of the isotopes of an element (58):

$$\text{Atomic mass} = \Sigma(\text{isotopic mass})(\text{fractional abundance of isotope})$$

2.4 Determining the molecular mass of a formula unit of a compound (76):

$$\text{Molecular mass} = \text{sum of atomic masses}$$

BRIEF SOLUTIONS TO FOLLOW-UP PROBLEMS

2.1A (a) There is only one type of atom (blue) present, so this is an element. (b) Two different atoms (brown and green) appear in a fixed ratio of 1/1, so this is a compound. (c) These molecules consist of one type of atom (orange), so this is an element.

2.1B There are two types of particles reacting (left circle), one with two blue atoms and the other with two orange; the depiction shows a mixture of two elements. In the product (right circle), all the particles have one blue atom and one orange; this is a compound.

2.2A Mass (g) of fool's gold

$$= 86.2 \text{ g iron} \times \frac{110.0 \text{ g fool's gold}}{51.2 \text{ g iron}} \\ = 185 \text{ g fool's gold}$$

$$\text{Mass (g) of sulfur} = 185 \text{ g fool's gold} \times \frac{(110.0 - 51.2 \text{ g sulfur})}{110.0 \text{ g fool's gold}} \\ = 98.9 \text{ g sulfur}$$

2.2B Mass (g) of silver

$$= 3.57 \text{ g silver bromide} \times \frac{15.4 \text{ g silver}}{26.8 \text{ g silver bromide}} \\ = 2.05 \text{ g silver}$$

Mass (g) of bromine

$$= 3.57 \text{ g silver bromide} \times \frac{(26.8 - 15.4 \text{ g bromine})}{26.8 \text{ g silver bromide}} \\ = 1.52 \text{ g bromine}$$

2.3A There are 12 black atoms and 14 red atoms in each circle (mass conservation). In the right circle, there are molecules of two compounds—one compound has one black and one red atom, and the other has one black and two red atoms (multiple proportions). Each compound has a fixed ratio of black-to-red atoms (definite composition).

2.3B Sample B. Two bromine-fluorine compounds appear. In one, there are three fluorine atoms for each bromine; in the other, there is one fluorine for each bromine. Therefore, the masses of fluorine that combine with a given mass of bromine are in a 3/1 ratio.

2.4A Titanium has an atomic number of 22. Mass number – 22 = number of neutrons.

^{46}Ti has 22p^+ , 22e^- , and $(46 - 22) = 24\text{n}^0$.

^{47}Ti has 22p^+ , 22e^- , and $(47 - 22) = 25\text{n}^0$.

^{48}Ti has 22p^+ , 22e^- , and $(48 - 22) = 26\text{n}^0$.

^{49}Ti has 22p^+ , 22e^- , and $(49 - 22) = 27\text{n}^0$.

^{50}Ti has 22p^+ , 22e^- , and $(50 - 22) = 28\text{n}^0$.

2.4B (a) 5p^+ , 5e^- , $(11 - 5) = 6\text{n}^0$; Q = B

(b) 20p^+ , 20e^- , $(41 - 20) = 21\text{n}^0$; R = Ca

(c) 53p^+ , 53e^- , $(131 - 53) = 78\text{n}^0$; X = I

2.5A First, divide the percent abundance value (Figure B2.2C, Tools of the Laboratory) by 100 to obtain the fractional value for each isotope. Multiply each isotopic mass by the fractional

value, and add the resulting masses to obtain neon's atomic mass:

Atomic mass of Ne

$$= (\text{isotopic mass of } ^{20}\text{Ne})(\text{fractional abundance of } ^{20}\text{Ne}) \\ + (\text{isotopic mass of } ^{21}\text{Ne})(\text{fractional abundance of } ^{21}\text{Ne}) \\ + (\text{isotopic mass of } ^{22}\text{Ne})(\text{fractional abundance of } ^{22}\text{Ne}) \\ = (19.99244 \text{ amu})(0.9048) + (20.99385 \text{ amu})(0.0027) \\ + (21.99139 \text{ amu})(0.0925) \\ = 20.18 \text{ amu}$$

2.5B $10.0129x + [11.0093(1 - x)] = 10.81$; $0.9964x = 0.1993$; $x = 0.2000$ and $1 - x = 0.8000$; percent abundance of $^{10}\text{B} = 20.00\%$; percent abundance of $^{11}\text{B} = 80.00\%$

2.6A (a) Silicon, Si; Group 4A(14) and Period 3; metalloid
(b) Cesium, Cs; Group 1A(1) and Period 6; main-group metal
(c) Xenon, Xe; Group 8A(18) and Period 5; nonmetal

2.6B (a) Magnesium, Mg; Group 2A(2) and Period 3; main-group metal

(b) Nitrogen, N; Group 5A(15) and Period 2; nonmetal
(c) Zinc, Zn; Group 2B(12) and Period 4; transition metal

2.7A (a) S^{2-} ; (b) Rb^+ ; (c) Ba^{2+}

2.7B (a) Sr^{2+} ; (b) O^{2-} ; (c) Cs^+

2.8A (a) Zinc oxide; (b) silver bromide; (c) lithium chloride; (d) aluminum sulfide

2.8B (a) Potassium sulfide; (b) barium iodide; (c) cesium nitride; (d) sodium hydride

2.9A (a) ZnO ; (b) AgBr ; (c) LiCl ; (d) Al_2S_3

2.9B (a) K_2S ; (b) BaI_2 ; (c) Cs_3N ; (d) NaH

2.10A (a) PbO_2 ; (b) copper(I) sulfide (cuprous sulfide); (c) iron(II) bromide (ferrous bromide); (d) HgCl_2

2.10B (a) Cu_3N_2 ; (b) lead(II) iodide; (c) Cr_2S_3 ; (d) iron(II) oxide

2.11A (a) $\text{Cu}(\text{NO}_3)_2 \cdot 3\text{H}_2\text{O}$; (b) $\text{Zn}(\text{OH})_2$; (c) lithium cyanide

2.11B (a) $(\text{NH}_4)_2\text{SO}_4$; (b) nickel(II) nitrate hexahydrate; (c) KHCO_3

2.12A (a) $(\text{NH}_4)_3\text{PO}_4$; ammonium is NH_4^+ and phosphate is PO_4^{3-} . (b) $\text{Al}(\text{OH})_3$; parentheses are needed around the polyatomic ion OH^- . (c) Magnesium hydrogen carbonate; Mg^{2+} is magnesium and can have only a 2+ charge, so (II) is not needed in the name; HCO_3^- is hydrogen carbonate (or bicarbonate).

2.12B (a) Chromium(III) nitrate; the -ic ending is not used with roman numerals; NO_3^- is nitrate.

(b) Calcium nitrite; Ca^{2+} is calcium and NO_2^- is nitrite.

(c) KClO_3 ; potassium is K^+ and chlorate is ClO_3^- ; parentheses are not needed when only one polyatomic ion is present.

2.13A (a) ClO_3^- , chlorate; (b) F^- , fluoride; (c) CH_3COO^- (or $\text{C}_2\text{H}_3\text{O}_2^-$), acetate; (d) NO_2^- , nitrite

2.13B (a) Sulfurous acid; add one H^+ ion to hydrogen sulfite, HSO_3^- , or two H^+ to sulfite, SO_3^{2-} ; (b) hypobromous acid, hypobromite, BrO^- ; (c) chlorous acid, chlorite, ClO_2^- ; (d) hydriodic acid, iodide, I^-

2.14A (a) Sulfur trioxide; (b) silicon dioxide; (c) N₂O; (d) SeF₆

2.14B (a) Sulfur dichloride; (b) dinitrogen pentoxide;
(c) BF₃; (d) IBr₃

2.15A (a) Disulfur dichloride; the *-ous* suffix is not used.

(b) NO; the name indicates one nitrogen.

(c) Bromine trichloride; Br is in a higher period in Group 7A(17), so it is named first.

2.15B (a) Tetraphosphorus hexoxide; the name of the element phosphorus ends in *-us* not *-ous*, and the prefix *hexa-* is shortened to *hex-* before *oxide*. (b) Sulfur hexafluoride; sulfur has a lower group number so it comes first, and fluorine gets the *-ide* ending. (c) NBr₃; nitrogen's symbol is N, and the second letter of a symbol is lowercase: bromine is Br.

2.16A (a) Hydrogen peroxide is H₂O₂.

Molecular mass

$$\begin{aligned} &= (2 \times \text{atomic mass of H}) + (2 \times \text{atomic mass of O}) \\ &= (2 \times 1.008 \text{ amu}) + (2 \times 16.00 \text{ amu}) = 34.02 \text{ amu} \end{aligned}$$

(b) Cesium carbonate is Cs₂CO₃.

Formula mass

$$\begin{aligned} &= (2 \times \text{atomic mass of Cs}) + (1 \times \text{atomic mass of C}) \\ &\quad + (3 \times \text{atomic mass of O}) \\ &= (2 \times 132.9 \text{ amu}) + 12.01 \text{ amu} + (3 \times 16.00 \text{ amu}) \\ &= 325.8 \text{ amu} \end{aligned}$$

2.16B (a) Sulfuric acid is H₂SO₄.

Molecular mass

$$\begin{aligned} &= (2 \times \text{atomic mass of H}) + (1 \times \text{atomic mass of S}) \\ &\quad + (4 \times \text{atomic mass of O}) \\ &= (2 \times 1.008 \text{ amu}) + 32.06 \text{ amu} + (4 \times 16.00 \text{ amu}) \\ &= 98.08 \text{ amu} \end{aligned}$$

(b) Potassium sulfate is K₂SO₄.

Formula mass

$$\begin{aligned} &= (2 \times \text{atomic mass of K}) + (1 \times \text{atomic mass of S}) \\ &\quad + (4 \times \text{atomic mass of O}) \\ &= (2 \times 39.10 \text{ amu}) + 32.06 \text{ amu} + (4 \times 16.00 \text{ amu}) \\ &= 174.26 \text{ amu} \end{aligned}$$

2.17A (a) Na₂O. This is an ionic compound, so the name is sodium oxide.

Formula mass

$$\begin{aligned} &= (2 \times \text{atomic mass of Na}) + (1 \times \text{atomic mass of O}) \\ &= (2 \times 22.99 \text{ amu}) + 16.00 \text{ amu} = 61.98 \text{ amu} \end{aligned}$$

(b) NO₂. This is a covalent compound, and N has the lower group number, so the name is nitrogen dioxide.

Molecular mass

$$\begin{aligned} &= (1 \times \text{atomic mass of N}) + (2 \times \text{atomic mass of O}) \\ &= 14.01 \text{ amu} + (2 \times 16.00 \text{ amu}) = 46.01 \text{ amu} \end{aligned}$$

2.17B (a) Magnesium chloride, MgCl₂

Formula mass

$$\begin{aligned} &= (1 \times \text{atomic mass of Mg}) + (2 \times \text{atomic mass of Cl}) \\ &= (1 \times 24.31 \text{ amu}) + (2 \times 35.45 \text{ amu}) = 95.21 \text{ amu} \end{aligned}$$

(b) Chlorine trifluoride, ClF₃

Molecular mass

$$\begin{aligned} &= (1 \times \text{atomic mass of Cl}) + (3 \times \text{atomic mass of F}) \\ &= 35.45 \text{ amu} + (3 \times 19.00 \text{ amu}) = 92.45 \text{ amu} \end{aligned}$$

PROBLEMS

Problems with **colored** numbers are answered in Appendix E and worked in detail in the Student Solutions Manual. Problem sections match those in the text and give the numbers of relevant sample problems. Most offer Concept Review Questions, Skill-Building Exercises (grouped in pairs covering the same concept), and Problems in Context. The Comprehensive Problems are based on material from any section or previous chapter.

Elements, Compounds, and Mixtures: An Atomic Overview (Sample Problem 2.1)

Concept Review Questions

2.1 What is the key difference between an element and a compound?

2.2 List two differences between a compound and a mixture.

2.3 Which of the following are pure substances? Explain.

- (a) Calcium chloride, used to melt ice on roads, consists of two elements, calcium and chlorine, in a fixed mass ratio.
- (b) Sulfur consists of sulfur atoms combined into octatomic molecules.

- (c) Baking powder, a leavening agent, contains 26–30% sodium hydrogen carbonate and 30–35% calcium dihydrogen phosphate by mass.
- (d) Cytosine, a component of DNA, consists of H, C, N, and O atoms bonded in a specific arrangement.

2.4 Classify each substance in Problem 2.3 as an element, compound, or mixture, and explain your answers.

2.5 Explain the following statement: The smallest particles unique to an element may be atoms or molecules.

2.6 Explain the following statement: The smallest particles unique to a compound cannot be atoms.

2.7 Can the relative amounts of the components of a mixture vary? Can the relative amounts of the components of a compound vary? Explain.

Problems in Context

2.8 The tap water found in many areas of the United States leaves white deposits when it evaporates. Is this tap water a mixture or a compound? Explain.

2.9 Each scene below represents a mixture. Describe each one in terms of the number(s) of elements and/or compounds present.

2.10 Samples of illicit “street” drugs often contain an inactive component, such as ascorbic acid (vitamin C). After obtaining a sample of cocaine, government chemists calculate the mass of vitamin C per gram of drug sample and use it to track the drug’s distribution. For example, if different samples of cocaine obtained on the streets of New York, Los Angeles, and Paris all contain 0.6384 g of vitamin C per gram of sample, they very likely come from a common source. Do these street samples consist of a compound, element, or mixture? Explain.

The Observations That Led to an Atomic View of Matter

(Sample Problem 2.2)

Concept Review Questions

2.11 Why was it necessary for separation techniques and methods of chemical analysis to be developed before the laws of definite composition and multiple proportions could be formulated?

2.12 To which class(es) of matter—elements, compounds, and/or mixtures—do the following apply: (a) law of mass conservation; (b) law of definite composition; (c) law of multiple proportions?

2.13 In our modern view of matter and energy, is the law of mass conservation still relevant to chemical reactions? Explain.

2.14 Identify the mass law that each of the following observations demonstrates, and explain your reasoning:

- A sample of potassium chloride from Chile contains the same percent by mass of potassium as one from Poland.
- A flashbulb contains magnesium and oxygen before use and magnesium oxide afterward, but its mass does not change.
- Arsenic and oxygen form one compound that is 65.2 mass % arsenic and another that is 75.8 mass % arsenic.

2.15 Which of the following scenes illustrate(s) the fact that compounds of chlorine (green) and oxygen (red) exhibit the law of multiple proportions? Name the compounds.

2.16 (a) Does the percent by mass of each element in a compound depend on the amount of compound? Explain.

(b) Does the mass of each element in a compound depend on the amount of compound? Explain.

2.17 Does the percent by mass of each element in a compound depend on the amount of that element used to make the compound? Explain.

Skill-Building Exercises (grouped in similar pairs)

2.18 State the mass law(s) demonstrated by the following experimental results, and explain your reasoning:

Experiment 1: A student heats 1.00 g of a blue compound and obtains 0.64 g of a white compound and 0.36 g of a colorless gas.

Experiment 2: A second student heats 3.25 g of the same blue compound and obtains 2.08 g of a white compound and 1.17 g of a colorless gas.

2.19 State the mass law(s) demonstrated by the following experimental results, and explain your reasoning:

Experiment 1: A student heats 1.27 g of copper and 3.50 g of iodine to produce 3.81 g of a white compound; 0.96 g of iodine remains.

Experiment 2: A second student heats 2.55 g of copper and 3.50 g of iodine to form 5.25 g of a white compound; 0.80 g of copper remains.

2.20 Fluorite, a mineral of calcium, is a compound of the metal with fluorine. Analysis shows that a 2.76-g sample of fluorite contains 1.42 g of calcium. Calculate the (a) mass of fluorine in the sample; (b) mass fractions of calcium and fluorine in fluorite; (c) mass percents of calcium and fluorine in fluorite.

2.21 Galena, a mineral of lead, is a compound of the metal with sulfur. Analysis shows that a 2.34-g sample of galena contains 2.03 g of lead. Calculate the (a) mass of sulfur in the sample; (b) mass fractions of lead and sulfur in galena; (c) mass percents of lead and sulfur in galena.

2.22 Magnesium oxide (MgO) forms when the metal burns in air. (a) If 1.25 g of MgO contains 0.754 g of Mg, what is the mass ratio of magnesium to magnesium oxide?

(b) How many grams of Mg are in 534 g of MgO ?

2.23 Zinc sulfide (ZnS) occurs in the zincblende crystal structure. (a) If 2.54 g of ZnS contains 1.70 g of Zn, what is the mass ratio of zinc to zinc sulfide?

(b) How many kilograms of Zn are in 3.82 kg of ZnS ?

2.24 A compound of copper and sulfur contains 88.39 g of metal and 44.61 g of nonmetal. How many grams of copper are in 5264 kg of compound? How many grams of sulfur?

2.25 A compound of iodine and cesium contains 63.94 g of metal and 61.06 g of nonmetal. How many grams of cesium are in 38.77 g of compound? How many grams of iodine?

2.26 Show, with calculations, how the following data illustrate the law of multiple proportions:

Compound 1: 47.5 mass % sulfur and 52.5 mass % chlorine

Compound 2: 31.1 mass % sulfur and 68.9 mass % chlorine

2.27 Show, with calculations, how the following data illustrate the law of multiple proportions:

Compound 1: 77.6 mass % xenon and 22.4 mass % fluorine

Compound 2: 63.3 mass % xenon and 36.7 mass % fluorine

Problems in Context

2.28 Dolomite is a carbonate of magnesium and calcium. Analysis shows that 7.81 g of dolomite contains 1.70 g of Ca. Calculate the mass percent of Ca in dolomite. On the basis of the mass percent of Ca, and neglecting all other factors, which is the richer source of Ca, dolomite or fluorite (see Problem 2.20)?

2.29 The mass percent of sulfur in a sample of coal is a key factor in the environmental impact of the coal because the sulfur combines with oxygen when the coal is burned and the oxide can then be incorporated into acid rain. Which of the following coals would have the smallest environmental impact?

	Mass (g) of Sample	Mass (g) of Sulfur in Sample
Coal A	378	11.3
Coal B	495	19.0
Coal C	675	20.6

Dalton's Atomic Theory

(Sample Problem 2.3)

Concept Review Questions

2.30 Which of Dalton's postulates about atoms are inconsistent with later observations? Do these inconsistencies mean that Dalton was wrong? Is Dalton's model still useful? Explain.

2.31 Use Dalton's theory to explain why potassium nitrate from India or Italy has the same mass percents of K, N, and O.

The Observations That Led to the Nuclear Atom Model

Concept Review Questions

2.32 Thomson was able to determine the mass/charge ratio of the electron but not its mass. How did Millikan's experiment allow determination of the electron's mass?

2.33 The following charges on individual oil droplets were obtained during an experiment similar to Millikan's: -3.204×10^{-19} C; -4.806×10^{-19} C; -8.010×10^{-19} C; -1.442×10^{-18} C. Determine a charge for the electron (in C, coulombs), and explain your answer.

2.34 Describe Thomson's model of the atom. How might it account for the production of cathode rays?

2.35 When Rutherford's coworkers bombarded gold foil with α particles, they obtained results that overturned the existing (Thomson) model of the atom. Explain.

The Atomic Theory Today

(Sample Problems 2.4 and 2.5)

Concept Review Questions

2.36 Define *atomic number* and *mass number*. Which can vary without changing the identity of the element?

2.37 Choose the correct answer. The difference between the mass number of an isotope and its atomic number is (a) directly related to the identity of the element; (b) the number of electrons; (c) the number of neutrons; (d) the number of isotopes.

2.38 Even though several elements have only one naturally occurring isotope and all atomic nuclei have whole numbers of protons and neutrons, no atomic mass is a whole number. Use the data from Table 2.2 to explain this fact.

Skill-Building Exercises (grouped in similar pairs)

2.39 Argon has three naturally occurring isotopes, ^{36}Ar , ^{38}Ar , and ^{40}Ar . What is the mass number of each isotope? How many protons, neutrons, and electrons are present in each?

2.40 Chlorine has two naturally occurring isotopes, ^{35}Cl and ^{37}Cl . What is the mass number of each isotope? How many protons, neutrons, and electrons are present in each?

2.41 Do both members of the following pairs have the same number of protons? Neutrons? Electrons?

- (a) $^{16}_8\text{O}$ and $^{17}_8\text{O}$ (b) $^{40}_{18}\text{Ar}$ and $^{41}_{19}\text{K}$ (c) $^{60}_{27}\text{Co}$ and $^{60}_{28}\text{Ni}$

Which pair(s) consist(s) of atoms with the same Z value? N value? A value?

2.42 Do both members of the following pairs have the same number of protons? Neutrons? Electrons?

- (a) ^3_1H and ^3_2He (b) $^{14}_6\text{C}$ and $^{15}_7\text{N}$ (c) $^{19}_9\text{F}$ and $^{18}_9\text{F}$

Which pair(s) consist(s) of atoms with the same Z value? N value? A value?

2.43 Write the ${}^A_Z\text{X}$ notation for each atomic depiction:

2.44 Write the ${}^A_Z\text{X}$ notation for each atomic depiction:

2.45 Draw atomic depictions similar to those in Problem 2.43 for (a) $^{48}_{22}\text{Ti}$; (b) $^{79}_{34}\text{Se}$; (c) $^{11}_{5}\text{B}$.

2.46 Draw atomic depictions similar to those in Problem 2.43 for (a) $^{207}_{82}\text{Pb}$; (b) $^9_{4}\text{Be}$; (c) $^{75}_{33}\text{As}$.

2.47 Gallium has two naturally occurring isotopes, ^{69}Ga (isotopic mass = 68.9256 amu, abundance = 60.11%) and ^{71}Ga (isotopic mass = 70.9247 amu, abundance = 39.89%). Calculate the atomic mass of gallium.

2.48 Magnesium has three naturally occurring isotopes, ^{24}Mg (isotopic mass = 23.9850 amu, abundance = 78.99%), ^{25}Mg (isotopic mass = 24.9858 amu, abundance = 10.00%), and ^{26}Mg (isotopic mass = 25.9826 amu, abundance = 11.01%). Calculate the atomic mass of magnesium.

2.49 Chlorine has two naturally occurring isotopes, ^{35}Cl (isotopic mass = 34.9689 amu) and ^{37}Cl (isotopic mass = 36.9659 amu). If chlorine has an atomic mass of 35.4527 amu, what is the percent abundance of each isotope?

2.50 Copper has two naturally occurring isotopes, ^{63}Cu (isotopic mass = 62.9296 amu) and ^{65}Cu (isotopic mass = 64.9278 amu). If copper has an atomic mass of 63.546 amu, what is the percent abundance of each isotope?

Elements: A First Look at the Periodic Table

(Sample Problem 2.6)

Concept Review Questions

2.51 How can iodine ($Z = 53$) have a higher atomic number yet a lower atomic mass than tellurium ($Z = 52$)?

2.52 Correct each of the following statements:

- (a) In the modern periodic table, the elements are arranged in order of increasing atomic mass.
- (b) Elements in a period have similar chemical properties.
- (c) Elements can be classified as either metalloids or nonmetals.

2.53 What class of elements lies along the “staircase” line in the periodic table? How do the properties of these elements compare with those of metals and nonmetals?

2.54 What are some characteristic properties of elements to the left of the elements along the “staircase”? To the right?

2.55 The elements in Groups 1A(1) and 7A(17) are all quite reactive. What is a major difference between them?

Skill-Building Exercises (grouped in similar pairs)

2.56 Give the name, atomic symbol, and group number of the element with each Z value, and classify it as a metal, metalloid, or nonmetal;

- (a) $Z = 32$ (b) $Z = 15$ (c) $Z = 2$ (d) $Z = 3$ (e) $Z = 42$

2.57 Give the name, atomic symbol, and group number of the element with each Z value, and classify it as a metal, metalloid, or nonmetal:

- (a) $Z = 33$ (b) $Z = 20$ (c) $Z = 35$ (d) $Z = 19$ (e) $Z = 13$

2.58 Fill in the blanks:

- (a) The symbol and atomic number of the heaviest alkaline earth metal are _____ and _____.
- (b) The symbol and atomic number of the lightest metalloid in Group 4A(14) are _____ and _____.
- (c) Group 1B(11) consists of the *coinage metals*. The symbol and atomic mass of the coinage metal whose atoms have the fewest electrons are _____ and _____.
- (d) The symbol and atomic mass of the halogen in Period 4 are _____ and _____.

2.59 Fill in the blanks:

- (a) The symbol and atomic number of the heaviest nonradioactive noble gas are _____ and _____.
- (b) The symbol and group number of the Period 5 transition element whose atoms have the fewest protons are _____ and _____.
- (c) The elements in Group 6A(16) are sometimes called the *chalcogens*. The symbol and atomic number of the first metallic chalcogen are _____ and _____.
- (d) The symbol and number of protons of the Period 4 alkali metal atom are _____ and _____.

Compounds: Introduction to Bonding

(Sample Problem 2.7)

Concept Review Questions

2.60 Describe the type and nature of the bonding that occurs between reactive metals and nonmetals.

2.61 Describe the type and nature of the bonding that often occurs between two nonmetals.

2.62 How can ionic compounds be neutral if they consist of positive and negative ions?

2.63 Given that the ions in LiF and in MgO are of similar size, which compound has stronger ionic bonding? Use Coulomb’s law in your explanation.

2.64 Are molecules present in a sample of BaF₂? Explain.

2.65 Are ions present in a sample of P₄O₆? Explain.

2.66 The monatomic ions of Groups 1A(1) and 7A(17) are all singly charged. In what major way do they differ? Why?

2.67 Describe the formation of solid magnesium chloride (MgCl₂) from large numbers of magnesium and chlorine atoms.

2.68 Describe the formation of solid potassium sulfide (K₂S) from large numbers of potassium and sulfur atoms.

2.69 Does potassium nitrate (KNO₃) incorporate ionic bonding, covalent bonding, or both? Explain.

Skill-Building Exercises (grouped in similar pairs)

2.70 What monatomic ions would you expect potassium ($Z = 19$) and bromine ($Z = 35$) to form?

2.71 What monatomic ions would you expect radium ($Z = 88$) and selenium ($Z = 34$) to form?

2.72 For each ionic depiction, give the name of the parent atom, its mass number, and its group and period numbers:

2.73 For each ionic depiction, give the name of the parent atom, its mass number, and its group and period numbers:

2.74 An ionic compound forms when lithium ($Z = 3$) reacts with oxygen ($Z = 8$). If a sample of the compound contains 8.4×10^{21} lithium ions, how many oxide ions does it contain?

2.75 An ionic compound forms when calcium ($Z = 20$) reacts with iodine ($Z = 53$). If a sample of the compound contains 7.4×10^{21} calcium ions, how many iodide ions does it contain?

2.76 The radii of the sodium and potassium ions are 102 pm and 138 pm, respectively. Which compound has stronger ionic attractions, sodium chloride or potassium chloride?

2.77 The radii of the lithium and magnesium ions are 76 pm and 72 pm, respectively. Which compound has stronger ionic attractions, lithium oxide or magnesium oxide?

Compounds: Formulas, Names, and Masses

(Sample Problems 2.8 to 2.17)

Concept Review Questions

2.78 What information about the relative numbers of ions and the percent masses of elements is contained in the formula MgF₂?

2.79 How is a structural formula similar to a molecular formula? How is it different?

2.80 Consider a mixture of 10 billion O₂ molecules and 10 billion H₂ molecules. In what way is this mixture similar to a sample containing 10 billion hydrogen peroxide (H₂O₂) molecules? In what way is it different?

2.81 For what type(s) of compound do we use roman numerals in the names?

2.82 For what type(s) of compound do we use Greek numerical prefixes in the names?

2.83 For what type of compound are we unable to write a molecular formula?

Skill-Building Exercises (grouped in similar pairs)

2.84 Give the name and formula of the compound formed from each pair of elements: (a) sodium and nitrogen; (b) oxygen and strontium; (c) aluminum and chlorine.

2.85 Give the name and formula of the compound formed from each pair of elements: (a) cesium and bromine; (b) sulfur and barium; (c) calcium and fluorine.

2.86 Give the name and formula of the compound formed from each pair of elements:

(a) ₁₂L and ₉M (b) ₃₀L and ₁₆M (c) ₁₇L and ₃₈M

2.87 Give the name and formula of the compound formed from each pair of elements:

(a) ₃₇Q and ₃₅R (b) ₈Q and ₁₃R (c) ₂₀Q and ₅₃R

2.88 Give the systematic names for the formulas or the formulas for the names:

(a) tin(IV) chloride; (b) FeBr₃; (c) cuprous bromide; (d) Mn₂O₃.

2.89 Give the systematic names for the formulas or the formulas for the names: (a) CoO; (b) mercury(I) chloride; (c) chromic oxide; (d) CuBr₂.

2.90 Give the systematic names for the formulas or the formulas for the names:

(a) Na₂HPO₄; (b) ammonium perchlorate; (c) Pb(C₂H₃O₂)₂·3H₂O; (d) sodium nitrite.

2.91 Give the systematic names for the formulas or the formulas for the names: (a) Sn(SO₃)₂; (b) potassium dichromate; (c) FeCO₃; (d) potassium carbonate dihydrate.

2.92 Correct each of the following formulas:

- (a) Barium oxide is BaO₂.
- (b) Iron(II) nitrate is Fe(NO₃)₃.
- (c) Magnesium sulfide is MnSO₃.

2.93 Correct each of the following names:

- (a) CuI is cobalt(II) iodide.
- (b) Fe(HSO₄)₃ is iron(II) sulfate.
- (c) MgCr₂O₇ is magnesium dichromium heptaoxide.

2.94 Give the name and formula for the acid derived from each of the following anions:

- (a) hydrogen carbonate (b) IO₄⁻ (c) cyanide (d) HS⁻

2.95 Give the name and formula for the acid derived from each of the following anions:

- (a) perchlorate (b) NO₃⁻ (c) bromite (d) H₂PO₄⁻

2.96 Many chemical names are similar at first glance. Give the formulas of the species in each set:

- (a) Ammonium ion and ammonia
- (b) Magnesium sulfide, magnesium sulfite, and magnesium sulfate
- (c) Hydrochloric acid, chloric acid, and chlorous acid
- (d) Cuprous bromide and cupric bromide

2.97 Give the formulas of the compounds in each set:

- (a) Lead(II) oxide and lead(IV) oxide
- (b) Lithium nitride, lithium nitrite, and lithium nitrate
- (c) Strontium hydride and strontium hydroxide
- (d) Magnesium oxide and manganese(II) oxide

2.98 Give the name and formula of the compound whose molecules consist of two sulfur atoms and four fluorine atoms.

2.99 Give the name and formula of the compound whose molecules consist of two chlorine atoms and one oxygen atom.

2.100 Correct the name to match the formula of the following compounds: (a) calcium(II) dichloride, CaCl₂; (b) copper(II) oxide, Cu₂O; (c) stannous tetrafluoride, SnF₄; (d) hydrogen chloride acid, HCl.

2.101 Correct the formula to match the name of the following compounds: (a) iron(III) oxide, Fe₃O₄; (b) chloric acid, HCl; (c) mercuric oxide, Hg₂O; (d) potassium iodide, P₂I₃.

2.102 Write the formula of each compound, and determine its molecular (formula) mass: (a) ammonium sulfate; (b) sodium dihydrogen phosphate; (c) potassium bicarbonate.

2.103 Write the formula of each compound, and determine its molecular (formula) mass: (a) sodium dichromate; (b) ammonium perchlorate; (c) magnesium nitrite trihydrate.

2.104 Calculate the molecular (formula) mass of each compound: (a) dinitrogen pentoxide; (b) lead(II) nitrate; (c) calcium peroxide.

2.105 Calculate the molecular (formula) mass of each compound: (a) iron(II) acetate tetrahydrate; (b) sulfur tetrachloride; (c) potassium permanganate.

2.106 Give the number of atoms of the specified element in a formula unit of each of the following compounds, and calculate the molecular (formula) mass:

- (a) Oxygen in aluminum sulfate, Al₂(SO₄)₃
- (b) Hydrogen in ammonium hydrogen phosphate, (NH₄)₂HPO₄
- (c) Oxygen in the mineral azurite, Cu₃(OH)₂(CO₃)₂

2.107 Give the number of atoms of the specified element in a formula unit of each of the following compounds, and calculate the molecular (formula) mass:

- (a) Hydrogen in ammonium benzoate, C₆H₅COONH₄
- (b) Nitrogen in hydrazinium sulfate, N₂H₆SO₄
- (c) Oxygen in the mineral leadhillite, Pb₄SO₄(CO₃)₂(OH)₂

2.108 Give the formula, name, and molecular mass of the following molecules:

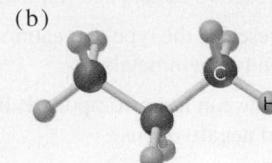

- 2.109** Give the formula, name, and molecular mass of the following molecules:

Problems in Context

- 2.110** Before the use of systematic names, many compounds had common names. Give the systematic name for each of the following:

- (a) Blue vitriol, $\text{CuSO}_4 \cdot 5\text{H}_2\text{O}$
- (b) Slaked lime, $\text{Ca}(\text{OH})_2$
- (c) Oil of vitriol, H_2SO_4
- (d) Washing soda, Na_2CO_3
- (e) Muriatic acid, HCl
- (f) Epsom salt, $\text{MgSO}_4 \cdot 7\text{H}_2\text{O}$
- (g) Chalk, CaCO_3
- (h) Dry ice, CO_2
- (i) Baking soda, NaHCO_3
- (j) Lye, NaOH

- 2.111** Each circle contains a representation of a binary compound. Determine its name, formula, and molecular (formula) mass.

oxygen
nitrogen
chlorine

Mixtures: Classification and Separation

Concept Review Questions

- 2.112** In what main way is separating the components of a mixture different from separating the components of a compound?

- 2.113** What is the difference between a homogeneous and a heterogeneous mixture?

- 2.114** Is a solution a homogeneous or a heterogeneous mixture? Give an example of an aqueous solution.

Skill-Building Exercises (grouped in similar pairs)

- 2.115** Classify each of the following as a compound, a homogeneous mixture, or a heterogeneous mixture: (a) distilled water; (b) gasoline; (c) beach sand; (d) wine; (e) air.

- 2.116** Classify each of the following as a compound, a homogeneous mixture, or a heterogeneous mixture: (a) orange juice; (b) vegetable soup; (c) cement; (d) calcium sulfate; (e) tea.

Problems in Context

- 2.117** Which separation method is operating in each of the following procedures?

- (a) Pouring a mixture of cooked pasta and boiling water into a colander
- (b) Removing colored impurities from raw sugar to make refined sugar

- 2.118** A quality-control laboratory analyzes a product mixture using gas-liquid chromatography. The separation of components is more than adequate, but the process takes too long. Suggest two ways, other than changing the stationary phase, to shorten the analysis time.

Comprehensive Problems

- 2.119** Helium is the lightest noble gas and the second most abundant element (after hydrogen) in the universe.

(a) The radius of a helium atom is 3.1×10^{-11} m; the radius of its nucleus is 2.5×10^{-15} m. What fraction of the spherical atomic volume is occupied by the nucleus (V of a sphere = $\frac{4}{3}\pi r^3$)?

(b) The mass of a helium-4 atom is 6.64648×10^{-24} g, and each of its two electrons has a mass of 9.10939×10^{-28} g. What fraction of this atom's mass is contributed by its nucleus?

- 2.120** From the following ions (with their radii in pm), choose the pair that forms the strongest ionic bond and the pair that forms the weakest:

Ion:	Mg^{2+}	K^+	Rb^+	Ba^{2+}	Cl^-	O^{2-}	I^-
Radius:	72	138	152	135	181	140	220

- 2.121** Give the molecular mass of each compound depicted below, and provide a correct name for any that are named incorrectly.

- 2.122** Polyatomic ions are named by patterns that apply to elements in a given group. Using the periodic table and Table 2.5, give the name of each of the following: (a) SeO_4^{2-} ; (b) AsO_4^{3-} ; (c) BrO_2^- ; (d) HSeO_4^- ; (e) TeO_3^{2-} .

- 2.123** Ammonium dihydrogen phosphate, formed from the reaction of phosphoric acid with ammonia, is used as a crop fertilizer as well as a component of some fire extinguishers. (a) What are the mass percentages of N and P in the compound? (b) How much ammonia is incorporated into 100. g of the compound?

- 2.124** Nitrogen forms more oxides than any other element. The percents by mass of N in three different nitrogen oxides are (I) 46.69%, (II) 36.85%, and (III) 25.94%. For each compound, determine (a) the simplest whole-number ratio of N to O and (b) the number of grams of oxygen per 1.00 g of nitrogen.

- 2.125** The number of atoms in 1 dm^3 of aluminum is nearly the same as the number of atoms in 1 dm^3 of lead, but the densities of these metals are very different (see Table 1.5). Explain.

- 2.126** You are working in the laboratory preparing sodium chloride. Consider the following results for three preparations of the compound:

Case 1: $39.34 \text{ g Na} + 60.66 \text{ g Cl}_2 \longrightarrow 100.00 \text{ g NaCl}$

Case 2: $39.34 \text{ g Na} + 70.00 \text{ g Cl}_2 \longrightarrow$

$100.00 \text{ g NaCl} + 9.34 \text{ g Cl}_2$

Case 3: $50.00 \text{ g Na} + 50.00 \text{ g Cl}_2 \longrightarrow$

$82.43 \text{ g NaCl} + 17.57 \text{ g Na}$

Explain these results in terms of the laws of conservation of mass and definite composition.

- 2.127** Scenes A–I on the next page depict various types of matter on the atomic scale. Choose the correct scene(s) for each of the following:

- (a) A mixture that fills its container

- (b) A substance that cannot be broken down into simpler ones
 (c) An element with a very high resistance to flow
 (d) A homogeneous mixture
 (e) An element that conforms to the walls of its container and displays an upper surface
 (f) A gas consisting of diatomic particles
 (g) A gas that can be broken down into simpler substances
 (h) A substance with a 2/1 ratio of its component atoms
 (i) Matter that can be separated into its component substances by physical means
 (j) A heterogeneous mixture
 (k) Matter that obeys the law of definite composition

2.128 The seven most abundant ions in seawater make up more than 99% by mass of the dissolved compounds. Here are their abundances in units of mg ion/kg seawater: chloride 18,980; sodium 10,560; sulfate 2650; magnesium 1270; calcium 400; potassium 380; hydrogen carbonate 140.

- (a) What is the mass % of each ion in seawater?
 (b) What percent of the total mass of ions is represented by sodium ions?
 (c) How does the total mass % of alkaline earth metal ions compare with the total mass % of alkali metal ions?
 (d) Which make up the larger mass fraction of dissolved components, anions or cations?

2.129 The following scenes represent a mixture of two monoatomic gases undergoing a reaction when heated. Which mass law(s) is (are) illustrated by this change?

2.130 When barium (Ba) reacts with sulfur (S) to form barium sulfide (BaS), each Ba atom reacts with an S atom. If 2.50 cm^3 of Ba reacts with 1.75 cm^3 of S, are there enough Ba atoms to react with the S atoms (d of Ba = 3.51 g/cm^3 ; d of S = 2.07 g/cm^3)?

2.131 Succinic acid (*below*) is an important metabolite in biological energy production. Give the molecular formula, molecular mass, and the mass percent of each element in succinic acid.

2.132 Fluoride ion is poisonous in relatively low amounts: 0.2 g of F^- per 70 kg of body weight can cause death. Nevertheless, in order to prevent tooth decay, F^- ions are added to drinking water at a concentration of 1 mg of F^- ion per L of water. How many liters of fluoridated drinking water would a 70-kg person have to consume in one day to reach this toxic level? How many kilograms of sodium fluoride would be needed to treat an $8.50 \times 10^7\text{-gal}$ reservoir?

2.133 Antimony has many uses, for example, in infrared devices and as part of an alloy in lead storage batteries. The element has two naturally occurring isotopes, one with mass 120.904 amu and the other with mass 122.904 amu. (a) Write the ${}_{Z}^{A}\text{X}$ notation for each isotope. (b) Use the atomic mass of antimony from the periodic table to calculate the natural abundance of each isotope.

2.134 Dinitrogen monoxide (N_2O ; nitrous oxide) is a greenhouse gas that enters the atmosphere principally from natural fertilizer breakdown. Some studies have shown that the isotope ratios of ${}^{15}\text{N}$ to ${}^{14}\text{N}$ and of ${}^{18}\text{O}$ to ${}^{16}\text{O}$ in N_2O depend on the source, which can thus be determined by measuring the relative abundances of molecular masses in a sample of N_2O .

- (a) What different molecular masses are possible for N_2O ?
 (b) The percent abundance of ${}^{14}\text{N}$ is 99.6%, and that of ${}^{16}\text{O}$ is 99.8%. Which molecular mass of N_2O is least common, and which is most common?

2.135 Use the box color(s) in the periodic table below to identify the element(s) described by each of the following:

- (a) Four elements that are nonmetals
 (b) Two elements that are metals
 (c) Three elements that are gases at room temperature
 (d) Three elements that are solid at room temperature
 (e) One pair of elements likely to form a covalent compound
 (f) Another pair of elements likely to form a covalent compound
 (g) One pair of elements likely to form an ionic compound with formula MX
 (h) Another pair of elements likely to form an ionic compound with formula MX
 (i) Two elements likely to form an ionic compound with formula M_2X

- (j) Two elements likely to form an ionic compound with formula MX_2
 (k) An element that forms no compounds
 (l) A pair of elements whose compounds exhibit the law of multiple proportions

2.136 The two isotopes of potassium with significant abundances in nature are ^{39}K (isotopic mass = 38.9637 amu, 93.258%) and ^{41}K (isotopic mass = 40.9618 amu, 6.730%). Fluorine has only one naturally occurring isotope, ^{19}F (isotopic mass = 18.9984 amu). Calculate the formula mass of potassium fluoride.

2.137 Boron trifluoride is used as a catalyst in the synthesis of organic compounds. When this compound is analyzed by mass spectrometry (see Tools of the Laboratory: Mass Spectrometry, following Section 2.5), several different 1+ ions form, including ions representing the whole molecule as well as molecular fragments formed by the loss of one, two, and three F atoms. Given that boron has two naturally occurring isotopes, ^{10}B and ^{11}B , and fluorine has one, ^{19}F , calculate the masses of all possible 1+ ions.

2.138 Nitrogen monoxide (NO) is a bioactive molecule in blood. Low NO concentrations cause respiratory distress and the formation of blood clots. Doctors prescribe nitroglycerin, $\text{C}_3\text{H}_5\text{N}_3\text{O}_9$, and isoamyl nitrate, $(\text{CH}_3)_2\text{CHCH}_2\text{CH}_2\text{ONO}_2$, to increase the blood level of NO. If each compound releases one molecule of NO per atom of N it contains, calculate the mass percent of NO in each.

2.139 TNT (trinitrotoluene; *below*) is used as an explosive in construction. Calculate the mass of each element in 1.00 lb of TNT.

2.140 Nuclei differ in their stability, and some are so unstable that they undergo radioactive decay. The ratio of the number of neutrons to number of protons (N/Z) in a nucleus correlates with its stability. Calculate the N/Z ratio for (a) ^{144}Sm ; (b) ^{56}Fe ; (c) ^{20}Ne ; (d) ^{107}Ag . (e) The radioactive isotope ^{238}U decays in a series of

nuclear reactions that includes another uranium isotope, ^{234}U , and three lead isotopes, ^{214}Pb , ^{210}Pb , and ^{206}Pb . How many neutrons, protons, and electrons are in each of these five isotopes?

2.141 The anticancer drug Platinol (cisplatin), $\text{Pt}(\text{NH}_3)_2\text{Cl}_2$, reacts with a cancer cell's DNA and interferes with its growth. (a) What is the mass % of platinum (Pt) in Platinol? (b) If Pt costs \$51/g, how many grams of Platinol can be made for \$1.00 million (assume that the cost of Pt determines the cost of the drug)?

2.142 From the periodic table below, give the name, symbol, atomic number, atomic mass, period number, and group number of (a) the *building-block elements* (red), which occur in nearly every biological molecule, and (b) the *macronutrients* (green), which are either essential ions in cell fluids or are part of many biomolecules.

2.143 The block diagram below classifies the components of matter on the macroscopic scale. Identify blocks (a)–(d).

2.144 Which of the steps in the following process involve(s) a physical change and which involve(s) a chemical change?

3

Stoichiometry of Formulas and Equations

3.1 The Mole

Defining the Mole
Molar Mass
Amount-Mass-Number Conversions
Mass Percent

3.2 Determining the Formula of an Unknown Compound

Empirical Formulas
Molecular Formulas
Formulas and Structures

3.3 Writing and Balancing Chemical Equations

3.4 Calculating Quantities of Reactant and Product

Molar Ratios from Balanced Equations
Reaction Sequences
Limiting Reactants
Reaction Yields

Source: NASA

Concepts and Skills to Review Before You Study This Chapter

- › atomic mass (Section 2.5)
- › names and formulas of compounds (Section 2.8)
- › molecular (or formula) mass (Section 2.8)
- › molecular and structural formulas and ball-and-stick and space-filling models (Section 2.8)

Chemistry is, above all, a practical science. Imagine that you're a biochemist who has extracted a substance with medicinal activity from a tropical plant: what is its formula, and what quantity of metabolic products will establish a safe dosage level? Or, suppose you're a chemical engineer studying rocket-fuel thrust (*see photo*): what amount of propulsive gases will a fuel produce? Perhaps you're on a team of environmental chemists examining coal samples: what quantity of air pollutants will a sample produce when burned? Or, maybe you're a polymer chemist preparing a plastic with unusual properties: how much of this new material will the polymerization reaction yield? You can answer countless questions like these with a knowledge of **stoichiometry** (pronounced "stoy-key-AHM-uh-tree"; from the Greek *stoicheion*, "element or part," and *metron*, "measure"), the study of the quantitative aspects of formulas and reactions.

IN THIS CHAPTER . . . We relate the mass of a substance to the number of chemical entities comprising it (atoms, ions, molecules, or formula units) and apply this relationship to formulas and equations.

- › We discuss the mole, the chemist's unit for amount of a substance, and use it to convert between mass and number of entities.
- › We also use the mole concept to derive a chemical formula from the results of mass analysis.
- › We compare three types of chemical formulas.
- › We learn how to write chemical equations and how to balance them in terms of the amounts of substances reacting and produced.
- › We calculate the amounts of reactants and products in a reaction and see why one of the reactants limits the amount of product that can form and, thus, the reaction yield.

3.1 THE MOLE

In daily life, we often measure things by weighing or by counting: we weigh coffee beans or bananas, but we count eggs or pencils. And we use mass units (a kilogram of coffee beans) or counting units (a dozen pencils) to express the amount. Similarly, the daily routine in the laboratory involves measuring substances. We want to know the numbers of chemical entities—atoms, ions, molecules, or formula units—that react with each other, but how can we possibly count or weigh such minute objects? As you'll see, chemists have devised a unit, called the *mole*, to *count chemical entities by weighing a very large number of them*.

Defining the Mole

The **mole** (abbreviated **mol**) is the SI unit for *amount of substance*. It is defined as *the amount of a substance that contains the same number of entities as the number*

Imagine a Mole of ...

A mole of any ordinary object is a staggering amount: a mole of periods (.) lined up side by side would equal the radius of our galaxy; a mole of marbles stacked tightly together would cover the continental United States 70 miles deep. However, atoms and molecules are not ordinary objects: you can swallow a mole of water molecules (about 18 mL) in one gulp!

1 molecule of H_2O has a mass of 18.02 amu and 1 mol (6.022×10^{23} molecules) of H_2O has a mass of 18.02 g
1 formula unit of NaCl has a mass of 58.44 amu and 1 mol (6.022×10^{23} formula units) of NaCl has a mass of 58.44 g

Figure 3.1 One mole (6.022×10^{23} entities) of some familiar substances.

From left to right: 1 mol of copper (63.55 g), of liquid H_2O (18.02 g), of sodium chloride (table salt, 58.44 g), of sucrose (table sugar, 342.3 g), and of aluminum (26.98 g).

Source: © McGraw-Hill Education/Charles Winters/Timeframe Photography, Inc.

of atoms in 12 g of carbon-12. This number, called **Avogadro's number** (in honor of the 19th-century Italian physicist Amedeo Avogadro), is enormous: ↗

One mole (1 mol) contains 6.022×10^{23} entities (to four significant figures) **(3.1)**

A counting unit, like *dozen*, tells you the number of objects but not their mass; a mass unit, like *kilogram*, tells you the mass of the objects but not their number. The mole tells you both—the *number* of objects in a given *mass* of substance:

1 mol of carbon-12 contains 6.022×10^{23} carbon-12 atoms and has a mass of 12 g

What does it mean that the mole unit allows you to count entities by weighing the sample? Suppose you have a sample of carbon-12 and want to know the number of atoms present. You find that the sample weighs 6 g, so it is 0.5 mol of carbon-12 and contains $0.5(6.022 \times 10^{23})$, or 3.011×10^{23} atoms:

6 g of carbon-12 is 0.5 mol of carbon-12 and contains 3.011×10^{23} atoms

Knowing the amount (in moles), the mass (in grams), and the number of entities becomes very important when we mix different substances to run a reaction. The central relationship between masses on the atomic scale and on the macroscopic scale is the same for elements and compounds:

- **Elements.** The mass in *atomic mass units (amu)* of one atom of an element is the *same numerically* as the mass in *grams (g)* of 1 mole of atoms of the element. Recall from Chapter 2 that each atom of an element is considered to have the *atomic mass* given in the periodic table. Thus,

1 atom of S has a mass of 32.06 amu and 1 mol (6.022×10^{23} atoms) of S has a mass of 32.06 g
1 atom of Fe has a mass of 55.85 amu and 1 mol (6.022×10^{23} atoms) of Fe has a mass of 55.85 g

Note, also, that since atomic masses are relative, 1 Fe atom weighs $55.85/32.06$ as much as 1 S atom, and 1 mol of Fe weighs $55.85/32.06$ as much as 1 mol of S.

- **Compounds.** The mass in *atomic mass units (amu)* of one molecule (or formula unit) of a compound is the *same numerically* as the mass in *grams (g)* of 1 mole of the compound. Thus, for example,

1 molecule of H_2O has a mass of 18.02 amu and 1 mol (6.022×10^{23} molecules) of H_2O has a mass of 18.02 g
1 formula unit of NaCl has a mass of 58.44 amu and 1 mol (6.022×10^{23} formula units) of NaCl has a mass of 58.44 g

Here, too, because masses are relative, 1 H_2O molecule weighs $18.02/58.44$ as much as 1 NaCl formula unit, and 1 mol of H_2O weighs $18.02/58.44$ as much as 1 mol of NaCl.

The two key points to remember about the importance of the mole unit are

- The *mole* lets us relate the *number* of entities to the *mass* of a sample of those entities.
- The mole maintains the *same numerical relationship* between mass on the atomic scale (atomic mass units, amu) and mass on the macroscopic scale (grams, g).

In everyday terms, a grocer *does not* know that there are 1 dozen eggs from their weight or that there is 1 kilogram of coffee beans from their count, because eggs and coffee beans do not have fixed masses. But, by weighing out 63.55 g (1 mol) of copper, a chemist *does* know that there are 6.022×10^{23} copper atoms, because all copper atoms have an atomic mass of 63.55 amu. Figure 3.1 shows 1 mole of some familiar elements and compounds.

Determining Molar Mass

The **molar mass (M)** of a substance is the mass of a mole of its entities (atoms, molecules, or formula units) and has units of grams per mole (g/mol). The periodic table is indispensable for calculating molar mass:

1. *Elements.* To find the molar mass, look up the atomic mass and note whether the element is monatomic or molecular.

- *Monatomic elements.* The molar mass of a monatomic element is the periodic table value in grams per mole.* For example, the molar mass of neon is 20.18 g/mol, and the molar mass of gold is 197.0 g/mol.
- *Molecular elements.* You must know the formula of a molecular element to determine the molar mass (see Figure 2.15). For example, in air, oxygen exists most commonly as diatomic molecules, so the molar mass of O₂ is twice that of O:

$$\text{Molar mass } (\mathcal{M}) \text{ of O}_2 = 2 \times \mathcal{M} \text{ of O} = 2 \times 16.00 \text{ g/mol} = 32.00 \text{ g/mol}$$

The most common form of sulfur exists as octatomic molecules, S₈:

$$\mathcal{M} \text{ of S}_8 = 8 \times \mathcal{M} \text{ of S} = 8 \times 32.06 \text{ g/mol} = 256.5 \text{ g/mol}$$

2. *Compounds.* The molar mass of a compound is the sum of the molar masses of the atoms in the formula. Thus, from the formula of sulfur dioxide, SO₂, we know that 1 mol of SO₂ molecules contains 1 mol of S atoms and 2 mol of O atoms:

$$\mathcal{M} \text{ of SO}_2 = \mathcal{M} \text{ of S} + (2 \times \mathcal{M} \text{ of O}) = 32.06 \text{ g/mol} + (2 \times 16.00 \text{ g/mol}) = 64.06 \text{ g/mol}$$

Similarly, for ionic compounds, such as potassium sulfide (K₂S), we have

$$\mathcal{M} \text{ of K}_2\text{S} = (2 \times \mathcal{M} \text{ of K}) + \mathcal{M} \text{ of S} = (2 \times 39.10 \text{ g/mol}) + 32.06 \text{ g/mol} = 110.26 \text{ g/mol}$$

Thus, subscripts in a formula refer to individual atoms (or ions) as well as to moles of atoms (or ions). Table 3.1 summarizes these ideas for glucose, C₆H₁₂O₆, the essential sugar in energy metabolism.

Glucose

Table 3.1**Information Contained in the Chemical Formula of Glucose, C₆H₁₂O₆ (M = 180.16 g/mol)**

	Carbon (C)	Hydrogen (H)	Oxygen (O)
Atoms/molecule of compound	6 atoms	12 atoms	6 atoms
Moles of atoms/mole of compound	6 mol of atoms	12 mol of atoms	6 mol of atoms
Atoms/mole of compound	6(6.022×10 ²³) atoms	12(6.022×10 ²³) atoms	6(6.022×10 ²³) atoms
Mass/molecule of compound	6(12.01 amu) = 72.06 amu	12(1.008 amu) = 12.10 amu	6(16.00 amu) = 96.00 amu
Mass/mole of compound	72.06 g	12.10 g	96.00 g

Converting Between Amount, Mass, and Number of Chemical Entities

One of the most common skills in the lab—and on exams—is converting between amount (mol), mass (g), and number of entities of a substance.

1. *Converting between amount and mass.* If you know the amount of a substance, you can find its mass, and vice versa. The molar mass (\mathcal{M}), which expresses the equivalence between 1 mole of a substance and its mass in grams, is the conversion factor between amount and mass:

$$\frac{\text{no. of grams}}{1 \text{ mol}} \quad \text{or} \quad \frac{1 \text{ mol}}{\text{no. of grams}}$$

- From amount (mol) to mass (g), multiply by the molar mass to cancel the mole unit:

$$\text{Mass (g)} = \text{amount (mol)} \times \frac{\text{no. of grams}}{1 \text{ mol}} \quad (3.2)$$

*The mass value in the periodic table has no units because it is a *relative* atomic mass, given by the atomic mass (in amu) divided by 1 amu ($\frac{1}{12}$ mass of one ¹²C atom in amu):

$$\text{Relative atomic mass} = \frac{\text{atomic mass (amu)}}{\frac{1}{12} \text{ mass of } {}^{12}\text{C (amu)}}$$

Therefore, you use the same number (with different units) for the atomic mass and for the molar mass.

- From mass (g) to amount (mol), divide by the molar mass (multiply by $1/\mathcal{M}$) to cancel the mass unit:

$$\text{Amount (mol)} = \text{mass (g)} \times \frac{1 \text{ mol}}{\text{no. of grams}} \quad (3.3)$$

2. *Converting between amount and number.* Similarly, if you know the amount (mol), you can find the number of entities, and vice versa. Avogadro's number, which expresses the equivalence between 1 mole of a substance and the number of entities it contains, is the conversion factor between amount and number of entities:

$$\frac{6.022 \times 10^{23} \text{ entities}}{1 \text{ mol}} \quad \text{or} \quad \frac{1 \text{ mol}}{6.022 \times 10^{23} \text{ entities}}$$

- From amount (mol) to number of entities, multiply by Avogadro's number to cancel the mole unit:

$$\text{No. of entities} = \text{amount (mol)} \times \frac{6.022 \times 10^{23} \text{ entities}}{1 \text{ mol}} \quad (3.4)$$

- From number of entities to amount (mol), divide by Avogadro's number to cancel the number of entities:

$$\text{Amount (mol)} = \text{no. of entities} \times \frac{1 \text{ mol}}{6.022 \times 10^{23} \text{ entities}} \quad (3.5)$$

Figure 3.2 Mass-mole-number relationships for elements.

Amount-Mass-Number Conversions Involving Elements We begin with amount-mass-number relationships of elements. As Figure 3.2 shows, convert mass or number of entities (atoms or molecules) to amount (mol) first. For molecular elements, Avogadro's number gives molecules per mole.

Let's work through several sample problems that show these conversions for some elements.

SAMPLE PROBLEM 3.1

Converting Between Mass and Amount of an Element

Problem Silver (Ag) is used in jewelry and tableware but no longer in U.S. coins. How many grams of Ag are in 0.0342 mol of Ag?

Plan We know the amount of Ag (0.0342 mol) and have to find the mass (g). To convert units of *moles* of Ag to *grams* of Ag, we multiply by the *molar mass* of Ag, which we find in the periodic table (see the road map).

Solution Converting from amount (mol) of Ag to mass (g):

$$\text{Mass (g) of Ag} = 0.0342 \text{ mol Ag} \times \frac{107.9 \text{ g Ag}}{1 \text{ mol Ag}} = 3.69 \text{ g Ag}$$

Check We rounded the mass to three significant figures because the amount (in mol) has three. The units are correct. About $0.03 \text{ mol} \times 100 \text{ g/mol}$ gives 3 g; the small mass makes sense because 0.0342 is a small fraction of a mole.

FOLLOW-UP PROBLEMS

Brief Solutions for all Follow-up Problems appear at the end of the chapter.

3.1A Graphite is the crystalline form of carbon used in “lead” pencils. How many moles of carbon are in 315 mg of graphite? Include a road map that shows how you planned the solution.

3.1B A soda can contains about 14 g of aluminum (Al), the most abundant element in Earth's crust. How many soda cans can be made from 52 mol of Al? Include a road map that shows how you planned the solution.

SOME SIMILAR PROBLEMS 3.12(a) and 3.13(a)

SAMPLE PROBLEM 3.2**Converting Between Number of Entities and Amount of an Element**

Problem Gallium (Ga) is a key element in solar panels, calculators, and other light-sensitive electronic devices. How many Ga atoms are in 2.85×10^{-3} mol of gallium?

Plan We know the amount of gallium (2.85×10^{-3} mol) and need the number of Ga atoms. We multiply amount (mol) by Avogadro's number to find number of atoms (see the road map).

Solution Converting from amount (mol) of Ga to number of atoms:

$$\text{No. of Ga atoms} = 2.85 \times 10^{-3} \text{ mol Ga} \times \frac{6.022 \times 10^{23} \text{ Ga atoms}}{1 \text{ mol Ga}}$$

$$= 1.72 \times 10^{21} \text{ Ga atoms}$$

Check The number of atoms has three significant figures because the number of moles does. When we round amount (mol) of Ga and Avogadro's number, we have $\sim(3 \times 10^{-3} \text{ mol})(6 \times 10^{23} \text{ atoms/mol}) = 18 \times 10^{20}$, or 1.8×10^{21} atoms, so our answer seems correct.

FOLLOW-UP PROBLEMS

3.2A At rest, a person inhales 9.72×10^{21} nitrogen molecules in an average breath of air. How many moles of nitrogen atoms are inhaled? (Hint: In air, nitrogen occurs as a diatomic molecule.) Include a road map that shows how you planned the solution.

3.2B A tank contains 325 mol of compressed helium (He) gas. How many He atoms are in the tank? Include a road map that shows how you planned the solution.

SOME SIMILAR PROBLEMS 3.12(b) and 3.13(b)

For the next sample problem, note that mass and number of entities relate directly to amount (mol), but *not* to each other. Therefore, *to convert between mass and number, first convert to amount*.

SAMPLE PROBLEM 3.3**Converting Between Number of Entities and Mass of an Element**

Problem Iron (Fe) is the main component of steel and, thus, the most important metal in industrial society; it is also essential in the human body. How many Fe atoms are in 95.8 g of Fe?

Plan We know the mass of Fe (95.8 g) and need the number of Fe atoms. We cannot convert directly from mass to number of atoms, so we first convert to amount (mol) by dividing the mass of Fe by its molar mass. Then, we multiply amount (mol) by Avogadro's number to find number of atoms (see the road map).

Solution Converting from mass (g) of Fe to amount (mol):

$$\text{Amount (mol) of Fe} = 95.8 \text{ g Fe} \times \frac{1 \text{ mol Fe}}{55.85 \text{ g Fe}} = 1.72 \text{ mol Fe}$$

Converting from amount (mol) of Fe to number of Fe atoms:

$$\text{No. of Fe atoms} = 1.72 \text{ mol Fe} \times \frac{6.022 \times 10^{23} \text{ atoms Fe}}{1 \text{ mol Fe}}$$

$$= 1.04 \times 10^{24} \text{ atoms Fe}$$

Check Rounding the mass and the molar mass of Fe, we have $\sim 100 \text{ g} / (\sim 60 \text{ g/mol}) = 1.7 \text{ mol}$. Therefore, the number of atoms should be a bit less than twice Avogadro's number: $< 2(6 \times 10^{23}) = < 1.2 \times 10^{24}$, so the answer seems correct.

Comment The two steps can be combined into one:

$$\text{Amount (mol) of Fe} = 95.8 \text{ g Fe} \times \frac{1 \text{ mol Fe}}{55.85 \text{ g Fe}} \times \frac{6.022 \times 10^{23} \text{ atoms Fe}}{1 \text{ mol Fe}} = 1.04 \times 10^{24} \text{ atoms Fe}$$

Road Map

Amount (mol) of Ga

multiply by Avogadro's number
(1 mol Ga = 6.022×10^{23} Ga atoms)

Number of Ga atoms

Road Map

Mass (g) of Fe

divide by M of Fe
(55.85 g Fe = 1 mol Fe)

Amount (mol) of Fe

multiply by Avogadro's number
(1 mol Fe = 6.022×10^{23} Fe atoms)

Number of Fe atoms

FOLLOW-UP PROBLEMS

3.3A Manganese (Mn) is a transition element essential for the growth of bones. What is the mass in grams of 3.22×10^{20} Mn atoms, the number found in 1 kg of bone? Include a road map that shows how you planned the solution.

3.3B Pennies minted after 1982 are made of zinc plated with a thin coating of copper (Cu); the copper layer on each penny has a mass of 0.0625 g. How many Cu atoms are in a penny? Include a road map that shows how you planned the solution.

SOME SIMILAR PROBLEMS 3.12(c) and 3.13(c)

Amount-Mass-Number Conversions Involving Compounds Only one new step is needed to solve amount-mass-number problems involving compounds: we need the chemical formula to find the molar mass and the amount of each element in the compound. The relationships are shown in Figure 3.3, and Sample Problems 3.4 and 3.5 apply them to compounds with simple and more complicated formulas, respectively.

Figure 3.3 Amount-mass-number relationships for compounds. Use the chemical formula to find the amount (mol) of each element in a compound.

Road Map

Mass (g) of NO_2

divide by M (g/mol)
($46.01 \text{ g NO}_2 = 1 \text{ mol NO}_2$)

Amount (mol) of NO_2

multiply by Avogadro's number
($1 \text{ mol NO}_2 = 6.022 \times 10^{23}$
 NO_2 molecules)

Number of molecules of NO_2

SAMPLE PROBLEM 3.4

Converting Between Number of Entities and Mass of a Compound I

Problem Nitrogen dioxide is a component of urban smog that forms from gases in car exhaust. How many molecules are in 8.92 g of nitrogen dioxide?

Plan We know the mass of compound (8.92 g) and need to find the number of molecules. As you just saw in Sample Problem 3.3, to convert mass to number of entities, we have to find the amount (mol). To do so, we divide the mass by the molar mass (M), which we calculate from the molecular formula (see Sample Problem 2.16). Once we have the amount (mol), we multiply by Avogadro's number to find the number of molecules (see the road map).

Solution The formula is NO_2 . Calculating the molar mass:

$$\begin{aligned} M &= (1 \times M \text{ of N}) + (2 \times M \text{ of O}) \\ &= 14.01 \text{ g/mol} + (2 \times 16.00 \text{ g/mol}) \\ &= 46.01 \text{ g/mol} \end{aligned}$$

Converting from mass (g) of NO_2 to amount (mol):

$$\begin{aligned}\text{Amount (mol) of } \text{NO}_2 &= 8.92 \text{ g } \text{NO}_2 \times \frac{1 \text{ mol } \text{NO}_2}{46.01 \text{ g } \text{NO}_2} \\ &= 0.194 \text{ mol } \text{NO}_2\end{aligned}$$

Converting from amount (mol) of NO_2 to number of molecules:

$$\begin{aligned}\text{No. of molecules} &= 0.194 \text{ mol } \text{NO}_2 \times \frac{6.022 \times 10^{23} \text{ NO}_2 \text{ molecules}}{1 \text{ mol } \text{NO}_2} \\ &= 1.17 \times 10^{23} \text{ NO}_2 \text{ molecules}\end{aligned}$$

Check Rounding, we get $(\sim 0.2 \text{ mol})(6 \times 10^{23}) = 1.2 \times 10^{23}$, so the answer seems correct.

FOLLOW-UP PROBLEMS

3.4A Fluoride ion is added to drinking water to prevent tooth decay. What is the mass (g) of sodium fluoride in a liter of water that contains 1.19×10^{19} formula units of the compound? Include a road map that shows how you planned the solution.

3.4B Calcium chloride is applied to highways in winter to melt accumulated ice. A snow-plow truck applies 400 lb of CaCl_2 per mile of highway. How many formula units of the compound are applied per mile? Include a road map that shows how you planned the solution.

SOME SIMILAR PROBLEMS 3.14–3.19

SAMPLE PROBLEM 3.5

Converting Between Number of Entities and Mass of a Compound II

Problem Ammonium carbonate is a white solid that decomposes with warming. It has many uses, for example, as a component in baking powder, fire extinguishers, and smelling salts.

- (a) How many formula units are in 41.6 g of ammonium carbonate?
- (b) How many O atoms are in this sample?

Plan (a) We know the mass of compound (41.6 g) and need to find the number of formula units. As in Sample Problem 3.4, we find the amount (mol) and then multiply by Avogadro's number to find the number of formula units. (A road map for this step would be the same as the one in Sample Problem 3.4.) (b) To find the number of O atoms, we multiply the number of formula units by the number of O atoms in one formula unit (see the road map).

Solution (a) The formula is $(\text{NH}_4)_2\text{CO}_3$ (see Table 2.5). Calculating the molar mass:

$$\begin{aligned}M &= (2 \times M \text{ of N}) + (8 \times M \text{ of H}) + (1 \times M \text{ of C}) + (3 \times M \text{ of O}) \\ &= (2 \times 14.01 \text{ g/mol N}) + (8 \times 1.008 \text{ g/mol H}) + 12.01 \text{ g/mol C} + (3 \times 16.00 \text{ g/mol O}) \\ &= 96.09 \text{ g/mol } (\text{NH}_4)_2\text{CO}_3\end{aligned}$$

Converting from mass (g) to amount (mol):

$$\begin{aligned}\text{Amount (mol) of } (\text{NH}_4)_2\text{CO}_3 &= 41.6 \text{ g } (\text{NH}_4)_2\text{CO}_3 \times \frac{1 \text{ mol } (\text{NH}_4)_2\text{CO}_3}{96.09 \text{ g } (\text{NH}_4)_2\text{CO}_3} \\ &= 0.433 \text{ mol } (\text{NH}_4)_2\text{CO}_3\end{aligned}$$

Converting from amount (mol) to formula units:

$$\begin{aligned}\text{Formula units of } (\text{NH}_4)_2\text{CO}_3 &= 0.433 \text{ mol } (\text{NH}_4)_2\text{CO}_3 \\ &\quad \times \frac{6.022 \times 10^{23} \text{ formula units } (\text{NH}_4)_2\text{CO}_3}{1 \text{ mol } (\text{NH}_4)_2\text{CO}_3} \\ &= 2.61 \times 10^{23} \text{ formula units } (\text{NH}_4)_2\text{CO}_3\end{aligned}$$

- (b) Finding the number of O atoms:

$$\begin{aligned}\text{No. of O atoms} &= 2.61 \times 10^{23} \text{ formula units } (\text{NH}_4)_2\text{CO}_3 \times \frac{3 \text{ O atoms}}{1 \text{ formula unit } (\text{NH}_4)_2\text{CO}_3} \\ &= 7.83 \times 10^{23} \text{ O atoms}\end{aligned}$$

Road Map

Number of formula units of $(\text{NH}_4)_2\text{CO}_3$

multiply by number of O atoms in one formula unit
[1 formula unit of $(\text{NH}_4)_2\text{CO}_3$ = 3 O atoms]

Number of O atoms

Check In (a), the units are correct. Since the mass is less than half the molar mass ($\sim 42/96 < 0.5$), the number of formula units should be less than half Avogadro's number ($\sim 2.6 \times 10^{23}/6.0 \times 10^{23} < 0.5$).

Comment A common mistake is to forget the subscript 2 outside the parentheses in $(\text{NH}_4)_2\text{CO}_3$, which would give a much lower molar mass.

FOLLOW-UP PROBLEMS

3.5A Tetraphosphorus decoxide reacts with water to form phosphoric acid, a major industrial acid. In the laboratory, the oxide is a drying agent.

(a) What is the mass (g) of 4.65×10^{22} molecules of tetraphosphorus decoxide?

(b) How many P atoms are present in this sample?

3.5B Calcium phosphate is added to some foods, such as yogurt, to boost the calcium content and is also used as an anticaking agent.

(a) How many formula units are in 75.5 g of calcium phosphate?

(b) How many phosphate ions are present in this sample?

SOME SIMILAR PROBLEMS 3.14–3.19

Student Hot Spot

Student data indicate that you may struggle with converting between mass, moles, and number of entities. Access the Smartbook to view additional Learning Resources on this topic.

The Importance of Mass Percent

For many purposes, it is important to know how much of an element is present in a given amount of compound. A biochemist may want the ionic composition of a mineral nutrient; an atmospheric chemist may be studying the carbon content of a fuel; a materials scientist may want the metalloid composition of a semiconductor. In this section, we find the composition of a compound in terms of mass percent and use it to find the mass of each element in the compound.

Determining Mass Percent from a Chemical Formula Each element contributes a fraction of a compound's mass, and that fraction multiplied by 100 gives the element's mass percent. Finding the mass percent is similar on the molecular and molar scales:

- For a molecule (or formula unit) of compound, use the molecular (or formula) mass and chemical formula to find the mass percent of any element X in the compound:

$$\text{Mass \% of element X} = \frac{\text{atoms of X in formula} \times \text{atomic mass of X (amu)}}{\text{molecular (or formula) mass of compound (amu)}} \times 100$$

- For a mole of compound, use the molar mass and formula to find the mass percent of each element on a mole basis:

$$\text{Mass \% of element X} = \frac{\text{moles of X in formula} \times \text{molar mass of X (g/mol)}}{\text{mass (g) of 1 mol of compound}} \times 100 \quad (3.6)$$

Road Map

Amount (mol) of element X in 1 mol of ammonium nitrate

multiply by M (g/mol) of X

Mass (g) of X in 1 mol of ammonium nitrate

divide by mass (g) of 1 mol of compound

Mass fraction of X in ammonium nitrate

multiply by 100

Mass % of X in ammonium nitrate

SAMPLE PROBLEM 3.6

Calculating the Mass Percent of Each Element in a Compound from the Formula

Problem The effectiveness of fertilizers depends on their nitrogen content. Ammonium nitrate is a common fertilizer. What is the mass percent of each element in ammonium nitrate?

Plan We know the relative amounts (mol) of the elements from the formula, and we have to find the mass % of each element. We multiply the amount of each element by its molar mass to find its mass. Dividing each element's mass by the mass of 1 mol of ammonium nitrate gives the mass fraction of that element, and multiplying the mass fraction by 100 gives the mass %. The calculation steps for any element (X) are shown in the road map.

Solution The formula is NH_4NO_3 (see Table 2.5). In 1 mol of NH_4NO_3 , there are 2 mol of N, 4 mol of H, and 3 mol of O.

Converting amount (mol) of N to mass (g): We have 2 mol of N in 1 mol of NH_4NO_3 , so

$$\text{Mass (g) of N} = 2 \text{ mol N} \times \frac{14.01 \text{ g N}}{1 \text{ mol N}} = 28.02 \text{ g N}$$

Calculating the mass of 1 mol of NH_4NO_3 :

$$\begin{aligned}\mathcal{M} &= (2 \times \mathcal{M} \text{ of N}) + (4 \times \mathcal{M} \text{ of H}) + (3 \times \mathcal{M} \text{ of O}) \\ &= (2 \times 14.01 \text{ g/mol N}) + (4 \times 1.008 \text{ g/mol H}) + (3 \times 16.00 \text{ g/mol O}) \\ &= 80.05 \text{ g/mol } \text{NH}_4\text{NO}_3\end{aligned}$$

Finding the mass fraction of N in NH_4NO_3 :

$$\text{Mass fraction of N} = \frac{\text{total mass of N}}{\text{mass of 1 mol } \text{NH}_4\text{NO}_3} = \frac{28.02 \text{ g N}}{80.05 \text{ g } \text{NH}_4\text{NO}_3} = 0.3500$$

Changing to mass %:

$$\begin{aligned}\text{Mass \% of N} &= \text{mass fraction of N} \times 100 = 0.3500 \times 100 \\ &= 35.00 \text{ mass \% N}\end{aligned}$$

Combining the steps for each of the other elements in NH_4NO_3 :

$$\begin{aligned}\text{Mass \% of H} &= \frac{\text{mol H} \times \mathcal{M} \text{ of H}}{\text{mass of 1 mol } \text{NH}_4\text{NO}_3} \times 100 = \frac{4 \text{ mol H} \times \frac{1.008 \text{ g H}}{1 \text{ mol H}}}{80.05 \text{ g } \text{NH}_4\text{NO}_3} \times 100 \\ &= 5.037 \text{ mass \% H}\end{aligned}$$

$$\begin{aligned}\text{Mass \% of O} &= \frac{\text{mol O} \times \mathcal{M} \text{ of O}}{\text{mass of 1 mol } \text{NH}_4\text{NO}_3} \times 100 = \frac{3 \text{ mol O} \times \frac{16.00 \text{ g O}}{1 \text{ mol O}}}{80.05 \text{ g } \text{NH}_4\text{NO}_3} \times 100 \\ &= 59.96 \text{ mass \% O}\end{aligned}$$

Check The answers make sense. The mass % of O is greater than that of N because there are more moles of O in the compound and the molar mass of O is greater. The mass % of H is small because its molar mass is small. The sum of the mass percents is 100.00%.

Comment From here on, you should be able to determine the molar mass of a compound, so that calculation will no longer be shown.

FOLLOW-UP PROBLEMS

3.6A In mammals, lactose (milk sugar) is metabolized to glucose ($\text{C}_6\text{H}_{12}\text{O}_6$), the key nutrient for generating chemical potential energy. Calculate the mass percent of C in glucose.

3.6B For many years, compounds known as *chlorofluorocarbons* were used as refrigerants, until it was discovered that the chlorine atoms in these compounds destroy ozone molecules in the atmosphere. The compound CCl_3F is a chlorofluorocarbon with a high chlorine content. Calculate the mass percent of Cl in CCl_3F .

SOME SIMILAR PROBLEMS 3.20–3.23

Determining the Mass of an Element from Its Mass Fraction Sample Problem 3.6 shows that *an element always constitutes the same fraction of the mass of a given compound* (see Equation 3.6). We can use that fraction to find the mass of element in any mass of a compound:

$$\text{Mass of element} = \text{mass of compound} \times \frac{\text{mass of element in 1 mol of compound}}{\text{mass of 1 mol of compound}} \quad (3.7)$$

For example, to find the mass of oxygen in 15.5 g of nitrogen dioxide, we have

$$\text{Mass (g) of O} = 15.5 \text{ g NO}_2 \times \frac{2 \text{ mol} \times \mathcal{M} \text{ of O (g/mol)}}{\text{mass (g) of 1 mol NO}_2}$$

$$= 15.5 \text{ g NO}_2 \times \frac{32.00 \text{ g O}}{46.01 \text{ g NO}_2} = 10.8 \text{ g O}$$

SAMPLE PROBLEM 3.7

Calculating the Mass of an Element in a Compound

Problem Use the information in Sample Problem 3.6 to determine the mass (g) of nitrogen in 650. g of ammonium nitrate.

Plan To find the mass of N in the sample of ammonium nitrate, we multiply the mass of the sample by the mass of 2 mol of N divided by the mass of 1 mol of ammonium nitrate.

Solution Finding the mass of N in a given mass of ammonium nitrate:

$$\text{Mass (g) of N} = \text{mass (g) of NH}_4\text{NO}_3 \times \frac{2 \text{ mol N} \times \mathcal{M} \text{ of N (g/mol)}}{\text{mass (g) of 1 mol NH}_4\text{NO}_3}$$

$$= 650. \text{ g NH}_4\text{NO}_3 \times \frac{28.02 \text{ g N}}{80.05 \text{ g NH}_4\text{NO}_3} = 228 \text{ g N}$$

Check Rounding shows that the answer is “in the right ballpark”: N accounts for about one-third of the mass of NH₄NO₃ and $\frac{1}{3}$ of 700 g is 233 g.

FOLLOW-UP PROBLEMS

3.7A Use the information in Follow-up Problem 3.6A to find the mass (g) of C in 16.55 g of glucose.

3.7B Use the information in Follow-up Problem 3.6B to find the mass (g) of Cl in 112 g of CCl₃F.

SOME SIMILAR PROBLEMS 3.27 and 3.28

› Summary of Section 3.1

- › A mole of substance is the amount that contains Avogadro’s number (6.022×10^{23}) of chemical entities (atoms, ions, molecules, or formula units).
- › The mass (in grams) of a mole of a given entity (atom, ion, molecule, or formula unit) has the same numerical value as the mass (in amu) of the entity. Thus, the mole allows us to count entities by weighing them.
- › Using the molar mass (\mathcal{M} , g/mol) of an element (or compound) and Avogadro’s number as conversion factors, we can convert among amount (mol), mass (g), and number of entities.
- › The mass fraction of element X in a compound is used to find the mass of X in a given amount of the compound.

3.2

DETERMINING THE FORMULA OF AN UNKNOWN COMPOUND

In Sample Problems 3.6 and 3.7, we used a compound’s formula to find the mass percent (or mass fraction) of each element in it *and* the mass of each element in any size sample of it. In this section, we do the reverse: we use the masses of elements in a compound to find the formula. Then, we look briefly at the relationship between molecular formula and molecular structure.

Let’s compare three common types of formula, using hydrogen peroxide as an example:

- The **empirical formula** is derived from mass analysis. It shows the *lowest* whole number of moles, and thus the *relative* number of atoms, of each element in the compound. For example, in hydrogen peroxide, there is 1 part by mass of hydrogen

for every 16 parts by mass of oxygen. Because the atomic mass of hydrogen is 1.008 amu and that of oxygen is 16.00 amu, there is one H atom for every O atom (a 1/1 H/O atom ratio). Thus, the empirical formula is HO.

Recall from Section 2.8 that

- The **molecular formula** shows the *actual* number of atoms of each element in a molecule: the molecular formula of hydrogen peroxide is H_2O_2 , twice the empirical formula. Notice that the molecular formula exhibits the same 1/1 H/O atom ratio as in the empirical formula.
- The **structural formula** also shows the relative *placement and connections of atoms* in the molecule: the structural formula of hydrogen peroxide is H—O—O—H.

Let's focus on how to determine empirical and molecular formulas.

Empirical Formulas

A chemist studying an unknown compound goes through a three-step process to find the empirical formula:

- Determine the mass (g) of each component element.
 - Convert each mass (g) to amount (mol), and write a preliminary formula.
 - Convert the amounts (mol) mathematically to whole-number (integer) subscripts.
- To accomplish this math conversion,
- Divide each subscript by the smallest subscript, and
 - If necessary, multiply through by the *smallest integer* that turns all subscripts into integers.

Sample Problem 3.8 demonstrates these steps.

SAMPLE PROBLEM 3.8

Determining an Empirical Formula from Amounts of Elements

Problem A sample of an unknown compound contains 0.21 mol of zinc, 0.14 mol of phosphorus, and 0.56 mol of oxygen. What is the empirical formula?

Plan We are given the amount (mol) of each element as a fraction. We use these fractional amounts directly in a preliminary formula as subscripts of the element symbols. Then, we convert the fractions to whole numbers.

Solution Using the fractions to write a preliminary formula, with the symbols Zn for zinc, P for phosphorus, and O for oxygen:

Converting the fractions to whole numbers:

- Divide each subscript by the smallest one, which in this case is 0.14:

- Multiply through by the *smallest integer* that turns all subscripts into integers. We multiply by 2 because that makes 1.5 (the subscript for Zn) into an integer:

Check The integer subscripts must be the smallest integers with the same ratio as the original fractional numbers of moles: 3/2/8 is *the same ratio* as 0.21/0.14/0.56.

Comment A more conventional way to write this formula is $\text{Zn}_3(\text{PO}_4)_2$; this compound is zinc phosphate, formerly used widely as a dental cement.

FOLLOW-UP PROBLEMS

3.8A A sample of a white solid contains 0.170 mol of boron and 0.255 mol of oxygen. What is the empirical formula?

3.8B A sample of an unknown compound contains 6.80 mol of carbon and 18.1 mol of hydrogen. What is the empirical formula?

SOME SIMILAR PROBLEMS 3.42(a), 3.43(a), and 3.50

Road Map

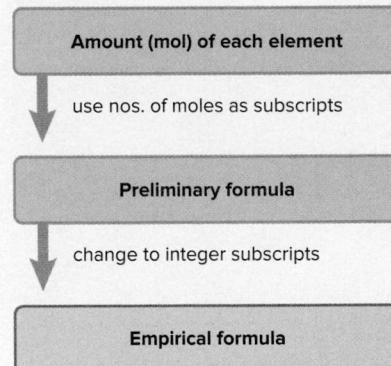

Sample Problems 3.9–3.11 show how other types of compositional data are used to determine chemical formulas.

SAMPLE PROBLEM 3.9
Determining an Empirical Formula from Masses of Elements

Problem Analysis of a sample of an ionic compound yields 2.82 g of Na, 4.35 g of Cl, and 7.83 g of O. What are the empirical formula and the name of the compound?

Plan This problem is similar to Sample Problem 3.8, except that we are given element *masses* that we must convert into integer subscripts. We first divide each mass by the element's molar mass to find the amount (mol). Then we construct a preliminary formula and convert the amounts (mol) to integers.

Solution Finding amount (mol) of each element:

$$\text{Amount (mol) of Na} = 2.82 \text{ g Na} \times \frac{1 \text{ mol Na}}{22.99 \text{ g Na}} = 0.123 \text{ mol Na}$$

$$\text{Amount (mol) of Cl} = 4.35 \text{ g Cl} \times \frac{1 \text{ mol Cl}}{35.45 \text{ g Cl}} = 0.123 \text{ mol Cl}$$

$$\text{Amount (mol) of O} = 7.83 \text{ g O} \times \frac{1 \text{ mol O}}{16.00 \text{ g O}} = 0.489 \text{ mol O}$$

Constructing a preliminary formula: $\text{Na}_{0.123}\text{Cl}_{0.123}\text{O}_{0.489}$

Converting to integer subscripts (dividing all by the smallest subscript):

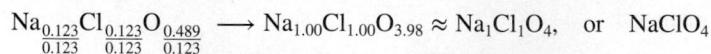

The empirical formula is NaClO_4 ; the name is sodium perchlorate.

Check The numbers of moles seem correct because the masses of Na and Cl are slightly more than 0.1 of their molar masses. The mass of O is greatest and its molar mass is smallest, so it should have the greatest number of moles. The ratio of subscripts, 1/1/4, is the same as the ratio of moles, 0.123/0.123/0.489 (within rounding).

FOLLOW-UP PROBLEMS

3.9A A sample of an unknown compound is found to contain 1.23 g of H, 12.64 g of P, and 26.12 g of O. What is the empirical formula and the name of the compound?

3.9B An unknown metal M reacts with sulfur to form a compound with the formula M_2S_3 . If 3.12 g of M reacts with 2.88 g of S, what are the names of M and M_2S_3 ? [Hint: Determine the amount (mol) of S, and use the formula to find the amount (mol) of M.]

SOME SIMILAR PROBLEMS 3.42(b), 3.43(b), 3.46, and 3.47

Molecular Formulas

If we know the molar mass of a compound, we can use the empirical formula to obtain the molecular formula, which uses as subscripts the *actual* numbers of moles of each element in 1 mol of compound. For some compounds, such as water (H_2O), ammonia (NH_3), and methane (CH_4), the empirical and molecular formulas are identical, but for many others, the molecular formula is a *whole-number multiple* of the empirical formula. As you saw, hydrogen peroxide has the empirical formula HO. Dividing the molar mass of hydrogen peroxide (34.02 g/mol) by the empirical formula mass of HO (17.01 g/mol) gives the whole-number multiple:

$$\text{Whole-number multiple} = \frac{\text{molar mass (g/mol)}}{\text{empirical formula mass (g/mol)}} = \frac{34.02 \text{ g/mol}}{17.01 \text{ g/mol}} = 2.000 = 2$$

Multiplying the empirical formula subscripts by 2 gives the molecular formula:

Since the molar mass of hydrogen peroxide is twice as large as the empirical formula mass, the molecular formula has twice the number of atoms as the empirical formula.

Instead of giving compositional data as masses of each element, analytical laboratories provide mass percents. We use this kind of data as follows:

1. Assume 100.0 g of compound to express each mass percent directly as a mass (g).
2. Convert each mass (g) to amount (mol).
3. Derive the empirical formula.
4. Divide the molar mass of the compound by the empirical formula mass to find the whole-number multiple and the molecular formula.

SAMPLE PROBLEM 3.10**Determining a Molecular Formula from Elemental Analysis and Molar Mass**

Problem During excessive physical activity, lactic acid ($\mathcal{M} = 90.08 \text{ g/mol}$) forms in muscle tissue and is responsible for muscle soreness. Elemental analysis shows that this compound has 40.0 mass % C, 6.71 mass % H, and 53.3 mass % O.

- (a) Determine the empirical formula of lactic acid.
 (b) Determine the molecular formula.

(a) Determining the empirical formula

Plan We know the mass % of each element and must convert each to an integer subscript. The mass of the sample of lactic acid is not given, but the mass percents are the same for any sample of it. Therefore, we assume there is 100.0 g of lactic acid and express each mass % as a number of grams. Then, we construct the empirical formula as in Sample Problem 3.9.

Solution Expressing mass % as mass (g) by assuming 100.0 g of lactic acid:

$$\text{Mass (g) of C} = \frac{40.0 \text{ parts C by mass}}{100 \text{ parts by mass}} \times 100.0 \text{ g} = 40.0 \text{ g C}$$

Similarly, we have 6.71 g of H and 53.3 g of O.

Converting from mass (g) of each element to amount (mol):

$$\text{Amount (mol) of C} = \text{mass of C} \times \frac{1}{\mathcal{M} \text{ of C}} = 40.0 \text{ g C} \times \frac{1 \text{ mol C}}{12.01 \text{ g C}} = 3.33 \text{ mol C}$$

Similarly, we have 6.66 mol of H and 3.33 mol of O.

Constructing the preliminary formula: $\text{C}_{3.33}\text{H}_{6.66}\text{O}_{3.33}$

Converting to integer subscripts by dividing each subscript by the smallest subscript:

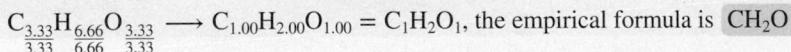

Check The numbers of moles seem correct: the masses of C and O are each slightly more than 3 times their molar masses (e.g., for C, $40 \text{ g}/(12 \text{ g/mol}) > 3 \text{ mol}$), and the mass of H is over 6 times its molar mass of 1.

(b) Determining the molecular formula

Plan The molecular formula subscripts are whole-number multiples of the empirical formula subscripts. To find this multiple, we divide the molar mass given in the problem (90.08 g/mol) by the empirical formula mass, which we find from the sum of the elements' molar masses. Then we multiply each subscript in the empirical formula by the multiple.

Solution The empirical formula mass is 30.03 g/mol. Finding the whole-number multiple:

$$\text{Whole-number multiple} = \frac{\mathcal{M} \text{ of lactic acid}}{\mathcal{M} \text{ of empirical formula}} = \frac{90.08 \text{ g/mol}}{30.03 \text{ g/mol}} = 3.000 = 3$$

Determining the molecular formula:

Check The calculated molecular formula has the same ratio of moles of elements (3/6/3) as the empirical formula (1/2/1) and corresponds to the given molar mass:

$$\begin{aligned} \mathcal{M} \text{ of lactic acid} &= (3 \times \mathcal{M} \text{ of C}) + (6 \times \mathcal{M} \text{ of H}) + (3 \times \mathcal{M} \text{ of O}) \\ &= (3 \times 12.01 \text{ g/mol}) + (6 \times 1.008 \text{ g/mol}) + (3 \times 16.00 \text{ g/mol}) \\ &= 90.08 \text{ g/mol} \end{aligned}$$

FOLLOW-UP PROBLEMS

3.10A One of the most widespread environmental carcinogens (cancer-causing agents) is benzo[a]pyrene ($M = 252.30$ g/mol). It is found in coal dust, cigarette smoke, and even charcoal-grilled meat. Analysis of this hydrocarbon shows 95.21 mass % C and 4.79 mass % H. What is the molecular formula of benzo[a]pyrene?

3.10B Caffeine ($M = 194.2$ g/mol) is a stimulant found in coffee, tea, many soft drinks, and chocolate. Elemental analysis of caffeine shows 49.47 mass % C, 5.19 mass % H, 28.86 mass % N, and 16.48 mass % O. What is the molecular formula of caffeine?

SOME SIMILAR PROBLEMS 3.44, 3.45, and 3.51

Figure 3.4 Combustion apparatus for determining formulas of organic compounds. A sample of an organic compound is burned in a stream of O_2 . The resulting H_2O is absorbed by $Mg(ClO_4)_2$, and the CO_2 is absorbed by NaOH on asbestos.

Combustion Analysis of Organic Compounds Still another type of compositional data is obtained through **combustion analysis**, a method commonly used to measure the amounts of carbon and hydrogen in a combustible organic compound. The unknown compound is burned in an excess of pure O_2 ; during the combustion, the compound's carbon and hydrogen react with the oxygen to form CO_2 and H_2O , respectively, which are absorbed in separate containers (Figure 3.4). By weighing the absorbers before and after combustion, we find the masses of CO_2 and H_2O produced and use them to find the masses of C and H in the compound; from these results, we find the empirical formula. Many organic compounds also contain oxygen, nitrogen, or a halogen. As long as the third element doesn't interfere with the absorption of H_2O and CO_2 , we calculate its mass by subtracting the masses of C and H from the original mass of the compound.

SAMPLE PROBLEM 3.11

Determining a Molecular Formula from Combustion Analysis

Problem Vitamin C ($M = 176.12$ g/mol) is a compound of C, H, and O found in many natural sources, especially citrus fruits. When a 1.000-g sample of vitamin C is burned in a combustion apparatus, the following data are obtained:

$$\text{Mass of } CO_2 \text{ absorber after combustion} = 85.35 \text{ g}$$

$$\text{Mass of } CO_2 \text{ absorber before combustion} = 83.85 \text{ g}$$

$$\text{Mass of } H_2O \text{ absorber after combustion} = 37.96 \text{ g}$$

$$\text{Mass of } H_2O \text{ absorber before combustion} = 37.55 \text{ g}$$

What is the molecular formula of vitamin C?

Plan We find the masses of CO_2 and H_2O by subtracting the mass of each absorber before the combustion from its mass after combustion. From the mass of CO_2 , we use Equation 3.7 to find the mass of C. Similarly, we find the mass of H from the mass of H_2O . The mass of vitamin C (1.000 g) minus the sum of the masses of C and H gives the mass of O, the third element present. Then, we proceed as in Sample Problem 3.10: calculate the amount (mol) of each element using its molar mass, construct the empirical formula, determine the whole-number multiple from the given molar mass, and construct the molecular formula.

Solution Finding the masses of combustion products:

$$\begin{aligned}\text{Mass (g) of CO}_2 &= \text{mass of CO}_2 \text{ absorber after} - \text{mass before} \\ &= 85.35 \text{ g} - 83.85 \text{ g} = 1.50 \text{ g CO}_2\end{aligned}$$

$$\begin{aligned}\text{Mass (g) of H}_2\text{O} &= \text{mass of H}_2\text{O absorber after} - \text{mass before} \\ &= 37.96 \text{ g} - 37.55 \text{ g} = 0.41 \text{ g H}_2\text{O}\end{aligned}$$

Calculating masses (g) of C and H using Equation 3.7:

$$\begin{aligned}\text{Mass of element} &= \text{mass of compound} \times \frac{\text{mass of element in 1 mol of compound}}{\text{mass of 1 mol of compound}} \\ \text{Mass (g) of C} &= \text{mass of CO}_2 \times \frac{1 \text{ mol C} \times \mathcal{M} \text{ of C}}{\text{mass of 1 mol CO}_2} = 1.50 \text{ g CO}_2 \times \frac{12.01 \text{ g C}}{44.01 \text{ g CO}_2} \\ &= 0.409 \text{ g C} \\ \text{Mass (g) of H} &= \text{mass of H}_2\text{O} \times \frac{2 \text{ mol H} \times \mathcal{M} \text{ of H}}{\text{mass of 1 mol H}_2\text{O}} = 0.41 \text{ g H}_2\text{O} \times \frac{2.016 \text{ g H}}{18.02 \text{ g H}_2\text{O}} \\ &= 0.046 \text{ g H}\end{aligned}$$

Calculating mass (g) of O:

$$\begin{aligned}\text{Mass (g) of O} &= \text{mass of vitamin C sample} - (\text{mass of C} + \text{mass of H}) \\ &= 1.000 \text{ g} - (0.409 \text{ g} + 0.046 \text{ g}) = 0.545 \text{ g O}\end{aligned}$$

Finding the amounts (mol) of elements: Dividing the mass (g) of each element by its molar mass gives 0.0341 mol of C, 0.046 mol of H, and 0.0341 mol of O.

Constructing the preliminary formula: $\text{C}_{0.0341}\text{H}_{0.046}\text{O}_{0.0341}$

Determining the empirical formula: Dividing through by the smallest subscript gives

We find that 3 is the smallest integer that makes all subscripts into integers:

Determining the molecular formula:

$$\begin{aligned}\text{Whole-number multiple} &= \frac{\mathcal{M} \text{ of vitamin C}}{\mathcal{M} \text{ of empirical formula}} = \frac{176.12 \text{ g/mol}}{88.06 \text{ g/mol}} = 2.000 = 2 \\ \text{C}_{(3 \times 2)}\text{H}_{(4 \times 2)}\text{O}_{(3 \times 2)} &= \text{C}_6\text{H}_8\text{O}_6\end{aligned}$$

Check The element masses seem correct: carbon makes up slightly more than 0.25 of the mass of CO_2 ($12 \text{ g}/44 \text{ g} > 0.25$), as do the masses in the problem ($0.409 \text{ g}/1.50 \text{ g} > 0.25$). Hydrogen makes up slightly more than 0.10 of the mass of H_2O ($2 \text{ g}/18 \text{ g} > 0.10$), as do the masses in the problem ($0.046 \text{ g}/0.41 \text{ g} > 0.10$). The molecular formula has the same ratio of subscripts (6/8/6) as the empirical formula (3/4/3) and the preliminary formula (0.0341/0.046/0.0341), and it gives the known molar mass:

$$\begin{aligned}(6 \times \mathcal{M} \text{ of C}) + (8 \times \mathcal{M} \text{ of H}) + (6 \times \mathcal{M} \text{ of O}) &= \mathcal{M} \text{ of vitamin C} \\ (6 \times 12.01 \text{ g/mol}) + (8 \times 1.008 \text{ g/mol}) + (6 \times 16.00 \text{ g/mol}) &= 176.12 \text{ g/mol}\end{aligned}$$

Comment The subscript we calculated for H was 3.9, which we rounded to 4. But, if we had strung the calculation steps together, we would have obtained 4.0:

$$\text{Subscript of H} = 0.41 \text{ g H}_2\text{O} \times \frac{2.016 \text{ g H}}{18.02 \text{ g H}_2\text{O}} \times \frac{1 \text{ mol H}}{1.008 \text{ g H}} \times \frac{1}{0.0341 \text{ mol}} \times 3 = 4.0$$

FOLLOW-UP PROBLEMS

3.11A A dry-cleaning solvent ($\mathcal{M} = 146.99 \text{ g/mol}$) that contains C, H, and Cl is suspected to be a cancer-causing agent. When a 0.250-g sample was studied by combustion analysis, 0.451 g of CO_2 and 0.0617 g of H_2O were formed. Find the molecular formula.

3.11B Anabolic steroids are sometimes used illegally by athletes to increase muscle strength. A forensic chemist analyzes some tablets suspected of being a popular steroid. He determines that the substance in the tablets contains only C, H, and O and has a molar mass of 300.42 g/mol. When a 1.200-g sample is studied by combustion analysis, 3.516 g of CO_2 and 1.007 g of H_2O are collected. What is the molecular formula of the substance in the tablets?

SOME SIMILAR PROBLEMS 3.48 and 3.49

Table 3.2

Some Compounds with Empirical Formula CH_2O (Composition by Mass: 40.0% C, 6.71% H, 53.3% O)

Name	Molecular Formula	Whole-Number Multiple	\mathcal{M} (g/mol)	Use or Function
Formaldehyde	CH_2O	1	30.03	Disinfectant; biological preservative
Acetic acid	$\text{C}_2\text{H}_4\text{O}_2$	2	60.05	Acetate polymers; vinegar (5% solution)
Lactic acid	$\text{C}_3\text{H}_6\text{O}_3$	3	90.08	Causes milk to sour; forms in muscles during exercise
Erythrose	$\text{C}_4\text{H}_8\text{O}_4$	4	120.10	Forms during sugar metabolism
Ribose	$\text{C}_5\text{H}_{10}\text{O}_5$	5	150.13	Component of many nucleic acids and vitamin B ₂
Glucose	$\text{C}_6\text{H}_{12}\text{O}_6$	6	180.16	Major nutrient for energy in cells

 CH_2O $\text{C}_2\text{H}_4\text{O}_2$ $\text{C}_3\text{H}_6\text{O}_3$ $\text{C}_4\text{H}_8\text{O}_4$ $\text{C}_5\text{H}_{10}\text{O}_5$ $\text{C}_6\text{H}_{12}\text{O}_6$

Chemical Formulas and Molecular Structures; Isomers

A *formula* represents a real, three-dimensional object. The structural formula makes this point, with its relative placement of atoms, but do empirical and molecular formulas contain structural information?

1. *Different compounds with the same empirical formula.* The empirical formula tells nothing about molecular structure because it is based solely on mass analysis. In fact, different compounds can have the *same* empirical formula. NO_2 and N_2O_4 are inorganic cases, and there are numerous organic ones. For example, many organic compounds have the empirical formula CH_2 (the general formula is C_nH_{2n} , with n an integer greater than or equal to 2), such as ethylene (C_2H_4) and propylene (C_3H_6), starting materials for two common plastics. Table 3.2 shows some biological compounds with the same empirical formula, CH_2O .

2. *Isomers: Different compounds with the same molecular formula.* A molecular formula also tells nothing about structure. Different compounds can have the *same* molecular formula because their atoms can bond in different arrangements to give more than one *structural formula*. **Isomers** are compounds with the same molecular formula, and thus molar mass, but different properties. *Constitutional, or structural, isomers* occur when the atoms link together in different arrangements. Table 3.3 shows

Table 3.3

Two Pairs of Constitutional Isomers

Property	C_4H_{10}		$\text{C}_2\text{H}_6\text{O}$	
	Butane	2-Methylpropane	Ethanol	Dimethyl Ether
\mathcal{M} (g/mol)	58.12	58.12	46.07	46.07
Boiling point	-0.5°C	-11.6°C	78.5°C	-25°C
Density (at 20°C)	0.00244 g/mL (gas)	0.00247 g/mL (gas)	0.789 g/mL (liquid)	0.00195 g/mL (gas)
Structural formula	<pre> H H H H H-C-C-C-C-H H H H </pre>	<pre> H H H H-C-C-C-H H H </pre>	<pre> H H H-C-C-O-H H H </pre>	<pre> H H H-C-O-C-H H H </pre>
Space-filling model				

two pairs of examples. The left pair, butane and 2-methylpropane, share the molecular formula C₄H₁₀. One has a four-C chain and the other a one-C branch off a three-C chain. Both are small alkanes, so their properties are similar, but not identical. The two compounds with the molecular formula C₂H₆O have very different properties; indeed, they are different classes of organic compound—one is an alcohol and the other an ether.

As the numbers of the different kinds of atoms increase, the number of constitutional isomers—that is, the number of structural formulas that can be written for a given molecular formula—also increases: C₂H₆O has two structural formulas (Table 3.3), C₃H₈O has three, and C₄H₁₀O seven. Imagine how many there are for C₁₆H₁₉N₃O₄S! Of all the possible isomers with this molecular formula, only one is the antibiotic ampicillin (Figure 3.5). We'll discuss constitutional and other types of isomerism fully later in the text.

› Summary of Section 3.2

- › From the masses of elements in a compound, their relative numbers of moles are found, which gives the empirical formula.
- › If the molar mass of the compound is known, the molecular formula, the actual numbers of moles of each element, can also be determined, because the molecular formula is a whole-number multiple of the empirical formula.
- › Combustion analysis provides data on the masses of carbon and hydrogen in an organic compound, which are used to obtain the formula.
- › Atoms can bond in different arrangements (structural formulas). Two or more compounds with the same molecular formula are constitutional isomers.

Figure 3.5 The antibiotic ampicillin.

3.3 WRITING AND BALANCING CHEMICAL EQUATIONS

Thinking in terms of amounts, rather than masses, allows us to view reactions as interactions among large populations of particles rather than as involving grams of material. For example, for the formation of HF from H₂ and F₂, if we weigh the substances, we find that

Macroscopic level (grams): 2.016 g of H₂ and 38.00 g of F₂ react to form 40.02 g of HF. This information tells us little except that mass is conserved. However, if we convert these masses (g) to amounts (mol), we find that

Macroscopic level (moles): 1 mol of H₂ and 1 mol of F₂ react to form 2 mol of HF. This information reveals that an enormous number of H₂ molecules react with just as many F₂ molecules to form twice as many HF molecules. Dividing by Avogadro's number gives the reaction between individual molecules:

Molecular level: 1 molecule of H₂ and 1 molecule of F₂ react to form 2 molecules of HF. Thus, the macroscopic (molar) change corresponds to the submicroscopic (molecular) change (Figure 3.6). This information forms the essence of a **chemical equation**, a

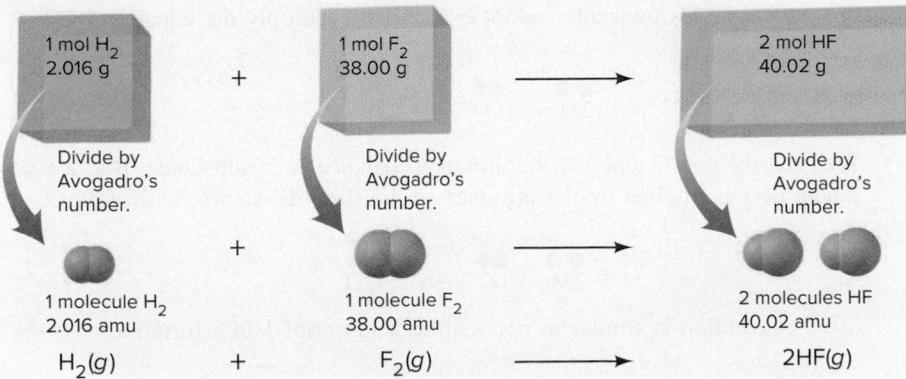

Figure 3.6 The formation of HF on the macroscopic and molecular levels and written as a balanced chemical equation.

statement that uses formulas to express the identities and quantities of substances involved in a chemical or physical change.

Steps for Balancing an Equation To present a chemical change quantitatively, an equation must be *balanced*: *the same number of each type of atom must appear on both sides*. As an example, here is a description of a chemical change that occurs in many fireworks and in a common lecture demonstration: a magnesium strip burns in oxygen gas to yield powdery magnesium oxide. (Light and heat are also produced, but we are concerned here only with substances.) Converting this description into a balanced equation involves the following steps:

1. *Translating the statement.* We first translate the chemical statement into a “skeleton” equation: the substances present *before* the change, called **reactants**, are placed to the left of a yield arrow, which points to the substances produced *during* the change, called **products**:

At the beginning of the balancing process, we put a blank *in front* of each formula to remind us that we have to account for its atoms.

2. *Balancing the atoms.* By shifting our attention back and forth, we *match the numbers of each type of atom on the left and the right of the yield arrow*. In each blank, we place a **balancing (stoichiometric) coefficient**, a numerical multiplier of *all the atoms* in the formula that follows it. In general, balancing is easiest when we
 - Start with the most complex substance, the one with the largest number of different types of atoms.
 - End with the least complex substance, such as an element by itself.
 In this case, MgO is the most complex, so we place a coefficient 1 in that blank:

To balance the Mg in MgO, we place a 1 in front of Mg on the left:

The O atom in MgO must be balanced by one O atom on the left. One-half an O₂ molecule provides one O atom:

In terms of numbers of each type of atom, the equation is balanced.

3. *Adjusting the coefficients.* There are several conventions about the final coefficients:
 - In most cases, *the smallest whole-number coefficients are preferred*. In this case, one-half of an O₂ molecule cannot exist, so we multiply the equation by 2:

- We used the coefficient 1 to remind us to balance each substance. But, a coefficient of 1 is implied by the presence of the formula, so we don't write it:

(This convention is similar to not writing a subscript 1 in a formula.)

4. *Checking.* After balancing and adjusting the coefficients, we always check that the equation is balanced:

<i>g</i>	for gas
<i>l</i>	for liquid
<i>s</i>	for solid
<i>aq</i>	for aqueous solution

5. *Specifying the states of matter.* The final equation also indicates the physical state of each substance or whether it is dissolved in water. The abbreviations used for these states are shown in the margin. From the original statement, we know that the Mg “strip” is solid, O₂ is a gas, and “powdery” MgO is also solid. The balanced equation, therefore, is

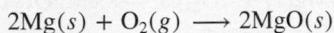

As you saw in Figure 3.6, *balancing coefficients refer to both individual chemical entities and moles of entities*. Thus,

2 atoms of Mg and 1 molecule of O₂ yield 2 formula units of MgO

2 moles of Mg and 1 mole of O₂ yield 2 moles of MgO

Figure 3.7 depicts this reaction on three levels:

- *Macroscopic level (photos)*, as it appears in the laboratory
- *Atomic level (blow-up circles)*, as chemists imagine it (with darker colored atoms representing the stoichiometry)
- *Symbolic level*, in the form of the balanced chemical equation

Keep in mind several key points about the balancing process:

- A coefficient operates on *all* the atoms in the formula that follows it:

2MgO means 2 × (MgO), or 2 Mg atoms + 2 O atoms

2Ca(NO₃)₂ means 2 × [Ca(NO₃)₂], or 2 Ca atoms + 4 N atoms + 12 O atoms

Figure 3.7 A three-level view of the reaction between magnesium and oxygen.

Source: (all): © McGraw-Hill Education/Charles Winters/Timeframe Photography, Inc.

- Chemical formulas *cannot* be altered. Thus, in step 2 of the example, we *cannot* balance the O atoms by changing MgO to MgO₂ because MgO₂ is a different compound.
- Other reactants or products *cannot* be added. Thus, we *cannot* balance the O atoms by changing the reactant from O₂ molecules to O atoms or by adding an O atom to the products. The description of the reaction mentions oxygen gas, which consists of O₂ molecules, *not* separate O atoms.
- A balanced equation remains balanced if you multiply all the coefficients by the same number. For example,

is also balanced because the coefficients have all been multiplied by 2. However, *by convention*, we balance an equation with the *smallest* whole-number coefficients.

- While atoms must be conserved in a chemical equation, each side of the equation may *not* have the same number of molecules or moles. In the reaction between magnesium and oxygen, three moles of reactants (Mg and O₂) produce only two moles of product (MgO).

SAMPLE PROBLEM 3.12

Balancing a Chemical Equation

Problem Within the cylinders of a car's engine, the hydrocarbon octane (C₈H₁₈), one of many components of gasoline, mixes with oxygen from the air and burns to form carbon dioxide and water vapor. Write a balanced equation for this reaction.

Solution

- Translate* the statement into a skeleton equation (with coefficient blanks). Octane and oxygen are reactants; "oxygen from the air" implies molecular oxygen, O₂. Carbon dioxide and water vapor are products:

- Balance the atoms.* Start with the most complex substance, C₈H₁₈, and balance O₂ last:

The C atoms in C₈H₁₈ end up in CO₂. Each CO₂ contains one C atom, so 8 molecules of CO₂ are needed to balance the 8 C atoms in each C₈H₁₈:

The H atoms in C₈H₁₈ end up in H₂O. The 18 H atoms in C₈H₁₈ require the coefficient 9 in front of H₂O:

There are 25 atoms of O on the right (16 in 8CO₂ plus 9 in 9H₂O), so we place the coefficient $\frac{25}{2}$ in front of O₂:

- Adjust the coefficients.* Multiply through by 2 to obtain whole numbers:

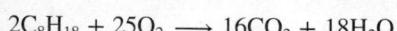

- Check* that the equation is balanced:

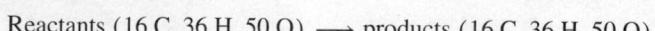

- Specify* states of matter. C₈H₁₈ is liquid; O₂, CO₂, and H₂O vapor are gases:

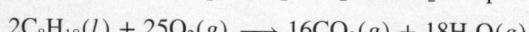

Comment This is an example of a combustion reaction. Any compound containing C and H that burns in an excess of air produces CO₂ and H₂O.

FOLLOW-UP PROBLEMS

- 3.12A** Write a balanced equation for each of the following:

- (a) A characteristic reaction of Group 1A(1) elements: chunks of sodium react violently with water to form hydrogen gas and sodium hydroxide solution.

- (b) The destruction of marble statuary by acid rain: aqueous nitric acid reacts with calcium carbonate to form carbon dioxide, water, and aqueous calcium nitrate.
 (c) Halogen compounds exchanging bonding partners: phosphorus trifluoride is prepared by the reaction of phosphorus trichloride and hydrogen fluoride; hydrogen chloride is the other product. The reaction involves gases only.

3.12B Write a balanced equation for each of the following:

- (a) Explosive decomposition of dynamite: liquid nitroglycerine ($C_3H_5N_3O_9$) explodes to produce a mixture of gases—carbon dioxide, water vapor, nitrogen, and oxygen.
 (b) A reaction that takes place in a self-contained breathing apparatus: solid potassium superoxide (KO_2) reacts with carbon dioxide gas to produce oxygen gas and solid potassium carbonate.
 (c) The production of iron from its ore in a blast furnace: solid iron(III) oxide reacts with carbon monoxide gas to produce solid iron metal and carbon dioxide gas.

SOME SIMILAR PROBLEMS 3.58–3.63

Visualizing a Reaction with a Molecular Scene A great way to focus on the rearrangement of atoms from reactants to products is by visualizing an equation as a molecular scene. Here's a representation of the combustion of octane we just balanced in Sample Problem 3.12:

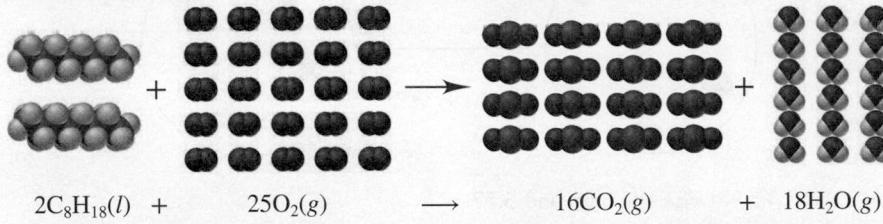

Now let's work through a sample problem to do the reverse—derive a balanced equation from a molecular scene.

SAMPLE PROBLEM 3.13

Writing a Balanced Equation from a Molecular Scene

Problem The following molecular scenes depict an important reaction in nitrogen chemistry (nitrogen is blue; oxygen is red):

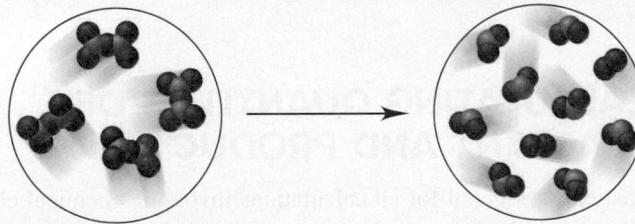

Write a balanced equation for this reaction.

Plan To write a balanced equation, we first have to determine the formulas of the molecules and obtain coefficients by counting the number of each type of molecule. Then, we arrange this information in the correct equation format, using the smallest whole-number coefficients and including states of matter.

Solution The reactant circle shows only one type of molecule. It has two N and five O atoms, so the formula is N_2O_5 ; there are four of these molecules. The product circle shows two different types of molecules, one type with one N and two O atoms, and the other with two O atoms; there are eight NO_2 and two O_2 . Thus, we have

Writing the balanced equation with the smallest whole-number coefficients and all substances as gases:

Check Reactant (4 N, 10 O) \longrightarrow products (4 N, 8 + 2 = 10 O)

FOLLOW-UP PROBLEMS

3.13A Write a balanced equation for the important atmospheric reaction depicted below (carbon is black; oxygen is red):

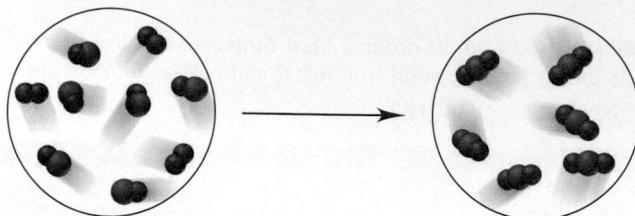

3.13B Write a balanced equation for the important industrial reaction depicted below (nitrogen is dark blue; hydrogen is light blue):

SOME SIMILAR PROBLEMS 3.56 and 3.57

› Summary of Section 3.3

- › A chemical equation has reactant formulas on the left of a yield arrow and product formulas on the right.
- › A balanced equation has the same number of each type of atom on both sides.
- › Balancing coefficients are integer multipliers for *all* the atoms in a formula and apply to the individual entities or to moles of entities.

3.4 CALCULATING QUANTITIES OF REACTANT AND PRODUCT

A balanced equation is essential for all calculations involving chemical change: *if you know the number of moles of one substance, the balanced equation tells you the numbers of moles of the others.*

Stoichiometrically Equivalent Molar Ratios from the Balanced Equation

In a balanced equation, *the amounts (mol) of substances are stoichiometrically equivalent to each other*, which means that a specific amount of one substance is formed from, produces, or reacts with a specific amount of the other. The quantitative relationships are expressed as *stoichiometrically equivalent molar ratios* that we use as conversion factors to calculate the amounts. For example, consider the

equation for the combustion of propane, a hydrocarbon fuel used in cooking and water heating:

If we view the reaction quantitatively in terms of C_3H_8 , we see that

- 1 mol of C_3H_8 reacts with 5 mol of O_2
- 1 mol of C_3H_8 produces 3 mol of CO_2
- 1 mol of C_3H_8 produces 4 mol of H_2O

Therefore, in this reaction,

- 1 mol of C_3H_8 is stoichiometrically equivalent to 5 mol of O_2
- 1 mol of C_3H_8 is stoichiometrically equivalent to 3 mol of CO_2
- 1 mol of C_3H_8 is stoichiometrically equivalent to 4 mol of H_2O

We chose to look at C_3H_8 , but any two of the substances are stoichiometrically equivalent to each other. Thus,

- 3 mol of CO_2 is stoichiometrically equivalent to 4 mol of H_2O
- 5 mol of O_2 is stoichiometrically equivalent to 3 mol of CO_2

and so on. A balanced equation contains a wealth of quantitative information relating individual chemical entities, amounts (mol) of substances, and masses of substances, and Table 3.4 presents the quantitative information contained in the equation for the combustion of propane.

Here's a typical problem that shows how stoichiometric equivalence is used to create conversion factors: in the combustion of propane, how many moles of O_2 are consumed when 10.0 mol of H_2O are produced? To solve this problem, we have to find the molar ratio between O_2 and H_2O . From the balanced equation, we see that for every 5 mol of O_2 consumed, 4 mol of H_2O is formed:

$$5 \text{ mol of } \text{O}_2 \text{ is stoichiometrically equivalent to 4 mol of } \text{H}_2\text{O}$$

As with any equivalent quantities, we can construct two conversion factors, depending on the quantity we want to find:

$$\frac{5 \text{ mol O}_2}{4 \text{ mol H}_2\text{O}} \quad \text{or} \quad \frac{4 \text{ mol H}_2\text{O}}{5 \text{ mol O}_2}$$

Table 3.4 Information Contained in a Balanced Equation

Viewed in Terms of	Reactants $\text{C}_3\text{H}_8(g)$ + $5\text{O}_2(g)$	→	Products $3\text{CO}_2(g)$ + $4\text{H}_2\text{O}(g)$
Molecules	1 molecule C_3H_8 + 5 molecules O_2	→	3 molecules CO_2 + 4 molecules H_2O
		→	
Amount (mol)	1 mol C_3H_8 + 5 mol O_2	→	3 mol CO_2 + 4 mol H_2O
Mass (amu)	44.09 amu C_3H_8 + 160.00 amu O_2	→	132.03 amu CO_2 + 72.06 amu H_2O
Mass (g)	44.09 g C_3H_8 + 160.00 g O_2	→	132.03 g CO_2 + 72.06 g H_2O
Total mass (g)	204.09 g	→	204.09 g

Since we want to find the amount (mol) of O₂ and we know the amount (mol) of H₂O, we choose “5 mol O₂/4 mol H₂O” to cancel “mol H₂O”:

$$\text{Amount (mol) of O}_2 \text{ consumed} = 10.0 \text{ mol H}_2\text{O} \times \frac{5 \text{ mol O}_2}{4 \text{ mol H}_2\text{O}} = 12.5 \text{ mol O}_2$$

mol H₂O $\xrightarrow{\text{molar ratio as conversion factor}}$ mol O₂

Be sure to note that the 5/4 ratio between O₂ and H₂O is a *molar ratio* and *not* a *mass ratio*:

$$5 \text{ mol O}_2 = 4 \text{ mol H}_2\text{O} \quad \text{but} \quad 5 \text{ g O}_2 \neq 4 \text{ g H}_2\text{O}$$

You cannot solve this type of problem without the balanced equation. Here is an approach for solving *any* stoichiometry problem that involves a reaction:

1. Write the balanced equation.
2. When necessary, convert the known mass (or number of entities) of one substance to amount (mol) using its molar mass (or Avogadro's number).
3. Use the molar ratio in the balanced equation to calculate the unknown amount (mol) of the other substance.
4. When necessary, convert the amount of that other substance to the desired mass (or number of entities) using its molar mass (or Avogadro's number).

Figure 3.8 summarizes the possible relationships among quantities of substances in a reaction, and Sample Problems 3.14–3.16 apply three of them in the first chemical step of converting copper ore to copper metal.

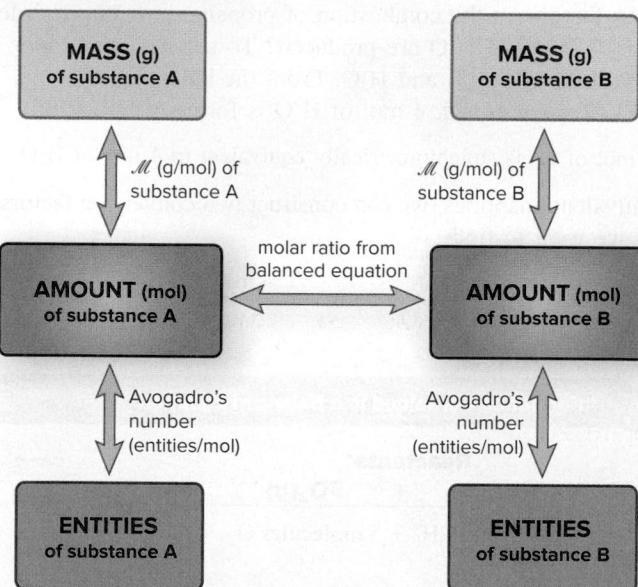

Figure 3.8 Summary of amount-mass-number relationships in a chemical equation. Start at any box (known) and move to any other (unknown) by using the conversion factor on the arrow. As always, convert to amount (mol) first.

Source: © McGraw-Hill Education/Stephen Frisch, photographer

SAMPLE PROBLEM 3.14

Calculating Quantities of Reactants and Products: Amount (mol) to Amount (mol)

Problem In a lifetime, the average American uses more than a half ton (>500 kg) of copper in coins, plumbing, and wiring. Copper is obtained from sulfide ores, such as chalcocite [copper(I) sulfide] by a multistep process. After initial grinding, the ore is “roasted” (heated strongly with oxygen gas) to form powdered copper(I) oxide and gaseous sulfur dioxide. How many moles of oxygen are required to roast 10.0 mol of copper(I) sulfide?

Plan We always write the balanced equation first. The formulas of the reactants are Cu₂S and O₂, and the formulas of the products are Cu₂O and SO₂, so we have

We know the amount of Cu₂S (10.0 mol) and must find the amount (mol) of O₂ that is needed to roast it. The balanced equation shows that 3 mol of O₂ is needed to roast 2 mol of Cu₂S, so the conversion factor for finding amount (mol) of O₂ is 3 mol O₂/2 mol Cu₂S (see the road map).

Solution Calculating the amount of O₂:

$$\text{Amount (mol) of O}_2 = 10.0 \text{ mol Cu}_2\text{S} \times \frac{3 \text{ mol O}_2}{2 \text{ mol Cu}_2\text{S}} = 15.0 \text{ mol O}_2$$

Check The units are correct, and the answer is reasonable because this molar ratio of O₂ to Cu₂S (15/10) is identical to the ratio in the balanced equation (3/2).

Comment A common mistake is to invert the conversion factor; that calculation would be

$$\text{Amount (mol) of O}_2 = 10.0 \text{ mol Cu}_2\text{S} \times \frac{2 \text{ mol Cu}_2\text{S}}{3 \text{ mol O}_2} = \frac{6.67 \text{ mol}^2 \text{ Cu}_2\text{S}}{1 \text{ mol O}_2}$$

The strange units should alert you that an error was made in setting up the conversion factor. Also note that this answer, 6.67, is less than 10.0, whereas the equation shows that there should be more moles of O₂ (3 mol) than moles of Cu₂S (2 mol). Be sure to think through the calculation when setting up the conversion factor and canceling units.

FOLLOW-UP PROBLEMS

3.14A Thermite is a mixture of iron(III) oxide and aluminum powders that was once used to weld railroad tracks. It undergoes a spectacular reaction to yield solid aluminum oxide and molten iron. How many moles of iron(III) oxide are needed to form 3.60×10^3 mol of iron? Include a road map that shows how you planned the solution.

3.14B The tarnish that forms on objects made of silver is solid silver sulfide; it can be removed by reacting it with aluminum metal to produce silver metal and solid aluminum sulfide. How many moles of aluminum are required to remove 0.253 mol of silver sulfide from a silver bowl? Include a road map that shows how you planned the solution.

SOME SIMILAR PROBLEMS 3.69(a) and 3.70(a)

Road Map

Amount (mol) of Cu₂S

molar ratio
(2 mol Cu₂S = 3 mol O₂)

Amount (mol) of O₂

SAMPLE PROBLEM 3.15

Calculating Quantities of Reactants and Products: Amount (mol) to Mass (g)

Problem During the roasting process, how many grams of sulfur dioxide form when 10.0 mol of copper(I) sulfide reacts?

Plan We use the balanced equation in Sample Problem 3.14, but here we are given amount of reactant (10.0 mol of Cu₂S) and need the mass (g) of product (SO₂) that forms. We find the amount (mol) of SO₂ using the molar ratio (2 mol SO₂/2 mol Cu₂S) and then multiply by its molar mass (64.07 g/mol) to find the mass (g) of SO₂ (see the road map).

Solution Combining the two conversion steps into one calculation, we have

$$\text{Mass (g) of SO}_2 = 10.0 \text{ mol Cu}_2\text{S} \times \frac{2 \text{ mol SO}_2}{2 \text{ mol Cu}_2\text{S}} \times \frac{64.07 \text{ g SO}_2}{1 \text{ mol SO}_2} = 641 \text{ g SO}_2$$

Check The answer makes sense, since the molar ratio shows that 10.0 mol of SO₂ is formed and each mole weighs about 64 g. We rounded to three significant figures.

FOLLOW-UP PROBLEMS

3.15A In the thermite reaction (see Follow-up Problem 3.14A), what amount (mol) of iron forms when 1.85×10^{25} formula units of iron(III) oxide react? Include a road map that shows how you planned the solution.

3.15B In the reaction that removes silver tarnish (see Follow-up Problem 3.14B), how many moles of silver are produced when 32.6 g of silver sulfide reacts? Include a road map that shows how you planned the solution.

SOME SIMILAR PROBLEMS 3.69(b), 3.70(b), 3.71(a), and 3.72(a)

Road Map

Amount (mol) of Cu₂S

molar ratio
(2 mol Cu₂S = 2 mol SO₂)

Amount (mol) of SO₂

multiply by M (g/mol)
(1 mol SO₂ = 64.07 g SO₂)

Mass (g) of SO₂

SAMPLE PROBLEM 3.16**Calculating Quantities of Reactants and Products: Mass to Mass****Road Map**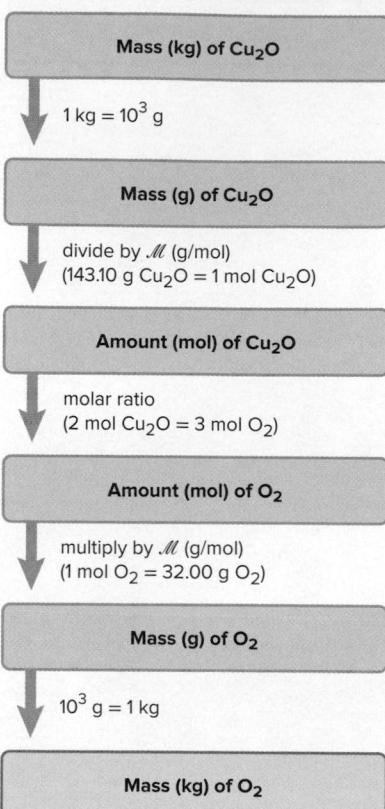

Problem During the roasting of chalcocite (see Sample Problem 3.14), how many kilograms of oxygen are required to form 2.86 kg of copper(I) oxide?

Plan In this problem, we know the mass of the product, Cu₂O (2.86 kg), and we need the mass (kg) of O₂ that reacts to form it. Therefore, we must convert from mass of product to amount of product to amount of reactant to mass of reactant. We convert the mass of Cu₂O from kg to g and then to amount (mol). Then, we use the molar ratio (3 mol O₂/2 mol Cu₂O) to find the amount (mol) of O₂ required. Finally, we convert the amount of O₂ to g and then kg (see the road map).

Solution Converting from kilograms of Cu₂O to moles of Cu₂O: Combining the mass unit conversion with the mass-to-amount conversion gives

$$\text{Amount (mol) of Cu}_2\text{O} = 2.86 \text{ kg Cu}_2\text{O} \times \frac{10^3 \text{ g}}{1 \text{ kg}} \times \frac{1 \text{ mol Cu}_2\text{O}}{143.10 \text{ g Cu}_2\text{O}} = 20.0 \text{ mol Cu}_2\text{O}$$

Converting from moles of Cu₂O to moles of O₂:

$$\text{Amount (mol) of O}_2 = 20.0 \text{ mol Cu}_2\text{O} \times \frac{3 \text{ mol O}_2}{2 \text{ mol Cu}_2\text{O}} = 30.0 \text{ mol O}_2$$

Converting from moles of O₂ to kilograms of O₂: Combining the amount-to-mass conversion with the mass unit conversion gives

$$\text{Mass (kg) of O}_2 = 30.0 \text{ mol O}_2 \times \frac{32.00 \text{ g O}_2}{1 \text{ mol O}_2} \times \frac{1 \text{ kg}}{10^3 \text{ g}} = 0.960 \text{ kg O}_2$$

Check The units are correct. Rounding to check the math, for example, in the final step, $\sim 30 \text{ mol} \times 30 \text{ g/mol} \times 1 \text{ kg}/10^3 \text{ g} = 0.90 \text{ kg}$. The answer seems reasonable: even though the amount (mol) of O₂ is greater than the amount (mol) of Cu₂O, the mass of O₂ is less than the mass of Cu₂O because M of O₂ is less than M of Cu₂O.

Comment The three related sample problems (3.14–3.16) highlight the main point for solving stoichiometry problems: *convert the information given into amount (mol)*. Then, use the appropriate molar ratio and any other conversion factors to complete the solution.

FOLLOW-UP PROBLEMS

3.16A During the thermite reaction (see Follow-up Problems 3.14A and 3.15A), how many atoms of aluminum react for every 1.00 g of aluminum oxide that forms? Include a road map that shows how you planned the solution.

3.16B During the reaction that removes silver tarnish (see Follow-up Problems 3.14B and 3.15B), how many grams of aluminum react to form 12.1 g of aluminum sulfide? Include a road map that shows how you planned the solution.

SOME SIMILAR PROBLEMS 3.71(b), 3.72(b), and 3.73–3.76

Reactions That Occur in a Sequence

In many situations, a product of one reaction becomes a reactant for the next in a sequence of reactions. For stoichiometric purposes, when the same substance forms in one reaction and reacts in the next (it is common to both reactions), we eliminate that substance in an **overall (net) equation**. The steps in writing the overall equation are

1. Write the sequence of balanced equations.
2. Adjust the equations arithmetically to cancel the common substance(s).
3. Add the adjusted equations together to obtain the overall balanced equation.

Sample Problem 3.17 shows the approach by continuing with the copper recovery process that started in Sample Problem 3.14.

SAMPLE PROBLEM 3.17**Writing an Overall Equation for a Reaction Sequence**

Problem Roasting is the first step in extracting copper from chalcocite. In the next step, copper(I) oxide reacts with powdered carbon to yield copper metal and carbon monoxide gas. Write a balanced overall equation for the two-step sequence.

Plan To obtain the overall equation, we write the individual equations in sequence, adjust coefficients to cancel the common substance (or substances), and add the equations together. In this case, only Cu₂O appears as a product in one equation and a reactant in the other, so it is the common substance.

Solution Writing the individual balanced equations:

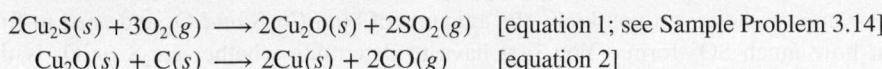

Adjusting the coefficients: Since 2 mol of Cu₂O form in equation 1 but 1 mol of Cu₂O reacts in equation 2, we double *all* the coefficients in equation 2 to use up the Cu₂O:

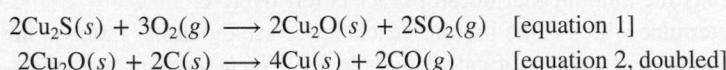

Adding the two equations and canceling the common substance: We keep the reactants of both equations on the left and the products of both equations on the right:

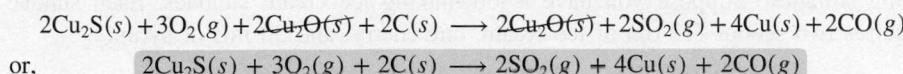

Check Reactants (4 Cu, 2 S, 6 O, 2 C) → products (4 Cu, 2 S, 6 O, 2 C)

Comment 1. Even though Cu₂O *does* participate in the chemical change, it is not involved in the reaction stoichiometry. An overall equation *may not* show which substances actually react; for example, C(s) and Cu₂S(s) do not interact directly in this reaction sequence, even though both are shown as reactants.

2. The SO₂ formed in copper recovery contributes to acid rain, so chemists have devised microbial and electrochemical methods to extract metals without roasting sulfide ores. Such methods are examples of *green chemistry*, a topic discussed further at the end of this section.
3. These reactions were shown to explain how to obtain an overall equation. The actual extraction of copper is more complex, as you'll see in Chapter 22.

FOLLOW-UP PROBLEMS

3.17A The SO₂ formed in copper recovery reacts in air with oxygen and forms sulfur trioxide. This gas, in turn, reacts with water to form a sulfuric acid solution that falls in rain. Write a balanced overall equation for this process.

3.17B During a lightning strike, nitrogen gas can react with oxygen gas to produce nitrogen monoxide. This gas then reacts with the gas ozone, O₃, to produce nitrogen dioxide gas and oxygen gas. The nitrogen dioxide that is produced is a pollutant in smog. Write a balanced overall equation for this process.

SOME SIMILAR PROBLEMS 3.77 and 3.78

Reaction Sequences in Organisms Multistep reaction sequences called *metabolic pathways* occur throughout biological systems. (We discuss them again in Chapter 17.) For example, in most cells, the chemical energy in glucose is released through a sequence of about 30 individual reactions. The product of each reaction step is the reactant of the next, so once all the common substances are canceled out, the overall equation is

We eat food that contains glucose, inhale O₂, and excrete CO₂ and H₂O. In our cells, these reactants and products are many steps apart: O₂ never reacts *directly* with glucose, and CO₂ and H₂O are formed at various, often distant, steps along the sequence of reactions. Even so, the molar ratios in the overall equation are the same as if the glucose burned in a combustion chamber filled with O₂ and formed CO₂ and H₂O directly (Figure 3.9).

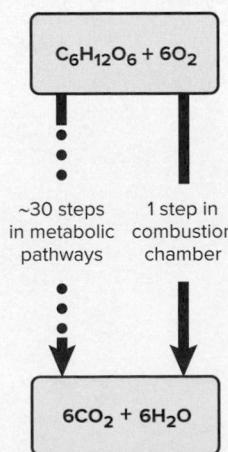

Figure 3.9 An overall equation equals the sum of the individual steps.

Reactions That Involve a Limiting Reactant

In problems up to now, the amount of *one* reactant was given, and we assumed there was enough of the other reactants to react with it completely. For example, using the chemical reaction for the roasting of copper ore (see Sample Problem 3.14), suppose we want the amount (mol) of SO₂ that forms when 5.2 mol of Cu₂S reacts with O₂:

We assume the 5.2 mol of Cu₂S reacts with as much O₂ as needed. Because all the Cu₂S reacts, its initial amount of 5.2 mol determines, or *limits*, the amount of SO₂ that can form, no matter how much more O₂ is present. In this situation, we call Cu₂S the **limiting reactant** (or *limiting reagent*).

Suppose, however, you know the amounts of both Cu₂S and O₂ and need to find out how much SO₂ forms. You first have to determine whether Cu₂S or O₂ is the limiting reactant—that is, which one is completely used up—because that reactant limits how much SO₂ can form. The reactant that is *not* limiting is present *in excess*, which means the amount that doesn't react is left over. ↗

To determine which is the limiting reactant, we use the molar ratios in the balanced equation to perform a series of calculations to see which reactant forms less product.

Determining the Limiting Reactant Let's clarify these ideas in a much more appetizing situation. Suppose you have a job making ice cream sundaes. Each sundae requires two scoops (12 oz) of ice cream, one cherry, and 50 mL of syrup:

A mob of 25 ravenous school kids enters, and each one wants a sundae with vanilla ice cream and chocolate syrup. You have 300 oz of vanilla ice cream (at 6 oz per scoop), 30 cherries, and 1 L of syrup: can you feed them all? A series of calculations based on the balanced equation shows the number of sundaes you can make from each ingredient:

$$\text{Ice cream: No. of sundaes} = 300 \text{ oz} \times \frac{1 \text{ scoop}}{6 \text{ oz}} \times \frac{1 \text{ sundae}}{2 \text{ scoops}} = 25 \text{ sundaes}$$

$$\text{Cherries: No. of sundaes} = 30 \text{ cherries} \times \frac{1 \text{ sundae}}{1 \text{ cherry}} = 30 \text{ sundaes}$$

$$\text{Syrup: No. of sundaes} = 1000 \text{ mL syrup} \times \frac{1 \text{ sundae}}{50 \text{ mL syrup}} = 20 \text{ sundaes}$$

Of the reactants (ice cream, cherry, syrup), the syrup forms the *least* amount of product (sundaes), so it is the limiting “reactant.” When all the syrup has been used up, some ice cream and cherries are “unreacted” so they are in excess:

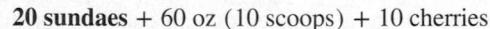

Figure 3.10 shows a similar example with different initial (starting) quantities.

Using Reaction Tables in Limiting-Reactant Problems A good way to keep track of the quantities in a limiting-reactant problem is with a *reaction table*. The balanced equation appears at the top for the column heads. The table shows the

- *Initial* quantities of reactants and products *before* the reaction
- *Change* in the quantities of reactants and products *during* the reaction
- *Final* quantities of reactants and products remaining *after* the reaction

For example, for the ice cream sundae “reaction,” the reaction table would be

Quantity	12 oz (2 scoops)	+	1 cherry	+	50 mL syrup	→	1 sundae
Initial	300 oz (50 scoops)		30 cherries		1000 mL syrup		0 sundaes
Change	-240 oz (40 scoops)		-20 cherries		-1000 mL syrup		+20 sundaes
Final	60 oz (10 scoops)		10 cherries		0 mL syrup		20 sundaes

The “reactants” (ice cream, cherry, and syrup) form the “product” (sundae).

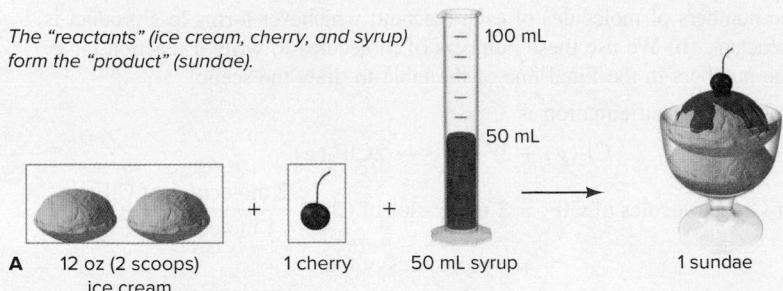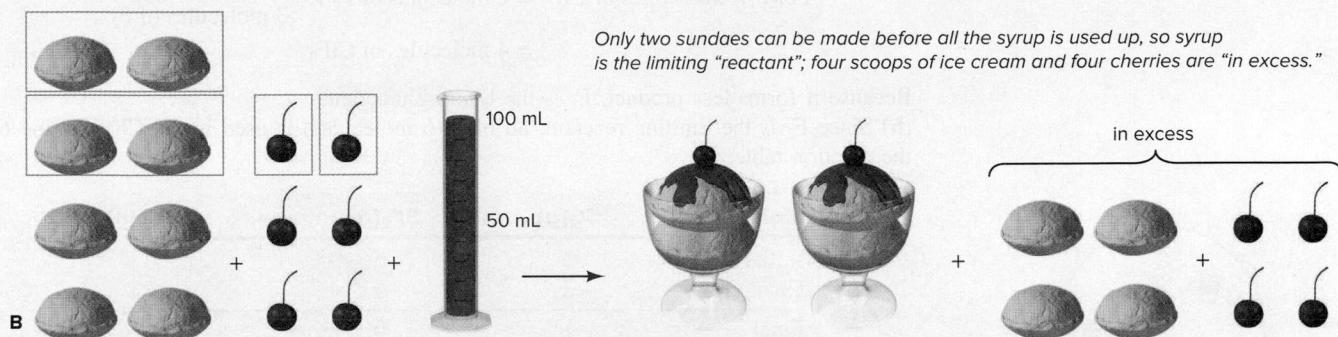

The body of the table shows the following important points:

- In the **Initial** line, “product” has not yet formed, so the entry is “0 sundaes.”
- In the **Change** line, since the reactants (ice cream, cherries, and syrup) are used during the reaction, their quantities decrease, so the changes in their quantities have a *negative* sign. At the same time, the quantity of product (sundaes) increases, so the change in its quantity has a *positive* sign.
- For the **Final** line, we *add* the Change and Initial lines. Notice that some reactants (ice cream and cherries) are in excess, while the limiting reactant (syrup) is used up.

Solving Limiting-Reactant Problems In limiting-reactant problems, *the amounts of two (or more) reactants are given, and we first determine which is limiting*. To do this, just as we did with the ice cream sundaes, we use the balanced equation to solve a series of calculations to see how much product forms from the given amount of each reactant: the limiting reactant is the one that yields the *least* amount of product.

The following problems examine these ideas from several aspects. In Sample Problem 3.18, we solve the problem by looking at a molecular scene; in Sample Problem 3.19, we start with the amounts (mol) of two reactants; and in Sample Problem 3.20, we start with masses of two reactants.

SAMPLE PROBLEM 3.18

Using Molecular Depictions in a Limiting-Reactant Problem

Problem Nuclear engineers use chlorine trifluoride to prepare uranium fuel for power plants. The compound is formed as a gas by the reaction of elemental chlorine and fluorine. The circle shows a representative portion of the reaction mixture before the reaction starts (chlorine is green; fluorine is yellow).

- Find the limiting reactant.
- Write a reaction table for the process.
- Draw a representative portion of the mixture after the reaction is complete. (*Hint:* The ClF_3 molecule has Cl bonded to three individual F atoms.)

Plan (a) We have to find the limiting reactant. The first step is to write the balanced equation, so we need the formulas and states of matter. From the name, chlorine trifluoride, we know the product consists of one Cl atom bonded to three F atoms, or ClF_3 . Elemental chlorine and fluorine are the diatomic molecules Cl_2 and F_2 , and all three substances are gases. To find the limiting reactant, we find the number of molecules of product that would

Figure 3.10 An ice cream sundae analogy for limiting reactants.

form from the numbers of molecules of each reactant: whichever forms less product is the limiting reactant. (b) We use these numbers of molecules to write a reaction table. (c) We use the numbers in the Final line of the table to draw the scene.

Solution (a) The balanced equation is

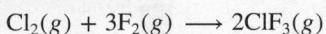

$$\text{For Cl}_2: \text{Molecules of ClF}_3 = 3 \text{ molecules of Cl}_2 \times \frac{2 \text{ molecules of ClF}_3}{1 \text{ molecule of Cl}_2}$$

$$= 6 \text{ molecules of ClF}_3$$

$$\text{For F}_2: \text{Molecules of ClF}_3 = 6 \text{ molecules of F}_2 \times \frac{2 \text{ molecules of ClF}_3}{3 \text{ molecules of F}_2}$$

$$= 4 \text{ molecules of ClF}_3$$

Because it forms less product, F_2 is the limiting reactant.

(b) Since F_2 is the limiting reactant, all of it (6 molecules) is used in the Change line of the reaction table:

Molecules	$\text{Cl}_2(g)$	+	$3\text{F}_2(g)$	\longrightarrow	$2\text{ClF}_3(g)$
Initial	3		6		0
Change	-2		-6		+4
Final	1		0		4

(c) The representative portion of the final reaction mixture includes 1 molecule of Cl_2 (the reactant in excess) and 4 molecules of product ClF_3 .

Check The equation is balanced: reactants (2 Cl, 6 F) \rightarrow products (2 Cl, 6 F). And, as shown in the circles, the numbers of each type of atom before and after the reaction are equal. Let's think through our choice of limiting reactant. From the equation, one Cl_2 needs three F_2 to form two ClF_3 . Therefore, the three Cl_2 molecules in the circle depicting reactants need nine (3×3) F_2 . But there are only six F_2 , so there is not enough F_2 to react with the available Cl_2 ; or put the other way, there is too much Cl_2 to react with the available F_2 . From either point of view, F_2 is the limiting reactant.

Comment Notice that there are fewer Cl_2 molecules than F_2 molecules initially. The limiting reactant is *not* the reactant present in the smaller amount, but the reactant that forms *less product*.

FOLLOW-UP PROBLEMS

3.18A B_2 (B is red) reacts with AB as shown below:

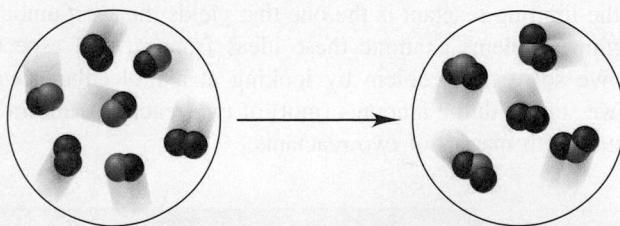

Write a balanced equation for the reaction, and determine the limiting reactant.

3.18B Sulfur dioxide gas reacts with oxygen gas to produce sulfur trioxide, as shown below (sulfur is yellow; oxygen is red):

Write a balanced equation for the reaction, and determine the limiting reactant.

SOME SIMILAR PROBLEMS 3.79 and 3.80

SAMPLE PROBLEM 3.19**Calculating Quantities in a Limiting-Reactant Problem: Amount to Amount**

Problem In another preparation of ClF_3 (see Sample Problem 3.18), 0.750 mol of Cl_2 reacts with 3.00 mol of F_2 . **(a)** Find the limiting reactant. **(b)** Write a reaction table.

Plan **(a)** We find the limiting reactant by calculating the amount (mol) of ClF_3 formed from the amount (mol) of each reactant: the reactant that forms fewer moles of ClF_3 is limiting.

(b) We enter those values into the reaction table.

Solution **(a)** Determining the limiting reactant:

Finding amount (mol) of ClF_3 from amount (mol) of Cl_2 :

$$\text{Amount (mol) of } \text{ClF}_3 = 0.750 \text{ mol } \text{Cl}_2 \times \frac{2 \text{ mol } \text{ClF}_3}{1 \text{ mol } \text{Cl}_2} = 1.50 \text{ mol } \text{ClF}_3$$

Finding amount (mol) of ClF_3 from amount (mol) of F_2 :

$$\text{Amount (mol) of } \text{ClF}_3 = 3.00 \text{ mol } \text{F}_2 \times \frac{2 \text{ mol } \text{ClF}_3}{3 \text{ mol } \text{F}_2} = 2.00 \text{ mol } \text{ClF}_3$$

In this case, Cl_2 is limiting because it forms fewer moles of ClF_3 .

(b) Writing the reaction table, with Cl_2 limiting:

Amount (mol)	$\text{Cl}_2(g)$	+	$3\text{F}_2(g)$	→	$2\text{ClF}_3(g)$
Initial	0.750		3.00		0
Change	-0.750		-2.25		+1.50
Final	0		0.75		1.50

Check Let's check that Cl_2 is the limiting reactant by assuming, for the moment, that F_2 is limiting. If that were true, all 3.00 mol of F_2 would react to form 2.00 mol of ClF_3 . However, based on the balanced equation, obtaining 2.00 mol of ClF_3 would require 1.00 mol of Cl_2 , and only 0.750 mol of Cl_2 is present. Thus, Cl_2 must be the limiting reactant.

Comment A major point to note from Sample Problems 3.18 and 3.19 is that the relative amounts of reactants *do not* determine which is limiting, but rather the amount of product formed, which is based on the *molar ratio in the balanced equation*. In both problems, there is more F_2 than Cl_2 . However,

- Sample Problem 3.18 has an F_2/Cl_2 ratio of 6/3, or 2/1, which is less than the required molar ratio of 3/1, so F_2 is limiting and Cl_2 is in excess.
- Sample Problem 3.19 has an F_2/Cl_2 ratio of 3.00/0.750, which is greater than the required molar ratio of 3/1, so Cl_2 is limiting and F_2 is in excess.

FOLLOW-UP PROBLEMS

3.19A In the reaction in Follow-up Problem 3.18A, how many moles of product form from 1.5 mol of each reactant?

3.19B In the reaction in Follow-up Problem 3.18B, 4.2 mol of SO_2 reacts with 3.6 mol of O_2 . How many moles of SO_3 are produced?

SOME SIMILAR PROBLEMS 3.81 and 3.82

SAMPLE PROBLEM 3.20**Calculating Quantities in a Limiting-Reactant Problem: Mass to Mass**

Problem A fuel mixture used in the early days of rocketry consisted of two liquids, hydrazine (N_2H_4) and dinitrogen tetroxide (N_2O_4), which ignite on contact to form nitrogen gas and water vapor.

- How many grams of nitrogen gas form when 1.00×10^2 g of N_2H_4 and 2.00×10^2 g of N_2O_4 are mixed?
- How many grams of the excess reactant remain unreacted when the reaction is over?
- Write a reaction table for this process.

Road Map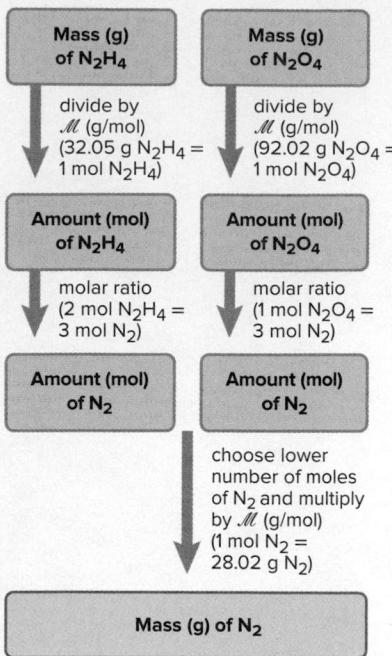

Plan The amounts of two reactants are given, which means this is a limiting-reactant problem. **(a)** To determine the mass of product formed, we must find the limiting reactant by calculating which of the given masses of reactant forms *less* nitrogen gas. As always, we first write the balanced equation. We convert the grams of each reactant to moles using that reactant's molar mass and then use the molar ratio from the balanced equation to find the number of moles of N₂ each reactant forms. Next, we convert the lower amount of N₂ to mass (see the road map). **(b)** To determine the mass of the excess reactant, we use the molar ratio to calculate the mass of excess reactant that is required to react with the given amount of the limiting reactant. We subtract that mass from the given amount of excess reactant; this difference is the mass of unreacted excess reactant. **(c)** We use the values based on the limiting reactant for the reaction table.

Solution **(a)** Writing the balanced equation:

Finding the amount (mol) of N₂ from the amount (mol) of each reactant:

$$\text{For N}_2\text{H}_4: \text{Amount (mol)} = 1.00 \times 10^2 \frac{\text{g N}_2\text{H}_4}{32.05 \frac{\text{g}}{\text{mol N}_2\text{H}_4}} \times \frac{1 \text{ mol N}_2\text{H}_4}{32.05 \frac{\text{g}}{\text{mol N}_2\text{H}_4}} = 3.12 \text{ mol N}_2\text{H}_4$$

$$\text{Amount (mol)} = 3.12 \text{ mol N}_2\text{H}_4 \times \frac{3 \text{ mol N}_2}{2 \text{ mol N}_2\text{H}_4} = 4.68 \text{ mol N}_2$$

$$\text{For N}_2\text{O}_4: \text{Amount (mol)} = 2.00 \times 10^2 \frac{\text{g N}_2\text{O}_4}{92.02 \frac{\text{g}}{\text{mol N}_2\text{O}_4}} \times \frac{1 \text{ mol N}_2\text{O}_4}{92.02 \frac{\text{g}}{\text{mol N}_2\text{O}_4}} = 2.17 \text{ mol N}_2\text{O}_4$$

$$\text{Amount (mol)} = 2.17 \text{ mol N}_2\text{O}_4 \times \frac{3 \text{ mol N}_2}{1 \text{ mol N}_2\text{O}_4} = 6.51 \text{ mol N}_2$$

Thus, N₂H₄ is the limiting reactant because it yields less N₂.

Converting from amount (mol) of N₂ to mass (g):

$$\text{Mass (g)} = 4.68 \text{ mol N}_2 \times \frac{28.02 \frac{\text{g N}_2}{1 \text{ mol N}_2}}{1 \text{ mol N}_2} = 131 \text{ g N}_2$$

(b) Finding the mass (g) of N₂O₄ that reacts with 1.00 × 10² g of N₂H₄:

$$\begin{aligned} \text{Mass (g)} &= 1.00 \times 10^2 \frac{\text{g N}_2\text{H}_4}{32.05 \frac{\text{g}}{\text{mol N}_2\text{H}_4}} \times \frac{1 \text{ mol N}_2\text{H}_4}{32.05 \frac{\text{g}}{\text{mol N}_2\text{H}_4}} \times \frac{1 \text{ mol N}_2\text{O}_4}{2 \text{ mol N}_2\text{H}_4} \times \frac{92.02 \frac{\text{g N}_2\text{O}_4}{1 \text{ mol N}_2\text{O}_4}}{1 \text{ mol N}_2\text{O}_4} \\ &= 144 \text{ g N}_2\text{O}_4 \end{aligned}$$

$$\begin{aligned} \text{Mass (g) of N}_2\text{O}_4 \text{ in excess} &= \text{initial mass of N}_2\text{O}_4 - \text{mass of N}_2\text{O}_4 \text{ reacted} \\ &= 2.00 \times 10^2 \text{ g N}_2\text{O}_4 - 144 \text{ g N}_2\text{O}_4 = 56 \text{ g N}_2\text{O}_4 \end{aligned}$$

(c) With N₂H₄ as the limiting reactant, the reaction table is

Amount (mol)	2N ₂ H ₄ (l)	+	N ₂ O ₄ (l)	→	3N ₂ (g)	+	4H ₂ O(g)
Initial	3.12		2.17		0		0
Change	-3.12		-1.56		+4.68		+6.24
Final	0		0.61		4.68		6.24

Check There are more grams of N₂O₄ than N₂H₄, but there are fewer moles of N₂O₄ because its *M* is much higher. Rounding for N₂H₄: 100 g N₂H₄ × 1 mol/32 g ≈ 3 mol; ~3 mol × $\frac{3}{2}$ ≈ 4.5 mol N₂; ~4.5 mol × 30 g/mol ≈ 135 g N₂.

Comment 1. Recall this *common mistake* in solving limiting-reactant problems: The limiting reactant is not the *reactant* present in fewer moles (or grams). Rather, it is the reactant that forms fewer moles (or grams) of *product*.

2. An *alternative approach* to finding the limiting reactant compares “How much is needed?” with “How much is given?” That is, based on the balanced equation,

- Find the amount (mol) of each reactant needed to react with the other reactant.
- Compare that *needed* amount with the *given* amount in the problem statement. There will be *more* than enough of one reactant (excess) and *less* than enough of the other (limiting).

For example, the balanced equation for this problem shows that 2 mol of N_2H_4 reacts with 1 mol of N_2O_4 . The amount (mol) of N_2O_4 needed to react with the given 3.12 mol of N_2H_4 is

$$\text{Amount (mol) of } \text{N}_2\text{O}_4 \text{ needed} = 3.12 \text{ mol } \text{N}_2\text{H}_4 \times \frac{1 \text{ mol } \text{N}_2\text{O}_4}{2 \text{ mol } \text{N}_2\text{H}_4} = 1.56 \text{ mol } \text{N}_2\text{O}_4$$

The amount of N_2H_4 needed to react with the given 2.17 mol of N_2O_4 is

$$\text{Amount (mol) of } \text{N}_2\text{H}_4 \text{ needed} = 2.17 \text{ mol } \text{N}_2\text{O}_4 \times \frac{2 \text{ mol } \text{N}_2\text{H}_4}{1 \text{ mol } \text{N}_2\text{O}_4} = 4.34 \text{ mol } \text{N}_2\text{H}_4$$

We are given 2.17 mol of N_2O_4 , which is *more* than the 1.56 mol of N_2O_4 needed, and we are given 3.12 mol of N_2H_4 , which is *less* than the 4.34 mol of N_2H_4 needed. Therefore, N_2H_4 is limiting, and N_2O_4 is in excess.

FOLLOW-UP PROBLEMS

3.20A How many grams of solid aluminum sulfide can be prepared by the reaction of 10.0 g of aluminum and 15.0 g of sulfur? How many grams of the nonlimiting reactant are in excess?

3.20B Butane gas (C_4H_{10}) is used as the fuel in disposable lighters. It burns in oxygen to form carbon dioxide gas and water vapor. What mass of carbon dioxide is produced when 4.65 g of butane is burned in 10.0 g of oxygen? How many grams of the excess reactant remain unreacted when the reaction is over?

SOME SIMILAR PROBLEMS 3.83–3.90

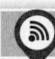

Student Hot Spot

Student data indicate that you may struggle with limiting reactant calculations. Access the Smartbook to view additional Learning Resources on this topic.

Figure 3.11 provides an overview of all of the stoichiometric relationships we've discussed in this chapter.

Theoretical, Actual, and Percent Reaction Yields

Up until now, we've assumed that 100% of the limiting reactant becomes product, that ideal methods exist for isolating the product, and that we have perfect lab technique and collect all the product. In theory, this may happen, but in reality, it doesn't, and chemists recognize three types of reaction yield:

Figure 3.11 An overview of amount-mass-number stoichiometric relationships.

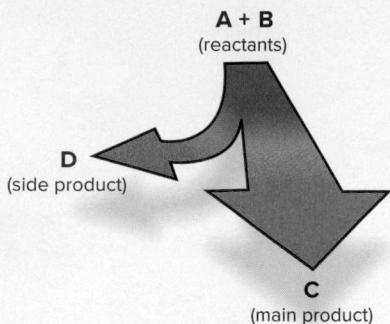

Figure 3.12 The effect of a side reaction on the yield of the main product.

1. **Theoretical yield.** The amount of product calculated from the molar ratio in the balanced equation is the **theoretical yield**. But, there are several reasons why the theoretical yield is *never* obtained:
 - Reactant mixtures often proceed through **side reactions** that form different products (Figure 3.12). In the rocket fuel reaction in Sample Problem 3.20, for example, the reactants might form some NO in the following side reaction:

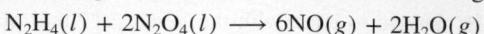

This reaction decreases the amounts of reactants available for N₂ production.

- Even more important, many reactions seem to stop before they are complete, so some limiting reactant is unused. (We'll see why in Chapter 4.)
 - Physical losses occur in every step of a separation (see Tools of the Laboratory, Section 2.9): some solid clings to filter paper, some distillate evaporates, and so forth. With careful technique, you can minimize, but never eliminate, such losses.
2. **Actual yield.** Given these reasons for obtaining less than the theoretical yield, the amount of product *actually* obtained is the **actual yield**. Theoretical and actual yields are expressed in units of amount (moles) or mass (grams).
 3. **Percent yield.** The **percent yield (% yield)** is the actual yield expressed as a percentage of the theoretical yield:

$$\% \text{ yield} = \frac{\text{actual yield}}{\text{theoretical yield}} \times 100 \quad (3.8)$$

By definition, the actual yield is less than the theoretical yield, so the percent yield is *always* less than 100%.

SAMPLE PROBLEM 3.21

Calculating Percent Yield

Problem Silicon carbide (SiC) is an important ceramic material made by reacting sand (silicon dioxide, SiO₂) with powdered carbon at a high temperature. Carbon monoxide is also formed. When 100.0 kg of sand is processed, 51.4 kg of SiC is recovered. What is the percent yield of SiC from this process?

Plan We are given the actual yield of SiC (51.4 kg), so we need the theoretical yield to calculate the percent yield. After writing the balanced equation, we convert the given mass of SiO₂ (100.0 kg) to amount (mol). We use the molar ratio to find the amount of SiC formed and convert it to mass (kg) to obtain the theoretical yield. Then, we use Equation 3.8 to find the percent yield (see the road map).

Solution Writing the balanced equation:

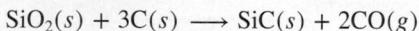

Converting from mass (kg) of SiO₂ to amount (mol):

$$\text{Amount (mol) of SiO}_2 = 100.0 \text{ kg-SiO}_2 \times \frac{1000 \text{ g}}{1 \text{ kg}} \times \frac{1 \text{ mol SiO}_2}{60.09 \text{ g-SiO}_2} = 1664 \text{ mol SiO}_2$$

Converting from amount (mol) of SiO₂ to amount (mol) of SiC: The molar ratio is 1 mol SiC/1 mol SiO₂, so

$$\text{Amount (mol) of SiO}_2 = \text{moles of SiC} = 1664 \text{ mol SiC}$$

Converting from amount (mol) of SiC to mass (kg):

$$\text{Mass (kg) of SiC} = 1664 \text{ mol-SiC} \times \frac{40.10 \text{ g SiC}}{1 \text{ mol-SiC}} \times \frac{1 \text{ kg}}{1000 \text{ g}} = 66.73 \text{ kg SiC}$$

Calculating the percent yield:

$$\% \text{ yield of SiC} = \frac{\text{actual yield}}{\text{theoretical yield}} \times 100 = \frac{51.4 \text{ kg-SiC}}{66.73 \text{ kg-SiC}} \times 100 = 77.0\%$$

Check Rounding shows that the mass of SiC seems correct: $\sim 1500 \text{ mol} \times 40 \text{ g/mol} \times 1 \text{ kg}/1000 \text{ g} = 60 \text{ kg}$. The molar ratio of SiC/SiO₂ is 1/1, and \mathcal{M} of SiC is about two-thirds ($\sim \frac{40}{60}$) of \mathcal{M} of SiO₂, so 100 kg of SiO₂ should form about 66 kg of SiC.

Road Map

FOLLOW-UP PROBLEMS

3.21A Marble (calcium carbonate) reacts with hydrochloric acid solution to form calcium chloride solution, water, and carbon dioxide. Find the percent yield of carbon dioxide if 3.65 g is collected when 10.0 g of marble reacts.

3.21B Sodium carbonate, also known as *soda ash*, is used in glassmaking. It is obtained from a reaction between sodium chloride and calcium carbonate; calcium chloride is the other product. Calculate the percent yield of sodium carbonate if 92.6 g is collected when 112 g of sodium chloride reacts with excess calcium carbonate.

SOME SIMILAR PROBLEMS

Yields in Multistep Syntheses In the multistep synthesis of a complex compound, the overall yield can be surprisingly low, even if the yield of each step is high. For example, suppose a six-step synthesis has a 90.0% yield for each step. To find the overall percent yield, *express the yield of each step as a decimal, multiply all the decimal amounts together, and then convert back to a percentage*. The overall yield in this case is only slightly more than 50%:

$$\text{Overall \% yield} = (0.900 \times 0.900 \times 0.900 \times 0.900 \times 0.900 \times 0.900) \times 100 = 53.1\%$$

Such multistep sequences are common in laboratory syntheses of medicines, dyes, pesticides, and many other organic compounds. For example, the antidepressant Sertraline is prepared from a simple starting compound in six steps, with yields of 80%, 80%, 50%, 100%, 48%, and 30%, respectively, and an overall percent yield of only 4.6% (Figure 3.13). Because a typical synthesis begins with large amounts of inexpensive, simple reactants and ends with small amounts of expensive, complex products, the overall yield greatly influences the commercial potential of a product.

Atom Economy: A Green Chemistry Perspective on Yield In the relatively new field of **green chemistry**, academic, industrial, and government chemists develop methods that reduce or prevent the release of harmful substances into the environment and the wasting of energy resources.

One way that green chemists evaluate a synthetic route is to focus on its *atom economy*, the proportion of reactant atoms that end up in the desired product. The efficiency of a synthesis is quantified in terms of the *percent atom economy*:

$$\% \text{ atom economy} = \frac{\text{no. of moles} \times \text{molar mass of desired product}}{\text{sum of (no. of moles} \times \text{molar mass) for all products}} \times 100$$

Consider two synthetic routes—one starting with benzene (C_6H_6), the other with butane (C_4H_{10})—for the production of maleic anhydride ($C_4H_2O_3$), a key substance in the manufacture of polymers, dyes, medicines, pesticides, and other products:

Let's compare the efficiency of these routes in terms of percent atom economy:

Route 1:

$$\begin{aligned}\% \text{ atom economy} &= \frac{2 \times \text{M of } \text{C}_4\text{H}_2\text{O}_3}{(2 \times \text{M of } \text{C}_4\text{H}_2\text{O}_3) + (4 \times \text{M of } \text{H}_2\text{O}) + (4 \times \text{M of } \text{CO}_2)} \times 100 \\ &= \frac{2 \times 98.06 \text{ g}}{(2 \times 98.06 \text{ g}) + (4 \times 18.02 \text{ g}) + (4 \times 44.01 \text{ g})} \times 100 \\ &= 44.15\%\end{aligned}$$

Route 2:

$$\begin{aligned}\% \text{ atom economy} &= \frac{2 \times \text{M of } \text{C}_4\text{H}_2\text{O}_3}{(2 \times \text{M of } \text{C}_4\text{H}_2\text{O}_3) + (8 \times \text{M of } \text{H}_2\text{O})} \times 100 \\ &= \frac{2 \times 98.06 \text{ g}}{(2 \times 98.06 \text{ g}) + (8 \times 18.02 \text{ g})} \times 100 \\ &= 57.63\%\end{aligned}$$

Figure 3.13 Low overall yield in a multistep synthesis.

From the perspective of atom economy, route 2 is preferable because a larger percentage of reactant atoms end up in the desired product. It is also a “greener” approach than route 1 because it avoids the use of the toxic reactant benzene and does not produce CO₂, a gas that contributes to global warming.

› Summary of Section 3.4

- › The substances in a balanced equation are related to each other by stoichiometrically equivalent molar ratios, which are used as conversion factors to find the amount (mol) of one substance given the amount of another.
- › In limiting-reactant problems, the quantities of two (or more) reactants are given, and the limiting reactant is the one that forms the lower quantity of product. Reaction tables show the initial and final quantities of all reactants and products, as well as the changes in those quantities.
- › In practice, side reactions, incomplete reactions, and physical losses result in an actual yield of product that is less than the theoretical yield (the quantity based on the molar ratio from the balanced equation), giving a percent yield less than 100%. In multistep reaction sequences, the overall yield is found by multiplying the yields for each step.
- › Atom economy, or the proportion of reactant atoms found in the product, is one criterion for choosing a “greener” reaction process.

CHAPTER REVIEW GUIDE

Learning Objectives

Relevant section (§) and/or sample problem (SP) numbers appear in parentheses.

Understand These Concepts

1. The definition of the mole unit (§3.1)
2. Relationship between the mass of a chemical entity (in amu) and the mass of a mole of that entity (in g) (§3.1)
3. The relationships among amount of substance (in mol), mass (in g), and number of chemical entities (§3.1)
4. Mole-mass-number information in a chemical formula (§3.1)
5. The difference between empirical and molecular formulas of a compound (§3.2)
6. How more than one substance can have the same empirical formula or the same molecular formula (isomers) (§3.2)
7. The importance of balancing equations for the quantitative study of chemical reactions (§3.3)
8. Mole-mass-number information in a balanced equation (§3.4)
9. The relationship between amounts of reactants and amounts of products (§3.4)
10. Why one reactant limits the amount of product (§3.4)
11. The causes of lower-than-expected yields and the distinction between theoretical and actual yields (§3.4)

Master These Skills

1. Calculating the molar mass of any substance (§3.1; SPs 3.4–3.6)
2. Converting between amount of substance (in moles), mass (in grams), and number of chemical entities (SPs 3.1–3.5)
3. Using mass percent to find the mass of an element in a given mass of compound (SPs 3.6, 3.7)
4. Determining empirical and molecular formulas of a compound from mass percents and molar masses of elements (SPs 3.8–3.10)
5. Determining a molecular formula from combustion analysis (SP 3.11)
6. Converting a chemical statement or a molecular depiction into a balanced equation (SPs 3.12, 3.13)
7. Using stoichiometrically equivalent molar ratios to convert between amounts of reactants and products in reactions (SPs 3.14–3.16)
8. Writing an overall equation for a reaction sequence (SP 3.17)
9. Solving limiting-reactant problems for reactions (SPs 3.18–3.20)
10. Calculating percent yield (SP 3.21)

Key Terms

Page numbers appear in parentheses.

- actual yield (128)
Avogadro’s number (96)
balancing (stoichiometric coefficient (112))
chemical equation (111)
combustion analysis (108)

- empirical formula (104)
green chemistry (129)
isomer (110)
limiting reactant (122)
mole (mol) (95)

- molar mass (\mathcal{M}) (96)
molecular formula (105)
overall (net) equation (120)
percent yield (% yield) (128)
product (112)

- reactant (111)
side reaction (128)
stoichiometry (95)
structural formula (105)
theoretical yield (128)

Key Equations and Relationships

Page numbers appear in parentheses.

3.1 Number of entities in one mole (96):1 mol contains 6.022×10^{23} entities (to 4 sf)**3.2** Converting amount (mol) to mass (g) using \mathcal{M} (97):

$$\text{Mass (g)} = \text{amount (mol)} \times \frac{\text{no. of grams}}{1 \text{ mol}}$$

3.3 Converting mass (g) to amount (mol) using $1/\mathcal{M}$ (98):

$$\text{Amount (mol)} = \text{mass (g)} \times \frac{1 \text{ mol}}{\text{no. of grams}}$$

3.4 Converting amount (mol) to number of entities (98):

$$\text{No. of entities} = \text{amount (mol)} \times \frac{6.022 \times 10^{23} \text{ entities}}{1 \text{ mol}}$$

3.5 Converting number of entities to amount (mol) (98):

$$\text{Amount (mol)} = \text{no. of entities} \times \frac{1 \text{ mol}}{6.022 \times 10^{23} \text{ entities}}$$

BRIEF SOLUTIONS TO FOLLOW-UP PROBLEMS

3.1A Amount (mol) of C = $315 \text{ mg C} \times \frac{1 \text{ g}}{10^3 \text{ mg}} \times \frac{1 \text{ mol C}}{12.01 \text{ g C}}$
 $= 2.62 \times 10^{-2} \text{ mol C}$

See Road Map 3.1A.

3.1B 14 g Al = 1 soda can provides a conversion factor between mass of Al and number of soda cans:

$$\text{Number of cans} = 52 \text{ mol Al} \times \frac{26.98 \text{ g Al}}{1 \text{ mol Al}} \times \frac{1 \text{ can}}{14 \text{ g Al}}
= 100 \text{ cans}$$

See Road Map 3.1B.

Road Map 3.1A**Road Map 3.1B****3.2A** Amount (mol) of N = $9.72 \times 10^{21} \text{ N}_2 \text{ molecules}$

$$\times \frac{1 \text{ mol N}_2 \text{ molecules}}{6.022 \times 10^{23} \text{ N}_2 \text{ molecules}}
\times \frac{2 \text{ mol N atoms}}{1 \text{ mol N}_2 \text{ molecules}}
= 3.23 \times 10^{-2} \text{ mol N atoms}$$

See Road Map 3.2A.

3.2B No. of He atoms = $325 \text{ mol He} \times \frac{6.022 \times 10^{23} \text{ He atoms}}{1 \text{ mol He}}$
 $= 1.96 \times 10^{26} \text{ He atoms}$

See Road Map 3.2B.

3.6 Calculating mass % (102):

Mass % of element X

$$= \frac{\text{moles of X in formula} \times \text{molar mass of X (g/mol)}}{\text{mass (g) of 1 mol of compound}} \times 100$$

3.7 Finding the mass of an element in any mass of compound (103):

Mass of element = mass of compound

$$\times \frac{\text{mass of element in 1 mol of compound}}{\text{mass of 1 mol of compound}}$$

3.8 Calculating percent yield (128):

$$\% \text{ yield} = \frac{\text{actual yield}}{\text{theoretical yield}} \times 100$$

Road Map 3.2A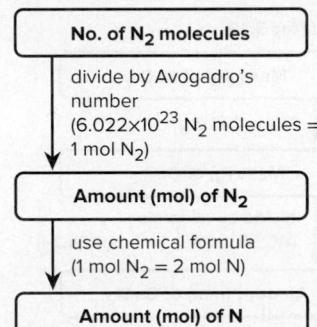**Road Map 3.2B**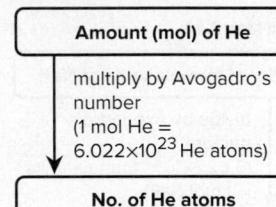**3.3A** Mass (g) of Mn = $3.22 \times 10^{20} \text{ Mn atoms}$

$$\times \frac{1 \text{ mol Mn}}{6.022 \times 10^{23} \text{ Mn atoms}} \times \frac{54.94 \text{ g Mn}}{1 \text{ mol Mn}}
= 2.94 \times 10^{-2} \text{ g Mn}$$

See Road Map 3.3A.

3.3B No. of Cu atoms = 0.0625 g Cu

$$\times \frac{1 \text{ mol Cu}}{63.55 \text{ g Cu}} \times \frac{6.022 \times 10^{23} \text{ Cu atoms}}{1 \text{ mol Cu}}
= 5.92 \times 10^{20} \text{ Cu atoms}$$

See Road Map 3.3B.

Road Map 3.3A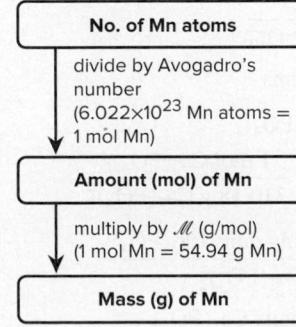**Road Map 3.3B**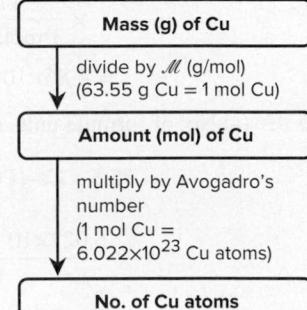

3.4A $\mathcal{M} = (1 \times \mathcal{M} \text{ of Na}) + (1 \times \mathcal{M} \text{ of F})$
 $= 22.99 \text{ g/mol} + 19.00 \text{ g/mol} = 41.99 \text{ g/mol}$

Mass (g) of NaF
 $= 1.19 \times 10^{19} \text{ NaF formula units}$
 $\times \frac{1 \text{ mol NaF}}{6.022 \times 10^{23} \text{ NaF formula units}} \times \frac{41.99 \text{ g NaF}}{1 \text{ mol NaF}}$
 $= 8.30 \times 10^{-4} \text{ g NaF}$

See Road Map 3.4A.

3.4B $\mathcal{M} = (1 \times \mathcal{M} \text{ of Ca}) + (2 \times \mathcal{M} \text{ of Cl})$
 $= 40.08 \text{ g/mol} + (2 \times 35.45 \text{ g/mol}) = 110.98 \text{ g/mol}$

No. of CaCl_2 formula units = 400 lb CaCl_2
 $\times \frac{453.6 \text{ g}}{1 \text{ lb}} \times \frac{1 \text{ mol CaCl}_2}{110.98 \text{ g CaCl}_2}$
 $\times \frac{6.022 \times 10^{23} \text{ CaCl}_2 \text{ formula units}}{1 \text{ mol CaCl}_2}$
 $= 1 \times 10^{27} \text{ CaCl}_2 \text{ formula units}$

See Road Map 3.4B.

Road Map 3.4A

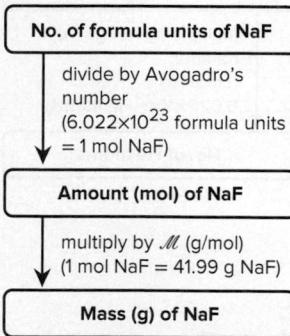

Road Map 3.4B

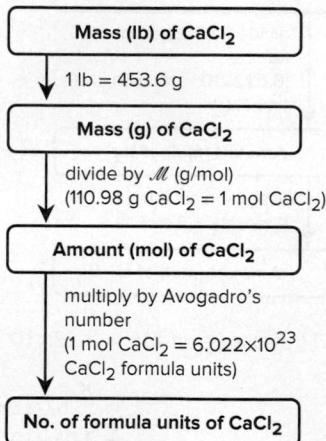

3.5A (a) Mass (g) of P_4O_{10}

$$= 4.65 \times 10^{22} \text{ molecules } \text{P}_4\text{O}_{10}$$
 $\times \frac{1 \text{ mol } \text{P}_4\text{O}_{10}}{6.022 \times 10^{23} \text{ molecules } \text{P}_4\text{O}_{10}} \times \frac{283.88 \text{ g } \text{P}_4\text{O}_{10}}{1 \text{ mol } \text{P}_4\text{O}_{10}}$
 $= 21.9 \text{ g } \text{P}_4\text{O}_{10}$

(b) No. of P atoms = $4.65 \times 10^{22} \text{ molecules } \text{P}_4\text{O}_{10}$

$$\times \frac{4 \text{ atoms P}}{1 \text{ molecule } \text{P}_4\text{O}_{10}}$$
 $= 1.86 \times 10^{23} \text{ P atoms}$

3.5B (a) No. of formula units of $\text{Ca}_3(\text{PO}_4)_2$

$$= 75.5 \text{ g } \text{Ca}_3(\text{PO}_4)_2 \times \frac{1 \text{ mol } \text{Ca}_3(\text{PO}_4)_2}{310.18 \text{ g } \text{Ca}_3(\text{PO}_4)_2}$$
 $\times \frac{6.022 \times 10^{23} \text{ formula units } \text{Ca}_3(\text{PO}_4)_2}{1 \text{ mol } \text{Ca}_3(\text{PO}_4)_2}$
 $= 1.47 \times 10^{23} \text{ formula units } \text{Ca}_3(\text{PO}_4)_2$

(b) No. of PO_4^{3-} ions = $1.47 \times 10^{23} \text{ formula units } \text{Ca}_3(\text{PO}_4)_2$

$$\times \frac{2 \text{ PO}_4^{3-} \text{ ions}}{1 \text{ formula unit } \text{Ca}_3(\text{PO}_4)_2}$$
 $= 2.94 \times 10^{23} \text{ PO}_4^{3-} \text{ ions}$

3.6A Mass % of C = $\frac{6 \text{ mol C} \times \frac{12.01 \text{ g C}}{1 \text{ mol C}}}{180.16 \text{ g } \text{C}_6\text{H}_{12}\text{O}_6} \times 100$
 $= 40.00 \text{ mass \% C}$

3.6B Mass % of Cl = $\frac{3 \text{ mol Cl} \times \frac{35.45 \text{ g Cl}}{1 \text{ mol Cl}}}{137.36 \text{ g } \text{CCl}_3\text{F}} \times 100$
 $= 77.42 \text{ mass \% Cl}$

3.7A Mass (g) of C = $16.55 \text{ g } \text{C}_6\text{H}_{12}\text{O}_6 \times \frac{72.06 \text{ g C}}{180.16 \text{ g } \text{C}_6\text{H}_{12}\text{O}_6}$
 $= 6.620 \text{ g C}$

3.7B Mass (g) of Cl = $112 \text{ g } \text{CCl}_3\text{F} \times \frac{106.35 \text{ g Cl}}{137.36 \text{ g } \text{CCl}_3\text{F}}$
 $= 86.7 \text{ g Cl}$

3.8A Preliminary formula: $\text{B}_{0.170}\text{O}_{0.255}$

Divide by smaller subscript: $\frac{\text{B}_{0.170}\text{O}_{0.255}}{0.170} = \text{B}_{1.00}\text{O}_{1.50}$

Multiply by 2: $\text{B}_{(2 \times 1.00)}\text{O}_{(2 \times 1.50)} = \text{B}_{2.00}\text{O}_{3.00} = \text{B}_2\text{O}_3$

3.8B Preliminary formula: $\text{C}_{6.80}\text{H}_{18.1}$

Divide by smallest subscript: $\frac{\text{C}_{6.80}\text{O}_{18.1}}{6.80} = \text{C}_{1.00}\text{H}_{2.66}$

Multiply by 3: $\text{C}_{(3 \times 1.00)}\text{H}_{(3 \times 2.66)} = \text{C}_{3.00}\text{H}_{7.98} = \text{C}_3\text{H}_8$

3.9A Amount (mol) of H = $1.23 \text{ g H} \times \frac{1 \text{ mol H}}{1.008 \text{ g H}}$
 $= 1.22 \text{ mol H}$

Similarly, there are 0.408 mol P and 1.63 mol O.

Preliminary formula: $\text{H}_{1.22}\text{P}_{0.408}\text{O}_{1.63}$

Divide by smallest subscript:

$$\frac{\text{H}_{1.22}\text{P}_{0.408}\text{O}_{1.63}}{0.408} = \text{H}_{2.99}\text{P}_{1.00}\text{O}_{4.00} = \text{H}_3\text{PO}_4$$

This is phosphoric acid.

3.9B Amount (mol) of S = $2.88 \text{ g S} \times \frac{1 \text{ mol S}}{32.06 \text{ g S}}$
 $= 0.0898 \text{ mol S}$

Amount (mol) of M = $0.0898 \text{ mol S} \times \frac{2 \text{ mol M}}{3 \text{ mol S}} = 0.0599 \text{ mol M}$

Molar mass of M = $\frac{3.12 \text{ g M}}{0.0599 \text{ mol M}} = 52.1 \text{ g/mol}$

M is chromium, and M_2S_3 is chromium(III) sulfide.

3.10A Assuming 100.00 g of compound, we have 95.21 g of C and 4.79 g of H:

$$\text{Amount (mol) of C} = 95.21 \text{ g C} \times \frac{1 \text{ mol C}}{12.01 \text{ g C}} = 7.928 \text{ mol C}$$

Similarly, there is 4.75 mol H.

Preliminary formula: $C_{7.928} H_{4.75} = C_{\frac{7.928}{4.75}} H_{\frac{4.75}{4.75}} = C_{1.67} H_{1.00}$

Empirical formula: $C_{(3 \times 1.67)} H_{(3 \times 1.00)} = C_5 H_3$

$$\begin{aligned}\text{Whole-number multiple} &= \frac{\text{M of benzo[a]pyrene}}{\text{M of empirical formula}} \\ &= \frac{252.30 \text{ g/mol}}{63.07 \text{ g/mol}} = 4\end{aligned}$$

Molecular formula: $C_{(5 \times 4)} H_{(3 \times 4)} = C_{20} H_{12}$

3.10B Assuming 100.00 g of compound, we have 49.47 g C, 5.19 g H, 28.86 g N, and 16.48 g O:

$$\text{Amount (mol) of C} = 49.47 \text{ g C} \times \frac{1 \text{ mol C}}{12.01 \text{ g C}} = 4.119 \text{ mol C}$$

Similarly, there are 5.15 mol H, 2.060 mol N, and 1.030 mol O.

$$\begin{aligned}\text{Preliminary formula: } &C_{4.119} H_{5.15} N_{2.060} O_{1.030} \\ &= C_{\frac{4.119}{1.030}} H_{\frac{5.15}{1.030}} N_{\frac{2.060}{1.030}} O_{\frac{1.030}{1.030}} = C_{4.00} H_{5.00} N_{2.00} O_{1.00}\end{aligned}$$

Empirical formula: $C_4 H_5 N_2 O$

$$\begin{aligned}\text{Whole-number multiple} &= \frac{\text{M of caffeine}}{\text{M of empirical formula}} \\ &= \frac{194.2 \text{ g/mol}}{97.10 \text{ g/mol}} = 2\end{aligned}$$

Molecular formula: $C_{(4 \times 2)} H_{(5 \times 2)} N_{(2 \times 2)} O_{(1 \times 2)} = C_8 H_{10} N_4 O_2$

$$\begin{aligned}\text{3.11A Mass (g) of C} &= 0.451 \text{ g CO}_2 \times \frac{12.01 \text{ g C}}{44.01 \text{ g CO}_2} \\ &= 0.123 \text{ g C}\end{aligned}$$

Similarly, there is 0.00690 g H.

Mass (g) of Cl = 0.250 g – (0.123 g + 0.00690 g) = 0.120 g Cl

Amount (mol) of elements: 0.0102 mol C; 0.00685 mol H; 0.00339 mol Cl

$$\begin{aligned}\text{Empirical formula: } &C_{0.0102} H_{0.00685} Cl_{0.00339} \\ &= C_{\frac{0.0102}{0.00339}} H_{\frac{0.00685}{0.00339}} Cl_{\frac{0.00339}{0.00339}} = C_3 H_2 Cl\end{aligned}$$

$$\begin{aligned}\text{Whole-number multiple} &= \frac{\text{M of compound}}{\text{M of empirical formula}} \\ &= \frac{146.99 \text{ g/mol}}{73.50 \text{ g/mol}} = 2\end{aligned}$$

Molecular formula: $C_{(3 \times 2)} H_{(2 \times 2)} Cl_{(1 \times 2)} = C_6 H_4 Cl_2$

$$\begin{aligned}\text{3.11B Mass (g) of C} &= 3.516 \text{ g CO}_2 \times \frac{12.01 \text{ g C}}{44.01 \text{ g CO}_2} \\ &= 0.9595 \text{ g C}\end{aligned}$$

Similarly, there is 0.1127 g H.

Mass (g) of O = 1.200 g – (0.9595 g + 0.1127 g) = 0.128 g O

Amount (mol) of elements: 0.07989 mol C; 0.1118 mol H; 0.00800 mol O

$$\begin{aligned}\text{Empirical formula: } &C_{0.07989} H_{0.1118} O_{0.00800} \\ &= C_{\frac{0.07989}{0.00800}} H_{\frac{0.1118}{0.00800}} O_{\frac{0.00800}{0.00800}} = C_{10} H_{14} O\end{aligned}$$

$$\begin{aligned}\text{Whole-number multiple} &= \frac{\text{M of compound}}{\text{M of empirical formula}} \\ &= \frac{300.42 \text{ g/mol}}{150.21 \text{ g/mol}} = 2\end{aligned}$$

Molecular formula: $C_{(10 \times 2)} H_{(14 \times 2)} O_{(1 \times 2)} = C_{20} H_{28} O_2$

3.12A (a) $2\text{Na}(s) + 2\text{H}_2\text{O}(l) \rightarrow \text{H}_2(g) + 2\text{NaOH}(aq)$

(b) $2\text{HNO}_3(aq) + \text{CaCO}_3(s) \rightarrow \text{CO}_2(g) + \text{H}_2\text{O}(l) + \text{Ca}(\text{NO}_3)_2(aq)$

(c) $\text{PCl}_3(g) + 3\text{HF}(g) \rightarrow \text{PF}_3(g) + 3\text{HCl}(g)$

3.12B (a) $4\text{C}_3\text{H}_5\text{N}_3\text{O}_9(l) \rightarrow 12\text{CO}_2(g) + 10\text{H}_2\text{O}(g) + 6\text{N}_2(g) + \text{O}_2(g)$

(b) $4\text{KO}_2(s) + 2\text{CO}_2(g) \rightarrow 3\text{O}_2(g) + 2\text{K}_2\text{CO}_3(s)$

(c) $\text{Fe}_2\text{O}_3(s) + 3\text{CO}(g) \rightarrow 2\text{Fe}(s) + 3\text{CO}_2(g)$

3.13A From the depiction, we have

Or,

3.13B From the depiction, we have

Or,

3.14A $\text{Fe}_2\text{O}_3(s) + 2\text{Al}(s) \rightarrow \text{Al}_2\text{O}_3(s) + 2\text{Fe}(l)$

$$\begin{aligned}\text{Amount (mol) of Fe}_2\text{O}_3 &= 3.60 \times 10^3 \text{ mol Fe} \times \frac{1 \text{ mol Fe}_2\text{O}_3}{2 \text{ mol Fe}} \\ &= 1.80 \times 10^3 \text{ mol Fe}_2\text{O}_3\end{aligned}$$

See Road Map 3.14A.

3.14B $3\text{Ag}_2\text{S}(s) + 2\text{Al}(s) \rightarrow 6\text{Ag}(s) + \text{Al}_2\text{S}_3(s)$

$$\begin{aligned}\text{Amount (mol) of Al} &= 0.253 \text{ mol Ag}_2\text{S} \times \frac{2 \text{ mol Al}}{3 \text{ mol Ag}_2\text{S}} \\ &= 0.169 \text{ mol Al}\end{aligned}$$

See Road Map 3.14B.

Road Map 3.14A

Road Map 3.14B

3.15A Amount (mol) of Fe

$$\begin{aligned}&= 1.85 \times 10^{25} \text{ formula units Fe}_2\text{O}_3 \\ &\times \frac{1 \text{ mol Fe}_2\text{O}_3}{6.022 \times 10^{23} \text{ formula units Fe}_2\text{O}_3} \times \frac{2 \text{ mol Fe}}{1 \text{ mol Fe}_2\text{O}_3} \\ &= 61.4 \text{ mol Fe}\end{aligned}$$

See Road Map 3.15A.

3.15B Amount (mol) of Ag = $32.6 \text{ g Ag}_2\text{S} \times \frac{1 \text{ mol Ag}_2\text{S}}{247.9 \text{ g Ag}_2\text{S}} \times \frac{6 \text{ mol Ag}}{3 \text{ mol Ag}_2\text{S}}$

$$\begin{aligned}&\times \frac{1 \text{ mol Ag}_2\text{S}}{247.9 \text{ g Ag}_2\text{S}} \times \frac{6 \text{ mol Ag}}{3 \text{ mol Ag}_2\text{S}} \\ &= 0.263 \text{ mol Ag}\end{aligned}$$

See Road Map 3.15B.

Road Map 3.15A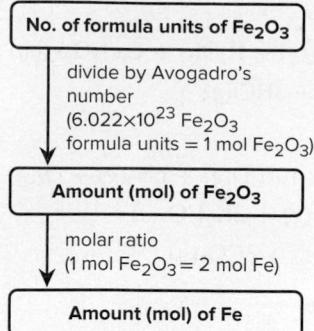**Road Map 3.15B**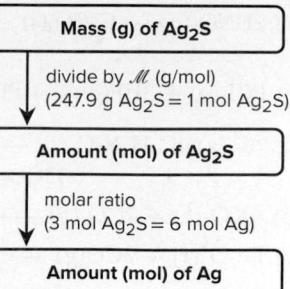**3.16A**

$$\text{No. of Al atoms} = 1.00 \text{ g Al}_2\text{O}_3 \times \frac{1 \text{ mol Al}_2\text{O}_3}{101.96 \text{ g Al}_2\text{O}_3} \times \frac{2 \text{ mol Al}}{1 \text{ mol Al}_2\text{O}_3} \times \frac{6.022 \times 10^{23} \text{ Al atoms}}{1 \text{ mol Al}} = 1.18 \times 10^{22} \text{ Al atoms}$$

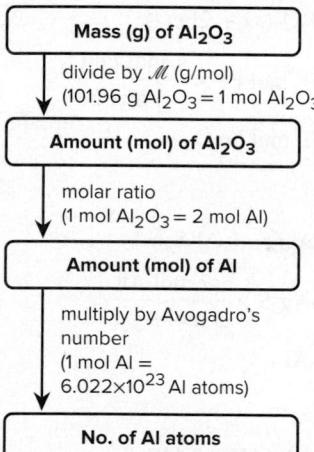

$$\text{3.16B Mass (g) of Al} = 12.1 \text{ g Al}_2\text{S}_3 \times \frac{1 \text{ mol Al}_2\text{S}_3}{150.14 \text{ g Al}_2\text{S}_3} \times \frac{2 \text{ mol Al}}{1 \text{ mol Al}_2\text{S}_3} \times \frac{26.98 \text{ g Al}}{1 \text{ mol Al}} = 4.35 \text{ g Al}$$

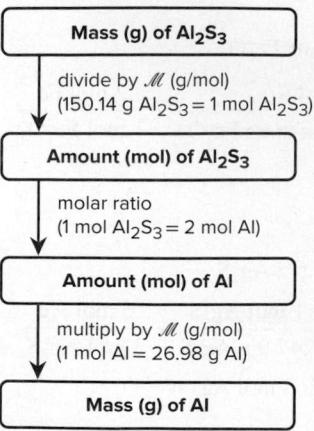**3.17A**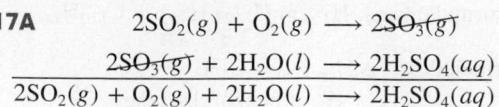**3.17B**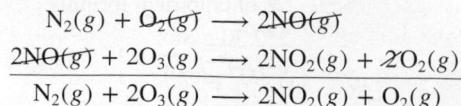**3.18A** $4\text{AB}(g) + 2\text{B}_2(g) \longrightarrow 4\text{AB}_2(g)$ Or $2\text{AB}(g) + \text{B}_2(g) \longrightarrow 2\text{AB}_2(g)$ For AB: Molecules of AB₂

$$= 4 \text{ molecules of AB} \times \frac{2 \text{ molecules of AB}_2}{2 \text{ molecules of AB}} = 4 \text{ molecules of AB}_2$$

For B₂: Molecules of AB₂

$$= 3 \text{ molecules of B}_2 \times \frac{2 \text{ molecules of AB}_2}{1 \text{ molecule of B}_2} = 6 \text{ molecules of AB}_2$$

Thus, AB is the limiting reactant; one B₂ molecule is in excess.**3.18B** $4\text{SO}_2(g) + 2\text{O}_2(g) \longrightarrow 4\text{SO}_3(g)$ Or $2\text{SO}_2(g) + \text{O}_2(g) \longrightarrow 2\text{SO}_3(g)$ For SO₂: Molecules of SO₃

$$= 5 \text{ molecules of SO}_2 \times \frac{2 \text{ molecules of SO}_3}{2 \text{ molecules of SO}_2} = 5 \text{ molecules of SO}_3$$

For O₂: Molecules of SO₃

$$= 2 \text{ molecules of O}_2 \times \frac{2 \text{ molecules of SO}_3}{1 \text{ molecule of O}_2} = 4 \text{ molecules of SO}_3$$

Thus, O₂ is the limiting reactant; one SO₂ molecule is in excess.**3.19A** Amount (mol) of AB₂

$$= 1.5 \text{ mol AB} \times \frac{2 \text{ mol AB}_2}{2 \text{ mol AB}} = 1.5 \text{ mol AB}_2$$

Amount (mol) of AB₂

$$= 1.5 \text{ mol B}_2 \times \frac{2 \text{ mol AB}_2}{1 \text{ mol B}_2} = 3.0 \text{ mol AB}_2$$

Therefore, 1.5 mol of AB₂ can form.

$$\begin{aligned} \text{3.19B Amount (mol) of SO}_3 &= 4.2 \text{ mol SO}_2 \times \frac{2 \text{ mol SO}_3}{2 \text{ mol SO}_2} \\ &= 4.2 \text{ mol SO}_3 \end{aligned}$$

$$\begin{aligned} \text{Amount (mol) of SO}_3 &= 3.6 \text{ mol O}_2 \times \frac{2 \text{ mol SO}_3}{1 \text{ mol O}_2} \\ &= 7.2 \text{ mol SO}_3 \end{aligned}$$

Therefore, 4.2 mol of SO₃ is produced.**3.20A** $2\text{Al}(s) + 3\text{S}(s) \longrightarrow \text{Al}_2\text{S}_3(s)$ Mass (g) of Al₂S₃ formed from 10.0 g of Al

$$\begin{aligned} &= 10.0 \text{ g Al} \times \frac{1 \text{ mol Al}}{26.98 \text{ g Al}} \times \frac{1 \text{ mol Al}_2\text{S}_3}{2 \text{ mol Al}} \times \frac{150.14 \text{ g Al}_2\text{S}_3}{1 \text{ mol Al}_2\text{S}_3} \\ &= 27.8 \text{ g Al}_2\text{S}_3 \end{aligned}$$

Mass (g) of Al_2S_3 formed from 15.0 g of S

$$\begin{aligned} &= 15.0 \text{ g S} \times \frac{1 \text{ mol S}}{32.06 \text{ g S}} \times \frac{1 \text{ mol Al}_2\text{S}_3}{3 \text{ mol S}} \times \frac{150.14 \text{ g Al}_2\text{S}_3}{1 \text{ mol Al}_2\text{S}_3} \\ &= 23.4 \text{ g Al}_2\text{S}_3 \end{aligned}$$

Thus, S is the limiting reactant, and 23.4 g of Al_2S_3 forms.

Mass (g) of Al in excess

= initial mass of Al – mass of Al reacted

$$\begin{aligned} &= 10.0 \text{ g Al} - \left(15.0 \text{ g S} \times \frac{1 \text{ mol S}}{32.06 \text{ g S}} \times \frac{2 \text{ mol Al}}{3 \text{ mol S}} \times \frac{26.98 \text{ g Al}}{1 \text{ mol Al}} \right) \\ &= 1.6 \text{ g Al} \end{aligned}$$

(We would obtain the same answer if sulfur were shown more correctly as S_8 .)

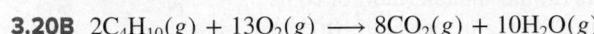

Mass (g) of CO_2 formed from 4.65 g of C_4H_{10}

$$\begin{aligned} &= 4.65 \text{ g C}_4\text{H}_{10} \times \frac{1 \text{ mol C}_4\text{H}_{10}}{58.12 \text{ g C}_4\text{H}_{10}} \times \frac{8 \text{ mol CO}_2}{2 \text{ mol C}_4\text{H}_{10}} \times \frac{44.01 \text{ g CO}_2}{1 \text{ mol CO}_2} \\ &= 14.1 \text{ g CO}_2 \end{aligned}$$

Mass (g) of CO_2 formed from 10.0 g of O_2

$$\begin{aligned} &= 10.0 \text{ g O}_2 \times \frac{1 \text{ mol O}_2}{32.00 \text{ g O}_2} \times \frac{8 \text{ mol CO}_2}{13 \text{ mol O}_2} \times \frac{44.01 \text{ g CO}_2}{1 \text{ mol CO}_2} \\ &= 8.46 \text{ g CO}_2 \end{aligned}$$

Thus, O_2 is the limiting reactant, and 8.46 g of CO_2 forms.

Mass (g) of C_4H_{10} in excess

= initial mass of C_4H_{10} – mass of C_4H_{10} reacted

$$\begin{aligned} &= 4.65 \text{ g} - \left(10.0 \text{ g O}_2 \times \frac{1 \text{ mol O}_2}{32.00 \text{ g O}_2} \times \frac{2 \text{ mol C}_4\text{H}_{10}}{13 \text{ mol O}_2} \times \frac{58.12 \text{ g C}_4\text{H}_{10}}{1 \text{ mol C}_4\text{H}_{10}} \right) \\ &= 1.86 \text{ g C}_4\text{H}_{10} \end{aligned}$$

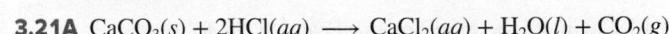

$$\text{Theoretical yield (g) of CO}_2 = 10.0 \text{ g CaCO}_3 \times \frac{1 \text{ mol CO}_2}{100.09 \text{ g CaCO}_3}$$

$$\times \frac{1 \text{ mol CO}_2}{1 \text{ mol CaCO}_3} \times \frac{44.01 \text{ g CO}_2}{1 \text{ mol CO}_2}$$

$$= 4.40 \text{ g CO}_2$$

$$\% \text{ yield} = \frac{\text{actual yield}}{\text{theoretical yield}} \times 100 = \frac{3.65 \text{ g CO}_2}{4.40 \text{ g CO}_2} \times 100 = 83.0\%$$

Theoretical yield of Na_2CO_3

$$= 112 \text{ g NaCl} \times \frac{1 \text{ mol NaCl}}{58.44 \text{ g NaCl}} \times \frac{1 \text{ mol Na}_2\text{CO}_3}{2 \text{ mol NaCl}}$$

$$\times \frac{105.99 \text{ g Na}_2\text{CO}_3}{1 \text{ mol Na}_2\text{CO}_3}$$

$$= 102 \text{ g Na}_2\text{CO}_3$$

$$\% \text{ yield} = \frac{\text{actual yield}}{\text{theoretical yield}} \times 100 = \frac{92.6 \text{ g Na}_2\text{CO}_3}{102 \text{ g Na}_2\text{CO}_3} \times 100 = 90.8\%$$

PROBLEMS

Problems with **colored** numbers are answered in Appendix E and worked in detail in the Student Solutions Manual. Problem sections match those in the text and give the numbers of relevant sample problems. Most offer Concept Review Questions, Skill-Building Exercises (grouped in pairs covering the same concept), and Problems in Context. The Comprehensive Problems are based on material from any section or previous chapter.

The Mole

(Sample Problems 3.1 to 3.7)

Concept Review Questions

3.1 The atomic mass of Cl is 35.45 amu, and the atomic mass of Al is 26.98 amu. What are the masses in grams of 3 mol of Al atoms and of 2 mol of Cl atoms?

3.2 (a) How many moles of C atoms are in 1 mol of sucrose ($\text{C}_{12}\text{H}_{22}\text{O}_{11}$)?

(b) How many C atoms are in 2 mol of sucrose?

3.3 Why might the expression “1 mol of chlorine” be confusing? What change would remove any uncertainty? For what other elements might a similar confusion exist? Why?

3.4 How is the molecular mass of a compound the same as the molar mass, and how is it different?

3.5 What advantage is there to using a counting unit (the mole) for amount of substance rather than a mass unit?

3.6 You need to calculate the number of P_4 molecules that can form from 2.5 g of $\text{Ca}_3(\text{PO}_4)_2$. Draw a road map for solving this and write a Plan, without doing any calculations.

3.7 Each of the following balances weighs the indicated numbers of atoms of two elements:

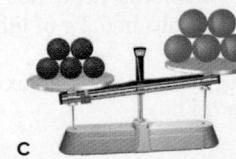

For each balance, which element—left, right, or neither,

- Has the higher molar mass?
- Has more atoms per gram?
- Has fewer atoms per gram?
- Has more atoms per mole?

Skill-Building Exercises (grouped in similar pairs)**3.8** Calculate the molar mass of each of the following:

- (a)
- $\text{Sr}(\text{OH})_2$
- (b)
- N_2O_3
- (c)
- NaClO_3
- (d)
- Cr_2O_3

3.9 Calculate the molar mass of each of the following:

- (a)
- $(\text{NH}_4)_3\text{PO}_4$
- (b)
- CH_2Cl_2
- (c)
- $\text{CuSO}_4 \cdot 5\text{H}_2\text{O}$
- (d)
- BrF_3

3.10 Calculate the molar mass of each of the following:

- (a)
- SnO
- (b)
- BaF_2
- (c)
- $\text{Al}_2(\text{SO}_4)_3$
- (d)
- MnCl_2

3.11 Calculate the molar mass of each of the following:

- (a)
- N_2O_4
- (b)
- $\text{C}_4\text{H}_9\text{OH}$
- (c)
- $\text{MgSO}_4 \cdot 7\text{H}_2\text{O}$
- (d)
- $\text{Ca}(\text{C}_2\text{H}_3\text{O}_2)_2$

3.12 Calculate each of the following quantities:

- (a) Mass (g) of 0.346 mol of Zn

- (b) Number of F atoms in 2.62 mol of
- F_2

- (c) Number of Ca atoms in 28.5 g of Ca

3.13 Calculate each of the following quantities:

- (a) Amount (mol) of Mn atoms in 62.0 mg of Mn

- (b) Amount (mol) for
- 1.36×10^{22}
- atoms of Cu

- (c) Mass (g) of
- 8.05×10^{24}
- Li atoms

3.14 Calculate each of the following quantities:

- (a) Mass (g) of 0.68 mol of
- KMnO_4

- (b) Amount (mol) of O atoms in 8.18 g of
- $\text{Ba}(\text{NO}_3)_2$

- (c) Number of O atoms in
- 7.3×10^{-3}
- g of
- $\text{CaSO}_4 \cdot 2\text{H}_2\text{O}$

3.15 Calculate each of the following quantities:

- (a) Mass (kg) of
- 4.6×10^{21}
- molecules of
- NO_2

- (b) Amount (mol) of Cl atoms in 0.0615 g of
- $\text{C}_2\text{H}_4\text{Cl}_2$

- (c) Number of
- H^-
- ions in 5.82 g of
- SrH_2

3.16 Calculate each of the following quantities:

- (a) Mass (g) of
- 6.44×10^{-2}
- mol of
- MnSO_4

- (b) Amount (mol) of compound in 15.8 kg of
- $\text{Fe}(\text{ClO}_4)_3$

- (c) Number of N atoms in 92.6 mg of
- NH_4NO_2

3.17 Calculate each of the following quantities:

- (a) Total number of ions in 38.1 g of
- SrF_2

- (b) Mass (kg) of 3.58 mol of
- $\text{CuCl}_2 \cdot 2\text{H}_2\text{O}$

- (c) Mass (mg) of
- 2.88×10^{22}
- formula units of
- $\text{Bi}(\text{NO}_3)_3 \cdot 5\text{H}_2\text{O}$

3.18 Calculate each of the following quantities:

- (a) Mass (g) of 8.35 mol of copper(I) carbonate

- (b) Mass (g) of
- 4.04×10^{20}
- molecules of dinitrogen pentoxide

- (c) Amount (mol) and number of formula units in 78.9 g of sodium perchlorate

- (d) Number of sodium ions, perchlorate ions, chlorine atoms, and oxygen atoms in the mass of compound in part (c)

3.19 Calculate each of the following quantities:

- (a) Mass (g) of 8.42 mol of chromium(III) sulfate decahydrate

- (b) Mass (g) of
- 1.83×10^{24}
- molecules of dichlorine heptoxide

- (c) Amount (mol) and number of formula units in 6.2 g of lithium sulfate

- (d) Number of lithium ions, sulfate ions, sulfur atoms, and oxygen atoms in the mass of compound in part (c)

3.20 Calculate each of the following:

- (a) Mass % of H in ammonium bicarbonate

- (b) Mass % of O in sodium dihydrogen phosphate heptahydrate

3.21 Calculate each of the following:

- (a) Mass % of I in strontium periodate

- (b) Mass % of Mn in potassium permanganate

3.22 Calculate each of the following:

- (a) Mass fraction of C in cesium acetate

- (b) Mass fraction of O in uranyl sulfate trihydrate (the uranyl ion is
- UO_2^{2+}
-)

3.23 Calculate each of the following:

- (a) Mass fraction of Cl in calcium chlorate

- (b) Mass fraction of N in dinitrogen trioxide

Problems in Context**3.24** Oxygen is required for the metabolic combustion of foods. Calculate the number of atoms in 38.0 g of oxygen gas, the amount absorbed from the lungs in about 15 min when a person is at rest.**3.25** Cisplatin (*right*), or Platinol, is used in the treatment of certain cancers.

Calculate (a) the amount (mol) of compound in 285.3 g of cisplatin; (b) the number of hydrogen atoms in 0.98 mol of cisplatin.

3.26 Allyl sulfide (*below*) gives garlic its characteristic odor. Calculate (a) the mass (g) of 2.63 mol of allyl sulfide; (b) the number of carbon atoms in 35.7 g of allyl sulfide.**3.27** Iron reacts slowly with oxygen and water to form a compound commonly called rust ($\text{Fe}_2\text{O}_3 \cdot 4\text{H}_2\text{O}$). For 45.2 kg of rust, calculate (a) moles of compound; (b) moles of Fe_2O_3 ; (c) grams of Fe.**3.28** Propane is widely used in liquid form as a fuel for barbecue grills and camp stoves. For 85.5 g of propane, calculate (a) moles of compound; (b) grams of carbon.**3.29** The effectiveness of a nitrogen fertilizer is determined mainly by its mass % N. Rank the following fertilizers, most effective first: potassium nitrate; ammonium nitrate; ammonium sulfate; urea, $\text{CO}(\text{NH}_2)_2$.**3.30** The mineral galena is composed of lead(II) sulfide and has an average density of 7.46 g/cm^3 . (a) How many moles of lead(II) sulfide are in 1.00 ft^3 of galena? (b) How many lead atoms are in 1.00 dm^3 of galena?**3.31** Hemoglobin, a protein in red blood cells, carries O_2 from the lungs to the body's cells. Iron (as ferrous ion, Fe^{2+}) makes up 0.33 mass % of hemoglobin. If the molar mass of hemoglobin is $6.8 \times 10^4 \text{ g/mol}$, how many Fe^{2+} ions are in one molecule?**Determining the Formula of an Unknown Compound**

(Sample Problems 3.8 to 3.11)

Concept Review Questions**3.32** What is the difference between an empirical formula and a molecular formula? Can they ever be the same?**3.33** List three ways compositional data may be given in a problem that involves finding an empirical formula.**3.34** Which of the following sets of information allows you to obtain the molecular formula of a covalent compound? In each case that allows it, explain how you would proceed (draw a road map and write a plan for a solution).

- (a) Number of moles of each type of atom in a given sample of the compound
 (b) Mass % of each element and the total number of atoms in a molecule of the compound
 (c) Mass % of each element and the number of atoms of one element in a molecule of the compound
 (d) Empirical formula and mass % of each element
 (e) Structural formula

3.35 Is $MgCl_2$ an empirical or a molecular formula for magnesium chloride? Explain.

Skill-Building Exercises (grouped in similar pairs)

3.36 What is the empirical formula and empirical formula mass for each of the following compounds?

- (a) C_2H_4 (b) $C_2H_6O_2$ (c) N_2O_5 (d) $Ba_3(PO_4)_2$ (e) Te_4I_{16}

3.37 What is the empirical formula and empirical formula mass for each of the following compounds?

- (a) C_4H_8 (b) $C_3H_6O_3$ (c) P_4O_{10} (d) $Ga_2(SO_4)_3$ (e) Al_2Br_6

3.38 Give the name, empirical formula, and molar mass of the compound depicted in Figure P3.38.

3.39 Give the name, empirical formula, and molar mass of the compound depicted in Figure P3.39.

Figure P3.38

Figure P3.39

3.40 What is the molecular formula of each compound?

- (a) Empirical formula CH_2 ($\mathcal{M} = 42.08$ g/mol)
 (b) Empirical formula NH_2 ($\mathcal{M} = 32.05$ g/mol)
 (c) Empirical formula NO_2 ($\mathcal{M} = 92.02$ g/mol)
 (d) Empirical formula CHN ($\mathcal{M} = 135.14$ g/mol)

3.41 What is the molecular formula of each compound?

- (a) Empirical formula CH ($\mathcal{M} = 78.11$ g/mol)
 (b) Empirical formula $C_3H_6O_2$ ($\mathcal{M} = 74.08$ g/mol)
 (c) Empirical formula $HgCl$ ($\mathcal{M} = 472.1$ g/mol)
 (d) Empirical formula $C_7H_4O_2$ ($\mathcal{M} = 240.20$ g/mol)

3.42 Find the empirical formula of each of the following compounds: (a) 0.063 mol of chlorine atoms combined with 0.22 mol of oxygen atoms; (b) 2.45 g of silicon combined with 12.4 g of chlorine; (c) 27.3 mass % carbon and 72.7 mass % oxygen

3.43 Find the empirical formula of each of the following compounds: (a) 0.039 mol of iron atoms combined with 0.052 mol of oxygen atoms; (b) 0.903 g of phosphorus combined with 6.99 g of bromine; (c) a hydrocarbon with 79.9 mass % carbon

3.44 An oxide of nitrogen contains 30.45 mass % N. (a) What is the empirical formula of the oxide? (b) If the molar mass is 90 ± 5 g/mol, what is the molecular formula?

3.45 A chloride of silicon contains 79.1 mass % Cl. (a) What is the empirical formula of the chloride? (b) If the molar mass is 269 g/mol, what is the molecular formula?

3.46 A sample of 0.600 mol of a metal M reacts completely with excess fluorine to form 46.8 g of MF_2 .

- (a) How many moles of F are in the sample of MF_2 that forms?
 (b) How many grams of M are in this sample of MF_2 ?
 (c) What element is represented by the symbol M?

3.47 A 0.370-mol sample of a metal oxide (M_2O_3) weighs 55.4 g.

- (a) How many moles of O are in the sample?
 (b) How many grams of M are in the sample?
 (c) What element is represented by the symbol M?

3.48 Menthol ($\mathcal{M} = 156.3$ g/mol), the strong-smelling substance in many cough drops, is a compound of carbon, hydrogen, and oxygen. When 0.1595 g of menthol was burned in a combustion apparatus, 0.449 g of CO_2 and 0.184 g of H_2O formed. What is menthol's molecular formula?

3.49 The compound dimethyl phthalate, used in insect repellants, is composed of carbon, hydrogen, and oxygen and has a molar mass of 194.2 g/mol. A 0.2572-g sample of the compound was burned in a combustion apparatus and 0.583 g of CO_2 and 0.119 g of H_2O were collected. What is the molecular formula of dimethyl phthalate?

Problems in Context

3.50 Nicotine is a poisonous, addictive compound found in tobacco. A sample of nicotine contains 6.16 mmol of C, 8.56 mmol of H, and 1.23 mmol of N [1 mmol (1 millimole) = 10^{-3} mol]. What is the empirical formula of nicotine?

3.51 Cortisol ($\mathcal{M} = 362.47$ g/mol) is a steroid hormone involved in protein synthesis. Medically, it has a major use in reducing inflammation from rheumatoid arthritis. Cortisol is 69.6% C, 8.34% H, and 22.1% O by mass. What is its molecular formula?

3.52 Acetaminophen (*below*) is a popular nonaspirin pain reliever. What is the mass % of each element in acetaminophen?

Writing and Balancing Chemical Equations

(Sample Problems 3.12 and 3.13)

Concept Review Questions

3.53 What three types of information does a balanced chemical equation provide? How?

3.54 How does a balanced chemical equation apply the law of conservation of mass?

3.55 In the process of balancing the equation

Student I writes: $Al + Cl_2 \longrightarrow AlCl_2$

Student II writes: $Al + Cl_2 + Cl \longrightarrow AlCl_3$

Student III writes: $2Al + 3Cl_2 \longrightarrow 2AlCl_3$

Is the approach of Student I valid? Student II? Student III? Explain.

Skill-Building Exercises (grouped in similar pairs)

3.56 The scenes below represent a chemical reaction between elements A (red) and B (green):

Which best represents the balanced equation for the reaction?

- $2A + 2B \rightarrow A_2 + B_2$
- $A_2 + B_2 \rightarrow 2AB$
- $B_2 + 2AB \rightarrow 2B_2 + A_2$
- $4A_2 + 4B_2 \rightarrow 8AB$

3.57 Write a balanced equation for the following gas phase reaction (carbon is black, hydrogen is light blue, and fluorine is green):

3.58 Write balanced equations for each of the following by inserting the correct coefficients in the blanks:

- $\underline{\quad}Cu(s) + \underline{\quad}S_8(s) \rightarrow \underline{\quad}Cu_2S(s)$
- $\underline{\quad}P_4O_{10}(s) + \underline{\quad}H_2O(l) \rightarrow \underline{\quad}H_3PO_4(l)$
- $\underline{\quad}B_2O_3(s) + \underline{\quad}NaOH(aq) \rightarrow \underline{\quad}Na_3BO_3(aq) + \underline{\quad}H_2O(l)$
- $\underline{\quad}CH_3NH_2(g) + \underline{\quad}O_2(g) \rightarrow \underline{\quad}CO_2(g) + \underline{\quad}H_2O(g) + \underline{\quad}N_2(g)$

3.59 Write balanced equations for each of the following by inserting the correct coefficients in the blanks:

- $\underline{\quad}Cu(NO_3)_2(aq) + \underline{\quad}KOH(aq) \rightarrow \underline{\quad}Cu(OH)_2(s) + \underline{\quad}KNO_3(aq)$
- $\underline{\quad}BCl_3(g) + \underline{\quad}H_2O(l) \rightarrow \underline{\quad}H_3(BO_3)(s) + \underline{\quad}HC1(g)$
- $\underline{\quad}CaSiO_3(s) + \underline{\quad}HF(g) \rightarrow \underline{\quad}SiF_4(g) + \underline{\quad}CaF_2(s) + \underline{\quad}H_2O(l)$
- $\underline{\quad}(CN)_2(g) + \underline{\quad}H_2O(l) \rightarrow \underline{\quad}H_2C_2O_4(aq) + \underline{\quad}NH_3(g)$

3.60 Write balanced equations for each of the following by inserting the correct coefficients in the blanks:

- $\underline{\quad}SO_2(g) + \underline{\quad}O_2(g) \rightarrow \underline{\quad}SO_3(g)$
- $\underline{\quad}Sc_2O_3(s) + \underline{\quad}H_2O(l) \rightarrow \underline{\quad}Sc(OH)_3(s)$
- $\underline{\quad}H_3PO_4(aq) + \underline{\quad}NaOH(aq) \rightarrow \underline{\quad}Na_2HPO_4(aq) + \underline{\quad}H_2O(l)$
- $\underline{\quad}C_6H_{10}O_5(s) + \underline{\quad}O_2(g) \rightarrow \underline{\quad}CO_2(g) + \underline{\quad}H_2O(g)$

3.61 Write balanced equations for each of the following by inserting the correct coefficients in the blanks:

- $\underline{\quad}As_4S_6(s) + \underline{\quad}O_2(g) \rightarrow \underline{\quad}As_4O_6(s) + \underline{\quad}SO_2(g)$
- $\underline{\quad}Ca_3(PO_4)_2(s) + \underline{\quad}SiO_2(s) + \underline{\quad}C(s) \rightarrow \underline{\quad}P_4(g) + \underline{\quad}CaSiO_3(l) + \underline{\quad}CO(g)$

3.62 Convert the following into balanced equations:

- When gallium metal is heated in oxygen gas, it melts and forms solid gallium(III) oxide.
- Liquid hexane burns in oxygen gas to form carbon dioxide gas and water vapor.
- When solutions of calcium chloride and sodium phosphate are mixed, solid calcium phosphate forms and sodium chloride remains in solution.

3.63 Convert the following into balanced equations:

- When lead(II) nitrate solution is added to potassium iodide solution, solid lead(II) iodide forms and potassium nitrate solution remains.
- Liquid disilicon hexachloride reacts with water to form solid silicon dioxide, hydrogen chloride gas, and hydrogen gas.
- When nitrogen dioxide is bubbled into water, a solution of nitric acid forms and gaseous nitrogen monoxide is released.

Problem in Context

3.64 Loss of atmospheric ozone has led to an ozone “hole” over Antarctica. The loss occurs in part through three consecutive steps:

- Chlorine atoms react with ozone (O_3) to form chlorine monoxide and molecular oxygen.
 - Chlorine monoxide forms $ClOOCl$.
 - $ClOOCl$ absorbs sunlight and breaks into chlorine atoms and molecular oxygen.
- Write a balanced equation for each step.
 - Write an overall balanced equation for the sequence.

Calculating Quantities of Reactant and Product

(Sample Problems 3.14 to 3.21)

Concept Review Questions

3.65 What does the term *stoichiometrically equivalent molar ratio* mean, and how is it applied in solving problems?

3.66 Percent yields are generally calculated from masses. Would the result be the same if amounts (mol) were used instead? Why?

Skill-Building Exercises (grouped in similar pairs)

3.67 Reactants A and B form product C. Draw a road map and write a Plan to find the mass (g) of C when 25 g of A reacts with excess B.

3.68 Reactants D and E form product F. Draw a road map and write a Plan to find the mass (g) of F when 27 g of D reacts with 31 g of E.

3.69 Chlorine gas can be made in the laboratory by the reaction of hydrochloric acid and manganese(IV) oxide:

When 1.82 mol of HCl reacts with excess MnO_2 , how many (a) moles of Cl_2 and (b) grams of Cl_2 form?

3.70 Bismuth oxide reacts with carbon to form bismuth metal:

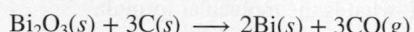

When 0.607 mol of Bi_2O_3 reacts with excess carbon, how many (a) moles of Bi and (b) grams of CO form?

3.71 Potassium nitrate decomposes on heating, producing potassium oxide and gaseous nitrogen and oxygen:

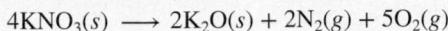

To produce 56.6 kg of oxygen, how many (a) moles of KNO_3 and (b) grams of KNO_3 must be heated?

3.72 Chromium(III) oxide reacts with hydrogen sulfide (H_2S) gas to form chromium(III) sulfide and water:

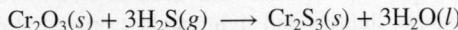

To produce 421 g of Cr_2S_3 , how many (a) moles of Cr_2O_3 and (b) grams of Cr_2O_3 are required?

3.73 Calculate the mass (g) of each product formed when 43.82 g of diborane (B_2H_6) reacts with excess water:

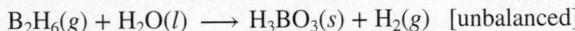

3.74 Calculate the mass (g) of each product formed when 174 g of silver sulfide reacts with excess hydrochloric acid:

3.75 Elemental phosphorus occurs as tetratomic molecules, P_4 . What mass (g) of chlorine gas is needed to react completely with 455 g of phosphorus to form phosphorus pentachloride?

3.76 Elemental sulfur occurs as octatomic molecules, S_8 . What mass (g) of fluorine gas is needed to react completely with 17.8 g of sulfur to form sulfur hexafluoride?

3.77 Solid iodine trichloride is prepared in two steps: first, a reaction between solid iodine and gaseous chlorine to form solid iodine monochloride; second, treatment of the solid with more chlorine gas.

- (a) Write a balanced equation for each step.
- (b) Write a balanced equation for the overall reaction.
- (c) How many grams of iodine are needed to prepare 2.45 kg of final product?

3.78 Lead can be prepared from galena [lead(II) sulfide] by first roasting the galena in oxygen gas to form lead(II) oxide and sulfur dioxide. Heating the metal oxide with more galena forms the molten metal and more sulfur dioxide.

- (a) Write a balanced equation for each step.
- (b) Write an overall balanced equation for the process.
- (c) How many metric tons of sulfur dioxide form for every metric ton of lead obtained?

3.79 The scene below represents a mixture of A_2 (blue) and B_2 (green) before they react to form AB_3 .

- (a) What is the limiting reactant?
- (b) How many molecules of product can form?

3.80 The following scene shows a mixture of nitrogen (dark blue) and hydrogen (light blue) before they react to produce

ammonia, NH_3 . What is the limiting reactant? Draw a scene that shows the number of reactant and product molecules present after reaction.

3.81 Methanol, CH_3OH , is produced from the reaction of carbon monoxide and hydrogen:

How many moles of methanol can be produced when 4.5 mol of CO reacts with 7.2 mol of H_2 ?

3.82 In the following reaction, 2.35 mol of NH_3 reacts with 2.75 mol of O_2 ; how many moles of water form?

3.83 Many metals react with oxygen gas to form the metal oxide. For example, calcium reacts as follows:

You wish to calculate the mass (g) of calcium oxide that can be prepared from 4.20 g of Ca and 2.80 g of O_2 .

- (a) What amount (mol) of CaO can be produced from the given mass of Ca?
- (b) What amount (mol) of CaO can be produced from the given mass of O_2 ?
- (c) Which is the limiting reactant?
- (d) How many grams of CaO can be produced?

3.84 Metal hydrides react with water to form hydrogen gas and the metal hydroxide. For example,

You wish to calculate the mass (g) of hydrogen gas that can be prepared from 5.70 g of SrH_2 and 4.75 g of H_2O .

- (a) What amount (mol) of H_2 can be produced from the given mass of SrH_2 ?
- (b) What amount (mol) of H_2 can be produced from the given mass of H_2O ?
- (c) Which is the limiting reactant?
- (d) How many grams of H_2 can be produced?

3.85 Calculate the maximum numbers of moles and grams of iodic acid (HIO_3) that can form when 635 g of iodine trichloride reacts with 118.5 g of water:

How many grams of the excess reactant remain?

3.86 Calculate the maximum numbers of moles and grams of H_2S that can form when 158 g of aluminum sulfide reacts with 131 g of water:

How many grams of the excess reactant remain?

3.87 When 0.100 mol of carbon is burned in a closed vessel with 8.00 g of oxygen, how many grams of carbon dioxide can form? Which reactant is in excess, and how many grams of it remain after the reaction?

3.88 A mixture of 0.0375 g of hydrogen and 0.0185 mol of oxygen in a closed container is sparked to initiate a reaction. How many grams of water can form? Which reactant is in excess, and how many grams of it remain after the reaction?

3.89 Aluminum nitrite and ammonium chloride react to form aluminum chloride, nitrogen, and water. How many grams of each substance are present after 72.5 g of aluminum nitrite and 58.6 g of ammonium chloride react completely?

3.90 Calcium nitrate and ammonium fluoride react to form calcium fluoride, dinitrogen monoxide, and water vapor. How many grams of each substance are present after 16.8 g of calcium nitrate and 17.50 g of ammonium fluoride react completely?

3.91 Two successive reactions, A → B and B → C, have yields of 73% and 68%, respectively. What is the overall percent yield for conversion of A to C?

3.92 Two successive reactions, D → E and E → F, have yields of 48% and 73%, respectively. What is the overall percent yield for conversion of D to F?

3.93 What is the percent yield of a reaction in which 45.5 g of tungsten(VI) oxide (WO_3) reacts with excess hydrogen gas to produce metallic tungsten and 9.60 mL of water ($d = 1.00 \text{ g/mL}$)?

3.94 What is the percent yield of a reaction in which 200. g of phosphorus trichloride reacts with excess water to form 128 g of HCl and aqueous phosphorous acid (H_3PO_3)?

3.95 When 20.5 g of methane and 45.0 g of chlorine gas undergo a reaction that has a 75.0% yield, what mass (g) of chloromethane (CH_3Cl) forms? Hydrogen chloride also forms.

3.96 When 56.6 g of calcium and 30.5 g of nitrogen gas undergo a reaction that has a 93.0% yield, what mass (g) of calcium nitride forms?

Problems in Context

3.97 Cyanogen, $(\text{CN})_2$, has been observed in the atmosphere of Titan, Saturn's largest moon, and in the gases of interstellar nebulas. On Earth, it is used as a welding gas and a fumigant. In its reaction with fluorine gas, carbon tetrafluoride and nitrogen trifluoride gases are produced. What mass (g) of carbon tetrafluoride forms when 60.0 g of each reactant is used?

3.98 Gaseous dichlorine monoxide decomposes readily to chlorine (green) and oxygen (red) gases.

(a) Which scene best depicts the product mixture after the decomposition?

(b) Write the balanced equation for the decomposition.

(c) If each oxygen atom represents 0.050 mol, how many molecules of dichlorine monoxide were present before the decomposition?

3.99 An intermediate step in the production of nitric acid involves the reaction of ammonia with oxygen gas to form nitrogen monoxide and water. How many grams of nitrogen monoxide can form in the reaction of 485 g of ammonia with 792 g of oxygen?

3.100 Butane gas is compressed and used as a liquid fuel in disposable cigarette lighters and lightweight camping stoves. Suppose a lighter contains 5.50 mL of butane ($d = 0.579 \text{ g/mL}$).

(a) How many grams of oxygen are needed to burn the butane completely?

(b) How many moles of H_2O form when all the butane burns?

(c) How many total molecules of gas form when the butane burns completely?

3.101 Sodium borohydride (NaBH_4) is used industrially in many organic syntheses. One way to prepare it is by reacting sodium hydride with gaseous diborane (B_2H_6). Assuming an 88.5% yield, how many grams of NaBH_4 can be prepared by reacting 7.98 g of sodium hydride and 8.16 g of diborane?

Comprehensive Problems

3.102 The mole is defined in terms of the carbon-12 atom. Use the definition to find (a) the mass in grams equal to 1 atomic mass unit; (b) the ratio of the gram to the atomic mass unit.

3.103 The first sulfur-nitrogen compound was prepared in 1835 and has been used to synthesize many others. In the early 1980s, researchers made another such compound that conducts electricity like a metal. Mass spectrometry of the compound shows a molar mass of 184.27 g/mol, and analysis shows it to contain 2.288 g of S for every 1.000 g of N. What is its molecular formula?

3.104 Hydroxyapatite, $\text{Ca}_5(\text{PO}_4)_3(\text{OH})$, is the main mineral component of dental enamel, dentin, and bone. Coating the compound on metallic implants (such as titanium alloys and stainless steels) helps the body accept the implant. When placed in bone voids, the powder encourages natural bone to grow into the void. Hydroxyapatite is prepared by adding aqueous phosphoric acid to a dilute slurry of calcium hydroxide. (a) Write a balanced equation for this preparation. (b) What mass (g) of hydroxyapatite could form from 100. g of 85% phosphoric acid and 100. g of calcium hydroxide?

3.105 Narceine is a narcotic in opium that crystallizes from solution as a hydrate that contains 10.8 mass % water and has a molar mass of 499.52 g/mol. Determine x in narceine $\cdot x\text{H}_2\text{O}$.

3.106 Hydrogen-containing fuels have a “fuel value” based on their mass % H. Rank the following compounds from highest fuel value to lowest: ethane, propane, benzene, ethanol, cetyl palmitate (whale oil, $\text{C}_{32}\text{H}_{64}\text{O}_2$).

3.107 Serotonin ($\mathcal{M} = 176$ g/mol) transmits nerve impulses between neurons. It contains 68.2% C, 6.86% H, 15.9% N, and 9.08% O by mass. What is its molecular formula?

3.108 In 1961, scientists agreed that the atomic mass unit (amu) would be defined as $\frac{1}{12}$ the mass of an atom of ^{12}C . Before then, it was defined as $\frac{1}{16}$ the average mass of an atom of naturally occurring oxygen (a mixture of ^{16}O , ^{17}O , and ^{18}O). The current atomic mass of oxygen is 15.994 amu. (a) Did Avogadro's number change after the definition of an amu changed and, if so, in what direction? (b) Did the definition of the mole change? (c) Did the mass of a mole of a substance change? (d) Before 1961, was Avogadro's number 6.02×10^{23} (to three significant figures), as it is today?

3.109 Convert the following descriptions into balanced equations:

- In a gaseous reaction, hydrogen sulfide burns in oxygen to form sulfur dioxide and water vapor.
- When crystalline potassium chlorate is heated to just above its melting point, it reacts to form two different crystalline compounds, potassium chloride and potassium perchlorate.
- When hydrogen gas is passed over powdered iron(III) oxide, iron metal and water vapor form.
- The combustion of gaseous ethane in air forms carbon dioxide and water vapor.
- Iron(II) chloride is converted to iron(III) fluoride by treatment with chlorine trifluoride gas. Chlorine gas is also formed.

3.110 Isobutylene is a hydrocarbon used in the manufacture of synthetic rubber. When 0.847 g of isobutylene was subjected to combustion analysis, the gain in mass of the CO_2 absorber was 2.657 g and that of the H_2O absorber was 1.089 g. What is the empirical formula of isobutylene?

3.111 The multistep smelting of ferric oxide to form elemental iron occurs at high temperatures in a blast furnace. In the first step, ferric oxide reacts with carbon monoxide to form Fe_3O_4 . This substance reacts with more carbon monoxide to form iron(II) oxide, which reacts with still more carbon monoxide to form molten iron. Carbon dioxide is also produced in each step. (a) Write an overall balanced equation for the iron-smelting process. (b) How many grams of carbon monoxide are required to form 45.0 metric tons of iron from ferric oxide?

3.112 One of the compounds used to increase the octane rating of gasoline is toluene (ball-and-stick model is shown).

Suppose 20.0 mL of toluene ($d = 0.867$ g/mL) is consumed when a sample of gasoline burns in air.

- How many grams of oxygen are needed for complete combustion of the toluene?
- How many total moles of gaseous products form?
- How many molecules of water vapor form?

3.113 During studies of the reaction in Sample Problem 3.20,

a chemical engineer measured a less-than-expected yield of N_2 and discovered that the following side reaction occurs:

In one experiment, 10.0 g of NO formed when 100.0 g of each reactant was used. What is the highest percent yield of N_2 that can be expected?

3.114 A 0.652-g sample of a pure strontium halide reacts with excess sulfuric acid. The solid strontium sulfate formed is separated, dried, and found to weigh 0.755 g. What is the formula of the original halide?

3.115 The following scenes represent a chemical reaction between AB_2 and B_2 :

(a) Write a balanced equation for the reaction. (b) What is the limiting reactant? (c) How many moles of product can be made from 3.0 mol of B_2 and 5.0 mol of AB_2 ? (d) How many moles of excess reactant remain after the reaction in part (c)?

3.116 Which of the following models represent compounds having the same empirical formula? What is the empirical formula mass of this common formula?

3.117 The zirconium oxalate $\text{K}_2\text{Zr}(\text{C}_2\text{O}_4)_3(\text{H}_2\text{C}_2\text{O}_4) \cdot \text{H}_2\text{O}$ was synthesized by mixing 1.68 g of $\text{ZrOCl}_2 \cdot 8\text{H}_2\text{O}$ with 5.20 g of $\text{H}_2\text{C}_2\text{O}_4 \cdot 2\text{H}_2\text{O}$ and an excess of aqueous KOH. After 2 months, 1.25 g of crystalline product was obtained, along with aqueous KCl and water. Calculate the percent yield.

3.118 Seawater is approximately 4.0% by mass dissolved ions, 85% of which are from NaCl. (a) Find the mass % of NaCl in seawater. (b) Find the mass % of Na^+ ions and of Cl^- ions in seawater.

3.119 Is each of the following statements true or false? Correct any that are false.

- A mole of one substance has the same number of atoms as a mole of any other substance.
- The theoretical yield for a reaction is based on the balanced chemical equation.
- A limiting-reactant problem is being stated when the available quantity of one of the reactants is given in moles.
- The empirical and molecular formulas of a compound are always different.

3.120 In each pair, choose the larger of the indicated quantities or state that the samples are equal:

- Entities: 0.4 mol of O_3 molecules or 0.4 mol of O atoms
- Grams: 0.4 mol of O_3 molecules or 0.4 mol of O atoms
- Moles: 4.0 g of N_2O_4 or 3.3 g of SO_2
- Grams: 0.6 mol of C_2H_4 or 0.6 mol of F_2
- Total ions: 2.3 mol of sodium chlorate or 2.2 mol of magnesium chloride
- Molecules: 1.0 g of H_2O or 1.0 g of H_2O_2
- Grams: 6.02×10^{23} atoms of ^{235}U or 6.02×10^{23} atoms of ^{238}U

3.121 For the reaction between solid tetraphosphorus trisulfide and oxygen gas to form solid tetraphosphorus decoxide and sulfur dioxide gas, write a balanced equation. Show the equation (see Table 3.4) in terms of (a) molecules, (b) moles, and (c) grams.

3.122 Hydrogen gas is considered a clean fuel because it produces only water vapor when it burns. If the reaction has a 98.8% yield, what mass (g) of hydrogen forms 105 kg of water?

3.123 Solar winds composed of free protons, electrons, and α particles bombard Earth constantly, knocking gas molecules out of the atmosphere. In this way, Earth loses about 3.0 kg of matter per second. It is estimated that the atmosphere will be gone in about 50 billion years. Use this estimate to calculate (a) the mass (kg) of Earth's atmosphere and (b) the amount (mol) of nitrogen, which makes up 75.5 mass % of the atmosphere.

3.124 Calculate each of the following quantities:

- Amount (mol) of 0.588 g of ammonium bromide
- Number of potassium ions in 88.5 g of potassium nitrate
- Mass (g) of 5.85 mol of glycerol ($C_3H_8O_3$)
- Volume (L) of 2.85 mol of chloroform ($CHCl_3$; $d = 1.48 \text{ g/mL}$)
- Number of sodium ions in 2.11 mol of sodium carbonate
- Number of atoms in 25.0 μg of cadmium
- Number of atoms in 0.0015 mol of fluorine gas

3.125 Elements X (green) and Y (purple) react according to the following equation: $X_2 + 3Y_2 \rightarrow 2XY_3$. Which molecular scene represents the product of the reaction?

3.126 Hydrocarbon mixtures are used as fuels. (a) How many grams of $CO_2(g)$ are produced by the combustion of 200. g of a mixture that is 25.0% CH_4 and 75.0% C_3H_8 by mass? (b) A 252-g gaseous mixture of CH_4 and C_3H_8 burns in excess O_2 , and 748 g of CO_2 gas is collected. What is the mass % of CH_4 in the mixture?

3.127 Nitrogen (N), phosphorus (P), and potassium (K) are the main nutrients in plant fertilizers. By industry convention, the numbers on a label refer to the mass percents of N, P_2O_5 , and K_2O , in that order. Calculate the N/P/K ratio of a 30/10/10 fertilizer in terms of moles of each element, and express it as $x/y/1.0$.

3.128 What mass percents of ammonium sulfate, ammonium hydrogen phosphate, and potassium chloride would you use to prepare 10/10/10 plant fertilizer (see Problem 3.127)?

3.129 Ferrocene, synthesized in 1951, was the first organic iron compound with Fe—C bonds. An understanding of the structure of ferrocene gave rise to new ideas about chemical bonding and led to the preparation of many useful compounds. In the combustion analysis of ferrocene, which contains only Fe, C, and H, a 0.9437-g

sample produced 2.233 g of CO_2 and 0.457 g of H_2O . What is the empirical formula of ferrocene?

3.130 When carbon-containing compounds are burned in a limited amount of air, some $CO(g)$ as well as $CO_2(g)$ is produced. A gaseous product mixture is 35.0 mass % CO and 65.0 mass % CO_2 . What is the mass % of C in the mixture?

3.131 Write a balanced equation for the reaction depicted below:

If each reactant molecule represents 1.25×10^{-2} mol and the reaction yield is 87%, how many grams of Si-containing product form?

3.132 Citric acid (*below*) is concentrated in citrus fruits and plays a central metabolic role in nearly every animal and plant cell. (a) What are the molar mass and formula of citric acid? (b) How many moles of citric acid are in 1.50 qt of lemon juice ($d = 1.09 \text{ g/mL}$) that is 6.82% citric acid by mass?

3.133 Various nitrogen oxides, as well as sulfur oxides, contribute to acidic rainfall through complex reaction sequences. Nitrogen and oxygen combine during the high-temperature combustion of fuels in air to form nitrogen monoxide gas, which reacts with more oxygen to form nitrogen dioxide gas. In contact with water vapor, nitrogen dioxide forms aqueous nitric acid and more nitrogen monoxide. (a) Write balanced equations for these reactions. (b) Use the equations to write one overall balanced equation that does *not* include nitrogen monoxide and nitrogen dioxide. (c) How many metric tons (t) of nitric acid form when 1350 t of atmospheric nitrogen is consumed (1 t = 1000 kg)?

3.134 Nitrogen monoxide reacts with elemental oxygen to form nitrogen dioxide. The first scene below represents an initial mixture of reactants. If the reaction has a 66% yield, which of the lower scenes (A, B, or C) best represents the final product mixture?

3.135 Fluorine is so reactive that it forms compounds with several of the noble gases.

(a) When 0.327 g of platinum is heated in fluorine, 0.519 g of a dark red, volatile solid forms. What is its empirical formula?

(b) When 0.265 g of this red solid reacts with excess xenon gas, 0.378 g of an orange-yellow solid forms. What is the empirical formula of this compound, the first to contain a noble gas?

(c) Fluorides of xenon can be formed by direct reaction of the elements at high pressure and temperature. Under conditions that produce only the tetra- and hexafluorides, 1.85×10^{-4} mol of xenon reacted with 5.00×10^{-4} mol of fluorine, and 9.00×10^{-6} mol of xenon was found in excess. What are the mass percents of each xenon fluoride in the product mixture?

3.136 Hemoglobin is 6.0% heme ($C_{34}H_{32}FeN_4O_4$) by mass. To remove the heme, hemoglobin is treated with acetic acid and NaCl, which forms hemin ($C_{34}H_{32}N_4O_4FeCl$). A blood sample from a crime scene contains 0.65 g of hemoglobin. (a) How many grams of heme are in the sample? (b) How many moles of heme? (c) How many grams of Fe? (d) How many grams of hemin could be formed for a forensic chemist to measure?

3.137 Manganese is a key component of extremely hard steel. The element occurs naturally in many oxides. A 542.3-g sample of a manganese oxide has an Mn/O ratio of 1.00/1.42 and consists of braunite (Mn_2O_3) and manganosite (MnO). (a) How many grams of braunite and of manganosite are in the ore? (b) What is the Mn^{3+}/Mn^{2+} ratio in the ore?

3.138 The human body excretes nitrogen in the form of urea, NH_2CONH_2 . The key step in its biochemical formation is the reaction of water with arginine to produce urea and ornithine:

(a) What is the mass % of nitrogen in urea, in arginine, and in ornithine? (b) How many grams of nitrogen can be excreted as urea when 135.2 g of ornithine is produced?

3.139 Aspirin (acetylsalicylic acid, $C_9H_8O_4$) is made by reacting salicylic acid ($C_7H_6O_3$) with acetic anhydride [$(CH_3CO)_2O$]:

In one preparation, 3.077 g of salicylic acid and 5.50 mL of acetic anhydride react to form 3.281 g of aspirin. (a) Which is the limiting reactant (the density of acetic anhydride is 1.080 g/mL)? (b) What is the percent yield of this reaction? (c) What is the percent atom economy of this reaction?

3.140 The rocket fuel hydrazine (N_2H_4) is made by the three-step Raschig process, which has the following overall equation:

What is the percent atom economy of this process?

3.141 Lead(II) chromate ($PbCrO_4$) is used as the yellow pigment for marking traffic lanes but is banned from house paint because of the risk of lead poisoning. It is produced from chromite ($FeCr_2O_4$), an ore of chromium:

Lead(II) ion then replaces the K^+ ion. If a yellow paint is to have 0.511% $PbCrO_4$ by mass, how many grams of chromite are needed per kilogram of paint?

3.142 Ethanol (CH_3CH_2OH), the intoxicant in alcoholic beverages, is also used to make other organic compounds. In concentrated sulfuric acid, ethanol forms diethyl ether and water:

In a side reaction, some ethanol forms ethylene and water:

(a) If 50.0 g of ethanol yields 35.9 g of diethyl ether, what is the percent yield of diethyl ether? (b) If 45.0% of the ethanol that did not produce the ether reacts by the side reaction, what mass (g) of ethylene is produced?

3.143 When powdered zinc is heated with sulfur, a violent reaction occurs, and zinc sulfide forms:

Some of the reactants also combine with oxygen in air to form zinc oxide and sulfur dioxide. When 83.2 g of Zn reacts with 52.4 g of S_8 , 104.4 g of ZnS forms.

(a) What is the percent yield of ZnS ?

(b) If all the remaining reactants combine with oxygen, how many grams of each of the two oxides form?

3.144 Cocaine ($C_{17}H_{21}O_4N$) is a natural substance found in coca leaves, which have been used for centuries as a local anesthetic and stimulant. Illegal cocaine arrives in the United States either as the pure compound or as the hydrochloride salt ($C_{17}H_{21}O_4NHCl$). At $25^\circ C$, the salt is very soluble in water (2.50 kg/L), but cocaine is much less so (1.70 g/L).

(a) What is the maximum mass (g) of the hydrochloride salt that can dissolve in 50.0 mL of water?

(b) If the solution from part (a) is treated with NaOH, the salt is converted to cocaine. How much more water (L) is needed to dissolve it?

3.145 High-temperature superconducting oxides hold great promise in the utility, transportation, and computer industries.

(a) One superconductor is $La_{2-x}Sr_xCuO_4$. Calculate the molar masses of this oxide when $x = 0$, $x = 1$, and $x = 0.163$.

(b) Another common superconducting oxide is made by heating a mixture of barium carbonate, copper(II) oxide, and yttrium(III) oxide, followed by further heating in O_2 :

When equal masses of the three reactants are heated, which reactant is limiting?

(c) After the product in part (b) is removed, what is the mass % of each reactant in the remaining solid mixture?

4

Three Major Classes of Chemical Reactions

4.1 Solution Concentration and the Role of Water as a Solvent

Polar Nature of Water
Ionic Compounds in Water
Covalent Compounds in Water
Expressing Concentration in Terms of Molarity
Amount-Mass-Number Conversions Involving Solutions
Preparing and Diluting Molar Solutions

4.2 Writing Equations for Aqueous Ionic Reactions

4.3 Precipitation Reactions

The Key Event: Formation of a Solid

Predicting Whether a Precipitate Will Form
Stoichiometry of Precipitation Reactions

4.4 Acid-Base Reactions

The Key Event: Formation of Water
Proton Transfer in Acid-Base Reactions
Stoichiometry of Acid-Base Reactions: Acid-Base Titrations

4.5 Oxidation-Reduction (Redox) Reactions

The Key Event: Movement of Electrons

Redox Terminology
Oxidation Numbers
Stoichiometry of Redox Reactions: Redox Titrations

4.6 Elements in Redox Reactions

Combination Reactions
Decomposition Reactions
Displacement Reactions and Activity Series
Combustion Reactions

4.7 The Reversibility of Reactions and the Equilibrium State

Source: © Nicolas Rung/age fotostock

Concepts and Skills to Review Before You Study This Chapter

- › names and formulas of compounds (Section 2.8)
- › nature of ionic and covalent bonding (Section 2.7)
- › amount-mass-number conversions (Section 3.1)
- › balancing chemical equations (Section 3.3)
- › calculating quantities of reactants and products (Section 3.4)

Water is a precious commodity; the United States uses about 408 billion gallons of water every day, and you probably use about 80–100 of those gallons! Water treatment plants use chemical reactions to provide safe, uncontaminated drinking water and to remove dissolved heavy metals and phosphates from polluted groundwater and industrial wastewater. These reactions convert dissolved substances into solid particles, which can then be removed from the water by filtration. The reactions involved in water purification are just a few examples of the myriad of important reactions that take place in aqueous solution. In nature, aqueous reactions occur unceasingly in the gigantic containers we know as oceans. And, in every cell of your body, thousands of reactions taking place right now enable you to function. With millions of reactions occurring in and around you, it would be impossible to describe them all. Fortunately, it isn't necessary because when we survey even a small percentage of reactions, especially those in aqueous solution, a few major classes emerge.

IN THIS CHAPTER . . . We examine the underlying nature of three classes of reactions and the complex part that water plays in aqueous chemistry.

- › We visualize the molecular structure of water to learn its role as solvent, how it interacts with ionic and covalent compounds, and the nature of electrolytes.
- › We discuss molarity as a way to express the concentration of an ionic or covalent compound in solution.
- › We write ionic equations that represent the species in solution and the actual change that occurs when ionic compounds dissolve and react in water.
- › We describe precipitation reactions and learn how to predict when they will occur.
- › We see how acids and bases act as electrolytes and how they neutralize each other. We view acid-base reactions as proton-transfer processes and discuss how to quantify these reactions through titration.
- › We examine oxidation-reduction (redox) reactions, which can form ionic or covalent substances. We learn how to determine oxidation numbers and use them to determine oxidizing and reducing agents and how to quantify these reactions through titration. We describe several important types of redox reactions, one of which is used to predict the relative reactivity of metals.
- › An introduction to the reversible nature of all chemical change and the nature of equilibrium previews coverage of this central topic in later chapters.

4.1 SOLUTION CONCENTRATION AND THE ROLE OF WATER AS A SOLVENT

In Chapter 2, we defined a solution as a homogeneous mixture with a uniform composition. A solution consists of a smaller quantity of one substance, the **solute**, dissolved in a larger quantity of another, the **solvent**; in an aqueous solution, water serves as the solvent. For any reaction in solution, the solvent plays a key role that depends on its chemical nature. Some solvents passively disperse the substances into individual molecules. But water is much more active, interacting strongly with the substances and even reacting with them in some cases. Let's focus on how the water molecule interacts with both ionic and covalent solutes.

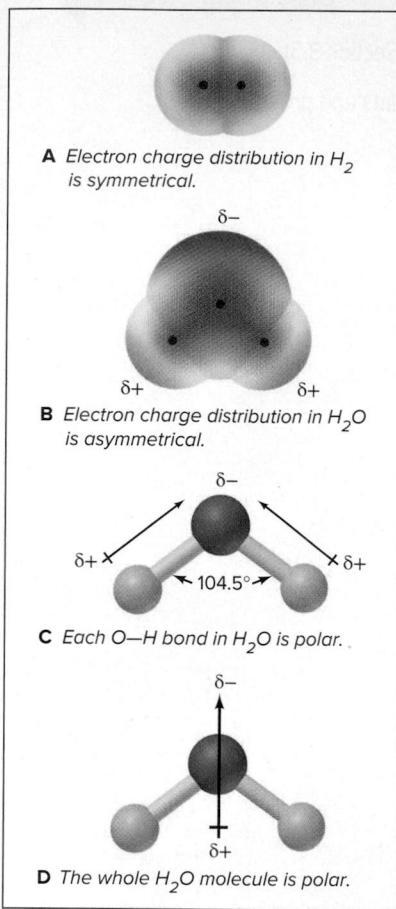

Figure 4.1 Electron distribution in molecules of H_2 and H_2O .

The Polar Nature of Water

On the atomic scale, water's great solvent power arises from the *uneven distribution of electron charge* and its *bent molecular shape*, which create a *polar molecule*:

1. *Uneven charge distribution.* Recall from Section 2.7 that the electrons in a covalent bond are shared between the atoms. In a bond between identical atoms—as in H_2 , Cl_2 , O_2 —the sharing is equal and electron charge is distributed evenly between the two nuclei (symmetrical shading in the space-filling model in Figure 4.1A). In covalent bonds between different atoms, the sharing is uneven because one atom attracts the electron pair more strongly than the other atom does.

For example, in each O—H bond of water, the shared electrons are closer to the O atom because an O atom attracts electrons more strongly than an H atom does. (We'll discuss the reasons in Chapter 9.) This uneven charge distribution creates a *polar bond*, one with partially charged “poles.” In Figure 4.1B, the asymmetrical shading shows this distribution, and the δ symbol is used to indicate a partial charge. The O end is partially negative, represented by red shading and $\delta-$, and the H end is partially positive, represented by blue shading and $\delta+$. In the ball-and-stick model in Figure 4.1C, the *polar arrow* points to the negative pole, and the arrow's tail, shaped like a plus sign, marks the positive pole. There are two polar O—H bonds in each water molecule.

2. *Bent molecular shape.* The sequence of the H—O—H atoms in water is not linear: the water molecule is bent with a bond angle of 104.5° (Figure 4.1C).

3. *Molecular polarity.* The combination of polar bonds and bent shape makes water a **polar molecule**: the region near the O atom is partially negative (there is a higher electron density), and the region between the H atoms is partially positive (there is a lower electron density) (Figure 4.1D). The H_2O molecule is still electrically neutral overall, although its electrons are distributed asymmetrically.

Ionic Compounds in Water

In this subsection, we consider two closely related aspects of aqueous solutions of ionic compounds—how they occur and how they behave. We also use a compound's formula to calculate the amount (mol) of each ion in solution.

How Ionic Compounds Dissolve: Replacement of Charge Attractions In an ionic solid, oppositely charged ions are held together by electrostatic attractions (see Figure 1.3C and Section 2.7). Water separates the ions in an ionic compound by *replacing these attractions with others between several water molecules and each ion*. Picture a granule of a soluble ionic compound in water: the negative ends of some water molecules are attracted to the cations, and the positive ends of other water molecules are attracted to the anions (Figure 4.2). Dissolution occurs because the

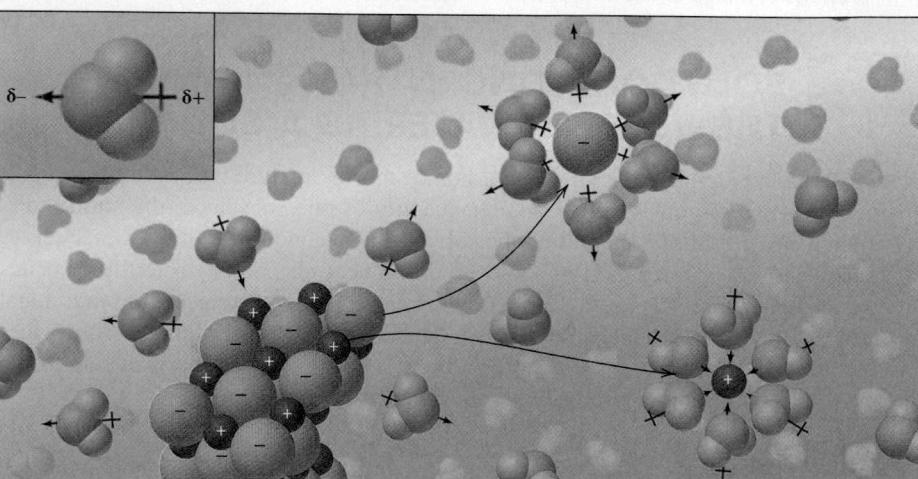

Figure 4.2 An ionic compound dissolving in water. The inset shows the polar arrow and partial charges (not shown in the rest of the scene) for a water molecule.

attractions between each type of ion and several water molecules outweigh the attractions between the ions themselves. Gradually, all the ions separate (dissociate), become **solvated**—surrounded closely by solvent molecules—and then move randomly in the solution. The solvent molecules prevent the cations and anions from recombining.

For an ionic compound that doesn't dissolve in water, the attraction between its cations and anions is *greater* than the attraction between the ions and water. Actually, these so-called insoluble substances *do* dissolve to a very small extent, usually several orders of magnitude less than so-called soluble substances. For example, NaCl (a “soluble” compound) is over 4×10^4 times more soluble in water than AgCl (an “insoluble” compound):

$$\text{Solubility of NaCl in H}_2\text{O at } 20^\circ\text{C} = 365 \text{ g/L}$$

$$\text{Solubility of AgCl in H}_2\text{O at } 20^\circ\text{C} = 0.009 \text{ g/L}$$

In Chapter 13, you'll see that dissolving involves more than a contest between the relative energies of attraction of ions for each other or for water. It is also favored by the greater freedom of motion the ions have when they leave the solid and disperse randomly through the solution.

How Ionic Solutions Behave: Electrolytes and Electrical Conductivity When an ionic compound dissolves, the solution's *electrical conductivity*, the flow of electric current, increases dramatically. When electrodes are immersed in distilled water (Figure 4.3A) or pushed into an ionic solid (Figure 4.3B), no current flows, as shown by the unlit bulb. But when the electrodes are submerged in an aqueous solution of the compound, a large current flows, as shown by the lit bulb (Figure 4.3C). Current flow implies the *movement of charged particles*: when the ionic compound dissolves,

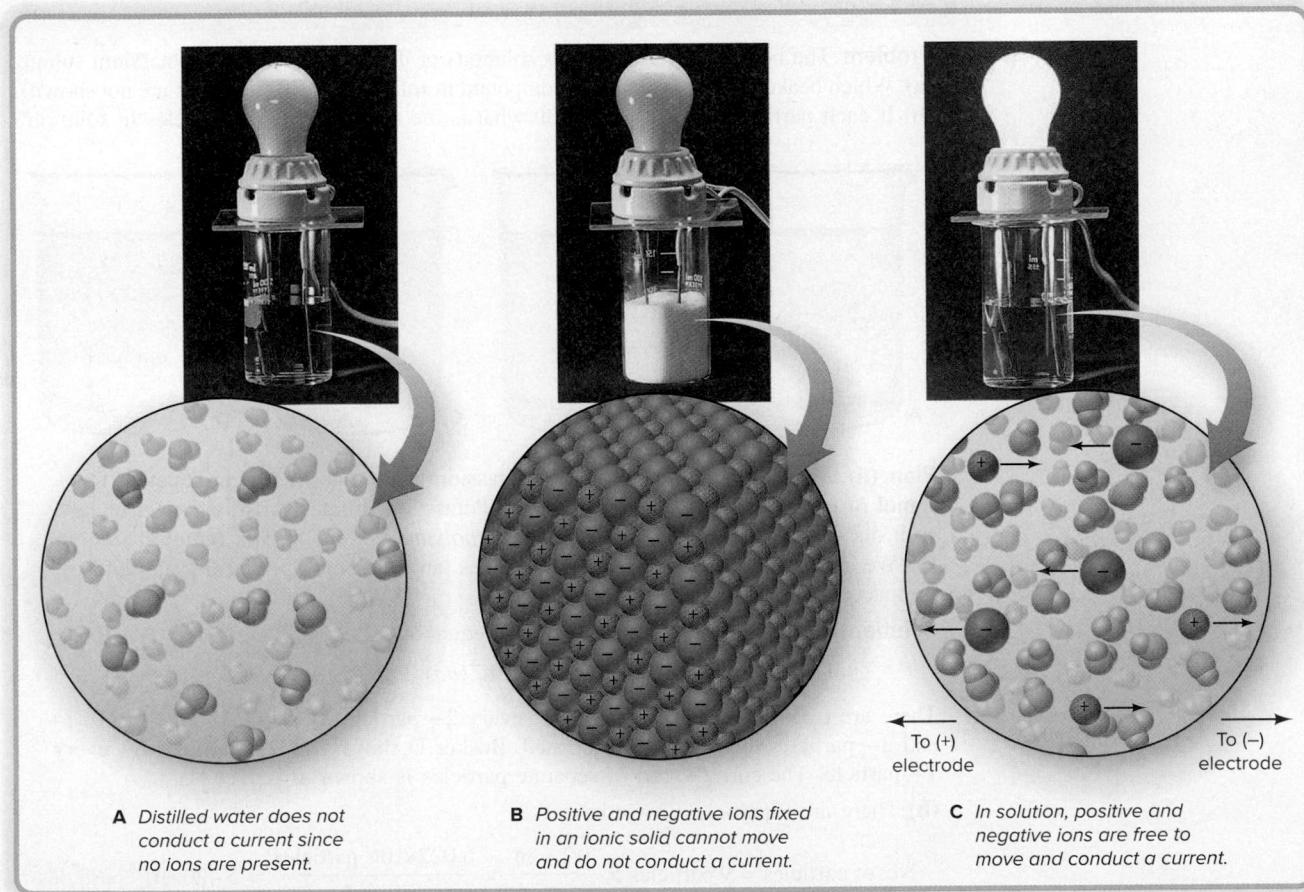

Figure 4.3 The electrical conductivity of ionic solutions.

Source: © McGraw-Hill Education/Stephen Frisch, photographer

the separate solvated ions move toward the electrode of opposite charge. A substance that conducts a current when dissolved in water is an **electrolyte**. Soluble ionic compounds are *strong electrolytes* because they dissociate completely and conduct a large current.

Calculating the Number of Moles of Ions in Solution *From the formula of the soluble ionic compound, we know the number of moles of each ion in solution.* For example, the equations for dissolving KBr, CaBr₂, and Fe(NO₃)₃ in water to form solvated ions are

(“H₂O” above the arrows means that water is the solvent, not a reactant.) The subscripts of the ions in the formula of an ionic compound indicate the moles of each ion produced when the compound dissociates. Thus, 1 mol of KBr dissociates into 2 mol of ions—1 mol of K⁺ and 1 mol of Br⁻—and 1 mol of CaBr₂ dissociates into 3 mol of ions—1 mol of Ca²⁺ and 2 mol of Br⁻. (*not* 1 mol of Ca²⁺ and 1 mol of Br⁻). Note that the NO₃⁻ polyatomic ion remains intact so that 1 mol of Fe(NO₃)₃ dissociates into 4 mol of ions—1 mol of Fe³⁺ and 3 mol of NO₃⁻. Polyatomic ions, whose atoms are covalently bonded, stay together as a charged unit. Sample Problems 4.1 and 4.2 apply these ideas, first with molecular scenes and then in calculations.

SAMPLE PROBLEM 4.1

Using Molecular Scenes to Depict an Ionic Compound in Aqueous Solution

Problem The beakers contain aqueous solutions of the strong electrolyte potassium sulfate.

- Which beaker best represents the compound in solution (water molecules are not shown)?
- If each particle represents 0.1 mol, what is the total number of particles in solution?

Plan (a) We determine the formula of potassium sulfate and write an equation for 1 mol of compound dissociating into ions. Potassium sulfate is a strong electrolyte, so it dissociates completely, but, in general, *Polyatomic ions remain intact in solution.*

(b) We count the number of separate particles, and then multiply by 0.1 mol and by Avogadro's number.

Solution (a) The formula is K₂SO₄, so the equation is

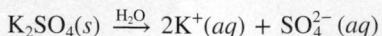

There are two separate 1+ particles for every 2- particle; Beakers A and B show 1+ and 2- particles that are not dissociated. Beaker D shows two 2- particles for every 1+ particle. The correct ratio of separate particles is shown in beaker C.

(b) There are 9 particles so we have

$$\text{No. of particles} = 9 \text{ particles} \times \frac{0.1 \text{ mol}}{1 \text{ particle}} \times \frac{6.022 \times 10^{23} \text{ particles}}{1 \text{ mol}} = 5.420 \times 10^{23} \text{ particles}$$

Check Rounding to check the math in (b) gives $9 \times 0.1 \times 6 = 5.4$, so the answer seems correct. The number of particles is an exact number since we actually counted them; thus, the answer can have as many significant figures as in Avogadro's number.

FOLLOW-UP PROBLEMS

Brief Solutions for all Follow-up Problems appear at the end of the chapter.

4.1A (a) Which strong electrolyte is dissolved in water (water molecules not shown) in the beaker shown: LiBr, Cs₂CO₃, or BaCl₂? (b) If each particle represents 0.05 mol, what mass (g) of compound was dissolved?

4.1B (a) Make a drawing similar to that in Follow-up Problem 4.1A that shows two formula units of the strong electrolyte sodium phosphate dissolved in water (without showing any water molecules). (b) When 0.40 mol of sodium phosphate is dissolved in water, how many moles of ions result?

SOME SIMILAR PROBLEMS 4.5 and 4.6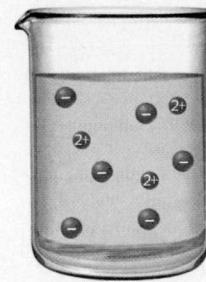**SAMPLE PROBLEM 4.2****Determining Amount (mol) of Ions in Solution**

Problem What amount (mol) of each ion is in each solution?

- (a) 5.0 mol of ammonium sulfate dissolved in water
- (b) 78.5 g of cesium bromide dissolved in water
- (c) 7.42×10²² formula units of copper(II) nitrate dissolved in water

Plan We write an equation that shows 1 mol of compound dissociating into ions.

- (a) We multiply the number of moles of ions by 5.0. (b) We first convert grams to moles. (c) We first convert formula units to moles.

Solution (a) $(\text{NH}_4)_2\text{SO}_4(s) \xrightarrow{\text{H}_2\text{O}} 2\text{NH}_4^+(aq) + \text{SO}_4^{2-}(aq)$

Calculating amount (mol) of NH₄⁺ ions:

$$\text{Amount (mol) of } \text{NH}_4^+ = 5.0 \text{ mol } (\text{NH}_4)_2\text{SO}_4 \times \frac{2 \text{ mol } \text{NH}_4^+}{1 \text{ mol } (\text{NH}_4)_2\text{SO}_4} = 10. \text{ mol } \text{NH}_4^+$$

The formula shows 1 mol of SO₄²⁻ per mole of (NH₄)₂SO₄, so 5.0 mol SO₄²⁻ is also present.

(b) $\text{CsBr}(s) \xrightarrow{\text{H}_2\text{O}} \text{Cs}^+(aq) + \text{Br}^-(aq)$

Converting from mass (g) to amount (mol):

$$\text{Amount (mol) of } \text{CsBr} = 78.5 \text{ g } \text{CsBr} \times \frac{1 \text{ mol } \text{CsBr}}{212.8 \text{ g } \text{CsBr}} = 0.369 \text{ mol } \text{CsBr}$$

Thus, 0.369 mol of Cs⁺ and 0.369 mol of Br⁻ are present.

(c) $\text{Cu}(\text{NO}_3)_2(s) \xrightarrow{\text{H}_2\text{O}} \text{Cu}^{2+}(aq) + 2\text{NO}_3^-(aq)$

Converting from formula units to amount (mol):

Amount (mol) of Cu(NO₃)₂ = 7.42×10²² formula units Cu(NO₃)₂

$$\times \frac{1 \text{ mol } \text{Cu}(\text{NO}_3)_2}{6.022 \times 10^{23} \text{ formula units } \text{Cu}(\text{NO}_3)_2} = 0.123 \text{ mol } \text{Cu}(\text{NO}_3)_2$$

$$\text{Amount (mol) of } \text{NO}_3^- = 0.123 \text{ mol } \text{Cu}(\text{NO}_3)_2 \times \frac{2 \text{ mol } \text{NO}_3^-}{1 \text{ mol } \text{Cu}(\text{NO}_3)_2} = 0.246 \text{ mol } \text{NO}_3^-$$

0.123 mol of Cu²⁺ is also present.

Check Round off to check the math and see if the relative numbers of moles of ions are consistent with the formula. For instance, in (a), 10. mol NH₄⁺/5.0 mol SO₄²⁻ = 2 NH₄⁺/1 SO₄²⁻, or (NH₄)₂SO₄.

FOLLOW-UP PROBLEMS

4.2A What amount (mol) of each ion is in each solution?

- (a) 2 mol of potassium perchlorate dissolved in water
- (b) 354 g of magnesium acetate dissolved in water
- (c) 1.88×10²⁴ formula units of ammonium chromate dissolved in water

4.2B What amount (mol) of each ion is in each solution?

- (a) 4 mol of lithium carbonate dissolved in water
- (b) 112 g of iron(III) sulfate dissolved in water
- (c) 8.09×10²² formula units of aluminum nitrate dissolved in water

SOME SIMILAR PROBLEMS 4.18–4.21

Covalent Compounds in Water

Water dissolves many covalent (molecular) compounds also. Table sugar (sucrose, $C_{12}H_{22}O_{11}$), beverage (grain) alcohol (ethanol, CH_3CH_2OH), and automobile anti-freeze (ethylene glycol, $HOCH_2CH_2OH$) are some familiar examples. All contain their own polar bonds, which are attracted to the polar bonds of water. However, most soluble covalent substances *do not* separate into ions, but remain intact molecules. For example,

As a result, their aqueous solutions do not conduct an electric current, and these substances are **nonelectrolytes**. (As you'll see shortly, however, a small group of H-containing molecules that act as acids in aqueous solution *do* dissociate into ions.) Many other covalent substances, such as benzene (C_6H_6) and octane (C_8H_{18}), do not contain polar bonds, and these substances do not dissolve appreciably in water.

Expressing Concentration in Terms of Molarity

When working quantitatively with any solution, it is essential to know the **concentration**—*the quantity of solute dissolved in a given quantity of solution (or of solvent)*.

Concentration is an *intensive* property (like density or temperature; Section 1.4) and thus is independent of the solution volume: a 50-L tank of a solution has the *same concentration* (solute quantity/solution quantity) as a 50-mL beaker of the solution. **Molarity (M)** is the most common unit of concentration (Chapter 13 covers others). It expresses the concentration in units of *moles of solute per liter of solution*:

$$\text{Molarity} = \frac{\text{moles of solute}}{\text{liters of solution}} \quad \text{or} \quad M = \frac{\text{mol solute}}{\text{L soln}} \quad (4.1)$$

SAMPLE PROBLEM 4.3

Calculating the Molarity of a Solution

Problem Glycine ($C_2H_5NO_2$) has the simplest structure of the 20 amino acids that make up the proteins in the human body. What is the molarity of a solution that contains 53.7 g of glycine dissolved in 495 mL of solution?

Plan The molarity is the number of moles of solute in each liter of solution. We convert the mass (g) of glycine (53.7 g) to amount (mol) by dividing by the molar mass. We divide that number of moles by the volume (495 mL) and convert the volume to liters to find the molarity (see the road map).

Solution Finding the amount (mol) of glycine:

$$\text{Amount (mol) of glycine} = 53.7 \text{ g glycine} \times \frac{1 \text{ mol glycine}}{75.07 \text{ g glycine}} = 0.715 \text{ mol glycine}$$

Dividing by the volume and converting the volume units to obtain molarity:

$$\text{Molarity} = \frac{0.715 \text{ mol glycine}}{495 \text{ mL soln}} \times \frac{1000 \text{ mL}}{1 \text{ L}} = 1.44 \text{ M glycine}$$

Check A quick look at the math shows about 0.7 mol of glycine in about 0.5 L of solution, so the concentration should be about 1.4 mol/L, or 1.4 M .

FOLLOW-UP PROBLEMS

4.3A Calculate the molarity of the solution made when 6.97 g of KI is dissolved in enough water to give a total volume of 100. mL.

4.3B Calculate the molarity of a solution that contains 175 mg of sodium nitrate in a total volume of 15.0 mL.

SOME SIMILAR PROBLEMS 4.22(b), 4.23(c), 4.24(b), and 4.25(a)

Road Map

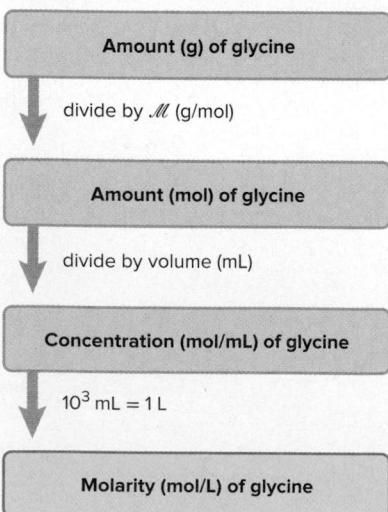

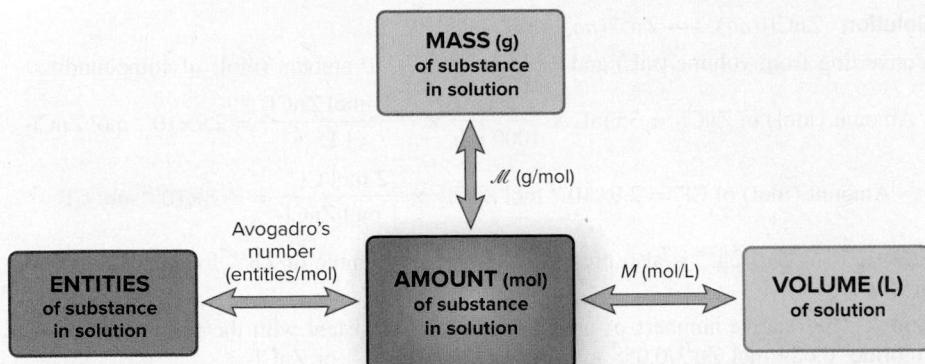

Figure 4.4 Summary of amount-mass-number relationships in solution. The amount (mol) of a substance in solution is related to the volume (L) of solution through the molarity (M ; mol/L). As always, convert the given quantity to amount (mol) first.

Amount-Mass-Number Conversions Involving Solutions

Like many intensive properties, molarity can be used as a *conversion factor* between volume (L) of solution and amount (mol) of solute:

$$\frac{\text{mol solute}}{\text{L solution}} \quad \text{or} \quad \frac{\text{L solution}}{\text{mol solute}}$$

From moles of solute, we can find the mass or the number of entities of solute (Figure 4.4), as applied in Sample Problems 4.4 and 4.5.

SAMPLE PROBLEM 4.4

Calculating Mass of Solute in a Given Volume of Solution

Problem Biochemists often study reactions in solutions containing phosphate ion, which is commonly found in cells. How many grams of solute are in 1.75 L of 0.460 M sodium hydrogen phosphate?

Plan We need the mass (g) of solute, so we multiply the known solution volume (1.75 L) by the known molarity (0.460 M) to find the amount (mol) of solute and convert it to mass (g) using the solute's molar mass (see the road map).

Solution Calculating amount (mol) of solute in solution:

$$\text{Amount (mol) of Na}_2\text{HPO}_4 = 1.75 \text{ L soln} \times \frac{0.460 \text{ mol Na}_2\text{HPO}_4}{1 \text{ L soln}} = 0.805 \text{ mol Na}_2\text{HPO}_4$$

Converting from amount (mol) of solute to mass (g):

$$\text{Mass (g) Na}_2\text{HPO}_4 = 0.805 \text{ mol Na}_2\text{HPO}_4 \times \frac{141.96 \text{ g Na}_2\text{HPO}_4}{1 \text{ mol Na}_2\text{HPO}_4} = 114 \text{ g Na}_2\text{HPO}_4$$

Check The answer seems to be correct: ~1.8 L of 0.5 mol/L solution contains 0.9 mol, and $150 \text{ g/mol} \times 0.9 \text{ mol} = 135 \text{ g}$, which is close to 114 g of solute.

FOLLOW-UP PROBLEMS

4.4A In biochemistry laboratories, solutions of sucrose (table sugar, $\text{C}_{12}\text{H}_{22}\text{O}_{11}$) are used in high-speed centrifuges to separate the parts of a biological cell. How many liters of 3.30 M sucrose contain 135 g of solute? Include a road map that shows how you planned the solution.

4.4B A chemist adds 40.5 mL of a 0.128 M solution of sulfuric acid to a reaction mixture. How many moles of sulfuric acid are being added? Include a road map that shows how you planned the solution.

SOME SIMILAR PROBLEMS 4.22(a), 4.22(c), 4.23(a), 4.24(a), 4.25(b), and 4.25(c)

Road Map

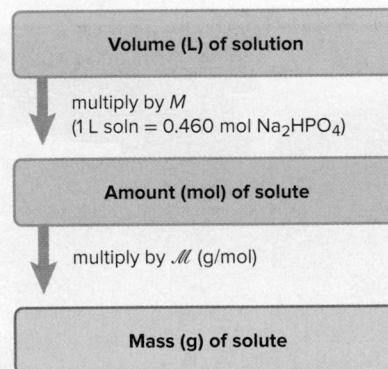

SAMPLE PROBLEM 4.5

Determining Amount (mol) of Ions in a Solution

Problem What amount (mol) of each ion is in 35 mL of 0.84 M zinc chloride?

Plan We write an equation that shows 1 mol of compound dissociating into ions. We convert molarity and volume to moles of zinc chloride and use the dissociation equation to convert moles of compound to moles of ions.

Converting from volume (mL) and molarity (mol/L) to amount (mol) of compound:

$$\text{Amount (mol) of } \text{ZnCl}_2 = 35 \text{ mL} \times \frac{1 \text{ L}}{1000 \text{ mL}} \times \frac{0.84 \text{ mol } \text{ZnCl}_2}{1 \text{ L}} = 2.9 \times 10^{-2} \text{ mol } \text{ZnCl}_2$$

$$\text{Amount (mol) of } \text{Cl}^- = 2.9 \times 10^{-2} \text{ mol } \text{ZnCl}_2 \times \frac{2 \text{ mol } \text{Cl}^-}{1 \text{ mol } \text{ZnCl}_2} = 5.8 \times 10^{-2} \text{ mol } \text{Cl}^-$$

2.9×10^{-2} mol of Zn^{2+} is also present since there is 1 mole of Zn^{2+} for every 1 mole of ZnCl_2 .

Check The relative numbers of moles of ions are consistent with the formula for zinc chloride: $0.029 \text{ mol } \text{Zn}^{2+}/0.058 \text{ mol } \text{Cl}^- = 1 \text{ Zn}^{2+}/2 \text{ Cl}^-$, or ZnCl_2 .

FOLLOW-UP PROBLEMS

4.5A What amount (mol) of each ion is in 1.32 L of 0.55 M sodium phosphate?

4.5B What is the molarity of aluminum ion in a solution that contains 1.25 mol of aluminum sulfate in 875 mL?

SOME SIMILAR PROBLEMS 4.23(b), 4.24(c), 4.26, 4.27

Preparing and Diluting Molar Solutions

Notice that the volume term in the denominator of the molarity expression in Equation 4.1 is the *solution* volume, **not** the *solvent* volume. This means that you *cannot* dissolve 1 mol of solute in 1 L of solvent to make a 1 M solution. Because the solute volume adds to the solvent volume, the total volume (solute + solvent) would be *more* than 1 L, so the concentration would be *less* than 1 M.

Preparing a Solution Correctly preparing a solution of a solid solute requires four steps. Let's prepare 0.500 L of 0.350 M nickel(II) nitrate hexahydrate $[\text{Ni}(\text{NO}_3)_2 \cdot 6\text{H}_2\text{O}]$:

1. *Weigh the solid.* Calculate the mass of solid needed by converting from volume (L) to amount (mol) and then to mass (g):

$$\begin{aligned} \text{Mass (g) of solute} &= 0.500 \text{ L}_{\text{soln}} \times \frac{0.350 \text{ mol } \text{Ni}(\text{NO}_3)_2 \cdot 6\text{H}_2\text{O}}{1 \text{ L}_{\text{soln}}} \\ &\quad \times \frac{290.82 \text{ g } \text{Ni}(\text{NO}_3)_2 \cdot 6\text{H}_2\text{O}}{1 \text{ mol } \text{Ni}(\text{NO}_3)_2 \cdot 6\text{H}_2\text{O}} \\ &= 50.9 \text{ g } \text{Ni}(\text{NO}_3)_2 \cdot 6\text{H}_2\text{O} \end{aligned}$$

2. *Transfer the solid.* We need 0.500 L of solution, so we choose a 500-mL volumetric flask (a flask with a fixed volume indicated by a mark on the neck), add enough distilled water to fully dissolve the solute (usually about half the final volume, or 250 mL of distilled water in this case), and transfer the solute. Wash down any solid clinging to the neck with some solvent.
3. *Dissolve the solid.* Swirl the flask until all the solute is dissolved. If necessary, wait until the solution is at room temperature. (As we discuss in Chapter 13, the solution process may be accompanied by heating or cooling.)
4. *Add solvent to the final volume.* Add distilled water to bring the solution volume to the line on the flask neck; cover and mix thoroughly again.

Figure 4.5 shows the last three steps.

Diluting a Solution A concentrated solution (higher molarity) is converted to a dilute solution (lower molarity) by adding solvent, which means the solution volume increases but the amount (mol) of solute

Figure 4.5 Laboratory preparation of molar solutions.

Source: © McGraw-Hill Education/Stephen Frisch, photographer

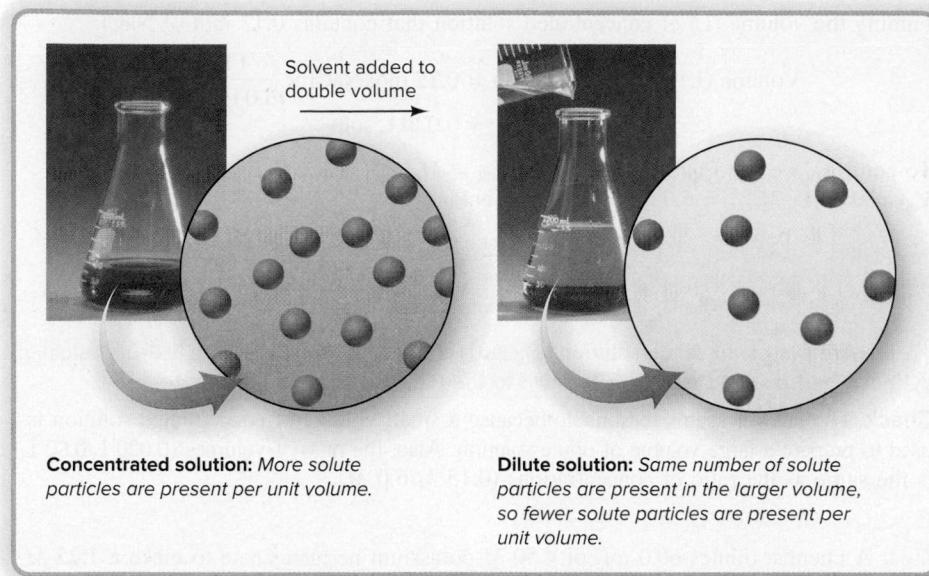

Figure 4.6 Converting a concentrated solution to a dilute solution.

Source: © McGraw-Hill Education/Stephen Frisch, photographer

stays the same. As a result, the dilute solution contains *fewer solute particles per unit volume* and, thus, has a lower concentration than the concentrated solution (Figure 4.6). Chemists often prepare and store a concentrated solution (*stock solution*) and then dilute it as needed.

Solving Dilution Problems To solve dilution problems, we use the fact that the amount (mol) of solute does not change during the dilution process. Therefore, once we calculate the amount of solute needed to make a particular volume of a dilute solution, we can then calculate the volume of concentrated solution that contains that amount of solute. This two-part calculation can be combined into one step using the following relationship:

$$M_{\text{dil}} \times V_{\text{dil}} = \text{amount (mol) of solute} = M_{\text{conc}} \times V_{\text{conc}} \quad (4.2)$$

where *M* and *V* are the molarity and volume of the *dilute* (subscript “dil”) and *concentrated* (subscript “conc”) solutions. In Sample Problem 4.6, we first use a two-part calculation, followed by the one-step relationship.

SAMPLE PROBLEM 4.6

Preparing a Dilute Solution from a Concentrated Solution

Problem Isotonic saline is 0.15 *M* aqueous NaCl. It simulates the total concentration of ions in many cellular fluids, and its uses range from cleaning contact lenses to washing red blood cells. How would you prepare 0.80 L of isotonic saline from a 6.0 *M* stock solution?

Plan To dilute a concentrated solution, we add only solvent, so the *moles of solute are the same in both solutions*. First, we will use a two-part calculation. We know the volume (0.80 L) and molarity (0.15 *M*) of the dilute (dil) NaCl solution needed, so we find the amount (mol) of NaCl it contains. Then, we find the volume (L) of concentrated (conc; 6.0 *M*) NaCl solution that contains the same amount (mol) (see the road map). We will confirm this answer by using Equation 4.2. Once the final volume is calculated, we add solvent *up to* the final volume.

Solution Two-part calculation: Finding amount (mol) of solute in dilute solution:

$$\begin{aligned} \text{Amount (mol) of NaCl in dil soln} &= 0.80 \text{ L soln} \times \frac{0.15 \text{ mol NaCl}}{1 \text{ L soln}} \\ &= 0.12 \text{ mol NaCl} \end{aligned}$$

Finding amount (mol) of solute in concentrated solution: Because we add only solvent to dilute the solution,

$$\begin{aligned} \text{Amount (mol) of NaCl in dil soln} &= \text{amount (mol) of NaCl in conc soln} \\ &= 0.12 \text{ mol NaCl} \end{aligned}$$

Road Map

Finding the volume (L) of concentrated solution that contains 0.12 mol of NaCl:

$$\text{Volume (L) of conc NaCl soln} = 0.12 \text{ mol NaCl} \times \frac{1 \text{ L soln}}{6.0 \text{ mol NaCl}} \\ = 0.020 \text{ L soln}$$

To confirm, we use Equation 4.2 $M_{\text{dil}} \times V_{\text{dil}} = M_{\text{conc}} \times V_{\text{conc}}$, with $M_{\text{dil}} = 0.15 \text{ M}$, $V_{\text{dil}} = 0.80 \text{ L}$, $M_{\text{conc}} = 6.0 \text{ M}$, and $V_{\text{conc}} = \text{unknown}$:

$$V_{\text{conc}} = \frac{M_{\text{dil}} \times V_{\text{dil}}}{M_{\text{conc}}} = \frac{0.15 \text{ M} \times 0.80 \text{ L}}{6.0 \text{ M}} \\ = 0.020 \text{ L soln}$$

To prepare 0.80 L of dilute solution, place 0.020 L of 6.0 M NaCl in a 1.0-L graduated cylinder, add distilled water (~780 mL) to the 0.80-L mark, and stir thoroughly.

Check The answer seems reasonable because a small volume of concentrated solution is used to prepare a large volume of dilute solution. Also, the ratio of volumes (0.020 L/0.80 L) is the same as the ratio of concentrations (0.15 M/6.0 M).

FOLLOW-UP PROBLEMS

4.6A A chemist dilutes 60.0 mL of 4.50 M potassium permanganate to make a 1.25 M solution. What is the final volume of the diluted solution?

4.6B A chemical engineer dilutes a stock solution of sulfuric acid by adding 25.0 m³ of 7.50 M acid to enough water to make 500. m³. What is the concentration of sulfuric acid in the diluted solution, in g/mL?

SOME SIMILAR PROBLEMS 4.28 and 4.29

In the next sample problem, we use a variation of Equation 4.2, with molecular scenes showing numbers of particles, to visualize changes in concentration.

SAMPLE PROBLEM 4.7

Visualizing Changes in Concentration

Problem The top circle at left represents a unit volume of a solution. Draw a circle representing a unit volume of the solution after each of these changes:

- (a) For every 1 mL of solution, 1 mL of solvent is added.
- (b) One-third of the solvent is boiled off.

Plan Given the starting solution, we have to find the number of solute particles in a unit volume after each change. The number of particles per unit volume, N , is directly related to the number of moles per unit volume, M , so we can use a relationship similar to Equation 4.2 to find the number of particles.

- (a) The volume increases, so the final solution is more dilute—fewer particles per unit volume.
- (b) One-third of the solvent is lost, so the final solution is more concentrated—more particles per unit volume.

Solution (a) Finding the number of particles in the dilute solution, N_{dil} :

$$N_{\text{dil}} \times V_{\text{dil}} = N_{\text{conc}} \times V_{\text{conc}}$$

where $N_{\text{conc}} = 8$ particles, $V_{\text{conc}} = 1 \text{ mL}$, and $V_{\text{dil}} = 2 \text{ mL}$; thus,

$$N_{\text{dil}} = N_{\text{conc}} \times \frac{V_{\text{conc}}}{V_{\text{dil}}} = 8 \text{ particles} \times \frac{1 \text{ mL}}{2 \text{ mL}} = 4 \text{ particles}$$

(b) Finding the number of particles in the concentrated solution, N_{conc} :

$$N_{\text{dil}} \times V_{\text{dil}} = N_{\text{conc}} \times V_{\text{conc}}$$

where $N_{\text{dil}} = 8$ particles, $V_{\text{dil}} = 1 \text{ mL}$, and $V_{\text{conc}} = \frac{2}{3} \text{ mL}$; thus,

$$N_{\text{conc}} = N_{\text{dil}} \times \frac{V_{\text{dil}}}{V_{\text{conc}}} = 8 \text{ particles} \times \frac{1 \text{ mL}}{\frac{2}{3} \text{ mL}} = 12 \text{ particles}$$

Check In (a), the volume is doubled (from 1 mL to 2 mL), so the number of particles should be halved; $\frac{1}{2}$ of 8 is 4. In (b), the volume is $\frac{2}{3}$ of the original, so the number of particles should be $\frac{3}{2}$ of the original; $\frac{3}{2}$ of 8 is 12.

Comment In (b), we assumed that only solvent boils off. This is true with nonvolatile solutes, such as ionic compounds, but in Chapter 13, we'll encounter solutions in which both solvent *and* solute are volatile.

FOLLOW-UP PROBLEMS

- 4.7A** The circle labeled A represents a unit volume of a solution. Explain the changes that must be made to A to obtain the unit volumes in B and C.

- 4.7B** Circle A represents a unit volume of 100. mL of a solution. Which circle (B, C, or D) best represents the unit volume after 300. mL of solvent has been added?

SOME SIMILAR PROBLEMS 4.10 and 4.12

› Summary of Section 4.1

- › Because of polar bonds and a bent shape, the water molecule is polar, and water dissolves many ionic and covalent compounds.
- › When an ionic compound dissolves, the attraction between each ion and water molecules replaces the attraction between ions. Soluble ionic compounds are electrolytes because the ions are free to move and, thus, the solution conducts electricity.
- › The formula of a soluble ionic compound shows the number of moles of each ion in solution per mole of compound dissolved.
- › Water dissolves many covalent substances that contain polar bonds. These compounds are nonelectrolytes because the molecules remain intact, and, thus, the solution does not conduct electricity.
- › The concentration of a solute in a solution can be expressed by molarity which is the number of moles of solute dissolved in 1 liter of solution. A more concentrated solution (higher molarity) is converted to a more dilute solution (lower molarity) by adding solvent.
- › Molarity can be used as a conversion factor between volume of solution and amount (mol) of solute, from which you can find mass of solute.

4.2 WRITING EQUATIONS FOR AQUEOUS IONIC REACTIONS

Chemists use three types of equations to represent aqueous ionic reactions. Let's examine a reaction to see what each type shows. When solutions of silver nitrate and sodium chromate are mixed, brick-red, solid silver chromate (Ag_2CrO_4) forms.

Figure 4.7 depicts the reaction at the macroscopic level (*photos*), the atomic level (*blow-up circles*), and the symbolic level with the three types of equations (reacting ions are in red type):

- The **molecular equation** (*top*) reveals the least about the species that are actually in solution because *it shows all the reactants and products as if they were intact, undissociated compounds*. Only the designation for solid, (s), tells us that a change has occurred:

- The **total ionic equation** (*middle*) is much more accurate because *it shows all the soluble ionic substances as they actually exist in solution, where they are dissociated into ions*. The $\text{Ag}_2\text{CrO}_4(\text{s})$ stands out as the only undissociated substance:

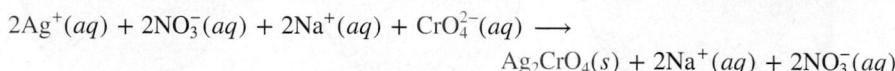

The charges also balance: four positive and four negative for a net zero charge on the left side, and two positive and two negative for a net zero charge on the right.

Notice that $\text{Na}^+(\text{aq})$ and $\text{NO}_3^-(\text{aq})$ appear unchanged on both sides of the equation. These are called **spectator ions** (shown with pale colors in the atomic-level scenes). They are not involved in the actual chemical change but are present only as part of the reactants; that is, we can't add an Ag^+ ion without also adding an anion, in this case, the NO_3^- ion.

Figure 4.7 An aqueous ionic reaction and the three types of equations.

Source: © McGraw-Hill Education/Stephen Frisch, photographer

- The **net ionic equation** (bottom) is very useful because *it eliminates the spectator ions and shows only the actual chemical change*:

The formation of solid silver chromate from silver ions and chromate ions *is* the only change. To make that point clearly, suppose we had mixed solutions of silver acetate $\text{AgC}_2\text{H}_3\text{O}_2(\text{aq})$ and potassium chromate, $\text{K}_2\text{CrO}_4(\text{aq})$, instead of silver nitrate and sodium chromate. The three equations for the reaction would then be

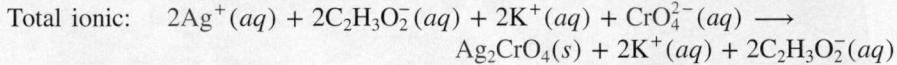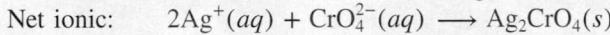

Thus, the same change would have occurred, and only the spectator ions would differ— $\text{K}^+(\text{aq})$ and $\text{C}_2\text{H}_3\text{O}_2^-(\text{aq})$ instead of $\text{Na}^+(\text{aq})$ and $\text{NO}_3^-(\text{aq})$.

Next, we'll apply these types of equations to three important classes of chemical reactions—precipitation, acid-base, and oxidation-reduction.

› Summary of Section 4.2

- A molecular equation shows all substances as intact and undissociated into ions.
- A total ionic equation shows all soluble ionic compounds as separate, solvated ions. Spectator ions appear unchanged on both sides of the equation.
- A net ionic equation eliminates the spectator ions and, thus, shows only the actual chemical change.

Student Hot Spot

Student data indicate that you may struggle with writing total and net ionic equations. Access the Smartbook to view additional Learning Resources on this topic.

4.3 PRECIPITATION REACTIONS

Precipitation reactions occur commonly in both nature and commerce. Coral reefs and some gems and minerals form, in part, through this process. And the chemical industry employs precipitation methods to make several important inorganic compounds.

The Key Event: Formation of a Solid from Dissolved Ions

In a **precipitation reaction**, two soluble ionic compounds react to form an insoluble product, a **precipitate**. The reaction between silver nitrate and sodium chromate you saw in Section 4.2 is one example. Precipitates form for the same reason that some ionic compounds don't dissolve: the electrostatic attraction between the ions outweighs the tendency of the ions to remain solvated and move throughout the solution. When the two solutions are mixed, the ions collide and stay together, and a solid product “comes out of solution.” Thus, the key event in a precipitation reaction is *the formation of an insoluble product through the net removal of ions from solution*. Figure 4.8 (*on the next page*) shows the process for calcium fluoride.

In an aqueous solution of CaCl_2 , Ca^{2+} and Cl^- ions are dissociated and solvated (surrounded by water molecules); the attraction between each ion and water molecules is greater than the attraction between the ions. The same is true for an aqueous solution of NaF , which consists of solvated Na^+ and F^- ions. When the four ions are mixed, however, the attraction between Ca^{2+} and F^- ions is greater than the attraction between those ions and water molecules; CaF_2 is insoluble in water.

Predicting Whether a Precipitate Will Form

To predict whether a precipitate will form when we mix two aqueous ionic solutions, we refer to the short list of solubility rules in Table 4.1 (*on page 159*); the solubility rules tell us which ionic compounds are soluble, and thus dissociate in water, and which ionic compounds are insoluble in water.

Let's see how to apply these rules. According to Table 4.1, all compounds containing Group 1A(1) ions and all compounds containing the nitrate ion are soluble,

Figure 4.8 The precipitation of calcium fluoride. When aqueous solutions of NaF (from pipet) and CaCl₂ (in test tube) react, solid CaF₂ forms (water molecules are omitted for clarity).

Source: © McGraw-Hill Education/
Richard Megna, photographer

so sodium iodide and potassium nitrate each dissolve in water to form solutions of solvated, dispersed ions:

Three steps help us predict if a precipitate forms when these two solutions are combined:

1. Note the ions in the reactants. The reactant ions are

2. Consider all possible cation-anion combinations. In addition to NaI and KNO₃, which we know are soluble, the other cation-anion combinations are NaNO₃ and KI.

3. Decide whether any combination is insoluble. Remember that Table 4.1 tells us that all compounds of Group 1A(I) ions and all nitrate compounds are soluble. Therefore, all possible cation-anion combinations—NaI, KNO₃, NaNO₃, and KI—are soluble and no reaction occurs:

All the ions are spectator ions, so when we eliminate them, we have no net ionic equation.

Now, what happens if we substitute a solution of lead(II) nitrate, Pb(NO₃)₂, for the KNO₃ solution? The reactant ions are Na⁺, I⁻, Pb²⁺, and NO₃⁻. In addition to the two soluble reactants, NaI and Pb(NO₃)₂, the other two possible cation-anion combinations are

Table 4.1**Solubility Rules for Ionic Compounds in Water**

Soluble Ionic Compounds	Insoluble Exceptions
All common compounds of Group 1A(1) ions (Li^+ , Na^+ , K^+ , etc.)	None
All common compounds of ammonium ion (NH_4^+)	None
All common nitrates (NO_3^-), acetates (CH_3COO^- or $\text{C}_2\text{H}_3\text{O}_2^-$), and perchlorates (ClO_4^-)	None
All common chlorides (Cl^-), bromides (Br^-), and iodides (I^-)	Chlorides, bromides, and iodides of Ag^+ , Pb^{2+} , Cu^+ , and Hg^{2+}
All common fluorides (F^-)	PbF_2 and fluorides of Group 2A(2)
All common sulfates (SO_4^{2-})	CaSO_4 , SrSO_4 , BaSO_4 , Ag_2SO_4 , PbSO_4
Insoluble Ionic Compounds	Soluble Exceptions
All common metal hydroxides	Group 1A(1) hydroxides and $\text{Ca}(\text{OH})_2$, $\text{Sr}(\text{OH})_2$, and $\text{Ba}(\text{OH})_2$
All common carbonates (CO_3^{2-}) and phosphates (PO_4^{3-})	Carbonates and phosphates of Group 1A(1) and NH_4^+
All common sulfides	Sulfides of Group 1A(1), Group 2A(2), and NH_4^+

NaNO_3 and PbI_2 . According to Table 4.1, NaNO_3 is soluble, but PbI_2 is *not*. The total ionic equation shows the reaction that occurs as Pb^{2+} and I^- ions collide and form a precipitate:

And the net ionic equation confirms it:

A Type of Metathesis Reaction The molecular equation for the reaction between $\text{Pb}(\text{NO}_3)_2$ and NaI shows the ions exchanging partners (Figure 4.9):

Such reactions are called *double-displacement reactions*, or **metathesis** (pronounced *meh-TA-thuh-sis*) **reactions**. Some that involve precipitation are important in industry, including the preparation of silver bromide used in black-and-white film:

The reactions that form Ag_2CrO_4 (Figure 4.7) and CaF_2 (Figure 4.8) are also examples of metathesis reactions, as are acid-base reactions (Section 4.4). Sample Problems 4.8 and 4.9 provide practice in predicting if a precipitate forms.

SAMPLE PROBLEM 4.8

Predicting Whether a Precipitation Reaction Occurs; Writing Ionic Equations

Problem Does a reaction occur when each of these pairs of solutions is mixed? If so, write balanced molecular, total ionic, and net ionic equations, and identify the spectator ions.

- (a) Potassium fluoride(*aq*) + strontium nitrate(*aq*) \longrightarrow
 (b) Ammonium perchlorate(*aq*) + sodium bromide(*aq*) \longrightarrow

Plan We note the reactant ions, write the cation-anion combinations, and refer to Table 4.1 to see if any are insoluble. For the molecular equation, we predict the products and write them all as intact compounds. For the total ionic equation, we write the soluble compounds as separate ions. For the net ionic equation, we eliminate the spectator ions.

Solution (a) In addition to the reactants, the two other ion combinations are strontium fluoride and potassium nitrate. Table 4.1 shows that strontium fluoride is insoluble, so a reaction *does* occur. Writing the molecular equation:

Writing the total ionic equation:

Writing the net ionic equation:

The spectator ions are K^+ and NO_3^- .

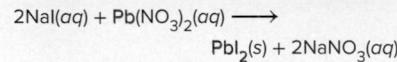

Figure 4.9 The precipitation of PbI_2 , a metathesis reaction.

Source: © McGraw-Hill Education/Stephen Frisch, photographer

(b) The other ion combinations are ammonium bromide and sodium perchlorate. Table 4.1 shows that ammonium, sodium, and perchlorate compounds are soluble, and all bromides are soluble except those of Ag^+ , Pb^{2+} , Cu^+ , and Hg_2^{2+} . Therefore, **no** reaction occurs. The compounds remain as solvated ions:

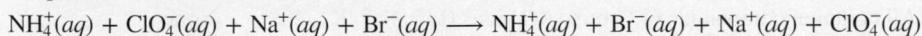

FOLLOW-UP PROBLEMS

4.8A Predict whether a reaction occurs, and if so, write balanced total and net ionic equations:

- (a) Iron(III) chloride(*aq*) + cesium phosphate(*aq*) \longrightarrow
 (b) Sodium hydroxide(*aq*) + cadmium nitrate(*aq*) \longrightarrow
 (c) Magnesium bromide(*aq*) + potassium acetate(*aq*) \longrightarrow

4.8B Predict whether a reaction occurs, and if so, write balanced total and net ionic equations:

- (a) Silver nitrate(*aq*) + barium chloride(*aq*) \longrightarrow
 (b) Ammonium carbonate(*aq*) + potassium sulfide(*aq*) \longrightarrow
 (c) Nickel(II) sulfate(*aq*) + lead(II) nitrate(*aq*) \longrightarrow

SOME SIMILAR PROBLEMS 4.41–4.46

SAMPLE PROBLEM 4.9

Using Molecular Depictions in Precipitation Reactions

Problem The molecular views below depict reactant solutions for a precipitation reaction (with ions shown as colored spheres and water molecules omitted for clarity):

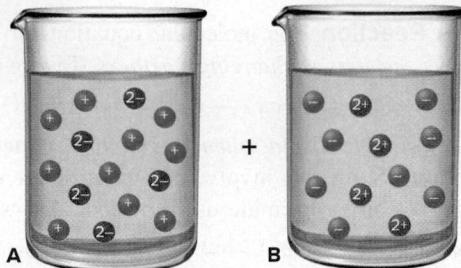

- (a) Which compound is dissolved in beaker A: KCl , Na_2SO_4 , MgBr_2 , or Ag_2SO_4 ?
 (b) Which compound is dissolved in beaker B: NH_4NO_3 , MgSO_4 , $\text{Ba}(\text{NO}_3)_2$, or CaF_2 ?
 (c) Name the precipitate and the spectator ions when solutions A and B are mixed, and write balanced molecular, total ionic, and net ionic equations for any reaction.
 (d) If each particle represents 0.010 mol of ions, what is the maximum mass (g) of precipitate that can form (assuming complete reaction)?

Plan **(a)** and **(b)** From the depictions, we note the charge and number of each kind of ion and use Table 4.1 to determine the ion combinations that are soluble. **(c)** Once we know the combinations, Table 4.1 tells which two ions form the solid, so the other two are spectator ions. **(d)** This part is a limiting-reactant problem because the amounts of two species are involved. We count the number of each kind of ion that forms the solid. We multiply the number of each reactant ion by 0.010 mol and calculate the amount (mol) of product that forms from each. Whichever ion forms less is limiting, so we use the molar mass of the precipitate to find mass (g).

Solution **(a)** In solution A, there are two $1+$ particles for each $2-$ particle. Therefore, the dissolved compound cannot be KCl or MgBr_2 . Of the remaining two choices, Ag_2SO_4 is insoluble, so the dissolved compound must be Na_2SO_4 .

(b) In solution B, there are two $1-$ particles for each $2+$ particle. Therefore, the dissolved compound cannot be NH_4NO_3 or MgSO_4 . Of the remaining two choices, CaF_2 is insoluble, so the dissolved compound must be $\text{Ba}(\text{NO}_3)_2$.

(c) Of the two possible ion combinations, BaSO_4 and NaNO_3 , BaSO_4 is insoluble, so Na^+ and NO_3^- are spectator ions.

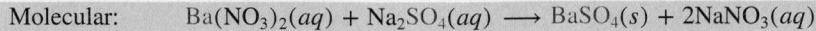

(d) Finding the ion that is the limiting reactant:

For Ba^{2+} :

$$\begin{aligned}\text{Amount (mol) of } \text{BaSO}_4 &= 4 \text{ Ba}^{2+} \text{ particles} \times \frac{0.010 \text{ mol Ba}^{2+} \text{ ions}}{1 \text{ Ba}^{2+} \text{ particle}} \times \frac{1 \text{ mol BaSO}_4}{1 \text{ mol Ba}^{2+} \text{ ions}} \\ &= 0.040 \text{ mol BaSO}_4\end{aligned}$$

For SO_4^{2-} :

$$\begin{aligned}\text{Amount (mol) of } \text{BaSO}_4 &= 5 \text{ SO}_4^{2-} \text{ particles} \times \frac{0.010 \text{ mol SO}_4^{2-} \text{ ions}}{1 \text{ SO}_4^{2-} \text{ particle}} \times \frac{1 \text{ mol BaSO}_4}{1 \text{ mol SO}_4^{2-} \text{ ions}} \\ &= 0.050 \text{ mol BaSO}_4\end{aligned}$$

Therefore, Ba^{2+} ion is the limiting reactant.

Calculating the mass (g) of product (M of $\text{BaSO}_4 = 233.4 \text{ g/mol}$):

$$\text{Mass (g) of } \text{BaSO}_4 = 0.040 \text{ mol BaSO}_4 \times \frac{233.4 \text{ g BaSO}_4}{1 \text{ mol BaSO}_4} = 9.3 \text{ g BaSO}_4$$

Check Counting the number of Ba^{2+} particles allows a more direct calculation for a check: four Ba^{2+} particles means the maximum mass of BaSO_4 that can form is

$$\begin{aligned}\text{Mass(g) of } \text{BaSO}_4 &= 4 \text{ Ba}^{2+} \text{ particles} \times \frac{0.010 \text{ mol Ba}^{2+} \text{ ions}}{1 \text{ Ba}^{2+} \text{ particle}} \times \frac{1 \text{ mol BaSO}_4}{1 \text{ mol Ba}^{2+} \text{ ions}} \times \frac{233.4 \text{ g BaSO}_4}{1 \text{ mol}} \\ &= 9.3 \text{ g BaSO}_4\end{aligned}$$

FOLLOW-UP PROBLEMS

4.9A Molecular views of the reactant solutions for a precipitation reaction are shown below (with ions represented as spheres and water molecules omitted):

- (a) Which compound is dissolved in beaker A: $\text{Zn}(\text{NO}_3)_2$, KCl , Na_2SO_4 , or PbCl_2 ?
- (b) Which compound is dissolved in beaker B: $(\text{NH}_4)_2\text{SO}_4$, $\text{Cd}(\text{OH})_2$, $\text{Ba}(\text{OH})_2$, or KNO_3 ?
- (c) Name the precipitate and the spectator ions when solutions A and B are mixed, and write balanced molecular, total ionic, and net ionic equations for the reaction.
- (d) If each particle represents 0.050 mol of ions, what is the maximum mass (g) of precipitate that can form (assuming complete reaction)?

4.9B Molecular views of the reactant solutions for a precipitation reaction are shown below (with ions represented as spheres and water molecules omitted):

- (a) Which compound is dissolved in beaker A: Li_2CO_3 , NH_4Cl , Ag_2SO_4 , or FeS ?
- (b) Which compound is dissolved in beaker B: $\text{Ni}(\text{OH})_2$, AgNO_3 , CaCl_2 , or BaSO_4 ?
- (c) Name the precipitate and the spectator ions when solutions A and B are mixed, and write balanced molecular, total ionic, and net ionic equations for the reaction.
- (d) If each particle represents 0.20 mol of ions, what is the maximum mass (g) of precipitate that can form (assuming complete reaction)?

SOME SIMILAR PROBLEMS 4.51 and 4.52

Stoichiometry of Precipitation Reactions

In Chapter 3, we saw that the amounts (mol) of reactants and products in a reaction are stoichiometrically equivalent to each other and that the molar ratios between them can be used as conversion factors to calculate the amount of one substance that reacts with, produces, or is formed from a specific amount of another substance. Solving stoichiometry problems for any reaction that takes place in solution, such as a precipitation reaction, requires the additional step of using the solution molarity (mol/L) to convert the volume of reactant or product in solution to amount (mol):

1. Write a balanced equation.
2. Find the amount (mol) of one substance using the volume and molarity (for a substance in solution) or using its molar mass (for a pure substance).
3. Use the molar ratio to relate that amount to the stoichiometrically equivalent amount of another substance.
4. Convert to the desired units.

Figure 4.10 summarizes the possible relationships among quantities of substances in a reaction occurring in solution. Sample Problems 4.10 and 4.11 apply these relationships to precipitation reactions, and we'll also use them for the other classes of reactions.

Figure 4.10 Summary of amount-mass-number relationships for a chemical reaction in solution.

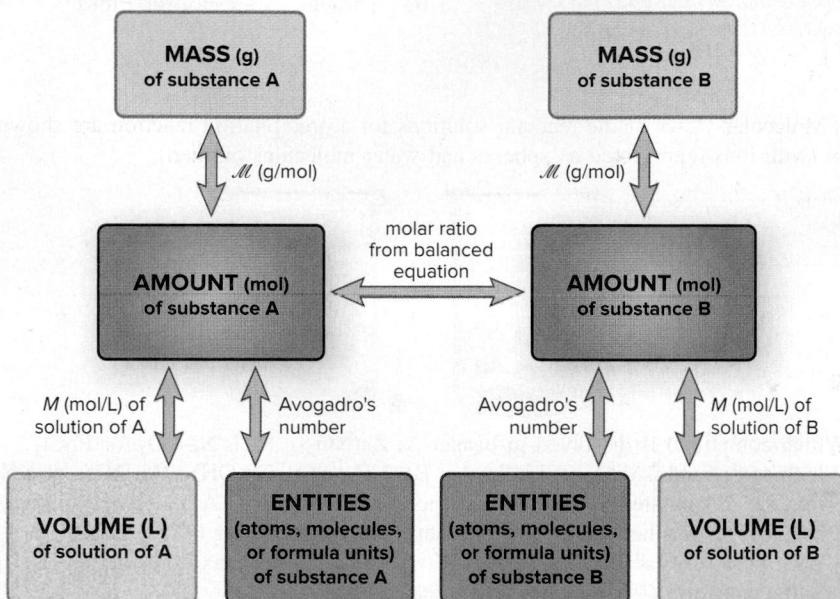

Road Map

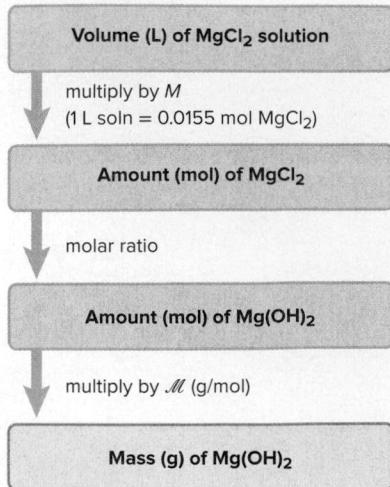

SAMPLE PROBLEM 4.10

Calculating Amounts of Reactants and Products in a Precipitation Reaction

Problem Magnesium is the second most abundant metal in seawater, after sodium. The first step in its industrial extraction involves the reaction of the magnesium ion with calcium hydroxide to precipitate magnesium hydroxide. What mass of magnesium hydroxide is formed when 0.180 L of 0.0155 M magnesium chloride reacts with excess calcium hydroxide?

Plan We are given the molarity (0.0155 M) and the volume (0.180 L) of magnesium chloride solution that reacts with excess calcium hydroxide, and we must find the mass of precipitate. After writing the balanced equation, we find the amount (mol) of magnesium chloride from its molarity and volume and use the molar ratio to find the amount (mol) of magnesium hydroxide that is produced. Finally, we use the molar mass to convert from amount (mol) to mass (g) of magnesium hydroxide (see the road map).

Solution Writing the balanced equation:

Finding the amount (mol) of MgCl_2 :

$$\text{Amount (mol) of } \text{MgCl}_2 = 0.180 \text{ L } \text{MgCl}_2 \times \frac{0.0155 \text{ mol } \text{MgCl}_2}{1 \text{ L } \text{MgCl}_2} = 0.00279 \text{ mol } \text{MgCl}_2$$

Using the molar ratio to convert amount (mol) of MgCl_2 to amount (mol) of Mg(OH)_2 :

$$\text{Amount (mol) of } \text{Mg(OH)}_2 = 0.00279 \text{ mol } \text{MgCl}_2 \times \frac{1 \text{ mol } \text{Mg(OH)}_2}{1 \text{ mol } \text{MgCl}_2}$$

$$= 0.00279 \text{ mol } \text{Mg(OH)}_2$$

Converting from amount (mol) of Mg(OH)_2 to mass (g):

$$\text{Mass (g) of } \text{Mg(OH)}_2 = 0.00279 \text{ mol } \text{Mg(OH)}_2 \times \frac{58.33 \text{ g } \text{Mg(OH)}_2}{1 \text{ mol } \text{Mg(OH)}_2} = 0.163 \text{ g } \text{Mg(OH)}_2$$

Check The answer seems reasonable; rounding to check the math shows that we have $(0.2 \text{ L}) \times (0.02 \text{ M}) = 0.004 \text{ mol}$ of MgCl_2 ; due to the 1/1 molar ratio, 0.004 mol of Mg(OH)_2 is produced.

FOLLOW-UP PROBLEMS

4.10A It is desirable to remove calcium ion from hard water to prevent the formation of precipitates known as *boiler scale* that reduce heating efficiency. The calcium ion is reacted with sodium phosphate to form solid calcium phosphate, which is easier to remove than boiler scale. What volume of 0.260 M sodium phosphate is needed to react completely with 0.300 L of 0.175 M calcium chloride?

4.10B To lift fingerprints from a crime scene, a solution of silver nitrate is sprayed on a surface to react with the sodium chloride left behind by perspiration. What is the molarity of a silver nitrate solution if 45.0 mL of it reacts with excess sodium chloride to produce 0.148 g of precipitate?

SOME SIMILAR PROBLEMS 4.47, 4.48, 4.53, and 4.54

Except for the additional step of finding amounts (mol) in solution, limiting-reactant problems for precipitation reactions in solution are handled just like other such problems.

SAMPLE PROBLEM 4.11

Solving a Limiting-Reactant Problem for a Precipitation Reaction

Problem Iron(III) hydroxide, used to adsorb arsenic and heavy metals from contaminated soil and water, is produced by reacting aqueous solutions of iron(III) chloride and sodium hydroxide.

(a) What mass of iron(III) hydroxide is formed when 0.155 L of 0.250 M iron(III) chloride reacts with 0.215 L of 0.300 M sodium hydroxide?

(b) Write a reaction table for this process.

Plan This is a limiting-reactant problem because *the quantities of two reactants are given*. After balancing the equation, we determine the limiting reactant. From the molarity and volume of each solution, we calculate the amount (mol) of each reactant. Then, we use the molar ratio to find the amount of product $[\text{Fe(OH)}_3]$ that each reactant forms. The limiting reactant forms fewer moles of Fe(OH)_3 , which we convert to mass (g) of Fe(OH)_3 using its molar mass (see the road map). We use the amount of Fe(OH)_3 formed from the limiting reactant in a reaction table (see Section 3.4).

Solution (a) Writing the balanced equation:

Finding the amount (mol) of Fe(OH)_3 formed from FeCl_3 : Combining the steps gives

$$\text{Amount (mol) of } \text{Fe(OH)}_3 = 0.155 \text{ L soln} \times \frac{0.250 \text{ mol } \text{FeCl}_3}{1 \text{ L soln}} \times \frac{1 \text{ mol } \text{Fe(OH)}_3}{1 \text{ mol } \text{FeCl}_3}$$

$$= \mathbf{0.0388 \text{ mol } \text{Fe(OH)}_3}$$

Finding the amount (mol) of Fe(OH)_3 from NaOH: Combining the steps gives

$$\text{Amount (mol) of } \text{Fe(OH)}_3 = 0.215 \text{ L soln} \times \frac{0.300 \text{ mol } \text{NaOH}}{1 \text{ L soln}} \times \frac{1 \text{ mol } \text{Fe(OH)}_3}{3 \text{ mol } \text{NaOH}}$$

$$= \mathbf{0.0215 \text{ mol } \text{Fe(OH)}_3}$$

NaOH is the limiting reactant because it forms fewer moles of Fe(OH)_3 .

Road Map

Converting the amount (mol) of Fe(OH)_3 formed from NaOH to mass (g):

$$\text{Mass (g) of } \text{Fe(OH)}_3 = 0.0215 \text{ mol } \text{Fe(OH)}_3 \times \frac{106.87 \text{ g } \text{Fe(OH)}_3}{1 \text{ mol } \text{Fe(OH)}_3} = 2.30 \text{ g } \text{Fe(OH)}_3$$

(b) With NaOH as the limiting reactant, the reaction table is

Amount (mol)	$\text{FeCl}_3(\text{aq})$	$+ 3\text{NaOH}(\text{aq})$	\longrightarrow	$\text{Fe(OH)}_3(\text{s})$	$+ 3\text{NaCl}(\text{aq})$
Initial	0.0388			0	0
Change	-0.0215			+0.0215	+0.0645
Final	0.0173	0		0.0215	0.0645

A large excess of FeCl_3 remains after the reaction. Note that the amount of NaCl formed is three times the amount of FeCl_3 consumed, as the balanced equation shows.

Check As a check on our choice of the limiting reactant, let's use the alternative method outlined in the Comment in Sample Problem 3.20.

Finding amounts (mol) of reactants given:

$$\begin{aligned}\text{Amount (mol) of } \text{FeCl}_3 &= 0.155 \text{ L soln} \times \frac{0.250 \text{ mol } \text{FeCl}_3}{1 \text{ L soln}} \\ &= 0.0388 \text{ mol } \text{FeCl}_3\end{aligned}$$

$$\begin{aligned}\text{Amount (mol) of } \text{NaOH} &= 0.215 \text{ L soln} \times \frac{0.300 \text{ mol } \text{NaOH}}{1 \text{ L soln}} \\ &= 0.0645 \text{ mol } \text{NaOH}\end{aligned}$$

The molar ratio of the reactants is $1 \text{ FeCl}_3 / 3 \text{ NaOH}$. Therefore, NaOH is limiting because there is less of it than the $3 \times 0.0388 = 0.116$ mol we would need to react with all of the available FeCl_3 .

FOLLOW-UP PROBLEMS

4.11A Despite the toxicity of lead, many of its compounds are still used to make pigments. (a) When 268 mL of 1.50 M lead(II) acetate reacts with 130. mL of 3.40 M sodium chloride, how many grams of solid lead(II) chloride can form? (b) Using the abbreviation “Ac” for the acetate ion, write a reaction table for the process.

4.11B Mercury and its compounds have uses from fillings for teeth (as a mixture with silver, copper, and tin) to the production of chlorine. Because of their toxicity, however, soluble mercury compounds, such as mercury(II) nitrate, must be removed from industrial wastewater. One removal method reacts the wastewater with sodium sulfide solution to produce solid mercury(II) sulfide and sodium nitrate solution. In a laboratory simulation, 0.050 L of 0.010 M mercury(II) nitrate reacts with 0.020 L of 0.10 M sodium sulfide. (a) What mass of mercury(II) sulfide is formed? (b) Write a reaction table for this process.

SOME SIMILAR PROBLEMS 4.49, 4.50, and 4.56

› Summary of Section 4.3

- › In a precipitation reaction, an insoluble ionic compound forms when solutions of two soluble ones are mixed. The electrostatic attraction between certain pairs of solvated ions is strong enough to overcome the attraction of each ion for water molecules.
- › Based on a set of solubility rules, we can predict the formation of a precipitate by noting which of all possible cation-anion combinations is insoluble.
- › When chemical changes such as precipitation reactions occur in solution, amounts of reactants and products are given in terms of concentration and volume.
- › By using molarity as a conversion factor, we can apply the principles of stoichiometry to precipitation reactions in solution.

4.4 ACID-BASE REACTIONS

Aqueous acid-base reactions occur in processes as diverse as the metabolic action of proteins and carbohydrates, the industrial production of fertilizer, and the revitalization of lakes damaged by acid rain.

These reactions involve water as reactant or product, in addition to its common role as solvent. Of course, an **acid-base reaction** (also called a **neutralization reaction**) occurs when an acid reacts with a base, but the definitions of these terms and the scope of this reaction class have changed over the years. For our purposes at this point, we'll use definitions that apply to substances found commonly in the lab:

- An **acid** is a substance that produces H^+ ions when dissolved in water.

- A **base** is a substance that produces OH^- ions when dissolved in water.

(Other definitions are presented later in this section and in Chapter 18.)

Acids and the Solvated Proton Acidic solutions arise when certain covalent H-containing molecules dissociate into ions in water. In every case, these molecules contain a *polar bond to H* in which the other atom pulls much more strongly on the electron pair. A good example is HBr. The Br end of the H—Br bond is partially negative, and the H end is partially positive. When hydrogen bromide gas dissolves in water, the poles of H_2O molecules are attracted to the oppositely charged poles of HBr molecules. The bond breaks, with H becoming the solvated cation $H^+(aq)$ and Br becoming the solvated anion $Br^-(aq)$:

The solvated H^+ ion is a very unusual species. The H atom is a proton surrounded by an electron, so H^+ is just a proton. With a full positive charge concentrated in such a tiny volume, H^+ attracts the negative pole of water molecules so strongly that it forms a covalent bond to one of them. We can show this interaction by writing the solvated H^+ ion as an H_3O^+ ion (**hydronium ion**) that also is solvated:

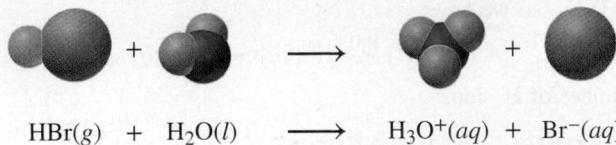

The hydronium ion, which we write as H_3O^+ [or $(H_2O)H^+$], associates with other water molecules to give species such as $H_5O_2^+$ [or $(H_2O)_2H^+$], $H_7O_3^+$ [or $(H_2O)_3H^+$], $H_9O_4^+$ [or $(H_2O)_4H^+$], and so forth. Figure 4.11 shows $H_7O_3^+$, an H_3O^+ ion associated (*dotted lines*) with two H_2O molecules. As a general notation for these various species, we write $H^+(aq)$, but later in this chapter and in much of the text, we'll use $H_3O^+(aq)$.

Acids and Bases as Electrolytes Acids and bases are categorized in terms of their “strength,” the degree to which they dissociate into ions in water:

- *Strong acids and strong bases dissociate completely into ions.* Therefore, like soluble ionic compounds, they are *strong electrolytes* and conduct a large current, as shown by the brightly lit bulb (Figure 4.12A, on the next page).
- *Weak acids and weak bases dissociate very little into ions.* Most of their molecules remain intact. Therefore, they are *weak electrolytes*, which means they conduct a small current (Figure 4.12B).

Table 4.2 lists the strong acids and bases and a few examples of weak acids and bases. Because a strong acid (or strong base) dissociates completely, we can find the molarity

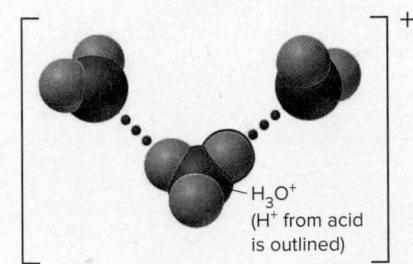

Figure 4.11 The H^+ ion as a solvated hydronium ion.

Strong and Weak Acids and Bases

Table 4.2

Acids

Strong

Hydrochloric acid, HCl
Hydrobromic acid, HBr
Hydriodic acid, HI
Nitric acid, HNO_3
Sulfuric acid, H_2SO_4
Perchloric acid, $HClO_4$

Weak (a few of many examples)

Hydrofluoric acid, HF
Phosphoric acid, H_3PO_4
Acetic acid, CH_3COOH (or $HC_2H_3O_2$)

Bases

Strong

Group 1A(1) hydroxides:
Lithium hydroxide, LiOH
Sodium hydroxide, NaOH
Potassium hydroxide, KOH
Rubidium hydroxide, RbOH
Cesium hydroxide, CsOH

Heavy Group 2A(2) hydroxides:

Calcium hydroxide, $Ca(OH)_2$
Strontium hydroxide, $Sr(OH)_2$
Barium hydroxide, $Ba(OH)_2$

Weak (one of many examples)

Ammonia, NH_3

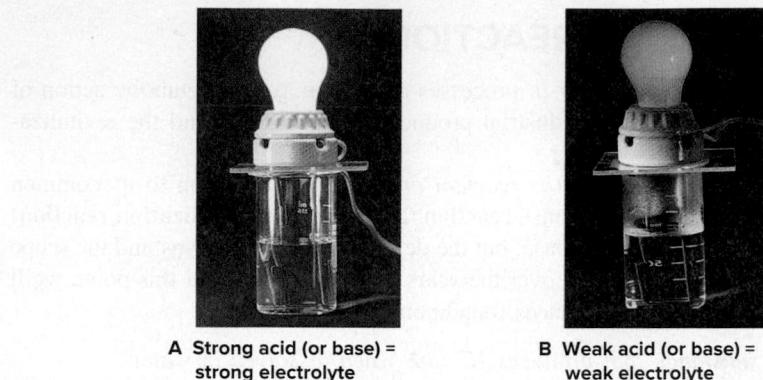

Figure 4.12 Acids and bases as electrolytes.

Source: © McGraw-Hill Education/Stephen Frisch, photographer

of H^+ (or OH^-) and the amount (mol) or number of each ion in solution. (You'll see how to determine these quantities for weak acids in Chapter 18.)

SAMPLE PROBLEM 4.12**Determining the Number of H^+ (or OH^-) Ions in Solution**

Problem Nitric acid is a major chemical in the fertilizer and explosives industries. How many $\text{H}^+(\text{aq})$ ions are in 25.3 mL of 1.4 M nitric acid?

Plan We know the volume (25.3 mL) and molarity (1.4 M) of the nitric acid, and we need the number of $\text{H}^+(\text{aq})$. We convert from mL to L and multiply by the molarity to find the amount (mol) of acid. Table 4.2 shows that nitric acid is a strong acid, so it dissociates completely. With the formula, we write a dissociation equation, which shows the amount (mol) of H^+ ions per mole of acid. We multiply that amount by Avogadro's number to find the number of $\text{H}^+(\text{aq})$ ions (see the road map).

Solution Finding the amount (mol) of nitric acid:

$$\text{Amount (mol) of } \text{HNO}_3 = 25.3 \text{ mL} \times \frac{1 \text{ L}}{1000 \text{ mL}} \times \frac{1.4 \text{ mol}}{1 \text{ L}} = 0.035 \text{ mol}$$

Nitric acid is HNO_3 , so we have:

Finding the number of H^+ ions:

$$\begin{aligned} \text{No. of } \text{H}^+ \text{ ions} &= 0.035 \text{ mol } \text{HNO}_3 \times \frac{1 \text{ mol } \text{H}^+}{1 \text{ mol } \text{HNO}_3} \times \frac{6.022 \times 10^{23} \text{ H}^+ \text{ ions}}{1 \text{ mol } \text{H}^+} \\ &= 2.1 \times 10^{22} \text{ H}^+ \text{ ions} \end{aligned}$$

Check The number of moles seems correct: $0.025 \text{ L} \times 1.4 \text{ mol/L} = 0.035 \text{ mol}$, and multiplying by 6×10^{23} ions/mol gives 2×10^{22} ions.

FOLLOW-UP PROBLEMS

4.12A How many $\text{OH}^-(\text{aq})$ ions are present in 451 mL of 0.0120 M calcium hydroxide?

4.12B How many $\text{H}^+(\text{aq})$ ions are present in 65.5 mL of 0.722 M hydrochloric acid?

SOME SIMILAR PROBLEMS 4.63 and 4.64

Structural Features of Acids and Bases A key structural feature appears in common laboratory acids and bases:

- **Acids.** Strong acids, such as HNO_3 and H_2SO_4 , and weak acids, such as HF and H_3PO_4 , have one or more H atoms as part of their structure, which are either completely released (strong) or partially released (weak) as protons in water.

- Bases.** Strong bases have either OH^- (e.g., NaOH) or O^{2-} (e.g., K_2O) as part of their structure. The oxide ion is not stable in water and reacts to form OH^- ion:

Weak bases, such as ammonia, do not contain OH^- ions, but, as you'll see in later chapters, they all have an electron pair on a nitrogen atom. That nitrogen atom attracts one of the H atoms in a water molecule. The loss of an H^+ ion from the H_2O molecule produces OH^- ions:

(The reaction arrow in the preceding equation indicates that the reaction proceeds in both directions; we'll discuss this important idea further in Section 4.7.)

The Key Event: Formation of H_2O from H^+ and OH^-

To see the key event in acid-base reactions, we'll focus on the reaction between the strong acid HCl and the strong base $\text{Ba}(\text{OH})_2$ and write the three types of aqueous ionic equations (with color):

- The molecular equation is

- HCl and $\text{Ba}(\text{OH})_2$ dissociate completely, so the total ionic equation is

- In the net ionic equation, we eliminate the spectator ions, $\text{Ba}^{2+}(aq)$ and $\text{Cl}^-(aq)$:

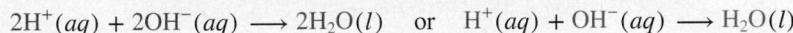

Thus, *the key event in aqueous reactions between a strong acid and a strong base is that an H^+ ion from the acid and an OH^- ion from the base form a water molecule*. Only the spectator ions differ from one strong acid-strong base reaction to another.

Like precipitation reactions, acid-base reactions occur through *the electrostatic attraction of ions and their removal from solution as the product*. In this case, rather than an insoluble ionic solid, the product is H_2O , which consists almost entirely of undissociated molecules. Actually, water molecules dissociate *very* slightly (which, as you'll see in Chapter 18, is very important), but the formation of water in an acid-base reaction results in an enormous net removal of H^+ and OH^- ions.

The molecular and total ionic equations above show that if you evaporate the water, the spectator ions remain: the ionic compound that results from the reaction of an acid and a base is called a **salt**, which in this case is barium chloride. Thus, in an aqueous neutralization reaction, *an acid and a base form a salt solution and water*:

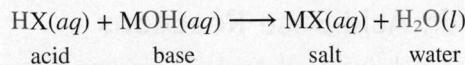

Note that *the cation of the salt comes from the base and the anion from the acid*.

Like precipitation reactions, *acid-base reactions are metathesis (double-displacement) reactions*. The reaction of aluminum hydroxide, the active ingredient in some antacids, with HCl , the major component of stomach acid, is another example:

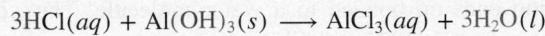

SAMPLE PROBLEM 4.13

Writing Ionic Equations for Acid-Base Reactions

Problem Write balanced molecular, total ionic, and net ionic equations for each of the following acid-base reactions and identify the spectator ions:

- Hydrochloric acid(aq) + potassium hydroxide(aq) \longrightarrow
- Strontium hydroxide(aq) + perchloric acid(aq) \longrightarrow
- Barium hydroxide(aq) + sulfuric acid(aq) \longrightarrow

Plan All are strong acids and bases (see Table 4.2), so the actual reaction is between H^+ and OH^- . The products are H_2O and a salt solution of spectator ions. In (c), we note that the salt (BaSO_4) is insoluble (see Table 4.1), so there are no spectator ions.

Solution

(a) Writing the molecular equation:

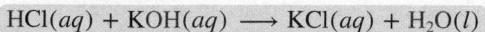

Writing the total ionic equation:

Writing the net ionic equation:

$\text{K}^+(aq)$ and $\text{Cl}^-(aq)$ are the spectator ions.

(b) Writing the molecular equation:

Writing the total ionic equation:

Writing the net ionic equation:

$\text{Sr}^{2+}(aq)$ and $\text{ClO}_4^-(aq)$ are the spectator ions.

(c) Writing the molecular equation:

Writing the total ionic equation:

This is a neutralization *and* a precipitation reaction, so the net ionic equation is the same as the total ionic. There are no spectator ions.

FOLLOW-UP PROBLEMS

4.13A Write balanced molecular, total ionic, and net ionic equations for the reaction between aqueous solutions of calcium hydroxide and nitric acid.

4.13B Write balanced molecular, total ionic, and net ionic equations for the reaction between aqueous solutions of hydriodic acid and lithium hydroxide.

SOME SIMILAR PROBLEMS 4.65(a) and 4.66(a)

Proton Transfer in Acid-Base Reactions

When we take a closer look (with color) at the reaction between a strong acid and strong base, as well as several related reactions, a unifying pattern appears. Let's examine three types of reaction to gain insight into this pattern.

Reaction Between a Strong Acid and a Strong Base When HCl gas dissolves in water, the H^+ ion ends up bonded to a water molecule. Thus, hydrochloric acid actually consists of solvated H_3O^+ and Cl^- ions:

If we add NaOH solution, the total ionic equation shows that H_3O^+ transfers a proton to OH^- (leaving a water molecule written as H_2O , and forming a water molecule written as HOH):

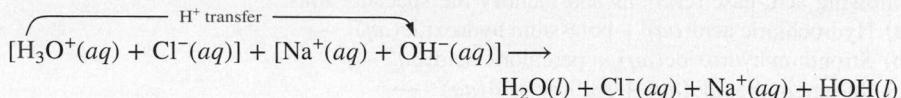

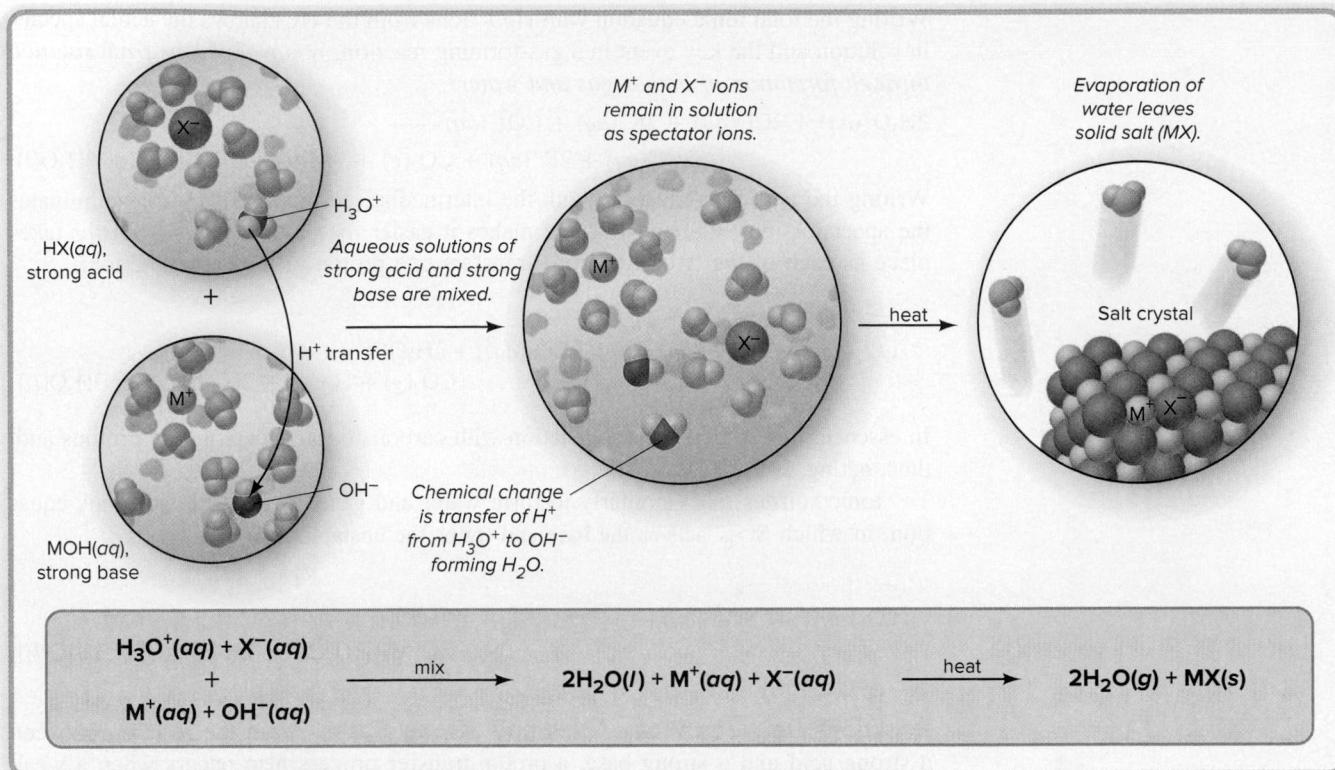

Figure 4.13 An aqueous strong acid–strong base reaction as a proton-transfer process.

Without the spectator ions, the net ionic equation shows more clearly the *transfer of a proton* from H_3O^+ to OH^- :

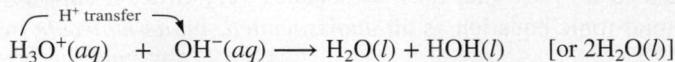

This equation is identical to the one we saw earlier in this section for the reaction of HCl and $\text{Ba}(\text{OH})_2$,

but with an additional H_2O molecule left over from the H_3O^+ . Figure 4.13 shows this process on the atomic level and also shows that, if the water is evaporated, the spectator ions, Cl^- and Na^+ , crystallize as the salt NaCl .

Thus, *an acid-base reaction is a proton-transfer process*. In the early 20th century, the chemists Johannes Brønsted and Thomas Lowry stated:

- *An acid is a molecule (or ion) that donates a proton.*
- *A base is a molecule (or ion) that accepts a proton.*

Therefore, in an aqueous reaction between strong acid and strong base, H_3O^+ ion acts as the acid and donates a proton to OH^- ion, which acts as the base and accepts it. (We discuss the Brønsted-Lowry concept thoroughly in Chapter 18.)

Gas-Forming Reactions: Acids with Carbonates (or Sulfites) When an ionic carbonate, such as K_2CO_3 , is treated with an acid, such as HCl , one of the products is carbon dioxide, as the molecular equations show:

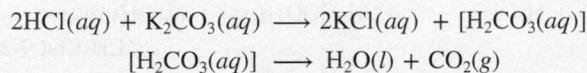

Square brackets around a species, in this case H_2CO_3 , mean it is very unstable: H_2CO_3 decomposes immediately into water and carbon dioxide. Combining these two equations (see Sample Problem 3.17) cancels $[\text{H}_2\text{CO}_3]$ and gives the overall equation:

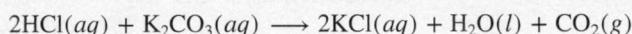

Writing the total ionic equation with H_3O^+ ions from the HCl shows the actual species in solution and the key event in a gas-forming reaction, *removal of ions from solution through formation of both a gas and water*:

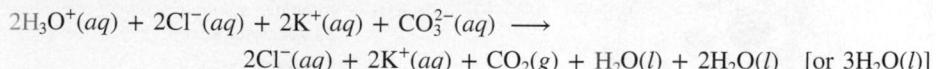

Writing the net ionic equation, with the intermediate formation of H_2CO_3 , eliminates the spectator ions, Cl^- and K^+ , and makes it easier to see that *proton transfer* takes place as each of the two H_3O^+ ions transfers one proton to the carbonate ion:

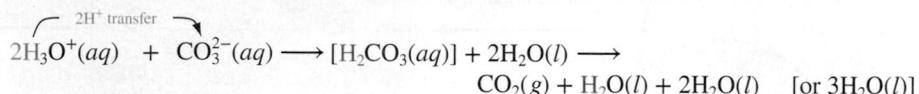

In essence, this is an acid-base reaction with carbonate ion accepting the protons and, thus, acting as the base.

Ionic sulfites react similarly to form water and gaseous SO_2 ; the net ionic equation, in which SO_3^{2-} acts as the base and forms the unstable H_2SO_3 , is

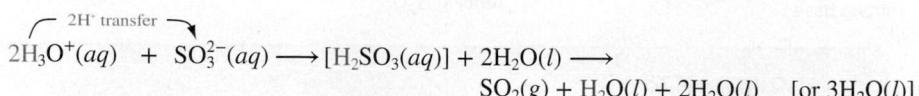

Reactions Between Weak Acids and Strong Bases As in the reaction between a strong acid and a strong base, a proton-transfer process also occurs when a weak acid reacts with a strong base, but the total ionic equation is written differently.

For example, when solutions of the weak acid acetic acid (CH_3COOH , Table 4.2) and the strong base sodium hydroxide are mixed, the molecular equation is

Since acetic acid is weak and, thus, dissociates very little, it appears on the left side of the total ionic equation as an *undissociated, intact molecule* instead of as ions:

The net ionic equation reveals that proton transfer occurs directly from the weak acid rather than from H_3O^+ (as is the case with a strong acid):

There is only one spectator ion, $\text{Na}^+(\text{aq})$, the cation of the strong base. For the reaction of *any weak acid with any strong base*, the net ionic equation has the form

Only the spectator ion from the strong base differs from one weak acid-strong base reaction to another. Table 4.3 compares the reactions of strong and weak acids with a strong base.

Student Hot Spot

Student data indicate that you may struggle with reactions between weak acids and strong bases. Access the Smartbook to view additional Learning Resources on this topic.

Table 4.3

Reactions of Strong and Weak Acids with a Strong Base

	Strong Acid and Strong Base	Weak Acid and Strong Base
Molecular equation	$\text{HCl}(\text{aq}) + \text{NaOH}(\text{aq}) \longrightarrow \text{NaCl}(\text{aq}) + \text{H}_2\text{O}(\text{l})$	$\text{CH}_3\text{COOH}(\text{aq}) + \text{NaOH}(\text{aq}) \longrightarrow$ $\text{CH}_3\text{COONa}(\text{aq}) + \text{H}_2\text{O}(\text{l})$
Total ionic equation	$\text{H}_3\text{O}^+(\text{aq}) + \text{Cl}^-(\text{aq}) + \text{Na}^+(\text{aq}) + \text{OH}^-(\text{aq}) \longrightarrow$ $\text{H}_2\text{O}(\text{l}) + \text{Na}^+(\text{aq}) + \text{Cl}^-(\text{aq}) + \text{H}_2\text{O}(\text{l})$	$\text{CH}_3\text{COOH}(\text{aq}) + \text{Na}^+(\text{aq}) + \text{OH}^-(\text{aq}) \longrightarrow$ $\text{CH}_3\text{COO}^-(\text{aq}) + \text{Na}^+(\text{aq}) + \text{H}_2\text{O}(\text{l})$
Net ionic equation	$\text{H}^+(\text{aq}) + \text{OH}^-(\text{aq}) \longrightarrow \text{H}_2\text{O}(\text{l})$	$\text{CH}_3\text{COOH}(\text{aq}) + \text{OH}^-(\text{aq}) \longrightarrow$ $\text{CH}_3\text{COO}^-(\text{aq}) + \text{H}_2\text{O}(\text{l})$

Molecular equation	$\text{NaHCO}_3(aq) + \text{CH}_3\text{COOH}(aq) \longrightarrow \text{CH}_3\text{COONa}(aq) + \text{CO}_2(g) + \text{H}_2\text{O}(l)$
Total ionic equation	$\text{Na}^+(aq) + \text{HCO}_3^-(aq) + \text{CH}_3\text{COOH}(aq) \longrightarrow \text{CH}_3\text{COO}^-(aq) + \text{Na}^+(aq) + \text{CO}_2(g) + \text{H}_2\text{O}(l)$
Net ionic equation	$\text{HCO}_3^-(aq) + \text{CH}_3\text{COOH}(aq) \longrightarrow \text{CH}_3\text{COO}^-(aq) + \text{CO}_2(g) + \text{H}_2\text{O}(l)$

Figure 4.14 A gas-forming reaction with a weak acid. Note that the two ionic equations include acetic acid because it does *not* dissociate appreciably into ions.

Source: © McGraw-Hill Education/Charles Winters/Timeframe Photography, Inc.

Weak acids also react with carbonates to form CO_2 , but as we have seen, the weak acid is written as an intact molecule, instead of as ions, because it dissociates very little in solution. Figure 4.14 shows the reaction between vinegar (a 5% solution of acetic acid) and baking soda (sodium hydrogen carbonate) solution. In fact, when stomach acid (mostly HCl) builds up, your duodenum releases the hormone secretin, which stimulates your pancreas to release HCO_3^- ions that react with the excess acid in an analogous reaction.

SAMPLE PROBLEM 4.14

Writing Proton-Transfer Equations for Acid-Base Reactions

Problem Write balanced total and net ionic equations for the following reactions and use curved arrows to show how the proton transfer occurs. For (a), give the name and formula of the salt present when the water evaporates. For (b), note that propanoic acid ($\text{CH}_3\text{CH}_2\text{COOH}$) is a weak acid and identify the spectator ion(s).

- (a) Hydriodic acid(*aq*) + calcium hydroxide(*aq*) →
 (b) Potassium hydroxide(*aq*) + propanoic acid(*aq*) →

Plan (a) The reactants are a strong acid and a strong base (Table 4.2), so the acidic species is H_3O^+ , which transfers a proton to the OH^- from the base. The products are H_2O and a solution of spectator ions that becomes a solid salt when the water evaporates.

(b) Since the acid is weak, it occurs as intact molecules in solution and transfers its proton to the OH^- from the base. The only spectator ion is the cation of the base.

Solution (a) Writing the total ionic equation:

Writing the net ionic equation:

$\text{I}^-(aq)$ and $\text{Ca}^{2+}(aq)$ are spectator ions, so the salt is calcium iodide, CaI_2 .

- (b) Writing the total ionic equation:

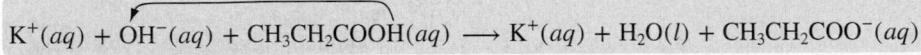

Writing the net ionic equation:

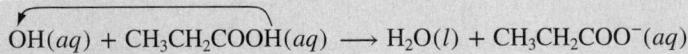

$\text{K}^+(aq)$ is the only spectator ion.

FOLLOW-UP PROBLEMS

4.14A Write balanced total and net ionic equations for the reaction between aqueous solutions of nitrous acid (a weak acid) and strontium hydroxide. Use a curved arrow in the net ionic equation to show the proton transfer. Give the name and formula of the salt that is present when the water evaporates, and identify the spectator ion(s).

4.14B Write balanced total and net ionic equations for the reaction between aqueous solutions of calcium hydrogen carbonate and hydrobromic acid. Use a curved arrow in the net ionic equation to show the proton transfer. Give the name and formula of the salt that is present when the water evaporates.

SOME SIMILAR PROBLEMS 4.65(b), 4.66(b), 4.67, and 4.68

Stoichiometry of Acid-Base Reactions: Acid-Base Titrations

As we saw for precipitation reactions, the molar ratios in an acid-base reaction can also be combined with concentration and volume information to quantify the reactants and products involved in the reaction. Sample Problem 4.15 demonstrates this type of calculation.

SAMPLE PROBLEM 4.15

Calculating the Amounts of Reactants and Products in an Acid-Base Reaction

Problem Specialized cells in the stomach release HCl to aid digestion. If they release too much, the excess can be neutralized with a base in the form of an antacid. Magnesium hydroxide is a common active ingredient in antacids. As a government chemist testing commercial antacids, you use 0.10 M HCl to simulate the acid concentration in the stomach. How many liters of this “stomach acid” will react with a tablet containing 0.10 g of magnesium hydroxide?

Plan We are given the mass (0.10 g) of magnesium hydroxide, Mg(OH)₂, that reacts with the acid. We also know the acid concentration (0.10 M) and must find the acid volume. After writing the balanced equation, we convert the mass (g) of Mg(OH)₂ to amount (mol) and use the molar ratio to find the amount (mol) of HCl that reacts with it. Then, we use the molarity of HCl to find the volume (L) that contains this amount (see the road map).

Solution Writing the balanced equation:

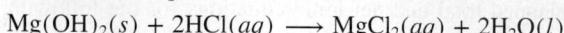

Converting from mass (g) of Mg(OH)₂ to amount (mol):

$$\begin{aligned}\text{Amount (mol) of Mg(OH)}_2 &= 0.10 \text{ g Mg(OH)}_2 \times \frac{1 \text{ mol Mg(OH)}_2}{58.33 \text{ g Mg(OH)}_2} \\ &= 1.7 \times 10^{-3} \text{ mol Mg(OH)}_2\end{aligned}$$

Converting from amount (mol) of Mg(OH)₂ to amount (mol) of HCl:

$$\begin{aligned}\text{Amount (mol) of HCl} &= 1.7 \times 10^{-3} \text{ mol Mg(OH)}_2 \times \frac{2 \text{ mol HCl}}{1 \text{ mol Mg(OH)}_2} \\ &= 3.4 \times 10^{-3} \text{ mol HCl}\end{aligned}$$

Converting from amount (mol) of HCl to volume (L):

$$\begin{aligned}\text{Volume (L) of HCl} &= 3.4 \times 10^{-3} \text{ mol HCl} \times \frac{1 \text{ L}}{0.10 \text{ mol HCl}} \\ &= 3.4 \times 10^{-2} \text{ L}\end{aligned}$$

Check The size of the answer seems reasonable: a small volume of dilute acid (0.034 L of 0.10 M) reacts with a small amount of antacid (0.0017 mol).

FOLLOW-UP PROBLEMS

4.15A Another active ingredient in some antacids is aluminum hydroxide. What mass of aluminum hydroxide is needed to react with the volume of 0.10 M HCl calculated in Sample Problem 4.15?

4.15B The active ingredient in an aspirin tablet is acetylsalicylic acid, HC₉H₇O₄, which is mixed with inert binding agents and fillers. An aspirin tablet dissolved in water requires 14.10 mL of 0.128 M NaOH for complete reaction of the acetylsalicylic acid. What mass of acetylsalicylic acid is in the tablet? (*Hint:* Only one proton in acetylsalicylic acid reacts with the base.)

SOME SIMILAR PROBLEMS 4.69, 4.70, 4.76, and 4.77

Quantifying Acid-Base Reactions by Titration Acid-base reactions are studied quantitatively in a laboratory procedure called a *titration*. In any **titration**, the known concentration of one solution is used to determine the unknown concentration of another. In a typical acid-base titration, a *standardized* solution of base, one whose concentration is *known*, is added to a solution of acid whose concentration is *unknown* (or vice versa).

Road Map

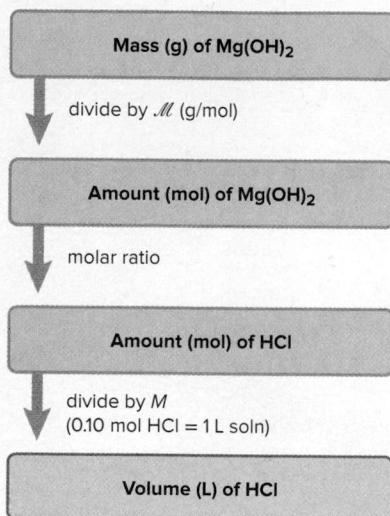

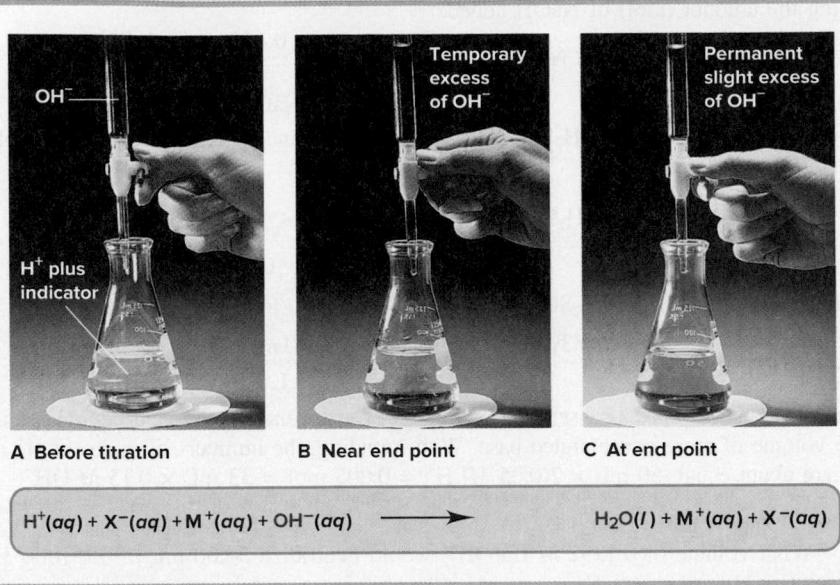

Figure 4.15A shows the laboratory setup for an acid-base titration with a known volume of acid and a few drops of indicator in a flask. An *acid-base indicator* is a substance whose color is different in acid than in base; the indicator used in the figure is phenolphthalein, which is pink in base and colorless in acid. (We examine indicators in Chapters 18 and 19.) Base is added from a buret, and the OH^- ions react with the H^+ ions. As the titration nears its end (Figure 4.15B), the drop of added base creates a temporary excess of OH^- , causing some indicator molecules to change to the basic color; they return to the acidic color when the flask is swirled. There are two key stages in the titration:

- The **equivalence point** occurs when *the amount (mol) of H^+ ions in the original volume of acid has reacted with the same amount (mol) of OH^- ions from the buret*:
Amount (mol) of H^+ (originally in flask) = amount (mol) of OH^- (added from buret)
- The **end point** occurs when a tiny excess of OH^- ions changes the indicator permanently to its basic color (Figure 4.15C).

In calculations, such as in Sample Problem 4.16, we assume that this tiny excess of OH^- ions is insignificant and that *the amount of base needed to reach the end point is the same as the amount needed to reach the equivalence point*.

SAMPLE PROBLEM 4.16

Finding the Concentration of an Acid from a Titration

Problem To standardize an H_2SO_4 solution, you put 50.00 mL of it in a flask with a few drops of indicator and put 0.1524 M NaOH in a buret. The buret reads 0.55 mL at the start and 33.87 mL at the end point. Find the molarity of the H_2SO_4 solution.

Plan We have to find the molarity of the acid from the volume of acid (50.00 mL), the initial (0.55 mL) and final (33.87 mL) volumes of base, and the molarity of the base (0.1524 M). First, we balance the equation. The volume of added base is the difference in buret readings, and we use the base's molarity to calculate the amount (mol) of base. Then, we use the molar ratio from the balanced equation to find the amount (mol) of acid originally present and divide by the acid's original volume to find the molarity (see the road map).

Solution Writing the balanced equation:

Finding the volume (L) of NaOH solution added:

$$\begin{aligned}\text{Volume (L) of solution} &= (33.87 \text{ mL soln} - 0.55 \text{ mL soln}) \times \frac{1 \text{ L}}{1000 \text{ mL}} \\ &= 0.03332 \text{ L soln}\end{aligned}$$

Figure 4.15 An acid-base titration.
Source: © McGraw-Hill Education/Stephen Frisch, photographer

Road Map

Volume (L) of base
(difference in buret readings)

multiply by M of base
(1 L soln = 0.1524 mol NaOH)

Amount (mol) of base

molar ratio

Amount (mol) of acid

divide by volume (L) of acid

M (mol/L) of acid

Finding the amount (mol) of NaOH added:

$$\text{Amount (mol) of NaOH} = 0.03332 \text{ L sohn} \times \frac{0.1524 \text{ mol NaOH}}{1 \text{ L sohn}} \\ = 5.078 \times 10^{-3} \text{ mol NaOH}$$

Finding the amount (mol) of H₂SO₄ originally present: Since the molar ratio is 2 mol NaOH/1 mol H₂SO₄,

$$\text{Amount (mol) of H}_2\text{SO}_4 = 5.078 \times 10^{-3} \text{ mol NaOH} \times \frac{1 \text{ mol H}_2\text{SO}_4}{2 \text{ mol NaOH}} \\ = 2.539 \times 10^{-3} \text{ mol H}_2\text{SO}_4$$

Calculating the molarity of H₂SO₄:

$$\text{Molarity of H}_2\text{SO}_4 = \frac{2.539 \times 10^{-3} \text{ mol H}_2\text{SO}_4}{50.00 \text{ mL}} \times \frac{1000 \text{ mL}}{1 \text{ L}} = 0.05078 \text{ M H}_2\text{SO}_4$$

Check The answer makes sense: a large volume of less concentrated acid neutralized a small volume of more concentrated base. With rounding, the numbers of moles of H⁺ and OH⁻ are about equal: 50 mL × 2(0.05 M) H⁺ = 0.005 mol = 33 mL × 0.15 M OH⁻.

FOLLOW-UP PROBLEMS

4.16A What volume of 0.1292 M Ba(OH)₂ would neutralize 50.00 mL of a 0.1000 M HCl solution?

4.16B Calculate the molarity of a solution of KOH if 18.15 mL of it is required for the titration of a 20.00-mL sample of a 0.2452 M HNO₃ solution.

SOME SIMILAR PROBLEMS 4.71 and 4.72

› Summary of Section 4.4

- › In an acid-base (neutralization) reaction between an acid (an H⁺-yielding substance) and a base (an OH⁻-yielding substance), H⁺ and OH⁻ ions form H₂O.
- › Strong acids and bases dissociate completely in water (strong electrolytes); weak acids and bases dissociate slightly (weak electrolytes).
- › An acid-base reaction involves the transfer of a proton from an acid (a species that donates H⁺) to a base (a species that accepts H⁺).
- › A gas-forming acid-base reaction occurs when an acid transfers a proton to a carbonate (or sulfite), forming water and a gas that leaves the reaction mixture.
- › Since weak acids dissociate very little, an ionic equation shows a weak acid as an intact molecule transferring its proton to the base.
- › Molarity can be used as a conversion factor to solve stoichiometric problems involving acid-base reactions.
- › In a titration, the known concentration of one solution is used to determine the concentration of the other.

4.5

OXIDATION-REDUCTION (REDOX) REACTIONS

Oxidation-reduction (redox) reactions include the formation of a compound from its elements (and the reverse process), all combustion processes, the generation of electricity in batteries, the production of cellular energy, and many others. In fact, redox reactions are so widespread that many do not occur in solution at all. In this section, we examine the key event in the redox process, discuss important terminology, see how to determine whether a reaction involves a redox process, and learn how to quantify redox reactions. (The redox reactions in this section can be balanced by methods you learned in Chapter 3; you'll learn how to balance more complex ones when we discuss electrochemistry in Chapter 21.)

The Key Event: Movement of Electrons Between Reactants

The key chemical event in an **oxidation-reduction** (or **redox**) reaction is the *net movement of electrons from one reactant to another*. The movement occurs from the

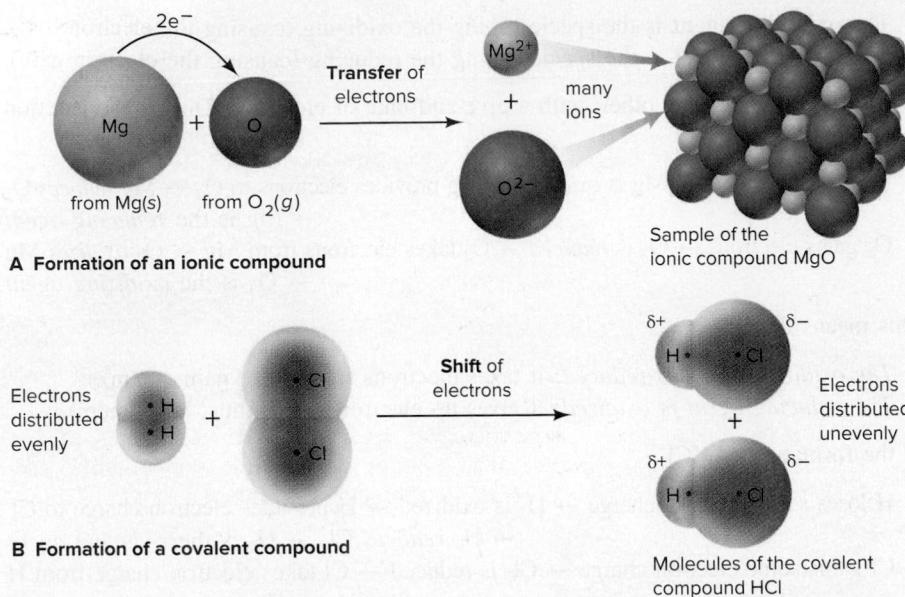

Figure 4.16 The redox process in the formation of (A) ionic and (B) covalent compounds from their elements.

reactant (or atom in the reactant) with *less* attraction for electrons to the reactant (or atom) with *more* attraction for electrons.

This process occurs in the formation of both ionic and covalent compounds:

- *Ionic compounds: transfer of electrons.* In the reaction that forms MgO from its elements (see Figure 3.7), the balanced equation is

Figure 4.16A shows that each Mg atom loses two electrons and each O atom gains them. This loss and gain is a *transfer of electrons* away from each Mg atom to each O atom. The resulting Mg²⁺ and O²⁻ ions aggregate into an ionic solid.

- *Covalent compounds: shift of electrons.* During the formation of a covalent compound from its elements, there is more a *shift of electrons* rather than a full transfer. Thus, *ions do not form*. Consider the formation of HCl gas:

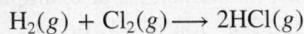

To see the electron movement, we'll compare the electron distribution in reactant and product. As Figure 4.16B shows, in H₂ and Cl₂, the electrons are shared equally between the atoms (*symmetrical shading*). Because the Cl atom attracts electrons more than the H atom, in HCl, the electrons are shared unequally (*asymmetrical shading*). Electrons shift away from H and toward Cl, so the Cl atom has more negative charge (red and δ-) in HCl than it had in Cl₂, and the H atom has less negative charge (blue and δ+) than it had in H₂. Thus, H₂ loses some electron charge and Cl₂ gains some electron charge.

Some Essential Redox Terminology

Certain key terms describe the process and explain the name of this reaction class:

- **Oxidation** is the *loss* of electrons.
- **Reduction** is the *gain* of electrons.

During the formation of MgO, Mg undergoes oxidation (loss of electrons), and O₂ undergoes reduction (gain of electrons). The loss and gain are simultaneous, but we can imagine them occurring separately:

(Throughout this discussion, blue type indicates oxidation, and red type reduction.)

- The **oxidizing agent** is the species doing the oxidizing (causing the electron loss).
- The **reducing agent** is the species doing the reducing (causing the electron gain).

One reactant acts on the other, with a give-and-take of electrons. During the reaction that forms MgO,

- Mg loses electrons → Mg is *oxidized* → Mg provides electrons to O₂ → Mg *reduces* O₂
→ Mg is the *reducing agent*
- O₂ gains electrons → O₂ is *reduced* → O₂ takes electrons from Mg → O₂ *oxidizes* Mg
→ O₂ is the *oxidizing agent*

This means that

- The oxidizing agent is reduced:* it takes electrons (and, thus, gains them).
- The reducing agent is oxidized:* it gives up electrons (and, thus, loses them).

In the formation of HCl,

- H loses some electron charge → H₂ is oxidized → H provides electron charge to Cl
→ H₂ *reduces* Cl₂ → H₂ is the *reducing agent*
- Cl gains some electron charge → Cl₂ is reduced → Cl takes electron charge from H
→ Cl₂ *oxidizes* H₂ → Cl₂ is the *oxidizing agent*

Using Oxidation Numbers to Monitor Electron Charge

Chemists have devised a “bookkeeping” system to monitor which atom loses electron charge and which atom gains it: each atom in a molecule (or formula unit) is assigned an **oxidation number (O.N.)**, or *oxidation state*, which is the charge the atom would have if its electrons were transferred completely, not shared.

Each element in a binary *ionic* compound has a full charge because the atom transferred its electron(s), and so the atom’s oxidation number equals the ionic charge. But, each element in a *covalent* compound (or in a polyatomic ion) has a partial charge because the electrons shifted away from one atom and toward the other. For these cases, we determine oxidation number by a set of rules (presented in Table 4.4; you’ll learn the atomic basis of the rules in Chapters 8 and 9).

An O.N. has the sign *before* the number (e.g., +2), whereas an ionic charge has the sign *after* the number (e.g., 2+). Also, unlike a unitary ionic charge, as in Na⁺ or Cl⁻, an O.N. of +1 or -1 retains the numeral. For example, we don’t write the sodium ion as Na¹⁺, but the O.N. of the Na⁺ ion is +1, not +.

Table 4.4 Rules for Assigning an Oxidation Number (O.N.)

General Rules

- For an atom in its elemental form (Na, C, O₂, Cl₂, P₄, etc.): O.N. = 0
- For a monatomic ion: O.N. = ion charge (with the sign *before* the numeral)
- The sum of O.N. values for the atoms in a molecule or formula unit of a compound equals zero. The sum of O.N. values for the atoms in a polyatomic ion equals the ion’s charge.

Rules for Specific Atoms or Periodic Table Groups

- For Group 1A(1): O.N. = +1 in all compounds
- For Group 2A(2): O.N. = +2 in all compounds
- For hydrogen: O.N. = +1 in combination with nonmetals
O.N. = -1 in combination with metals and boron (e.g. NaH)
- For fluorine: O.N. = -1 in all compounds
- For oxygen: O.N. = -1 in peroxides (e.g. H₂O₂)
O.N. = -2 in all other compounds (except with F)
- For Group 7A(17): O.N. = -1 in combination with metals, nonmetals (except O),
and other halogens lower in the group

SAMPLE PROBLEM 4.17**Determining the Oxidation Number of Each Element in a Compound (or Ion)**

Problem Determine the oxidation number (O.N.) of each element in these species:

- (a) Zinc chloride (b) Sulfur trioxide (c) Nitric acid (d) Dichromate ion

Plan We determine the formulas and consult Table 4.4, noting the general rules that the O.N. values for a compound add up to zero and those for a polyatomic ion add up to the ion's charge.

Solution (a) ZnCl_2 . The O.N. of each chloride ion is -1 (rule 6 in Table 4.4), for a total of -2 , so the O.N. of Zn must be $+2$ since the sum of O.N.s must equal zero for a compound.

(b) SO_3 . The O.N. of each oxygen is -2 (rule 5 in Table 4.4), for a total of -6 . The O.N.s must add up to zero, so the O.N. of S is $+6$.

(c) HNO_3 . The O.N. of H is $+1$ (rule 3 in Table 4.4) and the O.N. of each O is -2 (rule 5 in Table 4.4), for a total of -6 . Therefore, the O.N. of N is $+5$.

(d) $\text{Cr}_2\text{O}_7^{2-}$. The sum of the O.N. values in a polyatomic ion equals the ion's charge. The O.N. of each O is -2 (rule 5 in Table 4.4), so the total for seven O atoms is -14 . Therefore, each Cr must have an O.N. of $+6$ in order for the sum of the O.N.s to equal the charge of the ion:

FOLLOW-UP PROBLEMS

4.17A Determine the O.N. of each element in the following:

- (a) Scandium oxide (Sc_2O_3) (b) Gallium chloride (GaCl_3)
 (c) Hydrogen phosphate ion (d) Iodine trifluoride

4.17B Determine the O.N. of each element in the following:

- (a) Potassium carbonate (b) Ammonium ion
 (c) Calcium phosphide (Ca_3P_2) (d) Sulfur tetrachloride

SOME SIMILAR PROBLEMS 4.84–4.91**Using O.N.s to Identify Redox Reactions and Oxidizing and Reducing Agents**

A redox reaction is defined as one in which the oxidation numbers of the species change. By assigning an oxidation number to each atom, we can see which species was oxidized and which reduced and, thus, which is the oxidizing agent and which the reducing agent:

- If an atom has a higher (more positive or less negative) O.N. in the product than it had in the reactant, the reactant that contains that atom was oxidized (lost electrons) and is the reducing agent. Thus, *oxidation is shown by an increase in O.N.*
- If an atom has a lower (more negative or less positive) O.N. in the product than it had in the reactant, the reactant that contains that atom was reduced (gained electrons) and is the oxidizing agent. Thus, *reduction is shown by a decrease in O.N.*

Sample Problem 4.18 introduces the *tie-line*, a useful device for keeping track of changes in oxidation numbers.

Student Hot Spot

Student data indicate that you may struggle with identifying the reducing and oxidizing agents in a redox reaction. Access the Smartbook to view additional Learning Resources on this topic.

SAMPLE PROBLEM 4.18

Identifying Redox Reactions and Oxidizing and Reducing Agents

Problem Use oxidation numbers to decide which of the following are redox reactions. For each redox reaction, identify the oxidizing agent and the reducing agent:

- $2\text{Al}(s) + 3\text{H}_2\text{SO}_4(aq) \rightarrow \text{Al}_2(\text{SO}_4)_3(aq) + 3\text{H}_2(g)$
- $\text{H}_2\text{SO}_4(aq) + 2\text{NaOH}(aq) \rightarrow \text{Na}_2\text{SO}_4(aq) + 2\text{H}_2\text{O}(l)$
- $\text{PbO}(s) + \text{CO}(g) \rightarrow \text{Pb}(s) + \text{CO}_2(g)$

Plan To determine whether a reaction is an oxidation-reduction process, we use Table 4.4 to assign each atom an O.N. and then note whether it changes as the reactants become products. If the O.N. of an atom changes during the reaction, we draw a tie-line from the atom on the left side to the same atom on the right side and label the change. For those reactions that are redox reactions, a reactant is the reducing agent if it contains an atom that is oxidized (O.N. *increases* from left to right in the equation). A reactant is the oxidizing agent if it contains an atom that is reduced (O.N. *decreases*). Note that products are never oxidizing or reducing agents.

Solution (a) Assigning oxidation numbers and marking the changes:

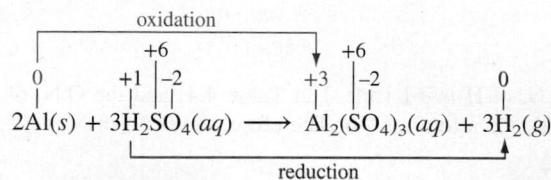

In this case, the O.N.s of Al and H change, so this is a redox reaction. The O.N. of Al changes from 0 to +3 (Al loses electrons), so Al is oxidized; Al is the reducing agent. The O.N. of H decreases from +1 to 0 (H gains electrons), so H^+ is reduced; H_2SO_4 is the oxidizing agent.

(b) Assigning oxidation numbers:

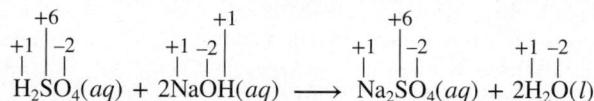

Because each atom in the products has the same O.N. that it had in the reactants, we conclude that this is *not* a redox reaction.

(c) Assigning oxidation numbers and marking the changes:

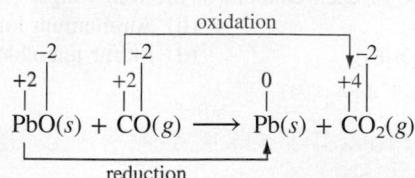

In this case, the O.N.s of Pb and C change, so this is a redox reaction. The O.N. of Pb decreases from +2 to 0, so Pb is reduced; PbO is the oxidizing agent. The O.N. of C increases from +2 to +4, so CO is oxidized; CO is the reducing agent.

In general, when a substance (such as CO) changes to one with more O atoms (such as CO_2), it is oxidized; and when a substance (such as PbO) changes to one with fewer O atoms (such as Pb), it is reduced.

Comment The reaction in part (b) is an acid-base reaction in which H_2SO_4 transfers two H^+ ions to two OH^- ions to form two H_2O molecules. In the net ionic equation,

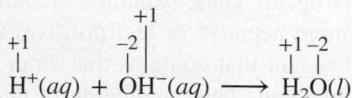

we see that the O.N.s remain the same on both sides. Therefore, *an acid-base reaction is not a redox reaction*.

FOLLOW-UP PROBLEMS

4.18A Use oxidation numbers to decide which of the following are redox reactions. For all redox reactions, identify the oxidizing agent and the reducing agent:

- $\text{NCl}_3(l) + 3\text{H}_2\text{O}(l) \rightarrow \text{NH}_3(aq) + 3\text{HOCl}(aq)$
- $\text{AgNO}_3(aq) + \text{NH}_4\text{I}(aq) \rightarrow \text{AgI}(s) + \text{NH}_4\text{NO}_3(aq)$
- $2\text{H}_2\text{S}(g) + 3\text{O}_2(g) \rightarrow 2\text{SO}_2(g) + 2\text{H}_2\text{O}(g)$

4.18B Use oxidation numbers to decide which of the following are redox reactions. For all redox reactions, identify the oxidizing agent and the reducing agent:

- $\text{SiO}_2(s) + 4\text{HF}(g) \rightarrow \text{SiF}_4(g) + 2\text{H}_2\text{O}(l)$
- $2\text{C}_2\text{H}_6(g) + 7\text{O}_2(g) \rightarrow 4\text{CO}_2(g) + 6\text{H}_2\text{O}(g)$
- $5\text{CO}(g) + \text{I}_2\text{O}_5(s) \rightarrow 5\text{CO}_2(g) + \text{I}_2(s)$

SOME SIMILAR PROBLEMS 4.92–4.95

Be sure to remember that *transferred electrons are never free because the reducing agent loses electrons and the oxidizing agent gains them simultaneously*. In other words, a complete reaction *cannot* be “an oxidation” or “a reduction”; it must be an oxidation-reduction. Figure 4.17 summarizes redox terminology.

Stoichiometry of Redox Reactions: Redox Titrations

Just as for precipitation and acid-base reactions, stoichiometry is important for redox reactions; a special application of stoichiometry that we focus on here is redox titration. In an acid-base titration, a known concentration of a base is used to find an unknown concentration of an acid (or vice versa). Similarly, in a redox titration, a known concentration of oxidizing agent is used to find an unknown concentration of reducing agent (or vice versa). This kind of titration has many applications, from measuring the iron content in drinking water to quantifying vitamin C in fruits and vegetables.

The permanganate ion, MnO_4^- , is a common oxidizing agent because it is deep purple, and so also serves as an indicator. In Figure 4.18, MnO_4^- is used to determine oxalate ion ($\text{C}_2\text{O}_4^{2-}$) concentration. As long as $\text{C}_2\text{O}_4^{2-}$ is present, it reduces the added MnO_4^- to faint pink (nearly colorless) Mn^{2+} (Figure 4.18, *left*). When all the $\text{C}_2\text{O}_4^{2-}$ has been oxidized, the next drop of MnO_4^- turns the solution light purple (Figure 4.18, *right*). This color change indicates the *end point*, which we assume is the same as the *equivalence point*, the point at which the electrons lost by the oxidized species ($\text{C}_2\text{O}_4^{2-}$) equal the electrons gained by the reduced species (MnO_4^-). We can calculate the $\text{C}_2\text{O}_4^{2-}$ concentration from the known volume of $\text{Na}_2\text{C}_2\text{O}_4$ solution and the known volume and concentration of KMnO_4 solution.

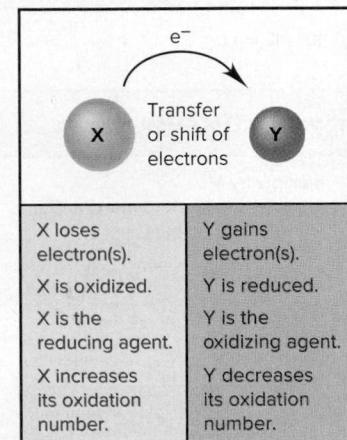

Figure 4.17 A summary of terminology for redox reactions.

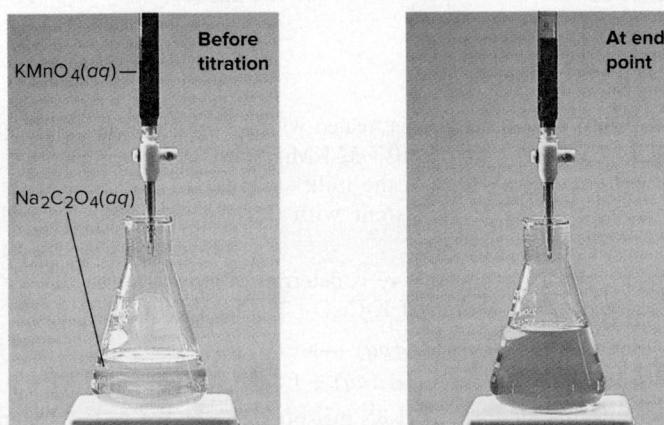

Figure 4.18 The redox titration of $\text{C}_2\text{O}_4^{2-}$ with MnO_4^- .

Source: © McGraw-Hill Education/Stephen Frisch, photographer

Net ionic equation:

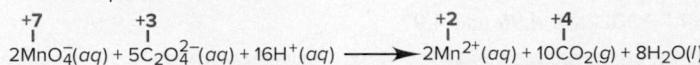

SAMPLE PROBLEM 4.19

Finding the Amount of Reducing Agent by Titration

Problem Calcium ion (Ca^{2+}) is necessary for the clotting of blood and many other physiological processes. To measure the Ca^{2+} concentration in 1.00 mL of human blood, $\text{Na}_2\text{C}_2\text{O}_4$ solution is added, which precipitates the Ca^{2+} as CaC_2O_4 . This solid is dissolved in dilute H_2SO_4 to release $\text{C}_2\text{O}_4^{2-}$, and 2.05 mL of $4.88 \times 10^{-4} M$ KMnO_4 is required to reach the end point. The balanced equation is

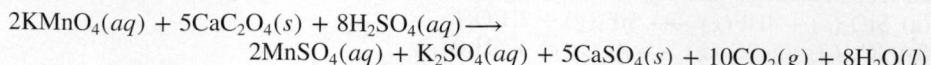

Calculate the amount (mol) of Ca^{2+} in 1.00 mL of blood.

Plan We have to find the amount (mol) of Ca^{2+} from the volume (2.05 mL) and concentration ($4.88 \times 10^{-4} M$) of KMnO_4 used to oxidize the CaC_2O_4 precipitated from 1.00 mL of blood. We find the amount (mol) of KMnO_4 needed to reach the end point and use the molar ratio to find the amount (mol) of CaC_2O_4 . Then we use the chemical formula, which shows 1 mol of Ca^{2+} for every mol of CaC_2O_4 (see the road map).

Solution Converting volume (mL) and concentration (M) to amount (mol) of KMnO_4 :

$$\begin{aligned}\text{Amount (mol) of KMnO}_4 &= 2.05 \text{ mL soln} \times \frac{1 \text{ L}}{1000 \text{ mL}} \times \frac{4.88 \times 10^{-4} \text{ mol KMnO}_4}{1 \text{ L soln}} \\ &= 1.00 \times 10^{-6} \text{ mol KMnO}_4\end{aligned}$$

Using the molar ratio to convert amount (mol) of KMnO_4 to amount (mol) of CaC_2O_4 :

$$\begin{aligned}\text{Amount (mol) of CaC}_2\text{O}_4 &= 1.00 \times 10^{-6} \text{ mol KMnO}_4 \times \frac{5 \text{ mol CaC}_2\text{O}_4}{2 \text{ mol KMnO}_4} \\ &= 2.50 \times 10^{-6} \text{ mol CaC}_2\text{O}_4\end{aligned}$$

Finding the amount (mol) of Ca^{2+} :

$$\text{Amount (mol) of Ca}^{2+} = 2.50 \times 10^{-6} \text{ mol CaC}_2\text{O}_4 \times \frac{1 \text{ mol Ca}^{2+}}{1 \text{ mol CaC}_2\text{O}_4} = 2.50 \times 10^{-6} \text{ mol Ca}^{2+}$$

Check A very small volume of dilute KMnO_4 is needed, so 10^{-6} mol of KMnO_4 seems reasonable. The molar ratio of CaC_2O_4 to KMnO_4 is 5/2, which gives 2.5×10^{-6} mol of CaC_2O_4 and thus 2.5×10^{-6} mol of Ca^{2+} .

Comment 1. When blood is donated, the receiving bag contains $\text{Na}_2\text{C}_2\text{O}_4$ solution, which precipitates the Ca^{2+} ion to prevent clotting.

2. Normal Ca^{2+} concentration in human adult blood is 9.0–11.5 mg $\text{Ca}^{2+}/100 \text{ mL}$. If we multiply the amount of Ca^{2+} in 1 mL by 100 and then multiply by the molar mass of Ca (40.08 g/mol), we get 1.0×10^{-2} g, or 10.0 mg Ca^{2+} in 100 mL:

$$\begin{aligned}\text{Mass (mg) of Ca}^{2+} &= \frac{2.50 \times 10^{-6} \text{ mol Ca}^{2+}}{1 \text{ mL}} \times 100 \text{ mL} \times \frac{40.08 \text{ g Ca}^{2+}}{1 \text{ mol Ca}^{2+}} \times \frac{1000 \text{ mg}}{1 \text{ g}} \\ &= 10.0 \text{ mg Ca}^{2+}\end{aligned}$$

FOLLOW-UP PROBLEMS

4.19A When 2.50 mL of low-fat milk is treated with sodium oxalate and the precipitate dissolved in H_2SO_4 , 6.53 mL of $4.56 \times 10^{-3} M$ KMnO_4 is required to reach the end point. **(a)** Calculate the molarity of Ca^{2+} in the milk sample. **(b)** What is the concentration of Ca^{2+} in g/L? Is this value consistent with the typical value for milk of about 1.2 g Ca^{2+}/L ?

4.19B The amount of iron in an iron ore is determined by converting the Fe to FeSO_4 , followed by titration with a solution of $\text{K}_2\text{Cr}_2\text{O}_7$. The balanced equation is

(a) What is the molarity of Fe^{2+} if 21.85 mL of 0.250 M $\text{K}_2\text{Cr}_2\text{O}_7$ is required for the titration of 30.0 mL of FeSO_4 solution? **(b)** If the original sample of iron ore had a mass of 2.58 g, what is the mass percent of iron in the ore?

SOME SIMILAR PROBLEMS 4.96 and 4.97

› Summary of Section 4.5

- › When one reactant has a greater attraction for electrons than another, there is a net movement of electrons, and a redox reaction takes place. Electron gain (reduction) and electron loss (oxidation) occur simultaneously.
- › Assigning oxidation numbers to all atoms in a reaction is a method for identifying a redox reaction. The species that is oxidized (contains an atom that increases in oxidation number) is the reducing agent; the species that is reduced (contains an atom that decreases in oxidation number) is the oxidizing agent.
- › A redox titration determines the concentration of an oxidizing agent from the known concentration of the reducing agent (or vice versa).

4.6 ELEMENTS IN REDOX REACTIONS

In many redox reactions, such as those in parts (a) and (c) of Sample Problem 4.18, *atoms occur as an element on one side of an equation and as part of a compound on the other.** One way to classify these reactions is by comparing the *numbers* of reactants and products. With that approach, we have three types—*combination, decomposition, and displacement*; one other type involving elements is *combustion*. In this section, we survey each type and consider several examples.

Combination Redox Reactions

In a combination redox reaction, two or more reactants, at least one of which is an element, form a compound:

Combining Two Elements Two elements may react to form binary ionic or covalent compounds. Here are some important examples:

1. *Metal and nonmetal form an ionic compound.* Figure 4.19 (*on the next page*) shows a typical example of a combination redox reaction, between the alkali metal potassium and the halogen chlorine, on the macroscopic, atomic, and symbolic levels. Note the change in oxidation numbers in the balanced equation: K is oxidized, so it is the reducing agent; Cl₂ is reduced, so it is the oxidizing agent. In fact, whenever a binary ionic compound forms from its elements, *the metal is the reducing agent and the nonmetal is the oxidizing agent*.

In another example of metal reacting with nonmetal, aluminum reacts with O₂, as does nearly every metal, to form an ionic oxide:

The Al₂O₃ layer on the surface of an aluminum pot prevents oxygen from reacting with the next layer of Al atoms, thus protecting the metal from further oxidation.

2. *Two nonmetals form a covalent compound.* In one of thousands of examples, ammonia forms from nitrogen and hydrogen in a reaction that occurs in industry on an enormous scale:

Halogens react with many other nonmetals, as in the formation of phosphorus trichloride, a reactant in the production of pesticides and other organic compounds:

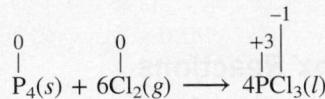

*Many other redox reactions, however, do not involve elements (see Sample Problem 4.19).

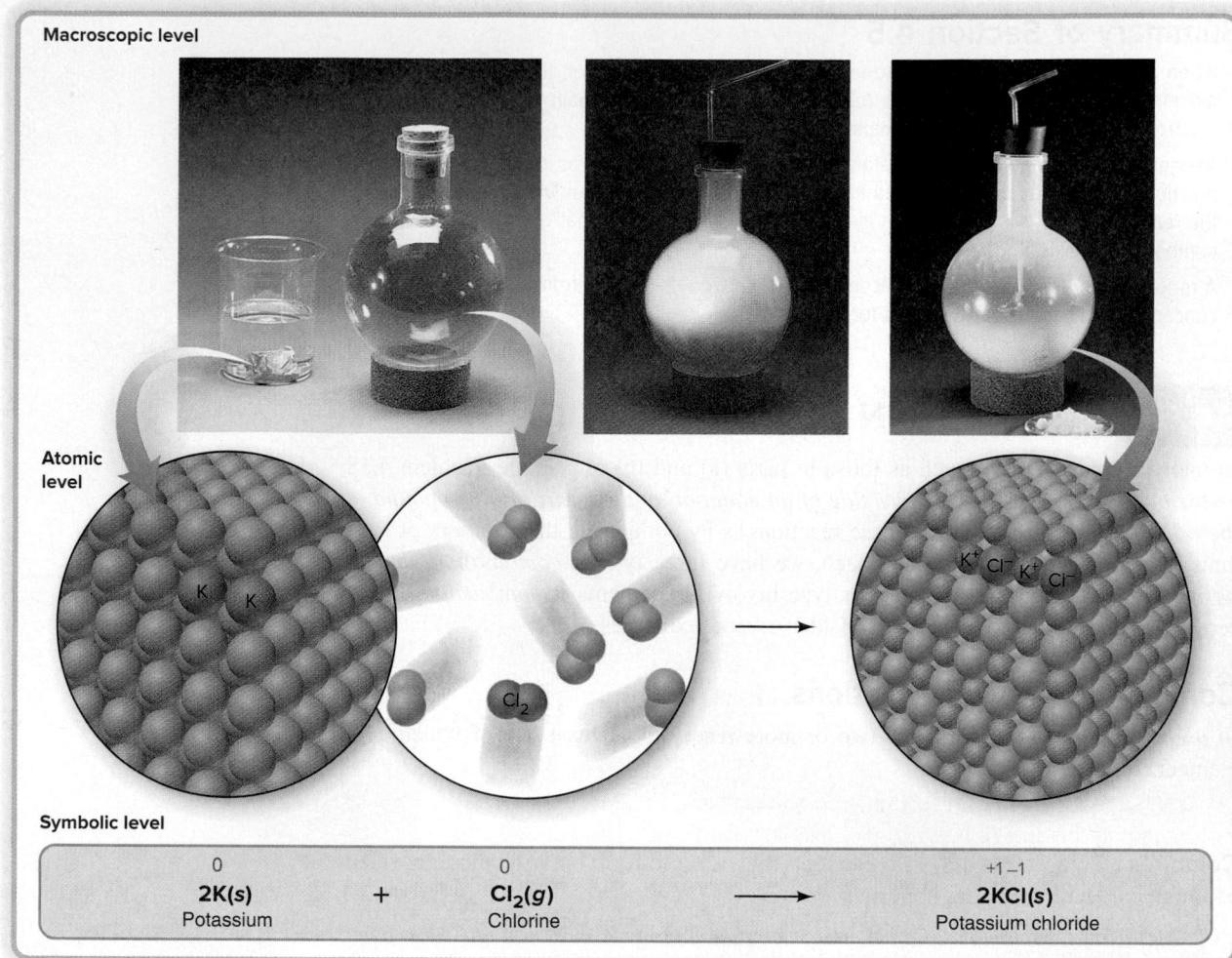

Figure 4.19 Combining elements to form an ionic compound: potassium metal and chlorine gas form solid potassium chloride. Darker atoms in the atomic view indicate the stoichiometry.

Source: © McGraw-Hill Education/Stephen Frisch, photographer

Nearly every nonmetal reacts with O₂ to form a covalent oxide, as when nitrogen monoxide forms from the nitrogen and oxygen in air at the very high temperatures created by lightning and in a car's engine:

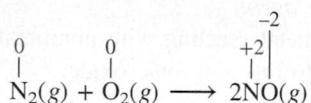

Combining a Compound and an Element Many binary covalent compounds react with nonmetals to form larger compounds. Many nonmetal oxides react with additional O₂ to form “higher” oxides (those with more O atoms in each molecule). For example,

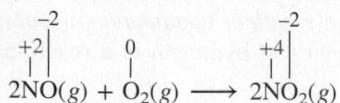

Similarly, many nonmetal halides combine with additional halogen to form “higher” halides:

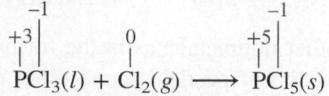

Decomposition Redox Reactions

In a *decomposition redox reaction*, a compound forms two or more products, at least one of which is an element:

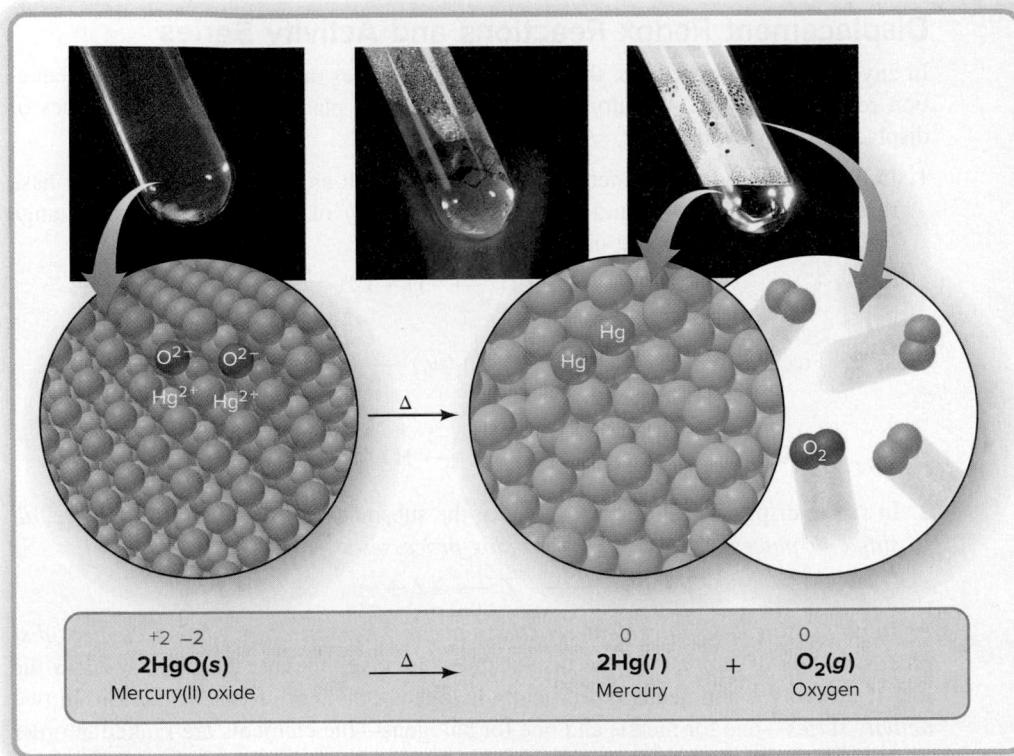

Figure 4.20 Decomposition of the compound mercury(II) oxide to its elements.

Source: © McGraw-Hill Education/
Stephen Frisch, photographer

In any decomposition reaction, the reactant absorbs enough energy for one or more bonds to break. The energy can take several forms, but the most important are decomposition by heat (thermal) and by electricity (electrolytic). The products are either elements or elements and smaller compounds.

Thermal Decomposition When the energy absorbed is heat, the reaction is called a *thermal decomposition*. (A Greek delta, Δ , above the yield arrow indicates strong heating is required for the reaction to occur.) Many metal oxides, chlorates, and perchlorates release oxygen when strongly heated. Heating potassium chlorate is a method for forming small amounts of oxygen in the laboratory; the same reaction occurs in some explosives and fireworks. In this reaction, Cl in potassium chlorate is reduced, while oxygen in the reactant is oxidized to elemental O_2 :

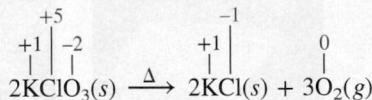

The decomposition of mercury(II) oxide, used by Lavoisier in his classic experiments, is shown in Figure 4.20. Notice that, in these thermal decomposition reactions, the lone reactant is the oxidizing *and* the reducing agent. For example, in the reactant HgO , the O^{2-} ion reduces the Hg^{2+} ion, and at the same time, Hg^{2+} oxidizes O^{2-} .

Electrolytic Decomposition In the process of electrolysis, a compound absorbs electrical energy and decomposes into its elements. In the early 19th century, the observation of the electrolysis of water was crucial for establishing atomic masses:

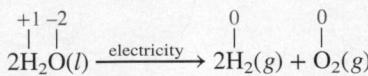

Many active metals, such as sodium, magnesium, and calcium, are produced industrially by electrolysis of their molten halides:

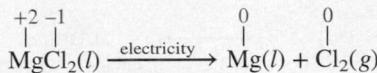

(We examine the details of electrolysis in Chapter 21 and its role in the industrial recovery of several elements in Chapter 22.)

Displacement Redox Reactions and Activity Series

In any *displacement reaction*, the number of substances on the two sides of the equation remains the same, but atoms (or ions) exchange places. There are two types of displacement reactions:

1. In *double-displacement* (metathesis) reactions, such as precipitation and acid-base reactions (Sections 4.3 and 4.4), atoms (or ions) of two *compounds* exchange places; these reactions are *not* redox processes:

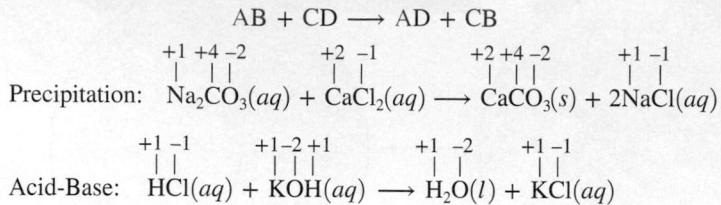

2. In *single-displacement* reactions, one of the substances is an *element*; therefore, *all single-displacement reactions are redox processes*:

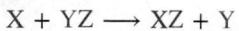

In solution, single-displacement reactions occur when an atom of one element displaces the ion of another: if the displacement involves metals, the atom *reduces* the ion; if it involves nonmetals (specifically halogens), the atom *oxidizes* the ion. In two *activity series*—one for metals and one for halogens—the elements are ranked in order of their ability to displace hydrogen (for metals) and one another.

The Activity Series of the Metals Metals are ranked by their ability to displace H₂ from various sources and another metal from solution. In all displacements of H₂, the metal is the reducing agent (O.N. increases), and water or acid is the oxidizing agent (O.N. of H decreases). The activity series of the metals is based on these facts:

- *The most reactive metals displace H₂ from liquid water.* Group 1A(1) metals and Ca, Sr, and Ba from Group 2A(2) displace H₂ from water (Figure 4.21).

Figure 4.21 The active metal lithium displaces hydrogen from water. Only water molecules involved in the reaction are red and blue.

Source: © McGraw-Hill Education/
Stephen Frisch, photographer

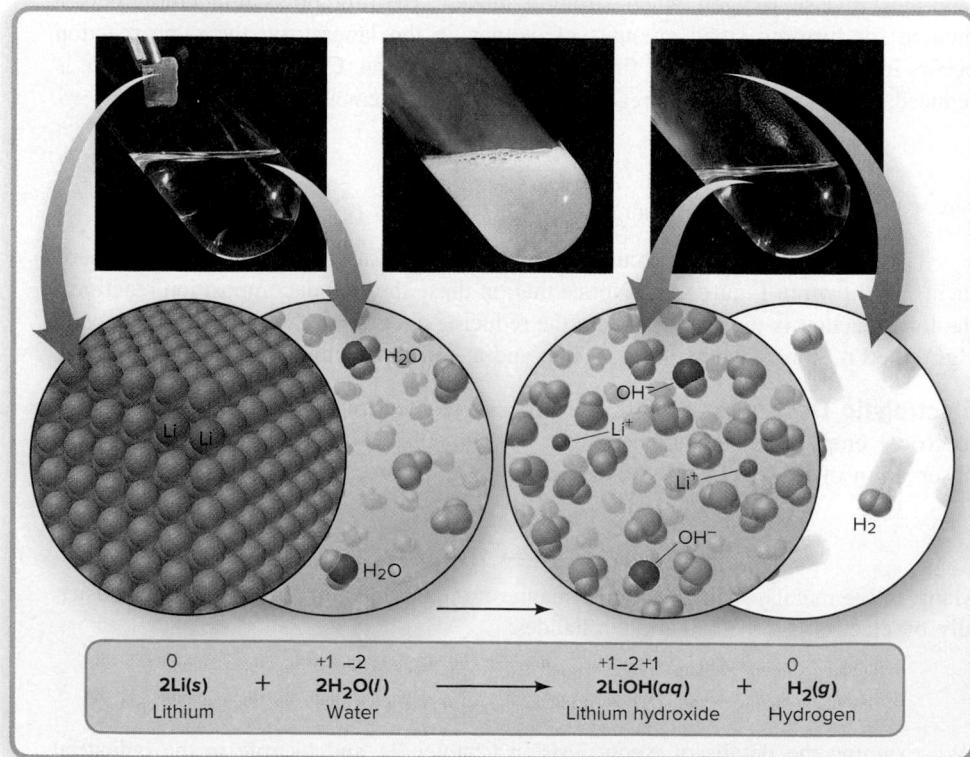

- Slightly less reactive metals displace H₂ from steam. Heat supplied by steam is needed for less reactive metals such as Al and Zn to displace H₂:

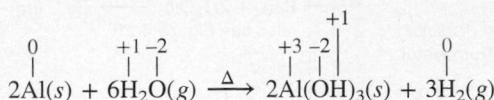

- Still less reactive metals displace H₂ from acids. The higher concentration of H⁺ in acid solutions is needed for even less reactive metals such as Ni and Sn to displace H₂ (Figure 4.22). For nickel, the net ionic equation is

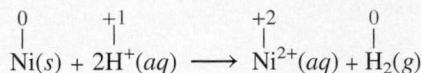

- The least reactive metals cannot displace H₂ from any source. Fortunately, precious metals, such as silver, gold, and platinum, do not react with water or acid.
- An atom of one metal displaces the ion of another. Comparisons of metal reactivity show, for example, that Zn metal displaces Cu²⁺ ion from aqueous CuSO₄:

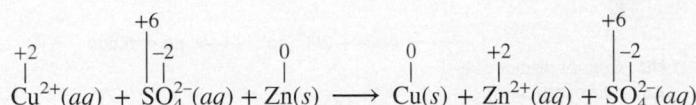

And Figure 4.23 shows that Cu metal displaces silver (Ag⁺) ion from solution; therefore, zinc is more reactive than copper, which is more reactive than silver.

Many such reactions form the basis of the **activity series of the metals**. Note these two points from Figure 4.24 (on the next page):

- Elements higher on the list are stronger reducing agents than elements lower down; in other words, any metal can reduce, or displace, the ions of metals below it. For example, since Mn is higher in the list than Ni, Mn(s) can reduce Ni²⁺ ions, displacing them from solution:

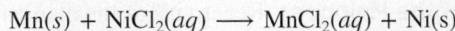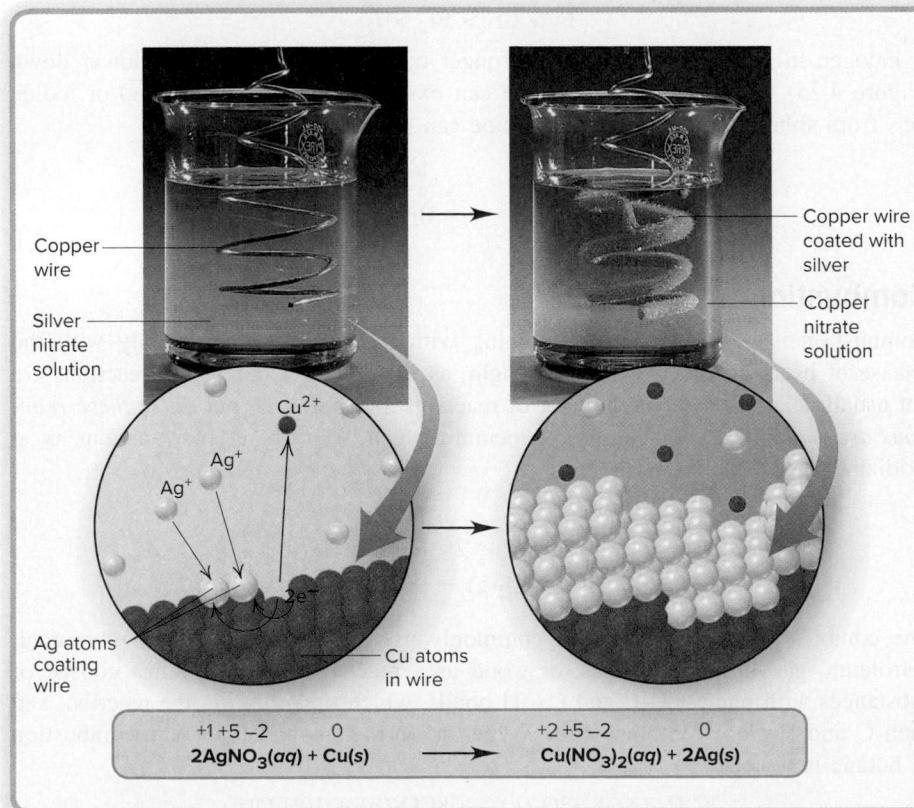

Figure 4.22 The displacement of H₂ from acid by nickel.

Source: © McGraw-Hill Education/Stephen Frisch, photographer

Figure 4.23 A more reactive metal (Cu) displacing the ion of a less reactive metal (Ag⁺) from solution.

Source: © McGraw-Hill Education/Stephen Frisch, photographer

Figure 4.24 The activity series of the metals.

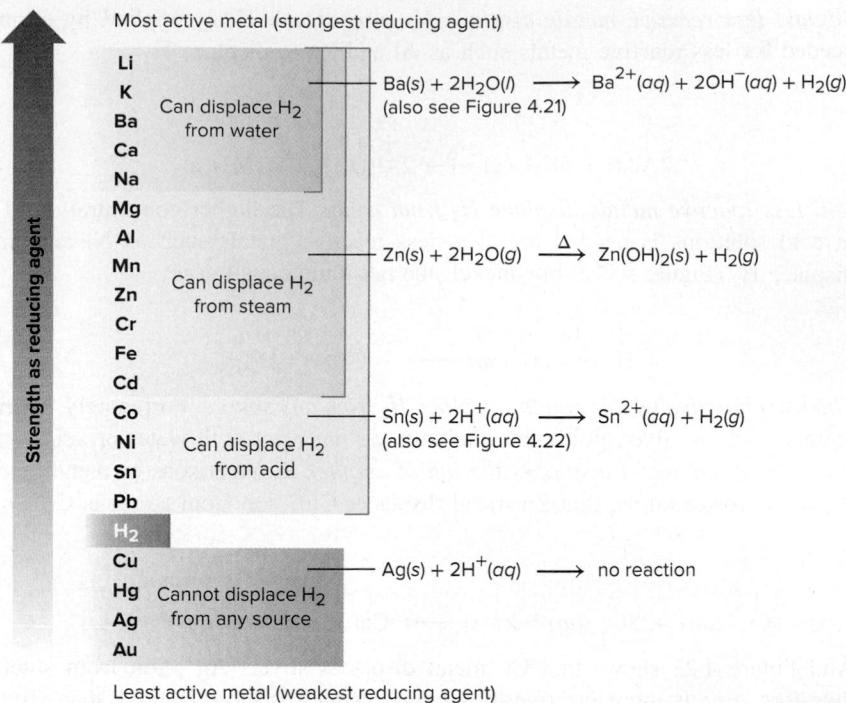

but Ni(s) cannot reduce Mn²⁺ ions:

- From higher to lower, a metal can displace H₂ (reduce H⁺) from water, steam, acid, or not at all.

The Activity Series of the Halogens Reactivity of the elements increases up Group 7A(17), so we have

A halogen higher in the group is a stronger oxidizing agent than one lower down (Figure 4.25). Thus, elemental chlorine can oxidize bromide ions (*below*) or iodide ions from solution, and elemental bromine can oxidize iodide ions:

Combustion Reactions

Combustion is the process of combining with oxygen, most commonly with the release of heat and the production of light, as in a flame. Combustion reactions are not usually classified by the number of reactants and products, but *all of these reactions are redox processes* because elemental oxygen is a reactant and functions as an oxidizing agent:

The combustion reactions that we commonly use to produce energy involve coal, petroleum, gasoline, natural gas, or wood as a reactant. These mixtures consist of substances with many C—C and C—H bonds, which break during the reaction, and each C and H atom combines with oxygen to form CO₂ and H₂O. The combustion of butane is typical:

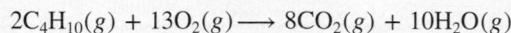

7A (17)	
9 F 19.00	F ₂ is the most reactive halogen and can displace (oxidize) Cl ⁻ , Br ⁻ , and I ⁻ .
17 Cl 35.45	Cl ₂ can oxidize Br ⁻ and I ⁻ .
35 Br 79.90	Br ₂ can oxidize only I ⁻ .
53 I 126.9	I ₂ is the least reactive halogen and cannot oxidize any halide ions above it.

Figure 4.25 Reactivity of the halogens.

Biological *respiration* is a multistep combustion process that occurs within our cells when we “burn” foodstuffs, such as glucose, for energy:

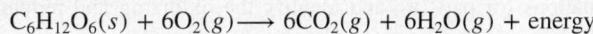**SAMPLE PROBLEM 4.20****Identifying the Type of Redox Reaction**

Problem Classify each of these redox reactions as a combination, decomposition, or displacement reaction, write a balanced molecular equation for each, as well as total and net ionic equations for part (c), and identify the oxidizing and reducing agents:

- (a) Magnesium(s) + nitrogen(g) \longrightarrow magnesium nitride(s)
- (b) Hydrogen peroxide(l) \longrightarrow water + oxygen gas
- (c) Aluminum(s) + lead(II) nitrate(aq) \longrightarrow aluminum nitrate(aq) + lead(s)

Plan To decide on reaction type, recall that combination reactions have fewer products than reactants, decomposition reactions have more products than reactants, and displacement reactions have the same number of reactants and products. The oxidation number (O.N.) becomes more positive for the reducing agent and less positive for the oxidizing agent.

Solution (a) Combination: two substances form one. This reaction occurs, along with formation of magnesium oxide, when magnesium burns in air, which is mostly N₂:

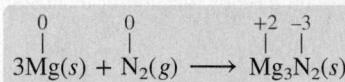

Mg is the reducing agent; N₂ is the oxidizing agent.

(b) Decomposition: one substance forms two. Because hydrogen peroxide is very unstable and breaks down from heat, light, or just shaking, this reaction occurs within every bottle of this common household antiseptic:

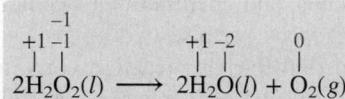

H₂O₂ is both the oxidizing *and* the reducing agent. The O.N. of O in peroxides is -1 . It is shown in blue *and* red because it both increases to 0 in O₂ and decreases to -2 in H₂O.

(c) Displacement: two substances form two others. As Figure 4.24 shows, Al is more active than Pb and, thus, displaces it from aqueous solution:

Al is the reducing agent; Pb(NO₃)₂ is the oxidizing agent.

The total ionic equation is

The net ionic equation is

FOLLOW-UP PROBLEMS

4.20A Classify each of the following redox reactions as a combination, decomposition, or displacement reaction, write a balanced molecular equation for each, as well as total and net ionic equations for parts (b) and (c), and identify the oxidizing and reducing agents:

- (a) S₈(s) + F₂(g) \longrightarrow SF₄(g)
- (b) CsI(aq) + Cl₂(aq) \longrightarrow CsCl(aq) + I₂(aq)
- (c) Ni(NO₃)₂(aq) + Cr(s) \longrightarrow Ni(s) + Cr(NO₃)₃(aq)

4.20B Classify each of the following redox reactions as a combination, decomposition, or displacement reaction, write a balanced molecular equation for each, as well as total and net ionic equations for part (a), and identify the oxidizing and reducing agents:

- $\text{Co}(s) + \text{HCl}(aq) \rightarrow \text{CoCl}_2(aq) + \text{H}_2(g)$
- $\text{CO}(g) + \text{O}_2(g) \rightarrow \text{CO}_2(g)$
- $\text{N}_2\text{O}_5(s) \rightarrow \text{NO}_2(g) + \text{O}_2(g)$

SOME SIMILAR PROBLEMS 4.103–4.106

› Summary of Section 4.6

- › A reaction that has an element as reactant or product is a redox reaction.
- › In combination redox reactions, elements combine to form a compound, or a compound and an element combine.
- › In decomposition redox reactions, a compound breaks down by absorption of heat or electricity into elements or into a different compound and an element.
- › In displacement redox reactions, one element displaces the ion of another from solution.
- › Activity series rank elements in order of ability to displace each other. A more reactive metal can displace (reduce) hydrogen ion or the ion of a less reactive metal from solution. A more reactive halogen can displace (oxidize) the ion of a less reactive halogen from solution.
- › Combustion releases heat through a redox reaction of a substance with O_2 .

4.7 THE REVERSIBILITY OF REACTIONS AND THE EQUILIBRIUM STATE

So far, we have viewed reactions as transformations of reactants into products that proceed until completion, that is, until the limiting reactant is used up. However, many reactions stop before this happens because two opposing reactions are taking place simultaneously: the forward (left-to-right) reaction continues, but the reverse (right-to-left) reaction occurs just as fast (at the same rate). At this point, *no further changes appear in the amounts of reactants or products*, and the reaction mixture has reached **dynamic equilibrium**. On the macroscopic level, the reaction is *static*, but it is *dynamic* on the molecular level.

Reversibility of Calcium Carbonate Decomposition In principle, *every reaction is reversible and will reach dynamic equilibrium if all the reactants and products are present*. Consider the reversible breakdown and formation of calcium carbonate. When heated, this compound breaks down to calcium oxide and carbon dioxide:

And it forms when calcium oxide and carbon dioxide react:

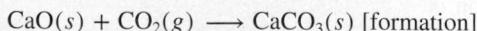

Let's study this process with two experiments:

1. We place CaCO_3 in an *open* steel container and heat it to approximately 900°C (Figure 4.26A). The CaCO_3 starts breaking down to CaO and CO_2 , and the CO_2 escapes from the open container. The reaction goes to completion because the reverse reaction (formation) cannot occur in the absence of CO_2 .
2. We perform the same experiment in a *closed* container from which the CO_2 produced cannot escape (Figure 4.26B). The breakdown (forward reaction) starts as before, but soon the CaO and CO_2 start reacting with each other (formation). Gradually, with time, as the amounts of CaO and CO_2 increase, the formation reaction speeds up. Eventually, the reverse reaction (formation) occurs as fast as the forward reaction (breakdown), and the amounts of CaCO_3 , CaO , and CO_2 no

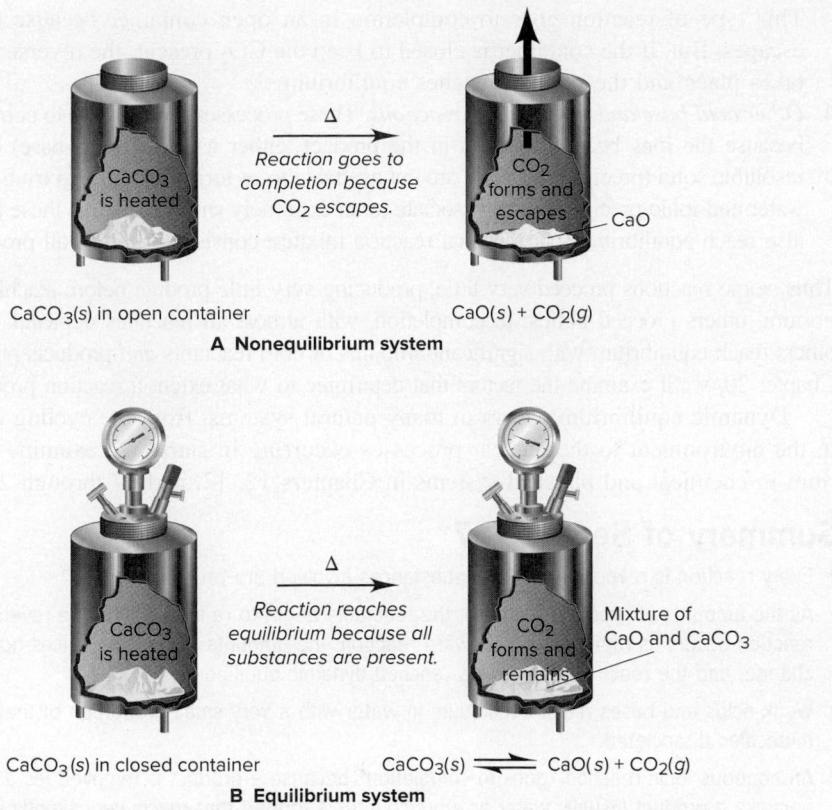**Figure 4.26** The equilibrium state.

longer change: the system has reached a state of equilibrium. We indicate this condition with a pair of arrows pointing in opposite directions:

In contrast to the reaction in the open container, equilibrium *is* reached because *all the substances remain in contact with each other*.

Some Other Types of Reversible Reactions Reaction reversibility applies to other systems as well:

1. **Weak acids in water.** Weak acids dissociate very little into ions in water because the dissociation becomes balanced by a reassociation of H_3O^+ with the anion to re-form the weak acid and water. For example, when acetic acid dissolves, some CH_3COOH molecules transfer a proton to H_2O and form H_3O^+ and CH_3COO^- ions. As more ions form, the ions react with each other more often to re-form acetic acid and water:

In fact, in 0.1 M CH_3COOH at 25°C, only about 1.3% of acid molecules are dissociated! Each weak acid dissociates to its own extent. For example, under the same conditions, propionic acid ($\text{CH}_3\text{CH}_2\text{COOH}$) is 1.1% dissociated, and hydrofluoric acid (HF) is 8.6% dissociated.

2. **Weak bases in water.** Similarly, the weak base ammonia reacts with water to form NH_4^+ and OH^- ions. As more ions form, they interact more often to re-form ammonia and water, and the rates of the forward and reverse reactions soon balance:

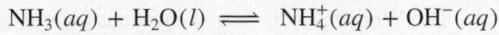

The weak base methylamine (CH_3NH_2) reacts with water to a greater extent than ammonia does before reaching equilibrium, and the weak base aniline ($\text{C}_6\text{H}_5\text{NH}_2$) reacts to a lesser extent.

3. **Gas-forming reactions.** Acids react with carbonates (see the subsection on Gas-Forming Reactions in Section 4.4):

This type of reaction goes to completion in an open container because the CO₂ escapes. But, if the container is closed to keep the CO₂ present, the reverse reaction takes place and the mixture reaches equilibrium.

4. *Other acid-base and precipitation reactions.* These processes seem to “go to completion” because the ions become tied up in the product, either as water (acid-base) or as an insoluble solid (precipitation), and are not available to re-form reactants. In truth, though, water and ionic precipitates do dissociate to an extremely small extent, so these reactions also reach equilibrium, but the final reaction mixture consists of *almost* all product.

Thus, some reactions proceed very little, producing very little product before reaching equilibrium, others proceed almost to completion, with almost all reactants depleted, and still others reach equilibrium with significant amounts of both reactants *and* products present. In Chapter 20, we’ll examine the factors that determine to what extent a reaction proceeds.

Dynamic equilibrium occurs in many natural systems, from the cycling of water in the environment to the nuclear processes occurring in stars. We examine equilibrium in chemical and physical systems in Chapters 12, 13, and 17 through 21.

› Summary of Section 4.7

- › Every reaction is reversible if all the substances involved are present.
- › As the amounts of products increase, the reactants begin to re-form. When the reverse reaction occurs as rapidly as the forward reaction, the amounts of the substances no longer change, and the reaction mixture has reached dynamic equilibrium.
- › Weak acids and bases reach equilibrium in water with a very small proportion of their molecules dissociated.
- › An aqueous ionic reaction “goes to completion” because a product is removed (as a gas) or because a product (usually water or a precipitate) is formed that reacts very slightly in a reverse reaction.

CHAPTER REVIEW GUIDE

Learning Objectives

Relevant section (§) and/or sample problem (SP) numbers appear in parentheses.

Understand These Concepts

1. Why water is a polar molecule and how it dissociates ionic compounds into ions (§4.1)
2. The differing nature of the species present when ionic and covalent compounds dissolve in water (§4.1)
3. The distinctions among strong electrolytes, weak electrolytes, and nonelectrolytes (§4.1, §4.4)
4. The meanings of *concentration* and *molarity* (§4.1)
5. The effect of dilution on the concentration of a solute (§4.1)
6. The three types of equations that specify the species and the chemical change in an aqueous ionic reaction (§4.2)
7. The key event in three classes of aqueous ionic reactions (§4.3–§4.5)
8. How to decide whether a precipitation reaction occurs (§4.3)
9. The distinction between strong and weak aqueous acids and bases (§4.4)
10. How acid-base reactions are proton transfers; how carbonates (and sulfites) act as bases in gas-forming reactions (§4.4)
11. The distinction between a transfer and a shift of electrons in the formation of ionic and covalent compounds (§4.5)
12. The relation between changes in oxidation number and identities of oxidizing and reducing agents (§4.5)
13. The presence of elements in combination, decomposition, and displacement redox reactions; the meaning of an activity series (§4.6)
14. The balance between forward and reverse reactions in dynamic equilibrium; why some acids and bases are weak (§4.7)

Master These Skills

1. Using molecular scenes to depict an ionic compound in aqueous solution (SP 4.1)
2. Using the formula of a compound to find the number of moles of ions in solution (SP 4.2)
3. Calculating molarity or mass of a solute in solution (SPs 4.3–4.5)
4. Preparing a dilute solution from a concentrated one (SP 4.6)
5. Using molecular scenes to visualize changes in concentration (SP 4.7)
6. Predicting whether a precipitation reaction occurs (SP 4.8)
7. Using molecular scenes to understand precipitation reactions (SP 4.9)
8. Using molar ratios to convert between amounts of reactants and products for reactions in solution (SPs 4.10, 4.11, 4.15)
9. Determining the number of H⁺ (or OH⁻) ions in an aqueous acid (or base) solution (SP 4.12)
10. Writing ionic equations to describe precipitation and acid-base reactions (SPs 4.8, 4.9, 4.13)
11. Writing proton-transfer equations for acid-base reactions (SP 4.14)
12. Calculating an unknown concentration from an acid-base or redox titration (SPs 4.16, 4.19)
13. Determining the oxidation number of any element in a compound or ion (SP 4.17)
14. Identifying redox reactions and oxidizing and reducing agents from changes in O.N.s (SP 4.18)
15. Distinguishing among combination, decomposition, and displacement redox reactions (SP 4.20)

Key Terms

Page numbers appear in parentheses.

acid (165)
 acid-base (neutralization) reaction (165)
 activity series of the metals (185)
 base (165)
 concentration (150)
 dynamic equilibrium (188)
 electrolyte (148)

end point (173)
 equivalence point (173)
 hydronium ion (165)
 metathesis reaction (159)
 molarity (*M*) (150)
 molecular equation (156)
 net ionic equation (157)
 nonelectrolyte (150)
 oxidation (175)

oxidation number (O.N.) (or oxidation state) (176)
 oxidation-reduction (redox) reaction (174)
 oxidizing agent (176)
 polar molecule (146)
 precipitate (157)
 precipitation reaction (157)
 reducing agent (176)

reduction (175)
 salt (167)
 solute (145)
 solvated (147)
 solvent (145)
 spectator ion (156)
 titration (172)
 total ionic equation (156)

Key Equations and Relationships

Page numbers appear in parentheses.

4.1 Defining molarity (150):

$$\text{Molarity} = \frac{\text{moles of solute}}{\text{liters of solution}} \quad \text{or} \quad M = \frac{\text{mol solute}}{\text{L soln}}$$

4.2 Diluting a concentrated solution (153):

$$M_{\text{dil}} \times V_{\text{dil}} = \text{amount (mol)} = M_{\text{conc}} \times V_{\text{conc}}$$

BRIEF SOLUTIONS TO FOLLOW-UP PROBLEMS

4.1A (a) There are three 2+ particles and twice as many 1– particles. The compound is BaCl₂.

$$\begin{aligned} \text{(b) Mass (g) of BaCl}_2 &= 9 \text{ particles} \times \frac{0.05 \text{ mol particles}}{1 \text{ particle}} \\ &\times \frac{1 \text{ mol BaCl}_2}{3 \text{ mol particles}} \times \frac{208.2 \text{ g BaCl}_2}{1 \text{ mol BaCl}_2} \\ &= 31.2 \text{ g BaCl}_2 \end{aligned}$$

$$\begin{aligned} \text{(b) Amount (mol) of ions} &= 0.40 \text{ mol Na}_3\text{PO}_4 \times \frac{4 \text{ mol ions}}{1 \text{ mol Na}_3\text{PO}_4} \\ &= 1.6 \text{ mol ions} \end{aligned}$$

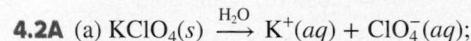

2 mol of K⁺ and 2 mol of ClO₄⁻

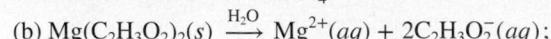

Amount (mol) of Mg²⁺

$$\begin{aligned} &= 354 \text{ g Mg}(\text{C}_2\text{H}_3\text{O}_2)_2 \times \frac{1 \text{ mol Mg}(\text{C}_2\text{H}_3\text{O}_2)_2}{142.40 \text{ g Mg}(\text{C}_2\text{H}_3\text{O}_2)_2} \\ &\times \frac{1 \text{ mol Mg}^{2+}}{1 \text{ mol Mg}(\text{C}_2\text{H}_3\text{O}_2)_2} \\ &= 2.49 \text{ mol Mg}^{2+} \end{aligned}$$

Amount (mol) of C₂H₃O₂⁻

$$\begin{aligned} &= 354 \text{ g Mg}(\text{C}_2\text{H}_3\text{O}_2)_2 \times \frac{1 \text{ mol Mg}(\text{C}_2\text{H}_3\text{O}_2)_2}{142.40 \text{ g Mg}(\text{C}_2\text{H}_3\text{O}_2)_2} \\ &\times \frac{2 \text{ mol C}_2\text{H}_3\text{O}_2^-}{1 \text{ mol Mg}(\text{C}_2\text{H}_3\text{O}_2)_2} \\ &= 4.97 \text{ mol C}_2\text{H}_3\text{O}_2^- \end{aligned}$$

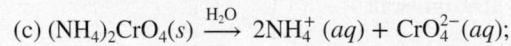

Amount (mol) of NH₄⁺ = 1.88×10^{24} formula units $(\text{NH}_4)_2\text{CrO}_4$

$$\begin{aligned} &\times \frac{1 \text{ mol } (\text{NH}_4)_2\text{CrO}_4}{6.022 \times 10^{23} \text{ formula units } (\text{NH}_4)_2\text{CrO}_4} \\ &\times \frac{2 \text{ mol NH}_4^+}{1 \text{ mol } (\text{NH}_4)_2\text{CrO}_4} \\ &= 6.24 \text{ mol NH}_4^+ \end{aligned}$$

Amount (mol) of CrO₄²⁻ = 1.88×10^{24} formula units $(\text{NH}_4)_2\text{CrO}_4$

$$\begin{aligned} &\times \frac{1 \text{ mol } (\text{NH}_4)_2\text{CrO}_4}{6.022 \times 10^{23} \text{ formula units } (\text{NH}_4)_2\text{CrO}_4} \\ &\times \frac{1 \text{ mol CrO}_4^{2-}}{1 \text{ mol } (\text{NH}_4)_2\text{CrO}_4} \\ &= 3.12 \text{ mol CrO}_4^{2-} \end{aligned}$$

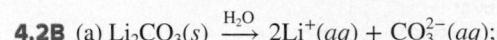

8 mol of Li⁺ and 4 mol of CO₃²⁻

Amount (mol) of Fe³⁺

$$\begin{aligned} &= 112 \text{ g Fe}_2(\text{SO}_4)_3 \times \frac{1 \text{ mol Fe}_2(\text{SO}_4)_3}{399.88 \text{ g Fe}_2(\text{SO}_4)_3} \\ &\times \frac{2 \text{ mol Fe}^{3+}}{1 \text{ mol Fe}_2(\text{SO}_4)_3} \\ &= 0.560 \text{ mol Fe}^{3+} \end{aligned}$$

BRIEF SOLUTIONS TO FOLLOW-UP PROBLEMS

(continued)

Amount (mol) of SO_4^{2-}

$$= 112 \text{ g } \text{Fe}_2(\text{SO}_4)_3 \times \frac{1 \text{ mol } \text{Fe}_2(\text{SO}_4)_3}{399.88 \text{ g } \text{Fe}_2(\text{SO}_4)_3} \times \frac{3 \text{ mol } \text{SO}_4^{2-}}{1 \text{ mol } \text{Fe}_2(\text{SO}_4)_3} = 0.840 \text{ mol } \text{SO}_4^{2-}$$

Amount (mol) of $\text{Al}^{3+} = 8.09 \times 10^{22}$ formula units $\text{Al}(\text{NO}_3)_3$

$$\times \frac{1 \text{ mol } \text{Al}(\text{NO}_3)_3}{6.022 \times 10^{23} \text{ formula units } \text{Al}(\text{NO}_3)_3} \times \frac{1 \text{ mol } \text{Al}^{3+}}{1 \text{ mol } \text{Al}(\text{NO}_3)_3} = 0.134 \text{ mol } \text{Al}^{3+}$$

Amount (mol) of $\text{NO}_3^- = 8.09 \times 10^{22}$ formula units $\text{Al}(\text{NO}_3)_3$

$$\times \frac{1 \text{ mol } \text{Al}(\text{NO}_3)_3}{6.022 \times 10^{23} \text{ formula units } \text{Al}(\text{NO}_3)_3} \times \frac{3 \text{ mol } \text{NO}_3^-}{1 \text{ mol } \text{Al}(\text{NO}_3)_3} = 0.403 \text{ mol } \text{NO}_3^-$$

$$4.3A \text{ Amount (mol) of KI} = 6.97 \text{ g KI} \times \frac{1 \text{ mol KI}}{166.0 \text{ g KI}} = 0.0420 \text{ mol KI}$$

$$M = \frac{0.0420 \text{ mol KI}}{100. \text{ mL soln}} \times \frac{1000 \text{ mL}}{1 \text{ L}} = 0.420 M$$

$$4.3B \text{ Amount (mol) of NaNO}_3 = 175 \text{ mg NaNO}_3 \times \frac{1 \text{ g}}{1000 \text{ mg}} \times \frac{1 \text{ mol NaNO}_3}{85.00 \text{ g NaNO}_3} = 2.06 \times 10^{-3} \text{ mol NaNO}_3$$

$$M = \frac{2.06 \times 10^{-3} \text{ mol NaNO}_3}{15.0 \text{ mL soln}} \times \frac{1000 \text{ mL}}{1 \text{ L}} = 0.137 M$$

4.4A

Mass (g) of sucrose

divide by M (g/mol)

Amount (mol) of sucrose

divide by M
(3.30 mol sucrose
= 1 L soln)

Volume (L) of solution

Volume (L) of sucrose soln

$$= 135 \text{ g sucrose} \times \frac{1 \text{ mol sucrose}}{342.30 \text{ g sucrose}} \times \frac{1 \text{ L soln}}{3.30 \text{ mol sucrose}} = 0.120 \text{ L soln}$$

4.4B

Volume (mL) of soln

1000 mL = 1 L

Volume (L) of soln

multiply by M
(1 L soln
= 0.128 mol H_2SO_4)Amount (mol) of H_2SO_4 Amount (mol) of H_2SO_4

$$= 40.5 \text{ mL soln} \times \frac{1 \text{ L}}{1000 \text{ mL}} \times \frac{0.128 \text{ mol } \text{H}_2\text{SO}_4}{1 \text{ L soln}} = 5.18 \times 10^{-3} \text{ mol } \text{H}_2\text{SO}_4$$

Amount (mol) of Na_3PO_4

$$= 1.32 \text{ L} \times \frac{0.55 \text{ mol Na}_3\text{PO}_4}{1 \text{ L}} \times \frac{3 \text{ mol Na}^+}{1 \text{ mol Na}_3\text{PO}_4} = 2.2 \text{ mol Na}^+$$

Similarly, there are 0.73 mol PO_4^{3-} .Amount (mol) of Al^{3+}

$$= 1.25 \text{ mol Al}_2(\text{SO}_4)_3 \times \frac{2 \text{ mol Al}^{3+}}{1 \text{ mol Al}_2(\text{SO}_4)_3} = 2.50 \text{ mol Al}^{3+}$$

$$M = \frac{2.50 \text{ mol Al}^{3+}}{0.875 \text{ L}} = 2.86 M$$

$$4.6A V_{\text{dil}} = \frac{M_{\text{conc}} \times V_{\text{conc}}}{M_{\text{dil}}} = \frac{4.50 M \times 60.0 \text{ mL}}{1.25 M} = 216 \text{ mL}$$

$$4.6B M \text{ of diluted H}_2\text{SO}_4 = \frac{M_{\text{conc}} \times V_{\text{conc}}}{V_{\text{dil}}} = \frac{7.50 M \times 25.0 \text{ mL}}{500. \text{ mL}} = 0.375 M \text{ H}_2\text{SO}_4$$

$$\text{Mass (g) of H}_2\text{SO}_4/\text{mL soln} = \frac{0.375 \text{ mol H}_2\text{SO}_4}{1 \text{ L soln}} \times \frac{1 \text{ L}}{1000 \text{ mL}} \times \frac{98.08 \text{ g H}_2\text{SO}_4}{1 \text{ mol H}_2\text{SO}_4} = 3.68 \times 10^{-2} \text{ g/mL soln}$$

4.7A To obtain B, the total volume of solution A was reduced by half:

$$V_{\text{conc}} = V_{\text{dil}} \times \frac{N_{\text{dil}}}{N_{\text{conc}}} = 1.0 \text{ mL} \times \frac{6 \text{ particles}}{12 \text{ particles}} = 0.50 \text{ mL}$$

To obtain C, $\frac{1}{2}$ of a unit volume of solvent was added to the unit volume of A:

$$V_{\text{dil}} = V_{\text{conc}} \times \frac{N_{\text{conc}}}{N_{\text{dil}}} = 1.0 \text{ mL} \times \frac{6 \text{ particles}}{4 \text{ particles}} = 1.5 \text{ mL}$$

$$\begin{aligned} \text{4.7B } N_{\text{dil}} &= N_{\text{conc}} \times \frac{V_{\text{conc}}}{V_{\text{dil}}} = 12 \text{ particles} \times \frac{100. \text{ mL}}{400. \text{ mL}} \\ &= 3 \text{ particles} \end{aligned}$$

Circle B is the best representation of the unit volume.

- 4.8A** (a) $\text{Fe}^{3+}(aq) + 3\text{Cl}^-(aq) + 3\text{Cs}^+(aq) + \text{PO}_4^{3-}(aq) \rightarrow \text{FePO}_4(s) + 3\text{Cl}^-(aq) + 3\text{Cs}^+(aq)$
 $\text{Fe}^{3+}(aq) + \text{PO}_4^{3-}(aq) \rightarrow \text{FePO}_4(s)$
(b) $2\text{Na}^+(aq) + 2\text{OH}^-(aq) + \text{Cd}^{2+}(aq) + 2\text{NO}_3^-(aq) \rightarrow 2\text{Na}^+(aq) + 2\text{NO}_3^-(aq) + \text{Cd}(\text{OH})_2(s)$
 $2\text{OH}^-(aq) + \text{Cd}^{2+}(aq) \rightarrow \text{Cd}(\text{OH})_2(s)$
(c) No reaction occurs.

- 4.8B** (a) $2\text{Ag}^+(aq) + 2\text{NO}_3^-(aq) + \text{Ba}^{2+}(aq) + 2\text{Cl}^-(aq) \rightarrow 2\text{AgCl}(s) + 2\text{NO}_3^-(aq) + \text{Ba}^{2+}(aq)$
 $\text{Ag}^+(aq) + \text{Cl}^-(aq) \rightarrow \text{AgCl}(s)$

(b) No reaction occurs.

- (c) $\text{Ni}^{2+}(aq) + \text{SO}_4^{2-}(aq) + \text{Pb}^{2+}(aq) + 2\text{NO}_3^-(aq) \rightarrow \text{Ni}^{2+}(aq) + 2\text{NO}_3^-(aq) + \text{PbSO}_4(s)$
 $\text{SO}_4^{2-}(aq) + \text{Pb}^{2+}(aq) \rightarrow \text{PbSO}_4(s)$

- 4.9A** (a) There are 2+ and 1- ions. PbCl_2 is insoluble, so beaker A contains a solution of $\text{Zn}(\text{NO}_3)_2$.
(b) There are 2+ and 1- ions. $\text{Cd}(\text{OH})_2$ is insoluble, so beaker B contains a solution of $\text{Ba}(\text{OH})_2$.
(c) The precipitate is zinc hydroxide, and the spectator ions are Ba^{2+} and NO_3^- .

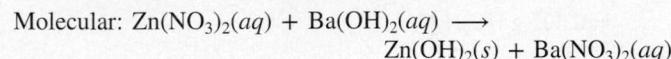

Total ionic:

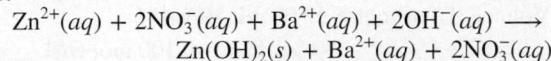

Net ionic: $\text{Zn}^{2+}(aq) + 2\text{OH}^-(aq) \rightarrow \text{Zn}(\text{OH})_2(s)$

(d) The OH^- ion is limiting.

$$\begin{aligned} \text{Mass (g) of Zn(OH)}_2 &= 6 \text{ OH}^- \text{ particles} \times \frac{0.050 \text{ mol OH}^- \text{ ions}}{1 \text{ OH}^- \text{ particle}} \\ &\quad \times \frac{1 \text{ mol Zn(OH)}_2}{2 \text{ mol OH}^- \text{ ions}} \times \frac{99.40 \text{ g Zn(OH)}_2}{1 \text{ mol Zn(OH)}_2} \\ &= 15 \text{ g Zn(OH)}_2 \end{aligned}$$

- 4.9B** (a) There are 1+ and 2- ions. Ag_2SO_4 is insoluble, so beaker A contains a solution of Li_2CO_3 .
(b) There are 2+ and 1- ions. $\text{Ni}(\text{OH})_2$ is insoluble, so beaker B contains a solution of CaCl_2 .
(c) The precipitate is CaCO_3 , and the spectator ions are Li^+ and Cl^- .

Molecular:

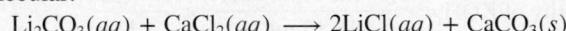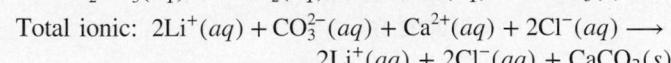

Net ionic: $\text{Ca}^{2+}(aq) + \text{CO}_3^{2-}(aq) \rightarrow \text{CaCO}_3(s)$

(d) The Ca^{2+} ion is limiting.

$$\begin{aligned} \text{Mass (g) of CaCO}_3 &= 3 \text{ Ca}^{2+} \text{ particles} \times \frac{0.20 \text{ mol Ca}^{2+} \text{ ions}}{1 \text{ Ca}^{2+} \text{ particle}} \\ &\quad \times \frac{1 \text{ mol CaCO}_3}{1 \text{ mol Ca}^{2+} \text{ ions}} \times \frac{100.09 \text{ g CaCO}_3}{1 \text{ mol CaCO}_3} \\ &= 60. \text{ g CaCO}_3 \end{aligned}$$

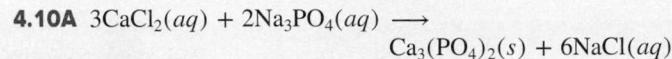

$$\begin{aligned} \text{Volume (L) of Na}_3\text{PO}_4 &= 0.300 \text{ L CaCl}_2 \text{ soln} \\ &\quad \times \frac{0.175 \text{ mol CaCl}_2}{1 \text{ L CaCl}_2 \text{ soln}} \times \frac{2 \text{ mol Na}_3\text{PO}_4}{3 \text{ mol CaCl}_2} \\ &\quad \times \frac{1 \text{ L Na}_3\text{PO}_4 \text{ solution}}{0.260 \text{ mol Na}_3\text{PO}_4} \\ &= 0.135 \text{ L soln} \end{aligned}$$

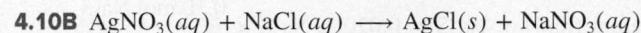

$$\begin{aligned} \text{Amount (mol) of AgNO}_3 &= 0.148 \text{ g AgCl} \times \frac{1 \text{ mol AgCl}}{143.4 \text{ g AgCl}} \\ &\quad \times \frac{1 \text{ mol AgNO}_3}{1 \text{ mol AgCl}} \\ &= 0.00103 \text{ mol AgNO}_3 \end{aligned}$$

$$\begin{aligned} \text{Molarity of AgNO}_3 &= \frac{0.00103 \text{ mol AgNO}_3}{45.0 \text{ mL}} \times \frac{10^3 \text{ mL}}{1 \text{ L}} \\ &= 0.0229 \text{ M} \end{aligned}$$

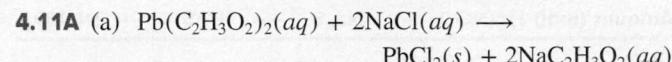

$$\begin{aligned} \text{For Pb}(\text{C}_2\text{H}_3\text{O}_2)_2: \text{Amount (mol) of Pb}(\text{C}_2\text{H}_3\text{O}_2)_2 &= 0.268 \text{ L} \times \frac{1.50 \text{ mol Pb}(\text{C}_2\text{H}_3\text{O}_2)_2}{1 \text{ L}} \\ &= 0.402 \text{ mol Pb}(\text{C}_2\text{H}_3\text{O}_2)_2 \end{aligned}$$

$$\begin{aligned} \text{Amount (mol) of PbCl}_2 &= 0.402 \text{ mol Pb}(\text{C}_2\text{H}_3\text{O}_2)_2 \\ &\quad \times \frac{1 \text{ mol PbCl}_2}{1 \text{ mol Pb}(\text{C}_2\text{H}_3\text{O}_2)_2} \\ &= 0.402 \text{ mol PbCl}_2 \end{aligned}$$

$$\begin{aligned} \text{For NaCl: Amount (mol) of NaCl} &= 0.130 \text{ L} \times \frac{3.40 \text{ mol NaCl}}{1 \text{ L}} \\ &= 0.442 \text{ mol NaCl} \end{aligned}$$

$$\begin{aligned} \text{Amount (mol) of PbCl}_2 &= 0.442 \text{ mol NaCl} \times \frac{1 \text{ mol PbCl}_2}{2 \text{ mol NaCl}} \\ &= 0.221 \text{ mol PbCl}_2 \end{aligned}$$

Thus, NaCl is the limiting reactant.

$$\begin{aligned} \text{Mass (g) of PbCl}_2 &= 0.221 \text{ mol PbCl}_2 \times \frac{278.1 \text{ g PbCl}_2}{1 \text{ mol PbCl}_2} \\ &= 61.5 \text{ g PbCl}_2 \end{aligned}$$

(b) Using "Ac" for acetate ion and with NaCl limiting:

Amount (mol) $\text{Pb}(\text{Ac})_2 + 2\text{NaCl} \rightarrow \text{PbCl}_2 + 2\text{NaAc}$				
Initial	0.402	0.442	0	0
Change	-0.221	-0.442	+0.221	+0.442
Final	0.181	0	0.221	0.442

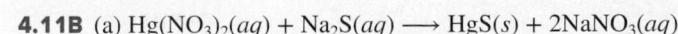

For $\text{Hg}(\text{NO}_3)_2$:

Amount (mol) of $\text{Hg}(\text{NO}_3)_2$

$$\begin{aligned} &= 0.050 \text{ L Hg}(\text{NO}_3)_2 \times \frac{0.010 \text{ mol Hg}(\text{NO}_3)_2}{1 \text{ L Hg}(\text{NO}_3)_2} \\ &= 5.0 \times 10^{-4} \text{ mol Hg}(\text{NO}_3)_2 \end{aligned}$$

BRIEF SOLUTIONS TO FOLLOW-UP PROBLEMS

(continued)

Amount (mol) of HgS

$$= 5.0 \times 10^{-4} \text{ mol Hg(NO}_3)_2 \times \frac{1 \text{ mol HgS}}{1 \text{ mol Hg(NO}_3)_2}$$

$$= 5.0 \times 10^{-4} \text{ mol HgS}$$

For Na₂S:

$$\text{Amount (mol) of Na}_2\text{S} = 0.020 \text{ L Na}_2\text{S} \times \frac{0.10 \text{ mol Na}_2\text{S}}{1 \text{ L Na}_2\text{S}}$$

$$= 2.0 \times 10^{-3} \text{ mol Na}_2\text{S}$$

$$\text{Amount (mol) of HgS} = 2.0 \times 10^{-3} \text{ mol Na}_2\text{S} \times \frac{1 \text{ mol HgS}}{1 \text{ mol Na}_2\text{S}}$$

$$= 2.0 \times 10^{-3} \text{ mol HgS}$$

Thus, Hg(NO₃)₂ is the limiting reactant.

$$\text{Mass (g) of HgS} = 5.0 \times 10^{-4} \text{ mol HgS} \times \frac{232.7 \text{ g HgS}}{1 \text{ mol HgS}}$$

$$= 0.12 \text{ g HgS}$$

(b)

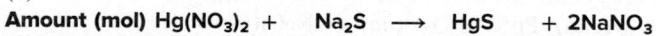

Initial	5.0 × 10 ⁻⁴	2.0 × 10 ⁻³	0	0
Change	-5.0 × 10 ⁻⁴	-5.0 × 10 ⁻⁴	+5.0 × 10 ⁻⁴	+5.0 × 10 ⁻⁴
Final	0	1.5 × 10 ⁻³	5.0 × 10 ⁻⁴	1.0 × 10 ⁻³

4.12A

$$\text{No. of OH}^- \text{ ions} = 451 \text{ mL} \times \frac{1 \text{ L}}{10^3 \text{ mL}} \times \frac{0.0120 \text{ mol Ca(OH)}_2}{1 \text{ L soln}}$$

$$\times \frac{2 \text{ mol OH}^-}{1 \text{ mol Ca(OH)}_2}$$

$$\times \frac{6.022 \times 10^{23} \text{ OH}^- \text{ ions}}{1 \text{ mol OH}^-}$$

$$= 6.52 \times 10^{21} \text{ OH}^- \text{ ions}$$

4.12B

$$\text{No. of H}^+ \text{ ions} = 65.5 \text{ mL} \times \frac{1 \text{ L}}{10^3 \text{ mL}} \times \frac{0.722 \text{ mol HCl}}{1 \text{ L soln}}$$

$$\times \frac{1 \text{ mol H}^+}{1 \text{ mol HCl}} \times \frac{6.022 \times 10^{23} \text{ H}^+ \text{ ions}}{1 \text{ mol H}^+}$$

$$= 2.85 \times 10^{22} \text{ H}^+ \text{ ions}$$

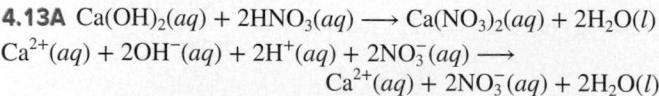

4.13B

4.14A

HNO₂ is a weak acid and Sr(OH)₂ is a strong base.The salt is strontium nitrite, Sr(NO₂)₂, and Sr²⁺ is the spectator ion.

4.14B

The salt is calcium bromide, CaBr₂.4.15A $\text{Al(OH)}_3(s) + 3\text{HCl}(aq) \rightarrow \text{AlCl}_3(aq) + 3\text{H}_2\text{O}(l)$

$$\text{Mass (g) of Al(OH)}_3 = 3.4 \times 10^{-2} \text{ L HCl soln}$$

$$\times \frac{0.10 \text{ mol HCl}}{1 \text{ L soln}} \times \frac{1 \text{ mol Al(OH)}_3}{3 \text{ mol HCl}}$$

$$\times \frac{78.00 \text{ g Al(OH)}_3}{1 \text{ mol Al(OH)}_3}$$

$$= 0.088 \text{ g Al(OH)}_3$$

4.15B $\text{HC}_9\text{H}_7\text{O}_4(aq) + \text{NaOH}(aq) \rightarrow$ 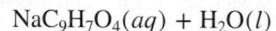Mass (g) of HC₉H₇O₄

$$= 14.10 \text{ mL NaOH soln} \times \frac{1 \text{ L}}{10^3 \text{ mL}} \times \frac{0.128 \text{ mol NaOH}}{1 \text{ L soln}}$$

$$\times \frac{1 \text{ mol HC}_9\text{H}_7\text{O}_4}{1 \text{ mol NaOH}} \times \frac{180.15 \text{ g HC}_9\text{H}_7\text{O}_4}{1 \text{ mol HC}_9\text{H}_7\text{O}_4}$$

$$= 0.325 \text{ g HC}_9\text{H}_7\text{O}_4$$

4.16A $\text{Ba(OH)}_2(aq) + 2\text{HCl}(aq) \rightarrow \text{BaCl}_2(aq) + 2\text{H}_2\text{O}(l)$

Volume (L) of soln = 50.00 mL HCl soln

$$\times \frac{1 \text{ L}}{10^3 \text{ mL}} \times \frac{0.100 \text{ mol HCl}}{1 \text{ L soln}}$$

$$\times \frac{1 \text{ mol Ba(OH)}_2}{2 \text{ mol HCl}} \times \frac{1 \text{ L soln}}{0.1292 \text{ mol Ba(OH)}_2}$$

$$= 0.01935 \text{ L}$$

4.16B $\text{KOH}(aq) + \text{HNO}_3(aq) \rightarrow \text{KNO}_3(aq) + \text{H}_2\text{O}(l)$

$$\text{Amount (mol) of KOH} = 20.00 \text{ mL HNO}_3 \text{ soln} \times \frac{1 \text{ L}}{10^3 \text{ mL}}$$

$$\times \frac{0.2452 \text{ mol HNO}_3}{1 \text{ L soln}}$$

$$\times \frac{1 \text{ mol KOH}}{1 \text{ mol HNO}_3}$$

$$= 0.004904 \text{ mol KOH}$$

$$\text{Molarity of KOH} = \frac{0.004904 \text{ mol KOH}}{18.15 \text{ mL}} \times \frac{10^3 \text{ mL}}{1 \text{ L}}$$

$$= 0.2702 \text{ M}$$

4.17A (a) O.N. of Sc = +3; O.N. of O = -2

(b) O.N. of Ga = +3; O.N. of Cl = -1

(c) O.N. of H = +1; O.N. of P = +5; O.N. of O = -2

(d) O.N. of I = +3; O.N. of F = -1

4.17B (a) O.N. of K = +1; O.N. of C = +4; O.N. of O = -2

(b) O.N. of N = -3; O.N. of H = +1

(c) O.N. of Ca = +2; O.N. of P = -3

(d) O.N. of S = +4; O.N. of Cl = -1

4.18A O.N. decreased: reduction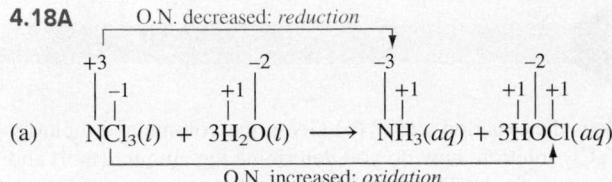

Redox; O.N. of N decreases, and O.N. of Cl increases. NCl_3 is both the reducing and the oxidizing agent.

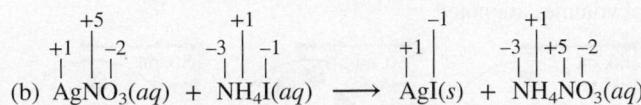

Not redox; no changes in O.N. values.

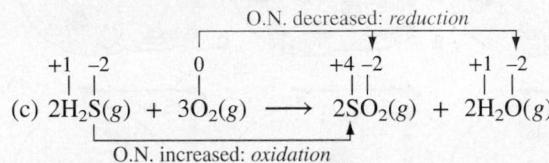

Redox; O.N. of S increases, and O.N. of O decreases. H_2S is the reducing agent; O_2 is the oxidizing agent.

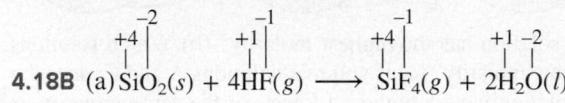

Not redox; no changes in O.N. values.

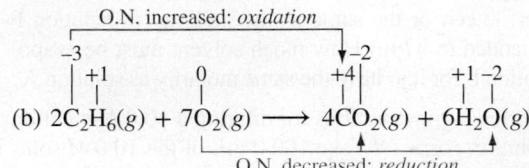

Redox; O.N. of O decreases, and O.N. of C increases. C_2H_6 is the reducing agent; O_2 is the oxidizing agent.

4.19A O.N. increased: oxidation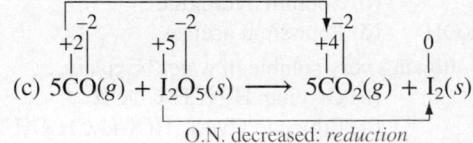

Redox; O.N. of I decreases, and O.N. of C increases. CO is the reducing agent; I_2O_5 is the oxidizing agent.

4.19A (a) Amount (mol) of Ca^{2+}

$$\begin{aligned} &= 6.53 \text{ mL soln} \times \frac{1 \text{ L}}{10^3 \text{ mL}} \\ &\times \frac{4.56 \times 10^{-3} \text{ mol KMnO}_4}{1 \text{ L soln}} \\ &\times \frac{5 \text{ mol CaC}_2\text{O}_4}{2 \text{ mol KMnO}_4} \times \frac{1 \text{ mol Ca}^{2+}}{1 \text{ mol CaC}_2\text{O}_4} \\ &= 7.44 \times 10^{-5} \text{ mol Ca}^{2+} \end{aligned}$$

$$\begin{aligned} \text{Molarity of Ca}^{2+} &= \frac{7.44 \times 10^{-5} \text{ mol Ca}^{2+}}{2.50 \text{ mL milk}} \times \frac{10^3 \text{ mL}}{1 \text{ L}} \\ &= 2.98 \times 10^{-2} \text{ M Ca}^{2+} \end{aligned}$$

$$\begin{aligned} (\text{b}) \text{Conc. of Ca}^{2+} (\text{g/L}) &= \frac{2.98 \times 10^{-2} \text{ mol Ca}^{2+}}{1 \text{ L}} \times \frac{40.08 \text{ g Ca}^{2+}}{1 \text{ mol Ca}^{2+}} \\ &= \frac{1.19 \text{ g Ca}^{2+}}{1 \text{ L}} \end{aligned}$$

Yes, the calculated value is close to the typical value.

4.19B (a) Amount (mol) of Fe^{2+}

$$\begin{aligned} &= 21.85 \text{ mL soln} \times \frac{1 \text{ L}}{10^3 \text{ mL}} \times \frac{0.250 \text{ mol K}_2\text{Cr}_2\text{O}_7}{1 \text{ L soln}} \\ &\times \frac{6 \text{ mol FeSO}_4}{1 \text{ mol K}_2\text{Cr}_2\text{O}_7} \times \frac{1 \text{ mol Fe}^{2+}}{1 \text{ mol FeSO}_4} \\ &= 0.0328 \text{ mol Fe}^{2+} \end{aligned}$$

$$\begin{aligned} \text{Molarity of Fe}^{2+} &= \frac{0.0328 \text{ mol Fe}^{2+}}{30.0 \text{ mL soln}} \times \frac{10^3 \text{ mL}}{1 \text{ L}} \\ &= 1.09 \text{ M Fe}^{2+} \end{aligned}$$

$$\begin{aligned} (\text{b}) \text{Mass (g) of Fe} &= 0.0328 \text{ mol Fe}^{2+} \times \frac{1 \text{ mol Fe}}{1 \text{ mol Fe}^{2+}} \\ &\times \frac{55.85 \text{ g Fe}}{1 \text{ mol Fe}} \\ &= 1.83 \text{ g Fe} \end{aligned}$$

$$\begin{aligned} \text{Mass \% of Fe} &= \frac{\text{mass of Fe}}{\text{mass of iron ore sample}} \times 100 \\ &= \frac{1.83 \text{ g Fe}}{2.58 \text{ g ore}} \times 100 = 70.9\% \end{aligned}$$

4.20A (a) Combination: $\text{S}_8(s) + 16\text{F}_2(g) \longrightarrow 8\text{SF}_4(g)$

S_8 is the reducing agent; F_2 is the oxidizing agent.

(b) Displacement:

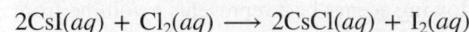

Cl_2 is the oxidizing agent; CsI is the reducing agent.

(c) Displacement:

Cr is the reducing agent; $\text{Ni}(\text{NO}_3)_2$ is the oxidizing agent.

4.20B (a) Displacement: $\text{Co}(s) + 2\text{HCl}(aq) \longrightarrow$

Co is the reducing agent; HCl is the oxidizing agent.

(b) Combination: $2\text{CO}(g) + \text{O}_2(g) \longrightarrow 2\text{CO}_2(g)$

CO is the reducing agent; O_2 is the oxidizing agent.

(c) Decomposition: $2\text{N}_2\text{O}_5(s) \longrightarrow 4\text{NO}_2(g) + \text{O}_2(g)$

N_2O_5 is both the oxidizing and the reducing agent.

PROBLEMS

Problems with **colored** numbers are answered in Appendix E and worked in detail in the Student Solutions Manual. Problem sections match those in the text and give the numbers of relevant sample problems. Most offer Concept Review Questions, Skill-Building Exercises (grouped in pairs covering the same concept), and Problems in Context. The Comprehensive Problems are based on material from any section or previous chapter.

Solution Concentration and the Role of Water as a Solvent

(Sample Problems 4.1 to 4.7)

Concept Review Questions

4.1 What two factors cause water to be polar?

4.2 What types of substances are most likely to be soluble in water?

4.3 What must be present in an aqueous solution for it to conduct an electric current? What general classes of compounds form solutions that conduct?

4.4 What occurs on the molecular level when an ionic compound dissolves in water?

4.5 Which of the following scenes best represents how the ions occur in an aqueous solution of: (a) CaCl_2 ; (b) Li_2SO_4 ; (c) NH_4Br ?

4.6 Which of the following scenes best represents a volume from a solution of magnesium nitrate?

4.7 Why are some ionic compounds soluble in water and others are not?

4.8 Why are some covalent compounds soluble in water and others are not?

4.9 Some covalent compounds dissociate into ions in water. What atom do these compounds have in their structures? What type of solution do they form? Name three examples of such a solution.

4.10 Box A represents one unit volume of solution A. Which box—B, C, or D—represents one unit volume after adding enough solvent to solution A to (a) triple its volume; (b) double its volume; (c) quadruple its volume?

4.11 A mathematical equation useful for dilution calculations is $M_{\text{dil}} \times V_{\text{dil}} = M_{\text{conc}} \times V_{\text{conc}}$. (a) What does each symbol mean, and

why does the equation work? (b) Given the volume and molarity of a CaCl_2 solution, how do you determine the amount (mol) and the mass (g) of solute?

4.12 Six different aqueous solutions (with solvent molecules omitted for clarity) are represented in the beakers below, and their total volumes are noted.

(a) Which solution has the highest molarity? (b) Which solutions have the same molarity? (c) If you mix solutions A and C, does the resulting solution have a higher, a lower, or the same molarity as solution B? (d) After 50. mL of water is added to solution D, is its molarity higher, lower, or the same as the molarity of solution F after 75 mL is added to it? (e) How much solvent must be evaporated from solution E for it to have the same molarity as solution A?

4.13 Are the following instructions for diluting a 10.0 M solution to a 1.00 M solution correct: “Take 100.0 mL of the 10.0 M solution and add 900.0 mL water”? Explain.

Skill-Building Exercises (grouped in similar pairs)

4.14 Is each of the following very soluble in water? Explain.

- | | |
|--|-----------------------|
| (a) Benzene, C_6H_6 | (b) Sodium hydroxide |
| (c) Ethanol, $\text{CH}_3\text{CH}_2\text{OH}$ | (d) Potassium acetate |

4.15 Is each of the following very soluble in water? Explain.

- | | |
|---------------------|--|
| (a) Lithium nitrate | (b) Glycine, $\text{H}_2\text{NCH}_2\text{COOH}$ |
| (c) Pentane | (d) Ethylene glycol, $\text{HOCH}_2\text{CH}_2\text{OH}$ |

4.16 Does an aqueous solution of each of the following conduct an electric current? Explain.

- | | |
|--------------------|---------------------|
| (a) Cesium bromide | (b) Hydrogen iodide |
|--------------------|---------------------|

4.17 Does an aqueous solution of each of the following conduct an electric current? Explain.

- | | |
|-----------------------|--|
| (a) Potassium sulfate | (b) Sucrose, $\text{C}_{12}\text{H}_{22}\text{O}_{11}$ |
|-----------------------|--|

4.18 How many total moles of ions are released when each of the following dissolves in water?

- | | |
|--|---|
| (a) 0.32 mol of NH_4Cl | (b) 25.4 g of $\text{Ba}(\text{OH})_2 \cdot 8\text{H}_2\text{O}$ |
| (c) 3.55×10^{19} formula units of LiCl | |

4.19 How many total moles of ions are released when each of the following dissolves in water?

- | | |
|--|--|
| (a) 0.805 mol of Rb_2SO_4 | (b) $3.85 \times 10^{-3}\text{ g}$ of $\text{Ca}(\text{NO}_3)_2$ |
| (c) 4.03×10^{19} formula units of $\text{Sr}(\text{HCO}_3)_2$ | |

4.20 How many total moles of ions are released when each of the following dissolves in water?

- | | |
|--|---|
| (a) 0.75 mol of K_3PO_4 | (b) $6.88 \times 10^{-3}\text{ g}$ of $\text{NiBr}_2 \cdot 3\text{H}_2\text{O}$ |
| (c) 2.23×10^{22} formula units of FeCl_3 | |

- 4.21** How many total moles of ions are released when each of the following dissolves in water?
- 0.734 mol of Na_2HPO_4
 - 3.86 g of $\text{CuSO}_4 \cdot 5\text{H}_2\text{O}$
 - 8.66×10^{20} formula units of NiCl_2

4.22 Calculate each of the following quantities:

- Mass (g) of solute in 185.8 mL of 0.267 M calcium acetate
- Molarity of 500. mL of solution containing 21.1 g of potassium iodide
- Amount (mol) of solute in 145.6 L of 0.850 M sodium cyanide

4.23 Calculate each of the following quantities:

- Volume (mL) of 2.26 M potassium hydroxide that contains 8.42 g of solute
- Number of Cu^{2+} ions in 52 L of 2.3 M copper(II) chloride
- Molarity of 275 mL of solution containing 135 mmol of glucose

4.24 Calculate each of the following quantities:

- Mass (g) of solute needed to make 475 mL of 5.62×10^{-2} M potassium sulfate
- Molarity of a solution that contains 7.25 mg of calcium chloride in each milliliter
- Number of Mg^{2+} ions in each milliliter of 0.184 M magnesium bromide

4.25 Calculate each of the following quantities:

- Molarity of the solution resulting from dissolving 46.0 g of silver nitrate in enough water to give a final volume of 335 mL
- Volume (L) of 0.385 M manganese(II) sulfate that contains 63.0 g of solute
- Volume (mL) of 6.44×10^{-2} M adenosine triphosphate (ATP) that contains 1.68 mmol of ATP

4.26 How many moles and how many ions of each type are present in each of the following?

- 130 mL of 0.45 M aluminum chloride
- 9.80 mL of a solution containing 2.59 g lithium sulfate/L
- 245 mL of a solution containing 3.68×10^{22} formula units of potassium bromide per liter

4.27 How many moles and how many ions of each type are present in each of the following?

- 88 mL of 1.75 M magnesium chloride
- 321 mL of a solution containing 0.22 g aluminum sulfate/L
- 1.65 L of a solution containing 8.83×10^{21} formula units of cesium nitrate per liter

4.28 Calculate each of the following quantities:

- Molarity of a solution prepared by diluting 37.00 mL of 0.250 M potassium chloride to 150.00 mL
- Molarity of a solution prepared by diluting 25.71 mL of 0.0706 M ammonium sulfate to 500.00 mL
- Molarity of sodium ion in a solution made by mixing 3.58 mL of 0.348 M sodium chloride with 500. mL of 6.81×10^{-2} M sodium sulfate (assume volumes are additive)

4.29 Calculate each of the following quantities:

- Volume (L) of 2.050 M copper(II) nitrate that must be diluted with water to prepare 750.0 mL of a 0.8543 M solution
- Volume (L) of 1.63 M calcium chloride that must be diluted with water to prepare 350. mL of a 2.86×10^{-2} M chloride ion solution
- Final volume (L) of a 0.0700 M solution prepared by diluting 18.0 mL of 0.155 M lithium carbonate with water

4.30 A sample of concentrated nitric acid has a density of 1.41 g/mL and contains 70.0% HNO_3 by mass.

- What mass (g) of HNO_3 is present per liter of solution?
- What is the molarity of the solution?

- 4.31** Concentrated sulfuric acid (18.3 M) has a density of 1.84 g/mL.
- How many moles of H_2SO_4 are in each milliliter of solution?
 - What is the mass % of H_2SO_4 in the solution?

Problems in Context

- 4.32** Ordinary household bleach is an aqueous solution of sodium hypochlorite. What is the molarity of a bleach solution that contains 20.5 g of sodium hypochlorite in 375 mL? 20.5 g of sodium hypochlorite in 375 mL?

- 4.33** Muriatic acid, an industrial grade of concentrated HCl, is used to clean masonry and cement. Its concentration is 11.7 M. (a) Write instructions for diluting the concentrated acid to make 3.0 gallons of 3.5 M acid for routine use (1 gal = 4 qt; 1 qt = 0.946 L). (b) How many milliliters of the muriatic acid solution contain 9.66 g of HCl?

- 4.34** To study a marine organism, a biologist prepares a 1.00-kg sample to simulate the ion concentrations in seawater. She mixes 26.5 g of NaCl, 2.40 g of MgCl_2 , 3.35 g of MgSO_4 , 1.20 g of CaCl_2 , 1.05 g of KCl, 0.315 g of NaHCO_3 , and 0.098 g of NaBr in distilled water. (a) If the density of the solution is 1.025 g/cm^3 , what is the molarity of each ion? (b) What is the total molarity of alkali metal ions? (c) What is the total molarity of alkaline earth metal ions? (d) What is the total molarity of anions?

- 4.35** Water “softeners” remove metal ions such as Ca^{2+} and Fe^{3+} by replacing them with enough Na^+ ions to maintain the same number of positive charges in the solution. If 1.0×10^3 L of “hard” water is 0.015 M Ca^{2+} and 0.0010 M Fe^{3+} , how many moles of Na^+ are needed to replace these ions?

Writing Equations for Aqueous Ionic Reactions**Concept Review Questions**

- 4.36** Which ions do not appear in a net ionic equation? Why?

- 4.37** Write two sets of equations (both molecular and total ionic) with different reactants that have the same net ionic equation as the following equation:

Precipitation Reactions

(Sample Problems 4.8 to 4.11)

Concept Review Questions

- 4.38** Why do some pairs of ions precipitate and others do not?

- 4.39** Use Table 4.1 to determine which of the following combinations leads to a precipitation reaction. How can you identify the spectator ions in the reaction?

- Calcium nitrate(*aq*) + sodium chloride(*aq*) →
- Potassium chloride(*aq*) + lead(II) nitrate(*aq*) →

- 4.40** The beakers represent the aqueous reaction of AgNO_3 and NaCl . Silver ions are gray. What colors are used to represent NO_3^- , Na^+ , and Cl^- ? Write molecular, total ionic, and net ionic equations for the reaction.

Skill-Building Exercises (grouped in similar pairs)

- 4.41** Complete the following precipitation reactions with balanced molecular, total ionic, and net ionic equations:

- $\text{Hg}_2(\text{NO}_3)_2(aq) + \text{KI}(aq) \longrightarrow$
- $\text{FeSO}_4(aq) + \text{Sr}(\text{OH})_2(aq) \longrightarrow$

4.42 Complete the following precipitation reactions with balanced molecular, total ionic, and net ionic equations:

4.43 When each of the following pairs of aqueous solutions is mixed, does a precipitation reaction occur? If so, write balanced molecular, total ionic, and net ionic equations:

- (a) Sodium nitrate + copper(II) sulfate
(b) Ammonium bromide + silver nitrate

4.44 When each of the following pairs of aqueous solutions is mixed, does a precipitation reaction occur? If so, write balanced molecular, total ionic, and net ionic equations:

- (a) Potassium carbonate + barium hydroxide
(b) Aluminum nitrate + sodium phosphate

4.45 When each of the following pairs of aqueous solutions is mixed, does a precipitation reaction occur? If so, write balanced molecular, total ionic, and net ionic equations:

- (a) Potassium chloride + iron(III) nitrate
(b) Ammonium sulfate + barium chloride

4.46 When each of the following pairs of aqueous solutions is mixed, does a precipitation reaction occur? If so, write balanced molecular, total ionic, and net ionic equations:

- (a) Sodium sulfide + nickel(II) sulfate
(b) Lead(II) nitrate + potassium bromide

4.47 If 38.5 mL of lead(II) nitrate solution reacts completely with excess sodium iodide solution to yield 0.628 g of precipitate, what is the molarity of lead(II) ion in the original solution?

4.48 If 25.0 mL of silver nitrate solution reacts with excess potassium chloride solution to yield 0.842 g of precipitate, what is the molarity of silver ion in the original solution?

4.49 How many grams of barium sulfate form when 35.0 mL of 0.160 M barium chloride reacts with 58.0 mL of 0.065 M sodium sulfate?

4.50 How many grams of iron(III) sulfide form when 62.0 mL of 0.135 M iron(III) chloride reacts with 45.0 mL of 0.285 M calcium sulfide?

4.51 With ions shown as spheres and solvent molecules omitted for clarity, the circle illustrates the solid formed when a solution containing K^+ , Mg^{2+} , Ag^+ , or Pb^{2+} (blue) is mixed with one containing ClO_4^- , NO_3^- , or SO_4^{2-} (yellow). (a) Identify the solid. (b) Write a balanced net ionic equation for the reaction. (c) If each sphere represents 5.0×10^{-4} mol of ion, what mass of product forms?

4.52 The precipitation reaction between 25.0 mL of a solution containing a cation (purple) and 35.0 mL of a solution containing an anion (green) is depicted below (with ions shown as spheres and solvent molecules omitted for clarity).

(a) Given the following choices of reactants, write balanced total ionic and net ionic equations that best represent the reaction:

- (1) $\text{KNO}_3(aq) + \text{CuCl}_2(aq) \longrightarrow$
(2) $\text{NaClO}_4(aq) + \text{CaCl}_2(aq) \longrightarrow$

(b) If each sphere represents 2.5×10^{-3} mol of ion, find the total number of ions present.

(c) What is the mass of solid formed?

4.53 A 1.50-g sample of an unknown alkali-metal carbonate was dissolved in water, and 31.10 mL of 0.350 M CaCl_2 was required to precipitate all the carbonate ions as CaCO_3 . Give the name and formula of the unknown compound.

4.54 A 0.750-g sample of a compound that might be iron(II) chloride, nickel(II) chloride, or zinc chloride is dissolved in water, and 22.40 mL of 0.515 M AgNO_3 is required to completely precipitate all the chloride ion as AgCl . Name the compound, and write its formula.

Problems in Context

4.55 The mass percent of Cl^- in a seawater sample is determined by titrating 25.00 mL of seawater with AgNO_3 solution, causing a precipitation reaction. An indicator is used to detect the end point, which occurs when free Ag^+ ion is present in solution after all the Cl^- has reacted. If 53.63 mL of 0.2970 M AgNO_3 is required to reach the end point, what is the mass percent of Cl^- in the seawater (d of seawater = 1.024 g/mL)?

4.56 Aluminum sulfate, known as *cake alum*, has a wide range of uses, from dyeing leather and cloth to purifying sewage. In aqueous solution, it reacts with base to form a white precipitate. (a) Write balanced total and net ionic equations for its reaction with aqueous NaOH . (b) What mass of precipitate forms when 185.5 mL of 0.533 M NaOH is added to 627 mL of a solution that contains 15.8 g of aluminum sulfate per liter?

Acid-Base Reactions

(Sample Problems 4.12 to 4.16)

Concept Review Questions

4.57 Is the total ionic equation the same as the net ionic equation when $\text{Sr}(\text{OH})_2(aq)$ and $\text{H}_2\text{SO}_4(aq)$ react? Explain.

4.58 Write a general equation for a neutralization reaction.

4.59 (a) Name three common strong acids. (b) Name three common strong bases. (c) What is a characteristic behavior of a strong acid or a strong base?

4.60 (a) Name three common weak acids. (b) Name one common weak base. (c) What is the major difference between a weak acid and a strong acid or between a weak base and a strong base, and what experiment would you perform to observe it?

4.61 Do either of the following reactions go to completion? If so, what factor(s) cause(s) each to do so?

4.62 (a) The net ionic equation for the aqueous neutralization reaction between acetic acid and sodium hydroxide is different from that for the reaction between hydrochloric acid and sodium hydroxide. Explain by writing balanced net ionic equations. (b) For a solution of acetic acid in water, list the major species in decreasing order of concentration.

Skill-Building Exercises (grouped in similar pairs)

4.63 How many moles of H^+ ions are present in each of the following aqueous solutions?

4.64 How many moles of H^+ ions are present in each of the following aqueous solutions?

- 1.4 mL of 0.75 M hydrobromic acid
- 2.47 mL of 1.98 M hydriodic acid
- 395 mL of 0.270 M nitric acid

4.65 Complete the following acid-base reactions with balanced molecular, total ionic, and net ionic equations:

- Potassium hydroxide(*aq*) + hydrobromic acid(*aq*) \longrightarrow
- Ammonia(*aq*) + hydrochloric acid(*aq*) \longrightarrow

4.66 Complete the following acid-base reactions with balanced molecular, total ionic, and net ionic equations:

- Cesium hydroxide(*aq*) + nitric acid(*aq*) \longrightarrow
- Calcium hydroxide(*aq*) + acetic acid(*aq*) \longrightarrow

4.67 Limestone (calcium carbonate) is insoluble in water but dissolves in aqueous hydrochloric acid. Write balanced total ionic and net ionic equations, showing hydrochloric acid as it actually exists in water and the reaction as a proton-transfer process.

4.68 Zinc hydroxide is insoluble in water but dissolves in aqueous nitric acid. Why? Write balanced total ionic and net ionic equations, showing nitric acid as it actually exists in water and the reaction as a proton-transfer process.

4.69 How many milliliters of 0.383 M HCl are needed to react with 16.2 g of CaCO_3 ?

4.70 How many grams of NaH_2PO_4 are needed to react with 43.74 mL of 0.285 M NaOH?

4.71 If 25.98 mL of 0.1180 M KOH solution reacts with 52.50 mL of CH_3COOH solution, what is the molarity of the acid solution?

4.72 If 26.25 mL of 0.1850 M NaOH solution reacts with 25.00 mL of H_2SO_4 , what is the molarity of the acid solution?

Problems in Context

4.73 An auto mechanic spills 88 mL of 2.6 M H_2SO_4 solution from an auto battery. How many milliliters of 1.6 M NaHCO_3 must be poured on the spill to react completely with the sulfuric acid?

4.74 Sodium hydroxide is used extensively in acid-base titrations because it is a strong, inexpensive base. A sodium hydroxide solution was standardized by titrating 25.00 mL of 0.1528 M standard hydrochloric acid. The initial buret reading of the sodium hydroxide was 2.24 mL, and the final reading was 39.21 mL. What was the molarity of the base solution?

4.75 An unknown amount of acid can often be determined by adding an excess of base and then “back-titrating” the excess. A 0.3471-g sample of a mixture of oxalic acid, which has two ionizable protons, and benzoic acid, which has one, is treated with 100.0 mL of 0.1000 M NaOH. The excess NaOH is titrated with 20.00 mL of 0.2000 M HCl. Find the mass % of benzoic acid.

4.76 One of the first steps in the enrichment of uranium for use in nuclear power plants involves a displacement reaction between UO_2 and aqueous HF:

How many liters of 2.40 M HF will react with 2.15 kg of UO_2 ?

4.77 A mixture of bases can sometimes be the active ingredient in antacid tablets. If 0.4826 g of a mixture of Al(OH)_3 and Mg(OH)_2 is neutralized with 17.30 mL of 1.000 M HNO_3 , what is the mass % of Al(OH)_3 in the mixture?

Oxidation-Reduction (Redox) Reactions

(Sample Problems 4.17 to 4.19)

Concept Review Questions

4.78 Describe how to determine the oxidation number of sulfur in (a) H_2S and (b) SO_3^{2-} .

4.79 Is the following a redox reaction? Explain.

4.80 Explain why an oxidizing agent undergoes reduction.

4.81 Why must every redox reaction involve an oxidizing agent and a reducing agent?

4.82 In which of the following equations does sulfuric acid act as an oxidizing agent? In which does it act as an acid? Explain.

- $4\text{H}^+(aq) + \text{SO}_4^{2-}(aq) + 2\text{NaI}(s) \longrightarrow 2\text{Na}^+(aq) + \text{I}_2(s) + \text{SO}_2(g) + 2\text{H}_2\text{O}(l)$
- $\text{BaF}_2(s) + 2\text{H}^+(aq) + \text{SO}_4^{2-}(aq) \longrightarrow 2\text{HF}(aq) + \text{BaSO}_4(s)$

4.83 Identify the oxidizing agent and the reducing agent in the following reaction, and explain your answer:

Skill-Building Exercises (grouped in similar pairs)

4.84 Give the oxidation number of carbon in each of the following:

- CF_2Cl_2
- $\text{Na}_2\text{C}_2\text{O}_4$
- HCO_3^-
- C_2H_6

4.85 Give the oxidation number of bromine in each of the following:

- KBr
- BrF_3
- HBrO_3
- CBr_4

4.86 Give the oxidation number of nitrogen in each of the following:

- NH_2OH
- N_2F_4
- NH_4^+
- HNO_2

4.87 Give the oxidation number of sulfur in each of the following:

- SOCl_2
- H_2S_2
- H_2SO_3
- Na_2S

4.88 Give the oxidation number of arsenic in each of the following:

- AsH_3
- H_2AsO_4^-
- AsCl_3

4.89 Give the oxidation number of phosphorus in each of the following:

- $\text{H}_2\text{P}_2\text{O}_7^{2-}$
- PH_4^+
- PCl_5

4.90 Give the oxidation number of manganese in each of the following:

- MnO_4^-
- Mn_2O_3
- KMnO_4

4.91 Give the oxidation number of chromium in each of the following:

- CrO_3
- $\text{Cr}_2\text{O}_7^{2-}$
- $\text{Cr}_2(\text{SO}_4)_3$

4.92 Identify the oxidizing and reducing agents in the following reactions:

4.93 Identify the oxidizing and reducing agents in the following reactions:

4.94 Identify the oxidizing and reducing agents in the following reactions:

4.95 Identify the oxidizing and reducing agents in the following reactions:

Problems in Context

4.96 The active agent in many hair bleaches is hydrogen peroxide. The amount of H_2O_2 in 14.8 g of hair bleach was determined by titration with a standard potassium permanganate solution:

- (a) How many moles of MnO_4^- were required for the titration if 43.2 mL of 0.105 M KMnO_4 was needed to reach the end point?
- (b) How many moles of H_2O_2 were present in the 14.8-g sample of bleach?
- (c) How many grams of H_2O_2 were in the sample?
- (d) What is the mass percent of H_2O_2 in the sample?
- (e) What is the reducing agent in the redox reaction?

4.97 A person's blood alcohol ($\text{C}_2\text{H}_5\text{OH}$) level can be determined by titrating a sample of blood plasma with a potassium dichromate solution. The balanced equation is

If 35.46 mL of 0.05961 M $\text{Cr}_2\text{O}_7^{2-}$ is required to titrate 28.00 g of plasma, what is the mass percent of alcohol in the blood?

Elements in Redox Reactions

(Sample Problem 4.20)

Concept Review Questions

4.98 Which type of redox reaction leads to each of the following?

- (a) An increase in the number of substances
- (b) A decrease in the number of substances
- (c) No change in the number of substances

4.99 Why do decomposition redox reactions typically have compounds as reactants, whereas combination redox and displacement redox reactions have one or more elements as reactants?

4.100 Which of the types of reactions discussed in Section 4.6 commonly produce more than one compound?

4.101 Are all combustion reactions redox reactions? Explain.

4.102 Give one example of a combination reaction that is a redox reaction and another that is not a redox reaction.

Skill-Building Exercises (grouped in similar pairs)

4.103 Balance each of the following redox reactions and classify it as a combination, decomposition, or displacement reaction:

- (a) $\text{Ca}(\text{s}) + \text{H}_2\text{O}(\text{l}) \longrightarrow \text{Ca}(\text{OH})_2(\text{aq}) + \text{H}_2(\text{g})$
- (b) $\text{NaNO}_3(\text{s}) \longrightarrow \text{NaNO}_2(\text{s}) + \text{O}_2(\text{g})$
- (c) $\text{C}_2\text{H}_2(\text{g}) + \text{H}_2(\text{g}) \longrightarrow \text{C}_2\text{H}_6(\text{g})$

4.104 Balance each of the following redox reactions and classify it as a combination, decomposition, or displacement reaction:

- (a) $\text{HI}(\text{g}) \longrightarrow \text{H}_2(\text{g}) + \text{I}_2(\text{g})$
- (b) $\text{Zn}(\text{s}) + \text{AgNO}_3(\text{aq}) \longrightarrow \text{Zn}(\text{NO}_3)_2(\text{aq}) + \text{Ag}(\text{s})$
- (c) $\text{NO}(\text{g}) + \text{O}_2(\text{g}) \longrightarrow \text{N}_2\text{O}_4(\text{g})$

4.105 Balance each of the following redox reactions and classify it as a combination, decomposition, or displacement reaction:

- (a) $\text{Sb}(\text{s}) + \text{Cl}_2(\text{g}) \longrightarrow \text{SbCl}_3(\text{s})$
- (b) $\text{AsH}_3(\text{g}) \longrightarrow \text{As}(\text{s}) + \text{H}_2(\text{g})$
- (c) $\text{Zn}(\text{s}) + \text{Fe}(\text{NO}_3)_2(\text{aq}) \longrightarrow \text{Zn}(\text{NO}_3)_2(\text{aq}) + \text{Fe}(\text{s})$

4.106 Balance each of the following redox reactions and classify it as a combination, decomposition, or displacement reaction:

- (a) $\text{Mg}(\text{s}) + \text{H}_2\text{O}(\text{g}) \longrightarrow \text{Mg}(\text{OH})_2(\text{s}) + \text{H}_2(\text{g})$
- (b) $\text{Cr}(\text{NO}_3)_3(\text{aq}) + \text{Al}(\text{s}) \longrightarrow \text{Al}(\text{NO}_3)_3(\text{aq}) + \text{Cr}(\text{s})$
- (c) $\text{PF}_3(\text{g}) + \text{F}_2(\text{g}) \longrightarrow \text{PF}_5(\text{g})$

4.107 Predict the product(s) and write a balanced equation for each of the following redox reactions:

- (a) $\text{Sr}(\text{s}) + \text{Br}_2(\text{l}) \longrightarrow$
- (b) $\text{Ag}_2\text{O}(\text{s}) \xrightarrow{\Delta}$
- (c) $\text{Mn}(\text{s}) + \text{Cu}(\text{NO}_3)_2(\text{aq}) \longrightarrow$

4.108 Predict the product(s) and write a balanced equation for each of the following redox reactions:

- (a) $\text{Mg}(\text{s}) + \text{HCl}(\text{aq}) \longrightarrow$
- (b) $\text{LiCl}(\text{l}) \xrightarrow{\text{electricity}}$
- (c) $\text{SnCl}_2(\text{aq}) + \text{Co}(\text{s}) \longrightarrow$

4.109 Predict the product(s) and write a balanced equation for each of the following redox reactions:

- (a) $\text{N}_2(\text{g}) + \text{H}_2(\text{g}) \longrightarrow$
- (b) $\text{NaClO}_3(\text{s}) \xrightarrow{\Delta}$
- (c) $\text{Ba}(\text{s}) + \text{H}_2\text{O}(\text{l}) \longrightarrow$

4.110 Predict the product(s) and write a balanced equation for each of the following redox reactions:

- (a) $\text{Fe}(\text{s}) + \text{HClO}_4(\text{aq}) \longrightarrow$
- (b) $\text{S}_8(\text{s}) + \text{O}_2(\text{g}) \longrightarrow$
- (c) $\text{BaCl}_2(\text{l}) \xrightarrow{\text{electricity}}$

4.111 Predict the product(s) and write a balanced equation for each of the following redox reactions:

- (a) Cesium + iodine \longrightarrow
- (b) Aluminum + aqueous manganese(II) sulfate \longrightarrow
- (c) Sulfur dioxide + oxygen \longrightarrow
- (d) Butane + oxygen \longrightarrow
- (e) Write a balanced net ionic equation for (b).

4.112 Predict the product(s) and write a balanced equation for each of the following redox reactions:

- (a) Pentane (C_5H_{12}) + oxygen \longrightarrow
- (b) Phosphorus trichloride + chlorine \longrightarrow
- (c) Zinc + hydrobromic acid \longrightarrow
- (d) Aqueous potassium iodide + bromine \longrightarrow
- (e) Write a balanced net ionic equation for (d).

4.113 How many grams of O_2 can be prepared from the thermal decomposition of 4.27 kg of HgO ? Name and calculate the mass (in kg) of the other product.

4.114 How many grams of chlorine gas can be produced from the electrolytic decomposition of 874 g of calcium chloride? Name and calculate the mass (in g) of the other product.

4.115 In a combination reaction, 1.62 g of lithium is mixed with 6.50 g of oxygen.

- (a) Which reactant is present in excess?
- (b) How many moles of product are formed?
- (c) After reaction, how many grams of each reactant and product are present?

4.116 In a combination reaction, 2.22 g of magnesium is heated with 3.75 g of nitrogen.

- (a) Which reactant is present in excess?
- (b) How many moles of product are formed?
- (c) After reaction, how many grams of each reactant and product are present?

4.117 A mixture of KClO_3 and KCl with a mass of 0.950 g was heated to produce O_2 . After heating, the mass of residue was 0.700 g. Assuming all the KClO_3 decomposed to KCl and O_2 , calculate the mass percent of KClO_3 in the original mixture.

4.118 A mixture of CaCO_3 and CaO weighing 0.693 g was heated to produce gaseous CO_2 . After heating, the remaining solid weighed 0.508 g. Assuming all the CaCO_3 broke down to CaO and CO_2 , calculate the mass percent of CaCO_3 in the original mixture.

Problems in Context

4.119 Before arc welding was developed, a displacement reaction involving aluminum and iron(III) oxide was commonly used to produce molten iron. Called the thermite process, this reaction was used, for example, to connect sections of iron rails for train tracks. Calculate the mass of molten iron produced when 1.50 kg of aluminum reacts with 25.0 mol of iron(III) oxide.

4.120 Iron reacts rapidly with chlorine gas to form a reddish-brown, ionic compound (A), which contains iron in the higher of its two common oxidation states. Strong heating decomposes compound A to compound B, another ionic compound, which contains iron in the lower of its two oxidation states. When compound A is formed by the reaction of 50.6 g of Fe and 83.8 g of Cl_2 and then heated, how much compound B forms?

4.121 A sample of impure magnesium was analyzed by allowing it to react with excess HCl solution. After 1.32 g of the impure metal was treated with 0.100 L of 0.750 M HCl, 0.0125 mol of HCl remained. Assuming the impurities do not react, what is the mass % of Mg in the sample?

The Reversibility of Reactions and the Equilibrium State

Concept Review Questions

4.122 Why is the equilibrium state said to be “dynamic”?

4.123 In a decomposition reaction involving a gaseous product, what must be done for the reaction to reach equilibrium?

4.124 Describe what happens on the molecular level when acetic acid dissolves in water.

4.125 When either a mixture of NO and Br_2 or pure nitrosyl bromide (NOBr) is placed in a reaction vessel, the product mixture contains NO, Br_2 , and NOBr . Explain.

Problem in Context

4.126 Ammonia is produced by the millions of tons annually for use as a fertilizer. It is commonly made from N_2 and H_2 by the Haber process. Because the reaction reaches equilibrium before going completely to product, the stoichiometric amount of ammonia is not obtained. At a particular temperature and pressure, 10.0 g of H_2 reacts with 20.0 g of N_2 to form ammonia. When equilibrium is reached, 15.0 g of NH_3 has formed. (a) Calculate the percent yield. (b) How many moles of N_2 and H_2 are present at equilibrium?

Comprehensive Problems

4.127 Nutritional biochemists have known for decades that acidic foods cooked in cast-iron cookware can supply significant amounts of dietary iron (ferrous ion). (a) Write a balanced net ionic equation, with oxidation numbers, that supports this fact. (b) Measurements show an increase from 3.3 mg of iron to 49 mg of iron per $\frac{1}{2}$ -cup (125-g) serving during the slow preparation of tomato sauce in a cast-iron pot. How many ferrous ions are present in a 26-oz (737-g) jar of the tomato sauce?

4.128 Limestone (CaCO_3) is used to remove acidic pollutants from smokestack flue gases. It is heated to form lime (CaO), which reacts with sulfur dioxide to form calcium sulfite. Assuming a 70% yield in the overall reaction, what mass of limestone is required to remove all the sulfur dioxide formed by the combustion of 8.5×10^4 kg of coal that is 0.33 mass % sulfur?

4.129 The brewing industry uses yeast to convert glucose to ethanol. The baking industry uses the carbon dioxide produced in the same reaction to make bread rise:

How many grams of ethanol can be produced from 100. g of glucose? What volume of CO_2 is produced? (Assume 1 mol of gas occupies 22.4 L at the conditions used.)

4.130 A chemical engineer determines the mass percent of iron in an ore sample by converting the Fe to Fe^{2+} in acid and then titrating the Fe^{2+} with MnO_4^- . A 1.1081-g ore sample was dissolved in acid and then titrated with 39.32 mL of 0.03190 M KMnO_4 . The balanced equation is

Calculate the mass percent of iron in the ore.

4.131 Mixtures of CaCl_2 and NaCl are used to melt ice on roads. A dissolved 1.9348-g sample of such a mixture was analyzed by using excess $\text{Na}_2\text{C}_2\text{O}_4$ to precipitate the Ca^{2+} as CaC_2O_4 . The CaC_2O_4 was dissolved in sulfuric acid, and the resulting $\text{H}_2\text{C}_2\text{O}_4$ was titrated with 37.68 mL of 0.1019 M KMnO_4 solution.

- Write the balanced net ionic equation for the precipitation reaction.
- Write the balanced net ionic equation for the titration reaction. (See Sample Problem 4.19.)
- What is the oxidizing agent?
- What is the reducing agent?
- Calculate the mass percent of CaCl_2 in the original sample.

4.132 You are given solutions of HCl and NaOH and must determine their concentrations. You use 27.5 mL of NaOH to titrate 100. mL of HCl and 18.4 mL of NaOH to titrate 50.0 mL of 0.0782 M H_2SO_4 . Find the unknown concentrations.

4.133 The flask represents the products of the titration of 25 mL of sulfuric acid with 25 mL of sodium hydroxide.

- Write balanced molecular, total ionic, and net ionic equations for the reaction.
- If each orange sphere represents 0.010 mol of sulfate ion, how many moles of acid and of base reacted?
- What are the molarities of the acid and the base?

4.134 To find the mass percent of dolomite [$\text{CaMg}(\text{CO}_3)_2$] in a soil sample, a geochemist titrates 13.86 g of soil with 33.56 mL of 0.2516 M HCl. What is the mass percent of dolomite in the soil?

4.135 On a lab exam, you have to find the concentrations of the monoprotic (one proton per molecule) acids HA and HB. You are given 43.5 mL of HA solution in one flask. A second flask contains 37.2 mL of HA, and you add enough HB solution to it to reach a final volume of 50.0 mL. You titrate the first HA solution with 87.3 mL of 0.0906 M NaOH and the mixture of HA and HB in the second flask with 96.4 mL of the NaOH solution. Calculate the molarity of the HA and HB solutions.

4.136 Nitric acid, a major industrial and laboratory acid, is produced commercially by the multistep Ostwald process, which begins with the oxidation of ammonia:

- What are the oxidizing and reducing agents in each step?
- Assuming 100% yield in each step, what mass (in kg) of ammonia must be used to produce 3.0×10^4 kg of HNO_3 ?

4.137 Various data can be used to find the composition of an alloy (a metallic mixture). Show that calculating the mass % of Mg in a magnesium-aluminum alloy ($d = 2.40 \text{ g/cm}^3$) using each of the following pieces of data gives the same answer (within rounding): (a) a sample of the alloy has a mass of 0.263 g (d of Mg = 1.74 g/cm^3 ; d of Al = 2.70 g/cm^3); (b) an identical sample reacting with excess aqueous HCl forms 1.38×10^{-2} mol of H_2 ; (c) an identical sample reacting with excess O_2 forms 0.483 g of oxide.

4.138 In 1995, Mario Molina, Paul Crutzen, and F. Sherwood Rowland shared the Nobel Prize in chemistry for their work on atmospheric chemistry. One reaction sequence they proposed for the role of chlorine in the decomposition of stratospheric ozone (we'll see another sequence in Chapter 16) is

Over the tropics, O atoms are more common in the stratosphere:

- (a) Which, if any, of these are oxidation-reduction reactions?
 (b) Write an overall equation combining reactions 1–3.

4.139 Sodium peroxide (Na_2O_2) is often used in self-contained breathing devices, such as those used in fire emergencies, because it reacts with exhaled CO_2 to form Na_2CO_3 and O_2 . How many liters of respired air can react with 80.0 g of Na_2O_2 if each liter of respired air contains 0.0720 g of CO_2 ?

4.140 A student forgets to weigh a mixture of sodium bromide dihydrate and magnesium bromide hexahydrate. Upon strong heating, the sample loses 252.1 mg of water. The mixture of anhydrous salts reacts with excess AgNO_3 solution to form 6.00×10^{-3} mol of solid AgBr . Find the mass % of each compound in the original mixture.

4.141 A typical formulation for window glass is 75% SiO_2 , 15% Na_2O , and 10% CaO by mass. What masses of sand (SiO_2), sodium carbonate, and calcium carbonate must be combined to produce 1.00 kg of glass after carbon dioxide is driven off by thermal decomposition of the carbonates?

4.142 The quantity of dissolved oxygen (DO) in natural waters is an essential parameter for monitoring survival of most aquatic life. DO is affected by temperature and the amount of organic waste. An earlier method for determining DO involved a two-step process:

- (1) The water sample is treated with KI,

- (2) The I_2 is titrated with sodium thiosulfate,

A 50.0-mL water sample is treated with KI, and then 15.75 mL of 0.0105 M $\text{Na}_2\text{S}_2\text{O}_3$ is required to reach the end point.

- (a) Which substance is oxidized in step 1, and which is reduced in step 2?
 (b) What mass (g) of O_2 is dissolved in the water sample?

4.143 Physicians who specialize in sports medicine routinely treat athletes and dancers. Ethyl chloride, a local anesthetic commonly used for simple injuries, is the product of the combination of ethylene with hydrogen chloride:

Assume that 0.100 kg of C_2H_4 and 0.100 kg of HCl react. (a) How many molecules of gas (reactants plus products) are present when the reaction is complete? (b) How many moles of gas are present when half the product forms?

4.144 Thyroxine ($\text{C}_{15}\text{H}_{11}\text{I}_4\text{NO}_4$) is a hormone synthesized by the thyroid gland and used to control many metabolic functions in the body. A physiologist determines the mass percent of thyroxine in

a thyroid extract by igniting 0.4332 g of extract with sodium carbonate, which converts the iodine to iodide. The iodide is dissolved in water, and bromine and hydrochloric acid are added, which convert the iodide to iodate.

- (a) How many moles of iodate form per mole of thyroxine?
 (b) Excess bromine is boiled off and more iodide is added, which reacts as shown in the following equation:

How many moles of iodine are produced per mole of thyroxine? (Hint: Be sure to balance the charges as well as the atoms.) What are the oxidizing and reducing agents in the reaction?

- (c) The iodine reacts completely with 17.23 mL of 0.1000 M thiosulfate as shown in the following unbalanced equation:

What is the mass percent of thyroxine in the thyroid extract?

4.145 Over time, as their free fatty acid (FFA) content increases, edible fats and oils become rancid. To measure rancidity, the fat or oil is dissolved in ethanol, and any FFA present is titrated with KOH dissolved in ethanol. In a series of tests on olive oil, a stock solution of 0.050 M ethanolic KOH was prepared at 25°C, stored at 0°C, and then placed in a 100-mL buret to titrate oleic acid [an FFA with formula $\text{CH}_3(\text{CH}_2)_7\text{CH}=\text{CH}(\text{CH}_2)_7\text{COOH}$] in the oil. Each of four 10.00-g samples of oil took several minutes to titrate: the first required 19.60 mL, the second 19.80 mL, and the third and fourth 20.00 mL of the ethanolic KOH.

- (a) What is the apparent acidity of each sample, in terms of mass % of oleic acid? (Note: As the ethanolic KOH warms in the buret, its volume increases by a factor of 0.00104/°C.)

- (b) Is the variation in acidity a random or systematic error? Explain.
 (c) What is the actual acidity? How would you demonstrate this?

4.146 A chemist mixes solid AgCl , CuCl_2 , and MgCl_2 in enough water to give a final volume of 50.0 mL.

- (a) With ions shown as spheres and solvent molecules omitted for clarity, which scene best represents the resulting mixture?

- (b) If each sphere represents 5.0×10^{-3} mol of ions, what is the total concentration of dissolved (separated) ions?

- (c) What is the total mass of solid?

4.147 Calcium dihydrogen phosphate, $\text{Ca}(\text{H}_2\text{PO}_4)_2$, and sodium hydrogen carbonate, NaHCO_3 , are ingredients of baking powder that react to produce CO_2 , which causes dough or batter to rise:

If the baking powder contains 31% NaHCO_3 and 35% $\text{Ca}(\text{H}_2\text{PO}_4)_2$ by mass:

(a) How many moles of CO_2 are produced from 1.00 g of baking powder?

(b) If 1 mol of CO_2 occupies 37.0 L at 350°F (a typical baking temperature), what volume of CO_2 is produced from 1.00 g of baking powder?

4.148 In a titration of HNO_3 , you add a few drops of phenolphthalein indicator to 50.00 mL of acid in a flask. You quickly add 20.00 mL of 0.0502 M NaOH but overshoot the end point, and the solution turns deep pink. Instead of starting over, you add 30.00 mL of the acid, and the solution turns colorless. Then, it takes 3.22 mL of the NaOH to reach the end point.

(a) What is the concentration of the HNO_3 solution?

(b) How many moles of NaOH were in excess after the first addition?

4.149 The active compound in Pepto-Bismol contains C, H, O, and Bi.

(a) When 0.22105 g of the compound was burned in excess O_2 , 0.1422 g of bismuth(III) oxide, 0.1880 g of carbon dioxide, and 0.02750 g of water were formed. What is the empirical formula of the compound?

(b) Given a molar mass of 1086 g/mol, determine the molecular formula.

(c) Complete and balance the acid-base reaction between bismuth(III) hydroxide and salicylic acid ($\text{HC}_7\text{H}_5\text{O}_3$), which is used to form this compound.

(d) A dose of Pepto-Bismol contains 0.600 mg of active ingredient. If the yield of the reaction in part (c) is 88.0%, what mass (in mg) of bismuth(III) hydroxide is required to prepare one dose?

4.150 Two aqueous solutions contain the ions indicated below.

(a) Write balanced molecular, total ionic, and net ionic equations for the reaction that occurs when the solutions are mixed.

(b) If each sphere represents 0.050 mol of ion, what mass (in g) of precipitate forms, assuming 100% yield?

(c) What is the concentration of each ion in solution after reaction?

4.151 In 1997 and 2009, at United Nations conferences on climate change, many nations agreed to expand their research efforts to develop renewable sources of carbon-based fuels. For more than a quarter century, Brazil has been engaged in a program to replace gasoline with ethanol derived from the root crop manioc (cassava).

(a) Write separate balanced equations for the complete combustion of ethanol ($\text{C}_2\text{H}_5\text{OH}$) and of gasoline (represented by the formula C_8H_{18}).

(b) What mass (g) of oxygen is required to burn completely 1.00 L of a mixture that is 90.0% gasoline ($d = 0.742 \text{ g/mL}$) and 10.0% ethanol ($d = 0.789 \text{ g/mL}$) by volume?

(c) If 1.00 mol of O_2 occupies 22.4 L, what volume of O_2 is needed to burn 1.00 L of the mixture?

(d) Air is 20.9% O_2 by volume. What volume of air is needed to burn 1.00 L of the mixture?

4.152 In a car engine, gasoline (represented by C_8H_{18}) does not burn completely, and some CO, a toxic pollutant, forms along with CO_2 and H_2O . If 5.0% of the gasoline forms CO:

(a) What is the ratio of CO_2 to CO molecules in the exhaust?

(b) What is the mass ratio of CO_2 to CO?

(c) What percentage of the gasoline must form CO for the mass ratio of CO_2 to CO to be exactly 1/1?

4.153 The amount of ascorbic acid (vitamin C; $\text{C}_6\text{H}_8\text{O}_6$) in tablets is determined by reaction with bromine and then titration of the hydrobromic acid with standard base:

A certain tablet is advertised as containing 500 mg of vitamin C. One tablet was dissolved in water and reacted with Br_2 . The solution was then titrated with 43.20 mL of 0.1350 M NaOH . Did the tablet contain the advertised quantity of vitamin C?

4.154 In the process of *salting-in*, protein solubility in a dilute salt solution is increased by adding more salt. Because the protein solubility depends on the total ion concentration as well as the ion charge, salts containing doubly charged ions are often more effective at increasing the protein solubility than those containing singly charged ions.

(a) How many grams of MgCl_2 must dissolve to equal the ion concentration of 12.4 g of NaCl ?

(b) How many grams of CaS must dissolve?

(c) Which of the three salt solutions would dissolve the most protein?

4.155 At liftoff, a space shuttle uses a solid mixture of ammonium perchlorate and aluminum powder to obtain great thrust from the volume change of solid to gas. In the presence of a catalyst, the mixture forms solid aluminum oxide and aluminum trichloride and gaseous water and nitrogen monoxide.

(a) Write a balanced equation for the reaction, and identify the reducing and oxidizing agents.

(b) How many total moles of gas (water vapor and nitrogen monoxide) are produced when 50.0 kg of ammonium perchlorate reacts with a stoichiometric amount of Al?

(c) What is the change in volume from this reaction? (d of $\text{NH}_4\text{ClO}_4 = 1.95 \text{ g/cc}$, d of Al = 2.70 g/cc, d of $\text{Al}_2\text{O}_3 = 3.97 \text{ g/cc}$, and d of $\text{AlCl}_3 = 2.44 \text{ g/cc}$; assume 1 mol of gas occupies 22.4 L.)

4.156 A *reaction cycle* for an element is a series of reactions beginning and ending with that element. In the following copper reaction cycle, copper has either a 0 or a +2 oxidation state. Write balanced molecular and net ionic equations for each step.

(1) Copper metal reacts with aqueous bromine to produce a green-blue solution.

(2) Adding aqueous sodium hydroxide forms a blue precipitate.

(3) The precipitate is heated and turns black (water is released).

(4) The black solid dissolves in nitric acid to give a blue solution.

(5) Adding aqueous sodium phosphate forms a green precipitate.

(6) The precipitate forms a blue solution in sulfuric acid.

(7) Copper metal is recovered from the blue solution when zinc metal is added.

4.157 Two 25.0-mL aqueous solutions, labeled A and B, contain the ions indicated:

(a) If each sphere represents 1.0×10^{-3} mol of ion, will the equivalence point have been reached when all of B has been added to A?

(b) What is the molarity of B?

(c) What additional volume (mL) of B must be added to reach the equivalence point?

5

Gases and the Kinetic-Molecular Theory

5.1 An Overview of the Physical States of Matter

5.2 Gas Pressure and Its Measurement

Measuring Pressure
Units of Pressure

5.3 The Gas Laws and Their Experimental Foundations

Relationship Between Volume and Pressure: Boyle's Law
Relationship Between Volume and Temperature: Charles's Law

Relationship Between Volume and Amount: Avogadro's Law

Gas Behavior at Standard Conditions

The Ideal Gas Law

Solving Gas Law Problems

5.4 Rearrangements of the Ideal Gas Law

Density of a Gas
Molar Mass of a Gas
Partial Pressure of a Gas
Reaction Stoichiometry

5.5 The Kinetic-Molecular Theory: A Model for Gas Behavior

How the Theory Explains the Gas Laws
Effusion and Diffusion
Mean Free Path and Collision Frequency

5.6 Real Gases: Deviations from Ideal Behavior

Effects of Extreme Conditions
The van der Waals Equation:
Adjusting the Ideal Gas Law

Source: © Rich Carey/Shutterstock.com

- › physical states of matter (Section 1.1)
- › amount-mass-number conversions (Section 3.1)
- › SI unit conversions (Section 1.4)

Tained scuba divers know not to hold their breath underwater, especially while ascending. These divers are familiar with one of the properties of gases—as the water pressure decreases during an ascent, air in the lungs expands in volume, causing lung damage. Divers also know that the gas pressure in a warm scuba tank will drop when the tank is submerged in cold water; that drop in pressure is the reason scuba tanks are sometimes overfilled. Other properties of gases are at work in the inflation of a car's air bag, the rising of a loaf of bread, and the operation of a car engine. People have been studying the behavior of gases and the other states of matter throughout history; in fact, three of the four “elements” of the ancient Greeks were air (gas), water (liquid), and earth (solid). Yet, despite millennia of observations, many questions remain. In this chapter and its companion, Chapter 12, we examine the physical states and their interrelations. Here, we highlight the gaseous state, the one we understand best.

Gases are everywhere. Our atmosphere is a colorless, odorless mixture of 18 gases, some of which— O_2 , N_2 , H_2O vapor, and CO_2 —take part in life-sustaining cycles of redox reactions throughout the environment. And several other gases, such as chlorine and ammonia, have essential roles in industry. Yet, in this chapter, we put aside the *chemical behavior unique to any particular gas* and focus instead *on the physical behavior common to all gases*.

IN THIS CHAPTER . . . We explore the physical behavior of gases and the theory that explains it. In the process, we see how scientists use mathematics to model nature.

- › We compare the behaviors of gases, liquids, and solids.
- › We discuss laboratory methods for measuring gas pressure.
- › We consider laws that describe the behavior of a gas in terms of how its volume changes with a change in (1) pressure, (2) temperature, or (3) amount. We focus on the ideal gas law, which encompasses these three laws, and apply it to solve gas law problems.
- › We rearrange the ideal gas law to determine the density and molar mass of an unknown gas, the partial pressure of any gas in a mixture, and the amounts of gaseous reactants and products in a chemical change.
- › We see how the kinetic-molecular theory explains the gas laws and accounts for other important behaviors of gas particles.
- › We apply key ideas about gas behavior to Earth's atmosphere.
- › We find that the behavior of real, not ideal, gases, especially under extreme conditions, requires refinements of the ideal gas law and the kinetic-molecular theory.

5.1 AN OVERVIEW OF THE PHYSICAL STATES OF MATTER

Most substances can exist as a solid, a liquid, or a gas under appropriate conditions of pressure and temperature. In Chapter 1, we used the relative position and motion of the particles of a substance to distinguish how each state fills a container (see Figure 1.1):

- A gas adopts the container shape and fills it, because its particles are far apart and move randomly.
- A liquid adopts the container shape to the extent of its volume, because its particles stay close together but are free to move around each other.
- A solid has a fixed shape regardless of the container shape, because its particles are close together and held rigidly in place.

Figure 5.1 The three states of matter.

Many pure substances, such as bromine (Br_2), can exist under appropriate conditions of pressure and temperature as a gas, liquid, or solid.

Source: A–C: © McGraw-Hill Education/
Stephen Frisch, photographer

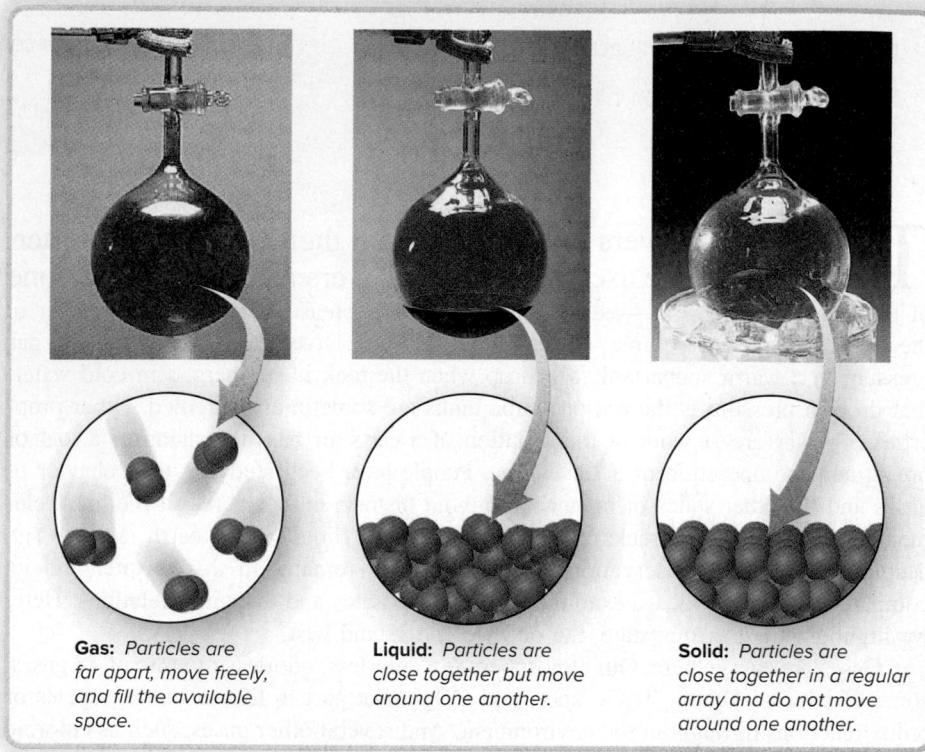

Figure 5.1 focuses on the three states of bromine.

Several other aspects of their behaviors distinguish gases from liquids and solids:

1. *Gas volume changes significantly with pressure.* When a sample of gas is confined to a container of variable volume, such as a cylinder with a piston, *increasing* the force on the piston *decreases* the gas volume; thus, gases are compressible—the gas particles can be forced closer together into a smaller volume. Removing the external force allows the volume to increase again. Gases under pressure can do a lot of work: rapidly expanding compressed air in a jackhammer breaks rock and cement; compressed air in tires lifts the weight of a car. In contrast, liquids and solids exhibit very little or no compressibility; the volume of a liquid or a solid does not change significantly under pressure.
2. *Gas volume changes significantly with temperature.* When a sample of gas is heated, it expands; when it is cooled, it shrinks. This volume change is 50 to 100 times greater for gases than for liquids or solids. The expansion that occurs when gases are rapidly heated can have dramatic effects, like lifting a rocket into space, and everyday ones, like popping corn.
3. *Gases flow very freely.* Gases flow much more freely than liquids and solids. This behavior allows gases to be transported more easily through pipes, but it also means they leak more rapidly out of small holes and cracks.
4. *Gases have relatively low densities.* Gas density is usually measured in units of grams per liter (g/L), whereas liquid and solid densities are in grams per milliliter (g/mL), about 1000 times as dense (see Table 1.5). For example, compare the density values of a gas, liquid, and solid at 20°C and normal atmospheric pressure:

Density	
$\text{O}_2(g)$	1.3 g/L or 0.0013 g/mL
$\text{H}_2\text{O}(l)$	1.0 g/mL
$\text{NaCl}(s)$	2.2 g/mL

When a gas cools, its density *increases* because its volume *decreases*: on cooling from 20°C to 0°C, the density of $\text{O}_2(g)$ increases from 1.3 to 1.4 g/L.

5. *Gases form a solution in any proportions.* Air is a solution of 18 gases. Two liquids, however, may or may not form a solution: water and ethanol do, but water and gasoline do not. Two solids generally do not form a solution unless they are melted and mixed while liquids, then allowed to solidify (as is done to make the alloy bronze from copper and tin).

Like the way a gas completely fills a container, these macroscopic properties—changing volume with pressure or temperature, great ability to flow, low density, and ability to form solutions—arise because the particles in a gas are much farther apart than those in either a liquid or a solid at ordinary pressures.

› Summary of Section 5.1

- › The volume of a gas can be altered significantly by changing the applied force or the temperature. Corresponding changes for liquids and solids are *much* smaller.
- › Gases flow more freely and have much lower densities than liquids and solids.
- › Gases mix in any proportions to form solutions; liquids and solids generally do not.
- › Differences in the physical states are due to the greater average distance between particles in a gas than in a liquid or a solid.

5.2 GAS PRESSURE AND ITS MEASUREMENT

Gas particles move randomly within a container with relatively high velocities, colliding frequently with the container's walls. The force of these collisions with the walls, called the *pressure* of the gas, is the reason you can blow up a balloon or pump up a tire. **Pressure (P)** is defined as the force exerted per unit of surface area:

$$\text{Pressure} = \frac{\text{force}}{\text{area}}$$

The gases in the atmosphere exert a force (or *weight*) uniformly on *all* surfaces; the resulting pressure is called *atmospheric pressure* and is typically about 14.7 pounds per square inch (lb/in²; psi) of surface. Thus, a pressure of 14.7 lb/in² exists on the outside of your room (or your body), and it equals the pressure on the inside.

What would happen if the inside and outside pressures on a container were *not* equal? Consider the empty can attached to a vacuum pump in Figure 5.2. With the pump off (*left*), the can maintains its shape because the pressure caused by gas particles in the room colliding with the outside walls of the can is equal to the pressure caused by gas particles in the can colliding with the inside walls. When the pump is turned on (*right*), it removes much of the air inside the can; fewer gas particles inside the can mean fewer collisions with its inside walls, decreasing the internal pressure greatly. The external pressure of the atmosphere then easily crushes the can. Vacuum-filtration flasks and tubing used in chemistry labs have thick walls that withstand the relatively higher external pressure.

Figure 5.2 Effect of atmospheric pressure on a familiar object.

Source: A–B: © McGraw-Hill Education/Charles Winters/Timeframe Photography, Inc.

Figure 5.3 A mercury barometer. The pressure of the atmosphere, P_{atm} , balances the pressure of the mercury column, P_{Hg} .

Measuring Gas Pressure: Barometers and Manometers

The **barometer** is used to measure atmospheric pressure. The device is still essentially the same as it was when invented in 1643 by the Italian physicist Evangelista Torricelli: a tube about 1 m long, closed at one end, filled with mercury (atomic symbol, Hg), and inverted into a dish containing more mercury. When the tube is inverted, some of the mercury flows out into the dish, and a vacuum forms above the mercury remaining in the tube (Figure 5.3). At sea level, under ordinary atmospheric conditions, the mercury stops flowing out when the surface of the mercury in the tube is about 760 mm above the surface of the mercury in the dish. At that height, *the column of mercury exerts the same pressure (weight/area) on the mercury surface in the dish as the atmosphere does: $P_{\text{Hg}} = P_{\text{atm}}$* . Likewise, if you evacuate a closed tube and invert it into a dish of mercury, the atmosphere pushes the mercury up to a height of about 760 mm.

Notice that we did not specify the diameter of the barometer tube. If the mercury in a 1-cm diameter tube rises to a height of 760 mm, the mercury in a 2-cm diameter tube will rise to that height also. The *weight* of mercury is greater in the wider tube, but so is the area; thus, the *pressure*, the *ratio* of weight to area, is the same.

Because the pressure of the mercury column is directly proportional to its height, a unit commonly used for pressure is millimeters of mercury (mmHg). We discuss other units of pressure shortly. *At sea level and 0°C, normal atmospheric pressure is 760 mmHg*; at the top of Mt. Everest (elevation 29,028 ft, or 8848 m), the atmospheric pressure is only about 270 mmHg. Thus, *pressure decreases with altitude*: the column of air above the sea is taller, so it weighs more than the column of air above Mt. Everest.

Laboratory barometers contain mercury because its high density (13.6 g/mL) allows a barometer to be a convenient size. If a barometer contained water ($d = 1.0 \text{ g/mL}$) instead, it would have to be more than 34 ft high, because the pressure of the atmosphere equals the pressure of a column of water whose height is about $13.6 \times 760 \text{ mm} = 10,300 \text{ mm}$ (almost 34 ft). For a given pressure, the ratio of heights (h) of the liquid columns is inversely related to the ratio of the densities (d) of the liquids:

$$\frac{h_{\text{H}_2\text{O}}}{h_{\text{Hg}}} = \frac{d_{\text{Hg}}}{d_{\text{H}_2\text{O}}}$$

Interestingly, several centuries ago, people thought a vacuum had mysterious “suction” powers, and they didn’t understand why a suction pump could remove water from a well only to a depth of 34 feet. We know now, as the great 17th-century scientist Galileo explained, that a vacuum does not suck mercury up into a barometer tube, a suction pump does not suck water up from a well, the vacuum you create in a straw does not suck the drink into your mouth, and the vacuum pump in Figure 5.2 does not suck in the walls of the crushed can. Instead, the atmospheric gases exert a force, pushing the mercury up into the tube, the water up from the well, and the drink up into the straw, and crushing the can.

Manometers are devices used to measure the pressure of a gas in an experiment. Figure 5.4 shows two types of manometers. In the *closed-end manometer* (left side), a mercury-filled, curved tube is *closed* at one end and attached to a flask at the other. When the flask is evacuated, the mercury levels in the two arms of the tube are the same because no gas exerts pressure on either mercury surface. When a gas is in the flask, it pushes down the mercury level in the near arm, causing the level to rise in the far arm. The *difference* in column heights (Δh) equals the gas pressure.

The *open-end manometer* (right side of Figure 5.4) also consists of a curved tube filled with mercury, but one end of the tube is *open* to the atmosphere and the other is connected to the gas sample. The atmosphere pushes on one mercury surface, and the gas pushes on the other. Again, Δh equals the difference between two pressures. But, when using this type of manometer, we must measure the atmospheric pressure with a barometer and either add or subtract Δh from that value.

The device used to measure blood pressure is based on a manometer apparatus.

Source: © Fotosearch Premium/Getty Images RF

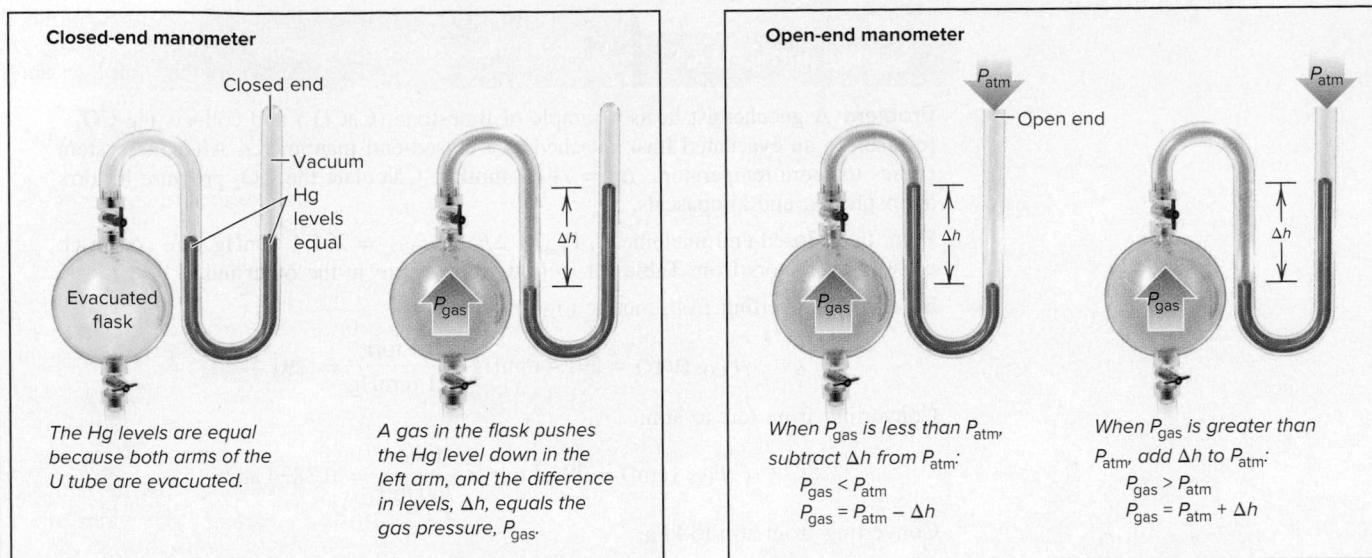

Figure 5.4 Two types of manometer.

Units of Pressure

Pressure results from a force exerted on an area. The SI unit of force is the newton (N): $1 \text{ N} = 1 \text{ kg}\cdot\text{m/s}^2$ (about the weight of an apple). The SI unit of pressure is the **pascal (Pa)**, which equals a force of one newton exerted on an area of one square meter:

$$1 \text{ Pa} = 1 \text{ N/m}^2$$

A much larger unit is the **standard atmosphere (atm)**, the average atmospheric pressure measured at sea level and 0°C. It is defined in terms of the pascal:

$$1 \text{ atm} = 101.325 \text{ kilopascals (kPa)} = 1.01325 \times 10^5 \text{ Pa}$$

Another common unit is the **millimeter of mercury (mmHg)**, mentioned earlier; in honor of Torricelli, this unit has been renamed the **torr**:

$$1 \text{ torr} = 1 \text{ mmHg} = \frac{1}{760} \text{ atm} = \frac{101.325}{760} \text{ kPa} = 133.322 \text{ Pa}$$

The *bar* is coming into more common use in chemistry:

$$1 \text{ bar} = 1 \times 10^5 \text{ kPa} = 1 \times 10^5 \text{ Pa}$$

Despite a gradual change to SI units, many chemists still express pressure in torrs and atmospheres, so those units are used in this book, with reference to pascals and bars. Table 5.1 lists some important pressure units with the corresponding values for normal atmospheric pressure.

Table 5.1

Common Units of Pressure

Unit	Normal Atmospheric Pressure at Sea Level and 0°C
pascal (Pa); kilopascal (kPa)	$1.01325 \times 10^5 \text{ Pa}$; 101.325 kPa
atmosphere (atm)	1 atm*
millimeters of mercury (mmHg)	760 mmHg*
torr	760 torr*
pounds per square inch (lb/in ² or psi)	14.7 lb/in ²
bar	1.01325 bar

*These are exact quantities; in calculations, we use as many significant figures as necessary.

SAMPLE PROBLEM 5.1**Converting Units of Pressure**

Problem A geochemist heats a sample of limestone (CaCO_3) and collects the CO_2 released in an evacuated flask attached to a closed-end manometer. After the system comes to room temperature, $\Delta h = 291.4 \text{ mmHg}$. Calculate the CO_2 pressure in torrs, atmospheres, and kilopascals.

Plan In a closed-end manometer, $P_{\text{gas}} = \Delta h$, so $P_{\text{CO}_2} = 291.4 \text{ mmHg}$. We construct conversion factors from Table 5.1 to find the pressure in the other units.

Solution Converting from mmHg to torr:

$$P_{\text{CO}_2} (\text{torr}) = 291.4 \text{ mmHg} \times \frac{1 \text{ torr}}{1 \text{ mmHg}} = 291.4 \text{ torr}$$

Converting from torr to atm:

$$P_{\text{CO}_2} (\text{atm}) = 291.4 \text{ torr} \times \frac{1 \text{ atm}}{760 \text{ torr}} = 0.3834 \text{ atm}$$

Converting from atm to kPa:

$$P_{\text{CO}_2} (\text{kPa}) = 0.3834 \text{ atm} \times \frac{101.325 \text{ kPa}}{1 \text{ atm}} = 38.85 \text{ kPa}$$

Check There are 760 torr in 1 atm, so ~ 300 torr should be < 0.5 atm. There are ~ 100 kPa in 1 atm, so < 0.5 atm should be < 50 kPa.

Comment 1. In the conversion from torr to atm, we retained four significant figures because this unit conversion factor involves *exact* numbers; that is, 760 torr has as many significant figures as the calculation requires (see the footnote to Table 5.1). **2.** From here on, except in particularly complex situations, *unit canceling will no longer be shown*.

FOLLOW-UP PROBLEMS

Brief Solutions to all Follow-up Problems appear at the end of the chapter.

5.1A The CO_2 released from another limestone sample is collected in an evacuated flask connected to an open-end manometer. If the barometer reading is 753.6 mmHg and P_{gas} is less than P_{atm} , giving $\Delta h = 174.0 \text{ mmHg}$, calculate P_{CO_2} in torrs, pascals, and lb/in^2 .

5.1B A third sample of limestone is heated, and the CO_2 released is collected in an evacuated flask connected to an open-end manometer. If the atmospheric pressure is 0.9475 atm and P_{gas} is greater than P_{atm} , giving $\Delta h = 25.8 \text{ torr}$, calculate P_{CO_2} in mmHg, pascals, and lb/in^2 .

SOME SIMILAR PROBLEMS 5.10–5.13**› Summary of Section 5.2**

- › Gases exert pressure (force/area) on all surfaces they contact.
- › A barometer measures atmospheric pressure based on the height of a mercury column that the atmosphere can support (760 mmHg at sea level and 0°C).
- › Closed-end and open-end manometers are used to measure the pressure of a gas sample.
- › Pressure units include the atmosphere (atm), torr (identical to mmHg), and pascal (Pa, the SI unit).

5.3 THE GAS LAWS AND THEIR EXPERIMENTAL FOUNDATIONS

The physical behavior of a sample of gas can be described completely by four variables: pressure (P), volume (V), temperature (T), and amount (number of moles, n). The variables are interdependent, which means that *any one of them can be determined by measuring the other three*. Three key relationships exist among the four gas variables—Boyle's, Charles's, and Avogadro's laws. Each of these *gas laws expresses*

the effect of one variable on another, with the remaining two variables held constant. Because gas volume is so easy to measure, the laws are expressed as the effect on gas volume of a change in the pressure, temperature, or amount of the gas.

The individual gas laws are special cases of a unifying relationship called the *ideal gas law*, which quantitatively describes the behavior of an **ideal gas**, one that exhibits linear relationships among volume, pressure, temperature, and amount. Although no ideal gas actually exists, most simple gases, such as N₂, O₂, H₂, and the noble gases, behave nearly ideally at ordinary temperatures and pressures. We discuss the ideal gas law after the three individual laws.

The Relationship Between Volume and Pressure: Boyle's Law

Following Torricelli's invention of the barometer, the great 17th-century English chemist Robert Boyle studied the effect of pressure on the volume of a sample of gas.

1. *The experiment.* Figure 5.5 illustrates the setup Boyle might have used in his experiments (parts A and B), the data he might have collected (part C), and graphs of the data (parts D and E). Boyle sealed the shorter leg of a J-shaped glass tube and poured mercury into the longer open leg, thereby trapping some air (the gas in the experiment) in the shorter leg. He calculated the gas volume (V_{gas}) from the height of the trapped air and the diameter of the tube. The total pressure, P_{total} , applied to the trapped gas is the pressure of the atmosphere, P_{atm} (760 mm, measured with a barometer), plus the difference in the heights of the mercury columns (Δh) in the two legs of the J tube, 20 mm (Figure 5.5A); thus, P_{total} is 780 torr. By adding mercury, Boyle increased P_{total} , and the gas volume decreased. In Figure 5.5B, more mercury has been added to the tube, increasing Δh from its original value of 20 mm to 800 mm, so P_{total} doubles to 1560 torr; note that V_{gas} is *halved* from 20 mL to 10 mL. In this way, by keeping the temperature and amount of gas constant, Boyle was able to measure the effect of the applied pressure on gas volume.

Note the following results in Figure 5.5:

- The product of corresponding P and V values is a constant (part C, rightmost column).
- V is *inversely* proportional to P —the greater the pressure, the smaller the gas volume (part D).
- V is *directly* proportional to $1/P$ (part E), and a plot of V versus $1/P$ is linear. This *linear relationship between two gas variables* is a hallmark of ideal gas behavior.

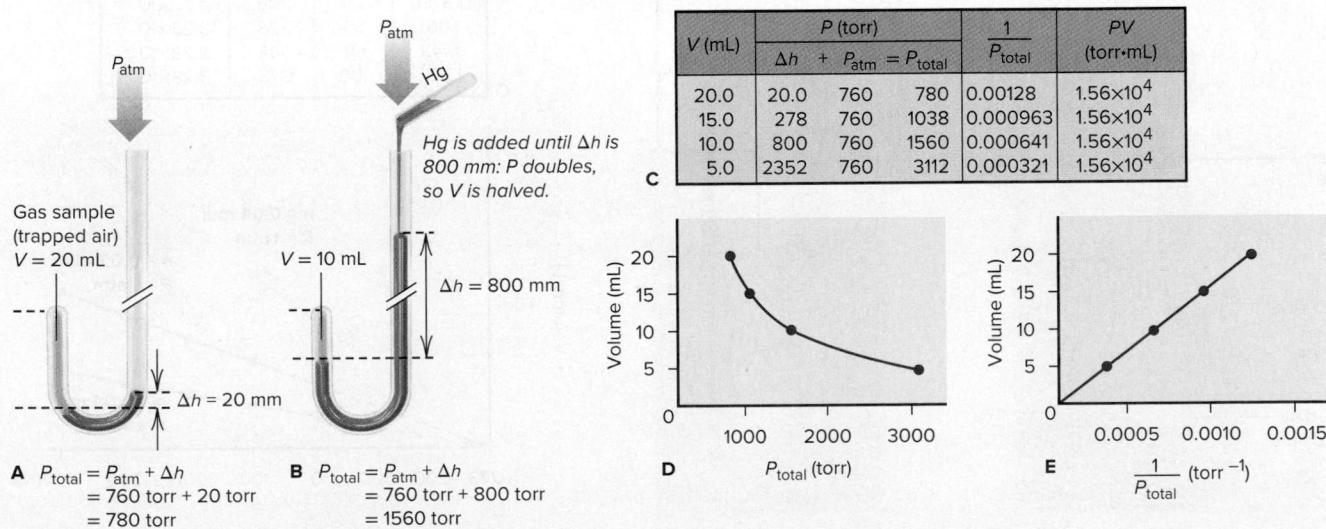

Figure 5.5 Boyle's law, the relationship between the volume and pressure of a gas.

2. Conclusion and statement of the law. The generalization of Boyle's observations is known as **Boyle's law**: *at constant temperature, the volume occupied by a fixed amount of gas is inversely proportional to the applied (external) pressure*, or

$$V \propto \frac{1}{P} \quad [T \text{ and } n \text{ fixed}] \quad (5.1)$$

This relationship can also be expressed as

$$V = \frac{\text{constant}}{P} \quad \text{or} \quad PV = \text{constant} \quad [T \text{ and } n \text{ fixed}]$$

That is, at fixed T and n , $P \uparrow, V \downarrow$ and $P \downarrow, V \uparrow$

The constant is the same for most simple gases under ordinary conditions. Thus, tripling the external pressure reduces the volume of a gas to a third of its initial value; halving the pressure doubles the volume; and so forth.

The wording of Boyle's law focuses on *external* pressure. But, notice that the mercury level rises as mercury is added, until the pressure of the trapped gas *on* the mercury increases enough to stop its rise. At that point, the pressure exerted *on* the gas equals the pressure exerted *by* the gas (P_{gas}). Thus, in general, at constant temperature, if V_{gas} increases, P_{gas} decreases, and vice versa.

The Relationship Between Volume and Temperature: Charles's Law

Boyle's work showed that the pressure-volume relationship holds only at constant temperature, but why should that be so? It would take more than a century, until the work of French scientists J. A. C. Charles and J. L. Gay-Lussac, for the relationship between gas volume and temperature to be understood.

1. *The experiment.* Let's examine this relationship by measuring the volume at different temperatures of a fixed amount of a gas under constant pressure. A straight tube, closed at one end, traps a fixed amount of gas (air) under a small mercury plug. The tube is immersed in a water bath that is warmed with a heater or cooled with ice. After each change of temperature, we calculate the gas volume from the length of the gas column and the diameter of the tube. The total pressure exerted on the gas is constant because the mercury plug and the atmospheric pressure do not change (Figure 5.6, parts A and B).

Figure 5.6 Charles's law, the relationship between the volume and temperature of a gas.

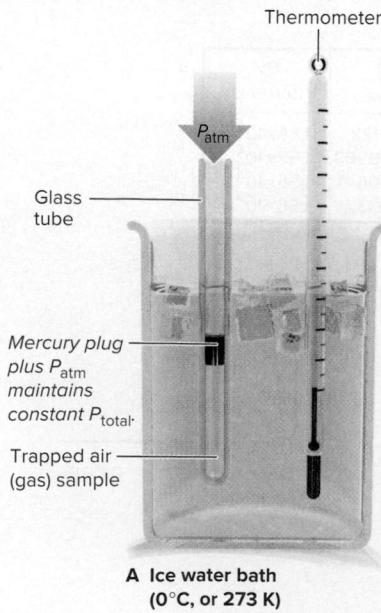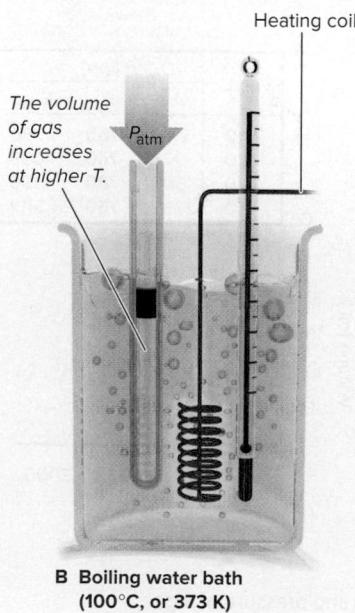

V (L)	T (°C)	T (K)	$\frac{V}{T}$ (L/K)
0.8965	0	273	3.28×10^{-3}
0.9786	25	298	3.28×10^{-3}
1.061	50	323	3.28×10^{-3}
1.143	75	348	3.28×10^{-3}
1.225	100	373	3.28×10^{-3}

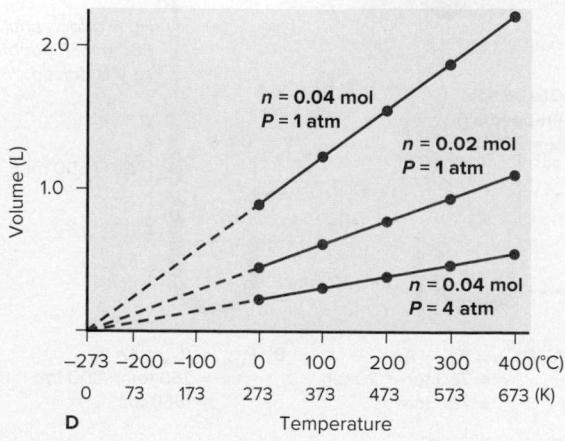

Note the following results in Figure 5.6:

- Typical data (for a 0.04-mol sample of gas at 1 atm) show that dividing the volume of gas by the corresponding Kelvin temperature results in a constant (part C, right-most column).
- V is *directly* proportional to T in kelvins (red line in part D).
- There is a *linear relationship between V and T* .
- Extrapolating the red line in the graph in part D to lower temperatures (dashed portion) shows that, in theory, the gas occupies zero volume at -273.15°C (the intercept on the temperature axis).
- Plots for a different amount of gas (green line in part D) or for a different gas pressure (blue line) have different slopes, but they converge at -273.15°C .

2. *Conclusion and statement of the law.* Above all, note that *the volume-temperature relationship is linear*, but, unlike volume and pressure, volume and temperature are *directly* proportional. This behavior is incorporated into the modern statement of the volume-temperature relationship, which is known as **Charles's law**: *at constant pressure, the volume occupied by a fixed amount of gas is directly proportional to its absolute (Kelvin) temperature*, or

$$V \propto T \quad [P \text{ and } n \text{ fixed}] \quad (5.2)$$

This relationship can also be expressed as

$$V = \text{constant} \times T \quad \text{or} \quad \frac{V}{T} = \text{constant} \quad [P \text{ and } n \text{ fixed}]$$

That is, at fixed P and n , $T \uparrow, V \uparrow$ and $T \downarrow, V \downarrow$

If T increases, V increases, and vice versa. As with Boyle's law, the constant is the same for most simple gases under ordinary conditions and for any given P and n .

William Thomson (Lord Kelvin) used the linear relationship between gas volume and temperature to devise the absolute temperature scale (Section 1.4). Absolute zero (0 K or -273.15°C) is the temperature at which an ideal gas would have zero volume. (Absolute zero has never been reached, but physicists have attained 10^{-9} K.) In reality, no sample of matter can have zero volume, and every real gas condenses to a liquid at some temperature higher than 0 K. Nevertheless, the linear dependence of volume on absolute temperature holds for most common gases over a wide temperature range. This dependence of gas volume on the *absolute* temperature adds a practical requirement for chemists (and chemistry students): *the Kelvin scale must be used in gas law calculations*. For instance, if the temperature changes from 200 K to 400 K, the volume of gas doubles because the absolute temperature doubles. But, if the temperature doubles from 200°C to 400°C , the volume increases by a factor of 1.42, not be a factor of 2; that is,

$$\left(\frac{400^{\circ}\text{C} + 273.15}{200^{\circ}\text{C} + 273.15} \right) = \frac{673}{473} = 1.42$$

Other Relationships Based on Boyle's and Charles's Laws Two other important relationships arise from Boyle's and Charles's laws:

1. *The pressure-temperature relationship.* Charles's law is expressed as the effect of temperature on gas *volume* at constant pressure. But volume and pressure are interdependent, so a similar relationship can be expressed for the effect of temperature on pressure (sometimes referred to as *Amontons's law*). You can examine this relationship for yourself: measure the pressure in your car or bike tires before and after a long ride and you will find that the air pressure in the tires increases. The air temperature inside the tires also increases from heating due to friction between the tires and the road; a tire's volume can't increase very much, but the increased temperature results in increased pressure. So we observe that, *at constant volume, the pressure exerted by a fixed amount of gas is directly proportional to the absolute temperature*:

$$P \propto T \quad [V \text{ and } n \text{ fixed}] \quad (5.3)$$

or

$$P = \text{constant} \times T \quad \text{or} \quad \frac{P}{T} = \text{constant} \quad [V \text{ and } n \text{ fixed}]$$

That is, at fixed V and n , $T \uparrow, P \uparrow$ and $T \downarrow, P \downarrow$ If T increases, V increases, and vice versa.

2. The combined gas law. Combining Boyle's and Charles's laws gives the *combined gas law*, which applies to cases when changes in *two* of the three variables (V , P , T) affect the third:

$$\text{Boyle's law: } V \propto \frac{1}{P}; \text{ Charles's law: } V \propto T$$

$$\text{Combined gas law: } V \propto \frac{T}{P} \quad \text{or} \quad V = \text{constant} \times \frac{T}{P} \quad \text{or} \quad \frac{PV}{T} = \text{constant}$$

The Relationship Between Volume and Amount: Avogadro's Law

Let's see why both Boyle's and Charles's laws specify a fixed amount of gas.

1. The experiment. Figure 5.7 shows an experiment that involves two small test tubes, each fitted to a much larger piston-cylinder assembly. We add 0.10 mol (4.4 g) of dry ice (solid CO_2) to the first tube (A) and 0.20 mol (8.8 g) to the second tube (B). As the solid CO_2 warms to room temperature, it changes to gaseous CO_2 , and the volume increases until $P_{\text{gas}} = P_{\text{atm}}$. At constant temperature, when all the solid has changed to gas, cylinder B has twice the volume of cylinder A.

2. Conclusion and statement of the law. Thus, *at fixed temperature and pressure, the volume occupied by a gas is directly proportional to the amount (mol) of gas*:

$$V \propto n \quad [P \text{ and } T \text{ fixed}] \quad (5.4)$$

That is, as n increases, V increases, and vice versa. This relationship is also expressed as

$$V = \text{constant} \times n \quad \text{or} \quad \frac{V}{n} = \text{constant} \quad [P \text{ and } T \text{ fixed}]$$

That is, at fixed P and T , $n \uparrow, V \uparrow$ and $n \downarrow, V \downarrow$

The constant is the same for all simple gases at ordinary temperature and pressure. This relationship is another way of expressing **Avogadro's law**, which states that *at fixed temperature and pressure, equal volumes of any ideal gas contain equal numbers (or moles) of particles*.

Familiar Applications of the Gas Laws The gas laws apply to countless familiar phenomena. In a car engine, a reaction occurs in which fewer moles of gasoline and O_2 form more moles of CO_2 and H_2O vapor, and heat is released. The increase in n

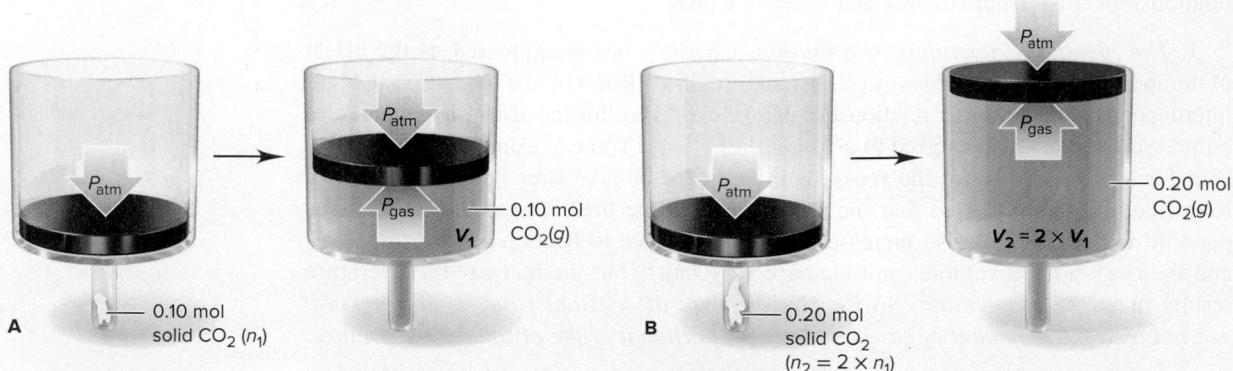

Figure 5.7 Avogadro's law, the relationship between the volume and amount of a gas.

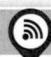

Student Hot Spot

Student data indicate that you may struggle with applying the relationships between the pressure, volume, temperature, and amount of a gas. Access the Smartbook to view additional Learning Resources on this topic.

(Avogadro's law) and T (Charles's law) increases V , and the pistons in the engine are pushed back. Dynamite is a solid that forms more moles of hot gases very rapidly when it reacts (Avogadro's and Charles's laws). Dough rises because yeast digests sugar, which creates bubbles of CO_2 (Avogadro's law); the dough expands more as the bread bakes in a hot oven (Charles's law).

No application of the gas laws can be more vital or familiar than breathing (Figure 5.8). When you inhale, muscles move your diaphragm down and your rib cage out (blue). This coordinated movement increases the volume of your lungs, which decreases the air pressure inside them (Boyle's law). The inside pressure is 1–3 torr less than atmospheric pressure, so air rushes in. The greater amount of air stretches the elastic tissue of the lungs and expands the volume further (Avogadro's law). The air also expands as it warms from the external temperature to your body temperature (Charles's law). When you exhale, the diaphragm moves up and the rib cage moves in, so your lung volume decreases (red). The inside pressure becomes 1–3 torr more than the outside pressure (Boyle's law), so air rushes out.

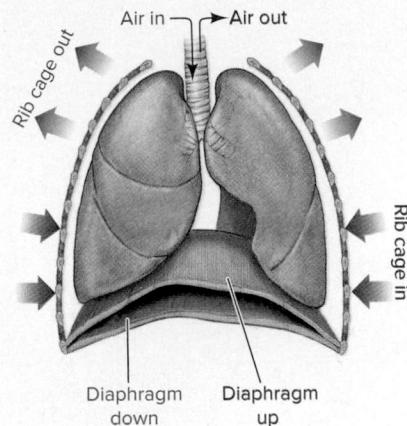

Figure 5.8 The process of breathing applies the gas laws.

Gas Behavior at Standard Conditions

To better understand the factors that influence gas behavior, chemists have assigned a baseline set of *standard conditions* called **standard temperature and pressure (STP)**:

$$\text{STP: } 0^\circ\text{C} (273.15 \text{ K}) \text{ and } 1 \text{ atm (760 torr)} \quad (5.5)$$

Under these conditions, the volume of 1 mol of an ideal gas is called the **standard molar volume**:

$$\text{Standard molar volume} = 22.4141 \text{ L or } 22.4 \text{ L [to 3 sf]} \quad (5.6)$$

At STP, helium, nitrogen, oxygen, and other simple gases behave nearly ideally (Figure 5.9). Note that the mass, and thus the density (d), depends on the specific gas, but 1 mol of any of them occupies 22.4 L at STP.

Figure 5.10 compares the volumes of some familiar objects with the standard molar volume of an ideal gas.

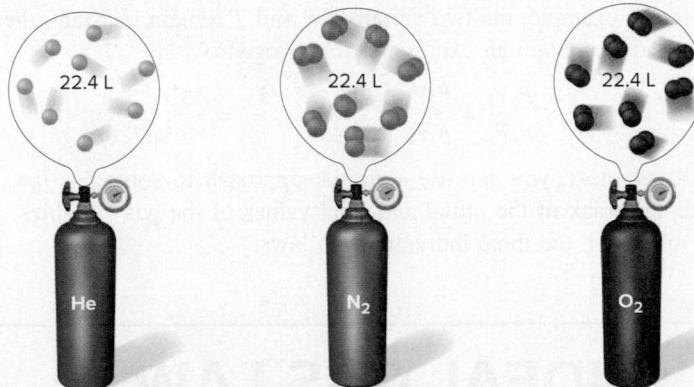

$n = 1 \text{ mol}$	$n = 1 \text{ mol}$	$n = 1 \text{ mol}$
$P = 1 \text{ atm (760 torr)}$	$P = 1 \text{ atm (760 torr)}$	$P = 1 \text{ atm (760 torr)}$
$T = 0^\circ\text{C (273 K)}$	$T = 0^\circ\text{C (273 K)}$	$T = 0^\circ\text{C (273 K)}$
$V = 22.4 \text{ L}$	$V = 22.4 \text{ L}$	$V = 22.4 \text{ L}$
Number of gas particles $= 6.022 \times 10^{23}$	Number of gas particles $= 6.022 \times 10^{23}$	Number of gas particles $= 6.022 \times 10^{23}$
Mass = 4.003 g	Mass = 28.02 g	Mass = 32.00 g
$d = 0.179 \text{ g/L}$	$d = 1.25 \text{ g/L}$	$d = 1.43 \text{ g/L}$

Figure 5.9 Standard molar volume. One mole of an ideal gas occupies 22.4 L at STP (0°C and 1 atm).

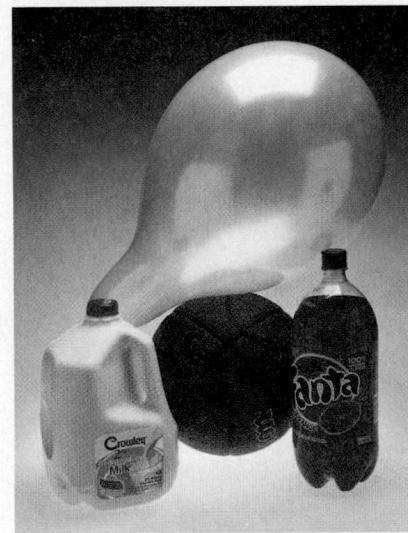

Figure 5.10 The volumes of 1 mol (22.4 L) of an ideal gas and of some familiar objects: 1 gal of milk (3.79 L), a basketball (7.50 L), and 2.00 L of a carbonated drink.

Source: © McGraw-Hill Education/Charles Winters/Timeframe Photography, Inc.

The Ideal Gas Law

Each of the three gas laws shows how one of the other three gas variables affects gas volume:

- Boyle's law focuses on pressure ($V \propto 1/P$).
- Charles's law focuses on temperature ($V \propto T$).
- Avogadro's law focuses on amount (mol) of gas ($V \propto n$).

By combining these individual effects, we obtain the **ideal gas law** (or *ideal gas equation*):

$$V \propto \frac{nT}{P} \quad \text{or} \quad PV \propto nT \quad \text{or} \quad PV = \text{constant} \times nT \quad \text{or} \quad \frac{PV}{nT} = R$$

where R is a proportionality constant known as the **universal gas constant**. Rearranging gives the most common form of the ideal gas law:

$$PV = nRT \quad (5.7)$$

We obtain a value of R by measuring the volume, temperature, and pressure of a given amount of gas and substituting the values into the ideal gas law. For example, using standard conditions for the gas variables and 1 mol of gas, we have

$$R = \frac{PV}{nT} = \frac{1 \text{ atm} \times 22.4141 \text{ L}}{1 \text{ mol} \times 273.15 \text{ K}} = 0.082058 \frac{\text{atm}\cdot\text{L}}{\text{mol}\cdot\text{K}} = 0.0821 \frac{\text{atm}\cdot\text{L}}{\text{mol}\cdot\text{K}} [3 \text{ sf}] \quad (5.8)$$

This numerical value of R corresponds to P , V , and T expressed *in these units*; R has a different numerical value when different units are used. For example, in the equation for root-mean-square speed in Section 5.5, R has the value 8.314 J/mol·K (J stands for joule, the SI unit of energy).

Figure 5.11 makes a central point: the ideal gas law becomes one of the individual gas laws when two of the four variables are kept constant. When initial conditions (subscript 1) change to final conditions (subscript 2), we have

$$P_1V_1 = n_1RT_1 \quad \text{and} \quad P_2V_2 = n_2RT_2$$

Thus,

$$\frac{P_1V_1}{n_1T_1} = R \quad \text{and} \quad \frac{P_2V_2}{n_2T_2} = R, \quad \text{so} \quad \frac{P_1V_1}{n_1T_1} = \frac{P_2V_2}{n_2T_2}$$

Notice that if, for example, the two variables P and T remain constant, then $P_1 = P_2$ and $T_1 = T_2$, and we obtain an expression for Avogadro's law:

$$\frac{P_1V_1}{n_1T_1} = \frac{P_2V_2}{n_2T_2} \quad \text{or} \quad \frac{V_1}{n_1} = \frac{V_2}{n_2}$$

As you'll see next, you can use a similar approach to solve gas law problems. Thus, by keeping track of the initial and final values of the gas variables, you avoid the need to memorize the three individual gas laws.

Figure 5.11 The individual gas laws as special cases of the ideal gas law.

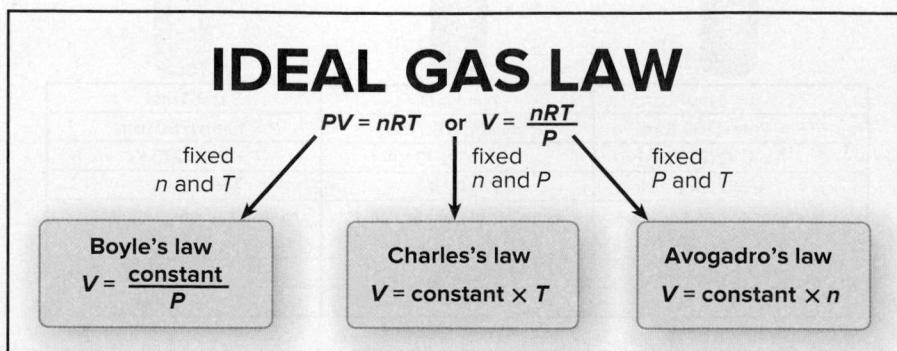

Solving Gas Law Problems

Gas law problems are phrased in many ways but can usually be grouped into two types:

1. *There is a change in one of the four variables which causes a change in another, while the two other variables remain constant.* In this type, the ideal gas law reduces to one of the individual gas laws when you omit the variables that remain constant; you then solve for the new value of the affected variable. Units must be consistent and T must always be in kelvins, but R is not involved. Sample Problems 5.2 to 5.4 are of this type. A variation on this type, shown in Sample Problem 5.5, involves the combined gas law when simultaneous changes in two of the variables cause a change in a third.

2. *One variable is unknown, but the other three are known, as is R , and no change occurs.* In this type, exemplified by Sample Problem 5.6, you apply the ideal gas law directly to find the unknown, and the units must conform to those in R .

Solving these problems requires a systematic approach:

- Summarize the changing gas variables—knowns and unknown—and those held constant.
- Convert units, if necessary.
- Rearrange the ideal gas law to obtain the needed relationship of variables, and solve for the unknown.

SAMPLE PROBLEM 5.2

Applying the Volume-Pressure Relationship

Problem Boyle's apprentice finds that the air trapped in a J tube occupies 24.8 cm³ at 851 torr. By adding mercury to the tube, he increases the pressure on the trapped air to 2.64 atm. Assuming constant temperature, what is the new volume of air (in L)?

Plan We must find the final volume (V_2) in liters, given the initial volume (V_1), initial pressure (P_1), and final pressure (P_2). The temperature and amount of gas are fixed. We must use consistent units of pressure, so we convert the unit of P_1 from torr to atm. We then convert the unit of V_1 from cm³ to mL and then to L, rearrange the ideal gas law to the appropriate form, and solve for V_2 . (Note that the road map has two parts, unit conversion and the gas law calculation.)

Solution Summarizing the gas variables:

$$P_1 = 851 \text{ torr} \quad P_2 = 2.64 \text{ atm}$$

$$V_1 = 24.8 \text{ cm}^3 \quad V_2 = \text{unknown} \quad T \text{ and } n \text{ remain constant}$$

Converting P_1 from torr to atm:

$$P_1 (\text{atm}) = 851 \text{ torr} \times \frac{1 \text{ atm}}{760 \text{ torr}} = 1.12 \text{ atm}$$

Converting V_1 from cm³ to L:

$$V_1 (\text{L}) = 24.8 \text{ cm}^3 \times \frac{1 \text{ mL}}{1 \text{ cm}^3} \times \frac{1 \text{ L}}{1000 \text{ mL}} = 0.0248 \text{ L}$$

Rearranging the ideal gas law and solving for V_2 : At fixed n and T , we have

$$\frac{P_1 V_1}{n_1 T_1} = \frac{P_2 V_2}{n_2 T_2} \quad \text{or} \quad P_1 V_1 = P_2 V_2$$

$$V_2 = V_1 \times \frac{P_1}{P_2} = 0.0248 \text{ L} \times \frac{1.12 \text{ atm}}{2.64 \text{ atm}} = 0.0105 \text{ L}$$

Check The relative values of P and V can help us check the math: P more than doubled, so V_2 should be less than $\frac{1}{2}V_1$ ($0.0105/0.0248 < \frac{1}{2}$).

Comment 1. Predicting the direction of the change provides another check on the problem setup: since P increases, V will decrease; thus, V_2 should be less than V_1 . To make $V_2 < V_1$, we must multiply V_1 by a number *less than 1*. This means the ratio of pressures must be *less than 1*, so the larger pressure (P_2) must be in the denominator, or P_1/P_2 . **2.** Since R was not involved in this problem, any unit of pressure can be used, as long as the same unit is used for both P_1 and P_2 . We used atm, but we could have used torr instead; however, both torr and atm cannot be used.

Road Map

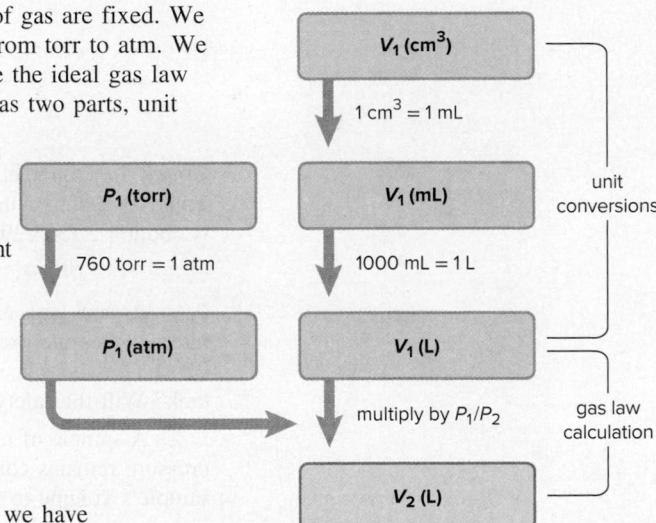

FOLLOW-UP PROBLEMS

5.2A A sample of argon gas occupies 105 mL at 0.871 atm. If the volume of the gas is increased to 352 mL at constant temperature, what is the final pressure of the gas (in kPa)?

5.2B A tank contains 651 L of compressed oxygen gas at a pressure of 122 atm. Assuming the temperature remains constant, what is the volume of the oxygen (in L) at 745 mmHg?

SOME SIMILAR PROBLEMS 5.24 and 5.25

SAMPLE PROBLEM 5.3**Applying the Volume-Temperature and Pressure-Temperature Relationships**

Problem A balloon is filled with 1.95 L of air at 25°C and then placed in a car sitting in the sun. What is the volume of the balloon when the temperature in the car reaches 90°C?

Plan We know the initial volume (V_1) and the initial (T_1) and final temperatures (T_2) of the gas; we must find the final volume (V_2). The pressure of the gas is fixed since the balloon is subjected to atmospheric pressure, and n is fixed since air cannot escape or enter the balloon. We convert both T values to kelvins, rearrange the ideal gas law, and solve for V_2 (see the road map).

Solution Summarizing the gas variables:

$$\begin{aligned}V_1 &= 1.95 \text{ L} \\ T_1 &= 25^\circ\text{C} (\text{convert to K}) \\ P &\text{ and } n \text{ remain constant}\end{aligned}$$

$$\begin{aligned}V_2 &= \text{unknown} \\ T_2 &= 90^\circ\text{C} (\text{convert to K})\end{aligned}$$

Converting T from °C to K:

$$T_1 (\text{K}) = 25^\circ\text{C} + 273.15 = 298 \text{ K} \quad T_2 (\text{K}) = 90^\circ\text{C} + 273.15 = 363 \text{ K}$$

Rearranging the ideal gas law and solving for V_2 : At fixed n and P , we have

$$\frac{P_1 V_1}{n_1 T_1} = \frac{P_2 V_2}{n_2 T_2} \quad \text{or} \quad \frac{V_1}{T_1} = \frac{V_2}{T_2}$$

$$V_2 = V_1 \times \frac{T_2}{T_1} = 1.95 \text{ L} \times \frac{363 \text{ K}}{298 \text{ K}} = 2.38 \text{ L}$$

Check Let's predict the change to check the math: because $T_2 > T_1$, we expect $V_2 > V_1$. Thus, the temperature ratio should be greater than 1 (T_2 in the numerator). The T ratio is about 1.2 (363/298), so the V ratio should also be about 1.2 (2.4/2.0 ≈ 1.2).

FOLLOW-UP PROBLEMS

5.3A A steel tank used for fuel delivery is fitted with a safety valve that opens if the internal pressure exceeds 1.00×10^3 torr. The tank is filled with methane at 23°C and 0.991 atm and placed in boiling water at 100.°C. What is the pressure in the heated tank? Will the safety valve open?

5.3B A sample of nitrogen occupies a volume of 32.5 L at 40°C. Assuming that the pressure remains constant, what temperature (in °C) will result in a decrease in the sample's volume to 28.6 L?

SOME SIMILAR PROBLEMS 5.26–5.29

SAMPLE PROBLEM 5.4**Applying the Volume-Amount and Pressure-Amount Relationships**

Problem A scale model of a blimp rises when it is filled with helium to a volume of 55.0 dm³. When 1.10 mol of He is added to the blimp, the volume is 26.2 dm³. How many more grams of He must be added to make it rise? Assume constant T and P .

Plan We are given the initial amount of helium (n_1), the initial volume of the blimp (V_1), and the volume needed for it to rise (V_2), and we need the additional mass of helium to make it rise. So we first need to find n_2 . We rearrange the ideal gas law to the appropriate form, solve for n_2 , subtract n_1 to find the additional amount (n_{add}^{\prime}), and then convert moles to grams (see the road map).

Road Map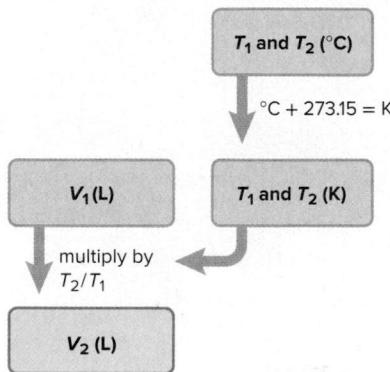

Solution Summarizing the gas variables:

$$n_1 = 1.10 \text{ mol}$$

$$V_1 = 26.2 \text{ dm}^3$$

P and T remain constant

n_2 = unknown (find, and then subtract n_1)

$$V_2 = 55.0 \text{ dm}^3$$

Rearranging the ideal gas law and solving for n_2 : At fixed P and T , we have

$$\frac{P_1 V_1}{n_1 T_1} = \frac{P_2 V_2}{n_2 T_2} \quad \text{or} \quad \frac{V_1}{n_1} = \frac{V_2}{n_2}$$

$$n_2 = n_1 \times \frac{V_2}{V_1} = 1.10 \text{ mol He} \times \frac{55.0 \text{ dm}^3}{26.2 \text{ dm}^3}$$

$$= 2.31 \text{ mol He}$$

Finding the additional amount of He:

$$n_{\text{add'l}} = n_2 - n_1 = 2.31 \text{ mol He} - 1.10 \text{ mol He}$$

$$= 1.21 \text{ mol He}$$

Converting amount (mol) of He to mass (g):

$$\text{Mass (g) of He} = 1.21 \text{ mol He} \times \frac{4.003 \text{ g He}}{1 \text{ mol He}}$$

$$= 4.84 \text{ g He}$$

Check We predict that $n_2 > n_1$ because $V_2 > V_1$; since V_2 is about twice V_1 ($55/26 \approx 2$), n_2 should be about twice n_1 ($2.3/1.1 \approx 2$). Since $n_2 > n_1$, we were right to multiply n_1 by a number greater than 1 (that is, V_2/V_1). About $1.2 \text{ mol} \times 4 \text{ g/mol} \approx 4.8 \text{ g}$.

Comment 1. Because we did not use R , notice that any unit of volume, in this case dm^3 , is acceptable as long as V_1 and V_2 are expressed in the same unit.

2. A different sequence of steps should give you the same answer: first find the additional volume ($V_{\text{add'l}} = V_2 - V_1$), and then solve directly for $n_{\text{add'l}}$. Try it for yourself.

3. You saw that Charles's law ($V \propto T$ at fixed P and n) becomes a similar relationship between P and T at fixed V and n . Follow-up Problem 5.4A demonstrates that Avogadro's law ($V \propto n$ at fixed P and T) becomes a similar relationship at fixed V and T .

FOLLOW-UP PROBLEMS

5.4A A rigid plastic container holds 35.0 g of ethylene gas (C_2H_4) at a pressure of 793 torr. What is the pressure if 5.0 g of ethylene is removed at constant temperature?

5.4B A balloon filled with 1.26 g of nitrogen gas has a volume of 1.12 L. Calculate the volume of the balloon after 1.26 g of helium gas is added while T and P remain constant.

SOME SIMILAR PROBLEMS 5.30 and 5.31

Road Map

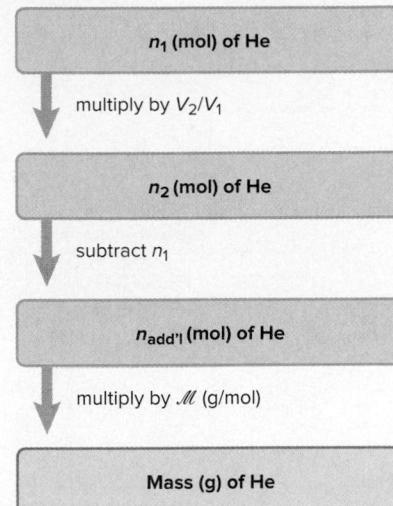

SAMPLE PROBLEM 5.5

Applying the Volume-Pressure-Temperature Relationship

Problem A helium-filled balloon has a volume of 15.8 L at a pressure of 0.980 atm and 22°C . What is its volume at the summit of Mt. Hood, Oregon's highest mountain, where the atmospheric pressure is 532 mmHg and the temperature is 0°C ?

Plan We know the initial volume (V_1), pressure (P_1), and temperature (T_1) of the gas; we also know the final pressure (P_2) and temperature (T_2), and we must find the final volume (V_2). Since the amount of helium in the balloon does not change, n is fixed. We convert both T values to kelvins, the final pressure to atm, rearrange the ideal gas law, and solve for V_2 . This is a combined gas law problem.

Solution Summarizing the gas variables:

$$V_1 = 15.8 \text{ L}$$

$$T_1 = 22^\circ\text{C} \text{ (convert to K)}$$

$$P_1 = 0.980 \text{ atm}$$

n remains constant

$$V_2 = \text{unknown}$$

$$T_2 = 0^\circ\text{C} \text{ (convert to K)}$$

$$P_2 = 532 \text{ mmHg} \text{ (convert to atm)}$$

Converting T from $^\circ\text{C}$ to K:

$$T_1 \text{ (K)} = 22^\circ\text{C} + 273.15 = 295 \text{ K} \quad T_2 \text{ (K)} = 0^\circ\text{C} + 273.15 = 273 \text{ K}$$

Converting P_2 to atm:

$$P_2 \text{ (atm)} = 532 \text{ mmHg} \times \frac{1 \text{ atm}}{760 \text{ mmHg}} = 0.700 \text{ atm}$$

Rearranging the ideal gas law and solving for V_2 : At fixed n , we have

$$\frac{P_1 V_1}{n_1 T_1} = \frac{P_2 V_2}{n_2 T_2} \quad \text{or} \quad \frac{P_1 V_1}{T_1} = \frac{P_2 V_2}{T_2}$$

$$V_2 = V_1 \times \frac{P_1 T_2}{P_2 T_1} = 15.8 \text{ L} \times \frac{(0.980 \text{ atm})(273 \text{ K})}{(0.700 \text{ atm})(295 \text{ K})} = 20.5 \text{ L}$$

Check Let's predict the change to check the math: because $T_2 < T_1$, we expect $V_2 < V_1$; but because $P_2 < P_1$, we expect $V_2 > V_1$. The temperature ratio (T_2 in the numerator) is about 0.93 (273/295), and the pressure ratio (P_1 in the numerator) is about 1.4 (0.980/0.700), so the V ratio should be about 0.93×1.4 , or 1.3 ($20.5/15.8 \approx 1.3$). The pressure decreases by a larger factor than the temperature increases, so there is an overall increase in volume.

FOLLOW-UP PROBLEMS

5.5A A sample of nitrogen gas occupies a volume of 2.55 L at 755 mmHg and 23°C. Its volume increases to 4.10 L, and its temperature decreases to 18°C. What is the final pressure?

5.5B A diver has 2.2 L of air in his lungs at an air temperature of 28°C and a pressure of 0.980 atm. What is the volume of air in his lungs after he dives, while holding his breath, to a depth of 10 m, where the temperature is 21°C and the pressure is 1.40 atm?

SOME SIMILAR PROBLEMS 5.32 and 5.33

SAMPLE PROBLEM 5.6

Solving for an Unknown Gas Variable at Fixed Conditions

Problem A steel tank has a volume of 438 L and is filled with 0.885 kg of O₂. Calculate the pressure of O₂ at 21°C.

Plan We are given V , T , and the mass of O₂, and we must find P . Since the conditions are not changing, we apply the ideal gas law without rearranging it. We use the given V in liters, convert T to kelvins and mass (kg) of O₂ to amount (mol), and solve for P .

Solution Summarizing the gas variables:

$$V = 438 \text{ L} \quad T = 21^\circ\text{C} \text{ (convert to K)}$$

$$n = 0.885 \text{ kg O}_2 \text{ (convert to mol)} \quad P = \text{unknown}$$

Converting T from °C to K:

$$T(\text{K}) = 21^\circ\text{C} + 273.15 = 294 \text{ K}$$

Converting from mass (g) of O₂ to amount (mol):

$$n = \text{mol of O}_2 = 0.885 \text{ kg O}_2 \times \frac{1000 \text{ g}}{1 \text{ kg}} \times \frac{1 \text{ mol O}_2}{32.00 \text{ g O}_2} = 27.7 \text{ mol O}_2$$

Solving for P (note the unit canceling here):

$$P = \frac{nRT}{V} = \frac{27.7 \text{ mol} \times 0.0821 \frac{\text{atm}\cdot\text{L}}{\text{mol}\cdot\text{K}} \times 294 \text{ K}}{438 \text{ L}}$$

$$= 1.53 \text{ atm}$$

Check The amount of O₂ seems correct: $\sim 900 \text{ g}/(30 \text{ g/mol}) = 30 \text{ mol}$. To check the approximate size of the final calculation, round off the values, including that for R :

$$P = \frac{30 \text{ mol O}_2 \times 0.1 \frac{\text{atm}\cdot\text{L}}{\text{mol}\cdot\text{K}} \times 300 \text{ K}}{450 \text{ L}} = 2 \text{ atm}$$

which is reasonably close to 1.53 atm.

FOLLOW-UP PROBLEMS

5.6A The tank in Sample Problem 5.6 develops a slow leak that is discovered and sealed. The new pressure is 1.37 atm. How many grams of O₂ remain?

5.6B A blimp is filled with 3950 kg of helium at 731 mmHg and 20°C. What is the volume of the blimp under these conditions?

SOME SIMILAR PROBLEMS 5.34–5.37

Finally, in a picture problem, we apply the gas laws to determine the balanced equation for a gaseous reaction.

SAMPLE PROBLEM 5.7**Using Gas Laws to Determine a Balanced Equation**

Problem The piston-cylinder below is depicted before and after a gaseous reaction that is carried out in it at constant pressure: the temperature is 150 K before and 300 K after the reaction. (Assume the cylinder is insulated.)

Which of the following balanced equations describes the reaction?

- (1) A₂(g) + B₂(g) → 2AB(g) (2) 2AB(g) + B₂(g) → 2AB₂(g)
 (3) A(g) + B₂(g) → AB₂(g) (4) 2AB₂(g) → A₂(g) + 2B₂(g)

Plan We are shown a depiction of the volume and temperature of a gas mixture before and after a reaction and must deduce the balanced equation. The problem says that P is constant, and the picture shows that, when T doubles, V stays the same. If n were also constant, Charles's law tells us that V should double when T doubles. But, since V does not change, n cannot be constant. From Avogadro's law, the only way to maintain V constant, with P constant and T doubling, is for n to be halved. So we examine the four balanced equations and count the number of moles on each side to see in which equation n is halved.

Solution In equation (1), n does not change, so doubling T would double V.

In equation (2), n decreases from 3 mol to 2 mol, so doubling T would increase V by one-third.

In equation (3), n decreases from 2 mol to 1 mol. Doubling T would exactly balance the decrease from halving n, so V would stay the same.

In equation (4), n increases, so doubling T would more than double V.

Therefore, equation (3) is correct:

FOLLOW-UP PROBLEMS

5.7A The piston-cylinder below shows the volumes of a gaseous reaction mixture before and after a reaction that takes place at constant pressure and an initial temperature of -73°C.

If the *unbalanced* equation is CD(g) → C₂(g) + D₂(g), what is the final temperature (in °C)?

5.7B The piston-cylinder below shows a gaseous reaction mixture before and after a reaction that takes place at constant pressure.

Which of the following balanced equations describes the reaction?

- (1) $2X_2(g) + Y_2(g) \rightarrow 2X_2Y(g)$ (2) $2XY_3(g) \rightarrow X_2(g) + 3Y_2(g)$
 (3) $X_2Y_2(g) \rightarrow 2X(g) + Y_2(g)$ (4) $2XY(g) \rightarrow X_2(g) + Y_2(g)$

SOME SIMILAR PROBLEMS 5.19 and 5.67

› Summary of Section 5.3

- › Four interdependent variables define the physical behavior of an ideal gas: volume (V), pressure (P), temperature (T), and amount (number of moles, n).
- › Most simple gases display nearly ideal behavior at ordinary temperatures and pressures.
- › Boyle's, Charles's, and Avogadro's laws refer to the linear relationships between the volume of a gas and the pressure, temperature, and amount of the gas, respectively.
- › At STP (0°C and 1 atm), 1 mol of an ideal gas occupies 22.4 L.
- › The ideal gas law incorporates the individual gas laws into one equation: $PV = nRT$, where R is the universal gas constant.

5.4 REARRANGEMENTS OF THE IDEAL GAS LAW

The ideal gas law can be mathematically rearranged to find gas density, molar mass, the partial pressure of each gas in a mixture, and the amount of gaseous reactant or product in a reaction.

The Density of a Gas

One mole of any gas behaving ideally occupies the same volume at a given temperature and pressure, so differences in gas density ($d = m/V$) depend on differences in molar mass (see Figure 5.9). For example, at STP, 1 mol (32.00 g) of O₂ occupies 22.4 L, the same volume occupied by 1 mol (28.02 g) of N₂ so

$$d \text{ of O}_2 = \frac{32.00 \text{ g}}{22.4 \text{ L}} = 1.43 \text{ g/L} \quad \text{and} \quad d \text{ of N}_2 = \frac{28.02 \text{ g}}{22.4 \text{ L}} = 1.25 \text{ g/L}$$

O₂ is denser because each O₂ molecule has a greater mass (32.00 amu) than each N₂ molecule (28.02 amu). Thus,

$$d \text{ of O}_2 = \frac{32.00}{28.02} \times d \text{ of N}_2 = \frac{32.00}{28.02} \times 1.25 \text{ g/L} = 1.43 \text{ g/L}$$

We can rearrange the ideal gas law to calculate the density of a gas from its molar mass. Recall that the number of moles (n) is the mass of substance (m) divided by its molar mass (\mathcal{M}), $n = m/\mathcal{M}$. Substituting for n in the ideal gas law gives

$$PV = \frac{m}{\mathcal{M}} RT$$

Rearranging to isolate m/V gives

$$\frac{m}{V} = d = \frac{P \times \mathcal{M}}{RT} \tag{5.9}$$

Three important ideas are expressed by Equation 5.9:

- *The density of a gas is directly proportional to its molar mass.* The volume of a given amount of a heavier gas equals the volume of the same amount of a lighter gas at the same conditions of temperature and pressure (Avogadro's law), so the density of the heavier gas is higher (as you just saw for O₂ and N₂).
- *The density of a gas is inversely proportional to the temperature.* As the volume of a gas increases with temperature (Charles's law), the same mass occupies more space, so the density of the gas is lower.
- *The density of a gas is directly proportional to the pressure.* As the volume of a gas decreases with increasing pressure (Boyle's law), the same mass occupies less space, so the density of the gas is higher.

We use Equation 5.9 to find the density of a gas at any temperature and pressure near standard conditions.

SAMPLE PROBLEM 5.8

Calculating Gas Density

Problem To apply a green chemistry approach, a chemical engineer uses waste CO₂ from a manufacturing process, instead of chlorofluorocarbons, as a “blowing agent” in the production of polystyrene. Find the density (in g/L) of CO₂ and the number of molecules per liter (**a**) at STP (0°C and 1 atm) and (**b**) at room conditions (20.°C and 1.00 atm).

Plan We must find the density (*d*) and the number of molecules of CO₂, given two sets of *P* and *T* data. We find *M*, convert *T* to kelvins, and calculate *d* with Equation 5.9. Then we convert the mass per liter to molecules per liter with Avogadro's number.

Solution (**a**) Density and molecules per liter of CO₂ at STP. Summary of gas properties:

$$T = 0^\circ\text{C} + 273.15 = 273 \text{ K} \quad P = 1 \text{ atm} \quad M \text{ of CO}_2 = 44.01 \text{ g/mol}$$

Calculating density (note the unit canceling here):

$$d = \frac{P \times M}{RT} = \frac{1.00 \text{ atm} \times 44.01 \text{ g/mol}}{0.0821 \frac{\text{atm}\cdot\text{L}}{\text{mol}\cdot\text{K}} \times 273 \text{ K}} = 1.96 \text{ g/L}$$

Converting from mass/L to molecules/L:

$$\begin{aligned} \text{Molecules CO}_2/\text{L} &= \frac{1.96 \text{ g CO}_2}{1 \text{ L}} \times \frac{1 \text{ mol CO}_2}{44.01 \text{ g CO}_2} \times \frac{6.022 \times 10^{23} \text{ molecules CO}_2}{1 \text{ mol CO}_2} \\ &= 2.68 \times 10^{22} \text{ molecules CO}_2/\text{L} \end{aligned}$$

(**b**) Density and molecules of CO₂ per liter at room conditions. Summary of gas properties:

$$T = 20.^\circ\text{C} + 273.15 = 293 \text{ K} \quad P = 1.00 \text{ atm} \quad M \text{ of CO}_2 = 44.01 \text{ g/mol}$$

Calculating density:

$$d = \frac{P \times M}{RT} = \frac{1.00 \text{ atm} \times 44.01 \text{ g/mol}}{0.0821 \frac{\text{atm}\cdot\text{L}}{\text{mol}\cdot\text{K}} \times 293 \text{ K}} = 1.83 \text{ g/L}$$

Converting from mass/L to molecules/L:

$$\begin{aligned} \text{Molecules CO}_2/\text{L} &= \frac{1.83 \text{ g CO}_2}{1 \text{ L}} \times \frac{1 \text{ mol CO}_2}{44.01 \text{ g CO}_2} \times \frac{6.022 \times 10^{23} \text{ molecules CO}_2}{1 \text{ mol CO}_2} \\ &= 2.50 \times 10^{22} \text{ molecules CO}_2/\text{L} \end{aligned}$$

Check Round off to check the density values; for example, in (a), at STP:

$$\frac{50 \text{ g/mol} \times 1 \text{ atm}}{0.1 \frac{\text{atm}\cdot\text{L}}{\text{mol}\cdot\text{K}} \times 250 \text{ K}} = 2 \text{ g/L} \approx 1.96 \text{ g/L}$$

At the higher temperature in (b), the density should decrease, which can happen only if there are fewer molecules per liter, so the answer is reasonable.

Comment 1. An *alternative approach* for finding the density of most simple gases, but at STP only, is to divide the molar mass by the standard molar volume, 22.4 L:

$$d = \frac{\mathcal{M}}{V} = \frac{44.01 \text{ g/mol}}{22.4 \text{ L/mol}} = 1.96 \text{ g/L}$$

Once you know the density at one temperature (0°C), you can find it at any other temperature with the following relationship: $d_1/d_2 = T_2/T_1$ (if the pressure is constant).

2. Note that we have different numbers of significant figures for the pressure values. In (a), “1 atm” is part of the definition of STP, so it is an exact number. In (b), we specified “1.00 atm” to allow three significant figures in the answer.

FOLLOW-UP PROBLEMS

5.8A Compare the density of CO_2 at 0°C and 380. torr with its density at STP.

5.8B Nitrogen oxide (NO_2) is a reddish-brown gas that is a component of smog. Calculate its density at 0.950 atm and 24°C . How does the density of NO_2 compare to that of dry air ($d = 1.13 \text{ g/L}$ at the same conditions)?

SOME SIMILAR PROBLEMS 5.45–5.48

Source: © Charles F. McCarthy/
Shutterstock.com

Gas Density and the Human Condition A few applications demonstrate the wide-ranging relevance of gas density:

- *Engineering.* Architectural designers and heating engineers place heating ducts near the floor so that the warmer, and thus less dense, air coming from the ducts will rise and mix with the cooler room air.
- *Safety and air pollution.* In the absence of mixing, a less dense gas will lie above a more dense one. Fire extinguishers that release CO_2 are effective because this gas is heavier than air: it sinks onto the fire and keeps more O_2 from reaching the fuel. The dense gases in smog that blanket urban centers, such as Mexico City, Los Angeles, and Beijing, contribute to respiratory illnesses (see Follow-up Problem 5.8B).
- *Toxic releases.* During World War I, poisonous phosgene gas (COCl_2) was used against ground troops because it was dense enough to sink into their trenches. In 1984, the accidental release of poisonous methylisocyanate gas from a Union Carbide plant in India killed thousands of people as it blanketed nearby neighborhoods. In 1986, CO_2 released naturally from Lake Nyos in Cameroon suffocated thousands of people as it flowed down valleys into villages. Some paleontologists suggest that the release of CO_2 from volcanic lakes may have contributed to widespread dying off of dinosaurs.
- *Ballooning.* When the gas in a hot-air balloon is heated, its volume increases and the balloon inflates. Further heating causes some of the gas to escape. Thus, the gas density decreases and the balloon rises. In 1783, Jacques Charles (of Charles's law) made one of the first balloon flights, and 20 years later, Joseph Gay-Lussac (who studied the pressure-temperature relationship) set a solo altitude record that held for 50 years.

The Molar Mass of a Gas

Through another rearrangement of the ideal gas law, we can determine the molar mass of an unknown gas or a volatile liquid (one that is easily vaporized):

$$n = \frac{m}{\mathcal{M}} = \frac{PV}{RT} \quad \text{so} \quad \mathcal{M} = \frac{mRT}{PV} \quad (5.10)$$

Notice that this equation is just a rearrangement of Equation 5.9.

SAMPLE PROBLEM 5.9**Finding the Molar Mass of a Volatile Liquid**

Problem An organic chemist isolates a colorless liquid from a petroleum sample. She places the liquid in a preweighed flask and puts the flask in boiling water, which vaporizes the liquid and fills the flask with gas. She closes the flask and reweighs it. She obtains the following data:

$$\begin{array}{lll} \text{Volume } (V) \text{ of flask} = 213 \text{ mL} & T = 100.0^\circ\text{C} & P = 754 \text{ torr} \\ \text{Mass of flask + gas} = 78.416 \text{ g} & \text{Mass of flask} = 77.834 \text{ g} & \end{array}$$

Calculate the molar mass of the liquid.

Plan We are given V , T , P , and mass data and must find the molar mass (\mathcal{M}) of the liquid. We convert V to liters, T to kelvins, and P to atmospheres, find the mass of gas by subtracting the mass of the flask from the mass of the flask plus gas, and use Equation 5.10 to calculate \mathcal{M} .

Solution Summarizing and converting the gas variables:

$$\begin{aligned} V (\text{L}) &= 213 \text{ mL} \times \frac{1 \text{ L}}{1000 \text{ mL}} = 0.213 \text{ L} & T (\text{K}) &= 100.0^\circ\text{C} + 273.15 = 373.2 \text{ K} \\ P (\text{atm}) &= 754 \text{ torr} \times \frac{1 \text{ atm}}{760 \text{ torr}} = 0.992 \text{ atm} & m &= 78.416 \text{ g} - 77.834 \text{ g} = 0.582 \text{ g} \end{aligned}$$

Calculating \mathcal{M} :

$$\mathcal{M} = \frac{mRT}{PV} = \frac{0.582 \text{ g} \times 0.0821 \frac{\text{atm}\cdot\text{L}}{\text{mol}\cdot\text{K}} \times 373.2 \text{ K}}{0.992 \text{ atm} \times 0.213 \text{ L}} = 84.4 \text{ g/mol}$$

Check Rounding to check the arithmetic, we have

$$\frac{0.6 \text{ g} \times 0.08 \frac{\text{atm}\cdot\text{L}}{\text{mol}\cdot\text{K}} \times 375 \text{ K}}{1 \text{ atm} \times 0.2 \text{ L}} = 90 \text{ g/mol} \quad (\text{which is close to } 84.4 \text{ g/mol})$$

FOLLOW-UP PROBLEMS

5.9A An empty 149-mL flask weighs 68.322 g before a sample of volatile liquid is added. The flask is then placed in a hot (95.0°C) water bath; the barometric pressure is 740. torr. The liquid vaporizes and the gas fills the flask. After cooling, flask and condensed liquid together weigh 68.697 g. What is the molar mass of the liquid?

5.9B An empty glass bulb has a volume of 350. mL and a mass of 82.561 g. When filled with an unknown gas at 733 mmHg and 22°C, the bulb has a mass of 82.786 g. Is the gas argon (Ar), methane (CH₄), or nitrogen monoxide (NO)?

SOME SIMILAR PROBLEMS 5.49 and 5.50

The Partial Pressure of Each Gas in a Mixture of Gases

The ideal gas law holds for virtually any gas at ordinary conditions, whether it is a pure gas or a mixture of gases such as air, because

- Gases mix homogeneously (form a solution) in any proportions.
- Each gas in a mixture behaves as if it were the only gas present (assuming no chemical interactions).

Dalton's Law of Partial Pressures The second point above was discovered by John Dalton during his lifelong study of humidity. He observed that when water vapor is added to dry air, the total air pressure increases by the pressure of the water vapor:

$$P_{\text{humid air}} = P_{\text{dry air}} + P_{\text{added water vapor}}$$

He concluded that each gas in the mixture exerts a **partial pressure** equal to the pressure it would exert *by itself*. Stated as **Dalton's law of partial pressures**, his

discovery was that *in a mixture of unreacting gases, the total pressure is the sum of the partial pressures of the individual gases:*

$$P_{\text{total}} = P_1 + P_2 + P_3 + \dots \quad (5.11)$$

As an example, suppose we have a tank of fixed volume that contains nitrogen gas at a certain pressure, and we introduce a sample of hydrogen gas into the tank. Each gas behaves independently, so we can write an ideal gas law expression for each:

$$P_{\text{N}_2} = \frac{n_{\text{N}_2}RT}{V} \quad \text{and} \quad P_{\text{H}_2} = \frac{n_{\text{H}_2}RT}{V}$$

Because each gas occupies the same total volume and is at the same temperature, the pressure of each gas depends only on its amount, n . Thus, the total pressure is

$$P_{\text{total}} = P_{\text{N}_2} + P_{\text{H}_2} = \frac{n_{\text{N}_2}RT}{V} + \frac{n_{\text{H}_2}RT}{V} = \frac{(n_{\text{N}_2} + n_{\text{H}_2})RT}{V} = \frac{n_{\text{total}}RT}{V}$$

where $n_{\text{total}} = n_{\text{N}_2} + n_{\text{H}_2}$.

Each component in a mixture contributes a fraction of the total number of moles in the mixture; this portion is the **mole fraction** (X) of that component. Multiplying X by 100 gives the mole percent. The sum of the mole fractions of all components must be 1, and the sum of the mole percents must be 100%. For N_2 in our mixture, the mole fraction is

$$X_{\text{N}_2} = \frac{\text{mol of N}_2}{\text{total amount (mol)}} = \frac{n_{\text{N}_2}}{n_{\text{N}_2} + n_{\text{H}_2}}$$

If the total pressure is due to the total number of moles, the partial pressure of gas A is the total pressure multiplied by the mole fraction of A, X_A :

$$P_A = X_A \times P_{\text{total}} \quad (5.12)$$

For example, if $\frac{1}{4}$ (0.25) of a gas mixture is gas A, then gas A contributes $\frac{1}{4}$ of the total pressure.

Equation 5.12 is a very useful result. To see that it is valid for the mixture of N_2 and H_2 , we recall that $X_{\text{N}_2} + X_{\text{H}_2} = 1$; then we obtain

$$P_{\text{total}} = P_{\text{N}_2} + P_{\text{H}_2} = (X_{\text{N}_2} \times P_{\text{total}}) + (X_{\text{H}_2} \times P_{\text{total}}) = (X_{\text{N}_2} + X_{\text{H}_2})P_{\text{total}} = 1 \times P_{\text{total}}$$

SAMPLE PROBLEM 5.10

Applying Dalton's Law of Partial Pressures

Problem In a study of O_2 uptake by muscle tissue at high altitude, a physiologist prepares an atmosphere consisting of 79 mole % N_2 , 17 mole % $^{16}\text{O}_2$, and 4.0 mole % $^{18}\text{O}_2$. (The isotope ^{18}O will be measured to determine O_2 uptake.) The total pressure is 0.75 atm to simulate high altitude. Calculate the mole fraction and partial pressure of $^{18}\text{O}_2$ in the mixture.

Plan We must find $X_{^{18}\text{O}_2}$ and $P_{^{18}\text{O}_2}$ from P_{total} (0.75 atm) and the mole % of $^{18}\text{O}_2$ (4.0). Dividing the mole % by 100 gives the mole fraction, $X_{^{18}\text{O}_2}$. Then, using Equation 5.12, we multiply $X_{^{18}\text{O}_2}$ by P_{total} to find $P_{^{18}\text{O}_2}$ (see the road map).

Solution Calculating the mole fraction of $^{18}\text{O}_2$:

$$X_{^{18}\text{O}_2} = \frac{4.0 \text{ mol \% } ^{18}\text{O}_2}{100} = 0.040$$

Solving for the partial pressure of $^{18}\text{O}_2$:

$$P_{^{18}\text{O}_2} = X_{^{18}\text{O}_2} \times P_{\text{total}} = 0.040 \times 0.75 \text{ atm} = 0.030 \text{ atm}$$

Check $X_{^{18}\text{O}_2}$ is small because the mole % is small, so $P_{^{18}\text{O}_2}$ should be small also.

Comment At high altitudes, specialized brain cells that are sensitive to O_2 and CO_2 levels in the blood trigger an increase in rate and depth of breathing for several days, until a person becomes acclimated.

Road Map

Mole % of $^{18}\text{O}_2$

divide by 100

Mole fraction, $X_{^{18}\text{O}_2}$

multiply by P_{total}

Partial pressure, $P_{^{18}\text{O}_2}$

FOLLOW-UP PROBLEMS

5.10A To prevent air from interacting with highly reactive chemicals, noble gases are placed over the chemicals to act as inert “blanketing” gases. A chemical engineer places a mixture of noble gases consisting of 5.50 g of He, 15.0 g of Ne, and 35.0 g of Kr in a piston-cylinder assembly at STP. Calculate the partial pressure of each gas.

5.10B Trimix is a breathing mixture of He, O₂, and N₂ used by deep-sea scuba divers; He reduces the chances of N₂ narcosis and O₂ toxicity. A tank of Trimix has a total pressure of 204 atm and a partial pressure of He of 143 atm. What is the mole percent of He in the mixture?

SOME SIMILAR PROBLEMS 5.51 and 5.52

Collecting a Gas over Water Whenever a gas is in contact with water, some of the water vaporizes into the gas. The water vapor that mixes with the gas contributes a pressure known as the *vapor pressure*, a portion of the total pressure that depends only on the water temperature (Table 5.2). A common use of the law of partial pressures is to determine the amount of a water-insoluble gas formed in a reaction: the gaseous product bubbles through water, some water vaporizes into the bubbles, and the mixture of product gas and water vapor is collected into an inverted container (Figure 5.12).

To determine the amount of gas formed, we look up the vapor pressure (P_{H_2O}) at the temperature of the experiment in Table 5.2 and subtract it from the total gas pressure (P_{total} , corrected for barometric pressure) to get the partial pressure of the gaseous product (P_{gas}). With V and T known, we can calculate the amount of product.

Table 5.2 Vapor Pressure of Water (P_{H_2O}) at Different T

T (°C)	P_{H_2O} (torr)						
0	4.6	20	17.5	40	55.3	75	289.1
5	6.5	22	19.8	45	71.9	80	355.1
10	9.2	24	22.4	50	92.5	85	433.6
12	10.5	26	25.2	55	118.0	90	525.8
14	12.0	28	28.3	60	149.4	95	633.9
16	13.6	30	31.8	65	187.5	100	760.0
18	15.5	35	42.2	70	233.7		

The vapor pressure (P_{H_2O}) adds to P_{gas} to give P_{total} . Here, the water level in the vessel is above the level in the beaker, so $P_{\text{total}} < P_{\text{atm}}$.

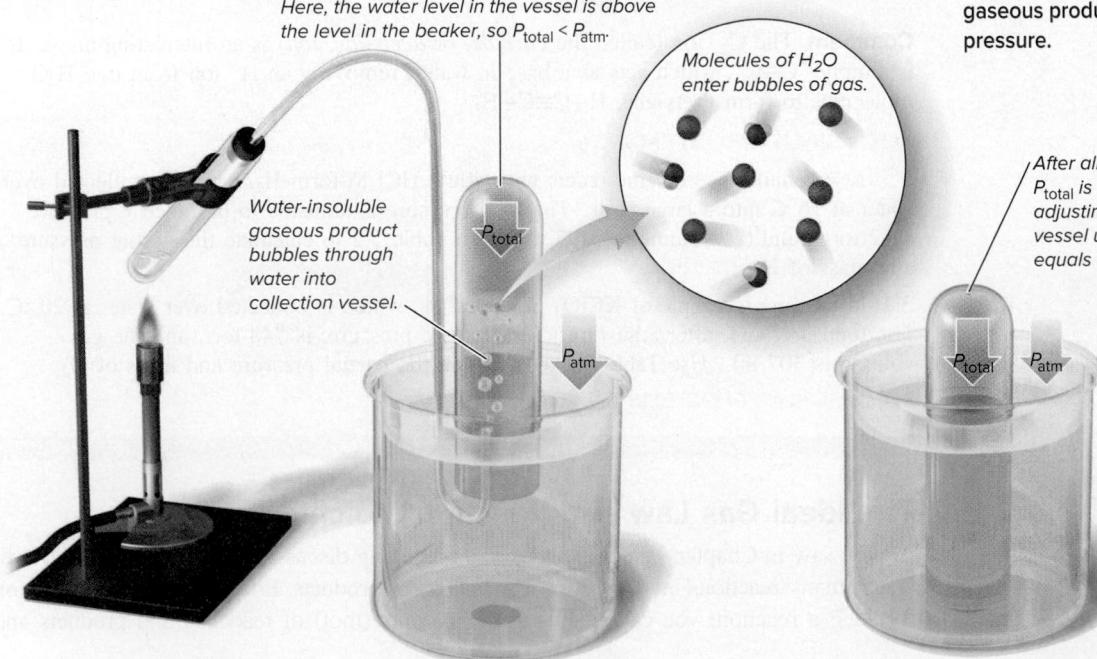

Figure 5.12 Collecting a water-insoluble gaseous product and determining its pressure.

After all the gas has been collected, P_{total} is made equal to P_{atm} by adjusting the height of the collection vessel until the water level in it equals the level in the beaker.

$$\begin{array}{c} \downarrow \\ P_{\text{total}} \end{array} = \begin{array}{c} \downarrow \\ P_{\text{gas}} \end{array} + \begin{array}{c} \downarrow \\ P_{H_2O} \end{array}$$

P_{total} equals P_{gas} plus P_{H_2O} at the temperature of the experiment. Therefore, $P_{\text{gas}} = P_{\text{total}} - P_{H_2O}$.

SAMPLE PROBLEM 5.11

Calculating the Amount of Gas Collected over Water

Problem Acetylene (C_2H_2), an important fuel in welding, is produced in the laboratory when calcium carbide (CaC_2) reacts with water:

For a sample of acetylene collected over water, total gas pressure (adjusted to barometric pressure) is 738 torr and the volume is 523 mL. At the temperature of the gas ($23^\circ C$), the vapor pressure of water is 21 torr. How many grams of acetylene are collected?

Plan In order to find the mass of C_2H_2 , we first need to find the number of moles of C_2H_2 , $n_{C_2H_2}$, which we can obtain from the ideal gas law by calculating $P_{C_2H_2}$. The barometer reading gives us P_{total} , which is the sum of $P_{C_2H_2}$ and P_{H_2O} , and we are given P_{H_2O} , so we subtract to find $P_{C_2H_2}$. We are also given V and T , so we convert to consistent units, and find $n_{C_2H_2}$ from the ideal gas law. Then we convert moles to grams using the molar mass from the formula for acetylene, as shown in the road map.

Solution Summarizing and converting the gas variables:

$$P_{C_2H_2}(\text{torr}) = P_{\text{total}} - P_{H_2O} = 738 \text{ torr} - 21 \text{ torr} = 717 \text{ torr}$$

$$P_{C_2H_2}(\text{atm}) = 717 \text{ torr} \times \frac{1 \text{ atm}}{760 \text{ torr}} = 0.943 \text{ atm}$$

$$V(\text{L}) = 523 \text{ mL} \times \frac{1 \text{ L}}{1000 \text{ mL}} = 0.523 \text{ L}$$

$$T(\text{K}) = 23^\circ C + 273.15 = 296 \text{ K}$$

$$n_{C_2H_2} = \text{unknown}$$

Solving for $n_{C_2H_2}$:

$$n_{C_2H_2} = \frac{PV}{RT} = \frac{0.943 \text{ atm} \times 0.523 \text{ L}}{0.0821 \frac{\text{atm} \cdot \text{L}}{\text{mol} \cdot \text{K}} \times 296 \text{ K}} = 0.0203 \text{ mol}$$

Converting $n_{C_2H_2}$ to mass (g):

$$\begin{aligned} \text{Mass (g) of } C_2H_2 &= 0.0203 \text{ mol } C_2H_2 \times \frac{26.04 \text{ g } C_2H_2}{1 \text{ mol } C_2H_2} \\ &= 0.529 \text{ g } C_2H_2 \end{aligned}$$

Check Rounding to one significant figure, a quick arithmetic check for n gives

$$n \approx \frac{1 \text{ atm} \times 0.5 \text{ L}}{0.08 \frac{\text{atm} \cdot \text{L}}{\text{mol} \cdot \text{K}} \times 300 \text{ K}} = 0.02 \text{ mol} \approx 0.0203 \text{ mol}$$

Comment The C_2^{2-} ion (called the *carbide*, or *acetylide*, *ion*) is an interesting anion. It is simply $\text{C}\equiv\text{C}^-$, which acts as a base in water, removing an H^+ ion from two H_2O molecules to form acetylene, $\text{H}-\text{C}\equiv\text{C}-\text{H}$.

FOLLOW-UP PROBLEMS

5.11A A small piece of zinc reacts with dilute HCl to form H_2 , which is collected over water at $16^\circ C$ into a large flask. The total pressure is adjusted to barometric pressure (752 torr), and the volume is 1495 mL. Use Table 5.2 to calculate the partial pressure and mass of H_2 .

5.11B Heating a sample of $KClO_3$ produces O_2 , which is collected over water at $20.^\circ C$. The total pressure, after adjusting to barometric pressure, is 748 torr, and the gas volume is 307 mL. Use Table 5.2 to calculate the partial pressure and mass of O_2 .

SOME SIMILAR PROBLEMS 5.57 and 5.58

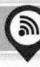

Student Hot Spot

Student data indicate that you may struggle with problems that combine stoichiometry and the ideal gas law. Access the Smartbook to view additional Learning Resources on this topic.

The Ideal Gas Law and Reaction Stoichiometry

As you saw in Chapters 3 and 4, and in the preceding discussion of collecting a gas over water, many reactions involve gases as reactants or products. From the balanced equation for such a reaction, you can calculate the amounts (mol) of reactants and products and

convert these quantities into masses or numbers of molecules. Figure 5.13 shows how you use the ideal gas law to convert between gas variables (P , T , and V) and amounts (mol) of gaseous reactants and products. In effect, you combine a gas law problem with a stoichiometry problem, as you'll see in Sample Problems 5.12 and 5.13.

Figure 5.13 The relationships among the amount (mol, n) of gaseous reactant (or product) and the gas pressure (P), volume (V), and temperature (T).

SAMPLE PROBLEM 5.12

Using Gas Variables to Find Amounts of Reactants or Products I

Problem Solid lithium hydroxide is used to “scrub” CO_2 from the air in spacecraft and submarines; it reacts with the CO_2 to produce lithium carbonate and water. What volume of CO_2 at 23°C and 716 torr can be removed by reaction with 395 g of lithium hydroxide?

Plan This is a stoichiometry *and* a gas law problem. To find V_{CO_2} , we first need n_{CO_2} . We write and balance the equation. Next, we convert the given mass (395 g) of lithium hydroxide, LiOH , to amount (mol) and use the molar ratio to find amount (mol) of CO_2 that reacts (stoichiometry portion). Then, we use the ideal gas law to convert moles of CO_2 to liters (gas law portion). A road map is shown, but you are familiar with all the steps.

Solution Writing the balanced equation:

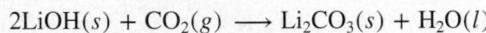

Calculating n_{CO_2} :

$$n_{\text{CO}_2} = 395 \text{ g LiOH} \times \frac{1 \text{ mol LiOH}}{23.95 \text{ g LiOH}} \times \frac{1 \text{ mol CO}_2}{2 \text{ mol LiOH}} = 8.25 \text{ mol CO}_2$$

Summarizing and converting other gas variables:

$$V = \text{unknown} \quad P (\text{atm}) = 716 \text{ torr} \times \frac{1 \text{ atm}}{760 \text{ torr}} = 0.942 \text{ atm}$$

$$T (\text{K}) = 23^\circ\text{C} + 273.15 = 296 \text{ K}$$

Solving for V_{CO_2} :

$$V = \frac{nRT}{P} = \frac{8.25 \text{ mol} \times 0.0821 \frac{\text{atm}\cdot\text{L}}{\text{mol}\cdot\text{K}} \times 296 \text{ K}}{0.942 \text{ atm}} = 213 \text{ L}$$

Check One way to check the answer is to compare it with the molar volume of an ideal gas at STP (22.4 L at 273.15 K and 1 atm). One mole of CO_2 at STP occupies about 22 L, so about 8 mol occupies $8 \times 22 = 176$ L. T is a little higher than 273 K and P is slightly lower than 1 atm, so V should be somewhat larger than 176 L.

Comment The main point here is that the stoichiometry provides one gas variable (n), two more are given (P and T), and the ideal gas law is used to find the fourth (V).

FOLLOW-UP PROBLEMS

5.12A Sulfuric acid reacts with sodium chloride to form aqueous sodium sulfate and hydrogen chloride gas. How many milliliters of gas form at STP when 0.117 kg of sodium chloride reacts with excess sulfuric acid?

5.12B Engineers use copper in absorbent beds to react with and remove oxygen impurities from ethylene that is used to make polyethylene. The beds are regenerated when hot H_2 reduces the copper(II) oxide, forming the pure metal and H_2O . On a laboratory scale, what volume of H_2 at 765 torr and 225°C is needed to reduce 35.5 g of copper(II) oxide?

SOME SIMILAR PROBLEMS 5.53 and 5.54

Road Map

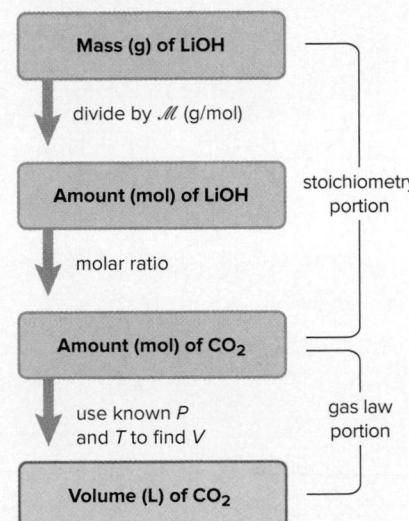

SAMPLE PROBLEM 5.13**Using Gas Variables to Find Amounts of Reactants or Products II****Chlorine gas reacting with potassium.**

Source: © McGraw-Hill Education/Stephen Frisch, photographer

Problem The alkali metals [Group 1A(1)] react with the halogens [Group 7A(17)] to form ionic metal halides. What mass of potassium chloride forms when 5.25 L of chlorine gas at 0.950 atm and 293 K reacts with 17.0 g of potassium (*see photo*)?

Plan The amounts of two reactants are given, so this is a limiting-reactant problem. The only difference between this and previous limiting-reactant problems (see Sample Problem 3.20) is that here we use the ideal gas law to find the amount (*n*) of gaseous reactant from the known *V*, *P*, and *T*. We first write the balanced equation and then use it to find the limiting reactant and the amount and mass of product.

Solution Writing the balanced equation:

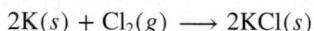

Summarizing the gas variables for $\text{Cl}_2(g)$:

$$\begin{array}{ll} P = 0.950 \text{ atm} & V = 5.25 \text{ L} \\ T = 293 \text{ K} & n = \text{unknown} \end{array}$$

Solving for n_{Cl_2} :

$$n_{\text{Cl}_2} = \frac{PV}{RT} = \frac{0.950 \text{ atm} \times 5.25 \text{ L}}{0.0821 \frac{\text{atm} \cdot \text{L}}{\text{mol} \cdot \text{K}} \times 293 \text{ K}} = 0.207 \text{ mol}$$

Converting from mass (g) of potassium (K) to amount (mol):

$$\text{Amount (mol) of K} = 17.0 \text{ g K} \times \frac{1 \text{ mol K}}{39.10 \text{ g K}} = 0.435 \text{ mol K}$$

Determining the limiting reactant: If Cl_2 is limiting,

$$\text{Amount (mol) of KCl} = 0.207 \text{ mol Cl}_2 \times \frac{2 \text{ mol KCl}}{1 \text{ mol Cl}_2} = 0.414 \text{ mol KCl}$$

If K is limiting,

$$\text{Amount (mol) of KCl} = 0.435 \text{ mol K} \times \frac{2 \text{ mol KCl}}{2 \text{ mol K}} = 0.435 \text{ mol KCl}$$

Cl_2 is the limiting reactant because it forms less KCl. Converting from amount (mol) of KCl to mass (g):

$$\text{Mass (g) of KCl} = 0.414 \text{ mol KCl} \times \frac{74.55 \text{ g KCl}}{1 \text{ mol KCl}} = 30.9 \text{ g KCl}$$

Check The gas law calculation seems correct. At STP, 22 L of Cl_2 gas contains about 1 mol, so a 5-L volume will contain a bit less than 0.25 mol of Cl_2 . Moreover, since *P* (in numerator) is slightly lower than STP, and *T* (in denominator) is slightly higher than STP, these should lower the calculated *n* further below the ideal value. The mass of KCl seems correct: less than 0.5 mol of KCl gives $<0.5 \text{ mol} \times \mathcal{M}$ ($\sim 75 \text{ g/mol}$), and 30.9 g $< 0.5 \text{ mol} \times 75 \text{ g/mol}$.

FOLLOW-UP PROBLEMS

5.13A Ammonia and hydrogen chloride gases react to form solid ammonium chloride. A 10.0-L reaction flask contains ammonia at 0.452 atm and 22°C, and 155 mL of hydrogen chloride gas at 7.50 atm and 271 K is introduced. After the reaction occurs and the temperature returns to 22°C, what is the pressure inside the flask? (Neglect the volume of the solid product.)

5.13B What volume of gaseous iodine pentafluoride, measured at 105°C and 0.935 atm, can be prepared by the reaction of 4.16 g of solid iodine with 2.48 L of gaseous fluorine at 18°C and 0.974 atm?

SOME SIMILAR PROBLEMS 5.55 and 5.56

› Summary of Section 5.4

- › Gas density is inversely related to temperature and directly related to pressure: higher T and lower P causes lower d , and vice versa. At the same P and T , gases with larger values of \mathcal{M} have higher values of d .
- › In a mixture of gases, each component contributes its partial pressure to the total pressure (Dalton's law of partial pressures). The mole fraction of each component is the ratio of its partial pressure to the total pressure.
- › When a gaseous reaction product is collected by bubbling it through water, the total pressure is the sum of the gas pressure and the vapor pressure of water at the given temperature.
- › By converting the variables P , V , and T for a gaseous reactant (or product) to amount (n , mol), we can solve stoichiometry problems for gaseous reactions.

5.5 THE KINETIC-MOLECULAR THEORY: A MODEL FOR GAS BEHAVIOR

The **kinetic-molecular theory** is the model that accounts for macroscopic gas behavior at the level of individual particles (atoms or molecules). Developed by some of the great scientists of the 19th century, most notably James Clerk Maxwell and Ludwig Boltzmann, the theory was able to explain the gas laws that some of the great scientists of the 18th century had arrived at empirically. The theory draws quantitative conclusions based on a few postulates (assumptions), but our discussion will be largely qualitative.

How the Kinetic-Molecular Theory Explains the Gas Laws

Let's address some questions the theory must answer, then state the postulates, and draw conclusions that explain the gas laws and related phenomena.

Questions Concerning Gas Behavior Observing gas behavior at the macroscopic level, we must derive a molecular model that explains it:

1. *Origin of pressure.* Pressure is a measure of the force a gas exerts on a surface. How do individual gas particles create this force?
2. *Boyle's law* ($V \propto 1/P$). A change in gas pressure in one direction causes a change in gas volume in the other. What happens to the particles when external pressure compresses the gas volume? And why aren't liquids and solids compressible?
3. *Dalton's law* ($P_{\text{total}} = P_1 + P_2 + P_3 + \dots$). The pressure of a gas mixture is the sum of the pressures of the individual gases. Why does each gas contribute to the total pressure in proportion to its number of particles?
4. *Charles's law* ($V \propto T$). A change in temperature causes a corresponding change in volume. What effect does higher temperature have on gas particles that increases gas volume? This question raises a more fundamental one: what does temperature measure on the molecular scale?
5. *Avogadro's law* ($V \propto n$). Gas volume depends on the number of moles present, not on the chemical nature of the gas. But shouldn't 1 mol of heavier particles exert more pressure, and thus take up more space, than 1 mol of lighter ones?

Postulates of the Kinetic-Molecular Theory The theory is based on three postulates:

Postulate 1. Particle volume. A gas consists of a large collection of individual particles with empty space between them. The volume of each particle is so small compared with the volume of the whole sample that it is assumed to be zero; each particle is essentially a point of mass.

Postulate 2. Particle motion. The particles are in constant, random, straight-line motion, except when they collide with the container walls or with each other.

Postulate 3. Particle collisions. The collisions are *elastic*, which means that, like minute billiard balls on a frictionless billiards table, the colliding molecules exchange energy but do not lose any energy through friction. Thus, *their total kinetic energy (E_k) is constant*. Between collisions, the molecules do not influence each other by attractive or repulsive forces.

Figure 5.14 Distribution of molecular speeds for N₂ at three temperatures.

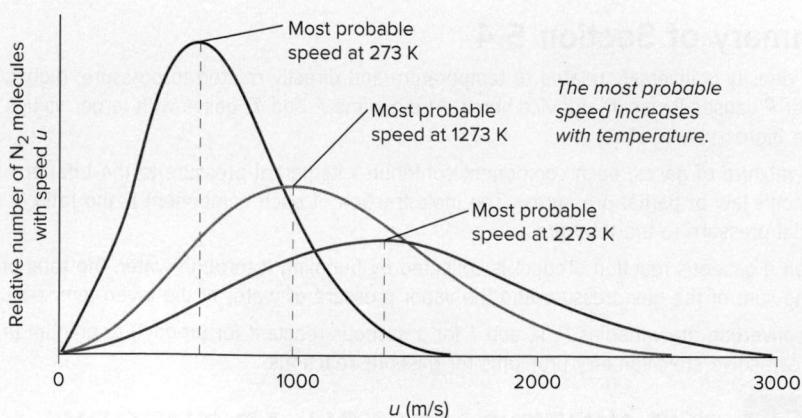

Imagine what a sample of gas in a container looks like. Countless minute particles move in every direction, smashing into the container walls and each other. Any given particle changes its speed often—at one moment standing still from a head-on collision and the next moment zooming away from a smash on the side.

In the sample as a whole, *each particle has a molecular speed (u); most are moving near the most probable speed, but some are much faster and others much slower*. Figure 5.14 depicts this distribution of molecular speeds for N₂ gas at three temperatures. Two observations can be made from the graph:

- the curves flatten and spread at higher temperatures
- the *most probable speed (the peak of each curve) increases as the temperature increases*.

The increase in most probable speed occurs because the average kinetic energy of the molecules, which is related to the most probable speed, is proportional to the absolute temperature:

$$\overline{E_k} \propto T \quad \text{or} \quad \overline{E_k} = c \times T$$

where $\overline{E_k}$ is the average kinetic energy of the molecules (an overbar indicates the average value of a quantity) and c is a constant that is the same for any gas. (We'll return to this equation shortly.) Thus, a major conclusion based on the distribution of speeds, which arises directly from postulate 3, is that *at a given temperature, all gases have the same average kinetic energy*.

A Molecular View of the Gas Laws Let's keep visualizing gas particles in a container to see how the theory explains the macroscopic behavior of gases and answers the questions we just posed:

1. *Origin of pressure* (Figure 5.15). From postulates 1 and 2, each gas particle (point of mass) colliding with the container walls (and bottom of piston) exerts a force. Countless collisions over the inner surface of the container result in a pressure. The greater the number of particles, the more frequently they collide with the container, and so the greater the pressure.

2. *Boyle's law ($V \propto 1/P$)* (Figure 5.16). The particles in a gas are points of mass with empty space between them (postulate 1). Before any change in pressure, the pressure exerted by the gas (P_{gas}) equals the pressure exerted on the gas (P_{ext}), and there is some average distance (d_1) between the particles and the container walls. As P_{ext} increases at constant temperature, the average distance (d_2) between the particles and the walls decreases (that is, $d_2 < d_1$), and so the sample volume decreases. Collisions of the particles with the walls become more frequent over the shorter average distance, which causes P_{gas} to increase until it again equals P_{ext} . The fact that liquids and solids cannot be compressed implies there is little, if any, free space between their particles.

Figure 5.15 Pressure arises from countless collisions between gas particles and walls.

Figure 5.16 A molecular view of Boyle's law.

3. Dalton's law of partial pressures ($P_{\text{total}} = P_A + P_B$) (Figure 5.17). Adding a given amount (mol) of gas A to a given amount of gas B causes an increase in the total number of particles, in proportion to the particles of A added. This increase causes a corresponding increase in the total number of collisions with the walls per second (postulate 2), which causes a corresponding increase in the total pressure of the gas mixture (P_{total}). Each gas exerts a fraction of P_{total} in proportion to its fraction of the total number of particles (or equivalently, its fraction of the total number of moles, that is, the mole fraction).

Figure 5.17 A molecular view of Dalton's law.

4. Charles's law ($V \propto T$) (Figure 5.18). At some starting temperature, T_1 , the external (atmospheric) pressure (P_{atm}) equals the pressure of the gas (P_{gas}). When the gas is heated and the temperature increases to T_2 , the most probable molecular speed and the average kinetic energy increase (postulate 3). Thus, the particles hit the walls more frequently and more energetically. This change temporarily increases P_{gas} . As a result, the piston moves up, which increases the volume and lowers the number of collisions with the walls until P_{atm} and P_{gas} are again equal.

Figure 5.18 A molecular view of Charles's law.

5. *Avogadro's law ($V \propto n$)* (Figure 5.19). At some starting amount, n_1 , of gas, P_{atm} equals P_{gas} . When more gas is added from the attached tank, the amount increases to n_2 . Thus, more particles hit the walls more frequently, which temporarily increases P_{gas} . As a result, the piston moves up, which increases the volume and lowers the number of collisions with the walls until P_{atm} and P_{gas} are again equal.

Figure 5.19 A molecular view of Avogadro's law.

The Central Importance of Kinetic Energy Recall from Chapter 1 that the kinetic energy of an object is the energy associated with its motion. This energy is key to explaining some implications of Avogadro's law and, most importantly, the meaning of temperature.

1. *Key implication of Avogadro's law.* As we just saw, Avogadro's law says that, at any given T and P , the volume of a gas depends only on the number of moles—that is, number of particles—in the sample. Notice that the law doesn't mention the chemical nature of the gas, so equal numbers of particles of any two gases, say O_2 and H_2 , should occupy the same volume. But why don't the heavier O_2 molecules, which strike the container walls with more force than the lighter H_2 molecules, exert more pressure and thus take up more volume? To answer this, we'll use three important relationships, the third of which you've already seen:

- *Molecular speed.* Figure 5.20 shows that, for several gases at a particular temperature, the most probable molecular speed (top of the curve) increases as the molar mass (number in parentheses) decreases: *lighter molecules move faster, on average, than heavier molecules.*
- *Kinetic energy.* One way to express kinetic energy mathematically is

$$E_k = \frac{1}{2} \text{mass} \times \text{speed}^2$$

This equation means that, for a given E_k , an object's mass and speed are inversely related: *a heavy object moving slower can have the same kinetic energy as a light object moving faster.*

- *Postulate 3 of the kinetic-molecular theory.* Recall that this postulate implies that, *at a given T , all gases have the same average kinetic energy.*

Figure 5.20 The relationship between molar mass and molecular speed.

Their higher most probable speed means that H₂ molecules collide with the walls of a container more often than O₂ molecules do, but their lower mass means that each collision has less force. Therefore, because the molecules of any gas hit the walls with the same kinetic energy, *at a given T, equimolar samples of any gases exert the same pressure (force per unit area) and, thus, occupy the same volume.*

2. The meaning of temperature. Closely related to these ideas is the central relation between kinetic energy and temperature. Earlier we saw that the average kinetic energy of the particles (\bar{E}_k) equals the absolute temperature times a constant; that is, $\bar{E}_k = c \times T$. The definitions of velocity, momentum, force, and pressure let us express this relationship as the following equation (although we won't derive it):

$$\bar{E}_k = \frac{3}{2} \left(\frac{R}{N_A} \right) T$$

where R is the gas constant and N_A is the symbol for Avogadro's number. This equation makes the essential point that *temperature is a measure of the average kinetic energy of the particles*: as T goes up, \bar{E}_k increases, and as T goes down, \bar{E}_k decreases. Temperature is an intensive property (Section 1.4), so it is not related to the *total* energy of motion of the particles, which depends on the size of the sample, but to the *average* energy.

Thus, for example, in the macroscopic world, we heat a beaker of water over a flame and see the mercury rise inside a thermometer in the beaker. We see this because, in the molecular world, kinetic energy transfers, in turn, from higher energy gas particles in the flame to lower energy particles in the beaker glass, the water molecules, the particles in the thermometer glass, and the atoms of mercury.

Root-Mean-Square Speed Finally, let's derive an expression for the speed of a gas particle that has the average kinetic energy of the particles in a sample. From the general expression for kinetic energy of an object,

$$E_k = \frac{1}{2} \text{mass} \times \text{speed}^2$$

the average kinetic energy of each particle in a large population is

$$\bar{E}_k = \frac{1}{2} m \bar{u}^2$$

where m is the particle's mass (atomic or molecular) and \bar{u}^2 is the average of the squares of the molecular speeds. Setting this expression for average kinetic energy equal to the earlier one gives

$$\frac{1}{2} m \bar{u}^2 = \frac{3}{2} \left(\frac{R}{N_A} \right) T$$

Multiplying through by Avogadro's number, N_A , gives the average kinetic energy for a mole of gas particles:

$$\frac{1}{2} N_A m \bar{u}^2 = \frac{3}{2} R T$$

Avogadro's number times the molecular mass, $N_A \times m$, is the molar mass, \mathcal{M} , and solving for \bar{u}^2 , we have

$$\bar{u}^2 = \frac{3RT}{\mathcal{M}}$$

The square root of \bar{u}^2 is the root-mean-square speed, or **rms speed** (u_{rms}): *a particle moving at this speed has the average kinetic energy.** That is, taking the square root of both sides of the previous equation gives

$$u_{\text{rms}} = \sqrt{\frac{3RT}{\mathcal{M}}} \quad (5.13)$$

where R is the gas constant, T is the absolute temperature, and \mathcal{M} is the molar mass. (Because we want u in m/s and R includes the joule, which has units of kg·m²/s², we use the value 8.314 J/mol·K for R and express \mathcal{M} in kg/mol.)

*The rms speed, u_{rms} , is proportional to, but slightly higher than, the most probable speed; for an ideal gas, $u_{\text{rms}} = 1.09 \times$ average speed.

Thus, as an example, the root-mean-square speed of an O₂ molecule ($\mathcal{M} = 3.200 \times 10^{-2}$ kg/mol) at room temperature (20°C, or 293 K) in the air you're breathing right now is

$$\begin{aligned} u_{\text{rms}} &= \sqrt{\frac{3RT}{\mathcal{M}}} = \sqrt{\frac{3(8.314 \text{ J/mol}\cdot\text{K})(293 \text{ K})}{3.200 \times 10^{-2} \text{ kg/mol}}} \\ &= \sqrt{\frac{3(8.314 \text{ kg}\cdot\text{m}^2/\text{s}^2\cdot\text{mol}\cdot\text{K})(293 \text{ K})}{3.200 \times 10^{-2} \text{ kg/mol}}} \\ &= 478 \text{ m/s (about 1070 mi/hr)} \end{aligned}$$

Effusion and Diffusion

The movement of a gas into a vacuum and the movement of gases through one another are phenomena with some vital applications.

Figure 5.21 Effusion. Lighter (black) particles effuse faster than heavier (red) particles.

The Process of Effusion One of the early triumphs of the kinetic-molecular theory was an explanation of **effusion**, the process by which a gas escapes through a tiny hole in its container into an evacuated space. In 1846, Thomas Graham studied the effusion rate of a gas, the number of molecules escaping per unit time, and found that it was inversely proportional to the square root of the gas density. But, density is directly related to molar mass, so **Graham's law of effusion** is stated as follows: *the rate of effusion of a gas is inversely proportional to the square root of its molar mass*, or

$$\text{Rate of effusion} \propto \frac{1}{\sqrt{\mathcal{M}}}$$

From Equation 5.13, we see that, at a given temperature and pressure, a gas with a lower molar mass has a greater rms speed than a gas with a higher molar mass; *since the rms speed of its atoms is higher, more atoms of the lighter gas reach the hole and escape per unit time* (Figure 5.21). At constant T , the ratio of the effusion rates of two gases, A and B, is

$$\frac{\text{Rate}_A}{\text{Rate}_B} = \frac{u_{\text{rms of } A}}{u_{\text{rms of } B}} = \frac{\sqrt{3RT/\mathcal{M}_A}}{\sqrt{3RT/\mathcal{M}_B}} = \frac{\sqrt{\mathcal{M}_B}}{\sqrt{\mathcal{M}_A}} = \sqrt{\frac{\mathcal{M}_B}{\mathcal{M}_A}} \quad (5.14)$$

Graham's law can be used to determine the molar mass of an unknown gas. By comparing the effusion rate of gas X with that of a known gas, such as He, we can solve for the molar mass of X:

$$\frac{\text{Rate}_X}{\text{Rate}_{\text{He}}} = \sqrt{\frac{\mathcal{M}_{\text{He}}}{\mathcal{M}_X}}$$

Squaring both sides and solving for the molar mass of X gives

$$\mathcal{M}_X = \mathcal{M}_{\text{He}} \times \left(\frac{\text{rate}_{\text{He}}}{\text{rate}_X} \right)^2$$

SAMPLE PROBLEM 5.14

Applying Graham's Law of Effusion

Problem A mixture of helium (He) and methane (CH₄) is placed in an effusion apparatus.

- (a) Calculate the ratio of the effusion rates of the two gases. (b) If it takes 7.55 min for a given volume of CH₄ to effuse from the apparatus, how long will it take for the same volume of He to effuse?

Plan (a) The effusion rate is inversely proportional to $\sqrt{\mathcal{M}}$, so we find the molar mass of each substance from the formula and take its square root. The inverse of the ratio of the square roots is the ratio of the effusion rates. (b) Once we know the ratio of effusion rates, we can apply that ratio to the time.

Solution (a) \mathcal{M} of $\text{CH}_4 = 16.04 \text{ g/mol}$ \mathcal{M} of He = 4.003 g/mol

Calculating the ratio of the effusion rates:

$$\frac{\text{Rate}_{\text{He}}}{\text{Rate}_{\text{CH}_4}} = \sqrt{\frac{\mathcal{M}_{\text{CH}_4}}{\mathcal{M}_{\text{He}}}} = \sqrt{\frac{16.04 \text{ g/mol}}{4.003 \text{ g/mol}}} = \sqrt{4.007} = 2.002$$

A ratio of 2.002 indicates that He atoms effuse a bit more than twice as fast as CH_4 molecules under the same conditions.

(b) Since He atoms effuse twice as fast as CH_4 molecules, a volume of He will effuse in half the time it takes for an equal volume of CH_4 :

$$\frac{7.55 \text{ min}}{2.002} = 3.77 \text{ min}$$

Check A ratio greater than 1 makes sense because the lighter He should effuse faster than the heavier CH_4 . Because the molar mass of CH_4 is about four times the molar mass of He, He should effuse about twice as fast as CH_4 ($\sqrt{4}$) and therefore take half as long for a given volume to effuse from the apparatus.

FOLLOW-UP PROBLEMS

5.14A If it takes 1.25 min for 0.010 mol of He to effuse, how long will it take for the same amount of ethane (C_2H_6) to effuse?

5.14B If 7.23 mL of an unknown gas effuses in the same amount of time as 13.8 mL of argon under the same conditions, what is the molar mass of the unknown gas?

SOME SIMILAR PROBLEMS 5.75, 5.76, 5.79, and 5.80

A Key Application of Effusion: Preparation of Nuclear Fuel By far the most important application of Graham's law is in the preparation of fuel for nuclear energy reactors. The process of *isotope enrichment* increases the proportion of fissionable, but rarer, ^{235}U (only 0.7% by mass of naturally occurring uranium) relative to the nonfissionable, more abundant ^{238}U (99.3% by mass). Because the two isotopes have identical chemical properties, they are extremely difficult to separate chemically. But, one way to separate them takes advantage of a difference in a physical property—the effusion rate of gaseous compounds. Uranium ore is treated with fluorine to yield a gaseous mixture of $^{238}\text{UF}_6$ and $^{235}\text{UF}_6$ that is pumped through a series of chambers separated by porous barriers. Molecules of $^{235}\text{UF}_6$ are slightly lighter ($\mathcal{M} = 349.03$) than molecules of $^{238}\text{UF}_6$ ($\mathcal{M} = 352.04$), so they move slightly faster and effuse through each barrier 1.0043 times faster. Many passes must be made, each one increasing the fraction of $^{235}\text{UF}_6$, until the mixture obtained is 3–5% by mass $^{235}\text{UF}_6$. This process was developed during the latter years of World War II and produced enough ^{235}U for two of the world's first atomic bombs. Today, a less expensive centrifuge process is used more often. The ability to enrich uranium has become a key international concern, as more countries aspire to develop nuclear energy and nuclear arms.

The Process of Diffusion Closely related to effusion is the process of gaseous diffusion, the movement of one gas (or fluid) through another (for example, the movement of gaseous molecules from perfume through air). Diffusion rates are also described generally by Graham's law:

$$\text{Rate of diffusion} \propto \frac{1}{\sqrt{\mathcal{M}}}$$

For two gases at equal pressures, such as NH_3 and HCl , moving through another gas or a mixture of gases, such as air, we find

$$\frac{\text{Rate}_{\text{NH}_3}}{\text{Rate}_{\text{HCl}}} = \sqrt{\frac{\mathcal{M}_{\text{HCl}}}{\mathcal{M}_{\text{NH}_3}}}$$

The reason for this dependence on molar mass is the same as for effusion rates: *lighter molecules have higher average speeds than heavier molecules, so they move farther in a given time*.

Figure 5.22 Diffusion of gases. Different gases (black, from the left, and green, from the right) move through each other in a tube and mix. For simplicity, the complex path of only one black particle is shown (in red). In reality, all the particles have similar paths.

If gas molecules move at hundreds of meters per second (see Figure 5.14), why does it take a second or two after you open a bottle of perfume to smell it? Although convection plays an important role in this process, another reason for the time lag is that a gas particle does not travel very far before it collides with another particle (Figure 5.22). Thus, a perfume molecule travels slowly because it collides with countless molecules in the air. The presence of so many other particles means that *diffusion rates are much lower than effusion rates*. Think about how quickly you could walk through an empty room compared to a room crowded with other moving people.

Diffusion also occurs when a gas enters a liquid (and even to a small extent a solid). However, the average distances between molecules are so much shorter in a liquid that collisions are much more frequent; thus, diffusion of a gas through a liquid is *much* slower than through a gas. Nevertheless, this type of diffusion is a vital process in biological systems, for example, in the movement of O₂ from lungs to blood.

The Chaotic World of Gases: Mean Free Path and Collision Frequency

Refinements of the basic kinetic-molecular theory provide a view into the chaotic molecular world of gases. Try to visualize an “average” N₂ molecule in the room you are in now. It is continually changing speed as it collides with other molecules—at one instant, going 2500 mi/h, and at another, standing still. But these extreme speeds are *much* less likely than the most probable one and those near it (see Figure 5.14). At 20°C and 1 atm pressure, the N₂ molecule is hurtling at an average speed of 470 m/s (rms speed = 510 m/s), or nearly 1100 mi/h!

Mean Free Path From a particle’s diameter, we can obtain the **mean free path**, the average distance it travels between collisions at a given temperature and pressure. The N₂ molecule (3.7×10⁻¹⁰ m in diameter) has a mean free path of 6.6×10⁻⁸ m, which means it travels an average of 180 molecular diameters before smashing into a fellow traveler. (An N₂ molecule the size of a billiard ball would travel an average of about 30 ft before hitting another molecule.) Therefore, even though gas molecules are *not* points of mass, it is still valid to assume that a gas sample *is* nearly all empty space. Mean free path is a key factor in the rate of diffusion and the rate of heat flow through a gas.

Collision Frequency Divide the most probable speed (meters per second) by the mean free path (meters per collision) and you obtain the **collision frequency**, the average number of collisions per second that each particle undergoes, whether with another particle or with the container. As you can see, the N₂ molecule experiences, on average, an enormous number of collisions every second: ↪

$$\text{Collision frequency} = \frac{4.7 \times 10^2 \text{ m/s}}{6.6 \times 10^{-8} \text{ m/collision}} = 7.0 \times 10^9 \text{ collision/s}$$

Distribution of speed (and kinetic energy) and collision frequency are essential ideas for understanding the speed of a reaction, as you’ll see in Chapter 16. And, as the Chemical Connections essay below shows, many of the concepts we’ve discussed so far apply directly to our planet’s atmosphere.

Danger in a Molecular Amusement Park

To really appreciate the astounding events in the molecular world, let’s use a two-dimensional analogy to compare the N₂ molecule moving in air at 1 atm with a bumper car you are driving in an enormous amusement park ride. To match the collision frequency of the N₂ molecule, you would need to be traveling 2.8 billion mi/s (4.5 billion km/s, much faster than the speed of light!) and would smash into another bumper car every 700 yd (640 m).

An atmosphere is the envelope of gases that extends continuously from a planet's surface outward, thinning gradually until it is identical with outer space. A sample of clean, dry air at sea level on Earth contains 18 gases (Table B5.1). Under standard conditions, they behave nearly ideally, so volume percent equals mole percent (Avogadro's law), and the mole fraction of a component relates directly to its partial pressure (Dalton's law). Let's see how the gas laws and kinetic-molecular theory apply to our atmosphere, first with regard to variations in pressure and temperature, and then as explanations of some very familiar phenomena.

The Smooth Variation in Pressure with Altitude

Because gases are compressible (Boyle's law), the pressure of the atmosphere increases smoothly as we approach Earth's surface, with a more rapid increase at lower altitudes (Figure B5.1, left). No boundary delineates the beginning of the atmosphere from the end of outer space, but the densities and compositions are identical at an altitude of about 10,000 km (6000 mi). Yet, about 99% of the atmosphere's mass lies within 30 km (almost 19 mi) of the surface, and 75% lies within the lowest 11 km (almost 7 mi).

Table B5.1 Composition of Clean, Dry Air at Sea Level

Component	Mole Fraction
Nitrogen (N_2)	0.78084
Oxygen (O_2)	0.20946
Argon (Ar)	0.00934
Carbon dioxide (CO_2)	0.00040
Neon (Ne)	1.818×10^{-5}
Helium (He)	5.24×10^{-6}
Methane (CH_4)	2×10^{-6}
Krypton (Kr)	1.14×10^{-6}
Hydrogen (H_2)	5×10^{-7}
Dinitrogen monoxide (N_2O)	5×10^{-7}
Carbon monoxide (CO)	1×10^{-7}
Xenon (Xe)	8×10^{-8}
Ozone (O_3)	2×10^{-8}
Ammonia (NH_3)	6×10^{-9}
Nitrogen dioxide (NO_2)	6×10^{-9}
Nitrogen monoxide (NO)	6×10^{-10}
Sulfur dioxide (SO_2)	2×10^{-10}
Hydrogen sulfide (H_2S)	2×10^{-10}

The Zig-Zag Variation in Temperature with Altitude

Unlike pressure, temperature does *not* change smoothly with altitude above Earth's surface. The atmosphere is classified into regions based on the direction of temperature change, and we'll start at the surface (Figure B5.1, right).

1. *The troposphere.* In the troposphere, which extends from the surface to between 7 km (23,000 ft) at the poles and 17 km (60,000 ft) at the equator, the temperature drops 7°C per kilometer to -55°C (218 K). This region contains about 80% of the total mass of the atmosphere, with 50% of the mass in the lower 5.6 km (18,500 ft). All weather occurs in this region, and nearly all, except supersonic, aircraft fly within it.

(continued)

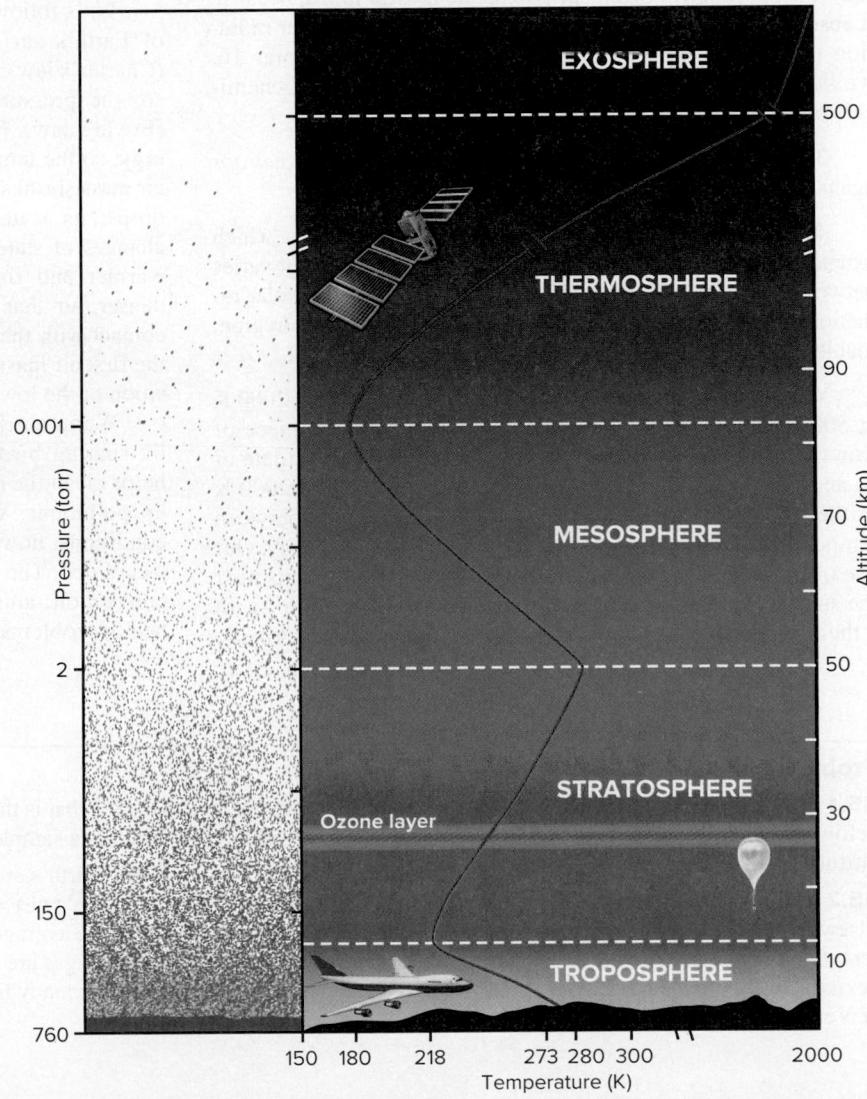

Figure B5.1 Variations in pressure and temperature with altitude in Earth's atmosphere.

2. The stratosphere and the ozone layer. In the stratosphere, the temperature rises from -55°C to about 7°C (280 K) at 50 km. This rise is due to a variety of complex reactions, mostly involving ozone (O_3), another molecular form of oxygen, which are initiated by the absorption of solar radiation. Most high-energy radiation is absorbed by upper levels of the atmosphere, but some that reaches the stratosphere breaks O_2 into O atoms. The energetic O atoms collide with more O_2 to form O_3 :

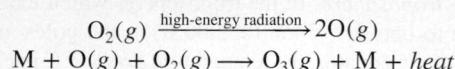

where M is any particle that can carry away excess energy. This reaction releases heat, which is why stratospheric temperatures increase with altitude. Over 90% of atmospheric ozone remains in a thin layer within the stratosphere, its thickness varying both geographically (greatest at the poles) and seasonally (greatest in spring in the northern hemisphere and in fall in the southern). Stratospheric ozone is vital to life because it absorbs over 95% of the harmful ultraviolet (UV) solar radiation that would otherwise reach the surface. In Chapter 16, we'll discuss the destructive effect of certain industrial chemicals on the ozone layer.

3. The mesosphere. In the mesosphere, the temperature drops again to -93°C (180 K) at around 80 km.

4. The outer atmosphere. Within the *thermosphere*, which extends to around 500 km, the temperature rises again, but varies between 700 and 2000 K, depending on the intensity of solar radiation and sunspot activity. The *exosphere*, the outermost region, maintains these temperatures and merges with outer space.

What does it actually mean to have a temperature of 2000 K at 500 km (300 mi) above Earth's surface? Would a piece of iron (melting point = 1808 K) glow red-hot within a minute or so and melt in the thermosphere, as it does if heated to 2000 K in the troposphere? The answer involves the relation between temperature and the time it takes to transfer kinetic energy. Our use of the words "hot" and "cold" refers to measurements near the surface. There, the collision frequency of gas particles with a thermometer is enormous, and so the transfer of their kinetic

energy is very fast. But, at an altitude of 500 km, where the density of gas particles is a million times *less*, collision frequency is extremely low, and a thermometer, or any object, experiences *very slow transfer of kinetic energy*. Thus, the object would not become "hot" in the usual sense in any reasonable time. But the high-energy solar radiation that is transferred to the few particles present in these regions makes their average kinetic energy extremely high, as indicated by the high absolute temperature.

Convection in the Lower Atmosphere

Why must you take more breaths per minute on a high mountain-top than at sea level? Because at the higher elevation, there is a smaller *amount* of O_2 in each breath. However, the *proportion* (mole percent) of O_2 throughout the lower atmosphere remains about 21%. This uniform composition arises from *vertical (convective) mixing*, and the gas laws explain how it occurs.

Let's follow an air mass from ground level, as solar heating of Earth's surface warms it. The warmer air mass expands (Charles's law), which makes it less dense, so it rises. As it does so, the pressure on it decreases, making it expand further (Boyle's law). Pushing against the surrounding air requires energy, so the temperature of the air mass decreases and thus the air mass shrinks slightly (Charles's law). But, as its temperature drops, its water vapor condenses (or solidifies), and these changes of state release heat; therefore, the air mass becomes warmer and rises further. Meanwhile, the cooler, and thus denser, air that was above it sinks, becomes warmer through contact with the surface, and goes through the same process as the first air mass. As a result of this vertical mixing, the composition of the lower atmosphere remains uniform.

Warm air rising from the ground, called a *thermal*, is used by soaring birds and glider pilots to stay aloft. Convection helps clean the air in urban areas, because the rising air carries up pollutants, which are dispersed by winds. Under certain conditions, however, a warm air mass remains stationary over a cool one. The resulting *temperature inversion* blocks normal convection, and harmful pollutants build up, causing severe health problems.

Problems

B5.1 Suggest a reason why supersonic aircraft are kept well below their maximum speeds until they reach their highest altitudes.

B5.2 Gases behave nearly ideally under Earth's conditions. Elsewhere in the Solar System, however, conditions are very different. On which planet would you expect atmospheric gases to deviate most from ideal behavior, Saturn (4×10^6 atm and 130 K) or Venus (90 atm and 730 K)? Explain.

B5.3 What is the volume percent and partial pressure (in torr) of argon in a sample of dry air at sea level?

B5.4 Earth's atmosphere is estimated to have a mass of 5.14×10^{15} t (1 t = 1000 kg).

(a) If the average molar mass of air is 28.8 g/mol, how many moles of gas are in the atmosphere?

(b) How many liters would the atmosphere occupy at 25°C and 1 atm?

› Summary of Section 5.5

- › The kinetic-molecular theory postulates that gas particles have no volume, move in random, straight-line paths between elastic (energy-conserving) collisions, and have average kinetic energies proportional to the absolute temperature of the gas.
- › This theory explains the gas laws in terms of changes in distances between particles and the container walls, changes in molecular speed, and the energy of collisions.
- › Temperature is a measure of the average kinetic energy of the particles.
- › Effusion and diffusion rates are *inversely* proportional to the square root of the molar mass (Graham's law) because they are *directly* proportional to molecular speed.
- › Molecular motion is characterized by a temperature-dependent, most probable speed (within a range of speeds), which affects mean free path and collision frequency.
- › The atmosphere is a complex mixture of gases that exhibits variations in pressure and temperature with altitude. High temperatures in the upper atmosphere result from absorption of high-energy solar radiation. The lower atmosphere has a uniform composition as a result of convective mixing.

5.6 REAL GASES: DEVIATIONS FROM IDEAL BEHAVIOR

A fundamental principle of science is that simpler models are more useful than complex ones, as long as they explain the data. With only a few postulates, the kinetic-molecular theory explains the behavior of most gases under ordinary conditions of temperature and pressure. But, two of the postulates are useful approximations that do not reflect reality:

1. *Gas particles are not points of mass with zero volume* but have volumes determined by the sizes of their atoms and the lengths and directions of their bonds.
2. *Attractive and repulsive forces do exist among gas particles* because atoms contain charged subatomic particles and many substances are polar. (As you'll see in Chapter 12, such forces lead to changes of physical state.)

These two features cause deviations from ideal behavior under *extreme conditions of low temperature and high pressure*. These deviations mean that we must alter the simple model and the ideal gas law to predict the behavior of real gases.

Effects of Extreme Conditions on Gas Behavior

At ordinary conditions—relatively high temperatures and low pressures—most real gases exhibit nearly ideal behavior. Yet, even at STP (0°C and 1 atm), gases deviate *slightly* from ideal behavior. Table 5.3 shows that the standard molar volumes of several gases, when measured to five significant figures, do not equal the ideal value of 22.414 L/mol. Note that gases with higher boiling points exhibit greater deviations.

The phenomena that cause slight deviations under standard conditions exert more influence as temperature decreases and pressure increases. Figure 5.23 on the next page shows a plot of PV/RT versus external pressure (P_{ext}) for 1 mol of several real gases and an ideal gas. The PV/RT values range from normal (at $P_{\text{ext}} = 1$ atm, $PV/RT = 1$) to very high (at $P_{\text{ext}} \approx 1000$ atm, $PV/RT \approx 1.6$ to 2.3). For the *ideal* gas, PV/RT is 1 at any P_{ext} .

The PV/RT curve for methane (CH_4) is typical of most gases: it decreases *below* the ideal value at moderately high P_{ext} and then rises *above* the ideal value as P_{ext} increases to very high values. This shape arises from two overlapping effects:

- At moderately high P_{ext} , PV/RT values are lower than ideal values (less than 1) because of *interparticle attractions*.
- At very high P_{ext} , PV/RT values are greater than ideal values (more than 1) because of *particle volume*.

Molar Volume of Some Common Gases at STP (0°C and 1 atm)

Table 5.3

Gas	Molar Volume (L/mol)	Boiling Point (°C)
He	22.435	-268.9
H ₂	22.432	-252.8
Ne	22.422	-246.1
Ideal gas	22.414	—
Ar	22.397	-185.9
N ₂	22.396	-195.8
O ₂	22.390	-183.0
CO	22.388	-191.5
Cl ₂	22.184	-34.0
NH ₃	22.079	-33.4

Figure 5.23 Deviations from ideal behavior with increasing external pressure. The horizontal line shows that, for 1 mol of ideal gas, $PV/RT = 1$ at all P_{ext} . At very high P_{ext} , real gases deviate significantly from ideal behavior, but small deviations appear even at ordinary pressures (expanded portion).

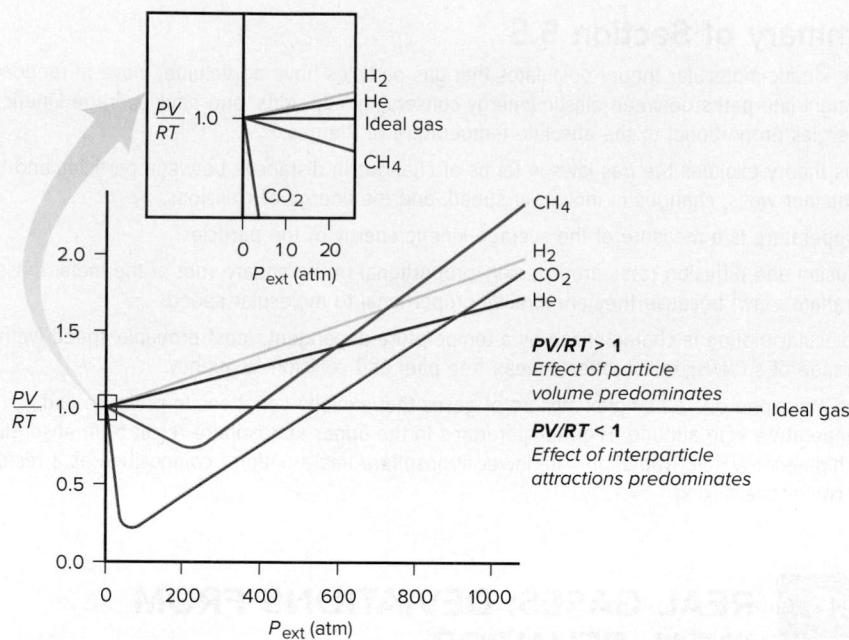

Let's examine these effects on the molecular level:

1. *Effect of interparticle attractions.* Interparticle attractions occur between separate atoms or molecules and are caused by imbalances in electron distributions. They are important only over very short distances and are *much* weaker than the covalent bonding forces that hold a molecule together. At normal P_{ext} , the spaces between the particles are so large that attractions between the gas particles are negligible and the gas behaves nearly ideally. As conditions of pressure and temperature become more extreme, however, the interparticle attractions become more important:

- *High pressure.* As P_{ext} rises, the volume of the sample decreases and the particles get closer together, so interparticle attractions have a greater effect. As a particle approaches the container wall under these higher pressures, nearby particles attract it, which lessens the force of its impact (Figure 5.24). *Repeated throughout the sample, this effect results in decreased gas pressure and, thus, a smaller numerator in PV/RT.*
- *Low temperature.* Lowering the temperature slows the particles, so they attract each other for a longer time. (As you'll see in Chapter 12, given a low enough temperature,

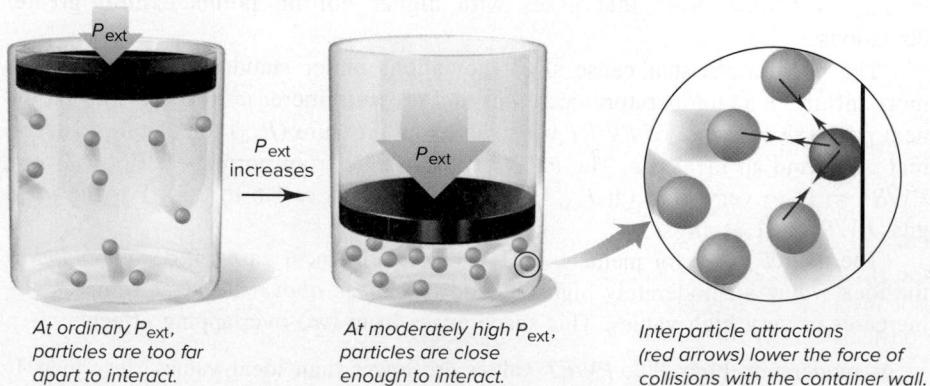

Figure 5.24 The effect of interparticle attractions on measured gas pressure.

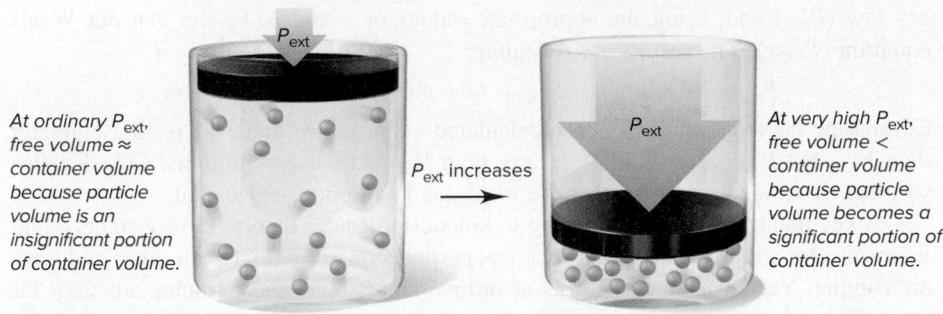

Figure 5.25 The effect of particle volume on measured gas volume.

the interparticle attractions cause the gas particles to lose enough kinetic energy that they condense to a liquid.)

2. *Effect of particle volume.* At normal P_{ext} , the space between particles (free volume) is enormous compared with the volume of the particles *themselves* (particle volume); thus, the free volume is essentially equal to V , the container volume in PV/RT . At *moderately* high P_{ext} and as free volume decreases, the particle volume makes up an increasing proportion of the container volume (Figure 5.25). At *extremely* high pressures, the space taken up by the particles themselves makes the free volume significantly *less* than the container volume. Nevertheless, we continue to use the container volume for V in PV/RT , which causes the numerator, and thus the ratio, to become artificially high. This particle volume effect increases as P_{ext} increases, eventually outweighing the effect of interparticle attractions and causing PV/RT to rise above the ideal value.

In Figure 5.23, note that the H_2 and He curves do not show the typical dip at moderate pressures. These gases consist of particles with such weak interparticle attractions that the particle volume effect predominates at all pressures.

The van der Waals Equation: Adjusting the Ideal Gas Law

To describe real gas behavior more accurately, we need to adjust the ideal gas equation in two ways:

1. Adjust P *up* by adding a factor that accounts for interparticle attractions.
2. Adjust V *down* by subtracting a factor that accounts for particle volume.

In 1873, Johannes van der Waals revised the ideal gas equation to account for the behavior of real gases. The **van der Waals equation** for n moles of a real gas is

$$\left(P + \frac{n^2 a}{V^2} \right) (V - nb) = nRT \quad (5.15)$$

adjusts adjusts
 P up V down

where P is the measured pressure, V is the known container volume, n and T have their usual meanings, and a and b are **van der Waals constants**, experimentally determined and specific for a given gas (Table 5.4). The constant a depends on the number and distribution of electrons, which relates to the complexity of a particle and the strength of its interparticle attractions. The constant b relates to particle volume. For instance, CO_2 is both more complex and larger than H_2 , and the values of their constants reflect this.

Here is a typical application of the van der Waals equation. A 1.98-L vessel contains 215 g (4.89 mol) of dry ice. After standing at 26°C (299 K), the $\text{CO}_2(s)$ changes to $\text{CO}_2(g)$. The pressure is measured (P_{real}) and then calculated by the ideal

Values of the van der Waals Constants for Some Common Gases

Table 5.4

Gas	$a \left(\frac{\text{atm} \cdot \text{L}^2}{\text{mol}^2} \right)$	$b \left(\frac{\text{L}}{\text{mol}} \right)$
He	0.034	0.0237
Ne	0.211	0.0171
Ar	1.35	0.0322
Kr	2.32	0.0398
Xe	4.19	0.0511
H_2	0.244	0.0266
N_2	1.39	0.0391
O_2	1.36	0.0318
Cl_2	6.49	0.0562
CH_4	2.25	0.0428
CO	1.45	0.0395
CO_2	3.59	0.0427
NH_3	4.17	0.0371
H_2O	5.46	0.0305

gas law (P_{IGL}) and, using the appropriate values of a and b , by the van der Waals equation (P_{VDW}). The results are revealing:

$$P_{\text{real}} = 44.8 \text{ atm} \quad P_{\text{IGL}} = 60.6 \text{ atm} \quad P_{\text{VDW}} = 45.9 \text{ atm}$$

Comparing the real value with each calculated value shows that P_{IGL} is 35.3% greater than P_{real} , but P_{VDW} is only 2.5% greater than P_{real} . At these conditions, CO_2 deviates so much from ideal behavior that the ideal gas law is not very useful.

A key point to realize: According to kinetic-molecular theory, the constants a and b are zero for an ideal gas because the gas particles do not attract each other and have no volume. Yet, even in a real gas at ordinary pressures, the particles are very far apart. This large average interparticle distance has two consequences:

- Attractive forces are minuscule, so $P + \frac{n^2 a}{V^2} \approx P$.
- The particle volume is a minute fraction of the container volume, so $V - nb \approx V$

Therefore, *at ordinary conditions, the van der Waals equation becomes the ideal gas equation.*

Student Hot Spot

Student data indicate that you may struggle with the van der Waals equation. Access the Smartbook to view additional Learning Resources on this topic.

› Summary of Section 5.6

- › At very high P or low T , all gases deviate significantly from ideal behavior.
- › As external pressure increases, most real gases exhibit first a lower and then a higher PV/RT ; for 1 mol of an ideal gas, this ratio remains constant at 1.
- › The deviations from ideal behavior are due to (1) attractions between particles, which lower the pressure (and decrease PV/RT), and (2) the volume of the particles themselves, which takes up an increasingly larger fraction of the container volume (and increases PV/RT).
- › The van der Waals equation includes constants specific for a given gas to correct for deviations from ideal behavior. At ordinary P and T , the van der Waals equation reduces to the ideal gas equation.

CHAPTER REVIEW GUIDE

Learning Objectives

Relevant section (§) and/or sample problem (SP) numbers appear in parentheses.

Understand These Concepts

1. How gases differ in their macroscopic properties from liquids and solids (§5.1)
2. The meaning of pressure and the operation of a barometer and a manometer (§5.2)
3. The relations among gas variables expressed by Boyle's, Charles's, and Avogadro's laws (§5.3)
4. How the individual gas laws are incorporated into the ideal gas law (§5.3)
5. How the ideal gas law can be used to study gas density, molar mass, and amounts of gases in reactions (§5.4)
6. The relation between the density and the temperature and pressure of a gas (§5.4)
7. The meaning of Dalton's law and the relation between partial pressure and mole fraction of a gas; how Dalton's law applies to collecting a gas over water (§5.4)
8. How the postulates of the kinetic-molecular theory are applied to explain the origin of pressure and the gas laws (§5.5)
9. The relations among molecular speed, average kinetic energy, and temperature (§5.5)
10. The meanings of *effusion* and *diffusion* and how their rates are related to molar mass (§5.5)
11. The relations among mean free path, molecular speed, and collision frequency (§5.5)

12. Why interparticle attractions and particle volume cause gases to deviate from ideal behavior at low temperatures and high pressures (§5.6)
13. How the van der Waals equation corrects the ideal gas law for extreme conditions (§5.6)

Master These Skills

1. Interconverting among the units of pressure (atm, mmHg, torr, kPa) (SP 5.1)
2. Reducing the ideal gas law to the individual gas laws (SPs 5.2–5.6)
3. Applying gas laws to choose the correct balanced chemical equation (SP 5.7)
4. Rearranging the ideal gas law to calculate gas density (SP 5.8) and molar mass of a volatile liquid (SP 5.9)
5. Calculating the mole fraction and the partial pressure of a gas in a mixture (SP 5.10)
6. Using the vapor pressure of water to correct for the amount of a gas collected over water (SP 5.11)
7. Applying stoichiometry and gas laws to calculate amounts of reactants and products (SPs 5.12, 5.13)
8. Using Graham's law to solve problems involving gaseous effusion (SP 5.14)

Key Terms

Page numbers appear in parentheses.

atmosphere (239)	diffusion (237)	millimeter of mercury (mmHg) (209)	standard molar volume (215)
Avogadro's law (214)	effusion (236)	mole fraction (X) (226)	standard temperature and pressure (STP) (215)
barometer (208)	Graham's law of effusion (236)	partial pressure (225)	torr (209)
Boyle's law (212)	ideal gas (211)	pascal (Pa) (209)	universal gas constant (R) (216)
Charles's law (213)	ideal gas law (216)	pressure (P) (207)	van der Waals constants (243)
collision frequency (238)	kinetic-molecular theory (231)	rms speed (u_{rms}) (235)	van der Waals equation (243)
Dalton's law of partial pressures (225)	manometer (208)	standard atmosphere (atm) (209)	
	mean free path (238)		

Key Equations and Relationships

Page numbers appear in parentheses.

5.1 Expressing the volume-pressure relationship (Boyle's law) (212):

$$V \propto \frac{1}{P} \quad \text{or} \quad PV = \text{constant} \quad [T \text{ and } n \text{ fixed}]$$

5.2 Expressing the volume-temperature relationship (Charles's law) (213):

$$V \propto T \quad \text{or} \quad \frac{V}{T} = \text{constant} \quad [P \text{ and } n \text{ fixed}]$$

5.3 Expressing the pressure-temperature relationship (Amontons's law) (213):

$$P \propto T \quad \text{or} \quad \frac{P}{T} = \text{constant} \quad [V \text{ and } n \text{ fixed}]$$

5.4 Expressing the volume-amount relationship (Avogadro's law) (214):

$$V \propto n \quad \text{or} \quad \frac{V}{n} = \text{constant} \quad [P \text{ and } T \text{ fixed}]$$

5.5 Defining standard temperature and pressure (215):

STP: 0°C (273.15 K) and 1 atm (760 torr)

5.6 Defining the volume of 1 mol of an ideal gas at STP (215):

Standard molar volume = 22.4141 L or 22.4 L [to 3 sf]

5.7 Relating volume to pressure, temperature, and amount (ideal gas law) (216):

$$PV = nRT \quad \text{and} \quad \frac{P_1 V_1}{n_1 T_1} = \frac{P_2 V_2}{n_2 T_2}$$

5.8 Calculating the value of R (216):

$$\begin{aligned} R &= \frac{PV}{nT} = \frac{1 \text{ atm} \times 22.4141 \text{ L}}{1 \text{ mol} \times 273.15 \text{ K}} \\ &= 0.082058 \frac{\text{atm} \cdot \text{L}}{\text{mol} \cdot \text{K}} = 0.0821 \frac{\text{atm} \cdot \text{L}}{\text{mol} \cdot \text{K}} \quad [3 \text{ sf}] \end{aligned}$$

BRIEF SOLUTIONS TO FOLLOW-UP PROBLEMS**5.1A** P_{CO_2} (torr) = $P_{\text{atm}} - \Delta h$

$$\begin{aligned} &= (753.6 \text{ mmHg} - 174.0 \text{ mmHg}) \times \frac{1 \text{ torr}}{1 \text{ mmHg}} \\ &= 579.6 \text{ torr} \end{aligned}$$

$$\begin{aligned} P_{\text{CO}_2} (\text{Pa}) &= 579.6 \text{ torr} \times \frac{1 \text{ atm}}{760 \text{ torr}} \times \frac{1.01325 \times 10^5 \text{ Pa}}{1 \text{ atm}} \\ &= 7.727 \times 10^4 \text{ Pa} \end{aligned}$$

$$\begin{aligned} P_{\text{CO}_2} (\text{lb/in}^2) &= 579.6 \text{ torr} \times \frac{1 \text{ atm}}{760 \text{ torr}} \times \frac{14.7 \text{ lb/in}^2}{1 \text{ atm}} \\ &= 11.2 \text{ lb/in}^2 \end{aligned}$$

5.9 Rearranging the ideal gas law to find gas density (222):

$$PV = \frac{m}{M} RT \quad \text{so} \quad \frac{m}{V} = d = \frac{P \times M}{RT}$$

5.10 Rearranging the ideal gas law to find molar mass (224):

$$n = \frac{m}{M} = \frac{PV}{RT} \quad \text{so} \quad M = \frac{mRT}{PV}$$

5.11 Relating the total pressure of a gas mixture to the partial pressures of the components (Dalton's law of partial pressures) (226):

$$P_{\text{total}} = P_1 + P_2 + P_3 + \dots$$

5.12 Relating partial pressure to mole fraction (226):

$$P_A = X_A \times P_{\text{total}}$$

5.13 Defining rms speed as a function of molar mass and temperature (235):

$$u_{\text{rms}} = \sqrt{\frac{3RT}{M}}$$

5.14 Applying Graham's law of effusion (236):

$$\frac{\text{Rate}_A}{\text{Rate}_B} = \frac{\sqrt{M_B}}{\sqrt{M_A}} = \sqrt{\frac{M_B}{M_A}}$$

5.15 Applying the van der Waals equation to find the pressure or volume of a gas under extreme conditions (243):

$$\left(P + \frac{n^2 a}{V^2} \right) (V - nb) = nRT$$

5.1B P_{atm} (torr) = $P_{\text{atm}} \times \frac{760 \text{ torr}}{1 \text{ atm}} = 720.1 \text{ torr}$

$$\begin{aligned} P_{\text{CO}_2} (\text{mmHg}) &= P_{\text{atm}} + \Delta h \\ &= (720.1 \text{ torr} + 25.8 \text{ torr}) \times \frac{1 \text{ mmHg}}{1 \text{ torr}} \\ &= 745.9 \text{ mmHg} \end{aligned}$$

$$\begin{aligned} P_{\text{CO}_2} (\text{Pa}) &= 745.9 \text{ mmHg} \times \frac{1 \text{ atm}}{760 \text{ mmHg}} \times \frac{1.01325 \times 10^5 \text{ Pa}}{1 \text{ atm}} \\ &= 9.945 \times 10^4 \text{ Pa} \end{aligned}$$

$$\begin{aligned} P_{\text{CO}_2} (\text{lb/in}^2) &= 745.9 \text{ mmHg} \times \frac{1 \text{ atm}}{760 \text{ mmHg}} \times \frac{14.7 \text{ lb/in}^2}{1 \text{ atm}} \\ &= 14.4 \text{ lb/in}^2 \end{aligned}$$

BRIEF SOLUTIONS TO FOLLOW-UP PROBLEMS

(continued)

5.2A $P_2 = P_1 \times \frac{V_1}{V_2}$

$$P_2 \text{ (atm)} = 0.871 \text{ atm} \times \frac{105 \text{ mL}}{352 \text{ mL}} = 0.260 \text{ atm}$$

$$P_2 \text{ (kPa)} = 0.260 \text{ atm} \times \frac{101.325 \text{ kPa}}{1 \text{ atm}} = 26.3 \text{ kPa}$$

5.2B $P_2 \text{ (atm)} = 745 \text{ mmHg} \times \frac{1 \text{ atm}}{760 \text{ mmHg}} = 0.980 \text{ atm}$

$$V_2 = V_1 \times \frac{P_1}{P_2}$$

$$V_2 \text{ (L)} = 651 \text{ L} \times \frac{122 \text{ atm}}{0.980 \text{ atm}} = 8.10 \times 10^4 \text{ L}$$

5.3A $P_1 \text{ (torr)} = 0.991 \text{ atm} \times \frac{760 \text{ torr}}{1 \text{ atm}} = 753 \text{ torr}$

$$P_2 = P_1 \times \frac{T_2}{T_1} = 753 \text{ torr} \times \frac{373 \text{ K}}{296 \text{ K}} = 949 \text{ torr}$$

$P_2 < 1.00 \times 10^3 \text{ torr}$, so the safety valve will not open.

5.3B $T_2 \text{ (K)} = T_1 \times \frac{V_2}{V_1} = 313 \text{ K} \times \frac{28.6 \text{ L}}{32.5 \text{ L}} = 275 \text{ K}$

$$T_2 \text{ (°C)} = 275 \text{ K} - 273.15 = 2^\circ\text{C}$$

5.4A $P_2 \text{ (torr)} = P_1 \times \frac{n_2}{n_1} = 793 \text{ torr} \times \frac{35.0 \text{ g} - 5.0 \text{ g}}{35.0 \text{ g}} = 680 \text{ torr}$

(There is no need to convert mass to moles because the ratio of masses equals the ratio of moles.)

5.4B Amount (mol) of N₂ = 1.26 g N₂ × $\frac{1 \text{ mol N}_2}{28.02 \text{ g N}_2}$
= 0.0450 mol N₂

$$\text{Amount (mol) of He} = 1.26 \text{ g He} \times \frac{1 \text{ mol He}}{4.003 \text{ g He}} = 0.315 \text{ mol He}$$

$$V_2 = V_1 \times \frac{n_2}{n_1} = 1.12 \text{ L} \times \frac{0.0450 \text{ mol} + 0.315 \text{ mol}}{0.0450 \text{ mol}} = 8.96 \text{ L}$$

5.5A

$$P_2 \text{ (mmHg)} = P_1 \times \frac{V_1 T_2}{V_2 T_1} = 755 \text{ mmHg} \times \frac{(2.55 \text{ L})(291 \text{ K})}{(4.10 \text{ L})(296 \text{ K})} = 462 \text{ mmHg}$$

5.5B $V_2 \text{ (L)} = V_1 \times \frac{P_1 T_2}{P_2 T_1} = 2.2 \text{ L} \times \frac{(0.980 \text{ atm})(294 \text{ K})}{(1.40 \text{ atm})(301 \text{ K})} = 1.5 \text{ L}$

5.6A $n = \frac{PV}{RT} = \frac{1.37 \text{ atm} \times 438 \text{ L}}{0.0821 \frac{\text{atm} \cdot \text{L}}{\text{mol} \cdot \text{K}} \times 294 \text{ K}} = 24.9 \text{ mol O}_2$

$$\text{Mass (g) of O}_2 = 24.9 \text{ mol O}_2 \times \frac{32.00 \text{ g O}_2}{1 \text{ mol O}_2} = 7.97 \times 10^2 \text{ g O}_2$$

5.6B

$$\text{Amount (mol) of He} = 3950 \text{ kg He} \times \frac{1000 \text{ g}}{1 \text{ kg}} \times \frac{1 \text{ mol He}}{4.003 \text{ g He}} = 9.87 \times 10^5 \text{ mol He}$$

$$V = \frac{nRT}{P} = \frac{9.87 \times 10^5 \text{ mol} \times 0.0821 \frac{\text{atm} \cdot \text{L}}{\text{mol} \cdot \text{K}} \times 293 \text{ K}}{731 \text{ mmHg} \times \frac{1 \text{ atm}}{760 \text{ mmHg}}} = 2.47 \times 10^7 \text{ L}$$

5.7A The balanced equation is $2\text{CD}(g) \rightarrow \text{C}_2(g) + \text{D}_2(g)$, so n does not change. The volume has doubled. Therefore, given constant P , the temperature, T , must also double: $T_1 = -73^\circ\text{C} + 273.15 = 200 \text{ K}$; so $T_2 = 400 \text{ K}$, or $400 \text{ K} - 273.15 = 127^\circ\text{C}$.

5.7B $T_1 = 199^\circ\text{C} + 273.15 = 472 \text{ K}$
 $T_2 = -155^\circ\text{C} + 273.15 = 118 \text{ K}$

Temperature has been reduced by $\frac{1}{4}$; if n were constant, V would also be reduced by $\frac{1}{4}$. But, since V has been halved, n must be doubled. The number of moles of gas doubles (from 2 mol to 4 mol) in equation (2).

5.8A $d \text{ (at } 0^\circ\text{C and 380 torr)} = \frac{\frac{380 \text{ torr}}{760 \text{ torr/atm}} \times 44.01 \text{ g/mol}}{0.0821 \frac{\text{atm} \cdot \text{L}}{\text{mol} \cdot \text{K}} \times 273 \text{ K}} = 0.982 \text{ g/L}$

The density is lower at the smaller P because V is larger. In this case, d is lowered by one-half because P is one-half as much.

5.8B $d \text{ (at } 24^\circ\text{C and 0.950 atm)} = \frac{0.950 \text{ atm} \times 46.01 \text{ g/mol}}{0.0821 \frac{\text{atm} \cdot \text{L}}{\text{mol} \cdot \text{K}} \times 297 \text{ K}} = 1.79 \text{ g/L}$

NO₂ is more dense than dry air.

5.9A Mass of gas = 68.697 g - 68.322 g = 0.375 g

$$\mathcal{M} = \frac{mRT}{PV} = \frac{0.375 \text{ g} \times 0.0821 \frac{\text{atm} \cdot \text{L}}{\text{mol} \cdot \text{K}} \times (273.15 + 95.0) \text{ K}}{\frac{740 \text{ torr}}{760 \text{ torr/atm}} \times \frac{149 \text{ mL}}{1000 \text{ mL/L}}} = 78.1 \text{ g/mol}$$

5.9B Mass of gas = 82.786 g - 82.561 g = 0.225 g

$$\mathcal{M} = \frac{mRT}{PV} = \frac{0.225 \text{ g} \times 0.0821 \frac{\text{atm} \cdot \text{L}}{\text{mol} \cdot \text{K}} \times (273.15 + 22) \text{ K}}{\frac{733 \text{ mmHg}}{760 \text{ mmHg/atm}} \times \frac{350 \text{ mL}}{1000 \text{ mL/L}}} = 16.1 \text{ g/mol}$$

This is the molar mass of CH₄.

5.10A $n_{\text{He}} = 5.50 \text{ g He} \times \frac{1 \text{ mol He}}{4.003 \text{ g He}} = 1.37 \text{ mol He}$

Similarly, there are 0.743 mol of Ne and 0.418 mol Kr.
 $n_{\text{total}} = 1.37 \text{ mol He} + 0.743 \text{ mol Ne} + 0.418 \text{ mol Kr}$
 $= 2.53 \text{ mol}$

$$P_{\text{He}} = X_{\text{He}} \times P_{\text{total}} = \frac{1.37 \text{ mol He}}{2.53 \text{ mol gas}} \times 1 \text{ atm} = 0.542 \text{ atm}$$

$$P_{\text{Ne}} = 0.294 \text{ atm} \quad P_{\text{Kr}} = 0.165 \text{ atm}$$

$$\mathbf{5.10B} \quad X_{\text{He}} = \frac{P_{\text{He}}}{P_{\text{total}}} = \frac{143 \text{ atm}}{204 \text{ atm}} = 0.701$$

$$\text{Mole \% He} = 0.701 \times 100 = 70.1\%$$

$$\mathbf{5.11A} \quad P_{\text{H}_2} (\text{torr}) = P_{\text{total}} - P_{\text{H}_2\text{O}} = 752 \text{ torr} - 13.6 \text{ torr} = 738 \text{ torr}$$

$$P_{\text{H}_2} (\text{atm}) = 738 \text{ torr} \times \frac{1 \text{ atm}}{760 \text{ torr}} = 0.971 \text{ atm}$$

$$n_{\text{H}_2} = \frac{PV}{RT} = \frac{0.971 \text{ atm} \times 1.495 \text{ L}}{0.0821 \frac{\text{atm}\cdot\text{L}}{\text{mol}\cdot\text{K}} \times 289 \text{ K}} = 0.0612 \text{ mol H}_2$$

$$\text{Mass (g) of H}_2 = 0.0612 \text{ mol H}_2 \times \frac{2.016 \text{ g H}_2}{1 \text{ mol H}_2} = 0.123 \text{ g H}_2$$

$$\mathbf{5.11B} \quad P_{\text{O}_2} = P_{\text{total}} - P_{\text{H}_2\text{O}} = 748 \text{ torr} - 17.5 \text{ torr} = 730 \text{ torr}$$

$$P_{\text{O}_2} (\text{atm}) = 730 \text{ torr} \times \frac{1 \text{ atm}}{760 \text{ torr}} = 0.961 \text{ atm}$$

$$n_{\text{O}_2} = \frac{PV}{RT} = \frac{0.961 \text{ atm} \times 0.307 \text{ L}}{0.0821 \frac{\text{atm}\cdot\text{L}}{\text{mol}\cdot\text{K}} \times 293 \text{ K}} = 0.0123 \text{ mol O}_2$$

$$\text{Mass (g) of O}_2 = 0.0123 \text{ mol O}_2 \times \frac{32.00 \text{ g O}_2}{1 \text{ mol O}_2} = 0.394 \text{ g O}_2$$

$$n_{\text{HCl}} = 0.117 \text{ kg NaCl} \times \frac{10^3 \text{ g}}{1 \text{ kg}} \times \frac{1 \text{ mol NaCl}}{58.44 \text{ g NaCl}} \times \frac{2 \text{ mol HCl}}{2 \text{ mol NaCl}}$$

$$= 2.00 \text{ mol HCl}$$

$$\text{At STP, } V \text{ (mL)} = 2.00 \text{ mol} \times \frac{22.4 \text{ L}}{1 \text{ mol}} \times \frac{10^3 \text{ mL}}{1 \text{ L}}$$

$$= 4.48 \times 10^4 \text{ mL}$$

$$n_{\text{H}_2} = 35.5 \text{ g CuO} \times \frac{1 \text{ mol CuO}}{79.55 \text{ g CuO}} \times \frac{1 \text{ mol H}_2}{1 \text{ mol CuO}} = 0.446 \text{ mol H}_2$$

$$V = \frac{nRT}{P} = \frac{0.446 \text{ mol} \times 0.0821 \frac{\text{atm}\cdot\text{L}}{\text{mol}\cdot\text{K}} \times 498 \text{ K}}{765 \text{ torr} \times \frac{1 \text{ atm}}{760 \text{ torr}}} = 18.1 \text{ L}$$

$$n_{\text{NH}_3} = \frac{PV}{RT} = \frac{0.452 \text{ atm} \times 10.0 \text{ L}}{0.0821 \frac{\text{atm}\cdot\text{L}}{\text{mol}\cdot\text{K}} \times 295 \text{ K}} = 0.187 \text{ mol NH}_3$$

$$n_{\text{HCl}} = \frac{PV}{RT} = \frac{7.50 \text{ atm} \times 0.155 \text{ L}}{0.0821 \frac{\text{atm}\cdot\text{L}}{\text{mol}\cdot\text{K}} \times 271 \text{ K}} = 0.0522 \text{ mol HCl}$$

$n_{\text{NH}_3} = 0.187 \text{ mol}$ and $n_{\text{HCl}} = 0.0522 \text{ mol}$; thus, HCl is the limiting reactant.

n_{NH_3} after reaction

$$= 0.187 \text{ mol NH}_3 - \left(0.0522 \text{ mol HCl} \times \frac{1 \text{ mol NH}_3}{1 \text{ mol HCl}} \right)$$

$$= 0.135 \text{ mol NH}_3$$

$$P = \frac{nRT}{V} = \frac{0.135 \text{ mol} \times 0.0821 \frac{\text{atm}\cdot\text{L}}{\text{mol}\cdot\text{K}} \times 295 \text{ K}}{10.0 \text{ L}} = 0.327 \text{ atm}$$

For I_2 :

$$\text{Amount (mol) of IF}_5 = 4.16 \text{ g I}_2 \times \frac{1 \text{ mol I}_2}{253.8 \text{ g I}_2} \times \frac{2 \text{ mol IF}_5}{1 \text{ mol I}_2}$$

$$= 0.0328 \text{ mol IF}_5$$

For F_2 :

$$n_{\text{F}_2} = \frac{PV}{RT} = \frac{0.974 \text{ atm} \times 2.48 \text{ L}}{0.0821 \frac{\text{atm}\cdot\text{L}}{\text{mol}\cdot\text{K}} \times 291 \text{ K}} = 0.101 \text{ mol F}_2$$

$$\text{Amount (mol) of IF}_5 = 0.101 \text{ mol F}_2 \times \frac{2 \text{ mol IF}_5}{5 \text{ mol F}_2}$$

$$= 0.0404 \text{ mol IF}_5$$

Thus, I_2 is the limiting reactant.

$$\text{Volume (L) of IF}_5 = \frac{nRT}{P} = \frac{0.0328 \text{ mol} \times 0.0821 \frac{\text{atm}\cdot\text{L}}{\text{mol}\cdot\text{K}} \times 378 \text{ K}}{0.935 \text{ atm}}$$

$$= 1.09 \text{ L}$$

$$\mathbf{5.14A} \quad \frac{\text{Rate of He}}{\text{Rate of C}_2\text{H}_6} = \sqrt{\frac{30.07 \text{ g/mol}}{4.003 \text{ g/mol}}} = 2.741$$

Time for C_2H_6 to effuse = $1.25 \text{ min} \times 2.741 = 3.43 \text{ min}$

$$\mathbf{5.14B} \quad \mathcal{M} \text{ of unknown gas} = \mathcal{M}_{\text{Ar}} \times \left(\frac{\text{rate of Ar}}{\text{rate of unknown gas}} \right)^2$$

$$= \left(\frac{13.8 \text{ mL/time}}{7.23 \text{ mL/time}} \right)^2 \times 39.95 \text{ g/mol}$$

$$= 146 \text{ g/mol}$$

PROBLEMS

Problems with **colored** numbers are answered in Appendix E and worked in detail in the Student Solutions Manual. Problem sections match those in the text and give the numbers of relevant sample problems. Most offer Concept Review Questions, Skill-Building

Exercises (grouped in pairs covering the same concept), and Problems in Context. The Comprehensive Problems are based on material from any section or previous chapter.

An Overview of the Physical States of Matter

Concept Review Questions

5.1 How does a sample of gas differ in its behavior from a sample of liquid in each of the following situations?

- The sample is transferred from one container to a larger one.
- The sample is heated in an expandable container, but no change of state occurs.
- The sample is placed in a cylinder with a piston, and an external force is applied.

5.2 Are the particles in a gas farther apart or closer together than the particles in a liquid? Use your answer to explain each of the following general observations:

- Gases are more compressible than liquids.
- Gases have lower viscosities than liquids.
- After thorough stirring, all gas mixtures are solutions.
- The density of a substance in the gas state is lower than in the liquid state.

Gas Pressure and Its Measurement

(Sample Problem 5.1)

Concept Review Questions

5.3 How does a barometer work? Is the column of mercury in a barometer shorter when it is on a mountaintop or at sea level? Explain.

5.4 How can a unit of length such as millimeter of mercury (mmHg) be used as a unit of pressure, which has the dimensions of force per unit area?

5.5 In a closed-end manometer, the mercury level in the arm attached to the flask can never be higher than the mercury level in the other arm, whereas in an open-end manometer, it *can* be higher. Explain.

Skill-Building Exercises (grouped in similar pairs)

5.6 On a cool, rainy day, the barometric pressure is 730 mmHg. Calculate the barometric pressure in centimeters of water (cmH₂O) (*d* of Hg = 13.5 g/mL; *d* of H₂O = 1.00 g/mL).

5.7 A long glass tube, sealed at one end, has an inner diameter of 10.0 mm. The tube is filled with water and inverted into a pail of water. If the atmospheric pressure is 755 mmHg, how high (in cmH₂O) is the column of water in the tube (*d* of Hg = 13.5 g/mL; *d* of H₂O = 1.00 g/mL)?

5.8 Convert the following:

- | | |
|-----------------------|---------------------|
| (a) 0.745 atm to mmHg | (b) 992 torr to bar |
| (c) 365 kPa to atm | (d) 804 mmHg to kPa |

5.9 Convert the following:

- | | |
|----------------------|-----------------------|
| (a) 76.8 cmHg to atm | (b) 27.5 atm to kPa |
| (c) 6.50 atm to bar | (d) 0.937 kPa to torr |

5.10 In Figure P5.10, what is the pressure of the gas in the flask (in atm) if the barometer reads 738.5 torr?

5.11 In Figure P5.11, what is the pressure of the gas in the flask (in kPa) if the barometer reads 765.2 mmHg?

Figure P5.10

Figure P5.11

5.12 If the sample flask in Figure P5.12 is open to the air, what is the atmospheric pressure (in atm)?

5.13 In Figure P5.13, what is the pressure (in Pa) of the gas in the flask?

Figure P5.12

Figure P5.13

Problems in Context

5.14 Convert each of the pressures described below to atm:

- At the peak of Mt. Everest, atmospheric pressure is only 2.75×10^2 mmHg.
- A cyclist fills her bike tires to 86 psi.
- The surface of Venus has an atmospheric pressure of 9.15×10^6 Pa.
- At 100 ft below sea level, a scuba diver experiences a pressure of 2.54×10^4 torr.

5.15 The gravitational force exerted by an object is given by $F = mg$, where *F* is the force in newtons, *m* is the mass in kilograms, and *g* is the acceleration due to gravity (9.81 m/s^2).

- Use the definition of the pascal to calculate the mass (in kg) of the atmosphere above 1 m^2 of ocean.
- Osmium (*Z* = 76) is a transition metal in Group 8B(8) and has the highest density of any element (22.6 g/mL). If an osmium column is 1 m^2 in area, how high must it be for its pressure to equal atmospheric pressure? [Use the answer from part (a) in your calculation.]

The Gas Laws and Their Experimental Foundations

(Sample Problems 5.2 to 5.7)

Concept Review Questions

5.16 A student states Boyle's law as follows: "The volume of a gas is inversely proportional to its pressure." How is this statement incomplete? Give a correct statement of Boyle's law.

5.17 In the following relationships, which quantities are variables and which are fixed: (a) Charles's law; (b) Avogadro's law; (c) Amontons's law?

5.18 Boyle's law relates gas volume to pressure, and Avogadro's law relates gas volume to amount (mol). State a relationship between gas pressure and amount (mol).

5.19 Each of the following processes caused the gas volume to double, as shown. For each process, tell how the remaining gas variable changed or state that it remained fixed:

- T* doubles at fixed *P*.
- T* and *n* are fixed.

- (c) At fixed T , the reaction is $\text{CD}_2(g) \rightarrow \text{C}(g) + \text{D}_2(g)$.
 (d) At fixed P , the reaction is $\text{A}_2(g) + \text{B}_2(g) \rightarrow 2\text{AB}(g)$.

Skill-Building Exercises (grouped in similar pairs)

5.20 What is the effect of the following on the volume of 1 mol of an ideal gas?

- (a) The pressure is tripled (at constant T).
- (b) The absolute temperature is increased by a factor of 3.0 (at constant P).
- (c) Three more moles of the gas are added (at constant P and T).

5.21 What is the effect of the following on the volume of 1 mol of an ideal gas?

- (a) The pressure changes from 760 torr to 202 kPa, and the temperature changes from 37°C to 155 K.
- (b) The temperature changes from 305 K to 32°C, and the pressure changes from 2 atm to 101 kPa.
- (c) The pressure is reduced by a factor of 4 (at constant T).

5.22 What is the effect of the following on the volume of 1 mol of an ideal gas?

- (a) Temperature decreases from 800 K to 400 K (at constant P).
- (b) Temperature increases from 250°C to 500°C (at constant P).
- (c) Pressure increases from 2 atm to 6 atm (at constant T).

5.23 What is the effect of the following on the volume of 1 mol of an ideal gas?

- (a) The initial pressure is 722 torr, and the final pressure is 0.950 atm; the initial temperature is 32°F, and the final temperature is 273 K.
- (b) Half the gas escapes (at constant P and T).
- (c) Both the pressure and temperature decrease to one-fourth of their initial values.

5.24 A weather balloon is filled with helium to a volume of 1.61 L at 734 torr. What is the volume of the balloon after it has been released and its pressure has dropped to 0.844 atm? Assume that the temperature remains constant.

5.25 A sample of methane is placed in a 10.0-L container at 25°C and 725 mmHg. The gas sample is then moved to a 7.50-L container at 25°C. What is the gas pressure in the second container?

5.26 A sample of sulfur hexafluoride gas occupies 9.10 L at 198°C. Assuming that the pressure remains constant, what temperature (in °C) is needed to reduce the volume to 2.50 L?

5.27 A 93-L sample of dry air cools from 145°C to -22°C while the pressure is maintained at 2.85 atm. What is the final volume?

5.28 A gas cylinder is filled with argon at a pressure of 177 atm and 25°C. What is the gas pressure when the temperature of the cylinder and its contents are heated to 195°C by exposure to fire?

5.29 A bicycle tire is filled to a pressure of 110. psi at a temperature of 30.0°C. At what temperature will the air pressure in the tire decrease to 105 psi? Assume that the volume of the tire remains constant.

5.30 A balloon filled with 1.92 g of helium has a volume of 12.5 L. What is the balloon's volume after 0.850 g of helium has leaked out through a small hole (assume constant pressure and temperature)?

5.31 The average person takes 500 mL of air into the lungs with each normal inhalation, which corresponds to approximately 1×10^{22} molecules of air. Calculate the number of molecules of air inhaled by a person with a respiratory problem who takes in only 350 mL of air with each breath. Assume constant pressure and temperature.

5.32 A sample of Freon-12 (CF_2Cl_2) occupies 25.5 L at 298 K and 153.3 kPa. Find its volume at STP.

5.33 A sample of carbon monoxide occupies 3.65 L at 298 K and 745 torr. Find its volume at -14°C and 367 torr.

5.34 A sample of chlorine gas is confined in a 5.0-L container at 328 torr and 37°C. How many moles of gas are in the sample?

5.35 If 1.47×10^{-3} mol of argon occupies a 75.0-mL container at 26°C, what is the pressure (in torr)?

5.36 You have 357 mL of chlorine trifluoride gas at 699 mmHg and 45°C. What is the mass (in g) of the sample?

5.37 A 75.0-g sample of dinitrogen monoxide is confined in a 3.1-L vessel. What is the pressure (in atm) at 115°C?

Problems in Context

5.38 In preparation for a demonstration, your professor brings a 1.5-L bottle of sulfur dioxide into the lecture hall before class to allow the gas to reach room temperature. If the pressure gauge reads 85 psi and the temperature in the classroom is 23°C, how many moles of sulfur dioxide are in the bottle? (Hint: The gauge reads zero when the gas pressure in the bottle is 14.7 psi.)

5.39 A gas-filled weather balloon with a volume of 65.0 L is released at sea-level conditions of 745 torr and 25°C. The balloon can expand to a maximum volume of 835 L. When the balloon rises to an altitude at which the temperature is -5°C and the pressure is 0.066 atm, will it have expanded to its maximum volume?

Rearrangements of the Ideal Gas Law

(Sample Problems 5.8 to 5.13)

Concept Review Questions

5.40 Why is moist air less dense than dry air?

5.41 To collect a beaker of H_2 gas by displacing the air already in the beaker, would you hold the beaker upright or inverted? Why? How would you hold the beaker to collect CO_2 ?

5.42 Why can we use a gas mixture, such as air, to study the general behavior of an ideal gas under ordinary conditions?

5.43 How does the partial pressure of gas A in a mixture compare to its mole fraction in the mixture? Explain.

5.44 The scene at right represents a portion of a mixture of four gases A (purple), B (black), C (green), and D₂ (orange). (a) Which gas has the highest partial pressure? (b) Which has the lowest partial pressure? (c) If the total pressure is 0.75 atm, what is the partial pressure of D₂?

Skill-Building Exercises (grouped in similar pairs)

5.45 What is the density of Xe gas at STP?

5.46 Find the density of Freon-11 (CFCl_3) at 120°C and 1.5 atm.

5.47 How many moles of gaseous arsine (AsH_3) occupy 0.0400 L at STP? What is the density of gaseous arsine?

5.48 The density of a noble gas is 2.71 g/L at 3.00 atm and 0°C. Identify the gas.

5.49 Calculate the molar mass of a gas at 388 torr and 45°C if 206 ng occupies 0.206 μL .

5.50 When an evacuated 63.8-mL glass bulb is filled with a gas at 22°C and 747 mmHg, the bulb gains 0.103 g in mass. Is the gas N_2 , Ne, or Ar?

5.51 After 0.600 L of Ar at 1.20 atm and 227°C is mixed with 0.200 L of O_2 at 501 torr and 127°C in a 400-mL flask at 27°C, what is the pressure in the flask?

5.52 A 355-mL container holds 0.146 g of Ne and an unknown amount of Ar at 35°C and a total pressure of 626 mmHg. Calculate the number of moles of Ar present.

5.53 How many grams of phosphorus react with 35.5 L of O_2 at STP to form tetraphosphorus decoxide?

5.54 How many grams of potassium chlorate decompose to potassium chloride and 638 mL of O_2 at 128°C and 752 torr?

5.55 How many grams of phosphine (PH_3) can form when 37.5 g of phosphorus and 83.0 L of hydrogen gas react at STP?

5.56 When 35.6 L of ammonia and 40.5 L of oxygen gas at STP burn, nitrogen monoxide and water form. After the products return to STP, how many grams of nitrogen monoxide are present?

5.57 Aluminum reacts with excess hydrochloric acid to form aqueous aluminum chloride and 35.8 mL of hydrogen gas over water at 27°C and 751 mmHg. How many grams of aluminum reacted?

5.58 How many liters of hydrogen gas are collected over water at 18°C and 725 mmHg when 0.84 g of lithium reacts with water? Aqueous lithium hydroxide also forms.

Problems in Context

5.59 The air in a hot-air balloon at 744 torr is heated from 17°C to 60.0°C. Assuming that the amount (mol) of air and the pressure remain constant, what is the density of the air at each temperature? (The average molar mass of air is 28.8 g/mol.)

5.60 On a certain winter day in Utah, the average atmospheric pressure is 650. torr. What is the molar density (in mol/L) of the air if the temperature is -25°C?

5.61 A sample of a liquid hydrocarbon known to consist of molecules with five carbon atoms is vaporized in a 0.204-L flask by immersion in a water bath at 101°C. The barometric pressure is 767 torr, and the remaining gas weighs 0.482 g. What is the molecular formula of the hydrocarbon?

5.62 A sample of air contains 78.08% nitrogen, 20.94% oxygen, 0.05% carbon dioxide, and 0.93% argon, by volume. How many molecules of each gas are present in 1.00 L of the sample at 25°C and 1.00 atm?

5.63 An environmental chemist sampling industrial exhaust gases from a coal-burning plant collects a $\text{CO}_2\text{-SO}_2\text{-H}_2\text{O}$ mixture in a 21-L steel tank until the pressure reaches 850. torr at 45°C.

(a) How many moles of gas are collected?

(b) If the SO_2 concentration in the mixture is 7.95×10^3 parts per million by volume (ppmv), what is its partial pressure? [Hint: $\text{ppmv} = (\text{volume of component}/\text{volume of mixture}) \times 10^6$.]

5.64 “Strike anywhere” matches contain the compound tetraphosphorus trisulfide, which burns to form tetraphosphorus decoxide and sulfur dioxide gas. How many milliliters of sulfur dioxide, measured at 725 torr and 32°C, can be produced from burning 0.800 g of tetraphosphorus trisulfide?

5.65 Freon-12 (CF_2Cl_2), widely used as a refrigerant and aerosol propellant, is a dangerous air pollutant. In the troposphere, it traps heat 25 times as effectively as CO_2 , and in the stratosphere, it participates in the breakdown of ozone. Freon-12 is prepared industrially by reaction of gaseous carbon tetrachloride with hydrogen fluoride. Hydrogen chloride gas also forms. How many grams of carbon tetrachloride are required for the production of 16.0 dm^3 of Freon-12 at 27°C and 1.20 atm?

5.66 Xenon hexafluoride was one of the first noble gas compounds synthesized. The solid reacts rapidly with the silicon dioxide in glass or quartz containers to form liquid XeOF_4 and gaseous silicon tetrafluoride. What is the pressure in a 1.00-L container at 25°C after 2.00 g of xenon hexafluoride reacts? (Assume that silicon tetrafluoride is the only gas present and that it occupies the entire volume.)

5.67 In the four piston-cylinder assemblies below, the reactant in the left cylinder is about to undergo a reaction at constant T and P :

Which of the other three depictions best represents the products of the reaction?

5.68 Roasting galena [lead(II) sulfide] is a step in the industrial isolation of lead. How many liters of sulfur dioxide, measured at STP, are produced by the reaction of 3.75 kg of galena with 228 L of oxygen gas at 220°C and 2.0 atm? Lead(II) oxide also forms.

5.69 In one of his most critical studies on the nature of combustion, Lavoisier heated mercury(II) oxide and isolated elemental mercury and oxygen gas. If 40.0 g of mercury(II) oxide is heated in a 502-mL vessel and 20.0% (by mass) decomposes, what is the pressure (in atm) of the oxygen that forms at 25.0°C? (Assume that the gas occupies the entire volume.)

The Kinetic-Molecular Theory: A Model for Gas Behavior (Sample Problem 5.14)

Concept Review Questions

5.70 Use the kinetic-molecular theory to explain the change in gas pressure that results from warming a sample of gas.

5.71 How does the kinetic-molecular theory explain why 1 mol of krypton and 1 mol of helium have the same volume at STP?

5.72 Is the rate of effusion of a gas higher than, lower than, or equal to its rate of diffusion? Explain. For two gases with molecules of approximately the same size, is the ratio of their effusion rates higher than, lower than, or equal to the ratio of their diffusion rates? Explain.

5.73 Consider two 1-L samples of gas: one is H₂ and the other is O₂. Both are at 1 atm and 25°C. How do the samples compare in terms of (a) mass, (b) density, (c) mean free path, (d) average molecular kinetic energy, (e) average molecular speed, and (f) time for a given fraction of molecules to effuse?

5.74 Three 5-L flasks, fixed with pressure gauges and small valves, each contain 4 g of gas at 273 K. Flask A contains H₂, flask B contains He, and flask C contains CH₄. Rank the flask contents in terms of (a) pressure, (b) average kinetic energy of the particles, (c) diffusion rate after the valve is opened, (d) total kinetic energy of the particles, (e) density, and (f) collision frequency.

Skill-Building Exercises (grouped in similar pairs)

5.75 What is the ratio of effusion rates for the lightest gas, H₂, and the heaviest known gas, UF₆?

5.76 What is the ratio of effusion rates for O₂ and Kr?

5.77 The graph below shows the distribution of molecular speeds for argon and helium at the same temperature.

- (a) Does curve 1 or 2 better represent the behavior of argon?
- (b) Which curve represents the gas that effuses more slowly?
- (c) Which curve more closely represents the behavior of fluorine gas? Explain.

5.78 The graph below shows the distribution of molecular speeds for a gas at two different temperatures.

- (a) Does curve 1 or 2 better represent the behavior of the gas at the lower temperature?
- (b) Which curve represents the gas when it has a higher E_k ?
- (c) Which curve is consistent with a higher diffusion rate?

5.79 At a given pressure and temperature, it takes 4.85 min for a 1.5-L sample of He to effuse through a membrane. How long does it take for 1.5 L of F₂ to effuse under the same conditions?

5.80 A sample of an unknown gas effuses in 11.1 min. An equal volume of H₂ in the same apparatus under the same conditions effuses in 2.42 min. What is the molar mass of the unknown gas?

Problems in Context

5.81 White phosphorus melts and then vaporizes at high temperatures. The gas effuses at a rate that is 0.404 times that of neon in the same apparatus under the same conditions. How many atoms are in a molecule of gaseous white phosphorus?

5.82 Helium (He) is the lightest noble gas component of air, and xenon (Xe) is the heaviest. [For this problem, use $R = 8.314 \text{ J/(mol}\cdot\text{K)}$ and express M in kg/mol.]

- (a) Find the rms speed of He in winter (0°C) and in summer (30°C).
- (b) Compare the rms speed of He with that of Xe at 30°C.
- (c) Find the average kinetic energy per mole of He and of Xe at 30°C.
- (d) Find the average kinetic energy per molecule of He at 30°C.

5.83 A mixture of gaseous disulfur difluoride, dinitrogen tetrafluoride, and sulfur tetrafluoride is placed in an effusion apparatus.

- (a) Rank the gases in order of increasing effusion rate.
- (b) Find the ratio of effusion rates of disulfur difluoride and dinitrogen tetrafluoride.
- (c) If gas X is added, and it effuses at 0.935 times the rate of sulfur tetrafluoride, find the molar mass of X.

Real Gases: Deviations from Ideal Behavior

Skill-Building Exercises (grouped in similar pairs)

5.84 Do interparticle attractions cause negative or positive deviations from the PV/RT ratio of an ideal gas? Use Table 5.3 to rank Kr, CO₂, and N₂ in order of increasing magnitude of these deviations.

5.85 Does particle volume cause negative or positive deviations from the PV/RT ratio of an ideal gas? Use Table 5.3 to rank Cl₂, H₂, and O₂ in order of increasing magnitude of these deviations.

5.86 Does N₂ behave more ideally at 1 atm or at 500 atm? Explain.

5.87 Does SF₆ (boiling point = 16°C at 1 atm) behave more ideally at 150°C or at 20°C? Explain.

Comprehensive Problems

5.88 An “empty” gasoline can with dimensions 15.0 cm by 40.0 cm by 12.5 cm is attached to a vacuum pump and evacuated. If the atmospheric pressure is 14.7 lb/in², what is the total force (in pounds) on the outside of the can?

5.89 Hemoglobin is the protein that transports O₂ through the blood from the lungs to the rest of the body. To do so, each molecule of hemoglobin combines with four molecules of O₂. If 1.00 g of hemoglobin combines with 1.53 mL of O₂ at 37°C and 743 torr, what is the molar mass of hemoglobin?

5.90 A baker uses sodium hydrogen carbonate (baking soda) as the leavening agent in a banana-nut quickbread. The baking soda decomposes in either of two possible reactions:

- (1) $2\text{NaHCO}_3(s) \rightarrow \text{Na}_2\text{CO}_3(s) + \text{H}_2\text{O}(l) + \text{CO}_2(g)$
- (2) $\text{NaHCO}_3(s) + \text{H}^+(aq) \rightarrow \text{H}_2\text{O}(l) + \text{CO}_2(g) + \text{Na}^+(aq)$

Calculate the volume (in mL) of CO₂ that forms at 200°C and 0.975 atm per gram of NaHCO₃ by each of the reaction processes.

5.91 A weather balloon containing 600. L of He is released near the equator at 1.01 atm and 305 K. It rises to a point where conditions are 0.489 atm and 218 K and eventually lands in the northern hemisphere under conditions of 1.01 atm and 250 K. If one-fourth of the helium leaked out during this journey, what is the volume (in L) of the balloon at landing?

5.92 Chlorine is produced from sodium chloride by the electrochemical chlor-alkali process. During the process, the chlorine is collected in a container that is isolated from the other products to prevent unwanted (and explosive) reactions. If a 15.50-L container holds 0.5950 kg of Cl₂ gas at 225°C, calculate:

(a) P_{IGL}
 (b) P_{VDW} (use $R = 0.08206 \frac{\text{atm} \cdot \text{L}}{\text{mol} \cdot \text{K}}$)

5.93 In a certain experiment, magnesium boride (Mg₃B₂) reacted with acid to form a mixture of four boron hydrides (B_xH_y), three as liquids (labeled I, II, and III) and one as a gas (IV).

(a) When a 0.1000-g sample of each liquid was transferred to an evacuated 750.0-mL container and volatilized at 70.00°C, sample I had a pressure of 0.05951 atm; sample II, 0.07045 atm; and sample III, 0.05767 atm. What is the molar mass of each liquid?

(b) Boron was determined to be 85.63% by mass in sample I, 81.10% in II, and 82.98% in III. What is the molecular formula of each sample?

(c) Sample IV was found to be 78.14% boron. The rate of effusion for this gas was compared to that of sulfur dioxide; under identical conditions, 350.0 mL of sample IV effused in 12.00 min and 250.0 mL of sulfur dioxide effused in 13.04 min. What is the molecular formula of sample IV?

5.94 Three equal volumes of gas mixtures, all at the same T , are depicted below (with gas A red, gas B green, and gas C blue):

- (a) Which sample, if any, has the highest partial pressure of A?
 (b) Which sample, if any, has the lowest partial pressure of B?
 (c) In which sample, if any, do the gas particles have the highest average kinetic energy?

5.95 Will the volume of a gas increase, decrease, or remain unchanged with each of the following sets of changes?

- (a) The pressure is decreased from 2 atm to 1 atm, while the temperature is decreased from 200°C to 100°C.
 (b) The pressure is increased from 1 atm to 3 atm, while the temperature is increased from 100°C to 300°C.
 (c) The pressure is increased from 3 atm to 6 atm, while the temperature is increased from -73°C to 127°C.
 (d) The pressure is increased from 0.2 atm to 0.4 atm, while the temperature is decreased from 300°C to 150°C.

5.96 When air is inhaled, it enters the alveoli of the lungs, and varying amounts of the component gases exchange with dissolved gases in the blood. The resulting alveolar gas mixture is quite different from the atmospheric mixture. The following table presents selected data on the composition and partial pressure of four gases in the atmosphere and in the alveoli:

Atmosphere (sea level)			Alveoli	
Gas	Partial		Partial	
	Mole %	Pressure (torr)	Mole %	Pressure (torr)
N ₂	78.6	—	—	569
O ₂	20.9	—	—	104
CO ₂	00.04	—	—	40
H ₂ O	00.46	—	—	47

If the total pressure of each gas mixture is 1.00 atm, calculate:

- (a) The partial pressure (in torr) of each gas in the atmosphere
 (b) The mole % of each gas in the alveoli
 (c) The number of O₂ molecules in 0.50 L of alveolar air (volume of an average breath of a person at rest) at 37°C

5.97 Radon (Rn) is the heaviest, and only radioactive, member of Group 8A(18) (noble gases). It is a product of the disintegration of heavier radioactive nuclei found in minute concentrations in many common rocks used for building and construction. In recent years, there has been growing concern about the cancers caused from inhaled residential radon. If 1.0×10^{15} atoms of radium (Ra) produce an average of 1.373×10^4 atoms of Rn per second, how many liters of Rn, measured at STP, are produced per day by 1.0 g of Ra?

5.98 At 1450. mmHg and 286 K, a skin diver exhales a 208-mL bubble of air that is 77% N₂, 17% O₂, and 6.0% CO₂ by volume.

- (a) What would the volume (in mL) of the bubble be if it were exhaled at the surface at 1 atm and 298 K?
 (b) How many moles of N₂ are in the bubble?

5.99 Nitrogen dioxide is used industrially to produce nitric acid, but it contributes to acid rain and photochemical smog. What volume (in L) of nitrogen dioxide is formed at 735 torr and 28.2°C by reacting 4.95 cm³ of copper ($d = 8.95 \text{ g/cm}^3$) with 230.0 mL of nitric acid ($d = 1.42 \text{ g/cm}^3$, 68.0% HNO₃ by mass)?

5.100 In the average adult male, the *residual volume* (RV) of the lungs, the volume of air remaining after a forced exhalation, is 1200 mL.

- (a) How many moles of air are present in the RV at 1.0 atm and 37°C?
 (b) How many molecules of gas are present under these conditions?

5.101 In a bromine-producing plant, how many liters of gaseous elemental bromine at 300°C and 0.855 atm are formed by the reaction of 275 g of sodium bromide and 175.6 g of sodium bromate in aqueous acid solution? (Assume that no Br₂ dissolves.)

5.102 In a collision of sufficient force, automobile air bags respond by electrically triggering the explosive decomposition of sodium azide (NaN₃) to its elements. A 50.0-g sample of sodium azide was decomposed, and the nitrogen gas generated was collected over water at 26°C. The total pressure was 745.5 mmHg. How many liters of dry N₂ were generated?

5.103 An anesthetic gas contains 64.81% carbon, 13.60% hydrogen, and 21.59% oxygen, by mass. If 2.00 L of the gas at 25°C and 0.420 atm weighs 2.57 g, what is the molecular formula of the anesthetic?

5.104 Aluminum chloride is easily vaporized above 180°C. The gas escapes through a pinhole 0.122 times as fast as helium at the same conditions of temperature and pressure in the same apparatus. What is the molecular formula of aluminum chloride gas?

5.105 (a) What is the total volume (in L) of gaseous *products*, measured at 350°C and 735 torr, when an automobile engine burns 100. g of C₈H₁₈ (a typical component of gasoline)?

(b) For part (a), the source of O₂ is air, which is 78% N₂, 21% O₂, and 1.0% Ar by volume. Assuming all the O₂ reacts, but no N₂ or Ar does, what is the total volume (in L) of the engine's gaseous exhaust?

5.106 An atmospheric chemist studying the pollutant SO₂ places a mixture of SO₂ and O₂ in a 2.00-L container at 800. K and 1.90 atm. When the reaction occurs, gaseous SO₃ forms, and the pressure falls to 1.65 atm. How many moles of SO₃ form?

5.107 The thermal decomposition of ethylene occurs during the compound's transit in pipelines and during the formation of polyethylene. The decomposition reaction is

If the decomposition begins at 10°C and 50.0 atm with a gas density of 0.215 g/mL and the temperature increases by 950 K,

- (a) What is the final pressure of the confined gas (ignore the volume of graphite and use the van der Waals equation)?
- (b) How does the PV/RT value of CH₄ compare to that in Figure 5.23? Explain.

5.108 Ammonium nitrate, a common fertilizer, was used by terrorists in the tragic explosion in Oklahoma City in 1995. How many liters of gas at 307°C and 1.00 atm are formed by the explosive decomposition of 15.0 kg of ammonium nitrate to nitrogen, oxygen, and water vapor?

5.109 An environmental engineer analyzes a sample of air contaminated with sulfur dioxide. To a 500.-mL sample at 700. torr and 38°C, she adds 20.00 mL of 0.01017 M aqueous iodine, which reacts as follows:

Excess I₂ reacts with 11.37 mL of 0.0105 M sodium thiosulfate:

What is the volume % of SO₂ in the air sample?

5.110 Canadian chemists have developed a modern variation of the 1899 Mond process for preparing extremely pure metallic nickel. A sample of impure nickel reacts with carbon monoxide at 50°C to form gaseous nickel carbonyl, Ni(CO)₄.

- (a) How many grams of nickel can be converted to the carbonyl with 3.55 m³ of CO at 100.7 kPa?
- (b) The carbonyl is then decomposed at 21 atm and 155°C to pure (>99.95%) nickel. How many grams of nickel are obtained per cubic meter of the carbonyl?
- (c) The released carbon monoxide is cooled and collected for reuse by passing it through water at 35°C. If the barometric pressure is 769 torr, what volume (in m³) of CO is formed per cubic meter of carbonyl?

5.111 Analysis of a newly discovered gaseous silicon-fluorine compound shows that it contains 33.01 mass % silicon. At 27°C, 2.60 g of the compound exerts a pressure of 1.50 atm in a 0.250-L vessel. What is the molecular formula of the compound?

5.112 A gaseous organic compound containing only carbon, hydrogen, and nitrogen is burned in oxygen gas, and the volume of each reactant and product is measured under the same conditions of temperature and pressure. Reaction of four volumes of the compound produces four volumes of CO₂, two volumes of N₂, and ten volumes of water vapor. (a) How many volumes of O₂ were required? (b) What is the empirical formula of the compound?

5.113 Containers A, B, and C are attached by closed stopcocks of negligible volume.

If each particle shown in the picture represents 10⁶ particles,

- (a) How many blue particles and black particles are in B after the stopcocks are opened and the system reaches equilibrium?
- (b) How many blue particles and black particles are in A after the stopcocks are opened and the system reaches equilibrium?
- (c) If the pressure in C, P_C, is 750 torr before the stopcocks are opened, what is P_C afterward?
- (d) What is P_B afterward?

5.114 Combustible vapor-air mixtures are flammable over a limited range of concentrations. The minimum volume % of vapor that gives a combustible mixture is called the *lower flammable limit* (LFL). Generally, the LFL is about half the stoichiometric mixture, which is the concentration required for complete combustion of the vapor in air. (a) If oxygen is 20.9 vol % of air, estimate the LFL for n-hexane, C₆H₁₄. (b) What volume (in mL) of n-hexane ($d = 0.660 \text{ g/cm}^3$) is required to produce a flammable mixture of hexane in 1.000 m³ of air at STP?

5.115 By what factor would a scuba diver's lungs expand if she ascended rapidly to the surface from a depth of 125 ft without inhaling or exhaling? If an expansion factor greater than 1.5 causes lung rupture, how far could she safely ascend from 125 ft without breathing? Assume constant temperature (d of seawater = 1.04 g/mL; d of Hg = 13.5 g/mL).

5.116 When 15.0 g of fluorite (CaF₂) reacts with excess sulfuric acid, hydrogen fluoride gas is collected at 744 torr and 25.5°C. Solid calcium sulfate is the other product. What gas temperature is required to store the gas in an 8.63-L container at 875 torr?

5.117 Dilute aqueous hydrogen peroxide is used as a bleaching agent and for disinfecting surfaces and small cuts. Its concentration is sometimes given as a certain number of "volumes hydrogen peroxide," which refers to the number of volumes of O₂ gas, measured at STP, that a given volume of hydrogen peroxide solution will release when it decomposes to O₂ and liquid H₂O. How many grams of hydrogen peroxide are in 0.100 L of "20 volumes hydrogen peroxide" solution?

5.118 At a height of 300 km above Earth's surface, an astronaut finds that the atmospheric pressure is about 10⁻⁸ mmHg and the temperature is 500 K. How many molecules of gas are there per milliliter at this altitude?

5.119 (a) What is the rms speed of O₂ at STP? (b) If the mean free path of O₂ molecules at STP is 6.33×10^{-8} m, what is their collision frequency? [Use $R = 8.314 \text{ J/(mol}\cdot\text{K)}$ and express \mathcal{M} in kg/mol.]

5.120 Acrylic acid (CH₂=CHCOOH) is used to prepare polymers, adhesives, and paints. The first step in making acrylic acid involves the vapor-phase oxidation of propylene (CH₂=CHCH₃) to acrolein (CH₂=CHCHO). This step is carried out at 330°C and 2.5 atm in a large bundle of tubes around which a heat-transfer agent circulates. The reactants spend an average of 1.8 s in the tubes, which have a void space of 100 ft³. How many pounds of propylene must be added per hour in a mixture whose mole fractions are 0.07 propylene, 0.35 steam, and 0.58 air?

5.121 Standard conditions are based on relevant environmental conditions. If normal average surface temperature and pressure on Venus are 730. K and 90 atm, respectively, what is the standard molar volume of an ideal gas on Venus?

5.122 A barometer tube is 1.00×10^2 cm long and has a cross-sectional area of 1.20 cm^2 . The height of the mercury column is 74.0 cm, and the temperature is 24°C. A small amount of N₂ is introduced into the evacuated space above the mercury, which causes the mercury level to drop to a height of 64.0 cm. How many grams of N₂ were introduced?

5.123 What is the molarity of the cleaning solution formed when 10.0 L of ammonia gas at 33°C and 735 torr dissolves in enough water to give a final volume of 0.750 L?

5.124 The Hawaiian volcano Kilauea emits an average of $1.5 \times 10^3 \text{ m}^3$ of gas each day, when corrected to 298 K and 1.00 atm. The mixture contains gases that contribute to global warming and acid rain, and some are toxic. An atmospheric chemist analyzes a sample and finds the following mole fractions: 0.4896 CO₂, 0.0146 CO, 0.3710 H₂O, 0.1185 SO₂, 0.0003 S₂, 0.0047 H₂, 0.0008 HCl, and 0.0003 H₂S. How many metric tons (t) of each gas are emitted per year (1 t = 1000 kg)?

5.125 To study a key fuel-cell reaction, a chemical engineer has 20.0-L tanks of H₂ and of O₂ and wants to use up both tanks to form 28.0 mol of water at 23.8°C. (a) Use the ideal gas law to find the pressure needed in each tank. (b) Use the van der Waals equation to find the pressure needed in each tank. (c) Compare the results from the two equations.

5.126 For each of the following, which shows the greater deviation from ideal behavior at the same set of conditions? Explain.

- (a) Argon or xenon
- (b) Water vapor or neon
- (c) Mercury vapor or radon
- (d) Water vapor or methane

5.127 How many liters of gaseous hydrogen bromide at 29°C and 0.965 atm will a chemist need if she wishes to prepare 3.50 L of 1.20 M hydrobromic acid?

5.128 A mixture consisting of 7.0 g of CO and 10.0 g of SO₂, two atmospheric pollutants, has a pressure of 0.33 atm when placed in a sealed container. What is the partial pressure of CO?

5.129 Sulfur dioxide is used to make sulfuric acid. One method of producing it is by roasting mineral sulfides, for example,

A production error leads to the sulfide being placed in a 950-L vessel with insufficient oxygen. Initially, the partial pressure of O₂ is 0.64 atm, and the total pressure is 1.05 atm, with the balance due to N₂. The reaction is run until 85% of the O₂ is consumed, and the vessel is then cooled to its initial temperature. What is the total pressure in the vessel and the partial pressure of each gas in it?

5.130 A mixture of CO₂ and Kr weighs 35.0 g and exerts a pressure of 0.708 atm in its container. Since Kr is expensive, you wish to recover it from the mixture. After the CO₂ is completely removed by absorption with NaOH(s), the pressure in the container is 0.250 atm. How many grams of CO₂ were originally present? How many grams of Kr can you recover?

5.131 When a car accelerates quickly, the passengers feel a force that presses them back into their seats, but a balloon filled with helium floats forward. Why?

5.132 Gases such as CO are gradually oxidized in the atmosphere, not by O₂ but by the hydroxyl radical, ·OH, a species with one fewer electron than a hydroxide ion. At night, the ·OH concentration is nearly zero, but it increases to 2.5×10^{12} molecules/m³ in polluted air during the day. At daytime conditions of 1.00 atm and 22°C, what is the partial pressure and mole percent of ·OH in air?

5.133 Aqueous sulfurous acid (H₂SO₃) was made by dissolving 0.200 L of sulfur dioxide gas at 19°C and 745 mmHg in water to yield 500.0 mL of solution. The acid solution required 10.0 mL of sodium hydroxide solution to reach the titration end point. What was the molarity of the sodium hydroxide solution?

5.134 In the 19th century, J. B.

A. Dumas devised a method for finding the molar mass of a volatile liquid from the volume, temperature, pressure, and mass of its vapor. He placed a sample of such a liquid in a flask that was closed with a stopper fitted with a narrow tube, immersed the flask in a hot water bath to vaporize the liquid, and then cooled the flask. Find the molar mass of a volatile liquid from the following:

Mass of empty flask = 65.347 g

Mass of flask filled with water at 25°C = 327.4 g

Density of water at 25°C = 0.997 g/mL

Mass of flask plus condensed unknown liquid = 65.739 g

Barometric pressure = 101.2 kPa

Temperature of water bath = 99.8°C

5.135 During World War II, a portable source of hydrogen gas was needed for weather balloons, and solid metal hydrides were the most convenient form. Many metal hydrides react with water to generate the metal hydroxide and hydrogen. Two candidates were lithium hydride and magnesium hydride. What volume (in L) of gas is formed from 1.00 lb of each hydride reacting with excess water at 750. torr and 27°C?

5.136 The lunar surface reaches 370 K at midday. The atmosphere consists of neon, argon, and helium at a total pressure of only 2×10^{-14} atm. Calculate the rms speed of each component in the lunar atmosphere. [Use $R = 8.314 \text{ J/(mol}\cdot\text{K)}$ and express \mathcal{M} in kg/mol.]

5.137 A person inhales air richer in O₂ and exhales air richer in CO₂ and water vapor. During each hour of sleep, a person exhales a total of about 300 L of this CO₂-enriched and H₂O-enriched air.

(a) If the partial pressures of CO₂ and H₂O in exhaled air are each 30.0 torr at 37.0°C, calculate the mass (g) of CO₂ and of H₂O exhaled in 1 h of sleep. (b) How many grams of body mass does the person lose in 8 h of sleep if all the CO₂ and H₂O exhaled come from the metabolism of glucose?

5.138 Popcorn pops because the horny endosperm, a tough, elastic material, resists gas pressure within the heated kernel until the pressure reaches explosive force. A 0.25-mL kernel has a water content of 1.6% by mass, and the water vapor reaches 170°C and 9.0 atm before the kernel ruptures. Assume that water vapor can occupy 75% of the kernel's volume. (a) What is the mass (in g) of the kernel? (b) How many milliliters would this amount of water vapor occupy at 25°C and 1.00 atm?

5.139 Sulfur dioxide emissions from coal-burning power plants are removed by *flue-gas desulfurization*. The flue gas passes through a scrubber, and a slurry of wet calcium carbonate reacts with it to form carbon dioxide and calcium sulfite. The calcium sulfite then reacts with oxygen to form calcium sulfate, which is

sold as gypsum. (a) If the sulfur dioxide concentration is 1000 times higher than its mole fraction in clean dry air (2×10^{-10}), how much calcium sulfate (kg) can be made from scrubbing 4 GL of flue gas ($1 \text{ GL} = 1 \times 10^9 \text{ L}$)? A state-of-the-art scrubber removes at least 95% of the sulfur dioxide. (b) If the mole fraction of oxygen in air is 0.209, what volume (L) of air at 1.00 atm and 25°C is needed to react with all the calcium sulfite?

5.140 Many water treatment plants use chlorine gas to kill microorganisms before the water is released for residential use. A plant engineer has to maintain the chlorine pressure in a tank below the 85.0-atm rating and, to be safe, decides to fill the tank to 80.0% of this maximum pressure. (a) How many moles of Cl_2 gas can be kept in an 850.-L tank at 298 K if she uses the ideal gas law in the calculation? (b) What is the tank pressure if she uses the van der Waals equation for this amount of gas? (c) Did the engineer fill the tank to the desired pressure?

5.141 At 10.0°C and 102.5 kPa, the density of dry air is 1.26 g/L. What is the average “molar mass” of dry air at these conditions?

5.142 In A, the picture shows a cylinder with 0.1 mol of a gas that behaves ideally. Choose the cylinder (B, C, or D) that correctly represents the volume of the gas after each of the following changes. If none of the cylinders is correct, specify “none.”

- P is doubled at fixed n and T .
- T is reduced from 400 K to 200 K at fixed n and P .
- T is increased from 100°C to 200°C at fixed n and P .
- 0.1 mol of gas is added at fixed P and T .
- 0.1 mol of gas is added and P is doubled at fixed T .

5.143 Ammonia is essential to so many industries that, on a molar basis, it is the most heavily produced substance in the world. Calculate P_{IGL} and P_{VDW} (in atm) of 51.1 g of ammonia in a 3.000-L container at 0°C and 400.°C, the industrial temperature. (See Table 5.4 for the values of the van der Waals constants.)

5.144 A 6.0-L flask contains a mixture of methane (CH_4), argon, and helium at 45°C and 1.75 atm. If the mole fractions of helium and argon are 0.25 and 0.35, respectively, how many molecules of methane are present?

5.145 A large portion of metabolic energy arises from the biological combustion of glucose:

- If this reaction is carried out in an expandable container at 37°C and 780. torr, what volume of CO_2 is produced from 20.0 g of glucose and excess O_2 ?
- If the reaction is carried out at the same conditions with the stoichiometric amount of O_2 , what is the partial pressure of each gas when the reaction is 50% complete (10.0 g of glucose remains)?

5.146 What is the average kinetic energy and rms speed of N_2 molecules at STP? Compare these values with those of H_2 molecules at STP. [Use $R = 8.314 \text{ J}/(\text{mol} \cdot \text{K})$ and express \mathcal{M} in kg/mol.]

5.147 According to government standards, the 8-h threshold limit value is 5000 ppmv for CO_2 and 0.1 ppmv for Br_2 (1 ppmv is 1 part by volume in 10^6 parts by volume). Exposure to either gas for

8 h above these limits is unsafe. At STP, which of the following would be unsafe for 8 h of exposure?

- Air with a partial pressure of 0.2 torr of Br_2
- Air with a partial pressure of 0.2 torr of CO_2
- 1000 L of air containing 0.0004 g of Br_2 gas
- 1000 L of air containing 2.8×10^{22} molecules of CO_2

5.148 One way to prevent emission of the pollutant NO from industrial plants is by a catalyzed reaction with NH_3 :

(a) If the NO has a partial pressure of 4.5×10^{-5} atm in the flue gas, how many liters of NH_3 are needed per liter of flue gas at 1.00 atm? (b) If the reaction takes place at 1.00 atm and 365°C, how many grams of NH_3 are needed per kiloliter (kL) of flue gas?

5.149 An equimolar mixture of Ne and Xe is accidentally placed in a container that has a tiny leak. After a short while, a very small proportion of the mixture has escaped. What is the mole fraction of Ne in the effusing gas?

5.150 From the relative rates of effusion of $^{235}\text{UF}_6$ and $^{238}\text{UF}_6$, find the number of steps needed to produce a sample of the enriched fuel used in many nuclear reactors, which is 3.0 mole % ^{235}U . The natural abundance of ^{235}U is 0.72%.

5.151 A slight deviation from ideal behavior exists even at normal conditions. If it behaved ideally, 1 mol of CO would occupy 22.414 L and exert 1 atm pressure at 273.15 K. Calculate P_{VDW} for 1.000 mol of CO at 273.15 K. (Use $R = 0.08206 \frac{\text{atm} \cdot \text{L}}{\text{mol} \cdot \text{K}}$)

5.152 In preparation for a combustion demonstration, a professor fills a balloon with equal molar amounts of H_2 and O_2 , but the demonstration has to be postponed until the next day. During the night, both gases leak through pores in the balloon. If 35% of the H_2 leaks, what is the O_2/H_2 ratio in the balloon the next day?

5.153 Phosphorus trichloride is important in the manufacture of insecticides, fuel additives, and flame retardants. Phosphorus has only one naturally occurring isotope, ^{31}P , whereas chlorine has two, ^{35}Cl (75%) and ^{37}Cl (25%). (a) What different molecular masses (in amu) can be found for PCl_3 ? (b) Which is the most abundant? (c) What is the ratio of the effusion rates of the heaviest and the lightest PCl_3 molecules?

5.154 A truck tire has a volume of 218 L and is filled with air to 35.0 psi at 295 K. After a drive, the air heats up to 318 K. (a) If the tire volume is constant, what is the pressure (in psi)? (b) If the tire volume increases 2.0%, what is the pressure (in psi)? (c) If the tire leaks 1.5 g of air per minute and the temperature is constant, how many minutes will it take for the tire to reach the original pressure of 35.0 psi (\mathcal{M} of air = 28.8 g/mol)?

5.155 Allotropes are different molecular forms of an element, such as dioxygen (O_2) and ozone (O_3). (a) What is the density of each oxygen allotrope at 0°C and 760 torr? (b) Calculate the ratio of densities, $d_{\text{O}_3}/d_{\text{O}_2}$, and explain the significance of this number.

5.156 When gaseous F_2 and solid I_2 are heated to high temperatures, the I_2 sublimes and gaseous iodine heptafluoride forms. If 350. torr of F_2 and 2.50 g of solid I_2 are put into a 2.50-L container at 250. K and the container is heated to 550. K, what is the final pressure (in torr)? What is the partial pressure of I_2 gas?

6

Thermochemistry: Energy Flow and Chemical Change

6.1 Forms of Energy and Their Interconversion

Defining System and Surroundings
Energy Change (ΔE)
Heat and Work
Law of Energy Conservation
Units of Energy
State Functions
Calculating Pressure-Volume Work

6.2 Enthalpy: Changes at Constant Pressure

The Meaning of Enthalpy
Comparing ΔE and ΔH
Exothermic and Endothermic Processes

6.3 Calorimetry: Measuring the Heat of a Chemical or Physical Change

Specific Heat Capacity
The Two Major Types of Calorimetry

6.4 Stoichiometry of Thermochemical Equations

6.5 Hess's Law: Finding ΔH of Any Reaction

6.6 Standard Enthalpies of Reaction (ΔH_{rxn}°)

Formation Equations
Determining ΔH_{rxn}° from ΔH_f° Values

Source: © Maya Kruchankova/Shutterstock.com

Concepts and Skills to Review Before You Study This Chapter

- › interconverting potential and kinetic energy (Section 1.1)
- › distinction between heat and temperature (Section 1.4)
- › nature of chemical bonding (Section 2.7)
- › calculations of reaction stoichiometry (Section 3.4)
- › properties of the gaseous state (Section 5.1)
- › relation between kinetic energy and temperature (Section 5.5)

All matter contains energy, so whenever matter undergoes a change, the quantity of energy that the matter contains also changes. Both chemical and physical changes are involved when a gas stove is used to boil the water for your morning cup of tea. In the chemical change, energy is released as heat when higher energy natural gas and O₂ react to form lower energy products. The heat energy released by this chemical change is absorbed by lower energy liquid water in the tea kettle as it vaporizes to higher energy gaseous water.

This interplay of matter and energy is profoundly important and has an enormous impact on society. On an everyday level, many familiar materials release, absorb, or alter the flow of energy. Fuels such as natural gas and oil release energy to cook our food, warm our homes, or power our vehicles. Fertilizers help crops convert solar energy into food. Metal wires increase the flow of electrical energy, and polymer fibers in winter clothing slow the flow of thermal energy away from our bodies.

Thermodynamics is the study of energy and its transformations, and three chapters in this text address this central topic. Our focus in this chapter is on **thermochemistry**, the branch of thermodynamics that deals with heat in chemical and physical change. In Chapter 20, we consider *why* reactions occur, and in Chapter 21, we apply those insights to electrical energy.

IN THIS CHAPTER . . . We see how heat, or thermal energy, flows when matter changes, how to measure the quantity of heat for a given change, and how to determine the direction and magnitude of heat flow for any reaction.

- › We see that energy always flows between a system and its surroundings in the form of heat or work, so the total energy is conserved.
- › We discuss the units of energy and show that the total size of an energy change does not depend on how the change occurs.
- › We identify the heat of a reaction in an open container as a change in enthalpy, which can be negative (exothermic reaction) or positive (endothermic reaction).
- › We describe how a calorimeter measures heat and how the quantity of heat in a reaction is proportional to the amounts of substances.
- › We define standard conditions in order to compare enthalpies of reactions and see how to obtain the change in enthalpy for any reaction.
- › We discuss some current and future energy sources and describe the critical relationship between energy demand and climate change.

6.1 FORMS OF ENERGY AND THEIR INTERCONVERSION

In Chapter 1, we saw that all energy is either potential or kinetic, and that these forms are interconvertible. An object has potential energy by virtue of its position and kinetic energy by virtue of its motion. Let's re-examine these ideas by considering a weight raised above the ground. As the weight is lifted by your muscles or a motor, its potential energy increases; this energy is converted to kinetic energy as the weight falls (see Figure 1.3). When it hits the ground, some of that kinetic energy appears as work done to move the soil and pebbles slightly, and some appears as heat when it warms them slightly. Thus, in this situation, *potential energy is converted to kinetic energy, which appears as work and heat*.

Several other forms of energy—solar, electrical, nuclear, and chemical—are examples of potential and kinetic energy on the atomic scale. No matter what the form of energy or the situation, *when energy is transferred from one object to another, it appears as work and/or heat*. In this section, we examine this idea in terms of the release or absorption of energy during a chemical or physical change.

Figure 6.1 A chemical system and its surroundings.

Source: © McGraw-Hill Education. Stephen Frisch, photographer

Defining the System and Its Surroundings

In any thermodynamic study, including measuring a change in energy, the first step is to define the **system**—the part of the universe we are focusing on. And the moment we define the system, everything else is defined as the **surroundings**.

Figure 6.1 shows a typical chemical system—the contents of a flask, usually substances undergoing physical or chemical change. The flask itself, the air surrounding the flask, other equipment, and perhaps the rest of the laboratory are the surroundings. In principle, the rest of the universe is the surroundings, but in practice, we consider only the parts that are relevant to the system: it's not likely that a thunderstorm in central Asia or a methane blizzard on Neptune will affect the contents of the flask, but the temperature and pressure of the lab might. Thus, the experimenter defines the system and the relevant surroundings. An astronomer defines a galaxy as the system and nearby galaxies as the surroundings; a microbiologist defines a given cell as the system and neighboring cells and the extracellular fluid as the surroundings; and so forth.

Energy Change (ΔE): Energy Transfer to or from a System

Each particle in a system has potential energy and kinetic energy, and the sum of all these energies is the **internal energy**, E , of the system (some texts use the symbol U). When the reactants in a chemical system change to products, the system's internal energy has changed. This change, ΔE , is the difference between the internal energy *after* the change (E_{final}) and the internal energy *before* the change (E_{initial}), where Δ (Greek *delta*) means “change (or difference) in” calculated as the *final state minus the initial state*. Thus, ΔE is the final quantity of energy of the system **minus** the initial quantity:

$$\Delta E = E_{\text{final}} - E_{\text{initial}} = E_{\text{products}} - E_{\text{reactants}} \quad (6.1)$$

Because the universe consists of only system and surroundings, *a change in the energy of the system must be accompanied by an equal and opposite change in the energy of the surroundings*. In an *energy diagram*, the final and initial states are horizontal lines along a vertical energy axis, with ΔE being the difference in the heights of the lines. A system can change its internal energy in one of two ways:

- By releasing some energy in a transfer *to* the surroundings (Figure 6.2A):

$$E_{\text{final}} < E_{\text{initial}} \quad \text{so} \quad \Delta E < 0$$

- By absorbing some energy in a transfer *from* the surroundings (Figure 6.2B):

$$E_{\text{final}} > E_{\text{initial}} \quad \text{so} \quad \Delta E > 0$$

Thus, ΔE is a *transfer* of energy from system to surroundings, or vice versa.

Heat and Work: Two Forms of Energy Transfer

Energy transferred from system to surroundings, or vice versa, appears in two forms:

1. **Heat.** **Heat**, or *thermal energy* (symbolized by q), is the energy transferred as a result of a difference in temperature between the system and the surroundings. For example, energy in the form of heat is transferred *from* hot coffee (system) *to* the mug, your hand, and air (surroundings) because they are at a lower temperature, while heat is transferred *from* a hot stove (surroundings) *to* an ice cube (system) because the ice is at a lower temperature.

Figure 6.2 Energy diagrams for the transfer of internal energy (E) between two systems and their surroundings.

A, When the system releases energy, $\Delta E (E_{\text{final}} - E_{\text{initial}})$ is negative. **B**, When the system absorbs energy, $\Delta E (E_{\text{final}} - E_{\text{initial}})$ is positive. (The vertical yellow arrow always has its tail at the initial state.)

2. Work. All other forms of energy transfer involve some type of **work (w)**, the energy transferred when an object is moved by a force. When you (system) kick a football, energy is transferred as work because the force of the kick moves the ball and air (surroundings). When you pump up a ball, energy is transferred as work because the added air (system) exerts a force on the inner wall of the ball (surroundings) and moves it outward.

The total change in a system's internal energy is the sum of the energy transferred as heat and/or as work:

$$\Delta E = q + w \quad (6.2)$$

The values of q and w (and, therefore, of ΔE) can have either a positive or negative sign. *We define the sign of the energy change from the system's perspective:*

- Energy transferred *into* the system is *positive* because the *system ends up with more energy*.
- Energy transferred *out from* the system is *negative*, because the *system ends up with less energy*.

Innumerable combinations of heat and/or work can change a system's internal energy. In the rest of this subsection, we'll examine the four simplest cases—two that involve only heat and two that involve only work.

Energy Transferred as Heat Only For a system that transfers energy only as heat (q) and does no work ($w = 0$), we have, from Equation 6.2, $\Delta E = q + 0 = q$. There are two ways this transfer can happen:

1. Heat flowing out from a system (Figure 6.3A, next page). Suppose hot water is the system, and the beaker holding it and the rest of the lab are the surroundings. The water transfers energy as heat outward until the temperature of the water and the surroundings are equal. Since heat flows *out* from the system, the final energy of the system is less than the initial energy.

System *releases* energy as heat $\rightarrow q$ is *negative* $\rightarrow E_{\text{final}} < E_{\text{initial}}$ $\rightarrow \Delta E$ is *negative*

2. Heat flowing into a system (Figure 6.3B, next page). If the system consists of ice water, the surroundings transfer energy as heat *into* the system, once again until the ice melts and the temperature of the water and the surroundings become equal. In this case, heat flows *in*, so the final energy of the system is higher than its initial energy. ➤

System *absorbs* energy as heat $\rightarrow q$ is *positive* $\rightarrow E_{\text{final}} > E_{\text{initial}}$ $\rightarrow \Delta E$ is *positive*

Energy Transferred as Work Only For a system that transfers energy only as work, $q = 0$; therefore, $\Delta E = 0 + w = w$. There are two ways this transfer can happen:

1. Work done by a system (Figure 6.4A, next page). Consider the aqueous reaction between zinc and hydrochloric acid:

Thermodynamics in the Kitchen

The functioning of two familiar kitchen appliances can clarify the sign of q . The air in a refrigerator (surroundings) has a lower temperature than a newly added piece of food (system), so the food releases energy as heat to the refrigerator air, $q < 0$. The air in a hot oven (surroundings) has a higher temperature than a newly added piece of food (system), so the food absorbs energy as heat from the oven air, $q > 0$.

Figure 6.3 The two cases where energy is transferred as heat only. **A**, The system releases heat. **B**, The system absorbs heat.

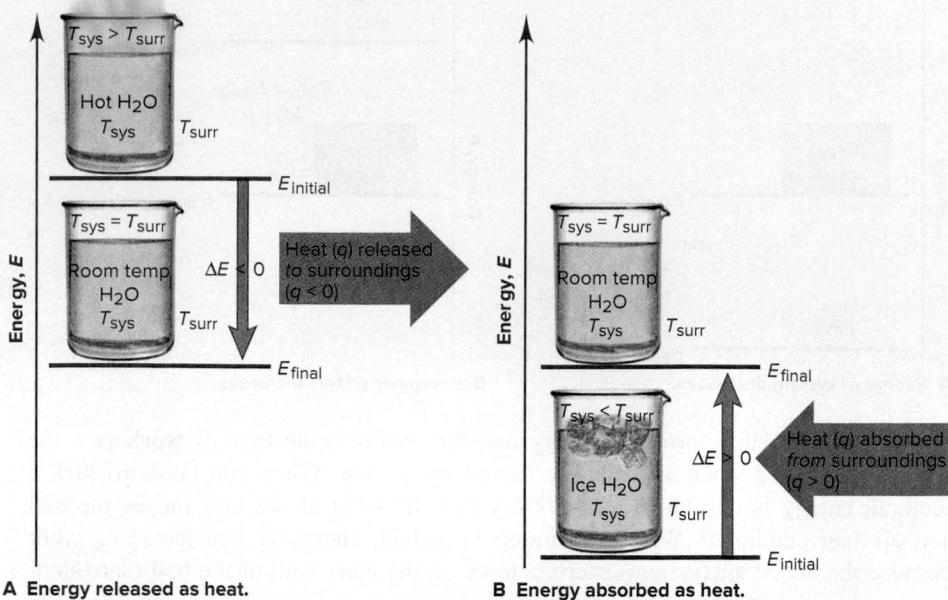

The reaction takes place in a nearly evacuated (narrow P_{sys} arrow), insulated container attached to a piston-cylinder assembly. (The container is insulated so that heat does not flow.) We define the system as the reaction mixture, and the container, piston-cylinder, outside air, and so forth as the surroundings. In the initial state, the internal energy is the energy of the reactants, and in the final state, it is the energy of the products. Hydrogen gas (shown in purple) forms, pushing back the piston as it expands. Thus, energy is transferred as work done by the system *on* the surroundings.

System *releases* energy as work done by it $\rightarrow w$ is negative $\rightarrow E_{\text{final}} < E_{\text{initial}} \rightarrow \Delta E$ is negative

(The work done here is not very useful because it just pushes back the piston and outside air. But, if the reaction mixture is gasoline and oxygen and the surroundings are an automobile engine, much of the internal energy is transferred as the work done to move the car.)

2. Work done *on* a system (Figure 6.4B). Suppose that, after the reaction is over, we increase the pressure of the surroundings (wider P_{surr} arrow) so that the piston moves in, compressing the hydrogen gas into a smaller volume. Energy is transferred as work done by the surroundings *on* the system.

System *absorbs* energy as work done on it $\rightarrow w$ is positive $\rightarrow E_{\text{final}} > E_{\text{initial}} \rightarrow \Delta E$ is positive

Table 6.1 summarizes the sign conventions for q and w and the effect on the sign of ΔE .

Figure 6.4 The two cases where energy is transferred as work only. **A**, The system does work on the surroundings. **B**, The system has work done on it by the surroundings.

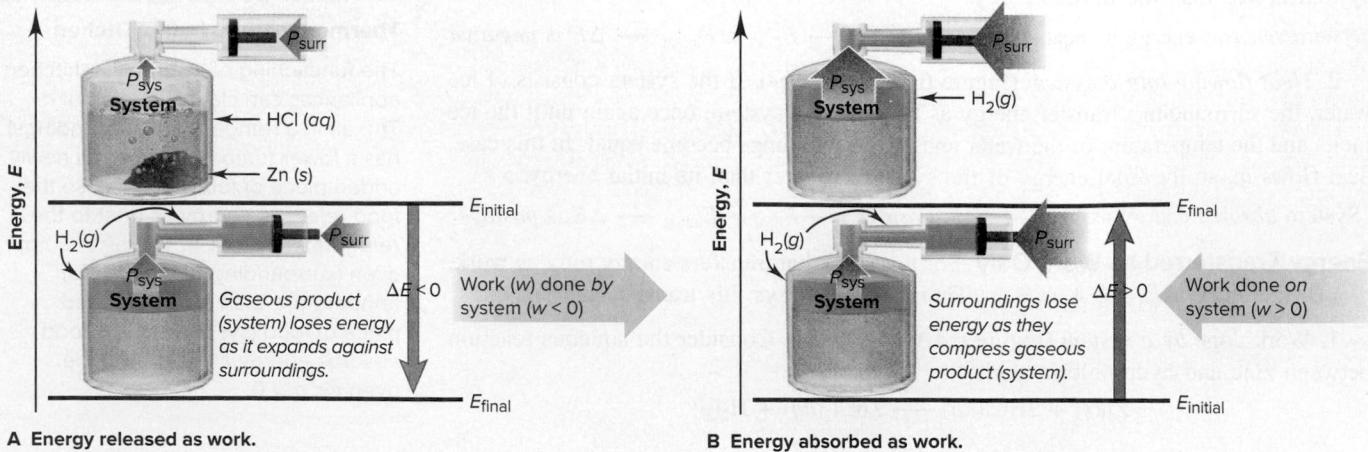

Table 6.1**The Sign Conventions* for q , w , and ΔE**

q	+	w	=	ΔE
+ (heat absorbed)		+ (work done <i>on</i>)		+ (energy <i>absorbed</i>)
+ (heat absorbed)		- (work done <i>by</i>)		Depends on the <i>sizes</i> of q and w
- (heat released)		+ (work done <i>on</i>)		Depends on the <i>sizes</i> of q and w
- (heat released)		- (work done <i>by</i>)		- (energy <i>released</i>)

*From the perspective of the system.

The Law of Energy Conservation

As you've seen, when a system absorbs energy, the surroundings release it, and when a system releases energy, the surroundings absorb it. Energy transferred between system and surroundings can be in the form of heat and/or various types of work—mechanical, electrical, radiant, chemical, and so forth.

Indeed, energy is often converted from one form to another during transfers. For example, when gasoline burns in a car engine, the reaction releases energy that is transferred as heat and work. The heat warms the car parts, passenger compartment, and surrounding air. The work is done when mechanical energy turns the car's wheels and belts. That energy is converted into the electrical energy of the sound system, the radiant energy of the headlights, the chemical energy of the battery, and so forth. The sum of all these forms equals the change in energy between reactants and products as the gasoline burns and the exhaust forms.

Complex biological processes follow the same general pattern. During photosynthesis, green plants use solar energy to convert the chemical energy of the bonds in CO_2 and H_2O into the energy of the bonds in starch and O_2 ; when you digest starch, the energy in its bonds is converted into the muscular (mechanical) energy you need to run a marathon or engage in any activity.

The most important point to realize in these, and all other situations, is that the form of energy may change, but energy does not appear or disappear—energy cannot be created or destroyed. Put another way, *energy is conserved: the total energy of the system plus the surroundings remains constant*. The **law of conservation of energy**, also known as the **first law of thermodynamics**, restates this basic observation: *the total energy of the universe is constant*. It is expressed mathematically as

$$\Delta E_{\text{universe}} = \Delta E_{\text{system}} + \Delta E_{\text{surroundings}} = 0 \quad (6.3)$$

This law applies, as far as we know, to all systems, from a burning match to continental drift, from the pumping of your heart to the formation of the Solar System.

Units of Energy

The SI unit of energy is the **joule (J)**, a derived unit composed of three base units:

$$1 \text{ J} = 1 \text{ kg}\cdot\text{m}^2/\text{s}^2$$

Both heat and work are expressed in joules. Let's see why the joule is the unit for work. The work (w) done on a mass is the force (F) times the distance (d) that the mass moves: $w = F \times d$. A *force* changes the velocity of a mass over time; that is, a force *accelerates* a mass. Velocity has units of meters per second (m/s), so acceleration (a) has units of meters per second per second (m/s²). Force, therefore, has units of mass (m , in kilograms) times acceleration:

$$F = m \times a \quad \text{has units of} \quad \text{kg}\cdot\text{m/s}^2$$

Therefore, $w = F \times d \quad \text{has units of} \quad (\text{kg}\cdot\text{m/s}^2) \times \text{m} = \text{kg}\cdot\text{m}^2/\text{s}^2 = \text{J}$

The **calorie (cal)** is an older unit defined originally as the quantity of energy needed to raise the temperature of 1 g of water by 1°C (specifically, from 14.5°C to 15.5°C). The calorie is now defined in terms of the joule:

$$1 \text{ cal} \equiv 4.184 \text{ J} \quad \text{or} \quad 1 \text{ J} = \frac{1}{4.184} \text{ cal} = 0.2390 \text{ cal}$$

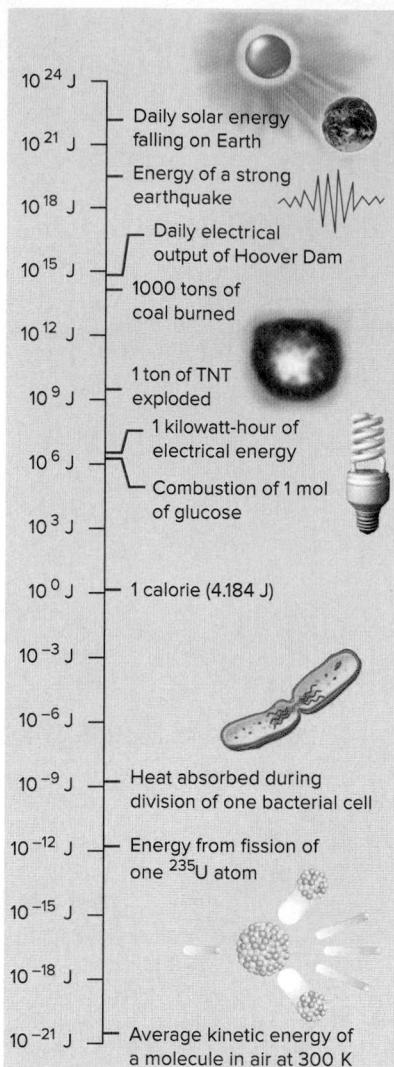

Figure 6.5 Some quantities of energy.
The vertical scale is exponential.

Since the quantities of energy involved in chemical reactions are usually quite large, chemists use the kilojoule (kJ) or, in earlier sources, the kilocalorie (kcal):

$$1 \text{ kJ} = 1000 \text{ J} = 0.2390 \text{ kcal} = 239.0 \text{ cal}$$

The nutritional Calorie (note the capital C), the unit that measures the energy available from food, is actually a kilocalorie:

$$1 \text{ Cal} = 1000 \text{ cal} = 1 \text{ kcal} = 4184 \text{ J}$$

The *British thermal unit (Btu)*, a unit that you may have seen used for the energy output of appliances, is the quantity of energy required to raise the temperature of 1 lb of water by 1°F; 1 Btu is equivalent to 1055 J. In general, the SI unit (J or kJ) is used in this text. Some interesting quantities of energy are featured in Figure 6.5.

SAMPLE PROBLEM 6.1

Determining the Change in Internal Energy of a System

Problem When gasoline burns in a car engine, the heat released causes the gaseous products CO₂ and H₂O to expand, which pushes the pistons outward. Excess heat is removed by the radiator. If the expanding gases do 451 J of work on the pistons and the system releases 325 J to the surroundings as heat, calculate the change in energy (ΔE) in J, kJ, and kcal.

Plan We define system and surroundings to choose signs for q and w , and then we calculate ΔE with Equation 6.2. The system is the reactants and products, and the surroundings are the pistons, the radiator, and the rest of the car. Heat is released by the system, so q is negative. Work is done by the system to push the pistons outward, so w is also negative. We obtain the answer in J and then convert it to kJ and kcal.

Solution Calculating ΔE (from Equation 6.2) in J:

$$q = -325 \text{ J}$$

$$w = -451 \text{ J}$$

$$\Delta E = q + w = -325 \text{ J} + (-451 \text{ J}) = -776 \text{ J}$$

Converting from J to kJ:

$$\Delta E = -776 \text{ J} \times \frac{1 \text{ kJ}}{1000 \text{ J}} = -0.776 \text{ kJ}$$

Converting from J to kcal:

$$\Delta E = -776 \text{ J} \times \frac{1 \text{ cal}}{4.184 \text{ J}} \times \frac{1 \text{ kcal}}{1000 \text{ cal}} = -0.185 \text{ kcal}$$

Check The answer is reasonable: combustion of gasoline releases energy from the system, so $E_{\text{final}} < E_{\text{initial}}$ and ΔE should be negative.

FOLLOW-UP PROBLEMS

Brief Solutions for all Follow-up Problems appear at the end of the chapter.

6.1A A sample of liquid absorbs 13.5 kJ of heat and does 1.8 kJ of work when it vaporizes. Calculate ΔE (in J).

6.1B In a reaction, gaseous reactants form a liquid product. The heat absorbed by the surroundings is 26.0 kcal, and the work done on the system is 15.0 Btu. Calculate ΔE (in kJ).

SOME SIMILAR PROBLEMS 6.9–6.12

State Functions and the Path Independence of the Energy Change

The internal energy (E) of a system is called a **state function**, a property dependent only on the *current state* of the system (its composition, volume, pressure, and temperature), *not* on the path the system takes to reach that state. The energy change of a system can occur through countless combinations of heat (q) and/or work (w).

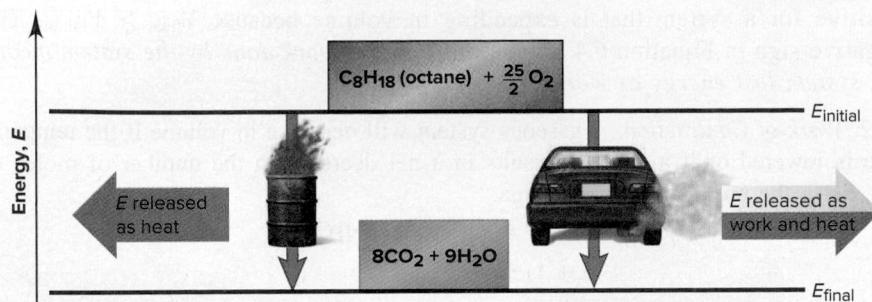

Figure 6.6 Two different paths for the energy change of a system. Even though q and w for the two paths are different, ΔE is the same.

However, because E is a state function, the overall ΔE is the same no matter what the specific combination may be. That is, ΔE does not depend on how the change takes place, but only on the difference between the final and initial states.

As an example, let's define a system in its initial state as 1 mol of octane (a component of gasoline) together with enough O_2 to burn it completely. In its final state, the system is the CO_2 and H_2O that form:

Energy is transferred *out* from the system as heat and/or work, so ΔE is negative. Figure 6.6 shows just two of the many ways the change can occur. If we burn the octane in an open container (*left*), ΔE is transferred almost completely as heat (with a small quantity of work done to push back the atmosphere). If we burn it in a car engine (*right*), a much larger portion (~30%) of ΔE is transferred as work that moves the car, with the rest transferred as heat that warms the car, exhaust gases, and surrounding air. If we burn the octane in a lawn mower or a motorcycle, ΔE appears as other combinations of work and heat. Thus, q and w are *not* state functions because their values *do* depend on the path the system takes, but ΔE (the sum of q and w) *does not*. ➤

As a final example, consider temperature, another state function. If you add enough heat to raise the temperature of a sample of water from an initial temperature of 10°C to a final temperature of 60°C , $\Delta T = \Delta T_{\text{final}} - T_{\text{initial}} = 60^\circ\text{C} - 10^\circ\text{C} = 50^\circ\text{C}$. If instead, you add enough heat to raise the temperature of the water from 10°C to 80°C and then you cool the water to 60°C , ΔT is still $60^\circ\text{C} - 10^\circ\text{C} = 50^\circ\text{C}$. Pressure (P) and volume (V) are some other state functions. Path independence means that *changes in state functions— ΔE , ΔT , ΔP , and ΔV —depend only on the initial and final states*.

Your Personal Financial State Function

The *balance* in your checking account is a state function of your personal financial system. You can open a new checking account with a birthday gift of \$50 or with a deposit of a \$100 paycheck and then write two \$25 checks. The two paths to the balance are different, but the balance (current state) is the same.

Calculating Pressure-Volume Work (PV Work)

The two most important types of chemical work are electrical work, done by moving charged particles (Chapter 21), and a type of mechanical work called **pressure-volume work (PV work)**, done when the volume of the system changes in the presence of an external pressure (P). The quantity of PV work equals P times the change in volume (ΔV , or $V_{\text{final}} - V_{\text{initial}}$):

$$w = -P\Delta V \quad (6.4)$$

The volume of the system may increase (expand) or decrease (contract).

1. *Work of Expansion.* The volume of a gaseous system will increase if the temperature is raised (Charles's law) or if a chemical reaction results in a net increase in the number of moles of gas (Avogadro's law), as in the combustion of propane:

In an open flask (or in a cylinder with a weightless, frictionless piston, Figure 6.7, *next page*), a system of an expanding gas does PV work *on* the surroundings as it pushes against the atmosphere, so the work has a negative sign. Note that ΔV is

Figure 6.7 Pressure-volume work. An expanding gas pushing back the atmosphere does PV work ($w = -P\Delta V$).

positive for a system that is expanding in volume because $V_{\text{final}} > V_{\text{initial}}$. The negative sign in Equation 6.4 is required because *work done by the system means the system lost energy as work*.

2. Work of Contraction. A gaseous system will decrease in volume if the temperature is lowered or if a reaction results in a net decrease in the number of moles of gas, as in the production of ammonia:

4 (3 + 1) mol of gas 2 mol of gas

In these situations, *the system has work done on it by the surroundings* as the gas is contracted into a smaller volume by the external pressure. Since $V_{\text{final}} < V_{\text{initial}}$, ΔV is negative, and the work has a positive sign, which means *the system has gained energy as work*.

When using Equation 6.4, P is expressed in atmospheres and ΔV in liters, resulting in a unit of $\text{atm}\cdot\text{L}$ for work; an important relationship is that 101.3 J of energy is equivalent to 1 $\text{atm}\cdot\text{L}$.

SAMPLE PROBLEM 6.2

Calculating Pressure-Volume Work Done by or on a System

Problem A reaction taking place in a container with a piston-cylinder assembly at constant temperature produces a gas, and the volume increases from 125 mL to 652 mL against an external pressure of 988 torr. Calculate the work done (in J; 1 $\text{atm}\cdot\text{L} = 101.3 \text{ J}$).

Plan We are given the external pressure (988 torr) and initial (125 mL) and final volumes (652 mL) and have to find the work done by the gas. We subtract the initial V from the final V to find ΔV and convert it from mL to L. We convert the given P from torr to atm and use Equation 6.4 to calculate w . Then we convert the answer from $\text{atm}\cdot\text{L}$ to J (see the road map).

Solution Calculating ΔV :

$$\Delta V (\text{mL}) = V_{\text{final}} - V_{\text{initial}} = 652 \text{ mL} - 125 \text{ mL} = 527 \text{ mL}$$

Converting ΔV from mL to L:

$$\Delta V (\text{L}) = 527 \text{ mL} \times \frac{1 \text{ L}}{1000 \text{ mL}} = 0.527 \text{ L}$$

Converting P from torr to atm:

$$P (\text{atm}) = 988 \text{ torr} \times \frac{1 \text{ atm}}{760 \text{ torr}} = 1.30 \text{ atm}$$

Calculating w (using Equation 6.4):

$$w (\text{atm}\cdot\text{L}) = -P\Delta V = -(1.30 \text{ atm} \times 0.527 \text{ L}) = -0.685 \text{ atm}\cdot\text{L}$$

Converting from $\text{atm}\cdot\text{L}$ to J:

$$w (\text{J}) = -0.685 \text{ atm}\cdot\text{L} \times \frac{101.3 \text{ J}}{1 \text{ atm}\cdot\text{L}} = -69.4 \text{ J}$$

Check Since gas is produced, the system expands and does work on the surroundings (energy is released as work), so the negative sign is correct. Rounding shows that the size of the answer is reasonable: $w \approx -1 \text{ atm}\cdot\text{L} \times 0.5 \text{ L} = -0.5 \text{ atm}\cdot\text{L}$.

FOLLOW-UP PROBLEMS

6.2A A gas is compressed at constant temperature from a volume of 5.68 L to a volume of 2.35 L by an external pressure of 732 torr. Calculate the work done (in J).

6.2B A gas-producing reaction occurs in a container with a piston-cylinder assembly under an external pressure of 5.5 atm. At constant temperature, the volume increases from 10.5 L to 16.3 L. Calculate the work done (in J).

SOME SIMILAR PROBLEMS 6.15 and 6.16

› Summary of Section 6.1

- › Internal energy (E) is transferred as heat (q) when system and surroundings are at different temperatures or as work (w) when an object is moved by a force.
- › Heat absorbed by a system ($q > 0$) or work done on a system ($w > 0$) increases the system's E ; heat released by a system ($q < 0$) or work done by a system ($w < 0$) decreases its E . The change in the internal energy is the sum of the heat and work: $\Delta E = q + w$. Heat and work are measured in joules (J).
- › Energy is always conserved: it can change from one form to another and be transferred into or out of a system, but the total quantity of energy in the universe (system *plus* surroundings) is constant.
- › The internal energy of a system is a state function and, thus, is independent of how the system attained that energy; therefore, the same overall ΔE can occur through any combination of q and w .
- › A system can lose energy by doing work of expansion (increase in volume) or gain energy by having work of contraction done on it (decrease in volume), both of which are forms of pressure-volume (PV) work.

6.2 ENTHALPY: CHANGES AT CONSTANT PRESSURE

Most physical and chemical changes occur at nearly constant atmospheric pressure—a reaction in an open flask, the freezing of a lake, a biochemical process in an organism. In this section, we discuss **enthalpy**, a thermodynamic variable that relates directly to energy changes at constant pressure.

The Meaning of Enthalpy

To determine ΔE , we must measure both heat and work. But, for reactions *at constant pressure*, a thermodynamic quantity called **enthalpy** (H) eliminates the need to measure PV work. The enthalpy of a system is defined as the internal energy *plus* the product of the pressure and volume:

$$H = E + PV$$

The **change in enthalpy** (ΔH) is the change in the system's internal energy *plus* the product of the pressure, which is constant, and the change in volume (ΔV):

$$\Delta H = \Delta E + P\Delta V \quad (6.5)$$

Combining Equations 6.2 ($\Delta E = q + w$) and 6.5 gives

$$\Delta H = \Delta E + P\Delta V = q + w + P\Delta V$$

At constant pressure, we denote q as q_P , giving $\Delta H = q_P + w + P\Delta V$. According to Equation 6.4, $w = -P\Delta V$, so $-w$ can be substituted for $P\Delta V$ to give

$$\Delta H = q_P + w + P\Delta V = q_P + w - w$$

which simplifies to:

$$\Delta H = \Delta E + P\Delta V = q_P \quad (6.6)$$

Thus, *the change in enthalpy equals the heat absorbed or released at constant pressure*. For most changes occurring at constant pressure, ΔH is more relevant than ΔE and easier to obtain: *to find ΔH , measure q_P only; work need not be measured*. We discuss the laboratory method for doing this in Section 6.3.

Comparing ΔE and ΔH

Knowing the *enthalpy* change of a system tells us a lot about its *energy* change as well. In fact, because many reactions involve little (if any) PV work, most (or all) of

the energy change is due to a transfer of heat. Here are three cases:

1. *Reactions that do not involve gases.* Gases do not appear in precipitation, many acid-base, many redox reactions, and so forth. For example,

Because liquids and solids undergo very small volume changes, $\Delta V \approx 0$; thus $P\Delta V \approx 0$; and $\Delta H = \Delta E + P\Delta V \approx \Delta E + 0 \approx \Delta E$.

2. *Reactions in which the amount (mol) of gas does not change.* When the total amount of gaseous reactants equals the total amount of gaseous products, the volume is constant, $\Delta V = 0$, so $P\Delta V = 0$ and $\Delta H = \Delta E$. For example,

3. *Reactions in which the amount (mol) of gas does change.* In these cases, $P\Delta V \neq 0$. However, q_P is usually much larger than $P\Delta V$, so ΔH is still very close to ΔE . For instance, in the combustion of H_2 , 3 mol of gas yields 2 mol of gas:

In this reaction, $\Delta H = -483.6 \text{ kJ}$ and $P\Delta V = -2.5 \text{ kJ}$, so (using Equation 6.5),

$$\Delta H = \Delta E + P\Delta V$$

and

$$\Delta E = \Delta H - P\Delta V = -483.6 \text{ kJ} - (-2.5 \text{ kJ}) = -481.1 \text{ kJ}$$

Since most of ΔE occurs as energy transferred as heat, $\Delta H \approx \Delta E$.

Thus, for most reactions, ΔH equals, or is very close to, ΔE .

Exothermic and Endothermic Processes

Because H is a combination of the three state functions E , P , and V , it is also a state function. Therefore, ΔH equals H_{final} minus H_{initial} . For a reaction, H_{final} is H_{products} and H_{initial} is $H_{\text{reactants}}$, so the enthalpy change of a reaction is

$$\Delta H = H_{\text{final}} - H_{\text{initial}} = H_{\text{products}} - H_{\text{reactants}}$$

Since H_{products} can be either more or less than $H_{\text{reactants}}$, the sign of ΔH indicates whether heat is absorbed or released during the reaction. We determine the sign of ΔH by imagining the heat as a “reactant” or a “product.” The two possible types of processes are

1. *Exothermic process: heat as a “product.”* An **exothermic process** releases heat (*exothermic* means “heat out”) and results in a *decrease* in the enthalpy of the system:

$$\text{Exothermic: } H_{\text{products}} < H_{\text{reactants}} \quad \text{so} \quad \Delta H < 0$$

For example, when methane burns in air, heat flows out of the system into the surroundings, so we show it as a “product”:

The reactants (1 mol of CH_4 and 2 mol of O_2) release heat during the reaction, so they originally had more enthalpy than the products (1 mol of CO_2 and 2 mol of H_2O):

$$H_{\text{reactants}} > H_{\text{products}} \quad \text{so} \quad \Delta H (H_{\text{products}} - H_{\text{reactants}}) < 0$$

This exothermic change is shown in the **enthalpy diagram** in Figure 6.8A. The ΔH arrow always points from reactants to products in this kind of diagram.

2. *Endothermic process: heat as a “reactant.”* An **endothermic process** absorbs heat (*endothermic* means “heat in”) and results in an *increase* in the enthalpy of the system:

$$\text{Endothermic: } H_{\text{products}} > H_{\text{reactants}} \quad \text{so} \quad \Delta H > 0$$

Figure 6.8 Enthalpy diagrams for exothermic and endothermic processes.

A, The combustion of methane is exothermic: $\Delta H < 0$. B, The melting of ice is endothermic: $\Delta H > 0$.

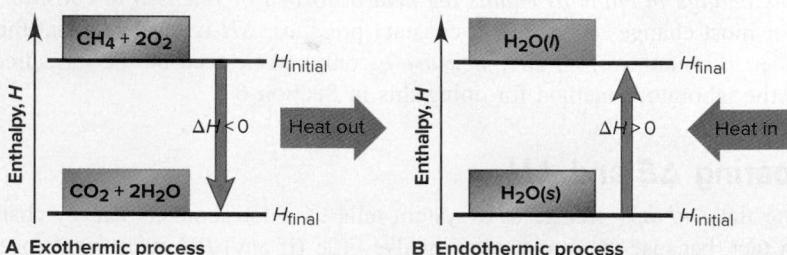

When ice melts, for instance, heat flows *into* the ice from the surroundings, so we show the heat as a “reactant”:

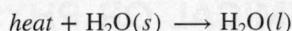

Because heat is absorbed, the enthalpy of the product (water) must be higher than that of the reactant (ice):

$$H_{\text{water}} > H_{\text{ice}} \quad \text{so} \quad \Delta H (H_{\text{water}} - H_{\text{ice}}) > 0$$

This endothermic change is shown in Figure 6.8B. (In general, the value of an enthalpy change is determined with reactants and products at the same temperature.)

SAMPLE PROBLEM 6.3

Drawing Enthalpy Diagrams and Determining the Sign of ΔH

Problem In each of the following cases, determine the sign of ΔH , state whether the reaction is exothermic or endothermic, and draw an enthalpy diagram:

Plan In each equation, we note whether heat is a “product” (exothermic; $\Delta H < 0$) or a “reactant” (endothermic; $\Delta H > 0$). For exothermic reactions, reactants are above products on the enthalpy diagram; for endothermic reactions, reactants are below products. The ΔH arrow always points from reactants to products.

Solution (a) Heat is a product (on the right), so $\Delta H < 0$ and the reaction is exothermic.

Heat is released during the reaction. See the enthalpy diagram (*top*).

(b) Heat is a reactant (on the left), so $\Delta H > 0$ and the reaction is endothermic. Heat is absorbed during the reaction. See the enthalpy diagram (*bottom*).

Check Substances that are on the same side of the equation as the heat have less enthalpy than substances on the other side, so make sure those substances are placed on the lower line of the diagram.

FOLLOW-UP PROBLEMS

6.3A Nitroglycerine decomposes through a violent explosion that releases $5.72 \times 10^3 \text{ kJ}$ of heat per mole:

Is the decomposition of nitroglycerine exothermic or endothermic? Draw an enthalpy diagram for the process.

6.3B Ammonium nitrate is used in some “instant” cold packs because the salt absorbs 25.7 kJ per mole as it dissolves:

Is dissolving ammonium nitrate an exothermic or endothermic process? Draw an enthalpy diagram for the process.

SOME SIMILAR PROBLEMS 6.24–6.29

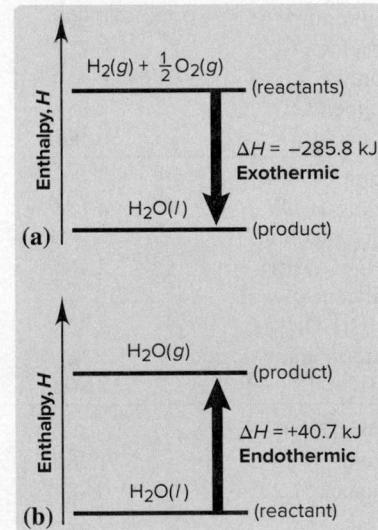

› Summary of Section 6.2

- › Enthalpy (H) is a state function, so any change in enthalpy (ΔH) is independent of how the change occurred. At constant P , the value of ΔH equals ΔE plus the PV work, which occurs when the volume of the system changes in the presence of an external pressure.
- › ΔH equals q_P , the heat released or absorbed during a chemical or physical change that takes place at constant pressure.
- › In most cases, ΔH is equal, or very close, to ΔE .
- › A change that releases heat is exothermic ($\Delta H < 0$); a change that absorbs heat is endothermic ($\Delta H > 0$).

6.3

CALORIMETRY: MEASURING THE HEAT OF A CHEMICAL OR PHYSICAL CHANGE

Data about energy content and usage are everywhere, from the caloric value of a slice of pizza to the gas mileage of a car. In this section, we consider the basic ideas used to determine such values.

Specific Heat Capacity

To find the energy change during a process, we measure the quantity of heat released or absorbed by relating it to the change in temperature. You know from everyday experience that the more you heat an object, the higher its temperature, and the more you cool it, the lower its temperature; in other words, the quantity of heat (q) absorbed or released by an object is proportional to its temperature change:

$$q \propto \Delta T \quad \text{or} \quad q = \text{constant} \times \Delta T \quad \text{or} \quad \frac{q}{\Delta T} = \text{constant}$$

What you might not know is that the temperature change depends on the object. Every object has its own **heat capacity** (C), the quantity of heat required to change its temperature by 1 K. Heat capacity is the proportionality constant in the preceding equation:

$$\text{Heat capacity } (C) = \frac{q}{\Delta T} \quad [\text{in units of J/K}]$$

A related property is **specific heat capacity** (c) (note the lowercase letter), the quantity of heat required to change the temperature of 1 *gram* of a substance or material by 1 K:

$$\text{Specific heat capacity } (c) = \frac{q}{\text{mass} \times \Delta T} \quad [\text{in units of J/g·K}]$$

If we know c for the object being heated (or cooled), we can measure the mass and the temperature change and calculate the heat absorbed (or released):

$$q = c \times \text{mass} \times \Delta T \quad (6.7)$$

Equation 6.7 says that when an object gets hotter, that is, when $\Delta T (T_{\text{final}} - T_{\text{initial}})$ is positive, $q > 0$ (the object absorbs heat). And when an object gets cooler, that is, when ΔT is negative, $q < 0$ (the object releases heat). Table 6.2 lists the specific heat capacities of some representative substances and materials. Notice that metals have relatively low values of c and water has a very high value: for instance, it takes over 30 times as much energy to increase the temperature of a gram of water by 1 K as it does a gram of gold!

Closely related to the specific heat capacity (but reserved for substances) is the **molar heat capacity** (C_m), the quantity of heat required to change the temperature of 1 *mole* of a substance by 1 K:

$$\text{Molar heat capacity } (C_m) = \frac{q}{\text{amount (mol)} \times \Delta T} \quad [\text{in units of J/mol·K}]$$

To find C_m of liquid H₂O, we multiply c of liquid H₂O (4.184 J/g·K) by the molar mass of H₂O (18.02 g/mol):

$$C_m \text{ of H}_2\text{O}(l) = 4.184 \frac{\text{J}}{\text{g} \cdot \text{K}} \times \frac{18.02 \text{ g}}{1 \text{ mol}} = 75.40 \frac{\text{J}}{\text{mol} \cdot \text{K}}$$

Liquid water has a *very* high specific heat capacity (~4.2 J/g·K), about six times that of rock (~0.7 J/g·K). If Earth had no oceans (*see photo*), it would take one-sixth as much energy for the Sun to heat the rocky surface, and the surface would give off six times as much heat after sundown. Days would be scorching and nights frigid. Water's high specific heat capacity means that large bodies of water require a lot more heat for a given increase in temperature than land masses do. Earth's oceans help regulate its weather and climate.

Table 6.2

Specific Heat Capacities (c) of Some Elements, Compounds, and Materials

Substance	c (J/g·K)*
Elements	
Aluminum, Al	0.900
Graphite, C	0.711
Iron, Fe	0.450
Copper, Cu	0.387
Gold, Au	0.129
Compounds	
Water, H ₂ O(l)	4.184
Ethyl alcohol, C ₂ H ₅ OH(l)	2.46
Ethylene glycol, (CH ₂ OH) ₂ (l)	2.42
Carbon tetrachloride, CCl ₄ (l)	0.862
Materials	
Wood	1.76
Cement	0.88
Glass	0.84
Granite	0.79
Steel	0.45

*At 298 K (25°C)

Earth without oceans.

SAMPLE PROBLEM 6.4**Relating Quantity of Heat and Temperature Change**

Problem A layer of copper welded to the bottom of a skillet weighs 125 g. How much heat is needed to raise the temperature of the copper layer from 25°C to 300°C? The specific heat capacity (c) of Cu is given in Table 6.2.

Plan We know the mass (125 g) and c (0.387 J/g·K) of Cu and can find ΔT in °C, which equals ΔT in K. We then use Equation 6.7 to calculate the heat required for the change.

Solution Calculating ΔT and then q :

$$\Delta T = T_{\text{final}} - T_{\text{initial}} = 300^\circ\text{C} - 25^\circ\text{C} = 275^\circ\text{C} = 275 \text{ K}$$

$$q = c \times \text{mass (g)} \times \Delta T = 0.387 \text{ J/g}\cdot\text{K} \times 125 \text{ g} \times 275 \text{ K} = 1.33 \times 10^4 \text{ J}$$

Check Heat is absorbed by the copper bottom (system), so q is positive. Rounding shows the arithmetic is reasonable:

$$q \approx 0.4 \text{ J/g}\cdot\text{K} \times 100 \text{ g} \times 300 \text{ K} = 1.2 \times 10^4 \text{ J.}$$

Comment Remember that the Kelvin temperature scale uses the same size degree as the Celsius scale; for this reason, ΔT has the same value regardless of which of the two temperature scales is used to express T_{initial} and T_{final} . In this problem, 300°C = 573 K, 25°C = 298 K, and $\Delta T = 573 \text{ K} - 298 \text{ K} = 275 \text{ K}$, as shown above.

FOLLOW-UP PROBLEMS

6.4A Before baking a pie, you line the bottom of an oven with a 7.65-g piece of aluminum foil and then raise the oven temperature from 18°C to 375°C. Use Table 6.2 to find the heat (in J) absorbed by the foil.

6.4B The ethylene glycol ($d = 1.11 \text{ g/mL}$; also see Table 6.2) in a car radiator cools from 37.0°C to 25.0°C by releasing 177 kJ of heat. What volume of ethylene glycol is in the radiator?

SOME SIMILAR PROBLEMS 6.37–6.40**The Two Major Types of Calorimetry**

How do we know the heat of an acid-base reaction or the Calories in a teaspoon of sugar? In the lab, we construct “surroundings” that retain the heat as reactants change to products, and then note the temperature change. These “surroundings” take the form of a **calorimeter**, a device used to measure the heat released (or absorbed) by a physical or chemical process. Let’s look at two types of calorimeter—one designed to measure the heat at constant pressure and the other at constant volume.

Constant-Pressure Calorimetry For processes that take place at constant pressure, the heat transferred (q_P) is often measured in a *coffee-cup calorimeter* (Figure 6.9). This simple apparatus can be used to find the heat of an aqueous reaction, the heat accompanying the dissolving of a salt, or even the specific heat capacity of a solid that does not react with or dissolve in water.

Let’s examine the third application first. The solid (the system) is weighed, heated to some known temperature, and added to a known mass and temperature of water (surroundings) in the calorimeter. After stirring, the final water temperature is measured, which is also the final temperature of the solid. Assuming no heat escapes the calorimeter, the heat released by the system ($-q_{\text{sys}}$ or $-q_{\text{solid}}$) as it cools is equal in magnitude but opposite in sign to the heat absorbed by the surroundings ($+q_{\text{surr}}$ or $+q_{\text{H}_2\text{O}}$) as they warm:

$$-q_{\text{solid}} = q_{\text{H}_2\text{O}}$$

Substituting from Equation 6.7 on each side of this equation gives

$$-(c_{\text{solid}} \times \text{mass}_{\text{solid}} \times \Delta T_{\text{solid}}) = c_{\text{H}_2\text{O}} \times \text{mass}_{\text{H}_2\text{O}} \times \Delta T_{\text{H}_2\text{O}}$$

All the quantities are known or measured except c_{solid} :

$$c_{\text{solid}} = -\frac{c_{\text{H}_2\text{O}} \times \text{mass}_{\text{H}_2\text{O}} \times \Delta T_{\text{H}_2\text{O}}}{\text{mass}_{\text{solid}} \times \Delta T_{\text{solid}}}$$

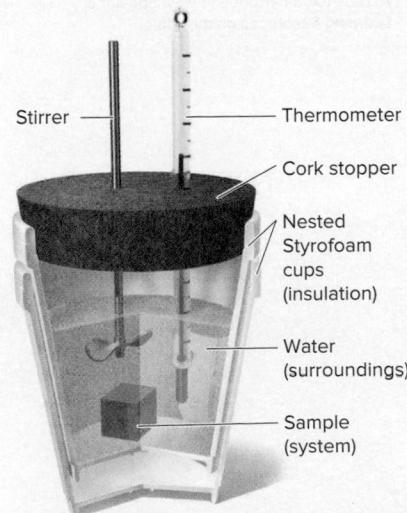

Figure 6.9 Coffee-cup calorimeter. This device measures the heat transferred at constant pressure (q_P).

SAMPLE PROBLEM 6.5**Determining the Specific Heat Capacity of a Solid**

Problem You heat 22.05 g of a solid in a test tube to 100.00°C and then add the solid to 50.00 g of water in a coffee-cup calorimeter. The water temperature changes from 25.10°C to 28.49°C. Find the specific heat capacity of the solid.

Plan We are given the masses of the solid (22.05 g) and of H₂O (50.00 g), and we can find the temperature changes of the water and of the solid by subtracting the given values, always using $T_{\text{final}} - T_{\text{initial}}$. Using Equation 6.7, we set the heat released by the solid ($-q_{\text{solid}}$) equal to the heat absorbed by the water ($q_{\text{H}_2\text{O}}$). The specific heat of water is known, and we solve for c_{solid} .

Solution Finding ΔT_{solid} and $\Delta T_{\text{H}_2\text{O}}$:

$$T_{\text{initial}} (\text{solid}) = 100.00^\circ\text{C}; \quad T_{\text{initial}} (\text{H}_2\text{O}) = 25.10^\circ\text{C}; \quad T_{\text{final}} (\text{solid and H}_2\text{O}) = 28.49^\circ\text{C}$$

$$\Delta T_{\text{H}_2\text{O}} = T_{\text{final}} - T_{\text{initial}} = 28.49^\circ\text{C} - 25.10^\circ\text{C} = 3.39^\circ\text{C} = 3.39 \text{ K}$$

$$\Delta T_{\text{solid}} = T_{\text{final}} - T_{\text{initial}} = 28.49^\circ\text{C} - 100.00^\circ\text{C} = -71.51^\circ\text{C} = -71.51 \text{ K}$$

Solving for c_{solid} :

$$c_{\text{solid}} = -\frac{c_{\text{H}_2\text{O}} \times \text{mass}_{\text{H}_2\text{O}} \times \Delta T_{\text{H}_2\text{O}}}{\text{mass}_{\text{solid}} \times \Delta T_{\text{solid}}} = -\frac{4.184 \text{ J/g}\cdot\text{K} \times 50.00 \text{ g} \times 3.39 \text{ K}}{22.05 \text{ g} \times (-71.51 \text{ K})} = 0.450 \text{ J/g}\cdot\text{K}$$

Check Rounding gives $-4 \text{ J/g}\cdot\text{K} \times 50 \text{ g} \times 3 \text{ K}/[20 \text{ g} \times (-70 \text{ K})] = 0.4 \text{ J/g}\cdot\text{K}$, so the answer seems correct.

FOLLOW-UP PROBLEMS

6.5A A 12.18-g sample of a shiny, orange-brown metal is heated to 65.00°C and then added to 25.00 g of water in a coffee-cup calorimeter. The water temperature changes from 25.55°C to 27.25°C. What is the unknown metal (see Table 6.2)?

6.5B A 33.2-g titanium bicycle part is added to 75.0 g of water in a coffee-cup calorimeter at 50.00°C, and the temperature drops to 49.30°C. What was the initial temperature (in °C) of the metal part (c of titanium is 0.228 J/g·K)?

SOME SIMILAR PROBLEMS 6.41–6.46**Student Hot Spot**

Student data indicate you may struggle with constant-pressure calorimetry calculations. Access the Smartbook to view additional Learning Resources on this topic.

In the next sample problem, the calorimeter is used to study the transfer of heat during an aqueous acid-base reaction. Recall that, if a reaction takes place at constant pressure, the heat of the reaction (q_{rxn}) is equal to its enthalpy change (ΔH).

SAMPLE PROBLEM 6.6**Determining the Enthalpy Change of an Aqueous Reaction**

Problem You place 50.0 mL of 0.500 M NaOH in a coffee-cup calorimeter at 25.00°C and add 25.0 mL of 0.500 M HCl, also at 25.00°C. After stirring, the final temperature is 27.21°C. [Assume that the total volume is the sum of the individual volumes and that the final solution has the same density (1.00 g/mL) and specific heat capacity (Table 6.2) as water.] **(a)** Calculate q_{soln} (in J). **(b)** Calculate the change in enthalpy, ΔH , of the reaction (in kJ/mol of H₂O formed).

(a) Calculate q_{soln}

Plan The solution is the surroundings, and as the reaction takes place, heat flows into the solution. To find q_{soln} , we use Equation 6.7, so we need the mass of solution, the change in temperature, and the specific heat capacity. We know the solutions' volumes (25.0 mL and 50.0 mL), so we find their masses with the given density (1.00 g/mL). Then, to find q_{soln} , we multiply the total mass by the given c (4.184 J/g·K) and the change in T , which we find from $T_{\text{final}} - T_{\text{initial}}$.

Solution Finding $\text{mass}_{\text{soln}}$ and ΔT_{soln} :

$$\text{Total mass (g) of solution} = (25.0 \text{ mL} + 50.0 \text{ mL}) \times 1.00 \text{ g/mL} = 75.0 \text{ g}$$

$$\Delta T = 27.21^\circ\text{C} - 25.00^\circ\text{C} = 2.21^\circ\text{C} = 2.21 \text{ K}$$

Finding q_{soln} :

$$q_{\text{soln}} = c_{\text{soln}} \times \text{mass}_{\text{soln}} \times \Delta T_{\text{soln}} = (4.184 \text{ J/g}\cdot\text{K})(75.0 \text{ g})(2.21 \text{ K}) = 693 \text{ J}$$

Check The value of q_{soln} is positive because the reaction releases heat to the solution. Rounding to check the size of q_{soln} gives $4 \text{ J/g}\cdot\text{K} \times 75 \text{ g} \times 2 \text{ K} = 600 \text{ J}$, which is close to the answer.

(b) Calculate the change in enthalpy (ΔH)

Plan The heat of the surroundings is q_{soln} , and it is the negative of the heat of the reaction (q_{rxn}), which equals ΔH . And dividing q_{rxn} by the amount (mol) of water formed in the reaction gives ΔH in kJ per mole of water formed. To calculate the amount (mol) of water formed, we write the balanced equation for the acid-base reaction and use the volumes and the concentrations (0.500 M) to find amount (mol) of each reactant (H^+ and OH^-). Since the amounts of two reactants are given, we determine which is limiting, that is, which gives less product (H_2O).

Solution Writing the balanced equation:

Finding amounts (mol) of reactants:

$$\text{Amount (mol) of HCl} = 0.500 \text{ mol HCl/L} \times 0.0250 \text{ L} = 0.0125 \text{ mol HCl}$$

$$\text{Amount (mol) of NaOH} = 0.500 \text{ mol NaOH/L} \times 0.0500 \text{ L} = 0.0250 \text{ mol NaOH}$$

Finding the amount (mol) of product: All the coefficients in the equation are 1, which means that the amount (mol) of reactant yields that amount of product. Therefore, HCl is limiting because it yields less product: 0.0125 mol of H_2O .

Finding ΔH : Heat absorbed by the solution was released by the reaction; that is,

$$q_{\text{soln}} = -q_{\text{rxn}} = 693 \text{ J} \quad \text{so} \quad q_{\text{rxn}} = -693 \text{ J}$$

$$\Delta H (\text{kJ/mol}) = \frac{q_{\text{rxn}}}{\text{mol H}_2\text{O}} \times \frac{1 \text{ kJ}}{1000 \text{ J}} = \frac{-693 \text{ J}}{0.0125 \text{ mol H}_2\text{O}} \times \frac{1 \text{ kJ}}{1000 \text{ J}} = -55.4 \text{ kJ/mol H}_2\text{O}$$

Check We check for the limiting reactant: The volume of H^+ is half the volume of OH^- , but they have the same concentration and a 1/1 stoichiometric ratio. Therefore, the amount (mol) of H^+ determines the amount of product. Rounding and taking the negative of q_{soln} to find ΔH gives $-600 \text{ J}/0.012 \text{ mol} = -5 \times 10^4 \text{ J/mol}$, or -50 kJ/mol , so the answer seems correct.

FOLLOW-UP PROBLEMS

6.6A When 25.0 mL of 2.00 M HNO_3 and 50.0 mL of 1.00 M KOH , both at 21.90°C , are mixed, a reaction causes the temperature of the mixture to rise to 27.05°C .

(a) Write balanced molecular and net ionic equations for the reaction.

(b) Calculate q_{rxn} (in kJ). (Assume that the final volume is the sum of the volumes being mixed and that the final solution has $d = 1.00 \text{ g/mL}$ and $c = 4.184 \text{ J/g}\cdot\text{K}$.)

6.6B After 50.0 mL of 0.500 M Ba(OH)_2 and the same volume of HCl of the same concentration react in a coffee-cup calorimeter, you find q_{soln} to be 1.386 kJ. Calculate ΔH of the reaction in kJ/mol of H_2O formed.

SOME SIMILAR PROBLEMS

6.47 and 6.48

Constant-Volume Calorimetry Constant-volume calorimetry is carried out in a *bomb calorimeter*, a device commonly used to measure the heat of combustion reactions, usually involving fuels or foods. With a coffee-cup calorimeter, we simply assume that all the heat is absorbed by the water, but in reality, some is absorbed by the stirrer, thermometer, cups, and so forth. With the much more precise bomb calorimeter, the *heat capacity of the entire calorimeter* is known (or can be determined).

Figure 6.10 (*next page*) depicts the preweighed combustible sample in a metal-walled chamber (the bomb), which is filled with oxygen gas and immersed in an insulated water bath fitted with motorized stirrer and thermometer. A heating coil connected to an

Figure 6.10 A bomb calorimeter. This device measures the heat released at constant volume (q_V).

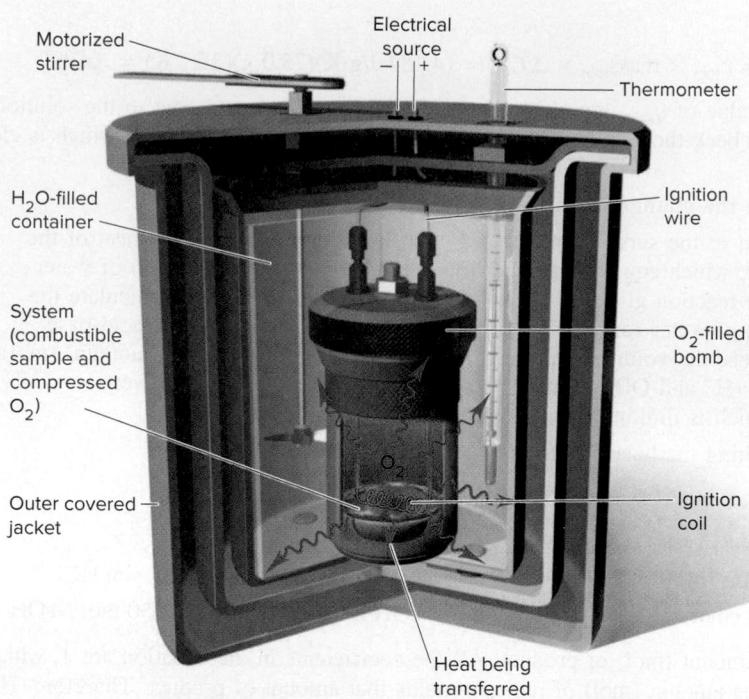

electrical source ignites the sample, and the heat released raises the temperature of the bomb, water, and other calorimeter parts.

Recall from Equation 6.7 that the heat absorbed by the calorimeter can be calculated using the relationship

$$q_{\text{calorimeter}} = c_{\text{calorimeter}} \times \text{mass}_{\text{calorimeter}} \times \Delta T_{\text{calorimeter}}$$

The heat capacity of the entire calorimeter, $C_{\text{calorimeter}}$, in units of J/K or kJ/K, combines $c_{\text{calorimeter}}$ and $\text{mass}_{\text{calorimeter}}$. Thus, Equation 6.7 can be simplified to

$$q_{\text{calorimeter}} = C_{\text{calorimeter}} \times \Delta T_{\text{calorimeter}} \quad (6.8)$$

Because we know the heat capacity of the entire calorimeter, we can use the measured ΔT to calculate the heat released during the combustion of the sample:

$$-q_{\text{rxn}} = q_{\text{calorimeter}}$$

Note that the steel bomb is tightly sealed, not open to the atmosphere as is the coffee cup, so the pressure is *not* constant. And the volume of the bomb is fixed, so $\Delta V = 0$, and thus $P\Delta V = 0$. Thus, the energy change measured is the *heat released at constant volume* (q_V), which equals ΔE , not ΔH :

$$\Delta E = q + w = q_V + 0 = q_V$$

Recall from Section 6.2, however, that even though the number of moles of gas may change, $P\Delta V$ is usually *much* less than ΔE , so ΔH is very close to ΔE . For example, ΔH is only 0.5% larger than ΔE for the combustion of H_2 and only 0.2% smaller than ΔE for the combustion of octane.

SAMPLE PROBLEM 6.7

Calculating the Heat of a Combustion Reaction

Problem Oxyacetylene torches produce such high temperatures that they are often used to weld and cut metal. When 2.50 g of acetylene (C_2H_2) is burned in a bomb calorimeter with a heat capacity of 10.85 kJ/K, the temperature increases from 23.488°C to 34.988°C . What is ΔE (in kJ/mol) for this combustion reaction?

Plan To find the heat released during the combustion of 2.50 g of acetylene, we find ΔT , multiply it by the given heat capacity of the calorimeter (10.85 kJ/K), and change

the sign since $-q_{rxn} = q_{calorimeter}$. We use the molar mass of acetylene to calculate the heat released by 1 mole of acetylene (ΔE).

Solution Finding ΔT :

$$\Delta T = T_{\text{final}} - T_{\text{initial}} = 34.988^\circ\text{C} - 23.488^\circ\text{C} = 11.500^\circ\text{C} = 11.500 \text{ K}$$

Calculating the heat absorbed by the calorimeter:

$$q_{\text{calorimeter}} = C_{\text{calorimeter}} \times \Delta T = 10.85 \text{ kJ/K} \times 11.500 \text{ K} = 124.8 \text{ kJ}$$

Therefore, $q_{rxn} = -124.8 \text{ kJ}$ for 2.50 g of acetylene.

$$\Delta E = \frac{-124.8 \text{ kJ}}{2.50 \text{ g C}_2\text{H}_2} \times \frac{26.04 \text{ g C}_2\text{H}_2}{1 \text{ mol C}_2\text{H}_2} = -1.30 \times 10^3 \text{ kJ/mol C}_2\text{H}_2$$

Check A quick math check shows that the answer is reasonable: $11 \text{ kJ/K} \times 12 \text{ K} = 132 \text{ kJ}$ for combustion of a 2.50-g sample. Since 1 mol of C_2H_2 has about ten times that mass, ΔE should be $10 \times -132 \text{ kJ} = -1320 \text{ kJ}$.

FOLLOW-UP PROBLEMS

6.7A A chemist burns 0.8650 g of graphite (a form of carbon) in a bomb calorimeter, and CO_2 forms. If 393.5 kJ of heat is released per mole of graphite and ΔT is 3.116 K, what is the heat capacity of the bomb calorimeter?

6.7B A manufacturer claims that its new dietetic dessert has “fewer than 10 Calories per serving.” To test the claim, a chemist at the Department of Consumer Affairs places one serving in a bomb calorimeter and burns it in O_2 . The initial temperature is 21.862°C , and the temperature rises to 26.799°C . If the heat capacity of the calorimeter is 8.151 kJ/K, is the manufacturer’s claim correct?

SOME SIMILAR PROBLEMS 6.49, 6.50, 6.51, and 6.53

Student Hot Spot

Student data indicate you may struggle with constant-volume calorimetry calculations. Access the Smartbook to view additional Learning Resources on this topic.

› Summary of Section 6.3

- › We calculate ΔH of a process by measuring the energy transferred as heat at constant pressure (q_p). To do this, we determine ΔT and multiply it by the substance’s mass and by its specific heat capacity (c), which is the quantity of energy needed to raise the temperature of 1 g of the substance by 1 K.
- › Calorimeters measure the heat released (or absorbed) during a process either at constant pressure (coffee cup; $q_p = \Delta H$) or at constant volume (bomb; $q_v = \Delta E$).

6.4 STOICHIOMETRY OF THERMOCHEMICAL EQUATIONS

A **thermochemical equation** is a balanced equation that includes the enthalpy change of the reaction (ΔH). Keep in mind that a given ΔH refers only to the *amounts (mol) of substances and their states of matter in that equation*. The enthalpy change of any process has two aspects:

- *Sign.* The sign of ΔH depends on whether the reaction is exothermic (–) or endothermic (+). A forward reaction has the *opposite* sign of the reverse reaction. Decomposition of 2 mol of water to its elements (endothermic):

Formation of 2 mol of water from its elements (exothermic):

- *Magnitude.* The magnitude of ΔH is *proportional to the amount of substance*. Formation of 1 mol of water from its elements (half the preceding amount):

Figure 6.11 The relationship between amount (mol) of substance and the energy (kJ) transferred as heat during a reaction.

Two key points to understand about thermochemical equations are

1. *Balancing coefficients.* When necessary, we use fractional coefficients to balance an equation, because we are specifying the magnitude of ΔH for a *particular amount*, often 1 mol, of a substance, for example, gaseous SO_2 :

2. *Thermochemical equivalence.* For a *particular reaction*, a certain amount of substance is thermochemically equivalent to a certain quantity of energy. Just as we use stoichiometrically equivalent molar ratios to find amounts of substances, we use thermochemically equivalent quantities to find the ΔH of a reaction for a given amount of substance. Some examples from the previous two reactions are

296.8 kJ is thermochemically equivalent to $\frac{1}{8}$ mol of $\text{S}_8(s)$

286 kJ is thermochemically equivalent to $\frac{1}{2}$ mol of $\text{O}_2(g)$

286 kJ is thermochemically equivalent to 1 mol of $\text{H}_2\text{O}(l)$

Also, just as we use molar mass (in g/mol) to convert an amount (mol) of a substance to mass (g), we use the ΔH (in kJ/mol) to convert an amount (mol) of a substance to an equivalent quantity of heat (in kJ). Figure 6.11 shows this new relationship, and Sample Problem 6.8 applies it.

SAMPLE PROBLEM 6.8

Using the Enthalpy Change of a Reaction (ΔH) to Find the Amount of a Substance

Problem The major source of aluminum in the world is bauxite (mostly aluminum oxide). Its thermal decomposition can be written as

If aluminum is produced this way (see Comment), how many grams of aluminum can form when 1.000×10^3 kJ of heat is transferred?

Plan From the balanced equation and the enthalpy change, we see that 1676 kJ of heat is thermochemically equivalent to 2 mol of Al. With this equivalent quantity, we convert the given number of kJ to amount (mol) formed and then convert amount to mass in g (see the road map).

Solution Combining steps to convert from heat transferred to mass of Al:

$$\text{Mass (g) of Al} = (1.000 \times 10^3 \text{ kJ}) \times \frac{2 \text{ mol Al}}{1676 \text{ kJ}} \times \frac{26.98 \text{ g Al}}{1 \text{ mol Al}} = 32.20 \text{ g Al}$$

Check The mass of aluminum seems correct: ~ 1700 kJ forms about 2 mol of Al (54 g), so 1000 kJ should form a bit more than half that amount (27 g).

Comment In practice, aluminum is not obtained by heating bauxite but by supplying electrical energy (as you'll see in Chapter 22). Because H is a state function, however, the total energy required for the change is the same no matter how it occurs.

FOLLOW-UP PROBLEMS

6.8A Hydrogenation reactions, in which H_2 and an “unsaturated” organic compound combine, are used in the food, fuel, and polymer industries. In the simplest case, ethene (C_2H_4) and H_2 form ethane (C_2H_6). If 137 kJ is given off per mole of C_2H_4 reacting, how much heat is released when 15.0 kg of C_2H_6 forms?

6.8B In the searing temperatures reached in a lightning bolt, nitrogen and oxygen form nitrogen monoxide, NO. If 180.58 kJ of heat is absorbed per mole of N_2 reacting, how much heat is absorbed when 3.50 metric tons (t ; $1 t = 10^3$ kg) of NO forms?

SOME SIMILAR PROBLEMS 6.57–6.60

Road Map

Heat (kJ)

$1676 \text{ kJ} = 2 \text{ mol Al}$

Amount (mol) of Al

multiply by M (g/mol)

Mass (g) of Al

› Summary of Section 6.4

- › A thermochemical equation shows a balanced reaction *and* its ΔH value. The sign of ΔH for a forward reaction is opposite that for the reverse reaction. The magnitude of ΔH is specific for the given equation.
- › The amount of a substance and the quantity of heat specified in a thermochemical equation are thermochemically equivalent and form a conversion factor for finding the quantity of heat transferred when any amount of the substance reacts.

6.5 HESS'S LAW: FINDING ΔH OF ANY REACTION

In some cases, a reaction is difficult, even impossible, to carry out individually: it may be part of a complex biochemical process, or take place under extreme conditions, or require a change in conditions to occur. Even if we can't run a reaction in the lab, we can still find its enthalpy change. In fact, the state-function property of enthalpy (H) allows us to find ΔH of *any* reaction for which we can write an equation.

This application is based on **Hess's law**, which states that *the enthalpy change of an overall process is the sum of the enthalpy changes of its individual steps*:

$$\Delta H_{\text{overall}} = \Delta H_1 + \Delta H_2 + \dots + \Delta H_n \quad (6.9)$$

This law follows from the fact that ΔH for a process depends only on the difference between the final and initial states. To apply Hess's law, we

- Imagine that an overall (target) reaction occurs through a series of individual reaction steps, whether or not it actually does. (Adding the steps must give the overall reaction.)
- Choose individual reaction steps, with each one having a known ΔH .
- Adjust, as needed, the equations for the individual steps, as well as their ΔH values, to obtain the overall equation.
- Add the ΔH values for the steps to get the unknown ΔH of the overall reaction. We can also find an unknown ΔH of any step by subtraction, if we know the ΔH values for the overall reaction and all the other steps.

Let's apply Hess's law to the oxidation of sulfur to sulfur trioxide, the key change in the industrial production of sulfuric acid and in the formation of acid rain. (To introduce this approach, we'll use S as the formula for sulfur, rather than the more correct S_8 .) When we burn S in an excess of O_2 , sulfur dioxide (SO_2) forms (equation 1), *not* sulfur trioxide (SO_3). After a change in conditions, we add more O_2 and oxidize SO_2 to SO_3 (equation 2). Thus, we cannot put S and O_2 in a calorimeter and find ΔH for the overall reaction of S to SO_3 (equation 3). But, we *can* find it with Hess's law.

If we can adjust equation 1 and/or equation 2, *along with their ΔH value(s)*, so that these equations add up to equation 3, then their ΔH values will add up to the unknown ΔH_3 .

First, we identify our “target” equation, the one whose ΔH we want to find, and note the amount (mol) of each reactant and product; our “target” is equation 3. Then, we adjust equations 1 and/or 2 to make them add up to equation 3:

- Equations 3 and 1 have the same amount of S, so we don't change equation 1.
- Equation 3 has half as much SO_3 as equation 2, so we multiply equation 2 *and* ΔH_2 by $\frac{1}{2}$; that is, we always treat the equation and its ΔH value the same.

- With the targeted amounts of reactants and products present, we add equation 1 to the halved equation 2 and *cancel terms that appear on both sides*:

Because ΔH depends only on the difference between H_{final} and H_{initial} , Hess's law tells us that the difference between the enthalpies of the reactants (1 mol of S and $\frac{3}{2}$ mol of O_2) and that of the product (1 mol of SO_3) is the same, whether S is oxidized directly to SO_3 (impossible) or through the intermediate formation of SO_2 (actual).

To summarize, calculating an unknown ΔH involves three steps:

- Identify the target equation, the step whose ΔH is unknown, and note the amount (mol) of each reactant and product.
- Adjust each equation with known ΔH values so that the target amount (mol) of each substance is on the correct side of the equation. Remember to:
 - Change the sign of ΔH when you reverse an equation.
 - Multiply amount (mol) and ΔH by the same factor.
- Add the adjusted equations and their resulting ΔH values to get the target equation and its ΔH . All substances except those in the target equation must cancel.

Student Hot Spot

Student data indicate that you may struggle with the application of Hess's law. Access the Smartbook to view additional Learning Resources on this topic.

SAMPLE PROBLEM 6.9

Using Hess's Law to Calculate an Unknown ΔH

Problem Two pollutants that form in automobile exhaust are CO and NO. An environmental chemist must convert these pollutants to less harmful gases through the following:

Given the following information, calculate the unknown ΔH :

Plan We note the amount (mol) of each substance and on which side each appears in the target equation. We adjust equations A and/or B *and* their ΔH values as needed and add them together to obtain the target equation and the unknown ΔH .

Solution Noting substances in the target equation: For reactants, there are 1 mol of CO and 1 mol of NO; for products, there are 1 mol of CO_2 and $\frac{1}{2}$ mol of N_2 .

Adjusting the given equations:

- Equation A has the same amounts of CO and CO_2 on the same sides of the arrow as in the target, so we leave that equation as written.
- Equation B has twice as much N_2 and NO as the target, and they are on the opposite sides in the target. Thus, we reverse equation B, change the sign of its ΔH , and multiply both by $\frac{1}{2}$:

or

Adding the adjusted equations to obtain the target equation:

Check Obtaining the desired target equation is a sufficient check. Be sure to remember to change the *sign* of ΔH for any equation you reverse.

FOLLOW-UP PROBLEMS

6.9A Nitrogen oxides undergo many reactions in the environment and in industry. Given the following information, calculate ΔH for the overall equation, $2\text{NO}_2(g) + \frac{1}{2}\text{O}_2(g) \longrightarrow \text{N}_2\text{O}_5(s)$:

6.9B Use the following reactions to find ΔH when 1 mol of HCl gas forms from its elements:

SOME SIMILAR PROBLEMS 6.70 and 6.71

› Summary of Section 6.5

- › Because H is a state function, we can use Hess's law to determine ΔH of any reaction by assuming that it is the sum of other reactions.
- › After adjusting the equations of the other reactions and their ΔH values to match the substances in the target equation, we add the adjusted ΔH values to find the unknown ΔH .

6.6 STANDARD ENTHALPIES OF REACTION (ΔH_{rxn}°)

In this section, we see how Hess's law is used to determine the ΔH values of an enormous number of reactions. Thermodynamic variables, such as ΔH , vary somewhat with conditions. Therefore, in order to study and compare reactions, chemists have established a set of specific conditions called **standard states**:

- For a *gas*, the standard state is 1 atm* and ideal behavior.
- For a substance in *aqueous solution*, the standard state is 1 M concentration.
- For a *pure substance* (element or compound), the standard state is usually the most stable form of the substance at 1 atm and the temperature of interest. In this text (and in most thermodynamic tables), that temperature is usually 25°C (298 K).

The standard-state symbol (shown as a superscript degree sign) indicates that the variable has been measured with *all the substances in their standard states*. For example, when the enthalpy change of a reaction is measured at the standard state, it is the **standard enthalpy of reaction**, ΔH_{rxn}° (also called the *standard heat of reaction*).

Formation Equations and Their Standard Enthalpy Changes

In a **formation equation**, 1 mol of a compound forms from its elements. The **standard enthalpy of formation** (ΔH_f°) (or *standard heat of formation*) is the enthalpy change for the formation equation when all the substances are in their standard states. For instance, the formation equation for methane (CH_4) is

*The definition of the standard state for gases has been changed to 1 bar, a slightly lower pressure than the 1 atm standard on which the data in this book are based (1 atm = 101.3 kPa = 1.013 bar). For most purposes, this makes very little difference in the standard enthalpy values.

**Selected Standard
Enthalpies of Formation
at 298 K**

Table 6.3

Formula	ΔH_f° (kJ/mol)*
Bromine	
Br ₂ (l)	0
Br ₂ (g)	30.9
Calcium	
Ca(s)	0
CaO(s)	-635.1
CaCO ₃ (s)	-1206.9
Carbon	
C(graphite)	0
C(diamond)	1.9
CO(g)	-110.5
CO ₂ (g)	-393.5
CH ₄ (g)	-74.9
CH ₃ OH(l)	-238.6
HCl(g)	135
CS ₂ (l)	87.9
Chlorine	
Cl ₂ (g)	0
Cl(l)	121.0
HCl(g)	-92.3
Hydrogen	
H ₂ (g)	0
H(g)	218.0
Mercury	
Hg(l)	0
Hg(g)	61.3
Nitrogen	
N ₂ (g)	0
NH ₃ (g)	-45.9
NO(g)	90.3
Oxygen	
O ₂ (g)	0
O ₃ (g)	143
H ₂ O(g)	-241.8
H ₂ O(l)	-285.8
Silver	
Ag(s)	0
AgCl(s)	-127.0
Sodium	
Na(s)	0
Na(g)	107.8
NaCl(s)	-411.1
Sulfur	
S ₈ (rhombic)	0
S ₈ (monoclinic)	0.3
SO ₂ (g)	-296.8
SO ₃ (g)	-396.0

*Values given to one decimal place.

Fractional coefficients are often used with reactants in a formation equation to obtain 1 mol of the product:

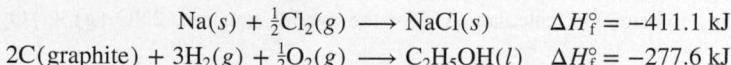

Standard enthalpies of formation have been tabulated for many substances. The values in Table 6.3 make two points (see Appendix B for a more extensive table):

1. *For an element in its standard state, $\Delta H_f^\circ = 0$.*

- The standard state for an element is the state of matter (solid, liquid, or gas) that exists at standard conditions. For most metals, like sodium, the standard state is the solid:

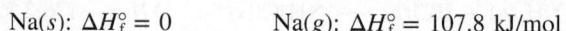

An additional 107.8 kJ of heat is needed to vaporize 1 mol of solid Na to gaseous Na.

For the metal mercury and the nonmetal bromine, however, the standard state is the liquid phase since these elements exist as liquids at standard conditions:

- The standard state for molecular elements, such as the halogens, is the molecular form, not separate atoms:

An additional 121.0 kJ of heat is required to break the bonds in 1 mol of Cl₂ to produce separate Cl atoms and 218.0 kJ is required to break the bonds in 1 mol of H₂.

- Some elements exist in different forms (called *allotropes*; Chapter 14), but only one is the standard state:

2. *Most compounds have a negative ΔH_f° . That is, most compounds have exothermic formation reactions: under standard conditions, heat is released when most compounds form from their elements.*

SAMPLE PROBLEM 6.10

Writing Formation Equations

Problem Write a balanced formation equation for each of the following and include the value of ΔH_f° : (a) AgCl(s); (b) CaCO₃(s); (c) HCN(g).

Plan We write the elements as the reactants and 1 mol of the compound as the product, being sure all substances are in their standard states. Then, we balance the equations, keeping a coefficient of 1 for the product, and find the ΔH_f° values in Appendix B.

FOLLOW-UP PROBLEMS

6.10A Write a balanced formation equation for each of the following and include the value of ΔH_f° : (a) CH₃OH(l); (b) CaO(s); (c) CS₂(l).

6.10B Write a balanced formation equation for each of the following and include the value of ΔH_f° : (a) CHCl₃(l); (b) NH₄Cl(s); (c) PbSO₄(s).

SOME SIMILAR PROBLEMS 6.80 and 6.81

Determining ΔH_{rxn}° from ΔH_f° Values for Reactants and Products

We can use ΔH_f° values to determine ΔH_{rxn}° for any reaction. By applying Hess's law, we can imagine the reaction occurring in two steps (Figure 6.12):

Step 1. Each reactant decomposes to its elements. This is the *reverse* of the formation reaction for the *reactant*, so the standard enthalpy change is $-\Delta H_f^\circ$.

Step 2. Each product forms from its elements. This step is the formation reaction for the *product*, so the standard enthalpy change is ΔH_f° .

According to Hess's law, we add the enthalpy changes for these steps to obtain the overall enthalpy change for the reaction (ΔH_{rxn}°). Suppose we want ΔH_{rxn}° for

We write this equation as though it were the sum of four individual equations, one for each compound. The first two show step 1, the decomposition of the reactants to their elements (*reverse* of their formation); the second two show step 2, the formation of the products from their elements:

Note that when titanium(IV) chloride and water react, the reactants don't *actually* decompose to their elements, which then recombine to form the products. But the great usefulness of Hess's law and the state-function concept is that ΔH_{rxn}° is the difference between two state functions, $H_{products}^\circ$ minus $H_{reactants}^\circ$, so it doesn't matter how the reaction *actually* occurs. We add the individual enthalpy changes to find ΔH_{rxn}° (Hess's law):

$$\begin{aligned} \Delta H_{rxn}^\circ &= \Delta H_f^\circ[\text{TiO}_2(s)] + 4\Delta H_f^\circ[\text{HCl}(g)] + \{-\Delta H_f^\circ[\text{TiCl}_4(l)]\} + \{-2\Delta H_f^\circ[\text{H}_2\text{O}(g)]\} \\ &= \underbrace{\{\Delta H_f^\circ[\text{TiO}_2(s)] + 4\Delta H_f^\circ[\text{HCl}(g)]\}}_{\text{Products}} - \underbrace{\{\Delta H_f^\circ[\text{TiCl}_4(l)] + 2\Delta H_f^\circ[\text{H}_2\text{O}(g)]\}}_{\text{Reactants}} \end{aligned}$$

For this example, the arithmetic gives $\Delta H_{rxn}^\circ = -25.39$ kJ. When we generalize the pattern, we see that *the standard enthalpy of reaction is the sum of the standard enthalpies of formation of the products minus the sum of the standard enthalpies of formation of the reactants* (see Figure 6.12):

$$\Delta H_{rxn}^\circ = \Sigma m\Delta H_f^\circ_{\text{(products)}} - \Sigma n\Delta H_f^\circ_{\text{(reactants)}} \quad (6.10)$$

where Σ means "sum of," and m and n are the amounts (mol) of the products and reactants given by the coefficients in the balanced equation.

Figure 6.12 The two-step process for determining ΔH_{rxn}° from ΔH_f° values.

SAMPLE PROBLEM 6.11**Calculating ΔH_{rxn}° from ΔH_f° Values**

Problem Nitric acid is used to make many products, including fertilizers, dyes, and explosives. The first step in its production is the oxidation of ammonia:

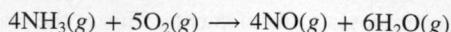

Calculate ΔH_{rxn}° from ΔH_f° values.

Plan We use values from Appendix B and apply Equation 6.10.

Solution Calculating ΔH_{rxn}° :

$$\begin{aligned}\Delta H_{rxn}^\circ &= \Sigma m\Delta H_f^\circ(\text{products}) - \Sigma n\Delta H_f^\circ(\text{reactants}) \\ &= \{4\Delta H_f^\circ[\text{NO}(g)] + 6\Delta H_f^\circ[\text{H}_2\text{O}(g)]\} - \{4\Delta H_f^\circ[\text{NH}_3(g)] + 5\Delta H_f^\circ[\text{O}_2(g)]\} \\ &= [(4 \text{ mol})(90.29 \text{ kJ/mol}) + (6 \text{ mol})(-241.840 \text{ kJ/mol})] \\ &\quad - [(4 \text{ mol})(-45.9 \text{ kJ/mol}) + (5 \text{ mol})(0 \text{ kJ/mol})] \\ &= [361.2 \text{ kJ} + (-1451.04 \text{ kJ})] - [-184 \text{ kJ} + 0 \text{ kJ}] = -906 \text{ kJ}\end{aligned}$$

Check We write formation equations, with ΔH_f° values for the amounts of each compound, in the correct direction (forward for products and reverse for reactants) and find the sum:

Comment In this problem, we know the individual ΔH_f° values and find the sum, ΔH_{rxn}° . In Follow-up Problem 6.11B, we know the sum and want to find one of the ΔH_f° values.

FOLLOW-UP PROBLEMS

6.11A Tetraphosphorus decoxide reacts vigorously with water to form phosphoric acid, one of the top-10 industrial chemicals:

Calculate ΔH_{rxn}° from ΔH_f° values in Appendix B.

6.11B Use the following to find ΔH_f° of methanol $\text{CH}_3\text{OH}(l)$:

$$\Delta H_f^\circ \text{ of CO}_2(g) = -393.5 \text{ kJ/mol}$$

$$\Delta H_f^\circ \text{ of H}_2\text{O}(g) = -241.826 \text{ kJ/mol}$$

SOME SIMILAR PROBLEMS 6.82–6.85

The upcoming Chemical Connections essay applies ideas from this chapter to new approaches for energy utilization.

› Summary of Section 6.6

- › Standard states are a set of specific conditions used for determining thermodynamic variables for all substances.
- › When 1 mol of a compound forms from its elements with all substances in their standard states, the enthalpy change is the standard enthalpy of formation, ΔH_f° .
- › Hess's law allows us to picture a reaction as the decomposition of the reactants to their elements followed by the formation of the products from their elements.
- › We use tabulated ΔH_f° values to find ΔH_{rxn}° or use known ΔH_{rxn}° and ΔH_f° values to find an unknown ΔH_f° .
- › Because of major concerns about climate change, chemists are developing energy alternatives, including coal and biomass conversion, hydrogen fuel, and noncombustible energy sources.

Out of necessity, we are totally rethinking our global use of energy. The dwindling supplies of our most common fuels and the environmental impact of their combustion products threaten human well-being and the survival of many other species. Energy production presents scientists, engineers, and political leaders with some of the greatest challenges of our time.

A changeover in energy sources from wood to coal and then petroleum took place over the 20th century. The **fossil fuels**—coal, petroleum, and natural gas—remain our major sources, but they are *nonrenewable* because natural processes form them many orders of magnitude slower than we consume them. In the United States, ongoing research seeks new approaches to using coal and nuclear energy, and utilizing *renewable* sources—biomass, hydrogen, sunlight, wind, geothermal heat, and tides—is also the focus of intensive efforts.

This discussion considers converting coal and biomass to cleaner fuels, understanding the effect of carbon-based fuels on climate, developing hydrogen as a fuel, utilizing solar energy, and conserving energy.

Converting Coal to Cleaner Fuels

U.S. reserves of coal are enormous, but the burning of coal, in addition to forming CO₂, produces SO₂ and particulates, and releases mercury. Exposure to SO₂ and particulates causes respiratory disease, and SO₂ can be oxidized to H₂SO₄, the key component of acid rain (Chapter 19). The trace amounts of Hg, a neurotoxin, spread as Hg vapor and bioaccumulate in fish.

Two processes are used to reduce the amounts of SO₂:

Desulfurization. The removal of sulfur dioxide from flue gases is done with devices called *scrubbers* that heat powdered limestone (CaCO₃) or spray lime-water slurries [Ca(OH)₂]:

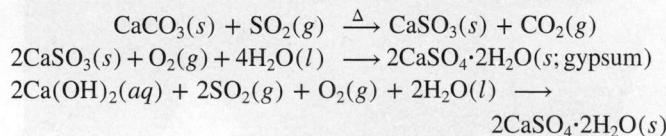

A wallboard (drywall) plant built next to the power plant uses the gypsum (1 ton per customer each year); about 20% of the drywall produced each year is made with this synthetic gypsum.

Gasification. In **coal gasification**, solid coal is converted to sulfur-free gaseous fuels. In this process, the sulfur in the coal is reduced to H₂S, which is removed through an acid-base reaction with a base, such as ethanolamine (HOCH₂CH₂NH₂). The resulting salt is heated to release H₂S, which is converted to elemental sulfur by the Claus process (Chapter 22) and sold. Several reactions yield mixtures with increasing fuel value, that is, with a lower C/H ratio:

- Pulverized coal reacts with limited O₂ and water at 800–1500°C to form approximately a 2/1 mixture of CO and H₂.
- Alternatively, in the *water-gas reaction* (or *steam-carbon reaction*), an exothermic oxidation of C to CO is followed by the

endothermic reaction of C with steam to form a nearly 1/1 mixture of CO and H₂ called *water gas*:

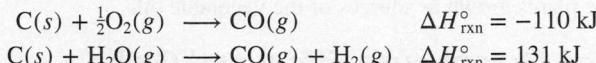

However, water gas has a much lower fuel value than methane (CH₄). For example, a mixture of 0.5 mol of CO and 0.5 mol of H₂ releases about one-third as much energy as 1.0 mol of methane ($\Delta H = -802 \text{ kJ/mol}$):

- In the *CO-shift* (or *water-gas shift*) reaction, the H₂ content of water gas is increased to produce synthesis gas (*syngas*):

- To produce CH₄, syngas that is a 3/1 mixture of H₂ and CO from which the CO₂ has been removed is employed:

Drying the product gives **synthetic natural gas (SNG)**.

Syngas is used in some newer methods as well. In *integrated gasification combined cycle (IGCC)*, electricity is produced in two coordinated steps—by burning syngas in a combustion turbine and then using the hot product gases to generate steam to power a steam turbine. In the *Fischer-Tropsch process*, syngas is used to form liquid hydrocarbon fuels that have higher molar masses than methane:

Converting Biomass to Fuels

Nearly half the world's people rely on wood for energy. In principle, wood is renewable, but widespread deforestation has resulted from its use for fuel, lumber, and paper. Therefore, great emphasis has been placed on **biomass conversion** of vegetable and animal waste. In one process, chemical and/or microbial methods convert vegetable (sugarcane, corn, switchgrass) and tree waste into fuel, mainly ethanol (C₂H₅OH). In the United States, ethanol is mixed with gasoline to form *gasohol*; in Brazil, it substitutes directly for gasoline.

Methanogenesis is the production of methane by anaerobic (oxygen-free) biodegradation of organic materials such as manure and vegetable waste or wastewater. China's biogas-generating facilities apply this technique, and similar ones in the United States use garbage and sewage. In addition to producing methane, the process yields residues that improve soil; it also prevents the wastes from polluting natural waters.

Another biomass conversion process changes vegetable oils (soybean, cottonseed, sunflower, canola, and even used cooking oil) into a mixture called *biodiesel*, whose combustion produces less CO, SO₂, and particulate matter than fossil-fuel-based diesel.

(continued)

The CO₂ produced in combustion of biodiesel has minimal impact on the net atmospheric amount because the carbon is taken up by the plants grown as sources of the vegetable oils.

The Greenhouse Effect and Global Warming

Combustion of all carbon-based fuels releases CO₂, and over the past two decades, it has become clear that the atmospheric buildup of this gas from our increased use of these fuels is changing the climate. Let's examine the basis of climate change, its current effects, and the long-term outlook.

The natural greenhouse effect. Throughout Earth's history, CO₂ has played a key temperature-regulating role in the atmosphere. Much of the sunlight that shines on Earth is absorbed by the land and oceans and converted to heat (IR radiation; Figure B6.1). Like the glass of a greenhouse, CO₂ does not absorb visible light from the Sun, but it absorbs and re-emits some of the heat radiating from Earth's surface and, thus, helps warm the atmosphere. This process is called the *natural greenhouse effect* (Figure B6.1, left). Over several billion years, due to the spread of plant life, which uses CO₂ in photosynthesis, the amount of CO₂ originally present in the atmosphere (from volcanic activity) decreased to 0.028% by volume. With this amount, Earth's average temperature was about 14°C (57°F); without CO₂, it would be -17°C (2°F)!

The enhanced greenhouse effect. As a result of intensive use of fossil fuels for the past 150 years, the amount of CO₂ in the atmosphere increased to 0.040%. Thus, although the same quantity of solar energy passes through the atmosphere, more is being

trapped as heat, which has created an *enhanced greenhouse effect* that is changing the climate through *global warming* (Figure B6.1, right). Based on current trends, CO₂ amounts will increase to between 0.049% and 0.126% by 2100 (Figure B6.2).

Modeling global warming and its effects. If this projected increase in CO₂ occurs, there are two closely related questions that must be addressed by models: (1) How much will the temperature rise? (2) How will this rise affect life on Earth? Despite constantly improving models, answers are difficult to obtain. Natural fluctuations in temperature must be taken into account, as well as cyclic changes in solar activity. Moreover, as the amount of CO₂ increases from fossil-fuel burning, so do the amounts of particulate matter and SO₂-based aerosols, which may block sunlight and have a cooling effect. Water vapor also traps heat, and as temperatures rise, more water evaporates. The increased amounts of water vapor may thicken the cloud cover and lead to cooling as well.

Despite such opposing factors, all of the best models predict net warming, and we are already observing the effects. The average temperature has increased by $0.6 \pm 0.2^\circ\text{C}$ since the late 19th century and 0.2–0.3°C over the past 25 years. Globally, the decade from 2001 to 2010 was the warmest on record and the current decade is continuing this trend. December 2014 was the 358th month in a row with an average temperature above the 20th-century norm, and 2014 was the hottest year on record, with severe droughts and damaging storms in many areas. Snow cover and glacial size in the northern hemisphere and floating ice in the Arctic Ocean have decreased dramatically. Antarctica is also experiencing widespread breakup of icebound regions. Globally, sea

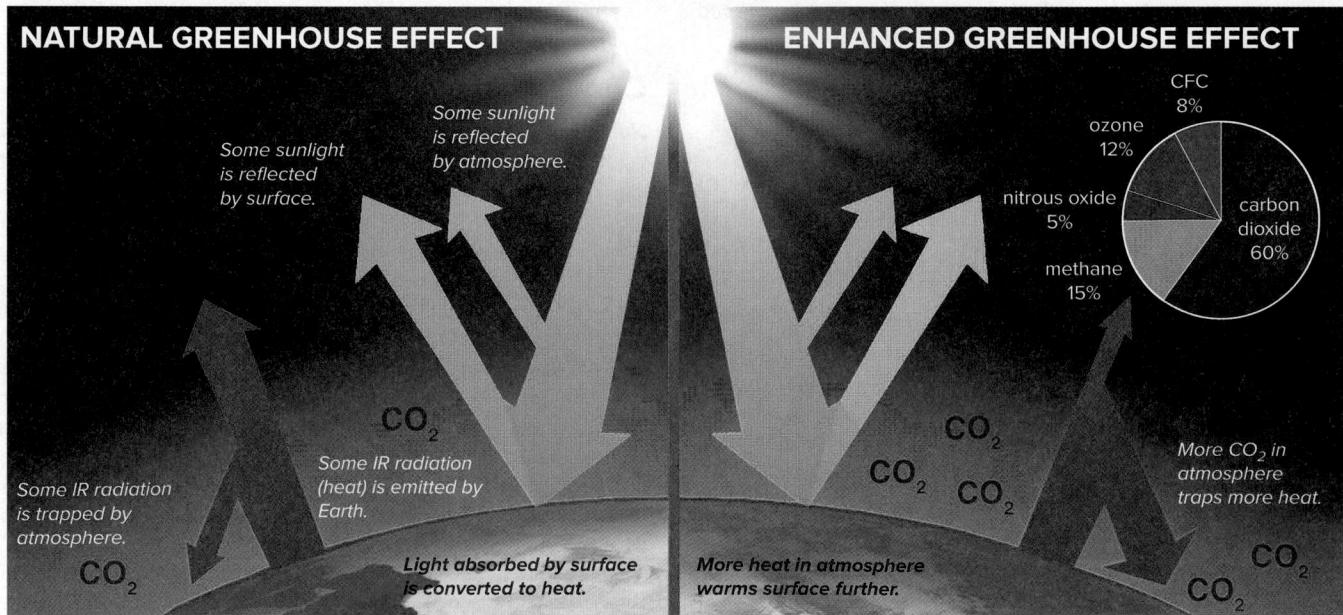

Figure B6.1 The trapping of heat by the atmosphere. Of the total sunlight reaching Earth, some is reflected and some is absorbed and converted to IR radiation (heat). Some heat emitted by the surface is trapped by atmospheric CO₂, creating a *natural greenhouse effect* (*left*) that has been essential to life. But, largely as a result of human activity in the past 150 years, and especially the past several decades, the buildup of CO₂ and several other greenhouse gases (*pie chart*) has created an *enhanced greenhouse effect* (*right*).

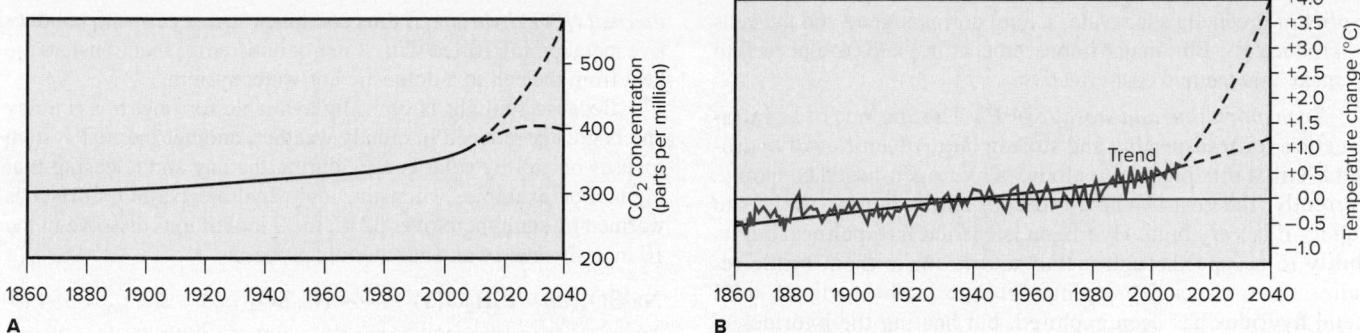

Figure B6.2 Evidence for the enhanced greenhouse effect.
A, Since the mid-19th century, atmospheric CO₂ has increased.
B, Since the mid-19th century, average global temperature has risen

level has risen an average of 17 cm (6.7 in) over the past century, and flooding and other extreme weather events have increased.

Fifteen years ago, the best models predicted a temperature rise of 1.0–3.5°C; today, their predictions are more than 50% higher. Such increases would alter rainfall patterns and crop yields throughout the world and increase sea level as much as 1 m, thus flooding regions such as the Netherlands, half of Florida, much of southern Asia, coastal New England and New York, and many Pacific island nations. To make matters worse, as we burn fossil fuels that *release* CO₂, we cut down forests that *absorb* it.

Addressing the challenge of climate change. In addition to ways to reduce fossil-fuel consumption, some of which we discuss below, researchers are studying methods of *carbon capture and storage* (CCS), including *CO₂ sequestration*, both naturally by maintaining forests and jungles and industrially by liquefying CO₂ that is produced and either burying it underground or using it to produce mineral carbonates.

The 1997 United Nations Conference on Climate Change in Kyoto, Japan, created a treaty with legally binding targets to limit greenhouse gases. It was ratified by 189 countries, but not by the United States, then the largest emitter. The 2009 conference in Copenhagen, Denmark, was attended by representatives from 192 countries (including the United States), but did not result in legally binding emission targets or financial commitments. In late 2010, however, a conference in Cancun, Mexico, resulted in financial commitments to help developing nations rely on alternative energy sources. And most recently, at the United Nations Framework Convention on Climate Change in December 2015, 195 countries adopted a legally binding global climate action plan aimed at limiting global warming to 1.5°C by reducing emission of greenhouse gases. Rising standards of living in China and India, the two most populous nations, are leading to a need for more energy, which makes large and sustained global reductions in CO₂ even more urgent.

Hydrogen

The use of H₂ as an energy source holds great promise but presents several problems. The simplest element and most plentiful gas in the universe always occurs on Earth in compounds, most

importantly with oxygen in water and carbon in hydrocarbons. Once freed, however, H₂ is an excellent energy source because of several properties:

- It has the highest energy content per *mass* unit of any fuel—nearly three times as much as gasoline.
- The energy content per *volume* unit of H₂ is low at STP but increases greatly when the gas is liquefied under extremely high *P* and low *T*.
- The combustion of H₂ does not produce CO₂, particulates, or sulfur oxides. It is such a clean energy source that H₂-fuel cells operate electrical systems aboard the space shuttles, and the crews drink the pure water product.

A hydrogen-based economy is the dream of many because, even though combustion of H₂ ($\Delta H_{rxn}^{\circ} = -242$ kJ/mol) produces less than one-third as much energy per mole as combustion of CH₄ ($\Delta H_{rxn}^{\circ} = -802$ kJ/mol), it yields nonpolluting water vapor. The keys to realizing the dream, however, involve major improvements in both the production of H₂ and its transportation and storage.

Production of H₂. Hydrogen is produced by a number of methods, some more widely used than others.

- *Fossil-fuel byproduct.* In the United States today, almost all H₂ is produced by the *steam-reforming process*, in which methane or natural gas is treated with steam in high-temperature reactions (Chapter 22).
- *Electrolysis of liquid water.* Formation of H₂ from the decomposition of liquid water is endothermic ($\Delta H_{rxn}^{\circ} = 286$ kJ/mol), and most direct methods that utilize electricity are costly. However, energy from flowing water, wind, and geothermal sources can provide the needed electricity. An exciting new *photoelectrochemical approach* uses a photovoltaic panel coupled to an electrolysis unit: the energy of sunlight powers the decomposition of water.
- *Biological methods.* Green algae and cyanobacteria store the energy of sunlight in the form of starch or glycogen for their own metabolism. Under certain conditions, however, these microbes can be made to produce H₂ gas instead of these large organic molecules. For example, eliminating sulfur from the

(continued)

diet of green algae activates a long dormant gene and the cells produce H₂. But, major improvements in yields are needed to make this method cost-effective.

Transportation and storage of H₂. The absence of an infrastructure for transporting and storing large quantities of hydrogen is still a roadblock to realizing a hydrogen-based economy. Currently, the cost of energy to cool and compress the gas to liquefy it is very high. Hydrogen is carried in pipelines, but its ability to escape through metals and to make them brittle requires more expensive piping. Storage in the form of solid metal hydrides has been explored, but heating the hydrides to release the stored hydrogen requires energy. Use of H₂ in fuel cells is a major area of electrochemical research (Chapter 21). Tests are underway to commercialize fuel-cell technology using the hydrogen that is a byproduct of the petrochemical and coal industries.

Solar Energy

The Sun's energy drives global winds and ocean currents, the cycle of evaporation and condensation, and many biological processes, especially photosynthesis. More energy falls on Earth's surface as sunlight in 1 h [1.2×10^5 TW (terawatts); 1 TW = 1×10^{12} W] than is used in all human activity in 1 year. Solar energy is, however, a dilute source (only 1 kW/m² at noon); in 1 h, about 600–1000 TW strikes land at sites suitable for collecting. Nevertheless, covering 0.16% of that land with today's photovoltaic systems would provide 20 TW/h, equivalent to the output of 20,000 nuclear power plants producing 1 GW (gigawatt) each. Clearly, solar energy is the largest carbon-free option among renewable sources.

Three important ways to utilize solar energy are with electronic materials, biomass, and thermal systems:

Electronic materials. A **photovoltaic cell** converts sunlight directly into electricity by employing certain combinations of elements (usually metalloids; we discuss the behavior of elements with *semiconductor* properties in Chapter 12). Early cells relied primarily on crystalline silicon, but their *yield*, the proportion of electrical energy produced relative to the radiant energy supplied, was only about 10%. More recent devices have achieved much higher yields by using thin films of polycrystalline materials that incorporate combinations of other elements, such as cadmium telluride (CdTe cells, 16%), gallium arsenide (GaAs cells, 18%), and copper indium gallium selenide (CIGS cells, 20%). And ongoing research on nanometer-sized semiconductor devices, called *quantum dots*, suggests the possibility of yields as high as 70%.

Biomass. Solar energy is used to convert CO₂ and water via photosynthesis to plant material (carbohydrate) and oxygen. Plant biomass can be burned directly as a fuel or converted to other fuels, such as ethanol or hydrogen, as discussed in an earlier section in this Chemical Connections (see "Converting Biomass to Fuels").

Thermal systems. The operation of a photovoltaic cell creates a buildup of heat, which lowers its efficiency. A *photovoltaic*

thermal (PVT) hybrid cell thus combines such a cell with conductive metal piping (filled with water or antifreeze) that transfers the heat from the cell to a domestic hot-water system.

Because sunlight is typically available for only 6–8 h a day and is greatly reduced in cloudy weather, another thermal system focuses on storing solar energy during the day and releasing it at night. For example, when the ionic hydrate Na₂SO₄·10H₂O is warmed by sunlight to over 32°C, the 3 mol of ions dissolve in the 10 mol of water in an endothermic process:

When cooled below 32°C after sunset, the solution recrystallizes, releasing the absorbed energy for heating:

Unfortunately, as of the middle of the second decade of the 21st century, solar energy is still not competitive with highly subsidized fossil fuels. Nevertheless, changes in economic policy as well as improvements in photovoltaic technology and biomass processing should greatly increase solar energy's contribution to a carbon-free energy future.

Nuclear Energy

Despite ongoing problems with disposal of radioactive waste, energy from nuclear *fission*—the splitting of large, unstable atomic nuclei—is used extensively, especially in France and other parts of northern Europe. Nuclear *fusion*—the combining of small atomic nuclei—avoids the problems of fission but has been achieved so far only with a net consumption of power. (We'll discuss these processes in detail in Chapter 24.)

Energy Conservation: More from Less

All systems, whether organisms or factories, waste energy, which is, in effect, a waste of fuel. For example, the production of one aluminum beverage can requires the amount of energy that comes from burning 0.25 L of gasoline. Energy conservation lowers costs, extends our fuel supply, and reduces the effects of climate change. Following are three examples of conservation.

Passive solar design. Heating and cooling costs can be reduced by as much as 50% when buildings are constructed with large windows and materials that absorb the Sun's heat in the day and release it slowly at night.

Residential heating systems. A high-efficiency gas-burning furnace channels hot waste gases through a system of baffles to transfer more heat to the room and then to an attached domestic hot-water system. While moving through the system, the gases cool to 100°C, so the water vapor condenses, thus releasing about 10% more heat:

Modern lighting. Incandescent bulbs give off light when the material in their filament reaches a high temperature. They are very inefficient because less than 7% of the electrical energy is converted to light, the rest being wasted as heat. *Compact fluorescent lamps* (CFLs) have an efficiency of about 18% and are having a major economic impact: in many parts of Europe, incandescent bulbs are no longer sold. *Light-emitting diodes* (LEDs) are even more efficient (about 30%) and are already being used in car indicator lamps and tail lights. Light-emitting devices based on organic semiconductors (OLEDs) are used in flat-panel displays, and recent use of Al-In-Ga-P materials and Ga and In nitrides in LEDs has improved their brightness and color richness. Over 20% of electricity generated in the United States is used for lighting, and burning of fossil fuels in power plants creates smog, particulates, and CO₂. By 2020, use of LEDs for lighting can cut electricity usage by 50%, eliminating the emission of 2.8×10^7 metric tons of carbon per year.

Engineers and chemists will continue to explore alternatives for energy production and use, but a more hopeful energy future ultimately depends on our dedication to conserving planetary resources.

Problems

B6.1 To make use of an ionic hydrate for storing solar energy, you place 500.0 kg of sodium sulfate decahydrate on your house roof. Assuming complete reaction and 100% efficiency of heat transfer, how much heat (in kJ) is released to your house at night?

B6.2 In one step of coal gasification, coal reacts with superheated steam:

(a) Use this reaction and the following two to write an overall reaction for the production of methane:

(b) Calculate $\Delta H_{\text{rxn}}^\circ$ for this overall change.

(c) Using the value from part (b) and a calculated value of $\Delta H_{\text{rxn}}^\circ$ for the combustion of methane, find the total ΔH for gasifying 1.00 kg of coal and burning the methane formed (assume that water forms as a gas and M of coal is 12.00 g/mol).

CHAPTER REVIEW GUIDE

Learning Objectives

Relevant section (§) and/or sample problem (SP) numbers appear in parentheses.

Understand These Concepts

1. The distinction between a system and its surroundings (§6.1)
2. The transfer of energy to or from a system as heat and/or work (§6.1)
3. The relation of internal energy change, heat, and work (§6.1)
4. The meaning of energy conservation (§6.1)
5. The meaning of a state function and why ΔE is constant even though q and w vary (§6.1)
6. The meaning of enthalpy and the relation between ΔE and ΔH (§6.2)
7. The meaning of ΔH and the distinction between exothermic and endothermic processes (§6.2)
8. The relation between specific heat capacity and heat (§6.3)
9. How constant-pressure (coffee-cup) and constant-volume (bomb) calorimeters work (§6.3)
10. The relation between ΔH and amount of substance (§6.4)
11. The calculation of ΔH values with Hess's law (§6.5)
12. The meaning of a formation equation and the standard enthalpy of formation (§6.6)
13. How a reaction can be viewed as the decomposition of reactants followed by the formation of products (§6.6)

Master These Skills

1. Determining the change in a system's internal energy in different units (SP 6.1)
2. Calculating PV work done by or on a system (SP 6.2)
3. Drawing enthalpy diagrams for chemical and physical changes (SP 6.3)
4. Solving problems involving specific heat capacity and heat transferred in a reaction (SPs 6.4–6.7)
5. Relating the heat transferred in a reaction to the amounts of substances changing (SP 6.8)
6. Using Hess's law to find an unknown ΔH (SP 6.9)
7. Writing formation equations and using ΔH_f° values to find $\Delta H_{\text{rxn}}^\circ$ (SPs 6.10, 6.11)

Key Terms

Page numbers appear in parentheses.

biomass conversion (281)	fossil fuel (281)	molar heat capacity (C_m) (268)	state function (262)
calorie (cal) (261)	heat (q) (258)	photovoltaic cell (284)	surroundings (258)
calorimeter (269)	heat capacity (268)	pressure-volume work (PV work) (263)	synthetic natural gas (SNG) (281)
change in enthalpy (ΔH) (265)	Hess's law (275)	specific heat capacity (c) (268)	system (258)
coal gasification (281)	internal energy (E) (258)	standard enthalpy of formation (ΔH_f°) (277)	thermochemical equation (273)
endothermic process (266)	joule (J) (261)	standard enthalpy of reaction (ΔH_{rxn}°) (277)	thermodynamics (257)
enthalpy (H) (265)	law of conservation of energy (first law of thermodynamics) (261)	standard state (277)	work (w) (259)
enthalpy diagram (266)			
exothermic process (266)			
formation equation (277)			

Key Equations and Relationships

Page numbers appear in parentheses.

6.1 Defining the change in internal energy (258):

$$\Delta E = E_{final} - E_{initial} = E_{products} - E_{reactants}$$

6.2 Expressing the change in internal energy in terms of heat and work (259):

$$\Delta E = q + w$$

6.3 Stating the first law of thermodynamics (law of conservation of energy) (261):

$$\Delta E_{universe} = \Delta E_{system} + \Delta E_{surroundings} = 0$$

6.4 Determining the work due to a change in volume at constant pressure (PV work) (263):

$$w = -P\Delta V$$

6.5 Relating the enthalpy change to the internal energy change at constant pressure (265):

$$\Delta H = \Delta E + P\Delta V$$

6.6 Identifying the enthalpy change with the heat absorbed or released at constant pressure (265):

$$\Delta H = \Delta E + P\Delta V = q_p$$

6.7 Calculating the heat absorbed or released when a substance undergoes a temperature change or a reaction occurs (268):

$$q = c \times \text{mass} \times \Delta T$$

6.8 Calculating heat absorbed by a bomb calorimeter during a combustion reaction (272):

$$q_{\text{calorimeter}} = C_{\text{calorimeter}} \times \Delta T_{\text{calorimeter}}$$

6.9 Calculating the overall enthalpy change of a reaction (Hess's law) (275):

$$\Delta H_{\text{overall}} = \Delta H_1 + \Delta H_2 + \cdots + \Delta H_n$$

6.10 Calculating the standard enthalpy of reaction (279):

$$\Delta H_{rxn}^\circ = \Sigma m \Delta H_{f(\text{products})}^\circ - \Sigma n \Delta H_{f(\text{reactants})}^\circ$$

BRIEF SOLUTIONS TO FOLLOW-UP PROBLEMS

6.1A The liquid (system) *absorbs* heat, so q is +13.5 kJ; the system *does* work, so w is -1.8 kJ.

$$\Delta E = q + w$$

$$= [13.5 \text{ kJ} + (-1.8 \text{ kJ})] \times \frac{1000 \text{ J}}{1 \text{ kJ}} \\ = 1.17 \times 10^4 \text{ J}$$

6.1B The system *releases* heat (the surroundings absorb heat), so $q = -26.0 \text{ kcal}$; the system has work *done on it*, so $w = +15.0 \text{ Btu}$. $\Delta E = q + w$

$$= \left(-26.0 \text{ kcal} \times \frac{4.184 \text{ kJ}}{1 \text{ kcal}} \right) + \left(15.0 \text{ Btu} \times \frac{1.055 \text{ kJ}}{1 \text{ Btu}} \right) \\ = -93 \text{ kJ}$$

$$\text{6.2A } P \text{ (atm)} = 732 \text{ torr} \times \frac{1 \text{ atm}}{760 \text{ torr}} = 0.963 \text{ atm}$$

$$w \text{ (atm} \cdot \text{L)} = -P\Delta V = -0.963 \text{ atm} \times (2.35 \text{ L} - 5.68 \text{ L}) \\ = 3.21 \text{ atm} \cdot \text{L}$$

$$w \text{ (J)} = 3.21 \text{ atm} \cdot \text{L} \times \frac{101.3 \text{ J}}{1 \text{ atm} \cdot \text{L}} = 325 \text{ J}$$

$$\text{6.2B } w \text{ (atm} \cdot \text{L)} = -P\Delta V = -5.5 \text{ atm} \times (16.3 \text{ L} - 10.5 \text{ L}) \\ = -32 \text{ atm} \cdot \text{L}$$

$$w \text{ (J)} = -32 \text{ atm} \cdot \text{L} \times \frac{101.3 \text{ J}}{1 \text{ atm} \cdot \text{L}} = -3.2 \times 10^3 \text{ J}$$

6.3A The reaction is exothermic (heat energy is released); $H_{\text{reactants}} > H_{\text{products}}$.

6.3B The process is endothermic (heat energy is absorbed); $H_{\text{products}} > H_{\text{reactants}}$.

$$\text{6.4A } \Delta T = 375^\circ\text{C} - 18^\circ\text{C} = 357^\circ\text{C} = 357 \text{ K}$$

$$q = c \times \text{mass} \times \Delta T = (0.900 \text{ J/g} \cdot \text{K})(7.65 \text{ g})(357 \text{ K}) \\ = 2.46 \times 10^3 \text{ J}$$

6.4B $\Delta T = 25.0^\circ\text{C} - 37.0^\circ\text{C} = -12.0^\circ\text{C} = -12.0 \text{ K}$

$q = -177 \text{ kJ}$ since heat is released.

$$q = c \times \text{mass} \times \Delta T$$

$$\text{Mass} = \frac{q}{c \times \Delta T} = \frac{-177 \text{ kJ}}{(2.42 \text{ J/g}\cdot\text{K})(-12.0 \text{ K})} \times \frac{1000 \text{ J}}{1 \text{ kJ}} = 6.10 \times 10^3 \text{ g}$$

$$\text{Volume (L)} = 6.10 \times 10^3 \text{ g} \times \frac{1 \text{ mL}}{1.11 \text{ g}} \times \frac{1 \text{ L}}{1000 \text{ mL}} = 5.50 \text{ L}$$

6.5A $\Delta T (\text{solid}) = 27.25^\circ\text{C} - 65.00^\circ\text{C} = -37.75^\circ\text{C} = -37.75 \text{ K}$

$$\Delta T (\text{H}_2\text{O}) = 27.25^\circ\text{C} - 25.55^\circ\text{C} = 1.70^\circ\text{C} = 1.70 \text{ K}$$

$$\begin{aligned} c_{\text{solid}} &= -\frac{c_{\text{H}_2\text{O}} \times \text{mass}_{\text{H}_2\text{O}} \times \Delta T_{\text{H}_2\text{O}}}{\text{mass}_{\text{solid}} \times \Delta T_{\text{solid}}} \\ &= -\frac{4.184 \text{ J/g}\cdot\text{K} \times 25.00 \text{ g} \times 1.70 \text{ K}}{12.18 \text{ g} \times (-37.75 \text{ K})} \\ &= 0.387 \text{ J/g}\cdot\text{K} \end{aligned}$$

From Table 6.2, the metal is copper.

6.5B $\Delta T (\text{H}_2\text{O}) = 49.30^\circ\text{C} - 50.00^\circ\text{C} = -0.70^\circ\text{C} = -0.70 \text{ K}$

$$-c_{\text{solid}} \times \text{mass}_{\text{solid}} \times \Delta T_{\text{solid}} = c_{\text{H}_2\text{O}} \times \text{mass}_{\text{H}_2\text{O}} \times \Delta T_{\text{H}_2\text{O}}$$

$$\begin{aligned} \Delta T_{\text{solid}} &= \frac{c_{\text{H}_2\text{O}} \times \text{mass}_{\text{H}_2\text{O}} \times \Delta T_{\text{H}_2\text{O}}}{-c_{\text{solid}} \times \text{mass}_{\text{solid}}} \\ &= \frac{(4.184 \text{ J/g}\cdot\text{K})(75.0 \text{ g})(-0.70 \text{ K})}{-(0.228 \text{ J/g}\cdot\text{K})(33.2 \text{ g})} \\ &= 29 \text{ K} = 29^\circ\text{C} \end{aligned}$$

$$\Delta T_{\text{solid}} = T_{\text{final}} - T_{\text{initial}}$$

$$T_{\text{initial}} = T_{\text{final}} - \Delta T_{\text{solid}} = 49.30^\circ\text{C} - 29^\circ\text{C} = 20.^\circ\text{C}$$

(b) Total mass of solution = $(25.0 \text{ mL} + 50.0 \text{ mL}) \times 1.00 \text{ g/mL} = 75.0 \text{ g}$

$$\Delta T_{\text{soln}} = 27.05^\circ\text{C} - 21.90^\circ\text{C} = 5.15^\circ\text{C} = 5.15 \text{ K}$$

$$\begin{aligned} q_{\text{soln}} &= c_{\text{soln}} \times \text{mass}_{\text{soln}} \times \Delta T_{\text{soln}} = -q_{\text{rxn}} \\ &= (4.184 \text{ J/g}\cdot\text{K})(75.0 \text{ g})(5.15 \text{ K}) \\ &= 1620 \text{ J} \times 1 \text{ kJ}/1000 \text{ J} = 1.62 \text{ kJ} \end{aligned}$$

$$q_{\text{rxn}} = -1.62 \text{ kJ}$$

$$q_{\text{soln}} = -q_{\text{rxn}} = 1.386 \text{ kJ} \quad \text{so} \quad q_{\text{rxn}} = -1.386 \text{ kJ}$$

$$\begin{aligned} \text{Amount (mol) of HCl} &= 0.500 \text{ mol HCl/L} \times 0.0500 \text{ L} \\ &= 0.0250 \text{ mol HCl} \end{aligned}$$

Similarly, we have 0.0250 mol BaCl₂.

Finding the limiting reactant from the balanced equation:

$$\begin{aligned} \text{Amount (mol) of H}_2\text{O} &= 0.0250 \text{ mol HCl} \times \frac{2 \text{ mol H}_2\text{O}}{2 \text{ mol HCl}} \\ &= 0.0250 \text{ mol H}_2\text{O} \end{aligned}$$

$$\begin{aligned} \text{Amount (mol) of H}_2\text{O} &= 0.0250 \text{ mol Ba(OH)}_2 \times \frac{2 \text{ mol H}_2\text{O}}{1 \text{ mol Ba(OH)}_2} \\ &= 0.0500 \text{ mol H}_2\text{O} \end{aligned}$$

Thus, HCl is limiting.

$$\begin{aligned} \Delta H (\text{kJ/mol H}_2\text{O}) &= \frac{q_{\text{rxn}}}{\text{mol H}_2\text{O}} = \frac{-1.386 \text{ kJ}}{0.0250 \text{ mol H}_2\text{O}} \\ &= -55.4 \text{ kJ/mol H}_2\text{O} \end{aligned}$$

6.7A $-q_{\text{rxn}} = q_{\text{calorimeter}}$

$$q_{\text{calorimeter}} = -0.8650 \text{ g C} \times \frac{1 \text{ mol C}}{12.01 \text{ g C}} \times \frac{-393.5 \text{ kJ}}{1 \text{ mol C}} = 28.34 \text{ kJ}$$

$$q_{\text{calorimeter}} = C_{\text{calorimeter}} \times \Delta T$$

$$C_{\text{calorimeter}} = \frac{q_{\text{calorimeter}}}{\Delta T} = \frac{28.34 \text{ kJ}}{3.116 \text{ K}} = 9.09 \text{ kJ/K}$$

6.7B $\Delta T = 26.799^\circ\text{C} - 21.862^\circ\text{C} = 4.937^\circ\text{C} = 4.937 \text{ K}$

$$q_{\text{calorimeter}} = C_{\text{calorimeter}} \times \Delta T = (8.151 \text{ kJ/K})(4.937 \text{ K}) = 40.24 \text{ kJ}$$

$$q (\text{Calories}) = 40.24 \text{ kJ} \times \frac{1 \text{ kcal}}{4.184 \text{ kJ}} \times \frac{1 \text{ Calorie}}{1 \text{ kcal}} = 9.618 < 10 \text{ Calories}$$

The claim is correct.

$$\begin{aligned} \text{Heat (kJ)} &= 15.0 \text{ kg} \times \frac{1000 \text{ g}}{1 \text{ kg}} \times \frac{1 \text{ mol C}_2\text{H}_6}{30.07 \text{ g C}_2\text{H}_6} \times \frac{137 \text{ kJ}}{1 \text{ mol}} \\ &= 6.83 \times 10^4 \text{ kJ released} \end{aligned}$$

$$\begin{aligned} \text{Heat (kJ)} &= 3.50 \text{ t NO} \times \frac{1000 \text{ kg}}{1 \text{ t}} \times \frac{1000 \text{ g}}{1 \text{ kg}} \times \frac{1 \text{ mol NO}}{30.01 \text{ g NO}} \\ &\times \frac{180.58 \text{ kJ}}{2 \text{ mol NO}} \\ &= 1.05 \times 10^7 \text{ kJ absorbed} \end{aligned}$$

6.9A Reverse equation 1:

Reverse equation 2 and multiply by 2:

6.9B Reverse equation 1 and divide by 2:

Divide equation 2 by 2:

Reverse equation 3:

$$\begin{aligned} \Delta H_{\text{rxn}}^\circ &= \{4\Delta H_f^\circ[\text{H}_3\text{PO}_4(l)]\} - \{\Delta H_f^\circ[\text{P}_4\text{O}_{10}(s)] \\ &\quad + 6\Delta H_f^\circ[\text{H}_2\text{O}(l)]\} \\ &= [(4 \text{ mol})(-1271.7 \text{ kJ/mol})] \\ &\quad - [(1 \text{ mol})(-2984 \text{ kJ/mol}) \\ &\quad + (6 \text{ mol})(-285.840 \text{ kJ/mol})] \\ &= -5086.8 \text{ kJ} - (-2984 \text{ kJ} - 1715.04 \text{ kJ}) \\ &= -387.8 \text{ kJ} \end{aligned}$$

6.11B Note that the ΔH_f° of O₂(g) = 0.

PROBLEMS

Problems with **colored** numbers are answered in Appendix E and worked in detail in the Student Solutions Manual. Problem sections match those in the text and give the numbers of relevant sample problems. Most offer Concept Review Questions, Skill-Building Exercises (grouped in pairs covering the same concept), and Problems in Context. The Comprehensive Problems are based on material from any section or previous chapter.

Forms of Energy and Their Interconversion

(Sample Problems 6.1 and 6.2)

Concept Review Questions

6.1 Why do heat (q) and work (w) have positive values when entering a system and negative values when leaving?

6.2 If you feel warm after exercising, have you increased the internal energy of your body? Explain.

6.3 An *adiabatic* process is one that involves no heat transfer. What is the relationship between work and the change in internal energy in an adiabatic process?

6.4 State two ways that you increase the internal energy of your body and two ways that you decrease it.

6.5 Name a common device used to accomplish each change:

- (a) Electrical energy to thermal energy
- (b) Electrical energy to sound energy
- (c) Electrical energy to light energy
- (d) Mechanical energy to electrical energy
- (e) Chemical energy to electrical energy

6.6 In winter, an electric heater uses a certain amount of electrical energy to heat a room to 20°C . In summer, an air conditioner uses the same amount of electrical energy to cool the room to 20°C . Is the change in internal energy of the heater larger, smaller, or the same as that of the air conditioner? Explain.

6.7 You lift your textbook and drop it onto a desk. Describe the energy transformations (from one form to another) that occur, moving backward in time from a moment after impact.

6.8 Why is the work done when a system expands against a constant external pressure assigned a negative sign?

Skill-Building Exercises (grouped in similar pairs)

6.9 A system receives 425 J of heat from and delivers 425 J of work to its surroundings. What is the change in internal energy of the system (in J)?

6.10 A system releases 255 cal of heat to the surroundings and delivers 428 cal of work. What is the change in internal energy of the system (in cal)?

6.11 What is the change in internal energy (in J) of a system that releases 675 J of thermal energy to its surroundings and has 530 cal of work done on it?

6.12 What is the change in internal energy (in J) of a system that absorbs 0.615 kJ of heat from its surroundings and has 0.247 kcal of work done on it?

6.13 Complete combustion of 2.0 metric tons of coal to gaseous carbon dioxide releases 6.6×10^{10} J of heat. Convert this energy to (a) kilojoules; (b) kilocalories; (c) British thermal units.

6.14 Thermal decomposition of 5.0 metric tons of limestone to lime and carbon dioxide absorbs 9.0×10^6 kJ of heat. Convert this energy to (a) joules; (b) calories; (c) British thermal units.

6.15 At constant temperature, a sample of helium gas expands from 922 mL to 1.14 L against a pressure of 2.33 atm. Find w (in J) done by the gas ($101.3 \text{ J} = 1 \text{ atm} \cdot \text{L}$).

6.16 The external pressure on a gas sample is 2660 mmHg, and the volume changes from 0.88 L to 0.63 L at constant temperature. Find w (in kJ) done on the gas ($1 \text{ atm} \cdot \text{L} = 101.3 \text{ J}$).

Problems in Context

6.17 The nutritional calorie (Calorie) is equivalent to 1 kcal. One pound of body fat is equivalent to about 4.1×10^3 Calories. Express this quantity of energy in joules and kilojoules.

6.18 If an athlete expends 1950 kJ/h, how long does it take her to work off 1.0 lb of body fat? (See Problem 6.17.)

Enthalpy: Changes at Constant Pressure

(Sample Problem 6.3)

Concept Review Questions

6.19 Why is it often more convenient to measure ΔH than ΔE ?

6.20 Hot packs used by skiers produce heat via the crystallization of sodium acetate from a concentrated solution. What is the sign of ΔH for this crystallization? Is the reaction exothermic or endothermic?

6.21 Classify the following processes as exothermic or endothermic: (a) freezing of water; (b) boiling of water; (c) digestion of food; (d) a person running; (e) a person growing; (f) wood being chopped; (g) heating with a furnace.

6.22 What are the two main components of the internal energy of a substance? On what are they based?

6.23 For each process, state whether ΔH is less than (more negative), equal to, or greater than ΔE of the system. Explain.

- (a) An ideal gas is cooled at constant pressure.
- (b) A gas mixture reacts exothermically at fixed volume.
- (c) A solid reacts exothermically to yield a mixture of gases in a container of variable volume.

Skill-Building Exercises (grouped in similar pairs)

6.24 Draw an enthalpy diagram for a general exothermic reaction; label the axis, reactants, products, and ΔH with its sign.

6.25 Draw an enthalpy diagram for a general endothermic reaction; label the axis, reactants, products, and ΔH with its sign.

6.26 Write a balanced equation and draw an enthalpy diagram for: (a) combustion of 1 mol of ethane; (b) freezing of liquid water.

6.27 Write a balanced equation and draw an enthalpy diagram for (a) formation of 1 mol of sodium chloride from its elements (heat is released); (b) vaporization of liquid benzene.

6.28 Write a balanced equation and draw an enthalpy diagram for (a) combustion of 1 mol of liquid methanol (CH_3OH); (b) formation of 1 mol of NO_2 from its elements (heat is absorbed).

6.29 Write a balanced equation and draw an enthalpy diagram for (a) sublimation of dry ice [conversion of $\text{CO}_2(s)$ directly to $\text{CO}_2(g)$]; (b) reaction of 1 mol of SO_2 with O_2 .

6.30 The circles represent a phase change at constant temperature:

Is the value of each of the following positive (+), negative (-), or zero: (a) q_{sys} ; (b) ΔE_{sys} ; (c) ΔE_{univ} ?

6.31 The scene below represents a physical change taking place in a piston-cylinder assembly:

(a) Is w_{sys} +, -, or 0? (b) Is ΔH_{sys} +, -, or 0? (c) Can you determine whether ΔE_{surr} is +, -, or 0? Explain.

Calorimetry: Measuring the Heat of a Chemical or Physical Change

(Sample Problems 6.4 to 6.7)

Concept Review Questions

6.32 Which is larger, the specific heat capacity or the molar heat capacity of a substance? Explain.

6.33 What data do you need to determine the specific heat capacity of a substance?

6.34 Is the specific heat capacity of a substance an intensive or extensive property? Explain.

6.35 Distinguish between specific heat capacity, molar heat capacity, and heat capacity.

6.36 Both a coffee-cup calorimeter and a bomb calorimeter can be used to measure the heat transferred in a reaction. Which measures ΔE and which measures ΔH ? Explain.

Skill-Building Exercises (grouped in similar pairs)

6.37 Find q when 22.0 g of water is heated from 25.0°C to 100.°C.

6.38 Calculate q when 0.10 g of ice is cooled from 10.°C to -75°C ($c_{\text{ice}} = 2.087 \text{ J/g}\cdot\text{K}$).

6.39 A 295-g aluminum engine part at an initial temperature of 13.00°C absorbs 75.0 kJ of heat. What is the final temperature of the part (c of Al = 0.900 J/g·K)?

6.40 A 27.7-g sample of the radiator coolant ethylene glycol releases 688 J of heat. What was the initial temperature of the sample if the final temperature is 32.5°C (c of ethylene glycol = 2.42 J/g·K)?

6.41 Two iron bolts of equal mass—one at 100.°C, the other at 55°C—are placed in an insulated container. Assuming the heat

capacity of the container is negligible, what is the final temperature inside the container (c of iron = 0.450 J/g·K)?

6.42 One piece of copper jewelry at 105°C has twice the mass of another piece at 45°C. Both are placed in a calorimeter of negligible heat capacity. What is the final temperature inside the calorimeter (c of copper = 0.387 J/g·K)?

6.43 When 155 mL of water at 26°C is mixed with 75 mL of water at 85°C, what is the final temperature? (Assume that no heat is released to the surroundings; d of water = 1.00 g/mL.)

6.44 An unknown volume of water at 18.2°C is added to 24.4 mL of water at 35.0°C. If the final temperature is 23.5°C, what was the unknown volume? (Assume that no heat is released to the surroundings; d of water = 1.00 g/mL.)

6.45 A 455-g piece of copper tubing is heated to 89.5°C and placed in an insulated vessel containing 159 g of water at 22.8°C. Assuming no loss of water and a heat capacity of 10.0 J/K for the vessel, what is the final temperature (c of copper = 0.387 J/g·K)?

6.46 A 30.5-g sample of an alloy at 93.0°C is placed into 50.0 g of water at 22.0°C in an insulated coffee-cup calorimeter with a heat capacity of 9.2 J/K. If the final temperature of the system is 31.1°C, what is the specific heat capacity of the alloy?

6.47 When 25.0 mL of 0.500 M H_2SO_4 is added to 25.0 mL of 1.00 M KOH in a coffee-cup calorimeter at 23.50°C, the temperature rises to 30.17°C. Calculate ΔH in kJ per mole of H_2O formed. (Assume that the total volume is the sum of the volumes and that the density and specific heat capacity of the solution are the same as for water.)

6.48 When 20.0 mL of 0.200 M AgNO_3 and 30.0 mL of 0.100 M NaCl, both at 24.72°C, are mixed in a coffee-cup calorimeter, AgCl precipitates and the temperature of the mixture increases to 25.65°C. Calculate ΔH in kJ per mole of $\text{AgCl}(s)$ produced. (Assume that the total volume is the sum of the volumes and that the density and specific heat capacity of the solution are the same as for water.)

6.49 When a 2.150-g sample of glucose, $\text{C}_6\text{H}_{12}\text{O}_6$, is burned in a bomb calorimeter with a heat capacity of 6.317 kJ/K, the temperature of the calorimeter increases from 23.446°C to 28.745°C. Calculate ΔE for the combustion of glucose in kJ/mol.

6.50 A chemist places 1.750 g of ethanol, $\text{C}_2\text{H}_6\text{O}$, in a bomb calorimeter with a heat capacity of 12.05 kJ/K. The sample is burned and the temperature of the calorimeter increases by 4.287°C. Calculate ΔE for the combustion of ethanol in kJ/mol.

Problems in Context

6.51 High-purity benzoic acid ($\text{C}_6\text{H}_5\text{COOH}$; ΔH for combustion = -3227 kJ/mol) is used to calibrate bomb calorimeters. A 1.221-g sample burns in a calorimeter that has a heat capacity of 6.384 kJ/°C. What is the temperature change?

6.52 Two aircraft rivets, one iron and the other copper, are placed in a calorimeter that has an initial temperature of 20.°C. The data for the rivets are as follows:

	Iron	Copper
Mass (g)	30.0	20.0
Initial T (°C)	0.0	100.0
c (J/g·K)	0.450	0.387

- (a) Will heat flow from Fe to Cu or from Cu to Fe?
- (b) What other information is needed to correct any measurements in an actual experiment?
- (c) What is the maximum final temperature of the system (assuming the heat capacity of the calorimeter is negligible)?

6.53 A chemical engineer burned 1.520 g of a hydrocarbon in the bomb of a calorimeter (see Figure 6.10). The water temperature rose from 20.00°C to 23.55°C. If the calorimeter had a heat capacity of 11.09 kJ/K, what was the heat released (q_V) per gram of hydrocarbon?

Stoichiometry of Thermochemical Equations

(Sample Problem 6.8)

Concept Review Questions

6.54 Does a negative ΔH mean that the heat should be treated as a reactant or as a product?

6.55 Would you expect $O_2(g) \rightarrow 2O(g)$ to have a positive or a negative ΔH ? Explain.

6.56 Is ΔH positive or negative when 1 mol of water vapor condenses to liquid water? Why? How does this value compare with ΔH for the vaporization of 2 mol of liquid water to water vapor?

Skill-Building Exercises (grouped in similar pairs)

6.57 Consider the following balanced thermochemical equation for a reaction sometimes used for H_2S production:

- (a) Is this an exothermic or endothermic reaction?
- (b) What is ΔH for the reverse reaction?
- (c) What is ΔH when 2.6 mol of S_8 reacts?
- (d) What is ΔH when 25.0 g of S_8 reacts?

6.58 Consider the following balanced thermochemical equation for the decomposition of the mineral magnesite:

- (a) Is heat absorbed or released in the reaction?
- (b) What is ΔH for the reverse reaction?
- (c) What is ΔH when 5.35 mol of CO_2 reacts with excess MgO ?
- (d) What is ΔH when 35.5 g of CO_2 reacts with excess MgO ?

6.59 When 1 mol of $NO(g)$ forms from its elements, 90.29 kJ of heat is absorbed. (a) Write a balanced thermochemical equation. (b) What is ΔH when 3.50 g of NO decomposes to its elements?

6.60 When 1 mol of $KBr(s)$ decomposes to its elements, 394 kJ of heat is absorbed. (a) Write a balanced thermochemical equation. (b) What is ΔH when 10.0 kg of KBr forms from its elements?

Problems in Context

6.61 Liquid hydrogen peroxide, an oxidizing agent in many rocket fuel mixtures, releases oxygen gas on decomposition:

How much heat is released when 652 kg of H_2O_2 decomposes?

6.62 Compounds of boron and hydrogen are remarkable for their unusual bonding (described in Section 14.5) and also for their reactivity. With the more reactive halogens, for example, diborane (B_2H_6) forms trihalides even at low temperatures:

What is ΔH per kilogram of diborane that reacts?

6.63 Deterioration of buildings, bridges, and other structures through the rusting of iron costs millions of dollars a day. The actual process requires water, but a simplified equation is

- (a) How much heat is released when 0.250 kg of iron rusts?
- (b) How much rust forms when 4.85×10^3 kJ of heat is released?

6.64 A mercury mirror forms inside a test tube as a result of the thermal decomposition of mercury(II) oxide:

- (a) How much heat is absorbed to decompose 555 g of the oxide?
- (b) If 275 kJ of heat is absorbed, how many grams of Hg form?

6.65 Most ethylene (C_2H_4), the starting material for producing polyethylene, comes from petroleum processing. It also occurs naturally as a fruit-ripening hormone and as a component of natural gas. (a) The heat transferred during combustion of C_2H_4 is -1411 kJ/mol . Write a balanced thermochemical equation. (b) How many grams of C_2H_4 must burn to give 70.0 kJ of heat?

6.66 Sucrose ($C_{12}H_{22}O_{11}$, table sugar) is oxidized in the body by O_2 via a complex set of reactions that produces $CO_2(g)$ and $H_2O(g)$ and releases $5.64 \times 10^3 \text{ kJ/mol}$ sucrose. (a) Write a balanced thermochemical equation for the overall process. (b) How much heat is released per gram of sucrose oxidized?

Hess's Law: Finding ΔH of Any Reaction

(Sample Problem 6.9)

Concept Review Questions

6.67 Express Hess's law in your own words.

6.68 What is the main application of Hess's law?

6.69 When carbon burns in a deficiency of O_2 , a mixture of CO and CO_2 forms. Carbon burns in excess O_2 to form only CO_2 , and CO burns in excess O_2 to form only CO_2 . Use ΔH values of the latter two reactions (from Appendix B) to calculate ΔH for

Skill-Building Exercises (grouped in similar pairs)

6.70 Calculate ΔH for

given the following reactions:

6.71 Calculate ΔH for

given the following reactions:

6.72 Write the balanced overall equation (equation 3) for the following process, calculate $\Delta H_{\text{overall}}$, and match the number of each equation with the letter of the appropriate arrow in Figure P6.72:

6.73 Write the balanced overall equation (equation 3) for the following process, calculate $\Delta H_{\text{overall}}$, and match the number of each equation with the letter of the appropriate arrow in Figure P6.73:

Figure P6.72

Figure P6.73

6.74 At a given set of conditions, 241.8 kJ of heat is released when 1 mol of $\text{H}_2\text{O}(g)$ forms from its elements. Under the same conditions, 285.8 kJ is released when 1 mol of $\text{H}_2\text{O}(l)$ forms from its elements. Find ΔH for the vaporization of water at these conditions.

6.75 When 1 mol of $\text{CS}_2(l)$ forms from its elements at 1 atm and 25°C, 89.7 kJ of heat is absorbed, and it takes 27.7 kJ to vaporize 1 mol of the liquid. How much heat is absorbed when 1 mol of $\text{CS}_2(g)$ forms from its elements at these conditions?

Problems in Context

6.76 Diamond and graphite are two crystalline forms of carbon. At 1 atm and 25°C, diamond changes to graphite so slowly that the enthalpy change of the process must be obtained indirectly. Using equations from the list below, determine ΔH for

- (1) $\text{C(diamond)} + \text{O}_2(g) \longrightarrow \text{CO}_2(g) \quad \Delta H = -395.4 \text{ kJ}$
- (2) $2\text{CO}_2(g) \longrightarrow 2\text{CO}(g) + \text{O}_2(g) \quad \Delta H = 566.0 \text{ kJ}$
- (3) $\text{C(graphite)} + \text{O}_2(g) \longrightarrow \text{CO}_2(g) \quad \Delta H = -393.5 \text{ kJ}$
- (4) $2\text{CO}(g) \longrightarrow \text{C(graphite)} + \text{CO}_2(g) \quad \Delta H = -172.5 \text{ kJ}$

Standard Enthalpies of Reaction (ΔH_{rxn}°)

(Sample Problems 6.10 and 6.11)

Concept Review Questions

6.77 What is the difference between the standard enthalpy of formation and the standard enthalpy of reaction?

6.78 How are ΔH_f° values used to calculate ΔH_{rxn}° ?

6.79 Make any changes needed in each of the following equations so that the enthalpy change is equal to ΔH_f° for the compound:

- (a) $\text{Cl}(g) + \text{Na}(s) \longrightarrow \text{NaCl}(s)$
- (b) $\text{H}_2\text{O}(g) \longrightarrow 2\text{H}(g) + \frac{1}{2}\text{O}_2(g)$
- (c) $\frac{1}{2}\text{N}_2(g) + \frac{3}{2}\text{H}_2(g) \longrightarrow \text{NH}_3(g)$

Skill-Building Exercises (grouped in similar pairs)

6.80 Use Table 6.3 or Appendix B to write a balanced formation equation at standard conditions for each of the following compounds: (a) CaCl_2 ; (b) NaHCO_3 ; (c) CCl_4 ; (d) HNO_3 .

6.81 Use Table 6.3 or Appendix B to write a balanced formation equation at standard conditions for each of the following compounds: (a) HI ; (b) SiF_4 ; (c) O_3 ; (d) $\text{Ca}_3(\text{PO}_4)_2$.

6.82 Calculate ΔH_{rxn}° for each of the following:

- (a) $2\text{H}_2\text{S}(g) + 3\text{O}_2(g) \longrightarrow 2\text{SO}_2(g) + 2\text{H}_2\text{O}(g)$
- (b) $\text{CH}_4(g) + \text{Cl}_2(g) \longrightarrow \text{CCl}_4(l) + \text{HCl}(g)$ [unbalanced]

6.83 Calculate ΔH_{rxn}° for each of the following:

- (a) $\text{SiO}_2(s) + 4\text{HF}(g) \longrightarrow \text{SiF}_4(g) + 2\text{H}_2\text{O}(l)$
- (b) $\text{C}_2\text{H}_6(g) + \text{O}_2(g) \longrightarrow \text{CO}_2(g) + \text{H}_2\text{O}(g)$ [unbalanced]

6.84 Copper(I) oxide can be oxidized to copper(II) oxide:

Given ΔH_f° of $\text{Cu}_2\text{O}(s) = -168.6 \text{ kJ/mol}$, find ΔH_f° of $\text{CuO}(s)$.

6.85 Acetylene burns in air according to the following equation:

$$\Delta H_{rxn}^\circ = -1255.8 \text{ kJ}$$

Given ΔH_f° of $\text{CO}_2(g) = -393.5 \text{ kJ/mol}$ and ΔH_f° of $\text{H}_2\text{O}(g) = -241.8 \text{ kJ/mol}$, find ΔH_f° of $\text{C}_2\text{H}_2(g)$.

Problems in Context

6.86 The common lead-acid car battery produces a large burst of current, even at low temperatures, and is rechargeable. The reaction that occurs while recharging a “dead” battery is

(a) Use ΔH_f° values from Appendix B to calculate ΔH_{rxn}° .

(b) Use the following equations to check your answer to part (a):

$$\Delta H_{rxn}^\circ = -768 \text{ kJ}$$

$$\Delta H_{rxn}^\circ = -132 \text{ kJ}$$

Comprehensive Problems

6.87 Stearic acid ($\text{C}_{18}\text{H}_{36}\text{O}_2$) is a fatty acid, a molecule with a long hydrocarbon chain and an organic acid group (COOH) at the end. It is used to make cosmetics, ointments, soaps, and candles and is found in animal tissue as part of many saturated fats. In fact, when you eat meat, you are ingesting some fats containing stearic acid.

(a) Write a balanced equation for the combustion of stearic acid to gaseous products.

(b) Calculate ΔH_{rxn}° for this combustion (ΔH_f° of $\text{C}_{18}\text{H}_{36}\text{O}_2 = -948 \text{ kJ/mol}$).

(c) Calculate the heat (q) released in kJ and kcal when 1.00 g of stearic acid is burned completely.

(d) A candy bar contains 11.0 g of fat and provides 100. Cal from fat; is this consistent with your answer for part (c)?

6.88 Diluting sulfuric acid with water is highly exothermic:

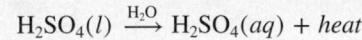

(a) Use Appendix B to find ΔH_{rxn}° for diluting 1.00 mol of $\text{H}_2\text{SO}_4(l)$ ($d = 1.83 \text{ g/mL}$) to 1 L of 1.00 M $\text{H}_2\text{SO}_4(aq)$ ($d = 1.060 \text{ g/mL}$).

(b) Suppose you carry out the dilution in a calorimeter. The initial T is 25.0°C, and the specific heat capacity of the final solution is 3.50 J/g·K. What is the final T ?

(c) Use the ideas of density and heat capacity to explain why you should add acid to water rather than water to acid.

6.89 A balloonist begins a trip in a helium-filled balloon in early morning when the temperature is 15°C. By mid-afternoon, the temperature is 30°C. Assuming the pressure remains at 1.00 atm, for each mole of helium, calculate the following:

(a) The initial and final volumes

(b) The change in internal energy, ΔE (Hint: Helium behaves like an ideal gas, so $E = \frac{3}{2}nRT$. Be sure the units of R are consistent with those of E .)

(c) The work (w) done by the helium (in J)

(d) The heat (q) transferred (in J)

(e) ΔH for the process (in J)

(f) Explain the relationship between the answers to parts (d) and (e).

6.90 In winemaking, the sugars in grapes undergo *fermentation* by yeast to yield $\text{CH}_3\text{CH}_2\text{OH}$ and CO_2 . During cellular *respiration* (combustion), sugar and ethanol yield water vapor and CO_2 .

(a) Using $\text{C}_6\text{H}_{12}\text{O}_6$ for sugar, calculate $\Delta H_{\text{rxn}}^\circ$ of fermentation and of respiration.

(b) Write a combustion reaction for ethanol. Which has a higher $\Delta H_{\text{rxn}}^\circ$ for combustion per mole of C, sugar or ethanol?

6.91 Three of the reactions that occur when the paraffin of a candle (typical formula $\text{C}_{21}\text{H}_{44}$) burns are as follows:

- (1) Complete combustion forms CO_2 and water vapor.
 - (2) Incomplete combustion forms CO and water vapor.
 - (3) Some wax is oxidized to elemental C (soot) and water vapor.
- (a) Find $\Delta H_{\text{rxn}}^\circ$ of each reaction (ΔH_f° of $\text{C}_{21}\text{H}_{44} = -476 \text{ kJ/mol}$; use graphite for elemental carbon).

- (b) Find q (in kJ) when a 254-g candle burns completely.
- (c) Find q (in kJ) when 8.00% by mass of the candle burns incompletely and 5.00% by mass of it undergoes soot formation.

6.92 Ethylene oxide (EO) is prepared by the vapor-phase oxidation of ethylene. Its main uses are in the preparation of the anti-freeze ethylene glycol and in the production of poly(ethylene terephthalate), which is used to make beverage bottles and fibers. Pure EO vapor can decompose explosively:

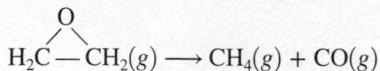

Liquid EO has $\Delta H_f^\circ = -77.4 \text{ kJ/mol}$ and ΔH° for its vaporization = 569.4 J/g. (a) Calculate $\Delta H_{\text{rxn}}^\circ$ for the gas-phase reaction. (b) External heating causes the vapor to decompose at 10 bar and 93°C in a distillation column. What is the final temperature if the average specific heat capacity of the products is 2.5 J/g·°C?

6.93 The following scenes represent a gaseous reaction between compounds of nitrogen (blue) and oxygen (red) at 298 K:

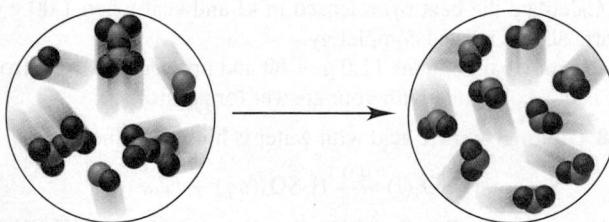

(a) Write a balanced equation and use Appendix B to calculate $\Delta H_{\text{rxn}}^\circ$.

(b) If each molecule of product represents $1.50 \times 10^{-2} \text{ mol}$, what quantity of heat (in J) is released or absorbed?

6.94 Isooctane (C_8H_{18} ; $d = 0.692 \text{ g/mL}$) is used as the fuel in a test of a new automobile drive train.

(a) How much energy (in kJ) is released by combustion of 20.4 gal of isooctane to gases ($\Delta H_{\text{rxn}}^\circ = -5.44 \times 10^3 \text{ kJ/mol}$)?

(b) The energy delivered to the automobile's wheels at 65 mph is $5.5 \times 10^4 \text{ kJ/h}$. Assuming *all* the energy is transferred as work to the wheels, how far (in km) can the vehicle travel on the 20.4 gal of fuel?

(c) If the actual range is 455 mi, explain your answer to (b).

6.95 Four 50.-g samples of different colorless liquids are placed in beakers at $T_{\text{initial}} = 25.00^\circ\text{C}$. Each liquid is heated until 450. J of heat has been absorbed; T_{final} is shown on each beaker below. Rank the liquids in order of increasing specific heat capacity.

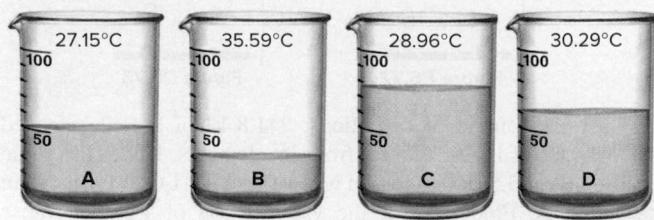

6.96 Reaction of gaseous ClF with F_2 yields liquid ClF_3 , an important fluorinating agent. Use the following thermochemical equations to calculate $\Delta H_{\text{rxn}}^\circ$ for this reaction:

- (1) $2\text{ClF}(g) + \text{O}_2(g) \longrightarrow \text{Cl}_2\text{O}(g) + \text{OF}_2(g)$ $\Delta H_{\text{rxn}}^\circ = 167.5 \text{ kJ}$
- (2) $2\text{F}_2(g) + \text{O}_2(g) \longrightarrow 2\text{OF}_2(g)$ $\Delta H_{\text{rxn}}^\circ = -43.5 \text{ kJ}$
- (3) $2\text{ClF}_3(l) + 2\text{O}_2(g) \longrightarrow \text{Cl}_2\text{O}(g) + 3\text{OF}_2(g)$ $\Delta H_{\text{rxn}}^\circ = 394.1 \text{ kJ}$

6.97 Silver bromide is used to coat ordinary black-and-white photographic film, while high-speed film uses silver iodide.

(a) When 50.0 mL of 5.0 g/L AgNO_3 is added to a coffee-cup calorimeter containing 50.0 mL of 5.0 g/L NaI , with both solutions at 25°C , what mass of AgI forms?

(b) Use Appendix B to find $\Delta H_{\text{rxn}}^\circ$.

(c) What is ΔT_{soln} (assuming the volumes are additive and the solution has the density and specific heat capacity of water)?

6.98 The calorie (4.184 J) is defined as the quantity of energy needed to raise the temperature of 1.00 g of liquid water by 1.00°C . The British thermal unit (Btu) is defined as the quantity of energy needed to raise the temperature of 1.00 lb of liquid water by 1.00°F .

(a) How many joules are in 1.00 Btu (1 lb = 453.6 g; $1.0^\circ\text{C} = 1.8^\circ\text{F}$)?

(b) The *therm* is a unit of energy consumption and is defined as 100,000 Btu. How many joules are in 1.00 therm?

(c) How many moles of methane must be burned to give 1.00 therm of energy? (Assume that water forms as a gas.)

(d) If natural gas costs \$0.66 per therm, what is the cost per mole of methane? (Assume that natural gas is pure methane.)

(e) How much would it cost to warm 318 gal of water in a hot tub from 15.0°C to 42.0°C by burning methane (1 gal = 3.78 L)?

6.99 When organic matter decomposes under oxygen-free (anaerobic) conditions, methane is one of the products. Thus, enormous deposits of natural gas, which is almost entirely methane, serve as a major source of fuel for home and industry.

(a) Known deposits of natural gas can produce 5600 EJ of energy (1 EJ = 10^{18} J). Current total global energy usage is $4.0 \times 10^2 \text{ EJ}$ per year. Find the mass (in kg) of known deposits of natural gas ($\Delta H_{\text{rxn}}^\circ$ for the combustion of $\text{CH}_4 = -802 \text{ kJ/mol}$).

(b) At current rates of usage, for how many years could these deposits supply the world's total energy needs?

- (c) What volume (in ft^3) of natural gas, measured at STP, is required to heat 1.00 qt of water from 25.0°C to 100.0°C (d of $\text{H}_2\text{O} = 1.00 \text{ g/mL}$; d of CH_4 at STP = 0.72 g/L)?
 (d) The fission of 1 mol of uranium (about $4 \times 10^{-4} \text{ ft}^3$) in a nuclear reactor produces $2 \times 10^{13} \text{ J}$. What volume (in ft^3) of natural gas would produce the same amount of energy?

6.100 A reaction takes place in a steel vessel within a chamber filled with argon gas. Shown below are atomic-scale views of the argon adjacent to the surface of the container wall of the reaction vessel before and after the reaction. Was the reaction exothermic or endothermic? Explain.

6.101 An aqueous waste stream with a maximum concentration of $0.50 \text{ M H}_2\text{SO}_4$ ($d = 1.030 \text{ g/mL}$ at 25°C) is neutralized by controlled addition of 40% NaOH ($d = 1.430 \text{ g/L}$) before it goes to the process sewer and then to the chemical plant waste treatment facility. A safety review finds that the waste stream could meet a small stream of an immiscible organic compound, which could form a flammable vapor in air at 40°C . The maximum temperature reached by the NaOH solution and the waste stream is 31°C . Could the temperature increase due to the heat transferred by the neutralization cause the organic vapor to explode? Assume that the specific heat capacity of each solution is $4.184 \text{ J/g}\cdot\text{K}$.

- 6.102** Kerosene, a common space-heater fuel, is a mixture of hydrocarbons whose “average” formula is $\text{C}_{12}\text{H}_{26}$.
- Write a balanced equation, using the simplest whole-number coefficients, for the complete combustion of kerosene to gases.
 - If $\Delta H_{\text{rxn}}^\circ = -1.50 \times 10^4 \text{ kJ}$ for the combustion equation as written in part (a), determine ΔH_f° of kerosene.
 - Calculate the heat released by combustion of 0.50 gal of kerosene (d of kerosene = 0.749 g/mL).
 - How many gallons of kerosene must be burned for a kerosene furnace to produce 1250. Btu (1 Btu = 1.055 kJ)?

6.103 Silicon tetrachloride is produced annually on the multikiloton scale and used in making transistor-grade silicon. It can be produced directly from the elements (reaction 1) or, more cheaply, by heating sand and graphite with chlorine gas (reaction 2). If water is present in reaction 2, some tetrachloride may be lost in an unwanted side reaction (reaction 3):

- $\text{Si}(s) + 2\text{Cl}_2(g) \rightarrow \text{SiCl}_4(g)$
- $\text{SiO}_2(s) + 2\text{C(graphite)} + 2\text{Cl}_2(g) \rightarrow \text{SiCl}_4(g) + 2\text{CO}(g)$
- $\text{SiCl}_4(g) + 2\text{H}_2\text{O}(g) \rightarrow \text{SiO}_2(s) + 4\text{HCl}(g)$

$$\Delta H_{\text{rxn}}^\circ = -139.5 \text{ kJ}$$

(a) Use reaction 3 to calculate the standard enthalpies of reaction of reactions 1 and 2.

(b) What is the standard enthalpy of reaction for a fourth reaction that is the sum of reactions 2 and 3?

6.104 One mole of nitrogen gas confined within a cylinder by a piston is heated from 0°C to 819°C at 1.00 atm.

- Calculate the work done by the expanding gas in joules ($1 \text{ J} = 9.87 \times 10^{-3} \text{ atm}\cdot\text{L}$). Assume that all the energy is used to do work.
- What would be the temperature change if the gas were heated using the same amount of energy in a container of fixed volume? (Assume that the specific heat capacity of N_2 is $1.00 \text{ J/g}\cdot\text{K}$.)

6.105 The chemistry of nitrogen oxides is very versatile. Given the following reactions and their standard enthalpy changes,

- | | |
|---|---|
| (1) $\text{NO}(g) + \text{NO}_2(g) \rightarrow \text{N}_2\text{O}_3(g)$ | $\Delta H_{\text{rxn}}^\circ = -39.8 \text{ kJ}$ |
| (2) $\text{NO}(g) + \text{NO}_2(g) + \text{O}_2(g) \rightarrow \text{N}_2\text{O}_5(g)$ | $\Delta H_{\text{rxn}}^\circ = -112.5 \text{ kJ}$ |
| (3) $2\text{NO}_2(g) \rightarrow \text{N}_2\text{O}_4(g)$ | $\Delta H_{\text{rxn}}^\circ = -57.2 \text{ kJ}$ |
| (4) $2\text{NO}(g) + \text{O}_2(g) \rightarrow 2\text{NO}_2(g)$ | $\Delta H_{\text{rxn}}^\circ = -114.2 \text{ kJ}$ |
| (5) $\text{N}_2\text{O}_5(s) \rightarrow \text{N}_2\text{O}_5(g)$ | $\Delta H_{\text{rxn}}^\circ = 54.1 \text{ kJ}$ |

calculate the standard enthalpy of reaction for

6.106 Electric generating plants transport large amounts of hot water through metal pipes, and oxygen dissolved in the water can cause a major corrosion problem. Hydrazine (N_2H_4) added to the water prevents this problem by reacting with the oxygen:

About $4 \times 10^7 \text{ kg}$ of hydrazine is produced every year by reacting ammonia with sodium hypochlorite in the *Raschig process*:

- If ΔH_f° of $\text{NaOCl}(aq) = -346 \text{ kJ/mol}$, find ΔH_f° of $\text{N}_2\text{H}_4(aq)$.
- What is the heat released when aqueous N_2H_4 is added to $5.00 \times 10^3 \text{ L}$ of water that is $2.50 \times 10^{-4} \text{ M O}_2$?

6.107 Liquid methanol (CH_3OH) can be used as an alternative fuel by pickup trucks and SUVs. An industrial method for preparing it involves the catalytic hydrogenation of carbon monoxide:

How much heat (in kJ) is released when 15.0 L of CO at 85°C and 112 kPa reacts with 18.5 L of H_2 at 75°C and 744 torr ?

- 6.108** (a) How much heat is released when 25.0 g of methane burns in excess O_2 to form gaseous CO_2 and H_2O ?
 (b) Calculate the temperature of the product mixture if the methane and air are both at an initial temperature of 0.0°C . Assume a stoichiometric ratio of methane to oxygen from the air, with air being 21% O_2 by volume (c of $\text{CO}_2 = 57.2 \text{ J/mol}\cdot\text{K}$; c of $\text{H}_2\text{O}(g) = 36.0 \text{ J/mol}\cdot\text{K}$; c of $\text{N}_2 = 30.5 \text{ J/mol}\cdot\text{K}$).

7

Quantum Theory and Atomic Structure

7.1 The Nature of Light

Wave Nature of Light
Particle Nature of Light

7.2 Atomic Spectra

Line Spectra and the Rydberg Equation
Bohr Model of the Hydrogen Atom
Energy Levels of the Hydrogen Atom

7.3 The Wave-Particle Duality of Matter and Energy

Wave Nature of Electrons and
Particle Nature of Photons
Heisenberg's Uncertainty Principle

7.4 The Quantum-Mechanical Model of the Atom

Atomic Orbital and Probable
Location of the Electron
Quantum Numbers of an Orbital
Quantum Numbers and Energy Levels
Shapes of Atomic Orbitals
The Special Case of the H Atom

Source: © Jeffrey Johnson

Concepts and Skills to Review Before You Study This Chapter

- › discovery of the electron and atomic nucleus (Section 2.4)
- › changes in the energy state of a system (Section 6.1)
- › major features of atomic structure (Section 2.5)

Neon signs, introduced to the United States in 1923, quickly became popular with businesses eager to catch the attention of potential customers. These signs are now everywhere, from the simple “OPEN” in the window of your local pizza place to more elaborate creations in Times Square and Las Vegas. The science behind neon signs (which can involve other elements as well) fascinated scientists in the early 20th century. The fact that neon emitted light was one of several observations that led to a new view of matter and energy that not only explains fireworks, sodium-vapor streetlights, and TV screens, but clarifies the structure of the atom! New ideas about atomic structure were some of many revolutions that took place in Western science (and culture) from around 1890 to 1930. ›

But revolutions in science are not the violent upheavals of political overthrow. Flaws appear in a model due to conflicting evidence, a startling discovery widens the flaws into cracks, and the theoretical structure crumbles. Then, new insight, verified by experiment, builds a model more consistent with reality. So it was when Lavoisier’s theory of combustion overthrew the phlogiston model, when Dalton’s atomic theory established the idea of individual units of matter, and when Rutherford’s model substituted nuclear atoms for “billiard balls” or “plum puddings.” You will see this process unfold again as we discuss the development of modern atomic theory.

IN THIS CHAPTER . . . We discuss quantum mechanics, the theory that explains the fundamental nature of energy and matter and accounts for atomic structure.

- › We consider the classical distinction between the wave properties of energy and the particle properties of matter.
- › We then examine two observations—blackbody radiation and the photoelectric effect—whose explanations led to a *quantized*, or particulate, model of light.
- › We see that light emitted by excited atoms—an *atomic spectrum*—suggests an atom with distinct energy levels, and we apply spectra to chemical analysis.
- › We see how wave-particle duality, which shows that matter and energy have similar properties, and the uncertainty principle, which proposes that electron behavior can never be known exactly, led to the current model of the H atom.
- › We present quantum numbers, which specify the size, shape, and orientation of atomic orbitals, the regions an electron occupies in the H atom. (In Chapter 8, we’ll examine quantum numbers for atoms with more than one electron.)

A Time of Revolution

Here are some of the revolutionary discoveries and events occurring in the Western world during those decades:

- 1895 Röntgen: discovery of x-rays
- 1896 Becquerel: discovery of radioactivity
- 1897 Thomson: discovery of the electron
- 1900 Freud: theory of the unconscious
- 1900 Planck: quantum theory
- 1901 Marconi: invention of the radio
- 1903 Wright brothers: flight of a plane
- 1905 Ford: assembly line to build cars
- 1905 Rutherford: radioactivity explained
- 1905 Einstein: relativity/photon theories
- 1906 St. Denis: modern dance
- 1908 Matisse/Picasso: modern art
- 1909 Schoenberg/Berg: modern music
- 1911 Rutherford: nuclear model
- 1913 Bohr: atomic spectra and new model
- 1914–1918: World War I
- 1923 Compton: photon momentum
- 1924 de Broglie: wave theory of matter
- 1926 Schrödinger: wave equation
- 1927 Heisenberg: uncertainty principle

7.1 THE NATURE OF LIGHT

To understand current atomic theory, you need to know about **electromagnetic radiation** (also called *electromagnetic energy*, or *radiant energy*). Visible light, x-rays, radio waves, and microwaves are some of the types of electromagnetic radiation. All of these consist of energy propagated by electric and magnetic fields that increase and decrease in intensity as they move, wavelike, through space. This *classical wave model* explains why rainbows form, how magnifying glasses work, and many other familiar observations. But it cannot explain observations on the very *unfamiliar* atomic scale. In this section, we describe some properties of electromagnetic radiation and note how they are distinguished from the properties of matter. But, we will see that some properties blur the distinction between energy and matter, requiring a new model to explain them.

Figure 7.1 The inverse relationship of frequency and wavelength.

Figure 7.2 Differing amplitude (brightness, or intensity) of a wave.

The Wave Nature of Light

The wave properties of electromagnetic radiation are described by three variables and one constant (Figure 7.1):

1. *Frequency (ν , Greek *nu*).* The **frequency** of electromagnetic radiation is the number of complete waves, or cycles, that pass a given point per second, expressed by the unit 1/second [s^{-1} ; also called a *hertz* (Hz)]. An FM radio station's channel is the frequency, in MHz, at which it broadcasts.
2. *Wavelength (λ , Greek *lambda*).* The **wavelength** is the distance between any point on a wave and the corresponding point on the next crest (or trough) of the wave, that is, the distance the wave travels during one cycle. Wavelength has units of length such as meters or, for very short wavelengths, nanometers (nm, 10^{-9} m), picometers (pm, 10^{-12} m), or the non-SI unit angstroms (\AA , 10^{-10} m).
3. *Speed.* The speed of a wave is the distance it moves per unit time (meters per second), the product of its frequency (cycles per second) and the wavelength (meters per cycle):

$$\text{Units for speed of wave: } \frac{\text{cycles}}{\text{s}} \times \frac{\text{m}}{\text{cycle}} = \frac{\text{m}}{\text{s}}$$

In a vacuum, electromagnetic radiation moves at 2.99792458×10^8 m/s (3.00×10^8 m/s to three significant figures), a *physical constant* called the **speed of light (c)**:

$$c = \nu \times \lambda \quad (7.1)$$

Since the product of ν and λ is a constant, they have an inverse relationship—*radiation with a high frequency has a short wavelength, and radiation with a low frequency has a long wavelength:*

$$\nu \uparrow \lambda \downarrow \quad \text{and} \quad \nu \downarrow \lambda \uparrow$$

Wave A in Figure 7.1 has a wavelength that is four times longer than that of wave C; since both waves are traveling at the same speed, one wavelength of wave A passes a point in the same amount of time as four wavelengths of wave C—the frequency of wave C is four times that of wave A.

4. *Amplitude.* The **amplitude** of a wave is the height of the crest (or depth of the trough). For an electromagnetic wave, the amplitude is related to the *intensity* of the radiation, or its brightness in the case of visible light. Light of a particular color has a specific frequency (and thus, wavelength), but, as Figure 7.2 shows, its amplitude can vary; the light can be dimmer (lower amplitude, less intense) or brighter (higher amplitude, more intense).

The Electromagnetic Spectrum All waves of electromagnetic radiation travel at the same speed through a vacuum but differ in frequency and, therefore, wavelength. The types of radiation are arranged in order of increasing wavelength (decreasing frequency) in the **electromagnetic spectrum** (Figure 7.3). As a *continuum of radiant energy*, the spectrum is broken down into regions according to wavelength and frequency, with each region adjoining the next.

Visible light represents just a small region of the spectrum. We perceive different wavelengths (or frequencies) of visible light as different colors, from violet ($\lambda \approx 400$ nm) to red ($\lambda \approx 750$ nm). Light of a single wavelength is called *monochromatic* (Greek, “one color”), whereas light of many wavelengths is *polychromatic*. White light, composed of all of the colors of visible light, is polychromatic. The region adjacent to visible light on the short-wavelength (high-frequency) end consists of **ultraviolet (UV)** radiation (also called *ultraviolet light*); still shorter wavelengths make up the x-ray and gamma (γ) ray regions. The region adjacent to visible light on the long-wavelength (low-frequency) end consists of **infrared (IR)** radiation; still longer wavelengths make up the microwave and radio wave regions.

Some types of electromagnetic radiation are utilized by familiar devices; for example, long-wavelength, low-frequency radiation is used by microwave ovens, radios, and cell phones. But electromagnetic emissions are everywhere: coming from

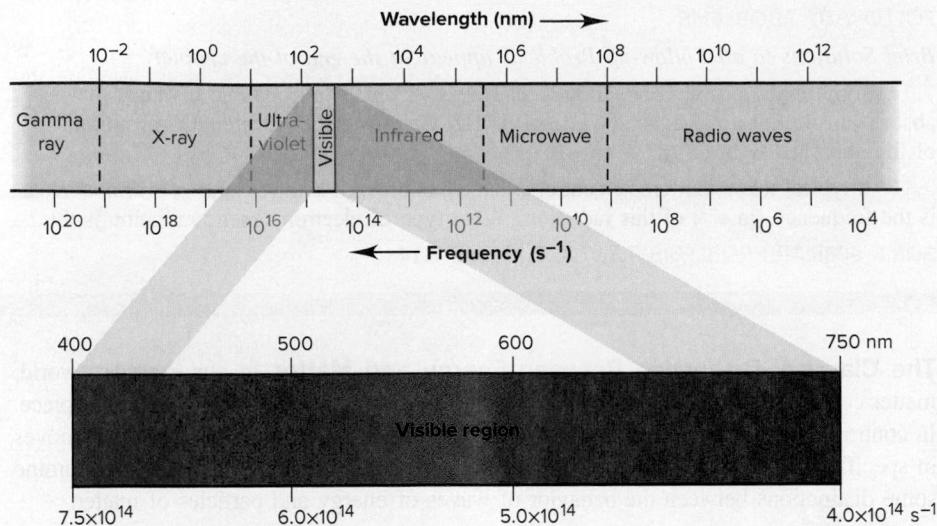

Figure 7.3 Regions of the electromagnetic spectrum. The visible region is expanded (and the scale made linear) to show the component colors.

human artifacts such as lightbulbs, x-ray equipment, and car motors, and from natural sources such as the Sun, lightning, radioactivity, and even the glow of fireflies! Our knowledge of the universe comes from radiation that enters our eyes and our light, x-ray, and radio telescopes.

SAMPLE PROBLEM 7.1

Interconverting Wavelength and Frequency

Problem A dental hygienist uses x-rays ($\lambda = 0.50 \text{ \AA}$) to take a series of dental radiographs while the patient listens to a radio station ($\lambda = 325 \text{ cm}$) and looks out the window at the blue sky ($\lambda = 473 \text{ nm}$). What is the frequency (in s^{-1}) of the electromagnetic radiation from each source? (Assume that the radiation travels at the speed of light, $3.00 \times 10^8 \text{ m/s}$.)

Plan We are given the wavelengths, so we use Equation 7.1 to find the frequencies. However, we must first convert the wavelengths to meters because c has units of m/s (see the road map).

Solution For the x-rays: Converting from angstroms to meters,

$$\lambda = 0.50 \text{ \AA} \times \frac{10^{-10} \text{ m}}{1 \text{ \AA}} = 5.0 \times 10^{-11} \text{ m}$$

Calculating the frequency:

$$v = \frac{c}{\lambda} = \frac{3.00 \times 10^8 \text{ m/s}}{5.0 \times 10^{-11} \text{ m}} = 6.0 \times 10^{18} \text{ s}^{-1}$$

For the radio signal: Combining steps to calculate the frequency,

$$v = \frac{c}{\lambda} = \frac{3.00 \times 10^8 \text{ m/s}}{325 \text{ cm} \times \frac{10^{-2} \text{ m}}{1 \text{ cm}}} = 9.23 \times 10^7 \text{ s}^{-1}$$

For the blue sky: Combining steps to calculate the frequency,

$$v = \frac{c}{\lambda} = \frac{3.00 \times 10^8 \text{ m/s}}{473 \text{ nm} \times \frac{10^{-9} \text{ m}}{1 \text{ nm}}} = 6.34 \times 10^{14} \text{ s}^{-1}$$

Check The orders of magnitude are correct for the regions of the electromagnetic spectrum (see Figure 7.3): x-rays (10^{19} to 10^{16} s^{-1}), radio waves (10^9 to 10^4 s^{-1}), and visible light (7.5×10^{14} to $4.0 \times 10^{14} \text{ s}^{-1}$).

Comment Note that the x-ray, with the shortest wavelength, has the highest frequency, while the radio wave, with the longest wavelength, has the lowest frequency. The radio station here is broadcasting at $92.3 \times 10^6 \text{ s}^{-1}$, or 92.3 million Hz (92.3 MHz), about midway in the FM range.

Road Map

FOLLOW-UP PROBLEMS

Brief Solutions to all Follow-up Problems appear at the end of the chapter.

7.1A Some diamonds appear yellow because they contain nitrogen compounds that absorb purple light of frequency 7.23×10^{14} Hz. Calculate the wavelength (in nm and Å) of the absorbed light.

7.1B A typical television remote control emits radiation with a wavelength of 940 nm. What is the frequency (in s^{-1}) of this radiation? What type of electromagnetic radiation is this?

SOME SIMILAR PROBLEMS 7.7, 7.8, 7.13, and 7.14

Wave theory explains the colors of a rainbow.

Source: © Anthony McAulay/Shutterstock.com

Figure 7.4 Different behaviors of waves and particles.

The Classical Distinction Between Energy and Matter In our everyday world, matter comes in chunks you can hold, weigh, and change the quantity of, piece by piece. In contrast, energy is “massless,” and its quantity can change continuously. Matter moves in specific paths, whereas radiant energy (light) travels in diffuse waves. Let’s examine some distinctions between the behavior of waves of energy and particles of matter.

1. *Refraction and dispersion.* Light of a given wavelength travels at different speeds through various transparent media—vacuum, air, water, quartz, and so forth. Therefore, when a light wave passes from one medium into another, the speed of the wave changes. Figure 7.4A shows the phenomenon known as **refraction**. If the wave strikes the boundary between media, say, between air and water, at an angle other than 90°, the change in speed causes a change in direction, and the wave continues at a different angle. The angle of refraction depends on the two media and the wavelength of the light. In the related process of *dispersion*, white light separates (disperses) into its component colors when it passes through a prism (or other refracting object) because each incoming wave is refracted at a slightly different angle.

Two of many familiar applications of refraction and dispersion involve rainbows and diamonds. You see a rainbow when sunlight entering the near surface of countless droplets is dispersed and reflected off the far surface. Red light is bent least, so it appears higher in the sky and violet lower (see photo). A diamond sparkles with various colors because its facets disperse and reflect the incoming light.

Wave	Particle
A <p><i>The speed of a light wave passing between media changes immediately, which bends its path (refraction).</i></p>	B <p><i>The speed of a particle continues changing gradually.</i></p>
C <p><i>A wave bends around both edges of a small opening, forming a semicircular wave (diffraction).</i></p>	D <p><i>Particles either enter a small opening or do not.</i></p>

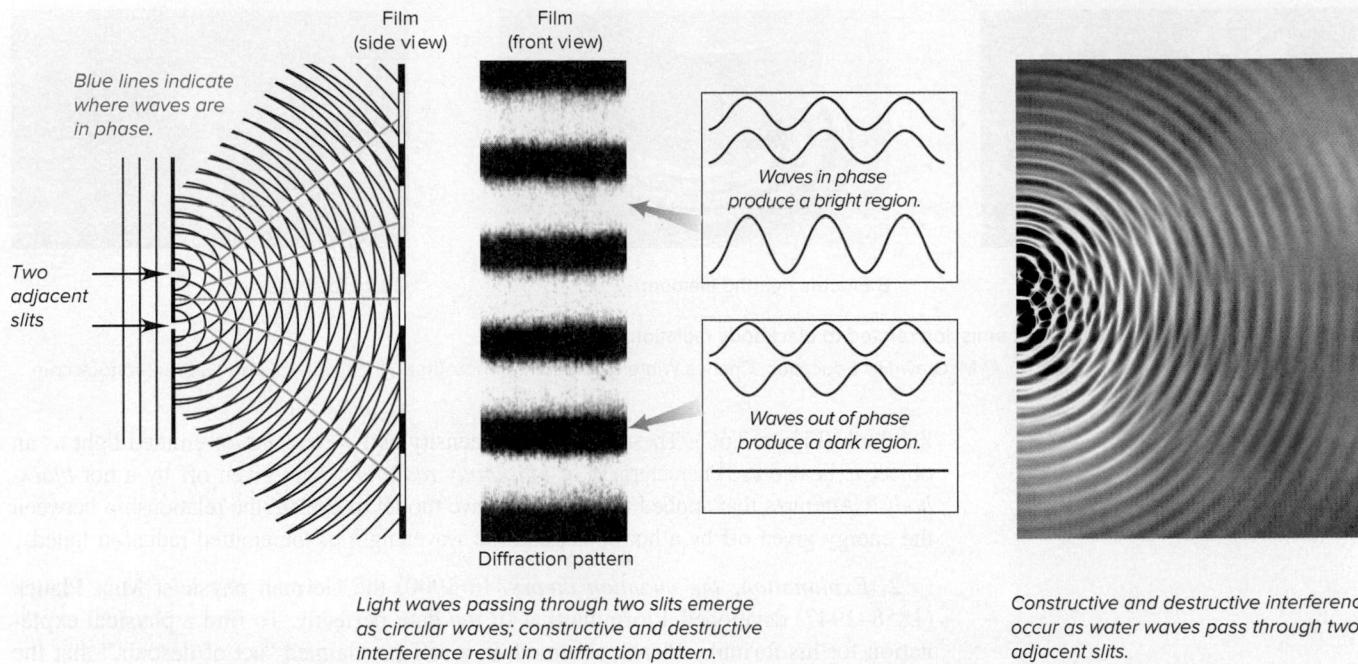

Figure 7.5 Formation of a diffraction pattern.

Source: © Berenice Abbott/Science Source

In contrast to a wave of light, a particle of matter, like a pebble, does not undergo refraction. If you throw a pebble through the air into a pond, it continues to slow down gradually along a curved path after entering the water (Figure 7.4B).

2. Diffraction and interference. When a wave strikes the edge of an object, it bends around it in a phenomenon called **diffraction**. If the wave passes through a slit about as wide as its wavelength, it bends around both edges of the slit and forms a semi-circular wave on the other side of the opening (Figure 7.4C).

In contrast, when you throw a collection of particles, like a handful of sand, at a small opening, some particles hit the edge, while others go through the opening and continue in a narrower group (Figure 7.4D).

When waves of light pass through two adjacent slits, the nearby emerging circular waves interact through the process of *interference*. If the crests of the waves coincide (*in phase*), they interfere *constructively*—the amplitudes add together to form a brighter region. If crests coincide with troughs (*out of phase*), they interfere *destructively*—the amplitudes cancel to form a darker region. The result is a *diffraction pattern* (Figure 7.5).

In contrast, particles passing through adjacent openings continue in straight paths, some colliding and moving at different angles.

The Particle Nature of Light

Three observations involving matter and light confounded physicists at the turn of the 20th century: blackbody radiation, the photoelectric effect, and atomic spectra. Explaining these phenomena required a radically new view of energy. We discuss the first two of them here and the third in Section 7.2.

Blackbody Radiation and the Quantum Theory of Energy The first of the puzzling observations involved the light given off by an object being heated.

1. Observation: blackbody radiation. When a solid object is heated to about 1000 K, it begins to emit visible light, as you can see in the red glow of smoldering coal (Figure 7.6A, *next page*). At about 1500 K, the light is brighter and more orange, like that from an electric heating coil (Figure 7.6B, *next page*). At temperatures greater than 2000 K, the light is still brighter and whiter, like that emitted by the filament of a

A Smoldering coal

B Electric heating element

C Lightbulb filament

Figure 7.6 Familiar examples of light emission related to blackbody radiation.

Source: (a): © Ravi/Shutterstock.com; (b): © McGraw-Hill Education. Charles Winters/Timeframe Photography, Inc.; (c): © Feng Yu/Shutterstock.com

lightbulb (Figure 7.6C). These changes in intensity and wavelength of emitted light as an object is heated are characteristic of *blackbody radiation*, light given off by a hot *blackbody*.* Attempts that applied the classical wave model to explain the relationship between the energy given off by a hot object and the wavelength of the emitted radiation failed.

2. Explanation: the quantum theory. In 1900, the German physicist Max Planck (1858–1947) developed a formula that fit the data perfectly. To find a physical explanation for his formula, Planck assumed, in a self-proclaimed “act of despair,” that the hot, glowing object could emit (or absorb) only *certain* quantities of energy:

$$E = nh\nu$$

where E is the energy of the radiation, ν is its frequency, n is a positive integer (1, 2, 3, and so on) called a **quantum number**, and h is **Planck's constant**. With energy in joules (J) and frequency in s^{-1} , h has units of J·s:

$$h = 6.62606876 \times 10^{-34} \text{ J}\cdot\text{s} = 6.626 \times 10^{-34} \text{ J}\cdot\text{s} \quad (4 \text{ sf})$$

Since the hot object emits only certain quantities of energy, and the energy must be emitted by the object's atoms, this means that each atom *emits* only certain quantities of energy. It follows, then, that each atom *has* only certain quantities of energy. Thus, the energy of an atom is *quantized*: it occurs in fixed quantities, rather than being continuous. Each change in an atom's energy occurs when the atom absorbs or emits one or more “packets,” or definite amounts, of energy. Each energy packet is called a **quantum** (“fixed quantity”; plural, *quanta*). A quantum of energy is equal to $h\nu$. Thus, *an atom changes its energy state by emitting (or absorbing) one or more quanta*, and the energy of the emitted (or absorbed) radiation is equal to the *difference in the atom's energy states*:

$$\Delta E_{\text{atom}} = E_{\text{emitted (or absorbed) radiation}} = \Delta n h\nu$$

Because the atom can change its energy only by integer multiples of $h\nu$, the smallest change occurs when an atom in a given energy state changes to an adjacent state, that is, when $\Delta n = 1$:

$$\Delta E = h\nu \quad (7.2)$$

Rearranging Equation 7.1,

$$c = \nu \times \lambda \quad \text{or} \quad \frac{c}{\lambda} = \nu$$

and substituting c/λ for frequency, ν , in Equation 7.2 gives the direct relationship between wavelength and energy:

$$\Delta E = h\nu = \frac{hc}{\lambda} \quad (7.3)$$

These relationships indicate that energy is directly proportional to frequency and inversely proportional to wavelength. Short-wavelength radiation such as x-rays has high frequency and high energy, while long-wavelength radiation such as radio waves has low frequency and low energy.

*A blackbody is an idealized object that absorbs all the radiation incident on it. A hollow cube with a small hole in one wall approximates a blackbody.

The Photoelectric Effect and the Photon Theory of Light Despite the idea of quantization, physicists still pictured energy as traveling in waves. But, the wave model could not explain the second confusing observation, the flow of current when light strikes a metal.

1. *Observation: the photoelectric effect.* When monochromatic light of sufficient frequency shines on a metal plate, a current flows (Figure 7.7). It was thought that the current arises because light transfers energy that frees electrons from the metal surface. However, the effect had two confusing features, the presence of a threshold frequency and the absence of a time lag:

- *Presence of a threshold frequency.* For current to flow, the light shining on the metal must have a minimum, or threshold, *frequency*, and different metals have different minimum frequencies. But, the wave theory associates the energy of light with its *amplitude* (intensity), not its frequency (color). Thus, the theory predicts that an electron would break free when it absorbed enough energy from light of *any* color.
- *Absence of a time lag.* Current flows the moment light of the minimum frequency shines on the metal, regardless of the light's intensity. But the wave theory predicts that with dim light there would be a time lag before the current flows, because the electrons would have to absorb enough energy to break free.

2. *Explanation: the photon theory.* Building on Planck's ideas, Albert Einstein (1879–1955) proposed that light itself is particulate, quantized into tiny "bundles" of energy, later called **photons**. Each atom changes its energy by an amount ΔE_{atom} when it absorbs or emits one photon, one "particle" of light, whose energy is related to its *frequency*, not its amplitude:

$$E_{\text{photon}} = h\nu = \Delta E_{\text{atom}}$$

Let's see how the photon theory explains the two features of the photoelectric effect:

- *Why there is a threshold frequency.* A beam of light consists of an enormous number of photons. The intensity (brightness) is related to the *number* of photons, but *not* to the energy of each. Therefore, a photon of a certain *minimum* energy must be absorbed to free an electron from the surface (see Figure 7.7). Since energy depends on frequency ($h\nu$), the theory predicts a threshold frequency.
- *Why there is no time lag.* An electron breaks free when it absorbs a photon of *enough* energy; it cannot break free by "saving up" energy from several photons, each having less than the minimum energy. The current is weak in dim light because fewer photons of enough energy can free fewer electrons per unit time, but some current flows *as soon as* light of sufficient energy (frequency) strikes the metal. ➤

Figure 7.7 The photoelectric effect.

Ping-Pong Photons

This analogy helps explain why light of insufficient energy cannot free an electron from the metal surface. If one Ping-Pong ball doesn't have enough energy to knock a book off a shelf, neither does a series of Ping-Pong balls, because the book can't save up the energy from the individual impacts. But one baseball traveling at the same speed does have enough energy to move the book.

SAMPLE PROBLEM 7.2

Interconverting Energy, Wavelength, and Frequency

Problem A student uses a microwave oven to heat a meal. The wavelength of the radiation is 1.20 cm. What is the energy of one photon of this microwave radiation?

Plan We know λ in centimeters (1.20 cm) so we convert to meters and then find the energy of one photon with Equation 7.3.

Solution Combining steps to find the energy of a photon:

$$E = \frac{hc}{\lambda} = \frac{(6.626 \times 10^{-34} \text{ J}\cdot\text{s})(3.00 \times 10^8 \text{ m/s})}{(1.20 \text{ cm})\left(\frac{10^{-2} \text{ m}}{1 \text{ cm}}\right)} = 1.66 \times 10^{-23} \text{ J}$$

Check Checking the order of magnitude gives

$$\frac{(10^{-33} \text{ J}\cdot\text{s})(10^8 \text{ m/s})}{10^{-2} \text{ m}} = 10^{-23} \text{ J}$$

FOLLOW-UP PROBLEMS

7.2A Calculate the wavelength (in nm) and the frequency of a photon with an energy of $8.2 \times 10^{-19} \text{ J}$, the minimum amount of energy required to dislodge an electron from the metal gold.

7.2B Calculate the energy of one photon of (a) ultraviolet light ($\lambda = 1 \times 10^{-8}$ m); (b) visible light ($\lambda = 5 \times 10^{-7}$ m); and (c) infrared light ($\lambda = 1 \times 10^{-4}$ m). What do the answers indicate about the relationship between light's wavelength and energy?

SOME SIMILAR PROBLEMS 7.9–7.12

› Summary of Section 7.1

- › Electromagnetic radiation travels in waves characterized by a given wavelength (λ) and frequency (ν).
- › Electromagnetic waves travel through a vacuum at the speed of light, c (3.00×10^8 m/s), which equals $\nu \times \lambda$. Therefore, wavelength and frequency are inversely proportional to each other.
- › The intensity (brightness) of light is related to the amplitude of its waves.
- › The electromagnetic spectrum ranges from very long radio waves to very short gamma rays and includes the visible region between wavelengths 750 nm (red) and 400 nm (violet).
- › Refraction (change in a wave's speed when entering a different medium) and diffraction (bend of a wave around an edge of an object) indicate that energy is wavelike, with properties distinct from those of particles of mass.
- › Blackbody radiation and the photoelectric effect, however, are consistent with energy occurring in discrete packets, like particles.
- › Light exists as photons (quanta) whose energy is directly proportional to the frequency.
- › According to quantum theory, an atom has only certain quantities of energy ($E = nh\nu$), and it can change its energy only by absorbing or emitting a photon whose energy equals the change in the atom's energy.

7.2 ATOMIC SPECTRA

The third confusing observation about matter and energy involved the light emitted when an element is vaporized and then excited electrically. In this section, we discuss the nature of that light and see why it created a problem for the existing atomic model and how a new model solved the problem.

Line Spectra and the Rydberg Equation

When light from electrically excited gaseous atoms passes through a slit and is refracted by a prism, it does not create a *continuous spectrum*, or rainbow, as sunlight does. Instead, it creates a **line spectrum**, a series of fine lines at specific wavelengths (specific frequencies) separated by black spaces. Figure 7.8A shows the apparatus for obtaining these spectra and the line spectrum of atomic hydrogen. Figure 7.8B shows that each element produces a unique line spectrum. For example, the brilliant color of a simple neon sign is due to intense orange and red lines in the spectrum of neon.

Features of the Rydberg Equation Spectroscopists studying atomic hydrogen identified several series of spectral lines in different regions of the electromagnetic spectrum. Figure 7.9 shows the spectral lines in the ultraviolet, visible, and infrared regions.

Using data, not theory, the Swedish physicist Johannes Rydberg (1854–1919) developed a relationship, called the *Rydberg equation*, that predicts the position and wavelength of any line in a given series:

$$\frac{1}{\lambda} = R \left(\frac{1}{n_1^2} - \frac{1}{n_2^2} \right) \quad (7.4)$$

where λ is the wavelength of the line, n_1 and n_2 are positive integers with $n_2 > n_1$, and R is the Rydberg constant (1.096776×10^7 m⁻¹). To calculate the wavelengths of the lines in the visible series, $n_1 = 2$:

$$\frac{1}{\lambda} = R \left(\frac{1}{2^2} - \frac{1}{n_2^2} \right), \quad \text{with } n_2 = 3, 4, 5, \dots$$

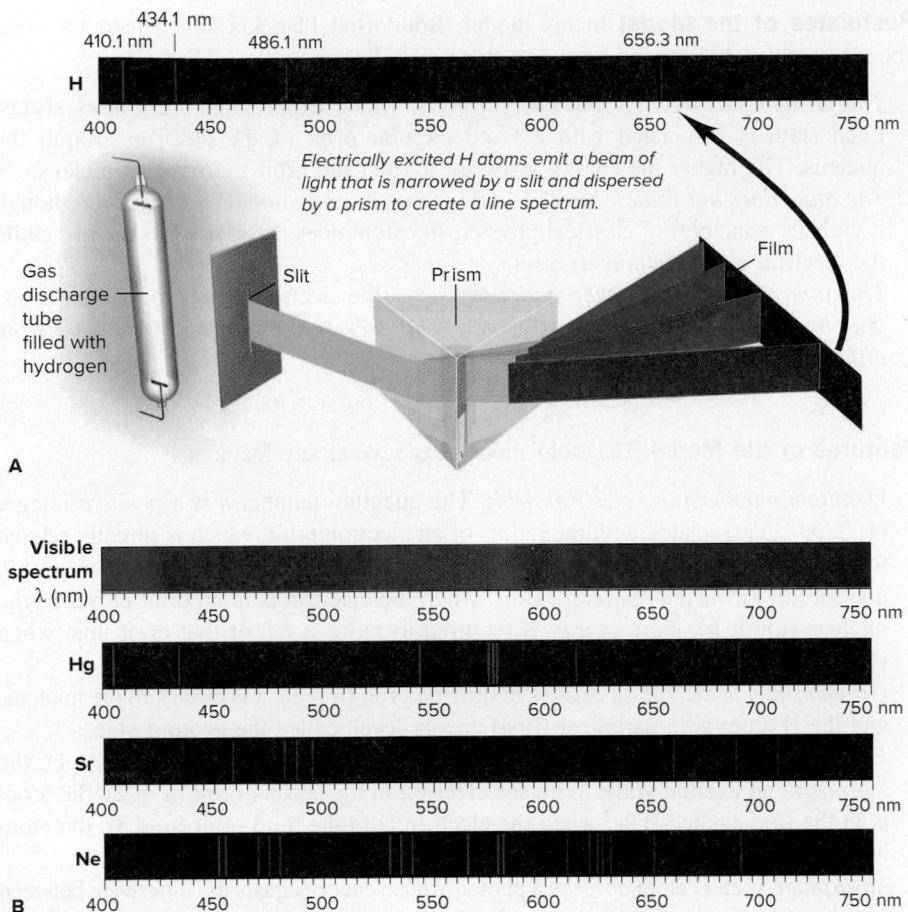

Figure 7.8 The line spectra of several elements. **A**, The line spectrum of atomic hydrogen. **B**, Unlike the continuous spectrum of white light, emission spectra of elements, such as mercury, strontium, and neon, appear as characteristic series of colored lines.

For the ultraviolet series, $n_1 = 1$ ($n_2 = 2, 3, 4, \dots$), and for the infrared series, $n_1 = 3$ ($n_2 = 4, 5, 6, \dots$). While the Rydberg equation predicts the wavelengths in the line spectrum of hydrogen, *it does not explain why line spectra occur*.

Problems with Rutherford's Nuclear Model Almost as soon as Rutherford proposed his nuclear model (described in Chapter 2), a major problem arose. A positive nucleus and a negative electron attract each other, and for them to stay apart, the kinetic energy of the electron's motion must counterbalance the potential energy of attraction. However, the laws of classical physics say that a negative particle moving in a curved path around a positive particle *must* emit radiation and thus lose energy. If the orbiting electrons behaved in that way, they would spiral into the nucleus, and all atoms would collapse! The laws of classical physics also say that the frequency of the emitted radiation should change smoothly as the negative particle spirals inward and, thus, create a continuous spectrum, not a line spectrum. The behavior of subatomic particles seemed to violate real-world experience and accepted principles.

The Bohr Model of the Hydrogen Atom

Two years after the nuclear model was proposed, Niels Bohr (1885–1962), a young Danish physicist working in Rutherford's laboratory, suggested a model for the H atom that *did* predict the existence of line spectra.

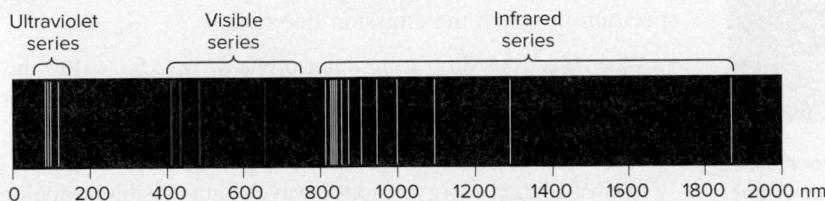

Figure 7.9 Three series of spectral lines of atomic hydrogen.

Postulates of the Model In his model, Bohr used Planck's and Einstein's ideas about quantized energy and proposed three postulates:

1. *The H atom has only certain energy levels*, which Bohr called **stationary states**. Each state is associated with a fixed circular orbit of the electron around the nucleus. The higher the energy level, the farther the orbit is from the nucleus.
2. *The atom does not radiate energy while in one of its stationary states*. Even though it violates principles of classical physics, the atom does not change its energy while the electron moves *within* an orbit.
3. *The atom changes to another stationary state* (the electron moves to another orbit) *only by absorbing or emitting a photon*. *The energy of the photon ($h\nu$) equals the difference in the energies of the two states*:

$$E_{\text{photon}} = \Delta E_{\text{atom}} = E_{\text{final}} - E_{\text{initial}} = h\nu$$

Features of the Model The Bohr model has several key features:

- *Quantum numbers and electron orbit*. The quantum number n is a positive integer (1, 2, 3, ...) associated with the radius of an electron orbit, which is directly related to the electron's energy: *the lower the n value, the smaller the radius of the orbit, and the lower the energy level*. Thus, when the electron is in an orbit closer to the nucleus (lower n), more energy is required to move it out of that orbit than when it is in an orbit farther from the nucleus (higher n).
- *Ground state*. When the electron is in the first orbit ($n = 1$), it is closest to the nucleus, and the H atom is in its lowest (first) energy level, called the **ground state**.
- *Excited states*. If the electron is in any orbit farther from the nucleus ($n > 1$), the atom is in an **excited state**. With the electron in the second orbit ($n = 2$), the atom is in the first excited state; when the electron is in the third orbit ($n = 3$), the atom is in the second excited state, and so forth.
- *Absorption*. If an H atom *absorbs* a photon whose energy equals the *difference* between lower and higher energy levels, the electron moves to the outer (higher energy) orbit.
- *Emission*. If an H atom in a higher energy level (with its electron in a farther orbit) returns to a lower energy level (electron in a closer orbit), the atom *emits* a photon whose energy equals the *difference* between the two levels. Figure 7.10 shows a staircase analogy that illustrates absorption and emission. Note that the energy difference between two consecutive orbits decreases as n increases.

How the Model Explains Line Spectra When an electron moves to an orbit closer to the nucleus, the atom's energy changes from a higher state to a lower state, resulting in a loss of a specific quantity of energy; that energy is *emitted* as a photon of a specific wavelength, producing a line in the atom's line spectrum. Since there are only certain energy levels in the atom, only certain quantities of energy (and photons of certain wavelengths) can be emitted as the electron transitions from one orbit to another. *Since an atom's energy is not continuous, but rather has only certain states, an atomic spectrum is not continuous.*

Figure 7.11A shows how Bohr's model accounts for three series of spectral lines of hydrogen. When a sample of gaseous H atoms is excited, the atoms absorb different quantities of energy. Each atom has one electron, but there are so many atoms in the whole sample that all the energy levels (orbits) have electrons. As electrons transition from one energy level to another, the n value of the final energy level determines the region of the electromagnetic spectrum in which the emission line falls.

- When electrons drop from outer orbits ($n = 4, 5, \dots$) to the $n = 3$ orbit (second excited state), photons with the energy of infrared radiation are emitted, creating the *infrared* series of lines.
- When electrons drop to the $n = 2$ orbit (first excited state), photons of higher energy (shorter wavelength) visible radiation are emitted, creating the *visible* series of lines.

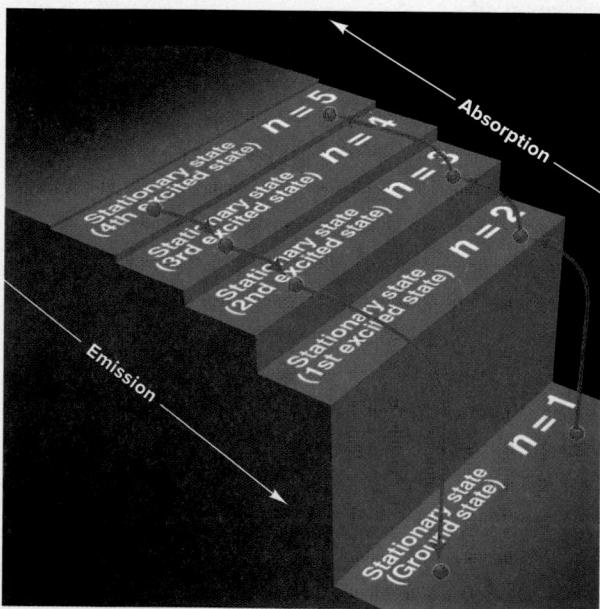

Figure 7.10 A quantum "staircase" as an analogy for atomic energy levels. Note that the electron can move up or down one or more steps at a time but cannot lie between steps.

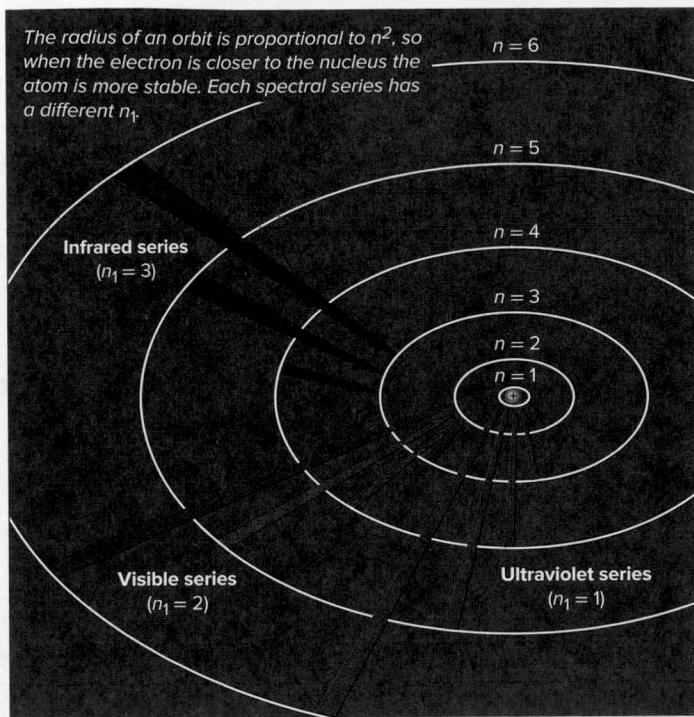**A**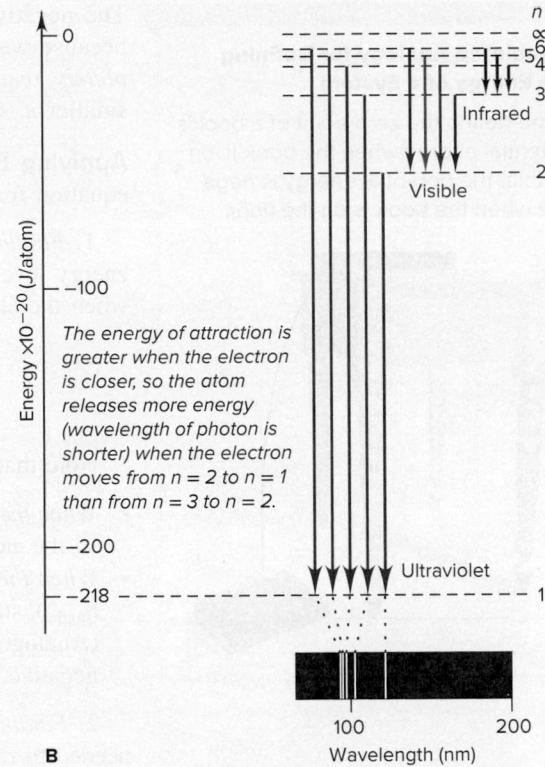**B**

Figure 7.11 The Bohr explanation of three series of spectral lines emitted by the H atom. **A**, In a given series, the outer electron drops to the same inner orbit (the same value of n_1 in the Rydberg equation). **B**, An energy diagram shows how the ultraviolet series arises.

- When electrons drop to the $n = 1$ orbit (ground state), photons of even higher energy, corresponding to ultraviolet radiation, are emitted, resulting in the *ultraviolet series* of lines. Figure 7.11B shows how the specific lines in the ultraviolet series appear.

Limitations of the Model Despite its great success in accounting for the spectral lines of the H atom, the Bohr model failed to predict the spectrum of any other atom. The reason is that it is a *one-electron model*: it works beautifully for the H atom and for other one-electron species, such as He^+ ($Z = 2$), Li^{2+} ($Z = 3$), and Be^{3+} ($Z = 4$). It fails completely for atoms with more than one electron because the electron-electron repulsions and additional nucleus-electron attractions that are present create much more complex interactions. But, even more fundamentally, as we'll see in Section 7.4, *electrons do not move in fixed, defined orbits*. Even though, as a picture of the atom, the Bohr model is incorrect, we still use the terms "ground state" and "excited state" and retain the central idea that *the energy of an atom occurs in discrete levels and it changes when the atom absorbs or emits a photon of specific energy*.

The Energy Levels of the Hydrogen Atom

Bohr's work leads to an equation for calculating the energy levels of an atom:

$$E = -2.18 \times 10^{-18} \text{ J} \left(\frac{Z^2}{n^2} \right)$$

where Z is the charge of the nucleus. For the H atom, $Z = 1$, so we have

$$\begin{aligned} E &= -2.18 \times 10^{-18} \text{ J} \left(\frac{1^2}{n^2} \right) \\ &= -2.18 \times 10^{-18} \text{ J} \left(\frac{1}{n^2} \right) \end{aligned}$$

Therefore, the energy of the ground state ($n = 1$) of the H atom is

$$\begin{aligned} E &= -2.18 \times 10^{-18} \text{ J} \left(\frac{1}{1^2} \right) \\ &= -2.18 \times 10^{-18} \text{ J} \end{aligned}$$

A Tabletop Analogy for Defining the Energy of a System

If you define the zero point of a book's potential energy when the book is on a table, the potential energy is negative when the book is on the floor.

The negative sign for the energy (also used on the axis in Figure 7.11B) appears because we *define* the zero point of the atom's energy when the electron is completely removed from the nucleus. Thus, $E = 0$ when $n = \infty$, so $E < 0$ for any smaller n . ◀

Applying Bohr's Equation for the Energy Levels of an Atom We can use the equation for the energy levels in several ways:

1. *Finding the difference in energy between two levels.* By subtracting the initial energy level of the atom from its final energy level, we find the change in energy when the electron moves between the two levels:

$$\Delta E = E_{\text{final}} - E_{\text{initial}} = -2.18 \times 10^{-18} \text{ J} \left(\frac{1}{n_{\text{final}}^2} - \frac{1}{n_{\text{initial}}^2} \right) \quad (7.5)$$

Note that, since n is in the denominator,

- When the atom emits energy, the electron moves closer to the nucleus ($n_{\text{final}} < n_{\text{initial}}$), so the atom's final energy is a *larger* negative number and ΔE is negative.
- When the atom absorbs energy, the electron moves away from the nucleus ($n_{\text{final}} > n_{\text{initial}}$), so the atom's final energy is a *smaller* negative number and ΔE is positive. (Analogously, in Chapter 6, you saw that, when the system releases heat, ΔH is negative, and when it absorbs heat, ΔH is positive.)

2. *Finding the energy needed to ionize the H atom.* We can also find the energy needed to remove the electron completely, that is, find ΔE for the following change:

We substitute $n_{\text{final}} = \infty$ and $n_{\text{initial}} = 1$ into Equation 7.5 and obtain

$$\begin{aligned} \Delta E = E_{\text{final}} - E_{\text{initial}} &= -2.18 \times 10^{-18} \text{ J} \left(\frac{1}{\infty^2} - \frac{1}{1^2} \right) \\ &= -2.18 \times 10^{-18} \text{ J} (0 - 1) = 2.18 \times 10^{-18} \text{ J} \end{aligned}$$

Energy must be *absorbed* to remove the electron from the nucleus, so ΔE is positive.

The *ionization energy* of hydrogen is the energy required to form 1 mol of gaseous H^+ ions from 1 mol of gaseous H atoms. Thus, for 1 mol of H atoms,

$$\Delta E = \left(2.18 \times 10^{-18} \frac{\text{J}}{\text{atom}} \right) \left(6.022 \times 10^{23} \frac{\text{atoms}}{\text{mol}} \right) \left(\frac{1 \text{ kJ}}{10^3 \text{ J}} \right) = 1.31 \times 10^3 \text{ kJ/mol}$$

Ionization energy is a key atomic property, and we'll return to it in (Chapter 8).

3. *Finding the wavelength of a spectral line.* Once we know ΔE from Equation 7.5, we find the wavelengths of the spectral lines of the H atom from Equation 7.3:

$$\lambda = \frac{hc}{\Delta E}$$

Alternatively, we combine Equation 7.3 with 7.5 and use Bohr's model to derive Rydberg's equation (Equation 7.4):

$$\begin{aligned} \frac{hc}{\lambda} &= \Delta E = -2.18 \times 10^{-18} \text{ J} \left(\frac{1}{n_{\text{final}}^2} - \frac{1}{n_{\text{initial}}^2} \right) \\ \frac{1}{\lambda} &= \frac{-2.18 \times 10^{-18} \text{ J}}{hc} \left(\frac{1}{n_{\text{final}}^2} - \frac{1}{n_{\text{initial}}^2} \right) \\ &= \frac{-2.18 \times 10^{-18} \text{ J}}{(6.626 \times 10^{-34} \text{ J}\cdot\text{s})(3.00 \times 10^8 \text{ m/s})} \left(\frac{1}{n_{\text{final}}^2} - \frac{1}{n_{\text{initial}}^2} \right) \\ &= 1.0967 \times 10^7 \text{ m}^{-1} \left(\frac{1}{n_1^2} - \frac{1}{n_2^2} \right) \end{aligned}$$

SAMPLE PROBLEM 7.3**Determining ΔE and λ of an Electron Transition**

Problem A hydrogen atom absorbs a photon of UV light (see Figure 7.11), and its electron enters the $n = 4$ energy level. Calculate (a) the change in energy of the atom and (b) the wavelength (in nm) of the absorbed photon.

Plan (a) The H atom absorbs energy, so $E_{\text{final}} > E_{\text{initial}}$. We are given $n_{\text{final}} = 4$, and Figure 7.11 shows that $n_{\text{initial}} = 1$ because a UV photon is absorbed. We apply Equation 7.5 to find ΔE . (b) Once we know ΔE , we find the wavelength (in m) with Equation 7.3. Then we convert from meters to nanometers.

Solution (a) Substituting the known values into Equation 7.5:

$$\begin{aligned}\Delta E &= -2.18 \times 10^{-18} \text{ J} \left(\frac{1}{n_{\text{final}}^2} - \frac{1}{n_{\text{initial}}^2} \right) = -2.18 \times 10^{-18} \text{ J} \left(\frac{1}{4^2} - \frac{1}{1^2} \right) \\ &= -2.18 \times 10^{-18} \text{ J} \left(\frac{1}{16} - 1 \right) = 2.04 \times 10^{-18} \text{ J}\end{aligned}$$

(b) Using Equation 7.3 to solve for λ :

$$\Delta E = \frac{hc}{\lambda}$$

therefore,

$$\lambda = \frac{hc}{\Delta E} = \frac{(6.626 \times 10^{-34} \text{ J} \cdot \text{s})(3.00 \times 10^8 \text{ m/s})}{2.04 \times 10^{-18} \text{ J}} = 9.74 \times 10^{-8} \text{ m}$$

Converting m to nm:

$$\begin{aligned}\lambda &= 9.74 \times 10^{-8} \text{ m} \times \frac{1 \text{ nm}}{10^{-9} \text{ m}} \\ &= 97.4 \text{ nm}\end{aligned}$$

Check (a) The energy change is positive, which is consistent with absorption of a photon. (b) The wavelength is within the UV region (about 10–380 nm).

Comment 1. We could instead use Equation 7.4 to find the wavelength (recall that in this equation, $n_2 > n_1$):

$$\begin{aligned}\frac{1}{\lambda} &= R \left(\frac{1}{n_1^2} - \frac{1}{n_2^2} \right) \\ &= 1.096776 \times 10^7 \text{ m}^{-1} \left(\frac{1}{1^2} - \frac{1}{4^2} \right)\end{aligned}$$

$$\frac{1}{\lambda} = 1.028228 \times 10^7 \text{ m}^{-1}$$

$$\lambda (\text{m}) = \frac{1}{1.028228 \times 10^7 \text{ m}^{-1}} = 9.73 \times 10^{-8} \text{ m}$$

$$\lambda (\text{nm}) = 9.73 \times 10^{-8} \text{ m} \times \frac{1 \text{ nm}}{10^{-9} \text{ m}} = 97.3 \text{ nm}$$

2. In Follow-up Problem 7.3A, note that if ΔE is negative (the atom loses energy), we use its absolute value, $|\Delta E|$, because λ must have a positive value.

FOLLOW-UP PROBLEMS

7.3A A hydrogen atom with its electron in the $n = 6$ energy level emits a photon of IR light. Calculate (a) the change in energy of the atom and (b) the wavelength (in Å) of the photon.

7.3B An electron in the $n = 6$ energy level of an H atom drops to a lower energy level; the atom emits a photon of wavelength 410. nm. (a) What is ΔE for this transition in 1 mol of H atoms? (b) To what energy level did the electron move?

SOME SIMILAR PROBLEMS 7.23–7.28, 7.31, and 7.32

Spectrometric analysis of the H atom led to the Bohr model, the first step toward our current model of the atom. From its use by 19th-century chemists as a means of identifying elements and compounds, spectrometry has developed into a major tool of modern chemistry (see Tools of the Laboratory).

The use of spectral data to identify and quantify substances is essential to modern chemical analysis. The terms *spectroscopy* and **spectrometry** refer to a large group of instrumental techniques that obtain spectra to gather data on a substance's atomic and molecular energy levels.

Types of Spectra

Line spectra occur in two important types:

1. An **emission spectrum**, such as the H atom line spectrum, occurs when atoms in an excited state *emit* photons as they return to a lower energy state. Some elements produce an intense spectral line (or several closely spaced ones) that is evidence of their presence. **Flame tests**, performed by placing a granule of an ionic compound or a drop of its solution in a flame, rely on these intense emissions (Figure B7.1A), and some colors of fireworks are due to the same elements (Figure B7.1B). The colors of sodium-vapor and mercury-vapor streetlamps are due to intense emissions lines in these elements' spectra.
2. An **absorption spectrum** is produced when atoms *absorb* photons of certain wavelengths and become excited. When white light passes through sodium vapor, for example, the absorption

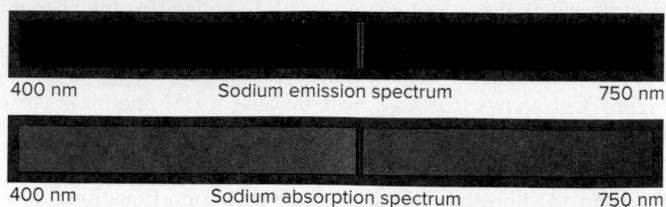

Figure B7.2 Emission and absorption spectra of sodium atoms.

The wavelengths of the bright emission lines correspond to those of the dark absorption lines because both are created by the same energy change: $\Delta E_{\text{emission}} = -\Delta E_{\text{absorption}}$. (Only the two most intense lines in the Na spectra are shown.)

spectrum shows dark lines at the same wavelengths as the yellow-orange lines in sodium's emission spectrum (Figure B7.2).

Because elements and compounds have unique line spectra, astronomers can use such spectra to determine the composition of the Sun, planets, stars, comets, and other celestial bodies. For example, the presence of helium (helios, Greek for sun) in the Sun was discovered by examining sunlight with a spectroscope.

Basic Instrumentation

Instruments that are based on absorption spectra are much more common than those based on emission spectra because many substances absorb relatively few wavelengths so their absorption spectra are more characteristic, and absorption is less destructive of fragile molecules.

Design differences depend on the region of the electromagnetic spectrum used to irradiate the sample, but all modern spectrometers have components that perform the same basic functions (Figure B7.3). (We discuss infrared spectroscopy and nuclear magnetic resonance spectroscopy in later chapters.)

Identifying and Quantifying a Substance

In chemical analysis, spectra are used to identify a substance and/or quantify the amount in a sample. Visible light is often used for colored substances, because they absorb only some of the wavelengths. A leaf looks green, for example, because its chlorophyll absorbs red and blue light strongly but green light weakly, so most of the green light is reflected.

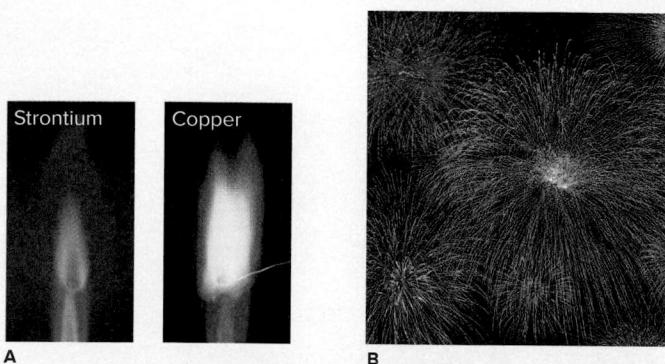

Figure B7.1 Flame tests and fireworks. **A**, The flame's color is due to intense emission by the element of light of a particular wavelength. **B**, Fireworks display emissions similar to those seen in flame tests.

Source: A(1–2): © McGraw-Hill Education, Stephen Frisch, photographer; B: © Studio Photogram/Alamy RF

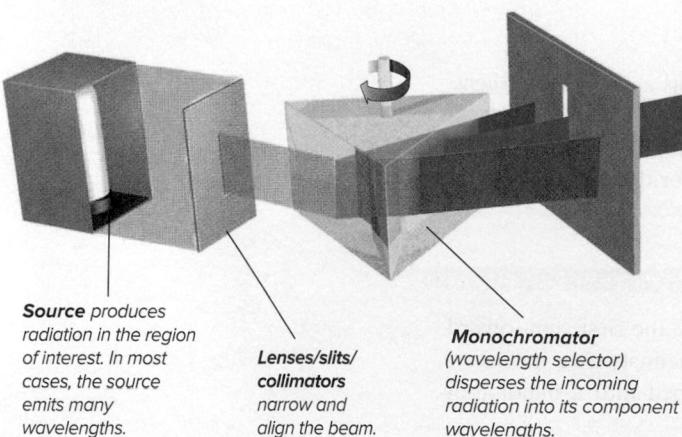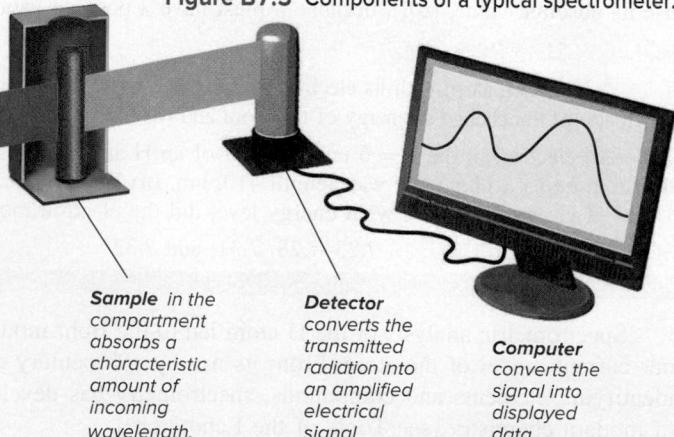

Figure B7.3 Components of a typical spectrometer.

Figure B7.4 shows the visible absorption spectrum of chlorophyll *a* in ether solution. The shape of the curve and the wavelengths of the major peaks are characteristic of chlorophyll *a*. The curve varies in height because chlorophyll *a* absorbs light of different wavelengths to different extents. The absorptions appear as broad bands, rather than as the distinct lines seen on absorption spectra of elements, because there are greater numbers and types of energy levels within a molecule as well as interactions between molecules and solvent.

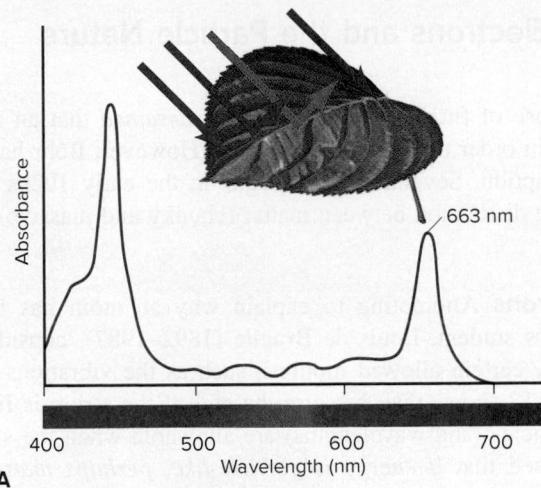

Figure B7.4 Measuring chlorophyll *a* concentration in leaf extract. **A**, The spectrometer is set to measure the strong absorption at 663 nm

Problems

B7.1 The sodium salt of 2-quinizarinsulfonic acid forms a complex with Al^{3+} that absorbs strongly at 560 nm.

(a) Use the data below to draw a plot of absorbance vs. concentration of the complex in solution and find the slope and *y*-intercept:

Concentration (<i>M</i>)	Absorbance (560 nm)
1.0×10^{-5}	0.131
1.5×10^{-5}	0.201
2.0×10^{-5}	0.265
2.5×10^{-5}	0.329
3.0×10^{-5}	0.396

In addition to identifying a substance, a spectrometer can be used to measure its concentration because *absorbance*, the quantity of light of a given wavelength absorbed by a substance, is proportional to the number of molecules. Suppose you want to determine the concentration of chlorophyll *a* in a leaf extract. You select a strongly absorbed wavelength from the compound's spectrum (such as 663 nm in Figure B7.4A), measure the absorbance of the *unknown* solution, and compare it with the absorbances of a series of solutions of *known* concentration (Figure B7.4B).

in the chlorophyll *a* spectrum. **B**, The absorbance from the leaf extract is compared to a series of known standards.

(b) When 20.0 mL of a solution of this complex is diluted with water to 150. mL, the measured absorbance is 0.236. Find the concentrations of the diluted solution and of the original solution.

B7.2 In fireworks displays, flame tests, and other emission events, light of a given wavelength may indicate the presence of a particular element or ion. What are the frequency and color of the light associated with each of the following?

- (a) Li, $\lambda = 671$ nm
- (b) Cs⁺, $\lambda = 453$ nm
- (c) Na, $\lambda = 589$ nm

› Summary of Section 7.2

- › Unlike sunlight, light emitted by electrically excited atoms of elements and refracted through a prism appears as separate spectral lines.
- › Spectroscopists use an empirical formula (the Rydberg equation) to determine the wavelength of a spectral line. Atomic hydrogen displays several series of spectral lines.
- › To explain the existence of line spectra, Bohr proposed that an electron moves in fixed orbits. It moves from one orbit to another when the atom absorbs or emits a photon whose energy equals the difference in energy levels (orbits).
- › Bohr's model predicts only the spectrum of the H atom and other one-electron species. Despite this, Bohr was correct that an atom's energy is quantized.
- › Spectrometry is an instrumental technique that uses emission and absorption spectra to identify substances and measure their concentrations.

7.3 THE WAVE-PARTICLE DUALITY OF MATTER AND ENERGY

The year 1905 was a busy one for Albert Einstein. He had just presented the photon theory and explained the photoelectric effect. A friend remembered him in his small apartment, rocking his baby in its carriage with one hand, while scribbling with the other ideas for a new branch of physics—the theory of relativity. One of its revelations was that *matter and energy are alternate forms of the same entity*. This idea is embodied in his famous equation $E = mc^2$, identifying the quantity of energy that is equivalent to a given mass. Some results that showed energy to be particle-like had to coexist with others that showed matter to be wavelike. These remarkable ideas are the key to understanding our modern atomic model.

The Wave Nature of Electrons and the Particle Nature of Photons

Bohr's model was a perfect case of fitting theory to data: he *assumed* that an atom has only certain energy levels in order to *explain* line spectra. However, Bohr had no theoretical basis for the assumption. Several breakthroughs in the early 1920s provided that basis and blurred the distinction between matter (chunky and massive) and energy (diffuse and massless).

The Wave Nature of Electrons Attempting to explain why an atom has fixed energy levels, a French physics student, Louis de Broglie (1892–1987), considered other systems that display only certain allowed motions, such as the vibrations of a plucked guitar string. Figure 7.12 shows that, because the end of the string is fixed, only certain vibrational frequencies (and wavelengths) are allowable when the string is plucked. De Broglie proposed that *if energy is particle-like, perhaps matter is wavelike*. He reasoned that *if electrons have wavelike motion in orbits of fixed radii, they would have only certain allowable frequencies and energies*.

Combining the equations for mass-energy equivalence ($E = mc^2$) and energy of a photon ($E = h\nu = hc/\lambda$), de Broglie derived an equation for the wavelength of any particle of mass m —whether planet, baseball, or electron—moving at speed u :

$$\lambda = \frac{h}{mu} \quad (7.6)$$

Figure 7.12 Wave motion in restricted systems. **A**, One half-wavelength ($\lambda/2$) is the “quantum” of the guitar string’s vibration. With string length L fixed by a finger on the fret, allowed vibrations occur when L is a whole-number multiple (n) of $\lambda/2$. **B**, In a circular electron orbit, only whole numbers of wavelengths are allowed ($n = 3$ and $n = 5$ are shown). A wave with a fractional number of wavelengths (such as $n = 3\frac{1}{3}$) is “forbidden” because it dies out through overlap of crests and troughs.

According to this equation for the **de Broglie wavelength**, matter behaves as though it moves in a wave. An object's wavelength is inversely proportional to its mass, so heavy objects such as planets and baseballs have wavelengths many orders of magnitude smaller than the objects themselves, too small to be detected, in fact (Table 7.1).

Table 7.1**The de Broglie Wavelengths of Several Objects**

Substance	Mass (g)	Speed (m/s)	λ (m)
Slow electron	9×10^{-28}	1.0	7×10^{-4}
Fast electron	9×10^{-28}	5.9×10^6	1×10^{-10}
Alpha particle	6.6×10^{-24}	1.5×10^7	7×10^{-15}
1-gram mass	1.0	0.01	7×10^{-29}
Baseball	142	40.0	1×10^{-34}
Earth	6.0×10^{27}	3.0×10^4	4×10^{-63}

SAMPLE PROBLEM 7.4**Calculating the de Broglie Wavelength of an Electron**

Problem Find the de Broglie wavelength of an electron with a speed of 1.00×10^6 m/s (electron mass = 9.11×10^{-31} kg; $h = 6.626 \times 10^{-34}$ kg·m²/s).

Plan We know the speed (1.00×10^6 m/s) and mass (9.11×10^{-31} kg) of the electron, so we substitute these into Equation 7.6 to find λ .

Solution

$$\lambda = \frac{h}{mu} = \frac{6.626 \times 10^{-34} \text{ kg}\cdot\text{m}^2/\text{s}}{(9.11 \times 10^{-31} \text{ kg})(1.00 \times 10^6 \text{ m/s})} = 7.27 \times 10^{-10} \text{ m}$$

Check The order of magnitude and the unit seem correct:

$$\lambda \approx \frac{10^{-33} \text{ kg}\cdot\text{m}^2/\text{s}}{(10^{-30} \text{ kg})(10^6 \text{ m/s})} = 10^{-9} \text{ m}$$

Comment As you'll see in the upcoming discussion, such fast-moving electrons, with wavelengths in the range of atomic sizes, exhibit remarkable properties.

FOLLOW-UP PROBLEMS

7.4A (a) What is the speed of an electron that has a de Broglie wavelength of 100. nm (electron mass = 9.11×10^{-31} kg)?

(b) At what speed would a 45.9-g golf ball need to move to have a de Broglie wavelength of 100. nm?

7.4B Find the de Broglie wavelength of a 39.7-g racquetball traveling at a speed of 55 mi/h.

SOME SIMILAR PROBLEMS 7.39(a), 7.40(a), and 7.41–7.42

If electrons travel in waves, they should exhibit diffraction and interference. A fast-moving electron has a wavelength of about 10^{-10} m, so a beam of such electrons should be diffracted by the spaces between atoms in a crystal—which measure about 10^{-10} m. In 1927, C. Davisson and L. Germer guided a beam of x-rays and then a beam of electrons at a nickel crystal and obtained two diffraction patterns; Figure 7.13 shows such patterns for aluminum. Thus, electrons—particles with mass and charge—create diffraction patterns, just as electromagnetic waves do.

A major application of electrons traveling in waves is the *electron microscope*. Its great advantage over light microscopes is that high-speed electrons have much smaller wavelengths than visible light, which allow much higher resolution. A transmission electron microscope (TEM) focuses a beam of electrons through a lens, and the beam then passes through a thin section of the specimen to a second and then third lens. In this instrument, these “lenses” are electromagnetic fields, which can result in up to 200,000-fold magnification. In a scanning electron microscope (SEM),

A**B**

Figure 7.13 Diffraction patterns of aluminum. **A**, With x-rays. **B**, With electrons.
Source: A–B: Copyright 2016 Education Development Center, Inc. Reprinted with permission with all other rights reserved.

Figure 7.14 False-color scanning electron micrograph of blood cells ($\times 1200$).

Source: © Yorgos Nikas/Stone/Getty Images.

the beam scans the specimen, knocking electrons from it that create a current, which generates an image that looks like the object's surface (Figure 7.14).

The Particle Nature of Photons If electrons have properties of energy, do photons have properties of matter? The de Broglie equation suggests that we can calculate the momentum (p), the product of mass and speed, for a photon. Substituting the speed of light (c) for speed u in Equation 7.6 and solving for p gives

$$\lambda = \frac{h}{mc} = \frac{h}{p} \quad \text{and} \quad p = \frac{h}{\lambda}$$

The inverse relationship between p and λ in this equation means that shorter wavelength (higher energy) photons have greater momentum. Thus, a decrease in a photon's momentum should appear as an increase in its wavelength. In 1923, Arthur Compton directed a beam of x-ray photons at graphite and observed an increase in the wavelength of the reflected photons. Thus, just as billiard balls transfer momentum when they collide, the photons transferred momentum to the electrons in the carbon atoms of the graphite. In this experiment, photons behaved as particles.

Wave-Particle Duality Classical experiments had shown matter to be particle-like and energy to be wavelike. But, results on the atomic scale show electrons moving in waves and photons having momentum. Thus, every property of matter was also a property of energy. The truth is that *both* matter and energy show *both* behaviors: each possesses both "faces." In some experiments, we observe one face; in other experiments, we observe the other face. Our everyday distinction between matter and energy is meaningful in the macroscopic world,

but *not* in the atomic world. The distinction is in our minds and the limited definitions we have created, not inherent in nature. This dual character of matter and energy is known as the **wave-particle duality**—particles have wavelike properties and energy has particle-like properties. Figure 7.15 summarizes the theories and observations that led to this new understanding.

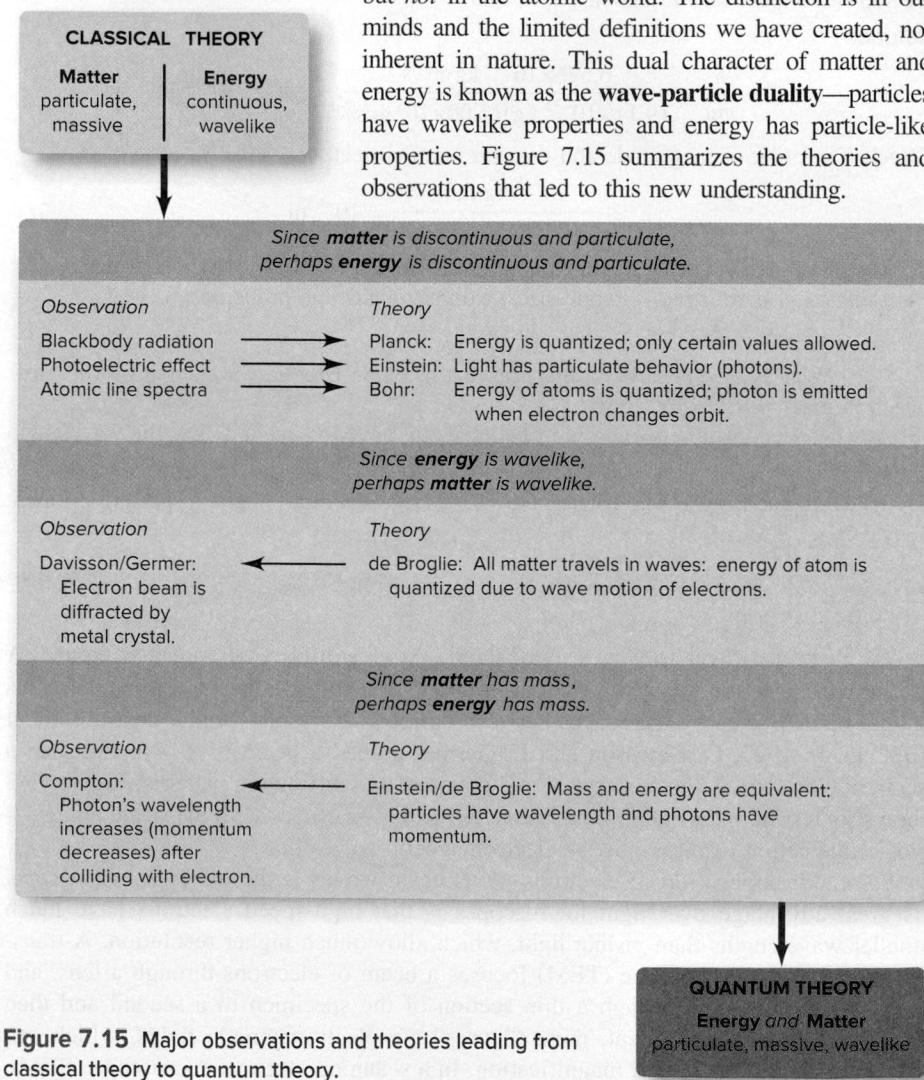

Figure 7.15 Major observations and theories leading from classical theory to quantum theory.

Heisenberg's Uncertainty Principle

In classical physics, a moving particle has a definite location at any instant, whereas a wave is spread out in space. If an electron has the properties of *both* a particle and a wave, can we determine its position in the atom? In 1927, the German physicist Werner Heisenberg (1901–1976) postulated the **uncertainty principle**, which states that it is impossible to know simultaneously the position *and* momentum (mass times speed) of a particle. For a particle with constant mass m , the principle is expressed mathematically as

$$\Delta x \cdot m \Delta u \geq \frac{h}{4\pi} \quad (7.7)$$

where Δx is the uncertainty in position, Δu is the uncertainty in speed, and h is Planck's constant. The more accurately we know the position of the particle (smaller Δx), the less accurately we know its speed (larger Δu), and vice versa. The best-case scenario is that we know the product of these uncertainties, which is equal to $h/4\pi$.

For a macroscopic object like a baseball, Δx and Δu are insignificant because the mass is enormous compared with $h/4\pi$. Thus, if we know the position and speed of a pitched baseball, we can use the laws of motion to predict its trajectory and whether it will be a ball or a strike. However, using the position and speed of an electron to find its trajectory is a very different proposition, as Sample Problem 7.5 demonstrates.

SAMPLE PROBLEM 7.5

Applying the Uncertainty Principle

Problem An electron moving near an atomic nucleus has a speed of 6×10^6 m/s \pm 1%. What is the uncertainty in its position (Δx)?

Plan The uncertainty in the speed (Δu) is given as 1%, so we multiply u (6 $\times 10^6$ m/s) by 0.01 to calculate the value of Δu , substitute that value into Equation 7.7, and solve for the uncertainty in position (Δx).

Solution Finding the uncertainty in speed, Δu :

$$\Delta u = 1\% \text{ of } u = 0.01(6 \times 10^6 \text{ m/s}) = 6 \times 10^4 \text{ m/s}$$

Calculating the uncertainty in position, Δx :

$$\Delta x \cdot m \Delta u \geq \frac{h}{4\pi}$$

Thus,

$$\Delta x \geq \frac{h}{4\pi m \Delta u} \geq \frac{6.626 \times 10^{-34} \text{ kg} \cdot \text{m}^2/\text{s}}{4\pi(9.11 \times 10^{-31} \text{ kg})(6 \times 10^4 \text{ m/s})} \geq 1 \times 10^{-9} \text{ m}$$

Check Be sure to round off and check the order of magnitude of the answer:

$$\Delta x \geq \frac{10^{-33} \text{ kg} \cdot \text{m}^2/\text{s}}{(10^1)(10^{-30} \text{ kg})(10^5 \text{ m/s})} = 10^{-9} \text{ m}$$

Comment The uncertainty in the electron's position is about 10 times greater than the diameter of the entire atom (10^{-10} m)! Therefore, we have no precise idea where in the atom the electron is located. In Follow-up Problem 7.5A, you'll see whether an umpire has any better idea about the position of a baseball.

FOLLOW-UP PROBLEMS

7.5A How accurately can an umpire know the position of a baseball (mass = 0.142 kg) moving at 100.0 mi/h \pm 1.00% (44.7 m/s \pm 1.00%)?

7.5B A neutron has a speed of 8×10^7 m/s \pm 1%. What is the uncertainty in its position? The mass of a neutron is 1.67×10^{-27} kg.

SOME SIMILAR PROBLEMS 7.39(b) and 7.40(b)

› Summary of Section 7.3

- › As a result of Planck's quantum theory and Einstein's theory of relativity, we no longer view matter and energy as distinct entities.
- › The de Broglie wavelength is based on the idea that an electron (or any object) has wavelike motion. Allowed atomic energy levels are related to allowed wavelengths of the electron's motion.
- › Electrons exhibit diffraction, just as light waves do, and photons exhibit transfer of momentum, just as objects do. This wave-particle duality of matter and energy is observable only on the atomic scale.
- › According to the uncertainty principle, we can never know the position and speed of an electron simultaneously.

7.4

THE QUANTUM-MECHANICAL MODEL OF THE ATOM

Acceptance of the dual nature of matter and energy and of the uncertainty principle culminated in the field of **quantum mechanics**, which examines the wave nature of objects on the atomic scale. In 1926, Erwin Schrödinger (1887–1961) derived an equation that is the basis for the *quantum-mechanical model* of the H atom. The model describes an atom with specific quantities of energy that result from allowed frequencies of its electron's wavelike motion. The electron's position can only be known within a certain probability. Key features of the model are described in the following subsections.

The Atomic Orbital and the Probable Location of the Electron

Two central aspects of the quantum-mechanical model concern the atomic orbital and the electron's probable location.

The Schrödinger Equation and the Atomic Orbital The electron's matter-wave occupies the space near the nucleus and is continuously influenced by it. The **Schrödinger equation** is quite complex but can be represented in simpler form as

$$\hat{\mathcal{H}}\psi = E\psi$$

where E is the energy of the atom. The symbol ψ (Greek *psi*, pronounced “sigh”) is called a **wave function**, or **atomic orbital**, a mathematical description of the electron's matter-wave in three dimensions. The symbol $\hat{\mathcal{H}}$, called the Hamiltonian operator, represents a set of mathematical operations that, when carried out with a particular ψ , yields one of the allowed energy states of the atom.* Thus, *each solution of the equation gives an energy state associated with a given atomic orbital*.

An important point to keep in mind throughout this discussion is that an “orbital” in the quantum-mechanical model *bears no resemblance* to an “orbit” in the Bohr model: an *orbit* is an electron's actual path around the nucleus, whereas an *orbital* is a mathematical function that describes the electron's matter-wave but has no physical meaning.

The Probable Location of the Electron While we cannot know *exactly* where the electron is at any moment, we can know where it *probably* is, that is, where it spends most of its time. We get this information by squaring the wave function. Thus, even though ψ has no physical meaning, ψ^2 does and is called the *probability density*, a measure of the probability of finding the electron in some tiny volume of the atom.

*The complete form of the Schrödinger equation in terms of the three linear axes is

$$\left[-\frac{\hbar^2}{8\pi^2 m_e} \left(\frac{d^2}{dx^2} + \frac{d^2}{dy^2} + \frac{d^2}{dz^2} \right) + V(x, y, z) \right] \psi(x, y, z) = E\psi(x, y, z)$$

where ψ is the wave function, m_e is the electron's mass, E is the total quantized energy of the atomic system, and V is the potential energy at point (x, y, z) .

We depict the electron's probable location in several ways, which we'll look at first for the H atom's *ground state*:

1. *Probability of the electron being in some tiny volume of the atom.* For each energy level, we can create an *electron probability density diagram*, or more simply, an **electron density diagram**. The value of ψ^2 for a given volume is shown with dots: the greater the density of dots, the higher the probability of finding the electron in that volume. Note, that for the ground state of the H atom, the *electron probability density decreases with distance from the nucleus* along a line, r (Figure 7.16A). In other words, the probability of finding the electron decreases with increasing distance from the nucleus.

These diagrams are also called **electron cloud depictions** because, if we *could* take a time-exposure photograph of the electron in wavelike motion around the nucleus, it would appear as a "cloud" of positions. The electron cloud is an *imaginary* picture of the electron changing its position rapidly over time; it does *not* mean that an electron is a diffuse cloud of charge.

Figure 7.16B shows a plot of ψ^2 vs. r . Due to the thickness of the printed line, the curve appears to touch the axis; however, in the blow-up circle, we see that *the probability of the electron being far from the nucleus is very small, but not zero.*

2. *Total probability density at some distance from the nucleus.* To find *radial probability distribution*, that is, the *total* probability of finding the electron at some distance r from the nucleus, we first mentally divide the volume around the nucleus into thin, concentric, spherical layers, like the layers of an onion (shown in cross section in Figure 7.16C). Then, we find the *sum of ψ^2 values* in each layer to see which is most likely to contain the electron.

The falloff in probability density with distance has an important effect. Near the nucleus, *the volume of each layer increases faster than its density of dots decreases*. The result of these opposing effects is that the *total* probability peaks in a layer *near*, but not *at*, the nucleus. For example, the total probability in the second layer is higher than in the first, but this result disappears with greater distance. Figure 7.16D shows this result as a **radial probability distribution plot**.

3. *Probability contour and the size of the atom.* How far away from the nucleus can we find the electron? This is the same as asking "How big is the H atom?" Recall from Figure 7.16B that the probability of finding the electron far from the nucleus is not zero. Therefore, we *cannot* assign a definite volume to an atom. However, we can visualize an atom with a **90% probability contour**: the electron is somewhere within that volume 90% of the time (Figure 7.16E).

A Radial Probability Distribution of Apples

An analogy might clarify why the curve in the radial probability distribution plot peaks and then falls off. Picture fallen apples around the base of an apple tree: the density of apples is greatest near the trunk and decreases with distance. Divide the ground under the tree into foot-wide concentric rings and collect the apples within each ring. Apple density is greatest in the first ring, but the area of the second ring is larger, and so it contains a greater *total* number of apples. Farther out near the edge of the tree, rings have more area but lower apple "density," so the total number of apples decreases. A plot of "number of apples in each ring" vs. "distance from trunk" shows a peak at some distance close to the trunk, as in Figure 7.16D.

Figure 7.16 Electron probability density in the ground-state H atom. **A**, In the electron density diagram, the density of dots represents the probability of the electron being within a tiny volume and decreases with distance, r , from the nucleus. **B**, The probability density (ψ^2) decreases with r but does not reach zero (blow-up circle). **C**, Counting dots within each layer gives the total probability of the electron being in that layer. **D**, A radial probability distribution plot shows that total electron density peaks *near*, but not *at*, the nucleus. **E**, A 90% probability contour for the ground state of the H atom.

Student Hot Spot

Student data indicate that you may struggle with the concept of probability density. Access the Smartbook to view additional Learning Resources on this topic.

As you'll see later in this section, each atomic orbital has a distinctive radial probability distribution and 90% probability contour.

Quantum Numbers of an Atomic Orbital

An *atomic orbital* is specified by three quantum numbers that are part of the solution of the Schrödinger equation and indicate the size, shape, and orientation in space of the orbital.*

1. The principal quantum number (*n*):

- *n* is a positive integer (1, 2, 3, and so forth).
- It indicates the relative *size* of the orbital and therefore the relative *distance from the nucleus* of the peak in the radial probability distribution plot. As *n* increases, the orbital becomes larger and the electron spends more time farther from the nucleus.
- The principal quantum number specifies the *energy level* of the H atom: *the higher the n value, the higher the energy level*. When the electron occupies an orbital with *n* = 1, the H atom is in its ground state and has its lowest energy. When the electron occupies an orbital with *n* = 2 (first excited state), the atom has more energy.

2. The angular momentum quantum number (*l*):

- *l* is an integer from 0 to *n* – 1. Thus, the values of *l* depend on the value of the principal quantum number, *n*, which sets a limit on the angular momentum quantum number: *n* limits *l*. For example:

$$\begin{aligned} n = 1 &\longrightarrow l = 0 \text{ (1 value)} \\ n = 2 &\longrightarrow l = 0, 1 \text{ (2 values)} \\ n = 3 &\longrightarrow l = 0, 1, 2 \text{ (3 values)} \end{aligned}$$

Thus, the *number* of possible *l* values equals the value of *n*.

- The angular momentum quantum number is related to the *shape* of the orbital; the characteristic shape of each type of orbital will be described later in this section.

3. The magnetic quantum number (*m_l*):

- *m_l* is an integer from *-l* through 0 to *+l*. The angular momentum quantum number, *l*, sets a limit on the magnetic quantum number: *l* limits *m_l*.
- The number of *m_l* values = *2l* + 1 = the number of orbitals for a given *l*:

$$\begin{aligned} l = 0 &\longrightarrow m_l = 0 \text{ (1 value)} \\ l = 1 &\longrightarrow m_l = -1, 0, +1 \text{ (3 values)} \\ l = 2 &\longrightarrow m_l = -2, -1, 0, +1, +2 \text{ (5 values)} \end{aligned}$$

Thus, for a particular value of *n*, there is only one possible orbital with *l* = 0, but three possible orbitals with *l* = 1, each with its own *m_l* value.

- The total number of *m_l* values for a given *n* value = *n*² = the total number of orbitals in that energy level.
- The magnetic quantum number prescribes the three-dimensional *orientation* of the orbital in the space around the nucleus. For example, each of the three orbitals with *l* = 1 has its own orientation.

Table 7.2 presents a summary of these quantum numbers.

*For ease in discussion, chemists often refer to the size, shape, and orientation of an “atomic orbital,” although we really mean the size, shape, and orientation of an “atomic orbital’s radial probability distribution.”

Table 7.2 The Hierarchy of Quantum Numbers for Atomic Orbitals

Name, Symbol (Property)	Allowed Values	Quantum Numbers
Principal, n (size, energy)	Positive integer (1, 2, 3, ...)	1 0 0 2 0 1 -1 0 +1
Angular momentum, l (shape)	0 to $n - 1$	0 0 1 -1 0 +1 0 1 -1 0 +1
Magnetic, m_l (orientation)	$-l, \dots, 0, \dots, +l$	0 -1 0 +1 -2 -1 0 +1 +2

SAMPLE PROBLEM 7.6**Determining Quantum Numbers for an Energy Level**

Problem What values of the angular momentum (l) and magnetic (m_l) quantum numbers are allowed for a principal quantum number (n) of 3? How many orbitals are there in this energy level?

Plan We determine allowable quantum numbers with the rules from the text: l values are integers from 0 to $n - 1$, and m_l values are integers from $-l$ to 0 to $+l$. One m_l value is assigned to each orbital, so the number of m_l values gives the number of orbitals.

Solution Determining l values: for $n = 3$:

$$l = 0 \text{ to } (3 - 1): l = 0, 1, 2.$$

Determining m_l for each l value:

$$\text{For } l = 0, m_l = 0$$

$$\text{For } l = 1, m_l = -1, 0, +1$$

$$\text{For } l = 2, m_l = -2, -1, 0, +1, +2$$

There are nine m_l values, so there are nine orbitals with $n = 3$.

Check Table 7.2 shows that we are correct. As we saw, the total number of orbitals for a given n value is n^2 , and for $n = 3$, $n^2 = 9$.

FOLLOW-UP PROBLEMS

7.6A What are the possible l and m_l values for $n = 4$?

7.6B For what value of the principal quantum number n are there five allowed values of l ? What are the allowed m_l values for this n ?

SOME SIMILAR PROBLEMS 7.51 and 7.52**Quantum Numbers and Energy Levels**

The energy states and orbitals of the atom are described with specific terms and are associated with one or more quantum numbers:

1. *Level*. The atom's energy **levels**, or **shells**, are given by the n value: the smaller the n value, the lower the energy level and the greater the probability that the electron is closer to the nucleus.

2. *Sublevel*. The atom's levels are divided into **sublevels**, or **subshells**, that are given by the l value. Each l value is designated by a letter:

$l = 0$ is an *s* sublevel.

$l = 1$ is a *p* sublevel.

$l = 2$ is a *d* sublevel.

$l = 3$ is an *f* sublevel.

Student Hot Spot

Student data indicate that you may struggle with applying quantum numbers. Access the Smartbook to view additional Learning Resources on this topic.

(The letters derive from names of spectroscopic lines: sharp, principal, diffuse, and fundamental.) Sublevels with l values greater than 3 are designated by consecutive letters after f : g sublevel, h sublevel, and so on. A sublevel is named with its n value and letter designation; for example, the sublevel (subshell) with $n = 2$ and $l = 0$ is called the $2s$ sublevel. We discuss orbital shapes below.

3. Orbital. Each combination of n , l , and m_l specifies the size (energy), shape, and spatial orientation of one of the atom's orbitals. We know the quantum numbers of the orbitals in a sublevel from the sublevel name and the quantum-number hierarchy. For example,

- For the $2s$ sublevel: $n = 2$, $l = 0$, $m_l = 0$; **one** value of m_l indicates **one** orbital in this sublevel.
- For the $3p$ sublevel: $n = 3$, $l = 1$, $m_l = -1, 0, +1$; **three** values of m_l indicate **three** orbitals in this sublevel, one with $m_l = -1$, one with $m_l = 0$, and one with $m_l = +1$.

SAMPLE PROBLEM 7.7**Determining Sublevel Names and Orbital Quantum Numbers**

Problem Give the name, possible magnetic quantum number(s), and number of orbitals for the sublevel that has the given n and l quantum numbers:

- (a) $n = 3$, $l = 2$ (b) $n = 2$, $l = 0$ (c) $n = 5$, $l = 1$ (d) $n = 4$, $l = 3$

Plan We name the sublevel (subshell) with the n value and the letter designation of the l value. From the l value, we find the number of possible m_l values, which equals the number of orbitals in that sublevel.

Solution

n	l	Sublevel Name	Possible m_l Values	No. of Orbitals
(a) 3	2	$3d$	-2, -1, 0, +1, +2	5
(b) 2	0	$2s$	0	1
(c) 5	1	$5p$	-1, 0, +1	3
(d) 4	3	$4f$	-3, -2, -1, 0, +1, +2, +3	7

Check Check the number of orbitals in each sublevel using

$$\text{No. of orbitals} = \text{no. of } m_l \text{ values} = 2l + 1$$

FOLLOW-UP PROBLEMS

7.7A What are the n , l , and possible m_l values for the $2p$ and $5f$ sublevels?

7.7B What are the n , l , and possible m_l values for the $4d$ and $6s$ sublevels? How many orbitals are in these sublevels of an atom?

SOME SIMILAR PROBLEMS 7.49, 7.50, and 7.55–7.58**SAMPLE PROBLEM 7.8****Identifying Incorrect Quantum Numbers**

Problem What is wrong with each quantum number designation and/or sublevel name?

n	l	m_l	Name
(a) 1	1	0	$1p$
(b) 4	3	+1	$4d$
(c) 3	1	-2	$3p$

Solution

- (a) A sublevel with $n = 1$ can only have $l = 0$, not $l = 1$. The correct sublevel name is $1s$.
 (b) A sublevel with $l = 3$ is an f sublevel, not a d sublevel. The name should be $4f$.
 (c) A sublevel with $l = 1$ can have only -1, 0, or +1 for m_l , not -2.

Check Check that l is always less than n , and m_l is always $\geq -l$ and $\leq +l$.

FOLLOW-UP PROBLEMS

7.8A Supply the missing quantum numbers and sublevel names.

<i>n</i>	<i>l</i>	<i>m_l</i>	Name
(a) ?	?	0	4p
(b) 2	1	0	?
(c) 3	2	-2	?
(d) ?	?	?	2s

7.8B What is wrong with each quantum number designation and/or sublevel name?

<i>n</i>	<i>l</i>	<i>m_l</i>	Name
(a) 5	3	4	5f
(b) 2	2	1	2d
(c) 6	1	-1	6s

SOME SIMILAR PROBLEMS 7.59, 7.60, and 7.72

Shapes of Atomic Orbitals

Each sublevel of the H atom consists of a set of orbitals with characteristic shapes. As you'll see in Chapter 8, orbitals for the other atoms have similar shapes.

The s Orbital An orbital with $l = 0$ has a *spherical* shape with the nucleus at its center and is called an **s orbital**. Because a sphere has only one orientation, an *s* orbital has only one m_l value: for any *s* orbital, $m_l = 0$.

1. *The 1s orbital* holds the electron in the H atom's ground state. *The electron probability density is highest at the nucleus.* Figure 7.17A on the next page shows this graphically (*top*), and an electron density *relief map* (*inset*) depicts the graph's curve in three dimensions. Note the quarter-section of a three-dimensional electron cloud depiction (*middle*) has the darkest shading at the nucleus. For reasons discussed earlier (see Figure 7.16D and the discussion about the radial probability distribution of apples), the radial probability distribution plot (*bottom*) is highest slightly out from the nucleus. Both plots fall off smoothly with distance from the nucleus.

2. *The 2s orbital* (Figure 7.17B, *next page*) has two regions of higher electron density. The radial probability distribution (Figure 7.17B, *bottom*) of the more distant region is *higher* than that of the closer one because the sum of Ψ^2 for it is taken over a much larger volume. Between the two regions is a spherical **node**, where the probability of finding the electron drops to zero ($\Psi^2 = 0$ at the node, analogous to zero amplitude of a wave exactly between the peak and trough). Because the *2s* orbital is larger than the *1s*, an electron in the *2s* spends more time farther from the nucleus (in the larger of the two regions) than it does when it occupies the *1s*.

3. *The 3s orbital* (Figure 7.17C, *next page*) has three regions of high electron density and two nodes. Here again, the highest radial probability is at the greatest distance from the nucleus. This pattern of more nodes and higher probability with distance from the nucleus continues with the *4s*, *5s*, and so forth.

The p Orbital An orbital with $l = 1$ is called a **p orbital** and has two regions (lobes) of high probability, one on *either side* of the nucleus (Figure 7.18, *next page*). The *nucleus lies at the nodal plane* of this dumbbell-shaped orbital. Since the maximum value of l is $n - 1$, only levels with $n = 2$ or higher have a *p* orbital: the lowest energy *p* orbital (the one closest to the nucleus) is the *2p*. *One p orbital* consists of *two lobes*, and the electron spends *equal* time in both. Similar to the pattern for *s* orbitals, a *3p* orbital is larger than a *2p*, a *4p* is larger than a *3p*, and so forth.

Unlike *s* orbitals, *p* orbitals *have* different spatial orientations. The three possible m_l values of -1, 0, and +1 refer to three *mutually perpendicular* orientations; that is,

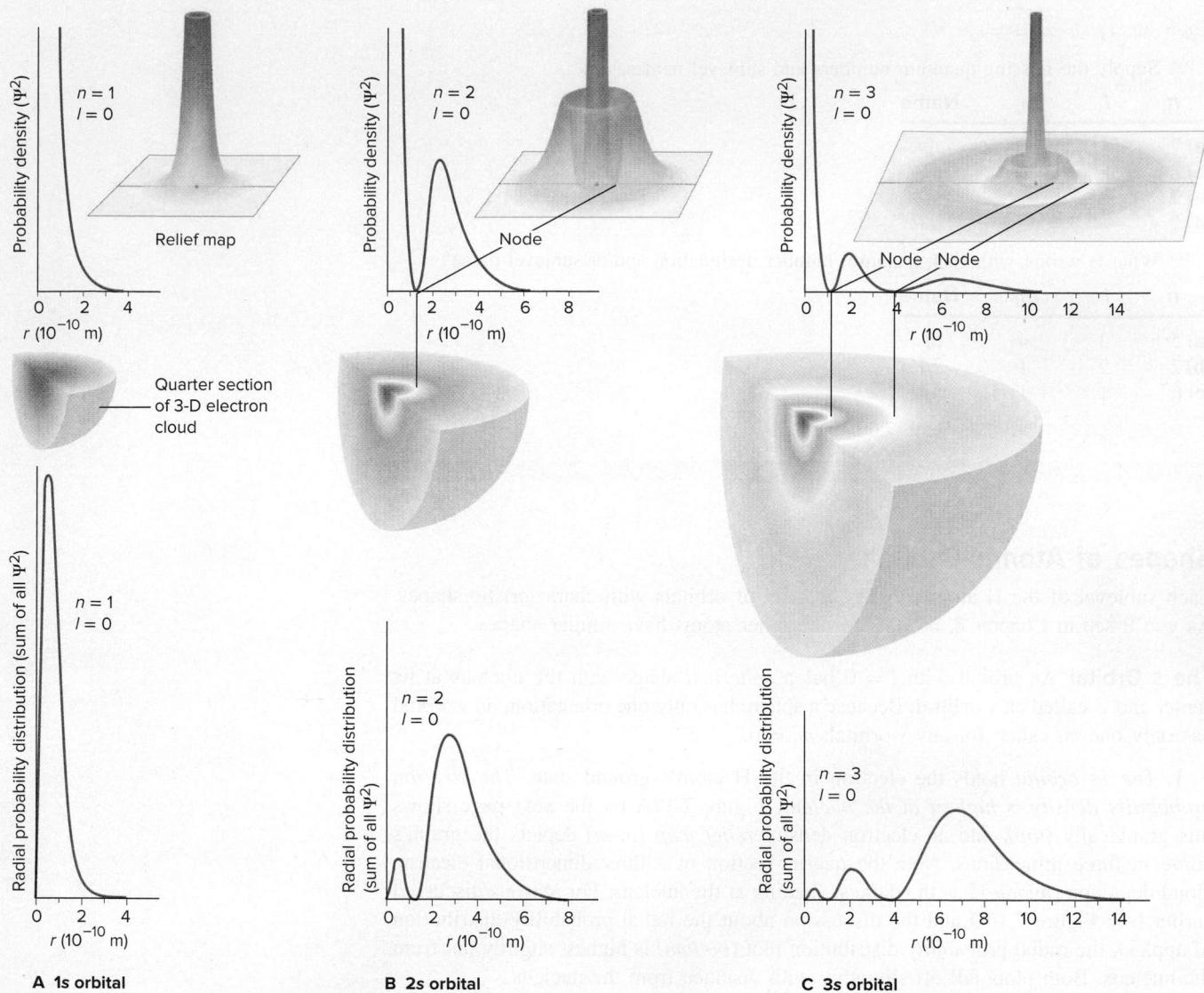

Figure 7.17 The 1s, 2s, and 3s orbitals. For each of the s orbitals, a plot of probability density vs. distance (top, with the relief map, inset, showing the plot in three dimensions) lies above a quarter section of an electron cloud depiction of the 90% probability contour (middle), which lies above a radial probability distribution plot (bottom). **A**, The 1s orbital. **B**, The 2s orbital. **C**, The 3s orbital.

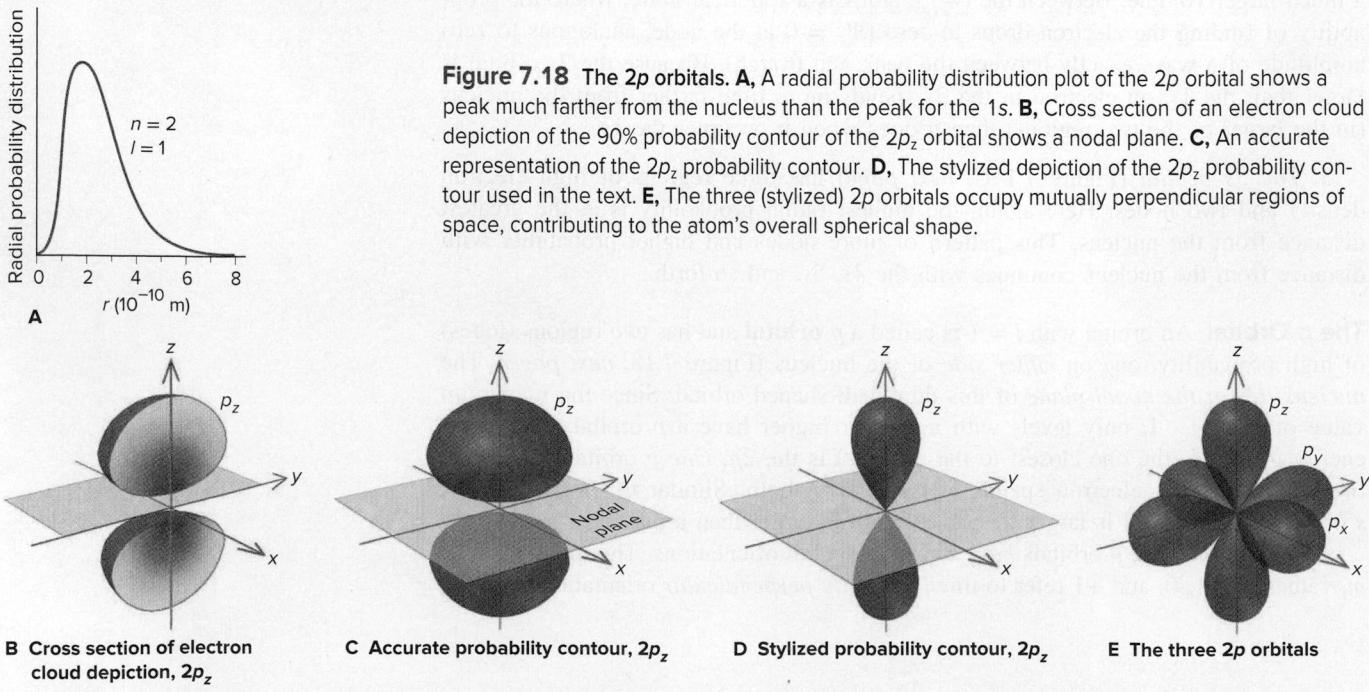

while identical in size, shape, and energy, the three p orbitals differ in orientation. We associate p orbitals with the x , y , and z axes: the p_x orbital lies along the x axis, the p_y along the y axis, and the p_z along the z axis. (There is no relationship between a particular axis and a given m_l value.)

The d Orbital An orbital with $l = 2$ is called a **d orbital**. There are five possible m_l values for $l = 2$: $-2, -1, 0, +1$, and $+2$. Thus, a d orbital has any one of five orientations (Figure 7.19). Four of the five d orbitals have four lobes (a cloverleaf shape) with two mutually perpendicular nodal planes between them and the nucleus at the junction of the lobes (Figure 7.19C). (The orientation of the nodal planes always lies between the orbital lobes.) Three of these orbitals lie in the xy , xz , and yz planes, with their lobes *between* the axes, and are called the d_{xy} , d_{xz} , and d_{yz} orbitals. A fourth, the $d_{x^2-y^2}$ orbital, also lies in the xy plane, but its lobes are *along* the axes. The fifth d orbital, the d_{z^2} , has two major lobes *along* the z axis, and a donut-shaped region girdles the center. An electron in a d orbital spends equal time in all of its lobes.

In keeping with the quantum-number hierarchy, a d orbital ($l = 2$) must have a principal quantum number of $n = 3$ or higher, so $3d$ is the lowest energy d sublevel. Orbitals in the $4d$ sublevel are larger (extend farther from the nucleus) than those in the $3d$, and the $5d$ orbitals are larger still.

The f Orbital and Orbitals with Higher l Values An orbital with $l = 3$ is called an **f orbital** and has a principal quantum number of at least $n = 4$. For the $l = 3$

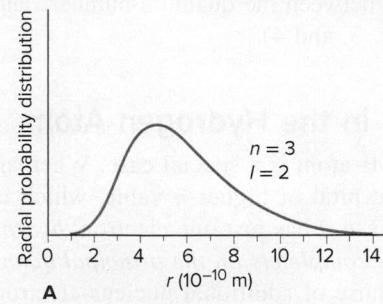

Figure 7.19 The $3d$ orbitals. **A**, A radial probability distribution plot. **B**, Cross section of an electron cloud depiction of the $3d_{yz}$ orbital probability contour shows two mutually perpendicular nodal planes and lobes lying *between* the axes. **C**, An accurate representation of the $3d_{yz}$ orbital probability contour. **D**, The stylized depiction of the $3d_{yz}$ orbital used in the text. **E**, The $3d_{xz}$ orbital. **F**, The $3d_{xy}$ orbital. **G**, The lobes of the $3d_{x^2-y^2}$ orbital lie *along* the x and y axes. **H**, The $3d_{z^2}$ orbital has two lobes and a central, donut-shaped region. **I**, A composite of the five $3d$ (stylized) orbitals shows how they contribute to the atom's spherical shape.

Table 7.3

Summary of n , l , and m_l Values for the First Four Principal Energy Levels

n	l	Sublevel Designation	m_l	Number of Orbitals in Sublevel ($2l + 1$)	Total Number of Orbitals in Energy Level (n^2)
1	0	1s	0	1	1
2	0	2s	0	1	4
	1	2p	-1, 0, +1	3	
	0	3s	0	1	
3	1	3p	-1, 0, +1	3	9
	2	3d	-2, -1, 0, +1, +2	5	
	0	4s	0	1	
4	1	4p	-1, 0, +1	3	16
	2	4d	-2, -1, 0, +1, +2	5	
	3	4f	-3, -2, -1, 0, +1, +2, +3	7	

Figure 7.20 The $4f_{xy}$ orbital, one of the seven $4f$ orbitals.

sublevel, $m_l = -3, -2, -1, 0, +1, +2, +3$; seven values of m_l indicate seven f orbitals in the sublevel, with seven orientations. Figure 7.20 shows one of the seven f orbitals; each f orbital has a complex, multilobed shape with several nodal planes.

Orbitals with $l = 4$ are g orbitals, but they play no known role in chemical bonding. Table 7.3 summarizes the relationships between the quantum numbers and orbitals for the first four energy levels ($n = 1, 2, 3$, and 4).

The Special Case of Energy Levels in the Hydrogen Atom

With regard to energy levels and sublevels, the H atom is a special case. When an H atom gains energy, its electron occupies an orbital of higher n value, which is (on average) farther from the nucleus. But, because it has just one electron, *hydrogen is the only atom whose energy state depends completely on the principal quantum number, n .* As you'll see in Chapter 8, because of additional nucleus-electron attractions and electron-electron repulsions, the energy states of all other atoms depend on the n and l values of the occupied orbitals. Thus, *for the H atom only*, all four $n = 2$ orbitals (one $2s$ and three $2p$) have the same energy, all nine $n = 3$ orbitals (one $3s$, three $3p$, and five $3d$) have the same energy (Figure 7.21), and so forth.

Figure 7.21 Energy levels of the H atom.

› Summary of Section 7.4

- › The atomic orbital (ψ , wave function) is a mathematical description of the electron's wavelike behavior in an atom. The Schrödinger equation converts each allowed wave function to one of the atom's energy states.
- › The probability density of finding the electron at a particular location is represented by ψ^2 . For a given energy level, an electron density diagram and a radial probability distribution plot show how the electron occupies the space near the nucleus.
- › An atomic orbital is described by three quantum numbers: size (n), shape (l), and orientation (m_l): n limits l to n values, and l limits m_l to $2l + 1$ values.
- › An energy level has sublevels with the same n value; a sublevel has orbitals with the same n and l values but differing m_l values.
- › A sublevel with $l = 0$ has a spherical (s) orbital; a sublevel with $l = 1$ has three, two-lobed (p) orbitals; a sublevel with $l = 2$ has five multilobed (d) orbitals; and a sublevel with $l = 3$ has seven multilobed (f) orbitals.
- › In the special case of the H atom, the energy levels depend only on the n value.

CHAPTER REVIEW GUIDE

Learning Objectives

Relevant section (§) and/or sample problem (SP) numbers appear in parentheses.

Understand These Concepts

- The wave characteristics of light (the interrelations of frequency, wavelength, and speed; the meaning of amplitude) and the general regions of the electromagnetic spectrum (§7.1)
- How particles and waves differ in terms of the phenomena of refraction, diffraction, and interference (§7.1)
- The quantization of energy and how an atom changes its energy by emitting or absorbing quanta of radiation (§7.1)
- How the photon theory explains the photoelectric effect (§7.1)
- How Bohr's theory explained the line spectra of the H atom; why the theory is wrong and which ideas we retain (§7.2)
- The wave-particle duality of matter and energy and the relevant theories and experiments that led to it (de Broglie wavelength, electron diffraction, and photon momentum) (§7.3)
- The meaning of the uncertainty principle and how uncertainty limits our knowledge of electron properties (§7.3)
- The distinction between ψ (wave function, or atomic orbital) and ψ^2 (probability density) (§7.4)
- How electron density diagrams and radial probability distribution plots depict the electron's location within the atom (§7.4)

- The hierarchy of quantum numbers that describe the size and energy (n), shape (l), and orientation (m_l) of an orbital (§7.4)
- The distinction between energy level (shell), sublevel (subshell), and orbital (§7.4)
- The shapes of s , p , d , and f orbitals (§7.4)

Master These Skills

- Interconverting wavelength and frequency (SP 7.1)
- Interconverting energy, wavelength, and frequency (SP 7.2)
- Finding the energy change and the wavelength of the photon absorbed or emitted when an H atom changes its energy level (SP 7.3)
- Applying de Broglie's equation to find the wavelength of an electron (SP 7.4)
- Applying the uncertainty principle to see that the location and speed of a particle cannot be determined simultaneously (SP 7.5)
- Determining quantum numbers and sublevel designations (SPs 7.6–7.8)

Key Terms

Page numbers appear in parentheses.

absorption spectrum (308)	emission spectrum (308)	photoelectric effect (301)	s orbital (319)
amplitude (296)	excited state (304)	photon (301)	Schrödinger equation (314)
angular momentum quantum number (l) (316)	f orbital (321)	Planck's constant (h) (300)	spectrometry (308)
atomic orbital (wave function) (314)	flame test (308)	principal quantum number (n) (316)	speed of light (c) (296)
d orbital (321)	frequency (ν) (296)	probability contour (315)	stationary state (304)
de Broglie wavelength (311)	ground state (304)	quantum (300)	sublevel (subshell) (317)
diffraction (299)	infrared (IR) (296)	quantum mechanics (314)	ultraviolet (UV) (296)
electromagnetic radiation (295)	level (shell) (317)	quantum number (300)	uncertainty principle (313)
electromagnetic spectrum (296)	line spectrum (302)	radial probability distribution plot (315)	wavelength (λ) (296)
electron cloud depiction (315)	magnetic quantum number (m_l) (316)	refraction (298)	wave-particle duality (312)
electron density diagram (315)	node (319)		
	p orbital (319)		

Key Equations and Relationships

Page numbers appear in parentheses.

7.1 Relating the speed of light to its frequency and wavelength (296):

$$c = \nu \times \lambda$$

7.2 Relating energy change and frequency (300):

$$\Delta E = h\nu$$

7.3 Relating energy change and wavelength (300):

$$\Delta E = \frac{hc}{\lambda}$$

7.4 Calculating the wavelength of any line in the H atom spectrum (Rydberg equation) (302):

$$\frac{1}{\lambda} = R \left(\frac{1}{n_1^2} - \frac{1}{n_2^2} \right)$$

where n_1 and n_2 are positive integers and $n_2 > n_1$

7.5 Finding the difference between two energy levels in the H atom (306):

$$\Delta E = E_{\text{final}} - E_{\text{initial}} = -2.18 \times 10^{-18} \text{ J} \left(\frac{1}{n_{\text{final}}^2} - \frac{1}{n_{\text{initial}}^2} \right)$$

7.6 Calculating the wavelength of any moving particle (de Broglie wavelength) (310):

$$\lambda = \frac{h}{mu}$$

7.7 Finding the uncertainty in position or speed of a particle (the uncertainty principle) (313):

$$\Delta x \cdot m \Delta u \geq \frac{h}{4\pi}$$

BRIEF SOLUTIONS TO FOLLOW-UP PROBLEMS

7.1A $\lambda(\text{nm}) = \frac{c}{\nu} = \frac{3.00 \times 10^8 \text{ m/s}}{7.23 \times 10^{14} \text{ s}^{-1}} \times \frac{10^9 \text{ nm}}{1 \text{ m}} = 415 \text{ nm}$

$$\lambda(\text{\AA}) = 415 \text{ nm} \times \frac{10^{-9} \text{ m}}{1 \text{ nm}} \times \frac{1 \text{\AA}}{10^{-10} \text{ m}} = 4150 \text{\AA}$$

7.1B $\nu = \frac{c}{\lambda} = \frac{3.00 \times 10^8 \text{ m/s}}{940 \text{ nm}} \times \frac{10^9 \text{ nm}}{1 \text{ m}} = 3.2 \times 10^{14} \text{ s}^{-1}$

This is infrared radiation.

7.2A $\lambda = \frac{hc}{E} = \frac{(6.626 \times 10^{-34} \text{ J}\cdot\text{s})(3.00 \times 10^8 \text{ m/s})}{8.2 \times 10^{-19} \text{ J}} \times \frac{10^9 \text{ nm}}{1 \text{ m}} = 240 \text{ nm}$

$$\nu = \frac{E}{h} = \frac{8.2 \times 10^{-19} \text{ J}}{6.626 \times 10^{-34} \text{ J}\cdot\text{s}} = 1.2 \times 10^{15} \text{ s}^{-1}$$

7.2B (a) UV: $E = hc/\lambda$
 $= \frac{(6.626 \times 10^{-34} \text{ J}\cdot\text{s})(3.00 \times 10^8 \text{ m/s})}{1 \times 10^{-8} \text{ m}}$
 $= 2 \times 10^{-17} \text{ J}$

(b) Visible: $E = 4 \times 10^{-19} \text{ J}$ (c) IR: $E = 2 \times 10^{-21} \text{ J}$

As λ increases, E decreases.

7.3A (a) With $n_{\text{final}} = 3$ for an IR photon:

$$\begin{aligned} \Delta E &= -2.18 \times 10^{-18} \text{ J} \left(\frac{1}{n_{\text{final}}^2} - \frac{1}{n_{\text{initial}}^2} \right) \\ &= -2.18 \times 10^{-18} \text{ J} \left(\frac{1}{3^2} - \frac{1}{6^2} \right) \\ &= -2.18 \times 10^{-18} \text{ J} \left(\frac{1}{9} - \frac{1}{36} \right) = -1.82 \times 10^{-19} \text{ J} \end{aligned}$$

(ΔE is negative since the photon is emitted.)

(b) Use the absolute value of ΔE since wavelength must have a positive value:

$$\lambda = \frac{hc}{|\Delta E|} = \frac{(6.626 \times 10^{-34} \text{ J}\cdot\text{s})(3.00 \times 10^8 \text{ m/s})}{1.82 \times 10^{-19} \text{ J}} \times \frac{1 \text{\AA}}{10^{-10} \text{ m}} = 1.09 \times 10^4 \text{\AA}$$

7.3B

(a) $\Delta E (\text{J/atom}) = \frac{hc}{\lambda}$
 $= \frac{(6.626 \times 10^{-34} \text{ J}\cdot\text{s})(3.00 \times 10^8 \text{ m/s})}{410 \text{ nm}} \times \frac{10^9 \text{ nm}}{1 \text{ m}}$
 $= 4.85 \times 10^{-19} \text{ J} = -4.85 \times 10^{-19} \text{ J}$

(ΔE is negative since the photon is emitted.)

$$\Delta E (\text{kJ/mol}) = \frac{-4.85 \times 10^{-19} \text{ J}}{\text{atom}} \times \frac{6.022 \times 10^{23} \text{ atoms}}{\text{mol}} \times \frac{1 \text{ kJ}}{10^3 \text{ J}} = -292 \text{ kJ/mol}$$

(b) $\Delta E = -2.18 \times 10^{-18} \text{ J} \left(\frac{1}{n_{\text{final}}^2} - \frac{1}{n_{\text{initial}}^2} \right)$

$$\frac{1}{n_{\text{final}}^2} = \frac{\Delta E}{-2.18 \times 10^{-18} \text{ J}} + \frac{1}{n_{\text{initial}}^2}$$

$$= \frac{-4.85 \times 10^{-19} \text{ J}}{-2.18 \times 10^{-18} \text{ J}} + \frac{1}{6^2} = 0.25025$$

$$n_{\text{final}}^2 = \frac{1}{0.25025} = 4$$

$$n_{\text{final}} = 2$$

7.4A (a) $\lambda = \frac{h}{mu}$

$$u = \frac{h}{m\lambda} = \frac{6.626 \times 10^{-34} \text{ kg}\cdot\text{m}^2/\text{s}}{(9.11 \times 10^{-31} \text{ kg}) \left(100 \text{ nm} \times \frac{1 \text{ m}}{10^9 \text{ nm}} \right)} = 7.27 \times 10^3 \text{ m/s}$$

(b) $u = \frac{h}{m\lambda} = \frac{6.626 \times 10^{-34} \text{ kg}\cdot\text{m}^2/\text{s}}{(0.0459 \text{ kg}) \left(100. \text{ nm} \times \frac{1 \text{ m}}{10^9 \text{ nm}} \right)} = 1.44 \times 10^{-25} \text{ m/s}$

7.4B $u (\text{m/s}) = \frac{55 \text{ mi}}{1 \text{ h}} \times \frac{1 \text{ h}}{3600 \text{ s}} \times \frac{1.609 \text{ km}}{1 \text{ mi}} \times \frac{10^3 \text{ m}}{1 \text{ km}} = 25 \text{ m/s}$

$$\lambda = \frac{h}{mu} = \frac{6.626 \times 10^{-34} \text{ kg}\cdot\text{m}^2/\text{s}}{(0.0397 \text{ kg})(25 \text{ m/s})} = 6.7 \times 10^{-34} \text{ m}$$

7.5A $\Delta u = 1.00\% \text{ of } u = 0.0100 \times 44.7 \text{ m/s} = 0.447 \text{ m/s}$

$$\Delta x \geq \frac{h}{4\pi m \Delta u} \geq \frac{6.626 \times 10^{-34} \text{ kg}\cdot\text{m}^2/\text{s}}{4\pi(0.142 \text{ kg})(0.447 \text{ m/s})} \geq 8.31 \times 10^{-34} \text{ m}$$

7.5B $\Delta u = 1\% \text{ of } u = 0.01(8 \times 10^5 \text{ m/s}) = 8 \times 10^5 \text{ m/s}$

$$\Delta x \geq \frac{h}{4\pi m \Delta u} \geq \frac{6.626 \times 10^{-34} \text{ kg}\cdot\text{m}^2/\text{s}}{4\pi(1.67 \times 10^{-27} \text{ kg})(8 \times 10^5 \text{ m/s})} \geq 4 \times 10^{-14} \text{ m}$$

7.6A $n = 4$, so $l = 0, 1, 2, 3$. In addition to the nine m_l values given in Sample Problem 7.6, there are those for
 $l = 3$: $m_l = -3, -2, -1, 0, +1, +2, +3$.

7.6B For $l = 0, 1, 2, 3, 4$, $n = 5$. In addition to the nine m_l values listed in Sample Problem 7.6 and the seven m_l values listed in Follow-up Problem 7.6A, there are those for
 $l = 4$: $m_l = -4, -3, -2, -1, 0, +1, +2, +3, +4$.

7.7A For $2p$: $n = 2, l = 1, m_l = -1, 0, +1$

For $5f$: $n = 5, l = 3, m_l = -3, -2, -1, 0, +1, +2, +3$

7.7B For $4d$: $n = 4, l = 2, m_l = -2, -1, 0, +1, +2$; there are five $4d$ orbitals.

For $6s$: $n = 6, l = 0, m_l = 0$; there is one $6s$ orbital.

7.8A (a) $n = 4, l = 1$; (b) name is $2p$; (c) name is $3d$; (d) $n = 2, l = 0, m_l = 0$

7.8B (a) For $l = 3$, the allowed values for m_l are $-3, -2, -1, 0, +1, +2, +3$, not 4.

(b) For $n = 2, l = 0$ or 1 only, not 2; the sublevel is $2p$, since $m_l = 1$.

(c) The value $l = 1$ indicates the p sublevel, not the s ; the sublevel name is $6p$.

PROBLEMS

Problems with **colored** numbers are answered in Appendix E and worked in detail in the Student Solutions Manual. Problem sections match those in the text and give the numbers of relevant sample problems. Most offer Concept Review Questions, Skill-Building Exercises (grouped in pairs covering the same concept), and Problems in Context. Comprehensive Problems are based on material from any section or previous chapter.

The Nature of Light

(Sample Problems 7.1 and 7.2)

Concept Review Questions

7.1 In what ways are microwave and ultraviolet radiation the same? In what ways are they different?

7.2 Consider the following types of electromagnetic radiation:

- | | | |
|---------------|-----------------|-----------------|
| (1) Microwave | (2) Ultraviolet | (3) Radio waves |
| (4) Infrared | (5) X-ray | (6) Visible |

- Arrange them in order of increasing wavelength.
- Arrange them in order of increasing frequency.
- Arrange them in order of increasing energy.

7.3 Define each of the following wave phenomena, and give an example of where each occurs: (a) refraction; (b) diffraction; (c) dispersion; (d) interference.

7.4 In the 17th century, Isaac Newton proposed that light was a stream of particles. The wave-particle debate continued for over 250 years until Planck and Einstein presented their ideas. Give two pieces of evidence for the wave model and two for the particle model.

7.5 Portions of electromagnetic waves A, B, and C are represented by the following (not drawn to scale):

Rank them in order of (a) increasing frequency; (b) increasing energy; (c) increasing amplitude. (d) If wave B just barely fails to cause a current when shining on a metal, is wave A or C more likely to do so? (e) If wave B represents visible radiation, is wave A or C more likely to be IR radiation?

7.6 What new idea about light did Einstein use to explain the photoelectric effect? Why does the photoelectric effect exhibit a threshold frequency but not a time lag?

Skill-Building Exercises (grouped in similar pairs)

7.7 An AM station broadcasts rock music at “950 on your radio dial.” Units for AM frequencies are given in kilohertz (kHz). Find the wavelength of the station’s radio waves in meters (m), nanometers (nm), and angstroms (Å).

7.8 An FM station broadcasts music at 93.5 MHz (megahertz, or 10^6 Hz). Find the wavelength (in m, nm, and Å) of these waves.

7.9 A radio wave has a frequency of 3.8×10^{10} Hz. What is the energy (in J) of one photon of this radiation?

7.10 An x-ray has a wavelength of 1.3 Å. Calculate the energy (in J) of one photon of this radiation.

7.11 Rank these photons in terms of increasing energy: blue ($\lambda = 453$ nm; red ($\lambda = 660$ nm); yellow ($\lambda = 595$ nm)).

7.12 Rank these photons in terms of decreasing energy: IR ($\nu = 6.5 \times 10^{13} \text{ s}^{-1}$); microwave ($\nu = 9.8 \times 10^{11} \text{ s}^{-1}$); UV ($\nu = 8.0 \times 10^{15} \text{ s}^{-1}$).

Problems in Context

7.13 Police often monitor traffic with “K-band” radar guns, which operate in the microwave region at 22.235 GHz (1 GHz = 10^9 Hz). Find the wavelength (in nm and Å) of this radiation.

7.14 Covalent bonds in a molecule absorb radiation in the IR region and vibrate at characteristic frequencies.

- The C–O bond absorbs radiation of wavelength 9.6 μm. What frequency (in s^{-1}) corresponds to that wavelength?
- The H–Cl bond has a frequency of vibration of 8.652×10^{13} Hz. What wavelength (in μm) corresponds to that frequency?

7.15 Cobalt-60 is a radioactive isotope used to treat cancers. A gamma ray emitted by this isotope has an energy of 1.33 MeV (million electron volts; 1 eV = 1.602×10^{-19} J). What is the frequency (in Hz) and the wavelength (in m) of this gamma ray?

7.16 (a) Ozone formation in the upper atmosphere starts when oxygen molecules absorb UV radiation with wavelengths less than or equal to 242 nm. Find the frequency and energy of the least energetic of these photons. (b) Ozone absorbs radiation with wavelengths in the range 2200–2900 Å, thus protecting organisms from this radiation. Find the frequency and energy of the most energetic of these photons.

Atomic Spectra

(Sample Problem 7.3)

Concept Review Questions

7.17 How is n_1 in the Rydberg equation (Equation 7.4) related to the quantum number n in the Bohr model?

7.18 What key assumption of Bohr’s model would a “Solar System” model of the atom violate? What was the theoretical basis for this assumption?

7.19 Distinguish between an absorption spectrum and an emission spectrum. With which did Bohr work?

7.20 Which of these electron transitions correspond to absorption of energy and which to emission?

- | | |
|------------------------|------------------------|
| (a) $n = 2$ to $n = 4$ | (b) $n = 3$ to $n = 1$ |
| (c) $n = 5$ to $n = 2$ | (d) $n = 3$ to $n = 4$ |

7.21 Why couldn’t the Bohr model predict spectra for atoms other than hydrogen?

7.22 The H atom and the Be³⁺ ion each have one electron. Would you expect the Bohr model to predict their spectra accurately? Would you expect their spectra to be identical? Explain.

Skill-Building Exercises (grouped in similar pairs)

7.23 Use the Rydberg equation to find the wavelength (in nm) of the photon emitted when an electron in an H atom undergoes a transition from $n = 5$ to $n = 2$.

7.24 Use the Rydberg equation to find the wavelength (in Å) of the photon absorbed when an electron in an H atom undergoes a transition from $n = 1$ to $n = 3$.

7.25 What is the wavelength (in nm) of the least energetic spectral line in the infrared series of the H atom?

7.26 What is the wavelength (in nm) of the least energetic spectral line in the visible series of the H atom?

7.27 Calculate the energy difference (ΔE) for the transition in Problem 7.23 for 1 mol of H atoms.

7.28 Calculate the energy difference (ΔE) for the transition in Problem 7.24 for 1 mol of H atoms.

7.29 Arrange the following H atom electron transitions in order of increasing frequency of the photon absorbed or emitted:

- (a) $n = 2$ to $n = 4$ (b) $n = 2$ to $n = 1$
 (c) $n = 2$ to $n = 5$ (d) $n = 4$ to $n = 3$

7.30 Arrange the following H atom electron transitions in order of decreasing wavelength of the photon absorbed or emitted:

- (a) $n = 2$ to $n = \infty$ (b) $n = 4$ to $n = 20$
 (c) $n = 3$ to $n = 10$ (d) $n = 2$ to $n = 1$

7.31 The electron in a ground-state H atom absorbs a photon of wavelength 97.20 nm. To what energy level does it move?

7.32 An electron in the $n = 5$ level of an H atom emits a photon of wavelength 1281 nm. To what energy level does it move?

Problems in Context

7.33 In addition to continuous radiation, fluorescent lamps emit some visible lines from mercury. A prominent line has a wavelength of 436 nm. What is the energy (in J) of one photon of it?

7.34 A Bohr-model representation of the H atom is shown below with several electron transitions depicted by arrows:

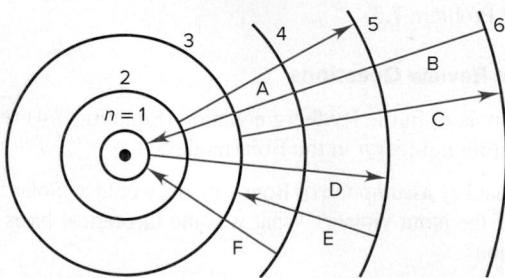

- (a) Which transitions are absorptions and which are emissions?
 (b) Rank the emissions in terms of increasing energy.
 (c) Rank the absorptions in terms of increasing wavelength of light absorbed.

The Wave-Particle Duality of Matter and Energy

(Sample Problems 7.4 and 7.5)

Concept Review Questions

7.35 In what sense is the wave motion of a guitar string analogous to the motion of an electron in an atom?

7.36 What experimental support did de Broglie's concept receive?

7.37 If particles have wavelike motion, why don't we observe that motion in the macroscopic world?

7.38 Why can't we overcome the uncertainty predicted by Heisenberg's principle by building more precise instruments to reduce the error in measurements below the $h/4\pi$ limit?

Skill-Building Exercises (grouped in similar pairs)

7.39 A 232-lb fullback runs 40 yd at 19.8 ± 0.1 mi/h.

- (a) What is his de Broglie wavelength (in meters)?
 (b) What is the uncertainty in his position?

7.40 An alpha particle (mass = 6.6×10^{-24} g) emitted by a radium isotope travels at $3.4 \times 10^7 \pm 0.1 \times 10^7$ mi/h.

- (a) What is its de Broglie wavelength (in meters)?
 (b) What is the uncertainty in its position?

7.41 How fast must a 56.5-g tennis ball travel to have a de Broglie wavelength equal to that of a photon of green light (5400 Å)?

7.42 How fast must a 142-g baseball travel to have a de Broglie wavelength equal to that of an x-ray photon with $\lambda = 100$. pm?

7.43 A sodium flame has a characteristic yellow color due to emission of light of wavelength 589 nm. What is the mass equivalence of one photon with this wavelength ($1 \text{ J} = 1 \text{ kg} \cdot \text{m}^2/\text{s}^2$)?

7.44 A lithium flame has a characteristic red color due to emission of light of wavelength 671 nm. What is the mass equivalence of 1 mol of photons with this wavelength ($1 \text{ J} = 1 \text{ kg} \cdot \text{m}^2/\text{s}^2$)?

The Quantum-Mechanical Model of the Atom

(Sample Problems 7.6 to 7.8)

Concept Review Questions

7.45 What physical meaning is attributed to ψ^2 ?

7.46 What does "electron density in a tiny volume of space" mean?

7.47 Explain the significance of the fact that the peak in the radial probability distribution plot for the $n = 1$ level of an H atom is at 0.529 Å. Is the probability of finding an electron at 0.529 Å from the nucleus greater for the 1s or the 2s orbital?

7.48 What feature of an orbital is related to each of the following?

- (a) Principal quantum number (n)
 (b) Angular momentum quantum number (l)
 (c) Magnetic quantum number (m_l)

Skill-Building Exercises (grouped in similar pairs)

7.49 How many orbitals in an atom can have each of the following designations: (a) 1s; (b) 4d; (c) 3p; (d) $n = 3$?

7.50 How many orbitals in an atom can have each of the following designations: (a) 5f; (b) 4p; (c) 5d; (d) $n = 2$?

7.51 Give all possible m_l values for orbitals that have each of the following: (a) $l = 2$; (b) $n = 1$; (c) $n = 4, l = 3$.

7.52 Give all possible m_l values for orbitals that have each of the following: (a) $l = 3$; (b) $n = 2$; (c) $n = 6, l = 1$.

7.53 Draw 90% probability contours (with axes) for each of the following orbitals: (a) s ; (b) p_x .

7.54 Draw 90% probability contours (with axes) for each of the following orbitals: (a) p_z ; (b) d_{xy} .

7.55 For each of the following, give the sublevel designation, the allowable m_l values, and the number of orbitals:

- (a) $n = 4, l = 2$ (b) $n = 5, l = 1$
 (c) $n = 6, l = 3$

7.56 For each of the following, give the sublevel designation, the allowable m_l values, and the number of orbitals:

- (a) $n = 2, l = 0$ (b) $n = 3, l = 2$
 (c) $n = 5, l = 1$

7.57 For each of the following sublevels, give the n and l values and the number of orbitals: (a) $5s$; (b) $3p$; (c) $4f$.

7.58 For each of the following sublevels, give the n and l values and the number of orbitals: (a) $6g$; (b) $4s$; (c) $3d$.

7.59 Are the following combinations allowed? If not, show two ways to correct them:

- (a) $n = 2; l = 0; m_l = -1$ (b) $n = 4; l = 3; m_l = -1$
 (c) $n = 3; l = 1; m_l = 0$ (d) $n = 5; l = 2; m_l = +3$

7.60 Are the following combinations allowed? If not, show two ways to correct them:

- (a) $n = 1; l = 0; m_l = 0$ (b) $n = 2; l = 2; m_l = +1$
 (c) $n = 7; l = 1; m_l = +2$ (d) $n = 3; l = 1; m_l = -2$

Comprehensive Problems

7.61 The orange color of carrots and orange peel is due mostly to β -carotene, an organic compound insoluble in water but soluble in benzene and chloroform. Describe an experiment to determine the concentration of β -carotene in the oil from orange peel.

7.62 The quantum-mechanical treatment of the H atom gives the energy, E , of the electron as a function of n :

$$E = -\frac{h^2}{8\pi^2 m_e a_0^2 n^2} \quad (n = 1, 2, 3, \dots)$$

where h is Planck's constant, m_e is the electron's mass, and a_0 is 52.92×10^{-12} m.

(a) Write the expression in the form $E = -(constant)(1/n^2)$, evaluate the constant (in J), and compare it with the corresponding expression from Bohr's theory.

(b) Use the expression from part (a) to find ΔE between $n = 2$ and $n = 3$.

(c) Calculate the wavelength of the photon that corresponds to this energy change.

7.63 The photoelectric effect is illustrated in a plot of the kinetic energies of electrons ejected from the surface of potassium metal or silver metal at different frequencies of incident light.

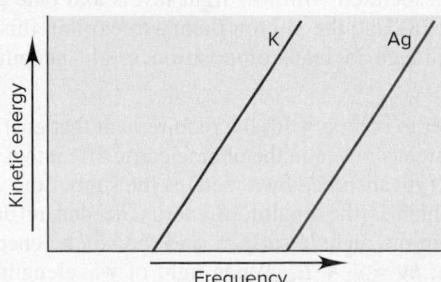

- (a) Why don't the lines begin at the origin? (b) Why don't the lines begin at the same point? (c) From which metal will light of shorter wavelength eject an electron? (d) Why are the slopes equal?

7.64 The optic nerve needs a minimum of 2.0×10^{-17} J of energy to trigger a series of impulses that eventually reach the brain.

- (a) How many photons of red light (700 nm) are needed? (b) How many photons of blue light (475 nm)?

7.65 One reason carbon monoxide (CO) is toxic is that it binds to the blood protein hemoglobin more strongly than oxygen does. The bond between hemoglobin and CO absorbs radiation of 1953 cm^{-1} . (The unit is the reciprocal of the wavelength in centimeters.) Calculate the wavelength (in nm and Å) and the frequency (in Hz) of the absorbed radiation.

7.66 A metal ion M^{n+} has a single electron. The highest energy line in its emission spectrum has a frequency of 2.961×10^{16} Hz. Identify the ion.

7.67 Compare the wavelengths of an electron (mass = 9.11×10^{-31} kg) and a proton (mass = 1.67×10^{-27} kg), each having (a) a speed of 3.4×10^6 m/s; (b) a kinetic energy of 2.7×10^{-15} J.

7.68 Five lines in the H atom spectrum have these wavelengths (in Å): (a) 1212.7; (b) 4340.5; (c) 4861.3; (d) 6562.8; (e) 10,938. Three lines result from transitions to $n_{\text{final}} = 2$ (visible series). The other two result from transitions in different series, one with $n_{\text{final}} = 1$ and the other with $n_{\text{final}} = 3$. Identify n_{initial} for each line.

7.69 In his explanation of the threshold frequency in the photoelectric effect, Einstein reasoned that the absorbed photon must have a minimum energy to dislodge an electron from the metal surface. This energy is called the *work function* (ϕ) of the metal. What is the longest wavelength of radiation (in nm) that could cause the photoelectric effect in each of these metals: (a) calcium, $\phi = 4.60 \times 10^{-19}$ J; (b) titanium, $\phi = 6.94 \times 10^{-19}$ J; (c) sodium, $\phi = 4.41 \times 10^{-19}$ J?

7.70 Refractometry is based on the difference in the speed of light through a substance (v) and through a vacuum (c). In the procedure, light of known wavelength passes through a fixed thickness of the substance at a known temperature. The index of refraction equals c/v . Using yellow light ($\lambda = 589$ nm) at 20°C , for example, the index of refraction of water is 1.33 and that of diamond is 2.42. Calculate the speed of light in (a) water and (b) diamond.

7.71 A laser (light amplification by stimulated emission of radiation) provides nearly monochromatic high-intensity light. Lasers are used in eye surgery, CD/DVD players, basic research, and many other areas. Some dye lasers can be "tuned" to emit a desired wavelength. Fill in the blanks in the following table of the properties of some common types of lasers:

Type	λ (nm)	ν (s $^{-1}$)	E (J)	Color
He-Ne	632.8	?	?	?
Ar	?	6.148×10^{14}	?	?
Ar-Kr	?	?	3.499×10^{-19}	?
Dye	663.7	?	?	?

7.72 The following combinations are not allowed. If n and m_l are correct, change the l value to create an allowable combination:

- (a) $n = 3; l = 0; m_l = -1$ (b) $n = 3; l = 3; m_l = +1$
 (c) $n = 7; l = 2; m_l = +3$ (d) $n = 4; l = 1; m_l = -2$

7.73 A ground-state H atom absorbs a photon of wavelength 94.91 nm, and its electron attains a higher energy level. The atom then emits two photons: one of wavelength 1281 nm to reach an

intermediate energy level, and a second to return to the ground state.

- What higher level did the electron reach?
- What intermediate level did the electron reach?
- What was the wavelength of the second photon emitted?

7.74 Ground-state ionization energies of some one-electron species are

$$H = 1.31 \times 10^3 \text{ kJ/mol} \quad He^+ = 5.24 \times 10^3 \text{ kJ/mol}$$

$$Li^{2+} = 1.18 \times 10^4 \text{ kJ/mol}$$

(a) Write a general expression for the ionization energy of any one-electron species.

- Use your expression to calculate the ionization energy of B^{4+} .
- What is the minimum wavelength required to remove the electron from the $n = 3$ level of He^+ ?
- What is the minimum wavelength required to remove the electron from the $n = 2$ level of Be^{3+} ?

7.75 Use the relative size of the $3s$ orbital below to answer the following questions about orbitals A–D.

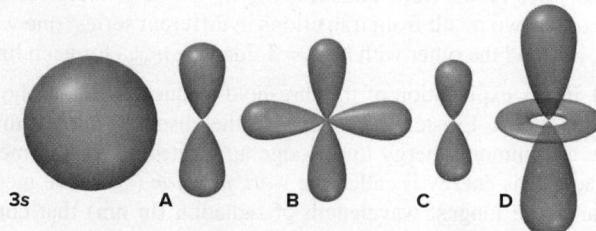

- Which orbital has the highest value of n ? (b) Which orbital(s) have a value of $l = 1$? $l = 2$? (c) How many other orbitals with the same value of n have the same shape as orbital B? Orbital C? (d) Which orbital has the highest energy? Lowest energy?

7.76 In the course of developing his model, Bohr arrived at the following formula for the radius of the electron's orbit: $r_n = n^2 h^2 \epsilon_0 / \pi m_e e^2$, where m_e is the electron's mass, e is its charge, and ϵ_0 is a constant related to charge attraction in a vacuum. Given that $m_e = 9.109 \times 10^{-31} \text{ kg}$, $e = 1.602 \times 10^{-19} \text{ C}$, and $\epsilon_0 = 8.854 \times 10^{-12} \text{ C}^2/\text{J} \cdot \text{m}$, calculate the following:

- The radius of the first ($n = 1$) orbit in the H atom
- The radius of the tenth ($n = 10$) orbit in the H atom

7.77 (a) Find the Bohr radius of an electron in the $n = 3$ orbit of an H atom (see Problem 7.76). (b) What is the energy (in J) of the atom in part (a)? (c) What is the energy of an Li^{2+} ion with its electron in the $n = 3$ orbit? (d) Why are the answers to parts (b) and (c) different?

7.78 Enormous numbers of microwave photons are needed to warm macroscopic samples of matter. A portion of soup containing 252 g of water is heated in a microwave oven from $20.^\circ\text{C}$ to 98°C , with radiation of wavelength $1.55 \times 10^{-2} \text{ m}$. How many photons are absorbed by the water in the soup?

7.79 The quantum-mechanical treatment of the hydrogen atom gives this expression for the wave function, ψ , of the $1s$ orbital:

$$\Psi = \frac{1}{\sqrt{\pi}} \left(\frac{1}{a_0} \right)^{3/2} e^{-r/a_0}$$

where r is the distance from the nucleus and a_0 is 52.92 pm. The probability of finding the electron in a tiny volume at distance r from the nucleus is proportional to ψ^2 . The total probability of finding the electron at all points at distance r from the nucleus is

proportional to $4\pi r^2 \psi^2$. Calculate the values (to three significant figures) of ψ , ψ^2 , and $4\pi r^2 \psi^2$ to fill in the following table and sketch a plot of each set of values versus r . Compare the latter two plots with those in Figure 7.17A.

$r(\text{pm})$	$\Psi(\text{pm}^{-3/2})$	$\Psi^2(\text{pm}^{-3})$	$4\pi r^2 \Psi^2(\text{pm}^{-1})$
0			
50			
100			
200			

7.80 Lines in one spectral series can overlap lines in another.

- Does the range of wavelengths in the $n_1 = 1$ series for the H atom overlap the range in the $n_1 = 2$ series?
- Does the range in the $n_1 = 3$ series overlap the range in the $n_1 = 4$ series?
- How many lines in the $n_1 = 4$ series lie in the range of the $n_1 = 5$ series?
- What does this overlap imply about the H atom line spectrum at longer wavelengths?

7.81 The following values are the only energy levels of a hypothetical one-electron atom:

$$\begin{array}{ll} E_6 = -2 \times 10^{-19} \text{ J} & E_5 = -7 \times 10^{-19} \text{ J} \\ E_4 = -11 \times 10^{-19} \text{ J} & E_3 = -15 \times 10^{-19} \text{ J} \\ E_2 = -17 \times 10^{-19} \text{ J} & E_1 = -20 \times 10^{-19} \text{ J} \end{array}$$

- If the electron were in the $n = 3$ level, what would be the highest frequency (and minimum wavelength) of radiation that could be emitted?
- What is the ionization energy (in kJ/mol) of the atom in its ground state?
- If the electron were in the $n = 4$ level, what would be the shortest wavelength (in nm) of radiation that could be absorbed without causing ionization?

7.82 Photoelectron spectroscopy applies the principle of the photoelectric effect to study orbital energies of atoms and molecules. High-energy radiation (usually UV or x-ray) is absorbed by a sample and an electron is ejected. The orbital energy can be calculated from the known energy of the radiation and the measured energy of the electron lost. The following energy differences were determined for several electron transitions:

$$\begin{array}{ll} \Delta E_{2 \rightarrow 1} = 4.098 \times 10^{-17} \text{ J} & \Delta E_{3 \rightarrow 1} = 4.854 \times 10^{-17} \text{ J} \\ \Delta E_{5 \rightarrow 1} = 5.242 \times 10^{-17} \text{ J} & \Delta E_{4 \rightarrow 2} = 1.024 \times 10^{-17} \text{ J} \end{array}$$

Calculate ΔE and λ of a photon emitted in the following transitions: (a) level 3 \rightarrow 2; (b) level 4 \rightarrow 1; (c) level 5 \rightarrow 4.

7.83 Horticulturists know that, for many plants, dark green leaves are associated with low light levels and pale green with high levels. (a) Use the photon theory to explain this behavior. (b) What change in leaf composition might account for this difference?

7.84 In order to comply with the requirement that energy be conserved, Einstein showed in the photoelectric effect that the energy of a photon ($h\nu$) absorbed by a metal is the sum of the work function (ϕ), which is the minimum energy needed to dislodge an electron from the metal's surface, and the kinetic energy (E_k) of the electron: $h\nu = \phi + E_k$. When light of wavelength 358.1 nm falls on the surface of potassium metal, the speed (u) of the dislodged electron is $6.40 \times 10^5 \text{ m/s}$.

- What is E_k ($\frac{1}{2} mu^2$) of the dislodged electron?
- What is ϕ (in J) of potassium?

7.85 For any microscope, the size of the smallest observable object is one-half the wavelength of the radiation used. For example, the smallest object observable with 400-nm light is 2×10^{-7} m. (a) What is the smallest observable object for an electron microscope using electrons moving at 5.5×10^4 m/s? (b) At 3.0×10^7 m/s?

7.86 In fireworks, the heat of the reaction of an oxidizing agent, such as KClO_4 , with an organic compound excites certain salts, which emit specific colors. Strontium salts have an intense emission at 641 nm, and barium salts have one at 493 nm.

- (a) What colors do these emissions produce?
- (b) What is the energy (in kJ) of these emissions for 5.00 g each of the chloride salts of Sr and Ba? (Assume that all the heat produced is converted to emitted light.)

7.87 Atomic hydrogen produces several series of spectral lines. Each series fits the Rydberg equation with its own particular n_1 value. Calculate the value of n_1 (by trial and error if necessary) that would produce a series of lines in which:

- (a) The *highest* energy line has a wavelength of 3282 nm.
- (b) The *lowest* energy line has a wavelength of 7460 nm.

7.88 Fish-liver oil is a good source of vitamin A, whose concentration is measured spectrometrically at a wavelength of 329 nm.

- (a) Suggest a reason for using this wavelength.
- (b) In what region of the spectrum does this wavelength lie?
- (c) When 0.1232 g of fish-liver oil is dissolved in 500. mL of solvent, the absorbance is 0.724 units. When 1.67×10^{-3} g of vitamin A is dissolved in 250. mL of solvent, the absorbance is 1.018 units. Calculate the vitamin A concentration in the fish-liver oil.

7.89 Many calculators use photocells as their energy source. Find the maximum wavelength needed to remove an electron from silver ($\phi = 7.59 \times 10^{-19}$ J). Is silver a good choice for a photocell that uses visible light? [The concept of the work function (ϕ) is explained in Problem 7.69.]

7.90 In a game of "Clue," Ms. White is killed in the conservatory. A spectrometer in each room records who is present to help find the murderer. For example, if someone wearing yellow is in a room, light at 580 nm is reflected. The suspects are Col. Mustard, Prof. Plum, Mr. Green, Ms. Peacock (blue), and Ms. Scarlet. At the time of the murder, the spectrometer in the dining room shows a reflection at 520 nm, those in the lounge and the study record lower frequencies, and the one in the library records the shortest possible wavelength. Who killed Ms. White? Explain.

7.91 Technetium (Tc; $Z = 43$) is a synthetic element used as a radioactive tracer in medical studies. A Tc atom emits a beta particle (electron) with a kinetic energy ($E_k = \frac{1}{2} mv^2$) of 4.71×10^{-15} J. What is the de Broglie wavelength of this electron?

7.92 Electric power is measured in watts ($1 \text{ W} = 1 \text{ J/s}$). About 95% of the power output of an incandescent bulb is converted to heat and 5% to light. If 10% of that light shines on your chemistry textbook, how many photons per second shine on the book from a 75-W bulb? (Assume that the photons have a wavelength of 550 nm.)

7.93 The flame tests for sodium and potassium are based on the emissions at 589 nm and 404 nm, respectively. When both elements are present, the Na^+ emission is so strong that the K^+ emission can be seen only by looking through a cobalt-glass filter.

- (a) What are the colors of the Na^+ and K^+ emissions?
- (b) What does the cobalt-glass filter do?
- (c) Why is KClO_4 used as an oxidizing agent in fireworks rather than NaClO_4 ?

7.94 The net change during photosynthesis involves CO_2 and H_2O forming glucose ($\text{C}_6\text{H}_{12}\text{O}_6$) and O_2 . Chlorophyll absorbs light in the 600–700 nm region.

- (a) Write a balanced thermochemical equation for formation of 1.00 mol of glucose.
- (b) What is the minimum number of photons with $\lambda = 680.$ nm needed to form 1.00 mol of glucose?

7.95 Only certain transitions are allowed from one energy level to another. In one-electron species, the change in l for an allowed transition is ± 1 . For example, a $3p$ electron can move to a $2s$ orbital but not to a $2p$. Thus, in the UV series, where $n_{\text{final}} = 1$, allowed transitions can start in a p orbital ($l = 1$) of $n = 2$ or higher, not in an s ($l = 0$) or d ($l = 2$) orbital of $n = 2$ or higher. From what orbital do each of the allowed transitions start for the first four emission lines in the visible series ($n_{\text{final}} = 2$)?

7.96 The discharge of phosphate in detergents to the environment has led to imbalances in the life cycle of freshwater lakes. A chemist uses a spectrometric method to measure total phosphate and obtains the following data for known standards:

Absorbance (880 nm)	Concentration (mol/L)
0	0.0×10^{-5}
0.10	2.5×10^{-5}
0.16	3.2×10^{-5}
0.20	4.4×10^{-5}
0.25	5.6×10^{-5}
0.38	8.4×10^{-5}
0.48	10.5×10^{-5}
0.62	13.8×10^{-5}
0.76	17.0×10^{-5}
0.88	19.4×10^{-5}

- (a) Draw a curve of absorbance vs. phosphate concentration.
- (b) If a sample of lake water has an absorbance of 0.55, what is its phosphate concentration?

8

Electron Configuration and Chemical Periodicity

8.1 Characteristics of Many-Electron Atoms

The Electron-Spin Quantum Number
The Exclusion Principle
Electrostatic Effects and Energy-Level Splitting

8.2 The Quantum-Mechanical Model and the Periodic Table

Building Up Period 1
Building Up Period 2

Building Up Period 3
Building Up Period 4
General Principles of Electron Configurations
Transition and Inner Transition Elements
Electron Configurations Within Groups

8.3 Trends in Three Atomic Properties

Atomic Size
Ionization Energy
Electron Affinity

8.4 Atomic Properties and Chemical Reactivity

Trends in Metallic Behavior
Properties of Monatomic Ions

Source: © Mikhail Tolstoy/Alamy RF

Concepts and Skills to Review Before You Study This Chapter

- › format of the periodic table (Section 2.6)
- › characteristics of acids and bases (Section 4.4)
- › characteristics of metals and nonmetals (Section 2.6)
- › rules for assigning quantum numbers (Section 7.4)
- › attractions, repulsions, and Coulomb's law (Section 2.7)

Every year, we know that spring will follow winter because the seasons are one of the recurring patterns of nature. Day and night, the rhythm of a heartbeat, tides, and the phases of the moon are other examples of nature's patterns that make it possible for us to know what to expect. Elements also exhibit recurring patterns in their properties, patterns that we can use to make predictions about their behavior.

The outpouring of scientific creativity by early 20th-century physicists that led to the new quantum-mechanical model of the atom was preceded by countless hours of laboratory work by 19th-century chemists who were exploring the nature of electrolytes, the kinetic-molecular theory, and chemical thermodynamics. The fields of organic chemistry and biochemistry were born in the 19th century, as were the fertilizer, explosives, glassmaking, soapmaking, bleaching, and dyestuff industries. And, for the first time, chemistry became a subject taught in universities in Europe and America.

Condensed from all these efforts was an enormous body of facts about the elements, which became organized into the periodic table:

- *The original periodic table.* In 1870, the Russian chemist Dmitri Mendeleev arranged the 65 elements known at the time into a table and summarized their behavior in the **periodic law**: when arranged by *atomic mass*, the elements exhibit a periodic recurrence of similar properties. Mendeleev left blank spaces in his table and was even able to *predict* the properties of several elements, for example, germanium, that were not discovered until later.
- *The modern periodic table.* Today's periodic table (*inside front cover*) includes 53 elements not known in 1870 and, most importantly, arranges the elements by *atomic number* (number of protons) *not* atomic mass. This change is based on the work of the British physicist Henry G. J. Moseley, who obtained x-ray spectra of various metals by bombarding the metals with electrons. Moseley found that the largest x-ray peak for each metal was related to the nuclear charge, which increased by 1 for each successive element.

The great test for the new atomic model was to answer one of the central questions in chemistry: *why* do the elements behave as they do? Or, rephrasing to fit the main topic of this chapter, how does the **electron configuration** of an element—*the distribution of electrons within the levels and sublevels of its atoms*—relate to its chemical and physical properties?

IN THIS CHAPTER . . . We explore recurring patterns of electron distributions in atoms to see how they account for the recurring behavior of the elements.

- › We describe a new quantum number and a restriction on the number of electrons in an orbital, which allows us to define a unique set of quantum numbers for each electron in an atom of any element.
- › We explore electrostatic effects that lead to splitting of atomic energy levels into sublevels and give rise to the order in which orbitals fill with electrons. This filling order correlates with the order of elements in the periodic table.
- › We examine the reasons for periodic trends in three atomic properties.
- › We see how these trends account for chemical reactivity with regard to metallic and redox behavior, oxide acidity, ion formation, and magnetic behavior.

8.1 CHARACTERISTICS OF MANY-ELECTRON ATOMS

The Schrödinger equation (introduced in Chapter 7) does not give *exact* solutions for the energy levels of *many-electron atoms*, those with more than one electron—that is, all atoms except hydrogen. However, unlike the Bohr model, it gives excellent *approximate* solutions. Three additional features become important in many-electron atoms: (1) a fourth quantum number, (2) a limit on the number of electrons in an orbital, and (3) a splitting of energy levels into sublevels.

The Electron-Spin Quantum Number

The three quantum numbers n , l , and m_l describe the size (energy), shape, and orientation in space, respectively, of an atomic orbital. A fourth quantum number describes a property called *spin*, which is a property of the electron and not the orbital.

When a beam of atoms that have one or more lone electrons passes through a nonuniform magnetic field (created by magnet faces with different shapes), it splits into two beams. Half of the electrons are *attracted* by the large external magnetic field, while the other half are *repelled* by it; Figure 8.1 shows this for a beam of H atoms.

Figure 8.1 The effect of electron spin. A beam of H atoms splits because each atom's electron has one of the two possible values of spin.

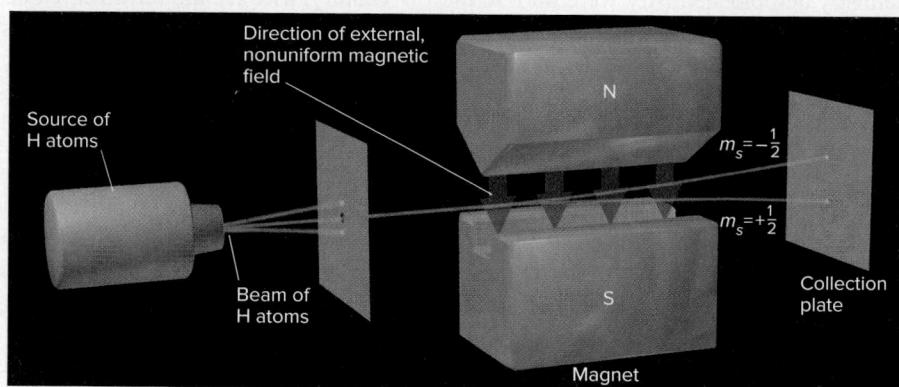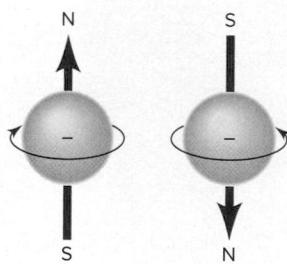

Figure 8.2 The direction of electron spin. The electron spins in one of two opposite directions, generating a magnetic field whose direction depends on the direction of spin.

This observation is explained by the idea that an electron spins on its axis in one of two opposite directions, clockwise or counterclockwise; a spinning charge generates a tiny magnetic field whose direction depends on the direction of the spin (Figure 8.2). Thus, there are two magnetic fields with opposing directions, resulting in the two beams seen in Figure 8.1. Corresponding to the two directions of the electron's magnetic field, the **spin quantum number (m_s)** has two possible values, $+\frac{1}{2}$ or $-\frac{1}{2}$.

Thus, *each electron in an atom is described completely by a set of four quantum numbers: the first three describe its orbital, and the fourth describes its spin*. The quantum numbers are summarized in Table 8.1.

Now we can write a set of four quantum numbers for any electron in the ground state of any atom. For example, the lone electron in hydrogen (H; $Z = 1$), which occupies the $1s$ orbital, has the following quantum numbers: $n = 1$, $l = 0$, $m_l = 0$,

Table 8.1 Summary of Quantum Numbers of Electrons in Atoms

Name	Symbol	Permitted Values	Property
Principal	n	Positive integers (1, 2, 3, ...)	Orbital energy (size)
Angular momentum	l	Integers from 0 to $n - 1$	Orbital shape (The l values 0, 1, 2, and 3 correspond to s , p , d , and f orbitals, respectively.)
Magnetic Spin	m_l m_s	Integers from $-l$ to 0 to $+l$ $+\frac{1}{2}$ or $-\frac{1}{2}$	Orbital orientation Direction of e^- spin

and $m_s = +\frac{1}{2}$. (The spin quantum number could just as well be $-\frac{1}{2}$, but by convention, we assign $+\frac{1}{2}$ to the first electron in an orbital.)

The Exclusion Principle

The element after hydrogen is helium ($\text{He}; Z = 2$), the first with atoms having more than one electron. The first electron in the He ground state has the same set of quantum numbers as the electron in the H atom, but the second He electron does not. Based on observations of excited states, the Austrian physicist Wolfgang Pauli formulated the **exclusion principle**: *no two electrons in the same atom can have the same four quantum numbers*. Therefore, the second He electron occupies the same $1s$ orbital as the first but has an opposite spin: $n = 1$, $l = 0$, $m_l = 0$, and $m_s = -\frac{1}{2}$.

The major consequence of the exclusion principle is that *an atomic orbital can hold a maximum of two electrons, which must have opposing spins*. Two electrons can occupy the same orbital, thus having the same values of n , l and m_l , but each electron must have a unique value of m_s . Since there are only two values of m_s , a third electron cannot be added to that orbital without repeating an m_s value. We say that the $1s$ orbital in He, with its two electrons, is *filled* and that the electrons have *paired spins*. Thus, a beam of He atoms is not split in an experiment like that in Figure 8.1.

Electrostatic Effects and Energy-Level Splitting

Electrostatic effects—attraction of opposite charges and repulsion of like charges—play a major role in determining the energy states of many-electron atoms. Unlike the H atom, in which there is only the attraction between nucleus and electron and the energy state is determined *only* by the n value, the energy states of many-electron atoms are also affected by electron-electron repulsions. You'll see shortly how these additional interactions give rise to *the splitting of energy levels into sublevels of differing energies: the energy of an orbital in a many-electron atom depends mostly on its n value (size) and to a lesser extent on its l value (shape)*.

Our first encounter with energy-level splitting occurs with lithium ($\text{Li}; Z = 3$). The first two electrons of Li fill its $1s$ orbital, so the third Li electron must go into the $n = 2$ level. But, this level has $2s$ and $2p$ sublevels: which does the third electron enter? For reasons we discuss below, the $2s$ is lower in energy than the $2p$, so the ground state of Li has its third electron in the $2s$.

This energy difference arises from three factors—*nuclear attraction, electron repulsions, and orbital shape* (i.e., radial probability distribution). Their interplay leads to two phenomena—*shielding* and *penetration*—that occur in all atoms *except* hydrogen. [In the following discussion, keep in mind that more energy is needed to remove an electron from a more stable (lower energy) sublevel than from a less stable (higher energy) sublevel.]

The Effect of Nuclear Charge (Z) on Sublevel Energy Higher charges interact more strongly than lower charges (Coulomb's law, Section 2.7). Therefore, *a higher nuclear charge (more protons in the nucleus) increases nucleus-electron attractions and, thus, lowers sublevel energy (stabilizes the atom)*. We see this effect by comparing the $1s$ sublevel energies of three species with one electron: the H atom ($Z = 1$), the He^+ ion ($Z = 2$), and the Li^{2+} ion ($Z = 3$). Figure 8.3 shows that the $1s$ sublevel in H (one proton attracting one electron) is the least stable (highest energy), so the least energy is needed to remove its electron; and the $1s$ sublevel in Li^{2+} (three protons attracting one electron) is the most stable, so the most energy is needed to remove its electron.

Shielding: The Effect of Electron Repulsions on Sublevel Energy In many-electron atoms, each electron “feels” not only the attraction to the nucleus but also repulsions from other electrons. Repulsions counteract the nuclear attraction somewhat, making each electron easier to remove by, in effect, helping to push it away. We speak of each electron “shielding” the other electrons to some extent from the nuclear charge. **Shielding** (also called *screening*) reduces the full nuclear charge to an **effective nuclear charge (Z_{eff})**, the nuclear charge an electron *actually experiences, and this lower nuclear charge makes the electron easier to remove*.

Baseball Quantum Numbers

The unique set of quantum numbers that describes an electron is analogous to the unique location of a box seat at a baseball game. The stadium (atom) is divided into section (n , level), box (l , sublevel), row (m_l , orbital), and seat (m_s , spin). Only one person (electron) can have this particular set of stadium “quantum numbers.” While many people can occupy the same section, box, and row in the stadium, only one person can occupy a particular seat.

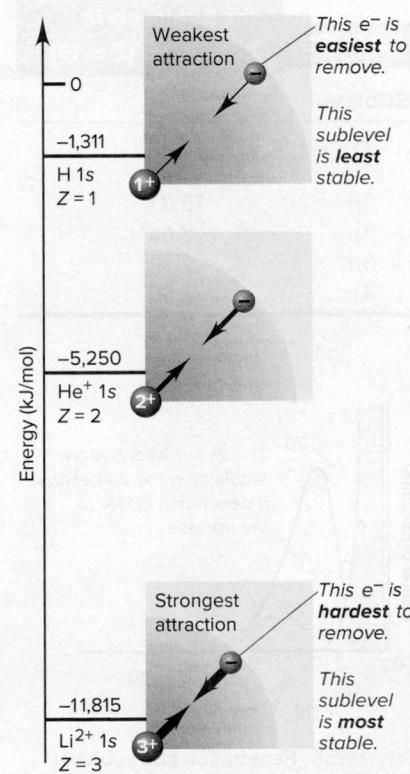

Figure 8.3 The effect of nuclear charge on sublevel energy. Greater nuclear charge lowers sublevel energy (to a more negative number), which makes the electron harder to remove. (The strength of attraction is indicated by the thickness of the black arrows.)

Figure 8.4 Shielding and energy levels.

A. Within an energy level, each electron shields (red arrows) other electrons from the full nuclear charge (black arrows), so they experience a lower Z_{eff} . **B.** Inner electrons shield outer electrons much more effectively than electrons in the same energy level shield each other.

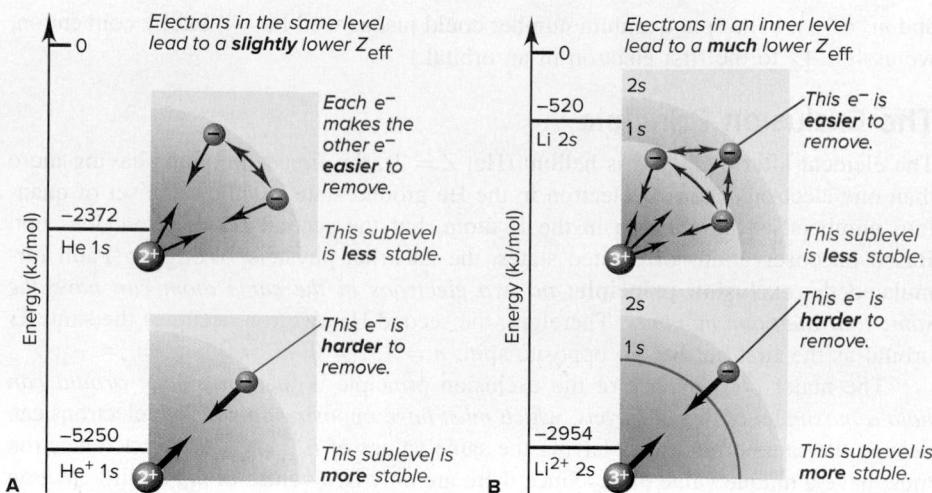

1. *Shielding by other electrons in a given energy level.* Electrons in the *same* energy level shield each other somewhat. Compare the He atom and He^+ ion: both have a $2+$ nuclear charge, but He has two electrons in the $1s$ sublevel and He^+ has only one (Figure 8.4A). It takes less than half as much energy to remove an electron from He (2372 kJ/mol) than from He^+ (5250 kJ/mol) because the second electron in He repels the first, in effect causing a lower Z_{eff} .

2. *Shielding by electrons in inner energy levels.* Because inner electrons spend nearly all their time *between* the outer electrons and the nucleus, they cause a *much* lower Z_{eff} than do electrons in the same level. We can see this by comparing two atomic systems with the same nucleus, one *with* inner electrons and the other *without*. The ground-state Li atom has two inner ($1s$) electrons and one outer ($2s$) electron, while the Li^{2+} ion has only one electron, which occupies the $2s$ orbital in the first excited state (Figure 8.4B). It takes about one-sixth as much energy to remove the $2s$ electron from the Li atom (520 kJ/mol) as it takes to remove it from the Li^{2+} ion (2954 kJ/mol), because the *inner electrons shield very effectively*.

Table 8.2 lists the values of Z_{eff} for the electrons in a potassium atom. Although K ($Z = 19$) has a nuclear charge of $19+$, all of its electrons have $Z_{\text{eff}} < 19$. The two innermost ($1s$) electrons have a slightly lower Z_{eff} of 18.49 because they shield each other. The outermost ($4s$) electron has a significantly lower Z_{eff} of 3.50, as a result of the effective shielding by the 18 inner electrons.

Table 8.2 Values of Z_{eff} for the Sublevels in Potassium ($Z = 19$)

Sublevel	Z_{eff}
$1s$	18.49
$2s$	13.01
$2p$	15.03
$3s$	8.68
$3p$	7.73
$4s$	3.50

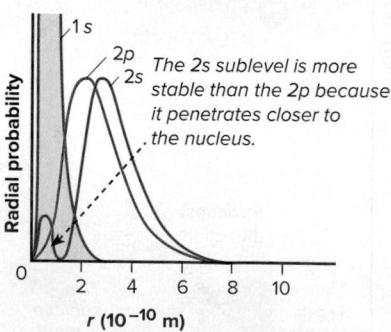**Figure 8.5** Penetration and sublevel energy.

Penetration: The Effect of Orbital Shape on Sublevel Energy To see why the third Li electron occupies the $2s$ sublevel rather than the $2p$, we have to consider orbital shapes, that is, radial probability distributions (Figure 8.5). A $2p$ orbital (orange curve) is slightly closer to the nucleus, on average, than the major portion of the $2s$ orbital (blue curve). But a small portion of the $2s$ radial probability distribution peaks within the $1s$ region. Thus, an electron in the $2s$ orbital spends part of its time “penetrating” very close to the nucleus. **Penetration** has two effects:

- It *increases the nuclear attraction* for a $2s$ electron over that for a $2p$ electron.
- It *decreases the shielding* of a $2s$ electron by the $1s$ electrons.

Thus, since it takes more energy to remove a $2s$ electron (520 kJ/mol) than a $2p$ (341 kJ/mol), the $2s$ sublevel is lower in energy than the $2p$.

Splitting of Levels into Sublevels In general, *penetration and the resulting effects on shielding split an energy level into sublevels of differing energy*. The lower the l value of a sublevel, the more its electrons penetrate, and so the greater their attraction to the nucleus. Therefore, *for a given n value, a lower l value indicates a more stable (lower energy) sublevel*:

Order of sublevel energies: $s < p < d < f$

(8.1)

Thus, the 2s ($l = 0$) is lower in energy than the 2p ($l = 1$), the 3p ($l = 1$) is lower than the 3d ($l = 2$), and so forth.

Figure 8.6 shows the general energy order of levels (n value) and how they are split into sublevels (l values) of differing energies. (Compare this with the H atom energy levels in Figure 7.21.) Next, we'll use this energy order to construct a periodic table of ground-state atoms.

› Summary of Section 8.1

- › Identifying electrons in many-electron atoms requires four quantum numbers: three (n, l, m_l) describe the orbital, and a fourth (m_s) describes the electron's spin.
- › The exclusion principle requires each electron to have a unique set of four quantum numbers; therefore, an orbital can hold no more than two electrons, and their spins must be paired (opposite).
- › Electrostatic interactions determine sublevel energies as follows:
 1. Greater nuclear charge lowers sublevel energy, making electrons harder to remove.
 2. Electron-electron repulsions raise sublevel energy, making electrons easier to remove. Repulsions shield electrons from the full nuclear charge, reducing it to an effective nuclear charge, Z_{eff} . Inner electrons shield outer electrons very effectively.
 3. Penetration makes an electron harder to remove because nuclear attraction increases and shielding decreases. As a result, an energy level is split into sublevels with the energy order $s < p < d < f$.

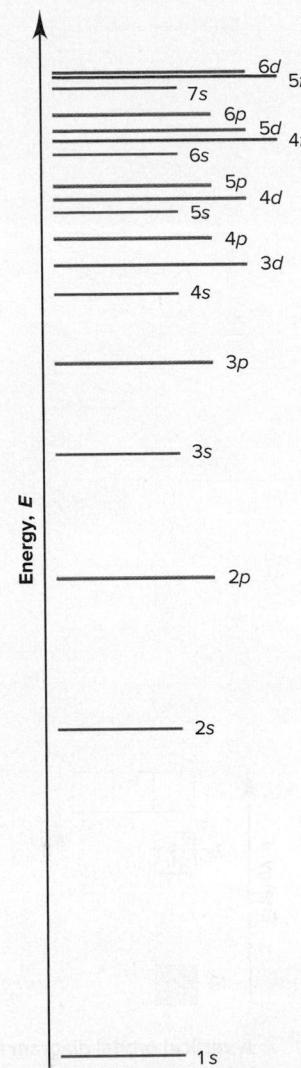

8.2 THE QUANTUM-MECHANICAL MODEL AND THE PERIODIC TABLE

Quantum mechanics provides the theoretical foundation for the experimentally based periodic table. In this section, we fill the table by determining the *ground-state* electron configuration of each element—the *lowest energy distribution of electrons in the sublevels of its atoms*. Note especially the *recurring pattern in electron configurations, which is the basis for recurring patterns in chemical behavior*.

A useful way to determine electron configurations is based on the **aufbau principle** (German *aufbauen*, “to build up”). We start at the beginning of the periodic table and add one proton to the nucleus and one electron to the *lowest energy sublevel available*. (Of course, one or more neutrons are also added to the nucleus.)

There are two common ways to indicate the distribution of electrons in the sublevels:

- **The electron configuration.** This shorthand notation consists of the principal energy level (n value), the letter designation of the sublevel (l value), and the number of electrons (#) in the sublevel, written as a superscript:

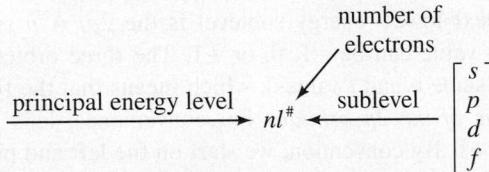

- **The orbital diagram.** An **orbital diagram** consists of a box (or just a line) for each orbital in a given energy level, grouped by sublevel (with nl designation shown beneath), with an arrow representing each electron and its spin: \uparrow is $+\frac{1}{2}$ and \downarrow is $-\frac{1}{2}$. (Throughout the text, orbital occupancy is also indicated by color intensity: no color is empty, pale color is half-filled, and full color is filled.)

Figure 8.6 Order for filling energy sublevels with electrons. In general, energies of sublevels increase with the principal quantum number n ($1 < 2 < 3$, etc.) and the angular momentum quantum number l ($s < p < d < f$). As n increases, some sublevels overlap; for example, the 4s sublevel is lower in energy than the 3d. (The color of each line indicates the sublevel type.)

Building Up Period 1

Let's begin by applying the aufbau principle to Period 1, whose ground-state elements have only the $n = 1$ level and, thus, only the 1s sublevel, which consists of only the 1s orbital. We'll also assign a set of four quantum numbers to each element's *last added* electron.

1. *Hydrogen.* For the electron in H, as you've seen, the set of quantum numbers is H ($Z = 1$): $n = 1$, $l = 0$, $m_l = 0$, $m_s = +\frac{1}{2}$. The electron configuration (spoken "one-ess-one") and orbital diagram are

2. *Helium.* Recall that the first electron in He has the same quantum numbers as the electron in H, but the second He electron has opposing spin (exclusion principle), giving He ($Z = 2$): $n = 1$, $l = 0$, $m_l = 0$, $m_s = -\frac{1}{2}$. The electron configuration (spoken "one-ess-two," *not* "one-ess-squared") and orbital diagram are

Building Up Period 2

The exclusion principle says an orbital can hold no more than two electrons. Therefore, in He, the 1s orbital, the 1s sublevel, the $n = 1$ level, and Period 1 are filled. Filling the $n = 2$ level builds up Period 2 and begins with the 2s sublevel, which is the next lowest in energy (see Figure 8.6) and consists of only the 2s orbital. When the 2s sublevel is filled, we proceed to fill the 2p orbital.

1. *Lithium.* The first two electrons in Li fill the 1s sublevel, so the last added Li electron enters the 2s sublevel and has quantum numbers $n = 2$, $l = 0$, $m_l = 0$, $m_s = +\frac{1}{2}$. The electron configuration and orbital diagram are

Figure 8.7 A vertical orbital diagram for the Li ground state.

(Note that a complete orbital diagram shows all the orbitals for the given n value, whether or not they are occupied.) To save space on a page, orbital diagrams are written horizontally, with the *sublevel energy increasing left to right*. But Figure 8.7 highlights the energy increase with a vertical orbital diagram for lithium.

2. *Beryllium.* The 2s orbital is only half-filled in Li, so the fourth electron of beryllium fills it with the electron's spin paired: $n = 2$, $l = 0$, $m_l = 0$, $m_s = -\frac{1}{2}$.

3. *Boron.* The next lowest energy sublevel is the 2p. A p sublevel has $l = 1$, so the m_l (orientation) value can be -1 , 0 , or $+1$. The three orbitals in the 2p sublevel have *equal energy* (same n and l values), which means that the fifth electron of boron can go into *any one of the 2p orbitals*. For convenience, let's label the boxes from left to right: -1 , 0 , $+1$. By convention, we start on the left and place the fifth electron in the $m_l = -1$ orbital: $n = 2$, $l = 1$, $m_l = -1$, $m_s = +\frac{1}{2}$.

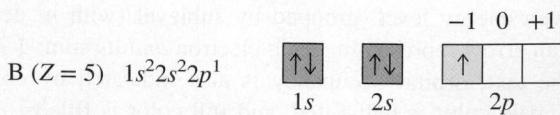

4. *Carbon.* To minimize electron-electron repulsions, the sixth electron of carbon enters one of the *unoccupied* 2p orbitals rather than the 2p orbital that already holds one electron; by convention, we place it in the $m_l = 0$ orbital. Experiment shows that the spin of this electron is *parallel* to (the same as) the spin of the other 2p electron. This fact exemplifies **Hund's rule:** *when orbitals of equal energy are available, the electron configuration of lowest energy has the maximum number of unpaired electrons*

with parallel spins. Thus, the sixth electron of carbon has $n = 2$, $l = 1$, $m_l = 0$ and $m_s = +\frac{1}{2}$.

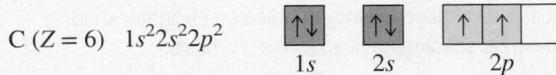

5. *Nitrogen*. Based on Hund's rule, nitrogen's seventh electron enters the last empty $2p$ orbital, with its spin parallel to the other two: $n = 2$, $l = 1$, $m_l = +1$, $m_s = +\frac{1}{2}$.

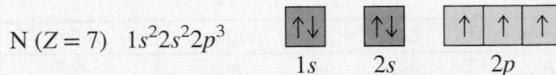

6. *Oxygen*. The eighth electron in oxygen must enter one of the three half-filled $2p$ orbitals and "pair up" with (oppose the spin of) the electron already there. We place the electron in the first half-filled $2p$ orbital: $n = 2$, $l = 1$, $m_l = -1$, $m_s = -\frac{1}{2}$.

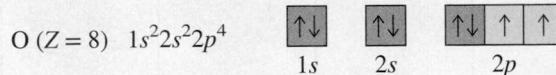

7. *Fluorine*. Fluorine's ninth electron enters the next of the two remaining half-filled $2p$ orbitals: $n = 2$, $l = 1$, $m_l = 0$, $m_s = -\frac{1}{2}$.

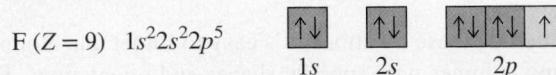

8. *Neon*. Only one half-filled $2p$ orbital remains, so the tenth electron of neon occupies it: $n = 2$, $l = 1$, $m_l = +1$, $m_s = -\frac{1}{2}$. With neon, the $n = 2$ level is filled.

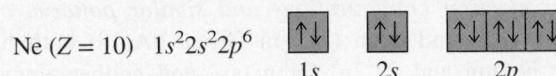

SAMPLE PROBLEM 8.1

Correlating Quantum Numbers and Orbital Diagrams

Problem Use the orbital diagram for fluorine (shown above) to write sets of quantum numbers for the third and eighth electrons of the F atom.

Plan Referring to the orbital diagram, we identify the electron of interest and note its level (n), sublevel (l), orbital (m_l), and spin (m_s).

Solution The orbital diagram of fluorine is shown below with the electrons of interest in red:

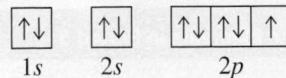

The third electron is in the $2s$ orbital. Recall that $l = 0$ for an s orbital. The upward arrow indicates a spin of $+\frac{1}{2}$:

$$n = 2, l = 0, m_l = 0, m_s = +\frac{1}{2}$$

The eighth electron is in the first $2p$ orbital ($l = 1$ for a p orbital), which is designated $m_l = -1$, and is represented by a downward arrow because it was the second electron added to that $2p$ orbital:

$$n = 2, l = 1, m_l = -1, m_s = -\frac{1}{2}$$

FOLLOW-UP PROBLEMS

Brief Solutions for all Follow-up Problems appear at the end of the chapter.

8.1A Use the periodic table to identify the element with the electron configuration $1s^2 2s^2 2p^4$. Write its orbital diagram and the set of quantum numbers for its sixth electron.

8.1B The last electron added to an atom has the following set of quantum numbers: $n = 2$, $l = 1$, $m_l = 0$, $m_s = +\frac{1}{2}$. Identify the element, and write its electron configuration and orbital diagram.

SOME SIMILAR PROBLEMS 8.21(a), 8.22(a), and 8.22(d)

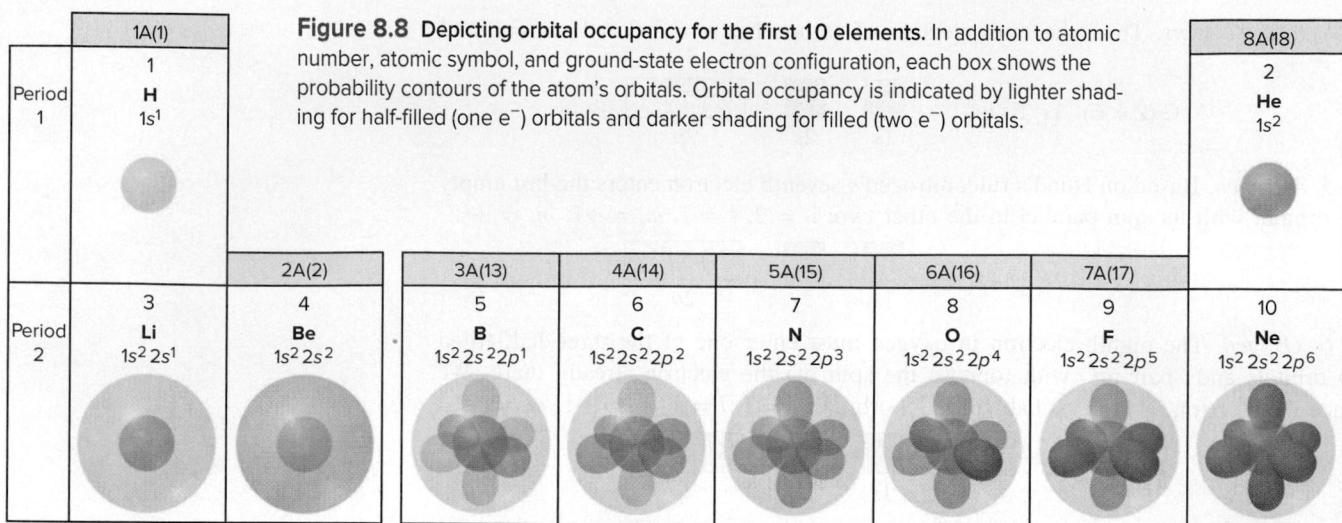

With our attention on these notations, it's easy to forget that atoms are real objects and electrons occupy volumes with specific shapes and orientations. Figure 8.8 shows orbital contours for the first 10 elements arranged in periodic table format.

At this point, we can make an important correlation: *elements in the same group have similar outer electron configurations and similar patterns of reactivity*. As an example, helium (He) and neon (Ne) in Group 8A(18) both have filled outer sublevels— $1s^2$ for helium and $2s^2 2p^6$ for neon—and neither element forms compounds. In general, we find that filled outer sublevels make elements much more stable and unreactive.

Building Up Period 3

The Period 3 elements, Na through Ar, lie directly under the Period 2 elements, Li through Ne. That is, even though the $n = 3$ level splits into $3s$, $3p$, and $3d$ sublevels, Period 3 fills only $3s$ and $3p$; as you'll see shortly, the $3d$ is filled in Period 4. Table 8.3

Table 8.3 Partial Orbital Diagrams and Electron Configurations* for the Elements in Period 3

Atomic Number	Element	Partial Orbital Diagram ($3s$ and $3p$ Sublevels Only)	Full Electron Configuration	Condensed Electron Configuration
11	Na		$[1s^2 2s^2 2p^6] 3s^1$	[Ne] $3s^1$
12	Mg		$[1s^2 2s^2 2p^6] 3s^2$	[Ne] $3s^2$
13	Al		$[1s^2 2s^2 2p^6] 3s^2 3p^1$	[Ne] $3s^2 3p^1$
14	Si		$[1s^2 2s^2 2p^6] 3s^2 3p^2$	[Ne] $3s^2 3p^2$
15	P		$[1s^2 2s^2 2p^6] 3s^2 3p^3$	[Ne] $3s^2 3p^3$
16	S		$[1s^2 2s^2 2p^6] 3s^2 3p^4$	[Ne] $3s^2 3p^4$
17	Cl		$[1s^2 2s^2 2p^6] 3s^2 3p^5$	[Ne] $3s^2 3p^5$
18	Ar		$[1s^2 2s^2 2p^6] 3s^2 3p^6$	[Ne] $3s^2 3p^6$

*Colored type indicates the sublevel to which the last electron has been added.

introduces two ways to present electron distributions more concisely:

- *Partial orbital diagrams* show only the sublevels being filled, here the $3s$ and $3p$.
- *Condensed electron configurations* (rightmost column) have the element symbol of the noble gas from the previous row in brackets, to represent its configuration, followed by the electron configuration of filled inner sublevels and the energy level being filled. For example, the condensed electron configuration of sulfur is $[\text{Ne}] 3s^2 3p^4$, where $[\text{Ne}]$ stands for $1s^2 2s^2 2p^6$.

In Na (the second alkali metal) and Mg (the second alkaline earth metal), electrons are added to the $3s$ sublevel, which contains only the $3s$ orbital; this is directly comparable to the filling of the $2s$ sublevel in Li and Be in Period 2. Then, in the same way as the $2p$ orbitals of B, C, and N in Period 2 are half-filled, the last electrons added to Al, Si, and P in Period 3 half-fill successive $3p$ orbitals with spins parallel (Hund's rule). The last electrons added to S, Cl, and Ar then successively pair up to fill those $3p$ orbitals, and thus the $3p$ sublevel.

Building Up Period 4: The First Transition Series

Period 4 contains the first series of **transition elements**, those in which d orbitals are being filled. Let's examine three factors that affect the filling pattern in a period with a transition series; we focus on Period 4, but similar effects occur in Periods 5–7.

1. *Effects of shielding and penetration on sublevel energy.* The $3d$ sublevel is filled in Period 4, but the $4s$ sublevel is filled first. This switch in filling order is due to shielding and penetration effects. Based on the $3d$ radial probability distribution (see Figure 7.19), a $3d$ electron spends most of the time outside the filled inner $n = 1$ and $n = 2$ levels, so it is shielded very effectively from the nuclear charge. However, the outermost $4s$ electron penetrates close to the nucleus part of the time, so it is subject to a greater attraction. As a result, the $4s$ orbital is slightly *lower* in energy than the $3d$ and fills first. In any period, *the ns sublevel fills before the $(n - 1)d$ sublevel*. Other variations in the filling pattern occur at higher values of n because sublevel energies become very close together (see Figure 8.6).

2. *Filling the 4s and 3d sublevels.* Table 8.4 on the next page shows the partial orbital diagrams and full and condensed electron configurations for the 18 elements in Period 4. The first two elements, K and Ca, are the next alkali and alkaline earth metals, respectively; the last electron of K half-fills and that of Ca fills the $4s$ sublevel. The last electron of scandium (Sc; $Z = 21$), the first transition element, occupies any one of the five $3d$ orbitals because they are equal in energy; Sc has the electron configuration $[\text{Ar}] 4s^2 3d^1$. Filling of the $3d$ orbitals proceeds one electron at a time, as with the p orbitals, except in two cases, chromium (Cr; $Z = 24$) and copper (Cu; $Z = 29$), discussed next.

3. *Stability of half-filled and filled sublevels.* Vanadium (V ; $Z = 23$) has three half-filled d orbitals ($[\text{Ar}] 4s^2 3d^3$). However, the last electron of the next element, Cr, does not enter a fourth empty d orbital to give $[\text{Ar}] 4s^2 3d^4$; instead, Cr has one electron in the $4s$ sublevel and five in the $3d$ sublevel, making both sublevels half-filled: $[\text{Ar}] 4s^1 3d^5$. In the next element, manganese (Mn ; $Z = 25$), the $4s$ sublevel is filled again ($[\text{Ar}] 4s^2 3d^5$).

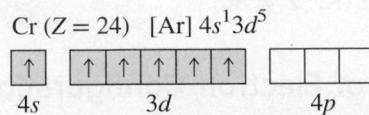

Because it follows nickel (Ni ; $[\text{Ar}] 4s^2 3d^8$), copper would be expected to have the configuration $[\text{Ar}] 4s^2 3d^9$. Instead, the $4s$ sublevel of Cu is *half-filled* with 1 electron,

Table 8.4 Partial Orbital Diagrams and Electron Configurations* for the Elements in Period 4

Atomic Number	Element	Partial Orbital Diagram (4s, 3d, and 4p Sublevels Only)	Full Electron Configuration	Condensed Electron Configuration	
19	K	4s ↑	3d 	4p 	$1s^2 2s^2 2p^6 3s^2 3p^6 4s^1$ [Ar] $4s^1$
20	Ca	4s ↑↓	3d 	4p 	$1s^2 2s^2 2p^6 3s^2 3p^6 4s^2$ [Ar] $4s^2$
21	Sc	4s ↑↓	3d ↑	4p 	$1s^2 2s^2 2p^6 3s^2 3p^6 4s^2 3d^1$ [Ar] $4s^2 3d^1$
22	Ti	4s ↑↓	3d ↑↑	4p 	$1s^2 2s^2 2p^6 3s^2 3p^6 4s^2 3d^2$ [Ar] $4s^2 3d^2$
23	V	4s ↑↓	3d ↑↑↑	4p 	$1s^2 2s^2 2p^6 3s^2 3p^6 4s^2 3d^3$ [Ar] $4s^2 3d^3$
24	Cr	4s ↑	3d ↑↑↑↑↑	4p 	$1s^2 2s^2 2p^6 3s^2 3p^6 4s^1 3d^5$ [Ar] $4s^1 3d^5$
25	Mn	4s ↑↓	3d ↑↑↑↑↑	4p 	$1s^2 2s^2 2p^6 3s^2 3p^6 4s^2 3d^5$ [Ar] $4s^2 3d^5$
26	Fe	4s ↑↓	3d ↑↑↑↑↑	4p 	$1s^2 2s^2 2p^6 3s^2 3p^6 4s^2 3d^6$ [Ar] $4s^2 3d^6$
27	Co	4s ↑↓	3d ↑↓↑↑↑	4p 	$1s^2 2s^2 2p^6 3s^2 3p^6 4s^2 3d^7$ [Ar] $4s^2 3d^7$
28	Ni	4s ↑↓	3d ↑↓↑↓↑↓↑	4p 	$1s^2 2s^2 2p^6 3s^2 3p^6 4s^2 3d^8$ [Ar] $4s^2 3d^8$
29	Cu	4s ↑	3d ↑↓↑↓↑↓↑↓	4p 	$1s^2 2s^2 2p^6 3s^2 3p^6 4s^1 3d^{10}$ [Ar] $4s^1 3d^{10}$
30	Zn	4s ↑↓	3d ↑↓↑↓↑↓↑↓↑	4p 	$1s^2 2s^2 2p^6 3s^2 3p^6 4s^2 3d^{10}$ [Ar] $4s^2 3d^{10}$
31	Ga	4s ↑↓	3d ↑↓↑↓↑↓↑↓↑↓	4p ↑	$1s^2 2s^2 2p^6 3s^2 3p^6 4s^2 3d^{10} 4p^1$ [Ar] $4s^2 3d^{10} 4p^1$
32	Ge	4s ↑↓	3d ↑↓↑↓↑↓↑↓↑↓	4p ↑↑	$1s^2 2s^2 2p^6 3s^2 3p^6 4s^2 3d^{10} 4p^2$ [Ar] $4s^2 3d^{10} 4p^2$
33	As	4s ↑↓	3d ↑↓↑↓↑↓↑↓↑↓	4p ↑↑↑	$1s^2 2s^2 2p^6 3s^2 3p^6 4s^2 3d^{10} 4p^3$ [Ar] $4s^2 3d^{10} 4p^3$
34	Se	4s ↑↓	3d ↑↓↑↓↑↓↑↓↑↓	4p ↑↓↑↑↑	$1s^2 2s^2 2p^6 3s^2 3p^6 4s^2 3d^{10} 4p^4$ [Ar] $4s^2 3d^{10} 4p^4$
35	Br	4s ↑↓	3d ↑↓↑↓↑↓↑↓↑↓	4p ↑↓↑↓↑	$1s^2 2s^2 2p^6 3s^2 3p^6 4s^2 3d^{10} 4p^5$ [Ar] $4s^2 3d^{10} 4p^5$
36	Kr	4s ↑↓	3d ↑↓↑↓↑↓↑↓↑↓	4p ↑↓↑↓↑↓	$1s^2 2s^2 2p^6 3s^2 3p^6 4s^2 3d^{10} 4p^6$ [Ar] $4s^2 3d^{10} 4p^6$

*Colored type indicates sublevel(s) whose occupancy changes when the last electron is added.

and the 3d sublevel is *filled* with 10. From these two exceptions, Cr and Cu, we conclude that *half-filled and filled sublevels are unexpectedly stable (low in energy)*; we see this pattern with many other elements.

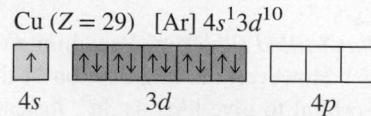

With zinc (Zn; Z = 30), the 4s sublevel is filled ($[\text{Ar}] 4s^2 3d^{10}$), and the first transition series ends. The 4p sublevel is filled in the next six elements, and Period 4 ends with the noble gas krypton (Kr; Z = 36).

General Principles of Electron Configurations

Figure 8.9 shows the partial (just the highest energy sublevels being filled) ground-state electron configurations of the 118 known elements. Let's highlight some key relationships among them.

Period number: highest occupied energy level

Main-Group Elements (s block)		Transition Elements (d block)																		Main-Group Elements (p block)																																																																					
1 A (1)	2 A (2)	Transition Elements (d block)										8 A (18)																																																																													
ns ¹	ns ²											ns ^{2np} ⁶																																																																													
1 H 1s ¹	2 Be 2s ²	3 Li 2s ¹	4 Be 2s ²	5 B 3s ¹	6 C 3s ²	7 N 3s ¹	8 O 3s ²	9 F 3s ²	10 Ne 1s ²	11 Na 3s ¹	12 Mg 3s ²	13 Al 3s ² p ¹	14 Si 3s ² p ²	15 P 3s ² p ³	16 S 3s ² p ⁴	17 Cl 3s ² p ⁵	18 Ar 3s ² p ⁶	19 K 4s ¹	20 Ca 4s ²	21 Sc 4s ² 3d ¹	22 Ti 4s ² 3d ²	23 V 4s ² 3d ³	24 Cr 4s ¹ 3d ⁵	25 Mn 4s ² 3d ⁵	26 Fe 4s ² 3d ⁶	27 Co 4s ² 3d ⁷	28 Ni 4s ² 3d ⁸	29 Cu 4s ¹ 3d ¹⁰	30 Zn 4s ² 3d ¹⁰	31 Ga 4s ² 4p ¹	32 Ge 4s ² 4p ²	33 As 4s ² 4p ³	34 Se 4s ² 4p ⁴	35 Br 4s ² 4p ⁵	36 Kr 4s ² 4p ⁶	37 Rb 5s ¹	38 Sr 5s ²	39 Y 5s ² 4d ¹	40 Zr 5s ² 4d ²	41 Nb 5s ¹ 4d ⁴	42 Mo 5s ¹ 4d ⁵	43 Tc 5s ² 4d ⁵	44 Ru 5s ¹ 4d ⁷	45 Rh 5s ¹ 4d ⁸	46 Pd 4d ¹⁰	47 Ag 5s ¹ 4d ¹⁰	48 Cd 5s ² 4d ¹⁰	49 In 5s ² 5p ¹	50 Sn 5s ² 5p ²	51 Sb 5s ² 5p ³	52 Te 5s ² 5p ⁴	53 I 5s ² 5p ⁵	54 Xe 5s ² 5p ⁶	55 Cs 6s ¹	56 Ba 6s ²	57 La 6s ² 5d ¹	72 Hf 6s ² 5d ²	73 Ta 6s ² 5d ³	74 W 6s ² 5d ⁴	75 Re 6s ² 5d ⁵	76 Os 6s ² 5d ⁶	77 Ir 6s ² 5d ⁷	78 Pt 6s ¹ 5d ⁹	79 Au 6s ¹ 5d ¹⁰	80 Hg 6s ² 6p ¹	81 Tl 6s ² 6p ²	82 Pb 6s ² 6p ³	83 Bi 6s ² 6p ⁴	84 Po 6s ² 6p ⁵	85 At 6s ² 6p ⁶	86 Rn 6s ² 6p ⁶	87 Fr 7s ¹	88 Ra 7s ²	89 Ac 7s ² 6d ¹	104 Rf 7s ² 6d ²	105 Db 7s ² 6d ³	106 Sg 7s ² 6d ⁴	107 Bh 7s ² 6d ⁵	108 Hs 7s ² 6d ⁶	109 Mt 7s ² 6d ⁷	110 Ds 7s ² 6d ⁸	111 Rg 7s ² 6d ⁹	112 Cn 7s ² 6d ¹⁰	113 Nh 7s ² 7p ¹	114 Fl 7s ² 7p ²	115 Mc 7s ² 7p ³	116 Lv 7s ² 7p ⁴	117 Ts 7s ² 7p ⁵	118 Og 7s ² 7p ⁶
Inner Transition Elements (f block)																																																																																									
6	Lanthanides	58 Ce 6s ² 4f ¹ 5d ¹	59 Pr 6s ² 4f ³	60 Nd 6s ² 4f ⁴	61 Pm 6s ² 4f ⁵	62 Sm 6s ² 4f ⁶	63 Eu 6s ² 4f ⁷	64 Gd 6s ² 4f ⁹	65 Tb 6s ² 4f ¹⁰	66 Dy 6s ² 4f ¹¹	67 Ho 6s ² 4f ¹²	68 Er 6s ² 4f ¹³	69 Tm 6s ² 4f ¹⁴	70 Yb 6s ² 4f ¹⁴ 6d ¹	71 Lu 6s ² 4f ¹⁴ 6d ¹	7	Actinides	90 Th 7s ² 6d ²	91 Pa 7s ² f ² 6d ¹	92 U 7s ² f ³ 6d ¹	93 Np 7s ² f ⁴ 6d ¹	94 Pu 7s ² f ⁶	95 Am 7s ² f ⁷	96 Cm 7s ² f ⁷	97 Bk 7s ² f ⁹	98 Cf 7s ² f ¹⁰	99 Es 7s ² f ¹¹	100 Fm 7s ² f ¹²	101 Md 7s ² f ¹³	102 No 7s ² f ¹⁴	103 Lr 7s ² f ¹⁴ 6d ¹																																																										

Orbital Filling Order When the elements are “built up” by filling levels and sublevels in order of increasing energy, we obtain the sequence in the periodic table. Reading the table from left to right, like words on a page, gives the energy order of levels and sublevels (Figure 8.10); this is the same energy order illustrated in Figure 8.6. A

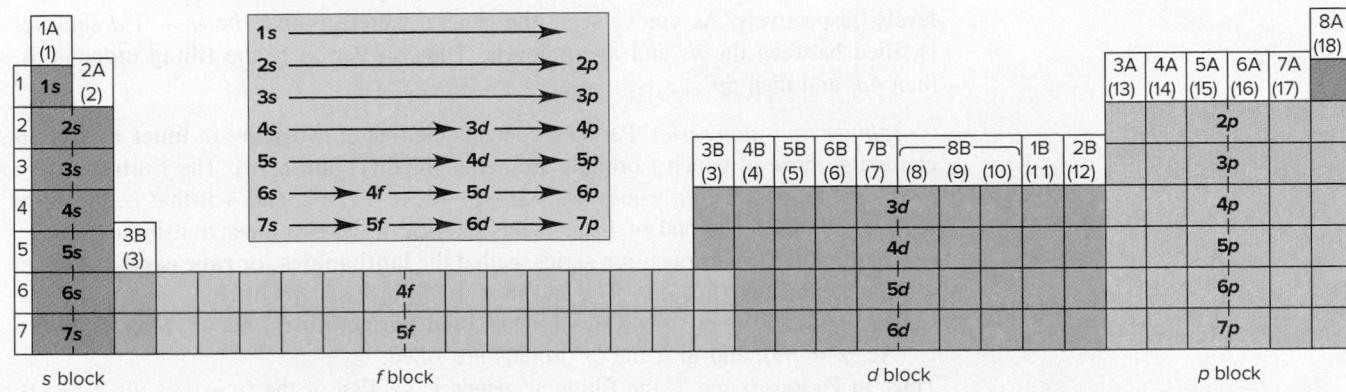

Figure 8.10 Orbital filling and the periodic table. This form of the periodic table shows the sublevel blocks. Pale green inset: A summary of the sublevel filling order.

Aid to Memorizing Sublevel Filling Order

List the sublevels as shown, and read from 1s, following the direction of the arrows. Note that the

- n value is constant horizontally,
- l value is constant vertically, and
- $n + l$ is constant diagonally.

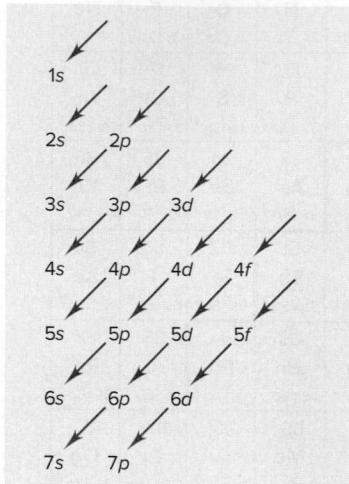

memory aid for recalling sublevel filling order when a periodic table is not available is provided in the margin note. ↗

Categories of Electrons Atoms have three categories of electrons; the electron configurations of P, Mn, and Te will be used to show examples of each category:

1. **Inner (core) electrons** are those an atom has in common with the previous noble gas and any completed transition series. They fill all the *lower energy levels* of an atom.

2. **Outer electrons** are those in the *highest energy level* (highest n value). They spend most of their time farthest from the nucleus.

3. **Valence electrons** are those involved in forming compounds:

- For main-group elements, the *valence electrons are the outer electrons*.
- For transition elements, in addition to the outer ns electrons, the $(n - 1)d$ electrons are also valence electrons, though the metals Fe ($Z = 26$) through Zn ($Z = 30$) may use only a few, if any, of their d electrons in bonding.

Group and Period Numbers Key information is embedded in the periodic table:

- Among the main-group elements (A groups), the *A number equals the number of outer electrons* (those with the highest n); thus, chlorine (Cl; Group 7A) has 7 outer electrons, and so forth.
- *The period number is the n value of the outermost s and p sublevels. The period number – 1 is the n value of the outermost d sublevel (Periods 4 – 7). The period number – 2 is the n value of the outermost f sublevel (Periods 6 and 7).*
- For an energy level, the n value squared (n^2) is the number of *orbitals*, and $2n^2$ is the maximum number of *electrons* (or elements). For example, consider the $n = 3$ level:
Number of orbitals: $n^2 = 3^2 = 9$: one 3s, three 3p, and five 3d.
Number of electrons: $2n^2 = 2(3^2) = 18$: two 3s and six 3p electrons for the eight elements of Period 3, and ten 3d electrons for the ten transition elements of Period 4.

Intervening Series: Transition and Inner Transition Elements

As Figure 8.10 shows, the *d* block and *f* block occur between the main-group *s* and *p* blocks.

1. *Transition series.* Periods 4, 5, 6, and 7 incorporate the $3d$, $4d$, $5d$, and $6d$ sublevels, respectively. As you've seen, the general pattern is that the $(n - 1)d$ sublevel is filled between the ns and np sublevels. Thus, in Period 5, the filling order is $5s$, then $4d$, and then $5p$.

2. *Inner transition series.* Period 6 contains the first of two series of **inner transition elements**, those in which *f* orbitals are being filled (Figure 8.10). The *f* orbitals have $l = 3$, so the possible m_l values are $-3, -2, -1, 0, +1, +2$, and $+3$; that is, there are seven *f* orbitals, for a total of 14 elements in *each* of the two inner transition series:

- The Period 6 inner transition series, called the **lanthanides** (or **rare earths**), occurs after lanthanum (La; $Z = 57$), and in it the $4f$ orbitals are filled.
- The Period 7 inner transition series, called the **actinides**, occurs after actinium (Ac; $Z = 89$), and in it the $5f$ orbitals are filled.

Thus, in Periods 6 and 7, the filling sequence is ns , first of the $(n - 1)d$, all $(n - 2)f$, remainder of the $(n - 1)d$, and np . Period 6 ends with the $6p$ sublevel, and Period 7 ends with the $7p$ sublevel.

3. Irregular filling patterns. Irregularities in the filling pattern, such as those for Cr and Cu in Period 4, occur in the *d* and *f* blocks because the sublevel energies in these larger atoms differ very little. Even though occasional deviations occur in the *d* block, the sum of *ns* electrons and $(n - 1)d$ electrons always equals the new group number (in parentheses). For instance, despite variations in Group 6B(6)—Cr, Mo, W, and Sg—the sum of *ns* and $(n - 1)d$ electrons is 6; for Group 8B(10)—Ni, Pd, Pt, and Ds—the sum is 10.

In summary, we will use the following guidelines to write the electron configuration of any element, keeping in mind that deviations do occur:

- Place each successive electron in the next available orbital of lowest possible energy; the order of filling is shown in Figures 8.6 and 8.10.
- Each orbital holds a maximum of two electrons:
The one *s* orbital in a sublevel can hold two electrons (s^2).
The three orbitals in a *p* sublevel can hold a total of six electrons (p^6).
The five orbitals in a *d* sublevel can hold a total of ten electrons (d^{10}).
The seven orbitals in an *f* sublevel can hold a total of fourteen electrons (f^{14}).
- Electrons will not pair in a set of equal energy orbitals if an empty orbital is available (Hund's rule).

Similar Electron Configurations Within Groups

As shown in Figure 8.9, there is similarity in outer electron configuration within a group of elements. Among the main-group elements (A groups)—the *s*-block and *p*-block elements—outer electron configurations within a group are identical. Some variations do occur in the transition elements (B groups, *d* block) and inner transition elements (*f* block). One of the central points in chemistry is that *similar outer electron configurations correlate with similar chemical behavior*. Here are examples from three of the groups:

- The Group 1A(1) elements, Li, Na, K, Rb, Cs, and Fr, have the outer electron configuration ns^1 (where *n* is the quantum number of the highest energy level). All are highly reactive metals whose atoms lose the outer electron when they form ionic compounds with nonmetals, and all react vigorously with water to displace H₂ (Figure 8.11A).
- The Group 7A(17) elements, F, Cl, Br, I, and At, have the outer electron configuration ns^2np^5 . All are reactive nonmetals that occur as diatomic molecules (X₂), and all form ionic compounds with metals (KX, MgX₂) in which their ionic charge is 1– (Figure 8.11B), covalent compounds with hydrogen (HX) that yield acidic solutions in water, and covalent compounds with carbon (CX₄).
- In Group 8A(18), He has the electron configuration ns^2 , and all the other elements in the group have the outer configuration ns^2np^6 . Consistent with their *filled* energy levels, all the members are very unreactive monatomic gases.

Figure 8.11 Similar reactivities in a group. **A**, Potassium reacting with water. **B**, Chlorine reacting with potassium.
Source: © McGraw-Hill Education/Stephen Frisch, photographer

Student Hot Spot

Student data indicate that you may struggle with writing electron configurations. Access the SmartBook to view additional Learning Resources on this topic.

To summarize the major connection between quantum mechanics and chemical periodicity: *sublevels are filled in order of increasing energy, which leads to outer electron configurations that recur periodically, leading to chemical properties that recur periodically.*

SAMPLE PROBLEM 8.2**Determining Electron Configurations**

Problem Using only the periodic table (not Figure 8.9 or Table 8.4) and assuming a regular filling pattern, give the full and condensed electron configurations, partial orbital diagram showing valence electrons only, and number of inner electrons for the following elements:

- (a) Potassium (K; Z = 19) (b) Technetium (Tc; Z = 43) (c) Lead (Pb; Z = 82)

Plan The atomic number tells us the number of electrons, and the periodic table shows the order for filling sublevels. In the partial orbital diagrams, we include all electrons added after the previous noble gas *except* those in *filled* inner sublevels. The number of inner electrons is the sum of those in the previous noble gas and in filled *d* and *f* sublevels.

Solution (a) For K (Z = 19), the full electron configuration is $1s^2 2s^2 2p^6 3s^2 3p^6 4s^1$.

The condensed configuration is [Ar] 4s¹.

The partial orbital diagram showing valence electrons is

The inner electrons in K are those in the [Ar] part of the condensed electron configuration; there are 18 inner electrons.

(b) For Tc (Z = 43), assuming the expected pattern, the full electron configuration is $1s^2 2s^2 2p^6 3s^2 3p^6 4s^2 3d^{10} 4p^6 5s^2 4d^5$.

The condensed electron configuration is [Kr] 5s²4d⁵.

The partial orbital diagram showing valence electrons is

The inner electrons in Tc are those in the [Kr] part of the condensed electron configuration; there are 36 inner electrons.

(c) For Pb (Z = 82), the full electron configuration is $1s^2 2s^2 2p^6 3s^2 3p^6 4s^2 3d^{10} 4p^6 5s^2 4d^{10} 5p^6 6s^2 4f^{14} 5d^{10} 6p^2$.

The condensed electron configuration is [Xe] 6s²4f¹⁴5d¹⁰6p².

The partial orbital diagram showing valence electrons (no filled inner sublevels) is

The inner electrons in Pb are the 54 electrons represented by [Xe] plus the 14 electrons in the filled 4f sublevel plus the 10 electrons in the filled 5d sublevel, for a total of 78 inner electrons.

Check Be sure that the sum of the superscripts (numbers of electrons) in the full electron configuration equals the atomic number and that the number of *valence* electrons in the condensed configuration equals the number of electrons in the partial orbital diagram.

FOLLOW-UP PROBLEMS

8.2A Without referring to Table 8.4 or Figure 8.9, give full and condensed electron configurations, partial orbital diagram showing valence electrons only, and number of inner electrons for the following elements:

- (a) Ni (Z = 28) (b) Sr (Z = 38) (c) Po (Z = 84)

8.2B From each partial orbital diagram (valence electrons only), identify the element and give its full and condensed electron configuration and the number of inner electrons. Use only the periodic table, without referring to Table 8.4 or Figure 8.9.

SOME SIMILAR PROBLEMS 8.23–8.36

› Summary of Section 8.2

- › In applying the aufbau principle, one electron is added to an atom of each successive element in accord with the exclusion principle (no two electrons can have the same set of quantum numbers) and Hund's rule (orbitals of equal energy become half-filled, with electron spins parallel, before any pairing of spins occurs).
- › For the main-group elements, valence electrons (those involved in reactions) are in the outer (highest energy) level only. For transition elements, $(n - 1)d$ electrons are also considered valence electrons.
- › Because of shielding of d electrons by electrons in inner sublevels and penetration by the ns electron, the $(n - 1)d$ sublevel fills after the ns and before the np sublevels.
- › In Periods 6 and 7, $(n - 2)f$ orbitals fill between the first and second $(n - 1)d$ orbitals.
- › The elements of a group have similar outer electron configurations and similar chemical behavior.

8.3 TRENDS IN THREE ATOMIC PROPERTIES

In this section, we focus on three atomic properties directly influenced by electron configuration and effective nuclear charge: atomic size, ionization energy, and electron affinity. Most importantly, these properties are *periodic*, which means they generally exhibit consistent changes, or *trends*, within a group or period.

Trends in Atomic Size

Recall from Chapter 7 that we often represent atoms with spherical contours in which the electrons spend 90% of their time. We *define atomic size* (the extent of the spherical contour for a given atom) in terms of how closely one atom lies next to another. But, in practice, as we discuss in Chapter 12, we measure the distance between atomic nuclei in a sample of an element and divide that distance in half. Because atoms do not have hard surfaces, the size of an atom in a given compound depends somewhat on the atoms near it. In other words, *atomic size varies slightly from substance to substance*.

Figure 8.12 shows two common definitions of atomic size:

1. **Metallic radius.** Used mostly for *metals*, it is one-half the shortest distance between nuclei of adjacent, individual atoms in a crystal of the element (Figure 8.12A).
2. **Covalent radius.** Used for elements occurring as molecules, mostly *nonmetals*, it is one-half the shortest distance between nuclei of bonded atoms (Figure 8.12B).

Radii measured for some elements are used to determine the radii of other elements from the distances between the atoms in compounds. For instance, in a carbon-chlorine compound, the distance between nuclei in a C–Cl bond is 177 pm. Using the known covalent radius of Cl (100 pm), we find the covalent radius of C ($177 \text{ pm} - 100 \text{ pm} = 77 \text{ pm}$) (Figure 8.12C).

Figure 8.12 Defining atomic size. **A**, The metallic radius of aluminum. **B**, The covalent radius of chlorine. **C**, Known covalent radii and distances between nuclei can be used to find unknown radii.

Main-Group Elements Figure 8.13 shows the atomic radii of the main-group elements and most of the transition elements. Among the main-group elements, atomic size varies within both groups and periods as a result of two opposing influences:

1. *Changes in n.* As the principal quantum number (n) increases, the probability that outer electrons spend most of their time farther from the nucleus increases as well; thus, *atomic size increases*.
2. *Changes in Z_{eff} .* As the effective nuclear charge (Z_{eff}) increases, outer electrons are pulled closer to the nucleus; thus, *atomic size decreases*.

The net effect of these influences depends on how effectively the inner electrons shield the increasing nuclear charge:

1. *Down a group, n dominates.* As we move down a main group, each member has *one more level of inner electrons that shield the outer electrons very effectively*. Even though additional protons do moderately increase Z_{eff} for the outer electrons, the atoms get larger as a result of the increasing n value:

Atomic radius generally increases down a group.

Figure 8.13 Atomic radii of the main-group and transition elements. Atomic radii (in picometers) are shown for the main-group elements (tan) and the transition elements (blue). (Values for the noble gases are calculated.)

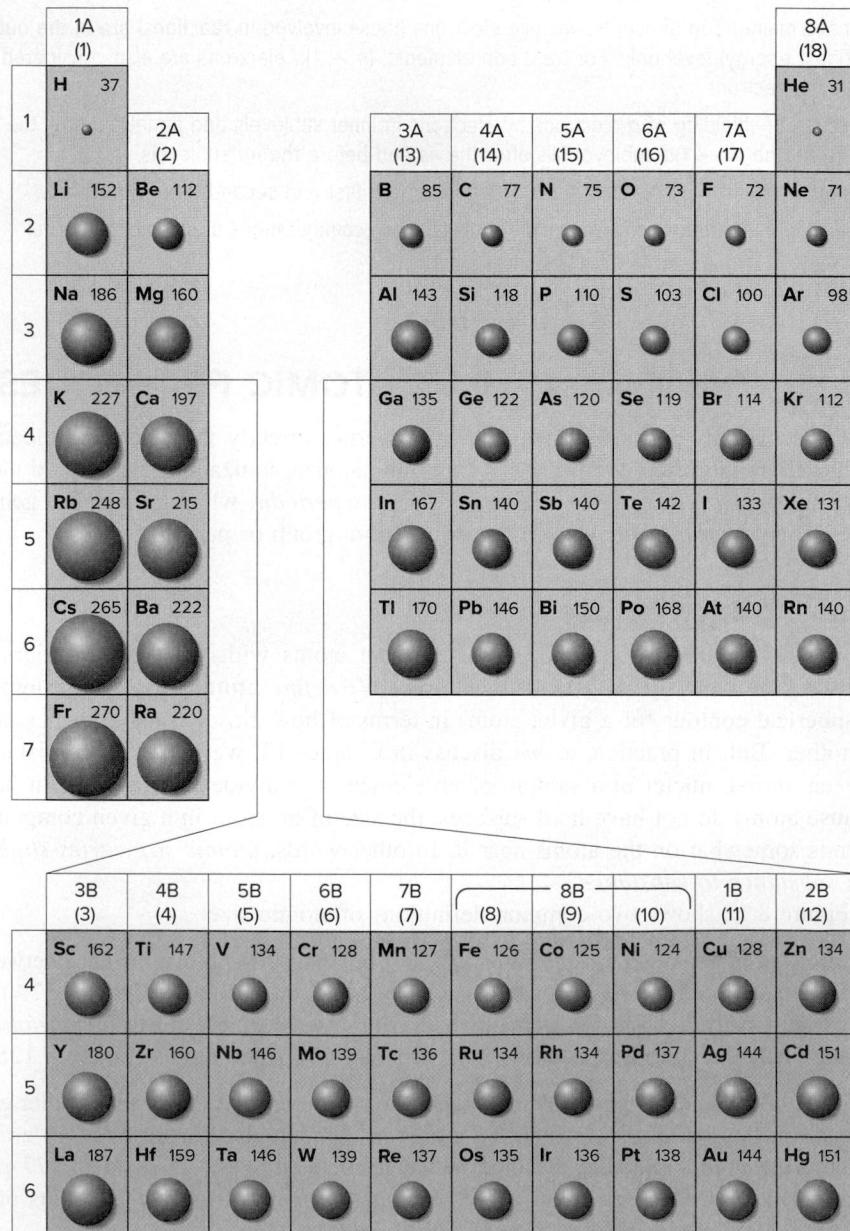

2. *Across a period, Z_{eff} dominates.* Across a period from left to right, electrons are added to the *same* outer level, so the shielding by inner electrons does not change. Despite greater electron repulsions, outer electrons shield each other only slightly, so Z_{eff} rises significantly, and the outer electrons are pulled closer to the nucleus:

Atomic radius generally decreases across a period.

Transition Elements As Figure 8.13 shows, size trends are *not* as consistent for the transition elements:

1. *Down a transition group, n increases, but shielding by an additional level of inner electrons results in only a small size increase from Period 4 to 5 and none from 5 to 6.*

2. *Across a transition series, atomic size shrinks through the first two or three elements because of the increasing nuclear charge. But, from then on, size remains relatively constant because shielding by the inner d electrons counteracts the increase in Z_{eff} .* Thus, for example, in Period 4, the third transition element, vanadium (V; $Z = 23$), has the same radius as the last, zinc (Zn; $Z = 30$). This pattern also appears in Periods 5 and 6 in the transition and both inner transition series.

3. *A transition series affects atomic size in neighboring main groups.* Shielding by d electrons causes a *major size decrease from Group 2A(2) to Group 3A(13)* in Periods 4 through 6. Because the np sublevel has more penetration than the $(n - 1)d$, the first np electron [added in Group 3A(13)] “feels” a much greater Z_{eff} , due to all the protons added in the intervening transition elements. The greatest decrease occurs in Period 4: calcium (Ca; $Z = 20$) in Group 2A(2) is nearly 50% larger than gallium (Ga; $Z = 31$) in 3A(13). In fact, d -orbital shielding causes gallium to be slightly *smaller* than aluminum (Al; $Z = 13$), the element above it!

SAMPLE PROBLEM 8.3

Ranking Elements by Atomic Size

Problem Using only the periodic table (not Figure 8.13), rank each set of main-group elements in order of *decreasing* atomic size:

- (a) Ca, Mg, Sr (b) K, Ga, Ca (c) Br, Rb, Kr (d) Sr, Ca, Rb

Plan To rank the elements by atomic size, we find them in the periodic table. They are main-group elements, so size increases down a group and decreases across a period.

Solution (a) Sr > Ca > Mg. These three elements are in Group 2A(2), and size increases down the group.

(b) K > Ca > Ga. These three elements are in Period 4, and size decreases across a period.

(c) Rb > Br > Kr. Rb is largest because it has one more energy level (Period 5) and is farthest to the left. Kr is smaller than Br because Kr is farther to the right in Period 4.

(d) Rb > Sr > Ca. Ca is smallest because it has one fewer energy level. Sr is smaller than Rb because it is farther to the right.

Check From Figure 8.13, we see that the rankings are correct.

FOLLOW-UP PROBLEMS

8.3A Using only the periodic table, rank the elements in each set in order of *increasing* size: (a) Se, Br, Cl; (b) I, Xe, Ba.

8.3B Using only the periodic table, rank the elements in each set in order of *decreasing* size: (a) As, Cs, S; (b) F, P, K.

SOME SIMILAR PROBLEMS

8.53 and 8.54

Periodicity of Atomic Size Figure 8.14 on the next page shows the variation in atomic size with atomic number. Note the up-and-down pattern as size drops across a period to the noble gas (*purple*) and then leaps up to the alkali metal (*brown*) that begins the next period. Also note the deviations from the smooth size decrease in each transition (*blue*) and inner transition (*green*) series.

Figure 8.14 Periodicity of atomic radius.

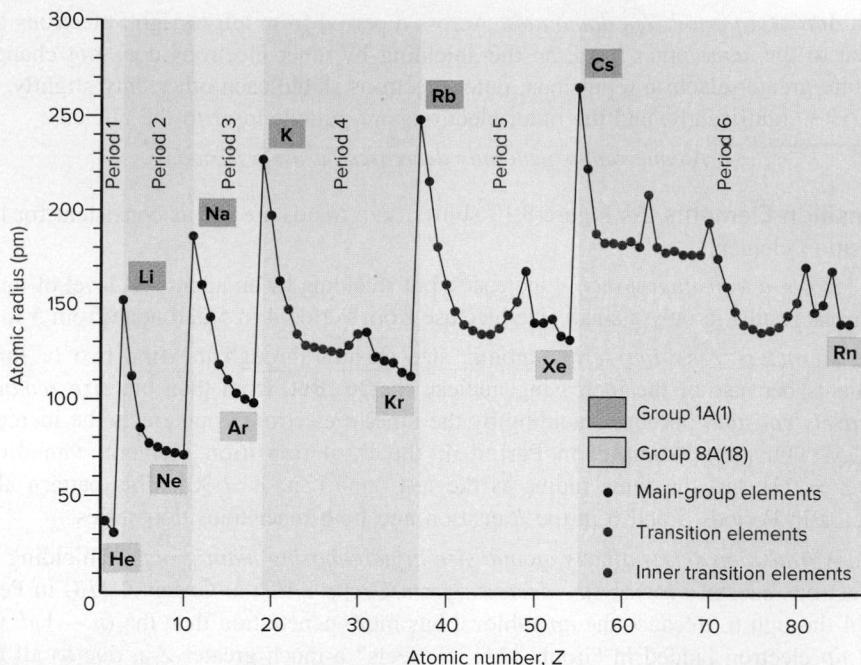

Trends in Ionization Energy

The **ionization energy (IE)** is the energy required for the *complete removal* of 1 mol of electrons from 1 mol of gaseous atoms or ions. Pulling an electron away from a nucleus *requires* energy to overcome electrostatic attraction between the negatively charged electron and the positively charged protons in the nucleus. Because energy flows *into* the system, the ionization energy is always positive (like ΔH of an endothermic reaction). (Chapter 7 viewed the ionization energy of the H atom as the energy difference between $n = 1$ and $n = \infty$, where the electron is completely removed.) The ionization energy is a key factor in an element's reactivity:

- Atoms with a low IE tend to form cations during reactions.
- Atoms with a high IE (except the noble gases) tend to form anions.

Many-electron atoms can lose more than one electron. The *first* ionization energy (IE_1) removes an outermost electron (one in the highest energy sublevel) from a gaseous atom:

The *second* ionization energy (IE_2) removes a second electron. Since this electron is pulled away from a positive ion, more energy is required for its removal and IE_2 is always larger than IE_1 :

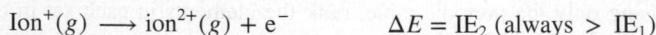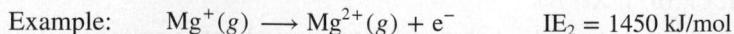

Periodicity of First Ionization Energy Figure 8.15 shows the variation in first ionization energy with atomic number. This up-and-down pattern— IE_1 rising across a period to the noble gas (*purple*) and then dropping down to the next alkali metal (*brown*)—is the *inverse* of the variation in atomic size (Figure 8.14): *as size decreases, it takes more energy to remove an electron because the nucleus is closer to the electron, so IE_1 increases*.

Let's examine the group and period trends and their exceptions:

- Down a group. As we move *down* a main group, the n value increases, so atomic size does as well. As the distance from nucleus to outer electron increases,

Figure 8.15 Periodicity of first ionization energy (IE_1). This trend is the *inverse* of the trend in atomic size (see Figure 8.14).

the attraction between nucleus and outer electron lessens, so the electron is easier to remove (Figure 8.16):

Ionization energy generally decreases down a group.

The only significant exception occurs in Group 3A(13): IE_1 decreases from boron (B) to aluminum (Al), but not for the rest of the group. Filling the transition series in Periods 4, 5, and 6 causes a much higher Z_{eff} and an unusually small change in size, so outer electrons in the larger Group 3A members are held tighter.

Figure 8.16 First ionization energies of the main-group elements.

2. *Across a period.* As we move left to right across a period, Z_{eff} increases and atomic size decreases. The attraction between nucleus and outer electron increases, so the electron is harder to remove:

Ionization energy generally increases across a period.

There are two exceptions to the otherwise smooth increase in IE_1 across periods:

- In Periods 2 and 3, there are dips in IE at the Group 3A(13) elements, B and Al. These elements have the first np electrons, which are removed more easily because the resulting ion has a filled (stable) ns sublevel. For Al, for example,

- In Periods 2 and 3, once again, there are dips at the Group 6A(16) elements, O and S. These elements have a fourth np electron, the first to pair up with another np electron, and electron-electron repulsions raise the orbital energy. The fourth np electron is easier to remove because doing so relieves the repulsions and leaves a half-filled (stable) np sublevel. For S, for example,

SAMPLE PROBLEM 8.4

Ranking Elements by First Ionization Energy

Problem Using the periodic table only, rank the elements in each set in order of *decreasing* IE_1 :

- (a) Kr, He, Ar (b) Sb, Te, Sn (c) K, Ca, Rb (d) I, Xe, Cs

Plan We find the elements in the periodic table and then apply the general trends of decreasing IE_1 down a group and increasing IE_1 across a period.

Solution (a) He > Ar > Kr. These are in Group 8A(18), and IE_1 decreases down a group.

(b) Te > Sb > Sn. These are in Period 5, and IE_1 increases across a period.

(c) Ca > K > Rb. IE_1 of K is larger than IE_1 of Rb because K is higher in Group 1A(1). IE_1 of Ca is larger than IE_1 of K because Ca is farther to the right in Period 4.

(d) Xe > I > Cs. IE_1 of I is smaller than IE_1 of Xe because I is farther to the left. IE_1 of I is larger than IE_1 of Cs because I is farther to the right and in the previous period.

Check Because trends in IE_1 are generally the opposite of the trends in size, you can rank the elements by size and check that you obtain the reverse order.

FOLLOW-UP PROBLEMS

8.4A Rank the elements in each set in order of *increasing* IE_1 :

- (a) Sb, Sn, I (b) Na, Mg, Cs

8.4B Rank the elements in each set in order of *decreasing* IE_1 :

- (a) O, As, Rb (b) Sn, Cl, Si

SOME SIMILAR PROBLEMS 8.55 and 8.56

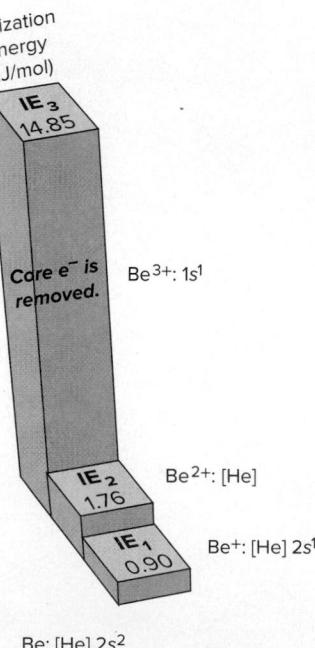

Figure 8.17 The first three ionization energies of beryllium. Beryllium has two valence electrons, so IE_3 is much larger than IE_2 .

Successive Ionization Energies For a given element, IE_1 , IE_2 , and so on, increase because each electron is pulled away from a species with a higher positive charge. This increase includes an enormous jump *after* the outer (valence) electrons have been removed because *much* more energy is needed to remove an inner (core) electron (Figure 8.17).

Table 8.5 shows successive ionization energies for Period 2 and the first element in Period 3. Move across the row of values for any element, and you reach a point that

Table 8.5**Successive Ionization Energies of the Elements Lithium Through Sodium**

Z	Element	Number of Valence Electrons	Ionization Energy (MJ/mol)*									
			IE ₁	IE ₂	IE ₃	IE ₄	IE ₅	IE ₆	IE ₇	IE ₈	IE ₉	IE ₁₀
3	Li	1	0.52	7.30	11.81							
4	Be	2	0.90	1.76	14.85	21.01						
5	B	3	0.80	2.43	3.66	25.02	32.82					
6	C	4	1.09	2.35	4.62	6.22	37.83	47.28				
7	N	5	1.40	2.86	4.58	7.48	9.44	53.27	64.36			
8	O	6	1.31	3.39	5.30	7.47	10.98	13.33	71.33	84.08		
9	F	7	1.68	3.37	6.05	8.41	11.02	15.16	17.87	92.04	106.43	
10	Ne	8	2.08	3.95	6.12	9.37	12.18	15.24	20.00	23.07	115.38	131.43
11	Na	1	0.50	4.56	6.91	9.54	13.35	16.61	20.11	25.49	28.93	141.37

*MJ/mol, or megajoules per mole = 10^3 kJ/mol.

separates relatively low from relatively high IE values (*shaded area*). For example, follow the values for boron (B): IE₁ (0.80 MJ/mol) is lower than IE₂ (2.43 MJ/mol), which is lower than IE₃ (3.66 MJ/mol), which is *much* lower than IE₄ (25.02 MJ/mol). From this jump, we know that boron has three electrons in the highest energy level ($1s^22s^22p^1$). Because they are so difficult to remove, *core electrons are not involved in reactions*.

SAMPLE PROBLEM 8.5

Identifying an Element from Its Ionization Energies

Problem Name the Period 3 element with the following ionization energies (kJ/mol), and write its full electron configuration:

IE ₁	IE ₂	IE ₃	IE ₄	IE ₅	IE ₆
1012	1903	2910	4956	6278	22,230

Plan We look for a large jump in the IE values, which occurs after all valence electrons have been removed. Then we refer to the periodic table to find the Period 3 element with this number of valence electrons and write its electron configuration.

Solution The large jump occurs after IE₅, indicating that the element has five valence electrons and, thus, is in Group 5A(15). This Period 3 element is phosphorus (P; Z = 15). Its full electron configuration is $1s^22s^22p^63s^23p^3$.

FOLLOW-UP PROBLEMS

8.5A Element Q is in Period 3 and has the following ionization energies (in kJ/mol):

IE ₁	IE ₂	IE ₃	IE ₄	IE ₅	IE ₆
577	1816	2744	11,576	14,829	18,375

Name element Q, and write its full electron configuration.

8.5B Write the condensed electron configurations of the elements Rb, Sr, and Y. Which has the *highest* IE₂? Which has the highest IE₃?

SOME SIMILAR PROBLEMS 8.57–8.60

Student Hot Spot

Student data indicate that you may struggle with the concept of successive ionization energies. Access the Smartbook to view additional Learning Resources on this topic.

Trends in Electron Affinity

The **electron affinity (EA)** is the energy change accompanying the *addition* of 1 mol of electrons to 1 mol of gaseous atoms or ions. The *first electron affinity* (EA₁) refers to the formation of 1 mol of monovalent (1⁻) gaseous anions:

1A (1)						8A (18)
H -72.8	2A (2)	3A (13)	4A (14)	5A (15)	6A (16)	7A (17)
Li -59.6	Be ≤ 0	B -26.7	C -122	N +7	O -141	F -328
Na -52.9	Mg ≤ 0	Al -42.5	Si -134	P -72.0	S -200	Cl -349
K -48.4	Ca -2.37	Ga -28.9	Ge -119	As -78.2	Se -195	Br -325
Rb -46.9	Sr -5.03	In -28.9	Sn -107	Sb -103	Te -190	I -295
Cs -45.5	Ba -13.95	Tl -19.3	Pb -35.1	Bi -91.3	Po -183	At -270
						Rn (+39)

Figure 8.18 Electron affinities of the main-group elements (in kJ/mol). Values for Group 8A(18) are estimates, which is indicated by parentheses.

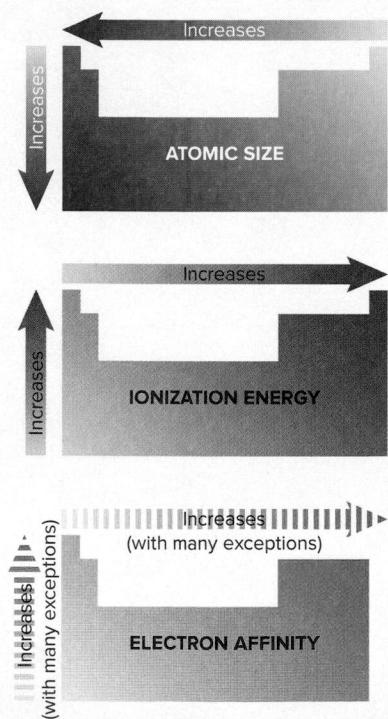

Figure 8.19 Trends in three atomic properties. For electron affinity, the dashed arrows indicate that there are numerous exceptions to the expected trends.

As with ionization energy, there is a first electron affinity, a second, and so forth. The first electron is *attracted* by the atom's nucleus, so in most cases, EA_1 is negative (energy is released), analogous to the negative ΔH for an exothermic reaction.* But, the second electron affinity (EA_2) is always positive because energy must be *absorbed* to overcome electrostatic repulsions and add another electron to a negative ion.

Factors other than Z_{eff} and atomic size affect electron affinities, so trends are not regular, as are those for size and IE_1 . The many exceptions arise from changes in sublevel energy and electron-electron repulsion:

- *Down a group.* We might expect a smooth decrease (smaller negative number) down a group because atomic size increases, and the nucleus is farther away from an electron being added. But only Group 1A(1) exhibits this behavior (Figure 8.18).
- *Across a period.* We might expect a regular increase (larger negative number) across a period because atomic size decreases, and higher Z_{eff} should attract the electron being added more strongly. There is an overall left-to-right increase, but it is not at all regular.

Despite these irregularities, relative values of IE and EA show three general behavior patterns:

1. *Reactive nonmetals.* Members of Group 6A(16) and especially Group 7A(17) (the halogens) have high IEs and highly negative (exothermic) EAs: these elements lose electrons with difficulty but attract them strongly. Therefore, *in their ionic compounds, they form negative ions*.
2. *Reactive metals.* Members of Groups 1A(1) and 2A(2) have low IEs and slightly negative (exothermic) EAs: they lose electrons easily but attract them weakly, if at all. Therefore, *in their ionic compounds, they form positive ions*.
3. *Noble gases.* Members of Group 8A(18) have very high IEs and slightly positive (endothermic) EAs: *they tend not to lose or gain electrons*. In fact, only the larger members of the group (Kr, Xe, and Rn) form compounds at all.

› Summary of Section 8.3

- › Trends in three atomic properties are summarized in Figure 8.19.
- › Atomic size (half the distance between nuclei of adjacent atoms) increases down a main group and decreases across a period. In a transition series, size remains relatively constant.
- › First ionization energy (the energy required to remove a mole of electrons from a mole of gaseous atoms or ions) is inversely related to atomic size: IE_1 decreases down a main group and increases across a period.
- › Successive ionization energies of an element show a very large increase after all valence electrons have been removed, because the first inner (core) electron is in an orbital of much lower energy and so is held very tightly.
- › Electron affinity (the energy involved in adding a mole of electrons to a mole of gaseous atoms or ions) shows many variations from expected trends.
- › Based on the relative sizes of IEs and EAs, Group 1A(1) and 2A(2) elements tend to form cations, and Group 6A(16) and 7A(17) elements tend to form anions in ionic compounds. Group 8A(18) elements are very unreactive.

*Some tables of EA_1 values list them as positive values because that quantity of energy would be *absorbed* to remove an electron from the anion.

8.4 ATOMIC PROPERTIES AND CHEMICAL REACTIVITY

All physical and chemical behaviors of the elements and their compounds are based on electron configuration and effective nuclear charge. In this section, you'll see how atomic properties determine metallic behavior and the properties of ions.

Trends in Metallic Behavior

The three general classes of elements have distinguishing properties:

- **Metals**, found in the left and lower three-quarters of the periodic table, are typically shiny solids, have moderate to high melting points, are good conductors of heat and electricity, can be machined into wires and sheets, and lose electrons to nonmetals.
- **Nonmetals**, found in the upper right quarter of the table, are typically not shiny, have relatively low melting points, are poor conductors, are mostly crumbly solids or gases, and tend to gain electrons from metals.
- **Metalloids**, found between the other two classes, have intermediate properties.

Thus, *metallic behavior decreases from left to right across a period and increases down a group in the periodic table* (Figure 8.20).

Remember, though, that some elements don't fit these categories: as graphite, nonmetallic carbon is a good electrical conductor; the nonmetal iodine is shiny; metallic gallium melts in your hand; mercury is a liquid; and iron is brittle. Despite such exceptions, in this discussion, we'll make several generalizations about metallic behavior and its applications to redox behavior and the acid-base properties of oxides.

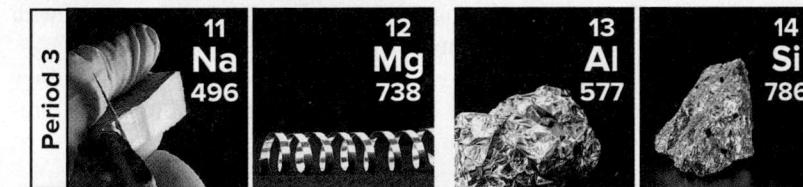

Relative Tendency to Lose or Gain Electrons Metals tend to lose electrons to nonmetals during reactions:

1. *Down a main group*. The increase in metallic behavior down a group is consistent with an increase in size and a decrease in IE and is most obvious in groups with more than one class of element, such as Group 5A(15) (Figure 8.21, vertical): *elements at the top can form anions, and those at the bottom can form cations*. Nitrogen (N) is a gaseous nonmetal, and phosphorus (P) is a soft nonmetal; both occur occasionally as 3⁻ anions in their compounds. Arsenic (As) and antimony (Sb) are metalloids, with Sb the more metallic, and neither forms ions readily. Bismuth (Bi) is a typical metal, forming a 3+ cation in its mostly ionic compounds. Groups 3A(13), 4A(14), and 6A(16) show a similar trend. But even in Group 2A(2), which contains only metals, the tendency to form cations increases down the group: beryllium (Be) forms covalent compounds with nonmetals, whereas all compounds of barium (Ba) are ionic.

2. *Across a period*. The decrease in metallic behavior across a period is consistent with a decrease in size, an increase in IE, and a more favorable (more negative) EA. Consider Period 3 (Figure 8.21, horizontal): *elements at the left tend to form cations, and those at the right tend to form anions*. Sodium and magnesium are metals that occur as Na⁺ and Mg²⁺ in seawater, minerals, and organisms.

Figure 8.20 Trends in metallic behavior. (Hydrogen appears next to helium.)

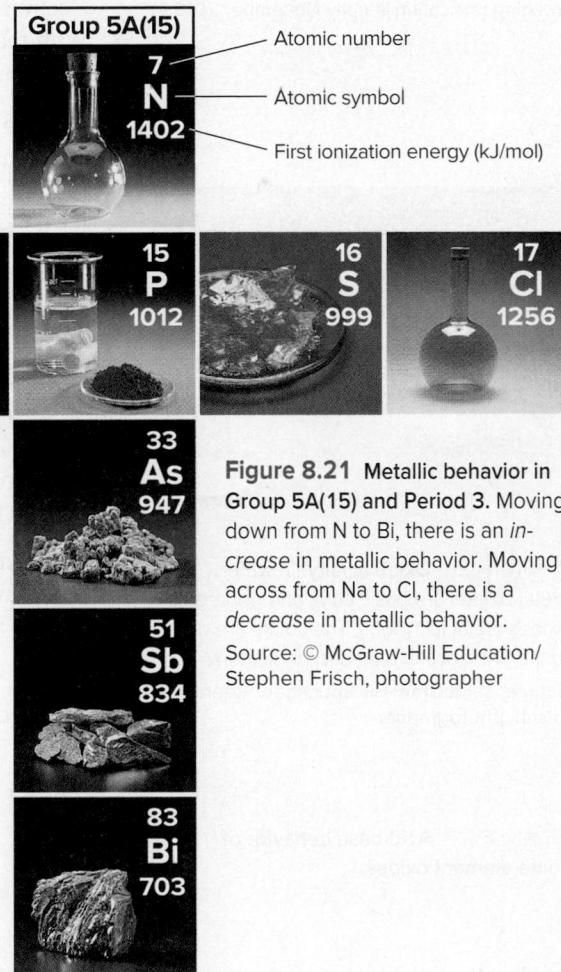

Figure 8.21 Metallic behavior in Group 5A(15) and Period 3. Moving down from N to Bi, there is an *increase* in metallic behavior. Moving across from Na to Cl, there is a *decrease* in metallic behavior.

Source: © McGraw-Hill Education/Stephen Frisch, photographer

Period			Group number								
			Highest O.N./Lowest O.N.								
	1A	2A	3A	4A	5A	6A	7A				
	+1	+2	+3	+4	+5	+6	+7	-1	-2	-3	-4
1	H										
2	Li	Be	B	C	N	O	F				
3	Na	Mg	Al	Si	P	S	Cl				
4	K	Ca	Ga	Ge	As	Se	Br				
5	Rb	Sr	In	Sn	Sb	Te	I				
6	Cs	Ba	Tl	Pb	Bi	Po	At				
7	Fr	Ra	Nh*	Fl	Mc*	Lv	Ts*				

Figure 8.22 Highest and lowest O.N.s of reactive main-group elements.

*As of the printing of this book, these are the proposed symbols for these elements, awaiting ratification in early November 2016.

Aluminum is metallic physically and occurs as Al^{3+} in some compounds, but it bonds covalently in most others. Silicon (Si) is a shiny metalloid that does not occur as a monatomic ion. Phosphorus is a white, waxy nonmetal that occurs rarely as P^{3-} , whereas crumbly, yellow sulfur exists as S^{2-} in many compounds, and gaseous, yellow-green chlorine occurs in nature almost always as Cl^- .

Redox Behavior of the Main-Group Elements Closely related to an element's tendency to lose or gain electrons is its redox behavior—that is, whether it behaves as an oxidizing or reducing agent and the associated changes in its oxidation number (O.N.). You can find the highest and lowest oxidation numbers of many main-group elements from the periodic table (Figure 8.22):

- For most elements, the A-group number is the *highest* oxidation number (always positive) of any element in the group. The exceptions are O and F (see Table 4.4).
- For nonmetals and some metalloids, the A-group number minus 8 is the *lowest* oxidation number (always negative) of any element in the group.

For example, the highest oxidation number of S (Group 6A) is +6, as in SF_6 , and the lowest is $6 - 8$, or -2 , as in FeS and other metal sulfides.

Redox behavior is closely related to atomic properties:

- With their low IEs and small EAs, the members of Groups 1A(1) and 2A(2) lose electrons readily, so they are *strong reducing agents* and become oxidized.
- With their high IEs and large EAs, nonmetals in Groups 6A(16) and 7A(17) gain electrons readily, so they are *strong oxidizing agents* and become reduced.

Acid-Base Behavior of Oxides Metals are also distinguished from nonmetals by the acid-base behavior of their oxides in water:

- Most main-group metals *transfer* electrons to oxygen, so their *oxides are ionic*. In water, these oxides act as bases, producing OH^- ions from O^{2-} and reacting with acids. Calcium oxide is an example (Figure 8.23).
- Nonmetals *share* electrons with oxygen, so *nonmetal oxides are covalent*. They react with water to form acids, producing H^+ ions and reacting with bases. Tetraphosphorus decoxide is an example (Figure 8.23).

Some metals and many metalloids form oxides that are **amphoteric**: they can act as acids *or* bases in water.

In Figure 8.24, the acid-base behavior of some common oxides of elements in Group 5A(15) and Period 3 is shown, with a gradient from blue (basic) to red (acidic):

- As elements become more metallic down a group (larger size and smaller IE), their oxides become more basic. In Group 5A(15), dinitrogen pentoxide, N_2O_5 , forms the strong acid HNO_3 :

Tetraphosphorus decoxide, P_4O_{10} , forms the weaker acid H_3PO_4 :

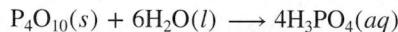

3	Na ₂ O	MgO			5A (15)	N ₂ O ₅		
			Al ₂ O ₃	SiO ₂	P ₄ O ₁₀	SO ₃	Cl ₂ O ₇	Ar
						As ₂ O ₅		
						Sb ₂ O ₅		
						Bi ₂ O ₃		

Figure 8.24 Acid-base behavior of some element oxides.

Source: © McGraw-Hill Education/Stephen Frisch, photographer

The oxide of the metalloid arsenic is weakly acidic, whereas that of the metalloid antimony is weakly basic. Bismuth, the most metallic of the group, forms a basic oxide that is insoluble in water but reacts with acid to yield a salt and water:

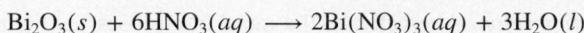

2. As the elements become less metallic across a period (smaller size and higher IE), their oxides become more acidic. In Period 3, Na_2O and MgO are strongly basic, and amphoteric aluminum oxide (Al_2O_3) reacts with acid or with base:

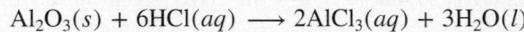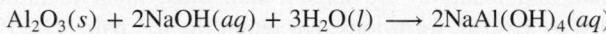

Silicon dioxide is weakly acidic, forming a salt and water with base:

The common oxides of phosphorus, sulfur, and chlorine form acids of increasing strength: H_3PO_4 , H_2SO_4 , and HClO_4 .

Properties of Monatomic Ions

So far we have focused on the reactants—the atoms—in the process of electron loss and gain. Now we focus on the products—the ions—considering their electron configurations, magnetic properties, and sizes.

Electron Configurations of Main-Group Ions Why does an ion have a particular charge: Na^+ not Na^{2+} , or F^- not F^{2-} ? Why do some metals form two ions, such as Sn^{2+} and Sn^{4+} ? The answer relates to the location of the element in the periodic table and the energy associated with losing or gaining electrons:

1. Ions with a noble gas configuration. Atoms of the noble gases have very low reactivity because their highest energy level is *filled* (ns^2np^6). Thus, *when elements at either end of a period form ions, they attain a filled outer level—a noble gas configuration.* These elements lie on either side of Group 8A(18), and their ions are **isoelectronic** (Greek *iso*, “same”) with the nearest noble gas (Figure 8.25; see also Figure 2.13).

- Elements in Group 1A(1) *lose one* electron and elements in Group 2A(2) *lose two* electrons and become isoelectronic with the *previous* noble gas. The Na^+ ion, for example, is isoelectronic with neon (Ne):

- Elements in Group 6A(16) *gain two* electrons and elements in Group 7A(17) *gain one* electron and become isoelectronic with the *next* noble gas. The Br^- ion, for example, is isoelectronic with krypton (Kr):

The energy needed to remove electrons from metals or add them to nonmetals determines the charges of the resulting ions:

- Cations.** Removing another electron from Na^+ or from Mg^{2+} means removing a core electron, which requires too much energy: thus, NaCl_2 and MgF_3 do *not* exist.
- Anions.** Similarly, adding another electron to F^- or to O^{2-} means putting it into the next higher energy level ($n = 3$). With 10 electrons ($1s^22s^22p^6$) acting as inner electrons, the nuclear charge would be shielded very effectively, and adding an outer electron would require too much energy: thus, we never see Na_2F or Mg_3O_2 .

2. Ions without a noble gas configuration. Except for aluminum, the metals of Groups 3A(13) to 5A(15) do not form ions with noble gas configurations. Instead, they form cations with two different stable configurations:

- Pseudo-noble gas configuration.** If the metal atom empties its highest energy level, it attains the stability of empty ns and np sublevels and a filled inner ($n - 1$) d sublevel. This $(n - 1)d^{10}$ configuration is called a **pseudo-noble gas configuration**.

Figure 8.25 Main-group elements whose ions have noble gas electron configurations.

For example, tin (Sn; $Z = 50$) loses four electrons to form the tin(IV) ion (Sn^{4+}), which has empty $5s$ and $5p$ sublevels and a filled inner $4d$ sublevel:

- *Inert pair configuration.* Alternatively, the metal atom loses just its np electrons and attains a stable configuration with filled ns and $(n - 1)d$ sublevels. The retained ns^2 electrons are sometimes called an *inert pair*. For example, in the more common tin(II) ion (Sn^{2+}), the atom loses only the two $5p$ electrons and has filled $5s$ and $4d$ sublevels:

Thallium, lead, and bismuth, the largest and, thus, most metallic members of Groups 3A(13) to 5A(15), form ions that retain the ns^2 pair: Tl^+ , Pb^{2+} , and Bi^{3+} .

Once again, energy considerations explain these configurations. It would be energetically impossible for metals in Groups 3A(13) to 5A(15) to achieve noble gas configurations: tin, for example, would have to lose 14 electrons—ten $4d$ in addition to the two $5p$ and two $5s$ —to be isoelectronic with krypton (Kr; $Z = 36$), the previous noble gas.

SAMPLE PROBLEM 8.6

Writing Electron Configurations of Main-Group Ions

Problem Using condensed electron configurations, write equations representing the formation of the ion(s) of the following elements:

- (a) Iodine ($Z = 53$) (b) Potassium ($Z = 19$) (c) Indium ($Z = 49$)

Plan We identify the element's position in the periodic table and recall that

- Ions of elements in Groups 1A(1), 2A(2), 6A(16), and 7A(17) are isoelectronic with the nearest noble gas.
- Metals in Groups 3A(13) to 5A(15) lose the ns and np electrons or just the np .

Solution (a) Iodine is in Group 7A(17), so it gains one electron, and I^- is isoelectronic with xenon:

(b) Potassium is in Group 1A(1), so it loses one electron; K^+ is isoelectronic with argon:

(c) Indium is in Group 3A(13), so it loses either three electrons to form In^{3+} (with a pseudo-noble gas configuration) or one to form In^+ (with an inert pair):

Check Be sure that the number of electrons in the ion's electron configuration, plus the number gained or lost to form the ion, equals Z .

FOLLOW-UP PROBLEMS

8.6A Using condensed electron configurations, write equations representing the formation of the ion(s) of the following elements:

- (a) Ba ($Z = 56$) (b) O ($Z = 8$) (c) Pb ($Z = 82$)

8.6B Using condensed electron configurations, write equations representing the formation of the ion(s) of the following elements:

- (a) F ($Z = 9$) (b) Tl ($Z = 81$) (c) Mg ($Z = 12$)

SOME SIMILAR PROBLEMS 8.75–8.78

Electron Configurations of Transition Metal Ions In contrast to many main-group ions, *transition metal ions rarely attain a noble gas configuration*. Aside from the Period 4 elements scandium, which forms Sc^{3+} , and titanium, which occasionally

Figure 8.26 The crossover of sublevel energies in Period 4.

forms Ti^{4+} , a transition element typically forms more than one cation by losing all of its ns and some of its $(n - 1)d$ electrons.

The reason, once again, is that the energy cost of attaining a noble gas configuration is too high. Let's consider again the filling of Period 4. At the beginning of Period 4 (the same point holds in other periods), penetration makes the $4s$ sublevel *more stable* than the $3d$. Therefore, the first and second electrons added enter the $4s$, which is the outer sublevel. But, the $3d$ is an *inner* sublevel, so as it begins to fill, its electrons are not well shielded from the increasing nuclear charge.

A *crossover in sublevel energy* results: the $3d$ becomes *more stable* than the $4s$ in the transition series (Figure 8.26). This crossover has a major effect on the formation of Period 4 transition metal ions: because the $3d$ electrons are held tightly and shield those in the outer sublevel, the $4s$ electrons of a transition metal *are lost before the $3d$ electrons*. Thus, $4s$ electrons are added before $3d$ electrons to form the *atom* and are lost before them to form the *ion*, the so-called “first-in, first-out” rule.

Ion Formation: A Summary of Electron Loss or Gain The various ways that cations form have one point in common—*outer electrons are removed first*. Here is a summary of the rules for formation of any main-group or transition metal ion:

- Main-group *s*-block metals lose all electrons with the highest n value.
- Main-group *p*-block metals lose np electrons before ns electrons.
- Transition (*d*-block) metals lose ns electrons before $(n - 1)d$ electrons.
- Nonmetals gain electrons in the *p* orbitals of highest n value.

Magnetic Properties of Transition Metal Ions We learn a great deal about an element's electron configuration from atomic spectra, and magnetic studies provide additional evidence.

Recall that electron spin generates a tiny magnetic field, which causes a beam of H atoms to split in an external magnetic field (see Figure 8.1). Only a beam of a species (atoms, ions, or molecules) with one or more *unpaired* electrons will split. A beam of silver atoms (Ag ; $Z = 47$) was used in the original 1921 experiment:

Note the unpaired $5s$ electron (recall that this irregularity is due to the stability of filled sublevels). A beam of cadmium atoms (Cd ; $Z = 48$) is not split because the $5s$ electrons in this species are *paired* ($[\text{Kr}] \ 5s^2 4d^{10}$).

A species with unpaired electrons exhibits **paramagnetism**: it is attracted by an external magnetic field. A species with all of its electrons paired exhibits **diamagnetism**: it is not attracted (and is slightly repelled) by the magnetic field (Figure 8.27). Many transition metals and their compounds are paramagnetic because their atoms and ions have unpaired electrons.

Figure 8.27 Measuring the magnetic behavior of a sample. The substance is weighed with the external magnetic field “off.” **A**, If the substance is diamagnetic (has all *paired* electrons), its apparent mass is unaffected (or slightly reduced) with the field “on.” **B**, If the substance is paramagnetic (has *unpaired* electrons), its apparent mass increases.

Let's consider three examples of how magnetic studies provide evidence for a proposed electron configuration:

1. The Ti^{2+} ion. Spectral analysis of titanium metal yields the electron configuration $[Ar] 4s^2 3d^2$, and experiment shows that the metal is paramagnetic, which indicates the presence of unpaired electrons. Spectral analysis shows that the Ti^{2+} ion is $[Ar] 3d^2$, indicating loss of the $4s$ electrons. In support of the spectra, magnetic studies show that Ti^{2+} compounds are paramagnetic:

The partial orbital diagrams are

If Ti lost its $3d$ electrons to form Ti^{2+} , its compounds would be diamagnetic.

2. The Fe^{3+} ion. An increase in paramagnetism occurs when iron metal (Fe) becomes Fe^{3+} in compounds, which indicates an increase in the number of unpaired electrons. This fact is consistent with Fe losing its $4s$ pair and one electron of a $3d$ pair:

2. The Cu^+ and Zn^{2+} ions. Copper (Cu) metal is paramagnetic, but zinc (Zn) is diamagnetic. The Cu^+ and Zn^{2+} ions are diamagnetic, too. These observations are consistent with the ions being isoelectronic, which means $4s$ electrons were lost:

SAMPLE PROBLEM 8.7 Writing Electron Configurations and Predicting Magnetic Behavior of Transition Metal Ions

Problem Use condensed electron configurations to write an equation for the formation of each transition metal ion, and predict whether it is paramagnetic:

- (a) Co^{3+} ($Z = 27$) (b) Cr^{3+} ($Z = 24$) (c) Hg^{2+} ($Z = 80$)

Plan We first write the condensed electron configuration of the atom, recalling the irregularity for Cr. Then we remove electrons, beginning with ns electrons, to attain the ion charge. If unpaired electrons are present, the ion is paramagnetic.

Solution

There are four unpaired e^- , so Co^{3+} is paramagnetic.

<input type="checkbox"/>	<input type="checkbox"/>	<input checked="" type="checkbox"/>	<input checked="" type="checkbox"/>	<input type="checkbox"/>	<input type="checkbox"/>
4s	3d	4p			

There are three unpaired e^- , so Cr^{3+} is paramagnetic.

The 4f and 5d sublevels are filled, so there are no unpaired e^- : Hg^{2+} is not paramagnetic.

Check We removed the ns electrons first, and the sum of the lost electrons and those in the electron configuration of the ion equals Z .

FOLLOW-UP PROBLEMS

8.7A Write the condensed electron configuration of each transition metal ion, and predict whether it is paramagnetic:

8.7B Write the condensed electron configuration of each transition metal ion, and give the number of unpaired electrons:

SOME SIMILAR PROBLEMS 8.82–8.84

Ionic Size vs. Atomic Size The **ionic radius** is a measure of the size of an ion and is obtained from the distance between the nuclei of adjacent ions in a crystalline ionic compound (Figure 8.28). From the relation between effective nuclear charge (Z_{eff}) and atomic size, we can predict the size of an ion relative to its parent atom:

- *Cations are smaller than parent atoms.* When a cation forms, electrons are *removed* from the outer level. The resulting decrease in shielding and the value of nl allows the nucleus to pull the remaining electrons closer.
- *Anions are larger than parent atoms.* When an anion forms, electrons are *added* to the outer level. The increases in shielding and electron repulsions means the electrons occupy more space.

Figure 8.29 on the next page shows the radii of some main-group ions and their parent atoms; we can make the following observations:

1. *Down a group, ionic size increases* because n increases.
2. *Across a period, the pattern is complex.* For instance, consider Period 3:
 - *Among cations*, the increase in Z_{eff} from left to right makes Na^+ larger than Mg^{2+} , which is larger than Al^{3+} . Across a period, cation size decreases with increasing charge.
 - *From last cation to first anion*, a great jump in size occurs: we are *adding* electrons rather than removing them, so repulsions increase sharply. For instance, P^{3-} has eight more electrons than Al^{3+} .
 - *Among anions*, the increase in Z_{eff} from left to right makes P^{3-} larger than S^{2-} , which is larger than Cl^- . Across a period, anion size decreases with decreasing charge.
 - *Within an isoelectronic series*, these factors have striking results. Within the dashed outline in Figure 8.29, the ions are isoelectronic with neon. Period 2 anions are much larger than Period 3 cations because the same number of electrons are attracted by an increasing nuclear charge. The size pattern is

Figure 8.28 Ionic radius. Cation radius (r^+) and anion radius (r^-) together make up the distance between nuclei.

Figure 8.29 Ionic vs. atomic radii.

Atomic radii (color) and ionic radii (gray) are given in picometers. Metal atoms (blue) form smaller positive ions, and nonmetal atoms (red) form larger negative ions. Ions in the dashed outline are isoelectronic with neon.

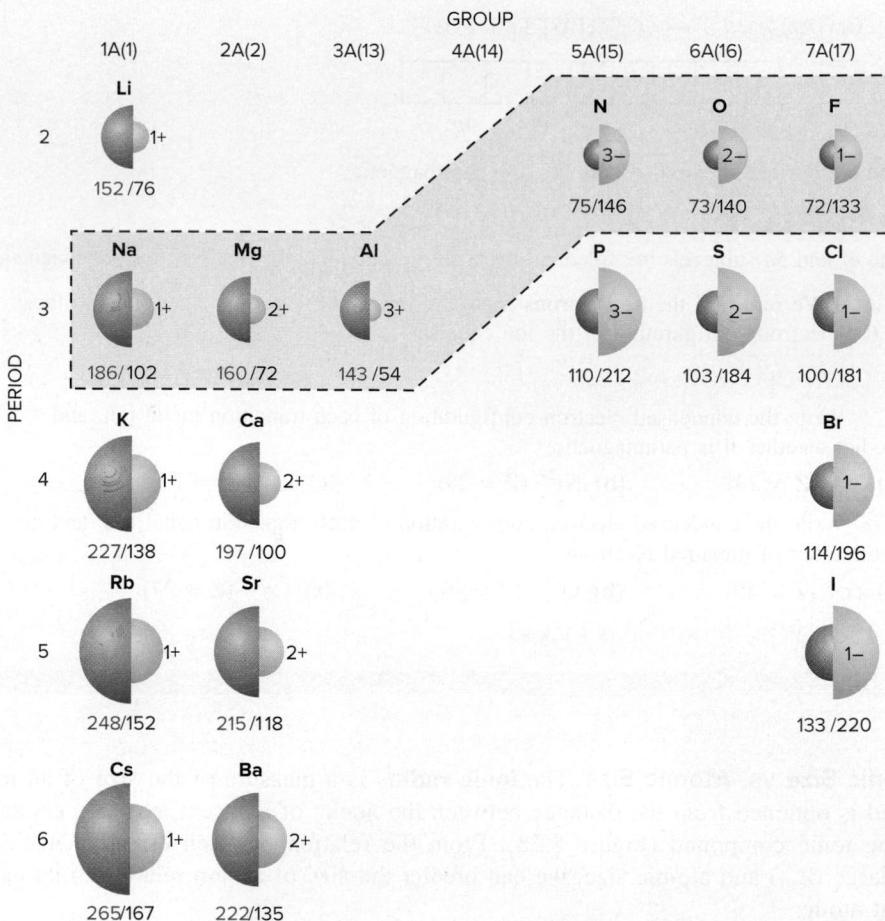

3. *Cation size decreases with increasing charge.* When a metal forms more than one cation, *the greater the ionic charge, the smaller the ionic radius.* With the two ions of iron, for example, Fe^{3+} has one fewer electron than Fe^{2+} , so shielding is reduced somewhat, and the same nucleus is attracting fewer electrons. As a result, Z_{eff} increases, so Fe^{3+} (65 pm) is smaller than Fe^{2+} (78 pm).

SAMPLE PROBLEM 8.8
Ranking Ions by Size

Problem Rank each set of ions in order of *decreasing* size, and explain your ranking:

(a) Ca^{2+} , Sr^{2+} , Mg^{2+} (b) K^+ , S^{2-} , Cl^- (c) Au^+ , Au^{3+}

Plan We find the position of each element in the periodic table and apply the ideas presented in the text.

Solution (a) Mg^{2+} , Ca^{2+} , and Sr^{2+} are all from Group 2A(2), so their sizes decrease up the group: $\text{Sr}^{2+} > \text{Ca}^{2+} > \text{Mg}^{2+}$.

(b) The ions K^+ , S^{2-} , and Cl^- are isoelectronic. S^{2-} has a lower Z_{eff} than Cl^- , so it is larger. K^+ is a cation and has the highest Z_{eff} , so it is smallest: $\text{S}^{2-} > \text{Cl}^- > \text{K}^+$.

(c) Au^+ has a lower charge than Au^{3+} , so it is larger: $\text{Au}^+ > \text{Au}^{3+}$.

FOLLOW-UP PROBLEMS

8.8A Rank the ions in each set in order of *increasing* size:

(a) Cl^- , Br^- , F^- (b) Na^+ , Mg^{2+} , F^- (c) Cr^{2+} , Cr^{3+}

8.8B Rank the ions in each set in order of *decreasing* size:

(a) S^{2-} , P^{3-} , Cl^- (b) Rb^+ , K^+ , Cs^+ (c) I^- , Ba^{2+} , Cs^+

SOME SIMILAR PROBLEMS 8.87 and 8.88

› Summary of Section 8.4

- › Metallic behavior correlates with large atomic size and low ionization energy. Thus, metallic behavior increases down a group and decreases from left to right across a period.
- › Elements in Groups 1A(1) and 2A(2) are strong reducing agents; nonmetals in Groups 6A(16) and 7A(17) are strong oxidizing agents.
- › Within the main groups, metal oxides are basic and nonmetal oxides acidic. Thus, oxides become more acidic across a period and more basic down a group.
- › Many main-group elements form ions that are isoelectronic with the nearest noble gas. Removing (or adding) more electrons than needed to attain the noble gas configuration requires a prohibitive amount of energy.
- › Metals in Groups 3A(13) to 5A(15) lose either their np electrons or both their ns and np electrons.
- › Transition metals lose ns electrons before $(n - 1)d$ electrons and commonly form more than one ion.
- › Many transition metals and their compounds are paramagnetic because their atoms (or ions) have unpaired electrons.
- › Cations are smaller and anions larger than their parent atoms. Ionic radius increases down a group. Across a period, ionic radii generally decrease, but a large increase occurs from the last cation to the first anion.

CHAPTER REVIEW GUIDE

Learning Objectives

Relevant section (§) and/or sample problem (SP) numbers appear in parentheses.

Understand These Concepts

1. The meaning of the periodic law and the arrangement of elements by atomic number (Introduction)
2. The reason for the spin quantum number and its two possible values (§8.1)
3. How the exclusion principle applies to orbital filling (§8.1)
4. The effects of nuclear charge, shielding, and penetration on the splitting of energy levels; the meaning of effective nuclear charge (§8.1)
5. How the arrangement of the periodic table is based on the order of sublevel energies (§8.2)
6. How sublevels are filled in main-group and transition elements; the importance of Hund's rule (§8.2)
7. The distinction among inner, outer, and valence electrons (§8.2)
8. How outer electron configuration within a group is related to chemical behavior (§8.2)
9. The meaning of atomic radius, ionization energy, and electron affinity (§8.3)
10. How n value and effective nuclear charge give rise to the periodic trends of atomic size and ionization energy (§8.3)
11. The importance of core electrons to the pattern of successive ionization energies (§8.3)
12. How atomic properties relate to the tendency to form ions (§8.3)

13. The general properties of metals and nonmetals (§8.4)
14. How vertical and horizontal trends in metallic behavior are related to ion formation and oxide acidity (§8.4)
15. How atomic size and IE relate to redox behavior (§8.4)
16. Why main-group ions are either isoelectronic with the nearest noble gas or have a pseudo-noble gas electron configuration (§8.4)
17. Why transition elements lose ns electrons first (§8.4)
18. The origin of paramagnetic and diamagnetic behavior (§8.4)
19. The relation between ionic and atomic size and the trends in ionic size (§8.4)

Master These Skills

1. Correlating an orbital diagram and the set of quantum numbers for any electron in an atom (SP 8.1)
2. Writing full and condensed electron configurations for an element (SP 8.2)
3. Using periodic trends to rank elements by atomic size and first ionization energy (SPs 8.3, 8.4)
4. Identifying an element from its successive ionization energies (SP 8.5)
5. Writing electron configurations of main-group and transition metal ions and predicting magnetic behavior of transition metal ions (SPs 8.6, 8.7)
6. Using periodic trends to rank ions by size (SP 8.8)

Key Terms

Page numbers appear in parentheses.

actinides (342)
amphoteric (354)
atomic size (345)
aufbau principle (335)

covalent radius (345)
diamagnetism (357)
effective nuclear
charge (Z_{eff}) (333)

electron affinity (EA) (351)
electron configuration (331)
exclusion principle (333)
Hund's rule (336)

inner (core) electrons (342)
inner transition elements (342)
ionic radius (359)
ionization energy (IE) (348)

isoelectronic (355)
lanthanides (rare earths) (342)
metallic radius (345)

orbital diagram (335)
outer electrons (342)
paramagnetism (357)
penetration (334)

periodic law (331)
pseudo-noble gas configuration (355)
shielding (333)

spin quantum number (m_s) (332)
transition elements (339)
valence electrons (342)

Key Equations and Relationships

Page numbers appear in parentheses.

8.1 Defining the energy order of sublevels in terms of the angular momentum quantum number (l value) (334):

Order of sublevel energies: $s < p < d < f$

8.2 Meaning of the first ionization energy (348):

BRIEF SOLUTIONS TO FOLLOW-UP PROBLEMS

8.1A The element has eight electrons (two in the $1s$ orbital, two in the $2s$ orbital, and four in $2p$ orbitals), so $Z = 8$: oxygen.

The sixth electron (shown in red) is the first electron in the $2p$ orbital whose m_l value is 0: $n = 2$, $l = 1$, $m_l = 0, +\frac{1}{2}$

8.1B Since $n = 2$ and $l = 1$, the electron is in a $2p$ orbital; since $m_l = 0$ and $m_s = +\frac{1}{2}$, the electron is the second electron in the $2p$ sublevel. The $1s$ and $2s$ orbitals are full and there are two electrons in the $2p$ sublevel for a total of 6 electrons. $Z = 6$ and the element is carbon; $1s^22s^22p^2$.

8.2A (a) For Ni, $1s^22s^22p^63s^23p^64s^23d^8$; [Ar] $4s^23d^8$

Ni has 18 inner electrons.

(b) For Sr, $1s^22s^22p^63s^23p^64s^23d^{10}4p^65s^2$; [Kr] $5s^2$

Sr has 36 inner electrons.

(c) For Po, $1s^22s^22p^63s^23p^64s^23d^{10}4p^65s^24d^{10}5p^66s^24f^{14}5d^{10}6p^4$; [Xe] $6s^24f^{14}5d^{10}6p^4$

Po has 78 inner electrons.

8.2B (a) As; $1s^22s^22p^63s^23p^64s^23d^{10}4p^3$; [Ar] $4s^23d^{10}4p^3$;

As has 28 inner electrons.

(b) Zr; $1s^22s^22p^63s^23p^64s^23d^{10}4p^65s^24d^2$; [Kr] $5s^24d^2$;

Zr has 36 inner electrons.

(c) I; $1s^22s^22p^63s^23p^64s^23d^{10}4p^65s^24d^{10}5p^5$; [Kr] $5s^24d^{10}5p^5$;

I has 46 inner electrons.

8.3A (a) Cl < Br < Se; (b) Xe < I < Ba

8.3B (a) Cs > As > S; (b) K > P > F

8.4A (a) Sn < Sb < I; (b) Cs < Na < Mg

8.4B (a) O > As > Rb; (b) Cl > Si > Sn

8.5A The large jump occurs after IE_3 , indicating that the element has three valence electrons and is in Group 3A(13). Q is aluminum: $1s^22s^22p^63s^23p^1$.

8.5B Rb: [Kr] $5s^1$; Sr: [Kr] $5s^2$; Y: [Kr] $5s^24d^1$

Highest IE_2 : Rb, since the second electron removed is a core electron, which is much more difficult to remove. Highest IE_3 : Sr, since the third electron removed is a core electron.

8.6A (a) $\text{Ba}([\text{Xe}] 6s^2) \longrightarrow \text{Ba}^{2+}([\text{Xe}]) + 2e^-$

(b) $\text{O}([\text{He}] 2s^22p^4) + 2e^- \longrightarrow \text{O}^{2-}([\text{He}] 2s^22p^6)$ (same as Ne)

(c) $\text{Pb}([\text{Xe}] 6s^24f^{14}5d^{10}6p^2) \longrightarrow \text{Pb}^{2+}([\text{Xe}] 6s^24f^{14}5d^{10}) + 2e^-$
 $\text{Pb}([\text{Xe}] 6s^24f^{14}5d^{10}6p^2) \longrightarrow \text{Pb}^{4+}([\text{Xe}] 4f^{14}5d^{10}) + 4e^-$

8.6B (a) $\text{F}([\text{He}] 2s^22p^5) + e^- \longrightarrow \text{F}^{-}([\text{He}] 2s^22p^6)$ (same as Ne)

(b) $\text{Tl}([\text{Xe}] 6s^24f^{14}5d^{10}6p^1) \longrightarrow \text{Tl}^{1+}([\text{Xe}] 6s^24f^{14}5d^{10}) + e^-$

$\text{Tl}([\text{Xe}] 6s^24f^{14}5d^{10}6p^1) \longrightarrow \text{Tl}^{1+}([\text{Xe}] 4f^{14}5d^{10}) + 3e^-$

(c) $\text{Mg}([\text{Ne}] 3s^2) \longrightarrow \text{Mg}^{2+}([\text{Ne}]) + 2e^-$

8.7A (a) V: [Ar] $4s^23d^3$; V^{3+} : [Ar] $3d^2$; paramagnetic

(b) Ni: [Ar] $4s^23d^8$; Ni^{2+} : [Ar] $3d^8$; paramagnetic

(c) La: [Xe] $6s^25d^1$; La^{3+} : [Xe]; not paramagnetic (diamagnetic)

8.7B (a) Zr: [Kr] $5s^24d^2$; Zr^{2+} : [Kr] $4d^2$; 2 unpaired electrons

(b) Os: [Xe] $6s^24f^{14}5d^6$; Os^{3+} : [Xe] $4f^{14}5d^5$; 5 unpaired electrons

(c) Co: [Ar] $4s^23d^7$; Co^{2+} : [Ar] $3d^7$; 3 unpaired electrons

8.8A (a) $\text{F}^- < \text{Cl}^- < \text{Br}^-$ Ion size increases down a group.

(b) $\text{Mg}^{2+} < \text{Na}^+ < \text{F}^-$ Across a period, cation size decreases with increasing charge; in a series of isoelectronic ions, anions are larger than the cations.

(c) $\text{Cr}^{3+} < \text{Cr}^{2+}$ Cation size decreases with increasing charge.

8.8B (a) $\text{P}^{3-} > \text{S}^{2-} > \text{Cl}^-$ Anion size decreases with decreasing charge.

(b) $\text{Cs}^+ > \text{Rb}^+ > \text{K}^+$ Ion size increases down a group.

(c) $\text{I}^- > \text{Cs}^+ > \text{Ba}^{2+}$ Across a period, cation size decreases with increasing charge; in a series of isoelectronic ions, anions are larger than the cations.

PROBLEMS

Problems with **colored** numbers are answered in Appendix E and worked in detail in the Student Solutions Manual. Problem sections match those in the text and give the numbers of relevant sample problems. Most offer Concept Review Questions, Skill-Building Exercises (grouped in pairs covering the same concept), and Problems in Context. Comprehensive Problems are based on material from any section or previous chapter.

Introduction

Concept Review Questions

8.1 What would be your reaction to a claim that a new element had been discovered and it fit between tin (Sn) and antimony (Sb) in the periodic table?

8.2 Based on results of his study of atomic x-ray spectra, Moseley discovered a relationship that replaced atomic mass as the criterion for ordering the elements. By what criterion are the elements now ordered in the periodic table? Give an example of a sequence of element order that was confirmed by Moseley's findings.

Skill-Building Exercises (grouped in similar pairs)

8.3 Before Mendeleev published his periodic table, German scientist Johann Döbereiner grouped elements with similar properties into "triads," in which the unknown properties of one member could be predicted by averaging known values of the properties of the others. To test this idea, predict the values of the following quantities:

- The atomic mass of K from the atomic masses of Na and Rb
- The melting point of Br₂ from the melting points of Cl₂ (-101.0°C) and I₂ (113.6°C) (actual value = -7.2°C)

8.4 To test Döbereiner's idea (Problem 8.3), predict:

- The boiling point of HBr from the boiling points of HCl (-84.9°C) and HI (-35.4°C) (actual value = -67.0°C)
- The boiling point of AsH₃ from the boiling points of PH₃ (-87.4°C) and SbH₃ (-17.1°C) (actual value = -55°C)

Characteristics of Many-Electron Atoms

Concept Review Questions

8.5 Summarize the rules for the allowable values of the four quantum numbers of an electron in an atom.

8.6 Which of the quantum numbers relate(s) to the electron only? Which relate(s) to the orbital?

8.7 State the exclusion principle. What does it imply about the number and spin of electrons in an atomic orbital?

8.8 What is the key distinction between sublevel energies in one-electron species, such as the H atom, and those in many-electron species, such as the C atom? What factors lead to this distinction? Would you expect the pattern of sublevel energies in Be³⁺ to be more like that in H or that in C? Explain.

8.9 Define *shielding* and *effective nuclear charge*. What is the connection between the two?

8.10 What is penetration? How is it related to shielding? Use the penetration effect to explain the difference in relative orbital energies of a 3p and a 3d electron in the same atom.

Skill-Building Exercises (grouped in similar pairs)

8.11 How many electrons in an atom can have each of the following quantum number or sublevel designations?

- (a) $n = 2, l = 1$ (b) $3d$ (c) $4s$

8.12 How many electrons in an atom can have each of the following quantum number or sublevel designations?

- (a) $n = 2, l = 1, m_l = 0$ (b) $5p$ (c) $n = 4, l = 3$

8.13 How many electrons in an atom can have each of the following quantum number or sublevel designations?

- (a) $4p$ (b) $n = 3, l = 1, m_l = +1$ (c) $n = 5, l = 3$

8.14 How many electrons in an atom can have each of the following quantum number or sublevel designations?

- (a) $2s$ (b) $n = 3, l = 2$ (c) $6d$

The Quantum-Mechanical Model and the Periodic Table

(Sample Problems 8.1 and 8.2)

Concept Review Questions

8.15 State the periodic law, and explain its relation to electron configuration. (Use Na and K in your explanation.)

8.16 State Hund's rule in your own words, and show its application in the orbital diagram of the nitrogen atom.

8.17 How does the aufbau principle, in connection with the periodic law, lead to the format of the periodic table?

8.18 For main-group elements, are outer electron configurations similar or different within a group? Within a period? Explain.

8.19 For which blocks of elements are outer electrons the same as valence electrons? For which elements are *d* electrons often included among the valence electrons?

8.20 What is the electron capacity of the *n*th energy level? What is the capacity of the fourth energy level?

Skill-Building Exercises (grouped in similar pairs)

8.21 Write a full set of possible quantum numbers for each of the following:

- The outermost electron in an Rb atom
- The electron gained when an S⁻ ion becomes an S²⁻ ion
- The electron lost when an Ag atom ionizes
- The electron gained when an F⁻ ion forms from an F atom

8.22 Write a full set of possible quantum numbers for each of the following:

- The outermost electron in an Li atom
- The electron gained when a Br atom becomes a Br⁻ ion
- The electron lost when a Cs atom ionizes
- The highest energy electron in the ground-state B atom

8.23 Write the full ground-state electron configuration for each:
 (a) Rb (b) Ge (c) Ar

8.24 Write the full ground-state electron configuration for each:
 (a) Br (b) Mg (c) Se

8.25 Write the full ground-state electron configuration for each:
 (a) Cl (b) Si (c) Sr

8.26 Write the full ground-state electron configuration for each:
 (a) S (b) Kr (c) Cs

8.27 Draw a partial (valence-level) orbital diagram, and write the condensed ground-state electron configuration for each:
 (a) Ti (b) Cl (c) V

8.28 Draw a partial (valence-level) orbital diagram, and write the condensed ground-state electron configuration for each:
 (a) Ba (b) Co (c) Ag

8.29 Draw a partial (valence-level) orbital diagram, and write the condensed ground-state electron configuration for each:
 (a) Mn (b) P (c) Fe

8.30 Draw a partial (valence-level) orbital diagram, and write the condensed ground-state electron configuration for each:
 (a) Ga (b) Zn (c) Sc

8.31 Draw the partial (valence-level) orbital diagram, and write the symbol, group number, and period number of the element:
 (a) [He] $2s^22p^4$ (b) [Ne] $3s^23p^3$

8.32 Draw the partial (valence-level) orbital diagram, and write the symbol, group number, and period number of the element:
 (a) [Kr] $5s^24d^{10}$ (b) [Ar] $4s^23d^8$

8.33 Draw the partial (valence-level) orbital diagram, and write the symbol, group number, and period number of the element:
 (a) [Ne] $3s^23p^5$ (b) [Ar] $4s^23d^{10}4p^3$

8.34 Draw the partial (valence-level) orbital diagram, and write the symbol, group number, and period number of the element:
 (a) [Ar] $4s^23d^5$ (b) [Kr] $5s^24d^2$

8.35 From each partial (valence-level) orbital diagram, write the condensed electron configuration and group number:

8.36 From each partial (valence-level) orbital diagram, write the condensed electron configuration and group number:

8.37 How many inner, outer, and valence electrons are present in an atom of each of the following elements?

- (a) O (b) Sn (c) Ca (d) Fe (e) Se

8.38 How many inner, outer, and valence electrons are present in an atom of each of the following elements?

- (a) Br (b) Cs (c) Cr (d) Sr (e) F

8.39 Identify each element below, and give the symbols of the other elements in its group:

- (a) [He] $2s^22p^1$ (b) [Ne] $3s^23p^4$ (c) [Xe] $6s^25d^1$

8.40 Identify each element below, and give the symbols of the other elements in its group:

- (a) [Ar] $4s^23d^{10}4p^4$ (b) [Xe] $6s^24f^{14}5d^2$ (c) [Ar] $4s^23d^5$

8.41 Identify each element below, and give the symbols of the other elements in its group:

- (a) [He] $2s^22p^2$ (b) [Ar] $4s^23d^3$ (c) [Ne] $3s^23p^3$

8.42 Identify each element below, and give the symbols of the other elements in its group:

- (a) [Ar] $4s^23d^{10}4p^2$ (b) [Ar] $4s^23d^7$ (c) [Kr] $5s^24d^5$

Problems in Context

8.43 After an atom in its ground state absorbs energy, it exists in an excited state. Spectral lines are produced when the atom returns to its ground state. The yellow-orange line in the sodium spectrum, for example, is produced by the emission of energy when excited sodium atoms return to their ground state. Write the electron configuration and the orbital diagram of the first excited state of sodium. (*Hint:* The outermost electron is excited.)

8.44 One reason spectroscopists study excited states is to gain information about the energies of orbitals that are unoccupied in an atom's ground state. Each of the following electron configurations represents an atom in an excited state. Identify the element, and write its condensed ground-state configuration:

- (a) $1s^22s^22p^33s^13p^1$ (b) $1s^22s^22p^63s^23p^44s^1$
 (c) $1s^22s^22p^63s^23p^64s^23d^44p^1$ (d) $1s^22s^22p^53s^1$

Trends in Three Atomic Properties

(Sample Problems 8.3 to 8.5)

Concept Review Questions

8.45 If the exact outer limit of an isolated atom cannot be measured, what criterion can we use to determine atomic radii? What is the difference between a covalent radius and a metallic radius?

8.46 Given the following partial (valence-level) electron configurations, (a) identify each element, (b) rank the four elements in order of increasing atomic size, and (c) rank them in order of increasing ionization energy:

8.47 In what region of the periodic table will you find elements with relatively high IEs? With relatively low IEs?

8.48 (a) Why do successive IEs of a given element always increase? (b) When the difference between successive IEs of a given element is exceptionally large (for example, between IE_1

and IE_2 of K), what do we learn about the element's electron configuration? (c) The bars represent the relative magnitudes of the first five ionization energies of an atom:

Identify the element and write its complete electron configuration, assuming it comes from (i) Period 2; (ii) Period 3; (iii) Period 4.

8.49 In a plot of IE_1 for the Period 3 elements (see Figure 8.15), why do the values for elements in Groups 3A(13) and 6A(16) drop slightly below the generally increasing trend?

8.50 Which group in the periodic table has elements with high (endothermic) IE_1 and very negative (exothermic) first electron affinities (EA_1)? Give the charge on the ions these atoms form.

8.51 The EA_2 of an oxygen atom is positive, even though its EA_1 is negative. Why does this change of sign occur? Which other elements exhibit a positive EA_2 ? Explain.

8.52 How does d -electron shielding influence atomic size among the Period 4 transition elements?

Skill-Building Exercises (grouped in similar pairs)

8.53 Arrange each set in order of *increasing* atomic size:

- (a) Rb, K, Cs (b) C, O, Be
(c) Cl, K, S (d) Mg, K, Ca

8.54 Arrange each set in order of *decreasing* atomic size:

- (a) Ge, Pb, Sn (b) Sn, Te, Sr
(c) F, Ne, Na (d) Be, Mg, Na

8.55 Arrange each set of atoms in order of *increasing* IE_1 :

- (a) Sr, Ca, Ba (b) N, B, Ne
(c) Br, Rb, Se (d) As, Sb, Sn

8.56 Arrange each set of atoms in order of *decreasing* IE_1 :

- (a) Na, Li, K (b) Be, F, C
(c) Cl, Ar, Na (d) Cl, Br, Se

8.57 Write the full electron configuration of the Period 2 element with the following successive IEs (in kJ/mol):

$$\begin{array}{lll} \text{IE}_1 = 801 & \text{IE}_2 = 2427 & \text{IE}_3 = 3659 \\ \text{IE}_4 = 25,022 & \text{IE}_5 = 32,822 & \end{array}$$

8.58 Write the full electron configuration of the Period 3 element with the following successive IEs (in kJ/mol):

$$\begin{array}{lll} \text{IE}_1 = 738 & \text{IE}_2 = 1450 & \text{IE}_3 = 7732 \\ \text{IE}_4 = 10,539 & \text{IE}_5 = 13,628 & \end{array}$$

8.59 Which element in each of the following sets would you expect to have the *highest* IE_2 ?

- (a) Na, Mg, Al (b) Na, K, Fe
(c) Sc, Be, Mg

8.60 Which element in each of the following sets would you expect to have the *lowest* IE_3 ?

- (a) Na, Mg, Al (b) K, Ca, Sc
(c) Li, Al, B

Atomic Properties and Chemical Reactivity

(Sample Problems 8.6 to 8.8)

Concept Review Questions

8.61 List three ways in which metals and nonmetals differ.

8.62 Summarize the trend in metallic character as a function of position in the periodic table. Is it the same as the trend in atomic size? The trend in ionization energy?

8.63 Explain the relationship between atomic size and reducing strength in Group 1A(1). Explain the relationship between IE and oxidizing strength in Group 7A(17).

8.64 Summarize the acid-base behavior of the main-group metal and nonmetal oxides in water. How does oxide acidity in water change down a group and across a period?

8.65 What ions are possible for the two largest stable elements in Group 4A(14)? How does each arise?

8.66 What is a pseudo-noble gas configuration? Give an example of one ion from Group 3A(13) that has it.

8.67 How are measurements of paramagnetism used to support electron configurations derived spectroscopically? Use Cu(I) and Cu(II) chlorides as examples.

8.68 The charges of a set of isolectronic ions vary from 3+ to 3-. Place the ions in order of increasing size.

Skill-Building Exercises (grouped in similar pairs)

8.69 Which element would you expect to be *more* metallic?

- (a) Ca or Rb (b) Mg or Ra (c) Br or I

8.70 Which element would you expect to be *more* metallic?

- (a) S or Cl (b) In or Al (c) As or Br

8.71 Which element would you expect to be *less* metallic?

- (a) Sb or As (b) Si or P (c) Be or Na

8.72 Which element would you expect to be *less* metallic?

- (a) Cs or Rn (b) Sn or Te (c) Se or Ge

8.73 Does the reaction of a main-group nonmetal oxide in water produce an acidic or a basic solution? Write a balanced equation for the reaction of a Group 6A(16) nonmetal oxide with water.

8.74 Does the reaction of a main-group metal oxide in water produce an acidic or a basic solution? Write a balanced equation for the reaction of a Group 2A(2) oxide with water.

8.75 Write the charge and full ground-state electron configuration of the monatomic ion most likely to be formed by each:

- (a) Cl (b) Na (c) Ca

8.76 Write the charge and full ground-state electron configuration of the monatomic ion most likely to be formed by each:

- (a) Rb (b) N (c) Br

8.77 Write the charge and full ground-state electron configuration of the monatomic ion most likely to be formed by each:

- (a) Al (b) S (c) Sr

8.78 Write the charge and full ground-state electron configuration of the monatomic ion most likely to be formed by each:

- (a) P (b) Mg (c) Se

8.79 How many unpaired electrons are present in a ground-state atom from each of the following groups?
 (a) 2A(2) (b) 5A(15) (c) 8A(18) (d) 3A(13)

8.80 How many unpaired electrons are present in a ground-state atom from each of the following groups?
 (a) 4A(14) (b) 7A(17) (c) 1A(1) (d) 6A(16)

8.81 Which of these atoms are paramagnetic in their ground state?
 (a) Ga (b) Si (c) Be (d) Te

8.82 Are compounds of these ground-state ions paramagnetic?
 (a) Ti^{2+} (b) Zn^{2+} (c) Ca^{2+} (d) Sn^{2+}

8.83 Write the condensed ground-state electron configurations of these transition metal ions, and state which are paramagnetic:
 (a) V^{3+} (b) Cd^{2+} (c) Co^{3+} (d) Ag^+

8.84 Write the condensed ground-state electron configurations of these transition metal ions, and state which are paramagnetic:
 (a) Mo^{3+} (b) Au^+ (c) Mn^{2+} (d) Hf^{2+}

8.85 Palladium (Pd; $Z = 46$) is diamagnetic. Draw partial orbital diagrams to show which of the following electron configurations is consistent with this fact:

- (a) $[\text{Kr}] 5s^2 4d^8$ (b) $[\text{Kr}] 4d^{10}$ (c) $[\text{Kr}] 5s^1 4d^9$

8.86 Niobium (Nb; $Z = 41$) has an anomalous ground-state electron configuration for a Group 5B(5) element: $[\text{Kr}] 5s^1 4d^4$. What is the expected electron configuration for elements in this group? Draw partial orbital diagrams to show how paramagnetic measurements could support niobium's actual configuration.

8.87 Rank the ions in each set in order of *increasing* size, and explain your ranking:

- (a) Li^+ , K^+ , Na^+ (b) Se^{2-} , Rb^+ , Br^- (c) O^{2-} , F^- , N^{3-}

8.88 Rank the ions in each set in order of *decreasing* size, and explain your ranking:

- (a) Se^{2-} , S^{2-} , O^{2-} (b) Te^{2-} , Cs^+ , I^- (c) Sr^{2+} , Ba^{2+} , Cs^+

Comprehensive Problems

8.89 Name the element described in each of the following:

- (a) Smallest atomic radius in Group 6A(16)
- (b) Largest atomic radius in Period 6
- (c) Smallest metal in Period 3
- (d) Highest IE_1 in Group 4A(14)
- (e) Lowest IE_1 in Period 5
- (f) Most metallic in Group 5A(15)
- (g) Group 3A(13) element that forms the most basic oxide
- (h) Period 4 element with highest energy level filled
- (i) Condensed ground-state electron configuration of $[\text{Ne}] 3s^2 3p^2$
- (j) Condensed ground-state electron configuration of $[\text{Kr}] 5s^2 4d^6$
- (k) Forms $2+$ ion with electron configuration $[\text{Ar}] 3d^3$
- (l) Period 5 element that forms $3+$ ion with pseudo-noble gas configuration
- (m) Period 4 transition element that forms $3+$ diamagnetic ion
- (n) Period 4 transition element that forms $2+$ ion with a half-filled d sublevel
- (o) Heaviest lanthanide
- (p) Period 3 element whose $2-$ ion is isoelectronic with Ar
- (q) Alkaline earth metal whose cation is isoelectronic with Kr
- (r) Group 5A(15) metalloid with the most acidic oxide

8.90 Use electron configurations to account for the stability of the lanthanide ions Ce^{4+} and Eu^{2+} .

8.91 When a nonmetal oxide reacts with water, it forms an oxoacid in which the nonmetal retains the same oxidation number as in the oxide. Give the name and formula of the oxide used to prepare each of these oxoacids: (a) hypochlorous acid; (b) chlorous acid; (c) chloric acid; (d) perchloric acid; (e) sulfuric acid; (f) sulfurous acid; (g) nitric acid; (h) nitrous acid; (i) carbonic acid; (j) phosphoric acid.

8.92 A fundamental relationship of electrostatics states that the energy required to separate opposite charges of magnitudes Q_1 and Q_2 that are a distance d apart is proportional to $\frac{Q_1 \times Q_2}{d}$. Use this relationship and any other relevant factors to explain the following:
 (a) The IE_2 of He ($Z = 2$) is *more* than twice the IE_1 of H ($Z = 1$).
 (b) The IE_1 of He is *less* than twice the IE_1 of H.

8.93 The energy difference between the $5d$ and $6s$ sublevels in gold accounts for its color. Assuming this energy difference is about 2.7 eV (electron volts; 1 eV = 1.602×10^{-19} J), explain why gold has a warm yellow color.

8.94 Write the formula and name of the compound formed from the following ionic interactions: (a) The $2+$ ion and the $1-$ ion are both isoelectronic with the atoms of a chemically unreactive Period 4 element. (b) The $2+$ ion and the $2-$ ion are both isoelectronic with the Period 3 noble gas. (c) The $2+$ ion is the smallest with a filled d sublevel; the anion forms from the smallest halogen. (d) The ions form from the largest and smallest ionizable atoms in Period 2.

8.95 The energy changes for many unusual reactions can be determined using Hess's law (Section 6.5).

- (a) Calculate ΔE for the conversion of $\text{F}^-(g)$ into $\text{F}^+(g)$.
- (b) Calculate ΔE for the conversion of $\text{Na}^+(g)$ into $\text{Na}^-(g)$.

8.96 Discuss each conclusion from a study of redox reactions:

- (a) The sulfide ion functions only as a reducing agent.
- (b) The sulfate ion functions only as an oxidizing agent.
- (c) Sulfur dioxide functions as an oxidizing or a reducing agent.

8.97 The hot glowing gases around the Sun, the *corona*, can reach millions of degrees Celsius, temperatures high enough to remove many electrons from gaseous atoms. Iron ions with charges as high as $14+$ have been observed in the corona. Which ions from Fe^+ to Fe^{14+} are paramagnetic? Which would be most strongly attracted to a magnetic field?

8.98 There are some exceptions to the trends of first and successive ionization energies. For each of the following pairs, explain which ionization energy would be higher:

- (a) IE_1 of Ga or IE_1 of Ge (b) IE_2 of Ga or IE_2 of Ge
- (c) IE_3 of Ga or IE_3 of Ge (d) IE_4 of Ga or IE_4 of Ge

8.99 Use Figure 8.16, to find: (a) the longest wavelength of electromagnetic (EM) radiation that can ionize an alkali metal atom; (b) the longest wavelength of EM radiation that can ionize an alkaline earth metal atom; (c) the elements, other than the alkali and alkaline earth metals, that could also be ionized by the radiation in part (b); (d) the region of the EM spectrum in which these photons are found.

8.100 Rubidium and bromine atoms are depicted at right. (a) What monatomic ions do they form? (b) What electronic feature characterizes this pair of ions, and which noble

gas are they related to? (c) Which pair best represents the relative ionic sizes?

8.101 Partial (valence-level) electron configurations for four different ions are shown below:

- (a)

--

↑↓	↑↓	↑↓	↑↓	↑	↑
----	----	----	----	---	---

 (2+ ion)
5s 4d
- (b)

--

↑↓	↑	↑	↑	↑	↑
----	---	---	---	---	---

 (3+ ion)
4s 3d
- (c)

--

↑↓	↑↓	↑↓	↑↓	↑↓	↑↓
----	----	----	----	----	----

 (1+ ion)
5s 4d
- (d)

--

↑	↑	↑		
---	---	---	--	--

 (4+ ion)
4s 3d

Identify the elements from which the ions are derived, and write the formula of the oxide each ion forms.

8.102 Data from the planet Zog for some main-group elements are shown below (Zoggian units are linearly related to Earth units but are not shown). Radio signals from Zog reveal that balloonium is a monatomic gas with two positive nuclear charges. Use the data to deduce the names that Earthlings give to these elements:

Name	Atomic Radius	IE ₁	EA ₁
Balloonium	10	339	0
Inertium	24	297	+4.1
Allotropium	34	143	-28.6
Brinium	63	70.9	-7.6
Canium	47	101	-15.3
Fertilium	25	200	0
Liquidium	38	163	-46.4
Utilium	48	82.4	-6.1
Crimsonium	72	78.4	-2.9

9

Models of Chemical Bonding

9.1 Atomic Properties and Chemical Bonds

The Three Ways Elements Combine
Lewis Symbols and the Octet Rule

9.2 The Ionic Bonding Model

Importance of Lattice Energy
Periodic Trends in Lattice Energy
How the Model Explains the
Properties of Ionic Compounds

9.3 The Covalent Bonding Model

Formation of a Covalent Bond
Bonding Pairs and Lone Pairs

Bond Order, Energy, and Length
How the Model Explains the
Properties of Covalent
Substances

9.4 Bond Energy and Chemical Change

Where Does ΔH°_{rxn} Come From?
Using Bond Energies to
Calculate ΔH°_{rxn}
Bond Strengths and Heat Released
from Fuels and Foods

9.5 Between the Extremes: Electronegativity and Bond Polarity

Electronegativity
Bond Polarity and Partial Ionic
Character
Gradation in Bonding Across a Period

9.6 An Introduction to Metallic Bonding

The Electron-Sea Model
How the Model Explains the
Properties of Metals

Source: © Chip Clark/Fundamental Photographs, NYC

Concepts and Skills to Review Before You Study This Chapter

- › characteristics of ionic and covalent substances; Coulomb's law (Section 2.7)
- › polar covalent bonds and the polarity of water (Section 4.1)
- › Hess's law, ΔH_{rxn}° , and ΔH_f° (Sections 6.5 and 6.6)
- › atomic and ionic electron configurations (Sections 8.2 and 8.4)
- › trends in atomic properties and metallic behavior (Sections 8.3 and 8.4)

Two distinctly different elements react to form table salt, a compound that is distinctly different from either reactant! Sodium, like most metals, is shiny, malleable, and able to conduct a current whether molten or solid. Chlorine, like most covalent substances, is low melting (it's a gas at room temperature) and nonconducting. The product of the reaction, sodium chloride, is a hard, brittle, high-melting solid that conducts a current only when molten or dissolved in water, like any other ionic compound. Why do these substances behave so differently? The answer lies in the *type of bonding within each substance*. In Chapter 8, we examined the properties of individual atoms and ions. But the behavior of matter really depends on how those atoms and ions bond.

IN THIS CHAPTER . . . We examine how atomic properties give rise to three models of chemical bonding—ionic, covalent, and metallic—and how each model explains the behavior of substances.

- › We see how metals and nonmetals combine via three types of bonding and learn how to depict atoms and ions with Lewis symbols.
- › We detail the steps in the formation of an ionic solid and focus on the importance of lattice energy.
- › Covalent bonding occurs in the vast majority of compounds, so we look at how a bond forms and discuss the relations among bond order, energy, and length.
- › We explore the relationship between bond energy and the enthalpy change of a reaction, with a focus on fuels and foods.
- › We examine periodic trends in electronegativity and learn its role in the range of bonding, from pure covalent to ionic, and in bond polarity.
- › We consider a simple bonding model that explains the properties of metals.

9.1 ATOMIC PROPERTIES AND CHEMICAL BONDS

Just as the electron configuration and the strength of nucleus-electron attractions determine the properties of an atom, the type and strength of chemical bonds determine the properties of a substance.

The Three Ways Elements Combine

Before we examine the types of chemical bonding, we should answer a fundamental question: why do atoms bond at all? In general, *bonding lowers the potential energy between positive and negative particles* (see Figure 1.3C), whether they are oppositely charged ions or nuclei and electrons.

As you saw in Chapter 8, there is, in general, a gradation from more metallic elements to more nonmetallic elements across a period *and* up a group (Figure 9.1, *next page*). Three models of bonding result from the three ways atoms of these two types of elements can combine.

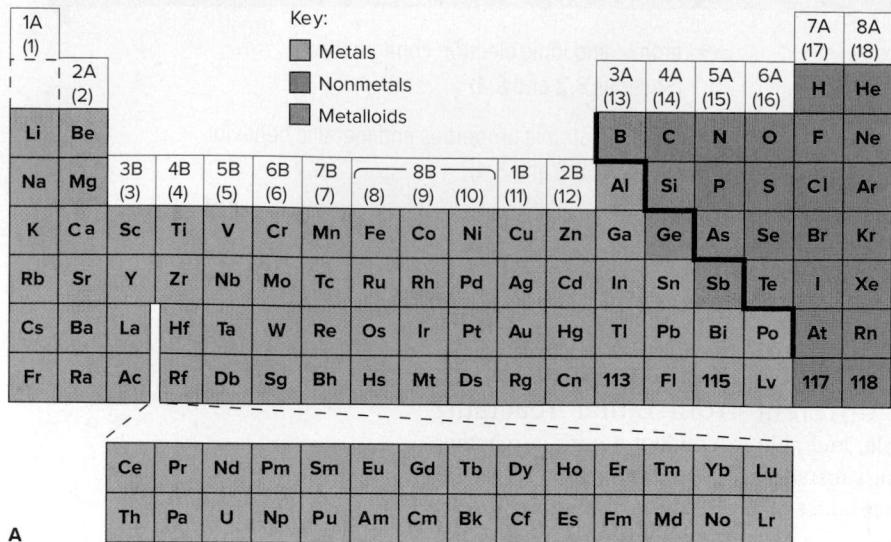

Figure 9.1 A comparison of metals and nonmetals. **A**, Location within the periodic table. **B**, Relative magnitudes of some atomic properties across a period.

1. *Metal with nonmetal: electron transfer and ionic bonding* (Figure 9.2A). We observe *electron transfer* and **ionic bonding** between atoms with *large differences in their tendencies to lose or gain electrons*. Such differences occur between reactive metals [Groups 1A(1) and 2A(2)] and nonmetals [Group 7A(17) and the top of Group 6A(16)]. A metal atom (low IE) loses its one or two valence electrons, and a nonmetal atom (highly negative EA) gains the electron(s). As the transfer of electron(s) from metal atom to nonmetal atom occurs, each atom forms an ion with a noble gas electron configuration. The electrostatic attractions between these positive and negative ions draw them into a three-dimensional array to form an ionic solid. The chemical formula of an ionic compound is the *empirical formula* because it gives the cation-to-anion ratio.

2. *Nonmetal with nonmetal: electron sharing and covalent bonding* (Figure 9.2B). When two atoms *differ little, or not at all, in their tendencies to lose or gain electrons*, we observe *electron sharing* and **covalent bonding**, which occurs most commonly between nonmetals. Each nonmetal atom holds onto its own electrons tightly (high IE) and attracts other electrons as well (highly negative EA). The nucleus of each atom attracts the valence electrons of the other, which draws the atoms together. The shared electron pair is typically *localized* between the two atoms, linking them in a covalent bond of a particular length and strength. In most cases, separate molecules result when atoms bond covalently. Note that the chemical formula of a covalent substance is the *molecular formula* because it gives the actual numbers of atoms in each molecule.

Figure 9.2 Three models of chemical bonding.

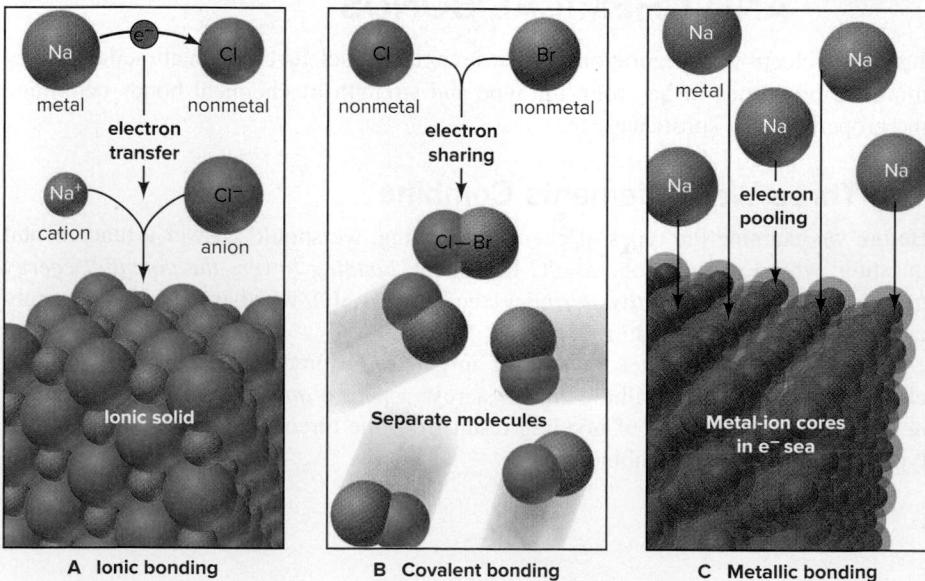

3. **Metal with metal: electron pooling and metallic bonding** (Figure 9.2C). Metals share electrons in a different way. Their atoms are relatively large, and the few outer electrons are well shielded by filled inner levels (core electrons). Thus, metals lose outer electrons easily (low IE) and do not gain them readily (slightly negative or positive EA). These properties lead metal atoms to share their valence electrons, but not by covalent bonding. In the simplest model of **metallic bonding**, the enormous number of atoms in a sample of a metal *pool* their valence electrons in a “sea” of electrons that “flows” between and around each metal-ion core (nucleus plus inner electrons), thereby attracting and holding them together. Unlike the localized electrons in covalent bonding, electrons in metallic bonding are *delocalized*, moving freely throughout the entire piece of metal.

In the world of real substances, there are exceptions to these idealized models, so you can't always predict bond type from positions of the elements in the periodic table. As just one example, when the metal beryllium [Group 2A(2)] combines with the nonmetal chlorine [Group 7A(17)], the bonding fits the covalent model better than the ionic model. Just as we see gradations in atomic behavior within a group or period, we see a gradation in bonding from one type to another between atoms from different groups and periods (Figure 9.3).

Lewis Symbols and the Octet Rule

Before examining each of the models, we consider a method for depicting the valence electrons of interacting atoms that predicts how they bond. In a **Lewis electron-dot symbol** (named for the American chemist G. N. Lewis), the element symbol represents the nucleus *and* inner electrons, and dots around the symbol represent the valence electrons (Figure 9.4). Note that the pattern of dots is the same for elements within a group.

	1A(1)	2A(2)		3A(13)	4A(14)	5A(15)	6A(16)	7A(17)	8A(18)
	ns^1	ns^2		ns^2np^1	ns^2np^2	ns^2np^3	ns^2np^4	ns^2np^5	ns^2np^6
Period	• Li	• Be •		• B •	• C •	• N •	: O :	: F :	: Ne : ..
2									
3	• Na	• Mg •		• Al •	• Si •	• P •	: S :	: Cl :	: Ar : ..

We use these steps to write the Lewis symbol for any main-group element:

1. Note its A-group number (1A to 8A), which is the number of valence electrons in the atom and thus the number of valence-electron dots needed in the electron-dot symbol.
2. Place one dot at a time on each of the four sides (top, right, bottom, left) of the element symbol.
3. Keep adding dots, pairing them, until all are used up.

The specific placement of dots is not important; that is, in addition to the one shown in Figure 9.4, the Lewis symbol for nitrogen can *also* be written as

The Lewis symbol provides information about an element's bonding behavior:

- For a **metal**, the *total* number of dots is the number of electrons an atom loses to form a cation; for example, Mg loses 2 to form Mg^{2+} .
- For a **nonmetal**, the number of *unpaired* dots equals either the number of electrons an atom gains to form an anion (F gains 1 to form F^-) or the number it *shares* to form covalent bonds.

The Lewis symbol for carbon illustrates the last point. Rather than one pair of dots and two unpaired dots, as its electron configuration seems to call for ($[\text{He}] 2s^2 2p^2$), carbon has four unpaired dots because it forms four bonds. Larger nonmetals can form as many bonds as the number of dots in their Lewis symbol (Chapter 10).

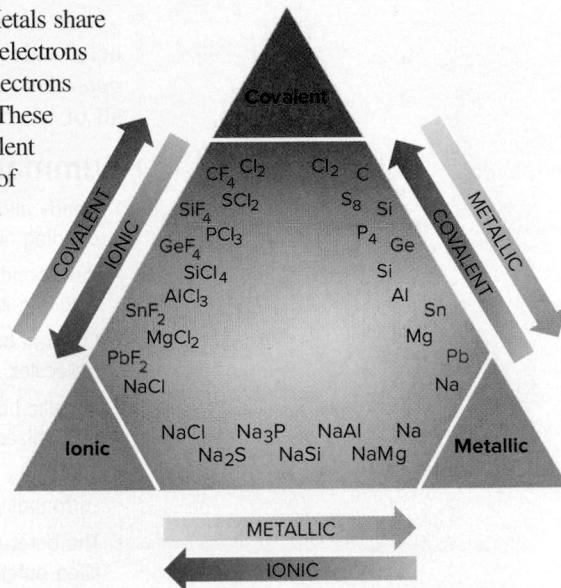

Figure 9.3 Gradations in bond type among Period 3 (black type) and Group 4A (red type) elements.

Figure 9.4 Lewis electron-dot symbols for elements in Periods 2 and 3.

In his pioneering studies, Lewis generalized much of bonding behavior into the **octet rule**: *when atoms bond, they lose, gain, or share electrons to attain a filled outer level of eight electrons (or two, for H and Li)*. The octet rule holds for nearly all of the compounds of Period 2 elements and a large number of others as well.

› Summary of Section 9.1

- › Nearly all naturally occurring substances consist of atoms or ions bonded to others. Chemical bonding allows atoms to lower their energy.
- › Ionic bonding occurs when metal atoms transfer electrons to nonmetal atoms, and the resulting ions attract each other and form an ionic solid.
- › Covalent bonding is most common between nonmetal atoms and usually results in individual molecules. Bonded atoms share one or more pairs of electrons that are localized between them.
- › Metallic bonding occurs when many metal atoms pool their valence electrons into a delocalized electron “sea” that holds all the atoms in the sample together.
- › The Lewis electron-dot symbol of a main-group atom shows valence electrons as dots surrounding the element symbol.
- › The octet rule says that, when bonding, many atoms lose, gain, or share electrons to attain a filled outer level of eight (or two) electrons.

9.2 THE IONIC BONDING MODEL

The central idea of the ionic bonding model is the *transfer of electrons from metal atoms to nonmetal atoms to form ions that attract each other and form a solid compound*. In most cases, for the main groups, the ion that forms has a filled outer level of either two or eight electrons (octet rule), the number in the nearest noble gas. In other words, a metal will lose the number of electrons needed to achieve the configuration of the noble gas that precedes it in the periodic table, while a nonmetal will gain the number of electrons needed to achieve the configuration of the noble gas at the end of its period.

The transfer of an electron from a lithium atom to a fluorine atom is depicted in three ways in Figure 9.5. In each, Li loses its single outer electron and is left with a filled $n = 1$ level (two e^-), while F gains a single electron to fill its $n = 2$ level (eight e^-). In this case, each atom is one electron away from the configuration of its nearest noble gas, so the number of electrons lost by each Li equals the number gained by each F. Therefore, equal numbers of Li^+ and F^- ions form, as the formula LiF indicates. That is, in ionic bonding, *the total number of electrons lost by the metal atom(s) equals the total number of electrons gained by the nonmetal atom(s)*.

Figure 9.5 Three ways to depict electron transfer in the formation of Li^+ and F^- . The electron being transferred is shown in red.

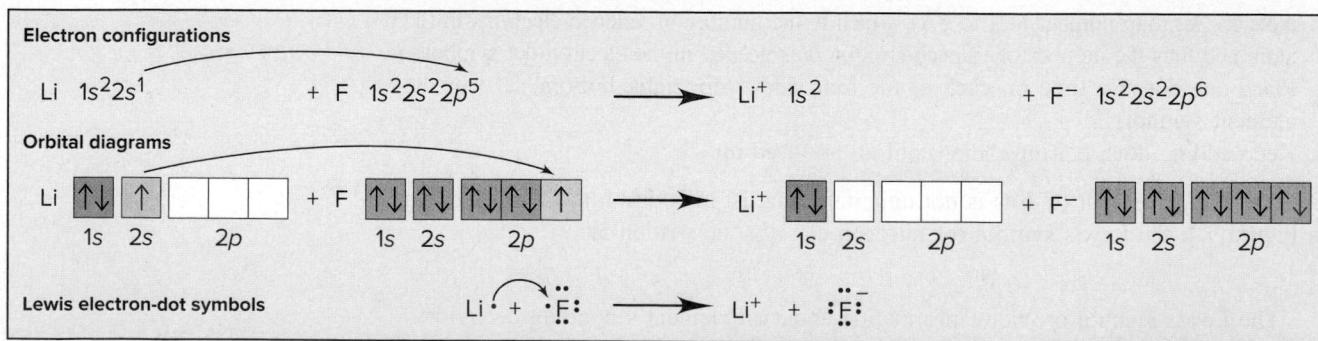

SAMPLE PROBLEM 9.1

Depicting Ion Formation

Problem Use partial orbital diagrams and Lewis symbols to depict the formation of Na^+ and O^{2-} ions from the atoms, and give the formula of the compound formed.

Plan First we draw the orbital diagrams and Lewis symbols for Na and O atoms. To attain filled outer levels (noble gas configurations), Na loses one electron and O gains two. To make the number of electrons lost equal the number gained, two Na atoms are needed for each O atom.

Solution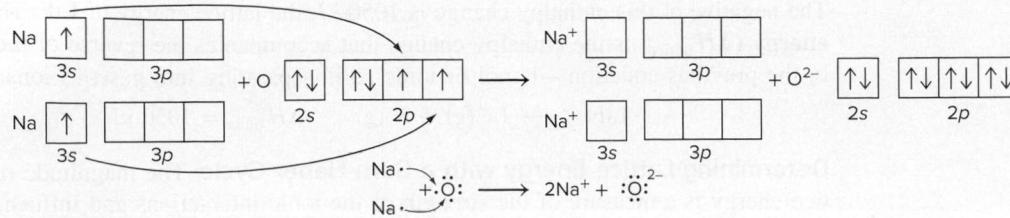

The formula is Na_2O .

FOLLOW-UP PROBLEMS

Brief Solutions for all Follow-up Problems appear at the end of the chapter.

9.1A Use condensed electron configurations, partial orbital diagrams (ns and np only), and Lewis symbols to depict the formation of Mg^{2+} and Cl^- ions from the atoms, and give the formula of the compound formed.

9.1B Use condensed electron configurations, partial orbital diagrams (ns and np only), and Lewis symbols to depict the formation of Ca^{2+} and O^{2-} ions, and give the formula of the compound formed.

SOME SIMILAR PROBLEMS 9.20 and 9.21

Why Ionic Compounds Form: The Importance of Lattice Energy

You may be surprised to learn that energy is actually *absorbed* during electron transfer. So why does it occur? And, given this absorption of energy, why do ionic substances exist at all? As you'll see, the answer involves the enormous quantity of energy *released* after electron transfer, as the ions form a solid.

1. The electron-transfer process. Consider just the electron-transfer process for the formation of lithium fluoride, which involves a gaseous Li atom losing an electron and a gaseous F atom gaining it:

- The first ionization energy (IE_1) of Li is the energy absorbed when 1 mol of gaseous Li atoms loses 1 mol of valence electrons:

- The first electron affinity (EA_1) of F is the energy released when 1 mol of gaseous F atoms gains 1 mol of electrons:

- Taking the sum shows that electron transfer *by itself* requires energy:

2. Other steps that absorb energy. The total energy needed prior to ion formation is added to the sum of IE_1 and EA_1 : metallic Li must be made into gaseous Li atoms (161 kJ/mol), and F_2 molecules must be broken into separate F atoms (79.5 kJ/mol).

3. Steps that release energy. Despite these endothermic steps, the standard enthalpy of formation (ΔH_f°) of solid LiF is -617 kJ/mol ; that is, 617 kJ is *released* when 1 mol of $\text{LiF}(s)$ forms from its elements. Formation of LiF is typical of reactions between active metals and nonmetals: ionic solids form readily (Figure 9.6).

If the overall reaction releases energy, there must be some step that is exothermic enough to outweigh the endothermic steps. This step involves the *strong attraction between pairs of oppositely charged ions*. When 1 mol of $\text{Li}^+(g)$ and 1 mol of $\text{F}^-(g)$ form 1 mol of gaseous LiF molecules, a large quantity of heat is released:

But, as you know, under ordinary conditions, LiF does not exist as gaseous molecules: *even more energy is released when the separate gaseous ions coalesce into a crystalline solid because each ion attracts several oppositely charged ions*:

A

B

Figure 9.6 The exothermic formation of sodium bromide. **A**, Sodium (in beaker under mineral oil) and bromine. **B**, The reaction is rapid and vigorous.

Source: © McGraw-Hill Education/Stephen Frisch, photographer

The negative of this enthalpy change is 1050 kJ, the lattice energy of LiF. The **lattice energy ($\Delta H_{\text{lattice}}^{\circ}$)** is the enthalpy change that accompanies the reverse of the process in the previous equation—1 mol of ionic solid separating into gaseous ions:

Determining Lattice Energy with a Born-Haber Cycle The magnitude of the lattice energy is a measure of the strength of the ionic interactions and influences macroscopic properties, such as melting point, hardness, and solubility. Despite playing this crucial role in the formation of ionic compounds, lattice energy is usually *not* measured directly. One way to determine it applies Hess's law (see Section 6.5) in a **Born-Haber cycle**, a series of steps from elements to ionic solid for which all the enthalpies* are known except the lattice energy.

Let's go through a Born-Haber cycle for the formation of lithium fluoride to calculate $\Delta H_{\text{lattice}}^{\circ}$. Figure 9.7 shows two possible paths, a direct combination reaction (ΔH_f° ; black arrow) and a multistep path (orange arrows) in which one step is the unknown $\Delta H_{\text{lattice}}^{\circ}$. Hess's law tells us both paths involve the same overall enthalpy change:

$$\Delta H_f^{\circ} \text{ of LiF}(s) = \text{sum of } \Delta H^{\circ} \text{ values for multistep path}$$

Hess's law lets us choose *hypothetical* steps whose enthalpy changes we can measure, even though *they are not the actual steps that occur when lithium reacts with fluorine*. We identify each ΔH° by its step number in Figure 9.7:

Step 1. From solid Li to gaseous Li atoms. This step, called *atomization*, has the enthalpy change $\Delta H_{\text{atom}}^{\circ}$. It involves breaking metallic bonds and vaporizing the atoms, so it absorbs energy:

*Strictly speaking, ionization energy (IE) and electron affinity (EA) are internal energy changes (ΔE), not enthalpy changes (ΔH), but in these steps, $\Delta H = \Delta E$ because $\Delta V = 0$ (Section 6.2).

Figure 9.7 The Born-Haber cycle for lithium fluoride. The formation of LiF(s) from its elements can happen in one combination reaction (black arrow) or in five steps (orange arrows). The unknown enthalpy change is $\Delta H_{\text{step 5}}^{\circ}$ ($-\Delta H_{\text{lattice}}^{\circ}$ of LiF).

Step 2. From F_2 molecules to F atoms. This step involves breaking a covalent bond, so it absorbs energy; as we discuss later, this is the *bond energy* (BE) of F_2 . Since we need 1 mol of F atoms to make 1 mol of LiF, we start with $\frac{1}{2}$ mol of F_2 :

Step 3. From Li to Li^+ . Removing the $2s$ electron from Li absorbs energy:

Step 4. From F to F^- . Adding an electron to F releases energy:

Step 5. From gaseous ions to ionic solid. Forming solid LiF from gaseous Li^+ and F^- releases a lot of energy. The enthalpy change for this step is unknown but is, by definition, the negative of the lattice energy:

The enthalpy change of the combination reaction (*black arrow*) is

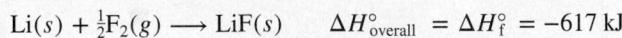

We set ΔH_f° equal to the sum of the ΔH° values for the steps and solve for $\Delta H_{\text{lattice}}^{\circ}$:

$$\Delta H_f^{\circ} = \Delta H_{\text{step 1}}^{\circ} + \Delta H_{\text{step 2}}^{\circ} + \Delta H_{\text{step 3}}^{\circ} + \Delta H_{\text{step 4}}^{\circ} + (-\Delta H_{\text{lattice}}^{\circ} \text{ of LiF})$$

Solving for $-\Delta H_{\text{lattice}}^{\circ}$ of LiF gives

$$\begin{aligned} -\Delta H_{\text{lattice}}^{\circ} \text{ of LiF} &= \Delta H_f^{\circ} - (\Delta H_{\text{step 1}}^{\circ} + \Delta H_{\text{step 2}}^{\circ} + \Delta H_{\text{step 3}}^{\circ} + \Delta H_{\text{step 4}}^{\circ}) \\ &= -617 \text{ kJ} - [161 \text{ kJ} + 79.5 \text{ kJ} + 520 \text{ kJ} + (-328 \text{ kJ})] \\ &= -1050 \text{ kJ} \end{aligned}$$

And changing the sign gives

$$\Delta H_{\text{lattice}}^{\circ} \text{ of LiF} = -(-1050 \text{ kJ}) = 1050 \text{ kJ}$$

Note that *the lattice energy is, by far, the largest component of the multistep process.* (Problems 9.30 and 9.31 are among several that focus on Born-Haber cycles.)

The Born-Haber cycle shows that the energy *required* for elements to form ions is *supplied* by the attraction among the ions in the solid. And the “take-home lesson” is that *ionic solids exist only because the lattice energy far exceeds the total energy needed to form the ions.*

Periodic Trends in Lattice Energy

The lattice energy results from electrostatic interactions among ions, so its magnitude depends on ionic size, ionic charge, and the arrangement of the ions in the solid. Therefore, we expect to see periodic trends in lattice energy.

Explaining the Trends with Coulomb’s Law Recall from Chapter 2 that **Coulomb’s law** states that the electrostatic energy between particles A and B is directly proportional to the product of their charges and inversely proportional to the distance between them:

$$\text{Electrostatic energy} \propto \frac{\text{charge A} \times \text{charge B}}{\text{distance}}$$

Lattice energy is directly proportional to electrostatic energy. In an ionic solid, cations and anions lie as close to each other as possible, so the distance between them is the sum of the ionic radii (see Figure 8.28):

$$\text{Electrostatic energy} \propto \frac{\text{cation charge} \times \text{anion charge}}{\text{cation radius} + \text{anion radius}} \propto \Delta H_{\text{lattice}}^{\circ} \quad (9.1)$$

This relationship helps us explain the effects of ionic size and charge on trends in lattice energy (also see Figure 2.12):

1. *Effect of ionic size.* Smaller ions attract each other more strongly than larger ions, because the charges are closer to each other. As we move down a group, ionic

Figure 9.8 Trends in lattice energy. The lattice energies are shown for compounds formed from a given Group 1A(1) cation (left side) and one of the Group 7A(17) anions (bottom). LiF (smallest ions) has the highest lattice energy, and RbI (largest ions) has the lowest.

radii increase, so the electrostatic energy between cations and anions decreases; thus, lattice energies should decrease as well:

ionic size increases ↑, lattice energy decreases ↓

Figure 9.8 shows that, for the alkali-metal halides, lattice energy decreases down the group whether the cation remains the same (LiF to LiI) or the anion remains the same (LiF to RbF).

2. *Effect of ionic charge.* Ions with higher charges attract each other more strongly than ions with lower charges; thus, lattice energy increases with increasing ionic charge:

ionic charge increases ↑, lattice energy increases ↑

Across a period, ionic charge changes. For example, lithium fluoride and magnesium oxide have cations and anions of about equal radii ($\text{Li}^+ = 76 \text{ pm}$ and $\text{Mg}^{2+} = 72 \text{ pm}$; $\text{F}^- = 133 \text{ pm}$ and $\text{O}^{2-} = 140 \text{ pm}$). The major difference is between singly charged Li^+ and F^- ions and doubly charged Mg^{2+} and O^{2-} ions. The difference in the lattice energies of the two compounds is striking:

$$\Delta H_{\text{lattice}}^\circ \text{ of LiF} = 1050 \text{ kJ/mol} \quad \text{and} \quad \Delta H_{\text{lattice}}^\circ \text{ of MgO} = 3923 \text{ kJ/mol}$$

This nearly fourfold increase in $\Delta H_{\text{lattice}}^\circ$ reflects the fourfold increase in the product of the charges (1 × 1 vs. 2 × 2) in the numerator of Equation 9.1.

Student Hot Spot

Student data indicate that you may struggle with predicting relative lattice energies of ionic compounds. Access the SmartBook to view additional Learning Resources on this topic.

SAMPLE PROBLEM 9.2

Predicting Relative Lattice Energy from Ionic Properties

Problem Use ionic properties to explain which compound in each pair has the larger lattice energy: (a) RbI or NaBr; (b) KCl or CaS.

Plan To choose the compound with the larger lattice energy, we apply Coulomb's law and periodic trends in ionic radius and charge (see Figure 2.12). We examine the ions in each compound: for ions of similar size, higher charge leads to a larger lattice energy; for ions with the same charge, smaller size leads to larger lattice energy because the ions can get closer together.

Solution (a) NaBr. All the ions have single charges, so charge is not a factor. Size increases down a group, so Rb^+ is larger than Na^+ , and I^- is larger than Br^- . Therefore, NaBr has the larger lattice energy because it consists of smaller ions.

(b) CaS. Size decreases from left to right across a period, so K^+ is slightly larger than Ca^{2+} , and S^{2-} is slightly larger than Cl^- . However, these small differences are not nearly as important as the charges: Ca^{2+} and S^{2-} have twice the charge of K^+ and Cl^- , so CaS has the larger lattice energy.

Check The actual lattice energies are **(a)** $\text{RbI} = 598 \text{ kJ/mol}$ and $\text{NaBr} = 719 \text{ kJ/mol}$;

(b) $\text{KCl} = 676 \text{ kJ/mol}$ and $\text{CaS} = 3039 \text{ kJ/mol}$.

FOLLOW-UP PROBLEMS

9.2A Use ionic properties to explain which compound has the *smaller* lattice energy: BaF_2 or SrF_2 .

9.2B Use ionic properties to arrange the following compounds in order of *increasing* lattice energy: MgF_2 , Na_2O , CaO .

SOME SIMILAR PROBLEMS 9.26–9.29

Why Does MgO Exist? We might ask how ionic solids, like MgO, with doubly charged ions, could even form. After all, forming 1 mol of Mg^{2+} involves the sum of the first *and* second ionization energies:

And, while forming 1 mol of O^- ions is exothermic (first electron affinity, EA_1), adding a second mole of electrons (second electron affinity, EA_2) is endothermic because the electron is added to a negative ion. The overall formation of O^{2-} ions is endothermic:

There are also the endothermic steps for converting $\text{Mg}(s)$ to $\text{Mg}(g)$ (148 kJ/mol) and breaking $\frac{1}{2}$ mol of O_2 molecules into O atoms ($\frac{1}{2}[498 \text{ kJ/mol}] = 249 \text{ kJ}$). Thus, the total energy that must be absorbed in the formation of the compound is significant: $2188 + 737 + 148 + 249 \text{ kJ} = 3322 \text{ kJ}$. Nevertheless, the 2+ and 2- ionic charges make the lattice energy so large ($\Delta H_{\text{lattice}}^\circ = 3923 \text{ kJ/mol}$) that MgO forms readily whenever Mg burns in air ($\Delta H_f^\circ = -601 \text{ kJ/mol}$; Figure 3.7).

How the Model Explains the Properties of Ionic Compounds

The central role of any model is to explain the facts. With atomic-level views, we can see how the ionic bonding model accounts for the properties of ionic solids:

1. Physical behavior. As a typical ionic compound, a piece of rock salt (NaCl) is *hard* (does not dent), *rigid* (does not bend), and *brittle* (cracks without deforming). These properties arise from the strong attractive forces that hold the ions *in specific positions*. Moving them out of position requires overcoming these forces, so rock salt does not dent or bend. If enough force is applied, ions of like charge are brought next to each other, and repulsions between them crack the sample suddenly (Figure 9.9).

Figure 9.9 Why ionic compounds crack.

A, Ionic compounds crack when struck with enough force. **B,** When a force moves like charges near each other, repulsions cause a crack.

Source: (A) © McGraw-Hill Education/Stephen Frisch, photographer

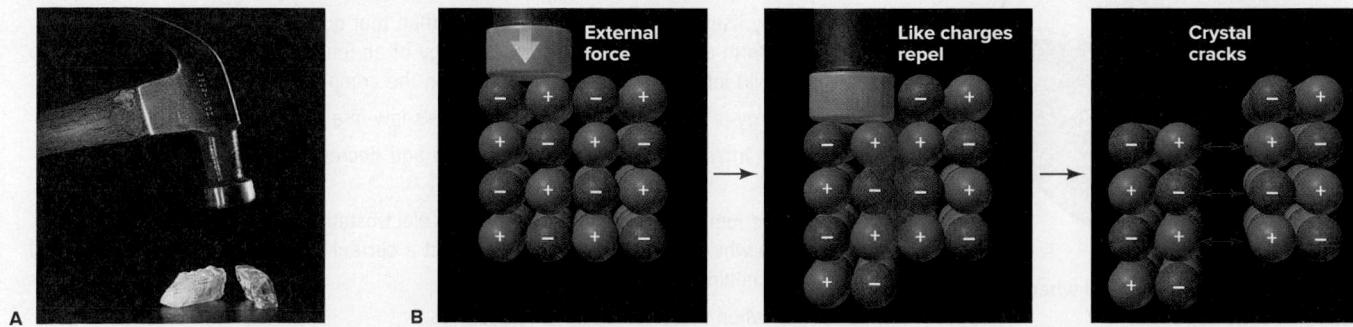

Figure 9.10 Electrical conductance and ion mobility.

Source: © McGraw-Hill Education/Stephen Frisch, photographer

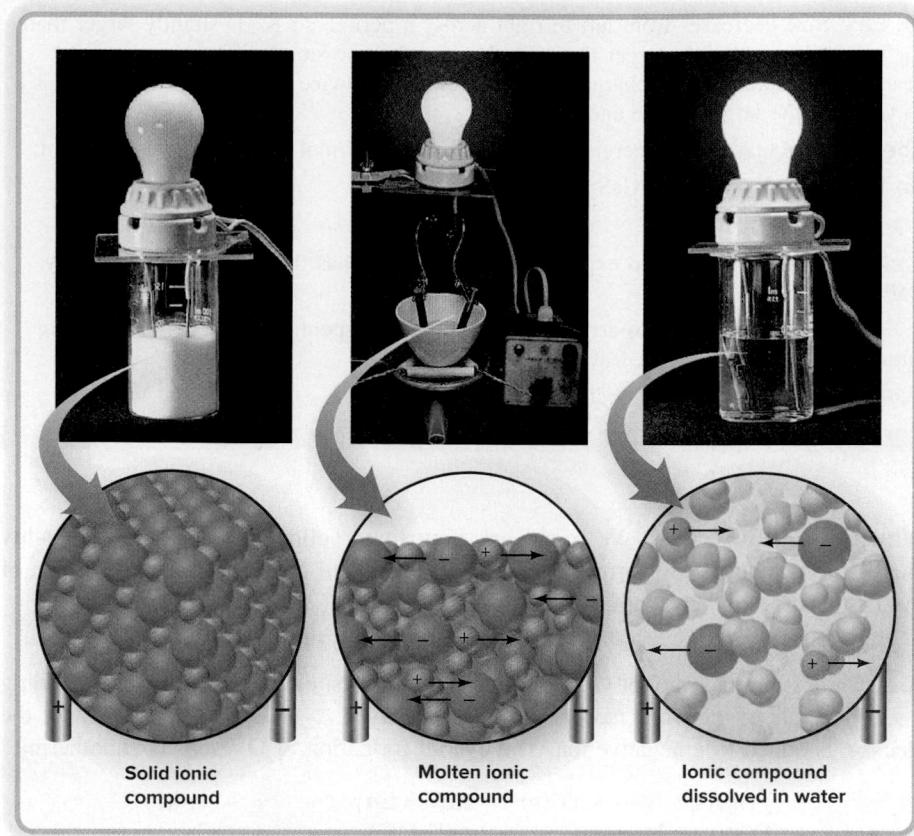

Table 9.1

Melting and Boiling Points of Some Ionic Compounds

Compound	mp (°C)	bp (°C)
CsBr	636	1300
NaI	661	1304
MgCl ₂	714	1412
KBr	734	1435
CaCl ₂	782	>1600
NaCl	801	1413
LiF	845	1676
KF	858	1505
MgO	2852	3600

2. *Electrical conductivity.* Ionic compounds typically *do not* conduct electricity in the solid state but *do* conduct when melted or dissolved. According to the model, the solid consists of fixed ions, but when it melts or dissolves, the ions can move and carry a current (Figure 9.10).

3. *Melting and boiling point.* Large amounts of energy are needed to free the ions from their positions and separate them. Thus, we expect ionic compounds to have high melting points and much higher boiling points (Table 9.1). In fact, the interionic attraction is so strong that a vaporized ionic compound consists of **ion pairs**, gaseous ionic molecules, rather than individual ions (Figure 9.11). In their normal state, as you know, *ionic compounds are solid arrays of ions, and no separate molecules exist*.

› Summary of Section 9.2

- › In ionic bonding, a metal transfers electrons to a nonmetal, and the resulting ions attract each other to form a solid.
- › Main-group elements often attain a filled outer level (either eight electrons or two electrons) by forming ions that have the electron configuration of the nearest noble gas.
- › Ion formation by itself *absorbs* energy, but more than that quantity of energy is *released* when the ions form a solid. The high lattice energy of an ionic solid, the energy required to separate the solid into gaseous ions, is the reason the compound forms.
- › The lattice energy is determined by applying Hess's law in a Born-Haber cycle.
- › Lattice energies increase with higher ionic charge and decrease with larger ionic radius (Coulomb's law).
- › According to the ionic bonding model, the strong electrostatic attractions that keep ions in position explain why ionic solids are hard, conduct a current only when melted or dissolved, and have high melting and boiling points.
- › Ion pairs form when an ionic compound vaporizes.

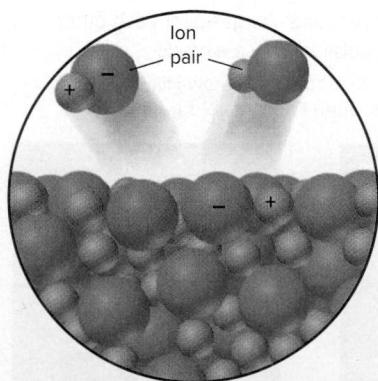

Figure 9.11 Ion pairs formed when an ionic compound vaporizes.

9.3 THE COVALENT BONDING MODEL

Look through the *Handbook of Chemistry and Physics*, and you'll find that the number of covalent compounds dwarfs the number of ionic compounds. Covalent substances range from diatomic hydrogen to biological and synthetic macromolecules with many thousands of atoms and even to some minerals that have covalent bonds throughout the sample. And covalent bonds occur in all polyatomic ions, too. Without doubt, *sharing electrons is the main way that atoms interact.*

The Formation of a Covalent Bond

Why does hydrogen gas consist of H_2 molecules and not separate H atoms? Figure 9.12 plots the potential energy of a system of two isolated H atoms versus the distance between their nuclei (see also Figure 2.14). Let's start at the right end of the curve and move along it to the left, as the atoms get closer:

- At point 1, the atoms are far apart, and each acts as though the other were not present.
- At point 2, the distance between the atoms has decreased enough for each nucleus to start attracting the other atom's electron, which lowers the potential energy. As the atoms get closer, these attractions increase, but so do repulsions between the nuclei and between the electrons.
- At point 3 (bottom of the energy "well"), the maximum attraction is achieved in the face of the increasing repulsion, and the system has its minimum energy.
- At point 4, if it were reached, the atoms would be too close, and the rise in potential energy from increasing repulsions between the nuclei and between the electrons would push them apart toward point 3 again.

Thus, a **covalent bond** arises from the balance between the nuclei attracting the electrons and electrons and nuclei repelling each other, as shown in the blow-up of the structure at point 3. (We'll return to Figure 9.12 shortly.)

*Formation of a covalent bond always results in greater electron density **between** the nuclei.* Figure 9.13 (on the next page) depicts this fact with an *electron density contour map* (A), and an *electron density relief map* (B).

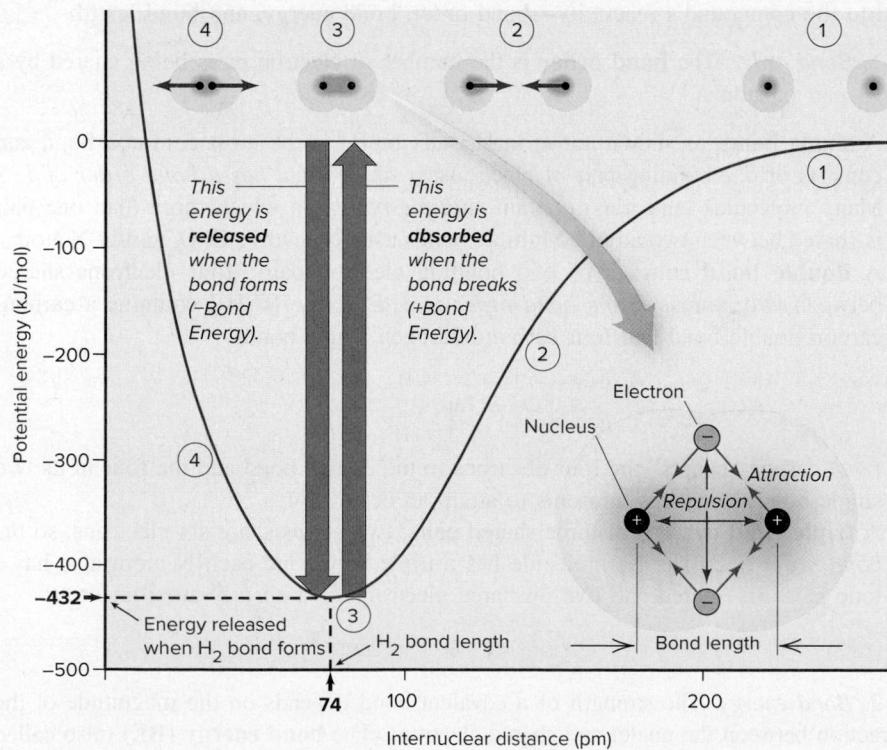

Figure 9.12 Covalent bond formation in H_2 . The energy difference between points 1 and 3 is the H_2 bond energy (432 kJ/mol). The internuclear distance at point 3 is the H_2 bond length (74 pm).

Figure 9.13 Distribution of electron density in H₂. **A**, Electron density (blue shading) is high around and between the nuclei. Electron density doubles with each concentric curve. **B**, The highest regions of electron density are shown as peaks.

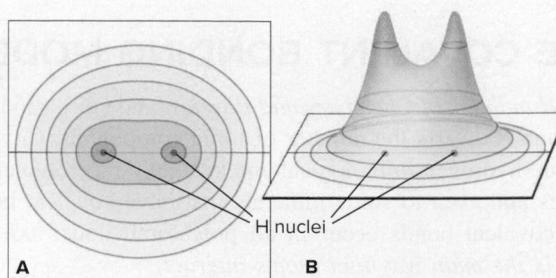

Bonding Pairs and Lone Pairs

Unlike ionic compounds in which atoms gain or lose enough electrons to obtain an octet of electrons, atoms in covalent compounds share electrons. To achieve a full outer (valence) level of electrons, *each atom in a covalent bond “counts” the shared electrons as belonging entirely to itself*. Thus, the two shared electrons in H₂ simultaneously fill the outer level of *both* H atoms, as clarified by the blue circles added below. The **shared pair**, or **bonding pair**, is represented by a pair of dots or a line:

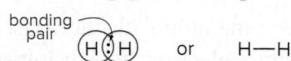

An outer-level electron pair that is *not* involved in bonding is called a **lone pair**, or **unshared pair**. The bonding pair in HF fills the outer level of the H atom *and*, together with three lone pairs, fills the outer level of the F atom as well:

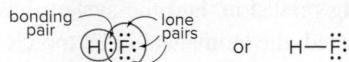

In F₂, the bonding pair and three lone pairs fill the outer level of *each* F atom, so that each has an octet of electrons:

(This text generally shows bonding pairs as lines and lone pairs as dots.)

Properties of a Covalent Bond: Order, Energy, and Length

A covalent bond has three important properties that are closely related to one another and to the compound’s reactivity—bond order, bond energy, and bond length.

1. *Bond order*. The **bond order** is the number of electron pairs being shared by a given pair of atoms:

- A **single bond**, as shown above in H₂, HF, or F₂, is the most common bond and consists of one bonding pair of electrons: *a single bond has a bond order of 1*.
- Many molecules (and ions) contain **multiple bonds**, in which more than one pair is shared between two atoms. Multiple bonds usually involve C, O, and/or N atoms. A **double bond** consists of two bonding electron pairs, four electrons shared between two atoms, so *the bond order is 2*. Ethylene (C₂H₄) contains a carbon–carbon double bond and four carbon–hydrogen single bonds:

Each carbon “counts” the four electrons in the double bond and the four in its two single bonds to hydrogen atoms to attain an octet.

- A **triple bond** consists of three shared pairs: two atoms share six electrons, so *the bond order is 3*. The N₂ molecule has a triple bond, and each N atom also has a lone pair. Six shared and two unshared electrons give *each* N atom an octet:

2. *Bond energy*. The strength of a covalent bond depends on the magnitude of the attraction between the nuclei and shared electrons. The **bond energy (BE)** (also called *bond enthalpy* or *bond strength*) is the energy needed to overcome this attraction and

is defined as *the standard enthalpy change for breaking the bond in 1 mol of gaseous molecules*. Bond breakage is an *endothermic* process, so *bond energy is always positive*:

The bond energy is the difference in energy between separated and bonded atoms (the potential energy difference between points 1 and 3—the energy “well”—in Figure 9.12). *The same quantity of energy absorbed to break the bond is released when the bond forms.* Bond formation is an *exothermic* process, so *the sign of its enthalpy change is always negative:*

Table 9.2 lists the energies of some common bonds. By definition,

- Stronger bonds have a larger BE because they are lower in energy (have a deeper energy well).
 - Weaker bonds have a smaller BE because they are higher in energy (have a shallower energy well).

The energy of a given bond varies slightly from molecule to molecule and even within the same molecule, so each value is an *average* bond energy. In other words, the C—H bond energy value of 413 kJ/mol is the average of the C—H bond energy values in all molecules containing this bond.

3. Bond length. A covalent bond has a **bond length**, the distance between the nuclei of the two bonded atoms. In Figure 9.12, bond length is the distance between the nuclei at the point of minimum energy (bottom of the well), and Table 9.2 shows the lengths of some covalent bonds. Like bond energies, these values are *average* bond lengths for a bond in different substances. Bond length is related to the sum of the radii of the bonded atoms. In fact, most atomic radii are calculated from measured bond lengths (see Figure 8.12C). Bond lengths for a series of similar bonds, as in the halogens, increase with atomic size (Figure 9.14).

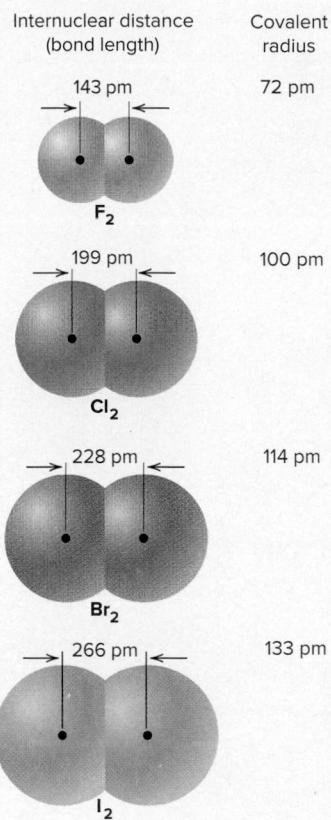

Figure 9.14 Bond length and covalent radius.

Table 9.2 Average Bond Energies (kJ/mol) and Bond Lengths (pm)

Table 9.3

The Relation of Bond Order, Bond Length, and Bond Energy

Bond	Bond Order	Average Bond Length (pm)	Average Bond Energy (kJ/mol)
C—O	1	143	358
C=O	2	123	745
C≡O	3	113	1070
C—C	1	154	347
C=C	2	134	614
C≡C	3	121	839
N—N	1	146	160
N=N	2	122	418
N≡N	3	110	945

The order, energy, and length of a covalent bond are interrelated. Two nuclei are more strongly attracted to two shared electron pairs than to one, so double-bonded atoms are drawn closer together and are more difficult to pull apart than single-bonded atoms. Therefore, for a given pair of atoms:

- a higher bond order results in a smaller bond length. As bond order increases, bond length decreases.
- a higher bond order results in a higher bond energy. As bond order increases, bond energy also increases.

Thus, as Table 9.3 shows, for a given pair of atoms, *a shorter bond is a stronger bond*.

In some cases, we can see a relation among atomic size, bond length, and bond energy by varying one of the atoms involved in a single bond while holding the other constant:

- *Variation within a group.* The trend in carbon-halogen single bond lengths, C—I > C—Br > C—Cl > C—F, parallels the trend in atomic size, I > Br > Cl > F, and is opposite to the trend in bond energy, C—F > C—Cl > C—Br > C—I.
- *Variation within a period.* Looking again at single bonds involving carbon, the trend in bond lengths, C—N > C—O > C—F, parallels the trend in atomic size, N > O > F, and is opposite to the trend in bond energy, C—F > C—O > C—N.

In general, bond length increases (and bond energy decreases) with increasing atomic radii of the atoms in the bond.

Student Hot Spot

Student data indicate that you may struggle with comparing bond length and strength. Access the SmartBook to view additional Learning Resources on this topic.

SAMPLE PROBLEM 9.3

Comparing Bond Length and Bond Strength

Problem Without referring to Table 9.2, rank the bonds in each set in order of *decreasing* bond length and *decreasing* bond strength:

- (a) S—F, S—Br, S—Cl (b) C=O, C—O, C≡O

Plan (a) S is singly bonded to three different halogen atoms, so the bond order is the same. Bond length increases and bond strength decreases as the halogen's atomic radius increases. (b) The same two atoms are bonded, but the bond orders differ. In this case, bond strength increases and bond length decreases as bond order increases.

Solution (a) Atomic size increases down a group, so F < Cl < Br.

Bond length: S—Br > S—Cl > S—F

Bond strength: S—F > S—Cl > S—Br

(b) By ranking the bond orders, C≡O > C=O > C—O, we obtain

Bond length: C—O > C=O > C≡O

Bond strength: C≡O > C=O > C—O

Check From Table 9.2, we see that the rankings are correct.

Comment Remember that for bonds involving pairs of different atoms, as in part (a), the relationship between length and strength holds only for single bonds and not in every case, so apply it carefully.

FOLLOW-UP PROBLEMS

9.3A Rank the bonds in each set in order of *decreasing* bond length and *decreasing* bond strength:

9.3B Rank the bonds in each set in order of *increasing* bond length and *increasing* bond strength:

SOME SIMILAR PROBLEMS 9.39 and 9.40

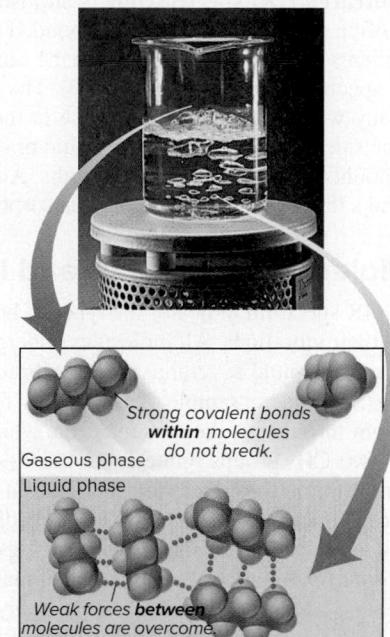

Figure 9.15 Strong forces within molecules and weak forces between them.

Source: © McGraw-Hill Education/Stephen Frisch, photographer

How the Model Explains the Properties of Covalent Substances

The covalent bonding model proposes that electron sharing between pairs of atoms leads to *strong, localized bonds*. Most, but not all, covalent substances consist of individual molecules. These *molecular* covalent substances have very different *physical* properties than *network* covalent solids do because different types of forces give rise to the two kinds of substances.

1. *Physical properties of molecular covalent substances.* At first glance, the model seems inconsistent with physical properties of covalent substances. Most are gases (such as methane and ammonia), liquids (such as benzene and water), or low-melting solids (such as sulfur and paraffin wax). If covalent bonds are so strong (~200 to 500 kJ/mol), why do covalent substances melt and boil at such low temperatures? To answer this, we'll focus on two different forces:

- (1) *strong bonding forces* hold the atoms together *within* the molecule, and
- (2) *weak intermolecular forces* act *between* separate molecules in the sample.

It is the weak forces *between* one molecule and the other molecules around it that account for the physical properties of *molecular* covalent substances. For example, look what happens when pentane (C_5H_{12}) boils (Figure 9.15): weak forces *between* pentane molecules are overcome during this process; the strong C—C and C—H covalent bonds *within* each pentane molecule are *not* broken.

2. *Physical properties of network covalent solids.* Some covalent substances do not consist of separate molecules. Rather, these *network covalent solids* are held together by covalent bonds *between atoms throughout the sample*, and their properties *do* reflect the strength of covalent bonds. Two examples are quartz and diamond (Figure 9.16). Quartz (SiO_2 ; *top*) has silicon-oxygen covalent bonds in three dimensions; no separate SiO_2 molecules exist. It is very hard and melts at 1550°C. Diamond (*bottom*) has covalent bonds connecting each carbon atom to four others. It is the hardest natural substance known and melts at around 3550°C. Thus, covalent bonds *are* strong, but most covalent substances consist of separate molecules with weak forces between them. (We discuss intermolecular forces in detail in Chapter 12.)

3. *Electrical conductivity.* An electric current is carried by either mobile electrons or mobile ions. Most covalent substances are poor electrical conductors, whether melted or dissolved, because their electrons are localized as either shared or unshared pairs and are not mobile, and no ions are present.

The Tools of the Laboratory essay describes a technique used widely for studying the types of bonds in covalent substances.

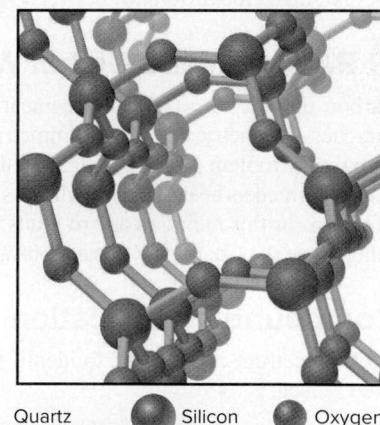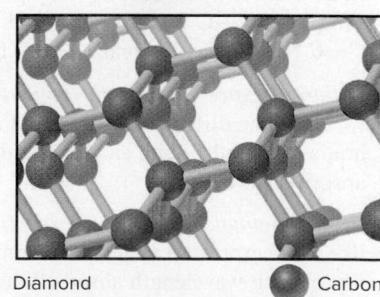

Figure 9.16 Covalent bonds of network covalent solids: quartz and diamond.

Infrared (IR) spectroscopy is an instrumental technique most often used to study covalently bonded molecules. The key components of an IR spectrometer are the same as those of other types of spectrometers (see Figure B7.3). The source emits radiation of many wavelengths, but only those in the IR region are selected. The sample is typically a pure liquid or solid that absorbs varying amounts of different IR wavelengths. An IR spectrum consists of peaks that indicate these various absorptions.

Molecular Vibrations and IR Absorption

An IR spectrum indicates the types of bonds in a molecule based on their vibrations. All molecules undergo motion through space, rotation around several axes, and vibrations between bonded atoms. Consider a sample of ethane gas. The $\text{H}_3\text{C}-\text{CH}_3$ molecules zoom throughout the container, the whole molecule rotates, and its two CH_3 groups rotate about the C—C bond. But let's disregard motion through space and rotation and focus on the motion most important to IR spectroscopy: each pair of atoms is vibrating as though the bonds were springs that stretch and bend. Figure B9.1 depicts the vibrations of diatomic and triatomic molecules; larger molecules vibrate in many more ways.

The energies of IR photons are in the range of these vibrational energies. *Each vibration has a frequency based on the type of motion, masses of the atoms, and strength of the bond.* The frequencies correspond to IR wavelengths between 2.5 and 25 μm . *The energy of these vibrations is quantized.* Just as an atom can absorb a photon whose energy equals the difference between *electron* energy levels, a molecule can absorb an IR photon whose energy equals the difference between *vibrational* energy levels.

IR Radiation and Global Warming

Carbon dioxide, $\text{O}=\text{C}=\text{O}$, is a linear molecule that bends and stretches symmetrically and asymmetrically when it absorbs IR radiation (Problem B9.2). Sunlight is absorbed by Earth's surface and re-emitted as heat, much of which is IR radiation. Atmospheric CO_2 absorbs this radiation and re-emits it, thus warming the atmosphere (see the Chemical Connections at the end of Section 6.6).

Compound Identification

An IR spectrum can be used to identify a compound for three related reasons:

1. *Each kind of bond absorbs a specific range of wavelengths.* That is, a C—C bond absorbs a different range than does a C=C bond, a C—H bond, a C=O bond, and so forth.
2. *Different types of organic compounds have characteristic spectra.* The different groupings of atoms that define an alcohol, a carboxylic acid, an ether, and so forth (see Chapter 15) absorb differently.
3. *Each compound has a unique spectrum.* The IR spectrum acts like a fingerprint to identify the compound, because the quantity of each wavelength absorbed depends on the detailed molecular structure. For example, no other compound has the IR spectrum of acrylonitrile, a compound used to make plastics (Figure B9.2).

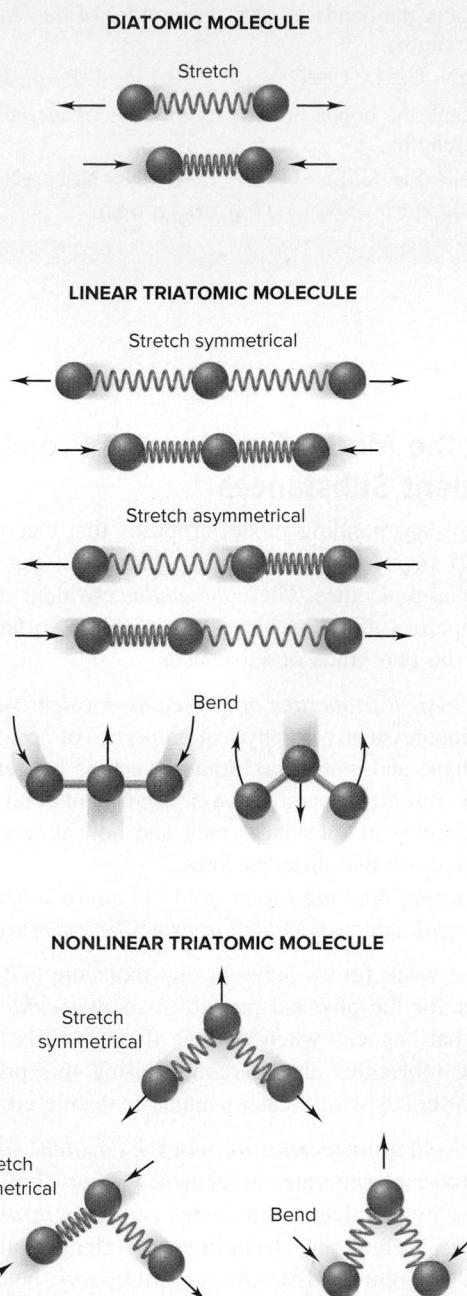

Figure B9.1 Vibrational motions in general diatomic and triatomic molecules.

Recall from Chapter 3 that constitutional (structural) isomers have the same molecular formula but different structures. We expect to see very different IR spectra for the isomers diethyl ether and 2-butanol because their molecular structures are so dissimilar (Figure B9.3). However, as shown in Figure B9.4, even the very similar 1,3-dimethylbenzene and 1,4-dimethylbenzene have different spectra.

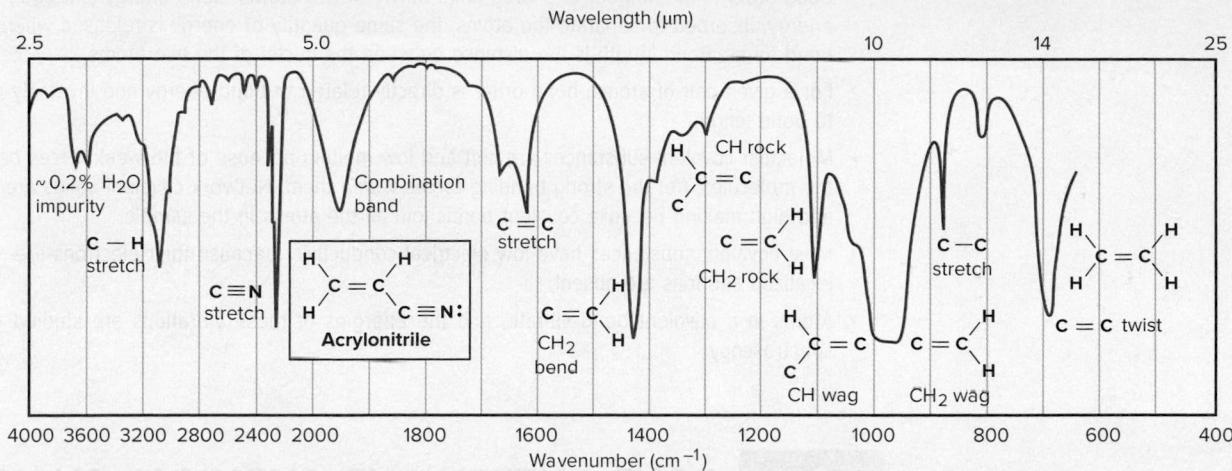

Figure B9.2 The infrared (IR) spectrum of acrylonitrile. In this typical IR spectrum, many absorption bands appear as downward-projecting “peaks” of differing depths and sharpness. Most correspond to a particular type of vibration (stretch, bend, rock, wag, or twist). Some broad peaks (e.g., “combination band”) represent several overlapping vibrations. The bottom axis identifies the wavenumber, the inverse of wavelength, which has the unit cm^{-1} . (The scale expands to the right of 2000 cm^{-1} .)

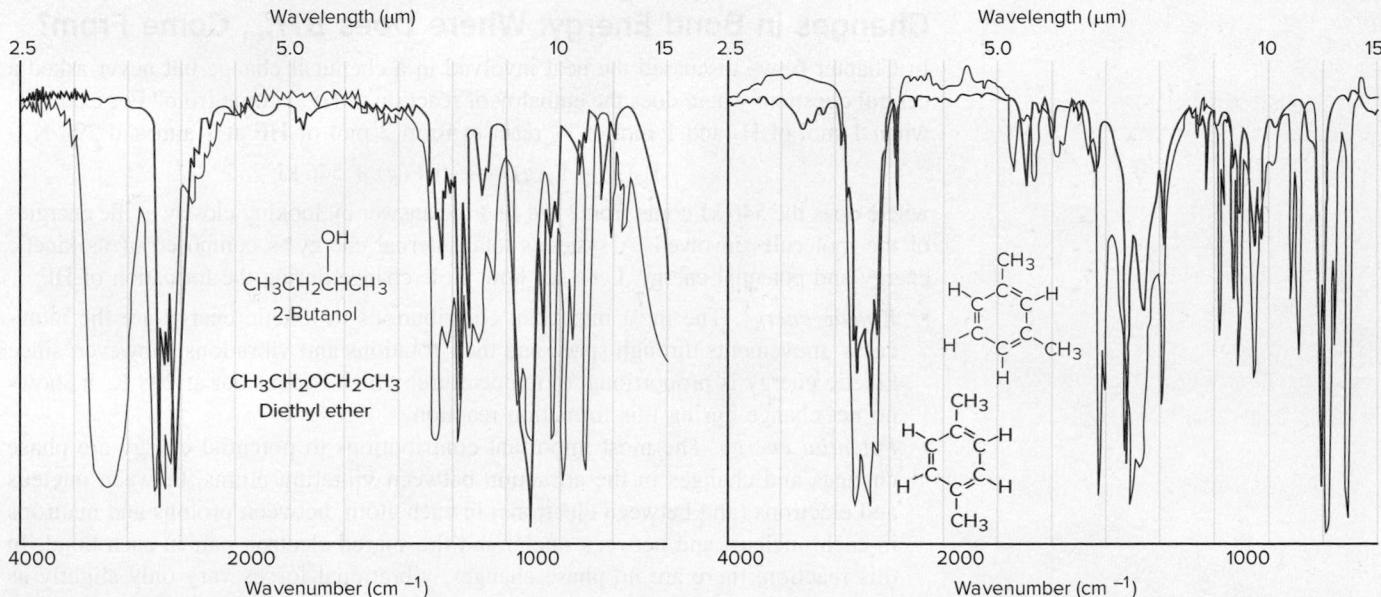

Figure B9.3 The infrared spectra of 2-butanol (green) and diethyl ether (red).

Figure B9.4 The infrared spectra of 1,3-dimethylbenzene (green) and 1,4-dimethylbenzene (red).

Problems

B9.1 In Figure B9.2, the peak labeled “ $\text{C}=\text{C}$ stretch” occurs at a shorter wavelength (higher wavenumber) than that labeled “ $\text{C}-\text{C}$ stretch,” as it does in the IR spectrum of any substance with those bonds. Explain the relative positions of these peaks. In what relative position along the wavelength scale of Figure B9.2 would you expect to find a peak for a $\text{C}\equiv\text{C}$ stretch? Explain.

B9.2 The vibrations of a CO_2 molecule are symmetrical stretch, bend, and asymmetrical stretch (Figure B9.1), with frequencies of $4.02\times 10^{13} \text{ s}^{-1}$, $2.00\times 10^{13} \text{ s}^{-1}$, and $7.05\times 10^{13} \text{ s}^{-1}$, respectively.

- What wavelengths correspond to these vibrations?
- Calculate the energy (in J) of each vibration. Which uses the least energy?

› Summary of Section 9.3

- › A shared, localized pair of valence electrons holds the nuclei of two atoms together in a covalent bond, filling each atom's outer level.
- › Bond order is the number of shared pairs between two atoms. Bond energy (strength) is the energy absorbed to separate the atoms; the same quantity of energy is released when the bond forms. Bond length is the distance between the nuclei of the two atoms.
- › For a given pair of atoms, bond order is directly related to bond energy and inversely related to bond length.
- › Molecular covalent substances are soft and low melting because of the weak forces *between* the molecules, not the strong bonding forces *within* them. Network covalent solids are hard and high melting because covalent bonds join all the atoms in the sample.
- › Most covalent substances have low electrical conductivity because their electrons are localized and ions are absent.
- › Atoms in a covalent bond vibrate, and the energies of these vibrations are studied with IR spectroscopy.

9.4 BOND ENERGY AND CHEMICAL CHANGE

The relative strengths of the bonds in reactants and products determine whether heat is released or absorbed in a chemical reaction. In Chapter 20, you'll see that the change in bond energy is one of two factors determining whether the reaction occurs at all. In this section, we'll discuss the origin of the enthalpy of reaction, use bond energies to calculate it, and look at the energy available from fuels and foods.

Changes in Bond Energy: Where Does ΔH_{rxn}° Come From?

In Chapter 6, we discussed the heat involved in a chemical change but never asked a central question: where does the enthalpy of reaction (ΔH_{rxn}°) come from? For example, when 1 mol of H₂ and 1 mol of F₂ react to form 2 mol of HF at 1 atm and 298 K,

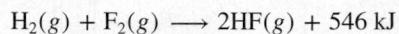

where does the 546 kJ come from? We find the answer by looking closely at the energies of the molecules involved. A system's total internal energy is composed of its kinetic energy and potential energy. Let's see how these change during the formation of HF:

- *Kinetic energy.* The most important contributions to kinetic energy are the molecules' movements through space and their rotations and vibrations. However, since kinetic energy is proportional to temperature, which is constant at 298 K, it shows no net change during this formation reaction.
- *Potential energy.* The most important contributions to potential energy are phase changes and changes in the attraction between vibrating atoms, between nucleus and electrons (and between electrons) in each atom, between protons and neutrons in each nucleus, and between nuclei and the shared electron pair in each bond. In this reaction, there are no phase changes, vibrational forces vary only slightly as the bonded atoms change, and forces within the atoms and nuclei don't change at all. The only major change in potential energy comes from changes in the attraction between the nuclei and the shared electron pair—the bond energies—of H₂, F₂, and HF.

Thus, our answer to “where does ΔH_{rxn}° come from?” is that it doesn’t really “come from” anywhere: *the heat released or absorbed during a chemical change is due to differences between reactant bond energies and product bond energies.*

Using Bond Energies to Calculate ΔH_{rxn}°

Recall that Hess’s law (Section 6.5) allows us to think of any reaction as a two-step process, whether or not it actually occurs that way:

1. A certain quantity of heat is absorbed ($\Delta H^\circ > 0$) to break the reactant bonds and form separate atoms.
2. A different quantity of heat is then released ($\Delta H^\circ < 0$) when the atoms form product bonds.

The sum (symbolized by Σ) of these enthalpy changes is the enthalpy of reaction, $\Delta H_{\text{rxn}}^\circ$:

$$\Delta H_{\text{rxn}}^\circ = \Sigma \Delta H_{\text{reactant bonds broken}}^\circ + \Sigma \Delta H_{\text{product bonds formed}}^\circ \quad (9.2)$$

- In an exothermic reaction, the energy released during the formation of bonds in the product molecules is *greater* than the energy required to break bonds in the reactant molecules; the magnitude of $\Delta H_{\text{product bonds formed}}^\circ$ is greater than that of $\Delta H_{\text{reactant bonds broken}}^\circ$, so the sum, $\Delta H_{\text{rxn}}^\circ$, is *negative* (heat is released).
- In an endothermic reaction, the opposite situation is true: the energy released during bond formation in the product molecules is *smaller* than the energy required to break bonds in the reactant molecules; the magnitude of $\Delta H_{\text{product bonds formed}}^\circ$ is smaller than that of $\Delta H_{\text{reactant bonds broken}}^\circ$, so $\Delta H_{\text{rxn}}^\circ$ is *positive* (heat is absorbed).

An equivalent form of Equation 9.2 uses bond energies:

$$\Delta H_{\text{rxn}}^\circ = \Sigma \text{BE}_{\text{reactant bonds broken}} - \Sigma \text{BE}_{\text{product bonds formed}}$$

(We need the minus sign because all bond energies are positive.)

In reality, only certain bonds break and form during a typical reaction, but we can apply Hess's law and use the following simpler method for calculating $\Delta H_{\text{rxn}}^\circ$:

1. Break **all** the reactant bonds to obtain individual atoms.
2. Use the atoms to form **all** the product bonds.
3. Add the bond energies, with appropriate signs, to obtain the enthalpy of reaction.

(This method assumes reactants and products do not change physical state; additional heat is involved when phase changes occur. We address this topic in Chapter 12.)

Let's use the method to calculate $\Delta H_{\text{rxn}}^\circ$ for two reactions:

1. *Formation of HF.* When 1 mol of H—H bonds and 1 mol of F—F bonds absorb energy and break, the 2 mol of H atoms and 2 mol of F atoms form 2 mol of H—F bonds, which releases energy (Figure 9.17). We find the bond energy values in Table 9.2 and use a positive sign for bonds broken and a negative sign for bonds formed:

Bonds broken:

$$\begin{aligned} 1 \times \text{H—H} &= (1 \text{ mol})(432 \text{ kJ/mol}) = 432 \text{ kJ} \\ 1 \times \text{F—F} &= (1 \text{ mol})(159 \text{ kJ/mol}) = 159 \text{ kJ} \\ \Sigma \Delta H_{\text{reactant bonds broken}}^\circ &= 591 \text{ kJ} \end{aligned}$$

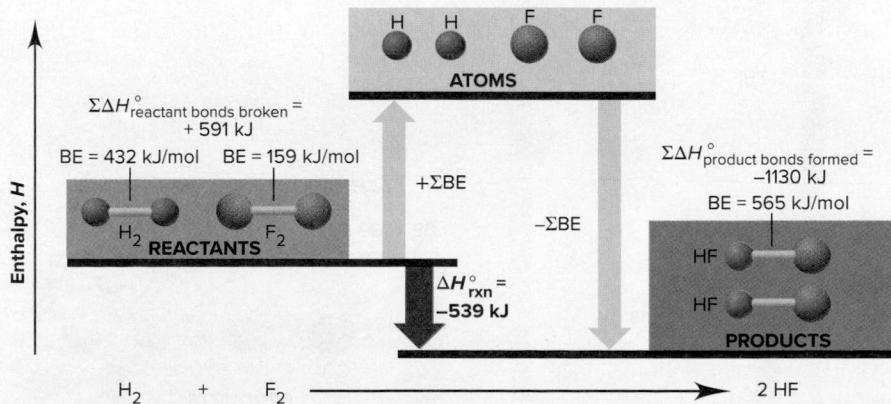

Figure 9.17 Using bond energies to calculate $\Delta H_{\text{rxn}}^\circ$ for HF formation.

Bonds formed:

$$2 \times \text{H—F} = (2 \text{ mol})(-565 \text{ kJ/mol}) = -1130 \text{ kJ} = \Sigma\Delta H_{\text{product bonds formed}}^{\circ}$$

Applying Equation 9.2 gives

$$\begin{aligned}\Delta H_{\text{rxn}}^{\circ} &= \Sigma\Delta H_{\text{reactant bonds broken}}^{\circ} + \Sigma\Delta H_{\text{product bonds formed}}^{\circ} \\ &= 591 \text{ kJ} + (-1130 \text{ kJ}) = -539 \text{ kJ}\end{aligned}$$

The small discrepancy between this bond energy value (-539 kJ) and the value from tabulated ΔH° values (-546 kJ) is due to variations in experimental method.

2. *Combustion of CH₄*. For this more complicated reaction, we assume that all the bonds in CH₄ and O₂ break, and the atoms form all the bonds in CO₂ and H₂O (Figure 9.18):

Once again, we use Table 9.2 and appropriate signs for bonds broken and bonds formed:

Bonds broken:

$$\begin{array}{r} 4 \times \text{C—H} = (4 \text{ mol})(413 \text{ kJ/mol}) = 1652 \text{ kJ} \\ 2 \times \text{O}_2 = (2 \text{ mol})(498 \text{ kJ/mol}) = 996 \text{ kJ} \\ \hline \Sigma\Delta H_{\text{reactant bonds broken}}^{\circ} = 2648 \text{ kJ} \end{array}$$

Bonds formed:

$$\begin{array}{r} 2 \times \text{C=O} = (2 \text{ mol})(-799 \text{ kJ/mol}) = -1598 \text{ kJ} \\ 4 \times \text{O—H} = (4 \text{ mol})(-467 \text{ kJ/mol}) = -1868 \text{ kJ} \\ \hline \Sigma\Delta H_{\text{product bonds formed}}^{\circ} = -3466 \text{ kJ} \end{array}$$

Applying Equation 9.2 gives

$$\begin{aligned}\Delta H_{\text{rxn}}^{\circ} &= \Sigma\Delta H_{\text{reactant bonds broken}}^{\circ} + \Sigma\Delta H_{\text{product bonds formed}}^{\circ} \\ &= 2648 \text{ kJ} + (-3466 \text{ kJ}) = -818 \text{ kJ}\end{aligned}$$

In addition to variations in experimental method, there is a more basic reason for the discrepancy between the $\Delta H_{\text{rxn}}^{\circ}$ obtained from bond energies (-818 kJ) and the value obtained by calorimetry (-802 kJ ; Section 6.3) for the combustion of methane. A bond energy is an *average* value for a given bond in many compounds. The value *in a particular substance* is usually close, but not equal, to the average. For example, the C—H bond energy of 413 kJ/mol is the average for C—H bonds in many molecules. In fact, 415 kJ is actually required to break 1 mol of C—H bonds in methane, or 1660 kJ for 4 mol of these bonds, which gives a $\Delta H_{\text{rxn}}^{\circ}$ closer to the calorimetric value. Thus, it isn't surprising to find small discrepancies between $\Delta H_{\text{rxn}}^{\circ}$ values obtained in different ways.

Figure 9.18 Using bond energies to calculate $\Delta H_{\text{rxn}}^{\circ}$ for the combustion of methane.

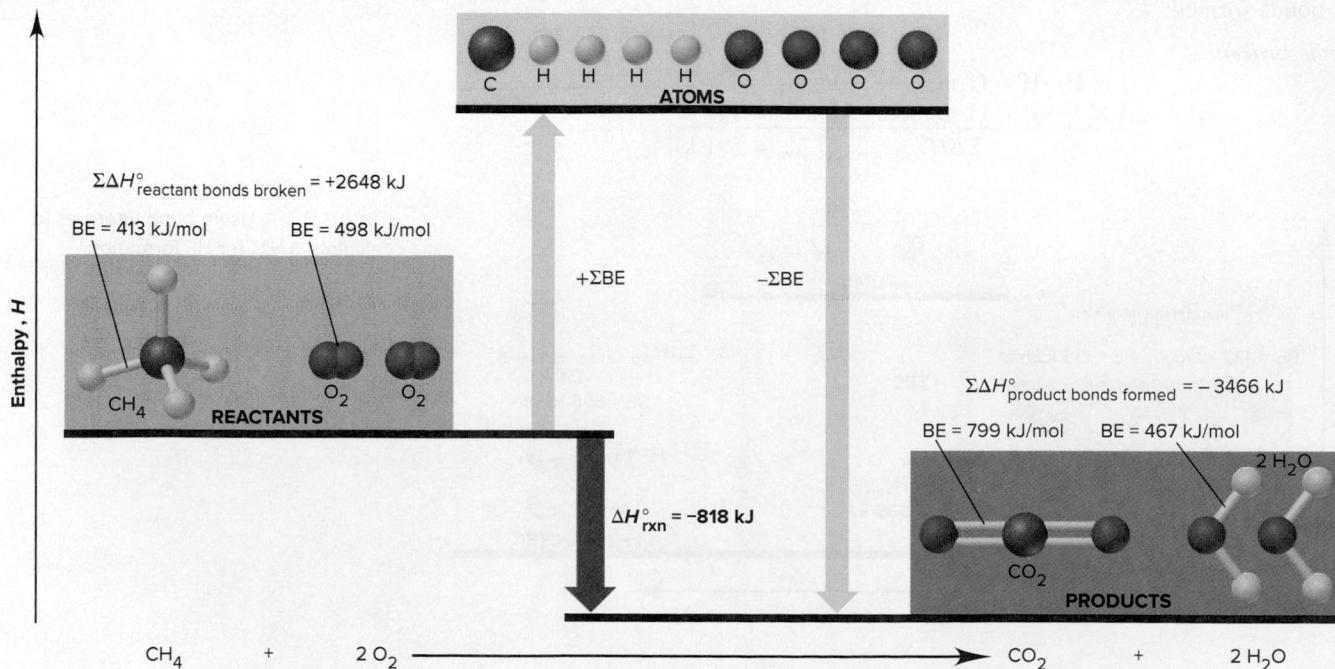

SAMPLE PROBLEM 9.4**Using Bond Energies to Calculate ΔH_{rxn}°**

Problem Calculate ΔH_{rxn}° for the chlorination of methane to form chloroform:

Plan All the reactant bonds break, and all the product bonds form. We find the bond energies in Table 9.2 and substitute the two sums, with correct signs, into Equation 9.2.

Solution Finding the standard enthalpy changes for bonds broken and for bonds formed: For bonds broken, the bond energy values are positive:

$$\begin{aligned} 4 \times \text{C-H} &= (4 \text{ mol})(413 \text{ kJ/mol}) = 1652 \text{ kJ} \\ 3 \times \text{Cl-Cl} &= (3 \text{ mol})(243 \text{ kJ/mol}) = 729 \text{ kJ} \\ \Sigma \Delta H_{\text{bonds broken}}^\circ &= 2381 \text{ kJ} \end{aligned}$$

For bonds formed, the values are negative:

$$\begin{aligned} 3 \times \text{C-Cl} &= (3 \text{ mol})(-339 \text{ kJ/mol}) = -1017 \text{ kJ} \\ 1 \times \text{C-H} &= (1 \text{ mol})(-413 \text{ kJ/mol}) = -413 \text{ kJ} \\ 3 \times \text{H-Cl} &= (3 \text{ mol})(-427 \text{ kJ/mol}) = -1281 \text{ kJ} \\ \Sigma \Delta H_{\text{bonds formed}}^\circ &= -2711 \text{ kJ} \end{aligned}$$

Calculating ΔH_{rxn}° :

$$\Delta H_{rxn}^\circ = \Sigma \Delta H_{\text{bonds broken}}^\circ + \Sigma \Delta H_{\text{bonds formed}}^\circ = 2381 \text{ kJ} + (-2711 \text{ kJ}) = -330 \text{ kJ}$$

Check The signs of the enthalpy changes are correct: $\Sigma \Delta H_{\text{bonds broken}}^\circ > 0$, and $\Sigma \Delta H_{\text{bonds formed}}^\circ < 0$. More energy is released than absorbed, so ΔH_{rxn}° is negative:

$$\sim 2400 \text{ kJ} + [\sim (-2700 \text{ kJ})] = -300 \text{ kJ}$$

FOLLOW-UP PROBLEMS

9.4A One of the most important industrial reactions is the formation of ammonia from its elements:

Use bond energies to calculate ΔH_{rxn}° .

9.4B Oxygen difluoride reacts with water to produce hydrofluoric acid:

Use bond energies to calculate ΔH_{rxn}° .

SOME SIMILAR PROBLEMS 9.47–9.50**Bond Strengths and the Heat Released from Fuels and Foods**

A fuel is a material that reacts with atmospheric oxygen to release energy and is available at a reasonable cost. The most common fuels for machines are hydrocarbons and coal, and the most common ones for organisms are fats and carbohydrates. All of these fuels contain large organic molecules with many C–C and C–H bonds and fewer C–O and O–H bonds. According to our two-step approach for determining the enthalpy of reaction from bond energies, when the fuel reacts with O_2 , all of the bonds break, and the C, H, and O atoms form C=O and O–H bonds in the products (CO_2 and H_2O). Because the combustion is exothermic, the total of the bond energies in the products is greater than the total in the reactants. Weaker bonds (less stable, more reactive) are easier to break than stronger bonds (more stable, less reactive) because they are already higher in energy. Therefore, the bonds in CO_2 and H_2O are stronger (lower energy, more stable) than those in gasoline (or cooking oil) and O_2 (weaker, higher energy, less stable).

Fuels with more weak bonds yield more energy than fuels with fewer weak bonds. When a hydrocarbon (alkane) burns, C–C and C–H bonds break; when an alcohol burns, C–O and O–H bonds break as well. Table 9.2 shows that the sum for C–C and C–H bonds (760 kJ/mol) is less than the sum for C–O and O–H bonds (825 kJ/mol). Therefore, it takes more energy to break the bonds of a fuel with a lot of C–O and O–H bonds. Thus, in general, a fuel with fewer bonds to O releases more energy (Figure 9.19).

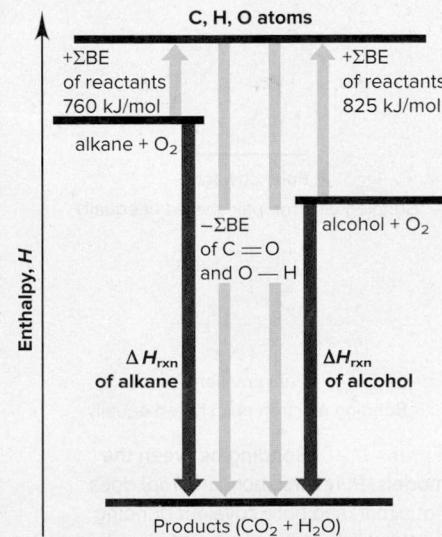

Figure 9.19 Relative bond strength and energy from fuels.

**Enthalpies of Reaction
for Combustion of
Some Foods**
Table 9.4

Substance	ΔH_{rxn} (kJ/g)
Fats	
Vegetable oil	-37.0
Margarine	-30.1
Butter	-30.0
Carbohydrates	
Table sugar (sucrose)	-16.2
Brown rice	-14.9
Maple syrup	-10.4

Both fats and carbohydrates serve as high-energy foods and consist of chains or rings of C atoms attached to H atoms, with some C—O, C=O, and O—H bonds (shown in red below):

Carbohydrates have fewer chains of C atoms and bonds to H and more bonds to O. Fats “contain more Calories” per gram than carbohydrates because fats have fewer bonds to O (Table 9.4).

› Summary of Section 9.4

- The only component of internal energy that changes significantly during a reaction is the bond energies of reactants and products, and this change appears as the enthalpy of reaction, ΔH_{rxn}° .
- A reaction involves breaking reactant bonds and forming product bonds. Applying Hess’s law, we use tabulated bond energies to calculate ΔH_{rxn}° .
- Bonds in fuels are weaker (less stable, higher energy) than bonds in the combustion products. Fuels with more weak bonds release more energy than fuels with fewer.

9.5 BETWEEN THE EXTREMES: ELECTRONEGATIVITY AND BOND POLARITY

Scientific models are idealized descriptions of reality. The ionic and covalent bonding models portray compounds as formed by *either* complete electron transfer *or* complete electron sharing. But, in real substances, most atoms are joined by *polar covalent bonds*—between pure ionic and pure covalent (see Figure 9.20). In this section, we explore the “in-between” nature of these bonds and its importance for the properties of substances.

Electronegativity

Electronegativity (EN) is the relative ability of a bonded atom to attract shared electrons.* We might expect, for instance, the H—F bond energy to be the average of an H—H bond (432 kJ/mol) and an F—F bond (159 kJ/mol), or 296 kJ/mol. But, the actual HF bond energy is 565 kJ/mol, or 269 kJ/mol *higher!* To explain this difference, the American chemist Linus Pauling reasoned that, if F attracts the shared electron pair more strongly than H—that is, if F is more *electronegative* than H—the electrons will spend more time closer to F, and this unequal sharing makes the F end of the bond partially negative and the H end partially positive. The *electrostatic attraction* between these partial charges *increases* the energy required to break the bond. From studies with many compounds, Pauling derived a scale of *relative EN values* based on fluorine having the highest EN value, 4.0 (Figure 9.21).

Trends in Electronegativity In general, *electronegativity is inversely related to atomic size* because the nucleus of a smaller atom is closer to the shared pair than the nucleus of a larger atom, so it attracts the electrons more strongly (Figure 9.22):

- Down a main group*, electronegativity (height of post) decreases as atomic size (hemisphere on top of post) increases.
- Across a period of main-group elements*, electronegativity increases.
- Nonmetals are *more* electronegative than metals.

*Electronegativity refers to a *bonded* atom attracting a shared pair; electron affinity refers to a gaseous atom gaining an electron to form an anion. Elements with a high EN also have a highly negative EA.

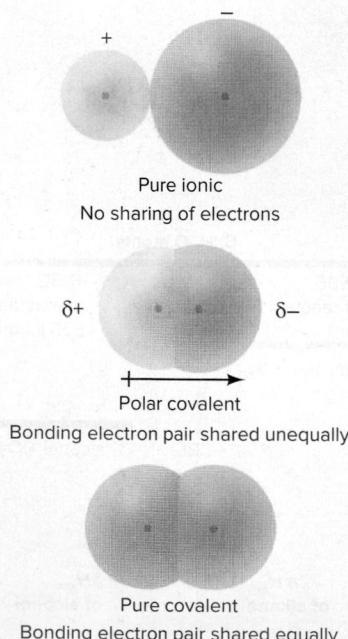

Figure 9.20 Bonding between the models. Pure ionic bonding (top) does not occur, and pure covalent bonding (bottom) is far less common than polar covalent bonding (middle).

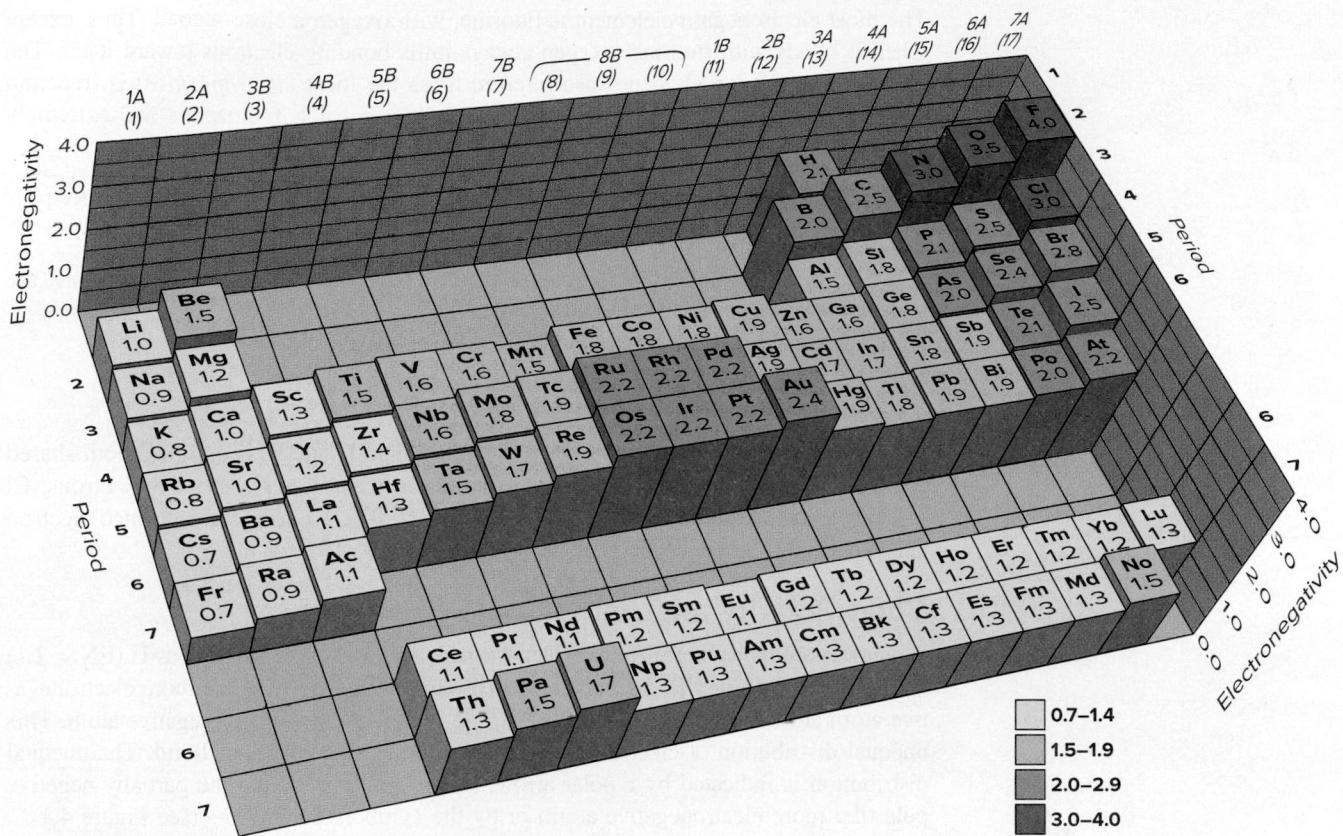

Figure 9.21 The Pauling electronegativity (EN) scale. The height of each post is proportional to the EN, which is shown on top. The key has several EN cutoffs. In the main groups, EN *increases* across and *decreases* down. The transition and inner transition elements show little change in EN. Here hydrogen is placed near elements with similar EN values.

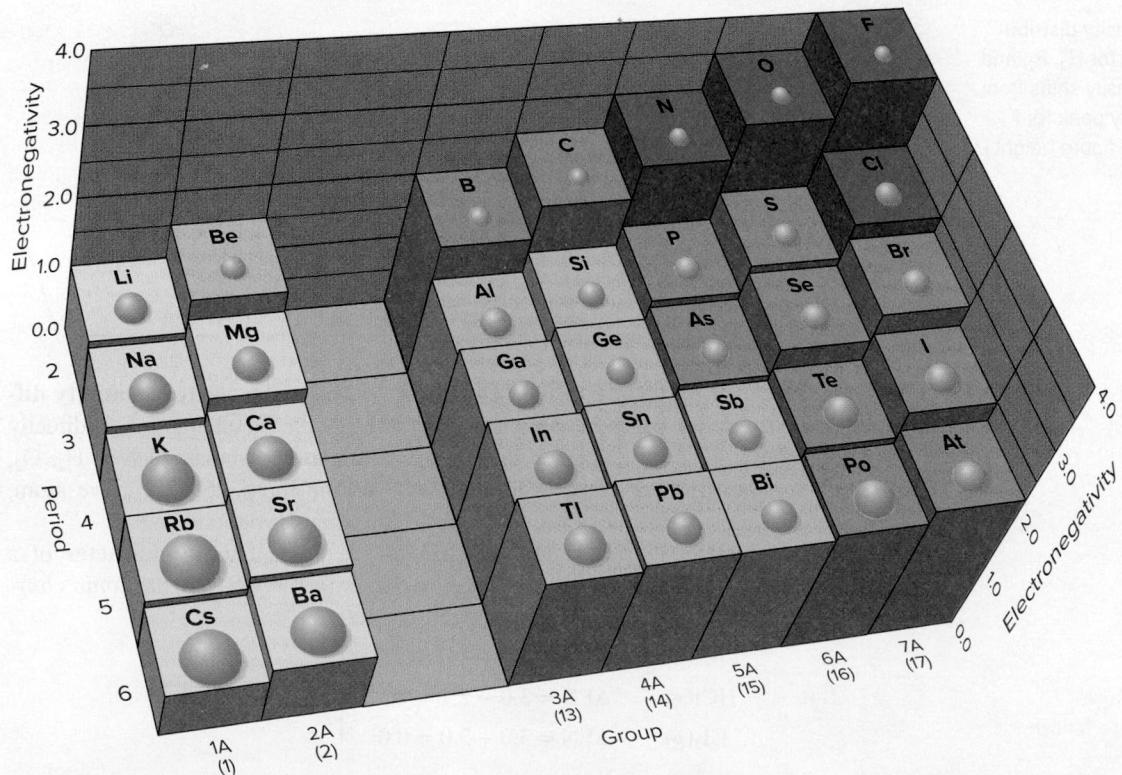

Figure 9.22 Electronegativity and atomic size.

The most electronegative element is fluorine, with oxygen a close second. Thus, except when it bonds with fluorine, oxygen always pulls bonding electrons toward itself. The least electronegative element (also referred to as the most *electropositive*) is francium (Fr), in the lower left corner of the periodic table, but it is radioactive and extremely rare, so for all practical purposes, cesium (Cs) is the most electropositive.*

Electronegativity and Oxidation Number An important use of electronegativity is in determining an atom's oxidation number (O.N.; see Section 4.5):

1. The more electronegative atom in a bond is assigned *all* the *shared* electrons; the less electronegative atom is assigned *none*.
2. Each atom in a bond is assigned *all* of its *unshared* electrons.
3. The oxidation number is given by

$$\text{O.N.} = \text{no. of valence } e^- - (\text{no. of shared } e^- + \text{no. of unshared } e^-)$$

In HCl, for example, Cl is more electronegative than H and so is assigned both shared electrons in the bond and its own 6 unshared electrons, for a total of 8 electrons. Cl has 7 valence electrons so its O.N. is $7 - 8 = -1$. The H atom has 1 valence electron and is assigned none, so its O.N. is $1 - 0 = +1$.

Bond Polarity and Partial Ionic Character

Whenever atoms having different electronegativities form a bond, such as H (EN = 2.1) and F (EN = 4.0) in HF, the bonding pair is shared *unequally* as the more electronegative atom attracts the shared pair more strongly than the less electronegative atom. This unequal distribution of electron density results in a **polar covalent bond**. The unequal distribution is indicated by a polar arrow, \longleftrightarrow , pointing toward the partially negative pole (the more electronegative atom) or by the symbols $\delta+$ and $\delta-$ (see Figure 4.1):

In the H–H and F–F bonds, where the atoms are identical, the bonding pair is shared *equally*, and a **nonpolar covalent bond** results. In Figure 9.23, relief maps show the distribution of electron density in H₂, F₂, and HF.

Figure 9.23 Electron density distributions shown as relief maps for H₂, F₂, and HF. In HF, the electron density shifts from H to F. (The electron density peak for F has been cut off to limit the figure height.)

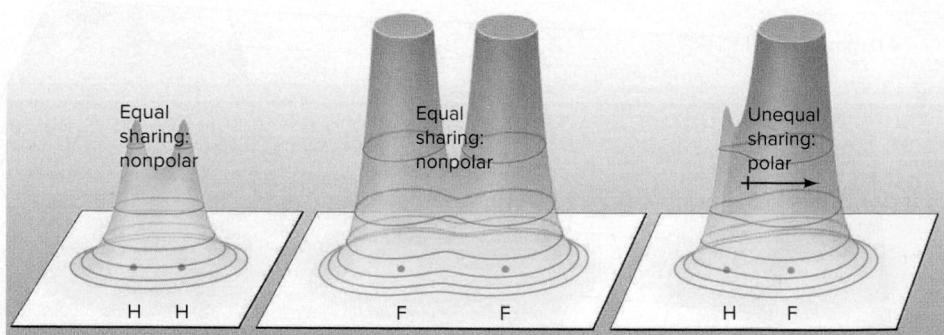

The Importance of Electronegativity Difference (ΔEN) The **electronegativity difference (ΔEN)**, the difference between the EN values of the bonded atoms, is directly related to a bond's polarity. It ranges from 0.0 in a diatomic element, such as H₂, O₂, or Cl₂, all the way up to 3.3, the difference between the most electronegative atom, F (4.0), and the most electropositive, Cs (0.7), in the ionic compound CsF.

Another parameter closely related to ΔEN is the **partial ionic character** of a bond: *a greater ΔEN results in larger partial charges and higher partial ionic character*. Consider three Cl-containing gaseous molecules:

$$\text{LiCl}(g): \quad \Delta\text{EN} = 3.0 - 1.0 = 2.0$$

$$\text{HCl}(g): \quad \Delta\text{EN} = 3.0 - 2.1 = 0.9$$

$$\text{Cl}_2(g): \quad \Delta\text{EN} = 3.0 - 3.0 = 0.0$$

↓
ionic character
decreases

*In 1934, the American physicist Robert S. Mulliken developed electronegativity values based on atomic properties: $\text{EN} = (\text{IE} - \text{EA})/2$. By this approach as well, fluorine, with a high ionization energy (IE) and a large negative electron affinity (EA), has a high EN; and cesium, with a low IE and a small EA, has a low EN.

The bond in LiCl has more ionic character than the one in HCl, which has more than the one in Cl₂.

Here are two approaches for quantifying ionic character. Both use arbitrary cut-offs, which is not really consistent with the actual gradation in bonding:

1. ΔEN range. This approach divides bonds into mostly ionic, polar covalent, mostly covalent, and nonpolar covalent based on a range of ΔEN values (Figure 9.24).
2. Percent ionic character. This approach is based on the behavior of a gaseous diatomic molecule in an electric field. A plot of percent ionic character vs. ΔEN for several molecules shows that, as expected, *percent ionic character generally increases with ΔEN* (Figure 9.25A). A value of 50% divides ionic from covalent bonds. Note that a substance like Cl₂(g) has 0% ionic character, but none has 100% ionic character: *electron sharing occurs to some extent in every bond, even between an ion pair of an alkali halide* (Figure 9.25B).

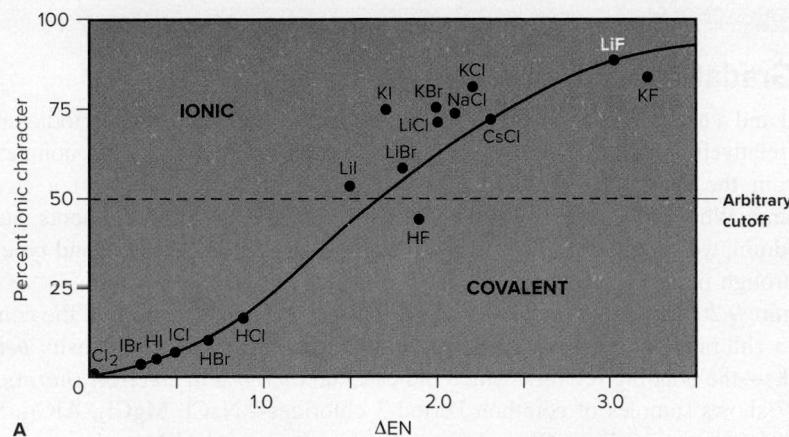

A

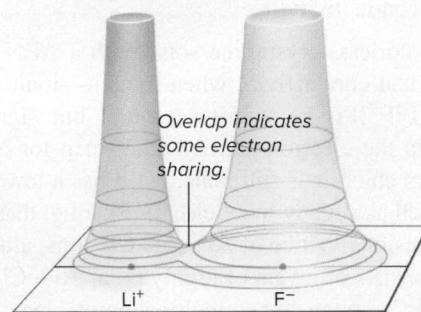

B

Figure 9.25 Percent ionic character as a function of ΔEN . **A**, ΔEN correlates with ionic character. **B**, Even in highly ionic LiF ($\Delta EN = 3.0$), some electron sharing occurs between the ions in the gaseous ion pair.

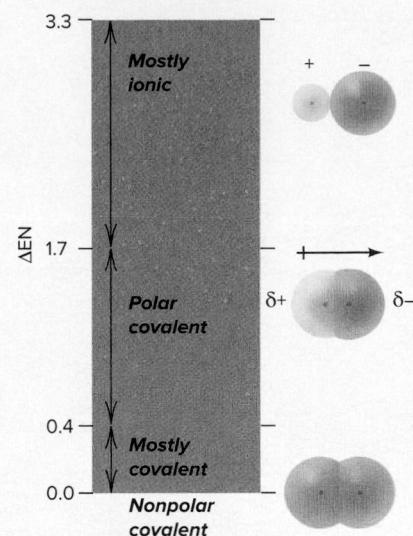

Figure 9.24 ΔEN ranges for classifying the partial ionic character of bonds.

SAMPLE PROBLEM 9.5

Determining Bond Polarity from EN Values

Problem (a) Use a polar arrow to indicate the polarity of each bond: N—H, F—N, I—Cl.
 (b) Rank the following bonds in order of *increasing* polarity and *decreasing* percent ionic character: H—N, H—O, H—C.

Plan (a) We use Figure 9.21 to find the EN values for the atoms and point the polar arrow toward the more electronegative atom, which is the negative end of the bond.
 (b) To rank the bond polarity, we determine ΔEN : the higher the value, the greater the polarity. Percent ionic character is also directly related to ΔEN (and bond polarity); it decreases in the opposite order that polarity increases.

Solution (a) The EN of N = 3.0 and the EN of H = 2.1, so $\text{N} \rightarrow \text{H}$.

The EN of F = 4.0 and the EN of N = 3.0, so $\text{F} \rightarrow \text{N}$.

The EN of I = 2.5 and the EN of Cl = 3.0, so $\text{I} \rightarrow \text{Cl}$.

(b) The ΔEN values are $3.0 - 2.1 = 0.9$ for H—N, $3.5 - 2.1 = 1.4$ for H—O, and $2.5 - 2.1 = 0.4$ for H—C.

The order of *increasing* bond polarity is H—C < H—N < H—O.

The order of *decreasing* percent ionic character is H—O > H—N > H—C.

Student Hot Spot

Student data indicate that you may struggle with using electronegativity to determine bond polarity. Access the Smartbook to view additional Learning Resources on this topic.

Check In (b), we can check the order of bond polarity using periodic trends. Each bond involves H and a Period 2 atom. Since atomic size decreases and EN increases across a period, the polarity is greatest for the bond to O (farthest to the right in Period 2).

Comment In Chapter 10, you'll see that the bond polarity contributes to the overall polarity of the molecule, which is a major factor in determining behavior.

FOLLOW-UP PROBLEMS

9.5A Arrange each set of bonds in order of *increasing* polarity, and indicate bond polarity with $\delta+$ and $\delta-$ symbols:

(a) Cl—F, Br—Cl, Cl—Cl (b) P—F, N—O, N—F

9.5B Arrange each set of bonds in order of *decreasing* polarity, and indicate bond polarity with a polar arrow:

(a) Se—Cl, Se—F, Se—Br (b) S—B, F—B, Cl—B

SOME SIMILAR PROBLEMS 9.60–9.63, 9.66, and 9.67

The Gradation in Bonding Across a Period

A metal and a nonmetal—elements from the left and right sides of the periodic table—have a relatively large ΔEN and typically form an ionic compound. Two nonmetals—both from the right side of the table—have a small ΔEN and form a covalent compound. When we combine chlorine with each of the Period 3 elements, starting with sodium, we observe a steady decrease in ΔEN and a gradation in bond type from ionic through polar covalent to nonpolar covalent.

Figure 9.26 shows an electron density relief map of a bond in each of the common Period 3 chlorides; note the steady increase in the height of electron density *between* the peaks—the bonding region—which indicates an *increase in electron sharing*. Figure 9.27 shows samples of common Period 3 chlorides—NaCl, MgCl₂, AlCl₃, SiCl₄, PCl₃, and SCl₂, as well as Cl₂—along with the change in ΔEN and two physical properties, melting point and electrical conductivity:

- *NaCl.* Sodium chloride is a white (colorless) crystalline solid with a ΔEN of 2.1, a high melting point, and high electrical conductivity when molten—ionic by any criterion. Nevertheless, just as for LiF (Figure 9.25B), a small but significant amount of electron sharing appears in the electron density relief map for NaCl.
- *MgCl₂.* With a ΔEN of 1.8, magnesium chloride is still ionic, but it has a lower melting point and lower conductivity, as well as slightly more electron sharing, than NaCl.
- *AlCl₃.* Rather than being a three-dimensional lattice of Al³⁺ and Cl⁻ ions, aluminum chloride, with a ΔEN value of 1.5, consists of layers of highly polar Al—Cl bonds. Weak forces between layers result in a much lower melting point, and the low conductivity implies few free ions. Electron density between the nuclei is even higher than in MgCl₂. AlCl₃ has less ionic character than NaCl or MgCl₂.
- *SiCl₄, PCl₃, SCl₂, and Cl₂.* The trend toward bonding that is more covalent continues through the remaining substances. The three compounds, with polar covalent bonds, occur as separate molecules, which have no conductivity (no ions) and such weak forces *between* them that melting points are below 0°C. In Cl₂, the bond is nonpolar ($\Delta\text{EN} = 0.0$). The relief maps show the increasing electron density in the bonding region.

Thus, as ΔEN decreases, the bond becomes more covalent, and the character of the substance changes from ionic solid to covalent gas.

Figure 9.26 Electron density relief maps for bonds of Period 3 chlorides. Note the steady increase in electron sharing from NaCl to Cl₂.

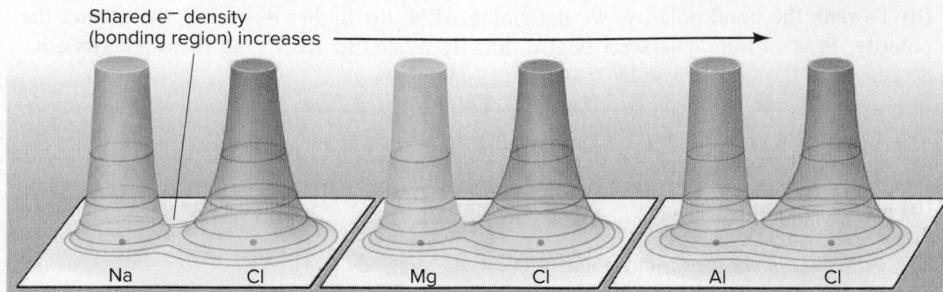

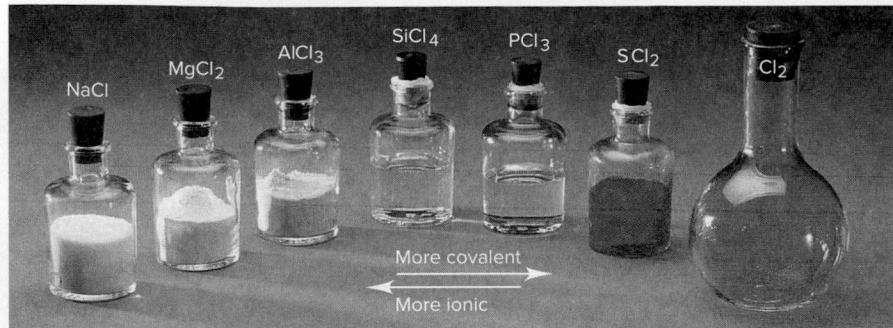

Figure 9.27 Properties of Period 3 chlorides. As ΔEN decreases, melting point and electrical conductivity decrease because the bond type changes from ionic to polar covalent to nonpolar covalent.

Source: © McGraw-Hill Education/Stephen Frisch, photographer

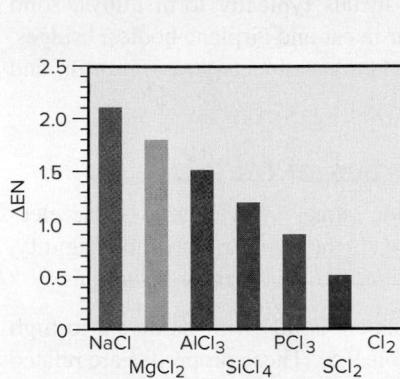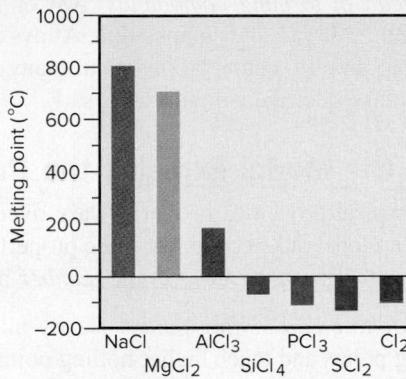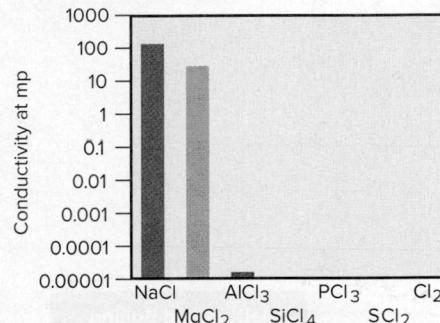

› Summary of Section 9.5

- Electronegativity is the ability of a bonded atom to attract shared electrons, which generates opposite partial charges at the ends of the bond and contributes to the bond energy.
- Electronegativity increases across a period and decreases down a group, the reverse of the trends in atomic size.
- The larger the ΔEN for two bonded atoms, the more polar the bond is and the greater its ionic character.
- For Period 3 chlorides, there is a gradation in bond type from ionic to polar covalent to nonpolar covalent.

9.6 AN INTRODUCTION TO METALLIC BONDING

In this section, you'll see how a simple, qualitative model for metallic bonding accounts for the properties of metals; a more detailed model is presented in Chapter 12.

The Electron-Sea Model

Metals can transfer electrons to nonmetals and form ionic solids, such as NaCl. And experiments with metals in the gas phase show that two metal atoms can even share their valence electrons to form gaseous, diatomic molecules, such as Na₂. But what holds the atoms together in a chunk of Na metal? The **electron-sea model** of metallic

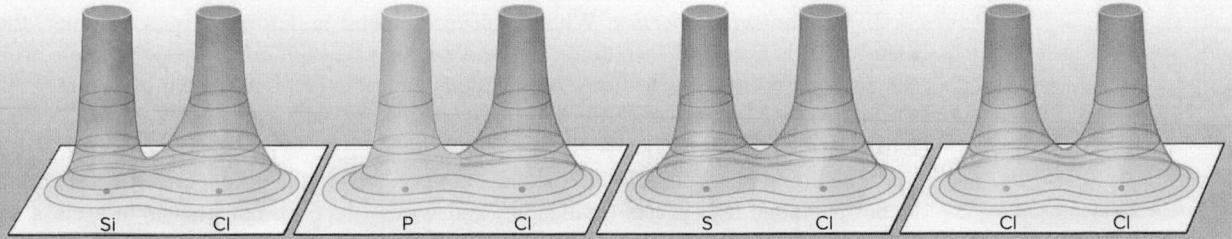

bonding proposes that all the metal atoms in the sample contribute their valence electrons to form a delocalized electron “sea” throughout the piece, with the metal ions (nuclei and core electrons) lying in an orderly array (see Figure 9.2C). All the atoms in the sample share the electrons, and the piece is held together by the mutual attraction of the metal cations for the mobile valence electrons. Thus, bonding in metals is fundamentally different than the other two types:

- In contrast to ionic bonding, no anions are present, and the metal ions are not held in place as rigidly.
- In contrast to covalent bonding, no particular pair of metal atoms is bonded through a localized electron pair.
- Instead of forming compounds, two or more metals typically form **alloys**, solid mixtures of variable composition. Alloys appear in car and airplane bodies, bridges, coins, jewelry, dental fillings, and many other familiar objects; brass, bronze, and stainless steel are common alloys.

How the Model Explains the Properties of Metals

The physical properties of metals vary over a wide range. Two features of the electron-sea model that account for these properties are (1) the *regularity*, without rigidity, of the metal-ion array and (2) the *number* and *mobility* of the valence electrons.

1. *Melting and boiling points.* Nearly all metals are solids with moderate to high melting points and much higher boiling points (Table 9.5). These properties are related to the energy of the metallic bonding. Melting points are only moderately high because the cations can move without disrupting their attraction to the surrounding electrons. Boiling points are very high because each cation and its valence electron(s) must break away from the others to vaporize. Gallium provides a striking example: it can melt in your hand (mp 29.8°C) but doesn’t boil until over 2400°C.

Periodic trends are consistent with the strength of the bonding:

- Down a group, melting points decrease because the larger metal ions have a weaker attraction to the electron sea.
- Across a period, melting points increase. Alkaline earth metals [Group 2A(2)] have higher melting points than alkali metals [Group 1A(1)] because their 2+ cations have stronger attractions to twice as many valence electrons (Figure 9.28).

Table 9.5

Melting and Boiling Points of Some Metals

Element	mp (°C)	bp (°C)
Lithium (Li)	180	1347
Tin (Sn)	232	2623
Aluminum (Al)	660	2467
Barium (Ba)	727	1850
Silver (Ag)	961	2155
Copper (Cu)	1083	2570
Uranium (U)	1130	3930

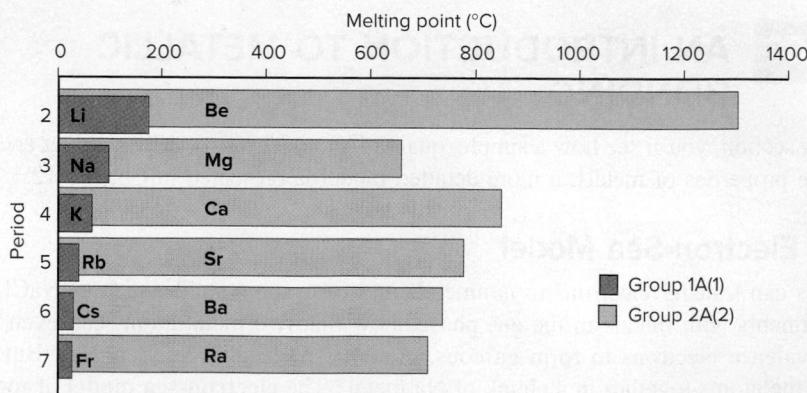

Figure 9.28 Melting points of Group 1A(1) and Group 2A(2) metals.

2. *Mechanical properties.* When a piece of metal is deformed by a hammer, the metal ions do not repel each other, but rather slide past each other through the electron sea and end up in new positions; thus, metals dent and bend, as shown in Figure 9.29. Compare this behavior with the interionic repulsions that occur when an ionic solid is struck (see Figure 9.9).

The common Group 1B(11) metals—copper, silver, and gold—are all soft enough to be machined into sheets (malleable) and wires (ductile), but gold is in a class by

Figure 9.29 Why metals dent and bend rather than crack.

Source: © McGraw-Hill Education/Stephen Frisch, photographer

itself. One gram of gold, about the size of a small ball-bearing, can be drawn into a wire 20 μm thick and 165 m long or hammered into a 1.0- m^2 sheet that is 230 atoms (about 70 nm) thick (see photo)!

3. *Electrical conductivity.* Unlike ionic and covalent substances, metals are good conductors of electricity in both the solid and liquid states because of their mobile electrons. When a piece of metal wire is attached to a battery, electrons flow from the negative terminal into the wire, replacing the electrons that flow from the wire into the positive terminal. Foreign atoms disrupt the array of metal atoms and reduce conductivity. Copper used in electrical wiring is over 99.99% pure because traces of other atoms drastically restrict electron flow.

4. *Thermal conductivity.* Mobile electrons also make metals good conductors of heat. Place your hand on a piece of metal and a piece of wood that are both at room temperature. The metal feels colder because it conducts heat away from your hand much faster than the wood. The mobile, delocalized electrons in the metal disperse the heat from your hand more quickly than the localized electron pairs in the covalent bonds of wood.

How thin is gold leaf?

Source: © Westend61 GmbH/Alamy RF

› Summary of Section 9.6

- › According to the electron-sea model, the valence electrons of the metal atoms in a sample are highly delocalized and attract all the metal cations, holding them together.
- › Metals have only moderately high melting points because the metal ions remain attracted to the electrons in the electron sea even if their relative positions change.
- › Vaporization involves complete separation of individual cations with their valence electrons from all the others, so metals have very high boiling points.
- › Metals can be deformed because the electron sea prevents repulsions among the cations.
- › Metals conduct electricity and heat because their electrons are mobile.

CHAPTER REVIEW GUIDE

Learning Objectives

Relevant section (S) and/or sample problem (SP) numbers appear in parentheses.

Understand These Concepts

1. How differences in atomic properties lead to differences in bond type; the basic distinctions among the three types of bonding (§9.1)
2. The essential features of ionic bonding: electron transfer to form ions, and their electrostatic attraction to form a solid (§9.2)

3. How lattice energy is ultimately responsible for the formation of ionic compounds (§9.2)
4. How ionic compound formation is conceptualized as occurring in hypothetical steps (a Born-Haber cycle) to calculate the lattice energy (§9.2)
5. How Coulomb's law explains the periodic trends in lattice energy (§9.2)

6. Why ionic compounds are brittle and high melting and conduct electricity only when molten or dissolved in water (§9.2)
7. How nonmetal atoms form a covalent bond (§9.3)
8. How bonding and lone electron pairs fill the outer (valence) level of each atom in a molecule (§9.3)
9. The interrelationships among bond order, bond length, and bond energy (§9.3)
10. How the distinction between bonding and nonbonding forces explains the properties of covalent molecules and network covalent solids (§9.3)
11. How changes in bond energy account for the enthalpy of reaction (§9.4)
12. How a reaction can be divided conceptually into bond-breaking and bond-forming steps (§9.4)
13. The periodic trends in electronegativity and the inverse relationship of EN values to atomic sizes (§9.5)
14. How bond polarity arises from differences in the electronegativities of the bonded atoms; the direction of bond polarity (§9.5)
15. The relation of partial ionic character to ΔEN and the change from ionic to polar covalent to nonpolar covalent bonding across a period (§9.5)

16. The role of delocalized electrons in metallic bonding (§9.6)
17. How the electron-sea model explains why metals bend, have very high boiling points, and conduct electricity in solid or molten form (§9.6)

Master These Skills

1. Using Lewis electron-dot symbols to depict main-group atoms (§9.1)
2. Depicting the formation of ions with partial orbital diagrams and Lewis symbols, and writing the formula of the ionic compound (SP 9.1)
3. Calculating lattice energy from the enthalpies of the steps to ionic compound formation (§9.2)
4. Ranking lattice energies from ionic properties (SP 9.2)
5. Ranking similar covalent bonds according to their length and strength (SP 9.3)
6. Using bond energies to calculate $\Delta H_{\text{rxn}}^{\circ}$ (SP 9.4)
7. Determining bond polarity from EN values (SP 9.5)

Key Terms

Page numbers appear in parentheses.

alloy (396)
bond energy (BE) (380)
bond length (381)
bond order (380)
bonding (shared) pair (380)
Born-Haber cycle (374)
Coulomb's law (375)

covalent bond (379)
covalent bonding (370)
double bond (380)
electron-sea model (395)
electronegativity (EN) (390)
electronegativity difference (ΔEN) (392)

infrared (IR) spectroscopy (384)
ion pairs (378)
ionic bonding (370)
lattice energy ($\Delta H_{\text{lattice}}^{\circ}$) (374)
Lewis electron-dot symbol (371)
lone (unshared) pair (380)

metallic bonding (371)
nonpolar covalent bond (392)
octet rule (372)
partial ionic character (392)
polar covalent bond (392)
single bond (380)
triple bond (380)

Key Equations and Relationships

Page numbers appear in parentheses.

9.1 Relating the energy of attraction to the lattice energy (375):

$$\text{Electrostatic energy} \propto \frac{\text{cation charge} \times \text{anion charge}}{\text{cation radius} + \text{anion radius}} \propto \Delta H_{\text{lattice}}^{\circ}$$

9.2 Calculating enthalpy of reaction from bond enthalpies or bond energies (387):

$$\Delta H_{\text{rxn}}^{\circ} = \sum \Delta H_{\text{reactant bonds broken}}^{\circ} + \sum \Delta H_{\text{product bonds formed}}^{\circ}$$

$$\text{or } \Delta H_{\text{rxn}}^{\circ} = \Sigma \text{BE}_{\text{reactant bonds broken}} - \Sigma \text{BE}_{\text{product bonds formed}}$$

BRIEF SOLUTIONS TO FOLLOW-UP PROBLEMS

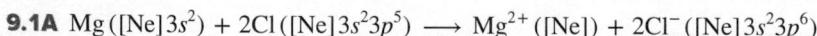

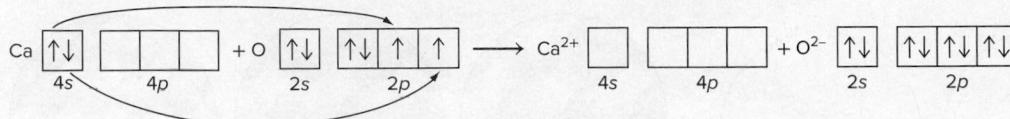

9.2A BaF_2 . The only difference between these compounds is the size of the cation: the Ba^{2+} ion is larger than the Sr^{2+} ion (ionic size increases down the group), so the lattice energy of BaF_2 is smaller than that of SrF_2 .

9.2B $\text{Na}_2\text{O} < \text{MgF}_2 < \text{CaO}$. In Na_2O , the ions are Na^+ and O^{2-} ; the ions in MgF_2 are Mg^{2+} and F^- . The products of the cation charge and anion charge (Equation 9.1) are the same for these two compounds (1×2 and 2×1); however, since Na^+ is larger than Mg^{2+} , and O^{2-} is larger than F^- , Na_2O has the smaller lattice energy. In CaO , the ions are Ca^{2+} and O^{2-} . The larger product of cation and anion charge (2×2 for CaO) results in a larger lattice energy for CaO . In nearly every case, charge is more important than size.

9.3A (a) All three bonds have a bond order of 3. Since atomic size decreases left to right across a period, $\text{C} > \text{N} > \text{O}$.

Bond length: $\text{C}\equiv\text{C} > \text{C}\equiv\text{N} > \text{C}\equiv\text{O}$

Bond strength: $\text{C}\equiv\text{O} > \text{C}\equiv\text{N} > \text{C}\equiv\text{C}$

(b) All three bonds have a bond order of 1. Since atomic size increases down a group, $\text{I} > \text{Br} > \text{F}$

Bond length: $\text{P—I} > \text{P—Br} > \text{P—F}$

Bond strength: $\text{P—F} > \text{P—Br} > \text{P—I}$

9.3B (a) All three bonds have a bond order of 1. Since atomic size decreases left to right across a period, $\text{F} < \text{O} < \text{C}$.

Bond length: $\text{Si—F} < \text{Si—O} < \text{Si—C}$

Bond strength: $\text{Si—C} < \text{Si—O} < \text{Si—F}$

(b) As bond order decreases, bond length increases and bond strength decreases.

Bond length: $\text{N}\equiv\text{N} < \text{N}=\text{N} < \text{N}—\text{N}$

Bond strength: $\text{N}—\text{N} < \text{N}=\text{N} < \text{N}\equiv\text{N}$

$$\begin{aligned}\Sigma \Delta H_{\text{bonds broken}}^\circ &= 1 \text{ N}\equiv\text{N} + 3 \text{ H—H} \\ &= (1 \text{ mol})(945 \text{ kJ/mol}) + (3 \text{ mol})(432 \text{ kJ/mol}) \\ &= 2241 \text{ kJ}\end{aligned}$$

$$\Sigma \Delta H_{\text{bonds formed}}^\circ = 6 \text{ N—H} = (6 \text{ mol})(-391 \text{ kJ/mol}) = -2346 \text{ kJ}$$

$$\begin{aligned}\Delta H_{\text{rxn}}^\circ &= \Sigma \Delta H_{\text{bonds broken}}^\circ + \Sigma \Delta H_{\text{bonds formed}}^\circ \\ &= 2241 \text{ kJ} + (-2346 \text{ kJ}) = -105 \text{ kJ}\end{aligned}$$

9.4B

$$\begin{aligned}\Sigma \Delta H_{\text{bonds broken}}^\circ &= 2 \text{ O—F} + 2 \text{ O—H} \\ &= (2 \text{ mol})(190 \text{ kJ/mol}) + (2 \text{ mol})(467 \text{ kJ/mol}) \\ &= 1314 \text{ kJ}\end{aligned}$$

$$\begin{aligned}\Sigma \Delta H_{\text{bonds formed}}^\circ &= 2 \text{ H—F} + 1 \text{ O=O} \\ &= (2 \text{ mol})(-565 \text{ kJ/mol}) + (1 \text{ mol})(-498 \text{ kJ/mol}) \\ &= -1628 \text{ kJ}\end{aligned}$$

$$\begin{aligned}\Delta H_{\text{rxn}}^\circ &= \Sigma \Delta H_{\text{bonds broken}}^\circ + \Sigma \Delta H_{\text{bonds formed}}^\circ \\ &= 1314 \text{ kJ} + (-1628 \text{ kJ}) = -314 \text{ kJ}\end{aligned}$$

9.5A (a) Cl—F : $\Delta \text{EN} = 4.0 - 3.0 = 1.0$;

Br—Cl : $\Delta \text{EN} = 3.0 - 2.8 = 0.2$; Cl—Cl : $\Delta \text{EN} = 3.0 - 3.0 = 0$

(b) P—F : $\Delta \text{EN} = 4.0 - 2.1 = 1.9$; N—O : $\Delta \text{EN} = 3.5 - 3.0 = 0.5$; N—F : $\Delta \text{EN} = 4.0 - 3.0 = 1.0$

9.5B (a) Se—Cl : $\Delta \text{EN} = 3.0 - 2.4 = 0.6$;

Se—F : $\Delta \text{EN} = 4.0 - 2.4 = 1.6$; Se—Br : $\Delta \text{EN} = 2.8 - 2.4 = 0.4$

(b) S—B : $\Delta \text{EN} = 2.5 - 2.0 = 0.5$; F—B : $\Delta \text{EN} = 4.0 - 2.0 = 2.0$; Cl—B : $\Delta \text{EN} = 3.0 - 2.0 = 1.0$

PROBLEMS

Problems with **colored** numbers are answered in Appendix E and worked in detail in the Student Solutions Manual. Problem sections match those in the text and give the numbers of relevant sample problems. Most offer Concept Review Questions, Skill-Building Exercises (grouped in pairs covering the same concept), and Problems in Context. The Comprehensive Problems are based on material from any section or previous chapter.

Atomic Properties and Chemical Bonds

Concept Review Questions

9.1 In general terms, how does each of the following atomic properties influence the metallic character of the main-group elements in a period?

- (a) Ionization energy
- (b) Atomic radius
- (c) Number of outer electrons
- (d) Effective nuclear charge

9.2 Three solids are represented below. What is the predominant type of bonding in each?

9.3 What is the relationship between the tendency of a main-group element to form a monatomic ion and its position in the periodic table? In what part of the table are the main-group elements that typically form cations? Anions?

Skill-Building Exercises (grouped in similar pairs)

9.4 Which member of each pair is *more* metallic?

- (a) Na or Cs (b) Mg or Rb (c) As or N

9.5 Which member of each pair is *less* metallic?

- (a) I or O (b) Be or Ba (c) Se or Ge

9.6 State the type of bonding—ionic, covalent, or metallic—you would expect in each:

- (a) CsF(s) (b) N₂(g) (c) Na(s)

9.7 State the type of bonding—ionic, covalent, or metallic—you would expect in each:

- (a) ICl₃(g) (b) N₂O(g) (c) LiCl(s)

9.8 State the type of bonding—ionic, covalent, or metallic—you would expect in each:

- (a) O₃(g) (b) MgCl₂(s) (c) BrO₂(g)

9.9 State the type of bonding—ionic, covalent, or metallic—you would expect in each:

- (a) Cr(s) (b) H₂S(g) (c) CaO(s)

9.10 Draw a Lewis electron-dot symbol for each atom:

- (a) Rb (b) Si (c) I

9.11 Draw a Lewis electron-dot symbol for each atom:

- (a) Ba (b) Kr (c) Br

9.12 Draw a Lewis electron-dot symbol for each:

- (a) Sr (b) P (c) S

9.13 Draw a Lewis electron-dot symbol for each:

- (a) As (b) Se (c) Ga

9.14 Give the group number and condensed electron configuration of an element corresponding to each electron-dot symbol:

- (a) ·᷊: (b) ᷊·

9.15 Give the group number and condensed electron configuration of an element corresponding to each electron-dot symbol:

- (a) ·᷊: (b) ᷊·

The Ionic Bonding Model

(Sample Problems 9.1 and 9.2)

Concept Review Questions

9.16 If energy is required to form monatomic ions from metals and nonmetals, why do ionic compounds exist?

9.17 (a) In general, how does the lattice energy of an ionic compound depend on the charges and sizes of the ions?

(b) Ion arrangements of three general salts are represented below. Rank them in order of increasing lattice energy.

9.18 When gaseous Na⁺ and Cl⁻ ions form ion pairs, 548 kJ/mol of energy is released. Why, then, does NaCl occur as a solid under ordinary conditions?

9.19 To form S²⁻ ions from gaseous sulfur atoms requires 214 kJ/mol, but these ions exist in solids such as K₂S. Explain.

Skill-Building Exercises (grouped in similar pairs)

9.20 Use condensed electron configurations and Lewis electron-dot symbols to depict the ions formed from each of the following atoms, and predict the formula of their compound:

- (a) Ba and Cl (b) Sr and O (c) Al and F (d) Rb and O

9.21 Use condensed electron configurations and Lewis electron-dot symbols to depict the ions formed from each of the following atoms, and predict the formula of their compound:

- (a) Cs and S (b) O and Ga (c) N and Mg (d) Br and Li

9.22 For each ionic compound formula, identify the main group to which X belongs:

- (a) XF₂ (b) MgX (c) X₂SO₄

9.23 For each ionic compound formula, identify the main group to which X belongs:

- (a) X₃PO₄ (b) X₂(SO₄)₃ (c) X(NO₃)₂

9.24 For each ionic compound formula, identify the main group to which X belongs:

- (a) X₂O₃ (b) XCO₃ (c) Na₂X

9.25 For each ionic compound formula, identify the main group to which X belongs:

- (a) CaX₂ (b) Al₂X₃ (c) XPO₄

9.26 For each pair, choose the compound with the larger lattice energy, and explain your choice:

- (a) BaS or CsCl (b) LiCl or CsCl

9.27 For each pair, choose the compound with the larger lattice energy, and explain your choice:

- (a) CaO or CaS (b) BaO or SrO

9.28 For each pair, choose the compound with the smaller lattice energy, and explain your choice:

- (a) CaS or BaS (b) NaF or MgO

9.29 For each pair, choose the compound with the smaller lattice energy, and explain your choice:

- (a) NaF or NaCl (b) K₂O or K₂S

9.30 Use the following to calculate $\Delta H_{\text{lattice}}^{\circ}$ of NaCl:

Compared with the lattice energy of LiF (1050 kJ/mol), is the magnitude of the value for NaCl what you expected? Explain.

9.31 Use the following to calculate $\Delta H_{\text{lattice}}^{\circ}$ of MgF_2 :

$\text{Mg}(s) \rightarrow \text{Mg}(g)$	$\Delta H^{\circ} = 148 \text{ kJ}$
$\text{F}_2(g) \rightarrow 2\text{F}(g)$	$\Delta H^{\circ} = 159 \text{ kJ}$
$\text{Mg}(g) \rightarrow \text{Mg}^{+}(g) + e^{-}$	$\Delta H^{\circ} = 738 \text{ kJ}$
$\text{Mg}^{+}(g) \rightarrow \text{Mg}^{2+}(g) + e^{-}$	$\Delta H^{\circ} = 1450 \text{ kJ}$
$\text{F}(g) + e^{-} \rightarrow \text{F}^{-}(g)$	$\Delta H^{\circ} = -328 \text{ kJ}$
$\text{Mg}(s) + \text{F}_2(g) \rightarrow \text{MgF}_2(s)$	$\Delta H^{\circ} = -1123 \text{ kJ}$

Compared with the lattice energy of LiF (1050 kJ/mol) or the lattice energy you calculated for NaCl in Problem 9.30, does the relative magnitude of the value for MgF_2 surprise you? Explain.

Problems in Context

9.32 Aluminum oxide (Al_2O_3) is a widely used industrial abrasive (known as emery or corundum), for which the specific application depends on the hardness of the crystal. What does this hardness imply about the magnitude of the lattice energy? Would you have predicted from the chemical formula that Al_2O_3 is hard? Explain.

9.33 Born-Haber cycles were used to obtain the first reliable values for electron affinity by considering the EA value as the unknown and using a theoretically calculated value for the lattice energy. Use a Born-Haber cycle for KF and the following values to calculate a value for the electron affinity of fluorine:

$\text{K}(s) \rightarrow \text{K}(g)$	$\Delta H^{\circ} = 90 \text{ kJ}$
$\text{K}(g) \rightarrow \text{K}^{+}(g) + e^{-}$	$\Delta H^{\circ} = 419 \text{ kJ}$
$\text{F}_2(g) \rightarrow 2\text{F}(g)$	$\Delta H^{\circ} = 159 \text{ kJ}$
$\text{K}(s) + \frac{1}{2}\text{F}_2(g) \rightarrow \text{KF}(s)$	$\Delta H^{\circ} = -569 \text{ kJ}$
$\text{K}^{+}(g) + \text{F}^{-}(g) \rightarrow \text{KF}(s)$	$\Delta H^{\circ} = -821 \text{ kJ}$

The Covalent Bonding Model

(Sample Problem 9.3)

Concept Review Questions

9.34 Describe the interactions that occur between individual chlorine atoms as they approach each other and form Cl_2 . What combination of forces gives rise to the energy holding the atoms together and to the final internuclear distance?

9.35 Define *bond energy* using the $\text{H}-\text{Cl}$ bond as an example. When this bond breaks, is energy absorbed or released? Is the accompanying ΔH value positive or negative? How do the magnitude and sign of this ΔH value relate to the value that accompanies $\text{H}-\text{Cl}$ bond formation?

9.36 For single bonds between similar types of atoms, how does the strength of the bond relate to the sizes of the atoms? Explain.

9.37 How does the energy of the bond between a given pair of atoms relate to the bond order? Why?

9.38 When liquid benzene (C_6H_6) boils, does the gas consist of molecules, ions, or separate atoms? Explain.

Skill-Building Exercises (grouped in similar pairs)

9.39 Using the periodic table only, arrange the members of each of the following sets in order of increasing bond *strength*:

- (a) $\text{Br}-\text{Br}$, $\text{Cl}-\text{Cl}$, $\text{I}-\text{I}$ (b) $\text{S}-\text{H}$, $\text{S}-\text{Br}$, $\text{S}-\text{Cl}$
 (c) $\text{C}=\text{N}$, $\text{C}-\text{N}$, $\text{C}\equiv\text{N}$

9.40 Using the periodic table only, arrange the members of each of the following sets in order of increasing bond *length*:

- (a) $\text{H}-\text{F}$, $\text{H}-\text{I}$, $\text{H}-\text{Cl}$ (b) $\text{C}-\text{S}$, $\text{C}=\text{O}$, $\text{C}-\text{O}$
 (c) $\text{N}-\text{H}$, $\text{N}-\text{S}$, $\text{N}-\text{O}$

Problem in Context

9.41 Formic acid (HCOOH ; structural formula shown below) is secreted by certain species of ants when they bite.

Rank the relative strengths of

- (a) the $\text{C}-\text{O}$ and $\text{C}=\text{O}$ bonds and
 (b) the $\text{H}-\text{C}$ and $\text{O}-\text{H}$ bonds. Explain these rankings.

Bond Energy and Chemical Change

(Sample Problem 9.4)

Concept Review Questions

9.42 Write a solution Plan (without actual numbers, but including the bond energies you would use and how you would combine them algebraically) for calculating the total enthalpy change of the following reaction:

9.43 The text points out that, for similar types of substances, one with weaker bonds is usually more reactive than one with stronger bonds. Why is this generally true?

9.44 Why is there a discrepancy between an enthalpy of reaction obtained from calorimetry and one obtained from bond energies?

Skill-Building Exercises (grouped in similar pairs)

9.45 Which of the following gases would you expect to have the greater enthalpy of reaction per mole for combustion? Why?

methane or formaldehyde

9.46 Which of the following gases would you expect to have the greater enthalpy of reaction per mole for combustion? Why?

ethanol or methanol

9.47 Use bond energies to calculate the enthalpy of reaction:

9.48 Use bond energies to calculate the enthalpy of reaction:

Problems in Context

9.49 An important industrial route to extremely pure acetic acid is the reaction of methanol with carbon monoxide:

Use bond energies to calculate the enthalpy of reaction.

9.50 Sports trainers treat sprains and soreness with ethyl bromide. It is manufactured by reacting ethylene with hydrogen bromide:

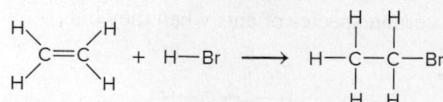

Use bond energies to find the enthalpy of reaction.

Between the Extremes: Electronegativity and Bond Polarity

(Sample Problem 9.5)

Concept Review Questions

9.51 Describe the vertical and horizontal trends in electronegativity (EN) among the main-group elements. According to Pauling's scale, what are the two most electronegative elements? The two least electronegative elements?

9.52 What is the general relationship between IE_1 and EN for the elements? Why?

9.53 Is the H—O bond in water nonpolar covalent, polar covalent, or ionic? Define each term, and explain your choice.

9.54 How does electronegativity differ from electron affinity?

9.55 How is the partial ionic character of a bond in a diatomic molecule related to ΔEN for the bonded atoms? Why?

Skill-Building Exercises (grouped in similar pairs)

9.56 Using the periodic table only, arrange the elements in each set in order of *increasing* EN:

- (a) S, O, Si (b) Mg, P, As

9.57 Using the periodic table only, arrange the elements in each set in order of *increasing* EN:

- (a) I, Br, N (b) Ca, H, F

9.58 Using the periodic table only, arrange the elements in each set in order of *decreasing* EN:

- (a) N, P, Si (b) Ca, Ga, As

9.59 Using the periodic table only, arrange the elements in each set in order of *decreasing* EN:

- (a) Br, Cl, P (b) I, F, O

9.60 Use Figure 9.21 to indicate the polarity of each bond with a *polar arrow*:

- | | | |
|---------|---------|----------|
| (a) N—B | (b) N—O | (c) C—S |
| (d) S—O | (e) N—H | (f) Cl—O |

9.61 Use Figure 9.21 to indicate the polarity of each bond with *partial charges*:

- | | | |
|-----------|----------|---------|
| (a) Br—Cl | (b) F—Cl | (c) H—O |
| (d) Se—H | (e) As—H | (f) S—N |

9.62 Which is the more polar bond in each of the following pairs from Problem 9.60: (a) or (b); (c) or (d); (e) or (f)?

9.63 Which is the more polar bond in each of the following pairs from Problem 9.61: (a) or (b); (c) or (d); (e) or (f)?

9.64 Are the bonds in each of the following substances ionic, nonpolar covalent, or polar covalent? Arrange the substances with polar covalent bonds in order of increasing bond polarity:

- | | | |
|----------------------|--------------------|---------------------|
| (a) S ₈ | (b) RbCl | (c) PF ₃ |
| (d) SCl ₂ | (e) F ₂ | (f) SF ₂ |

9.65 Are the bonds in each of the following substances ionic, nonpolar covalent, or polar covalent? Arrange the substances

with polar covalent bonds in order of increasing bond polarity:

- | | | |
|---------------------|---------------------|---------------------|
| (a) KCl | (b) P ₄ | (c) BF ₃ |
| (d) SO ₂ | (e) Br ₂ | (f) NO ₂ |

9.66 Rank the members of each set of compounds in order of *increasing* ionic character of their bonds. Use *polar arrows* to indicate the bond polarity of each:

- (a) HBr, HCl, HI (b) H₂O, CH₄, HF (c) SCl₂, PCl₃, SiCl₄

9.67 Rank the members of each set of compounds in order of *decreasing* ionic character of their bonds. Use *partial charges* to indicate the bond polarity of each:

- (a) PCl₃, PBr₃, PF₃ (b) BF₃, NF₃, CF₄ (c) SeF₄, TeF₄, BrF₃

Problem in Context

9.68 The energy of the C—C bond is 347 kJ/mol, and that of the Cl—Cl bond is 243 kJ/mol. Which of the following values might you expect for the C—Cl bond energy? Explain.

- | |
|---|
| (a) 590 kJ/mol (sum of the values given) |
| (b) 104 kJ/mol (difference of the values given) |
| (c) 295 kJ/mol (average of the values given) |
| (d) 339 kJ/mol (greater than the average of the values given) |

An Introduction to Metallic Bonding

Concept Review Questions

9.69 (a) List four physical characteristics of a solid metal.
(b) List two chemical characteristics of a metallic element.

9.70 Briefly account for the following relative values:

- | |
|---|
| (a) The melting points of Na and K are 89°C and 63°C, respectively. |
| (b) The melting points of Li and Be are 180°C and 1287°C, respectively. |
| (c) Li boils more than 1100°C higher than it melts. |

9.71 Magnesium metal is easily deformed by an applied force, whereas magnesium fluoride is shattered. Why do these two solids behave so differently?

Comprehensive Problems

9.72 Geologists have a rule of thumb: when molten rock cools and solidifies, crystals of compounds with the smallest lattice energies appear at the bottom of the mass. Suggest a reason for this.

9.73 Acetylene gas (ethyne; HC≡CH) burns in an oxyacetylene torch to produce carbon dioxide and water vapor. The enthalpy of reaction for the combustion of acetylene is 1259 kJ/mol.

- | |
|---|
| (a) Calculate the C≡C bond energy, and compare your value with that in Table 9.2. |
| (b) When 500.0 g of acetylene burns, how many kilojoules of heat are given off? |
| (c) How many grams of CO ₂ form? |
| (d) How many liters of O ₂ at 298 K and 18.0 atm are consumed? |

9.74 Use Lewis electron-dot symbols to represent the formation of (a) BrF₃ from bromine and fluorine atoms;

(b) AlF₃ from aluminum and fluorine atoms.

9.75 Even though so much energy is required to form a metal cation with a 2+ charge, the alkaline earth metals form halides with the general formula MX₂, rather than MX.

(a) Use the following data to calculate ΔH_f° of MgCl:

$$\Delta H_{\text{lattice}}^\circ \text{ of MgCl} = 783.5 \text{ kJ/mol}$$

(b) Is MgCl favored energetically relative to Mg and Cl₂? Explain.

(c) Use Hess's law to calculate ΔH° for the conversion of MgCl to MgCl₂ and Mg (ΔH_f° of MgCl₂ = -641.6 kJ/mol).

(d) Is MgCl favored energetically relative to MgCl₂? Explain.

9.76 Gases react explosively if the heat released when the reaction begins is sufficient to cause more reaction, which leads to a rapid expansion of the gases. Use bond energies to calculate ΔH° of each of the following reactions, and predict which occurs explosively:

9.77 By using photons of specific wavelengths, chemists can dissociate gaseous HI to produce H atoms with certain speeds. When HI dissociates, the H atoms move away rapidly, whereas the heavier I atoms move more slowly.

(a) What is the longest wavelength (in nm) that can dissociate a molecule of HI?

(b) If a photon of 254 nm is used, what is the excess energy (in J) over that needed for dissociation?

(c) If this excess energy is carried away by the H atom as kinetic energy, what is its speed (in m/s)?

9.78 In developing the concept of electronegativity, Pauling used the term *excess bond energy* for the difference between the actual bond energy of X—Y and the average bond energies of X—X and Y—Y (see the discussion of HF in Section 9.5). Based on the values in Figure 9.21, which of the following substances contain bonds with no excess bond energy?

- (a) PH₃ (b) CS₂ (c) BrCl (d) BH₃ (e) Se₈

9.79 Use condensed electron configurations to predict the relative hardnesses and melting points of rubidium ($Z = 37$), vanadium ($Z = 23$), and cadmium ($Z = 48$).

9.80 Without stratospheric ozone (O₃), harmful solar radiation would cause gene alterations. Ozone forms when the bond in O₂ breaks and each O atom reacts with another O₂ molecule. It is destroyed by reaction with the Cl atoms formed when the C—Cl bond in synthetic chemicals breaks. Find the wavelengths of light that can break the C—Cl bond and the bond in O₂.

9.81 “Inert” xenon actually forms many compounds, especially with highly electronegative fluorine. The ΔH_f° values for xenon difluoride, tetrafluoride, and hexafluoride are -105, -284, and -402 kJ/mol, respectively. Find the average bond energy of the X—F bonds in each fluoride.

9.82 The HF bond length is 92 pm, 16% shorter than the sum of the covalent radii of H (37 pm) and F (72 pm). Suggest a reason for this difference. Similar data show that the difference becomes smaller down the group, from HF to HI. Explain.

9.83 There are two main types of covalent bond breakage. In homolytic breakage (as in Table 9.2), each atom in the bond gets one of the shared electrons. In some cases, the electronegativity of adjacent atoms affects the bond energy. In heterolytic breakage, one atom gets both electrons and the other gets none; thus, a cation and an anion form.

(a) Why is the C—C bond in H₃C—CF₃ (423 kJ/mol) stronger than that in H₃C—CH₃ (376 kJ/mol)?

(b) Use bond energy and any other data to calculate the enthalpy of reaction for the heterolytic cleavage of O₂.

9.84 Find the longest wavelengths of light that can cleave the bonds in elemental nitrogen, oxygen, and fluorine.

9.85 The work function (ϕ) of a metal is the minimum energy needed to remove an electron from its surface.

(a) Is it easier to remove an electron from a gaseous silver atom or from the surface of solid silver ($\phi = 7.59 \times 10^{-19}$ J; IE = 731 kJ/mol)?
 (b) Explain the results in terms of the electron-sea model of metallic bonding.

9.86 Lattice energies can also be calculated for covalent network solids using a Born-Haber cycle, and the network solid silicon dioxide has one of the highest $\Delta H_{lattice}^\circ$ values. Silicon dioxide is found in pure crystalline form as transparent rock quartz. Much harder than glass, this material was once prized for making lenses for optical devices and expensive spectacles. Use Appendix B and the following data to calculate $\Delta H_{lattice}^\circ$ of SiO₂:

$Si(s) \longrightarrow Si(g)$	$\Delta H^\circ = 454$ kJ
$Si(g) \longrightarrow Si^{4+}(g) + 4e^-$	$\Delta H^\circ = 9949$ kJ
$O_2(g) \longrightarrow 2O(g)$	$\Delta H^\circ = 498$ kJ
$O(g) + 2e^- \longrightarrow O^{2-}(g)$	$\Delta H^\circ = 737$ kJ

9.87 The average C—H bond energy in CH₄ is 415 kJ/mol. Use Table 9.2 and the following data to calculate the average C—H bond energy in ethane (C₂H₆; C—C bond), in ethene (C₂H₄; C=C bond), and in ethyne (C₂H₂; C≡C bond):

$C_2H_6(g) + H_2(g) \longrightarrow 2CH_4(g)$	$\Delta H_{rxn}^\circ = -65.07$ kJ/mol
$C_2H_4(g) + 2H_2(g) \longrightarrow 2CH_4(g)$	$\Delta H_{rxn}^\circ = -202.21$ kJ/mol
$C_2H_2(g) + 3H_2(g) \longrightarrow 2CH_4(g)$	$\Delta H_{rxn}^\circ = -376.74$ kJ/mol

9.88 Carbon-carbon bonds form the “backbone” of nearly every organic and biological molecule. The average bond energy of the C—C bond is 347 kJ/mol. Calculate the frequency and wavelength of the least energetic photon that can break an average C—C bond. In what region of the electromagnetic spectrum is this radiation?

9.89 In a future hydrogen-fuel economy, the cheapest source of H₂ will certainly be water. It takes 467 kJ to produce 1 mol of H atoms from water. What is the frequency, wavelength, and minimum energy of a photon that can free an H atom from water?

9.90 Dimethyl ether (CH₃OCH₃) and ethanol (CH₃CH₂OH) are constitutional isomers (see Table 3.3).

(a) Use Table 9.2 to calculate ΔH_{rxn}° for the formation of each compound as a gas from methane and oxygen; water vapor also forms.

(b) State which reaction is more exothermic.

(c) Calculate ΔH_{rxn}° for the conversion of ethanol to dimethyl ether.

9.91 Enthalpies of reaction calculated from bond energies and from enthalpies of formation are often, but not always, close to each other.

(a) Industrial ethanol (CH₃CH₂OH) is produced by a catalytic reaction of ethylene (CH₂=CH₂) with water at high pressures and temperatures. Calculate ΔH_{rxn}° for this gas-phase hydration of ethylene to ethanol, using bond energies and then using enthalpies of formation.

(b) Ethylene glycol is produced by the catalytic oxidation of ethylene to ethylene oxide, which then reacts with water to form ethylene glycol:

The ΔH_{rxn}° for this hydrolysis step, based on enthalpies of formation, is -97 kJ/mol. Calculate ΔH_{rxn}° for the hydrolysis using bond energies.

(c) Why are the two values relatively close for the hydration in part (a) but not close for the hydrolysis in part (b)?

10

The Shapes of Molecules

10.1 Depicting Molecules and Ions with Lewis Structures

Applying the Octet Rule

Resonance

Formal Charge

Exceptions to the Octet Rule

10.2 Valence-Shell Electron-Pair Repulsion (VSEPR) Theory

Electron-Group Arrangements and Molecular Shapes

Molecular Shape with Two Electron Groups

Molecular Shapes with Three Electron Groups

Molecular Shapes with Four Electron Groups

Molecular Shapes with Five Electron Groups

Molecular Shapes with Six Electron Groups

Using VSEPR Theory to Determine Molecular Shape

Molecular Shapes with More Than One Central Atom

10.3 Molecular Shape and Molecular Polarity

Bond Polarity, Bond Angle, and Dipole Moment

Molecular Polarity and Behavior

Source: © Mikhail Rulkov/Shutterstock.com

Concepts and Skills to Review Before You Study This Chapter

- › electron configurations of main-group elements (Section 8.2)
- › bond order, bond length, and bond energy (Sections 9.3 and 9.4)
- › electron-dot symbols (Section 9.1)
- › polar covalent bonds and bond polarity (Section 9.5)
- › octet rule (Section 9.1)

Very young children often play with a shape-sorting toy that teaches them to match blocks of different shapes to the correct holes in the toy. Chemists, biochemists, and pharmacologists are also interested in shape matching because molecular shape plays a crucial role in the interactions of reactants, in the behavior of synthetic materials, in the life-sustaining processes in cells, in the senses of taste and smell, and in the discovery of new pharmaceutical drugs. All the symbols, lines, and dots you've been seeing in representations of molecules make it easy to forget that every molecule has a characteristic minute architecture. Each atom, bonding pair, and lone pair of electrons has a specific position relative to the others, and the angles and distances between these constituents are determined by the attractive and repulsive forces governing all matter.

IN THIS CHAPTER . . . We learn how to picture a molecule by writing a two-dimensional structure for it and converting it to a three-dimensional shape, and we examine some effects of molecular shape on physical and biochemical behavior.

- › We learn how to apply the octet rule to convert a molecular formula into a flat structural formula that shows atom attachments and electron-pair locations.
- › We see how electron delocalization limits our ability to depict a molecule with a single structural formula and requires us to apply the concept of resonance.
- › We introduce bond angle and apply a theory that converts two-dimensional formulas into three-dimensional shapes.
- › We describe five basic classes of shapes that many molecules adopt and consider how multiple bonds and lone pairs affect them and how to combine smaller molecular portions into the shapes of more complex molecules.
- › We discuss the relation among bond polarity, shape, and molecular polarity and the effect of polarity on behavior.
- › We describe a few examples of the influence of shape on biological function.

10.1 DEPICTING MOLECULES AND IONS WITH LEWIS STRUCTURES

The first step toward visualizing a molecule is to convert its molecular formula to its **Lewis structure** (or **Lewis formula***), which shows symbols for the atoms, the bonding electron pairs as lines, and the lone electron pairs that fill each atom's outer level (valence shell) as pairs of dots.

Applying the Octet Rule to Write Lewis Structures

To write a Lewis structure, we decide on the relative placement of the atoms in the molecule or polyatomic ion and then distribute the total number of valence electrons as bonding and lone pairs. In many, but not all, cases, the octet rule (Section 9.1) guides us in distributing the electrons. We begin with species that "obey" the octet rule, in which each atom fills its outer level with eight electrons (or two for hydrogen).

*A Lewis structure does **not** indicate the three-dimensional shape, so it may be more correct to call it a Lewis *formula*, but we follow convention and use the term *structure*.

A Species with single bonds only**B Species with multiple bonds**

Figure 10.1 The steps in converting a molecular formula into a Lewis structure.

Molecules with Single Bonds Figure 10.1A shows the four steps for writing Lewis structures for species with only single bonds. Let's use two species, nitrogen trifluoride, NF_3 , and the tetrafluoroborate ion, BF_4^- , to introduce the steps:

Step 1. Place the atoms relative to each other. For compounds with the general molecular formula AB_n , place the atom with the *lower group number* in the center because it needs more electrons to attain an octet; usually, this is also the atom with the *lower electronegativity*. In NF_3 , nitrogen [Group 5A(15); EN = 3.0] has a lower group number and lower electronegativity than F [Group 7A(17); EN = 4.0], so it goes in the center with the three F atoms around it. In BF_4^- , boron [Group 3A(13); EN = 2.0] has the lower group number and lower electronegativity, so it goes in the center with the four F atoms around it:

If the atoms have the same group number, as in SO_3 , place the atom with the *higher period number* (also the lower EN) in the center. H can form only one bond, so it is *never* a central atom.

Step 2. Determine the total number of valence electrons.

- For molecules, like NF_3 , add up the valence electrons of the atoms. (Recall that the number of valence electrons equals the A-group number.) In NF_3 , N has five valence electrons, and each F has seven:

$$[1 \times \text{N}(5\text{e}^-)] + [3 \times \text{F}(7\text{e}^-)] = 5\text{e}^- + 21\text{e}^- = 26 \text{ valence e}^-$$

- For polyatomic ions, like BF_4^- , *add* one e^- for each negative charge, or *subtract* one e^- for each positive charge. In the BF_4^- ion, B has three valence electrons, each F atom has seven, and one more electron is included because of the negative charge:

$$[1 \times \text{B}(3\text{e}^-)] + [4 \times \text{F}(7\text{e}^-)] + [\text{charge } (1\text{e}^-)] = 32 \text{ valence e}^-$$

You don't need to keep track of which electrons come from which atoms, because only the total number of valence electrons is important.

Step 3. Draw a single bond from each surrounding atom to the central atom, and subtract 2e^- for each bond from the total number of valence electrons to find the number of e^- remaining:

Step 4. Distribute the remaining electrons in pairs so that each atom ends up with 8e^- (or 2e^- for H). First, place lone pairs on the *surrounding (more electronegative) atoms* to give each an octet. If any electrons remain, place them around the central atom:

The Lewis structure for the neutral species NF_3 is complete. Since BF_4^- is a polyatomic ion, we also take the charge into account, as described in step 2, and put the structure in square brackets with the ion charge as a superscript outside the brackets:

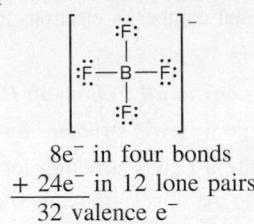

Since Lewis structures do not indicate shape, an equally correct depiction of NF_3 is

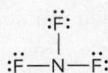

or any other that retains the *same connections among the atoms*—a central N atom connected by single bonds to each of three surrounding F atoms.

Using these four steps, you can write a Lewis structure for any singly bonded species with a central C, N, or O atom, as well as for some species with central atoms from higher periods. In nearly all their compounds,

- Hydrogen atoms form one bond.
- Carbon atoms form four bonds.
- Nitrogen atoms form three bonds.
- Oxygen atoms form two bonds.
- Surrounding halogens form one bond; fluorine is *always* a surrounding atom.

SAMPLE PROBLEM 10.1

Writing Lewis Structures for Species with Single Bonds and One Central Atom

Problem Write a Lewis structure for (a) CCl_2F_2 ; (b) PCl_2^- .

Solution (a) *Step 1.* Place the atoms relative to each other. In CCl_2F_2 , carbon has the lowest group number and EN, so it is the central atom. The halogen atoms surround it, but their specific positions are not important.

Step 2. Determine the total number of valence electrons (from A-group numbers): C is in Group 4A; F and Cl are in Group 7A. Therefore, we have

$$[1 \times \text{C}(4\text{e}^-)] + [2 \times \text{F}(7\text{e}^-)] + [2 \times \text{Cl}(7\text{e}^-)] = 32 \text{ valence e}^-$$

Step 3. Draw single bonds to the central atom and subtract 2e^- for each bond:

$$4 \text{ bonds} \times 2\text{e}^- = 8\text{e}^- \quad 32\text{e}^- - 8\text{e}^- = 24\text{e}^- \text{ remaining}$$

Step 4. Distribute the 24 remaining electrons in pairs, beginning with the surrounding atoms, so that each atom has an octet. Each surrounding fluorine atom gets three pairs. All atoms have an octet of electrons.

(b) *Step 1.* Place the atoms relative to each other. In PCl_2^- , phosphorus has the lower group number and EN, so it is the central atom. The chlorine atoms surround it.

Step 2. Determine the total number of valence electrons (from A-group numbers and ion charge): P is in Group 5A, and Cl is in Group 7A. Add 1e^- to the total number of valence electrons because of the 1^- charge:

$$[1 \times \text{P}(5\text{e}^-)] + [2 \times \text{Cl}(7\text{e}^-)] + [\text{charge } (1\text{e}^-)] = 20 \text{ valence e}^-$$

Step 3. Draw single bonds to the central atom and subtract 2e^- for each bond:

$$2 \text{ bonds} \times 2\text{e}^- = 4\text{e}^- \quad 20\text{e}^- - 4\text{e}^- = 16\text{e}^- \text{ remaining}$$

Step 4. Distribute the 16 remaining electrons in pairs, beginning with the surrounding atoms, so that each atom has an octet. Each surrounding chlorine atom gets three pairs, and the central phosphorus atom gets two pairs. Each atom has an octet of electrons. Since this species is an ion, place brackets around the Lewis structure and indicate the 1^- charge as a superscript negative sign outside the brackets.

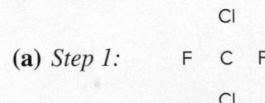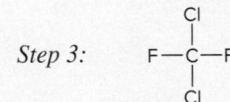

Check Always check that each atom has an octet. Bonding electrons belong to each atom in the bond. In CCl_2F_2 , the total number in bonds (8e^-) and lone pairs (24e^-) equals 32 valence e^- . As expected, C has four bonds and each of the surrounding halogens has one bond. In PCl_2^- , the total number of electrons in bonds (4e^-) and lone pairs (16e^-) equals 20 valence e^- .

FOLLOW-UP PROBLEMS

Brief Solutions to all Follow-up Problems appear at the end of the chapter.

10.1A Write a Lewis structure for (a) H_2S ; (b) AlCl_4^- ; (c) SOCl_2 .

10.1B Write a Lewis structure for (a) OF_2 ; (b) CH_2Br_2 ; (c) IBr_2^+ .

SOME SIMILAR PROBLEMS 10.5(a), 10.5(b), 10.6(a), 10.6(c), 10.7(a), and 10.8(c)

In molecules with two or more central atoms bonded to each other, it is usually clear which atoms are central and which are surrounding.

SAMPLE PROBLEM 10.2

Writing Lewis Structures for Molecules with Single Bonds and More Than One Central Atom

Problem Write the Lewis structure for methanol (molecular formula CH_4O), an important industrial alcohol that can be used as a gasoline alternative in cars.

Solution Step 1. Place the atoms relative to each other. The H atoms can have only one bond, so C and O must be central and adjacent to each other. C has four bonds and O has two, so we arrange the H atoms accordingly.

Step 2. Find the sum of valence electrons (C is in Group 4A; O is in Group 6A):

$$[1 \times \text{C}(4\text{e}^-)] + [1 \times \text{O}(6\text{e}^-)] + [4 \times \text{H}(1\text{e}^-)] = 14\text{e}^-$$

Step 3. Add single bonds and subtract 2e^- for each bond:

$$5 \text{ bonds} \times 2\text{e}^- = 10\text{e}^- \quad 14\text{e}^- - 10\text{e}^- = 4\text{e}^- \text{ remaining}$$

Step 4. Add the remaining four electrons in pairs to fill each valence level. C already has an octet, and each H shares 2e^- with the C; so the remaining 4e^- form two lone pairs on O to give the Lewis structure for methanol.

Check Each H atom has 2e^- , and C and O each have 8e^- . The total number of valence electrons is 14e^- , which equals 10e^- in bonds plus 4e^- in two lone pairs. Each H has one bond, C has four, and O has two.

FOLLOW-UP PROBLEMS

10.2A Write a Lewis structure for (a) hydroxylamine (NH_3O); (b) dimethyl ether ($\text{C}_2\text{H}_6\text{O}$; no O—H bonds).

10.2B Write a Lewis structure for (a) hydrazine (N_2H_4); (b) methylamine (CH_3NH_2).

SOME SIMILAR PROBLEMS 10.8(a) and 10.8(b)

Molecules with Multiple Bonds After completing steps 1–4 to write the Lewis structure for a species, we may find that the central atom still does not have an octet. In most of these cases, we add the following step (Figure 10.1B):

Step 5. If a central atom does not end up with an octet, form one or more multiple bonds. Change a lone pair on a surrounding atom into another bonding pair to the central atom, thus forming a double bond. This may be done again if necessary to form a triple bond or to form another double bond.

Let's draw the Lewis structure for the O_2 molecule to illustrate this:

Step 1. Place the atoms relative to each other.

Step 2. Find the sum of valence electrons (O is in Group 6A):

$$[2 \times \text{O}(6\text{e}^-)] = 12\text{e}^-$$

Step 3. Draw single bonds and subtract 2e^- for each bond:

$$1 \text{ bond} \times 2\text{e}^- = 2\text{e}^- \quad \text{so} \quad 12\text{e}^- - 2\text{e}^- = 10\text{e}^- \text{ remaining}$$

Step 4. Add the remaining 10 electrons in pairs; there are enough electrons for the O atom on the left to get three pairs to complete its octet, but the O atom on the right only gets two pairs of electrons and thus does not have an octet. Step 5 is necessary.

Step 5. Change a lone pair on the left O atom to another bonding pair between the two O atoms so that each O atom in the molecule has an octet:

SAMPLE PROBLEM 10.3
Writing Lewis Structures for Molecules with Multiple Bonds

Problem Write Lewis structures for the following:

- (a) Ethylene (C_2H_4), the most important reactant in the manufacture of polymers
 (b) Nitrogen (N_2), the most abundant atmospheric gas

Solution (a) **Step 1.** Place the atoms relative to each other. In C_2H_4 , the two C atoms must be bonded to each other since H atoms can have only one bond.

Step 2. Determine the total number of valence electrons (C is in Group 4A; H is in Group 1A):

$$[2 \times \text{C}(4e^-)] + [4 \times \text{H}(1e^-)] = 12 \text{ valence } e^-$$

Step 3. Add single bonds and subtract $2e^-$ for each bond:

$$5 \text{ bonds} \times 2e^- = 10e^- \quad \text{so} \quad 12e^- - 10e^- = 2e^- \text{ remaining}$$

Step 4. Distribute the remaining valence electrons to attain octets.

Step 5. Change a lone pair to a bonding pair. The right C has an octet, but the left C has only $6e^-$, so we change the lone pair on the right C to another bonding pair between the two C atoms.

(b) **Step 1.** Place the atoms relative to each other.

Step 2. Determine the total number of valence electrons (N is in Group 5A):

$$[2 \times \text{N}(5e^-)] = 10 \text{ valence } e^-$$

Step 3. Add single bonds and subtract $2e^-$ for each bond:

$$1 \text{ bond} \times 2e^- = 2e^- \quad 10e^- - 2e^- = 8e^- \text{ remaining}$$

Step 4. Distribute the remaining valence electrons to attain octets.

Step 5. Neither N ends up with an octet, so we change a lone pair to a bonding pair. In this case, moving one lone pair to make a double bond still does not give both N atoms an octet, so we also move another lone pair from the other N to make a triple bond.

Check (a) Each C has four bonds and counts the $4e^-$ in the double bond as part of its own octet. The valence electron total is $12e^-$, all in six bonds. (b) Each N counts the $6e^-$ in the triple bond as part of its own octet. The valence electron total is $10e^-$, which equals the electrons in three bonds and two lone pairs.

FOLLOW-UP PROBLEMS

10.3A Write Lewis structures for (a) CO (the only common molecule in which C has three bonds); (b) HCN; (c) CO_2 .

10.3B Write Lewis structures for (a) NO^+ ; (b) H_2CO ; (c) N_2H_2 .

SOME SIMILAR PROBLEMS 10.5(c), 10.6(b), 10.7(b), and 10.7(c)

(a) C_2H_4 (b) N_2

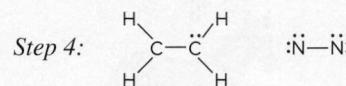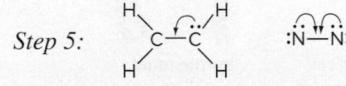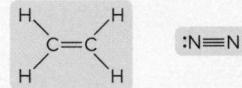

Resonance: Delocalized Electron-Pair Bonding

We often find that, for a molecule or polyatomic ion with *double bonds next to single bonds*, we can write more than one Lewis structure. Which, if any, is correct?

The Need for Resonance Structures To understand this issue, consider ozone (O_3), an air pollutant at ground level but an absorber of harmful ultraviolet (UV) radiation in the stratosphere. Since oxygen is in Group 6A(16), there are $[3 \times \text{O}(6e^-)] = 18 \text{ valence } e^-$ in the molecule. Four electrons are used in the formation of two single bonds, leaving $18e^- - 4e^- = 14e^-$, enough electrons to give the surrounding O atoms (designated A and C for clarity) an octet of electrons, but not enough to complete the octet of the central O atom (designated B). Applying Step 5 gives two Lewis structures:

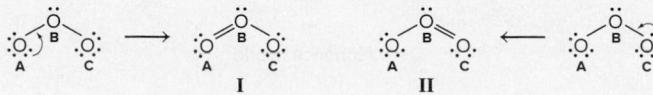

A Purple Mule, Not a Blue Horse and a Red Donkey

A mule is a genetic mix, a hybrid, of a horse and a donkey; it is not a horse one instant and a donkey the next. Similarly, the color purple is a mix of red and blue, not red one instant and blue the next. In the same sense, a resonance hybrid is one molecular species, not one resonance form this instant and another resonance form the next. The problem is that we cannot depict the actual species, the hybrid, accurately with a single Lewis structure.

In structure I, a lone pair on oxygen A is changed to another bonding pair so that oxygen B has a double bond to oxygen A and a single bond to oxygen C. In structure II, the single and double bonds are reversed as a lone pair on oxygen C is changed to a bonding pair. You can rotate I to get II, so these are *not* different types of ozone molecules, but different Lewis structures for the *same* molecule.

Lewis structures I and II each have one O=O double bond (bond length = 121 pm) and one O—O single bond (bond length = 148 pm). But, *neither* Lewis structure depicts O₃ accurately, because the two oxygen-oxygen bonds in O₃ are actually identical in length (bond length = 128 pm) and energy. Each bond in O₃ has properties between those of an O—O bond and an O=O bond, making it something like a “one-and-a-half” bond. The molecule is shown more correctly as two Lewis structures, called **resonance structures** (or **resonance forms**), with a two-headed resonance arrow (↔) between them. Resonance structures *have the same relative placement of atoms but different locations of bonding and lone electron pairs*. You can convert one resonance form to another by moving lone pairs to bonding positions, and vice versa:

Resonance structures are not real bonding depictions: O₃ does *not* change back and forth quickly from structure I to structure II. The actual molecule is a **resonance hybrid**, an average of the resonance structures. ↗

Electron Delocalization Our need for more than one Lewis structure to depict O₃ is due to **electron-pair delocalization**. In a single, double, or triple bond, each electron pair is *localized* between the bonded atoms. In a resonance hybrid, two of the electron pairs (one bonding and one lone pair) are *delocalized*: their density is “spread” over a few adjacent atoms. (This delocalization involves just a few e⁻ pairs, so it is *much* less extensive than the electron delocalization in metals that we considered in Section 9.6.)

In O₃, the result is two identical bonds, each consisting of a single bond (the localized pair) and a *partial bond* (the contribution from one of the delocalized pairs). We draw the resonance hybrid with a curved dashed line to show the delocalized pairs:

Resonance is very common. For example, benzene (C₆H₆, *shown below*) has two important resonance structures in which alternating single and double bonds have different positions. The actual molecule is an average of the two structures, with six carbon-carbon bonds of equal length and three electron pairs delocalized over all six C atoms. The delocalized pairs are often shown as a dashed circle (or simply a circle):

Student Hot Spot

Student data indicate that you may struggle with the concept of resonance. Access the Smartbook to view additional Learning Resources on this topic.

Fractional Bond Orders Partial bonding, as in resonance hybrids, often leads to fractional bond orders. For O₃, which has a total of three bonds (shared electron pairs) between two bonded-atom (O—O) pairs, we have

$$\text{Bond order} = \frac{\text{3 shared electron pairs}}{\text{2 bonded-atom (O—O) pairs}} = 1\frac{1}{2}$$

The bond order in the benzene ring is 9 shared electron pairs/6 bonded-atom (C—C) pairs, or 1½ also. For the carbonate ion, CO₃²⁻, three resonance structures can be drawn:

Each has 4 electron pairs shared among 3 bonded-atom (C—O) pairs, so the bond order is $\frac{4}{3}$, or 1½.

Formal Charge: Selecting the More Important Resonance Structure

If one resonance structure “looks” more like the resonance hybrid than the others, it “weights” the average in its favor. One way to select the more important resonance structure is by determining each atom’s **formal charge**, the charge it would have *if the bonding electrons were shared equally*. We’ll examine this concept and then see how formal charge compares with oxidation number.

Determining Formal Charge An atom’s formal charge is its total number of valence electrons minus the number of electrons associated with that atom in the Lewis structure: *all* of its unshared valence electrons and *half* of its shared valence electrons:

$$\begin{aligned} \text{Formal charge of atom} &= \\ \text{no. of valence e}^- &- (\text{no. of unshared valence e}^- + \frac{1}{2} \text{ no. of shared valence e}^-) \end{aligned} \quad (10.1)$$

If the number of electrons associated with an atom in the Lewis structure equals the number of valence electrons in the atom, its formal charge is 0. If the number of electrons associated with an atom in the Lewis structure is greater than the number of valence electrons in the atom, its formal charge is negative; a positive formal charge results when an atom has fewer valence electrons in the Lewis structure than there are in the atom.

For example, in O₃, the formal charge of oxygen A in resonance form I is

$$6 \text{ valence e}^- - (4 \text{ unshared e}^- + \frac{1}{2} \text{ of } 4 \text{ shared e}^-) = 6 - 4 - 2 = 0$$

The formal charges of all the atoms in the two O₃ resonance structures are

Structures I and II have the same formal charges but on different O atoms, so they contribute equally to the resonance hybrid. *Formal charges must sum to the actual charge on the species*: zero for a molecule or the ionic charge for an ion. In O₃, the formal charges add to 0: (+1) + (-1) + 0 = 0.

Note that, in structure I, instead of oxygen’s usual two bonds, O_B has three bonds and O_C has one. Only when an atom has a zero formal charge does it have its usual number of bonds; this observation also applies to C in CO₃²⁻, N in NO₃⁻, and so forth.

Choosing the More Important Resonance Structure Three criteria help us choose the more important resonance structure:

- Smaller formal charges (positive *or* negative) are preferable to larger ones.
- The *same* nonzero formal charges on adjacent atoms are not preferred.
- A more negative formal charge should reside on a more electronegative atom.

Structure I

$$\begin{aligned} \text{N} [5 - 6 - \frac{1}{2}(2)] &= -2 \\ \text{C} [4 - 0 - \frac{1}{2}(8)] &= 0 \\ \text{O} [6 - 2 - \frac{1}{2}(6)] &= +1 \end{aligned}$$

Structure II

$$\begin{aligned} \text{N} [5 - 4 - \frac{1}{2}(4)] &= -1 \\ \text{C} [4 - 0 - \frac{1}{2}(8)] &= 0 \\ \text{O} [6 - 4 - \frac{1}{2}(4)] &= 0 \end{aligned}$$

Structure III

$$\begin{aligned} \text{N} [5 - 2 - \frac{1}{2}(6)] &= 0 \\ \text{C} [4 - 0 - \frac{1}{2}(8)] &= 0 \\ \text{O} [6 - 6 - \frac{1}{2}(2)] &= -1 \end{aligned}$$

Student Hot Spot

Student data indicate that you may struggle with using formal charges to select the more important resonance structure. Access the SmartBook to view additional Learning Resources on this topic.

As in the case of O_3 , the resonance structures for CO_3^{2-} , NO_3^- , and benzene all have identical atoms surrounding the central atom(s) and, thus, have identical formal charges and are equally important contributors to the resonance hybrid. But, let's apply these criteria to the cyanate ion, NCO^- , which has two *different* atoms around the central one. Three resonance structures with formal charges are (see margin)

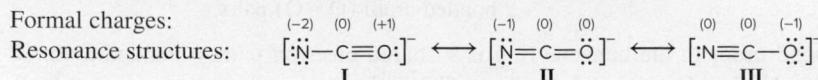

Structure I is *not* an important contributor to the hybrid because it has a larger formal charge on N and a positive formal charge on the more electronegative O. Structures II and III have the same magnitude of charges, but III has a -1 formal charge on O, the more electronegative atom. Therefore, II and III are more important than I, and III is more important than II. Note that the formal charges in each structure sum to -1 , the charge of the ion.

Formal Charge vs. Oxidation Number Formal charge (used to examine resonance structures) is *not* the same as oxidation number (used to monitor redox reactions):

- For a *formal charge*, bonding electrons are *shared equally* by the atoms (as if the bonding were *nonpolar covalent*), so each atom has half of them:

$$\text{Formal charge} = \text{valence e}^- - (\text{lone pair e}^- + \frac{1}{2} \text{bonding e}^-)$$

- For an *oxidation number*, bonding electrons are *transferred completely* to the more electronegative atom (as if the bonding were *pure ionic*):

$$\text{Oxidation number} = \text{valence e}^- - (\text{lone pair e}^- + \text{bonding e}^-)$$

Compare the two sets of numbers for the three cyanate ion resonance structures. When determining the oxidation numbers of the atoms in this ion, all electrons in the bonds between N and C are assigned to the more electronegative N atom, while all electrons in the bonds between C and O are assigned to the more electronegative O atom:

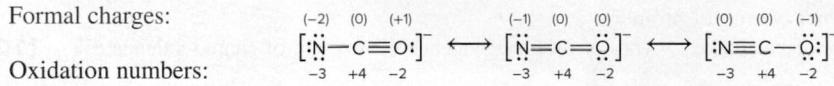

Oxidation numbers: $\begin{matrix} -3 & +4 & -2 \\ \vdots & \vdots & \vdots \\ \text{:}\ddot{\text{N}}-\text{C}\equiv\text{O}:^- \end{matrix} \longleftrightarrow \begin{matrix} -3 & +4 & -2 \\ \vdots & \vdots & \vdots \\ \text{:}\ddot{\text{N}}=\text{C}=\ddot{\text{O}}^- \end{matrix} \longleftrightarrow \begin{matrix} -3 & +4 & -2 \\ \vdots & \vdots & \vdots \\ \text{:}\ddot{\text{N}}\equiv\text{C}-\ddot{\text{O}}:^- \end{matrix}$

Notice that the oxidation numbers *do not* change from one resonance structure to another (because the electronegativities of the atoms *do not* change), but the formal charges *do* change (because the numbers of bonding and lone pairs *do* change). Neither an atom's formal charge nor its oxidation number represents an actual charge on the atom; both of these types of numbers serve simply to keep track of electrons.

SAMPLE PROBLEM 10.4

Writing Resonance Structures and Assigning Formal Charges

Problem Write resonance structures for the nitrate ion, NO_3^- , assign formal charges to the atoms in each resonance structure, and find the bond order.

Plan We write a Lewis structure, remembering to add 1e^- to the total number of valence electrons because of the -1 ionic charge. Then we move lone and bonding pairs to write other resonance structures and connect them with resonance arrows. We use Equation 10.1 to assign formal charges. The bond order is the number of shared electron pairs divided by the number of atom pairs.

Solution Steps 1 and 2. Nitrogen has the lower group number and is placed in the center. There are $[1 \times \text{N}(5\text{e}^-)] + [3 \times \text{O}(6\text{e}^-)] + [\text{charge } (1\text{e}^-)] = 24 \text{ valence e}^-$.

Steps 3 and 4 give us:

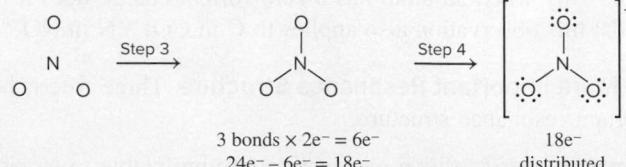

Step 5. Since N has only 6e^- , we change a lone pair on one of the O atoms to a bonding pair to form a double bond, which gives each atom an octet. All the O atoms

are equivalent, however, so we can move a lone pair from any one of the three and obtain three resonance structures:

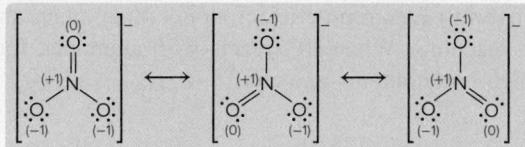

Formal charge of atom = no. of valence e^- – (no. of unshared valence e^- + $\frac{1}{2}$ no. of shared valence e^-)

$$\text{For N: } [5 - 0 - \frac{1}{2}(8)] = +1$$

$$\text{For O (single-bonded): } [6 - 6 - \frac{1}{2}(2)] = -1$$

$$\text{For O (double-bonded): } [6 - 4 - \frac{1}{2}(4)] = 0$$

The bond order is

$$\frac{4 \text{ shared electron pairs}}{3 \text{ bonded-atom (N—O) pairs}} = 1\frac{1}{3}$$

Check Each structure has the same relative placement of atoms, an octet around each atom, and $24e^-$ (the sum of the valence electrons and $1e^-$ from the ionic charge, distributed in four bonds and eight lone pairs).

Comment These three resonance structures contribute equally to the resonance hybrid because all of the surrounding atoms are identical and each resonance hybrid has the same set of formal charges.

FOLLOW-UP PROBLEMS

10.4A Write resonance structures for nitromethane, H_3CNO_2 (the H atoms are bonded to C, and the C atom is bonded to N, which is bonded to both O atoms). Assign formal charges to the atoms in each resonance structure.

10.4B Write resonance structures for the thiocyanate ion, SCN^- (C is the central atom). Use formal charges to determine which resonance structure is the most important.

SOME SIMILAR PROBLEMS 10.9–10.16

Lewis Structures for Exceptions to the Octet Rule

The octet rule applies to most molecules (and ions) with Period 2 central atoms, but not every one, and not to many with central atoms from Period 3 and higher. Three important exceptions occur for molecules with (1) electron-deficient atoms, (2) odd-electron atoms, and (3) atoms with expanded valence shells. In discussing these exceptions, you'll also see that formal charge has limitations for selecting the best resonance structure.

Molecules with Electron-Deficient Atoms In gaseous molecules containing either beryllium or boron as the central atom, that atom is often **electron deficient**: it has fewer than eight electrons around it (an incomplete octet). The Lewis structures, with formal charges, of gaseous beryllium chloride* and boron trifluoride are

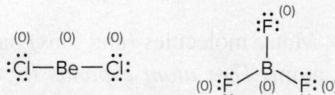

There are only four electrons around Be and only six around B. Surrounding halogen atoms don't form multiple bonds to the central atoms to give them an octet, because the halogens are much more electronegative than either Be or B. Formal charges make the following structures unlikely:

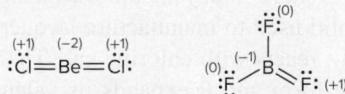

*Even though beryllium is in Group 2A(2), most Be compounds have considerable covalent bonding. For example, molten BeCl_2 does not conduct electricity, indicating a lack of ions.

(Some data for BF_3 show a shorter than expected B—F bond. Shorter bonds indicate double-bond character, so the structure with the $\text{B}=\text{F}$ bond may be a minor contributor to a resonance hybrid.) Electron-deficient atoms often attain an octet by forming additional bonds in reactions. When BF_3 reacts with ammonia, for instance, a compound forms in which boron attains an octet:[†]

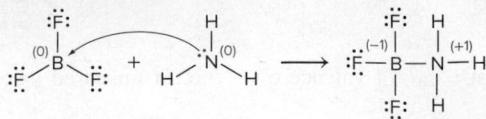

Molecules with Odd-Electron Atoms A few molecules contain a central atom with an odd number of valence electrons, so they cannot have all their electrons in pairs. Most of these molecules have a central atom from an odd-numbered group, such as N [Group 5A(15)] or Cl [Group 7A(17)]. They are called **free radicals**, species that contain a lone (unpaired) electron, which makes them paramagnetic (Section 8.4) and extremely reactive. Free radicals are dangerous because they can bond to an H atom in a biomolecule and extract it, which forms a new free radical. This step repeats and can disrupt genes and membranes. Recent studies suggest that free radicals may be involved in cancer and even aging. Antioxidants like vitamin E interrupt free-radical proliferation.

Consider the free radical nitrogen dioxide, NO_2 , a major contributor to urban smog that is formed when the NO in auto exhaust is oxidized. NO_2 has several resonance structures. Two of them differ as to which O atom is doubly bonded to the central atom, as in the case of ozone. Two others have the lone electron residing on the N or on an O, so the resonance hybrid has the lone electron delocalized over these two atoms:

Let's see if formal charge considerations help us decide where the lone electron resides most of the time. The structure with it on the singly bonded O has zero formal charges (*right*), while the structure with it on N (*left*) has some nonzero charges. Thus, based on formal charges, the structure on the right is more important. But, chemical facts suggest otherwise. Free radicals often react with each other to pair their lone electrons. When two NO_2 molecules react, the lone electrons pair up to form the N—N bond in dinitrogen tetroxide (N_2O_4) and each N attains an octet:

Thus, given the way NO_2 reacts, the lone electron may spend most of its time on N, making *that* resonance structure more important. Apparently, in this case, formal charge is not very useful for picking the most important resonance structure; we'll see other cases below.

Expanded Valence Shells Many molecules (and ions) have more than eight valence electrons around the central atom. *That atom expands its valence shell to form more bonds, which releases energy.* The central atom must be large and have empty orbitals that can hold the additional pairs. Therefore, **expanded valence shells** (expanded octets) occur only with *nonmetals from Period 3 or higher because they have d orbitals available.* Such a central atom may be bonded to more than four atoms, or to four or fewer.

1. *Central atom bonded to more than four atoms.* Phosphorus pentachloride, PCl_5 , is a fuming yellow-white solid used to manufacture lacquers and films. It forms when phosphorus trichloride, PCl_3 , reacts with chlorine gas. The P in PCl_3 has an octet, but two more bonds to chlorine form and P expands its valence shell to 10 electrons in

[†]Reactions in which one species "donates" an electron pair to another to form a covalent bond are Lewis acid-base reactions, which we discuss fully in Chapter 18.

PCl_5 . Note that when PCl_5 forms, *one* Cl—Cl bond breaks (*left side of the equation*), and two P—Cl bonds form (*right side*), for a net increase of one bond:

Sulfur hexafluoride, SF_6 , is a dense, inert gas used as an electrical insulator. Analogously to PCl_5 , it forms when sulfur tetrafluoride, SF_4 , reacts with more F_2 . The S in SF_4 already has an expanded valence shell of 10 electrons, but two more bonds to F expand the valence shell further to 12 electrons:

2. *Central atoms bonded to four or fewer atoms.* In some species, a central atom bonded to *four or fewer* atoms has an expanded valence shell. The S in SF_4 is one example; another is the Cl in chlorine trifluoride, ClF_3 . There are 28 valence electrons in a ClF_3 molecule, 6 in the three single Cl—F bonds and 20 that complete the octets of the four atoms. The 2 remaining valence electrons are placed on the central Cl, giving it an expanded valence shell of 10 electrons:

In general, just as in ClF_3 , *any valence electrons remaining after completing the octets of all atoms in a species are given to the central atom.*

For some species with central atoms bonded to four or fewer atoms, the concept of formal charge can be applied to draw Lewis structures with expanded valence shells. Some examples follow:

- *Sulfuric acid.* Two resonance structures of H_2SO_4 , with formal charges, are

Structure I obeys the octet rule, but it has several nonzero formal charges. In structure II, two lone pairs from two O atoms have been changed to bonding pairs; now sulfur has 12 electrons (six bonds) around it, but all atoms have zero formal charges. Thus, based on the formal charge rules alone, II contributes more than I to the resonance hybrid. More important than whether rules are followed, structure II is consistent with observation. In gaseous H_2SO_4 , the two sulfur-oxygen bonds *with* an H atom attached to the O are 157 pm long, whereas the two sulfur-oxygen bonds *without* an H attached to O are 142 pm long. This shorter bond length indicates double-bond character, and other measurements indicate greater electron density in the bonds without the attached H.

- *Sulfate ion.* When sulfuric acid loses two H^+ ions, it forms the sulfate ion, SO_4^{2-} . Measurements indicate that all the bonds in SO_4^{2-} are 149 pm long, between the length of an S=O bond (~142 pm) and that of an S—O bond (~157 pm). Six of the seven resonance structures consistent with these data have an expanded valence shell and zero formal charges on some of the atoms. Two of those six (*left*) and the one that obeys the octet rule (*right*) are

- Two sulfur oxides. Measurements show that the sulfur-oxygen bonds in SO_2 and SO_3 are all approximately 142 pm long, indicating $\text{S}=\text{O}$ bonds. Lewis structures consistent with these data have zero formal charges (two at left), but others (two at right) obey the octet rule:

3. *Limitations of Lewis structures and formal charge.* Chemistry has been a central science for well over two centuries, yet controversies often arise over interpretation of data, even in established areas like bonding and structure. We've seen that a single Lewis structure often cannot accurately depict a molecule; in such cases, we need several resonance structures to do so.

Formal charge rules have limitations, too. They were not useful in choosing the correct location for the lone electron in NO_2 . And, quantum-mechanical calculations indicate that resonance structures with expanded valence shells that have zero formal charges look *less* like the actual species than structures that follow the octet rule but have higher formal charges. Shorter bonds arise, these findings suggest, not from double-bond character, but because the higher formal charges draw the bonded atoms closer. Such considerations favor the octet-rule structures for H_2SO_4 , SO_4^{2-} , SO_2 , and SO_3 . Thus, formal charge may be a useful tool for selecting the most important resonance structure, but it is far from perfect. Nevertheless, while keeping these contrary findings in mind, we will continue to draw structures based on formal charge rules because they provide a simple approach consistent with most experimental data.

SAMPLE PROBLEM 10.5

Writing Lewis Structures for Octet-Rule Exceptions

Problem Write a Lewis structure and identify the octet-rule exception for (a) XeF_4 ; (b) H_3PO_4 (draw two resonance structures and select the more important; all O atoms are bonded to P and three O atoms have H bonded to them); (c) BFCl_2 .

Plan We write each Lewis structure and examine it for exceptions to the octet rule. (a) and (b) The central atoms are in Periods 5 and 3, respectively, so they can have more than an octet. (c) The central atom is B, which can have fewer than an octet of electrons.

Solution (a) XeF_4 has a total of 36 valence electrons: 8 form the bonds and 24 complete the octets of the F atoms. The remaining 4 valence electrons are placed on the central atom, resulting in an *expanded valence shell*:

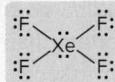

(b) H_3PO_4 has 32 valence electrons: 14 form bonds and 18 complete the octets of the O and P atoms (structure I, shown with formal charges). Another resonance structure (structure II) can be drawn in which a lone pair from the O atom with nonzero formal charge is changed to a bonding pair.

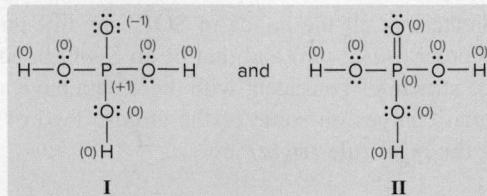

Structure I obeys the octet rule but has nonzero formal charges. Structure II has an expanded valence shell with zero formal charges. According to formal charge rules, structure II is the more important structure.

(c) BFCl_2 has 24 valence electrons: 6 form bonds and 18 complete the octets of the F and Cl atoms. This molecule has an *electron-deficient atom (incomplete octet)*; B has only six electrons surrounding it:

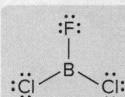

Comment In (b), structure II is consistent with bond-length measurements, which show one shorter (152 pm) phosphorus-oxygen bond and three longer (157 pm) ones. Nevertheless, quantum-mechanical calculations show that structure I may be more important.

FOLLOW-UP PROBLEMS

10.5A Write a Lewis structure with minimal formal charges for (a) POCl_3 ; (b) ClO_2 ; (c) IBr_4^- .

10.5B Write a Lewis structure with minimal formal charges for (a) BeH_2 ; (b) I_3^- ; (c) XeO_3 .

SOME SIMILAR PROBLEMS 10.19–10.22

› Summary of Section 10.1

- › A stepwise process converts a molecular formula into a Lewis structure, a two-dimensional representation of a molecule (or ion) that shows the placement of atoms and the distribution of valence electrons among bonding and lone pairs.
- › When two or more Lewis structures can be drawn for the same relative placement of atoms, the actual structure is a hybrid of those resonance structures.
- › Formal charges can be useful for choosing the more important contributor to the hybrid, but experimental data always determine the choice.
- › Molecules with an electron-deficient atom (central Be or B) or an odd-electron atom (free radicals) have less than an octet around the central atom but often attain an octet in reactions.
- › In a molecule (or ion) with a central atom from Period 3 or higher, that atom can have more than eight valence electrons because it is larger and has empty *d* orbitals for expanding its valence shell.

10.2 VALENCE-SHELL ELECTRON-PAIR REPULSION (VSEPR) THEORY

Virtually every biochemical process hinges to a great extent on the shapes of interacting molecules. Every medicine you take, odor you smell, or flavor you taste depends on part or all of one molecule fitting together with another. Biologists have found that complex behaviors in many organisms, such as mating, defense, navigation, and feeding, often depend on one molecule's shape matching that of another. In this section, we discuss a model for predicting the shape of a molecule.

To determine the molecular shape, chemists start with the Lewis structure and apply **valence-shell electron-pair repulsion (VSEPR) theory**. Its basic principle is that, *to minimize repulsions, each group of valence electrons around a central atom is located as far as possible from the others*. A “group” of electrons is any number that occupies a localized region around an atom. Each of the following represents a single electron group:

- a single bond
- a double bond
- a triple bond*
- a lone pair of electrons
- one lone electron

Only electron groups around the *central atom* affect shape; electrons on atoms other than the central atom do not. The **molecular shape** is the three-dimensional arrangement of nuclei joined by the bonding groups.

*The two electron pairs in a double bond (or the three pairs in a triple bond) occupy separate orbitals, but they remain near each other and act as one electron group (see Chapter 11).

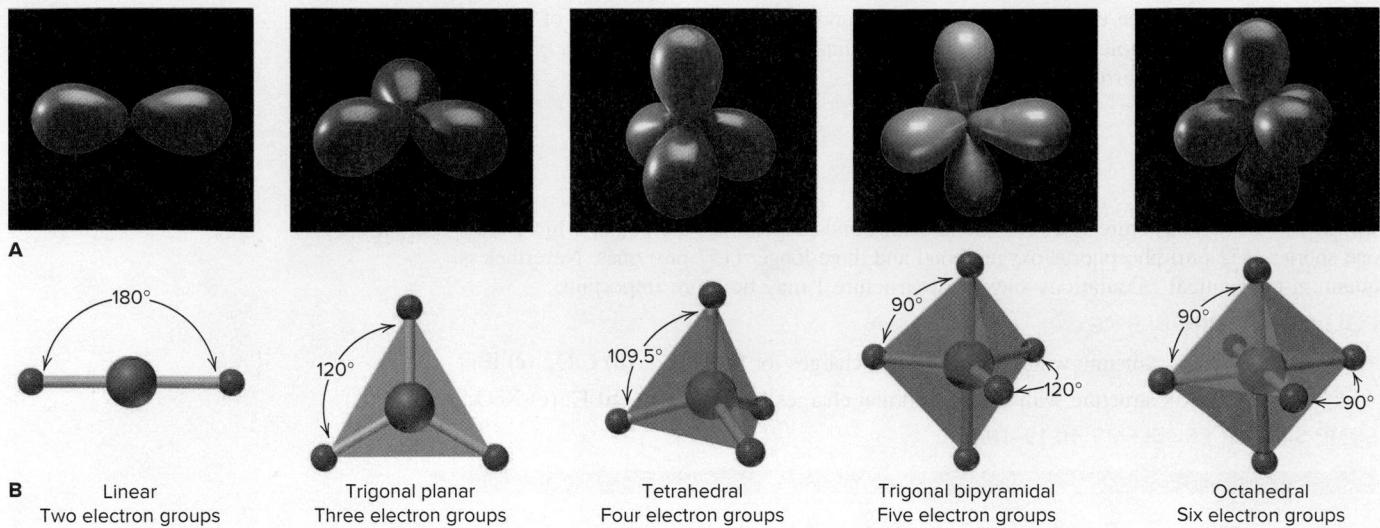

Figure 10.2 Electron-group repulsions and molecular shapes. **A**, Five geometric orientations arise when each balloon occupies as much space as possible. **B**, Mutually repelling bonding groups (gray sticks) attach a surrounding atom (dark gray) to the central atom (red). The name is the electron-group arrangement.

Source: (A) © McGraw-Hill Education/
Stephen Frisch, photographer

Electron-Group Arrangements and Molecular Shapes

When two, three, four, five, or six objects attached to a central point maximize the space between them, five geometric patterns result, which Figure 10.2A shows with balloons. If the objects are valence-electron groups, repulsions maximize the space each occupies around the central atom, and we obtain the five *electron-group arrangements* seen in the great majority of molecules and polyatomic ions.

Classifying Molecular Shapes The *electron-group arrangement* is defined by the bonding groups (shared electron pairs) and nonbonding electron groups (lone electron pairs) around the central atom, but the *molecular shape* is defined by the relative positions of the nuclei, which are connected by the bonding groups only. Figure 10.2B shows the molecular shapes that occur when *all* the surrounding electron groups are *bonding* groups. When some are *nonbonding* groups, different molecular shapes occur. Thus, *the same electron-group arrangement can give rise to different molecular shapes*: some with all bonding groups (as in Figure 10.2B) and others with bonding and nonbonding groups. To classify molecular shapes, we assign each a specific AX_mE_n designation, where m and n are integers. In such a designation,

- A is the central atom;
- X is a surrounding atom; and
- E is a nonbonding valence-electron group (usually a lone pair).

Bond Angle and Deviations from the Ideal Value The **bond angle** is the angle formed by the bonds joining the nuclei of two surrounding atoms to the nucleus of the central atom, which is at the vertex. The angles shown for the shapes in Figure 10.2B are *ideal* bond angles determined by basic geometry alone. We observe them when all the bonding groups are the same and connected to the same type of atom (structure I, *below*). When this is not the case, the real bond angles deviate from the ideal angles. Deviations occur when the bonds are not the same (structure II), the surrounding atoms are not the same (structure III), or one or more of the electron groups are nonbonding groups (structure IV). We'll see examples of these deviations among the compounds discussed in this section.

The Molecular Shape with Two Electron Groups (Linear Arrangement)

Two electron groups attached to a central atom point in opposite directions. This **linear arrangement** of electron groups results in a molecule with a **linear shape** and a bond angle of 180° . Figure 10.3 shows the general form (*top*) and shape (*middle*) for VSEPR shape class AX_2 and gives the formulas of some linear molecules.

Gaseous beryllium chloride (BeCl_2) is a linear molecule. Recall that in gaseous Be compounds, Be is electron deficient, with two electron pairs around it:

In carbon dioxide, the central C atom forms two double bonds with the O atoms:

Each double bond acts as one electron group and is 180° away from the other. The lone pairs on the O atoms of CO_2 or on the Cl atoms of BeCl_2 are *not* involved in the molecular shape: only the two electron groups around the central C or Be atom affect the shape.

Molecular Shapes with Three Electron Groups (Trigonal Planar Arrangement)

Three electron groups around a central atom point to the corners of an equilateral triangle, which gives the **trigonal planar arrangement** and an ideal bond angle of 120° (Figure 10.4). This arrangement has two molecular shapes—one with all bonding groups and the other with one lone pair. In this case, we can see the *effects of lone pairs and double bonds on bond angles*.

1. *All bonding groups: trigonal planar shape (AX_3)*. Boron trifluoride (BF_3), another electron-deficient species, is an example of a trigonal planar molecule. It has six electrons around the central B atom in three single bonds to F atoms. The four nuclei lie in a plane, and each $\text{F}-\text{B}-\text{F}$ angle is 120° :

The nitrate ion (NO_3^-) is one of several polyatomic ions with the trigonal planar shape. One of three resonance structures of the nitrate ion (Sample Problem 10.4) is

Any of the three resonance structures of NO_3^- can be used to determine its molecular shape. Remember that the resonance hybrid has three identical bonds with bond order $1\frac{1}{3}$, so the ideal bond angle is observed.

2. *One lone pair: bent or V shape (AX_2E)*. Gaseous tin(II) chloride is a molecule with a **bent shape**, or **V shape**, with three electron groups in a trigonal plane, including a lone pair at any one of the triangle's corners. A lone pair often has a major effect on bond angle. Because it is held by only one nucleus, a lone pair is less confined than a bonding pair and so exerts stronger repulsions. In general, *a lone pair repels bonding pairs more than bonding pairs repel each other, so it decreases the angle*

Class	Shape
AX_2	Linear
Examples: CS_2 , HCN, BeF_2	
$A =$	$X =$
$E =$	

Figure 10.3 The single molecular shape of the linear electron-group arrangement. The key (bottom) for A, X, and E also refers to Figures 10.4, 10.5, 10.7, and 10.8.

Class	Shape
AX_3	Trigonal planar
Examples: SO_3 , BF_3 , NO_3^- , CO_3^{2-}	
AX_2E	Bent (V shaped)
Examples: SO_2 , O_3 , PbCl_2 , SnBr_2	

Figure 10.4 The two molecular shapes of the trigonal planar electron-group arrangement.

between bonding pairs. Note the 95° bond angle in SnCl_2 , which is considerably less than the ideal 120° :

Effect of Double Bonds on Bond Angle When the surrounding atoms and electron groups are not identical, the bond angles are often affected. Consider formaldehyde (CH_2O), whose uses include the manufacture of countertops and the production of methanol. The three electron groups around the central C result in a trigonal planar shape. But there are two types of surrounding atoms (O and H) and two types of electron groups (single and double bonds):

The actual $\text{H}-\text{C}-\text{H}$ bond angle is less than the ideal 120° because *the greater electron density of a double bond repels electrons in single bonds more than the single bonds repel each other.*

Molecular Shapes with Four Electron Groups (Tetrahedral Arrangement)

Shapes based on two or three electron groups lie in a plane, but four electron groups require three dimensions to maximize separation. Consider methane, whose Lewis structure (below, left) shows four bonds pointing to the corners of a square, which suggests 90° bond angles. But, *Lewis structures do not depict shape*. In three dimensions, the four electron groups lie at the corners of a **tetrahedron**, a polyhedron with four faces made of equilateral triangles, giving bond angles of 109.5° (Figure 10.5).

A *perspective drawing* for methane (above, middle) indicates depth by using solid and dashed wedges for bonds out of the plane of the page. The normal bond lines (blue) are in the plane of the page; the solid wedge (green) is the bond from the C atom in the plane of the page to the H above that plane; and the dashed wedge (red) is the bond from the C to the H below the plane of the page. The ball-and-stick model (above, right) shows the tetrahedral shape more clearly.

All molecules or ions with four electron groups around a central atom adopt the **tetrahedral arrangement**. There are three shapes with this arrangement:

1. *All bonding groups: tetrahedral shape (AX_4)*. Methane has a tetrahedral shape, a very common geometry in organic molecules. In Sample Problem 10.1, we drew the Lewis structure for CCl_2F_2 , without regard to relative placement of the four halogen atoms around the carbon atom. Because Lewis structures are flat, it may seem like you can write two different ones for CCl_2F_2 , but they represent the same molecule, as a twist of the wrist reveals (Figure 10.6).

2. *One lone pair: trigonal pyramidal shape (AX_3E)*. Ammonia (NH_3) is an example of a molecule with a **trigonal pyramidal shape**, a tetrahedron with one vertex “missing.” Stronger repulsions by the lone pair make the $\text{H}-\text{N}-\text{H}$ bond angle slightly less than the ideal 109.5° . The lone pair forces the $\text{N}-\text{H}$ pairs closer to each other, and

TETRAHEDRAL	
Class	Shape
AX_4	Tetrahedral
Examples: CH_4 , SiCl_4 , SO_4^{2-} , ClO_4^-	
AX_3E	Trigonal pyramidal
Examples: NH_3 , PF_3 , ClO_3^- , H_3O^+	
AX_2E_2	Bent (V shaped)
Examples: H_2O , OF_2 , SCl_2	

Figure 10.5 The three molecular shapes of the tetrahedral electron-group arrangement.

Figure 10.6 Lewis structures do not indicate molecular shape. In this model, Cl is green and F is yellow.

Source: © McGraw-Hill Education/Stephen Frisch, photographer

the bond angle is 107.3° . NF_3 , whose Lewis structure we drew at the beginning of Section 10.1, also has a trigonal pyramidal shape.

Picturing shapes is a great way to visualize a reaction. For instance, when ammonia reacts with an acid, the lone pair on N forms a bond to the H^+ and yields the ammonium ion (NH_4^+), one of many tetrahedral polyatomic ions. As the lone pair becomes a bonding pair, the $\text{H}-\text{N}-\text{H}$ angle expands from 107.3° to 109.5° :

3. Two lone pairs: bent or V shape (AX_2E_2). Water is the most important V-shaped molecule with the tetrahedral arrangement. [Note that, in the trigonal planar arrangement, the V shape has two bonding groups and *one* lone pair (AX_2E), and its ideal bond angle is 120° , not 109.5° .] Repulsions from two lone pairs are greater than from one, and the $\text{H}-\text{O}-\text{H}$ bond angle is 104.5° , less than the $\text{H}-\text{N}-\text{H}$ angle in NH_3 :

Thus, for similar molecules within a given electron-group arrangement, electron-electron repulsions cause deviations from ideal bond angles in the following order:

$$\text{Lone pair-lone pair} > \text{lone pair-bonding pair} > \text{bonding pair-bonding pair} \quad (10.2)$$

Molecular Shapes with Five Electron Groups (Trigonal Bipyramidal Arrangement)

All molecules with five or six electron groups have a central atom from Period 3 or higher because only those atoms have *d* orbitals available to expand the valence shell.

Relative Positions of Electron Groups Five mutually repelling electron groups form the **trigonal bipyramidal arrangement**, in which two trigonal pyramids share a common base (Figure 10.7, next page). This is the only case in which *there are two different positions for electron groups and two ideal bond angles*:

- Three **equatorial groups** lie in a trigonal plane that includes the central atom; a 120° bond angle separates the equatorial groups.
- Two **axial groups** lie above and below this plane; a 90° angle separates axial from equatorial groups.

TRIGONAL BIPYRAMIDAL	
Class	Shape
AX_5	<p>Axial position Equatorial position Trigonal bipyramidal</p>
Examples: PF_5 , AsF_5 , SOF_4	
AX_4E	
AX_4E	<p>Seesaw</p>
Examples: SF_4 , XeO_2F_2 , IF_4^+ , IO_2F_2	
AX_3E_2	
AX_3E_2	<p>T shaped</p>
Examples: ClF_3 , BrF_3	
AX_2E_3	
AX_2E_3	<p>Linear</p>
Examples: XeF_2 , I_3^- , IF_2^-	

Figure 10.7 The four molecular shapes of the trigonal bipyramidal electron-group arrangement.

Two factors come into play:

- The greater the bond angle, the weaker the repulsions, so *equatorial-equatorial* (120°) repulsions are weaker than *axial-equatorial* (90°) repulsions.
- The stronger repulsions from lone pairs means that, when possible, *lone pairs occupy equatorial positions*.

Shapes for the Trigonal Bipyramidal Arrangement The tendency for lone pairs to occupy equatorial positions, and thus minimize stronger axial-equatorial repulsions, governs three of the four shapes for this arrangement.

1. *All bonding groups: trigonal bipyramidal shape (AX_5)*. Phosphorus pentachloride (PCl_5) has a trigonal bipyramidal shape. With five identical surrounding atoms, the bond angles are ideal:

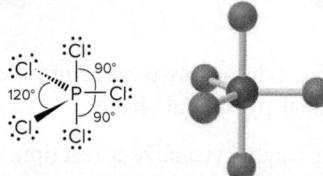

2. *One lone pair: seesaw shape (AX_4E)*. Sulfur tetrafluoride (SF_4), a strong fluorinating agent, has the **seesaw shape**; in Figure 10.7, the “seesaw” is tipped on an end. This is the first example of a *lone pair occupying an equatorial position* to minimize repulsions. The lone pair, which can be placed in any of the three equatorial positions, repels all four bonding pairs, reducing the bond angles to 101.5° and 86.8° :

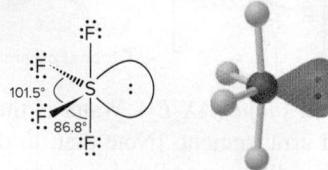

3. *Two lone pairs: T shape (AX_3E_2)*. Bromine trifluoride (BrF_3), one of many compounds with fluorine bonded to a larger halogen, has a **T shape**. Since both lone pairs occupy equatorial positions, we see a greater decrease in the axial-equatorial bond angle, bringing it down to 86.2° :

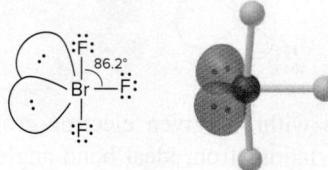

4. *Three lone pairs: linear shape (AX_2E_3)*. The triiodide ion (I_3^-), which forms when I_2 dissolves in aqueous I^- solution, is linear. With three equatorial lone pairs and two axial bonding pairs, the three nuclei form a straight line and a 180° $\text{X}-\text{A}-\text{X}$ bond angle:

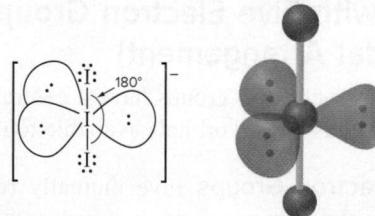

Molecular Shapes with Six Electron Groups (Octahedral Arrangement)

Six electron groups form the **octahedral arrangement**. An *octahedron* is a polyhedron with eight equilateral triangles for faces and six identical vertices (Figure 10.8). Each of the six groups points to a corner, giving 90° ideal bond angles.

1. All bonding groups: octahedral shape (AX_6). When seesaw-shaped SF_4 reacts with more F_2 , the central S atom expands its valence shell further to form octahedral sulfur hexafluoride (SF_6):

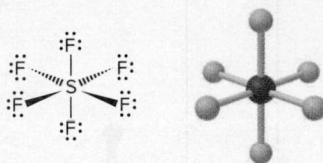

2. One lone pair: square pyramidal shape (AX_5E). Iodine pentafluoride (IF_5) has a **square pyramidal shape**. Note that it makes no difference where the one lone pair resides because all the ideal bond angles are 90° . The lone pair reduces the bond angles to 81.9° :

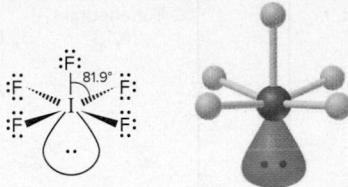

3. Two lone pairs: square planar shape (AX_4E_2). Xenon tetrafluoride (XeF_4) has a **square planar shape**. To avoid the stronger lone pair–lone pair repulsions that would result if the two lone pairs were adjacent to each other, they lie *opposite* each other:

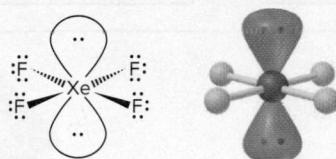

Figure 10.9 displays the shapes possible for elements in different periods, and Figure 10.10 on the next page summarizes the molecular shapes we've discussed.

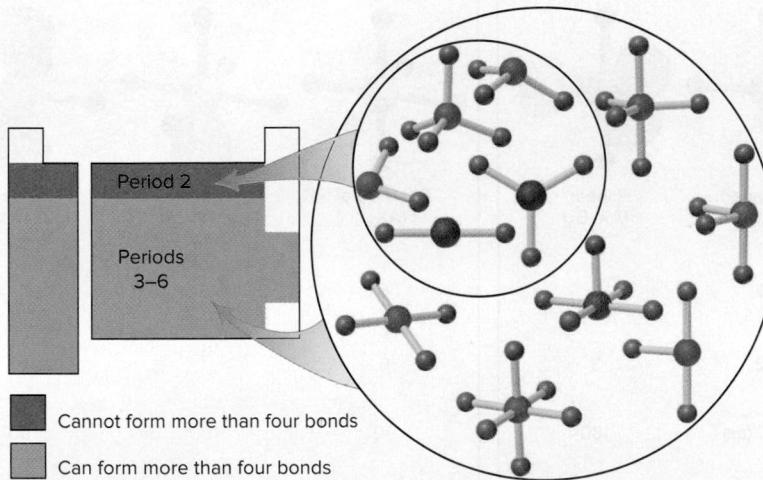

Figure 10.9 Molecular shapes for central atoms in Period 2 and in higher periods.

Using VSEPR Theory to Determine Molecular Shape

Let's apply a stepwise method for using VSEPR theory to determine a molecular shape from a molecular formula (Figure 10.11, *next page*):

Step 1. Write the Lewis structure from the molecular formula (Figure 10.1) to see the relative placement of atoms and the number of electron groups.

Step 2. Assign one of the five electron-group arrangements (Figure 10.2) by counting all electron groups (bonding plus nonbonding) around the central atom.

OCTAHEDRAL	
Class	Shape
AX_6	
Octahedral	
Examples: SF_6 , IOF_5	
AX_5E	
Square pyramidal	
Examples: BrF_5 , TeF_5^- , $XeOF_4$	
AX_4E_2	
Square planar	
Examples: XeF_4 , ICl_4^-	

Figure 10.8 The three molecular shapes of the octahedral electron-group arrangement.

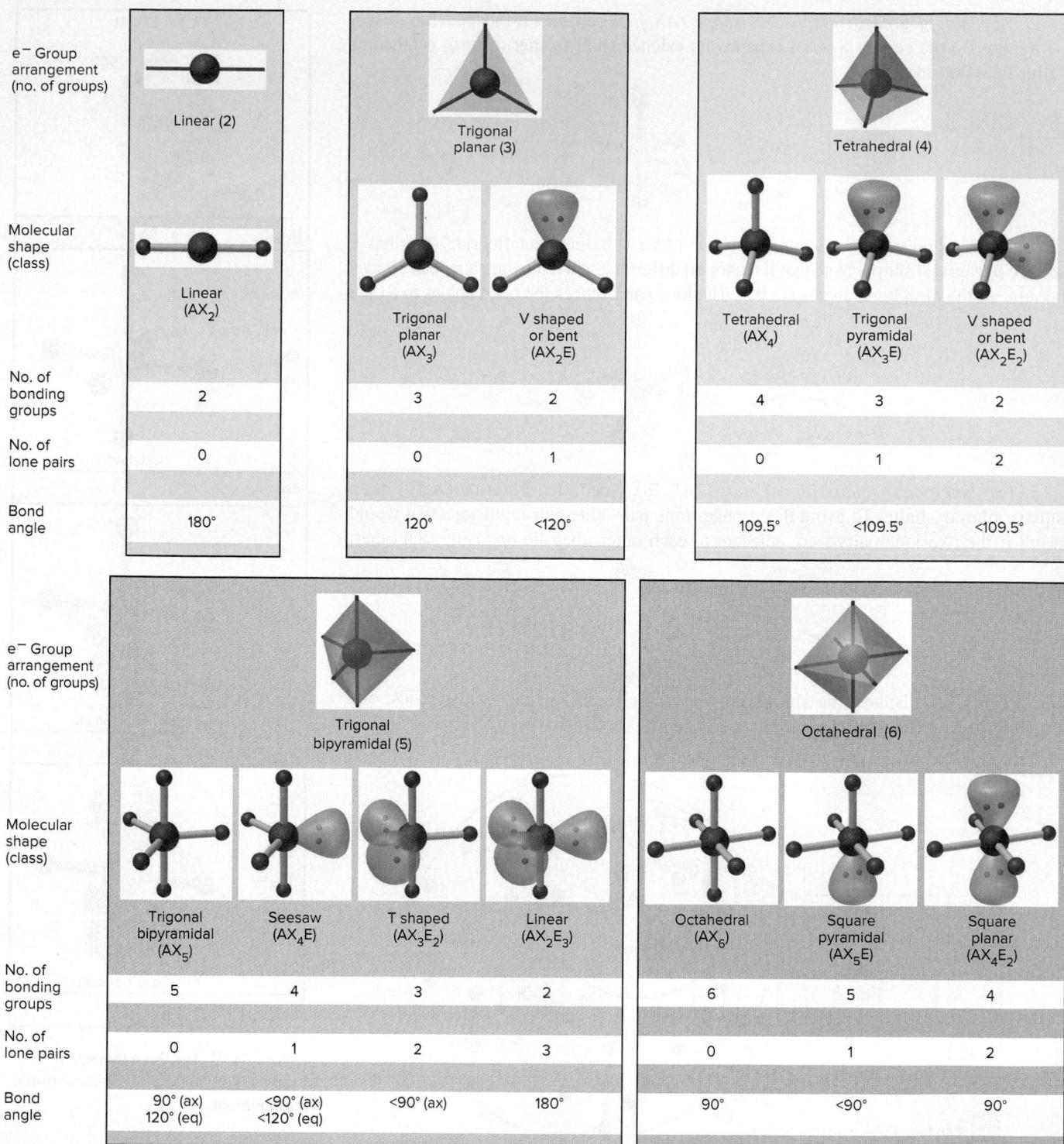

Figure 10.10 A summary of common molecular shapes with two to six electron groups around a central atom.

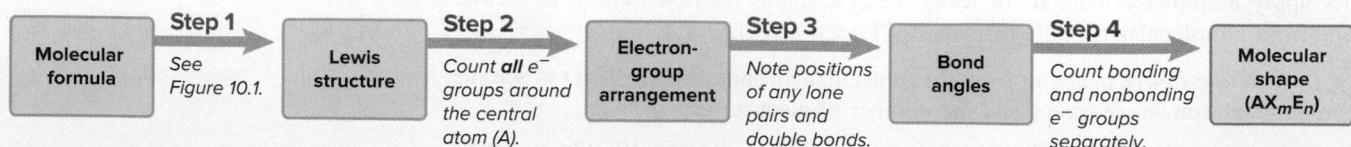

Figure 10.11 The four steps in converting a molecular formula to a molecular shape.

Step 3. Predict the ideal bond angle from the electron-group arrangement and the effect of any deviation caused by lone pairs or double bonds.

Step 4. Draw and name the molecular shape by counting bonding groups and non-bonding groups separately.

The next two sample problems apply these steps.

SAMPLE PROBLEM 10.6

Examining Shapes with Two, Three, or Four Electron Groups

Problem Draw the molecular shapes and predict the bond angles (relative to the ideal angles) of (a) PF_3 and (b) COCl_2 .

Solution (a) For PF_3 .

Step 1. Write the Lewis structure from the formula (see below).

Step 2. Assign the electron-group arrangement: Three bonding groups and one lone pair give four electron groups around P and the *tetrahedral arrangement*.

Step 3. Predict the bond angle: The ideal bond angle in a tetrahedron is 109.5° . There is one lone pair, so the actual bond angle will be less than 109.5° .

Step 4. Draw and name the molecular shape: With one lone pair, PF_3 has a *trigonal pyramidal shape* (AX_3E):

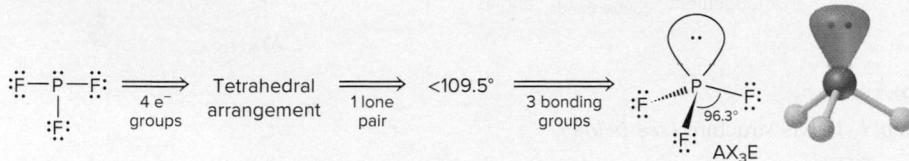

(b) For COCl_2 .

Step 1. Write the Lewis structure from the formula (see below).

Step 2. Assign the electron-group arrangement: Two single bonds and one double bond give three electron groups around C and the *trigonal planar arrangement*.

Step 3. Predict the bond angles: The ideal bond angle in the trigonal planar arrangement is 120° , but the double bond between C and O will compress the $\text{Cl}-\text{C}-\text{Cl}$ angle to less than 120° .

Step 4. Draw and name the molecular shape: With three electron groups and no lone pairs, COCl_2 has a *trigonal planar shape* (AX_3):

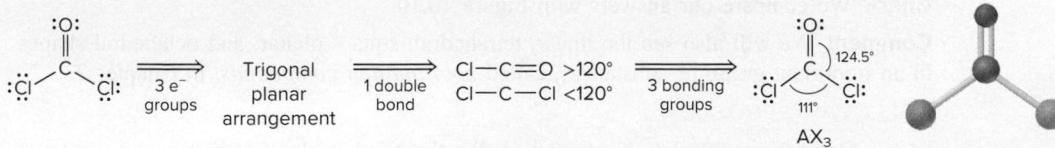

Check We compare the answers with the general information in Figure 10.10.

Comment Be sure the Lewis structure is correct because it determines the other steps. Notice that the electron-group arrangement and the molecular geometry are the same for COCl_2 since there are no lone pairs on the central C atom; because the central P atom in PF_3 has a lone pair, the electron-group arrangement and molecular geometry are different for this molecule.

FOLLOW-UP PROBLEMS

10.6A Draw the molecular shapes and predict the bond angles (relative to the ideal angles) of (a) CS_2 ; (b) PbCl_2 ; (c) CBr_4 ; (d) SF_2 .

10.6B Name the electron-group arrangements, draw and name the molecular shapes, and predict the bond angles (relative to the ideal angles) of (a) BrO_2^- ; (b) AsH_3 ; (c) N_3^- ; (d) SeO_3 .

SOME SIMILAR PROBLEMS 10.34–10.37

SAMPLE PROBLEM 10.7

Examining Shapes with Five or Six Electron Groups

Problem Draw the molecular shapes and predict the bond angles (relative to the ideal angles) of (a) SbF_5 and (b) BrF_5 .

Plan We proceed as in Sample Problem 10.6, being sure to minimize the number of axial-equatorial repulsions.

Solution (a) For SbF_5 .

Step 1. Lewis structure (see below).

Step 2. Electron-group arrangement: With five electron groups (five bonding pairs), this molecule has the *trigonal bipyramidal* arrangement.

Step 3. Bond angles: All the groups and surrounding atoms are identical, so the bond angles are ideal: 120° between equatorial groups and 90° between axial and equatorial groups.

Step 4. Molecular shape: Five electron groups and no lone pairs give the trigonal bipyramidal shape (AX_5):

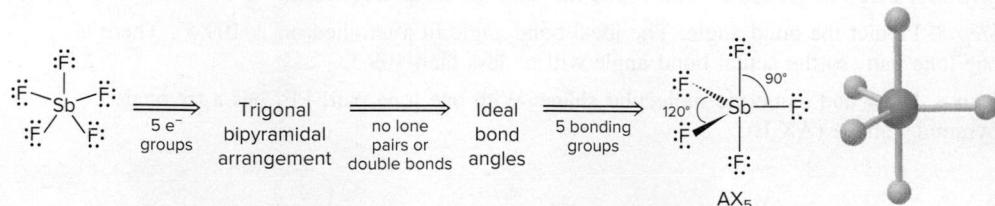

(b) For BrF_5 .

Step 1. Lewis structure (see below).

Step 2. Electron-group arrangement: Six electron groups (five bonding pairs and one lone pair) give the *octahedral* arrangement.

Step 3. Bond angles: The lone pair will make all bond angles less than the ideal 90° .

Step 4. Molecular shape: With one lone pair, BrF_5 has the square pyramidal shape (AX_5E):

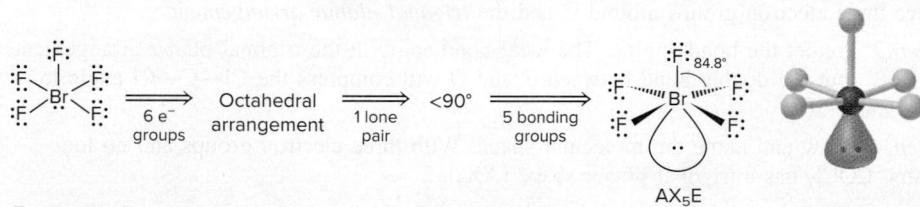

Check We compare our answers with Figure 10.10.

Comment We will also see the linear, tetrahedral, square planar, and octahedral shapes in an important group of substances, called *coordination compounds*, in Chapter 23.

FOLLOW-UP PROBLEMS

10.7A Draw the molecular shapes and predict the bond angles (relative to the ideal angles) of (a) ICl_2^- ; (b) ClF_3 ; (c) SOF_4^- .

10.7B Draw the molecular shapes and predict the bond angles (relative to the ideal angles) of (a) BrF_4^- ; (b) ClF_4^+ ; (c) PCl_6^- .

SOME SIMILAR PROBLEMS 10.40 and 10.41

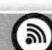

Student Hot Spot

Student data indicate that you may struggle with determining molecular shapes and bond angles. Access the Smartbook to view additional Learning Resources on this topic.

Molecular Shapes with More Than One Central Atom

The shapes of molecules with more than one central atom are composites of the shapes around each of the atoms. Here are two examples:

- Ethane (CH_3CH_3 ; molecular formula C_2H_6) is a component of natural gas. With four bonding groups and no lone pairs around the two central carbons, ethane is shaped like two overlapping tetrahedra (Figure 10.12A).
- Ethanol ($\text{CH}_3\text{CH}_2\text{OH}$; molecular formula $\text{C}_2\text{H}_6\text{O}$), the intoxicating substance in beer, wine, and whiskey, has three central atoms (Figure 10.12B). The $-\text{CH}_3$ group is tetrahedrally shaped, and the $-\text{CH}_2-$ group has four bonding groups around its

Figure 10.12 The tetrahedral shapes around the central atoms and the overall shapes of ethane (A) and ethanol (B).

central C atom, so it is also tetrahedrally shaped. The O atom has two bonding groups and two lone pairs around it, so the —OH group has a V shape (AX_2E_2).

SAMPLE PROBLEM 10.8

Predicting Molecular Shapes with More Than One Central Atom

Problem Determine the shape around each central atom in acetone, $(\text{CH}_3)_2\text{CO}$.

Plan There are three central C atoms, two of which are in CH_3- groups. We determine the shape around one central atom at a time.

Solution Step 1. Lewis structure (see below).

Step 2. Electron-group arrangement: Each CH_3- group has four electron groups around its central C, so its electron-group arrangement is *tetrahedral*. The third C atom has three electron groups around it, so it has the *trigonal planar arrangement*.

Step 3. Bond angles: The H—C—H angle in CH_3- should be near the ideal 109.5° . The C=O double bond will compress the C—C—C angle to less than the ideal 120° .

Step 4. Shapes around central atoms: With four electron groups and no lone pairs, the shape around C in each CH_3- is *tetrahedral* (AX_4). With three electron groups and no lone pairs, the shape around the middle C is *trigonal planar* (AX_3):

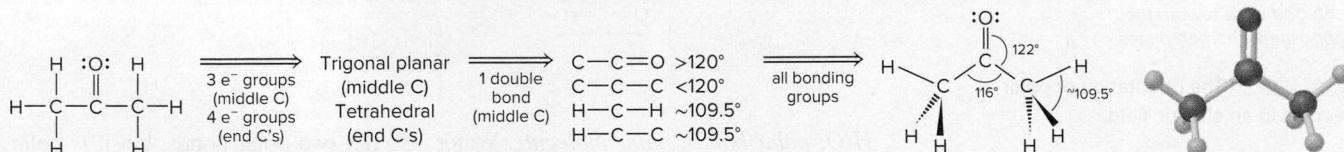

FOLLOW-UP PROBLEMS

10.8A Determine the shape around each central atom and predict any deviations from ideal bond angles in the following: (a) H_2SO_4 ; (b) propyne (C_3H_4 ; there is one $\text{C}\equiv\text{C}$ bond); (c) S_2F_2 .

10.8B Determine the shape around each central atom and predict any deviations from ideal bond angles in the following: (a) CH_3NH_2 ; (b) C_2Cl_4 ; (c) Cl_2O_7 ($\text{O}_3\text{ClOClO}_3$).

SOME SIMILAR PROBLEMS 10.42–10.45

› Summary of Section 10.2

- › VSEPR theory proposes that each electron group (single bond, multiple bond, lone pair, or lone electron) around a central atom remains as far from the others as possible.
- › Five electron-group arrangements are possible when two, three, four, five, or six electron groups surround a central atom. Each arrangement is associated with one or more molecular shapes, depending on the numbers of bonding and lone pairs.
- › Ideal bond angles are based on the regular geometric arrangements. Deviations from them occur when surrounding atoms and/or electron groups are not identical.
- › Lone pairs and double bonds exert stronger repulsions on other electron groups than single bonds do.
- › Shapes of larger molecules are composites of the shapes around each central atom.

Electric field off: HF molecules are oriented randomly.

Electric field on: HF molecules are oriented with their partially charged ends toward the oppositely charged plates.

Figure 10.13 The orientation of polar molecules in an electric field.

10.3 MOLECULAR SHAPE AND MOLECULAR POLARITY

Knowing the shape of its molecules is key to understanding the physical and chemical behavior of a substance. One of the most far-reaching effects of molecular shape is molecular polarity, which can influence melting and boiling points, solubility, reactivity, and even biological function.

Recall from Chapter 9 that a covalent bond is *polar* when the atoms have different electronegativities and, thus, share the electrons unequally. In diatomic molecules, such as HF, the only bond is polar, so the molecule is polar. In larger molecules, *both shape and bond polarity determine molecular polarity*, an uneven distribution of charge over the whole molecule or large portion of it. Polar molecules become oriented in an electric field with their partially charged ends pointing toward the oppositely charged plates (Figure 10.13). **Dipole moment (μ)** is a measure of molecular polarity, given in the unit called a *debye* (D),* which is derived from SI units of charge (coulomb, C) and length (m): $1 \text{ D} = 3.34 \times 10^{-30} \text{ C}\cdot\text{m}$.

Bond Polarity, Bond Angle, and Dipole Moment

The presence of polar bonds does not *always* result in a polar molecule; we must also consider shape and the atoms surrounding the central atom. Here are three cases:

1. *CO₂: polar bonds, nonpolar molecule.* In carbon dioxide, the electronegativity difference between C (EN = 2.5) and O (EN = 3.5) makes each C=O bond polar, with electron density pulled from C toward O. But CO₂ is linear, so the bonds point 180° from each other. Since the two bonds have polarities that are equal in magnitude but opposite in direction, their polarities cancel, resulting in *no net dipole moment* for the molecule ($\mu = 0 \text{ D}$), just as two numbers of equal magnitude but opposite sign (for example, +1 and -1) add to 0. The electron density model shows regions of high negative charge (red) distributed equally on either side of the central region of high positive charge (blue):

2. *H₂O: polar bonds, polar molecule.* Water also has two polar bonds, but it *is* polar ($\mu = 1.85 \text{ D}$). In each O—H bond, electron density is pulled from H (EN = 2.1) toward O (EN = 3.5). Bond polarities do *not* cancel because the molecule is V shaped (see also Figure 4.1). The bond polarities are partially reinforced, making the O end partially negative and the other end (the region between the H atoms) partially positive:

(The molecular polarity of water has some amazing effects, from determining the composition of the oceans to supporting life itself, as you'll see in Chapter 12.)

3. *Same shapes, different polarities.* When different molecules have the same shape, the identities of the surrounding atoms affect polarity. Carbon tetrachloride (CCl₄) and chloroform (CHCl₃) are tetrahedral molecules with very different polarities. In CCl₄, all the surrounding atoms are Cl atoms. Each C—Cl bond is equally polar ($\Delta\text{EN} = 0.5$), but the molecule is nonpolar ($\mu = 0 \text{ D}$) because the bond polarities cancel each other. In CHCl₃, an H replaces one Cl. The polarity of the H—C bond differs in magnitude ($\Delta\text{EN} = 0.4$) and direction from that of the three C—Cl

*The unit is named for the Dutch-American scientist Peter Debye (1884–1966), who won the Nobel Prize in chemistry in 1936 for contributions to the fields of molecular structure and solution behavior.

bonds; thus, it disrupts the balance and gives chloroform a significant dipole moment ($\mu = 1.01 \text{ D}$):

SAMPLE PROBLEM 10.9

Predicting the Polarity of Molecules

Problem For each of the following, use the molecular shape and EN values and trends (Figure 9.21) to predict the direction of bond and molecular polarity, if present: (a) ammonia, NH_3 ; (b) boron trifluoride, BF_3 ; (c) carbonyl sulfide, COS (atom sequence SCO).

Plan We draw and name the molecular shape and point a polar arrow toward the atom with higher EN in each bond. If the bond polarities balance one another, the molecule is nonpolar; if they reinforce each other, we show the direction of the molecular polarity.

Solution (a) For NH_3 . The molecular shape is trigonal pyramidal. N (EN = 3.0) is more electronegative than H (EN = 2.1), so the bond polarities point toward N and partially reinforce each other; thus the molecular polarity points toward N:

Therefore, ammonia is polar.

(b) For BF_3 . The molecular shape is trigonal planar. F (EN = 4.0) is farther to the right in Period 2 than B (EN = 2.0), so it is more electronegative; thus, each bond polarity points toward F. However, the bond angle is 120° , so the three bond polarities balance each other, and BF_3 has no molecular polarity:

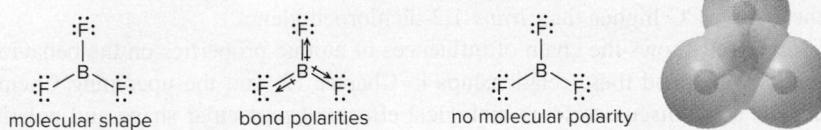

Therefore, boron trifluoride is nonpolar.

(c) For COS . The molecular shape is linear. With C and S having the same EN, the $\text{C}=\text{S}$ bond is nonpolar, but the $\text{C}=\text{O}$ bond is quite polar ($\Delta\text{EN} = 1.0$), so there is a net molecular polarity toward the O:

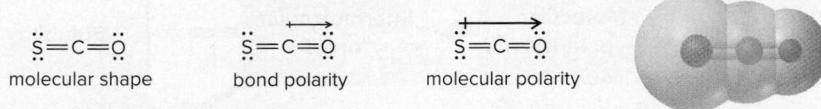

Therefore, carbonyl sulfide is polar.

Check The electron density models confirm our conclusions. Note that, in (b), the negative (red) regions surround the central B (blue) symmetrically.

FOLLOW-UP PROBLEMS

10.9A Show the bond polarities and molecular polarity, if any, for each of the following: (a) dichloromethane (CH_2Cl_2); (b) iodine oxide pentafluoride (IOF_5); (c) iodine pentafluoride (IF_5).

10.9B Show the bond polarities and molecular polarity, if any, for each of the following: (a) xenon tetrafluoride (XeF_4); (b) chlorine trifluoride (ClF_3); (c) sulfur monoxide tetrafluoride (SOF_4).

SOME SIMILAR PROBLEMS 10.55–10.58

Student Hot Spot

Student data indicate that you may struggle with determining molecular polarity. Access the SmartBook to view additional Learning Resources on this topic.

The Effect of Molecular Polarity on Behavior

Earlier we mentioned that molecular polarity influences physical behavior. Let's see how a molecular property like dipole moment affects a macroscopic property like boiling point.

Consider the two dichloroethylenes shown below. They have the *same* molecular formula ($C_2H_2Cl_2$) but *different* physical and chemical properties; that is, they are isomers (Section 3.2). Both molecules are planar, with a trigonal planar shape around each C atom. The *trans* isomer with the two Cl atoms on opposite sides of the double bond is nonpolar ($\mu = 0\text{ D}$) because the polar C—Cl bonds balance each other. The *cis* isomer with the Cl atoms on the same side of the double bond is polar ($\mu = 1.90\text{ D}$) because the bond polarities partially reinforce each other, with the molecular polarity pointing between the Cl atoms.

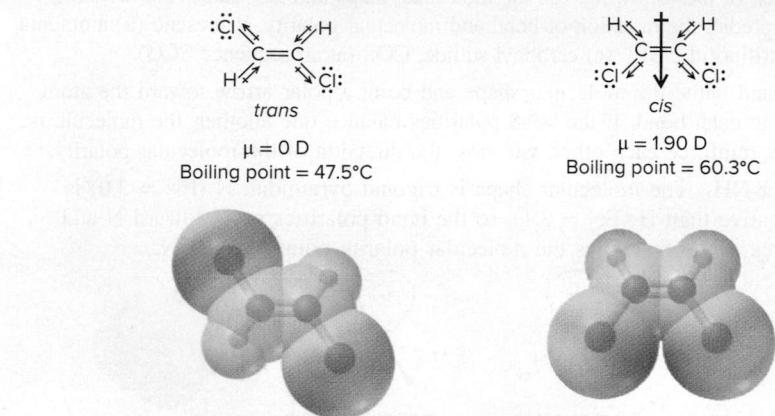

A liquid boils when it forms bubbles against the atmospheric pressure. To enter the bubble, molecules in the liquid must overcome the weak attractive forces *between* them. Because of their polarity, the *cis* molecules attract each other more strongly than the *trans* molecules do. Since more energy is needed to overcome the stronger attractions, we expect the *cis* isomer to have a higher boiling point: *cis*-1,2-dichloroethylene boils 13°C higher than *trans*-1,2-dichloroethylene.

Figure 10.14 shows the chain of influences of atomic properties on the behavior of substances. We extend these relationships in Chapter 12, and the upcoming Chemical Connections essay discusses some biological effects of molecular shape and polarity.

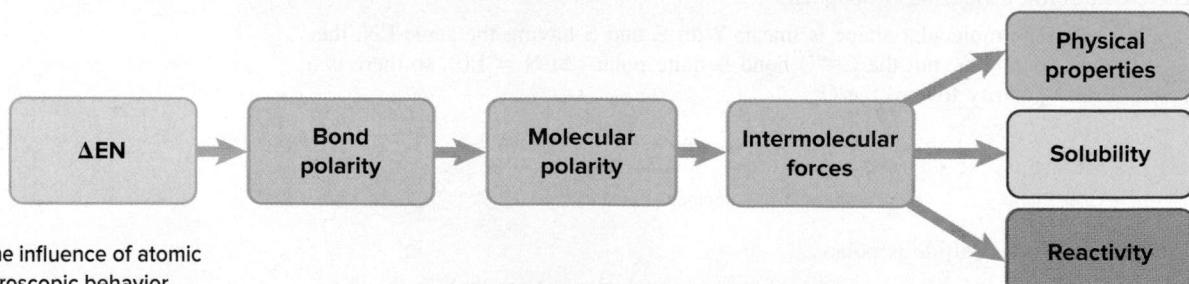

Figure 10.14 The influence of atomic properties on macroscopic behavior.

› Summary of Section 10.3

- › Bond polarity and molecular shape determine molecular polarity, which is measured as a dipole moment.
- › A molecule with polar bonds is not necessarily a polar molecule. When bond polarities cancel each other, the molecule is nonpolar; when they reinforce each other, the molecule is polar.
- › Molecular shape and polarity can affect physical properties, such as boiling point, and they play a central role in biological function.

A biological cell can be thought of as a membrane-bound sack filled with an aqueous fluid containing many molecules of various shapes. Many complex processes begin when a molecular “key” fits into a molecular “lock” with a complementary shape. Typically, the key is a small molecule circulating in cellular or other bodily fluid, and the lock, the *biological receptor*, is a large molecule often embedded in a membrane. The *receptor site* is a small region of the receptor with a shape that matches the molecular key. Thousands of molecules per second collide with the receptor site, but when one with the correct shape does, the receptor site “grabs” it through intermolecular attractions, and the biological response begins.

Molecular Shape and the Sense of Smell

Molecular shapes fitting together is crucial to the sense of smell (olfaction). To have an odor, a substance must be a gas or a volatile liquid or solid and must be at least slightly soluble in the aqueous film of the nasal passages. And the odorous molecule, or a portion of it, must fit into one of the receptor sites on nerve endings in this area. When this happens, nerve impulses travel to the brain, which interprets them as a specific odor.

Over half a century ago, a new theory proposed that molecular shape (and sometimes polarity), but *not* composition, determines odor. It stated that any molecule producing one of seven primary odors—camphor-like, musky, floral, minty, ethereal, pungent, and putrid—matches a receptor site of a particular shape. Figure B10.1 shows three of the seven sites holding a molecule with that odor.

Several predictions of the theory proved to be correct:

- If different substances fit a given receptor, they have the same odor. The four molecules in Figure B10.2 fit the camphor-like receptor and smell like moth repellent.
- If different parts of a molecule fit different receptors, it has a mixed odor. Portions of benzaldehyde fit the camphor-like, floral, and minty receptors, and it smells like almonds; other molecules with this odor fit the same three receptors.

But, other predictions were not confirmed. For example, an odor predicted from the shape was often not the odor smelled. The reason is that molecules may not have the same shape in solution at the receptor as they have in the gas phase.

Evidence from the 1990s suggests that the original model is far too simple. The 2004 Nobel Prize in medicine or physiology was given to Richard Axel and Linda B. Buck for showing that olfaction involves about 1000 different receptors and molecules fitting various combinations of them produce the more than 10,000 odors humans can distinguish.

Thus, although the process is much more complex than originally thought, the central idea that odor depends on molecular shape is valid and is being actively researched in the food, cosmetics, and insecticide industries.

Biological Significance of Molecular Shape

Countless other examples show that no chemical property is more crucial to living systems than molecular shape. Here are just a few of the many biochemical processes controlled by one molecule fitting into a receptor site on another:

- Enzymes are proteins that bind cellular reactants and speed their reaction. An early step in energy metabolism involves glucose binding to the “active” site of the enzyme hexokinase (Figure B10.3, *next page*).
- Nerve impulses are transmitted when small molecules released from one nerve fit into receptors on the next. Mind-altering drugs act by chemically mimicking the molecular fit at such nerve receptors in the brain.
- One type of immune response is triggered when a molecule on a bacterial surface binds to the receptors on “killer” cells in the bloodstream.
- Hormones regulate processes by fitting into and activating specific receptors on target tissues and organs.
- Genes function when certain nucleic acid molecules fit into specific regions of others.

Figure B10.1 Shapes of some olfactory receptor sites.

Figure B10.2 Different molecules with the same odor.

(continued)

Figure B10.3 Molecular shape and enzyme action. **A**, A small sugar molecule (*bottom*) is shown near a specific region of an enzyme molecule. **B**, When the sugar lands in that region, the reaction begins.

Problems

B10.1 As you'll learn in Chapter 11, groups joined by a single bond rotate freely around the bond, but those joined by double bonds don't. Peptide bonds make up a major portion of protein chains. Determine the molecular shapes around the central C and N atoms in the two resonance forms of the peptide bond:

B10.2 Lewis structures of mescaline, a hallucinogenic compound in peyote cactus, and dopamine, a neurotransmitter in

the mammalian brain, are shown below. Suggest a reason for mescaline's ability to disrupt nerve impulses.

CHAPTER REVIEW GUIDE

Learning Objectives

Relevant section (**S**) and/or sample problem (**SP**) numbers appear in parentheses.

Understand These Concepts

- How Lewis structures depict the atoms, bonding pairs, and lone electron pairs in a molecule or polyatomic ion (§10.1)
- How resonance and electron delocalization explain bond properties in many compounds with double bonds adjacent to single bonds (§10.1)
- The meaning of formal charge and how it is used to select the more important resonance structure; the difference between formal charge and oxidation number (§10.1)

- The octet rule and its three major exceptions—molecules with a central atom that has an electron deficiency, an odd number of electrons, or an expanded valence shell (§10.1)
- How electron-group repulsions lead to molecular shapes (§10.2)
- The five electron-group arrangements and their associated molecular shapes (§10.2)
- Why double bonds and lone pairs cause deviations from ideal bond angles (§10.2)
- How bond polarities and molecular shape combine to give a molecule polarity (§10.3)

Learning Objectives (continued)

Relevant section (§) and/or sample problem (SP) numbers appear in parentheses.

Master These Skills

- Using a stepwise method for writing a Lewis structure from a molecular formula (SPs 10.1–10.3, 10.5)
- Writing resonance structures for molecules and ions (SP 10.4)
- Calculating the formal charge of any atom in a molecule or ion (SPs 10.4, 10.5)

- Predicting molecular shapes from Lewis structures (SPs 10.6–10.8)
- Using molecular shape and electronegativity values to predict the polarity of a molecule (SP 10.9)

Key Terms

Page numbers appear in parentheses.

axial group (421)
 bent shape (V shape) (419)
 bond angle (418)
 dipole moment (μ) (428)
 electron deficient (413)
 electron-pair delocalization (410)
 equatorial group (421)
 expanded valence shell (414)

formal charge (411)
 free radical (414)
 Lewis structure (Lewis formula) (405)
 linear arrangement (419)
 linear shape (419)
 molecular polarity (428)
 molecular shape (417)
 octahedral arrangement (422)

resonance hybrid (410)
 resonance structure (resonance form) (410)
 seesaw shape (422)
 square planar shape (423)
 square pyramidal shape (423)
 T shape (422)
 tetrahedral arrangement (420)

trigonal bipyramidal arrangement (421)
 trigonal planar arrangement (419)
 trigonal pyramidal shape (420)
 valence-shell electron-pair repulsion (VSEPR) theory (417)

Key Equations and Relationships

Page numbers appear in parentheses.

10.1 Calculating the formal charge on an atom (411):

Formal charge of atom

$$\text{FC} = \text{no. of valence } e^- - (\text{no. of unshared valence } e^- + \frac{1}{2} \text{ no. of shared valence } e^-)$$

10.2 Ranking the effect of electron-pair repulsions on bond angle (421):

Lone pair-lone pair > lone pair-bonding pair > bonding pair-bonding pair

BRIEF SOLUTIONS TO FOLLOW-UP PROBLEMS

10.1A (a) H_2S has $[2 \times \text{H}(1e^-)] + [1 \times \text{S}(6e^-)] = 8$ valence e^- . Draw two bonds: 2 bonds $\times 2e^- = 4e^-$, with $8e^- - 4e^- = 4e^-$ remaining to complete the octet of S.

(b) AlCl_4^- has $[1 \times \text{Al}(3e^-)] + [4 \times \text{Cl}(7e^-)] + [\text{charge } 1e^-] = 32$ valence e^- . Draw four bonds: 4 bonds $\times 2e^- = 8e^-$, with $32e^- - 8e^- = 24e^-$ remaining to complete the octets of the Cl atoms (Al already has an octet). Since this is an ion, place the structure in square brackets with the charge as a superscript.

(c) SOCl_2 has $[1 \times \text{S}(6e^-)] + [1 \times \text{O}(6e^-)] + [2 \times \text{Cl}(7e^-)] = 26$ valence e^- . Place S in the center since it has the lowest electronegativity value. Draw three bonds: 3 bonds $\times 2e^- = 6e^-$, with $26e^- - 6e^- = 20e^-$ remaining to complete the octets of all atoms.

10.1B (a) OF_2 has $[1 \times \text{O}(6e^-)] + [2 \times \text{F}(7e^-)] = 20$ valence e^- . Draw two bonds: 2 bonds $\times 2e^- = 4e^-$, with $20e^- - 4e^- = 16e^-$ remaining to complete the octets of the O and F atoms.

(b) CH_2Br_2 has $[1 \times \text{C}(4e^-)] + [2 \times \text{H}(1e^-)] + [2 \times \text{Br}(7e^-)] = 20$ valence e^- . Place C in the center since it has a lower electronegativity than Br, and H cannot be a central atom. Draw four bonds: 4 bonds $\times 2e^- = 8e^-$, with $20e^- - 8e^- = 12e^-$ remaining to complete the octets of the Br atoms.

(c) IBr_2^+ has $[1 \times \text{I}(7e^-)] + [2 \times \text{Br}(7e^-)] - [\text{charge } 1e^-] = 20$ valence e^- . Draw two bonds: 2 bonds $\times 2e^- = 4e^-$, with $20e^- - 4e^- = 16e^-$ remaining to complete the octets of all atoms. Since this is an ion, place the structure in square brackets with the charge as a superscript.

BRIEF SOLUTIONS TO FOLLOW-UP PROBLEMS

(continued)

10.2A (a) H atoms can have only one bond; O should have two bonds and N should have three bonds, so the atoms are arranged as shown below. NH_3O has $[1 \times \text{N}(5e^-)] + [3 \times \text{H}(1e^-)] + [1 \times \text{O}(6e^-)] = 14$ valence e^- . Draw four bonds: 4 bonds $\times 2e^- = 8e^-$, with $14e^- - 8e^- = 6e^-$ remaining to complete the octets of the O and N atoms.

(b) H atoms can have only one bond; O should have two bonds and C should have four bonds; there are no O—H bonds, so the atoms are arranged as shown. $\text{C}_2\text{H}_6\text{O}$ has $[2 \times \text{C}(4e^-)] + [6 \times \text{H}(1e^-)] + [1 \times \text{O}(6e^-)] = 20$ valence e^- . Draw eight bonds: 8 bonds $\times 2e^- = 16e^-$, with $20e^- - 16e^- = 4e^-$ remaining to complete the octet of the O atom (the C atoms already have octets).

10.2B (a) H atoms can have only one bond, so the atoms are arranged as shown below. N_2H_4 has $[2 \times \text{N}(5e^-)] + [4 \times \text{H}(1e^-)] = 14$ valence e^- . Draw five bonds: 5 bonds $\times 2e^- = 10e^-$, with $14e^- - 10e^- = 4e^-$ remaining to complete the octets of the N atoms.

(b) H atoms can have only one bond; N should have three bonds and C should have four bonds, so the atoms are arranged as shown below. CH_3NH_2 has $[1 \times \text{C}(4e^-)] + [5 \times \text{H}(1e^-)] + [1 \times \text{N}(5e^-)] = 14$ valence e^- . Draw six bonds: 6 bonds $\times 2e^- = 12e^-$, with $14e^- - 12e^- = 2e^-$ remaining to complete the octet of the N atom (the C atom already has an octet).

10.3A (a) Using the 10 valence e^- in CO gives a Lewis structure in which C does not have an octet; two lone pairs on O are changed to bonding pairs:

(b) Using the 10 valence e^- in HCN gives a Lewis structure in which C does not have an octet; two lone pairs on N are changed to bonding pairs:

(c) Using the 16 valence e^- in CO_2 gives a Lewis structure in which C does not have an octet; one lone pair on each O atom is changed to a bonding pair:

10.3B (a) Using the 10 valence e^- in NO^+ gives a Lewis structure in which an atom does not have an octet; two lone pairs are changed to bonding pairs:

(b) Using the 12 valence e^- in H_2CO gives a Lewis structure in which C does not have an octet; one lone pair on O is changed to a bonding pair:

(c) Using the 12 valence e^- in N_2H_2 gives a Lewis structure in which one N atom does not have an octet; one lone pair on the other N atom is changed to a bonding pair:

10.4A After distributing the 24 valence e^- , the N atom does not have an octet. A lone pair on either O atom is changed to a bonding pair to give N an octet.

Formal charge of atom = no. of valence e^- – (no. of unshared valence e^- + $\frac{1}{2}$ no. of shared valence e^-)

$\text{N} [5 - 0 - \frac{1}{2}(8)] = +1$; $\text{C} [4 - 0 - \frac{1}{2}(8)] = 0$; $\text{H} [1 - 0 - \frac{1}{2}(2)] = 0$;
 O (single-bonded) $[6 - 6 - \frac{1}{2}(2)] = -1$;
 O (double-bonded) $[6 - 4 - \frac{1}{2}(4)] = 0$

10.4B After distributing the 16 valence e^- , C has only two bonds (four e^-); lone pairs on either S, N, or both are changed to bonding pairs. Formal charges:

Structure I is the most important resonance structure; the formal charges are lower than those in structure III, and the negative formal charge is on the more electronegative N atom, while the negative formal charge in structure II is on the less electronegative S atom.

10.5A (a) A structure in which all atoms have an octet can be drawn, but minimal formal charges are achieved by changing a lone pair on O to a bonding pair, giving P an expanded octet.

(b) A structure in which all atoms have an octet can be drawn, but minimal formal charges are achieved by changing a lone pair on each O to a bonding pair and giving Cl the unpaired electron.

(c) The ion has 36 valence electrons, 32 of which are used in the four single bonds and completing the octets of the four Br atoms. The remaining 4 valence electrons are placed on the central I atom, resulting in an expanded valence shell.

10.5B (a) Be has only four electrons surrounding it so the molecule is electron deficient:

(b) The ion has 22 valence electrons, 20 of which are used in the two single bonds and completing the octets of the I atoms. The remaining 2 valence electrons are placed on the central I atom, resulting in an expanded valence shell.

(c) A structure in which all atoms have an octet can be drawn, but minimal formal charges are achieved by changing a lone pair on each O to a bonding pair, giving Xe an expanded octet.

10.6A (a) There are two electron groups with a linear electron-group arrangement. There are no lone pairs, so the molecular shape is linear, with a bond angle of 180°.

(b) There are three electron groups (two bonding pairs and one lone pair) with a trigonal planar electron-group arrangement. Since there is one lone pair, the molecular shape is bent (V shaped), with a bond angle < 120°.

(c) There are four electron groups with a tetrahedral electron-group arrangement. Since there are no lone pairs, the molecular shape is tetrahedral with bond angles of 109.5°.

(d) There are four electron groups with a tetrahedral electron-group arrangement. Since there are two lone pairs, the molecular shape is bent (V shaped) with a bond angle < 109.5°.

10.6B (a) There are four electron groups with a tetrahedral electron-group arrangement. Since there are two lone pairs, the molecular shape is bent (V shaped) with a bond angle < 109.5°.

(b) There are four electron groups with a tetrahedral electron-group arrangement. Since there is one lone pair, the molecular shape is trigonal pyramidal with bond angles < 109.5°.

(c) There are two electron groups with a linear electron-group arrangement. There are no lone pairs, so the molecular shape is linear, with a bond angle of 180°.

(d) There are three electron groups with a trigonal planar electron-group arrangement. There are no lone pairs, so the molecular shape is trigonal planar, with bond angles of 120°.

10.7A (a) There are five electron groups with a trigonal bipyramidal electron-group arrangement. Since there are three lone pairs, the molecular shape is linear with a bond angle of 180°. The three lone pairs occupy equatorial positions to minimize repulsions.

(b) There are five electron groups with a trigonal bipyramidal electron-group arrangement. Since there are two lone pairs, the molecular shape is T shaped with bond angles < 90°. The two lone pairs occupy equatorial positions to minimize repulsions.

(c) There are five electron groups with a trigonal bipyramidal electron-group arrangement. Since there are no lone pairs, the molecular shape is trigonal bipyramidal. The double bond reduces the bond angles: F_{eq}—S—F_{eq} angle < 120°; F_{ax}—S—F_{eq} angle < 90°.

10.7B (a) There are six electron groups with an octahedral electron-group arrangement. Since there are two lone pairs, the molecular shape is square planar with bond angles of 90°.

(b) There are five electron groups with a trigonal bipyramidal electron-group arrangement. Since there is one lone pair, the molecular shape is seesaw. The lone pair reduces the bond angles: F_{eq}—Cl—F_{eq} angle < 120°; F_{ax}—Cl—F_{eq} angle < 90°. The lone pair occupies an equatorial position to minimize repulsions.

BRIEF SOLUTIONS TO FOLLOW-UP PROBLEMS

(continued)

(c) There are six electron groups with an octahedral electron-group arrangement. Since there are no lone pairs, the molecular shape is octahedral with bond angles of 90° .

10.8A (a) S has four electron groups, and the shape around it is tetrahedral; double bonds compress the O—S—O angle to $<109.5^\circ$. The O atoms have four electron groups, two of which are lone pairs, so the shape around each O in an —OH is bent (V shaped); the lone pairs compress the H—O—S angle to $<109.5^\circ$.

(b) The C in the CH₃— group has four electron groups, all of which are bonding pairs, so the shape around C in CH₃— is tetrahedral, with angles $\sim 109.5^\circ$; the other C atoms have two electron groups and the shape around each of these atoms is linear, with a bond angle of 180°.

(c) Each S atom has four electron groups (tetrahedral), two of which are lone pairs so the shape around each S is bent (V shaped); F—S—S angle < 109.5°.

10.8B (a) C, with four bonding pairs, has a tetrahedral shape around it, with H—C—H and H—C—N angles $\sim 109.5^\circ$; N has four electron groups, one of which is a lone pair, so the shape around N is trigonal pyramidal; the lone pair compresses the H—N—H angle to $<109.5^\circ$.

(b) Each C has three electron groups; there are no lone pairs, so the shape around each C is trigonal planar; the double bond compresses each Cl—C—Cl angle to $<120^\circ$.

(c) Each Cl, with four electron groups and no lone pairs, has a tetrahedral shape around it, with angles $\sim 109.5^\circ$; the central O atom has two bonding pairs and two lone pairs, and thus the

shape around this O is bent (V shaped) with the lone pairs compressing the Cl—O—Cl angle to $<109.5^\circ$.

10.9A (a) In the C—H bonds ($\Delta EN = 0.4$), the bond polarity points toward the more electronegative C atom; in the C—Cl bonds ($\Delta EN = 0.5$), the bond polarity points toward the more electronegative Cl atoms. The polar bonds reinforce each other, with the molecular polarity pointing between the Cl atoms.

(b) The bond polarity points toward the more electronegative F or O atom. Four of the I—F bonds balance each other but the fifth I—F bond is not balanced by the O—I bond. Since the I—F bond is more polar ($\Delta EN = 1.5$) than the O—I bond ($\Delta EN = 1.0$), the molecular polarity points toward the F atom.

(c) The bond polarity points toward the more electronegative F atom. Four of the I—F bonds balance each other but the fifth I—F bond is not balanced. The molecular polarity points toward the F atom.

10.9B (a) The bond polarity points toward the more electronegative F atom. The four Xe—F bonds balance each other, so there is no molecular polarity; this is a nonpolar molecule.

(b) The bond polarity points toward the more electronegative F atom. Two of the Cl—F bonds balance each other, but the third Cl—F bond is not balanced. The molecular polarity points toward the F atom.

(c) The bond polarity points toward the more electronegative F or O atom. The two axial S—F bonds balance each other, but the two equatorial S—F bonds ($\Delta EN = 1.5$) are not balanced by the double bond between S and O ($\Delta EN = 1.0$). Since the S—F bonds are more polar, the molecular polarity points toward the F atoms.

PROBLEMS

Problems with **colored** numbers are answered in Appendix E and worked in detail in the Student Solutions Manual. Problem sections match those in the text and give the numbers of relevant sample problems. Most offer Concept Review Questions, Skill-Building Exercises (grouped in pairs covering the same concept), and Problems in Context. The Comprehensive Problems are based on material from any section or previous chapter.

Depicting Molecules and Ions with Lewis Structures

(Sample Problems 10.1 to 10.5)

Concept Review Questions

10.1 Which of these atoms *cannot* serve as a central atom in a Lewis structure: (a) O; (b) He; (c) F; (d) H; (e) P? Explain.

10.2 When is a resonance hybrid needed to adequately depict the bonding in a molecule? Using NO_2 as an example, explain how a resonance hybrid is consistent with the actual bond length, bond strength, and bond order.

10.3 In which of these structures does X obey the octet rule?

10.4 What is required for an atom to expand its valence shell? Which of the following atoms can expand its valence shell: F, S, H, Al, Se, Cl?

Skill-Building Exercises (grouped in similar pairs)

10.5 Draw a Lewis structure for (a) SiF_4 ; (b) SeCl_2 ; (c) COF_2 (C is the central atom).

10.6 Draw a Lewis structure for (a) PH_4^+ ; (b) C_2F_4 ; (c) SbH_3 .

10.7 Draw a Lewis structure for (a) PF_3 ; (b) H_2CO_3 (both H atoms are attached to O atoms); (c) CS_2 .

10.8 Draw a Lewis structure for (a) CH_4S ; (b) S_2Cl_2 ; (c) CHCl_3 .

10.9 Draw Lewis structures of all the important resonance forms of (a) NO_2^+ ; (b) NO_2F (N is central).

10.10 Draw Lewis structures of all the important resonance forms of (a) HNO_3 (HONO_2); (b) HAsO_4^{2-} (HOAsO_3^{2-}).

10.11 Draw Lewis structures of all the important resonance forms of (a) N_3^- ; (b) NO_2^- .

10.12 Draw Lewis structures of all the important resonance forms of (a) HCO_2^- (H is attached to C); (b) HBrO_4 (HOBrO_3).

10.13 Draw the Lewis structure with lowest formal charges, and determine the charge of each atom in (a) IF_5 ; (b) AlH_4^- .

10.14 Draw the Lewis structure with lowest formal charges, and determine the charge of each atom in (a) OCS ; (b) NO .

10.15 Draw the Lewis structure with lowest formal charges, and determine the charge of each atom in (a) CN^- ; (b) ClO^- .

10.16 Draw the Lewis structure with lowest formal charges, and determine the charge of each atom in (a) ClF_2^+ ; (b) ClNO .

10.17 Draw a Lewis structure for a resonance form of each ion with the lowest possible formal charges, show the charges, and give oxidation numbers of the atoms: (a) BrO_3^- ; (b) SO_3^{2-} .

10.18 Draw a Lewis structure for a resonance form of each ion with the lowest possible formal charges, show the charges, and give oxidation numbers of the atoms: (a) AsO_4^{3-} ; (b) ClO_2^- .

10.19 These species do not obey the octet rule. Draw a Lewis structure for each, and state the type of octet-rule exception: (a) BH_3 (b) AsF_4^- (c) SeCl_4

10.20 These species do not obey the octet rule. Draw a Lewis structure for each, and state the type of octet-rule exception: (a) PF_6^- (b) ClO_3 (c) H_3PO_3 (one P—H bond)

10.21 These species do not obey the octet rule. Draw a Lewis structure for each, and state the type of octet-rule exception: (a) BrF_3 (b) ICl_2^- (c) BeF_2

10.22 These species do not obey the octet rule. Draw a Lewis structure for each, and state the type of octet-rule exception: (a) O_3^- (b) XeF_2 (c) SbF_4^-

Problems in Context

10.23 Molten beryllium chloride reacts with chloride ion from molten NaCl to form the BeCl_4^{2-} ion, in which the Be atom attains an octet. Show the net ionic reaction with Lewis structures.

10.24 Despite many attempts, the perbromate ion (BrO_4^-) was not prepared in the laboratory until about 1970. (In fact, articles were published explaining theoretically why it could never be prepared!) Draw a Lewis structure for BrO_4^- in which all atoms have lowest formal charges.

10.25 Cryolite (Na_3AlF_6) is an indispensable component in the electrochemical production of aluminum. Draw a Lewis structure for the AlF_6^{3-} ion.

10.26 Phosgene is a colorless, highly toxic gas that was employed against troops in World War I and is used today as a key reactant in organic syntheses. From the following resonance structures, select the one with the lowest formal charges:

Valence-Shell Electron-Pair Repulsion (VSEPR) Theory

(Sample Problems 10.6 to 10.8)

Concept Review Questions

10.27 If you know the formula of a molecule or ion, what is the first step in predicting its shape?

10.28 In what situation is the name of the molecular shape the same as the name of the electron-group arrangement?

10.29 Which of the following numbers of electron groups can give rise to a bent (V shaped) molecule: two, three, four, five, six? Draw an example for each case, showing the shape classification (AX_mE_n) and the ideal bond angle.

10.30 Name all the molecular shapes that have a tetrahedral electron-group arrangement.

10.31 Consider the following molecular shapes. (a) Which has the most electron pairs (both bonding and lone pairs) around the central atom? (b) Which has the most lone pairs around the central atom? (c) Do any have only bonding pairs around the central atom?

10.32 Use wedge-bond perspective drawings (if necessary) to sketch the atom positions in a general molecule of formula (not shape class) AX_n that has each of the following shapes:

- (a) V shaped (b) trigonal planar (c) trigonal bipyramidal
 (d) T shaped (e) trigonal pyramidal (f) square pyramidal

10.33 What would you expect to be the electron-group arrangement around atom A in each of the following cases? For each arrangement, give the ideal bond angle and the direction of any expected deviation:

Skill-Building Exercises (grouped in similar pairs)

10.34 Determine the electron-group arrangement, molecular shape, and ideal bond angle(s) for each of the following:

- (a) O_3 (b) H_3O^+ (c) NF_3

10.35 Determine the electron-group arrangement, molecular shape, and ideal bond angle(s) for each of the following:

- (a) SO_4^{2-} (b) NO_2^- (c) PH_3

10.36 Determine the electron-group arrangement, molecular shape, and ideal bond angle(s) for each of the following:

- (a) CO_3^{2-} (b) SO_2 (c) CF_4

10.37 Determine the electron-group arrangement, molecular shape, and ideal bond angle(s) for each of the following:

- (a) SO_3 (b) N_2O (N is central) (c) CH_2Cl_2

10.38 Name the shape and give the AX_mE_n classification and ideal bond angle(s) for each of the following general molecules:

10.39 Name the shape and give the AX_mE_n classification and ideal bond angle(s) for each of the following general molecules:

10.40 Determine the shape, ideal bond angle(s), and the direction of any deviation from those angles for each of the following:

- (a) ClO_2^- (b) PF_5 (c) SeF_4 (d) KrF_2

10.41 Determine the shape, ideal bond angle(s), and the direction of any deviation from those angles for each of the following:
 (a) ClO_3^- (b) IF_4^- (c) $SeOF_2$ (d) TeF_5^-

10.42 Determine the shape around each central atom in each molecule, and explain any deviation from ideal bond angles:
 (a) CH_3OH (b) N_2O_4 (O_2NNO_2)

10.43 Determine the shape around each central atom in each molecule, and explain any deviation from ideal bond angles:
 (a) H_3PO_4 (no H—P bond) (b) $CH_3-O-CH_2CH_3$

10.44 Determine the shape around each central atom in each molecule, and explain any deviation from ideal bond angles:
 (a) CH_3COOH (b) H_2O_2

10.45 Determine the shape around each central atom in each molecule, and explain any deviation from ideal bond angles:
 (a) H_2SO_3 (no H—S bond) (b) N_2O_3 ($ONNO_2$)

10.46 Arrange the following AF_n species in order of increasing F—A—F bond angles: BF_3 , BeF_2 , CF_4 , NF_3 , OF_2 .

10.47 Arrange the following ACl_n species in order of decreasing Cl—A—Cl bond angles: $SiCl_2$, OCl_2 , PCl_3 , $SiCl_4$, $SiCl_6^{2-}$.

10.48 State an ideal value for each of the bond angles in each molecule, and note where you expect deviations:

10.49 State an ideal value for each of the bond angles in each molecule, and note where you expect deviations:

Problems in Context

10.50 Because both tin and carbon are members of Group 4A(14), they form structurally similar compounds. But tin exhibits a greater variety of structures because it forms several ionic species. Predict the shapes and ideal bond angles, including any deviations:

- (a) $Sn(CH_3)_2$ (b) $SnCl_3^-$ (c) $Sn(CH_3)_4$ (d) SnF_5^- (e) SnF_6^{2-}

10.51 In the gas phase, phosphorus pentachloride exists as separate molecules. In the solid phase, however, the compound is composed of alternating PCl_4^+ and PCl_6^- ions. What change(s) in molecular shape occur(s) as PCl_5 solidifies? How does the Cl—P—Cl angle change?

Molecular Shape and Molecular Polarity

(Sample Problem 10.9)

Concept Review Questions

10.52 For molecules of general formula AX_n (where $n > 2$), how do you determine if a particular molecule is polar?

10.53 How can a molecule with polar covalent bonds not be polar? Give an example.

10.54 Explain in general why the shape of a biomolecule is important to its function.

Skill-Building Exercises (grouped in similar pairs)

10.55 Consider the molecules SCl_2 , F_2 , CS_2 , CF_4 , and BrCl .

- Which has bonds that are the most polar?
- Which molecules have a dipole moment?

10.56 Consider the molecules BF_3 , PF_3 , BrF_3 , SF_4 , and SF_6 .

- Which has bonds that are the most polar?
- Which molecules have a dipole moment?

10.57 Which molecule in each pair has the greater dipole moment? Give the reason for your choice.

- | | |
|-------------------------------------|--|
| (a) SO_2 or SO_3 | (b) ICl or IF |
| (c) SiF_4 or SF_4 | (d) H_2O or H_2S |

10.58 Which molecule in each pair has the greater dipole moment? Give the reason for your choice.

- | | |
|---------------------------------------|--------------------------------------|
| (a) ClO_2 or SO_2 | (b) HBr or HCl |
| (c) BeCl_2 or SCl_2 | (d) AsF_3 or AsF_5 |

Problems in Context

10.59 There are three different dichloroethylenes (molecular formula $\text{C}_2\text{H}_2\text{Cl}_2$), which we can designate X, Y, and Z. Compound X has no dipole moment, but compound Z does. Compounds X and Z each combine with hydrogen to give the same product:

What are the structures of X, Y, and Z? Would you expect compound Y to have a dipole moment?

10.60 Dinitrogen difluoride, N_2F_2 , is the only stable, simple inorganic molecule with an $\text{N}=\text{N}$ bond. It occurs in two forms: *cis* (both F atoms on the same side of the $\text{N}=\text{N}$ bond) and *trans* (the F atoms on opposite sides of the $\text{N}=\text{N}$ bond).

- Draw the molecular shapes of the two forms of N_2F_2 .
- Predict the direction of the molecular polarity, if any, of each form.

Comprehensive Problems

10.61 In addition to ammonia, nitrogen forms three other hydrides: hydrazine (N_2H_4), diazene (N_2H_2), and tetrazene (N_4H_4).

- Use Lewis structures to compare the strength, length, and order of the nitrogen-nitrogen bonds in hydrazine, diazene, and N_2 .
- Tetrazene (atom sequence H_2NNNNH_2) decomposes above 0°C to hydrazine and nitrogen gas. Draw a Lewis structure for tetrazene, and calculate $\Delta H_{\text{rxn}}^{\circ}$ for this decomposition.

10.62 Draw a Lewis structure for each species: (a) PF_5 ; (b) CCl_4 ; (c) H_3O^+ ; (d) ICl_3 ; (e) BeH_2 ; (f) PH_2^- ; (g) GeBr_4 ; (h) CH_3^- ; (i) BCl_3 ; (j) BrF_4^+ ; (k) XeO_3 ; (l) TeF_4 .

10.63 Give the molecular shape of each species in Problem 10.62.

10.64 Consider the following reaction of silicon tetrafluoride:

- Which depiction below best illustrates the change in molecular shape around Si? (b) Give the name and AX_mE_n designation of each shape in the depiction chosen in part (a).

10.65 Both aluminum and iodine form chlorides, Al_2Cl_6 and I_2Cl_6 , with “bridging” Cl atoms. The Lewis structures are

- What is the formal charge on each atom in molecule?
- Which of these molecules has a planar shape? Explain.

10.66 The VSEPR model was developed before any xenon compounds had been prepared. Thus, these compounds provided an excellent test of the model’s predictive power. What would you have predicted for the shapes of XeF_2 , XeF_4 , and XeF_6 ?

10.67 When SO_3 gains two electrons, SO_3^{2-} forms. (a) Which depiction best illustrates the change in molecular shape around S? (b) Does molecular polarity change during this reaction?

10.68 The actual bond angle in NO_2 is 134.3° , and in NO_2^- it is 115.4° , although the ideal bond angle is 120° for both. Explain.

10.69 “Inert” xenon actually forms several compounds, especially with the highly electronegative elements oxygen and fluorine. The simple fluorides XeF_2 , XeF_4 , and XeF_6 are all formed by direct reaction of the elements. As you might expect from the size of the xenon atom, the $\text{Xe}-\text{F}$ bond is not a strong one. Calculate the $\text{Xe}-\text{F}$ bond energy in XeF_6 , given that the enthalpy of formation is -402 kJ/mol .

10.70 Propylene oxide is used to make many products, including plastics such as polyurethane. One method for synthesizing it involves oxidizing propene with hydrogen peroxide:

- What is the molecular shape and ideal bond angle around each carbon atom in propylene oxide?

- Predict any deviation from the ideal for the actual $\text{C}-\text{C}-\text{C}$ bond angles (assume the three atoms in the ring form an equilateral triangle).

10.71 Chloral, $\text{Cl}_3\text{C}-\text{CH}=\text{O}$, reacts with water to form the sedative and hypnotic agent chloral hydrate, $\text{Cl}_3\text{C}-\text{CH}(\text{OH})_2$. Draw Lewis structures for these substances, and describe the change in molecular shape, if any, that occurs around each of the carbon atoms during the reaction.

10.72 Like several other bonds, carbon-oxygen bonds have lengths and strengths that depend on the bond order. Draw Lewis structures for the following species, and arrange them in order of increasing carbon-oxygen bond length and then by increasing carbon-oxygen bond strength: (a) CO ; (b) CO_3^{2-} ; (c) H_2CO ; (d) CH_4O ; (e) HCO_3^- (H attached to O).

10.73 In the 1980s, there was an international agreement to destroy all stockpiles of mustard gas, $\text{ClCH}_2\text{CH}_2\text{SCH}_2\text{CH}_2\text{Cl}$. When this substance contacts the moisture in eyes, nasal passages, and skin, the $-\text{OH}$ groups of water replace the Cl atoms and create high local concentrations of hydrochloric acid, which cause severe blistering and tissue destruction. Write a balanced equation for this reaction, and calculate $\Delta H_{\text{rxn}}^{\circ}$.

10.74 The four bonds of carbon tetrachloride (CCl_4) are polar, but the molecule is nonpolar because the bond polarity is canceled by the symmetric tetrahedral shape. When other atoms substitute for some of the Cl atoms, the symmetry is broken and the molecule becomes polar. Use Figure 9.21 to rank the following molecules from the least polar to the most polar: CH_2Br_2 , CF_2Cl_2 , CH_2F_2 , CH_2Cl_2 , CBr_4 , CF_2Br_2 .

10.75 Ethanol ($\text{CH}_3\text{CH}_2\text{OH}$) is being used as a gasoline additive or alternative in many parts of the world.

- Use bond energies to find $\Delta H_{\text{rxn}}^{\circ}$ for the combustion of gaseous ethanol. (Assume H_2O forms as a gas.)
- In its standard state at 25°C , ethanol is a liquid. Its vaporization requires 40.5 kJ/mol . Correct the value from part (a) to find the enthalpy of reaction for the combustion of liquid ethanol.
- How does the value from part (b) compare with the value you calculate from standard enthalpies of formation (Appendix B)?
- "Greener" methods produce ethanol from corn and other plant material, but the main industrial method involves hydrating ethylene from petroleum. Use Lewis structures and bond energies to calculate $\Delta H_{\text{rxn}}^{\circ}$ for the formation of gaseous ethanol from ethylene gas with water vapor.

10.76 In each of the following compounds, the C atoms form a single ring. Draw a Lewis structure for each molecule, identify cases for which resonance exists, and determine the carbon-carbon bond order(s): (a) C_3H_4 ; (b) C_3H_6 ; (c) C_4H_6 ; (d) C_4H_4 ; (e) C_6H_6 .

10.77 An experiment requires 50.0 mL of 0.040 M NaOH for the titration of 1.00 mmol of acid. Mass analysis of the acid shows 2.24% hydrogen, 26.7% carbon, and 71.1% oxygen. Draw the Lewis structure of the acid.

10.78 A gaseous compound has a composition by mass of 24.8% carbon, 2.08% hydrogen, and 73.1% chlorine. At STP, the gas has a density of 4.3 g/L . Draw a Lewis structure that fits these facts. Would another structure be equally satisfactory? Explain.

10.79 Perchlorates are powerful oxidizing agents used in fireworks, flares, and the booster rockets of space shuttles. Lewis structures for the perchlorate ion (ClO_4^-) can be drawn with all single bonds or with one, two, or three double bonds. Draw each of these possible resonance forms, use formal charges to determine the more important structure, and calculate its average bond order.

10.80 Methane burns in oxygen to form carbon dioxide and water vapor. Hydrogen sulfide burns in oxygen to form sulfur dioxide and water vapor. Use bond energies (Table 9.2) to determine the enthalpy of each reaction per mole of O_2 (assume Lewis structures with zero formal charges; BE of $\text{S}=\text{O}$ is 552 kJ/mol).

10.81 Use Lewis structures to determine which *two* of the following are unstable: (a) SF_2 ; (b) SF_3 ; (c) SF_4 ; (d) SF_5 ; (e) SF_6 .

10.82 A major short-lived, neutral species in flames is OH .
(a) What is unusual about the electronic structure of OH ?

- Use the standard enthalpy of formation of $\text{OH}(g)$ (39.0 kJ/mol) and bond energies to calculate the O—H bond energy in $\text{OH}(g)$.
- From the average value for the O—H bond energy in Table 9.2 and your value for the O—H bond energy in $\text{OH}(g)$, find the energy needed to break the first O—H bond in water.

10.83 Pure HN_3 (atom sequence HNNN) is explosive. In aqueous solution, it is a weak acid that yields the azide ion, N_3^- . Draw resonance structures to explain why the nitrogen-nitrogen bond lengths are equal in N_3^- but unequal in HN_3 .

10.84 Except for nitrogen, the elements of Group 5A(15) all form pentafluorides, and most form pentachlorides. The chlorine atoms of PCl_5 can be replaced with fluorine atoms one at a time to give, successively, PCl_4F , PCl_3F_2 , ..., PF_5 . (a) Given the sizes of F and Cl, would you expect the first two F substitutions to be at axial or equatorial positions? Explain. (b) Which of the five fluorine-containing molecules have no dipole moment?

10.85 Dinitrogen monoxide (N_2O) supports combustion in a manner similar to oxygen, with the nitrogen atoms forming N_2 . Draw three resonance structures for N_2O (one N is central), and use formal charges to decide the relative importance of each. What correlation can you suggest between the more important structure and the observation that N_2O supports combustion?

10.86 Oxalic acid ($\text{H}_2\text{C}_2\text{O}_4$) is found in toxic concentrations in rhubarb leaves. The acid forms two ions, HC_2O_4^- and $\text{C}_2\text{O}_4^{2-}$, by the sequential loss of H^+ ions. Draw Lewis structures for the three species, and comment on the relative lengths and strengths of their carbon-oxygen bonds. The connections among the atoms are shown below with single bonds only.

10.87 The Murchison meteorite that landed in Australia in 1969 contained 92 different amino acids, including 21 found in Earth organisms. A skeleton structure (single bonds only) of one of these extraterrestrial amino acids is shown below.

Draw a Lewis structure, and identify any atoms having a nonzero formal charge.

10.88 Hydrazine (N_2H_4) is used as a rocket fuel because it reacts very exothermically with oxygen to form nitrogen gas and water vapor. The heat released and the increase in number of moles of gas provide thrust. Calculate the enthalpy of reaction.

10.89 A student isolates a product with the molecular shape shown at right (F is orange). (a) If the species is a neutral compound, can the black sphere represent selenium (Se)? (b) If the species is an anion, can the black sphere represent N? (c) If the black sphere represents Br, what is the charge of the species?

10.90 When gaseous sulfur trioxide is dissolved in concentrated sulfuric acid, disulfuric acid forms:

Use bond energies (Table 9.2) to determine ΔH_{rxn}° . (The S atoms in $H_2S_2O_7$ are bonded through an O atom. Assume Lewis structures with zero formal charges; BE of $S=O$ is 552 kJ/mol.)

10.91 A molecule of formula AY_3 is found experimentally to be polar. Which molecular shapes are possible and which are impossible for AY_3 ?

10.92 Consider the following molecular shapes:

- (a) Match each shape with one of the following species: XeF_3^+ , $SbBr_3$, $GaCl_3$.
 (b) Which, if any, is polar?
 (c) Which has the most valence electrons around the central atom?

10.93 Hydrogen cyanide can be catalytically reduced with hydrogen to form methylamine. Use Lewis structures and bond energies to determine ΔH_{rxn}° for

10.94 Ethylene, C_2H_4 , and tetrafluoroethylene, C_2F_4 , are used to make the polymers polyethylene and polytetrafluoroethylene (Teflon), respectively.

- (a) Draw the Lewis structures for C_2H_4 and C_2F_4 , and give the ideal $H-C-H$ and $F-C-F$ bond angles.
 (b) The actual $H-C-H$ and $F-C-F$ bond angles are 117.4° and 112.4° , respectively. Explain these deviations.

10.95 Using bond lengths in Table 9.2 and assuming ideal bond angles, calculate each of the following distances:

- (a) Between H atoms in C_2H_2
 (b) Between F atoms in SF_6 (two answers)
 (c) Between equatorial F atoms in PF_5

10.96 Phosphorus pentachloride, a key industrial compound with annual world production of about 2×10^7 kg, is used to make other compounds. It reacts with sulfur dioxide to produce phosphorus oxychloride ($POCl_3$) and thionyl chloride ($SOCl_2$). Draw a Lewis structure and name the molecular shape of each of these products.

11

Theories of Covalent Bonding

11.1 Valence Bond (VB) Theory and Orbital Hybridization

Central Themes of VB Theory
Types of Hybrid Orbitals

11.2 Modes of Orbital Overlap and the Types of Covalent Bonds

Orbital Overlap in Single and Multiple Bonds
Orbital Overlap and Rotation Within a Molecule

11.3 Molecular Orbital (MO) Theory and Electron Delocalization

Central Themes of MO Theory
Homonuclear Diatomic Molecules of Period 2 Elements
Two Heteronuclear Diatomic Molecules: HF and NO
Two Polyatomic Molecules: Benzene and Ozone

Source: © Richard Megna/Fundamental Photographs, NYC

Concepts and Skills to Review Before You Study This Chapter

- atomic orbital shapes (Section 7.4)
- exclusion principle (Section 8.1)
- Hund's rule (Section 8.2)
- Lewis structures (Section 10.1)
- resonance in covalent bonding (Section 10.1)
- molecular shapes (Section 10.2)
- molecular polarity (Section 10.3)

All scientific models have limitations because they are simplifications of reality. The VSEPR theory, covered in Chapter 10, accounts for molecular shapes, but it doesn't explain how they arise from atomic orbitals. After all, the orbitals described in Chapter 7 aren't oriented toward the corners of, say, a trigonal bipyramidal, like the one for phosphorus in PF_5 . Moreover, knowing the shape doesn't help us explain the magnetic and spectral properties of a molecule; for example, the Lewis structure of O_2 that we draw does not account for the presence of unpaired electrons that cause liquid oxygen to be attracted to the poles of a magnet (*photo*). We need an understanding of orbitals and energy levels to explain that.

The two theories presented in this chapter focus on different questions and complement each other. Don't be concerned that we need several models to explain a complex phenomenon like bonding. In every science, one model may account for some aspect of a topic better than another, and several are employed to explain a wider range of phenomena.

IN THIS CHAPTER . . . We introduce two theories of bonding in molecules that are based on the interactions of the orbitals of their atoms.

- We discuss valence bond (VB) theory, which rationalizes molecular shapes through interactions of atomic orbitals during bonding to form hybrid orbitals.
- We apply VB theory to sigma and pi bonds, the two types of covalent bonds.
- We see why parts of molecules don't rotate freely around multiple bonds, which has major effects on reactivity, physical properties, and biological behavior.
- We discuss molecular orbital (MO) theory, which explains molecular energy levels and properties based on the formation of orbitals that spread over a whole molecule.
- We apply MO theory to understand key properties of some diatomic and simple polyatomic molecules.

11.1 VALENCE BOND (VB) THEORY AND ORBITAL HYBRIDIZATION

What is a covalent bond, and what characteristic gives it strength? And how can we explain *molecular* shapes based on the interactions of *atomic* orbitals? One very useful approach for answering these questions is based on quantum mechanics (Chapter 7) and is called **valence bond (VB) theory**.

The Central Themes of VB Theory

The basic principle of VB theory is that *a covalent bond forms when orbitals of two atoms overlap and a pair of electrons occupy the overlap region*. In the terminology of quantum mechanics, overlap of the two orbitals means their wave functions are *in phase* (constructive interference; see Figure 7.5), so the amplitude between the nuclei increases. The central themes of VB theory derive from this principle:

1. *Opposing spins of the electron pair.* As the exclusion principle (Section 8.1) requires, the space formed by the overlapping orbitals *has a maximum capacity for two electrons that have opposite (paired) spins*. In the simplest case, a molecule of H_2 forms when the 1s orbitals of two H atoms overlap, and the electrons, with their spins paired, spend more time in the overlap region (up and down arrows in Figure 11.1A).

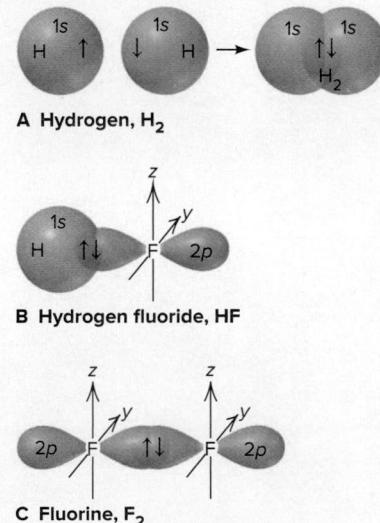

Figure 11.1 Orbital overlap and spin pairing in three diatomic molecules. (In **B** and **C**, the $2p_x$ orbital is shown involved in the bonding; the other two $2p$ orbitals of F are omitted for clarity.)

2. *Maximum overlap of bonding orbitals.* Bond strength depends on the attraction between nuclei and shared electrons, so *the greater the orbital overlap, the closer the nuclei are to the electrons, and the stronger the bond.* Extent of overlap depends on orbital shape and direction. An *s* orbital is spherical, but *p* and *d* orbitals have specified directions. Thus, a *p* or *d* orbital involved in a bond is oriented so as to *maximize overlap*. In HF, for example, the 1*s* orbital of H overlaps a half-filled 2*p* orbital of F *along its long axis* (Figure 11.1B). In F₂, the two half-filled 2*p* orbitals interact end to end, that is, *along their long axes* (Figure 11.1C).

3. *Hybridization of atomic orbitals.* To account for the bonding in diatomic molecules like HF and F₂, we picture direct overlap of *s* and/or *p* orbitals of isolated atoms. But how can we account for the shape of a molecule like methane from the shapes and orientations of C and H atomic orbitals? A C atom ([He] 2s²2p²) has two valence electrons in the spherical 2*s* orbital and one valence electron in two of the three mutually perpendicular 2*p* orbitals. If the two half-filled *p* orbitals overlapped the 1*s* orbitals of two H atoms, *two C—H bonds would form with a 90° H—C—H bond angle.* But methane has the formula CH₄, not CH₂, and its bond angles are 109.5°.

To explain such facts, Linus Pauling proposed that, during bonding, *the valence orbitals in the isolated atoms become new orbitals in the molecule.* Quantum-mechanical calculations show that if we mathematically “mix” certain combinations of orbitals, we form new ones whose spatial orientations *do* match the observed molecular shapes. The process of orbital mixing is called **hybridization**, and the new atomic orbitals are called **hybrid orbitals**.

4. *Features of hybrid orbitals.* Here are some central points about the hybrid orbitals that form during bonding:

- The *number* of hybrid orbitals formed *equals* the number of atomic orbitals mixed.
- The *type* of hybrid orbitals formed *varies* with the types of atomic orbitals mixed.
- The *shape and orientation* of a hybrid orbital *maximize* its overlap with the orbital of the other atom in the bond.

It is useful to think of hybridization as a process in which atomic orbitals mix, hybrid orbitals form, they overlap other orbitals, and electrons enter the overlap region with opposing spins, thus forming stable bonds. In truth, hybridization is a mathematical concept that helps us explain the molecular shapes we observe.

Types of Hybrid Orbitals

We postulate the type of hybrid orbitals in a molecule *after* we observe its shape. Note that the orientations of the five types of hybrid orbitals we discuss next correspond to the five electron-group arrangements in VSEPR theory (see Figure 10.2).

sp Hybridization When two electron groups surround the central atom, we observe a linear shape, as in BeCl₂. Beryllium’s two valence electrons are paired in the 2*s* orbital ([He] 2s²) in the ground state; with no unpaired electrons, Be cannot form bonds. The beryllium atom can promote an electron from the 2*s* orbital to an empty 2*p* orbital, resulting in two unpaired electrons that could participate in two bonds with Cl atoms to form BeCl₂:

However, this would result in two nonidentical bonds: the 2*s* orbital of Be would overlap with a 3*p* orbital of one Cl atom to form one bond, while the 2*p* orbital of Be would overlap with a 3*p* orbital of a second Cl atom to form the second bond. But experimentally, we know that the two Be—Cl bonds are identical in length and energy. The concept of hybridization offers an explanation for the linear shape and identical bonds in BeCl₂.

1. *Orbitals mixed and orbitals formed.* VB theory proposes that two *nonequivalent* orbitals of a central atom, one *s* and one *p*, mix and form two *equivalent sp hybrid orbitals* that are oriented 180° apart (Figure 11.2A). The shape of these hybrid orbitals,

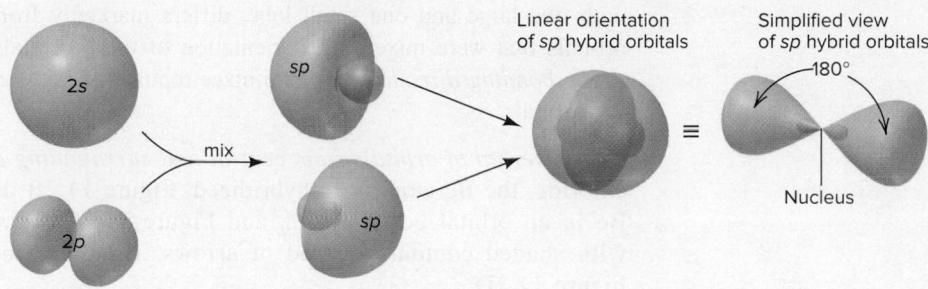**A** Formation of *sp* hybrid orbitals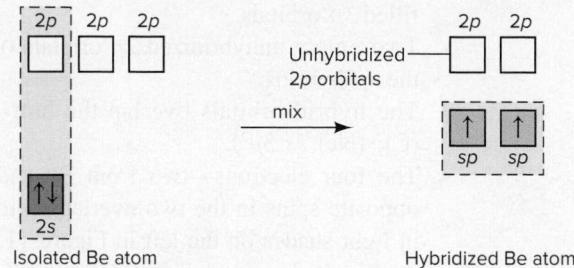**B** Hybridization shown through orbital box diagram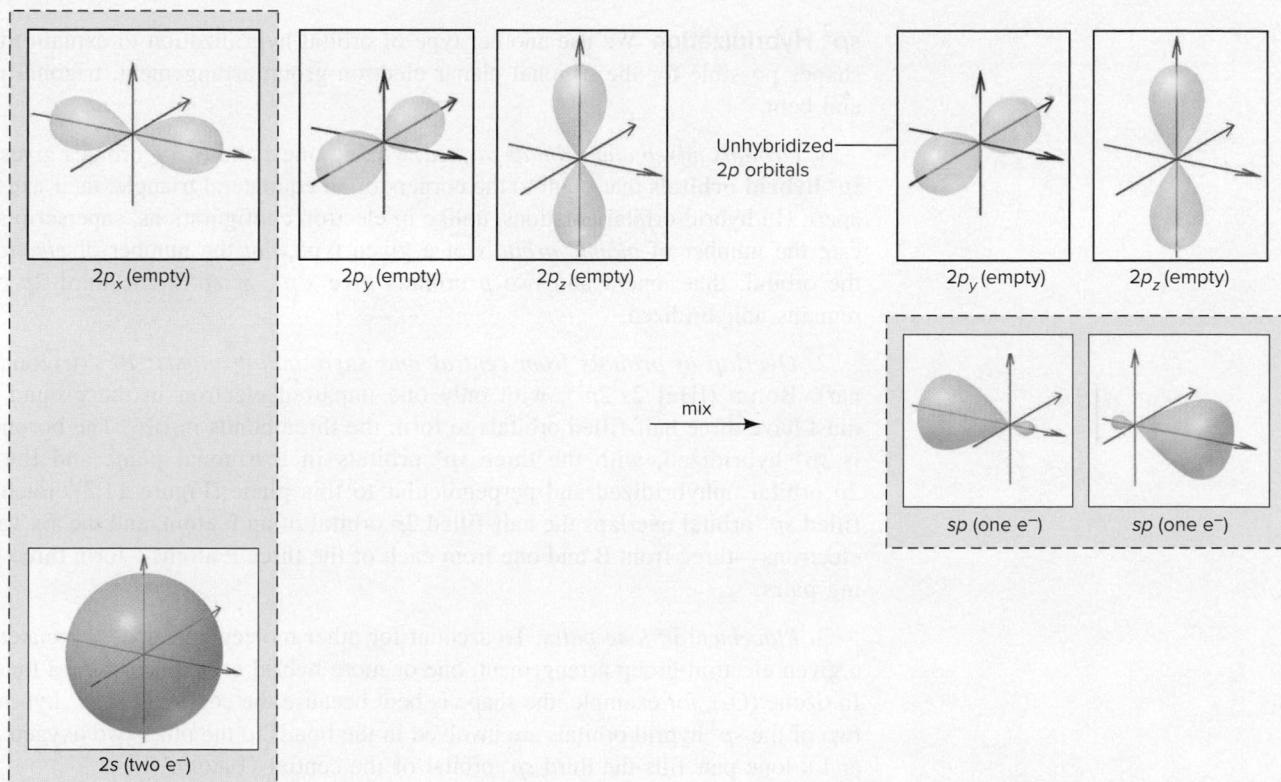**C** Hybridization shown through box diagram with orbital contours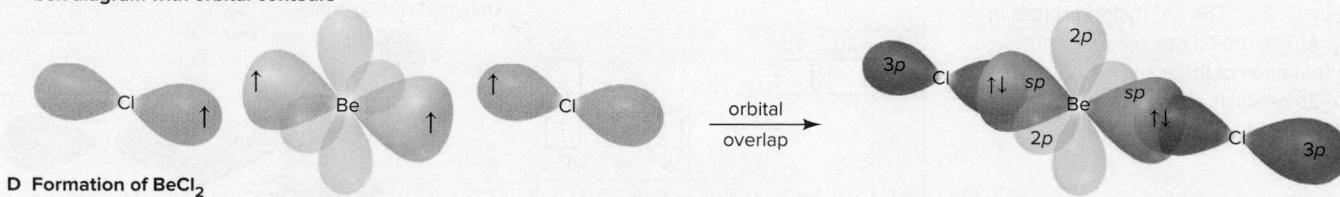

Figure 11.2 Formation and orientation of *sp* hybrid orbitals and the bonding in BeCl_2 . **A**, One 2s and one 2p atomic orbital mix to form two *sp* hybrid orbitals. (The simplified hybrid orbitals at far right are used elsewhere, often even without the small lobe.) **B**, The orbital box diagram for hybridization of Be, drawn vertically. (Full color, light shading, or no shading indicates orbital occupancy.) **C**, The orbital box diagram with orbital contours. **D**, Overlap of Be and Cl orbitals to form BeCl_2 . (Simplified hybrid orbitals are shown for Be; only the 3p orbital of Cl that is involved in bonding is shown.)

with one large and one small lobe, differs markedly from the shapes of the atomic orbitals that were mixed. The orientation of these orbitals increases electron density *in the bonding direction* and minimizes repulsions between the electrons that occupy the orbitals.

2. Overlap of orbitals from central and surrounding atoms: BeCl_2 . In beryllium chloride, the Be atom is sp hybridized. Figure 11.2B depicts the hybridization of Be in an orbital box diagram, and Figure 11.2C shows an orbital box diagram with shaded contours instead of arrows. Bond formation with Cl is shown in Figure 11.2D:

- The filled 2s and one of the three empty 2p orbitals of Be mix and form two half-filled sp orbitals.
- Two empty unhybridized 2p orbitals of Be lie perpendicular to each other and to the sp hybrids.
- The hybrid orbitals overlap the half-filled 3p orbital in each of two Cl atoms (Cl: [Ne] $3s^23p^5$).
- The four electrons—two from Be and one from each Cl—appear as pairs with opposite spins in the two overlap regions. (The 3p and sp hybrid orbitals that are in light shades on the left in Figure 11.2D become fully colored on the right, after the bonds form and each orbital is filled with two electrons.)

sp^2 Hybridization We use another type of orbital hybridization to explain the two shapes possible for the trigonal planar electron-group arrangement, trigonal planar and bent.

1. Orbitals mixed and orbitals formed. Mixing one s and two p orbitals gives three **sp^2 hybrid orbitals** that point to the corners of an equilateral triangle, their axes 120° apart. (In hybrid-orbital notations, unlike in electron configurations, superscripts indicate the number of *atomic orbitals* of a given type, *not* the number of *electrons* in the orbital: thus, one s and two p orbitals give s^1p^2 , or sp^2 .) The third 2p orbital remains unhybridized.

2. Overlap of orbitals from central and surrounding atoms: BF_3 (trigonal planar). Boron ([He] $2s^22p^1$), with only one unpaired electron in the ground state, must have three half-filled orbitals to form the three bonds in BF_3 . The boron atom is sp^2 hybridized, with the three sp^2 orbitals in a trigonal plane and the third 2p orbital unhybridized and perpendicular to this plane (Figure 11.3). Each half-filled sp^2 orbital overlaps the half-filled 2p orbital of an F atom, and the six valence electrons—three from B and one from each of the three F atoms—form three bonding pairs.

3. Placement of lone pairs. To account for other molecular shapes associated with a given electron-group arrangement, one or more hybrid orbitals contains a lone pair. In ozone (O_3), for example, the shape is bent because the central O is sp^2 hybridized; two of the sp^2 hybrid orbitals are involved in the bonds to the other two oxygen atoms and a lone pair fills the third sp^2 orbital of the central O atom.

Figure 11.3 The sp^2 hybrid orbitals in BF_3 . **A**, The orbital box diagram shows the formation of three sp^2 hybrid orbitals. One 2p orbital is unhybridized and empty. **B**, Contour depiction of BF_3 .

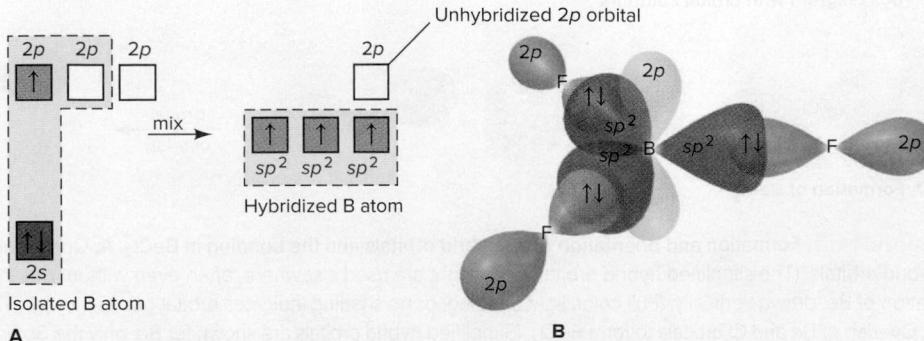

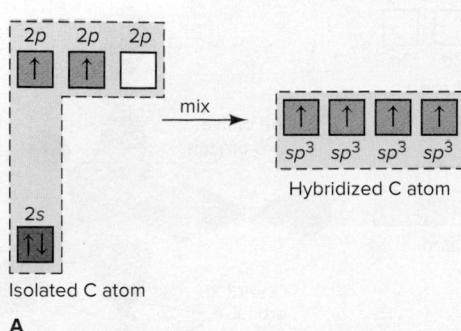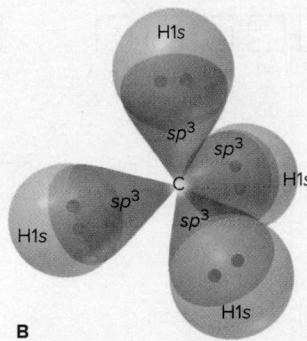

Figure 11.4 The sp^3 hybrid orbitals in CH_4 . **A**, The orbital box diagram shows formation of four sp^3 hybrids. **B**, Contour depiction of CH_4 , with electron pairs shown as dots.

sp^3 Hybridization Let's return to the question posed earlier about the shape of methane. The type of hybridization that accounts for methane's shape applies to any species with a tetrahedral electron-group arrangement.

1. *Orbitals mixed and orbitals formed.* Mixing one s and three p orbitals gives four **sp^3 hybrid orbitals** that point to the corners of a tetrahedron.

2. *Overlap of orbitals from central and surrounding atoms:* CH_4 . Carbon ($[\text{He}] 2s^2 2p^2$), with only two unpaired electrons in the ground state, must have four half-filled orbitals to form the four bonds in CH_4 . The C atom in methane is sp^3 hybridized. Its four valence electrons half-fill the four sp^3 hybrids, which overlap the half-filled 1s orbitals of four H atoms to form four C—H bonds (Figure 11.4).

3. *Placement of lone pairs.* The trigonal pyramidal shape of NH_3 arises because the three half-filled sp^3 hybrid orbitals form the three N—H bonds and a lone pair fills the fourth sp^3 orbital. The bent shape of H_2O arises because lone pairs fill any two of the sp^3 orbitals of O (Figure 11.5).

sp^3d Hybridization Molecules with shapes due to the trigonal bipyramidal electron-group arrangement (trigonal bipyramidal, seesaw, T shaped, and linear) must have central atoms from Period 3 or higher, because d orbitals, as well as s and p orbitals, are mixed to form the hybrid orbitals.

1. *Orbitals mixed and orbitals formed.* Mixing one $3s$, the three $3p$, and one of the five $3d$ orbitals gives five **sp^3d hybrid orbitals**, which point to the corners of a trigonal bipyramid.

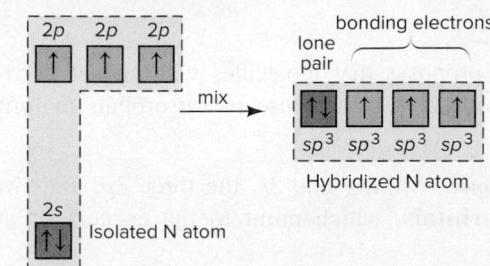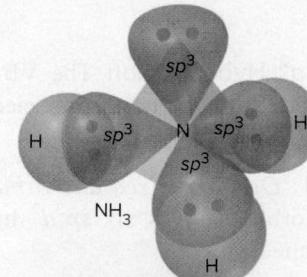

Figure 11.5 The sp^3 hybrid orbitals in NH_3 and H_2O . **A**, The orbital box diagrams show sp^3 hybridization, with lone pairs filling one (in NH_3) or two (in H_2O) hybrid orbitals. **B**, Contour depictions of NH_3 and H_2O .

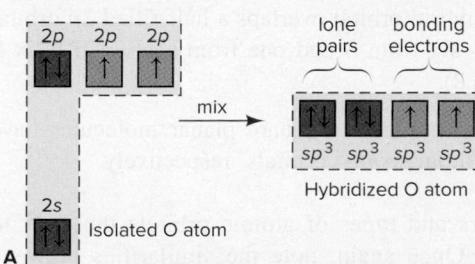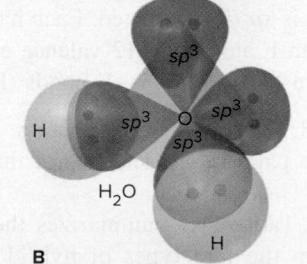

Figure 11.6 The sp^3d hybrid orbitals in PCl_5 . **A**, The orbital box diagram shows the formation of five half-filled sp^3d orbitals. Four $3d$ orbitals are unhybridized and empty. **B**, Contour depiction of PCl_5 . (For clarity, the unhybridized $3d$ orbitals of P, the other two $3p$ orbitals of Cl, and the five bonding P—Cl pairs are not shown.)

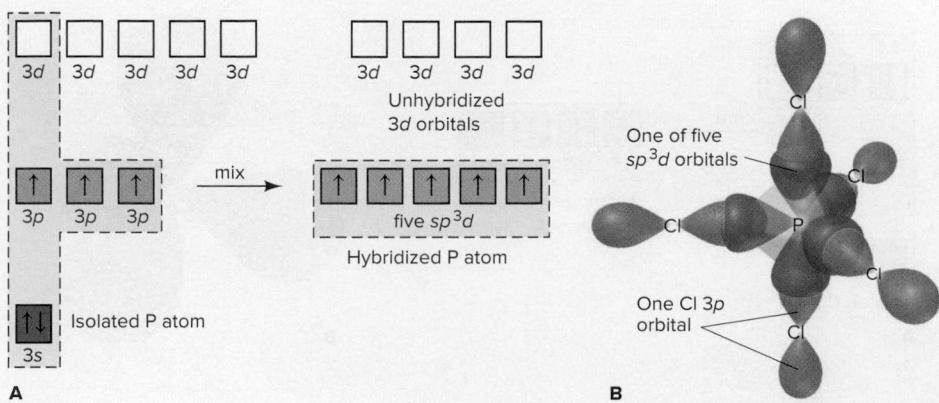

2. Overlap of orbitals from central and surrounding atoms: PCl_5 . The P atom in PCl_5 is sp^3d hybridized. Each hybrid orbital overlaps a $3p$ orbital of a Cl atom, and ten valence electrons—five from P and one from each of the five Cl atoms—form five P—Cl bonds (Figure 11.6).

3. Placement of lone pairs. Seesaw, T-shaped, and linear molecules have lone pairs in one, two, or three of the central atom's sp^3d orbitals, respectively. Figure 11.7 shows the bonding for the T-shaped molecule ClF_3 .

Figure 11.7 The sp^3d hybrid orbitals in ClF_3 . **A**, The orbital box diagram shows sp^3d hybridization. **B**, Contour depiction of ClF_3 , with lone pairs filling two hybrid orbitals. (For clarity, the unhybridized $3d$ orbitals of Cl, the other two $2p$ orbitals of F, and the three bonding Cl—F pairs are not shown.)

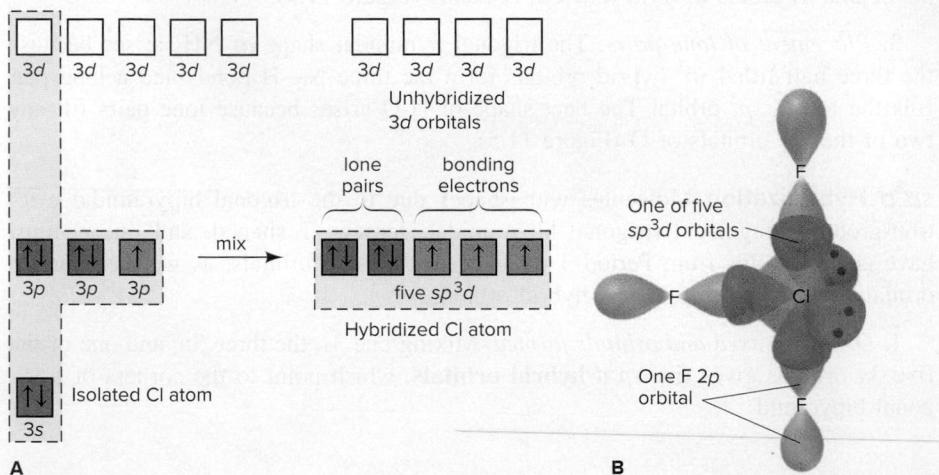

sp^3d^2 Hybridization The VB model proposes that molecules with shapes corresponding to the octahedral electron-group arrangement use two d orbitals to form hybrids.

1. Orbitals mixed and orbitals formed. Mixing one $3s$, the three $3p$, and two $3d$ orbitals gives six sp^3d^2 hybrid orbitals, which point to the corners of an octahedron.

2. Overlap of orbitals from central and surrounding atoms: SF_6 . The S atom in SF_6 is sp^3d^2 hybridized. Each half-filled hybrid orbital overlaps a half-filled $2p$ orbital of an F atom, and 12 valence electrons—six from S and one from each of the six F atoms—form six S—F bonds (Figure 11.8).

3. Placement of lone pairs. Square pyramidal and square planar molecules have lone pairs in one and two of the central atom's sp^3d^2 orbitals, respectively.

Table 11.1 summarizes the numbers and types of atomic orbitals that mix to form the five types of hybrid orbitals. Once again, note the similarities between

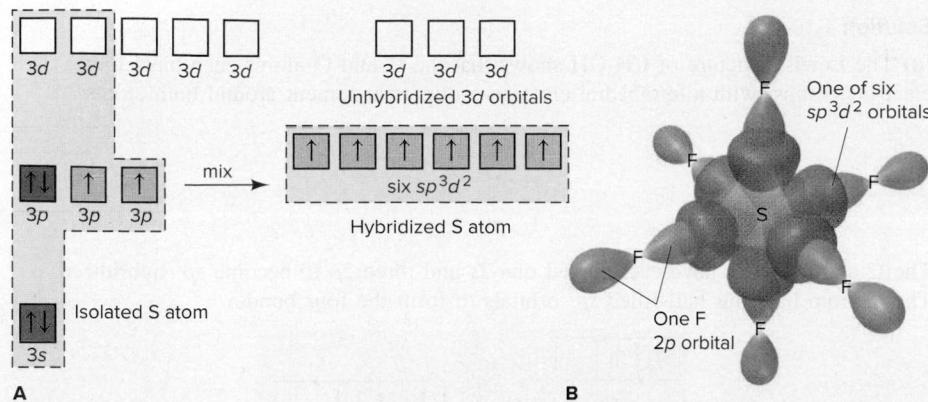

Figure 11.8 The sp^3d^2 hybrid orbitals in SF_6 . **A**, The orbital box diagram shows formation of six half-filled sp^3d^2 orbitals; three 3d orbitals remain unhybridized and empty. **B**, Contour depiction of SF_6 .

Table 11.1

Composition and Orientation of Hybrid Orbitals

	Linear	Trigonal Planar	Tetrahedral	Trigonal Bipyramidal	Octahedral
Atomic orbitals mixed	one s one p	one s two p	one s three p	one s three p one d	one s three p two d
Hybrid orbitals formed	two sp	three sp^2	four sp^3	five sp^3d	six sp^3d^2
Unhybridized orbitals remaining	two p	one p	none	four d	three d
Orientation of hybrid orbitals					

hybrid-orbital orientations and the shapes predicted by VSEPR theory. Figure 11.9 shows three conceptual steps from a molecular formula to the hybrid orbitals in the molecule, and Sample Problem 11.1 focuses on the last step of that process.

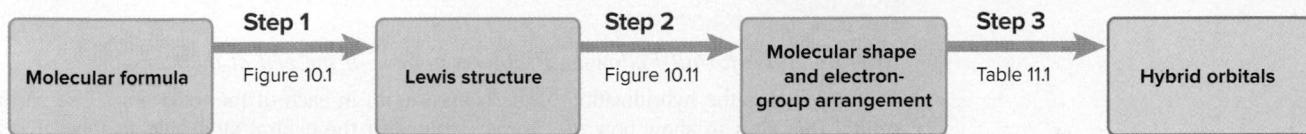

Figure 11.9 From molecular formula to hybrid orbitals. (See Figures 10.1 and 10.11.)

SAMPLE PROBLEM 11.1

Postulating Hybrid Orbitals in a Molecule

Problem Use partial orbital diagrams to describe how mixing the atomic orbitals of the central atom(s) leads to the hybrid orbitals in each of the following:

(a) Methanol, CH_3OH

(b) Sulfur tetrafluoride, SF_4

Plan We use the molecular formula to draw the Lewis structure and determine the electron-group arrangement of each central atom. Then we use Table 11.1 to postulate the type of hybrid orbitals. We write the partial orbital diagram for each central atom before and after the orbitals are hybridized.

Student Hot Spot

Student data indicate that you may struggle with the concept of orbital hybridization. Access the SmartBook to view additional Learning Resources on this topic.

Solution

(a) The Lewis structure of CH₃OH shows that the C and O atoms each have four electron groups, with a tetrahedral electron-group arrangement around both atoms:

The C and O atoms have each mixed one 2s and three 2p to become sp^3 hybridized. The C atom has four half-filled sp^3 orbitals to form the four bonds:

The O atom has two half-filled sp^3 orbitals that are used to form two bonds and two sp^3 orbitals filled with lone pairs:

(b) The Lewis structure of SF₄ shows that S has four bonds and one lone pair, for a total of five electron groups. The electron-group arrangement is trigonal bipyramidal, so the central S atom is sp^3d hybridized, which means one 3s, three 3p, and one 3d orbital were mixed. One of the hybrid orbitals is filled with a lone pair, and four are half-filled. Four unhybridized 3d orbitals remain empty:

FOLLOW-UP PROBLEMS

Brief Solutions for all Follow-up Problems appear at the end of the chapter.

11.1A What is the hybridization of the central atom in each of the following? Use partial orbital diagrams to show how the atomic orbitals of the central atom mix to form hybrid orbitals in (a) beryllium fluoride, BeF₂; (b) silicon tetrachloride, SiCl₄; (c) xenon tetrafluoride, XeF₄.

11.1B What is the hybridization of the central atom in each of the following? Use partial orbital diagrams to show how the atomic orbitals of the central atom mix to form hybrid orbitals in (a) nitrogen dioxide, NO₂; (b) phosphorus trichloride, PCl₃; (c) bromine pentafluoride, BrF₅.

SOME SIMILAR PROBLEMS 11.7–11.12 and 11.15–11.18

Limitations to the Concept of Hybridization We rely on the VSEPR and VB theories to explain an observed molecular shape. In some cases, however, the theories may not be consistent with other findings.

1. *Hybridization does not apply: large nonmetal hydrides.* Consider the Lewis structure and bond angle of H₂S:

Based on VSEPR theory, we would predict that, as in H₂O, the four electron groups around H₂S point to the corners of a tetrahedron, and the two lone pairs compress the H—S—H bond angle below the ideal 109.5°. Based on VB theory, we would propose that the 3s and 3p orbitals of the S atom mix and form four sp^3 hybrids, two of which are filled with lone pairs, while the other two overlap 1s orbitals of two H atoms and are filled with bonding pairs.

But observation does *not* support these arguments. The bond angle of 92° is close to the 90° angle between *unhybridized p* orbitals. Similar angles occur in the hydrides of other large nonmetals of Groups 5A(15) and 6A(16). Why apply a theory if the facts don't warrant it? Real factors—bond length, atomic size, and electrostatic repulsions—influence shape. Larger atoms form longer bonds to H, which decreases repulsions; thus, overlap of *unhybridized* orbitals adequately explains these shapes.

2. *d-Orbital hybridization is less important: shapes with expanded valence shells.* Quantum-mechanical calculations show that *d* orbitals have such high energies that they do not hybridize effectively with the *much* more stable *s* and *p* orbitals of a given *n* value. Thus, for example, some have proposed that SF₆ is most stable when the bonding orbitals of the central S use a combination of *sp* hybrid orbitals and unhybridized 3*p* orbitals instead of *sp*³*d*² hybrid orbitals. Others prefer explanations that involve molecular orbitals or even ionic structures. These topics are beyond the scope of this text, and while they are being actively debated, we will continue to use the traditional, though limited, approach of including *d*-orbital hybridization for molecules with expanded valence shells.

› Summary of Section 11.1

- › VB theory explains that a covalent bond forms when two atomic orbitals overlap and two electrons with paired (opposite) spins occupy the overlap region.
- › To explain molecular shape, VB theory proposes that, during bonding, atomic orbitals mix to form hybrid orbitals whose shape and orientation differ from those of the mixed atomic orbitals. This process gives rise to greater orbital overlap and, thus, stronger bonds.
- › Based on an observed molecular shape (and the related electron-group arrangement), we postulate the type of hybrid orbital that accounts for that shape. In many cases, especially for molecules with larger central atoms, the concept of hybridization has major limitations.

11.2 MODES OF ORBITAL OVERLAP AND THE TYPES OF COVALENT BONDS

Orbitals can overlap by two *modes*—end to end or side to side—which gives rise to two types of covalent bonds—*sigma* and *pi*. We'll use VB theory to describe the two types here; as you'll see, they are described by molecular orbital theory as well.

Orbital Overlap in Single and Multiple Bonds

Ethane (C₂H₆), ethylene (C₂H₄), and acetylene (C₂H₂) have different shapes. Ethane is tetrahedral at both carbons with bond angles near the ideal 109.5°. Ethylene is trigonal planar at both carbons with bond angles near the ideal 120°. Acetylene is linear with bond angles of 180°:

In these molecules, two modes of orbital overlap result in two types of bonds.

End-to-End Overlap and Sigma (σ) Bonding Both C atoms of ethane are sp^3 hybridized; the four valence electrons of C half-fill the four sp^3 orbitals:

The C—C bond arises from overlap of the end of one sp^3 orbital on one C atom with the end of one sp^3 orbital on the other C atom (Figure 11.10). Each of the six C—H bonds is formed by the overlap of the end of a sp^3 hybrid orbital on the C atom with the 1s orbital of a hydrogen atom. Each bond in ethane is a **sigma (σ) bond**:

- A sigma bond is formed by *end-to-end* overlap of orbitals.
- A sigma bond has its *highest electron density along the bond axis* and is shaped like an ellipse rotated about its long axis (like a football).
- *All single bonds are σ bonds.*

Figure 11.10 The σ bonds in ethane (C_2H_6). **A**, Depiction using atomic contours. **B**, An electron density model shows very slightly positive (blue) and negative (red) regions. **C**, Wedge-bond perspective drawing of the ethane molecule.

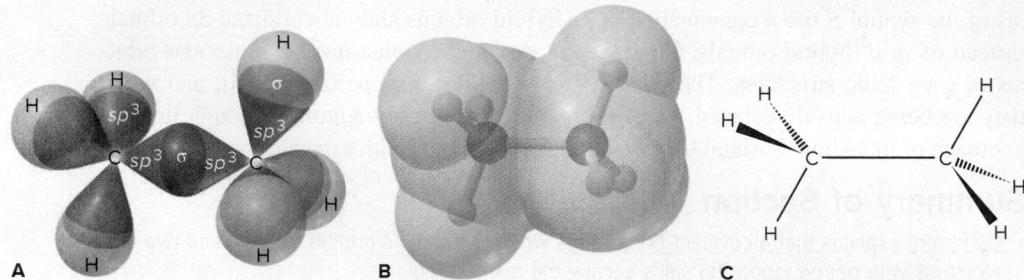

Side-to-Side Overlap and Pi (π) Bonding For this type of bonding, we'll examine ethylene and acetylene:

1. In ethylene, each C atom is sp^2 hybridized. The four valence electrons of C half-fill the three sp^2 orbitals *and* the unhybridized $2p$ orbital:

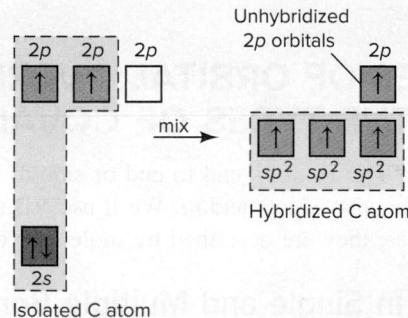

The unhybridized $2p$ orbital lies perpendicular to the sp^2 plane (Figure 11.11). Two sp^2 orbitals of each C form C—H σ bonds. The third sp^2 orbital forms a σ bond with the other C. With the σ -bonded C atoms near each other, a second bond is formed between the two C atoms when their half-filled unhybridized $2p$ orbitals overlap to form a **pi (π) bond**:

- A pi bond is formed by *side to side* overlap of orbitals.
- A pi bond has *two regions (lobes) of electron density*, one above and one below the σ -bond axis. *The two electrons in one π bond occupy both lobes.*
- *A double bond consists of one σ bond and one π bond*, which increases electron density between the nuclei (Figure 11.11D). The two electron pairs act as one electron group because each pair occupies a different orbital, which reduces repulsions.

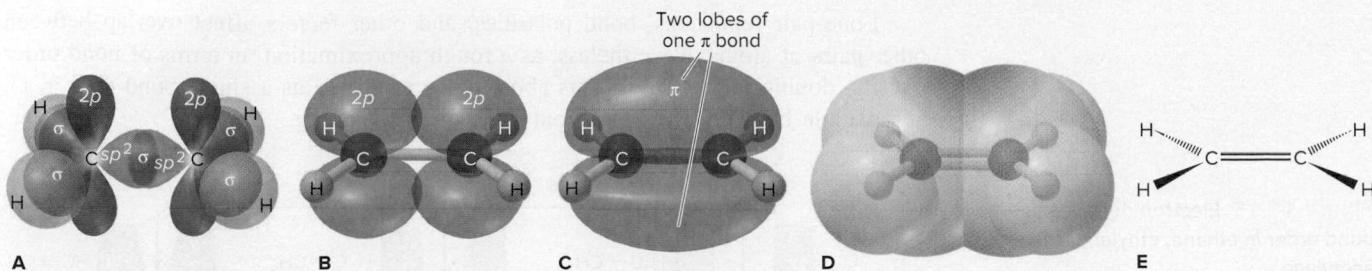

Figure 11.11 The σ and π bonds in ethylene (C_2H_4). **A**, The C—C σ bond and the four C—H σ bonds are shown with the unhybridized $2p$ orbitals. **B**, An accurate depiction of the $2p$ orbitals shows the side-to-side overlap; σ bonds are shown with a ball-and-stick model. **C**, Two overlapping regions comprise one π bond, which is occupied by two electrons. **D**, With four electrons (one σ bond and one π bond) between the C atoms, electron density (red) is higher there. **E**, Wedge-bond perspective drawing of the ethylene molecule.

2. In acetylene, each C atom is sp hybridized, and its four valence electrons half-fill the two sp hybrids *and* the two unhybridized $2p$ orbitals:

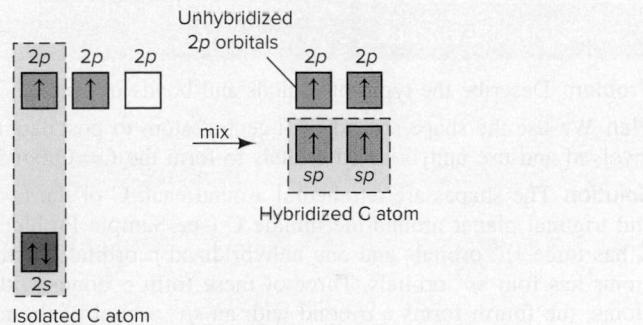

Each C forms a C—H σ bond with one sp orbital and a C—C σ bond with the other (Figure 11.12). Side-to-side overlap of one pair of unhybridized $2p$ orbitals gives one π bond, with electron density above and below the σ bond. Side-to-side overlap of the other pair of unhybridized $2p$ orbitals gives another π bond, 90° away from the first, with electron density in front and back of the σ bond. The result is a *cylindrically symmetrical* H—C≡C—H molecule. Note the greater electron density between the C atoms created by the six bonding electrons.

- A triple bond consists of one σ and two π bonds.

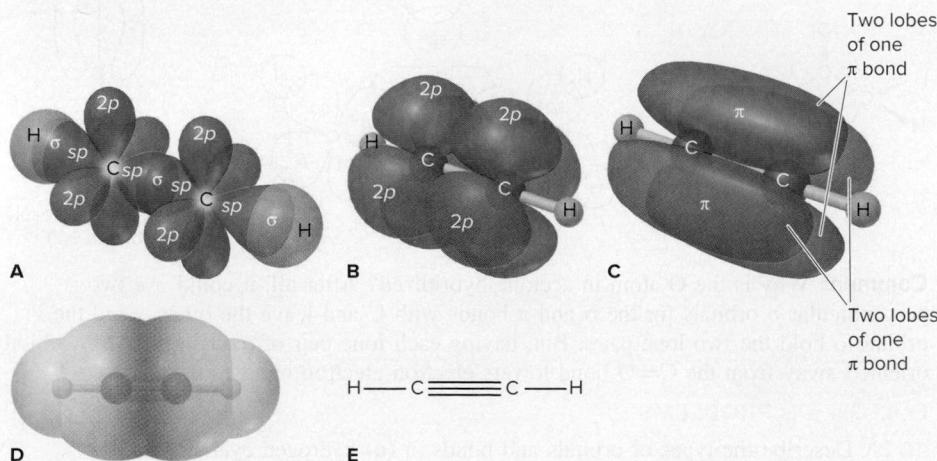

Figure 11.12 The σ bonds and π bonds in acetylene (C_2H_2). **A**, A contour depiction shows the C—C σ bond, the two C—H σ bonds, and two unhybridized $2p$ orbitals (one pair is in red for clarity). **B**, The $2p$ orbitals (accurate form) overlap side to side; σ bonds are shown with a ball-and-stick model. **C**, Overlapping regions of two π bonds, one black and the other red. **D**, The molecule has cylindrical symmetry. Six electrons (one σ bond and two π bonds) create even higher electron density (red) between the C atoms. **E**, Bond-line drawing of the acetylene molecule.

Mode of Overlap, Bond Strength, and Bond Order Because orbitals overlap less side to side than they do end to end, a π bond is weaker than a σ bond; thus, for carbon-carbon bonds, a double bond is less than twice as strong as a single bond (Table 9.2). Figure 11.13 on the next page shows electron density relief maps of the three types of carbon-carbon bonds; note the increasing electron density between the nuclei from single to double to triple bond.

Lone-pair repulsions, bond polarities, and other factors affect overlap between other pairs of atoms. Nevertheless, as a rough approximation, in terms of bond order (BO), a double bond (BO = 2) is about twice as strong as a single bond (BO = 1), and a triple bond (BO = 3) is about three times as strong.

Figure 11.13 Electron density and bond order in ethane, ethylene, and acetylene.

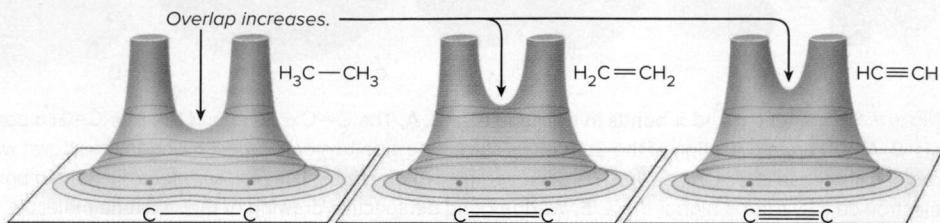

SAMPLE PROBLEM 11.2

Describing the Types of Orbitals and Bonds in Molecules

Problem Describe the types of orbitals and bonds in acetone, $(\text{CH}_3)_2\text{CO}$.

Plan We use the shape around each central atom to postulate the hybrid orbitals involved and use unhybridized orbitals to form the $\text{C}=\text{O}$ bond.

Solution The shapes are tetrahedral around each C of the two CH_3 (methyl) groups and trigonal planar around the middle C (see Sample Problem 10.8). Thus, the middle C has three sp^2 orbitals and one unhybridized p orbital. Each of the two methyl C atoms has four sp^3 orbitals. Three of these form σ bonds with the $1s$ orbitals of H atoms; the fourth forms a σ bond with an sp^2 orbital of the middle C. Thus, two of the three sp^2 orbitals of the middle C form σ bonds to the other two C atoms.

The O atom is also sp^2 hybridized and has an unhybridized p orbital that can form a π bond. Two of the O atom's sp^2 orbitals hold lone pairs, and the third forms a σ bond with the third sp^2 orbital of the middle C atom. The unhybridized, half-filled $2p$ orbitals of C and O form a π bond. The σ and π bonds constitute the $\text{C}=\text{O}$ bond:

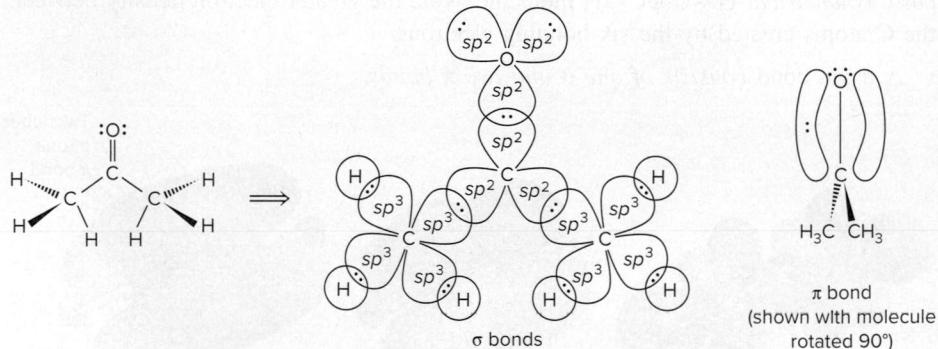

Comment Why is the O atom in acetone hybridized? After all, it could use two perpendicular p orbitals for the σ and π bonds with C and leave the other p and the s orbital to hold the two lone pairs. But, having each lone pair of oxygen in an sp^2 orbital oriented away from the $\text{C}=\text{O}$ bond lowers electron-electron repulsions.

FOLLOW-UP PROBLEMS

11.2A Describe the types of orbitals and bonds in (a) hydrogen cyanide, HCN; (b) carbon dioxide, CO_2 .

11.2B Describe the types of orbitals and bonds in (a) carbon monoxide; (b) urea, H_2NCNH_2 .

SOME SIMILAR PROBLEMS 11.21–11.24

Orbital Overlap and Rotation Within a Molecule

The type of overlap—end to end or side to side—affects rotation around the bond:

- *Sigma bond.* A σ bond allows free rotation because the extent of overlap is not affected. If you could hold one CH_3 group of ethane, the other CH_3 could spin without affecting the overlap of the $\text{C}=\text{C}$ σ bond (see Figure 11.10).
- *Pi bond.* A π bond restricts rotation because p orbitals must be parallel to each other to overlap most effectively. Holding one CH_2 group in ethylene and trying to spin the other decreases the side-to-side overlap and breaks the π bond. For this reason, distinct *cis* and *trans* structures exist for compounds such as 1,2-dichloroethylene (Section 10.3). As Figure 11.14 shows, the π bond allows two different arrangements of atoms around the C atoms, which has a major effect on molecular polarity (see Section 10.3). Rotation around a triple bond is not meaningful: each triple-bonded C atom is bonded to one other group in a linear arrangement, so there can be no difference in the relative positions of attached groups.

› Summary of Section 11.2

- › End-to-end overlap of atomic orbitals forms a σ bond, which allows free rotation of the bonded parts of the molecule.
- › A multiple bond consists of a σ bond and either one π bond (double bond) or two π bonds (triple bond). Multiple bonds have greater electron density between the nuclei than single bonds do and, thus, higher bond energies.
- › Side-to-side overlap of orbitals in a π bond restricts rotation.

cis-1,2-Dichloroethylene

trans-1,2-Dichloroethylene

Figure 11.14 Restricted rotation around a π bond. *Cis*- and *trans*-1,2-dichloroethylene are different molecules because the π bond restricts rotation.

11.3 MOLECULAR ORBITAL (MO) THEORY AND ELECTRON DELOCALIZATION

Scientists choose the model that best answers the question they are posing: VSEPR theory for one about molecular shape, or VB theory for one about orbital overlap. But neither model adequately explains magnetic and spectral properties, and both underestimate the importance of electron delocalization. To deal with these phenomena, which involve molecular energy levels, chemists apply **molecular orbital (MO) theory**. The MO model is a quantum-mechanical treatment for molecules similar to the one for atoms (Chapter 8): just as an atom has atomic orbitals (AOs) of given energies and shapes that are occupied by the atom's electrons, a molecule has **molecular orbitals (MOs)** of given energies and shapes that are occupied by the molecule's electrons.

There is a key distinction between VB and MO theories:

- VB theory pictures a molecule as a group of atoms bonded through overlapping of valence-shell atomic and/or hybrid orbitals occupied by *localized* electrons.
- MO theory pictures a molecule as a collection of nuclei with orbitals that extend over the whole molecule and are occupied by *delocalized* electrons.

Despite its usefulness, MO theory has the drawback that MOs are more difficult to visualize than the shapes of VSEPR theory or the hybrid AOs of VB theory.

The Central Themes of MO Theory

Several key ideas of MO theory appear in its description of H_2 and other simple species: how MOs form, what their energies and shapes are, and how they fill with electrons.

Formation of Molecular Orbitals Just as the Schrödinger equation gives only approximate solutions for any atom with more than one electron (Chapter 8), determining the MOs of even the simplest molecule, H_2 , requires an approximation. The approximation is to mathematically *combine* (add or subtract) AOs (atomic wave

Figure 11.15 An analogy between light waves and atomic wave functions.

functions) of nearby atoms to form MOs (molecular wave functions). Thus, when two H nuclei lie near each other, their AOs overlap and combine in two ways:

- *Adding the wave functions together.* This combination forms a **bonding MO**, which has *a region of high electron density between the nuclei*. Additive overlap is analogous to light waves reinforcing each other, which makes the amplitude higher and the light brighter. For electron waves, the overlap *increases* the probability that the electrons are between the nuclei (Figure 11.15A).
- *Subtracting the wave functions from each other.* This combination forms an **antibonding MO**, which has *a node, a region of zero electron density, between the nuclei* (Figure 11.15B). Subtractive overlap is analogous to light waves canceling each other, causing the light to disappear. With electron waves, subtractive overlap means the probability that the electrons lie between the nuclei *decreases* to zero.

The two possible combinations for hydrogen atoms H_A and H_B are

$$\text{AO of } H_A + \text{AO of } H_B = \text{bonding MO of } H_2 \text{ (more } e^- \text{ density between nuclei)}$$

$$\text{AO of } H_A - \text{AO of } H_B = \text{antibonding MO of } H_2 \text{ (less } e^- \text{ density between nuclei)}$$

Notice that *the number of AOs combined always equals the number of MOs formed:* two H atomic orbitals combine to form two H_2 molecular orbitals.

Shape and Energy of H_2 Molecular Orbitals Bonding and antibonding MOs have different shapes and energies. Figure 11.16 shows these orbitals for H_2 :

- **Bonding MO.** A bonding MO is *lower in energy* than the AOs that form it. Because the electron density is spread mostly *between* the nuclei, nuclear repulsions decrease while nucleus-electron attractions increase. Moreover, two electrons in this MO can delocalize their charges over a larger volume than they could in nearby, separate AOs, which lowers electron repulsions. Because of these electrostatic effects, when electrons occupy this MO, the H_2 molecule is *more stable* than the separate H atoms.
- **Antibonding MO.** An antibonding MO is *higher in energy* than the AOs that form it. With most of the electron density *outside* the internuclear region and *a node between the nuclei*, nuclear repulsions increase. Therefore, when electrons occupy this MO, the H_2 molecule is *less stable* than the separate H atoms.

Both the bonding and antibonding MOs of H_2 are **sigma (σ) MOs** because they are cylindrically symmetrical about an imaginary line between the nuclei. The bonding MO is denoted by σ_{1s} ; that is, a σ MO derived from 1s AOs. Antibonding orbitals are denoted with a superscript star: the antibonding MO derived from 1s AOs is σ_{1s}^* (spoken “sigma, one ess, star”).

For AOs to interact enough to form MOs, they must be similar in *energy* and *orientation*. The 1s orbitals of two H atoms have identical energy and orientation, so they interact strongly. We’ll revisit this requirement for molecules composed of many-electron atoms.

Electrons in Molecular Orbitals Several aspects of MO theory—filling of MOs, energy-level diagrams, electron configuration, and bond order—relate to earlier ideas:

1. *Filling MOs with electrons.* Electrons enter MOs just as they do AOs:
- MOs are filled in order of increasing energy (aufbau principle).

Student Hot Spot

Student data indicate that you may struggle with the concept of molecular orbitals. Access the SmartBook to view additional Learning Resources on this topic.

Figure 11.16 Contours and energies of H_2 bonding and antibonding MOs.

- An MO can hold a maximum of two electrons with opposite spins (exclusion principle).
- Orbitals of equal energy are half-filled, with electron spins parallel, before any of them are filled (Hund's rule).

2. MO energy-level diagrams. A **molecular orbital (MO) diagram** shows the relative energy and number of electrons for each MO, as well as for the AOs from which they are formed. In the MO diagram for H₂ (Figure 11.17), two electrons, one from the AO of each H, fill the lower energy bonding MO, while the higher energy antibonding MO remains empty.

3. Electron configuration. Just as we can write the electron configuration for an atom, we can write one for a molecule. The symbol of each occupied MO is written in parentheses, with the number of electrons in it as a superscript outside: the electron configuration of H₂ is (σ_{1s})².

4. Bond order. In a Lewis structure, bond order is the number of electron pairs per atom-to-atom linkage. The **MO bond order** is the number of electrons in bonding MOs minus the number in antibonding MOs, multiplied by $\frac{1}{2}$:

$$\text{Bond order} = \frac{1}{2}[(\text{no. of } e^- \text{ in bonding MOs}) - (\text{no. of } e^- \text{ in antibonding MOs})] \quad (11.1)$$

Here are three key points about MO bond order:

- Bond order > 0: the molecule is more stable than the separate atoms, so it *will* form. For H₂, the bond order is $\frac{1}{2}(2 - 0) = 1$.
- Bond order = 0: the molecule is as stable as the separate atoms, so it *will not* form (occurs when equal numbers of electrons occupy bonding and antibonding MOs).
- In general, the *higher* the bond order, the *stronger* the bond is.

Do He₂⁺ and He₂ Exist? One of the early triumphs of MO theory was its ability to *predict* the existence of He₂⁺, the helium molecule-ion, which consists of two He nuclei and three electrons. Let's use MO diagrams to see why He₂⁺ exists but He₂ doesn't:

- In He₂⁺, the 1s AOs form MOs (Figure 11.18A). The three electrons are distributed as a pair in the σ_{1s} MO and a lone electron in the σ_{1s}^* MO. The bond order is $\frac{1}{2}(2 - 1) = \frac{1}{2}$. Thus, He₂⁺ has a relatively weak bond, but it should exist. Indeed, this species has been observed frequently when He atoms collide with He⁺ ions. Its electron configuration is (σ_{1s})² (σ_{1s}^*)¹.
- In He₂, with two electrons in the σ_{1s} MO and two electrons in the σ_{1s}^* MO, both the bonding and antibonding orbitals are filled (Figure 11.18B). Stabilization from the electron pair in the bonding MO is canceled by destabilization from the electron pair in the antibonding MO. Because the bond order is zero [$\frac{1}{2}(2 - 2) = 0$], we predict, and experiment has so far confirmed, that a covalent He₂ molecule does not exist.

SAMPLE PROBLEM 11.3

Predicting Stability of Species Using MO Diagrams

Problem Use an MO diagram to find the bond order and predict whether H₂⁺ exists. If it exists, write its electron configuration.

Plan Since the 1s AOs form the MOs, the MO diagram is similar to the one for H₂. We find the number of electrons and distribute them one at a time to the MOs in order of increasing energy. We obtain the bond order with Equation 11.1 and write the electron configuration as described in the text.

Solution H₂ has two e⁻, so H₂⁺ has only one, which enters the bonding MO (see diagram in margin). The bond order is $\frac{1}{2}(1 - 0) = \frac{1}{2}$, so we predict that H₂⁺ exists. The electron configuration is (σ_{1s})¹.

Check The number of electrons in the MOs equals the number of electrons in the AOs.

Comment This species has been detected spectroscopically in the material around stars.

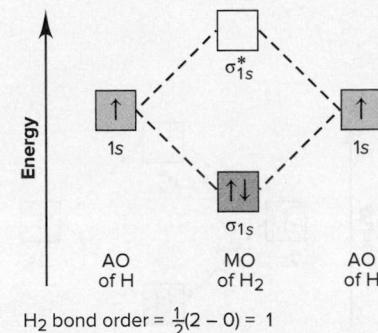

Figure 11.17 MO diagram for H₂. The vertical placement of the boxes indicates relative energies. Orbital occupancy is shown with arrows and color (darker color = full occupancy, paler color = half-filled, no color = empty).

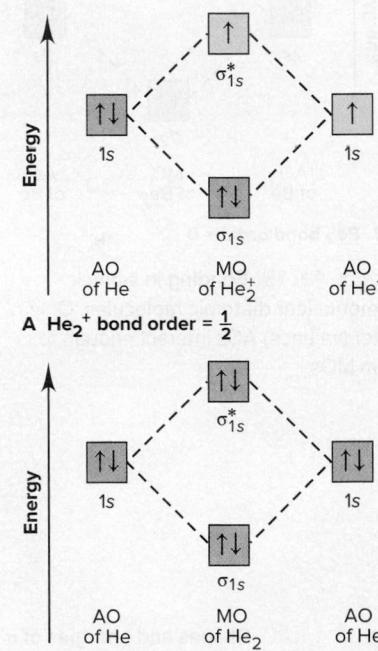

Figure 11.18 MO diagrams for He₂⁺ and He₂.

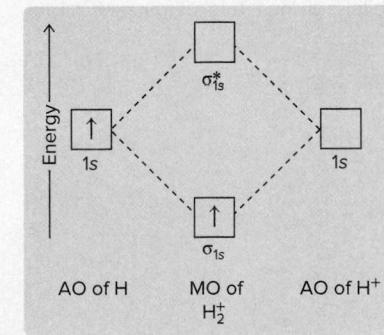

FOLLOW-UP PROBLEMS

11.3A Use an MO diagram to find the bond order and predict whether two H^- ions could form H_2^{2-} . If this species exists, write its electron configuration.

11.3B Use an MO diagram to find the bond order and predict whether two He^+ ions could form He_2^{2+} . If this species exists, write its electron configuration.

A SIMILAR PROBLEM 11.55

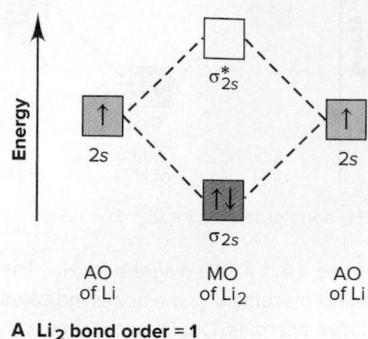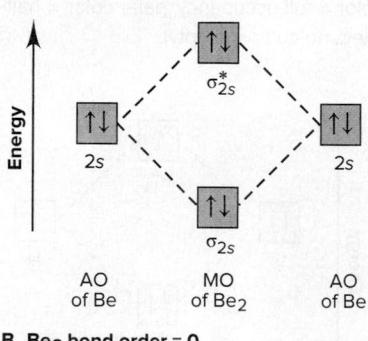

Figure 11.19 Bonding in s-block homonuclear diatomic molecules. Only outer (valence) AOs interact enough to form MOs.

Homonuclear Diatomic Molecules of Period 2 Elements

Homonuclear diatomic molecules are composed of two identical atoms. In addition to H_2 from Period 1, you’re familiar with N_2 , O_2 , and F_2 from Period 2 as the elemental forms under standard conditions. Others in Period 2— Li_2 , Be_2 , B_2 , C_2 , and Ne_2 —are observed, if at all, at high temperatures. We’ll divide them into molecules from the *s* block, Groups 1A(1) and 2A(2), and those from the *p* block, Groups 3A(13) through 8A(18).

Bonding in the s-Block Homonuclear Diatomic Molecules Both Li and Be occur as metals under normal conditions, but MO theory can examine their stability as diatomic gases, dilithium (Li_2) and diberyllium (Be_2).

These atoms have electrons in inner ($1s$) and outer ($2s$) AOs, but we ignore the inner ones because, in general, *only outer (valence) AOs interact enough to form MOs*. Like those formed from $1s$ AOs, these $2s$ AOs form σ MOs, cylindrically symmetrical around the internuclear axis.

- In Li_2 , the two valence electrons fill the bonding (σ_{2s}) MO, with opposing spins, leaving the antibonding (σ_{2s}^*) MO empty (Figure 11.19A). The bond order is $\frac{1}{2}(2 - 0) = 1$. In fact, Li_2 has been observed; the electron configuration is $(\sigma_{2s})^2$.
- In Be_2 , the four valence electrons fill the σ_{2s} and σ_{2s}^* MOs (Figure 11.19B), giving an orbital occupancy similar to that in He_2 . The bond order is $\frac{1}{2}(2 - 2) = 0$, and the ground state of Be_2 has never been observed.

Shape and Energy of MOs from Atomic *p*-Orbital Combinations In boron, atomic $2p$ orbitals are occupied. Recall that *p* orbitals can overlap by two modes, which correspond to two ways their wave functions combine (Figure 11.20):

- End-to-end combination gives a pair of σ MOs, σ_{2p} and σ_{2p}^* .
- Side-to-side combination gives a pair of pi (π) MOs, π_{2p} and π_{2p}^* .

Figure 11.20 Shapes and energies of σ and π MOs from combinations of $2p$ atomic orbitals. **A**, The p orbitals lying along the internuclear axis (designated p_x) overlap end to end and form σ_{2p} and σ_{2p}^* MOs. **B**, The p orbitals perpendicular to the internuclear axis overlap side to side and form two π MOs. (The p_y interactions, shown here, are the same as for the p_z orbitals, giving a total of four π MOs.)

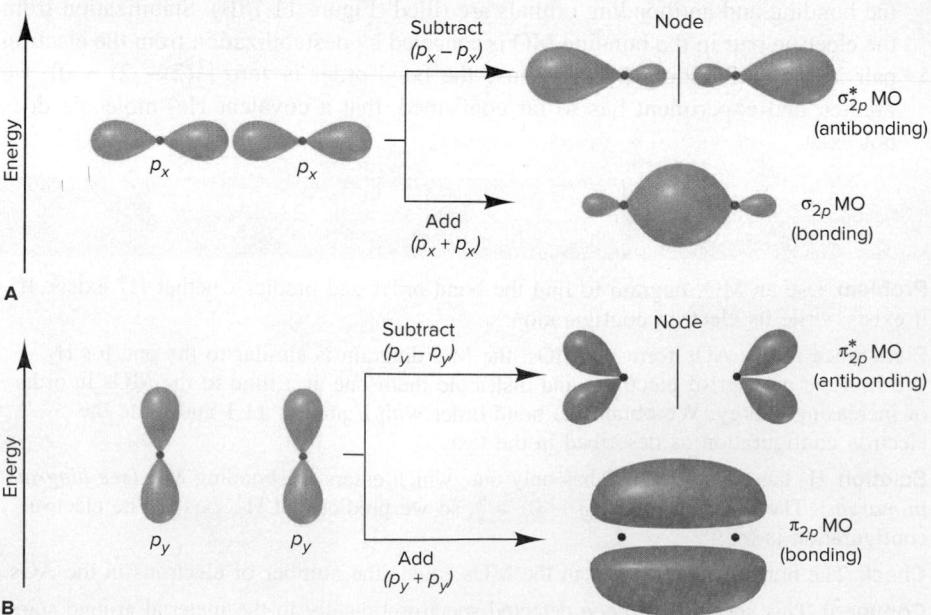

Despite the different shapes, MOs derived from *p* orbitals are like those from *s* orbitals. Bonding MOs have most of the electron density *between* the nuclei, and antibonding MOs have most of it *outside* the internuclear region, with a node between the nuclei.

The order of energy levels for MOs, whether bonding or antibonding, is based on the order of AO energy levels *and* on the mode of the *p*-orbital overlap:

- MOs formed from *2s* orbitals are *lower in energy* than MOs formed from *2p* orbitals because *2s* AOs are lower in energy than *2p* AOs.
- Bonding MOs are *lower in energy* than antibonding MOs: σ_{2p} is lower in energy than σ_{2p}^* and π_{2p} is lower than π_{2p}^* .
- Atomic *p* orbitals overlap more extensively end to end than side to side. Thus, the σ_{2p} MO is usually lower in energy than the π_{2p} MO. We also find that the destabilizing effect of the σ_{2p}^* MO is greater than that of the π_{2p}^* MO.

Thus, the energy order for MOs derived from *2p* orbitals is typically

Each atom has three mutually perpendicular *2p* orbitals. When the six *p* orbitals in two atoms combine, the two that interact end to end form one σ and one σ^* MO, and the two pairs of orbitals that interact side to side form two π MOs and two π^* MOs. Placing these orientations within the energy order gives the *expected* MO diagram for the *p*-block Period 2 homonuclear diatomic molecules (Figure 11.21A).

Recall that only AOs of similar energy interact enough to form MOs. This fact leads to two energy orders:

1. Without mixing of *s* and *p* orbitals: O_2 , F_2 , and Ne_2 . The order in Figure 11.21A assumes that *s* and *p* AOs are so different in energy that they do not interact; we say the orbitals do not *mix*. Lying at the right of Period 2, O, F, and Ne are relatively small. Thus, as electrons start to pair up in the half-filled *2p* orbitals, strong repulsions raise the energy of the *2p* orbitals high enough above the *2s* orbitals to prevent orbital mixing. Thus the energy order of the MOs derived from the *2p* orbitals is as expected for O_2 , F_2 , and Ne_2 :

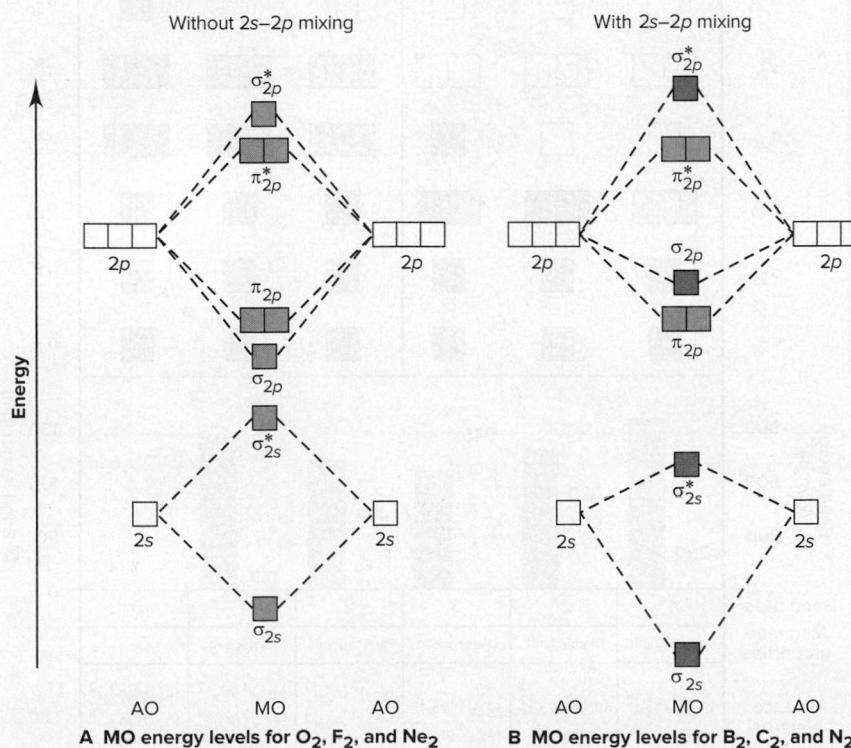

Figure 11.21 Relative MO energy levels for Period 2 homonuclear diatomic molecules. (For clarity, the MOs affected by mixing are shown in purple.)

2. With mixing of s and p orbitals: B_2 , C_2 , and N_2 . B, C, and N atoms are relatively large, with $2p$ AOs only half-filled, so repulsions are weaker. As a result, orbital energies are close enough for some mixing to occur between the $2s$ of one atom and the end-on $2p$ of the other. The effect is to *lower* the energy of the σ_{2s} and σ_{2s}^* MOs and *raise* the energy of the σ_{2p} and σ_{2p}^* MOs; the π MOs are not affected. The MO diagram for B_2 , C_2 , and N_2 reflects this mixing (Figure 11.21B). The only qualitative difference from the MO diagram for O_2 , F_2 , and Ne_2 is the *reversal in energy order* of the σ_{2p} and π_{2p} MOs:

$$\pi_{2p} < \sigma_{2p} < \pi_{2p}^* < \sigma_{2p}^*$$

Bonding in the p-Block Homonuclear Diatomic Molecules Figure 11.22 shows the MOs, electron occupancy, and some properties of B_2 through Ne_2 . Note that

1. *Higher bond order correlates with greater bond energy and shorter bond length.*

2. Orbital occupancy correlates with magnetic properties. Recall from Chapter 8 that if a substance has unpaired electrons, it is *paramagnetic*, and if all electrons are paired, the substance is *diamagnetic*; the same distinction applies to molecules. Let's examine the MO occupancy and some properties of these molecules:

- B_2 . The B_2 molecule has six outer electrons: four fill the σ_{2s} and σ_{2s}^* MOs. The remaining two electrons occupy the two π_{2p} MOs, one in each orbital, in keeping with Hund's rule. With four electrons in bonding MOs and two in antibonding MOs, the bond order of B_2 is $\frac{1}{2}(4 - 2) = 1$. As expected from the two lone electrons, B_2 is paramagnetic.
- C_2 . Two additional electrons in C_2 fill the two π_{2p} MOs. With two more bonding electrons than B_2 , the bond order of C_2 is 2 and the bond is stronger and shorter. But with all the electrons paired, C_2 is diamagnetic.
- N_2 . Two more electrons in N_2 fill the σ_{2p} MO, so the molecule is also diamagnetic. The bond order of 3 is consistent with the triple bond in the Lewis structure and with a stronger, shorter bond.

Figure 11.22 MO occupancy and some properties of B_2 through Ne_2 . Energy order and occupancy of MOs are above a bar graph showing bond energy and length, bond orders, magnetic properties, and outer (valence) electron configurations.

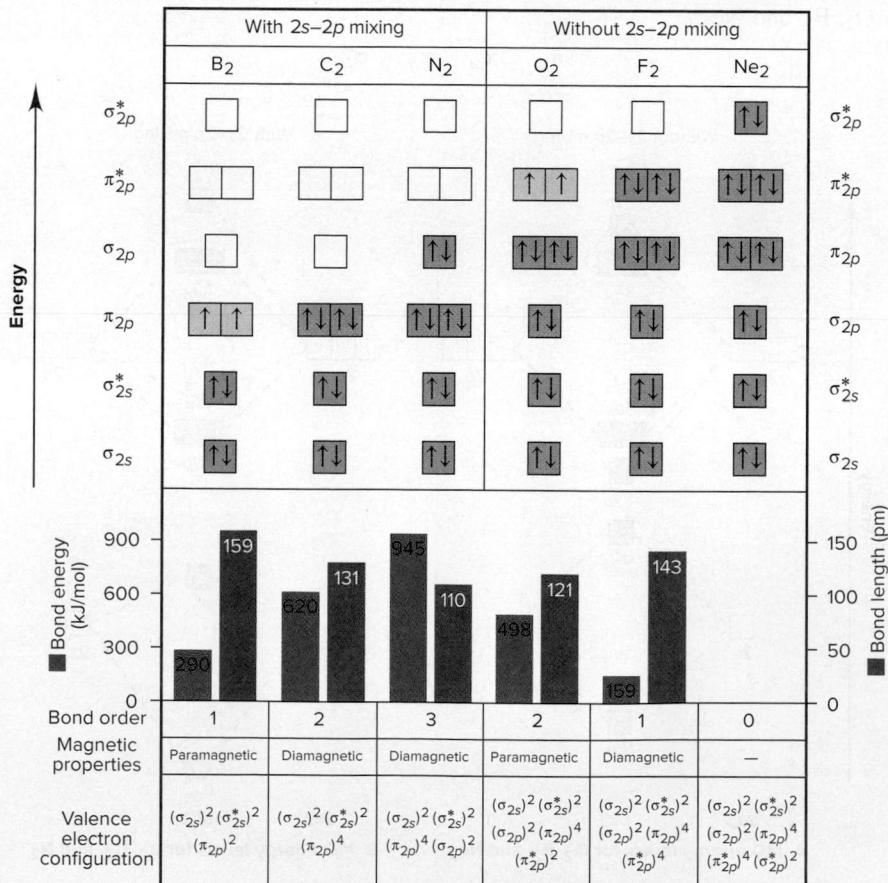

- O_2 . With this molecule, we see the power of MO theory over VB theory and others based on electrons in localized orbitals. It is impossible to write one Lewis structure consistent with the fact that O_2 has a double bond and is paramagnetic. We can write one structure with a double bond and paired electrons, and another with a single bond and two unpaired electrons:

MO theory resolves this paradox beautifully: with eight electrons in bonding MOs and four in antibonding MOs, the bond order is $\frac{1}{2}(8 - 4) = 2$, and the molecule is paramagnetic because *one* electron occupies each of *two* π_{2p}^* MOs and these two electrons have unpaired (parallel) spins. A thin stream of liquid O_2 will remain suspended between the poles of a powerful magnet (*see the chapter-opening photo*). As expected, the bond is weaker and longer than the one in N_2 .

- F_2 . Two more electrons in F_2 fill the π_{2p}^* orbitals, so it is diamagnetic. The bond has an order of 1 and is weaker and longer than the one in O_2 . Note that this bond is shorter than the single bond in B_2 but only about half as strong. We might have expected it to be stronger because F is smaller than B. But 18 electrons in the smaller volume of F_2 cause greater repulsions than the 10 electrons in B_2 , making the F_2 bond weaker.
- Ne_2 . The final member of the Period 2 series doesn't exist for the same reason He_2 doesn't: all the MOs are filled, which gives a bond order of zero.

SAMPLE PROBLEM 11.4

Using MO Theory to Explain Bond Properties

Problem Explain the following data with diagrams showing the occupancy of MOs:

	N_2	N_2^+	O_2	O_2^+
Bond energy (kJ/mol)	945	841	498	623
Bond length (pm)	110	112	121	112

Plan The data show that removing an electron from each parent molecule has opposite effects: N_2^+ has a weaker, longer bond than N_2 , but O_2^+ has a stronger, shorter bond than O_2 . We determine the valence electrons in each species, draw the sequence of MO energy levels (showing orbital mixing in N_2 but not in O_2), and fill them with electrons. To explain the data, we calculate bond orders, which relate directly to bond energy and inversely to bond length.

Solution Determining the valence electrons:

N has 5 valence e⁻, so N_2 has 10 and N_2^+ has 9.

O has 6 valence e⁻, so O_2 has 12 and O_2^+ has 11.

Drawing and filling the MO diagrams:

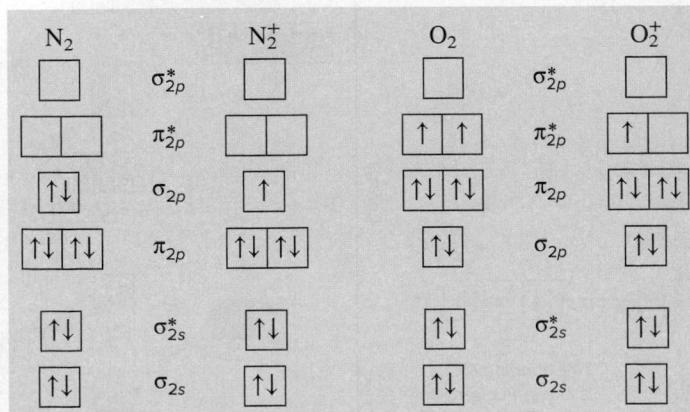

Calculating bond orders:

$$\frac{1}{2}(8 - 2) = 3 \quad \frac{1}{2}(7 - 2) = 2.5 \quad \frac{1}{2}(8 - 4) = 2 \quad \frac{1}{2}(8 - 3) = 2.5$$

Explaining the data:

- When N_2 becomes N_2^+ , a *bonding* electron is removed, so the bond order decreases. Thus, N_2^+ has a weaker, longer bond than N_2 .
- When O_2 becomes O_2^+ , an *antibonding* electron is removed, so the bond order increases. Thus, O_2^+ has a stronger, shorter bond than O_2 .

Check The answers make sense in terms of bond order, bond energy, and bond length. Check that the total number of bonding and antibonding electrons equals the total number of valence electrons for each species.

FOLLOW-UP PROBLEMS

11.4A Determine the bond orders for these other dinitrogen species: N_2^{2+} , N_2^{2-} , and N_2^{2-} . List the species in order of decreasing bond energy and in order of decreasing bond length.

11.4A Determine the bond orders for the following difluorine species: F_2^{2-} , F_2^- , F_2 , F_2^+ , and F_2^{2+} . List the species that exist in order of increasing bond energy and in order of increasing bond length.

SOME SIMILAR PROBLEMS 11.36 and 11.37

Student Hot Spot

Student data indicate that you may struggle with drawing molecular orbital diagrams. Access the Smartbook to view additional Learning Resources on this topic.

Two Heteronuclear Diatomic Molecules: HF and NO

Heteronuclear diatomic molecules have asymmetric MO diagrams because the AOs of the *different* atoms have unequal energies. Atoms with greater effective nuclear charge (Z_{eff}) pull their electrons closer, so they have more stable (lower energy) AOs (Section 8.1) and higher EN values (Section 9.5). Let's examine the bonding in HF and NO.

Bonding in HF To form the MOs in HF, we decide which AOs will combine. The high Z_{eff} of F means that its electrons are held so tightly that the 1s, 2s, and 2p orbitals have lower energy than the 1s of H. The half-filled 2p orbital of F interacts with the 1s of H through end-on overlap, which forms σ and σ^* MOs. The two filled 2p orbitals of F are called **nonbonding MOs**. Because they are not involved in bonding, they have the same energy as the isolated AOs (Figure 11.23A).

The bonding MO of HF is closer in energy to the AOs of F, so the F 2p orbital contributes more to the HF bond than the H 1s does. In polar covalent molecules, *bonding MOs are closer in energy to the AOs of the more electronegative atom*. In

Figure 11.23 The MO diagrams for (A) HF and (B) NO.

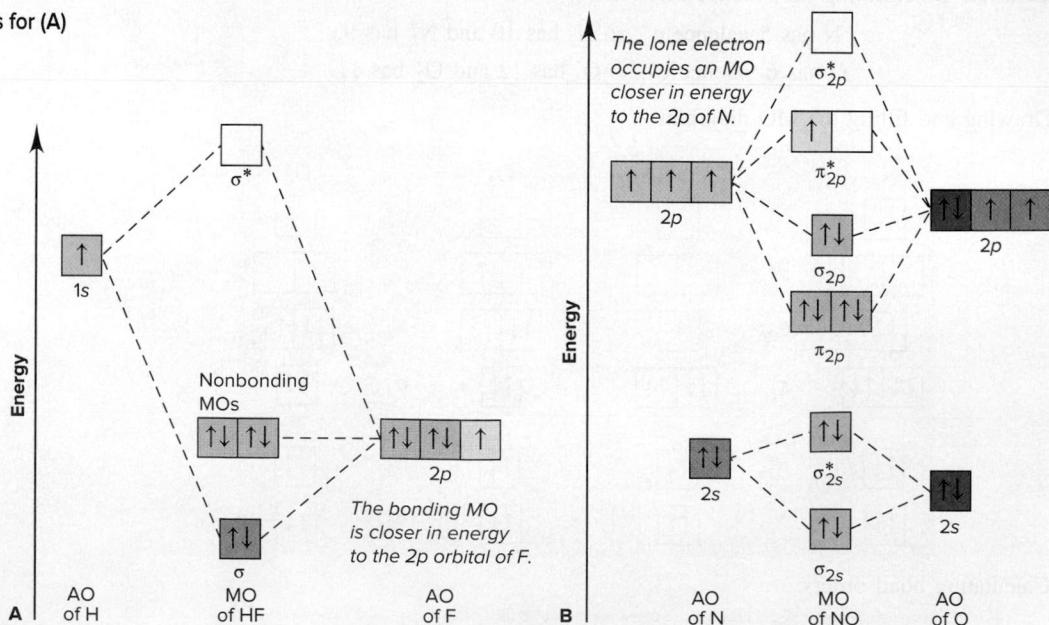

effect, fluorine's greater electronegativity lowers the energy of the bonding MO and draws the bonding electrons closer.

Bonding in NO Nitrogen monoxide (nitric oxide) is highly reactive because of its lone electron. Two possible Lewis structures for NO, with formal charges (Section 10.1), are

Both structures show a double bond, but the *measured* bond energy suggests a bond order *higher* than 2. Moreover, it is not clear where the lone electron resides, although the lower formal charges for structure I suggest that it is on the N.

The MO diagram is asymmetric, with the AOs of the more electronegative O lower in energy (Figure 11.23B). When the 11 valence electrons fill the MOs of NO, the lone electron occupies one of the π_{2p}^* orbitals. Eight bonding and three antibonding electrons give a bond order of $\frac{1}{2}(8 - 3) = 2.5$, more in keeping with the data than either Lewis structure. Bonding electrons lie in MOs closer in energy to the AOs of the O atom. The $2p$ orbitals of N contribute more to the orbital that holds the lone electron, so it spends more time closer to N. (This diagram shows the energy order *with* mixing of the $2s$ and $2p$ orbitals, as in Figure 11.21, but the result is the same as the order without mixing.)

Two Polyatomic Molecules: Benzene and Ozone

The orbital shapes and MO diagrams for polyatomic molecules are too complex for detailed treatment here. But we'll briefly discuss how the model eliminates the need for resonance forms and helps explain the effects of the absorption of energy.

Recall that we cannot draw one Lewis structure for either benzene or ozone, so we draw separate forms of a resonance hybrid. The VB model also uses resonance because it relies on *localized* bonds. In contrast, MO theory pictures a structure of delocalized σ and π MOs. Figure 11.24 shows the lowest energy π bonding MOs in benzene and ozone. The extended areas of electron density allow delocalization of one electron pair in the π bonding MO over the entire molecule, thus eliminating the need for separate resonance forms:

- In benzene, the upper and lower hexagonal lobes of this MO lie above and below the plane of the six C nuclei.
- In ozone, the two lobes of this MO extend over and under the three O nuclei.

The full MO diagrams for these molecules help us rationalize how bonding electrons in O_3 become excited and occupy empty antibonding orbitals when the molecule absorbs UV radiation in the stratosphere, and why the UV spectrum of benzene has its characteristic absorption bands.

› Summary of Section 11.3

- › Molecular orbital (MO) theory treats a molecule as a collection of nuclei with MOs delocalized over the entire structure.
- › Atomic orbitals of comparable energy can be added or subtracted to obtain bonding or antibonding MOs, respectively.
- › Bonding MOs, whether σ or π , have most of the electron density between the nuclei and are lower in energy than the AOs that combine to form them; most of the electron density in antibonding MOs does not lie between the nuclei, so these MOs are higher in energy.
- › MOs are filled in order of their energy with paired electrons having opposite spins.
- › MO diagrams show energy levels and orbital occupancy. Diagrams for the Period 2 homonuclear diatomic molecules explain bond energy, bond length, and magnetic behavior.
- › In heteronuclear diatomic molecules, the more electronegative atom contributes more to the bonding MOs.
- › MO theory eliminates the need for resonance forms to depict polyatomic molecules.

Figure 11.24 The lowest energy π bonding MOs in benzene and ozone.

CHAPTER REVIEW GUIDE

Learning Objectives

Relevant section (§) and/or sample problem (SP) numbers appear in parentheses.

Understand These Concepts

- The main ideas of valence bond theory—orbital overlap, opposing electron spins, and hybridization—as a means of rationalizing molecular shapes (§11.1)
- How orbitals mix to form hybrid orbitals with different spatial orientations (§11.1)
- The distinction between end-to-end and side-to-side overlap and the origin of sigma (σ) and pi (π) bonds in simple molecules (§11.2)
- How the two modes of orbital overlap lead to single, double, and triple bonds (§11.2)
- Why π bonding restricts rotation around double bonds (§11.2)
- The distinction between the localized bonding of VB theory and the delocalized bonding of MO theory (§11.3)
- How addition or subtraction of AOs forms bonding or anti-bonding MOs (§11.3)

- The shapes of MOs formed from combinations of two s orbitals and combinations of two p orbitals (§11.3)
- How MO bond order predicts the stability of molecular species (§11.3)
- How MO theory explains the bonding and magnetic properties of homonuclear and heteronuclear diatomic molecules of Period 2 elements (§11.3)

Master These Skills

- Using a partial orbital diagram and molecular shape to postulate the hybrid orbitals used by a central atom (SP 11.1)
- Describing the types of orbitals and bonds in a molecule (SP 11.2)
- Using MO diagrams to find the bond order and predict the stability of molecular species and writing the electron configuration of a species that exists (SP 11.3)
- Explaining bond properties with MO theory (SP 11.4)

Key Terms

Page numbers appear in parentheses.

antibonding MO (456)
bonding MO (456)
homonuclear diatomic molecule (458)
hybrid orbital (444)
hybridization (444)

MO bond order (457)
molecular orbital (MO) diagram (457)
molecular orbital (MO) theory (455)
molecular orbital (MO) (455)

nonbonding MO (462)
 π (π) bond (452)
 π (π) MO (458)
sigma (σ) bond (452)
sigma (σ) MO (456)
 sp hybrid orbital (444)

sp^2 hybrid orbital (446)
 sp^3 hybrid orbital (447)
 sp^3d hybrid orbital (447)
 sp^3d^2 hybrid orbital (448)
valence bond (VB) theory (443)

Key Equations and Relationships

Page number appears in parentheses.

11.1 Calculating the MO bond order (457): Bond order = $\frac{1}{2}[(\text{no. of } e^- \text{ in bonding MOs}) - (\text{no. of } e^- \text{ in antibonding MOs})]$

BRIEF SOLUTIONS TO FOLLOW-UP PROBLEMS

11.1A (a) The central Be atom has two electron groups (two bonds); the electron-group arrangement and the molecular shape are linear, so Be is sp hybridized:

(b) The central Si atom has four electron groups (four bonds); the electron-group arrangement and the molecular shape are tetrahedral, so Si is sp^3 hybridized:

(c) The central Xe atom has six electron groups (four bonds and two lone pairs); the electron-group arrangement is octahedral and the molecular shape is square planar, so Xe is sp^3d^2 hybridized:

11.1B (a) The central N atom has three electron groups (a single bond, a double bond, and one unpaired electron); the electron-group arrangement is trigonal planar and the molecular shape is bent, so N is sp^2 hybridized:

(b) The central P atom has four electron groups (three bonds and one lone pair); the electron-group arrangement is tetrahedral and the molecular shape is trigonal pyramidal, so P is sp^3 hybridized:

(c) The central Br atom has six electron groups (five bonds and one lone pair); the electron-group arrangement is octahedral and the molecular shape is square pyramidal, so Br is sp^3d^2 hybridized:

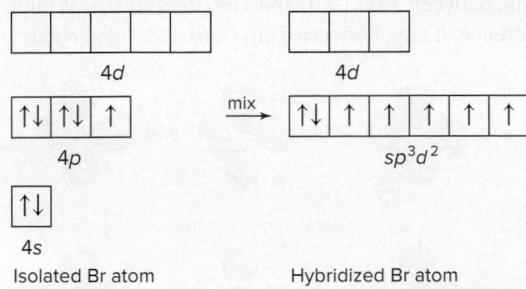

11.2A (a) H—C≡N:

HCN is linear (C has two electron groups), so C is sp hybridized. N is also sp hybridized. One sp of C overlaps the $1s$ of H to form a σ bond. The other sp of C overlaps one sp of N to form a σ bond. The other sp of N holds a lone pair. Two unhybridized p orbitals of N and two of C overlap to form two π bonds.

(b) $\ddot{\text{O}}=\text{C}=\ddot{\text{O}}$

CO_2 is linear (C has two electron groups), so C is sp hybridized. Both O atoms are sp^2 hybridized. Each sp of C overlaps one sp^2 of an O to form a σ bond, which gives a total of two σ bonds. Each of the two unhybridized p orbitals of C forms a π bond with the unhybridized p of one of the two O atoms. Two sp^2 orbitals of each O hold lone pairs.

11.2B (a) :C≡O:

Both C and O are sp hybridized. One sp of C overlaps one sp of O to form one σ bond. The other sp of both C and O holds a lone

pair. Two unhybridized p orbitals of C and two of O overlap to form two π bonds.

(b)

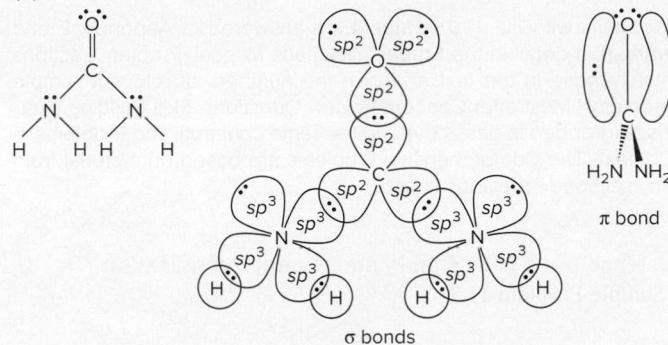

The C and O are sp^2 hybridized, and each N is sp^3 hybridized. The sp^3 orbitals of each N form three σ bonds, two with the $1s$ of two H atoms and one with an sp^2 of the C. A lone pair fills the fourth sp^3 of each N. The third sp^2 of the C forms a σ bond to one sp^2 of the O, and lone pairs fill the other sp^2 orbitals of the O. Unhybridized p orbitals on C and O form a π bond.

11.3A Each H^- ion has two electrons so H_2^- has four electrons. Two electrons are in the σ_{1s} MO and two electrons are in the σ_{1s}^* MO. Does not exist: bond order = $\frac{1}{2}(2 - 2) = 0$.

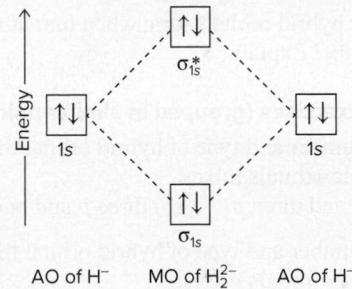

11.3B Each He^+ ion has one electron so He_2^{2+} has two electrons. Both electrons are in the σ_{1s} MO. Does exist: bond order = $\frac{1}{2}(2 - 0) = 1$; (σ_{1s})².

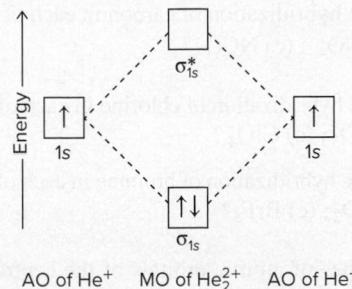

11.4A Bond orders: $\text{N}_2^+ = 2$; $\text{N}_2^- = 2.5$; $\text{N}_2^{2-} = 2$

Bond energy: $\text{N}_2^- > \text{N}_2^{2+} = \text{N}_2^{2-}$

Bond length: $\text{N}_2^{2+} = \text{N}_2^{2-} > \text{N}_2^-$

11.4B Bond orders: $\text{F}_2^{2-} = 0$; $\text{F}_2^- = 0.5$; $\text{F}_2 = 1$; $\text{F}_2^+ = 1.5$; $\text{F}_2^{2+} = 2$

Bond energy: F_2^- does not exist; $\text{F}_2^- < \text{F}_2 < \text{F}_2^+ < \text{F}_2^{2+}$

Bond length: $\text{F}_2^{2+} < \text{F}_2^+ < \text{F}_2 < \text{F}_2^-$; F_2^{2+} does not exist

PROBLEMS

Problems with **colored** numbers are answered in Appendix E and worked in detail in the Student Solutions Manual. Problem sections match those in the text and give the numbers of relevant sample problems. Most offer Concept Review Questions, Skill-Building Exercises (grouped in pairs covering the same concept), and Problems in Context. The Comprehensive Problems are based on material from any section or previous chapter.

Valence Bond (VB) Theory and Orbital Hybridization

(Sample Problem 11.1)

Concept Review Questions

11.1 What type of central-atom orbital hybridization corresponds to each electron-group arrangement: (a) trigonal planar; (b) octahedral; (c) linear; (d) tetrahedral; (e) trigonal bipyramidal?

11.2 What is the orbital hybridization of a central atom that has one lone pair and bonds to: (a) two other atoms; (b) three other atoms; (c) four other atoms; (d) five other atoms?

11.3 How do carbon and silicon differ with regard to the *types* of orbitals available for hybridization? Explain.

11.4 How many hybrid orbitals form when four atomic orbitals of a central atom mix? Explain.

Skill-Building Exercises (grouped in similar pairs)

11.5 Give the number and type of hybrid orbital that forms when each set of atomic orbitals mixes:

(a) two *d*, one *s*, and three *p* (b) three *p* and one *s*

11.6 Give the number and type of hybrid orbital that forms when each set of atomic orbitals mixes:

(a) one *p* and one *s* (b) three *p*, one *d*, and one *s*

11.7 What is the hybridization of nitrogen in each of the following: (a) NO; (b) NO₂; (c) NO₂⁻?

11.8 What is the hybridization of carbon in each of the following: (a) CO₃²⁻; (b) C₂O₄²⁻; (c) NCO⁻?

11.9 What is the hybridization of chlorine in each of the following: (a) ClO₂; (b) ClO₃⁻; (c) ClO₄⁻?

11.10 What is the hybridization of bromine in each of the following: (a) BrF₃; (b) BrO₃⁻; (c) BrF₅?

11.11 Which types of atomic orbitals of the central atom mix to form hybrid orbitals in (a) SiClH₃; (b) CS₂; (c) SCl₃F; (d) NF₃?

11.12 Which types of atomic orbitals of the central atom mix to form hybrid orbitals in (a) Cl₂O; (b) BrCl₃; (c) PF₅; (d) SO₃²⁻?

11.13 Phosphine (PH₃) reacts with borane (BH₃) as follows:

(a) Which of the accompanying illustrations in the next column depicts the change, if any, in the orbital hybridization of P during this reaction? (b) Which depicts the change, if any, in the orbital hybridization of B?

11.14 The illustrations below depict differences in orbital hybridization of some tellurium (Te) fluorides. (a) Which depicts the difference, if any, between TeF₆ (*left*) and TeF₅⁻ (*right*)? (b) Which depicts the difference, if any, between TeF₄ (*left*) and TeF₆ (*right*)?

11.15 Use partial orbital diagrams to show how the atomic orbitals of the central atom lead to hybrid orbitals in (a) GeCl₄; (b) BCl₃; (c) CH₃⁺.

11.16 Use partial orbital diagrams to show how the atomic orbitals of the central atom lead to hybrid orbitals in (a) BF₄⁻; (b) PO₄³⁻; (c) SO₃.

11.17 Use partial orbital diagrams to show how the atomic orbitals of the central atom lead to hybrid orbitals in (a) SeCl₂; (b) H₃O⁺; (c) IF₄⁻.

11.18 Use partial orbital diagrams to show how the atomic orbitals of the central atom lead to hybrid orbitals in (a) AsCl₃; (b) SnCl₂; (c) PF₆⁻.

Problems in Context

11.19 Methyl isocyanate, CH₃-N=C=O, is an intermediate in the manufacture of many pesticides. In 1984, a leak from a manufacturing plant resulted in the death of more than 2000 people in Bhopal, India. What are the hybridizations of the N atom and the two C atoms in methyl isocyanate? Sketch the molecular shape.

Modes of Orbital Overlap and the Types of Covalent Bonds

(Sample Problem 11.2)

Concept Review Questions

11.20 Are these statements true or false? Correct any false ones.

- (a) Two σ bonds comprise a double bond.
- (b) A triple bond consists of one π bond and two σ bonds.
- (c) Bonds formed from atomic *s* orbitals are always σ bonds.

- (d) A π bond restricts rotation about the σ -bond axis.
 (e) A π bond consists of two pairs of electrons.
 (f) End-to-end overlap results in a bond with electron density above and below the bond axis.

Skill-Building Exercises (grouped in similar pairs)

11.21 Identify the hybrid orbitals used by the central atom and the type(s) of bonds formed in (a) NO_3^- ; (b) CS_2 ; (c) CH_2O .

11.22 Identify the hybrid orbitals used by the central atom and the type(s) of bonds formed in (a) O_3 ; (b) I_3^- ; (c) COCl_2 (C is central).

11.23 Identify the hybrid orbitals used by the central atom(s) and the type(s) of bonds formed in (a) FNO ; (b) C_2F_4 ; (c) $(\text{CN})_2$.

11.24 Identify the hybrid orbitals used by the central atom(s) and the type(s) of bonds formed in (a) BrF_3 ; (b) $\text{CH}_3\text{C}\equiv\text{CH}$; (c) SO_2 .

Problem in Context

11.25 2-Butene ($\text{CH}_3\text{CH}=\text{CHCH}_3$) is a starting material in the manufacture of lubricating oils and many other compounds. Draw two different structures for 2-butene, indicating the σ and π bonds in each.

Molecular Orbital (MO) Theory and Electron Delocalization

(Sample Problems 11.3 and 11.4)

Concept Review Questions

11.26 Two p orbitals from one atom and two p orbitals from another atom are combined to form molecular orbitals for the joined atoms. How many MOs will result from this combination? Explain.

11.27 Certain atomic orbitals on two atoms were combined to form the following MOs. Name the atomic orbitals used and the MOs formed, and explain which MO has higher energy:

11.28 How do the bonding and antibonding MOs formed from a given pair of AOs compare to each other with respect to (a) energy; (b) presence of nodes; (c) internuclear electron density?

11.29 Antibonding MOs always have at least one node. Can a bonding MO have a node? If so, draw an example.

Skill-Building Exercises (grouped in similar pairs)

11.30 How many electrons does it take to fill (a) a σ bonding MO; (b) a π antibonding MO; (c) the MOs formed from combination of the 1s orbitals of two atoms?

11.31 How many electrons does it take to fill (a) the MOs formed from combination of the $2p$ orbitals of two atoms; (b) a σ_{2p}^* MO; (c) the MOs formed from combination of the $2s$ orbitals of two atoms?

11.32 The molecular orbitals depicted are derived from $2p$ atomic orbitals in F_2^+ . (a) Give the orbital designations. (b) Which is

occupied by at least one electron in F_2^+ ? (c) Which is occupied by only one electron in F_2^+ ?

11.33 The molecular orbitals depicted below are derived from $n = 2$ atomic orbitals. (a) Give the orbital designations. (b) Which is highest in energy? (c) Lowest in energy? (d) Rank the MOs in order of increasing energy for B_2 .

11.34 Use an MO diagram and the bond order you obtain from it to answer these questions: (a) Is Be_2^+ stable? (b) Is Be_2^+ diamagnetic? (c) What is the outer (valence) electron configuration of Be_2^+ ?

11.35 Use an MO diagram and the bond order you obtain from it to answer these questions: (a) Is O_2^- stable? (b) Is O_2^- paramagnetic? (c) What is the outer (valence) electron configuration of O_2^- ?

11.36 Use MO diagrams to rank C_2^- , C_2 , and C_2^+ in order of (a) increasing bond energy; (b) increasing bond length.

11.37 Use MO diagrams to rank B_2^+ , B_2 , and B_2^- in order of (a) decreasing bond energy; (b) decreasing bond length.

Comprehensive Problems

11.38 Predict the shape, state the hybridization of the central atom, and give the ideal bond angle(s) and any expected deviations for: (a) BrO_3^- (b) AsCl_4^- (c) SeO_4^{2-} (d) BiF_5^{2-} (e) SbF_4^+ (f) AlF_6^{3-} (g) IF_7

11.39 Butadiene (*right*) is a colorless gas used to make synthetic rubber and many other compounds. (a) How many σ bonds and π bonds does the molecule have? (b) Are *cis-trans* arrangements about the double bonds possible? Explain.

11.40 Epinephrine (or adrenaline; *below*) is a naturally occurring hormone that is also manufactured commercially for use as a heart stimulant, a nasal decongestant, and a glaucoma treatment.

(a) What is the hybridization of each C, O, and N atom? (b) How many σ bonds does the molecule have? (c) How many π electrons are delocalized in the ring?

- 11.41** Use partial orbital diagrams to show how the atomic orbitals of the central atom lead to the hybrid orbitals in:
 (a) IF_2^- (b) ICl_3 (c) XeOF_4 (d) BHF_2

- 11.42** Isoniazid (*below*) is an antibacterial agent that is very useful in treating many common strains of tuberculosis.

- (a) How many σ bonds are in the molecule? (b) What is the hybridization of each C and N atom?

- 11.43** Hydrazine, N_2H_4 , and carbon disulfide, CS_2 , react to form a cyclic molecule (*below*). (a) Draw Lewis structures for N_2H_4 and CS_2 . (b) How do electron-group arrangement, molecular shape, and hybridization of N change when N_2H_4 reacts to form the product? (c) How do electron-group arrangement, molecular shape, and hybridization of C change when CS_2 reacts to form the product?

- 11.44** In each of the following equations, what hybridization change, if any, occurs for the underlined atom?

- (a) $\underline{\text{BF}}_3 + \text{NaF} \longrightarrow \text{Na}^+\underline{\text{BF}}_4^-$
 (b) $\underline{\text{PCl}}_3 + \text{Cl}_2 \longrightarrow \text{PCl}_5$
 (c) $\text{HC}\equiv\text{CH} + \text{H}_2 \longrightarrow \text{H}_2\text{C}=\text{CH}_2$
 (d) $\underline{\text{SiF}}_4 + 2\text{F}^- \longrightarrow \text{SiF}_6^{2-}$
 (e) $\underline{\text{SO}}_2 + \frac{1}{2}\text{O}_2 \longrightarrow \text{SO}_3$

- 11.45** The ionosphere lies about 100 km above Earth's surface. This layer of the atmosphere consists mostly of NO, O_2 , and N_2 , and photoionization creates NO^+ , O_2^+ , and N_2^+ . (a) Use MO theory to compare the bond orders of the molecules and ions. (b) Does the magnetic behavior of each species change when its ion forms?

- 11.46** Glyphosate (*below*) is a common herbicide that is relatively harmless to animals but deadly to most plants. Describe the shape around and the hybridization of the P, N, and three numbered C atoms.

- 11.47** Tryptophan is one of the amino acids found in proteins:

- (a) What is the hybridization of each of the numbered C, N, and O atoms? (b) How many σ bonds are present in tryptophan? (c) Predict the bond angles at points a, b, and c.

- 11.48** Some species consisting of just two oxygen atoms are the oxygen molecule, O_2 ; the peroxide ion, O_2^- ; the superoxide ion, O_2^+ ; and the dioxygenyl ion, O_2^+ . Draw an MO diagram for each, rank the species in order of increasing bond length, and find the number of unpaired electrons in each.

- 11.49** Molecular nitrogen, carbon monoxide, and cyanide ion are isoelectronic. (a) Draw an MO diagram for each. (b) CO and CN^- are toxic. What property may explain why N_2 isn't?

- 11.50** Government agencies that deal with health issues are concerned that the American diet contains too much meat, and numerous recommendations have been made urging people to consume more fruit and vegetables. One of the richest sources of vegetable protein is soy, available in many forms. One form is soybean curd, or tofu, which is a staple of many Asian diets. Chemists have isolated an anticancer agent called *genistein* from tofu, which may explain the much lower incidence of cancer among people in the Far East. A valid Lewis structure for genistein is

- (a) Is the hybridization of each C in the right-hand ring the same? Explain. (b) Is the hybridization of the O atom in the center ring the same as that of the O atoms in the OH groups? Explain. (c) How many carbon-oxygen σ bonds are there? How many carbon-oxygen π bonds? (d) Do all the lone pairs on oxygens occupy the same type of hybrid orbital? Explain.

- 11.51** An organic chemist synthesizes the molecule below:

- (a) Which of the orientations of hybrid orbitals shown below are present in the molecule? (b) Are there any present that are not shown below? If so, what are they? (c) How many of each type of hybrid orbital are present?

- 11.52** Simple proteins consist of amino acids linked together in a long chain; a small portion of such a chain is

Experiment shows that rotation about the C—N bond (indicated by the arrow) is somewhat restricted. Explain with resonance structures, and show the types of bonding involved.

11.53 Sulfur forms oxides, oxoanions, and halides. What is the hybridization of the central S in SO_2 , SO_3 , SO_3^{2-} , SCl_4 , SCl_6 , and S_2Cl_2 (atom sequence Cl—S—S—Cl)?

11.54 The compound 2,6-dimethylpyrazine (*below*) gives chocolate its odor and is used in flavorings. (a) Which atomic orbitals mix to form the hybrid orbitals of N? (b) In what type of hybrid orbital do the lone pairs of N reside? (c) Is C in CH_3 hybridized the same as any C in the ring? Explain.

11.55 Use an MO diagram to find the bond order and predict whether H_2^- exists.

11.56 Acetylsalicylic acid (aspirin), the most widely used medicine in the world, has the Lewis structure shown. (a) What is the hybridization of each C and each O atom?

(b) How many localized π bonds are present? (c) How many C atoms have a trigonal planar shape around them? A tetrahedral shape?

11.57 Linoleic acid is an essential fatty acid found in many vegetable oils, such as soy, peanut, and cottonseed. A key structural feature of the molecule is the *cis* orientation around its two double bonds, where R_1 and R_2 represent two different groups that form the rest of the molecule.

(a) How many different compounds are possible, changing only the *cis-trans* arrangements around these two double bonds?
 (b) How many are possible for a similar compound with three double bonds?

12

Intermolecular Forces: Liquids, Solids, and Phase Changes

12.1 An Overview of Physical States and Phase Changes

12.2 Quantitative Aspects of Phase Changes

Heat Involved in Phase Changes
Equilibrium Nature of Phase Changes
Phase Diagrams

12.3 Types of Intermolecular Forces

How Close Can Molecules Approach Each Other?
Ion-Dipole Forces
Dipole-Dipole Forces
The Hydrogen Bond

Polarizability and Induced Dipole Forces

Dispersion (London) Forces

12.4 Properties of the Liquid State

Surface Tension
Capillarity
Viscosity

12.5 The Uniqueness of Water

Solvent Properties
Thermal Properties
Surface Properties
Unusual Density of Solid Water

12.6 The Solid State: Structure, Properties, and Bonding

Structural Features
Crystalline Solids
Amorphous Solids
Bonding in Solids: Molecular Orbital Band Theory

12.7 Advanced Materials

Electronic Materials
Liquid Crystals
Ceramic Materials
Polymeric Materials
Nanotechnology

Source: © Franck Charton/hemis.fr/Getty Images

Concepts and Skills to Review Before You Study This Chapter

- › properties of gases, liquids, and solids (Section 5.1)
- › kinetic-molecular theory of gases (Section 5.5)
- › kinetic and potential energy (Section 6.1)
- › enthalpy change, heat capacity, and Hess's law (Sections 6.2, 6.3, and 6.5)
- › diffraction of light (Section 7.1)
- › Coulomb's law (Section 9.2)
- › chemical bonding models (Chapter 9)
- › molecular polarity (Section 10.3)
- › molecular orbitals in diatomic molecules (Section 11.3)

All the matter in and around you occurs in one or more of the three physical states—gas, liquid, or solid. Under different conditions, many substances can occur in any of the states. We're all familiar with the states of water, all of which can be seen in the photo of a hot spring in Yellowstone National Park in winter. We inhale and exhale gaseous water; drink, excrete, and wash with liquid water; and shovel, slide on, or cool our drinks with solid water. And, given the right conditions, other solids (gold jewelry, glass), liquids (gasoline, antifreeze), and gases (air, CO_2 bubbles) can exist in one or both of the other states.

The three states were introduced in Chapter 1, and their properties were compared when we examined gases in Chapter 5. You saw there that the particles in gases are, on average, very far apart. Now, we examine liquids and solids, which are called *condensed states* because *their particles are very close together*.

IN THIS CHAPTER . . . We explore the interplay of forces that give rise to the three states of matter and their changes, with special attention to liquids and solids.

- › We use kinetic-molecular theory to see how relative magnitudes of potential and kinetic energy account for the behavior of gases, liquids, and solids and how temperature is related to phase changes.
- › We calculate the heat associated with warming or cooling a phase and with a phase change.
- › We highlight the effects of temperature and pressure on phases and their changes with phase diagrams.
- › We describe the types and relative strengths of the intermolecular forces that give rise to the phases and phase changes of pure substances.
- › We see how intermolecular forces underlie the properties of liquids.
- › As a special case, we trace the unique and vital physical properties of water to the electron configurations of the atoms making up its molecules.
- › We discuss the properties of solids, emphasizing the relation between type of bonding and predominant intermolecular force, and we examine crystal structures and two of the methods used to study them.
- › We introduce key features of several kinds of advanced materials—semiconductors, liquid crystals, ceramics, polymers, and nanostructures.

12.1 AN OVERVIEW OF PHYSICAL STATES AND PHASE CHANGES

Each physical state is called a **phase**, a physically distinct, homogeneous part of a system. The water in a closed container constitutes one phase; the water vapor above the liquid is a second phase; add some ice, and there are three phases.

In this section, you'll see that interactions between the potential energy and the kinetic energy of the particles give rise to the properties of each phase:

- The *potential energy* in the form of **intermolecular forces** (or, more generally, *interparticle forces*) tends to draw the molecules together. According to Coulomb's law, the electrostatic potential energy depends on the charges of the particles and

the distances between them (Section 9.2). We'll examine the various types of intermolecular forces in Section 12.3.

- The *kinetic energy* associated with the random motion of the molecules tends to disperse them. It is related to their average speed and is proportional to the absolute temperature (Section 5.5).

These interactions also explain **phase changes**—liquid to solid, solid to gas, and so forth, or even one solid form to another.

A Kinetic-Molecular View of the Three States Imagine yourself among the particles in any of the three states of water. Look closely and you'll discover two types of electrostatic forces at work:

- Intramolecular* (bonding) forces exist *within* each molecule. The *chemical* behavior of the three states is identical because all of them consist of the same bent, polar H–O–H molecules, each held together by identical covalent bonding forces.
- Intermolecular* (nonbonding) forces exist *between* the molecules. The *physical* behavior of the states is different because the strengths of these forces differ from state to state.

Whether a substance occurs as a gas, liquid, or solid depends on the interplay of the potential and kinetic energy:

- In a gas*, the potential energy (energy of attraction) is small relative to the kinetic energy (energy of motion); thus, on average, the particles are far apart. This large distance has several macroscopic consequences: a gas fills its container, is highly compressible, and flows easily through another gas (Table 12.1).
- In a liquid*, attractions are stronger because the particles are touching, but they have enough kinetic energy to move randomly around each other. Thus, a liquid conforms to the shape of its container but has a surface, it resists an applied force and thus compresses very slightly, and it flows, but *much* more slowly than a gas.
- In a solid*, the attractions dominate the motion so much that the particles are fixed in position relative to one another, just jiggling in place. Thus, a solid has its own shape, compresses even less than a liquid, and does not flow significantly.

Table 12.1 A Macroscopic Comparison of Gases, Liquids, and Solids

State	Shape and Volume	Compressibility	Ability to Flow
Gas	Conforms to shape and volume of container	High	High
Liquid	Conforms to shape of container; volume limited by surface	Very low	Moderate
Solid	Maintains its own shape and volume	Almost none	Almost none

Relative ability to flow influences the degree of mixing and, thus, composition in nature.

Source: © Christopher Meder Photography/Shutterstock.com

The environment provides a perfect demonstration of these differences in ability to flow (*see photo*). Atmospheric gases mix so well that the lowest 80 km of air has a uniform composition. Much less mixing in the oceans allows the composition at various depths to support different species. And rocks intermingle so little that adjacent strata remain separated for millions of years.

Types of Phase Changes and Their Enthalpies When we consider phase changes, understanding the effect of temperature is critical:

- As *temperature increases*, the average kinetic energy does too, so the particles move faster and overcome attractions more easily.
- As *temperature decreases*, the average kinetic energy does too, so particles move more slowly and attractions can pull them together more easily.

Pressure also affects phase changes, most dramatically when gases are involved and to a lesser extent with liquids. Each phase change has a name and an associated enthalpy change:

- Gas to liquid, and vice versa.* As the temperature drops (and/or the pressure rises), the molecules in the gas phase come together and form a liquid in the

process of **condensation**; the opposite process, changing from a liquid to a gas, is **vaporization**.

2. Liquid to solid, and vice versa. As the temperature drops further, the particles move more slowly and become fixed in position in the process of **freezing**; the opposite change is called **melting**, or **fusion**. (For most substances, an increase in pressure supports freezing as well.) In common speech, *freezing* implies low temperature because we think of water. But, for example, molten metals freeze (solidify) at much higher temperatures, which gives them many medical, industrial, and artistic applications, such as gold dental crowns, steel auto bodies, and bronze statues.

3. Gas to solid, and vice versa. All three states of water are familiar because they are stable under ordinary conditions. Carbon dioxide, on the other hand, is familiar as a gas and a solid (dry ice), but liquid CO₂ occurs only at pressures of 5.1 atm or greater. At ordinary conditions, solid CO₂ changes directly to a gas, a process called **sublimation**. Freeze-dried foods are prepared by freezing the food and subliming the water. The opposite process, changing from a gas directly into a solid, is called **deposition**—ice crystals form on a cold window from the deposition of water vapor (Figure 12.1A).

The accompanying enthalpy changes are either exothermic or endothermic:

- **Exothermic changes.** As the molecules of a gas attract each other into a liquid, and then become fixed in a solid, the system of particles *loses* energy, which is released as heat. Thus, *condensing, freezing, and deposition are exothermic changes*.
- **Endothermic changes.** Heat must be absorbed by the system to overcome the attractive forces that keep the particles fixed in place in a solid or near each other in a liquid. Thus, *melting, vaporizing, and subliming are endothermic changes*.

Sweating has a cooling effect because heat from your body vaporizes the water. To achieve this cooling, cats lick themselves and dogs pant (Figure 12.1B).

For a pure substance, each phase change is accompanied by a standard enthalpy change, given in units of *kilojoules per mole* (measured at 1 atm and the temperature of the change). For vaporization, it is the **heat (or enthalpy) of vaporization ($\Delta H_{\text{vap}}^{\circ}$)**, and for fusion (melting), it is the **heat (or enthalpy) of fusion ($\Delta H_{\text{fus}}^{\circ}$)**. In the case of water, we have

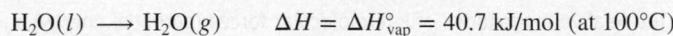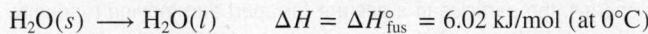

The reverse processes, condensing and freezing, have enthalpy changes of the *same magnitude but opposite sign*:

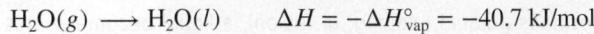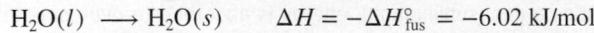

Water behaves typically in that it takes much less energy to melt the solid than to vaporize the liquid: $\Delta H_{\text{fus}}^{\circ} < \Delta H_{\text{vap}}^{\circ}$. That is, it takes less energy to reduce the intermolecular forces enough for the molecules to move out of their fixed positions (melt a solid) than to separate them completely (vaporize a liquid) (Figure 12.2).

A Deposition

B Vaporization

Figure 12.1 Two familiar phase changes.

Source: (A) © dinadesign/Shutterstock.com; (B) © Jill Birschbach Photo Services

Figure 12.2 Heats of vaporization and fusion for several common substances.

The **heat** (or *enthalpy*) of **sublimation** ($\Delta H_{\text{subl}}^{\circ}$) is the enthalpy change when 1 mol of a substance sublimes, and the negative of this value is the change when 1 mol of the substance deposits. Since sublimation can be considered a combination of melting and vaporizing steps, Hess's law (Section 6.5) says that the heat of sublimation equals the sum of the heats of fusion and vaporization:

Figure 12.3 summarizes the phase changes and their enthalpy changes.

Figure 12.3 Phase changes and their enthalpy changes. Fusion (or melting), vaporization, and sublimation are endothermic changes (positive ΔH°), whereas freezing, condensation, and deposition are exothermic changes (negative ΔH°).

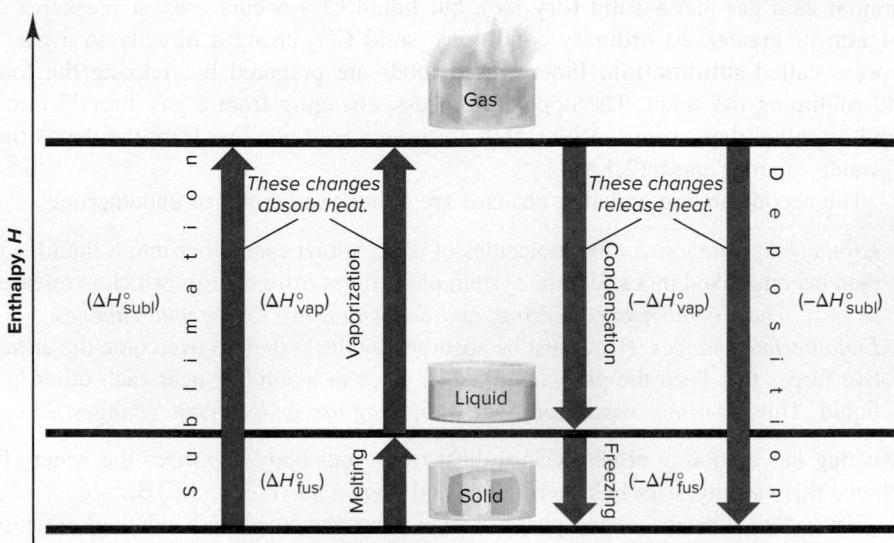

› Summary of Section 12.1

- › Because of the relative magnitudes of intermolecular forces (potential energy) and average speed (kinetic energy), the particles in a gas are far apart and moving randomly, those in a liquid are in contact and moving relative to each other, and those in a solid are in contact and in fixed positions. These molecular-level differences account for macroscopic differences in shape, compressibility, and ability to flow.
- › When a solid becomes a liquid (melting, or fusion), a liquid becomes a gas (vaporization), or a solid becomes a gas (sublimation), energy is absorbed to overcome intermolecular forces and increase the average distance between particles. As particles come closer together in the reverse changes (freezing, condensation, and deposition), energy is released. Each phase change is associated with a given enthalpy change under specified conditions.

12.2

QUANTITATIVE ASPECTS OF PHASE CHANGES

Of course, many phase changes of water occur around you every day, accompanied by the release or absorption of heat. When it rains, water vapor has condensed to a liquid, which changes back to a gas as puddles dry up. In the spring, solid water melts, and in winter, it freezes again. And the same phase changes take place whenever you make a pot of tea or a tray of ice cubes. In this section, we quantify the heat involved in a phase change and examine the equilibrium nature of the process.

Heat Involved in Phase Changes

We apply a kinetic-molecular approach to phase changes with a **heating-cooling curve**, which shows the changes in temperature of a sample when heat is absorbed or released at a constant rate. Let's examine what happens when 2.50 mol of gaseous water in a closed container undergoes a change from 130°C to -40°C at a constant pressure of 1 atm. We'll divide this process into five heat-releasing (exothermic) stages (Figure 12.4).

Stage 1. Gaseous water cools. Water molecules zoom chaotically at a range of speeds, smashing into each other and the container walls. At the starting temperature, the most probable speed of the molecules, and thus their average kinetic energy (E_k), is high enough to overcome the potential energy (E_p) of attractions. As the temperature falls, the average E_k decreases and attractions become more important. The change is

The heat lost in the cooling process (q) is the product of the amount (number of moles, n) of water, the molar heat capacity of *gaseous* water, $C_{m(\text{water}, g)}$ (J/mol·K or J/mol·°C), and the temperature change during this step, ΔT ($T_{\text{final}} - T_{\text{initial}}$):

$$\begin{aligned} q &= n \times C_{m(\text{water}, g)} \times \Delta T = (2.50 \text{ mol}) (33.1 \text{ J/mol}\cdot^\circ\text{C})(100^\circ\text{C} - 130^\circ\text{C}) \\ &= -2482 \text{ J} = -2.48 \text{ kJ} \end{aligned}$$

The negative sign indicates that heat is released. (For purposes of canceling, the units for molar heat capacity, C_m , include °C rather than K, but this doesn't affect the magnitude of C_m because 1°C and 1 K represent the same temperature increment.)

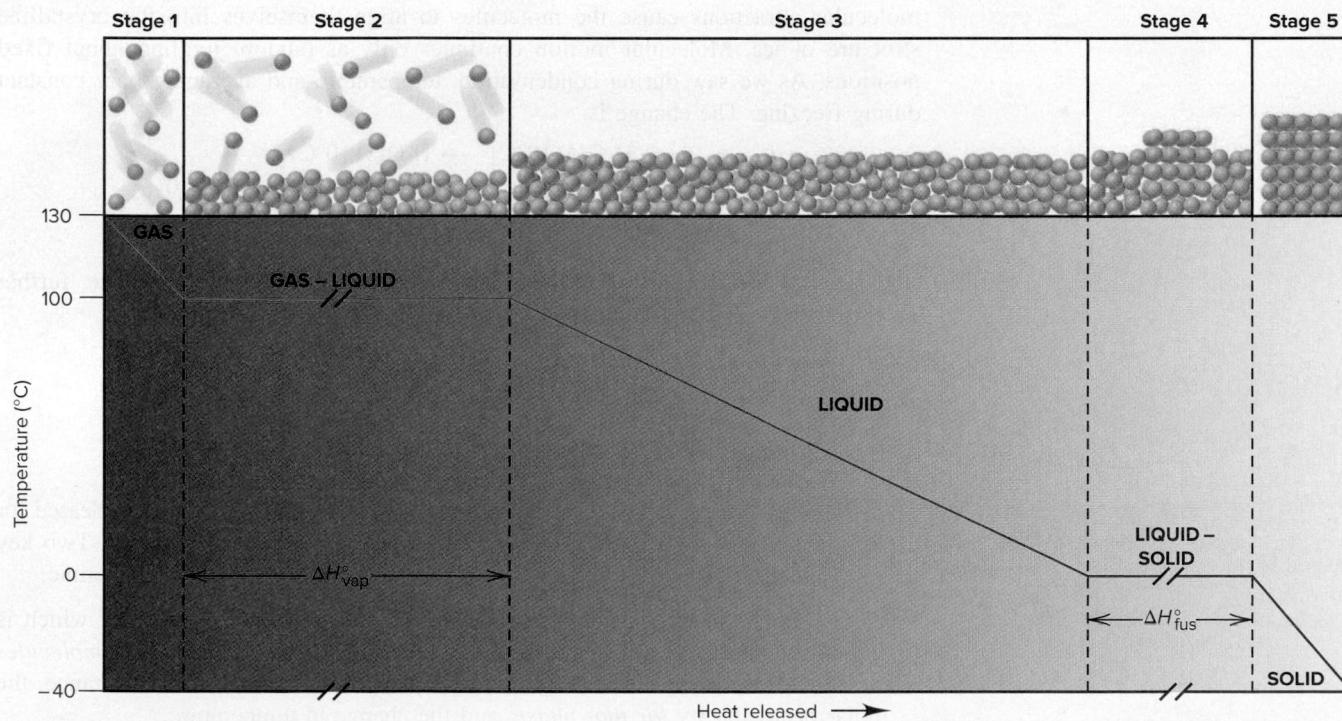

Figure 12.4 A heating-cooling curve for the conversion of gaseous water to ice. A plot of temperature vs. heat released as gaseous water changes to ice is shown, with a molecular-level depiction for each stage. The slopes of the lines in stages 1, 3, and 5 reflect the molar heat capacities of the phases. Although not drawn to scale, the line in stage 2 is longer than the line in stage 4 because $\Delta H_{\text{vap}}^\circ$ of water is greater than $\Delta H_{\text{fus}}^\circ$. A plot of temperature vs. heat absorbed starting at -40°C would have the same steps but in reverse order.

Stage 2. Gaseous water condenses. At the condensation point, intermolecular attractions cause the slowest of the molecules to aggregate into microdroplets and then a bulk liquid. Note that, during the phase change,

- The temperature of the sample, and thus its average E_k , is constant. At the same temperature, molecules move farther between collisions in a gas than in a liquid, but their *average speed* is the same.
- Releasing heat from the sample decreases the average E_p as the molecules approach and attract each other.

Thus, at 100°C, gaseous and liquid water have the same average E_k , but the liquid has lower average E_p . The change is

The heat is the amount (n) of water times the negative of the heat of vaporization ($-\Delta H_{\text{vap}}^\circ$):

$$q = n(-\Delta H_{\text{vap}}^\circ) = (2.50 \text{ mol})(-40.7 \text{ kJ/mol}) = -102 \text{ kJ}$$

This stage contributes the *greatest portion of the total heat released* because of the large decrease in E_p as the molecules become so much closer in the liquid than they were in the gas.

Stage 3. Liquid water cools. The molecules in the liquid state continue to lose heat, and the loss appears as a decrease in temperature, that is, as a decrease in the most probable molecular speed and, thus, the average E_k . The temperature decreases as long as the sample remains liquid. The change is

The heat depends on amount (n), the molar heat capacity of *liquid* water, and ΔT :

$$\begin{aligned} q &= n \times C_{\text{m(water, } l)} \times \Delta T = (2.50 \text{ mol})(75.4 \text{ J/mol}\cdot{}^\circ\text{C})(0^\circ\text{C} - 100^\circ\text{C}) \\ &= -18,850 \text{ J} = -18.8 \text{ kJ} \end{aligned}$$

Stage 4. Liquid water freezes. At 0°C, the sample loses E_p as increasing intermolecular attractions cause the molecules to align themselves into the crystalline structure of ice. Molecular motion continues only as random jiggling about fixed positions. As we saw during condensation, temperature and average E_k are constant during freezing. The change is

The heat is equal to n times the negative of the heat of fusion ($-\Delta H_{\text{fus}}^\circ$):

$$q = n(-\Delta H_{\text{fus}}^\circ) = (2.50 \text{ mol})(-6.02 \text{ kJ/mol}) = -15.0 \text{ kJ}$$

Stage 5. Solid water cools. With motion restricted to jiggling in place, further cooling merely reduces the average speed of this jiggling. The change is

The heat depends on n , the molar heat capacity of *solid* water, and ΔT :

$$\begin{aligned} q &= n \times C_{\text{m(water, } s)} \times \Delta T = (2.50 \text{ mol})(37.6 \text{ J/mol}\cdot{}^\circ\text{C})(-40^\circ\text{C} - 0^\circ\text{C}) \\ &= -3760 \text{ J} = -3.76 \text{ kJ} \end{aligned}$$

According to Hess's law, the total heat released is the sum of the heats released for the individual stages. The sum of the q values for stages 1 to 5 is -142 kJ . Two key points stand out for this or any similar process, whether exothermic or endothermic:

- *Within a phase*, heat flow is accompanied by *a change in temperature*, which is associated with a change in average E_k , as *the most probable speed of the molecules changes*. The heat released or absorbed depends on the amount of substance, the molar heat capacity *for that phase*, and the change in temperature.
- *During a phase change*, heat flow occurs at a *constant temperature*, which is associated with a change in average E_p , as *the average distance between molecules changes*. Both phases are present and (as you'll see) are in equilibrium during the change. The heat released or absorbed depends on the amount of substance and the enthalpy change for that phase change.

Let's work a molecular-scene sample problem to make sure these ideas are clear.

SAMPLE PROBLEM 12.1
Finding the Heat of a Phase Change Depicted by Molecular Scenes

Problem The scenes below represent a phase change of water. Use values for molar heat capacities and heats of phase changes from the text discussion to find the heat (in kJ) released or absorbed when 24.3 g of H₂O undergoes this change.

Plan From the molecular scenes, values given in the text discussion, and the given mass (24.3 g) of water, we have to find the heat that accompanies this change. The scenes show a disorderly, condensed phase at 85.0°C changing to separate molecules at 117°C. Thus, the phase change they depict is vaporization, an endothermic process. The values for molar heat capacities and heats of phase changes are per mole, so we first convert the mass (g) of water to amount (mol). There are three stages: (1) heating the liquid from 85.0°C to 100.°C; (2) converting liquid water at 100.°C to gaseous water at 100.°C; and (3) heating the gas from 100.°C to 117°C (see margin). We add the values of q for these stages to obtain the total heat.

Solution Converting from mass (g) of H₂O to amount (mol):

$$\text{Amount (mol)} \text{ of H}_2\text{O} = 24.3 \text{ g H}_2\text{O} \times \frac{1 \text{ mol}}{18.02 \text{ g H}_2\text{O}} = 1.35 \text{ mol}$$

Finding the heat accompanying stage 1, H₂O(l) [85.0°C] → H₂O(l) [100.°C]:

$$\begin{aligned} q &= n \times C_{m(\text{water, } l)} \times \Delta T = (1.35 \text{ mol})(75.4 \text{ J/mol}\cdot^\circ\text{C})(100.^\circ\text{C} - 85.0^\circ\text{C}) \\ &= 1527 \text{ J} = 1.53 \text{ kJ} \end{aligned}$$

Finding the heat accompanying stage 2, H₂O(l) [100.°C] → H₂O(g) [100.°C]:

$$q = n(\Delta H_{\text{vap}}^\circ) = (1.35 \text{ mol})(40.7 \text{ kJ/mol}) = 54.9 \text{ kJ}$$

Finding the heat accompanying stage 3, H₂O(g) [100.°C] → H₂O(g) [117°C]:

$$\begin{aligned} q &= n \times C_{m(\text{water, } g)} \times \Delta T = (1.35 \text{ mol})(33.1 \text{ J/mol}\cdot^\circ\text{C})(117^\circ\text{C} - 100.^\circ\text{C}) \\ &= 759.6 \text{ J} = 0.760 \text{ kJ} \end{aligned}$$

Adding the three heats to find the total heat for the process:

$$\text{Total heat (kJ)} = 1.53 \text{ kJ} + 54.9 \text{ kJ} + 0.760 \text{ kJ} = 57.2 \text{ kJ}$$

Check The heat should have a positive value because it is absorbed. Be sure to round to check each value of q ; for example, in stage 1, $1.35 \text{ mol} \times 75 \text{ J/mol}\cdot^\circ\text{C} \times 15^\circ\text{C} = 1500 \text{ J}$. Note that the phase change itself (stage 2) requires the most energy and, thus, dominates the final answer. The $\Delta H_{\text{vap}}^\circ$ units include kJ, whereas the molar heat capacity units include J, which is a thousandth as large.

FOLLOW-UP PROBLEMS

Brief Solutions for all Follow-up Problems appear at the end of the chapter.

12.1A The scenes below represent a phase change of water. Use values for molar heat capacities and heats of phase changes from the text discussion to find the heat (in kJ) released or absorbed when 2.25 mol of H₂O undergoes this change.

Student Hot Spot

Student data indicate that you may struggle with the quantitative aspects of phase changes. Access the Smartbook to view additional Learning Resources on this topic.

12.1B The scenes below represent a phase change of bromine, Br_2 . Use the following data to find the heat (in kJ) released or absorbed when 47.94 g of bromine undergoes this change: $C_{\text{m(liquid)}} = 75.7 \text{ J/mol}\cdot^\circ\text{C}$; $C_{\text{m(gas)}} = 36.0 \text{ J/mol}\cdot^\circ\text{C}$; $\Delta H_{\text{fus}}^\circ = 10.6 \text{ kJ/mol}$; $\Delta H_{\text{vap}}^\circ = 29.6 \text{ kJ/mol}$; $\text{mp} = -7.25^\circ\text{C}$; $\text{bp} = 59.5^\circ\text{C}$.

SOME SIMILAR PROBLEMS 12.19 and 12.20

The Equilibrium Nature of Phase Changes

In everyday experience, phase changes take place in *open* containers—the outdoors, a pot on a stove, the freezer compartment of a refrigerator—so they are not reversible. But, in a *closed* container, *phase changes are reversible and reach equilibrium*, just as chemical changes do. In this discussion, we examine the three phase equilibria.

Liquid-Gas Equilibria Vaporization and condensation are familiar events. Let's see how these processes differ in open and closed systems of a liquid in a flask:

1. *Open system: nonequilibrium process.* Picture an *open* flask containing a pure liquid at constant temperature. Within their range of speeds, some molecules at the surface have a high enough E_k to overcome attractions and vaporize. Nearby molecules fill the gap, and with heat supplied by the constant-temperature surroundings, the process continues until the entire liquid phase is gone.

2. *Closed system: equilibrium process.* Now picture a *closed* flask at constant temperature and assume a vacuum exists above a liquid in the flask (Figure 12.5A). Two processes take place: Some molecules at the surface have a high enough E_k to *vaporize*. After a short time, molecules in the vapor collide with the surface, and the slower ones are attracted strongly enough to *condense*.

At first, these two processes occur at different rates. The number of molecules in a given surface area is constant, so the number of molecules leaving the surface per unit time—the rate of vaporization—is also constant, and the pressure increases. With time, the number of molecules colliding with and entering the surface—the rate of condensation—increases as the vapor becomes more populated, so the increase in pressure slows. Eventually, the rate of condensation equals the rate of vaporization; from this time onward, *the pressure is constant* (Figure 12.5B).

Figure 12.5 Liquid-gas equilibrium. **A**, Molecules leave the surface at a constant rate and the pressure rises. **B**, At equilibrium, the same number of molecules leave and enter the liquid in a given time. **C**, Pressure increases until, at equilibrium, it is constant.

A Molecules in the liquid vaporize.

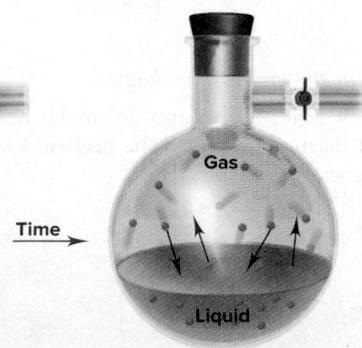

B Molecules vaporize and condense at the same rate.

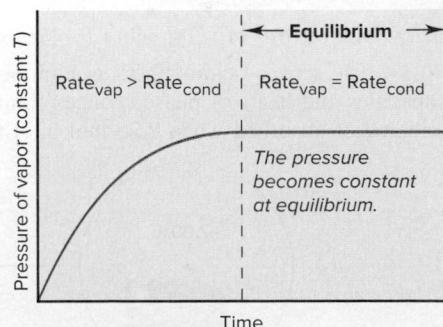

C Plot of pressure vs. time.

Macroscopically, the situation at this point seems static, but at the molecular level, molecules are entering and leaving the liquid at equal rates. The system has reached a state of *dynamic equilibrium*:

The pressure exerted by the vapor at equilibrium is called the *equilibrium vapor pressure*, or just the **vapor pressure**, of the liquid at that temperature. Figure 12.5C depicts the entire process graphically. If we started with a larger flask, the number of molecules in the vapor would be greater at equilibrium. But, as long as the temperature is constant and some liquid is present, the vapor pressure will be the same.

3. Disturbing a system at equilibrium. Let's see what happens if we alter certain conditions, called "disturbing" the system:

- *Decrease in pressure.* Suppose we pump some vapor out of the flask, immediately lowering the pressure. (In a cylinder fitted with a piston, we lower the pressure by moving the piston outward, thus increasing the volume.) The rate of condensation temporarily falls below the rate of vaporization (the forward process is faster) because fewer molecules enter the liquid than leave it. The pressure rises until, after a short time, the condensation rate increases enough for equilibrium to be reached again.
- *Increase in pressure.* Suppose we pump more vapor in (or move the piston inward, thus decreasing the volume), thereby immediately raising the pressure. The rate of condensation temporarily exceeds the rate of vaporization because more molecules enter the liquid than leave it (the reverse process is faster). Soon, however, the condensation rate decreases until the pressure again reaches the equilibrium value.

This general behavior of a liquid and its vapor is seen in any system at equilibrium: *when a system at equilibrium is disturbed, it counteracts the disturbance until it re-establishes equilibrium.* We'll return to this key idea often in later chapters.

The Effects of Temperature and Intermolecular Forces on Vapor Pressure The vapor pressure is affected by two factors—a change in temperature and a change in the gas itself, that is, in the type and/or strength of intermolecular forces:

1. *Effect of temperature.* Temperature has a major effect on vapor pressure because it changes the fraction of molecules moving fast enough to escape the liquid and, by the same token, the fraction moving slowly enough to be recaptured. In Figure 12.6, we see the familiar skewed bell-shaped curve of the distribution of molecular speeds (see also Figure 5.20). At the higher temperature, T_2 , more molecules have enough energy to leave the surface. Thus, in general, *the higher the temperature is, the higher the vapor pressure:*

$$\text{higher } T \implies \text{higher } P$$

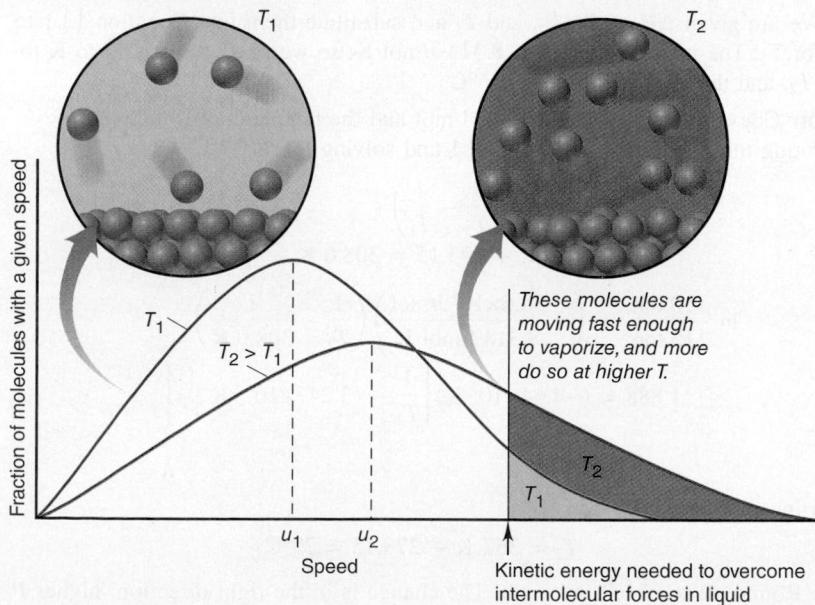

Figure 12.6 The effect of temperature on the distribution of molecular speeds.

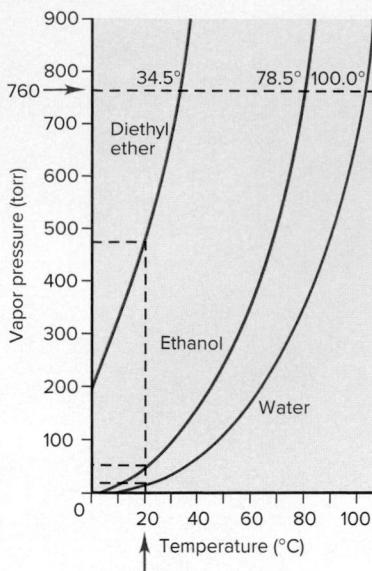

Figure 12.7 Vapor pressure as a function of temperature and intermolecular forces.

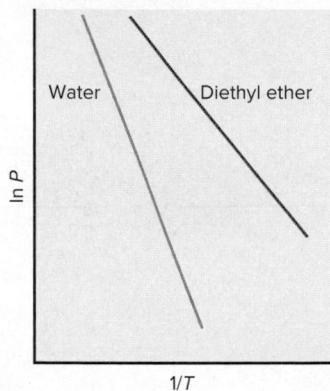

Figure 12.8 Linear plots of the relationship between vapor pressure and temperature. The slope is steeper for water because its ΔH_{vap} is greater.

2. *Effect of intermolecular forces.* At a given T , all substances have the same average E_k . Therefore, molecules with weaker intermolecular forces are held less tightly at the surface and vaporize more easily. In general, *the weaker the intermolecular forces are, the higher the vapor pressure*:

$$\text{weaker forces} \implies \text{higher } P$$

Figure 12.7 shows the vapor pressure of three liquids as a function of temperature:

- The effect of temperature is seen in the steeper rise as the temperature increases.
- The effect of intermolecular forces is seen in the values of the vapor pressure, the short, horizontal dashed lines intersecting the vertical (pressure) axis at a given temperature (*vertical dashed line at 20°C*): the intermolecular forces in diethyl ether (highest vapor pressure) are weaker than those in ethanol, which are weaker than those in water (lowest vapor pressure).

Quantifying the Effect of Temperature The nonlinear relationship between vapor pressure and temperature is converted to a linear one with the **Clausius-Clapeyron equation**:

$$\ln P = \frac{-\Delta H_{\text{vap}}}{R} \left(\frac{1}{T} \right) + C$$

$$y = m x + b$$

where $\ln P$ is the natural logarithm of the vapor pressure, ΔH_{vap} is the heat of vaporization, R is the universal gas constant (8.314 J/mol·K), T is the absolute temperature, and C is a constant (not related to heat capacity). The equation is often used to find the heat of vaporization. The equation for a straight line is shown under it in blue, with $y = \ln P$, $x = 1/T$, m (the slope) = $-\Delta H_{\text{vap}}/R$, and b (the y -axis intercept) = C . A plot of $\ln P$ vs. $1/T$ gives a straight line, as shown for diethyl ether and water in Figure 12.8.

A two-point version of the Clausius-Clapeyron equation allows us to calculate ΔH_{vap} if vapor pressures at two temperatures are known:

$$\ln \frac{P_2}{P_1} = \frac{-\Delta H_{\text{vap}}}{R} \left(\frac{1}{T_2} - \frac{1}{T_1} \right) \quad (12.1)$$

If ΔH_{vap} and P_1 at T_1 are known, we can also calculate the vapor pressure (P_2) at any other temperature (T_2) or the temperature at any other pressure.

SAMPLE PROBLEM 12.2

Applying the Clausius-Clapeyron Equation

Problem The vapor pressure of ethanol is 115 torr at 34.9°C. If ΔH_{vap} of ethanol is 38.6 kJ/mol, calculate the temperature (in °C) when the vapor pressure is 760 torr.

Plan We are given ΔH_{vap} , P_1 , P_2 , and T_1 and substitute them into Equation 12.1 to solve for T_2 . The value of R here is 8.314 J/mol·K, so we must convert T_1 to K to obtain T_2 , and then convert T_2 back to °C.

Solution Convert the units of ΔH_{vap} to J/mol and the temperature to kelvins. Substituting the values into Equation 12.1 and solving for T_2 :

$$\ln \frac{P_2}{P_1} = \frac{-\Delta H_{\text{vap}}}{R} \left(\frac{1}{T_2} - \frac{1}{T_1} \right)$$

$$T_1 = 34.9^\circ\text{C} + 273.15 = 308.0 \text{ K}$$

$$\ln \frac{760 \text{ torr}}{115 \text{ torr}} = \left(-\frac{38.6 \times 10^3 \text{ J/mol}}{8.314 \text{ J/mol}\cdot\text{K}} \right) \left(\frac{1}{T_2} - \frac{1}{308.0 \text{ K}} \right)$$

$$1.888 = (-4.64 \times 10^3 \text{ K}) \left[\frac{1}{T_2} - (3.247 \times 10^{-3} \text{ K}^{-1}) \right]$$

$$T_2 = 352 \text{ K}$$

Converting T_2 from K to °C:

$$T_2 = 352 \text{ K} - 273.15 = 79^\circ\text{C}$$

Check Round off to check the math. The change is in the right direction: higher P should occur at higher T . As we discuss next, a substance has a vapor pressure of

760 torr at its *normal boiling point*. Checking the *CRC Handbook of Chemistry and Physics* shows that the boiling point of ethanol is 78.5°C, very close to our answer.

FOLLOW-UP PROBLEMS

12.2A At 34.1°C, the vapor pressure of water is 40.1 torr. What is the vapor pressure at 85.5°C? The ΔH_{vap} of water is 40.7 kJ/mol.

12.2B Acetone is essential as an industrial solvent and a starting reactant in the manufacturing of countless products, from films to synthetic fibers. The vapor pressure of acetone is 24.50 kPa at 20.2°C and 10.00 kPa at 0.95°C. What is ΔH_{vap} of acetone?

SOME SIMILAR PROBLEMS 12.21–12.24

Vapor Pressure and Boiling Point Let's discuss what is happening when a liquid boils and then see the effect of pressure on boiling point.

1. *How a liquid boils.* In an *open* container, the weight of the atmosphere bears down on a liquid surface. As the temperature rises, molecules move more quickly throughout the liquid. At some temperature, the average E_k of the molecules in the liquid is great enough for them to form bubbles of vapor *in the interior*, and the liquid boils. At any lower temperature, the bubbles collapse as soon as they start to form because the external pressure is greater than the vapor pressure inside the bubbles. Thus, the **boiling point** is the temperature at which the vapor pressure inside bubbles in the liquid equals the external pressure, which is usually that of the atmosphere. As in condensation and freezing, once boiling begins, the temperature of the liquid remains constant until all of the liquid is gone.

2. *Effect of pressure on boiling point.* The boiling point of a liquid varies with elevation. At high elevations, a lower atmospheric pressure is exerted on the liquid surface, so molecules in the interior need less kinetic energy to form bubbles. Therefore, in mountainous regions, food takes *more* time to cook because the boiling point is lower and the boiling liquid is not as hot; for instance, in Boulder, Colorado (elevation 5430 ft, or 1655 m), water boils at 94°C. On the other hand, in a pressure cooker, food takes *less* time to cook because the boiling point is higher at the higher pressure. Thus, *the boiling point is directly proportional to the applied pressure:*

$$\text{higher } P \text{ (applied)} \implies \text{higher boiling point}$$

The *normal boiling point* is observed at standard atmospheric pressure (760 torr, or 101.3 kPa; long, horizontal dashed line in Figure 12.7).

Solid-Liquid Equilibria The particles in a crystal are continually jiggling about their fixed positions. As the temperature rises, the particles jiggle more rapidly, until some have enough kinetic energy to break free of their positions. At this point, melting begins. As more molecules enter the liquid (molten) phase, some collide with the solid and become fixed in position again. Because the phases remain in contact, a dynamic equilibrium is established when the melting rate equals the freezing rate. The temperature at which this occurs is called the **melting point**. The temperature remains fixed at the melting point until all the solid melts.

Because liquids and solids are nearly incompressible, pressure has little effect on the rates of melting and freezing: a plot of pressure vs. temperature for a solid-liquid phase change is typically a *nearly* vertical straight line.

Solid-Gas Equilibria Sublimation is not very familiar because solids have *much* lower vapor pressures than liquids. A substance sublimes rather than melts because the intermolecular attractions are not great enough to keep the molecules near each other when they leave the solid state. Some solids *do* have high enough vapor pressures to sublime at ordinary conditions, including dry ice (carbon dioxide), iodine (Figure 12.9), and moth repellants, all of which consist of nonpolar molecules with weak intermolecular forces.

The plot of pressure vs. temperature for a solid-gas phase change reflects the large effect of temperature on vapor pressure; thus, it resembles the liquid-gas curve in rising steeply with higher temperatures.

Figure 12.9 Iodine subliming. As the solid sublimes, I_2 vapor deposits on a cold surface (water-filled inner test tube).

Source: © McGraw-Hill Education/ Richard Megna, photographer

Phase Diagrams: Effect of Pressure and Temperature on Physical State

The **phase diagram** of a substance combines the liquid-gas, solid-liquid, and solid-gas curves and gives the conditions of temperature and pressure at which each phase is stable and at which phase changes occur.

The Phase Diagram for Carbon Dioxide and Most Substances The diagram for CO_2 , which is typical of most substances, has four general features (Figure 12.10):

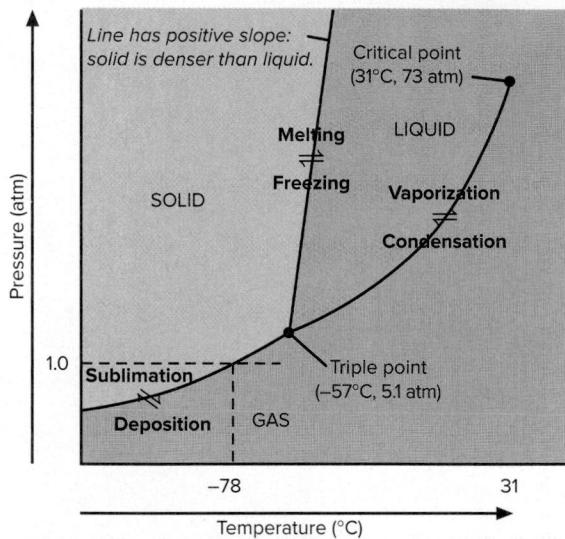

Figure 12.10 Phase diagram for CO_2 . (In both this figure and Figure 12.11, the slope of the solid-liquid line is exaggerated and the axes are not linear.)

1. *Regions of the diagram.* Each region presents the conditions of pressure and temperature at which the phase is stable. If another phase is placed under those conditions, it will change to the stable phase. In general, the solid is stable at low temperature and high pressure, the gas at high temperature and low pressure, and the liquid at intermediate conditions.

2. *Lines between regions.* The lines are the phase-transition curves discussed earlier. Any point along a line shows the pressure and temperature at which the phases are in equilibrium. The solid-liquid line has a slightly *positive* slope (slants to the *right* with increasing pressure) because, for most substances, the solid is more dense than the liquid: an increase in pressure converts the liquid to the solid. (Water is *the* major exception.)

3. *The triple point.* The three phase-transition curves meet at the **triple point**, at which all three phases are in equilibrium. As strange as it sounds, at the triple point in Figure 12.10, CO_2 is subliming and depositing, melting and freezing, and vaporizing and condensing simultaneously! Substances with several solid and/or liquid forms can have more than one triple point.

The CO_2 phase diagram shows why dry ice (solid CO_2) doesn't melt under ordinary conditions. The triple-point pressure is 5.1 atm, so liquid CO_2 doesn't occur at 1 atm because it is not stable. The horizontal dashed line at 1.0 atm crosses the solid-gas line, so when solid CO_2 is heated, it sublimes at -78°C rather than melts. If our normal atmospheric pressure were 5.2 atm, liquid CO_2 would occur.

4. *The critical point.* Heat a liquid in a closed container and its density decreases. At the same time, more of the liquid vaporizes, so the density of the vapor increases. At the **critical point**, the two densities become equal and the phase boundary disappears. The temperature at the critical point is the *critical temperature* (T_c), and the pressure is the *critical pressure* (P_c). The average E_k is so high at this point that the vapor cannot be condensed at any pressure. The two most common gases in air have critical temperatures far below room temperature: O_2 cannot be condensed above -119°C , and N_2 cannot be condensed above -147°C .

Beyond the critical temperature, a *supercritical fluid* (SCF) exists rather than separate liquid and gaseous phases. An SCF expands and contracts like a gas and has unusual solvent properties. Supercritical CO_2 is used to extract caffeine from coffee beans, nicotine from tobacco, and fats from potato chips, and acts as a dry cleaning agent. Lower the pressure, and the SCF disperses as a harmless gas. Supercritical H_2O dissolves nonpolar substances, even though liquid water cannot. Studies are under way to use supercritical H_2O for removing nonpolar organic toxins, such as PCBs, from industrial waste.

The Solid-Liquid Line for Water The phase diagram for water differs from others in one major respect that reveals a key property. Unlike almost any other substance, the solid form is *less dense* than the liquid; that is, *water expands upon freezing*. Thus, the solid-liquid line has a *negative* slope (slants to the *left* with increasing pressure): an increase in pressure converts the solid to the liquid, and the higher the pressure, the lower the temperature at which water freezes (Figure 12.11). The

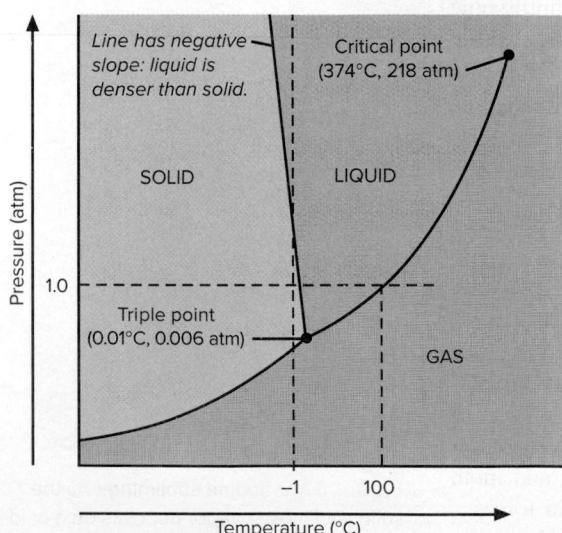

Figure 12.11 Phase diagram for H_2O .

vertical dashed line at -1°C crosses the solid-liquid line, which means that ice melts with only an increase in pressure.

The triple point of water occurs at low pressure (0.006 atm). Therefore, when solid water is heated at 1.0 atm (*horizontal dashed line*), the solid-liquid line is crossed at 0°C , the normal melting point. Thus, ice melts rather than sublimes. The horizontal dashed line crosses the liquid-gas curve at 100°C , the normal boiling point.

SAMPLE PROBLEM 12.3

Using a Phase Diagram to Predict Phase Changes

Problem Use the phase diagram for carbon (shown at right) to describe the phase changes that a sample of carbon undergoes during the following:

- The sample is heated at 10^2 bar (99 atm) from 1000 K to 5000 K.
- The sample is then compressed at 5000 K to 10^6 bar (990,000 atm).

Plan We have to describe the phase changes due to heating at constant pressure (10^2 bar) and then compressing at constant temperature (5000 K).

(a) Using the phase diagram, we find the starting conditions (10^2 bar and 1000 K), the point labeled *a*, and draw a horizontal line from there to point *b*, at the ending conditions (10^2 bar and 5000 K). We note any phase-transition curves that the line crosses.

(b) Then, from the new starting conditions at point *b* (10² bar and 5000 K), we draw a vertical line to the ending pressure (10^6 bar) and note any phase-transition curves that this line crosses.

Solution **(a)** At 10^2 bar and 1000 K, the sample is in the form of solid graphite. As it is heated, the graphite sublimes and becomes carbon gas (at around 4400 K).

(b) As it is compressed at 5000 K, the gas first condenses to liquid carbon (at around 300 bar), which then solidifies to diamond (at around 3×10^5 bar).

Check **(a)** From the phase diagram, the first triple point occurs above 10^2 bar, so graphite will vaporize before it liquefies. **(b)** The liquid carbon will solidify to diamond because graphite does not exist at 5000 K under any pressure.

Comment Synthetic diamonds are made by compressing graphite at approximately 7×10^4 bar and 2300 K. The process occurs at a commercially useful rate when carried out in molten nickel. Traces of nickel remain in the diamonds, which are used for grinding tools and are not of gem quality.

FOLLOW-UP PROBLEMS

12.3A Describe the phase changes that a sample of carbon undergoes when it is heated at 3×10^2 bar from 2000 K (point *c* on the phase diagram in the sample problem) to 6000 K.

12.3B Describe the phase changes that a sample of carbon undergoes when it is compressed at 4600 K from 10^4 bar (point *d* on the phase diagram in the sample problem) to 10^6 bar.

SOME SIMILAR PROBLEMS 12.27 and 12.28

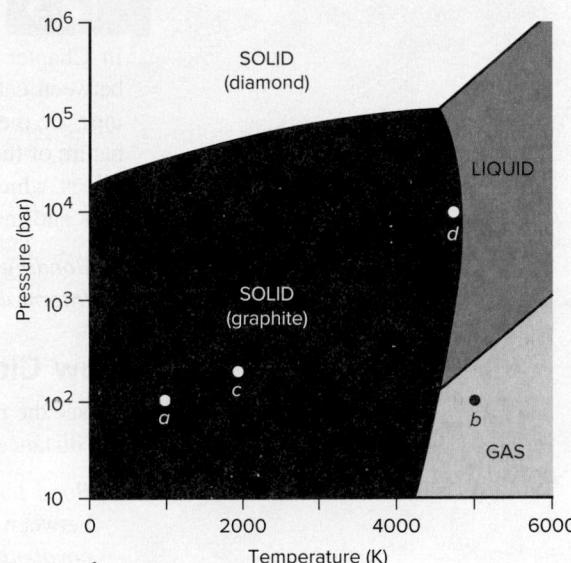

› Summary of Section 12.2

- › A heating-cooling curve depicts the change in temperature when a substance absorbs or releases heat at a constant rate. Within a phase, temperature (and average E_k) changes. During a phase change, temperature (and average E_k) is constant, but E_p changes. The total enthalpy change for the system is found using Hess's law.
- › In a closed container, the liquid and gas phases of a substance reach equilibrium. The vapor pressure, the pressure of the gas at equilibrium, increases with temperature and decreases with the strength of the intermolecular forces.
- › The Clausius-Clapeyron equation relates the vapor pressure to the temperature and is often used to find ΔH_{vap} .

- › A liquid in an open container boils when the vapor pressure inside bubbles forming in the liquid equals the external pressure.
- › Solid-liquid equilibrium occurs at the melting point. Some solids sublime because they have very weak intermolecular forces.
- › The phase diagram of a substance shows the phase that is stable at any P and T , the conditions at which phase changes occur, and the conditions at the critical point and the triple point. Water differs from most substances in that its solid phase is less dense than its liquid phase, so its solid-liquid line has a negative slope.

12.3 TYPES OF INTERMOLECULAR FORCES

In Chapter 9, we saw that bonding (*intramolecular*) forces are due to the attraction between cations and anions (ionic bonding), nuclei and electron pairs (covalent bonding), or metal cations and delocalized electrons (metallic bonding). But the physical nature of the phases and their changes are due primarily to *intermolecular* (nonbonding) forces, which arise from the attraction between molecules with partial charges or between ions and molecules. Coulomb's law explains the relative strength of these forces:

- *Bonding forces are relatively strong* because larger charges are closer together.
- *Intermolecular forces are relatively weak* because smaller charges are farther apart.

How Close Can Molecules Approach Each Other?

To see the minimum distance *between* molecules, consider solid Cl_2 . When we measure the distances between two Cl nuclei, we obtain two different values (Figure 12.12A):

- *Bond length and covalent radius*. The shorter distance, called the *bond length*, is between *two bonded Cl atoms in the same molecule*. One-half this distance is the *covalent radius*.
- *Van der Waals distance and radius*. The longer distance is between *two nonbonded Cl atoms in adjacent molecules*. It is called the *van der Waals (VDW) distance*. At this distance, intermolecular attractions balance electron-cloud repulsions; thus, the VDW distance is as close as one Cl_2 molecule can approach another. The **van der Waals radius** is one-half the closest distance between nuclei of identical *nonbonded* atoms. The VDW radius of an atom is *always larger than its covalent radius*. Like covalent radii, VDW radii decrease across a period and increase down a group (Figure 12.12B).

As we discuss intermolecular forces (also called *van der Waals forces*), consult Table 12.2, which compares them with bonding forces.

Figure 12.12 Covalent and van der Waals radii and their periodic trends. **A**, The van der Waals (VDW) radius is one-half the closest distance between nuclei of adjacent *nonbonded* atoms ($\frac{1}{2} \times$ VDW distance). **B**, Like covalent radii (blue quarter circles and numbers), VDW radii (red quarter-circles and numbers) increase down a group and decrease across a period.

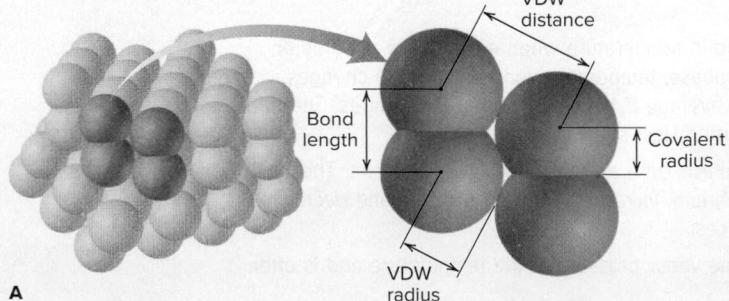

	4A(14)	5A(15)	6A(16)	7A(17)
C	77 165	N 75 150	O 73 140	F 72 135
P	110 190	S 103 185	Cl 100 180	Br 114 195
				I 133 215

Table 12.2**Comparison of Bonding and Nonbonding (Intermolecular) Forces**

Force	Model	Basis of Attraction	Energy (kJ/mol)	Example
Bonding				
Ionic		Cation–anion	400–4000	NaCl
Covalent		Nuclei–shared e ⁻ pair	150–1100	H—H
Metallic		Cations–delocalized electrons	75–1000	Fe
Nonbonding (Intermolecular)				
Ion-dipole		Ion charge–dipole charge	40–600	$\text{Na}^+ \cdots \text{O}-\text{H}$
H bond		Polar bond to H–dipole charge (high EN of N, O, F)	10–40	$\text{:O}-\text{H} \cdots \text{:O}-\text{H}$
Dipole-dipole		Dipole charges	5–25	$\text{I}-\text{Cl} \cdots \text{I}-\text{Cl}$
Ion-induced dipole		Ion charge–polarizable e ⁻ cloud	3–15	$\text{Fe}^{2+} \cdots \text{O}_2$
Dipole-induced dipole		Dipole charge–polarizable e ⁻ cloud	2–10	$\text{H}-\text{Cl} \cdots \text{Cl}-\text{Cl}$
Dispersion (London)		Polarizable e ⁻ clouds	0.05–40	$\text{F}-\text{F} \cdots \text{F}-\text{F}$

Ion-Dipole Forces

When an ion and a nearby polar molecule (dipole) attract each other, an **ion-dipole force** results. The most important example takes place when an ionic compound dissolves in water. As you'll see in Chapter 13, one main reason the ions become separated is because the attractions between the ions and the oppositely charged poles of the H_2O molecules are stronger than the attractions between the ions themselves.

Dipole-Dipole Forces

In Figure 10.13, an external electric field orients gaseous polar molecules. The polar molecules in liquids and solids lie near each other, and their partial charges act as tiny electric fields and give rise to **dipole-dipole forces**: the positive pole (blue) of one molecule attracts the negative pole (red) of another (Figure 12.13). The orientation is more orderly in a solid than in a liquid because the average kinetic energy of the molecules is lower.

These forces depend on the magnitude of the molecular dipole moment. For compounds of similar molar mass, the greater the molecular dipole moment, the greater the dipole-dipole forces, so the more energy it takes to separate the molecules; thus, the boiling point is higher. Methyl chloride, for instance, has a smaller dipole

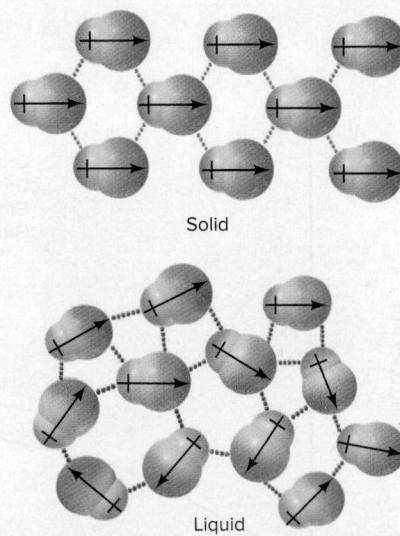

Figure 12.13 Polar molecules and dipole-dipole forces. (Spaces between the molecules are exaggerated.)

Figure 12.14 Dipole moment and boiling point.

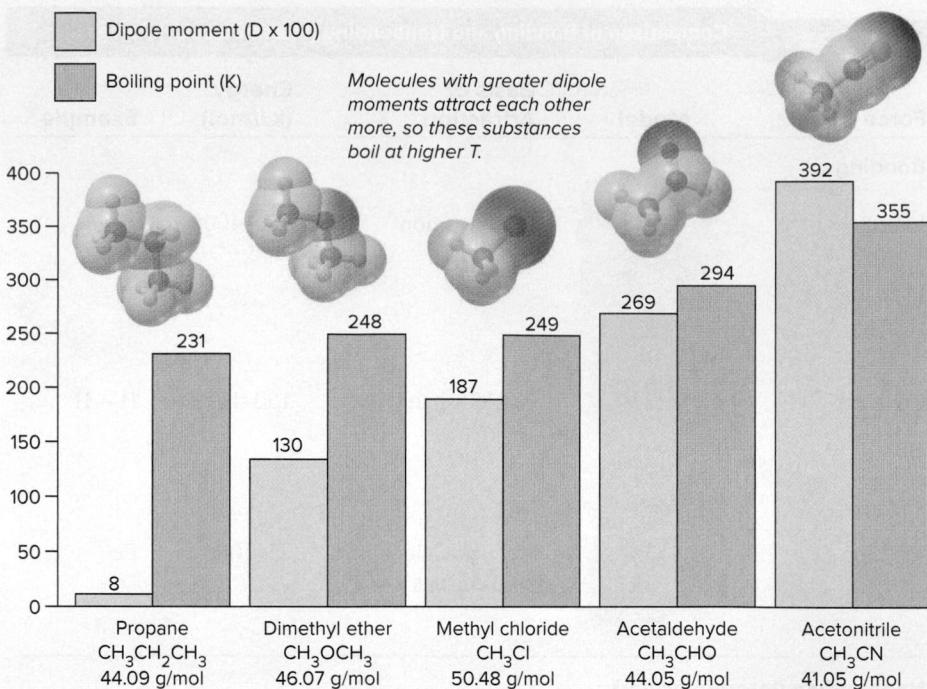

moment than acetaldehyde and boils at a lower temperature (Figure 12.14). Dipole-dipole forces do not exist for nonpolar molecules.

The Hydrogen Bond

A special type of dipole-dipole force arises between molecules that have an H atom bonded to a small, highly electronegative atom with lone electron pairs, specifically N, O, or F. The H—N, H—O, and H—F bonds are very polar. When the partially positive H of one molecule is attracted to the partially negative lone pair on the N, O, or F of another molecule, a **hydrogen bond (H bond)** forms. Thus, the atom sequence of an H bond (dotted line) is —B···H—A—, where A and B are N, O, or F. Some examples are

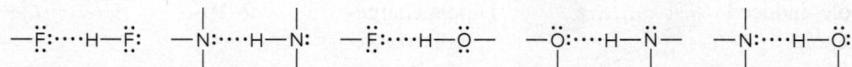

The first two are found in pure samples of HF and NH₃, respectively.

The small sizes of N, O, and F are essential to H bonding for two reasons:

1. The atoms are so electronegative that their covalently bonded H is highly positive.
2. The lone pair on the N, O, or F of the other molecule can come close to the H.

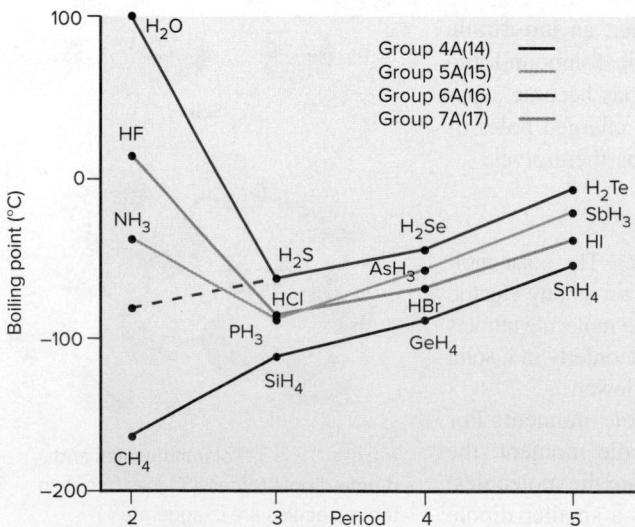

The Significance of Hydrogen Bonding Hydrogen bonding has a profound impact in many systems. We'll examine one effect on physical properties and preview its importance in biological systems, a topic we address in Chapters 13 and 15.

Figure 12.15 shows the effect of H bonding on the boiling points of the binary hydrides of Groups 4A(14) through 7A(17). For reasons we'll discuss shortly, boiling points rise with molar mass, as the Group 4A(14) hydrides show. However, the first member in each of the other groups—NH₃, H₂O, and HF—deviates enormously from this expected trend. Within samples of these substances, the molecules form strong H bonds, so it takes more energy for the molecules to separate and enter the gas phase. For example, on the basis of molar mass alone, we would

Figure 12.15 Hydrogen bonding and boiling point. NH₃, H₂O, and HF have exceptionally high boiling points because they form H bonds.

expect water to boil about 200°C lower than it actually does (*red dashed line*). (In Section 12.5 we'll discuss the effects that H bonds in water have in nature.)

The significance of hydrogen bonding in biological systems cannot be emphasized too strongly. In Chapter 13, you'll see that it is a key feature in the structure and function of the biological macromolecules. As such, it is responsible for the action of many *enzymes*—the proteins that speed metabolic reactions—and for the functioning of genes, not to mention the strength of wood and texture of cotton.

SAMPLE PROBLEM 12.4**Drawing Hydrogen Bonds Between Molecules of a Substance**

Problem Which of these substances exhibits H bonding? Draw examples of the H bonds between two molecules of each substance that does.

Plan If the molecule does *not* contain N, O, or F, it cannot form H bonds. If it contains any of these atoms covalently bonded to H, we draw two molecules in the $-\text{B}:\cdots\text{H}-\text{A}-$ pattern.

Solution (a) For C_2H_6 . No N, O, or F, so no H bonds can form.

(b) For CH_3OH . The H covalently bonded to the O in one molecule forms an H bond to the lone pair on the O of an adjacent molecule:

(c) For $\text{CH}_3\text{C}=\text{O}-\text{NH}_2$. Two of these molecules can form one H bond between an H bonded to N and the O, or they can form two such H bonds:

A third possibility (not shown) could be between an H attached to N in one molecule and the lone pair of N in another molecule.

Check The $-\text{B}:\cdots\text{H}-\text{A}-$ sequence (with A and B either N, O, or F) is present.

Comment Note that H covalently bonded to C *does not form H bonds* because carbon is not electronegative enough to make the C—H bond sufficiently polar.

FOLLOW-UP PROBLEMS

12.4A Which of these substances exhibits H bonding? Draw one possible example of the H bond(s) between two molecules of each substance that does.

12.4B Which of these substances exhibits H bonding? Draw one possible example of the H bond(s) between two molecules of each substance that does.

SOME SIMILAR PROBLEMS 12.43 and 12.44**Polarizability and Induced Dipole Forces**

Even though electrons are attracted to nuclei and localized in bonding and lone pairs, we often picture them as “clouds” of negative charge because they are in constant motion. A nearby electric field can *induce* a distortion in the cloud, pulling

Figure 12.16 Dispersion forces among nonpolar particles. **A**, When atoms are far apart, an instantaneous dipole in one atom (left) doesn't influence another. **B**, When atoms are close together, the instantaneous dipole in one atom induces a dipole in the other. **C**, The process occurs through the sample.

electron density toward a positive pole of a field or pushing it away from a negative one:

- For a nonpolar molecule, the distortion induces a temporary dipole moment.
- For a polar molecule, the distortion induces an increase in the already existing dipole moment.

In addition to charged plates connected to a battery, the source of the electric field can be the charge of an ion or the partial charges of a polar molecule.

How easily the electron cloud of an atom (or ion) can be distorted is called its **polarizability**. Smaller particles are less polarizable than larger ones because their electrons are closer to the nucleus and therefore held more tightly. Thus, we observe several trends:

- Polarizability *increases down a group* because atomic size increases and larger electron clouds are easier to distort.
- Polarizability *decreases across a period* because increasing Z_{eff} makes the atoms smaller and holds the electrons more tightly.
- Cations are *less* polarizable than their parent atoms because they are smaller; anions are *more* polarizable because they are larger.

Ion-induced dipole and dipole-induced dipole forces are the two types of charge-induced dipole forces; they are most important in solution, so we'll focus on them in Chapter 13. Nevertheless, *polarizability affects all intermolecular forces*.

Dispersion (London) Forces

So far, we've discussed forces that depend on the existing charge of an ion or a polar molecule. But what forces cause nonpolar substances like octane, chlorine, and argon to condense and solidify? As you'll see, polarizability plays the central role in the most universal intermolecular force.

The intermolecular force responsible for the condensed states of nonpolar substances is the **dispersion force** (or **London force**, for Fritz London, the physicist who explained its quantum-mechanical basis). *Dispersion forces are present between all particles (atoms, ions, and molecules) because they result from the motion of electrons in atoms.* Let's examine key aspects of this force:

1. Origin. Picture one atom in a sample of, say, argon gas. Over time, its 18 electrons are distributed uniformly, so the atom is nonpolar. But at any instant, there may be more electrons on one side of the nucleus than the other, which gives the atom an *instantaneous dipole*. When a pair of argon atoms is far apart, they don't influence each other, but when close together, *the instantaneous dipole in one atom induces a dipole in its neighbor*, and they attract each other. This process spreads to other atoms and throughout the sample. At low temperatures, these attractions keep the atoms together (Figure 12.16). Thus, dispersion forces are *instantaneous dipole-induced dipole forces*.

2. Universal presence. While they are the *only* force existing between nonpolar particles, dispersion forces contribute to the energy of attraction in all substances because they exist between *all* particles. In fact, except for the forces between small, highly polar molecules or between molecules forming H bonds, the *dispersion force is the dominant intermolecular force*. Calculations show, for example, that 85% of the attraction between HCl molecules is due to dispersion forces and only 15% to dipole-dipole forces. Even for water, 75% of the attraction comes from H bonds and 25% from dispersion forces.

3. Relative strength. The relative strength of dispersion forces depends on the polarizability of the particles, so they are weak for small particles, like H_2 and He, but stronger for larger particles, like I_2 and Xe. *Polarizability depends on the number of electrons, which correlates closely with molar mass* because heavier particles are either larger atoms or molecules with more atoms and, thus, more electrons. For this reason, as molar mass increases down the Group 4A(14) hydrides (see Figure 12.15) or down the halogens or the noble gases, dispersion forces increase and so do boiling points (Figure 12.17).

7A (17)	8A (18)
Formula Model	He
Molar mass	4.003 4.22
Boiling point (K)	
F_2 38.00 85.0	Ne 20.18 27.1
Cl_2 70.91 239	Ar 39.95 87.3
Br_2 159.8 333	Kr 83.80 120
I_2 253.8 458	Xe 131.3 165

Increasing strength of dispersion forces ↓

Figure 12.17 Molar mass and trends in boiling point.

Figure 12.18 Molecular shape, intermolecular contact, and boiling point.

4. *Effect of molecular shape.* For a pair of nonpolar substances with the same molar mass, a molecular shape that has more area over which electron clouds can be distorted allows stronger attractions. For example, the two five-carbon alkanes, *n*-pentane and neopentane (2,2-dimethylpropane) are isomers—same molecular formula (C_5H_{12}) but different structures and properties. *n*-Pentane is more cylindrical and neopentane more spherical (Figure 12.18). Thus, two *n*-pentane molecules make more contact than do two neopentane molecules, so dispersion forces act at more points, and *n*-pentane has a higher boiling point.

Figure 12.19 shows how to decide what intermolecular forces are present in a sample.

Student Hot Spot

Student data indicate that you may struggle with identifying the type(s) of intermolecular forces in a substance. Access the Smartbook to view additional Learning Resources on this topic.

Figure 12.19 Determining the intermolecular forces in a sample.

SAMPLE PROBLEM 12.5

Identifying the Types of Intermolecular Forces

Problem For each substance, identify the key bonding and/or intermolecular force(s), and predict which substance of the pair has the higher boiling point:

- (a) MgCl₂ or PCl₃
- (b) CH₃NH₂ or CH₃F
- (c) CH₃OH or CH₃CH₂OH
- (d) Hexane (CH₃CH₂CH₂CH₂CH₂CH₃) or 2,2-dimethylbutane $\left(\begin{array}{c} \text{CH}_3 \\ | \\ \text{CH}_3\text{CCH}_2\text{CH}_3 \\ | \\ \text{CH}_3 \end{array} \right)$

Plan We examine the formulas and structures for key differences between members of the pair: Are ions present? Are molecules polar or nonpolar? Is N, O, or F bonded to H? Do the molecules have different masses or shapes?

To rank boiling points, we consult Figure 12.19 and Table 12.2. Remember that

- Bonding forces are stronger than intermolecular forces.
- Hydrogen bonding is a strong type of dipole-dipole force.
- Dispersion forces are decisive when the difference is molar mass or molecular shape.

Solution (a) MgCl_2 consists of Mg^{2+} and Cl^- ions held together by ionic bonding forces; PCl_3 , with a trigonal pyramidal geometry, consists of polar molecules, so intermolecular dipole-dipole forces are present. The forces in MgCl_2 are stronger, so it should have a higher boiling point.

(b) CH_3NH_2 and CH_3F both consist of polar molecules of about the same molar mass. CH_3NH_2 has N—H bonds, so it can form H bonds (see margin). CH_3F contains a C—F bond but no H—F bond, so dipole-dipole forces occur but not H bonds. Therefore, CH_3NH_2 should have the higher boiling point.

(c) CH_3OH and $\text{CH}_3\text{CH}_2\text{OH}$ molecules both contain an O—H bond, so they can form H bonds (see margin). $\text{CH}_3\text{CH}_2\text{OH}$ has an additional $-\text{CH}_2-$ group and thus a larger molar mass, which correlates with stronger dispersion forces; therefore, it should have a higher boiling point.

(d) Hexane and 2,2-dimethylbutane are nonpolar molecules of the same molar mass but different molecular shapes (see margin). Cylindrical hexane molecules make more intermolecular contact than more compact 2,2-dimethylbutane molecules do, so hexane should have stronger dispersion forces and a higher boiling point.

Check The actual boiling points show that our predictions are correct:

- (a) MgCl_2 (1412°C) and PCl_3 (76°C)
- (b) CH_3NH_2 (-6.3°C) and CH_3F (-78.4°C)
- (c) CH_3OH (64.7°C) and $\text{CH}_3\text{CH}_2\text{OH}$ (78.5°C)
- (d) Hexane (69°C) and 2,2-dimethylbutane (49.7°C)

Comment Dispersion forces are *always* present, but in parts (a) and (b), they are much less significant than the other forces that occur.

FOLLOW-UP PROBLEMS

12.5A In each pair, identify the intermolecular forces present for each substance, and predict which substance has the *higher* boiling point:

- (a) CH_3Br or CH_3F
- (b) $\text{CH}_3\text{CH}_2\text{CH}_2\text{OH}$ or $\text{CH}_3\text{CH}_2\text{OCH}_3$
- (c) C_2H_6 or C_3H_8

12.5B In each pair, identify the intermolecular forces present for each substance, and predict which substance has the *lower* boiling point:

- (a) CH_3CHO or $\text{CH}_3\text{CH}_2\text{OH}$
- (b) SO_2 or CO_2
- (c) $\text{H}_2\text{N}-\underset{\parallel}{\text{C}}\text{H}_2\text{CH}_3$ or $(\text{CH}_3)_2\text{N}-\underset{\parallel}{\text{C}}\text{H}$

SOME SIMILAR PROBLEMS 12.49–12.54

› Summary of Section 12.3

- › The van der Waals radius determines the shortest distance over which intermolecular forces operate; it is always larger than the covalent radius.
- › Intermolecular forces are much weaker than bonding (intramolecular) forces.
- › Ion-dipole forces occur between ions and polar molecules.
- › Dipole-dipole forces occur between oppositely charged poles on polar molecules.
- › Hydrogen bonding, a special type of dipole-dipole force, occurs when H bonded to N, O, or F is attracted to the lone pair of N, O, or F in another molecule.
- › Electron clouds can be distorted (polarized) in an electric field.
- › Ion- and dipole-induced dipole forces arise between a charge and the dipole it induces in another molecule.
- › Dispersion (London) forces are instantaneous dipole-induced dipole forces that occur among all particles and increase with number of electrons (molar mass). Molecular shape determines the extent of contact between molecules and can be a factor in the strength of dispersion forces.

12.4 PROPERTIES OF THE LIQUID STATE

Of the three states, only liquids combine the ability to flow with the effects of strong intermolecular forces. We understand this state least at the molecular level. Because of the *random* arrangement of the particles in a gas, any region of the sample is virtually identical to any other. And, different regions of a crystalline solid are identical because of the *orderly* arrangement of the particles (Section 12.6). Liquids, however, have regions that are orderly one moment and random the next. Nevertheless, many macroscopic properties, such as surface tension, capillarity, and viscosity, are well understood.

Surface Tension

Intermolecular forces have different effects on a molecule at the surface than on one in the interior (Figure 12.20):

- An interior molecule is attracted by others on all sides.
- A surface molecule is only attracted by others below and to the sides, so it experiences a *net attraction downward*.

Therefore, to increase attractions and become more stable, a surface molecule tends to move into the interior. For this reason, *a liquid surface has the fewest molecules and, thus, the smallest area possible*. In effect, the surface behaves like a “taut skin” covering the interior.

The only way to increase the surface area is for molecules to move up by breaking attractions in the interior, which requires energy. The **surface tension** is the energy required to increase the surface area by a given amount and has units of J/m^2 . This property is dependent on the intermolecular forces present and the temperature:

- In general, *the stronger the intermolecular forces between particles, the more energy it takes to increase the surface area, so the greater the surface tension* (Table 12.3). Water has a high surface tension because its molecules form multiple H bonds. *Surfactants* (surface-active agents), such as soaps, petroleum recovery agents, and fat emulsifiers, decrease the surface tension of water by congregating at the surface and disrupting the H bonds.
- Surface tension *decreases with increasing temperature*. For example, the surface tension of water is $7.3 \times 10^{-2} \text{ J/m}^2$ at 20°C , $6.8 \times 10^{-2} \text{ J/m}^2$ at 50°C , and $6.1 \times 10^{-2} \text{ J/m}^2$ at 90°C . At higher temperatures, the liquid molecules have increased kinetic energy with which to break attractions to molecules in the interior. Hot water is more effective than cold water at cleaning greasy dishes as the lower surface tension of hot water allows it to “wet” the surface of the dish to a greater extent. The surfactants in the soap further decrease water’s surface tension.

Table 12.3

Surface Tension, Viscosity, and Forces Between Particles

Substance	Formula	Surface Tension (J/m^2) at 20°C	Viscosity ($\text{N}\cdot\text{s}/\text{m}^2$) at 20°C	Major Force(s)
Diethyl ether	$\text{CH}_3\text{CH}_2\text{OCH}_2\text{CH}_3$	1.7×10^{-2}	0.240×10^{-3}	Dipole-dipole; dispersion
Ethanol	$\text{CH}_3\text{CH}_2\text{OH}$	2.3×10^{-2}	1.20×10^{-3}	H bonding
Butanol	$\text{CH}_3\text{CH}_2\text{CH}_2\text{CH}_2\text{OH}$	2.5×10^{-2}	2.95×10^{-3}	H bonding; dispersion
Water	H_2O	7.3×10^{-2}	1.00×10^{-3}	H bonding
Mercury	Hg	48×10^{-2}	1.55×10^{-3}	Metallic bonding

Surface tension is the cause of many familiar phenomena. Bubbles are round because this shape minimizes the surface area around the gas, and surface tension is the reason some insects can walk on water (see photo).

Capillarity

The rising of a liquid against the pull of gravity through a narrow space, such as a thin tube, is called *capillary action*, or **capillarity**. Capillarity results from a competition between the intermolecular forces within the liquid (cohesive forces) and those between the liquid and the tube walls (adhesive forces). Let’s look at the difference between the capillarities of water and mercury in glass:

1. *Water in glass.* When you place a narrow glass tube in water, why does the liquid rise up the tube and form a concave meniscus? Glass is mostly silicon dioxide (SiO_2), so water molecules form adhesive H-bonding forces with the O atoms of the glass. As a result, a thin film of water creeps up the wall. At the same time, cohesive H-bonding forces between water molecules, which give rise to surface tension, make the surface taut. These adhesive and cohesive forces combine to raise the

Figure 12.20 The molecular basis of surface tension.

Because of its widespread legs, a water strider doesn’t exert enough pressure to exceed the surface tension.

Source: © Nuridsany & Perennou/Science Source

Figure 12.21 Capillary action and the shape of the water or mercury meniscus in glass. **A**, Water displays a concave meniscus. **B**, Mercury displays a convex meniscus.

Source: © McGraw-Hill Education/Stephen Frisch, photographer

water level and produce the concave meniscus (Figure 12.21A). The liquid rises until gravity pulling down is balanced by adhesive forces pulling up.

2. *Mercury in glass.* When you place a glass tube in a dish of mercury, why does the liquid drop below the level in the dish and form a convex meniscus? The cohesive forces among the mercury atoms are metallic bonds, so they are *much* stronger than the mostly dispersion adhesive forces between mercury and glass. As a result, the liquid pulls away from the walls. At the same time, the surface atoms are being pulled toward the interior by mercury's high surface tension, so the level drops. These combined forces produce the convex meniscus seen in a laboratory barometer (Figure 12.21B).

Capillarity plays a key role in many everyday events. The adhesive (dipole-induced dipole) forces between water and a nonpolar surface are much weaker than the cohesive (H-bond) forces within water. As a result, water pulls away from a nonpolar surface and forms beaded droplets, as on a freshly waxed car or on the waxy coating of a leaf after a rainfall. Even more familiar, after a shower, capillary action draws water away from your body through the closely spaced fibers in the cotton towel, which is made of cellulose molecules, so the water molecules also form H bonds with the $-\text{OH}$ groups of cellulose.

Viscosity

Viscosity is the resistance of a fluid to flow, and it results from intermolecular attractions that impede the movement of molecules around and past each other. Both gases and liquids flow, but liquid viscosities are *much* higher because the much shorter distances between the particles of a liquid result in many more points for intermolecular forces to act. Intermolecular forces, temperature, and molecular shape influence viscosity:

- In general, *the stronger the intermolecular forces between particles, the higher the viscosity* (Table 12.3) since stronger attractions prevent molecules from moving past each other freely.
- *Viscosity decreases with increasing temperature* (Table 12.4). Faster moving molecules overcome intermolecular forces more easily, so the resistance to flow decreases with increasing temperature. Next time you heat cooking oil, watch the oil flow more easily and spread out in the pan as it warms.
- *Viscosity is affected by molecular shape.* Small, spherical molecules make little contact and pour easily, like buckshot from a bowl. Long molecules make more contact and become entangled and pour slowly, like cooked spaghetti from a bowl. Thus, given the same types of intermolecular forces, liquids consisting of longer molecules have higher viscosities. As shown in Table 12.3, the viscosity of the longer butanol molecule is greater than that of the shorter ethanol molecule.

Viscosity of Water at Several Temperatures

Temperature (°C)	Viscosity (N·s/m ²)*
20	1.00×10^{-3}
40	0.65×10^{-3}
60	0.47×10^{-3}
80	0.35×10^{-3}

*The units of viscosity are newton-seconds per square meter.

To protect engine parts during long drives, motor oils contain *polymeric viscosity improvers*. As the oil warms, these additive molecules change from compact spheres to long strands that become tangled with the long hydrocarbon molecules of the oil. Greater dispersion forces increase the viscosity to compensate for the thinning of the oil due to heating.

› Summary of Section 12.4

- › Surface tension is a measure of the energy required to increase a liquid's surface area. Greater intermolecular forces within a liquid create higher surface tension.
- › Capillarity, the rising of a liquid through a narrow space, occurs when the forces between a liquid and a surface (adhesive) are greater than those in the liquid (cohesive).
- › Viscosity, the resistance to flow, depends on molecular shape and decreases with temperature. Stronger intermolecular forces create higher viscosity.

12.5 THE UNIQUENESS OF WATER

Water is absolutely amazing stuff, with some of the most unusual properties of any substance, but it is so familiar we take it for granted. Like any substance, its properties arise inevitably from those of its atoms. Each O and H atom attains a filled outer level by sharing electrons in single bonds. With two bonding pairs and two lone pairs around O and a large electronegativity difference in each O—H bond, the H_2O molecule is bent and highly polar. This arrangement is crucial because it allows each molecule to engage in four H bonds with its neighbors (Figure 12.22). From these basic atomic and molecular facts emerges some unique and remarkable macroscopic behavior.

Figure 12.22 H-bonding ability of water. One H_2O molecule can form four H bonds to other molecules, resulting in a tetrahedral arrangement.

Solvent Properties of Water

The *great solvent power* of water results from its polarity and H-bonding ability:

- It dissolves ionic compounds through ion-dipole forces that separate the ions from the solid and keep them in solution (see Figure 4.2).
- It dissolves polar nonionic substances, such as ethanol ($\text{CH}_3\text{CH}_2\text{OH}$) and glucose ($\text{C}_6\text{H}_{12}\text{O}_6$), by H bonding.
- It dissolves nonpolar atmospheric gases to a limited extent through dipole-induced dipole and dispersion forces.

Water is the environmental and biological solvent, forming the complex solutions we know as oceans, lakes, and cellular fluid. Aquatic animals could not survive without dissolved O_2 , nor could aquatic plants without dissolved CO_2 . Tiny marine animals form coral reefs made of carbonates from dissolved CO_2 and HCO_3^- . Life began in a “primordial soup,” an aqueous mixture of simple molecules from which emerged larger molecules capable of self-sustaining reactions. From a chemical point of view, all organisms, from bacteria to humans, are highly organized systems of membranes enclosing and compartmentalizing complex aqueous solutions.

Thermal Properties of Water

When a substance is heated, some of the added energy increases average molecular speed, some increases molecular vibration and rotation, and some is used to overcome intermolecular forces.

1. *Specific heat capacity.* Because water has so many strong H bonds, its *specific heat capacity* is higher than that of any common liquid. With oceans covering 70% of Earth’s surface, daytime energy from the Sun causes relatively small changes in temperature, allowing life to survive. On the waterless, airless Moon, temperatures range from 100°C to -150°C during a complete lunar day. Even in Earth’s deserts, day-night temperature differences of 40°C are common.

2. *Heat of vaporization.* Numerous strong H bonds give water a very *high heat of vaporization*. Two examples show why this is crucial. The average adult has 40 kg of

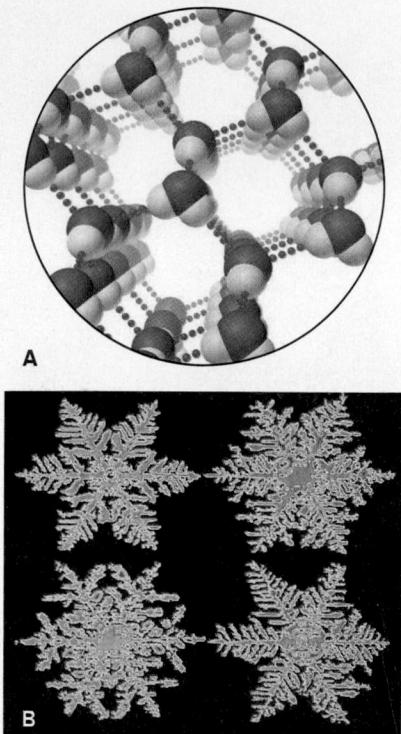

Figure 12.23 The hexagonal structure of ice. **A**, The open, hexagonal molecular structure of ice. **B**, The beauty of six-pointed snowflakes reflects this hexagonal structure.

Source: (B) © Scott Camazine/Science Source

body water and generates about 10,000 kJ of heat a day from metabolism. If this heat were used to increase the average E_k of water molecules in the body, the rise in body temperature of tens of degrees would mean immediate death. Instead, the heat is converted to E_p as it breaks H bonds and evaporates sweat, resulting in a stable body temperature and minimal loss of body fluid. On a planetary scale, the Sun's energy vaporizes ocean water in warm latitudes, and the potential energy is released as heat to warm cooler regions when the vapor condenses to rain. This global-scale cycling of water powers many weather patterns.

Surface Properties of Water

Hydrogen bonding is also responsible for water's *high surface tension* and *high capillarity*. Except for some molten metals and salts, water has the highest surface tension of any liquid. It keeps plant debris resting on a pond surface, providing shelter and nutrients for fish and insects. High capillarity means water rises through the tiny spaces between soil particles, so plant roots can absorb deep groundwater during dry periods.

The Unusual Density of Solid Water

In the solid state, the tetrahedral arrangement of H-bonded water molecules (see Figure 12.22) leads to the hexagonal, *open structure* of ice (Figure 12.23A), and the symmetrical beauty of snowflakes (Figure 12.23B) reflects this hexagonal organization. The large spaces within ice make *the solid less dense than the liquid* and explain the negative slope of the solid-liquid line in the phase diagram for water (see Figure 12.11). As pressure is applied, some H bonds break, so the crystal structure is disrupted, and the ice liquefies. When ice melts at 0°C, the loosened molecules pack much more closely, filling spaces in the collapsing solid structure. As a result, liquid water is most dense (1.000 g/mL) at around 4°C (3.98°C). With more heating, the density decreases through normal thermal expansion. This behavior has major effects in nature:

- *Surface ice of lakes.* When the surface of a lake freezes in winter, the ice floats. If the solid were denser than the liquid, as is true for nearly every other substance, the surface water would freeze and sink until the entire lake was solid. Aquatic life would not survive from year to year.
- *Nutrient turnover.* As lake water becomes colder in early winter, it becomes more dense *before* it freezes. Similarly, in spring, less dense ice thaws to form more dense water *before* the water expands. During both of these seasonal density changes, the top layer of water reaches maximum density first and sinks. The next layer of water rises because it is slightly less dense, reaches 4°C, and likewise sinks. This alternation of sinking and rising distributes nutrients and dissolved oxygen.
- *Soil formation.* When rain fills crevices in rocks and freezes, an outward force is applied that is relieved when the ice melts. In time, this repeated freeze-thaw stress cracks the rock. Over eons, this effect helps produce sand and soil.

The far-reaching consequences of the properties of water illustrate chemistry's central theme: the macroscopic world we know is the cumulative outcome of the atomic world we seek to know (Figure 12.24).

› Summary of Section 12.5

- The atomic properties of H and O result in water's bent molecular shape, polarity, and H-bonding ability.
- These properties give water the ability to dissolve many ionic and polar compounds.
- Water's high specific heat capacity and heat of vaporization give Earth and its organisms a narrow temperature range.
- Water's high surface tension and capillarity are essential to plants and animals.
- Because water expands on freezing, lake life survives in winter, nutrients mix from seasonal density changes, and soil forms through freeze-thaw stress on rocks.

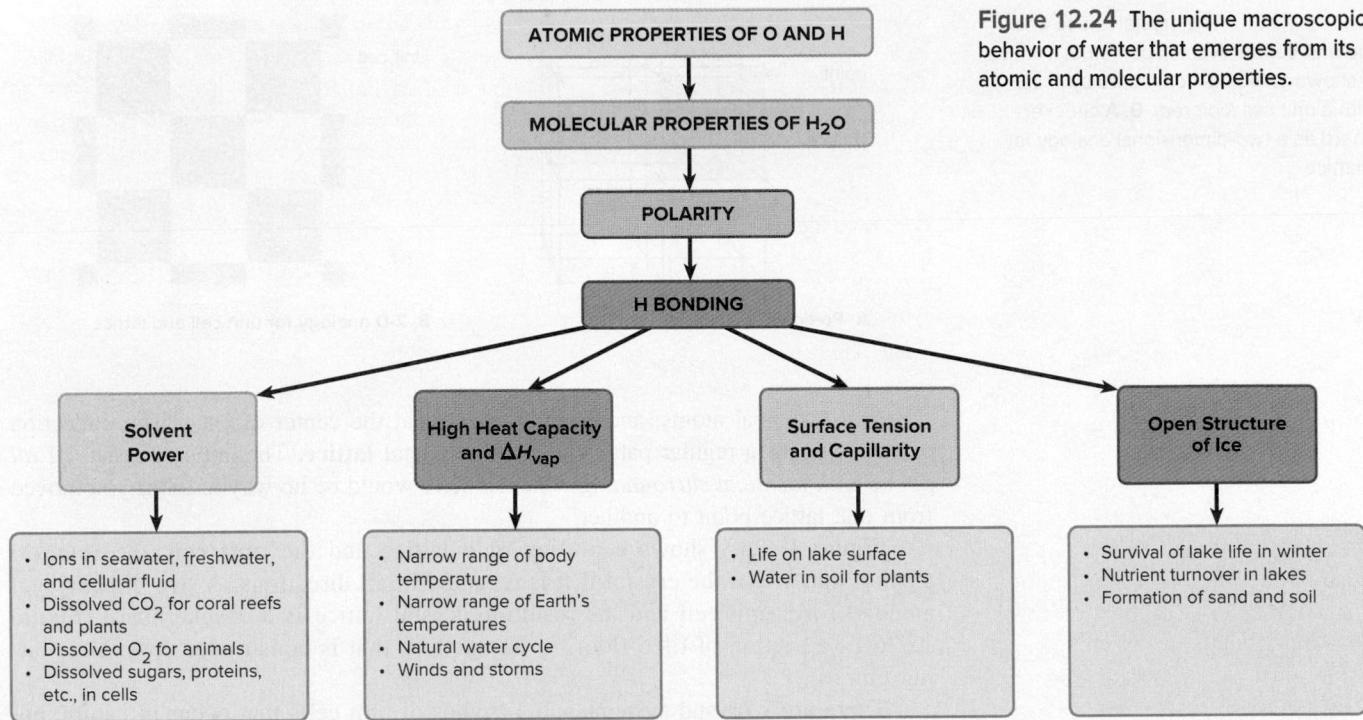

Figure 12.24 The unique macroscopic behavior of water that emerges from its atomic and molecular properties.

12.6 THE SOLID STATE: STRUCTURE, PROPERTIES, AND BONDING

Stroll through a museum’s mineral collection, and you’ll be struck by the variety and beauty of crystalline solids. In this section, we discuss the structural features of these and other solids and the intermolecular forces that create them. We also consider the main bonding model that explains many properties of solids.

Structural Features of Solids

We can divide solids into two broad categories:

- **Crystalline solids** have well-defined shapes because their particles—atoms, molecules, or ions—occur in an orderly arrangement (Figure 12.25).
- **Amorphous solids** have poorly defined shapes because their particles do not have an orderly arrangement throughout a sample.

The Crystal Lattice and the Unit Cell The particles in a crystal are packed tightly in an orderly, three-dimensional array. As the simplest case, consider the particles as

Figure 12.25 The beauty of crystalline solids. **A**, Wulfenite. **B**, Barite. **C**, Beryl (emerald). **D**, Quartz (amethyst).
Source: (A) © Matteo Chinellato/Shutterstock.com (B) © Albert Russ/Shutterstock.com (C) © Gabro/Alamy (D) © Walter Geiersperger/Corbis

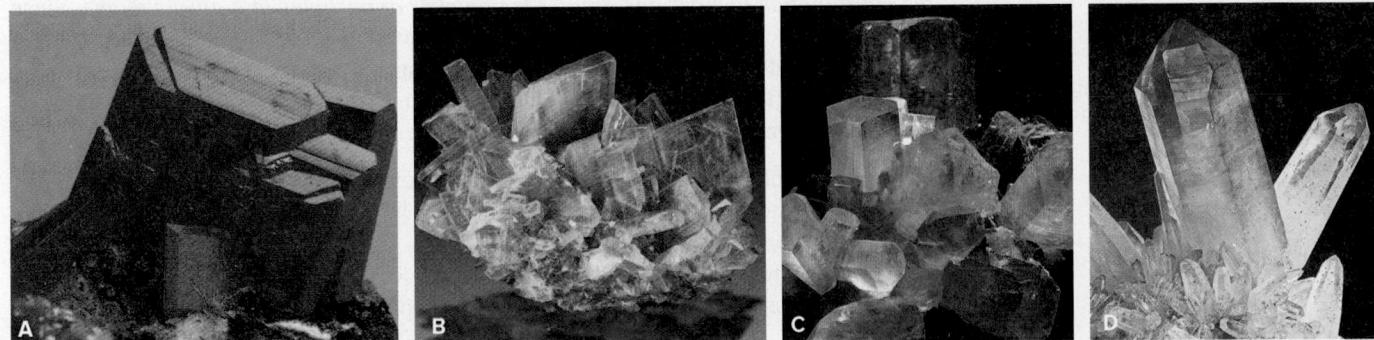

Figure 12.26 The crystal lattice and the unit cell. **A**, A small portion of a lattice is shown as points connected by lines, with a unit cell (colored). **B**, A checkerboard as a two-dimensional analogy for a lattice.

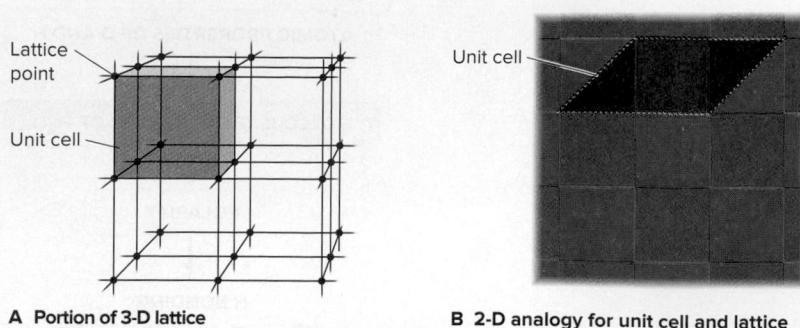

identical spherical atoms, and imagine a point at the center of each. The collection of points forms a regular pattern called the **crystal lattice**. The lattice consists of *all points with identical surroundings*; that is, there would be no way to tell if you moved from one lattice point to another.

Figure 12.26A shows a portion of a lattice and the **unit cell**, the *smallest* portion that yields the crystal if it is repeated in all directions. A two-dimensional analogy for a unit cell and the resulting crystal lattice is a checkerboard (Figure 12.26B), a section of tiled floor, or any pattern that is constructed from a repeating unit.

There are 7 crystal systems and 14 types of unit cells that occur in nature, but we will be concerned primarily with the *cubic system*. The solid states of a majority of metallic elements, some covalent compounds, and many ionic compounds occur as cubic lattices. A key parameter of any lattice is the **coordination number**, the number of *nearest* neighbors of a particle in a crystal. There are three types of cubic unit cells:

1. In the **simple cubic unit cell** (Figure 12.27A), the centers of eight identical particles define the corners of a cube (shown in the expanded view, *top row*). The particles touch along the cube edges (see the space-filling view, *second row*), but they do not touch diagonally along the cube faces or through its center. An expanded portion of the crystal (*third row*) shows that the coordination number of each particle is 6: four in its own layer, one in the layer above, and one in the layer below.
2. In the **body-centered cubic unit cell** (Figure 12.27B), identical particles lie at each corner *and* in the center of the cube. Those at the corners do not touch each other, but they all touch the one in the center. Each particle is surrounded by eight nearest neighbors, four above and four below, so the coordination number is 8.
3. In the **face-centered cubic unit cell** (Figure 12.27C), identical particles lie at each corner *and* in the center of each face but not in the center of the cube. Particles at the corners touch those in the faces but not each other. The coordination number is 12.

How many particles make up a unit cell? For particles of the same size, *the higher the coordination number, the greater the number of particles in a given volume*. Since one unit cell touches another, with no gaps, a particle at a corner or face is *shared* by adjacent cells. In the cubic unit cells, the particle at each corner is part of eight adjacent cells (Figure 12.27, *third row*), so one-eighth of each particle belongs to each cell (*bottom row*). There are eight corners in a cube, so

- A simple cubic unit cell contains $8 \times \frac{1}{8}$ particle = 1 particle.
- A body-centered cubic unit cell contains $8 \times \frac{1}{8}$ particle + 1 particle in the center, for a total of 2 particles.
- A face-centered cubic unit cell contains $8 \times \frac{1}{8}$ particle + one-half particle in each of the six faces $6 \times \frac{1}{2}$ particle = 3 particles, for a total of 4 particles.

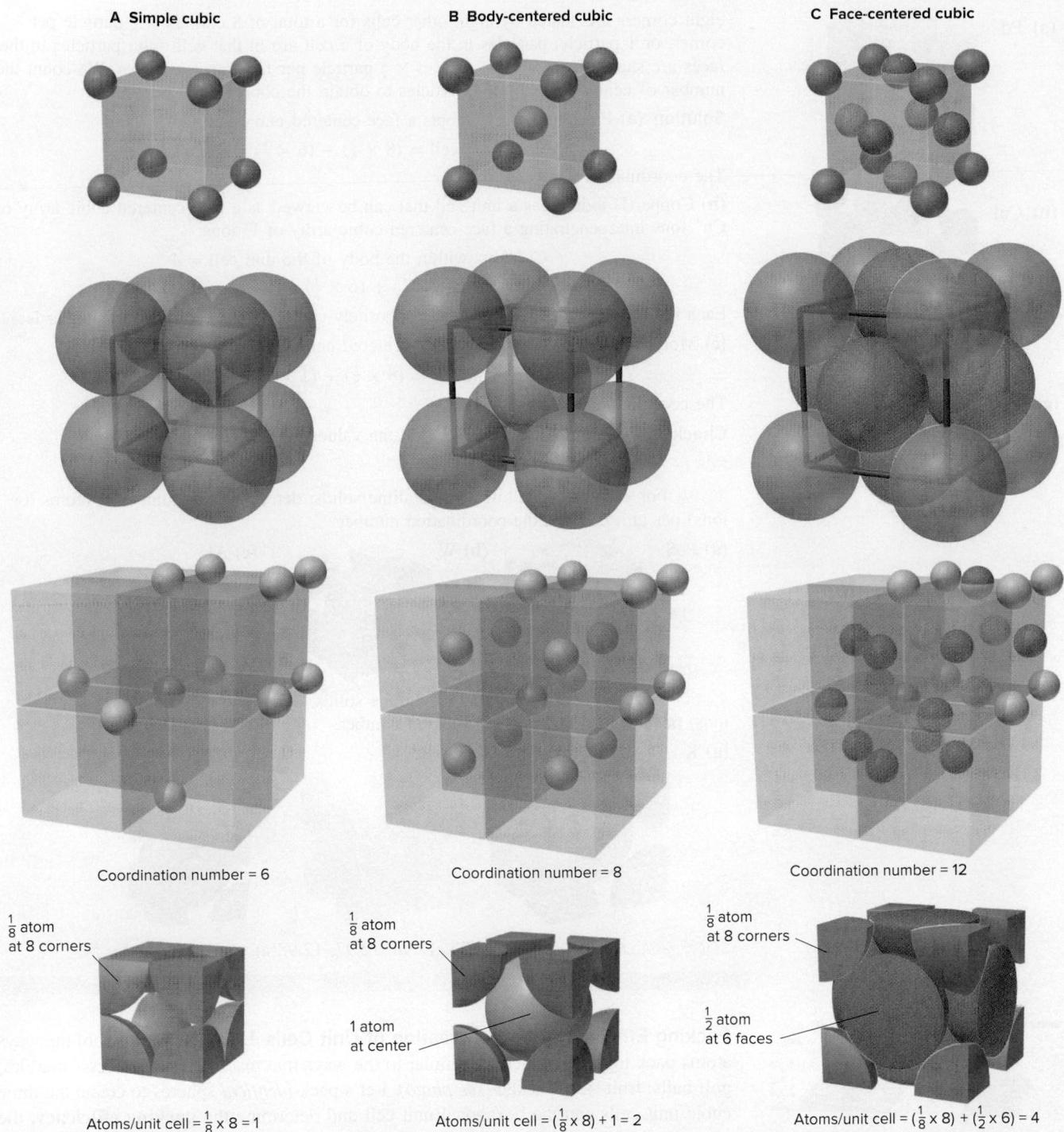

Figure 12.27 The three cubic unit cells. **A**, Simple cubic unit cell. **B**, Body-centered cubic unit cell. **C**, Face-centered cubic unit cell. Top row: Cubic arrangements of atoms in expanded view. Second row: Space-filling view of these cubic arrangements. All atoms are identical but, for clarity, corner atoms are blue, body-centered atoms pink, and face-centered atoms yellow. Third row: A unit cell (shaded blue) in an expanded portion of the crystal. The number of nearest neighbors around one particle (dark blue in center) is the coordination number. Bottom row: The total numbers of atoms in the actual unit cells. The simple cubic has one atom, the body-centered has two, and the face-centered has four.

SAMPLE PROBLEM 12.6

Determining the Number of Particles per Unit Cell and the Coordination Number

Problem For each of the crystalline solids shown in the margin on the next page, determine the number of atoms (or ions) per unit cell and the coordination number.

Plan To determine the number of particles (atoms or ions) in a unit cell, we count the number of particles at the corners, in the faces, and within the body of the cell. The

(a) Pd

(b) CuI

(c) Mo

eight corners are shared by eight other cells for a total of 8 corners $\times \frac{1}{8}$ particle per corner, or 1 particle; particles in the body of a cell are in that cell only; particles in the faces are shared by two cells, 6 faces $\times \frac{1}{2}$ particle per face, or 3 particles. We count the number of nearest neighboring particles to obtain the coordination number.

Solution (a) Palladium metal adopts a face-centered cubic unit cell:

$$\text{Atoms/unit cell} = (8 \times \frac{1}{8}) + (6 \times \frac{1}{2}) = 4 \text{ atoms}$$

The coordination number is 12.

(b) Copper(I) iodide has a unit cell that can be viewed as a face-centered cubic array of Cu⁺ ions interpenetrating a face-centered cubic array of I⁻ ions:

$$\text{Cu}^+ \text{ ions within the body of the unit cell} = 4$$

$$\text{I}^- \text{ ions/unit cell} = (8 \times \frac{1}{8}) + (6 \times \frac{1}{2}) = 4 \text{ Cu}^+ \text{ and } 4 \text{ I}^- \text{ ions}$$

Each ion is surrounded by four of the oppositely charged ions: coordination number is 4.

(c) Molybdenum metal adopts a body-centered cubic cell:

$$\text{Atoms/unit cell} = (8 \times \frac{1}{8}) + (1 \times 1) = 2 \text{ atoms}$$

The coordination number is 8.

Check Using Figure 12.27, we see that the values are correct.

FOLLOW-UP PROBLEMS

12.6A For each of the following crystalline solids, determine the number of atoms (or ions) per unit cell and the coordination number:

(a) PbS

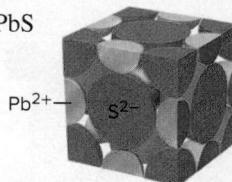

(b) W

(c) Al

12.6B For each of the following crystalline solids, determine the number of atoms (or ions) per unit cell and the coordination number:

(a) K

(b) Pt

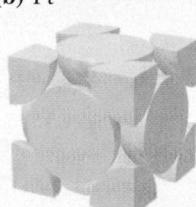

(c) CsCl

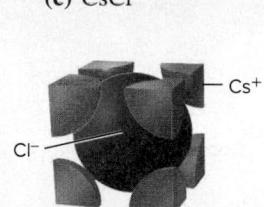

SOME SIMILAR PROBLEMS 12.87, 12.96, 12.97, 12.98(a), and 12.99(a)

The efficient packing of fruit.

Source: © Bryan Busovicki/Shutterstock.com

Packing Efficiency and the Creation of Unit Cells Unit cells result from the ways atoms pack together, which are similar to the ways that macroscopic spheres—marbles, golf balls, fruit—are packed (*see photo*). Let's pack *identical* spheres to create the three cubic unit cells and the hexagonal unit cell and determine the **packing efficiency**, the percentage of the total volume of the unit cell occupied by the spheres themselves:

1. *The simple cubic unit cell.* When we arrange the first layer of spheres in vertical and horizontal rows, large diamond-shaped spaces are formed (Figure 12.28A, *cutaway portion*). If we place the next layer of spheres *directly above* the first, we obtain an arrangement based on the *simple cubic unit cell* (Figure 12.28B). The spheres occupy only 52% of the unit-cell volume, so 48% is empty space between them. This is a very inefficient way to pack spheres, so neither fruit nor atoms are typically packed this way.

2. *The body-centered cubic unit cell.* Rather than placing the second layer (colored green for clarity) directly above the first, we use space more efficiently by placing its spheres over the diamond-shaped spaces in the first layer (Figure 12.28C). Then we pack the third layer onto the diamond-shaped spaces in the second, which makes the first and third layers line up vertically. This arrangement is based on the *body-centered cubic unit cell*, and its packing efficiency, at 68%, is much higher than that of the

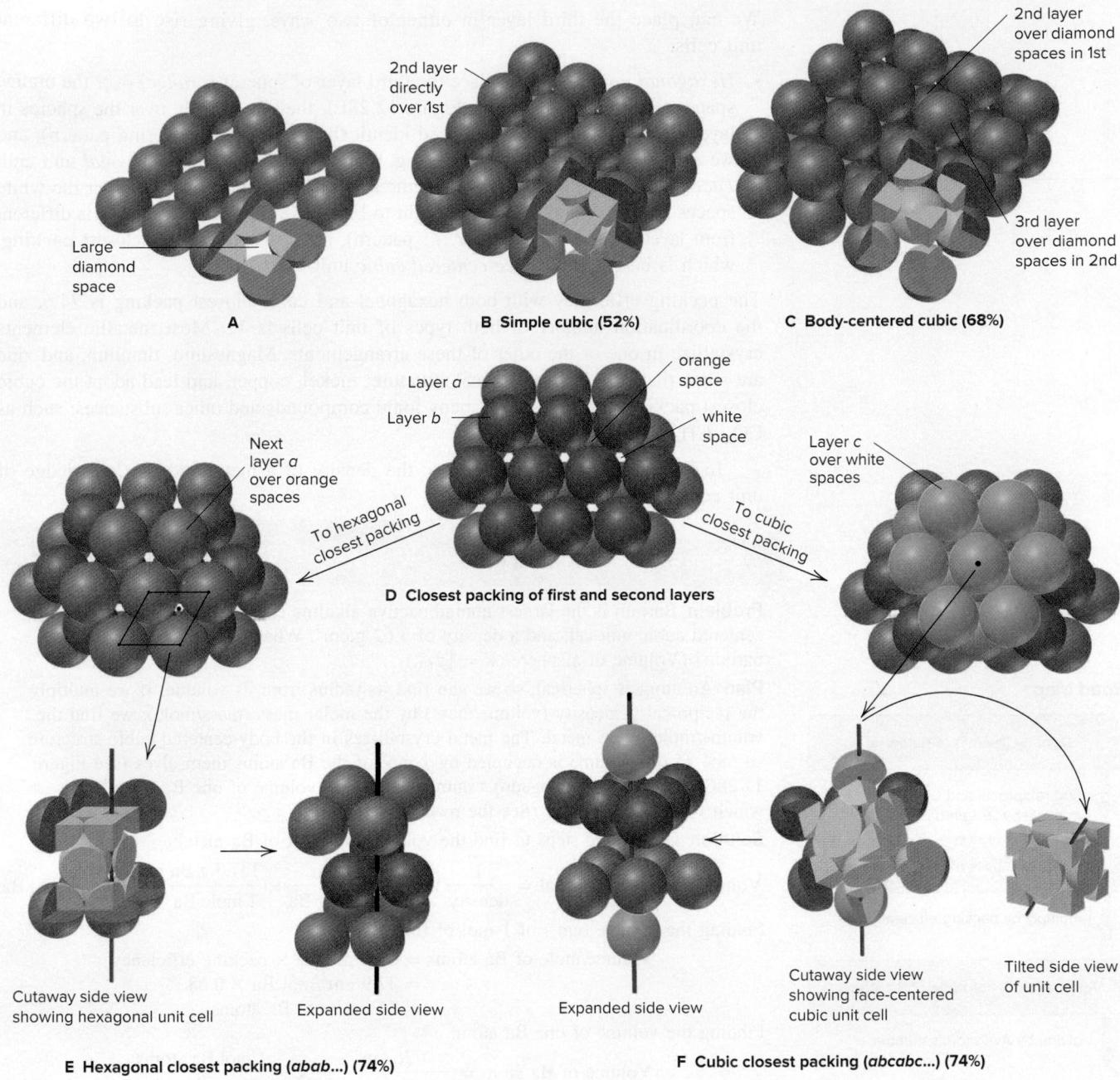

Figure 12.28 Packing spheres to obtain three cubic and hexagonal unit cells. **A**, In the first layer, each sphere lies next to another horizontally and vertically; note the large diamond-shaped spaces (see cutaway). **B**, If the spheres in the next layer lie directly over those in the first, the packing is based on the simple cubic unit cell (pale orange cube, lower right corner). **C**, If the spheres in the next layer lie in the diamond-shaped spaces of the first layer, the packing is based on the body-centered cubic unit cell (lower right corner). **D**, The closest possible packing of the first layer (layer *a*, orange) is obtained by shifting every other row in part A to obtain smaller triangular spaces. The spheres of the second layer (layer *b*, green) are placed above these spaces; note the orange and white spaces that result. **E**, When the third layer (next layer *a*, orange) is placed over the orange spaces, we obtain an *abab...* pattern and the hexagonal unit cell. **F**, When the third layer (layer *c*, blue) covers the white spaces, we get an *abcabc...* pattern and the face-centered cubic unit cell.

simple cubic unit cell. Several metallic elements, including chromium, iron, and all the Group 1A(1) elements, have a crystal structure based on this unit cell.

3. *The hexagonal and face-centered cubic unit cells.* Spheres are packed most efficiently in these cells. First, in the bottom layer (labeled *a*, orange), we shift every other row laterally so that the large diamond-shaped spaces become smaller triangular spaces. Then we place the second layer (*b*, green) over these spaces (Figure 12.28D).

In layer *b*, notice that some spaces are orange because they lie above *spheres* in layer *a*, whereas other spaces are white because they lie above *spaces* in layer *a*.

We can place the third layer in either of two ways, giving rise to two different unit cells:

- **Hexagonal unit cell.** If we place the third layer of spheres (*orange*) over the orange spaces (look down and left to Figure 12.28E), they lie directly over the spheres in layer *a*. Every other layer is placed identically (an *abab...* layering pattern), and we obtain **hexagonal closest packing**, which is based on the *hexagonal* unit cell.
- **Face-centered unit cell.** If we place the third layer of spheres (*blue*) over the white spaces in layer *b* (look down and right to Figure 12.28F), the placement is different from layers *a* and *b* (*abcabc...* pattern), and we obtain **cubic closest packing**, which is based on the *face-centered cubic* unit cell.

The packing efficiency with both hexagonal and cubic closest packing is 74%, and the coordination number of both types of unit cells is 12. Most metallic elements crystallize in one or the other of these arrangements. Magnesium, titanium, and zinc are some that adopt the hexagonal structure; nickel, copper, and lead adopt the cubic closest packing structure, as do many ionic compounds and other substances, such as CO₂, CH₄, and most noble gases.

In Sample Problem 12.7, we use the density of a metal and our knowledge of unit cells to find an atomic radius.

SAMPLE PROBLEM 12.7

Determining Atomic Radius

Problem Barium is the largest nonradioactive alkaline earth metal. It has a body-centered cubic unit cell and a density of 3.62 g/cm³. What is the atomic radius of barium? (Volume of a sphere: $V = \frac{4}{3}\pi r^3$.)

Plan An atom is spherical, so we can find its radius from its volume. If we multiply the reciprocal of density (volume/mass) by the molar mass (mass/mole), we find the volume/mole of Ba metal. The metal crystallizes in the body-centered cubic structure, so 68% of this volume is occupied by 1 mol of the Ba atoms themselves (see Figure 12.28C). Dividing by Avogadro's number gives the volume of one Ba atom, from which we find the radius. (See the road map.)

Solution Combining steps to find the volume of 1 mol of Ba metal:

$$\text{Volume/mole of Ba metal} = \frac{1}{\text{density}} \times \mathcal{M} = \frac{1 \text{ cm}^3}{3.62 \text{ g Ba}} \times \frac{137.3 \text{ g Ba}}{1 \text{ mole Ba}} = 37.9 \text{ cm}^3/\text{mol Ba}$$

Finding the volume (cm³) of 1 mol of Ba atoms:

$$\begin{aligned} \text{Volume/mole of Ba atoms} &= \text{cm}^3/\text{mol Ba} \times \text{packing efficiency} \\ &= 37.9 \text{ cm}^3/\text{mol Ba} \times 0.68 \\ &= 26 \text{ cm}^3/\text{mol Ba atoms} \end{aligned}$$

Finding the volume of one Ba atom:

$$\text{Volume of Ba atom} = \frac{26 \text{ cm}^3}{1 \text{ mol Ba atoms}} \times \frac{1 \text{ mol Ba atoms}}{6.022 \times 10^{23} \text{ Ba atoms}} = 4.3 \times 10^{-23} \text{ cm}^3/\text{Ba atom}$$

Finding the atomic radius of Ba from the volume of a sphere:

$$V \text{ of Ba atom} = \frac{4}{3}\pi r^3 \quad \text{so} \quad r^3 = \frac{3V}{4\pi}$$

Thus,

$$r = \sqrt[3]{\frac{3V}{4\pi}} = \sqrt[3]{\frac{3(4.3 \times 10^{-23} \text{ cm}^3)}{4 \times 3.14}} = 2.2 \times 10^{-8} \text{ cm}$$

Check The order of magnitude is correct for an atom ($\sim 10^{-8} \text{ cm} \approx 10^{-10} \text{ m}$). The actual value for barium is, in fact, $2.22 \times 10^{-8} \text{ cm}$ (see Figure 8.13).

FOLLOW-UP PROBLEMS

12.7A Cobalt has a face-centered cubic unit cell and an atomic radius of 125 pm. Calculate the density of cobalt metal.

12.7B Iron crystallizes in a body-centered cubic structure. The volume of one Fe atom is $8.38 \times 10^{-24} \text{ cm}^3$, and the density of Fe is 7.874 g/cm³. Calculate an approximate value for Avogadro's number.

SOME SIMILAR PROBLEMS 12.88 and 12.89

Road Map

Density (g/cm³) of Ba metal

find reciprocal and multiply by \mathcal{M} (g/mol)

Volume (cm³) per mole of Ba metal

multiply by packing efficiency

Volume (cm³) per mole of Ba atoms

divide by Avogadro's number

Volume (cm³) of Ba atom

$$V = \frac{4}{3}\pi r^3$$

Radius (cm) of Ba atom

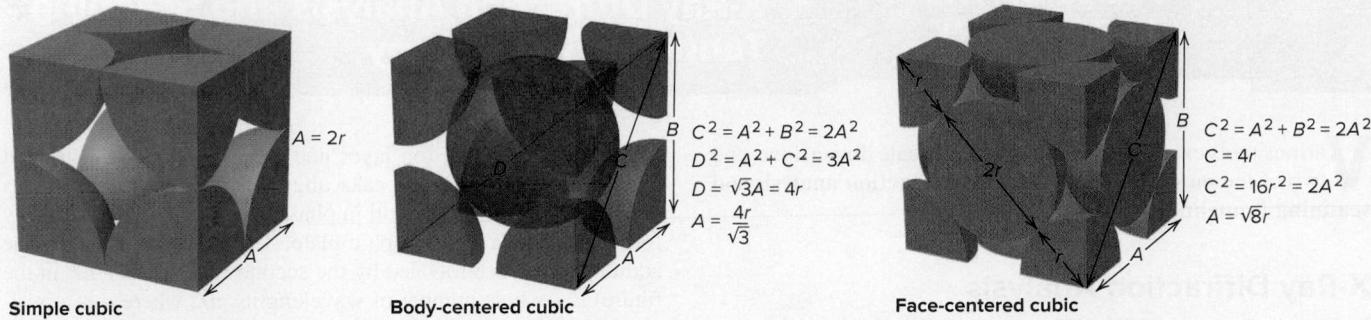

Figure 12.29 Edge length and atomic (ionic) radius in the three cubic unit cells.

Our understanding of crystal structures comes from our ability to “see” them. Two techniques for visualizing crystal structures are described in Tools of the Laboratory on the next page.

The edge length of the unit cell is obtained from x-ray crystallography. We can then apply the Pythagorean theorem and some arithmetic to find atomic (or ionic) radii in the three cubic unit cells (Figure 12.29). Sample Problem 12.8 applies this approach.

SAMPLE PROBLEM 12.8

Determining Atomic Radius from the Unit Cell

Problem Copper adopts cubic closest packing, and the edge length of the unit cell is 361.5 pm. What is the atomic radius of copper?

Plan Cubic closest packing gives a face-centered cubic unit cell, and we know the edge length. From Figure 12.29, with $A = 361.5$ pm, we solve for r .

Solution Using the Pythagorean theorem to find C , the diagonal of the cell's face:

$$C = \sqrt{A^2 + B^2}$$

The unit cell is a cube, so $A = B$. Therefore,

$$C = \sqrt{2A^2} = \sqrt{2(361.5 \text{ pm})^2} = 511.2 \text{ pm}$$

Finding r : $C = 4r$. Therefore,

$$r = 511.2 \text{ pm}/4 = 127.8 \text{ pm.}$$

We can combine these steps by using the equation presented in Figure 12.29:

$$A = \sqrt{8}r$$

$$r = 361.5 \text{ pm}/\sqrt{8} = 127.8 \text{ pm}$$

Check Rounding and quickly checking the math gives

$$C = \sqrt{2(4 \times 10^2 \text{ pm})^2} = \sqrt{2(16 \times 10^4 \text{ pm}^2)}$$

or ~ 500 –600 pm; thus, $r \approx 125$ –150 pm. The actual value for copper is 128 pm (see Figure 8.13).

FOLLOW-UP PROBLEMS

12.8A Iron crystallizes in a body-centered cubic structure. If the atomic radius of Fe is 126 pm, find the edge length (in nm) of the unit cell.

12.8B Aluminum crystallizes in a cubic closest packed structure. If the edge length of the unit cell is 0.405 nm, find the atomic radius (in pm).

SOME SIMILAR PROBLEMS 12.92 and 12.93

Various tools exist for measuring atomic-scale dimensions, and two of the most powerful are **x-ray diffraction analysis** and **scanning tunneling microscopy**.

X-Ray Diffraction Analysis

In Chapter 7, we saw how diffraction patterns of bright and dark regions appear when light passes through slits spaced as far apart as the wavelength (see Figure 7.5). X-ray wavelengths are about the same size as the spaces between layers of spheres in a crystal, so we use the spaces as “slits” to diffract x-rays.

As one example, let’s use this approach to measure the distance (d) between two adjacent layers of atoms in a simplified lattice (Figure B12.1). Two waves impinge on the crystal at an angle θ and are diffracted at that angle by the layers. When the

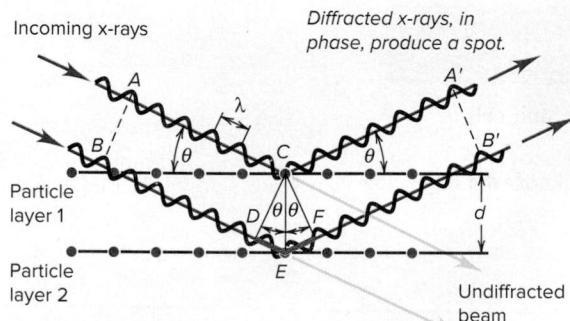

Figure B12.1 Diffraction of x-rays by crystal planes.

first wave strikes the top layer and the second strikes the next layer, they are *in phase* (peaks aligned with peaks and troughs with troughs). If they are still in phase after being diffracted, they form a spot on a photographic plate. This will occur only if the additional distance traveled by the second wave ($DE + EF$ in the figure) is a whole number of wavelengths, $n\lambda$, where n is a positive integer referred to as the *order* of the diffraction. From trigonometry, we find that

$$n\lambda = 2d \sin \theta$$

where θ is the angle of incoming light and d , the unknown, is the distance between layers. This is the *Bragg equation*, named for W. H. Bragg and his son W. L. Bragg, who shared the Nobel Prize in physics in 1915 for their work on crystal structure analysis.

Rotating the crystal changes θ and produces different sets of spots. Eventually, the complete diffraction pattern reveals distances and angles in the lattice (Figure B12.2). X-ray diffraction analysis is used in many studies, but its greatest recent impact is uncovering the structures of DNA and proteins.

Scanning Tunneling Microscopy

This technique, invented by Gerd Binnig and Heinrich Rohrer, who won the Nobel Prize in physics in 1986, is used to observe surfaces. It is based on the idea that an electron has a small, but finite, probability of being so far from its nucleus that it can move (“tunnel”) closer to another atom.

In practice, an extremely sharp tungsten-tipped probe, the source of the tunneling electrons, is placed very close to (about 0.5 nm from) the surface under study. A small applied electric

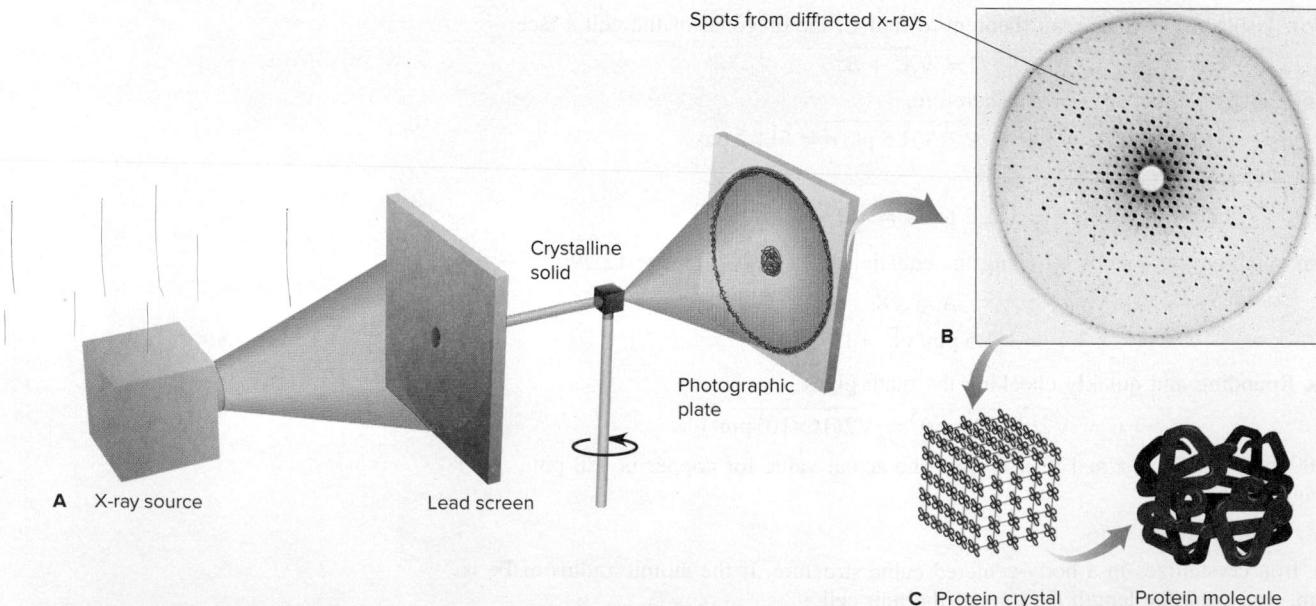

Figure B12.2 Formation of an x-ray diffraction pattern of the protein hemoglobin. **A**, A sample of crystalline protein is rotated to obtain different angles of incoming and diffracted x-rays. **B**, The diffraction pattern is a complex series of spots. **C**, Computerized analysis provides a picture of the molecule.

potential increases the probability that the electrons will tunnel across this minute gap. The probe moves tiny distances up and down to maintain the constant current across the gap, thus following the surface at the atomic scale. This movement is monitored electronically, and after many scans, a three-dimensional map of the surface is obtained. The method has revealed images of atoms and molecules coated on surfaces and is being used to study the nature of defects and many other surface features (Figure B12.3).

Problems

B12.1 X-rays of wavelength $\lambda = 0.709 \times 10^{-10}$ m undergo a first-order ($n = 1$) diffraction of 11.6° when aimed at crystalline nickel. What is the spacing between layers of Ni atoms?

B12.2 A first-order ($n = 1$) diffraction of x-rays aimed at a crystal of NaCl occurs at 15.9° .

- What is the wavelength (in pm) of the x-rays?
- At what angle would a second-order ($n = 2$) diffraction appear?

Figure B12.3 A scanning tunneling micrograph of cesium atoms (red) on gallium arsenide.

Source: Courtesy National Institute of Standards and Technology

Types and Properties of Crystalline Solids

The five most important types of solids are defined by the type(s) of particle(s) in the crystal (Table 12.5). We'll highlight interparticle forces and physical properties.

Table 12.5

Characteristics of the Major Types of Crystalline Solids

Type	Particle(s)	Interparticle Forces	Physical Properties	Examples [mp, °C]
Atomic	Atoms	Dispersion	Soft, very low mp, poor thermal and electrical conductors	Elements in Group 8A(18) (Ne [-249] to Rn [-71])
Molecular	Molecules	Dispersion, dipole-dipole, H bonds	Fairly soft, low to moderate mp, poor thermal and electrical conductors	<i>Nonpolar</i> * O ₂ [-219], C ₄ H ₁₀ [-138] Cl ₂ [-101], C ₆ H ₁₄ [-95], P ₄ [44.1]
				<i>Polar</i> SO ₂ [-73], CHCl ₃ [-64], HNO ₃ [-42], H ₂ O [0.0], CH ₃ COOH [17]
Ionic	Positive and negative ions	Ion-ion attraction	Hard and brittle, high mp, good thermal and electrical conductors when molten	NaCl [801] CaF ₂ [1423] MgO [2852]
Metallic	Atoms	Metallic bond	Soft to hard, low to very high mp, excellent thermal and electrical conductors, malleable and ductile	Na [97.8] Zn [420] Fe [1535]
Network covalent	Atoms	Covalent bond	Very hard, very high mp, usually poor thermal and electrical conductors	SiO ₂ (quartz) [1610] C (diamond) [~4000]

*Nonpolar molecular solids are arranged in order of increasing molar mass. Note the correlation with increasing melting point (mp).

Figure 12.30 Cubic closest packing of argon (face-centered cubic unit cell).

Figure 12.31 Cubic closest packing (face-centered unit cell) of CH_4 .

Atomic Solids Individual atoms held together only by *dispersion forces* form an **atomic solid** and the noble gases [Group 8A(18)] are the only substances that form such solids. The very weak forces among the atoms mean melting and boiling points and heats of vaporization and fusion are all very low, rising smoothly with increasing molar mass. Argon crystallizes in a cubic closest packed structure (Figure 12.30), as do the other noble gases.

Molecular Solids In the many thousands of **molecular solids**, individual molecules occupy the lattice points. Various combinations of dipole-dipole, dispersion, and H-bonding forces account for a wide range of physical properties. Dispersion forces in nonpolar substances lead to melting points that generally increase with molar mass (Table 12.5). Among polar molecules, dipole-dipole forces and, where possible, H bonding occur. Most molecular solids have much higher melting points than atomic solids (noble gases) but much lower melting points than other types of solids. Methane crystallizes in a face-centered cubic structure with the center of each carbon as the lattice point (Figure 12.31).

Ionic Solids To maximize attractions in a binary **ionic solid**, cations are surrounded by as many anions as possible, and vice versa, with *the smaller of the ions (usually the cation) lying in the spaces (holes) formed by the packing of the larger (usually the anion)*. The unit cell is the smallest portion that maintains the composition; that is, *the unit cell has the same cation/anion ratio as the empirical formula*.

As a result of cation-anion contact, the interparticle forces (ionic bonds) are *much stronger* than the van der Waals forces in atomic or molecular solids. The properties of ionic solids are a direct consequence of the *fixed ion positions* and *very strong attractive forces*, which create a high lattice energy. Thus, ionic solids typically have high melting points and low electrical conductivities. When a large quantity of heat is supplied and the ions gain enough kinetic energy to break free of their positions, the solid melts and the mobile ions conduct a current. Ionic compounds are hard because only a strong external force can change the relative positions of the huge number of ions attracting one another. If enough force is applied to move them, ions of like charge are brought near each other, and their repulsions crack the crystal (see Figure 9.9).

Ionic solids often adopt cubic closest packed crystal structures. Let's consider two examples with a 1/1 ratio of ions and then two with a 2/1 (or 1/2) ratio:

1. The *sodium chloride structure* is found in many ionic compounds, including most alkali [Group 1A(1)] halides and hydrides, alkaline earth [Group 2A(2)] oxides and sulfides, and several transition metal oxides and sulfides. To visualize this structure, imagine Cl^- anions and Na^+ cations in separate face-centered cubic arrays. Now picture the two arrays penetrating each other, the smaller Na^+ ions ending up in the holes between the larger Cl^- ions (Figure 12.32A). Thus, each Na^+ is surrounded by six Cl^- , and vice versa (coordination number = 6). Figure 12.32B is a space-filling depiction of the unit cell: four Cl^- [$(8 \times \frac{1}{8}) + (6 \times \frac{1}{2}) = 4 \text{ Cl}^-$] and four Na^+ [$(12 \times \frac{1}{4}) + 1$ in the center = 4 Na^+], give a 1/1 ion ratio.

Figure 12.32 The sodium chloride structure. **A**, Expanded view. **B**, Space-filling depiction of the NaCl unit cell.

2. The *zinc blende* (ZnS) structure can be pictured as two face-centered cubic arrays, one of Zn^{2+} ions (gray) and the other of S^{2-} ions (yellow), penetrating each other such that each ion is tetrahedrally surrounded by four of the other ions (coordination number = 4) (Figure 12.33). There are four [$(8 \times \frac{1}{8}) + (6 \times \frac{1}{2}) = 4$] S^{2-} ions and four Zn^{2+} ions for a 1/1 ion ratio. Many other compounds, including AgI , CdS , and the copper(I) halides, adopt the zinc blende structure.

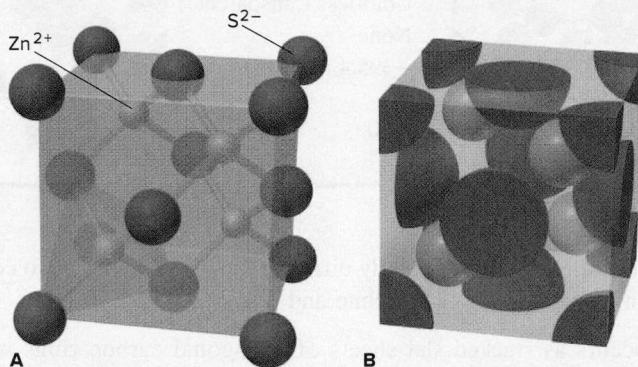

Figure 12.33 The zinc blende structure. **A**, Expanded view (with bonds shown for clarity). **B**, The unit cell is expanded a bit to show interior ions.

3. The *fluorite* (CaF_2) structure is common among salts with a 1/2 cation/anion ratio that have relatively large cations and small anions, such as SrF_2 and $BaCl_2$. In CaF_2 , the unit cell is a face-centered cubic array of Ca^{2+} ions with F^- ions occupying all eight available holes (Figure 12.34). This results in a Ca^{2+}/F^- ratio of 4/8, or 1/2.

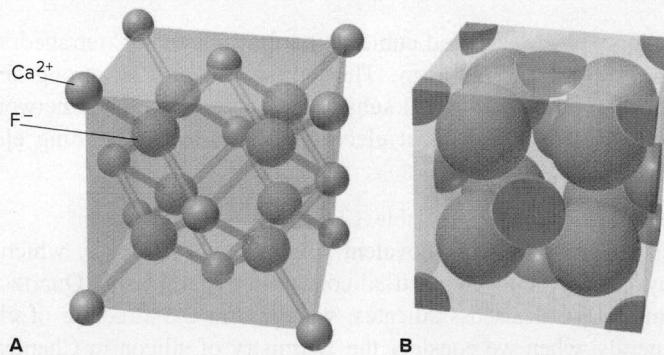

Figure 12.34 The fluorite structure. **A**, Expanded view (with bonds shown for clarity). **B**, The unit cell is expanded a bit to show interior ions.

4. The *antifluorite structure* is common in compounds with a 2/1 cation/anion ratio and a relatively large anion (such as K_2S). The ion arrangement is the opposite of that in the fluorite structure: the cations occupy all eight holes formed by the cubic closest packing of the anions.

Metallic Solids Most metallic elements crystallize in one of the two closest packed structures (Figure 12.35). In contrast to the weak dispersion forces in atomic solids, powerful metallic bonding forces hold atoms together in **metallic solids**. The properties of metals—high electrical and thermal conductivity, luster, and malleability—result from their delocalized electrons (Section 9.6). Melting points and hardnesses are related to the packing efficiency and number of valence electrons. For example, Group 2A metals are harder and melt higher than Group 1A metals (see Figure 9.28), because the 2A metals have twice as many delocalized valence electrons.

Network Covalent Solids Strong covalent bonds link the atoms together in a **network covalent solid**; thus, separate particles are not present. These substances adopt a variety of crystal structures depending on the details of their bonding.

As a consequence of strong bonding, all network covalent solids have extremely high melting and boiling points, but their conductivity and hardness vary. Two examples

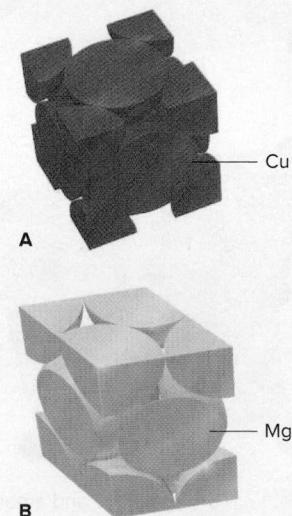

Figure 12.35 Crystal structures of metals. **A**, Copper adopts cubic closest packing. **B**, Magnesium adopts hexagonal closest packing.

Table 12.6

Comparison of the Properties of Diamond and Graphite

Property	Graphite	Diamond
Density (g/cm ³)	2.27	3.51
Hardness	<1 (very soft)	10 (hardest)
Melting point (K)	4100	4100
Color	Shiny black	Colorless transparent
Electrical conductivity	High (along sheet)	None
$\Delta H_{\text{rxn}}^{\circ}$ for combustion (kJ/mol)	-393.5	-395.4
ΔH_f° (kJ/mol)	0 (standard state)	1.90

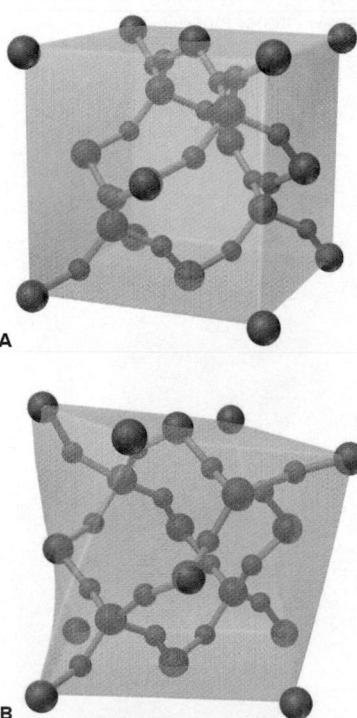

Figure 12.36 Crystalline and amorphous silicon dioxide. **A**, Cristobalite, a crystalline form of silica (SiO_2), shows cubic closest packing. **B**, Quartz glass is amorphous with a generally disordered structure.

with the same composition but strikingly different properties are the two common crystalline forms of elemental carbon, graphite and diamond:

- *Graphite* occurs as stacked flat sheets of hexagonal carbon rings with a strong σ -bond framework and delocalized π bonds, reminiscent of benzene; the arrangement looks like chicken wire or honeycomb. Whereas the π -bonding electrons of benzene are delocalized over one ring, those of graphite are delocalized over the entire sheet. Thus, graphite conducts electricity well—it is a common electrode material—but only in the plane of the sheets. The sheets interact via dispersion forces, and impurities, such as O_2 , between the sheets allow them to slide past each other, which explains why graphite is soft and used as a lubricant.
- *Diamond* adopts a face-centered cubic unit cell, with each C tetrahedrally bonded to four others in an endless array. Throughout the crystal, strong single bonds make diamond the hardest natural substance known. Like most network covalent solids, diamond does not conduct electricity because the bonding electrons are localized.

These properties are compared in Table 12.6.

The most important network covalent solids are the *silicates*, which consist of extended arrays of covalently bonded silicon and oxygen atoms. Quartz (SiO_2) is a common example. We'll discuss silicates, which form the structure of clays, rocks, and many minerals, when we consider the chemistry of silicon in Chapter 14.

Amorphous Solids

Amorphous solids are noncrystalline. Many have small, somewhat ordered regions interspersed among large disordered regions. Charcoal, rubber, and glass are examples.

The process that forms quartz glass is typical of many amorphous solids. Crystalline quartz (SiO_2), which adopts cubic closest packing, is melted and the viscous liquid is cooled rapidly to prevent it from recrystallizing. The chains of Si and O atoms cannot orient themselves quickly enough, so they solidify in a distorted jumble containing gaps and misaligned rows (Figure 12.36). The absence of regularity confers some properties of a liquid; in fact, glasses are sometimes referred to as *super-cooled liquids*.

Bonding in Solids: Molecular Orbital Band Theory

Chapter 9 introduced a qualitative model of metallic bonding, with metal ions submerged in a “sea” of delocalized valence electrons. Molecular orbital (MO) theory offers a more quantitative, and therefore more useful, model called **band theory**. We'll focus on bonding in metals and the resulting conductivity of metals, metalloids, and nonmetals.

Formation of Valence and Conduction Bands Recall from Section 11.3 that when two atoms form a diatomic molecule, their atomic orbitals (AOs) combine to form an equal number of molecular orbitals (MOs). Figure 12.37 shows the formation of MOs in lithium. To form Li_2 , four valence orbitals (one 2s and three 2p) of each Li atom combine to form eight MOs, four bonding and four antibonding. The order of MOs shows mixing of the 2s and 2p AOs (Figure 11.21B). Two more Li atoms form Li_4 , a slightly larger aggregate, with 16 delocalized MOs. As more Li atoms join the cluster, more MOs are created, and their energy levels lie closer and closer together. Extending this process to 7 g (1 mol) of lithium results in 6×10^{23} Li atoms (Li_{N_A}) combining to form an extremely large number ($4 \times$ Avogadro's number) of delocalized MOs. *The energies of the MOs are so close that they form a continuum, or band, of MOs.*

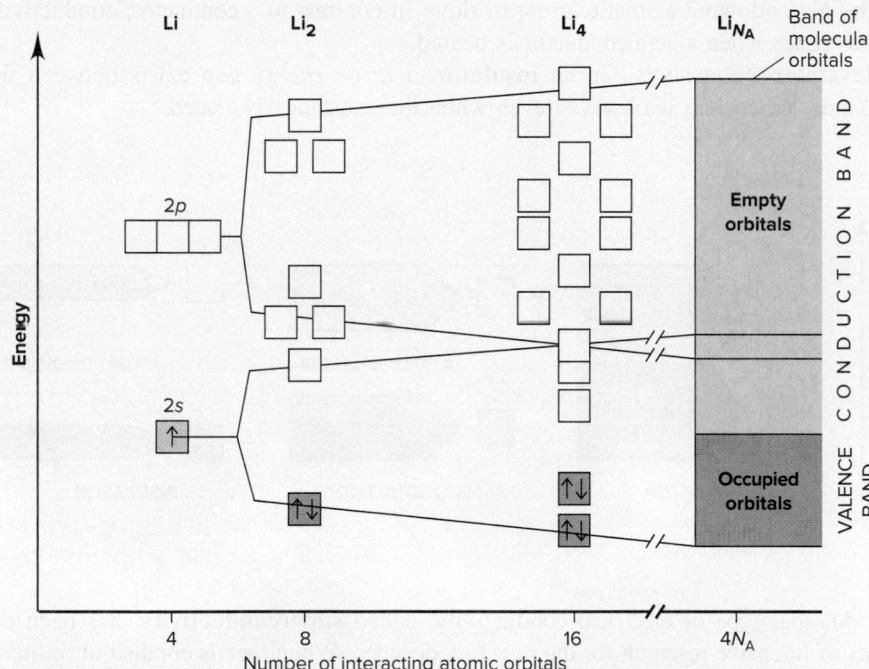

Figure 12.37 The band of molecular orbitals in lithium metal.

The lower energy MOs are occupied by the $2s^1$ valence electrons and make up the **valence band**. The empty MOs that are higher in energy make up the **conduction band**. In Li metal, the valence band is derived from the 2s AOs, and the conduction band is derived from 2s and mostly 2p AOs. In Li_2 , two valence electrons fill the lowest energy bonding MO and leave the antibonding MO empty. In Li metal, 1 mol of valence electrons fills the valence band and leaves the conduction band empty.

How Band Theory Explains Metallic Properties The key to understanding the properties of metals is that *the valence and conduction bands are contiguous*, that is, the highest level of one touches the lowest of the other. This means that, given an infinitesimal quantity of energy, electrons jump from the filled valence band to the unfilled conduction band: the electrons are completely delocalized and free to move.

- **Electrical conductivity.** Metals conduct electricity so well because an applied field easily excites the highest energy valence electrons into empty conduction orbitals, allowing them to move through the sample.
- **Luster.** With so many closely spaced levels available, electrons absorb and release photons of many frequencies as they move between the valence and conduction bands.
- **Malleability.** Under an applied force, layers of positive metal ions move past each other, always protected from mutual repulsions by the delocalized electrons.
- **Thermal conductivity.** When a metal wire is heated, the highest energy electrons are excited and their extra energy is transferred as kinetic energy along the wire's length.

Conductivity of Solids and the Size of the Energy Gap Like metal atoms, large numbers of nonmetal and metalloid atoms can form bands of MOs. Band theory explains differences in electrical conductivity and the effect of temperature among these three classes of substances in terms of the presence of an energy gap between their valence and conduction bands (Figure 12.38):

1. *Conductors (metals)*. The valence and conduction bands of a **conductor** have *no energy gap* between them, so electrons flow when a tiny electrical potential difference is applied. When the temperature is raised, greater random motion of the atoms hinders electron movement: conductivity *decreases* when a metal is heated.
2. *Semiconductors (metalloids)*. In a **semiconductor**, a *small energy gap* exists between the valence and conduction bands. Thermally excited electrons can cross the gap, allowing a small current to flow: in contrast to a conductor, conductivity *increases* when a semiconductor is heated.
3. *Insulators (nonmetals)*. In an **insulator**, a *large energy gap* exists between the bands: no current is observed even when the substance is heated.

Figure 12.38 Electrical conductivity in a conductor, semiconductor, and insulator.

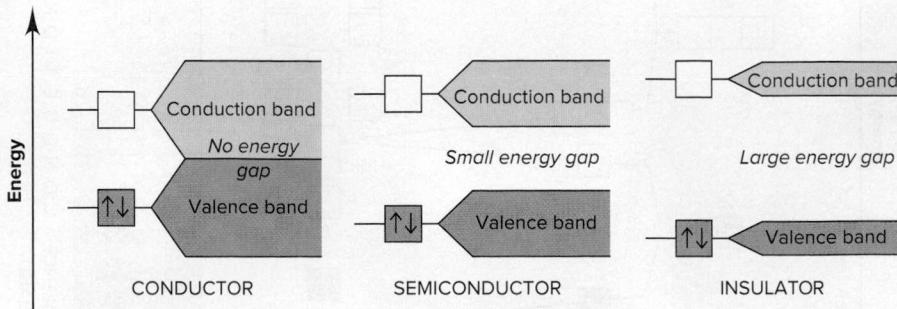

Another type of electrical conductivity, called **superconductivity**, has been the focus of intensive research for the past few decades. When metals conduct at ordinary temperatures, moving electrons collide with vibrating atoms; the reduction in their flow appears as resistive heating and represents a loss of energy.

For many years, to conduct with no energy loss—to superconduct—required minimizing atom movement by cooling with liquid helium ($\text{bp} = 4\text{ K}$; price $\approx \$11/\text{L}$). Then, in 1986, certain ionic oxides that superconduct near the boiling point of liquid nitrogen ($\text{bp} = 77\text{ K}$; price $= \$0.06/\text{L}$) were prepared. Like metal conductors, oxide superconductors, such as $\text{YBa}_2\text{Cu}_3\text{O}_7$, have no gap between bands. In 1989, oxides with Bi and Tl instead of Y and Ba were synthesized and found to superconduct at 125 K; and in 1993, an oxide with Hg, Ba, and Ca, in addition to Cu and O, superconducted at 133 K. Such materials could transmit electricity with no loss of energy, allowing power plants to be located far from cities. They could be part of ultrasmall microchips for ultrafast computers, electromagnets to levitate superfast trains, and inexpensive medical diagnostic equipment with superb image clarity. However, the oxides are brittle and not easy to machine, and when warmed, the superconductivity may disappear and not return on cooling. Addressing these and related problems will involve chemists, physicists, and engineers for many years.

› Summary of Section 12.6

- › Particles in crystalline solids lie at points that form a structure of repeating unit cells.
- › The three types of unit cells of the cubic system are simple, body-centered, and face-centered. The highest packing efficiency occurs with cubic (face-centered) and hexagonal closest packing.

- Bond angles and distances in a crystal are determined with x-ray diffraction analysis and scanning tunneling microscopy. These data are used to determine atomic radii.
- Atomic solids [Group 8A(18)] adopt cubic closest packing, with atoms held together by weak dispersion forces.
- Molecular solids have molecules at the lattice points and often adopt cubic closest packing. Combinations of intermolecular forces (dispersion, dipole-dipole, and H bonding) result in physical properties that vary greatly.
- Ionic solids crystallize with one ion filling holes in the cubic closest packed array of the other. High melting points and hardness and low conductivity arise from strong ionic attractions.
- Most metals have a closest packed structure. Their physical properties result from the high packing efficiency and the presence of delocalized electrons.
- Atoms of network covalent solids are covalently bonded throughout the sample, so these substances have very high melting and boiling points.
- Amorphous solids have little regularity in their structure.
- Band theory proposes that atomic orbitals of many atoms combine to form a continuum, or band, of molecular orbitals. Metals are electrical conductors because electrons move freely from the filled (valence) band to the empty (conduction) band. Insulators have a large energy gap between the two portions, and semiconductors have a small gap, which can be bridged by heating.

12.7 ADVANCED MATERIALS

In the last few decades, the exciting field of materials science has applied concepts from solid-state chemistry, physics, and engineering. Objects that were once considered futuristic fantasies have become realities: powerful, ultrafast computers smaller than a cell phone; cars powered by sunlight and made of nonmetallic parts stronger than steel and lighter than aluminum; ultrasmall machines constructed by manipulating individual atoms and molecules. In this section, we briefly discuss some of these remarkable materials.

Electronic Materials

The ideal of a perfectly ordered crystal is attainable only if the crystal is grown very slowly under carefully controlled conditions. When crystals form more rapidly, **crystal defects** inevitably result. Planes of particles are misaligned, particles are out of place or missing entirely, and foreign particles replace those that belong in the lattice. Although defects usually weaken a substance, they can be introduced intentionally to improve materials, giving them increased strength, hardness, or conductivity. Centuries of metal-working exemplify the traditional importance of crystal defects, which is the basis of modern electronic materials.

Introducing Crystal Defects in Welding and Alloying In the process of *welding* two metals together, *vacancies* form near the surface when atoms vaporize, and then these vacancies move deeper as atoms from lower rows rise to fill the gaps. Welding causes the two types of metal atoms to intermingle and fill each other's vacancies. Metal *alloying* introduces several kinds of crystal defects, as when some atoms of a second metal occupy lattice sites of the first. Often, the alloy is harder than the pure metal; an example is brass, an alloy of copper with zinc. One reason the welded metals are stronger and the alloy is harder is that the second metal contributes additional valence electrons for metallic bonding.

Doped Semiconductors By controlling the number of valence electrons through the creation of specific types of crystal defects, chemists and engineers can greatly increase the conductivity of a semiconductor. For example, pure silicon [Si; Group 4A(14)], conducts poorly at room temperature because an energy gap separates its filled valence band from its conduction band (Figure 12.39A). Silicon's conductivity

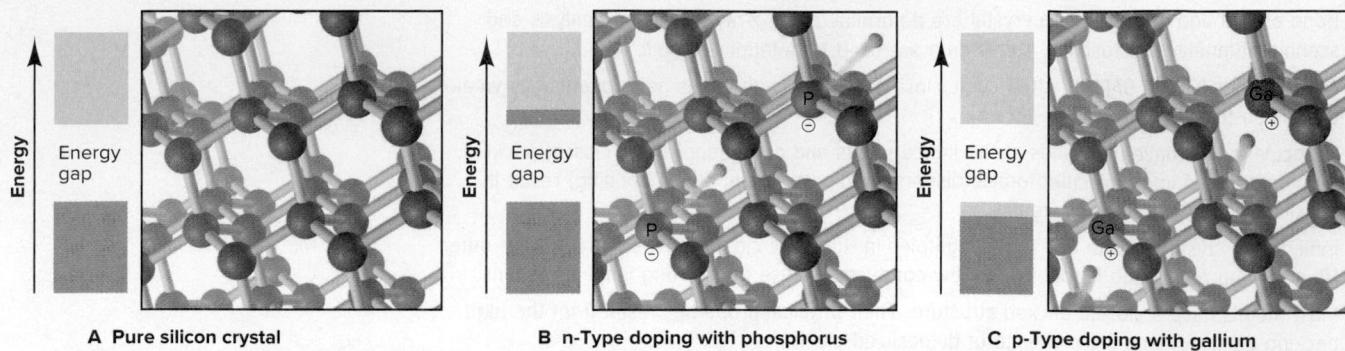

Figure 12.39 Crystal structures and band representations of doped semiconductors. **A**, Pure silicon has an energy gap between its valence and conduction bands, which keeps conductivity low at room temperature. **B**, Doping silicon with phosphorus (purple) adds additional valence electrons. **C**, Doping silicon with gallium (orange) removes electrons from the valence band and introduces positive holes.

can be greatly enhanced by **doping**, adding small amounts of other elements to increase or decrease the number of valence electrons in the bands.

- *Doping to create an n-type semiconductor: increasing the number of valence electrons.* When Si is doped with phosphorus [or another Group 5A(15) element], P atoms occupy some of the lattice sites. Since P has one more valence electron than Si, this additional electron must enter an empty orbital in the conduction band, thus bridging the energy gap and increasing conductivity. Such doping creates an *n-type semiconductor*, so called because extra negative charges (electrons) are present (Figure 12.39B).
- *Doping to create a p-type semiconductor: decreasing the number of valence electrons.* When Si is doped with gallium [or another Group 3A(13) element], Ga atoms occupy some sites (Figure 12.39C). Since Ga has one fewer valence electron than Si, some of the orbitals in the valence band are empty, which creates a positive site. Si electrons can migrate to these empty orbitals, thereby increasing conductivity. Such doping creates a *p-type semiconductor*, so called because the empty orbitals act as positive holes.

In contact with each other, an n-type and a p-type semiconductor form a *p-n junction*. When the negative terminal of a battery is connected to the n-type portion and the positive terminal to the p-type portion, electrons (*yellow, negative spheres*) flow freely in the n-to-p direction, which has the simultaneous effect of moving holes (*white, positive spheres*) in the p-to-n direction (Figure 12.40A). No current flows if the terminals are reversed (Figure 12.40B). Such unidirectional current flow makes a p-n junction act as a *rectifier*, a device that converts alternating current into direct current. A p-n junction in a modern integrated circuit can be made smaller than a square 10 μm on a side.

A modern computer chip the size of a nickel may incorporate millions of p-n junctions in the form of *transistors*. One of the most common types, an n-p-n transistor, is made by sandwiching a p-type portion between two n-type portions to form adjacent p-n junctions. The current flowing through one junction controls the current flowing through the other and results in an amplified signal.

Figure 12.40 The p-n junction. Placing a p-type semiconductor adjacent to an n-type creates a p-n junction.

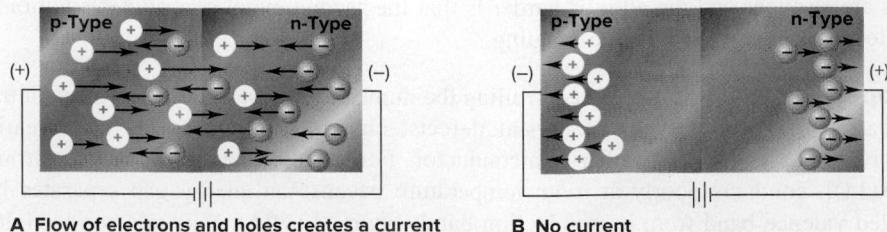

One of the more common types of *solar cell* is, in essence, a p-n junction with an n-type surface exposed to a light source. Light provides the energy to free electrons from the n-type region and accelerate them through an external circuit into the p-type region, thus producing a current.

Liquid Crystals

Incorporated in the membrane of every cell in your body and in the display of every electronic device are **liquid crystals**. These materials flow like liquids but, like crystalline solids, pack with a high degree of order at the molecular level.

Ordering of the Particles Let's examine how particles are ordered in the three physical states and how this affects their properties. Both gases and liquids are *isotropic*—their physical properties are the same in every direction within the phase. For example, the viscosity of a gas or a liquid is the same regardless of direction. Glasses and other amorphous solids are also isotropic because they have no regular lattice structure.

In contrast, crystalline solids have a high degree of order among their particles. The properties of a crystal *do* depend on direction, so a crystal is *anisotropic*. The facets in a cut diamond, for instance, arise because the crystal cracks in one direction more easily than in another. Liquid crystals are anisotropic with respect to several physical properties, including electrical and optical properties, which differ with direction through the phase.

Molecular Characteristics Liquid crystal phases consist of individual molecules with two characteristics: (1) a long, cylindrical shape and (2) a structure that fosters intermolecular attractions but inhibits perfect crystalline packing. Molecules that form liquid crystal phases have rodlike shapes and certain groups—in the cases shown in Figure 12.41, flat, benzene-like ring systems—that keep the molecules extended. Many of these molecules also have polarity associated with the long molecular axis. A strong electric field can orient these polar molecules like compass needles in a magnetic field.

The viscosity of a liquid crystal phase is lowest in the direction parallel to the long axis. Like moistened microscope slides, it is easier for the molecules to slide

Figure 12.41 Structures of two typical molecules that form liquid crystal phases. Note the long, extended shapes and the regions of high (red) and low (blue) electron density.

along each other (because the total attractive force remains the same), than it is for them to pull apart from each other sideways. As a result, the molecules tend to align while the phase flows.

Controlling Conditions to Form Phases Liquid crystal phases can arise in two general ways, and, sometimes, either way can occur in the same substance:

1. *Thermotropic phases* develop as a result of a change in temperature. As a crystalline solid is heated, the molecules leave their lattice sites, but the intermolecular interactions are still strong enough to keep the molecules aligned with each other along their long axes. Like any other phase, the liquid crystal phase has sharp transition temperatures, but they occur over a relatively small temperature range. Further heating provides enough kinetic energy for the molecules to become disordered, as in a normal liquid. The typical range for liquid crystal phases of pure substances is from $<1^{\circ}\text{C}$ to as much as 10°C , but mixing phases of two or more substances can greatly extend this range. For this reason, the liquid crystal phases used within display devices, as well as those within cell membranes, consist of mixtures of molecules.

2. *Lyotropic phases* occur in solution as the result of changes in concentration, but the conditions for forming such a phase vary for different substances. For example, when purified, some biomolecules that exist in cell membranes form lyotropic phases in water at the temperature that occurs within the organism. At the other extreme, Kevlar, a fiber used in bulletproof vests and high-performance sports equipment, forms a lyotropic phase in concentrated H_2SO_4 solution.

In some cases, a substance that forms a given liquid crystal phase under one set of conditions forms other phases under different conditions. Thus, a given thermotropic liquid crystal substance can pass from disordered liquid through a series of distinct liquid crystal phases to an ordered crystal through a decrease in temperature. A lyotropic substance can undergo similar changes through an increase in concentration.

Types of Order in Liquid Crystal Phases Molecules that form liquid crystal phases can exhibit various types of order. Three common types are nematic, cholesteric, and smectic:

1. In a *nematic phase*, the molecules lie in the same direction but their ends are not aligned, much like a school of fish swimming in synchrony (Figure 12.42A). The nematic phase is the least ordered type of liquid crystal phases.
2. In a *cholesteric phase*, which is somewhat more ordered, the molecules lie in layers that each exhibit nematic-type ordering. Rather than lying in parallel fashion, however, each layer is rotated by a fixed angle with respect to the next layer to give a helical (corkscrew) arrangement. A cholesteric phase is often called a *twisted nematic phase* (Figure 12.42B).

Figure 12.42 The three common types of ordering in liquid crystal phases.

A

B

Figure 12.43 Liquid crystal-type phases in biological systems. **A**, Nematic arrays of tobacco mosaic virus particles within the fluid of a tobacco leaf. **B**, The smectic-like arrangement of actin and myosin protein filaments in voluntary muscle cells.

Source: (A) © J. R. Factor/Science Source (B) © C. F. Armstrong/Science Source

3. In a *smectic phase*, which is the most ordered, the molecules lie parallel to each other, with their ends aligned, in layers that are stacked directly over each other (Figure 12.42C). The long molecular axis has a well-defined angle (shown in the figure as 90°) with respect to the plane of the layer. The molecules in Figure 12.41 form nematic or smectic phases. Liquid crystal-type phases appear in many biological systems (Figure 12.43).

Applications of Liquid Crystals The ability to control the orientation of the molecules in a liquid crystal allows us to produce materials with high strength or unique optical properties:

1. *High-strength applications* involve the use of extremely long molecules called *polymers*. While in a thermotropic liquid crystal phase and during their flow through the processing equipment, these molecules become highly aligned, like the fibers in wood. Cooling solidifies them into fibers, rods, and sheets that can be shaped into materials with superior mechanical properties. Sporting equipment, supersonic aircraft parts, and the sails used in the America's Cup races are fabricated from these polymeric materials. (We discuss the structure and physical behavior of polymers later in this section and their synthesis in Chapter 15.)

2. *Optical applications* include the liquid crystal displays (LCDs) used in countless devices, such as watches, calculators, cell phones, and tablets. All depend on *changes in molecular orientation in an electric field*. Figure 12.44 shows a small portion of a wristwatch LCD. Layers of nematic phases are sandwiched between thin glass plates that incorporate transparent electrodes. The long molecular axes lie parallel to the plane of the plates. The distance between plates (6–8 μm) allows the molecular axes within each succeeding layer to twist just enough for the molecular orientation at the bottom plate to be 90° from that at the top plate. Above and below this “sandwich” are thin polarizing filters that allow light waves oriented in only one direction to pass through. The filters are placed in a “crossed” arrangement, so that light passing through the top filter must twist 90° to pass through the bottom filter. This whole grouping of filters, plates, and liquid crystal phase lies on a mirror.

A current generated by the watch battery controls the orientation of the molecules. With the current on in one region of the display, the molecules become oriented toward the field, and thus block the light from passing through to the bottom filter, so that region appears dark. With the current off in another region, light passes through the molecules and bottom filter to the mirror and back again, so that region appears bright.

Cholesteric liquid crystals are used in applications that involve color changes with temperature. The twisted molecular orientation “unwinds” with heating, and the extent of the unwinding determines the color. Liquid crystal thermometers include a mixture of substances to widen their range of temperatures. Newer uses include “mapping” the area of a tumor, detecting faulty connections in electronic circuit boards, and nondestructive testing of materials under stress.

Figure 12.44 A liquid crystal display (LCD). A close-up of the “2” on a wristwatch LCD reveals two polarizers sandwiching two glass plates, which sandwich a liquid crystal (LC) layer, all lying on a mirror. When light waves enter the first polarizer, waves oriented in one direction emerge to enter the LC layer. Enlarging a dark region (*top blow-up*) shows the LC molecules aligned, keeping light waves from passing through; thus, the viewer sees no light. Enlarging a bright region (*bottom blow-up*) shows the LC molecules rotating the plane of the light waves, which can then pass through and reach the viewer.

Ceramic Materials

First developed by Stone Age people, **ceramics** are nonmetallic, nonpolymeric solids hardened by high temperature. Clay ceramics consist of silicate microcrystals suspended in a glassy cementing medium. In “firing” a ceramic pot, for example, a kiln heats the object, made of an aluminosilicate clay, such as kaolinite, to 1500°C and the clay loses water:

During the heating process, the structure rearranges to an extended network of Si-centered and Al-centered tetrahedra of O atoms (Section 14.6).

Bricks, porcelain, glazes, and other clay ceramics are hard and resistant to heat and chemicals. Today’s high-tech ceramics have these characteristics in addition to superior electrical and magnetic properties (Table 12.7). As just one example, consider the unusual electrical behavior of certain zinc oxide (ZnO) composites. Ordinarily a semiconductor, ZnO can be doped so that it becomes a conductor. Imbedding particles of the doped oxide into an insulating ceramic produces a variable resistor: at low voltage, the material conducts poorly, but at high voltage, it conducts well. The changeover voltage can be “preset” by controlling the size of the ZnO particles and the thickness of the insulating medium.

Table 12.7 Some Uses of Modern Ceramics and Ceramic Mixtures

Ceramic	Applications
SiC , Si_3N_4 , TiB_2 , Al_2O_3	Whiskers (fibers) to strengthen Al and other ceramics
Si_3N_4	Car engine parts; turbine rotors for “turbo” cars; electronic sensor units
Si_3N_4 , BN, Al_2O_3	Support or layering materials (as insulators) in electronic microchips
SiC , Si_3N_4 , TiB_2 , ZrO_2 , Al_2O_3 , BN	Cutting tools, edge sharpeners (as coatings and whole devices), scissors, surgical tools, industrial “diamond”
BN, SiC	Armor-plating reinforcement fibers (as in Kevlar composites)
ZrO_2 , Al_2O_3	Surgical implants (hip and knee joints)

Preparing Modern Ceramics Among the important modern ceramics are silicon carbide (SiC) and nitride (Si_3N_4), boron nitride (BN), and the superconducting oxides. They are prepared by standard chemical methods that involve driving off a volatile component during the reaction:

1. *SiC ceramics* are made from compounds used in silicone polymer manufacture (we’ll discuss these polymers in Section 14.6):

This product is heated to 800°C to form the ceramic:

Silicon carbide can also be prepared by the direct reaction of silicon and graphite under vacuum:

The nitride is also prepared by reaction of the elements:

2. *BN ceramics* are produced through the reaction of boron trichloride or boric acid with ammonia:

Heat drives off some of the bound nitrogen as NH_3 to yield the ceramic:

3. One type of *superconducting oxide* is made by heating a mixture of barium carbonate with copper and yttrium oxides, followed by further heating in the presence of O₂:

Ceramic Structures and Uses Structures of several ceramic materials are shown in Figure 12.45.

1. *Silicon carbide* has a diamond-like structure (Figure 12.45A). Network covalent bonding gives this material great strength. It is made into thin fibers, called *whiskers*, to reinforce other ceramics and prevent cracking in a composite structure, much like steel rods reinforcing concrete.

2. *Silicon nitride* is virtually inert chemically, retains its strength and wear resistance for extended periods above 1000°C, is dense and hard, and acts as an electrical insulator. Many automakers are testing it in high-efficiency car and truck engines because of its low weight, tolerance of high operating temperatures, and little need for lubrication.

3. *BN ceramics* exist in two structures, analogous to the common crystalline forms of carbon. In the graphite-like form, BN has extraordinary properties as an electrical insulator. At high temperature and very high pressure (1800°C and 8.5×10⁴ atm), BN converts to a diamond-like structure (Figure 12.45B), which is extremely hard and durable. Both forms are virtually invisible to radar.

4. *Superconducting oxides* often contain copper in an unusual oxidation state. In YBa₂Cu₃O₇ (Figure 12.45C), for instance, assuming oxidation states of +3 for Y, +2 for Ba, and -2 for O, the three Cu atoms have a total oxidation state of +7. This is allocated as Cu(II)₂Cu(III), with one Cu in the unusual +3 state. X-ray diffraction analysis indicates that a distortion in the structure makes four of the oxide ions unusually close to the Y³⁺ ion, which aligns the Cu ions into chains within the crystal. It is thought that a specific half-filled 3d orbital in Cu oriented toward a neighboring O²⁻ ion may be associated with superconductivity.

Because of brittleness, it is difficult to fashion these ceramics into wires, but methods for making films and ribbons have been developed. The brittleness arises from the strength of the ionic-covalent bonding and the resulting inability to deform. Under stress, a microfine defect widens until the material cracks. One new method forms defect-free superconducting oxide ceramics using controlled packing and heat treatment of extremely small, uniform oxide particles coated with organic polymers. Another method is aimed at arresting a widening crack. The ceramics are embedded with zirconia (ZrO₂), whose crystal structure expands up to 5% under mechanical stress. When an advancing crack reaches them, the zirconia particles pinch it shut. A third method prepares precisely grown crystals of Al₂O₃ and GdAlO₃, which become entangled during the solidification process. The resulting material bends without cracking above 1800 K.

A Silicon carbide

B Cubic BN (borazon)

C YBa₂Cu₃O₇

Figure 12.45 Expanded view of the atom arrangements in some ceramic materials.

Polymeric Materials

A **polymer** (Greek, “many parts”) is an extremely large molecule, or **macromolecule**, consisting of a covalently linked chain of smaller molecules, called **monomers** (Greek, “one part”). The monomer is the *repeat unit* of the polymer, and a polymer may have hundreds to hundreds of thousands of repeat units. Many types of monomers give polymers the complete repertoire of intermolecular forces.

- *Synthetic* polymers are created in the laboratory.
- *Natural* polymers (or *biopolymers*) are created within organisms.

In this section, we examine the physical nature of synthetic polymers and explore the role of intermolecular forces in their properties and uses. In Chapter 15, we’ll examine the types of monomers, the preparation of synthetic polymers, and the monomers, structures, and functions of some biopolymers.

Dimensions of a Polymer Chain Polymers differ from smaller molecules in terms of molar mass, chain length, shape, and size. We’ll discuss these, using polyethylene, by far the most common synthetic polymer, as an example.

1. *Polymer mass.* The molar mass of a polymer chain ($\mathcal{M}_{\text{polymer}}$, in g/mol, often referred to as the *molecular weight*) depends on the molar mass of the repeat unit ($\mathcal{M}_{\text{repeat}}$) and the **degree of polymerization (*n*)**, the number of repeat units in the chain:

$$\mathcal{M}_{\text{polymer}} = \mathcal{M}_{\text{repeat}} \times n$$

For example, the molar mass of the ethylene repeat unit ($-\text{CH}_2-\text{CH}_2-$) is 28 g/mol. If an individual polyethylene chain in a plastic grocery bag has a degree of polymerization of 7100, the molar mass of that chain is

$$\mathcal{M}_{\text{polymer}} = \mathcal{M}_{\text{repeat}} \times n = (28 \text{ g/mol}) (7.1 \times 10^3) = 2.0 \times 10^5 \text{ g/mol}$$

Table 12.8 shows some other examples.

Table 12.8 Molar Masses of Some Common Polymers

Name	$\mathcal{M}_{\text{polymer}}$ (g/mol)	<i>n</i>	Uses
Acrylates	2×10^5	2×10^3	Rugs, carpets
Polyamide (nylons)	1.5×10^4	1.2×10^2	Tires, fishing line
Polycarbonate	1×10^5	4×10^2	Compact discs
Polyethylene	3×10^5	1×10^4	Grocery bags
Polyethylene (ultrahigh molecular weight)	5×10^6	2×10^5	Hip joints
Poly(ethylene terephthalate)	2×10^4	1×10^2	Soda bottles
Polystyrene	3×10^5	3×10^3	Packing, coffee cups
Poly(vinyl chloride)	1×10^5	1.5×10^3	Plumbing

However, even though the monomer repeat unit in any given chain has the same molar mass, the degree of polymerization often varies considerably from chain to chain. Thus, *a sample of a synthetic polymer has a distribution of chain lengths and molar masses*. Polymer chemists use various definitions of the *average molar mass*, and a common one is the *number-average molar mass*, \mathcal{M}_n :

$$\mathcal{M}_n = \frac{\text{total mass of all chains}}{\text{number of moles of chains}}$$

If the number-average molar mass of the polyethylene in grocery bags is, for example, 1.6×10^5 g/mol, the chains may vary in molar mass from about 7.0×10^4 to 3.0×10^5 g/mol.

2. *Polymer chain length.* The long axis of a polymer chain is called its *backbone*. The length of an *extended* backbone is simply the number of repeat units (degree of polymerization, *n*) times the length of each repeat unit (l_0). For instance, the length

of an ethylene repeat unit is about 250 pm, so the extended length of our grocery-bag polyethylene chain is

$$\text{Length of extended chain} = n \times l_0 = (7.1 \times 10^3) (2.5 \times 10^2 \text{ pm}) = 1.8 \times 10^6 \text{ pm}$$

Comparing this length with the thickness of the chain, which is about 40 pm, shows the threadlike nature of the extended chain (length about 50,000 times width).

3. Coiled shape and size. A polymer molecule, however, whether pure or in solution, doesn't exist as an extended chain. In principle, the shape of the molecule arises from free rotation around all the single bonds. Thus, as each repeat unit rotates randomly, the chain continuously changes direction, turning back on itself many times and eventually arriving at the **random coil** shape that most polymers adopt (Figure 12.46). In reality, rotation is not completely free because intermolecular forces between chain portions, between different chains, and/or between chain and solvent have significant effects on the actual shape of a polymer chain.

The size of the coiled chain is expressed by its **radius of gyration**, R_g , the average distance from the center of mass of the molecule to the outer edge of the coil (Figure 12.46). Even though R_g is reported as a single value for a given polymer, it represents an average value for many chains. The mathematical expression for the radius of gyration includes the length of each repeat unit and the degree of polymerization:^{*}

$$R_g = \sqrt{\frac{nl_0^2}{6}}$$

As expected, the radius of gyration increases with the degree of polymerization, and thus with the molar mass as well. Light-scattering measurements correlate with these calculated results, so for many polymers the radius of gyration can be determined experimentally.

*The mathematical derivation of R_g is beyond the scope of this text, but it is analogous to the two-dimensional “walk of the drunken sailor.” With each step, the sailor stumbles in random directions and, given enough time, ends up very close to the starting position. The radius of gyration quantifies how far the end of the polymer chain (the sailor) has gone from the origin.

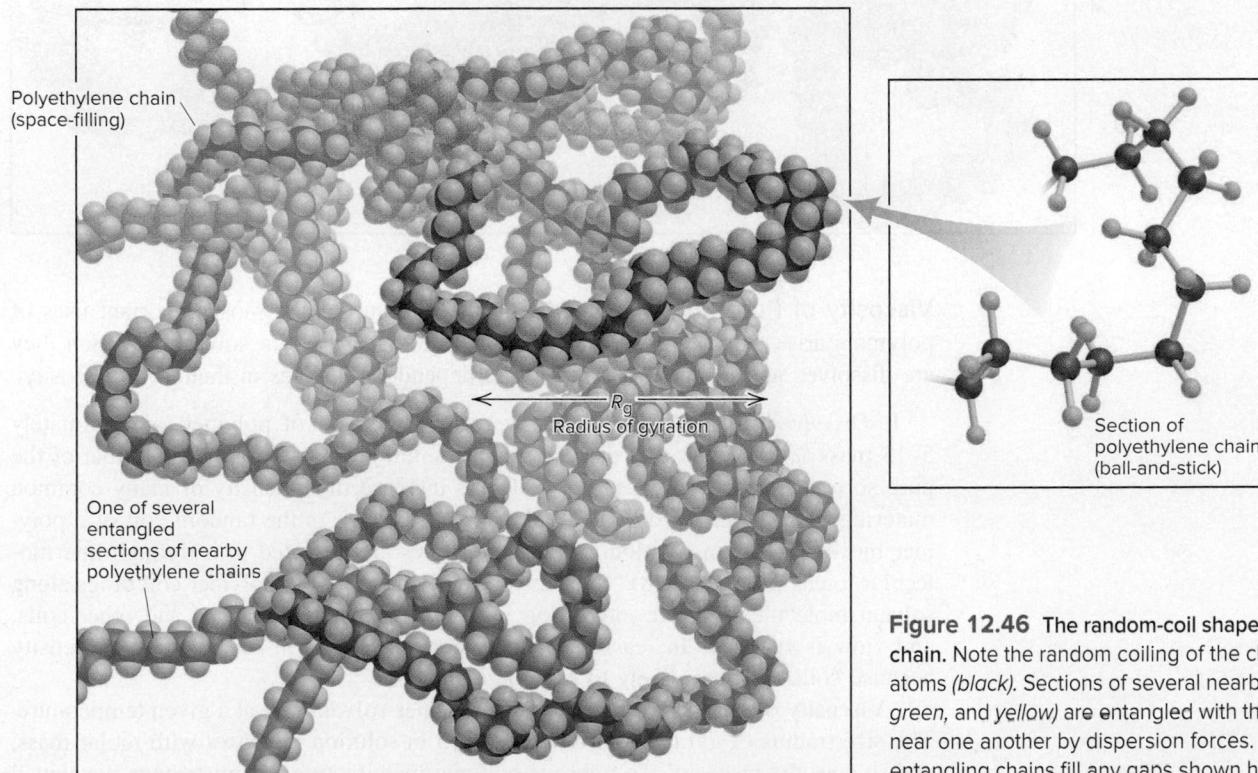

Figure 12.46 The random-coil shape of a polymer chain. Note the random coiling of the chain's carbon atoms (black). Sections of several nearby chains (red, green, and yellow) are entangled with this chain, kept near one another by dispersion forces. In reality, entangling chains fill any gaps shown here.

For our grocery-bag polyethylene chain, we have

$$R_g = \sqrt{\frac{nl_0^2}{6}} = \sqrt{\frac{(7.1 \times 10^3)(2.5 \times 10^2 \text{ pm})^2}{6}} = 8.6 \times 10^3 \text{ pm}$$

Doubling the radius gives a diameter of $1.7 \times 10^4 \text{ pm}$ for the coiled chain, less than one-hundredth the length of the extended chain!

Polymer Crystallinity A sample of a given polymer is not just a disorderly jumble of chains. If the molecular structure allows neighboring chains to pack together and if the chemical groups lead to favorable dipole-dipole, H bonding, and/or dispersion forces, portions of the chains can align regularly and exhibit crystallinity.

However, the crystallinity of a polymer is very different from the crystal structures we discussed earlier. In those structures, the orderly array extends over many atoms or molecules, and the unit cell includes at least one atom or molecule. In contrast, the orderly regions of a polymer rarely involve even one whole molecule (Figure 12.47). At best, a polymer is *semicrystalline*, because parts of the molecule align with parts of neighboring molecules (or with other parts of the same chain), while most of the chain remains as a random coil.

Figure 12.47 The semicrystallinity of a polymer chain. Several crystalline regions (darker color) have randomly coiled regions between them. Crystalline regions from nearby chains (red and yellow) align with those in the main chain.

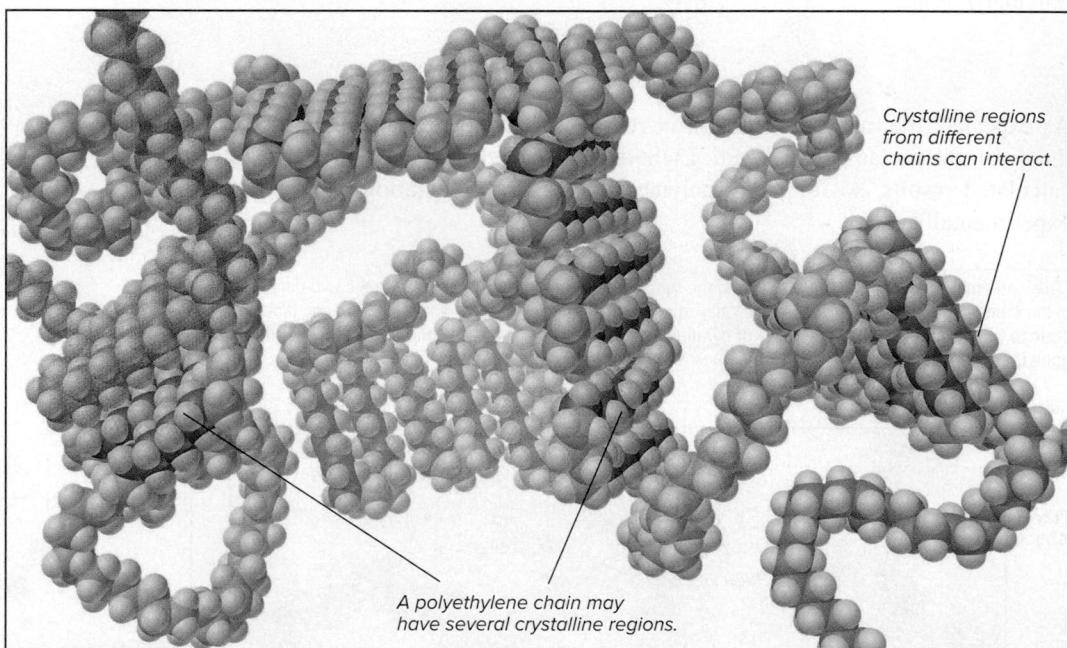

Viscosity of Pure and Dissolved Polymers Some of the most important uses of polymers arise from their ability to change the viscosity of a solvent in which they are dissolved and to undergo temperature-dependent changes in their own viscosity.

1. *Dissolved polymers.* When an appreciable amount of polymer (approximately 5–15 mass %) dissolves, the viscosity of the solution is much higher than that of the pure solvent. In fact, polymers are added to increase the viscosity of many common materials, such as motor oil, paint, and salad dressing. As the random coil of a polymer moves through a solution, solvent molecules are attracted to it through intermolecular forces (Figure 12.48). Thus, as the solution flows, the polymer coil drags along solvent molecules that are interacting with other solvent molecules and other coils, and flow is reduced. Increasing the polymer concentration increases the viscosity because coils are more likely to become entangled.

Viscosity is a property of a particular polymer-solvent pair at a given temperature. The size (radius of gyration) of a random coil in solution increases with molar mass, and so does the viscosity. To improve polymer manufacture, chemists have developed

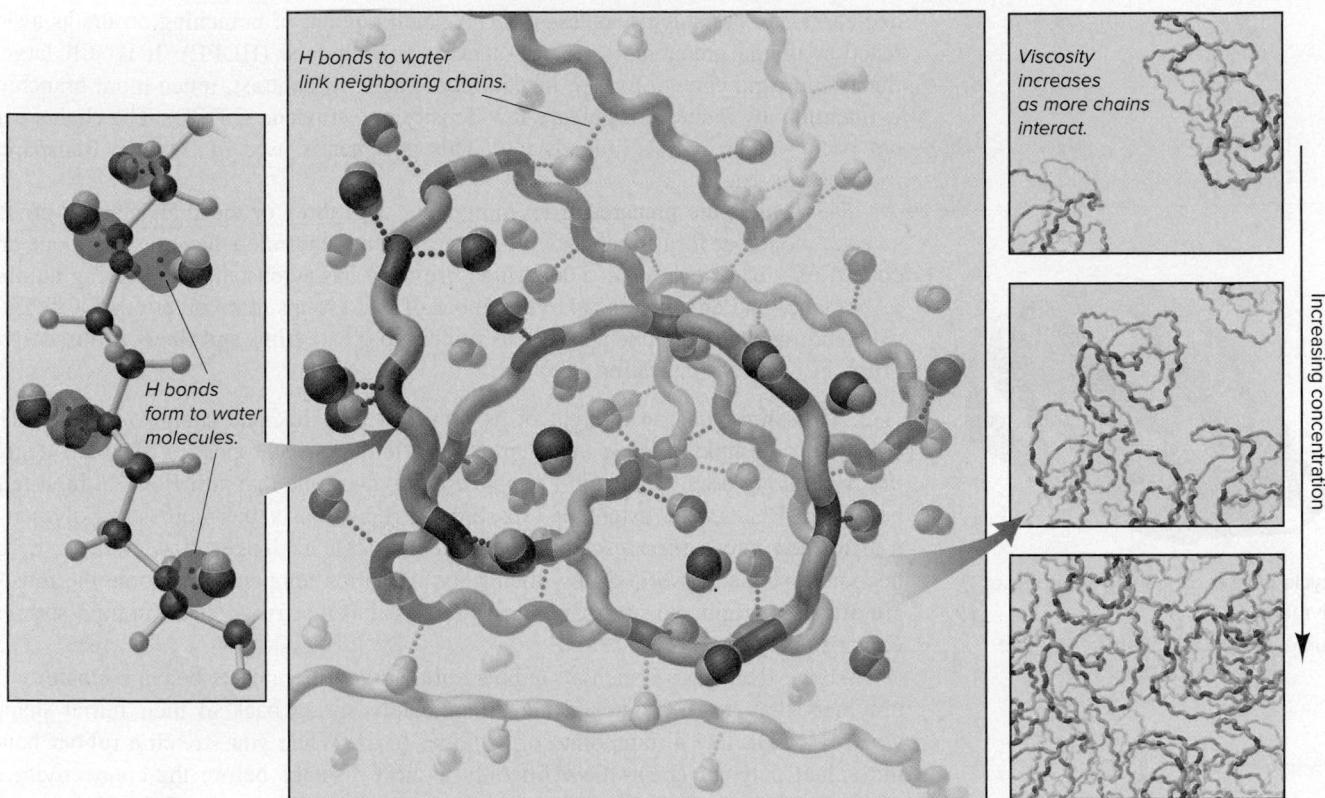

Figure 12.48 The viscosity of a polymer in aqueous solution. A section of a poly(ethylene oxide) chain (left panel) forms H bonds between the lone pairs of the chain's O atoms and the H atoms of water molecules. A polymer chain (blue and red coiled rod, center panel) forms many H bonds with water molecules that allow the chain to interact with other chains. As the concentration of polymer increases (three right panels), the viscosity of the solution increases.

equations to predict the viscosity of polymers of different molar masses in a variety of solvents (see Problem 12.147).

2. Pure polymers. Intermolecular forces also play a major role in the flow of a pure polymer. At temperatures high enough to melt them, many polymers exist as viscous liquids, flowing more like honey than water. The forces between the chains, as well as the entangling of chains, hinder the flow. As the temperature decreases, the intermolecular attractions exert a greater effect, and the eventual result is a rigid solid. If the chains don't crystallize, the resulting material is called a *polymer glass*. The transition from a liquid to a glass occurs over a narrow temperature range (10–20°C) for a given polymer; the temperature at the midpoint of the range is called the *glass transition temperature*, T_g . Like window glass, many polymer glasses are transparent, including polystyrene in drinking cups and polycarbonate in eyeglass lenses.

Plasticity of Polymers The flow-related properties of polymers give rise to their familiar **plastic** mechanical behavior. The word *plastic* refers to a material that, when deformed, retains its new shape; in contrast, when an *elastic* object is deformed, it returns to its original shape. Many polymers can be deformed (stretched, bent, twisted) when warm and retain their deformed shape when cooled. In this way, they are made into milk bottles, car parts, and countless other everyday objects.

Molecular Architecture of Polymers A polymer's architecture—its overall spatial layout and molecular structure—is crucial to its properties. In addition to linear chains, more complex architectures arise through branching and crosslinking:

1. **Branches** are smaller chains appended to a polymer backbone. As the number of branches increases, the chains cannot pack as well, so the degree of crystallinity

decreases and the polymer is less rigid. A small amount of branching occurs as a side reaction in the preparation of high-density polyethylene (HDPE). It is still largely linear and rigid enough for use in milk containers. In contrast, much more branching is intentionally induced to prepare low-density polyethylene (LDPE). The chains cannot pack well, so crystallinity is low. This polymer is used in flexible, transparent food storage bags.

Dendrimers are prepared from monomers with three or more attachment points, so each monomer forms branches. In essence, then, dendrimers have no backbone and consist only of branches. As a dendrimer grows, it has a constantly increasing number of branches and an incredibly large number of end groups at its outer edge. Chemists use dendrimers to bind one polymer to another to create films and fibers and to deliver drugs in medical applications.

Bicycle helmet containing a thermoset polymer.

Source: © Ingram Publishing/Alamy RF

2. **Crosslinks** can be thought of as branches that link one chain to another. The extent of crosslinking leads to remarkable differences in properties. A small degree of crosslinking often yields a *thermoplastic* polymer, one that still flows at high temperatures. But, as the extent of crosslinking increases, a thermoplastic polymer is transformed into a *thermoset* polymer, one that can no longer flow because it has become a single network. Below their glass transition temperatures, some thermosets are extremely rigid and strong, making them ideal as matrix materials in high-strength composites (see photo).

Above their glass transition temperatures, many thermosets become **elastomers**, polymers that can be stretched and immediately spring back to their initial shapes when released, like a trampoline or a rubber band. When you stretch a rubber band, individual polymer chains flow for only a short distance before the connectivity of the network returns them to their original positions. Table 12.9 is a list of some elastomers.

Table 12.9 Some Common Elastomers

Name	T _g (°C)	Uses
Poly(dimethyl siloxane)	-123	Breast implants
Polybutadiene	-106	Rubber bands
Polyisoprene	-65	Surgical gloves
Polychloroprene (neoprene)	-43	Footwear; medical tubing

Impact of Monomer Sequence Differences in monomer sequences influence polymer properties as well. A *homopolymer* consists of one type of monomer (A—A—A—A—A—...), whereas a **copolymer** consists of two or more types. The simplest copolymer is called an *AB block copolymer* because a chain (block) of monomer A and a chain of monomer B are linked at one point:

If the intermolecular forces between the A and B portions of the chain are weaker than those between different regions within each portion, the A and B portions form their own random coils. This ability makes AB block copolymers ideal *adhesives* for joining two polymer surfaces covalently. An ABA block copolymer has A chains linked at each end of a B chain:

Some of these block copolymers act as *thermoplastic elastomers*, materials shaped at high temperature that become elastomers at room temperature; many are used in the modern footwear industry.

Silicone polymers are described in Chapter 14, and organic reactions that form polymer chains from monomers are examined in Chapter 15.

Nanotechnology: Designing Materials Atom by Atom

Nanotechnology is the science and engineering of nanoscale systems, whose sizes range from 1 to 100 nm. (Recall that 1 nm is 10^{-9} m—about one-billionth the width of your dorm-room desk or one-millionth the width of your pen tip. A nanometer is to a meter as a marble is to Earth!) Nanotechnology joins scientists from physics, materials science, chemistry, biology, environmental science, medicine, and many branches of engineering.

Nanoscale materials behave neither like atoms, which are smaller (about 1×10^1 nm), nor like crystals, which are larger (at least 1×10^5 nm). The different behavior is due to a surface area that is similar to their interior volume—for example, a 5-nm particle has about half of its atoms on its surface. Cut a piece of ordinary aluminum foil into pieces just large enough to see with a light microscope and they still behave like the original piece. But, if you could cut the original piece into 20–30-nm pieces, they would explode. Indeed, aluminum nanoparticles are used in fireworks and propellants.

As so often happens in science, a technological advance allowed this new field to blossom. Nanotechnologists can use the scanning tunneling microscope (see Tools of the Laboratory in Section 12.6) and the similar scanning probe and atomic force microscopes to examine the chemical and physical properties of nanostructures and build them up, in many cases, atom by atom.

Two features of nanoscale engineering occur routinely in nature:

1. *Self-assembly* is the ability of smaller, simpler parts to organize themselves into a larger, more complex whole. On the molecular scale, self-assembly refers to atoms or small molecules aggregating through intermolecular forces. Oppositely charged regions on two such particles make contact to form a larger particle, which in turn aggregates with another to form a still larger one.
2. *Controlled orientation* is the positioning of two molecules near each other long enough for intermolecular forces to result in a change, often a bond breaking or forming. All enzymes function this way.

Because this field is changing so fast, we can only provide a glimpse of a few exciting research directions in nanotechnology.

Nanoscale Optical Materials *Quantum dots* are nanoparticles of a semiconducting material, such as gallium arsenide (GaAs) or gallium selenide (GaSe), that are smaller than 10 nm. Rather than having a band of energy levels, the dot has discrete energy levels, much like a single atom. As in atoms, the energy levels can be studied with spectroscopy; unlike atoms, quantum dots can be modified chemically. When high-energy (short-wavelength) UV light irradiates a suspension of quantum dots, they become excited and emit radiation of lower energy (longer wavelength). Most importantly, the emitted wavelengths depend on the size of the dots: the larger the particles, the longer the wavelength emitted. Thus, the color of the emitted light can be “tuned” by varying the dimensions of the nanoparticles (Figure 12.49). One use for quantum dots is the imaging of specific cells. The dot is encapsulated in a coating and then bonded to a particular protein used by a target organ. The cells in the target incorporate the protein, along with its attached quantum dot, and the location of the protein is viewed spectroscopically.

Nanostructured Materials *Nanostructuring*, the construction of bulk materials from nanoscale building blocks, increases strength, ductility, plasticity, and many other properties. The resulting *nanocomposites* behave as liquid magnets, ductile cements, conducting elastomers, and many other unique materials.

One example mimics a familiar natural material. Bones are natural nanocomposites of hydroxyapatite (a type of calcium phosphate) and other minerals. Synthetic nanocrystalline hydroxyapatite has weight-bearing properties identical to bone and can be formed into a framework into which natural bone tissue can grow to heal a fracture. Another material, called a *ferrofluid*, consists of magnetic nanoparticles (usually

Figure 12.49 The colors of quantum dots. The smaller the dots, the shorter the emitted wavelengths.

Source: Courtesy of Benoit Dubertret

Figure 12.50 The magnetic behavior of a ferrofluid. Nanoparticles of magnetite (Fe_3O_4) dispersed in a viscous fluid are suspended between the poles of a magnet. Source: © & by permission from Ferrotec (USA) Corporation. May not be reproduced without written permission.

Figure 12.51 Driving a nanocar.

Source: T. Sasaki/Rice University (Image courtesy of Rice University Office of Media Relations and Information)

magnetite, Fe_3O_4) dispersed in a viscous fluid. When placed in a magnetic field, the particles align to conform to the shape of the field (Figure 12.50). Ferrofluids find uses in automobile shock absorbers, magnetic plastics, audio speakers, computer hard drives, high-vacuum valves, and many other devices.

High-Surface-Area Materials Carbon nanotubes have remarkable mechanical and electrical properties. But, a possible future application for them is in storing H_2 gas for hydrogen-powered vehicles. Currently, H_2 is stored in metal cylinders at high pressures (>70 atm). Porous solids, such as carbon nanotubes, can store the same amount of gas at much lower pressures because they have surface areas of $4500 \text{ m}^2/\text{g}$ —about four football fields per gram of material! Thus, a medium-sized container of nanotubes could store a large amount of H_2 fuel under conditions safe enough for a family car.

Other high-surface-area materials being developed are porous membranes for water purification or batteries and multilayer films that incorporate photosynthetic molecules for high-efficiency solar cells. A very exciting development is a molecule-specific biosensor, which can detect as little as 10^{-14} mol of DNA using color changes in gold nanoparticles. Such biosensors could circulate freely in the bloodstream to measure levels of specific disease-related molecules, deliver drugs to individual cells, and even alter individual genes.

Nanomachines In nature, a virus is a marvel of nanoscale engineering, designed for delivering genetic material to infect a host cell. For example, the T4 virus latches onto a bacterial cell with its tail fibers, bores through the bacterial membrane with its end plate, and then injects the payload of DNA, packaged in its head, into the bacterium. These complex functions are performed by a biological “machine” measuring 60 by 200 nm. Researchers are exploring ways for viruses to deliver medicinal agents to specific cells. In other feats of nanoscale engineering, researchers have created nanovalves, nanopropellers, and even a nanocar, complete with a chassis, axles, and buckyball wheels, that is only 4 nm wide and is “driven” on a gold surface under the direction of an atomic force microscope (Figure 12.51).

› Summary of Section 12.7

- › Doping increases the conductivity of semiconductors and is essential to modern electronic materials. Doping silicon with Group 5A(15) atoms introduces negative sites (creating an n-type semiconductor) by adding valence electrons to the conduction band, whereas doping with Group 3A(13) atoms adds positive holes (for a p-type semiconductor) by emptying some orbitals in the valence band. Placing these two types of semiconductors in contact with one another forms a p-n junction. Sandwiching a p-type portion between two n-type portions forms a transistor.
- › Liquid crystal phases flow like liquids but have molecules ordered like crystalline solids. Typically, the molecules have rodlike shapes, and their intermolecular forces keep them aligned. Thermotropic phases are prepared by heating the solid; lyotropic phases form when the solvent concentration is varied. The nematic, cholesteric, and smectic phases of liquid crystals differ in their molecular order. Liquid crystal applications depend on controlling the orientation of the molecules.
- › Ceramics are very resistant to heat and chemicals. Most are network covalent solids formed at high temperature from simple reactants. They add lightweight strength to other materials.
- › Polymers are extremely large molecules that adopt the shape of a random coil, as a result of intermolecular forces. A polymer sample has an average molar mass because it consists of chains with a range of lengths. The high viscosity of a polymer arises from attractions between chains or, in the case of a dissolved polymer, between chains and solvent. By varying the degrees of branching, crosslinking, and ordering (crystallinity), chemists tailor polymers with specific properties.
- › Nanoscale materials can be made through construction processes involving self-assembly and controlled orientation of molecules.

CHAPTER REVIEW GUIDE

Learning Objectives

Relevant section (§) and/or sample problem (SP) numbers appear in parentheses.

Understand These Concepts

- How the interplay between kinetic and potential energy underlies the properties of the three states of matter and their phase changes (§12.1)
- The processes involved, both within a phase and during a phase change, when heat is added or removed from a pure substance (§12.2)
- The meaning of vapor pressure and how phase changes are dynamic equilibrium processes (§12.2)
- How temperature and intermolecular forces influence vapor pressure (§12.2)
- The relation between vapor pressure and boiling point (§12.2)
- How a phase diagram shows the phases of a substance at differing conditions of pressure and temperature (§12.2)
- The distinction between bonding and intermolecular forces on the basis of Coulomb's law and the meaning of the van der Waals radius of an atom (§12.3)
- The types and relative strengths of intermolecular forces acting in a substance (dipole-dipole, H bonding, dispersion), the impact of H bonding on physical properties, and the meaning of polarizability (§12.3)
- The meanings of surface tension, capillarity, and viscosity and how intermolecular forces influence their magnitudes (§12.4)
- How the important macroscopic properties of water arise from atomic and molecular properties (§12.5)
- The structure of a crystal lattice and the characteristics of the three types of cubic unit cells (§12.6)

- How packing of spheres gives rise to the hexagonal and cubic unit cells (§12.6)
- Types of crystalline solids and how their intermolecular forces give rise to their properties (§12.6)
- How band theory accounts for the properties of metals and the relative conductivities of metals, nonmetals, and metalloids (§12.6)
- The structures, properties, and functions of modern materials (doped semiconductors, liquid crystals, ceramics, polymers, and nanostructures) (§12.7)

Master These Skills

- Calculating the overall enthalpy change when heat is gained or lost by a pure substance (§12.2 and SP 12.1)
- Using the Clausius-Clapeyron equation to examine the relationship between vapor pressure and temperature (SP 12.2)
- Using a phase diagram to predict the phase changes of a substance (§12.2 and SP 12.3)
- Determining whether a substance can form H bonds and drawing the H-bonded structures (SP 12.4)
- Predicting the types and relative strength of the bonding and intermolecular forces acting within a substance from its structure (SP 12.5)
- Finding the number of particles per unit cell and the coordination number of a crystalline solid (§12.6 and SP 12.6)
- Calculating atomic radius from the density and/or crystal structure of an element (SPs 12.7, 12.8)

Key Terms

Page numbers appear in parentheses.

amorphous solid (495)	cubic closest packing (500)	hydrogen bond (H bond) (486)	plastic (519)
atomic solid (504)	degree of polymerization (<i>n</i>) (516)	insulator (508)	polarizability (488)
band theory (506)	deposition (473)	intermolecular forces (471)	polymer (516)
body-centered cubic unit cell (496)	dipole-dipole force (485)	ion-dipole force (485)	radius of gyration (<i>R</i> _g) (517)
boiling point (481)	dispersion (London) force (488)	ionic solid (504)	random coil (517)
branch (519)	doping (510)	lattice (496)	scanning tunneling microscopy (502)
capillarity (491)	elastomer (520)	liquid crystal (511)	semiconductor (508)
ceramic (514)	face-centered cubic unit cell (496)	London force (488)	simple cubic unit cell (496)
Clausius-Clapeyron equation (480)	freezing (473)	macromolecule (516)	sublimation (473)
condensation (473)	fusion (473)	melting point (481)	superconductivity (508)
conduction band (507)	heat of fusion ($\Delta H_{\text{fus}}^{\circ}$) (473)	melting (fusion) (473)	surface tension (491)
conductor (508)	heat of sublimation ($\Delta H_{\text{subl}}^{\circ}$) (474)	metallic solid (505)	triple point (482)
coordination number (496)	heat of vaporization ($\Delta H_{\text{vap}}^{\circ}$) (473)	molecular solid (504)	unit cell (496)
copolymer (520)	heating-cooling curve (475)	monomer (516)	valence band (507)
critical point (482)	hexagonal closest packing (500)	nanotechnology (521)	van der Waals radius (484)
crosslink (520)		network covalent solid (505)	vapor pressure (479)
crystal defect (509)		packing efficiency (498)	vaporization (473)
crystalline solid (495)		phase (471)	viscosity (492)
		phase change (472)	x-ray diffraction analysis (502)

Key Equations and Relationships

Page number appears in parentheses.

12.1 Using the vapor pressure at one temperature to find the vapor pressure at another temperature (two-point form of the Clausius-Clapeyron equation) (480):

$$\ln \frac{P_2}{P_1} = \frac{-\Delta H_{\text{vap}}}{R} \left(\frac{1}{T_2} - \frac{1}{T_1} \right)$$

BRIEF SOLUTIONS TO FOLLOW-UP PROBLEMS

12.1A The scenes represent solid water at -7.00°C melting to liquid water at 16.0°C , so heat is absorbed by the system (q is positive). There are three stages:

Stage 1, increasing the temperature of ice to the melting point: $\text{H}_2\text{O}(s) [-7.00^{\circ}\text{C}] \rightarrow \text{H}_2\text{O}(s) [0.00^{\circ}\text{C}]$:

$$q = n \times C_{m(\text{water}, s)} \times \Delta T = (2.25 \text{ mol})(37.6 \text{ J/mol} \cdot ^{\circ}\text{C}) [0^{\circ}\text{C} - (-7.00^{\circ}\text{C})] \\ = 592 \text{ J} = 0.592 \text{ kJ}$$

Stage 2, melting the ice: $\text{H}_2\text{O}(s) [0.00^{\circ}\text{C}] \rightarrow \text{H}_2\text{O}(l) [0.00^{\circ}\text{C}]$: $q = n(\Delta H_{\text{fus}}^{\circ}) = (2.25 \text{ mol})(6.02 \text{ kJ/mol}) = 13.5 \text{ kJ}$

Stage 3, increasing the temperature of the water:

$\text{H}_2\text{O}(l) [0.00^{\circ}\text{C}] \rightarrow \text{H}_2\text{O}(l) [16.0^{\circ}\text{C}]$:

$$q = n \times C_{m(\text{water}, l)} \times \Delta T = (2.25 \text{ mol})(75.4 \text{ J/mol} \cdot ^{\circ}\text{C})(16.0^{\circ}\text{C} - 0^{\circ}\text{C}) \\ = 2714 \text{ J} = 2.71 \text{ kJ}$$

$$\text{Total heat (kJ)} = 0.592 \text{ kJ} + 13.5 \text{ kJ} + 2.71 \text{ kJ} = 16.8 \text{ kJ}$$

12.1B The scenes represent gaseous bromine at 73.5°C condensing to liquid bromine at 23.8°C , so heat is released by the system (q is negative). First convert mass to moles:

$$\text{Amount (mol)} \text{ Br}_2 = 47.94 \text{ g Br}_2 \times \frac{1 \text{ mol Br}_2}{159.8 \text{ g Br}_2} = 0.3000 \text{ mol Br}_2$$

There are three stages:

Stage 1, cooling the gas: $\text{Br}_2(g) [73.5^{\circ}\text{C}] \rightarrow \text{Br}_2(g) [59.5^{\circ}\text{C}]$:

$$q = n \times C_{m(\text{Br}_2, g)} \times \Delta T \\ = (0.3000 \text{ mol})(36.0 \text{ J/mol} \cdot ^{\circ}\text{C})(59.5^{\circ}\text{C} - 73.5^{\circ}\text{C}) \\ = -151 \text{ J} = -0.151 \text{ kJ}$$

Stage 2, condensing the gas to liquid at the boiling point:

$\text{Br}_2(g) [59.5^{\circ}\text{C}] \rightarrow \text{Br}_2(l) [59.5^{\circ}\text{C}]$:

$$q = n(-\Delta H_{\text{vap}}^{\circ}) = (0.3000 \text{ mol})(-29.6 \text{ kJ/mol}) = -8.88 \text{ kJ}$$

Stage 3, cooling the liquid: $\text{Br}_2(l) [59.5^{\circ}\text{C}] \rightarrow \text{Br}_2(l) [23.8^{\circ}\text{C}]$:

$$q = n \times C_{m(\text{Br}_2, l)} \times \Delta T = (0.3000 \text{ mol})(75.7 \text{ J/mol} \cdot ^{\circ}\text{C})(23.8^{\circ}\text{C} - 59.5^{\circ}\text{C}) \\ = -811 \text{ J} = -0.811 \text{ kJ}$$

$$\text{Total heat (kJ)} = -0.151 \text{ kJ} + (-8.88 \text{ kJ}) + (-0.811 \text{ kJ}) \\ = -9.84 \text{ kJ}$$

$$\text{12.2A} \quad \ln \frac{P_2}{P_1} = \frac{-\Delta H_{\text{vap}}}{R} \left(\frac{1}{T_2} - \frac{1}{T_1} \right)$$

$$\ln \frac{P_2}{P_1} = \left(\frac{-40.7 \times 10^3 \text{ J/mol}}{8.314 \text{ J/mol} \cdot \text{K}} \right) \times \left(\frac{1}{273.15 + 85.5 \text{ K}} - \frac{1}{273.15 + 34.1 \text{ K}} \right)$$

$$\ln \frac{P_2}{P_1} = (-4.90 \times 10^3 \text{ K})(-4.66 \times 10^{-4} \text{ K}^{-1}) = 2.28$$

$$\frac{P_2}{P_1} = 9.8$$

$$\frac{P_2}{40.1 \text{ torr}} = 9.8; \quad P_2 = 40.1 \text{ torr} \times 9.8 = 390 \text{ torr}$$

$$\text{12.2B} \quad \ln \frac{P_2}{P_1} = \frac{-\Delta H_{\text{vap}}}{R} \left(\frac{1}{T_2} - \frac{1}{T_1} \right)$$

$$\ln \frac{24.50 \text{ kPa}}{10.00 \text{ kPa}} = \frac{-\Delta H_{\text{vap}}}{8.314 \text{ J/K} \cdot \text{mol}} \times \left(\frac{1}{273.15 + 20.2 \text{ K}} - \frac{1}{273.15 + 0.95 \text{ K}} \right)$$

$$0.8961 = \frac{-\Delta H_{\text{vap}}}{8.314 \text{ J/K} \cdot \text{mol}} \times (-0.0002394 \text{ K}^{-1})$$

$$\Delta H_{\text{vap}} = 3.11 \times 10^4 \text{ J/mol} = 31.1 \text{ kJ/mol}$$

12.3A At the starting conditions (3×10^2 bar and 2000 K ; point *c*), the carbon sample is in the form of graphite. As the sample is heated at constant pressure, it melts at around 4500 K , and then vaporizes at around 5000 K .

12.3B At the starting conditions (4600 K and 10^4 bar; point *d*), the carbon sample is in the form of graphite. As the sample is compressed at constant temperature, it melts at around 4×10^4 bar and then solidifies to diamond at around 2×10^5 bar.

12.4A

(c) No H bonding (H is not bonded to O in this molecule.)

12.4B (a) No H bonding (H is not bonded to O in this molecule.)

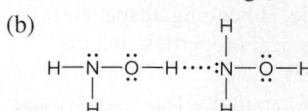

12.5A (a) Both molecules are polar (tetrahedral molecular geometry). Dipole-dipole and dispersion forces are present for both; CH_3Br has the higher boiling point because it has the larger molar mass.

(b) H bonding in $\text{CH}_3\text{CH}_2\text{CH}_2\text{OH}$, dipole-dipole and dispersion in both; $\text{CH}_3\text{CH}_2\text{CH}_2\text{OH}$ has the higher boiling point due to the H bonding.

(c) Both are nonpolar molecules. Dispersion forces; C_3H_8 has the higher boiling point because it has the larger molar mass.

12.5B (a) Dispersion and dipole-dipole forces in both, H bonding in $\text{CH}_3\text{CH}_2\text{OH}$; CH_3CHO has the lower boiling point since it does not have H bonding.

(b) SO_2 molecules, with a bent molecular geometry, are polar and have dispersion and dipole-dipole forces; CO_2 , which is a linear molecule, has only dispersion forces. With the weaker forces, CO_2 has the lower boiling point.

(c) Dispersion and dipole-dipole forces in both molecules; H bonding in $\text{H}_2\text{N}-\overset{\parallel}{\text{C}}\text{H}_2\text{CH}_3$; $(\text{CH}_3)_2\text{N}-\overset{\parallel}{\text{C}}\text{H}$ has the lower boiling point since it does not have H bonding.

12.6A (a) PbS : Pb^{2+} ions/unit cell = S^{2-} ions/unit cell = $(8 \times \frac{1}{8}) + (6 \times \frac{1}{2}) = 4 \text{ Pb}^{2+}$ and 4 S^{2-} ions; coordination number of each ion is 6.

(b) W : Atoms/unit cell = $(8 \times \frac{1}{8}) + 1 = 2$; coordination number is 8.

(c) Al : Atoms/unit cell = $(8 \times \frac{1}{8}) + (6 \times \frac{1}{2}) = 4$; coordination number is 12.

12.6B (a) K: Atoms/unit cell = $(8 \times \frac{1}{8}) + 1 = 2$; coordination number is 8.

(b) Pt: Atoms/unit cell = $(8 \times \frac{1}{8}) + (6 \times \frac{1}{2}) = 4$; coordination number is 12.

(c) CsCl: Cs^+ ions/unit cell = $(8 \times \frac{1}{8}) = 1$; Cl^- ions/unit cell = 1; coordination number of each ion is 8.

12.7A The packing efficiency in the face-centered cubic cell is 74%.

$$\begin{aligned} V \text{ of Co atom} &= \frac{4}{3}\pi r^3 = \frac{4}{3}(3.14)(125 \text{ pm})^3 \\ &= \frac{8.18 \times 10^6 \text{ pm}^3}{\text{atom}} \end{aligned}$$

V of 1 mol of Co atoms (cm^3)

$$\begin{aligned} &= \frac{8.18 \times 10^6 \text{ pm}^3}{\text{atom}} \times \frac{6.022 \times 10^{23} \text{ atoms}}{\text{mol atoms}} \times \frac{1 \text{ cm}^3}{10^{30} \text{ pm}^3} \\ &= 4.93 \text{ cm}^3/\text{mol atoms} \end{aligned}$$

$$\begin{aligned} V \text{ of 1 mol of Co metal } (\text{cm}^3) &= \frac{4.93 \text{ cm}^3/\text{mol atoms}}{0.74} \\ &= 6.66 \text{ cm}^3/\text{mol Co metal} \end{aligned}$$

$$d \text{ of Co metal} = \frac{58.93 \text{ g}}{\text{mol}} \times \frac{1 \text{ mol}}{6.66 \text{ cm}^3} = 8.85 \text{ g/cm}^3$$

12.7B The packing efficiency in the body-centered cubic cell is 68%.

$$\begin{aligned} \text{Avogadro's no.} &= \frac{1 \text{ cm}^3}{7.874 \text{ g Fe}} \times \frac{55.85 \text{ g Fe}}{1 \text{ mol Fe}} \times 0.68 \\ &\quad \times \frac{1 \text{ Fe atom}}{8.38 \times 10^{-24} \text{ cm}^3} \\ &= 5.8 \times 10^{23} \text{ Fe atoms/mol Fe} \end{aligned}$$

12.8A From Figure 12.29,

$$\begin{aligned} A \text{ (nm)} &= \frac{4r}{\sqrt{3}} = \frac{4(126 \text{ pm})}{\sqrt{3}} = 291 \text{ pm} \times \frac{1 \text{ nm}}{1000 \text{ pm}} \\ &= 0.291 \text{ nm} \end{aligned}$$

12.8B $A = \sqrt{8}r$

$$r = A/\sqrt{8} = 0.405 \text{ nm}/\sqrt{8} = 0.143 \text{ nm} = 143 \text{ pm}$$

PROBLEMS

Problems with **colored** numbers are answered in Appendix E and worked in detail in the Student Solutions Manual. Problem sections match those in the text and give the numbers of relevant sample problems. Most offer Concept Review Questions, Skill-Building Exercises (grouped in pairs covering the same concept), and Problems in Context. The Comprehensive Problems are based on material from any section or previous chapter.

An Overview of Physical States and Phase Changes

Concept Review Questions

12.1 How does the energy of attraction between particles compare with their energy of motion in a gas and in a solid? As part of your answer, identify two macroscopic properties that differ between a gas and a solid.

12.2 (a) Why are gases more easily compressed than liquids?
(b) Why do liquids have a greater ability to flow than solids?

12.3 What type of forces, intramolecular or intermolecular:
(a) Prevent ice cubes from adopting the shape of their container?
(b) Are overcome when ice melts?

(c) Are overcome when liquid water is vaporized?
(d) Are overcome when gaseous water is converted to hydrogen gas and oxygen gas?

12.4 (a) Why is the heat of fusion (ΔH_{fus}) of a substance smaller than its heat of vaporization (ΔH_{vap})?
(b) Why is the heat of sublimation (ΔH_{subl}) of a substance greater than its ΔH_{vap} ?
(c) At a given temperature and pressure, how does the magnitude of the heat of vaporization of a substance compare with that of its heat of condensation?

Skill-Building Exercises (grouped in similar pairs)

12.5 Which forces are intramolecular and which intermolecular?

- (a) Those preventing oil from evaporating at room temperature
- (b) Those preventing butter from melting in a refrigerator
- (c) Those allowing silver to tarnish
- (d) Those preventing O_2 in air from forming O atoms

12.6 Which forces are intramolecular and which intermolecular?

- (a) Those allowing fog to form on a cool, humid evening
- (b) Those allowing water to form when H_2 is sparked
- (c) Those allowing liquid benzene to crystallize when cooled
- (d) Those responsible for the low boiling point of hexane

12.7 Name the phase change in each of these events: (a) Dew appears on a lawn in the morning. (b) Icicles change into liquid water. (c) Wet clothes dry on a summer day.

12.8 Name the phase change in each of these events: (a) A diamond film forms on a surface from gaseous carbon atoms in a vacuum. (b) Mothballs in a bureau drawer disappear over time. (c) Molten iron from a blast furnace is cast into ingots (“pigs”).

Problems in Context

12.9 Liquid propane, a widely used fuel, is produced by compressing gaseous propane. During the process, approximately 15 kJ of energy is released for each mole of gas liquefied. Where does this energy come from?

12.10 Many heat-sensitive and oxygen-sensitive solids, such as camphor, are purified by warming under vacuum. The solid vaporizes directly, and the vapor crystallizes on a cool surface. What phase changes are involved in this method?

Quantitative Aspects of Phase Changes

(Sample Problems 12.1–12.3)

Concept Review Questions

12.11 Describe the changes (if any) in potential energy and in kinetic energy among the molecules when gaseous PCl_3 condenses to a liquid at a fixed temperature.

12.12 When benzene is at its melting point, two processes occur simultaneously and balance each other. Describe these processes on the macroscopic and molecular levels.

12.13 Liquid hexane ($\text{bp} = 69^\circ\text{C}$) is placed in a closed container at room temperature. At first, the pressure of the vapor phase increases, but after a short time, it stops changing. Why?

12.14 Explain the effect of strong intermolecular forces on each of these parameters: (a) critical temperature; (b) boiling point; (c) vapor pressure; (d) heat of vaporization.

12.15 Match each numbered point in the phase diagram for compound Q with the correct molecular scene below:

12.16 A liquid is in equilibrium with its vapor in a closed vessel at a fixed temperature. The vessel is connected by a stopcock to an evacuated vessel. When the stopcock is opened, will the final pressure of the vapor be different from the initial value if (a) some liquid remains; (b) all the liquid is first removed? Explain.

12.17 The phase diagram for substance A has a solid-liquid line with a positive slope, and that for substance B has a solid-liquid line with a negative slope. What macroscopic property can distinguish A from B?

12.18 Why does water vapor at 100°C cause a more severe burn than liquid water at 100°C ?

Skill-Building Exercises (grouped in similar pairs)

12.19 From the data below, calculate the total heat (in J) needed to convert 22.00 g of ice at -6.00°C to liquid water at 0.500°C :

$$\text{mp at 1 atm: } 0.0^\circ\text{C} \quad \Delta H_{\text{fus}}^\circ: 6.02 \text{ kJ/mol}$$

$$c_{\text{liquid}}: 4.21 \text{ J/g}\cdot^\circ\text{C} \quad c_{\text{solid}}: 2.09 \text{ J/g}\cdot^\circ\text{C}$$

12.20 From the data below, calculate the total heat (in J) needed to convert 0.333 mol of gaseous ethanol at 300°C and 1 atm to liquid ethanol at 25.0°C and 1 atm:

$$\text{bp at 1 atm: } 78.5^\circ\text{C} \quad \Delta H_{\text{vap}}^\circ: 40.5 \text{ kJ/mol}$$

$$c_{\text{gas}}: 1.43 \text{ J/g}\cdot^\circ\text{C} \quad c_{\text{liquid}}: 2.45 \text{ J/g}\cdot^\circ\text{C}$$

12.21 A liquid has a $\Delta H_{\text{vap}}^\circ$ of 35.5 kJ/mol and a boiling point of 122°C at 1.00 atm. What is its vapor pressure at 113°C ?

12.22 Diethyl ether has a $\Delta H_{\text{vap}}^\circ$ of 29.1 kJ/mol and a vapor pressure of 0.703 atm at 25.0°C . What is its vapor pressure at 95.0°C ?

12.23 What is the $\Delta H_{\text{vap}}^\circ$ of a liquid that has a vapor pressure of 621 torr at 85.2°C and a boiling point of 95.6°C at 1 atm?

12.24 Methane (CH_4) has a boiling point of -164°C at 1 atm and a vapor pressure of 42.8 atm at -100°C . What is the heat of vaporization of CH_4 ?

12.25 Use these data to draw a qualitative phase diagram for ethylene (C_2H_4). Is $\text{C}_2\text{H}_4(s)$ more or less dense than $\text{C}_2\text{H}_4(l)$?

$$\text{bp at 1 atm: } -103.7^\circ\text{C}$$

$$\text{mp at 1 atm: } -169.16^\circ\text{C}$$

$$\text{Critical point: } 9.9^\circ\text{C and } 50.5 \text{ atm}$$

$$\text{Triple point: } -169.17^\circ\text{C and } 1.20 \times 10^{-3} \text{ atm}$$

12.26 Use these data to draw a qualitative phase diagram for H_2 . Does H_2 sublime at 0.05 atm? Explain.

$$\text{mp at 1 atm: } 13.96 \text{ K}$$

$$\text{bp at 1 atm: } 20.39 \text{ K}$$

$$\text{Triple point: } 13.95 \text{ K and } 0.07 \text{ atm}$$

$$\text{Critical point: } 33.2 \text{ K and } 13.0 \text{ atm}$$

$$\text{Vapor pressure of solid at 10 K: } 0.001 \text{ atm}$$

12.27 The phase diagram for sulfur is shown below.

(a) Give a set of conditions under which it is possible to sublime the rhombic form of solid sulfur.

(b) Describe the phase changes that a sample of sulfur undergoes at 1 atm when it is heated from 90°C to 450°C .

12.28 The phase diagram for xenon is shown below.

(a) What phase is xenon in at room temperature and pressure?

(b) Describe the phase changes that a sample of xenon undergoes at -115°C as it is compressed from 0.5 atm to 25 atm. (The critical pressure of xenon is 58 atm.)

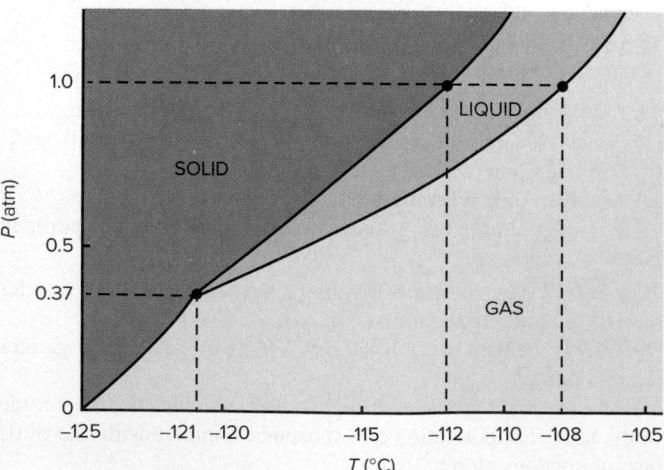

12.60 Why does an aqueous solution of ethanol ($\text{CH}_3\text{CH}_2\text{OH}$) have a lower surface tension than water?

12.61 Why are units of energy per area (J/m^2) used for surface tension values?

12.62 Does the *strength* of the intermolecular forces in a liquid change as the liquid is heated? Explain. Why does a liquid's viscosity decrease with rising temperature?

Skill-Building Exercises (grouped in similar pairs)

12.63 Rank the following in order of *increasing* surface tension at a given temperature, and explain your ranking:

- (a) $\text{CH}_3\text{CH}_2\text{CH}_2\text{OH}$ (b) $\text{HOCH}_2\text{CH}(\text{OH})\text{CH}_2\text{OH}$
 (c) $\text{HOCH}_2\text{CH}_2\text{OH}$

12.64 Rank the following in order of *decreasing* surface tension at a given temperature, and explain your ranking:

- (a) CH_3OH (b) CH_3CH_3 (c) $\text{H}_2\text{C}=\text{O}$

12.65 Rank the compounds in Problem 12.63 in order of *decreasing* viscosity at a given temperature; explain your ranking.

12.66 Rank the compounds in Problem 12.64 in order of *increasing* viscosity at a given temperature; explain your ranking.

Problems in Context

12.67 Soil vapor extraction (SVE) is used to remove volatile organic pollutants, such as chlorinated solvents, from soil at hazardous waste sites. Vent wells are drilled, and a vacuum pump is applied to the subsurface. (a) How does this method remove pollutants? (b) Why does heating combined with SVE speed the process?

12.68 Use Figure 12.2, to answer the following: (a) Does it take more heat to melt 12.0 g of CH_4 or 12.0 g of Hg ? (b) Does it take more heat to vaporize 12.0 g of CH_4 or 12.0 g of Hg ? (c) What is the principal intermolecular force in each sample?

12.69 Pentanol ($\text{C}_5\text{H}_{11}\text{OH}$; $M = 88.15 \text{ g/mol}$) has nearly the same molar mass as hexane (C_6H_{14} ; $M = 86.17 \text{ g/mol}$) but is more than 12 times as viscous at 20°C . Explain.

The Uniqueness of Water

Concept Review Questions

12.70 For what types of substances is water a good solvent? For what types is it a poor solvent? Explain.

12.71 A water molecule can engage in as many as four H bonds. Explain.

12.72 Warm-blooded animals have a narrow range of body temperature because their bodies have a high water content. Explain.

12.73 What property of water keeps plant debris on the surface of lakes and ponds? What is the ecological significance of this?

12.74 A drooping plant can be made to stand upright by watering the ground around it. Explain.

12.75 Describe the molecular basis of the property of water responsible for the presence of ice on the surface of a frozen lake.

12.76 Describe in molecular terms what occurs when ice melts.

The Solid State: Structure, Properties, and Bonding

(Sample Problems 12.6–12.8)

Concept Review Questions

12.77 What is the difference between an amorphous solid and a crystalline solid on the macroscopic and molecular levels? Give an example of each.

12.78 How are a solid's unit cell and crystal structure related?

12.79 For structures consisting of identical atoms, how many atoms are contained in a simple cubic, a body-centered cubic, and a face-centered cubic unit cell? Explain how you obtained the values.

12.80 An element has a crystal structure in which the width of the cubic unit cell equals the diameter of an atom. What type of unit cell does it have?

12.81 What specific difference in the positioning of spheres gives a crystal structure based on the face-centered cubic unit cell less empty space than one based on the body-centered cubic unit cell?

12.82 Both solid Kr and solid Cu consist of individual atoms. Why do their physical properties differ so much?

12.83 What is the energy gap in band theory? Compare its size in superconductors, conductors, semiconductors, and insulators.

12.84 Predict the effect (if any) of an increase in temperature on the electrical conductivity of (a) a conductor; (b) a semiconductor; (c) an insulator.

12.85 Besides the type of unit cell, what information is needed to find the density of a solid consisting of identical atoms?

Skill-Building Exercises (grouped in similar pairs)

12.86 What type of unit cell does each metal use in its crystal lattice? (The number of atoms per unit cell is given in parentheses.)

- (a) Ni (4) (b) Cr (2) (c) Ca (4)

12.87 What is the number of atoms per unit cell for each metal?

- (a) Polonium, Po (b) Manganese, Mn (c) Silver, Ag

12.88 Calcium crystallizes in a cubic closest packed structure. If the atomic radius of calcium is 197 pm, find the density of the solid.

12.89 Chromium adopts the body-centered cubic unit cell in its crystal structure. If the density of chromium is 7.14 g/cm^3 , find its atomic radius.

12.90 When cadmium oxide reacts to form cadmium selenide, a change in unit cell occurs, as depicted below:

(a) What is the change in unit cell?

(b) Does the coordination number of cadmium change? Explain.

12.91 As molten iron cools to 1674 K , it adopts one type of cubic unit cell; then, as the temperature drops below 1181 K , it changes to another, as depicted below:

(a) What is the change in unit cell?

(b) Which crystal structure has the greater packing efficiency?

12.92 Potassium adopts the body-centered cubic unit cell in its crystal structure. If the atomic radius of potassium is 227 pm, find the edge length of the unit cell.

12.93 Lead adopts the face-centered cubic unit cell in its crystal structure. If the edge length of the unit cell is 495 pm, find the atomic radius of lead.

12.94 Of the five major types of crystalline solid, which does each of the following form, and why: (a) Ni; (b) F₂; (c) CH₃OH; (d) Sn; (e) Si; (f) Xe?

12.95 Of the five major types of crystalline solid, which does each of the following form, and why: (a) SiC; (b) Na₂SO₄; (c) SF₆; (d) cholesterol (C₂₇H₄₅OH); (e) KCl; (f) BN?

12.96 Zinc oxide adopts the zinc blende crystal structure (Figure P12.96). How many Zn²⁺ ions are in the ZnO unit cell?

12.97 Calcium sulfide adopts the sodium chloride crystal structure (Figure P12.97). How many S²⁻ ions are in the CaS unit cell?

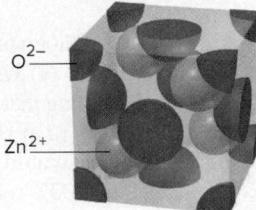

Figure P12.96

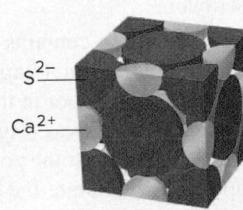

Figure P12.97

12.98 Zinc selenide (ZnSe) crystallizes in the zinc blende structure (see Figure P12.96) and has a density of 5.42 g/cm³.

- (a) How many Zn and Se ions are in each unit cell?
- (b) What is the mass of a unit cell?
- (c) What is the volume of a unit cell?
- (d) What is the edge length of a unit cell?

12.99 An element crystallizes in a face-centered cubic lattice, and it has a density of 1.45 g/cm³. The edge of its unit cell is 4.52×10⁻⁸ cm.

- (a) How many atoms are in each unit cell?
- (b) What is the volume of a unit cell?
- (c) What is the mass of a unit cell?
- (d) Calculate an approximate atomic mass for the element.

12.100 Classify each of the following as a conductor, insulator, or semiconductor: (a) phosphorus; (b) mercury; (c) germanium.

12.101 Classify each of the following as a conductor, insulator, or semiconductor: (a) carbon (graphite); (b) sulfur; (c) platinum.

12.102 Predict the effect (if any) of an increase in temperature on the electrical conductivity of (a) antimony; (b) tellurium; (c) bismuth.

12.103 Predict the effect (if any) of a decrease in temperature on the electrical conductivity of (a) silicon; (b) lead; (c) germanium.

Problems in Context

12.104 Polonium, the Period 6 member of Group 6A(16), is a rare radioactive metal that is the only element with a crystal structure based on the simple cubic unit cell. If its density is 9.142 g/cm³, calculate an approximate atomic radius for polonium.

12.105 The coinage metals—copper, silver, and gold—crystallize in a cubic closest packed structure. Use the density of copper (8.95 g/cm³) and its molar mass (63.55 g/mol) to calculate an approximate atomic radius for copper.

12.106 One of the most important enzymes in the world—nitrogenase, the plant protein that catalyzes nitrogen fixation—contains active clusters of iron, sulfur, and molybdenum atoms. Crystalline molybdenum (Mo) has a body-centered cubic unit cell (d of Mo = 10.28 g/cm³). (a) Determine the edge length of the unit cell. (b) Calculate the atomic radius of Mo.

12.107 Tantalum (Ta; d = 16.634 g/cm³ and M = 180.9479 g/mol) has a body-centered cubic structure with a unit-cell edge length of 3.3058 Å. Use these data to calculate Avogadro's number.

Advanced Materials

Concept Review Questions

12.108 When tin is added to copper, the resulting alloy (bronze) is much harder than copper. Explain.

12.109 In the process of doping a semiconductor, certain impurities are added to increase the electrical conductivity. Explain this process for an n-type and a p-type semiconductor.

12.110 State two molecular characteristics of substances that typically form liquid crystals. How is each related to function?

12.111 Distinguish between isotropic and anisotropic substances. To which category do liquid crystals belong?

12.112 How are the properties of high-tech ceramics the same as those of traditional clay ceramics, and how are they different? Refer to specific substances in your answer.

12.113 Why is the average molar mass of a polymer sample different from the molar mass of an individual chain?

12.114 How does the random coil shape relate to the radius of gyration of a polymer chain?

12.115 What factor(s) influence the viscosity of a polymer solution? What factor(s) influence the viscosity of a molten polymer? What is a polymer glass?

12.116 Use an example to show how branching and crosslinking can affect the physical behavior of a polymer.

Skill-Building Exercises (grouped in similar pairs)

12.117 Silicon and germanium are both semiconducting elements from Group 4A(14) that can be doped to improve their conductivity. Would each of the following form an n-type or a p-type semiconductor: (a) Ge doped with P; (b) Si doped with In?

12.118 Would each of the following form an n-type or a p-type semiconductor: (a) Ge doped with As; (b) Si doped with B?

12.119 The repeat unit of the polystyrene of a coffee cup has the formula C₆H₅CHCH₂. If the molar mass of the polymer is 3.5×10⁵ g/mol, what is the degree of polymerization?

12.120 The monomer of poly(vinyl chloride) has the formula C₂H₃Cl. If there are 1565 repeat units in a single chain of the polymer, what is the molecular mass (in amu) of that chain?

12.121 The polypropylene (repeat unit CH₃CHCH₂) in a plastic toy has a molar mass of 2.8×10⁵ g/mol, and the length of a repeat unit is 0.252 pm. Calculate the radius of gyration.

12.122 The polymer that is used to make 2-L soda bottles [poly(ethylene terephthalate)] has a repeat unit with molecular formula C₁₀H₈O₄ and a length of 1.075 nm. Calculate the radius of gyration of a chain with a molar mass of 2.30×10⁴ g/mol.

Comprehensive Problems

12.123 A 0.75-L bottle is cleaned, dried, and closed in a room where the air is 22°C and has 44% relative humidity (that is, the water vapor in the air is 0.44 of the equilibrium vapor pressure at 22°C). The bottle is then brought outside and stored at 0.0°C.

- What mass of liquid water condenses inside the bottle?
- Would liquid water condense at 10°C? (See Table 5.2.)

12.124 In an experiment, 5.00 L of N₂ is saturated with water vapor at 22°C and then compressed to half its volume at constant *T*.

- What is the partial pressure of H₂O in the compressed gas mixture?
- What mass of water vapor condenses to liquid?

12.125 Barium is the largest nonradioactive alkaline earth metal. It has a body-centered cubic unit cell and a density of 3.62 g/cm³. What is the atomic radius of barium? (Volume of a sphere: $V = \frac{4}{3}\pi r^3$.)

12.126 Two important characteristics used to evaluate the risk of fire or explosion are a compound's *lower flammable limit* (LFL) and *flash point*. The LFL is the minimum percentage by volume in air that is ignitable. Below that, the mixture is too "lean" to burn. The flash point is the temperature at which the air over a confined liquid becomes ignitable. *n*-Hexane boils at 68.7°C at 1 atm. At 20.0°C, its vapor pressure is 121 mmHg. The LFL of *n*-hexane is 1.1%. Calculate the flash point of *n*-hexane.

12.127 Bismuth is used to calibrate instruments employed in high-pressure studies because it has several well-characterized crystalline phases. Its phase diagram (right) shows the liquid phase and five solid phases that are stable above 1 katm (1000 atm) and up to 300°C.

- Which solid phases are stable at 25°C?
- Which phase is stable at 50 katm and 175°C?
- As the pressure is reduced from 100 to 1 katm at 200°C, what phase transitions does bismuth undergo?
- What phases are present at each of the triple points?

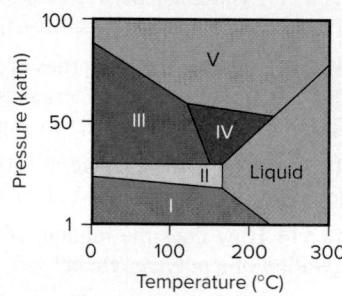

12.128 In making computer chips, a 4.00-kg cylindrical ingot of ultrapure n-type doped silicon that is 5.20 inches in diameter is sliced into wafers 1.12×10⁻⁴ m thick.

- Assuming no waste, how many wafers can be made?
- What is the mass of a wafer (*d* of Si = 2.34 g/cm³; *V* of a cylinder = $\pi r^2 h$)?
- A key step in making p-n junctions for the chip is chemical removal of the oxide layer on the wafer through treatment with gaseous HF. Write a balanced equation for this reaction.
- If 0.750% of the Si atoms are removed during the treatment in part (c), how many moles of HF are required per wafer, assuming 100% reaction yield?

12.129 Methyl salicylate, C₈H₈O₃, the odorous constituent of oil of wintergreen, has a vapor pressure of 1.00 torr at 54.3°C and 10.0 torr at 95.3°C. (a) What is its vapor pressure at 25°C? (b) What is the minimum number of liters of air that must pass over a sample of the compound at 25°C to vaporize 1.0 mg of it?

12.130 Mercury (Hg) vapor is toxic and readily absorbed from the lungs. At 20.°C, mercury ($\Delta H_{\text{vap}} = 59.1 \text{ kJ/mol}$) has a vapor pressure of 1.20×10⁻³ torr, which is high enough to be hazardous. To reduce the danger to workers in processing plants, Hg is cooled to lower its vapor pressure. At what temperature would the vapor pressure of Hg be at the safer level of 5.0×10⁻⁵ torr?

12.131 Polytetrafluoroethylene (Teflon) has a repeat unit with the formula F₂C—CF₂. A sample of the polymer consists of fractions with the following distribution of chains:

Fraction	Average Number of Repeat Units	Amount (mol) of Polymer
1	273	0.10
2	330	0.40
3	368	1.00
4	483	0.70
5	525	0.30
6	575	0.10

- Determine the molar mass of each fraction.
- Determine the number-average molar mass of the sample.
- Another type of average molar mass of a polymer sample is called the *weight-average molar mass*, M_w :

$$M_w = \frac{\Sigma(M \text{ of fraction} \times \text{mass of fraction})}{\text{total mass of all fractions}}$$

Calculate the weight-average molar mass of the sample of polytetrafluoroethylene.

12.132 A greenhouse contains 256 m³ of air at a temperature of 26°C, and a humidifier in it vaporizes 4.20 L of water. (a) What is the pressure of water vapor in the greenhouse, assuming that none escapes and that the air was originally completely dry (*d* of H₂O = 1.00 g/mL)? (b) What total volume of liquid water would have to be vaporized to saturate the air (that is, achieve 100% relative humidity)? (See Table 5.2.)

12.133 Like most transition metals, tantalum (Ta) exhibits several oxidation states. Give the formula of each tantalum compound whose unit cell is depicted below:

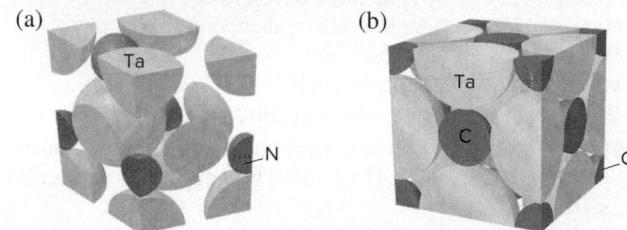

12.134 KF has the same type of crystal structure as NaCl. The unit cell of KF has an edge length of 5.39 Å. Find the density of KF.

12.135 Furfural, which is prepared from corncobs, is an important solvent in synthetic rubber manufacturing, and it is reduced to furfuryl alcohol, which is used to make polymer resins. Furfural can also be oxidized to 2-furoic acid.

furfuryl alcohol furfural 2-furoic acid

- Which of these compounds can form H bonds? Draw structures in each case.
- The molecules of some substances can form an "internal" H bond, that is, an H bond *within* a molecule. This takes the form of a polygon with atoms as corners and bonds as sides and an H bond as one of the sides. Which of these molecules is (are) likely to form a stable internal H bond? Draw the structure. (Hint: Structures with 5 or 6 atoms as corners are most stable.)

12.136 On a humid day in New Orleans, the temperature is 22.0°C, and the partial pressure of water vapor in the air is 31.0 torr. The 9000-ton air-conditioning system in the Louisiana Superdome maintains the inside air temperature at the same 22.0°C, but produces a partial pressure of water vapor of 10.0 torr. The volume of air in the dome is $2.4 \times 10^6 \text{ m}^3$, and the total pressure is 1.0 atm both inside and outside the dome.

(a) What mass of water (in metric tons) must be removed every time the inside air is completely replaced with outside air? (*Hint:* How many moles of gas are in the dome? How many moles of water vapor? How many moles of dry air? How many moles of outside air must be added to the air in the dome to simulate the composition of outside air?)

(b) Find the heat released when this mass of water condenses.

12.137 The boiling point of amphetamine, $\text{C}_9\text{H}_{13}\text{N}$, is 201°C at 760 torr and 83°C at 13 torr. What is the concentration (in g/m³) of amphetamine when it is in contact with 20.°C air?

12.138 Diamond has a face-centered cubic unit cell, with four more C atoms in tetrahedral holes within the cell. Densities of diamonds vary from 3.01 g/cm³ to 3.52 g/cm³ because C atoms are missing from some holes. (a) Calculate the unit-cell edge length of the densest diamond. (b) Assuming the cell dimensions are fixed, how many C atoms are in the unit cell of the diamond with the lowest density?

12.139 Is it possible for a salt of formula AB₃ to have a face-centered cubic unit cell of anions with cations in all eight of the available holes? Explain.

12.140 The density of solid gallium at its melting point is 5.9 g/cm³, whereas that of liquid gallium is 6.1 g/cm³. Is the temperature at the triple point higher or lower than the normal melting point? Is the slope of the solid-liquid line for gallium positive or negative?

12.141 A 4.7-L sealed bottle containing 0.33 g of liquid ethanol, $\text{C}_2\text{H}_6\text{O}$, is placed in a refrigerator and reaches equilibrium with its vapor at -11°C. (a) What mass of ethanol is present in the vapor? (b) When the container is removed and warmed to room temperature, 20.°C, will all the ethanol vaporize? (c) How much liquid ethanol would be present at 0.0°C? The vapor pressure of ethanol is 10. torr at -2.3°C and 40. torr at 19°C.

12.142 Substance A has the following properties.

mp at 1 atm:	-20.°C	bp at 1 atm:	85°C
ΔH_{fus} :	180. J/g	ΔH_{vap} :	500. J/g
c_{solid} :	1.0 J/g·°C	c_{liquid} :	2.5 J/g·°C
c_{gas} :	0.5 J/g·°C		

At 1 atm, a 25-g sample of A is heated from -40.°C to 100.°C at a constant rate of 450. J/min. (a) How many minutes does it take to heat the sample to its melting point? (b) How many minutes does it take to melt the sample? (c) Perform any other necessary calculations, and draw a curve of temperature vs. time for the entire heating process.

12.143 An aerospace manufacturer is building a prototype experimental aircraft that cannot be detected by radar. Boron nitride is chosen for incorporation into the body parts, and the boric acid/ammonia method is used to prepare the ceramic material. Given 85.5% and 86.8% yields for the two reaction steps, how much boron nitride can be prepared from 1.00 metric ton of boric acid

and 12.5 m³ of ammonia at 275 K and 3.07×10^3 kPa? Assume that ammonia does not behave ideally under these conditions and is recycled completely in the reaction process.

12.144 The ball-and-stick models below represent three compounds with the same molecular formula, $\text{C}_4\text{H}_8\text{O}_2$:

(a) Which compound(s) can form intermolecular H bonds?
(b) Which has the highest viscosity?

12.145 The ΔH_f° of gaseous dimethyl ether (CH_3OCH_3) is -185.4 kJ/mol; the vapor pressure is 1.00 atm at -23.7°C and 0.526 atm at -37.8°C. (a) Calculate $\Delta H_{\text{vap}}^\circ$ of dimethyl ether.
(b) Calculate ΔH_f° of liquid dimethyl ether.

12.146 The crystal structure of sodium is based on the body-centered cubic unit cell. What is the mass of one unit cell of Na?

12.147 The *intrinsic viscosity* of a polymer solute in a solvent, $[\eta]_{\text{solvent}}$, is the portion of the total viscosity due to the solute and is related to solute shape. It has also been found to relate to intermolecular interactions between solvent and polymer: higher $[\eta]_{\text{solvent}}$ means stronger interaction. The $[\eta]_{\text{solvent}}$ values of polymers in solution are given by the Mark-Houwink equation, $[\eta]_{\text{solvent}} = K \cdot M^a$, where M is the molar mass of the polymer and K and a are constants specific to the polymer and solvent. Use the data below for substances at 25°C to answer the following questions:

Polymer	Solvent	K (mL/g)	a
Polystyrene	Benzene	9.5×10^{-3}	0.74
	Cyclohexane	8.1×10^{-2}	0.50
Polyisobutylene	Benzene	8.3×10^{-2}	0.50
	Cyclohexane	2.6×10^{-1}	0.70

(a) A polystyrene sample has a molar mass of 104,160 g/mol. Calculate the intrinsic viscosity of this polymer in benzene and in cyclohexane. Which solvent has stronger interactions with the polymer?

(b) A different polystyrene sample has a molar mass of 52,000 g/mol. Calculate its $[\eta]_{\text{benzene}}$. Given a polymer standard of known M , how could you use its measured $[\eta]$ in a given solvent to determine the molar mass of any sample of that polymer?

(c) Compare $[\eta]$ values of a polyisobutylene sample [repeat unit $(\text{CH}_3)_2\text{CCH}_2$] with a molar mass of 104,160 g/mol with those of the polystyrene in part (a). What does this suggest about the solvent-polymer interactions of the two samples?

12.148 One way of purifying gaseous H_2 is to pass it under high pressure through the holes of a metal's crystal structure. Palladium, which adopts a cubic closest packed structure, absorbs more H_2 than any other element and is one of the metals used for this purpose. How the metal and H_2 interact is unclear, but it is estimated that the density of absorbed H_2 approaches that of liquid hydrogen (70.8 g/L). What volume (in L) of gaseous H_2 (at STP) can be packed into the spaces of 1 dm³ of palladium metal?

13

The Properties of Mixtures: Solutions and Colloids

13.1 Types of Solutions: Intermolecular Forces and Solubility

Intermolecular Forces in Solution
Liquid Solutions and Molecular Polarity
Gas and Solid Solutions

13.2 Intermolecular Forces and Biological Macromolecules

Structures of Proteins
Dual Polarity in Soaps, Membranes, and Antibiotics
Structure of DNA

13.3 Why Substances Dissolve: Breaking Down the Solution Process

Heat of Solution and Its Components
Heat of Hydration: Dissolving Ionic Solids in Water
Solution Process and Entropy Change

13.4 Solubility as an Equilibrium Process

Effect of Temperature on Solubility
Effect of Pressure on Solubility

13.5 Concentration Terms

Molarity and Molality

Parts of Solute by Parts of Solution
Interconverting Concentration Terms

13.6 Colligative Properties of Solutions

Nonvolatile Nonelectrolyte Solutions
Using Colligative Properties to Find Solute Molar Mass
Volatile Nonelectrolyte Solutions
Strong Electrolyte Solutions
Applications of Colligative Properties

13.7 Structure and Properties of Colloids

Source: © amnat11/Shutterstock.com

Concepts and Skills to Review Before You Study This Chapter

- › separation of mixtures (Section 2.9)
- › calculations involving mass percent (Section 3.1) and molarity (Section 4.1)
- › electrolytes; water as solvent (Sections 4.1 and 12.5)
- › mole fraction and Dalton's law (Section 5.4)
- › intermolecular forces and polarizability (Section 12.3)
- › monomers and polymers (Section 12.7)
- › equilibrium nature of phase changes and vapor pressure of liquids; phase diagrams (Section 12.2)

Virtually all the gases, liquids, and solids in the real world are mixtures—two or more substances mixed together physically, not combined chemically. Synthetic mixtures usually contain only a dozen or so components; for example, the soda you may be drinking while reading your chemistry text contains water, carbon dioxide, sugar, caffeine, caramel color, phosphoric and citric acids, and other flavorings. Natural mixtures, such as seawater and soil, often contain over 50 components. Living mixtures, such as trees and students, are the most complex—even a simple bacterial cell contains nearly 6000 different compounds (Table 13.1).

Recall from Chapter 2 that a mixture has two defining characteristics: *its composition is variable*, and *it retains some properties of its components*. We focus here on two common types of mixtures—solutions and colloids—whose main differences relate to particle size and number of phases:

- A *solution* is a *homogeneous* mixture; that is, it exists as one phase. In a solution, the particles are individual atoms, ions, or small molecules.
- A *colloid* is a type of *heterogeneous* mixture. A heterogeneous mixture has two or more phases. They may be visibly distinct, like pebbles in concrete, or not, like the much smaller particles in the colloids smoke and milk. In a colloid, the particles are typically macromolecules or aggregations of small molecules that are dispersed so finely they don't settle out.

IN THIS CHAPTER . . . We focus on how intermolecular forces and other energy considerations affect a solute dissolving in a solvent, how to calculate concentration, and how solutions differ from pure substances. We also briefly consider the behavior and applications of colloids.

- › We survey intermolecular forces between solute and solvent and find that substances with similar types of forces form a solution.
- › We see how the dual polarity of some organic molecules gives rise to these same intermolecular forces, and we find that they determine the structures and functions of soaps, antibiotics, biological macromolecules, and cell membranes.
- › We use a stepwise cycle to see why a substance dissolves and examine the heat involved and the dispersal of matter that occurs when a solution forms. To understand the latter factor, we introduce the concept of entropy.
- › We examine the equilibrium nature of solubility and see how temperature and pressure affect it.
- › We define various solution concentration units and see how to interconvert them mathematically.
- › We see why the physical properties of solutions are different from those of pure substances and learn how to apply those differences.
- › We investigate colloids and apply solution and colloid chemistry to the purification of water.

Table 13.1 Approximate Composition of a Bacterium

Substance	Mass % of Cell	Number of Types	Number of Molecules
Water	~70	1	5×10^{10}
Ions	1	20	?
Sugars*	3	200	3×10^8
Amino acids*	0.4	100	5×10^7
Lipids*	2	50	3×10^7
Nucleotides*	0.4	200	1×10^7
Other small molecules	0.2	~200	?
Macromolecules (proteins, nucleic acids, polysaccharides)	23	~5000	6×10^6

*Includes precursors and metabolites.

13.1 TYPES OF SOLUTIONS: INTERMOLECULAR FORCES AND SOLUBILITY

A **solute** dissolves in a **solvent** to form a solution. In general, *the solvent is the most abundant component*, but in some cases, the substances are **miscible**—soluble in each other in any proportion—so the terms “solute” and “solvent” lose their meaning. *The physical state of the solvent usually determines the physical state of the solution.* Solutions can be gaseous, liquid, or solid, but we focus mostly on liquid solutions because they are by far the most important.

The **solubility (S)** of a solute is the maximum amount that dissolves in a fixed quantity of a given solvent at a given temperature, when an excess of the solute is present. Different solutes have different solubilities:

- Sodium chloride (NaCl), $S = 39.12 \text{ g}/100. \text{ mL}$ water at $100.^\circ\text{C}$
- Silver chloride (AgCl), $S = 0.0021 \text{ g}/100. \text{ mL}$ water at $100.^\circ\text{C}$

Solubility is a *quantitative* term, but *dilute* and *concentrated* are qualitative, referring to the *relative* amounts of dissolved solute:

- The NaCl solution above is concentrated (a relatively large amount of solute dissolved in a given quantity of solvent).
- The AgCl solution is dilute (a relatively small amount of solute in a given quantity of solvent).

A given solute may dissolve in one solvent and not another. The explanation lies in the relative strengths of the intermolecular forces within both solute and solvent and between them. The useful rule-of-thumb “**like dissolves like**” says that *substances with similar types of intermolecular forces dissolve in each other*. Thus, by knowing the forces, we can often predict whether a solute will dissolve in a solvent.

Intermolecular Forces in Solution

All the intermolecular forces we discussed for pure substances also occur in solutions (Figure 13.1; also see Section 12.3):

1. **Ion-dipole forces** (attractions between ions and polar molecules) are the principal force involved when an ionic compound dissolves in water. Two events occur simultaneously:
 - *Forces compete.* When a soluble salt is added to water, each type of ion attracts the oppositely charged pole of a water molecule. These attractions between ions and water compete with and overcome attractions between the ions, and the crystal structure breaks down.
 - *Hydration shells form.* As an ion separates from the crystal structure, water molecules cluster around it in **hydration shells**. The number of water molecules in the innermost shell depends on the ion’s size: four fit tetrahedrally around small ions like Li^+ , while the larger Na^+ and F^- have six water molecules surrounding them octahedrally (Figure 13.2). In the innermost shell, normal hydrogen bonding between water molecules is disrupted to form the ion-dipole forces. But these water molecules are H bonded to others in the next shell, and those are H bonded to others still farther away.
2. **Hydrogen bonding** (attractions between molecules with an H atom bonded to N, O, or F) is the principal force in solutions of polar, O- and N-containing organic and biological compounds, such as alcohols, amines, and amino acids.
3. **Dipole-dipole forces** (attractions between polar molecules), in the absence of H bonding, allow polar molecules like propanal ($\text{CH}_3\text{CH}_2\text{CHO}$) to dissolve in polar solvents like dichloromethane (CH_2Cl_2).
4. **Ion-induced dipole forces**, one type of *charge-induced dipole force*, rely on polarizability. They arise when an ion’s charge distorts the electron cloud of a nearby non-polar molecule, giving it a temporary dipole moment. This type of force initiates the binding of the Fe^{2+} ion in hemoglobin to an O_2 molecule that enters a red blood cell.

Figure 13.1 Types of intermolecular forces in solutions. Forces are listed in order of decreasing strength (values are in kJ/mol), with an example of each.

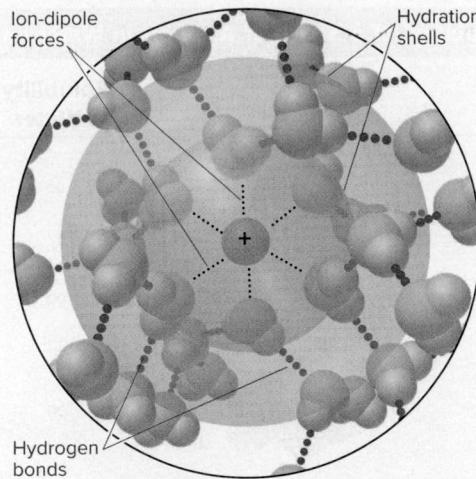

Figure 13.2 Hydration shells around an Na^+ ion. Ion-dipole forces orient water molecules around an ion. In the innermost shell here, six water molecules surround the cation octahedrally.

5. **Dipole-induced dipole forces**, also based on polarizability, arise when a polar molecule distorts the electron cloud of a nonpolar molecule. They are weaker than ion-induced dipole forces because the charge of each pole is less than an ion's (Coulomb's law). The solubility in water of atmospheric O_2 , N_2 , and noble gases, while limited, is due in part to these forces. Paint thinners and grease solvents also rely on them.
6. *Dispersion forces* contribute to the solubility of all solutes in all solvents, but they are the *principal* intermolecular force in solutions of nonpolar substances, such as petroleum and gasoline.

The same forces maintain the shapes of biological macromolecules (Section 13.2).

Liquid Solutions and the Role of Molecular Polarity

From cytoplasm to tree sap, gasoline to cleaning fluid, iced tea to urine, liquid solutions are very familiar. Water is the most prominent solvent, but there are many other liquid solvents, with polarities from very polar to nonpolar.

Applying the Like-Dissolves-Like Rule The like-dissolves-like rule says that when the forces *within* the solute are *similar* to those *within* the solvent, the forces can *replace* each other and a solution forms. Thus,

- *Salts are soluble in water* because the ion-dipole attractions between ion and water are similar in strength to the strong attractions between the ions and the strong H bonds between water molecules, so they *can* replace each other.
- *Salts are insoluble in hexane (C_6H_{14})* because the ion-induced dipole forces between ion and nonpolar hexane are very weak and *cannot* replace the strong attractions between the ions.
- *Oil is insoluble in water* because the weak dipole-induced dipole forces between oil and water molecules *cannot* replace the strong H bonds between water molecules or the extensive dispersion forces within the oil.
- *Oil is soluble in hexane* because dispersion forces in one *can* replace the similar dispersion forces in the other.

Dual Polarity and Effects on Solubility To examine these ideas further, let's compare the solubilities of a series of alcohols in water and in hexane ($\text{CH}_3\text{CH}_2\text{CH}_2\text{CH}_2\text{CH}_3$), two solvents with very different intermolecular forces; polar water molecules exhibit H bonds, while nonpolar hexane molecules have dispersion forces. Alcohols are organic compounds that have a dual polarity, a polar hydroxyl ($-\text{OH}$) group bonded to a nonpolar hydrocarbon group:

- The $-\text{OH}$ portion interacts through strong H bonds with water and through weak dipole-induced dipole forces with hexane.
- The hydrocarbon portion interacts through dispersion forces with hexane and through very weak dipole-induced dipole forces with water.

Table 13.2 Solubility* of a Series of Alcohols in Water and in Hexane

Alcohol	Model	Solubility in Water	Solubility in Hexane
CH_3OH (methanol)		∞	1.2
$\text{CH}_3\text{CH}_2\text{OH}$ (ethanol)		∞	∞
$\text{CH}_3(\text{CH}_2)_2\text{OH}$ (1-propanol)		∞	∞
$\text{CH}_3(\text{CH}_2)_3\text{OH}$ (1-butanol)		1.1	∞
$\text{CH}_3(\text{CH}_2)_4\text{OH}$ (1-pentanol)		0.30	∞
$\text{CH}_3(\text{CH}_2)_5\text{OH}$ (1-hexanol)		0.058	∞

*Expressed in mol alcohol/1000 g solvent at 20°C.

The general formula for an alcohol is $\text{CH}_3(\text{CH}_2)_n\text{OH}$, and we'll look at straight-chain examples with one to six carbons ($n = 0$ to 5):

1. *Solubility in water is high for smaller alcohols.* From the models in Table 13.2, we see that the —OH group is a relatively large portion of the alcohols with one to three carbons ($n = 0$ to 2). These molecules interact with each other through H bonding, just as water molecules do. When they mix with water, H bonding *within* solute and *within* solvent is replaced by H bonding *between* solute and solvent (Figure 13.3). As a result, these smaller alcohols are miscible with water.

2. *Solubility in water is low for larger alcohols.* Solubility decreases dramatically for alcohols larger than three carbons ($n > 2$); in fact, those with chains longer than six carbons ($n > 5$) are insoluble in water. For larger alcohols to dissolve, the nonpolar chains have to move among the water molecules, replacing the strong H-bond attractions between water molecules with the weak attractions of the chains for water. While the —OH portion of such an alcohol forms H bonds to water, these cannot make up for all the other H bonds between water molecules that have to break to make room for the long hydrocarbon portion.

Table 13.2 shows that the opposite trend occurs with hexane:

1. *Solubility in hexane is low for the smallest alcohol.* For alcohols in hexane, in addition to dispersion forces, weak dipole-induced dipole forces exist between the —OH of methanol (CH_3OH) and hexane. These cannot replace the strong H bonding between CH_3OH molecules, so solubility is relatively low.

2. *Solubility in hexane is high for larger alcohols.* In any larger alcohol ($n > 0$), dispersion forces between the hydrocarbon portion and hexane *can* replace dispersion forces between hexane molecules. With only weak forces within the solvent to be replaced, even ethanol, with a two-carbon chain, has enough dispersion forces between it and hexane to be miscible.

In pure water, H bonds link the molecules.

In pure methanol, H bonds link the molecules.

In a solution of water and methanol, H bonds link the two types of molecules.

Figure 13.3 Like dissolves like: solubility of methanol in water.

Many organic molecules have polar and nonpolar portions, which determine their solubility. For example, carboxylic acids and amines behave like alcohols: methanoic acid (HCOOH , formic acid) and methanamine (CH_3NH_2) are miscible with water and slightly soluble in hexane, whereas hexanoic acid [$\text{CH}_3(\text{CH}_2)_4\text{COOH}$] and 1-hexanamine [$\text{CH}_3(\text{CH}_2)_5\text{NH}_2$] are slightly soluble in water and very soluble in hexane.

SAMPLE PROBLEM 13.1**Predicting Relative Solubilities**

Problem Predict which solvent will dissolve more of the given solute:

- Sodium chloride in methanol (CH_3OH) or in 1-propanol ($\text{CH}_3\text{CH}_2\text{CH}_2\text{OH}$)
- Ethylene glycol ($\text{HOCH}_2\text{CH}_2\text{OH}$) in hexane ($\text{CH}_3\text{CH}_2\text{CH}_2\text{CH}_2\text{CH}_2\text{CH}_3$) or in water
- Diethyl ether ($\text{CH}_3\text{CH}_2\text{OCH}_2\text{CH}_3$) in water or in ethanol ($\text{CH}_3\text{CH}_2\text{OH}$)

Plan We examine the formulas of solute and solvent to determine the forces in and between solute and solvent. A solute is more soluble in a solvent whose intermolecular forces are similar to, and therefore can replace, its own.

Solution (a) **Methanol.** NaCl is ionic, so it dissolves through ion-dipole forces. Both methanol and 1-propanol have a polar $-\text{OH}$ group, but the hydrocarbon portion of each alcohol interacts only weakly with the ions and 1-propanol has a longer hydrocarbon portion than methanol.

(b) **Water.** Ethylene glycol molecules have two $-\text{OH}$ groups, so they interact with each other through H bonding. H bonds formed with H_2O can replace these H bonds between solute molecules better than dipole-induced dipole forces with hexane can.

(c) **Ethanol.** Diethyl ether molecules interact through dipole-dipole and dispersion forces. They can form H bonds to H_2O or to ethanol. But ethanol can also interact with the ether effectively through dispersion forces because it has a hydrocarbon chain.

FOLLOW-UP PROBLEMS

Brief Solutions for all Follow-up Problems appear at the end of the chapter.

13.1A State which solute is more soluble in the given solvent and which forces are most important: (a) 1-butanol ($\text{CH}_3\text{CH}_2\text{CH}_2\text{CH}_2\text{OH}$) or 1,4-butanediol ($\text{HOCH}_2\text{CH}_2\text{CH}_2\text{CH}_2\text{OH}$) in water; (b) chloroform (CHCl_3) or carbon tetrachloride (CCl_4) in water.

13.1B State which solvent can dissolve more of the given solute and which forces are most important: (a) chloromethane (CH_3Cl) in chloroform (CHCl_3) or in methanol (CH_3OH); (b) pentanol ($\text{C}_5\text{H}_{11}\text{OH}$) in water or in hexane (C_6H_{14}).

SOME SIMILAR PROBLEMS 13.13 and 13.14

Gas-Liquid Solutions A substance with very weak intermolecular attractions should have a low boiling point and, thus, would be a gas under ordinary conditions. Also, it would not be very soluble in water because of weak solute-solvent forces. Thus, for nonpolar or slightly polar gases, boiling point generally correlates with solubility in water (Table 13.3). A higher boiling point is an indication of stronger intermolecular forces, which result in a greater solubility in water.

The small amount of a nonpolar gas that *does* dissolve may be vital. At 25°C and 1 atm, the solubility of O_2 is only 3.2 mL/100. mL of water, but aquatic animal life requires it. At times, the solubility of a nonpolar gas may *seem* high because it is also *reacting* with the solvent. Oxygen seems more soluble in blood than in water because it bonds chemically to hemoglobin in red blood cells. Carbon dioxide, which is essential for aquatic plants and coral-reef growth, seems very soluble in water (~ 81 mL of CO_2 /100. mL of H_2O at 25°C and 1 atm) because it is dissolving *and* reacting:

Gas Solutions and Solid Solutions

Gas solutions and solid solutions also have vital importance and numerous applications.

Gas-Gas Solutions All gases are miscible with each other. Air is the classic example of a gaseous solution, consisting of about 18 gases in widely differing proportions.

Correlation Between Boiling Point and Solubility in Water

Table 13.3

Gas	Solubility (mol/L)*	bp (K)
He	4.2×10^{-4}	4.2
Ne	6.6×10^{-4}	27.1
N ₂	10.4×10^{-4}	77.4
CO	15.6×10^{-4}	81.6
O ₂	21.8×10^{-4}	90.2
NO	32.7×10^{-4}	121.4

*At 273 K and 1 atm.

A Brass, a substitutional alloy

B Carbon steel, an interstitial alloy

Figure 13.4 The arrangement of atoms in two types of alloys.

Source: (A) © Ruth Melnick; (B) © Ingram Publishing/age fotostock RF

Anesthetic gas proportions are finely adjusted to the needs of the patient and the length of the surgical procedure. The proportions of many industrial gas mixtures, such as CO/H₂ in syngas production or N₂/H₂ in ammonia production, are controlled to optimize product yield under varying conditions of temperature and pressure.

Gas-Solid Solutions When a gas dissolves in a solid, it occupies the spaces between the closely packed particles. Hydrogen gas can be purified by passing an impure sample through palladium. Only H₂ molecules are small enough to fit between the Pd atoms, where they form Pd—H bonds. The H atoms move from one Pd atom to another and emerge from the metal as H₂ molecules (see Figure 14.2).

The ability of gases to dissolve in a solid also has disadvantages. The electrical conductivity of copper is greatly reduced by the presence of O₂, which dissolves into the crystal structure and reacts to form copper(I) oxide. High-conductivity copper is prepared by melting and recasting the metal in an O₂-free atmosphere.

Solid-Solid Solutions Solids diffuse so little that their mixtures are usually heterogeneous. Some solid-solid solutions can be formed by melting the solids and then mixing them and allowing them to freeze. Many **alloys**, mixtures of elements that have a metallic character, are solid-solid solutions (although several have microscopic heterogeneous regions). Alloys generally fall into one of two categories:

- In a *substitutional alloy* like brass (Figure 13.4A), atoms of zinc *replace* atoms of the main element, copper, at some sites in the cubic closest packed array. This occurs when the atoms of the elements in the alloy are similar in size.
- In an *interstitial alloy* like carbon steel (Figure 13.4B), atoms of carbon (a nonmetal is typical in this type of alloy) *fill some spaces (interstices)* between atoms of the main element, iron, in the body-centered array.

Waxes are also solid-solid solutions. Most are amorphous solids with some small regions of crystalline regularity. A *wax* is defined as a solid of biological origin that is insoluble in water and soluble in nonpolar solvents. Beeswax, which bees secrete to build their combs, is a homogeneous mixture of fatty acids, long-chain carboxylic acids, and hydrocarbons in which some of the molecules are more than 40 carbon atoms long. Carnauba wax, from a South American palm, is a mixture of compounds, each consisting of a fatty acid bound to a long-chain alcohol. It is hard but forms a thick gel in nonpolar solvents, so it is perfect for waxing cars.

› Summary of Section 13.1

- › A solution is a homogeneous mixture of a solute dissolved in a solvent through the action of intermolecular forces.
- › Ion-dipole, ion-induced dipole, and dipole-induced dipole forces occur in solutions, in addition to all the intermolecular forces that also occur in pure substances.
- › If similar intermolecular forces occur in solute and solvent, they replace each other when the substances mix and a solution is likely to form (the like-dissolves-like rule).
- › When ionic compounds dissolve in water, the ions become surrounded by hydration shells of H-bonded water molecules.

- Solubility of organic molecules in various solvents depends on the relative sizes of their polar and nonpolar portions.
- The solubility of nonpolar gases in water is low because of weak intermolecular forces. Gases are miscible with one another and dissolve in solids by fitting into spaces in the crystal structure.
- Solid-solid solutions include alloys (some of which are formed by mixing molten components) and waxes.

13.2 INTERMOLECULAR FORCES AND BIOLOGICAL MACROMOLECULES

We discuss the shapes of proteins, nucleic acids, and cell membranes, as well as the functions of soaps and antibiotics, in this chapter on solutions because they depend on intermolecular forces too. These shapes and functions are explained by two ideas:

- Polar and ionic groups attract water, but nonpolar groups do not.
- Just as separate molecules attract each other, so do distant groups on the same molecule.

The Structures of Proteins

Proteins are very large molecules (called polymers) formed by linking together many smaller molecules called **amino acids**; about 20 different amino acids occur in proteins, which range in size from about 50 amino acids ($\mathcal{M} \approx 5 \times 10^3$ g/mol) to several thousand ($\mathcal{M} \approx 5 \times 10^5$ g/mol). Proteins with a few types of amino acids in repeating patterns have extended helical or sheetlike shapes and give structure to hair, skin, and so forth. Proteins with many types of amino acids have complex, globular shapes and function as antibodies, enzymes, and so forth. Let's see how intermolecular forces among amino acids influence the shapes of globular proteins.

The Polarity of Amino-Acid Side Chains In a cell, a free amino acid has four groups bonded to one C, which is called the α -carbon (Figure 13.5): charged carboxyl ($-\text{COO}^-$) and amine ($-\text{NH}_3^+$) groups, an H atom, and a *side chain*, represented by an R, which ranges from another H atom, to a few C atoms, to a two-ringed $\text{C}_9\text{H}_8\text{N}$ group. In a protein, the carboxyl group of one amino acid is linked covalently to the amine group of the next by a *peptide bond*. (We discuss amino acid structures and peptide bond formation in Chapter 15.) Thus, as Figure 13.6 shows, the *backbone* of a protein is a polypeptide chain: an α -carbon connected through a peptide bond (orange screen) to the next α -carbon, and so forth. The various side chains (gray screens) dangle off the α -carbons on alternate sides of the chain.

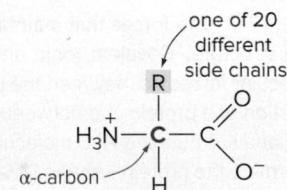

Figure 13.5 The charged form of an amino acid under physiological conditions.

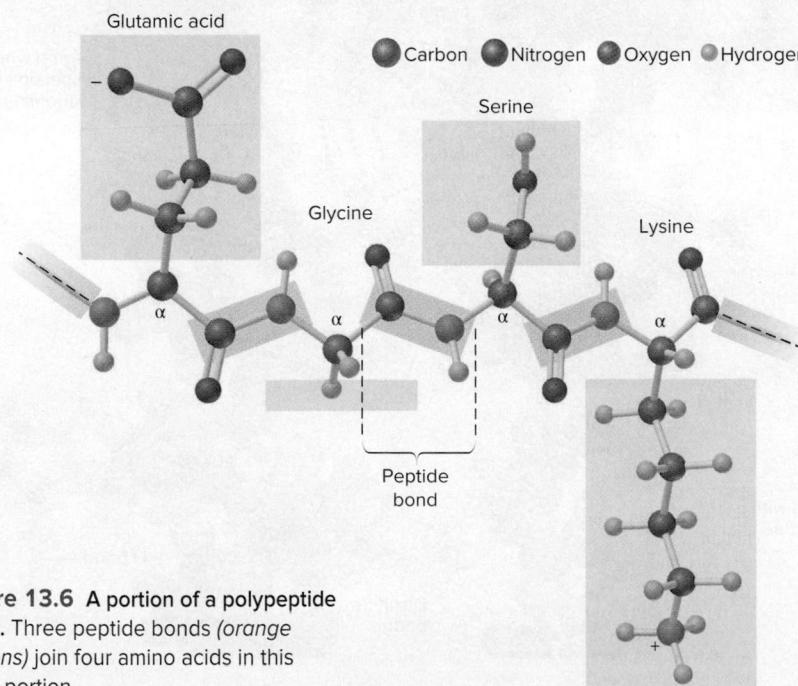

Figure 13.6 A portion of a polypeptide chain. Three peptide bonds (orange screens) join four amino acids in this chain portion.

Amino acids can be classified by the polarity or charge of their side chains: nonpolar, polar, and ionic. A few examples are

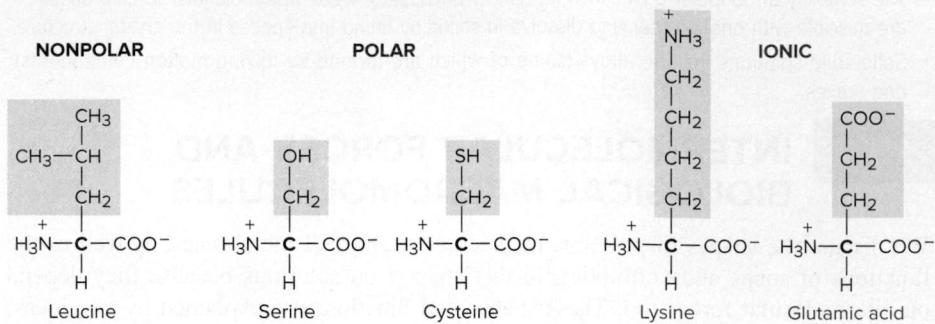

Intermolecular Forces and Protein Shape The same forces that act between separate molecules are responsible for a protein's shape, because *distant groups on the protein chain end up near each other as the chain bends*. Figure 13.7 depicts the forces within a small portion of a protein and between the protein and the aqueous medium of the cell. In general order of importance, they are

- Covalent peptide bonds create the backbone (polypeptide chain).
- Helical and sheetlike segments arise from H bonds between the C=O of one peptide bond and the N—H of another.
- Polar and ionic side chains protrude into the surrounding cell fluid, interacting with water through ion-dipole forces and H bonds.
- Nonpolar side chains interact through dispersion forces within the nonaqueous protein interior.

Figure 13.7 The forces that maintain protein structure. Covalent, ionic, and intermolecular forces act between the parts of a portion of a protein and between the protein and surrounding H_2O molecules to determine the protein's shape. (Water molecules and some amino-acid side chains are shown as ball-and-stick models within space-filling contours.)

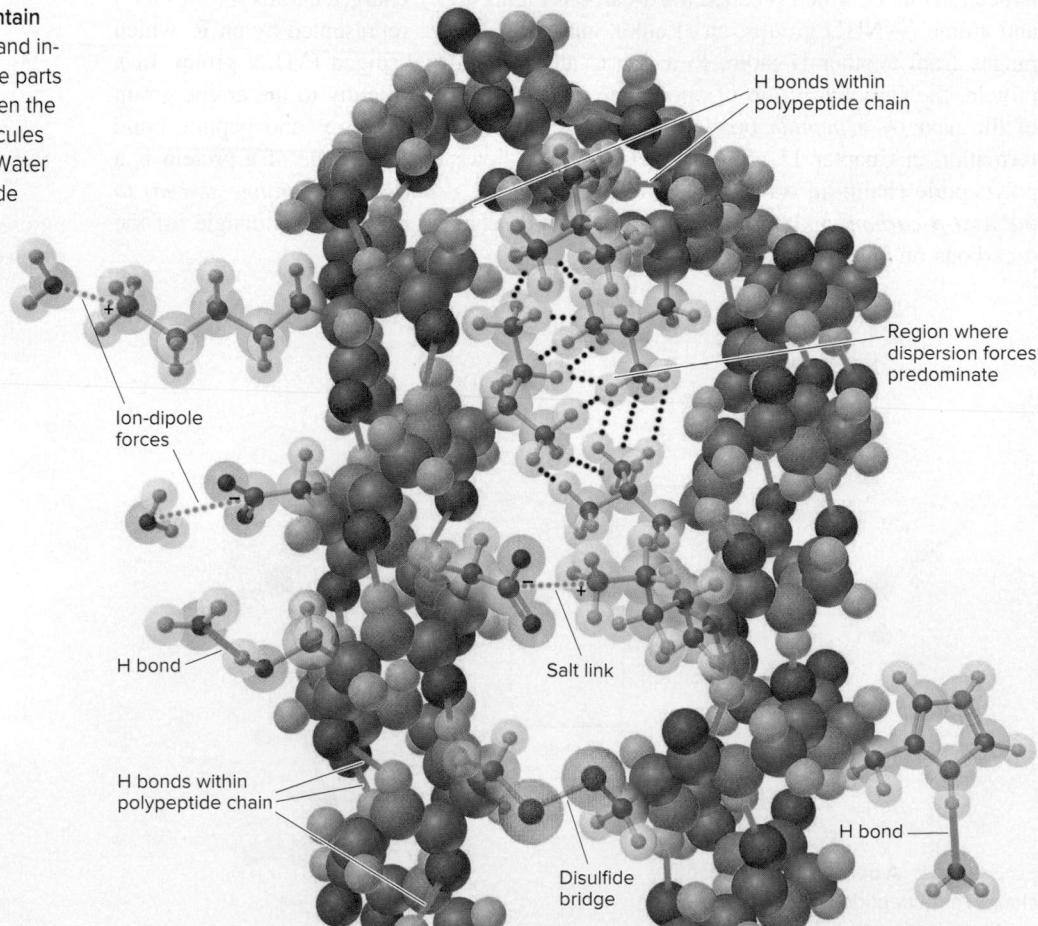

- The $-SH$ ends of two cysteine side chains form a covalent $-S-S-$ bond, a *disulfide bridge*, between distant parts of the chain that creates a loop.
- Oppositely charged ends of ionic side chains, $-COO^-$ and $-NH_3^+$ groups, that lie near each other form an electrostatic *salt link* (or *ion pair*) that creates bend in the protein chain.
- Other H bonds between side chains keep distant chain portions near each other.

Thus, *soluble proteins have polar-ionic exteriors and nonpolar interiors*. As we emphasize in Chapter 15, the amino acid *sequence* of a protein determines its *shape*, which determines its *function*.

Dual Polarity in Soaps, Membranes, and Antibiotics

Dual polarity, which we noted as a key factor in the solubility of alcohols, also helps explain how soaps, cell membranes, and antibiotics function.

Action of Soaps A **soap** is the salt formed when a strong base (a metal hydroxide) reacts with a *fatty acid*, a carboxylic acid with a long hydrocarbon chain. A typical soap molecule is made up of a nonpolar “tail” 15–19 carbons long and a polar-ionic “head” consisting of a $-COO^-$ group and the cation of the strong base. The cation greatly influences a soap’s properties. Lithium soaps are hard and high melting and used in car lubricants. Potassium soaps are low melting and used in liquid form. Several sodium soaps, including sodium stearate, $CH_3(CH_2)_{16}COONa$, are components of common bar soaps:

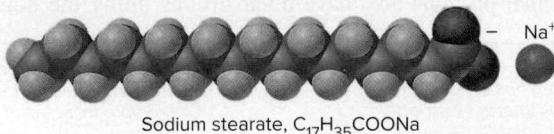

When grease on your hands or clothes is immersed in soapy water, the soap molecules’ nonpolar tails interact with the nonpolar grease molecules through dispersion forces, while the polar-ionic heads attract water molecules through ion-dipole forces and H bonds. Tiny aggregates of grease molecules, embedded with soap molecules whose polar-ionic heads stick into the water, are flushed away by added water (Figure 13.8).

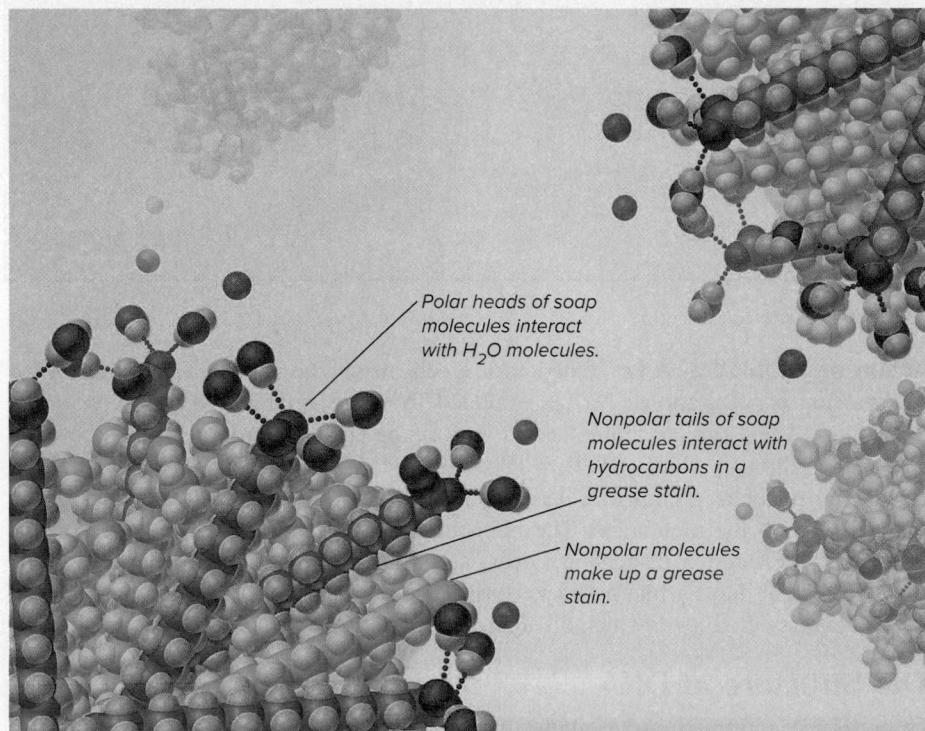

Figure 13.8 The cleaning ability of a soap depends on the dual polarity of its molecules.

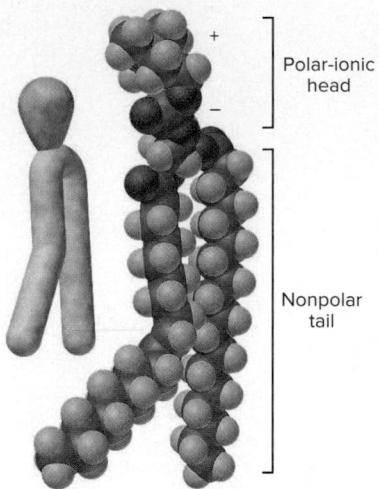

Figure 13.9 A membrane phospholipid. Lecithin (phosphatidylcholine), a phospholipid, is shown as a space-filling model and as a simplified purple-and-gray shape.

Lipid Bilayers and the Structure of the Cell Membrane The most abundant molecules in cell membranes are *phospholipids*. Like soaps, they have a dual polarity—a nonpolar tail consists of two fatty acid chains, and an organophosphate group is the polar-ionic head (Figure 13.9). Remarkably, phospholipids self-assemble in water into a sheetlike double layer called a **lipid bilayer**, with the tails of the two layers touching and the heads in the water. In the laboratory, bilayers form spherical vesicles that trap water inside. These structures are favored energetically because of their intermolecular forces:

- Ion-dipole forces occur between polar heads and water inside and outside.
- Dispersion forces occur between nonpolar tails within the bilayer interior.
- Minimal contact exists between nonpolar tails and water.

A typical animal cell membrane consists of a phospholipid bilayer with proteins partially embedded in it; a small portion of such a membrane appears in Figure 13.10. Membrane proteins, which play countless essential roles, differ fundamentally from soluble proteins in terms of their dual polarity:

- Soluble proteins have polar exteriors and nonpolar interiors. They form ion-dipole and H-bonding forces between water and *polar groups on the exterior* and dispersion forces between *nonpolar groups in the interior* (see Figure 13.7).
- Membrane proteins have exteriors that are partially polar (red) and partially nonpolar (blue). They have polar groups on the *exterior portion that juts into the aqueous surroundings* and nonpolar groups on the *exterior portion embedded in the membrane*. These nonpolar groups form dispersion forces with the phospholipid tails of the bilayer. Channel proteins also have polar groups lining the aqueous channel.

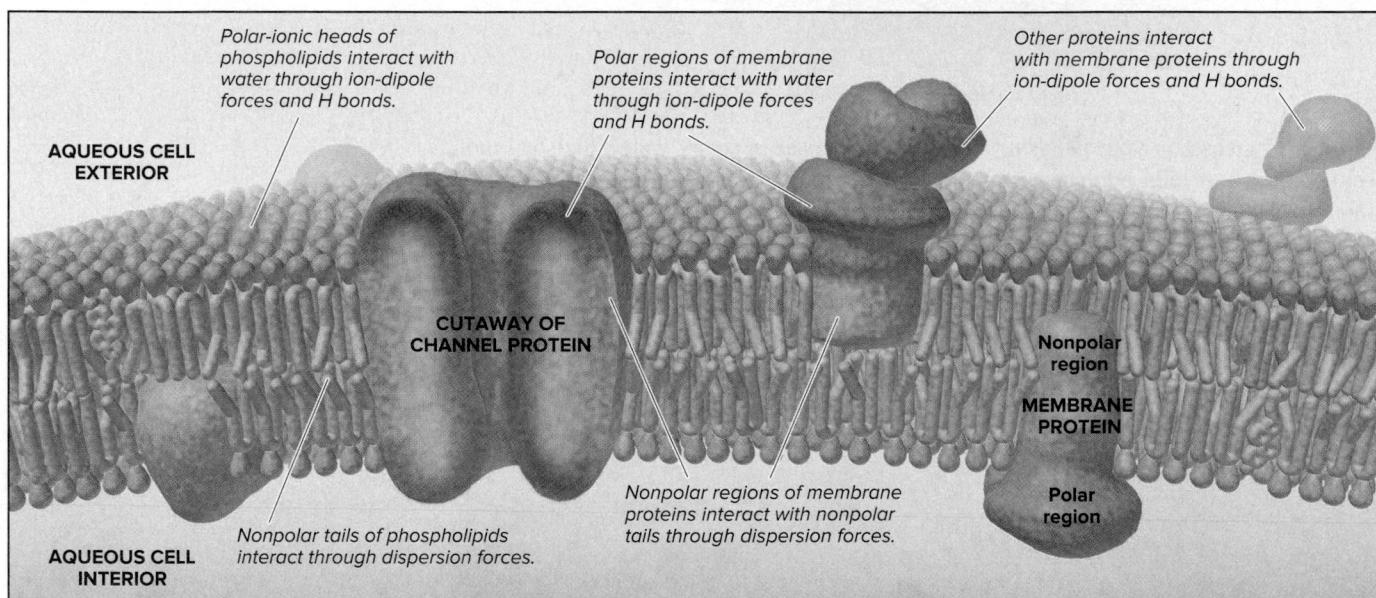

Figure 13.10 Intermolecular forces and cell membrane structure.

Action of Antibiotics A key function of a cell membrane is to balance internal and external ion concentrations: Na^+ is excluded from the cell, and K^+ is kept inside. Gramicidin A and similar antibiotics act by forming channels in the cell membrane of a bacterium through which ions flow (Figure 13.11). Two helical gramicidin A molecules, their nonpolar groups outside and polar groups inside, lie end to end to form a channel through the membrane. The nonpolar outside stabilizes the molecule in the cell membrane through dispersion forces, and the polar inside passes the ions along using ion-dipole forces, like a “bucket brigade.” Over 10^7 ions pass through each of these channels per second, which disrupts the vital ion balance, and the bacterium dies.

The Structure of DNA

The chemical information that guides the design and construction, and therefore the function, of all proteins is contained in **nucleic acids**, unbranched polymers made up

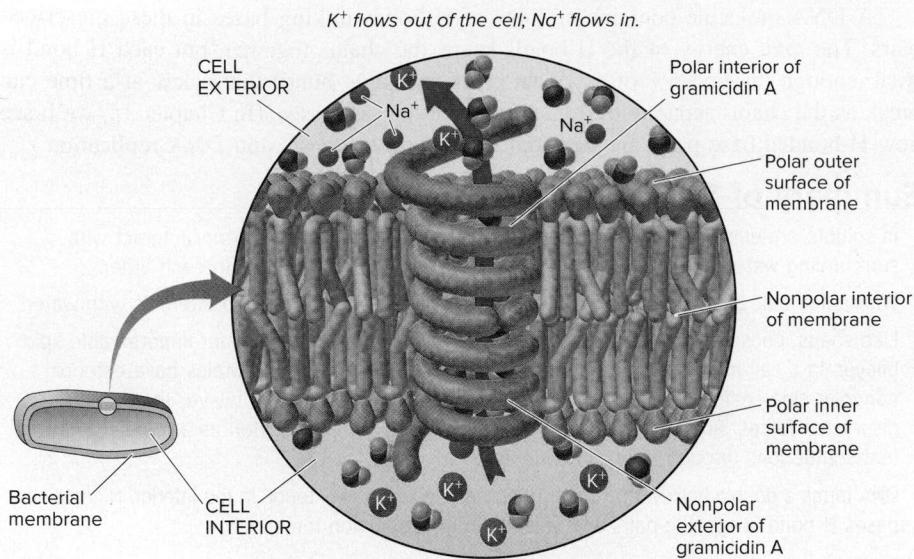

Figure 13.11 The mode of action of the antibiotic gramicidin A. The K⁺ ions are shown leaving the cell. At the same time (not shown), Na⁺ ions enter the cell.

of smaller units (monomers) called **mononucleotides**. Each mononucleotide consists of an N-containing base, a sugar, and a phosphate group (Figure 13.12). In DNA (*deoxyribonucleic acid*), the sugar is *2-deoxyribose*, in which —H substitutes for —OH on the second C atom of the five-C sugar ribose.

The repeating pattern of the DNA chain is *sugar linked to phosphate linked to sugar linked to phosphate*, and so on. Attached to each sugar is one of four N-containing bases, flat ring structures that dangle off the polynucleotide chain, similar to the way amino-acid side chains dangle off the polypeptide chain.

Intermolecular Forces and the Double Helix DNA exists as two chains wrapped around each other in a **double helix** that is stabilized by intermolecular forces (Figure 13.13):

- *On the more polar exterior*, negatively charged sugar-phosphate groups interact with the aqueous surroundings via ion-dipole forces and H bonds.
- *In the less polar interior*, flat, N-containing bases stack above each other and interact by dispersion forces.
- *Bases form specific interchain H bonds*; that is, each base in one chain is always H bonded with its complementary base in the other chain. Thus, *the base sequence of one chain is the H-bonded complement of the base sequence of the other*.

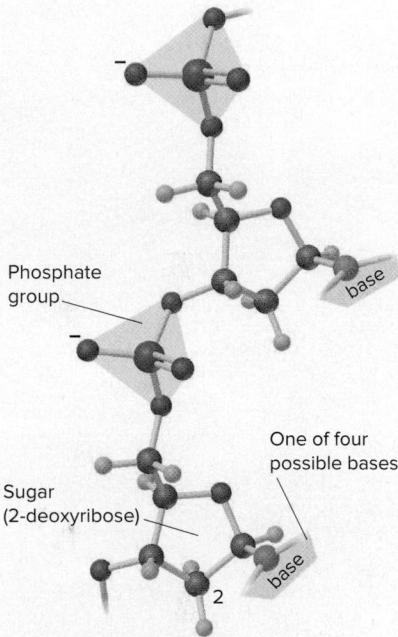

Figure 13.12 A short portion of the polynucleotide chain of DNA.

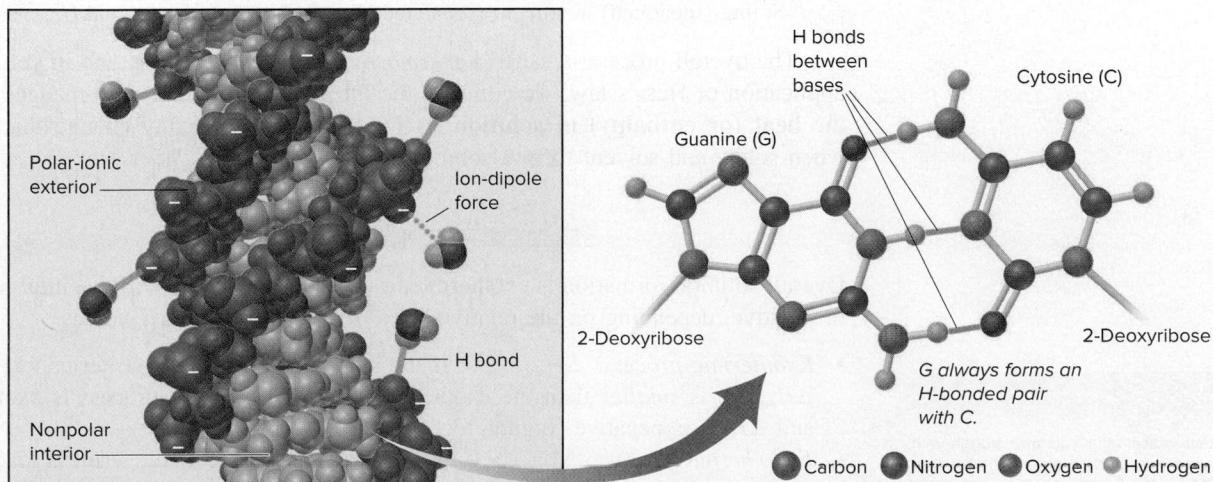

Figure 13.13 The double helix of DNA. A segment of DNA (left) has its polar-ionic sugar-phosphate portion (pink) facing the water and the nonpolar bases (gray) stacking in the interior. The expanded portion (right) shows an H-bonded pair of the bases guanine and cytosine.

A DNA molecule contains millions of H bonds linking bases in these prescribed pairs. The *total* energy of the H bonds keeps the chains together, but each H bond is weak enough (around 5% of a typical covalent single bond) that a few at a time can break as the chains separate during crucial cellular processes. (In Chapter 15, we'll see how H-bonded base pairs are essential for protein synthesis and DNA replication.)

› Summary of Section 13.2

- › In soluble proteins, polar and ionic amino-acid side chains on the exterior interact with surrounding water, and nonpolar side chains in the interior interact with each other.
- › With polar-ionic heads *and* nonpolar tails, a soap dissolves grease *and* interacts with water.
- › Like soaps, phospholipids have dual polarity. They assemble into a water-impermeable lipid bilayer. In a cell membrane, the embedded portions of membrane proteins have exterior nonpolar side chains that interact with the nonpolar tails in the lipid bilayer through dispersion forces. Some antibiotics form channels with nonpolar exteriors and polar interiors that shuttle ions through the cell membrane.
- › DNA forms a double helix with a sugar-phosphate, polar-ionic exterior. In the interior, N-containing bases H bond in specific pairs and stack through dispersion forces.

13.3 WHY SUBSTANCES DISSOLVE: BREAKING DOWN THE SOLUTION PROCESS

The qualitative *macroscopic* rule “like dissolves like” is based on *molecular* interactions between the solute and the solvent. To see *why* like dissolves like, we’ll break down the solution process conceptually into steps and examine each of them quantitatively.

The Heat of Solution and Its Components

Before a solution forms, solute particles (ions or molecules) are attracting each other, as are solvent particles (molecules). For one to dissolve in the other, three steps must take place, each accompanied by an enthalpy change:

Step 1. Solute particles separate from each other. This step involves overcoming intermolecular (or ionic) attractions, so it is *endothermic*:

Step 2. Solvent particles separate from each other. This step also involves overcoming attractions, so it is *endothermic*, too:

Step 3. Solute and solvent particles mix and form a solution. The different particles attract each other and come together, so this step is *exothermic*:

The overall process is called a *thermochemical solution cycle*, and in yet another application of Hess’s law, we combine the three individual enthalpy changes to find the **heat (or enthalpy) of solution (ΔH_{soln})**, the total enthalpy change that occurs when solute and solvent form a solution:

$$\Delta H_{\text{soln}} = \Delta H_{\text{solute}} + \Delta H_{\text{solvent}} + \Delta H_{\text{mix}} \quad (13.1)$$

Overall solution formation is exothermic or endothermic, and ΔH_{soln} is either negative or positive, depending on the relative sizes of the individual ΔH values:

- *Exothermic process:* $\Delta H_{\text{soln}} < 0$. If the sum of the endothermic terms ($\Delta H_{\text{solute}} + \Delta H_{\text{solvent}}$) is *smaller* than the exothermic term (ΔH_{mix}), the process is exothermic and ΔH_{soln} is negative (Figure 13.14A).
- *Endothermic process:* $\Delta H_{\text{soln}} > 0$. If the sum of the endothermic terms is *larger* than the exothermic term, the process is endothermic and ΔH_{soln} is positive (Figure 13.14B). If ΔH_{soln} is highly positive, the solute may not dissolve significantly in that solvent.

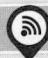

Student Hot Spot

Student data indicate that you may struggle with the concept of energy changes and the solution process. Access the Smartbook to view additional Learning Resources on this topic.

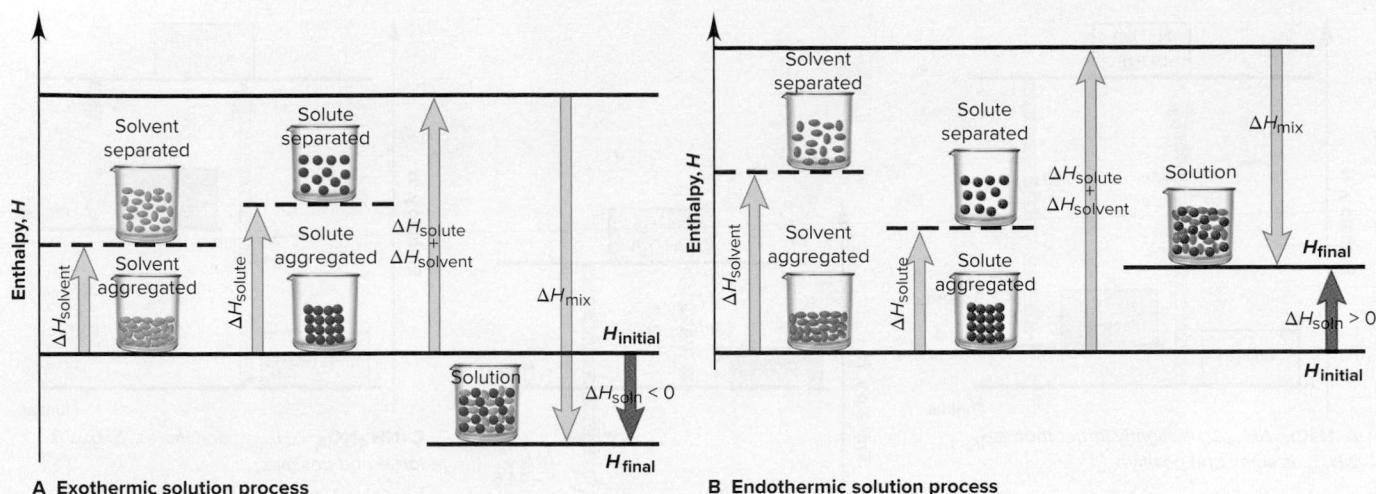

Figure 13.14 Enthalpy components of the heat of solution. **A**, ΔH_{mix} is larger than the sum of ΔH_{solute} and $\Delta H_{\text{solvent}}$, so ΔH_{soln} is negative. **B**, ΔH_{mix} is smaller than the sum of ΔH_{solute} and $\Delta H_{\text{solvent}}$, so ΔH_{soln} is positive.

The Heat of Hydration: Dissolving Ionic Solids in Water

The $\Delta H_{\text{solvent}}$ and ΔH_{mix} components of the solution cycle are difficult to measure individually. Combined, they equal the enthalpy change for **solvation**, the process of surrounding a solute particle with solvent particles:

$$\Delta H_{\text{solvation}} = \Delta H_{\text{solvent}} + \Delta H_{\text{mix}}$$

Solvation in water is called **hydration**. Thus, enthalpy changes for separating the water molecules ($\Delta H_{\text{solvent}}$) and mixing the separated solute with them (ΔH_{mix}) are combined into the **heat (or enthalpy) of hydration (ΔH_{hydr})**. In water, Equation 13.1 becomes

$$\Delta H_{\text{soln}} = \Delta H_{\text{solute}} + \Delta H_{\text{hydr}}$$

The heat of hydration is a key factor in dissolving an ionic solid. Breaking the H bonds in water is more than compensated for by forming the stronger ion-dipole forces, so hydration of an ion is *always* exothermic. The ΔH_{hydr} of an ion is defined as the enthalpy change for the hydration of 1 mol of separated (gaseous) ions:

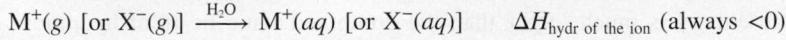

Importance of Charge Density Heats of hydration exhibit trends based on the ion's **charge density**, the ratio of its charge to its volume. In general, the higher the charge density, the more negative ΔH_{hydr} is. Coulomb's law says that the higher the charge of an ion and the smaller its radius, the closer it gets to the oppositely charged pole of an H_2O molecule (see Figure 2.12), and the stronger the attraction. Thus,

- A 2+ ion attracts H_2O molecules more strongly than a 1+ ion of similar size.
- A small 1+ ion attracts H_2O molecules more strongly than a large 1+ ion.

Periodic trends in ΔH_{hydr} values are based on trends in charge density (Table 13.4):

- *Down a group*, the charge stays the same and the size increases; thus, the charge densities decrease, as do the ΔH_{hydr} values.
- *Across a period*, say, from Group 1A(1) to Group 2A(2), the 2A ion has a smaller radius and a higher charge, so its charge density and ΔH_{hydr} are greater.

Components of Aqueous Heats of Solution To separate an ionic solute, MX , into gaseous ions requires a lot of energy (ΔH_{solute}); recall from Chapter 9 that this is the lattice energy, and it is highly positive:

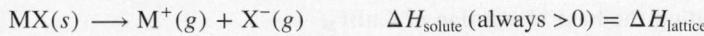

Thus, for ionic compounds in water, the heat of solution is the lattice energy (always positive) plus the combined heats of hydration of the ions (always negative):

$$\Delta H_{\text{soln}} = \Delta H_{\text{lattice}} + \Delta H_{\text{hydr}} \text{ of the ions}$$

Table 13.4 Trends in Ionic Heats of Hydration

Ion	Ionic Radius (pm)	ΔH_{hydr} (kJ/mol)
Group 1A(1)		
Na^+	102	-410
K^+	138	-336
Rb^+	152	-315
Cs^+	167	-282
Group 2A(2)		
Mg^{2+}	72	-1903
Ca^{2+}	100	-1591
Sr^{2+}	118	-1424
Ba^{2+}	135	-1317
Group 7A(17)		
F^-	133	-431
Cl^-	181	-313
Br^-	196	-284
I^-	220	-247

(13.2)

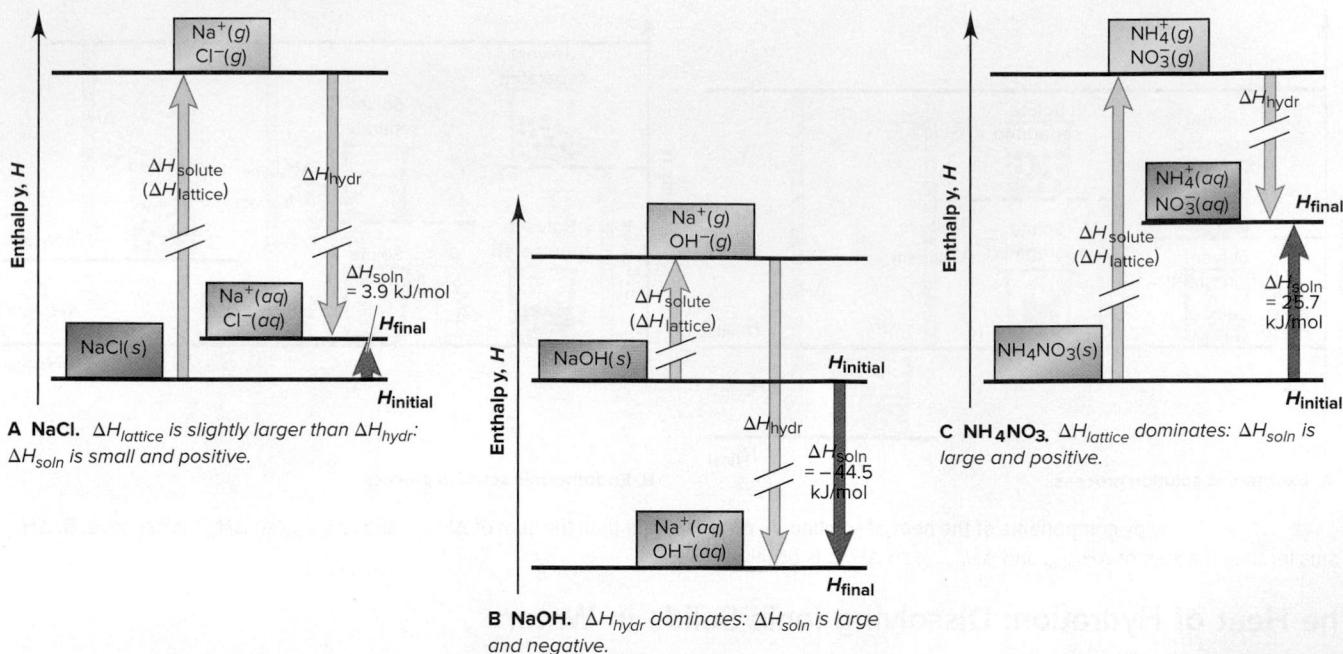

Figure 13.15 Enthalpy diagrams for three ionic compounds dissolving in water.

Once again, the sizes of the individual terms determine the sign of ΔH_{soln} .

Figure 13.15 shows qualitative enthalpy diagrams for three ionic solutes dissolving in water:

- NaCl . Sodium chloride has a small positive ΔH_{soln} (3.9 kJ/mol) because its lattice energy is only slightly greater than the combined ionic heats of hydration: if you dissolve NaCl in water in a flask, you don't feel the small temperature change.
- NaOH . Sodium hydroxide has a large negative ΔH_{soln} (-44.5 kJ/mol) because its lattice energy is much *smaller* than the combined ionic heats of hydration: if you dissolve NaOH in water, the flask feels hot.
- NH_4NO_3 . Ammonium nitrate has a large positive ΔH_{soln} (25.7 kJ/mol) because its lattice energy is much *larger* than the combined ionic heats of hydration: if you dissolve NH_4NO_3 in water, the flask feels cold.

Hot and cold “packs” consist of a thick outer pouch of water and a thin inner pouch of a salt. A squeeze breaks the inner pouch, and the salt dissolves. Most hot packs use anhydrous CaCl_2 ($\Delta H_{\text{soln}} = -82.8$ kJ/mol). In Japan, some soup is sold in double-walled cans with a salt in a packet immersed in water between the walls. Open the can and the packet breaks, the salt dissolves, and the soup quickly warms to about 90°C. Cold packs use NH_4NO_3 ($\Delta H_{\text{soln}} = 25.7$ kJ/mol). A cold pack can keep the solution at 0°C for about half an hour, long enough to soothe a sprain.

SAMPLE PROBLEM 13.2

Calculating an Aqueous Ionic Heat of Solution

Problem With secondary applications ranging from sedative to fire retardant, calcium bromide is used primarily in concentrated solution as an industrial drilling fluid.

(a) Use Table 13.4 and the lattice energy (2132 kJ/mol) to find the heat of solution (kJ/mol) of calcium bromide.

(b) Draw an enthalpy diagram for this solution process.

(a) **Calculating the heat of solution of CaBr_2**

Plan We are given, or can look up, the individual enthalpy components for a salt dissolving in water and have to determine their signs to calculate the overall heat of solution (ΔH_{soln}). The components are the lattice energy (the heat absorbed when the solid separates into gaseous ions) and the heat of hydration for each ion (the heat

released when the ion becomes hydrated). The lattice energy is always positive, so $\Delta H_{\text{lattice}} = 2132 \text{ kJ/mol}$. Heats of hydration are always negative, so from Table 13.4, ΔH_{hydr} of $\text{Ca}^{2+} = -1591 \text{ kJ/mol}$ and ΔH_{hydr} of $\text{Br}^- = -284 \text{ kJ/mol}$. We use Equation 13.2, noting that there are 2 mol of Br^- , to obtain ΔH_{soln} .

Solution

$$\begin{aligned}\Delta H_{\text{soln}} &= \Delta H_{\text{lattice}} + \Delta H_{\text{hydr}} \text{ of the ions} \\ &= \Delta H_{\text{lattice}} + \Delta H_{\text{hydr}} \text{ of } \text{Ca}^{2+} + 2(\Delta H_{\text{hydr}} \text{ of } \text{Br}^-) \\ &= 2132 \text{ kJ/mol} + (-1591 \text{ kJ/mol}) + 2(-284 \text{ kJ/mol}) \\ &= -27 \text{ kJ/mol}\end{aligned}$$

Check Rounding to check the math gives

$$2100 \text{ kJ/mol} - 1600 \text{ kJ/mol} - 560 \text{ kJ/mol} = -60 \text{ kJ/mol}$$

This small negative sum indicates that our answer is correct.

(b) Drawing an enthalpy diagram for the process of dissolving CaBr_2 .

Plan Along a vertical enthalpy axis, the lattice energy (endothermic) is represented by an upward arrow leading from solid salt to gaseous ions. The hydration of the ions (exothermic) is represented by a downward arrow from gaseous to hydrated ions. From part (a), ΔH_{soln} is small and negative, so the downward arrowhead is slightly below the tail of the upward arrow.

Solution The enthalpy diagram is shown in the margin.

FOLLOW-UP PROBLEMS

13.2A Use the following data to find the combined heat of hydration for the ions in KNO_3 : $\Delta H_{\text{soln}} = 34.89 \text{ kJ/mol}$ and $\Delta H_{\text{lattice}} = 685 \text{ kJ/mol}$.

13.2B Use the following data to find the heat of hydration of CN^- : ΔH_{soln} of $\text{NaCN} = 1.21 \text{ kJ/mol}$, $\Delta H_{\text{lattice}}$ of $\text{NaCN} = 766 \text{ kJ/mol}$, and ΔH_{hydr} of $\text{Na}^+ = -410 \text{ kJ/mol}$.

SOME SIMILAR PROBLEMS 13.30, 13.31, 13.36, and 13.37

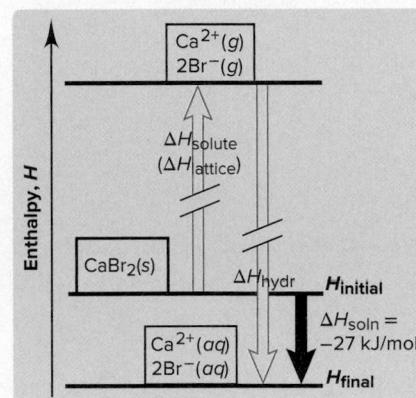

The Solution Process and the Change in Entropy

The heat of solution (ΔH_{soln}) is one of two factors that determine whether a solute dissolves. The other factor is the natural tendency of a system of particles to spread out, which results in the system's kinetic energy becoming more dispersed or more widely distributed. A thermodynamic variable called **entropy** (S) is directly related to the number of ways a system can distribute its energy, which involves the freedom of motion of the particles.

Let's see what it means for a system to "distribute its energy." We'll first compare the three physical states and then compare solute and solvent with solution.

Entropy and the Three Physical States The states of matter differ significantly in their entropy.

- In a solid, the particles are fixed in their positions with little freedom of motion. In a liquid, they can move around each other and so have greater freedom of motion. And in a gas, the particles have little restriction and much more freedom of motion.
- The more freedom of motion the particles have, the more ways they can distribute their kinetic energy; thus, a liquid has higher entropy than a solid, and a gas has higher entropy than a liquid:

$$S_{\text{gas}} > S_{\text{liquid}} > S_{\text{solid}}$$

- Thus, there is a *change* in entropy (ΔS) associated with a phase change, and it can be positive or negative. For example, when a liquid vaporizes, the change in entropy ($\Delta S_{\text{vap}} = S_{\text{gas}} - S_{\text{liquid}}$) is positive ($\Delta S_{\text{vap}} > 0$, increase in entropy) since $S_{\text{gas}} > S_{\text{liquid}}$; when a liquid freezes (fusion), the change in entropy ($\Delta S_{\text{fus}} = S_{\text{solid}} - S_{\text{liquid}}$) is negative ($\Delta S_{\text{fus}} < 0$, decrease in entropy) since $S_{\text{solid}} < S_{\text{liquid}}$.

Entropy and the Formation of Solutions The formation of solutions also involves a change in entropy. A *solution usually has higher entropy than the pure solute and pure solvent* because the number of ways to distribute the energy is related to the number of interactions between different molecules. There are far more interactions possible when solute and solvent are mixed than when they are pure; thus,

$$S_{\text{soln}} > (S_{\text{solute}} + S_{\text{solvent}}) \quad \text{or} \quad \Delta S_{\text{soln}} > 0$$

You know from everyday experience that solutions form naturally, but pure solutes and solvents don't: you've seen sugar dissolve in water, but you've never seen a sugar solution separate into pure sugar and water. In Chapter 20, we'll see that energy is needed to reverse the natural tendency of systems to distribute their energy—to get "mixed up." Water treatment plants, oil refineries, steel mills, and many other industrial facilities expend a lot of energy to separate mixtures into pure components.

Enthalpy vs. Entropy Changes in Solution Formation Solution formation involves the interplay of two factors: systems change toward a state of *lower enthalpy* and *higher entropy*, so the relative sizes of ΔH_{soln} and ΔS_{soln} determine whether a solution forms. Let's consider three solute-solvent pairs to see which factor dominates in each case:

1. *NaCl in hexane*. Given their very different intermolecular forces, we predict that sodium chloride does *not* dissolve in hexane (C_6H_{14}). An enthalpy diagram (Figure 13.16A) shows that separating the nonpolar solvent is easy because the dispersion forces are weak ($\Delta H_{\text{solvent}} \geq 0$), but separating the solute requires supplying the very large $\Delta H_{\text{lattice}}$ ($\Delta H_{\text{solute}} \gg 0$). Mixing releases little heat because ion-induced dipole forces between Na^+ (or Cl^-) and hexane are weak ($\Delta H_{\text{mix}} \leq 0$). Because the sum of the endothermic terms is *much* larger than the exothermic term, $\Delta H_{\text{soln}} \gg 0$. *A solution does not form because the entropy increase from mixing solute and solvent would be much smaller than the enthalpy increase required to separate the solute: $\Delta S_{\text{mix}} \ll \Delta H_{\text{solute}}$.*

2. *Octane in hexane*. We predict that octane (C_8H_{18}) is soluble in hexane because both are held together by dispersion forces of similar strength; in fact, these two substances are miscible. That is, both ΔH_{solute} and $\Delta H_{\text{solvent}}$ are around zero. The similar forces mean that ΔH_{mix} is also around zero. And a lot of heat is not released; in fact, ΔH_{soln} is around zero (Figure 13.16B). So why does a solution form so readily? *With no enthalpy change driving the process, octane dissolves in hexane because the entropy increases greatly when the pure substances mix: $\Delta S_{\text{mix}} \gg \Delta H_{\text{soln}}$.*

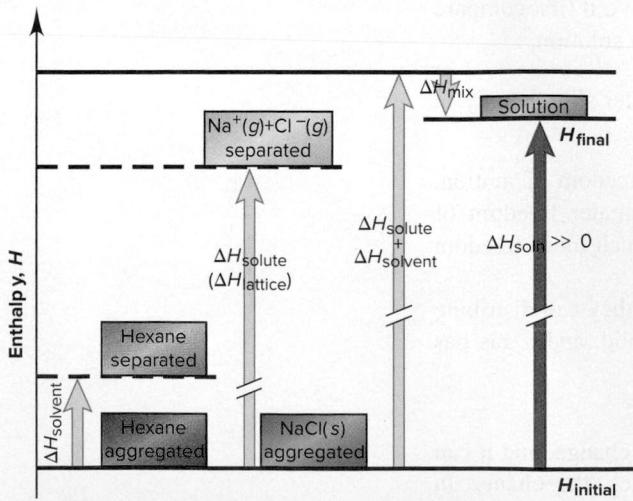

Figure 13.16 Enthalpy diagrams for dissolving (A) NaCl and (B) octane in hexane.

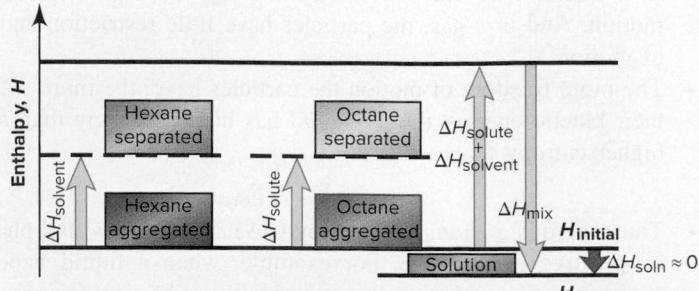

A NaCl. ΔH_{mix} is *much* smaller than ΔH_{solute} ; ΔH_{soln} is so much larger than the entropy increase due to mixing that NaCl does *not* dissolve.

B Octane. ΔH_{soln} is very small, but the entropy increase due to mixing is large, so octane *does* dissolve.

3. NH_4NO_3 in water. A large enough increase in entropy can sometimes cause a solution to form even when the enthalpy increase is large ($\Delta H_{\text{soln}} \gg 0$). As we saw previously, in Figure 13.15C, when ammonium nitrate dissolves in water, the process is highly endothermic; that is, $\Delta H_{\text{lattice}} \gg \Delta H_{\text{hydr}}$ of the ions. Nevertheless, *the increase in entropy that occurs when the crystal breaks down and the ions mix with water molecules is greater than the increase in enthalpy: $\Delta S_{\text{soln}} > \Delta H_{\text{soln}}$* .

In Chapter 20, we'll return in depth to the relation between enthalpy and entropy to understand physical and chemical systems.

› Summary of Section 13.3

- › In a thermochemical solution cycle, the heat of solution is the sum of the endothermic separations of solute and of solvent and the exothermic mixing of their particles.
- › In water, solvation (surrounding solute particles with solvent) is called hydration. For ions, heats of hydration depend on the ion's charge density but are always negative because ion-dipole forces are strong. Charge density exhibits periodic trends.
- › Systems naturally increase their entropy (distribute their energy in more ways). A gas has higher entropy than a liquid, which has higher entropy than a solid, and a solution has higher entropy than the pure solute and solvent.
- › Relative sizes of the enthalpy and entropy changes determine solution formation. A substance with a positive ΔH_{soln} dissolves *only* if ΔS_{soln} is larger than ΔH_{soln} .

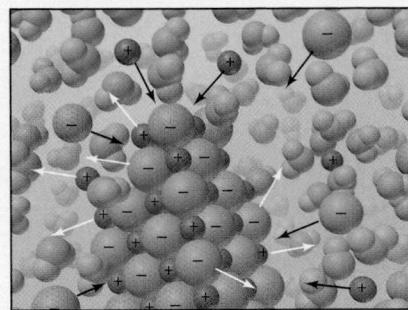

Figure 13.17 Equilibrium in a saturated solution. At some temperature, the number of solute particles dissolving (white arrows) per unit time equals the number recrystallizing (black arrows).

13.4 SOLUBILITY AS AN EQUILIBRIUM PROCESS

When an excess amount of solid is added to a solvent, particles leave the crystal, are surrounded by solvent, and move away. Some dissolved solute particles collide with undissolved solute and recrystallize, but, as long as the rate of dissolving is greater than the rate of recrystallizing, the concentration rises. At a given temperature, when solid is dissolving at the same rate as dissolved particles are recrystallizing, the concentration remains constant and *undissolved solute is in equilibrium with dissolved solute*:

Figure 13.17 shows an ionic solid in equilibrium with dissolved cations and anions. (We learned about the concept of equilibrium in Section 4.7 and saw how it occurs between phases in Section 12.2.)

Three terms express the extent of this solution process:

- A **saturated solution** is *at equilibrium* and contains the maximum amount of dissolved solute at a given temperature in the presence of undissolved solute. Therefore, if you filter off the solution and add more solute, the added solute doesn't dissolve.
- An **unsaturated solution** contains *less* than the equilibrium concentration of dissolved solute; add more solute, and more will dissolve until the solution is saturated.
- A **supersaturated solution** contains *more* than the equilibrium concentration and is unstable relative to the saturated solution. You can often prepare a supersaturated solution if the solute is more soluble at higher temperature. While heating, dissolve more than the amount required for saturation at some lower temperature, and then slowly cool the solution. If the excess solute remains dissolved, the solution is supersaturated. Add a “seed” crystal of solute or tap the container, and the excess solute crystallizes immediately, leaving behind a saturated solution (Figure 13.18).

Effect of Temperature on Solubility

You know that more sugar dissolves in hot tea than in iced tea; in fact, temperature affects the solubility of most substances. Let's examine the effects of temperature on the solubility of solids and gases.

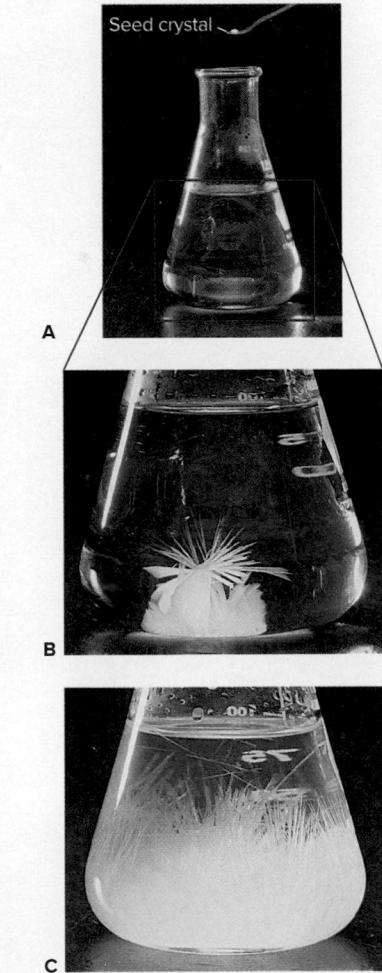

Figure 13.18 Sodium acetate crystallizing from a supersaturated solution. When a seed crystal of sodium acetate is added to a supersaturated solution of the compound (A), solute begins to crystallize (B) and continues until the remaining solution is saturated (C).

Source: A–C: © McGraw-Hill Education/Stephen Frisch, photographer

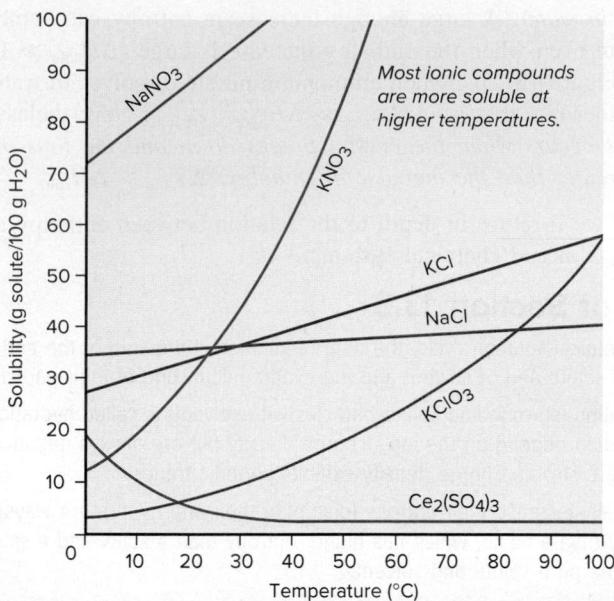

Figure 13.19 Relation between solubility and temperature for several ionic compounds.

Temperature and the Solubility of Solids in Water Like sugar, *most solids are more soluble at higher temperatures* (Figure 13.19). Note that cerium sulfate is one of several exceptions, most of which are other sulfates. Some salts have higher solubility up to a certain temperature and then lower solubility at still higher temperatures.

The effect of temperature on solubility is a complex phenomenon, and the sign of ΔH_{soln} does not reflect that complexity. Tabulated ΔH_{soln} values give the enthalpy change for making a solution at the standard state of 1 M; but in order to understand the effect of temperature, we need to know the sign of the enthalpy change very close to the point of saturation, which may differ from the sign of the tabulated value. For example, tables give a negative ΔH_{soln} for NaOH and a positive one for NH_4NO_3 , yet both compounds are more soluble at higher temperatures. Thus, even though the effect of temperature indicates the equilibrium nature of solubility, no single measure can predict the effect for a given solute.

Temperature and the Solubility of Gases in Water The effect of temperature on gas solubility is much more predictable. When a solid dissolves in a liquid, the solute particles must separate, so $\Delta H_{\text{solute}} > 0$. In contrast, gas particles are already separated, so $\Delta H_{\text{solute}} \approx 0$. Because hydration is exothermic ($\Delta H_{\text{hydr}} < 0$), the sum of these two terms is negative. Thus, $\Delta H_{\text{soln}} < 0$ for all gases in water:

Thus, *gas solubility in water decreases with rising temperature (addition of heat)*. Gases have weak intermolecular forces with water. When the temperature rises, the average kinetic energy increases, allowing the gas particles to easily overcome these forces and re-enter the gas phase.

This behavior leads to *thermal pollution*. Many electric power plants use large amounts of water from a nearby river or lake for cooling, and the warmed water is returned to the source. The metabolic rates of fish and other aquatic animals increase in this warmer water, increasing their need for O₂. But the concentration of dissolved O₂ is lower in warm water, so they become “oxygen deprived.” Also, the less dense warm water floats and prevents O₂ from reaching the cooler water below. Thus, even creatures at deeper levels become oxygen deprived. Farther from the plant, the water temperature and O₂ solubility return to normal. To mitigate the problem, cooling towers lower the temperature of the water before it exits the plant (Figure 13.20); nuclear power plants use a similar approach (Section 24.7).

Figure 13.20 Preventing thermal pollution with cooling towers.

Source: © Kristin Smith/Shutterstock.com

Effect of Pressure on Solubility

Pressure has little effect on the solubility of liquids and solids because they are almost incompressible. But it has a major effect on the solubility of gases. Consider a piston-cylinder assembly with a gas above a saturated aqueous solution of the gas (Figure 13.21A). At equilibrium, at a given pressure, the same number of gas molecules enter and leave the solution per unit time:

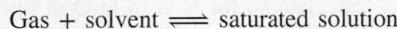

Push down on the piston, and you disturb the equilibrium: gas volume decreases, so gas pressure (and concentration) increases, and gas particles collide with the liquid surface more often. Thus, more particles enter than leave the solution per unit time (Figure 13.21B). More gas dissolves to reduce this disturbance (a shift to the right in the preceding equation) until the system re-establishes equilibrium (Figure 13.21C).

The relation between gas pressure and solubility has many familiar applications. In a closed can of cola, dissolved CO₂ is in equilibrium with 4 atm of CO₂ in the small volume above the solution. Open the can and the dissolved CO₂ bubbles out of solution until the drink goes “flat” because its CO₂ concentration reaches equilibrium with CO₂ in air ($P_{\text{CO}_2} = 4 \times 10^{-4}$ atm). In a different situation (see photo), scuba divers who breathe compressed air have a high concentration of N₂ dissolved in their blood. If they ascend too quickly, they may suffer decompression sickness (the “bends”), in which lower external pressure allows the dissolved N₂ to form bubbles in the blood that block capillaries.

Henry's law expresses the quantitative relationship between gas pressure and solubility: *the solubility of a gas (S_{gas}) is directly proportional to the partial pressure of the gas (P_{gas}) above the solution:*

$$S_{\text{gas}} = k_{\text{H}} \times P_{\text{gas}} \quad (13.3)$$

where k_{H} is the *Henry's law constant* and is specific for a given gas-solvent combination at a given temperature. With S_{gas} in mol/L and P_{gas} in atm, the units of k_{H} are mol/L·atm, or mol·L⁻¹·atm⁻¹.

What happens to gases dissolved in the blood of a scuba diver?

Source: © Peter Scoones/Science Source

Figure 13.21 The effect of pressure on gas solubility.

SAMPLE PROBLEM 13.3

Using Henry's Law to Calculate Gas Solubility

Problem The partial pressure of carbon dioxide gas inside a bottle of cola is 4 atm at 25°C. What mass of CO₂ is dissolved in a 0.5-L bottle of cola? The Henry's law constant for CO₂ in water is 3.3×10⁻² mol/L·atm at 25°C.

Plan We know P_{CO_2} (4 atm) and the value of k_H (3.3×10⁻² mol/L·atm), so we substitute them into Equation 13.3 to find S_{CO_2} in mol/L. Then we multiply the solubility by the volume of cola and molar mass of CO₂ to obtain the mass of dissolved CO₂.

Solution $S_{\text{CO}_2} = k_H \times P_{\text{CO}_2} = (3.3 \times 10^{-2} \text{ mol/L}\cdot\text{atm})(4 \text{ atm}) = 0.1 \text{ mol/L}$

$$\text{Mass (g) CO}_2 = \frac{0.1 \text{ mol}}{\text{L}} \times 0.5 \text{ L} \times \frac{44.01 \text{ g CO}_2}{1 \text{ mol CO}_2} = 2 \text{ g CO}_2$$

Check The units are correct. We rounded to one significant figure to match the number of significant figures in the given values for the pressure and the volume of cola.

FOLLOW-UP PROBLEMS

13.3A If air contains 78% N₂ by volume, what is the solubility of N₂ in water at 25°C and 1 atm (k_H for N₂ in H₂O at 25°C = 7×10⁻⁴ mol/L·atm)?

13.3B Dinitrogen monoxide (N₂O), commonly known as *laughing gas*, is mixed with oxygen for use as an analgesic during dental surgery. A mixture of N₂O and O₂ is 40% N₂O by volume and has a total pressure of 1.2 atm; the solubility of N₂O in water at 25°C is 1.2×10⁻² mol/L. Calculate k_H for N₂O in H₂O at this temperature.

SOME SIMILAR PROBLEMS 13.46 and 13.47

› Summary of Section 13.4

- › A solution that contains the maximum amount of dissolved solute in the presence of excess undissolved solute is saturated. A saturated solution is in equilibrium with excess solute, because solute particles are entering and leaving the solution at the same rate. An unsaturated solution contains less than this amount.
- › Most solids are more soluble at higher temperatures.
- › All gases have a negative ΔH_{soln} in water, so heating lowers gas solubility in water.
- › Henry's law says that the solubility of a gas is directly proportional to its partial pressure above the solution.

13.5 CONCENTRATION TERMS

Concentration is the *proportion* of a substance in a mixture, so it is an *intensive* property (like density and temperature), one that does not depend on the quantity of mixture: 1.0 L or 1.0 mL of 0.1 M NaCl have the same concentration. Concentration is a ratio of quantities (Table 13.5), most often solute to *solution*, but sometimes solute to *solvent*. Both parts of the ratio can be given in units of mass, volume, or amount (mol), and chemists express concentration by several terms, including molarity, molality, and various expressions of “parts of solute per part by solution.”

Molarity and Molality

Two very common concentration terms are molarity and molality:

1. Molarity (M) is the *number of moles of solute dissolved in 1 L of solution*:

$$\text{Molarity (M)} = \frac{\text{amount (mol) of solute}}{\text{volume (L) of solution}} \quad (13.4)$$

In Chapter 4, we used molarity to convert liters of solution into amount of dissolved solute. Molarity has two drawbacks that affect its use in precise work:

- *Effect of temperature.* A liquid expands when heated, so a unit volume of hot solution contains less solute than one of cold solution; thus, the molarity of the hot and cold solutions is different.

Table 13.5 Concentration Definitions

Concentration Term	Ratio
Molarity (<i>M</i>)	$\frac{\text{amount (mol) of solute}}{\text{volume (L) of solution}}$
Molality (<i>m</i>)	$\frac{\text{amount (mol) of solute}}{\text{mass (kg) of solvent}}$
Parts by mass	$\frac{\text{mass of solute}}{\text{mass of solution}}$
Parts by volume	$\frac{\text{volume of solute}}{\text{volume of solution}}$
Mole fraction (<i>X</i>)	$\frac{\text{amount (mol) of solute}}{\text{amount (mol) of solute} + \text{amount (mol) of solvent}}$

- *Effect of mixing.* Because of solute-solvent interactions that are difficult to predict, *volumes may not be additive*: adding 500. mL of one solution to 500. mL of another may not give 1000. mL of final solution.

2. **Molality (*m*)** does not contain volume in its ratio; it is *the number of moles of solute dissolved in 1000 g (1 kg) of solvent*:

$$\text{Molality } (m) = \frac{\text{amount (mol) of solute}}{\text{mass (kg) of solvent}} \quad (13.5)$$

Note that molality includes the quantity of *solvent*, not of solution. For precise work, molality has two advantages over molarity:

- *Effect of temperature.* Molal solutions are based on *masses* of components, not *volume*. Since mass does not change with temperature, neither does molality.
- *Effect of mixing.* Unlike volumes, masses *are additive*: adding 500. g of one solution to 500. g of another *does* give 1000. g of final solution.

For these reasons, molality is the preferred term when temperature, and hence density, may change, as in a study of physical properties. Note that, in the case of water, 1 L has a mass of 1 kg, so *molality and molarity are nearly the same for dilute aqueous solutions*.

SAMPLE PROBLEM 13.4

Calculating Molality

Problem What is the molality of a solution prepared by dissolving 32.0 g of CaCl_2 in 271 g of water?

Plan To use Equation 13.5, we convert the mass of CaCl_2 (32.0 g) to amount (mol) using the molar mass (g/mol) and then divide by the mass of water (271 g), being sure to convert from grams to kilograms (see the road map).

Solution Converting from grams of solute to moles:

$$\text{Amount (mol) of } \text{CaCl}_2 = 32.0 \text{ g } \text{CaCl}_2 \times \frac{1 \text{ mol } \text{CaCl}_2}{110.98 \text{ g } \text{CaCl}_2} = 0.288 \text{ mol } \text{CaCl}_2$$

Finding the molality:

$$\begin{aligned} \text{Molality} &= \frac{\text{mol solute}}{\text{kg solvent}} = \frac{0.288 \text{ mol } \text{CaCl}_2}{271 \text{ g} \times \frac{1 \text{ kg}}{10^3 \text{ g}}} \\ &= 1.06 \text{ m } \text{CaCl}_2 \end{aligned}$$

Check The answer seems reasonable: the given amount (mol) of CaCl_2 and mass (kg) of H_2O are about the same, so their ratio is about 1.

Road Map

FOLLOW-UP PROBLEMS

13.4A How many grams of glucose ($C_6H_{12}O_6$) must be dissolved in 563 g of ethanol (C_2H_5OH) to prepare a $2.40 \times 10^{-2} m$ solution?

13.4B What is the molality of a solution made by dissolving 15.20 g of I_2 in 1.33 mol of diethyl ether, $(CH_3CH_2)_2O$?

SOME SIMILAR PROBLEMS 13.64 and 13.65

Parts of Solute by Parts of Solution

Several concentration terms relate the parts of solute (or solvent) to the parts of *solution*. Both can be expressed in units of mass, volume, or amount (mol).

Parts by Mass The most common of these terms is **mass percent [% (w/w)]**, which you encountered in Chapter 3 as the fraction by mass of an element in a compound. The word *percent* means “per hundred,” so with respect to solution concentration, *mass percent* means mass of solute dissolved in 100. parts by mass of solution:

$$\begin{aligned}\text{Mass percent} &= \frac{\text{mass of solute}}{\text{mass of solute} + \text{mass of solvent}} \times 100 \\ &= \frac{\text{mass of solute}}{\text{mass of solution}} \times 100\end{aligned}\quad (13.6)$$

Mass percent values appear commonly on jars of solid laboratory chemicals to indicate impurities.

Two very similar terms are parts per million (ppm) by mass and parts per billion (ppb) by mass, or grams of solute per million or per billion grams of solution: in Equation 13.6, you multiply by 10^6 or by 10^9 , respectively, instead of by 100, to obtain these much smaller concentrations. Environmental toxicologists use these units to measure pollutants. For example, TCDD (*tetrachlorodibenzodioxin*) (see margin), a byproduct of paper bleaching, is unsafe at soil levels above 1 ppb. From normal contact with air, water, and soil, North Americans have an average of 0.01 ppb TCDD in their tissues.

Is this deadly toxin in your body?

Parts by Volume The most common parts-by-volume term is **volume percent [% (v/v)]**, the volume of solute in 100. volumes of solution:

$$\text{Volume percent} = \frac{\text{volume of solute}}{\text{volume of solution}} \times 100\quad (13.7)$$

For example, rubbing alcohol is an aqueous solution of isopropanol (a three-carbon alcohol) that contains 70 volumes of alcohol in 100. volumes of solution, or 70% (v/v).

Parts by volume is often used to express tiny concentrations of liquids or gases. Minor atmospheric components occur in parts per million by volume (ppmv). For example, about 0.05 ppmv of the toxic gas carbon monoxide (CO) is in clean air, 1000 times as much (50 ppmv of CO) in air over urban traffic, and 10,000 times as much (500 ppmv of CO) in cigarette smoke. *Pheromones* are compounds secreted by members of a species to signal food, danger, sexual readiness, and so forth. Many organisms, including dogs and monkeys, release pheromones, and researchers suspect that humans do as well. Some insect pheromones, such as the sexual attractant of the gypsy moth, are active at a few hundred molecules per milliliter of air, 100 parts per quadrillion by volume.

A concentration term often used in health-related facilities for aqueous solutions is % (w/v), a ratio of solute *weight* (actually mass) to solution *volume*. Thus, a 1.5% (w/v) NaCl solution contains 1.5 g of NaCl per 100. mL of *solution*.

Parts by Mole: Mole Fraction The **mole fraction (X)** of a solute is the ratio of the number of moles of solute to the total number of moles (solute plus solvent):

$$\text{Mole fraction (X)} = \frac{\text{amount (mol) of solute}}{\text{amount (mol) of solute} + \text{amount (mol) of solvent}}\quad (13.8)$$

Put another way, the mole fraction gives the proportion of solute (or solvent) particles in solution. The *mole percent* is the mole fraction expressed as a percentage:

$$\text{Mole percent (mol \%)} = \text{mole fraction} \times 100$$

SAMPLE PROBLEM 13.5**Expressing Concentrations in Parts by Mass, Parts by Volume, and Mole Fraction**

Problem (a) Find the concentration of calcium ion (in ppm) in a 3.50-g pill that contains 40.5 mg of Ca^{2+} .

(b) The label on a 0.750-L bottle of Italian chianti says “11.5% alcohol by volume.” How many liters of alcohol does the wine contain?

(c) A sample of rubbing alcohol contains 142 g of isopropyl alcohol ($\text{C}_3\text{H}_7\text{OH}$) and 58.0 g of water. What are the mole fractions of alcohol and water?

Plan (a) We know the mass of Ca^{2+} (40.5 mg) and the mass of the pill (3.50 g). We convert the mass of Ca^{2+} from mg to g, find the mass ratio of Ca^{2+} to pill, and multiply by 10^6 to obtain the concentration in ppm. (b) We know the volume % (11.5%, or 11.5 parts by volume of alcohol to 100. parts of chianti) and the total volume (0.750 L), so we use Equation 13.7 to find the number of liters of alcohol. (c) We know the mass and formula of each component, so we convert masses to amounts (mol) and apply Equation 13.8 to find the mole fractions.

Solution (a) Finding parts per million by mass of Ca^{2+} . Combining the steps, we have

$$\begin{aligned}\text{ppm Ca}^{2+} &= \frac{\text{mass of Ca}^{2+}}{\text{mass of pill}} \times 10^6 = \frac{40.5 \text{ mg Ca}^{2+} \times \frac{1 \text{ g}}{10^3 \text{ mg}}}{3.50 \text{ g}} \times 10^6 \\ &= 1.16 \times 10^4 \text{ ppm Ca}^{2+}\end{aligned}$$

(b) Finding volume (L) of alcohol:

$$\begin{aligned}\text{Volume percent} &= \frac{\text{volume of solute}}{\text{volume of solution}} \times 100 \\ \text{Volume of alcohol} &= \text{volume of solution} \times \frac{\text{volume percent}}{100} \\ \text{Volume (L) of alcohol} &= 0.750 \text{ L chianti} \times \frac{11.5 \text{ L alcohol}}{100. \text{ L chianti}} \\ &= 0.0862 \text{ L}\end{aligned}$$

(c) Finding mole fractions. Converting from mass (g) to amount (mol):

$$\begin{aligned}\text{Amount (mol) of } \text{C}_3\text{H}_7\text{OH} &= 142 \text{ g } \text{C}_3\text{H}_7\text{OH} \times \frac{1 \text{ mol } \text{C}_3\text{H}_7\text{OH}}{60.09 \text{ g } \text{C}_3\text{H}_7\text{OH}} = 2.36 \text{ mol } \text{C}_3\text{H}_7\text{OH} \\ \text{Amount (mol) of H}_2\text{O} &= 58.0 \text{ g H}_2\text{O} \times \frac{1 \text{ mol H}_2\text{O}}{18.02 \text{ g H}_2\text{O}} = 3.22 \text{ mol H}_2\text{O}\end{aligned}$$

Calculating mole fractions:

$$\begin{aligned}X_{\text{C}_3\text{H}_7\text{OH}} &= \frac{\text{moles of } \text{C}_3\text{H}_7\text{OH}}{\text{total moles}} = \frac{2.36 \text{ mol}}{2.36 \text{ mol} + 3.22 \text{ mol}} \\ &= 0.423 \\ X_{\text{H}_2\text{O}} &= \frac{\text{moles of H}_2\text{O}}{\text{total moles}} = \frac{3.22 \text{ mol}}{2.36 \text{ mol} + 3.22 \text{ mol}} \\ &= 0.577\end{aligned}$$

Check (a) The mass ratio is about $0.04 \text{ g}/4 \text{ g} = 10^{-2}$, and $10^{-2} \times 10^6 = 10^4 \text{ ppm}$, so it seems correct. (b) The volume % is a bit more than 10%, so the volume of alcohol should be a bit more than 75 mL (0.075 L). (c) Always check that the *mole fractions add up to 1*: $0.423 + 0.577 = 1.000$.

FOLLOW-UP PROBLEMS

13.5A An alcohol solution contains 35.0 g of 1-propanol ($\text{C}_3\text{H}_7\text{OH}$) and 150. g of ethanol ($\text{C}_2\text{H}_5\text{OH}$). Calculate the mass percent and the mole fraction of each alcohol.

13.5B A sample of gasoline contains 1.87 g of ethanol ($\text{C}_2\text{H}_5\text{OH}$), 27.4 g of 2,2,4-trimethylpentane (iso-octane, C_8H_{18}), and 4.10 g of heptane (C_7H_{16}). Calculate the mass percent and the mole percent of each component.

SOME SIMILAR PROBLEMS 13.70 and 13.71

Interconverting Concentration Terms

All the terms we just discussed represent different ways of expressing concentration, so they are interconvertible. Keep these points in mind:

- To convert a term based on amount to one based on mass, you need the molar mass. These conversions are similar to the mass-mole conversions you've done earlier.
- To convert a term based on mass to one based on volume, you need the solution density. Given the mass of solution, the density (mass/volume) gives the volume, or vice versa.
- Molality includes quantity of *solvent*; the other terms include quantity of *solution*.

Student Hot Spot

Student data indicate that you may struggle with converting from one concentration term to another. Access the SmartBook to view additional Learning Resources on this topic.

SAMPLE PROBLEM 13.6

Interconverting Concentration Terms

Problem Hydrogen peroxide is a powerful oxidizing agent; it is used in concentrated solution in rocket fuel and in dilute solution in hair bleach. An aqueous solution of H₂O₂ is 30.0% by mass and has a density of 1.11 g/mL. Calculate the (a) molality, (b) mole fraction of H₂O₂, and (c) molarity.

Plan We know the mass % (30.0) and the density (1.11 g/mL). (a) For molality, we need the amount (mol) of solute and the mass (kg) of *solvent*. If we assume 100.0 g of solution, the mass % equals the grams of H₂O₂, which we subtract from 100.0 g to obtain the grams of solvent. To find molality, we convert grams of H₂O₂ to moles and divide by mass of solvent (converting g to kg). (b) To find the mole fraction, we use the moles of H₂O₂ [from part (a)] and convert the grams of H₂O to moles. Then we divide the moles of H₂O₂ by the total moles. (c) To find molarity, we assume 100.0 g of solution and use the solution density to find the volume. Then we divide the moles of H₂O₂ [from part (a)] by *solution* volume (in L).

Solution (a) From mass % to molality:

Finding mass of solvent (assume a 100.0-g sample of solution; 30.0% of 100 g = 30.0 g of H₂O₂):

$$\text{Mass (g) of H}_2\text{O} = 100.0 \text{ g solution} - 30.0 \text{ g H}_2\text{O}_2 = 70.0 \text{ g H}_2\text{O}$$

Converting from grams of H₂O₂ to moles:

$$\text{Amount (mol) of H}_2\text{O}_2 = 30.0 \text{ g H}_2\text{O}_2 \times \frac{1 \text{ mol H}_2\text{O}_2}{34.02 \text{ g H}_2\text{O}_2} = 0.882 \text{ mol H}_2\text{O}_2$$

Calculating molality:

$$\text{Molality of H}_2\text{O}_2 = \frac{\text{mol H}_2\text{O}_2}{\text{kg H}_2\text{O}} = \frac{0.882 \text{ mol H}_2\text{O}_2}{70.0 \text{ g} \times \frac{1 \text{ kg}}{10^3 \text{ g}}} = 12.6 \text{ m H}_2\text{O}_2$$

(b) From mass % to mole fraction:

Amount (mol) of H₂O₂ = 0.882 mol H₂O₂ [from part (a)]

$$\text{Amount (mol) of H}_2\text{O} = 70.0 \text{ g H}_2\text{O} \times \frac{1 \text{ mol H}_2\text{O}}{18.02 \text{ g H}_2\text{O}} = 3.88 \text{ mol H}_2\text{O}$$

$$X_{\text{H}_2\text{O}_2} = \frac{\text{mol H}_2\text{O}_2}{\text{mol H}_2\text{O}_2 + \text{mol H}_2\text{O}} = \frac{0.882 \text{ mol}}{0.882 \text{ mol} + 3.88 \text{ mol}} = 0.185$$

(c) From mass % and density to molarity:

Using density to convert from solution mass to volume:

$$\text{Volume (mL) of solution} = 100.0 \text{ g} \times \frac{1 \text{ mL}}{1.11 \text{ g}} = 90.1 \text{ mL}$$

Calculating molarity:

$$\text{Molarity} = \frac{\text{mol H}_2\text{O}_2}{\text{L soln}} = \frac{0.882 \text{ mol H}_2\text{O}_2}{90.1 \text{ mL} \times \frac{1 \text{ L soln}}{10^3 \text{ mL}}} = 9.79 \text{ M H}_2\text{O}_2$$

Check Rounding shows the sizes of the answers to be reasonable: (a) The ratio ~0.9 mol/0.07 kg is greater than 10. (b) ~0.9 mol H₂O₂/(1 mol + 4 mol) ≈ 0.2. (c) The ratio of moles to liters (0.9/0.09) is around 10.

FOLLOW-UP PROBLEMS

13.6A Concentrated hydrochloric acid is 11.8 M HCl and has a density of 1.190 g/mL. Calculate the mass %, molality, and mole fraction of HCl.

13.6B Concentrated aqueous solutions of calcium bromide are used in drilling oil wells. If a solution of CaBr₂ is 5.44 m and has a density of 1.70 g/mL, find the mass %, molarity, and mole percent of CaBr₂.

SOME SIMILAR PROBLEMS 13.72–13.75

› Summary of Section 13.5

- › The concentration of a solution is independent of the quantity of solution and can be expressed as molarity (mol solute/L solution), molality (mol solute/kg solvent), parts by mass (mass solute/mass solution), parts by volume (volume solute/volume solution), or mole fraction [mol solute/(mol solute + mol solvent)] (Table 13.5).
- › Molality is based on mass, so it is independent of temperature; the mole fraction gives the proportion of dissolved particles.
- › If the quantities of solute and solution as well as the solution density are known, the various ways of expressing concentration are interconvertible.

A Strong electrolyte

B Weak electrolyte

C Nonelectrolyte

13.6 COLLIGATIVE PROPERTIES OF SOLUTIONS

The presence of solute gives a solution different physical properties than the pure solvent has. But, in the case of four important properties, it is the *number* of solute particles, *not* their chemical identity, that makes the difference. These **colligative properties** (*colligative* means “collective”) are vapor pressure lowering, boiling point elevation, freezing point depression, and osmotic pressure. Most of these effects are small, but they have many applications, including some that are vital to organisms.

We predict the magnitude of a colligative property from the solute formula, which shows the number of particles in solution and is closely related to our classification of solutes (Chapter 4) by their ability to conduct an electric current (Figure 13.22):

1. **Electrolytes.** An aqueous solution of an **electrolyte** conducts a current because the solute separates into ions as it dissolves.
 - **Strong electrolytes**—soluble salts, strong acids, and strong bases—dissociate completely, so their solutions conduct well.
 - **Weak electrolytes**—weak acids and weak bases—dissociate very little, so their solutions conduct poorly.
2. **Nonelectrolytes.** Compounds such as sugar and alcohol do not dissociate into ions at all. They are **nonelectrolytes** because their solutions do not conduct a current.

Thus, we can predict that

- For **nonelectrolytes**, 1 mol of compound yields 1 mol of particles when it dissolves in solution. For example, 0.35 M glucose contains 0.35 mol of solute particles per liter.
- For **strong electrolytes**, 1 mol of compound dissolves to yield the amount (mol) of ions shown in the formula unit: 0.4 M Na₂SO₄ has 0.8 mol of Na⁺ ions and 0.4 mol of SO₄²⁻ ions, or 1.2 mol of particles, per liter (see Sample Problem 4.2).
- For **weak electrolytes**, the calculation is complicated because the solution reaches equilibrium; we examine these systems in Chapters 18 and 19.

In this section, we discuss colligative properties of three types of solutions—those of nonvolatile nonelectrolytes, volatile nonelectrolytes, and strong electrolytes.

Figure 13.22 Conductivity of three types of electrolyte solutions. **A**, For strong electrolytes, the number of particles equals the number of ions in a formula unit. **B**, Weak electrolytes form few ions. **C**, For nonelectrolytes, the number of particles equals the number of molecules.

Source: A–C: © McGraw-Hill Education/Stephen Frisch, photographer

Nonvolatile Nonelectrolyte Solutions

We start with solutions of *nonvolatile nonelectrolytes*, because they provide the clearest examples of the colligative properties. These solutions contain solutes that are not ionic and thus do not dissociate, and they have negligible vapor pressure at the boiling point of the solvent; sucrose (table sugar) dissolved in water is an example.

Vapor Pressure Lowering *The vapor pressure of a nonvolatile nonelectrolyte solution is always lower than the vapor pressure of the pure solvent.* The difference in vapor pressures is the **vapor pressure lowering (ΔP)**.

1. *Why the vapor pressure of a solution is lower.* The fundamental reason for this lowering involves entropy, specifically the relative change in entropy that accompanies vaporization of solvent versus vaporization of the solution. A liquid vaporizes because a gas has higher entropy. In a closed container, vaporization continues until the numbers of particles leaving and entering the liquid phase per unit time are equal, that is, when the system reaches equilibrium. But, as we said, the entropy of a solution is already higher than that of a pure solvent, so fewer solvent particles need to vaporize to reach the same entropy. With fewer particles in the gas phase, the vapor above a solution has lower pressure (Figure 13.23).

Figure 13.23 Effect of solute on the vapor pressure of solution.

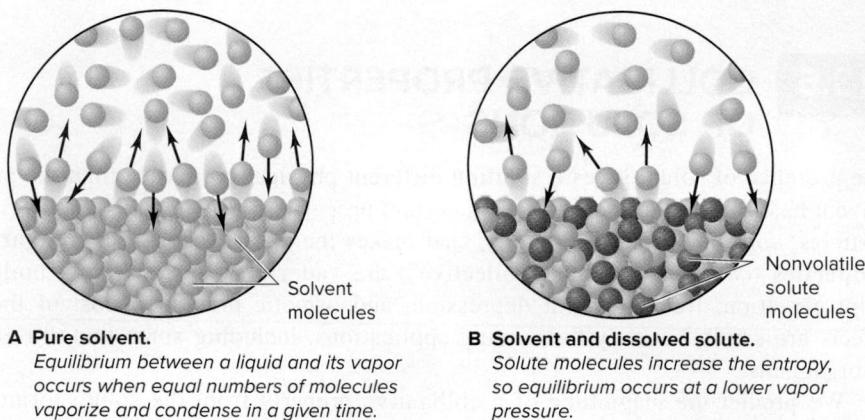

2. *Quantifying vapor pressure lowering.* **Raoult's law** says that the vapor pressure of solvent above a solution (P_{solvent}) equals the mole fraction of solvent (X_{solvent}) times the vapor pressure of the pure solvent ($P_{\text{solvent}}^{\circ}$):

$$P_{\text{solvent}} = X_{\text{solvent}} \times P_{\text{solvent}}^{\circ} \quad (13.9)$$

Since X_{solvent} is less than 1 in a solution, P_{solvent} is less than $P_{\text{solvent}}^{\circ}$. An **ideal solution** is one that follows Raoult's law at any concentration. However, just as real gases deviate from ideality, so do real solutions. In practice, Raoult's law works reasonably well for *dilute* solutions and becomes exact at infinite dilution.

Let's see how the *amount* of dissolved solute affects ΔP . The solution consists of solvent and solute, so the sum of their mole fractions equals 1:

$$X_{\text{solvent}} + X_{\text{solute}} = 1; \text{ thus } X_{\text{solvent}} = 1 - X_{\text{solute}}$$

From Raoult's law, we have

$$P_{\text{solvent}} = X_{\text{solvent}} \times P_{\text{solvent}}^{\circ} = (1 - X_{\text{solute}}) \times P_{\text{solvent}}^{\circ}$$

Multiplying through on the right side gives

$$P_{\text{solvent}} = P_{\text{solvent}}^{\circ} - (X_{\text{solute}} \times P_{\text{solvent}}^{\circ})$$

Rearranging and introducing ΔP gives

$$P_{\text{solvent}}^{\circ} - P_{\text{solvent}} = \Delta P = X_{\text{solute}} \times P_{\text{solvent}}^{\circ} \quad (13.10)$$

Thus, ΔP equals the mole fraction of solute times the vapor pressure of the pure solvent—a relationship applied in the next sample problem.

SAMPLE PROBLEM 13.7**Using Raoult's Law to Find ΔP**

Problem Find the vapor pressure lowering, ΔP , when 10.0 mL of glycerol ($C_3H_8O_3$) is added to 500. mL of water at 50.°C. At this temperature, the vapor pressure of pure water is 92.5 torr and its density is 0.988 g/mL. The density of glycerol is 1.26 g/mL.

Plan To calculate ΔP , we use Equation 13.10. We are given the vapor pressure of pure water ($P_{H_2O}^{\circ} = 92.5$ torr), so we just need the mole fraction of glycerol, X_{glycerol} . We convert the given volume of glycerol (10.0 mL) to mass using the given density (1.26 g/mL), find the molar mass from the formula, and convert mass (g) to amount (mol). The same procedure gives amount of H_2O . From these amounts, we find X_{glycerol} and ΔP .

Solution Calculating the amount (mol) of glycerol and of water:

$$\begin{aligned}\text{Amount (mol) of glycerol} &= 10.0 \text{ mL glycerol} \times \frac{1.26 \text{ g glycerol}}{1 \text{ mL glycerol}} \times \frac{1 \text{ mol glycerol}}{92.09 \text{ g glycerol}} \\ &= 0.137 \text{ mol glycerol} \\ \text{Amount (mol) of } H_2O &= 500. \text{ mL } H_2O \times \frac{0.988 \text{ g } H_2O}{1 \text{ mL } H_2O} \times \frac{1 \text{ mol } H_2O}{18.02 \text{ g } H_2O} \\ &= 27.4 \text{ mol } H_2O\end{aligned}$$

Calculating the mole fraction of glycerol:

$$X_{\text{glycerol}} = \frac{0.137 \text{ mol}}{0.137 \text{ mol} + 27.4 \text{ mol}} = 0.00498$$

Finding the vapor pressure lowering:

$$\Delta P = X_{\text{glycerol}} = P_{H_2O}^{\circ} = 0.00498 \times 92.5 \text{ torr} = 0.461 \text{ torr}$$

Check The amount of each component seems correct: for glycerol, $\sim 10 \text{ mL} \times 1.25 \text{ g/mL} \div 100 \text{ g/mol} = 0.125 \text{ mol}$; for H_2O , $\sim 500 \text{ mL} \times 1 \text{ g/mL} \div 20 \text{ g/mol} = 25 \text{ mol}$. The small ΔP is reasonable because the mole fraction of solute is small.

Comment 1. We can also find X_{H_2O} ($1 - 0.00498 = 0.99502$) and use Equation 13.9 to calculate P_{H_2O} (92.0 torr). Then $P_{H_2O}^{\circ} - P_{H_2O}$ gives ΔP (with fewer significant figures).

2. The calculation assumes that glycerol is nonvolatile. At 1 atm, glycerol boils at 290.0°C, so the vapor pressure of glycerol at 50°C is negligible.

3. We have assumed the solution is close to ideal and that Raoult's law holds.

FOLLOW-UP PROBLEMS

13.7A Calculate the vapor pressure lowering of a solution of 2.00 g of aspirin ($M = 180.15 \text{ g/mol}$) in 50.0 g of methanol (CH_3OH) at 21.2°C. Methanol has a vapor pressure of 101 torr at this temperature.

13.7B Because menthol ($C_{10}H_{20}O$) has a minty taste and soothes throat soreness, it is added to many medicinal products. Find the vapor pressure (in torr) of a solution that contains 6.49 g of menthol in 25.0 g of ethanol (C_2H_5OH) at 22°C. Ethanol has a vapor pressure of 6.87 kPa at this temperature (101.325 kPa = 1 atm).

SOME SIMILAR PROBLEMS 13.96 and 13.97**Road Map**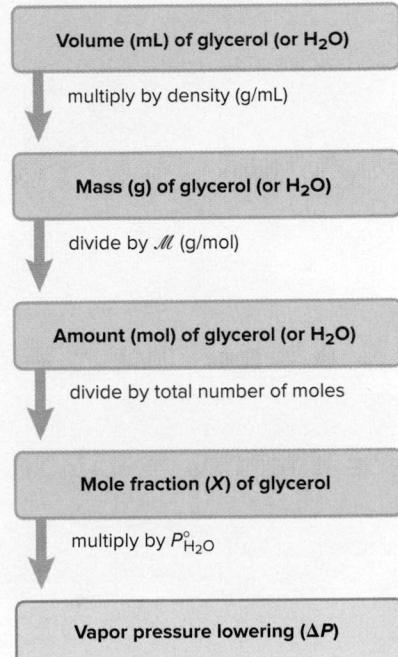

Boiling Point Elevation A solution boils at a higher temperature than the pure solvent. This colligative property results from the vapor pressure lowering:

1. *Why a solution boils at a higher T .* Recall that the boiling point, T_b , of a liquid is the temperature at which its vapor pressure equals the external pressure, P_{ext} . But, the vapor pressure of a solution is always lower than that of the pure solvent. Therefore, it is lower than P_{ext} at T_b of the solvent, so the solution doesn't boil. Thus, **boiling point elevation** (ΔT_b) results because a higher temperature is needed to raise the solution's vapor pressure to equal P_{ext} .

We superimpose a phase diagram for the solution on one for the solvent to see ΔT_b (Figure 13.24, next page): the gas-liquid line for the solution lies *below* the line for the solvent at any T and to the right of it at any P , and the line crosses 1 atm (P_{ext} , or P_{atm}) at a higher T .

Figure 13.24 Boiling and freezing points of solvent and solution. Phase diagrams of an aqueous solution (dashed lines) and of pure water (solid lines). (The slope of the solid-liquid line and the size of ΔP are exaggerated.)

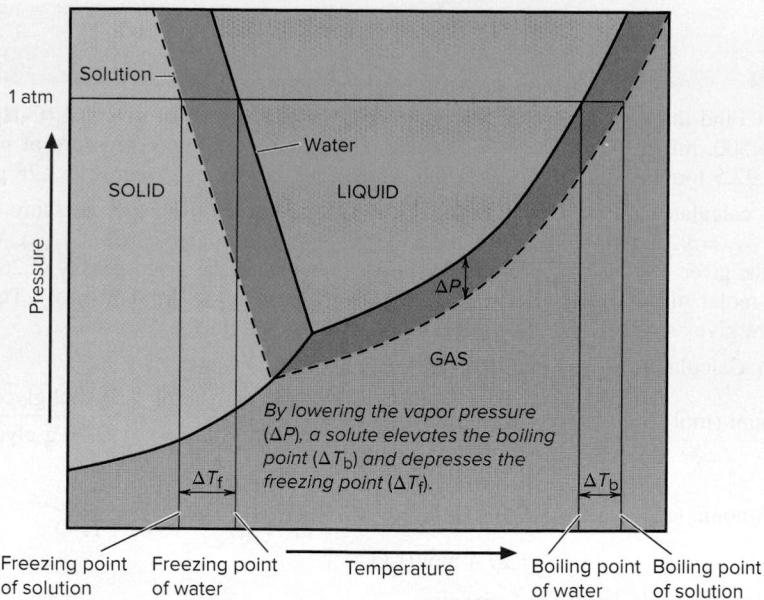

2. *Quantifying boiling point elevation.* Like vapor pressure lowering, boiling point elevation is proportional to the concentration of solute:

$$\Delta T_b \propto m \quad \text{or} \quad \Delta T_b = K_b m \quad (13.11)$$

where m is the solution molality and K_b is the *molal boiling point elevation constant*. Since $\Delta T_b > 0$, we subtract the lower solvent T_b from the higher solution T_b :

$$\Delta T_b = T_{b(\text{solution})} - T_{b(\text{solvent})}$$

Molality is used to determine the boiling point elevation because it relates to mole fraction and, thus, to particles of solute, and it is not affected by temperature.

The constant K_b has units of degrees Celsius per molal unit ($^{\circ}\text{C}/m$) and is specific for a given solvent (Table 13.6). The K_b for water is $0.512^{\circ}\text{C}/m$, so ΔT_b for aqueous solutions is quite small. For example, if you dissolve 1.00 mol of glucose (180. g; 1.00 mol of particles) or 0.500 mol of NaCl (29.2 g; also 1.00 mol of particles) in 1.00 kg of water at 1 atm, both solutions will boil at 100.512°C instead of 100.000°C .

Table 13.6

Molal Boiling Point Elevation and Freezing Point Depression Constants of Several Solvents

Solvent	Boiling Point ($^{\circ}\text{C}$)*	K_b ($^{\circ}\text{C}/m$)	Freezing Point ($^{\circ}\text{C}$)	K_f ($^{\circ}\text{C}/m$)
Acetic acid	117.9	3.07	16.6	3.90
Benzene	80.1	2.53	5.56	4.90
Carbon disulfide	46.2	2.34	-111.5	3.83
Carbon tetrachloride	76.5	5.03	-23	30.
Chloroform	61.7	3.63	-63.5	4.70
Diethyl ether	34.5	2.02	-116.2	1.79
Ethanol	78.5	1.22	-117.3	1.99
Water	100.0	0.512	0.0	1.86

*At 1 atm

Freezing Point Depression A solution freezes at a lower temperature than the pure solvent, and this colligative property also results from vapor pressure lowering:

1. *Why a solution freezes at a lower T .* Only solvent vaporizes from a solution, so solute molecules are left behind. Similarly, *only solvent freezes*, again leaving solute molecules behind. The freezing point of a solution is the temperature at which its vapor pressure equals that of the pure solvent, that is, when solid solvent and liquid

solution are in equilibrium. **Freezing point depression (ΔT_f)** occurs because the vapor pressure of the solution is always lower than that of the solvent, so the solution freezes at a lower temperature; that is, only at a lower temperature will solvent particles leave and enter the solid at the same rate. In Figure 13.24, the solid-liquid line for the solution is to the left of the pure solvent line at 1 atm, or at any pressure.

2. *Quantifying freezing point depression.* Like ΔT_b , the freezing point depression is proportional to the molal concentration of solute:

$$\Delta T_f \propto m \quad \text{or} \quad \Delta T_f = K_f m \quad (13.12)$$

where K_f is the *molal freezing point depression constant*, which also has units of $^{\circ}\text{C}/m$ (see Table 13.6). Also, like ΔT_b , $\Delta T_f > 0$, but in this case, we subtract the lower solution T_f from the higher solvent T_f :

$$\Delta T_f = T_{f(\text{solvent})} - T_{f(\text{solution})}$$

Here, too, the effect in aqueous solution is small because K_f for water is just $1.86^{\circ}\text{C}/m$. Thus, at 1 atm, 1 m glucose, 0.5 m NaCl, and 0.33 m K_2SO_4 , all solutions with 1 mol of particles per kilogram of water, freeze at -1.86°C instead of at 0.00°C .

SAMPLE PROBLEM 13.8

Determining Boiling and Freezing Points of a Solution

Problem You add 1.00 kg of ethylene glycol ($\text{C}_2\text{H}_6\text{O}_2$) antifreeze to 4450 g of water in your car's radiator. What are the boiling and freezing points of the solution?

Plan To find the boiling and freezing points, we need ΔT_b and ΔT_f . We first find the molality by converting mass of solute (1.00 kg) to amount (mol) and dividing by mass of solvent (4450 g, converted to kg). Then we calculate ΔT_b and ΔT_f from Equations 13.11 and 13.12 (using constants from Table 13.6). We add ΔT_b to the solvent boiling point and subtract ΔT_f from its freezing point. The road map shows the steps.

Solution Calculating the molality:

$$\begin{aligned} \text{Amount (mol) of } \text{C}_2\text{H}_6\text{O}_2 &= 1.00 \text{ kg } \text{C}_2\text{H}_6\text{O}_2 \times \frac{10^3 \text{ g}}{1 \text{ kg}} \times \frac{1 \text{ mol } \text{C}_2\text{H}_6\text{O}_2}{62.07 \text{ g } \text{C}_2\text{H}_6\text{O}_2} \\ &= 16.1 \text{ mol } \text{C}_2\text{H}_6\text{O}_2 \\ \text{Molality} &= \frac{\text{mol solute}}{\text{kg solvent}} = \frac{16.1 \text{ mol } \text{C}_2\text{H}_6\text{O}_2}{4450 \text{ g } \text{H}_2\text{O}} \times \frac{1 \text{ kg}}{10^3 \text{ g}} = 3.62 \text{ m } \text{C}_2\text{H}_6\text{O}_2 \end{aligned}$$

Finding the boiling point elevation and $T_{b(\text{solution})}$, with $K_b = 0.512^{\circ}\text{C}/m$:

$$\Delta T_b = \frac{0.512^{\circ}\text{C}}{m} \times 3.62 \text{ m} = 1.85^{\circ}\text{C}$$

$$T_{b(\text{solution})} = T_{b(\text{solvent})} + \Delta T_b = 100.00^{\circ}\text{C} + 1.85^{\circ}\text{C} = 101.85^{\circ}\text{C}$$

Finding the freezing point depression and $T_{f(\text{solution})}$, with $K_f = 1.86^{\circ}\text{C}/m$:

$$\Delta T_f = \frac{1.86^{\circ}\text{C}}{m} \times 3.62 \text{ m} = 6.73^{\circ}\text{C}$$

$$T_{f(\text{solution})} = T_{f(\text{solvent})} - \Delta T_f = 0.00^{\circ}\text{C} - 6.73^{\circ}\text{C} = -6.73^{\circ}\text{C}$$

Check The changes in boiling and freezing points should be in the same proportion as the constants used. That is, $\Delta T_b/\Delta T_f$ should equal K_b/K_f . $1.85/6.73 = 0.275 = 0.512/1.86$.

Comment These answers are approximate because the concentration far exceeds that of a *dilute* solution, for which Raoult's law is most accurate.

FOLLOW-UP PROBLEMS

13.8A Carbon disulfide (CS_2) has the unusual ability to dissolve several nonmetals as well as rubbers and resins. What are the boiling and freezing points of a solution consisting of 8.44 g of phosphorus (P_4) dissolved in 60.0 g of CS_2 (see Table 13.6)?

13.8B What is the lowest molality of ethylene glycol ($\text{C}_2\text{H}_6\text{O}_2$) solution that will protect your car's coolant from freezing at 0.00°F ? To make a solution of this molality, what mass of ethylene glycol must be added to 4.00 kg of water? (Assume that the solution is ideal.)

SOME SIMILAR PROBLEMS 13.98–13.103

Student Hot Spot

Student data indicate that you may struggle with colligative property calculations. Access the Smartbook to view additional Learning Resources on this topic.

Road Map

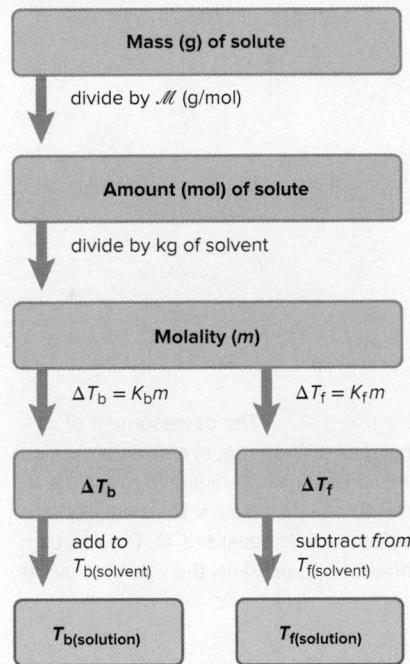

Osmotic Pressure Another colligative property is observed when solutions of higher and lower concentrations are separated by a **semipermeable membrane**, one that allows solvent, but *not* solute, to pass through. The phenomenon is called **osmosis**: a net flow of solvent into the more concentrated solution causes a pressure difference known as *osmotic pressure*. Many organisms regulate internal concentrations by osmosis.

1. *Why osmotic pressure arises.* Consider a simple apparatus in which a semipermeable membrane lies at the curve of a U tube and separates an aqueous sugar solution from pure water. Water molecules pass in *either* direction, but the larger sugar molecules do not. Because sugar molecules are on the solution side of the membrane, fewer water molecules touch that side, so fewer leave the solution than enter it in a given time (Figure 13.25A). As a result, the solution maintains higher entropy. This *net flow of water into the solution* increases its volume and thus decreases its concentration.

As the height of the solution column rises and the height of the water column falls, the difference in the weights of the columns produces a pressure difference that resists more water entering and pushes some water back through the membrane. When water is being pushed out of the solution at the same rate it is entering, the system is at equilibrium (Figure 13.25B). The pressure difference at this point is the **osmotic pressure** (Π), which is the same as the pressure that must be applied to *prevent* net movement of water from solvent to solution (or from lower to higher concentration, Figure 13.25C).

2. *Quantifying osmotic pressure.* The osmotic pressure is proportional to the number of solute particles in a given solution *volume*, that is, to the molarity (M):

$$\Pi \propto \frac{n_{\text{solute}}}{V_{\text{soln}}} \quad \text{or} \quad \Pi \propto M$$

The proportionality constant is R times the absolute temperature T . Thus,

$$\Pi = \frac{n_{\text{solute}}}{V_{\text{soln}}} RT = MRT \quad (13.13)$$

The similarity of Equation 13.13 to the ideal gas law ($P = nRT/V$) is not surprising, because both relate the pressure of a system to its concentration and temperature.

The Underlying Theme of Colligative Properties A common theme runs through the explanations of the four colligative properties of nonvolatile solutes. Each property arises because solute particles cannot move between two phases:

- They cannot enter the gas phase, which leads to *vapor pressure lowering* and *boiling point elevation*.

Figure 13.25 The development of osmotic pressure. **A**, In a given time, more solvent enters the solution through the membrane than leaves. **B**, At equilibrium, solvent flow is equalized. **C**, The osmotic pressure (Π) prevents the volume change.

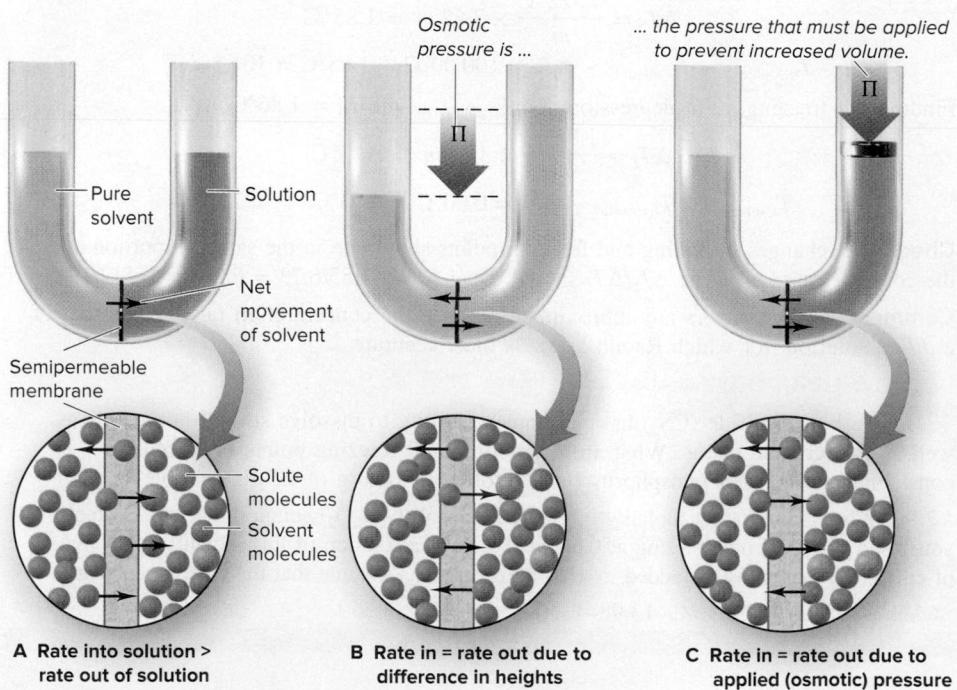

- They cannot enter the solid phase, which leads to *freezing point depression*.
- They cannot cross a semipermeable membrane, which leads to *osmotic pressure*.

In each situation, the presence of solute decreases the mole fraction of solvent, which lowers the number of solvent particles leaving the solution per unit time. This lowering maintains higher entropy and requires a new balance in numbers of particles moving between two phases per unit time, and this new balance results in the measured colligative property.

Using Colligative Properties to Find Solute Molar Mass

Each colligative property is proportional to solute concentration. Thus, by measuring the property—lower freezing point, higher boiling point, and so forth—we determine the amount (mol) of solute particles and, given the mass of solute, the molar mass.

In principle, any of the colligative properties can be used, but generally only freezing point depression and osmotic pressure are widely used. Osmotic pressure creates the largest changes and, thus, the most precise measurements. Polymer chemists and biochemists estimate molar masses as great as 10^5 g/mol by measuring osmotic pressure. Because only a tiny fraction of a mole of a macromolecular solute dissolves, the change in the other colligative properties would be too small.

SAMPLE PROBLEM 13.9

Determining Molar Mass from Colligative Properties

Problem Biochemists have discovered more than 400 mutant varieties of hemoglobin, the blood protein that binds O_2 and carries it to the body's cells. A physician dissolves 21.5 mg of one variety in water to make 1.50 mL of solution at $5.0^\circ C$. She measures an osmotic pressure of 3.61 torr. What is the molar mass of the protein?

Plan We know the osmotic pressure ($\Pi = 3.61$ torr), R , and T ($5.0^\circ C$). We convert Π from torr to atm, and T from $^\circ C$ to K, and then use Equation 13.13 to solve for molarity (M). Then we calculate the amount (mol) of hemoglobin from the known volume (1.50 mL) and use the known mass (21.5 mg) to find \mathcal{M} (see the road map).

Solution Combining unit conversion steps and solving for molarity:

$$M = \frac{\Pi}{RT} = \frac{3.61 \text{ torr}}{\left(0.0821 \frac{\text{atm}\cdot\text{L}}{\text{mol}\cdot\text{K}}\right)(273.15 \text{ K} + 5.0)} = 2.08 \times 10^{-4} M$$

Finding amount (mol) of solute (after changing mL to L):

$$\text{Amount (mol) of solute} = M \times V = \frac{2.08 \times 10^{-4} \text{ mol}}{1 \text{ L soln}} \times 0.00150 \text{ L soln} = 3.12 \times 10^{-7} \text{ mol}$$

Calculating molar mass of hemoglobin (after changing mg to g):

$$\mathcal{M} = \frac{0.0215 \text{ g}}{3.12 \times 10^{-7} \text{ mol}} = 6.89 \times 10^4 \text{ g/mol}$$

Check The small osmotic pressure implies a very low molarity. Hemoglobin is a biopolymer, so we expect a small number of moles [$(\sim 2 \times 10^{-4} \text{ mol/L})(1.5 \times 10^{-3} \text{ L}) = 3 \times 10^{-7} \text{ mol}$] and a high \mathcal{M} ($\sim 21 \times 10^{-3} \text{ g}/3 \times 10^{-7} \text{ mol} = 7 \times 10^4 \text{ g/mol}$). Mammalian hemoglobin has a molar mass of 64,500 g/mol.

FOLLOW-UP PROBLEMS

13.9A Pepsin is an enzyme in the intestines of mammals that breaks down proteins into amino acids. A 12.0-mL aqueous solution contains 0.200 g of pepsin and has an osmotic pressure of 8.98 torr at $27.0^\circ C$. What is the molar mass of pepsin?

13.9B Naphthalene is the main ingredient in some mothballs. The freezing point of a solution made by dissolving 7.01 g of naphthalene in 200. g of benzene is $4.20^\circ C$. What is the molar mass of naphthalene?

SOME SIMILAR PROBLEMS 13.106 and 13.107

Road Map

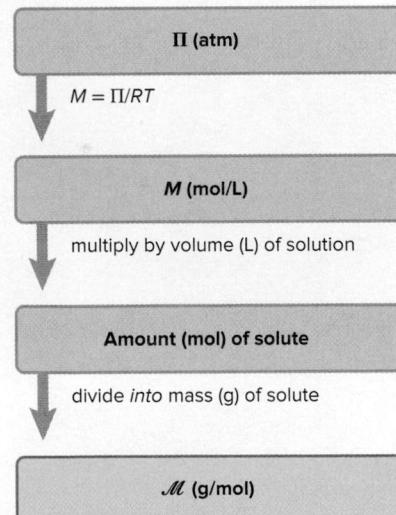

Volatile Nonelectrolyte Solutions

What is the effect on vapor pressure when the solute is volatile, that is, when the vapor consists of solute *and* solvent molecules? From Raoult's law (Equation 13.9),

$$P_{\text{solvent}} = X_{\text{solvent}} \times P_{\text{solvent}}^{\circ} \quad \text{and} \quad P_{\text{solute}} = X_{\text{solute}} \times P_{\text{solute}}^{\circ}$$

where X_{solvent} and X_{solute} are the mole fractions in the *liquid* phase. According to Dalton's law (Section 5.4), the total vapor pressure is the sum of the partial vapor pressures:

$$P_{\text{total}} = P_{\text{solvent}} + P_{\text{solute}} = (X_{\text{solvent}} \times P_{\text{solvent}}^{\circ}) + (X_{\text{solute}} \times P_{\text{solute}}^{\circ})$$

Thus, just as a nonvolatile solute lowers the vapor pressure of the solvent by making the solvent's mole fraction less than 1, *the presence of each volatile component lowers the vapor pressure of the other* by making each mole fraction less than 1.

Let's examine this idea with a solution of benzene (C_6H_6) and toluene (C_7H_8), which are miscible. The mole fractions of the two solution components in this example are equal: $X_{\text{ben}} = X_{\text{tol}} = 0.500$. At 25°C , the vapor pressures of the pure substances are 95.1 torr for benzene (P_{ben}°) and 28.4 torr for toluene (P_{tol}°). Note that benzene is *more volatile* than toluene. We find the partial pressures from Raoult's law:

$$P_{\text{ben}} = X_{\text{ben}} \times P_{\text{ben}}^{\circ} = 0.500 \times 95.1 \text{ torr} = 47.6 \text{ torr}$$

$$P_{\text{tol}} = X_{\text{tol}} \times P_{\text{tol}}^{\circ} = 0.500 \times 28.4 \text{ torr} = 14.2 \text{ torr}$$

Thus, the presence of benzene in the liquid lowers the vapor pressure of toluene, and vice versa.

Now let's calculate the mole fraction of each substance *in the vapor* by applying Dalton's law. Recall from Section 5.4 that $X_A = P_A/P_{\text{total}}$. Therefore, for benzene and toluene in the vapor,

$$X_{\text{ben}} = \frac{P_{\text{ben}}}{P_{\text{total}}} = \frac{47.6 \text{ torr}}{47.6 \text{ torr} + 14.2 \text{ torr}} = 0.770$$

$$X_{\text{tol}} = \frac{P_{\text{tol}}}{P_{\text{total}}} = \frac{14.2 \text{ torr}}{47.6 \text{ torr} + 14.2 \text{ torr}} = 0.230$$

The key point is that *the vapor has a higher mole fraction of the more volatile component*. Through a single vaporization-condensation step, a 50/50 *liquid* ratio of benzene to toluene created a 77/23 *vapor* ratio. Condense this vapor into a separate container, and the new *liquid* would have this 77/23 composition, and the new *vapor* above it would be enriched still further in the more volatile benzene.

In the laboratory method of **fractional distillation**, a solution of two or more volatile components is attached to a *fractionating column* packed with glass beads (or ceramic chunks), which increase surface area; the column is connected to a condenser and collection flask. As the solution is heated and the vapor mixture meets the beads, numerous vaporization-condensation steps enrich the mixture until the vapor leaving the column, and thus the liquid finally collected, consists only of the most volatile component. (As we'll see shortly, this method is essential in the oil refining industry.)

Strong Electrolyte Solutions

For strong electrolyte solutions, the solute formula tells us the number of particles for determining colligative properties. For instance, the boiling point elevation (ΔT_b) of 0.050 *m* NaCl should be $2 \times \Delta T_b$ of 0.050 *m* glucose ($C_6H_{12}O_6$), because NaCl dissociates into two particles per formula unit. Thus, we use a multiplying factor called the *van't Hoff factor* (*i*), named after the Dutch chemist Jacobus van't Hoff (1852–1911):

$$i = \frac{\text{measured value for electrolyte solution}}{\text{expected value for nonelectrolyte solution}}$$

To calculate colligative properties for strong electrolyte solutions, we include *i*:

For vapor pressure lowering: $\Delta P = i(X_{\text{solute}} \times P_{\text{solvent}}^{\circ})$

For boiling point elevation: $\Delta T_b = i(K_b m)$

For freezing point depression: $\Delta T_f = i(K_f m)$

For osmotic pressure: $\Pi = i(MRT)$

Nonideal Solutions and Ionic Atmospheres If strong electrolyte solutions behaved ideally, the factor i would be the amount (mol) of particles in solution divided by the amount (mol) of dissolved solute; that is, i would be 2 for KBr, 3 for Mg(NO₃)₂, and so forth. However, most strong electrolyte solutions are *not* ideal, and the measured value of i is typically *lower* than the value expected from the formula. For example, for the boiling point elevation of 0.050 m NaCl, the expected value is 2.0, but, from experiment, we have

$$i = \frac{\Delta T_b \text{ of } 0.050 \text{ m NaCl}}{\Delta T_b \text{ of } 0.050 \text{ m glucose}} = \frac{0.049^\circ\text{C}}{0.026^\circ\text{C}} = 1.9$$

It seems as though the ions are not behaving independently, even though other evidence indicates that soluble salts dissociate completely. One clue to understanding the results is that multiply-charged ions cause a larger deviation (Figure 13.26).

To explain this nonideal behavior, we picture positive ions clustered, on average, near negative ions, and vice versa, to form an **ionic atmosphere** of net opposite charge (Figure 13.27). In effect, each type of ion acts “tied up,” so its actual concentration seems *lower*. The *effective* concentration is the *stoichiometric* concentration, which is based on the formula, multiplied by i . The greater the charge, the stronger the attractions, which explains the larger deviation for salts with multiply-charged ions.

Comparing Real Solutions and Real Gases At ordinary conditions and concentrations, particles are *much* closer together in liquids than in gases. And, as a result, nonideal behavior is much more common for solutions, and the observed deviations are much larger. Nevertheless, the two systems have similarities:

- Gases display nearly ideal behavior at low pressures because the distances between particles are large. Similarly, the van't Hoff factor (i) approaches the ideal value as the solution becomes more dilute, that is, as the distance between ions increases.
- Attractions between particles cause deviations from the expected pressure in gases and from the expected size of a colligative property in ionic solutions.
- For both real gases and real solutions, we use empirically determined numbers (van der Waals constants or van't Hoff factors) to transform theories (the ideal gas law or Raoult's law) into more useful relations.

SAMPLE PROBLEM 13.10

Depicting Strong Electrolyte Solutions

Problem A 0.952-g sample of magnesium chloride dissolves in 100. g of water in a flask.

- Which scene depicts the solution best?
- What is the amount (mol) represented by each green sphere?
- Assuming the solution is ideal, what is its freezing point (at 1 atm)?

Plan (a) We find the numbers of cations and anions per formula unit from the name and compare it with the three scenes. (b) We convert the given mass to amount (mol), use the answer from part (a) to find moles of chloride ions (*green spheres*), and divide by the number of green spheres to get moles/sphere. (c) We find the molality (m) from amount (mol) of solute divided by the given mass of water (changed to kg). We multiply K_f for water (Table 13.6) by m to get ΔT_f , and then subtract that from 0.000°C to get the solution freezing point.

Solution (a) The formula is MgCl₂; only scene A has 1 Mg²⁺ for every 2 Cl⁻.

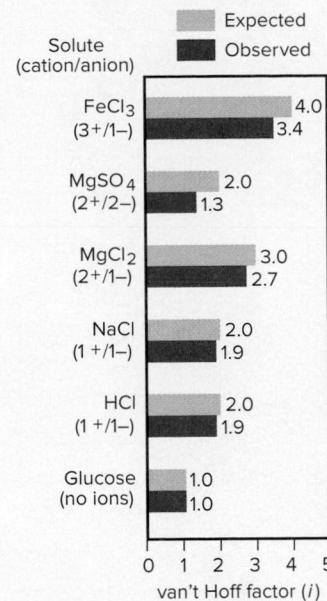

Figure 13.26 Nonideal behavior of strong electrolyte solutions. Van't Hoff factors (i) for 0.050 m solutions show the largest deviation for salts with multiply-charged ions. Glucose (a nonelectrolyte) behaves as expected.

Figure 13.27 An ionic atmosphere model for nonideal behavior of electrolyte solutions.

$$(b) \text{ Amount (mol) of MgCl}_2 = \frac{0.952 \text{ g MgCl}_2}{95.21 \text{ g/mol MgCl}_2} = 0.0100 \text{ mol MgCl}_2$$

$$\text{Therefore, Amount (mol) of Cl}^- = 0.0100 \text{ mol MgCl}_2 \times \frac{2 \text{ Cl}^-}{1 \text{ MgCl}_2} = 0.0200 \text{ mol Cl}^-$$

$$\text{Moles/sphere} = \frac{0.0200 \text{ mol Cl}^-}{8 \text{ spheres}} = 2.50 \times 10^{-3} \text{ mol/sphere}$$

$$(c) \text{ Molality (m)} = \frac{\text{mol of solute}}{\text{kg of solvent}} = \frac{0.0100 \text{ mol MgCl}_2}{100. \text{ g} \times \frac{1 \text{ kg}}{10^3 \text{ g}}} = 0.100 \text{ m MgCl}_2$$

Assuming an ideal solution, $i = 3$ for MgCl₂ (3 ions per formula unit), so we have

$$\Delta T_f = i(K_f m) = 3(1.86^\circ\text{C}/\text{m} \times 0.100 \text{ m}) = 0.558^\circ\text{C}$$

and

$$T_f = 0.000^\circ\text{C} - 0.558^\circ\text{C} = -0.558^\circ\text{C}$$

Check Let's quickly check the ΔT_f in part (c): We have 0.01 mol dissolved in 0.1 kg, or 0.1 m. Then, rounding K_f , we have about $3(2^\circ\text{C}/\text{m} \times 0.1 \text{ m}) = 0.6^\circ\text{C}$.

FOLLOW-UP PROBLEMS

- 13.10A** A solution is made by dissolving 31.2 g of potassium phosphate in 85.0 g of water in a beaker. (a) Which scene depicts the solution best? (b) Assuming ideal behavior, what is the boiling point of the solution (at 1 atm)?

- 13.10B** The MgCl₂ solution in the sample problem has a density of 1.006 g/mL at 20.0°C. (a) What is its osmotic pressure? (b) A U tube, with semipermeable membrane, is filled with this solution in the left arm and a glucose solution of equal molarity in the right. After time, which scene depicts the U tube best?

SOME SIMILAR PROBLEMS 13.108 and 13.109

Applications of Colligative Properties

Two colligative properties, freezing point depression (or boiling point elevation) and osmotic pressure, have key applications that involve all three types of solutes we've discussed, nonvolatile and volatile nonelectrolytes and strong electrolytes.

Uses of Freezing Point Depression Applications of this property appear in everyday life, nature, and industry:

- *Plane de-icer and car antifreeze.* The main ingredient in plane de-icer and car antifreeze, ethylene glycol (C₂H₆O₂), lowers the freezing point of water in winter and raises its boiling point in summer. Due to extensive H bonding, ethylene glycol is miscible with water and nonvolatile at 100°C.

- **Biological antifreeze.** Structurally similar to ethylene glycol and also miscible with water, glycerol ($C_3H_8O_3$) is produced by some fish and insects, including the common housefly, to lower the freezing point of their blood and thus allow them to survive winters.
- **De-icing sidewalks and roads.** NaCl, or a mixture of it with CaCl₂, is used to melt ice on roads. A small amount dissolves in the ice by lowering its freezing point and melting it. More salt dissolves, more ice melts, and so forth. An advantage of CaCl₂ is that it has a highly negative ΔH_{soln} , so heat is released when it dissolves, which melts more ice.
- **Refining petroleum and silicon.** In the oil refining industry, countless vaporization-condensation steps within a 30-m fractionating tower separate the hundreds of volatile compounds in crude oil into a few “fractions” based on boiling point range (Figure 13.28). Impure silicon is refined by continuous melting and refreezing into a sample pure enough for use in computer chips (Chapter 22).

Uses of Osmotic Pressure Of the four colligative properties, this one has the most applications vital to organisms.

- **Tonicity and cell shape.** The term *tonicity* refers to the tone, or firmness, of a cell. Placing a cell in an *isotonic* solution, one that has the same concentration of particles as the cell fluid, maintains the cell’s normal shape because water enters and leaves the cell at the same rate (Figure 13.29A). A *hypotonic* solution has a lower concentration of particles, so water enters the cell faster than it leaves, causing the cell to burst (Figure 13.29B). In contrast, a *hypertonic* solution has a higher concentration of particles, so the cell shrinks because water leaves faster than it enters (Figure 13.29C). To maintain cell shape, contact-lens rinse is isotonic saline (0.15 M NaCl), as are solutions used to deliver nutrients or drugs intravenously.
- **Absorption of water by trees.** Tree sap is a more concentrated solution than surrounding groundwater, so water passes through root membranes into the tree, creating an osmotic pressure that can exceed 20 atm in the tallest trees.
- **Regulation of water volume in the body.** Of the four major biological cations—Na⁺, K⁺, Mg²⁺, and Ca²⁺—sodium ion has the primary role in regulating water volume. It accounts for over 90 mol % of cations *outside* a cell: high Na⁺ draws water out of the cell and low Na⁺ leaves more inside. And the primary role of the kidneys is to regulate Na⁺ concentration.
- **Food preservation.** Before refrigeration, salt was valued as a preservative. Packed onto food, salt causes microbes on the surface to shrivel as they lose water. In fact, it was so highly prized for this purpose that Roman soldiers were paid in salt, from which comes the word *salary*. Salt is also used to draw water out of cucumbers to make pickles.

Figure 13.28 Fractional distillation in petroleum refining.

Figure 13.29 Osmotic pressure and cell shape. Isotonic (A), hypotonic (B), and hypertonic (C) solutions influence the shape of a red blood cell.

Source: A–C: © David M. Phillips/Science Source

› Summary of Section 13.6

- › Colligative properties arise from the number, not the type, of dissolved solute particles.
- › Compared to pure solvent, a solution has higher entropy, which results in lower vapor pressure (Raoult's law), elevated boiling point, and depressed freezing point. A difference in concentration of a solute between two solutions gives rise to osmotic pressure.
- › Colligative properties are used to determine solute molar mass; osmotic pressure gives the most precise measurements.
- › When solute *and* solvent are volatile, each lowers the vapor pressure of the other, with the vapor pressure of the more volatile component greater. When the vapor is condensed, the new solution is richer in that component than the original solution.
- › Calculating colligative properties of strong electrolyte solutions requires a factor (*i*) that adjusts for the number of ions per formula unit. These solutions exhibit nonideal behavior because charge attractions effectively reduce the concentration of ions.

13.7 THE STRUCTURE AND PROPERTIES OF COLLOIDS

Particle size plays a defining role in three types of mixtures:

- *Suspensions*. Stir a handful of fine sand into a glass of water, and the particles are suspended at first but gradually settle to the bottom. Sand in water is a **suspension**, a *heterogeneous* mixture containing particles large enough (>1000 nm) to be visibly distinct from the surrounding fluid.
- *Solutions*. In contrast, stirring sugar into water forms a solution, a *homogeneous* mixture in which the particles are invisible, individual sugar molecules (around 1 nm) distributed evenly throughout the surrounding fluid.
- *Colloids*. Between these extremes is a large group of mixtures called *colloidal dispersions*, or **colloids**, in which a dispersed (solute-like) substance is distributed throughout a dispersing (solvent-like) substance. The particles are larger than simple molecules but too small to settle out.

In this section, we examine the classification and key features of colloids.

1. *Particle size and surface area*. Colloidal particles range in diameter from 1 to 1000 nm (10^{-9} to 10^{-6} m). Each particle may be a single macromolecule (natural or synthetic) or an aggregate of many atoms, ions, or molecules. As a result of the small particle size, a colloid has a *very large total surface area*. A cube with 1-cm sides has a total surface area of 6 cm^2 . If we divide it equally into 10^{12} cubes, each cube is the size of a large colloidal particle and the total surface area is $60,000 \text{ cm}^2$, or 6 m^2 . The enormous surface area of a colloid attracts other particles through various intermolecular forces.

2. *Classification of colloids*. Colloids are commonly classified by the physical state of the dispersed and dispersing substances (Table 13.7). Many familiar commercial products and natural objects are colloids. Whipped cream and shaving cream are

Table 13.7 Types of Colloids

Colloid Type	Dispersed Substance	Dispersing Substance	Example(s)
Aerosol	Liquid	Gas	Fog
Aerosol	Solid	Gas	Smoke
Foam	Gas	Liquid	Whipped cream
Solid foam	Gas	Solid	Marshmallow
Emulsion	Liquid	Liquid	Milk
Solid emulsion	Liquid	Solid	Butter
Sol	Solid	Liquid	Paint, cell fluid
Solid sol	Solid	Solid	Opal

Figure 13.30 Light scattering and the Tyndall effect. **A**, The narrow, barely visible light beam that passes through a solution (*left*), is scattered and broadened by passing through a colloid (*right*). **B**, Sunlight is scattered by dust in air.

Source: (A) © McGraw-Hill Education/Charles Winters/Timeframe Photography, Inc. (B) © Corbis Royalty-Free RF

foams, a gas dispersed in a liquid. Styrofoam is a *solid foam*, a gas dispersed in a solid. Most biological fluids are aqueous *sols*, solids dispersed in water: proteins and nucleic acids are the colloidal-size particles dispersed in an aqueous fluid of ions and small molecules within a cell. Soaps and detergents work by forming an *emulsion*, a liquid dispersed in another liquid. Other emulsions are mayonnaise and hand cream. Bile salts convert fats to an emulsion in the watery fluid of the small intestine.

3. Tyndall effect and Brownian motion. Light passing through a colloid is scattered randomly because the dispersed particles have sizes similar to wavelengths of visible light (400 to 750 nm). The scattered light beam appears broader than one passing through a solution, an example of the **Tyndall effect** (Figure 13.30). Dust scatters sunlight shining through it, as does mist with headlight beams.

Under low magnification, colloidal particles exhibit *Brownian motion*, an erratic change of speed and direction. Brownian motion results from collisions of the particles with molecules of the dispersing medium, and Einstein's explanation of it in 1905 led many to accept the molecular nature of matter.

4. Stabilizing and destabilizing colloids. Why *don't* colloidal particles aggregate and settle out? Colloidal particles dispersed in water have charged surfaces that stabilize the colloid through ion-dipole forces. Molecules with dual polarities, like lipids and soaps, form spherical *micelles*, with the charged heads on the exterior and hydrocarbon tails in the interior (Section 13.2). Aqueous proteins mimic this arrangement, with charged amino acid groups facing the water and nonpolar groups buried within the molecule. Oily particles can be dispersed in water by adding ions, which are adsorbed onto their surfaces. Repulsions between the ions on the oil and partial charges on water molecules prevent the particles from aggregating.

Despite these forces, various methods that coagulate the particles destabilize the colloid. Heating makes the particles collide more often and with enough force to coalesce and settle out. Addition of an electrolyte solution containing oppositely charged ions neutralizes the surface charges, so the particles coagulate and settle. In smokestack gases from a coal-burning power plant, ions become adsorbed onto uncharged colloidal particles, which are then attracted to the charged plates of a device called a *Cotrell precipitator* installed in the stack. At the mouths of rivers, where salt concentrations increase near an ocean or sea, colloidal clay particles coalesce into muddy deltas, like those of the Mississippi and the Nile (Figure 13.31). Thus, the city of New Orleans and the ancient Egyptian empire were made possible by large-scale colloid chemistry.

The upcoming Chemical Connections essay applies solution and colloid chemistry to the purification of water for residential and industrial use.

› Summary of Section 13.7

- › Particles in a colloid are smaller than those in a suspension and larger than those in a solution.
- › Colloids are classified by the physical states of the dispersed and dispersing substances and involve many combinations of gas, liquid, and/or solid.
- › Colloids have extremely large surface areas, scatter incoming light (Tyndall effect), and exhibit random (Brownian) motion.
- › Colloidal particles in water are stabilized by charged surfaces that keep them dispersed, but they can be coagulated by heating or by the addition of ions.
- › Solution behavior and colloid chemistry are applied to water treatment and purification.

Figure 13.31 The Nile delta (reddish-brown area).

Source: © Earth Satellite Corporation/SPL/Science Source

Most water destined for human use comes from lakes, rivers, reservoirs, or groundwater. Present in this essential resource may be soluble toxic organic compounds and high concentrations of NO_3^- and Fe^{3+} , colloidal clay and microbes, and suspended debris. Let's see how water is treated to remove these dissolved, dispersed, and suspended particles.

Water Treatment Plants

Treating water involves several steps (Figure B13.1):

Step 1. Screening and settling. As water enters the facility, screens remove debris, and settling removes sand and other particles.

Step 2. Coagulating. This step and the next two remove colloids. These particles have negative surfaces that repel each other. Added aluminum sulfate [cake alum; $\text{Al}_2(\text{SO}_4)_3$] or iron(III) chloride (FeCl_3), which supply Al^{3+} or Fe^{3+} ions that neutralize the charges, coagulates the particles through intermolecular forces.

Step 3. Flocculating and sedimenting. Mixing water and flocculating agents in large basins causes a fluffy *floc* to form. Added cationic polymers form long-chain bridges between floc particles, which grow bigger and flow into other basins, where they form a sediment and are removed. Some plants use *dissolved air flotation* (DAF) instead: bubbles forced through the water attach to the floc, and the floating mass is skimmed.

Step 4. Filtering. Various filters remove remaining particles. In *slow sand filters*, the water passes through sand and/or gravel of increasing particle size. In *rapid sand filters*, the sand is backwashed with water, and the colloidal mass is removed. Membrane filters (*not shown*) with pore sizes of $0.1\text{--}10\ \mu\text{m}$ are thin tubes bundled together inside a vessel. The water is forced into these tubes, and the colloid-free filtrate is collected from a large central tube. Filtration is very effective at removing microorganisms resistant to disinfectants.

Step 5. Disinfecting. Water sources often contain harmful microorganisms that are killed by one of three agents:

- Chlorine, as aqueous bleach (ClO^-) or Cl_2 , is most common, but carcinogenic chlorinated organic compounds can form.
- UV light emitted by high-intensity fluorescent tubes disinfects by disrupting microorganisms' DNA.
- Ozone (O_3) gas is a powerful oxidizing agent.

Sodium fluoride (NaF) to prevent tooth decay and phosphate salts to prevent leaching of lead from pipes may then be added.

Step 6 (not shown). Adsorbing onto granular activated carbon (GAC). Petroleum and other organic contaminants are removed by adsorption. GAC is a highly porous agent formed by "activating" wood, coal, or coconut shells with steam: 1 kg of GAC has a surface area of 275 acres!

Water Softening via Ion Exchange

Water with large amounts of $2+$ ions, such as Ca^{2+} and Mg^{2+} , is called **hard water**. Combined with fatty-acid anions in soap, these cations form solid deposits on clothes, washing machines, and sinks:

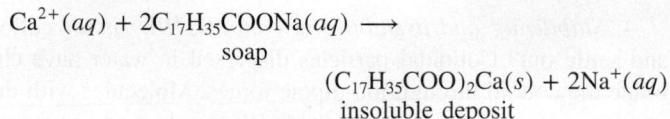

When a large amount of HCO_3^- is present, the cations form *scale*, a carbonate deposit in boilers and hot-water pipes that interferes with the transfer of heat:

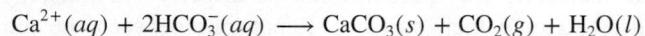

Removing hard-water cations, called **water softening**, is done by exchanging Na^+ ions for Ca^{2+} and Mg^{2+} ions. A home system for **ion exchange** contains an insoluble polymer **resin** with bonded

Figure B13.1 The typical steps in municipal water treatment.

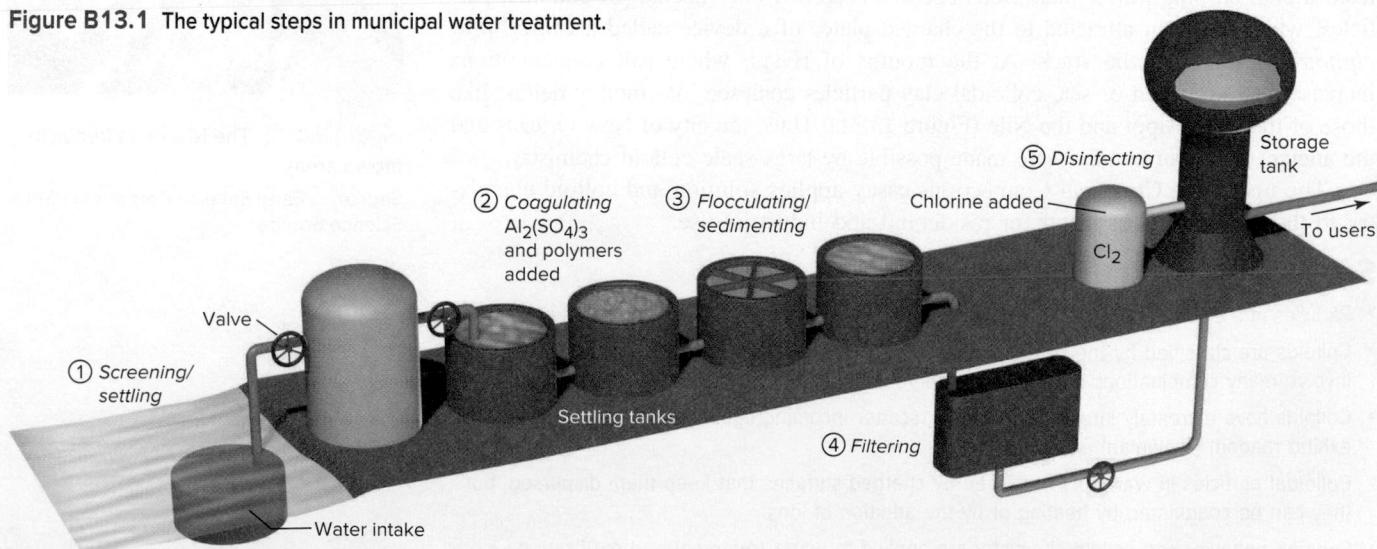

Figure B13.2 Ion exchange to remove hard-water cations.

anionic groups, such as SO_3^- or COO^- , and Na^+ ions for charge balance (Figure B13.2). The hard-water cations displace the Na^+ ions and bind to the anionic groups. When all resin sites are occupied, the resin is regenerated with concentrated Na^+ solution that exchanges Na^+ ions for bound Ca^{2+} and Mg^{2+} .

Membrane Processes and Reverse Osmosis

Membranes with $0.0001\text{--}0.01\ \mu\text{m}$ pores can remove unwanted ions from water. Recall that solutions of different concentrations separated by a semipermeable membrane create osmotic pressure. In **reverse osmosis**, a pressure *greater* than the osmotic pressure is *applied* to the more concentrated solution to force water back through the membrane and filter out ions. In homes, toxic **heavy-metal ions**, such as Pb^{2+} , Cd^{2+} , and Hg^{2+} , are removed this way. On a large scale, reverse osmosis is used for **desalination**, which can convert seawater (40,000 ppm of ions) to drinking water (400 ppm) (Figure B13.3).

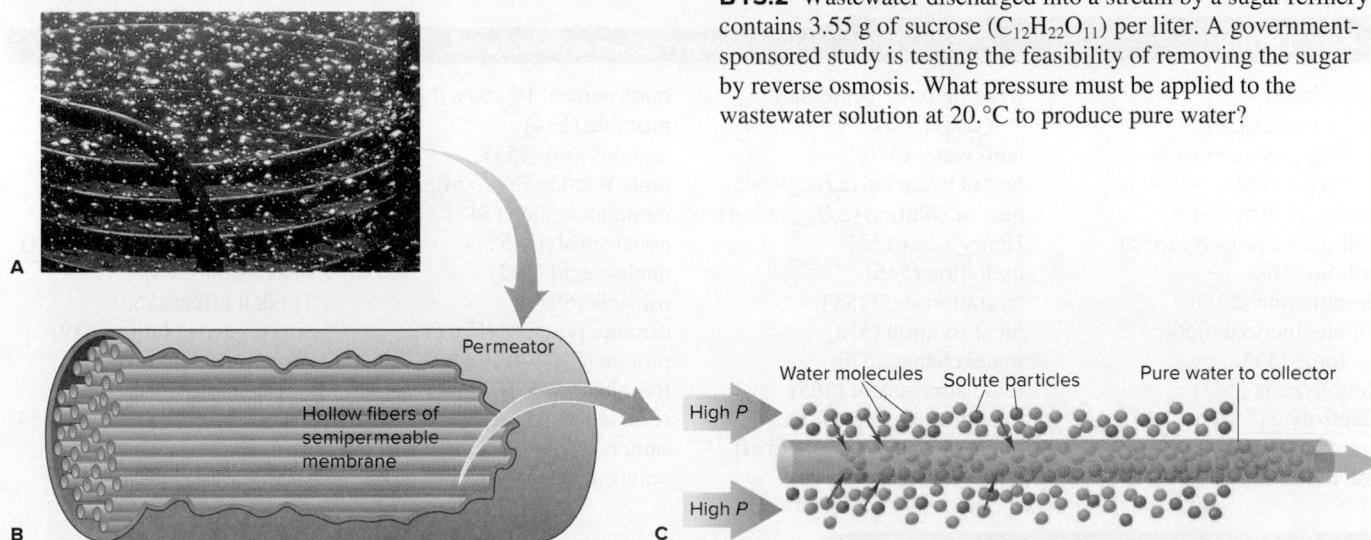

Figure B13.3 Reverse osmosis to remove ions. **A**, Part of a reverse-osmosis permeator. **B**, Each permeator contains a bundle of hollow fibers of semipermeable membrane. **C**, Pumping seawater at high pressure removes ions, and purer water enters the fibers and is collected.

Source: (A) © Robert Essel/Corbis.

Wastewater Treatment

Wastewater, used domestic or industrial water, is treated in several ways before being returned to a natural source:

- In *primary* treatment, the water enters a settling basin to remove particles.
- In *biological* treatment, bacteria metabolize organic compounds and are then removed by settling.
- In *advanced* treatment, a process is tailored to remove a specific pollutant. For example, ammonia, which causes excessive growth of plants and algae, is removed in two steps:

1. *Nitrification*. Certain bacteria oxidize ammonia (electron donor) with O_2 (electron acceptor) to form nitrate ion:

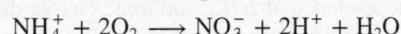

2. *Denitrification*. Other bacteria oxidize an added compound like methanol (CH_3OH) using the NO_3^- :

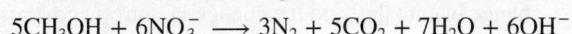

Thus, the process converts NH_3 in wastewater to N_2 , which is released to the atmosphere.

Problems

B13.1 Briefly answer each of the following:

- Why is cake alum [$\text{Al}_2(\text{SO}_4)_3$] added during water purification?
- Why is water that contains large amounts of Ca^{2+} and Mg^{2+} difficult to use for cleaning?
- What is the meaning of “reverse” in reverse osmosis?
- Why might a water treatment plant use ozone as a disinfectant instead of chlorine?
- How does passing a saturated NaCl solution through a “spent” ion-exchange resin regenerate the resin?

B13.2 Wastewater discharged into a stream by a sugar refinery contains 3.55 g of sucrose ($\text{C}_{12}\text{H}_{22}\text{O}_{11}$) per liter. A government-sponsored study is testing the feasibility of removing the sugar by reverse osmosis. What pressure must be applied to the wastewater solution at 20°C to produce pure water?

CHAPTER REVIEW GUIDE

Learning Objectives

Relevant section (§) and/or sample problem (SP) numbers appear in parentheses.

Understand These Concepts

1. The quantitative meaning of solubility (§13.1)
2. The major types of intermolecular forces in solution and their relative strengths (§13.1)
3. How the like-dissolves-like rule depends on intermolecular forces (§13.1)
4. Why gases have relatively low solubilities in water (§13.1)
5. General characteristics of solutions formed by various combinations of gases, liquids, and solids (§13.1)
6. How intermolecular forces stabilize the structures of proteins, the cell membrane, and DNA (§13.2)
7. The enthalpy components of a solution cycle and their effect on ΔH_{soln} (§13.3)
8. The dependence of ΔH_{hydr} on ionic charge density and the factors that determine whether ionic solution processes are exothermic or endothermic (§13.3)
9. The meaning of entropy and how the balance between the change in enthalpy and the change in entropy governs the solution process (§13.3)
10. The distinctions among saturated, unsaturated, and supersaturated solutions, and the equilibrium nature of a saturated solution (§13.4)
11. The relation between temperature and the solubility of solids (§13.4)
12. Why the solubility of gases in water decreases with a rise in temperature (§13.4)
13. The effect of gas pressure on solubility and its quantitative expression as Henry's law (§13.4)
14. The meaning of molarity, molality, mole fraction, and parts by mass or by volume of a solution, and how to convert among them (§13.5)
15. The distinction between electrolytes and nonelectrolytes in solution (§13.6)

16. The four colligative properties and their dependence on number of dissolved particles (§13.6)
17. Ideal solutions and the importance of Raoult's law (§13.6)
18. How the phase diagram of a solution differs from that of the pure solvent (§13.6)
19. Why the vapor over a solution of a volatile nonelectrolyte is richer in the more volatile component (§13.6)
20. Why strong electrolyte solutions are not ideal and the meanings of the van't Hoff factor and ionic atmosphere (§13.6)
21. How particle size distinguishes suspensions, colloids, and solutions (§13.7)
22. How colloidal behavior is demonstrated by the Tyndall effect and Brownian motion (§13.7)

Master These Skills

1. Predicting relative solubilities from intermolecular forces (SP 13.1)
2. Calculating the heat of solution for an ionic compound (SP 13.2)
3. Using Henry's law to calculate the solubility of a gas (SP 13.3)
4. Expressing concentration in terms of molality, parts by mass, parts by volume, and mole fraction (SPs 13.4, 13.5)
5. Interconverting among the various terms for expressing concentration (SP 13.6)
6. Using Raoult's law to calculate the vapor pressure lowering of a solution (SP 13.7)
7. Determining boiling and freezing points of a solution (SP 13.8)
8. Using a colligative property to calculate the molar mass of a solute (SP 13.9)
9. Calculating the composition of vapor over a solution of volatile nonelectrolyte (§13.6)
10. Calculating the van't Hoff factor (*i*) from the magnitude of a colligative property (§13.6)
11. Using a depiction to determine colligative properties (SP 13.10)

Key Terms

Page numbers appear in parentheses.

alloy (538)	freezing point depression (ΔT_f) (561)	mass percent [% (w/w)] (554)	soap (541)
amino acid (539)	hard water (570)	miscible (534)	solubility (S) (534)
boiling point elevation (ΔT_b) (559)	heat of hydration (ΔH_{hydr}) (545)	molality (<i>m</i>) (553)	solute (534)
charge density (545)	heat of solution (ΔH_{soln}) (544)	mole fraction (<i>X</i>) (554)	solvation (545)
colligative property (557)	Henry's law (551)	mononucleotide (543)	solvent (534)
colloid (568)	hydration (545)	nonelectrolyte (557)	supersaturated solution (549)
desalination (571)	hydration shell (534)	nucleic acid (542)	suspension (568)
dipole-induced dipole force (535)	ideal solution (558)	osmosis (562)	Tyndall effect (569)
double helix (543)	ion exchange (570)	osmotic pressure (Π) (562)	unsaturated solution (549)
electrolyte (557)	ionic atmosphere (565)	protein (539)	vapor pressure lowering (ΔP) (558)
entropy (S) (547)	ion-induced dipole force (534)	Raoult's law (558)	volume percent [% (v/v)] (554)
fractional distillation (564)	like-dissolves-like rule (534)	reverse osmosis (571)	wastewater (571)
	lipid bilayer (542)	saturated solution (549)	water softening (570)
		semipermeable membrane (562)	

Key Equations and Relationships

Page numbers appear in parentheses.

13.1 Dividing the general heat of solution into component enthalpies (544):

$$\Delta H_{\text{soln}} = \Delta H_{\text{solute}} + \Delta H_{\text{solvent}} + \Delta H_{\text{mix}}$$

13.2 Dividing the heat of solution of an ionic compound in water into component enthalpies (545):

$$\Delta H_{\text{soln}} = \Delta H_{\text{lattice}} + \Delta H_{\text{hydr}} \text{ of the ions}$$

13.3 Relating gas solubility to its partial pressure (Henry's law) (551):

$$S_{\text{gas}} = k_H \times P_{\text{gas}}$$

13.4 Defining concentration in terms of molarity (552):

$$\text{Molarity } (M) = \frac{\text{amount (mol) of solute}}{\text{volume (L) of solution}}$$

13.5 Defining concentration in terms of molality (553):

$$\text{Molality } (m) = \frac{\text{amount (mol) of solute}}{\text{mass (kg) of solvent}}$$

13.6 Defining concentration in terms of mass percent (554):

$$\text{Mass percent } [\%(\text{w/w})] = \frac{\text{mass of solute}}{\text{mass of solution}} \times 100$$

13.7 Defining concentration in terms of volume percent (554):

$$\text{Volume percent } [\%(\text{v/v})] = \frac{\text{volume of solute}}{\text{volume of solution}} \times 100$$

BRIEF SOLUTIONS TO FOLLOW-UP PROBLEMS

13.1A (a) 1-Butanol has one —OH group/molecule, while 1,4-butanediol has two —OH groups/molecule. 1,4-Butanediol is more soluble in water because it can form more H bonds. (b) Chloroform is more soluble in water because of dipole-dipole forces between the polar CHCl_3 molecules and water. The forces between nonpolar CCl_4 molecules and water are weaker dipole-induced dipole forces, which do not effectively replace H bonds between water molecules.

13.1B (a) Chloroform dissolves more chloromethane due to similar dipole-dipole forces between the polar molecules of these two substances. CH_3Cl molecules do not exhibit H bonding and so do not effectively replace H bonds between methanol molecules. (b) Hexane dissolves more pentanol due to dispersion forces between the hydrocarbon chains in each molecule.

13.2A From Equation 13.2, we have

$$\begin{aligned} \Delta H_{\text{soln}} \text{ of } \text{KNO}_3 &= \Delta H_{\text{lattice}} \text{ of } \text{KNO}_3 \\ &\quad + (\Delta H_{\text{hydr}} \text{ of } \text{K}^+ + \Delta H_{\text{hydr}} \text{ of } \text{NO}_3^-) \\ 34.89 \text{ kJ/mol} &= 685 \text{ kJ/mol} + (\Delta H_{\text{hydr}} \text{ of } \text{K}^+ + \Delta H_{\text{hydr}} \text{ of } \text{NO}_3^-) \\ \Delta H_{\text{hydr}} \text{ of } \text{K}^+ + \Delta H_{\text{hydr}} \text{ of } \text{NO}_3^- &= 34.89 \text{ kJ/mol} - 685 \text{ kJ/mol} \\ &= -650. \text{ kJ/mol} \end{aligned}$$

13.2B From Equation 13.2, we have

$$\begin{aligned} \Delta H_{\text{soln}} \text{ of } \text{NaCN} &= \Delta H_{\text{lattice}} \text{ of } \text{NaCN} \\ &\quad + (\Delta H_{\text{hydr}} \text{ of } \text{Na}^+ + \Delta H_{\text{hydr}} \text{ of } \text{CN}^-) \\ 1.21 \text{ kJ/mol} &= 766 \text{ kJ/mol} + (-410. \text{ kJ/mol} + \Delta H_{\text{hydr}} \text{ of } \text{CN}^-) \\ \Delta H_{\text{hydr}} \text{ of } \text{CN}^- &= 1.21 \text{ kJ/mol} - 766 \text{ kJ/mol} + 410. \text{ kJ/mol} \\ &= -355 \text{ kJ/mol} \end{aligned}$$

13.3A The partial pressure of N_2 in air is the volume percent divided by 100 times the total pressure (Dalton's law, Section 5.4): $P_{\text{N}_2} = 0.78 \times 1 \text{ atm} = 0.78 \text{ atm}$.

$$\begin{aligned} S_{\text{gas}} &= k_H \times P_{\text{gas}} \\ S_{\text{N}_2} &= (7 \times 10^{-4} \text{ mol/L} \cdot \text{atm})(0.78 \text{ atm}) \\ &= 5 \times 10^{-4} \text{ mol/L} \end{aligned}$$

13.8 Defining concentration in terms of mole fraction (554):

Mole fraction (X)

$$= \frac{\text{amount (mol) of solute}}{\text{amount (mol) of solute} + \text{amount (mol) of solvent}}$$

13.9 Expressing the relationship between the vapor pressure of solvent above a solution and its mole fraction in the solution (Raoult's law) (558):

$$P_{\text{solvent}} = X_{\text{solvent}} \times P_{\text{solvent}}^\circ$$

13.10 Calculating the vapor pressure lowering due to solute (558):

$$\Delta P = X_{\text{solute}} \times P_{\text{solvent}}^\circ$$

13.11 Calculating the boiling point elevation of a solution (560):

$$\Delta T_b = K_b m$$

13.12 Calculating the freezing point depression of a solution (561):

$$\Delta T_f = K_f m$$

13.13 Calculating the osmotic pressure of a solution (562):

$$\Pi = \frac{n_{\text{solute}}}{V_{\text{soln}}} RT = MRT$$

13.3B In a mixture of gases, the volume percent of a gas divided by 100 times the total pressure equals the gas's partial pressure (Dalton's law, Section 5.4):

$$P_{\text{gas}} = 0.40 \times 1.2 \text{ atm} = 0.48 \text{ atm}$$

$$k_H = \frac{S_{\text{gas}}}{P_{\text{gas}}} = \frac{1.2 \times 10^{-2} \text{ mol/L}}{0.48 \text{ atm}} = 2.5 \times 10^{-2} \text{ mol/L} \cdot \text{atm}$$

13.4A Convert mass (g) of ethanol to kg, multiply by the molality to obtain amount (mol) of glucose, and then multiply amount (mol) of glucose by the molar mass to obtain mass of glucose.

Amount (mol) of glucose

$$\begin{aligned} &= 563 \text{ g ethanol} \times \frac{1 \text{ kg}}{10^3 \text{ g}} \times \frac{2.40 \times 10^{-2} \text{ mol glucose}}{1 \text{ kg ethanol}} \\ &= 1.35 \times 10^{-2} \text{ mol glucose} \end{aligned}$$

$$\begin{aligned} \text{Mass (g) glucose} &= 1.35 \times 10^{-2} \text{ mol C}_6\text{H}_{12}\text{O}_6 \times \frac{180.16 \text{ g C}_6\text{H}_{12}\text{O}_6}{1 \text{ mol C}_6\text{H}_{12}\text{O}_6} \\ &= 2.43 \text{ g glucose} \end{aligned}$$

13.4B Convert mass (g) of I_2 to amount (mol) and amount (mol) of $(\text{CH}_3\text{CH}_2)_2\text{O}$ to mass (kg). Then divide moles of I_2 by kg of $(\text{CH}_3\text{CH}_2)_2\text{O}$.

$$\begin{aligned} \text{Amount (mol) of I}_2 &= 15.20 \text{ g I}_2 \times \frac{1 \text{ mol I}_2}{253.8 \text{ g I}_2} \\ &= 5.989 \times 10^{-2} \text{ mol I}_2 \end{aligned}$$

Mass (kg) of $(\text{CH}_3\text{CH}_2)_2\text{O}$

$$\begin{aligned} &= 1.33 \text{ mol } (\text{CH}_3\text{CH}_2)_2\text{O} \times \frac{74.12 \text{ g } (\text{CH}_3\text{CH}_2)_2\text{O}}{1 \text{ mol } (\text{CH}_3\text{CH}_2)_2\text{O}} \times \frac{1 \text{ kg}}{10^3 \text{ g}} \\ &= 9.86 \times 10^{-2} \text{ kg } (\text{CH}_3\text{CH}_2)_2\text{O} \end{aligned}$$

$$\text{Molality } (m) = \frac{5.989 \times 10^{-2} \text{ mol}}{9.86 \times 10^{-2} \text{ kg}} = 0.607 \text{ m}$$

BRIEF SOLUTIONS TO FOLLOW-UP PROBLEMS

(continued)

$$\text{13.5A} \text{ Mass \%} = \frac{\text{mass of solute}}{\text{mass of solution}} \times 100$$

$$\text{Mass \% C}_3\text{H}_7\text{OH} = \frac{35.0 \text{ g}}{35.0 \text{ g} + 150. \text{ g}} \times 100 = 18.9 \text{ mass \%}$$

$$\text{Mass \% C}_2\text{H}_5\text{OH} = 100.0 - 18.9 = 81.1 \text{ mass \%}$$

$$X_{\text{C}_3\text{H}_7\text{OH}} = \frac{35.0 \text{ g C}_3\text{H}_7\text{OH} \times \frac{1 \text{ mol C}_3\text{H}_7\text{OH}}{60.09 \text{ g C}_3\text{H}_7\text{OH}}}{\left(35.0 \text{ g C}_3\text{H}_7\text{OH} \times \frac{1 \text{ mol C}_3\text{H}_7\text{OH}}{60.09 \text{ g C}_3\text{H}_7\text{OH}} \right) + \left(150. \text{ g C}_2\text{H}_5\text{OH} \times \frac{1 \text{ mol C}_2\text{H}_5\text{OH}}{46.07 \text{ g C}_2\text{H}_5\text{OH}} \right)} = 0.152$$

$$X_{\text{C}_2\text{H}_5\text{OH}} = 1.000 - 0.152 = 0.848$$

$$\text{13.5B} \text{ Total mass (g)} = 1.87 \text{ g} + 27.4 \text{ g} + 4.10 \text{ g} = 33.4 \text{ g}$$

$$\text{Mass \%} = \frac{\text{mass of solute}}{\text{mass of solution}} \times 100$$

$$\text{Mass \% C}_2\text{H}_5\text{OH} = \frac{1.87 \text{ g}}{33.4 \text{ g}} \times 100 = 5.60\%$$

$$\text{Mass \% C}_8\text{H}_{18} = 82.0\%; \text{ mass \% C}_7\text{H}_{16} = 12.3\%$$

$$\text{Amount (mol) of C}_2\text{H}_5\text{OH} = 1.87 \text{ g C}_2\text{H}_5\text{OH} \times \frac{1 \text{ mol C}_2\text{H}_5\text{OH}}{46.07 \text{ g C}_2\text{H}_5\text{OH}} = 0.0406 \text{ mol C}_2\text{H}_5\text{OH}$$

$$\text{Amount (mol) of C}_8\text{H}_{18} = 0.240 \text{ mol C}_8\text{H}_{18}$$

$$\text{Amount (mol) of C}_7\text{H}_{16} = 0.0409 \text{ mol C}_7\text{H}_{16}$$

$$\text{Total amount (mol)} = 0.0406 \text{ mol} + 0.240 \text{ mol} + 0.0409 \text{ mol} = 0.322 \text{ mol}$$

$$\text{Mole \% C}_2\text{H}_5\text{OH} = \frac{\text{mol C}_2\text{H}_5\text{OH}}{\text{total mol}} \times 100$$

$$\text{Mole \% C}_2\text{H}_5\text{OH} = \frac{0.0406 \text{ mol}}{0.322 \text{ mol}} \times 100 = 12.6\%$$

$$\text{Mole \% C}_8\text{H}_{18} = 74.5\%; \text{ mole \% C}_7\text{H}_{16} = 12.7\%$$

(Slight differences from 100% are due to rounding.)

$$\text{13.6A} \text{ There are 11.8 moles of HCl in 1.00 L of solution:}$$

$$\text{Mass (g) of HCl} = 11.8 \text{ mol HCl} \times \frac{36.46 \text{ g HCl}}{1 \text{ mol HCl}} = 430. \text{ g HCl}$$

$$\text{Mass (g) of soln} = 1 \text{ L soln} \times \frac{10^3 \text{ mL soln}}{1 \text{ L soln}} \times \frac{1.190 \text{ g soln}}{1 \text{ mL soln}} = 1190. \text{ g soln}$$

$$\text{Mass \% HCl} = \frac{\text{mass of HCl}}{\text{mass of soln}} \times 100 = \frac{430. \text{ g}}{1190. \text{ g}} \times 100 = 36.1 \text{ mass \% HCl}$$

$$\text{Mass (kg) of H}_2\text{O} = (1190. \text{ g soln} - 430. \text{ g HCl}) \times \frac{1 \text{ kg}}{1000 \text{ g}} = 0.760 \text{ kg H}_2\text{O}$$

$$\text{Molality of HCl} = \frac{\text{mol HCl}}{\text{kg water}} = \frac{11.8 \text{ mol HCl}}{0.760 \text{ kg H}_2\text{O}} = 15.5 \text{ m HCl}$$

$$\text{Amount (mol) of H}_2\text{O} = 760 \text{ g H}_2\text{O} \times \frac{1 \text{ mol H}_2\text{O}}{18.02 \text{ g H}_2\text{O}} = 42.2 \text{ mol H}_2\text{O}$$

$$X_{\text{HCl}} = \frac{\text{mol HCl}}{\text{mol HCl} + \text{mol H}_2\text{O}} = \frac{11.8 \text{ mol}}{11.8 \text{ mol} + 42.2 \text{ mol}} = 0.219$$

$$\text{13.6B} \text{ There are 5.44 moles of CaBr}_2 \text{ in 1 kg (1000 g) of H}_2\text{O:}$$

$$\text{Mass (g) of CaBr}_2 = 5.44 \text{ mol CaBr}_2 \times \frac{199.88 \text{ g CaBr}_2}{1 \text{ mol CaBr}_2} = 1087 \text{ g CaBr}_2$$

$$\text{Mass (g) of soln} = 1087 \text{ g CaBr}_2 + 1000 \text{ g H}_2\text{O} = 2087 \text{ g soln}$$

$$\text{Mass \% CaBr}_2 = \frac{\text{mass of CaBr}_2}{\text{mass of soln}} \times 100 = \frac{1087 \text{ g}}{2087 \text{ g}} \times 100 = 52.1 \text{ mass \% CaBr}_2$$

$$\text{Volume(L) of soln} = 2087 \text{ g soln} \times \frac{1 \text{ mL soln}}{1.70 \text{ g soln}} \times \frac{1 \text{ L}}{10^3 \text{ mL}} = 1.228 \text{ L soln}$$

$$\text{Molarity (M)} = \frac{\text{amount (mol) CaBr}_2}{\text{L soln}} = \frac{5.44 \text{ mol CaBr}_2}{1.228 \text{ L}} = 4.43 \text{ M}$$

$$\text{Amount (mol) of H}_2\text{O} = 1000 \text{ g H}_2\text{O} \times \frac{1 \text{ mol H}_2\text{O}}{18.02 \text{ g H}_2\text{O}} = 55.5 \text{ mol H}_2\text{O}$$

$$\text{Mole \%} = \frac{\text{amount (mol) CaBr}_2}{\text{amount (mol) CaBr}_2 + \text{amount (mol) H}_2\text{O}} \times 100 = \frac{5.44 \text{ mol CaBr}_2}{5.44 \text{ mol CaBr}_2 + 55.5 \text{ mol H}_2\text{O}} \times 100 = 8.93\%$$

$$\text{13.7A} \text{ Find the mole fraction of aspirin and use Equation 13.10:}$$

$$\text{Amount (mol) of aspirin} = 2.00 \text{ g aspirin} \times \frac{1 \text{ mol aspirin}}{180.15 \text{ g aspirin}} = 0.0111 \text{ mol aspirin}$$

$$\text{Amount (mol) of CH}_3\text{OH} = 50.0 \text{ g CH}_3\text{OH} \times \frac{1 \text{ mol CH}_3\text{OH}}{32.04 \text{ g CH}_3\text{OH}} = 1.56 \text{ mol CH}_3\text{OH}$$

$$X_{\text{aspirin}} = \frac{\text{mol aspirin}}{\text{mol aspirin} + \text{mol CH}_3\text{OH}} = \frac{0.0111 \text{ mol}}{0.0111 \text{ mol} + 1.56 \text{ mol}} = 0.00707$$

$$\Delta P = X_{\text{aspirin}} \times P^\circ_{\text{methanol}} = 0.00707 \times 101 \text{ torr} = 0.714 \text{ torr}$$

13.7B Find mole fraction of ethanol, apply Equation 13.9, and convert kPa to torr:

$$\text{Amount (mol) of menthol} = 6.49 \text{ g menthol} \times \frac{1 \text{ mol menthol}}{156.26 \text{ g menthol}} = 0.0415 \text{ mol menthol}$$

$$\text{Amount (mol) of ethanol} = 25.0 \text{ g ethanol} \times \frac{1 \text{ mol ethanol}}{46.07 \text{ g ethanol}} = 0.543 \text{ mol ethanol}$$

$$X_{\text{ethanol}} = \frac{\text{mol of ethanol}}{\text{mol of ethanol} + \text{mol of menthol}} = \frac{0.543 \text{ mol}}{0.543 \text{ mol} + 0.0415 \text{ mol}} = 0.929$$

$$P_{\text{ethanol}} (\text{kPa}) = X_{\text{ethanol}} \times P_{\text{ethanol}}^{\circ} = 0.929 \times 6.87 \text{ kPa} = 6.38 \text{ kPa}$$

$$P_{\text{ethanol}} (\text{torr}) = 6.38 \text{ kPa} \times \frac{760 \text{ torr}}{101.325 \text{ kPa}} = 47.9 \text{ torr}$$

13.8A Find molality and then apply Equations 13.11 and 13.12:

$$\text{Amount (mol) of } P_4 = 8.44 \text{ g } P_4 \times \frac{1 \text{ mol } P_4}{123.88 \text{ g } P_4} = 0.0681 \text{ mol } P_4$$

$$\text{Molality (m)} = \frac{\text{amount (mol) } P_4}{\text{mass (kg) } CS_2} = \frac{0.0681 \text{ mol } P_4}{60.0 \text{ g } CS_2 \times \frac{1 \text{ kg}}{10^3 \text{ g}}} = 1.14 \text{ m}$$

$$\Delta T_b = K_b m = 2.34^\circ\text{C}/m \times 1.14 \text{ m} = 2.67^\circ\text{C}$$

$$T_{b(\text{solution})} = T_{b(\text{solvent})} + \Delta T_b = 46.2^\circ\text{C} + 2.67^\circ\text{C} = 48.9^\circ\text{C}$$

$$\Delta T_f = K_f m = 3.83^\circ\text{C}/m \times 1.14 \text{ m} = 4.37^\circ\text{C}$$

$$T_{f(\text{solution})} = T_{f(\text{solvent})} - \Delta T_f = -111.5^\circ\text{C} - 4.37^\circ\text{C} = -115.9^\circ\text{C}$$

13.8B Calculate ΔT_f in $^\circ\text{C}$ and use Equation 13.12:

$$\Delta T_f = T_{f(\text{solvent})} - T_{f(\text{solution})} = 32.00^\circ\text{F} - 0.00^\circ\text{F} = 32.00^\circ\text{F} \times \frac{5^\circ\text{C}}{9^\circ\text{F}} = 17.78^\circ\text{C}$$

$$\text{Molality of } C_2H_6O_2 = \frac{\Delta T_f}{K_f} = \frac{17.78^\circ\text{C}}{1.86^\circ\text{C}/m} = 9.56 \text{ m}$$

$$\begin{aligned} \text{Mass of } C_2H_6O_2 &= 4.00 \text{ kg H}_2\text{O} \times \frac{9.56 \text{ mol } C_2H_6O_2}{1 \text{ kg H}_2\text{O}} \\ &\quad \times \frac{62.07 \text{ g } C_2H_6O_2}{1 \text{ mol } C_2H_6O_2} = 2370 \text{ g } C_2H_6O_2 \end{aligned}$$

13.9A Find the molality with Equation 13.13, use V to find the amount (mol), and then use mass to find the molar mass:

$$\begin{aligned} \text{Molarity (M)} &= \frac{\Pi}{RT} = \frac{8.98 \text{ torr} \times \frac{1 \text{ atm}}{760 \text{ torr}}}{\left(0.0821 \frac{\text{atm}\cdot\text{L}}{\text{mol}\cdot\text{K}}\right)(273.15 \text{ K} + 27.0)} \\ &= 4.79 \times 10^{-4} \text{ mol/L} \end{aligned}$$

$$\begin{aligned} \text{Amount (mol)} &= M \times V = 4.79 \times 10^{-4} \text{ mol/L} \times 0.0120 \text{ L} \\ &= 5.75 \times 10^{-6} \text{ mol} \end{aligned}$$

$$\mathcal{M} = \frac{0.200 \text{ g}}{5.75 \times 10^{-6} \text{ mol}} = 3.48 \times 10^4 \text{ g/mol}$$

13.9B Find the molality with Equation 13.12, use the mass of solvent to find the amount (mol) of naphthalene, and then use mass to find the molar mass:

$$\text{Molality} = \frac{\Delta T_f}{K_f} = \frac{5.56^\circ\text{C} - 4.20^\circ\text{C}}{4.90^\circ\text{C}/m} = 0.278 \text{ m}$$

Amount (mol) of naphthalene

$$= 0.200 \text{ kg benzene} \times \frac{0.278 \text{ mol naphthalene}}{1 \text{ kg benzene}} = 0.0556 \text{ mol}$$

$$\mathcal{M} = \frac{7.01 \text{ g}}{0.0556 \text{ mol}} = 126 \text{ g/mol}$$

13.10A (a) Scene B shows separate ions in a $3 K^+/1 PO_4^{3-}$ ratio.

(b) Find the moles of K_3PO_4 and then the molality of the solution; use Equation 13.11 to find the boiling point:

$$\begin{aligned} \text{Amount (mol) of } K_3PO_4 &= 31.2 \text{ g } K_3PO_4 \times \frac{1 \text{ mol } K_3PO_4}{212.27 \text{ g } K_3PO_4} \\ &= 0.147 \text{ mol } K_3PO_4 \end{aligned}$$

$$\text{Molality (m)} = \frac{\text{amount (mol) of } K_3PO_4}{\text{mass (kg) of } H_2O} = \frac{0.147 \text{ mol}}{0.0850 \text{ kg}} = 1.73 \text{ m}$$

$$\text{With } i = 4, \Delta T_b = i K_b m = 4 \times 0.512^\circ\text{C}/m \times 1.73 \text{ m} = 3.54^\circ\text{C}$$

$$T_{b(\text{solution})} = T_{b(\text{solvent})} + \Delta T_b = 100.00^\circ\text{C} + 3.54^\circ\text{C} = 103.54^\circ\text{C}$$

13.10B (a) Find the molarity of the solution and use Equation 13.13; assume $i = 3$:

$$\text{Mass of solution} = 100. \text{ g water} + 0.952 \text{ g } MgCl_2 = 100.952 \text{ g}$$

$$\text{Volume of solution} = 100.952 \text{ g} \times \frac{1 \text{ mL}}{1.006 \text{ g}} \times \frac{1 \text{ L}}{10^3 \text{ mL}} = 0.1003 \text{ L}$$

$$\begin{aligned} \text{Amount (mol) of } MgCl_2 &= 0.952 \text{ g } MgCl_2 \times \frac{1 \text{ mol } MgCl_2}{95.21 \text{ g } MgCl_2} \\ &= 0.0100 \text{ mol } MgCl_2 \end{aligned}$$

$$\text{Molarity} = \frac{0.0100 \text{ mol } MgCl_2}{0.1003 \text{ L soln}} = 9.97 \times 10^{-2} \text{ M}$$

$$\text{Osmotic pressure} (\Pi) = i(MRT)$$

$$= 3(9.97 \times 10^{-2} \text{ mol/L}) \left(0.0821 \frac{\text{atm}\cdot\text{L}}{\text{mol}\cdot\text{K}}\right)(293 \text{ K}) = 7.19 \text{ atm}$$

(b) Scene C. There is net flow of water from the glucose solution into the $MgCl_2$ solution since there are fewer particles of solute in the glucose solution ($i = 1$ for glucose and $i = 3$ for $MgCl_2$).

PROBLEMS

Problems with **colored** numbers are answered in Appendix E and worked in detail in the Student Solutions Manual. Problem sections match those in the text and give the numbers of relevant sample problems. Most offer Concept Review Questions, Skill-Building Exercises (grouped in pairs covering the same concept), and Problems in Context. The Comprehensive Problems are based on material from any section or previous chapter.

Types of Solutions: Intermolecular Forces and Solubility

(Sample Problem 13.1)

Concept Review Questions

13.1 Describe how properties of seawater illustrate the two characteristics that define mixtures.

13.2 What types of intermolecular forces give rise to hydration shells in an aqueous solution of sodium chloride?

13.3 Acetic acid is miscible with water. Would you expect carboxylic acids with the general formula $\text{CH}_3(\text{CH}_2)_n\text{COOH}$ to become more or less water soluble as n increases? Explain.

13.4 Which would you expect to be more effective as a soap, sodium acetate or sodium stearate? Explain.

13.5 Hexane and methanol are miscible as gases but only slightly soluble in each other as liquids. Explain.

13.6 Hydrogen chloride (HCl) gas is much more soluble than propane gas (C_3H_8) in water, even though HCl has a lower boiling point. Explain.

Skill-Building Exercises (grouped in similar pairs)

13.7 Which gives the more concentrated solution, (a) KNO_3 in H_2O or (b) KNO_3 in carbon tetrachloride (CCl_4)? Explain.

13.8 Which gives the more concentrated solution, stearic acid [$\text{CH}_3(\text{CH}_2)_{16}\text{COOH}$] in (a) H_2O or (b) CCl_4 ? Explain.

13.9 What is the strongest type of intermolecular force between solute and solvent in each solution?

(a) $\text{CsCl}(s)$ in $\text{H}_2\text{O}(l)$
(c) $\text{CH}_3\text{OH}(l)$ in $\text{CCl}_4(l)$

13.10 What is the strongest type of intermolecular force between solute and solvent in each solution?

(a) $\text{Cu}(s)$ in $\text{Ag}(s)$
(c) $\text{CH}_3\text{CH}_3(g)$ in $\text{CH}_3\text{CH}_2\text{CH}_2\text{NH}_2(l)$

13.11 What is the strongest type of intermolecular force between solute and solvent in each solution?

(a) $\text{CH}_3\text{OCH}_3(g)$ in $\text{H}_2\text{O}(l)$
(c) $\text{N}_2(g)$ in $\text{C}_4\text{H}_{10}(g)$

13.12 What is the strongest type of intermolecular force between solute and solvent in each solution?

(a) $\text{C}_6\text{H}_{14}(l)$ in $\text{C}_8\text{H}_{18}(l)$
(c) $\text{Br}_2(l)$ in $\text{CCl}_4(l)$

13.13 Which member of each pair is more soluble in diethyl ether? Why?

(a) $\text{NaCl}(s)$ or $\text{HCl}(g)$
(c) $\text{MgBr}_2(s)$ or $\text{CH}_3\text{CH}_2\text{MgBr}(s)$

13.14 Which member of each pair is more soluble in water? Why?

(a) $\text{CH}_3\text{CH}_2\text{OCH}_2\text{CH}_3(l)$ or $\text{CH}_3\text{CH}_2\text{OCH}_3(g)$

(b) $\text{CH}_2\text{Cl}_2(l)$ or $\text{CCl}_4(l)$

Problems in Context

13.15 A dictionary definition of *homogeneous* is “uniform in composition throughout.” River water is a mixture of dissolved compounds, such as calcium bicarbonate, and suspended soil particles. Is river water homogeneous? Explain.

13.16 Gluconic acid is a derivative of glucose used in cleaners and in the dairy and brewing industries. Caproic acid is a carboxylic acid used in the flavoring industry. Although both are six-carbon acids (*see structures below*), gluconic acid is soluble in water and nearly insoluble in hexane, whereas caproic acid has the opposite solubility behavior. Explain.

Intermolecular Forces and Biological Macromolecules

Concept Review Questions

13.17 Name three intermolecular forces that stabilize the shape of a soluble, globular protein, and explain how they act.

13.18 Name three intermolecular forces that stabilize the structure of DNA, and explain how they act.

13.19 How can relatively weak H bonds hold the double helix together yet allow DNA to function?

13.20 Is sodium propanoate (the sodium salt of propanoic acid) as effective a soap as sodium stearate (the sodium salt of stearic acid)? Explain.

13.21 What intermolecular forces stabilize a lipid bilayer?

13.22 In what way do proteins embedded in a membrane differ structurally from soluble proteins?

13.23 Histones are proteins that control gene function by attaching through salt links to exterior regions of DNA. Name an amino acid whose side chain is often found on the exterior of histones.

Why Substances Dissolve: Understanding the Solution Process

(Sample Problem 13.2)

Concept Review Questions

13.24 What is the relationship between solvation and hydration?

13.25 For a general solvent, which enthalpy terms in the thermochemical solution cycle are combined to obtain $\Delta H_{\text{solvation}}$?

13.26 (a) What is the charge density of an ion, and what two properties of an ion affect it?

(b) Arrange the following in order of increasing charge density:

(c) How do the two properties in part (a) affect the ionic heat of hydration, ΔH_{hydr} ?

13.27 For ΔH_{soln} to be very small, what quantities must be nearly equal in magnitude? Will their signs be the same or opposite?

13.28 Water is added to a flask containing solid NH_4Cl . As the salt dissolves, the solution becomes colder.

- (a) Is the dissolving of NH_4Cl exothermic or endothermic?
- (b) Is the magnitude of $\Delta H_{\text{lattice}}$ for NH_4Cl larger or smaller than the combined ΔH_{hydr} values of its ions? Explain.
- (c) Given the answer to part (a), why does NH_4Cl dissolve in water?

13.29 An ionic compound has a highly negative ΔH_{soln} in water. Would you expect it to be very soluble or nearly insoluble in water? Explain in terms of enthalpy and entropy changes.

Skill-Building Exercises (grouped in similar pairs)

13.30 Sketch an enthalpy diagram for the process of dissolving $\text{KCl}(s)$ in H_2O (endothermic).

13.31 Sketch an enthalpy diagram for the process of dissolving $\text{NaI}(s)$ in H_2O (exothermic).

13.32 Which ion in each pair has greater charge density? Explain.

- | | | |
|---------------------------------------|---|--|
| (a) Na^+ or Cs^+ | (b) Sr^{2+} or Rb^+ | (c) Na^+ or Cl^- |
| (d) O^{2-} or F^- | (e) OH^- or SH^- | (f) Mg^{2+} or Ba^{2+} |
| (g) Mg^{2+} or Na^+ | (h) NO_3^- or CO_3^{2-} | |

13.33 Which ion has the lower ratio of charge to volume? Explain.

- | | | |
|--|--|--|
| (a) Br^- or I^- | (b) Sc^{3+} or Ca^{2+} | (c) Br^- or K^+ |
| (d) S^{2-} or Cl^- | (e) Sc^{3+} or Al^{3+} | (f) SO_4^{2-} or ClO_4^- |
| (g) Fe^{3+} or Fe^{2+} | (h) Ca^{2+} or K^+ | |

13.34 Which ion of each pair in Problem 13.32 has the *larger* ΔH_{hydr} ?

13.35 Which ion of each pair in Problem 13.33 has the *smaller* ΔH_{hydr} ?

13.36 (a) Use the following data to calculate the combined heat of hydration for the ions in potassium bromate (KBrO_3):

$$\Delta H_{\text{lattice}} = 745 \text{ kJ/mol} \quad \Delta H_{\text{soln}} = 41.1 \text{ kJ/mol}$$

(b) Which ion contributes more to the answer for part (a)? Why?

13.37 (a) Use the following data to calculate the combined heat of hydration for the ions in sodium acetate ($\text{NaC}_2\text{H}_3\text{O}_2$):

$$\Delta H_{\text{lattice}} = 763 \text{ kJ/mol} \quad \Delta H_{\text{soln}} = 17.3 \text{ kJ/mol}$$

(b) Which ion contributes more to the answer for part (a)? Why?

13.38 State whether the entropy of the system increases or decreases in each of the following processes:

- (a) Gasoline burns in a car engine.
- (b) Gold is extracted and purified from its ore.
- (c) Ethanol ($\text{CH}_3\text{CH}_2\text{OH}$) dissolves in 1-propanol ($\text{CH}_3\text{CH}_2\text{CH}_2\text{OH}$).

13.39 State whether the entropy of the system increases or decreases in each of the following processes:

- (a) Pure gases are mixed to prepare an anesthetic.
- (b) Electronic-grade silicon is prepared from sand.
- (c) Dry ice (solid CO_2) sublimes.

Problems in Context

13.40 Besides being used in black-and-white film, silver nitrate (AgNO_3) is used similarly in forensic science. The NaCl left behind in the sweat of a fingerprint is treated with AgNO_3 solution to form AgCl . This precipitate is developed to show the black-and-white fingerprint pattern. Given that $\Delta H_{\text{lattice}} = 822 \text{ kJ/mol}$ and $\Delta H_{\text{hydr}} = -799 \text{ kJ/mol}$ for AgNO_3 , calculate its ΔH_{soln} .

Solubility as an Equilibrium Process

(Sample Problem 13.3)

Concept Review Questions

13.41 You are given a bottle of solid X and three aqueous solutions of X—one saturated, one unsaturated, and one supersaturated. How would you determine which solution is which?

13.42 Potassium permanganate (KMnO_4) has a solubility of $6.4 \text{ g}/100 \text{ g}$ of H_2O at 20°C and a curve of solubility vs. temperature that slopes upward to the right. How would you prepare a supersaturated solution of KMnO_4 ?

13.43 Why does the solubility of any gas in water decrease with rising temperature?

Skill-Building Exercises (grouped in similar pairs)

13.44 For a saturated aqueous solution of each of the following at 20°C and 1 atm, will the solubility increase, decrease, or stay the same when the indicated change occurs?

- (a) $\text{O}_2(g)$, increase P
- (b) $\text{N}_2(g)$, increase V

13.45 For a saturated aqueous solution of each of the following at 20°C and 1 atm, will the solubility increase, decrease, or stay the same when the indicated change occurs?

- (a) $\text{He}(g)$, decrease T
- (b) $\text{RbI}(s)$, increase P

13.46 The Henry's law constant (k_H) for O_2 in water at 20°C is $1.28 \times 10^{-3} \text{ mol/L} \cdot \text{atm}$.

(a) How many grams of O_2 will dissolve in 2.50 L of H_2O that is in contact with pure O_2 at 1.00 atm?

(b) How many grams of O_2 will dissolve in 2.50 L of H_2O that is in contact with air, where the partial pressure of O_2 is 0.209 atm?

13.47 Argon makes up 0.93% by volume of air. Calculate its solubility (mol/L) in water at 20°C and 1.0 atm. The Henry's law constant for Ar under these conditions is $1.5 \times 10^{-3} \text{ mol/L} \cdot \text{atm}$.

Problems in Context

13.48 Caffeine is about 10 times as soluble in hot water as in cold water. A chemist puts a hot-water extract of caffeine into an ice bath, and some caffeine crystallizes. Is the remaining solution saturated, unsaturated, or supersaturated?

13.49 The partial pressure of CO_2 gas above the liquid in a bottle of champagne at 20°C is 5.5 atm. What is the solubility of CO_2 in champagne? Assume Henry's law constant is the same for champagne as for water: at 20°C , $k_H = 3.7 \times 10^{-2} \text{ mol/L} \cdot \text{atm}$.

13.50 Respiratory problems are treated with devices that deliver air with a higher partial pressure of O_2 than normal air. Why?

Concentration Terms

(Sample Problems 13.4 to 13.6)

Concept Review Questions

13.51 Explain the difference between molarity and molality. Under what circumstances would molality be a more accurate measure of the concentration of a prepared solution than molarity? Why?

13.52 Which way of expressing concentration includes (a) volume of solution; (b) mass of solution; (c) mass of solvent?

13.53 A solute has a solubility in water of 21 g/kg water. Is this value the same as 21 g/kg solution? Explain.

13.54 You want to convert among molarity, molality, and mole fraction of a solution. You know the masses of solute and solvent and the volume of solution. Is this enough information to carry out all the conversions? Explain.

13.55 When a solution is heated, which ways of expressing concentration change in value? Which remain unchanged? Explain.

Skill-Building Exercises (grouped in similar pairs)

13.56 Calculate the molarity of each aqueous solution:

- (a) 32.3 g of table sugar ($\text{C}_{12}\text{H}_{22}\text{O}_{11}$) in 100. mL of solution
- (b) 5.80 g of LiNO_3 in 505 mL of solution

13.57 Calculate the molality of each aqueous solution:

- (a) 0.82 g of ethanol ($\text{C}_2\text{H}_5\text{OH}$) in 10.5 mL of solution
- (b) 1.27 g of gaseous NH_3 in 33.5 mL of solution

13.58 Calculate the molarity of each aqueous solution:

- (a) 78.0 mL of 0.240 M NaOH diluted to 0.250 L with water
- (b) 38.5 mL of 1.2 M HNO_3 diluted to 0.130 L with water

13.59 Calculate the molarity of each aqueous solution:

- (a) 25.5 mL of 6.25 M HCl diluted to 0.500 L with water
- (b) 8.25 mL of 2.00×10^{-2} M KI diluted to 12.0 mL with water

13.60 How would you prepare the following aqueous solutions?

- (a) $365 \text{ mL of } 8.55 \times 10^{-2} \text{ M } \text{KH}_2\text{PO}_4$ from solid KH_2PO_4
- (b) 465 mL of 0.335 M NaOH from 1.25 M NaOH

13.61 How would you prepare the following aqueous solutions?

- (a) 2.5 L of 0.65 M NaCl from solid NaCl
- (b) 15.5 L of 0.3 M urea [$(\text{NH}_2)_2\text{C}=\text{O}$] from 2.1 M urea

13.62 How would you prepare the following aqueous solutions?

- (a) 1.40 L of 0.288 M KBr from solid KBr
- (b) 255 mL of 0.0856 M LiNO_3 from 0.264 M LiNO_3

13.63 How would you prepare the following aqueous solutions?

- (a) 57.5 mL of 1.53×10^{-3} M $\text{Cr}(\text{NO}_3)_3$ from solid $\text{Cr}(\text{NO}_3)_3$
- (b) $5.8 \times 10^3 \text{ m}^3$ of 1.45 M NH_4NO_3 from 2.50 M NH_4NO_3

13.64 Calculate the molality of the following:

- (a) A solution containing 85.4 g of glycine ($\text{NH}_2\text{CH}_2\text{COOH}$) dissolved in 1.270 kg of H_2O
- (b) A solution containing 8.59 g of glycerol ($\text{C}_3\text{H}_8\text{O}_3$) in 77.0 g of ethanol ($\text{C}_2\text{H}_5\text{OH}$)

13.65 Calculate the molality of the following:

- (a) A solution containing 174 g of HCl in 757 g of H_2O
- (b) A solution containing 16.5 g of naphthalene (C_{10}H_8) in 53.3 g of benzene (C_6H_6)

13.66 What is the molality of a solution consisting of 44.0 mL of benzene (C_6H_6 ; $d = 0.877 \text{ g/mL}$) in 167 mL of hexane (C_6H_{14} ; $d = 0.660 \text{ g/mL}$)?

13.67 What is the molality of a solution consisting of 2.66 mL of carbon tetrachloride (CCl_4 ; $d = 1.59 \text{ g/mL}$) in 76.5 mL of methylene chloride (CH_2Cl_2 ; $d = 1.33 \text{ g/mL}$)?

13.68 How would you prepare the following aqueous solutions?

- (a) $3.10 \times 10^2 \text{ g of } 0.125 \text{ M ethylene glycol (C}_2\text{H}_6\text{O}_2\text{)}$ from ethylene glycol and water
- (b) 1.20 kg of 2.20 mass % HNO_3 from 52.0 mass % HNO_3

13.69 How would you prepare the following aqueous solutions?

- (a) 1.50 kg of 0.0355 M ethanol ($\text{C}_2\text{H}_5\text{OH}$) from ethanol and water
- (b) 445 g of 13.0 mass % HCl from 34.1 mass % HCl

13.70 A solution contains 0.35 mol of isopropanol ($\text{C}_3\text{H}_7\text{OH}$) dissolved in 0.85 mol of water.

- (a) What is the mole fraction of isopropanol?
- (b) The mass percent?
- (c) The molality?

13.71 A solution contains 0.100 mol of NaCl dissolved in 8.60 mol of water.

- (a) What is the mole fraction of NaCl ?
- (b) The mass percent?
- (c) The molality?

13.72 What mass of cesium bromide must be added to 0.500 L of water ($d = 1.00 \text{ g/mL}$) to produce a 0.400 M solution? What are the mole fraction and the mass percent of CsBr ?

13.73 What are the mole fraction and the mass percent of a solution made by dissolving 0.30 g of KI in 0.400 L of water ($d = 1.00 \text{ g/mL}$)?

13.74 Calculate the molality, molarity, and mole fraction of NH_3 in ordinary household ammonia, which is an 8.00 mass % aqueous solution ($d = 0.9651 \text{ g/mL}$).

13.75 Calculate the molality, molarity, and mole fraction of FeCl_3 in a 28.8 mass % aqueous solution ($d = 1.280 \text{ g/mL}$).

Problems in Context

13.76 Wastewater from a cement factory contains 0.25 g of Ca^{2+} ions and 0.056 g of Mg^{2+} ions per 100.0 L of solution. The solution density is 1.001 g/mL. Calculate the Ca^{2+} and Mg^{2+} concentrations in ppm (by mass).

13.77 An automobile antifreeze mixture is made by mixing equal volumes of ethylene glycol ($d = 1.114 \text{ g/mL}$; $M = 62.07 \text{ g/mol}$) and water ($d = 1.00 \text{ g/mL}$) at 20°C. The density of the mixture is 1.070 g/mL. Express the concentration of ethylene glycol as:

- (a) Volume percent
- (b) Mass percent
- (c) Molarity
- (d) Molality
- (e) Mole fraction

Colligative Properties of Solutions

(Sample Problems 13.7 to 13.10)

Concept Review Questions

13.78 The chemical formula of a solute does *not* affect the extent of the solution's colligative properties. What characteristic of a solute *does* affect these properties? Name a physical property of a solution that *is* affected by the chemical formula of the solute.

13.79 What is a nonvolatile nonelectrolyte? Why is using this type of solute the simplest way to demonstrate colligative properties?

13.80 In what sense is a strong electrolyte "strong"? What property of a substance makes it a strong electrolyte?

13.81 Express Raoult's law in words. Is Raoult's law valid for a solution of a volatile solute? Explain.

13.82 What are the most important differences between the phase diagram of a pure solvent and the phase diagram of a solution of that solvent?

13.83 Is the composition of the vapor at the top of a fractionating column different from the composition at the bottom? Explain.

13.84 Is the boiling point of 0.01 m KF(aq) higher or lower than that of $0.01\text{ m glucose(aq)}$? Explain.

13.85 Which aqueous solution has a boiling point closer to its predicted value, 0.050 m NaF or 0.50 m KCl ? Explain.

13.86 Which aqueous solution has a freezing point closer to its predicted value, 0.01 m NaBr or 0.01 m MgCl_2 ? Explain.

13.87 The freezing point depression constants of the solvents cyclohexane and naphthalene are $20.1^\circ\text{C}/\text{m}$ and $6.94^\circ\text{C}/\text{m}$, respectively. Which solvent would give a more accurate result if you are using freezing point depression to determine the molar mass of a substance that is soluble in either one? Why?

Skill-Building Exercises (grouped in similar pairs)

13.88 Classify each substance as a strong electrolyte, weak electrolyte, or nonelectrolyte:

- | | |
|---|--|
| (a) Hydrogen chloride (HCl) | (b) Potassium nitrate (KNO_3) |
| (c) Glucose ($\text{C}_6\text{H}_{12}\text{O}_6$) | (d) Ammonia (NH_3) |

13.89 Classify each substance as a strong electrolyte, weak electrolyte, or nonelectrolyte:

- | |
|---|
| (a) Sodium permanganate (NaMnO_4) |
| (b) Acetic acid (CH_3COOH) |
| (c) Methanol (CH_3OH) |
| (d) Calcium acetate [$\text{Ca}(\text{C}_2\text{H}_3\text{O}_2)_2$] |

13.90 How many moles of solute particles are present in 1 L of each of the following aqueous solutions?

- | | |
|-------------------------------|--|
| (a) 0.3 M KBr | (b) 0.065 M HNO_3 |
| (c) 10^{-4} M KHSO_4 | (d) $0.06\text{ M ethanol (C}_2\text{H}_5\text{OH)}$ |

13.91 How many moles of solute particles are present in 1 mL of each of the following aqueous solutions?

- | | |
|--|---|
| (a) 0.02 M CuSO_4 | (b) 0.004 M Ba(OH)_2 |
| (c) $0.08\text{ M pyridine (C}_5\text{H}_5\text{N)}$ | (d) $0.05\text{ M (NH}_4)_2\text{CO}_3$ |

13.92 Which solution has the lower freezing point?

- (a) 11.0 g of CH_3OH in 100. g of H_2O or
22.0 g of $\text{CH}_3\text{CH}_2\text{OH}$ in 200. g of H_2O
(b) 20.0 g of H_2O in 1.00 kg of CH_3OH or
20.0 g of $\text{CH}_3\text{CH}_2\text{OH}$ in 1.00 kg of CH_3OH

13.93 Which solution has the higher boiling point?

- (a) 38.0 g of $\text{C}_3\text{H}_8\text{O}_3$ in 250. g of ethanol or
38.0 g of $\text{C}_2\text{H}_6\text{O}_2$ in 250. g of ethanol
(b) 15 g of $\text{C}_2\text{H}_6\text{O}_2$ in 0.50 kg of H_2O or
15 g of NaCl in 0.50 kg of H_2O

13.94 Rank the following aqueous solutions in order of increasing (a) osmotic pressure; (b) boiling point; (c) freezing point; (d) vapor pressure at 50°C :

- | |
|-------------------------------|
| (I) 0.100 m NaNO_3 |
| (II) 0.100 m glucose |
| (III) 0.100 m CaCl_2 |

13.95 Rank the following aqueous solutions in order of decreasing (a) osmotic pressure; (b) boiling point; (c) freezing point; (d) vapor pressure at 298 K :

- | |
|--|
| (I) $0.04\text{ m urea }[(\text{NH}_2)_2\text{C=O}]$ |
| (II) 0.01 m AgNO_3 |
| (III) 0.03 m CuSO_4 |

13.96 Calculate the vapor pressure of a solution of 34.0 g of glycerol ($\text{C}_3\text{H}_8\text{O}_3$) in 500.0 g of water at 25°C . The vapor pressure of water at 25°C is 23.76 torr. (Assume ideal behavior.)

13.97 Calculate the vapor pressure of a solution of 0.39 mol of cholesterol in 5.4 mol of toluene at 32°C . Pure toluene has a vapor pressure of 41 torr at 32°C . (Assume ideal behavior.)

13.98 What is the freezing point of 0.251 m urea in water?

13.99 What is the boiling point of 0.200 m lactose in water?

13.100 The boiling point of ethanol ($\text{C}_2\text{H}_5\text{OH}$) is 78.5°C . What is the boiling point of a solution of 6.4 g of vanillin ($M = 152.14\text{ g/mol}$) in 50.0 g of ethanol (K_b of ethanol = $1.22^\circ\text{C}/\text{m}$)?

13.101 The freezing point of benzene is 5.5°C . What is the freezing point of a solution of 5.00 g of naphthalene (C_{10}H_8) in 444 g of benzene (K_f of benzene = $4.90^\circ\text{C}/\text{m}$)?

13.102 What is the minimum mass of ethylene glycol ($\text{C}_2\text{H}_6\text{O}_2$) that must be dissolved in 14.5 kg of water to prevent the solution from freezing at -12.0°F ? (Assume ideal behavior.)

13.103 What is the minimum mass of glycerol ($\text{C}_3\text{H}_8\text{O}_3$) that must be dissolved in 11.0 mg of water to prevent the solution from freezing at -15°C ? (Assume ideal behavior.)

13.104 A small protein has a molar mass of $1.50 \times 10^4\text{ g/mol}$. What is the osmotic pressure exerted at 24.0°C by 25.0 mL of an aqueous solution that contains 37.5 mg of the protein?

13.105 At 37°C , 0.30 M sucrose has about the same osmotic pressure as blood. What is the osmotic pressure of blood?

13.106 A solution made by dissolving 31.7 g of an unknown compound in 150. g of water freezes at -1.15°C . What is the molar mass of the compound?

13.107 A 125-mL sample of an aqueous solution of the protein ovalbumin from chicken egg white contains 1.31 g of the dissolved protein and has an osmotic pressure of 4.32 torr at 25°C . What is the molar mass of ovalbumin?

13.108 Assuming ideal behavior, find the freezing point of a solution made by dissolving 13.2 g of ammonium phosphate in 45.0 g of water.

13.109 Assuming ideal behavior, find the boiling point of a solution made by dissolving 32.8 g of calcium nitrate in 108 g of water.

13.110 Calculate the molality and van't Hoff factor (i) for the following aqueous solutions:

- (a) 1.00 mass % NaCl , freezing point = -0.593°C
(b) 0.500 mass % CH_3COOH , freezing point = -0.159°C

13.111 Calculate the molality and van't Hoff factor (i) for the following aqueous solutions:

- (a) 0.500 mass % KCl , freezing point = -0.234°C
(b) 1.00 mass % H_2SO_4 , freezing point = -0.423°C

Problems in Context

13.112 In a study designed to prepare new gasoline-resistant coatings, a polymer chemist dissolves 6.053 g of poly(vinyl alcohol) in enough water to make 100.0 mL of solution. At 25°C, the osmotic pressure of this solution is 0.272 atm. What is the molar mass of the polymer sample?

13.113 The U.S. Food and Drug Administration lists dichloromethane (CH_2Cl_2) and carbon tetrachloride (CCl_4) among the many cancer-causing chlorinated organic compounds. What are the partial pressures of these substances in the vapor above a solution of 1.60 mol of CH_2Cl_2 and 1.10 mol of CCl_4 at 23.5°C ? The vapor pressures of pure CH_2Cl_2 and CCl_4 at 23.5°C are 352 torr and 118 torr, respectively. (Assume ideal behavior.)

The Structure and Properties of Colloids

Concept Review Questions

13.114 Is the fluid inside a bacterial cell considered a solution, a colloid, or both? Explain.

13.115 What type of colloid is each of the following?

- (a) Milk (b) Fog (c) Shaving cream

13.116 What is Brownian motion, and what causes it?

13.117 In a movie theater, you can see the beam of projected light. What phenomenon does this exemplify? Why does it occur?

13.118 Why don't soap micelles coagulate and form large globules? Is soap more effective in freshwater or in seawater? Why?

Comprehensive Problems

13.119 The three aqueous ionic solutions represented below have total volumes of 25. mL for A, 50. mL for B, and 100. mL for C. If each sphere represents 0.010 mol of ions, calculate:

- (a) the total molarity of ions for each solution;
(b) the highest molarity of solute;
(c) the lowest molality of solute (assuming the solution densities are equal);
(d) the highest osmotic pressure (assuming ideal behavior).

13.120 An aqueous solution is 10% glucose by mass ($d = 1.039 \text{ g/mL}$ at 20°C). Calculate its freezing point, boiling point at 1 atm, and osmotic pressure.

13.121 Because zinc has nearly the same atomic radius as copper ($d = 8.95 \text{ g/cm}^3$), zinc atoms substitute for some copper atoms in the many types of brass. Calculate the density of the brass with (a) 10.0 atom % Zn and (b) 38.0 atom % Zn.

13.122 Gold occurs in seawater at an average concentration of 1.1×10^{-2} ppb. How many liters of seawater must be processed to recover 1 troy ounce of gold, assuming 81.5% efficiency (d of seawater = 1.025 g/mL; 1 troy ounce = 31.1 g)?

13.123 Use atomic properties to explain why xenon is 11 times as soluble as helium in water at 0°C on a mole basis.

13.124 Which of the following best represents a molecular-scale view of an ionic compound in aqueous solution? Explain.

13.125 Four 0.50 m aqueous solutions are depicted below. Assume that the solutions behave ideally.

- (a) Which has the highest boiling point?
 (b) Which has the lowest freezing point?
 (c) Can you determine which one has the highest osmotic pressure? Explain.

13.126 Thermal pollution from industrial wastewater causes the temperature of river or lake water to rise, which can affect fish survival as the concentration of dissolved O₂ decreases. Use the following data to find the molarity of O₂ at each temperature (assume the solution density is the same as water).

Temperature (°C)	Solubility of O ₂ (mg/kg H ₂ O)	Density of H ₂ O (g/mL)
0.0	14.5	0.99987
20.0	9.07	0.99823
40.0	6.44	0.99224

13.127 Pyridine (right) is an essential portion of many biologically active compounds, such as nicotine and vitamin B₆. Like ammonia, it has a nitrogen with a lone pair, which makes it act as a weak base. Because it is miscible in a wide range of solvents, from water to benzene, pyridine is one of the most important bases and solvents in organic syntheses. Account for its solubility behavior in terms of intermolecular forces.

13.128 A chemist is studying small organic compounds to evaluate their potential for use as an antifreeze. When 0.243 g of a compound is dissolved in 25.0 mL of water, the freezing point of the solution is -0.201°C .

- (a) Calculate the molar mass of the compound (d of water = 1.00 g/mL).
(b) Analysis shows that the compound is 53.31 mass % C and 11.18 mass % H, the remainder being O. Determine the empirical and molecular formulas of the compound.
(c) Draw a Lewis structure for a compound with this formula that forms H bonds and another for one that does not.

13.129 Air in a smoky bar contains 4.0×10^{-6} mol/L of CO. What mass of CO is inhaled by a bartender who breathes at a rate of 11 L/min during an 8.0-h shift?

13.130 Is 50% by mass of methanol dissolved in ethanol different from 50% by mass of ethanol dissolved in methanol? Explain.

13.131 Three gaseous mixtures of N₂ (blue), Cl₂ (green), and Ne (purple) are depicted below.

- Which has the smallest mole fraction of N₂?
- Which have the same mole fraction of Ne?
- Rank all three in order of increasing mole fraction of Cl₂.

13.132 A water treatment plant needs to attain a fluoride concentration of 4.50×10^{-5} M in the drinking water it produces.

- What mass of NaF must be added to 5000. L of water in a blending tank?
- What mass per day of fluoride is ingested by a person who drinks 2.0 L of this water?

13.133 Four U tubes each have distilled water in the right arm, a solution in the left arm, and a semipermeable membrane between the arms.

- If the solute is KCl, which solution is most concentrated?
- If each solute is different but all the solutions have the same molarity, which contains the smallest number of dissolved ions?

13.134 β-Pinene (C₁₀H₁₆) and α-terpineol (C₁₀H₁₈O) are used in cosmetics to provide a “fresh pine” scent. At 367 K, the pure substances have vapor pressures of 100.3 torr and 9.8 torr, respectively. What is the composition of the vapor (in terms of mole fractions) above a solution containing equal masses of these compounds at 367 K? (Assume ideal behavior.)

13.135 A solution of 1.50 g of solute dissolved in 25.0 mL of H₂O at 25°C has a boiling point of 100.45°C.

- What is the molar mass of the solute if it is a nonvolatile nonelectrolyte and the solution behaves ideally (d of H₂O at 25°C = 0.997 g/mL)?
- Conductivity measurements show that the solute is ionic with general formula AB₂ or A₂B. What is the molar mass if the solution behaves ideally?
- Analysis indicates that the solute has an empirical formula of CaN₂O₆. Explain the difference between the actual formula mass and that calculated from the boiling point elevation.
- Find the van't Hoff factor (i) for this solution.

13.136 A pharmaceutical preparation made with ethanol (C₂H₅OH) is contaminated with methanol (CH₃OH). A sample of vapor above the liquid mixture contains a 97/1 mass ratio of C₂H₅OH to CH₃OH. What is the mass ratio of these alcohols in the liquid mixture? At the temperature of the liquid mixture, the vapor pressures of C₂H₅OH and CH₃OH are 60.5 torr and 126.0 torr, respectively.

13.137 Water treatment plants commonly use chlorination to destroy bacteria. A byproduct is chloroform (CHCl₃), a suspected carcinogen, produced when HOCl, formed by reaction of Cl₂ and water, reacts with dissolved organic matter. The United States, Canada, and the World Health Organization have set a limit of 100. ppb of CHCl₃ in drinking water. Convert this concentration into molarity, molality, mole fraction, and mass percent.

13.138 A saturated Na₂CO₃ solution is prepared, and a small excess of solid is present (white pile in beaker). A seed crystal of Na₂¹⁴CO₃ (¹⁴C is a radioactive isotope of ¹²C) is added (small red piece), and the radioactivity is measured over time.

- Would you expect radioactivity in the solution? Explain.
- Would you expect radioactivity in all the solid or just in the seed crystal? Explain.

13.139 A biochemical engineer isolates a bacterial gene fragment and dissolves a 10.0-mg sample in enough water to make 30.0 mL of solution. The osmotic pressure of the solution is 0.340 torr at 25°C.

- What is the molar mass of the gene fragment?
- If the solution density is 0.997 g/mL, how large is the freezing point depression for this solution (K_f of water = 1.86°C/m)?

13.140 A river is contaminated with 0.65 mg/L of dichloroethylene (C₂H₂Cl₂). What is the concentration (in ng/L) of dichloroethylene at 21°C in the air breathed by a person swimming in the river (k_H for C₂H₂Cl₂ in water is 0.033 mol/L·atm)?

13.141 At an air-water interface, fatty acids such as oleic acid lie in a one-molecule-thick layer (a monolayer), with the heads in the water and the tails perpendicular in the air. When 2.50 mg of oleic acid is placed on a water surface, it forms a circular monolayer 38.6 cm in diameter. Find the surface area (in cm²) occupied by one molecule (M of oleic acid = 283 g/mol).

13.142 A simple device used for estimating the concentration of total dissolved solids in an aqueous solution works by measuring the electrical conductivity of the solution. The method assumes that equal concentrations of different solids give approximately the same conductivity, and that the conductivity is proportional to concentration. The table below gives some actual electrical conductivities (in arbitrary units) for solutions of selected solids at the indicated concentrations (in ppm by mass):

Sample	Conductivity		
	0 ppm	5.00×10^3 ppm	10.00×10^3 ppm
CaCl ₂	0.0	8.0	16.0
K ₂ CO ₃	0.0	7.0	14.0
Na ₂ SO ₄	0.0	6.0	11.0
Seawater (dilute)	0.0	8.0	15.0
Sucrose (C ₁₂ H ₂₂ O ₁₁)	0.0	0.0	0.0
Urea [(NH ₂) ₂ C=O]	0.0	0.0	0.0

- How reliable are these measurements for estimating concentrations of dissolved solids?
- For what types of substances might this method have a large error? Why?
- Based on this method, an aqueous CaCl₂ solution has a conductivity of 14.0 units. Calculate its mole fraction and molality.

13.143 Two beakers are placed in a closed container (*left*). One beaker contains water, the other a concentrated aqueous sugar solution. With time, the solution volume increases and the water volume decreases (*right*). Explain on the molecular level.

13.144 The release of volatile organic compounds into the atmosphere is regulated to limit ozone formation. In a laboratory simulation, 5% of the ethanol in a liquid detergent is released. Thus, a “down-the-drain” factor of 0.05 is used to estimate ethanol emissions from the detergent. The k_H values for ethanol and 2-butoxyethanol ($C_4H_9OCH_2CH_2OH$) are 5×10^{-6} atm \cdot m 3 /mol and 1.6×10^{-6} atm \cdot m 3 /mol, respectively.

(a) Estimate a “down-the-drain” factor for 2-butoxyethanol in the detergent.

(b) What is the k_H for ethanol in units of L \cdot atm/mol?

(c) Is the value found in part (b) consistent with a value given as 0.64 Pa \cdot m 3 /mol?

13.145 Although other solvents are available, dichloromethane (CH_2Cl_2) is still often used to “decaffeinate” drinks because the solubility of caffeine in CH_2Cl_2 is 8.35 times that in water.

(a) A 100.0-mL sample of cola containing 10.0 mg of caffeine is extracted with 60.0 mL of CH_2Cl_2 . What mass of caffeine remains in the aqueous phase?

(b) A second identical cola sample is extracted with two successive 30.0-mL portions of CH_2Cl_2 . What mass of caffeine remains in the aqueous phase after each extraction?

(c) Which approach extracts more caffeine?

13.146 How would you prepare 250. g of 0.150 *M* aqueous $NaHCO_3$?

13.147 Tartaric acid occurs in crystalline residues found in wine vats. It is used in baking powders and as an additive in foods. It contains 32.3% by mass carbon and 3.97% by mass hydrogen; the balance is oxygen. When 0.981 g of tartaric acid is dissolved in 11.23 g of water, the solution freezes at $-1.26^\circ C$. Find the empirical and molecular formulas of tartaric acid.

13.148 Methanol (CH_3OH) and ethanol (C_2H_5OH) are miscible because the major intermolecular force for each is H bonding. In some methanol-ethanol solutions, the mole fraction of methanol is higher, but the mass percent of ethanol is higher. What is the range of mole fraction of methanol for these solutions?

13.149 A solution of 5.0 g of benzoic acid (C_6H_5COOH) in 100.0 g of carbon tetrachloride has a boiling point of 77.5°C.

(a) Calculate the molar mass of benzoic acid in the solution.

(b) Suggest a reason for the difference between the molar mass based on the formula and that found in part (a). (*Hint:* Consider intermolecular forces in this compound.)

13.150 Derive a general equation that expresses the relationship between the molarity and the molality of a solution. Why are the numerical values of these two terms approximately equal for very dilute aqueous solutions?

13.151 A florist prepares a solution of nitrogen-phosphorus fertilizer by dissolving 5.66 g of NH_4NO_3 and 4.42 g of $(NH_4)_3PO_4$ in enough water to make 20.0 L of solution. What are the molarities of NH_4^+ and of PO_4^{3-} in the solution?

13.152 Suppose coal-fired power plants used water in scrubbers to remove SO_2 from smokestack gases (see Chemical Connections, Section 6.6).

(a) If the partial pressure of SO_2 in the stack gases is 2.0×10^{-3} atm, what is the solubility of SO_2 in the scrubber liquid (k_H for SO_2 in water is 1.23 mol/L \cdot atm at $200.^\circ C$)?

(b) From your answer to part (a), why are basic solutions, such as limewater slurries [$Ca(OH)_2$], used in scrubbers?

13.153 Urea is a white crystalline solid used as a fertilizer, in the pharmaceutical industry, and in the manufacture of certain polymer resins. Analysis of urea reveals that, by mass, it is 20.1% carbon, 6.7% hydrogen, 46.5% nitrogen, and the balance oxygen.

(a) Find the empirical formula of urea.

(b) A 5.0 g/L solution of urea in water has an osmotic pressure of 2.04 atm, measured at $25^\circ C$. What are the molar mass and molecular formula of urea?

13.154 The total concentration of dissolved particles in blood is 0.30 *M*. An intravenous (IV) solution must be isotonic with blood, which means it must have the same concentration.

(a) To relieve dehydration, a patient is given 100. mL/h of IV glucose ($C_6H_{12}O_6$) for 2.5 h. What mass (g) of glucose did she receive?

(b) If isotonic saline ($NaCl$) is used, what is the molarity of the solution?

(c) If the patient is given 150. mL/h of IV saline for 1.5 h, how many grams of $NaCl$ did she receive?

13.155 Deviations from Raoult’s law lead to the formation of *azeotropes*, constant boiling mixtures that cannot be separated by distillation, making industrial separations difficult. For components A and B, there is a positive deviation if the A-B attraction is less than A-A and B-B attractions (A and B reject each other), and a negative deviation if the A-B attraction is greater than A-A and B-B attractions. If the A-B attraction is nearly equal to the A-A and B-B attractions, the solution obeys Raoult’s law. Explain whether the behavior of each pair of components will be nearly ideal, show a positive deviation, or show a negative deviation:

(a) Benzene (C_6H_6) and methanol

(b) Water and ethyl acetate

(c) Hexane and heptane

(d) Methanol and water

(e) Water and hydrochloric acid

13.156 Acrylic acid ($CH_2=CHCOOH$) is a monomer used to make superabsorbent polymers and various compounds for paint and adhesive production. At 1 atm, it boils at $141.5^\circ C$ but is prone to polymerization. Its vapor pressure at $25^\circ C$ is 4.1 mbar. What pressure (in mmHg) is needed to distill the pure acid at $65^\circ C$?

13.157 To effectively stop polymerization, certain inhibitors require the presence of a small amount of O_2 . At equilibrium with 1 atm of air, the concentration of O_2 dissolved in the monomer acrylic acid ($CH_2=CHCOOH$) is 1.64×10^{-3} *M*.

(a) What is k_H (mol/L \cdot atm) for O_2 in acrylic acid?

(b) If 0.005 atm of O_2 is sufficient to stop polymerization, what is the molarity of O_2 ?

(c) What is the mole fraction?

(d) What is the concentration in ppm? (Pure acrylic acid is 14.6 *M*; P_{O_2} in air is 0.2095 atm.)

13.158 Volatile organic solvents have been implicated in adverse health effects observed in industrial workers. Greener methods are phasing these solvents out. Rank the solvents in Table 13.6 in terms of increasing volatility.

13.159 At ordinary temperatures, water is a poor solvent for organic substances. But at high pressure and above 200°C, water develops many properties of organic solvents. Find the minimum pressure needed to maintain water as a liquid at 200°C ($\Delta H_{\text{vap}} = 40.7 \text{ kJ/mol}$ at 100°C and 1.00 atm; assume that this value remains constant with temperature).

13.160 In ice-cream making, the ingredients are kept below 0.0°C in an ice-salt bath.

(a) Assuming that NaCl dissolves completely and forms an ideal solution, what mass of it is needed to lower the melting point of 5.5 kg of ice to -5.0°C?

(b) Given the same assumptions as in part (a), what mass of CaCl₂ is needed?

13.161 Perfluorocarbons (PFCs), hydrocarbons with all H atoms replaced by F atoms, have very weak cohesive forces. One interesting consequence of this property is that a live mouse can breathe while submerged in O₂-saturated PFCs.

(a) At 298 K, perfluorohexane (C₆F₁₄, $M = 338 \text{ g/mol}$ and $d = 1.674 \text{ g/mL}$) in equilibrium with 101,325 Pa of O₂ has a mole fraction of O₂ of 4.28×10^{-3} . What is k_H in mol/L·atm?

(b) According to one source, k_H for O₂ in water at 25°C is 756.7 L·atm/mol. What is the solubility of O₂ in water at 25°C in ppm?

(c) Rank in descending order the k_H for O₂ in water, ethanol, C₆F₁₄, and C₆H₁₄. Explain your ranking.

13.162 The solubility of N₂ in blood is a serious problem for divers breathing compressed air (78% N₂ by volume) at depths greater than 50 ft.

(a) What is the molarity of N₂ in blood at 1.00 atm?

(b) What is the molarity of N₂ in blood at a depth of 50. ft?

(c) Find the volume (in mL) of N₂, measured at 25°C and 1.00 atm, released per liter of blood when a diver at a depth of 50. ft rises to the surface (k_H for N₂ in water at 25°C is $7.0 \times 10^{-4} \text{ mol/L}\cdot\text{atm}$ and at 37°C is $6.2 \times 10^{-4} \text{ mol/L}\cdot\text{atm}$; assume d of water is 1.00 g/mL).

13.163 Figure 12.11 shows the phase changes of pure water. Consider how the diagram would change if air were present at 1 atm and dissolved in the water.

(a) Would the three phases of water still attain equilibrium at some temperature? Explain.

(b) In principle, would that temperature be higher, lower, or the same as the triple point for pure water? Explain.

(c) Would ice sublime at a few degrees below the freezing point under this pressure? Explain.

(d) Would the liquid have the same vapor pressure as that shown in Figure 12.7 at 100°C? At 120°C?

13.164 KNO₃, KClO₃, KCl, and NaCl are recrystallized as follows:

Step 1. A saturated aqueous solution of the compound is prepared at 50°C.

Step 2. The mixture is filtered to remove undissolved compound.

Step 3. The filtrate is cooled to 0°C.

Step 4. The crystals that form are filtered, dried, and weighed.

(a) Which compound has the highest percent recovery and which the lowest (see Figure 13.19)?

(b) Starting with 100. g of each compound, how many grams of each can be recovered?

13.165 Eighty proof whiskey is 40% ethanol (C₂H₅OH) by volume. A man has 7.0 L of blood and drinks 28 mL of the whiskey, of which 22% of the ethanol goes into his blood.

(a) What concentration (in g/mL) of ethanol is in his blood (d of ethanol = 0.789 g/mL)?

(b) What volume (in mL) of whiskey would raise his blood alcohol level to $8.0 \times 10^{-4} \text{ g/mL}$, the level at which a person is considered intoxicated?

13.166 Soft drinks are canned under 4 atm of CO₂ and release CO₂ when the can is opened.

(a) How many moles of CO₂ are dissolved in 355 mL of soda in a can before it is opened?

(b) After the soda has gone flat?

(c) What volume (in L) would the released CO₂ occupy at 1.00 atm and 25°C (k_H for CO₂ at 25°C is $3.3 \times 10^{-2} \text{ mol/L}\cdot\text{atm}$; P_{CO_2} in air is $4 \times 10^{-4} \text{ atm}$)?

13.167 Gaseous O₂ in equilibrium with O₂ dissolved in water at 283 K is depicted at right.

(a) Which scene below represents the system at 298 K?

(b) Which scene represents the system when the pressure of O₂ is increased by half?

A

B

C

14

Periodic Patterns in the Main-Group Elements

14.1 Hydrogen, the Simplest Atom

Where Hydrogen Fits in the Periodic Table
Highlights of Hydrogen Chemistry

14.2 Trends Across the Periodic Table: The Period 2 Elements

14.3 Group 1A(1): The Alkali Metals

Why the Alkali Metals Are Unusual Physically
Why the Alkali Metals Are So Reactive

14.4 Group 2A(2): The Alkaline Earth Metals

How the Alkaline Earth and Alkali Metals Compare Physically
How the Alkaline Earth and Alkali Metals Compare Chemically
Diagonal Relationships: Lithium and Magnesium

14.5 Group 3A(13): The Boron Family

How Transition Elements Influence This Group's Properties

Features That First Appear in This Group's Chemical Properties

Highlights of Boron Chemistry
Diagonal Relationships: Beryllium and Aluminum

14.6 Group 4A(14): The Carbon Family

How Type of Bonding Affects Physical Properties
How Bonding Changes in This Group's Compounds
Highlights of Carbon Chemistry
Highlights of Silicon Chemistry
Diagonal Relationships: Boron and Silicon

14.7 Group 5A(15): The Nitrogen Family

The Wide Range of Physical Behavior
Patterns in Chemical Behavior
Highlights of Nitrogen Chemistry
Highlights of Phosphorus Chemistry

14.8 Group 6A(16): The Oxygen Family

How the Oxygen and Nitrogen Families Compare Physically
How the Oxygen and Nitrogen Families Compare Chemically
Highlights of Oxygen Chemistry
Highlights of Sulfur Chemistry

14.9 Group 7A(17): The Halogens

Physical Behavior of the Halogens
Why the Halogens Are So Reactive
Highlights of Halogen Chemistry

14.10 Group 8A(18): The Noble Gases

How the Noble Gases and Alkali Metals Contrast Physically
How Noble Gases Can Form Compounds

Concepts and Skills to Review Before You Study This Chapter

- › acids, bases, and salts (Section 4.4)
- › redox behavior and oxidation states (Section 4.5)
- › electron configurations (Section 8.2)
- › trends in atomic size, ionization energy, metallic behavior, and electronegativity (Sections 8.3, 8.4, and 9.5)
- › trends in element properties and type of bonding (Sections 8.4 and 9.5)
- › models of ionic, covalent, and metallic bonding (Sections 9.2, 9.3, 9.6, and 12.6)
- › resonance and formal charge (Section 10.1)
- › molecular shape and polarity (Sections 10.2 and 10.3)
- › orbital hybridization and modes of orbital overlap (Sections 11.1 and 11.2)
- › phase changes and phase diagrams, intermolecular forces, and crystalline solids (Sections 12.2, 12.3, and 12.6)

Recurring patterns appear throughout nature, helping us make sense of the diversity in the world around us. Physical patterns we observe in animals and plants give rise to systems of biological classification; patterns within our bodies, such as heartbeats, allow us to monitor health and disease; and astronomical patterns allow us to predict phases of the Moon, eclipses, and comet appearances. For example, astronomers know from studying the periodic pattern of its orbit that Halley's Comet (*see photo*), last seen in 1986, will appear next in 2061. As you'll see in the upcoming discussions, patterns also appear in the atomic, chemical, and physical properties of the elements, which help us make sense of their behavior.

IN THIS CHAPTER . . . We apply general ideas of bonding, structure, and reactivity (from Chapters 7–12) to the main-group elements and see how their behavior correlates with their position in the periodic table.

- › We begin with hydrogen, the simplest element, considering its position in the periodic table and examining the three types of hydrides.
- › We then survey Period 2 as an example of the general changes in chemical and physical properties from left to right *across* the periodic table.
- › We go on to discuss each of the eight families of main-group elements by exploring vertical trends in physical and chemical properties. In the process, we highlight some of the most important elements—boron, carbon, silicon, nitrogen, phosphorus, oxygen, sulfur, and the halogens.

14.1 HYDROGEN, THE SIMPLEST ATOM

A hydrogen atom consists of a nucleus with a single positive charge, surrounded by a single electron. Perhaps because of this simple structure, hydrogen may be the most important element of all. In the Sun, hydrogen (H) nuclei combine to form helium (He) nuclei in a process that provides nearly all Earth's energy. About 90% of all the atoms in the universe are H atoms, so it is the most abundant element by far. On Earth, only tiny amounts of the free, diatomic element occur naturally, but hydrogen is abundant in combination with oxygen in water. With a simple structure and low molar mass, nonpolar H₂ is a colorless, odorless gas with extremely weak dispersion forces that result in very low melting (−259°C) and boiling points (−253°C).

Where Hydrogen Fits in the Periodic Table

Hydrogen has no perfectly suitable position in the periodic table (Figure 14.1). Depending on the property, hydrogen may fit better in Group 1A(1), 4A(14), or 7A(17):

- Like the Group 1A(1) elements, hydrogen has an outer electron configuration of ns^1 and most commonly a +1 oxidation state. However, unlike the alkali metals, hydrogen shares its single valence electron with nonmetals rather than transferring it to them.

	1A	2A	3A	4A	5A	6A	7A	8A	
(1)	(2)	(13)	(14)	(15)	(16)	(17)	(18)		
1	H			H		H			
2									
3									
4									
5									
6									
7									

Figure 14.1 Where does hydrogen belong?

Moreover, hydrogen has a much higher ionization energy (IE = 1311 kJ/mol) and electronegativity (EN = 2.1) than any of the alkali metals. By comparison, lithium has an IE of only 520 kJ/mol and an EN of 1.0, the highest of the alkali metals.

- *Like the Group 4A(14) elements*, hydrogen's valence level is half-filled, but with only one electron, and it has an ionization energy, electron affinity, electronegativity, and bond energy similar to the values for Group 4A(14).
- *Like the Group 7A(17) elements*, hydrogen occurs as diatomic molecules and fills its outer level either by electron sharing or by gaining one electron from a metal to form a 1⁻ ion (hydride, H⁻). However, while the monatomic halide ions (X⁻) are common and stable, H⁻ is rare and reactive. Moreover, hydrogen has a lower electronegativity (EN = 2.1) than any of the halogens (whose ENs range from 4.0 to 2.2), and it lacks their three valence electron pairs.

Hydrogen's unique behavior arises from its tiny size. It has a high IE because its electron is very close to the nucleus, with no inner electrons to shield it from the positive charge. And it has a low EN (for a nonmetal) because it has only one proton to attract bonding electrons. In this chapter, H will be discussed as part of either Group 1A(1) or 7A(17) depending on the property being considered.

Highlights of Hydrogen Chemistry

In Chapters 12 and 13, we discussed the vital importance of H bonding, and in Chapter 22, we'll look at hydrogen's many uses in industry. Elemental hydrogen is very reactive and combines with nearly every other element. It forms three types of hydrides—ionic, covalent, and metallic.

Ionic (Saltlike) Hydrides With very reactive metals, such as those in Group 1A(1) and the larger members of Group 2A(2) (Ca, Sr, and Ba), hydrogen forms *saltlike hydrides*—white, crystalline solids composed of the metal cation and the hydride ion:

In water, H⁻ is a strong base that pulls H⁺ from surrounding H₂O molecules to form H₂ and OH⁻:

The hydride ion is also a powerful reducing agent; for example, it reduces Ti(IV) to the free metal:

Covalent (Molecular) Hydrides Hydrogen reacts with nonmetals to form many *covalent hydrides*, such as CH₄, PH₃, H₂S, and HCl. Most are gases, but many hydrides of boron and carbon are liquids or solids that consist of much larger molecules. In most covalent hydrides, hydrogen has an oxidation number of +1 because the other nonmetal has a higher electronegativity.

Conditions for preparing the covalent hydrides depend on the reactivity of the other nonmetal. For example, with stable, triple-bonded N₂, hydrogen reacts at high temperatures (~400°C) and pressures (~250 atm), and the reaction needs a catalyst to proceed at any practical speed:

Industrial facilities throughout the world use this reaction to produce millions of tons of ammonia each year for fertilizers, explosives, and synthetic fibers. On the other hand, hydrogen combines rapidly with reactive, single-bonded F₂, even at extremely low temperatures (~196°C):

Metallic (Interstitial) Hydrides Many transition elements form *metallic (interstitial) hydrides*, in which H₂ molecules (and H atoms) occupy the holes in the metal's crystal structure (Figure 14.2). Thus, such hydrides are *not* compounds but gas-solid solutions.

Figure 14.2 A metallic (interstitial) hydride.

Also, unlike ionic and covalent hydrides, interstitial hydrides, such as $\text{TiH}_{1.7}$, typically do not have a specific stoichiometric formula because the metal can incorporate variable amounts of hydrogen, depending on the pressure and temperature. Metallic hydrides cannot serve as “storage containers” for hydrogen fuel in cars; the metals that store the most hydrogen are expensive and heavy and release hydrogen only at very high temperatures. But other systems, including carbon nanotubes, are being studied for this role.

14.2 TRENDS ACROSS THE PERIODIC TABLE: THE PERIOD 2 ELEMENTS

Table 14.1 on pages 588–589 presents the main horizontal trends in atomic properties and the physical and chemical properties that emerge from them for the Period 2 elements, lithium through neon. In general, *these trends apply to the other periods as well*. Note the following points:

- Electrons fill the one ns and the three np orbitals according to Pauli’s exclusion principle and Hund’s rule.
- As a result of increasing nuclear charge and the addition of electrons to orbitals of the same energy level (same n value), atomic size generally decreases, whereas first ionization energy and electronegativity generally increase (see bar graphs).
- Metallic character decreases with increasing nuclear charge as elements change from metals to metalloids to nonmetals.
- Reactivity is highest at the left and right ends of the period, except for the inert noble gas, because members of Groups 1A(1) and 7A(17) are only one electron away from attaining a filled outer level.
- Bonding between atoms of an element changes from metallic, to covalent in networks, to covalent in individual molecules, to none (noble gases exist as separate atoms). As expected, physical properties, such as melting point, change abruptly at the network/molecule boundary, which occurs between carbon (solid) and nitrogen (gas).
- Bonding between each element and an active nonmetal changes from ionic, to polar covalent, to covalent. Bonding between each element and an active metal changes from metallic to polar covalent to ionic (see Figure 9.2).
- The acid-base behavior of the common element oxide in water changes from basic to amphoteric to acidic as the bond between the element and oxygen changes from ionic to covalent (see the similar trend for the Period 3 elements in Figure 8.24).
- Reducing strength decreases through the metals, and oxidizing strength increases through the nonmetals. In Period 2, oxidation numbers (O.N.s) equal the A-group number for Li and Be and the A-group number minus 8 for O and F. Boron has several O.N.s, Ne has none, and C and N show all the O.N.s that are possible for their groups.

The Anomalous Behavior of Period 2 Members One point that is not made in Table 14.1 is the *anomalous (unrepresentative) behavior specific for the Period 2 elements within their groups*. This behavior arises from the relatively *small atomic size* of these elements and the *small number of orbitals* in their outer energy level.

1. *Anomalous properties of lithium.* In Group 1A(1), Li is the only member that forms a simple oxide and nitride, Li_2O and Li_3N , on reaction with O_2 and N_2 in air and the only member that forms molecular compounds with organic halides:

Because of its small size, Li^+ has a relatively high charge density. Therefore, it can deform nearby electron clouds to a much greater extent than the other Group 1A(1) ions can, which increases orbital overlap and gives many lithium salts significant covalent character. Thus, LiCl , LiBr , and LiI are much more soluble in polar organic solvents, such as ethanol and acetone, than are the halides of Na and K, because the bond polarity of a lithium halide allows it to interact with these solvents through

Table 14.1

Trends in Atomic, Physical, and Chemical Properties of the Period 2 Elements

Group: Element/Atomic No.:	1A(1) Lithium (Li) Z = 3	2A(2) Beryllium (Be) Z = 4	3A(13) Boron (B) Z = 5	4A(14) Carbon (C) Z = 6
Atomic Properties				
Condensed electron configuration; partial orbital diagram	[He] 2s ¹ 	[He] 2s ² 	[He] 2s ² 2p ¹ 	[He] 2s ² 2p ²
Physical Properties				
Appearance				
Metallic character	Metal	Metal	Metalloid	Nonmetal
Hardness	Soft	Hard	Very hard	Graphite: soft Diamond: extremely hard
Melting point/ boiling point	Low mp for a metal	High mp	Extremely high mp	Extremely high mp
Chemical Properties				
General reactivity	Reactive	Low reactivity at room temperature	Low reactivity at room temperature	Low reactivity at room temperature; graphite more reactive
Bonding among atoms of element	Metallic	Metallic	Network covalent	Network covalent
Bonding with nonmetals	Ionic	Polar covalent	Polar covalent	Covalent (π bonds common)
Bonding with metals	Metallic	Metallic	Polar covalent	Polar covalent
Acid-base behavior of common oxide	Strongly basic	Amphoteric	Very weakly acidic	Very weakly acidic
Redox behavior (O.N.)	Strong reducing agent (+1)	Moderately strong reducing agent (+2)	Complex hydrides good reducing agents (+3, -3)	Every oxidation state from +4 to -4
Relevance/Uses of Element and Compounds				
Li soaps for auto grease; thermonuclear bombs; high-voltage, low-weight batteries; treatment of bipolar disorders (Li_2CO_3)	Rocket nose cones; alloys for springs and gears; nuclear reactor parts; x-ray tubes	Cleaning agent (borax); eyewash, antiseptic (boric acid); armor (B_4C); borosilicate glass; plant nutrient	Graphite: lubricant, structural fiber Diamond: jewelry, cutting tools, protective films Limestone (CaCO_3) Organic compounds: drugs, fuels, textiles, biomolecules, etc.	

5A(15)
Nitrogen (N) Z = 7

Nonmetal

Very low mp
and bpInactive at room
temperatureCovalent N₂ moleculesCovalent (π bonds
common)Ionic/polar covalent; anions
with active metalsStrongly acidic (NO₂)Every oxidation state
from +5 to -3Component of proteins,
nucleic acids; ammonia
for fertilizers, explo-
sives; oxides involved
in manufacturing and
air pollution (smog,
acid rain)
6A(16)
Oxygen (O) Z = 8

Nonmetal

Very low mp
and bp

Very reactive

Covalent O₂ (or O₃)
moleculesCovalent (π bonds
common)

Ionic

—

O₂ (and O₃) very
strong oxidizing
agents (-2)Component of biological
macromolecules; final
oxidizer in residential,
industrial, and
biological energy
production
7A(17)
Fluorine (F) Z = 9

Nonmetal

Very low mp
and bp

Extremely reactive

Covalent F₂ molecules

Covalent

Ionic

Acidic

Strongest oxidizing
agent (-1)Manufacture of coatings
(Teflon); glass etching
(HF); refrigerants
involved in ozone
depletion (CFCs);
dental protection
(NaF, SnF₂)
8A(18)
Neon (Ne) Z = 10

Nonmetal

Extremely low mp
and bp

Chemically inert

None; separate atoms

None

None

None

Electrified gas in
advertising signs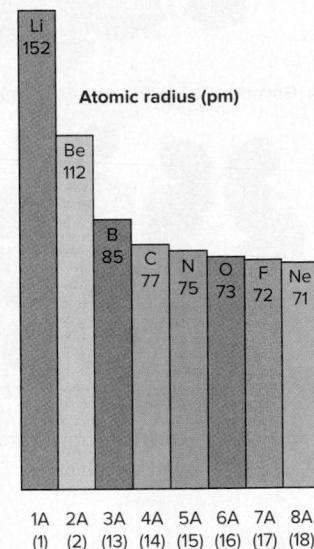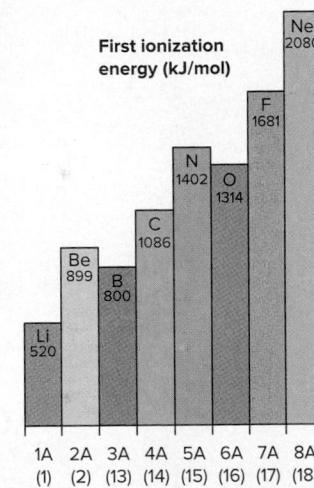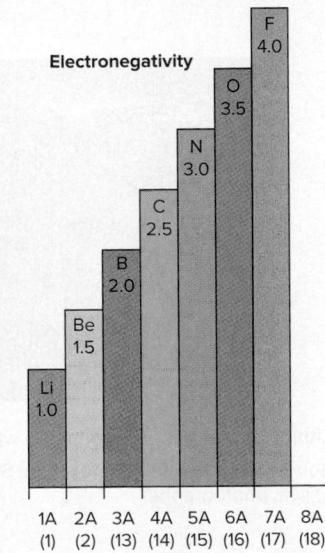

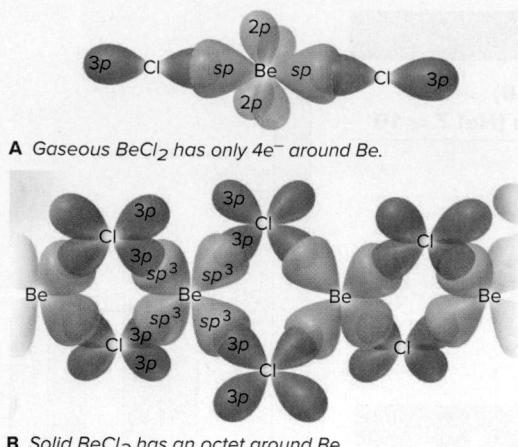

Figure 14.3 Overcoming electron deficiency in beryllium chloride.

dipole-dipole forces. The small, highly positive Li^+ makes Li salts much less soluble in water than those of Na and K.

2. Anomalous properties of beryllium. Because of the extremely high charge density of Be^{2+} , the discrete ion does not exist, and *all Be compounds exhibit covalent bonding*. With only two valence electrons, Be does not attain an octet in its simple gaseous compounds (Section 10.1), but this electron deficiency is overcome as the gas condenses.

Consider beryllium chloride (BeCl_2). At temperatures greater than 900°C , it consists of linear molecules in which two sp hybrid orbitals hold four electrons around the central Be (Figure 14.3A). As the temperature decreases, the molecules bond together, solidifying in long chains with each Cl bridging two Be atoms. Each Be is sp^3 hybridized and has attained an octet (Figure 14.3B).

3. Anomalous properties of other Period 2 elements. Boron is the only member of its group to form complex families of compounds with metals and with hydrogen (boranes). Carbon shows extremely unusual behavior: carbon atoms bond to other carbons (and to a small number of other elements) extensively and diversely, giving rise to countless organic compounds. Triple-bonded, unreactive, gaseous nitrogen is very different from its reactive, solid family members. Oxygen, the only gas in its group, is much more reactive than sulfur and the other members. Fluorine is so electronegative that it reacts violently with water, and it is the only member of its group that forms a weak hydrohalic acid, HF.

14.3 GROUP 1A(1): THE ALKALI METALS

The first group of elements in the periodic table is named for the alkaline (basic) nature of their oxides and for the basic solutions the elements form in water. Group 1A(1) provides the best example of regular trends with no significant exceptions. All the elements in the group—lithium (Li), sodium (Na), potassium (K), rubidium (Rb), cesium (Cs), and rare, radioactive francium (Fr)*—are very reactive metals. The Family Portrait of Group 1A(1) is the first in a series that provides an overview of each of the main groups, summarizing key atomic, physical, and chemical properties.

Why the Alkali Metals Are Unusual Physically

Alkali metals have some properties that are unique for metals:

- They are unusually soft and can be easily cut with a knife. Na has the consistency of cold butter, and K can be squeezed like clay.
- Alkali metals have lower melting and boiling points than any other group of metals. Li is the only member that melts above 100°C , and Cs melts only a few degrees above room temperature.
- They have lower densities than most metals. Li floats on lightweight mineral oil (see photo).

The unusual physical behavior of these metals can be traced to the largest atomic size in their respective periods and to the ns^1 valence electron configuration. Because the single valence electron is relatively far from the nucleus, only weak attractions exist in the solid between the delocalized electrons and the metal-ion cores. Such weak metallic bonding means that the alkali metal crystal structure can be easily deformed or broken down, which results in a soft consistency and low melting point. The low densities of the alkali metals result from their having the lowest molar masses and largest atomic radii (and, thus, volumes) in their periods.

Lithium floating in oil floating on water.

Source: © McGraw-Hill Education. Stephen Frisch, photographer

*Francium is so rare (estimates indicate only 15 g of the element in the top kilometer of Earth's crust) that its properties are largely unknown. Therefore, the discussion of this group mentions it only occasionally.

KEY ATOMIC PROPERTIES, PHYSICAL PROPERTIES, AND REACTIONS

KEY	Atomic No. Symbol Atomic mass Valence e ⁻ configuration (Common oxidation states)
3 Li 6.941 2s ¹ (+1)	
11 Na 22.99 3s ¹ (+1)	
19 K 39.10 4s ¹ (+1)	
37 Rb 85.47 5s ¹ (+1)	
55 Cs 132.9 6s ¹ (+1)	
87 Fr (223) 7s ¹ (+1)	No sample available

Atomic radius (pm)	Ionic radius (pm)
Li 152	Li ⁺ 76
Na 186	Na ⁺ 102
K 227	K ⁺ 138
Rb 248	Rb ⁺ 152
Cs 265	Cs ⁺ 167
Fr (~270)	Fr ⁺ 180

Atomic Properties

Group electron configuration is ns^1 . All members have the +1 oxidation state and form an E⁺ ion. Atoms have the largest size and lowest IE and EN in their periods. Down the group, atomic and ionic size increase, while IE and EN decrease.

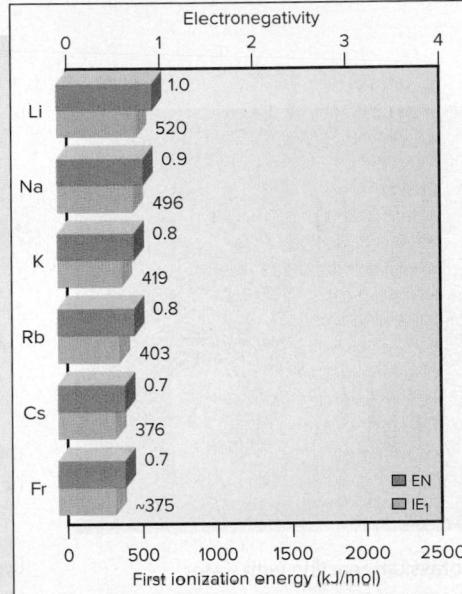

Physical Properties

Metallic bonding is relatively weak because there is only one valence electron. Therefore, these metals are soft with relatively low melting and boiling points. These values decrease down the group because larger atom cores attract delocalized electrons less strongly. Large atomic size and low atomic mass result in low density; thus, density generally increases down the group because mass increases more than size.

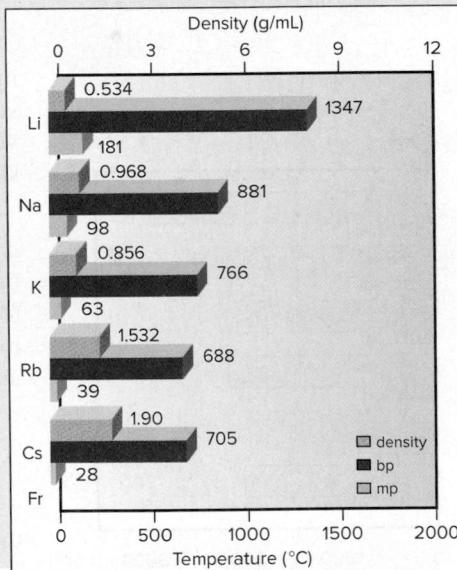

Source: (c) McGraw-Hill Education. Stephen Frisch, photographer

Reactions

1. The alkali metals reduce H in H₂O from the +1 to the 0 oxidation state (E represents any element in the group):

The reaction becomes more vigorous down the group.

2. The alkali metals reduce oxygen, but the product depends on the metal. Li forms the oxide, Li₂O; Na forms the peroxide (O.N. of O = -1), Na₂O₂; K, Rb, and Cs form the superoxide (O.N. of O = -½), EO₂:

In emergency breathing units, KO₂ reacts with H₂O and CO₂ in exhaled air to release O₂ (Section 22.4).

3. The alkali metals reduce hydrogen to form ionic (saltlike) hydrides:

NaH is an industrial base and reducing agent that is used to prepare other reducing agents, such as NaBH₄.

4. The alkali metals reduce halogens to form ionic halides:

Why the Alkali Metals Are So Reactive

The alkali metals are extremely reactive elements. They are *powerful reducing agents*, readily losing an electron and always occurring in nature as 1+ cations rather than as free metals. Some examples of their reactivity follow:

- The alkali metals (E)^{*} reduce halogens to form ionic solids in highly exothermic reactions:

- They reduce hydrogen in water, reacting vigorously (Rb and Cs explosively) to form H_2 and a metal hydroxide solution (see photo):

- They reduce molecular hydrogen to form ionic hydrides:

- They reduce O_2 in air, and thus tarnish rapidly. Because of this reactivity, Na and K are usually kept under mineral oil (an unreactive liquid) in the laboratory, and Rb and Cs are handled with gloves under an inert argon atmosphere.

The ns^1 configuration, which is the basis for the physical properties of the alkali metals, is also the basis of their reactivity, as shown in the steps for the reaction between an alkali metal and a nonmetal:

- Atomization: the solid metal separates into gaseous atoms.* The weak metallic bonding leads to *low values for ΔH_{atom}* (the heat needed to convert the solid into individual gaseous atoms), which decrease down the group:

- Ionization: the metal atom transfers its outer electron to the nonmetal.* Alkali metals have *low ionization energies* (the lowest in their periods) and form *cations with small radii* since a great decrease in size occurs when the outer electron is lost: the volume of the Li^+ is about 13% the volume of Li! Thus, Group 1A(1) ions are small spheres with considerable charge density.

- Lattice formation: the resulting cations and anions attract each other to form an ionic solid.* Group 1A(1) salts have *high lattice energies*, which easily overcome the endothermic atomization and ionization steps, because the small cations lie close to the anions. For a given anion, the trend in lattice energy is the inverse of the trend in cation size: *as cation radius increases, lattice energy decreases.* The Group 1A(1) and 2A(2) chlorides exemplify this steady decrease in lattice energy (Figure 14.4).

Despite these strong ionic attractions in the solid, *nearly all Group 1A(1) salts are water soluble*. The attraction between the ions and water molecules creates a highly exothermic heat of hydration (ΔH_{hydr}), and a large increase in entropy occurs when ions in the organized crystal become dispersed and hydrated in solution; together, these factors outweigh the high lattice energy.

The magnitude of the hydration energy *decreases* as ionic size increases:

Interestingly, the *smaller* ions form larger *hydrated ions*. This size trend is key to the function of nerves, kidneys, and cell membranes because the *sizes* of $Na^+(aq)$ and $K^+(aq)$, the most common cations in cell fluids, influence their movement into and out of cells.

14.4 GROUP 2A(2): THE ALKALINE EARTH METALS

The Group 2A(2) elements are called *alkaline earth metals* because their oxides give basic (alkaline) solutions and melt at such high temperatures that they remained as solids (“earths”) in the alchemists’ fires. The group is a fascinating collection of

*Throughout the chapter, we use E to represent any element in a group other than in Group 7A(17), for which the halogens are represented as X .

Potassium reacting with water.

Source: © McGraw-Hill Education/Stephen Frisch, photographer

Figure 14.4 Lattice energies of the Group 1A(1) and 2A(2) chlorides.

elements: rare beryllium (Be), common magnesium (Mg) and calcium (Ca), less familiar strontium (Sr) and barium (Ba), and radioactive radium (Ra). The Group 2A(2) Family Portrait (*next page*) presents an overview of these elements.

How the Alkaline Earth and Alkali Metals Compare Physically

In general terms, the elements in Groups 1A(1) and 2A(2) behave as close cousins physically, with the differences due to the change in outer electron configuration from ns^1 to ns^2 . Two electrons from each alkaline earth atom and one more proton in each nucleus strengthen metallic bonding. The following changes result:

- Melting and boiling points are much higher for Group 2A(2) elements; in fact, they melt at around the same temperatures as the Group 1A(1) elements boil.
- Compared to many transition metals, the alkaline earths are soft and lightweight, but they are harder and denser than the alkali metals.

How the Alkaline Earth and Alkali Metals Compare Chemically

The second valence electron in an alkaline earth metal lies in the same sublevel as the first and thus it is not shielded very well from the additional nuclear charge, so Z_{eff} is greater. As a result, Group 2A(2) elements have smaller atomic radii and higher ionization energies than Group 1A(1) elements. Despite the higher IEs, *all the alkaline earths (except Be) occur as 2+ cations in ionic compounds.* (As we said, Be behaves anomalously because so much energy is needed to remove two electrons from this tiny atom that it never forms discrete Be^{2+} ions, and so its bonds are polar covalent.)

Some important chemical properties of Group 2A(2) elements are the following:

1. *Reducing strength.* Like the alkali metals, the alkaline earth metals are *strong reducing agents*:

- Each reduces O_2 in air to form the oxide (Ba also forms the peroxide, BaO_2).
- Except for Be and Mg, which form adherent oxide coatings, each reduces H_2O at room temperature to form H_2 .
- Except for Be, each reduces the halogens, N_2 , and H_2 to form ionic compounds.

2. *Basicity of oxides.* The oxides are strongly basic (except for amphoteric BeO) and react with acidic oxides to form salts, such as sulfites and carbonates; for example,

Natural carbonates, such as limestone and marble, are major structural materials and the commercial sources for most alkaline earth compounds. Calcium carbonate is heated to obtain calcium oxide (lime); this important industrial compound has essential roles in steelmaking, water treatment, and smokestack scrubbing and is used to make glass, whiten paper, and neutralize acidic soil.

3. *Lattice energies and solubilities.* Lattice energy plays a role in the reactivity of the Group 2A(2) elements and the solubility of their salts in water:

- The elements are reactive because the high lattice energies of their compounds more than compensate for the large total IE required to form 2+ cations (Section 9.2). Because the cations are smaller and doubly charged, their charge densities and lattice energies are much higher than those for salts of Group 1A(1) (see Figure 14.4).
- High lattice energy also leads to lower solubility of Group 2A(2) salts in water. Higher charge density increases heat of hydration, but it increases lattice energy even more. Thus, unlike the corresponding Group 1A(1) compounds, most Group 2A(2) fluorides, carbonates, phosphates, and sulfates have very low solubility.
- Although solubility is limited for many Group 2A(2) compounds, the ion-dipole attractions between 2+ ions and water molecules are so strong that many slightly soluble salts of these elements crystallize as hydrates; two examples are Epsom salt, $\text{MgSO}_4 \cdot 7\text{H}_2\text{O}$, used as an aqueous soaking solution for treating inflammation, and gypsum, $\text{CaSO}_4 \cdot 2\text{H}_2\text{O}$, used as the bonding material between the paper sheets in wallboard and as the cement in surgical casts.

KEY ATOMIC PROPERTIES, PHYSICAL PROPERTIES, AND REACTIONS

KEY	Atomic No.	Symbol	Atomic mass	Valence e ⁻ configuration (Common oxidation states)
Be	4	Be	9.012	2s ² (+2)
Mg	12	Mg	24.30	3s ² (+2)
Ca	20	Ca	40.08	4s ² (+2)
Sr	38	Sr	87.62	5s ² (+2)
Ba	56	Ba	137.3	6s ² (+2)
Ra	88	Ra	(226)	7s ² (+2)
			No sample available	

	Atomic radius (pm)	Ionic radius (pm)
Be	112	
Mg	160	Mg ²⁺ 72
Ca	197	Ca ²⁺ 100
Sr	215	Sr ²⁺ 118
Ba	222	Ba ²⁺ 135
Ra	(~220)	Ra ²⁺ 148

Atomic Properties

Group electron configuration is ns² (filled ns sublevel). All members have the +2 oxidation state and, except for Be, form compounds with an E²⁺ ion. Atomic and ionic sizes increase down the group but are smaller than for the corresponding 1A(1) elements. IE and EN decrease down the group but are higher than for the corresponding 1A(1) elements.

Physical Properties

Metallic bonding involves two valence electrons. These metals are still relatively soft but are much harder than the 1A(1) metals. Melting and boiling points generally decrease and densities generally increase down the group. These values are much higher than for 1A(1) elements, and the trend is not as regular.

Source: © McGraw-Hill Education/Stephen Frisch, photographer

Reactions

1. The metals reduce O₂ to form the oxides:

Ba also forms the peroxide, BaO₂.

2. The larger metals reduce water to form hydrogen gas:

Be and Mg form an oxide coating that allows only slight reaction.

3. The metals reduce halogens to form ionic halides:

4. Most of the elements reduce hydrogen to form ionic hydrides:

5. The elements reduce nitrogen to form ionic nitrides:

6. Except for amphoteric BeO, the element oxides are basic:

Ca(OH)₂ is a component of cement and mortar.

7. All carbonates undergo thermal decomposition to the oxide:

This reaction is used to produce CaO (lime) in huge amounts from naturally occurring limestone.

Diagonal Relationships: Lithium and Magnesium

One of the clearest ways to see how atomic properties influence chemical behavior is to look at three **diagonal relationships**, similarities between a Period 2 element and one diagonally down and to the right in Period 3.

The first of these occurs between Li and Mg, which have similar atomic and ionic sizes (Figure 14.5). Note that *moving one period down increases atomic (or ionic) size and moving one group to the right decreases it*. The Li radius is 152 pm and that of Mg is 160 pm; the Li^+ radius is 76 pm and that of Mg^{2+} is 72 pm. From similar atomic properties emerge similar chemical properties. Both elements form nitrides with N_2 , hydroxides and carbonates that decompose easily with heat, organic compounds with a polar covalent metal–carbon bond, and salts with similar solubilities. We'll discuss the relationships between Be and Al and between B and Si in upcoming sections.

	1A (1)	2A (2)	3A (13)	4A (14)
2	Li	Be	B	
3		Mg	Al	Si

Figure 14.5 Three diagonal relationships in the periodic table.

14.5 GROUP 3A(13): THE BORON FAMILY

The third family of main-group elements contains both familiar and unusual members, which engage in some exotic bonding and have strange physical properties. Boron (B) heads the family, but, as we said, its properties are not representative. Metallic aluminum (Al) has properties more typical of the group, but its great abundance and importance contrast with the rareness of gallium (Ga), indium (In), thallium (Tl), and recently synthesized nihonium (Nh). The atomic, physical, and chemical properties of these elements are summarized in the Group 3A(13) Family Portrait (*next page*).

How the Transition Elements Influence This Group's Properties

If you look only at the main groups, Group 3A(13), the first of the *p* block, seems to be just one group away from Group 2A(2). In Period 4 and higher, however, 10 transition elements (*d* block) separate these groups (see Figure 8.10). And an additional 14 inner transition elements (*f* block) appear in Periods 6 and 7. Thus, the heavier Group 3A(13) members have nuclei with many more protons, but since *d* and *f* electrons penetrate very little (Section 8.1), the outer (*s* and *p*) electrons of Ga, In, and Tl are poorly shielded from the much higher positive charge. As a result, *these elements have greater Z_{eff} than the two lighter members*, and this stronger nuclear pull explains why Ga, In, and Tl have smaller atomic radii and larger ionization energies and electronegativities than expected. This effect is observed in higher groups, too.

Physical properties are influenced by the type of bonding. Boron is a network covalent metalloid—black, hard, and very high melting. The other group members are metals—shiny and relatively soft and low melting. Aluminum's low density and three valence electrons make it an exceptional conductor: for a given mass, aluminum conducts a current twice as effectively as copper. Gallium's metallic bonding gives it the largest liquid temperature range of any element: it melts at skin temperature (*see photo in the Family Portrait*) but does not boil until 2403°C. The bonding is too weak to keep the Ga atoms fixed when the solid is warmed, but strong enough to keep them from escaping the molten metal until it is very hot.

Features That First Appear in This Group's Chemical Properties

Looking down Group 3A(13), we see a wide range of chemical behavior:

- Boron, the anomalous member from Period 2, is the only metalloid. It is much less reactive at room temperature than the other members and forms covalent bonds exclusively.
- Although aluminum acts like a metal physically, its halides exist in the gas phase as covalent *dimers*—molecules formed by joining two identical smaller molecules (Figure 14.6)—and its oxide is amphoteric rather than basic.
- Most of the other Group 3A(13) compounds are ionic. However, because the cations of this group are smaller and triply charged, they polarize an anion more effectively than do Group 2A(2) cations, and so their compounds are more covalent.

Figure 14.6 The dimeric structure of gaseous aluminum chloride.

KEY ATOMIC PROPERTIES, PHYSICAL PROPERTIES, AND REACTIONS

KEY	Atomic No.	Symbol	Atomic mass	Valence e ⁻ configuration (Common oxidation states)
	5	B	10.81	2s ² 2p ¹ (+3)
	13	Al	26.98	3s ² 3p ¹ (+3)
	31	Ga	69.72	4s ² 4p ¹ (+3, +1)
	49	In	114.8	5s ² 5p ¹ (+3, +1)
	81	Tl	204.4	6s ² 6p ¹ (+1)
	113	Nh	(284)	7s ² 7p ¹

Observed in experiments at Dubna, Russia, in 2003

	Atomic radius (pm)	Ionic radius (pm)
B	85	
Al	143	Al ³⁺ 54
Ga	135	Ga ³⁺ 62
In	167	In ³⁺ 80
Tl	170	Tl ⁺ 150

Atomic Properties

Group electron configuration is ns^2np^1 . All except Tl commonly display the +3 oxidation state. The +1 state becomes more common down the group. Atomic size is smaller and EN is higher than for 2A(2) elements; IE is lower, however, because it is easier to remove an electron from the higher energy p sublevel. Atomic size, IE, and EN do not change as expected down the group because there are intervening transition and inner transition elements.

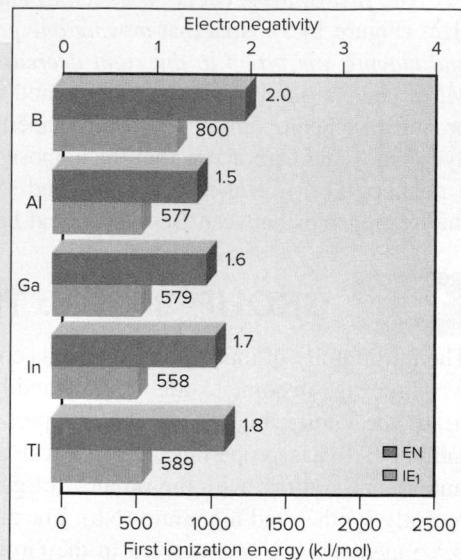

Physical Properties

Bonding changes from network covalent in B to metallic in the rest of the group. Thus, B has a much higher melting point than the others, but there is no overall trend. Boiling points decrease down the group. Densities increase down the group.

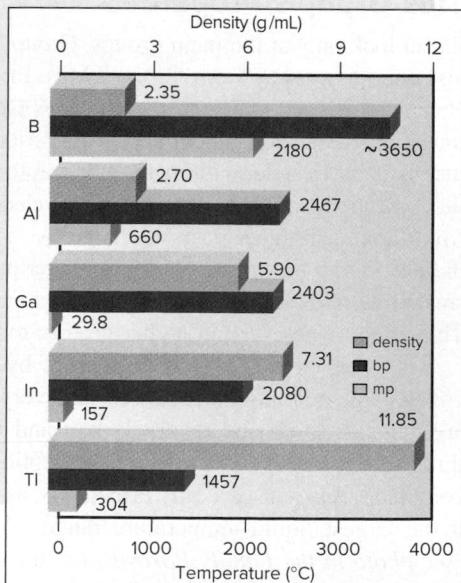

Source: © McGraw-Hill Education/Stephen Frisch, photographer

Reactions

1. The elements react sluggishly, if at all, with water:

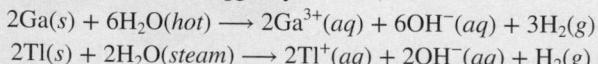

Al becomes covered with a layer of Al_2O_3 that prevents further reaction.

2. When strongly heated in pure O_2 , all members form oxides:

Oxide acidity decreases down the group: B_2O_3 (weakly acidic) > Al_2O_3 > Ga_2O_3 > In_2O_3 > Tl_2O (strongly basic), and the +1 oxide is more basic than the +3 oxide.

3. All members reduce halogens (X_2):

The BX_3 compounds are volatile and covalent. Trihalides of Al, Ga, and In are (mostly) ionic solids.

The redox behavior of Group 3A(13) exhibits three features that appear first here, but occur in Groups 4A(14) to 6A(16) as well:

1. *Presence of multiple oxidation states.* Larger members of these groups also have an important oxidation state of +1, two lower than the A-group number. The lower state occurs when the atoms lose their np electrons only, not their two ns electrons. This fact is often called the *inert-pair effect* (Section 8.4).

2. *Increasing stability of the lower oxidation state.* For these groups, the lower state becomes more stable going down the group. In Group 3A(13), for instance, all members exhibit the +3 state, but the +1 state first appears with some compounds of gallium and becomes the only important state of thallium.

3. *Increasing metallic behavior and basicity of oxides.* In general, oxides of the element in the lower oxidation state are more basic. Thus, for example, in Group 3A(13), In_2O is more basic than In_2O_3 . The reason is that an element acts more like a metal in its lower state. In this example, the lower charge of In^+ does not polarize the O^{2-} ion as much as the higher charge of In^{3+} does, so the In-to-O bonding is more ionic and the O^{2-} ion is more available to act as a base.

Highlights of Boron Chemistry

Like the other Period 2 elements, the chemical behavior of boron is strikingly different from that of the other members of its group. All boron compounds are covalent, and unlike the other Group 3A(13) members, boron forms network covalent compounds or large molecules with metals, H, O, N, and C. The unifying feature of many boron compounds is the element's *electron deficiency*. Boron adopts two strategies to fill its outer level: accepting a bonding pair from an electron-rich atom and forming bridge bonds with an electron-poor atom.

Accepting a Bonding Pair from an Electron-Rich Atom In gaseous boron trihalides (BX_3), the B atom is electron deficient, with only six electrons around it (Section 10.1). To attain an octet, the B atom accepts a lone pair (blue) from an electron-rich atom and forms a covalent bond:

(Reactions in which one reactant accepts an electron pair from another to form a covalent bond are very common and are known as *Lewis acid-base reactions*. We'll discuss them in Chapters 18 and 23 and see examples of them throughout the rest of the text.)

Similarly, B has only six electrons in boric acid, $\text{B}(\text{OH})_3$ (sometimes written as H_3BO_3). In water, the acid itself does not release a proton. Rather, it accepts an electron pair from the O in H_2O , forming a fourth bond and releasing an H^+ ion:

Boron's outer shell is filled in the wide variety of borate salts, such as the mineral borax (sodium borate), $\text{Na}_2[\text{B}_4\text{O}_5(\text{OH})_4] \cdot 8\text{H}_2\text{O}$, used for decades as a household cleaning agent. Strong heating of boric acid (or borate salts) drives off water molecules and gives molten boron oxide:

When mixed with silica (SiO_2), this molten oxide forms borosilicate glass. Its high transparency and small change in size when heated or cooled make borosilicate glass useful in cookware and in lab glassware (see photo).

Labware made of borosilicate glass.

Source: © McGraw-Hill Education. Stephen Frisch, photographer

Forming a Bridge Bond with an Electron-Poor Atom In elemental boron and its many hydrides (boranes), there is no electron-rich atom to supply boron with electrons. In these substances, boron attains an octet through some unusual bonding. In diborane (B_2H_6) and many larger boranes, for example, two types of B—H bonds exist. The first type is a normal electron-pair bond. The valence bond picture in Figure 14.7 (next page) shows an sp^3 orbital of B overlapping a $1s$ orbital of H in each of the four terminal B—H bonds, using two of the three electrons in the valence level of each B atom.

Figure 14.7 The two types of covalent bonding in diborane.

Figure 14.8 The boron icosahedron and one of the boranes.

The other type of bond is a hydride **bridge bond** (or *three-center, two-electron bond*), in which *each B—H—B grouping is held together by only two electrons*. Two sp^3 orbitals, one from *each B*, overlap an H 1s orbital between them. Two electrons move through this extended bonding orbital—one from one of the B atoms and the other from the H atom—and join the two B atoms via the H-atom bridge. Notice that *each B atom is surrounded by eight electrons*: four from the two normal B—H bonds and four from the two B—H—B bridge bonds with a tetrahedral arrangement around each B atom. In many boranes and in elemental boron (Figure 14.8), one B atom bridges two others in a three-center, two-electron B—B—B bond.

Diagonal Relationships: Beryllium and Aluminum

Beryllium in Group 2A(2) and aluminum in Group 3A(13) are another pair of diagonally related elements. Both form oxoanions in strong base: beryllate, $\text{Be}(\text{OH})_4^{2-}$, and aluminate, $\text{Al}(\text{OH})_4^-$. Both have bridge bonds in their hydrides and chlorides. Both form oxide coatings impervious to reaction with water (which explains aluminum's great use as a structural metal), and both oxides are amphoteric, extremely hard, and high melting. Although the atomic and ionic sizes of these elements differ, the small, highly charged Be^{2+} and Al^{3+} ions polarize nearby electron clouds strongly. Therefore, some Al compounds and all Be compounds have significant covalent character.

14.6 GROUP 4A(14): THE CARBON FAMILY

The whole range of behavior occurs in Group 4A(14): nonmetallic carbon (C) leads off, followed by the metalloids silicon (Si) and germanium (Ge), then metallic tin (Sn) and lead (Pb), and ending with flerovium (Fl), which was synthesized in 1998. Information about the compounds of C and of Si fills libraries: organic chemistry, most polymer chemistry, and biochemistry are based on carbon, whereas geochemistry and some essential polymer and electronic technologies are based on silicon. The Group 4A(14) Family Portrait summarizes atomic, physical, and chemical properties.

How Type of Bonding Affects Physical Properties

The elements of Group 4A(14) and their neighbors in Groups 3A(13) and 5A(15) illustrate how some physical properties depend on the type of bonding in an element (Table 14.2). Within Group 4A(14), the large decrease in melting point

Table 14.2

Bond Type and the Melting Process in Groups 3A(13) to 5A(15)

Period	Group 3A(13)				Group 4A(14)				Group 5A(15)			
	Element	Bond Type	Melting Point (°C)	ΔH_{fus} (kJ/mol)	Element	Bond Type	Melting Point (°C)	ΔH_{fus} (kJ/mol)	Element	Bond Type	Melting Point (°C)	ΔH_{fus} (kJ/mol)
2	B		2180	23.6	C		4100	Very high	N		-210	0.7
3	Al		660	10.5	Si		1420	50.6	P		44.1	2.5
4	Ga		30	5.6	Ge		945	36.8	As		816	27.7
5	In		157	3.3	Sn		232	7.1	Sb		631	20.0
6	Tl		304	4.3	Pb		327	4.8	Bi		271	10.5

Key:

- Metallic
- Covalent network
- Covalent molecule
- Metal
- Metalloid
- Nonmetal

KEY ATOMIC PROPERTIES, PHYSICAL PROPERTIES, AND REACTIONS

KEY	Atomic No.	Symbol	Atomic mass	Valence e ⁻ configuration (Common oxidation states)
6	C	12.01	2s ² 2p ² (-4, +4, +2)	
14	Si	28.09	3s ² 3p ² (-4, +4)	
32	Ge	72.63	4s ² 4p ² (+4, +2)	
50	Sn	118.7	5s ² 5p ² (+4, +2)	
82	Pb	207.2	6s ² 6p ² (+4, +2)	
114	Fl	(289)	7s ² 7p ²	Observed in experiments at Dubna, Russia, in 1998

	Atomic radius (pm)	Ionic radius (pm)
C	77	—
Si	118	—
Ge	122	—
Sn	140	Sn ²⁺ 118
Pb	146	Pb ²⁺ 119

Atomic Properties

Group electron configuration is ns^2np^2 . Down the group, the number of oxidation states decreases, and the lower (+2) state becomes more common. Down the group, size increases. Because transition and inner transition elements intervene, IE and EN do not decrease smoothly.

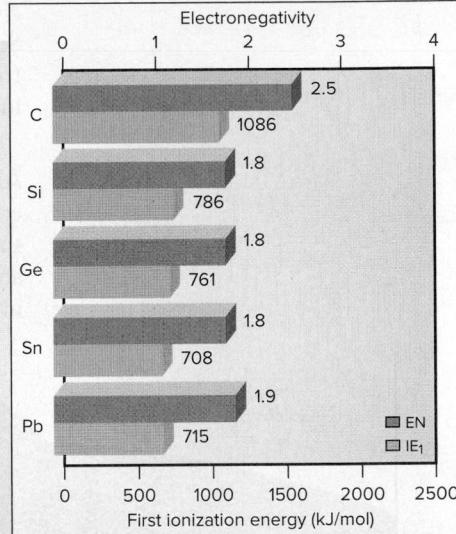

Physical Properties

Trends in properties, such as decreasing hardness and melting point, are due to changes in types of bonding within the solid: covalent network in C, Si, and Ge; metallic in Sn and Pb (*see text*). Down the group, density increases because of several factors, including differences in crystal packing.

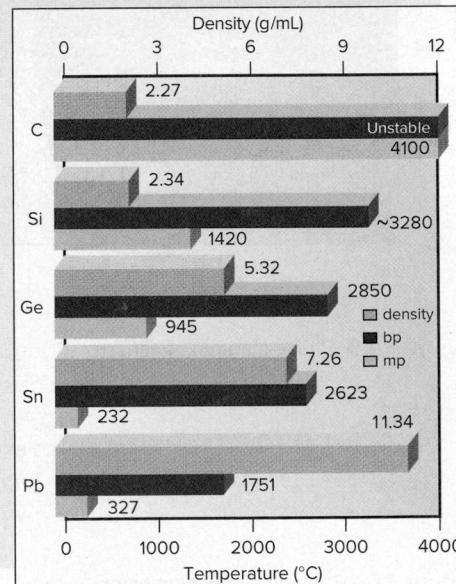

Source: © McGraw-Hill Education/Stephen Frisch, photographer

Reactions

1. The elements are oxidized by halogens:

The +2 halides are more stable for tin and lead, SnX_2 and PbX_2 .

2. The elements are oxidized by O₂:

Pb forms the +2 oxide, PbO. Oxides become more basic down the group. The reaction of CO₂ and H₂O provides the weak acidity of natural unpolluted waters:

3. Hydrocarbons react with O₂ to form CO₂ and H₂O. The reaction for methane is adapted to yield heat or electricity:

4. Silica is reduced to form elemental silicon:

This crude silicon is made ultrapure through zone refining for use in the manufacture of computer chips.

between the network covalent solids C and Si is due to longer, weaker bonds in the Si structure; the large decrease between Ge and Sn is due to the change from covalent network to metallic bonding. Similarly, considering horizontal trends, the large increases in melting point and ΔH_{fus} across a period between Al and Si and between Ga and Ge reflect the change from metallic to covalent network bonding. Note the abrupt rises in the values for these properties from metallic Al, Ga, and Sn to the network covalent metalloids Si, Ge, and Sb, and note the abrupt drops from the covalent networks of C and Si to the individual molecules of N and P in Group 5A(15).

Allotropism: Different Forms of an Element Striking variations in physical properties often appear among **allotropes**, different crystalline or molecular forms of a substance. One allotrope is usually more stable than another at a particular pressure and temperature. Group 4A(14) provides the first important examples of allotropism, in the forms of carbon and tin.

Figure 14.9 Phase diagram of carbon.

1. *Allotropes and other structures of carbon.* It is difficult to imagine two substances made entirely of the same atom that are more different than graphite and diamond. Graphite is a black electrical conductor that is soft and “greasy,” whereas diamond is a colorless electrical insulator that is extremely hard. Graphite is the standard state of carbon, the more stable form at ordinary temperature and pressure (Figure 14.9, red dot). Fortunately for jewelry owners, diamond changes to graphite at a negligible rate under normal conditions.

In the mid-1980s, a new allotrope was discovered. Mass spectra of soot showed a soccer ball-shaped molecule of formula C_{60} (Figure 14.10A). The molecule has also been found in geological samples formed by meteorite impacts, even the one that occurred around the time the dinosaurs became extinct. The molecule was dubbed *buckminsterfullerene* (and called a “buckyball”) after the architect-engineer R. Buckminster Fuller, who designed structures with similar shapes. Excitement rose in 1990, when scientists learned how to prepare enough C_{60} to study its behavior and applications. Since then, metal atoms have been incorporated in the balls and many different groups (fluorine, hydroxyl groups, sugars, etc.) have been attached, resulting in compounds with a range of useful properties.

In 1991, scientists passed an electric discharge through graphite rods and obtained extremely thin (~ 1 nm in diameter) graphite-like tubes with fullerene ends called *nanotubes* (Figure 14.10B; the model shows concentric nanotubes, colored differently, without the fullerene ends). Rigid and, on a mass basis, stronger than steel along their

Figure 14.10 Models of buckminsterfullerene (A), a carbon nanotube (B), and graphene (C).

long axis, they also conduct electricity along this axis because of the delocalized electrons. With applications in nanoscale electronics, energy storage, catalysis, polymers, and medicine, nanotube chemistry is a major area of materials research. Then, in 2010, the Nobel Prize in physics was awarded for studies of a new form of carbon called *graphene*, which exists as extended sheets only one atom thick but has remarkable conductivity and strength (Figure 14.10C).

2. Allotropes of tin. Tin has two allotropes. White β -tin is stable at room temperature and above, whereas gray α -tin is the more stable form below 13°C (56°F). When white tin is kept for long periods at a low temperature, some converts to microcrystals of gray tin. The random formation and growth of these regions of gray tin, which has a different crystal structure, weaken the metal and make it crumble. In the unheated cathedrals of medieval northern Europe, tin pipes of magnificent organs were sometimes destroyed by the “tin disease” caused by this allotropic transition.

How Bonding Changes in This Group's Compounds

The Group 4A(14) elements display a wide range of chemical behavior, from the covalent compounds of carbon to the ionic compounds of lead, and the features we saw first in Group 3A(13) appear here as well.

1. Multiple oxidation states. All the members have at least two important states (+4 and +2), and carbon has three (+4, +2, and -4).

2. Increasing stability of lower oxidation state. Compounds with Si in the +4 state are much more stable than those with Si in the +2 state, whereas compounds with Pb in the +2 state are more stable than those with Pb in the +4 state.

3. Increasing metallic behavior, ionic bonding, and oxide basicity. Carbon's intermediate EN of 2.5 ensures that it always bonds covalently, but the larger members form bonds with increasing ionic character. With nonmetals, Si and Ge form strong polar covalent bonds, such as the Si—O bond, one of the strongest Period 3 bonds ($\text{BE} = 368 \text{ kJ/mol}$) and responsible for the stability of Earth's solid surface. Although individual ions of Sn or Pb rarely exist, their bonding with a nonmetal has considerable ionic character. And the bonding becomes more ionic with the metal in the lower oxidation state. Thus, SnCl_2 and PbCl_2 are white, high-melting, water-soluble crystals—typical properties of a salt (Figure 14.11)—whereas SnCl_4 is a volatile, nonpolar liquid, and PbCl_4 is a thermally unstable oil. Similarly, SnO and PbO are more basic than SnO_2 and PbO_2 : because the +2 metals are less able to polarize the oxide ion, the E-to-O bonding is more ionic.

Figure 14.11 Saltlike +2 chlorides and oily +4 chlorides show the greater metallic character of tin and lead in their lower oxidation state.

Source: © McGraw-Hill Education/Stephen Frisch, photographer

Highlights of Carbon Chemistry

Like the other Period 2 elements, carbon is an anomaly in its group; indeed, it may be an anomaly in the entire periodic table. Carbon forms bonds with the smaller Group 1A(1) and 2A(2) metals, many transition metals, the halogens, and many other metalloids and nonmetals. In addition to the three common oxidation states, carbon exhibits all the others possible for its group, from +4 through -4.

Figure 14.12 Two of the several million known organic compounds of carbon.

A, Acrylonitrile, a precursor of acrylic fibers.
B, Lysine, one of about 20 amino acids that occur in proteins.

Organic Compounds Two major properties of carbon give rise to the enormous field of organic chemistry.

1. Carbon forms covalent bonds with other carbon atoms—a process known as *catenation*. As a result of its small size and its capacity for four bonds, carbon can form chains, branches, and rings that lead to myriad structures. Add a lot of H, some O and N, a bit of S, P, halogens, and a few metals, and you have the whole organic world! Figure 14.12 shows two of the several million organic compounds known.

Halogenated organic compounds have major polymer applications, such as poly(vinyl chloride) in plumbing and Teflon in cookware. Some are very long-lived in the environment. PCBs, previously used in electrical equipment, are now banned because they are carcinogenic (Figure 14.13). And Freons, used as cleaners of electronic parts and coolants in air conditioners, are responsible for a severe reduction in Earth's protective ozone layer (Chapter 16).

Figure 14.13 Two important halogenated organic compounds. **A**, A typical PCB (one of the polychlorinated biphenyls). **B**, Freon-12 (CCl_2F_2), a chlorofluorocarbon.

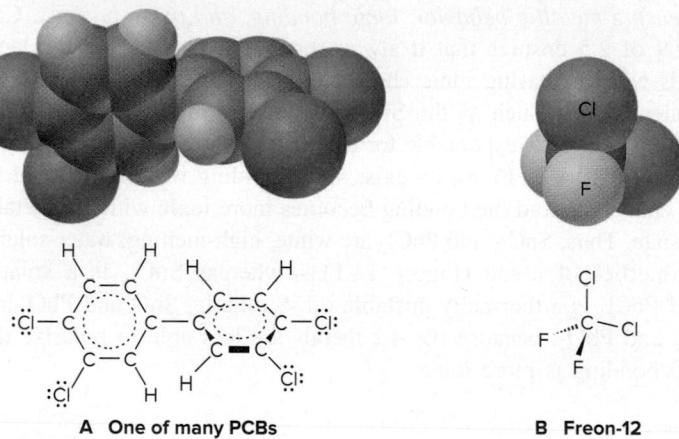

2. Carbon has the ability to form multiple bonds. Multiple bonds are common in carbon structures because the C—C bond is short enough for side-to-side overlap of two half-filled 2p orbitals to form π bonds. (In Chapter 15, we discuss how the properties of carbon give rise to the diverse structures and reactivities of organic compounds.)

Because the other Group 4A(4) members are larger, E—E bonds become longer and weaker, so catenation and multiple bonding are much less important down the group.

Inorganic Compounds In contrast to its organic compounds, carbon's inorganic compounds are simple.

1. **Carbonates.** Metal carbonates are the main mineral form. Marble, limestone, chalk, coral, and several other types are found in enormous deposits throughout the world. Many of these compounds are remnants of fossilized marine organisms. Carbonates are essential to many industries, and they occur in several common antacids because they react with the HCl in stomach acid:

Identical net ionic reactions with sulfuric and nitric acids protect lakes bounded by limestone deposits from the harmful effects of acid rain.

2. Oxides. Unlike the other Group 4A(4) members, which form only solid network covalent or ionic oxides, carbon forms two common gaseous oxides, CO_2 and CO .

- Carbon dioxide is essential to all life: it is the primary source of carbon in plants, through photosynthesis, and in animals who eat the plants. Its aqueous solution is the cause of mild acidity in natural waters. However, its atmospheric buildup from deforestation and excessive use of fossil fuels is severely affecting the global climate through warming.
- Carbon monoxide forms when carbon or its compounds burn in an inadequate supply of O_2 :

It is a key component of syngas fuels (see Chemical Connections, Chapter 6) and is widely used in the production of methanol, formaldehyde, and other major industrial compounds. CO binds strongly to many transition metals. When inhaled in cigarette smoke or polluted air, it enters the blood and binds strongly to the Fe(II) in hemoglobin, preventing the normal binding of O_2 , and to other iron-containing proteins. The cyanide ion (CN^-) is *isoelectronic* with CO :

Cyanide binds to many of the same iron-containing proteins and is also toxic.

Highlights of Silicon Chemistry

To a great extent, the chemistry of silicon is the chemistry of the *silicon-oxygen bond*. Just as carbon forms lengthy C—C chains, the —Si—O— grouping repeats itself almost endlessly in a wide variety of **silicates**, the most important minerals on the planet, and in **silicones**, synthetic polymers that have many applications:

1. Silicate minerals. From common sand and clay to semiprecious amethyst and carnelian, silicate minerals are the dominant form of matter in the nonliving world. Oxygen, the most abundant element on Earth, and silicon, the next most abundant, account for four of every five atoms on the surface of the planet!

The silicate building unit is the *orthosilicate grouping*, $-\text{SiO}_4-$, a tetrahedral arrangement of four O atoms around the central Si. Several minerals contain SiO_4^{4-} ions or small groups of them linked together. The gemstone zircon (ZrSiO_4) contains one unit; hemimorphite [$\text{Zn}_4(\text{OH})_2\text{Si}_2\text{O}_7 \cdot \text{H}_2\text{O}$] contains two units linked through an oxygen corner of each one; and beryl ($\text{Be}_3\text{Al}_2\text{Si}_6\text{O}_{18}$), the major source of beryllium, contains six units joined in a cyclic ion (Figure 14.14).

In extended structures, one of the O atoms links the next Si—O group to form chains, a second one forms crosslinks to neighboring chains to form sheets, and the

Figure 14.14 Structures of the silicate anions in some minerals.

Figure 14.15 Quartz is a three-dimensional framework silicate.

Source: © Albert Russ/Shutterstock.com

third forms more crosslinks to create three-dimensional frameworks. Chains of silicate groups compose the asbestos minerals, sheets give rise to talc and mica, and frameworks occur in feldspar and quartz (Figure 14.15).

2. Silicone polymers. Unlike the naturally occurring silicates, silicone polymers are manufactured substances that consist of alternating Si and O atoms with two organic groups also bonded to each Si atom in a very long Si—O chain, as in *poly(dimethyl siloxane)*:

Silicones have properties of both plastics and minerals. The organic groups give them the flexibility and weak intermolecular forces between chains that are characteristic of a plastic, while the O—Si—O backbone confers the thermal stability and nonflammability of a mineral. Structural categories similar to those of the silicates can be created by adding various reactants to form silicone chains, sheets, and frameworks. Chains are oily liquids used as lubricants and as components of car polish and makeup. Sheets are components of gaskets, space suits, and contact lenses. Frameworks have uses as laminates on circuit boards, in nonstick cookware, and in artificial skin and bone.

Diagonal Relationships: Boron and Silicon

Our final diagonal relationship occurs between the semiconducting metalloids boron and silicon. Both B and Si and their mineral oxoanions—borates and silicates—occur in extended covalent networks. Both boric acid $[\text{B}(\text{OH})_3]$ and silicic acid $[\text{Si}(\text{OH})_4]$ are weakly acidic solids that occur as layers held together by widespread H bonding. Their hydrides—the compact boranes and the extended silanes—are both flammable, low-melting compounds that act as reducing agents.

14.7 GROUP 5A(15): THE NITROGEN FAMILY

The first two elements of Group 5A(15), gaseous nonmetallic nitrogen (N) and solid nonmetallic phosphorus (P), play major roles in both nature and industry. Below these nonmetals are two metalloids, arsenic (As) and antimony (Sb), followed by the metal bismuth (Bi), and moscovium (Mc), synthesized in 2003. The Group 5A(15) Family Portrait provides an overview.

KEY ATOMIC PROPERTIES, PHYSICAL PROPERTIES, AND REACTIONS

KEY	Atomic No.	Symbol	Atomic mass	Valence e ⁻ configuration (Common oxidation states)
	7	N	14.01	2s ² 2p ³ (-3, +5, +4, +3, +2, +1)
	15	P	30.97	3s ² 3p ³ (-3, +5, +3)
	33	As	74.92	4s ² 4p ³ (-3, +5, +3)
	51	Sb	121.8	5s ² 5p ³ (-3, +5, +3)
	83	Bi	209.0	6s ² 6p ³ (+3)
	115	Mc	(288)	7s ² 7p ³

Observed in experiments at Dubna, Russia, in 2003

	Atomic radius (pm)	Ionic radius (pm)
N	75	N ³⁻ 146
P	110	P ³⁻ 212
As	120	
Sb	140	
Bi	150	Bi ³⁺ 103

Atomic Properties

Group electron configuration is ns^2np^3 . The np sublevel is half-filled, with each p orbital containing one electron (parallel spin). The number of oxidation states decreases down the group, and the lower (+3) state becomes more common. Atomic properties follow generally expected trends. The large (~50%) increase in size from N to P correlates with the much lower IE and EN of P.

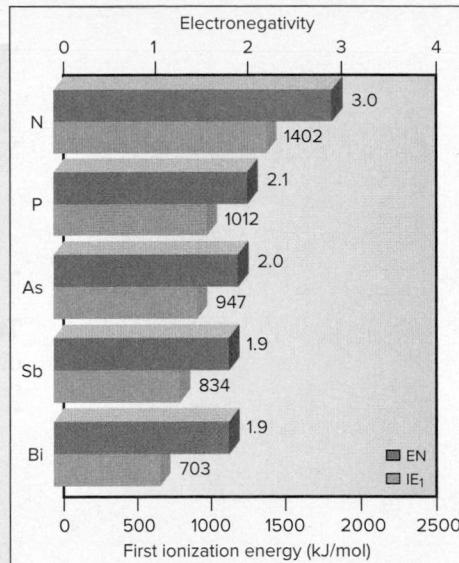

Physical Properties

Physical properties reflect the change from individual molecules (N, P) to network covalent solid (As, Sb) to metal (Bi). Thus, melting points increase and then decrease. Large atomic size and low atomic mass result in low density. Because mass increases more than size down the group, the density of the elements as solids increases. The dramatic increase in density from P to As is due to the intervening transition elements.

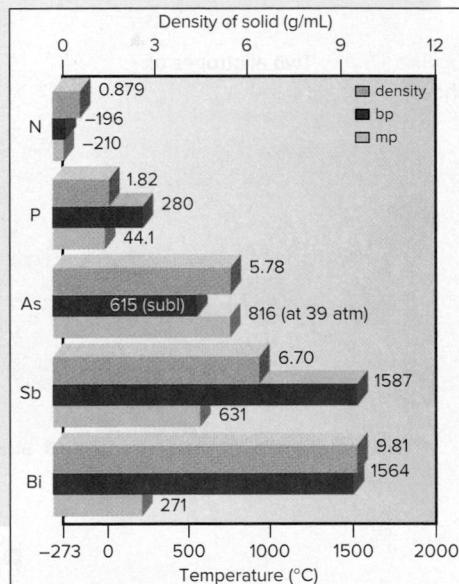

Source: © McGraw-Hill Education/Stephen Frisch, photographer

Reactions

1. Nitrogen is “fixed” industrially in the Haber process:

Further reactions convert NH₃ to NO, NO₂, and HNO₃ (*see text*).

Hydrides of some other group members are formed from reaction in water (or with H₃O⁺) of a metal phosphide, arsenide, and so forth:

2. Halides are formed by direct combination of the elements:

3. Oxoacids are formed from the halides in a reaction with water that is common to many nonmetal halides:

Note that the oxidation number of E does *not* change.

The Wide Range of Physical Behavior

Group 5A(15) displays the widest range of physical behavior we've seen so far because of large changes in bonding and intermolecular forces:

- *Nitrogen* is a gas consisting of N_2 molecules with such weak intermolecular forces that the element *boils* more than 200°C below room temperature.
- *Phosphorus* exists most commonly as tetrahedral P_4 molecules in the solid phase. Because P is heavier and more polarizable than N, it has stronger dispersion forces and melts about 25°C above room temperature.
- *Arsenic* consists of extended sheets. Each As atom bonds to three others in the sheet, and each sheet exhibits dispersion forces with adjacent sheets, which gives As the highest melting point in the group.
- *Antimony* has a similar covalent network, also resulting in a high melting point.
- *Bismuth* has metallic bonding and thus a lower melting point than As and Sb.

Two Allotropes of Phosphorus Phosphorus has several allotropes, which have very different properties. Two major ones are white and red phosphorus:

- *White phosphorus* consists of tetrahedral molecules (Figure 14.16A). It is a low-melting, whitish, waxy solid that is soluble in nonpolar solvents, such as CS_2 . Each P atom uses its half-filled $3p$ orbitals to bond to the other three; with a small bond angle (60°), and thus weak P—P bonds that are easily broken, it is highly reactive (Figure 14.16B).
- *Red phosphorus* is formed by heating the white form in the absence of air. One of the P—P bonds in each tetrahedron breaks, and those $3p$ orbitals overlap with others to form chains of P_4 units (Figure 14.16C). The chains make the red allotrope much less reactive, high melting, and insoluble.

Figure 14.16 Two allotropes of phosphorus.

Patterns in Chemical Behavior

Many of the patterns we saw in Group 4A(14) appear here in the change from nonmetallic N to metallic Bi. The great majority of Group 5A(15) compounds have *covalent bonds*. Whereas N can form no more than four bonds, the next three members can form more by expanding their valence levels and using empty *d* orbitals.

1. *Formation of ions.* For a Group 5A(15) element to form an ion with a noble gas electron configuration, it must *gain* three electrons, the last two in endothermic steps. Nevertheless, the enormous lattice energy released when such highly charged anions attract cations drives their formation. However, the $3-$ anion of N occurs only in compounds with active metals, such as Li_3N and Mg_3N_2 (and the $3-$ anion of P may occur in $\text{Na}_3\text{P}_3 \cdot 5\text{H}_2\text{O}$). Metallic Bi mostly bonds covalently but exists as a cation in a few compounds, such as BiF_3 and $\text{Bi}(\text{NO}_3)_3 \cdot 5\text{H}_2\text{O}$, through *loss* of its three *p* valence electrons.

2. *Oxidation states and basicity of oxides.* As in Groups 3A(13) and 4A(14), the lower oxidation state becomes more prominent down the group: N exhibits every state

possible for a Group 5A(15) element, from +5 to -3; only the +5 and +3 states are common for P, As, and Sb; and +3 is the only common state of Bi. The oxides change from acidic to amphoteric to basic, reflecting the increase in the metallic character of the elements. In addition, the lower oxide of an element is more basic than the higher oxide, reflecting the greater ionic character of its E-to-O bonding.

3. Formation of hydrides. All the Group 5A(15) elements form gaseous hydrides of formula EH₃. Except for NH₃, these are extremely reactive and poisonous and are synthesized by reaction of a metal phosphide, arsenide, and so forth, which acts as a strong base in water or aqueous acid. For example,

Ammonia is made industrially by direct combination of the elements at high pressure and moderately high temperature:

Nitrogen forms a second hydride, hydrazine, N₂H₄. Like NH₃, hydrazine is a weak base; it is used to make antituberculin drugs, plant growth regulators, and fungicides.

Molecular properties of the Group 5A(15) hydrides reveal some interesting bonding and structural patterns:

- Despite its much lower molar mass, NH₃ melts and boils at higher temperatures than the other 5A(15) hydrides, as a result of its *H bonding* (see Figure 12.15).
- Bond angles decrease from 107.3° for NH₃ to around 90° for the other hydrides, which suggests that the larger atoms use unhybridized *p* orbitals.
- E—H bond lengths increase down the group, so bond strength and thermal stability decrease: AsH₃ decomposes at 250°C, SbH₃ at 20°C, and BiH₃ at -45°C.

We'll see these features—H bonding for the smallest member, change in bond angles, change in bond energies—in the hydrides of Group 6A(16) as well.

4. Types and properties of halides. The Group 5A(15) elements all form trihalides (EX₃). All except nitrogen form pentafluorides (EF₅), but only a few other pentahalides (PCl₅, PBr₅, AsCl₅, and SbCl₅) are known. Nitrogen cannot form pentahalides because it cannot expand its valence level. Most trihalides are prepared by direct combination:

The pentahalides form with excess halogen:

As with the hydrides, thermal stability of the halides decreases as the E—X bond becomes longer; we see this trend easiest if we change the halogen. Among the nitrogen halides, for example, NF₃ is a stable, rather unreactive gas. NCl₃ is explosive and reacts rapidly with water. (The chemist who first prepared it lost three fingers and an eye!) NBr₃ can only be made below -87°C. NI₃ has never been prepared, but an ammoniated product (NI₃·NH₃) explodes at the slightest touch. Other Group 5A(15) members show less drastic trends, but stability decreases as the halogen gets larger.

5. Reaction of halides in water. In a reaction pattern typical of many nonmetal halides, each 5A(15) halide reacts with water to yield the hydrogen halide and the oxoacid, in which E has the same O.N. as in the original halide. For example, PX₅ (O.N. of P = +5) produces phosphoric acid (O.N. of P = +5) and HX:

Highlights of Nitrogen Chemistry

The most striking highlight of nitrogen chemistry is the inertness of N₂. Even with four-fifths of the atmosphere being N₂ and the other fifth nearly all O₂, it takes the searing temperature caused by lightning to form significant amounts of nitrogen oxides. Although N₂ is inert at moderate temperatures, it reacts at high temperatures with H₂, Li, Group 2A(2) metals, B, Al, C, Si, Ge, and many transition elements. In fact, nearly every element forms bonds to N. Here we focus on the oxides and the oxoacids and their salts.

Nitrogen Oxides Nitrogen is remarkable for having six stable oxides, each with a *positive* enthalpy of formation because of the great strength of the N≡N bond (BE = 945 kJ/mol). Their structures and some properties are shown in Table 14.3. Unlike the hydrides and halides of nitrogen, the oxides are planar. Nitrogen displays all its positive oxidation states in these compounds, and in N₂O and N₂O₃, the two N atoms have different states. Let's highlight the three most important:

1. *Dinitrogen monoxide* (N₂O; also called *nitrous oxide*) is the dental anesthetic “laughing gas” and the propellant in canned whipped cream. It is a linear molecule with an electronic structure described by three resonance forms (note formal charges):

2. *Nitrogen monoxide* (NO; also called *nitric oxide*) is a molecule with an odd electron and with biochemical functions ranging from neurotransmission to control of blood flow. In Section 11.3, we used MO theory to explain its bonding. The commercial preparation of NO occurs as a first step in the production of nitric acid:

Nitrogen monoxide is also produced whenever air is heated to high temperatures, as in a car engine or by lightning during a thunderstorm:

Heating converts NO to two other oxides:

Table 14.3 Structures and Properties of the Nitrogen Oxides

Formula	Name	Space-Filling Model	Lewis Structure	Oxidation State of N	ΔH_f° (kJ/mol) at 298 K	Comment
N ₂ O	Dinitrogen monoxide (nitrous oxide)		[:N≡N—O:]	+1 (0, +2)	82.0	Colorless gas; used as dental anesthetic (“laughing gas”) and aerosol propellant
NO	Nitrogen monoxide (nitric oxide)		[:N=O:]	+2	90.3	Colorless, paramagnetic gas; biochemical messenger; air pollutant
N ₂ O ₃	Dinitrogen trioxide		[:O: N=N :O:]	+3 (+2, +4)	83.7	Reddish-brown gas (reversibly dissociates to NO and NO ₂)
NO ₂	Nitrogen dioxide		[:O: N=O:]	+4	33.2	Orange-brown, paramagnetic gas formed during HNO ₃ manufacture; poisonous air pollutant
N ₂ O ₄	Dinitrogen tetroxide		[:O: N=N :O:]	+4	9.16	Colorless to yellow liquid (reversibly dissociates to NO ₂)
N ₂ O ₅	Dinitrogen pentoxide		[:O: N=N :O:]	+5	11.3	Colorless, volatile solid consisting of NO ₂ ⁺ and NO ₃ ⁻ ; gas consists of N ₂ O ₅ molecules

This type of redox reaction is called a **disproportionation**, in which *one substance acts as both the oxidizing and reducing agents*. In the process, an atom with an intermediate oxidation state in the reactant occurs in both lower and higher states in the products: the oxidation state of N in NO (+2) is intermediate between that in N₂O (+1) and that in NO₂ (+4).

3. *Nitrogen dioxide* (NO₂), a brown poisonous gas, forms to a small extent when NO reacts with additional oxygen:

Like NO, NO₂ is a molecule with an odd electron, which is more localized on the N atom in this species. Thus, NO₂ dimerizes reversibly to *dinitrogen tetroxide*:

Thunderstorms form NO and NO₂ and carry them down to the soil, where they act as natural fertilizers. In urban traffic, however, their formation leads to *photochemical smog* (see photo) in a series of reactions also involving sunlight, ozone (O₃), unburned gasoline, and various other species.

Nitrogen Oxoacids and Oxoanions There are two common oxoacids of nitrogen (Figure 14.17):

1. *Nitric acid* (HNO₃) is produced in the *Ostwald process*; we have already seen the first two steps—the oxidations of NH₃ to NO and of NO to NO₂. The final step is a disproportionation, as the oxidation numbers show:

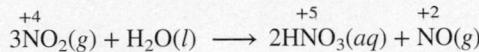

The NO is recycled to make more NO₂.

In nitric acid, as in all oxoacids, *the acidic H is attached to one of the O atoms*. When the proton is lost, the trigonal planar nitrate ion is formed (Figure 14.17A). In the laboratory, nitric acid is used as a strong oxidizing acid. The products of its reactions with metals vary with the metal's reactivity and the acid's concentration. In the following examples, notice that *the NO₃⁻ ion is the oxidizing agent*. Nitrate ion that is not reduced is a spectator ion and does not appear in the net ionic equations.

- With an active metal, such as Al, and dilute nitric acid, N is reduced from the +5 state all the way to the -3 state in the ammonium ion, NH₄⁺:

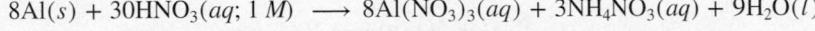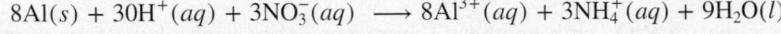

- With a less reactive metal, such as Cu, and more concentrated acid, N is reduced to the +2 state in NO:

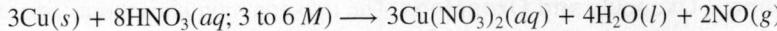

Photochemical smog over Los Angeles, California.

Source: © Daniel Stein/Getty Images RF

Figure 14.17 The structures of nitric and nitrous acids and their oxoanions.

- With still more concentrated acid, N is reduced only to the +4 state in NO_2 :

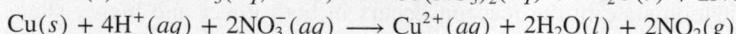

Nitrates form when HNO_3 reacts with metals or with their hydroxides, oxides, or carbonates. *All nitrates are soluble in water.*

2. Nitrous acid (HNO_2) is a much weaker acid that forms when metal nitrites are treated with a strong acid:

This acid forms the planar nitrite ion (Figure 14.17B) in which nitrogen's lone pair reduces the ideal 120° bond angle to 115° .

These two acids reveal a *general pattern in relative acid strength among oxoacids: the more O atoms bonded to the central nonmetal, the stronger the acid*. The O atoms pull electron density from the N atom, which in turn pulls electron density from the O of the O—H bond, facilitating the release of the H^+ ion. The O atoms also stabilize the resulting oxoanion by delocalizing its negative charge. The same pattern occurs in the oxoacids of sulfur and the halogens; we'll discuss the pattern quantitatively in Chapter 18.

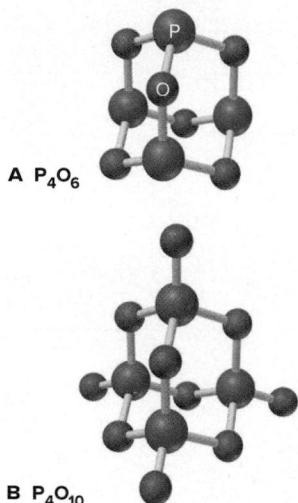

Figure 14.18 Important oxides of phosphorus.

Highlights of Phosphorus Chemistry

Like nitrogen, phosphorus forms important oxides (although not as many) and oxoacids. Here we focus on these compounds as well as on some other important phosphorus compounds.

Phosphorus Oxides

Phosphorus forms two important oxides:

1. *Tetraphosphorus hexoxide* (P_4O_6) has P in its +3 oxidation state. It forms when P_4 reacts with limited oxygen:

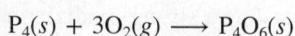

P_4O_6 has the same tetrahedral orientation of the P atoms as in P_4 , with an O atom between each pair of P atoms (Figure 14.18A).

2. *Tetraphosphorus decoxide* (P_4O_{10}) has P in the +5 oxidation state. Commonly known as “phosphorus pentoxide” from the empirical formula (P_2O_5), it forms when P_4 burns in excess O_2 :

Its structure is that of P_4O_6 with another O atom bonded to each of the four corner P atoms (Figure 14.18B). P_4O_{10} is a powerful drying agent.

Phosphorus Oxoacids and Oxoanions The two common phosphorus oxoacids are phosphorous acid (note the different spelling) and phosphoric acid.

1. *Phosphorous acid* (H_3PO_3) is formed when P_4O_6 reacts with water:

The formula H_3PO_3 is misleading because the acid has only two acidic H atoms; the third is bonded to the central P and does not dissociate. Phosphorous acid is a weak acid in water but reacts completely in two steps with excess strong base:

Salts of phosphorous acid contain the phosphite ion, HPO_3^{2-} .

2. *Phosphoric acid* (H_3PO_4), one of the “top-10” most important compounds in manufacturing, is formed in a vigorous exothermic reaction of P_4O_{10} with water:

The presence of many H bonds makes pure H_3PO_4 syrupy, more than 75 times as viscous as water. The laboratory-grade concentrated acid is an 85% by mass aqueous solution. H_3PO_4 is a weak triprotic acid; in water, it loses one proton:

In excess strong base, however, the three protons dissociate completely in three steps to give the three phosphate oxoanions:

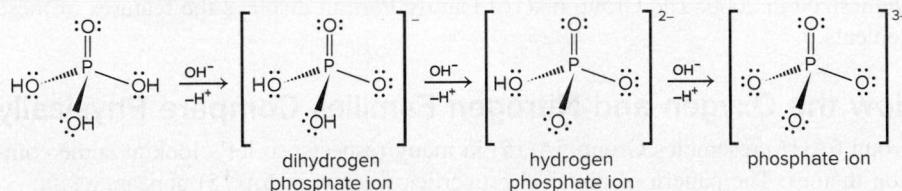

Phosphoric acid has a central role in fertilizer production and is also added to soft drinks for tartness. The various phosphate salts also have numerous essential applications. Na_3PO_4 is a paint stripper and grease remover. K_3PO_4 is used to stabilize latex for synthetic rubber, and K_2HPO_4 is a radiator corrosion inhibitor. Ammonium phosphates are used as fertilizers and as flame retardants on curtains, and calcium phosphates are used in baking powders and toothpastes, as mineral supplements in livestock feed, and as fertilizers.

Polyphosphates When they are heated, hydrogen phosphates lose water and form P—O—P linkages in compounds called *polyphosphates*. A reaction in which an H_2O molecule is lost for every pair of groups that join is called a **dehydration-condensation**; this type of reaction occurs frequently in the formation of polyoxoanion chains and other polymeric structures, both synthetic and natural. For example, sodium diphosphate, $\text{Na}_4\text{P}_2\text{O}_7$, is prepared by heating sodium hydrogen phosphate:

The diphosphate ion, $\text{P}_2\text{O}_7^{4-}$, the smallest of the polyphosphates, consists of two PO_4 units linked through a common oxygen corner (Figure 14.19A). Its reaction with water, the reverse of the previous reaction, generates heat:

A similar process is put to vital use by organisms, when a third PO_4 unit linked to diphosphate creates the triphosphate grouping, part of the all-important high-energy biomolecule adenosine triphosphate (ATP). In Chapters 20 and 21, we discuss the central role of ATP in biological energy production. Extended polyphosphate chains consist of many tetrahedral PO_4 units (Figure 14.19B) and are structurally similar to silicate chains.

Phosphorus Compounds with Sulfur and Nitrogen Phosphorus forms many sulfides and nitrides. P_4S_3 is used in “strike anywhere” match heads, and P_4S_{10} is used in the manufacture of organophosphorus pesticides, such as malathion. Compounds of phosphorus and nitrogen called *polyphosphazenes* have properties similar to those of silicones. The $-(\text{R}_2\text{P}=\text{N}-)$ unit is isoelectronic with the silicone unit, $-(\text{R}_2\text{Si}-\text{O}-)$. Sheets, films, fibers, and foams of polyphosphazene are water repellent, flame resistant, solvent resistant, and flexible at low temperatures—perfect for the gaskets and O-rings in spacecraft and polar vehicles.

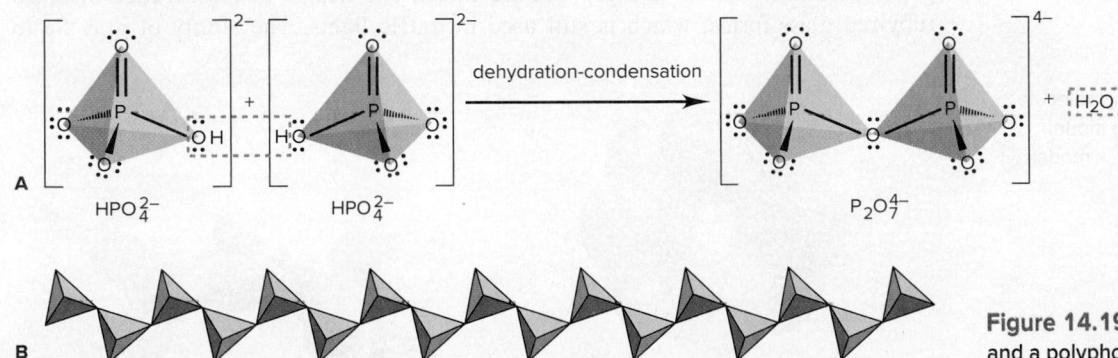

Figure 14.19 The diphosphate ion (A) and a polyphosphate chain (B).

14.8 GROUP 6A(16): THE OXYGEN FAMILY

The first two members of this group—gaseous nonmetallic oxygen (O) and solid nonmetallic sulfur (S)—are among the most important elements in industry, the environment, and living things. Two metalloids, selenium (Se) and tellurium (Te), appear next, followed by the radioactive metal polonium (Po), and finally livermorium (Lv), synthesized in 2000. The Group 6A(16) Family Portrait displays the features of these elements.

How the Oxygen and Nitrogen Families Compare Physically

Group 6A(16) resembles Group 5A(15) in many respects, so let's look at some common themes. The pattern of physical properties we saw in 5A(15) appears again:

- *Oxygen*, like nitrogen, occurs as a low-boiling diatomic gas.
- *Sulfur*, like phosphorus, occurs as a polyatomic molecular solid.
- *Selenium*, like arsenic, commonly occurs as a gray metalloid.
- *Tellurium*, like antimony, is slightly more metallic but still displays network covalent bonding.
- *Polonium*, like bismuth, has a metallic crystal structure.

As in Group 5A(15), electrical conductivities increase steadily down Group 6A(16) as bonding changes from nonmetal molecules (insulators) to metalloid networks (semiconductors) to a metallic solid (conductor).

Allotropism in the Oxygen Family

Allotropism is even more common in Group 6A(16) than in Group 5A(15).

1. *Oxygen*. Oxygen has two allotropes: life-giving dioxygen (O_2), and poisonous triatomic ozone (O_3). Dioxygen is colorless, odorless, paramagnetic, and thermally stable. In contrast, ozone is bluish, has a pungent odor, is diamagnetic, and decomposes in heat and especially in ultraviolet (UV) light:

This ability to absorb high-energy photons makes stratospheric ozone vital to life. A thinning of the ozone layer, observed above the North Pole and especially the South Pole, means that more UV light is reaching Earth's surface, with potentially hazardous effects. (We'll discuss the chemical causes of ozone depletion in Chapter 16.)

2. *Sulfur*. Sulfur is the allotrope “champion” of the periodic table, with more than 10 forms. The S atom's ability to bond to other S atoms (catenate) creates rings and chains, many with S—S bond lengths that range from 180 pm to 260 pm and bond angles ranging from 90° to 180° . The most stable allotrope is orthorhombic α - S_8 , which consists of a crown-shaped ring of eight atoms called *cyclo-S₈* (Figure 14.20); all other S allotropes eventually revert to this one.

3. *Selenium*. Selenium also has several allotropes, some consisting of crown-shaped Se_8 molecules. Gray Se is composed of layers of helical chains. When molten glass, cadmium sulfide, and gray Se are mixed and heated in the absence of air, a ruby-red glass forms, which is still used in traffic lights. The ability of gray Se to

Figure 14.20 The cyclo- S_8 molecule.

A, Top view of a space-filling model.

B, Side view of a ball-and-stick model; note the crownlike shape.

KEY ATOMIC PROPERTIES, PHYSICAL PROPERTIES, AND REACTIONS

Atomic No.	Symbol	Atomic mass	Valence e ⁻ configuration (Common oxidation states)
8	O	16.00	2s ² 2p ⁴ (-1, -2)
16	S	32.06	3s ² 3p ⁴ (-2, +6, +4, +2)
34	Se	78.96	4s ² 4p ⁴ (-2, +6, +4, +2)
52	Te	127.6	5s ² 5p ⁴ (-2, +6, +4, +2)
84	Po	(209)	6s ² 6p ⁴ (+4, +2)
116	Lv	(293)	7s ² 7p ⁴

Observed in experiments at Dubna, Russia, in 2000

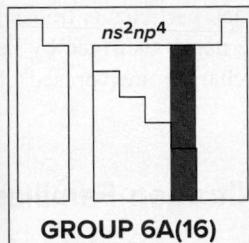

Atomic radius (pm)	Ionic radius (pm)
O 73	O ²⁻ 140
S 103	S ²⁻ 184
Se 119	Se ²⁻ 198
Te 142	
Po 168	Po ⁴⁺ 94

Atomic Properties

Group electron configuration is $ns^2 np^4$. As in Groups 3A(13) and 5A(15), a lower (+4) oxidation state becomes more common down the group. Down the group, atomic and ionic sizes increase, and IE and EN decrease.

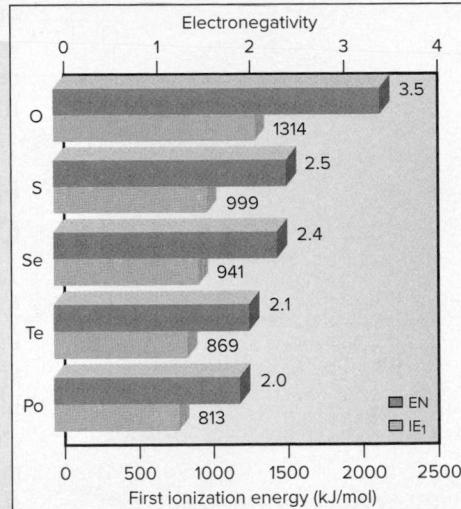

Physical Properties

Melting points increase through Te, which has covalent bonding, and then decrease for Po, which has metallic bonding. Densities of the elements as solids increase steadily.

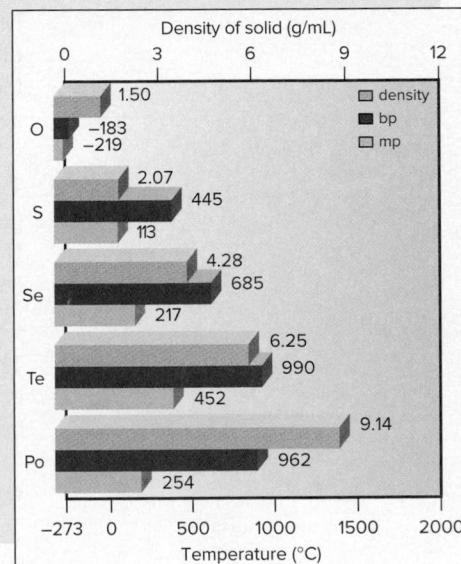

Source: © McGraw-Hill Education/Stephen Frisch, photographer

Reactions

1. Halides are formed by direct combination:

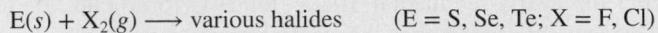

2. The other elements in the group are oxidized by O₂:

SO₂ is oxidized further, and the product is used in the final step of H₂SO₄ manufacture (see text):

3. The thiosulfate ion is formed when an alkali metal sulfite reacts with sulfur, as in the preparation of "hypo" (photographers' developing solution):

conduct an electric current when illuminated is applied in photocopying. A film of amorphous Se is deposited on an aluminum drum and electrostatically charged. Exposure to a document produces an “image” of low and high positive charges corresponding to the document’s bright and dark areas. Negatively charged black, dry ink (toner) particles are attracted to the regions of high charge more than to those of low charge. This pattern of black particles is transferred electrostatically to paper, and the particles are fused to the paper’s surface by heat or solvent. Excess toner is removed from the Se film, the charges are “erased” by exposure to light, and the film is ready for the next page.

How the Oxygen and Nitrogen Families Compare Chemically

Trends in Group 6A(16) chemical behavior are also similar to those in Group 5A(15). O and S occur as anions much more often than do N and P, but like N and P, they also bond covalently with almost every other nonmetal. Covalent bonds appear in the compounds of Se and Te (as in those of As and Sb), and Po behaves like a metal (as does Bi) in some saltlike compounds. In contrast to N, O has few common oxidation states, but the earlier pattern returns with the other Group 6A members: the +6, +4, and -2 states occur most often, with the lower positive (+4) state becoming more common in Te and Po [as the lower positive (+3) state does in Sb and Bi].

The range in atomic properties is wider in this group than in Group 5A(15) because of oxygen’s high EN (3.5) and great oxidizing strength, second only to that of fluorine. But the other members of Group 6A(16) behave very little like oxygen: they are much less electronegative, form anions much less often (S^{2-} occurs with active metals), and their hydrides exhibit no H bonding.

Types and Properties of Hydrides Oxygen forms two hydrides, water and hydrogen peroxide (H_2O_2). Both have relatively high boiling points and viscosities due to H bonding. In peroxides, O is in the -1 oxidation state, midway between that in O_2 (zero) and that in oxides (-2); thus, H_2O_2 readily disproportionates:

Though its most familiar use is in hair bleach and disinfectants, much more H_2O_2 is used to bleach paper, textiles, and leather and in sewage treatment to oxidize bacteria.

The other 6A(16) elements form foul-smelling, poisonous, gaseous hydrides (H_2E) when the metal sulfide, selenide, and so forth is treated with acid. For example,

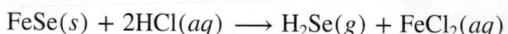

Hydrogen sulfide also forms naturally in swamps from the breakdown of organic matter. It is as toxic as HCN, and even worse, it anesthetizes your olfactory nerves, so that as its concentration increases, you smell it less! And the other hydrides are about 100 times *more* toxic.

In their bonding and thermal stability, these Group 6A(16) hydrides have several features in common with those of Group 5A(15):

- Only water and H_2O_2 can form H bonds, so these substances melt and boil much higher than the other H_2E compounds (see Figure 12.15).
- Bond angles drop from the nearly tetrahedral 104.5° for H_2O to around 90° for the larger 6A(16) hydrides, suggesting that the central atom uses unhybridized p orbitals.
- E—H bond length increases, so bond energy decreases down the group. Thus, H_2Te decomposes above $0^\circ C$, and H_2Po can be made only in extreme cold because thermal energy from radioactive Po decomposes it. Another result of longer (weaker) bonds is that the 6A(16) hydrides are acids in water, and their acidity increases from H_2S to H_2Po .

Types and Properties of Halides Except for O, the Group 6A(16) elements form a wide range of halides, whose structure and reactivity patterns depend on the sizes of the central atom and the surrounding halogens:

- Sulfur forms many fluorides, a few chlorides, and one bromide, but no stable iodides.
- As the central atom becomes larger, the halides become more stable. Thus, tetrachlorides and tetrabromides of Se, Te, and Po are known, as are tetraiodides of Te and Po. Hexafluorides are known only for S, Se, and Te.

The inverse relationship between bond length and bond strength that we've seen previously does not account for this pattern. Rather, it is based on the effect of electron repulsions due to crowding of lone pairs and halogen (X) atoms around the central Group 6A(16) atom. With S, the larger X atoms would be too crowded, which explains why sulfur iodides do not occur. With increasing size of E, and therefore increasing length of E—X bonds, however, lone pairs and X atoms do not crowd each other as much, so a greater number of stable halides form.

Highlights of Oxygen Chemistry: Range of Oxide Properties

Oxygen is the most abundant element on Earth's surface, occurring both as the free element and in innumerable oxides, silicates, carbonates, and phosphates, as well as in water. Virtually all free O₂ has been formed for billions of years by photosynthetic algae and multicellular plants in an overall equation that only looks simple:

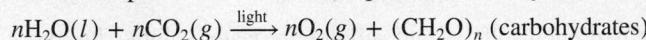

The reverse process occurs during combustion and respiration. Through these O₂-forming and O₂-utilizing processes, the $1.5 \times 10^9 \text{ km}^3$ of water on Earth is, on average, used and remade every 2 million years!

Every element (except He, Ne, and Ar) forms at least one oxide, many by direct combination. A spectrum of properties characterizes these compounds. Some oxides are gases that condense at very low temperatures, such as CO (bp = -192°C); others are solids that melt at extremely high temperatures, such as BeO (mp = 2530°C). Oxides cover the full range of conductivity: insulators (MgO), semiconductors (NiO), conductors (ReO₃), and superconductors (YBa₂Cu₃O₇). They may be thermally stable (CaO) or unstable (HgO), as well as chemically reactive (Li₂O) or inert (Fe₂O₃).

Another useful way to classify element oxides is by their acid-base properties. The oxides of Group 6A(16) exhibit expected trends in acidity, with SO₃ [the higher (+6) oxide] the most acidic and PoO₂ [the lower (+4) oxide] the most basic.

Highlights of Sulfur Chemistry

Like phosphorus, sulfur forms two common oxides and two oxoacids, one of which is essential to many industries. There are also several important metal sulfides.

Sulfur Oxides Sulfur forms two important oxides.

1. *Sulfur dioxide* (SO₂) has S in its +4 oxidation state. It is a colorless, choking gas that forms when S, H₂S, or a metal sulfide burns in air:

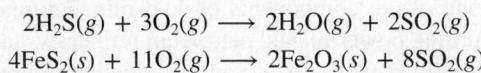

2. *Sulfur trioxide* (SO₃), which has S in the +6 oxidation state, is produced when SO₂ reacts in O₂. A catalyst (Chapter 16) must be used to speed up this very slow reaction. For the production of sulfuric acid, a vanadium(V) oxide catalyst is used:

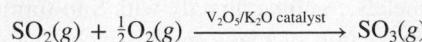

Sulfur Oxoacids Sulfur forms two important oxoacids.

1. *Sulfurous acid* (H₂SO₃), formed when SO₂ dissolves in water, exists in equilibrium with hydrated SO₂ rather than as stable H₂SO₃ molecules:

Sulfurous acid is weak and has two acidic protons, forming the hydrogen sulfite (bisulfite, HSO_3^-) and sulfite (SO_3^{2-}) ions with strong base. Because the S in SO_3^{2-} is in the +4 state and is easily oxidized to the +6 state, sulfites are good reducing agents and preserve foods and wine by eliminating undesirable products of air oxidation.

2. *Sulfuric acid* (H_2SO_4) is produced when SO_2 is oxidized catalytically to SO_3 , which is then absorbed into concentrated H_2SO_4 and treated with H_2O :

With more than 60 million tons produced each year in the United States alone, H_2SO_4 ranks first among all industrial chemicals: it is vital to fertilizer production; metal, pigment, and textile processing; and soap and detergent manufacturing. (The production of H_2SO_4 will be discussed in detail in Chapter 22.)

Concentrated laboratory-grade sulfuric acid is a viscous, colorless liquid that is 98% H_2SO_4 by mass. Like other strong acids, H_2SO_4 dissociates completely in water, forming the hydrogen sulfate (or bisulfate) ion, a much weaker acid:

Most common hydrogen sulfates and sulfates are water soluble, but those of the larger Group 2A(2) members (Ca^{2+} , Sr^{2+} , Ba^{2+} , and Ra^{2+}), Ag^+ , and Pb^{2+} are not.

Concentrated sulfuric acid is an excellent dehydrating agent. Its loosely held proton transfers to water in a highly exothermic formation of hydronium (H_3O^+) ions. This process can occur even when the reacting substance contains no free water. For example, H_2SO_4 dehydrates wood, natural fibers, and many other organic substances, such as table sugar (CH_2O)_n, by removing the components of water from the molecular structure, leaving behind a carbonaceous mass (Figure 14.21).

Figure 14.21 The dehydration of sugar by sulfuric acid.

Source: © McGraw-Hill Education/Stephen Frisch, photographer

Sulfuric acid is one of the components of acid rain. Enormous amounts of SO_2 are emitted by coal-burning power plants, petroleum refineries, and metal-ore smelters (see photo). In contact with H_2O , this SO_2 and its oxidation product, SO_3 , form H_2SO_3 and H_2SO_4 in the atmosphere, which then fall in rain, snow, and dust on animals, plants, buildings, and lakes (see Chemical Connections, Chapter 19).

Metal Sulfides Many metals combine directly with S to form *metal sulfides*. Sulfide ores are mined for the extraction of many metals, including copper, zinc, lead, and silver. Aside from the sulfides of Groups 1A(1) and 2A(2), most metal sulfides do not have discrete S^{2-} ions. Several transition metals, such as chromium, iron, and nickel, form covalent, alloy-like, nonstoichiometric compounds with S, such as $\text{Cr}_{0.88}\text{S}$ and $\text{Fe}_{0.86}\text{S}$. Some important minerals contain S_2^{2-} ions; an example is iron pyrite, or “fool’s gold” (FeS_2). We discuss the metallurgy of ores in Chapter 22.

Industrial sources produce the sulfur oxides that lead to acid rain.

Source: © Steve Cole/Getty Images RF

14.9 GROUP 7A(17): THE HALOGENS

The halogens, the last elements of great reactivity, begin with fluorine (F), the strongest electron “grabber” of all. Chlorine (Cl, the most important halogen industrially), bromine (Br), and iodine (I) also form compounds with most elements, and even rare, radioactive astatine (At) is reactive; little is known of tennessine (Ts, first synthesized in 2010). The key features of this group are presented in the Group 7A(17) Family Portrait (*next page*).

Physical Behavior of the Halogens

As expected from the increase in molar mass, the halogens display regular trends in their physical properties: melting and boiling points and heats of fusion and vaporization *increase* down Group 7A(17). The halogens exist as diatomic molecules that interact through dispersion forces, which *increase* in strength as the atoms become larger and, thus, more easily polarized. Even their color darkens with molar mass: F₂ is a very pale yellow gas, Cl₂ a yellow-green gas, Br₂ a brown-orange liquid, and I₂ a purple-black solid.

Why the Halogens Are So Reactive

The Group 7A(17) elements react with most metals and nonmetals to form many ionic and covalent compounds: metal and nonmetal halides, halogen oxides, and oxoacids. The main reason for halogen reactivity is the same as for alkali metal reactivity—an electron configuration one electron away from that of a noble gas. Whereas a Group 1A(1) metal atom must lose one electron to attain a filled outer level, a *Group 7A(17) nonmetal atom must gain one electron to fill its outer level*. It accomplishes this filling in either of two ways:

1. Gaining an electron from a metal atom, thus forming a negative ion and an ionic bond with the positive metal ion.
2. Sharing an electron pair with a nonmetal atom, thus forming a covalent bond.

Electronegativity and Bond Properties The halogens display the largest range in electronegativity of any group, but all are electronegative enough to behave as nonmetals. Down the group, reactivity reflects the decrease in electronegativity: F₂ is the most reactive and I₂ the least. The exceptional reactivity of elemental F₂ is also related to the weakness of the F—F bond. Although bond energy generally decreases as atomic size increases down the group (Figure 14.22), F₂ deviates from this trend. The short F—F bond is weaker than expected because lone pairs on each small F atom repel those on the other. As a result of these factors, F₂ reacts with every element (except He, Ne, and Ar), in many cases, explosively.

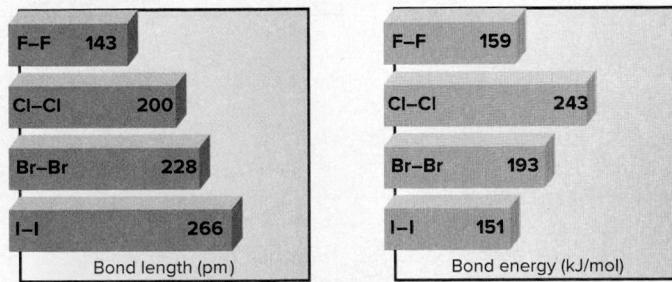

Figure 14.22 Bond energies and bond lengths of the halogens.

Redox Behavior The halogens act as *oxidizing agents* in the majority of their reactions, and halogens higher in the group can oxidize halide ions lower down:

Thus, the oxidizing ability of X₂ increases *up* the group: the higher the EN, the more strongly each X atom pulls electrons away. Similarly, the reducing ability of

KEY ATOMIC PROPERTIES, PHYSICAL PROPERTIES, AND REACTIONS

KEY	Atomic No.	Symbol	Atomic mass	Valence e ⁻ configuration (Common oxidation states)
	9	F	19.00	1s ² 2p ⁵ (-1)
	17	Cl	35.45	3s ² 3p ⁵ (-1, +7, +5, +3, +1)
	35	Br	79.90	4s ² 4p ⁵ (-1, +7, +5, +3, +1)
	53	I	126.9	5s ² 5p ⁵ (-1, +7, +5, +3, +1)
	85	At	(210)	6s ² 6p ⁵ (-1)
	117	Ts	(294)	7s ² 7p ⁵

GROUP 7A(17)

Atomic radius (pm)	Ionic radius (pm)
F 72	F ⁻ 133
Cl 100	Cl ⁻ 181
Br 114	Br ⁻ 196
I 133	I ⁻ 220
At (140)	no data

Atomic Properties

Group electron configuration is ns^2np^5 ; elements lack one electron to complete their outer level. The -1 oxidation state is the most common for all members. Except for F, the halogens exhibit all odd-numbered states (+7 through -1). Down the group, atomic and ionic sizes increase steadily, as IE and EN decrease.

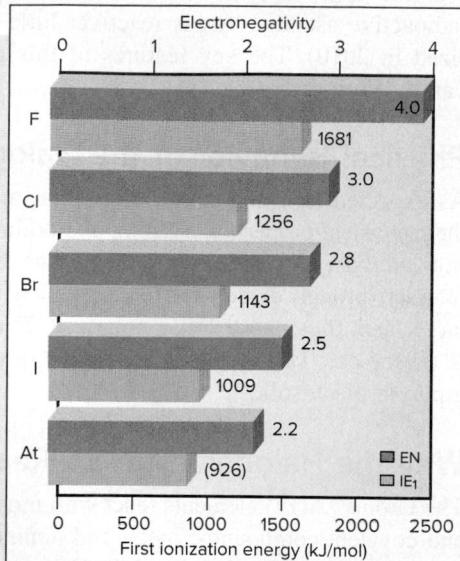

Physical Properties

Down the group, melting and boiling points increase smoothly as a result of stronger dispersion forces between larger molecules. The densities of the elements as liquids (at the given temperatures) increase steadily with molar mass.

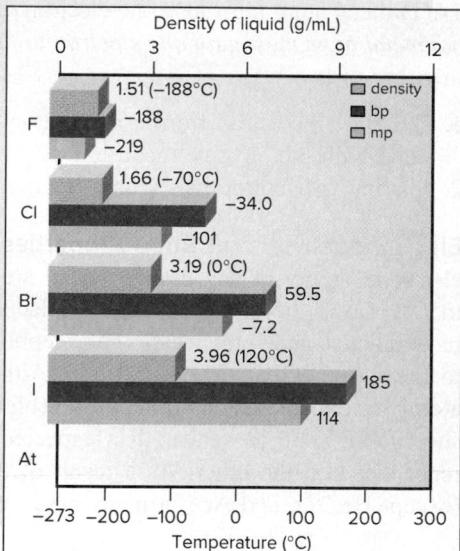

Source: © McGraw-Hill Education/Stephen Frisch, photographer

Reactions

1. The halogens (X_2) oxidize many metals and nonmetals. The reaction with hydrogen, although not used commercially for HX production (except for high-purity HCl), is characteristic of these strong oxidizing agents:

2. The halogens undergo disproportionation in water:

In aqueous base, the reaction goes to completion to form hypohalites and, at higher temperatures, halates, for example:

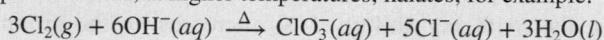

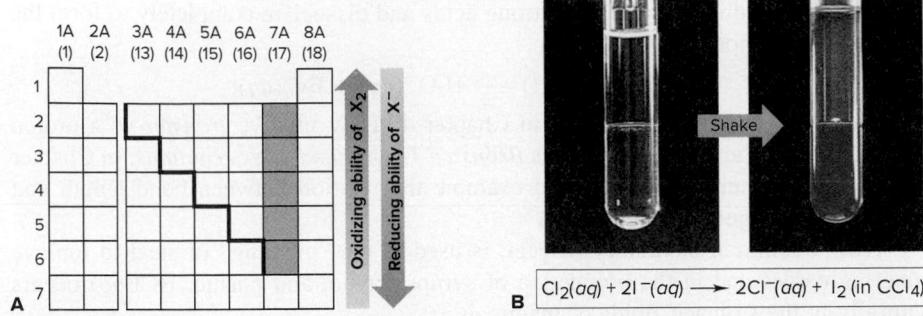

Figure 14.23 The relative oxidizing ability of the halogens.

Source: B: © McGraw-Hill Education/Stephen Frisch, photographer

X^- increases *down* the group: the larger the ion, the more easily it gives up its electron (Figure 14.23A). Aqueous Cl_2 added to a solution of I^- (Figure 14.23B, *top layer*) oxidizes the I^- to I_2 , which dissolves in the CCl_4 solvent (*bottom layer*) to give a purple solution.

The halogens undergo some important aqueous redox chemistry. Fluorine is such a powerful oxidizing agent that it reacts vigorously with water, oxidizing the O to produce O_2 , some O_3 , and HFO (hypofluorous acid). The other halogens undergo disproportionations (note the oxidation numbers):

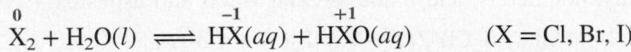

At equilibrium, very little product is present unless excess OH^- ion is added, which reacts with the HX and HXO and drives the reaction to completion:

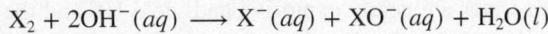

When X is Cl, the product mixture acts as a bleach: household bleach is a dilute solution of sodium hypochlorite (NaClO). Heating causes XO^- to disproportionate further, creating oxoanions with X in a higher oxidation state:

Highlights of Halogen Chemistry

Now, let's examine the compounds the halogens form with hydrogen and with each other, as well as their oxides, oxoanions, and oxoacids.

The Hydrogen Halides The halogens form gaseous hydrogen halides (HX) through direct combination with H_2 or through the action of a concentrated acid on the metal halide (a nonoxidizing acid is used for HBr and HI):

Commercially, most HCl is formed as a byproduct in the chlorination of hydrocarbons for plastics production:

In this case, the vinyl chloride reacts in a separate process to form poly(vinyl chloride), or PVC, a polymer used extensively in pipes for plumbing and other purposes.

In water, gaseous HX molecules form a *hydrohalic acid*. Only HF, with its relatively short, strong bond, forms a weak acid:

HF has many uses, including the synthesis of cryolite (Na_3AlF_6) for aluminum production (Chapter 22), of fluorocarbons for refrigeration, and of NaF for water fluoridation. HF is also used in nuclear fuel processing and for glass etching.

The other hydrohalic acids are strong acids and dissociate completely to form the stoichiometric amount of H_3O^+ ions:

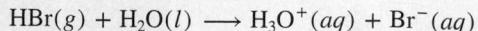

(We saw reactions similar to these in Chapter 4. They involve *transfer* of a proton from acid to H_2O and are classified as *Brønsted-Lowry acid-base reactions*. In Chapter 18, we discuss them thoroughly and examine the relation between bond length and acidity of the larger HX molecules.)

HCl , a common laboratory reagent, is used in the “pickling” of steel to remove adhering oxides and in the production of syrups, rayon, and plastic. $\text{HCl}(aq)$ occurs naturally in the stomach fluids of mammals.

Interhalogen Compounds: The “Halogen Halides” Halogens react exothermically with one another to form many **interhalogen compounds**. The simplest are diatomic molecules, such as ClF and BrCl . Every binary combination of the four common halogens is known. The more electronegative halogen is in the -1 oxidation state, and the less electronegative is in the $+1$ state. Interhalogens of general formula XY_n ($n = 3, 5, 7$) form through a variety of reactions, including direct reaction of the elements. In every case, the central atom has the lower *electronegativity* and a positive oxidation state.

Some interhalogens are used commercially as powerful *fluorinating agents*, which react with metals, nonmetals, and oxides—even wood and asbestos:

Their reactions with water are nearly explosive and yield HF and the *oxoacid with the central halogen in the same oxidation state*, for example:

The Oddness and Evenness of Oxidation States Almost all stable molecules have paired electrons, either as bonding or lone pairs. Therefore, when bonds form or break, two electrons are involved, so the oxidation state changes by 2. For this reason, odd-numbered groups exhibit odd-numbered oxidation states and even-numbered groups exhibit even-numbered states.

1. *Odd-numbered oxidation states*. Consider the interhalogens. Four general formulas are XY , XY_3 , XY_5 , and XY_7 ; examples are shown in Figure 14.24. With Y in the -1 state, X must be in the $+1$, $+3$, $+5$, or $+7$ state, respectively. The -1 state arises when Y fills its valence level; the $+7$ state arises when the central halogen (X) is completely oxidized, that is, when all seven valence electrons have shifted away from it to the more electronegative Y atoms around it.

Let’s examine the iodine fluorides to see why the oxidation states jump by two units. When I_2 reacts with F_2 , IF forms (note the oxidation number of I):

Figure 14.24 Molecular shapes of the main types of interhalogen compounds.

In IF_3 , I uses *two* more valence electrons to form *two* more bonds:

Otherwise, an unstable lone-electron species containing two fluorines would form. When IF_3 reacts with more fluorine, another jump of two units occurs and the pentafluoride forms:

With still more fluorine, the heptafluoride forms:

2. Even-numbered oxidation states. An element in an even-numbered group, such as sulfur in Group 6A(16), shows the same tendency to have paired electrons in its compounds. Elemental sulfur (oxidation number, O.N. = 0) gains or shares two electrons to complete its shell (O.N. = -2). It uses two electrons to react with fluorine, for example, to form SF_2 (O.N. = +2), two more electrons to form SF_4 (O.N. = +4), and two more to form SF_6 (O.N. = +6).

Thus, an element with one even state typically has all even states, and an element with one odd state typically has all odd states. To reiterate the main point, *successive oxidation states differ by two units because stable molecules have electrons in pairs around their atoms.*

Halogen Oxides, Oxoacids, and Oxoanions The Group 7A(17) elements form many oxides that are *powerful oxidizing agents and acids in water*. Dichlorine monoxide (Cl_2O) and especially chlorine dioxide (ClO_2) are used to bleach paper (Figure 14.25). ClO_2 is unstable to heat and shock, so it is prepared on site, and more than 100,000 tons are used annually:

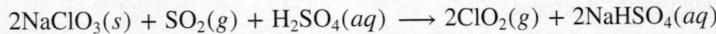

The dioxide has an unpaired electron and Cl in the unusual +4 oxidation state.

Chlorine is in its highest (+7) oxidation state in dichlorine heptoxide, Cl_2O_7 , which is a symmetrical molecule formed when two HClO_4 ($\text{HO}-\text{ClO}_3$) molecules undergo a dehydration-condensation reaction:

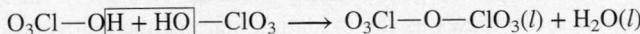

The halogen oxoacids and oxoanions are produced by reaction of the halogens and their oxides with water. Most of the oxoacids are stable only in solution. Table 14.4 (*on the next page*) shows ball-and-stick models of the acids in which each atom has its lowest formal charge; note the formulas, which emphasize that the H is bonded to O. The hypohalites (XO_4^-), halites (XO_2^-), and halates (XO_3^-) are oxidizing agents formed by aqueous disproportionation reactions [see the Group 7A(17) Family Portrait, reaction 2]. You may have heated solid alkali chlorates in the laboratory to form small amounts of O_2 :

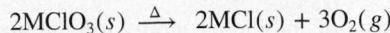

Potassium chlorate is the oxidizer in “safety” matches.

Several perhalates (XO_4^-) are also strong oxidizing agents. Thousands of tons of perchlorates are made each year for use in explosives and fireworks. Ammonium

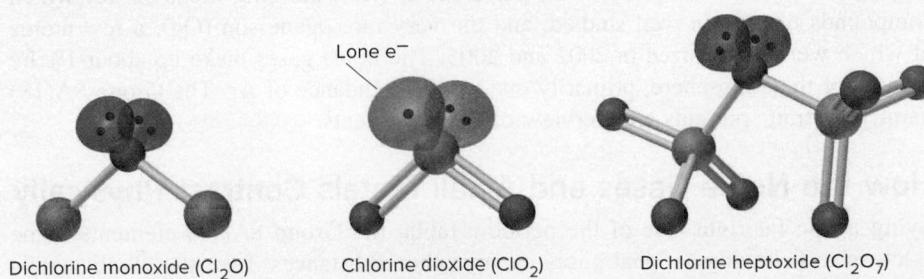

Figure 14.25 Chlorine oxides.
Structures show each central Cl atom with its lowest formal charge.

Table 14.4

The Known Halogen Oxoacids*

Central Atom	Hypohalous Acid (HOX)	Halous Acid (HOXO)	Halic Acid (HOXO ₂)	Perhalic Acid (HOXO ₃)
Fluorine	HOF	—	—	—
Chlorine	HOCl	HOCIO	HOClO ₂	HOClO ₃
Bromine	HOBr	HOBrO	HOBrO ₂	HOBrO ₃
Iodine	HOI	—	HOIO ₂	HOIO ₃ , (HO) ₅ IO
Oxoanion	Hypohalite	Halite	Halate	Perhalate

*Lone pairs are shown only on the halogen atom, and each atom has its lowest formal charge.

perchlorate, prepared from sodium perchlorate, was the oxidizing agent for the aluminum powder in the solid-fuel booster rockets of space shuttles; each launch used more than 700 tons of NH₄ClO₄:

The relative strengths of the halogen oxoacids depend on two factors:

1. *Electronegativity of the halogen.* Among oxoacids with the halogen in the same oxidation state, such as the halic acids, HXO₃ (or HOXO₂), acid strength decreases as the halogen's EN decreases:

The more electronegative the halogen, the more electron density it removes from the O—H bond, and the more easily the proton is lost.

2. *Oxidation state of the halogen.* Among oxoacids of a given halogen, such as chlorine, acid strength decreases as the oxidation state of the halogen decreases:

The higher the oxidation state (number of attached O atoms) of the halogen, the more electron density it pulls from the O—H bond. We consider these trends quantitatively in Chapter 18.

14.10 GROUP 8A(18): THE NOBLE GASES

The last main group consists of individual atoms too “noble” to interact much with others. The Group 8A(18) elements display regular trends in physical properties and very low, if any, reactivity. The group consists of the following elements: helium (He), the second most abundant element in the universe; neon (Ne); argon (Ar); krypton (Kr), xenon (Xe), and radioactive radon (Rn), the only members for which compounds have been well studied; and the very rare oganesson (Og), a few atoms of which were synthesized in 2002 and 2005. The noble gases make up about 1% by volume of the atmosphere, primarily due to the abundance of Ar. The Group 8A(18) Family Portrait presents an overview of these elements.

How the Noble Gases and Alkali Metals Contrast Physically

Lying at the far right side of the periodic table, the Group 8A(18) elements come as close to behaving as ideal gases as any other substances. Like the alkali metals

KEY ATOMIC AND PHYSICAL PROPERTIES

KEY	Atomic No.	Symbol	Atomic mass	Valence e ⁻ configuration (Common oxidation states)
2	He	He	4.003	1s ² (none)
10	Ne	Ne	20.18	2s ² 2p ⁶ (none)
18	Ar	Ar	39.95	3s ² 3p ⁶ (none)
36	Kr	Kr	83.80	4s ² 4p ⁶ (+2)
54	Xe	Xe	131.3	5s ² 5p ⁶ (+8, +6, +4, +2)
86	Rn	Rn	(222)	6s ² 6p ⁶ (+2)
118	Og	Og	(294)	7s ² 7p ⁶

Mass spectral peak

Observed in experiments at Dubna, Russia, in 2002 and 2005

Atomic radius (pm)
He 31
Ne 71
Ar 98
Kr 112
Xe 131
Rn (140)

Atomic Properties

Group electron configuration is 1s² for He and ns²np⁶ for the others. The valence shell is filled. Only Kr, Xe, and Rn are known to form compounds. The more reactive Xe exhibits all even oxidation states (+2 to +8). This group contains the smallest atoms with the highest IEs in their periods. Down the group, atomic size increases and IE decreases steadily. (EN values are given only for Kr and Xe.)

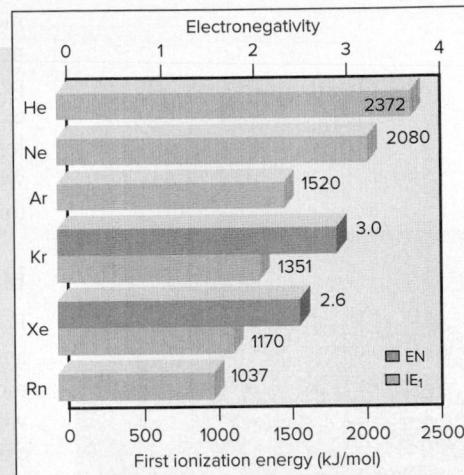

Physical Properties

Melting and boiling points of these gaseous elements are extremely low but increase down the group because of stronger dispersion forces. Note the extremely small liquid ranges. Densities (at STP) increase steadily, as expected.

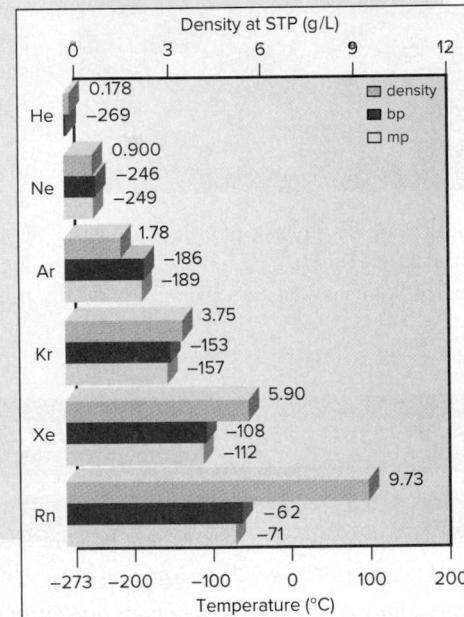

Source: © McGraw-Hill Education/Stephen Frisch, photographer

at the other end of the periodic table, the noble gases display regular trends in physical properties. However, whereas melting and boiling points and heats of fusion and vaporization *decrease* down Group 1A(1), these properties *increase* down Group 8A(18). The reason for these opposite trends is the different bonding interactions in the elements. The alkali metals consist of atoms held together by metallic bonding, which *decreases* in strength as the atoms become larger. The noble gases, on the other hand, exist as individual atoms that interact through dispersion forces, which *increase* in strength as the atoms become larger and more easily polarized. Nevertheless, these dispersion forces are so weak that only at very low temperatures do the elements condense and solidify. For example, even argon, which makes up almost 1% of the atmosphere, melts at -189°C and boils only about three degrees higher.

Figure 14.26 Crystals of xenon tetrafluoride (XeF_4).

Source: Argonne National Laboratory

How Noble Gases Can Form Compounds

Following their discovery in the late 19th century, these elements were considered, and even formerly named, the “inert” gases. Early 20th-century atomic theory and, more important, all experiments supported this idea. Then, in 1962, all this changed when the first noble gas compound was prepared. How, with filled outer levels and extremely high ionization energies, *can* noble gases react?

The discovery of noble gas reactivity is a classic example of clear thinking in the face of an unexpected event. A young inorganic chemist named Neil Bartlett was studying platinum fluorides, known to be strong oxidizing agents. When he accidentally exposed PtF_6 to air, its deep-red color lightened slightly, and analysis showed that the PtF_6 had oxidized O_2 to form the ionic compound $[\text{O}_2]^+[\text{PtF}_6]^-$. Knowing that the ionization energy of the oxygen molecule ($\text{O}_2 \rightarrow \text{O}_2^+ + \text{e}^-$; IE = 1175 kJ/mol) is very close to IE₁ of xenon (1170 kJ/mol), Bartlett reasoned that PtF_6 might be able to oxidize xenon. Shortly thereafter, he prepared XePtF_6 , an orange-yellow solid. Within a few months, the white crystalline XeF_2 and XeF_4 (Figure 14.26) were also prepared. In addition to its +2 and +4 oxidation states, Xe has the +6 state in several compounds, such as XeF_6 , and the +8 state in the unstable oxide, XeO_4 . A few compounds of Kr and Rn have also been made.

CHAPTER REVIEW GUIDE

Learning Objectives

Relevant section (§) numbers appear in parentheses.

Understand These Concepts

Note: Many characteristic reactions appear in the “Reactions” section of each group’s Family Portrait.

- How hydrogen is similar to, yet different from, alkali metals and halogens; the differences between ionic, covalent, and metallic hydrides (§14.1)
- Key horizontal trends in atomic properties, types of bonding, oxide acid-base properties, and redox behavior as the elements change from metals to nonmetals (§14.2)
- How small atomic size and limited number of valence orbitals account for the anomalous behavior of the Period 2 member of each group (§14.2)
- How the ns^1 configuration accounts for the physical and chemical properties of the alkali metals (§14.3)
- How the ns^2 configuration accounts for the key differences between Groups 1A(1) and 2A(2) (§14.4)
- The basis of the three important diagonal relationships (Li/Mg, Be/Al, B/Si) (§14.4–14.6)

- How the presence of inner $(n - 1)d$ electrons affects properties in Group 3A(13) (§14.5)
- Patterns among larger members of Groups 3A(13) to 6A(16): two common oxidation states (inert-pair effect), lower state more important going down the group, and more basic oxide with the element in the lower state (§14.5–14.8)
- How boron attains an octet of electrons (§14.5)
- The effect of bonding on the physical behavior of Groups 4A(14) to 6A(16) (§14.6–14.8)
- Allotropism in carbon, phosphorus, and sulfur (§14.6–14.8)
- How atomic properties lead to catenation and multiple bonds in organic compounds (§14.6)
- Structures and properties of the silicates and silicones (§14.6)
- Patterns of behavior among hydrides and halides of Groups 5A(15) and 6A(16) (§14.7, §14.8)
- The meaning of disproportionation (§14.7)

16. Structure and chemistry of the nitrogen oxides and oxoacids (§14.7)
17. Structure and chemistry of the phosphorus oxides and oxoacids (§14.7)
18. Dehydration-condensation reactions and polyphosphate structures (§14.7)
19. Structure and chemistry of the sulfur oxides and oxoacids (§14.8)
20. How the ns^2np^5 configuration accounts for halogen reactivity with metals (§14.9)
21. Why the oxidation states of an element change by two units (§14.9)
22. Structure and chemistry of the halogen oxides and oxoacids (§14.9)
23. How the ns^2np^6 configuration accounts for the relative inertness of the noble gases (§14.10)

Key Terms

Page numbers appear in parentheses.

allotrope (600)
 bridge bond (598)
 diagonal relationship (595)

disproportionation reaction (609)
 dehydration-condensation reaction (611)

interhalogen compound (620) silicone (603)
 silicate (603)

PROBLEMS

Problems with **colored** numbers are answered in Appendix E and worked in detail in the Student Solutions Manual. Problem sections match those in the text. Most offer Concept Review Questions, Skill-Building Exercises (grouped in pairs covering the same concept), and Problems in Context. The Comprehensive Problems are based on material from any section or previous chapter.

Hydrogen, the Simplest Atom**Concept Review Questions**

14.1 Hydrogen has only one proton, but its IE₁ is much greater than that of lithium, which has three protons. Explain.

14.2 Sketch a periodic table, and label the areas containing elements that give rise to the three types of hydrides.

Skill-Building Exercises (grouped in similar pairs)

14.3 Draw Lewis structures for the following compounds, and predict which member of each pair will form H bonds:

(a) NF₃ or NH₃ (b) CH₃OCH₃ or CH₃CH₂OH

14.4 Draw Lewis structures for the following compounds, and predict which member of each pair will form H bonds:

(a) NH₃ or AsH₃ (b) CH₄ or H₂O

14.5 Complete and balance the following equations:

(a) An active metal reacting with acid,

(b) A saltlike (alkali metal) hydride reacting with water,

14.6 Complete and balance the following equations:

(a) A saltlike (alkaline earth metal) hydride reacting with water,

(b) Reduction of a metal halide by hydrogen to form a metal,

Problems in Context

14.7 Compounds such as NaBH₄, Al(BH₄)₃, and LiAlH₄ are complex hydrides used as reducing agents in many syntheses.

(a) Give the oxidation state of each element in these compounds.

(b) Write a Lewis structure for the polyatomic anion in NaBH₄, and predict its shape.

14.8 Unlike the F⁻ ion, which has an ionic radius close to 133 pm in all alkali metal fluorides, the ionic radius of H⁻ varies from 137 pm in LiH to 152 pm in CsH. Suggest an explanation for the large variability in the size of H⁻ but not F⁻.

Trends Across the Periodic Table: The Period 2 Elements**Concept Review Questions**

14.9 How does the maximum oxidation number vary across a period in the main groups? Is the pattern in Period 2 different?

14.10 What correlation, if any, exists for the Period 2 elements between group number and the number of covalent bonds the element typically forms? How is the correlation different for elements in Periods 3 to 6?

14.11 Each of the chemically active Period 2 elements forms stable compounds in which it has bonds to fluorine.

(a) What are the names and formulas of these compounds?
 (b) Does ΔEN increase or decrease left to right across the period?

(c) Does percent ionic character increase or decrease left to right?

(d) Draw Lewis structures for these compounds.

14.12 Period 6 contains the first series of inner transition elements.

(a) How many elements belong to Period 6? How many metals?

(b) It contains no metalloids. Where is the metal/nonmetal boundary in Period 6?

14.13 An element forms an oxide, E₂O₃, and a fluoride, EF₃.

(a) Of which two groups might E be a member?
 (b) How does the group to which E belongs affect the properties of the oxide and the fluoride?

14.14 Fluorine lies between oxygen and neon in Period 2. Whereas atomic sizes and ionization energies of these three elements change smoothly, their electronegativities display a dramatic change. What is this change, and how do their electron configurations explain it?

Group 1A(1): The Alkali Metals

Concept Review Questions

14.15 Lithium salts are often much less soluble in water than the corresponding salts of other alkali metals. For example, at 18°C, the concentration of a saturated LiF solution is $1.0 \times 10^{-2} M$, whereas that of a saturated KF solution is $1.6 M$. How can you explain this behavior?

14.16 The alkali metals play virtually the same general chemical role in all their reactions.

- (a) What is this role?
- (b) How is it based on atomic properties?
- (c) Using sodium, write two balanced equations that illustrate this role.

14.17 How do atomic properties account for the low densities of the Group 1A(1) elements?

Skill-Building Exercises (grouped in similar pairs)

14.18 Each of the following properties shows a regular trend in Group 1A(1). Predict whether each increases or decreases *down* the group:

- | | | |
|---------------------|--|---------------------|
| (a) Density | (b) Ionic size | (c) E—E bond energy |
| (d) IE ₁ | (e) Magnitude of ΔH_{hydr} of E^+ ion | |

14.19 Each of the following properties shows a regular trend in Group 1A(1). Predict whether each increases or decreases *up* the group:

- | | | |
|-------------------|------------------------------------|--------------|
| (a) Melting point | (b) E—E bond length | (c) Hardness |
| (d) Molar volume | (e) Lattice energy of $E\text{Br}$ | |

14.20 Write a balanced equation for the formation from its elements of sodium peroxide, an industrial bleach.

14.21 Write a balanced equation for the formation of rubidium bromide through reaction of a strong acid and a strong base.

Problems in Context

14.22 Although the alkali metal halides can be prepared directly from the elements, the far less expensive industrial route is treatment of the carbonate or hydroxide with aqueous hydrohalic acid (HX) followed by recrystallization. Balance the reaction between potassium carbonate and aqueous hydriodic acid.

14.23 Lithium forms several useful organolithium compounds. Calculate the mass percent of Li in the following:

- (a) Lithium stearate ($\text{C}_{17}\text{H}_{35}\text{COOLi}$), a water-resistant grease used in cars because it does not harden at cold temperatures
- (b) Butyllithium (LiC_4H_9), a reagent in organic syntheses

Group 2A(2): The Alkaline Earth Metals

Concept Review Questions

14.24 How do Groups 1A(1) and 2A(2) compare with respect to reaction of the metals with water?

14.25 Alkaline earth metals are involved in two key diagonal relationships in the periodic table.

- (a) Give the two pairs of elements in these diagonal relationships.
- (b) For each pair, cite two similarities that demonstrate the relationship.
- (c) Why are the members of each pair so similar in behavior?

14.26 The melting points of alkaline earth metals are many times higher than those of the alkali metals. Explain this difference on the basis of atomic properties. Name three other physical properties for which Group 2A(2) metals have higher values than the corresponding 1A(1) metals.

Skill-Building Exercises (grouped in similar pairs)

14.27 Write a balanced equation for each reaction:

- (a) “Slaking” of lime (treatment with water)
- (b) Combustion of calcium in air

14.28 Write a balanced equation for each reaction:

- (a) Thermal decomposition of witherite (barium carbonate)
- (b) Neutralization of stomach acid (HCl) by milk of magnesia (magnesium hydroxide)

Problems in Context

14.29 Lime (CaO) is one of the most abundantly produced chemicals in the world. Write balanced equations for these reactions:

- (a) The preparation of lime from natural sources
- (b) The use of slaked lime to remove SO_2 from flue gases
- (c) The reaction of lime with arsenic acid (H_3AsO_4) to manufacture the insecticide calcium arsenate
- (d) The regeneration of NaOH in the paper industry by reaction of lime with aqueous sodium carbonate

14.30 In some reactions, Be behaves like a typical alkaline earth metal; in others, it does not. Complete and balance the following:

- (a) $\text{BeO}(s) + \text{H}_2\text{O}(l) \longrightarrow$
- (b) $\text{BeCl}_2(l) + \text{Cl}^-(l)$; from molten NaCl \longrightarrow

In which reaction does Be behave like the other Group 2A(2) members?

Group 3A(13): The Boron Family

Concept Review Questions

14.31 How do the transition metals in Period 4 affect the pattern of ionization energies in Group 3A(13)? How does this pattern compare with that in Group 3B(3)?

14.32 How do the acidities of aqueous solutions of Tl_2O and Tl_2O_3 compare with each other? Explain.

14.33 Despite the expected decrease in atomic size, there is an unexpected drop in the first ionization energy between Groups 2A(2) and 3A(13) in Periods 2 through 4. Explain this pattern in terms of electron configurations and orbital energies.

14.34 Many compounds of Group 3A(13) elements have chemical behavior that reflects an electron deficiency.

- (a) What is the meaning of *electron deficiency*?
- (b) Give two reactions that illustrate this behavior.

14.35 Boron's chemistry is not typical of its group.

- (a) Cite three ways in which boron and its compounds differ significantly from the other 3A(13) members and their compounds.
- (b) What is the reason for these differences?

Skill-Building Exercises (grouped in similar pairs)

14.36 Rank the following oxides in order of increasing *acidity* of their aqueous solutions: Ga_2O_3 , Al_2O_3 , In_2O_3 .

14.37 Rank the following hydroxides in order of increasing *basicity* of their aqueous solutions: $\text{Al}(\text{OH})_3$, $\text{B}(\text{OH})_3$, $\text{In}(\text{OH})_3$.

14.38 Thallium forms the compound TlI_3 . What is the apparent oxidation state of Tl in this compound? Given that the anion is I_3^- , what is the actual oxidation state of Tl? Draw the shape of the anion, giving its VSEPR class and bond angles. Propose a reason why the compound does not exist as $(\text{Tl}^{3+})(\text{I}^-)_3$.

14.39 Very stable dihalides of the Group 3A(13) metals are known. What is the apparent oxidation state of Ga in GaCl_2 ? Given that GaCl_2 consists of a Ga^+ cation and a GaCl_4^- anion, what are the actual oxidation states of Ga? Draw the shape of the anion, giving its VSEPR class and bond angles.

Problems in Context

14.40 Give the name and symbol or formula of a Group 3A(13) element or compound that fits each description or use:

- Component of heat-resistant (Pyrex-type) glass
- Largest temperature range for liquid state of an element
- Elemental substance with three-center, two-electron bonds
- Metal protected from oxidation by adherent oxide coat
- Toxic metal that lies between two other toxic metals

14.41 Indium (In) reacts with HCl to form a diamagnetic solid with the formula InCl_2 .

- Write condensed electron configurations for In, In^+ , In^{2+} , and In^{3+} .
- Which of these species is (are) diamagnetic and which paramagnetic?
- What is the apparent oxidation state of In in InCl_2 ?
- Given your answers to parts (b) and (c), explain how InCl_2 can be diamagnetic.

14.42 Use VSEPR theory to draw structures, with ideal bond angles, for boric acid and the anion it forms when it reacts with water.

14.43 Boron nitride (BN) has a structure similar to graphite, but is a white insulator rather than a black conductor. It is synthesized by heating diboron trioxide with ammonia at about 1000°C .

- Write a balanced equation for the formation of BN; water also forms.
- Calculate $\Delta H_{\text{rxn}}^\circ$ for the production of BN (ΔH_f° of BN is -254 kJ/mol).
- Boron is obtained from the mineral borax, $\text{Na}_2\text{B}_4\text{O}_7 \cdot 10\text{H}_2\text{O}$. How much borax is needed to produce 1.0 kg of BN, assuming 72% yield?

Group 4A(14): The Carbon Family

Concept Review Questions

14.44 How does the basicity of SnO_2 in water compare with that of CO_2 ? Explain.

14.45 Nearly every compound of silicon has the element in the +4 oxidation state. In contrast, most compounds of lead have the element in the +2 state.

- What general observation do these facts illustrate?
- Explain in terms of atomic and molecular properties.
- Give an analogous example from Group 3A(13).

14.46 The sum of IE_1 through IE_4 for Group 4A(14) elements shows a decrease from C to Si, a slight increase from Si to Ge, a decrease from Ge to Sn, and an increase from Sn to Pb.

- What is the expected trend for IEs down a group?
- Suggest a reason for the deviations in Group 4A(14).
- Which group might show even greater deviations?

14.47 Give explanations for the large drops in melting point from C to Si and from Ge to Sn.

14.48 What is an allotrope? Name two Group 4A(14) elements that exhibit allotropism, and identify two of their allotropes.

14.49 Even though EN values vary relatively little down Group 4A(14), the elements change from nonmetal to metal. Explain.

14.50 How do atomic properties account for the enormous number of carbon compounds? Why don't other Group 4A(14) elements behave similarly?

Skill-Building Exercises (grouped in similar pairs)

14.51 Draw a Lewis structure for each species:

- The cyclic silicate ion $\text{Si}_4\text{O}_{12}^{8-}$
- A cyclic hydrocarbon with formula C_4H_8

14.52 Draw a Lewis structure for each species:

- The cyclic silicate ion $\text{Si}_6\text{O}_{18}^{12-}$
- A cyclic hydrocarbon with formula C_6H_{12}

Problems in Context

14.53 Zeolite A, $\text{Na}_{12}[(\text{AlO}_2)_{12}(\text{SiO}_2)_{12}] \cdot 27\text{H}_2\text{O}$, is used to soften water because it replaces Ca^{2+} and Mg^{2+} dissolved in the water with Na^+ . Hard water from a certain source is $4.5 \times 10^{-3} \text{ M}$ Ca^{2+} and $9.2 \times 10^{-4} \text{ M}$ Mg^{2+} , and a pipe delivers 25,000 L of this hard water per day. What mass (in kg) of zeolite A is needed to soften a week's supply of the water? (Assume zeolite A loses its capacity to exchange ions when 85 mol % of its Na^+ has been lost.)

14.54 Give the name and symbol or formula of a Group 4A(14) element or compound that fits each description or use:

- Hardest known natural substance
- Medicinal antacid
- Atmospheric gas implicated in the greenhouse effect
- Gas that binds to Fe(II) in blood
- Element used in the manufacture of computer chips

14.55 One similarity between B and Si is the explosive combustion of their hydrides in air. Write balanced equations for the combustion of B_2H_6 and of Si_4H_{10} .

Group 5A(15): The Nitrogen Family

Concept Review Questions

14.56 Which Group 5A(15) elements form trihalides? Pentahalides? Explain.

14.57 As you move down Group 5A(15), the melting points of the elements increase and then decrease. Explain.

14.58 (a) What is the range of oxidation states shown by the elements of Group 5A(15) as you move down the group?

(b) How does this range illustrate the general rule for the range of oxidation states in groups on the right side of the periodic table?

14.59 Bismuth(V) compounds are such powerful oxidizing agents that they have not been prepared in pure form. How is this fact consistent with the location of Bi in the periodic table?

14.60 Rank the following oxides in order of increasing acidity in water: Sb_2O_3 , Bi_2O_3 , P_4O_{10} , Sb_2O_5 .

Skill-Building Exercises (grouped in similar pairs)

14.61 Assuming acid strength relates directly to electronegativity of the central atom, rank H_3PO_4 , HNO_3 , and H_3AsO_4 in order of increasing acid strength.

14.62 Assuming acid strength relates directly to number of O atoms bonded to the central atom, rank $\text{H}_2\text{N}_2\text{O}_2$ [or $(\text{HON})_2$], HNO_3 [or HONO_2], and HNO_2 [or HONO] in order of decreasing acid strength.

14.63 Complete and balance the following:

- (a) $\text{As}(s) + \text{excess O}_2(g) \longrightarrow$
 (b) $\text{Bi}(s) + \text{excess F}_2(g) \longrightarrow$
 (c) $\text{Ca}_3\text{As}_2(s) + \text{H}_2\text{O}(l) \longrightarrow$

14.64 Complete and balance the following:

- (a) Excess $\text{Sb}(s) + \text{Br}_2(l) \longrightarrow$
 (b) $\text{HNO}_3(aq) + \text{MgCO}_3(s) \longrightarrow$
 (c) $\text{K}_2\text{HPO}_4(s) \xrightarrow{\Delta} \longrightarrow$

14.65 Complete and balance the following:

- (a) $\text{N}_2(g) + \text{Al}(s) \xrightarrow{\Delta} \longrightarrow$ (b) $\text{PF}_5(g) + \text{H}_2\text{O}(l) \longrightarrow$

14.66 Complete and balance the following:

- (a) $\text{AsCl}_3(l) + \text{H}_2\text{O}(l) \longrightarrow$ (b) $\text{Sb}_2\text{O}_3(s) + \text{NaOH}(aq) \longrightarrow$

14.67 Based on the relative sizes of F and Cl, predict the structure of PF_2Cl_3 .

14.68 Use the VSEPR model to predict the structure of the cyclic ion $\text{P}_3\text{O}_9^{3-}$.

Problems in Context

14.69 The pentafluorides of the larger members of Group 5A(15) have been prepared, but N can have only eight electrons. A claim has been made that, at low temperatures, a compound with the empirical formula NF_5 forms. Draw a possible Lewis structure for this compound. (*Hint: NF_5 is ionic.*)

14.70 Give the name and symbol or formula of a Group 5A(15) element or compound that fits each description or use:

- (a) Hydride that exhibits hydrogen bonding
 (b) Compound used in “strike-anywhere” match heads
 (c) Oxide used as a laboratory drying agent
 (d) Molecule with an odd-electron atom (two examples)
 (e) Compound used as an additive in soft drinks

14.71 In addition to those in Table 14.3, other less stable nitrogen oxides exist. Draw a Lewis structure for each of the following:

- (a) N_2O_2 , a dimer of nitrogen monoxide with an N—N bond
 (b) N_2O_2 , a dimer of nitrogen monoxide with no N—N bond
 (c) N_2O_3 with no N—N bond
 (d) NO^+ and NO_3^- , products of the ionization of liquid N_2O_4

14.72 Nitrous oxide (N_2O), the “laughing gas” used as anesthetic by dentists, is made by thermal decomposition of solid NH_4NO_3 . Write a balanced equation for this reaction. What are the oxidation states of N in NH_4NO_3 and in N_2O ?

14.73 Write balanced equations for the thermal decomposition of potassium nitrate (O_2 is also formed in both cases):

- (a) At low temperature to the nitrite
 (b) At high temperature to the metal oxide and nitrogen

Group 6A(16): The Oxygen Family**Concept Review Questions**

14.74 Rank the following in order of increasing electrical conductivity, and explain your ranking: Po, S, Se.

14.75 The oxygen and nitrogen families have some obvious similarities and differences.

- (a) State two general physical similarities between Group 5A(15) and 6A(16) elements.
 (b) State two general chemical similarities between Group 5A(15) and 6A(16) elements.
 (c) State two chemical similarities between P and S.
 (d) State two physical similarities between N and O.
 (e) State two chemical differences between N and O.

14.76 A molecular property of the Group 6A(16) hydrides changes abruptly down the group. This change has been explained in terms of a change in orbital hybridization.

- (a) Between what periods does the change occur?
 (b) What is the change in the molecular property?
 (c) What is the change in hybridization?
 (d) What other group displays a similar change?

Skill-Building Exercises (grouped in similar pairs)

14.77 Complete and balance the following:

- (a) $\text{NaHSO}_4(aq) + \text{NaOH}(aq) \longrightarrow$
 (b) $\text{S}_8(s) + \text{excess F}_2(g) \longrightarrow$
 (c) $\text{FeS}(s) + \text{HCl}(aq) \longrightarrow$
 (d) $\text{Te}(s) + \text{I}_2(s) \longrightarrow$

14.78 Complete and balance the following:

- (a) $\text{H}_2\text{S}(g) + \text{O}_2(g) \longrightarrow$
 (b) $\text{SO}_3(g) + \text{H}_2\text{O}(l) \longrightarrow$
 (c) $\text{SF}_4(g) + \text{H}_2\text{O}(l) \longrightarrow$
 (d) $\text{Al}_2\text{Se}_3(s) + \text{H}_2\text{O}(l) \longrightarrow$

14.79 Is each oxide basic, acidic, or amphoteric in water?

- (a) SeO_2 (b) N_2O_3 (c) K_2O
 (d) BeO (e) BaO

14.80 Is each oxide basic, acidic, or amphoteric in water?

- (a) MgO (b) N_2O_5 (c) CaO
 (d) CO_2 (e) TeO_2

14.81 Rank the following hydrides in order of *increasing* acid strength: H_2S , H_2O , H_2Te .

14.82 Rank the following species in order of *decreasing* acid strength: H_2SO_4 , H_2SO_3 , HSO_3^- .

Problems in Context

14.83 Selenium tetrafluoride reacts with fluorine to form selenium hexafluoride.

- (a) Draw Lewis structures for both selenium fluorides, and predict any deviations from ideal bond angles.
 (b) Describe the change in orbital hybridization of the central Se during the reaction.

14.84 Give the name and symbol or formula of a Group 6A(16) element or compound that fits each description or use:

- (a) Unstable allotrope of oxygen
 (b) Oxide having sulfur with the same O.N. as in sulfuric acid
 (c) Air pollutant produced by burning sulfur-containing coal
 (d) Powerful dehydrating agent
 (e) Compound used in solution in the photographic process

14.85 Give the oxidation state of sulfur in each substance:

- (a) S_8 (b) SF_4 (c) SF_6
 (d) H_2S (e) FeS_2 (f) H_2SO_4
 (g) $\text{Na}_2\text{S}_2\text{O}_3 \cdot 5\text{H}_2\text{O}$

14.86 Disulfur decafluoride is intermediate in reactivity between SF_4 and SF_6 . It disproportionates at 150°C to these monosulfur fluorides. Write a balanced equation for this reaction, and give the oxidation state of S in each compound.

Group 7A(17): The Halogens**Concept Review Questions**

14.87 (a) Give the physical state and color of each halogen at STP.
 (b) Explain the change in physical state down Group 7A(17) in terms of molecular properties.

- 14.88** (a) What are the common oxidation states of the halogens?
 (b) Give an explanation based on electron configuration for the range and values of the oxidation states of chlorine.

(c) Why is fluorine an exception to the pattern of oxidation states found for the other group members?

14.89 How many electrons does a halogen atom need to complete its octet? Give examples of the ways a Cl atom can do so.

14.90 Select the stronger bond in each pair:

(a) Cl—Cl or Br—Br

(b) Br—Br or I—I

(c) F—F or Cl—Cl. Why doesn't the F—F bond strength follow the group trend?

14.91 In addition to interhalogen compounds, many interhalogen ions exist. Would you expect interhalogen ions with a 1+ or a 1– charge to have an even or odd number of atoms? Explain.

14.92 (a) A halogen (X_2) disproportionates in base in several steps to X^- and XO_3^- . Write the overall equation for the disproportionation of Br_2 in excess OH^- to Br^- and BrO_3^- .

(b) Write a balanced equation for the reaction of ClF_5 with aqueous base (Hint: Add base to the reaction of BrF_5 shown in Section 14.9).

Skill-Building Exercises (grouped in similar pairs)

14.93 Complete and balance the following equations. If no reaction occurs, write NR:

14.94 Complete and balance the following equations. If no reaction occurs, write NR:

14.95 Rank the following acids in order of *increasing* acid strength: $HClO$, $HClO_2$, $HBrO$, HIO .

14.96 Rank the following acids in order of *decreasing* acid strength: $HBrO_3$, $HBrO_4$, HIO_3 , $HClO_4$.

Problems in Context

14.97 Give the name and symbol or formula of a Group 7A(17) element or compound that fits each description or use:

(a) Used in etching glass

(b) Compound used in household bleach

(c) Weakest hydrohalic acid

(d) Element that is a liquid at room temperature

(e) Organic chloride used to make PVC

14.98 An industrial chemist treats solid $NaCl$ with concentrated H_2SO_4 and obtains gaseous HCl and $NaHSO_4$. When she substitutes solid NaI for $NaCl$, she obtains gaseous H_2S , solid I_2 , and S_8 , but no HI .

(a) What type of reaction did the H_2SO_4 undergo with NaI ?

(b) Why does NaI , but not $NaCl$, cause this type of reaction?

(c) To produce $HI(g)$ by reacting NaI with an acid, how does the acid have to differ from sulfuric acid?

14.99 Rank the halogens Cl_2 , Br_2 , and I_2 in order of increasing oxidizing strength based on their products with the metal rhenium (Re): $ReCl_6$, $ReBr_5$, ReI_4 . Explain your ranking.

Group 8A(18): The Noble Gases

14.100 Which noble gas is the most abundant in the universe? In Earth's atmosphere?

14.101 What oxidation states does Xe show in its compounds?

14.102 Why do the noble gases have such low boiling points?

14.103 Explain why Xe, and to a limited extent Kr, form compounds, whereas He, Ne, and Ar do not.

14.104 (a) Why do stable xenon fluorides have an even number of F atoms?

(b) Why do the ionic species XeF_3^+ and XeF_7^- have odd numbers of F atoms?

(c) Predict the shape of XeF_3^+ .

Comprehensive Problems

14.105 Xenon tetrafluoride reacts with antimony pentafluoride to form the ionic complex $[XeF_3]^+[SbF_6]^-$.

(a) Which depiction shows the molecular shapes of the reactants and product?

(b) How, if at all, does the hybridization of xenon change in the reaction?

14.106 Given the following information,

calculate the heat of solution of the hydronium ion:

14.107 The electronic transition in Na from $3p^1$ to $3s^1$ gives rise to a bright yellow-orange emission at 589.2 nm. What is the energy of this transition?

14.108 Unlike other Group 2A(2) metals, beryllium reacts like aluminum and zinc with concentrated aqueous base to release hydrogen gas and form oxoanions of formula $M(OH)_4^{n-}$. Write equations for the reactions of these three metals with $NaOH$.

14.109 The interhalogen IF undergoes the reaction depicted below (I is purple and F is green):

(a) Write the balanced equation. (b) Name the interhalogen product.

(c) What type of reaction is shown? (d) If each molecule of IF represents 2.50×10^{-3} mol, what mass of each product forms?

14.110 The main reason alkali metal dihalides (MX_2) do *not* form is the high IE_2 of the metal.

(a) Why is IE_2 so high for alkali metals?

(b) The IE_2 for Cs is 2255 kJ/mol, low enough for CsF_2 to form exothermically ($\Delta H_f^\circ = -125$ kJ/mol). This compound cannot be synthesized, however, because CsF forms with a much greater release of heat ($\Delta H_f^\circ = -530$ kJ/mol). Thus, the breakdown of CsF_2 to CsF happens readily. Write the equation for this breakdown, and calculate the enthalpy of reaction per mole of CsF .

14.111 Semiconductors made from elements in Groups 3A(13) and 5A(15) are typically prepared by direct reaction of the elements at high temperature. An engineer treats 32.5 g of molten gallium with 20.4 L of white phosphorus vapor at 515 K and 195 kPa. If purification losses are 7.2% by mass, how many grams of gallium phosphide will be prepared?

14.112 Two substances with the empirical formula HNO are hyponitrous acid ($\mathcal{M} = 62.04$ g/mol) and nitroxyl ($\mathcal{M} = 31.02$ g/mol).

(a) What is the molecular formula of each species?

(b) For each species, draw the Lewis structure having the lowest formal charges. (Hint: Hyponitrous acid has an $\text{N}=\text{N}$ bond.)

(c) Predict the shape around the N atoms of each species.

(d) When hyponitrous acid loses two protons, it forms the hyponitrite ion. Draw *cis* and *trans* forms of this ion.

14.113 The species CO , CN^- , and C_2^{2-} are isoelectronic.

(a) Draw their Lewis structures.

(b) Draw their MO diagrams (assume mixing of $2s$ and $2p$ orbitals, as in N_2), and give the bond order and electron configuration for each.

14.114 The Ostwald process is a series of three reactions used for the industrial production of nitric acid from ammonia.

(a) Write a series of balanced equations for the Ostwald process.

(b) If NO is *not* recycled, how many moles of NH_3 are consumed per mole of HNO_3 produced?

(c) In a typical industrial unit, the process is very efficient, with a 96% yield for the first step. Assuming 100% yields for the subsequent steps, what volume of concentrated aqueous nitric acid (60% by mass; $d = 1.37$ g/mL) can be prepared for each cubic meter of a gas mixture that is 90.0% air and 10.0% NH_3 by volume at the industrial conditions of 5.0 atm and 850. °C?

14.115 All common plant fertilizers contain nitrogen compounds. Determine the mass % of N in each compound:

(a) Ammonia

(b) Ammonium nitrate

(c) Ammonium hydrogen phosphate

14.116 Producer gas is a fuel formed by passing air over red-hot coke (amorphous carbon). What mass of a producer gas that consists of 25% CO, 5.0% CO_2 , and 70% N_2 by mass can be formed from 1.75 metric tons (t) of coke, assuming an 87% yield?

14.117 Gaseous F_2 reacts with water to form HF and O_2 . In NaOH solution, F_2 forms F^- , water, and oxygen difluoride (OF_2), a highly toxic gas and powerful oxidizing agent. The OF_2 reacts with excess OH^- , forming O_2 , water, and F^- .

(a) For each reaction, write a balanced equation, give the oxidation state of O in all compounds, and identify the oxidizing and reducing agents.

(b) Draw a Lewis structure for OF_2 , and predict its shape.

14.118 What is a disproportionation reaction, and which of the following fit the description?

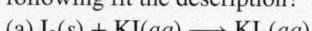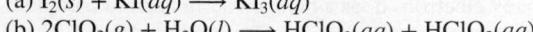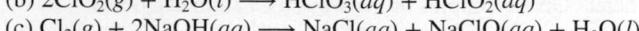

14.119 Explain the following observations:

(a) In reactions with Cl_2 , phosphorus forms PCl_5 in addition to the expected PCl_3 , but nitrogen forms only NCl_3 .

(b) Carbon tetrachloride is unreactive toward water, but silicon tetrachloride reacts rapidly and completely. (To give what?)

(c) The sulfur-oxygen bond in SO_4^{2-} is shorter than expected for an S—O single bond.

(d) Chlorine forms ClF_3 and ClF_5 , but ClF_4 is unknown.

14.120 Which group(s) of the periodic table is (are) described by each of the following general statements?

(a) The elements form compounds of VSEPR class AX_3E .

(b) The free elements are strong oxidizing agents and form monatomic ions and oxoanions.

(c) The atoms form compounds by combining with two other atoms that donate one electron each.

(d) The free elements are strong reducing agents, show only one nonzero oxidation state, and form mainly ionic compounds.

(e) The elements can form stable compounds with only three bonds, but as a central atom, they can accept a pair of electrons from a fourth atom without expanding their valence shell.

(f) Only larger members of the group are chemically active.

14.121 Diiodine pentoxide (I_2O_5) was discovered by Joseph Gay-Lussac in 1813, but its structure was unknown until 1970! Like Cl_2O_7 , it can be prepared by the dehydration-condensation of the corresponding oxoacid.

(a) Name the precursor oxoacid, write a reaction for formation of the oxide, and draw a likely Lewis structure.

(b) Data show that the bonds to the terminal O are shorter than the bonds to the bridging O. Why?

(c) I_2O_5 is one of the few chemicals that can oxidize CO rapidly and completely; elemental iodine forms in the process. Write a balanced equation for this reaction.

14.122 Bromine monofluoride (BrF) disproportionates to bromine gas and bromine trifluoride or pentafluoride. Use the following to find ΔH_{rxn}° for the decomposition of BrF to its elements:

14.123 White phosphorus is prepared by heating phosphate rock [principally $\text{Ca}_3(\text{PO}_4)_2$] with sand and coke:

How many kilograms of phosphate rock are needed to produce 315 mol of P_4 , assuming that the conversion is 90.0% efficient?

14.124 Element E forms an oxide of general structure A and a chloride of general structure B, shown at right. For the anion EF_5^- , what is (a) the molecular shape; (b) the hybridization of E; (c) the O.N. of E?

14.125 From its formula, one might expect CO to be quite polar, but its dipole moment is actually small (0.11 D).

(a) Draw the Lewis structure for CO.

(b) Calculate the formal charges.

(c) Based on your answers to parts (a) and (b), explain why the dipole moment is so small.

14.126 When an alkaline earth carbonate is heated, it releases CO₂, leaving the metal oxide. The temperature at which each Group 2A(2) carbonate yields a CO₂ partial pressure of 1 atm is listed below:

Carbonate	Temperature (°C)
MgCO ₃	542
CaCO ₃	882
SrCO ₃	1155
BaCO ₃	1360

(a) Suggest a reason for this trend.

(b) Mixtures of CaCO₃ and MgO are used to absorb dissolved silicates from boiler water. How would you prepare a mixture of CaCO₃ and MgO from dolomite, which contains CaCO₃ and MgCO₃?

14.127 The bond angles in the nitrite ion, nitrogen dioxide, and the nitronium ion (NO₂⁺) are 115°, 134°, and 180°, respectively. Explain these values using Lewis structures and VSEPR theory.

14.128 A common method for producing a gaseous hydride is to treat a salt containing the anion of the volatile hydride with a strong acid.

(a) Write an equation for each of the following examples: (1) the production of HF from CaF₂; (2) the production of HCl from NaCl; (3) the production of H₂S from FeS.

(b) In some cases, even as weak an acid as water can be used for this preparation if the anion of the salt has a sufficiently strong attraction for protons. An example is the production of PH₃ from Ca₃P₂ and water. Write the equation for this reaction.

(c) By analogy, predict the products and write the equation for the reaction of Al₄C₃ with water.

14.129 Chlorine trifluoride was formerly used in the production of uranium hexafluoride for the U.S. nuclear industry:

How many grams of UF₆ can form from 1.00 metric ton of uranium ore that is 1.55% by mass uranium and 12.75 L of chlorine trifluoride ($d = 1.88 \text{ g/mL}$)?

14.130 Chlorine is used to make bleach solutions containing 5.25% NaClO (by mass). Assuming 100% yield in the reaction producing NaClO from Cl₂, how many liters of Cl₂(g) at STP will be needed to make 1000. L of bleach solution ($d = 1.07 \text{ g/mL}$)?

14.131 The triatomic molecular ion H₃⁺ was first detected and characterized by J. J. Thomson using mass spectrometry. Use the bond energy of H₂ (432 kJ/mol) and the proton affinity of H₂ (H₂ + H⁺ → H₃⁺; $\Delta H = -337 \text{ kJ/mol}$) to calculate the enthalpy of reaction for H + H + H⁺ → H₃⁺.

14.132 An atomic hydrogen torch is used for cutting and welding thick sheets of metal. When H₂ passes through an electric arc, the molecules decompose into atoms, which react with O₂. Temperatures over 5000°C are reached, which can melt all metals. Write equations for the breakdown of H₂ to H atoms and for the subsequent overall reaction of the H atoms with oxygen. Use Appendix B to find the standard enthalpy of each reaction per mole of product.

14.133 Which of the following oxygen ions are paramagnetic: O⁺, O⁻, O²⁻, O²⁺?

14.134 Copper(II) hydrogen arsenite (CuHAsO₃) is a green pigment once used in wallpaper. In damp conditions, mold metabolizes this compound to trimethylarsine [(CH₃)₃As], a highly toxic gas.

(a) Calculate the mass percent of As in each compound.
 (b) How much CuHAsO₃ must react to reach a toxic level in a room that measures 12.35 m × 7.52 m × 2.98 m (arsenic is toxic at 0.50 mg/m³)?

14.135 Hydrogen peroxide can act as either an oxidizing agent or a reducing agent.

(a) When H₂O₂ is treated with aqueous KI, I₂ forms. In which role is H₂O₂ acting? What oxygen-containing product is formed?

(b) When H₂O₂ is treated with aqueous KMnO₄, the purple color of MnO₄⁻ disappears and a gas forms. In which role is H₂O₂ acting? What is the oxygen-containing product formed?

15

Organic Compounds and the Atomic Properties of Carbon

15.1 The Special Nature of Carbon and the Characteristics of Organic Molecules

Structural Complexity of Organic Molecules
Chemical Diversity of Organic Molecules

15.2 The Structures and Classes of Hydrocarbons

Carbon Skeletons and Hydrogen Skins
Alkanes
Dispersion Forces and the Physical Properties of Alkanes
Constitutional Isomerism

Chiral Molecules and Optical Isomerism

Alkenes
Geometric (*cis-trans*) Isomerism
Alkynes
Aromatic Hydrocarbons
Catenated Inorganic Hydrides

15.3 Some Important Classes of Organic Reactions

Types of Organic Reactions
Organic Redox Reactions

15.4 Properties and Reactivities of Common Functional Groups

Groups with Only Single Bonds

Groups with Double Bonds
Groups with Both Single and Double Bonds
Groups with Triple Bonds

15.5 The Monomer-Polymer Theme I: Synthetic Macromolecules

Addition Polymers
Condensation Polymers

15.6 The Monomer-Polymer Theme II: Biological Macromolecules

Sugars and Polysaccharides
Amino Acids and Proteins
Nucleotides and Nucleic Acids

Source: © McGraw-Hill Education/
Mark A. Dierker, photographer

Concepts and Skills to Review Before You Study This Chapter

- › naming straight-chain alkanes (Section 2.8)
- › constitutional isomerism (Section 3.2)
- › ΔEN and bond polarity (Section 9.5)
- › resonance structures (Section 10.1)
- › VSEPR theory (Section 10.2)
- › orbital hybridization (Section 11.1)
- › σ and π bonding (Section 11.2)
- › intermolecular forces and synthetic and biological macromolecules (Sections 12.3, 12.7, and 13.2)
- › properties of the Period 2 elements (Section 14.2)
- › properties of the Group 4A(14) elements (Section 14.6)

If you eat a snack during a study break, chances are you will consume organic compounds from containers composed of more organic compounds! Milk, apples, and cookies contain carbohydrates, fats, and proteins, and the plastic milk container and plate are a combination of polymeric organic compounds. In fact, except for a few inorganic salts and ever-present water, nearly everything you put into or on your body—food, medicine, cosmetics, and clothing—consists of organic compounds. Organic fuels warm our homes, cook our meals, and power our vehicles. Major industries are devoted to producing organic compounds, including plastics, pharmaceuticals, and insecticides.

What *is* an organic compound? According to the dictionary, it is “a compound of carbon,” but that definition is too general because carbonates, cyanides, carbides, cyanates, and so forth, also contain carbon but are classified as inorganic. Here is a more specific definition: all **organic compounds** contain carbon, nearly always bonded to one or more other carbons and to hydrogen, and often to other elements.

In the early 19th century, organic compounds were usually obtained from living things, so they were thought to possess a spiritual “vital force,” which made them impossible to synthesize and fundamentally different from inorganic compounds. But, in 1828, Friedrich Wöhler destroyed this notion when he obtained urea by heating ammonium cyanate. Today, we know that *the same chemical principles govern organic and inorganic systems* because the behavior of a compound—no matter how amazing—can be explained by understanding the properties of its elements.

IN THIS CHAPTER . . . We see that the structures and reactivities of organic molecules emerge naturally from the properties of their component atoms.

- › We begin by reviewing the atomic properties of carbon and seeing how they lead to the complex structures and reactivity of organic molecules.
- › We focus on drawing and naming hydrocarbons as a prelude to naming other types of organic compounds.
- › We classify the main types of organic reactions in terms of bond order and apply them to the functional groups that characterize families of organic compounds.
- › We examine the giant organic molecules of commerce and life—synthetic and natural polymers.

15.1 THE SPECIAL NATURE OF CARBON AND THE CHARACTERISTICS OF ORGANIC MOLECULES

Although there is nothing mystical about organic molecules, their indispensable role in biology and industry leads us to wonder if carbon is somehow special. Of course, each element has specific properties, but the atomic properties of carbon do give it bonding capabilities beyond those of any element, and this exceptional behavior

leads to the two characteristics of organic molecules—structural complexity and chemical diversity.

The Structural Complexity of Organic Molecules

Most organic molecules have more complex structures than most inorganic molecules. A quick review of carbon's atomic properties and bonding behavior shows why.

Figure 15.1 The position of carbon in the periodic table.

1. *Electron configuration, electronegativity, and bonding.* Carbon forms covalent, rather than ionic, bonds in all its elemental forms and compounds. This bonding behavior is the result of carbon's electron configuration and electronegativity:

- Carbon's ground-state electron configuration of $[He] 2s^2 2p^2$ —four electrons more than He and four fewer than Ne—means that the formation of carbon ions is energetically impossible under ordinary conditions. The loss of four e^- to form the C^{4+} cation requires the sum of IE_1 through IE_4 ($>14,000 \text{ kJ/mol!}$); the gain of four e^- to form the C^{4-} anion requires the sum of EA_1 through EA_4 , the last three steps of which are endothermic.
- Lying at the center of Period 2, carbon has an electronegativity ($EN = 2.5$) that is midway between that of the most metallic element (Li, $EN = 1.0$) and the most nonmetallic active element (F, $EN = 4.0$) (Figure 15.1).

2. *Catenation, bond properties, and molecular shape.* The *number and strength* of carbon's bonds lead to its property of **catenation**, the ability to bond to one or more other carbon atoms, which results in a multitude of chemically and thermally stable chain, ring, and branched compounds:

- Through the process of orbital hybridization (Section 11.1), carbon forms four bonds in virtually all its compounds, and they point in as many as four different directions.
- The small size of carbon allows close approach to another atom and thus greater orbital overlap, so carbon forms relatively short, strong bonds.
- The C—C bond is short enough to allow side-to-side overlap of half-filled, unhybridized *p* orbitals and the formation of multiple bonds. These restrict rotation of attached groups (see Figure 11.14), leading to additional structures.

3. *Molecular stability.* Although silicon and several other elements also catenate, none forms chains as stable as those of carbon. Atomic and bonding properties explain why carbon chains are so stable and, therefore, so common:

- *Atomic size and bond strength.* As atomic size increases down Group 4A(14), bonds between identical atoms become longer and weaker. Thus, a C—C bond (347 kJ/mol) is much stronger than an Si—Si bond (226 kJ/mol).
- *Relative enthalpies of reaction.* A C—C bond (347 kJ/mol), a C—O bond (358 kJ/mol), and a C—Cl bond (339 kJ/mol) have nearly the same energy, so relatively little heat is released when a C chain reacts and one bond replaces the other. In contrast, an Si—O bond (368 kJ/mol) or an Si—Cl bond (381 kJ/mol) is much stronger than an Si—Si bond (226 kJ/mol), so the large quantity of heat released when an Si chain reacts favors reactivity.
- *Orbitals available for reaction.* Unlike C, Si has low-energy *d* orbitals that can be attacked (occupied) by the lone pairs of incoming reactants. Thus, for example, ethane (CH_3-CH_3) is stable in water and reacts in air only when sparked, whereas disilane ($\text{SiH}_3-\text{SiH}_3$) breaks down in water and ignites spontaneously in air.

The Chemical Diversity of Organic Molecules

In addition to their complex structures, organic compounds are remarkable for their sheer number and diverse chemical behavior. Several million organic compounds are known, and thousands more are discovered or synthesized each year. This diversity is also founded on atomic behavior and is due to three interrelated factors—bonding to heteroatoms, variations in reactivity, and the occurrence of functional groups.

1. Bonding to heteroatoms. Many organic compounds contain **heteroatoms**, atoms other than C or H. The most common heteroatoms are N and O, but S, P, and the halogens often occur, and organic compounds with other elements are known as well. Figure 15.2 shows that 23 different molecular structures are possible from various arrangements of four C atoms singly bonded to each other, just one O atom (either singly or doubly bonded), and the necessary number of H atoms.

2. Electron density and reactivity. Most reactions start—that is, a new bond begins to form—when a region of high electron density on one molecule meets a region of low electron density on another. These regions may be due to the properties of a multiple bond or a carbon-heteroatom bond. Consider the reactivities of four bonds commonly found in organic molecules:

- **The C—C bond.** When C is singly bonded to another C, as occurs in portions of nearly every organic molecule, the EN values are equal and the bond is nonpolar. Therefore, in most cases, *C—C bonds are unreactive*.
- **The C—H bond.** This bond, which also occurs in nearly every organic molecule, is short (109 pm) and, with EN values of 2.1 for H and 2.5, very nearly nonpolar. Thus, *C—H bonds are largely unreactive*.
- **The C—O bond.** This bond, which occurs in many types of organic molecules, is highly polar ($\Delta\text{EN} = 1.0$), with the O end electron rich and the C end electron poor. As a result of this imbalance in electron density, *the C—O bond is reactive* (easy to break), and, given appropriate conditions, a reaction will occur there.
- **Bonds to other heteroatoms.** Even when a carbon-heteroatom bond has a small ΔEN , such as that for C—Br ($\Delta\text{EN} = 0.3$), or none at all, as for C—S ($\Delta\text{EN} = 0$), the heteroatoms are generally large, so their bonds to carbon are long, weak, and thus *reactive*.

3. Importance of functional groups. The central feature of most organic molecules is the **functional group**, a specific combination of bonded atoms that reacts in a characteristic way no matter what molecule it occurs in. In nearly every case, *the reaction of an organic compound takes place at the functional group*. (In fact, as you'll see in Section 15.3, we often write a general symbol for the remainder of the molecule because it stays the same while the functional group reacts.) Functional groups vary from carbon-carbon multiple bonds to several combinations of carbon-heteroatom bonds, and each has its own pattern of reactivity. A particular bond may be a functional group itself or part of one or more functional groups. For example, the C—O bond occurs in four functional groups. We will discuss the reactivity of three of these groups in this chapter:

Figure 15.2 Heteroatoms and different bonding arrangements lead to great chemical diversity among organic molecules.

› Summary of Section 15.1

- › Carbon's small size, intermediate electronegativity, four valence electrons, and ability to form multiple bonds result in the structural complexity of organic compounds.
- › These factors lead to carbon's ability to catenate, which creates chains, branches, and rings of C atoms. Small size and the absence of *d* orbitals in the valence level lead to strong, chemically resistant bonds that point in as many as four directions from each C.
- › Carbon's ability to bond to many other elements, especially O and N, creates polar, reactive bonds, which leads to the chemical diversity of organic compounds.
- › Most organic compounds contain functional groups, specific combinations of bonded atoms that react in characteristic ways.

15.2 THE STRUCTURES AND CLASSES OF HYDROCARBONS

Let's make an anatomical analogy between an organic molecule and an animal. The carbon-carbon bonds form the skeleton: the longest continual chain is the backbone, and any branches are the limbs. Covering the skeleton is a skin of hydrogen atoms, with functional groups protruding at specific locations, like chemical hands ready to grab an incoming reactant. In this section, we "dissect" one group of compounds down to their skeletons and see how to draw and name them.

Hydrocarbons, the simplest type of organic compound, contain only H and C atoms. Some common fuels, such as natural gas and gasoline, are hydrocarbon mixtures. Some hydrocarbons, such as ethylene, acetylene, and benzene, are important *feedstocks*, that is, precursor reactants used to make other compounds.

Carbon Skeletons and Hydrogen Skins

We'll begin by examining the possible bonding arrangements of C atoms only (leaving off the H atoms for now) in simple skeletons without multiple bonds or rings. To distinguish different skeletons, focus on the *arrangement* of C atoms (that is, the successive linkages of one to another) and keep in mind that *groups joined by a single (sigma) bond are relatively free to rotate* (Section 11.2).

Number of C Atoms and Number of Arrangements One, two, or three C atoms can be arranged in only one way. Whether you draw three C atoms in a line or with a bend, the arrangement is the same. Four C atoms, however, have two possible arrangements—a four-C chain or a three-C chain with a one-C branch at the central C:

When we show the chains with bends due to the tetrahedral C (as in the ball-and-stick models above), the different arrangements are especially clear. Notice that if the branch is added to either end of the three-C chain, it is simply a bend in a four-C chain, *not* a different arrangement. Similarly, if the branch points down instead of up, it represents the same arrangement because single-bonded groups rotate.

As the total number of C atoms increases, the number of different arrangements increases as well. Five C atoms joined by single bonds have 3 possible arrangements (Figure 15.3A); 6 C atoms can be arranged in 5 ways, 7 C atoms in 9 ways, 10 C atoms in 75 ways, and 20 C atoms in more than 300,000 ways! If we include multiple bonds and rings, the number of arrangements increases further. For example,

Figure 15.3 Some five-carbon skeletons.

including just one C=C bond in the five-C skeletons creates 5 more arrangements (Figure 15.3B), and including one ring creates 5 more (Figure 15.3C).

Drawing Hydrocarbons When determining the number of different skeletons for a given number of C atoms, remember that

- Each C atom can form four single bonds, two single and one double bond, or one single and one triple bond:

- A straight chain or a bent chain of C atoms represent the same skeleton.
- For a single-bonded arrangement, a branch pointing down is the same as one pointing up.
- A double bond *restricts rotation*, so different groups joined by a double bond can result in different arrangements.

If we put a hydrogen “skin” on a carbon skeleton, we obtain a hydrocarbon. Figure 15.4 shows that a skeleton has the correct number of H atoms *when each C has a total of four bonds*. Sample Problem 15.1 provides practice drawing hydrocarbons.

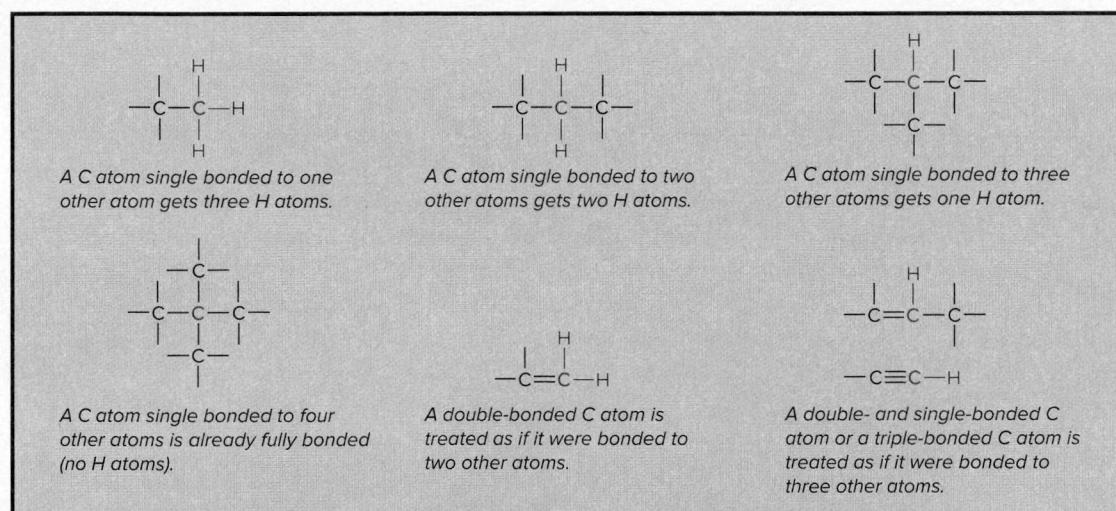

Figure 15.4 Adding the H-atom skin to the C-atom skeleton.

SAMPLE PROBLEM 15.1

Drawing Hydrocarbons

Problem Draw structures that have different atom arrangements for hydrocarbons with:

- Six C atoms, no multiple bonds, and no rings
- Four C atoms, one double bond, and no rings
- Four C atoms, no multiple bonds, and one ring

Plan In each case, we draw the longest carbon chain first and then work down to smaller chains with branches at different points along them. The process typically involves trial and error. Then, we add H atoms to give each C a total of four bonds.

Solution (a) Compounds with six C atoms:

(b) Compounds with four C atoms and one double bond:

4-C chains

3-C chain and
1 branch:

(c) Compounds with four C atoms and one ring:

4-C ring:

3-C ring:

Check Be sure each skeleton has the correct number of C atoms, multiple bonds, and/or rings, and no arrangements are repeated or omitted; remember a double bond counts as two bonds.

Comment Avoid some *common mistakes*:

In (a): $\begin{array}{c} \text{C} \\ | \\ \text{C}-\text{C}-\text{C}-\text{C}-\text{C} \end{array}$ is the same skeleton as $\begin{array}{c} \text{C} \\ | \\ \text{C}-\text{C}-\text{C}-\text{C}-\text{C} \\ | \\ \text{C} \end{array}$

$\begin{array}{c} \text{C} \\ | \\ \text{C}-\text{C}-\text{C}-\text{C} \\ | \\ \text{C} \end{array}$ is the same skeleton as $\begin{array}{c} \text{C} \\ | \\ \text{C}-\text{C}-\text{C}-\text{C} \\ | \\ \text{C} \end{array}$

In (b): $\text{C}-\text{C}-\text{C}=\text{C}$ is the same skeleton as $\text{C}=\text{C}-\text{C}-\text{C}$

The double bond restricts rotation, so, in addition to the *cis* form shown on the left of the 4-C chains in the solution for part (b), another possibility is the *trans* form:

(We discuss *cis* and *trans* forms fully later in this section.)

Also, avoid drawing too many bonds to one C, as here:

In (c): there would be too many bonds to one C in

FOLLOW-UP PROBLEMS

Brief Solutions to all Follow-up Problems appear at the end of the chapter.

15.1A Draw all hydrocarbons that have different atom arrangements with (a) seven C atoms, no multiple bonds, and no rings (nine arrangements); (b) five C atoms, one triple bond, and no rings (three arrangements).

15.1B Draw all hydrocarbons that have different atom arrangements with (a) four C atoms, one ring, and one double bond (four arrangements); (b) four C atoms, no rings, and two double bonds (two arrangements).

SOME SIMILAR PROBLEMS 15.13–15.16

Hydrocarbons can be classified into four main groups: alkanes, alkenes, alkynes, and aromatics. In the rest of this section, we discuss how to name them, as well as some structural features and physical properties of each group. Later, we'll discuss the chemical behavior of the hydrocarbons.

Alkanes: Hydrocarbons with Only Single Bonds

Hydrocarbons that contain only single bonds are **alkanes** and have the following general features:

- Alkanes have the general formula C_nH_{2n+2} , where n is a positive integer. For example, if $n = 5$, the formula is $C_5H_{[(2 \times 5)+2]}$, or C_5H_{12} .
- The alkanes comprise a **homologous series**, one in which each member differs from the next by a $—CH_2—$ (methylene) group.
- In an alkane, each C is sp^3 hybridized.
- Because each C is bonded to the *maximum number (4)* of other atoms (C or H), alkanes are referred to as **saturated hydrocarbons**.

Naming Alkanes You learned the names of the 10 smallest straight-chain alkanes in Section 2.8. Here we discuss the rules for naming any alkane and, by extension, other organic compounds as well. The key point is that *each chain, branch, or ring has a name based on the number of C atoms*. The name of a compound has three portions:

PREFIX + ROOT + SUFFIX

- **Root:** The root tells the number of C atoms in the longest *continuous* chain in the molecule. The roots for the ten smallest alkanes are listed in Table 15.1. As you can see, there are special roots for compounds with chains of one to four C atoms; roots of longer chains are based on Greek numbers.
- **Suffix:** The suffix tells the *type of organic compound* that is being named; that is, it identifies the key functional group the molecule possesses. The suffix is placed *after* the root.
- **Prefix:** Each prefix identifies a *group attached to the main chain* and the number of the carbon atom to which it is attached. Prefixes identifying hydrocarbon branches are the same as root names (Table 15.1) but have *-yl* as their ending; for example, a two-carbon branch is an ethyl group. Each prefix is placed *before* the root.

For example, in the name 2-methylbutane, 2-*methyl-* is the prefix, *-but-* is the root, and *-ane* is the suffix, with each portion indicating information about the molecular structure:

To obtain the systematic name of a compound,

1. Name the longest chain (ROOT).
2. Add the compound type (SUFFIX).
3. Name any branches (PREFIX).

Table 15.2 on the next page presents the rules for naming any organic compound and applies them to an alkane component of gasoline. Other organic compounds are named with a variety of other prefixes and suffixes (see Table 15.5). In addition to these *systematic* names, as you'll see, some *common* names are still in use.

Depicting Alkanes with Formulas and Models Chemists have several ways to depict organic compounds. Expanded, condensed, and carbon-skeleton formulas are easy to draw; ball-and-stick and space-filling models show the actual shapes and bond angles:

- The *expanded formula* is a Lewis structure, so it shows each atom and bond.
- One type of *condensed formula* groups each C atom with its H atoms; not all bonds are shown.
- The *carbon-skeleton formula* shows only carbon–carbon bonds and appears as a zig-zag line, with one or more branches as needed. *Each end or bend of a line or*

**Numerical Roots
for Carbon Chains
and Branches**

Table 15.1

Roots	Number of C Atoms
meth-	1
eth-	2
prop-	3
but-	4
pent-	5
hex-	6
hept-	7
oct-	8
non-	9
dec-	10

Table 15.2

Rules for Naming an Organic Compound

- Naming the longest chain (root)
 - Find the longest *continuous* chain of C atoms.
 - Select the root that corresponds to the number of C atoms in this chain.
- Naming the compound type (suffix)
 - For alkanes, add the suffix *-ane* to the chain root. (Other suffixes appear in Table 15.5 with their functional group and compound type.)
 - If the chain forms a ring, the name is preceded by *cyclo-*.
- Naming the branches (prefixes) (If the compound has no branches, the name consists only of the root and suffix.)
 - Each branch name consists of a root (indicating the number of C atoms) and the ending *-yl* to signify that it is not part of the main chain.
 - Branch names precede the chain name. When two or more branches are present, their names appear in *alphabetical* order.
 - To specify where a branch occurs along the chain, number the main-chain C atoms consecutively, starting at the end *closer* to the first branch, to achieve the *lowest* numbers for all the branches. Precede each branch name with the number of the main-chain C to which that branch is attached.

hex- + -ane \Rightarrow hexane

branch represents a C atom attached to the number of H atoms that gives it four bonds:

Figure 15.5 shows the formulas (and models) of the compound named in Table 15.2.

Cyclic Hydrocarbons A **cyclic hydrocarbon** contains one or more rings. When a straight-chain alkane (C_nH_{2n+2}) forms a ring, two H atoms are lost as the two ends of the chain form a C—C bond. Thus, *cycloalkanes* have the general formula C_nH_{2n} . Cyclic hydrocarbons are often drawn with carbon-skeleton formulas (Figure 15.6, top row). Except for three-carbon rings, *cycloalkanes are nonplanar*, as the ball-and-stick and space-filling models show. This structural feature arises from the tetrahedral shape around each C atom and the need to minimize electron repulsions between adjacent H atoms. The most stable form of cyclohexane is called the *chair conformation* (see the ball-and-stick model in Figure 15.6D).

Figure 15.5 Ways of depicting the alkane 3-ethyl-2-methylhexane.

Figure 15.6 Depicting cycloalkanes.

Dispersion Forces and the Physical Properties of Alkanes

Because alkanes are nearly nonpolar, we expect their physical properties and solubility behavior to be determined by dispersion forces (Section 12.3). A particularly clear example of this effect occurs among the unbranched alkanes (*n*-alkanes). Boiling points increase steadily with chain length (Figure 15.7): the longer the chain, the greater the molar mass and the greater the intermolecular contact, the stronger the dispersion forces, and, thus, the higher the boiling point. Pentane (five C atoms) is the smallest *n*-alkane that exists as a liquid at room temperature.

The solubility of alkanes, and of all hydrocarbons, is easy to predict from the like-dissolves-like rule (Section 13.1). Alkanes are miscible in each other and in other nonpolar solvents, such as benzene, but are nearly insoluble in water. The solubility of pentane in water, for example, is only 0.36 g/L at room temperature.

Constitutional Isomerism

Recall from Section 3.2 that two or more compounds that have the same molecular formula but different properties are called **isomers**. Those with *different arrangements*

Figure 15.7 Formulas, molar masses (\mathcal{M} , in g/mol), structures, and boiling points ($^{\circ}\text{C}$, at 1 atm pressure) of the first 10 unbranched alkanes.

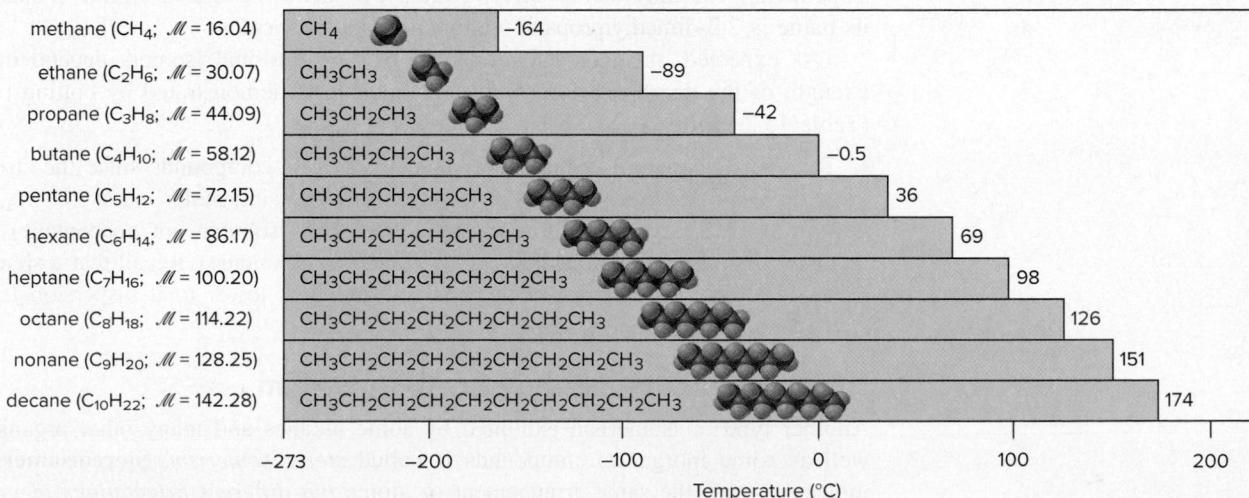

Table 15.3 The Constitutional Isomers of C_4H_{10} and C_5H_{12}

Systematic Name (Common Name)	Expanded Formula	Condensed and Skeleton Formulas	Space-Filling Model	Density (g/mL)	Boiling Point (°C)
Butane (<i>n</i> -butane)	<pre> H H H H H—C—C—C—C—H H H H H—C—H H </pre>	$CH_3—CH_2—CH_2—CH_3$ 		0.579	-0.5
2-Methylpropane (isobutane)	<pre> H H H H—C—C—C—H H H H—C—H H </pre>	$CH_3—CH(CH_3)_2$ 		0.549	-11.6
Pentane (<i>n</i> -pentane)	<pre> H H H H H H—C—C—C—C—C—H H H H H—C—H H </pre>	$CH_3—CH_2—CH_2—CH_2—CH_3$ 		0.626	36.1
2-Methylbutane (isopentane)	<pre> H H H H H—C—C—C—C—H H H H—C—H H </pre>	$CH_3—CH(CH_3)—CH_2—CH_3$ 		0.620	27.8
2,2-Dimethylpropane (neopentane)	<pre> H H—C—H H H—C—C—H H H H—C—H H </pre>	$CH_3\text{---}C(CH_3)_3$ 		0.614	9.5

of bonded atoms are **constitutional** (or **structural**) **isomers**; alkanes with the same number of C atoms but different skeletons are examples. The smallest alkane to exhibit constitutional isomerism has four C atoms, C_4H_{10} ; its two isomers are shown in the top of Table 15.3. The unbranched isomer is butane (common name, *n*-butane; *n*- stands for “normal,” or having a straight chain), and the other is 2-methylpropane (common name, *isobutane*). Similarly, the bottom three isomers in the table have the formula C_5H_{12} . The unbranched isomer is pentane (common name, *n*-pentane); the one with a methyl branch at C-2 of a four-C chain is 2-methylbutane (common name, *isopentane*). The third isomer has two methyl branches on C-2 of a three-C chain, so its name is 2,2-dimethylpropane (common name, *neopentane*).

As expected, the physical properties of constitutional isomers depend on the strength of the dispersion forces; this relationship is demonstrated by boiling points (Table 15.3, *rightmost column*).

- The four-C compounds boil lower than the five-C compounds since the strength of dispersion forces generally increases with increasing molar mass.
- Within each group, the more spherical member (*isobutane* or *neopentane*) boils lower than the more elongated one (*n*-butane or *n*-pentane). Recall that a spherical shape allows less intermolecular contact, and thus lower total dispersion forces, than does an elongated shape (see Figure 12.18).

Chiral Molecules and Optical Isomerism

Another type of isomerism exhibited by some alkanes and many other organic (as well as some inorganic) compounds is called **stereoisomerism**. **Stereoisomers** are molecules with the same arrangement of atoms *but different orientations of groups in space*. **Optical isomerism** is one type of stereoisomerism: *when two objects are*

mirror images of each other and cannot be superimposed, they are **optical isomers**, also called *enantiomers*. Your right hand is an optical isomer of your left. Look at your right hand in a mirror: the *image* is identical to your left hand (Figure 15.8). No matter how you twist your arms around, however, your hands cannot lie on top of each other with your palms facing in the same direction and be superimposed.

Asymmetry and Chirality Optical isomers are not superimposable because each is *asymmetric*: there is no plane of symmetry that divides the molecule (or your hand) into two identical parts. An asymmetric molecule is called **chiral** (Greek *cheir*, “hand”). Typically, an organic molecule is *chiral* if it contains a carbon atom that is bonded to four *different* groups. This C atom is called a *chiral center*, or an asymmetric carbon. In 3-methylhexane, for example, C-3 is a chiral center, because it is bonded to four different groups: H—, CH₃—, CH₃—CH₂—, and CH₃—CH₂—CH₂— (Figure 15.9A). Like your two hands, the two forms are mirror images: when two of the groups are superimposed, the other two are opposite each other. The central C atom in the amino acid alanine is also a chiral center (Figure 15.9B).

Figure 15.8 An analogy for optical isomers.

Source: © McGraw-Hill Education/Jill Braaten, photographer

Figure 15.9 Two chiral molecules.

Properties of Optical Isomers Unlike constitutional isomers, which have different physical properties, optical isomers are identical in all but two respects:

1. In their physical properties, *optical isomers differ only in the direction that each isomer rotates the plane of polarized light*. A **polarimeter** is used to measure the angle that the plane is rotated (Figure 15.10). A beam of light consists of waves that oscillate in all planes. A polarizing filter blocks all waves except those in one plane, so the light emerging through the filter is *plane-polarized*. An optical isomer is **optically active** because it rotates the plane of this polarized light. (Liquid crystal displays incorporate polarizing filters and optically active compounds; see Figure 12.44.) The *dextrorotatory* isomer (designated *d* or +) rotates the plane of light clockwise; the *levorotatory* isomer (designated *l* or −) is the mirror image of the *d* isomer and rotates the plane counter-clockwise. An equimolar mixture of the two isomers (called a *racemic mixture*) does not rotate the plane of light because the dextrorotation cancels the levorotation. The *specific rotation* is a characteristic, measurable property of an optical isomer at a certain temperature and concentration and with a particular wavelength of light.

2. In their chemical properties, *optical isomers differ only in a chiral (asymmetric) chemical environment*, one that distinguishes “right-handed” from “left-handed” molecules. As an analogy, your right hand fits well in your right glove but not in your left glove. Typically, one isomer of an optically active reactant is added to a mixture

Figure 15.10 The rotation of plane-polarized light by an optically active substance.

Figure 15.11 The binding site of an enzyme.

Naproxen

of optical isomers of another compound. The products of the reaction have different properties and can be separated.

The Role of Optical Isomerism in Organisms and Medicines Optical isomerism plays a vital role in living cells. Nearly all carbohydrates and amino acids are optically active, but only one of the isomers is biologically usable. For example, *d*-glucose is metabolized for energy, but *l*-glucose is not, and is excreted unused. Similarly, *l*-alanine is incorporated naturally into proteins, but *d*-alanine is not. An organism can utilize only one of a pair of optical isomers because of its enzymes (Section 16.7). Enzymes are proteins that speed virtually every reaction in a living cell by binding to the reactants and influencing bond breakage and formation. An enzyme distinguishes one optical isomer from another because its binding site is chiral (asymmetric) (Figure 15.11). The shape of one optical isomer fits at the binding site, but the mirror image shape of the other isomer does not fit, so it cannot bind.

Many drugs are chiral molecules. One optical isomer has certain biological activity, and the other has either a different type of activity or none at all. Naproxen (*see margin*), a pain reliever and anti-inflammatory agent, is an example: one isomer is active as an anti-arthritis agent, and the other is a potent liver toxin that must be removed from the mixture during manufacture. The notorious drug thalidomide is another example: one optical isomer is active against depression, whereas the other causes fetal mutations and deaths. Tragically, this drug was sold in the 1950s as the racemic mixture and caused limb malformations in many newborns whose mothers had it prescribed to relieve “morning sickness” during pregnancy.

Alkenes: Hydrocarbons with Double Bonds

A hydrocarbon that contains at least one $\text{C}=\text{C}$ bond is called an **alkene**, and has the following features:

- With two H atoms removed to make the double bond, alkenes have the general formula C_nH_{2n} . The five carbon alkene ($n = 5$), for example, has a formula of $\text{C}_5\text{H}_{(2 \times 5)}$, or C_5H_{10} .
- The double-bonded C atoms are sp^2 hybridized.
- Because their carbon atoms are bonded to fewer than the maximum of four atoms each, alkenes are considered **unsaturated hydrocarbons**.

Alkene names differ from those of alkanes in two respects:

- The main chain (root) *must* contain both C atoms of the double bond, even if it is not the longest chain. The chain is numbered from the end *closer* to the $\text{C}=\text{C}$ bond, and the position of the bond is indicated by the number of the *first* C atom in it.
- The suffix for alkenes is *-ene*.

For example, the three four-C alkenes (C_4H_8), two unbranched and one branched, whose structures were drawn in Sample Problem 15.1b, are named as follows:

1-butene

($\text{C}=\text{C}$ bond between C-1 and C-2)

2-butene

($\text{C}=\text{C}$ bond between C-2 and C-3)

2-methylpropene

(methyl branch on C-2)

(As you’ll see next, there are two different 2-butenes due to another type of stereoisomerism.)

There are two major structural differences between alkanes and alkenes.

- Alkanes have a *tetrahedral* geometry (bond angles of $\sim 109.5^\circ$) around each C atom, whereas the double-bonded C atoms in alkenes are *trigonal planar* ($\sim 120^\circ$).
- The C—C bond *allows* rotation of bonded groups, so the atoms in an alkane continually change their relative positions; in contrast, the π bond of the alkene $\text{C}=\text{C}$ bond *restricts* rotation, so the relative positions of the atoms attached to the double bond are fixed (see Section 11.2).

Table 15.4**The Geometric Isomers of 2-Butene**

Systematic Name	Condensed and Skeleton Formulas	Space-Filling Model	Density (g/mL)	Boiling Point (°C)
cis-2-Butene	 		0.621	3.7
trans-2-Butene	 		0.604	0.9

Restricted Rotation and Geometric (*cis-trans*) Isomerism

This rotational restriction of the π bond in the C=C bond leads to another type of stereoisomerism. **Geometric isomers** (also called *cis-trans isomers*) have different orientations of groups around a double bond (or similar structural feature). Table 15.4 shows the two geometric isomers of 2-butene (see Comment, Sample Problem 15.1):

- One isomer, *cis*-2-butene, has the CH₃ groups on the *same* side of the C=C bond; in general, the *cis* isomer has the *larger portions of the main chain* (in this case, two CH₃ groups) *on the same side* of the double bond.
- The other isomer, *trans*-2-butene, has the CH₃ on *opposite* sides of the C=C bond; the *trans* isomer generally has the *larger portions of the main chain on the opposite sides* of the double bond.

For a molecule to have geometric isomers, *each C atom in the C=C bond must also be bonded to two different groups*.

Like structural isomers, geometric isomers have different physical properties. Note in Table 15.4 that the two 2-butenes differ in molecular shape *and* physical properties. The *cis* isomer has a bend in the chain that the *trans* isomer lacks. In Chapters 10 and 12, you saw how such a difference affects molecular polarity and physical properties, which arise from differing strengths of intermolecular attractions.

Geometric Isomers and the Chemistry of Vision Differences in geometric isomers have profound effects in biological systems. For example, the first step in the sequence that allows us to see relies on the different shapes of two geometric isomers. *Retinal*, a 20-C compound consisting of a 15-C chain, including a ring, with five C=C bonds and five 1-C branches, is part of the molecule responsible for receiving light energy that is then converted to electrical signals transmitted to the brain. There are two biologically occurring isomers of retinal:

- The all-*trans* isomer has a *trans* orientation around all five double bonds and is elongated.
- The 11-*cis* isomer has a *cis* orientation around the C=C bond between C-11 and C-12 and, thus, is bent.

Certain cells of the retina are densely packed with *rhodopsin*, a large molecule consisting of a protein covalently bonded to 11-*cis* retinal. The initial chemical event in vision occurs when rhodopsin absorbs a photon of visible light. The energy range of visible photons (165–293 kJ/mol) encompasses the energy needed to break a C=C π bond (about 250 kJ/mol). Within a few millionths of a second after rhodopsin absorbs a photon, the 11-*cis* π bond of retinal breaks, the intact σ bond between C-11 and C-12 rotates, and the π bond re-forms to produce all-*trans* retinal (Figure 15.12, *next page*).

This rapid, and quite sizeable, change in retinal's shape causes the attached protein to change its shape as well, triggering a flow of ions into the retina's cells and initiating electrical impulses, which the optic nerve conducts to the brain. Meanwhile, the free all-*trans* retinal diffuses away from the protein and is changed back to the

Figure 15.12 The initial chemical event in vision and the change in the shape of retinal.

cis form, which then binds to the protein portion again. Because of the speed and efficiency with which light causes such a large structural change in retinal, evolutionary selection has made it the photon absorber in organisms as different as purple bacteria, mollusks, insects, and vertebrates.

Alkynes: Hydrocarbons with Triple Bonds

Hydrocarbons that contain at least one $\text{C}\equiv\text{C}$ bond are called **alkynes**, with the following features:

- Because they have two H atoms fewer than alkenes, their general formula is $\text{C}_n\text{H}_{2n-2}$. The alkyne with five carbon atoms has the formula $\text{C}_5\text{H}_{(2 \times 5)-2}$, or C_5H_8 .
- A carbon involved in a $\text{C}\equiv\text{C}$ bond can bond to only one other atom, so the geometry around each C atom is linear (180°): each C is *sp* hybridized.
- Alkynes are named in the same way as alkenes, except that the suffix is *-yne*.

Because of their localized π electrons, $\text{C}=\text{C}$ and $\text{C}\equiv\text{C}$ bonds are electron rich and act as functional groups. Thus, alkenes and alkynes are much more reactive than alkanes, as we'll discuss in Section 15.4.

SAMPLE PROBLEM 15.2

Naming Hydrocarbons and Understanding Chirality and Geometric Isomerism

Problem Give the systematic name for each of the following, identify the chiral center in part (d), and draw two geometric isomers for the alkene in part (e):

Plan For (a) to (c), we refer to Table 15.2. We first name the longest chain (*root-*) and add the suffix *-ane* because there are only single bonds. Then we find the *lowest* branch numbers by counting C atoms from the end *closer* to a branch. Finally, we name each branch (*root- + -yl*) and put these names alphabetically before the root name. For (c), we add *cyclo-* before the root. For (d) and (e), we number the longest chain that *includes* the multiple bond starting at the end closer to it. For (d), the chiral center is the C atom bonded to four different groups. In (e), the *cis* isomer has larger groups on the same side of the double bond, and the *trans* isomer has them on opposite sides.

Solution

When a type of branch appears more than once, we group the branch numbers and indicate the number of branches with a prefix, as in *2,2-dimethyl*.

In this case, we can number the chain from either end because the branches are the same and are attached to the two central C atoms.

We number the ring C atoms so that a branch is attached to C-1.

Check A good check (and excellent practice) is to reverse the process by drawing structures for the names to see if you come up with the structures given in the problem.

Comment 1. In (b), C-3 and C-4 are chiral centers, as are C-1 and C-2 in (c). However, in (b) the molecule is not chiral; it has a plane of symmetry between C-3 and C-4, so each half of the molecule rotates light in opposite directions. **2.** Avoid these common mistakes: In (b), 2-ethyl-3-methylpentane would be wrong: the longest chain is *hexane*. In (c), 1-methyl-2-ethylcyclopentane would be wrong: the branch names should appear *alphabetically*.

FOLLOW-UP PROBLEMS

15.2A Give the systematic name for each of the following, name the geometric isomer in (c), and identify the chiral centers in part (d):

15.2B Draw condensed formulas for the following compounds: (a) 3-ethyl-3-methyloctane; (b) 1-ethyl-3-propylcyclohexane (also draw a carbon-skeleton formula for this compound); (c) 3,3-diethyl-1-hexyne; (d) *trans*-3-methyl-3-heptene.

SOME SIMILAR PROBLEMS 15.19–15.30

Aromatic Hydrocarbons: Cyclic Molecules with Delocalized π Electrons

Unlike most cycloalkanes, **aromatic hydrocarbons** are planar molecules, usually with one or more rings of six C atoms, and are often drawn with alternating single and double bonds. As you learned for benzene (Section 10.1), however, all the ring bonds are identical, with values of length and strength *between* those of a C—C and a C=C bond. To indicate this, benzene is also shown as a resonance hybrid, with a circle (or dashed circle) representing the delocalized character of the π electrons (Figure 15.13A). An orbital picture shows the two lobes of the delocalized π cloud above and below the hexagonal plane of the σ -bonded C atoms (Figure 15.13B, next page).

The systematic naming of aromatic compounds in which benzene is the main structure is straightforward, because attached groups, or *substituents*, are named as prefixes. However, many common names are still in use. For example, benzene with one methyl group attached is systematically named *methylbenzene* but is better known

Figure 15.13 Representations of benzene.

by its common name, *toluene*. With only one substituent present, as in toluene, we do not number the ring C atoms; when two or more groups are attached, however, we number in such a way that one of the groups is attached to ring C-1:

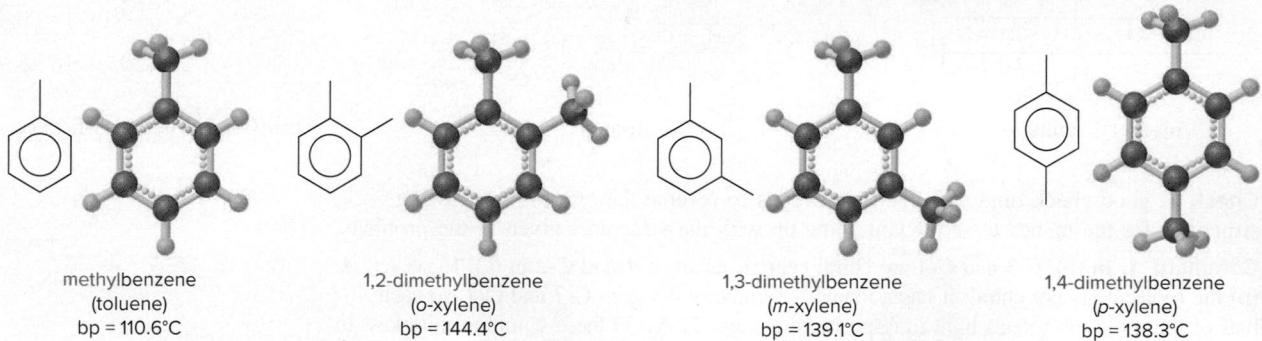

In common names, the positions of two groups are indicated by *o*- (ortho) for groups on adjacent ring C atoms, *m*- (meta) for groups separated by one ring C atom, and *p*- (para) for groups on opposite ring C atoms. The dimethylbenzenes (commonly known as *xylanes*) are important solvents and feedstocks for polyester fibers and dyes. Benzene and many other aromatic hydrocarbons have been shown to have carcinogenic (cancer-causing) activity.

The number of isomers increases with more than two attached groups. For example, there are six isomers for a compound with one methyl and three nitro (NO_2) groups attached to a benzene ring; the explosive TNT is one of the isomers (see margin).

One of the most important methods for determining the structures of organic molecules is discussed in the upcoming Tools of the Laboratory essay.

Variations on a Theme: Catenated Inorganic Hydrides

In brief discussions throughout this chapter, called Variations on a Theme, we examine similarities between organic and inorganic compounds. Although no other element has as many different hydrides as carbon, catenated hydrides occur for several other elements, and many ring, chain, and cage structures are known.

- **Boranes.** One such group of inorganic compounds is the boron hydrides, or boranes (Section 14.5). Although their varied shapes rival those of the hydrocarbons, the weakness of their unusual bridge bonds renders most of them thermally and chemically unstable.
- **Silanes.** An obvious structural similarity exists between alkanes and the silicon hydrides, or silanes. Silanes even have an analogous general formula ($\text{Si}_n\text{H}_{2n+2}$). Branched silanes are known, but no cyclic or unsaturated (containing an $\text{Si}=\text{Si}$ bond) compounds had been prepared until very recently. Unlike alkanes, silanes are unstable thermally and ignite spontaneously in air.
- **Polysulfanes.** Sulfur's ability to catenate is second only to carbon's, and many chains and rings occur among its allotropes (Section 14.8). A number of sulfur hydrides, or polysulfanes, are known. However, these molecules are unbranched chains with H atoms only at the ends ($\text{H}-\text{S}_n-\text{H}$). Like the silanes, the polysulfanes are oxidized easily and decompose readily, yielding sulfur's only stable hydride, H_2S , and its most stable allotrope, cyclo- S_8 .

In addition to mass spectrometry (Chapter 2) and infrared (IR) spectroscopy (Chapter 9), one of the most useful tools for analyzing organic and biochemical structures is **nuclear magnetic resonance (NMR) spectroscopy**, which measures the molecular environments of certain nuclei in a molecule.

Like electrons, several types of nuclei, such as ^{13}C , ^{19}F , ^{31}P , and ^1H , act as if they spin in either of two directions, each of which creates a tiny magnetic field. In this discussion, we focus primarily on $^1\text{H-NMR}$ spectroscopy, which measures changes in the nuclei of the most common isotope of hydrogen. Oriented randomly, the magnetic fields of all the ^1H nuclei in a sample of compound, when placed in a strong external magnetic field (B_0), become aligned either *with* the external field (parallel) or *against* it (antiparallel). Most nuclei adopt the parallel orientation, which is slightly lower in energy. The energy difference (ΔE) between the two energy states (spin states) lies in the radio-frequency (rf) region of the electromagnetic spectrum (Figure B15.1).

When an ^1H (blue arrow) in the lower energy (parallel) spin state absorbs a photon in the radio-frequency region with an energy equal to ΔE , it “flips,” in a process called *resonance*, to the higher energy (antiparallel) spin state. The system then re-emits that energy, which is detected by the rf receiver of the $^1\text{H-NMR}$ spectrometer. The ΔE between the two states depends on the *actual* magnetic field acting on each ^1H nucleus, which is affected by the tiny magnetic fields of the *electrons* of atoms adjacent to that nucleus. Thus, the ΔE required for resonance of each ^1H nucleus depends on its specific molecular environment—the C atoms, electronegative atoms, multiple bonds, and aromatic rings around it. ^1H nuclei in different molecular environments produce different peaks in the $^1\text{H-NMR}$ spectrum.

An $^1\text{H-NMR}$ spectrum, which is unique for each compound, is a series of peaks that represents the resonance as a function of the changing magnetic field. The *chemical shift* of the ^1H nuclei in a given environment is where a peak appears. Chemical shifts are shown relative to that of an added standard, tetramethylsilane [$(\text{CH}_3)_4\text{Si}$, or TMS]. TMS has 12 ^1H nuclei bonded to four C atoms that are bonded to one Si atom in a tetrahedral arrangement, so all 12 are in identical environments and produce only one peak.

Figure B15.2 shows the $^1\text{H-NMR}$ spectrum of acetone. The six ^1H nuclei of acetone have identical environments: all six are bonded to two C atoms that are each bonded to the C atom involved in the $\text{C}=\text{O}$ bond. So one peak is produced, but at a different position from the TMS peak. The spectrum of dimethoxymethane in Figure B15.3 shows *two* peaks in addition to the TMS peak since the ^1H nuclei have two different environments. The taller peak is due to the six ^1H nuclei in the two CH_3 groups, and the shorter peak is due to the two ^1H nuclei in the CH_2 group. The area under each peak (given as a number of chart-paper grid spaces) is proportional to the *number of ^1H nuclei in a given environment*. Note that the area ratio is $20.3/6.8 \approx 3/1$, the same as the ratio of six nuclei in the CH_3 groups to two in the CH_2 group. Thus, by analyzing the chemical shifts and peak areas, the chemist learns the type and number of hydrogen atoms in the compound.

Figure B15.1 The basis of ^1H spin resonance.

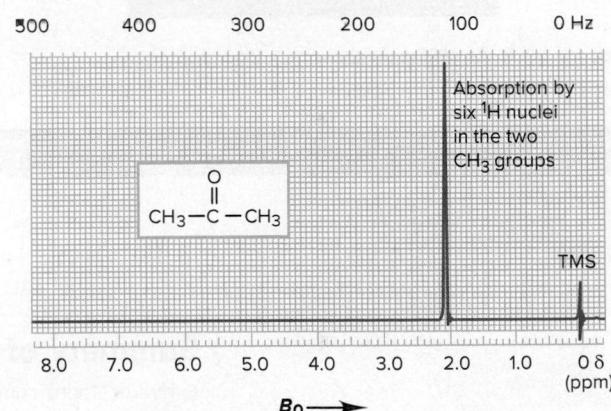

Figure B15.2 The $^1\text{H-NMR}$ spectrum of acetone.

Figure B15.3 The $^1\text{H-NMR}$ spectrum of dimethoxymethane.

(continued)

NMR has many applications in biochemistry and medicine. Applying the principle to the imaging of organs and other body parts is known as *computer-aided magnetic resonance imaging*, or *MRI*. For example, an MRI scan of a person's head (Figure B15.4) can reveal a brain tumor by mapping levels of metabolic activity in different regions of the brain.

Figure B15.4 An MRI scan showing a brain tumor.

Source: © Zephyr/Science Source

Problems

B15.1 How many peaks appear in the NMR spectrum of each isomer of C_4H_{10} and of C_5H_{12} shown in Table 15.3?

B15.2 Radio-frequency radiation is used in NMR since ΔE , the energy difference between the two spin states of the 1H nucleus, is very small. Calculate the ΔE (in J/mol) that corresponds to a frequency of 200. MHz.

B15.3 Consider three isomers of $C_4H_8Br_2$:

A

B

B

C

Which of these isomers is characterized by a 1H -NMR spectrum that consists of two peaks with a 3/1 area ratio?

› Summary of Section 15.2

- › Hydrocarbons contain only C and H atoms, so their physical properties depend on the strength of their dispersion forces.
- › Names of organic compounds consist of a root for the longest chain, a prefix for any attached group, and a suffix for the type of compound.
- › Alkanes (C_nH_{2n+2}) have only single bonds. Cycloalkanes (C_nH_{2n}) have ring structures that are typically nonplanar. Alkenes (C_nH_{2n}) have at least one $C=C$ bond. Alkynes (C_nH_{2n-2}) have at least one $C\equiv C$ bond. Aromatic hydrocarbons have at least one planar ring with delocalized π electrons.
- › Isomers are compounds with the same molecular formula but different properties.
- › Constitutional (structural) isomers have different arrangements of atoms.
- › Stereoisomers (optical and geometric) have the same arrangement of atoms, but their atoms are oriented differently in space. Optical isomers cannot be superimposed on each other because they are asymmetric, with four different groups bonded to the C that is the chiral center. They have identical physical and chemical properties except in their rotation of plane-polarized light, their reactivity with chiral reactants, and their biological activity. Geometric (*cis-trans*) isomers have groups oriented differently around a $C=C$ bond, which restricts rotation.
- › Light converts a *cis* isomer of retinal to the *all-trans* form, which initiates the process of vision.
- › Boron, silicon, and sulfur also form catenated hydrides, but these are unstable.
- › 1H -NMR spectroscopy indicates the relative numbers of H atoms in the various environments within an organic molecule.

15.3 SOME IMPORTANT CLASSES OF ORGANIC REACTIONS

In Chapter 4, we classified chemical reactions based on the chemical process involved (precipitation, acid-base, or redox) and then briefly included a classification based on the number of reactants and products (combination, decomposition, or displacement). We take a similar approach here with organic reactions.

To depict reactions more generally, it's common practice to use R— to signify a nonreacting organic group attached to one of the atoms; you can usually picture R— as an **alkyl group**, a saturated hydrocarbon chain with one bond available. Thus, R—CH₂—Br has an alkyl group attached to a CH₂ group bonded to a Br atom; R—CH=CH₂ is an alkene with an alkyl group attached to one of the carbons in the double bond; and so forth. (Often, when more than one R group is present, we write R, R', R'', and so forth, to indicate that these groups may be different.)

Types of Organic Reactions

Three important organic reaction types are *addition*, *elimination*, and *substitution* reactions, which can be identified by comparing the *number of bonds to C* in reactants and products.

Addition Reactions An **addition reaction** occurs when an unsaturated reactant becomes a saturated product:

Note the C atoms are bonded to *more* atoms in the product than in the reactant.

The C=C and C≡C bonds and the C=O bond commonly undergo addition reactions. In each case, the π bond breaks, leaving the σ bond intact. In the product, the two C atoms (or C and O) form two additional σ bonds. Let's examine the standard enthalpy of reaction ($\Delta H_{\text{rxn}}^{\circ}$) for a typical addition reaction to see why these reactions occur. Consider the reaction between ethene (common name, ethylene) and HCl:

Reactants (bonds broken)
1 C=C = 614 kJ
4 C—H = 1652 kJ
1 H—Cl = 427 kJ
Total = 2693 kJ

Product (bonds formed)
1 C—C = -347 kJ
5 C—H = -2065 kJ
1 C—Cl = -339 kJ
Total = -2751 kJ

$$\Delta H_{\text{rxn}}^{\circ} = \Sigma \Delta H_{\text{bonds broken}}^{\circ} + \Sigma \Delta H_{\text{bonds formed}}^{\circ} = 2693 \text{ kJ} + (-2751 \text{ kJ}) = -58 \text{ kJ}$$

The reaction is exothermic. By looking at the *net* change in bonds, we see that the driving force for many additions is the formation of two σ bonds (in this case, C—H and C—Cl) from one σ bond (in this case, H—Cl) and one relatively weak π bond. An addition reaction is the basis of a color test for the presence of C=C bonds (Figure 15.14).

Figure 15.14 A color test for C=C bonds. **A**, Br₂ (in pipet) reacts with a compound that has a C=C bond (in beaker), and its orange-brown color disappears:

B, Here the compound in the beaker has no C=C bond, so the Br₂ does not react.
Source: © McGraw-Hill Education/Richard Megna, photographer

Elimination Reactions **Elimination reactions** are the opposite of addition reactions. They occur when a saturated reactant becomes an unsaturated product:

Note that the C atoms are bonded to *fewer* atoms in the product than in the reactant. A pair of halogen atoms, an H atom and a halogen atom, or an H atom and an —OH group are typically eliminated, but C atoms are not. Thus, the driving force for many elimination reactions is the formation of a small, stable molecule, such as $\text{HCl}(g)$ or H_2O , which increases the entropy of the system (Section 13.3):

Substitution Reactions A **substitution reaction** occurs when an atom (or group) in one reactant substitutes for one attached to a carbon in the other reactant:

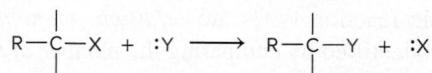

Note that the C atom is bonded to the *same number* of atoms in the product as in the reactant. The C atom may be saturated or unsaturated, and X and Y can be many different atoms, but generally *not* C. The main flavor ingredient in banana oil, for instance, forms through a substitution reaction; note that the O substitutes for the Cl:

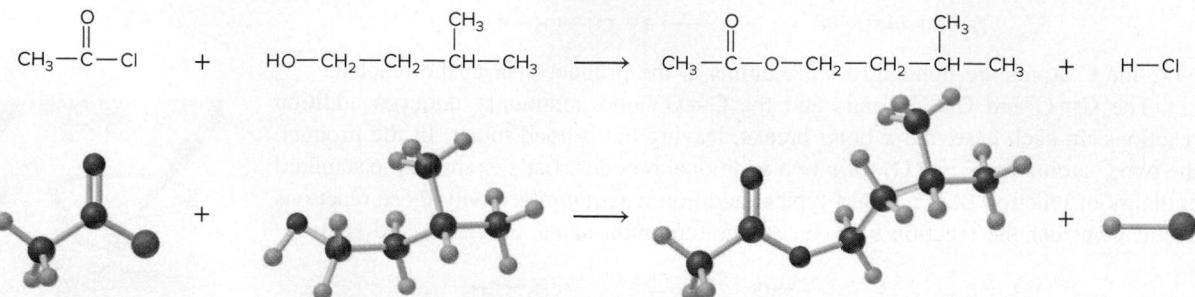

SAMPLE PROBLEM 15.3

Recognizing the Type of Organic Reaction

Problem State whether each reaction is an addition, elimination, or substitution:

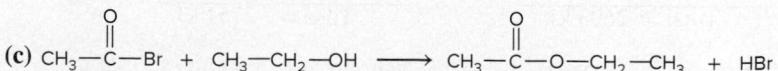

Plan We determine the type of reaction by looking for any change in the number of atoms bonded to C:

- More atoms bonded to C is an *addition*.
- Fewer atoms bonded to C is an *elimination*.
- Same number of atoms bonded to C is a *substitution*.

Solution (a) **Elimination:** two bonds in the reactant, C—H and C—Br, are absent in the product, so fewer atoms are bonded to C.

(b) **Addition:** two more C—H bonds have formed in the product, so more atoms are bonded to C.

(c) **Substitution:** the reactant C—Br bond becomes a C—O bond in the product, so the same number of atoms are bonded to C.

FOLLOW-UP PROBLEMS

15.3A State whether each reaction is an addition, elimination, or substitution:

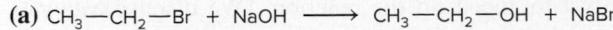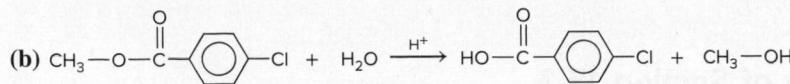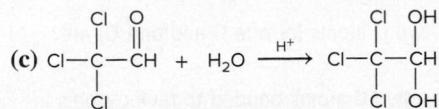

15.3B Write a balanced equation for each of the following:

(a) An addition reaction between 2-butene and Cl_2

(b) A substitution reaction between $\text{CH}_3\text{—CH}_2\text{—CH}_2\text{—Br}$ and OH^-

(c) The elimination of H_2O from $(\text{CH}_3)_3\text{C—OH}$

SOME SIMILAR PROBLEMS 15.40–15.43

The Redox Process in Organic Reactions

An important process in many organic reactions is *oxidation-reduction*. Even though a redox reaction always involves both an oxidation and a reduction, organic chemists typically *focus on the organic reactant only*. Instead of monitoring the change in oxidation numbers of the various C atoms, organic chemists usually note the movement of electron density around a C atom by counting the number of bonds to more electronegative atoms (usually O) or to less electronegative atoms (usually H). A more electronegative atom takes some electron density from the C, whereas a less electronegative atom gives some electron density to the C. Therefore,

- When a C atom in the organic reactant forms more bonds to O or fewer bonds to H, thus losing some electron density, the reactant is oxidized, and the reaction is called an *oxidation*.
- When a C atom in the organic reactant forms fewer bonds to O or more bonds to H, thus gaining some electron density, the reactant is reduced, and the reaction is called a *reduction*.

The most dramatic redox reactions are combustion reactions. Virtually all organic compounds contain C and H atoms and burn in excess O_2 to form CO_2 and H_2O . For ethane, the reaction is

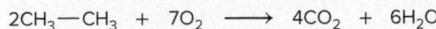

Obviously, when ethane is converted to CO_2 and H_2O , each of its C atoms has more bonds to O and fewer bonds to H. Thus, ethane is oxidized, and this reaction is referred to as an *oxidation*, even though O_2 is reduced as well.

Most oxidations do not involve a breakup of the entire molecule, however. When 2-propanol reacts with potassium dichromate in acidic solution (a common oxidizing agent in organic reactions), it forms 2-propanone (acetone):

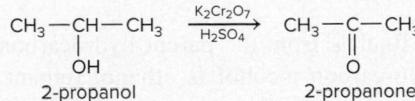

Note that C-2 has one fewer bond to H and one more bond to O in 2-propanone than it does in 2-propanol. Thus, 2-propanol is oxidized, so this is an *oxidation*. Don't forget, however, that the dichromate ion is reduced at the same time:

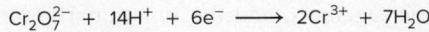

The reaction between H_2 and an alkene is both an addition and a *reduction*:

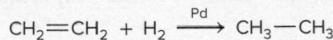

Note that each C has more bonds to H in ethane than it has in ethene, so the ethene is reduced. The H_2 is oxidized in the process, and the palladium shown over the arrow acts as a catalyst to speed up the reaction. (We discuss catalysts in Section 16.7.)

› Summary of Section 15.3

- In an addition reaction, a π bond breaks, and the two C atoms (or one C and one O) are bonded to more atoms in the product.
 - In an elimination reaction, a π bond forms, with the two C atoms bonded to fewer atoms in the product.
 - In a substitution reaction, one atom bonded to C is replaced by another, but the total number of atoms bonded to the C does not change.
 - In an organic redox reaction, the organic reactant is oxidized if at least one of its C atoms forms more bonds to O atoms (or fewer bonds to H atoms), and it is reduced if one of its C atoms forms more bonds to H (or fewer bonds to O).

Methanol (methyl alcohol)

Byproduct in coal gasification;
de-icing agent; gasoline substitute;
precursor of organic compounds

1,2-Ethanediol (ethylene glycol)
Main component of auto antifreeze

Main component of auto antifreeze

Serine
Amino acid found in most proteins

Cholesterol
Major sterol in animals; essential for cell membranes; precursor of steroid hormones

15.4 PROPERTIES AND REACTIVITIES OF COMMON FUNCTIONAL GROUPS

A central organizing principle of organic reactions is that *the distribution of electron density in a functional group is a key to the reactivity of the compound*. The electron density can be high, as in the C=C and C≡C bonds, or it can be low at one end of a bond and high at the other, as in the C—Cl and C—O bonds. Such electron-rich or polar bonds enhance the opposite charge in a polar bond of the other reactant. As a result, the reactants attract each other and begin a sequence of bond-forming and bond-breaking steps that lead to a product. Thus, *the intermolecular forces that affect physical properties and solubility also affect reactivity*. Table 15.5 lists some of the important functional groups in organic compounds.

When we classify functional groups by bond order, they follow certain patterns of reactivity:

- Functional groups with only single bonds undergo elimination or substitution.
 - Functional groups with double or triple bonds undergo addition.
 - Functional groups with both single and double bonds undergo substitution.

In this section, we see how to name compounds that contain each functional group, examine some of their properties, and summarize their common reactions.

Functional Groups with Only Single Bonds

The most common functional groups with only single bonds are alcohols, haloalkanes, and amines.

Alcohols The **alcohol** functional group consists of a carbon bonded to an OH group, —C— $\ddot{\text{O}}$ —H, and the general formula of an alcohol is R—OH. Alcohols are named by dropping the final *-e* from the parent hydrocarbon name and adding the suffix *-ol*. Thus, the two-carbon alcohol is ethanol (ethan- + *-ol*). The common name of an alcohol is the hydrocarbon *root-* + *-yl*, followed by “alcohol”; thus, the common name of ethanol is ethyl alcohol. (This substance, obtained from fermented grain, has been consumed by people as an intoxicant in beverages since ancient times; today, it is recognized as the most abused drug in the world.) Alcohols are common organic reactants, and the functional group occurs in many biomolecules, including carbohydrates, sterols, and some amino acids. Figure 15.15 shows the names, structures, and uses of some important compounds that contain the alcohol group.

Figure 15.15 Some molecules with the alcohol functional group.

Table 15.5

Important Functional Groups in Organic Compounds

Functional Group	Compound Type	Prefix or Suffix of Name	Lewis Structure	Ball-and-Stick Model	Systematic Name (Common Name)
	alkene	-ene			ethene (ethylene)
	alkyne	-yne			ethyne (acetylene)
	alcohol	-ol			methanol (methyl alcohol)
	haloalkane (X = halogen)	halo-			chloromethane (methyl chloride)
	amine	-amine			ethanamine (ethylamine)
	aldehyde	-al			ethanal (acetaldehyde)
	ketone	-one			2-propanone (acetone)
	carboxylic acid	-oic acid			ethanoic acid (acetic acid)
	ester	-oate			methyl ethanoate (methyl acetate)
	amide	-amide			ethanamide (acetamide)
	nitrile	-nitrile			ethanenitrile (acetonitrile, methyl cyanide)

The physical properties of the smaller alcohols are similar to those of water. They have high melting and boiling points as a result of hydrogen bonding, and they dissolve polar molecules and some salts.

Alcohols undergo elimination and substitution reactions:

- *Elimination* of H and OH, called *dehydration*, requires acid and forms an alkene:

- *Elimination* of two H atoms is an *oxidation* that requires an inorganic oxidizing agent, such as potassium dichromate ($K_2Cr_2O_7$) in aqueous H_2SO_4 . The product has a $C=O$ group:

- Alcohols with an OH group at the end of the chain ($R-\text{CH}_2-\text{OH}$) can be oxidized further to acids (but this step is *not* an elimination). Wine turns sour, for example, when the ethanol in contact with air is oxidized to acetic acid:

- *Substitution* yields products with other single-bonded functional groups. Reactions of hydrohalic acids with many alcohols give haloalkanes:

As you'll see below, the C atom undergoing the change in a substitution is bonded to a more electronegative element, which makes it partially positive and, thus, a target for a negatively charged or electron-rich group of an incoming reactant.

Haloalkanes A halogen atom (X) bonded to a carbon forms the **haloalkane** functional group, $\text{—C}(\text{—})\text{—}\ddot{\text{X}}$; found in compounds with the general formula R—X. Haloalkanes (common name, **alkyl halides**) are named by identifying the halogen using a prefix on the hydrocarbon name and numbering the C atom to which the halogen is attached, as in bromomethane, 2-chloropropane, or 1,3-diiodohexane.

Like alcohols, haloalkanes undergo substitution and elimination reactions.

- Just as many alcohols undergo substitution to form alkyl halides when treated with halide ions in acid, many haloalkanes undergo substitution in base to form alcohols. For example, OH^- attacks the positive C end of the C—X bond and displaces X^- :

Substitutions by groups such as —CN , —SH , —OR , and —NH_2 allow chemists to convert haloalkanes to a host of other types of compounds.

- Just as addition of HX to an alkene produces haloalkanes, elimination of HX from a haloalkane by reaction with a strong base, such as potassium ethoxide, produces an alkene:

Haloalkanes have many important uses, but some, like the chlorofluorocarbons, cause serious environmental problems (Chapter 16 Chemical Connections). Also, some halogenated *aromatic* hydrocarbons (*aryl* halides) are carcinogenic in mammals, have severe neurological effects in humans, and, to make matters worse, are very stable in the environment. For example, the polychlorinated biphenyls (PCBs) (Figure 15.16), used as insulating fluids in electrical transformers, have accumulated for decades in rivers and lakes and have been incorporated into the food chain. PCBs in natural waters pose health risks and present an enormous cleanup problem.

Amines The **amine** functional group is $\text{—C}\begin{array}{c} | \\ \text{—N} \\ | \\ :\ddot{\text{O}}\end{array}$. Chemists classify amines as

derivatives of ammonia, with R groups in place of one or more of the H atoms in NH_3 :

- *Primary* (1°) amines are RNH_2 .
- *Secondary* (2°) amines are R_2NH .
- *Tertiary* (3°) amines are R_3N .

The R groups in secondary and tertiary amines can be the same or different. Like ammonia, amines have trigonal pyramidal shapes and a lone pair of electrons on a partially negative N atom, which is the key to amine reactivity (Figure 15.17).

Systematic names drop the final *-e* of the alkane and add the suffix *-amine*, as in ethanamine. However, there is still wide usage of common names, in which the suffix *-amine* follows the name of the alkyl group; thus, methylamine has one methyl group attached to N, diethylamine has two ethyl groups attached, and so forth. Figure 15.18 shows that the amine functional group occurs in many biomolecules.

Figure 15.16 A tetrachlorobiphenyl, one of 209 polychlorinated biphenyls (PCBs).

Figure 15.17 General structures of amines.

Figure 15.18 Some biomolecules with the amine functional group.

Primary and secondary amines can form H bonds, so they have higher melting and boiling points than hydrocarbons and alkyl halides of similar molar mass. For example, dimethylamine ($M = 45.09$ g/mol) boils 45°C higher than ethyl fluoride ($M = 48.06$ g/mol). Trimethylamine has a greater molar mass than dimethylamine, but it melts more than 20°C *lower* because its N does not have an attached H atom that could participate in H bonding.

Amines of low molar mass are fishy smelling, water soluble, and weakly basic because of the lone pair on N. The reaction with water proceeds only slightly to the right to reach equilibrium:

The lone pair is also the reason amines undergo substitution reactions: the lone pair attacks the partially positive C in an alkyl halide to displace X^- and form a larger amine:

(Two molecules of amine are needed: one attacks the chloroethane, and the other binds the released H^+ to prevent it from remaining on the diethylamine product.)

SAMPLE PROBLEM 15.4

Predicting the Reactions of Alcohols, Alkyl Halides, and Amines

Problem Determine the reaction type and the organic product(s) for each reaction:

Plan We first determine the functional group(s) of the organic reactant(s) and then examine any inorganic reactant(s) to decide on the reaction type, keeping in mind that, in general, these functional groups undergo substitution or elimination. (a) The reactant is a haloalkane, so the OH^- of the inorganic base NaOH substitutes for I^- . (b) The reactants are an amine and an alkyl halide, so the N of the amine substitutes for the Br. (c) The organic reactant is an alcohol, the inorganic reactants form a strong oxidizing agent, and the alcohol group undergoes elimination to form a C=O group.

Solution (a) Substitution: The product is $\text{CH}_3-\text{CH}_2-\text{CH}_2-\text{OH} + \text{NaI}$

(b) Substitution: The products are $\text{CH}_3-\text{CH}_2-\text{CH}_2-\text{NH}_2 + \text{CH}_3-\text{CH}_2-\text{CH}_2-\overset{+}{\text{NH}_3}\text{Br}^-$

(c) Elimination (oxidation): The product is $\text{CH}_3-\underset{\text{O}}{\text{C}}-\text{CH}_3$

Check The only changes should be at the functional group.

FOLLOW-UP PROBLEMS

15.4A Determine the reaction type and the organic product(s) for each reaction:

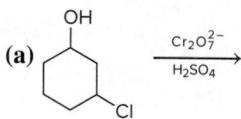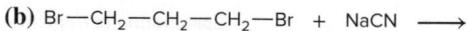

15.4B Fill in the blank in each reaction. (*Hint:* Examine any inorganic compounds and the organic product to determine the organic reactant.)

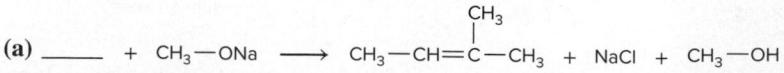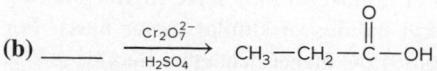

SOME SIMILAR PROBLEMS 15.65–15.74

Variations on a Theme: Inorganic Compounds with Single Bonds to O, X, or N

The $-\text{OH}$ group occurs frequently in inorganic compounds. All oxoacids contain at least one $-\text{OH}$, usually bonded to a relatively electronegative nonmetal atom, which in most cases is bonded to other O atoms. Oxoacids are acidic in water because these additional O atoms pull electron density from the central nonmetal, which pulls electron density from the O—H bond, releasing an H^+ ion and stabilizing the oxoanion through resonance. Alcohols are *not* acidic in water because they lack the additional O atoms and the electronegative nonmetal.

Halides of nearly every nonmetal are known, and many undergo substitution reactions in base. As in the case of a haloalkane, the process involves an attack on the partially positive central atom by OH^- :

Thus, haloalkanes undergo the same general reaction as other nonmetal halides, such as BCl_3 , SiF_4 , and PCl_5 .

The bonds between nitrogen and larger nonmetals, such as Si, P, and S, have significant double-bond character, which affects structure and reactivity. For example, $(\text{SiH}_3)_3\text{N}$, trisilylamine, the Si analog of trimethylamine, is trigonal planar, rather than trigonal pyramidal, because of the formation of a double bond between N and Si. Because the lone pair on N is delocalized in this π bond, trisilylamine is not basic.

Functional Groups with Double Bonds

The most important functional groups with double bonds are the $\text{C}=\text{C}$ group of alkenes and the $\text{C}=\text{O}$ group of aldehydes and ketones. Both appear in many organic and biological molecules. *Their most common reaction type is addition.*

Alkenes The $\text{C}=\text{C}$ bond is the essential portion of the *alkene* functional group, $\begin{array}{c} \diagup \\ \text{C}=\text{C} \\ \diagdown \end{array}$. Although they undergo elimination to alkynes, *alkenes typically undergo addition*. The electron-rich double bond is readily attracted to the partially positive H atoms of hydronium ions and hydrohalic acids, yielding alcohols and alkyl halides, respectively:

Comparing the Reactivities of Alkenes and Aromatic Compounds The *localized* unsaturation of alkenes is very different from the *delocalized* unsaturation of aromatic compounds. That is, despite the way we depict its resonance forms, benzene does *not* have double bonds and so, for example, it does not decolorize Br_2 (see Figure 15.14).

In general, aromatic rings are much *less* reactive than alkenes because of their delocalized π electrons. For example, let's compare the enthalpies of reaction for the

Figure 15.19 The stability of benzene.

addition of H_2 . Hydrogenation of cyclohexene, with one $\text{C}=\text{C}$ bond, has a $\Delta H_{\text{rxn}}^\circ$ of -120 kJ/mol . For the imaginary molecule “cyclohexatriene,” that is, the structure with three $\text{C}=\text{C}$ bonds, the hypothetical $\Delta H_{\text{rxn}}^\circ$ for hydrogenation would be three times as much, or -360 kJ/mol . Hydrogenation of benzene has a $\Delta H_{\text{rxn}}^\circ$ of -208 kJ/mol . Thus, the $\Delta H_{\text{rxn}}^\circ$ for hydrogenation of benzene is 152 kJ/mol less than that for “cyclohexatriene.” This energy difference is attributed to the aromatic resonance stabilization of benzene (Figure 15.19).

This extra energy needed to break up the delocalized π system means *addition* reactions with benzene occur rarely. But, benzene does undergo many *substitution* reactions in which the delocalization is retained when an H atom attached to a ring C is replaced by another group:

Aldehydes and Ketones The $\text{C}=\text{O}$ bond, or **carbonyl group**, is one of the most chemically versatile.

- In the **aldehyde** functional group, the carbonyl C is bonded to H (and typically to another C), so it occurs *at the end of a chain*, $\text{R}-\overset{\text{:O:}}{\underset{\parallel}{\text{C}}}-\text{H}$. Aldehyde names drop the final *-e* from the alkane name and add *-al*; thus, the three-C aldehyde is propanal.
- In the **ketone** functional group, the carbonyl C is bonded to two other C atoms, $\overset{\text{:O:}}{\underset{\parallel}{\text{C}}}-\text{C}-\text{C}-$, so it occurs *within the chain*. Ketones, $\text{R}-\overset{\text{:O:}}{\underset{\parallel}{\text{C}}}-\text{R}'$, are named by numbering the carbonyl C, dropping the final *-e* from the alkane name, and adding *-one*. For example, the unbranched, five-C ketone with the carbonyl C as C-2 in the chain is named 2-pentanone. Figure 15.20 shows some common carbonyl compounds.

Aldehydes and ketones are formed by the oxidation of alcohols:

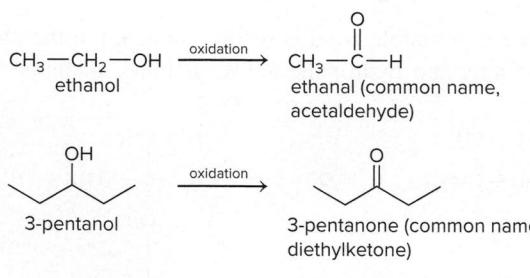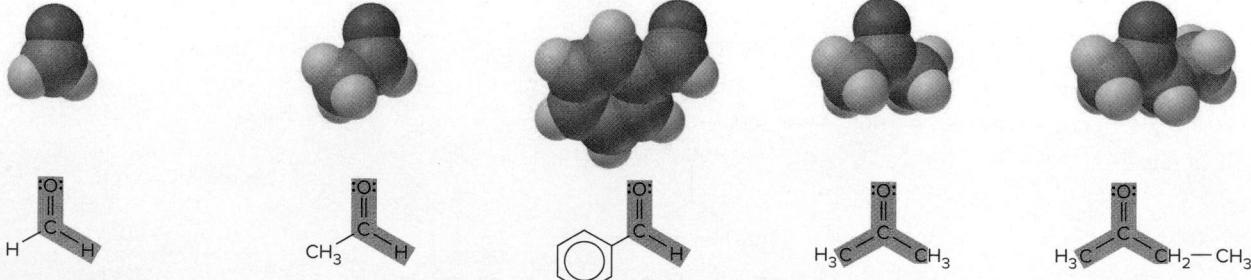

Figure 15.20 Some common aldehydes and ketones.

Conversely, as a result of their unsaturation, carbonyl compounds can undergo *addition* and be reduced to alcohols:

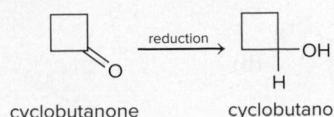

Like the C=C bond, the C=O bond is *electron rich*; unlike the C=C bond, it is *highly polar* ($\Delta EN = 1.0$). Figure 15.21 depicts this polarity with an orbital contour model (Figure 15.21A) and a charged resonance form (Figure 15.21B).

As a result of the bond polarity, addition often occurs with an electron-rich group bonding to the carbonyl C and an electron-poor group bonding to the carbonyl O. **Organometallic compounds**, which have a metal atom (usually Li or Mg) attached to an R group through a polar covalent bond, take part in this type of reaction. In a two-step sequence, they convert carbonyl compounds to alcohols with *different carbon skeletons*:

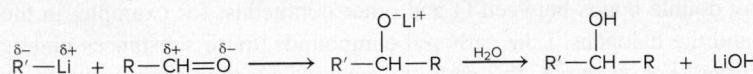

In the following example, the electron-rich C bonded to Li in ethyllithium, $CH_3CH_2—Li$, attacks the electron-poor carbonyl C of 2-propanone, adding the ethyl group to that C; at the same time, the Li adds to the carbonyl O. Treating the mixture with water forms the C—OH group in the product, 2-methyl-2-butanol:

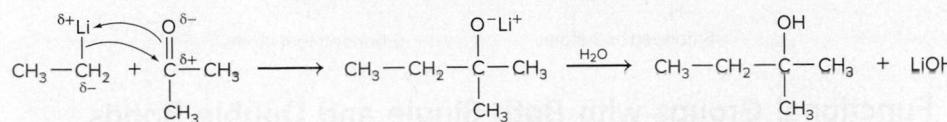

Note that the product skeleton combines the two reactant skeletons. The field of *organic synthesis* often employs organometallic compounds to create new compounds with different skeletons.

SAMPLE PROBLEM 15.5

Predicting the Steps in a Reaction Sequence

Problem Fill in the blanks in the following reaction sequence:

Plan For each step, we examine the functional group of the reactant and the reagent above the yield arrow to decide on the most likely product.

Solution The sequence starts with an alkyl halide reacting with OH^- . Substitution gives an alcohol. Oxidation of this alcohol with acidic dichromate gives a ketone. Finally, a two-step reaction of a ketone with $\text{CH}_3\text{—Li}$ and then water forms an alcohol with a carbon skeleton that has the $\text{CH}_3\text{—}$ group attached to the carbonyl C:

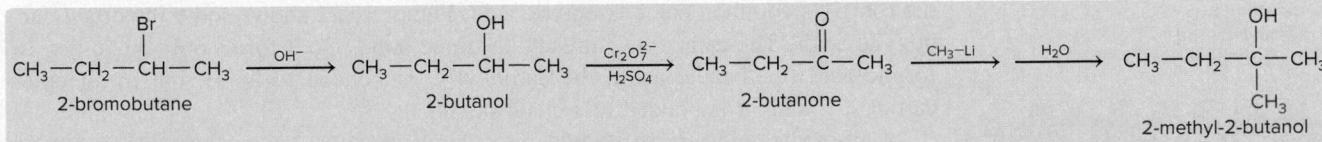

Check In this case, make sure that the first two reactions alter the functional group only and that the final steps change the C skeleton.

FOLLOW-UP PROBLEMS

15.5A Determine the organic product of each of the following reactions:

(Hint: Lithium aluminum hydride, LiAlH_4 , is an important reducing agent in organic reactions; the second step of the reaction requires H_2O .)

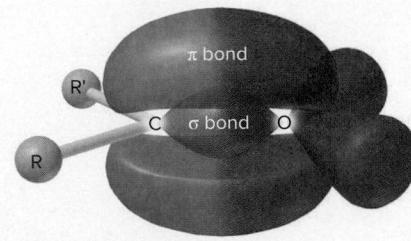

A Orbital contour model

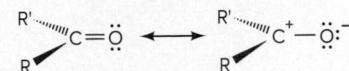

B Charged resonance form

Figure 15.21 The polar carbonyl group.

15.5B Choose reactants that will yield the following products:

SOME SIMILAR PROBLEMS 15.65–15.74

Variations on a Theme: Inorganic Compounds with Double Bonds Homonuclear (same kind of atom) double bonds are rare for atoms other than C. However, we've seen many double bonds between O and other nonmetals, for example, in the oxides of S, N, and the halogens. Like carbonyl compounds, these substances undergo addition reactions. For example, the partially negative O of water attacks the partially positive S of SO_3 to form sulfuric acid:

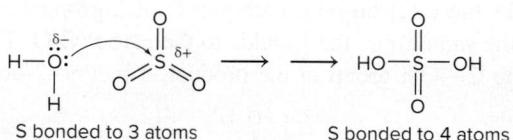

Functional Groups with Both Single and Double Bonds

A family of three functional groups contains C double bonded to O (a carbonyl group) and single bonded to O or N. The parent of the family is the **carboxylic acid** group.

for the —OH by the —OR of an alcohol gives the **ester** group, $\text{—C}(\text{O})\text{—}\ddot{\text{O}}\text{—R}$, and substi-

Carboxylic Acids Carboxylic acids, R— $\overset{\text{||}}{\text{C}}$ —OH, are named by dropping the *-e* from the alkane name and adding *-oic acid*; however, many common names are used. For example, the four-C acid is butanoic acid (the carboxyl C is counted when choosing the root); its common name is butyric acid. Figure 15.22 shows some important carboxylic acids. The carboxyl C already has three bonds, so it forms only one other. In formic acid (methanoic acid), the carboxyl C is bonded to an H, but in all other carboxylic acids it is bonded to a chain or ring.

Carboxylic acids are weak acids in water:

At equilibrium in a solution of typical concentration, more than 99% of the acid molecules are undissociated at any given moment. In strong base, however, a carboxylic acid reacts completely to form a salt and water:

Figure 15.22 Some molecules with the carboxylic acid functional group.

The anion of the salt is the *carboxylate ion*, named by dropping *-oic acid* and adding *-oate*; the sodium salt of butanoic acid, for instance, is sodium butanoate.

Carboxylic acids with long hydrocarbon chains are **fatty acids**, an essential group of compounds found in all cells. Animal fatty acids have saturated chains (see stearic acid, Figure 15.22, bottom), whereas many fatty acids from plants are unsaturated, usually with the C=C bonds in the *cis* configuration. The double bonds make them much easier to metabolize. Nearly all fatty acid skeletons have an even number of C atoms—16 and 18 carbons are very common—because cells use two-carbon units in synthesizing them. Fatty acid salts, usually with a cation from Group 1A(1) or 2A(2), are soaps (Section 13.2).

Substitution of carboxylic acids and other members of this family occurs through a two-step sequence: *addition plus elimination equals substitution*. Addition to the trigonal planar C atom gives an unstable tetrahedral intermediate, which immediately undergoes elimination to revert to a trigonal planar product (in this case, X is OH):

Strong heating of a carboxylic acid forms an **acid anhydride** through a type of substitution called a *dehydration-condensation reaction* (Section 14.7). Viewing this reaction as similar to the one above, but where X is OH, Z is H, and Y is the OOC—R group, we see the result is that two molecules condense into one with loss of a water molecule:

Esters An ester, R—C(=O)—O—R, is formed from an alcohol and a carboxylic acid. The first part of an ester name designates the alcohol portion and the second the acid portion (named in the same way as the carboxylate ion). For example, the ester formed between ethanol and ethanoic acid is ethyl ethanoate (common name, ethyl acetate), a solvent for nail polish and model glue.

The ester group occurs commonly in **lipids**, a large group of fatty biological substances. Most dietary fats are *triglycerides*, esters that are composed of three fatty acids linked to the alcohol 1,2,3-trihydroxypropane (common name, glycerol) and that function as energy stores. Some important lipids are shown in Figure 15.23; lecithin is one of several phospholipids that make up the lipid bilayer in all cell membranes (Section 13.2).

Cetyl palmitate The most common lipid in whale blubber

Lecithin Phospholipid found in all cell membranes

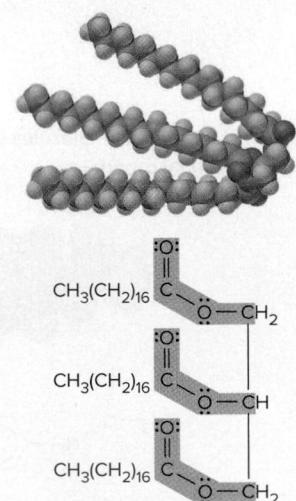

Tristearin Typical dietary fat used as an energy store in animals

Figure 15.23 Some lipid molecules with the ester functional group.

Esters, like acid anhydrides, form through a dehydration-condensation reaction; in this case, it is called an *esterification*:

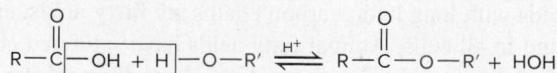

Carboxylic acids and esters have some familiar and distinctive odors.

Source: © Jill Braaten

Note that the esterification reaction is reversible. The opposite of dehydration-condensation is **hydrolysis**, in which the O atom of water is attracted to the partially positive C atom of the ester, cleaving (lysing) the ester molecule into two parts. One part bonds to water's —OH, and the other part to water's other H. In the process of soap manufacture, or *saponification* (Latin *sapon*, “soap”), used since ancient times, the ester bonds in animal or vegetable fats are hydrolyzed with a strong base:

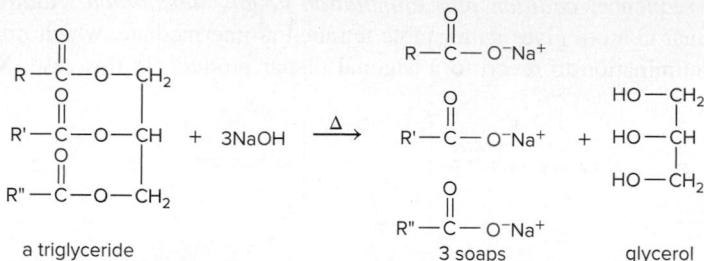

While carboxylic acids have pungent, vinegary, or cheesy odors, esters have pleasant odors. For example, ethyl butanoate has the scent of pineapple, and pentylpentanoate has the aroma of apples (*see photo*). Naturally occurring and synthetic esters are used to add fruity, floral, and herbal odors to foods, cosmetics, household deodorizers, and medicines.

Amides The product of a substitution between an amine (or NH_3) and an ester is an

amide, $\text{R}-\overset{\text{O}}{\underset{\parallel}{\text{C}}}-\text{N}-$. The partially negative N of the amine is attracted to the partially positive C of the ester, an alcohol (ROH) is lost, and an amide forms:

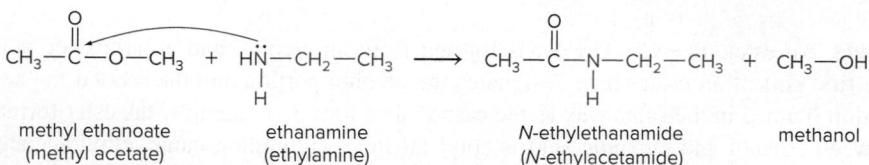

Amides are named by denoting the amine portion with *N*- (note that it is italic) and replacing *-oic acid* from the parent carboxylic acid with *-amide*. In the amide produced in the preceding reaction, the ethyl group comes from the amine, and the acid portion comes from ethanoic acid (acetic acid). Some amides are shown in Figure 15.24. The most important example of the amide group is the *peptide bond* (discussed in Sections 13.2 and 15.6), which links amino acids in a protein.

Acetaminophen

Active ingredient in nonaspirin pain relievers; used to make dyes and photographic chemicals

**N,N-Dimethylmethanamide
(dimethylformamide)**

Major organic solvent; used in production of synthetic fibers

Lysergic acid diethylamide (LSD-25) A potent hallucinogen

An amide is hydrolyzed in hot water (or base) to a carboxylic acid (or carboxylate ion) and an amine. Thus, even though amides are not normally formed in the following way, they can be viewed as the result of a reversible dehydration-condensation:

Reduction Reactions Compounds in the carboxylic acid family also undergo reduction to form other functional groups. For example, certain inorganic *reducing agents* (such as lithium aluminum hydride, LiAlH_4 , or sodium borohydride, NaBH_4) convert acids or esters to alcohols and convert amides to amines:

Predicting Reactions of the Carboxylic Acid Family

SAMPLE PROBLEM 15.6

Problem Predict the organic product(s) of the following reactions:

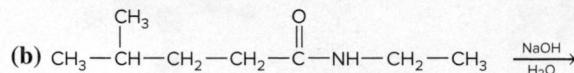

Plan (a) A carboxylic acid and an alcohol react, so the reaction must be a substitution to form an ester and water. (b) An amide reacts with OH^- , so it is hydrolyzed to an amine and a sodium carboxylate.

Solution (a) Formation of an ester:

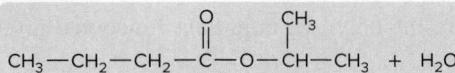

(b) Basic hydrolysis of an amide:

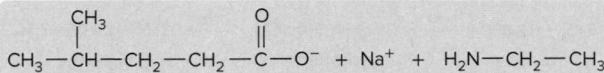

Check Note that in part (b), the carboxylate ion forms, rather than the acid, because the aqueous NaOH that is present reacts with any carboxylic acid as it forms.

FOLLOW-UP PROBLEMS

15.6A Predict the organic product(s) of the following reactions:

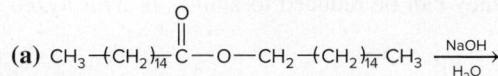

15.6B Fill in the blanks in the following reactions:

SOME SIMILAR PROBLEMS 15.67–15.74

Figure 15.25 The formation of carboxylic, phosphoric, and sulfuric acid anhydrides.

Variations on a Theme: Oxoacids, Esters, and Amides of Other Nonmetals A nonmetal that has both double and single bonds to oxygens occurs in most inorganic oxoacids, such as phosphoric, sulfuric, and chlorous acids. Those with additional O atoms are stronger acids than carboxylic acids.

Diphosphoric and disulfuric acids are acid anhydrides formed by dehydration-condensation reactions, like the one that yields a carboxylic acid anhydride (Figure 15.25). Inorganic oxoacids form esters and amides that are part of many biological molecules. We already saw that certain lipids are phosphate esters (see Figure 15.23). The first compound formed when glucose is digested is a phosphate ester (Figure 15.26A); a similar phosphate ester is a major structural feature of nucleic acids, as we'll see shortly. Amides of organic sulfur-containing oxoacids, called *sulfonamides*, are potent antibiotics; the simplest of these is depicted in Figure 15.26B. More than 10,000 different sulfonamides have been synthesized.

Figure 15.26 A phosphate ester and a sulfonamide.

Functional Groups with Triple Bonds

Alkynes and nitriles are the only two important functional groups with triple bonds.

Alkynes Alkynes, with an electron-rich $\text{—C}\equiv\text{C—}$ group, undergo addition (by H_2O , H_2 , HX , X_2 , and so forth) to form double-bonded or saturated compounds:

Nitriles Nitriles ($\text{R}-\text{C}\equiv\text{N}$) contain the **nitrile** group ($-\text{C}\equiv\text{N}:)$ and are made by substituting a CN^- (cyanide) ion for X^- in a reaction with an alkyl halide:

This reaction is useful because it *increases the chain by one C atom*. Nitriles are versatile because once they are formed, they can be reduced to amines or hydrolyzed to carboxylic acids:

Variations on a Theme: Inorganic Compounds with Triple Bonds Triple bonds are as scarce in the inorganic world as in the organic world. Carbon monoxide ($\text{:C}\equiv\text{O:}$), elemental nitrogen ($\text{:N}\equiv\text{N:}$), and the cyanide ion ($[\text{:C}\equiv\text{N:}]^-$) are the only common examples.

You've seen quite a few functional groups by this time, and it is especially important that you can recognize them in a complex organic molecule. Sample Problem 15.7 provides some practice.

SAMPLE PROBLEM 15.7

Recognizing Functional Groups

Problem Circle and name the functional groups in the following molecules:

Plan We use Table 15.5 to identify the various functional groups.

Solution (a)

FOLLOW-UP PROBLEMS

15.7A Circle and name the functional groups:

15.7B Circle and name the functional groups:

SOME SIMILAR PROBLEMS 15.59 and 15.60

› Summary of Section 15.4

- Organic reactions are initiated when regions of high and low electron density in reactant molecules attract each other.
 - Functional groups containing only single bonds—alcohols, haloalkanes, and amines—undergo substitution and elimination reactions.
 - Functional groups with double or triple bonds—alkenes, aldehydes, ketones, alkynes, and nitriles—mostly undergo addition reactions.
 - Aromatic compounds typically undergo substitution, rather than addition, because delocalization of the π electrons stabilizes the ring.
 - Functional groups with both double and single bonds—carboxylic acids, esters, and amides—undergo substitution (addition plus elimination) reactions.
 - Many reactions change one functional group to another, but some, including reactions with organometallic compounds and with the cyanide ion, change the carbon skeleton.

15.5 THE MONOMER-POLYMER THEME I: SYNTHETIC MACROMOLECULES

In Chapter 12, you saw that polymers are extremely large molecules that consist of many monomeric repeat units. There, we focused on the mass, shape, and physical properties of polymers. Now we'll discuss the two types of organic reactions that link monomers covalently into a chain. To name a polymer, we add the prefix *poly-* to the monomer name, as in *polyethylene* or *polystyrene*. When the monomer has a two-word name, parentheses are used, as in *poly(vinyl chloride)*.

The two major types of reaction processes that form synthetic polymers lend their names to the resulting classes of polymer—addition and condensation.

Addition Polymers

Addition polymers form when monomers undergo an addition reaction with one another. These substances are also called *chain-reaction* (or *chain-growth*) *polymers* because as each monomer adds to the chain, it forms a new reactive site to continue the process. The monomers of most addition polymers have the $\text{C}=\text{C}$ grouping.

As you can see from Table 15.6, the remarkably different physical behaviors of an acrylic sweater, a plastic grocery bag, and a bowling ball result from the different groups that are attached to the double-bonded C atoms of the monomers.

The *free-radical polymerization* of ethene (ethylene, $\text{CH}_2=\text{CH}_2$) to polyethylene is a simple example of the addition process (Figure 15.27). The monomer reacts to form a *free radical*, a species with an unpaired electron, which forms a covalent bond with an electron from another monomer:

- Step 1. The process begins when an *initiator*, usually a peroxide, generates a free radical.
- Step 2. The free radical attacks the π bond of an ethylene molecule, forming a σ bond with one of the p electrons and leaving the other unpaired, creating a new free radical.
- Step 3. This new free radical attacks the π bond of another ethylene, joining it to the chain end, and the backbone of the polymer grows one unit longer.
- Step 4. This process stops when two free radicals form a covalent bond or when a very stable free radical is formed by addition of an *inhibitor* molecule.

Recent progress in controlling the high reactivity of free-radical species promises an even wider range of polymers. In one method, polymerization is initiated by the formation of a cation (or anion) instead of a free radical. The cationic (or anionic) reactive end of the chain attacks the π bond of another monomer to form a new cationic (or anionic) end, and the process continues.

The most important polymerization reactions take place under relatively mild conditions through the use of catalysts that incorporate transition metals. In 1963, Karl Ziegler and Giulio Natta received the Nobel Prize in chemistry for developing *Ziegler-Natta catalysts*, which employ an organoaluminum compound, such as $\text{Al}(\text{C}_2\text{H}_5)_3$, and the tetrachloride of titanium or vanadium. Today, chemists use organometallic catalysts that are *stereoselective* to create polymers whose repeat units have groups spatially oriented in particular ways. Use of these catalysts with varying conditions and reagents allows polyethylene chains with molar masses of 10^4 to 10^5 g/mol to be made.

Similar methods are used to make polypropylenes, $[\text{CH}_2-\text{CH}-]_n$, that have

all the CH_3 groups of the repeat units oriented either on one side of the chain or on alternating sides. The different orientations lead to different packing efficiencies of the chains and, thus, different degrees of crystallinity, which lead to differences in such physical properties as density, rigidity, and elasticity (Section 12.7).

Figure 15.27 Steps in the free-radical polymerization of ethylene.

Table 15.6**Some Major Addition Polymers**

Monomer	Polymer	Applications
		polyethylene (R ₁ = R ₂ = R ₃ = R ₄ = H) Plastic bags; bottles; toys
		polytetrafluoroethylene (R ₁ = R ₂ = R ₃ = R ₄ = F) Cooking utensils (e.g., Teflon)
		polypropylene (R ₁ = R ₂ = R ₃ = H; R ₄ = CH ₃) Carpeting (indoor-outdoor); bottles
		poly(vinyl chloride) (R ₁ = R ₂ = R ₃ = H; R ₄ = Cl) Plastic wrap; garden hose; indoor plumbing
		polystyrene (R ₁ = R ₂ = R ₃ = H; R ₄ = C ₆ H ₅) Insulation; furniture; packing materials
		polyacrylonitrile (R ₁ = R ₂ = R ₃ = H; R ₄ = CN) Yarns (e.g., Orlon, Acrilan); fabrics; wigs
		poly(vinyl acetate) (R ₁ = R ₂ = R ₃ = H; R ₄ = OCCH ₃) Adhesives; paints; textile coatings; computer disks
		poly(vinylidene chloride) (R ₁ = R ₂ = H; R ₃ = R ₄ = Cl) Food wrap (e.g., Saran)
		poly(methyl methacrylate) (R ₁ = R ₂ = H; R ₃ = CH ₃ ; R ₄ = COCH ₃) Glass substitute (e.g., Lucite, Plexiglas); bowling balls; paint

Condensation Polymers

The monomers of **condensation polymers** must have *two functional groups*; we can designate such a monomer as A—R—B (where A and B may or may not be the same, and R is the rest of the molecule). Most commonly, the monomers link when an A group on one undergoes a *dehydration-condensation reaction* with a B group on another:

Many condensation polymers are *copolymers*, those consisting of two or more different repeat units (Section 12.7). Two major types are polyamides and polyesters.

1. **Polyamides.** Condensation of carboxylic acid and amine monomers forms *polyamides (nylons)*. One of the most common is *nylon-66*, manufactured by mixing equimolar amounts of a six-C diamine (1,6-diaminohexane) and a six-C diacid (1,6-hexamethylenedioic acid). The basic amine reacts with the acid to form a “nylon salt.” Heating drives off water and forms the amide bonds:

Figure 15.28 The formation of nylon-66. In the laboratory, the six-C diacid chloride, which is more reactive than the diacid, is used as one monomer; the polyamide forms between the two liquid phases.

Source: © McGraw-Hill Education/Charles Winters/Timeframe Photography, Inc.

In the laboratory, this nylon is made without heating by using a more reactive acid component (Figure 15.28). Covalent bonds within the chains give nylons great strength, and H bonds between chains give them great flexibility (see Table 2.8). About half of all nylons are made to reinforce automobile tires; the others are used for rugs, clothing, fishing line, and so forth.

2. *Polyesters*. Condensation of carboxylic acid and alcohol monomers forms *polyesters*. Dacron, a popular polyester fiber, is woven from polymer strands formed when equimolar amounts of 1,4-benzenedicarboxylic acid and 1,2-ethanediol react:

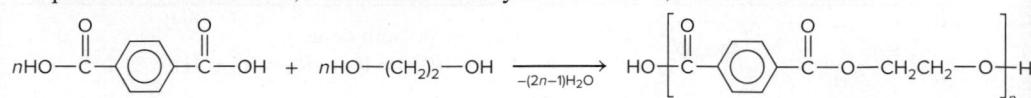

Blending these polyester fibers with various amounts of cotton gives fabrics that are durable, easily dyed, and crease-resistant. Extremely thin Mylar films, used for recording tape and food packaging, are also made from this polymer.

Variations on a Theme: Inorganic Polymers You already know that some synthetic polymers have inorganic backbones. In Chapter 14, we discussed the silicones, polymers with the repeat unit $-(\text{R}_2\text{Si}-\text{O})-$. Depending on the chain crosslinks and the R groups, silicones range from oily liquids to elastic sheets to rigid solids and have applications that include artificial limbs and space suits. Polyphosphazenes exist as flexible chains even at low temperatures and have the repeat unit $-(\text{R}_2\text{P}=\text{N})-$.

› Summary of Section 15.5

- › Polymers are extremely large molecules that are made of repeat units called monomers.
- › Addition polymers are formed from unsaturated monomers that commonly link through free-radical reactions.
- › Most condensation polymers are formed by linking monomers that each have two functional groups through a dehydration-condensation reaction.
- › Reaction conditions, catalysts, and monomers can be varied to produce polymers with different properties.

15.6 THE MONOMER-POLYMER THEME II: BIOLOGICAL MACROMOLECULES

The monomer-polymer theme was being played out in nature eons before humans employed it to such great advantage. Biological macromolecules are condensation polymers created by nature's reaction chemistry and improved through evolution. These remarkable molecules are the best demonstration of the versatility of carbon and its handful of atomic partners.

Natural polymers, such as polysaccharides, proteins, and nucleic acids, are the "stuff of life." Some have structures that make wood strong, fingernails hard, and wool flexible. Others speed up the myriad reactions that occur in every cell or defend the body against infection. Still others possess the genetic information organisms need to forge other biomolecules and reproduce themselves. Remarkable as these giant molecules are, the functional groups of their monomers and the reactions that link them are identical to those of other, smaller organic molecules. Moreover, as you saw in Section 13.2, the same intermolecular forces that dissolve smaller molecules stabilize these giant molecules in the aqueous medium of the cell.

Sugars and Polysaccharides

In essence, the same chemical change occurs when you burn a piece of wood or eat a piece of bread. Wood and bread are mixtures of *carbohydrates*, substances that provide energy through oxidation.

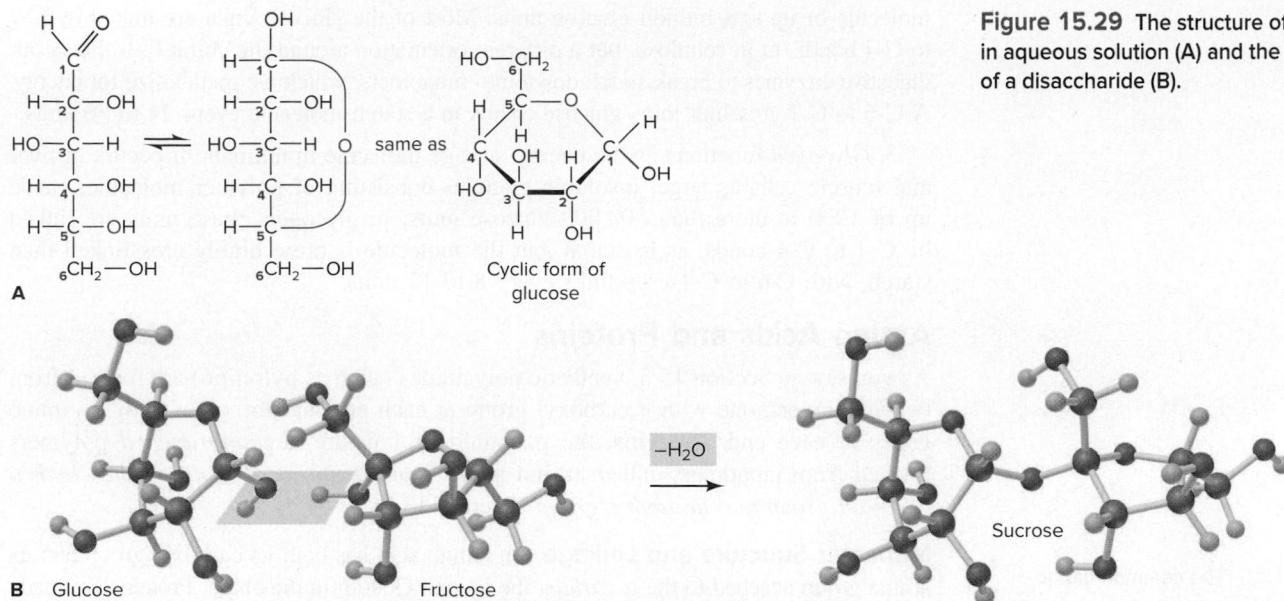

Figure 15.29 The structure of glucose in aqueous solution (A) and the formation of a disaccharide (B).

Monomer Structure and Linkage Glucose and other simple sugars, from the three-C *trioses* to the seven-C *heptoses*, are called **monosaccharides** and consist of carbon chains with attached hydroxyl and carbonyl groups. In aqueous solution, an OH (alcohol) group and a C=O (aldehyde or ketone) group of the same monosaccharide react with each other to form a cyclic molecule that has either a five- or six-membered ring. For example, glucose undergoes an internal addition reaction between the aldehyde group of C-1 and the alcohol group of C-5 (Figure 15.29A).

When two monosaccharides undergo a dehydration-condensation reaction, a **disaccharide** forms. For example,

- sucrose (table sugar) is a disaccharide of glucose (linked at C-1) and fructose (linked at C-2) (Figure 15.29B);
- lactose (milk sugar) is a disaccharide of glucose (C-1) and galactose (C-4);
- maltose, used in brewing and as a sweetener, is a disaccharide of two glucose units (linked from C-1 to C-4).

Three Major Types of Polysaccharides In addition to their roles as individual molecules engaged in energy metabolism, monosaccharides serve as the monomer units of **polysaccharides**. The three major natural polysaccharides—cellulose, starch, and glycogen—consist entirely of glucose units, but they differ in the ring positions of the links, in the orientation of certain bonds, and in the extent of crosslinking. Some other polysaccharides contain nitrogen in their attached groups. *Chitin* (pronounced “KY-tin”), the main component of the tough, external skeletons of insects and crustaceans (*see photo*), has an acetamide group at C-2 of the glucose ring.

1. *Cellulose* is the most abundant organic chemical on Earth. More than 50% of the carbon in plants occurs in the cellulose of stems and leaves, and wood is largely cellulose. Cellulose consists of long chains of glucose. The great strength of wood is due largely to the countless H bonds between cellulose chains. The monomers are linked in a particular way from C-1 in one unit to C-4 in the next. Humans lack the enzymes to break this link, so we cannot digest cellulose (unfortunately!); however, microorganisms in the digestive tracts of some animals, such as cows, sheep, and termites, can.

2. *Starch* is a mixture of polysaccharides of glucose and serves as an *energy store* in plants. When a plant needs energy, some starch is broken down by hydrolysis of the bonds between units, and the released glucose is oxidized through a multistep metabolic pathway. Starch occurs in plant cells as insoluble granules of amylose, a helical molecule of several thousand glucose units, and amylopectin, a highly branched, bushlike

Lobster shells contain a polysaccharide called *chitin*.

Source: © McGraw-Hill Education/Pat Watson, photographer

molecule of up to a million glucose units. Most of the glucose units are linked by C-1 to C-4 bonds, as in cellulose, but a different orientation around the chiral C-1 allows our digestive enzymes to break starch down into monomers, which we metabolize for energy. A C-6 to C-1 crosslink joins glucose chains in a starch molecule every 24 to 30 units.

3. *Glycogen* functions as the energy storage molecule in animals. It occurs in liver and muscle cells as large, insoluble granules consisting of polymer molecules made up of 1000 to more than 500,000 glucose units. In glycogen, these units are linked by C-1 to C-4 bonds, as in starch, but the molecule is more highly crosslinked than starch, with C-6 to C-1 crosslinks every 8 to 12 units.

Amino Acids and Proteins

As you saw in Section 15.5, synthetic polyamides (such as nylon-66) are formed from two monomers, one with a carboxyl group at each end and the other with an amine group at each end. **Proteins**, the polyamides of nature, are *unbranched* polymers formed from monomers called **amino acids**: *each amino acid molecule has both a carboxyl group and an amine group* (Section 13.2).

Monomer Structure and Linkage An amino acid has both its carboxyl group and its amine group attached to the α -carbon, the second C atom in the chain. Proteins are made up of about 20 different types of amino acids, distinguished by their R groups, which range from an H atom to a polycyclic N-containing aromatic structure (Figure 15.30). The R groups play a major role in the shape and function of the protein.

In the aqueous cellular fluid, the NH_2 and COOH groups of amino acids are charged because the carboxyl groups each transfer an H^+ ion to H_2O to form H_3O^+

Figure 15.30 The common amino acids. The R groups are screened gray, and the α -carbons (***boldface***), with carboxyl and amino groups, are screened yellow. Here the amino acids are shown with the charges they have under physiological conditions.

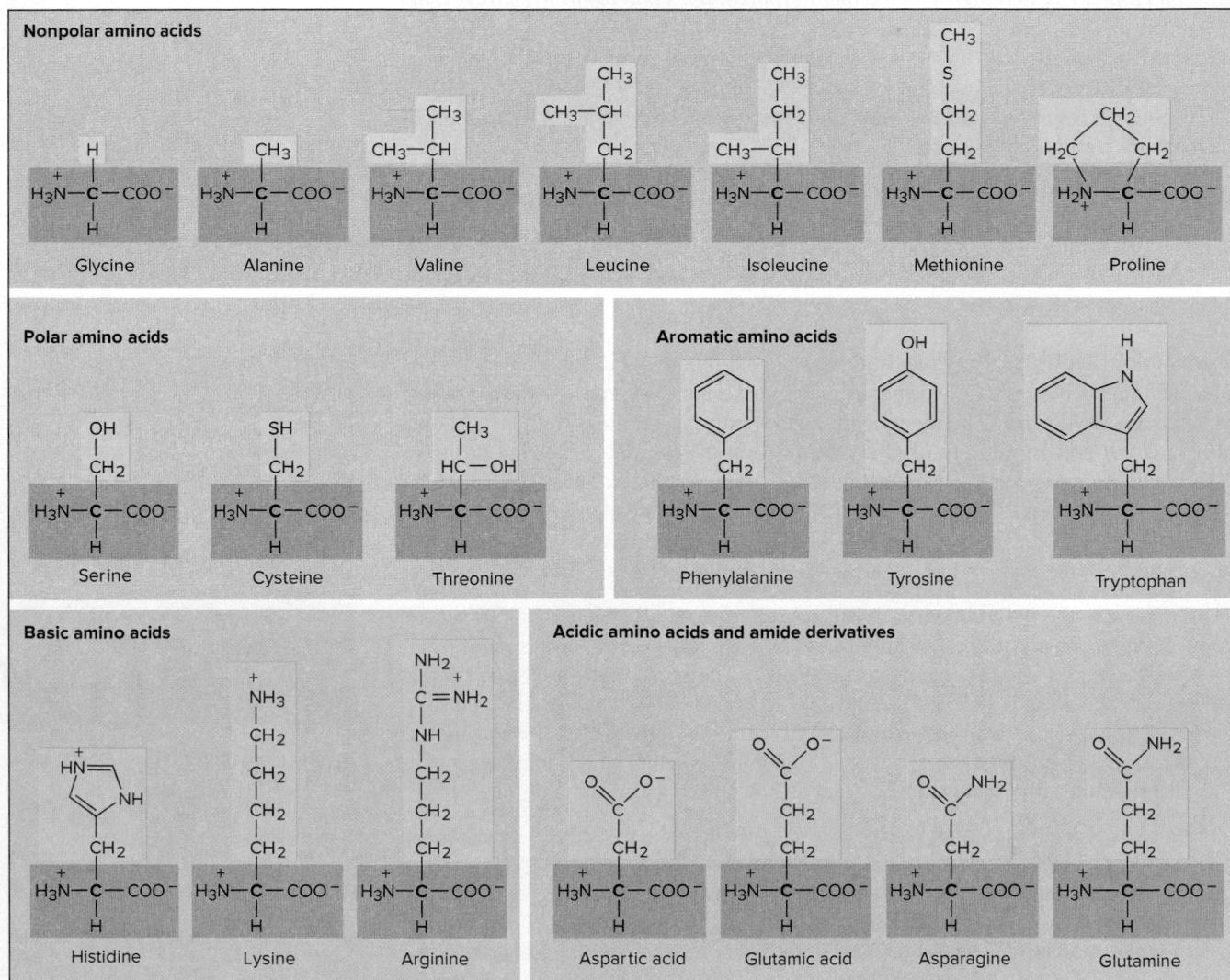

ions, which effectively transfer the H^+ to the amine groups. Occurring throughout the solution, the overall process can be viewed as an intramolecular acid-base reaction:

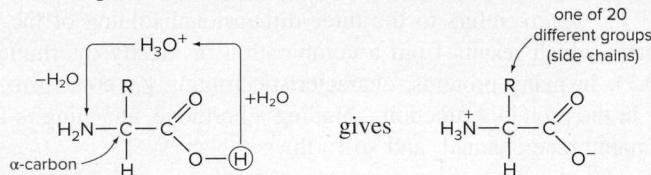

An H atom is the third group bonded to the α -carbon, and the fourth is the R group (also called the *side chain*).

Each amino acid is linked to the next through a *peptide (amide) bond* formed by a dehydration-condensation reaction in which the carboxyl group of one monomer reacts with the amine group of the next.

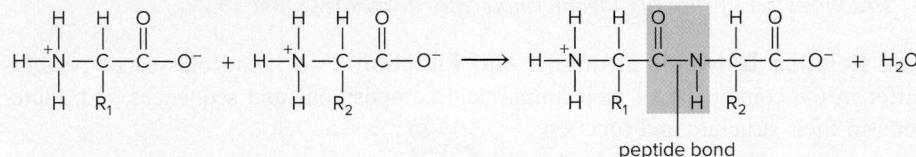

Therefore, the polypeptide chain—the backbone of the protein—has a repeating structure that consists of an α -carbon bonded to a peptide group bonded to the next α -carbon bonded to the next peptide group, and so forth (see Figure 13.6). The various R groups dangle from the α -carbons on alternate sides of the chain.

The Hierarchy of Protein Structure *Each protein has its own amino acid composition*, specific proportions of the various amino acids. However, it is not the composition that defines the protein’s role in the cell; rather, *the sequence of amino acids determines the protein’s shape and function*. Proteins range from about 50 to several thousand amino acids, yet from a purely mathematical point of view, even a small protein of 100 amino acids has a virtually limitless number of possible sequences of 20 different amino acids ($20^{100} \approx 10^{130}$). In fact, though, only a tiny fraction of these possibilities occur in actual proteins. For example, even in an organism as complex as a human being, there are only about 10^5 different types of proteins.

A protein folds into its native shape as it is being synthesized in the cell. Some shapes are simple—long helical tubes or undulating sheets. Others are far more complex—baskets, Y shapes, spheroid blobs, and countless other globular forms. Biochemists define a hierarchy for the overall structure of a protein (Figure 15.31):

1. *Primary (1°) structure*, the most basic level, refers to the sequence of covalently bonded amino acids in the polypeptide chain.

Figure 15.31 The structural hierarchy of proteins.

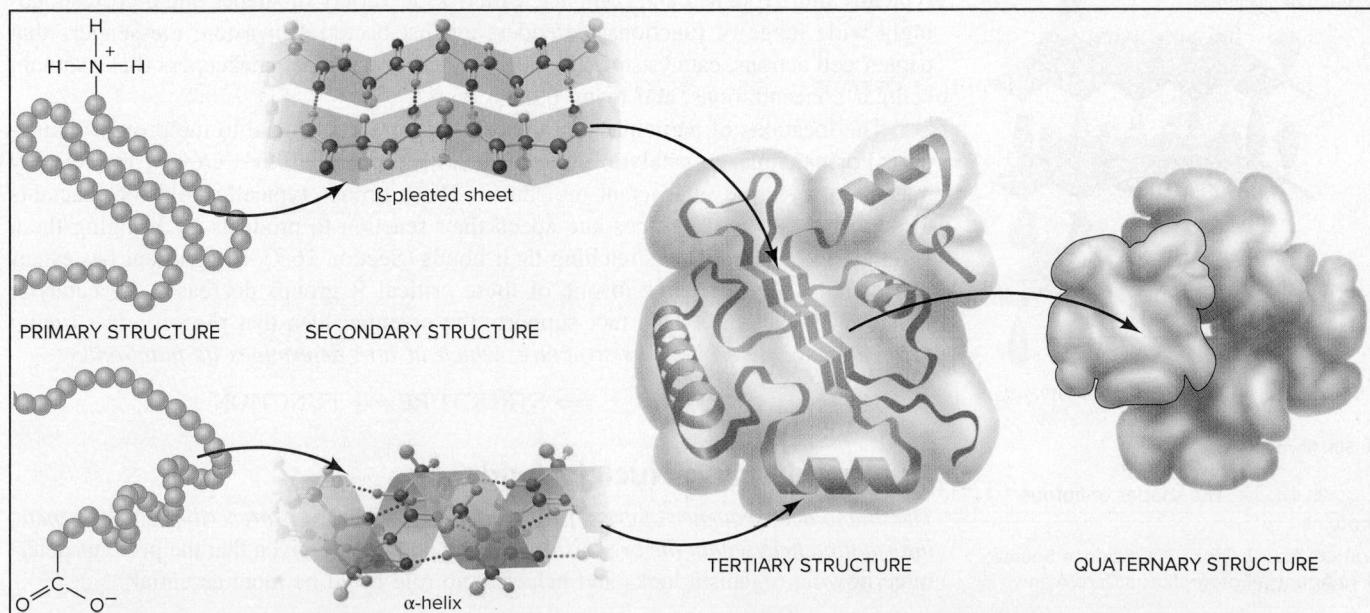

2. *Secondary (2°) structure* refers to sections of the chain that, as a result of H bonding between nearby peptide groupings, adopt shapes called α -helices and β -pleated sheets.
3. *Tertiary (3°) structure* refers to the three-dimensional folding of the whole polypeptide chain, which results from a combination of mostly intermolecular forces (Figure 13.7). In many proteins, characteristic folding patterns form regions that play a role in the protein's function—binding a hormone, attaching to a membrane, forming a membrane channel, and so forth.
4. *Quaternary (4°) structure*, the most complex level, occurs in proteins made up of several polypeptide chains (subunits) and refers to the way the chains assemble, typically through intermolecular forces, into the overall multi-subunit protein. Hemoglobin, for example, consists of four subunits (rightmost structure in Figure 15.31).

The key point is that *only the 1° structure relies on covalent bonds; the 2°, 3°, and 4° structures rely primarily on intermolecular forces* (Section 13.2).

The Relation Between Structure and Function Two broad classes of proteins differ in the complexity of their amino acid compositions and sequences and, therefore, in their structure and function:

1. *Fibrous proteins* have relatively simple amino acid compositions and correspondingly simple structures. They are key components of hair, wool, skin, and connective tissue—materials that require strength and flexibility. Like synthetic polymers, these proteins have a small number of different amino acids in a repeating sequence.
- *Collagen*, the most common animal protein, makes up as much as 40% of human body weight. More than 30% of its amino acids are glycine (G) and another 20% are proline (P). It consists of three chains, each an extended helix, that wind around each other. The peptide C=O groups in one chain form H bonds to the peptide N—H groups in another. The result is a long, triple-helical cable with the sequence —G—X—P—G—X—P— and so on (where X is another amino acid) (Figure 15.32A). As the main protein component of tendons, skin, and blood-vessel walls, collagen has a high tensile strength: a collagen strand 1-mm in diameter can support a 10-kg weight!
- *Silk fibroin*, which is secreted by the silk moth caterpillar, has glycine, alanine, and serine making up more than 85% of its amino acids (Figure 15.32B). Running back and forth alongside each other, fibroin chain segments form interchain H bonds to create a *pleated sheet*. Stacks of sheets interact through dispersion forces, which make fibroin strong and flexible but not very stretchable—perfect for a silkworm's cocoon.

2. *Globular proteins* have much more complex compositions, often containing all 20 amino acids in varying proportions. As the name implies, globular proteins are typically more rounded and compact, with a wide variety of shapes and a correspondingly wide range of functions: defenders against bacterial invasion, messengers that trigger cell actions, catalysts of chemical change, membrane gatekeepers that maintain cellular concentrations, and many others.

The locations of particular amino-acid R groups are crucial to the protein's function. For example, in catalytic proteins, a few R groups form a crevice that closely matches the shapes of reactant molecules. These groups typically hold the reactants through intermolecular forces and speed their reaction to products by bringing them together and twisting and stretching their bonds (Section 16.7). Experiment has established that a slight change in one of these critical R groups decreases the catalytic function dramatically. This fact supports the essential idea that *the protein's amino acid sequence determines its structure, which in turn determines its function*:

SEQUENCE \Rightarrow STRUCTURE \Rightarrow FUNCTION

Nucleotides and Nucleic Acids

The amino acid sequence of every protein in every organism is prescribed by the genetic information held within the organism's nucleic acids. And, given that the proteins determine how an organism looks and behaves, no role could be more essential.

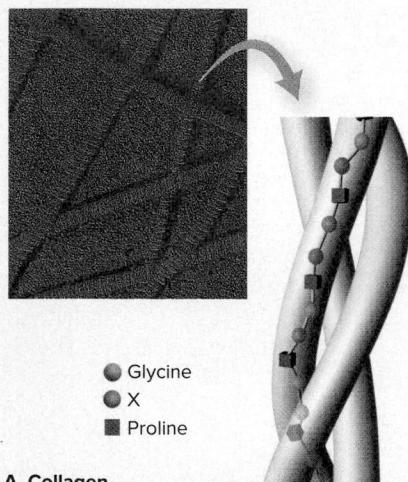

Figure 15.32 The shapes of fibrous proteins.

Source: A: © J. Gross/SPL/Science Source; B: © Agencja Fotograficzna Caro/Alamy

Monomer Structure and Linkage Nucleic acids are *unbranched* polymers made up of monomers called **mononucleotides**, which consist of a sugar, an N-containing base, and a phosphate group.

1. *Sugar*. The two types of nucleic acid differ in the sugar portions of their mononucleotides: *ribonucleic acid* (RNA) contains *ribose*, a five-C sugar, and *deoxyribonucleic acid* (DNA) contains *deoxyribose*, in which H replaces OH at the 2' carbon of the sugar. (Carbon atoms in the sugar portion are given numbers with primes to distinguish them from carbon atoms in the base.)

Ribose in RNA

Deoxyribose in DNA

2. *Nitrogen base*. Attached to the sugar molecule at the 1' carbon is one of four N-containing bases, either a pyrimidine (six-membered ring) or a purine (six- and five-membered rings sharing a side). The pyrimidines are cytosine (C), thymine (T), and uracil (U); thymine occurs in DNA and uracil occurs in RNA. The purines are guanine (G) and adenine (A).

3. *Phosphate group*. A phosphate group is attached to the 5' carbon of the sugar.

The cellular precursors that form a nucleic acid are *nucleoside triphosphates* (Figure 15.33A, *next page*). Dehydration-condensation reactions between them release inorganic diphosphate ($\text{HO}_3\text{P}-\text{O}-\text{PO}_3\text{H}^{2-}$) and create a *phosphodiester bond* between the phosphate group on the 5' carbon of one sugar and the —OH group on the 3' carbon of a second sugar, thereby building up a polynucleotide chain. Therefore, *the repeating pattern of the nucleic acid backbone is sugar-phosphate-sugar-phosphate*, and so on (Figure 15.33B), with the bases dangling off the chain, much like the R groups dangle off the polypeptide chain of a protein.

The Central Importance of Base Pairing In the cell nucleus, DNA exists as two chains wrapped around each other in a **double helix** (Figure 15.34, *next page*). The polar sugar-phosphate backbone of each chain interacts with water in cellular fluid. In the DNA core, the *nonpolar bases form intrachain H bonds*, which hold the chains together. A double helical DNA molecule may contain many millions of H-bonded bases. Two features of these **base pairs** are crucial to the structure and function of DNA:

- A pyrimidine and a purine are always paired, which gives the double helix a constant diameter.
- Each base is paired with the same partner: A always with T, and G always with C. Thus, *the base sequence on one chain is the complement of the base sequence on the other*. For example, the sequence A—C—T on one chain is *always* paired with the sequence T—G—A on the other: A with T, C with G, and T with A.

Each DNA molecule is crumpled into a tangled mass that forms one of the cell's *chromosomes*. But, the DNA molecule is amazingly long and thin: if the largest human chromosome were stretched out, it would be 4 cm (more than 1.5 in) long; in the cell nucleus, however, it is wound into a structure only 5 nm in diameter—8 million times shorter! Segments of the DNA chains are the *genes* that contain the chemical information for synthesizing the organism's proteins.

Figure 15.33 Nucleic acid precursors and their linkage.

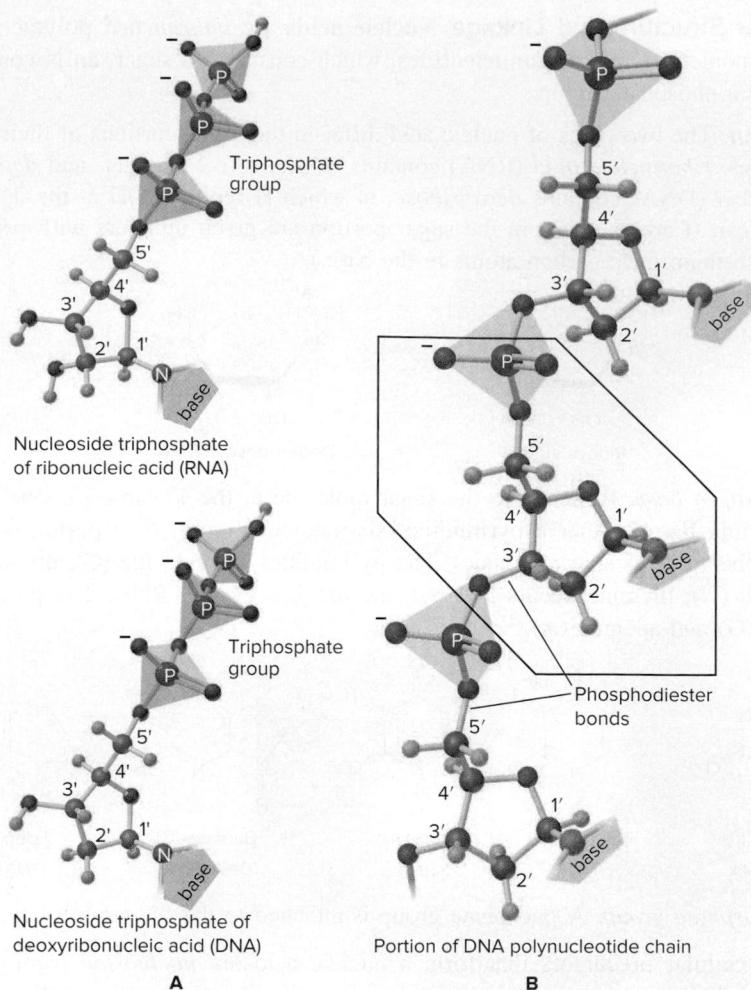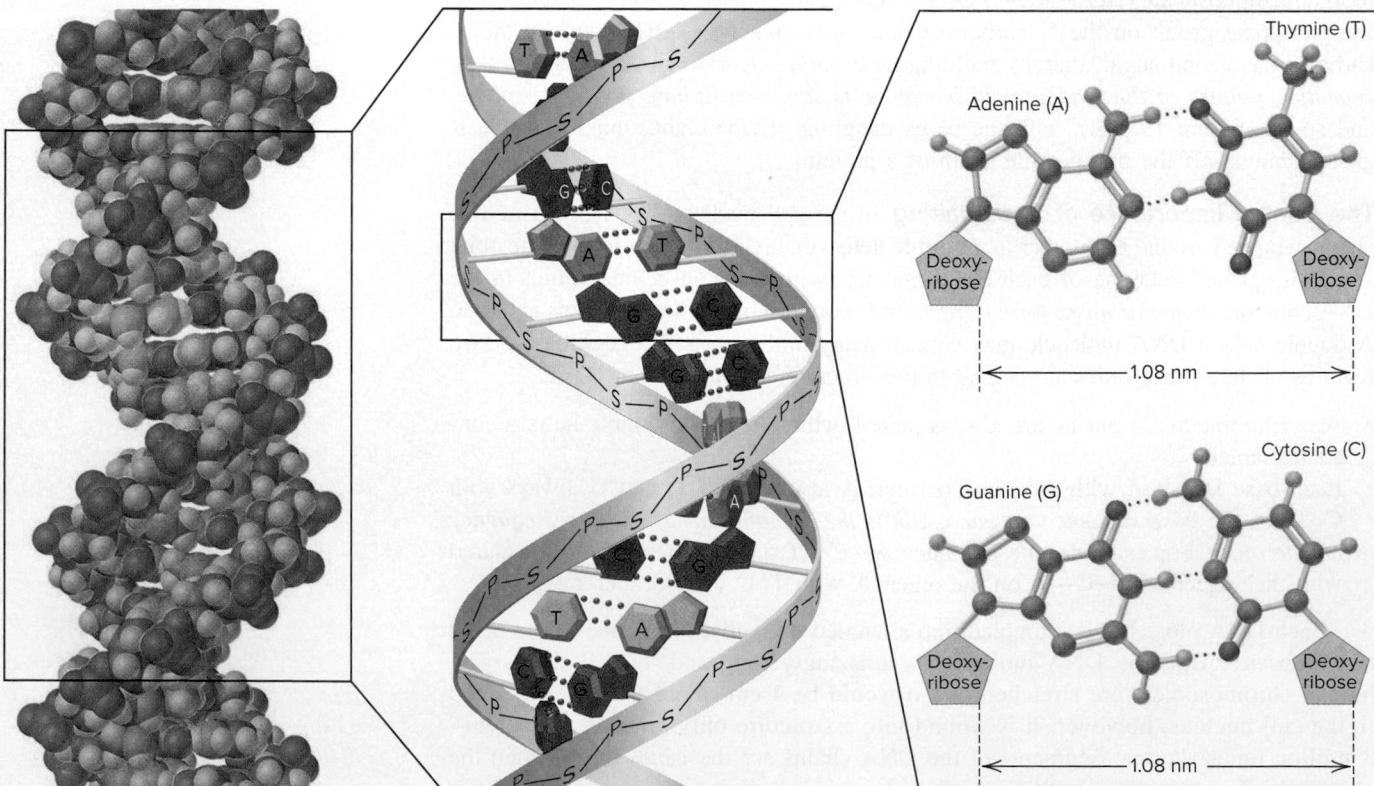

Figure 15.34 The double helix of DNA and a section showing base pairs.

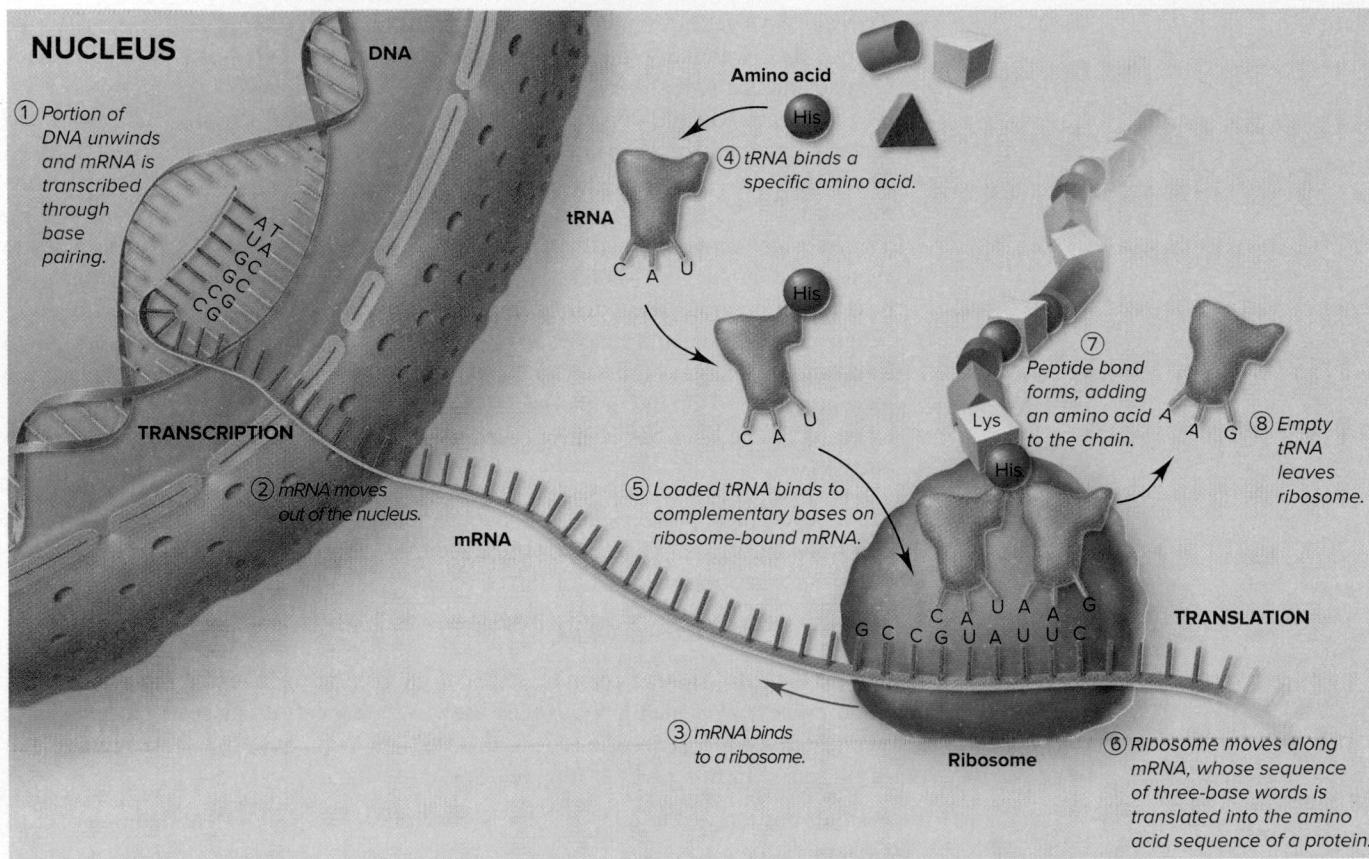

Figure 15.35 Key stages in protein synthesis.

Protein Synthesis The information content of a gene resides in its base sequence. In the **genetic code**, each base acts as a “letter,” each three-base sequence as a “word,” and *each word codes for a specific amino acid*. For example, the sequence C—A—C codes for the amino acid histidine, A—A—G codes for lysine, and so on. Through an amazingly complex series of interactions, one amino acid at a time is positioned and linked to the next to synthesize a protein. To fully appreciate this aspect of the chemical basis of biology, keep in mind that *this complex process occurs largely through H bonding between base pairs*.

Protein synthesis occurs as two main operations, transcription and translation. DNA occurs in the cell nucleus, but the genetic message is decoded in the cytoplasm of the cell. Therefore, the information must be sent from the DNA to the synthesis site. RNA serves this messenger role. The entire process is shown, greatly simplified, in Figure 15.35.

Transcription produces a *messenger RNA* (mRNA) copy of the DNA information; that is, the information is “transcribed” from one nucleic acid to another:

- A portion of the DNA is temporarily unwound, and one chain segment acts as a template for the formation of a complementary chain of mRNA made by linking individual mononucleoside triphosphates. The DNA code words are transcribed into RNA code words through base pairing. Cytosine (C) and guanine (G) are complementary bases. Adenine (A) is the complementary base for thymine (T) in DNA, and for uracil (U) in RNA (step 1).
- The DNA rewinds, and mRNA moves out of the cell nucleus through pores in its membrane (step 2).

Translation uses the mRNA to synthesize the protein; that is, the genetic message is “translated” from the language of nucleotides to that of amino acids:

- The mRNA binds, again through base pairing, to an RNA-rich particle in the cell called a *ribosome* (step 3).

- Transfer RNA (tRNA) molecules, smaller nucleic acids, bring amino acids to the mRNA that is bound to the ribosome. Each tRNA molecule has two key portions. On one end is a three-base sequence that is the complement of a three-base “word” on the mRNA. On the opposite end is a covalent binding site for the amino acid (greatly enlarged for clarity) that is coded by that word (step 4).
- The tRNA then “shuttles” the correct amino acid to the correct position on the mRNA (step 5).
- The ribosome moves along the bound mRNA, one three-base word at a time, while each tRNA molecule H-bonds to the mRNA, thereby positioning its amino acid next to the previous one (step 6).
- When a tRNA molecule attaches to the mRNA at the ribosome, it releases its amino acid, and an enzyme (not shown) catalyzes formation of a peptide bond to the growing chain of amino acids (step 7).
- Once its amino acid has been released, the empty tRNA molecule leaves the site (step 8).

In essence, then, protein synthesis involves *transcribing* the DNA three-base words into an RNA message of three-base words, and then *translating* the word, via three-base RNA carriers, into the sequence of linked amino acids that make up a protein:

DNA Replication Another complex series of interactions is involved in *DNA replication*, the process by which DNA copies itself. When a cell divides, its chromosomes are replicated, or reproduced, ensuring that the new cells have the same number and types of genes. In this process (Figure 15.36):

1. A small portion of the double helix is “unzipped,” so each DNA chain can act as a template for a new chain.
2. The bases in each DNA chain are H-bonded with the complementary bases of free mononucleoside triphosphate units.
3. The new units are linked through phosphodiester bonds to form a new chain in a process catalyzed by an enzyme called *DNA polymerase*. Gradually, each of the unzipped chains forms the complementary half of a double helix, which results in two double helices.

Because each base always pairs with its complement, the original double helix is copied and the genetic makeup of the cell preserved. (Base pairing is central to methods for learning the sequence of nucleotides in genes, and for analyzing evidence in criminal investigations, as the following Chemical Connections essay shows.)

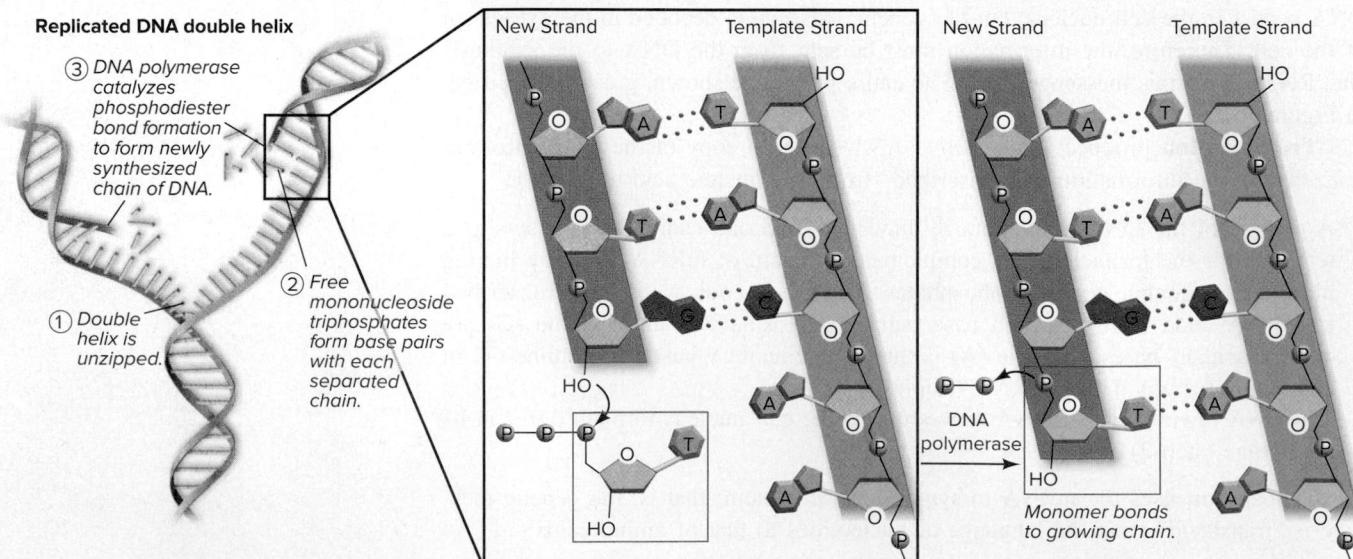

Figure 15.36 Key stages in DNA replication.

Thanks to *DNA sequencing*, the process of determining the identity and order of DNA bases, we now know the sequence of the 3 billion nucleotide base pairs in the DNA of the entire human genome! Sequencing has become indispensable to molecular biology and biochemical genetics.

Just as indispensable to forensic science is *DNA fingerprinting* (or *DNA profiling*), a different process that employs similar methods. Since the discovery that portions of an individual's DNA are as unique as fingerprints, this technique has been applied in countless situations, from confirming the parents of a child to identifying the victims of a terrorist attack.

DNA Sequencing

A given chromosome in the nucleus of a human cell may have 100 million nucleotide bases, but most common sequencing processes cut the DNA into fragments of a few thousand bases. The chromosome is first broken into pieces by enzymes that cleave at specific sites. Then, to obtain enough sample for analysis, the DNA is replicated through a variety of amplification methods, which make many copies of the individual DNA fragments, called target fragments.

One of the most popular approaches is the *Sanger chain-termination method*, which uses chemically altered bases to stop the growth of a complementary DNA chain at specific locations. As you've seen, the chain consists of linked 2'-deoxyribonucleoside monophosphate units (dNMP, where N represents A, T, G, or C). The link is a phosphodiester bond from the 3'-OH of one unit to the 5'-OH of the next, and the free monomers used to construct the chain are 2'-deoxyribonucleoside triphosphates (dNTP) (Figure B15.5A). The Sanger method uses a modified monomer, called a dideoxyribonucleoside triphosphate (ddNTP), in which the 3'-OH group is also missing from the ribose unit (Figure B15.5B). Once a ddNTP is incorporated into the growing chain, polymerization stops because there is no 3'-OH group to form a phosphodiester bond to the next dNTP unit.

The procedure is shown in Figure B15.6. After several preparation steps, the sample to be sequenced consists of single-stranded DNA target fragments, each of which is attached to one strand of a double-stranded segment of DNA (Figure B15.6A). This sample is divided into four tubes, and to each tube is added a mixture of

(continued)

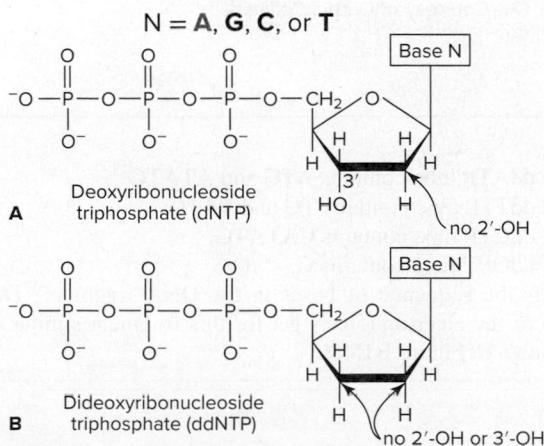

Figure B15.5 Nucleoside triphosphate monomers.

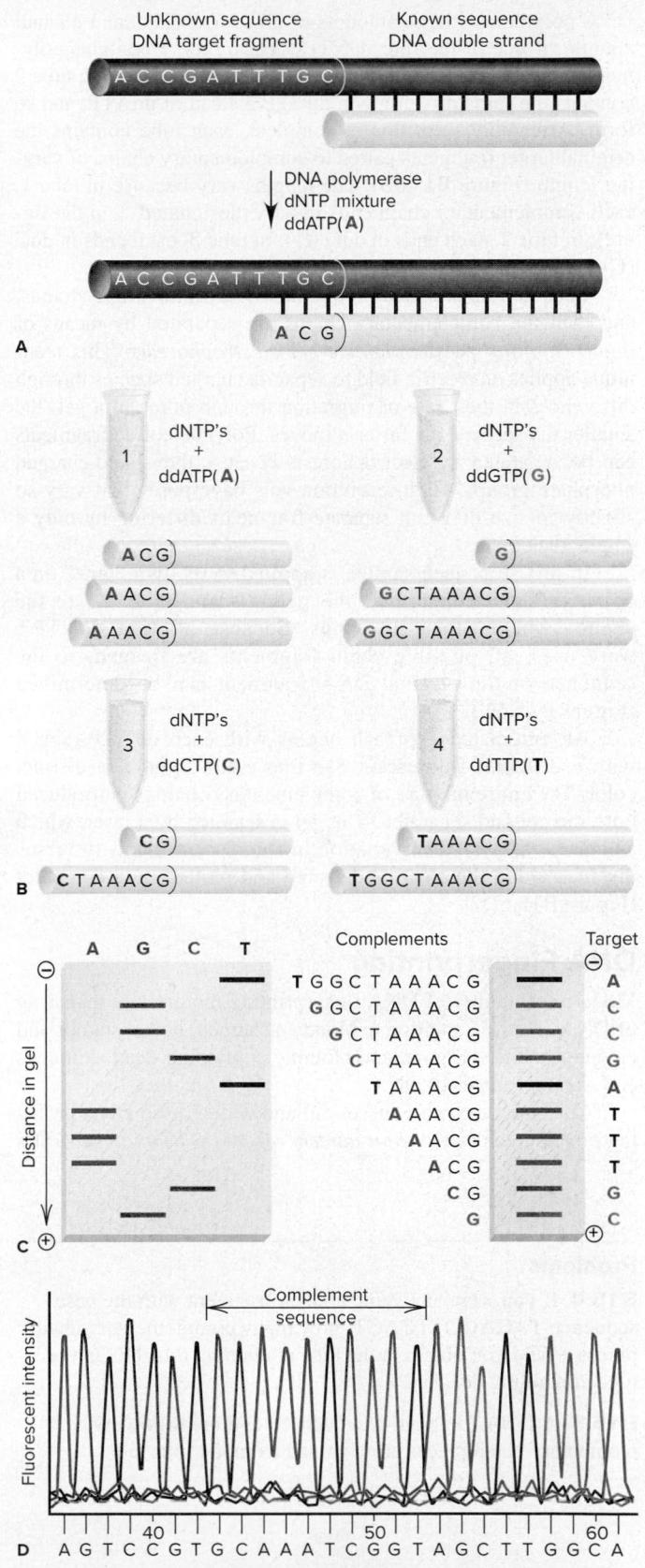

Figure B15.6 Steps in the Sanger method of DNA sequencing.

DNA polymerase, large amounts of all four dNTPs, and a small amount of one of the four ddNTPs. Thus, tube 1 contains polymerase, dATP, dGTP, dCTP, and dTTP, and, say, ddATP; tube 2 contains the same mixture with ddGTP instead of ddATP; and so forth. After polymerization is complete, each tube contains the original target fragments paired to complementary chains of varying length (Figure B15.6B). The lengths vary because in tube 1, each complementary chain ends in ddA (designated A in the figure); in tube 2, each ends in ddG (G); in tube 3, each ends in ddC (C); and in tube 4, each ends in ddT (T).

Each double-stranded product is divided into single strands, and then the complementary chains are separated by means of *high-resolution polyacrylamide-gel electrophoresis*. This technique applies an electric field to separate charged species through differences in their rate of migration through pores in a gel: the smaller the species, the faster it moves. Polynucleotide fragments can be separated by electrophoresis because they have charged phosphate groups. High-resolution gels have pores that vary so slightly in size they can separate fragments differing by only a single nucleotide.

In this step, each sample is applied to its own “lane” on a gel. After electrophoresis, the gel is scanned to locate the chains, which appear in bands. Because all four ddNTP’s were used, all possible chain fragments are formed, so the sequence of the original DNA fragment can be determined (Figure B15.6C).

An automated approach begins with each ddNTP tagged with a different fluorescent dye that emits light of a distinct color. The entire mixture of complementary chains is introduced onto the gel and separated. The gel is scanned by a laser, which activates the dyes. The variation in fluorescent intensity versus distance along the chain is detected and plotted by a computer (Figure B15.6D).

DNA Fingerprinting

Modern techniques of DNA fingerprinting require less than 1 ng of DNA. Thus, in addition to blood and semen, licked stamps and envelopes, chewed gum, and clothing containing dead skin cells can also be sources of DNA.

Currently, the most successful and widely used DNA profiling procedure is called *short tandem repeat (STR) analysis*. STRs

are specific areas on a chromosome that contain short (three to seven bases) sequences that repeat themselves within the DNA molecule. There are hundreds of different types of STRs, but each person has a unique number and assortment of types. Therefore, the more STRs that are characterized, the more discriminating the analysis.

Once the STRs have been amplified (multiple copies made), they are separated by electrophoresis, and an analyst determines the number of base repeats within each STR. In Figure B15.7, stained gels containing the STRs of DNA in blood samples from several suspects are compared with STRs from a blood stain at the crime scene. Suspect 3 has a pattern of STRs identical to that in the crime scene sample.

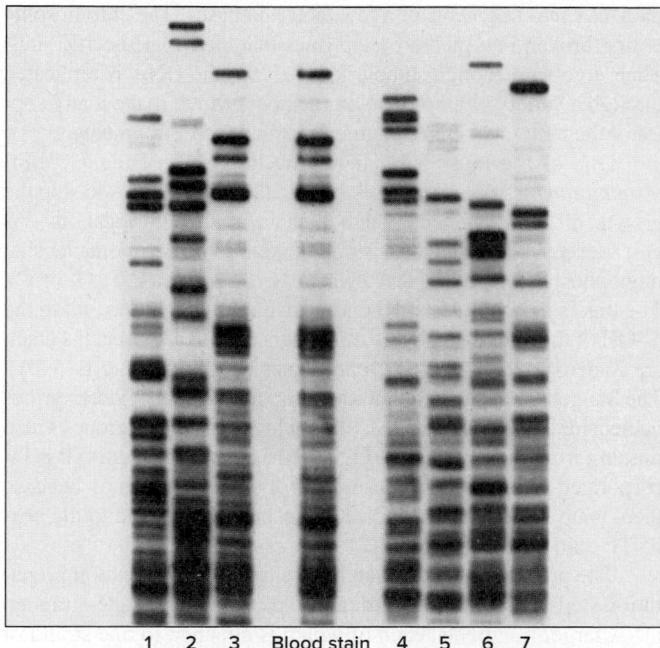

Figure B15.7 STR analysis of DNA in the blood of seven suspects and in a blood stain found at the crime scene.

Source: © & Courtesy of Orchid Cellmark

Problems

B15.4 If you were analyzing a DNA fragment with the base sequence TACAGGTTCACT, how many complementary chain pieces would you obtain in the tube containing ddATP? In the tube containing ddCTP?

B15.5 A DNA fragment is sequenced and the following complementary chain pieces are obtained from the four tubes:

1. The ddATP tube contains ATG and ATATG.
2. The ddTTP tube contains TG and TATG.
3. The ddCTP tube contains CATATG.
4. The ddGPT tube contains G.

What is the sequence of bases in the DNA fragment? Draw a sketch of the electrophoresis gel for this fragment similar to the one shown in Figure B15.6C.

› Summary of Section 15.6

- › The three types of natural polymers—polysaccharides, proteins, and nucleic acids—are formed by dehydration-condensation reactions.
- › Polysaccharides are formed from cyclic monosaccharides, such as glucose. Cellulose, starch, and glycogen have structural or energy-storage roles.
- › Proteins are polyamides formed from as many as 20 different types of amino acids. Fibrous proteins have extended shapes and play structural roles. Globular proteins have compact shapes and play metabolic, immunologic, and hormonal roles. The amino acid sequence of a protein determines its shape and function.
- › Nucleic acids (DNA and RNA) are polynucleotides consisting of four different types of mononucleotides. The base sequence of the DNA chain determines the sequence of amino acids in an organism's proteins. Hydrogen bonding between specific base pairs is the key to protein synthesis and DNA replication.
- › DNA sequencing is used to determine the identity and order of nucleotides in a fragment of a DNA chain. DNA fingerprinting is used to identify a person from the unique sequence of bases in his or her DNA.

CHAPTER REVIEW GUIDE

Learning Objectives

Relevant section (§) and/or sample problem (SP) numbers appear in parentheses.

Understand These Concepts

1. How carbon's atomic properties give rise to its ability to form four strong covalent bonds, multiple bonds, and chains, resulting in the great structural diversity of organic compounds (§15.1)
2. How carbon's atomic properties give rise to its ability to bond to various heteroatoms, which creates regions of charge imbalance that result in functional groups (§15.1)
3. Structures and names of alkanes, alkenes, and alkynes (§15.2)
4. The distinctions among constitutional, optical, and geometric isomers (§15.2)
5. The importance of optical isomerism in organisms (§15.2)
6. The effect of restricted rotation around a π bond on the structures and properties of alkenes (§15.2)
7. The nature of organic addition, elimination, and substitution reactions (§15.3)
8. The properties and reaction types of the various functional groups (§15.4):
 - Substitution and elimination for alcohols, haloalkanes, and amines
 - Addition for alkenes, alkynes, and aldehydes and ketones
 - Substitution for the carboxylic acid family (acids, esters, and amides)
9. Why delocalization of electrons causes aromatic rings to have lower reactivity than alkenes (§15.4)
10. The polarity of the carbonyl bond and the importance of organometallic compounds in addition reactions of carbonyl compounds (§15.4)
11. How addition plus elimination lead to substitution in the reactions of the carboxylic acid family (§15.4)
12. How addition and condensation polymers form (§15.5)
13. The three types of biopolymers and their monomers (§15.6)

14. How amino acid sequence determines protein shape, which determines function (§15.6)
15. How complementary base pairing controls the processes of protein synthesis and DNA replication (§15.6)
16. How DNA base sequence determines RNA base sequence, which determines amino acid sequence (§15.6)

Master These Skills

1. Drawing hydrocarbon structures given the number(s) of C atoms, multiple bonds, and rings (SP 15.1)
2. Naming hydrocarbons and drawing expanded, condensed, and carbon skeleton formulas (§15.2 and SP 15.2)
3. Drawing geometric isomers and identifying chiral centers of molecules (SP 15.2)
4. Recognizing the type of organic reaction from the structures of reactants and products (SP 15.3)
5. Recognizing an organic reaction as an oxidation or reduction from the structures of reactants and products (§15.3)
6. Determining reaction type and products for reactions of alcohols, haloalkanes, and amines (SP 15.4)
7. Determining the products in a stepwise reaction sequence (SP 15.5)
8. Determining the reactants in reactions involving aldehydes and ketones (SP 15.5)
9. Determining reactants and products in reactions of the carboxylic acid family (SP 15.6)
10. Recognizing and naming the functional groups in organic molecules (SP 15.7)
11. Drawing an abbreviated synthetic polymer structure based on monomer structures (§15.5)
12. Drawing small peptides from amino acid structures (§15.6)
13. Using the base sequence of one DNA strand to predict the sequence of the other (§15.6)

Key Terms

Page numbers appear in parentheses.

acid anhydride (663)
 addition polymer (668)
 addition reaction (651)
 alcohol (654)
 aldehyde (660)
 alkane (C_nH_{2n+2}) (639)
 alkene (C_nH_{2n}) (644)
 alkyl group (651)
 alkyne (C_nH_{2n-2}) (646)
 amide (662)
 amine (657)
 amino acid (672)
 aromatic hydrocarbon (647)
 base pair (675)
 carbonyl group (660)

carboxylic acid (662)
 catenation (634)
 chiral molecule (643)
 condensation polymer (669)
 constitutional (structural) isomers (642)
 cyclic hydrocarbon (640)
 disaccharide (671)
 double helix (675)
 elimination reaction (651)
 ester (662)
 fatty acid (663)
 functional group (635)
 genetic code (677)

geometric (*cis-trans*) isomers (645)
 haloalkane (alkyl halide) (656)
 heteroatom (635)
 homologous series (639)
 hydrocarbon (636)
 hydrolysis (664)
 isomers (641)
 ketone (660)
 lipid (663)
 mononucleotide (675)
 monosaccharide (671)
 nitrile (666)
 nuclear magnetic resonance (NMR) spectroscopy (649)

nucleic acid (675)
 optical isomers (643)
 optically active (643)
 organic compounds (633)
 organometallic compound (661)
 polarimeter (643)
 polysaccharide (671)
 protein (672)
 saturated hydrocarbon (639)
 stereoisomers (642)
 substitution reaction (652)
 transcription (677)
 translation (677)
 unsaturated hydrocarbon (644)

BRIEF SOLUTIONS TO FOLLOW-UP PROBLEMS**15.1A (a)**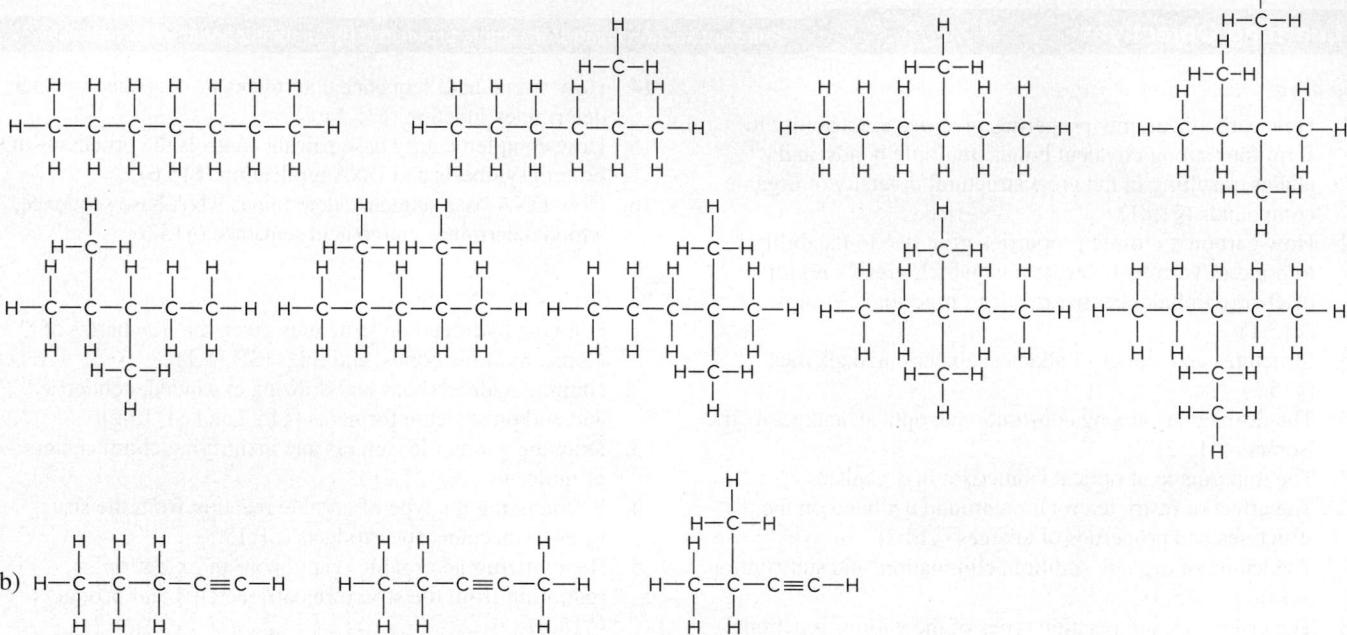**15.1B**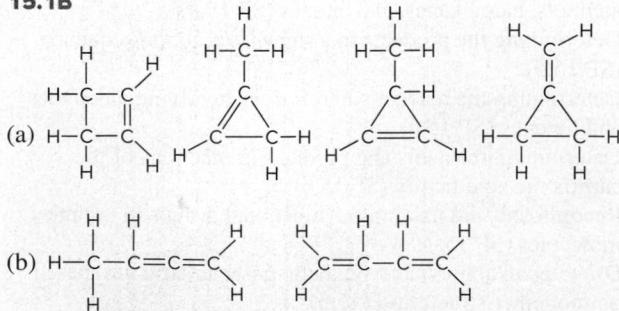

15.2A (a) 3,3-diethylpentane; (b) 1-ethyl-2-methylcyclobutane; (c) *trans*-3-methyl-3-hexene; (d) 1-methyl-2-propylcyclopentane, in which ring C-1 and ring C-2 are chiral

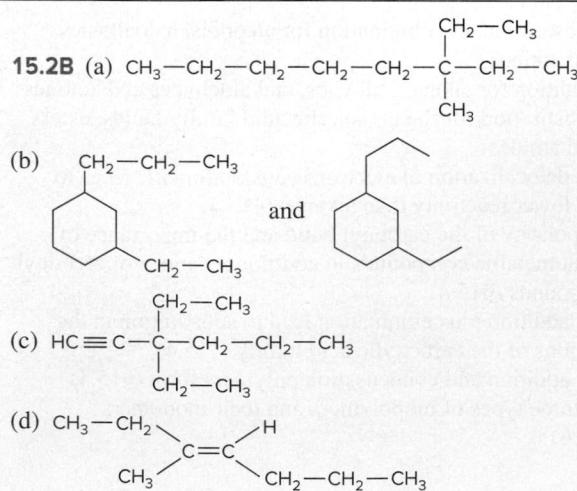

- 15.3A** (a) Substitution: OH replaces Br, but C has the same number of bonds.
 (b) Substitution: OH replaces OCH₃, but C has the same number of bonds.
 (c) Addition: a second O is bonded to C in the product.

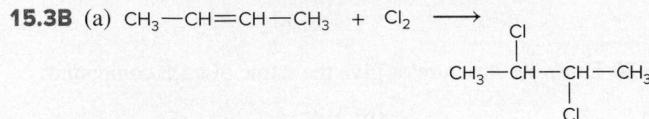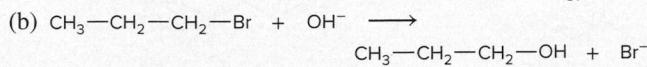

- (b) Substitution: N≡C—CH₂—CH₂—CH₂—C≡N

- (b) $\text{CH}_3-\text{CH}_2-\text{CH}_2-\text{OH}$ (An alcohol is oxidized to a carboxylic acid.)

- 15.5A** (a) A ketone is reduced to an alcohol.

The ethyl group from ethyllithium adds to the carbonyl carbon, and treating with water forms an alcohol.

- 15.5B** (a) An alcohol is oxidized to a ketone.

The ethyl group from ethyllithium adds to the carbonyl carbon, and treating with water forms an alcohol.

Hydrolysis of an ester with a strong base

Reduction of an amide to an amine

Production of an ester from a carboxylic acid and an alcohol

Production of an amide from an ester and an amine

PROBLEMS

Problems with **colored** numbers are answered in Appendix E and worked in detail in the Student Solutions Manual. Problem sections match those in the text and give the numbers of relevant sample problems. Most offer Concept Review Questions, Skill-Building Exercises (grouped in pairs covering the same concept), and Problems in Context. The Comprehensive Problems are based on material from any section or previous chapter.

- (b) Carbon has four bonds in all its organic compounds.
 (c) Carbon forms neither stable cations, like many metals, nor stable anions, like many nonmetals.
 (d) Carbon atoms bond to other carbon atoms more extensively than do the atoms of any other element.
 (e) Carbon forms stable multiple bonds.

15.3 Carbon bonds to many elements other than itself.

- (a) Name six elements that commonly bond to carbon in organic compounds.
 (b) Which of these elements are heteroatoms?
 (c) Which of these elements are more electronegative than carbon? Less electronegative?
 (d) How does bonding of carbon to heteroatoms increase the number of organic compounds?

The Special Nature of Carbon and the Characteristics of Organic Molecules

Concept Review Questions

- 15.1** Give the names and formulas of two carbon compounds that are organic and two that are inorganic.

- 15.2** Explain each statement in terms of atomic properties:
 (a) Carbon engages in covalent rather than ionic bonding.

15.4 Silicon lies just below carbon in Group 4A(14) and also forms four covalent bonds. Why aren't there as many silicon compounds as carbon compounds?

15.5 What is the range of oxidation states for carbon? Name a compound in which carbon has its highest oxidation state and one in which it has its lowest.

15.6 Which of these bonds to carbon would you expect to be relatively reactive: C—H, C—C, C—I, C=O, C—Li? Explain.

The Structures and Classes of Hydrocarbons

(Sample Problems 15.1 and 15.2)

Concept Review Questions

15.7 (a) What structural feature is associated with each type of hydrocarbon: alkane, cycloalkane, alkene, and alkyne?

(b) Give the general formula for each type.

(c) Which hydrocarbons are considered saturated?

15.8 Define each type of isomer: (a) constitutional; (b) geometric; (c) optical. Which types of isomers are stereoisomers?

15.9 Among alkenes, alkynes, and aromatic hydrocarbons, only alkenes exhibit *cis-trans* isomerism. Why don't the others?

15.10 Which objects are asymmetric (have no plane of symmetry): (a) a circular clock face; (b) a football; (c) a dime; (d) a brick; (e) a hammer; (f) a spring?

15.11 Explain how a polarimeter works and what it measures.

15.12 How does an aromatic hydrocarbon differ from a cycloalkane in terms of its bonding? How does this difference affect structure?

Skill-Building Exercises (grouped in similar pairs)

15.13 Draw all possible skeletons for a seven-C compound with

(a) A six-C chain and one double bond

(b) A five-C chain and one double bond

(c) A five-C ring and no double bonds

15.14 Draw all possible skeletons for a six-C compound with

(a) A five-C chain and two double bonds

(b) A five-C chain and one triple bond

(c) A four-C ring and no double bonds

15.15 Add the correct number of hydrogens to each of the skeletons in Problem 15.13.

15.16 Add the correct number of hydrogens to each of the skeletons in Problem 15.14.

15.17 Draw correct structures, by making a single change, for any that are incorrect:

15.18 Draw correct structures, by making a single change, for any that are incorrect:

15.19 Draw the structure or give the name of each compound:

(a) 2,3-dimethyloctane

(b) 1-ethyl-3-methylcyclohexane

15.20 Draw the structure or give the name of each compound:

(c) 1,2-diethylcyclopentane

(d) 2,4,5-trimethylnonane

15.21 Each of the following names is wrong. Draw structures based on them, and correct the names:

(a) 4-methylhexane

(b) 2-ethylpentane

(c) 2-methylcyclohexane

(d) 3,3-methyl-4-ethyloctane

15.22 Each of the following names is wrong. Draw structures based on them, and correct the names:

(a) 3,3-dimethylbutane

(b) 1,1,1-trimethylheptane

(c) 1,4-diethylcyclopentane

(d) 1-propylcyclohexane

15.23 Each of the following compounds can exhibit optical activity. Circle the chiral center(s) in each:

15.24 Each of the following compounds can exhibit optical activity. Circle the chiral center(s) in each:

15.25 Draw structures from the following names, and determine which compounds are optically active:

(a) 3-bromohexane

(b) 3-chloro-3-methylpentane

(c) 1,2-dibromo-2-methylbutane

15.26 Draw structures from the following names, and determine which compounds are optically active:

(a) 1,3-dichloropentane

(b) 3-chloro-2,2,5-trimethylhexane

(c) 1-bromo-1-chlorobutane

15.27 Which of the following structures exhibit geometric isomerism? Draw and name the two isomers in each case:

One method of synthesizing the compound for pharmacological and psychiatric studies involves two steps:

Classify each step as an addition, elimination, or substitution.

Properties and Reactivities of Common Functional Groups (Sample Problems 15.4 to 15.7)

Concept Review Questions

15.49 Compounds with nearly identical molar masses often have very different physical properties. Choose the compound with the higher value for each of the following properties, and explain your choice.

- Solubility in water: chloroethane or methylethylamine
- Melting point: diethyl ether or 1-butanol
- Boiling point: trimethylamine or propylamine

15.50 Fill in each blank with a general formula for the type of compound formed:

15.51 Of the three major types of organic reactions, which do *not* occur readily with benzene? Why?

15.52 Why does the C=O group react differently from the C=C group? Show an example of the difference.

15.53 Many substitution reactions are initiated by electrostatic attraction between reactants. Show where this attraction arises in the formation of an amide from an amine and an ester.

15.54 Although both carboxylic acids and alcohols contain an —OH group, one is acidic in water and the other is not. Explain.

15.55 What reaction type is common to the formation of esters and acid anhydrides? What is the other product?

15.56 Both alcohols and carboxylic acids undergo substitution, but the processes are very different. Explain.

Skill-Building Exercises (grouped in similar pairs)

15.57 Name the type of organic compound from each description of the functional group:

- polar group that has only single bonds and does not include O or N;
- group that is polar and has a triple bond;
- group that has single and double bonds and is acidic in water;
- group that has a double bond and must be at the end of a C chain.

15.58 Name the type of organic compound from each description of the functional group: (a) N-containing group with single and double bonds; (b) group that is not polar and has a double bond; (c) polar group that has a double bond and cannot be at the end of a C chain; (d) group that has only single bonds and is basic in water.

15.59 Circle and name the functional group(s) in each molecule:

15.60 Circle and name the functional group(s) in each molecule:

15.61 Draw all alcohols with the formula $\text{C}_5\text{H}_{12}\text{O}$.

15.62 Draw all aldehydes and ketones with the formula $\text{C}_5\text{H}_{10}\text{O}$.

15.63 Draw all amines with the formula $\text{C}_4\text{H}_{11}\text{N}$.

15.64 Draw all carboxylic acids with the formula $\text{C}_5\text{H}_{10}\text{O}_2$.

15.65 Draw the product resulting from mild oxidation of (a) 2-butanol; (b) 2-methylpropanal; (c) cyclopentanol.

15.66 Draw the alcohol whose oxidation will produce (a) 2-methylpropanal; (b) 2-pentanone; (c) 3-methylbutanoic acid.

15.67 Draw the organic product formed when the following compounds undergo a substitution reaction: (a) acetic acid and methylamine; (b) butanoic acid and 2-propanol; (c) formic acid and 2-methyl-1-propanol.

15.68 Draw the organic product formed when the following compounds undergo a substitution reaction: (a) acetic acid and 1-hexanol; (b) propanoic acid and dimethylamine; (c) ethanoic acid and diethylamine.

15.69 Draw condensed formulas for the carboxylic acid and alcohol that form the following esters:

15.70 Draw condensed formulas for the carboxylic acid and amine that form the following amides:

15.71 Fill in the expected organic substances:

15.72 Fill in the expected organic substances:

15.73 Supply the missing organic and/or inorganic substances:

15.74 Supply the missing organic and/or inorganic substances:

Problems in Context

15.75 (a) Draw the four isomers of $\text{C}_5\text{H}_{12}\text{O}$ that can be oxidized to an aldehyde. (b) Draw the three isomers of $\text{C}_5\text{H}_{12}\text{O}$ that can be oxidized to a ketone. (c) Draw the isomers of $\text{C}_5\text{H}_{12}\text{O}$ that cannot be easily oxidized to an aldehyde or ketone. (d) Name any isomer that is an alcohol.

15.76 Ethyl formate ($\text{HC}\overset{\text{O}}{\parallel}\text{C}-\text{O}-\text{CH}_2-\text{CH}_3$) is added to foods to give them the flavor of rum. How would you synthesize ethyl formate from ethanol, methanol, and any inorganic reagents?

The Monomer-Polymer Theme I: Synthetic Macromolecules

Concept Review Questions

15.77 Name the reaction processes that lead to the two types of synthetic polymers.

15.78 Which functional group occurs in the monomers of addition polymers? How are these polymers different from one another?

15.79 What is a free radical? How is it involved in polymer formation?

15.80 Which intermolecular force is primarily responsible for the different types of polyethylene? Explain.

15.81 Which of the two types of synthetic polymer is more similar chemically to biopolymers? Explain.

15.82 Which functional groups react to form nylons? Polyesters?

Skill-Building Exercises (grouped in similar pairs)

15.83 Draw an abbreviated structure for the following polymers, with brackets around the repeat unit:

15.84 Draw an abbreviated structure for the following polymers, with brackets around the repeat unit:

(a) Teflon from

(b) Polystyrene from

Problems in Context

15.85 Polyethylene terephthalate (PET) is used to make synthetic fibers, such as Dacron; thin films, such as Mylar; and bottles for carbonated beverages.

PET is produced from ethylene glycol and either of two monomers, depending on whether the reaction proceeds by dehydration-condensation or by displacement. Write equations for the two syntheses. (Hint: The displacement is reversed by adding methanol to PET at high T and P .)

15.86 Write a balanced equation for the reaction of dihydroxydimethylsilane (*right*) to form the condensation polymer known as Silly Putty.

The Monomer-Polymer Theme II: Biological Macromolecules

Concept Review Questions

15.87 Which type of polymer is formed from each of the following monomers: (a) amino acids; (b) alkenes; (c) simple sugars; (d) mononucleotides?

15.88 What is the key structural difference between fibrous and globular proteins? How is it related, in general, to the proteins' amino acid composition?

15.89 Protein shape, function, and amino acid sequence are interrelated. Which determines which?

15.90 What linkage joins the monomers in each strand of DNA?

15.91 What is base pairing? How does it pertain to DNA structure?

15.92 RNA base sequence, protein amino acid sequence, and DNA base sequence are interrelated. Which determines which in the process of protein synthesis?

Skill-Building Exercises (grouped in similar pairs)

15.93 Draw the R group of (a) alanine; (b) histidine; (c) methionine.

15.94 Draw the R group of (a) glycine; (b) isoleucine; (c) tyrosine.

15.95 Draw the structure of each of the following tripeptides:

(a) Aspartic acid-histidine-tryptophan

(b) Glycine-cysteine-tyrosine, with the charges that exist in cellular fluid

15.96 Draw the structure of each of the following tripeptides:

(a) Lysine-phenylalanine-threonine

(b) Alanine-leucine-valine, with the charges that exist in cellular fluid

15.97 Write the sequence of the complementary DNA strand that pairs with each of the following DNA base sequences:

(a) TTAGCC

(b) AGACAT

15.98 Write the sequence of the complementary DNA strand that pairs with each of the following DNA base sequences:

(a) GGTTAC

(b) CCCGAA

15.99 Write the base sequence of the DNA template from which this RNA sequence was derived: UGUUACCGA. How many amino acids are coded for in this sequence?

15.100 Write the base sequence of the DNA template from which this RNA sequence was derived: GUAUCAAUGAACUUG. How many amino acids are coded for in this sequence?

Problems in Context

15.101 Protein shapes are maintained by a variety of forces that arise from interactions between the R groups of the various amino acids. Name the amino acid that possesses each R group and the force that could arise in each of the following interactions:

(a) $-\text{CH}_2-\text{SH}$ with $\text{HS}-\text{CH}_2-$

(b) $-(\text{CH}_2)_4-\text{NH}_3^+$ with $-\text{O}-\overset{\text{O}}{\parallel}\text{C}-\text{CH}_2-$

(c) $-\text{CH}_2-\overset{\text{O}}{\parallel}\text{C}-\text{NH}_2$ with $\text{HO}-\text{CH}_2-$

(d) $-\overset{\text{CH}_3}{\text{CH}}-\text{CH}_3$ with

15.102 Amino acids have an average molar mass of 100 g/mol. How many bases on a single strand of DNA are needed to code for a protein with a molar mass of 5×10^5 g/mol?

Comprehensive Problems

15.103 Ethers (general formula $\text{R}-\text{O}-\text{R}'$) have many important uses. Until recently, methyl *tert*-butyl ether (MTBE, below) was used as an octane booster and fuel additive for gasoline. It increases the oxygen content of the fuel, which reduces CO emissions. MTBE is synthesized by the catalyzed reaction of 2-methylpropene with methanol.

(a) Write a balanced equation for the synthesis of MTBE. (*Hint:* Alcohols add to alkenes similarly to the way water does.)

(b) If the government required that auto fuel mixtures contain 2.7% oxygen by mass to reduce CO emissions, how many grams of MTBE would have to be added to each 100. g of gasoline?

(c) How many liters of MTBE would be in each liter of fuel mixture? (The density of both gasoline and MTBE is 0.740 g/mL.)

(d) How many liters of air (21% O₂ by volume) are needed at 24°C and 1.00 atm to fully combust 1.00 L of MTBE?

15.104 An alcohol is oxidized to a carboxylic acid, and 0.2003 g of the acid is titrated with 45.25 mL of 0.03811 M NaOH. (a) What is the molar mass of the acid? (b) What are the molar mass and molecular formula of the alcohol?

15.105 Some of the most useful compounds for organic synthesis are Grignard reagents (general formula $\text{R}-\text{MgX}$, where X is a halogen), which are made by combining a haloalkane, $\text{R}-\text{X}$, with Mg. They are used to change the carbon skeleton of a starting carbonyl compound in a reaction similar to that with $\text{R}-\text{Li}$:

(a) What is the product, after a final step with water, of the reaction between ethanal and the Grignard reagent of bromobenzene? (b) What is the product, after a final step with water, of the reaction between 2-butanone and the Grignard reagent of 2-bromopropane? (c) There are often two (or more) combinations of Grignard reagent and carbonyl compound that will give the same product. Choose another pair of reactants to give the product in part (a). (d) What carbonyl compound must react with a Grignard reagent to yield a product with the —OH group at the *end* of the carbon chain? (e) What Grignard reagent and carbonyl compound would you use to prepare 2-methyl-2-butanol?

15.106 Starting with the given organic reactant and any necessary inorganic reagents, explain how you would perform each of the following syntheses:

(a) From $\text{CH}_3-\text{CH}_2-\text{CH}_2-\text{OH}$, make $\text{CH}_3-\overset{\text{Br}}{\underset{|}{\text{CH}}}-\text{CH}_2-\text{Br}$

(b) From $\text{CH}_3-\text{CH}_2-\text{CH}_2-\text{OH}$, make $\text{CH}_3-\overset{\text{O}}{\parallel}\text{C}-\text{O}-\text{CH}_2-\text{CH}_3$

15.107 Compound A, composed of C, H, and O, is heated in a 1.00-L flask to 160.°C until all of the A has vaporized and displaced the air. The flask is then cooled, and 2.48 g of A remains. When 0.500 g of A burns in O₂, 0.409 g of H₂O and 1.00 g of CO₂ are produced. Compound A is not acidic, but it can be oxidized to compound B, which is weakly acidic: 1.000 g of B is neutralized with 33.9 mL of 0.5 M sodium hydroxide. When B is heated to 260°C, it gives off water and forms C, which, in solution in CDCl₃ (where D is deuterium, ²H), has one peak in its ¹H-NMR spectrum. (a) What are the structures of A, B, and C? (b) Compound A is a controlled substance because it is metabolized to the weakly acidic “date rape” drug GHB, C₄H₈O₃. What are the structure and name of GHB?

15.108 Cadaverine (1,5-diaminopentane) and putrescine (1,4-diaminobutane) are two compounds that are formed by bacterial action and are responsible for the odor of rotting flesh. Draw their structures. Suggest a series of reactions to synthesize putrescine from 1,2-dibromoethane and any inorganic reagents.

15.109 Pyrethrins, such as jasmolin II (*facing page*), are a group of natural compounds synthesized by flowers of the genus *Chrysanthemum* (known as pyrethrum flowers) to act as insecticides.

(a) Circle and name the functional groups in jasmolin II.

(b) What is the hybridization of the numbered carbons?

(c) Which, if any, of the numbered carbons are chiral centers?

15.110 Compound A is branched and optically active and contains C, H, and O. (a) A 0.500-g sample burns in excess O₂ to yield 1.25 g of CO₂ and 0.613 g of H₂O. Determine the empirical formula. (b) When 0.225 g of compound A vaporizes at 755 torr and 97°C, the vapor occupies 78.0 mL. Determine the molecular formula. (c) Careful oxidation of the compound yields a ketone. Name and draw compound A, and circle the chiral center.

15.111 Ibuprofen is one of the most common anti-inflammatory drugs. (a) Identify the functional group(s) and chiral center(s) in ibuprofen. (b) Write a four-step synthesis of a racemic mixture of ibuprofen from 4-isobutylbenzaldehyde, using inorganic reactants and one organometallic reactant (see Problem 15.105).

15.112 Which features of retinal make it so useful as a photon absorber in the visual systems of organisms?

15.113 The polypeptide chain in proteins does not exhibit free rotation because of the partial double-bond character of the peptide bond. Explain this fact with resonance structures.

15.114 Other nonmetals form compounds that are structurally analogous to those of carbon, but these inorganic compounds are usually more reactive. Predict any missing products and write balanced equations for each reaction: (a) the decomposition and chlorination of diborane to boron trichloride; (b) the combustion of pentaborane (B₅H₉) in O₂; (c) the hydrolysis of trisilane (Si₃H₈) to silica (SiO₂) and H₂; (d) the complete halogenation of disilane

with Cl₂; (e) the thermal decomposition of H₂S₅ to hydrogen sulfide and sulfur molecules; (f) the hydrolysis of PCl₅.

15.115 In addition to their use in water treatment, ion-exchange resins are used to extract Au, Ag, and Pt ions from solution. One of the most common resins consists of a polymer with a benzene-containing backbone to which sulfonic acid groups (—SO₃H) have been added. (a) What monomer can be used to prepare the polymer backbone? (b) This polymer typically contains 4–16% crosslinking. Draw the structure of the benzene-containing monomer used to crosslink the polymer.

15.116 Complete hydrolysis of a 100.00-g sample of a peptide gave the following amounts of individual amino acids (molar masses, in g/mol, appear in parentheses):

3.00 g of glycine (75.07)	0.90 g of alanine (89.10)
3.70 g of valine (117.15)	6.90 g of proline (115.13)
7.30 g of serine (105.10)	86.00 g of arginine (174.21)

(a) Why does the total mass of amino acids exceed the mass of peptide? (b) What are the relative numbers of amino acids in the peptide? (c) What is the minimum molar mass of the peptide?

15.117 2-Butanone is reduced by hydride ion donors, such as sodium borohydride (NaBH₄), to the alcohol 2-butanol. Even though the alcohol has a chiral center, the product isolated from the redox reaction is not optically active. Explain.

15.118 Wastewater from a cheese factory has the following composition: 8.0 g/L protein (C₁₆H₂₄O₅N₄); 12 g/L carbohydrate (CH₂O); and 2.0 g/L fat (C₈H₁₆O). What is the total organic carbon (TOC) of the wastewater in g/L?

15.119 Structures A, B, and C show the three common forms of vitamin A. (a) Match each structure with the correct vitamin A compound: retinal (an aldehyde), retinol (an alcohol), and retinoic acid (a carboxylic acid). (b) Retinal, the molecule responsible for the chemistry of vision, can be converted to retinol or to retinoic acid. Identify each of these reactions as a reduction or an oxidation. (c) Structure D is that of beta-carotene, found in carrots. Suggest a reason for the importance of beta-carotene in the vision process.

16

Kinetics: Rates and Mechanisms of Chemical Reactions

16.1 Focusing on Reaction Rate

16.2 Expressing the Reaction Rate

Average, Instantaneous, and Initial Rates
Rate and Concentration

16.3 The Rate Law and Its Components

Laboratory Methods for Determining Initial Rate
Determining Reaction Orders
Determining the Rate Constant

16.4 Integrated Rate Laws:

Concentration Changes over Time

First-, Second-, and Zero-Order Reactions

Determining Reaction Orders from an Integrated Rate Law
Reaction Half-Life

16.5 Theories of Chemical Kinetics

Collision Theory
Transition State Theory

16.6 Reaction Mechanisms: The Steps from Reactant to Product

Elementary Reactions and Molecularity
The Rate-Determining Step
The Mechanism and the Rate Law

16.7 Catalysis: Speeding Up a Reaction

Basis of Catalytic Action
Homogeneous Catalysis
Heterogeneous Catalysis
Biological Catalysts

Source: © Miroslav Hlavko/Shutterstock.com

- › influence of temperature on molecular speed and collision frequency (Section 5.5)

To survive a cold winter when food is scarce, some animals, such as deer mice, ground squirrels, and hedgehogs (*see photo*), sleep through! A hedgehog in hibernation drops its body temperature to 2–5°C to slow down its bodily functions, such as breathing rate (which is reduced to <2 breaths per minute), heart rate (decreases by 90%), and rates of metabolic reactions. At this slower pace, the hedgehog can conserve energy and survive with little food. When the weather is warmer, the life-sustaining processes increase in rate, and the animal goes about its business. Temperature, as you'll see, has a critical effect on the speed, or rate, of a reaction.

Until now, we haven't focused quantitatively on factors affecting reactions, other than the amounts of reactants and products and their molecular nature. Yet, while a balanced equation is essential for calculating yields, it tells us nothing about three dynamic aspects of chemical change:

- How fast is the reaction proceeding?
- How far will the reaction proceed toward completion?
- Will the reaction proceed by releasing energy or by absorbing it?

This chapter addresses the first of these questions and focuses on the field of *kinetics*. We'll address the other two questions in upcoming chapters. Answering all three is crucial to understanding modern technology, the environment, and the reactions in living things.

IN THIS CHAPTER . . . We examine the rate of a reaction, the factors that affect it, the theories that explain those effects, and the stepwise changes reactants undergo as they transform into products.

- › We introduce some general ideas about reaction rates and overview three key factors that affect them—concentration, physical state, and temperature.
- › We express rate through a rate law and determine its components.
- › We see how concentrations change as a reaction proceeds and discuss the meaning of reaction half-life.
- › To understand the effects of concentration and temperature on rate, we examine two related theories of chemical kinetics.
- › We discuss reaction mechanisms, noting the steps a reaction goes through and picturing the chemical species that exists as reactant bonds are breaking and product bonds are forming.
- › We see how catalysts increase reaction rates, highlighting two vital examples—the reactions in a living cell and the depletion of stratospheric ozone.

16.1 FOCUSING ON REACTION RATE

By definition, in a chemical reaction, reactants change into products. **Chemical kinetics**, the study of how fast that change occurs, focuses on the **reaction rate**, the change in the concentrations of reactants (or products) as a function of time. Different reactions have different rates: *in a faster reaction (higher rate), the reactant concentration decreases quickly, whereas in a slower reaction (lower rate), it decreases slowly* (Figure 16.1, *next page*). Under any given set of conditions, a rate is determined by the nature of the reactants. At room temperature, for example, hydrogen reacts explosively with fluorine but extremely slowly with nitrogen:

Furthermore, any given reaction has a different rate under different conditions.

Figure 16.1 A faster reaction (*top*) and a slower reaction (*bottom*). As time elapses, reactant decreases and product increases.

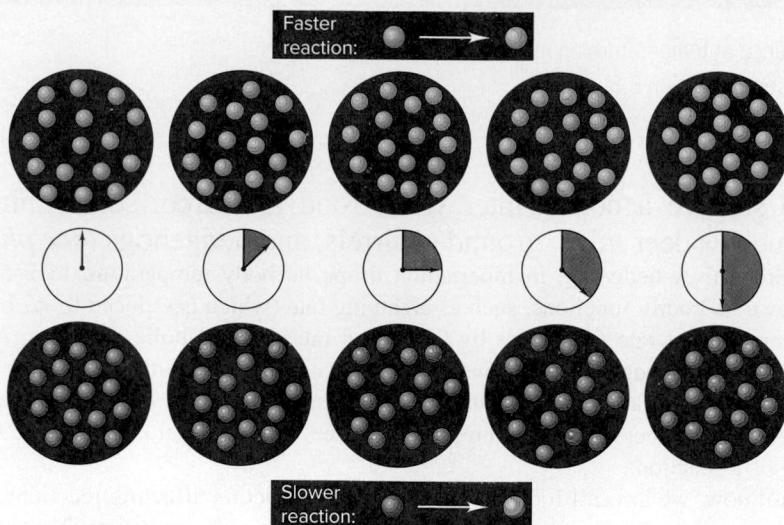

Chemical processes occur over a wide range of rates (Figure 16.2). Some—like a neutralization, a precipitation, or an explosion—may take a second or less. Processes that include many reactions—like the ripening of fruit—take days to months. Human aging continues for decades, and the formation of coal from dead plants takes hundreds of millions of years. Knowing the reaction rate can be essential: how quickly a medicine acts can make the difference between life and death, and how long a commercial product takes to form can make the difference between profit and loss.

We can control four factors that affect rate: the concentrations of reactants, their physical state, the temperature of the reaction, and the use of a catalyst. We consider the first three here and the fourth in Section 16.7.

1. **Concentration:** *molecules must collide to react.* A major factor influencing reaction rate is reactant concentration. Consider the reaction between ozone and nitrogen monoxide (nitric oxide):

This reaction occurs in the stratosphere, where the oxide is released in the exhaust gases of supersonic aircraft, but it can be simulated in the lab. In a reaction vessel, the molecules zoom every which way, crashing into each other and the vessel walls, but a reaction can occur only when NO and O₃ molecules collide. The more molecules present, the more frequently they collide, and the more often they react. Thus, *reaction rate is proportional to the number of collisions, which depends on the concentration of reactants:*

$$\text{Rate} \propto \text{collision frequency} \propto \text{concentration}$$

Figure 16.2 The wide range of reaction rates.

Source: (explosion): © Crown Copyright/Health & Safety Lab./Science Source; (fruit and baby): © Ruth Melnick; (landscape): © Publiphoto/Science Source

Figure 16.3 The effect of surface area on reaction rate.

Source: © McGraw-Hill Education/Stephen Frisch, photographer

2. *Physical state: molecules must mix to collide.* Collision frequency, and thus reaction rate, also depends on the physical state of the reactants, which determines how easily the reactants mix. When the reactants are in the same phase, as in an aqueous solution, random thermal motion brings them into contact, but gentle stirring mixes them further. When the reactants are in different phases, contact occurs only at the interface between the phases, so vigorous stirring or even grinding may be needed. *Thus, the more finely divided a solid or liquid reactant, the greater its surface area, the more contact it makes with the other reactant, and the faster the reaction occurs.* In Figure 16.3, a hot steel nail (left) placed in oxygen gas glows feebly, but the same mass of hot steel wool (right) bursts into flame. For the same reason, you start a campfire with twigs, not logs. The significant surface area of coal and grain dust in coal mines or grain elevators can cause massive explosions in the presence of an ignition source.

3. *Temperature: molecules must collide with enough energy.* Temperature usually has a major effect on the rate of a reaction. Two kitchen appliances employ this effect: a refrigerator slows down chemical processes that spoil food, whereas an oven speeds up other chemical processes that cook it. Temperature affects reaction rate by increasing the *frequency* and, more importantly, the *energy* of collisions:

- *Frequency of collisions.* Recall that molecules in a sample of gas have a range of speeds, with the most probable speed increasing with temperature (see Figure 5.14). Thus, *at a higher temperature, reactant particles move faster, collisions occur more frequently, and so more molecules react:*

$$\text{Rate} \propto \text{collision frequency} \propto \text{temperature}$$

- *Energy of collisions.* Even more important is that *temperature affects the kinetic energy of the molecules.* In the jumble of NO and O₃ molecules in the reaction vessel, most collisions have only enough energy for the molecules to bounce off each other without reacting. However, some collisions occur with sufficient energy for the molecules to react (Figure 16.4). *At a higher temperature, more sufficiently energetic collisions occur, and so more molecules react:*

$$\text{Rate} \propto \text{collision energy} \propto \text{temperature}$$

Figure 16.4 Sufficient collision energy is required for a reaction to occur.

› Summary of Section 16.1

- › Chemical kinetics focuses on reaction rate and the factors that affect it.
- › Under a given set of conditions, each reaction has its own rate.
- › Concentration affects rate by influencing the frequency of collisions between reactant molecules.
- › Physical state affects rate by determining how well reactants can mix.
- › Temperature affects rate by influencing the frequency and, more importantly, the energy of the collisions between reactant molecules.

Runners change positions with time.

Source: © Roberta Schmidt/AFP/Getty Images

16.2 EXPRESSING THE REACTION RATE

In general terms, a *rate* is a change in some variable per unit of time. The most familiar examples relate to speed (*see photo*), the change in position of an object divided by the change in time. For instance, if we measure a runner's initial position, x_1 , at time t_1 , and final position, x_2 , at time t_2 , the average speed is

$$\text{Rate of motion (speed)} = \frac{\text{change in position}}{\text{change in time}} = \frac{x_2 - x_1}{t_2 - t_1} = \frac{\Delta x}{\Delta t}$$

For the rate of a *reaction*, we measure the changes in concentrations of reactants or products per unit time: *reactant concentrations decrease while product concentrations increase* as the reaction proceeds. For the general reaction $A \rightarrow B$, we measure the initial reactant concentration (A_1) at t_1 , allow the reaction to proceed, and then quickly measure the final reactant concentration (A_2) at t_2 . The change in concentration divided by the change in time gives the rate:

$$\text{Rate} = -\frac{\text{change in concentration of } A}{\text{change in time}} = -\frac{\text{conc } A_2 - \text{conc } A_1}{t_2 - t_1} = -\frac{\Delta(\text{conc } A)}{\Delta t}$$

The negative sign is important because, by convention, reaction rate is a *positive* number. But, since conc A_2 must be *lower* than conc A_1 , the *change in concentration (final – initial) of reactant A is negative*. Therefore, we use the negative sign to convert the negative change in reactant concentration to a positive value for the rate. Suppose the concentration of A changes from 1.2 mol/L (conc A_1) to 0.75 mol/L (conc A_2) over a 125-s period. The rate is

$$\text{Rate} = -\frac{0.75 \text{ mol/L} - 1.2 \text{ mol/L}}{125 \text{ s} - 0 \text{ s}} = 3.6 \times 10^{-3} \text{ mol/L}\cdot\text{s}$$

Square brackets, [], indicate a concentration in moles per liter (molarity). For example, $[A]$ is the concentration of A in mol/L, and the rate expressed in terms of A is

$$\text{Rate} = -\frac{\Delta[A]}{\Delta t} \quad (16.1)$$

The units for the rate are moles per liter per second ($\text{mol L}^{-1} \text{ s}^{-1}$, or $\text{mol/L}\cdot\text{s}$), or any time unit convenient for the reaction (minutes, years, and so on).

If instead we measure the *product* concentrations to determine the rate, we find that conc B_2 is always *higher* than conc B_1 . Thus, the *change in product concentration, $\Delta[B]$* , is *positive*, and the reaction rate for $A \rightarrow B$ expressed in terms of B is

$$\text{Rate} = +\frac{\Delta[B]}{\Delta t}$$

The plus sign is usually understood and not shown.

Average, Instantaneous, and Initial Reaction Rates

In most cases, the *rate varies as a reaction proceeds*. Consider the reversible gas-phase reaction between ethylene and ozone, one of many reactions that may be involved in the formation of smog:

The equation shows that for every molecule of C_2H_4 that reacts, a molecule of O_3 reacts; thus, $[\text{O}_3]$ and $[\text{C}_2\text{H}_4]$ decrease at the same rate:

$$\text{Rate} = -\frac{\Delta[\text{C}_2\text{H}_4]}{\Delta t} = -\frac{\Delta[\text{O}_3]}{\Delta t}$$

When we start with a known $[\text{O}_3]$ in a closed vessel at 30°C (303 K) and measure $[\text{O}_3]$ at 10.0-s intervals during the first minute after adding C_2H_4 , we obtain the concentration vs. time data shown in the table in Figure 16.5, which gives the black curve. Note that

- The data points in Figure 16.5 result in a *curved* line, which means that the rate is changing over time (a straight line would mean that the rate was constant).

Figure 16.5 Three types of reaction rates for the reaction of O_3 and C_2H_4 .

Time (s)	Concentration of O_3 (mol/L)
0.0	3.20×10^{-5}
10.0	2.42×10^{-5}
20.0	1.95×10^{-5}
30.0	1.63×10^{-5}
40.0	1.40×10^{-5}
50.0	1.23×10^{-5}
60.0	1.10×10^{-5}

- The rate *decreases* during the course of the reaction because we are plotting *reactant* concentration vs. time: as O_3 molecules react, fewer are present to collide with C_2H_4 molecules, and the rate, the change in $[O_3]$ over time, therefore decreases.

Three types of reaction rates are shown in the figure:

1. *Average rate*. Over a given period of time, the **average rate** is the slope of the line joining two points along the curve. The rate over the entire 60.0 s is the total change in concentration divided by the total change in time (Figure 16.5, line a):

$$\text{Rate} = -\frac{\Delta [O_3]}{\Delta t} = -\frac{(1.10 \times 10^{-5} \text{ mol/L}) - (3.20 \times 10^{-5} \text{ mol/L})}{60.0 \text{ s} - 0.0 \text{ s}} = 3.50 \times 10^{-7} \text{ mol/L·s}$$

This quantity, which is the slope of line a (that is, $\Delta [O_3] / \Delta t$), is the average rate over the entire period: during the first 60.0 s of the reaction, $[O_3]$ decreases an *average* of 3.50×10^{-7} mol/L each second.

But, when you drive a car or ride a bike for a few miles, your speed over shorter distances may be lower or higher than your average speed. In the same sense, the decrease in $[O_3]$ over the whole time period does not show the rate over any shorter time period. This *change* in reaction rate is evident when we calculate the average rate over two shorter periods. For the first 10.0 s, between 0.0 s and 10.0 s, the average rate (Figure 16.5, line b) is

$$\text{Rate} = -\frac{\Delta [O_3]}{\Delta t} = -\frac{(2.42 \times 10^{-5} \text{ mol/L}) - (3.20 \times 10^{-5} \text{ mol/L})}{10.0 \text{ s} - 0.0 \text{ s}} = 7.80 \times 10^{-7} \text{ mol/L·s}$$

And, for the last 10.0 s, between 50.0 s and 60.0 s, the average rate (Figure 16.5, line c) is

$$\text{Rate} = -\frac{\Delta [O_3]}{\Delta t} = -\frac{(1.10 \times 10^{-5} \text{ mol/L}) - (1.23 \times 10^{-5} \text{ mol/L})}{60.0 \text{ s} - 50.0 \text{ s}} = 1.30 \times 10^{-7} \text{ mol/L·s}$$

The reaction rate over the first 10.0 s is six times faster than the rate over the last 10.0 s.

2. *Instantaneous rate*. The shorter the time period we choose, the closer we come to the **instantaneous rate**, the rate at a particular instant during the reaction. *The slope of a line tangent to the curve at any point gives the instantaneous rate at that time*. For example, the rate at 35.0 s is 2.50×10^{-7} mol/L·s, the slope of the line tangent to the curve through the point at $t = 35.0$ s (Figure 16.5, line d). In general, we use the term *reaction rate* to mean *instantaneous* reaction rate.

3. *Initial rate.* The instantaneous rate at the moment the reactants are mixed (that is, at $t = 0$) is the **initial rate**. We use this rate to avoid a complication: as a reaction proceeds in the *forward* direction (reactants \rightarrow products), product increases, causing the *reverse* reaction (reactants \leftarrow products), to occur more quickly. To find the overall (net) rate, we would have to calculate the difference between the forward and reverse rates. But, for the initial rate, $t = 0$, so product concentrations are negligible, and so is the reverse rate. We find the initial rate from the slope of the line tangent to the curve at $t = 0$ s (Figure 16.5, line e). Since reactant concentrations are the largest at $t = 0$, the initial rate is faster than the instantaneous rate at *any* later time during the reaction. We typically use initial rates to find other kinetic parameters.

Expressing Rate in Terms of Reactant and Product Concentrations

So far, for the reaction between C_2H_4 and O_3 , we've expressed the rate in terms of $[O_3]$, which is *decreasing*, and the rate would be expressed the same way in terms of $[C_2H_4]$. However, the rate is exactly the opposite in terms of the product concentrations because they are *increasing*. From the balanced equation, we see that one molecule each of C_2H_4O and of O_2 appear for every molecule of C_2H_4 and of O_3 that disappear. Thus, we can express the rate in terms of any of the four substances:

$$\text{Rate} = -\frac{\Delta[C_2H_4]}{\Delta t} = -\frac{\Delta[O_3]}{\Delta t} = \frac{\Delta[C_2H_4O]}{\Delta t} = \frac{\Delta[O_2]}{\Delta t}$$

Figure 16.6A plots the changes in concentrations of one reactant (C_2H_4) and one product (O_2) simultaneously. The curves have the same shape but are inverted relative to each other, because, *for this reaction*, product appears at the same rate as reactant disappears, because of the 1/1 reactant/product molar ratio.

For many other reactions, though, reactants disappear and products appear at different rates. Consider the reaction between hydrogen and iodine to form hydrogen iodide:

From the balancing coefficients, we see that, for every molecule of H_2 that disappears, one molecule of I_2 disappears and *two* molecules of HI appear (the molar ratio of H_2/HI is 1/2). In other words, the rate of $[H_2]$ decrease is the same as the rate of $[I_2]$ decrease, but both are only half the rate of $[HI]$ increase. Thus, in Figure 16.6B, the

Figure 16.6 Plots of [reactant] and [product] vs. time. A, C_2H_4 and O_2 . B, H_2 and HI .

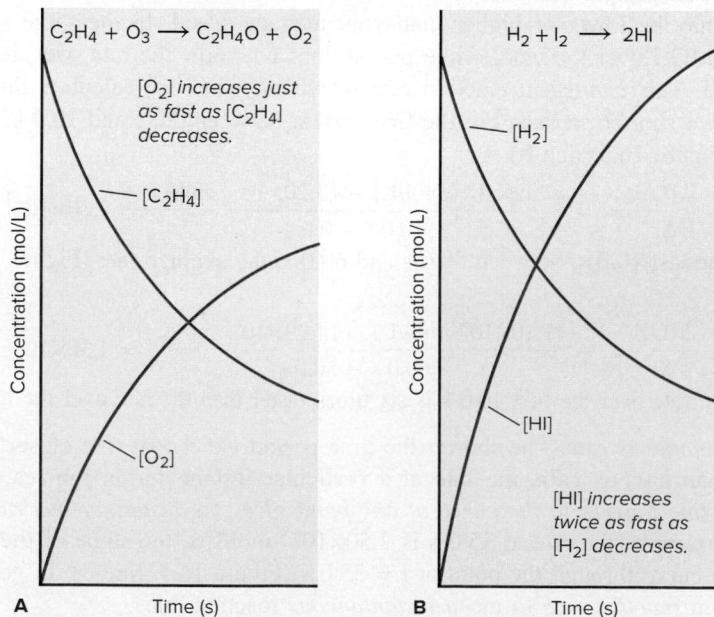

[HI] curve rises twice as fast as the [H₂] curve drops. If we refer the changes in [I₂] and [HI] to the change in [H₂], we have

$$\text{Rate} = -\frac{\Delta[\text{H}_2]}{\Delta t} = -\frac{\Delta[\text{I}_2]}{\Delta t} = \frac{1}{2} \frac{\Delta[\text{HI}]}{\Delta t}$$

If, instead, we refer the changes in [H₂] and [I₂] to the change in [HI], we obtain

$$\text{Rate} = \frac{\Delta[\text{HI}]}{\Delta t} = -2 \frac{\Delta[\text{H}_2]}{\Delta t} = -2 \frac{\Delta[\text{I}_2]}{\Delta t}$$

Note that this expression gives a rate that is double the previous one. Thus, *the expression for the rate of a reaction and its numerical value depend on which substance serves as the reference*.

We can summarize these results for any reaction,

where *a*, *b*, *c*, and *d* are coefficients of the balanced equation, as follows:

$$\text{Rate} = -\frac{1}{a} \frac{\Delta[\text{A}]}{\Delta t} = -\frac{1}{b} \frac{\Delta[\text{B}]}{\Delta t} = \frac{1}{c} \frac{\Delta[\text{C}]}{\Delta t} = \frac{1}{d} \frac{\Delta[\text{D}]}{\Delta t} \quad (16.2)$$

Expressing Rate in Terms of Changes in Concentration with Time

SAMPLE PROBLEM 16.1

Problem Hydrogen gas has a nonpolluting combustion product (water vapor). This gas is used as a fuel aboard the space shuttle and in earthbound cars with prototype engines:

- (a) Express the rate in terms of changes in [H₂], [O₂], and [H₂O] with time.
 (b) When [O₂] is decreasing at 0.23 mol/L·s, at what rate is [H₂O] increasing?

Plan (a) Of the three substances in the equation, let's choose O₂ as the reference because its coefficient is 1. For every molecule of O₂ that disappears, two molecules of H₂ disappear. Thus, the rate of [O₂] decrease is one-half the rate of [H₂] decrease. By similar reasoning, the rate of [O₂] decrease is one-half the rate of [H₂O] increase.
 (b) Because [O₂] is decreasing, the change in its concentration must be negative. We substitute the given rate as a negative value (−0.23 mol/L·s) into the expression and solve for Δ[H₂O]/Δ*t*.

Solution (a) Expressing the rate in terms of each component:

$$\text{Rate} = -\frac{\Delta[\text{O}_2]}{\Delta t} = -\frac{1}{2} \frac{\Delta[\text{H}_2]}{\Delta t} = \frac{1}{2} \frac{\Delta[\text{H}_2\text{O}]}{\Delta t}$$

(b) Calculating the rate of change of [H₂O]:

$$\begin{aligned} \frac{1}{2} \frac{\Delta[\text{H}_2\text{O}]}{\Delta t} &= -\frac{\Delta[\text{O}_2]}{\Delta t} = -(-0.23 \text{ mol/L}\cdot\text{s}) \\ \frac{\Delta[\text{H}_2\text{O}]}{\Delta t} &= 2(0.23 \text{ mol/L}\cdot\text{s}) = 0.46 \text{ mol/L}\cdot\text{s} \end{aligned}$$

Check (a) A good check is to use the rate expression to obtain the balanced equation: [H₂] changes twice as fast as [O₂], so two H₂ molecules react for each O₂. [H₂O] changes twice as fast as [O₂], so two H₂O molecules form from each O₂. Thus, we get 2H₂ + O₂ → 2H₂O. The values of [H₂] and [O₂] decrease, so they have negative signs; [H₂O] increases, so it has a plus sign. Another check is to use Equation 16.2, with A = H₂, a = 2; B = O₂, b = 1; and C = H₂O, c = 2:

$$\text{Rate} = -\frac{1}{a} \frac{\Delta[\text{A}]}{\Delta t} = -\frac{1}{b} \frac{\Delta[\text{B}]}{\Delta t} = \frac{1}{c} \frac{\Delta[\text{C}]}{\Delta t}$$

or $\text{Rate} = -\frac{1}{2} \frac{\Delta[\text{H}_2]}{\Delta t} = -\frac{\Delta[\text{O}_2]}{\Delta t} = \frac{1}{2} \frac{\Delta[\text{H}_2\text{O}]}{\Delta t}$

(b) Given the rate expression, it makes sense that the numerical value of the rate of [H₂O] increase is twice that of [O₂] decrease.

Comment Thinking through this type of problem at the molecular level is the best approach, but use Equation 16.2 to confirm your answer.

FOLLOW-UP PROBLEMS

Brief Solutions for all Follow-up Problems appear at the end of the chapter.

16.1A (a) Balance the following equation and express the rate in terms of the change in concentration with time for each substance:

(b) How fast is $[\text{O}_2]$ decreasing when $[\text{NO}]$ is decreasing at a rate of $1.60 \times 10^{-4} \text{ mol/L}\cdot\text{s}$?

16.1B For a particular reaction, the reaction rate in terms of the change in concentration with time for each substance is

$$\text{Rate} = -\frac{1}{4} \frac{\Delta[\text{NH}_3]}{\Delta t} = -\frac{1}{5} \frac{\Delta[\text{O}_2]}{\Delta t} = \frac{1}{4} \frac{\Delta[\text{NO}]}{\Delta t} = \frac{1}{6} \frac{\Delta[\text{H}_2\text{O}]}{\Delta t}$$

(a) Write a balanced equation for this gaseous reaction.

(b) When $[\text{H}_2\text{O}]$ is increasing at a rate of $2.52 \times 10^{-2} \text{ mol/L}\cdot\text{s}$, how fast is $[\text{O}_2]$ decreasing?

SOME SIMILAR PROBLEMS 16.14–16.19

› Summary of Section 16.2

- › The average reaction rate is the change in reactant (or product) concentration over a change in time, Δt . The rate slows as the reaction proceeds because reactants are used up.
- › The instantaneous rate at time t is the slope of the tangent to a curve that plots concentration vs. time.
- › The initial rate, the instantaneous rate at $t = 0$, occurs when reactants have just been mixed and before any product accumulates.
- › The expression for a reaction rate and its numerical value depend on which reaction component is being referenced.

16.3 THE RATE LAW AND ITS COMPONENTS

The centerpiece of any kinetic study of a reaction is the **rate law (or rate equation)**, which expresses the rate as a function of concentrations and temperature. The rate law is based on experiment, so any hypothesis about how the reaction occurs on the molecular level must conform to it.

In this discussion, we generally consider reactions for which the products do not appear in the rate law, so the rate depends only on *reactant* concentrations and temperature. For a general reaction occurring at a fixed temperature,

the rate law is

$$\text{Rate} = k[\text{A}]^m[\text{B}]^n \dots \quad (16.3)$$

The term k is a proportionality constant, called the **rate constant**, that is specific for a given reaction at a given temperature and does *not* change as the reaction proceeds. (As we'll see in Section 16.5, k *does* change with temperature.) The exponents m and n , called the **reaction orders**, define how the rate is affected by reactant concentration; we'll see how to determine them shortly. Two key points to remember are

- *The balancing coefficients a and b in the reaction equation are not necessarily related in any way to the reaction orders m and n .*
- *The components of the rate law—rate, reaction orders, and rate constant—must be found by experiment.*

In the remainder of this section, we'll find the components of the rate law by measuring concentrations to determine the *initial rate*, using initial rates to determine

the *reaction orders*, and using these values to calculate the *rate constant*. With the rate law for a reaction, we can predict the rate for any initial concentrations.

Some Laboratory Methods for Determining the Initial Rate

We determine an initial rate from a plot of concentration vs. time, so we need a quick, accurate method for measuring concentration as a reaction proceeds. Let's briefly discuss three common approaches.

1. *Spectrometric methods* measure the concentration of a component that absorbs (or emits) characteristic wavelengths of light. For example, in the reaction of NO and O₃, only NO₂ has a color (an indication that NO₂ absorbs some wavelength of visible light):

Known amounts of reactants are injected into a tube of known volume within a spectrometer (see Tools of the Laboratory, end of Section 7.2), which is set to measure the wavelength and intensity of the color. The rate of NO₂ formation is proportional to the increase in that intensity over time.

2. *Conductometric methods* rely on the change in electrical conductivity of the reaction solution when nonionic reactants form ionic products, or vice versa. Consider the substitution reaction between a haloalkane, such as 2-bromo-2-methylpropane, and water:

The HBr that forms is a strong acid, so it dissociates completely in the water. As time passes, more ions form, so the conductivity of the reaction mixture increases.

3. *Manometric methods* employ a manometer attached to a reaction vessel of fixed volume and temperature. The manometer measures the pressure change in the vessel due to a reaction that involves a change in the number of moles of gas. Consider the decomposition reaction of hydrogen peroxide:

The rate is directly proportional to the increase in pressure as O₂ gas forms.

Determining Reaction Orders

With the initial rate in hand, we can determine reaction orders. Let's first discuss what reaction orders are and then see how to determine them by controlling reactant concentrations.

First, Second, and Zero Orders A reaction has an *individual* order “with respect to” or “in” each reactant, and an *overall* order, the sum of the individual orders.

Consider first the simplest case, a reaction with only one reactant, A:

- *First order*. If the rate doubles when [A] doubles, the rate depends on [A] raised to the first power, [A]¹ (the superscript 1 is generally omitted). Thus, the reaction is *first order* in (or with respect to) A and *first order* overall:

$$\text{Rate} = k[\text{A}]^1 = k[\text{A}]$$

- *Second order*. If the rate quadruples when [A] doubles, the rate depends on [A] squared, [A]². In this case, the reaction is *second order* in A and *second order* overall:

$$\text{Rate} = k[\text{A}]^2$$

- *Zero order*. If the rate does not change when [A] doubles, the rate does *not* depend on [A], but we express this fact mathematically by saying that the rate depends on [A] raised to the zero power, [A]⁰. The reaction is *zero order* in A and *zero order* overall:

$$\text{Rate} = k[\text{A}]^0 = k(1) = k$$

Figure 16.7 Plots of reactant concentration, $[A]$, vs. time for first-, second-, and zero-order reactions.

Figure 16.8 Plots of rate vs. reactant concentration, $[A]$, for first-, second-, and zero-order reactions.

Figure 16.7 shows plots of $[A]$ vs. time for first-, second-, and zero-order reactions. (In all cases, the value of k was assumed to be the same.) Notice that

- The decrease in $[A]$ doesn't change as time goes on for a zero-order reaction; the rate is constant.
- The decrease slows down as time goes on for a first-order reaction.
- The decrease slows even more for a second-order reaction.

These results are reflected in Figure 16.8, which shows plots of rate vs. $[A]$ for the same reaction orders. Notice that

- The plot is a horizontal line for the zero-order reaction because the rate doesn't change regardless of the value of $[A]$.
- The plot is an upward-sloping *line* for the first-order reaction because the rate is directly proportional to $[A]$.
- The plot is an upward-sloping *curve* for the second-order reaction because the rate increases exponentially with $[A]$.

Let's look at some examples of observed rate laws and note the reaction orders.

- For the reaction between nitrogen monoxide and ozone,

the rate law is

$$\text{Rate} = k[\text{NO}][\text{O}_3]$$

This reaction is first order with respect to NO and first order with respect to O_3 , so it is second order overall ($1 + 1 = 2$).

- For the hydrolysis of 2-bromo-2-methylpropane,

the rate law is

$$\text{Rate} = k[(\text{CH}_3)_3\text{CBr}]$$

This reaction is first order in 2-bromo-2-methylpropane and zero order with respect to H_2O , *despite its coefficient of 1 in the balanced equation*. If we want to note that water is a reactant, we can write

$$\text{Rate} = k[(\text{CH}_3)_3\text{CBr}][\text{H}_2\text{O}]^0$$

Overall, this is a first-order reaction ($1 + 0 = 1$).

- Finally, for the reaction between NO and hydrogen gas,

the rate law is

$$\text{Rate} = k[\text{NO}]^2[\text{H}_2]$$

This reaction is second order in NO. And even though H_2 has a coefficient of 2 in the balanced equation, the reaction is *first order* in H_2 . It is third order overall ($2 + 1 = 3$).

These examples reiterate an important point: *reaction orders cannot be deduced from the balanced equation but must be determined from experimental data*.

The larger the reaction order for a reactant, the greater the effect the concentration of that reactant has on the rate. For example, consider the result of doubling both $[\text{NO}]$ and $[\text{H}_2]$ in the third reaction discussed above:

$$\text{Rate} = k[\text{NO}]^2[\text{H}_2] = k(2)^2(2) = k \times 4 \times 2 = k \times 8, \text{ or } 8k$$

Since the change in $[\text{NO}]$ is squared, doubling $[\text{NO}]$ results in the rate increasing by a factor of 4, while doubling $[\text{H}_2]$ increases the rate only by a factor of 2; the net effect of the change in both concentrations is that the rate increases by a factor of 8.

Other Reaction Orders Although usually positive integers or zero, reaction orders can also be fractional or negative.

- For the reaction

a fractional order appears in the rate law:

$$\text{Rate} = k[\text{CHCl}_3][\text{Cl}_2]^{1/2}$$

This *fractional reaction order* means that if, for example, $[\text{Cl}_2]$ increases by a factor of 4, the rate increases by a factor of 2, the square root of the change in $[\text{Cl}_2]$, or $(4)^{1/2}$. The overall order of this reaction is $1 + \frac{1}{2} = \frac{3}{2}$.

2. A *negative reaction order* means the rate *decreases* when the concentration of that component increases. Negative orders are often seen when the rate law includes products. For example, for the atmospheric reaction

the rate law is

$$\text{Rate} = k[\text{O}_3]^2[\text{O}_2]^{-1} = k \frac{[\text{O}_3]^2}{[\text{O}_2]}$$

If $[\text{O}_2]$ doubles, the reaction proceeds half as fast. This reaction is second order in O_3 and negative first order in O_2 , so it is first order overall $[2 + (-1) = 1]$.

SAMPLE PROBLEM 16.2

Determining Reaction Orders from Rate Laws

Problem For each of the following reactions, use the given rate law to determine the reaction order with respect to each reactant and the overall order; for the reaction in (a), determine the factor by which the rate changes if $[\text{NO}]$ is tripled and $[\text{O}_2]$ is doubled.

- (a) $2\text{NO}(g) + \text{O}_2(g) \rightarrow 2\text{NO}_2(g)$; rate = $k[\text{NO}]^2[\text{O}_2]$
- (b) $\text{CH}_3\text{CHO}(g) \rightarrow \text{CH}_4(g) + \text{CO}(g)$; rate = $k[\text{CH}_3\text{CHO}]^{3/2}$
- (c) $\text{H}_2\text{O}_2(aq) + 3\text{I}^-(aq) + 2\text{H}^+(aq) \rightarrow \text{I}_3^-(aq) + 2\text{H}_2\text{O}(l)$; rate = $k[\text{H}_2\text{O}_2][\text{I}^-]$

Plan We inspect the exponents in the rate law, *not* the coefficients of the balanced equation, to find the individual orders, and then take their sum to find the overall reaction order. To find the change in rate for the reaction in (a), we substitute 3 for $[\text{NO}]$ in the rate law (since that concentration changes by a factor of 3) and 2 for $[\text{O}_2]$ (since that concentration changes by a factor of 2), and solve for the rate.

Solution (a) The exponent of $[\text{NO}]$ is 2, so the reaction is second order with respect to NO , first order with respect to O_2 , and third order overall.

Finding the change in rate:

$$\text{Rate} = k[\text{NO}]^2[\text{O}_2] = k(3)^2(2) = k \times 18 = 18k$$

The rate increases by a factor of 18.

- (b) The reaction is $\frac{3}{2}$ order in CH_3CHO and $\frac{3}{2}$ order overall.
- (c) The reaction is first order in H_2O_2 , first order in I^- , and second order overall.

The reactant H^+ does not appear in the rate law, so the reaction is zero order in H^+ .

Check Be sure that each reactant has an order and that the sum of the individual orders gives the overall order. For the rate change in (a), be sure that the 3 used to indicate a tripled concentration is squared since the reaction is second order in NO .

FOLLOW-UP PROBLEMS

16.2A Experiment shows that the reaction

obeys this rate law: rate = $k[\text{I}^-][\text{BrO}_3^-][\text{H}^+]^2$. (a) What is the reaction order in each reactant and the overall reaction order? (b) By what factor does the rate change if $[\text{I}^-]$ and $[\text{BrO}_3^-]$ are tripled and $[\text{H}^+]$ is doubled?

16.2B The rate law for the reaction

is rate = $k[\text{ClO}_2]^2[\text{OH}^-]$. (a) What is the reaction order in each reactant and the overall reaction order? (b) By what factor does the rate change if $[\text{ClO}_2]$ is halved and $[\text{OH}^-]$ is doubled?

SOME SIMILAR PROBLEMS 16.26–16.33

Determining Reaction Orders by Changing Reactant Concentrations Now let's see how reaction orders are found *before* the rate law is known. Before looking at a real reaction, we'll go through the process for substances A and B in this reaction:

The rate law, expressed in general terms, is

$$\text{Rate} = k[A]^m[B]^n$$

To find the values of m and n , we run a series of experiments in which one reactant concentration changes while the other is kept constant, and we measure the effect on the initial rate in each case. Table 16.1 shows the results.

Table 16.1

Initial Rates for the Reaction Between A and B

Experiment	Initial Rate (mol/L·s)	Initial [A] (mol/L)	Initial [B] (mol/L)
1	1.75×10^{-3}	2.50×10^{-2}	3.00×10^{-2}
2	3.50×10^{-3}	5.00×10^{-2}	3.00×10^{-2}
3	3.50×10^{-3}	2.50×10^{-2}	6.00×10^{-2}
4	7.00×10^{-3}	5.00×10^{-2}	6.00×10^{-2}

1. *Finding m, the order with respect to A.* By comparing experiments 1 and 2, in which [A] doubles and [B] is constant, we can obtain m . First, we take the ratio of the general rate laws for these two experiments:

$$\frac{\text{Rate 2}}{\text{Rate 1}} = \frac{k[A]_2^m[B]_2^n}{k[A]_1^m[B]_1^n}$$

where $[A]_2$ is the concentration of A in experiment 2, $[B]_1$ is the concentration of B in experiment 1, and so forth. Because k is a constant and [B] does not change between these two experiments, those quantities cancel:

$$\frac{\text{Rate 2}}{\text{Rate 1}} = \frac{k[A]_2^m[B]_2^n}{k[A]_1^m[B]_1^n} = \frac{[A]_2^m}{[A]_1^m} = \left(\frac{[A]_2}{[A]_1}\right)^m$$

Substituting the values from Table 16.1, we have

$$\frac{3.50 \times 10^{-3} \text{ mol/L·s}}{1.75 \times 10^{-3} \text{ mol/L·s}} = \left(\frac{5.00 \times 10^{-2} \text{ mol/L}}{2.50 \times 10^{-2} \text{ mol/L}}\right)^m$$

Dividing, we obtain

$$2.00 = (2.00)^m \quad \text{so} \quad m = 1$$

Thus, the reaction is first order in A, because when [A] doubles, the rate doubles.

2. *Finding n, the order with respect to B.* To find n , we compare experiments 3 and 1 in which [A] is held constant and [B] doubles:

$$\frac{\text{Rate 3}}{\text{Rate 1}} = \frac{k[A]_3^m[B]_3^n}{k[A]_1^m[B]_1^n}$$

As before, k is a constant, and in this pair of experiments, [A] does not change, so those quantities cancel, and we have

$$\frac{\text{Rate 3}}{\text{Rate 1}} = \frac{k[A]_3^m[B]_3^n}{k[A]_1^m[B]_1^n} = \frac{[B]_3^n}{[B]_1^n} = \left(\frac{[B]_3}{[B]_1}\right)^n$$

The actual values give

$$\frac{3.50 \times 10^{-3} \text{ mol/L·s}}{1.75 \times 10^{-3} \text{ mol/L·s}} = \left(\frac{6.00 \times 10^{-2} \text{ mol/L}}{3.00 \times 10^{-2} \text{ mol/L}}\right)^n$$

Dividing, we obtain

$$2.00 = (2.00)^n \quad \text{so} \quad n = 1$$

Thus, the reaction is also first order in B because when [B] doubles, the rate doubles. We can check this conclusion from experiments 1 and 4: when *both* [A] and [B]

double, the rate should quadruple, and it does. Thus, the rate law, with m and n equal to 1, is

$$\text{Rate} = k[\text{A}][\text{B}]$$

Note, especially, that while the order with respect to B is 1, the coefficient of B in the balanced equation is 2. Thus, as we said earlier, *reaction orders must be determined from experiment*, not from the balanced equation.

Next, let's go through this process for a real reaction, the one between oxygen and nitrogen monoxide, a key step in the formation of acid rain and in the industrial production of nitric acid:

The general rate law is

$$\text{Rate} = k[\text{O}_2]^m[\text{NO}]^n$$

Table 16.2 shows experiments that change one reactant concentration while keeping the other constant.

Table 16.2

Initial Rates for the Reaction Between O_2 and NO

Experiment	Initial Rate (mol/L·s)	Initial Reactant Concentrations (mol/L)	
		[O_2]	[NO]
1	3.21×10^{-3}	1.10×10^{-2}	1.30×10^{-2}
2	6.40×10^{-3}	2.20×10^{-2}	1.30×10^{-2}
3	12.8×10^{-3}	1.10×10^{-2}	2.60×10^{-2}
4	9.60×10^{-3}	3.30×10^{-2}	1.30×10^{-2}
5	28.8×10^{-3}	1.10×10^{-2}	3.90×10^{-2}

1. *Finding m, the order with respect to O_2 .* If we compare experiments 1 and 2, in which $[\text{O}_2]$ doubles and [NO] is constant, we see the effect of doubling $[\text{O}_2]$ on the rate. First, we take the ratio of their rate laws:

$$\frac{\text{Rate 2}}{\text{Rate 1}} = \frac{k[\text{O}_2]_2^m [\text{NO}]_2^n}{k[\text{O}_2]_1^m [\text{NO}]_1^n}$$

As before, the constant quantities— k and [NO]—cancel:

$$\frac{\text{Rate 2}}{\text{Rate 1}} = \frac{k[\text{O}_2]_2^m [\text{NO}]_2^n}{k[\text{O}_2]_1^m [\text{NO}]_1^n} = \frac{[\text{O}_2]_2^m}{[\text{O}_2]_1^m} = \left(\frac{[\text{O}_2]_2}{[\text{O}_2]_1} \right)^m$$

Substituting the values from Table 16.2, we obtain

$$\frac{6.40 \times 10^{-3} \text{ mol/L}\cdot\text{s}}{3.21 \times 10^{-3} \text{ mol/L}\cdot\text{s}} = \left(\frac{2.20 \times 10^{-2} \text{ mol/L}}{1.10 \times 10^{-2} \text{ mol/L}} \right)^m$$

Dividing, we obtain

$$1.99 = (2.00)^m$$

Rounding to one significant figure gives

$$2 = 2^m, \quad \text{so } m = 1$$

Sometimes, the exponent is not as easy to find by inspection as it is here. In those cases, we solve for m with an equation of the form $a = b^m$, which in this case gives

$$\log a = m \log b \quad \text{or} \quad m = \frac{\log a}{\log b} = \frac{\log 1.99}{\log 2.00} = 0.993$$

which rounds to 1. Thus, the reaction is first order in O_2 : when $[\text{O}_2]$ doubles, the rate doubles.

2. *Finding n, the order with respect to NO.* We compare experiments 3 and 1, in which $[\text{O}_2]$ is held constant and [NO] is doubled, to find the order of NO:

$$\frac{\text{Rate 3}}{\text{Rate 1}} = \frac{k[\text{O}_2]_3^m [\text{NO}]_3^n}{k[\text{O}_2]_1^m [\text{NO}]_1^n}$$

Cancelling the constant k and the unchanging $[O_2]$, we have

$$\frac{\text{Rate 3}}{\text{Rate 1}} = \frac{k [O_2]_3^{m'} [NO]_3^n}{k [O_2]_1^{m'} [NO]_1^n} = \frac{[NO]_3^n}{[NO]_1^n} = \left(\frac{[NO]_3}{[NO]_1} \right)^n$$

The actual values give

$$\frac{12.8 \times 10^{-3} \text{ mol/L}\cdot\text{s}}{3.21 \times 10^{-3} \text{ mol/L}\cdot\text{s}} = \left(\frac{2.60 \times 10^{-2} \text{ mol/L}}{1.30 \times 10^{-2} \text{ mol/L}} \right)^n$$

Dividing, we obtain

$$3.99 = (2.00)^n$$

Solving for n :

$$n = \frac{\log 3.99}{\log 2.00} = 2.00 \quad (\text{or } 2)$$

The reaction is second order in NO: when $[NO]$ doubles, the rate quadruples. Thus, the actual rate law is

$$\text{Rate} = k [O_2]_1 [NO]^2$$

In this case, the reaction orders happen to be the same as the equation coefficients; nevertheless, they must *always* be determined by experiment.

Determining the Rate Constant

Let's find the rate constant for the reaction of O_2 and NO. With the rate, reactant concentrations, and reaction orders known, the sole remaining unknown in the rate law is the rate constant, k . We can use data from *any* of the experiments in Table 16.2 to solve for k . From experiment 1, for instance, we have

$$\text{Rate} = k [O_2]_1 [NO]_1^2$$

$$k = \frac{\text{rate 1}}{[O_2]_1 [NO]_1^2} = \frac{3.21 \times 10^{-3} \text{ mol/L}\cdot\text{s}}{(1.10 \times 10^{-2} \text{ mol/L}) (1.30 \times 10^{-2} \text{ mol/L})^2}$$

$$= \frac{3.21 \times 10^{-3} \text{ mol/L}\cdot\text{s}}{1.86 \times 10^{-6} \text{ mol}^3/\text{L}^3} = 1.73 \times 10^3 \text{ L}^2/\text{mol}^2\cdot\text{s}$$

Always check that the values of k for a series of experiments are constant within experimental error. To three significant figures, the average value of k for the five experiments in Table 16.2 is $1.72 \times 10^3 \text{ L}^2/\text{mol}^2\cdot\text{s}$.

With concentrations in mol/L and the reaction rate in units of mol/L·time, the units for k depend on the order of the reaction and, of course, the time unit. For this reaction, the units for k have to be $\text{L}^2/\text{mol}^2\cdot\text{s}$ to give a rate with units of mol/L·s:

$$\text{Rate} = k [O_2]_1 [NO]_1^2$$

$$\frac{\text{mol}}{\text{L}\cdot\text{s}} = \frac{\text{L}^2}{\text{mol}^2\cdot\text{s}} \times \frac{\text{mol}}{\text{L}} \times \left(\frac{\text{mol}}{\text{L}} \right)^2$$

The rate constant will *always* have these units for an overall third-order reaction with the time unit of seconds. Table 16.3 shows the units of k for common integer overall orders, but you can always determine the units mathematically.

Figure 16.9 summarizes the steps for studying the kinetics of a reaction. The next two sample problems offer practice in applying this approach; the first is based on data and the second on molecular scenes.

Figure 16.9 Information sequence to determine the kinetic parameters of a reaction.

SAMPLE PROBLEM 16.3**Determining Reaction Orders and Rate Constants from Rate Data**

Problem Many gaseous reactions occur in car engines and exhaust systems. One of these is

- (a) Use the following data to determine the individual and overall reaction orders.
 (b) Calculate k using the data from experiment 1.

Experiment	Initial Rate (mol/L·s)	Initial [NO ₂] (mol/L)	Initial [CO] (mol/L)
1	0.0050	0.10	0.10
2	0.080	0.40	0.10
3	0.0050	0.10	0.20

Plan (a) We need to solve the general rate law for m and for n and then add those orders to get the overall order. To solve for each exponent, we proceed as in the text, taking the ratio of the rate laws for two experiments in which only the reactant in question changes.
 (b) We substitute the values for the rate and the reactant concentrations from experiment 1 into the rate law and solve for k .

Solution (a) Calculating m in $[\text{NO}_2]^m$: We take the ratio of the rate laws for experiments 1 and 2, in which $[\text{NO}_2]$ varies but $[\text{CO}]$ is constant:

$$\frac{\text{Rate 2}}{\text{Rate 1}} = \frac{k[\text{NO}_2]_2^m[\text{CO}]_2^n}{k[\text{NO}_2]_1^m[\text{CO}]_1^n} = \left(\frac{[\text{NO}_2]_2}{[\text{NO}_2]_1} \right)^m \quad \text{or} \quad \frac{0.080 \text{ mol/L}\cdot\text{s}}{0.0050 \text{ mol/L}\cdot\text{s}} = \left(\frac{0.40 \text{ mol/L}}{0.10 \text{ mol/L}} \right)^m$$

This gives $16 = (4.0)^m$, so we have $m = \log 16 / \log 4.0 = 2.0$. The reaction is second order in NO₂.

Calculating n in $[\text{CO}]^n$: We take the ratio of the rate laws for experiments 1 and 3, in which $[\text{CO}]$ varies but $[\text{NO}_2]$ is constant:

$$\frac{\text{Rate 3}}{\text{Rate 1}} = \frac{k[\text{NO}_2]_3^2[\text{CO}]_3^n}{k[\text{NO}_2]_1^2[\text{CO}]_1^n} = \left(\frac{[\text{CO}]_3}{[\text{CO}]_1} \right)^n \quad \text{or} \quad \frac{0.0050 \text{ mol/L}\cdot\text{s}}{0.0050 \text{ mol/L}\cdot\text{s}} = \left(\frac{0.20 \text{ mol/L}}{0.10 \text{ mol/L}} \right)^n$$

We have $1.0 = (2.0)^n$, so $n = 0$. The rate does not change when $[\text{CO}]$ varies, so the reaction is zero order in CO.

Therefore, the rate law is

$$\text{Rate} = k[\text{NO}_2]^2[\text{CO}]^0 = k[\text{NO}_2]^2(1) = k[\text{NO}_2]^2$$

The reaction is second order overall.

(b) From experiment 1, rate = 0.0050 mol/L·s and [NO₂] = 0.10 mol/L. Calculating k :

$$\begin{aligned} \text{Rate} &= k[\text{NO}_2]^2 \\ k &= \frac{\text{Rate}}{[\text{NO}_2]^2} = \frac{0.0050 \text{ mol/L}\cdot\text{s}}{(0.10 \text{ mol/L})^2} \\ &= 0.50 \text{ L/mol}\cdot\text{s} \end{aligned}$$

Check A good check is to reason through the orders. If $m = 1$, quadrupling [NO₂] would quadruple the rate; but the rate *more* than quadruples, so $m > 1$. If $m = 2$, quadrupling [NO₂] would increase the rate by a factor of 16 (4^2). The ratio of rates is $0.080/0.005 = 16$, so $m = 2$. In contrast, increasing [CO] has no effect on the rate, which can happen only if $[\text{CO}]^n = 1$, so $n = 0$. The calculated value for the rate constant can be verified using the data from experiments 2 and 3.

FOLLOW-UP PROBLEMS

16.3A Find the rate law, the individual and overall reaction orders, and the average value of k for the reaction H₂ + I₂ → 2HI, using the following data at 450°C:

Experiment	Initial Rate (mol/L·s)	Initial [H ₂] (mol/L)	Initial [I ₂] (mol/L)
1	1.9×10^{-23}	0.0113	0.0011
2	1.1×10^{-22}	0.0220	0.0033
3	9.3×10^{-23}	0.0550	0.0011
4	1.9×10^{-22}	0.0220	0.0056

16.3B For the reaction $\text{H}_2\text{SeO}_3(aq) + 6\text{I}^-(aq) + 4\text{H}^+(aq) \rightarrow \text{Se}(s) + 2\text{I}_3^-(aq) + 3\text{H}_2\text{O}(l)$ at 0°C, the following data were obtained:

Experiment	Initial Rate (mol/L·s)	Initial $[\text{H}_2\text{SeO}_3]$ (mol/L)	Initial $[\text{I}^-]$ (mol/L)	Initial $[\text{H}^+]$ (mol/L)
1	9.85×10^{-7}	2.5×10^{-3}	1.5×10^{-2}	1.5×10^{-2}
2	7.88×10^{-6}	2.5×10^{-3}	3.0×10^{-2}	1.5×10^{-2}
3	3.94×10^{-6}	1.0×10^{-2}	1.5×10^{-2}	1.5×10^{-2}
4	3.15×10^{-5}	2.5×10^{-3}	3.0×10^{-2}	3.0×10^{-2}

- (a) Find the rate law for the reaction.
 (b) Find the value of k (using the data in experiment 1).

SOME SIMILAR PROBLEMS 16.34, 16.35, and 16.38

SAMPLE PROBLEM 16.4

Determining Reaction Orders from Molecular Scenes

Problem At a particular temperature and volume, two gases, A (red) and B (blue), react. The following molecular scenes represent starting mixtures for four experiments:

Expt no.: 1
Initial rate (mol/L·s): 0.50×10^{-4}

2
 1.0×10^{-4}

3
 2.0×10^{-4}

4
?

- (a) What is the reaction order with respect to A? With respect to B? The overall order?
 (b) Write the rate law for the reaction.
 (c) Predict the initial rate of Expt 4.

Plan (a) As before, we find the individual reaction orders by seeing how a change in each reactant changes the rate. In this case, however, instead of using concentration data, we count numbers of particles. The sum of the individual orders is the overall order. (b) To write the rate law, we use the orders from part (a) as exponents in the general rate law. (c) Using the results from Expts 1 through 3 and the rate law from part (b), we find the unknown initial rate of Expt 4.

Solution (a) The rate law is $\text{rate} = k[\text{A}]^m[\text{B}]^n$. For reactant A (red) in Expts 1 and 2 (k and number of B particles are constant):

$$\frac{\text{Rate 2}}{\text{Rate 1}} = \frac{k[\text{A}]_2^m[\text{B}]_2^n}{k[\text{A}]_1^m[\text{B}]_1^n} = \left(\frac{[\text{A}]_2}{[\text{A}]_1}\right)^m \quad \text{or} \quad \frac{1.0 \times 10^{-4} \text{ mol/L·s}}{0.50 \times 10^{-4} \text{ mol/L·s}} = \left(\frac{4 \text{ particles}}{2 \text{ particles}}\right)^m$$

Thus, $2 = (2)^m$ so the order with respect to A is 1. For reactant B (blue) in Expts 1 and 3 (k and number of A particles are constant):

$$\frac{\text{Rate 3}}{\text{Rate 1}} = \frac{k[\text{A}]_3^m[\text{B}]_3^n}{k[\text{A}]_1^m[\text{B}]_1^n} = \left(\frac{[\text{B}]_3}{[\text{B}]_1}\right)^n \quad \text{or} \quad \frac{2.0 \times 10^{-4} \text{ mol/L·s}}{0.50 \times 10^{-4} \text{ mol/L·s}} = \left(\frac{4 \text{ particles}}{2 \text{ particles}}\right)^n$$

Thus, $4 = (2)^n$ so the order with respect to B is 2. The overall order is $1 + 2 = 3$.

(b) Writing the rate law: The general rate law is $\text{rate} = k[\text{A}]^m[\text{B}]^n$, so we have

$$\text{Rate} = k[\text{A}][\text{B}]^2$$

(c) Finding the initial rate of Expt 4: There are several possibilities, but let's compare Expts 3 and 4, in which the number of particles of A doubles (from 2 to 4) and the number of particles of B doesn't change. Since the rate law shows that the reaction is first order in A, the initial rate in Expt 4 should be double the initial rate in Expt 3, or 4.0×10^{-4} mol/L·s.

Check A good check is to compare other pairs of experiments. (a) Comparing Expts 2 and 3 shows that the number of B doubles, which causes the rate to quadruple, and the

number of A decreases by half, which causes the rate to halve; so the overall rate change should double (from 1.0×10^{-4} mol/L·s to 2.0×10^{-4} mol/L·s), which it does.
(c) Comparing Expts 2 and 4, in which the number of A is constant and the number of B doubles, the rate should quadruple, which means the initial rate of Expt 4 would be 4.0×10^{-4} mol/L·s, as we found.

FOLLOW-UP PROBLEMS

16.4A The molecular scenes below show three experiments at a given temperature and volume involving reactants X (black) and Y (green):

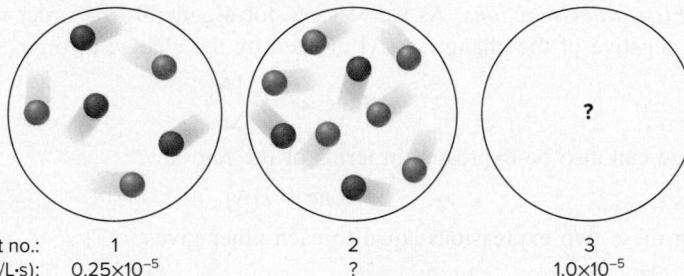

If the rate law for the reaction is $\text{rate} = k[\text{X}]^2$: **(a)** What is the initial rate of Expt 2?

(b) Draw a scene for Expt 3 that involves a single change of the scene for Expt 1.

16.4B The scenes below show mixtures of reactants A (blue) and B (yellow) at a given temperature and volume:

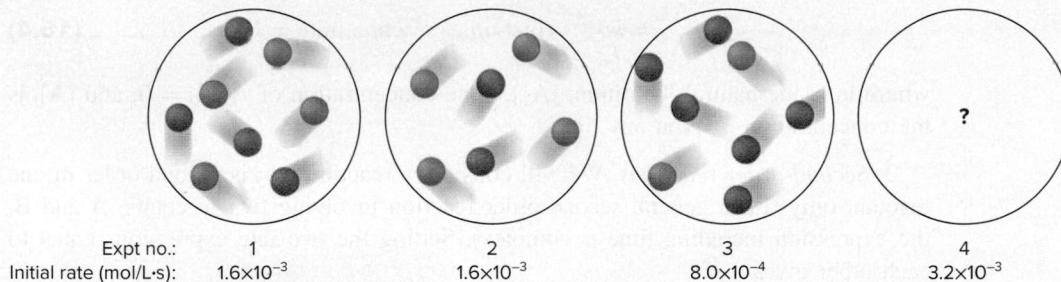

(a) Write the rate law for the reaction.

(b) How many particles of A should be shown in the scene for Expt 4?

SOME SIMILAR PROBLEMS 16.93, 16.122(a), and 16.122(b)

› Summary of Section 16.3

- › An experimentally determined rate law shows how the rate of a reaction depends on concentration. Considering only initial rates (that is, no products), the expression for a general rate law is $\text{rate} = k[\text{A}]^m[\text{B}]^n \dots$. This reaction is *m*th order with respect to A and *n*th order with respect to B; the overall reaction order is *m + n*.
- › With an accurate method for obtaining initial rates, reaction orders are determined experimentally by varying the concentration of one reactant at a time to see its effect on the rate.
- › By substituting the known rate, concentrations, and reaction orders into the rate law, we solve for the rate constant, *k*.

16.4 INTEGRATED RATE LAWS: CONCENTRATION CHANGES OVER TIME

The rate laws we've developed so far tell us the rate or concentration at a given instant, allowing us to answer questions such as "How fast is the reaction proceeding at the moment *y* moles per liter of A are mixed with *z* moles per liter of B?" and "What is [B], when [A] is *x* moles per liter?" By employing different forms of the rate laws, called **integrated rate laws**, we can include time as a variable and answer

questions such as “How long will it take to use up x moles per liter of A?” and “What is [A] after y minutes of reaction?”

Integrated Rate Laws for First-, Second-, and Zero-Order Reactions

Let’s examine the integrated rate laws for reactions that are first, second, or zero order in reactant A:

1. *First-order reactions.* As we’ve seen, for a general first-order reaction, the rate is the negative of the change in [A] divided by the change in time:

$$\text{Rate} = -\frac{\Delta[\text{A}]}{\Delta t}$$

The rate can also be expressed in terms of the rate law:

$$\text{Rate} = k[\text{A}]$$

Setting these two expressions equal to each other gives

$$-\frac{\Delta[\text{A}]}{\Delta t} = k[\text{A}] \quad \text{or} \quad -\frac{\Delta[\text{A}]}{[\text{A}]} = k\Delta t$$

Using methods of calculus, we integrate over time to obtain the integrated rate law for a first-order reaction:

$$\ln \frac{[\text{A}]_0}{[\text{A}]_t} = kt \quad (\text{first-order reaction; rate} = k[\text{A}]) \quad (16.4)$$

where \ln is the natural logarithm, $[\text{A}]_0$ is the concentration of A at $t = 0$, and $[\text{A}]_t$ is the concentration of A at any time t .

2. *Second-order reactions.* We will consider a reaction that is second-order in one reactant only (for a general second-order reaction involving two reactants, A and B, the expression including time is complex). Setting the two rate expressions equal to each other gives

$$\text{Rate} = -\frac{\Delta[\text{A}]}{\Delta t} = k[\text{A}]^2 \quad \text{or} \quad -\frac{\Delta[\text{A}]}{[\text{A}]^2} = k\Delta t$$

Integrating over time gives the integrated rate law for a second-order reaction involving one reactant:

$$\frac{1}{[\text{A}]_t} - \frac{1}{[\text{A}]_0} = kt \quad (\text{second-order reaction; rate} = k[\text{A}]^2) \quad (16.5)$$

3. *Zero-order reactions.* For a general zero-order reaction, setting the two rate expressions equal to each other gives

$$\text{Rate} = -\frac{\Delta[\text{A}]}{\Delta t} = k[\text{A}]^0 = k \quad \text{or} \quad -\Delta[\text{A}] = k\Delta t$$

Integrating over time gives the integrated rate law for a zero-order reaction:

$$[\text{A}]_t - [\text{A}]_0 = -kt \quad (\text{zero-order reaction; rate} = k[\text{A}]^0 = k) \quad (16.6)$$

Sample Problem 16.5 shows one way integrated rate laws are applied.

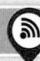

Student Hot Spot

Student data indicate that you may struggle with applying an integrated rate law. Access the Smartbook to view additional Learning Resources on this topic.

SAMPLE PROBLEM 16.5

Determining the Reactant Concentration After a Given Time

Problem At 1000°C, cyclobutane (C_4H_8) decomposes in a first-order reaction, with the very high rate constant of 87 s^{-1} , to two molecules of ethylene (C_2H_4).

- (a) The initial C_4H_8 concentration is 2.00 M . What is the concentration after 0.010 s ?
 (b) How long will it take for 70.0% of the C_4H_8 to decompose?

Plan (a) We must find the concentration of cyclobutane at time t , $[\text{C}_4\text{H}_8]_t$. We are told that this is a first-order reaction, so we use the integrated first-order rate law:

$$\ln \frac{[\text{C}_4\text{H}_8]_0}{[\text{C}_4\text{H}_8]_t} = kt$$

We know k (87 s^{-1}), t (0.010 s), and $[\text{C}_4\text{H}_8]_0$ (2.00 M), so we can solve for $[\text{C}_4\text{H}_8]_t$.

(b) If 70.0% of the C_4H_8 has decomposed, 30.0% of it remains ($[\text{C}_4\text{H}_8]_t$). We know k (87 s^{-1}), $[\text{C}_4\text{H}_8]_0$ (2.00 M), and $[\text{C}_4\text{H}_8]_t$ ($0.300 \times 2.00 \text{ M} = 0.600 \text{ M}$), so we can solve for t .

Solution (a) Substituting the data into the integrated rate law:

$$\ln \frac{2.00 \text{ mol/L}}{[\text{C}_4\text{H}_8]_t} = (87 \text{ s}^{-1}) (0.010 \text{ s}) = 0.87$$

Taking the antilog of both sides:

$$\frac{2.00 \text{ mol/L}}{[\text{C}_4\text{H}_8]_t} = e^{0.87} = 2.4$$

Solving for $[\text{C}_4\text{H}_8]_t$:

$$[\text{C}_4\text{H}_8]_t = \frac{2.00 \text{ mol/L}}{2.4} = 0.83 \text{ mol/L}$$

(b) Substituting the data into the integrated rate law:

$$\ln \frac{2.00 \text{ mol/L}}{0.600 \text{ mol/L}} = (87 \text{ s}^{-1}) (t)$$

$t = 0.014 \text{ s}$

Check The concentration remaining after 0.010 s (0.83 mol/L) is less than the starting concentration (2.00 mol/L), which makes sense. Raising e to an exponent slightly less than 1 should give a number (2.4) slightly less than the value of e (2.718). Moreover, the final result makes sense: a high rate constant indicates a fast reaction, so it's not surprising that so much decomposes in such a short time.

Comment Be sure to note that $[\text{A}]_t$ is the concentration of reactant A that *remains* at time t , not the amount of A that has reacted.

FOLLOW-UP PROBLEMS

16.5A At 25°C , hydrogen iodide breaks down very slowly to hydrogen and iodine: $\text{rate} = k[\text{HI}]^2$. The rate constant at 25°C is $2.4 \times 10^{-21} \text{ L/mol}\cdot\text{s}$. If 0.0100 mol of $\text{HI}(g)$ is placed in a 1.0-L container, how long will it take for $[\text{HI}]$ to reach 0.00900 mol/L (10.0% reacted)?

16.5B Hydrogen peroxide (H_2O_2) decomposes to water and oxygen in a first-order reaction. (a) If 1.28 M H_2O_2 changes to 0.85 M in 10.0 min at a given temperature, what is the rate constant for the decomposition reaction? (b) How long will it take for 25% of an initial amount of H_2O_2 to decompose? (Hint: Assume that $[\text{H}_2\text{O}_2]_0 = 1.0 \text{ M}$.)

SOME SIMILAR PROBLEMS 16.41 and 16.42

Determining Reaction Orders from an Integrated Rate Law

In Sample Problem 16.3, we found the reaction orders using rate data. If rate data are not available, we rearrange the integrated rate law into an equation for a straight line, $y = mx + b$, where m is the slope and b is the y -axis intercept. We then use a graphical method to find the order:

- For a *first-order reaction*, we have

$$\ln \frac{[\text{A}]_0}{[\text{A}]_t} = kt$$

From Appendix A, we know that $\ln \frac{a}{b} = \ln a - \ln b$, so we have

$$\ln [\text{A}]_0 - \ln [\text{A}]_t = kt$$

Rearranging gives

$$\begin{aligned} \ln [\text{A}]_t &= -kt + \ln [\text{A}]_0 \\ y &= mx + b \end{aligned}$$

Therefore, a plot of $\ln [\text{A}]_t$ vs. t gives a straight line with slope = $-k$ and y -intercept = $\ln [\text{A}]_0$ (Figure 16.10A, *next page*).

- For a *second-order reaction* with one reactant, we have

$$\frac{1}{[\text{A}]_t} - \frac{1}{[\text{A}]_0} = kt$$

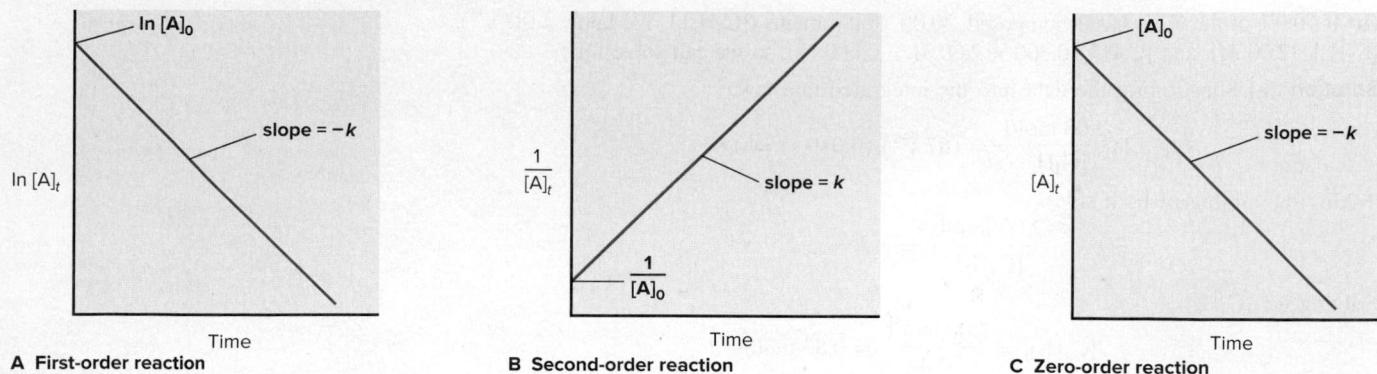

Figure 16.10 Graphical method for finding the reaction order from the integrated rate law.

Rearranging gives

$$\frac{1}{[A]_t} = kt + \frac{1}{[A]_0}$$

$$y = mx + b$$

In this case, a plot of $1/[A]_t$ vs. t gives a straight line with slope = k and y-intercept = $1/[A]_0$ (Figure 16.10B).

- For a zero-order reaction, we have

$$[A]_t - [A]_0 = -kt$$

Rearranging gives

$$[A]_t = -kt + [A]_0$$

$$y = mx + b$$

A plot of $[A]_t$ vs. t gives a straight line with slope = $-k$ and y-intercept = $[A]_0$ (Figure 16.10C).

Some trial-and-error graphical plotting is required to find the reaction order from the concentration and time data:

- If you obtain a straight line when you plot $\ln [\text{reactant}]$ vs. t , the reaction is *first order* with respect to that reactant.
- If you obtain a straight line when you plot $1/[\text{reactant}]$ vs. t , the reaction is *second order* with respect to that reactant.
- If you obtain a straight line when you plot $[\text{reactant}]$ vs. t , the reaction is *zero order* with respect to that reactant.

In Figure 16.11 we use this approach to determine the order for the decomposition of N_2O_5 . When we plot the data from each column in the table vs. time, we find that the plot of $\ln [\text{N}_2\text{O}_5]$ vs. t is linear (part B), while the plots of $[\text{N}_2\text{O}_5]$ vs. t (part A) and of $1/[\text{N}_2\text{O}_5]$ vs. t (part C) are *not*; therefore, the decomposition is first order in N_2O_5 .

Time (min)	$[\text{N}_2\text{O}_5]$	$\ln [\text{N}_2\text{O}_5]$	$1/[\text{N}_2\text{O}_5]$
0	0.0165	-4.104	60.6
10	0.0124	-4.390	80.6
20	0.0093	-4.68	11×10^2
30	0.0071	-4.95	1.4×10^2
40	0.0053	-5.24	1.9×10^2
50	0.0039	-5.55	2.6×10^2
60	0.0029	-5.84	3.4×10^2

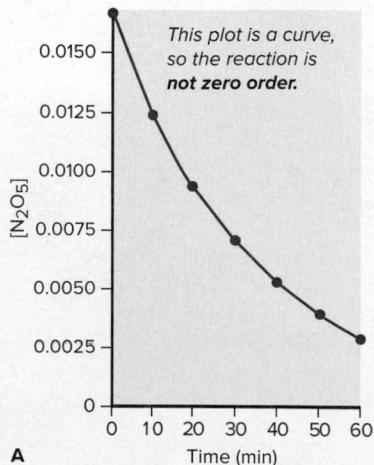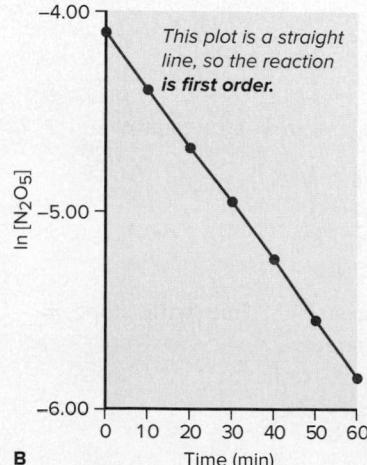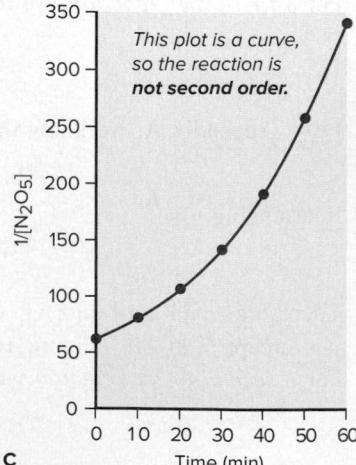

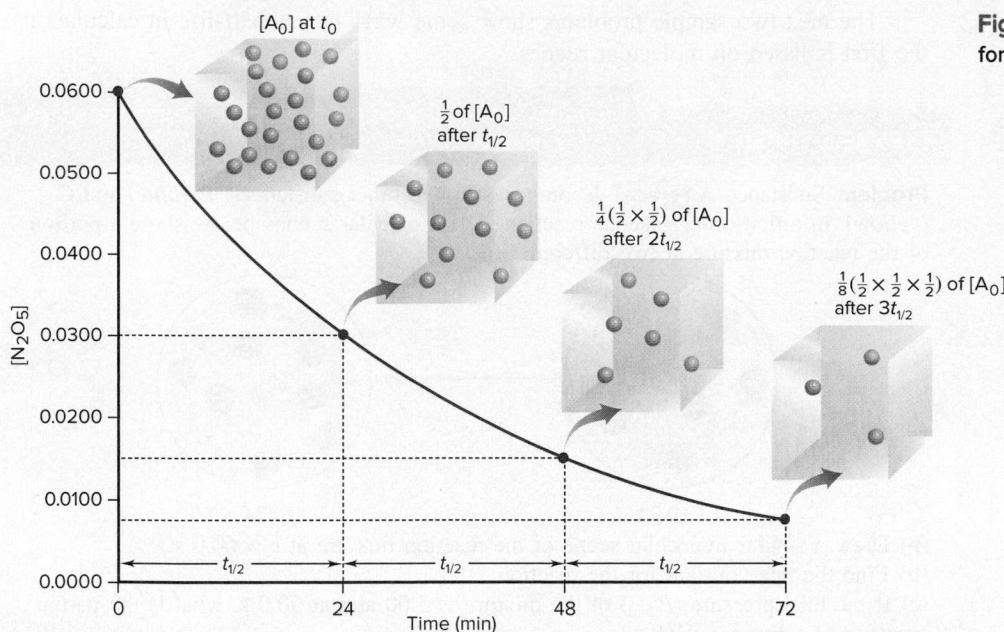

Figure 16.12 A plot of [N₂O₅] vs. time for three reaction half-lives.

Reaction Half-Life

The **half-life** ($t_{1/2}$) of a reaction is the time it takes for the reactant concentration to reach *half its initial value*. A half-life has time units appropriate for the specific reaction and is characteristic of that reaction at a given temperature. For example, at 45°C, the half-life for the decomposition of N₂O₅, which we know is first order, is 24.0 min. Therefore, if we start with, say, 0.0600 mol/L of N₂O₅ at 45°C, 0.0300 mol/L will have reacted after 24 min (one half-life), and 0.0300 mol/L will remain; after 48 min (two half-lives), 0.0150 mol/L will remain; after 72 min (three half-lives), 0.0075 mol/L will remain, and so forth (Figure 16.12). The mathematical expression for the half-life depends on the overall order of the reaction.

First-Order Reactions We can derive an expression for the half-life of a first-order reaction from the integrated rate law, which is

$$\ln \frac{[A]_0}{[A]_t} = kt$$

By definition, after one half-life, $t = t_{1/2}$, and $[A]_t = \frac{1}{2}[A]_0$. Substituting and canceling $[A]_0$ gives

$$\ln \frac{\frac{1}{2}[A]_0}{\frac{1}{2}[A]_0} = kt_{1/2} \quad \text{or} \quad \ln 2 = kt_{1/2}$$

Then, solving for $t_{1/2}$, we have

$$t_{1/2} = \frac{\ln 2}{k} = \frac{0.693}{k} \quad (\text{first-order process; rate} = k[A]) \quad (16.7)$$

Notice that $t_{1/2}$ and k are *inversely proportional*. Thus, a fast reaction, one with a relatively large rate constant, has a short half-life, and a slow reaction, one with a small rate constant, has a long half-life:

$$k \uparrow, t_{1/2} \downarrow \quad \text{and} \quad k \downarrow, t_{1/2} \uparrow$$

Because no concentration term appears, *for a first-order reaction, the time it takes to reach one-half the starting concentration is a constant and, thus, independent of reactant concentration*.

Decay of an unstable, radioactive nucleus is an example of a first-order process that does not involve a *chemical change*. For example, the half-life for the decay of uranium-235 is 7.1×10^8 years. Thus, a sample of ore containing uranium-235 will have half the original mass of uranium-235 after 7.1×10^8 years: a sample initially containing 1 kg will contain 0.5 kg of uranium-235, a sample initially containing 1 mg will contain 0.5 mg, and so forth. (We discuss radioactive decay thoroughly in Chapter 24.)

The next two sample problems show some ways to use half-life in calculations: the first is based on molecular scenes.

SAMPLE PROBLEM 16.6
Using Molecular Scenes to Find Quantities at Various Times

Problem Substance A (green) decomposes to two other substances, B (blue) and C (yellow), in a first-order gaseous reaction. The molecular scenes below show a portion of the reaction mixture at two different times:

- Draw a similar molecular scene of the reaction mixture at $t = 60.0\text{ s}$.
- Find the rate constant for the reaction.
- If the total pressure (P_{total}) of the mixture is 5.00 atm at 90.0 s, what is the partial pressure of substance B (P_B)?

Plan We are shown molecular scenes of a reaction at two times, with various numbers of reactant and product particles, and have to predict quantities at two later times.

(a) We count the number of A particles and see that A has decreased by half after 30.0 s; thus, the half-life is 30.0 s. The time $t = 60.0\text{ s}$ represents two half-lives, so the number of A will decrease by half again, and each A forms one B and one C. (b) We substitute the value of the half-life in Equation 16.7 to find k . (c) First, we find the numbers of particles at $t = 90.0\text{ s}$, which represents three half-lives. To find P_B , we multiply the mole fraction of B, X_B , by P_{total} (5.00 atm) (see Equation 5.12). To find X_B , we know that the number of particles is equivalent to the number of moles, so we divide the number of B particles by the total number of particles.

Solution (a) The number of A particles decreased from 8 to 4 in one half-life (30.0 s), so after two half-lives (60.0 s), the number of A particles will be 2 (1/2 of 4). Each A decomposes to 1 B and 1 C, so 6 (8 – 2) particles of A form 6 of B and 6 of C (see margin).

(b) Finding the rate constant, k :

$$t_{1/2} = \frac{0.693}{k} \quad \text{so} \quad k = \frac{0.693}{t_{1/2}} = \frac{0.693}{30.0\text{ s}} = 2.31 \times 10^{-2}\text{ s}^{-1}$$

(c) Finding the number of particles after 90.0 s: After a third half-life, there will be 1 A, 7 B, and 7 C particles.

Finding the mole fraction of B, X_B :

$$X_B = \frac{7 \text{ B particles}}{1 + 7 + 7 \text{ total particles}} = \frac{7}{15} = 0.467$$

Finding the partial pressure of B, P_B :

$$P_B = X_B \times P_{\text{total}} = 0.467 \times 5.00 \text{ atm} = 2.33 \text{ atm}$$

Check For (b), rounding gives 0.7/30, which is a bit over 0.02, so the answer seems correct. For (c), X_B is almost 0.5, so P_B is a bit less than half of 5 atm, or <2.5 atm.

FOLLOW-UP PROBLEMS

16.6A Substance X (black) changes to substance Y (red) in a first-order gaseous reaction. The scenes below represent the reaction mixture in a cubic container at two different times:

- (a) Draw a scene that represents the mixture at 5.0 min.
 (b) If each particle in the container actually represents 0.20 mol of particles and the volume of the cubic container is 0.50 L, what is the molarity of X at 10.0 min?
16.6B Substance A (*red*) changes to substance B (*blue*) in a first-order gaseous reaction. The scenes below represent the reaction mixture at three different times:

- (a) What is the time at which the third scene occurs?
 (b) If each particle in the circle actually represents 0.10 mol of particles and the volume of the container is 0.25 L, what is the molarity of A at 72 min?

SOME SIMILAR PROBLEMS 16.43 and 16.44

SAMPLE PROBLEM 16.7

Determining the Half-Life of a First-Order Reaction

Problem Cyclopropane is the smallest cyclic hydrocarbon. Because its 60° bond angles reduce orbital overlap, its bonds are weak. As a result, it is thermally unstable and rearranges to propene at 1000°C via the following first-order reaction:

The rate constant is 9.2 s^{-1} .

- (a) What is the half-life of the reaction?
 (b) How long does it take for the concentration of cyclopropane to reach one-quarter of the initial value?

Plan (a) The cyclopropane rearrangement is first order, so to find $t_{1/2}$ we use Equation 16.7 and substitute for k (9.2 s^{-1}). (b) Each half-life decreases the concentration to one-half of its initial value, so two half-lives decrease it to one-quarter of its initial value.

Solution (a) Solving for $t_{1/2}$:

$$\begin{aligned} t_{1/2} &= \frac{\ln 2}{k} = \frac{0.693}{9.2 \text{ s}^{-1}} \\ &= 0.075 \text{ s} \end{aligned}$$

It takes 0.075 s for half the cyclopropane to form propene at this temperature.

- (b) Finding the time to reach one-quarter of the initial concentration:

$$\begin{aligned} \text{Time} &= 2(t_{1/2}) = 2(0.075 \text{ s}) \\ &= 0.15 \text{ s} \end{aligned}$$

Check For part (a), rounding gives $0.7/9 \text{ s}^{-1} = 0.08 \text{ s}$, so the answer seems correct.

FOLLOW-UP PROBLEMS

16.7A Iodine-123 is used to study thyroid gland function. This radioactive isotope breaks down in a first-order process with a half-life of 13.1 h. What is the rate constant for the process?

16.7B The half-life of a pesticide determines its persistence in the environment. A common pesticide degrades in a first-order process with a rate constant of $9 \times 10^{-2} \text{ day}^{-1}$.

- (a) What is the half-life of the breakdown reaction?
 (b) What fraction of the pesticide remains in the environment after 40 days?

SOME SIMILAR PROBLEMS 16.45 and 16.46

Second-Order Reactions In contrast to the half-life of a first-order reaction, the half-life of a second-order reaction *does* depend on reactant concentration:

$$t_{1/2} = \frac{1}{k[A]_0} \quad (\text{second-order process; rate} = k[A]^2)$$

Note that here the *half-life is inversely proportional to the initial reactant concentration*. This relationship means that a second-order reaction with a high initial reactant concentration has a *shorter* half-life, and one with a low initial reactant concentration has a *longer* half-life. It also means that, for a particular reaction, each successive half-life is double the preceding one, since [A] is halved during each half-life.

Zero-Order Reactions In contrast to the half-life of a second-order reaction, the *half-life of a zero-order reaction is directly proportional to the initial reactant concentration*:

$$t_{1/2} = \frac{[A]_0}{2k} \quad (\text{zero-order process; rate} = k)$$

Thus, if a zero-order reaction begins with a high reactant concentration, it has a longer half-life than if it begins with a low reactant concentration.

Table 16.4 summarizes the features of zero-, first-, and second-order reactions.

Table 16.4

An Overview of Zero-Order, First-Order, and Simple Second-Order Reactions

	Zero Order	First Order	Second Order
Rate law	rate = k	rate = $k[A]$	rate = $k[A]^2$
Units for k	mol/L·s	1/s	L/mol·s
Half-life	$\frac{[A]_0}{2k}$	$\frac{\ln 2}{k}$	$\frac{1}{k[A]_0}$
Integrated rate law in straight-line form	$[A]_t = -kt + [A]_0$	$\ln [A]_t = -kt + \ln [A]_0$	$\frac{1}{[A]_t} = kt + \frac{1}{[A]_0}$
Plot for straight line	$[A]_t$ vs. t	$\ln [A]_t$ vs. t	$\frac{1}{[A]_t}$ vs. t
Slope, y-intercept	$-k, [A]_0$	$-k, \ln [A]_0$	$k, \frac{1}{[A]_0}$
	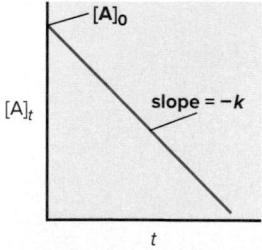	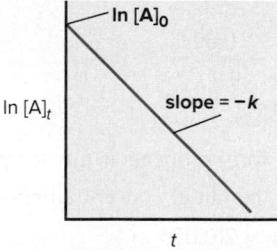	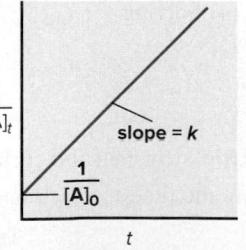

› Summary of Section 16.4

- › Integrated rate laws are used to find either the time needed to reach a certain concentration of reactant or the concentration present after a given time.
- › Rearrangements of the integrated rate laws that give equations that graph as a straight line allow us to determine reaction orders and rate constants graphically.
- › The half-life is the time needed for the reactant concentration to reach half its initial value; for first-order reactions, the half-life is constant, that is, independent of concentration.

16.5 THEORIES OF CHEMICAL KINETICS

As was pointed out in Section 16.1, concentration and temperature have major effects on reaction rate. Chemists employ two models—*collision theory* and *transition state theory*—to explain these effects.

Collision Theory: Basis of the Rate Law

The basic tenet of **collision theory** is that particles—atoms, molecules, or ions—must collide to react. But number of collisions can't be the only factor determining rate, or all reactions would be over in an instant. For example, at 1 atm and 20°C, the N₂ and O₂ molecules in 1 mL of air experience about 10²⁷ collisions per second. If all that was needed for a reaction to occur was an N₂ molecule colliding with an O₂ molecule, our atmosphere would consist of almost all NO; in fact, only traces are present. Thus, this theory also relies on the concepts of collision energy and molecular structure to explain the effects of concentration and temperature on rate.

Why Concentrations Are Multiplied in the Rate Law Particles must collide to react, so the collision frequency, the number of collisions per unit time, provides an *upper limit* on how fast a reaction can take place. In its basic form, collision theory deals with one-step reactions, those in which two particles collide and form products: A + B → products. Suppose we have only two particles of A and two of B confined in a vessel. Figure 16.13 shows that four A-B collisions are possible. The laws of probability tell us that the number of collisions depends on the *product* of the numbers of reactant particles, not their sum. Thus, when we add another particle of A, six A-B collisions (3 × 2) are possible, not just five (3 + 2). Similarly, when we add another particle of B, nine A-B collisions (3 × 3) are possible, not just six (3 + 3). Thus, collision theory explains why we *multiply* the concentrations in the rate law to obtain the observed rate.

The Effect of Temperature on the Rate Constant and the Rate Temperature typically has a dramatic effect on reaction rate: for many reactions near room temperature, an increase of 10 K (10°C) doubles or triples the rate. Figure 16.14A shows kinetic data for an organic reaction—hydrolysis, or reaction with water, of the organic compound ethyl acetate. To understand the effect of temperature, we measure concentrations and times for the reaction run at different temperatures. Solving each rate expression for *k* and plotting the results (Figure 16.14B), we find that *k* increases exponentially as *T* increases.

Expt	[Ester]	[H ₂ O]	T (K)	Rate (mol/L·s)	<i>k</i> (L/mol·s)
1	0.100	0.200	288	1.04×10 ⁻³	0.0521
2	0.100	0.200	298	2.02×10 ⁻³	0.101
3	0.100	0.200	308	3.68×10 ⁻³	0.184
4	0.100	0.200	318	6.64×10 ⁻³	0.332

A

These results are consistent with findings obtained in 1889 by the Swedish chemist Svante Arrhenius. In its modern form, the **Arrhenius equation** is

$$k = A e^{-E_a/RT} \quad (16.8)$$

where *k* is the rate constant, *e* is the base of natural logarithms, *T* is the absolute temperature, and *R* is the universal gas constant. (We'll focus on the term *E_a* in the next subsection and on the term *A* a bit later.) Note the relationship between *k* and *T*, especially that *T* is in the denominator of a negative exponent. Thus, as *T* increases, the value of the negative exponent becomes smaller, which means *k* becomes larger, so the rate increases:

Higher *T* → larger *k* → increased rate

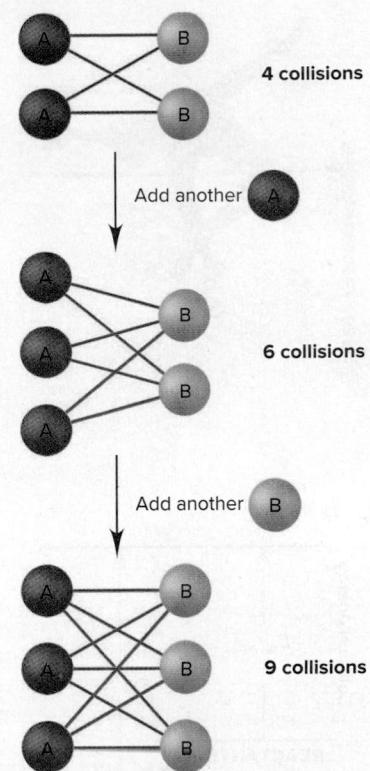

Figure 16.13 The number of possible collisions is the product, not the sum, of reactant concentrations.

Figure 16.14 Increase of the rate constant with temperature for the hydrolysis of an ester.

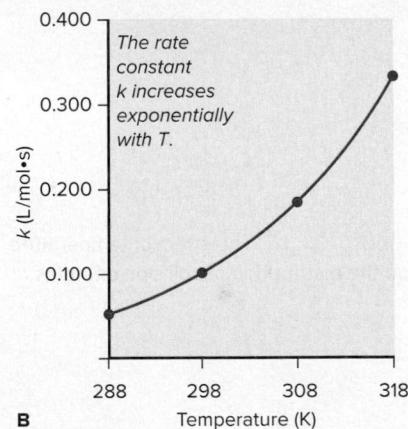

B

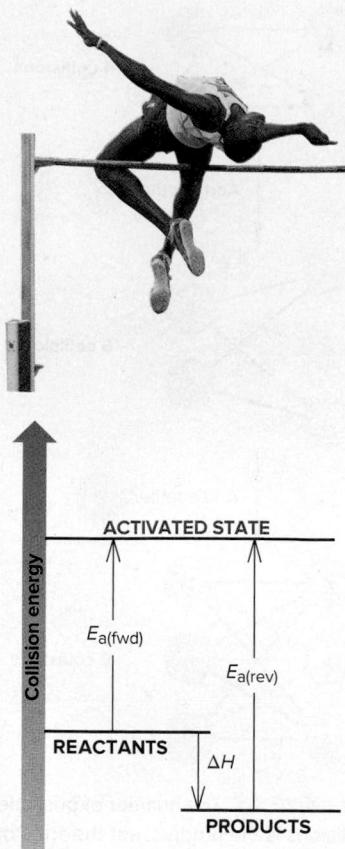

Figure 16.15 Energy-level diagram for a reaction. Like a high jumper with enough energy to go over the bar, molecules must collide with enough energy, E_a , to reach an activated state. (This reaction is reversible and is exothermic in the forward direction.)

Source: © Sipa via AP Images

The Central Importance of Activation Energy The effect of temperature on k is closely related to the **activation energy** (E_a) of a reaction, an energy *threshold* that the colliding molecules must exceed in order to react. As an analogy, in order to succeed at the high jump, an athlete must exert at least enough energy to get over the bar. Similarly, if reactant molecules collide with a certain minimum energy, they reach an *activated state*, from which they can change to products (Figure 16.15); collisions that occur with an energy below this minimum leave the reactants unchanged.

As you can see from Figure 16.15, a reversible reaction has two activation energies. The activation energy for the forward reaction, $E_{a(fwd)}$, is the energy difference between the activated state and the reactants; the activation energy for the reverse reaction, $E_{a(rev)}$, is the energy difference between the activated state and the products. The reaction represented in the diagram is exothermic ($\Delta H_{rxn} < 0$) in the forward direction. Thus, the products are at a lower energy than the reactants, and $E_{a(fwd)}$ is less than $E_{a(rev)}$. This difference equals the enthalpy of reaction, ΔH_{rxn} :

$$\Delta H_{rxn} = E_{a(fwd)} - E_{a(rev)} \quad (16.9)$$

The Effect of Temperature on Collision Energy As was mentioned in Section 16.1, a rise in temperature has two effects on moving particles: it causes a higher collision frequency and a higher collision energy. Let's see how each affects rate.

- *Collision frequency.* If particles move faster, they collide more often. Calculations show that a 10 K rise in temperature from, say, 288 K to 298 K, increases the average molecular speed by 2%, which would lead to, at most, a 4% increase in rate. Thus, higher collision frequency cannot possibly account for the doubling or tripling of rates observed with a 10 K rise. Indeed, the effect of temperature on collision frequency is only a minor factor.
- *Collision energy.* On the other hand, the effect of temperature on collision energy is a major factor. At a given temperature, the fraction f of collisions with energy equal to or greater than E_a is

$$f = e^{-E_a/RT}$$

where e is the base of natural logarithms, T is the absolute temperature, and R is the universal gas constant. The right side of this expression appears in the Arrhenius equation (Equation 16.8), which shows that a rise in T causes a larger k . We now see why—a rise in temperature increases the kinetic energy of the reactant particles and enlarges the fraction of collisions with enough energy to exceed E_a (Figure 16.16). It is important to note that increasing the temperature does not change the value of E_a —only the fraction of collisions with enough energy to get over this energy barrier.

Table 16.5 shows that the magnitudes of *both* E_a and T affect the size of this fraction for the hydrolysis of ethyl acetate that we discussed above. In the top portion, temperature is held constant, and the fraction of sufficiently energetic collisions shrinks several orders of magnitude with each 25-kJ/mol increase in E_a . (To extend

Figure 16.16 The effect of temperature on the distribution of collision energies.

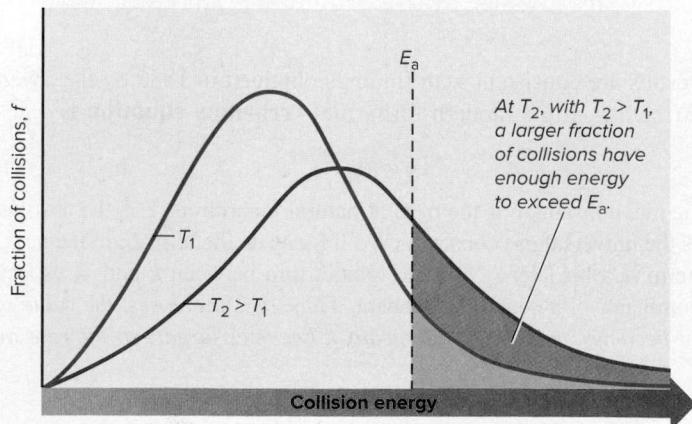

the high jump analogy, as the height of the bar is raised, a smaller fraction of the athletes have enough energy to jump over it.) In the bottom portion, E_a is held constant, and the fraction nearly doubles for each 10 K (10°C) rise in temperature.

Therefore, *the smaller the activation energy (or the higher the temperature), the larger the fraction of sufficiently energetic collisions, the larger the value of k , and the higher the reaction rate:*

$$\text{Smaller } E_a \text{ (or higher } T) \implies \text{larger } f \implies \text{larger } k \implies \text{higher rate}$$

Calculating the Activation Energy We can calculate E_a from the Arrhenius equation by taking the natural logarithm of both sides of the equation, which recasts it into the form of an equation for a straight line:

$$k = Ae^{-E_a/RT}$$

$$\ln k = \ln A - \frac{E_a}{R} \left(\frac{1}{T} \right)$$

$$y = b + mx$$

A plot of $\ln k$ vs. $1/T$ gives a straight line whose slope is $-E_a/R$ and whose y -intercept is $\ln A$ (Figure 16.17). We know the constant R , so we can determine E_a graphically from a series of k values at different temperatures.

We can find E_a in another way if we know the rate constants at two temperatures, T_2 and T_1 :

$$\ln k_2 = \ln A - \frac{E_a}{R} \left(\frac{1}{T_2} \right) \quad \ln k_1 = \ln A - \frac{E_a}{R} \left(\frac{1}{T_1} \right)$$

When we subtract $\ln k_1$ from $\ln k_2$, the term $\ln A$ drops out and the other terms can be rearranged to give

$$\ln \frac{k_2}{k_1} = \frac{E_a}{R} \left(\frac{1}{T_1} - \frac{1}{T_2} \right) \quad (16.10)$$

Then, we can solve for E_a , as in the next sample problem.

SAMPLE PROBLEM 16.8

Determining the Energy of Activation

Problem The decomposition of hydrogen iodide $2\text{HI}(g) \rightarrow \text{H}_2(g) + \text{I}_2(g)$, has rate constants of $9.51 \times 10^{-9} \text{ L/mol}\cdot\text{s}$ at 500. K and $1.10 \times 10^{-5} \text{ L/mol}\cdot\text{s}$ at 600. K. Find E_a .

Plan We are given the rate constants, k_1 and k_2 , at two temperatures, T_1 and T_2 , so we substitute into Equation 16.10 and solve for E_a .

Solution Rearranging Equation 16.10 to solve for E_a :

$$\begin{aligned} \ln \frac{k_2}{k_1} &= \frac{E_a}{R} \left(\frac{1}{T_1} - \frac{1}{T_2} \right) \\ E_a &= R \left(\ln \frac{k_2}{k_1} \right) \left(\frac{1}{T_1} - \frac{1}{T_2} \right)^{-1} \\ &= (8.314 \text{ J/mol}\cdot\text{K}) \left(\ln \frac{1.10 \times 10^{-5} \text{ L/mol}\cdot\text{s}}{9.51 \times 10^{-9} \text{ L/mol}\cdot\text{s}} \right) \left(\frac{1}{500. \text{ K}} - \frac{1}{600. \text{ K}} \right)^{-1} \\ &= 1.76 \times 10^5 \text{ J/mol} = 1.76 \times 10^2 \text{ kJ/mol} \end{aligned}$$

Comment Be sure to retain the same number of significant figures in $1/T$ as you have in T , or a significant error could be introduced. Round to the correct number of significant figures only at the final answer. On most pocket calculators, the expression $(1/T_1 - 1/T_2)$ is entered as follows: $(T_1)(1/x) - (T_2)(1/x) =$.

FOLLOW-UP PROBLEMS

16.8A The reaction $2\text{NOCl}(g) \rightarrow 2\text{NO}(g) + \text{Cl}_2(g)$ has an E_a of $1.00 \times 10^2 \text{ kJ/mol}$ and a rate constant of $0.286 \text{ L/mol}\cdot\text{s}$ at 500. K. What is the rate constant at 490. K?

16.8B The decomposition reaction $2\text{NO}_2(g) \rightarrow 2\text{NO}(g) + \text{O}_2(g)$ has an E_a of $1.14 \times 10^5 \text{ J/mol}$ and a rate constant of $7.02 \times 10^{-3} \text{ L/mol}\cdot\text{s}$ at 500. K. At what temperature will the rate be twice as fast?

SOME SIMILAR PROBLEMS

16.61, 16.62, and 16.65

The Effect of E_a and T on the Fraction (f) of Collisions with Sufficient Energy to Allow Reaction

Table 16.5

E_a (kJ/mol)	f (at $T = 298$ K)
50	1.70×10^{-9}
75	7.03×10^{-14}
100	2.90×10^{-18}
T	f (at $E_a = 50$ kJ/mol)
25°C (298 K)	1.70×10^{-9}
35°C (308 K)	3.29×10^{-9}
45°C (318 K)	6.12×10^{-9}

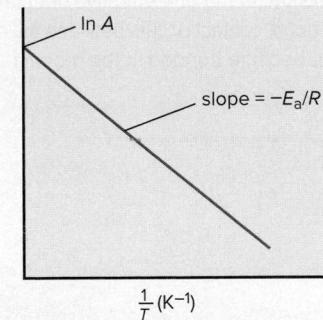

Figure 16.17 Graphical determination of the activation energy.

Figure 16.18 The importance of molecular orientation to an effective collision. In the one effective orientation (bottom), contact occurs between the atoms that become bonded in the product.

The Effect of Molecular Structure on Rate At ordinary temperatures, the enormous number of collisions per second between reactant particles is reduced by six or more orders of magnitude by counting only those with enough energy to react. And, even this tiny fraction of all collisions is typically much larger than the number of **effective collisions**, those that actually lead to product because *the atoms that become bonded in the product make contact*. Thus, to be effective, a collision must have enough energy and the appropriate *molecular orientation*.

In the Arrhenius equation, molecular orientation is contained in the term A :

$$k = Ae^{-E_a/RT}$$

This term is the **frequency factor**, the product of the collision frequency Z and an *orientation probability factor*, p , which is specific for each reaction:

$$A = pZ$$

The factor p is related to the structural complexity of the reactants. You can think of p as the ratio of effectively oriented collisions to all possible collisions. Figure 16.18 shows a few of the possible collision orientations for the following reaction:

Of the five orientations shown, only one has the effective orientation, with the N of NO making contact with an O of NO_3 to form a new nitrogen-oxygen bond. Actually, the p value for this reaction is 0.006: only 6 collisions in every 1000 (1 in 167) have the correct orientation.

The more complex the molecular structure, the smaller the p value is. Individual atoms are spherical, so reactions between them have p values near 1: as long as reacting atoms collide with enough energy, the product can form. At the other extreme are biochemical reactions in which two small molecules (or portions of larger molecules) react only when they collide with enough energy on a specific tiny region of a giant protein. The p value for these reactions is often much less than 10^{-6} , fewer than one in a million. The fact that countless such biochemical reactions are occurring in you right now attests to the astounding number of collisions per second!

Transition State Theory: What the Activation Energy Is Used For

Collision theory explains the importance of effective collisions, and **transition state theory** focuses on the high-energy species that exists at the moment of an effective collision when reactants are becoming products.

Visualizing the Transition State As two molecules approach each other, repulsions between their electron clouds continually increase, so they slow down as some of their kinetic energy is converted to potential energy. If they collide, but the energy of the collision is *less* than the activation energy, the molecules bounce off each other and no reaction occurs.

However, in a tiny fraction of collisions in which the molecules are moving fast enough, *their kinetic energies push them together with enough force to overcome the repulsions and surpass the activation energy*. And, in an even tinier fraction of these sufficiently energetic collisions, the molecules are oriented effectively. In those cases, nuclei in one molecule attract electrons in the other, atomic orbitals overlap, electron densities shift, and some bonds lengthen and weaken while others shorten and strengthen. At some point during this smooth transformation, *a species with partial bonds exists* that is neither reactant nor product. This very unstable species, called the **transition state** (or **activated complex**) exists only at the instant of highest potential energy. Thus, *the activation energy of a reaction is used to reach the transition state*.

Transition states cannot be isolated, but the work of Ahmed H. Zewail, who received the 1999 Nobel Prize in chemistry, greatly expanded our knowledge of them. Using lasers pulsing at the time scale of bond vibrations (10^{-15} s), his team observed transition states forming and decomposing. A few, such as the one that forms as methyl bromide reacts with hydroxide ion, have been well studied:

The electronegative bromine makes the carbon in BrCH_3 partially positive, and the carbon attracts the negatively charged oxygen in OH^- . As a C—O bond begins to form, the Br—C bond begins to weaken. In the transition state (Figure 16.19), C is surrounded by five atoms (trigonal bipyramidal; Section 10.2), which never occurs in carbon's stable compounds. This high-energy species has three normal C—H bonds and two partial bonds, one from C to O and the other from Br to C.

Reaching the transition state does not guarantee that a reaction will proceed to products because *a transition state can change in either direction*. In this case, if the C—O bond continues to strengthen, products form; but, if the Br—C bond becomes stronger again, the transition state reverts to reactants.

Depicting the Change with a Reaction Energy Diagram A useful way to depict these events is with a **reaction energy diagram**, which plots how potential energy changes as the reaction proceeds from reactants to products (the *reaction progress*). The diagram shows the relative energy levels of reactants, products, and transition state, as well as the forward and reverse activation energies and the enthalpy of reaction.

The bottom of Figure 16.20 shows the diagram for the reaction of BrCH_3 and OH^- . This reaction is exothermic, so reactants are higher in energy than products, which means $E_{\text{a(fwd)}}$ is less than $E_{\text{a(rev)}}$. Above the diagram are molecular-scale views at various points during the reaction and corresponding structural formulas. At the top of the figure

Figure 16.19 The transition state of the reaction between BrCH_3 and OH^- . Note the partial (dashed) Br—C and C—O bonds and the trigonal bipyramidal shape.

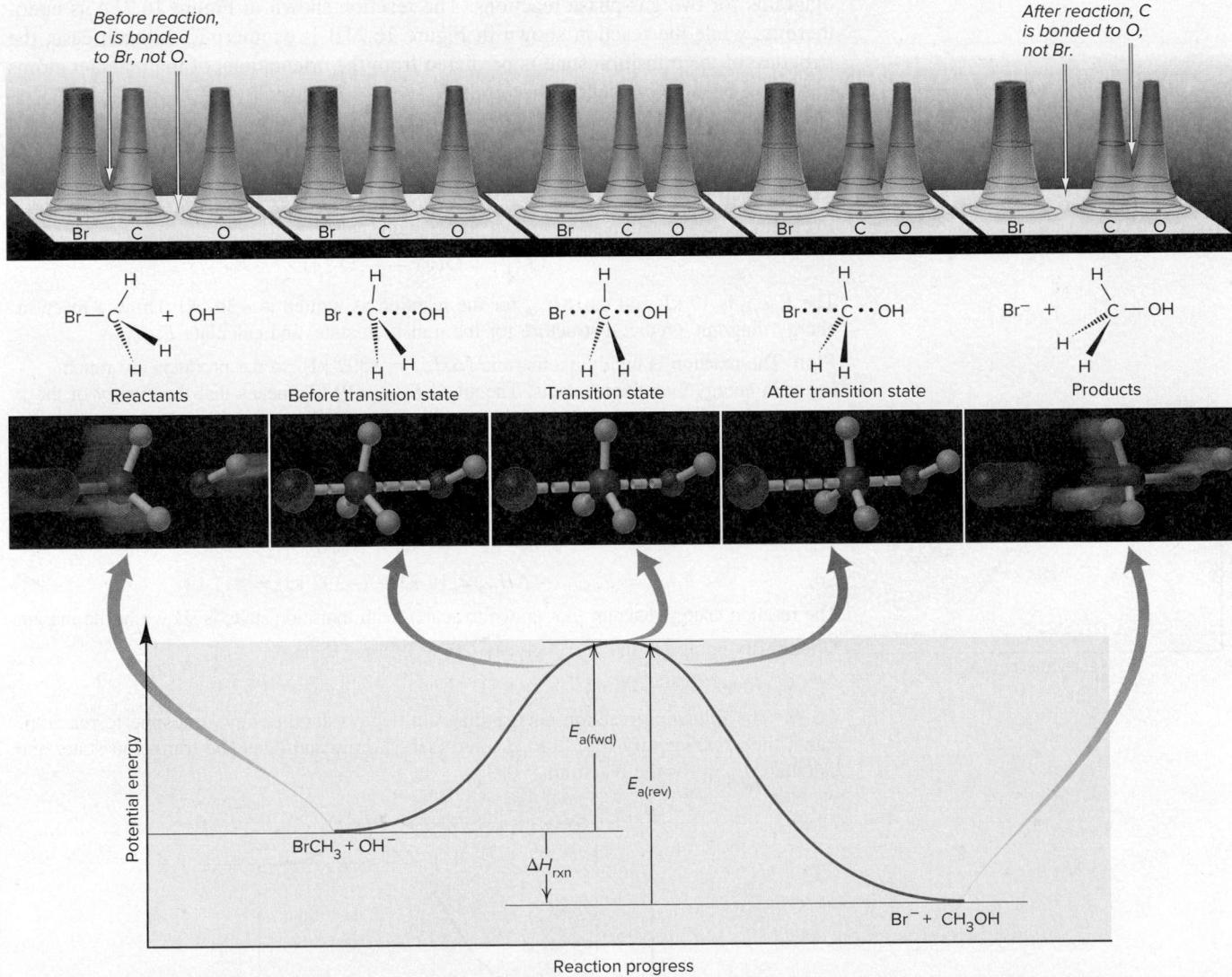

Figure 16.20 Depicting the reaction between BrCH_3 and OH^- . In order (bottom to top) are the reaction energy diagram with blow-up arrows at five points during the reaction, molecular-scale views, structural formulas, and electron density relief maps. Note the gradual, simultaneous C—O bond forming and Br—C bond breaking.

Figure 16.21 Reaction energy diagrams and possible transition states for two reactions.

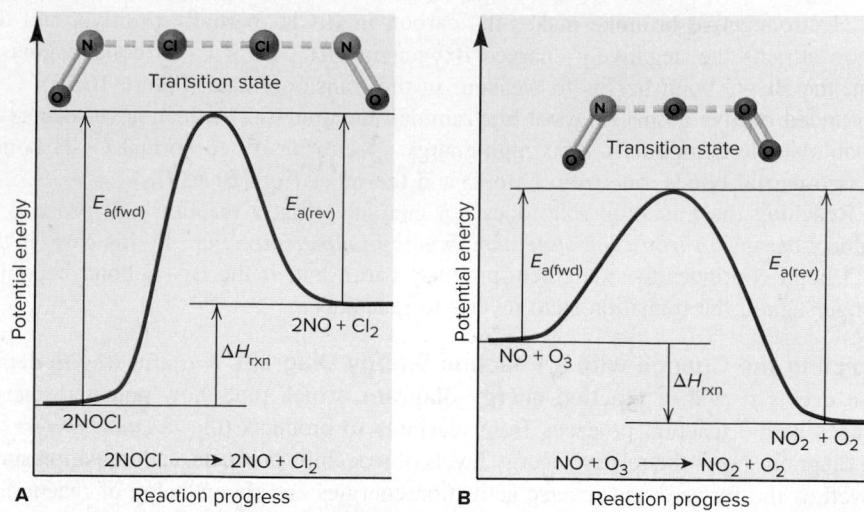

are electron density relief maps of the Br, C, and O atoms: note the gradual change in electron density from C overlapping Br (left) to C overlapping O (right).

Transition state theory proposes that *every reaction (or every step in an overall reaction) goes through its own transition state*. Figure 16.21 presents reaction energy diagrams for two gas-phase reactions. The reaction shown in Figure 16.21A is endothermic, while the reaction shown in Figure 16.21B is exothermic. In each case, the structure of the transition state is predicted from the orientations of the reactant atoms that must become bonded in the product.

SAMPLE PROBLEM 16.9

Drawing Reaction Energy Diagrams and Transition States

Problem A key reaction in the upper atmosphere is

The $E_{a(\text{fwd})}$ is 19 kJ, and the ΔH_{rxn} for the reaction as written is -392 kJ. Draw a reaction energy diagram, predict a structure for the transition state, and calculate $E_{a(\text{rev})}$.

Plan The reaction is highly exothermic ($\Delta H_{\text{rxn}} = -392 \text{ kJ}$), so the products are much lower in energy than the reactants. The small $E_{a(\text{fwd})}$ (19 kJ) means that the energy of the reactants lies slightly below that of the transition state. We use Equation 16.9 to calculate $E_{a(\text{rev})}$. To predict the transition state, we sketch the species and note that one of the bonds in O_3 weakens, and this partially bonded O begins forming a bond to the separate O atom.

Solution Solving for $E_{a(\text{rev})}$:

$$\Delta H_{\text{rxn}} = E_{a(\text{fwd})} - E_{a(\text{rev})}$$

$$\text{So, } E_{a(\text{rev})} = E_{a(\text{fwd})} - \Delta H_{\text{rxn}} = 19 \text{ kJ} - (-392 \text{ kJ}) = 411 \text{ kJ}$$

The reaction energy diagram (not drawn to scale), with transition state, is shown in the margin.

Check Rounding to find $E_{a(\text{rev})}$ gives $\sim 20 + 390 = 410$.

FOLLOW-UP PROBLEMS

16.9A The following reaction energy diagram depicts another key atmospheric reaction. Label the axes, identify $E_{a(\text{fwd})}$, $E_{a(\text{rev})}$, and ΔH_{rxn} , draw and label the transition state, and calculate $E_{a(\text{rev})}$ for the reaction.

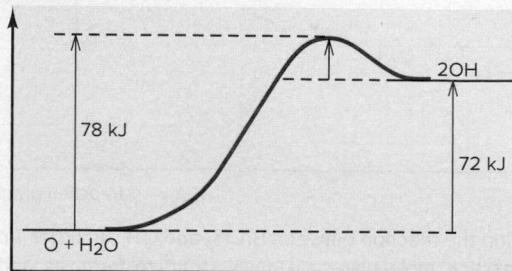

16.9B For the gas phase reaction $\text{Cl}(g) + \text{HBr}(g) \longrightarrow \text{HCl}(g) + \text{Br}(g)$, $E_{\text{a(fwd)}} = 7 \text{ kJ}$ and $E_{\text{a(rev)}} = 72 \text{ kJ}$. Draw a reaction energy diagram; include a predicted structure for the transition state and the value of ΔH_{rxn} .

SOME SIMILAR PROBLEMS 16.63, 16.64, and 16.66

› Summary of Section 16.5

- › According to collision theory, reactant particles must collide to react, and the number of possible collisions is found by multiplying the numbers of reactant particles.
- › As the Arrhenius equation shows, a rise in temperature increases the rate because it increases the rate constant.
- › The activation energy, E_a , is the minimum energy needed for colliding particles to react.
- › The relative E_a values for the forward and reverse reactions depend on whether the overall reaction is exothermic or endothermic.
- › At higher temperatures, more collisions have enough energy to exceed E_a .
- › E_a can be determined graphically from k values obtained at different T values.
- › Molecules must collide with an effective orientation for them to react, so structural complexity decreases rate.
- › Transition state theory focuses on the change of kinetic energy to potential energy as reactant particles collide and form an unstable transition state.
- › Given a sufficiently energetic collision and an effective molecular orientation, the reactant species form the transition state, which either continues toward product(s) or reverts to reactant(s).
- › A reaction energy diagram depicts the changing potential energy throughout a reaction's progress from reactants through transition states to products.

16.6 REACTION MECHANISMS: THE STEPS FROM REACTANT TO PRODUCT

You can't understand how a car works by examining the body, wheels, and dashboard, or even the engine as a whole. You need to look inside the engine to see how its parts fit together and function. Similarly, by examining the overall balanced equation, we can't know how a reaction "works." We must look "inside the reaction" to see how reactants change into products, step by step.

The steps for most reactions can be described by a **reaction mechanism**, a sequence of single reaction steps that sum to the overall equation. For example, a possible mechanism for the overall reaction

might involve these three simpler steps:

- (1) $\text{A} + \text{B} \longrightarrow \text{C}$
- (2) $\text{C} + \text{A} \longrightarrow \text{D}$
- (3) $\text{D} \longrightarrow \text{E} + \text{F}$

Adding the steps and canceling common substances gives the overall equation:

A mechanism is a hypothesis about how a reaction occurs; chemists *propose* a mechanism and then *test* to see that it fits with the observed rate law.

Elementary Reactions and Molecularity

The individual steps that make up a reaction mechanism are called **elementary reactions** (or **elementary steps**). Each describes a *single molecular event*—one particle decomposing, two particles combining, and so forth.

An elementary step is characterized by its **molecularity**, the number of *reactant* particles in the step. Consider the mechanism for the breakdown of ozone in the stratosphere. The overall equation is

A two-step mechanism has been proposed:

- (1) $\text{O}_3(g) \longrightarrow \text{O}_2(g) + \text{O}(g)$
- (2) $\text{O}_3(g) + \text{O}(g) \longrightarrow 2\text{O}_2(g)$

- The first step is a **unimolecular reaction**, one that involves the decomposition or rearrangement of a single particle (O_3).
- The second step is a **bimolecular reaction**, one in which two particles (O_3 and O) collide and react.

Some *termolecular* elementary steps occur, but they are extremely rare because the probability of three particles colliding simultaneously with enough energy and an effective orientation is very small. Higher molecularities are not known. Therefore, in general, *we propose unimolecular and/or bimolecular reactions as reasonable steps in a mechanism*.

Because an elementary reaction occurs in one step, its rate law, unlike that for an overall reaction, *can* be deduced from the reaction stoichiometry: *reaction order equals molecularity*. Therefore, *only* for an elementary step, *we use the equation coefficients as the reaction orders in the rate law* (Table 16.6). For example, in step 2 of the proposed mechanism for the decomposition of O_3 , one O_3 molecule collides with one O atom; therefore, this step is first-order in O_3 and first-order in O and the rate law for this step is rate = $k[\text{O}_3][\text{O}]$.

Table 16.6

Rate Laws for General Elementary Steps

Elementary Step	Molecularity	Rate Law
$\text{A} \longrightarrow \text{product}$	Unimolecular	Rate = $k[\text{A}]$
$2\text{A} \longrightarrow \text{product}$	Bimolecular	Rate = $k[\text{A}]^2$
$\text{A} + \text{B} \longrightarrow \text{product}$	Bimolecular	Rate = $k[\text{A}][\text{B}]$
$2\text{A} + \text{B} \longrightarrow \text{product}$	Termolecular	Rate = $k[\text{A}]^2[\text{B}]$

SAMPLE PROBLEM 16.10

Determining Molecularities and Rate Laws for Elementary Steps

Problem The following elementary steps are proposed for a reaction mechanism:

- (1) $\text{Cl}_2(g) \rightleftharpoons 2\text{Cl}(g)$
- (2) $\text{Cl}(g) + \text{CHCl}_3(g) \longrightarrow \text{HCl}(g) + \text{CCl}_3(g)$
- (3) $\text{Cl}(g) + \text{CCl}_3(g) \longrightarrow \text{CCl}_4(g)$

- (a) Write the balanced equation for the overall reaction.
- (b) Determine the molecularity of each step.
- (c) Write the rate law for each step.

Plan We find the overall equation by adding the elementary steps. The molecularity of each step equals the total number of *reactant* particles. We write the rate law for each step using the equation coefficients as reaction orders.

Solution (a) Writing the overall balanced equation:

- (b) Determining the molecularity of each step: The first step has one reactant, Cl_2 , so it is unimolecular. The second and third steps each have two reactants (Cl and CHCl_3 ; Cl and CCl_3), so they are bimolecular.

(c) Writing the rate laws for the elementary steps:

- (1) Rate₁ = $k_1[\text{Cl}_2]$
- (2) Rate₂ = $k_2[\text{Cl}][\text{CHCl}_3]$
- (3) Rate₃ = $k_3[\text{Cl}][\text{CCl}_3]$

Check In part (a), be sure the equation is balanced; in part (c), be sure the substances in brackets are the *reactants* of each elementary step.

FOLLOW-UP PROBLEMS

16.10A The mechanism below is proposed for the decomposition of hydrogen peroxide:

- (1) $\text{H}_2\text{O}_2(aq) \longrightarrow 2\text{OH}(aq)$
- (2) $\text{H}_2\text{O}_2(aq) + \text{OH}(aq) \longrightarrow \text{H}_2\text{O}(l) + \text{HO}_2(aq)$
- (3) $\text{HO}_2(aq) + \text{OH}(aq) \longrightarrow \text{H}_2\text{O}(l) + \text{O}_2(g)$

(a) Write the balanced equation for the overall reaction. (b) Determine the molecularity of each step. (c) Write the rate law for each step.

16.10B The following elementary steps are proposed for a reaction mechanism:

- (1) $2\text{NO}(g) \rightleftharpoons \text{N}_2\text{O}_2(g)$
- (2) $\text{N}_2\text{O}_2(g) + \text{H}_2(g) \longrightarrow \text{N}_2\text{O}(g) + \text{H}_2\text{O}(g)$
- (3) $\text{N}_2\text{O}(g) + \text{H}_2(g) \longrightarrow \text{N}_2(g) + \text{H}_2\text{O}(g)$

(a) Write the balanced equation for the overall reaction. (b) Determine the molecularity of each step. (c) Write the rate law for each step.

SOME SIMILAR PROBLEMS 16.74(a), 16.74(c), 16.75(a), and 16.75(c)

The Rate-Determining Step of a Reaction Mechanism

All the elementary steps in a mechanism have their own rates. However, one step is usually *much* slower than the others. This step, called the **rate-determining step** (or **rate-limiting step**), limits how fast the overall reaction proceeds. Therefore, *the rate law of the rate-determining step becomes the rate law for the overall reaction.*

Consider the reaction between nitrogen dioxide and carbon monoxide:

If this reaction were an elementary step—that is, if the mechanism consisted of only one step—we could immediately write the overall rate law as

$$\text{Rate} = k[\text{NO}_2][\text{CO}]$$

But, as you saw in Sample Problem 16.3, experimental data show the rate law is

$$\text{Rate} = k[\text{NO}_2]^2$$

Thus, the overall reaction cannot be elementary.

A proposed two-step mechanism is

- (1) $\text{NO}_2(g) + \text{NO}_2(g) \longrightarrow \text{NO}_3(g) + \text{NO}(g)$ [slow; rate determining]
- (2) $\text{NO}_3(g) + \text{CO}(g) \longrightarrow \text{NO}_2(g) + \text{CO}_2(g)$ [fast]

In this mechanism, NO_3 functions as a **reaction intermediate**, a substance formed in one step of the mechanism and used up in a subsequent step during the reaction. Even though it does not appear in the overall balanced equation, a reaction intermediate is essential for the reaction to occur. Intermediates are less stable than the reactants and products, but unlike *much* less stable transition states, they have normal bonds and can sometimes be isolated.

Rate laws for the two elementary steps listed above are

- (1) Rate₁ = $k_1[\text{NO}_2][\text{NO}_2] = k_1[\text{NO}_2]^2$
- (2) Rate₂ = $k_2[\text{NO}_3][\text{CO}]$

Three key points to notice about this mechanism are

- If $k_1 = k$, the rate law for the rate-determining step (step 1) becomes identical to the observed rate law.
- Because the first step is slow, $[\text{NO}_3]$ is low. As soon as any NO_3 forms, it is consumed by the fast second step, so the reaction takes as long as the first step does.

A Rate-Determining Step for Traffic Flow

Imagine driving home on a wide street that goes over a toll bridge. Traffic flows smoothly until the road narrows at the approach to the toll booth. Past the bridge, traffic returns to normal, and you proceed a couple of miles further to your destination. Getting through the bottleneck to pay the toll takes longer than the rest of the trip combined and, therefore, largely determines the time for the whole trip.

- CO does not appear in the rate law (reaction order = 0) because it takes part in the mechanism *after* the rate-determining step and so its concentration does not affect the rate.

Correlating the Mechanism with the Rate Law

Coming up with a reasonable reaction mechanism is a classic demonstration of the scientific method. Using observations and data from rate experiments, we hypothesize the individual steps and then test our hypothesis with further evidence. If the evidence supports our mechanism, we can accept it; if not, we must propose a different one. We can never *prove* that a mechanism represents the *actual* chemical change, only that it is consistent with the data.

A valid mechanism must meet three criteria:

1. *The elementary steps must add up to the overall balanced equation.*
2. *The elementary steps must be reasonable.* They should generally involve one reactant particle (unimolecular) or two (bimolecular).
3. *The mechanism must correlate with the rate law,* not the other way around.

Mechanisms with a Slow Initial Step The reaction between NO₂ and CO that we considered earlier has a mechanism with a slow initial step; that is, the first step is rate-determining. The reaction between nitrogen dioxide and fluorine is another example of such a reaction:

The experimental rate law is first order in NO₂ and in F₂,

$$\text{Rate} = k[\text{NO}_2][\text{F}_2]$$

and the accepted mechanism is

- (1) $\text{NO}_2(g) + \text{F}_2(g) \longrightarrow \text{NO}_2\text{F}(g) + \text{F}(g)$ [slow; rate determining]
- (2) $\text{NO}_2(g) + \text{F}(g) \longrightarrow \text{NO}_2\text{F}(g)$ [fast]

Note that the free fluorine atom is a reaction intermediate.

Let's see how this mechanism meets the three criteria.

1. The elementary reactions sum to the balanced equation:

or

2. Both steps are bimolecular and, thus, reasonable.
3. To determine whether the mechanism is consistent with the observed rate law, we first write the rate laws for the elementary steps:

- (1) $\text{Rate}_1 = k_1[\text{NO}_2][\text{F}_2]$
- (2) $\text{Rate}_2 = k_2[\text{NO}_2][\text{F}]$

Step 1 is the rate-determining step, and with $k_1 = k$, it is the same as the overall rate law, so the third criterion is met.

Note that the second molecule of NO₂ is involved *after* the rate-determining step, so it does not appear in the overall rate law. Thus, as in the mechanism for the reaction of NO₂ and CO, *the overall rate law includes all the reactants involved in the rate-determining step.*

Mechanisms with a Fast Initial Step If the rate-limiting step in a mechanism is *not* the initial step, the product of the fast initial step builds up and starts reverting to reactant. With time, this *fast, reversible step reaches equilibrium*, as product changes to reactant as fast as it forms. As you'll see, this situation allows us to fit the mechanism to the overall rate law.

Consider the oxidation of nitrogen monoxide:

The observed rate law is

$$\text{Rate} = k[\text{NO}]^2[\text{O}_2]$$

and a proposed mechanism is

- (1) $\text{NO}(g) + \text{O}_2(g) \rightleftharpoons \text{NO}_3(g)$ [fast, reversible]
- (2) $\text{NO}_3(g) + \text{NO}(g) \longrightarrow 2\text{NO}_2(g)$ [slow; rate determining]

Let's go through the three criteria to see if this mechanism is valid.

1. With cancellation of the reaction intermediate, NO_3 , the sum of the steps gives the overall equation, so the first criterion is met:

or

2. Both steps are bimolecular, so the second criterion is met.
3. To see whether the third criterion—that the mechanism is consistent with the observed rate law—is met, we first write rate laws for the elementary steps:

$$(1) \text{Rate}_{1(\text{fwd})} = k_1[\text{NO}][\text{O}_2]$$

$$\text{Rate}_{1(\text{rev})} = k_{-1}[\text{NO}_3]$$

where k_{-1} is the rate constant and NO_3 is the reactant for the reverse reaction.

$$(2) \text{Rate}_2 = k_2[\text{NO}_3][\text{NO}]$$

Next, we show that the rate law for the rate-determining step (step 2) gives the overall rate law. As written, it does not, because it contains the intermediate NO_3 , and *an overall rate law includes only reactants (and products)*. We eliminate $[\text{NO}_3]$ from the rate law for step 2 by expressing it in terms of reactants, as follows.

- Step 1 reaches equilibrium when the forward and reverse rates are equal:

$$\text{Rate}_{1(\text{fwd})} = \text{Rate}_{1(\text{rev})} \quad \text{or} \quad k_1[\text{NO}][\text{O}_2] = k_{-1}[\text{NO}_3]$$

- To express $[\text{NO}_3]$ in terms of reactants, we isolate it algebraically:

$$[\text{NO}_3] = \frac{k_1}{k_{-1}} [\text{NO}][\text{O}_2]$$

- Then, substituting for $[\text{NO}_3]$ in the rate law for the slow step, step 2, we obtain

$$\text{Rate}_2 = k_2[\text{NO}_3][\text{NO}] = k_2 \underbrace{\left(\frac{k_1}{k_{-1}} [\text{NO}][\text{O}_2] \right)}_{[\text{NO}_3]} [\text{NO}] = \frac{k_2 k_1}{k_{-1}} [\text{NO}]^2 [\text{O}_2]$$

With $k = \frac{k_2 k_1}{k_{-1}}$, this rate law is identical to the overall rate law.

To summarize, we assess the validity of a mechanism with a fast initial step by

1. Writing rate laws for the fast step (both directions) and for the slow step.
2. Expressing [intermediate] in terms of [reactant] by setting the forward rate law of the reversible step equal to the reverse rate law, and solving for [intermediate].
3. Substituting the expression for [intermediate] into the rate law for the slow step to obtain the overall rate law.

An important point to note is that, *for any mechanism, only reactants involved up to and including the slow (rate-determining) step appear in the overall rate law*.

Student Hot Spot

Student data indicate that you may struggle with the concept of reaction mechanisms. Access the Smartbook to view additional Learning Resources on this topic.

SAMPLE PROBLEM 16.11

Identifying Intermediates and Correlating Rate Laws and Reaction Mechanisms

Problem Consider the reaction mechanism in Sample Problem 16.10.

- (a) Identify the intermediates in the mechanism.
- (b) Assuming that step 2 is the slow (rate-determining) step, show that the mechanism is consistent with the observed rate law: Rate = $k[\text{Cl}_2]^{1/2}[\text{CHCl}_3]$.

Plan (a) We write each elementary step and sum to get the overall reaction. Intermediates are substances that are produced in one elementary step and consumed as reactants in a subsequent elementary step. (b) We use the reactants in the slow step to write its rate law; if an intermediate is present in the rate law, we eliminate it by expressing it in terms of reactants.

Solution (a) Determining the intermediates:

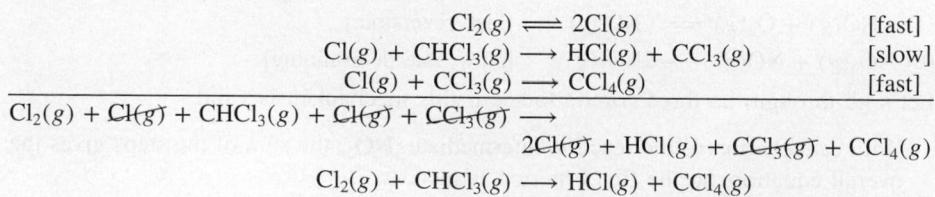

Cl and CCl_3 are formed and used up, so the intermediates are $\text{Cl}(g)$ and $\text{CCl}_3(g)$.

(b) Correlating the reaction mechanism and the rate law:

Step 2 is the rate-determining step:

Since it is an intermediate, $[\text{Cl}]$ must be expressed in terms of reactants:

From step 1: $\text{Rate}_{1(\text{fwd})} = \text{Rate}_{1(\text{rev})}$ or $k_1[\text{Cl}_2] = k_{-1}[\text{Cl}]^2$

Thus,

$$[\text{Cl}]^2 = \frac{k_1}{k_{-1}}[\text{Cl}_2] \quad \text{and} \quad [\text{Cl}] = \sqrt{\frac{k_1}{k_{-1}}[\text{Cl}_2]} = \sqrt{\frac{k_1}{k_{-1}}[\text{Cl}_2]^{1/2}}$$

Substituting for $[\text{Cl}]$ in the rate law for the slow step:

$$\text{Rate} = k_2[\text{Cl}][\text{CHCl}_3] = k_2 \sqrt{\frac{k_1}{k_{-1}}} [\text{Cl}_2]^{1/2} [\text{CHCl}_3]$$

With $k = k_2 \sqrt{\frac{k_1}{k_{-1}}}$, this rate law is consistent with the observed rate law.

Check Be sure that the substances identified as intermediates are not included in the overall balanced equation. In part (b), be sure that the rate-determining step is used to write the rate law and that no intermediates are included in the rate law.

FOLLOW-UP PROBLEMS

16.11A Examine the reaction mechanism in Follow-up Problem 16.10A. **(a)** Identify the intermediates in the mechanism. **(b)** The observed rate law for the decomposition of hydrogen peroxide is $\text{Rate} = k[\text{H}_2\text{O}_2]$. For the reaction mechanism to be consistent with this rate law, which step must be the rate-determining step?

16.11B The observed rate law for the overall reaction whose mechanism is shown in Follow-up Problem 16.10B is $\text{Rate} = k[\text{NO}]^2[\text{H}_2]$. **(a)** Identify the intermediates in this mechanism. **(b)** Assuming that step 2 is the slow (rate-determining) step, show that this mechanism is consistent with the observed rate law.

SOME SIMILAR PROBLEMS 16.74(b), 16.74(d), 16.74(e), 16.75(b), and 16.75(d)

Depicting a Multistep Mechanism with a Reaction Energy Diagram Figure 16.22 shows reaction energy diagrams for two reactions, each of which has a two-step mechanism, shown below the diagram. The reaction of NO_2 and F_2 (part A) starts with a slow step, and the reaction of NO and O_2 (part B) starts with a fast step. Both overall reactions are exothermic, so the product is lower in energy than the reactants. Note these key points:

- *Each step in the mechanism has its own peak with the transition state at the top.*
- The intermediates (F in part A and NO_3 in part B) are reactive, unstable species, so they are higher in energy than the reactants or product.
- The slow (rate-determining) step (step 1 in A and step 2 in B) has a *larger E_a* than the other step.

› Summary of Section 16.6

- › The mechanisms of most common reactions consist of two or more elementary steps, each of which describes a single molecular event.
- › The molecularity of an elementary step equals the number of reactant particles and is the same as the total reaction order of the step. Only unimolecular and bimolecular steps are reasonable.

Figure 16.22 Reaction energy diagrams for the two-step reaction of (A) NO_2 and F_2 and of (B) NO and O_2 .

- › The rate-determining (slowest) step in a mechanism determines how fast the overall reaction occurs, and its rate law is equivalent to the overall rate law.
- › Reaction intermediates are species that form in one step and react in a later one.
- › For a mechanism to be valid, (1) the elementary steps must add up to the overall balanced equation, (2) the steps must be reasonable, and (3) the mechanism must correlate with the rate law.
- › If a mechanism begins with a slow step, only those reactants involved in the slow step appear in the overall rate law.
- › If a mechanism begins with a fast step, the product of the fast step accumulates as an intermediate, and the step reaches equilibrium. To show that the mechanism is valid, we express [intermediate] in terms of [reactant].
- › Only reactants involved in steps up to and including the slow (rate-determining) step appear in the overall rate law.
- › Each step in a mechanism has its own transition state, which appears at the top of a peak in the reaction energy diagram. A slower step has a higher peak (larger E_a).

16.7 CATALYSIS: SPEEDING UP A REACTION

Increasing the rate of a reaction has countless applications, in both engineering and biology. Higher temperature can speed up a reaction, but energy for industrial processes is costly and many organic and biological substances are heat sensitive. More commonly, by far, a reaction is accelerated by a **catalyst**, a substance that increases the reaction rate *without* being consumed. Thus, only a small, nonstoichiometric amount of the catalyst is required to speed the reaction. Despite this, catalysts are employed in so many processes that several million tons are produced annually in the United States alone. Nature is the master designer and user of catalysts: every organism relies on protein catalysts, known as *enzymes*, to speed up life-sustaining reactions, and even the simplest bacterium employs thousands of them.

Figure 16.23 Reaction energy diagram for a catalyzed (green) and an uncatalyzed (red) process. A catalyst speeds a reaction by providing a different, lower energy pathway (green). (Only the first step of the catalyzed reverse reaction is labeled.)

The Basis of Catalytic Action

Each catalyst has its own specific way of functioning, but in general, *a catalyst provides a different reaction mechanism with a lower activation energy, which in turn makes the rate constant larger and, thus, the reaction rate higher:*

Consider a general *uncatalyzed* reaction that proceeds by a one-step mechanism involving a bimolecular collision between the reactants A and B (Figure 16.23). The activation energy is relatively large, so the rate is relatively low:

In the *catalyzed* reaction, reactant A interacts with the catalyst in one step to form the intermediate C, and then C reacts with B in a second step to form product and regenerate the catalyst:

Three points to note in Figure 16.23 are

- A catalyst speeds up the forward *and* reverse reactions. Thus, a reaction has the *same yield* with or without a catalyst, but the product forms *faster*.
- A catalyst causes a *lower total activation energy* by providing a *different mechanism* for the reaction. The total of the activation energies for both steps of the catalyzed pathway [$E_{a1(fwd)} + E_{a2(fwd)}$] is less than the forward activation energy of the uncatalyzed pathway.
- The catalyst is *not consumed*, but rather used and then regenerated.

Homogeneous Catalysis

Chemists classify catalysts based on whether or not they act in the same phase as the reactants and products. A **homogeneous catalyst** exists in solution with the reaction mixture, so it must be a gas, liquid, or soluble solid.

A thoroughly studied example of homogeneous catalysis in the gas phase was formerly used in sulfuric acid manufacture. The key step, the oxidation of sulfur dioxide to sulfur trioxide, occurs so slowly that it is not economical:

In the presence of nitrogen monoxide, however, the overall reaction rate speeds up dramatically:

Note that NO and NO₂ cancel to give the overall reaction:

- NO₂ acts as an intermediate (formed in the first step and then consumed in the second step) and
- NO acts as a catalyst (used in the first step and then regenerated in the second step).

Another well-studied example of homogeneous catalysis involves the decomposition of hydrogen peroxide in aqueous solution:

Commercial H₂O₂ decomposes in light and in the presence of the small amounts of ions dissolved from glass, but it is quite stable in dark plastic containers. Many other substances speed its decomposition, including bromide ion, Br⁻ (Figure 16.24). The catalyzed process is thought to occur in two steps, both of which are oxidation-reduction reactions:

In this case, Br₂, Br⁻, and H⁺ cancel to give the overall balanced equation:

- Br⁻ (in the presence of H⁺) is the catalyst, and
- Br₂ (which is orange in color) is the intermediate.

Heterogeneous Catalysis

A **heterogeneous catalyst** speeds up a reaction in a different phase. Most often solids interacting with gaseous or liquid reactants, these catalysts have enormous surface areas, sometimes as much as 500 m²/g. Very early in the reaction, the rate depends on reactant concentration, but almost immediately, the reaction becomes zero order: the rate-determining step occurs on the catalyst's surface, so once the reactant covers it, adding more reactant cannot increase the rate further.

A very important organic example of heterogeneous catalysis is used to speed up **hydrogenation**, the addition of H₂ to C=C bonds to form C—C bonds. The petroleum, plastics, and food industries employ this process on an enormous scale. The simplest hydrogenation converts ethylene (ethene) to ethane:

In the absence of a catalyst, the reaction is very slow. But, at high H₂ pressure (high [H₂]) and in the presence of finely divided Ni, Pd, or Pt metal, it is rapid even at ordinary temperatures. The Group 8B(10) metals catalyze by *chemically adsorbing the reactants onto their surface* (Figure 16.25, next page). In the rate-determining step, the adsorbed H₂ splits into two H atoms that become weakly bonded to the catalyst's surface (catM):

Then, C₂H₄ adsorbs and reacts with the H atoms, one at a time, to form C₂H₆. Thus, the catalyst acts by lowering the activation energy of the slow step (H—H bond breakage) as part of a different mechanism.

A solid mixture of transition metals and their oxides forms a heterogeneous catalyst in your car's exhaust system. The catalytic converter speeds both the oxidation of toxic CO and unburned gasoline to CO₂ and H₂O and the reduction of the pollutant NO to N₂. As in the hydrogenation mechanism, the catalyst adsorbs the molecules, which weakens and splits their bonds, thus allowing the atoms to form new bonds more quickly. The process is extremely efficient: for example, an NO molecule is split into catalyst-bound N and O atoms in less than 2×10⁻¹² s.

A

B

C

Figure 16.24 The catalyzed decomposition of H₂O₂. **A**, Solid NaBr is dissolved in an aqueous solution of H₂O₂. **B**, Bubbles of O₂ gas form quickly as Br⁻(aq) catalyzes the decomposition of H₂O₂. Note the intermediate Br₂ turns the solution orange. **C**, The solution becomes colorless when the Br₂ is consumed in the final step of the mechanism.

Source: © McGraw-Hill Education/Charles Winters/Timeframe Photography, Inc.

Figure 16.25 The metal-catalyzed hydrogenation of ethene.

Kinetics and Function of Biological Catalysts

Whereas most industrial chemical reactions occur under extreme conditions with high concentrations, thousands of complex reactions occur in every living cell in dilute solution at ordinary temperatures and pressures. Moreover, the rate of each reaction responds to the rates of other reactions, chemical signals from other cells, and environmental stress. In this marvelous chemical harmony, each rate is controlled by an **enzyme**, a protein catalyst whose function has been perfected through evolution.

Enzymes are typically globular proteins with complex shapes (Section 15.6) and molar masses ranging from about 15,000 to 1,000,000 g/mol. A small part of an enzyme's surface—like a hollow carved into a mountainside—is the **active site**, a region whose shape results from the amino-acid side chains involved in catalyzing the reaction. Often far apart in the sequence of the polypeptide chain, these groups lie near each other because of the chain's three-dimensional folding. When the reactant molecules, called **substrates**, collide effectively with the active site, they become attached through *intermolecular forces*, and the chemical change begins.

Characteristics of Enzyme Action The catalytic behavior of enzymes has several common features:

1. *Catalytic activity.* An enzyme behaves like both types of catalyst. Enzymes are typically *much* larger than the substrate, and many enzymes are embedded within cell membranes. Thus, like a heterogeneous catalyst, an enzyme provides a surface on which one reactant is temporarily immobilized to wait until the other reactant lands nearby. But, like many homogeneous catalysts, the active site groups interact with the substrate(s) in multistep sequences in the presence of solvent and other species.
2. *Catalytic efficiency.* Enzymes are incredibly *efficient* in terms of the number of reactions catalyzed per unit time. For example, for the hydrolysis of urea,

the rate constant is $3 \times 10^{-10} \text{ s}^{-1}$ for the uncatalyzed reaction in water at room temperature. Under the same conditions in the presence of the enzyme *urease* (pronounced "YUR-ee-ase"), the rate constant is $3 \times 10^4 \text{ s}^{-1}$, a 10^{14} -fold increase. Enzymes typically increase rates by 10^8 to 10^{20} times, values that industrial chemists who use catalysts can only dream of!

3. *Catalytic specificity.* As a result of the particular groups at the active site, enzymes are also highly *specific*: each enzyme generally catalyzes only one reaction. Urease catalyzes *only* the hydrolysis of urea, and no other enzyme does this.

Models of Enzyme Action Two models of enzyme action have been proposed.

1. According to the older **lock-and-key model** (Figure 16.26A), when the "key" (substrate) fits the "lock" (active site), the chemical change begins.

Figure 16.26 Two models of enzyme action.

2. According to the more current **induced-fit model** (Figure 16.26B), the substrate induces the active site to adopt a perfect fit. X-ray crystallographic and spectroscopic methods show that, in most cases, *the enzyme changes shape when the substrate lands at the active site*. Rather than a rigid key in a lock, we picture a flexible hand in a glove; the “glove” (active site) does not attain its functional shape until the “hand” (substrate) moves into it.

Kinetics of Enzyme Action Kinetic studies of enzyme catalysis show that substrate (*S*) and enzyme (*E*) form an intermediate **enzyme-substrate complex (ES)**, whose concentration determines the rate of formation of product (*P*). In other words, the rate of an enzyme-catalyzed reaction is proportional to the concentration of ES, that is, of reactant bound to catalyst. The steps common to virtually all enzyme-catalyzed reactions are

- (1) $E + S \rightleftharpoons ES$ [fast, reversible]
- (2) $ES \longrightarrow E + P$ [slow; rate-determining]

Thus, $\text{rate} = k[\text{ES}]$. As in the heterogeneous catalysis of hydrogenation (Figure 16.25), $[\text{S}]$ is much greater than $[\text{E}]$, and once all the enzyme molecules are bound to substrate, $[\text{ES}]$ is as high as possible. Then, increasing $[\text{S}]$ has no effect on rate, and the process is zero order.

Mechanisms of Enzyme Action Enzymes employ a variety of reaction mechanisms. In some cases, the active site groups bring specific atoms of the substrate close together. In others, the groups bound to the substrate move apart, stretching the bond to be broken. Many *hydrolases* have acidic groups that provide H^+ ions to speed bond cleavage. Two examples are lysozyme, an enzyme found in tears, which hydrolyzes a polysaccharide in bacterial cell walls to protect the eyes from infection, and chymotrypsin, an enzyme found in the small intestine, which hydrolyzes proteins during digestion.

No matter what their mode of action, *all enzymes catalyze by stabilizing the reaction’s transition state*. For instance, in the lysozyme-catalyzed reaction, the transition state is a portion of the polysaccharide whose bonds have been twisted and stretched by the active site groups until it fits the active site well. Stabilizing the transition state lowers the activation energy and thus increases the rate.

Like enzyme-catalyzed reactions, the process of stratospheric ozone depletion, discussed in the Chemical Connections essay, includes both homogeneous and heterogeneous catalysis.

› Summary of Section 16.7

- › A catalyst increases the rate of a reaction without being consumed. It accomplishes this by providing another mechanism that has a lower activation energy.
- › Homogeneous catalysts function in the same phase as the reactants. Heterogeneous catalysts act in a different phase from the reactants.
- › The hydrogenation of carbon-carbon double bonds takes place on a solid metal catalyst, which speeds up the rate-determining step, the breakage of the H_2 bond.
- › Enzymes are protein catalysts of high efficiency and specificity that act by stabilizing the transition state and, thus, lowering the activation energy.
- › Chlorine atoms from CFC molecules speed the breakdown of stratospheric O_3 in a process that is affected by both homogeneous and heterogeneous catalysis.

CHEMICAL CONNECTIONS TO ATMOSPHERIC SCIENCE

Depletion of Earth's Ozone Layer

The stratospheric ozone layer absorbs UV radiation that is emitted by the Sun and has wavelengths between 280 and 320 nm. If it reaches Earth's surface, this radiation has enough energy to damage genes by breaking bonds in DNA. Thus, depletion of stratospheric ozone increases human health risks, particularly the risks of skin cancer and cataracts (clouding of the eye's lens). The radiation may also damage plant life, especially forms at the bottom of the food chain. Both homogeneous and heterogeneous catalysts play roles in the depletion of ozone.

Before 1976, stratospheric ozone concentration varied seasonally but remained nearly constant from year to year as a result of a series of atmospheric reactions:

Then, in 1985, British scientists reported that a severe reduction of ozone, an *ozone hole*, appeared in the stratosphere over the Antarctic when the Sun ended the long winter darkness. Subsequent research by Paul J. Crutzen, Mario J. Molina, and F. Sherwood Rowland, for which they received the Nobel Prize in chemistry in 1995, revealed that industrial chlorofluorocarbons (CFCs) were lowering $[\text{O}_3]$ in the stratosphere by catalyzing the reaction in which ozone is broken down.

Widely used as aerosol propellants, foaming agents, and air-conditioning coolants, large quantities of CFCs were released for years. Unreactive in the troposphere, CFC molecules gradually reach the stratosphere, where UV radiation splits them:

(The dots are lone electrons resulting from C—Cl bond cleavage.)

Like many species with a lone electron (free radicals), atomic Cl is very reactive. It reacts with stratospheric O_3 to produce the

Figure B16.1 Satellite images of the increasing size of the Antarctic ozone hole (purple).

Source: NASA image courtesy Ozone Hole Watch

intermediate chlorine monoxide ($\text{ClO}\cdot$), which then reacts with a free O atom to regenerate a Cl atom:

The sum of these steps is the ozone breakdown reaction:

Studies finding high $[\text{ClO}\cdot]$ over Antarctica supported this mechanism. Figure B16.1 shows the ozone hole expanding over the years in which CFCs accumulated.

Figure B16.2 shows the reaction energy diagram for the process. Note that *chlorine acts as a homogeneous catalyst*: it exists in the same phase as the reactants, lowers the total activation energy via a different mechanism, and is regenerated. Each Cl atom has a stratospheric half-life of about 2 years, during which it speeds the breakdown of about 100,000 ozone molecules.

Later studies showed that the ozone hole enlarges by heterogeneous catalysis. Stratospheric clouds provide a surface for reactions that convert inactive chlorine compounds, such as HCl and chlorine nitrate (ClONO_2), to substances, such as Cl_2 , that are cleaved by UV radiation to Cl atoms. Fine particles in the stratosphere act in the same way: dust from the 1991 eruption of Mt. Pinatubo reduced stratospheric ozone for 2 years. The Montreal Protocol of 1987 and later amendments curtailed CFC production and proposed substituting hydrocarbon propellants, such as isobutane, $(\text{CH}_3)_3\text{CH}$. Nevertheless, because of the long lifetimes of CFCs, complete recovery of the ozone layer may take another century! The good news is that tropospheric halogen levels have begun to fall.

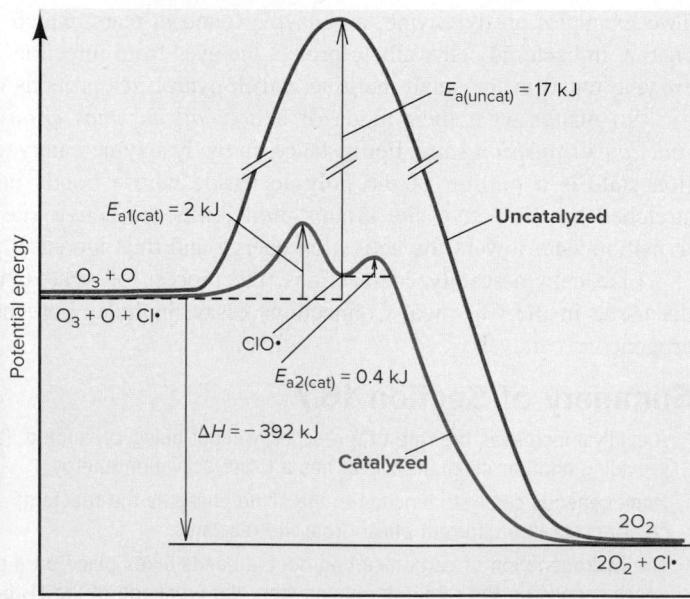

Figure B16.2 Reaction energy diagram for breakdown of O_3 by Cl atoms. (Not drawn to scale.)

Problems

B16.1 The catalytic destruction of ozone occurs via a two-step mechanism, where X can be one of several species:

(a) Write the overall reaction and the rate law for each step.

(b) X acts as _____, and XO acts as _____.

B16.2 Aircraft in the stratosphere release NO, which catalyzes ozone breakdown by the mechanism shown in Problem B16.1.

(a) Write the mechanism.

(b) What is the rate of O₃ depletion (k for the rate-determining step) is $6 \times 10^{-15} \text{ cm}^3/\text{molecule}\cdot\text{s}$) when [O₃] is $5 \times 10^{12} \text{ molecules/cm}^3$ and [NO] is $1.0 \times 10^9 \text{ molecules/cm}^3$?

B16.3 In the mechanism for O₃ breakdown in Problem B16.1:

(a) Which would you expect to have a higher value for the orientation probability factor, p , step 1 with NO or step 1 with Cl? Explain.

(b) Draw a possible transition state for the step with Cl.

CHAPTER REVIEW GUIDE

Learning Objectives

Relevant section (§) and/or sample problem (SP) numbers appear in parentheses.

Understand These Concepts

- How reaction rate depends on concentration, physical state, and temperature (§16.1)
- The meaning of *reaction rate* in terms of changing concentrations over time (§16.2)
- How the rate can be expressed in terms of reactant or product concentrations (§16.2)
- The distinction between average and instantaneous rate and why the instantaneous rate changes during a reaction (§16.2)
- The interpretation of a reaction rate in terms of reactant and product concentrations (§16.2)
- The experimental basis of the rate law and the information needed to determine it—initial rate data, reaction orders, and rate constant (§16.3)
- The importance of reaction order in determining the rate (§16.3)
- How reaction order is determined from initial rates at different concentrations (§16.3)
- How integrated rate laws show the dependence of concentration on time (§16.4)
- What reaction half-life means and why it is constant for a first-order reaction (§16.4)
- Why concentrations are multiplied in the rate law (§16.5)
- Activation energy and the effect of temperature on the rate constant (Arrhenius equation) (§16.5)
- How temperature affects rate by influencing collision energy and, thus, the fraction of collisions with energy exceeding the activation energy (§16.5)
- Why molecular orientation and complexity influence the number of effective collisions and the rate (§16.5)
- The transition state as the species that exists only momentarily between reactants and products and whose formation requires the activation energy (§16.5)
- How an elementary step represents a single molecular event and its molecularity equals the number of colliding particles (§16.6)

- How a reaction mechanism consists of several elementary steps, with the slowest step determining the overall rate (§16.6)
- The criteria for a valid reaction mechanism (§16.6)
- How a catalyst speeds a reaction by lowering the activation energy (§16.7)
- The distinction between homogeneous and heterogeneous catalysis (§16.7)

Master These Skills

- Calculating the instantaneous rate from the slope of a tangent to a concentration vs. time plot (§16.2)
- Expressing reaction rate in terms of changes in concentration with time (SP 16.1)
- Determining reaction order from a known rate law (SP 16.2)
- Determining reaction orders from rate data or molecular scenes (SPs 16.3, 16.4)
- Calculating the rate constant and its units (§16.3 and SP 16.3)
- Using an integrated rate law to find concentration at a given time or the time to reach a given concentration (SP 16.5)
- Determining reaction order graphically with a rearranged integrated rate law (§16.4)
- Determining the half-life of a reaction (SPs 16.6, 16.7)
- Using a form of the Arrhenius equation to calculate the activation energy (SP 16.8)
- Using reaction energy diagrams to depict the energy changes during a reaction (SP 16.9)
- Predicting a transition state for a simple reaction (SP 16.9)
- Determining the molecularity and rate law for an elementary step (SP 16.10)
- Constructing a mechanism with either a slow or a fast initial step (§16.6)
- Identifying intermediates and correlating rate laws and reaction mechanisms (SP 16.11)

Key Terms

Page numbers appear in parentheses.

- activation energy (E_a) (716)
active site (730)
Arrhenius equation (715)
average rate (695)
bimolecular reaction (722)
catalyst (727)
chemical kinetics (691)
collision theory (715)
effective collision (718)
elementary reaction
(elementary step) (721)

- enzyme (730)
enzyme-substrate complex (ES) (731)
frequency factor (718)
half-life ($t_{1/2}$) (711)
heterogeneous catalyst (729)
homogeneous catalyst (728)
hydrogenation (729)
induced-fit model (731)
initial rate (696)
instantaneous rate (695)

- integrated rate law (707)
lock-and-key model (730)
molecularity (722)
rate constant (698)
rate-determining (rate-limiting) step (723)
rate law (rate equation) (698)
reaction energy diagram (719)
reaction intermediate (723)

- reaction mechanism (721)
reaction orders (698)
reaction rate (691)
substrate (730)
transition state (activated complex) (718)
transition state theory (718)
unimolecular reaction (722)

Key Equations and Relationships

Page numbers appear in parentheses.

16.1 Expressing reaction rate in terms of reactant A (694):

$$\text{Rate} = -\frac{\Delta[\text{A}]}{\Delta t}$$

16.2 Expressing the rate of a general reaction (697):

$$\text{Rate} = -\frac{1}{a} \frac{\Delta[\text{A}]}{\Delta t} = -\frac{1}{b} \frac{\Delta[\text{B}]}{\Delta t} = \frac{1}{c} \frac{\Delta[\text{C}]}{\Delta t} = \frac{1}{d} \frac{\Delta[\text{D}]}{\Delta t}$$

16.3 Writing a general rate law (in which products do not appear) (698):

$$\text{Rate} = k[\text{A}]^m[\text{B}]^n \dots$$

16.4 Calculating the time to reach a given [A] for a first-order reaction (rate = $k[\text{A}]$) (708):

$$\ln \frac{[\text{A}]_0}{[\text{A}]_t} = kt$$

16.5 Calculating the time to reach a given [A] for a simple second-order reaction (rate = $k[\text{A}]^2$) (708):

$$\frac{1}{[\text{A}]_t} - \frac{1}{[\text{A}]_0} = kt$$

16.6 Calculating the time to reach a given [A] for a zero-order reaction (rate = k) (708):

$$[\text{A}]_t - [\text{A}]_0 = -kt$$

16.7 Finding the half-life of a first-order process (711):

$$t_{1/2} = \frac{\ln 2}{k} = \frac{0.693}{k}$$

16.8 Relating the rate constant to the temperature (Arrhenius equation) (715):

$$k = Ae^{-E_a/RT}$$

16.9 Relating the heat of reaction to the forward and reverse activation energies (716):

$$\Delta H_{\text{rxn}} = E_{\text{a(fwd)}} - E_{\text{a(rev)}}$$

16.10 Calculating the activation energy (rearranged form of Arrhenius equation) (717):

$$\ln \frac{k_2}{k_1} = \frac{E_a}{R} \left(\frac{1}{T_1} - \frac{1}{T_2} \right)$$

BRIEF SOLUTIONS TO FOLLOW-UP PROBLEMS**16.1A** (a) $4\text{NO}(g) + \text{O}_2(g) \longrightarrow 2\text{N}_2\text{O}_3(g)$

$$\text{Rate} = -\frac{\Delta[\text{O}_2]}{\Delta t} = -\frac{1}{4} \frac{\Delta[\text{NO}]}{\Delta t} = \frac{1}{2} \frac{\Delta[\text{N}_2\text{O}_3]}{\Delta t}$$

$$(b) -\frac{\Delta[\text{O}_2]}{\Delta t} = -\frac{1}{4} \frac{\Delta[\text{NO}]}{\Delta t} = -\frac{1}{4} (-1.60 \times 10^{-4} \text{ mol/L}\cdot\text{s}) \\ = 4.00 \times 10^{-5} \text{ mol/L}\cdot\text{s}$$

16.1B (a) Since the changes in concentrations of NH_3 and O_2 are negative, those substances are the reactants:

$$(b) -\frac{1}{5} \frac{\Delta[\text{O}_2]}{\Delta t} = \frac{1}{6} \frac{\Delta[\text{H}_2\text{O}]}{\Delta t} \\ -\frac{\Delta[\text{O}_2]}{\Delta t} = \frac{5}{6} \frac{\Delta[\text{H}_2\text{O}]}{\Delta t} = \frac{5}{6} (2.52 \times 10^{-2} \text{ mol/L}\cdot\text{s}) \\ = 2.10 \times 10^{-2} \text{ mol/L}\cdot\text{s}$$

16.2A (a) First order in I^- , first order in BrO_3^- , second order in H^+ ; fourth order overall(b) Rate = $k[\text{I}^-][\text{BrO}_3^-][\text{H}^+]^2 = k(3)(3)(2)^2 = 36k$; the rate increases by a factor of 36.**16.2B** (a) Second order in ClO_2 , first order in OH^- ; third order overall
(b) Rate = $k[\text{ClO}_2]^2[\text{OH}^-] = k(0.5)^2(2) = 0.5$; the rate decreases by a factor of 1/2.**16.3A** Rate = $k[\text{H}_2]^m[\text{I}_2]^n$ From experiments 1 and 3:

$$\frac{\text{Rate 3}}{\text{Rate 1}} = \frac{k[\text{H}_2]_3^m[\text{I}_2]_3^n}{k[\text{H}_2]_1^m[\text{I}_2]_1^n} = \left(\frac{[\text{H}_2]_3}{[\text{H}_2]_1} \right)^m$$

$$\text{or} \quad \frac{9.3 \times 10^{-23} \text{ mol/L}\cdot\text{s}}{1.9 \times 10^{-23} \text{ mol/L}\cdot\text{s}} = \left(\frac{0.0550 \text{ mol/L}}{0.0113 \text{ mol/L}} \right)^m$$

This gives $4.9 = (4.9)^m$, so $m = 1$. From experiments 2 and 4:

$$\frac{\text{Rate 4}}{\text{Rate 2}} = \frac{k[\text{H}_2]_4^m[\text{I}_2]_4^n}{k[\text{H}_2]_2^m[\text{I}_2]_2^n} = \left(\frac{[\text{I}_2]_4}{[\text{I}_2]_2} \right)^n$$

$$\text{or} \quad \frac{1.9 \times 10^{-22} \text{ mol/L}\cdot\text{s}}{1.1 \times 10^{-22} \text{ mol/L}\cdot\text{s}} = \left(\frac{0.0056 \text{ mol/L}}{0.0033 \text{ mol/L}} \right)^n$$

This gives $1.7 = (1.7)^n$, so $n = 1$. Therefore, rate = $k[\text{H}_2][\text{I}_2]$; second order overall. From experiment 1:

$$k = \frac{\text{rate}}{[\text{H}_2][\text{I}_2]} = \frac{1.9 \times 10^{-23} \text{ mol/L}\cdot\text{s}}{(0.0113 \text{ mol/L})(0.0011 \text{ mol/L})} \\ = 1.5 \times 10^{-18} \text{ L/mol}\cdot\text{s}$$

The average value of k from all four experiments is $1.5 \times 10^{-18} \text{ L/mol}\cdot\text{s}$.

16.3B (a) Rate = $k[\text{H}_2\text{SeO}_3]^m[\text{I}^-]^n[\text{H}^+]^p$

From experiments 1 and 3:

$$\frac{\text{Rate 3}}{\text{Rate 1}} = \left(\frac{[\text{H}_2\text{SeO}_3]_3}{[\text{H}_2\text{SeO}_3]_1} \right)^m$$

$$\text{or } \frac{3.94 \times 10^{-6} \text{ mol/L}\cdot\text{s}}{9.85 \times 10^{-7} \text{ mol/L}\cdot\text{s}} = \left(\frac{1.0 \times 10^{-2} \text{ mol/L}}{2.5 \times 10^{-3} \text{ mol/L}} \right)^m$$

This gives $4 = (4)^m$, so $m = 1$. From experiments 1 and 2:

$$\frac{\text{Rate 2}}{\text{Rate 1}} = \left(\frac{[\text{I}^-]_2}{[\text{I}^-]_1} \right)^n$$

$$\text{or } \frac{7.88 \times 10^{-6} \text{ mol/L}\cdot\text{s}}{9.85 \times 10^{-7} \text{ mol/L}\cdot\text{s}} = \left(\frac{3.0 \times 10^{-2} \text{ mol/L}}{1.5 \times 10^{-2} \text{ mol/L}} \right)^n$$

This gives $8 = (2)^n$, so $n = 3$. From experiments 2 and 4:

$$\frac{\text{Rate 4}}{\text{Rate 2}} = \left(\frac{[\text{H}^+]_4}{[\text{H}^+]_2} \right)^p$$

$$\text{or } \frac{3.15 \times 10^{-5} \text{ mol/L}\cdot\text{s}}{7.88 \times 10^{-6} \text{ mol/L}\cdot\text{s}} = \left(\frac{3.0 \times 10^{-2} \text{ mol/L}}{1.5 \times 10^{-2} \text{ mol/L}} \right)^p$$

This gives $4 = (2)^p$, so $p = 2$. Therefore, rate = $k[\text{H}_2\text{SeO}_3][\text{I}^-]^3[\text{H}^+]^2$.

(b) From experiment 1:

$$\begin{aligned} k &= \frac{\text{rate}}{[\text{H}_2\text{SeO}_3][\text{I}^-]^3[\text{H}^+]^2} \\ &= \frac{9.85 \times 10^{-7} \text{ mol/L}\cdot\text{s}}{(2.5 \times 10^{-3} \text{ mol/L})(1.5 \times 10^{-2} \text{ mol/L})^3(1.5 \times 10^{-2} \text{ mol/L})^2} \\ &= 5.2 \times 10^5 \text{ L}^5/\text{mol}^5\cdot\text{s} \end{aligned}$$

16.4A (a) The rate law shows the reaction is zero order in Y, so the rate is not affected by doubling Y. The reaction is first order in X; since the amount of X does not change, the rate does not change either: rate of Expt 2 = rate of Expt 1 = $0.25 \times 10^{-5} \text{ mol/L}\cdot\text{s}$

(b) The rate of Expt 3 is four times that of Expt 1, so [X] doubles.

16.4B (a) The rate law is rate = $k[\text{A}]^m[\text{B}]^n$. For reactant B in Expts 1 and 2:

$$\frac{\text{Rate 2}}{\text{Rate 1}} = \frac{k[\text{A}]_2^m[\text{B}]_2^n}{k[\text{A}]_1^m[\text{B}]_1^n} = \left(\frac{[\text{B}]_2}{[\text{B}]_1} \right)^n$$

$$\text{or } \frac{1.6 \times 10^{-3} \text{ mol/L}\cdot\text{s}}{1.6 \times 10^{-3} \text{ mol/L}\cdot\text{s}} = \left(\frac{2 \text{ particles}}{4 \text{ particles}} \right)^n$$

Thus, $1 = (0.5)^n$ so $n = 0$. For reactant A in Expts 1 and 3:

$$\frac{\text{Rate 3}}{\text{Rate 1}} = \frac{k[\text{A}]_3^m[\text{B}]_3^n}{k[\text{A}]_1^m[\text{B}]_1^n} = \left(\frac{[\text{A}]_3}{[\text{A}]_1} \right)^m$$

$$\text{or } \frac{8.0 \times 10^{-4} \text{ mol/L}\cdot\text{s}}{1.6 \times 10^{-3} \text{ mol/L}\cdot\text{s}} = \left(\frac{2 \text{ particles}}{4 \text{ particles}} \right)^m$$

Thus, $0.5 = (0.5)^m$ so $m = 1$. Therefore, rate = $k[\text{A}][\text{B}]^0$ or rate = $k[\text{A}]$.

(b) The rate for Expt 4 is twice as great as the rate for Expt 1; since [A] has a reaction order of 1, twice as many A particles should appear in the scene for Expt 4: 2×4 particles = 8 particles.

16.5A The reaction is second order in HI.

$$\frac{\frac{1}{[\text{A}]_t} - \frac{1}{[\text{A}]_0}}{\frac{1}{0.00900 \text{ mol/L}} - \frac{1}{0.0100 \text{ mol/L}}} = (2.4 \times 10^{-21} \text{ L/mol}\cdot\text{s})(t)$$

$$t = 4.6 \times 10^{21} \text{ s (or } 1.5 \times 10^{14} \text{ yr)}$$

$$\begin{aligned} \text{16.5B (a)} \quad \ln \frac{[\text{H}_2\text{O}_2]_0}{[\text{H}_2\text{O}_2]_t} &= kt \\ \ln \frac{1.28 \text{ mol/L}}{0.85 \text{ mol/L}} &= k(10.0 \text{ min}) \end{aligned}$$

$$k = 0.041/\text{min}$$

(b) If 25% of the H_2O_2 decomposes, 75% remains. Assuming an initial concentration of 1.0 M means that the concentration is 0.75 M at time t :

$$\begin{aligned} \ln \frac{[\text{H}_2\text{O}_2]_0}{[\text{H}_2\text{O}_2]_t} &= kt \\ \ln \frac{1.0 \text{ mol/L}}{0.75 \text{ mol/L}} &= (0.041/\text{min})(t) \\ t &= 7.0 \text{ min} \end{aligned}$$

16.6A (a) After 2.5 min, the number of particles of X has decreased from 12 to 6, so $t_{1/2} = 2.5 \text{ min}$. At 5.0 min, which is two half-lives, 3 particles of X will remain and an additional 3 particles of Y will be formed, for a total of 9 particles of Y.

(b) At 10.0 min (four half-lives), there are 0.75 particles of X ($12 \times \frac{1}{2} \times \frac{1}{2} \times \frac{1}{2} \times \frac{1}{2}$).

$$\text{Amount (mol)} = 0.75 \text{ particles} \times \frac{0.20 \text{ mol X}}{1 \text{ particle}} = 0.15 \text{ mol X}$$

$$M = \frac{0.15 \text{ mol X}}{0.50 \text{ L}} = 0.30 \text{ M}$$

16.6B (a) The half-life is 24 min; the third scene represents four half-lives (1 particle is $\frac{1}{16}$ of the initial amount; $\frac{1}{2} \times \frac{1}{2} \times \frac{1}{2} \times \frac{1}{2} = \frac{1}{16}$). Four half-lives is $4 \times 24 \text{ min} = 96 \text{ min}$.

(b) At 72 min (three half-lives), there are 2 particles of A.

$$\text{Amount (mol)} = 2 \text{ particles} \times \frac{0.10 \text{ mol A}}{1 \text{ particle}} = 0.20 \text{ mol A}$$

$$M = \frac{0.20 \text{ mol A}}{0.25 \text{ L}} = 0.80 \text{ M}$$

$$\text{16.7A } k = \frac{\ln 2}{t_{1/2}} = \frac{0.693}{13.1 \text{ h}} = 5.29 \times 10^{-2} \text{ h}^{-1}$$

$$\text{16.7B (a) } t_{1/2} = \frac{\ln 2}{k} = \frac{0.693}{9 \times 10^{-2} \text{ day}^{-1}} = 8 \text{ days}$$

(b) 40 days is five half-lives; $\frac{1}{2} \times \frac{1}{2} \times \frac{1}{2} \times \frac{1}{2} \times \frac{1}{2} = (\frac{1}{2})^5 = \frac{1}{32}$ remains in the environment.

BRIEF SOLUTIONS TO FOLLOW-UP PROBLEMS

(continued)

16.8A $\ln \frac{k_2}{k_1} = \frac{E_a}{R} \left(\frac{1}{T_1} - \frac{1}{T_2} \right)$

$$\ln \frac{0.286 \text{ L/mol}\cdot\text{s}}{k_1} = \frac{1.00 \times 10^5 \text{ J/mol}}{8.314 \text{ J/mol}\cdot\text{K}} \times \left(\frac{1}{490. \text{ K}} - \frac{1}{500. \text{ K}} \right) = 0.491$$

$$\frac{0.286 \text{ L/mol}\cdot\text{s}}{K_1} = e^{0.491} = 1.63$$

$$k_1 = 0.175 \text{ L/mol}\cdot\text{s}$$

16.8B If the reaction rate is twice as fast, $k_2 = k_1 \times 2 = 7.02 \times 10^{-3} \text{ L/mol}\cdot\text{s} \times 2 = 1.40 \times 10^{-2} \text{ L/mol}\cdot\text{s}$.

$$\ln \frac{k_2}{k_1} = \frac{E_a}{R} \left(\frac{1}{T_1} - \frac{1}{T_2} \right)$$

$$\ln \frac{1.40 \times 10^{-2} \text{ L/mol}\cdot\text{s}}{7.02 \times 10^{-3} \text{ L/mol}\cdot\text{s}} = \frac{1.14 \times 10^5 \text{ J/mol}}{8.314 \text{ J/mol}\cdot\text{K}} \times \left(\frac{1}{500. \text{ K}} - \frac{1}{T_2} \right)$$

$$0.69029 = 13712 \text{ K} \times \left(0.00200 \text{ K}^{-1} - \frac{1}{T_2} \right)$$

$$5.0342 \times 10^{-5} \text{ K}^{-1} = \left(0.00200 \text{ K}^{-1} - \frac{1}{T_2} \right)$$

$$0.00195 \text{ K}^{-1} = \frac{1}{T_2}$$

$$T_2 = 513 \text{ K}$$

16.9A $E_{a(\text{rev})} = E_{a(\text{fwd})} - \Delta H_{\text{rxn}} = 78 \text{ kJ} - 72 \text{ kJ} = 6 \text{ kJ}$

PROBLEMS

Problems with **colored** numbers are answered in Appendix E and worked in detail in the Student Solutions Manual. Problem sections match those in the text and give the numbers of relevant sample problems. Most offer Concept Review Questions, Skill-Building Exercises (grouped in pairs covering the same concept), and Problems in Context. The Comprehensive Problems are based on material from any section or previous chapter.

Focusing on Reaction Rate

Concept Review Questions

16.1 What variable of a chemical reaction is measured over time to obtain the reaction rate?

16.9B $\Delta H_{\text{rxn}} = E_{a(\text{fwd})} - E_{a(\text{rev})} = 7 \text{ kJ} - 72 \text{ kJ} = -65 \text{ kJ}$

16.10A (a) Balanced equation: $2\text{H}_2\text{O}_2(aq) \rightarrow 2\text{H}_2\text{O}(l) + \text{O}_2(g)$

(b) Step 1 is unimolecular; steps 2 and 3 are bimolecular.

(c) Rate₁ = $k_1[\text{H}_2\text{O}_2]$; Rate₂ = $k_2[\text{H}_2\text{O}_2][\text{OH}]$; Rate₃ = $k_3[\text{HO}_2][\text{OH}]$

16.10B (a) Balanced equation:

(b) All steps are bimolecular.

(c) Rate₁ = $k_1[\text{NO}]^2$; Rate₂ = $k_2[\text{N}_2\text{O}_2][\text{H}_2]$; Rate₃ = $k_3[\text{N}_2\text{O}][\text{H}_2]$

16.11A (a) The intermediates are OH and HO₂.

(b) The reaction is first order in H₂O₂; step 1 must be the rate-determining step.

16.11B (a) The intermediates are N₂O₂ and N₂O.

(b) From step 2, rate = $k_2[\text{N}_2\text{O}_2][\text{H}_2]$; from step 1,

$k_1[\text{NO}]^2 = k_{-1}[\text{N}_2\text{O}_2]$ or $[\text{N}_2\text{O}_2] = \frac{k_1}{k_{-1}}[\text{NO}]^2$. Substituting into the rate law from step 2 gives

$$\text{rate} = k_2 [\text{N}_2\text{O}_2] [\text{H}_2] = k_2 \frac{k_1}{k_{-1}} [\text{NO}]^2 [\text{H}_2], \text{ or rate} = k[\text{NO}]^2 [\text{H}_2].$$

16.2 How does an increase in pressure affect the rate of a gas-phase reaction? Explain.

16.3 A reaction is carried out with water as the solvent. How does the addition of more water to the reaction vessel affect the rate of the reaction? Explain.

16.4 A gas reacts with a solid that is present in large chunks. Then the reaction is run again with the solid pulverized. How does the increase in the surface area of the solid affect the rate of its reaction with the gas? Explain.

16.5 How does an increase in temperature affect the rate of a reaction? Explain the two factors involved.

16.6 In a kinetics experiment, a chemist places crystals of iodine in a closed reaction vessel, introduces a given quantity of H₂ gas, and obtains data to calculate the rate of HI formation. In a second experiment, she uses the same amounts of iodine and hydrogen, but first warms the flask to 130°C, a temperature above the sublimation point of iodine. In which of these experiments does the reaction proceed at a higher rate? Explain.

Expressing the Reaction Rate

(Sample Problem 16.1)

Concept Review Questions

16.7 Define *reaction rate*. Assuming constant temperature and a closed reaction vessel, why does the rate change with time?

16.8 (a) What is the difference between an average rate and an instantaneous rate? (b) What is the difference between an initial rate and an instantaneous rate?

16.9 Give two reasons to measure initial rates in a kinetics study.

16.10 For the reaction A(g) → B(g), sketch two curves on the same set of axes that show

- (a) The formation of product as a function of time
- (b) The consumption of reactant as a function of time

16.11 For the reaction C(g) → D(g), [C] vs. time is plotted:

How do you determine each of the following?

- (a) The average rate over the entire experiment
- (b) The reaction rate at time *x*
- (c) The initial reaction rate
- (d) Would the values in parts (a), (b), and (c) be different if you plotted [D] vs. time? Explain.

Skill-Building Exercises (grouped in similar pairs)

16.12 The compound AX₂ decomposes according to the equation 2AX₂(g) → 2AX(g) + X₂(g). In one experiment, [AX₂] was measured at various times and these data were obtained:

Time (s)	[AX ₂] (mol/L)
0.0	0.0500
2.0	0.0448
6.0	0.0300
8.0	0.0249
10.0	0.0209
20.0	0.0088

- (a) Find the average rate over the entire experiment.
- (b) Is the initial rate higher or lower than the rate in part (a)? Use graphical methods to estimate the initial rate.
- 16.13** (a) Use the data from Problem 16.12 to calculate the average rate from 8.0 to 20.0 s.
- (b) Is the rate at exactly 5.0 s higher or lower than the rate in part (a)? Use graphical methods to estimate the rate at 5.0 s.

16.14 Express the rate of this reaction in terms of the change in concentration of each of the reactants and products:

When [C] is increasing at 2 mol/L·s, how fast is [A] decreasing?

16.15 Express the rate of this reaction in terms of the change in concentration of each of the reactants and products:

When [E] is increasing at 0.25 mol/L·s, how fast is [F] increasing?

16.16 Express the rate of this reaction in terms of the change in concentration of each of the reactants and products:

When [B] is decreasing at 0.5 mol/L·s, how fast is [A] decreasing?

16.17 Express the rate of this reaction in terms of the change in concentration of each of the reactants and products:

When [D] is decreasing at 0.1 mol/L·s, how fast is [H] increasing?

16.18 Reaction rate is expressed in terms of changes in concentration of reactants and products. Write a balanced equation for the reaction with this rate expression:

$$\text{Rate} = -\frac{1}{2} \frac{\Delta[\text{N}_2\text{O}_5]}{\Delta t} = \frac{1}{4} \frac{\Delta[\text{NO}_2]}{\Delta t} = \frac{\Delta[\text{O}_2]}{\Delta t}$$

16.19 Reaction rate is expressed in terms of changes in concentration of reactants and products. Write a balanced equation for the reaction with this rate expression:

$$\text{Rate} = -\frac{\Delta[\text{CH}_4]}{\Delta t} = -\frac{1}{2} \frac{\Delta[\text{O}_2]}{\Delta t} = \frac{1}{2} \frac{\Delta[\text{H}_2\text{O}]}{\Delta t} = \frac{\Delta[\text{CO}_2]}{\Delta t}$$

Problems in Context

16.20 The decomposition of NOBr is studied manometrically because the number of moles of gas changes; it cannot be studied colorimetrically because both NOBr and Br₂ are reddish brown:

Use the data below to answer the following:

- (a) Determine the average rate over the entire experiment.
- (b) Determine the average rate between 2.00 and 4.00 s.
- (c) Use graphical methods to estimate the initial reaction rate.
- (d) Use graphical methods to estimate the rate at 7.00 s.
- (e) At what time does the instantaneous rate equal the average rate over the entire experiment?

Time (s)	[NOBr] (mol/L)
0.00	0.0100
2.00	0.0071
4.00	0.0055
6.00	0.0045
8.00	0.0038
10.00	0.0033

16.21 The formation of ammonia is one of the most important processes in the chemical industry:

Express the rate in terms of changes in [N₂], [H₂], and [NH₃].

16.22 Although the depletion of stratospheric ozone threatens life on Earth today, its accumulation was one of the crucial processes that allowed life to develop in prehistoric times:

- (a) Express the reaction rate in terms of $[\text{O}_2]$ and $[\text{O}_3]$.
 (b) At a given instant, the reaction rate in terms of $[\text{O}_2]$ is $2.17 \times 10^{-5} \text{ mol/L}\cdot\text{s}$. What is it in terms of $[\text{O}_3]$?

The Rate Law and Its Components

(Sample Problems 16.2 to 16.4)

Concept Review Questions

16.23 The rate law for the general reaction

is rate = $k[\text{A}]^m[\text{B}]^n \dots$ (a) Explain the meaning of k . (b) Explain the meanings of m and n . Does $m = a$ and $n = b$? Explain. (c) If the reaction is first order in A and second order in B, and time is measured in minutes (min), what are the units for k ?

16.24 You are studying the reaction

to determine its rate law. Assuming that you have a valid experimental procedure for obtaining $[\text{A}_2]$ and $[\text{B}_2]$ at various times, explain how you determine (a) the initial rate, (b) the reaction orders, and (c) the rate constant.

16.25 By what factor does the rate change in each of the following cases (assuming constant temperature)?

- (a) A reaction is first order in reactant A, and $[\text{A}]$ is doubled.
 (b) A reaction is second order in reactant B, and $[\text{B}]$ is halved.
 (c) A reaction is second order in reactant C, and $[\text{C}]$ is tripled.

Skill-Building Exercises (grouped in similar pairs)

16.26 Give the individual reaction orders for all substances and the overall reaction order from the following rate law:

$$\text{Rate} = k[\text{BrO}_3^-][\text{Br}^-][\text{H}^+]^2$$

16.27 Give the individual reaction orders for all substances and the overall reaction order from the following rate law:

$$\text{Rate} = k \frac{[\text{O}_3]^2}{[\text{O}_2]}$$

16.28 By what factor does the rate in Problem 16.26 change if each of the following changes occurs: (a) $[\text{BrO}_3^-]$ is doubled; (b) $[\text{Br}^-]$ is halved; (c) $[\text{H}^+]$ is quadrupled?

16.29 By what factor does the rate in Problem 16.27 change if each of the following changes occurs: (a) $[\text{O}_3]$ is doubled; (b) $[\text{O}_2]$ is doubled; (c) $[\text{O}_2]$ is halved?

16.30 Give the individual reaction orders for all substances and the overall reaction order from this rate law:

$$\text{Rate} = k[\text{NO}_2]^2[\text{Cl}_2]$$

16.31 Give the individual reaction orders for all substances and the overall reaction order from this rate law:

$$\text{Rate} = k \frac{[\text{HNO}_2]^4}{[\text{NO}]^2}$$

16.32 By what factor does the rate in Problem 16.30 change if each of the following changes occurs: (a) $[\text{NO}_2]$ is tripled; (b) $[\text{NO}_2]$ and $[\text{Cl}_2]$ are doubled; (c) $[\text{Cl}_2]$ is halved?

16.33 By what factor does the rate in Problem 16.31 change if each of the following changes occurs: (a) $[\text{HNO}_2]$ is doubled; (b) $[\text{NO}]$ is doubled; (c) $[\text{HNO}_2]$ is halved?

16.34 For the reaction

the following data were obtained at constant temperature:

Experiment	Initial Rate (mol/L·min)	Initial [A] (mol/L)	Initial [B] (mol/L)
1	5.00	0.100	0.100
2	45.0	0.300	0.100
3	10.0	0.100	0.200
4	90.0	0.300	0.200

(a) What is the order with respect to each reactant? (b) Write the rate law. (c) Calculate k (using the data from Expt 1).

16.35 For the reaction

the following data were obtained at constant temperature:

Expt	Initial Rate (mol/L·s)	Initial [A] (mol/L)	Initial [B] (mol/L)	Initial [C] (mol/L)
1	6.25×10^{-3}	0.0500	0.0500	0.0100
2	1.25×10^{-2}	0.1000	0.0500	0.0100
3	5.00×10^{-2}	0.1000	0.1000	0.0100
4	6.25×10^{-3}	0.0500	0.0500	0.0200

(a) What is the order with respect to each reactant? (b) Write the rate law. (c) Calculate k (using the data from Expt 1).

16.36 Without consulting Table 16.3, give the units of the rate constants for reactions with the following overall orders: (a) first order; (b) second order; (c) third order; (d) $\frac{5}{2}$ order.

16.37 Give the overall reaction order that corresponds to a rate constant with each of the following units: (a) mol/L·s; (b) yr⁻¹; (c) (mol/L)^{1/2}·s⁻¹; (d) (mol/L)^{-5/2}·min⁻¹.

Problems in Context

16.38 Phosgene is a toxic gas prepared by the reaction of carbon monoxide with chlorine:

These data were obtained in a kinetics study of its formation:

Experiment	Initial Rate (mol/L·s)	Initial [CO] (mol/L)	Initial [Cl ₂] (mol/L)
1	1.29×10^{-29}	1.00	0.100
2	1.33×10^{-30}	0.100	0.100
3	1.30×10^{-29}	0.100	1.00
4	1.32×10^{-31}	0.100	0.0100

(a) Write the rate law for the formation of phosgene.
 (b) Calculate the average value of the rate constant.

Integrated Rate Laws: Concentration Changes over Time
 (Sample Problems 16.5 to 16.7)

Concept Review Questions

16.39 How are integrated rate laws used to determine reaction order? What is the reaction order in each of these cases?

16.64 For the reaction $A_2 + B_2 \rightarrow 2AB$, $E_{a(fwd)} = 125 \text{ kJ/mol}$ and $E_{a(rev)} = 85 \text{ kJ/mol}$. Assuming the reaction occurs in one step, (a) draw a reaction energy diagram; (b) calculate ΔH_{rxn}° ; and (c) sketch a possible transition state.

Problems in Context

16.65 Understanding the high-temperature formation and breakdown of the nitrogen oxides is essential for controlling the pollutants generated from power plants and cars. The first-order breakdown of dinitrogen monoxide to its elements has rate constants of $0.76/\text{s}$ at 727°C and $0.87/\text{s}$ at 757°C . What is the activation energy of this reaction?

16.66 Aqua regia, a mixture of HCl and HNO_3 , has been used since alchemical times to dissolve many metals, including gold. Its orange color is due to the presence of nitrosyl chloride. Consider this one-step reaction for the formation of this compound:

- (a) Draw a reaction energy diagram, given $E_{a(fwd)} = 86 \text{ kJ/mol}$.
- (b) Calculate $E_{a(rev)}$.
- (c) Sketch a possible transition state for the reaction. (Note: The atom sequence of nitrosyl chloride is $\text{Cl}-\text{N}-\text{O}$.)

Reaction Mechanisms: The Steps from Reactant to Product

(Sample Problems 16.10 and 16.11)

Concept Review Questions

16.67 Is the rate of an overall reaction lower, higher, or equal to the average rate of the individual steps? Explain.

16.68 Explain why the coefficients of an elementary step equal the reaction orders of its rate law but those of an overall reaction do not.

16.69 Is it possible for more than one mechanism to be consistent with the rate law of a given reaction? Explain.

16.70 What is the difference between a reaction intermediate and a transition state?

16.71 Why is a bimolecular step more reasonable physically than a termolecular step?

16.72 If a slow step precedes a fast step in a two-step mechanism, do the substances in the fast step appear in the overall rate law? Explain.

16.73 If a fast step precedes a slow step in a two-step mechanism, how is the fast step affected? How is this effect used to determine the validity of the mechanism?

Skill-Building Exercises (grouped in similar pairs)

16.74 The proposed mechanism for a reaction is

- (1) $A(g) + B(g) \rightleftharpoons X(g)$ [fast]
- (2) $X(g) + C(g) \rightarrow Y(g)$ [slow]
- (3) $Y(g) \rightarrow D(g)$ [fast]

- (a) What is the overall equation?
- (b) Identify the intermediate(s), if any.
- (c) What are the molecularity and the rate law for each step?
- (d) Is the mechanism consistent with the actual rate law?
Rate = $k[A][B][C]$?
- (e) Is the following one-step mechanism equally valid?
 $A(g) + B(g) + C(g) \rightarrow D(g)$?

16.75 Consider the following mechanism:

- (1) $\text{ClO}^-(aq) + \text{H}_2\text{O}(l) \rightleftharpoons \text{HClO}(aq) + \text{OH}^-(aq)$ [fast]
- (2) $\text{I}^-(aq) + \text{HClO}(aq) \rightarrow \text{HIO}(aq) + \text{Cl}^-(aq)$ [slow]
- (3) $\text{OH}^-(aq) + \text{HIO}(aq) \rightarrow \text{H}_2\text{O}(l) + \text{IO}^-(aq)$ [fast]

- (a) What is the overall equation?
- (b) Identify the intermediate(s), if any.
- (c) What are the molecularity and the rate law for each step?
- (d) Is the mechanism consistent with the actual rate law: Rate = $k[\text{ClO}^-][\text{I}^-]$?

Problems in Context

16.76 In a study of nitrosyl halides, a chemist proposes the following mechanism for the synthesis of nitrosyl bromide:

If the rate law is rate = $k[\text{NO}]^2[\text{Br}_2]$, is the proposed mechanism valid? If so, show that it satisfies the three criteria for validity.

16.77 The rate law for $2\text{NO}(g) + \text{O}_2(g) \rightarrow 2\text{NO}_2(g)$ is rate = $k[\text{NO}]^2[\text{O}_2]$. In addition to the mechanism in the text (Section 16.6), the following ones have been proposed:

- I $2\text{NO}(g) + \text{O}_2(g) \rightarrow 2\text{NO}_2(g)$
- II $2\text{NO}(g) \rightleftharpoons \text{N}_2\text{O}_2(g)$ [fast]
 $\text{N}_2\text{O}_2(g) + \text{O}_2(g) \rightarrow 2\text{NO}_2(g)$ [slow]
- III $2\text{NO}(g) \rightleftharpoons \text{N}_2(g) + \text{O}_2(g)$ [fast]
 $\text{N}_2(g) + 2\text{O}_2(g) \rightarrow 2\text{NO}_2(g)$ [slow]

- (a) Which of these mechanisms is consistent with the rate law?
- (b) Which of these mechanisms is most reasonable? Why?

Catalysis: Speeding Up a Reaction

Concept Review Questions

16.78 Consider the reaction $\text{N}_2\text{O}(g) \xrightarrow{\text{Au}} \text{N}_2(g) + \frac{1}{2}\text{O}_2(g)$.

- (a) Does the gold catalyst (Au, above the arrow) act as a homogeneous or a heterogeneous catalyst?
- (b) On the same set of axes, sketch the reaction energy diagrams for the catalyzed and the uncatalyzed reaction.

16.79 Does a catalyst increase reaction rate by the same means as a rise in temperature does? Explain.

16.80 In a classroom demonstration, hydrogen gas and oxygen gas are mixed in a balloon. The mixture is stable under normal conditions, but if a spark is applied to it or some powdered metal is added, the mixture explodes. (a) Is the spark acting as a catalyst? Explain. (b) Is the metal acting as a catalyst? Explain.

16.81 A principle of green chemistry is that the energy needs of industrial processes should have minimal environmental impact. How can the use of catalysts lead to “greener” technologies?

16.82 Enzymes are remarkably efficient catalysts that can increase reaction rates by as many as 20 orders of magnitude.

- (a) How does an enzyme affect the transition state of a reaction, and how does this effect increase the reaction rate?
- (b) What characteristics of enzymes give them this effectiveness as catalysts?

Comprehensive Problems

16.83 Experiments show that each of the following redox reactions is second order overall:

- (a) When $[NO_2]$ in reaction 1 is doubled, the rate quadruples. Write the rate law for this reaction.
- (b) When $[NO]$ in reaction 2 is doubled, the rate doubles. Write the rate law for this reaction.
- (c) In each reaction, the initial concentrations of the reactants are equal. For each reaction, what is the ratio of the initial rate to the rate when the reaction is 50% complete?
- (d) In reaction 1, the initial $[NO_2]$ is twice the initial $[CO]$. What is the ratio of the initial rate to the rate at 50% completion?
- (e) In reaction 2, the initial $[NO]$ is twice the initial $[O_3]$. What is the ratio of the initial rate to the rate at 50% completion?

16.84 Consider the following reaction energy diagram:

- (a) How many elementary steps are in the reaction mechanism?
 (b) Which step is rate-limiting?
 (c) Is the overall reaction exothermic or endothermic?

16.85 Reactions between certain haloalkanes (alkyl halides) and water produce alcohols. Consider the overall reaction for *t*-butyl bromide (2-bromo-2-methylpropane):

The experimental rate law is rate = $k[(CH_3)_3CBr]$. The accepted mechanism for the reaction is

- (1) $(CH_3)_3C-Br(aq) \longrightarrow (CH_3)_3C^+(aq) + Br^-(aq)$ [slow]
 (2) $(CH_3)_3C^+(aq) + H_2O(l) \longrightarrow (CH_3)_3C-OH_2^+(aq)$ [fast]
 (3) $(CH_3)_3C-OH_2^+(aq) \longrightarrow H^+(aq) + (CH_3)_3C-OH(aq)$ [fast]

- (a) Why doesn't H_2O appear in the rate law?
 (b) Write rate laws for the elementary steps.
 (c) What reaction intermediates appear in the mechanism?
 (d) Show that the mechanism is consistent with the experimental rate law.

16.86 Archeologists can determine the age of an artifact made of wood or bone by measuring the amount of the radioactive isotope ^{14}C present in the object. The amount of this isotope decreases in a first-order process. If 15.5% of the original amount of ^{14}C is present in a wooden tool at the time of analysis, what is the age of the tool? The half-life of ^{14}C is 5730 yr.

16.87 A slightly bruised apple will rot extensively in about 4 days at room temperature (20°C). If it is kept in the refrigerator at 0°C, the same extent of rotting takes about 16 days. What is the activation energy for the rotting reaction?

16.88 Benzoyl peroxide, the substance most widely used against acne, has a half-life of 9.8×10^3 days when refrigerated. How long will it take to lose 5% of its potency (95% remaining)?

16.89 The rate law for the reaction

is rate = $k[NO_2]^2$; one possible mechanism is shown on p. 723.
 (a) Draw a reaction energy diagram for that mechanism, given that $\Delta H_{\text{overall}}^\circ = -226 \text{ kJ/mol}$.

(b) Consider the following alternative mechanism:

- (1) $2NO_2(g) \longrightarrow N_2(g) + 2O_2(g)$ [slow]
 (2) $2CO(g) + O_2(g) \longrightarrow 2CO_2(g)$ [fast]
 (3) $N_2(g) + O_2(g) \longrightarrow 2NO(g)$ [fast]

Is the alternative mechanism consistent with the rate law? Is one mechanism more reasonable physically? Explain.

16.90 Consider the following general reaction and data:

Expt	Initial Rate (mol/L·s)	Initial [A] (mol/L)	Initial [B] (mol/L)	Initial [C] (mol/L)
1	6.0×10^{-6}	0.024	0.085	0.032
2	9.6×10^{-5}	0.096	0.085	0.032
3	1.5×10^{-5}	0.024	0.034	0.080
4	1.5×10^{-6}	0.012	0.170	0.032

- (a) What is the reaction order with respect to each reactant?
 (b) Calculate the rate constant.
 (c) Write the rate law for this reaction.
 (d) Express the rate in terms of changes in concentration with time for each of the components.

16.91 In acidic solution, the breakdown of sucrose into glucose and fructose has this rate law: rate = $k[H^+][\text{sucrose}]$. The initial rate of sucrose breakdown is measured in a solution that is 0.01 M H^+ , 1.0 M sucrose, 0.1 M fructose, and 0.1 M glucose. How does the rate change if

- (a) [sucrose] is changed to 2.5 M?
 (b) [sucrose], [fructose], and [glucose] are all changed to 0.5 M?
 (c) $[H^+]$ is changed to 0.0001 M?
 (d) [sucrose] and $[H^+]$ are both changed to 0.1 M?

16.92 The citric acid cycle is the central reaction sequence in the cellular metabolism of humans and many other organisms. One of the key steps is catalyzed by the enzyme isocitrate dehydrogenase and the oxidizing agent NAD^+ . In yeast, the reaction is eleventh order:

$$\text{Rate} = k[\text{enzyme}] [\text{isocitrate}]^4 [\text{AMP}]^2 [NAD^+]^m [\text{Mg}^{2+}]^2$$

What is the order with respect to NAD^+ ?

16.93 The following molecular scenes represent starting mixtures I and II for the reaction of A (black) with B (orange):

Each sphere represents 0.010 mol, and the volume is 0.50 L. If the reaction is first order in A and first order in B and the initial rate for I is $8.3 \times 10^{-4} \text{ mol/L}\cdot\text{min}$, what is the initial rate for II?

16.94 Experiment shows that the rate of formation of carbon tetrachloride from chloroform,

is first order in $CHCl_3$, $\frac{1}{2}$ order in Cl_2 , and $\frac{3}{2}$ order overall. Show that the following mechanism is consistent with the rate law:

- (1) $Cl_2(g) \rightleftharpoons 2Cl(g)$ [fast]
 (2) $Cl(g) + CHCl_3(g) \longrightarrow HCl(g) + CCl_3(g)$ [slow]
 (3) $CCl_3(g) + Cl(g) \longrightarrow CCl_4(g)$ [fast]

16.95 A biochemist studying the breakdown of the insecticide DDT finds that it decomposes by a first-order reaction with a half-

life of 12 yr. How long does it take DDT in a soil sample to decrease from 275 ppbm to 10. ppbm (parts per billion by mass)?

16.96 Insulin is a polypeptide hormone that is released into the blood from the pancreas and stimulates fat and muscle to take up glucose; the insulin is used up in a first-order process. In a certain patient, this process has a half-life of 3.5 min. To maintain an adequate blood concentration of insulin, it must be replenished in a time interval equal to $1/k$. How long is the time interval for this patient?

16.97 For the reaction $A(g) + B(g) \rightarrow AB(g)$, the rate is $0.20 \text{ mol/L}\cdot\text{s}$, when $[A]_0 = [B]_0 = 1.0 \text{ mol/L}$. If the reaction is first order in B and second order in A, what is the rate when $[A]_0 = 2.0 \text{ mol/L}$ and $[B]_0 = 3.0 \text{ mol/L}$?

16.98 The acid-catalyzed hydrolysis of sucrose occurs by the following overall reaction, whose kinetic data are given below:

[Sucrose] (mol/L)	Time (h)
0.501	0.00
0.451	0.50
0.404	1.00
0.363	1.50
0.267	3.00

- (a) Determine the rate constant and the half-life of the reaction.
 - (b) How long does it take to hydrolyze 75% of the sucrose?
 - (c) Some studies have shown that this reaction is actually second order overall but appears to follow first-order kinetics. (Such a reaction is called a *pseudo-first-order reaction*.) Suggest a reason for this apparent first-order behavior.

16.99 At body temperature (37°C), the rate constant of an enzyme-catalyzed decomposition is 2.3×10^{14} times that of the uncatalyzed reaction. If the frequency factor, A , is the same for both processes, by how much does the enzyme lower the E_a ?

16.100 Is each of these statements true? If not, explain why.

- (a) At a given T , all molecules have the same kinetic energy.
 - (b) Halving the P for a gaseous reaction doubles the rate.
 - (c) A higher activation energy gives a lower reaction rate.
 - (d) A temperature rise of 10°C doubles the rate of any reaction.
 - (e) If reactant molecules collide with greater energy than the activation energy, they change into product molecules.
 - (f) The activation energy of a reaction depends on temperature.
 - (g) The rate of a reaction increases as the reaction proceeds.
 - (h) Activation energy depends on collision frequency.
 - (i) A catalyst increases the rate by increasing collision frequency.
 - (j) Exothermic reactions are faster than endothermic reactions.
 - (k) Temperature has no effect on the frequency factor (A).
 - (l) The activation energy of a reaction is lowered by a catalyst.
 - (m) For most reactions, ΔH_{rxn} is lowered by a catalyst.
 - (n) The orientation probability factor (p) is near 1 for reactions between single atoms.
 - (o) The initial rate of a reaction is its maximum rate.
 - (p) A bimolecular reaction is generally twice as fast as a unimolecular reaction.
 - (q) The molecularity of an elementary reaction is proportional to the molecular complexity of the reactant(s).

16.101 For the decomposition of gaseous dinitrogen pentoxide,

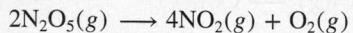

the rate constant is $k = 2.8 \times 10^{-3} \text{ s}^{-1}$ at 60°C . The initial concentration of N_2O_5 is 1.58 mol/L . (a) What is $[\text{N}_2\text{O}_5]$ after 5.00 min? (b) What fraction of the N_2O_5 has decomposed after 5.00 min?

16.102 Even when a mechanism is consistent with the rate law, later work may show it to be incorrect. For example, the reaction between hydrogen and iodine has this rate law: rate = $k[H_2][I_2]$. The long-accepted mechanism had a single bimolecular step; that is, the overall reaction was thought to be elementary:

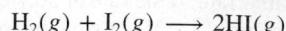

In the 1960s, however, spectroscopic evidence showed the presence of free I atoms during the reaction. Kineticists have since proposed a three-step mechanism:

- $$\begin{array}{l} (1) \text{I}_2(g) \rightleftharpoons 2\text{I}(g) \\ (2) \text{H}_2(g) + \text{I}(g) \rightleftharpoons \text{H}_2\text{I}(g) \\ (3) \text{H}_2\text{I}(g) + \text{I}(g) \longrightarrow 2\text{HI}(g) \end{array}$$

Show that this mechanism is consistent with the rate law.

16.103 Suggest an experimental method for measuring the change in concentration with time for each of the following reactions:

- (a) $\text{CH}_3\text{CH}_2\text{Br}(l) + \text{H}_2\text{O}(l) \longrightarrow \text{CH}_3\text{CH}_2\text{OH}(l) + \text{HBr}(aq)$
 (b) $2\text{NO}(g) + \text{Cl}_2(g) \longrightarrow 2\text{NOCl}(g)$

16.104 An atmospheric chemist fills a container with gaseous N_2O_5 to a pressure of 125 kPa, and the gas decomposes to NO_2 and O_2 . What is the partial pressure of NO_2 , P_{NO_2} (in kPa), when the total pressure is 178 kPa?

16.105 Many drugs decompose in blood by a first-order process.

- (a) Two tablets of aspirin supply 0.60 g of the active compound. After 30 min, this compound reaches a maximum concentration of 2 mg/100 mL of blood. If the half-life for its breakdown is 90 min, what is its concentration (in mg/100 mL) 2.5 h after it reaches its maximum concentration? (b) For the decomposition of an antibiotic in a person with a normal temperature (98.6°F), $k = 3.1 \times 10^{-5} \text{ s}^{-1}$; for a person with a fever (temperature of 101.9°F), $k = 3.9 \times 10^{-5} \text{ s}^{-1}$. If the person with the fever must take another pill when $\frac{2}{3}$ of the first pill has decomposed, how many hours should she wait to take a second pill? A third pill? (Assume that the pill is effective immediately.) (c) Calculate E_a for decomposition of the antibiotic in part (b).

16.106 While developing a catalytic process to make ethylene glycol from synthesis gas ($\text{CO} + \text{H}_2$), a chemical engineer finds the rate to be fourth order with respect to gas pressure. The uncertainty in the pressure reading is 5%. When the catalyst is modified, the rate increases by 10%. If you were the company patent attorney, would you file for a patent on this catalyst modification? Explain.

16.107 Iodide ion reacts with chloromethane to displace chloride ion in a common organic substitution reaction:

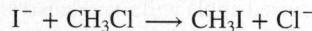

- (a) Draw a wedge-bond structure of chloroform, and indicate the most effective direction of I^- attack.
 (b) The analogous reaction with 2-chlorobutane results in a major change in specific rotation as measured by polarimetry. Explain, showing a wedge-bond structure of the product.

(c) Under different conditions, 2-chlorobutane loses Cl^- in a rate-determining step to form a planar intermediate. This cationic species reacts with HI and then loses H^+ to form a product that exhibits no optical activity. Explain, showing a wedge-bond structure.

16.108 Assume that water boils at 100.0°C in Houston (near sea level), and at 90.0°C in Cripple Creek, Colorado (near 9500 ft). If it takes 4.8 min to cook an egg in Cripple Creek and 4.5 min in Houston, what is E_a for this process?

16.109 Sulfonation of benzene has the following mechanism:

- (1) $2\text{H}_2\text{SO}_4 \longrightarrow \text{H}_3\text{O}^+ + \text{HSO}_4^- + \text{SO}_3$ [fast]
- (2) $\text{SO}_3 + \text{C}_6\text{H}_6 \longrightarrow \text{H}(\text{C}_6\text{H}_5^+)\text{SO}_3^-$ [slow]
- (3) $\text{H}(\text{C}_6\text{H}_5^+)\text{SO}_3^- + \text{HSO}_4^- \longrightarrow \text{C}_6\text{H}_5\text{SO}_3^- + \text{H}_2\text{SO}_4$ [fast]
- (4) $\text{C}_6\text{H}_5\text{SO}_3^- + \text{H}_3\text{O}^+ \longrightarrow \text{C}_6\text{H}_5\text{SO}_3\text{H} + \text{H}_2\text{O}$ [fast]

(a) Write an overall equation for the reaction. (b) Write the overall rate law in terms of the initial rate of the reaction.

16.110 In the lower troposphere, ozone is one of the components of photochemical smog. It is generated in air when nitrogen dioxide, formed by the oxidation of nitrogen monoxide from car exhaust, reacts by the following mechanism:

- (1) $\text{NO}_2(g) \xrightarrow[hv]{k_1} \text{NO}(g) + \text{O}(g)$
- (2) $\text{O}(g) + \text{O}_2(g) \xrightarrow[hv]{k_2} \text{O}_3(g)$

Assuming the rate of formation of atomic oxygen in step 1 equals the rate of its consumption in step 2, use the data below to calculate (a) the concentration of atomic oxygen $[\text{O}]$ and (b) the rate of ozone formation.

$$\begin{aligned} k_1 &= 6.0 \times 10^{-3} \text{ s}^{-1} & [\text{NO}_2] &= 4.0 \times 10^{-9} \text{ M} \\ k_2 &= 1.0 \times 10^6 \text{ L/mol} \cdot \text{s} & [\text{O}_2] &= 1.0 \times 10^{-2} \text{ M} \end{aligned}$$

16.111 Chlorine is commonly used to disinfect drinking water, and inactivation of pathogens by chlorine follows first-order kinetics. The following data are for *E. coli* inactivation:

Contact Time (min)	Percent (%) Inactivation
0.00	0.0
0.50	68.3
1.00	90.0
1.50	96.8
2.00	99.0
2.50	99.7
3.00	99.9

(a) Determine the first-order inactivation constant, k .

[Hint: % inactivation = $100 \times (1 - [\text{A}]/[\text{A}]_0)$.]

(b) How much contact time is required for 95% inactivation?

16.112 The overall equation and rate law for the gas-phase decomposition of dinitrogen pentoxide are

Which of the following can be considered valid mechanisms for the reaction?

I One-step collision

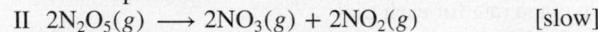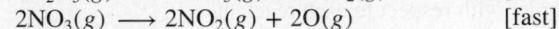

16.113 Nitrification is a biological process for removing NH_3 from wastewater as NH_4^+ :

The first-order rate constant is given as

$$k_1 = 0.47e^{0.095(T - 15^\circ\text{C})}$$

where k_1 is in day $^{-1}$ and T is in $^\circ\text{C}$.

(a) If the initial concentration of NH_3 is 3.0 mol/m^3 , how long will it take to reduce the concentration to 0.35 mol/m^3 in the spring ($T = 20^\circ\text{C}$)?

(b) In the winter ($T = 10^\circ\text{C}$)?

(c) Using your answer to part (a), what is the rate of O_2 consumption?

16.114 Carbon disulfide, a poisonous, flammable liquid, is an excellent solvent for phosphorus, sulfur, and some other nonmetals. A kinetic study of its gaseous decomposition gave these data:

Experiment	Initial Rate (mol/L·s)	Initial $[\text{CS}_2]$ (mol/L)
1	2.7×10^{-7}	0.100
2	2.2×10^{-7}	0.080
3	1.5×10^{-7}	0.055
4	1.2×10^{-7}	0.044

(a) Write the rate law for the decomposition of CS_2 .

(b) Calculate the average value of the rate constant.

16.115 Like any catalyst, palladium, platinum, or nickel catalyzes both directions of a reaction: addition of hydrogen to (hydrogenation) and its elimination from (dehydrogenation) carbon double bonds.

(a) Which variable determines whether an alkene will be hydrogenated or dehydrogenated?

(b) Which reaction requires a higher temperature?

(c) How can all-*trans* fats arise during hydrogenation of fats that contain some double bonds with a *cis* orientation?

16.116 In a *clock reaction*, a dramatic color change occurs at a time determined by concentration and temperature. Consider the iodine clock reaction, whose overall equation is

As I_2 forms, it is immediately consumed by its reaction with a fixed amount of added $\text{S}_2\text{O}_3^{2-}$:

Once the $\text{S}_2\text{O}_3^{2-}$ is consumed, the excess I_2 forms a blue-black product with starch present in solution:

The rate of the reaction is also influenced by the total concentration of ions, so KCl and $(\text{NH}_4)_2\text{SO}_4$ are added to maintain a constant value. Use the data below, obtained at 23°C, to determine:

- The average rate for each trial
- The order with respect to each reactant
- The rate constant
- The rate law for the overall reaction

	Expt 1	Expt 2	Expt 3
0.200 M KI (mL)	10.0	20.0	20.0
0.100 M $\text{Na}_2\text{S}_2\text{O}_8$ (mL)	20.0	20.0	10.0
0.0050 M $\text{Na}_2\text{S}_2\text{O}_3$ (mL)	10.0	10.0	10.0
0.200 M KCl (mL)	10.0	0.0	0.0
0.100 M $(\text{NH}_4)_2\text{SO}_4$ (mL)	0.0	0.0	10.0
Time to color (s)	29.0	14.5	14.5

16.117 Heat transfer to and from a reaction flask is often a critical factor in controlling reaction rate. The heat transferred (q) depends on a heat transfer coefficient (h) for the flask material, the temperature difference (ΔT) across the flask wall, and the commonly “wetted” area (A) of the flask and bath: $q = hA\Delta T$. When an exothermic reaction is run at a given T , there is a bath temperature at which the reaction can no longer be controlled, and the reaction “runs away” suddenly. A similar problem is often seen when a reaction is “scaled up” from, say, a half-filled small flask to a half-filled large flask. Explain these behaviors.

16.118 The growth of *Pseudomonas* bacteria is modeled as a first-order process with $k = 0.035 \text{ min}^{-1}$ at 37°C. The initial *Pseudomonas* population density is $1.0 \times 10^3 \text{ cells/L}$. (a) What is the population density after 2 h? (b) What is the time required for the population to go from 1.0×10^3 to $2.0 \times 10^3 \text{ cells/L}$?

16.119 Consider the following organic reaction, in which one halogen replaces another in a haloalkane:

In acetone, this particular reaction goes to completion because KI is soluble in acetone but KBr is not. In the mechanism, I^- approaches the carbon *opposite* to the Br (see Figure 16.20, with I^- instead of OH^-). After Br^- has been replaced by I^- and precipitates as KBr, other I^- ions react with the ethyl iodide by the same mechanism.

- If we designate the carbon bonded to the halogen as C-1, what is the shape around C-1 and the hybridization of C-1 in ethyl iodide?
- In the transition state, one of the two lobes of the unhybridized $2p$ orbital of C-1 overlaps a p orbital of I, while the other lobe overlaps a p orbital of Br. What is the shape around C-1 and the hybridization of this carbon in the transition state?
- The deuterated reactant, $\text{CH}_3\text{CHD}\text{Br}$ (where D is deuterium, ${}^2\text{H}$), has two optical isomers because C-1 is chiral. If the reaction is run with one of the isomers, the ethyl iodide is *not* optically active. Explain.

16.120 Another radioisotope of iodine, ${}^{131}\text{I}$, is also used to study thyroid function (see Follow-up Problem 16.7A). A patient is given a sample that is $1.7 \times 10^{-4} \text{ M}$ ${}^{131}\text{I}$. If the half-life is 8.04 days, what fraction of the radioactivity remains after 30. days?

16.121 The effect of substrate concentration on the first-order growth rate of a microbial population follows the Monod equation:

$$\mu = \frac{\mu_{\max} S}{K_s + S}$$

where μ is the first-order growth rate (s^{-1}), μ_{\max} is the maximum growth rate (s^{-1}), S is the substrate concentration (kg/m^3), and K_s is the value of S that gives one-half of the maximum growth rate (in kg/m^3). For $\mu_{\max} = 1.5 \times 10^{-4} \text{ s}^{-1}$ and $K_s = 0.03 \text{ kg/m}^3$:

- Plot μ vs. S for S between 0.0 and 1.0 kg/m^3 .
- The initial population density is $5.0 \times 10^3 \text{ cells/m}^3$. What is the density after 1.0 h, if the initial S is 0.30 kg/m^3 ?
- What is it if the initial S is 0.70 kg/m^3 ?

16.122 The scenes depict four initial reaction mixtures for the reaction of A (blue) and B (yellow), with and without a solid present (gray cubes). The initial rate, $-\Delta[\text{A}]/\Delta t$ (in $\text{mol/L}\cdot\text{s}$), is shown, with each sphere representing 0.010 mol and the container volume at 0.50 L.

- What is the rate law in the absence of a catalyst?
- What is the overall reaction order?
- Find the rate constant.
- Do the gray cubes have a catalytic effect? Explain.

16.123 The mathematics of the first-order rate law can be applied to any situation in which a quantity decreases by a constant fraction per unit of time (or unit of any other variable).

- As light moves through a solution, its intensity decreases per unit distance traveled in the solution. Show that

$$\ln \left(\frac{\text{intensity of light leaving the solution}}{\text{intensity of light entering the solution}} \right) = -\text{fraction of light removed per unit of length} \times \text{distance traveled in solution}$$

- The value of your savings declines under conditions of constant inflation. Show that

$$\ln \left(\frac{\text{value remaining}}{\text{initial value}} \right) = -\text{fraction lost per unit of time} \times \text{savings time interval}$$

16.124 Figure 16.25 shows key steps in the metal-catalyzed (M) hydrogenation of ethene:

Use the following symbols to write a mechanism that gives the overall equation:

$H_2(ads)$	adsorbed hydrogen molecules
$M-H$	hydrogen atoms bonded to metal atoms
$C_2H_4(ads)$	adsorbed ethene molecules
$C_2H_5(ads)$	adsorbed ethyl radicals

16.125 Human liver enzymes catalyze the degradation of ingested toxins. By what factor is the rate of a detoxification changed if an enzyme lowers the E_a by 5 kJ/mol at 37°C?

16.126 Acetone is one of the most important solvents in organic chemistry, used to dissolve everything from fats and waxes to airplane glue and nail polish. At high temperatures, it decomposes in a first-order process to methane and ketene ($CH_2=C=O$). At 600°C, the rate constant is $8.7 \times 10^{-3} \text{ s}^{-1}$.

(a) What is the half-life of the reaction?

(b) How long does it take for 40% of a sample of acetone to decompose?

(c) How long does it take for 90% of a sample of acetone to decompose?

16.127 A (green), B (blue), and C (red) are structural isomers. The molecular filmstrip depicts them undergoing a chemical change as time proceeds.

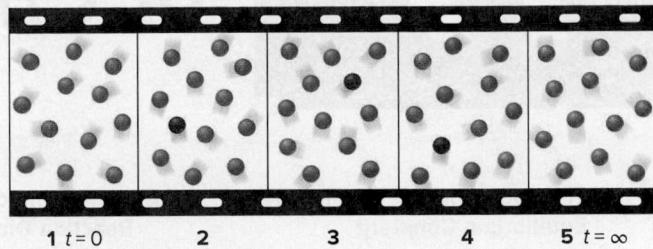

(a) Write a mechanism for the reaction.

(b) What role does C play?

17

Equilibrium: The Extent of Chemical Reactions

17.1 The Equilibrium State and the Equilibrium Constant

17.2 The Reaction Quotient and the Equilibrium Constant

The Changing Value of the Reaction Quotient
Writing the Reaction Quotient (Q)

17.3 Expressing Equilibria with Pressure Terms: Relation Between K_c and K_p

17.4 Comparing Q and K to Determine Reaction Direction

17.5 How to Solve Equilibrium Problems

Using Quantities to Find K
Using K to Find Quantities
Problems Involving Mixtures of Reactants and Products

17.6 Reaction Conditions and Equilibrium: Le Châtelier's Principle

Change in Concentration
Change in Pressure (Volume)
Change in Temperature
Lack of Effect of a Catalyst
Synthesis of Ammonia

Source: © hxdbzxy/Shutterstock.com

Concepts and Skills to Review Before You Study This Chapter

- › reversibility of reactions (Section 4.7)
- › dependence of rate on concentration (Sections 16.2 and 16.5)
- › equilibrium vapor pressure (Section 12.2)
- › rate laws for elementary reactions (Section 16.6)
- › equilibrium nature of a saturated solution (Section 13.4)
- › function of a catalyst (Section 16.7)

Just as reactions vary greatly in their speed, they also vary greatly in their extent. Indeed, kinetics and equilibrium apply to different aspects of a reaction:

- Kinetics applies to the *speed* (or rate) of a reaction, the concentration of reactant that disappears (or of product that appears) per unit time.
- Equilibrium applies to the *extent* of a reaction, the concentrations of reactant and product present after an unlimited time, that is, when no further change is occurring.

As you'll see, at equilibrium, no further *net* change occurs because the forward and reverse reactions reach a *balance*. Like traffic going back and forth across a bridge or people going up and down an escalator, the change in one direction is balanced by the change in the other. A fast reaction may go almost completely, just partially, or only slightly toward products before this balance is reached. Consider acid dissociation in water. In 1 M HCl, virtually all the hydrogen chloride molecules are dissociated into ions, whereas fewer than 1% of the acetic acid molecules are dissociated in 1 M CH₃COOH. Yet both reactions take less than a second. Similarly, some slow reactions yield a large amount of product, whereas others yield very little. After a few years, a steel water tank will start to rust, and it will do so completely given enough time. But, no matter how long you wait, the water inside the tank will not decompose to hydrogen and oxygen.

Knowing the extent of a given reaction is crucial. How much product—medicine, polymer, or fuel—can you obtain from a particular reaction mixture? How can you adjust conditions to obtain more? If a reaction is slow but eventually has a good yield, will a catalyst speed it up enough to make it useful?

IN THIS CHAPTER . . . We consider the principles of equilibrium in systems of gases and/or pure liquids and solids.

- › We examine the equilibrium state at the macroscopic and molecular levels and see that equilibrium occurs when the forward and reverse reaction rates are equal.
- › We contrast the reaction quotient, *Q*, which changes as the reaction proceeds, with the equilibrium constant, *K*, which applies to the reaction at equilibrium.
- › We express the equilibrium condition in terms of concentrations or pressures and see how the two expressions are related.
- › We compare values of *Q* and *K* to determine the direction in which a system must proceed to reach equilibrium.
- › We develop a systematic approach to solving a variety of equilibrium problems.
- › We explore Le Châtelier's principle, which explains how a change in conditions—in concentration, pressure, or temperature or by addition of a catalyst—affects the equilibrium state, and we apply this principle to a major industrial process.
- › We introduce equilibrium concepts operating in metabolic pathways.

17.1 THE EQUILIBRIUM STATE AND THE EQUILIBRIUM CONSTANT

Experimental results from countless reactions have shown that, *given sufficient time, the concentrations of reactants and products attain certain values that no longer change*. This apparent cessation of chemical change occurs because *all reactions are reversible and reach a state of equilibrium*. Let's examine a chemical system at the

macroscopic and molecular levels to see how equilibrium arises and then consider some quantitative aspects of the process.

1. A macroscopic view of equilibrium. The system we'll consider is the reversible gaseous reaction between colorless dinitrogen tetroxide and brown nitrogen dioxide:

As soon as we introduce some liquid N_2O_4 ($\text{bp} = 21^\circ\text{C}$) into a sealed container kept at 200°C (473 K), it vaporizes, and the gas begins to turn pale brown as NO_2 is produced. As time passes, the brown darkens, until, after more time, the color stops changing. The first three photos in Figure 17.1 show the color change, and the last photo shows no further change.

2. A molecular view of equilibrium. On the molecular level, as shown in the blow-up circles of Figure 17.1, a dynamic scene unfolds:

- The N_2O_4 molecules fly wildly throughout the container, a few splitting into two NO_2 molecules.
- As time passes, more N_2O_4 molecules decompose and the concentration of NO_2 rises.
- As the number of N_2O_4 molecules decreases, N_2O_4 decomposition slows down (recall that reaction rate decreases with decreasing reactant concentration for most reactions).
- At the same time, as the number of NO_2 molecules increases, more collide, and formation of N_2O_4 (the reverse reaction) speeds up.
- Eventually, the system reaches equilibrium: N_2O_4 molecules are decomposing into NO_2 molecules just as fast as NO_2 molecules are forming N_2O_4 .

Thus, at equilibrium, *reactant and product concentrations are constant because a change in one direction is balanced by a change in the other as the forward and reverse rates become equal*:

$$\text{At equilibrium: } \text{rate}_{\text{fwd}} = \text{rate}_{\text{rev}} \quad (17.1)$$

3. A quantitative view of equilibrium: a constant ratio of constants. Let's see how reactant and product concentrations affect this process. At a particular temperature, when the system reaches equilibrium, we have

$$\text{rate}_{\text{fwd}} = \text{rate}_{\text{rev}}$$

In this reaction system, both forward and reverse reactions are elementary steps (Section 16.6), so we can write their rate laws directly from the balanced equation:

$$k_{\text{fwd}}[\text{N}_2\text{O}_4]_{\text{eq}} = k_{\text{rev}}[\text{NO}_2]^2_{\text{eq}}$$

Figure 17.1 Reaching equilibrium on the macroscopic and molecular levels.

Source: © McGraw-Hill Education/Stephen Frisch, photographer

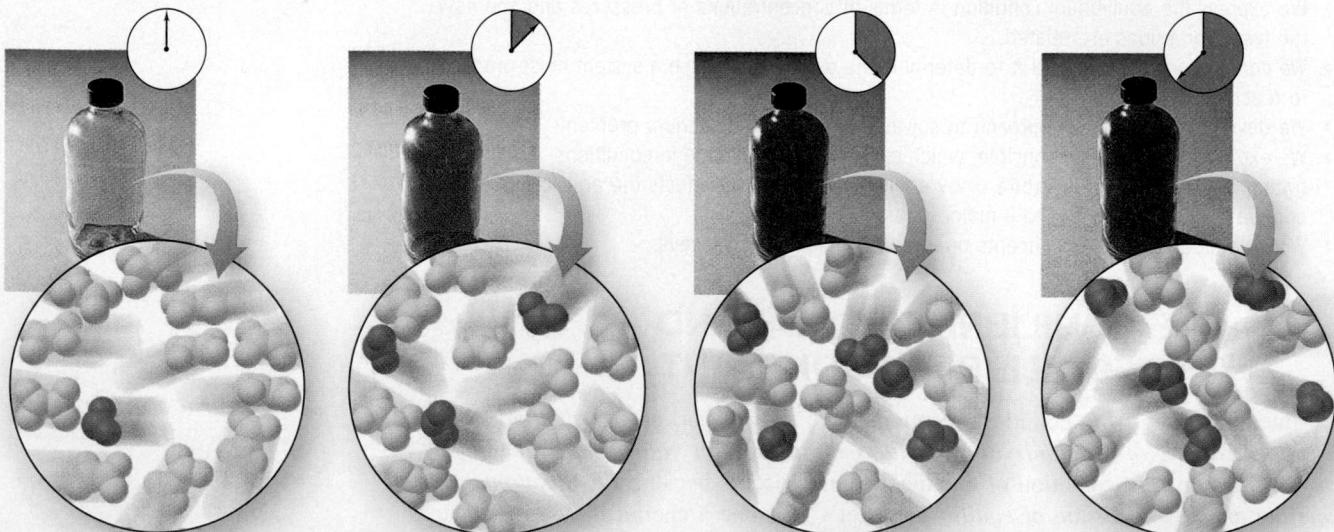

The reaction mixture consists mostly of colorless N_2O_4 .

As N_2O_4 decomposes to NO_2 , the mixture becomes pale brown.

The brown color deepens as more N_2O_4 decomposes and more NO_2 is produced, until the color reaches a maximum at equilibrium.

The reaction continues in both directions at equal rates, so the concentrations of NO_2 and N_2O_4 , and therefore the color, no longer change.

where k_{fwd} and k_{rev} are the forward and reverse rate constants, respectively, and the subscript “eq” refers to concentrations at equilibrium. By rearranging, we set the ratio of the rate constants equal to the ratio of the concentration terms:

$$\frac{k_{\text{fwd}}}{k_{\text{rev}}} = \frac{[\text{NO}_2]_{\text{eq}}^2}{[\text{N}_2\text{O}_4]_{\text{eq}}}$$

The ratio of rate constants creates a new constant called the **equilibrium constant (K)**:

$$K = \frac{k_{\text{fwd}}}{k_{\text{rev}}} = \frac{[\text{NO}_2]_{\text{eq}}^2}{[\text{N}_2\text{O}_4]_{\text{eq}}} \quad (17.2)$$

Thus, K is a number equal to a particular ratio of equilibrium concentrations of product(s) and reactant(s) at a particular temperature.

4. *K as a measure of reaction extent.* The magnitude of K is an indication of how far a reaction proceeds toward product at a given temperature. Different reactions, even at the same temperature, have a wide range of concentrations at equilibrium—from almost all reactant to almost all product—and so, they have a wide range of equilibrium constants. Here are three examples of different magnitudes of K :

- *Small K* (Figure 17.2A). If a reaction yields little product before reaching equilibrium, the ratio of product concentration to reactant concentration is small, and the reaction has a small K ; if K is very small, we may say there is “no reaction.” For example, there is “no reaction” between nitrogen and oxygen at 1000 K:^{*}

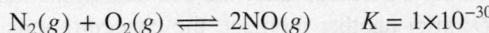

- *Large K* (Figure 17.2B). Conversely, if a reaction reaches equilibrium with little reactant remaining, its ratio of product concentration to reactant concentration is large, and it has a large K ; if K is very large, we say the reaction “goes to completion.” The oxidation of carbon monoxide “goes to completion” at 1000 K:

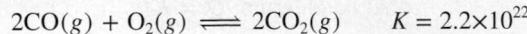

- *Intermediate K* (Figure 17.2C). When significant amounts of both reactant and product are present at equilibrium, K has an intermediate value, as when bromine monochloride breaks down to its elements at 1000 K:

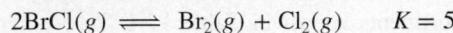

Figure 17.2 The range of equilibrium constants.

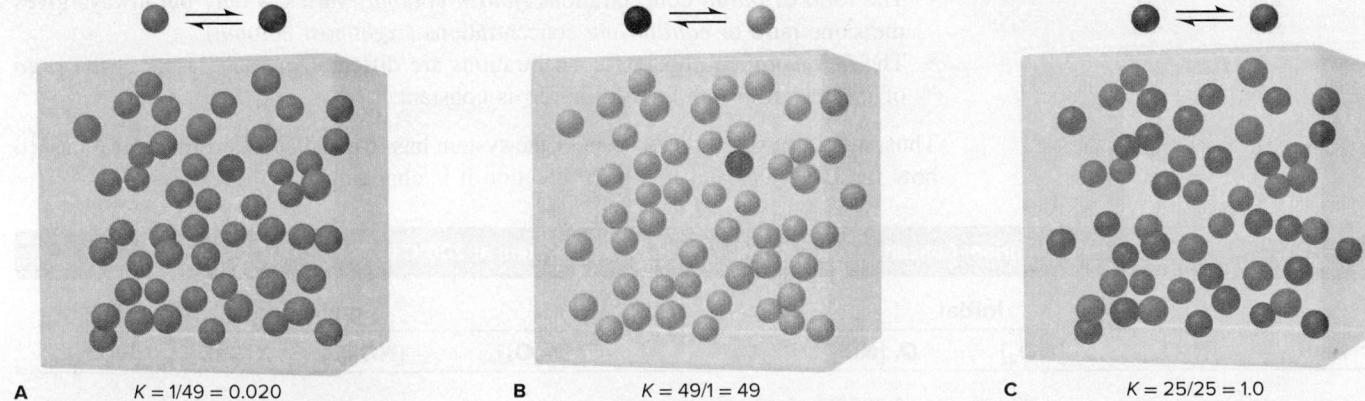

› Summary of Section 17.1

- › Kinetics and equilibrium are distinct aspects of a reaction system, and the rate and extent of a reaction are not necessarily related.
- › When the forward and reverse reactions occur at the same rate, concentrations no longer change and the system has reached equilibrium.
- › The equilibrium constant (K) is a number based on a particular ratio of product and reactant concentrations: K is small if a high concentration of reactant(s) is present at equilibrium, and it is large if a high concentration of product(s) is present at equilibrium.

*Note that the equilibrium constant is represented by a capital italic K , whereas the temperature unit, the kelvin, is a capital roman K . Also, since the kelvin is a unit, it always follows a number.

17.2 THE REACTION QUOTIENT AND THE EQUILIBRIUM CONSTANT

We have introduced the equilibrium constant in terms of a ratio of rate constants, but the original research on chemical equilibrium was developed many years before the principles of kinetics. In 1864, two Norwegian chemists, Cato Guldberg and Peter Waage, observed that *at a given temperature, a chemical system reaches a state in which a particular ratio of reactant and product concentrations has a constant value.* This is a statement of the **law of chemical equilibrium**, or the **law of mass action**.

The Changing Value of the Reaction Quotient

The particular ratio of concentration terms that we write for a given reaction is called the **reaction quotient (Q)** (also known as the *mass-action expression*). For the reversible breakdown of N_2O_4 to NO_2 , the reaction quotient is

$$\text{N}_2\text{O}_4(g) \rightleftharpoons 2\text{NO}_2(g) \quad Q = \frac{[\text{NO}_2]^2}{[\text{N}_2\text{O}_4]}$$

As the reaction proceeds toward equilibrium, the concentrations of reactants and products change continually, and so does their ratio, which is the value of Q : at a given temperature, at the beginning of the reaction, the concentrations have initial values, and Q has an initial value; a moment later, the concentrations have slightly different values, and so does Q ; after another moment, the concentrations and the value of Q change further. These changes continue, *until the system reaches equilibrium*. At that point, reactant and product concentrations have their equilibrium values and no longer change. Thus, the value of Q no longer changes and equals K at that temperature:

$$\text{At equilibrium: } Q = K$$

(17.3)

In formulating the law of mass action, Guldberg and Waage found that, *for a particular system and temperature, the same equilibrium state is attained regardless of starting concentrations.* For example, for the N_2O_4 - NO_2 system at 200°C (473 K), the data from four experiments appear in Table 17.1. Two essential points stand out:

- The ratio of *initial* concentrations (*fourth column*) varies widely but always gives the same ratio of *equilibrium* concentrations (*rightmost column*).
- The *individual* equilibrium concentrations are different in each case, but the *ratio* of these equilibrium concentrations is constant.

Thus, monitoring Q tells us whether the system has reached equilibrium or, if it hasn't, how far away it is and in which direction it is changing.

Table 17.1

Initial and Equilibrium Concentration Ratios for the N_2O_4 - NO_2 System at 200°C (473 K)

Expt	Initial			Equilibrium		
	$[\text{N}_2\text{O}_4]$	$[\text{NO}_2]$	$Q, [\text{NO}_2]^2 / [\text{N}_2\text{O}_4]$	$[\text{N}_2\text{O}_4]_{\text{eq}}$	$[\text{NO}_2]_{\text{eq}}$	$K, [\text{NO}_2]_{\text{eq}}^2 / [\text{N}_2\text{O}_4]_{\text{eq}}$
1	0.1000	0.0000	$\frac{(0.0000)^2}{(0.1000)} = 0.0000$	0.00357	0.193	$\frac{(0.193)^2}{(0.00357)} = 10.4$
2	0.0000	0.1000	$\frac{(0.1000)^2}{(0.0000)} = \infty$	0.000924	0.0982	$\frac{(0.0982)^2}{(0.000924)} = 10.4$
3	0.0500	0.0500	$\frac{(0.0500)^2}{(0.0500)} = 0.0500$	0.00204	0.146	$\frac{(0.146)^2}{(0.00204)} = 10.4$
4	0.0750	0.0250	$\frac{(0.0250)^2}{(0.0750)} = 0.00833$	0.00275	0.170	$\frac{(0.170)^2}{(0.00275)} = 10.5$

The curves in Figure 17.3 show experiment 1 in Table 17.1. Note that $[N_2O_4]$ and $[NO_2]$ change smoothly during the course of the reaction (as indicated by the changing brown color at the top), and so does the value of Q . Once the system reaches equilibrium (constant brown color), the concentrations no longer change and Q equals K . In other words, for any given chemical system, K is a special value of Q that occurs when the reactant and product concentrations have their equilibrium values.

Writing the Reaction Quotient in Its Various Forms

The reaction quotient *must* be written directly from the balanced equation. In contrast, as discussed in Chapter 16, the rate law for an overall reaction *cannot* be written from the balanced equation, but must be determined from rate data.

Constructing the Reaction Quotient The most common form of the reaction quotient shows reactant and product terms as molar concentrations, which are designated by square brackets, []. Thus, from now on, we designate the *reaction quotient based on concentrations* as Q_c . (We also designate the *equilibrium constant based on concentrations* as K_c .) For the general equation

where a , b , c , and d are the stoichiometric coefficients, the reaction quotient is

$$Q_c = \frac{[C]^c[D]^d}{[A]^a[B]^b} \quad (17.4)$$

Thus, Q is a ratio consisting of product concentration terms multiplied together and divided by reactant concentration terms multiplied together, with each term raised to the power of its balancing coefficient.

Two steps are needed to construct a reaction quotient for any chemical system:

1. Start with the balanced equation. For example, for the formation of ammonia from its elements, the balanced equation (with colored coefficients for reference) is

2. Arrange the terms and exponents. Place the product terms in the numerator and the reactant terms in the denominator, multiplied by each other, and raise each term to the power of its balancing coefficient (colored as in the balanced equation):

$$Q_c = \frac{[NH_3]^2}{[N_2][H_2]^3}$$

Why Q and K Have No Units In this text (and most others), the values of Q and K are unitless numbers. As we will discuss in Chapter 20, the reason is that Q and K are based on thermodynamic parameters. That is, each term in Q or K is actually an *activity*, or active concentration, the ratio of the concentration (or pressure) of a substance to its reference standard-state concentration (or pressure). Recall from Section 6.6 that the standard states are 1 M for a substance in solution, 1 atm for a gas, and the pure substance itself for a liquid or solid. The terms in Q or K thus become unitless as follows:

- For a concentration of, say, 1.20 M NaCl, we have

$$[NaCl] = \frac{1.20 \text{ M (measured quantity)}}{1 \text{ M (standard-state quantity)}} = 1.20$$

- For a pressure of, say, 0.53 atm N₂, we have

$$P_{N_2} = \frac{0.53 \text{ atm (measured quantity)}}{1 \text{ atm (standard-state quantity)}} = 0.53$$

- For a pure solid or a pure liquid, the concentration is the density of the substance, which when divided by its density, must equal 1.

Since each term used to write Q or K is a unitless ratio, Q and K are unitless also.

Figure 17.3 The change in Q during the N_2O_4 - NO_2 reaction. Based on data from Experiment 1 in Table 17.1.

Figure 17.4 The reaction quotient for a heterogeneous system depends only on concentrations that change.

Form of Q for a Reaction Involving Pure Liquids or Solids The formation of gaseous NH_3 from its elements in the gas phase is an example of a *homogeneous* equilibrium system in which all the components are in the same phase. When the components are in different phases, the equilibrium system is *heterogeneous*.

Consider the decomposition of limestone to lime and carbon dioxide:

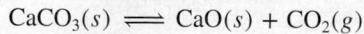

Using the rules for writing the reaction quotient, we would obtain

$$Q_c = \frac{[\text{CaO}][\text{CO}_2]}{[\text{CaCO}_3]}$$

However, as the preceding subsection about Q and K being unitless numbers stated, each term in the reaction quotient is actually the ratio of the measured quantity to the standard-state quantity and *for all pure solids and liquids, this ratio is 1*. Thus, we have

$$Q_c = \frac{(1)[\text{CO}_2]}{(1)} = [\text{CO}_2]$$

This means that as long as some CaO and some CaCO_3 are present, only the CO_2 concentration affects the value of Q_c (Figure 17.4).

It makes sense that we eliminate the terms for pure solids and liquids in the expressions for Q and K because we are concerned only with concentrations that change as they approach equilibrium, and the concentrations, like the densities, of pure solids and liquids are constant.

SAMPLE PROBLEM 17.1

Writing the Reaction Quotient from the Balanced Equation

Problem Write the reaction quotient, Q_c , for each of the following reactions:

- (a) $\text{N}_2\text{O}_5(g) \rightleftharpoons \text{NO}_2(g) + \text{O}_2(g)$
- (b) $\text{Na}(s) + \text{H}_2\text{O}(l) \rightleftharpoons \text{NaOH}(aq) + \text{H}_2(g)$
- (c) $\text{C}_3\text{H}_8(g) + \text{O}_2(g) \rightleftharpoons \text{CO}_2(g) + \text{H}_2\text{O}(g)$

Plan We balance the equation and then construct the reaction quotient using Equation 17.4. Remember that concentration terms for pure liquids and solids are *not* included in the reaction quotient.

Solution (a) From the balanced equation, $2\text{N}_2\text{O}_5(g) \rightleftharpoons 4\text{NO}_2(g) + \text{O}_2(g)$, we have

$$Q_c = \frac{[\text{NO}_2]^4[\text{O}_2]}{[\text{N}_2\text{O}_5]^2}$$

- (b) The solid Na and pure liquid H_2O are not included in the reaction quotient. $\text{NaOH}(aq)$ is a solution in the liquid phase, but it is included in the reaction quotient since it is not a

pure liquid. From the balanced equation, $2\text{Na}(s) + 2\text{H}_2\text{O}(l) \rightleftharpoons 2\text{NaOH}(aq) + \text{H}_2(g)$, we have

$$Q_c = [\text{NaOH}]^2[\text{H}_2]$$

(c) From the balanced equation, $\text{C}_3\text{H}_8(g) + 5\text{O}_2(g) \rightleftharpoons 3\text{CO}_2(g) + 4\text{H}_2\text{O}(g)$, we have

$$Q_c = \frac{[\text{CO}_2]^3[\text{H}_2\text{O}]^4}{[\text{C}_3\text{H}_8][\text{O}_2]^5}$$

Check Be sure that the exponents in the reaction quotient are the same as the balancing coefficients. A good check is to reverse the process and see if you obtain the balanced equation, except for any substances that are pure liquids or solids: change the numerator of the expression to products, the denominator to reactants, and the exponents to coefficients.

FOLLOW-UP PROBLEMS

Brief Solutions for all Follow-up Problems appear at the end of the chapter.

17.1A Write the reaction quotient, Q_c , for each of the following reactions:

- (a) $\text{NH}_3(g) + \text{O}_2(g) \rightleftharpoons \text{NO}(g) + \text{H}_2\text{O}(g)$
- (b) $\text{NO}_2(g) + \text{H}_2(g) \rightleftharpoons \text{NH}_3(g) + \text{H}_2\text{O}(l)$
- (c) $\text{KClO}_3(s) \rightleftharpoons \text{KCl}(s) + \text{O}_2(g)$

17.1B Write the reaction quotient, Q_c , for each of the following reactions:

- (a) $\text{CH}_4(g) + \text{CO}_2(g) \rightleftharpoons \text{CO}(g) + \text{H}_2(g)$
- (b) $\text{H}_2\text{S}(g) + \text{SO}_2(g) \rightleftharpoons \text{S}(s) + \text{H}_2\text{O}(g)$
- (c) $\text{HCN}(aq) + \text{NaOH}(aq) \rightleftharpoons \text{NaCN}(aq) + \text{H}_2\text{O}(l)$

SOME SIMILAR PROBLEMS 17.12–17.15 and 17.18–17.21

Form of Q for a Forward and a Reverse Reaction The form of the reaction quotient depends on the *direction* in which the balanced equation is written. Consider, for example, the oxidation of sulfur dioxide to sulfur trioxide. This reaction is a key step in acid-rain formation and sulfuric acid production. The balanced equation is

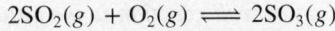

The reaction quotient for this equation *as written* is

$$Q_{c(\text{fwd})} = \frac{[\text{SO}_3]^2}{[\text{SO}_2]^2[\text{O}_2]}$$

If we had written the reverse reaction, the decomposition of sulfur trioxide,

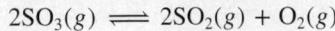

the reaction quotient would be the *reciprocal* of $Q_{c(\text{fwd})}$:

$$Q_{c(\text{rev})} = \frac{[\text{SO}_2]^2[\text{O}_2]}{[\text{SO}_3]^2} = \frac{1}{Q_{c(\text{fwd})}}$$

Thus, a reaction quotient (or equilibrium constant) for a forward reaction is the reciprocal of the reaction quotient (or equilibrium constant) for the reverse reaction:

$$Q_{c(\text{fwd})} = \frac{1}{Q_{c(\text{rev})}} \quad \text{and} \quad K_{c(\text{fwd})} = \frac{1}{K_{c(\text{rev})}} \tag{17.5}$$

The K_c values for the forward and reverse reactions shown above at 1000 K are

$$K_{c(\text{fwd})} = \frac{[\text{SO}_3]^2}{[\text{SO}_2]^2[\text{O}_2]} = 261 \quad \text{and} \quad K_{c(\text{rev})} = \frac{[\text{SO}_2]^2[\text{O}_2]}{[\text{SO}_3]^2} = \frac{1}{K_{c(\text{fwd})}} = \frac{1}{261} = 3.83 \times 10^{-3}$$

These values make sense: if the forward reaction goes far to the right (high K_c), yielding a large concentration of the product SO_3 at equilibrium, the reverse reaction does not go far to the right (low K_c), again resulting in a large concentration of unreacted SO_3 when equilibrium is reached.

Form of Q for a Reaction with Coefficients Multiplied by a Common Factor Multiplying all the coefficients of the equation by some factor also changes the form of Q . For example, multiplying all the coefficients in the equation for the formation of SO_3 by $\frac{1}{2}$ gives

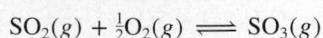

For this equation, the reaction quotient is

$$Q'_{\text{c(fwd)}} = \frac{[\text{SO}_3]}{[\text{SO}_2][\text{O}_2]^{1/2}}$$

Notice that Q'_c for the halved equation equals Q_c for the original equation raised to the $\frac{1}{2}$ power:

$$Q'_{\text{c(fwd)}} = Q_{\text{c(fwd)}}^{1/2} = \left(\frac{[\text{SO}_3]^2}{[\text{SO}_2]^2[\text{O}_2]} \right)^{1/2} = \frac{[\text{SO}_3]}{[\text{SO}_2][\text{O}_2]^{1/2}}$$

Once again, the same property holds for the equilibrium constants. Relating the halved reaction to the original, we have

$$K'_{\text{c(fwd)}} = K_{\text{c(fwd)}}^{1/2} = (261)^{1/2} = 16.2$$

It may seem that we have changed the extent of the reaction, as indicated by a different K , just by changing the coefficients of the equation, but that can't be true. A particular K has meaning only in relation to a particular equation. If $K_{\text{c(fwd)}}$ and $K'_{\text{c(fwd)}}$ relate to different equations, we cannot compare them directly.

In general, if all the coefficients of the balanced equation are multiplied by some factor, that factor becomes the exponent for relating the reaction quotients and the equilibrium constants. For a multiplying factor n , which we can write as

the reaction quotient and equilibrium constant are

$$Q' = Q^n = \left(\frac{[C]^c[D]^d}{[A]^a[B]^b} \right)^n \quad \text{and} \quad K' = K^n \quad (17.6)$$

Form of Q for an Overall Reaction We follow the same procedure for writing a reaction quotient whether an equation represents an individual reaction step or an overall multistep reaction. If an overall reaction is the sum of two or more reactions, the overall reaction quotient (or equilibrium constant) is the product of the reaction quotients (or equilibrium constants) for the steps:

$$Q_{\text{overall}} = Q_1 \times Q_2 \times Q_3 \times \dots$$

and

$$K_{\text{overall}} = K_1 \times K_2 \times K_3 \times \dots \quad (17.7)$$

Sample Problem 17.2 demonstrates calculations involving K values for reactions that are reversed or multiplied by a factor, and for an overall reaction.

SAMPLE PROBLEM 17.2

Finding K for Reactions Multiplied by a Common Factor or Reversed and for an Overall Reaction

Problem A chemist wants to find K_c for the following reaction at 700 K:

Use the following data at 700 K to find the unknown K_c :

- (1) $\text{N}_2(g) + 3\text{H}_2(g) \rightleftharpoons 2\text{NH}_3(g) \quad K_{c1} = 0.343$
 (2) $\text{H}_2(g) + \text{I}_2(g) \rightleftharpoons 2\text{HI}(g) \quad K_{c2} = 54$

Plan We must manipulate reactions (1) and (2) so that they add together to give the target reaction. Reaction (1) must be reversed; the new equilibrium constant (K'_{c1}) is the reciprocal of K_{c1} . Reaction (2) must be multiplied by 3; the new equilibrium constant (K'_{c2}) is K_{c2} raised to the third power. We then add the two manipulated reactions and multiply their K_c values to obtain the overall K_c .

Solution Reaction (1) must be reversed since 2NH_3 is a reactant in the target reaction; the K_c value of the reversed reaction is the reciprocal of the original K_c :

Reaction (2) must be multiplied by 3 (in the target reaction I_2 has a coefficient of 3 and HI has a coefficient of 6) so the new K_c value equals the original K_c value raised to the third power:

Adding the two reactions (cancelling common terms):

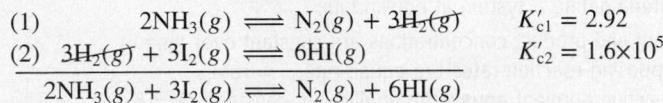

Multiplying the individual reaction quotients and calculating the overall K_c :

$$Q'_{c1} \times Q'_{c2} = \frac{[\text{N}_2][\text{H}_2]^3}{[\text{NH}_3]^2} \times \frac{[\text{HI}]^6}{[\text{H}_2]^3[\text{I}_2]^3} = \frac{[\text{N}_2][\text{HI}]^6}{[\text{NH}_3]^2[\text{I}_2]^3} = Q_{c(\text{overall})}$$

$$K_{c(\text{overall})} = K'_{c1} \times K'_{c2} = (2.92)(1.6 \times 10^5) = 4.7 \times 10^5$$

Check Round off and check the calculation of the overall K_c value:

$$K_c \approx (3)(2 \times 10^5) = 6 \times 10^5$$

FOLLOW-UP PROBLEMS

17.2A Find the K_c value of the following reaction at 1123 K

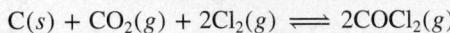

using the following data at the same temperature:

17.2B The reaction $2\text{NO}(g) + \text{Br}_2(g) \rightleftharpoons 2\text{NOBr}(g)$ has a K_c value of 1.3×10^{-2} at 1000 K. Calculate K_c for the following reactions:

SOME SIMILAR PROBLEMS 17.16, 17.17, 17.23, and 17.24

Table 17.2 summarizes the ways of writing Q and calculating K .

Table 17.2

Ways of Expressing Q and Calculating K

Form of Chemical Equations	Form of Q	Value of K
Reference reaction (ref): $A \rightleftharpoons B$	$Q_{(\text{ref})} = \frac{[B]}{[A]}$	$K_{(\text{ref})} = \frac{[B]_{\text{eq}}}{[A]_{\text{eq}}}$
Reverse reaction: $B \rightleftharpoons A$	$Q = \frac{1}{Q_{(\text{ref})}} = \frac{[A]}{[B]}$	$K = \frac{1}{K_{(\text{ref})}}$
Coefficients multiplied by n	$Q = Q_{(\text{ref})}^n$	$K = K_{(\text{ref})}^n$
Reaction as sum of two steps:		
(1) $A \rightleftharpoons C$	$Q_1 = \frac{[C]}{[A]}$; $Q_2 = \frac{[B]}{[C]}$	
(2) $C \rightleftharpoons B$	$Q_{\text{overall}} = Q_1 \times Q_2 = Q_{(\text{ref})}$ $= \frac{[C]}{[A]} \times \frac{[B]}{[C]} = \frac{[B]}{[A]}$	$K_{\text{overall}} = K_1 \times K_2$ $= K_{(\text{ref})}$
Reaction with pure solid or liquid component, such as $\text{A}(s)$	$Q = Q_{(\text{ref})}(1) = [B]$	$K = K_{(\text{ref})}(1) = [B]$

› Summary of Section 17.2

- › The reaction quotient based on concentration, Q_c , is a particular ratio of product to reactant concentrations. The value of Q_c changes as the reaction proceeds. When the system reaches equilibrium at a particular temperature, $Q_c = K_c$.
- › The concentration terms for pure liquids or solids do not appear in Q because they are equal to 1.
- › The form of Q is based on the balanced equation exactly as written, so it changes if the equation is reversed or multiplied by some factor, and K changes accordingly.
- › If a reaction is the sum of two or more steps, the overall Q (or K) is the product of the individual Q 's (or K 's).
- › Three criteria define a system at equilibrium:
 1. Reactant and product concentrations are constant over time.
 2. The opposing reaction rates are equal: $\text{rate}_{\text{fwd}} = \text{rate}_{\text{rev}}$.
 3. The reaction quotient equals the equilibrium constant: $Q = K$.

17.3 EXPRESSING EQUILIBRIA WITH PRESSURE TERMS: RELATION BETWEEN K_c AND K_p

It is easier to measure gas *pressure* than concentration, so when a reaction involves gases, we often express the reaction quotient in terms of partial pressures instead of concentrations. As long as the gases behave nearly ideally during the experiment, the ideal gas law (Section 5.3) allows us to relate pressure (P) to molar concentration (n/V):

$$PV = nRT, \quad \text{so} \quad P = \frac{n}{V} RT \quad \text{or} \quad \frac{P}{RT} = \frac{n}{V}$$

Thus, at constant T , *pressure is directly proportional to molar concentration*. For example, in the reaction between gaseous NO and O₂,

the *reaction quotient based on pressures*, Q_p , is

$$Q_p = \frac{P_{\text{NO}_2}^2}{P_{\text{NO}}^2 \times P_{\text{O}_2}}$$

The equilibrium constant obtained when all components are present at their equilibrium partial pressures is designated K_p , the *equilibrium constant based on pressures*. In many cases, K_p has a value different from K_c . But if you know one of these values, the *change in amount (mol) of gas*, Δn_{gas} , from the balanced equation allows you to calculate the other. Let's see how this conversion works for the oxidation of NO:

As the balanced equation shows,

With Δ meaning “final minus initial” (products *minus* reactants), we have

$$\Delta n_{\text{gas}} = \text{moles of gaseous product} - \text{moles of gaseous reactant} = 2 - 3 = -1$$

Keep this value of Δn_{gas} in mind because it appears in the conversion that follows.

The reaction quotient based on concentrations is

$$Q_c = \frac{[\text{NO}_2]^2}{[\text{NO}]^2 [\text{O}_2]}$$

Rearranging the ideal gas law to $n/V = P/RT$, we write the terms in square brackets as n/V and convert them to partial pressures, P ; then we collect the RT terms and cancel:

$$\begin{aligned} Q_c &= \frac{\frac{n_{\text{NO}_2}^2}{V^2}}{\frac{n_{\text{NO}}^2}{V^2} \times \frac{n_{\text{O}_2}}{V}} = \frac{\frac{P_{\text{NO}_2}^2}{(RT)^2}}{\frac{P_{\text{NO}}^2}{(RT)^2} \times \frac{P_{\text{O}_2}}{RT}} = \frac{P_{\text{NO}_2}^2}{P_{\text{NO}}^2 \times P_{\text{O}_2}} \times \frac{\frac{1}{(RT)^2}}{\frac{1}{(RT)^2} \times \frac{1}{RT}} \\ &= \frac{P_{\text{NO}_2}^2}{P_{\text{NO}}^2 \times P_{\text{O}_2}} \times RT \end{aligned}$$

Note that the far right side of the previous expression is Q_p multiplied by RT . Thus,

$$Q_c = Q_p(RT)$$

Also, at equilibrium, $K_c = K_p(RT)$; and, solving for K_p gives

$$K_p = \frac{K_c}{RT} = K_c(RT)^{-1}$$

Note especially that the exponent of the RT term equals the change in the amount (mol) of gas (Δn_{gas}) from the balanced equation, -1 in this case. Thus, in general, we have

$$K_p = K_c(RT)^{\Delta n_{\text{gas}}} \quad (17.8)$$

Based on Equation 17.8, if the amount (mol) of gas does not change in the reaction, $\Delta n_{\text{gas}} = 0$, and the RT term drops out (i.e., equals 1); then, $K_p = K_c$. (In calculations, be sure the units for R are consistent with units for pressure.)

SAMPLE PROBLEM 17.3

Converting Between K_c and K_p

Problem Ammonium hydrosulfide decomposes to ammonia and hydrogen sulfide gases. Find K_c for the decomposition reaction:

Plan We know K_p (0.19), so to convert between K_p and K_c , we must first determine Δn_{gas} from the balanced equation. Then we rearrange Equation 17.8. If we assume that pressure is measured in atmospheres, $R = 0.0821 \text{ atm}\cdot\text{L/mol}\cdot\text{K}$; the given temperature must be converted to kelvins.

Solution Determining Δn_{gas} : There are 2 moles of gaseous product (1 mol NH_3 and 1 mol H_2S) and no gaseous reactant, so $\Delta n_{\text{gas}} = 2 - 0 = 2$. (Note that only moles of *gaseous* reactants and products are used to determine Δn_{gas} .)

Converting T from $^\circ\text{C}$ to K : $T(\text{K}) = 218^\circ\text{C} + 273.15 = 491 \text{ K}$

Rearranging Equation 17.8 and calculating K_c :

$$K_p = K_c(RT)^{\Delta n_{\text{gas}}} \quad \text{or} \quad K_p = K_c(RT)^2$$

so

$$K_c = K_p(RT)^{-2} = (0.19)(0.0821 \times 491)^{-2} \\ = 1.2 \times 10^{-4}$$

Check Rounding gives

$$(0.2)(0.1 \times 500)^{-2} = (0.2)(4 \times 10^{-4}) = 0.8 \times 10^{-4}$$

FOLLOW-UP PROBLEMS

17.3A Calculate K_p for the following reaction:

17.3B Calculate K_c for the following reaction:

SOME SIMILAR PROBLEMS 17.30–17.33

› Summary of Section 17.3

- › For a gaseous reaction, the reaction quotient and the equilibrium constant can be expressed in terms of partial pressures (Q_p and K_p).
- › If you know K_p , you can find K_c , and vice versa: $K_p = K_c(RT)^{\Delta n_{\text{gas}}}$.

17.4 COMPARING Q AND K TO DETERMINE REACTION DIRECTION

Suppose you have a mixture of reactants and products and you know K at the temperature of the reaction. By comparing the value of Q with the known value of K , you can tell whether the reaction has reached equilibrium or, if not, in which direction

it is progressing. The value of K remains constant at a particular temperature, but as we've seen, the value of Q varies as the concentrations of reactants and products change. Since Q has product terms in the numerator and reactant terms in the denominator, *more product makes Q larger, and more reactant makes Q smaller*:

$$Q = \frac{[\text{product}]}{[\text{reactant}]}$$

There are three possibilities for the relative sizes of Q and K (Figure 17.5):

- $Q < K$. If Q is smaller than K , the denominator (reactants) is large relative to the numerator (products). For Q to equal K , the reactants must decrease and the products increase. The reaction is not at equilibrium and will progress to the right, toward products, until $Q = K$:

If $Q < K$, reactants → products

- $Q > K$. If Q is larger than K , the numerator (products) will decrease and the denominator (reactants) will increase. The reaction is not at equilibrium and will progress to the left, toward reactants, until $Q = K$:

If $Q > K$, reactants ← products

- $Q = K$. This situation occurs when the reactant and product terms equal their equilibrium values. The reaction is at equilibrium, and no further net change takes place:

If $Q = K$, reactants ⇌ products

Figure 17.5 Reaction direction and the relative sizes of Q and K . When Q_c is smaller or larger than K_c , the reaction continues until $Q_c = K_c$. Note that K_c remains the same throughout.

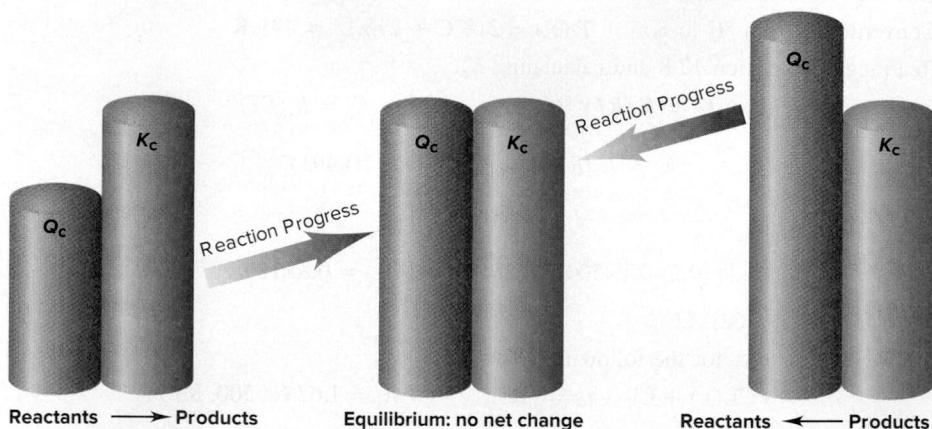

Sample Problem 17.4 relies on molecular scenes to determine reaction direction, and Sample Problem 17.5 uses concentration data.

SAMPLE PROBLEM 17.4

Using Molecular Scenes to Determine Reaction Direction

Problem For the reaction $A(g) \rightleftharpoons B(g)$, the equilibrium mixture at 175°C is $[A] = 2.8 \times 10^{-4} M$ and $[B] = 1.2 \times 10^{-4} M$. The molecular scenes below represent four different mixtures for the reaction (A is red; B is blue). For each mixture, does the reaction progress to the right or to the left or neither to reach equilibrium?

Plan We must compare Q_c with K_c to determine the reaction direction, so we first use the given equilibrium concentrations to find K_c . Then we count spheres and calculate Q_c for each mixture. If $Q_c < K_c$, the reaction progresses to the right (reactants to products); if $Q_c > K_c$, it progresses to the left (products to reactants); and if $Q_c = K_c$, there is no further net change.

Solution Writing the reaction quotient and using the data to find K_c :

$$Q_c = \frac{[B]}{[A]} = \frac{1.2 \times 10^{-4}}{2.8 \times 10^{-4}} = 0.43 = K_c$$

Counting red (A) and blue (B) spheres to calculate Q_c for each mixture:

1. $Q_c = 8/2 = 4.0$ 2. $Q_c = 3/7 = 0.43$ 3. $Q_c = 4/6 = 0.67$ 4. $Q_c = 2/8 = 0.25$

Comparing Q_c with K_c to determine reaction direction:

1. $Q_c > K_c$: left 2. $Q_c = K_c$: no net change 3. $Q_c > K_c$: left 4. $Q_c < K_c$: right

Check Making an error in the calculation for K_c would lead to incorrect conclusions throughout, so check that step: the exponents are the same, and $1.2/2.8$ is a bit less than 0.5, as is the calculated K_c . You can check the final answers by inspection; for example, for the number of B (8) in mixture 1 to equal the number at equilibrium (3), more B must change to A, so the reaction must proceed to the left.

FOLLOW-UP PROBLEMS

17.4A At 338 K, the reaction $X(g) \rightleftharpoons Y(g)$ has a K_c of 1.4. The scenes below represent different mixtures at 338 K, with X orange and Y green. In which direction does the reaction proceed (if there is any net change) for each mixture to reach equilibrium?

17.4B Scene 1 below represents the reaction $2C(g) \rightleftharpoons D(g)$ at equilibrium at 25°C (C is yellow and D is blue). Scenes 2 and 3 represent two different mixtures of C and D at 25°C. Calculate K_c for the reaction, and determine in which direction the reaction proceeds (if there is any net change) for the mixtures in scenes 2 and 3.

A SIMILAR PROBLEM 17.35

SAMPLE PROBLEM 17.5

Using Concentrations to Determine Reaction Direction

Problem For the reaction $N_2O_4(g) \rightleftharpoons 2NO_2(g)$, $K_c = 0.21$ at 100°C. At a point during the reaction, $[N_2O_4] = 0.12\text{ M}$ and $[NO_2] = 0.55\text{ M}$. Is the reaction at equilibrium at that time? If not, in which direction is it progressing?

Plan We write Q_c , find its value by substituting the given concentrations, and compare its value with the given K_c .

Solution Writing the reaction quotient and solving for Q_c :

$$Q_c = \frac{[NO_2]^2}{[N_2O_4]} = \frac{(0.55)^2}{0.12} = 2.5$$

With $Q_c > K_c$ ($2.5 > 0.21$), the reaction is not at equilibrium and will proceed to the left until $Q_c = K_c$.

Check With $[NO_2] > [N_2O_4]$, we expect to obtain a value for Q_c that is greater than 0.21. If $Q_c > K_c$, the numerator will decrease and the denominator will increase until $Q_c = K_c$; that is, this reaction will proceed toward reactants.

FOLLOW-UP PROBLEMS

17.5A Chloromethane forms by the reaction

At 1500 K, $K_p = 1.6 \times 10^4$. In the reaction mixture, $P_{CH_4} = 0.13$ atm, $P_{Cl_2} = 0.035$ atm, $P_{CH_3Cl} = 0.24$ atm, and $P_{HCl} = 0.47$ atm. Is CH_3Cl or CH_4 forming?

17.5B Sulfur trioxide is produced by the reaction of sulfur dioxide with oxygen:

Suppose 3.4 mol of SO_2 , 1.5 mol of O_2 , and 1.2 mol of SO_3 are placed in a 2.0-L flask. Is the system at equilibrium? If not, in which direction will the reaction proceed?

SOME SIMILAR PROBLEMS 17.36–17.38

› Summary of Section 17.4

- › We compare the values of Q and K to determine the direction in which a reaction will proceed toward equilibrium.
 - If $Q_c < K_c$, more product forms.
 - If $Q_c > K_c$, more reactant forms.
 - If $Q_c = K_c$, there is no further net change.

17.5 HOW TO SOLVE EQUILIBRIUM PROBLEMS

Many kinds of equilibrium problems arise in the real world—and on chemistry exams—but we can group most of them into two types:

1. We know the equilibrium quantities of reactants and products and solve for K .
2. We know K and the initial quantities of reactants and products and solve for the equilibrium quantities.

Using Quantities to Find the Equilibrium Constant

There are two common variations on this type of problem: one involves substituting equilibrium quantities into the reaction quotient to solve for K , and the other requires first finding some of the quantities.

Substituting Equilibrium Quantities into Q to Find K In this type of problem, we use given equilibrium quantities to calculate K . Suppose, for example, that equal amounts of gaseous hydrogen and iodine are injected into a 1.50-L flask at a fixed temperature. In time, the following equilibrium is attained:

At equilibrium, the flask contains 1.80 mol of H_2 , 1.80 mol of I_2 , and 0.520 mol of HI . We calculate K_c by finding the concentrations from the amounts and flask volume and substituting into the reaction quotient from the balanced equation:

$$Q_c = \frac{[HI]^2}{[H_2][I_2]}$$

We divide each amount (mol) by the volume (L) to find each concentration (mol/L):

$$[H_2] = \frac{1.80 \text{ mol}}{1.50 \text{ L}} = 1.20 \text{ M}$$

Similarly, $[I_2] = 1.20\ M$, and $[HI] = 0.347\ M$. Substituting these values into the expression for Q_c gives K_c :

$$K_c = \frac{(0.347)^2}{(1.20)(1.20)} = 8.36 \times 10^{-2}$$

Using a Reaction Table to Find Equilibrium Quantities and K When some quantities are not given, we determine them from the reaction stoichiometry and then find K . In the following example, note the use of the *reaction table*.

In a study of carbon oxidation, an evacuated vessel containing a small amount of powdered graphite is heated to 1080 K. Gaseous CO_2 is added to a pressure of 0.458 atm, and CO forms. At equilibrium, the total pressure is 0.757 atm. Calculate K_p .

As always, we start by writing the balanced equation and the reaction quotient:

The data are given in atmospheres and we must find K_p , so we write the expression for Q_p ; note that it does *not* include a term for the solid, C(graphite):

$$Q_p = \frac{P_{\text{CO}}^2}{P_{\text{CO}_2}}$$

We are given the initial P_{CO_2} and the P_{total} at equilibrium. To find K_p , we must find the equilibrium pressures of CO_2 and CO and then substitute them into Q_p .

Let's think through what happened in the vessel. An unknown portion of the CO_2 reacted with graphite to form an unknown amount of CO. We already know the *relative* amounts of CO_2 and CO from the balanced equation: for each mole of CO_2 that reacts, 2 mol of CO forms, which means that when x atm of CO_2 reacts, $2x$ atm of CO forms:

The pressure of CO_2 at equilibrium, $P_{\text{CO}_2(\text{eq})}$, is the initial pressure, $P_{\text{CO}_2(\text{init})}$, *minus* x , the CO_2 that reacts (the change in P_{CO_2} due to the reaction):

$$P_{\text{CO}_2(\text{init})} - x = P_{\text{CO}_2(\text{eq})} = 0.458 - x$$

Similarly, the pressure of CO at equilibrium, $P_{\text{CO}(\text{eq})}$, is the initial pressure, $P_{\text{CO}(\text{init})}$, *plus* $2x$, the CO that forms (the change in P_{CO} due to the reaction). $P_{\text{CO}(\text{init})}$ is zero, so

$$P_{\text{CO}(\text{init})} + 2x = 0 + 2x = 2x = P_{\text{CO}(\text{eq})}$$

We'll summarize this information in a reaction table, similar to those in Chapter 3, but for "Final" quantities, we use those at equilibrium. The table shows the balanced equation at the top, and

- the *initial* quantities (concentrations or pressures) of reactants and products,
- the *changes* in these quantities during the reaction, and
- the *equilibrium* quantities.

Pressure (atm)	$\text{CO}_2(g)$	+	C(graphite)	\rightleftharpoons	$2\text{CO}(g)$
Initial	0.458		—		0
Change	$-x$		—		$+2x$
Equilibrium	$0.458 - x$		—		$2x$

We treat each column like a list of numbers to add together: *the initial quantity plus the change in that quantity gives the equilibrium quantity*. Note that we *only* consider substances whose concentrations change; thus, the column for C(graphite) is blank.

To solve for K_p , we substitute equilibrium values into Q_p , so we first have to find x . To do this, we use the other piece of data given, $P_{\text{total}(\text{eq})}$. According to Dalton's law of partial pressures and using the equilibrium quantities from the reaction table,

$$P_{\text{total}(\text{eq})} = 0.757 \text{ atm} = P_{\text{CO}_2(\text{eq})} + P_{\text{CO}(\text{eq})} = (0.458 \text{ atm} - x) + 2x$$

Thus,

$$0.757 \text{ atm} = 0.458 \text{ atm} + x \quad \text{and} \quad x = 0.299 \text{ atm}$$

With x known, we determine the equilibrium partial pressures:

$$\begin{aligned}P_{\text{CO}_2(\text{eq})} &= 0.458 \text{ atm} - x = 0.458 \text{ atm} - 0.299 \text{ atm} = 0.159 \text{ atm} \\P_{\text{CO}(\text{eq})} &= 2x = 2(0.299 \text{ atm}) = 0.598 \text{ atm}\end{aligned}$$

Then we substitute them into Q_p to find K_p :

$$Q_p = \frac{P_{\text{CO}(\text{eq})}^2}{P_{\text{CO}_2(\text{eq})}} = \frac{(0.598)^2}{0.159} = 2.25 = K_p$$

(From now on, the subscripts “init” and “eq” appear only when it is not clear whether a quantity is an initial or equilibrium value.)

SAMPLE PROBLEM 17.6

Calculating K_c from Concentration Data

Problem In order to study hydrogen halide decomposition, a researcher fills an evacuated 2.00-L flask with 0.200 mol of HI gas and allows the reaction to proceed at 453°C:

At equilibrium, $[\text{HI}] = 0.078 \text{ M}$. Calculate K_c .

Plan To calculate K_c , we need the equilibrium concentrations. We can find the initial $[\text{HI}]$ from the amount (0.200 mol) and the flask volume (2.00 L), and we are given $[\text{HI}]$ at equilibrium (0.078 M). From the balanced equation, when $2x$ mol of HI reacts, x mol of H_2 and x mol of I_2 form. We set up a reaction table, use the known $[\text{HI}]$ at equilibrium to solve for x (the change in $[\text{H}_2]$ or $[\text{I}_2]$), and substitute the concentrations into Q_c .

Solution Calculating initial [HI]:

$$[\text{HI}] = \frac{0.200 \text{ mol}}{2.00 \text{ L}} = 0.100 \text{ M}$$

Setting up the reaction table, with $x = [\text{H}_2]$ or $[\text{I}_2]$ that forms and $2x = [\text{HI}]$ that reacts:

Concentration (M)	$2\text{HI}(g)$	\rightleftharpoons	$\text{H}_2(g)$	+	$\text{I}_2(g)$
Initial	0.100		0		0
Change	$-2x$		$+x$		$+x$
Equilibrium	$0.100 - 2x$		x		x

Solving for x , using the known $[\text{HI}]$ at equilibrium:

$$[\text{HI}] = 0.100 \text{ M} - 2x = 0.078 \text{ M} \quad \text{so} \quad x = 0.011 \text{ M}$$

Therefore, the equilibrium concentrations are

$$[\text{H}_2] = [\text{I}_2] = 0.011 \text{ M} \quad \text{and we were given} \quad [\text{HI}] = 0.078 \text{ M}$$

Substituting into the reaction quotient:

$$Q_c = \frac{[\text{H}_2][\text{I}_2]}{[\text{HI}]^2}$$

$$\text{Thus, } K_c = \frac{(0.011)(0.011)}{0.078^2} = 0.020$$

Check Rounding gives $\sim 0.01^2 / 0.08^2 = 0.02$. Because the initial $[\text{HI}]$ of 0.100 M fell slightly at equilibrium to 0.078 M, relatively little product formed; so we expect $K_c < 1$.

FOLLOW-UP PROBLEMS

17.6A The atmospheric oxidation of nitrogen monoxide, $2\text{NO}(g) + \text{O}_2(g) \rightleftharpoons 2\text{NO}_2(g)$, was studied at 184°C with initial pressures of 1.000 atm of NO and 1.000 atm of O_2 . At equilibrium, $P_{\text{O}_2} = 0.506 \text{ atm}$. Calculate K_p .

17.6B To study the reaction between ammonia and oxygen,

a flask was filled with 2.40 M NH_3 and 2.40 M O_2 at a particular temperature; the reaction proceeded, and at equilibrium $[\text{N}_2\text{O}_4] = 0.134 \text{ M}$. Calculate K_c .

SOME SIMILAR PROBLEMS 17.52, 17.53, 17.55, and 17.56

Student Hot Spot

Student data indicate that you may struggle with constructing a reaction table in equilibrium calculations. Access the Smartbook to view additional Learning Resources on this topic.

Using the Equilibrium Constant to Find Quantities

The type of problem that involves finding equilibrium quantities also has several variations. Sample Problem 17.7 is one variation, in which we know K and some of the equilibrium concentrations and must find another equilibrium concentration.

SAMPLE PROBLEM 17.7

Determining Equilibrium Concentrations from K_c

Problem In a study of the conversion of methane to other fuels, a chemical engineer mixes gaseous CH_4 and H_2O in a 0.32-L flask at 1200 K. At equilibrium, the flask contains 0.028 mol of CO, 0.084 mol of H_2 , and 0.045 mol of CH_4 . What is $[\text{H}_2\text{O}]$ at equilibrium ($K_c = 0.26$ for this process at 1200 K)?

Plan First, we write the balanced equation and the reaction quotient. We calculate the equilibrium concentrations from the given numbers of moles and the flask volume (0.32 L). Substituting these concentrations into Q_c and setting its value equal to the given K_c (0.26), we solve for the unknown equilibrium concentration, $[\text{H}_2\text{O}]$.

Solution Writing the balanced equation and reaction quotient:

Determining the equilibrium concentrations:

$$[\text{CH}_4] = \frac{0.045 \text{ mol}}{0.32 \text{ L}} = 0.14 \text{ M}$$

Similarly, $[\text{CO}] = 0.088 \text{ M}$ and $[\text{H}_2] = 0.26 \text{ M}$.

Calculating $[\text{H}_2\text{O}]$ at equilibrium: Since $Q_c = K_c$, rearranging gives

$$[\text{H}_2\text{O}] = \frac{[\text{CO}][\text{H}_2]^3}{[\text{CH}_4] K_c} = \frac{(0.088)(0.26)^3}{(0.14)(0.26)} = 0.042 \text{ M}$$

Check Always check by substituting the concentrations into Q_c to confirm that the result is equal to K_c :

$$Q_c = \frac{[\text{CO}][\text{H}_2]^3}{[\text{CH}_4][\text{H}_2\text{O}]} = \frac{(0.088)(0.26)^3}{(0.14)(0.042)} = 0.26 = K_c$$

FOLLOW-UP PROBLEMS

17.7A Nitrogen monoxide decomposes by the following equation:

$2\text{NO}(g) \rightleftharpoons \text{N}_2(g) + \text{O}_2(g)$; $K_c = 2.3 \times 10^{-30}$ at 298 K. In the atmosphere, $P_{\text{O}_2} = 0.209 \text{ atm}$ and $P_{\text{N}_2} = 0.781 \text{ atm}$. What is the equilibrium partial pressure of NO in the air we breathe? (Hint: You need K_p to find the partial pressure.)

17.7B Phosphine decomposes by the following equation:

In a reaction mixture at equilibrium, $P_{\text{PH}_3} = 0.112 \text{ atm}$ and $P_{\text{P}_2} = 0.215 \text{ atm}$. What is the equilibrium partial pressure of H_2 ?

SOME SIMILAR PROBLEMS 17.46 and 17.47

In a somewhat more involved variation, we know K and *initial* quantities and must find *equilibrium* quantities, for which we use a reaction table. Sample Problem 17.8 focuses on this type of situation.

SAMPLE PROBLEM 17.8

Determining Equilibrium Concentrations from Initial Concentrations and K_c

Problem Fuel engineers use the extent of the change from CO and H_2O to CO_2 and H_2 to regulate the proportions of synthetic fuel mixtures. If 0.250 mol of CO gas and 0.250 mol of H_2O gas are placed in a 125-mL flask at 900 K, what is the composition of the equilibrium mixture? At this temperature, K_c is 1.56.

Plan We have to find the “composition” of the equilibrium mixture, in other words, the equilibrium concentrations. As always, we write the balanced equation and use it to write the reaction quotient. We find the initial [CO] and [H₂O] from the amounts (0.250 mol of each) and volume (0.125 L), use the balanced equation to define x and set up a reaction table, substitute into Q_c , and solve for x , from which we calculate the concentrations.

Solution Writing the balanced equation and reaction quotient:

Calculating initial reactant concentrations:

$$[\text{CO}] = [\text{H}_2\text{O}] = \frac{0.250 \text{ mol}}{0.125 \text{ L}} = 2.00 \text{ M}$$

Setting up the reaction table, with $x = [\text{CO}]$ and $[\text{H}_2\text{O}]$ that react (note the 1/1 molar ratio among all reactants and products):

Concentration (M)	CO(g)	+	H ₂ O(g)	=	CO ₂ (g)	+	H ₂ (g)
Initial	2.00		2.00		0		0
Change	- x		- x		+ x		+ x
Equilibrium	2.00 - x		2.00 - x		x		x

Substituting into the reaction quotient and solving for x :

$$Q_c = \frac{[\text{CO}_2][\text{H}_2]}{[\text{CO}][\text{H}_2\text{O}]} = \frac{(x)(x)}{(2.00 - x)(2.00 - x)} = \frac{x^2}{(2.00 - x)^2}$$

At equilibrium, we have

$$Q_c = K_c = 1.56 = \frac{x^2}{(2.00 - x)^2}$$

We can apply the following math shortcut in this case *but not in general*: Because the right side of the preceding equation is a perfect square, we take the square root of both sides:

$$\sqrt{1.56} = \frac{x}{2.00 - x} = \pm 1.25$$

A positive number (1.56) has a positive *and* a negative root, but in this case, only the positive root has any chemical meaning, so we ignore the negative root:^{*}

$$1.25 = \frac{x}{2.00 - x} \quad \text{or} \quad 2.50 - 1.25x = x$$

$$\text{So} \quad 2.50 = 2.25x \quad \text{therefore} \quad x = 1.11 \text{ M}$$

Calculating equilibrium concentrations:

$$[\text{CO}] = [\text{H}_2\text{O}] = 2.00 \text{ M} - x = 2.00 \text{ M} - 1.11 \text{ M} = 0.89 \text{ M}$$

$$[\text{CO}_2] = [\text{H}_2] = x = 1.11 \text{ M}$$

Check Given the intermediate size of K_c (1.56), it makes sense that the changes in concentration are moderate. It's a good idea to check that the sign of x in the reaction table is correct—only reactants were initially present, so x has a negative sign for reactants and a positive sign for products. Also check that the equilibrium concentrations give the known K_c : $\frac{(1.11)(1.11)}{(0.89)(0.89)} = 1.56$.

^{*}The negative root gives $-1.25 = \frac{x}{2.00 - x}$, or $-2.50 + 1.25x = x$.

So $2.50 = 0.25x$ and $x = 10 \text{ M}$

This value has no chemical meaning because we started with 2.00 M as the concentration of each reactant, so it is impossible for x to be 10 M . Moreover, the square root of an equilibrium constant is another equilibrium constant, which cannot have a negative value.

FOLLOW-UP PROBLEMS

17.8A The decomposition of HI at low temperature was studied by injecting 2.50 mol of HI into a 10.32-L vessel at 25°C. What is [H₂] at equilibrium for the reaction 2HI(g) \rightleftharpoons H₂(g) + I₂(g); K_c = 1.26 × 10⁻³?

17.8B The following reaction has a K_c value of 0.18 at 500. K:

If 6.15 mol of Cl₂O gas and 6.15 mol of H₂O gas are added to a 5.00-L flask at 500. K, calculate the equilibrium concentrations of Cl₂O, H₂O, and HOCl.

SOME SIMILAR PROBLEMS 17.48, 17.54, and 17.57

Using the Quadratic Formula to Find the Unknown The shortcut we used to simplify the math in Sample Problem 17.8 is a special case that occurred because we started with equal concentrations of the reactants, but typically, we start with different concentrations of reactants. Suppose, for example, we start with 2.00 M CO and 1.00 M H₂O. Now, the reaction table becomes

Concentration (M)	CO(g)	+	H ₂ O(g)	=	CO ₂ (g)	+	H ₂ (g)
Initial	2.00		1.00		0		0
Change	-x		-x		+x		+x
Equilibrium	2.00 - x		1.00 - x		x		x

Substituting these values into Q_c, we obtain

$$Q_c = \frac{[\text{CO}_2][\text{H}_2]}{[\text{CO}][\text{H}_2\text{O}]} = \frac{(x)(x)}{(2.00 - x)(1.00 - x)} = \frac{x^2}{x^2 - 3.00x + 2.00}$$

At equilibrium, using the value of K_c from Sample Problem 17.8, we have

$$1.56 = \frac{x^2}{x^2 - 3.00x + 2.00}$$

To solve for x in this case, we rearrange the previous expression into the form of a quadratic equation:

$$\begin{aligned} a x^2 + b x + c &= 0 \\ 0.56x^2 - 4.68x + 3.12 &= 0 \end{aligned}$$

where a = 0.56, b = -4.68, and c = 3.12. Then we find x with the quadratic formula (Appendix A):

$$x = \frac{-b \pm \sqrt{b^2 - 4ac}}{2a}$$

The ± sign means that we obtain two possible values for x:

$$x = \frac{4.68 \pm \sqrt{(-4.68)^2 - 4(0.56)(3.12)}}{2(0.56)}$$

$$x = 7.6 \text{ M} \quad \text{and} \quad x = 0.73 \text{ M}$$

But only one of the values makes sense chemically. In this case, addition of the square root term gave the larger value, which would yield negative concentrations at equilibrium (for example, 2.00 M - 7.6 M = -5.6 M); these have no meaning. Therefore, x = 0.73 M, and we have

$$[\text{CO}] = 2.00 \text{ M} - x = 2.00 \text{ M} - 0.73 \text{ M} = 1.27 \text{ M}$$

$$[\text{H}_2\text{O}] = 1.00 \text{ M} - x = 0.27 \text{ M}$$

$$[\text{CO}_2] = [\text{H}_2] = x = 0.73 \text{ M}$$

Checking to see if these values give the known K_c, we have

$$K_c = \frac{(0.73)(0.73)}{(1.27)(0.27)} = 1.6 \text{ (within rounding of 1.56)}$$

A Simplifying Assumption for Finding the Unknown In many cases, we can use chemical “common sense” to make an assumption that simplifies the math by avoiding the need to use the quadratic formula to find x . In general,

- if a reaction has a relatively small K and a relatively large initial reactant concentration, the concentration change (x) can often be neglected.

This assumption does not mean that $x = 0$, because then there would be no reaction. It means that if a reaction starts with a high $[reactant]_{init}$ and proceeds very little to reach equilibrium (small K), the reactant concentration at equilibrium, $[reactant]_{eq}$, will be nearly the same as $[reactant]_{init}$.

Here’s an everyday analogy for this assumption. On a bathroom scale, you weigh 158 lb. Take off your wristwatch, and you still weigh 158 lb. Within the accuracy of the scale, the weight of the watch is so small compared with your body weight that it can be neglected:

Initial body weight – weight of watch = final body weight \approx initial body weight
Thus, let’s say the initial concentration of A is 0.500 M and, because of a small K_c , the concentration of A that reacts is 0.002 M . We can then assume that

$$0.500\text{ M} - 0.002\text{ M} = 0.498\text{ M} \approx 0.500\text{ M}$$

that is,

$$[A]_{init} - [A]_{reacting} = [A]_{eq} \approx [A]_{init} \quad (17.9)$$

To justify the assumption that x is negligible, we make sure the error introduced is not significant. One common criterion for “significant” is the 5% rule:

- if the assumption results in a change that is less than 5% of the initial concentration, the error is not significant, and the assumption is justified.

Let’s see how making this assumption simplifies the math and if it is justified in the cases of two different $[reactant]_{init}$ values.

Student Hot Spot

Student data indicate that you may struggle with applying the simplifying assumption in equilibrium problems. Access the Smartbook to view additional Learning Resources on this topic.

SAMPLE PROBLEM 17.9

Making a Simplifying Assumption to Calculate Equilibrium Concentrations

Problem Phosgene is a potent chemical warfare agent that is now outlawed by international agreement. It decomposes by the reaction

Calculate $[\text{CO}]$, $[\text{Cl}_2]$, and $[\text{COCl}_2]$ when each of the following amounts of phosgene decomposes and reaches equilibrium in a 10.0-L flask:

- (a) 5.00 mol of COCl_2 (b) 0.100 mol of COCl_2

Plan We know from the balanced equation that when x mol of COCl_2 decomposes, x mol of CO and x mol of Cl_2 form. We use the volume (10.0 L) to convert amount (5.00 mol or 0.100 mol) to molar concentration, define x and set up the reaction table, and substitute the values into Q_c . Before using the quadratic formula, we assume that x is negligibly small. After solving for x , we check the assumption and find the equilibrium concentrations. If the assumption is not justified, we use the quadratic formula to find x .

Solution (a) For 5.00 mol of COCl_2 . Writing the reaction quotient:

$$Q_c = \frac{[\text{CO}][\text{Cl}_2]}{[\text{COCl}_2]}$$

Calculating the initial reactant concentration, $[\text{COCl}_2]_{init}$:

$$[\text{COCl}_2]_{init} = \frac{5.00 \text{ mol}}{10.0 \text{ L}} = 0.500\text{ M}$$

Setting up the reaction table, with x equal to $[\text{COCl}_2]_{\text{reacting}}$:

Concentration (M)	$\text{COCl}_2(g)$	\rightleftharpoons	$\text{CO}(g)$	+	$\text{Cl}_2(g)$
Initial	0.500		0		0
Change	$-x$		$+x$		$+x$
Equilibrium	$0.500 - x$		x		x

If we use the equilibrium values in Q_c with the given K_c , we obtain

$$Q_c = \frac{[\text{CO}][\text{Cl}_2]}{[\text{COCl}_2]} = \frac{x^2}{0.500 - x} = K_c = 8.3 \times 10^{-4}$$

Because K_c is small, the reaction does not proceed very far to the right, so let's assume that x ($[\text{COCl}_2]_{\text{reacting}}$) can be neglected. In other words, we assume that the equilibrium concentration is nearly the same as the initial concentration, 0.500 M:

$$\frac{[\text{COCl}_2]_{\text{init}} - [\text{COCl}_2]_{\text{reacting}}}{0.500 \text{ M} - x} = [\text{COCl}_2]_{\text{eq}}$$

$$0.500 \text{ M} - x \approx 0.500 \text{ M}$$

Using this assumption, we substitute and solve for x :

$$K_c = 8.3 \times 10^{-4} \approx \frac{x^2}{0.500}$$

$$x^2 \approx (8.3 \times 10^{-4})(0.500) \quad \text{so} \quad x \approx 2.0 \times 10^{-2}$$

Checking the assumption by seeing if the error is <5%:

$$\frac{[\text{Change}]}{[\text{Initial}]} \times 100 = \frac{2.0 \times 10^{-2}}{0.500} \times 100 = 4\% \quad (<5\%, \text{ so the assumption is justified})$$

Solving for the equilibrium concentrations:

$$[\text{CO}] = [\text{Cl}_2] = x = 2.0 \times 10^{-2} \text{ M}$$

$$[\text{COCl}_2] = 0.500 \text{ M} - x = 0.480 \text{ M}$$

(b) For 0.100 mol of COCl_2 . The calculation in this case is the same as the calculation in part (a), except that $[\text{COCl}_2]_{\text{init}} = 0.100 \text{ mol}/10.0 \text{ L} = 0.0100 \text{ M}$. Thus, at equilibrium,

$$Q_c = \frac{[\text{CO}][\text{Cl}_2]}{[\text{COCl}_2]} = \frac{x^2}{0.0100 - x} = K_c = 8.3 \times 10^{-4}$$

Making the assumption that $0.0100 \text{ M} - x \approx 0.0100 \text{ M}$ and solving for x :

$$K_c = 8.3 \times 10^{-4} \approx \frac{x^2}{0.0100} \quad \text{so} \quad x \approx 2.9 \times 10^{-3}$$

Checking the assumption:

$$\frac{2.9 \times 10^{-3}}{0.0100} \times 100 = 29\% \quad (>5\%, \text{ so the assumption is not justified})$$

Rearranging Q_c and its value at equilibrium into the form of a quadratic equation gives

$$8.3 \times 10^{-4} = \frac{x^2}{0.0100 - x} \quad \text{or} \quad x^2 = (8.3 \times 10^{-6}) - (8.3 \times 10^{-4})x$$

and so

$$x^2 + (8.3 \times 10^{-4})x - (8.3 \times 10^{-6}) = 0$$

Solving this equation with the quadratic formula shows that

$$x = \frac{-8.3 \times 10^{-4} \pm \sqrt{(8.3 \times 10^{-4})^2 - 4(1)(-8.3 \times 10^{-6})}}{2(1)}$$

The only meaningful value of x is 2.5×10^{-3} .

Solving for the equilibrium concentrations:

$$[\text{CO}] = [\text{Cl}_2] = x = 2.5 \times 10^{-3} \text{ M}$$

$$[\text{COCl}_2] = 1.00 \times 10^{-2} \text{ M} - x = 7.5 \times 10^{-3} \text{ M}$$

Check Once again, use the calculated values to be sure you obtain the given K_c .

Comment The main point is that the simplifying assumption was justified at the high $[\text{COCl}_2]_{\text{init}}$ in part (a) but *not* at the low $[\text{COCl}_2]_{\text{init}}$ in part (b). The amount of $[\text{COCl}_2]_{\text{reacting}}$

is small in (b), but since $[COCl_2]_{init}$ is also small, $[COCl_2]_{reacting}$ is a high percentage of $[COCl_2]_{init}$ and cannot be neglected without introducing significant error.

FOLLOW-UP PROBLEMS

17.9A In a study of the effect of temperature on halogen decomposition, 0.50 mol of I_2 was heated in a 2.5-L vessel, and the following reaction occurred: $I_2(g) \rightleftharpoons 2I(g)$

- Calculate $[I_2]$ and $[I]$ at equilibrium at 600 K; $K_c = 2.94 \times 10^{-10}$.
- Calculate $[I_2]$ and $[I]$ at equilibrium at 2000 K; $K_c = 0.209$.

17.9B Phosphorus pentachloride decomposes as follows:

Calculate the equilibrium partial pressure of PCl_5 if the reaction begins with:

- a PCl_5 partial pressure of 0.18 atm;
- a PCl_5 partial pressure of 0.025 atm.

SOME SIMILAR PROBLEMS 17.49–17.51

Predicting When the Assumption Will Be Justified To summarize, we assume that $x ([A]_{reacting})$ can be neglected if K_c is relatively small and/or $[A]_{init}$ is relatively large. The same holds for K_p and $P_{A(init)}$. But *how* small or large must these variables be? Here's a benchmark for deciding when to make the assumption:

- If $\frac{[A]_{init}}{K_c} > 400$, the assumption is justified: neglecting x introduces an error $<5\%$.
- If $\frac{[A]_{init}}{K_c} < 400$, the assumption is *not* justified; neglecting x introduces an error $>5\%$, so we solve a quadratic equation to find x .

For example, using the values from Sample Problem 17.9, we have

Part (a): For $[A]_{init} = 0.500 \text{ M}$, $\frac{0.500}{8.3 \times 10^{-4}} = 6.0 \times 10^2$, which is greater than 400.

Part (b): For $[A]_{init} = 0.0100 \text{ M}$, $\frac{0.0100}{8.3 \times 10^{-4}} = 12$, which is less than 400.

We will make a similar assumption in many problems in Chapters 18 and 19.

Problems Involving Mixtures of Reactants and Products

In the problems so far, the reaction *had* to go toward products because it started with only reactants. And therefore, in the reaction tables, we knew that the unknown change in reactant concentration had a negative sign ($-x$) and the change in product concentration had a positive sign ($+x$). If, however, we start with a *mixture* of reactants and products, the reaction direction is not obvious. In those cases, we apply the idea from Section 17.4 and first *compare the values of Q and K to find the direction in which the reaction is proceeding to reach equilibrium*. (To focus on this idea, Sample Problem 17.10 uses concentrations that avoid the need for the quadratic formula.)

Student Hot Spot

Student data indicate that you may struggle with this type of equilibrium calculation. Access the Smartbook to view additional Learning Resources on this topic.

SAMPLE PROBLEM 17.10

Predicting Reaction Direction and Calculating Equilibrium Concentrations

Problem The research and development unit of a chemical company is studying the reaction of CH_4 and H_2S , two components of natural gas:

In one experiment, 1.00 mol of CH_4 , 1.00 mol of CS_2 , 2.00 mol of H_2S , and 2.00 mol of H_2 are mixed in a 250.-mL vessel at 960°C. At this temperature, $K_c = 0.036$.

- In which direction will the reaction proceed to reach equilibrium?
- If $[CH_4] = 5.56 \text{ M}$ at equilibrium, what are the equilibrium concentrations of the other substances?

Plan (a) To find the direction, we convert the given initial amounts and volume (0.250 L) to concentrations, calculate Q_c , and compare it with K_c . (b) Based on this information, we determine the sign of each concentration change for the reaction table and then use the known $[\text{CH}_4]$ at equilibrium (5.56 M) to determine x and the other equilibrium concentrations.

Solution (a) Calculating the initial concentrations:

$$[\text{CH}_4] = \frac{1.00\text{ mol}}{0.250\text{ L}} = 4.00\text{ M}$$

Similarly, $[\text{H}_2\text{S}] = 8.00\text{ M}$, $[\text{CS}_2] = 4.00\text{ M}$, and $[\text{H}_2] = 8.00\text{ M}$.

Calculating the value of Q_c :

$$Q_c = \frac{[\text{CS}_2][\text{H}_2]^4}{[\text{CH}_4][\text{H}_2\text{S}]^2} = \frac{(4.00)(8.00)^4}{(4.00)(8.00)^2} = 64.0$$

Comparing Q_c and K_c : $Q_c > K_c$ ($64.0 > 0.036$), so the reaction proceeds to the left. Therefore, concentrations of reactants increase ($+x$) and those of products decrease ($-x$).

(b) Setting up a reaction table, with $x = [\text{CS}_2]$ that reacts, which equals $[\text{CH}_4]$ that forms:

Concentration (M)	$\text{CH}_4(g)$	+	$2\text{H}_2\text{S}(g)$	\rightleftharpoons	$\text{CS}_2(g)$	+	$4\text{H}_2(g)$
Initial	4.00		8.00		4.00		8.00
Change	$+x$		$+2x$		$-x$		$-4x$
Equilibrium	$4.00 + x$		$8.00 + 2x$		$4.00 - x$		$8.00 - 4x$

Solving for x : At equilibrium,

$$[\text{CH}_4] = 5.56\text{ M} = 4.00\text{ M} + x \quad \text{so} \quad x = 1.56\text{ M}$$

Thus, $[\text{H}_2\text{S}] = 8.00\text{ M} + 2x = 8.00\text{ M} + 2(1.56\text{ M}) = 11.12\text{ M}$

$$[\text{CS}_2] = 4.00\text{ M} - x = 4.00\text{ M} - 1.56\text{ M} = 2.44\text{ M}$$

$$[\text{H}_2] = 8.00\text{ M} - 4x = 8.00\text{ M} - 4(1.56\text{ M}) = 1.76\text{ M}$$

Check The comparison of Q_c and K_c showed the reaction proceeding to the left. The given data from part (b) confirm this because $[\text{CH}_4]$ increases from 4.00 M to 5.56 M during the reaction. As always, you should check that the concentrations give the known K_c :

$$\frac{(2.44)(1.76)^4}{(5.56)(11.12)^2} = 0.0341, \text{ which is close to } 0.036$$

FOLLOW-UP PROBLEMS

17.10A An inorganic chemist studying the reactions of phosphorus halides mixes 0.1050 mol of PCl_5 with 0.0450 mol of Cl_2 and 0.0450 mol of PCl_3 in a 0.5000-L flask at 250°C :

(a) In which direction will the reaction proceed?

(b) If $[\text{PCl}_5] = 0.2065\text{ M}$ at equilibrium, what are the equilibrium concentrations of the other components?

17.10B A chemist studying the production of nitrogen monoxide (NO) in the atmosphere adds 0.500 atm of N_2 , 0.500 atm of O_2 , and 0.750 atm of NO to a sealed container at 2500°C :

Determine the direction in which the reaction proceeds, and calculate the equilibrium pressures of all three gases.

SOME SIMILAR PROBLEMS 17.94 and 17.102

Figure 17.6 on the next page groups the steps for solving equilibrium problems in which you know K and some initial quantities and must find the equilibrium quantities.

SOLVING EQUILIBRIUM PROBLEMS

PRELIMINARY SETTING UP

- Write the balanced equation.
- Write the reaction quotient, Q .
- Convert all amounts into the correct units (M or atm).

WORKING ON THE REACTION TABLE

- When reaction direction is not known, compare Q with K .
- Construct a reaction table.

✓ Check the sign of x , the change in the concentration (or pressure).

SOLVING FOR x AND EQUILIBRIUM QUANTITIES

- Substitute the quantities into Q .
- To simplify the math, assume that x is negligible:
 $([A]_{\text{init}} - x) \approx [A]_{\text{eq}}$
- Solve for x .

✓ Check that assumption is justified (<5% error). If not, solve quadratic equation for x .

- Find the equilibrium quantities.

✓ Check to see that calculated values give the known K .

› Summary of Section 17.5

- In equilibrium problems, we typically use quantities (concentrations or pressures) of reactants and products to find K , or we use K to find quantities.
- Reaction tables summarize the initial quantities, their changes during the reaction, and the equilibrium quantities.
- To simplify calculations, we assume that if K is small and the initial quantity of reactant is large, the unknown change in reactant (x) can be neglected. If this assumption is not justified (that is, if the resulting error is greater than 5%), we use the quadratic formula to find x .
- For reactions that start with a mixture of reactants and products, we first determine reaction direction by comparing Q and K to decide on the sign of x .

17.6 REACTION CONDITIONS AND EQUILIBRIUM: LE CHÂTELIER'S PRINCIPLE

Change conditions so that a system is no longer at equilibrium, and it has the remarkable ability to adjust itself and reattain equilibrium. This phenomenon is described by **Le Châtelier's principle:** when a chemical system at equilibrium is disturbed, it reattains equilibrium by undergoing a net reaction that reduces the effect of the disturbance.

Two phrases in this statement *need* further explanation:

1. How is a system “disturbed”? At equilibrium, Q equals K . The system is disturbed when a change in conditions forces it temporarily out of equilibrium ($Q \neq K$). Three common disturbances are a change in concentration, a change in pressure (caused by a change in volume), or a change in temperature. We’ll discuss each below.

2. What does a “net reaction” mean? This phrase refers to a shift in the *equilibrium position* to the right or left. The *equilibrium position* is defined by the specific equilibrium concentrations (or pressures). *Concentrations (or pressures) change in a way that reduces the effect of the change in conditions, and the system attains a new equilibrium position:*

- a shift to the right is a net reaction that converts reactant to product until equilibrium is reattained;
- a shift to the left is a net reaction that converts product to reactant until equilibrium is reattained.

For the remainder of this section, we’ll examine a system at equilibrium to see how it responds to changes in concentration, pressure (volume), or temperature; then, we’ll see what happens when we add a catalyst. As our example, we use the gaseous reaction between phosphorus trichloride and chlorine to produce phosphorus pentachloride:

Le Châtelier’s principle holds for many systems at equilibrium in both the natural and social sciences—the effects of disease or drought on populations of predators and prey on the African savannah (*see photo*), a change in the cost of petroleum based on a balance of supply and demand, and even the formation of certain elements in the core of a star.

The Effect of a Change in Concentration

When a system at equilibrium is disturbed by a change in concentration of one of the components, it reacts in the direction that reduces the change:

- If the concentration of A is increased, the system reacts to consume some of that component.
- If the concentration of A is decreased, the system reacts to produce some of it.

Only components that appear in Q can have an effect, so changes in the amounts of pure liquids and solids cannot.

Le Châtelier’s principle applies to many systems.

Source: © AfriPics.com/Alamy

A Qualitative View of a Concentration Change At 523 K, the $\text{PCl}_3\text{-Cl}_2\text{-PCl}_5$ system reaches equilibrium when

Starting with Q_c equal to K_c , let's think through some changes in concentration:

1. *Adding a reactant.* What happens if we disturb the system by adding some Cl_2 gas? To reduce this disturbance, the system will consume some of the added Cl_2 by shifting toward product. With regard to the reaction quotient, when the $[\text{Cl}_2]$ term increases, the value of Q_c decreases; thus, $Q_c < K_c$. As some of the added Cl_2 reacts with some of the PCl_3 to form more PCl_5 , the denominator becomes smaller again and the numerator larger, until eventually $Q_c = K_c$ again. Notice the changes in the new equilibrium concentrations: $[\text{Cl}_2]$ and $[\text{PCl}_5]$ are higher than in the original equilibrium position, and $[\text{PCl}_3]$ is lower. Nevertheless, the ratio of values gives the same K_c . Thus, *the equilibrium position shifts to the right when a component on the left is added:*

2. *Removing a reactant.* What happens if we disturb the system by removing some PCl_3 ? To reduce this disturbance, the system will replace the PCl_3 by consuming some PCl_5 and proceeding toward reactants. With regard to Q_c , when the $[\text{PCl}_3]$ term decreases, Q_c increases, so $Q_c > K_c$. As some PCl_5 decomposes to PCl_3 and Cl_2 , the numerator decreases and the denominator increases until $Q_c = K_c$ again. Once again, the new and old equilibrium concentrations are different, but the value of K_c is not. Thus, *the equilibrium position shifts to the left when a component on the left is removed:*

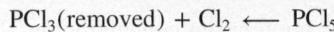

3. *Adding or removing a product.* The same points we just made for a reactant hold for a product. If we add PCl_5 , the equilibrium position shifts to the left to consume PCl_5 ; if we remove some PCl_5 , the equilibrium position shifts to the right to produce PCl_5 .

In other words, no matter how the disturbance in concentration comes about, *the system reacts to consume some of the added substance or produce some of the removed substance to make $Q_c = K_c$ again* (Figure 17.7):

- The equilibrium position shifts to the *right* if a reactant is added or a product is removed: [reactant] increases or [product] decreases.
- The equilibrium position shifts to the *left* if a reactant is removed or a product is added: [reactant] decreases or [product] increases.

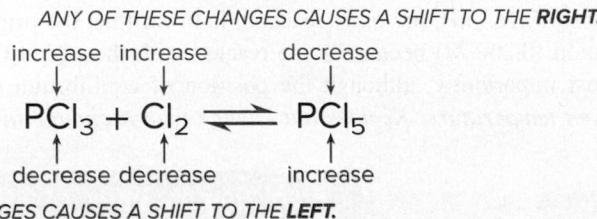

Figure 17.7 The effect of a change in concentration on a system at equilibrium.

A Quantitative View of a Concentration Change As you saw, the system “reduces the effect of the disturbance.” But the effect is not completely eliminated, as we can see from a quantitative comparison of original and new equilibrium positions.

Consider what happens when we add Cl_2 to a system whose original equilibrium position was established with $[\text{PCl}_3] = 0.200 \text{ M}$, $[\text{Cl}_2] = 0.125 \text{ M}$, and $[\text{PCl}_5] = 0.600 \text{ M}$. That is,

$$Q_c = \frac{[\text{PCl}_5]}{[\text{PCl}_3][\text{Cl}_2]} = \frac{0.600}{(0.200)(0.125)} = 24.0 = K_c$$

Table 17.3

The Effect of Added Cl₂ on the PCl₃-Cl₂-PCl₅ System

Concentration (M)	PCl ₃ (g)	+	Cl ₂ (g)	≡	PCl ₅ (g)
Original equilibrium	0.200		0.125		0.600
Disturbance			+0.075		
New initial	0.200		0.200		0.600
Change	$-x$		$-x$		$+x$
New equilibrium	$0.200 - x$		$0.200 - x$		$0.600 + x$ (0.637)*

*Experimentally determined value.

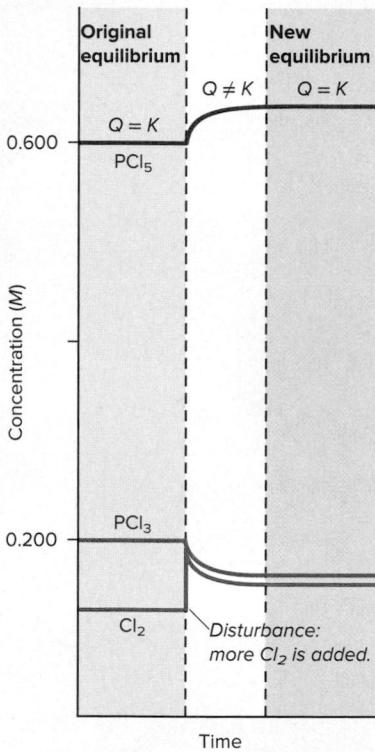

Figure 17.8 The effect of added Cl₂ on the PCl₃-Cl₂-PCl₅ system. The original equilibrium concentrations are shown at left (gray region). When Cl₂ (yellow curve) is added, its concentration increases instantly (vertical part of yellow curve) and then falls gradually as it reacts with PCl₃ to form more PCl₅. Soon, equilibrium is re-established at new concentrations (blue region) but with the same K .

Now we add enough Cl₂ to increase its concentration by 0.075 M to a new [Cl₂]_{init} of 0.200 M; the system is no longer at equilibrium since $Q_c < K_c$:

$$Q_c = \frac{[PCl_5]}{[PCl_3][Cl_2]} = \frac{0.600}{(0.200)(0.200)} = 15.0 < K_c$$

The reaction proceeds, and the system comes to a new equilibrium position. From Le Châtelier's principle, we predict that adding more reactant will shift the equilibrium position to the right. Experimental measurement shows that the new [PCl₅]_{eq} is 0.637 M.

Table 17.3 shows a reaction table for the entire process: the original equilibrium position, the disturbance, the (new) initial concentrations, the direction of x (the change needed to reattain equilibrium), and the new equilibrium position. Figure 17.8 depicts the process.

Let's determine the new equilibrium concentrations. From Table 17.3,

$$[PCl_5] = 0.600 M + x = 0.637 M \quad \text{so} \quad x = 0.037 M$$

Thus, $[PCl_3] = [Cl_2] = 0.200 M - x = 0.200 M - 0.037 M = 0.163 M$

Therefore, at equilibrium,

$$K_{c(\text{original})} = \frac{0.600}{(0.200)(0.125)} = 24.0$$

$$K_{c(\text{new})} = \frac{0.637}{(0.163)(0.163)} = 24.0$$

There are several key points to notice about the new equilibrium concentrations:

- As we predicted, [PCl₅] (0.637 M) is higher than the original concentration (0.600 M).
- [Cl₂] (0.163 M) is higher than the original equilibrium concentration (0.125 M), but lower than the new initial concentration (0.200 M); thus, the disturbance is *reduced but not eliminated*.
- [PCl₃] (0.163 M), the other reactant, is lower than the original equilibrium concentration (0.200 M) because some reacted with the added Cl₂.
- Most importantly, although the position of equilibrium shifted to the right, *at a given temperature, K_c does not change with a change in concentration*.

SAMPLE PROBLEM 17.11

Predicting the Effect of a Change in Concentration on the Equilibrium Position

Problem To improve air quality and obtain a useful product, chemists often remove sulfur from coal and natural gas by treating the contaminant hydrogen sulfide with O₂:

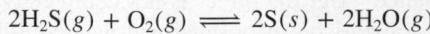

What happens to

(a) [H₂O] if O₂ is added?

(b) [H₂S] if O₂ is added?

(c) [O₂] if H₂S is removed?

(d) [H₂S] if sulfur is added?

Plan We write the reaction quotient to see how Q_c is affected by each disturbance, relative to K_c . In each case, the effect tells us the direction in which the reaction proceeds for the system to reattain equilibrium and how each concentration changes.

Solution Writing the reaction quotient (solid sulfur is not included): $Q_c = \frac{[H_2O]^2}{[H_2S]^2[O_2]}$

(a) When O_2 is added, the denominator of Q_c increases, so $Q_c < K_c$. The reaction proceeds to the right until $Q_c = K_c$ again, so $[H_2O]$ increases.

(b) As in part (a), when O_2 is added, $Q_c < K_c$. Some H_2S reacts with the added O_2 as the reaction proceeds to the right, so $[H_2S]$ decreases.

(c) When H_2S is removed, the denominator of Q_c decreases, so $Q_c > K_c$. As the reaction proceeds to the left to re-form H_2S , more O_2 forms as well, so $[O_2]$ increases.

(d) The concentration of solid S does not change, so it does not appear in the reaction quotient. As long as some S is present, adding more S has no effect, so $[H_2S]$ is unchanged (but see Comment 2 below).

Check Apply Le Châtelier's principle to see that the reaction proceeds in the direction that lowers the increased concentration or raises the decreased concentration.

Comment 1. As you know, sulfur exists most commonly as S_8 . How would this change in formula affect the answers? The balanced equation and Q_c would be

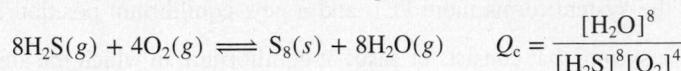

The value of K_c is different for this equation, but the changes described in the problem have the same effects. Thus, shifts in equilibrium position predicted by Le Châtelier's principle are not affected by a change in the balancing coefficients.

2. In part (d), you saw that adding a solid has no effect on the concentrations of other components: because the **concentration of the solid cannot change**, it does not appear in Q . But the **amount of solid can change**. Adding H_2S shifts the reaction to the right, so more S forms.

FOLLOW-UP PROBLEMS

17.11A In a study of glass etching, a chemist examines the reaction between sand (SiO_2) and hydrogen fluoride at $150^\circ C$:

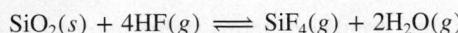

Predict the effect on $[SiF_4]$ when

- | | |
|---------------------------|---------------------------------|
| (a) $H_2O(g)$ is removed. | (b) some liquid water is added. |
| (c) HF is removed. | (d) some sand is removed. |

17.11B Water gas, a fuel mixture of carbon monoxide and hydrogen, is produced by passing steam over hot carbon:

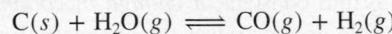

For each of the following changes, what happens to $[CO]$?

- | | |
|--------------------------|---------------------------|
| (a) Carbon is added. | (b) $H_2O(g)$ is removed. |
| (c) $H_2(g)$ is removed. | (d) $H_2O(g)$ is added. |

SOME SIMILAR PROBLEMS 17.64 and 17.65

The Effect of a Change in Pressure (Volume)

Changes in pressure can have a large effect on equilibrium systems containing gaseous components. (A change in pressure has a negligible effect on liquids and solids because they are nearly incompressible.) Pressure changes can occur in three ways:

- *Changing the concentration of a gaseous component.* We just considered the effect of changing the concentration of a component, and that reasoning applies here.
- *Adding an inert gas (one that does not take part in the reaction).* As long as the volume of the system is constant, adding an inert gas has no effect on the equilibrium position because *all concentrations, and thus partial pressures, remain the same*. Moreover, the inert gas does not appear in Q , so it cannot have an effect.
- *Changing the volume of the reaction vessel.* This change can cause a large shift in equilibrium position, but only for reactions in which the number of moles of gas, n_{gas} , changes.

Let's consider the two possible situations for the third way: changing the volume of the reaction vessel.

1. *Reactions in which n_{gas} changes.* Suppose the $\text{PCl}_3\text{-Cl}_2\text{-PCl}_5$ system is in a piston-cylinder assembly. We press down on the piston to halve the volume, so the gas pressure doubles (recall that pressure and volume are inversely proportional—Boyle's law). To reduce this disturbance, the system responds by *reducing the number of gas molecules* in order to reduce the pressure. And the only way to do that is through a net reaction toward the side with *fewer moles of gas*, in this case, toward product:

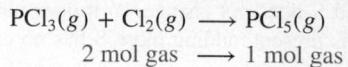

Recall that $Q_c = \frac{[\text{PCl}_5]}{[\text{PCl}_3][\text{Cl}_2]}$ for this reaction. When the volume is halved, the concentrations double, but the denominator of Q_c is the product of two concentrations, so it quadruples while the numerator only doubles. Thus, Q_c becomes less than K_c . As a result, the system forms more PCl_5 and a new equilibrium position is reached.

Thus, for a system that consists of gases at equilibrium, in which the amount (mol) of gas, n_{gas} , changes during the reaction (Figure 17.9):

- If the volume becomes smaller (pressure is higher), the reaction shifts so that the total number of gas molecules decreases.
- If the volume becomes larger (pressure is lower), the reaction shifts so that the total number of gas molecules increases.

2. *Reactions in which n_{gas} does not change.* For the formation of hydrogen iodide from its elements, we have the same amount (mol) of gas on both sides:

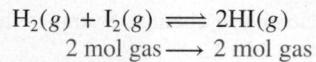

Therefore, Q_c has the same number of terms in the numerator and denominator:

$$Q_c = \frac{[\text{HI}]^2}{[\text{H}_2][\text{I}_2]} = \frac{[\text{HI}][\text{HI}]}{[\text{H}_2][\text{I}_2]}$$

Because a change in volume has the same effect on the numerator and denominator, *there is no effect on the equilibrium position*.

In terms of the equilibrium constant, *a change in volume is, in effect, a change in concentration*: a decrease in volume raises the concentration, and vice versa. Therefore, like other changes in concentration, *a change in pressure due to a change in volume does not alter K_c* .

Student Hot Spot

Student data indicate that you may struggle with using Le Chatelier's Principle to predict a change in equilibrium. Access the Smartbook to view additional Learning Resources on this topic.

Figure 17.9 The effect of a change in pressure (volume) on a system at equilibrium.

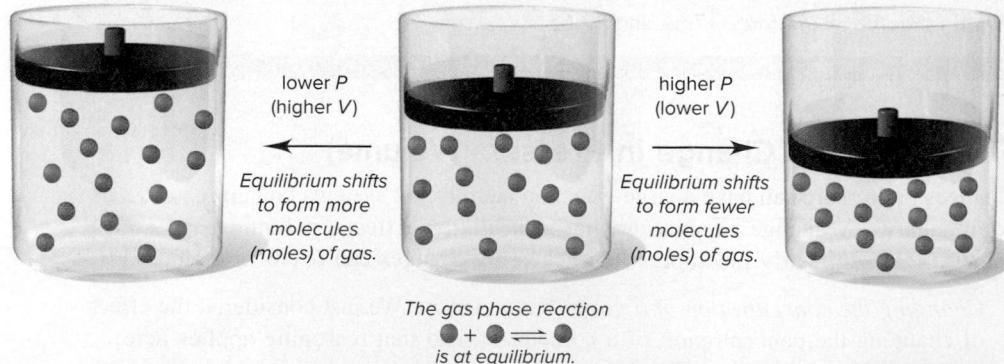

SAMPLE PROBLEM 17.12

Predicting the Effect of a Change in Volume (Pressure) on the Equilibrium Position

Problem How would you change the volume for each of the following reactions to *increase the yield of the product(s)*?

- (a) $\text{CaCO}_3(s) \rightleftharpoons \text{CaO}(s) + \text{CO}_2(g)$ (b) $\text{S}(s) + 3\text{F}_2(g) \rightleftharpoons \text{SF}_6(g)$
 (c) $\text{Cl}_2(g) + \text{I}_2(g) \rightleftharpoons 2\text{ICl}(g)$

Plan Whenever gases are present, a change in volume causes a change in concentration. For reactions in which the number of moles of gas changes, if the volume decreases (pressure increases), the equilibrium position shifts to lower the pressure by reducing the number of moles of gas. A volume increase (pressure decrease) has the opposite effect.

Solution (a) The only gas is the product CO_2 . To make the system produce more molecules of gas, that is, more CO_2 , we increase the volume (decrease the pressure).

(b) With 3 mol of gas on the left and only 1 mol on the right, we decrease the volume (increase the pressure) to form fewer molecules of gas and, thus, more SF_6 .

(c) The number of moles of gas is the same on both sides of the equation, so a change in volume (pressure) will have no effect on the yield of ICl .

Check Let's predict the relative values of Q_c and K_c .

(a) $Q_c = [\text{CO}_2]$, so increasing the volume will make $Q_c < K_c$, and the system will yield more CO_2 .

(b) $Q_c = [\text{SF}_6]/[\text{F}_2]^3$. Lowering the volume increases $[\text{F}_2]$ and $[\text{SF}_6]$ proportionately, but Q_c decreases because of the exponent 3 in the denominator. To make $Q_c = K_c$ again, $[\text{SF}_6]$ must increase.

(c) $Q_c = [\text{ICl}]^2/[\text{Cl}_2][\text{I}_2]$. A change in volume (pressure) affects the numerator (2 mol) and denominator (2 mol) equally, so it will have no effect.

FOLLOW-UP PROBLEMS

17.12A Would you increase or decrease the pressure (via a volume change) of each of the following reaction mixtures to *decrease* the yield of product(s)?

- $2\text{SO}_2(g) + \text{O}_2(g) \rightleftharpoons 2\text{SO}_3(g)$
- $4\text{NH}_3(g) + 5\text{O}_2(g) \rightleftharpoons 4\text{NO}(g) + 6\text{H}_2\text{O}(g)$
- $\text{CaC}_2\text{O}_4(s) \rightleftharpoons \text{CaCO}_3(s) + \text{CO}(g)$

17.12B Predict the effect of an increase in container volume (decrease in P) on the yield of products in each of the following:

- $\text{CH}_4(g) + \text{CO}_2(g) \rightleftharpoons 2\text{CO}(g) + 2\text{H}_2(g)$
- $\text{NO}(g) + \text{CO}_2(g) \rightleftharpoons \text{NO}_2(g) + \text{CO}(g)$
- $2\text{H}_2\text{S}(g) + \text{SO}_2(g) \rightleftharpoons 3\text{S}(s) + 2\text{H}_2\text{O}(g)$

SOME SIMILAR PROBLEMS 17.66–17.71

The Effect of a Change in Temperature

Of the three types of disturbances that may occur—a change in concentration, pressure, or temperature—only temperature changes alter the value of K . To see why, let's focus on the sign of $\Delta H_{\text{rxn}}^\circ$:

The forward reaction is exothermic (releases heat; $\Delta H_{\text{rxn}}^\circ < 0$), so the reverse reaction is endothermic (absorbs heat; $\Delta H_{\text{rxn}}^\circ > 0$):

If we consider *heat* as a component of the equilibrium system, a rise in temperature occurs when heat is “added” to the system and a drop in temperature occurs when heat is “removed” from the system. As with a change in any other component, the system shifts to reduce the effect of the change. Therefore, a *temperature increase* (adding heat) favors the endothermic (heat-absorbing) direction, and a *temperature decrease* (removing heat) favors the exothermic (heat-releasing) direction.

If we start with the system at equilibrium, Q_c equals K_c . Increase the temperature, and the system absorbs the added heat by decomposing some PCl_5 to PCl_3 and Cl_2 . The denominator of Q_c becomes larger and the numerator smaller, so the system reaches a new equilibrium position at a smaller ratio of concentration terms, that is, a lower K_c . Similarly, if the temperature drops, the system releases more heat by forming more PCl_5 from some PCl_3 and Cl_2 . The numerator of Q_c becomes larger, the denominator smaller, and the new equilibrium position has a higher K_c . Thus,

- A temperature rise will increase K_c for a system with a positive $\Delta H_{\text{rxn}}^\circ$.
- A temperature rise will decrease K_c for a system with a negative $\Delta H_{\text{rxn}}^\circ$.

Let's review these ideas with a sample problem.

SAMPLE PROBLEM 17.13
Predicting the Effect of a Change in Temperature on the Equilibrium Position

Problem How does an *increase* in temperature affect the equilibrium concentration of the underlined substance and K for each of the following reactions?

- (a) $\text{CaO}(s) + \underline{\text{H}_2\text{O}}(l) \rightleftharpoons \text{Ca}(\text{OH})_2(aq) \quad \Delta H^\circ = -82 \text{ kJ}$
 (b) $\text{CaCO}_3(s) \rightleftharpoons \text{CaO}(s) + \underline{\text{CO}_2(g)} \quad \Delta H^\circ = 178 \text{ kJ}$
 (c) $\underline{\text{SO}_2(g)} \rightleftharpoons \text{S}(s) + \text{O}_2(g) \quad \Delta H^\circ = 297 \text{ kJ}$

Plan We write each equation to show heat as a reactant or product. The temperature increases when we add heat, so the system shifts to absorb the heat; that is, the endothermic reaction occurs. Thus, K will increase if the forward reaction is endothermic and decrease if it is exothermic.

Solution (a) $\text{CaO}(s) + \text{H}_2\text{O}(l) \rightleftharpoons \text{Ca}(\text{OH})_2(aq) + \text{heat}$

Adding heat shifts the system to the left: $[\text{Ca}(\text{OH})_2]$ and K will decrease.

(b) $\text{CaCO}_3(s) + \text{heat} \rightleftharpoons \text{CaO}(s) + \text{CO}_2(g)$

Adding heat shifts the system to the right: $[\text{CO}_2]$ and K will increase.

(c) $\text{SO}_2(g) + \text{heat} \rightleftharpoons \text{S}(s) + \text{O}_2(g)$

Adding heat shifts the system to the right: $[\text{SO}_2]$ will decrease and K will increase.

Check Check your answers by reasoning through a *decrease* in temperature: heat is removed and the exothermic direction is favored. All the answers should be opposite.

Comment Note that, as part (a) shows, these ideas hold for solutions as well.

FOLLOW-UP PROBLEMS

17.13A How does a *decrease* in T affect the partial pressure of the underlined substance and the value of K for each of the following reactions?

- (a) $\text{C(graphite)} + \underline{2\text{H}_2(g)} \rightleftharpoons \text{CH}_4(g) \quad \Delta H^\circ = -75 \text{ kJ}$
 (b) $\underline{\text{N}_2(g)} + \text{O}_2(g) \rightleftharpoons 2\text{NO}(g) \quad \Delta H^\circ = 181 \text{ kJ}$
 (c) $\text{P}_4(s) + 10\text{Cl}_2(g) \rightleftharpoons \underline{4\text{PCl}_5(g)} \quad \Delta H^\circ = -1528 \text{ kJ}$

17.13B Should T be increased or decreased to yield more product(s) in each of the following reactions? What effect does the change in T have on the value of K for each reaction?

- (a) $2\text{Cl}_2(g) + 2\text{H}_2\text{O}(g) \rightleftharpoons 4\text{HCl}(g) + \text{O}_2(g) \quad \Delta H^\circ = 114 \text{ kJ}$
 (b) $2\text{NO}(g) + \text{Cl}_2(g) \rightleftharpoons 2\text{NOCl}(g) \quad \Delta H^\circ = -77.2 \text{ kJ}$
 (c) $2\text{HgO}(s) \rightleftharpoons 2\text{Hg}(l) + \text{O}_2(g) \quad \Delta H^\circ = 182 \text{ kJ}$

SOME SIMILAR PROBLEMS 17.72 and 17.73

The van't Hoff Equation: The Effect of T on K The *van't Hoff equation* shows quantitatively how the equilibrium constant is affected by changes in temperature:

$$\ln \frac{K_2}{K_1} = -\frac{\Delta H_{\text{rxn}}^\circ}{R} \left(\frac{1}{T_2} - \frac{1}{T_1} \right) \quad (17.10)$$

where K_1 is the equilibrium constant at T_1 , K_2 is the equilibrium constant at T_2 , and R is the universal gas constant ($8.314 \text{ J/mol}\cdot\text{K}$). If we know $\Delta H_{\text{rxn}}^\circ$ and K at one temperature, the *van't Hoff equation* allows us to find K at any other temperature (or to find $\Delta H_{\text{rxn}}^\circ$, given the two K 's at two T 's).

Equation 17.10 confirms the qualitative prediction from Le Châtelier's principle: for a temperature rise, we have

$$T_2 > T_1 \quad \text{and} \quad \frac{1}{T_2} < \frac{1}{T_1}$$

so

$$\frac{1}{T_2} - \frac{1}{T_1} < 0$$

Therefore,

- For an endothermic reaction ($\Delta H_{\text{rxn}}^\circ > 0$), the $-(\Delta H_{\text{rxn}}^\circ/R)$ term in Equation 17.10 is < 0 . With $1/T_2 - 1/T_1 < 0$, the right side of the equation is > 0 . Thus, $\ln(K_2/K_1) > 0$, so $K_2 > K_1$. An increase in temperature results in a shift to the right and an increase in K .

- For an exothermic reaction ($\Delta H_{rxn}^{\circ} < 0$), the $-(\Delta H_{rxn}^{\circ}/R)$ term in Equation 17.10 is > 0 . With $1/T_2 - 1/T_1 < 0$, the right side of the equation is < 0 . Thus, $\ln(K_2/K_1) < 0$, so $K_2 < K_1$. An increase in temperature results in a shift to the left and a decrease in K .

Here's a typical problem that requires the van't Hoff equation. Many coal gasification processes begin with the formation of syngas from carbon and steam:

An engineer knows that K_p is only 9.36×10^{-17} at 25°C and therefore wants to find a temperature that allows a much higher yield. Calculate K_p at 700°C .

$$\ln \frac{K_2}{K_1} = -\frac{\Delta H_{rxn}^{\circ}}{R} \left(\frac{1}{T_2} - \frac{1}{T_1} \right)$$

The temperatures must be in kelvins, and the units of ΔH° and R must be made consistent:

$$\begin{aligned} \ln \left(\frac{K_{p2}}{9.36 \times 10^{-17}} \right) &= -\frac{131 \times 10^3 \text{ J/mol}}{8.314 \text{ J/mol}\cdot\text{K}} \left(\frac{1}{973 \text{ K}} - \frac{1}{298 \text{ K}} \right) \\ \frac{K_{p2}}{9.36 \times 10^{-17}} &= 8.51 \times 10^{15} \\ K_{p2} &= 0.797 \quad (\text{a much higher yield}) \end{aligned}$$

(For further practice with the van't Hoff equation, see Problems 17.74 and 17.75.)

The Lack of Effect of a Catalyst

Let's briefly consider what effect, if any, adding a catalyst will have on the system. Recall from Chapter 16 that a catalyst speeds up a reaction by lowering the activation energy, thereby increasing the forward *and* reverse rates to the same extent. Thus, *a catalyst shortens the time it takes to reach equilibrium but has no effect on the equilibrium position*. That is, if we add a catalyst to a mixture of PCl_3 and Cl_2 at 523 K, the system attains the *same* equilibrium concentrations of PCl_3 , Cl_2 , and PCl_5 *more quickly* than it does without the catalyst. As you'll see in a moment, however, catalysts play key roles in optimizing reaction systems.

Table 17.4 summarizes the effects of changing conditions. Many changes alter the equilibrium *position*, but only temperature changes alter the equilibrium *constant*. Sample Problem 17.14 shows how to visualize equilibrium at the molecular level.

Table 17.4

Effects of Various Disturbances on a System at Equilibrium

Disturbance	Effect on Equilibrium Position	Effect on Value of K
Concentration		
Increase [reactant]	Toward formation of product	None
Decrease [reactant]	Toward formation of reactant	None
Increase [product]	Toward formation of reactant	None
Decrease [product]	Toward formation of product	None
Pressure		
Increase P (decrease V)	Toward formation of fewer moles of gas	None
Decrease P (increase V)	Toward formation of more moles of gas	None
Increase P (add inert gas, no change in V)	None; concentrations unchanged	None
Temperature		
Increase T	Toward absorption of heat	Increases if $\Delta H_{rxn}^{\circ} > 0$ Decreases if $\Delta H_{rxn}^{\circ} < 0$
Decrease T	Toward release of heat	Increases if $\Delta H_{rxn}^{\circ} < 0$ Decreases if $\Delta H_{rxn}^{\circ} > 0$
Catalyst added		
	None; forward and reverse rates increase equally, and equilibrium is reached sooner	None

SAMPLE PROBLEM 17.14

Determining Equilibrium Parameters from Molecular Scenes

Problem For the reaction,

the following molecular scenes depict different reaction mixtures (X is green, Y is purple):

- (a) If $K = 2$ at the temperature of the reaction, which scene represents the mixture at equilibrium? (b) Will the reaction mixtures in the other two scenes proceed toward reactants or toward products to reach equilibrium? (c) For the mixture at equilibrium, how will a rise in temperature affect $[Y_2]$?

Plan (a) We are given the balanced equation and K and must choose the scene that represents the mixture at equilibrium. We write Q , and for each scene, count particles and find the value of Q . Whichever scene gives a Q equal to K (that is, equal to 2) represents the mixture at equilibrium. (b) For each of the other two reaction mixtures, we compare the value of Q with 2. If $Q > K$, the numerator (product side) is too high, so the reaction proceeds toward reactants; if $Q < K$, the reaction proceeds toward products. (c) We are given that $\Delta H > 0$, so we must see whether a rise in T increases or decreases $[Y_2]$, one of the reactants.

Solution (a) For the reaction, we have $Q = \frac{[XY][Y]}{[X][Y_2]}$. Thus,

$$\text{scene 1 : } Q = \frac{5 \times 3}{1 \times 1} = 15 \quad \text{scene 2 : } Q = \frac{4 \times 2}{2 \times 2} = 2 \quad \text{scene 3 : } Q = \frac{3 \times 1}{3 \times 3} = \frac{1}{3}$$

For scene 2, $Q = K$, so scene 2 represents the mixture at equilibrium.

(b) For scene 1, $Q (15) > K (2)$, so the reaction proceeds toward reactants.

For scene 3, $Q (\frac{1}{3}) < K (2)$, so the reaction proceeds toward products.

(c) The reaction is endothermic, so heat acts as a reactant:

Therefore, adding heat shifts the reaction to the right, so $[Y_2]$ decreases.

Check (a) Remember that quantities in the numerator (or denominator) of Q are multiplied, not added. For example, the denominator for scene 1 is $1 \times 1 = 1$, not $1 + 1 = 2$.

(c) A good check is to imagine that $\Delta H < 0$ and see if you get the opposite result:

If $\Delta H < 0$, adding heat would shift the reaction to the left and increase $[Y_2]$.

FOLLOW-UP PROBLEMS

17.14A For the reaction $C_2(g) + D_2(g) \rightleftharpoons 2CD(g)$, for which $\Delta H < 0$, these molecular scenes depict different reaction mixtures (C is red, D is blue):

At equilibrium

- (a) Calculate the value of K_p . (b) In which direction will the reaction proceed for the mixtures *not* at equilibrium? (c) For the mixture at equilibrium, what effect will a rise in T have on the total amount (mol) of gas (increase, decrease, no effect)? Explain.

17.14B For the reaction $A(g) + B(g) \rightleftharpoons AB(g)$, these molecular scenes depict reaction mixtures at two different temperatures (A is red, B is green):

- (a) Calculate the value of K at T_1 . (b) If $T_2 < T_1$, what is the sign of ΔH for the reaction? (c) Calculate K at T_2 .

SOME SIMILAR PROBLEMS 17.60 and 17.81

Applying Le Châtelier's Principle to the Synthesis of Ammonia

Le Châtelier's principle has countless applications in natural systems and in the chemical industry. As a case study, we'll look at the synthesis of ammonia, which, on a mole basis, is produced industrially in greater amount than any other compound. Then, a Chemical Connections essay applies the principle to cellular metabolism.

Even though four of every five molecules in the atmosphere are N_2 , the supply of *usable* nitrogen is limited because the strong triple bond in N_2 lowers its reactivity. Thus, the N atom is very difficult to "fix," that is, to combine with other atoms into useful compounds. Natural nitrogen fixation occurs through the fine-tuned activity of enzymes found in bacteria that live on plant roots, or through the brute force of lightning. But, nearly 13% of nitrogen fixation is done industrially via the **Haber process**:

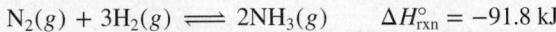

Developed by the German chemist Fritz Haber in 1913 and first used in a plant making 12,000 tons of ammonia a year, the process now yields over 110 million tons a year. Over 80% of this is used as fertilizer, with most of the remainder used to make explosives and nylons and other polymers, and smaller amounts going into production of refrigerants, rubber stabilizers, household cleaners, and pharmaceuticals.

Optimizing Reaction Conditions: Yield vs. Rate The Haber process applies equilibrium *and* kinetics principles to achieve a compromise that makes the process economical. From the balanced equation, we see three ways to maximize NH_3 yield:

1. *Decrease $[NH_3]$.* Removing NH_3 as it forms will make the system shift toward producing more to reattain equilibrium.
2. *Decrease volume (increase pressure).* Because 4 mol of reactant gases react to form 2 mol of product gas, decreasing the volume will shift the system toward making fewer moles of gas.
3. *Decrease temperature.* Because the formation of NH_3 is exothermic, decreasing the temperature (removing heat) will shift the equilibrium position toward product, thereby increasing K_c (Table 17.5).

Therefore, the conditions for maximizing the yield of product are continual removal of NH_3 , high pressure, and low temperature. Figure 17.10 on the next page shows the percent yield of NH_3 at various combinations of pressure and temperature. Note the almost complete conversion (98.3%) to product at 1000 atm and 473 K (200°C).

Although the *yield* is favored at this relatively low temperature, the *rate* of formation is so low that the process is uneconomical. The higher temperatures that would increase reaction rate would also result in a lower yield. In practice, a compromise optimizes yield *and* rate. High pressure and continuous removal are used to increase yield, but the temperature is raised to a moderate level and *a catalyst is used to increase the rate*. Achieving the same rate without a catalyst would require much higher temperatures and, thus, result in a much lower yield.

Effect of Temperature on K_c for Ammonia Synthesis

Table 17.5

T (K)	K_c
200.	7.17×10^{15}
300.	2.69×10^8
400.	3.94×10^4
500.	1.72×10^2
600.	4.53×10^0
700.	2.96×10^{-1}
800.	3.96×10^{-2}

Figure 17.10 Percent yield of ammonia vs. temperature at five different pressures. At very high P and low T (top left), the yield is high, but the rate is low. Industrial conditions (circle) are between 200 and 300 atm at about 400°C.

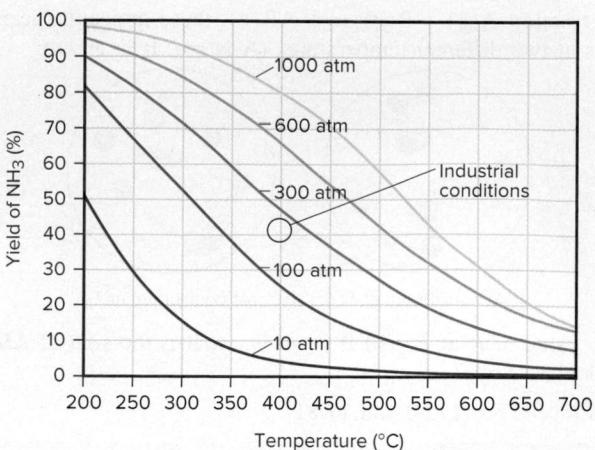

The Industrial Process Stages in the industrial production of NH_3 are shown in Figure 17.11. To extend equipment life and minimize cost, modern plants operate at about 200 to 300 atm and around 673 K (400°C). The stoichiometric ratio of reactant gases ($\text{N}_2/\text{H}_2 = 1/3$ by volume) is injected into the heated, pressurized reaction chamber. Some of the needed heat is supplied by $\Delta H_{\text{rxn}}^{\circ}$. The gases flow over catalyst beds that consist of 5-mm to 10-mm chunks of iron crystals embedded in a fused mixture of MgO , Al_2O_3 , and SiO_2 . The emerging equilibrium mixture contains about 35% NH_3 and is cooled by refrigeration until the NH_3 (bp -33.4°C) condenses; it is then removed and stored. Because N_2 and H_2 have much lower boiling points, they are recycled as gases by pumping them back into the reaction chamber.

Figure 17.11 Key stages in the Haber process for synthesizing ammonia.

› Summary of Section 17.6

- › If a system at equilibrium is disturbed, it undergoes a net reaction that reduces the disturbance and returns the system to equilibrium.
- › Changes in concentration cause a net reaction to consume the added component or to produce the removed component.
- › For a reaction that involves a change in amount (mol) of gas, an increase in pressure (decrease in volume) causes a net reaction toward fewer moles of gas, and a decrease in pressure causes the opposite change.
- › Although the equilibrium position changes as a result of a concentration or volume change, K does not.
- › A temperature change affects K : higher T increases K for an endothermic reaction (positive $\Delta H_{\text{rxn}}^{\circ}$) and decreases K for an exothermic reaction (negative $\Delta H_{\text{rxn}}^{\circ}$).
- › A catalyst causes the system to reach equilibrium more quickly by speeding forward and reverse reactions equally, but it does not affect the equilibrium position.
- › Ammonia is produced in a process favored by high pressure, low temperature, and continual removal of product. To make the process economical, intermediate temperature and pressure and a catalyst are used.
- › A metabolic pathway is a cellular reaction sequence with each step shifted completely toward product. Its overall yield is controlled by a feedback system that inhibits the activity of certain key enzymes.

From the simplest bacterium to the most specialized neuron, every cell performs thousands of reactions that allow it to grow and reproduce, feed and excrete, move and communicate. Taken together, these myriad feats of breakdown, synthesis, and energy flow constitute the cell's *metabolism* and are organized into reaction sequences called **metabolic pathways**.

Continual Shift Toward Product

In principle, each step in a metabolic pathway is a reversible reaction catalyzed by a specific enzyme (Section 16.7). However, equilibrium is never reached in a pathway, because the product of each reaction becomes the reactant of the next. Consider the five-step pathway by which the amino acid threonine is converted into the amino acid isoleucine (Figure B17.1). Threonine, supplied from a different region of the cell, forms ketobutyrate through the catalytic action of enzyme 1. The equilibrium position of reaction 1 shifts to the right because the product, ketobutyrate, is the reactant in reaction 2. Similarly, reaction 2 shifts to the right as its product, aceto-hydroxybutyrate, is used up in reaction 3. In this way, each subsequent reaction shifts the previous reaction to the right. The final product, isoleucine, is removed to make proteins elsewhere in the cell. Thus, the entire pathway operates in one direction.

Creation of a Steady State

This continuous shift in equilibrium position has two consequences for metabolic pathways:

1. *Each step proceeds with nearly 100% yield:* Virtually every molecule of threonine that enters this region of the cell eventually changes to ketobutyrate, every molecule of ketobutyrate to the next product, and so on.
2. *Reactant and product concentrations remain nearly constant,* because they reach a *steady state*.
 - In an equilibrium system, equal rates in *opposing directions* create constant concentrations of reactants and products.
 - In a steady-state system, the rates of reactions in *one direction*—into, through, and out of the system—create constant concentrations of intermediates.

Ketobutyrate, for example, is formed in reaction 1 as fast as it is consumed in reaction 2, so its concentration is constant. (A steady-state amount of water results if you fill a sink and then adjust the flow of faucet and drain so that water enters as fast as it leaves.)

Regulation by Feedback Inhibition

Recall from Chapter 16 that substrate concentrations are *much* higher than enzyme concentrations. If the active sites on all the

Figure B17.1 The biosynthesis of isoleucine from threonine. Isoleucine is synthesized from threonine in a sequence of five enzyme-catalyzed reactions. Once enough isoleucine is present, its concentration builds up and inhibits threonine dehydratase, the first enzyme in the pathway.

Substrate can bind to active site when inhibitor is absent, so catalysis occurs.

A Portion of enzyme
Inhibitor binding site

Active site is deformed when inhibitor is present, so substrate cannot bind and no catalysis occurs.

B Portion of enzyme
Inhibitor bound to site

Figure B17.2 Effect of inhibitor binding on shape of active site.

enzyme molecules were always occupied, all cellular reactions would occur at their maximum rates. This might be ideal for an industrial process, but an organism needs to control amounts carefully. To regulate product formation, certain key steps are catalyzed by *regulatory enzymes*, which contain an *inhibitor site* (Figure B17.2A) in addition to an active site: when the inhibitor site is occupied, the shape of the active site is deformed and the reaction is not catalyzed (Figure B17.2B).

In the simplest case of metabolic regulation (Figure B17.1), *the final product of a pathway is the inhibitor, and the regulatory enzyme catalyzes the first step*. Suppose, for instance, that a cell is temporarily making less protein, so isoleucine is not being removed as quickly. As its concentration rises, isoleucine lands more often on the inhibitor site of threonine dehydratase, the first enzyme in the pathway, thereby inhibiting its own production. This process is called *end-product feedback inhibition*. More complex pathways have more elaborate regulatory schemes.

Problem

B17.1 Many metabolites are products in branched pathways. In the one below, letters are compounds, and numbers are enzymes:

One method of control of these pathways occurs through inhibition of the first enzyme specific for a branch. (a) Which enzyme is inhibited by F? (b) Which enzyme is inhibited by I? (c) What is the disadvantage if F inhibited enzyme 1? (d) What would be the disadvantage if F inhibited enzyme 6?

CHAPTER REVIEW GUIDE

Learning Objectives

Relevant section (§) and/or sample problem (SP) numbers appear in parentheses.

Understand These Concepts

1. The distinction between the speed (rate) and the extent of a reaction (Introduction)
2. Why a system attains dynamic equilibrium when forward and reverse reaction rates are equal (§17.1)
3. The equilibrium constant as a number that is equal to a particular ratio of rate constants and of concentration terms (§17.1)
4. How the magnitude of K is related to the extent of the reaction (§17.1)
5. Why the same equilibrium state is reached no matter what the starting concentrations of the reacting system (§17.2)
6. How the reaction quotient (Q) changes continuously until the system reaches equilibrium, at which point $Q = K$ (§17.2)
7. Why the form of Q is based exactly on the balanced equation *as written* (§17.2)
8. Why terms for pure solids and liquids do not appear in Q (§17.2)
9. How the *sum* of reaction steps gives the overall reaction, and the *product* of Q 's (or K 's) gives the overall Q (or K) (§17.2)
10. How the interconversion of K_c and K_p is based on the ideal gas law and Δn_{gas} (§17.3)
11. How the reaction direction depends on the relative values of Q and K (§17.4)
12. How a reaction table is used to find an unknown quantity (concentration or pressure) (§17.5)
13. How assuming that the change in [reactant] is relatively small simplifies finding equilibrium quantities (§17.5)
14. How Le Châtelier's principle explains the effects of a change in concentration, pressure (volume), or temperature on a system at equilibrium and on K (§17.6)
15. Why a change in temperature *does* affect K (§17.6)
16. Why the addition of a catalyst does *not* affect K (§17.6)
17. How adjusting reaction conditions and using a catalyst optimizes the synthesis of ammonia (§17.6)

Master These Skills

1. Writing a reaction quotient (Q) from a balanced equation (SP 17.1)
2. Writing Q and finding K for a reaction multiplied by a common factor or reversed and for an overall reaction (SP 17.2)
3. Writing Q for heterogeneous equilibria (§17.2)
4. Converting between K_c and K_p (SP 17.3)
5. Comparing Q and K to determine reaction direction (SPs 17.4, 17.5)
6. Substituting quantities (concentrations or pressures) into Q to find K (§17.5)
7. Using a reaction table to determine quantities and find K (SP 17.6)
8. Finding one equilibrium quantity from other equilibrium quantities and K (SP 17.7)
9. Finding an equilibrium quantity from initial quantities and K (SP 17.8)
10. Solving a quadratic equation for an unknown equilibrium quantity (§17.5)
11. Assuming that the change in [reactant] is relatively small to find equilibrium quantities and checking the assumption (SP 17.9)
12. Comparing the values of Q and K to find reaction direction and x , the unknown change in a quantity (SP 17.10)
13. Using the relative values of Q and K to predict the effect of a change in concentration on the equilibrium position and on K (SP 17.11)
14. Using Le Châtelier's principle and Δn_{gas} to predict the effect of a change in pressure (volume) on the equilibrium position (SP 17.12)
15. Using Le Châtelier's principle and ΔH° to predict the effect of a change in temperature on the equilibrium position and on K (SP 17.13)
16. Using the van't Hoff equation to calculate K at one temperature given K at another temperature (§17.6)
17. Using molecular scenes to find equilibrium parameters (SP 17.14)

Key Terms

Page numbers appear in parentheses.

equilibrium constant (K) (749)
Haber process (779)

law of chemical equilibrium
(law of mass action) (750)

Le Châtelier's principle (770)
metabolic pathway (781)

reaction quotient (Q) (750)

Key Equations and Relationships

Page numbers appear in parentheses.

17.1 Defining equilibrium in terms of reaction rates (748):

$$\text{At equilibrium: } \text{rate}_{\text{fwd}} = \text{rate}_{\text{rev}}$$

17.2 Defining the equilibrium constant for the reaction $A \rightleftharpoons 2B$ (749):

$$K = \frac{k_{\text{fwd}}}{k_{\text{rev}}} = \frac{[\text{B}]^2}{[\text{A}]_{\text{eq}}}$$

17.3 Defining the equilibrium constant in terms of the reaction quotient (750):

$$\text{At equilibrium: } Q = K$$

17.4 Expressing Q_c for the reaction $aA + bB \rightleftharpoons cC + dD$ (751):

$$Q_c = \frac{[\text{C}]^c [\text{D}]^d}{[\text{A}]^a [\text{B}]^b}$$

17.5 Finding K of a reaction from K of the reverse reaction (753):

$$K_{\text{fwd}} = \frac{1}{K_{\text{rev}}}$$

17.6 Finding Q and K of a reaction multiplied by a factor n (754):

$$Q' = Q^n = \left(\frac{[\text{C}]^c [\text{D}]^d}{[\text{A}]^a [\text{B}]^b} \right)^n \quad \text{and} \quad K' = K^n$$

17.7 Finding the overall K for a reaction sequence (754):

$$K_{\text{overall}} = K_1 \times K_2 \times K_3 \times \dots$$

17.8 Relating K based on pressures to K based on concentrations (757):

$$K_p = K_c (RT)^{\Delta n_{\text{gas}}}$$

17.9 Assuming that ignoring the concentration that reacts introduces no significant error (766):

$$[\text{A}]_{\text{init}} - [\text{A}]_{\text{reacting}} = [\text{A}]_{\text{eq}} \approx [\text{A}]_{\text{init}}$$

17.10 Finding K at one temperature given K at another (van't Hoff equation) (776):

$$\ln \frac{K_2}{K_1} = -\frac{\Delta H_{\text{rxn}}^{\circ}}{R} \left(\frac{1}{T_2} - \frac{1}{T_1} \right)$$

BRIEF SOLUTIONS TO FOLLOW-UP PROBLEMS

17.1A (a) $Q_c = \frac{[\text{NO}]^4 [\text{H}_2\text{O}]^6}{[\text{NH}_3]^4 [\text{O}_2]^5}$

(b) $Q_c = \frac{[\text{NH}_3]^2}{[\text{NO}_2]^2 [\text{H}_2]^7}$ (Liquid H_2O is not included.)

(c) $Q_c = [\text{O}_2]^3$ (Solid KClO_3 and KCl are not included.)

17.1B (a) $Q_c = \frac{[\text{CO}]^2 [\text{H}_2]^2}{[\text{CH}_4][\text{CO}_2]}$

(b) $Q_c = \frac{[\text{H}_2\text{O}]^2}{[\text{H}_2\text{S}]^2 [\text{SO}_2]}$ (Solid S is not included.)

(c) $Q_c = \frac{[\text{NaCN}]}{[\text{HCN}][\text{NaOH}]}$ (Liquid H_2O is not included.)

17.2A

Multiply by 2

$$K_{c(\text{overall})} = K_{c1} \times K_{c2} = (1.4 \times 10^{12}) (0.30) = 4.2 \times 10^{11}$$

17.2B (a) $K_c = \left(\frac{1}{K_{c(\text{ref})}} \right)^2 = \left(\frac{1}{1.3 \times 10^{-2}} \right)^2 = 5.9 \times 10^3$

(b) $K_c = K_{c(\text{ref})}^{1/4} = (1.3 \times 10^{-2})^{1/4} = 0.34$

17.3A $\Delta n_{\text{gas}} = 1 - 2 = -1$

$$K_p = K_c (RT)^{-1} = 1.67 \left(0.0821 \frac{\text{atm} \cdot \text{L}}{\text{mol} \cdot \text{K}} \times 500. \text{K} \right)^{-1} = 4.07 \times 10^{-2}$$

17.3B $\Delta n_{\text{gas}} = 3 - 5 = -2$ and $K_p = K_c (RT)^{-2}$

$$K_c = \frac{K_p}{(RT)^{-2}} = K_p (RT)^2 = 3.0 \times 10^{-5} \left(0.0821 \frac{\text{atm} \cdot \text{L}}{\text{mol} \cdot \text{K}} \times 1173 \text{ K} \right)^2 = 0.28$$

17.4A $K_c = \frac{[\text{Y}]}{[\text{X}]} = 1.4$

Scene 1: $Q_c = \frac{3}{9} = 0.33$; $Q_c < K_c$, right

Scene 2: $Q_c = \frac{7}{5} = 1.4$; $Q_c = K_c$, no net change

Scene 3: $Q_c = \frac{8}{4} = 2.0$; $Q_c > K_c$, left

17.4B $K_c = \frac{[\text{D}]}{[\text{C}]^2} = \frac{5}{3^2} = 0.56$

Scene 2: $Q_c = \frac{6}{3^2} = 0.67$; $Q_c > K_c$, left

Scene 3: $Q_c = \frac{7}{4^2} = 0.44$; $Q_c < K_c$, right

17.5A $Q_p = \frac{(P_{\text{CH}_3\text{Cl}})(P_{\text{HCl}})}{(P_{\text{CH}_4})(P_{\text{Cl}_2})} = \frac{(0.24)(0.47)}{(0.13)(0.035)} = 25$

$Q_p < K_p$, so the reaction progresses to the right and CH_3Cl is forming.

17.5B $M_{\text{SO}_2} = \frac{3.4 \text{ mol}}{2.0 \text{ L}} = 1.7 \text{ M}; \quad M_{\text{O}_2} = \frac{1.5 \text{ mol}}{2.0 \text{ L}} = 0.75 \text{ M}$

$$M_{\text{SO}_2} = \frac{1.2 \text{ mol}}{2.0 \text{ L}} = 0.60 \text{ M}$$

$$Q_c = \frac{[\text{SO}_3]^2}{[\text{SO}_2]^2 [\text{O}_2]} = \frac{[0.60]^2}{[1.7]^2 [0.75]} = 0.17$$

$Q_c > K_c$, so the system is not at equilibrium, and the reaction will proceed toward the left.

17.6A

Initial	1.000	1.000	0
Change	-2x	-x	+2x

$$\text{Equilibrium} \quad 1.000 - 2x \quad 1.000 - x \quad 2x$$

$$P_{\text{O}_2} = 1.000 \text{ atm} - x = 0.506 \text{ atm}, \text{ so } x = 0.494 \text{ atm}$$

$$P_{\text{NO}_2} = 2x = 2(0.494 \text{ atm}) = 0.988 \text{ atm}$$

$$P_{\text{NO}} = 1.000 \text{ atm} - 2x = 1.000 \text{ atm} - 2(0.494 \text{ atm}) = 0.012 \text{ atm}$$

$$K_p = \frac{P_{\text{NO}_2}^2}{(P_{\text{NO}})(P_{\text{O}_2})} = \frac{0.988^2}{(0.012)^2 (0.506)} = 1.3 \times 10^4$$

17.6B

Initial	2.40	2.40	0	0
Change	-4x	-7x	+2x	+6x

$$\text{Equilibrium} \quad 2.40 - 4x \quad 2.40 - 7x \quad 2x \quad 6x$$

$$[\text{N}_2\text{O}_4] = 2x = 0.134 \text{ M}, \text{ so } x = 0.0670 \text{ M}$$

$$[\text{NH}_3] = 2.40 - 4x = 2.40 - 4(0.0670) = 2.13 \text{ M}$$

$$[\text{O}_2] = 2.40 - 7x = 2.40 - 7(0.0670) = 1.93 \text{ M}$$

$$[\text{H}_2\text{O}] = 6x = 6(0.0670) = 0.402 \text{ M}$$

$$K_c = \frac{[\text{N}_2\text{O}_4]^2 [\text{H}_2\text{O}]^6}{[\text{NH}_3]^4 [\text{O}_2]^7} = \frac{(0.134)^2 (0.402)^6}{(2.13)^4 (1.93)^7} = 3.69 \times 10^{-8}$$

BRIEF SOLUTIONS TO FOLLOW-UP PROBLEMS

(continued)

17.7A Since $\Delta n_{\text{gas}} = 2 - 2 = 0$,

$$K_p = K_c = 2.3 \times 10^{30} = \frac{(P_{\text{N}_2})(P_{\text{O}_2})}{P_{\text{NO}}^2}$$

$$P_{\text{NO}} = \sqrt{\frac{(P_{\text{N}_2})(P_{\text{O}_2})}{2.3 \times 10^{30}}} = \sqrt{\frac{(0.781)(0.209)}{2.3 \times 10^{30}}} = 2.7 \times 10^{-16} \text{ atm}$$

$$\text{17.7B } K_p = 19.6 = \frac{(P_{\text{P}_2})(P_{\text{H}_2}^3)}{P_{\text{PH}_3}^2}$$

$$P_{\text{H}_2} = \sqrt[3]{\frac{(P_{\text{PH}_3}^2)(K_p)}{(P_{\text{P}_2})}} = \sqrt[3]{\frac{(0.112)^2(19.6)}{0.215}} = 1.05 \text{ atm}$$

$$\text{17.8A } M_{\text{HI}} = \frac{2.50 \text{ mol}}{10.32 \text{ L}} = 0.242 \text{ M}$$

Concentration (M)	$2\text{HI}(g) \rightleftharpoons \text{H}_2(g) + \text{I}_2(g)$
Initial	0.242
Change	$-2x$
Equilibrium	$0.242 - 2x$

$$K_c = 1.26 \times 10^{-3} = \frac{[\text{H}_2][\text{I}_2]}{[\text{HI}]^2} = \frac{x^2}{(0.242 - 2x)^2}$$

Taking the square root of both sides, ignoring the negative root, and solving gives $x = [\text{H}_2] = 8.02 \times 10^{-3} \text{ M}$.

$$\text{17.8B } M_{\text{Cl}_2\text{O}} = M_{\text{H}_2\text{O}} = \frac{6.15 \text{ mol}}{5.00 \text{ L}} = 1.23 \text{ M}$$

Concentration (M)	$\text{Cl}_2\text{O}(g) + \text{H}_2\text{O}(g) \rightleftharpoons 2\text{HOCl}(g)$
Initial	1.23
Change	$-x$
Equilibrium	$1.23 - x$

$$K_c = 0.18 = \frac{[\text{HOCl}]^2}{[\text{Cl}_2\text{O}][\text{H}_2\text{O}]} = \frac{(2x)^2}{(1.23 - x)^2}$$

Taking the square root of both sides, ignoring the negative root, and solving gives $x = 0.21 \text{ M}$.

$$[\text{H}_2\text{O}] = [\text{Cl}_2\text{O}] = 1.23 - x = 1.23 - 0.21 = 1.02 \text{ M}$$

$$[\text{HClO}] = 2x = 2(0.21) = 0.42 \text{ M}$$

$$\text{17.9A (a) } M_{\text{I}_2} = \frac{0.50 \text{ mol}}{2.5 \text{ L}} = 0.20 \text{ M}$$

Concentration (M)	$\text{I}_2(g) \rightleftharpoons 2\text{I}(g)$
Initial	0.20
Change	$-x$
Equilibrium	$0.20 - x$

Assuming that $0.20 \text{ M} - x \approx 0.20 \text{ M}$:

$$K_c = 2.94 \times 10^{-10} = \frac{[\text{I}]^2}{[\text{I}_2]} = \frac{(2x)^2}{0.20 - x} \approx \frac{4x^2}{0.20} \quad x \approx 3.8 \times 10^{-6} \text{ M}$$

Error = $(3.8 \times 10^{-6}/0.20) \times 100 = 1.9 \times 10^{-3}\%$, so assumption is justified; therefore, at equilibrium, $[\text{I}_2] = 0.20 \text{ M}$ and $[\text{I}] = 2x = 2(3.8 \times 10^{-6}) = 7.6 \times 10^{-6} \text{ M}$.

(b) Based on the same reaction table and assumption that $0.20 \text{ M} - x \approx 0.20 \text{ M}$:

$$K_c = 0.209 = \frac{[\text{I}]^2}{[\text{I}_2]} = \frac{(2x)^2}{0.20 - x} \approx \frac{4x^2}{0.20} \quad x \approx 0.10 \text{ M}$$

Error is $(0.10/0.20) \times 100 = 50\%$, so assumption is *not* justified.

Solve the quadratic equation:

$$4x^2 + 0.209x - 0.042 = 0, \quad \text{so} \quad x = 0.080 \text{ M}$$

Therefore, at equilibrium, $[\text{I}_2] = 0.20 - x = 0.20 - 0.080 = 0.12 \text{ M}$; and $[\text{I}] = 2x = 2(0.080) = 0.16 \text{ M}$.

17.9B

(a) Pressure (atm)	$\text{PCl}_5(g) \rightleftharpoons \text{PCl}_3(g) + \text{Cl}_2(g)$
Initial	0.18
Change	$-x$
Equilibrium	$0.18 - x$

Assuming that $0.18 \text{ atm} - x \approx 0.18 \text{ atm}$:

$$K_p = 3.4 \times 10^{-4} = \frac{[\text{PCl}_3][\text{Cl}_2]}{[\text{PCl}_5]} = \frac{x^2}{0.18 - x} \approx \frac{x^2}{0.18}$$

$x \approx 7.8 \times 10^{-3} \text{ atm}$; error = $(7.8 \times 10^{-3}/0.18) \times 100 = 4.3\%$, so assumption is justified; at equilibrium, $P_{\text{PCl}_3} = 0.18 - x = 0.18 - (7.8 \times 10^{-3}) = 0.17 \text{ atm}$.

(b) Pressure (atm)	$\text{PCl}_5(g) \rightleftharpoons \text{PCl}_3(g) + \text{Cl}_2(g)$
Initial	0.025
Change	$-x$
Equilibrium	$0.025 - x$

Assuming that $0.025 \text{ atm} - x \approx 0.025 \text{ atm}$:

$$K_p = 3.4 \times 10^{-4} = \frac{[\text{PCl}_3][\text{Cl}_2]}{[\text{PCl}_5]} = \frac{x^2}{0.025 - x} \approx \frac{x^2}{0.025}$$

$x \approx 2.9 \times 10^{-3} \text{ atm}$; error = $(2.9 \times 10^{-3}/0.025) \times 100 = 12\%$, so assumption is *not* justified. Solving the quadratic equation:

$$x^2 + 3.4 \times 10^{-4}x - 8.5 \times 10^{-6} = 0, \quad \text{so} \quad x = 0.0028$$

Therefore, at equilibrium, $P_{\text{PCl}_3} = 0.025 - x = 0.025 - 0.0028 = 0.022 \text{ atm}$

17.10A (a) $M_{\text{PCl}_5} = 0.1050 \text{ mol}/0.5000 \text{ L} = 0.2100 \text{ M}$; similarly, $M_{\text{Cl}_2} = M_{\text{PCl}_3} = 0.0900 \text{ M}$

$$Q_c = \frac{[\text{PCl}_3][\text{Cl}_2]}{[\text{PCl}_5]} = \frac{[0.0900][0.0900]}{[0.2100]} = 3.86 \times 10^{-2}$$

$Q_c < K_c$, so reaction proceeds to the right.

(b) Concentration (M)	$\text{PCl}_5(g) \rightleftharpoons \text{PCl}_3(g) + \text{Cl}_2(g)$
Initial	0.2100
Change	$-x$
Equilibrium	$0.2100 - x$

$$[\text{PCl}_5] = 0.2100 \text{ M} - x = 0.2065 \text{ M}, \quad \text{so} \quad x = 0.0035 \text{ M}$$

$$[\text{Cl}_2] = [\text{PCl}_3] = 0.0900 \text{ M} + x = 0.0900 \text{ M} + 0.0035 \text{ M} = 0.0935 \text{ M}$$

$$17.10B Q_p = \frac{[\text{NO}]^2}{[\text{N}_2][\text{O}_2]} = \frac{[0.750]^2}{[0.500][0.500]} = 2.25$$

$Q_p > K_p$, so reaction proceeds to the left.

Pressure (atm)	$\text{N}_2(g) + \text{O}_2(g) \rightleftharpoons 2\text{NO}(g)$
Initial	0.500
Change	$+x$
Equilibrium	$0.500 + x$

$$K_p = 8.44 \times 10^{-3} = \frac{P_{\text{NO}}^2}{(P_{\text{N}_2})(P_{\text{O}_2})} = \frac{(0.750 - 2x)^2}{(0.500 + x)^2}$$

Taking the square root of both sides and solving gives $x = 0.337$, so

$$P_{N_2} = P_{O_2} = 0.500 + x = 0.500 + 0.337 = 0.837 \text{ atm}$$

$$P_{NO} = 0.750 - 2x = 0.750 - 2(0.337) = 0.076 \text{ atm}$$

17.11A (a) $[SiF_4]$ increases; (b) decreases since adding $H_2O(l)$ above the boiling point of water results in an increase in the concentration of $H_2O(g)$; (c) decreases; (d) no effect.

17.11B (a) $[CO]$ does not change; (b) decreases; (c) increases; (d) increases.

17.12A (a) Decrease P ; (b) increase P ; (c) increase P .

17.12B (a) More CO and H_2 ; (b) no change; (c) less S and H_2O .

17.13A (a) P_{H_2} will decrease; K will increase. (b) P_{N_2} will increase; K will decrease. (c) P_{PCl_5} will increase; K will increase.

17.13B (a) Increase T , and K increases; (b) decrease T , and K increases; (c) increase T , and K increases.

17.14A (a) Since $P = \frac{n}{V} RT$ and, in this case, V , R , and T cancel,

$$K_p = \frac{n_{CD}^2}{n_{C_2} \times n_{D_2}} = \frac{4^2}{2 \times 2} = 4$$

(b) Scene 2: $Q_p = \frac{(6)^2}{(1)(1)} = 36 > K_p$ (4); to the left;

Scene 3: $Q_p = \frac{(2)^2}{(3)(3)} = 0.44 < K_p$ (4); to the right.

(c) There are 2 mol of gas on each side of the balanced equation, so increasing T has no effect on total moles of gas.

17.14B (a) $K = \frac{[AB]}{[A][B]} = \frac{3}{2 \times 2} = 0.75$

(b) $\Delta H > 0$

(c) $K = \frac{2}{3 \times 3} = 0.22$

PROBLEMS

Problems with **colored** numbers are answered in Appendix E and worked in detail in the Student Solutions Manual. Problem sections match those in the text and give the numbers of relevant sample problems. Most offer Concept Review Questions, Skill-Building Exercises (grouped in pairs covering the same concept), and Problems in Context. The Comprehensive Problems are based on material from any section or previous chapter.

The Equilibrium State and the Equilibrium Constant

Concept Review Questions

17.1 A change in reaction conditions increases the rate of a certain forward reaction more than that of the reverse reaction. What is the effect on the equilibrium constant and on the concentrations of reactants and products at equilibrium?

17.2 When a chemical company employs a new reaction to manufacture a product, the chemists consider its rate (kinetics) and yield (equilibrium). How do each of these affect the usefulness of a manufacturing process?

17.3 If there is no change in concentrations, why is the equilibrium state considered dynamic?

17.4 Is K very large or very small for a reaction that goes essentially to completion? Explain.

17.5 White phosphorus, P_4 , is produced by the reduction of phosphate rock, $Ca_3(PO_4)_2$. If exposed to oxygen, the waxy, white solid smokes, bursts into flames, and releases a large quantity of heat:

Does this reaction have a large or small equilibrium constant? Explain.

The Reaction Quotient and the Equilibrium Constant

(Sample Problems 17.1 to 17.2)

Concept Review Questions

17.6 For a given reaction at a given temperature, the value of K is constant. Is the value of Q also constant? Explain.

17.7 In a study of the thermal decomposition of lithium peroxide,

a chemist finds that, as long as some Li_2O_2 is present at the end of the experiment, the amount of O_2 obtained in a given container at a given T is the same. Explain.

17.8 In a study of the formation of HI from its elements,

equal amounts of H_2 and I_2 were placed in a container, which was then sealed and heated.

(a) On one set of axes, sketch concentration vs. time curves for H_2 and HI , and explain how Q changes as a function of time.

(b) Is the value of Q different if $[I_2]$ is plotted instead of $[H_2]$?

17.9 Explain the difference between a heterogeneous and a homogeneous equilibrium. Give an example of each.

17.10 Does Q for the formation of 1 mol of NO from its elements differ from Q for the decomposition of 1 mol of NO to its elements? Explain and give the relationship between the two Q 's.

17.11 Does Q for the formation of 1 mol of NH_3 from H_2 and N_2 differ from Q for the formation of NH_3 from H_2 and 1 mol of N_2 ? Explain and give the relationship between the two Q 's.

Skill-Building Exercises (grouped in similar pairs)

17.12 Balance each reaction and write its reaction quotient, Q_c :

17.13 Balance each reaction and write its reaction quotient, Q_c :

17.14 Balance each reaction and write its reaction quotient, Q_c :

17.15 Balance each reaction and write its reaction quotient, Q_c :

- (a) $O_2(g) \rightleftharpoons O_3(g)$
 (b) $NO(g) + O_3(g) \rightleftharpoons NO_2(g) + O_2(g)$
 (c) $N_2O(g) + H_2(g) \rightleftharpoons NH_3(g) + H_2O(g)$

17.16 At a particular temperature, $K_c = 1.6 \times 10^{-2}$ for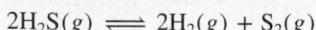Calculate K_c for each of the following reactions:

- (a) $\frac{1}{2}S_2(g) + H_2(g) \rightleftharpoons H_2S(g)$
 (b) $5H_2S(g) \rightleftharpoons 5H_2(g) + \frac{5}{2}S_2(g)$

17.17 At a particular temperature, $K_c = 6.5 \times 10^2$ for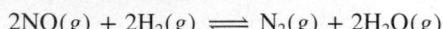Calculate K_c for each of the following reactions:

- (a) $NO(g) + H_2(g) \rightleftharpoons \frac{1}{2}N_2(g) + H_2O(g)$
 (b) $2N_2(g) + 4H_2O(g) \rightleftharpoons 4NO(g) + 4H_2(g)$

17.18 Balance each of the following examples of heterogeneous equilibria and write each reaction quotient, Q_c :

- (a) $Na_2O_2(s) + CO_2(g) \rightleftharpoons Na_2CO_3(s) + O_2(g)$
 (b) $H_2O(l) \rightleftharpoons H_2O(g)$
 (c) $NH_4Cl(s) \rightleftharpoons NH_3(g) + HCl(g)$

17.19 Balance each of the following examples of heterogeneous equilibria and write each reaction quotient, Q_c :

- (a) $H_2O(l) + SO_3(g) \rightleftharpoons H_2SO_4(aq)$
 (b) $KNO_3(s) \rightleftharpoons KNO_2(s) + O_2(g)$
 (c) $S_8(s) + F_2(g) \rightleftharpoons SF_6(g)$

17.20 Balance each of the following examples of heterogeneous equilibria and write each reaction quotient, Q_c :

- (a) $NaHCO_3(s) \rightleftharpoons Na_2CO_3(s) + CO_2(g) + H_2O(g)$
 (b) $SnO_2(s) + H_2(g) \rightleftharpoons Sn(s) + H_2O(g)$
 (c) $H_2SO_4(l) + SO_3(g) \rightleftharpoons H_2S_2O_7(l)$

17.21 Balance each of the following examples of heterogeneous equilibria and write each reaction quotient, Q_c :

- (a) $Al(s) + NaOH(aq) + H_2O(l) \rightleftharpoons Na[Al(OH)_4](aq) + H_2(g)$
 (b) $CO_2(s) \rightleftharpoons CO_2(g)$
 (c) $N_2O_5(s) \rightleftharpoons NO_2(g) + O_2(g)$

Problems in Context**17.22** Write Q_c for each of the following:

- (a) Hydrogen chloride gas reacts with oxygen gas to produce chlorine gas and water vapor.
 (b) Solid diarsenic trioxide reacts with fluorine gas to produce liquid arsenic pentafluoride and oxygen gas.
 (c) Gaseous sulfur tetrafluoride reacts with liquid water to produce gaseous sulfur dioxide and hydrogen fluoride gas.
 (d) Solid molybdenum(VI) oxide reacts with gaseous xenon difluoride to form liquid molybdenum(VI) fluoride, xenon gas, and oxygen gas.

17.23 The interhalogen ClF_3 is prepared via a two-step fluorination of chlorine gas: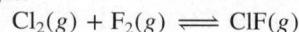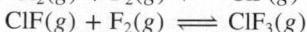

(a) Balance each step and write the overall equation.

(b) Show that the overall Q_c equals the product of the Q_c 's for the individual steps.**17.24** As an EPA scientist studying catalytic converters and urban smog, you want to find K_c for the following reaction:Use the following data to find the unknown K_c :**Expressing Equilibria with Pressure Terms:****Relation Between K_c and K_p**

(Sample Problem 17.3)

Concept Review Questions**17.25** Guldberg and Waage proposed the definition of the equilibrium constant as a certain ratio of *concentrations*. What relationship allows us to use a particular ratio of *partial pressures* (for a gaseous reaction) to express an equilibrium constant? Explain.**17.26** When are K_c and K_p equal, and when are they not?**17.27** A certain reaction at equilibrium has more moles of gaseous products than of gaseous reactants.(a) Is K_c larger or smaller than K_p ?(b) Write a statement about the relative sizes of K_c and K_p for any gaseous equilibrium.**Skill-Building Exercises (grouped in similar pairs)****17.28** Determine Δn_{gas} for each of the following reactions:

- (a) $2KClO_3(s) \rightleftharpoons 2KCl(s) + 3O_2(g)$
 (b) $2PbO(s) + O_2(g) \rightleftharpoons 2PbO_2(s)$
 (c) $I_2(s) + 3XeF_2(s) \rightleftharpoons 2IF_3(s) + 3Xe(g)$

17.29 Determine Δn_{gas} for each of the following reactions:

- (a) $MgCO_3(s) \rightleftharpoons MgO(s) + CO_2(g)$
 (b) $2H_2(g) + O_2(g) \rightleftharpoons 2H_2O(l)$
 (c) $HNO_3(l) + ClF(g) \rightleftharpoons ClONO_2(g) + HF(g)$

17.30 Calculate K_c for each of the following equilibria:

- (a) $CO(g) + Cl_2(g) \rightleftharpoons COCl_2(g); K_p = 3.9 \times 10^{-2}$ at 1000. K
 (b) $S_2(g) + C(s) \rightleftharpoons CS_2(g); K_p = 28.5$ at 500. K

17.31 Calculate K_c for each of the following equilibria:

- (a) $H_2(g) + I_2(g) \rightleftharpoons 2HI(g); K_p = 49$ at 730. K
 (b) $2SO_2(g) + O_2(g) \rightleftharpoons 2SO_3(g); K_p = 2.5 \times 10^{10}$ at 500. K

17.32 Calculate K_p for each of the following equilibria:

- (a) $N_2O_4(g) \rightleftharpoons 2NO_2(g); K_c = 6.1 \times 10^{-3}$ at 298 K
 (b) $N_2(g) + 3H_2(g) \rightleftharpoons 2NH_3(g); K_c = 2.4 \times 10^{-3}$ at 1000. K

17.33 Calculate K_p for each of the following equilibria:

- (a) $H_2(g) + CO_2(g) \rightleftharpoons H_2O(g) + CO(g); K_c = 0.77$ at 1020. K
 (b) $3O_2(g) \rightleftharpoons 2O_3(g); K_c = 1.8 \times 10^{-56}$ at 570. K

Comparing Q and K to Determine Reaction Direction

(Sample Problems 17.4 and 17.5)

Concept Review Questions**17.34** When the numerical value of Q is less than that of K , in which direction does the reaction proceed to reach equilibrium? Explain.**17.35** The following molecular scenes depict the aqueous reaction $2D \rightleftharpoons E$, with D red and E blue. Each sphere represents 0.0100 mol, but the volume is 1.00 L in scene A, whereas in scenes B and C, it is 0.500 L.

- (a) If the reaction in scene A is at equilibrium, calculate K_c .
 (b) Are the reactions in scenes B and C at equilibrium? Which, if either, is not, and in which direction will it proceed?

Skill-Building Exercises (grouped in similar pairs)

17.36 At 425°C , $K_p = 4.18 \times 10^{-9}$ for the reaction

In one experiment, 0.20 atm of $\text{HBr}(g)$, 0.010 atm of $\text{H}_2(g)$, and 0.010 atm of $\text{Br}_2(g)$ are introduced into a container. Is the reaction at equilibrium? If not, in which direction will it proceed?

17.37 At 100°C , $K_p = 60.6$ for the reaction

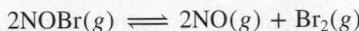

In a given experiment, 0.10 atm of each component is placed in a container. Is the system at equilibrium? If not, in which direction will the reaction proceed?

Problems in Context

17.38 The water-gas shift reaction plays a central role in the chemical methods for obtaining cleaner fuels from coal:

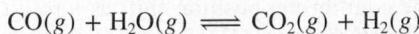

At a given temperature, $K_p = 2.7$. If 0.13 mol of CO , 0.56 mol of H_2O , 0.62 mol of CO_2 , and 0.43 mol of H_2 are put in a 2.0-L flask, in which direction does the reaction proceed?

How to Solve Equilibrium Problems

(Sample Problems 17.6 to 17.10)

Concept Review Questions

17.39 In the 1980s, CFC-11 was one of the most heavily produced chlorofluorocarbons. The last step in its formation is

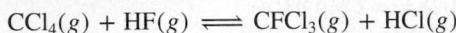

If you start the reaction with equal concentrations of CCl_4 and HF , you obtain equal concentrations of CFCl_3 and HCl at equilibrium. Are the final concentrations of CFCl_3 and HCl equal if you start with unequal concentrations of CCl_4 and HF ? Explain.

17.40 For a problem involving the catalyzed reaction of methane and steam, the following reaction table was prepared:

Pressure (atm)	$\text{CH}_4(g)$	$+ 2\text{H}_2\text{O}(g)$	\rightleftharpoons	$\text{CO}_2(g) + 4\text{H}_2(g)$
Initial	0.30	0.40		0
Change	$-x$	$-2x$		$+x$
Equilibrium	$0.30 - x$	$0.40 - 2x$		x
				$+4x$

Explain the entries in the “Change” and “Equilibrium” rows.

17.41 (a) What is the basis of the approximation that avoids the need to use the quadratic formula to find an equilibrium concentration?
 (b) When should this approximation *not* be made?

Skill-Building Exercises (grouped in similar pairs)

17.42 In an experiment to study the formation of $\text{HI}(g)$,

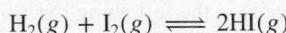

$\text{H}_2(g)$ and $\text{I}_2(g)$ were placed in a sealed container at a certain temperature. At equilibrium, $[\text{H}_2] = 6.50 \times 10^{-5} M$, $[\text{I}_2] = 1.06 \times 10^{-3} M$, and $[\text{HI}] = 1.87 \times 10^{-3} M$. Calculate K_c for the reaction at this temperature.

17.43 Gaseous ammonia was introduced into a sealed container and heated to a certain temperature:

At equilibrium, $[\text{NH}_3] = 0.0225 M$, $[\text{N}_2] = 0.114 M$, and $[\text{H}_2] = 0.342 M$. Calculate K_c for the reaction at this temperature.

17.44 Gaseous PCl_5 decomposes according to the reaction

In one experiment, 0.15 mol of $\text{PCl}_5(g)$ was introduced into a 2.0-L container. Construct the reaction table for this process.

17.45 Hydrogen fluoride, HF , can be made by the reaction

In one experiment, 0.10 mol of $\text{H}_2(g)$ and 0.050 mol of $\text{F}_2(g)$ are added to a 0.50-L flask. Write a reaction table for this process.

17.46 For the following reaction, $K_p = 6.5 \times 10^4$ at 308 K :

At equilibrium, $P_{\text{NO}} = 0.35\text{ atm}$ and $P_{\text{Cl}_2} = 0.10\text{ atm}$. What is the equilibrium partial pressure of $\text{NOCl}(g)$?

17.47 For the following reaction, $K_p = 0.262$ at 1000°C :

At equilibrium, $P_{\text{H}_2} = 1.22\text{ atm}$. What is the equilibrium partial pressure of $\text{CH}_4(g)$?

17.48 Ammonium hydrogen sulfide decomposes according to the following reaction, for which $K_p = 0.11$ at 250°C :

If 55.0 g of $\text{NH}_4\text{HS}(s)$ is placed in a sealed 5.0-L container, what is the partial pressure of $\text{NH}_3(g)$ at equilibrium?

17.49 Hydrogen sulfide decomposes according to the following reaction, for which $K_c = 9.30 \times 10^{-8}$ at 700°C :

If 0.45 mol of H_2S is placed in a 3.0-L container, what is the equilibrium concentration of $\text{H}_2(g)$ at 700°C ?

17.50 Even at high T , the formation of NO is not favored:

What is $[\text{NO}]$ when a mixture of 0.20 mol of $\text{N}_2(g)$ and 0.15 mol of $\text{O}_2(g)$ reach equilibrium in a 1.0-L container at 2000°C ?

17.51 Nitrogen dioxide decomposes according to the reaction

where $K_p = 4.48 \times 10^{-13}$ at a certain temperature. If 0.75 atm of NO_2 is added to a container and allowed to come to equilibrium, what are the equilibrium partial pressures of $\text{NO}(g)$ and $\text{O}_2(g)$?

17.52 Hydrogen iodide decomposes according to the reaction

A sealed 1.50-L container initially holds 0.00623 mol of H_2 , 0.00414 mol of I_2 , and 0.0244 mol of HI at 703 K . When equilibrium is reached, the concentration of $\text{H}_2(g)$ is 0.00467 M . What are the concentrations of $\text{HI}(g)$ and $\text{I}_2(g)$?

17.53 Compound A decomposes according to the equation

A sealed 1.00-L container initially contains $1.75 \times 10^{-3}\text{ mol}$ of $\text{A}(g)$, $1.25 \times 10^{-3}\text{ mol}$ of $\text{B}(g)$, and $6.50 \times 10^{-4}\text{ mol}$ of $\text{C}(g)$ at 100°C . At equilibrium, $[\text{A}]$ is $2.15 \times 10^{-3}\text{ M}$. Find $[\text{B}]$ and $[\text{C}]$.

Problems in Context

17.54 In an analysis of interhalogen reactivity, 0.500 mol of ICl was placed in a 5.00-L flask, where it decomposed at a high T :

Calculate the equilibrium concentrations of I_2 , Cl_2 , and ICl ($K_c = 0.110$ at this temperature).

17.55 A toxicologist studying mustard gas, $S(CH_2CH_2Cl)_2$, a blistering agent, prepares a mixture of 0.675 M SCl_2 and 0.973 M C_2H_4 and allows it to react at room temperature (20.0°C):

At equilibrium, $[S(CH_2CH_2Cl)_2] = 0.350\text{ M}$. Calculate K_p .

17.56 The first step in HNO_3 production is the catalyzed oxidation of NH_3 . Without a catalyst, a different reaction predominates:

When 0.0150 mol of $NH_3(g)$ and 0.0150 mol of $O_2(g)$ are placed in a 1.00-L container at a certain temperature, the N_2 concentration at equilibrium is $1.96 \times 10^{-3}\text{ M}$. Calculate K_c .

17.57 A key step in the extraction of iron from its ore is

This step occurs in the 700°C to 1200°C zone within a blast furnace. What are the equilibrium partial pressures of $CO(g)$ and $CO_2(g)$ when 1.00 atm of $CO(g)$ and excess $FeO(s)$ react in a sealed container at 1000°C ?

Reaction Conditions and Equilibrium: Le Châtelier's Principle

(Sample Problems 17.11 to 17.14)

Concept Review Questions

17.58 What does “disturbance” mean in Le Châtelier’s principle?

17.59 What is the difference between the equilibrium position and the equilibrium constant of a reaction? Which changes as a result of a change in reactant concentration?

17.60 Scenes A, B, and C below depict the following reaction at three temperatures:

(a) Which best represents the reaction mixture at the highest temperature? Explain. (b) Which best represents the reaction mixture at the lowest temperature? Explain.

17.61 What is implied by the word “constant” in the term *equilibrium constant*? Give two reaction parameters that can be changed without changing the value of an equilibrium constant.

17.62 Le Châtelier’s principle is related ultimately to the rates of the forward and reverse steps in a reaction. Explain (a) why an increase in reactant concentration shifts the equilibrium position to the right but does not change K ; (b) why a decrease in V shifts the equilibrium position toward fewer moles of gas but does not change K ; (c) why a rise in T shifts the equilibrium position of an exothermic reaction toward reactants and also changes K ; and (d) why a rise in temperature of an endothermic reaction from T_1 to T_2 results in K_2 being larger than K_1 .

17.63 An equilibrium mixture of two solids and a gas, in the reaction $XY(s) \rightleftharpoons X(g) + Y(s)$, is depicted at right (X is green and Y is black). Does scene A, B, or C best represent the system at equilibrium after two formula units of $Y(s)$ is added? Explain.

Skill-Building Exercises (grouped in similar pairs)

17.64 Consider this equilibrium system:

How does the equilibrium position shift as a result of each of the following disturbances? (a) CO is added. (b) CO_2 is removed by adding solid $NaOH$. (c) Additional $Fe_3O_4(s)$ is added to the system. (d) Dry ice is added at constant temperature.

17.65 Sodium bicarbonate undergoes thermal decomposition according to the reaction

How does the equilibrium position shift as a result of each of the following disturbances? (a) 0.20 atm of argon gas is added. (b) $NaHCO_3(s)$ is added. (c) $Mg(ClO_4)_2(s)$ is added as a drying agent to remove H_2O . (d) Dry ice is added at constant temperature.

17.66 Predict the effect of *increasing* the container volume on the amounts of each reactant and product in the following reactions:

- (a) $F_2(g) \rightleftharpoons 2F(g)$
 (b) $2CH_4(g) \rightleftharpoons C_2H_2(g) + 3H_2(g)$

17.67 Predict the effect of *increasing* the container volume on the amounts of each reactant and product in the following reactions:

- (a) $CH_3OH(l) \rightleftharpoons CH_3OH(g)$
 (b) $CH_4(g) + NH_3(g) \rightleftharpoons HCN(g) + 3H_2(g)$

17.68 Predict the effect of *decreasing* the container volume on the amounts of each reactant and product in the following reactions:

- (a) $H_2(g) + Cl_2(g) \rightleftharpoons 2HCl(g)$
 (b) $2H_2(g) + O_2(g) \rightleftharpoons 2H_2O(l)$

17.69 Predict the effect of *decreasing* the container volume on the amounts of each reactant and product in the following reactions:

- (a) $C_3H_8(g) + 5O_2(g) \rightleftharpoons 3CO_2(g) + 4H_2O(l)$
 (b) $4NH_3(g) + 3O_2(g) \rightleftharpoons 2N_2(g) + 6H_2O(g)$

17.70 How would you adjust the *volume* of the container in order to maximize product yield in each of the following reactions?

- (a) $Fe_3O_4(s) + 4H_2(g) \rightleftharpoons 3Fe(s) + 4H_2O(g)$
 (b) $2C(s) + O_2(g) \rightleftharpoons 2CO(g)$

17.71 How would you adjust the *volume* of the container in order to maximize product yield in each of the following reactions?

- (a) $Na_2O_2(s) \rightleftharpoons 2Na(l) + O_2(g)$
 (b) $C_2H_2(g) + 2H_2(g) \rightleftharpoons C_2H_6(g)$

17.72 Predict the effect of *increasing* the temperature on the amount(s) of product(s) in the following reactions:

- (a) $CO(g) + 2H_2(g) \rightleftharpoons CH_3OH(g) \quad \Delta H_{rxn}^\circ = -90.7\text{ kJ}$
 (b) $C(s) + H_2O(g) \rightleftharpoons CO(g) + H_2(g) \quad \Delta H_{rxn}^\circ = 131\text{ kJ}$
 (c) $2NO_2(g) \rightleftharpoons 2NO(g) + O_2(g)$ (endothermic)
 (d) $2C(s) + O_2(g) \rightleftharpoons 2CO(g)$ (exothermic)

17.73 Predict the effect of *decreasing* the temperature on the amount(s) of reactant(s) in the following reactions:

- (a) $C_2H_2(g) + H_2O(g) \rightleftharpoons CH_3CHO(g) \quad \Delta H_{rxn}^\circ = -151\text{ kJ}$
 (b) $CH_3CH_2OH(l) + O_2(g) \rightleftharpoons CH_3CO_2H(l) + H_2O(g) \quad \Delta H_{rxn}^\circ = -451\text{ kJ}$

17.74 The molecule D_2 (where D, deuterium, is ^2H) undergoes a reaction with ordinary H_2 that leads to isotopic equilibrium:

If $\Delta H_{\text{rxn}}^\circ$ is 0.32 kJ/mol DH, calculate K_p at 500. K.

17.75 The formation of methanol is important to the processing of new fuels. At 298 K, $K_p = 2.25 \times 10^4$ for the reaction

If $\Delta H_{\text{rxn}}^\circ = -128$ kJ/mol CH_3OH , calculate K_p at 0°C.

Problems in Context

17.76 The minerals hematite (Fe_2O_3) and magnetite (Fe_3O_4) exist in equilibrium with atmospheric oxygen:

(a) Determine P_{O_2} at equilibrium. (b) Given that P_{O_2} in air is 0.21 atm, in which direction will the reaction proceed to reach equilibrium? (c) Calculate K_c at 298 K.

17.77 The oxidation of SO_2 is the key step in H_2SO_4 production:

- (a) What qualitative combination of T and P maximizes SO_3 yield?
 (b) How does addition of O_2 affect Q ? K ?
 (c) Why is catalysis used for this reaction?

17.78 A mixture of 3.00 volumes of H_2 and 1.00 volume of N_2 reacts at 344°C to form ammonia. The equilibrium mixture at 110. atm contains 41.49% NH_3 by volume. Calculate K_p for the reaction, assuming that the gases behave ideally.

17.79 You are a member of a research team of chemists discussing plans for a plant to produce ammonia:

(a) The plant will operate at close to 700 K, at which K_p is 1.00×10^{-4} , and employs the stoichiometric 1/3 ratio of N_2/H_2 . At equilibrium, the partial pressure of NH_3 is 50. atm. Calculate the partial pressures of each reactant and P_{total} .

(b) One member of the team suggests the following: since the partial pressure of H_2 is cubed in the reaction quotient, the plant could produce the same amount of NH_3 if the reactants were in a 1/6 ratio of N_2/H_2 and could do so at a lower pressure, which would cut operating costs. Calculate the partial pressure of each reactant and P_{total} under these conditions, assuming an unchanged partial pressure of 50. atm for NH_3 . Is the suggestion valid?

Comprehensive Problems

17.80 For the following equilibrium system, which of the changes will form more CaCO_3 ?

- (a) Decrease temperature at constant pressure (no phase change)
 (b) Increase volume at constant temperature
 (c) Increase partial pressure of CO_2
 (d) Remove one-half of the initial CaCO_3

17.81 The “filmstrip” represents five molecular scenes of a gaseous mixture as it reaches equilibrium over time:

X is purple and Y is orange: $\text{X}_2(g) + \text{Y}_2(g) \rightleftharpoons 2\text{XY}(g)$.

- (a) Write the reaction quotient, Q , for this reaction.
 (b) If each particle represents 0.1 mol, find Q for each scene.
 (c) If $K > 1$, is time progressing to the right or to the left? Explain.
 (d) Calculate K at this temperature.
 (e) If $\Delta H_{\text{rxn}}^\circ < 0$, which scene, if any, best represents the mixture at a higher temperature? Explain.
 (f) Which scene, if any, best represents the mixture at a higher pressure (lower volume)? Explain.

17.82 Ammonium carbamate ($\text{NH}_2\text{COONH}_4$) is a salt of carbamic acid that is found in the blood and urine of mammals. At 250.°C, $K_c = 1.58 \times 10^{-8}$ for the following equilibrium:

If 7.80 g of $\text{NH}_2\text{COONH}_4$ is put into a 0.500-L evacuated container, what is the total pressure at equilibrium?

17.83 Isolation of Group 8B(10) elements, used as industrial catalysts, involves a series of steps. For nickel, the sulfide ore is roasted in air: $\text{Ni}_3\text{S}_2(s) + \text{O}_2(g) \rightleftharpoons \text{NiO}(s) + \text{SO}_2(g)$. The metal oxide is reduced by the H_2 in water gas ($\text{CO} + \text{H}_2$) to impure Ni: $\text{NiO}(s) + \text{H}_2(g) \rightleftharpoons \text{Ni}(s) + \text{H}_2\text{O}(g)$. The CO in water gas then reacts with the metal in the Mond process to form gaseous nickel carbonyl, $\text{Ni}(s) + \text{CO}(g) \rightleftharpoons \text{Ni}(\text{CO})_4(g)$, which is subsequently decomposed to the metal. (a) Balance each of the three steps, and obtain an overall balanced equation for the conversion of Ni_3S_2 to $\text{Ni}(\text{CO})_4$. (b) Show that the overall Q_c is the product of the Q_c 's for the individual reactions.

17.84 Consider the formation of ammonia in two experiments.

(a) To a 1.00-L container at 727°C, 1.30 mol of N_2 and 1.65 mol of H_2 are added. At equilibrium, 0.100 mol of NH_3 is present. Calculate the equilibrium concentrations of N_2 and H_2 , and find K_c for the reaction:

(b) In a different 1.00-L container at the same temperature, equilibrium is established with 8.34×10^{-2} mol of NH_3 , 1.50 mol of N_2 , and 1.25 mol of H_2 present. Calculate K_c for the reaction:

(c) What is the relationship between the K_c values in parts (a) and (b)? Why aren't these values the same?

17.85 An important industrial source of ethanol is the reaction, catalyzed by H_3PO_4 , of steam with ethylene derived from oil:

(a) At equilibrium, $P_{\text{C}_2\text{H}_5\text{OH}} = 200.$ atm and $P_{\text{H}_2\text{O}} = 400.$ atm. Calculate $P_{\text{C}_2\text{H}_4}$. (b) Is the highest yield of ethanol obtained at high or low P ? High or low T ? (c) Calculate K_c at 450. K. (d) In NH_3 manufacture, the yield is increased by condensing the NH_3 to a liquid and removing it. Would condensing the $\text{C}_2\text{H}_5\text{OH}$ have the same effect in ethanol production? Explain.

17.86 An industrial chemist introduces 2.0 atm of H₂ and 2.0 atm of CO₂ into a 1.00-L container at 25.0°C and then raises the temperature to 700. °C, at which K_c = 0.534:

How many grams of H₂ are present at equilibrium?

17.87 An engineer examining the oxidation of SO₂ in the manufacture of sulfuric acid determines that K_c = 1.7×10⁸ at 600. K:

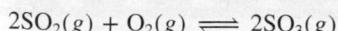

(a) At equilibrium, P_{SO₃} = 300. atm and P_{O₂} = 100. atm. Calculate P_{SO₃}. (b) The engineer places a mixture of 0.0040 mol of SO₂(g) and 0.0028 mol of O₂(g) in a 1.0-L container and raises the temperature to 1000 K. At equilibrium, 0.0020 mol of SO₃(g) is present. Calculate K_c and P_{SO₃} for this reaction at 1000. K.

17.88 Phosgene (COCl₂) is a toxic substance that forms readily from carbon monoxide and chlorine at elevated temperatures:

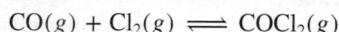

If 0.350 mol of each reactant is placed in a 0.500-L flask at 600 K, what are the concentrations of all three substances at equilibrium (K_c = 4.95 at this temperature)?

17.89 When 0.100 mol of CaCO₃(s) and 0.100 mol of CaO(s) are placed in an evacuated sealed 10.0-L container and heated to 385 K, P_{CO₂} = 0.220 atm after equilibrium is established:

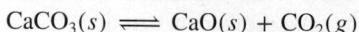

An additional 0.300 atm of CO₂(g) is pumped in. What is the total mass (in g) of CaCO₃ after equilibrium is re-established?

17.90 Use each of the following reaction quotients to write the balanced equation:

$$(a) Q = \frac{[\text{CO}_2]^2 [\text{H}_2\text{O}]^2}{[\text{C}_2\text{H}_4][\text{O}_2]^3}$$

$$(b) Q = \frac{[\text{NH}_3]^4 [\text{O}_2]^7}{[\text{NO}_2]^4 [\text{H}_2\text{O}]^6}$$

17.91 Hydrogenation of carbon-carbon π bonds is important in the petroleum and food industries. The conversion of acetylene to ethylene is a simple example of the process:

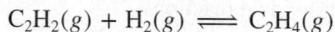

The calculated K_c at 2000. K is 2.9×10⁸. But the process is run at lower temperatures with the aid of a catalyst to prevent decomposition. Use ΔH° values to calculate K_c at 300. K.

17.92 For the reaction M₂ + N₂ ⇌ 2MN, scene A represents the mixture at equilibrium, with M black and N orange. If each molecule represents 0.10 mol and the volume is 1.0 L, how many moles of each substance will be present in scene B when that mixture reaches equilibrium?

17.93 Highly toxic disulfur decafluoride decomposes by a free-radical process: S₂F₁₀(g) ⇌ SF₄(g) + SF₆(g). In a study of the decomposition, S₂F₁₀ was placed in a 2.0-L flask and heated to 100°C; [S₂F₁₀] was 0.50 M at equilibrium. More S₂F₁₀ was added, and when equilibrium was reattained, [S₂F₁₀] was 2.5 M. How did [SF₄] and [SF₆] change from the original to the new equilibrium position after the addition of more S₂F₁₀?

17.94 A study of the water-gas shift reaction (see Problem 17.38) was made in which equilibrium was reached with [CO] = [H₂O] = [H₂] = 0.10 M and [CO₂] = 0.40 M. After 0.60 mol of H₂ is added to the 2.0-L container and equilibrium is re-established, what are the new concentrations of all the components?

17.95 A gaseous mixture of 10.0 volumes of CO₂, 1.00 volume of unreacted O₂, and 50.0 volumes of unreacted N₂ leaves an engine at 4.0 atm and 800. K. Assuming that the mixture reaches equilibrium, what are (a) the partial pressure and (b) the concentration (in picograms per liter, pg/L) of CO in this exhaust gas?

2CO₂(g) ⇌ 2CO(g) + O₂(g) K_p = 1.4×10⁻²⁸ at 800. K
(The actual concentration of CO in exhaust gas is much higher because the gases do *not* reach equilibrium in the short transit time through the engine and exhaust system.)

17.96 When ammonia is made industrially, the mixture of N₂, H₂, and NH₃ that emerges from the reaction chamber is far from equilibrium. Why does the plant supervisor use reaction conditions that produce less than the maximum yield of ammonia?

17.97 The following reaction can be used to make H₂ for the synthesis of ammonia from the greenhouse gases carbon dioxide and methane:

(a) What is the percent yield of H₂ when an equimolar mixture of CH₄ and CO₂ with a total pressure of 20.0 atm reaches equilibrium at 1200. K, at which K_p = 3.548×10⁶?

(b) What is the percent yield of H₂ for this system at 1300. K, at which K_p = 2.626×10⁷?

(c) Use the van't Hoff equation to find ΔH°_{rxn}.

17.98 The methane used to obtain H₂ for NH₃ manufacture is impure and usually contains other hydrocarbons, such as propane, C₃H₈. Imagine the reaction of propane occurring in two steps:

$$K_p = 8.175 \times 10^{15} \text{ at } 1200. \text{ K}$$

$$K_p = 0.6944 \text{ at } 1200. \text{ K}$$

(a) Write the overall equation for the reaction of propane and steam to produce carbon dioxide and hydrogen.

(b) Calculate K_p for the overall process at 1200. K.

(c) When 1.00 volume of C₃H₈ and 4.00 volumes of H₂O, each at 1200. K and 5.0 atm, are mixed in a container, what is the final pressure? Assume the total volume remains constant, that the reaction is essentially complete, and that the gases behave ideally.

(d) What percentage of the C₃H₈ remains unreacted?

17.99 Using CH₄ and steam as a source of H₂ for NH₃ synthesis requires high temperatures. Rather than burning CH₄ separately to heat the mixture, it is more efficient to inject some O₂ into the reaction mixture. All of the H₂ is thus released for the synthesis, and the heat of reaction for the combustion of CH₄ helps maintain the required temperature. Imagine the reaction occurring in two steps:

$$K_p = 9.34 \times 10^{28} \text{ at } 1000. \text{ K}$$

(a) Write the overall equation for the reaction of methane, steam, and oxygen to form carbon dioxide and hydrogen.

(b) What is K_p for the overall reaction?

(c) What is K_c for the overall reaction?

(d) A mixture of 2.0 mol of CH₄, 1.0 mol of O₂, and 2.0 mol of steam with a total pressure of 30. atm reacts at 1000. K at constant volume. Assuming that the reaction is complete and the ideal gas law is a valid approximation, what is the final pressure?

17.100 One mechanism for the synthesis of ammonia proposes that N₂ and H₂ molecules catalytically dissociate into atoms:

- Find the partial pressure of N in N₂ at 1000. K and 200. atm.
- Find the partial pressure of H in H₂ at 1000. K and 600. atm.
- How many N atoms and H atoms are present per liter?
- Based on these answers, which of the following is a more reasonable step to continue the mechanism after the catalytic dissociation? Explain.

17.101 The molecular scenes below depict the reaction Y \rightleftharpoons 2Z at four different times, out of sequence, as it reaches equilibrium. Each sphere (Y is red and Z is green) represents 0.025 mol, and the volume is 0.40 L. (a) Which scene(s) represent(s) equilibrium? (b) List the scenes in the correct sequence. (c) Calculate K_c.

17.102 For the equilibrium

the initial concentrations of the three gases are 0.300 M H₂S, 0.300 M H₂, and 0.150 M S₂. Determine the equilibrium concentrations of the gases.

17.103 The two most abundant atmospheric gases react to a tiny extent at 298 K in the presence of a catalyst:

- What are the equilibrium pressures of the three gases when the atmospheric partial pressures of O₂ (0.210 atm) and of N₂ (0.780 atm) are put into an evacuated 1.00-L flask at 298 K with the catalyst?
- What is P_{total} in the container? (c) Find K_c at 298 K.

17.104 The oxidation of nitrogen monoxide is favored at 457 K:

- Calculate K_c at 457 K. (b) Find ΔH_{rxn}[°] from standard heats of formation. (c) At what temperature does K_c = 6.4 × 10⁹?

17.105 The kinetics and equilibrium of the decomposition of hydrogen iodide have been studied extensively:

- At 298 K, K_c = 1.26 × 10⁻³ for this reaction. Calculate K_p.
- Calculate K_c for the formation of HI at 298 K.

(c) Calculate ΔH_{rxn}[°] for HI decomposition from ΔH_f[°] values.

(d) At 729 K, K_c = 2.0 × 10⁻² for HI decomposition. Calculate ΔH_{rxn}[°] for this reaction from the van't Hoff equation.

17.106 Isopentyl alcohol reacts with pure acetic acid to form isopentyl acetate, the essence of banana oil:

A student adds a drying agent to remove H₂O and thus increase the yield of banana oil. Is this approach reasonable? Explain.

17.107 Isomers Q (*blue*) and R (*yellow*) interconvert. They are depicted in an equilibrium mixture in scene A. Scene B represents the mixture after addition of more Q. How many molecules of each isomer are present when the mixture in scene B attains equilibrium again?

17.108 Glauber's salt, Na₂SO₄ · 10H₂O, was used by J. R. Glauber in the 17th century as a medicinal agent. At 25°C, K_p = 4.08 × 10⁻²⁵ for the loss of waters of hydration from Glauber's salt:

(a) What is the vapor pressure of water at 25°C in a closed container holding a sample of Na₂SO₄ · 10H₂O(s)?

(b) How do the following changes affect the ratio (higher, lower, same) of hydrated form to anhydrous form for the system above?

- Add more Na₂SO₄(s)
- Reduce the container volume
- Add more water vapor
- Add N₂ gas

17.109 In a study of synthetic fuels, 0.100 mol of CO and 0.100 mol of water vapor are added to a 20.00-L container at 900. °C, and they react to form CO₂ and H₂. At equilibrium, [CO] is 2.24 × 10⁻³ M. (a) Calculate K_c at this temperature. (b) Calculate P_{total} in the flask at equilibrium. (c) How many moles of CO must be added to double this pressure? (d) After P_{total} is doubled and the system reattains equilibrium, what is [CO]_{eq}?

17.110 Synthetic diamonds are made under conditions of high temperature (2000 K) and high pressure (10¹⁰ Pa; 10⁵ atm) in the presence of catalysts. Carbon's phase diagram is useful for finding the conditions for formation of natural and synthetic diamonds. Along the diamond-graphite line, the two allotropes are in equilibrium. (a) At point A, what is the sign of ΔH for the formation of diamond from graphite? Explain. (b) Which allotrope is denser? Explain.

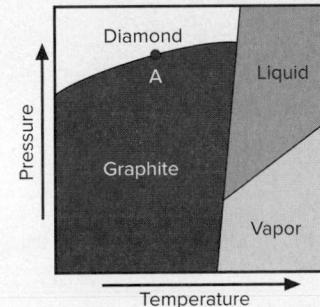

18

Acid-Base Equilibria

18.1 Acids and Bases in Water

Arrhenius Acid-Base Definition
Acid-Dissociation Constant (K_a)
Relative Strengths of Acids and Bases

18.2 Autoionization of Water and the pH Scale

Autoionization and K_w
The pH Scale

18.3 Proton Transfer and the Brønsted-Lowry Acid-Base Definition

Conjugate Acid-Base Pairs
Net Direction of Acid-Base Reactions

18.4 Solving Problems Involving Weak-Acid Equilibria

Finding K_a Given Concentrations
Finding Concentrations Given K_a
Extent of Acid Dissociation
Polyprotic Acids

18.5 Molecular Properties and Acid Strength

Nonmetal Hydrides
Oxoacids
Hydrated Metal Ions

18.6 Weak Bases and Their Relation to Weak Acids

Ammonia and the Amines
Anions of Weak Acids
Relation Between K_a and K_b

18.7 Acid-Base Properties of Salt Solutions

Salts That Yield Neutral Solutions
Salts That Yield Acidic Solutions
Salts That Yield Basic Solutions
Salts of Weakly Acidic Cations and Weakly Basic Anions
Salts of Amphiprotic Anions

18.8 Generalizing the Brønsted-Lowry Concept: The Leveling Effect

18.9 Electron-Pair Donation and the Lewis Acid-Base Definition

Molecules as Lewis Acids
Metal Cations as Lewis Acids
Overview of Acid-Base Definitions

Source: © McGraw-Hill Education/Mark A. Dierker, photographer

Concepts and Skills to Review Before You Study This Chapter

- › role of water as solvent (Section 4.1)
- › writing ionic equations (Section 4.2)
- › acids, bases, and acid-base reactions (Section 4.4)
- › proton transfer in acid-base reactions (Section 4.4)
- › properties of an equilibrium constant (Section 17.2)
- › solving equilibrium problems (Section 17.5)

It's lunch time: how about a meal of citric and ascorbic acids (lemons and oranges), oxalic acid (spinach), folic acid (broccoli), and lactic acid (yogurt), all washed down with some phosphoric acid (soft drink)—if you eat too much, you may need some magnesium or aluminum hydroxide base (antacid)! Acids and bases are in many common consumer products (Table 18.1) and are indispensable in academic and industrial research.

Acids give substances such as lemon juice and vinegar a sour taste. In fact, sourness was a defining property of an acid since the 17th century: an acid was any substance that had a sour taste; reacted with active metals, such as aluminum and zinc, to produce hydrogen gas; and turned certain organic compounds specific colors. (We discuss *indicators* in this chapter and Chapter 19.) Similarly, a base was any substance that had a bitter taste and slippery feel and turned the same organic compounds different colors. Moreover, it was known that *when an acid and a base react, each cancels the properties of the other in a process called neutralization*. Although these early definitions described distinctive properties, they gave way to others based on molecular behavior. As science progresses, limited definitions are replaced by broader ones that explain more phenomena.

Table 18.1

Some Common Acids and Bases and Their Household Uses

Substance	Use
Acids	
Acetic acid, CH_3COOH	Flavoring, preservative (vinegar)
Citric acid, $\text{H}_3\text{C}_6\text{H}_5\text{O}_7$	Flavoring (lemon juice)
Ascorbic acid, $\text{H}_2\text{C}_6\text{H}_6\text{O}_6$	Vitamin C; nutritional supplement
Aluminum salts, $\text{NaAl}(\text{SO}_4)_2 \cdot 12\text{H}_2\text{O}$	In baking powder, with sodium hydrogen carbonate
Bases	
Sodium hydroxide (lye), NaOH	Oven and drain cleaners
Ammonia, NH_3	Household cleaner
Sodium carbonate, Na_2CO_3	Water softener, grease remover
Sodium hydrogen carbonate, NaHCO_3	Fire extinguisher, rising agent in cake mixes (baking soda), mild antacid
Sodium phosphate, Na_3PO_4	Cleaner for surfaces before painting or wallpapering

Source: © McGraw-Hill Education/Stephen Frisch, photographer

IN THIS CHAPTER . . . We develop three definitions of acids and bases that explain an expanded range of reactions, and we apply equilibrium principles to understand acid-base behavior.

- › We begin with the *Arrhenius* acid-base definition, which relies on formulas and behavior in water.
- › We examine acid dissociation to see how variation in acid strength is expressed by a new equilibrium constant.
- › We introduce the pH scale to measure the acidity of aqueous solutions.
- › We discuss proton transfer in the *Brønsted-Lowry* acid-base definition, which expands the meaning of “base”, along with the scope of acid-base reactions.
- › We apply a systematic approach to solving acid-base equilibrium problems.
- › We examine the molecular structures of acids to rationalize their relative strengths.

- We examine weak bases and their interdependence with weak acids.
- We determine the relative acidity of salt solutions from the reactions of the salts' cations and anions with water.
- We see that the designations "acid" and "base" depend on the substances' relative strengths *and* on the solvent.
- We discuss the *Lewis* acid-base definition, which greatly expands the meanings of "acid" and "acid-base reaction".

18.1 ACIDS AND BASES IN WATER

Most laboratory work with acids and bases involves water, as do most environmental, biological, and industrial applications. Recall from our discussion in Chapter 4 that *water is the product in all reactions between strong acids and strong bases*, which the net ionic equation for any such reaction shows:

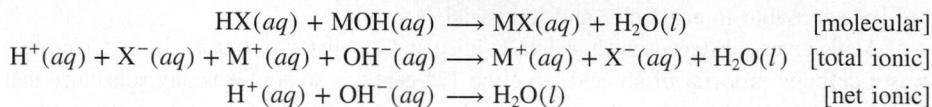

where M^+ is a metal ion and X^- is a nonmetal ion.

Furthermore, whenever an acid dissociates in water, solvent molecules participate in the reaction:

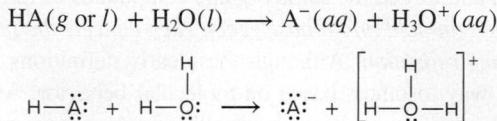

Water molecules surround the proton to form H-bonded species with the general formula $(\text{H}_2\text{O})_n\text{H}^+$. The proton's charge density is so high that it attracts water molecules especially strongly, covalently bonding to one of the lone electron pairs of a water molecule's O atom to form a **hydronium ion**, H_3O^+ , which forms H bonds to several other water molecules (see Figure 4.11). To emphasize the active role of water and the proton-water interaction, the hydrated proton is usually shown in the text as $\text{H}_3\text{O}^+(aq)$ [although, for simplicity, we sometimes show it as $\text{H}^+(aq)$].

Release of H^+ or OH^- and the Arrhenius Acid-Base Definition

The earliest definition that highlighted the molecular nature of acids and bases is the **Arrhenius acid-base definition**, which classifies these substances in terms of their formulas and behavior *in water*:

- An **acid** is a substance with H in its formula that dissociates in water to yield H_3O^+ .
- A **base** is a substance with OH in its formula that dissociates in water to yield OH^- .

Some typical Arrhenius acids are HCl , HNO_3 , and HCN , and some typical Arrhenius bases are NaOH , KOH , and $\text{Ba}(\text{OH})_2$. Because they are ionic compounds, Arrhenius bases contain discrete OH^- ions in their structures, but Arrhenius acids *never* contain discrete H^+ ions. Instead, they contain *covalently bonded H atoms that ionize when molecules of the acid dissolve in water*.

When an acid and a base react, they undergo **neutralization**. The meaning of this term has changed, as we'll see, but in the Arrhenius sense, neutralization occurs when the H^+ from the acid and the OH^- from the base form H_2O . A key point about neutralization that Arrhenius was able to explain is that no matter which strong acid and strong base react, and no matter which salt results, $\Delta H_{\text{rxn}}^\circ$ is -55.9 kJ per mole of water formed. Arrhenius suggested that the enthalpy change is always the same because the reaction is always the same—a hydrogen ion and a hydroxide ion form water:

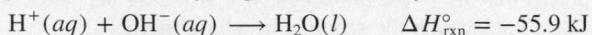

The dissolved salt that is present, for example, NaCl in the reaction of sodium hydroxide with hydrochloric acid,

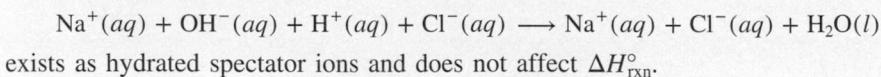

Despite its importance at the time, limitations in the Arrhenius definition soon became apparent. Arrhenius and many others realized that even though some substances do *not* have discrete OH⁻ ions, they still behave as bases. For example, NH₃ and K₂CO₃ also yield OH⁻ in water. As you'll see shortly, broader acid-base definitions are required to include species that do not have OH⁻ ions in their structures.

Variation in Acid Strength: The Acid-Dissociation Constant (K_a)

Acids (and bases) are classified by their *strength*, the amount of H₃O⁺ (or OH⁻) produced per mole of substance dissolved, in other words, by the extent of their dissociation into ions (see Table 4.2). Because acids and bases are electrolytes, their strength correlates with electrolyte strength: *strong electrolytes dissociate completely, and weak electrolytes dissociate slightly*.

1. Strong acids dissociate **completely** into ions in water (Figure 18.1A):

In a dilute solution of a strong acid, HA molecules are no longer present: [H₃O⁺] = [A⁻] ≈ [HA]_{init}. In other words, [HA]_{eq} ≈ 0, so the value of K_c is extremely large:

$$Q_c = \frac{[\text{H}_3\text{O}^+][\text{A}^-]}{[\text{HA}][\text{H}_2\text{O}]} \quad (\text{at equilibrium, } Q_c = K_c \gg 1)$$

Because the reaction is essentially complete, we usually don't express it as an equilibrium process. In dilute aqueous nitric acid, for example, there are virtually no undissociated nitric acid molecules:

2. Weak acids dissociate **slightly** into ions in water (Figure 18.1B):

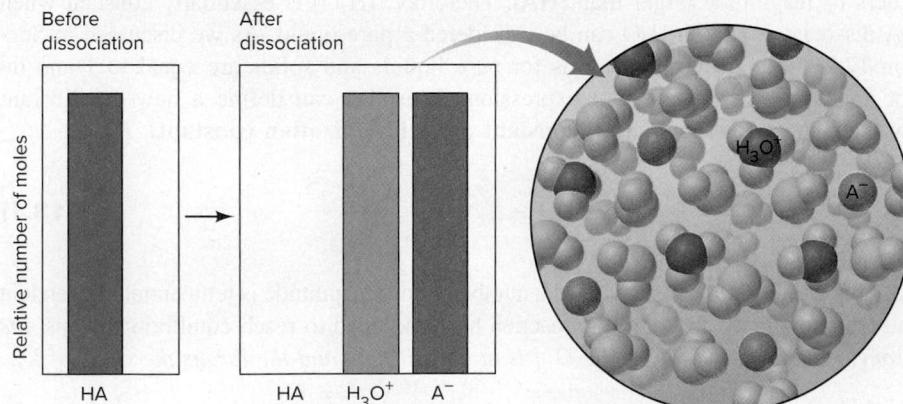

Figure 18.1 The extent of dissociation for strong acids and weak acids. The bar graphs show the relative numbers of moles of species before (left) and after (right) acid dissociation.

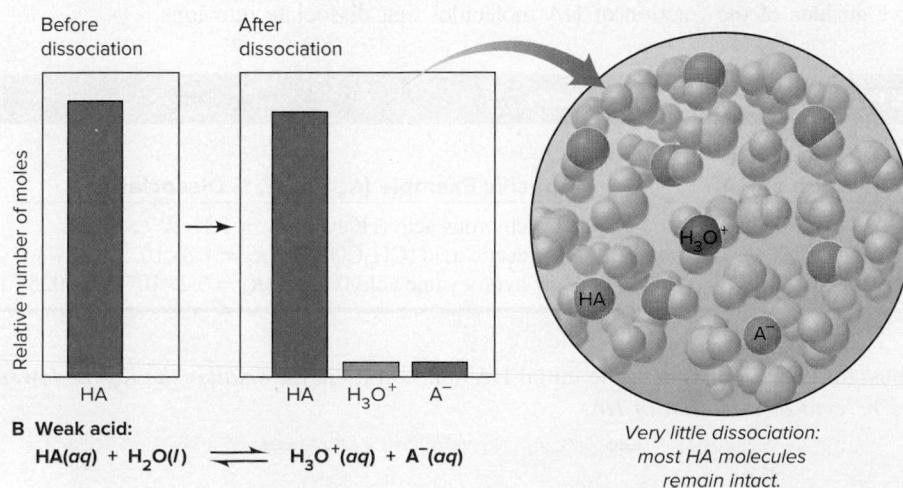

In a dilute solution of a weak acid, *the great majority of HA molecules are undissociated*. Thus, $[H_3O^+] = [A^-] \ll [HA]_{\text{init}}$, and $[HA]_{\text{eq}} \approx [HA]_{\text{init}}$, so K_c is very small. Hydrocyanic acid is an example of a weak acid:

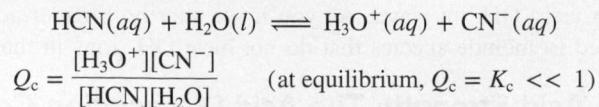

(As in Chapter 17, brackets with no subscript mean molar concentration *at equilibrium*; that is, $[X]$ means $[X]_{\text{eq}}$. In this chapter, we are dealing with systems *at equilibrium*, so instead of writing Q and stating that Q equals K at equilibrium, we'll express K directly as a collection of equilibrium concentration terms.)

The difference in $[H_3O^+]$ causes a much higher rate for the reaction of a strong acid with an active metal like zinc than for the same reaction of a weak acid (Figure 18.2):

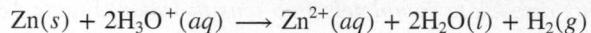

In a strong acid, with its much higher $[H_3O^+]$, zinc reacts rapidly, forming bubbles of H_2 vigorously. In a weak acid, $[H_3O^+]$ is much lower, so zinc reacts slowly.

The Meaning of K_a We write a *specific* equilibrium constant for acid dissociation that includes only the species whose concentrations change to any significant extent. For the dissociation of a general *weak acid*, HA,

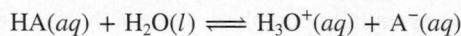

the equilibrium expression is

$$K_c = \frac{[\text{H}_3\text{O}^+][\text{A}^-]}{[\text{HA}][\text{H}_2\text{O}]}$$

The concentration of water ($[\text{H}_2\text{O}] = \frac{1000 \text{ g}}{18.02 \text{ g/mol}} = 55.5 \text{ M}$) is typically several orders of magnitude larger than $[\text{HA}]$. Therefore, $[\text{H}_2\text{O}]$ is essentially constant when HA dissociates, and so H_2O can be considered a pure liquid. As we discussed in Section 17.2, the concentration terms for pure liquids and solids are equal to 1 and do not appear in the equilibrium expression. Thus, we can define a new equilibrium constant, the **acid-dissociation constant (or acid-ionization constant)**, K_a :

$$K_c \times 1 = K_a = \frac{[\text{H}_3\text{O}^+][\text{A}^-]}{[\text{HA}]} \quad (18.1)$$

Like any equilibrium constant, K_a is a number whose magnitude is temperature dependent and tells how far to the right the reaction has proceeded to reach equilibrium. Thus, *the stronger the acid, the higher $[H_3O^+]$ is at equilibrium, and the larger the value of K_a* :

Stronger acid \Rightarrow higher $[H_3O^+]$ \Rightarrow larger K_a

The Range of K_a Values Acid-dissociation constants of weak acids range over many orders of magnitude. Some benchmark K_a values for typical weak acids in Table 18.2 give an idea of the fraction of HA molecules that dissociate into ions.

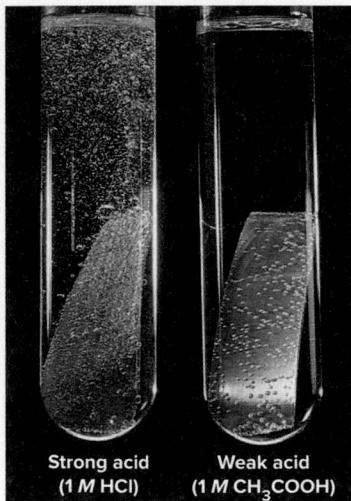

Figure 18.2 Reaction of zinc with a strong acid (left) and a weak acid (right).
Source: © McGraw-Hill Education/Stephen Frisch, photographer

Table 18.2

Magnitude of K_a Values and Percent Dissociation for Weak Acids

Magnitude of K_a	% Dissociation in a 1 M Solution of HA	Specific Example (K_a Value, % Dissociation)
Relatively high K_a ($\sim 10^{-2}$)	~10%	1 M chlorous acid (HClO_2) ($K_a = 1.1 \times 10^{-2}$, 10%)
Moderate K_a ($\sim 10^{-5}$)	~0.3%	1 M acetic acid (CH_3COOH) ($K_a = 1.8 \times 10^{-5}$, 0.42%)
Relatively low K_a ($\sim 10^{-10}$)	~0.001%	1 M hydrocyanic acid (HCN) ($K_a = 6.2 \times 10^{-10}$, 0.0025%)

Thus, for solutions of the same initial HA concentration, *the smaller the K_a , the lower the percent dissociation of HA*:

Weaker acid \Rightarrow lower % dissociation of HA \Rightarrow smaller K_a

Table 18.3 K_a Values for Some Monoprotic Acids at 25°C

Name (Formula)*	Lewis Structure*	Dissociation Reaction	K_a
Chlorous acid (HClO_2)	$\text{H}-\ddot{\text{O}}-\ddot{\text{C}}=\ddot{\text{O}}$	$\text{HClO}_2(aq) + \text{H}_2\text{O}(l) \rightleftharpoons \text{H}_3\text{O}^+(aq) + \text{ClO}_2^-(aq)$	1.1×10^{-2}
Nitrous acid (HNO_2)	$\text{H}-\ddot{\text{O}}-\ddot{\text{N}}=\ddot{\text{O}}$	$\text{HNO}_2(aq) + \text{H}_2\text{O}(l) \rightleftharpoons \text{H}_3\text{O}^+(aq) + \text{NO}_2^-(aq)$	7.1×10^{-4}
Hydrofluoric acid (HF)	$\text{H}-\ddot{\text{F}}:$	$\text{HF}(aq) + \text{H}_2\text{O}(l) \rightleftharpoons \text{H}_3\text{O}^+(aq) + \text{F}^-(aq)$	6.8×10^{-4}
Formic acid (HCOOH)	$\text{H}-\overset{\text{:O:}}{\underset{\parallel}{\text{C}}}-\ddot{\text{O}}-\text{H}$	$\text{HCOOH}(aq) + \text{H}_2\text{O}(l) \rightleftharpoons \text{H}_3\text{O}^+(aq) + \text{HCOO}^-(aq)$	1.8×10^{-4}
Acetic acid (CH_3COOH)	$\begin{array}{c} \text{H} & \text{:O:} \\ & \parallel \\ \text{H}-\text{C} & -\text{C}-\ddot{\text{O}}-\text{H} \\ & \quad \\ \text{H} & \text{H} \end{array}$	$\text{CH}_3\text{COOH}(aq) + \text{H}_2\text{O}(l) \rightleftharpoons \text{H}_3\text{O}^+(aq) + \text{CH}_3\text{COO}^-(aq)$	1.8×10^{-5}
Propanoic acid ($\text{CH}_3\text{CH}_2\text{COOH}$)	$\begin{array}{c} \text{H} & \text{H} & \text{:O:} \\ & & \parallel \\ \text{H}-\text{C} & -\text{C}-\text{C}-\ddot{\text{O}}-\text{H} \\ & \\ \text{H} & \text{H} \end{array}$	$\text{CH}_3\text{CH}_2\text{COOH}(aq) + \text{H}_2\text{O}(l) \rightleftharpoons \text{H}_3\text{O}^+(aq) + \text{CH}_3\text{CH}_2\text{COO}^-(aq)$	1.3×10^{-5}
Hypochlorous acid (HClO)	$\text{H}-\ddot{\text{O}}-\ddot{\text{C}}:\text{}$	$\text{HClO}(aq) + \text{H}_2\text{O}(l) \rightleftharpoons \text{H}_3\text{O}^+(aq) + \text{ClO}^-(aq)$	2.9×10^{-8}
Hydrocyanic acid (HCN)	$\text{H}-\text{C}\equiv\text{N}:$	$\text{HCN}(aq) + \text{H}_2\text{O}(l) \rightleftharpoons \text{H}_3\text{O}^+(aq) + \text{CN}^-(aq)$	6.2×10^{-10}

*Red type indicates the ionizable proton; all atoms have zero formal charge.

Table 18.3 lists K_a values of some weak *monoprotic* acids, those with one ionizable proton. (A more extensive list is in Appendix C.) Note that the ionizable proton in organic acids is bound to the O in $-\text{COOH}$; H atoms bonded to C do *not* ionize.

Classifying the Relative Strengths of Acids and Bases

Using a table of K_a values is the surest way to quantify strengths of weak acids, but you can classify acids and bases qualitatively as strong or weak from their formulas:

- **Strong acids.** Two types of strong acids, with examples *you should memorize*, are
 1. The hydrohalic acids HCl, HBr, and HI
 2. Oxoacids in which the number of O atoms exceeds the number of ionizable protons by two or more, such as HNO_3 , H_2SO_4 , and HClO_4 ; for example, in the case of H_2SO_4 , 4 O's – 2 H's = 2
- **Weak acids.** There are many *more* weak acids than strong ones. Four types are
 1. The hydrohalic acid HF
 2. Acids in which H is not bonded to O or to a halogen, such as HCN and H_2S
 3. Oxoacids in which the number of O atoms equals or exceeds by one the number of ionizable protons, such as HClO , HNO_2 , and H_3PO_4
 4. Carboxylic acids (general formula RCOOH , with the ionizable proton shown in red), such as CH_3COOH and $\text{C}_6\text{H}_5\text{COOH}$
- **Strong bases.** Water-soluble compounds containing O^{2-} or OH^- ions are strong bases. The cations are usually those of the most active metals:
 1. M_2O or MOH , where M = Group 1A(1) metal (Li, Na, K, Rb, Cs)
 2. MO or M(OH)_2 , where M = Group 2A(2) metal (Ca, Sr, Ba)

[MgO_2 and Mg(OH)_2 are only slightly soluble in water, but the soluble portion dissociates completely.]
- **Weak bases.** Many compounds with an electron-rich nitrogen atom are weak bases (none is an Arrhenius base). The common structural feature is an N atom with a lone electron pair (shown in blue):
 1. Ammonia ($\dot{\text{N}}\text{H}_3$)
 2. Amines (general formula $\text{R}\dot{\text{N}}\text{H}_2$, $\text{R}_2\dot{\text{N}}\text{H}$, or $\text{R}_3\dot{\text{N}}$), such as $\text{CH}_3\text{CH}_2\dot{\text{N}}\text{H}_2$, $(\text{CH}_3)_2\dot{\text{N}}\text{H}$, and $(\text{C}_3\text{H}_7)_3\dot{\text{N}}$

SAMPLE PROBLEM 18.1

Classifying Acid and Base Strength from the Chemical Formula

Problem Classify each of the following compounds as a strong acid, weak acid, strong base, or weak base, and write the K_a expression for any weak acid:

- (a) KOH (b) $(\text{CH}_3)_2\text{CHCOOH}$ (c) H_2SeO_4 (d) $(\text{CH}_3)_2\text{CHNH}_2$

Plan We examine the formula and classify each compound as acid or base, using the text descriptions. Particular points to note for acids are the numbers of O atoms relative to ionizable H atoms and the presence of the $-\text{COOH}$ group. For bases, we note the nature of the cation or the presence of an N atom that has a lone pair.

Solution (a) Strong base: KOH is one of the Group 1A(1) hydroxides.

(b) Weak acid: $(\text{CH}_3)_2\text{CHCOOH}$ is a carboxylic acid, as indicated by the $-\text{COOH}$ group; the dissociation reaction is:

and

$$K_a = \frac{[\text{H}_3\text{O}^+][((\text{CH}_3)_2\text{CHCOO}^-)]}{[(\text{CH}_3)_2\text{CHCOOH}]}$$

(c) Strong acid: H_2SeO_4 is an oxoacid in which the number of O atoms exceeds the number of ionizable protons by 2.

(d) Weak base: $(\text{CH}_3)_2\text{CHNH}_2$ has a lone electron pair on the N and is an amine.

FOLLOW-UP PROBLEMS

Brief Solutions for all Follow-up Problems appear at the end of the chapter.

18.1A Which member of each pair is the stronger acid or base?

- (a) HClO or HClO_3 (b) HCl or CH_3COOH (c) NaOH or CH_3NH_2

18.1B Classify each of the following compounds as a strong acid, weak acid, strong base, or weak base, and write the K_a expression for any weak acid:

- (a) $(\text{CH}_3)_3\text{N}$ (b) HI (c) HBrO (d) $\text{Ca}(\text{OH})_2$

SOME SIMILAR PROBLEMS 18.15–18.18

› Summary of Section 18.1

- › In aqueous solution, water binds the proton released from an acid to form a hydrated species represented by $\text{H}_3\text{O}^+(aq)$.
- › By the Arrhenius definition, acids contain H and yield H_3O^+ in water, bases contain OH and yield OH^- in water, and an acid-base reaction (neutralization) is the reaction of H^+ and OH^- to form H_2O .
- › Acid strength depends on $[\text{H}_3\text{O}^+]$ relative to $[\text{HA}]$ in aqueous solution. Strong acids dissociate completely and weak acids slightly.
- › The extent of dissociation is expressed by the acid-dissociation constant, K_a . Most weak acids have K_a values ranging from about 10^{-2} to 10^{-10} .
- › Many acids and bases can be classified as strong or weak based on their formulas.

18.2 AUTOIONIZATION OF WATER AND THE pH SCALE

Before we discuss the next major acid-base definition, let's examine a crucial property of water that enables us to quantify $[\text{H}_3\text{O}^+]$: water dissociates very slightly into ions in an equilibrium process known as **autoionization** (or *self-ionization*):

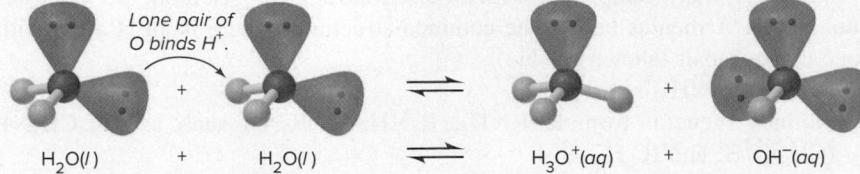

The Equilibrium Nature of Autoionization: The Ion-Product Constant for Water (K_w)

Like any equilibrium process, the autoionization of water is described quantitatively by an equilibrium constant:

$$K_c = \frac{[\text{H}_3\text{O}^+][\text{OH}^-]}{[\text{H}_2\text{O}]^2}$$

Because the concentration of H_2O (55.5 M) remains essentially constant, it is considered a pure liquid and is eliminated from the equilibrium expression. Thus, we obtain the **ion-product constant for water, K_w** :

$$K_c \times (1)^2 = K_w = [\text{H}_3\text{O}^+][\text{OH}^-] = 1.0 \times 10^{-14} \text{ (at } 25^\circ\text{C}) \quad (18.2)$$

Notice that *one H_3O^+ ion and one OH^- ion form for each H_2O molecule that dissociates*. Therefore, in pure water, we find that

$$[\text{H}_3\text{O}^+] = [\text{OH}^-] = \sqrt{1.0 \times 10^{-14}} = 1.0 \times 10^{-7} \text{ M (at } 25^\circ\text{C)}$$

Since pure water has a concentration of about 55.5 M, these equilibrium concentrations are attained when only 1 in 555 million water molecules dissociates reversibly into ions!

Autoionization of water affects aqueous acid-base chemistry in two major ways:

1. A change in $[\text{H}_3\text{O}^+]$ causes an inverse change in $[\text{OH}^-]$, and vice versa:

Recall from Le Châtelier's principle (Section 17.6) that a change in concentration shifts the equilibrium position but does *not* change the equilibrium constant. Therefore, if some acid is added, $[\text{H}_3\text{O}^+]$ increases and $[\text{OH}^-]$ decreases as the autoionization reaction proceeds to the left and the ions react to form water; similarly, if some base is added, $[\text{OH}^-]$ increases and $[\text{H}_3\text{O}^+]$ decreases. In both cases, as long as the temperature is constant, the value of K_w is constant.

2. Both ions are present in all aqueous systems. Thus, all acidic solutions contain a low $[\text{OH}^-]$, and all basic solutions contain a low $[\text{H}_3\text{O}^+]$. The equilibrium nature of autoionization allows us to define "acidic" and "basic" solutions in terms of relative magnitudes of $[\text{H}_3\text{O}^+]$ and $[\text{OH}^-]$:

In an *acidic* solution, $[\text{H}_3\text{O}^+] > [\text{OH}^-]$

In a *neutral* solution, $[\text{H}_3\text{O}^+] = [\text{OH}^-]$

In a *basic* solution, $[\text{H}_3\text{O}^+] < [\text{OH}^-]$

Figure 18.3 summarizes these relationships. Moreover, if you know the value of K_w at a particular temperature and the concentration of one of the two ions, you can find the concentration of the other:

$$[\text{H}_3\text{O}^+] = \frac{K_w}{[\text{OH}^-]} \quad \text{or} \quad [\text{OH}^-] = \frac{K_w}{[\text{H}_3\text{O}^+]}$$

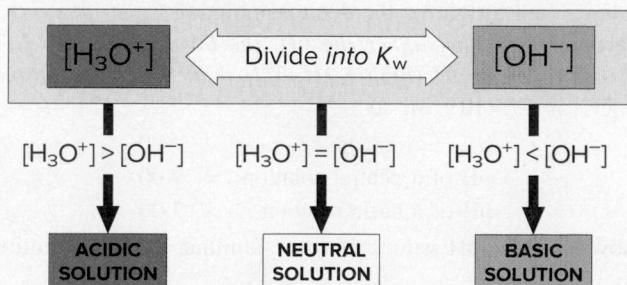

Figure 18.3 The relationship between $[\text{H}_3\text{O}^+]$ and $[\text{OH}^-]$ and the relative acidity of solutions.

SAMPLE PROBLEM 18.2

Calculating $[H_3O^+]$ or $[OH^-]$ in Aqueous Solution

Problem A research chemist adds a measured amount of HCl gas to pure water at 25°C and obtains a solution with $[H_3O^+] = 3.0 \times 10^{-4} M$. Calculate $[OH^-]$. Is the solution neutral, acidic, or basic?

Plan We use the known value of K_w at 25°C (1.0×10^{-14}) and the given $[H_3O^+]$ ($3.0 \times 10^{-4} M$) to solve for $[OH^-]$. Then we compare $[H_3O^+]$ with $[OH^-]$ to determine whether the solution is acidic, basic, or neutral (see Figure 18.3).

Solution Calculating $[OH^-]$:

$$[OH^-] = \frac{K_w}{[H_3O^+]} = \frac{1.0 \times 10^{-14}}{3.0 \times 10^{-4}} = 3.3 \times 10^{-11} M$$

Because $[H_3O^+] > [OH^-]$, the solution is acidic.

Check It makes sense that adding an acid to water results in an acidic solution. Also, since $[H_3O^+]$ is greater than $10^{-7} M$, $[OH^-]$ must be less than $10^{-7} M$ to give a constant K_w .

FOLLOW-UP PROBLEMS

18.2A Calculate $[H_3O^+]$ in a solution that has $[OH^-] = 6.7 \times 10^{-2} M$ at 25°C . Is the solution neutral, acidic, or basic?

18.2B An aqueous solution of window cleaner has $[H_3O^+] = 1.8 \times 10^{-10} M$ at 25°C . Calculate $[OH^-]$. Is the solution neutral, acidic, or basic?

SOME SIMILAR PROBLEMS 18.27–18.30

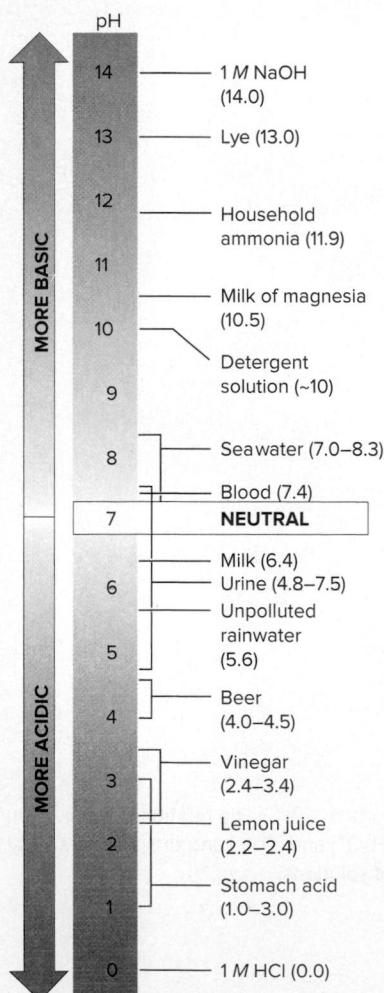

Figure 18.4 The pH values of some familiar aqueous solutions.

Expressing the Hydronium Ion Concentration: The pH Scale

In aqueous solutions, $[H_3O^+]$ can vary from about $10 M$ to $10^{-15} M$. To handle numbers with negative exponents more conveniently in calculations, we convert them to positive numbers using a numerical system called a *p-scale*, the negative of the common (base-10) logarithm of the number. Applying this numerical system to $[H_3O^+]$ gives **pH**, the negative of the common logarithm of $[H^+]$ (or $[H_3O^+]$):

$$\text{pH} = -\log [H_3O^+] \quad (18.3)$$

What is the pH of a $10^{-12} M$ H_3O^+ solution?

$$\text{pH} = -\log [H_3O^+] = -\log 10^{-12} = (-1)(-12) = 12$$

Similarly, a $10^{-3} M$ H_3O^+ solution has a pH of 3, and a $5.4 \times 10^{-4} M$ H_3O^+ solution has a pH of 3.27:

$$\text{pH} = -\log [H_3O^+] = (-1)(\log 5.4 + \log 10^{-4}) = 3.27$$

As with any measurement, the number of significant figures in a pH value reflects the precision with which the concentration is known. However, a pH value is a logarithm, so the number of significant figures in the concentration equals the number of digits *to the right of the decimal point in the pH value* (see Appendix A). In the preceding example, $5.4 \times 10^{-4} M$ has two significant figures, so its negative logarithm, 3.27, has two digits to the right of the decimal point.

Note in particular that *the higher the pH, the lower the $[H_3O^+]$* . Therefore, *an acidic solution has a lower pH (higher $[H_3O^+]$) than a basic solution*. At 25°C in pure water, $[H_3O^+]$ is $1.0 \times 10^{-7} M$, so

$$\text{pH of an acidic solution} < 7.00$$

$$\text{pH of a neutral solution} = 7.00$$

$$\text{pH of a basic solution} > 7.00$$

Figure 18.4 shows that the pH values of some familiar aqueous solutions fall within a range of 0 to 14.

Table 18.4 The Relationship Between K_a and pK_a

Acid Name (Formula)	K_a at 25°C	pK_a
Hydrogen sulfate ion (HSO_4^-)	1.0×10^{-2}	1.99
Nitrous acid (HNO_2)	7.1×10^{-4}	3.15
Acetic acid (CH_3COOH)	1.8×10^{-5}	4.75
Hypobromous acid (HBrO)	2.3×10^{-9}	8.64
Phenol ($\text{C}_6\text{H}_5\text{OH}$)	1.0×10^{-10}	10.00

Because the pH scale is logarithmic, a solution of pH 1.0 has an $[\text{H}_3\text{O}^+]$ that is 10 times higher than that of a pH 2.0 solution, 100 times higher than that of a pH 3.0 solution, and so forth. To find the $[\text{H}_3\text{O}^+]$ from the pH, you perform the opposite arithmetic process; that is, you find the negative antilog of pH:

$$[\text{H}_3\text{O}^+] = 10^{-\text{pH}}$$

A p-scale is used to express other quantities as well:

1. Hydroxide ion concentration can be expressed as pOH:

$$\text{pOH} = -\log [\text{OH}^-]$$

Acidic solutions have a higher pOH (lower $[\text{OH}^-]$) than basic solutions.

2. Equilibrium constants can be expressed as pK:

$$\text{pK} = -\log K$$

Specifically for weak acids:

$$pK_a = -\log K_a \text{ and } K_a = 10^{-pK_a}$$

A low pK corresponds to a high K. So

- a reaction that reaches equilibrium with mostly products present (proceeds far to the right) has a low pK (high K);
- a reaction that has mostly reactants present at equilibrium has a high pK (low K).

Table 18.4 shows this relationship for aqueous equilibria of some weak acids.

The Relationships Among pH, pOH, and pK_w Taking the negative log of both sides of the K_w expression gives a useful relationship among pK_w , pH, and pOH:

$$K_w = [\text{H}_3\text{O}^+][\text{OH}^-] = 1.0 \times 10^{-14} \text{ (at } 25^\circ\text{C)}$$

$$-\log K_w = (-\log [\text{H}_3\text{O}^+]) + (-\log [\text{OH}^-]) = -\log (1.0 \times 10^{-14})$$

$$pK_w = \text{pH} + \text{pOH} = 14.00 \quad (\text{at } 25^\circ\text{C}) \quad \boxed{\textbf{(18.4)}}$$

Note these important points:

1. The sum of pH and pOH is pK_w for any aqueous solution at any temperature, and pK_w equals 14.00 at 25°C .
2. Because K_w is constant, pH, pOH, $[\text{H}_3\text{O}^+]$, and $[\text{OH}^-]$ are interrelated:
 - $[\text{H}_3\text{O}^+]$ and $[\text{OH}^-]$ change in opposite directions.
 - pH and pOH also change in opposite directions.
 - At 25°C , the product of $[\text{H}_3\text{O}^+]$ and $[\text{OH}^-]$ is 1.0×10^{-14} , and the sum of pH and pOH is 14.00 (Figure 18.5, next page).

Calculating pH for Strong Acids and Bases Since strong acids and bases dissociate completely, calculating pH, $[\text{H}_3\text{O}^+]$, $[\text{OH}^-]$, and pOH for these substances is straightforward:

- The equilibrium concentration of H_3O^+ is equal to the initial concentration of a strong acid: 0.200 M HCl dissociates to produce 0.200 M H_3O^+ .
- The equilibrium concentration of OH^- is equal to the initial concentration of a Group 1A(1) hydroxide: 0.200 M KOH dissociates to produce 0.200 M OH^- .

Figure 18.5 The relationships among $[H_3O^+]$, pH, $[OH^-]$, and pOH.

	$[H_3O^+]$	pH	$[OH^-]$	pOH
BASIC	1.0×10^{-15}	15.00	1.0×10^1	-1.00
	1.0×10^{-14}	14.00	1.0×10^0	0.00
	1.0×10^{-13}	13.00	1.0×10^{-1}	1.00
	1.0×10^{-12}	12.00	1.0×10^{-2}	2.00
	1.0×10^{-11}	11.00	1.0×10^{-3}	3.00
	1.0×10^{-10}	10.00	1.0×10^{-4}	4.00
	1.0×10^{-9}	9.00	1.0×10^{-5}	5.00
	1.0×10^{-8}	8.00	1.0×10^{-6}	6.00
NEUTRAL	1.0×10^{-7}	7.00	1.0×10^{-7}	7.00
ACIDIC	1.0×10^{-6}	6.00	1.0×10^{-8}	8.00
	1.0×10^{-5}	5.00	1.0×10^{-9}	9.00
	1.0×10^{-4}	4.00	1.0×10^{-10}	10.00
	1.0×10^{-3}	3.00	1.0×10^{-11}	11.00
	1.0×10^{-2}	2.00	1.0×10^{-12}	12.00
	1.0×10^{-1}	1.00	1.0×10^{-13}	13.00
	1.0×10^0	0.00	1.0×10^{-14}	14.00
	1.0×10^1	-1.00	1.0×10^{-15}	15.00

- The equilibrium concentration of OH^- is equal to twice the initial concentration of a Group 2A(2) hydroxide: 0.200 M $Ba(OH)_2$ dissociates to produce $2(0.200\text{ M}) = 0.400\text{ M}$ OH^- since there are two moles of OH^- in every mole of $Ba(OH)_2$.

SAMPLE PROBLEM 18.3

Calculating $[H_3O^+]$, pH, $[OH^-]$, and pOH for Strong Acids and Bases

Problem Calculate $[H_3O^+]$, pH, $[OH^-]$, and pOH for each solution at $25^\circ C$:

- (a) 0.30 M HNO_3 , used for etching copper metal
 (b) 0.0042 M $Ca(OH)_2$, used in leather tanning to remove hair from hides

Plan We know that HNO_3 is a strong acid and dissociates completely; thus, $[H_3O^+] = [HNO_3]_{init}$. Similarly, $Ca(OH)_2$ is a strong base and dissociates completely; the molar ratio is 1 mol $Ca(OH)_2$ /2 mol OH^- so $[OH^-] = 2[Ca(OH)_2]_{init}$. We use these concentrations and the value of K_w at $25^\circ C$ (1.0×10^{-14}) to find $[OH^-]$ or $[H_3O^+]$, which we then use to calculate pH and pOH.

Solution (a) For 0.30 M HNO_3 :

$$[H_3O^+] = 0.30\text{ M}$$

$$pH = -\log [H_3O^+] = -\log 0.30 = 0.52$$

$$[OH^-] = \frac{K_w}{[H_3O^+]} = \frac{1.0 \times 10^{-14}}{0.30} = 3.3 \times 10^{-14}\text{ M}$$

$$pOH = -\log [OH^-] = -\log (3.3 \times 10^{-14}) = 13.48$$

(b) For 0.0042 M $Ca(OH)_2$: $Ca(OH)_2(aq) \longrightarrow Ca^{2+}(aq) + 2OH^-(aq)$

$$[OH^-] = 2(0.0042\text{ M}) = 0.0084\text{ M}$$

$$pOH = -\log [OH^-] = -\log (0.0084) = 2.08$$

$$[H_3O^+] = \frac{K_w}{[OH^-]} = \frac{1.0 \times 10^{-14}}{0.0084} = 1.2 \times 10^{-12}\text{ M}$$

$$pH = -\log [H_3O^+] = -\log (1.2 \times 10^{-12}) = 11.92$$

Check The strong acid has $pH < 7$ and the strong base has a $pH > 7$, as expected. In each case, $pH + pOH = 14$, so the arithmetic seems correct.

FOLLOW-UP PROBLEMS

18.3A Sodium hydroxide is used to clear clogged drains. A solution of NaOH has a pOH of 4.48 at 25°C. What are its pH, [OH⁻], and [H₃O⁺]?

18.3B Hydrochloric acid is sold commercially under the name *muriatic acid* and is used to clean concrete masonry. A dilute solution of HCl has a pH of 2.28 at 25°C. Calculate its pOH, [H₃O⁺], and [OH⁻].

SOME SIMILAR PROBLEMS 18.23–18.30

Measuring pH In the laboratory, pH values are usually obtained in two ways:

1. **Acid-base indicators** are organic molecules whose colors depend on the acidity of the solution in which they are dissolved. A pH can be estimated quickly with *pH paper*, a paper strip impregnated with one or a mixture of indicators. A drop of solution is placed on the strip, and the color is compared with a chart (Figure 18.6A).

2. A *pH meter* measures [H₃O⁺] by means of two electrodes immersed in the test solution. One electrode supplies a reference system; the other consists of a very thin glass membrane that separates a known internal [H₃O⁺] from the unknown external [H₃O⁺]. The difference in [H₃O⁺] creates a voltage difference across the membrane, which is displayed in pH units (Figure 18.6B). We examine this device in Chapter 21.

› Summary of Section 18.2

- › Pure water has a low conductivity because it autoionizes to a small extent in a process whose equilibrium constant is the ion-product constant for water, K_w (1.0×10^{-14} at 25°C).
- › [H₃O⁺] and [OH⁻] are inversely related: in acidic solution, [H₃O⁺] is greater than [OH⁻]; the reverse is true in basic solution; and the two are equal in neutral solution.
- › To express small values of [H₃O⁺], we use the pH scale: $\text{pH} = -\log [\text{H}_3\text{O}^+]$. Similarly, $\text{pOH} = -\log [\text{OH}^-]$, and $\text{pK} = -\log K$.
- › A high pH corresponds to a low [H₃O⁺]. In acidic solutions, $\text{pH} < 7.00$; in basic solutions, $\text{pH} > 7.00$; and in neutral solutions, $\text{pH} = 7.00$. The sum of pH and pOH equals pK_w (14.00 at 25°C).
- › A pH is typically measured with either an acid-base indicator or a pH meter.

18.3 PROTON TRANSFER AND THE BRØNSTED-LOWRY ACID-BASE DEFINITION

Earlier we noted a key limitation of the Arrhenius definition: many substances that yield OH⁻ ions in water do not contain OH in their formulas. Examples include ammonia, the amines, and many salts of weak acids, such as NaF. Another limitation is that water had to be the solvent for acid-base reactions. In the early 20th century, J. N. Brønsted and T. M. Lowry suggested definitions that remove these limitations. (We introduced some of these ideas in Section 4.4.)

According to the **Brønsted-Lowry acid-base definition**,

- An acid is a **proton donor**, any species that donates an H⁺ ion. An acid must contain H in its formula; HNO₃ and H₂PO₄⁻ are two of many examples. All Arrhenius acids are Brønsted-Lowry acids.
- A base is a **proton acceptor**, any species that accepts an H⁺ ion. A base must contain a lone pair of electrons to bind H⁺; a few examples are NH₃, CO₃²⁻, and F⁻, as well as OH⁻ itself. Brønsted-Lowry bases are not Arrhenius bases, but all Arrhenius bases contain the Brønsted-Lowry base OH⁻.

From this perspective, an acid-base reaction occurs when *one species donates a proton and another species simultaneously accepts it: an acid-base reaction is thus a proton-transfer process*. Acid-base reactions can occur between gases, in nonaqueous solutions, and in heterogeneous mixtures, as well as in aqueous solutions.

A

B

Figure 18.6 Methods for measuring the pH of an aqueous solution. A, pH paper.

B, pH meter. Solution is 10^{-4} M NaOH.

Source: © McGraw-Hill Education/Charles Winters/Timeframe Photography, Inc.

Figure 18.7 Dissolving of an acid or base in water as a Brønsted-Lowry acid-base reaction. **A**, The acid HCl dissolving in the base water. **B**, The base NH₃ dissolving in the acid water.

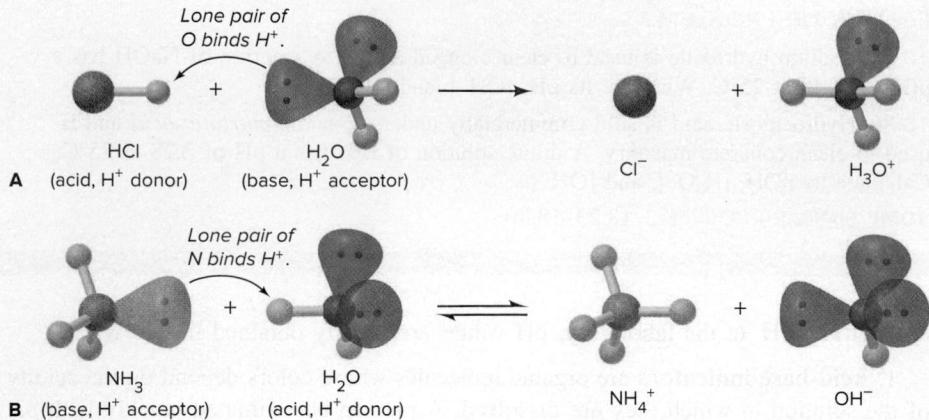

According to this definition, an acid-base reaction occurs even when an acid (or a base) just dissolves in water, because water acts as the proton acceptor (or donor):

1. *Acid donates a proton to water* (Figure 18.7A). When HCl dissolves in water, an H⁺ ion (a proton) is transferred from HCl to H₂O, where it becomes attached to a lone pair of electrons on the O atom, forming H₃O⁺. Thus, HCl (the acid) has *donated* the H⁺, and H₂O (the base) has *accepted* it:

2. *Base accepts a proton from water* (Figure 18.7B). When ammonia dissolves in water, an H⁺ from H₂O is transferred to the lone pair of N, forming NH₄⁺, and the H₂O becomes an OH⁻ ion:

In this case, H₂O (the acid) has *donated* the H⁺, and NH₃ (the base) has *accepted* it.

Note that H₂O is *amphiprotic*: it acts as a base (accepts an H⁺) in one case and as an acid (donates an H⁺) in the other. Many other species are amphiprotic as well.

Conjugate Acid-Base Pairs

The Brønsted-Lowry definition provides a new way to look at acid-base reactions because it focuses on the reactants *and* the products as acids and bases. For example, let's examine the reaction between hydrogen sulfide and ammonia:

In the forward reaction, H₂S acts as an acid by donating an H⁺ to NH₃, which acts as a base by accepting it. In the reverse reaction, the ammonium ion, NH₄⁺, acts as an acid by donating an H⁺ to the hydrogen sulfide ion, HS⁻, which acts as a base. Notice that the acid, H₂S, becomes a base, HS⁻, and the base, NH₃, becomes an acid, NH₄⁺.

In Brønsted-Lowry terminology, H₂S and HS⁻ are a **conjugate acid-base pair**: HS⁻ is the conjugate base of the acid H₂S. Similarly, NH₃ and NH₄⁺ are a conjugate acid-base pair: NH₄⁺ is the conjugate acid of the base NH₃. *Every acid has a conjugate base, and every base has a conjugate acid.* For any conjugate acid-base pair,

- The conjugate base has one *fewer* H and one *more* negative charge than the acid.
- The conjugate acid has one *more* H and one *fewer* negative charge than the base.

A Brønsted-Lowry acid-base reaction occurs when *an acid and a base react to form their conjugate base and conjugate acid, respectively*:

Table 18.5 shows some Brønsted-Lowry acid-base reactions. Note these points:

- Each reaction has an acid and a base as reactants *and* as products, comprising two conjugate acid-base pairs.
- Acids and bases can be neutral molecules, cations, or anions.
- The same species can be an acid or a base (amphiprotic), depending on the other species reacting. Water behaves this way in reactions 1 and 4 in Table 18.5 and HPO₄²⁻ does so in reactions 4 and 6.

Table 18.5**The Conjugate Pairs in Some Acid-Base Reactions**

	Acid	+	Base	Conjugate Pair		+	Acid
				=	Base		
					Conjugate Pair		
Reaction 1	HF	+	H ₂ O	⇒	F ⁻	+	H ₃ O ⁺
Reaction 2	HCOOH	+	CN ⁻	⇒	HCOO ⁻	+	HCN
Reaction 3	NH ₄ ⁺	+	CO ₃ ²⁻	⇒	NH ₃	+	HCO ₃ ⁻
Reaction 4	H ₂ PO ₄ ⁻	+	OH ⁻	⇒	HPO ₄ ²⁻	+	H ₂ O
Reaction 5	H ₂ SO ₄	+	N ₂ H ₅ ⁺	⇒	HSO ₄ ⁻	+	N ₂ H ₆ ²⁺
Reaction 6	HPO ₄ ²⁻	+	SO ₃ ²⁻	⇒	PO ₄ ³⁻	+	HSO ₃ ⁻

SAMPLE PROBLEM 18.4**Identifying Conjugate Acid-Base Pairs**

Problem The following reactions are important environmental processes. Identify the conjugate acid-base pairs.

Plan To find the conjugate pairs, we find the species that donated an H⁺ (acid) and the species that accepted it (base). The acid (or base) on the left becomes its conjugate base (or conjugate acid) on the right. Remember, the conjugate acid has one more H and one fewer negative charge than its conjugate base.

Solution (a) H₂PO₄⁻ has one more H⁺ than HPO₄²⁻; CO₃²⁻ has one fewer H⁺ than HCO₃⁻. Therefore, H₂PO₄⁻ and HCO₃⁻ are the acids, and HPO₄²⁻ and CO₃²⁻ are the bases. The conjugate acid-base pairs are H₂PO₄⁻/HPO₄²⁻ and HCO₃⁻/CO₃²⁻.

(b) H₂O has one more H⁺ than OH⁻; SO₃²⁻ has one fewer H⁺ than HSO₃⁻. The acids are H₂O and HSO₃⁻; the bases are OH⁻ and SO₃²⁻. The conjugate acid-base pairs are H₂O/OH⁻ and HSO₃⁻/SO₃²⁻.

FOLLOW-UP PROBLEMS

18.4A Identify the conjugate acid-base pairs:

18.4B Give the formula of each of the following:

SOME SIMILAR PROBLEMS 18.43–18.52**Student Hot Spot**

Student data indicate that you may struggle with the identification of conjugate acid-base pairs. Access the Smartbook to view additional Learning Resources on this topic.

Relative Acid-Base Strength and the Net Direction of Reaction

The *net* direction of an acid-base reaction depends on relative acid and base strengths: A reaction proceeds to the greater extent in the direction in which a stronger acid and stronger base form a weaker acid and weaker base.

Competition for the Proton The net direction of the reaction of H₂S and NH₃ is to the right ($K_c > 1$) because H₂S is a stronger acid than NH₄⁺, the other acid present, and NH₃ is a stronger base than HS⁻, the other base:

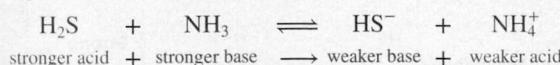

You might think of the process as a *competition for the proton between the two bases*, NH₃ and HS⁻, in which NH₃ wins.

In effect, the extent of acid (HA) dissociation in water can be viewed as the result of a competition for the proton between the two bases, A^- and H_2O . Strong and weak acids give different results:

1. *Strong acids.* When the strong acid HNO_3 dissolves, it completely transfers an H^+ to the base, H_2O , forming the conjugate base NO_3^- and the conjugate acid H_3O^+ :

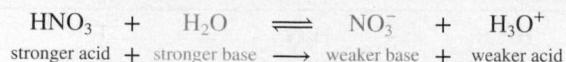

Even though we show an equilibrium arrow here, the net direction is so far to the right that $K_c \gg 1$ and the reaction is essentially complete. HNO_3 is a stronger acid than H_3O^+ , and H_2O is a stronger base than NO_3^- . Thus, with a strong HA, H_2O wins the competition for the proton because A^- is a *much* weaker base. In fact, *the only acidic species that remains in strong-acid solutions is H_3O^+* .

2. *Weak acids.* On the other hand, with weak acids such as HF, the A^- (F^- for this example) wins the competition because it is a stronger base than H_2O and the net direction is to the left ($K_c < 1$), with the net result that only a small percentage of HF molecules dissociate:

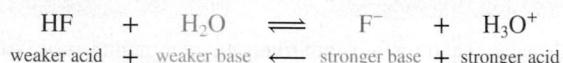

Ranking Conjugate Pairs Based on evidence from many such reactions, we can rank conjugate pairs in terms of the ability of the acid to transfer its proton (Figure 18.8). Note that *a weaker acid has a stronger conjugate base*: the acid can't give up its proton very readily because its conjugate base attracts the proton too strongly.

Figure 18.8 Strengths of conjugate acid-base pairs. The stronger the acid is, the weaker its conjugate base. The strongest acid is at top left and the strongest base at bottom right. When an acid reacts with a base farther down the list, the reaction proceeds to the right ($K_c > 1$).

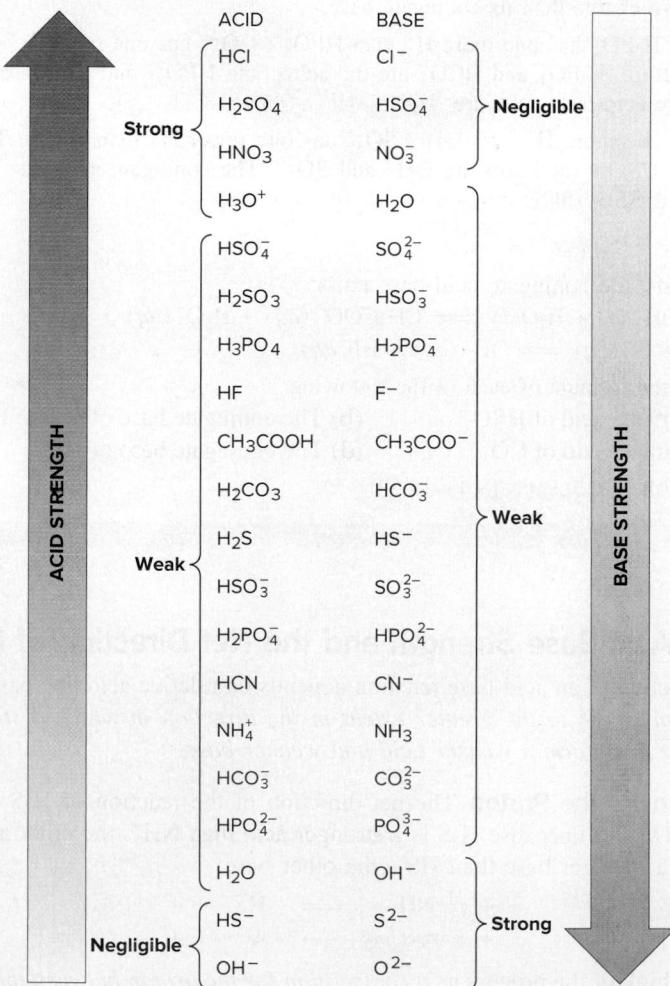

We use Figure 18.8 to predict the net direction of a reaction between any two pairs, that is, whether the equilibrium position lies to the right ($K_c > 1$, mostly products) or to the left ($K_c < 1$, mostly reactants). A reaction proceeds to the right if an acid reacts with a base lower on the list. The following two sample problems demonstrate this key idea.

SAMPLE PROBLEM 18.5**Predicting the Net Direction of an Acid-Base Reaction**

Problem Predict the net direction and indicate whether K_c is greater or less than 1 for each of the following reactions (assume equal initial concentrations of all species):

- (a) $\text{H}_2\text{PO}_4^-(aq) + \text{NH}_3(aq) \rightleftharpoons \text{NH}_4^+(aq) + \text{HPO}_4^{2-}(aq)$
 (b) $\text{H}_2\text{O}(l) + \text{HS}^-(aq) \rightleftharpoons \text{OH}^-(aq) + \text{H}_2\text{S}(aq)$

Plan We identify the conjugate acid-base pairs and consult Figure 18.8 to see which acid and base are stronger. The reaction proceeds in the direction in which the stronger acid and base form the weaker acid and base. If the reaction *as written* proceeds to the right, then [products] is higher than [reactants], so $K_c > 1$.

Solution (a) The conjugate pairs are $\text{H}_2\text{PO}_4^-/\text{HPO}_4^{2-}$ and $\text{NH}_3/\text{NH}_4^+$. Since H_2PO_4^- is higher on the list of acids, it is stronger than NH_4^+ ; since NH_3 is lower on the list of bases, it is stronger than HPO_4^{2-} . Therefore,

The net direction is to the right, so $K_c > 1$.

(b) The conjugate pairs are $\text{H}_2\text{O}/\text{OH}^-$ and $\text{H}_2\text{S}/\text{HS}^-$. Since H_2S is higher on the list of acids, and OH^- is lower on the list of bases, we have

The net direction is to the left, so $K_c < 1$.

FOLLOW-UP PROBLEMS

18.5A Use the following conjugate acid-base pairs and Figure 18.8 to write acid-base reactions with K_c values as specified:

- (a) $\text{H}_2\text{SO}_3/\text{HSO}_3^-$ and $\text{HCO}_3^-/\text{CO}_3^{2-}$, $K_c > 1$ (b) HF/F^- and HCN/CN^- , $K_c < 1$

18.5B Use balanced equations that show the net direction of the reaction to explain each of the following observations:

- (a) You smell ammonia when NH_3 dissolves in water.
 (b) The odor goes away when you add an excess of HCl to the solution in part (a).
 (c) The odor returns when you add an excess of NaOH to the solution in part (b).

SOME SIMILAR PROBLEMS 18.53–18.58**SAMPLE PROBLEM 18.6****Using Molecular Scenes to Predict the Net Direction of an Acid-Base Reaction**

Problem Given that 0.10 M HX (blue and green) has a pH of 2.88, and 0.10 M HY (blue and orange) has a pH of 3.52, which scene best represents the final mixture after equimolar solutions of HX and Y⁻ are mixed?

Plan A stronger acid and base yield a weaker acid and base, so we have to determine the relative acid strengths of HX and HY in order to choose the correct molecular scene. The concentrations of the acid solutions are equal, so we can pick the stronger acid directly from the pH values of the two acid solutions. Because the stronger acid reacts to a greater extent, fewer molecules of it will be in the scene than molecules of the weaker acid.

Solution The HX solution has a lower pH (2.88) than the HY solution (3.52), so we know right away that HX is the stronger acid and X⁻ is the weaker base and that HY is the weaker acid and Y⁻ is the stronger base. Therefore, the reaction of HX and Y⁻ has $K_c > 1$, which means the equilibrium mixture will have more HY than HX. Scene 1 has equal numbers of HX and HY, which would occur if the acids were of equal strength, and scene 2 shows fewer HY than HX, which would occur if HY were stronger. Therefore, only scene 3 is consistent with the relative acid strengths.

FOLLOW-UP PROBLEMS

18.6A The left-hand scene in the margin represents the equilibrium mixture after 0.10 M solutions of HA (*blue and red*) and B⁻ (*black*) react: Does this reaction have a K_c greater or less than 1? Which acid is stronger, HA or HB?

18.6A

18.6B The right-hand scene depicts an aqueous solution of two conjugate acid-base pairs: HC/C⁻ and HD/D⁻. HD is a stronger acid than HC. What colors represent the base C⁻ and the base D⁻? Does the reaction between HC and D⁻ have a K_c greater or less than 1?

A SIMILAR PROBLEM 18.39

› Summary of Section 18.3

- › The Brønsted-Lowry acid-base definition does not require that bases contain OH in their formula or that acid-base reactions occur in aqueous solution.
- › An acid is a species that donates a proton and a base is one that accepts it, so an acid-base reaction is a proton-transfer process.
- › When an acid donates a proton, it becomes the conjugate base; when a base accepts a proton, it becomes the conjugate acid. In an acid-base reaction, acids and bases form their conjugates. A stronger acid has a weaker conjugate base, and vice versa.
- › An acid-base reaction proceeds to the greater extent ($K > 1$) in the direction in which a stronger acid and base form a weaker base and acid.

18.4

SOLVING PROBLEMS INVOLVING WEAK-ACID EQUILIBRIA

Just as you saw in Chapter 17 for equilibrium problems in general, there are two types of equilibrium problems involving weak acids and their conjugate bases:

1. Given equilibrium concentrations, find K_a .
2. Given K_a and some concentrations, find other equilibrium concentrations.

For all of these problems, we'll apply the same problem-solving approach, notation system, and assumptions:

- *The problem-solving approach.* Start with what is given in the problem and move toward what you want to find. Make a habit of applying the following steps:
 1. Write the balanced equation and K_a expression; these tell you what to find.
 2. Define x as the unknown change in concentration that occurs during the reaction. Frequently, $x = [\text{HA}]_{\text{dissoc}}$, the concentration of HA that dissociates, which, based on certain assumptions, also equals $[\text{H}_3\text{O}^+]$ and $[\text{A}^-]$ at equilibrium.
 3. Construct a reaction table (for most problems) that incorporates x .
 4. Make assumptions (usually that x is very small relative to the initial concentration) that simplify the calculations.
 5. Substitute the values into the K_a expression, and solve for x .
 6. Check that the assumptions are justified with the 5% test first used in Sample Problem 17.9. If they are not justified, use the quadratic formula to find x .

- The notation system.** As always, molar concentration is indicated with brackets. A subscript indicates where the species comes from or when it occurs in the reaction process. For example, $[\text{H}_3\text{O}^+]$ from HA is the molar concentration of H_3O^+ that comes from the dissociation of HA; $[\text{HA}]_{\text{init}}$ is the initial molar concentration of HA, that is, before dissociation; $[\text{HA}]_{\text{dissoc}}$ is the molar concentration of HA that dissociates; and so forth. A bracketed formula with *no* subscript represents the molar concentration of the species *at equilibrium*.

- The assumptions.** We make two assumptions to simplify the arithmetic:

- $[\text{H}_3\text{O}^+]$ from the autoionization of water is negligible. It is so much smaller than the $[\text{H}_3\text{O}^+]$ from the dissociation of HA that we can neglect it in these problems:

$$[\text{H}_3\text{O}^+] = [\text{H}_3\text{O}^+]_{\text{from HA}} + [\text{H}_3\text{O}^+]_{\text{from H}_2\text{O}} \approx [\text{H}_3\text{O}^+]_{\text{from HA}}$$

Note that each molecule of HA that dissociates forms one H_3O^+ and one A^- :

$$[\text{HA}]_{\text{dissoc}} = [\text{H}_3\text{O}^+] = [\text{A}^-]$$

- A weak acid has a small K_a . Therefore, it dissociates to such a small extent that we can neglect the change in its concentration to find its equilibrium concentration:

$$[\text{HA}] = [\text{HA}]_{\text{init}} - [\text{HA}]_{\text{dissoc}} \approx [\text{HA}]_{\text{init}}$$

Finding K_a Given Concentrations

This type of problem involves finding K_a of a weak acid from the concentration of one of the species in solution, usually $[\text{H}_3\text{O}^+]$ from a given pH:

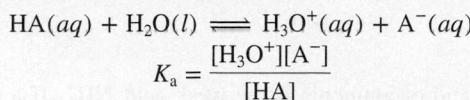

You prepare an aqueous solution of HA and measure its pH. Thus, you know $[\text{HA}]_{\text{init}}$, can calculate $[\text{H}_3\text{O}^+]$ from the pH, and then determine $[\text{A}^-]$ and $[\text{HA}]$ at equilibrium. You substitute these values into the K_a expression and solve for K_a . Let's go through the approach in a sample problem.

SAMPLE PROBLEM 18.7

Finding K_a of a Weak Acid from the Solution pH

Problem Phenylacetic acid ($\text{C}_6\text{H}_5\text{CH}_2\text{COOH}$, simplified here to HPAc; *see model*) builds up in the blood of persons with phenylketonuria, an inherited disorder that, if untreated, causes mental retardation and death. A study of the acid shows that the pH of 0.12 M HPAc is 2.62. What is the K_a of phenylacetic acid?

Plan We are given $[\text{HPAc}]_{\text{init}}$ (0.12 M) and the pH (2.62) and must find K_a . As always, we first write the equation for HPAc dissociation and the expression for K_a to see which values we need. We set up a reaction table and use the given pH to find $[\text{H}_3\text{O}^+]$, which equals $[\text{PAc}^-]$ and $[\text{HPAc}]_{\text{dissoc}}$ (we assume that $[\text{H}_3\text{O}^+]$ from H_2O is negligible). To find $[\text{HPAc}]$, we assume that, because it is a weak acid, very little dissociates, so $[\text{HPAc}]_{\text{init}} - [\text{HPAc}]_{\text{dissoc}} = [\text{HPAc}] \approx [\text{HPAc}]_{\text{init}}$. We make these assumptions, substitute the equilibrium values, solve for K_a , and then check the assumptions using the 5% rule (Sample Problem 17.9).

Solution Writing the dissociation equation and K_a expression:

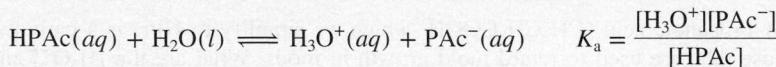

Setting up a reaction table, with $x = [\text{HPAc}]_{\text{dissoc}} = [\text{H}_3\text{O}^+]_{\text{from HPAc}} = [\text{PAc}^-]$:

Concentration (M)	$\text{HPAc}(aq)$	$+ \text{H}_2\text{O}(l)$	\rightleftharpoons	$\text{H}_3\text{O}^+(aq)$	$+ \text{PAc}^-(aq)$
Initial	0.12	—		0	0
Change	$-x$	—		$+x$	$+x$
Equilibrium	$0.12 - x$	—		x	x

Phenylalanine, one of the amino acids that make up aspartame, is metabolized to phenylacetic acid (model).

Calculating $[H_3O^+]$:

$$[H_3O^+] = 10^{-pH} = 10^{-2.62} = 2.4 \times 10^{-3} M$$

Making the assumptions:

1. The calculated $[H_3O^+] (2.4 \times 10^{-3} M) \gg [H_3O^+]_{\text{from } H_2O} (1.0 \times 10^{-7} M)$, so we assume that $[H_3O^+] \approx [H_3O^+]_{\text{from HPAc}} = [PAc^-] = x$ (the change in $[HPAc]$, or $[HPAc]_{\text{dissoc}}$).
2. HPAc is a weak acid, so we assume that $[HPAc] = 0.12 M - x \approx 0.12 M$.

Solving for the equilibrium concentrations:

$$x \approx [H_3O^+] = [PAc^-] = 2.4 \times 10^{-3} M$$

$$[HPAc] = 0.12 M - x = 0.12 M - (2.4 \times 10^{-3} M) \approx 0.12 M \text{ (to 2 sf)}$$

Substituting these values into K_a :

$$K_a = \frac{[H_3O^+][PAc^-]}{[HPAc]} \approx \frac{(2.4 \times 10^{-3})(2.4 \times 10^{-3})}{0.12} = 4.8 \times 10^{-5}$$

Checking the assumptions by finding the percent error in concentration:

1. For $[H_3O^+]_{\text{from } H_2O}$: $\frac{1 \times 10^{-7} M}{2.4 \times 10^{-3} M} \times 100 = 4 \times 10^{-3}\% (<5\%; \text{ assumption is justified.})$
2. For $[HPAc]_{\text{dissoc}}$: $\frac{2.4 \times 10^{-3} M}{0.12 M} \times 100 = 2.0\% (<5\%; \text{ assumption is justified.})$

Check The $[H_3O^+]$ makes sense: pH 2.62 should give $[H_3O^+]$ between 10^{-2} and $10^{-3} M$. The K_a calculation also seems in the correct range: $(10^{-3})^2 / 10^{-1} = 10^{-5}$, and this value seems reasonable for a weak acid.

FOLLOW-UP PROBLEMS

18.7A The conjugate acid of ammonia is the weak acid NH_4^+ . If a $0.2 M$ NH_4Cl solution has a pH of 5.0, what is the K_a of NH_4^+ ?

18.7B Over a million tons of acrylic acid ($H_2C=CHCOOH$) are produced each year for manufacturing plastics, adhesives, and paint. A $0.30 M$ solution of the acid has a pH of 2.43. What is K_a for this acid?

SOME SIMILAR PROBLEMS 18.64, 18.65, 18.72, and 18.73

Finding Concentrations Given K_a

The second type of equilibrium problem gives some concentration data and K_a and asks for the equilibrium concentration of some component. Such problems are very similar to those we solved in Chapter 17 in which a substance with a given initial concentration reacted to an unknown extent (see Sample Problems 17.8 to 17.10). We will use a reaction table in these problems to find the values, and, as we just found, $[H_3O^+]_{\text{from } H_2O}$ is so small relative to $[H_3O^+]_{\text{from HA}}$ that we will neglect it and enter the initial $[H_3O^+]$ in all reaction tables as zero.

SAMPLE PROBLEM 18.8

Determining Concentration and pH from K_a and Initial $[HA]$

Problem Propanoic acid (CH_3CH_2COOH , which we simplify to HPr) is a carboxylic acid whose salts are used to retard mold growth in foods. What are the $[H_3O^+]$ and the pH of $0.10 M$ HPr ($K_a = 1.3 \times 10^{-5}$)?

Plan We know the initial concentration ($0.10 M$) and $K_a (1.3 \times 10^{-5})$ of HPr, and we need to find $[H_3O^+]$ and pH. First, we write the balanced equation and the expression for K_a . We know $[HPr]_{\text{init}}$ but not $[HPr]$ (that is, the concentration at equilibrium). If we let $x = [HPr]_{\text{dissoc}}$, x is also $[H_3O^+]_{\text{from HPr}}$ and $[Pr^-]$ because each HPr dissociates into one H_3O^+ and one Pr^- . With this information, we set up a reaction table. We assume

that, because HPr has a small K_a , it dissociates very little. After solving for x , which is $[\text{H}_3\text{O}^+]$, we check the assumption. Then we use the value for $[\text{H}_3\text{O}^+]$ to find the pH.

Solution Writing the balanced equation and expression for K_a :

Setting up a reaction table, with $x = [\text{HPr}]_{\text{dissoc}} = [\text{H}_3\text{O}^+]_{\text{from HPr}} = [\text{Pr}^-] = [\text{H}_3\text{O}^+]$:

Concentration (M)	HPr(aq)	+	H ₂ O(l)	↔	H ₃ O ⁺ (aq)	+	Pr ⁻ (aq)
Initial	0.10	—			0	0	
Change	$-x$	—			$+x$	$+x$	
Equilibrium	$0.10 - x$	—			x	x	

Making the assumption: K_a is small, so x is small compared with $[\text{HPr}]_{\text{init}}$; therefore, $[\text{HPr}]_{\text{init}} - x = [\text{HPr}] \approx [\text{HPr}]_{\text{init}}$, or $0.10 \text{ M} - x \approx 0.10 \text{ M}$. Substituting into the K_a expression and solving for x :

$$K_a = \frac{[\text{H}_3\text{O}^+][\text{Pr}^-]}{[\text{HPr}]} = 1.3 \times 10^{-5} \approx \frac{(x)(x)}{0.10}$$

$$x \approx \sqrt{(0.10)(1.3 \times 10^{-5})} = 1.1 \times 10^{-3} \text{ M} = [\text{H}_3\text{O}^+]$$

Checking the assumption for $[\text{HPr}]_{\text{dissoc}}$:

$$\frac{[\text{H}_3\text{O}^+]}{[\text{HPr}]_{\text{init}}} \times 100 = \frac{1.1 \times 10^{-3} \text{ M}}{0.10 \text{ M}} \times 100 = 1.1\% \text{ (<5%; assumption is justified.)}$$

Finding the pH:

$$\text{pH} = -\log [\text{H}_3\text{O}^+] = -\log (1.1 \times 10^{-3}) = 2.96$$

Check The $[\text{H}_3\text{O}^+]$ and pH seem reasonable for a dilute solution of a weak acid with a moderate K_a . By reversing the calculation, we can check the math: $(1.1 \times 10^{-3})^2 / 0.10 = 1.2 \times 10^{-5}$, which is within rounding of the given K_a .

Comment In Chapter 17 we introduced a benchmark, aside from the 5% rule, to see if the assumption is justified (see the discussion following Sample Problem 17.9):

- If $\frac{[\text{HA}]_{\text{init}}}{K_a} > 400$, the assumption is justified: neglecting x introduces an error <5%.
- If $\frac{[\text{HA}]_{\text{init}}}{K_a} < 400$, the assumption is *not* justified; neglecting x introduces an error >5%, so we solve a quadratic equation to find x .

In this sample problem, we have $\frac{0.10}{1.3 \times 10^{-5}} = 7.7 \times 10^3$, which is greater than 400. The alternative situation occurs in the next follow-up problem.

FOLLOW-UP PROBLEMS

18.8A Cyanic acid (HOCl) is an extremely acrid, unstable substance. What are the $[\text{H}_3\text{O}^+]$ and the pH of 0.10 M HOCl ($K_a = 3.5 \times 10^{-4}$)?

18.8B Benzoic acid ($\text{C}_6\text{H}_5\text{COOH}$) is used as a food preservative. What are the $[\text{H}_3\text{O}^+]$ and the pH of $0.25 \text{ M C}_6\text{H}_5\text{COOH}$ ($pK_a = 4.20$)?

SOME SIMILAR PROBLEMS 18.66–18.69 and 18.74–18.77

Student Hot Spot

Student data indicate that you may struggle with calculating the pH of a weak acid. Access the Smartbook to view additional Learning Resources on this topic.

The Effect of Concentration on the Extent of Acid Dissociation

If we repeat the calculation in Sample Problem 18.8, but start with a lower [HPr], we observe a very interesting fact about the extent of dissociation of a weak acid. Suppose the initial concentration of HPr is one-tenth as much, 0.010 M , rather than

0.10 M. After filling in the reaction table and making the same assumptions, we find that

$$x = [\text{H}_3\text{O}^+] = [\text{HPr}]_{\text{dissoc}} = 3.6 \times 10^{-4} \text{ M}$$

Now, let's compare the percentages of HPr molecules dissociated at the two different initial acid concentrations, using the relationship

$$\text{Percent HA dissociated} = \frac{[\text{HA}]_{\text{dissoc}}}{[\text{HA}]_{\text{init}}} \times 100 \quad (18.5)$$

Case 1: $[\text{HPr}]_{\text{init}} = 0.10 \text{ M}$

$$\text{Percent HPr dissociated} = \frac{1.1 \times 10^{-3} \text{ M}}{1.0 \times 10^{-1} \text{ M}} \times 100 = 1.1\%$$

Case 2: $[\text{HPr}]_{\text{init}} = 0.010 \text{ M}$

$$\text{Percent HPr dissociated} = \frac{3.6 \times 10^{-4} \text{ M}}{1.0 \times 10^{-2} \text{ M}} \times 100 = 3.6\%$$

As the initial acid concentration decreases, the percent dissociation of the acid increases. Don't confuse the concentration of HA dissociated with the percent HA dissociated. The concentration, $[\text{HA}]_{\text{dissoc}}$, is lower in the diluted HA solution because the actual number of dissociated HA molecules is smaller. It is the fraction (or the percent) of dissociated HA molecules that increases with dilution.

This phenomenon is analogous to a change in container volume (pressure) for a reaction involving gases at equilibrium (Section 17.6). In the case of gases, an increase in volume shifts the equilibrium position to favor more moles of gas. In the case of HA dissociation, a lower HA concentration, which is the same as an increase in volume, shifts the equilibrium position to favor more moles of ions.

SAMPLE PROBLEM 18.9

Finding the Percent Dissociation of a Weak Acid

Problem In 2011, researchers showed that hypochlorous acid (HClO) generated by white blood cells kills bacteria. Calculate the percent dissociation of (a) 0.40 M HClO ; (b) 0.035 M HClO ($K_a = 2.9 \times 10^{-8}$).

Plan We know the K_a of HClO and need $[\text{HClO}]_{\text{dissoc}}$ to find the percent dissociation at two different initial concentrations. We write the balanced equation and the expression for K_a and then set up a reaction table, with $x = [\text{HClO}]_{\text{dissoc}} = [\text{ClO}^-] = [\text{H}_3\text{O}^+]$. We assume that because HClO has a small K_a , it dissociates very little. Once $[\text{HClO}]_{\text{dissoc}}$ is known, we use Equation 18.5 to find the percent dissociation and check the assumption.

Solution (a) Writing the balanced equation and the expression for K_a :

Setting up a reaction table with $x = [\text{HClO}]_{\text{dissoc}} = [\text{ClO}^-] = [\text{H}_3\text{O}^+]$:

Concentration (M)	$\text{HClO}(aq)$	+	$\text{H}_2\text{O}(l)$	\rightleftharpoons	$\text{H}_3\text{O}^+(aq)$	+	$\text{ClO}^-(aq)$
Initial	0.40		—		0		0
Change	$-x$		—		$+x$		$+x$
Equilibrium	$0.40 - x$		—		x		x

Making the assumption: K_a is small, so x is small compared with $[\text{HClO}]_{\text{init}}$; therefore, $[\text{HClO}]_{\text{init}} - x \approx [\text{HClO}]_{\text{init}}$, or $0.40 \text{ M} - x \approx 0.40 \text{ M}$. Substituting into the K_a expression and solving for x :

$$K_a = \frac{[\text{ClO}^-][\text{H}_3\text{O}^+]}{[\text{HClO}]} = 2.9 \times 10^{-8} \approx \frac{(x)(x)}{0.40}$$

Thus,

$$\begin{aligned}x^2 &= (0.40)(2.9 \times 10^{-8}) \\x &= \sqrt{(0.40)(2.9 \times 10^{-8})} = 1.1 \times 10^{-4} M = [\text{HClO}]_{\text{dissoc}}\end{aligned}$$

Finding the percent dissociation:

$$\text{Percent dissociation} = \frac{[\text{HClO}]_{\text{dissoc}}}{[\text{HClO}]_{\text{init}}} \times 100 = \frac{1.1 \times 10^{-4} M}{0.40 M} \times 100 = 0.028\%$$

Since the percent dissociation is <5%, the assumption is justified.

(b) Performing the same calculations using $[\text{HClO}]_{\text{init}} = 0.035 M$:

$$\begin{aligned}K_a &= \frac{[\text{ClO}^-][\text{H}_3\text{O}^+]}{[\text{HClO}]} = 2.9 \times 10^{-8} \approx \frac{(x)(x)}{0.035} \\x &= \sqrt{(0.035)(2.9 \times 10^{-8})} = 3.2 \times 10^{-5} M = [\text{HClO}]_{\text{dissoc}}\end{aligned}$$

Finding the percent dissociation:

$$\text{Percent dissociation} = \frac{[\text{HClO}]_{\text{dissoc}}}{[\text{HClO}]_{\text{init}}} \times 100 = \frac{3.2 \times 10^{-5} M}{0.035 M} \times 100 = 0.091\%$$

Since the percent dissociation is <5%, the assumption is justified.

Check The percent dissociation is very small, as we expect for an acid with such a low K_a . Note, however, that the percent dissociation is larger for the lower initial concentration, as we also expect.

FOLLOW-UP PROBLEMS

18.9A Calculate the percent dissociation of $0.75 M$ HCN, an extremely poisonous acid that can be obtained from the pits of fruits such as cherries and apples ($K_a = 6.2 \times 10^{-10}$).

18.9B A weak acid is 3.16% dissociated in a $1.5 M$ solution. What is the K_a of the acid?

SOME SIMILAR PROBLEMS 18.70, 18.71, 18.78, and 18.79

The Behavior of Polyprotic Acids

Acids with more than one ionizable proton are **polyprotic acids**. In solution, each dissociation step has a different K_a . For example, phosphoric acid is a triprotic acid (three ionizable protons), so it has three K_a values:

$$K_{a1} = \frac{[\text{H}_2\text{PO}_4^-][\text{H}_3\text{O}^+]}{[\text{H}_3\text{PO}_4]} = 7.2 \times 10^{-3}$$

$$K_{a2} = \frac{[\text{HPO}_4^{2-}][\text{H}_3\text{O}^+]}{[\text{H}_2\text{PO}_4^-]} = 6.3 \times 10^{-8}$$

$$K_{a3} = \frac{[\text{PO}_4^{3-}][\text{H}_3\text{O}^+]}{[\text{HPO}_4^{2-}]} = 4.2 \times 10^{-13}$$

The relative K_a values show that H_3PO_4 is a much stronger acid than H_2PO_4^- , which is much stronger than HPO_4^{2-} .

Table 18.6 (next page) lists some common polyprotic acids and their K_a values. (More are listed in Appendix C.) Note that the general pattern seen for H_3PO_4 occurs for all polyprotic acids:

$$K_{a1} \gg K_{a2} \gg K_{a3}$$

This trend occurs because it is more difficult for the positively charged H^+ ion to leave a singly charged anion (such as H_2PO_4^-) than to leave a neutral molecule (such as H_3PO_4), and more difficult still for it to leave a doubly charged anion (such as HPO_4^{2-}). Successive K_a values typically differ by several orders of magnitude. This fact simplifies calculations because we usually neglect the H_3O^+ coming from the subsequent dissociations.

Table 18.6 Successive K_a Values for Some Polyprotic Acids at 25°C

Name (Formula)	Lewis Structure*	K_{a1}	K_{a2}	K_{a3}
Oxalic acid ($\text{H}_2\text{C}_2\text{O}_4$)		5.6×10^{-2}	5.4×10^{-5}	
Sulfurous acid (H_2SO_3)		1.4×10^{-2}	6.5×10^{-8}	
Phosphoric acid (H_3PO_4)		7.2×10^{-3}	6.3×10^{-8}	4.2×10^{-13}
Arsenic acid (H_3AsO_4)		6×10^{-3}	1.1×10^{-7}	3×10^{-12}
Carbonic acid (H_2CO_3)		4.5×10^{-7}	4.7×10^{-11}	
Hydrosulfuric acid (H_2S)		9×10^{-8}	1×10^{-17}	

*Red type indicates the ionizable protons.

SAMPLE PROBLEM 18.10
Calculating Equilibrium Concentrations for a Polyprotic Acid

Problem Ascorbic acid ($\text{H}_2\text{C}_6\text{H}_6\text{O}_6$; represented as H_2Asc for this problem), known as vitamin C, is a diprotic acid ($K_{a1} = 1.0 \times 10^{-5}$ and $K_{a2} = 5 \times 10^{-12}$) found in citrus fruit. Calculate $[\text{HAsc}^-]$, $[\text{Asc}^{2-}]$, and the pH of 0.050 M H_2Asc .

Plan We know the initial concentration (0.050 M) and both K_a 's for H_2Asc , and we have to calculate the equilibrium concentrations of all species and convert $[\text{H}_3\text{O}^+]$ to pH. We first write the equations and K_a expressions. Because $K_{a1} \gg K_{a2}$, we can assume that the first dissociation produces almost all the H_3O^+ : $[\text{H}_3\text{O}^+]_{\text{from } \text{H}_2\text{Asc}} \gg [\text{H}_3\text{O}^+]_{\text{from } \text{HAsc}^-}$. Also, because K_{a1} is small, the amount of H_2Asc that dissociates can be neglected. We set up a reaction table for the first dissociation, with $x = [\text{H}_2\text{Asc}]_{\text{dissoc}}$, and then we solve for $[\text{H}_3\text{O}^+]$ and $[\text{HAsc}^-]$. Because the second dissociation occurs to a much lesser extent, we can substitute values from the first dissociation directly to find $[\text{Asc}^{2-}]$ from the second.

Solution Writing the equations and K_a expressions:

$$K_{a1} = \frac{[\text{HAsc}^-][\text{H}_3\text{O}^+]}{[\text{H}_2\text{Asc}]} = 1.0 \times 10^{-5}$$

$$K_{a2} = \frac{[\text{Asc}^{2-}][\text{H}_3\text{O}^+]}{[\text{HAsc}^-]} = 5 \times 10^{-12}$$

Setting up a reaction table with $x = [\text{H}_2\text{Asc}]_{\text{dissoc}} = [\text{HAsc}^-] \approx [\text{H}_3\text{O}^+]$:

Concentration (M)	$\text{H}_2\text{Asc}(aq)$	$+ \text{H}_2\text{O}(l)$	\rightleftharpoons	$\text{H}_3\text{O}^+(aq)$	$+ \text{HAsc}^-(aq)$
Initial	0.050	—		0	0
Change	$-x$	—		$+x$	$+x$
Equilibrium	$0.050 - x$	—		x	x

ACID STRENGTH

Making the assumptions:

- Because $K_{a2} \ll K_{a1}$, $[H_3O^+]_{\text{from HAsc}^-} \ll [H_3O^+]_{\text{from H}_2\text{Asc}}$. Therefore,

$$[H_3O^+]_{\text{from H}_2\text{Asc}} \approx [H_3O^+]$$
- Because K_{a1} is small, $[H_2\text{Asc}]_{\text{init}} - x = [H_2\text{Asc}] \approx [H_2\text{Asc}]_{\text{init}}$. Thus,

$$[H_2\text{Asc}] = 0.050 \text{ M} - x \approx 0.050 \text{ M}$$

Substituting into the expression for K_{a1} and solving for x :

$$K_{a1} = \frac{[H_3O^+][\text{HAsc}^-]}{[H_2\text{Asc}]} = \frac{1.0 \times 10^{-5}}{0.050 - x} = \frac{x^2}{0.050 - x} \approx \frac{x^2}{0.050}$$

$$x = [\text{HAsc}^-] \approx [H_3O^+] \approx 7.1 \times 10^{-4} \text{ M}$$

$$\text{pH} = -\log (H_3O^+) = -\log (7.1 \times 10^{-4}) = 3.15$$

Checking the assumptions:

- $[H_3O^+]_{\text{from HAsc}^-} \ll [H_3O^+]_{\text{from H}_2\text{Asc}}$: For any second dissociation that does occur,

$$K_{a2} = \frac{[H_3O^+][\text{Asc}^{2-}]}{[\text{HAsc}^-]} = \frac{(x)(x)}{7.1 \times 10^{-4}}$$

$$x = [H_3O^+]_{\text{from HAsc}^-} = 6 \times 10^{-8} \text{ M}$$

This is even less than $[H_3O^+]_{\text{from H}_2\text{O}}$, so the assumption is justified.

- $[H_2\text{Asc}]_{\text{dissoc}} \ll [H_2\text{Asc}]_{\text{init}}$: $\frac{7.1 \times 10^{-4} \text{ M}}{0.050 \text{ M}} \times 100 = 1.4\% < 5\%$; assumption is justified).

Also, note that

$$\frac{[H_2\text{Asc}]_{\text{init}}}{K_{a1}} = \frac{0.050}{1.0 \times 10^{-5}} = 5000 > 400$$

Using the equilibrium concentrations from the first dissociation to calculate $[\text{Asc}^{2-}]$:

$$K_{a2} = \frac{[H_3O^+][\text{Asc}^{2-}]}{[\text{HAsc}^-]} \quad \text{and} \quad [\text{Asc}^{2-}] = \frac{(K_{a2})[\text{HAsc}^-]}{[H_3O^+]}$$

$$[\text{Asc}^{2-}] = \frac{(5 \times 10^{-12})(7.1 \times 10^{-4})}{7.1 \times 10^{-4}} = 5 \times 10^{-12} \text{ M}$$

Check $K_{a1} \gg K_{a2}$, so it makes sense that $[\text{HAsc}^-] \gg [\text{Asc}^{2-}]$ because Asc^{2-} is produced only in the second (much weaker) dissociation. Both K_a 's are small, so all concentrations except $[\text{H}_2\text{Asc}]$ should be much lower than the original 0.050 M.

FOLLOW-UP PROBLEMS

18.10A Oxalic acid ($\text{HOOC}-\text{COOH}$, or $\text{H}_2\text{C}_2\text{O}_4$) is the simplest diprotic carboxylic acid. Its commercial uses include bleaching straw and leather and removing rust and ink stains. Calculate the equilibrium values of $[\text{H}_2\text{C}_2\text{O}_4]$, $[\text{HC}_2\text{O}_4^-]$, and $[\text{C}_2\text{O}_4^{2-}]$, and find the pH of a 0.150 M $\text{H}_2\text{C}_2\text{O}_4$ solution. Use K_a values from Appendix C. (Hint: First check whether you need the quadratic equation to find x .)

18.10B Carbonic acid (H_2CO_3) plays a role in blood chemistry, cave formation, and ocean acidification. Using its K_a values from Appendix C, calculate the equilibrium values of $[\text{H}_2\text{CO}_3]$, $[\text{HCO}_3^-]$, and $[\text{CO}_3^{2-}]$, and find the pH of a 0.075 M H_2CO_3 solution.

SOME SIMILAR PROBLEMS 18.80 and 18.81

› Summary of Section 18.4

- Two types of weak-acid equilibrium problems involve finding K_a from a given concentration and finding a concentration from a given K_a .
- We simplify the arithmetic by assuming (1) that $[H_3O^+]_{\text{from H}_2\text{O}}$ is much smaller than $[H_3O^+]_{\text{from HA}}$ and can be neglected and (2) that weak acids dissociate so little that $[\text{HA}]_{\text{init}} \approx [\text{HA}]$ at equilibrium.
- The fraction of weak acid molecules that dissociate is greater in a more dilute solution, even though the total $[H_3O^+]$ is lower.
- Polyprotic acids have more than one ionizable proton, but we assume that the first dissociation provides virtually all the H_3O^+ .

Figure 18.9 The effect of atomic and molecular properties on nonmetal hydride acidity.

18.5 MOLECULAR PROPERTIES AND ACID STRENGTH

The strength of an acid depends on its ability to donate a proton, which depends in turn on the strength of the bond to the acidic proton. In this section, we apply trends in atomic and bond properties to determine the trends in acid strength of nonmetal hydrides and oxoacids and then discuss the acidity of hydrated metal ions.

Acid Strength of Nonmetal Hydrides

Two factors determine how easily a proton is released from a nonmetal hydride:

- The electronegativity of the central nonmetal (E)
- The strength of the E—H bond

Figure 18.9 displays two periodic trends among the nonmetal hydrides:

1. *Across a period, acid strength increases.* The electronegativity of the nonmetal E determines this horizontal trend. From left to right, as E becomes more electronegative, it withdraws electron density from H, and the E—H bond becomes more polar. As a result, H^+ is pulled away more easily by an O atom of a water molecule. In aqueous solution, the hydrides of Groups 3A(13) to 5A(15) do not behave as acids, but an increase in acid strength is seen from Group 6A(16) to 7A(17).

2. *Down a group, acid strength increases.* E—H bond strength determines this vertical trend. As E becomes larger, the E—H bond becomes longer and weaker, so H^+ comes off more easily.* For example, hydrohalic acid strength increases down Group 7A(17):

Acid strength:	$\text{HF} << \text{HCl} < \text{HBr} < \text{HI}$
Bond length (pm):	92 127 141 161
Bond energy (kJ/mol):	565 427 363 295

(This trend is not seen in aqueous solution, where HCl , HBr , and HI are all equally strong; we discuss how it *is* observed in Section 18.8.)

Acid Strength of Oxoacids

All oxoacids have the acidic H atom bonded to an O atom, so bond length is not involved. As we mentioned for the halogen oxoacids (Section 14.9), two other factors determine the acid strength of oxoacids:

- The electronegativity of the central nonmetal (E)
- The number of O atoms around E (related to the oxidation number, O.N., of E)

Figure 18.10 summarizes these trends:

1. *For oxoacids with the same number of O atoms, acid strength increases with the electronegativity of E.* Consider the hypohalous acids (HOE , where E is a halogen atom). The more electronegative E is, the more polar the O—H bond becomes and the more easily H^+ is lost (Figure 18.10A). Electronegativity (EN) decreases down a group, as does acid strength:

$$\begin{array}{lll} K_{\text{a}} \text{ of } \text{HOCl} = 2.9 \times 10^{-8} & K_{\text{a}} \text{ of } \text{HOBr} = 2.3 \times 10^{-9} & K_{\text{a}} \text{ of } \text{HOI} = 2.3 \times 10^{-11} \\ \text{EN of Cl} = 3.5 & \text{EN of Br} = 2.8 & \text{EN of I} = 2.5 \end{array}$$

Similarly, in Group 6A(16), H_2SO_4 (EN of S = 2.5) is stronger than H_2SeO_4 (EN of Se = 2.4); in Group 5A(15), H_3PO_4 (EN of P = 2.1) is stronger than H_3AsO_4 (EN of As = 2.0), and so forth.

2. *For oxoacids with different numbers of O atoms, acid strength increases with the number of O atoms (or with the O.N. of the central nonmetal).* The electronegative O atoms pull electron density away from E, which makes the O—H bond more polar. The

*Actually, bond energy refers to bond breakage that forms an H atom, whereas acidity refers to bond breakage that forms an H^+ ion. Although these two types of bond breakage are not the same, the trends in bond energy and acid strength are opposites.

Figure 18.10 The relative strengths of oxoacids. A, Cl withdraws electron density (thickness of green arrow) from the O—H bond most effectively, making that bond most polar (relative size of δ symbols). B, Additional O atoms pull more electron density from the O—H bond.

more O atoms present, the greater the shift in electron density, and the more easily the H^+ ion comes off (Figure 18.10B). Therefore, the chlorine oxoacids (HOClO_n , with n from 0 to 3) increase in strength with the number of O atoms (and the O.N. of Cl):

$$K_a \text{ of HOCl} = 2.9 \times 10^{-8} \quad K_a \text{ of HOClO} = 1.12 \times 10^{-2} \quad K_a \text{ of HOClO}_2 \approx 1 \quad K_a \text{ of HOClO}_3 > 10^7$$

Similarly, HNO_3 is stronger than HNO_2 , H_2SO_4 is stronger than H_2SO_3 , and so forth.

Acidity of Hydrated Metal Ions

The aqueous solutions of certain metal ions are acidic because the *hydrated* metal ion transfers an H^+ ion to water. Consider a general metal nitrate, $\text{M}(\text{NO}_3)_n$, as it dissolves in water. The ions separate and the metal ion becomes bonded to some number of H_2O molecules. This equation shows the hydration of the cation (M^{n+}) using H_2O molecules and “(aq)”; hydration of the anion (NO_3^-) is indicated with just “(aq)”:

If the metal ion, M^{n+} , is *small and highly charged*, its high charge density withdraws sufficient electron density from the O—H bonds of the bound water molecules for an H^+ to be released. Thus, the hydrated cation, $\text{M}(\text{H}_2\text{O})_x^{n+}$, is a typical Brønsted-Lowry acid. The bound H_2O that releases the H^+ becomes a bound OH^- ion:

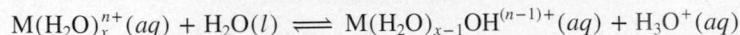

Salts of most M^{2+} and M^{3+} ions yield acidic aqueous solutions. The K_a values for some acidic hydrated metal ions appear in Appendix C.

Consider the small, highly charged Al^{3+} ion. When an aluminum salt, such as $\text{Al}(\text{NO}_3)_3$, dissolves in water, the following steps occur:

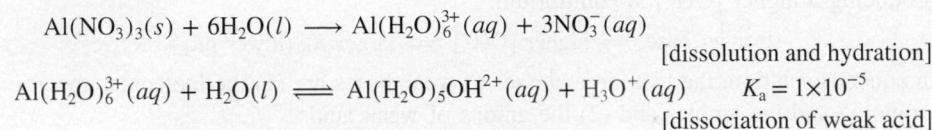

Note the formulas of the hydrated metal ions in the last step. When H^+ is released, the number of bound H_2O molecules decreases by 1 (from 6 to 5) and the number of bound OH^- ions increases by 1 (from 0 to 1), which reduces the ion's positive charge by 1 (from 3 to 2) (Figure 18.11). This pattern of changes in the formula of the hydrated metal ion before and after it loses a proton occurs with any highly charged metal ion in water.

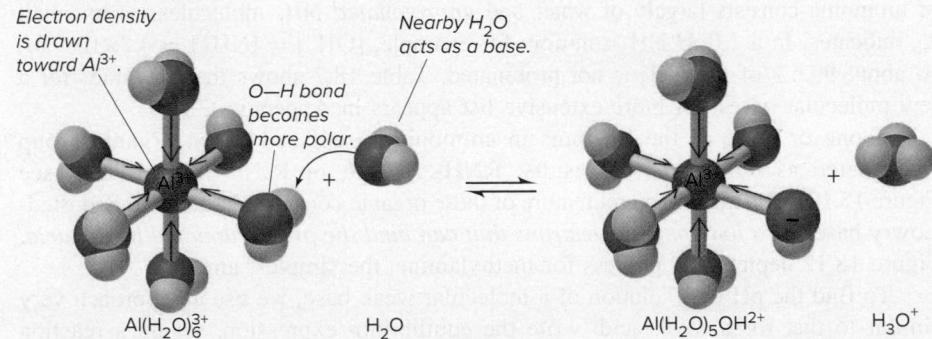

Figure 18.11 The acidic behavior of the hydrated Al^{3+} ion. The hydrated Al^{3+} ion is small and highly charged and pulls electron density from the O—H bonds, so an H^+ ion can be transferred to a nearby water molecule.

› Summary of Section 18.5

- › For nonmetal hydrides, acid strength increases across a period, with the electronegativity of the nonmetal (E), and down a group, with the length of the E—H bond.
- › For oxoacids with the same number of O atoms, acid strength increases with electronegativity of E; for oxoacids with the same E, acid strength increases with number of O atoms (or O.N. of E).
- › Small, highly charged metal ions are acidic in water because they withdraw electron density from the O—H bonds of bound H₂O molecules, releasing an H⁺ ion to the solution.

18.6 WEAK BASES AND THEIR RELATION TO WEAK ACIDS

The Brønsted-Lowry concept expands the definition of a base to encompass a host of species that the Arrhenius definition excludes: *to accept a proton, a base needs only a lone electron pair.*

Let's examine the equilibrium system of a weak base (B) as it dissolves in water: B accepts a proton from H₂O, which acts as an acid, leaving behind an OH⁻ ion:

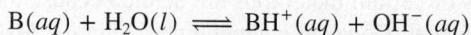

This general reaction for a base in water is described by the equilibrium expression

$$K_c = \frac{[\text{BH}^+][\text{OH}^-]}{[\text{B}][\text{H}_2\text{O}]}$$

Based on our earlier reasoning, we eliminate [H₂O] from the equilibrium expression and obtain the **base-dissociation constant** (or **base-ionization constant**), K_b:

$$K_b = \frac{[\text{BH}^+][\text{OH}^-]}{[\text{B}]} \quad (18.6)$$

Despite the name “base-dissociation constant,” *no base dissociates in the process.*

Base-dissociation constants can be expressed as pK_b values:

$$\text{p}K_b = -\log K_b \quad \text{and} \quad 10^{-\text{p}K_b} = K_b$$

The larger the value of K_b, the smaller the value of pK_b and the stronger the base, producing a higher [OH⁻] at equilibrium:

stronger base \Rightarrow higher [OH⁻] \Rightarrow larger K_b (lower pK_b)

In aqueous solution, the two large classes of weak bases are (1) the molecular species ammonia and the amines and (2) the anions of weak acids.

Molecules as Weak Bases: Ammonia and the Amines

Ammonia is the simplest N-containing compound that acts as a weak base in water:

Despite labels on reagent bottles that read “ammonium hydroxide,” an aqueous solution of ammonia consists largely of water and *unprotonated* NH₃ molecules, as its small K_b indicates. In a 1.0 M NH₃ solution, for example, [OH⁻] = [NH₄⁺] = 4.2 × 10⁻³ M, so about 99.6% of the NH₃ is not protonated. Table 18.7 shows the K_b values for a few molecular bases. (A more extensive list appears in Appendix C.)

If one or more of the H atoms in ammonia is replaced by an organic group (designated as R), an *amine* results: RNH₂, R₂NH, or R₃N (Section 15.4; see Figure 15.17). The key structural feature of these organic compounds, as in all Brønsted-Lowry bases, is *a lone pair of electrons that can bind the proton donated by the acid.* Figure 18.12 depicts this process for methylamine, the simplest amine.

To find the pH of a solution of a molecular weak base, we use an approach very similar to that for a weak acid: write the equilibrium expression, set up a reaction

Table 18.7 K_b Values for Some Molecular (Amine) Bases at 25°C

Name (Formula)	Lewis Structure*	Reaction	K_b	pK_b
Diethylamine $[(\text{CH}_3\text{CH}_2)_2\text{NH}]$		$(\text{CH}_3\text{CH}_2)_2\text{NH}(aq) + \text{H}_2\text{O}(l) \rightleftharpoons (\text{CH}_3\text{CH}_2)_2\text{NH}_2^+(aq) + \text{OH}^-(aq)$	8.6×10^{-4}	3.07
Dimethylamine $[(\text{CH}_3)_2\text{NH}]$		$(\text{CH}_3)_2\text{NH}(aq) + \text{H}_2\text{O}(l) \rightleftharpoons (\text{CH}_3)_2\text{NH}_2^+(aq) + \text{OH}^-(aq)$	5.9×10^{-4}	3.23
Methylamine (CH_3NH_2)		$\text{CH}_3\text{NH}_2(aq) + \text{H}_2\text{O}(l) \rightleftharpoons \text{CH}_3\text{NH}_3^+(aq) + \text{OH}^-(aq)$	4.4×10^{-4}	3.36
Ammonia (NH_3)		$\text{NH}_3(aq) + \text{H}_2\text{O}(l) \rightleftharpoons \text{NH}_4^+(aq) + \text{OH}^-(aq)$	1.76×10^{-5}	4.75
Pyridine $(\text{C}_5\text{H}_5\text{N})$		$\text{C}_5\text{H}_5\text{N}(aq) + \text{H}_2\text{O}(l) \rightleftharpoons \text{C}_5\text{H}_5\text{NH}_2^+(aq) + \text{OH}^-(aq)$	1.7×10^{-9}	8.77
Aniline $(\text{C}_6\text{H}_5\text{NH}_2)$		$\text{C}_6\text{H}_5\text{NH}_2(aq) + \text{H}_2\text{O}(l) \rightleftharpoons \text{C}_6\text{H}_5\text{NH}_3^+(aq) + \text{OH}^-(aq)$	4.0×10^{-10}	9.40

*Blue type indicates the basic nitrogen and its lone pair.

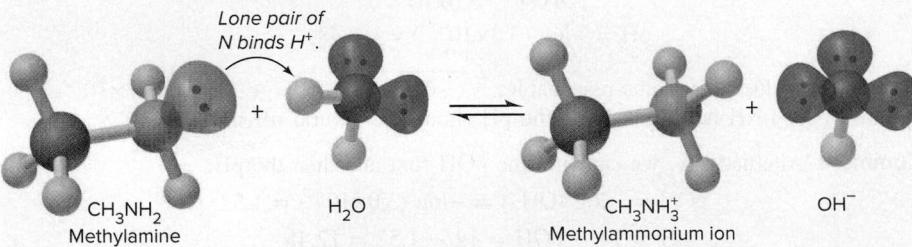

Figure 18.12 Abstraction of a proton from water by the base methylamine.

table to find $[\text{B}]_{\text{reacting}}$, make the usual assumptions, and then solve for $[\text{OH}^-]$. The only additional step is to convert $[\text{OH}^-]$ to $[\text{H}_3\text{O}^+]$ in order to calculate pH.

SAMPLE PROBLEM 18.11

Determining pH from K_b and Initial $[\text{B}]$

Problem Dimethylamine, $(\text{CH}_3)_2\text{NH}$ (see the space-filling model), a key intermediate in detergent manufacture, has a K_b of 5.9×10^{-4} . What is the pH of 1.5 M $(\text{CH}_3)_2\text{NH}$?

Plan We know the initial concentration (1.5 M) and K_b (5.9×10^{-4}) of $(\text{CH}_3)_2\text{NH}$ and have to find the pH. The amine reacts with water to form OH^- , so we have to find $[\text{OH}^-]$ and then calculate $[\text{H}_3\text{O}^+]$ and pH. We first write the balanced equation and K_b expression. Because $K_b \gg K_w$, the $[\text{OH}^-]$ from the autoionization of water is negligible, so we disregard it and assume that all the $[\text{OH}^-]$ comes from the base reacting with water. Because K_b is small, we assume that the amount of amine reacting, $[(\text{CH}_3)_2\text{NH}]_{\text{reacting}}$, can be neglected. We set up a reaction table, make the assumption, and solve for x . Then we check the assumption and convert $[\text{OH}^-]$ to $[\text{H}_3\text{O}^+]$ using K_w ; finally, we calculate pH.

Solution Writing the balanced equation and K_b expression:

Dimethylamine

Setting up the reaction table, with $x = [(\text{CH}_3)_2\text{NH}]_{\text{reacting}} = [(\text{CH}_3)_2\text{NH}_2^+] = [\text{OH}^-]$:

Concentration (M)	$(\text{CH}_3)_2\text{NH}(aq) + \text{H}_2\text{O}(l) \rightleftharpoons (\text{CH}_3)_2\text{NH}_2^+(aq) + \text{OH}^-(aq)$			
Initial	1.5	—	0	0
Change	$-x$	—	$+x$	$+x$
Equilibrium	$1.5 - x$	—	x	x

Making the assumption: K_b is small, so

$$[(\text{CH}_3)_2\text{NH}]_{\text{init}} - [(\text{CH}_3)_2\text{NH}]_{\text{reacting}} = [(\text{CH}_3)_2\text{NH}] \approx [(\text{CH}_3)_2\text{NH}]_{\text{init}}$$

Thus, $1.5 M - x \approx 1.5 M$.

Substituting into the K_b expression and solving for x :

$$K_b = \frac{[(\text{CH}_3)_2\text{NH}_2^+][\text{OH}^-]}{[(\text{CH}_3)_2\text{NH}]} = 5.9 \times 10^{-4} \approx \frac{x^2}{1.5}$$

$$x = [\text{OH}^-] \approx 3.0 \times 10^{-2} M$$

Checking the assumption:

$$\frac{3.0 \times 10^{-2} M}{1.5 M} \times 100 = 2.0\% (< 5\%; \text{assumption is justified.})$$

Note that the Comment in Sample Problem 18.8 applies in these cases as well:

$$\frac{[\text{B}]_{\text{init}}}{K_b} = \frac{1.5}{5.9 \times 10^{-4}} = 2.5 \times 10^3 > 400$$

Calculating pH:

$$[\text{H}_3\text{O}^+] = \frac{K_w}{[\text{OH}^-]} = \frac{1.0 \times 10^{-14}}{3.0 \times 10^{-2}} = 3.3 \times 10^{-13} M$$

$$\text{pH} = -\log(3.3 \times 10^{-13}) = 12.48$$

Check The value of x seems reasonable: $\sqrt{(\sim 6 \times 10^{-4})(1.5)} = \sqrt{9 \times 10^{-4}} = 3 \times 10^{-2}$. Because $(\text{CH}_3)_2\text{NH}$ is a weak base, the pH should be several pH units above 7.

Comment Alternatively, we can find the pOH first and then the pH:

$$\text{pOH} = -\log[\text{OH}^-] = -\log(3.0 \times 10^{-2}) = 1.52$$

$$\text{pH} = 14 - \text{pOH} = 14 - 1.52 = 12.48$$

FOLLOW-UP PROBLEMS

18.11A Pyridine (C_5H_5N , see the space-filling model) serves as a solvent and a base in many organic syntheses. It has a pK_b of 8.77. What is the pH of 0.10 M pyridine?

18.11B The weak base amphetamine, $C_6H_5CH_2CH(CH_3)NH_2$, is a stimulant used to treat narcolepsy and attention deficit disorder. What is the pH of 0.075 M amphetamine ($K_b = 6.3 \times 10^{-5}$)?

SOME SIMILAR PROBLEMS 18.103–18.106

Pyridine

Anions of Weak Acids as Weak Bases

The other large group of Brønsted-Lowry bases consists of anions of weak acids:^{*}

For example, F^- , the anion of the weak acid HF, is a weak base:

^{*}This equation and equilibrium expression are sometimes referred to as a *hydrolysis reaction* and a *hydrolysis constant*, K_h , because water is dissociated (hydrolyzed). Actually, except for the charge on the base, this process is the same as the proton-abstraction process by ammonia and amines. That is, K_h is just another symbol for K_b , so we'll use K_b throughout.

Why is a solution of HA acidic and a solution of A⁻ basic? We'll find the answer from relative concentrations of species in 1 M HF and in 1 M NaF:

1. *The acidity of HA(aq).* HF is a weak acid, so the equilibrium position of the acid dissolving in water lies far to the left:

Water also contributes H₃O⁺ and OH⁻, but their concentrations are extremely small:

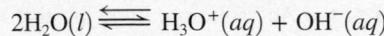

Of all the species present—HF, H₂O, H₃O⁺, F⁻, and OH⁻—the two that can influence the acidity of the solution are H₃O⁺, predominantly from HF, and OH⁻ from water. Thus, the HF solution is acidic because [H₃O⁺]_{from HF} >> [OH⁻]_{from H₂O}.

2. *The basicity of A⁻(aq).* Now, consider the species present in 1 M NaF. The salt dissociates completely to yield 1 M Na⁺ and 1 M F⁻. The Na⁺ behaves as a spectator ion, while some F⁻ reacts as a weak base to produce small amounts of HF and OH⁻:

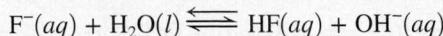

As before, water dissociation contributes minute amounts of H₃O⁺ and OH⁻. Thus, in addition to the Na⁺ ion, the species present are the same as in the HF solution: HF, H₂O, H₃O⁺, F⁻, and OH⁻. The two species that affect the acidity are OH⁻, predominantly from F⁻ reacting with water, and H₃O⁺ from water. In this case, [OH⁻]_{from F⁻} >> [H₃O⁺]_{from H₂O}, so the solution is basic.

To summarize,

- In an HA solution, [HA] >> [A⁻] and [H₃O⁺]_{from HA} >> [OH⁻]_{from H₂O}, so the solution is acidic.
- In an A⁻ solution, [A⁻] >> [HA] and [OH⁻]_{from A⁻} >> [H₃O⁺]_{from H₂O}, so the solution is basic.

The Relation Between K_a and K_b of a Conjugate Acid-Base Pair

A key relationship exists between the K_a of HA and the K_b of its conjugate base, A⁻, which we can see by writing the two reactions as a reaction sequence and adding them:

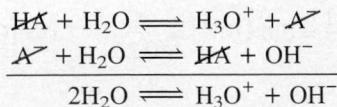

The sum of the two dissociation reactions is the autoionization of water. Recall from Chapter 17 that, for a reaction that is the *sum* of two or more reactions, the overall equilibrium constant is the *product* of the individual equilibrium constants. Therefore, writing the equilibrium expressions for each reaction gives

$$\frac{[\text{H}_3\text{O}^+][\text{A}^-]}{[\text{HA}]} \times \frac{[\text{HA}][\text{OH}^-]}{[\text{A}^-]} = [\text{H}_3\text{O}^+][\text{OH}^-]$$

or

$$K_a(\text{of HA}) \times K_b(\text{of A}^-) = K_w \quad (18.7)$$

This relationship allows us to find K_a of the acid in a conjugate pair given K_b of the base, and vice versa. Reference tables typically have K_a and K_b values for *molecular species only*. The K_b for F⁻ and the K_a for CH₃NH₃⁺, for example, do not appear in standard tables, but you can calculate them by looking up the value for the molecular conjugate species and relating it to K_w. To find the K_b value for F⁻, for instance, we look up the K_a value for HF and apply Equation 18.7:

$$K_a \text{ of HF} = 6.8 \times 10^{-4} \text{ (from Appendix C)}$$

So, we have

$$K_a \text{ of HF} \times K_b \text{ of F}^- = K_w$$

or

$$K_b \text{ of F}^- = \frac{K_w}{K_a \text{ of HF}} = \frac{1.0 \times 10^{-14}}{6.8 \times 10^{-4}} = 1.5 \times 10^{-11}$$

SAMPLE PROBLEM 18.12

Determining the pH of a Solution of A^-

Problem Sodium acetate (CH_3COONa , represented by NaAc for this problem) is used in textile dyeing. What is the pH of 0.25 M NaAc at 25°C ? The K_a of acetic acid (HAc) is 1.8×10^{-5} .

Plan We know the initial concentration of Ac^- (0.25 M) and the K_a of HAc (1.8×10^{-5}), and we have to find the pH of the Ac^- solution, knowing that Ac^- acts as a weak base in water. We write the base-dissociation equation and K_b expression. If we can find $[\text{OH}^-]$, we can use K_w to find $[\text{H}_3\text{O}^+]$ and convert it to pH. To solve for $[\text{OH}^-]$, we need the K_b of Ac^- , which we obtain from the K_a of its conjugate acid HAc by applying Equation 18.7. We set up a reaction table to find $[\text{OH}^-]$ and make the usual assumption that K_b is small, so $[\text{Ac}^-]_{\text{init}} \approx [\text{Ac}^-]$. Notice that Na^+ is a spectator ion and is not included in the base-dissociation equation.

Solution Writing the base-dissociation equation and K_b expression:

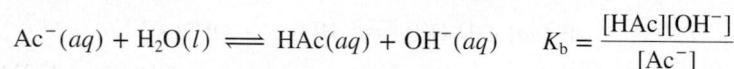

Setting up the reaction table, with $x = [\text{Ac}^-]_{\text{reacting}} = [\text{HAc}] = [\text{OH}^-]$:

Concentration (M)	$\text{Ac}^-(aq)$	+	$\text{H}_2\text{O}(l)$	\rightleftharpoons	$\text{HAc}(aq)$	+	$\text{OH}^-(aq)$
Initial	0.25		—		0		0
Change	$-x$		—		$+x$		$+x$
Equilibrium	$0.25 - x$		—		x		x

Solving for K_b of Ac^- :

$$K_b = \frac{K_w}{K_a} = \frac{1.0 \times 10^{-14}}{1.8 \times 10^{-5}} = 5.6 \times 10^{-10}$$

Making the assumption: Because K_b is small, $0.25 \text{ M} - x \approx 0.25 \text{ M}$.

Substituting into the expression for K_b and solving for x :

$$K_b = \frac{[\text{HAc}][\text{OH}^-]}{[\text{Ac}^-]} = 5.6 \times 10^{-10} \approx \frac{x^2}{0.25} \quad x = [\text{OH}^-] \approx 1.2 \times 10^{-5} \text{ M}$$

Checking the assumption:

$$\frac{1.2 \times 10^{-5} \text{ M}}{0.25 \text{ M}} \times 100 = 4.8 \times 10^{-3\%} (< 5\% \text{; assumption is justified.})$$

Also note that

$$\frac{0.25}{5.6 \times 10^{-10}} = 4.5 \times 10^8 > 400$$

Solving for pH:

$$[\text{H}_3\text{O}^+] = \frac{K_w}{[\text{OH}^-]} = \frac{1.0 \times 10^{-14}}{1.2 \times 10^{-5}} = 8.3 \times 10^{-10} \text{ M}$$

$$\text{pH} = -\log(8.3 \times 10^{-10}) = 9.08$$

Check The K_b calculation seems reasonable: $\sim 10 \times 10^{-15} / 2 \times 10^{-5} = 5 \times 10^{-10}$. Because Ac^- is a weak base, $[\text{OH}^-] > [\text{H}_3\text{O}^+]$; thus, $\text{pH} > 7$, which makes sense.

FOLLOW-UP PROBLEMS

18.12A Sodium hypochlorite (NaClO) is the active ingredient in household laundry bleach. What is the pH of 0.20 M NaClO ?

18.12B Sodium nitrite (NaNO_2) is added to cured meats such as bacon to prevent growth of bacteria. What is the pH of 0.80 M NaNO_2 ?

SOME SIMILAR PROBLEMS 18.111–18.114

 Student Hot Spot

Student data indicate that you may struggle with pH calculations involving weakly basic anions. Access the Smartbook to view additional Learning Resources on this topic.

› Summary of Section 18.6

- › The extent to which a weak base accepts a proton from water to form OH^- is expressed by a base-dissociation constant, K_b .
- › Brønsted-Lowry bases include NH_3 and amines and the anions of weak acids. All produce basic solutions by accepting H^+ from water, which yields OH^- , thus making $[\text{H}_3\text{O}^+] < [\text{OH}^-]$.
- › A solution of HA is acidic because $[\text{HA}] \gg [\text{A}^-]$, so $[\text{H}_3\text{O}^+] > [\text{OH}^-]$. A solution of A^- is basic because $[\text{A}^-] \gg [\text{HA}]$, so $[\text{OH}^-] > [\text{H}_3\text{O}^+]$.
- › By multiplying the expressions for K_a of HA and K_b of A^- , we obtain K_w . This relationship allows us to calculate either K_a of BH^+ or K_b of A^- .

18.7 ACID-BASE PROPERTIES OF SALT SOLUTIONS

In many cases, when a salt dissolves, one or both of its ions may react with water and affect the pH of the solution. You've seen that cations of weak bases (such as NH_4^+) are acidic, anions of weak acids (such as CN^-) are basic, and small, highly charged metal cations (such as Al^{3+}) are acidic. In addition, certain ions (such as H_2PO_4^- and HCO_3^-) can act as an acid or a base. In this section, we classify the acid-base behavior of the various types of salt solutions.

Salts That Yield Neutral Solutions

A salt consisting of the anion of a strong acid and the cation of a strong base yields a neutral solution because the ions do not react with water. When a strong acid such as HNO_3 dissolves, the reaction goes essentially to completion because *the anion of a strong acid is a much weaker base than water*. The anion, in this case NO_3^- , is hydrated, but it does not react with water:

Similarly, a strong base, such as NaOH , dissolves completely. The cation, in this case Na^+ , is hydrated, but it is not small and charged enough to react with water:

The ions that do not react with water are:

- the anions of the strong hydrohalic acids: Cl^- , Br^- , I^- ;
- the ions of strong oxoacids, such as NO_3^- and ClO_4^- ;
- the Group 1A(1) ions (cations of strong bases); and
- Ca^{2+} , Sr^{2+} , and Ba^{2+} in Group 2A(2) (cations of strong bases).

Salts containing only these anions and cations yield neutral solutions. The salts LiNO_3 and CaCl_2 are two examples.

Salts That Yield Acidic Solutions

There are two types of salts that yield acidic solutions; in both types, the cation is responsible for the acidity:

1. *A salt consisting of the cation of a weak base and the anion of a strong acid yields an acidic solution because the cation acts as a weak acid, and the anion does not react.* For example, NH_4Cl yields an acidic solution because NH_4^+ , the cation of the weak base NH_3 , is a weak acid; Cl^- , the anion of the strong HCl , does not react:

2. *A salt consisting of a small, highly charged metal cation and the anion of a strong acid yields an acidic solution because the cation acts as a weak acid (see Figure 18.11), and the anion does not react.* For example, $\text{Fe}(\text{NO}_3)_3$ yields an acidic

solution because the hydrated Fe^{3+} ion is a weak acid; NO_3^- , the anion of the strong HNO_3 , does not react:

Salts That Yield Basic Solutions

A salt consisting of the anion of a weak acid and the cation of a strong base yields a basic solution because the anion acts as a weak base, and the cation does not react. Sodium acetate, for example, yields a basic solution because the CH_3COO^- ion, the anion of the weak acid CH_3COOH , acts as a weak base; Na^+ , the cation of the strong base NaOH , does not react:

SAMPLE PROBLEM 18.13

Predicting Relative Acidity of Salt Solutions from Reactions of the Ions with Water

Problem Predict whether aqueous solutions of the following salts are acidic, basic, or neutral, and write an equation for the reaction of any ion with water:

- (a) Potassium perchlorate, KClO_4 (b) Sodium benzoate, $\text{C}_6\text{H}_5\text{COONa}$
 (c) Chromium(III) nitrate, $\text{Cr}(\text{NO}_3)_3$

Plan The formula shows the cation and the anion. Depending on an ion's ability to react with water, the solution will be neutral (strong-acid anion and strong-base cation), acidic (weak-base cation or highly charged metal cation with strong-acid anion), or basic (weak-acid anion and strong-base cation).

Solution (a) **Neutral.** The ions are K^+ and ClO_4^- . The K^+ is from the strong base KOH , and the ClO_4^- is from the strong acid HClO_4 . Neither ion reacts with water.
 (b) **Basic.** The ions are Na^+ and $\text{C}_6\text{H}_5\text{COO}^-$. The Na^+ is the cation of the strong base NaOH , so it does not react with water. The benzoate ion, $\text{C}_6\text{H}_5\text{COO}^-$, is the anion of the weak acid benzoic acid, so it reacts with water to produce OH^- ion:

(c) **Acidic.** The ions are Cr^{3+} and NO_3^- . The NO_3^- is the anion of the strong acid HNO_3 , so it does not react with water. The Cr^{3+} ion is small and highly charged, so the hydrated ion, $\text{Cr}(\text{H}_2\text{O})_6^{3+}$, reacts with water to produce H_3O^+ :

FOLLOW-UP PROBLEMS

18.13A Write equations to predict whether solutions of the following salts are acidic, basic, or neutral: (a) KClO_4 ; (b) $\text{CH}_3\text{NH}_3\text{NO}_3$; (c) RbBr .

18.13B Write equations to predict whether solutions of the following salts are acidic, basic, or neutral: (a) FeBr_3 ; (b) $\text{Ca}(\text{NO}_2)_2$; (c) $\text{C}_6\text{H}_5\text{NH}_3\text{I}$.

SOME SIMILAR PROBLEMS 18.120, 18.121(a), 18.122, 18.123(a), 18.123(b), 18.124, 18.125(c), 18.126(c), and 18.127(c)

Student Hot Spot

Student data indicate that you may struggle with predicting the pH of a salt solution. Access the Smartbook to view additional Learning Resources on this topic.

Salts of Weakly Acidic Cations and Weakly Basic Anions

If a salt consists of a cation that is a weak acid *and* an anion that is a weak base, the overall acidity of the solution depends on the relative acid strength (K_a) and base strength (K_b) of the separated ions. Consider a solution of ammonium cyanide, NH_4CN , and the reactions that occur between the separated ions and water. Ammonium ion is the conjugate acid of a weak base, so it is a weak acid:

Cyanide ion is the anion of a weak acid, so it is a weak base:

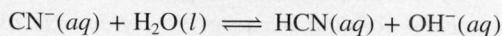

The reaction that goes farther to the right determines the pH of the solution, so we compare the K_a of NH_4^+ with the K_b of CN^- . Only molecular compounds are listed

in K_a and K_b tables, so we use Equation 18.7 to calculate these values for the two ions:

$$K_a \text{ of } \text{NH}_4^+ = \frac{K_w}{K_b \text{ of } \text{NH}_3} = \frac{1.0 \times 10^{-14}}{1.76 \times 10^{-5}} = 5.7 \times 10^{-10}$$

$$K_b \text{ of } \text{CN}^- = \frac{K_w}{K_a \text{ of } \text{HCN}} = \frac{1.0 \times 10^{-14}}{6.2 \times 10^{-10}} = 1.6 \times 10^{-5}$$

Because K_b of $\text{CN}^- > K_a$ of NH_4^+ , we know that CN^- is a stronger base than NH_4^+ is an acid. Thus, more OH^- than H_3O^+ is produced, and the NH_4CN solution is basic.

Salts of Amphiprotic Anions

The only salts left to consider are those in which the cation comes from a strong base and therefore does not react with water, and the anion comes from a polyprotic acid with one or more ionizable protons still attached. These anions are amphiprotic—they can act as an acid and release a proton *to* water or as a base and abstract a proton *from* water. As in the previous case, to determine the overall acidity of their solutions, we compare the magnitudes of K_a and K_b , but here we compare the K_a and K_b of the *same* species, the anion.

For example, Na_2HPO_4 consists of Na^+ , the cation of a strong base, which does not react with water, and HPO_4^{2-} , the second anion of the weak polyprotic acid H_3PO_4 . In water, the salt undergoes three steps:

1. $\text{Na}_2\text{HPO}_4(s) \xrightarrow{\text{H}_2\text{O}} 2\text{Na}^+(aq) + \text{HPO}_4^{2-}(aq)$ [dissolution and hydration]
2. $\text{HPO}_4^{2-}(aq) + \text{H}_2\text{O}(l) \rightleftharpoons \text{PO}_4^{3-}(aq) + \text{H}_3\text{O}^+(aq)$ [acting as a weak acid]
3. $\text{HPO}_4^{2-}(aq) + \text{H}_2\text{O}(l) \rightleftharpoons \text{H}_2\text{PO}_4^-(aq) + \text{OH}^-(aq)$ [acting as a weak base]

We must decide whether step 2 or step 3 goes farther to the right. Appendix C lists the K_a of HPO_4^{2-} as 4.2×10^{-13} , but the K_b of HPO_4^{2-} is not given, so we find it from the K_a of its conjugate acid, H_2PO_4^- , using Equation 18.7:

$$K_b \text{ of } \text{HPO}_4^{2-} = \frac{K_w}{K_a \text{ of } \text{H}_2\text{PO}_4^-} = \frac{1.0 \times 10^{-14}}{6.3 \times 10^{-8}} = 1.6 \times 10^{-7}$$

Because $K_b (1.6 \times 10^{-7}) > K_a (4.2 \times 10^{-13})$, HPO_4^{2-} is stronger as a base than as an acid, so a solution of Na_2HPO_4 is basic.

Table 18.8 displays the acid-base behavior of the various types of salts in water.

Table 18.8 The Acid-Base Behavior of Salts in Water

Nature of Ions	Examples	Ion(s) That React(s) with Water: Example(s)	pH
Neutral			
Cation of strong base	NaCl , KBr , $\text{Ba}(\text{NO}_3)_2$	None	7.0
Anion of strong acid			
Acidic			
Cation of weak base	NH_4Cl , NH_4NO_3 ,	Cation:	<7.0
Anion of strong acid	$\text{CH}_3\text{NH}_3\text{Br}$	$\text{NH}_4^+ + \text{H}_2\text{O} \rightleftharpoons \text{NH}_3 + \text{H}_3\text{O}^+$	
Small, highly charged metal cation	$\text{Al}(\text{NO}_3)_3$, CrBr_3 ,	Cation:	<7.0
Anion of strong acid	FeCl_3	$\text{Al}(\text{H}_2\text{O})_6^{3+} + \text{H}_2\text{O} \rightleftharpoons \text{Al}(\text{H}_2\text{O})_5\text{OH}^{2+} + \text{H}_3\text{O}^+$	
Basic			
Cation of strong base	KNO_2 , NaClO ,	Anion:	>7.0
Anion of weak acid	Na_2CO_3	$\text{NO}_2^- + \text{H}_2\text{O} \rightleftharpoons \text{HNO}_2 + \text{OH}^-$	
Acidic/Basic			
Cation of weak base or small,	NH_4ClO_2 , NH_4CN ,	Cation <i>and</i> anion:	<7.0 if
highly charged metal cation	$\text{Pb}(\text{CH}_3\text{COO})_2$	$\text{NH}_4^+ + \text{H}_2\text{O} \rightleftharpoons \text{NH}_3 + \text{H}_3\text{O}^+$	$K_{a(\text{cation})} > K_{b(\text{anion})}$
Anion of weak acid		$\text{ClO}_2^- + \text{H}_2\text{O} \rightleftharpoons \text{HClO}_2 + \text{OH}^-$	>7.0 if $K_{b(\text{anion})} > K_{a(\text{cation})}$
Cation of strong base	NaH_2PO_4 , KHCO_3 ,	Anion:	<7.0 if
Anion of polyprotic acid	NaHSO_3	$\text{HSO}_3^- + \text{H}_2\text{O} \rightleftharpoons \text{SO}_3^{2-} + \text{H}_3\text{O}^+$	$K_{a(\text{anion})} > K_{b(\text{anion})}$
		$\text{HSO}_3^- + \text{H}_2\text{O} \rightleftharpoons \text{H}_2\text{SO}_3 + \text{OH}^-$	>7.0 if $K_{b(\text{anion})} > K_{a(\text{anion})}$

SAMPLE PROBLEM 18.14

Predicting the Relative Acidity of a Salt Solution from K_a and K_b of the Ions

Problem Determine whether aqueous solutions of the following salts are acidic, basic, or neutral at 25°C:

(a) zinc formate, $\text{Zn}(\text{HCOO})_2$ (b) potassium hydrogen sulfite, KHSO_3

Plan (a) The formula consists of the small, highly charged, and therefore weakly acidic, Zn^{2+} cation and the weakly basic HCOO^- anion of the weak acid HCOOH . To determine the relative acidity of the solution, we write equations that show the reactions of the ions with water, and then find K_a of Zn^{2+} (in Appendix C) and calculate K_b of HCOO^- (from K_a of HCOOH in Appendix C) to see which ion reacts with water to a greater extent.

(b) K^+ is from the strong base KOH and does not react with water; the anion, HSO_3^- , is the first anion of the weak polyprotic acid H_2SO_3 . We write the reactions of this anion acting as a weak acid and as a weak base in water; we find its K_a (in Appendix C) and calculate its K_b (from the K_a of its conjugate acid, H_2SO_3 , in Appendix C) to determine if the ion is a stronger acid or a stronger base.

Solution (a) Writing the reactions with water:

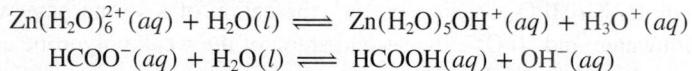

Obtaining K_a and K_b of the ions: From Appendix C, the K_a of $\text{Zn}(\text{H}_2\text{O})_6^{2+}(aq)$ is 1×10^{-9} . We obtain K_a of HCOOH and solve for K_b of HCOO^- :

$$K_b \text{ of } \text{HCOO}^- = \frac{K_w}{K_a \text{ of HCOOH}} = \frac{1.0 \times 10^{-14}}{1.8 \times 10^{-4}} = 5.6 \times 10^{-11}$$

K_a of $\text{Zn}(\text{H}_2\text{O})_6^{2+} > K_b$ of HCOO^- , so the solution is acidic.

(b) Writing the reactions with water:

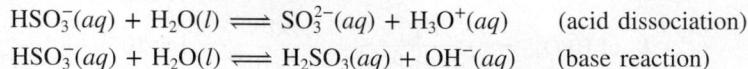

Obtaining K_a and K_b of HSO_3^- : From Appendix C, K_a is 6.5×10^{-8} . We obtain K_a of H_2SO_3 and solve for K_b of HSO_3^- :

$$K_b \text{ of } \text{HSO}_3^- = \frac{K_w}{K_a \text{ of H}_2\text{SO}_3} = \frac{1.0 \times 10^{-14}}{1.4 \times 10^{-2}} = 7.1 \times 10^{-13}$$

$K_a > K_b$, so the solution is acidic.

FOLLOW-UP PROBLEMS

18.14A Determine whether solutions of the following salts are acidic, basic, or neutral at 25°C: (a) $\text{Cu}(\text{CH}_3\text{COO})_2$; (b) NH_4F ; (c) $\text{KHC}_6\text{H}_5\text{O}_6$.

18.14B Determine whether solutions of the following salts are acidic, basic, or neutral at 25°C: (a) NaHCO_3 ; (b) $\text{C}_6\text{H}_5\text{NH}_3\text{NO}_2$; (c) NaH_2PO_4 .

SOME SIMILAR PROBLEMS 18.121(b), 18.121(c), 18.123(c), 18.125(a), 18.125(b), 18.126(a), 18.127(a), and 18.127(b)

› Summary of Section 18.7

- › Salts that yield a neutral solution consist of ions that do not react with water.
- › Salts that yield an acidic solution contain an unreactive anion (from a strong acid) and a cation that releases a proton to water.
- › Salts that yield a basic solution contain an unreactive cation (from a strong base) and an anion that accepts a proton from water.
- › If both cation and anion react with water, the ion that reacts to the greater extent (higher K) determines the acidity or basicity of the salt solution.
- › If the anion is amphiprotic (from a polyprotic acid), the strength of the anion as an acid (K_a) or as a base (K_b) determines the acidity of the salt solution.

18.8 GENERALIZING THE BRØNSTED-LOWRY CONCEPT: THE LEVELING EFFECT

In general, in solution, *an acid yields the cation and a base yields the anion that would be produced by autoionization of the solvent*. For example, in H₂O, all Brønsted-Lowry acids yield H₃O⁺ and all Brønsted-Lowry bases yield OH⁻, which are the ions that form when water autoionizes.

This information lets us examine a key question: Why are all strong acids and strong bases *equally strong* in water? The answer is that *in water, the strongest acid possible is H₃O⁺ and the strongest base possible is OH⁻*:

- *For strong acids.* The moment we put gaseous HCl in water, it reacts with the base H₂O to form H₃O⁺. The same holds for any strong acid because it dissociates *completely* to form H₃O⁺. Thus, we are actually observing the acid strength of H₃O⁺.
- *For strong bases.* A strong base, such as Ba(OH)₂, dissociates completely in water to yield OH⁻. Even strong bases that do not contain hydroxide ions in the solid, such as K₂O, do so. The oxide ion, which is a stronger base than OH⁻, immediately takes a proton from water to form OH⁻:

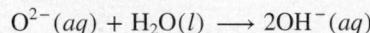

Thus, water exerts a **leveling effect** on any strong acid or base by reacting with it to form the products of water's autoionization. Acting as a base, water levels the strength of all strong acids by making them appear equally strong, and acting as an acid, it levels the strength of all strong bases.

Therefore, to rank the relative strengths of strong acids, we must dissolve them in a solvent that is a *weaker base* than water, so it accepts their protons less readily. For example, the hydrohalic acids increase in strength as the halogen becomes larger, as a result of the longer, weaker H—X bond (see Figure 18.9). But, in water, HF is weak, and HCl, HBr, and HI appear equally strong because they dissociate completely. When we dissolve them in pure acetic acid, however, *the acetic acid acts as the base* and accepts a proton:

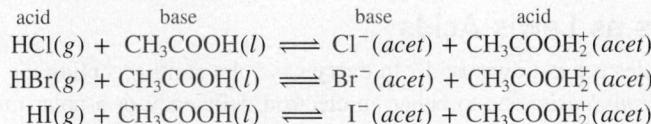

[The use of “(acet)” instead of “(aq)” indicates solvation by CH₃COOH.] Because acetic acid is a *weaker base* than water, the three acids donate their protons to *different extents*. Measurements show that HI protonates the solvent to a greater extent than HBr, and HBr does so more than HCl; that is, in pure acetic acid, $K_{\text{HI}} > K_{\text{HBr}} > K_{\text{HCl}}$. Similarly, the relative strengths of strong bases are determined in a solvent that is a weaker acid than H₂O, such as pure liquid NH₃.

› Summary of Section 18.8

- › Strong acids (or strong bases) dissociate completely to yield H₃O⁺ (or OH⁻) in water; in effect, water equalizes (levels) their strengths.
- › Strong acids show differences in strength when dissolved in a weaker base than water, such as acetic acid.

18.9 ELECTRON-PAIR DONATION AND THE LEWIS ACID-BASE DEFINITION

The final acid-base concept we consider was developed by Gilbert N. Lewis, whose contribution to understanding valence electron pairs in bonding we discussed in Chapter 9. Whereas the Brønsted-Lowry concept focuses on the proton in defining a

species as an acid or a base, the Lewis concept highlights the role of the *electron pair*. The **Lewis acid-base definition** holds that

- A *base* is any species that *donates* an electron pair to form a bond.
- An *acid* is any species that *accepts* an electron pair to form a bond.

The Lewis definition, like the Brønsted-Lowry definition, requires that a base have an electron pair to donate, so it does not expand the classes of bases. However, *it greatly expands the classes of acids*. Many species, such as CO_2 and Cu^{2+} , that do not contain H in their formula (and thus cannot be Brønsted-Lowry acids) are Lewis acids because they accept an electron pair in reactions. In fact, the proton itself is a Lewis acid because it accepts the electron pair donated by a base:

Thus, *all Brønsted-Lowry acids donate H^+ , a Lewis acid*.

The product of a Lewis acid-base reaction is an **adduct**, *a single species that contains a new covalent bond*:

Thus, the Lewis concept radically broadens the idea of an acid-base reaction:

- To Arrhenius, it is the formation of H_2O from H^+ and OH^- .
- To Brønsted and Lowry, it is H^+ transfer from a stronger acid to a stronger base to form a weaker base and weaker acid.
- To Lewis, it is *the donation and acceptance of an electron pair to form a covalent bond in an adduct*.

By definition, then,

- A *Lewis base must have a lone pair of electrons to donate*.
- A *Lewis acid must have a vacant orbital (or the ability to rearrange its bonds to form one) to accept a lone electron pair and form a new bond*.

In this section, we discuss molecules and positive metal ions that act as Lewis acids.

Molecules as Lewis Acids

Many molecules act as Lewis acids. In every case, the atom accepting the electron pair has *low electron density* due to either an electron deficiency or a polar multiple bond.

Lewis Acids with Electron-Deficient Atoms The most important of the *electron-deficient* Lewis acids are compounds of the Group 3A(13) elements boron and aluminum. Recall from Chapters 10 and 14 that these compounds have fewer than eight electrons around the central atom, so they react to complete that atom's octet. For example, boron trifluoride accepts an electron pair from ammonia to form a covalent bond:

Aluminum chloride, a salt, dissolves freely in relatively nonpolar diethyl ether when the ether's O atom donates an electron pair to Al to form a covalent bond:

This acidic behavior of boron and aluminum halides is often used in organic syntheses. For example, a methyl group is added to the benzene ring by the action of CH_3Cl

in the presence of AlCl_3 . The Lewis acid AlCl_3 abstracts the Lewis base Cl^- from CH_3Cl to form an ionic adduct that has a reactive CH_3^+ group, which then attacks the electron-rich benzene ring:

Lewis Acids with Polar Multiple Bonds Molecules with a polar double bond also function as Lewis acids. An electron pair on the Lewis base approaches the partially positive end of the double bond to form the new bond in the adduct, as the π bond breaks. For example, consider the reaction of SO_2 in water. The electronegative O atoms in SO_2 make the central S partially positive. The O atom of water donates a lone pair to the S, thus forming an S—O bond and breaking one of the π bonds. Then, a proton is transferred from water to the O that was part of the π bond. The resulting adduct is sulfuric acid:

The analogous formation of a carbonate from a metal oxide and carbon dioxide occurs in a nonaqueous system. The O^{2-} ion (shown coming from CaO) donates an electron pair to the partially positive C in CO_2 , a π bond breaks, and the CO_3^{2-} ion (shown as part of CaCO_3) is the adduct:

Metal Cations as Lewis Acids

In the Lewis sense, hydration of a metal ion is itself an acid-base reaction. When electron pairs on the O atoms of H_2O molecules form covalent bonds, the hydrated cation is the adduct; thus, *a metal ion acts as a Lewis acid when it dissolves in water*:

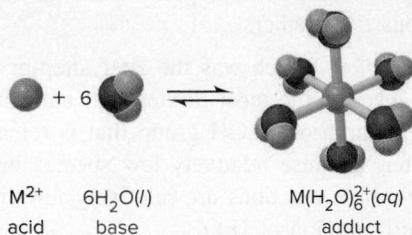

Ammonia is a stronger Lewis base than water because, when it is added to the aqueous solution of the hydrated cation, it displaces H_2O , with $K \gg 1$:

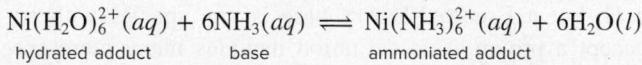

We discuss the equilibrium nature of these acid-base reactions in greater detail in Chapter 19, and we investigate the structures of these ions in Chapter 23.

Many biomolecules with central metal ions are Lewis adducts. Most often, O and N atoms of organic groups donate their lone pairs as the Lewis bases. Chlorophyll is a Lewis adduct of a central Mg^{2+} and the four N atoms of a tetrapyrrole (porphyrin) ring system (Figure 18.13). Vitamin B_{12} has a similar structure with a central Co^{3+} , and so does heme with a central Fe^{2+} . Several other metal ions, such as Zn^{2+} , Mo^{2+} , and Cu^{2+} , are bound at the active sites of enzymes and function as Lewis acids in the catalytic process (see the Chemical Connections at the end of Section 23.4).

Figure 18.13 The Mg^{2+} ion as a Lewis acid in chlorophyll.

SAMPLE PROBLEM 18.15

Identifying Lewis Acids and Bases

Problem Identify the Lewis acids and Lewis bases in the following reactions:

Plan We examine the formulas to see which species accepts the electron pair (Lewis acid) and which donates it (Lewis base) in forming the adduct. The Lewis base must have a lone pair of electrons.

Solution (a) The H^+ ion accepts an electron pair from the OH^- ion in forming a bond. H^+ is the Lewis acid and OH^- is the Lewis base.

(b) The Cl^- ion has four lone pairs and uses one to form a new bond to the central B. BCl_3 is the Lewis acid and Cl^- is the Lewis base.

(c) The K^+ ion does not have any valence electrons to provide, so the bond is formed when electron pairs from O atoms of water enter empty orbitals on K^+ . K^+ is the Lewis acid and H_2O is the Lewis base.

Check The Lewis acids (H^+ , BCl_3 , and K^+) each have an unfilled valence shell that can accept an electron pair from the Lewis base (OH^- , Cl^- , or H_2O).

FOLLOW-UP PROBLEMS

18.15A Identify the Lewis acids and Lewis bases:

18.15B Identify the Lewis acids and Lewis bases:

SOME SIMILAR PROBLEMS 18.142 and 18.143

An Overview of Acid-Base Definitions

From a broader chemical perspective, the diversity of acid-base reactions takes on more unity. Chemists see a common theme in reactions as diverse as a standardized base being used to analyze an unknown fatty acid, baking soda being used in bread-making, and even oxygen binding to hemoglobin in a blood cell. Let's see how the three acid-base definitions fit together.

1. The *Arrhenius definition*, which was the first attempt at describing acids and bases on the molecular level, is the most limited and narrow of the three. It applies only to species with an H atom or an OH group that is released as an ion when the species dissolves in water. Because relatively few species have these structural prerequisites, Arrhenius acid-base reactions are relatively few in number, and all occur in H_2O and result in the formation of H_2O .

2. The *Brønsted-Lowry definition* sees acid-base reactions as proton-transfer processes that need not occur in water. A Brønsted-Lowry acid, like an Arrhenius acid, must have an H, but a Brønsted-Lowry base is any species with an electron pair available to accept a proton. This definition includes many more species as bases, including OH^- . It defines the acid-base reaction in terms of conjugate acid-base pairs, with an acid and a base on both sides of the reaction. The system reaches equilibrium based on the relative strengths of the acid, the base, and their conjugates.

3. The *Lewis definition* has the widest scope and includes the other two. The defining event of a Lewis acid-base reaction is the donation and acceptance of an electron pair to form a new covalent bond in an adduct. Lewis bases still must have an electron pair to donate, but Lewis acids—the electron-pair acceptors—include many species not encompassed by the other definitions, including molecules with electron-deficient atoms or with polar double bonds, metal ions, and even H^+ itself.

› Summary of Section 18.9

- › The Lewis acid-base definition focuses on the donation or acceptance of an electron pair to form a new covalent bond in an adduct, the product of an acid-base reaction. Lewis bases donate the electron pair, and Lewis acids accept it.
- › Thus, many species that do not contain H are Lewis acids. Molecules with polar double bonds act as Lewis acids, as do those with electron-deficient atoms.
- › Metal ions act as Lewis acids when they dissolve in water, which acts as a Lewis base, to form a hydrated cation as the adduct.
- › Many metal ions function as Lewis acids in biomolecules.

CHAPTER REVIEW GUIDE

Learning Objectives

Relevant section (§) and/or sample problem (SP) numbers appear in parentheses.

Understand These Concepts

1. Why the proton is bonded to a water molecule, as H_3O^+ , in all aqueous acid-base systems (§18.1)
2. The Arrhenius definitions of an acid and a base (§18.1)
3. Why all reactions of a strong acid and a strong base have the same $\Delta H^\circ_{\text{rxn}}$ (§18.1)
4. How the strength of an acid (or base) relates to the extent of its dissociation into ions in water (§18.1)
5. How relative acid strength is expressed by the acid-dissociation constant K_a (§18.1)
6. How the autoionization of water is expressed by K_w (§18.2)
7. Why $[\text{H}_3\text{O}^+]$ is inversely related to $[\text{OH}^-]$ in any aqueous solution (§18.2)
8. How the relative magnitudes of $[\text{H}_3\text{O}^+]$ and $[\text{OH}^-]$ define whether a solution is acidic, basic, or neutral (§18.2)
9. The Brønsted-Lowry definitions of an acid and a base and how an acid-base reaction can be viewed as a proton-transfer process (§18.3)
10. How water acts as a base (or as an acid) when an acid (or a base) dissolves in it (§18.3)
11. How a conjugate acid-base pair differs by one proton (§18.3)
12. How a Brønsted-Lowry acid-base reaction involves two conjugate acid-base pairs (§18.3)
13. Why a stronger acid and base react ($K_c > 1$) to form a weaker base and acid (§18.3)
14. How the percent dissociation of a weak acid increases as its concentration decreases (§18.4)
15. How a polyprotic acid dissociates in two or more steps and why only the first step supplies significant $[\text{H}_3\text{O}^+]$ (§18.4)
16. The effects of electronegativity, bond polarity, and bond strength on acid strength (§18.5)
17. Why aqueous solutions of small, highly charged metal ions are acidic (§18.5)
18. How weak bases in water accept a proton rather than dissociate; the meaning of K_b and pK_b (§18.6)
19. How ammonia, amines, and weak-acid anions act as weak bases in water (§18.6)
20. Why relative concentrations of HA and A^- determine the acidity or basicity of their solutions (§18.6)

21. The relationship of the K_a and K_b of a conjugate acid-base pair to K_w (§18.6)
22. The various combinations of cations and anions that lead to acidic, basic, or neutral salt solutions (§18.7)
23. Why the strengths of strong acids are leveled in water but differ in a less basic solvent (§18.8)
24. The Lewis definitions of an acid and a base and how a Lewis acid-base reaction involves the donation and acceptance of an electron pair to form a covalent bond (§18.9)
25. How molecules with electron-deficient atoms, molecules with polar multiple bonds, and metal cations act as Lewis acids (§18.9)

Master These Skills

1. Classifying strong and weak acids and bases from their formulas (SP 18.1)
2. Using K_w to calculate $[\text{H}_3\text{O}^+]$ or $[\text{OH}^-]$ in an aqueous solution (SP 18.2)
3. Using p-scales to express $[\text{H}_3\text{O}^+]$, $[\text{OH}^-]$, and K (§18.2)
4. Calculating $[\text{H}_3\text{O}^+]$, pH, $[\text{OH}^-]$, and pOH (SP 18.3)
5. Identifying conjugate acid-base pairs (SP 18.4)
6. Using relative acid strengths to predict the net direction of an acid-base reaction (SPs 18.5, 18.6)
7. Calculating K_a of a weak acid from pH (SP 18.7)
8. Calculating $[\text{H}_3\text{O}^+]$ (and, thus, pH) from K_a and $[\text{HA}]_{\text{init}}$ (SP 18.8)
9. Applying the quadratic equation to find a concentration (Follow-Up Problem 18.8A)
10. Calculating the percent dissociation of a weak acid (§18.4 and SP 18.9)
11. Calculating $[\text{H}_3\text{O}^+]$ and other concentrations for a polyprotic acid (SP 18.10)
12. Predicting relative acid strengths of nonmetal hydrides and oxoacids (§18.5)
13. Calculating pH from K_b and $[\text{B}]_{\text{init}}$ (SP 18.11)
14. Finding K_b of A^- from K_a of HA and K_w (§18.6 and SP 18.12)
15. Calculating pH from K_b of A^- and $[\text{A}^-]_{\text{init}}$ (SP 18.12)
16. Predicting the relative acidity of a salt solution from the nature of the cation and anion (SPs 18.13, 18.14)
17. Identifying Lewis acids and bases (SP 18.15)

Key Terms

Page numbers appear in parentheses.

acid-base indicator (803)
 acid-dissociation (acid-ionization) constant (K_a) (796)
 adduct (828)
 Arrhenius acid-base definition (794)

autoionization (798)
 base-dissociation (base-ionization) constant (K_b) (818)
 Brønsted-Lowry acid-base definition (803)
 conjugate acid-base pair (804)

hydronium ion, H_3O^+ (794)
 ion-product constant for water (K_w) (799)
 leveling effect (827)
 Lewis acid-base definition (828)

neutralization (794)
 pH (800)
 polyprotic acid (813)
 proton acceptor (803)
 proton donor (803)

Key Equations and Relationships

Page numbers appear in parentheses.

18.1 Defining the acid-dissociation constant (796):

$$K_a = \frac{[\text{H}_3\text{O}^+][\text{A}^-]}{[\text{HA}]}$$

18.2 Defining the ion-product constant for water (799):

$$K_w = [\text{H}_3\text{O}^+][\text{OH}^-] = 1.0 \times 10^{-14} \text{ (at } 25^\circ\text{C)}$$

18.3 Defining pH (800):

$$\text{pH} = -\log [\text{H}_3\text{O}^+]$$

18.4 Relating pK_w to pH and pOH (801):

$$pK_w = \text{pH} + \text{pOH} = 14.00 \text{ (at } 25^\circ\text{C)}$$

18.5 Finding the percent dissociation of HA (812):

$$\text{Percent HA dissociated} = \frac{[\text{HA}]_{\text{dissoc}}}{[\text{HA}]_{\text{init}}} \times 100$$

18.6 Defining the base-dissociation constant (818):

$$K_b = \frac{[\text{BH}^+][\text{OH}^-]}{[\text{B}]}$$

18.7 Expressing the relationship among K_a , K_b , and K_w (821):

$$K_a \times K_b = K_w$$

BRIEF SOLUTIONS TO FOLLOW-UP PROBLEMS**18.1A** (a) HClO_3 ; number of O atoms exceeds number of H atoms by two.(b) HCl ; one of the strong hydrohalic acids.(c) NaOH ; one of the Group 1A(1) hydroxides.**18.1B** (a) Weak base; this is an amine with a lone electron pair on the N.

(b) Strong acid; one of the strong hydrohalic acids.

(c) Weak acid; number of O atoms equals the number of H atoms.

$$K_a = \frac{[\text{H}_3\text{O}^+][\text{BrO}^-]}{[\text{HBrO}]}$$

(d) Strong base; Group 2A(2) metal hydroxide with Ca as the metal.

$$18.2A \quad [\text{H}_3\text{O}^+] = \frac{K_w}{[\text{OH}^-]} = \frac{1.0 \times 10^{-14}}{6.7 \times 10^{-2}} = 1.5 \times 10^{-13} M; \text{ basic}$$

$$18.2B \quad [\text{OH}^-] = \frac{K_w}{[\text{H}_3\text{O}^+]} = \frac{1.0 \times 10^{-14}}{1.8 \times 10^{-10}} = 5.6 \times 10^{-5} M; \text{ basic}$$

$$18.3A \quad \text{pH} = 14.00 - \text{pOH} = 14.00 - 4.48 = 9.52$$

$$[\text{OH}^-] = 10^{-\text{pOH}} = 10^{-4.48} = 3.3 \times 10^{-5} M$$

$$[\text{H}_3\text{O}^+] = \frac{K_w}{[\text{OH}^-]} = \frac{1.0 \times 10^{-14}}{3.3 \times 10^{-5}} = 3.0 \times 10^{-10} M$$

$$18.3B \quad \text{pOH} = 14.00 - \text{pH} = 14.00 - 2.28 = 11.72$$

$$[\text{H}_3\text{O}^+] = 10^{-\text{pH}} = 10^{-2.28} = 5.2 \times 10^{-3} M$$

$$[\text{OH}^-] = \frac{K_w}{[\text{H}_3\text{O}^+]} = \frac{1.0 \times 10^{-14}}{5.2 \times 10^{-3}} = 1.9 \times 10^{-12} M$$

18.4A (a) $\text{CH}_3\text{COOH}/\text{CH}_3\text{COO}^-$ and $\text{H}_3\text{O}^+/\text{H}_2\text{O}$ (b) $\text{H}_2\text{O}/\text{OH}^-$ and HF/F^- **18.4B** (a) H_2SO_3 (b) $\text{C}_5\text{H}_5\text{N}$ (c) HCO_3^- (d) CN^- **18.5A** (a) $\text{H}_2\text{SO}_3(aq) + \text{CO}_3^{2-}(aq) \rightleftharpoons \text{HSO}_3^-(aq) + \text{HCO}_3^-(aq)$
 stronger acid + stronger base → weaker base + weaker acid(b) $\text{HCN}(aq) + \text{F}^-(aq) \rightleftharpoons \text{CN}^-(aq) + \text{HF}(aq)$
 weaker acid + weaker base ← stronger base + stronger acid**18.5B** (a) $\text{NH}_3(g) + \text{H}_2\text{O}(l) \rightleftharpoons \text{NH}_4^+(aq) + \text{OH}^-(aq)$ (b) $\text{NH}_3(g) + \text{H}_3\text{O}^+(aq; \text{from HCl}) \longrightarrow \text{NH}_4^+(aq) + \text{H}_2\text{O}(l)$ (c) $\text{NH}_4^+(aq) + \text{OH}^-(aq; \text{from NaOH}) \longrightarrow \text{NH}_3(g) + \text{H}_2\text{O}(l)$ **18.6A** There are more HB molecules than HA, so $K_c > 1$ and HA is the stronger acid.**18.6B** Since HD is the stronger acid, there should be more D^- particles than C^- particles: thus, D^- is black (5 particles) and C^- is green (3 particles). $K_c < 1$ for $\text{HC}(aq) + \text{D}^-(aq) \rightleftharpoons \text{HD}(aq) + \text{C}^-(aq)$ **18.7A** $\text{NH}_4^+(aq) + \text{H}_2\text{O}(l) \rightleftharpoons \text{NH}_3(aq) + \text{H}_3\text{O}^+(aq)$

$$[\text{H}_3\text{O}^+] = 10^{-\text{pH}} = 10^{-5.0} = 1 \times 10^{-5} M = [\text{NH}_3]$$

And, $[\text{NH}_4^+] = 0.2 M - (1 \times 10^{-5} M) \approx 0.2 M$

$$K_a = \frac{[\text{H}_3\text{O}^+][\text{NH}_3]}{[\text{NH}_4^+]} \approx \frac{(1 \times 10^{-5})^2}{0.2} = 5 \times 10^{-10}$$

18.7B $\text{CH}_2\text{CHCOOH}(aq) + \text{H}_2\text{O}(l) \rightleftharpoons \text{CH}_2\text{CHCOO}^-(aq) + \text{H}_3\text{O}^+(aq)$

$$[\text{H}_3\text{O}^+] = 10^{-\text{pH}} = 10^{-2.43} = 0.0037 M = [\text{CH}_2\text{CHCOO}^-]$$

$$K_a = \frac{[\text{H}_3\text{O}^+][\text{CH}_2\text{CHCOO}^-]}{[\text{CH}_2\text{CHCOOH}]} \approx \frac{(0.0037)^2}{0.30} = 4.6 \times 10^{-5}$$

18.8A $\frac{[\text{HOCl}]_{\text{init}}}{K_a} = \frac{0.10}{3.5 \times 10^{-4}} = 286 < 400$

You must solve a quadratic equation:

$$K_a = \frac{[\text{H}_3\text{O}^+][\text{OCN}^-]}{[\text{HOCl}]} = 3.5 \times 10^{-4} = \frac{(x)(x)}{0.10 - x}$$

$$x^2 + (3.5 \times 10^{-4})x - (3.5 \times 10^{-5}) = 0$$

$$x = [\text{H}_3\text{O}^+] = 5.7 \times 10^{-3} M$$

$$\text{pH} = -\log (5.7 \times 10^{-3}) = 2.24$$

$$\mathbf{18.8B} K_a = 10^{-pK_a} = 10^{-4.20} = 6.3 \times 10^{-5}$$

$$\frac{[C_6H_5COOH]_{init}}{K_a} = \frac{0.25}{6.3 \times 10^{-5}} = 3968 > 400$$

You may assume that $0.25 - x = 0.25 M$:

$$K_a = \frac{[H_3O^+][C_6H_5COO^-]}{[C_6H_5COOH]} = 6.3 \times 10^{-5} = \frac{(x)(x)}{0.25 - x} \approx \frac{x^2}{0.25}$$

$$x = [H_3O^+] = 4.0 \times 10^{-3} M$$

$$pH = -\log[H_3O^+] = -\log[4.0 \times 10^{-3}] = 2.40$$

$$\mathbf{18.9A} \frac{[HCN]_{init}}{K_a} = \frac{0.75}{6.2 \times 10^{-10}} = 1.2 \times 10^9 > 400$$

You may assume that $0.75 - x = 0.75 M$:

$$K_a = \frac{[H_3O^+][CN^-]}{[HCN]} = 6.2 \times 10^{-10} = \frac{(x)(x)}{0.75 - x} \approx \frac{x^2}{0.75}$$

$$x = 2.2 \times 10^{-5} M = [HCN]_{dissoc}$$

$$\text{Percent dissociation} = \frac{[HCN]_{dissoc}}{[HCN]_{init}} \times 100 = \frac{2.2 \times 10^{-5}}{0.75} \times 100 = 0.0029\%$$

$$\mathbf{18.9B} 3.16\% = \frac{[HA]_{dissoc}}{[HA]_{init}} \times 100 = \frac{x}{1.5} \times 100$$

$$x = 0.047 M = [HA]_{dissoc} = [H_3O^+] = [A^-]$$

$$K_a = \frac{[H_3O^+][A^-]}{[HA]} = \frac{(0.047)(0.047)}{1.5 - 0.047} = 1.5 \times 10^{-3}$$

$$\mathbf{18.10A} \frac{[H_2C_2O_4]_{init}}{K_{a1}} = \frac{0.150}{5.6 \times 10^{-2}} = 2.7 < 400$$

You must solve a quadratic equation:

$$K_{a1} = \frac{[H_3O^+][HC_2O_4^-]}{[H_2C_2O_4]} = 5.6 \times 10^{-2} = \frac{(x)(x)}{0.150 - x}$$

$$x^2 + (5.6 \times 10^{-2})x - (8.4 \times 10^{-3}) = 0$$

$$x = [H_3O^+] = 0.068 M; pH = -\log(0.068) = 1.17$$

$$x = [HC_2O_4^-] = 0.068 M; [H_2C_2O_4] = 0.150 M - x = 0.082 M$$

$$K_{a2} = \frac{[H_3O^+][C_2O_4^{2-}]}{[HC_2O_4^-]}$$

$$[C_2O_4^{2-}] = \frac{K_{a2}[HC_2O_4^-]}{[H_3O^+]} = \frac{(5.4 \times 10^{-5})(0.068)}{0.068} = 5.4 \times 10^{-5} M$$

$$\mathbf{18.10B} \frac{[H_2CO_3]_{init}}{K_{a1}} = \frac{0.075}{4.5 \times 10^{-7}} = 1.7 \times 10^5 > 400$$

You may assume that $0.075 - x = 0.075 M$:

$$K_{a1} = \frac{[H_3O^+][HCO_3^-]}{[H_2CO_3]} = 4.5 \times 10^{-7} = \frac{(x)(x)}{0.075 - x} \approx \frac{x^2}{0.075}$$

$$x = [H_3O^+] = 1.8 \times 10^{-4} M; pH = 3.74$$

$$x = [HCO_3^-] = 1.8 \times 10^{-4} M; [H_2CO_3] = 0.075 M - x = 0.075 M$$

$$K_{a2} = \frac{[H_3O^+][CO_3^{2-}]}{[HCO_3^-]}$$

$$[CO_3^{2-}] = \frac{K_{a2}[HCO_3^-]}{[H_3O^+]} = \frac{(4.7 \times 10^{-11})(1.8 \times 10^{-4})}{1.8 \times 10^{-4}} = 4.7 \times 10^{-11} M$$

$$\mathbf{18.11A} K_b = 10^{-pK_b} = 10^{-8.77} = 1.7 \times 10^{-9}$$

$$\frac{[C_5H_5N]_{init}}{K_b} = \frac{0.10}{1.7 \times 10^{-9}} = 5.9 \times 10^7 > 400$$

You may assume that $0.10 - x = 0.10 M$:

$$K_b = \frac{[C_5H_5NH^+][OH^-]}{[C_5H_5N]} = 1.7 \times 10^{-9} = \frac{(x)(x)}{0.10 - x} \approx \frac{x^2}{0.10}$$

$$x = [OH^-] = 1.3 \times 10^{-5} M;$$

$$[H_3O^+] = \frac{K_w}{[OH^-]} = \frac{1.0 \times 10^{-14}}{1.3 \times 10^{-5}} = 7.7 \times 10^{-10} M$$

$$pH = -\log[H_3O^+] = -\log(7.7 \times 10^{-10}) = 9.11$$

$$\mathbf{18.11B} \frac{[C_6H_5CH_2CH(CH_3)NH_2]_{init}}{K_b} = \frac{0.075}{6.3 \times 10^{-5}} = 1200 > 400$$

You may assume that $0.075 - x = 0.075 M$:

$$K_b = \frac{[C_6H_5CH_2CH(CH_3)NH_3^+][OH^-]}{[C_6H_5CH_2CH(CH_3)NH_2]} = 6.3 \times 10^{-5}$$

$$= \frac{(x)(x)}{0.075 - x} \approx \frac{x^2}{0.075}$$

$$x = [OH^-] = 2.2 \times 10^{-3} M;$$

$$[H_3O^+] = \frac{K_w}{[OH^-]} = \frac{1.0 \times 10^{-14}}{2.2 \times 10^{-3}} = 4.5 \times 10^{-12} M$$

$$pH = -\log[H_3O^+] = -\log(4.5 \times 10^{-12}) = 11.35$$

$$\mathbf{18.12A} K_b \text{ of } ClO^- = \frac{K_w}{K_a \text{ of HClO}} = \frac{1.0 \times 10^{-14}}{2.9 \times 10^{-8}} = 3.4 \times 10^{-7}$$

Assuming $0.20 M - x \approx 0.20 M$,

$$K_b = \frac{[HClO][OH^-]}{[ClO^-]} = 3.4 \times 10^{-7} = \frac{(x)(x)}{0.20 - x} \approx \frac{x^2}{0.20}$$

$$x = [OH^-] = 2.6 \times 10^{-4} M; [H_3O^+] = 3.8 \times 10^{-11} M; pH = 10.42$$

$$\mathbf{18.12B} K_b \text{ of } NO_2^- = \frac{K_w}{K_a \text{ of HNO}_2} = \frac{1.0 \times 10^{-14}}{7.1 \times 10^{-4}} = 1.4 \times 10^{-11}$$

Assuming $0.80 M - x \approx 0.80 M$,

$$K_b = \frac{[HNO_2][OH^-]}{[NO_2^-]} = 1.4 \times 10^{-11} = \frac{(x)(x)}{0.80 - x} \approx \frac{x^2}{0.80}$$

$$x = [OH^-] = 3.3 \times 10^{-6} M; [H_3O^+] = 3.0 \times 10^{-9} M; pH = 8.52$$

18.13A (a) Basic: K^+ is from the strong base KOH, so it does not react with water; ClO_2^- is the anion of the weak acid $HClO_2$ and reacts with water to produce OH^- :

(b) Acidic: NO_3^- is from the strong acid HNO_3 , so it does not react with water; $CH_3NH_3^+$ is the cation of the weak base CH_3NH_2 and reacts with water to produce H_3O^+ :

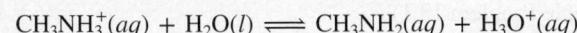

(c) Neutral: Rb^+ is from the strong base RbOH; Br^- is from the strong acid HBr. Neither ion reacts with water.

18.13B (a) Acidic: Br^- is from the strong acid HBr, so it does not react with water; the small, highly charged Fe^{3+} ion forms $Fe(H_2O)_6^{3+}$, which reacts with water to produce H_3O^+ :

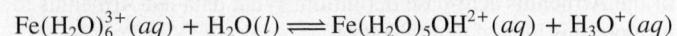

(b) Basic: Ca^{2+} is from the strong base $Ca(OH)_2$, so it does not react with water; NO_2^- is the anion of the weak acid HNO_2 and reacts with water to produce OH^- :

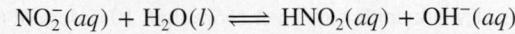

(c) Acidic: I^- is from the strong acid HI, so it does not react with water; $C_6H_5NH_3^+$ is the cation of the weak base $C_6H_5NH_2$ and reacts with water to produce H_3O^+ :

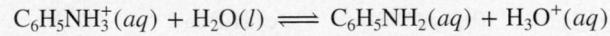

18.14A (a) From Appendix C, K_a of $Cu(H_2O)_6^{2+} = 3 \times 10^{-8}$

$$K_b \text{ of } CH_3COO^- = \frac{K_w}{K_a \text{ of } CH_3COOH} = \frac{1.0 \times 10^{-14}}{1.8 \times 10^{-5}} = 5.6 \times 10^{-10}$$

Since $K_a > K_b$, $Cu(CH_3COO)_2(aq)$ is acidic.

$$(b) K_a \text{ of } NH_4^+ = \frac{K_w}{K_b \text{ of } NH_3} = \frac{1.0 \times 10^{-14}}{1.76 \times 10^{-5}} = 5.7 \times 10^{-10}$$

$$K_b \text{ of } F^- = \frac{K_w}{K_a \text{ of HF}} = \frac{1.0 \times 10^{-14}}{6.8 \times 10^{-4}} = 1.5 \times 10^{-11}$$

Because $K_a > K_b$, $NH_4F(aq)$ is acidic.

BRIEF SOLUTIONS TO FOLLOW-UP PROBLEMS

(continued)

(c) From Appendix C, K_a of $\text{HC}_6\text{H}_6\text{O}_6^- = 5 \times 10^{-12}$

$$K_b \text{ of } \text{HC}_6\text{H}_6\text{O}_6^- = \frac{K_w}{K_a \text{ of } \text{HC}_6\text{H}_6\text{O}_6} = \frac{1.0 \times 10^{-14}}{5 \times 10^{-12}} = 1.0 \times 10^{-2}$$

Because $K_b > K_a$, $\text{KHC}_6\text{H}_6\text{O}_6(aq)$ is basic.**18.14B** (a) From Appendix C, K_a of $\text{HCO}_3^- = 4.7 \times 10^{-11}$

$$K_b \text{ of } \text{HCO}_3^- = \frac{K_w}{K_a \text{ of } \text{H}_2\text{CO}_3} = \frac{1.0 \times 10^{-14}}{4.7 \times 10^{-11}} = 2.2 \times 10^{-4}$$

Because $K_b > K_a$, $\text{NaHCO}_3(aq)$ is basic.

$$(b) K_a \text{ of } \text{C}_6\text{H}_5\text{NH}_3^+ = \frac{K_w}{K_b \text{ of } \text{C}_6\text{H}_5\text{NH}_2} = \frac{1.0 \times 10^{-14}}{4.0 \times 10^{-10}} = 2.5 \times 10^{-5}$$

$$K_b \text{ of } \text{NO}_2^- = \frac{K_w}{K_a \text{ of } \text{HNO}_2} = \frac{1.0 \times 10^{-14}}{7.1 \times 10^{-4}} = 1.4 \times 10^{-11}$$

Because $K_a > K_b$, $\text{C}_6\text{H}_5\text{NH}_3\text{NO}_2(aq)$ is acidic.(c) From Appendix C, K_a of $\text{H}_2\text{PO}_4^- = 6.3 \times 10^{-8}$

$$K_b \text{ of } \text{H}_2\text{PO}_4^- = \frac{K_w}{K_a \text{ of } \text{H}_3\text{PO}_4} = \frac{1.0 \times 10^{-14}}{6.3 \times 10^{-8}} = 1.4 \times 10^{-7}$$

Because $K_a > K_b$, $\text{NaH}_2\text{PO}_4(aq)$ is acidic.**18.15A** (a) OH^- is the Lewis base; $\text{Al}(\text{OH})_3$ is the Lewis acid.(b) H_2O is the Lewis base; SO_3^- is the Lewis acid.(c) NH_3 is the Lewis base; Co^{3+} is the Lewis acid.**18.15B** (a) H_2O is the Lewis base; $\text{B}(\text{OH})_3$ is the Lewis acid.(b) I^- is the Lewis base; Cd^{2+} is the Lewis acid.(c) F^- is the Lewis base; SiF_4 is the Lewis acid.**PROBLEMS**

Problems with **colored** numbers are answered in Appendix E and worked in detail in the Student Solutions Manual. Problem sections match those in the text and give the numbers of relevant sample problems. Most offer Concept Review Questions, Skill-Building Exercises (grouped in pairs covering the same concept), and Problems in Context. The Comprehensive Problems are based on material from any section or previous chapter.

Note: Unless stated otherwise, all problems refer to aqueous solutions at 298 K (25°C).

Acids and Bases in Water

(Sample Problem 18.1)

Concept Review Questions**18.1** What is the role of water in the Arrhenius acid-base definition?**18.2** What do Arrhenius acids have in common? What do Arrhenius bases have in common? Explain neutralization in terms of the Arrhenius acid-base definition. What data led Arrhenius to propose this idea of neutralization?**18.3** Why is the Arrhenius acid-base definition too limited? Give an example for which the Arrhenius definition does not apply.**18.4** What do “strong” and “weak” mean for acids and bases? The K_a values of weak acids vary over more than 10 orders of magnitude. What do the acids have in common that makes them “weak”?**Skill-Building Exercises (grouped in similar pairs)****18.5** Which of the following are Arrhenius acids?

- (a)
- H_2O
- (b)
- $\text{Ca}(\text{OH})_2$
- (c)
- H_3PO_4
- (d)
- HI

18.6 Which of the following are Arrhenius acids?

- (a)
- NaHSO_4
- (b)
- CH_4
- (c)
- NaH
- (d)
- H_3N

18.7 Which of the following are Arrhenius bases?

- (a)
- H_3AsO_4
- (b)
- $\text{Ba}(\text{OH})_2$
- (c)
- HClO
- (d)
- KOH

18.8 Which of the following are Arrhenius bases?

- (a)
- CH_3COOH
- (b)
- HOH
- (c)
- CH_3OH
- (d)
- H_2NNH_2

18.9 Write the K_a expression for each of the following in water:

- (a)
- HCN
- (b)
- HCO_3^-
- (c)
- HCOOH

18.10 Write the K_a expression for each of the following in water:

- (a)
- CH_3NH_3^+
- (b)
- HClO
- (c)
- H_2S

18.11 Write the K_a expression for each of the following in water:

- (a)
- HNO_2
- (b)
- CH_3COOH
- (c)
- HBrO_2

18.12 Write the K_a expression for each of the following in water:

- (a)
- H_2PO_4^-
- (b)
- H_3PO_2
- (c)
- HSO_4^-

18.13 Use Appendix C to rank the following in order of *increasing* acid strength: HIO_3 , HI , CH_3COOH , HF .**18.14** Use Appendix C to rank the following in order of *decreasing* acid strength: HClO , HCl , HCN , HNO_2 .**18.15** Classify each as a strong or weak acid or base:

- (a)
- H_3AsO_4
- (b)
- $\text{Sr}(\text{OH})_2$
- (c)
- HIO
- (d)
- HClO_4

18.16 Classify each as a strong or weak acid or base:

- (a)
- CH_3NH_2
- (b)
- K_2O
- (c)
- HI
- (d)
- HCOOH

18.17 Classify each as a strong or weak acid or base:

- (a)
- RbOH
- (b)
- HBr
- (c)
- H_2Te
- (d)
- HClO

18.18 Classify each as a strong or weak acid or base:

- (a)
- $\text{HOCH}_2\text{CH}_2\text{NH}_2$
- (b)
- H_2SeO_4
- (c)
- HS^-
- (d)
- $\text{B}(\text{OH})_3$

Autoionization of Water and the pH Scale

(Sample Problems 18.2 and 18.3)

Concept Review Questions**18.19** What is an autoionization reaction? Write equations for the autoionization reactions of H_2O and of H_2SO_4 .**18.20** What is the difference between K_c and K_w for the autoionization of water?**18.21** (a) What is the change in pH when $[\text{OH}^-]$ increases by a factor of 10? (b) What is the change in $[\text{H}_3\text{O}^+]$ when the pH decreases by 3 units?

18.22 Which solution has the higher pH? Explain.

- A 0.1 M solution of an acid with $K_a = 1 \times 10^{-4}$ or one with $K_a = 4 \times 10^{-5}$
- A 0.1 M solution of an acid with $pK_a = 3.0$ or one with $pK_a = 3.5$
- A 0.1 M solution or a 0.01 M solution of a weak acid
- A 0.1 M solution of a weak acid or a 0.1 M solution of a strong acid
- A 0.1 M solution of an acid or a 0.01 M solution of a base
- A solution of pOH 6.0 or one of pOH 8.0

Skill-Building Exercises (grouped in similar pairs)

18.23 (a) What is the pH of 0.0111 M NaOH? Is the solution neutral, acidic, or basic? (b) What is the pOH of 1.35×10^{-3} M HCl? Is the solution neutral, acidic, or basic?

18.24 (a) What is the pH of 0.0333 M HNO₃? Is the solution neutral, acidic, or basic? (b) What is the pOH of 0.0347 M KOH? Is the solution neutral, acidic, or basic?

18.25 (a) What is the pH of 6.14×10^{-3} M HI? Is the solution neutral, acidic, or basic? (b) What is the pOH of 2.55 M Ba(OH)₂? Is the solution neutral, acidic, or basic?

18.26 (a) What is the pH of 7.52×10^{-4} M CsOH? Is the solution neutral, acidic, or basic? (b) What is the pOH of 1.59×10^{-3} M HClO₄? Is the solution neutral, acidic, or basic?

18.27 (a) What are $[H_3O^+]$, $[OH^-]$, and pOH in a solution with a pH of 9.85? (b) What are $[H_3O^+]$, $[OH^-]$, and pH in a solution with a pOH of 9.43?

18.28 (a) What are $[H_3O^+]$, $[OH^-]$, and pOH in a solution with a pH of 3.47? (b) What are $[H_3O^+]$, $[OH^-]$, and pH in a solution with a pOH of 4.33?

18.29 (a) What are $[H_3O^+]$, $[OH^-]$, and pOH in a solution with a pH of 4.77? (b) What are $[H_3O^+]$, $[OH^-]$, and pH in a solution with a pOH of 5.65?

18.30 (a) What are $[H_3O^+]$, $[OH^-]$, and pOH in a solution with a pH of 8.97? (b) What are $[H_3O^+]$, $[OH^-]$, and pH in a solution with a pOH of 11.27?

18.31 How many moles of H₃O⁺ or OH⁻ must you add to a liter of strong acid solution to adjust its pH from 3.15 to 3.65? Assume a negligible volume change.

18.32 How many moles of H₃O⁺ or OH⁻ must you add to a liter of strong base solution to adjust its pH from 9.33 to 9.07? Assume a negligible volume change.

18.33 How many moles of H₃O⁺ or OH⁻ must you add to 5.6 L of strong acid solution to adjust its pH from 4.52 to 5.25? Assume a negligible volume change.

18.34 How many moles of H₃O⁺ or OH⁻ must you add to 87.5 mL of strong base solution to adjust its pH from 8.92 to 8.45? Assume a negligible volume change.

Problems in Context

18.35 The two molecular scenes shown depict the relative concentrations of H₃O⁺ (*purple*) in solutions of the same volume (with counter ions and solvent molecules omitted for clarity). If the pH in scene A is 4.8, what is the pH in scene B?

18.36 Like any equilibrium constant, K_w changes with temperature. (a) Given that autoionization is endothermic, how does K_w change with rising T ? Explain with a reaction that includes heat as reactant or product. (b) In many medical applications, the value of K_w at 37°C (body temperature) may be more appropriate than the value at 25°C, 1.0×10^{-14} . The pH of pure water at 37°C is 6.80. Calculate K_w , pOH, and $[OH^-]$ at this temperature.

Proton Transfer and the Brønsted-Lowry Acid-Base Definition (Sample Problems 18.4 to 18.6)

Concept Review Questions

18.37 How are the Arrhenius and Brønsted-Lowry acid-base definitions different? How are they similar? Name two Brønsted-Lowry bases that are not Arrhenius bases. Can you do the same for acids? Explain.

18.38 What is a conjugate acid-base pair? What is the relationship between the two members of the pair?

18.39 (a) A Brønsted-Lowry acid-base reaction proceeds in the net direction in which a stronger acid and stronger base form a weaker acid and weaker base. Explain.
(b) The molecular scene at right depicts an aqueous solution of two conjugate acid-base pairs: HA/A⁻ and HB/B⁻. The base in the first pair is represented by red spheres, and the base in the second pair by green spheres; solvent molecules are omitted for clarity. Which is the stronger acid? The stronger base? Explain.

18.40 What is an amphiprotic species? Name one and write balanced equations that show why it is amphiprotic.

Skill-Building Exercises (grouped in similar pairs)

18.41 Write balanced equations and K_a expressions for these Brønsted-Lowry acids in water:

- H₃PO₄
- C₆H₅COOH
- HSO₄⁻

18.42 Write balanced equations and K_a expressions for these Brønsted-Lowry acids in water:

- HCOOH
- HClO₃
- H₂AsO₄⁻

18.43 Give the formula of the conjugate base:

- HCl
- H₂CO₃
- H₂O

18.44 Give the formula of the conjugate base:

- HPO₄²⁻
- NH₄⁺
- HS⁻

18.45 Give the formula of the conjugate acid:

- NH₃
- NH₂⁻
- nicotine, C₁₀H₁₄N₂

18.46 Give the formula of the conjugate acid:

- O²⁻
- SO₄²⁻
- H₂O

18.47 In each equation, label the acids, bases, and conjugate pairs:

- $\text{HCl} + \text{H}_2\text{O} \rightleftharpoons \text{Cl}^- + \text{H}_3\text{O}^+$
- $\text{HClO}_4 + \text{H}_2\text{SO}_4 \rightleftharpoons \text{ClO}_4^- + \text{H}_3\text{SO}_4^+$
- $\text{HPO}_4^{2-} + \text{H}_2\text{SO}_4 \rightleftharpoons \text{H}_2\text{PO}_4^- + \text{HSO}_4^-$

18.48 In each equation, label the acids, bases, and conjugate pairs:

- $\text{NH}_3 + \text{HNO}_3 \rightleftharpoons \text{NH}_4^+ + \text{NO}_3^-$
- $\text{O}^{2-} + \text{H}_2\text{O} \rightleftharpoons \text{OH}^- + \text{OH}^-$
- $\text{NH}_4^+ + \text{BrO}_3^- \rightleftharpoons \text{NH}_3 + \text{HBrO}_3$

18.49 In each equation, label the acids, bases, and conjugate pairs:

- $\text{NH}_3 + \text{H}_3\text{PO}_4 \rightleftharpoons \text{NH}_4^+ + \text{H}_2\text{PO}_4^-$
- $\text{CH}_3\text{O}^- + \text{NH}_3 \rightleftharpoons \text{CH}_3\text{OH} + \text{NH}_2^-$
- $\text{HPO}_4^{2-} + \text{HSO}_4^- \rightleftharpoons \text{H}_2\text{PO}_4^- + \text{SO}_4^{2-}$

18.50 In each equation, label the acids, bases, and conjugate pairs:

- $\text{NH}_4^+ + \text{CN}^- \rightleftharpoons \text{NH}_3 + \text{HCN}$
- $\text{H}_2\text{O} + \text{HS}^- \rightleftharpoons \text{OH}^- + \text{H}_2\text{S}$
- $\text{HSO}_3^- + \text{CH}_3\text{NH}_2 \rightleftharpoons \text{SO}_3^{2-} + \text{CH}_3\text{NH}_3^+$

18.51 Write balanced net ionic equations for the following reactions, and label the conjugate acid-base pairs:

- $\text{NaOH}(aq) + \text{NaH}_2\text{PO}_4(aq) \rightleftharpoons \text{H}_2\text{O}(l) + \text{Na}_2\text{HPO}_4(aq)$
- $\text{KHSO}_4(aq) + \text{K}_2\text{CO}_3(aq) \rightleftharpoons \text{K}_2\text{SO}_4(aq) + \text{KHCO}_3(aq)$

18.52 Write balanced net ionic equations for the following reactions, and label the conjugate acid-base pairs:

- $\text{HNO}_3(aq) + \text{Li}_2\text{CO}_3(aq) \rightleftharpoons \text{LiNO}_3(aq) + \text{LiHCO}_3(aq)$
- $2\text{NH}_4\text{Cl}(aq) + \text{Ba}(\text{OH})_2(aq) \rightleftharpoons 2\text{H}_2\text{O}(l) + \text{BaCl}_2(aq) + 2\text{NH}_3(aq)$

18.53 The following aqueous species constitute two conjugate acid-base pairs. Use them to write one acid-base reaction with $K_c > 1$ and another with $K_c < 1$: HS^- , Cl^- , HCl , H_2S .

18.54 The following aqueous species constitute two conjugate acid-base pairs. Use them to write one acid-base reaction with $K_c > 1$ and another with $K_c < 1$: NO_3^- , F^- , HF , HNO_3 .

18.55 Use Figure 18.8 to determine whether $K_c > 1$ for

- $\text{HCl} + \text{NH}_3 \rightleftharpoons \text{NH}_4^+ + \text{Cl}^-$
- $\text{H}_2\text{SO}_3 + \text{NH}_3 \rightleftharpoons \text{HSO}_3^- + \text{NH}_4^+$

18.56 Use Figure 18.8 to determine whether $K_c > 1$ for

- $\text{OH}^- + \text{HS}^- \rightleftharpoons \text{H}_2\text{O} + \text{S}^{2-}$
- $\text{HCN} + \text{HCO}_3^- \rightleftharpoons \text{H}_2\text{CO}_3 + \text{CN}^-$

18.57 Use Figure 18.8 to determine whether $K_c < 1$ for

- $\text{NH}_4^+ + \text{HPO}_4^{2-} \rightleftharpoons \text{NH}_3 + \text{H}_2\text{PO}_4^-$
- $\text{HSO}_3^- + \text{HS}^- \rightleftharpoons \text{H}_2\text{SO}_3 + \text{S}^{2-}$

18.58 Use Figure 18.8 to determine whether $K_c < 1$ for

- $\text{H}_2\text{PO}_4^- + \text{F}^- \rightleftharpoons \text{HPO}_4^{2-} + \text{HF}$
- $\text{CH}_3\text{COO}^- + \text{HSO}_4^- \rightleftharpoons \text{CH}_3\text{COOH} + \text{SO}_4^{2-}$

Solving Problems Involving Weak-Acid Equilibria

(Sample Problems 18.7 to 18.10)

Concept Review Questions

18.59 In each of the following cases, is the concentration of acid before and after dissociation nearly the same or very different? Explain your reasoning: (a) a concentrated solution of a strong acid; (b) a concentrated solution of a weak acid; (c) a dilute solution of a weak acid; (d) a dilute solution of a strong acid.

18.60 A sample of 0.0001 M HCl has $[\text{H}_3\text{O}^+]$ close to that of a sample of 0.1 M CH_3COOH . Are acetic acid and hydrochloric acid equally strong in these samples? Explain.

18.61 A 0.15 M solution of HA (*blue and green*) is 33% dissociated. Which of the scenes below represents a sample of that solution after it is diluted with water? (An actual weak acid does not have a percent dissociation this high.)

18.62 In which of the following solutions will $[\text{H}_3\text{O}^+]$ be approximately equal to $[\text{CH}_3\text{COO}^-]$: (a) 0.1 M CH_3COOH ; (b) $1 \times 10^{-7}\text{ M}$ CH_3COOH ; (c) a solution containing both 0.1 M CH_3COOH and 0.1 M CH_3COONa ? Explain.

18.63 Why do successive K_a 's decrease for all polyprotic acids?

Skill-Building Exercises (grouped in similar pairs)

18.64 A 0.15 M solution of butanoic acid, $\text{CH}_3\text{CH}_2\text{CH}_2\text{COOH}$, contains $1.51 \times 10^{-3}\text{ M}$ H_3O^+ . What is the K_a of butanoic acid?

18.65 A 0.035 M solution of a weak acid (HA) has a pH of 4.88. What is the K_a of the acid?

18.66 Nitrous acid, HNO_2 , has a K_a of 7.1×10^{-4} . What are $[\text{H}_3\text{O}^+]$, $[\text{NO}_2^-]$, and $[\text{OH}^-]$ in 0.60 M HNO_2 ?

18.67 Hydrofluoric acid, HF, has a K_a of 6.8×10^{-4} . What are $[\text{H}_3\text{O}^+]$, $[\text{F}^-]$, and $[\text{OH}^-]$ in 0.75 M HF?

18.68 Chloroacetic acid, ClCH_2COOH , has a pK_a of 2.87. What are $[\text{H}_3\text{O}^+]$, pH, $[\text{ClCH}_2\text{COO}^-]$, and $[\text{ClCH}_2\text{COOH}]$ in 1.25 M ClCH_2COOH ?

18.69 Hypochlorous acid, HClO , has a pK_a of 7.54. What are $[\text{H}_3\text{O}^+]$, pH, $[\text{ClO}^-]$, and $[\text{HClO}]$ in 0.115 M HClO ?

18.70 In a 0.20 M solution, a weak acid is 3.0% dissociated.

- Calculate the $[\text{H}_3\text{O}^+]$, pH, $[\text{OH}^-]$, and pOH of the solution.
- Calculate K_a of the acid.

18.71 In a 0.735 M solution, a weak acid is 12.5% dissociated.

- Calculate the $[\text{H}_3\text{O}^+]$, pH, $[\text{OH}^-]$, and pOH of the solution.
- Calculate K_a of the acid.

18.72 A 0.250-mol sample of HX is dissolved in enough H_2O to form 655 mL of solution. If the pH of the solution is 3.54, what is the K_a of HX?

18.73 A 4.85×10^{-3} -mol sample of HY is dissolved in enough H_2O to form 0.095 L of solution. If the pH of the solution is 2.68, what is the K_a of HY?

18.74 The weak acid HZ has a K_a of 2.55×10^{-4} .

- Calculate the pH of 0.075 M HZ.
- Calculate the pOH of 0.045 M HZ.

18.75 The weak acid HQ has a pK_a of 4.89.

- Calculate the $[\text{H}_3\text{O}^+]$ of $3.5 \times 10^{-2}\text{ M}$ HQ.
- Calculate the $[\text{OH}^-]$ of 0.65 M HQ.

18.76 (a) Calculate the pH of 0.175 M HY, if $K_a = 1.50 \times 10^{-4}$.

- Calculate the pOH of 0.175 M HX, if $K_a = 2.00 \times 10^{-2}$.

18.77 (a) Calculate the pH of 0.55 M HCN, if $K_a = 6.2 \times 10^{-10}$.

- Calculate the pOH of 0.044 M HIO_3 , if $K_a = 0.16$.

18.78 Use Appendix C to calculate the percent dissociation of 0.55 M benzoic acid, C_6H_5COOH .

18.79 Use Appendix C to calculate the percent dissociation of 0.050 M CH_3COOH .

18.80 Use Appendix C to calculate $[H_2S]$, $[HS^-]$, $[S^{2-}]$, $[H_3O^+]$, pH, $[OH^-]$, and pOH in a 0.10 M solution of the diprotic acid hydrosulfuric acid.

18.81 Use Appendix C to calculate $[H_2C_3H_2O_4]$, $[HC_3H_2O_4^-]$, $[C_3H_2O_4^{2-}]$, $[H_3O^+]$, pH, $[OH^-]$, and pOH in a 0.200 M solution of the diprotic acid malonic acid.

Problems in Context

18.82 Acetylsalicylic acid (aspirin), $HC_9H_7O_4$, is the most widely used pain reliever and fever reducer. Find the pH of 0.018 M aqueous aspirin at body temperature (K_a at $37^\circ C = 3.6 \times 10^{-4}$).

18.83 Formic acid, $HCOOH$, the simplest carboxylic acid, is used in the textile and rubber industries and is secreted as a defense by many species of ants (family *Formicidae*). Calculate the percent dissociation of 0.75 M $HCOOH$.

Molecular Properties and Acid Strength

Concept Review Questions

18.84 Across a period, how does the electronegativity of a nonmetal affect the acidity of its binary hydride?

18.85 How does the atomic size of a nonmetal affect the acidity of its binary hydride?

18.86 A strong acid has a weak bond to its acidic proton, whereas a weak acid has a strong bond to its acidic proton. Explain.

18.87 Perchloric acid, $HClO_4$, is the strongest of the halogen oxoacids, and hypoiodous acid, HIO , is the weakest. What two factors govern this difference in acid strength?

Skill-Building Exercises (grouped in similar pairs)

18.88 Choose the *stronger* acid in each of the following pairs:

- (a) H_2SeO_3 or H_2SeO_4 (b) H_3PO_4 or H_3AsO_4 (c) H_2S or H_2Te

18.89 Choose the *weaker* acid in each of the following pairs:

- (a) HBr or H_2Se (b) $HClO_4$ or H_2SO_4 (c) H_2SO_3 or H_2SO_4

18.90 Choose the *stronger* acid in each of the following pairs:

- (a) H_2Se or H_3As (b) $B(OH)_3$ or $Al(OH)_3$ (c) $HBrO_2$ or $HBrO$

18.91 Choose the *weaker* acid in each of the following pairs:

- (a) HI or HBr (b) H_3AsO_4 or H_2SeO_4 (c) HNO_3 or HNO_2

18.92 Use Appendix C to choose the solution with the *lower* pH:

- (a) 0.5 M $CuBr_2$ or 0.5 M $AlBr_3$
(b) 0.3 M $ZnCl_2$ or 0.3 M $SnCl_2$

18.93 Use Appendix C to choose the solution with the *lower* pH:

- (a) 0.1 M $FeCl_3$ or 0.1 M $AlCl_3$
(b) 0.1 M $BeCl_2$ or 0.1 M $CaCl_2$

18.94 Use Appendix C to choose the solution with the *higher* pH:

- (a) 0.2 M $Ni(NO_3)_2$ or 0.2 M $Co(NO_3)_2$
(b) 0.35 M $Al(NO_3)_3$ or 0.35 M $Cr(NO_3)_3$

18.95 Use Appendix C to choose the solution with the *higher* pH:

- (a) 0.1 M $NiCl_2$ or 0.1 M $NaCl$
(b) 0.1 M $Sn(NO_3)_2$ or 0.1 M $Co(NO_3)_2$

Weak Bases and Their Relation to Weak Acids

(Sample Problems 18.11 and 18.12)

Concept Review Questions

18.96 What is the key structural feature of all Brønsted-Lowry bases? How does this feature function in an acid-base reaction?

18.97 Why are most anions basic in H_2O ? Give formulas of four anions that are not basic.

18.98 Except for the Na^+ spectator ion, aqueous solutions of CH_3COOH and CH_3COONa contain the same species. (a) What are the species (other than H_2O)? (b) Why is 0.1 M CH_3COOH acidic and 0.1 M CH_3COONa basic?

Skill-Building Exercises (grouped in similar pairs)

18.99 Write balanced equations and K_b expressions for these Brønsted-Lowry bases in water:

- (a) Pyridine, C_5H_5N (b) CO_3^{2-}

18.100 Write balanced equations and K_b expressions for these Brønsted-Lowry bases in water:

- (a) Benzoate ion, $C_6H_5COO^-$ (b) $(CH_3)_3N$

18.101 Write balanced equations and K_b expressions for these Brønsted-Lowry bases in water:

- (a) Hydroxylamine, $HO-NH_2$ (b) HPO_4^{2-}

18.102 Write balanced equations and K_b expressions for these Brønsted-Lowry bases in water:

- (a) Guanidine, $(H_2N)_2C=NH$ (the double-bonded N is more basic)
(b) Acetylide ion, $HC\equiv C^-$

18.103 What is the pH of 0.070 M dimethylamine?

18.104 What is the pH of 0.12 M diethylamine?

18.105 What is the pH of 0.25 M ethanolamine?

18.106 What is the pH of 0.26 M aniline?

18.107 (a) What is the K_b of the acetate ion?

(b) What is the K_a of the anilinium ion, $C_6H_5NH_3^+$?

18.108 (a) What is the K_b of the benzoate ion, $C_6H_5COO^-$?

(b) What is the K_a of the 2-hydroxyethylammonium ion, $HOCH_2CH_2NH_3^+$ (pK_b of $HOCH_2CH_2NH_2 = 4.49$)?

18.109 (a) What is the pK_b of ClO_4^- ?

(b) What is the pK_a of the dimethylammonium ion, $(CH_3)_2NH_3^+$?

18.110 (a) What is the pK_b of NO_2^- ?

(b) What is the pK_a of the hydrazinium ion, $H_2N-NH_3^+$ (K_b of hydrazine = 8.5×10^{-7})?

18.111 (a) What is the pH of 0.150 M KCN ?

(b) What is the pH of 0.40 M triethylammonium chloride, $(CH_3CH_2)_3NHCl$?

18.112 (a) What is the pH of 0.100 M sodium phenolate, C_6H_5ONa , the sodium salt of phenol?

(b) What is the pH of 0.15 M methylammonium bromide, CH_3NH_3Br (K_b of $CH_3NH_2 = 4.4 \times 10^{-4}$)?

18.113 (a) What is the pH of 0.65 M potassium formate, $HCOOK$?

(b) What is the pH of 0.85 M NH_4Br ?

18.114 (a) What is the pH of 0.75 M NaF ?

(b) What is the pH of 0.88 M pyridinium chloride, C_5H_5NHCl ?

Problems in Context

18.115 Sodium hypochlorite solution, sold as chlorine bleach, is potentially dangerous because of the basicity of ClO^- , the active bleaching ingredient. What is $[\text{OH}^-]$ in an aqueous solution that is 6.5% NaClO by mass? What is the pH of the solution? (Assume that d of the solution is 1.0 g/mL.)

18.116 Codeine ($\text{C}_{18}\text{H}_{21}\text{NO}_3$) is a narcotic pain reliever that forms a salt with HCl. What is the pH of 0.050 M codeine hydrochloride ($\text{p}K_b$ of codeine = 5.80)?

Acid-Base Properties of Salt Solutions

(Sample Problems 18.13 and 18.14)

Concept Review Questions

18.117 What determines whether an aqueous solution of a salt will be acidic, basic, or neutral? Give an example of each type of salt.

18.118 Why is aqueous NaF basic but aqueous NaCl neutral?

18.119 The NH_4^+ ion forms acidic solutions, and the CH_3COO^- ion forms basic solutions. However, a solution of ammonium acetate is almost neutral. Do all of the ammonium salts of weak acids form neutral solutions? Explain your answer.

Skill-Building Exercises (grouped in similar pairs)

18.120 Explain with equations and calculations, when necessary, whether an aqueous solution of each of these salts is acidic, basic, or neutral: (a) KBr; (b) NH_4I ; (c) KCN.

18.121 Explain with equations and calculations, when necessary, whether an aqueous solution of each of these salts is acidic, basic, or neutral: (a) SnCl_2 ; (b) NaHS ; (c) $\text{Zn}(\text{CH}_3\text{COO})_2$.

18.122 Explain with equations and calculations, when necessary, whether an aqueous solution of each of these salts is acidic, basic, or neutral: (a) Na_2CO_3 ; (b) CaCl_2 ; (c) $\text{Cu}(\text{NO}_3)_2$.

18.123 Explain with equations and calculations, when necessary, whether an aqueous solution of each of these salts is acidic, basic, or neutral: (a) $\text{CH}_3\text{NH}_3\text{Cl}$; (b) LiClO_4 ; (c) CoF_2 .

18.124 Explain with equations and calculations, when necessary, whether an aqueous solution of each of these salts is acidic, basic, or neutral: (a) SrBr_2 ; (b) $\text{Ba}(\text{CH}_3\text{COO})_2$; (c) $(\text{CH}_3)_2\text{NH}_2\text{Br}$.

18.125 Explain with equations and calculations, when necessary, whether an aqueous solution of each of these salts is acidic, basic, or neutral: (a) $\text{Fe}(\text{HCOO})_3$; (b) KHCO_3 ; (c) K_2S .

18.126 Explain with equations and calculations, when necessary, whether an aqueous solution of each of these salts is acidic, basic, or neutral: (a) $(\text{NH}_4)_3\text{PO}_4$; (b) Na_2SO_4 ; (c) LiClO_4 .

18.127 Explain with equations and calculations, when necessary, whether an aqueous solution of each of these salts is acidic, basic, or neutral: (a) $\text{Pb}(\text{CH}_3\text{COO})_2$; (b) $\text{Cr}(\text{NO}_2)_3$; (c) CsI .

18.128 Rank the following salts in order of *increasing* pH of their 0.1 M aqueous solutions:

- KNO_3 , K_2SO_3 , K_2S , $\text{Fe}(\text{NO}_3)_2$
- NH_4NO_3 , NaHSO_4 , NaHCO_3 , Na_2CO_3

18.129 Rank the following salts in order of *decreasing* pH of their 0.1 M aqueous solutions:

- FeCl_2 , FeCl_3 , MgCl_2 , KClO_2
- NH_4Br , NaBrO_2 , NaBr , NaClO_2

Generalizing the Brønsted-Lowry Concept: The Leveling Effect

Concept Review Questions

18.130 Methoxide ion, CH_3O^- , and amide ion, NH_2^- , are very strong bases that are “leveled” by water. What does this mean? Write the reactions that occur in the leveling process. What species do the two leveled solutions have in common?

18.131 Explain the differing extents of dissociation of H_2SO_4 in CH_3COOH , H_2O , and NH_3 .

18.132 In H_2O , HF is weak and the other hydrohalic acids are equally strong. In NH_3 , however, all the hydrohalic acids are equally strong. Explain.

Electron-Pair Donation and the Lewis Acid-Base Definition

(Sample Problem 18.15)

Concept Review Questions

18.133 What feature must a molecule or ion have in order to act as a Lewis base? A Lewis acid? Explain the roles of these features.

18.134 How do Lewis acids differ from Brønsted-Lowry acids? How are they similar? Do Lewis bases differ from Brønsted-Lowry bases? Explain.

18.135 (a) Is a weak Brønsted-Lowry base necessarily a weak Lewis base? Explain with an example.

(b) Identify the Lewis bases in the following reaction:

(c) Given that $K_c > 1$ for the reaction in part (b), which Lewis base is stronger?

18.136 In which of the three acid-base concepts can water be a product of an acid-base reaction? In which is it the only product?

18.137 (a) Give an example of a *substance* that is a base in two of the three acid-base definitions, but not in the third.

(b) Give an example of a *substance* that is an acid in one of the three acid-base definitions, but not in the other two.

Skill-Building Exercises (grouped in similar pairs)

18.138 Which are Lewis acids and which are Lewis bases?

- Cu^{2+}
- Cl^-
- SnCl_2
- OF_2

18.139 Which are Lewis acids and which are Lewis bases?

- Na^+
- NH_3
- CN^-
- BF_3

18.140 Which are Lewis acids and which are Lewis bases?

- BF_3
- S^{2-}
- SO_3^{2-}
- SO_3

18.141 Which are Lewis acids and which are Lewis bases?

- Mg^{2+}
- OH^-
- SiF_4
- BeCl_2

18.142 Identify the Lewis acid and Lewis base in each reaction:

18.143 Identify the Lewis acid and Lewis base in each reaction:

18.144 Classify the following as Arrhenius, Brønsted-Lowry, or Lewis acid-base reactions. A reaction may fit all, two, one, or none of the categories:

18.145 Classify the following as Arrhenius, Brønsted-Lowry, or Lewis acid-base reactions. A reaction may fit all, two, one, or none of the categories:

- (a) $\text{Cu}^{2+} + 4\text{Cl}^- \rightleftharpoons \text{CuCl}_4^{2-}$
 (b) $\text{Al}(\text{OH})_3 + 3\text{HNO}_3 \rightleftharpoons \text{Al}^{3+} + 3\text{H}_2\text{O} + 3\text{NO}_3^-$
 (c) $\text{N}_2 + 3\text{H}_2 \rightleftharpoons 2\text{NH}_3$
 (d) $\text{CN}^- + \text{H}_2\text{O} \rightleftharpoons \text{HCN} + \text{OH}^-$

Comprehensive Problems

18.146 Chloral ($\text{Cl}_3\text{C}-\text{CH}=\text{O}$) forms a monohydrate, chloral hydrate, the sleep-inducing depressant called “knockout drops” in old movies. (a) Write two possible structures for chloral hydrate, one involving hydrogen bonding and one that is a Lewis adduct. (b) What spectroscopic method could be used to identify the real structure? Explain.

18.147 In humans, blood pH is maintained within a narrow range. *acidosis* occurs if the blood pH is below 7.35, and *alkalosis* occurs if the pH is above 7.45. Given that the pK_w of blood is 13.63 at 37°C (body temperature), what is the normal range of $[H_3O^+]$ and of $[OH^-]$ in blood?

18.148 The disinfectant phenol, C_6H_5OH , has a pK_a of 10.0 in water, but 14.4 in methanol.

- (a) Why are the values different?
 - (b) Is methanol a stronger or weaker base than water?
 - (c) Write the dissociation reaction of phenol in methanol.
 - (d) Write an expression for the autoionization constant of methanol.

18.149 When carbon dioxide dissolves in water, it undergoes a multistep equilibrium process, with $K_{\text{overall}} = 4.5 \times 10^{-7}$, which is simplified to the following:

- (a) Classify each step as a Lewis or a Brønsted-Lowry reaction.

(b) What is the pH of nonpolluted rainwater in equilibrium with clean air (P_{CO_2} in clean air = 4×10^{-4} atm; Henry's law constant for CO_2 at $25^\circ C$ is 0.033 mol/L·atm)?

(c) What is $[CO_3^{2-}]$ in rainwater (K_a of HCO_3^- = 4.7×10^{-11})?

(d) If the partial pressure of CO_2 in clean air doubles in the next few decades, what will the pH of rainwater become?

18.150 Seashells are mostly calcium carbonate, which reacts with H_3O^+ according to the equation

If K_w increases at higher pressure, will seashells dissolve more rapidly near the surface of the ocean or at great depths? Explain.

18.151 Many molecules with central atoms from Period 3 or higher take part in Lewis acid-base reactions in which the central atom expands its valence shell. SnCl_4 reacts with $(\text{CH}_3)_3\text{N}$ as follows:

- (a) Identify the Lewis acid and the Lewis base in the reaction.
(b) Give the *nl* designation of the sublevel of the central atom in the acid before it accepts the lone pair.

18.152 A chemist makes four successive ten-fold dilutions of $1.0 \times 10^{-5} M$ HCl. Calculate the pH of the original solution and of each diluted solution (through $1.0 \times 10^{-9} M$ HCl).

18.153 Chlorobenzene, C_6H_5Cl , is a key intermediate in the manufacture of dyes and pesticides. It is made by the chlorination of benzene, catalyzed by $FeCl_3$, in this series of steps:

- (1) $\text{Cl}_2 + \text{FeCl}_3 \rightleftharpoons \text{FeCl}_5$ (or $\text{Cl}^+ \text{FeCl}_4^-$)
 - (2) $\text{C}_6\text{H}_6 + \text{Cl}^+ \text{FeCl}_4^- \rightleftharpoons \text{C}_6\text{H}_5\text{Cl}^+ + \text{FeCl}_4^-$
 - (3) $\text{C}_6\text{H}_5\text{Cl}^+ \rightleftharpoons \text{C}_6\text{H}_5\text{Cl} + \text{H}^+$
 - (4) $\text{H}^+ + \text{FeCl}_4^- \rightleftharpoons \text{HCl} + \text{FeCl}_3$

- (a) Which of the step(s) is (are) Lewis acid-base reactions?
 (b) Identify the Lewis acids and bases in each of those steps

18.154 The beakers shown below contain 0.300 L of aqueous solutions of a moderately weak acid HY. Each particle represents 0.010 mol; solvent molecules are omitted for clarity. (a) The reaction in beaker A is at equilibrium. Calculate Q for the reactions in beakers B, C, and D to determine which, if any, is also at equilibrium. (b) For any not at equilibrium, in which direction does the reaction proceed? (c) Does dilution affect the extent of dissociation of a weak acid? Explain.

18.155 The strength of an acid or base is related to its strength as an electrolyte. (a) Is the electrical conductivity of 0.1 M HCl higher, lower, or the same as that of $0.1\text{ M CH}_3\text{COOH}$? Explain. (b) Is the electrical conductivity of $1\times 10^{-7}\text{ M HCl}$ higher, lower, or the same as that of $1\times 10^{-7}\text{ M CH}_3\text{COOH}$? Explain.

18.156 Esters, RCOOR' , are formed by the reaction of carboxylic acids, RCOOH , and alcohols, $\text{R}'\text{OH}$, where R and R' are hydrocarbon groups. Many esters are responsible for the odors of fruit and, thus, have important uses in the food and cosmetics industries. The first two steps in the mechanism of ester formation are

Identify the Lewis acids and Lewis bases in these two steps

18.157 Three beakers contain 100. mL of 0.10 M HCl, HClO_2 , and HClO , respectively. (a) Find the pH of each. (b) Describe quantitatively how to make the pH equal in the beakers through the addition of water only.

18.158 Human urine has a normal pH of 6.2. If a person eliminates an average of 1250. mL of urine per day, how many H⁺ ions are eliminated per week?

18.159 Liquid ammonia autoionizes like water:

where (am) represents solvation by NH_3 .

- Write the ion-product constant expression, K_{am} .
- What are the strongest acid and base that can exist in $\text{NH}_3(l)$?
- HNO_3 and HCOOH are leveled in $\text{NH}_3(l)$. Explain with equations.
- At the boiling point of ammonia (-33°C), $K_{\text{am}} = 5.1 \times 10^{-27}$. Calculate $[\text{NH}_4^+]$ at this temperature.
- Pure sulfuric acid also autoionizes. Write the ion-product constant expression, K_{sulf} , and find the concentration of the conjugate base at 20°C ($K_{\text{sulf}} = 2.7 \times 10^{-4}$ at 20°C).

18.160 Thiamine hydrochloride ($\text{C}_{12}\text{H}_{18}\text{ON}_4\text{SCl}_2$) is a water-soluble form of thiamine (vitamin B₁; $K_a = 3.37 \times 10^{-7}$). How many grams of the hydrochloride must be dissolved in 10.00 mL of water to give a pH of 3.50?

18.161 Tris(hydroxymethyl)aminomethane, known as TRIS or THAM, is a water-soluble base used in synthesizing surfactants and pharmaceuticals, as an emulsifying agent in cosmetics, and in cleaning mixtures for textiles and leather. In biomedical research, solutions of TRIS are used to maintain nearly constant pH for the study of enzymes and other cellular components. Given that the pK_b is 5.91, calculate the pH of 0.075 M TRIS.

18.162 When an Fe^{3+} salt is dissolved in water, the solution becomes acidic due to formation of $\text{Fe}(\text{H}_2\text{O})_5\text{OH}^{2+}$ and H_3O^+ . The overall process involves both Lewis and Brønsted-Lowry acid-base reactions. Write the equations for the process.

18.163 What is the pH of a vinegar with 5.0% (w/v) acetic acid in water?

18.164 The scene below represents a sample of a weak acid HB (blue and purple) dissolved in water. Draw a scene that represents the same volume after the solution has been diluted with water.

18.165 How would you differentiate between a strong and a weak monoprotic acid from the results of the following procedures?
(a) Electrical conductivity of an equimolar solution of each acid is measured.
(b) Equal molarities of each are tested with pH paper.
(c) Zinc metal is added to solutions of equal concentration.

18.166 The catalytic efficiency of an enzyme, called its *activity*, indicates the rate at which it catalyzes the reaction. Most enzymes have optimum activity over a relatively narrow pH range, which is related to the pH of the local cellular fluid. The pH profiles of three digestive enzymes are shown.

Salivary amylase begins digestion of starches in the mouth and has optimum activity at a pH of 6.8; pepsin begins protein digestion in the stomach and has optimum activity at a pH of 2.0; and trypsin, released in pancreatic juices, continues protein digestion in the small intestine and has optimum activity at a pH of 9.5. Calculate $[\text{H}_3\text{O}^+]$ in the local cellular fluid for each enzyme.

18.167 Acetic acid has a K_a of 1.8×10^{-5} , and ammonia has a K_b of 1.8×10^{-5} . Find $[\text{H}_3\text{O}^+]$, $[\text{OH}^-]$, pH, and pOH for (a) 0.240 M acetic acid and (b) 0.240 M ammonia.

18.168 The uses of sodium phosphate include clarifying crude sugar, manufacturing paper, removing boiler scale, and washing concrete. What is the pH of a solution containing 33 g of Na_3PO_4 per liter? What is $[\text{OH}^-]$ of this solution?

18.169 The Group 5A(15) hydrides react with boron trihalides in a reversible Lewis acid-base reaction. When 0.15 mol of $\text{PH}_3\text{BCl}_3(s)$ is introduced into a 3.0-L container at a certain temperature, 8.4×10^{-3} mol of PH_3 is present at equilibrium:

- Find K_c for the reaction at this temperature.
- Draw a Lewis structure for the reactant.

18.170 A 1.000 m solution of chloroacetic acid (ClCH_2COOH) freezes at -1.93°C . Find the K_a of chloroacetic acid. (Assume that the molarities equal the molalities.)

18.171 Sodium stearate ($\text{C}_{17}\text{H}_{35}\text{COONa}$) is a major component of bar soap. The K_a of the stearic acid is 1.3×10^{-5} . What is the pH of 10.0 mL of a solution containing 0.42 g of sodium stearate?

18.172 Calcium propionate [$\text{Ca}(\text{CH}_3\text{CH}_2\text{COO})_2$; calcium propanoate] is a mold inhibitor used in food, tobacco, and pharmaceuticals. (a) Use balanced equations to show whether aqueous calcium propionate is acidic, basic, or neutral. (b) Use Appendix C to find the resulting pH when 8.75 g of $\text{Ca}(\text{CH}_3\text{CH}_2\text{COO})_2$ dissolves in enough water to give 0.500 L of solution.

18.173 A site in Pennsylvania receives a total annual deposition of 2.688 g/m^2 of sulfate from fertilizer and acid rain. The mass ratio of ammonium sulfate/ammonium bisulfate/sulfuric acid is 3.0/5.5/1.0. (a) How much acid, expressed as kilograms (kg) of sulfuric acid, is deposited over an area of $10. \text{ km}^2$? (b) How many pounds of CaCO_3 are needed to neutralize this acid? (c) If $10. \text{ km}^2$ is the area of an unpolluted lake 3 m deep and there is no loss of acid, what pH will the lake water attain by the end of the year? (Assume constant volume.)

18.174 (a) If $K_w = 1.139 \times 10^{-15}$ at 0°C and 5.474×10^{-14} at 50°C , find $[\text{H}_3\text{O}^+]$ and pH of water at 0°C and 50°C .

(b) The autoionization constant for heavy water (deuterium oxide, D_2O) is 3.64×10^{-16} at 0°C and 7.89×10^{-15} at 50°C . Find $[\text{D}_3\text{O}^+]$ and pD of heavy water at 0°C and 50°C .

(c) Suggest a reason for these differences.

18.175 HX ($M = 150. \text{ g/mol}$) and HY ($M = 50.0 \text{ g/mol}$) are weak acids. A solution of 12.0 g/L of HX has the same pH as one containing 6.00 g/L of HY. Which is the stronger acid? Why?

18.176 The beakers on the facing page depict the aqueous dissociations of weak acids HA (blue and green) and HB (blue and yellow); solvent molecules are omitted for clarity. If the HA solution is 0.50 L, and the HB solution is 0.25 L, and each particle represents 0.010 mol, find the K_a of each acid. Which acid, if either, is stronger?

18.177 In his acid-base studies, Arrhenius discovered an important fact involving reactions like the following:

(a) Complete the reactions and use the data for the individual ions in Appendix B to calculate each $\Delta H_{\text{rxn}}^\circ$.

(b) Explain your results and use them to predict $\Delta H_{\text{rxn}}^\circ$ for

18.178 Putrescine [$\text{NH}_2(\text{CH}_2)_4\text{NH}_2$], found in rotting animal tissue, is now known to be in all cells and essential for normal and abnormal (cancerous) growth. It also plays a key role in the formation of GABA, a neurotransmitter. A 0.10 M aqueous solution of putrescine has $[\text{OH}^-] = 2.1 \times 10^{-3}$. What is the K_b ?

18.179 The molecular scene depicts the relative concentrations of H_3O^+ (purple) and OH^- (green) in an aqueous solution at 25°C. (Counter ions and solvent molecules are omitted for clarity.) (a) Calculate the pH. (b) How many H_3O^+ ions would you have to draw for every OH^- ion to depict a solution of pH 4?

18.180 Polymers are not very soluble in water, but their solubility increases if they have charged groups. (a) Casein, a milk protein, contains many $-\text{COO}^-$ groups on its side chains. How does the solubility of casein vary with pH? (b) Histones are proteins essential to the function of DNA. They are weakly basic due to the presence of side chains with $-\text{NH}_2$ and $=\text{NH}$ groups. How does the solubility of a histone vary with pH?

18.181 Hemoglobin (Hb) transports oxygen in the blood:

In blood, $[\text{H}_3\text{O}^+]$ is held nearly constant at 4×10^{-8} M.

(a) How does the equilibrium position change in the lungs?

(b) How does it change in O_2 -deficient cells?

(c) Excessive vomiting may lead to metabolic *alkalosis*, in which $[\text{H}_3\text{O}^+]$ in blood *decreases*. How does this condition affect the ability of Hb to transport O_2 ?

(d) Diabetes mellitus may lead to metabolic *acidosis*, in which $[\text{H}_3\text{O}^+]$ in blood *increases*. How does this condition affect the ability of Hb to transport O_2 ?

18.182 Nitrogen is discharged from wastewater treatment facilities into rivers and streams, usually as NH_3 and NH_4^+ :

One strategy for removing nitrogen is to raise the pH and “strip” the NH_3 from solution by bubbling air through the water. (a) At pH 7.00, what fraction of the total nitrogen in solution is NH_3 , defined as $[\text{NH}_3]/([\text{NH}_3] + [\text{NH}_4^+])$? (b) What is the fraction at pH 10.00? (c) Explain the basis of ammonia stripping.

18.183 A solution of propanoic acid ($\text{CH}_3\text{CH}_2\text{COOH}$), made by dissolving 7.500 g in sufficient water to make 100.0 mL, has a freezing point of -1.890°C .

(a) Calculate the molarity of the solution.

(b) Calculate the molarity of the propanoate ion. (Assume the molarity of the solution equals the molality.)

(c) Calculate the percent dissociation of propanoic acid.

18.184 The antimalarial properties of quinine ($\text{C}_{20}\text{H}_{24}\text{N}_2\text{O}_2$) saved thousands of lives during construction of the Panama Canal. This substance is a classic example of the medicinal wealth that tropical forests hold. Both N atoms are basic, but the N (colored) of the 3° amine group is far more basic ($pK_b = 5.1$) than the N within the aromatic ring system ($pK_b = 9.7$).

(a) A saturated solution of quinine in water is only 1.6×10^{-3} M. What is the pH of this solution?

(b) Show that the aromatic N contributes negligibly to the pH of the solution.

(c) Because of its low solubility, quinine is given as the salt quinine hydrochloride ($\text{C}_{20}\text{H}_{24}\text{N}_2\text{O}_2 \cdot \text{HCl}$), which is 120 times more soluble than quinine. What is the pH of 0.33 M quinine hydrochloride?

(d) An antimalarial concentration in water is 1.5% quinine hydrochloride by mass ($d = 1.0$ g/mL). What is the pH?

18.185 Drinking water is often disinfected with Cl_2 , which hydrolyzes to form HClO , a weak acid but powerful disinfectant:

The fraction of HClO in solution is defined as

$$\frac{[\text{HClO}]}{[\text{HClO}] + [\text{ClO}^-]}$$

(a) What is the fraction of HClO at pH 7.00 (K_a of $\text{HClO} = 2.9 \times 10^{-8}$)?

(b) What is the fraction at pH 10.00?

18.186 The following scenes represent three weak acids HA (where A = X, Y, or Z) dissolved in water (H_2O is not shown):

(a) Rank the acids in order of increasing K_a . (b) Rank the acids in order of increasing pK_a . (c) Rank the conjugate bases in order of increasing pK_b . (d) What is the percent dissociation of HX? (e) If equimolar amounts of the sodium salts of the acids (NaX , NaY , and NaZ) were dissolved in water, which solution would have the highest pOH? The lowest pH?

19

Ionic Equilibria in Aqueous Systems

19.1 Equilibria of Acid-Base Buffers

Common-Ion Effect
Henderson-Hasselbalch Equation
Buffer Capacity and Range
Preparing a Buffer

19.2 Acid-Base Titration Curves

Strong Acid–Strong Base Titrations
Weak Acid–Strong Base Titrations
Weak Base–Strong Acid Titrations

Acid-Base Indicators
Polyprotic Acid Titrations
Amino Acids as Polyprotic Acids

19.3 Equilibria of Slightly Soluble Ionic Compounds

Solubility-Product Constant (K_{sp})
Calculations Involving K_{sp}
Effect of a Common Ion
Effect of pH

Formation of a Limestone Cave
Predicting Precipitate
Formation: Q_{sp} vs. K_{sp}
Selective Precipitation and Simultaneous Equilibria

19.4 Equilibria Involving Complex Ions

Formation of Complex Ions
Complex Ions and Solubility
Amphoteric Hydroxides

Source: © Joe Scherschel/Getty Images

Concepts and Skills to Review Before You Study This Chapter

- › solubility rules for ionic compounds (Section 4.3)
- › equilibrium nature of a saturated solution (Section 13.4)
- › effect of concentration on equilibrium position (Section 17.6)
- › conjugate acid-base pairs (Section 18.3)
- › calculations for weak-acid and weak-base equilibria (Sections 18.4 and 18.6)
- › acid-base properties of salt solutions (Section 18.7)
- › Lewis acids and bases (Section 18.9)

Continuing our exploration of the universal nature of equilibrium, we now examine aqueous ionic systems. Acid-base and carbonate solubility equilibria are responsible for limestone caves and formations such as those found at Mammoth Hot Springs in Yellowstone National Park (*see photo*). Organisms survive by maintaining cellular pH within narrow limits through complex carbonate and phosphate equilibria. In soils, equilibria involving clays control the availability of ionic nutrients for plants. In industrial settings, the principles of equilibrium govern the softening of water and the purification of products by precipitation of unwanted ions. And they even explain how the weak acids in wine and vinegar influence the delicate taste of a fine sauce.

IN THIS CHAPTER . . . We define and quantify three aqueous ionic equilibrium systems—acid-base buffers, slightly soluble salts, and complex ions.

- › We introduce the common-ion effect to explain how buffers work, and see why buffers are important and how to prepare them.
- › We describe several types of acid-base titrations and explore the role buffers play in them.
- › We see that slightly soluble salts have their own equilibrium constant and learn how a common ion and pH influence the solubilities of these compounds.
- › We use concepts of aqueous ionic equilibria to understand how a cave forms.
- › We investigate how complex ions form and change from one type to another.

19.1 EQUILIBRIA OF ACID-BASE BUFFERS

Why do some lakes become acidic when showered by acid rain, while others remain unaffected? How does blood maintain a constant pH in contact with countless cellular acid-base reactions? How can a chemist sustain a nearly constant $[H_3O^+]$ in reactions that consume or produce H_3O^+ or OH^- ? The answer in each case depends on the action of a buffer, and in this section we discuss how buffers work and how to prepare them.

What a Buffer Is and How It Works: The Common-Ion Effect

In everyday language, a *buffer* is something that lessens the impact of an external force. An **acid-base buffer** is a solution that *lessens the impact on its pH of the addition of acid or base*. Add a small amount of H_3O^+ or OH^- to an *unbuffered* solution, and the pH changes by several units; thus, $[H_3O^+]$ changes by *several orders of magnitude* (Figure 19.1).

Figure 19.1 The effect of adding acid or base to an unbuffered solution. **A**, A 100-mL sample of dilute HCl is adjusted to pH 5.00 (left). **B**, Adding 1 mL of strong acid (left) or of strong base (right) changes the pH by several units.

Source: © McGraw-Hill Education/Stephen Frisch, photographer

Figure 19.2 The effect of adding acid or base to a buffered solution. **A**, A 100-mL sample of an acetate buffer, which was made by mixing 1 M CH_3COOH with 1 M CH_3COONa , is adjusted to pH 5.00. **B**, Adding 1 mL of strong acid (left) or of strong base (right) changes the pH negligibly.
Source: © McGraw-Hill Education/Stephen Frisch, photographer

The same addition of strong acid or strong base to a buffered solution causes only a minor change in pH (Figure 19.2). To withstand these additions, a buffer must have an acidic component that reacts with the added OH^- and a basic component that reacts with the added H_3O^+ . However, these components can't be any acid and base because they would neutralize each other.

- Most often, the components of a buffer are a conjugate acid-base pair (weak acid and conjugate base or weak base and conjugate acid).

The buffer in Figure 19.2, for example, is a mixture of acetic acid (CH_3COOH) and acetate ion (CH_3COO^-).

Presence of a Common Ion Buffers work through the **common-ion effect**. When you dissolve acetic acid in water, the acid dissociates slightly:

What happens if you now introduce acetate ion by adding the soluble salt sodium acetate? First, we need to recognize that, as a strong electrolyte, sodium acetate dissociates completely in water:

The sodium ion does not interact with water (Section 18.7) and thus is a spectator ion. From Le Châtelier's principle (Section 17.6), we know that adding CH_3COO^- ion will shift the equilibrium position to the left; thus, $[\text{H}_3\text{O}^+]$ decreases, in effect lowering the extent of acid dissociation:

We get the same result when we add acetic acid to a sodium acetate solution instead of water. The acetate ion already present suppresses the acid from dissociating as much as it does in water, thus keeping the $[\text{H}_3\text{O}^+]$ lower (and pH higher). In either case, the effect is less acid dissociation. Acetate ion is called the **common ion** because it is "common" to both the acetic acid and sodium acetate solutions. *The common-ion effect occurs when a given ion is added to an equilibrium mixture that already contains that ion, and the position of equilibrium shifts away from forming it.*

Table 19.1 shows that the percent dissociation (and the $[\text{H}_3\text{O}^+]$) of an acetic acid solution decreases as the concentration of acetate ion (supplied by dissolving sodium acetate) increases. Thus, the **common ion**, A^- , *suppresses the dissociation of HA*, which makes the solution less acidic (higher pH).

Table 19.1 The Effect of Added Acetate Ion on the Dissociation of Acetic Acid

$[\text{CH}_3\text{COOH}]_{\text{init}}$	$[\text{CH}_3\text{COO}^-]_{\text{added}}$	% Dissociation*	H_3O^+	pH
0.10	0.00	1.3	1.3×10^{-3}	2.89
0.10	0.050	0.036	3.6×10^{-5}	4.44
0.10	0.10	0.018	1.8×10^{-5}	4.74
0.10	0.15	0.012	1.2×10^{-5}	4.92

$$*\% \text{ Dissociation} = \frac{[\text{CH}_3\text{COOH}]_{\text{dissoc}}}{[\text{CH}_3\text{COOH}]_{\text{init}}} \times 100$$

Relative Concentrations of Buffer Components A buffer works because a *large amount of the acidic component (HA) of the buffer consumes small amounts of added OH⁻ and a large amount of the basic component (A⁻) consumes small amounts of added H₃O⁺*. Consider what happens in a solution containing high [CH₃COOH] and high [CH₃COO⁻] when we add small amounts of strong acid or base. The equilibrium expression for HA dissociation is

$$K_a = \frac{[\text{CH}_3\text{COO}^-][\text{H}_3\text{O}^+]}{[\text{CH}_3\text{COOH}]}$$

Solving for [H₃O⁺] gives

$$[\text{H}_3\text{O}^+] = K_a \times \frac{[\text{CH}_3\text{COOH}]}{[\text{CH}_3\text{COO}^-]}$$

Since K_a is constant, the $[\text{H}_3\text{O}^+]$ of the solution depends on the buffer-component concentration ratio, $\frac{[\text{CH}_3\text{COOH}]}{[\text{CH}_3\text{COO}^-]}$:

- If the ratio $[\text{HA}]/[\text{A}^-]$ goes up (more acid and less conjugate base), then $[\text{H}_3\text{O}^+]$ goes up.
- If the ratio $[\text{HA}]/[\text{A}^-]$ goes down (less acid and more conjugate base), then $[\text{H}_3\text{O}^+]$ goes down.

Let's track this ratio as we add strong acid or strong base to a buffer in which $[\text{HA}] = [\text{A}^-]$ (Figure 19.3, *middle*):

1. *Strong acid.* When we add a small amount of strong acid, the H₃O⁺ ions react with an *equal (stoichiometric) amount* of acetate ion, the base component in the buffer, to form more acetic acid:

As a result, [CH₃COO⁻] goes down by that small amount and [CH₃COOH] goes up by that amount, which increases the buffer-component concentration ratio (Figure 19.3, *left*). The [H₃O⁺] increases *very slightly*.

2. *Strong base.* The addition of a small amount of strong base produces the opposite result. The OH⁻ ions react with an *equal (stoichiometric) amount* of CH₃COOH, the acid component in the buffer, to form that much more CH₃COO⁻ (Figure 19.3, *right*):

This time, the buffer-component concentration ratio decreases, which decreases [H₃O⁺] *very slightly*.

Figure 19.3 How a buffer works. The relative concentrations of the buffer components, acetic acid (CH₃COOH, red) and acetate ion (CH₃COO⁻, blue) are indicated by the heights of the bars.

Thus, the buffer components consume *nearly all* the added H_3O^+ or OH^- . To reiterate, as long as the amount of added H_3O^+ or OH^- is small compared with the amounts of the buffer components, *the conversion of one component into the other produces a small change in the buffer-component concentration ratio and, consequently, a small change in $[\text{H}_3\text{O}^+]$ and in pH*. Sample Problem 19.1 demonstrates how small these pH changes typically are. Note that the latter two parts of the problem combine a stoichiometry portion, like the problems in Chapter 4, and a weak-acid dissociation portion, like those in Chapter 18.

SAMPLE PROBLEM 19.1

Calculating the Effect of Added H_3O^+ or OH^- on Buffer pH

Problem Calculate the pH: (a) of a buffer solution consisting of 0.50 M HClO ($K_a = 2.9 \times 10^{-8}$) and 0.60 M NaClO; (b) after adding 0.020 mol of solid NaOH to 1.0 L of the buffer solution in part (a); (c) after adding 30.0 mL of 1.5 M HCl to 0.50 L of the buffer solution in part (a). [In part (b), assume that the addition of NaOH causes negligible volume change.]

Plan For each part, we know, or can find, $[\text{HClO}]_{\text{init}}$ and $[\text{ClO}^-]_{\text{init}}$. We know the K_a of HClO (2.9×10^{-8}) and need to find $[\text{H}_3\text{O}^+]$ at equilibrium and convert it to pH. (a) We use the given concentrations of buffer components (0.50 M HClO and 0.60 M ClO^-) as the initial values. As in earlier problems, we assume that x , the $[\text{HClO}]$ that dissociates, which equals $[\text{H}_3\text{O}^+]$, is so small relative to $[\text{HClO}]_{\text{init}}$ that it can be neglected. We set up a reaction table, solve for x , and check the assumption. (b) and (c) We assume that the added OH^- or H_3O^+ reacts completely with the buffer components to yield new $[\text{HClO}]_{\text{init}}$ and $[\text{ClO}^-]_{\text{init}}$, and then the acid dissociates to an unknown extent. We set up two reaction tables. The first summarizes the stoichiometry of adding strong base or acid. The second summarizes the dissociation of the new $[\text{HClO}]_{\text{init}}$, and we proceed as in part (a) to find the new $[\text{H}_3\text{O}^+]$. Since there is a volume change due to the added HCl in part (c), we must calculate the new initial concentrations of the buffer components.

Solution (a) The original pH: $[\text{H}_3\text{O}^+]$ in the original buffer. Setting up a reaction table with $x = [\text{HClO}]_{\text{dissoc}} = [\text{H}_3\text{O}^+]$ (as in Chapter 18, we assume that $[\text{H}_3\text{O}^+]$ from H_2O is negligible and disregard it):

Concentration (M)	HClO(aq)	+	$\text{H}_2\text{O}(l)$	\rightleftharpoons	$\text{ClO}^-(aq)$	+	$\text{H}_3\text{O}^+(aq)$
Initial	0.50		—		0.60		0
Change	$-x$		—		$+x$		$+x$
Equilibrium	$0.50 - x$		—		$0.60 + x$		x

Making the assumption and finding the equilibrium $[\text{HClO}]$ and $[\text{ClO}^-]$: With K_a small, x is small, so we assume

$$[\text{HClO}] = 0.50 \text{ M} - x \approx 0.50 \text{ M} \quad \text{and} \quad [\text{ClO}^-] = 0.60 \text{ M} + x \approx 0.60 \text{ M}$$

Solving for x ($[\text{H}_3\text{O}^+]$ at equilibrium):

$$x = [\text{H}_3\text{O}^+] = K_a \times \frac{[\text{HClO}]}{[\text{ClO}^-]} \approx (2.9 \times 10^{-8}) \times \frac{0.50}{0.60} = 2.4 \times 10^{-8} \text{ M}$$

Checking the assumption:

$$\frac{2.4 \times 10^{-8} \text{ M}}{0.50 \text{ M}} \times 100 = 4.8 \times 10^{-6\%} < 5\%$$

The assumption is justified, and we will use the same assumption in parts (b) and (c). Also, according to the other criterion (see Sample Problem 18.8),

$$\frac{[\text{HA}]_{\text{init}}}{K_a} = \frac{0.50}{2.9 \times 10^{-8}} = 1.7 \times 10^7 > 400$$

Calculating pH:

$$\text{pH} = -\log [\text{H}_3\text{O}^+] = -\log (2.4 \times 10^{-8}) = 7.62$$

(b) The pH after adding base (0.020 mol of NaOH to 1.0 L of buffer). Finding $[\text{OH}^-]_{\text{added}}$:

$$[\text{OH}^-]_{\text{added}} = \frac{0.020 \text{ mol OH}^-}{1.0 \text{ L soln}} = 0.020 \text{ M OH}^-$$

Setting up a reaction table for the *stoichiometry* of adding OH^- to HClO (notice that the reaction between weak acid and strong base goes to completion):

Concentration (M)	HClO(aq)	$+$	$\text{OH}^-(aq)$	\longrightarrow	$\text{ClO}^-(aq)$	$+$	$\text{H}_2\text{O(l)}$
Initial	0.50		0.020		0.60		—
Change	-0.020		-0.020		+0.020		—
Final	0.48		0		0.62		—

Setting up a reaction table for the *acid dissociation*, using these new initial concentrations.

As in part (a), $x = [\text{HClO}]_{\text{dissoc}} = [\text{H}_3\text{O}^+]$:

Concentration (M)	HClO(aq)	$+$	$\text{H}_2\text{O(l)}$	\rightleftharpoons	$\text{ClO}^-(aq)$	$+$	$\text{H}_3\text{O}^+(aq)$
Initial	0.48		—		0.62		0
Change	$-x$		—		$+x$		$+x$
Equilibrium	$0.48 - x$		—		$0.62 + x$		x

Making the assumption that x is small, and solving for x :

$$[\text{HClO}] = 0.48 \text{ M} - x \approx 0.48 \text{ M} \quad \text{and} \quad [\text{ClO}^-] = 0.62 \text{ M} + x \approx 0.62 \text{ M}$$

$$x = [\text{H}_3\text{O}^+] = K_a \times \frac{[\text{HClO}]}{[\text{ClO}^-]} \approx (2.9 \times 10^{-8}) \times \frac{0.48}{0.62} = 2.2 \times 10^{-8} \text{ M}$$

Calculating the pH:

$$\text{pH} = -\log [\text{H}_3\text{O}^+] = -\log (2.2 \times 10^{-8}) = 7.66$$

The addition of strong base increased the concentration of the basic buffer component at the expense of the acidic buffer component. Note especially that the pH *increased only slightly*, from 7.62 to 7.66.

(c) The pH after adding acid (30.0 mL of 1.5 M HCl to 0.50 L of buffer). Use Equation 4.2 to find the new $[\text{HClO}]_{\text{init}}$ and $[\text{ClO}^-]_{\text{init}}$ and $[\text{H}_3\text{O}^+]_{\text{added}}$ after combining the HCl and buffer solutions; the new volume is $0.50 \text{ L} + 0.0300 \text{ L} = 0.53 \text{ L}$:

$$[\text{HClO}]_{\text{init}} = \frac{M_{\text{conc}} \times V_{\text{conc}}}{V_{\text{dil}}} = \frac{0.50 \text{ M} \times 0.50 \text{ L}}{0.53 \text{ L}} = 0.47 \text{ M HClO}$$

$$[\text{ClO}^-]_{\text{init}} = \frac{M_{\text{conc}} \times V_{\text{conc}}}{V_{\text{dil}}} = \frac{0.60 \text{ M} \times 0.50 \text{ L}}{0.53 \text{ L}} = 0.57 \text{ M ClO}^-$$

$$[\text{H}_3\text{O}^+]_{\text{added}} = \frac{M_{\text{conc}} \times V_{\text{conc}}}{V_{\text{dil}}} = \frac{1.5 \text{ M} \times 0.0300 \text{ L}}{0.53 \text{ L}} = 0.085 \text{ M H}_3\text{O}^+$$

Now we proceed as in part (b), by first setting up a reaction table for the *stoichiometry* of adding H_3O^+ to ClO^- (notice that the reaction between strong acid and weak base goes to completion):

Concentration (M)	$\text{ClO}^-(aq)$	$+$	$\text{H}_3\text{O}^+(aq)$	\longrightarrow	HClO(aq)	$+$	$\text{H}_2\text{O(l)}$
Initial	0.57		0.085		0.47		—
Change	-0.085		-0.085		+0.085		—
Final	0.48		0		0.56		—

The reaction table for the *acid dissociation*, with $x = [\text{HClO}]_{\text{dissoc}} = [\text{H}_3\text{O}^+]$ is

Concentration (M)	HClO(aq)	$+$	$\text{H}_2\text{O(l)}$	\rightleftharpoons	$\text{ClO}^-(aq)$	$+$	$\text{H}_3\text{O}^+(aq)$
Initial	0.56		—		0.48		0
Change	$-x$		—		$+x$		$+x$
Equilibrium	$0.56 - x$		—		$0.48 + x$		x

Making the assumption that x is small, and solving for x :

$$[\text{HClO}] = 0.56 \text{ M} - x \approx 0.56 \text{ M} \quad \text{and} \quad [\text{ClO}^-] = 0.48 \text{ M} + x \approx 0.48 \text{ M}$$

$$x = [\text{H}_3\text{O}^+] = K_a \times \frac{[\text{HClO}]}{[\text{ClO}^-]} \approx (2.9 \times 10^{-8}) \times \frac{0.56}{0.48} = 3.4 \times 10^{-8} \text{ M}$$

Calculating the pH:

$$\text{pH} = -\log [\text{H}_3\text{O}^+] = -\log (3.4 \times 10^{-8}) = 7.47$$

The addition of strong acid increased the concentration of the acidic buffer component at the expense of the basic buffer component and *lowered* the pH only slightly, from 7.62 to 7.47.

Check The changes in $[HClO]$ and $[ClO^-]$ occur in opposite directions in parts (b) and (c), which makes sense. The pH increased when base was added in (b) and decreased when acid was added in (c).

Comment In part (a), we justified our assumption that x can be neglected. Therefore, in parts (b) and (c), we could have used the “Final” values from the last line of the stoichiometry reaction tables directly for the ratio of buffer components; that would have allowed us to dispense with a reaction table for the acid dissociation. In subsequent problems in this chapter, we will follow this more straightforward approach.

FOLLOW-UP PROBLEMS

Brief Solutions for all Follow-up Problems appear at the end of the chapter.

19.1A Calculate the pH of a buffer consisting of 0.50 M HF and 0.45 M KF (a) before and (b) after addition of 0.40 g of NaOH to 1.0 L of the buffer (K_a of HF = 6.8×10^{-4}).

19.1B Calculate the pH of a buffer consisting of 0.25 M $(CH_3)_2NH_2Cl$ and 0.30 M $(CH_3)_2NH$ (a) before and (b) after addition of 50.0 mL of 0.75 M HCl to 1.0 L of the buffer [pK_b of $(CH_3)_2NH$ = 3.23].

SOME SIMILAR PROBLEMS 19.12–19.21 and 19.28–19.31

Figure 19.4 summarizes the changes in concentrations of buffer components upon addition of strong acid or strong base.

Figure 19.4 Summary of the effect of added acid or base on the concentrations of buffer components.

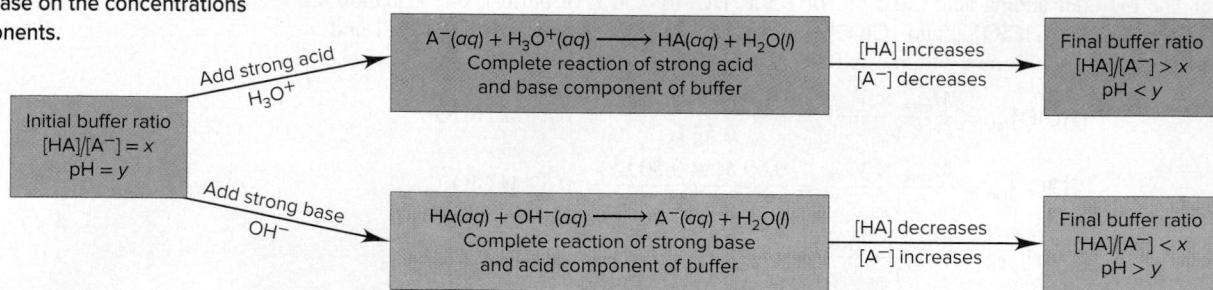

The Henderson-Hasselbalch Equation

For any weak acid, HA, the dissociation equation and K_a expression are

$$K_a = \frac{[H_3O^+][A^-]}{[HA]}$$

The key variable that determines $[H_3O^+]$ is the concentration *ratio* of acid species to base species, so, as before, rearranging to isolate $[H_3O^+]$ gives

$$[H_3O^+] = K_a \times \frac{[HA]}{[A^-]}$$

Taking the negative common (base 10) logarithm of both sides gives

$$\underbrace{-\log[H_3O^+]}_{\text{which, from definitions, is } pH} = \underbrace{-\log K_a}_{pK_a} - \log \left(\frac{[HA]}{[A^-]} \right)$$

Then, because of the nature of logarithms, when we invert the buffer-component concentration ratio, the sign of the logarithm changes, to give $pH = pK_a + \log \left(\frac{[A^-]}{[HA]} \right)$.

Generalizing the previous equation for any conjugate acid-base pair gives the **Henderson-Hasselbalch equation**:

$$\text{pH} = \text{p}K_a + \log \left(\frac{[\text{base}]}{[\text{acid}]} \right) \quad (19.1)$$

This relationship allows us to solve directly for pH instead of having to calculate $[\text{H}_3\text{O}^+]$ first. For instance, using the Henderson-Hasselbalch equation in part (b) of Sample Problem 19.1, the pH of the buffer after the addition of NaOH is

$$\text{pH} = \text{p}K_a + \log \left(\frac{[\text{ClO}^-]}{[\text{HClO}]} \right) = 7.54 + \log \left(\frac{0.62}{0.48} \right) = 7.65$$

Buffer Capacity and Buffer Range

Let's consider two key aspects of a buffer—its capacity and the closely related range.

Buffer Capacity **Buffer capacity** is a measure of the “strength” of the buffer, its ability to maintain the pH following addition of strong acid or base. Capacity depends ultimately on component concentrations, both the absolute and relative concentrations:

1. In terms of *absolute* concentrations, *the more concentrated the buffer components, the greater the capacity*. Thus, for a given amount of added H_3O^+ or OH^- , the pH of a higher capacity buffer changes less than the pH of a lower capacity buffer (Figure 19.5). Note that *buffer pH is independent of buffer capacity*. A buffer made of equal volumes of 1.0 M CH_3COOH and 1.0 M CH_3COO^- has the same pH (4.74) as a buffer made of equal volumes of 0.10 M CH_3COOH and 0.10 M CH_3COO^- , but the more concentrated buffer has a greater capacity.

2. In terms of *relative* concentrations, *the closer the component concentrations are to each other, the greater the capacity*. As a buffer functions, the concentration of one component increases relative to the other. Because the concentration ratio determines the pH, the less the ratio changes, the less the pH changes. Let's compare the percent change in component concentration ratio for a buffer at two different initial ratios:

- Add 0.010 mol of OH^- to 1.00 L of buffer with initial concentrations $[\text{HA}] = [\text{A}^-] = 1.000 \text{ M}$: $[\text{A}^-]$ becomes 1.010 M and $[\text{HA}]$ becomes 0.990 M,

$$\begin{aligned} \frac{[\text{A}^-]_{\text{init}}}{[\text{HA}]_{\text{init}}} &= \frac{1.000 \text{ M}}{1.000 \text{ M}} = 1.000 & \frac{[\text{A}^-]_{\text{final}}}{[\text{HA}]_{\text{final}}} &= \frac{1.010 \text{ M}}{0.990 \text{ M}} = 1.02 \\ \text{Percent change} &= \frac{1.02 - 1.000}{1.000} \times 100 = 2\% \end{aligned}$$

- Add 0.010 mol of OH^- to 1.00 L of buffer with initial concentrations $[\text{HA}] = 0.250 \text{ M}$ and $[\text{A}^-] = 1.750 \text{ M}$: $[\text{A}^-]$ becomes 1.760 M and $[\text{HA}]$ becomes 0.240 M,

$$\begin{aligned} \frac{[\text{A}^-]_{\text{init}}}{[\text{HA}]_{\text{init}}} &= \frac{1.750 \text{ M}}{0.250 \text{ M}} = 7.000 & \frac{[\text{A}^-]_{\text{final}}}{[\text{HA}]_{\text{final}}} &= \frac{1.760 \text{ M}}{0.240 \text{ M}} = 7.33 \\ \text{Percent change} &= \frac{7.33 - 7.00}{7.00} \times 100 = 4.7\% \end{aligned}$$

Note that the change in the concentration ratio is more than twice as large when the initial component concentrations are different than when they are the same. Thus, *a buffer has the highest capacity when the component concentrations are equal*. In the Henderson-Hasselbalch equation, when $[\text{A}^-] = [\text{HA}]$, their ratio is 1, the log term is 0, and so $\text{pH} = \text{p}K_a$:

$$\text{pH} = \text{p}K_a + \log \left(\frac{[\text{A}^-]}{[\text{HA}]} \right) = \text{p}K_a + \log 1 = \text{p}K_a + 0 = \text{p}K_a$$

Therefore, *a buffer whose pH is equal to or near the $\text{p}K_a$ of its acid component has the highest capacity for a given concentration*.

Buffer Range **Buffer range** is the pH range over which the buffer is effective and is also related to the *relative* buffer-component concentrations. The further the concentration ratio is from 1, the less effective the buffer (the lower the buffer capacity). In practice, if the $[\text{A}^-]/[\text{HA}]$ ratio is greater than 10 or less than 0.1—that is, if one component concentration is more than 10 times the other—buffering action is poor.

Student Hot Spot

Student data indicate that you may struggle with acid-base buffer calculations. Access the Smartbook to view additional Learning Resources on this topic.

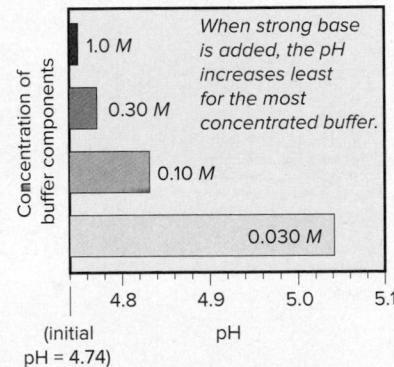

Figure 19.5 The relation between buffer capacity and pH change. The bars indicate the final pH values, after strong base was added, for four $\text{CH}_3\text{COOH}/\text{CH}_3\text{COO}^-$ buffers with the same initial pH (4.74) and different component concentrations.

Consider the two extreme concentration ratios for effective buffering:

- For a buffer with $[A^-]/[HA] = 10$: $pH = pK_a + \log\left(\frac{10}{1}\right) = pK_a + 1$.
- For a buffer with $[A^-]/[HA] = 0.1$: $pH = pK_a + \log\left(\frac{1}{10}\right) = pK_a - 1$.

Therefore:

- Buffers have a usable range within ± 1 pH unit of the pK_a of the acid component: $pH = pK_a \pm 1$.*

For example, a buffer consisting of CH_3COOH ($pK_a = 4.74$) and CH_3COO^- has a usable pH range of 4.74 ± 1 , or from about 3.7 to 5.7.

SAMPLE PROBLEM 19.2

Using Molecular Scenes to Examine Buffers

Problem The molecular scenes below represent equal-volume samples of four HA/A^- buffers. (HA is blue and green, and A^- is green; other ions and water are not shown.)

- Which buffer has the highest pH?
- Which buffer has the greatest capacity?
- Should you add a small amount of concentrated strong acid or strong base to convert sample 1 to sample 2 (assuming no volume change)?

Plan The molecular scenes show varying numbers of weak acid molecules (HA) and the conjugate base (A^-). Because the volumes are equal, the scenes represent molarities as well as numbers. (a) As the pH rises, more HA loses its H^+ and becomes A^- , so the $[\text{A}^-]/[\text{HA}]$ ratio will increase. We examine the scenes to see which has the highest ratio. (b) Buffer capacity depends on buffer-component concentration *and* ratio. We examine the scenes to see which has a high concentration and a ratio close to 1. (c) Adding strong acid converts some A^- to HA, and adding strong base does the opposite. Comparing the $[\text{A}^-]/[\text{HA}]$ ratios in samples 1 and 2 tells which to add.

Solution (a) The $[\text{A}^-]/[\text{HA}]$ ratios are as follows: For sample 1, $[\text{A}^-]/[\text{HA}] = 3/3 = 1$. Similarly, sample 2 = 0.5; sample 3 = 1; sample 4 = 2. Sample 4 has the highest pH because it has the highest $[\text{A}^-]/[\text{HA}]$ ratio.

- Samples 1 and 3 have a $[\text{A}^-]/[\text{HA}]$ ratio of 1, but sample 3 has the greater capacity because it has a higher concentration.
- Sample 2 has a lower $[\text{A}^-]/[\text{HA}]$ ratio than sample 1, so you would add strong acid to sample 1 to convert some A^- to HA.

FOLLOW-UP PROBLEMS

19.2A The molecular scene (see margin) shows a sample of an HB/B^- buffer. (HB is blue and yellow, and B^- is yellow; other ions and water are not shown.)

- Would you add a small amount of concentrated strong acid or strong base to increase the buffer capacity?

(b) Assuming no volume change, draw a scene that represents the buffer with the highest possible capacity after the addition in part (a).

19.2B The molecular scenes below show three samples of a buffer consisting of HA ($pK_a = 4.2$) and A^- . (HA is blue and red, and A^- is red; other ions and water are not shown.)

- (a) Which buffer has $\text{pH} > \text{p}K_a$?
 (b) Which buffer can react with the largest amount of added strong base?
 (c) Is this conjugate acid-base pair suitable for preparing a buffer with a pH of 6.1?

SIMILAR PROBLEMS 19.10 and 19.11

Preparing a Buffer

Even though chemical supply-houses offer buffers in a variety of pH values and concentrations, you may have to prepare a specific one, for example, in an environmental or biomedical application. Several steps are required to prepare a buffer:

1. *Choose the conjugate acid-base pair.* Deciding on the chemical composition is based to a large extent on the desired pH. Suppose that, for a biochemical experiment, you need a buffer whose pH is 3.90. Therefore, to maximize the capacity, the $\text{p}K_a$ of the acid component should be close to 3.90; or $K_a = 10^{-3.90} = 1.3 \times 10^{-4}$. A table of K_a values (see Appendix C) shows that lactic acid ($\text{p}K_a = 3.86$), glycolic acid ($\text{p}K_a = 3.83$), and formic acid ($\text{p}K_a = 3.74$) are possibilities. To avoid substances that are common in biochemical systems, you choose formic acid, HCOOH, and formate ion, HCOO^- , supplied by a soluble salt, such as sodium formate, HCOONa, as the basic component.

2. *Calculate the ratio of buffer component concentrations.* To find the ratio $[\text{A}^-]/[\text{HA}]$ that gives the desired pH, you use Equation 19.1:

$$\begin{aligned}\text{pH} &= \text{p}K_a + \log\left(\frac{[\text{A}^-]}{[\text{HA}]}\right) && \text{or} && 3.90 = 3.74 + \log\left(\frac{[\text{HCOO}^-]}{[\text{HCOOH}]}\right) \\ \log\left(\frac{[\text{HCOO}^-]}{[\text{HCOOH}]}\right) &= 0.16 && \text{so} && \left(\frac{[\text{HCOO}^-]}{[\text{HCOOH}]}\right) = 10^{0.16} = 1.4\end{aligned}$$

Thus, for every 1.0 mol of HCOOH in a given volume of solution, you need 1.4 mol of HCOONa.

3. *Determine the buffer concentration.* For most laboratory-scale applications, concentrations of about 0.5 M are suitable, but the decision is often based on availability of stock solutions. Suppose you have a large stock of 0.40 M HCOOH and you need approximately 1.0 L of final buffer. First, you find the amount (mol) of sodium formate that will give the needed 1.4/1.0 ratio, and then convert to mass (g):

$$\text{Amount (mol) of HCOOH} = 1.0 \text{ L soln} \times \frac{0.40 \text{ mol HCOOH}}{1.0 \text{ L soln}} = 0.40 \text{ mol HCOOH}$$

$$\text{Amount (mol) of HCOONa} = 0.40 \text{ mol HCOOH} \times \frac{1.4 \text{ mol HCOONa}}{1.0 \text{ mol HCOOH}} = 0.56 \text{ mol HCOONa}$$

$$\text{Mass (g) of HCOONa} = 0.56 \text{ mol HCOONa} \times \frac{68.01 \text{ g HCOONa}}{1 \text{ mol HCOONa}} = 38 \text{ g HCOONa}$$

4. *Mix the solution and correct the pH.* You dissolve 38 g of sodium formate in the stock 0.40 M HCOOH to a total volume of 1.0 L. Because of nonideal behavior (Section 13.6), the buffer may vary slightly from the desired pH, so you add strong acid or strong base dropwise, while monitoring the solution with a pH meter.

SAMPLE PROBLEM 19.3

Preparing a Buffer

Problem An environmental chemist needs a carbonate buffer of pH 10.00 to study the effects of acid rain on limestone-rich soils. How many grams of Na_2CO_3 must she add to 1.5 L of 0.20 M NaHCO_3 to make the buffer (K_a of $\text{HCO}_3^- = 4.7 \times 10^{-11}$)?

Plan The conjugate pair is HCO_3^- (acid) and CO_3^{2-} (base), and we know the buffer volume (1.5 L) and the concentration (0.20 M) of HCO_3^- , so we need to find the buffer-component concentration ratio that gives a pH of 10.00 and the mass of Na_2CO_3 to dissolve. We convert K_a to $\text{p}K_a$ and use Equation 19.1 to find the ratio $[\text{CO}_3^{2-}]/[\text{HCO}_3^-]$ that gives a pH of 10.00. Multiplying the given molarity of HCO_3^- by the volume of solution gives the amount (mol)

of HCO_3^- and the ratio of $[\text{CO}_3^{2-}]/[\text{HCO}_3^-]$ gives the amount (mol) of CO_3^{2-} needed, which we convert to mass (g) of Na_2CO_3 .

Solution Calculating pK_a :

$$pK_a = -\log K_a = -\log (4.7 \times 10^{-11}) = 10.33$$

Solving for $[\text{CO}_3^{2-}]/[\text{HCO}_3^-]$:

$$\text{pH} = pK_a + \log \left(\frac{[\text{CO}_3^{2-}]}{[\text{HCO}_3^-]} \right) \quad 10.00 = 10.33 + \log \left(\frac{[\text{CO}_3^{2-}]}{[\text{HCO}_3^-]} \right)$$

$$-0.33 = \log \left(\frac{[\text{CO}_3^{2-}]}{[\text{HCO}_3^-]} \right) \quad \text{and} \quad \left(\frac{[\text{CO}_3^{2-}]}{[\text{HCO}_3^-]} \right) = 10^{-0.33} = 0.47$$

Calculating the amount (mol) of CO_3^{2-} needed for the given volume of solution:

$$\text{Amount (mol) of HCO}_3^- = 1.5 \text{ L soln} \times \frac{0.20 \text{ mol HCO}_3^-}{1.0 \text{ L soln}} = 0.30 \text{ mol HCO}_3^-$$

$$\text{Amount (mol) of CO}_3^{2-} = 0.30 \text{ mol HCO}_3^- \times \frac{0.47 \text{ mol CO}_3^{2-}}{1.0 \text{ mol HCO}_3^-} = 0.14 \text{ mol CO}_3^{2-}$$

Calculating the mass (g) of Na_2CO_3 needed:

$$\text{Mass (g) of Na}_2\text{CO}_3 = 0.14 \text{ mol Na}_2\text{CO}_3 \times \frac{105.99 \text{ g Na}_2\text{CO}_3}{1 \text{ mol Na}_2\text{CO}_3} = 15 \text{ g Na}_2\text{CO}_3$$

The buffer is prepared by dissolving 15 g of Na_2CO_3 into about 1.3 L of 0.20 M NaHCO_3 and adding more 0.20 M NaHCO_3 to make 1.5 L. Then a pH meter is used to adjust the pH to 10.00 by dropwise addition of concentrated strong acid or base.

Check For a useful buffer range, the concentration of the acidic component, $[\text{HCO}_3^-]$ in this case, must be within a factor of 10 of the concentration of the basic component, $[\text{CO}_3^{2-}]$. And we have 0.30 mol of HCO_3^- , and 0.14 mol of CO_3^{2-} ; $0.30/0.14 = 2.1$. Make sure the relative amounts of components are reasonable: we want a pH below the pK_a of HCO_3^- (10.33), so we want more of the acidic than the basic species.

FOLLOW-UP PROBLEMS

19.3A How would you prepare a benzoic acid/benzoate buffer with a pH of 4.25, starting with 5.0 L of 0.050 M sodium benzoate ($\text{C}_6\text{H}_5\text{COONa}$) solution and adding the acidic component (K_a of benzoic acid ($\text{C}_6\text{H}_5\text{COOH}$) = 6.3×10^{-5})?

19.3B What is the component concentration ratio, $[\text{NH}_3]/[\text{NH}_4^+]$ of a buffer that has a pH of 9.18? What mass of NH_4Cl must be added to 750 mL of 0.15 M NH_3 to prepare the buffer with this pH (K_b of NH_3 = 1.76×10^{-5})?

SOME SIMILAR PROBLEMS 19.24–19.27

Another way to prepare a buffer is to form one of the components by *partial neutralization* of the other. For example, you can prepare an $\text{HCOOH}/\text{HCOO}^-$ buffer by mixing aqueous solutions of HCOOH and NaOH . As OH^- reacts with HCOOH , neutralization of some of the HCOOH produces the HCOO^- needed:

This method is based on the same chemical process that occurs when a weak acid is titrated with a strong base, as you'll see in Section 19.2.

› Summary of Section 19.1

- › The pH of a buffered solution changes much less than the pH of an unbuffered solution when H_3O^+ or OH^- is added.
- › A buffer consists of a weak acid and its conjugate base (or a weak base and its conjugate acid). To be effective, the amounts of the components must be *much* greater than the amount of H_3O^+ or OH^- added.
- › The buffer-component concentration ratio determines the pH; the ratio and the pH are related by the Henderson-Hasselbalch equation.

- When H_3O^+ or OH^- is added to a buffer, one component reacts to form the other; thus, $[\text{H}_3\text{O}^+]$ (and pH) changes only slightly.
- A concentrated (higher capacity) buffer undergoes smaller changes in pH than a dilute buffer. When the buffer pH equals the pK_a of the acid component, the buffer has its highest capacity.
- A buffer has an effective pH range of $pK_a \pm 1$ pH unit.
- To prepare a buffer, choose the conjugate acid-base pair, calculate the ratio of components, determine the buffer concentration, and adjust the final solution to the desired pH.

19.2 ACID-BASE TITRATION CURVES

In Chapter 4, we used titrations to quantify acid-base (and redox) reactions. In this section, we focus on the **acid-base titration curve**, a plot of pH vs. volume of titrant added. We discuss curves for strong acid-strong base, weak acid-strong base, weak base-strong acid, and polyprotic acid-strong base titrations. Running a titration is an exercise for the lab, but understanding the role of acid-base indicators and seeing how salt solutions (Section 18.7) and buffers are involved apply key principles of acid-base equilibria.

Strong Acid–Strong Base Titration Curves

Figure 19.6 shows a typical curve for the titration of a strong acid with a strong base, the data used to construct it, and molecular views of the key species in solution at various points during the titration.

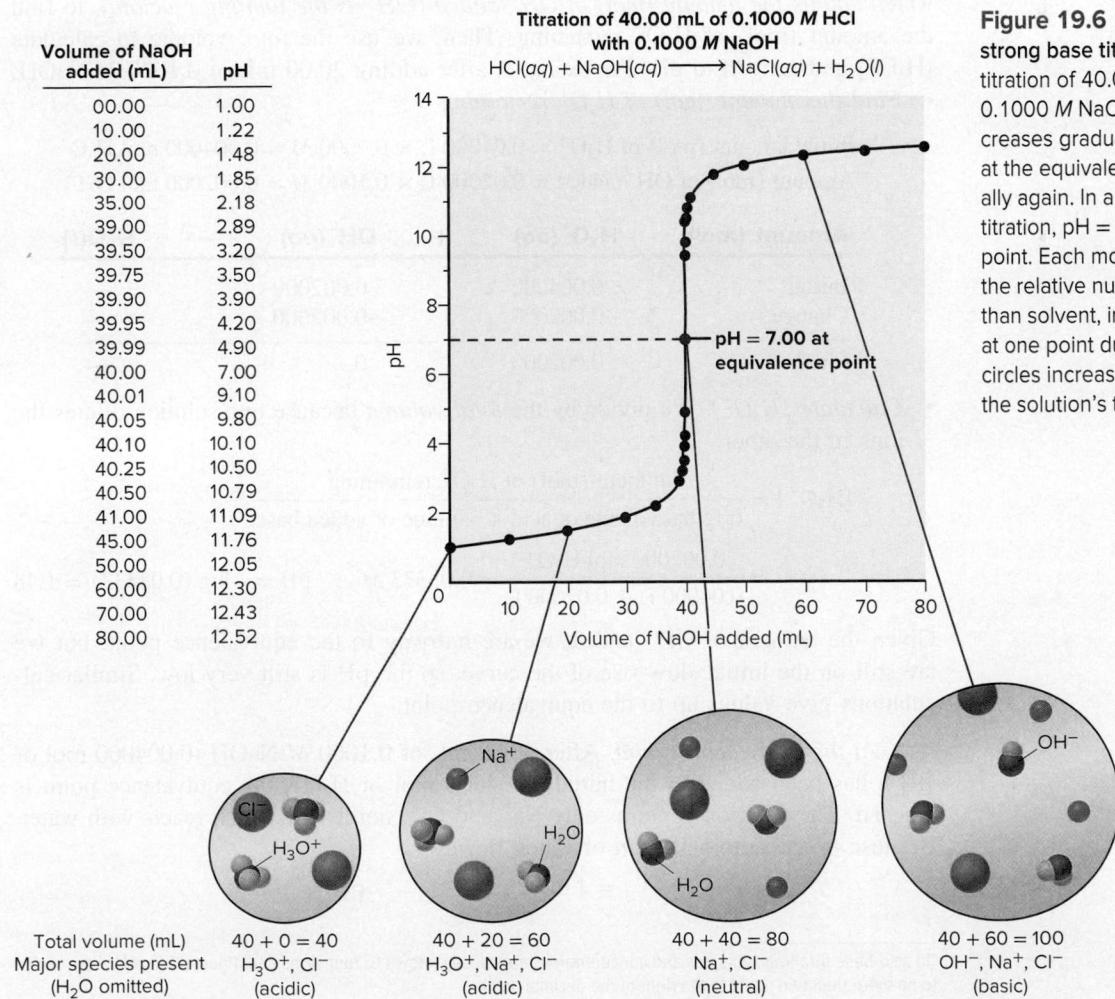

Figure 19.6 Curve for a strong acid–strong base titration. Data (*at left*) for the titration of 40.00 mL of 0.1000 M HCl with 0.1000 M NaOH. In the titration, pH increases gradually, then rapidly near and at the equivalence point, and then gradually again. In a strong acid–strong base titration, pH = 7.00 at the equivalence point. Each molecular-scale view shows the relative numbers of species, other than solvent, in a portion of the solution at one point during the titration. The circles increase in size in proportion to the solution's total volume.

Features of the Curve There are three distinct regions of the titration curve, which correspond to three major changes in slope:

1. *The pH starts out low*, reflecting the high $[H_3O^+]$ of the strong acid, and increases slowly as acid is gradually neutralized by the added base.
2. *The pH rises 6 to 8 units very rapidly*. This steep increase begins when the amount (mol) of OH^- added nearly equals the amount (mol) of H_3O^+ originally present in the acid. One or two more drops of base neutralize the remaining tiny excess of acid and introduce a tiny excess of base.

The **equivalence point** occurs when the *number of moles of added OH^- equals the number of moles of H_3O^+ originally present*. The solution consists of the anion of the strong acid and the cation of the strong base. Recall from Chapter 18 that *these ions do not react with water, so the solution is neutral: $pH = 7.00$* .

3. *The pH increases slowly* beyond the steep rise as more base is added.

Calculating the pH During This Titration By knowing the chemical species present during the titration, we can calculate the pH at various points along the way:

1. *Initial solution of strong HA*. In Figure 19.6, 40.00 mL of 0.1000 M HCl is titrated with 0.1000 M NaOH. Because a strong acid is completely dissociated, $[HCl] = [H_3O^+] = 0.1000\text{ M}$. Therefore, the initial pH is*

$$pH = -\log [H_3O^+] = -\log (0.1000) = 1.00$$

2. *Before the equivalence point*. As we start adding base, some acid is neutralized and the volume of solution increases. To find the pH at various points up to the equivalence point, we find the *initial* amount (mol) of H_3O^+ and amount (mol) of added OH^- ; next, we set up a reaction table and subtract the amount of H_3O^+ *reacted*, which equals the amount (mol) of OH^- added (OH^- is the limiting reactant), to find the amount (mol) of H_3O^+ remaining. Then, we use the *total* volume to calculate $[H_3O^+]$ and convert to pH. For example, after adding 20.00 mL of 0.1000 M NaOH:

- Find the amount (mol) of H_3O^+ remaining.

$$\text{Initial amount (mol) of } H_3O^+ = 0.04000\text{ L} \times 0.1000\text{ M} = 0.004000\text{ mol } H_3O^+$$

$$\text{Amount (mol) of } OH^- \text{ added} = 0.02000\text{ L} \times 0.1000\text{ M} = 0.002000\text{ mol } OH^-$$

Amount (mol)	$H_3O^+(aq)$	+	$OH^-(aq)$	→	$H_2O(l)$
Initial	0.004000		0.002000		—
Change	-0.002000		-0.002000		—
Final	0.002000		0		—

- Calculate $[H_3O^+]$. We divide by the *total volume* because one solution dilutes the ions in the other:

$$\begin{aligned} [H_3O^+] &= \frac{\text{amount (mol) of } H_3O^+ \text{ remaining}}{\text{original volume of acid} + \text{volume of added base}} \\ &= \frac{0.002000 \text{ mol } H_3O^+}{0.04000 \text{ L} + 0.02000 \text{ L}} = 0.03333 \text{ M} \quad pH = -\log (0.03333) = 1.48 \end{aligned}$$

Given the amount of OH^- added, we are halfway to the equivalence point; but we are still on the initial slow rise of the curve, so the pH is still very low. Similar calculations give values up to the equivalence point.

3. *At the equivalence point*. After 40.00 mL of 0.1000 M NaOH (0.004000 mol of OH^-) has been added to the initial 0.004000 mol of H_3O^+ , the equivalence point is reached. The solution contains only Na^+ and Cl^- , neither of which reacts with water. Because of the autoionization of water, however,

$$[H_3O^+] = 1.0 \times 10^{-7} \text{ M} \quad pH = 7.00$$

*In acid-base titrations, volumes and concentrations are usually known to four significant figures, but pH is reported to no more than two digits to the right of the decimal point.

4. After the equivalence point. From the equivalence point on, the pH calculation is based on the amount (mol) of excess OH^- present. Find the amount (mol) of added OH^- and set up a reaction table with the *original* amount of HCl; subtract the amount of OH^- reacted, which equals the amount (mol) of initial H_3O^+ (H_3O^+ is now the limiting reactant), to find the amount (mol) of OH^- remaining. Then, we use the total volume to calculate $[\text{OH}^-]$ and convert to pOH and then to pH. For example, after adding 50.00 mL of NaOH to the 40.00 mL of HCl:

- Find the amount (mol) of OH^- remaining.

$$\text{Total amount (mol) of } \text{OH}^- \text{ added} = 0.05000 \text{ L} \times 0.1000 \text{ M} = 0.005000 \text{ mol } \text{OH}^-$$

Amount (mol)	$\text{H}_3\text{O}^+(\text{aq})$	+	$\text{OH}^-(\text{aq})$	→	$\text{H}_2\text{O}(\text{l})$
Initial	0.004000		0.005000		—
Change	-0.004000		-0.004000		—
Final	0		0.001000		—

- Calculate $[\text{OH}^-]$.

$$[\text{OH}^-] = \frac{\text{amount (mol) of } \text{OH}^- \text{ remaining}}{\text{original volume of acid} + \text{volume of added base}}$$

$$= \frac{0.001000 \text{ mol } \text{OH}^-}{0.04000 \text{ L} + 0.05000 \text{ L}} = 0.01111 \text{ M} \quad \text{pOH} = -\log (0.01111) = 1.95$$

$$\text{pH} = \text{p}K_w - \text{pOH} = 14.00 - 1.95 = 12.05$$

Weak Acid–Strong Base Titration Curves

Figure 19.7 shows a curve for the titration of a weak acid with strong base: 40.00 mL of 0.1000 M propanoic acid ($K_a = 1.3 \times 10^{-5}$) titrated with 0.1000 M NaOH. (We abbreviate the acid, $\text{CH}_3\text{CH}_2\text{COOH}$, as HPr and the conjugate base, $\text{CH}_3\text{CH}_2\text{COO}^-$, as Pr⁻.)

Titration of 40.00 mL of 0.1000 M HPr with 0.1000 M NaOH
 $\text{HPr}(\text{aq}) + \text{NaOH}(\text{aq}) \longrightarrow \text{NaPr}(\text{aq}) + \text{H}_2\text{O}(\text{l})$

Figure 19.7 Curve for a weak acid–strong base titration.

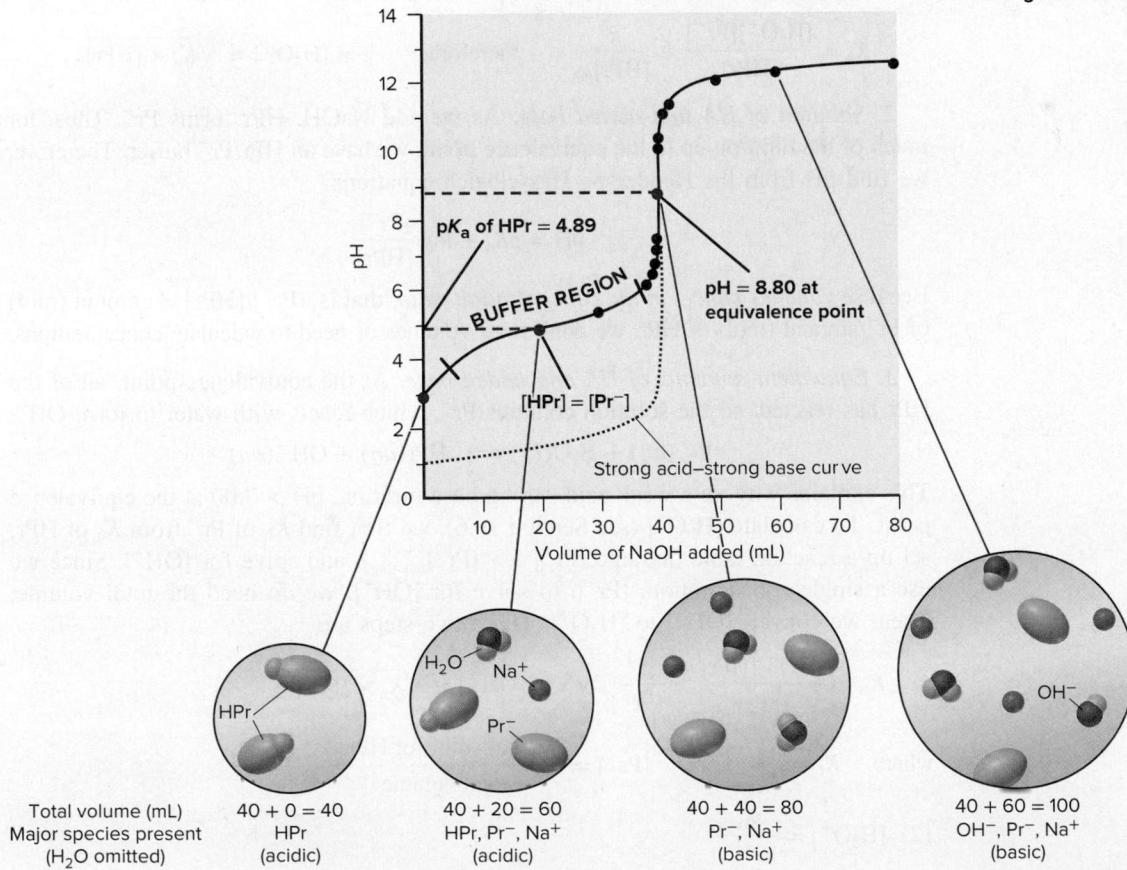

Features of the Curve The dotted portion of the curve in Figure 19.7 corresponds to the bottom half of the strong acid–strong base curve (Figure 19.6). There are four key points to note for the weak acid curve (the first three differ from the points about the strong acid curve):

1. *The initial pH is higher.* Because the weak acid (HPr) dissociates slightly, much less H_3O^+ is present than with the strong acid.
2. *The curve rises gradually in the so-called buffer region before the steep rise to the equivalence point.* As HPr reacts with strong base, more Pr^- forms, which creates an HPr/Pr^- buffer. At the midpoint of the buffer region, half the initial HPr has reacted (that is, half of the OH^- needed to reach the equivalence point has been added), so $[\text{HPr}] = [\text{Pr}^-]$, or $[\text{Pr}^-]/[\text{HPr}] = 1$. Therefore, at this point, the pH equals the $\text{p}K_a$:

$$\text{pH} = \text{p}K_a + \log \left(\frac{[\text{Pr}^-]}{[\text{HPr}]} \right) = \text{p}K_a + \log 1 = \text{p}K_a + 0 = \text{p}K_a$$

The pH observed at this point, halfway through the titration, is used to estimate the $\text{p}K_a$ of an unknown acid.

3. *The pH at the equivalence point is above 7.00.* The solution contains the strong-base cation Na^+ , which does not react with water, and Pr^- , the conjugate base of HPr , which, as a weak base, accepts a proton from H_2O and yields OH^- .
4. *The pH increases slowly beyond the equivalence point as excess OH^- is added.*

Calculating the pH During This Titration During the weak acid–strong base titration we must take into account the partial dissociation of the weak acid, the presence of the buffer, and the reaction of the conjugate base with water. Thus, each of four regions of the curve requires its own calculation to find $[\text{H}_3\text{O}^+]$:

1. *Initial HA solution.* Before base is added, a weak acid dissociates:

We find $[\text{H}_3\text{O}^+]$ as in Section 18.4 by setting up a reaction table with $x = [\text{HPr}]_{\text{dissoc}}$, assuming $[\text{H}_3\text{O}^+] = [\text{HPr}]_{\text{dissoc}} \ll [\text{HPr}]_{\text{init}}$, and solving for x :

$$K_a = \frac{[\text{H}_3\text{O}^+][\text{Pr}^-]}{[\text{HPr}]} \approx \frac{x^2}{[\text{HPr}]_{\text{init}}} \quad \text{therefore,} \quad x = [\text{H}_3\text{O}^+] \approx \sqrt{K_a \times [\text{HPr}]_{\text{init}}}$$

2. *Solution of HA and added base.* As we add NaOH , HPr forms Pr^- . Thus, for much of the titration up to the equivalence point, we have an HPr/Pr^- buffer. Therefore, we find pH from the Henderson-Hasselbalch equation:

$$\text{pH} = \text{p}K_a + \log \frac{[\text{Pr}^-]}{[\text{HPr}]}$$

Because *volumes cancel in the concentration ratio*, that is, $[\text{Pr}^-]/[\text{HPr}] = \text{amount (mol)} \text{ of } \text{Pr}^-/\text{amount (mol)} \text{ of } \text{HPr}$, we don't need volumes or need to calculate concentrations.

3. *Equivalent amounts of HA and added base.* At the equivalence point, all of the HPr has reacted, so the solution contains Pr^- , which reacts with water to form OH^- :

This explains why, in a weak acid–strong base titration, $\text{pH} > 7.00$ at the equivalence point. To calculate $[\text{H}_3\text{O}^+]$ (see Section 18.6), we first find K_b of Pr^- from K_a of HPr , set up a reaction table (assume $[\text{Pr}^-] \gg [\text{Pr}^-]_{\text{reacting}}$), and solve for $[\text{OH}^-]$. Since we use a single concentration, $[\text{Pr}^-]$, to solve for $[\text{OH}^-]$, we *do* need the total volume. Then, we convert $[\text{OH}^-]$ to $[\text{H}_3\text{O}^+]$. These two steps are

$$(1) K_b = \frac{[\text{OH}^-][\text{HPr}]}{[\text{Pr}^-]} \approx \frac{x^2}{[\text{Pr}^-]}, \text{ or } x = [\text{OH}^-] \approx \sqrt{K_b \times [\text{Pr}^-]},$$

where $K_b = \frac{K_w}{K_a}$ and $[\text{Pr}^-] = \frac{\text{amount (mol)} \text{ of } \text{HPr}_{\text{init}}}{\text{total volume}}$

$$(2) [\text{H}_3\text{O}^+] = \frac{K_w}{[\text{OH}^-]}$$

Student Hot Spot

Student data indicate that you may struggle with the concept of acid-base titration curves. Access the Smartbook to view additional Learning Resources on this topic.

4. *Solution of excess base.* Beyond the equivalence point, as in the strong acid-strong base titration, we are adding excess OH^- ; the very small amount of OH^- produced by the reaction of Pr^- with water is negligible compared to the amount of OH^- from the excess NaOH:

$$[\text{H}_3\text{O}^+] = \frac{K_w}{[\text{OH}^-]} \quad \text{where} \quad [\text{OH}^-] = \frac{\text{amount (mol) of excess } \text{OH}^-}{\text{total volume}}$$

Sample Problem 19.4 shows the overall approach.

SAMPLE PROBLEM 19.4
Finding the pH During a Weak Acid–Strong Base Titration

Problem Calculate the pH during the titration of 40.00 mL of 0.1000 M propanoic acid (HPr ; $K_a = 1.3 \times 10^{-5}$) after each of the following additions of 0.1000 M NaOH:

- (a) 0.00 mL (b) 30.00 mL (c) 40.00 mL (d) 50.00 mL

Plan (a) 0.00 mL: No base has been added yet, so this is a weak-acid dissociation. We calculate the pH as we did in Section 18.4. (b) 30.00 mL: We find the amount (mol) of Pr^- and of HPr , and substitute into the Henderson-Hasselbalch equation to solve for pH. (c) 40.00 mL: The amount (mol) of NaOH added equals the initial amount (mol) of HPr , so a solution of Na^+ and Pr^- exists. We calculate the pH as we did in Section 18.6, except that we need *total volume* to find $[\text{Pr}^-]$. (d) 50.00 mL: We calculate the amount (mol) of excess OH^- in the total volume, convert to $[\text{H}_3\text{O}^+]$ and then to pH.

Solution (a) 0.00 mL of 0.1000 M NaOH added. Following the approach used in Sample Problem 18.8 and just described in the text, we obtain

Concentration (M)	$\text{HPr}(aq)$	+	$\text{H}_2\text{O}(l)$	\rightleftharpoons	$\text{H}_3\text{O}^+(aq)$	+	$\text{Pr}^-(aq)$
Initial	0.1000		—		0		0
Change	$-x$		—		$+x$		$+x$

Equilibrium 0.1000 – x — x x

$$K_a = \frac{[\text{H}_3\text{O}^+][\text{Pr}^-]}{[\text{HPr}]} = 1.3 \times 10^{-5} \approx \frac{(x)(x)}{0.1000}$$

$$[\text{H}_3\text{O}^+] = x \approx \sqrt{K_a \times [\text{HPr}]_{\text{init}}} = \sqrt{(1.3 \times 10^{-5})(0.1000)} = 1.1 \times 10^{-3} \text{ M}$$

$$\text{pH} = 2.96$$

(b) 30.00 mL of 0.1000 M NaOH added. Calculating the initial amounts of HPr and OH^- :

$$\begin{aligned} \text{Initial amount (mol) of HPr} &= 0.04000 \text{ L} \times 0.1000 \text{ M} = 0.004000 \text{ mol HPr} \\ \text{Amount (mol) of NaOH added} &= 0.03000 \text{ L} \times 0.1000 \text{ M} = 0.003000 \text{ mol OH}^- \end{aligned}$$

For every mole of NaOH, 1 mol of Pr^- forms, so we have this stoichiometry reaction table:

Amount (mol)	$\text{HPr}(aq)$	+	$\text{OH}^-(aq)$	\longrightarrow	$\text{Pr}^-(aq)$	+	$\text{H}_2\text{O}(l)$
Initial	0.004000		0.003000		0		—
Change	-0.003000		-0.003000		$+0.003000$		—
Final	0.001000		0		0.003000		—

The last line of the table gives the new initial amounts of HPr and Pr^- that react to attain a new equilibrium. With x very small, we assume that the $[\text{HPr}]/[\text{Pr}^-]$ ratio at equilibrium is essentially equal to the ratio of these new initial amounts (see Comment in Sample Problem 19.1).

Calculating $\text{p}K_a$:

$$\text{p}K_a = -\log K_a = -\log (1.3 \times 10^{-5}) = 4.89$$

Solving for pH using the Henderson-Hasselbalch equation:

$$\begin{aligned} \text{pH} &= \text{p}K_a + \log \frac{[\text{Pr}^-]}{[\text{HPr}]} = 4.89 + \log \frac{0.003000}{0.001000} \\ \text{pH} &= 5.37 \end{aligned}$$

(c) 40.00 mL of 0.1000 M NaOH added. Calculating the initial amounts of HPr and OH⁻:

$$\text{Initial amount (mol) of HPr} = 0.04000 \text{ L} \times 0.1000 \text{ M} = 0.004000 \text{ mol HPr}$$

$$\text{Amount (mol) of NaOH added} = 0.04000 \text{ L} \times 0.1000 \text{ M} = 0.004000 \text{ mol OH}^-$$

We have this stoichiometry reaction table:

Amount (mol)	HPr(aq)	+	OH ⁻ (aq)	→	Pr ⁻ (aq)	+	H ₂ O(l)
Initial	0.004000		0.004000		0		—
Change	0.004000		-0.004000		+0.004000		—
Final	0		0		0.004000		—

Calculating [Pr⁻] after all HPr has reacted:

$$[\text{Pr}^-] = \frac{0.004000 \text{ mol}}{0.04000 \text{ L} + 0.04000 \text{ L}} = 0.05000 \text{ M}$$

Setting up a reaction table for the base dissociation, with $x = [\text{Pr}^-]_{\text{reacting}} = [\text{OH}^-]$ and assuming $[\text{Pr}^-]_{\text{reacting}} \ll [\text{Pr}^-]_{\text{init}}$, calculating K_b , and solving for x (see Sample Problem 18.12 for similar steps):

Concentration, M	Pr ⁻ (aq)	+	H ₂ O(l)	↔	HPr(aq)	+	OH ⁻
Initial	0.05000		—		0		0
Change	-x		—		+x		+x
Equilibrium	0.05000 - x		—		x		x

$$K_b = \frac{K_w}{K_a} = \frac{1.0 \times 10^{-14}}{1.3 \times 10^{-5}} = 7.7 \times 10^{-10}$$

$$K_b = \frac{[\text{HPr}][\text{OH}^-]}{[\text{Pr}^-]} = 7.7 \times 10^{-10} \approx \frac{(x)(x)}{0.05000}$$

$$[\text{OH}^-] = x \approx \sqrt{K_b \times [\text{Pr}^-]_{\text{init}}} = \sqrt{(7.7 \times 10^{-10})(0.05000)} = 6.2 \times 10^{-6} \text{ M}$$

$$[\text{H}_3\text{O}^+] = \frac{K_w}{[\text{OH}^-]} = \frac{1.0 \times 10^{-14}}{6.2 \times 10^{-6}} = 1.6 \times 10^{-9} \text{ M}$$

$$\text{pH} = 8.80$$

(d) 50.00 mL of 0.1000 M NaOH added. Calculating the initial amounts of HPr and OH⁻:

$$\text{Initial amount (mol) of HPr} = 0.04000 \text{ L} \times 0.1000 \text{ M} = 0.004000 \text{ mol HPr}$$

$$\text{Amount (mol) of NaOH added} = 0.05000 \text{ L} \times 0.1000 \text{ M} = 0.005000 \text{ mol OH}^-$$

We have this stoichiometry reaction table:

Amount (mol)	HPr(aq)	+	OH ⁻ (aq)	→	Pr ⁻ (aq)	+	H ₂ O(l)
Initial	0.004000		0.005000		0		—
Change	-0.004000		-0.004000		+0.004000		—
Final	0		0.001000		0.004000		—

$$[\text{OH}^-] = \frac{\text{amount (mol) of excess OH}^-}{\text{total volume}} = \frac{0.001000 \text{ mol}}{0.04000 \text{ L} + 0.05000 \text{ L}} = 0.01111 \text{ M}$$

$$[\text{H}_3\text{O}^+] = \frac{K_w}{[\text{OH}^-]} = \frac{1.0 \times 10^{-14}}{0.01111} = 9.0 \times 10^{-13} \text{ M}$$

$$\text{pH} = 12.05$$

Check As expected, the pH increases through the four regions of the titration. Be sure to round off and check the arithmetic along the way.

FOLLOW-UP PROBLEMS

19.4A A chemist titrates 20.00 mL of 0.2000 M HBrO ($K_a = 2.3 \times 10^{-9}$) with 0.1000 M NaOH. What is the pH:

(a) before any base is added?

(b) when $[\text{HBrO}] = [\text{BrO}^-]$?

(c) at the equivalence point?

- (d) when the amount (mol) of OH^- added is twice the amount of HBrO present initially?
 (e) Sketch the titration curve, and label the pK_a and the equivalence point.

19.4B For the titration of 30.00 mL of 0.1000 M benzoic acid ($\text{C}_6\text{H}_5\text{COOH}$; $K_a = 6.3 \times 10^{-5}$) with 0.1500 M NaOH, calculate:

- (a) the initial pH, before the titration begins;
 (b) the pH after the addition of 12.00 mL of base;
 (c) the pH at the equivalence point; and
 (d) the pH after addition of 22.00 mL of base.

SOME SIMILAR PROBLEMS 19.51, 19.53(a), and 19.54(a)

Student Hot Spot

Student data indicate that you may struggle with the calculation of pH during a weak acid-strong base titration. Access the Smartbook to view additional Learning Resources on this topic.

Weak Base–Strong Acid Titration Curves

The opposite of a weak acid–strong base titration is the titration of a weak base (NH_3) with a strong acid (HCl). This titration curve, shown in Figure 19.8, has the *same shape as the weak acid–strong base curve, but it is inverted*.

Thus, we have the same features as the weak acid–strong base curve, but *the pH decreases throughout the process*:

1. *The initial weak-base solution has a pH well above 7.00 since NH_3 in water produces OH^- :*

$[\text{H}_3\text{O}^+]$ can be calculated from the following relationships (see Sample Problem 18.11):

$$K_b = \frac{[\text{NH}_4^+][\text{OH}^-]}{[\text{NH}_3]} \approx \frac{x^2}{[\text{NH}_3]_{\text{init}}} \quad \text{therefore,} \quad x = [\text{OH}^-] \approx \sqrt{K_b \times [\text{NH}_3]_{\text{init}}}$$

$$[\text{H}_3\text{O}^+] \approx \frac{K_w}{[\text{OH}^-]}$$

Titration of 40.00 mL of 0.1000 M NH_3 with 0.1000 M HCl
 $\text{NH}_3(\text{aq}) + \text{HCl}(\text{aq}) \longrightarrow \text{NH}_4\text{Cl}(\text{aq})$

Figure 19.8 Curve for a weak base–strong acid titration.

2. The pH decreases gradually in the buffer region, where significant amounts of NH₃ and its conjugate acid, NH₄⁺, are present. At the midpoint of this region, the pH equals the pK_a of NH₄⁺:

3. The curve drops steeply at the equivalence point. All the NH₃ has reacted with added HCl, and the solution contains only NH₄⁺ and Cl⁻. Note that the pH at the equivalence point is below 7.00 because Cl⁻ does not react with water and NH₄⁺ is acidic:

The pH at the equivalence point is calculated with this relationship:

$$K_a = \frac{[\text{NH}_3][\text{H}_3\text{O}^+]}{[\text{NH}_4^+]} \approx \frac{x^2}{[\text{NH}_4^+]} \quad \text{therefore, } x = [\text{H}_3\text{O}^+] \approx \sqrt{K_a \times [\text{NH}_4^+]}$$

4. The pH decreases slowly beyond the equivalence point as excess H₃O⁺ is added.

$$[\text{H}_3\text{O}^+] = \frac{\text{amount (mol) of excess H}_3\text{O}^+}{\text{total volume}}$$

Monitoring pH with Acid-Base Indicators

An acid-base indicator is a weak organic acid (denoted as HIn) whose color (A) differs from the color (B) of its conjugate base (In⁻) because the two species have slightly different structures. For example, the acid form of the very commonly used indicator phenolphthalein is colorless, while the conjugate base form is pink:

The color change between HIn and In⁻ occurs over a specific, narrow pH range. Typically, either HIn or In⁻ or both are highly colored, so only a tiny amount of indicator is needed, far too little to affect the pH during the titration.

Color Changes of Acid-Base Indicators Figure 19.9 shows the color change(s) and pH range(s) of some acid-base indicators. To select an indicator, you must know the approximate pH of the titration end point, which means you know the ionic species present. Because the indicator is a weak acid, the [In⁻]/[HIn] ratio is governed by the [H₃O⁺] of the solution:

During an acid-base titration, [H₃O⁺] changes and the indicator equilibrium reaction will shift. Thus, the [H₃O⁺] (or pH) of the solution being titrated determines the [In⁻]/[HIn] ratio, which determines the color of the indicator in the solution:

- At lower pH, [H₃O⁺] is higher and the indicator equilibrium lies to the left, so [HIn] >> [In⁻]. The acid color of the indicator is seen when there is at least ten times more HIn than In⁻ or when [In⁻]/[HIn] ≤ 1/10.
- As pH increases, [H₃O⁺] decreases and, according to Le Châtelier's principle, the indicator equilibrium shifts to the right, decreasing [HIn] and increasing [In⁻]. We see a color that is intermediate between the acid and base colors of the indicator when [In⁻]/[HIn] ≈ 1.
- At even higher pH, [H₃O⁺] decreases until the indicator equilibrium is shifted far enough to the right that [In⁻] >> [HIn]. We see the base color of the indicator when [In⁻]/[HIn] ≥ 10/1.

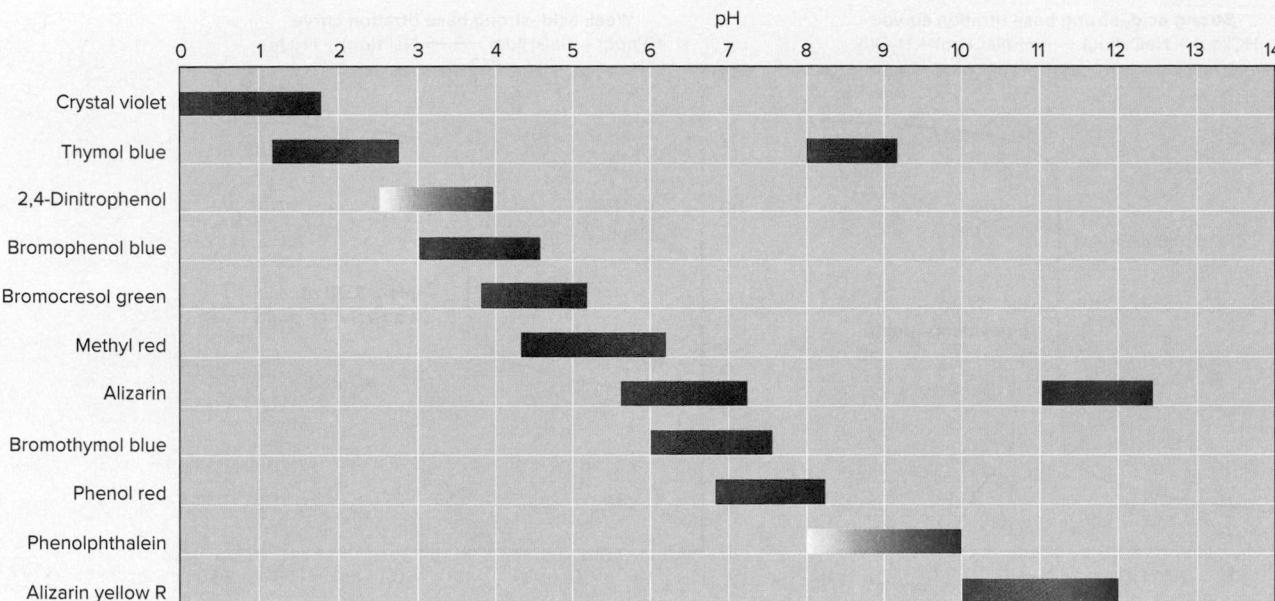

Figure 19.9 Colors and approximate pH ranges of some common acid-base indicators.

The Henderson-Hasselbalch equation relates the ratio of $[In^-]/[HIn]$ to the pK_a of the indicator and the pH of the solution:

$$pH = pK_a + \log\left(\frac{[In^-]}{[HIn]}\right)$$

- When $pH = pK_a - 1$, $\frac{[In^-]}{[HIn]} = 1/10$ and the acid (HIn) color is seen.
- When $pH = pK_a$, $\frac{[In^-]}{[HIn]} = 1$ and the acid (HIn) and base (In^-) colors merge into an intermediate hue.
- When $pH = pK_a + 1$, $\frac{[In^-]}{[HIn]} = 10/1$ and the base (In^-) color is seen.

Thus, an indicator has a *color range* equal to a 10^2 -fold range in the $[In^-]/[HIn]$ ratio (from 1/10, or 0.1, to 10/1, or 10): an *indicator changes color over a range of about 2 pH units approximately centered around its pK_a* :

$$\text{pH of indicator color change} \approx pK_a \text{ of indicator} \pm 1$$

For example, bromothymol blue ($pK_a = 7.0$) has a pH range of about 6.0 to 7.6. As Figure 19.10 shows, it is yellow below a pH of 6.0 (*left*), blue above a pH of 7.6 (*right*), and greenish in between (*center*).

Choosing an Acid-Base Indicator During an acid-base titration, we are generally interested in the *equivalence point* of the titration, which must be distinguished from the *end point*:

- The equivalence point occurs when the number of moles of added OH^- (or H_3O^+) equals the number of moles of H_3O^+ (or OH^-) originally present in the flask.
- The **end point** occurs when the indicator, which we added before the titration began, changes color. We choose an indicator with a color change close to the pH of the equivalence point because we want the visible end point to signal the invisible equivalence point.

Figure 19.11 on the next page shows titration curves for the three titrations we examined earlier in this section, with the color change of two indicators, methyl red and phenolphthalein, superimposed on the curves. Figure 19.11A shows that both indicators are suitable for a strong acid-strong base titration. Methyl red changes from red at pH 4.2 to yellow at pH 6.3, and phenolphthalein changes from colorless at pH 8.3 to pink at pH 10.0. Neither change occurs at the equivalence point (pH = 7.00), but both occur on the

Figure 19.10 The color change of the indicator bromothymol blue.

Source: © McGraw-Hill Education/Stephen Frisch, photographer

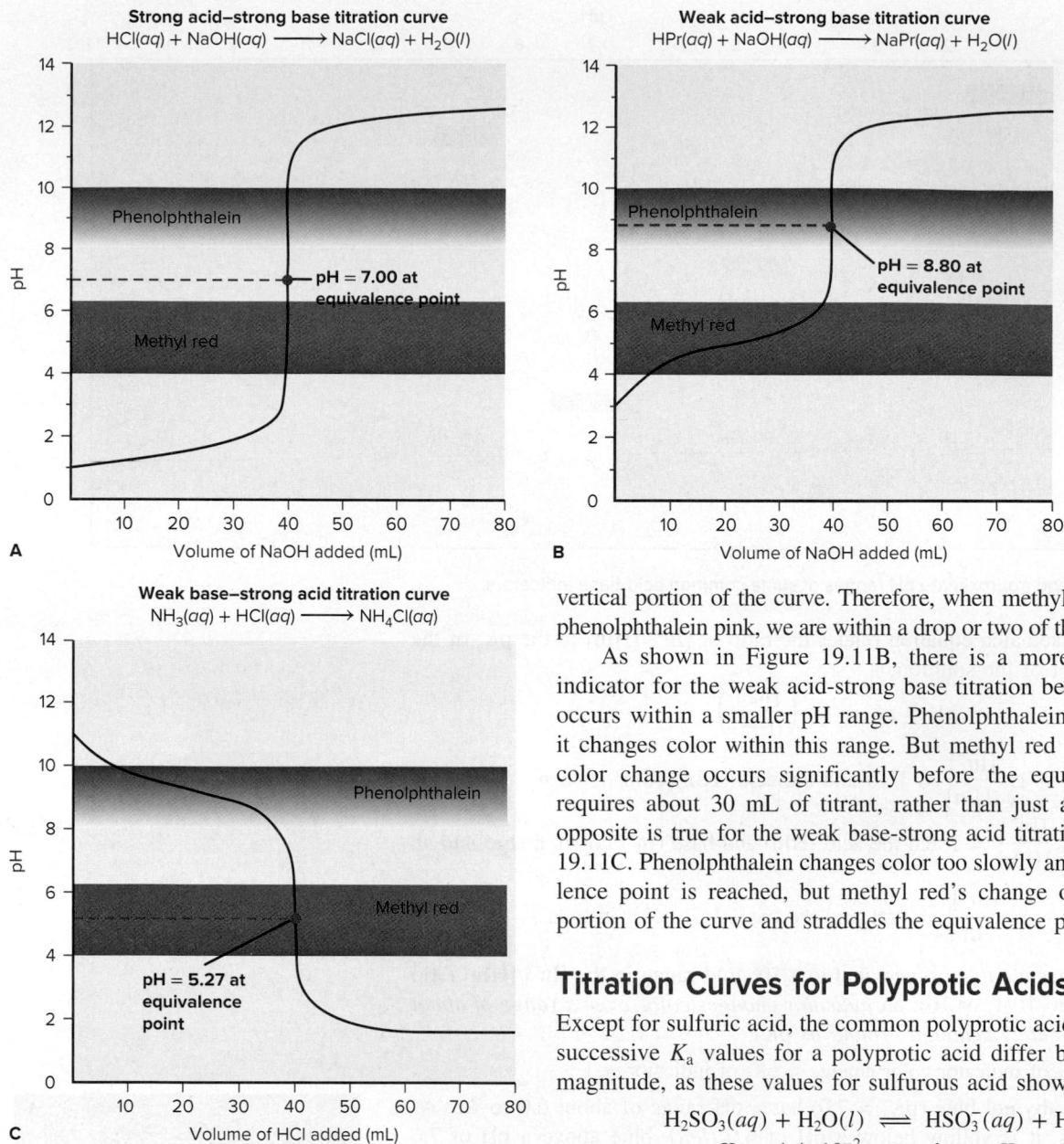

Figure 19.11 Acid-base indicator selection for different acid-base titrations.

vertical portion of the curve. Therefore, when methyl red turns yellow or phenolphthalein pink, we are within a drop or two of the equivalence point.

As shown in Figure 19.11B, there is a more limited choice of indicator for the weak acid-strong base titration because the steep rise occurs within a smaller pH range. Phenolphthalein will work because it changes color within this range. But methyl red will not because its color change occurs significantly before the equivalence point and requires about 30 mL of titrant, rather than just a drop or two. The opposite is true for the weak base-strong acid titration shown in Figure 19.11C. Phenolphthalein changes color too slowly and before the equivalence point is reached, but methyl red's change occurs on the steep portion of the curve and straddles the equivalence point.

Titration Curves for Polyprotic Acids

Except for sulfuric acid, the common polyprotic acids are all weak. The successive K_a values for a polyprotic acid differ by several orders of magnitude, as these values for sulfurous acid show:

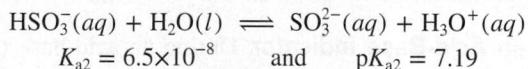

In a titration of a diprotic acid such as H_2SO_3 , two OH^- ions are required to react with the two H^+ ions of each acid molecule. Figure 19.12 shows the titration curve for sulfurous acid with strong base. Because of the large difference in K_a values, each mole of H^+ is titrated separately, so H_2SO_3 molecules lose one H^+ before any HSO_3^- ions do:

Several features of the curve are

- The same amount of base ($0.004000 \text{ mol OH}^-$) is required per mole of H^+ .
- There are two equivalence points and two buffer regions. The pH at the midpoint of each buffer region is equal to the pK_a of the acidic species present then.
- The pH of the first equivalence point is below 7.00, because HSO_3^- is a stronger acid than it is a base (K_a of $\text{HSO}_3^- = 6.5 \times 10^{-8}$; K_b of $\text{HSO}_3^- = 7.1 \times 10^{-13}$).
- The pH of the second equivalence point is above 7.00, because SO_3^{2-} acts as a weak base and accepts a proton from H_2O to yield OH^- .

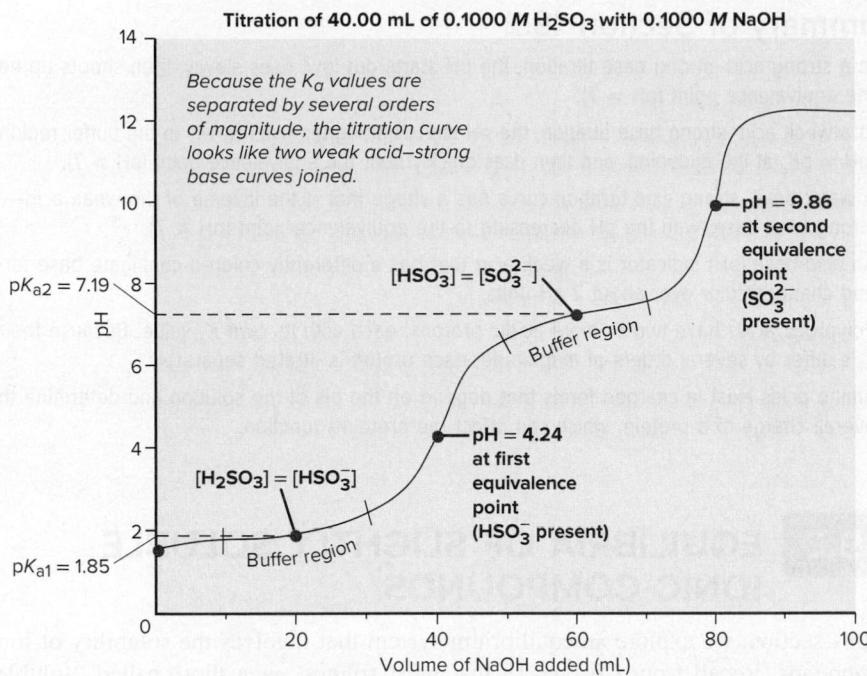

Figure 19.12 Curve for the titration of a weak polyprotic acid.

Amino Acids as Biological Polyprotic Acids

Amino acids have the general formula $\text{NH}_2-\text{CH}(\text{R})-\text{COOH}$, where R can be one of about 20 different groups (Sections 13.2 and 15.6). In essence, amino acids contain a weak base ($-\text{NH}_2$) and a weak acid ($-\text{COOH}$) on the same molecule. Both the amino and carboxylic acid groups are protonated at low pH: $^+\text{NH}_3^+-\text{CH}(\text{R})-\text{COOH}$. Thus, in this form, the amino acid behaves like a polyprotic acid. For glycine, the simplest amino acid (R = H), the dissociation reactions and pK_a values are

These values show that the $-\text{COOH}$ group is *much* more acidic than the $-\text{NH}_3^+$ group. As we saw with H_2SO_3 , the acidic protons (black circles) are titrated separately, so all the $-\text{COOH}$ protons are removed before any $-\text{NH}_3^+$ protons are:

Thus, at physiological pH (~7), which is between the two pK_a values, *an amino acid exists as a zwitterion* (German *zwitter*, “double”), a species with opposite charges on the same molecule; the zwitterion of glycine is $^+\text{NH}_3^+\text{CH}_2\text{COO}^-$.

Of the 20 different R groups of amino acids, several have *additional* $-\text{COO}^-$ or $-\text{NH}_3^+$ groups at pH 7 (see Figure 15.30). When amino acids link to form a protein, their charged R groups give the protein its overall charge, which is often related to its function. A widely studied example of this relationship occurs in the hereditary disease sickle cell anemia. Normal red blood cells contain hemoglobin molecules that have two glutamic acid R groups ($-\text{CH}_2\text{CH}_2\text{COO}^-$), each providing a negative charge at a critical region. Abnormal hemoglobin molecules in sickle cell anemia have two valine R groups ($-\text{CH}_3$), which are uncharged, at the same region. This change in just 2 of hemoglobin’s 574 amino acids lowers charge repulsions between the hemoglobin molecules. As a result, they clump together in fiber-like structures, which leads to the sickle shape of the red blood cells (Figure 19.13). The misshapen cells block capillaries, and the painful course of sickle cell anemia usually ends in early death.

Figure 19.13 Abnormal shape of red blood cells in sickle cell anemia.

Source: © Jackie Lewin, Royal Free Hospital/Science Source

› Summary of Section 19.2

- › In a strong acid–strong base titration, the pH starts out low, rises slowly, then shoots up near the equivalence point ($\text{pH} = 7$).
- › In a weak acid–strong base titration, the pH starts out higher, rises slowly in the buffer region ($\text{pH} = \text{p}K_a$ at the midpoint), and then rises quickly near the equivalence point ($\text{pH} > 7$).
- › A weak base–strong acid titration curve has a shape that is the inverse of the weak acid–strong base case, with the pH decreasing to the equivalence point ($\text{pH} < 7$).
- › An acid-base (pH) indicator is a weak acid that has a differently colored conjugate base form and changes color over about 2 pH units.
- › Polyprotic acids have two or more acidic protons, each with its own K_a value. Because the K_a 's differ by several orders of magnitude, each proton is titrated separately.
- › Amino acids exist in charged forms that depend on the pH of the solution and determine the overall charge of a protein, which can affect the protein's function.

19.3 EQUILIBRIA OF SLIGHTLY SOLUBLE IONIC COMPOUNDS

In this section, we explore an equilibrium system that involves the solubility of ionic compounds. Recall from Chapter 13 that most solutes, even those called “soluble,” have a limited solubility in a particular solvent. In a saturated solution at a particular temperature, equilibrium exists between dissolved and undissolved solute. Slightly soluble ionic compounds, which we’ve been calling “insoluble,” reach equilibrium with very little solute dissolved. In this introductory discussion, we will *assume* that, as with a soluble ionic compound, the small amount of a slightly soluble ionic compound that does dissolve dissociates completely into ions.

The Ion-Product Expression (Q_{sp}) and the Solubility-Product Constant (K_{sp})

For a slightly soluble ionic compound, *equilibrium exists between solid solute and aqueous ions*. Thus, for example, for a saturated solution of lead(II) fluoride, we have

As for any equilibrium system, we can write a reaction quotient:

$$Q_c = \frac{[\text{Pb}^{2+}][\text{F}^-]^2}{[\text{PbF}_2]}$$

And, as in earlier cases, the concentration term for the pure solid, $[\text{PbF}_2]$ in this case, equals 1, and so we obtain a relationship called the *ion-product expression*, Q_{sp} :

$$Q_c \times 1 = Q_{\text{sp}} = [\text{Pb}^{2+}][\text{F}^-]^2$$

When the solution is saturated, the numerical value of Q_{sp} attains a constant value called the **solubility-product constant**, K_{sp} . The K_{sp} for PbF_2 at 25°C , for example, is 3.6×10^{-8} . Like other equilibrium constants, K_{sp} depends *only* on the temperature, not on the individual ion concentrations.

The form of Q_{sp} is identical to that of other reaction quotients: each concentration is raised to an exponent equal to the coefficient for that species in the balanced equation, which in this case also *equals the subscript of each ion in the compound's formula*. At saturation, the concentration terms have their equilibrium values. Thus, in general, for a slightly soluble ionic compound, M_pX_q , composed of the ions M^{n+} and X^{z-} , the ion-product expression at equilibrium is

$$Q_{\text{sp}} = [\text{M}^{n+}]^p[\text{X}^{z-}]^q = K_{\text{sp}}$$

(19.2)

We'll write Q_{sp} directly using the symbol K_{sp} .

SAMPLE PROBLEM 19.5**Writing Ion-Product Expressions**

Problem Write the ion-product expression at equilibrium for each compound:

(a) magnesium carbonate; (b) iron(II) hydroxide; (c) calcium phosphate; (d) silver sulfide.

Plan We write an equation for a saturated solution and then write the ion-product expression at equilibrium, K_{sp} (Equation 19.2).

Solution (a) Magnesium carbonate:

(b) Iron(II) hydroxide:

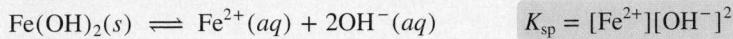

(c) Calcium phosphate:

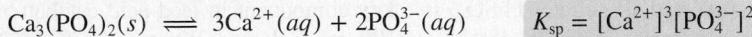

(d) Silver sulfide:

Check You can check by using the exponents as subscripts to see if you obtain the formula of the compound from K_{sp} .

Comment The S^{2-} ion in Ag_2S in part (d) is so basic that it reacts completely with water to form the hydrogen sulfide ion (HS^-) and OH^- :

We more correctly write the ion-product expression for Ag_2S (and other metal sulfides) by replacing $[\text{S}^{2-}]$ with $[\text{HS}^-][\text{OH}^-]$:

However, as a simplification, we will present the ion-product expression for a metal sulfide in terms of $[\text{S}^{2-}]$, as shown in part (d) of this sample problem.

FOLLOW-UP PROBLEMS

19.5A Write the ion-product expression at equilibrium for each compound: (a) calcium sulfate; (b) chromium(III) carbonate; (c) magnesium hydroxide; (d) aluminum hydroxide.

19.5B Write the formula and give the name of the compound having each ion-product expression: (a) $K_{\text{sp}} = [\text{Pb}^{2+}][\text{CrO}_4^{2-}]$; (b) $K_{\text{sp}} = [\text{Fe}^{2+}][\text{S}^{2-}]$; (c) $K_{\text{sp}} = [\text{Sr}^{2+}][\text{F}^-]^2$; (d) $K_{\text{sp}} = [\text{Cu}^{2+}]^3[\text{PO}_4^{3-}]^2$.

SOME SIMILAR PROBLEMS 19.67–19.70**Calculations Involving the Solubility-Product Constant**

In Chapters 17 and 18, we considered two types of equilibrium problems. In one type, we use concentrations (or other quantities) to find K , and in the other, we use K to find concentrations. Here we encounter the same two types.

The Problem with Assuming Complete Dissociation Before we focus on calculations, let's address a complication that affects accuracy and results in approximate answers. Our assumption that the small dissolved amount of these compounds dissociates completely into separate ions is an oversimplification. Many slightly soluble salts have polar covalent metal-nonmetal bonds (Section 9.5), and partially dissociated or even undissociated species occur in solution. Here are two of many examples:

- With slightly soluble lead(II) chloride, the aqueous solution contains not only the separate $\text{Pb}^{2+}(aq)$ and $\text{Cl}^-(aq)$ ions we expect from complete dissociation, but also undissociated $\text{PbCl}_2(aq)$ molecules and $\text{PbCl}^+(aq)$ ions.
- In an aqueous solution of CaSO_4 , undissociated ion pairs, $\text{Ca}^{2+}\text{SO}_4^{2-}(aq)$, are present.

These partly dissociated and undissociated species increase the *apparent* solubility of a slightly soluble salt above the value obtained by assuming complete dissociation.

Table 19.2

Solubility-Product Constants (K_{sp}) of Selected Ionic Compounds at 25°C

Name, Formula	K_{sp}
Aluminum hydroxide, $\text{Al}(\text{OH})_3$	3×10^{-34}
Cobalt(II) carbonate, CoCO_3	1.0×10^{-10}
Iron(II) hydroxide, $\text{Fe}(\text{OH})_2$	4.1×10^{-15}
Lead(II) fluoride, PbF_2	3.6×10^{-8}
Lead(II) sulfate, PbSO_4	1.6×10^{-8}
Mercury(I) iodide, Hg_2I_2	4.7×10^{-29}
Silver sulfide, Ag_2S	8×10^{-48}
Zinc iodate, $\text{Zn}(\text{IO}_3)_2$	3.9×10^{-6}

More advanced courses discuss these factors, but we simply mention them in the Comments of several sample problems. Thus, it is best to view the specific results of the calculations as first approximations.

The Meaning of K_{sp} and How to Determine It from Solubility Values The K_{sp} value indicates *how far the dissolution proceeds at equilibrium (saturation)*. Table 19.2 presents a few K_{sp} values; Appendix C lists many more. Note that all the values are low, but they range over many orders of magnitude. In Sample Problem 19.6, we find the K_{sp} from the solubility of a compound.

SAMPLE PROBLEM 19.6

Determining K_{sp} from Solubility

Problem (a) Lead(II) sulfate (PbSO_4) is a key component in lead-acid car batteries. Its solubility in water at 25°C is 4.25×10^{-3} g/100. mL solution. What is the K_{sp} of PbSO_4 ? (b) When lead(II) fluoride (PbF_2) is shaken with pure water at 25°C, the solubility is found to be 0.64 g/L. Calculate the K_{sp} of PbF_2 .

Plan We are given solubilities in various units and must find K_{sp} values. As always, we write the dissolution equation and ion-product expression for each compound, which show the number of moles of each ion. We use the molar mass to convert the solubility of the compound from the given mass units to *molar solubility* (molarity), then use that value to find the molarity of each ion, and substitute into the ion-product expression to calculate K_{sp} .

Solution (a) For PbSO_4 . Writing the equation and ion-product (K_{sp}) expression:

Converting solubility to molar solubility:

$$\begin{aligned} \text{Molar solubility of } \text{PbSO}_4 &= \frac{0.00425 \text{ g PbSO}_4}{100. \text{ mL soln}} \times \frac{1000 \text{ mL}}{1 \text{ L}} \times \frac{1 \text{ mol PbSO}_4}{303.3 \text{ g PbSO}_4} \\ &= 1.40 \times 10^{-4} \text{ M PbSO}_4 \end{aligned}$$

Determining molarities of the ions: Because 1 mol of Pb^{2+} and 1 mol of SO_4^{2-} form when 1 mol of PbSO_4 dissolves, $[\text{Pb}^{2+}] = [\text{SO}_4^{2-}] = 1.40 \times 10^{-4} \text{ M}$.

Substituting these values into the ion-product expression to calculate K_{sp} :

$$K_{sp} = [\text{Pb}^{2+}][\text{SO}_4^{2-}] = (1.40 \times 10^{-4})^2 = 1.96 \times 10^{-8}$$

(b) For PbF_2 . Writing the equation and K_{sp} expression:

Converting solubility to molar solubility:

$$\text{Molar solubility of } \text{PbF}_2 = \frac{0.64 \text{ g PbF}_2}{1 \text{ L soln}} \times \frac{1 \text{ mol PbF}_2}{245.2 \text{ g PbF}_2} = 2.6 \times 10^{-3} \text{ M PbF}_2$$

Determining molarities of the ions: Since 1 mol of Pb^{2+} and 2 mol of F^- form when 1 mol of PbF_2 dissolves, we have

$$[\text{Pb}^{2+}] = 2.6 \times 10^{-3} \text{ M} \quad \text{and} \quad [\text{F}^-] = 2(2.6 \times 10^{-3} \text{ M}) = 5.2 \times 10^{-3} \text{ M}$$

Substituting these values into the ion-product expression to calculate K_{sp} :

$$K_{sp} = [\text{Pb}^{2+}][\text{F}^-]^2 = (2.6 \times 10^{-3})(5.2 \times 10^{-3})^2 = 7.0 \times 10^{-8}$$

Check The low solubilities are consistent with K_{sp} values being small. (a) The molar solubility seems about right: $\sim \frac{4 \times 10^{-2} \text{ g/L}}{3 \times 10^2 \text{ g/mol}} \approx 1.3 \times 10^{-4} \text{ M}$. Squaring this number gives 1.7×10^{-8} , close to the calculated K_{sp} . (b) Let's check the math in the final step as follows: $\sim (3 \times 10^{-3})(5 \times 10^{-3})^2 = 7.5 \times 10^{-8}$, close to the calculated K_{sp} .

Comment 1. In part (b), the formula PbF_2 means that $[\text{F}^-]$ is twice $[\text{Pb}^{2+}]$. We follow the ion-product expression exactly and square this value of $[\text{F}^-]$.

- The tabulated K_{sp} values for these compounds (Table 19.2) are lower than our calculated values. For PbF_2 , for instance, the tabulated value is 3.6×10^{-8} , but we calculated 7.0×10^{-8} from solubility data. The discrepancy arises because we assumed that PbF_2 in solution dissociates completely to Pb^{2+} and F^- . Here is an example of the

complication pointed out earlier. Actually, about a third of the PbF_2 dissolves as $\text{PbF}^+(aq)$ and a small amount dissolves as undissociated $\text{PbF}_2(aq)$. The solubility given in the problem statement (0.64 g/L) is determined experimentally and includes these other species, which we did *not* include in our calculation.

FOLLOW-UP PROBLEMS

19.6A When fluorite (CaF_2 ; *see photo*) is pulverized and shaken in water at 18°C , 10.0 mL of the solution contains 1.5×10^{-4} g of solute. Find the K_{sp} of CaF_2 at 18°C .

19.6B At 20°C , 3.2×10^{-4} g of silver phosphate (Ag_3PO_4) is soluble in 50. mL of solution. Find the K_{sp} of Ag_3PO_4 at 20°C .

SOME SIMILAR PROBLEMS 19.71–19.74

A sample of fluorite.

Source: © Joel Arem/Science Source

Determining Solubility from K_{sp} The reverse of Sample Problem 19.6 involves finding the solubility of a compound based on its formula and K_{sp} value. We'll use an approach similar to the one we used for weak acids in Sample Problem 18.8: we define the unknown amount dissolved—the molar solubility—as S , include ion concentrations in terms of this unknown in a reaction table, and solve for S .

SAMPLE PROBLEM 19.7

Determining Solubility from K_{sp}

Problem Calcium hydroxide (slaked lime) is a major component of mortar, plaster, and cement, and solutions of $\text{Ca}(\text{OH})_2$ are used in industry as a strong, inexpensive base. Calculate the molar solubility of $\text{Ca}(\text{OH})_2$ in water given that the K_{sp} is 6.5×10^{-6} .

Plan We write the dissolution equation and the ion-product expression. We know K_{sp} (6.5×10^{-6}), so to find molar solubility (S), we set up a reaction table that expresses $[\text{Ca}^{2+}]$ and $[\text{OH}^-]$ in terms of S , substitute into the ion-product expression, and solve for S .

Solution Writing the equation and ion-product expression:

Setting up a reaction table, with S = molar solubility:

Concentration (M)	$\text{Ca}(\text{OH})_2(s)$	\rightleftharpoons	$\text{Ca}^{2+}(aq)$	+	$2\text{OH}^-(aq)$
Initial	—		0		0
Change	—		+S		+2S
Equilibrium	—		S		2S

Substituting into the ion-product expression and solving for S :

$$K_{\text{sp}} = [\text{Ca}^{2+}][\text{OH}^-]^2 = (S)(2S)^2 = (S)(4S^2) = 4S^3 = 6.5 \times 10^{-6}$$

$$S = \sqrt[3]{\frac{6.5 \times 10^{-6}}{4}} = 1.2 \times 10^{-2} \text{ M}$$

Check We expect a low solubility from a slightly soluble salt. If we reverse the calculation, we should obtain the given K_{sp} : $4(1.2 \times 10^{-2})^3 = 6.9 \times 10^{-6}$, which is close to 6.5×10^{-6} .

Comment 1. Note that we did not double and *then* square $[\text{OH}^-]$. $2S$ is the $[\text{OH}^-]$, so we just squared it, as the ion-product expression required.

2. Once again, we assumed that the solid dissociates completely. Actually, the solubility is increased to about $2.0 \times 10^{-2} \text{ M}$ by the presence of $\text{CaOH}^+(aq)$ formed in the reaction $\text{Ca}(\text{OH})_2(s) \rightleftharpoons \text{CaOH}^+(aq) + \text{OH}^-(aq)$. Our calculated answer is only approximate because we did not take this other species into account.

FOLLOW-UP PROBLEMS

19.7A Milk of magnesia, a suspension of $\text{Mg}(\text{OH})_2$ in water, relieves indigestion by neutralizing stomach acid. What is the molar solubility of $\text{Mg}(\text{OH})_2$ ($K_{\text{sp}} = 6.3 \times 10^{-10}$) in water?

19.7B Calcium phosphate, $\text{Ca}_3(\text{PO}_4)_2$, is used as a dietary supplement to treat low blood calcium. What is the molar solubility of $\text{Ca}_3(\text{PO}_4)_2$ ($K_{\text{sp}} = 1.2 \times 10^{-29}$) in water?

SOME SIMILAR PROBLEMS 19.75(a) and 19.76(a)

Table 19.3

Relationship Between K_{sp} and Solubility at 25°C

No. of Ions	Formula	Cation/Anion	K_{sp}	Solubility (M)
2	MgCO ₃	1/1	3.5×10^{-8}	1.9×10^{-4}
2	PbSO ₄	1/1	1.6×10^{-8}	1.3×10^{-4}
2	BaCrO ₄	1/1	2.1×10^{-10}	1.4×10^{-5}
3	Ca(OH) ₂	1/2	6.5×10^{-6}	1.2×10^{-2}
3	BaF ₂	1/2	1.5×10^{-6}	7.2×10^{-3}
3	CaF ₂	1/2	3.2×10^{-11}	2.0×10^{-4}
3	Ag ₂ CrO ₄	2/1	2.6×10^{-12}	8.7×10^{-5}

Using K_{sp} Values to Compare Solubilities As long as we compare compounds with the *same total number of ions* in their formulas, K_{sp} values indicate *relative solubility: the higher the K_{sp} , the greater the solubility* (Table 19.3). Note that for compounds that form three ions, the relationship holds whether the cation/anion ratio is 1/2 or 2/1, because the mathematical expression containing S is the same ($4S^3$) in the calculation (see Sample Problem 19.7).

Effect of a Common Ion on Solubility

From Le Châtelier's principle (Section 17.6), we know that *adding a common ion decreases the solubility of a slightly soluble ionic compound*. Consider a saturated solution of lead(II) chromate:

At a given temperature, K_{sp} depends on the product of the ion concentrations. If the concentration of either ion goes up, the other goes down to maintain K_{sp} . Suppose we add Na₂CrO₄, a soluble salt, to the saturated PbCrO₄ solution. The concentration of the common ion, CrO₄²⁻, increases, and some of it combines with Pb²⁺ ion to form more solid PbCrO₄ (Figure 19.14). That is, the equilibrium position shifts to the left:

As a result of the addition, [Pb²⁺] is lower. And, since [Pb²⁺] defines the solubility of PbCrO₄, in effect, the solubility of PbCrO₄ has decreased. Note that we would get the same result if Na₂CrO₄ solution were the solvent; that is, PbCrO₄ is more soluble in water than in aqueous Na₂CrO₄.

Figure 19.14 The effect of a common ion on solubility.

Source: © McGraw-Hill Education/Stephen Frisch, photographer

SAMPLE PROBLEM 19.8**Calculating the Effect of a Common Ion on Solubility**

Problem In Sample Problem 19.7, we calculated the solubility of $\text{Ca}(\text{OH})_2$ in water. What is its solubility in 0.10 M $\text{Ca}(\text{NO}_3)_2$ (K_{sp} of $\text{Ca}(\text{OH})_2 = 6.5 \times 10^{-6}$)?

Plan Addition of Ca^{2+} , the common ion, should lower the solubility. We write the equation and ion-product expression and set up a reaction table, with $[\text{Ca}^{2+}]_{\text{init}}$ reflecting the 0.10 M $\text{Ca}(\text{NO}_3)_2$ and S equal to $[\text{Ca}^{2+}]_{\text{from Ca(OH)}_2}$. To simplify the math, we assume that, because K_{sp} is low, S is so small relative to $[\text{Ca}^{2+}]_{\text{init}}$ that it can be neglected. Then we solve for S and check the assumption.

Solution $\text{Ca}(\text{NO}_3)_2$ is a soluble salt that dissociates completely in water; in a solution of 0.10 M $\text{Ca}(\text{NO}_3)_2$, $[\text{Ca}^{2+}] = 0.10\text{ M}$, and NO_3^- is a spectator ion that does not affect the solubility of $\text{Ca}(\text{OH})_2$.

Writing the equation and ion-product expression for $\text{Ca}(\text{OH})_2$:

Setting up the reaction table, with $S = [\text{Ca}^{2+}]_{\text{from Ca(OH)}_2}$:

Concentration (M)	$\text{Ca}(\text{OH})_2(s)$	\rightleftharpoons	$\text{Ca}^{2+}(aq)$	+	$2\text{OH}^-(aq)$
Initial	—		0.10 (from $\text{Ca}(\text{NO}_3)_2$)	0	
Change	—		+ S (from $\text{Ca}(\text{OH})_2$)	+ $2S$	
Equilibrium	—		0.10 + S	2 S	

Making the assumption: K_{sp} is small, so $S \ll 0.10\text{ M}$; thus, $0.10\text{ M} + S \approx 0.10\text{ M}$. Substituting into the ion-product expression and solving for S :

$$K_{\text{sp}} = [\text{Ca}^{2+}][\text{OH}^-]^2 = 6.5 \times 10^{-6} \approx (0.10)(2S)^2$$

$$\text{Therefore, } 4S^2 \approx \frac{6.5 \times 10^{-6}}{0.10} \quad \text{so} \quad S \approx \sqrt{\frac{6.5 \times 10^{-5}}{4}} = 4.0 \times 10^{-3}\text{ M}$$

Checking the assumption by comparing the magnitude of S to 0.10 M :

$$\frac{4.0 \times 10^{-3}\text{ M}}{0.10\text{ M}} \times 100 = 4.0\% < 5\%$$

Check In Sample Problem 19.7, the solubility of $\text{Ca}(\text{OH})_2$ was 0.012 M ; here it is 0.0040 M , one-third as much. As expected, the solubility *decreased* in the presence of added Ca^{2+} , the common ion.

FOLLOW-UP PROBLEMS

19.8A To improve the x-ray image used to diagnose an intestinal disorder, a patient drinks an aqueous suspension of BaSO_4 , because Ba^{2+} is opaque to x-rays (photo). However, Ba^{2+} is also toxic; thus, $[\text{Ba}^{2+}]$ is lowered by adding dilute Na_2SO_4 . What is the solubility of BaSO_4 ($K_{\text{sp}} = 1.1 \times 10^{-10}$) in (a) water and (b) 0.10 M Na_2SO_4 ?

19.8B Calculate the solubility of CaF_2 ($K_{\text{sp}} = 3.2 \times 10^{-11}$) in (a) water, (b) 0.20 M CaCl_2 , and (c) 0.20 M NiF_2 .

SOME SIMILAR PROBLEMS 19.75(b), 19.76(b), 19.77, and 19.78**Student Hot Spot**

Student data indicate that you may struggle with solubility calculations involving a common ion. Access the Smartbook to view additional Learning Resources on this topic.

BaSO_4 imaging of a large intestine.

Source: © CNRI/Science Source

Effect of pH on Solubility

If a slightly soluble ionic compound contains the anion of a weak acid, *addition of H_3O^+ (from a strong acid) increases the compound's solubility*. Once again, Le Châtelier's principle explains why. Consider a saturated solution of calcium carbonate:

Adding strong acid introduces H_3O^+ , which reacts with the anion of a weak acid, CO_3^{2-} , to form the anion of another weak acid, HCO_3^- :

Figure 19.15 Test for the presence of a carbonate. When a carbonate mineral is treated with HCl, bubbles of CO₂ form.
Source: © McGraw-Hill Education/Stephen Frisch, photographer

If enough H₃O⁺ is added, carbonic acid forms, which decomposes to H₂O and CO₂, and the gas escapes the container:

The net effect of adding H₃O⁺ is a shift in the equilibrium position to the right, and more CaCO₃ dissolves:

In fact, this example illustrates a qualitative field test for carbonate minerals because the CO₂ bubbles vigorously (Figure 19.15).

In contrast, adding H₃O⁺ to a saturated solution of a slightly soluble ionic compound that contains a strong-acid anion, such as AgCl, has no effect on its solubility:

The Cl⁻ ion can coexist with high [H₃O⁺], so the equilibrium position is not affected.

SAMPLE PROBLEM 19.9

Predicting the Effect on Solubility of Adding Strong Acid

Problem Write balanced equations to explain whether addition of H₃O⁺ from a strong acid affects the solubility of each ionic compound:

- (a) Lead(II) bromide (b) Copper(II) hydroxide (c) Iron(II) sulfide

Plan We write the balanced dissolution equation and note the anion:

- Weak-acid anions react with H₃O⁺ and increase solubility when a strong acid is added.
- Strong-acid anions do not react with H₃O⁺, so addition of a strong acid has no effect.

Solution (a) $\text{PbBr}_2(s) \rightleftharpoons \text{Pb}^{2+}(aq) + 2\text{Br}^-(aq)$

No effect. Br⁻ is the anion of HBr, a strong acid, so it does not react with H₃O⁺.

(b) $\text{Cu}(\text{OH})_2(s) \rightleftharpoons \text{Cu}^{2+}(aq) + 2\text{OH}^-(aq)$

Increases solubility. OH⁻ is the anion of H₂O, a very weak acid, so it reacts with the added H₃O⁺:

As OH⁻ is removed from solution by this reaction, the solubility equilibrium shifts to the right and additional Cu(OH)₂ dissolves.

(c) $\text{FeS}(s) \rightleftharpoons \text{Fe}^{2+}(aq) + \text{S}^{2-}(aq)$

Increases solubility. S²⁻ is the anion of the weak acid HS⁻, so it reacts with the added H₃O⁺, removing it from solution; the solubility equilibrium shifts to the right and additional FeS dissolves:

FOLLOW-UP PROBLEMS

19.9A Write balanced equations to show how addition of HNO₃(aq) affects the solubility of: (a) calcium fluoride; (b) iron(III) hydroxide; (c) silver iodide.

19.9B Write balanced equations to show how addition of HBr(aq) affects the solubility of: (a) silver cyanide; (b) copper(I) chloride; (c) magnesium phosphate.

SOME SIMILAR PROBLEMS

19.83–19.86

Applying Ionic Equilibria to the Formation of a Limestone Cave

Limestone caves and the remarkable structures within them provide striking evidence of the results of aqueous ionic equilibria involving carbonate rocks and the carbon dioxide and water that have flowed through them for many hundreds of millennia (Figure 19.16).

Figure 19.16 Limestone cave in Nerja, Málaga, Spain.

Source: © Ruth Melnick

The Cave-Forming Reactions Limestone is mostly calcium carbonate (CaCO_3 ; $K_{\text{sp}} = 3.3 \times 10^{-9}$). Two key reactions help us understand how limestone caves form:

1. Gaseous CO_2 in air is in equilibrium with aqueous CO_2 in natural waters:

The concentration of aqueous CO_2 is proportional to the partial pressure of $\text{CO}_2(g)$ in contact with the water (Henry's law; Section 13.4):

$$[\text{CO}_2(aq)] \propto P_{\text{CO}_2}$$

Due to the continual release of CO_2 from within Earth (outgassing), P_{CO_2} in soil-trapped air is *higher* than P_{CO_2} in the atmosphere.

2. The reaction of CO_2 with water produces H_3O^+ :

Thus, since CaCO_3 contains the anion of a weak acid, this formation of H_3O^+ increases the solubility of CaCO_3 :

The Cave-Forming Process Here is an overview of the process that forms most limestone caves:

1. As surface water trickles through cracks in the ground, it meets soil-trapped air with a high P_{CO_2} . As a result, $[\text{CO}_2(aq)]$ increases (equation 1 shifts to the right), and the solution becomes more acidic.
2. When this CO_2 -rich water contacts CaCO_3 , more CaCO_3 dissolves (equation 2 shifts to the right). As a result, more rock is carved out, more water flows in, and so on. Centuries pass, and a cave slowly begins to form.
3. Some of the aqueous solution, dilute $\text{Ca}(\text{HCO}_3)_2$, passes through the ceiling of the growing cave. As it drips, it meets air, which has a lower P_{CO_2} than the soil, so some $\text{CO}_2(aq)$ comes out of solution (equation 1 shifts to the left).
4. Consequently, some CaCO_3 precipitates on the ceiling and on the floor below, where the drops land (equation 2 shifts to the left). After many decades, the ceiling bears a *stalactite*, while a spike, called a *stalagmite*, grows up from the floor. Eventually, they meet to form a column of precipitated limestone.

The same chemical process can lead to different shapes. Standing pools of $\text{Ca}(\text{HCO}_3)_2$ solution form limestone “lily pads” or “corals.” Cascades of solution form delicate limestone “draperies” on a cave wall, with fabulous colors arising from trace metal ions, such as iron (reddish brown) or copper (bluish green).

Predicting the Formation of a Precipitate: Q_{sp} vs. K_{sp}

As in Section 17.4, here we compare the values of Q_{sp} and K_{sp} to see if a reaction has reached equilibrium and, if not, in which net direction it will progress until it does. Using solutions of *soluble* salts that contain the ions of *slightly* soluble salts, we can calculate the ion concentrations and predict the result when we mix the solutions:

- If $Q_{\text{sp}} = K_{\text{sp}}$, the solution is saturated and no change will occur.
- If $Q_{\text{sp}} > K_{\text{sp}}$, a precipitate will form until the remaining solution is saturated.
- If $Q_{\text{sp}} < K_{\text{sp}}$, no precipitate will form because the solution is unsaturated.

SAMPLE PROBLEM 19.10

Predicting Whether a Precipitate Will Form

Problem A common laboratory method for preparing a precipitate is to mix solutions containing the component ions. Does a precipitate form when 0.100 L of 0.30 M $\text{Ca}(\text{NO}_3)_2$ is mixed with 0.200 L of 0.060 M NaF ?

Plan First, we decide which slightly soluble salt could form, look up its K_{sp} value in Appendix C, and write a dissolution equation and ion-product expression. To see

Precipitation of CaF_2

Source: © McGraw-Hill Education/
Stephen Frisch, photographer

whether mixing these solutions forms the precipitate, we find the initial ion concentrations by calculating the amount (mol) of each ion from its concentration and volume, and dividing by the *total* volume because each solution dilutes the other. Finally, we substitute these concentrations to calculate Q_{sp} , and compare Q_{sp} with K_{sp} .

Solution The ions present are Ca^{2+} , Na^+ , F^- , and NO_3^- . All sodium and all nitrate salts are soluble (Table 4.1), so the only possible compound that could precipitate is CaF_2 ($K_{\text{sp}} = 3.2 \times 10^{-11}$). Writing the equation and ion-product expression:

Calculating the ion concentrations:

$$\text{Amount (mol) of } \text{Ca}^{2+} = 0.30 \text{ M } \text{Ca}^{2+} \times 0.100 \text{ L} = 0.030 \text{ mol } \text{Ca}^{2+}$$

$$[\text{Ca}^{2+}]_{\text{init}} = \frac{0.030 \text{ mol } \text{Ca}^{2+}}{0.100 \text{ L} + 0.200 \text{ L}} = 0.10 \text{ M } \text{Ca}^{2+}$$

$$\text{Amount (mol) of } \text{F}^- = 0.060 \text{ M } \text{F}^- \times 0.200 \text{ L} = 0.012 \text{ mol } \text{F}^-$$

$$[\text{F}^-]_{\text{init}} = \frac{0.012 \text{ mol } \text{F}^-}{0.100 \text{ L} + 0.200 \text{ L}} = 0.040 \text{ M } \text{F}^-$$

Substituting into the ion-product expression and comparing Q_{sp} with K_{sp} :

$$Q_{\text{sp}} = [\text{Ca}^{2+}]_{\text{init}}[\text{F}^-]_{\text{init}}^2 = (0.10)(0.040)^2 = 1.6 \times 10^{-4}$$

Because $Q_{\text{sp}} > K_{\text{sp}}$, CaF_2 will precipitate until $Q_{\text{sp}} = 3.2 \times 10^{-11}$.

Check Make sure you round off and quickly check the math. For example, $Q_{\text{sp}} = (1 \times 10^{-1})(4 \times 10^{-2})^2 = 1.6 \times 10^{-4}$. With K_{sp} so low, CaF_2 must have a low solubility, and given the sizable concentrations being mixed, we would expect CaF_2 to precipitate.

FOLLOW-UP PROBLEMS

19.10A As a result of mineral erosion and biological activity, phosphate ion is common in natural waters, where it often precipitates as insoluble salts such as $\text{Ca}_3(\text{PO}_4)_2$. If $[\text{Ca}^{2+}]_{\text{init}} = [\text{PO}_4^{3-}]_{\text{init}} = 1.0 \times 10^{-9} \text{ M}$ in a given river, will $\text{Ca}_3(\text{PO}_4)_2$ ($K_{\text{sp}} = 1.2 \times 10^{-29}$) precipitate?

19.10B Addition of a soluble sulfide compound such as sodium sulfide is an effective way to remove metals such as lead from wastewater. Does a precipitate form when 0.500 L of 0.10 M Na_2S is added to 25 L of wastewater containing 0.015 g Pb^{2+}/L ?

SOME SIMILAR PROBLEMS 19.87–19.90

SAMPLE PROBLEM 19.11

Using Molecular Scenes to Predict Whether a Precipitate Will Form

Problem These four scenes represent solutions of silver (gray) and carbonate (black and red) ions above solid silver carbonate. (The solid, other ions, and water are not shown.)

- (a) Which scene best represents the solution in equilibrium with the solid?
- (b) In which, if any, other scene(s) will additional solid silver carbonate form?
- (c) Explain how, if at all, addition of a small volume of concentrated strong acid affects the $[\text{Ag}^+]$ in scene 4 and the mass of solid present.

Plan (a) The solution of silver and carbonate ions in equilibrium with the solid (Ag_2CO_3) should have the same relative numbers of cations and anions as in the formula. We examine the scenes to see which has a ratio of 2 Ag^+ to 1 CO_3^{2-} . (b) A solid forms

if the value of Q_{sp} exceeds that of K_{sp} . We write the dissolution equation and Q_{sp} expression. Then we count ions to calculate Q_{sp} for each scene and see which Q_{sp} value, if any, exceeds the value for the scene identified in part (a). (c) The CO_3^{2-} ion reacts with added H_3O^+ , so adding strong acid will shift the equilibrium to the right. We write the equations and determine how a shift to the right affects $[\text{Ag}^+]$ and the mass of solid Ag_2CO_3 .

Solution (a) Scene 3 is the only one with an $\text{Ag}^+/\text{CO}_3^{2-}$ ratio of 2/1, as in the solid's formula.

(b) Calculating the ion products:

$$\begin{array}{ll} \text{Scene 1: } Q_{sp} = (2)^2(4) = 16 & \text{Scene 2: } Q_{sp} = (3)^2(3) = 27 \\ \text{Scene 3: } Q_{sp} = (4)^2(2) = 32 & \text{Scene 4: } Q_{sp} = (3)^2(4) = 36 \end{array}$$

Therefore, for scene 3, $K_{sp} = 32$; the Q_{sp} value for scene 4 is the only other one that equals or exceeds 32, so a precipitate of Ag_2CO_3 will form there.

(c) Writing the equations:

The CO_2 leaves as a gas, so adding H_3O^+ shifts the equilibrium position of reaction 2 to the right. This change lowers the $[\text{CO}_3^{2-}]$ in reaction 1, thereby causing more CO_3^{2-} to form. As a result, more solid dissolves, which means that the $[\text{Ag}^+]$ increases and the mass of Ag_2CO_3 decreases.

Check (a) In scene 1, the formula has two CO_3^{2-} per formula unit, not two Ag^+ .

(b) Even though scene 4 has fewer Ag^+ ions than scene 3, its Q_{sp} value is higher and exceeds the K_{sp} .

FOLLOW-UP PROBLEMS

19.11A The following scenes represent solutions of nickel(II) (gray) and hydroxide (red and blue) ions that are above solid nickel(II) hydroxide. (The solid, other ions, and water are not shown.)

- (a) Which scene best depicts the solution at equilibrium with the solid?
- (b) In which, if any, other scene(s) will additional solid form?
- (c) Will addition of a small amount of concentrated strong acid or strong base affect the mass of solid present in any scene? Explain.

19.11B The following scenes represent solutions of lead(II) (black) and chloride (green) ions that are above solid lead(II) chloride. (The solid, other ions, and water are not shown.)

- (a) Which scene best represents the solution in equilibrium with the solid?
- (b) In which, if any, other scene(s) will additional solid form?
- (c) Explain how, if at all, addition of a small amount of concentrated $\text{HCl}(aq)$ will affect the mass of solid present in any scene.

SOME SIMILAR PROBLEMS 19.121 and 19.147

Separating Ions by Selective Precipitation and Simultaneous Equilibria

Let's consider two ways to separate one ion from another by reacting them with a given precipitating ion to form compounds with different solubilities.

Selective Precipitation In the process of **selective precipitation**, a solution of one precipitating ion is added to a solution of two ionic compounds until the Q_{sp} of the *more soluble* compound is almost equal to its K_{sp} . This method ensures that the K_{sp} of the *less soluble* compound is exceeded as much as possible. As a result, the maximum amount of the less soluble compound precipitates, but none of the more soluble compound does.

SAMPLE PROBLEM 19.12

Separating Ions by Selective Precipitation

Problem A solution consists of 0.20 M MgCl_2 and 0.10 M CuCl_2 . Calculate the $[\text{OH}^-]$ needed to separate the metal ions. The K_{sp} of $\text{Mg}(\text{OH})_2$ is 6.3×10^{-10} , and the K_{sp} of $\text{Cu}(\text{OH})_2$ is 2.2×10^{-20} .

Plan Because both compounds have a 1/2 ratio of cation/anion (see the discussion on page 868), when we compare their K_{sp} values, we find that $\text{Mg}(\text{OH})_2$ is about 10^{10} times more soluble than $\text{Cu}(\text{OH})_2$; thus, $\text{Cu}(\text{OH})_2$ precipitates first. We write the dissolution equations and ion-product expressions. We are given both cation concentrations, so we solve for the $[\text{OH}^-]$ that gives a saturated solution of $\text{Mg}(\text{OH})_2$, because this $[\text{OH}^-]$ will precipitate the most Cu^{2+} . Then, we calculate the $[\text{Cu}^{2+}]$ remaining to see if the separation was accomplished.

Solution Writing the equations and ion-product expressions:

Calculating the $[\text{OH}^-]$ that gives a saturated $\text{Mg}(\text{OH})_2$ solution:

$$[\text{OH}^-] = \sqrt{\frac{K_{sp}}{[\text{Mg}^{2+}]}} = \sqrt{\frac{6.3 \times 10^{-10}}{0.20}} = 5.6 \times 10^{-5}\text{ M}$$

This is the maximum $[\text{OH}^-]$ that will *not* precipitate Mg^{2+} ion.

Calculating the $[\text{Cu}^{2+}]$ remaining in the solution with this $[\text{OH}^-]$:

$$[\text{Cu}^{2+}] = \frac{K_{sp}}{[\text{OH}^-]^2} = \frac{2.2 \times 10^{-20}}{(5.6 \times 10^{-5})^2} = 7.0 \times 10^{-12}\text{ M}$$

Since the initial $[\text{Cu}^{2+}]$ is 0.10 M , virtually all the Cu^{2+} ion is precipitated.

Check Rounding, we find that $[\text{OH}^-]$ seems right: $\sim \sqrt{(6 \times 10^{-10})/0.2} = 5 \times 10^{-5}$. The $[\text{Cu}^{2+}]$ remaining also seems correct: $(200 \times 10^{-22})/(5 \times 10^{-5})^2 = 8 \times 10^{-12}$.

FOLLOW-UP PROBLEMS

19.12A A solution is 0.050 M BaCl_2 and 0.025 M CaCl_2 . What concentration of SO_4^{2-} will separate the cations in solution? K_{sp} of BaSO_4 is 1.1×10^{-10} , and K_{sp} of CaSO_4 is 2.4×10^{-5} .

19.12B A solution consists of 0.020 M $\text{Ba}(\text{NO}_3)_2$ and 0.015 M $\text{Ca}(\text{NO}_3)_2$. What concentration of NaF will separate the cations in solution? K_{sp} of BaF_2 is 1.5×10^{-6} , and K_{sp} of CaF_2 is 3.2×10^{-11} .

SOME SIMILAR PROBLEMS 19.92 and 19.140

Simultaneous Equilibria Sometimes two or more equilibrium systems are controlled simultaneously to separate one metal ion from another as their sulfides, using S^{2-} as the precipitating ion. We control the $[\text{S}^{2-}]$ in order to exceed the K_{sp} value of one metal sulfide but not the other, and we do so by shifting H_2S dissociation through adjustments of $[\text{H}_3\text{O}^+]$:

- If we add strong acid, the high $[H_3O^+]$ shifts H_2S dissociation to the left, which decreases $[S^{2-}]$, so the *less* soluble sulfide precipitates.
- If we add strong base, the low $[H_3O^+]$ shifts H_2S dissociation to the right, which increases $[S^{2-}]$, so the *more* soluble sulfide precipitates.

Thus, we shift one equilibrium system (H_2S dissociation) by adjusting a second (H_2O ionization) to control a third (metal sulfide solubility).

As the upcoming Chemical Connections essay demonstrates, the principles of ionic equilibria often help us understand the chemical basis of complex environmental problems and may provide ways to solve them.

› Summary of Section 19.3

- Only as a first approximation does the dissolved portion of a slightly soluble salt dissociate completely into ions.
- In a saturated solution, dissolved ions and the undissolved solid salt are in equilibrium. The product of the ion concentrations, each raised to the power of its subscript in the formula, has a constant value ($Q_{sp} = K_{sp}$).
- The value of K_{sp} can be obtained from the solubility, and vice versa.
- Adding a common ion lowers a compound's solubility.
- Adding H_3O^+ (lowering pH) increases an ionic compound's solubility if the anion of the compound is also that of a weak acid.
- Limestone caves result from shifts in the $CaCO_3/CO_2$ equilibrium system.
- When two solutions, each containing one of the ions of a slightly soluble ionic compound, are mixed, an ionic solid forms if $Q_{sp} > K_{sp}$.
- Ions are precipitated selectively from a solution of two ionic compounds by adding a precipitating ion until the K_{sp} of one compound is exceeded as much as possible without exceeding the K_{sp} of the other. An extension of this approach uses simultaneous control of three equilibrium systems to separate metal ions as their sulfides.
- Lakes bounded by limestone-rich soils form buffer systems that prevent acidification.

CHEMICAL CONNECTIONS TO ENVIRONMENTAL SCIENCE

Acid rain, the deposition of acids in wet form as rain, snow, or fog or in dry form as solid particles, is a global environmental problem. It has been observed in the United States, Canada, Mexico, the Amazon basin, Europe, Russia, many parts of Asia, and even at the North and South Poles. Let's see how it arises and how to prevent some of its harmful effects.

Origins of Acid Rain

The strong acids H_2SO_4 and HNO_3 cause the greatest concern, so let's see how they form (Figure B19.1, on the next page):

1. *Sulfuric acid.* Sulfur dioxide (SO_2), produced mostly by the burning of high-sulfur coal, forms sulfurous acid (H_2SO_3) in contact with water. The atmospheric pollutants hydrogen peroxide (H_2O_2) and ozone (O_3) dissolve in the water in clouds and oxidize the sulfurous acid to sulfuric acid:

Alternatively, SO_2 is oxidized by atmospheric hydroxyl radicals ($HO\cdot$) to sulfur trioxide (SO_3), which forms H_2SO_4 with water.

2. *Nitric acid.* Nitrogen oxides (NO_x) form from N_2 and O_2 during high-temperature combustion in car and truck engines and electric power plants. NO then forms NO_2 and HNO_3 in a process

The Acid-Rain Problem

that creates smog. At night, NO_x is converted to N_2O_5 , which reacts with water to form HNO_3 :

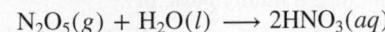

Ammonium salts, deposited as NH_4HSO_4 or NH_4NO_3 , produce HNO_3 in soil through biochemical oxidation.

The pH of Acid Rain

Normal rainwater is weakly acidic from the reaction of atmospheric CO_2 with water (see Problem 19.141):

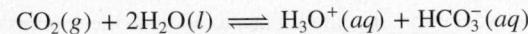

Yet, as long ago as 1984, rainfall in the United States had already reached an average pH of 4.2, an increase of about 25 times as much H_3O^+ . Rain in Wheeling, West Virginia, has had a pH of 1.8, lower than the pH of lemon juice. And rain in industrial parts of Sweden once had a pH of 2.7, about the same as vinegar.

Effects of Acid Rain

Some fish and shellfish die at pH values between 4.5 and 5.0. The young of most species are generally more vulnerable. At pH 5, most fish eggs cannot hatch. With tens of thousands of rivers and lakes around the world becoming or already acidified, the loss of freshwater fish became a major concern long ago.

(continued)

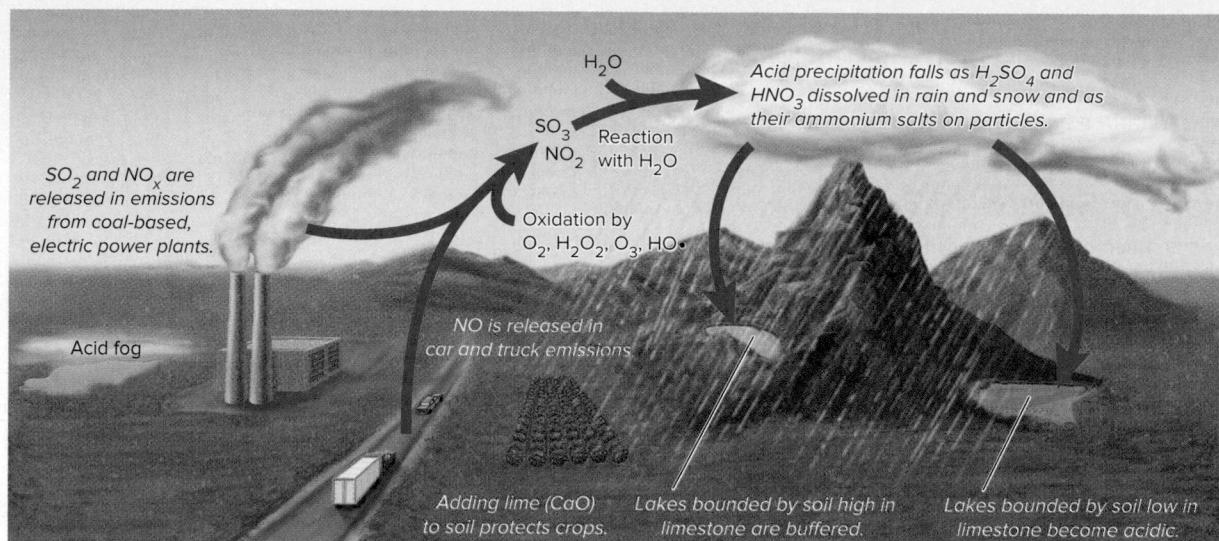

Figure B19.1 Formation of acidic precipitation. A complex interplay of human activities, atmospheric chemistry, and environmental distribution leads to acidic precipitation and its harmful effects.

In addition, acres of forest have been harmed by the acid, which removes nutrients and releases toxic substances from the soil. The aluminosilicates that make up most soils are extremely insoluble in water. Through a complex series of simultaneous equilibria, contact with water at pH < 5 causes these materials to release some bound Al³⁺, which is toxic to fish and plants. At the same time, acid rain dissolves Ca²⁺ and Mg²⁺ ions from the soil, which are nutrients for plants and animals.

Marble and limestone (both primarily CaCO₃) in buildings and monuments react with sulfuric acid to form gypsum (CaSO₄·2H₂O), which flakes off. Ironically, the same process that destroys these structures rescues lakes that are bounded by limestone-rich soil. Limestone dissolves sufficiently in lake water to form an HCO₃⁻/CO₃²⁻ buffer capable of absorbing the incoming H₃O⁺ and maintaining a mildly basic pH:

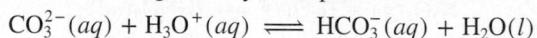

Acidified lakes and rivers that are in contact with granite and other weathering-resistant bedrock can be remediated by *liming* (treating with limestone). This approach is expensive and is only a stopgap measure because the lakes are acidic again within several years.

Preventing Acid Rain

Effective prevention of acid rain has to address the sources of the sulfur and nitrogen pollutants:

1. *Sulfur pollutants.* As was pointed out earlier (Chemical Connections, Chapter 6), the principal means of minimizing sulfur dioxide release is by “scrubbing” power plant emissions with limestone in both dry and wet form. Another method reduces SO₂ with methane, coal, or H₂S, and the mixture is converted catalytically to sulfur, which is sold as a byproduct:

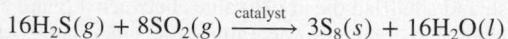

Although low-sulfur coal is rare and expensive to mine, coal can be converted into gaseous and liquid low-sulfur fuels.

The sulfur is removed (as H₂S) in an acid-gas scrubber after gasification.

2. *Nitrogen pollutants.* Through the use of a catalytic converter in an auto exhaust system, NO_x species are reduced to N₂. In power plant emissions, NO_x is decreased by adjusting conditions and by treating hot stack gases with ammonia in the presence of a heterogeneous catalyst:

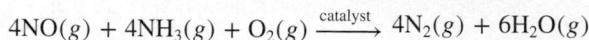

Reducing power plant emissions in North America and Europe has increased the pH of rainfall and some surface waters. Lime (CaO) is routinely used to react with acid rain falling on crop lands. Further progress is expected under current legislation, but, in much of eastern North America and northern Europe, additional measures are needed for full recovery.

Problems

B19.1 An environmental technician collects a sample of rainwater. Back in her lab, the pH meter isn’t working, so she uses indicator solutions to estimate the pH. A piece of litmus paper turns red, indicating acidity, so she divides the sample into thirds and obtains the following results: thymol blue turns yellow; bromophenol blue turns green; and methyl red turns red. Estimate the pH of the rainwater.

B19.2 A lake that has a surface area of 10.0 acres (1 acre = $4.840 \times 10^3 \text{ yd}^2$) receives 1.00 in of rain of pH 4.20. (Assume that the acidity of the rain is due to a strong, monoprotic acid.)

- (a) How many moles of H₃O⁺ are in the rain falling on the lake?
- (b) If the lake is unbuffered and its average depth is 10.0 ft before the rain, find the pH after the rain has been mixed with lake water. (Assume the initial pH is 7.00, and ignore runoff from the surrounding land.)
- (c) If the lake contains hydrogen carbonate ions (HCO₃⁻), what mass of HCO₃⁻ will neutralize the acid in the rain?

19.4 EQUILIBRIA INVOLVING COMPLEX IONS

A third kind of aqueous ionic equilibrium involves a type of ion we mentioned briefly in Section 18.9. A *simple ion*, such as Na^+ or CH_3COO^- , consists of one or a few bonded atoms, with an excess or deficit of electrons. A **complex ion** consists of a central metal ion covalently bonded to two or more anions or molecules, called **ligands**. Hydroxide, chloride, and cyanide ions are examples of ionic ligands; water, carbon monoxide, and ammonia are some molecular ligands. In the complex ion $\text{Cr}(\text{NH}_3)_6^{3+}$, for example, the central Cr^{3+} is surrounded by six NH_3 ligands (Figure 19.17). Hydrated metal ions are complex ions with water molecules as ligands (Section 18.5). In Chapter 23, we discuss the transition metals and the structures and properties of the numerous complex ions they form. Here, we focus on equilibria of hydrated ions with ligands other than water.

Formation of Complex Ions

When a salt dissolves in water, a complex ion forms, with water as ligands around the metal ion. In many cases, when we treat this hydrated cation with a solution of another ligand, the bound water molecules are replaced by the other ligand. For example, a hydrated M^{2+} ion, $\text{M}(\text{H}_2\text{O})_4^{2+}$, forms the ammoniated ion, $\text{M}(\text{NH}_3)_4^{2+}$, in aqueous NH_3 :

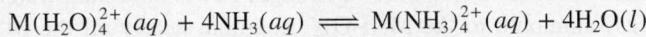

At equilibrium, this system is expressed by a ratio of concentration terms whose form follows that of any other equilibrium expression:

$$K_c = \frac{[\text{M}(\text{NH}_3)_4^{2+}][\text{H}_2\text{O}]^4}{[\text{M}(\text{H}_2\text{O})_4^{2+}][\text{NH}_3]^4}$$

Once again, because $[\text{H}_2\text{O}]$ is essentially constant, water is treated as a pure liquid, with its concentration term equal to 1. Thus, we obtain the expression for a new equilibrium constant called the **formation constant**, K_f :

$$\frac{K_c}{(1)^4} = K_f = \frac{[\text{M}(\text{NH}_3)_4^{2+}]}{[\text{M}(\text{H}_2\text{O})_4^{2+}][\text{NH}_3]^4}$$

At the molecular level, depicted in Figure 19.18 (*next page*), the actual process is stepwise, with ammonia molecules replacing water molecules one at a time. This process yields a series of intermediate species, each with its own formation constant:

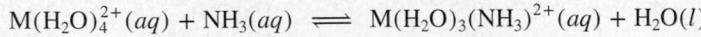

$$K_{f1} = \frac{[\text{M}(\text{H}_2\text{O})_3(\text{NH}_3)^{2+}]}{[\text{M}(\text{H}_2\text{O})_4^{2+}][\text{NH}_3]}$$

$$K_{f2} = \frac{[\text{M}(\text{H}_2\text{O})_2(\text{NH}_3)_2^{2+}]}{[\text{M}(\text{H}_2\text{O})_3(\text{NH}_3)^{2+}][\text{NH}_3]}$$

$$K_{f3} = \frac{[\text{M}(\text{H}_2\text{O})(\text{NH}_3)_3^{2+}]}{[\text{M}(\text{H}_2\text{O})_2(\text{NH}_3)_2^{2+}][\text{NH}_3]}$$

$$K_{f4} = \frac{[\text{M}(\text{NH}_3)_4^{2+}]}{[\text{M}(\text{H}_2\text{O})(\text{NH}_3)_3^{2+}][\text{NH}_3]}$$

The *sum* of the equations gives the overall equation, so the *product* of the individual formation constants gives the overall formation constant:

$$K_f = K_{f1} \times K_{f2} \times K_{f3} \times K_{f4}$$

Recall that *all complex ions are Lewis adducts* (Section 18.9). The metal ion acts as a Lewis acid (accepts an electron pair), and the ligand acts as a Lewis base (donates an electron pair). In the formation of $\text{M}(\text{NH}_3)_4^{2+}$, the K_f for each step is

Figure 19.17 $\text{Cr}(\text{NH}_3)_6^{3+}$, a typical complex ion.

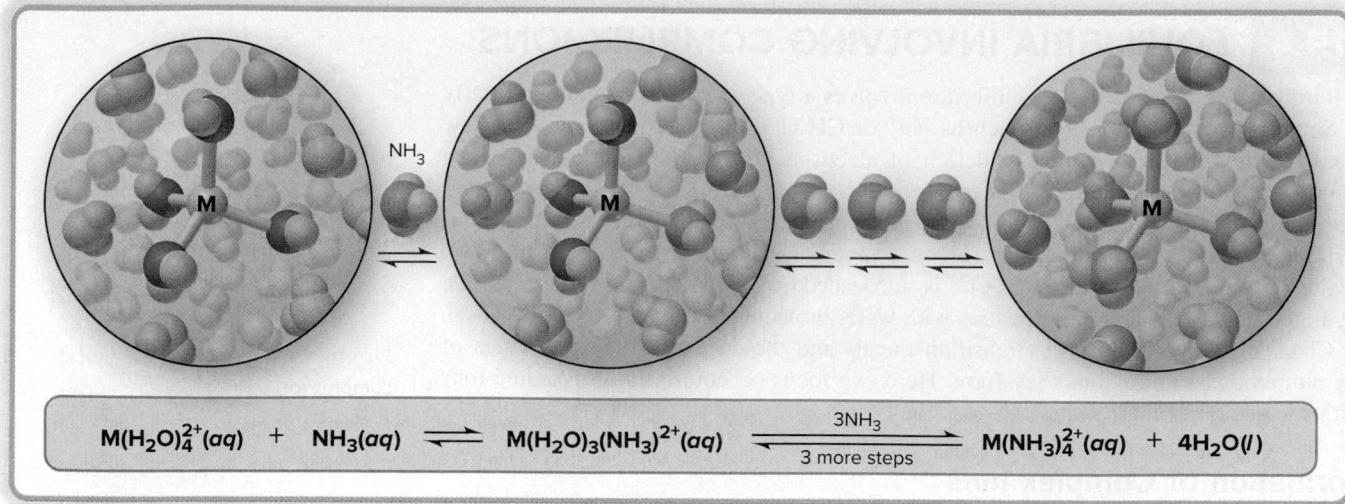

Figure 19.18 The stepwise exchange of NH_3 for H_2O in $M(H_2O)_4^{2+}$. The molecular views show the first exchange and the fully ammoniated ion.

much larger than 1 because ammonia is a stronger Lewis base than water. Therefore, if we add excess ammonia to the $M(H_2O)_4^{2+}$ solution, nearly all the M^{2+} ions exist as $M(NH_3)_4^{2+}(aq)$.

Table 19.4 (and Appendix C) shows K_f values of some complex ions. Notice that they are all of the order 10^6 or greater, which means that these ions form readily from the hydrated ion. Because of this behavior, some uses of complex-ion formation are to retrieve a metal from its ore, eliminate a toxic or unwanted metal ion from a solution, or convert a metal ion to a different form, as Sample Problem 19.13 shows for the zinc ion.

Table 19.4 Formation Constants (K_f) of Some Complex Ions at 25°C

Complex Ion	K_f	Complex Ion	K_f
$Ag(CN)_2^-$	3.0×10^{20}	$Fe(CN)_6^{4-}$	3×10^{35}
$Ag(NH_3)_2^+$	1.7×10^7	$Fe(CN)_6^{3-}$	4.0×10^{43}
$Ag(S_2O_3)_2^{3-}$	4.7×10^{13}	$Hg(CN)_4^{2-}$	9.3×10^{38}
AlF_6^{3-}	4×10^{19}	$Ni(NH_3)_6^{2+}$	2.0×10^8
$Al(OH)_4^-$	3×10^{33}	$Pb(OH)_3^-$	8×10^{13}
$Be(OH)_4^{2-}$	4×10^{18}	$Sn(OH)_3^-$	3×10^{25}
CdI_4^{2-}	1×10^6	$Zn(CN)_4^{2-}$	4.2×10^{19}
$Co(OH)_4^{2-}$	5×10^9	$Zn(NH_3)_4^{2+}$	7.8×10^8
$Cr(OH)_4^-$	8.0×10^{29}	$Zn(OH)_4^{2-}$	3×10^{15}
$Cu(NH_3)_4^{2+}$	5.6×10^{11}		

SAMPLE PROBLEM 19.13

Calculating the Concentration of a Complex Ion

Problem An industrial chemist converts $Zn(H_2O)_4^{2+}$ to the more stable $Zn(NH_3)_4^{2+}$ ($K_f = 7.8 \times 10^8$) by mixing 50.0 L of 0.0020 M $Zn(H_2O)_4^{2+}$ and 25.0 L of 0.15 M NH_3 . What is the $[Zn(H_2O)_4^{2+}]$ at equilibrium?

Plan We write the complex-ion formation equation and the K_f expression and use a reaction table to calculate the equilibrium concentrations. To set up the table, we must first find $[Zn(H_2O)_4^{2+}]_{\text{init}}$. We are given the individual volumes and molar concentrations, so we find the number of moles and divide by the total volume because the solutions are mixed. With the large excess of NH_3 and the high K_f , we assume that almost all the $Zn(H_2O)_4^{2+}$ is converted to $Zn(NH_3)_4^{2+}$. Because $[Zn(H_2O)_4^{2+}]$ at equilibrium is very small, we use x to represent it.

Solution Writing the equation and the K_f expression:

Finding the initial reactant concentrations:

$$[\text{Zn}(\text{H}_2\text{O})_4^{2+}]_{\text{init}} = \frac{50.0 \text{ L} \times 0.0020 \text{ M}}{50.0 \text{ L} + 25.0 \text{ L}} = 1.3 \times 10^{-3} \text{ M}$$

$$[\text{NH}_3]_{\text{init}} = \frac{25.0 \text{ L} \times 0.15 \text{ M}}{50.0 \text{ L} + 25.0 \text{ L}} = 5.0 \times 10^{-2} \text{ M}$$

Setting up a reaction table: We assume that nearly all the $\text{Zn}(\text{H}_2\text{O})_4^{2+}$ is converted to $\text{Zn}(\text{NH}_3)_4^{2+}$, so we set up the table with $x = [\text{Zn}(\text{H}_2\text{O})_4^{2+}]$ at equilibrium. Because 4 mol of NH_3 is needed per mole of $\text{Zn}(\text{H}_2\text{O})_4^{2+}$, the change in $[\text{NH}_3]$ is

$$[\text{NH}_3]_{\text{reacted}} \approx 4(1.3 \times 10^{-3} \text{ M}) = 5.2 \times 10^{-3} \text{ M} \quad \text{and} \quad [\text{Zn}(\text{NH}_3)_4^{2+}] \approx 1.3 \times 10^{-3} \text{ M}$$

Concentration (M)	$\text{Zn}(\text{H}_2\text{O})_4^{2+}(aq)$	$+ 4\text{NH}_3(aq)$	$\rightleftharpoons \text{Zn}(\text{NH}_3)_4^{2+}(aq) + 4\text{H}_2\text{O}(l)$	
Initial	1.3×10^{-3}	5.0×10^{-2}	0	—
Change	$\sim(-1.3 \times 10^{-3})$	$\sim(-5.2 \times 10^{-3})$	$\sim(+1.3 \times 10^{-3})$	—
Equilibrium	x	4.5×10^{-2}	1.3×10^{-3}	—

Solving for x , the $[\text{Zn}(\text{H}_2\text{O})_4^{2+}]$ remaining at equilibrium:

$$K_f = \frac{[\text{Zn}(\text{NH}_3)_4^{2+}]}{[\text{Zn}(\text{H}_2\text{O})_4^{2+}][\text{NH}_3]^4} = 7.8 \times 10^8 \approx \frac{1.3 \times 10^{-3}}{x(4.5 \times 10^{-2})^4}$$

$$x = [\text{Zn}(\text{H}_2\text{O})_4^{2+}] \approx 4.1 \times 10^{-7} \text{ M}$$

Check The K_f is large, so we expect the $[\text{Zn}(\text{H}_2\text{O})_4^{2+}]$ remaining to be very low.

FOLLOW-UP PROBLEMS

19.13A Cyanide ion is toxic because it forms stable complex ions with the Fe^{3+} ion in certain proteins involved in cellular energy production. To study this effect, a biochemist mixes 25.5 mL of $3.1 \times 10^{-2} \text{ M}$ $\text{Fe}(\text{H}_2\text{O})_6^{3+}$ with 35.0 mL of 1.5 M NaCN. What is the final $[\text{Fe}(\text{H}_2\text{O})_6^{3+}]$? The K_f of $\text{Fe}(\text{CN})_6^{4-}$ is 4.0×10^{43} .

19.13B The production of aluminum from its ore utilizes a stable complex ion formed from the reaction of $\text{Al}(\text{H}_2\text{O})_6^{3+}$ with F^- . When 2.4 g of AlCl_3 is dissolved in 250 mL of 0.560 M NaF, what is the final $[\text{Al}(\text{H}_2\text{O})_6^{3+}]$? The K_f of AlF_6^{3-} is 4×10^{19} .

SOME SIMILAR PROBLEMS 19.100, 19.101, 19.104, and 19.105

Complex Ions and the Solubility of Precipitates

In Section 19.3, you saw that H_3O^+ increases the solubility of a slightly soluble ionic compound if its anion is that of a weak acid. Similarly, a ligand increases the solubility of a slightly soluble ionic compound if it forms a complex ion with the compound's cation. For example, iron(II) sulfide is very slightly soluble:

When we add some 1.0 M NaCN, the CN^- ions act as ligands and react with the small amount of $\text{Fe}^{2+}(aq)$ to form the complex ion $\text{Fe}(\text{CN})_6^{4-}$:

To see the effect of complex-ion formation on the solubility of FeS, we add the equations and, therefore, multiply their equilibrium constants:

$$K_{\text{overall}} = K_{\text{sp}} \times K_f = (8 \times 10^{-16})(3 \times 10^{35}) = 2 \times 10^{20}$$

The overall dissociation of FeS into ions increased by more than a factor of 10^{35} in the presence of the ligand.

SAMPLE PROBLEM 19.14

Calculating the Effect of Complex-Ion Formation on Solubility

Developing an image in “hypo.”

Source: © McGraw-Hill Education/Mark A. Dierker, photographer

Problem In black-and-white film developing (see photo), excess AgBr is removed from a film negative with “hypo,” an aqueous solution of sodium thiosulfate ($\text{Na}_2\text{S}_2\text{O}_3$), which causes the formation of the complex ion $\text{Ag}(\text{S}_2\text{O}_3)_2^{3-}$. Calculate the solubility of AgBr in (a) H_2O ; (b) 1.0 M hypo. K_f of $\text{Ag}(\text{S}_2\text{O}_3)_2^{3-}$ is 4.7×10^{13} , and K_{sp} of AgBr is 5.0×10^{-13} .

Plan (a) After writing the dissolution equation and the ion-product expression, we use the given K_{sp} to solve for S , the molar solubility of AgBr. **(b)** In hypo, Ag^+ forms a complex ion with $\text{S}_2\text{O}_3^{2-}$, which shifts the equilibrium and dissolves more AgBr. We write the complex-ion equation and add it to the equation for dissolving AgBr to obtain the overall equation for dissolving AgBr in hypo. We multiply K_{sp} by K_f to find K_{overall} . To find the solubility of AgBr in hypo, we set up a reaction table, with $S = [\text{Ag}(\text{S}_2\text{O}_3)_2^{3-}]$, substitute into the expression for K_{overall} , and solve for S .

Solution (a) Solubility in water. Writing the equation for the saturated solution and the ion-product expression:

Solving for solubility (S) directly from the equation: We know that

$$S = [\text{AgBr}]_{\text{dissolved}} = [\text{Ag}^+] = [\text{Br}^-]$$

Thus,

$$K_{\text{sp}} = [\text{Ag}^+][\text{Br}^-] = S^2 = 5.0 \times 10^{-13}$$

so

$$S = 7.1 \times 10^{-7} \text{ M}$$

(b) Solubility in 1.0 M hypo. Writing the overall equation:

Calculating K_{overall} :

$$K_{\text{overall}} = \frac{[\text{Ag}(\text{S}_2\text{O}_3)_2^{3-}][\text{Br}^-]}{[\text{S}_2\text{O}_3^{2-}]^2} = K_{\text{sp}} \times K_f = (5.0 \times 10^{-13})(4.7 \times 10^{13}) = 24$$

Setting up a reaction table, with $S = [\text{AgBr}]_{\text{dissolved}} = [\text{Ag}(\text{S}_2\text{O}_3)_2^{3-}]$:

Concentration (M)	$\text{AgBr}(s)$	$+ 2\text{S}_2\text{O}_3^{2-}(aq)$	\rightleftharpoons	$\text{Ag}(\text{S}_2\text{O}_3)_2^{3-}(aq)$	$+ \text{Br}^-(aq)$
Initial	—	1.0		0	0
Change	—	$-2S$		$+S$	$+S$
Equilibrium	—	$1.0 - 2S$		S	S

Substituting the values into the expression for K_{overall} and solving for S :

$$K_{\text{overall}} = \frac{[\text{Ag}(\text{S}_2\text{O}_3)_2^{3-}][\text{Br}^-]}{[\text{S}_2\text{O}_3^{2-}]^2} = \frac{S^2}{(1.0 \text{ M} - 2S)^2} = 24$$

Taking the square root of both sides gives

$$\frac{S}{1.0 \text{ M} - 2S} = \sqrt{24} = 4.9 \quad \text{so} \quad S = 4.9 \text{ M} - 9.8S \quad \text{and} \quad 10.8S = 4.9 \text{ M}$$

$$[\text{Ag}(\text{S}_2\text{O}_3)_2^{3-}] = S = 0.45 \text{ M}$$

Check (a) From the number of ions in the formula of AgBr, we know that $S = \sqrt{K_{\text{sp}}}$, so the order of magnitude seems right: $\sim \sqrt{10^{-14}} \approx 10^{-7}$. **(b)** The K_{overall} seems correct: the exponents cancel, and $5 \times 5 = 25$. Most importantly, the answer makes sense.

because the photographic process requires the remaining AgBr to be washed off the film and the large K_{overall} confirms that. We can check S by rounding and working backward to find K_{overall} : from the reaction table, we find that

$$[(S_2O_3)^{2-}] = 1.0 \text{ M} - 2S = 1.0 \text{ M} - 2(0.45 \text{ M}) = 1.0 \text{ M} - 0.90 \text{ M} = 0.1 \text{ M}$$

so $K_{\text{overall}} \approx (0.45)^2/(0.1)^2 = 20$, within rounding of the calculated value.

FOLLOW-UP PROBLEMS

19.14A How does the solubility of AgBr in 1.0 M NH₃ compare with its solubility in 1.0 M hypo, calculated in part (b) of Sample Problem 19.14? The K_f of Ag(NH₃)₃⁺ is 1.7×10^7 .

19.14B Calculate the solubility of PbCl₂ in 0.75 M NaOH. The K_f of Pb(OH)₃⁻ is 8×10^{13} , and the K_{sp} of PbCl₂ is 1.7×10^{-5} .

SOME SIMILAR PROBLEMS 19.102 and 19.103

Complex Ions of Amphoteric Hydroxides

Many of the same metals that form amphoteric oxides (Chapter 8, p. 354) also form slightly soluble *amphoteric hydroxides*. These compounds dissolve very little in water, but they dissolve to a much greater extent in both acidic and basic solutions. Aluminum hydroxide is one of several examples:

It is insoluble in water ($K_{\text{sp}} = 3 \times 10^{-34}$), but

- It dissolves in acid because H₃O⁺ reacts with the OH⁻ anion [Sample Problem 19.9(b)],

giving the overall equation

- It dissolves in base through the formation of a complex ion:

Let's look more closely at this behavior. When we dissolve a soluble aluminum salt, such as Al(NO₃)₃, in water and then slowly add a strong base, a white precipitate first forms and then dissolves as more base is added. What reactions are occurring? The formula for the hydrated Al³⁺ ion is Al(H₂O)₆³⁺(aq). It acts as a weak polyprotic acid and reacts with added OH⁻ ions in a stepwise manner. In each step, one of the bound H₂O molecules loses a proton and becomes a bound OH⁻ ion, so the number of bound H₂O molecules is reduced by 1:

After three protons have been removed from each Al(H₂O)₆³⁺, the white precipitate has formed, which is the insoluble hydroxide Al(H₂O)₃(OH)₃(s), often written more simply as Al(OH)₃(s). Now you can see that the precipitate actually consists of the hydrated Al³⁺ ion with an H⁺ removed from each of three bound H₂O molecules (Figure 19.19, *next page, center*). Addition of H₃O⁺ protonates the OH⁻ ions and reforms the hydrated Al³⁺ ion (Figure 19.19, *left*).

Further addition of OH⁻ removes a fourth H⁺ and the precipitate dissolves as the soluble ion Al(H₂O)₂(OH)₄⁻(aq) forms (Figure 19.19, *right*), which we usually write with the formula Al(OH)₄⁻(aq):

In other words, this complex ion is not created by ligands substituting for bound water molecules but through an acid-base reaction in which added OH⁻ ions titrate bound water molecules.

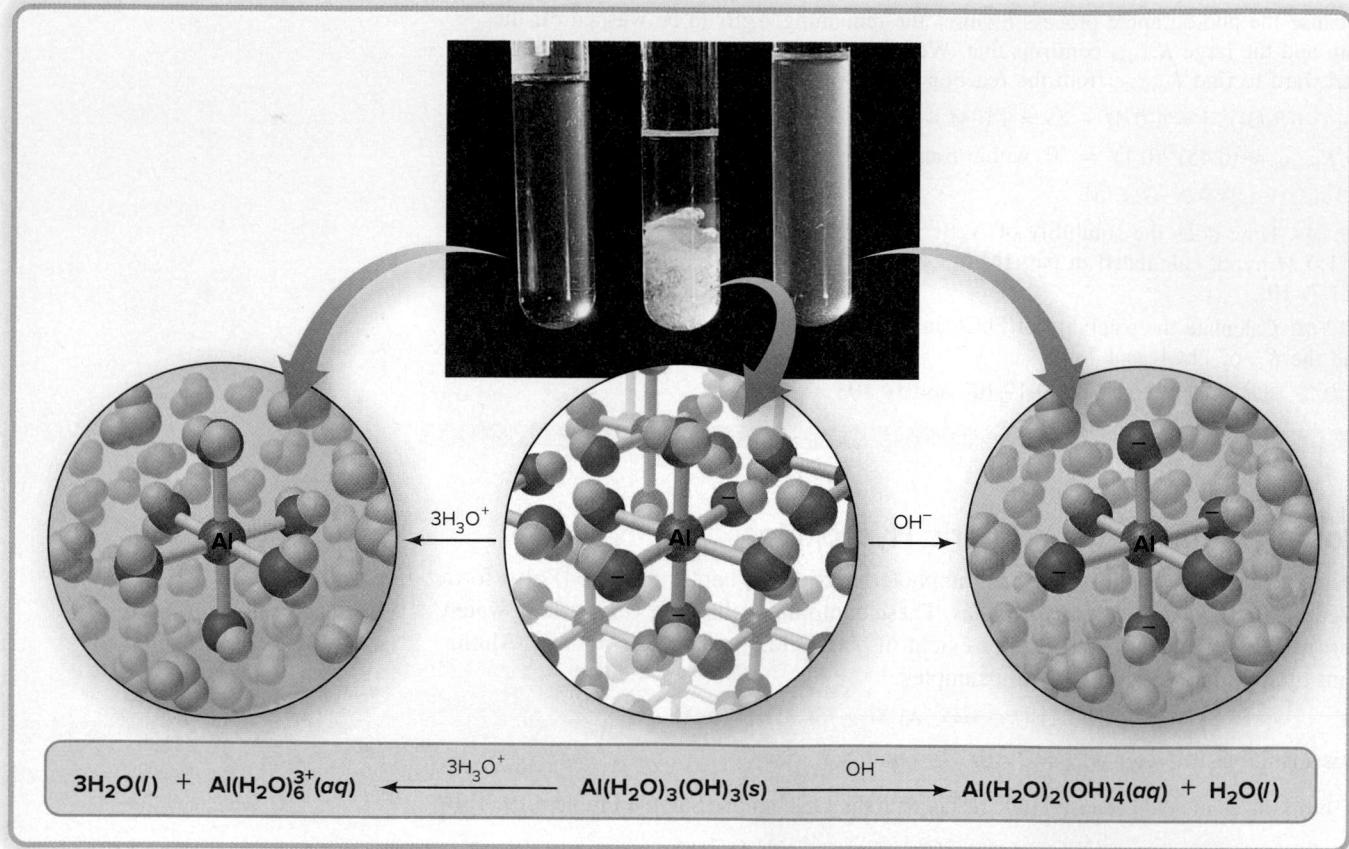

Figure 19.19 The amphoteric behavior of aluminum hydroxide. When solid $\text{Al}(\text{OH})_3$ is treated with H_3O^+ (left) or with OH^- (right), it dissolves as a result of the formation of soluble complex ions.

Source: © McGraw-Hill Education/Stephen Frisch, photographer

Several other slightly soluble hydroxides, including those of cadmium, chromium(III), cobalt(III), lead(II), tin(II), and zinc, are amphoteric and exhibit similar reactions:

In contrast, the slightly soluble hydroxides of iron(II), iron(III), and calcium dissolve in acid, but do *not* dissolve in base, because the three remaining bound water molecules are not acidic enough to lose any of their protons:

This difference in solubility in base between $\text{Al}(\text{OH})_3$ and $\text{Fe}(\text{OH})_3$ is the key to an important separation step in the production of aluminum metal, so we'll consider it again in Section 22.4.

› Summary of Section 19.4

- › A complex ion consists of a central metal ion covalently bonded to two or more negatively charged or neutral ligands. Its formation is characterized by a formation constant, K_f .
- › A hydrated metal ion is a complex ion with water molecules as ligands. Other ligands (stronger Lewis bases) can displace the water molecules in a stepwise process. In most cases, the K_f value for each step is large, so the fully substituted complex ion forms almost completely in the presence of excess ligand.
- › Adding a solution containing a ligand increases the solubility of an ionic precipitate if the cation forms a complex ion with the ligand.
- › Amphoteric metal hydroxides dissolve in acid and base due to reactions that involve complex ions.

CHAPTER REVIEW GUIDE

Learning Objectives

Relevant section (§) and/or sample problem (SP) numbers appear in parentheses.

Understand These Concepts

- How the presence of a common ion suppresses a reaction that forms it (§19.1)
- Why the concentrations of buffer components must be high to minimize the change in pH due to addition of small amounts of H_3O^+ or OH^- (§19.1)
- How buffer capacity depends on buffer concentration and on the pK_a of the acid component; why buffer range is within ± 1 pH unit of the pK_a (§19.1)
- Why the shapes of strong acid-strong base, weak acid-strong base, and weak base-strong acid titration curves differ (§19.2)
- How the pH at the equivalence point is determined by the species present; why the pH at the midpoint of the buffer region equals the pK_a of the acid (§19.2)
- The nature of an acid-base indicator as a conjugate acid-base pair with differently colored acidic and basic forms (§19.2)
- The distinction between equivalence point and end point in an acid-base titration (§19.2)
- How the titration curve of a polyprotic acid has a buffer region and equivalence point for each ionizable proton (§19.2)
- How a slightly soluble ionic compound reaches equilibrium in water, expressed by an equilibrium (solubility-product) constant, K_{sp} (§19.3)
- Why incomplete dissociation of an ionic compound means that calculated values for K_{sp} and solubility are approximations (§19.3)
- Why a common ion in a solution decreases the solubility of its compounds (§19.3)
- How pH affects the solubility of a compound that contains a weak-acid anion (§19.3)
- How precipitate formation depends on the relative values of Q_{sp} and K_{sp} (§19.3)
- How selective precipitation and simultaneous equilibria are used to separate ions (§19.3)
- How complex-ion formation occurs in steps and is characterized by an overall equilibrium (formation) constant, K_f (§19.4)

- Why addition of a ligand increases the solubility of a compound whose metal ion forms a complex ion (§19.4)
- How the aqueous chemistry of amphoteric hydroxides involves precipitation, complex-ion formation, and acid-base equilibria (§19.4)

Master These Skills

- Using stoichiometry and equilibrium problem-solving techniques to calculate the effect of added H_3O^+ or OH^- on buffer pH (SP 19.1)
- Using the Henderson-Hasselbalch equation to calculate buffer pH (§19.1)
- Using molecular scenes to examine buffers (SP 19.2)
- Choosing the components for a buffer with a given pH and calculating their quantities (SP 19.3)
- Calculating the pH at any point in an acid-base titration (§19.2 and SP 19.4)
- Choosing an appropriate indicator based on the pH at various points in a titration (§19.2)
- Writing K_{sp} expressions for slightly soluble ionic compounds (SP 19.5)
- Calculating a K_{sp} value from solubility data (SP 19.6)
- Calculating solubility from a K_{sp} value (SP 19.7)
- Using K_{sp} values to compare solubilities for compounds with the same total number of ions (§19.3)
- Calculating the decrease in solubility caused by the presence of a common ion (SP 19.8)
- Predicting the effect of added H_3O^+ on solubility (SP 19.9)
- Using ion concentrations to calculate Q_{sp} and compare it with K_{sp} to predict whether a precipitate forms (SPs 19.10, 19.11)
- Comparing K_{sp} values in order to separate ions by selective precipitation (SP 19.12)
- Calculating the equilibrium concentration of a hydrated metal ion after addition of excess ligand forms a complex ion (SP 19.13)
- Using an overall equilibrium constant ($K_{\text{sp}} \times K_f$) to calculate the effect of complex-ion formation on solubility (SP 19.14)

Key Terms

Page numbers appear in parentheses.

acid-base buffer (843)
acid-base titration curve (853)
buffer capacity (849)
buffer range (849)

common-ion effect (844)
complex ion (877)
end point (861)
equivalence point (854)

formation constant (K_f) (877)
Henderson-Hasselbalch equation (849)
ligand (877)

selective precipitation (874)
solubility-product constant (K_{sp}) (864)

Key Equations and Relationships

Page numbers appear in parentheses.

19.1 Finding the pH from known concentrations of a conjugate acid-base pair (Henderson-Hasselbalch equation) (849):

$$\text{pH} = \text{p}K_a + \log \left(\frac{[\text{base}]}{[\text{acid}]} \right)$$

19.2 Defining the equilibrium condition for a saturated solution of a slightly soluble compound, M_pX_q , composed of M^{n+} and X^{z-} ions (864):

$$Q_{\text{sp}} = [M^{n+}]^p[X^{z-}]^q = K_{\text{sp}}$$

BRIEF SOLUTIONS TO FOLLOW-UP PROBLEMS

19.1A (a) Before addition:

Assuming x is small enough to be neglected,

$$[\text{HF}] = 0.50 \text{ M} \quad \text{and} \quad [\text{F}^-] = 0.45 \text{ M}$$

$$[\text{H}_3\text{O}^+] = K_a \times \frac{[\text{HF}]}{[\text{F}^-]} \approx (6.8 \times 10^{-4}) \left(\frac{0.50}{0.45} \right) = 7.6 \times 10^{-4} \text{ M}$$

$$\text{pH} = 3.12$$

(b) After addition of 0.40 g of NaOH to 1.0 L of buffer: Since 0.40 g of NaOH = 0.010 mol, we have

Concentration (M)	HF(aq)	+	OH ⁻ (aq)	→	F ⁻ (aq)	+	H ₂ O(l)
Initial	0.50		0.010		0.45		—
Change	-0.010		-0.010		+0.010		—
Equilibrium	0.49		0		0.46		—

$$[\text{HF}] = 0.49 \text{ M} \quad \text{and} \quad [\text{F}^-] = 0.46 \text{ M}$$

$$[\text{H}_3\text{O}^+] \approx (6.8 \times 10^{-4}) \left(\frac{0.49}{0.46} \right) = 7.2 \times 10^{-4} \text{ M}; \text{ pH} = 3.14$$

19.1B (a) Before addition:

$$K_b \text{ of } (\text{CH}_3)_2\text{NH} = 10^{-pK_b} = 10^{-3.23} = 5.9 \times 10^{-4}$$

$$K_a \text{ of } (\text{CH}_3)_2\text{NH}_2^+ = \frac{K_w}{K_b \text{ of } (\text{CH}_3)_2\text{NH}} = \frac{1.0 \times 10^{-14}}{5.9 \times 10^{-4}} = 1.7 \times 10^{-11}$$

$$[(\text{CH}_3)_2\text{NH}_2^+] = 0.25 \text{ M} \text{ and } [(\text{CH}_3)_2\text{NH}] = 0.30 \text{ M}$$

$$[\text{H}_3\text{O}^+] = K_a \times \frac{[(\text{CH}_3)_2\text{NH}_2^+]}{[(\text{CH}_3)_2\text{NH}]} \approx (1.7 \times 10^{-11}) \left(\frac{0.25}{0.30} \right) = 1.4 \times 10^{-11} \text{ M}$$

$$\text{pH} = 10.85$$

(b) After addition of 50.0 mL of 0.75 M HCl to 1.0 L of buffer:

$$[(\text{CH}_3)_2\text{NH}_2^+]_{\text{init}} = \frac{M_{\text{conc}} \times V_{\text{conc}}}{V_{\text{dil}}} = \frac{0.25 \text{ M} \times 1.0 \text{ L}}{1.05 \text{ L}} = 0.24 \text{ M}$$

$$\text{Similarly, } [(\text{CH}_3)_2\text{NH}] = 0.29 \text{ M} \quad \text{and} \quad [\text{H}_3\text{O}^+] = 0.036 \text{ M}$$

Concentration (M)	(CH ₃) ₂ NH(aq)	+	H ₃ O ⁺	↔	(CH ₃) ₂ NH ₂ ⁺ (aq)	+	H ₂ O(l)
Initial	0.29		0.036		0.24		—
Change	-0.036		-0.036		+0.036		—
Equilibrium	0.25		0		0.28		—

$$[\text{H}_3\text{O}^+] \approx (1.7 \times 10^{-11}) \left(\frac{0.28}{0.25} \right) = 1.9 \times 10^{-11} \text{ M}; \text{ pH} = 10.72$$

19.2A (a) There are more HB molecules than B⁻ ions. Strong base would convert HB to B⁻, thereby making the ratio closer to 1.

(b) Enough strong base is added to convert three HB molecules to three B⁻ ions, resulting in a buffer with four acid molecules and four conjugate base ions:

19.2B (a) $\text{pH} = \text{p}K_a + \log \left(\frac{[\text{A}^-]}{[\text{HA}]} \right)$, and sample 3 has $\frac{[\text{A}^-]}{[\text{HA}]} = \frac{6}{3} = 2$; $\frac{[\text{A}^-]}{[\text{HA}]} > 1$ results in $\text{pH} > \text{p}K_a$

(b) Added strong base reacts with the acid HA; sample 2 has the largest concentration of HA.

(c) pH of buffer = $\text{p}K_a \pm 1 = 4.2 \pm 1$, so the buffer pH range is 3.2–5.2; the acid-base pair HA/A⁻ is not suitable for preparing a buffer with a pH of 6.1.

$$19.3A \quad \text{p}K_a = -\log K_a = -\log (6.3 \times 10^{-5}) = 4.20$$

$$\text{pH} = \text{p}K_a + \log \left(\frac{[\text{C}_6\text{H}_5\text{COO}^-]}{[\text{C}_6\text{H}_5\text{COOH}]} \right)$$

$$4.25 = 4.20 + \log \left(\frac{[\text{C}_6\text{H}_5\text{COO}^-]}{[\text{C}_6\text{H}_5\text{COOH}]} \right)$$

$$\left(\frac{[\text{C}_6\text{H}_5\text{COO}^-]}{[\text{C}_6\text{H}_5\text{COOH}]} \right) = 1.1$$

Amount (mol) C₆H₅COOH

$$= 5.0 \text{ L soln} \times \frac{0.050 \text{ mol C}_6\text{H}_5\text{COO}^-}{1 \text{ L soln}} \times \frac{1.0 \text{ mol C}_6\text{H}_5\text{COOH}}{1.1 \text{ mol C}_6\text{H}_5\text{COO}^-}$$

$$= 0.23 \text{ mol C}_6\text{H}_5\text{COOH}$$

Mass (g) of C₆H₅COOH

$$= 0.23 \text{ mol C}_6\text{H}_5\text{COOH} \times \frac{122.12 \text{ g C}_6\text{H}_5\text{COOH}}{1 \text{ mol C}_6\text{H}_5\text{COOH}}$$

$$= 28 \text{ g C}_6\text{H}_5\text{COOH}$$

Dissolve 28 g of C₆H₅COOH into about 4.8 L of 0.050 M C₆H₅COONa and add more 0.050 M C₆H₅COONa for a total volume of 5.0 L. Add strong acid or base dropwise as needed.

$$19.3B \quad K_a \text{ of NH}_4^+ = \frac{K_w}{K_b \text{ of NH}_3} = \frac{1.0 \times 10^{-14}}{1.76 \times 10^{-5}} = 5.68 \times 10^{-10}$$

$$\text{p}K_a = -\log (5.68 \times 10^{-10}) = 9.25$$

$$\text{pH} = \text{p}K_a + \log \left(\frac{[\text{NH}_3]}{[\text{NH}_4^+]} \right)$$

$$9.18 = 9.25 + \log \left(\frac{[\text{NH}_3]}{[\text{NH}_4^+]} \right)$$

$$\left(\frac{[\text{NH}_3]}{[\text{NH}_4^+]} \right) = 0.85 \text{ (buffer-component concentration ratio)}$$

$$\text{Mass of NH}_4\text{Cl} = 0.75 \text{ L soln} \times \frac{0.15 \text{ mol NH}_3}{1 \text{ L soln}}$$

$$\times \frac{1 \text{ mol NH}_4\text{Cl}}{0.85 \text{ mol NH}_3} \times \frac{53.49 \text{ g NH}_4\text{Cl}}{1 \text{ mol NH}_4\text{Cl}}$$

$$= 7.1 \text{ g NH}_4\text{Cl}$$

$$K_a = \frac{[\text{H}_3\text{O}^+][\text{Br}^-]}{[\text{HBrO}]} = 2.3 \times 10^{-9} \approx \frac{(x)(x)}{0.2000}$$

$$x \approx [\text{H}_3\text{O}^+] \approx \sqrt{(2.3 \times 10^{-9})(0.2000)} = 2.1 \times 10^{-5} M$$

$$\text{pH} = 4.68$$

(b) When $[\text{HBrO}] = [\text{Br}^-]$, $[\text{HBrO}]/[\text{Br}^-] = 1$:

$$\text{pH} = \text{p}K_a + \log \frac{[\text{Br}^-]}{[\text{HBrO}]} = 8.64 + \log 1 = 8.64$$

(c) Initial amount (mol) of $\text{HBrO} = 0.02000 \text{ L} \times 0.2000 M = 0.004000 \text{ mol}$

Amount (mol) of added NaOH at the equivalence point = 0.004000 mol

Volume (L) of added NaOH = $0.004000 \text{ mol} \times 1 \text{ L}/0.1000 \text{ mol} = 0.04000 \text{ L}$

From the reaction table, there are 0.004000 mol of BrO^- at the equivalence point.

$$[\text{BrO}^-] = \frac{\text{amount (mol) of } \text{BrO}^-}{\text{total volume (L)}} = \frac{0.004000 \text{ mol}}{0.02000 \text{ L} + 0.04000 \text{ L}} = 0.06667 M$$

$$K_b \text{ of } \text{BrO}^- = \frac{K_w}{K_a \text{ of HBrO}} = \frac{1.0 \times 10^{-14}}{2.3 \times 10^{-9}} = 4.3 \times 10^{-6}$$

$$K_b = \frac{[\text{HBrO}][\text{OH}^-]}{[\text{BrO}^-]} = 4.3 \times 10^{-6} = \frac{(x)(x)}{0.06667}$$

$$x = [\text{OH}^-] = \sqrt{(4.3 \times 10^{-6})(0.06667)}$$

$$= 5.3 \times 10^{-4} M$$

$$[\text{H}_3\text{O}^+] = 1.9 \times 10^{-11} M; \text{pH} = 10.72$$

(d) Amount (mol) of OH^- added = $2 \times 0.004000 \text{ mol} = 0.008000 \text{ mol}$

Volume (L) of OH^- soln = $0.008000 \text{ mol} \times 1 \text{ L}/0.1000 \text{ mol} = 0.08000 \text{ L}$

$$[\text{OH}^-] = \frac{\text{amount (mol) of } \text{OH}^- \text{ unreacted}}{\text{total volume (L)}}$$

$$= \frac{0.008000 \text{ mol} - 0.004000 \text{ mol}}{(0.02000 + 0.08000) \text{ L}} = 0.04000 M$$

$$[\text{H}_3\text{O}^+] = \frac{K_w}{[\text{OH}^-]} = \frac{1.0 \times 10^{-14}}{0.04000} = 2.5 \times 10^{-13} M$$

$$\text{pH} = 12.60$$

$$K_a = \frac{[\text{H}_3\text{O}^+][\text{C}_6\text{H}_5\text{COO}^-]}{[\text{C}_6\text{H}_5\text{COOH}]} = 6.3 \times 10^{-5} \approx \frac{(x)(x)}{0.1000}$$

$$x \approx [\text{H}_3\text{O}^+] \approx \sqrt{(6.3 \times 10^{-5})(0.1000)} = 2.5 \times 10^{-3} M$$

$$\text{pH} = 2.60$$

(b) Initial amount (mol) of $\text{C}_6\text{H}_5\text{COOH} = 0.03000 \text{ L} \times 0.1000 M = 0.003000 \text{ mol}$

Amount (mol) of added NaOH = $0.01200 \text{ L} \times 0.1500 M = 0.001800 \text{ mol}$

From the reaction table, $0.003000 \text{ mol} - 0.001800 \text{ mol} = 0.001200 \text{ mol}$ of $\text{C}_6\text{H}_5\text{COOH}$ remains and 0.001800 mol of $\text{C}_6\text{H}_5\text{COO}^-$ is produced:

$$\text{pH} = \text{p}K_a + \log \frac{[\text{C}_6\text{H}_5\text{COO}^-]}{[\text{C}_6\text{H}_5\text{COOH}]} = 4.20 + \log \frac{0.001800 \text{ mol}}{0.001200 \text{ mol}} = 4.38$$

(c) Initial amount (mol) of $\text{C}_6\text{H}_5\text{COOH} = 0.03000 \text{ L} \times 0.1000 M = 0.003000 \text{ mol}$

Amount (mol) of added NaOH at the equivalence point = 0.003000 mol

Volume (L) of added NaOH = $0.003000 \text{ mol} \times 1 \text{ L}/0.1500 M = 0.02000 \text{ L}$

From the reaction table, 0.003000 mol of $\text{C}_6\text{H}_5\text{COO}^-$ is present at the equivalence point.

$$[\text{C}_6\text{H}_5\text{COO}^-] = \frac{\text{amount (mol) of } \text{C}_6\text{H}_5\text{COO}^-}{\text{total volume (L)}} \\ = \frac{0.003000 \text{ mol}}{0.03000 \text{ L} + 0.02000 \text{ L}} = 0.06000 M$$

$$K_b \text{ of } \text{C}_6\text{H}_5\text{COO}^- = \frac{K_w}{K_a \text{ of C}_6\text{H}_5\text{COOH}} = \frac{1.0 \times 10^{-14}}{6.3 \times 10^{-5}} = 1.6 \times 10^{-10}$$

$$K_b = \frac{[\text{C}_6\text{H}_5\text{COOH}][\text{OH}^-]}{[\text{C}_6\text{H}_5\text{COO}^-]} = 1.6 \times 10^{-10} = \frac{(x)(x)}{0.06000}$$

$$x = [\text{OH}^-] = \sqrt{(1.6 \times 10^{-10})(0.06000)} \\ = 3.1 \times 10^{-6} M$$

$$[\text{H}_3\text{O}^+] = 3.2 \times 10^{-9} M; \text{pH} = 8.49$$

(d) Amount (mol) of OH^- added = $0.02200 \text{ L} \times 0.1500 M = 0.003300 \text{ mol}$

$$[\text{OH}^-] = \frac{\text{amount (mol) of } \text{OH}^- \text{ unreacted}}{\text{total volume (L)}}$$

$$= \frac{0.003300 \text{ mol} - 0.003000 \text{ mol}}{(0.03000 + 0.02200) \text{ L}} = 0.00577 M$$

$$[\text{H}_3\text{O}^+] = \frac{K_w}{[\text{OH}^-]} = 1.73 \times 10^{-12} M$$

$$\text{pH} = 11.76 \text{ (pH is shown to two decimal places)}$$

19.5A (a) $K_{sp} = [\text{Ca}^{2+}][\text{SO}_4^{2-}]$ (b) $K_{sp} = [\text{Cr}^{3+}]^2[\text{CO}_3^{2-}]^3$

(c) $K_{sp} = [\text{Mg}^{2+}][\text{OH}^-]^2$ (d) $K_{sp} = [\text{Al}^{3+}][\text{OH}^-]^3$

19.5B (a) PbCrO₄, lead(II) chromate; (b) FeS, iron(II) sulfide; (c) SrF₂, strontium fluoride; (d) Cu₃(PO₄)₂, copper(II) phosphate

$$19.6A \quad [\text{CaF}_2] = \frac{1.5 \times 10^{-4} \text{ g CaF}_2}{10.0 \text{ mL soln}} \times \frac{1000 \text{ mL}}{1 \text{ L}} \times \frac{1 \text{ mol CaF}_2}{78.08 \text{ g CaF}_2} \\ = 1.9 \times 10^{-4} M$$

$$[\text{Ca}^{2+}] = 1.9 \times 10^{-4} M \text{ and } [\text{F}^-] = 2(1.9 \times 10^{-4} M) = 3.8 \times 10^{-4} M$$

$$K_{sp} = [\text{Ca}^{2+}][\text{F}^-]^2 = (1.9 \times 10^{-4})(3.8 \times 10^{-4})^2 = 2.7 \times 10^{-11}$$

BRIEF SOLUTIONS TO FOLLOW-UP PROBLEMS

(continued)

$$\begin{aligned} \text{19.6B } [\text{Ag}_3\text{PO}_4] &= \frac{3.2 \times 10^{-4} \text{ g Ag}_3\text{PO}_4}{50. \text{ mL soln}} \times \frac{1000 \text{ mL}}{1 \text{ L}} \\ &\times \frac{1 \text{ mol Ag}_3\text{PO}_4}{418.7 \text{ g Ag}_3\text{PO}_4} \\ &= 1.5 \times 10^{-5} \text{ M} \end{aligned}$$

$$\begin{aligned} [\text{Ag}^+] &= 3(1.5 \times 10^{-5} \text{ M}) = 4.5 \times 10^{-5} \text{ M} \text{ and } [\text{PO}_4^{3-}] = 1.5 \times 10^{-5} \text{ M} \\ K_{\text{sp}} &= [\text{Ag}^+]^3[\text{PO}_4^{3-}] = (4.5 \times 10^{-5})^3(1.5 \times 10^{-5}) = 1.4 \times 10^{-18} \end{aligned}$$

$$\begin{aligned} \text{19.7A } \text{From the reaction table, } [\text{Mg}^{2+}] &= S \text{ and } [\text{OH}^-] = 2S. \\ K_{\text{sp}} &= [\text{Mg}^{2+}][\text{OH}^-]^2 = [S][2S]^2 = 4S^3 = 6.3 \times 10^{-10}; S = 5.4 \times 10^{-4} \text{ M} \end{aligned}$$

$$\begin{aligned} \text{19.7B } \text{From the reaction table, } [\text{Ca}^{2+}] &= 3S \text{ and } [\text{PO}_4^{3-}] = 2S. \\ K_{\text{sp}} &= [\text{Ca}^{2+}]^3[\text{PO}_4^{3-}]^2 = (3S)^3(2S)^2 = 27S^3 \times 4S^2 = 108S^5 = 1.2 \times 10^{-29} \\ S &= 6.4 \times 10^{-7} \text{ M} \end{aligned}$$

$$\begin{aligned} \text{19.8A (a) In water: } K_{\text{sp}} &= [\text{Ba}^{2+}][\text{SO}_4^{2-}] = (S)(S) = S^2 = 1.1 \times 10^{-10} \\ S &= 1.0 \times 10^{-5} \text{ M} \end{aligned}$$

$$\begin{aligned} \text{(b) In } 0.10 \text{ M Na}_2\text{SO}_4: [\text{SO}_4^{2-}] &= 0.10 \text{ M from Na}_2\text{SO}_4; \\ [\text{SO}_4^{2-}] &= S \text{ from BaSO}_4 \end{aligned}$$

$$\text{Assume } S + 0.10 \text{ M} \approx 0.10 \text{ M}$$

$$K_{\text{sp}} = 1.1 \times 10^{-10} \approx S \times 0.10; S = 1.1 \times 10^{-9} \text{ M}$$

S decreases in presence of the common ion $[\text{SO}_4^{2-}]$.

$$\begin{aligned} \text{19.8B (a) In water: } K_{\text{sp}} &= [\text{Ca}^{2+}][\text{F}^-]^2 = (S)(2S)^2 = 4S^3 = 3.2 \times 10^{-11} \\ S &= 2.0 \times 10^{-4} \text{ M} \end{aligned}$$

$$\begin{aligned} \text{(b) In } 0.20 \text{ M CaCl}_2: [\text{Ca}^{2+}] \text{ from CaCl}_2 &= 0.20 \text{ M}; \\ [\text{Ca}^{2+}] \text{ from CaF}_2 &= S \end{aligned}$$

$$\text{Assume } S + 0.20 \text{ M} \approx 0.20 \text{ M}$$

$$K_{\text{sp}} = 3.2 \times 10^{-11} \approx S \times (0.20)^2; S = 6.3 \times 10^{-6} \text{ M}$$

$$\begin{aligned} \text{(c) In } 0.20 \text{ M NiF}_2: [\text{F}^-] \text{ from NiF}_2 &= 2(0.20) = 0.40 \text{ M}; \\ [\text{F}^-] \text{ from CaF}_2 &= 2S \end{aligned}$$

$$\text{Assume } 2S + 0.40 \text{ M} \approx 0.40 \text{ M}$$

$$K_{\text{sp}} = 3.2 \times 10^{-11} \approx S \times (0.40)^2; S = 2.0 \times 10^{-10} \text{ M}$$

19.9A (a) Increases solubility.

(b) Increases solubility.

(c) No effect. $\text{I}^-(aq)$ is the conjugate base of strong acid HI.

19.9B (a) Increases solubility.

(b) No effect. $\text{Cl}^-(aq)$ is the conjugate base of strong acid HCl.

(c) Increases solubility.

$$\begin{aligned} Q_{\text{sp}} &= [\text{Ca}^{2+}]^3[\text{PO}_4^{3-}]^2 = (1.0 \times 10^{-9})^3(1.0 \times 10^{-9})^2 \\ &= (1.0 \times 10^{-9})^5 = 1.0 \times 10^{-45} \end{aligned}$$

$Q_{\text{sp}} < K_{\text{sp}}$, so $\text{Ca}_3(\text{PO}_4)_2$ will not precipitate.

$$\begin{aligned} \text{Amount (mol) of Pb}^{2+} &= 25 \text{ L} \times \frac{0.015 \text{ g Pb}^{2+}}{1.0 \text{ L}} \times \frac{1 \text{ mol Pb}^{2+}}{207.2 \text{ g Pb}^{2+}} \\ &= 1.8 \times 10^{-3} \text{ mol} \end{aligned}$$

$$\begin{aligned} [\text{Pb}^{2+}] &= \frac{1.8 \times 10^{-3} \text{ mol Pb}^{2+}}{25 \text{ L} + 0.500 \text{ L}} = 7.1 \times 10^{-5} \text{ M} \end{aligned}$$

$$\begin{aligned} \text{Amount (mol) of S}^{2-} &= 0.10 \text{ M S}^{2-} \times 0.500 \text{ L} = 0.050 \text{ mol} \\ [\text{S}^{2-}] &= \frac{0.050 \text{ mol}}{25 \text{ L} + 0.500 \text{ L}} = 2.0 \times 10^{-3} \text{ M} \end{aligned}$$

$$Q_{\text{sp}} = [\text{Pb}^{2+}][\text{S}^{2-}] = (7.1 \times 10^{-5})(2.0 \times 10^{-3}) = 1.4 \times 10^{-7}$$

$Q_{\text{sp}} > K_{\text{sp}}$ (which is 3×10^{-25}), so PbS will precipitate.

19.11A (a) Scene 3 has the same relative numbers of ions as in the compound's formula (ratio of 1 Ni^{2+} to every 2 OH^-).

(b) Based on $\text{Ni}(\text{OH})_2(s) \rightleftharpoons \text{Ni}^{2+}(aq) + 2\text{OH}^-(aq)$ and $Q_{\text{sp}} = [\text{Ni}^{2+}][\text{OH}^-]^2$, the ion products are $(3)(4)^2 = 48$ in scene 1; $(4)(2)^2 = 16$ in scene 2; and $(2)(4)^2 = 32 = K_{\text{sp}}$ in scene 3. Since Q_{sp} for scene 1 exceeds K_{sp} for scene 3, more solid forms.

(c) Addition of acid will decrease the mass of $\text{Ni}(\text{OH})_2(s)$ by reacting with OH^- , thereby causing more solid to dissolve; addition of base will increase the mass of $\text{Ni}(\text{OH})_2(s)$ due to the common-ion effect.

19.11B (a) Scene 1 has the same relative numbers of ions as in the compound's formula (ratio of 1 Pb^{2+} to every 2 Cl^-).

(b) Based on $\text{PbCl}_2(s) \rightleftharpoons \text{Pb}^{2+}(aq) + 2\text{Cl}^-(aq)$ and $Q_{\text{sp}} = [\text{Pb}^{2+}][\text{Cl}^-]^2$, the ion products are $(3)(6)^2 = 108 = K_{\text{sp}}$ in scene 1; $(4)(5)^2 = 100$ in scene 2; and $(5)(5)^2 = 125$ in scene 3. Since Q_{sp} for scene 3 exceeds K_{sp} for scene 1, more solid forms.

(c) Addition of $\text{HCl}(aq)$ will increase the mass of PbCl_2 due to the common-ion effect (Cl^- is the common ion).

19.12A Both salts have 1/1 ion ratios, and K_{sp} values show that CaSO_4 is more soluble:

$$[\text{SO}_4^{2-}] = \frac{K_{\text{sp}}}{[\text{Ca}^{2+}]} = \frac{2.4 \times 10^{-5}}{0.025} 9.6 \times 10^{-4} \text{ M}$$

19.12B Both salts have 1/2 ion ratios, and K_{sp} values show that BaF_2 is more soluble:

$$[\text{F}^-] = \sqrt{\frac{K_{\text{sp}}}{[\text{Ba}^{2+}]}} = \sqrt{\frac{1.5 \times 10^{-6}}{0.020 \text{ M}}} = 8.7 \times 10^{-3} \text{ M}$$

$$\begin{aligned} \text{19.13A } [\text{Fe}(\text{H}_2\text{O})_6^{3+}]_{\text{init}} &= \frac{(0.0255 \text{ L})(3.1 \times 10^{-2} \text{ M})}{0.0255 \text{ L} + 0.0350 \text{ L}} \\ &= 1.3 \times 10^{-2} \text{ M} \end{aligned}$$

Similarly, $[\text{CN}^-]_{\text{init}} = 0.87 \text{ M}$. From the reaction table,

Concentration (M)	$\text{Fe}(\text{H}_2\text{O})_6^{3+}(aq)$	$6\text{CN}^-(aq)$	$\text{Fe}(\text{CN})_6^{3-}(aq)$	$6\text{H}_2\text{O}(l)$
Initial	1.3×10^{-2}	0.87	0	—
Change	$-(1.3 \times 10^{-2})$	$-(6 \times [1.3 \times 10^{-2}])$	$+(1.3 \times 10^{-2})$	—
Equilibrium	x	0.79	1.3×10^{-2}	—

$$[\text{F}^-]_{\text{init}} = 0.560 M$$

Concentration (M)	$\text{Al}(\text{H}_2\text{O})_6^{3+}(aq)$	$+ 6\text{F}^-(aq)$	\rightleftharpoons	$\text{AlF}_6^{3-}(aq)$	$+ 6\text{H}_2\text{O}(l)$
Initial	0.072	0.560		0	—
Change	$\sim(-0.072)$	$\sim(-6 \times 0.072)$		$\sim(+0.072)$	—
Equilibrium	x	0.128		0.072	—

$$K_f = \frac{[\text{AlF}_6^{3-}]}{[\text{Al}(\text{H}_2\text{O})_6^{3+}][\text{F}^-]^6} = 4 \times 10^{19} \approx \frac{0.072}{x(0.128)^6}$$

$$x = [\text{Al}(\text{H}_2\text{O})_6^{3+}] \approx 4 \times 10^{-16} M$$

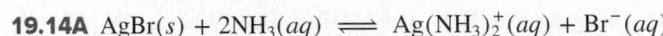

$$K_{\text{overall}} = K_{\text{sp}} \text{ of AgBr} \times K_f \text{ of } \text{Ag}(\text{NH}_3)_2^+ \\ = 8.5 \times 10^{-6}$$

From the reaction table, $[\text{NH}_3] = 1.0 - 2S$ and $[\text{Ag}(\text{NH}_3)_2^+] = [\text{Br}^-] = S$.

$$K_{\text{overall}} = \frac{[\text{Ag}(\text{NH}_3)_2^+][\text{Br}^-]}{[\text{NH}_3]^2} = 8.5 \times 10^{-6} = \frac{[S][S]}{(1.0 - 2S)^2}$$

$$\frac{S}{1.0 - 2S} = \sqrt{8.5 \times 10^{-6}} = 2.9 \times 10^{-3}$$

$$S = [\text{Ag}(\text{NH}_3)_2^+] = 2.9 \times 10^{-3} M$$

Solubility is greater in 1.0 M hypo than in 1.0 M NH_3 .

PROBLEMS

Problems with **colored** numbers are answered in Appendix E and worked in detail in the Student Solutions Manual. Problem sections match those in the text and give the numbers of relevant sample problems. Most offer Concept Review Questions, Skill-Building Exercises (grouped in pairs covering the same concept), and Problems in Context. The Comprehensive Problems are based on material from any section or previous chapter.

Note: Unless stated otherwise, all of the problems for this chapter refer to aqueous solutions at 298 K (25°C).

Equilibria of Acid-Base Buffers

(Sample Problems 19.1 to 19.3)

Concept Review Questions

19.1 What is the purpose of an acid-base buffer?

19.2 How do the acid and base components of a buffer function? Why are they often the conjugate acid-base pair of a weak acid?

19.3 What is the common-ion effect? How is it related to Le Châtelier's principle? Explain with equations that include HF and NaF.

19.4 What is the difference between buffers with high and low capacities? Will adding 0.01 mol of HCl produce a greater pH change in a buffer with a high or a low capacity? Explain.

19.5 Which of these factors influence buffer capacity? How?
(a) The identity of the conjugate acid-base pair

- (b) pH of the buffer
- (c) Concentration of buffer components
- (d) Buffer range
- (e) pK_a of the acid component

19.6 What is the relationship between the buffer range and the buffer-component concentration ratio?

19.7 A chemist needs a pH 3.5 buffer. Should she use NaOH with formic acid ($K_a = 1.8 \times 10^{-4}$) or with acetic acid ($K_a = 1.8 \times 10^{-5}$)? Why? What is the disadvantage of choosing the other acid? What is the role of the NaOH?

19.8 State and explain the relative change in the pH and in the buffer-component concentration ratio, $[\text{NaA}]/[\text{HA}]$, for each of the following additions:

- (a) Add 0.1 M NaOH to the buffer
- (b) Add 0.1 M HCl to the buffer
- (c) Dissolve pure NaA in the buffer
- (d) Dissolve pure HA in the buffer

19.9 Does the pH increase or decrease with each of the following additions, and does it do so to a large or small extent in each case?

- (a) 5 drops of 0.1 M NaOH to 100 mL of 0.5 M acetate buffer
- (b) 5 drops of 0.1 M HCl to 100 mL of 0.5 M acetate buffer
- (c) 5 drops of 0.1 M NaOH to 100 mL of 0.5 M HCl
- (d) 5 drops of 0.1 M NaOH to distilled water

Skill-Building Exercises (grouped in similar pairs)

19.10 The scenes below depict solutions of the same HA/A⁻ buffer (HA is red and blue and A⁻ is red; other ions and water molecules have been omitted for clarity). (a) Which solution has the greatest buffer capacity? (b) Explain how the pH ranges of the buffers compare. (c) Which solution can react with the largest amount of added strong acid?

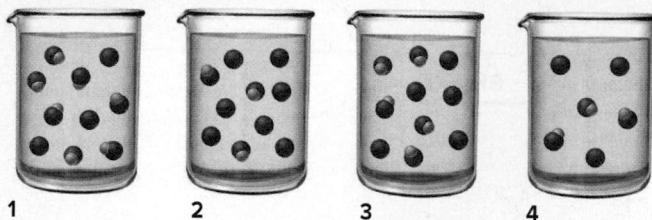

19.11 The scenes below show three samples of a buffer consisting of HA and A⁻ (HA is green and blue and A⁻ is green; other ions and water are not shown). (a) Which buffer can react with the largest amount of added strong base? (b) Which buffer has the highest pH? (c) Which buffer has pH = pK_a?

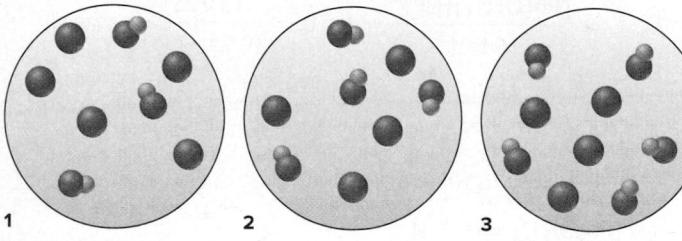

19.12 What are the [H₃O⁺] and the pH of a propanoic acid–propanoate buffer that consists of 0.35 M CH₃CH₂COONa and 0.15 M CH₃CH₂COOH (K_a of propanoic acid = 1.3×10^{-5})?

19.13 What are the [H₃O⁺] and the pH of a benzoic acid–benzoate buffer that consists of 0.33 M C₆H₅COOH and 0.28 M C₆H₅COONa (K_a of benzoic acid = 6.3×10^{-5})?

19.14 What are the [H₃O⁺] and the pH of a buffer that consists of 0.55 M HNO₂ and 0.75 M KNO₂ (K_a of HNO₂ = 7.1×10^{-4})?

19.15 What are the [H₃O⁺] and the pH of a buffer that consists of 0.20 M HF and 0.25 M KF (K_a of HF = 6.8×10^{-4})?

19.16 Find the pH of a buffer that consists of 0.45 M HCOOH and 0.63 M HCOONa (p K_a of HCOOH = 3.74).

19.17 Find the pH of a buffer that consists of 0.95 M HBrO and 0.68 M KBrO (p K_a of HBrO = 8.64).

19.18 Find the pH of a buffer that consists of 1.3 M sodium phenolate (C₆H₅ONa) and 1.2 M phenol (C₆H₅OH) (p K_a of phenol = 10.00).

19.19 Find the pH of a buffer that consists of 0.12 M boric acid (H₃BO₃) and 0.82 M sodium borate (NaH₂BO₃) (p K_a of boric acid = 9.24).

19.20 Find the pH of a buffer that consists of 0.25 M NH₃ and 0.15 M NH₄Cl (p K_b of NH₃ = 4.75).

19.21 Find the pH of a buffer that consists of 0.50 M methylamine (CH₃NH₂) and 0.60 M CH₃NH₃Cl (p K_b of CH₃NH₂ = 3.35).

19.22 A buffer consists of 0.22 M KHCO₃ and 0.37 M K₂CO₃. Carbonic acid is a diprotic acid with $K_{a1} = 4.5 \times 10^{-7}$ and $K_{a2} = 4.7 \times 10^{-11}$. (a) Which K_a value is more important to this buffer? (b) What is the buffer pH?

19.23 A buffer consists of 0.50 M NaH₂PO₄ and 0.40 M Na₂HPO₄. Phosphoric acid is a triprotic acid ($K_{a1} = 7.2 \times 10^{-3}$, $K_{a2} = 6.3 \times 10^{-8}$, and $K_{a3} = 4.2 \times 10^{-13}$). (a) Which K_a value is most important to this buffer? (b) What is the buffer pH?

19.24 What is the component concentration ratio, [Pr⁻]/[HPr], of a buffer that has a pH of 5.44 (K_a of HPr = 1.3×10^{-5})?

19.25 What is the component concentration ratio, [NO₂⁻]/[HNO₂], of a buffer that has a pH of 2.95 (K_a of HNO₂ = 7.1×10^{-4})?

19.26 What is the component concentration ratio, [BrO⁻]/[HBrO], of a buffer that has a pH of 7.95 (K_a of HBrO = 2.3×10^{-9})?

19.27 What is the component concentration ratio, [CH₃COO⁻]/[CH₃COOH], of a buffer that has a pH of 4.39 (K_a of CH₃COOH = 1.8×10^{-5})?

19.28 A buffer containing 0.2000 M of acid, HA, and 0.1500 M of its conjugate base, A⁻, has a pH of 3.35. What is the pH after 0.0015 mol of NaOH is added to 0.5000 L of this solution?

19.29 A buffer that contains 0.40 M of a base, B, and 0.25 M of its conjugate acid, BH⁺, has a pH of 8.88. What is the pH after 0.0020 mol of HCl is added to 0.25 L of this solution?

19.30 A buffer that contains 0.110 M HY and 0.220 M Y⁻ has a pH of 8.77. What is the pH after 0.0015 mol of Ba(OH)₂ is added to 0.350 L of this solution?

19.31 A buffer that contains 1.05 M B and 0.750 M BH⁺ has a pH of 9.50. What is the pH after 0.0050 mol of HCl is added to 0.500 L of this solution?

19.32 A buffer is prepared by mixing 204 mL of 0.452 M HCl and 0.500 L of 0.400 M sodium acetate. (See Appendix C.) (a) What is the pH? (b) How many grams of KOH must be added to 0.500 L of the buffer to change the pH by 0.15 units?

19.33 A buffer is prepared by mixing 50.0 mL of 0.050 M sodium bicarbonate and 10.7 mL of 0.10 M NaOH. (See Appendix C.) (a) What is the pH? (b) How many grams of HCl must be added to 25.0 mL of the buffer to change the pH by 0.07 units?

19.34 Choose specific acid-base conjugate pairs to make the following buffers: (a) pH ≈ 4.5; (b) pH ≈ 7.0. (See Appendix C.)

19.35 Choose specific acid-base conjugate pairs to make the following buffers: (a) [H₃O⁺] ≈ 1×10^{-9} M; (b) [OH⁻] ≈ 3×10^{-5} M. (See Appendix C.)

19.36 Choose specific acid-base conjugate pairs to make the following buffers: (a) pH ≈ 3.5; (b) pH ≈ 5.5. (See Appendix C.)

19.37 Choose specific acid-base conjugate pairs to make the following buffers: (a) [OH⁻] ≈ 1×10^{-6} M; (b) [H₃O⁺] ≈ 4×10^{-4} M. (See Appendix C.)

Problems in Context

19.38 An industrial chemist studying bleaching and sterilizing prepares several hypochlorite buffers. Find the pH of

- (a) 0.100 M HClO and 0.100 M NaClO;
- (b) 0.100 M HClO and 0.150 M NaClO;
- (c) 0.150 M HClO and 0.100 M NaClO;
- (d) 1.0 L of the solution in part (a) after 0.0050 mol of NaOH has been added.

19.39 Oxoanions of phosphorus are buffer components in blood. For a KH₂PO₄/Na₂HPO₄ buffer with pH = 7.40 (pH of normal arterial blood), what is the buffer-component concentration ratio?

Acid-Base Titration Curves

(Sample Problem 19.4)

Concept Review Questions

19.40 The scenes below depict the relative concentrations of H_3PO_4 , H_2PO_4^- , and HPO_4^{2-} during a titration with aqueous NaOH , but they are out of order. (Phosphate groups are *purple*, hydrogens are *blue*, and Na^+ ions and water molecules are not shown.) (a) List the scenes in the correct order. (b) What is the pH in the correctly ordered second scene (see Appendix C)? (c) If it requires 10.00 mL of the NaOH solution to reach this scene, how much more is needed to reach the last scene?

19.41 Explain how *strong acid*-*strong base*, *weak acid*-*strong base*, and *weak base*-*strong acid* titrations using the same concentrations differ in terms of (a) the initial pH and (b) the pH at the equivalence point. (The component in *italics* is in the flask.)

19.42 What species are in the buffer region of a weak acid-*strong base* titration? How are they different from the species at the equivalence point? How are they different from the species in the buffer region of a weak base-*strong acid* titration?

19.43 Why is the midpoint of the buffer region of a weak acid-*strong base* titration significant?

19.44 How can you estimate the pH range of an indicator's color change? Why do some indicators have two separate pH ranges?

19.45 Why does the color change of an indicator take place over a range of about 2 pH units?

19.46 Why doesn't the addition of an acid-base indicator affect the pH of a test solution?

19.47 What is the difference between the end point of a titration and the equivalence point? Is the equivalence point always reached first? Explain.

19.48 How does the titration curve of a monoprotic acid differ from that of a diprotic acid?

Skill-Building Exercises (grouped in similar pairs)

19.49 Calculate the pH during the titration of 40.00 mL of 0.1000 *M* HCl with 0.1000 *M* NaOH solution after each of the following additions of base:

- (a) 0 mL (b) 25.00 mL (c) 39.00 mL (d) 39.90 mL
 (e) 40.00 mL (f) 40.10 mL (g) 50.00 mL

19.50 Calculate the pH during the titration of 30.00 mL of 0.1000 *M* KOH with 0.1000 *M* HBr solution after each of the following additions of acid:

- (a) 0 mL (b) 15.00 mL (c) 29.00 mL (d) 29.90 mL
 (e) 30.00 mL (f) 30.10 mL (g) 40.00 mL

19.51 Find the pH during the titration of 20.00 mL of 0.1000 *M* butanoic acid, $\text{CH}_3\text{CH}_2\text{CH}_2\text{COOH}$ ($K_a = 1.54 \times 10^{-5}$), with 0.1000 *M* NaOH solution after the following additions of titrant:

- (a) 0 mL (b) 10.00 mL (c) 15.00 mL (d) 19.00 mL
 (e) 19.95 mL (f) 20.00 mL (g) 20.05 mL (h) 25.00 mL

19.52 Find the pH during the titration of 20.00 mL of 0.1000 *M* triethylamine, $(\text{CH}_3\text{CH}_2)_3\text{N}$ ($K_b = 5.2 \times 10^{-4}$), with 0.1000 *M* HCl solution after the following additions of titrant:

- (a) 0 mL (b) 10.00 mL (c) 15.00 mL (d) 19.00 mL
 (e) 19.95 mL (f) 20.00 mL (g) 20.05 mL (h) 25.00 mL

19.53 Find the pH of the equivalence point(s) and the volume (mL) of 0.0372 *M* NaOH needed to reach the point(s) in titrations of

- (a) 42.2 mL of 0.0520 *M* CH_3COOH
 (b) 28.9 mL of 0.0850 *M* H_2SO_3 (two equivalence points)

19.54 Find the pH of the equivalence point(s) and the volume (mL) of 0.0588 *M* KOH needed to reach the point(s) in titrations of

- (a) 23.4 mL of 0.0390 *M* HNO_2
 (b) 17.3 mL of 0.130 *M* H_2CO_3 (two equivalence points)

19.55 Find the pH of the equivalence point(s) and the volume (mL) of 0.125 *M* HCl needed to reach the point(s) in titrations of

- (a) 65.5 mL of 0.234 *M* NH_3
 (b) 21.8 mL of 1.11 *M* CH_3NH_2

19.56 Find the pH of the equivalence point(s) and the volume (mL) of 0.447 *M* HNO_3 needed to reach the point(s) in titrations of

- (a) 2.65 L of 0.0750 *M* pyridine ($\text{C}_5\text{H}_5\text{N}$)
 (b) 0.188 L of 0.250 *M* ethylenediamine ($\text{H}_2\text{NCH}_2\text{CH}_2\text{NH}_2$)

19.57 The indicator cresol red has $K_a = 3.5 \times 10^{-9}$. Over what approximate pH range does it change color?

19.58 The indicator ethyl red has $K_a = 3.8 \times 10^{-6}$. Over what approximate pH range does it change color?

19.59 Use Figure 19.9 to find an indicator for these titrations:

- (a) 0.10 *M* HCl with 0.10 *M* NaOH
 (b) 0.10 *M* HCOOH (see Appendix C) with 0.10 *M* NaOH

19.60 Use Figure 19.9 to find an indicator for these titrations:

- (a) 0.10 *M* CH_3NH_2 (see Appendix C) with 0.10 *M* HCl
 (b) 0.50 *M* HI with 0.10 *M* KOH

19.61 Use Figure 19.9 to find an indicator for these titrations:

- (a) 0.5 *M* $(\text{CH}_3)_2\text{NH}$ (see Appendix C) with 0.5 *M* HBr
 (b) 0.2 *M* KOH with 0.2 *M* HNO_3

19.62 Use Figure 19.9 to find an indicator for these titrations:

- (a) 0.25 *M* $\text{C}_6\text{H}_5\text{COOH}$ (see Appendix C) with 0.25 *M* KOH
 (b) 0.50 *M* NH_4Cl (see Appendix C) with 0.50 *M* NaOH

Equilibria of Slightly Soluble Ionic Compounds

(Sample Problems 19.5 to 19.12)

Concept Review Questions

19.63 The molar solubility (*S*) of M_2X is 5×10^{-5} *M*. Find *S* of each ion. How do you set up the calculation to find K_{sp} ? What assumption must you make about the dissociation of M_2X into ions? Why is the calculated K_{sp} higher than the actual value?

19.64 Why does pH affect the solubility of BaF_2 but not of BaCl_2 ?

19.65 A list of K_{sp} values like that in Appendix C can be used to compare the solubility of silver chloride directly with that of silver bromide but not with that of silver chromate. Explain.

19.66 In a gaseous equilibrium, the reverse reaction occurs when $Q_c > K_c$. What occurs in aqueous solution when $Q_{\text{sp}} > K_{\text{sp}}$?

Skill-Building Exercises (grouped in similar pairs)

19.67 Write the ion-product expressions for (a) silver carbonate; (b) barium fluoride; (c) copper(II) sulfide.

19.68 Write the ion-product expressions for (a) iron(III) hydroxide; (b) barium phosphate; (c) magnesium fluoride.

19.69 Write the ion-product expressions for (a) calcium chromate; (b) silver cyanide; (c) silver phosphate.

19.70 Write the ion-product expressions for (a) lead(II) iodide; (b) strontium sulfate; (c) chromium(III) hydroxide.

19.71 The solubility of silver carbonate is 0.032 M at 20°C . Calculate its K_{sp} .

19.72 The solubility of zinc oxalate is $7.9 \times 10^{-3}\text{ M}$ at 18°C . Calculate its K_{sp} .

19.73 The solubility of silver dichromate at 15°C is $8.3 \times 10^{-3}\text{ g}/100.\text{ mL}$ solution. Calculate its K_{sp} .

19.74 The solubility of calcium sulfate at 30°C is $0.209\text{ g}/100.\text{ mL}$ solution. Calculate its K_{sp} .

19.75 Find the molar solubility of SrCO_3 ($K_{\text{sp}} = 5.4 \times 10^{-10}$) in (a) pure water and (b) 0.13 M $\text{Sr}(\text{NO}_3)_2$.

19.76 Find the molar solubility of BaCrO_4 ($K_{\text{sp}} = 2.1 \times 10^{-10}$) in (a) pure water and (b) $1.5 \times 10^{-3}\text{ M}$ Na_2CrO_4 .

19.77 Calculate the molar solubility of $\text{Ca}(\text{IO}_3)_2$ in (a) 0.060 M $\text{Ca}(\text{NO}_3)_2$ and (b) 0.060 M NaIO_3 . (See Appendix C.)

19.78 Calculate the molar solubility of Ag_2SO_4 in (a) 0.22 M AgNO_3 and (b) 0.22 M Na_2SO_4 . (See Appendix C.)

19.79 Which compound in each pair is more soluble in water?

- (a) Magnesium hydroxide or nickel(II) hydroxide
- (b) Lead(II) sulfide or copper(II) sulfide
- (c) Silver sulfate or magnesium fluoride

19.80 Which compound in each pair is more soluble in water?

- (a) Strontium sulfate or barium chromate
- (b) Calcium carbonate or copper(II) carbonate
- (c) Barium iodate or silver chromate

19.81 Which compound in each pair is more soluble in water?

- (a) Barium sulfate or calcium sulfate
- (b) Calcium phosphate or magnesium phosphate
- (c) Silver chloride or lead(II) sulfate

19.82 Which compound in each pair is more soluble in water?

- (a) Manganese(II) hydroxide or calcium iodate
- (b) Strontium carbonate or cadmium sulfide
- (c) Silver cyanide or copper(I) iodide

19.83 Write equations to show whether the solubility of either of the following is affected by pH: (a) AgCl ; (b) SrCO_3 .

19.84 Write equations to show whether the solubility of either of the following is affected by pH: (a) CuBr ; (b) $\text{Ca}_3(\text{PO}_4)_2$.

19.85 Write equations to show whether the solubility of either of the following is affected by pH: (a) $\text{Fe}(\text{OH})_2$; (b) CuS .

19.86 Write equations to show whether the solubility of either of the following is affected by pH: (a) PbI_2 ; (b) $\text{Hg}_2(\text{CN})_2$.

19.87 Does any solid $\text{Cu}(\text{OH})_2$ form when 0.075 g of KOH is dissolved in 1.0 L of $1.0 \times 10^{-3}\text{ M}$ $\text{Cu}(\text{NO}_3)_2$?

19.88 Does any solid PbCl_2 form when 3.5 mg of NaCl is dissolved in 0.250 L of 0.12 M $\text{Pb}(\text{NO}_3)_2$?

19.89 Does any solid $\text{Ba}(\text{IO}_3)_2$ form when 7.5 mg of BaCl_2 is dissolved in $500.\text{ mL}$ of 0.023 M NaIO_3 ?

19.90 Does any solid Ag_2CrO_4 form when $2.7 \times 10^{-5}\text{ g}$ of AgNO_3 is dissolved in 15.0 mL of $4.0 \times 10^{-4}\text{ M}$ K_2CrO_4 ?

Problems in Context

19.91 When blood is donated, sodium oxalate solution is used to precipitate Ca^{2+} , which triggers clotting. A 104-mL sample of blood contains $9.7 \times 10^{-5}\text{ g}$ Ca^{2+}/mL . A technologist treats the sample with 100.0 mL of 0.1550 M $\text{Na}_2\text{C}_2\text{O}_4$. Calculate $[\text{Ca}^{2+}]$ after the treatment. (See Appendix C for K_{sp} of $\text{CaC}_2\text{O}_4 \cdot \text{H}_2\text{O}$.)

19.92 A 50.0-mL volume of 0.50 M $\text{Fe}(\text{NO}_3)_3$ is mixed with 125 mL of 0.25 M $\text{Cd}(\text{NO}_3)_2$.

(a) If aqueous NaOH is added, which ion precipitates first? (See Appendix C.)

(b) Describe how the metal ions can be separated using NaOH .

(c) Calculate the $[\text{OH}^-]$ that will accomplish the separation.

Equilibria Involving Complex Ions

(Sample Problems 19.13 and 19.14)

Concept Review Questions

19.93 How can a metal cation be at the center of a complex anion?

19.94 Write equations to demonstrate the stepwise reaction of $\text{Cd}(\text{H}_2\text{O})_4^{2+}$ in an aqueous solution of KI to form CdI_4^{2-} . Show that $K_{\text{f(overall)}} = K_{\text{f1}} \times K_{\text{f2}} \times K_{\text{f3}} \times K_{\text{f4}}$.

19.95 Consider the dissolution of $\text{Zn}(\text{OH})_2$ in water:

Adding aqueous NaOH causes more $\text{Zn}(\text{OH})_2$ to dissolve. Does this violate Le Châtelier's principle? Explain.

Skill-Building Exercises (grouped in similar pairs)

19.96 Write a balanced equation for the reaction of $\text{Hg}(\text{H}_2\text{O})_4^{2+}$ in aqueous KCN .

19.97 Write a balanced equation for the reaction of $\text{Zn}(\text{H}_2\text{O})_4^{2+}$ in aqueous NaCN .

19.98 Write a balanced equation for the reaction of $\text{Ag}(\text{H}_2\text{O})_2^+$ in aqueous $\text{Na}_2\text{S}_2\text{O}_3$.

19.99 Write a balanced equation for the reaction of $\text{Al}(\text{H}_2\text{O})_6^{3+}$ in aqueous KF .

19.100 What is $[\text{Ag}^+]$ when 25.0 mL each of 0.044 M AgNO_3 and 0.57 M $\text{Na}_2\text{S}_2\text{O}_3$ are mixed? [K_{f} of $\text{Ag}(\text{S}_2\text{O}_3)_2^{3-} = 4.7 \times 10^{13}$?]

19.101 Potassium thiocyanate, KSCN , is often used to detect the presence of Fe^{3+} ions in solution through the formation of the red $\text{Fe}(\text{H}_2\text{O})_5\text{SCN}^{2+}$ (or, more simply, FeSCN^{2+} ; $K_{\text{f}} = 8.9 \times 10^2$). What is $[\text{Fe}^{3+}]$ when 0.50 L each of 0.0015 M $\text{Fe}(\text{NO}_3)_3$ and 0.20 M KSCN are mixed?

19.102 Find the solubility of $\text{Cr}(\text{OH})_3$ in a buffer of pH 13.0 [K_{sp} of $\text{Cr}(\text{OH})_3 = 6.3 \times 10^{-31}$; K_{f} of $\text{Cr}(\text{OH})_4^- = 8.0 \times 10^{29}$].

19.103 Find the solubility of AgI in 2.5 M NH_3 [K_{sp} of $\text{AgI} = 8.3 \times 10^{-17}$; K_{f} of $\text{Ag}(\text{NH}_3)_2^+ = 1.7 \times 10^7$].

19.104 When 0.84 g of ZnCl_2 is dissolved in 245 mL of 0.150 M NaCN , what are $[\text{Zn}^{2+}]$, $[\text{Zn}(\text{CN})_4^{2-}]$, and $[\text{CN}^-]$ [K_{f} of $\text{Zn}(\text{CN})_4^{2-} = 4.2 \times 10^{19}$]?

19.105 When 2.4 g of $\text{Co}(\text{NO}_3)_2$ is dissolved in 0.350 L of 0.22 M KOH, what are $[\text{Co}^{2+}]$, $[\text{Co}(\text{OH})_4^{2-}]$, and $[\text{OH}^-]$? K_f of $\text{Co}(\text{OH})_4^{2-} = 5 \times 10^9$?

Comprehensive Problems

19.106 What volumes of 0.200 M HCOOH and 2.00 M NaOH would make 500. mL of a buffer with the same pH as a buffer made from 475 mL of 0.200 M benzoic acid and 25 mL of 2.00 M NaOH?

19.107 A microbiologist is preparing a medium on which to culture *E. coli* bacteria. She buffers the medium at pH 7.00 to minimize the effect of acid-producing fermentation. What volumes of equimolar aqueous solutions of K_2HPO_4 and KH_2PO_4 must she combine to make 100. mL of the pH 7.00 buffer?

19.108 As an FDA physiologist, you need 0.700 L of formic acid-formate buffer with a pH of 3.74. (a) What is the required buffer-component concentration ratio? (b) How do you prepare this solution from stock solutions of 1.0 M HCOOH and 1.0 M NaOH? (c) What is the final concentration of HCOOH in this solution?

19.109 Tris(hydroxymethyl)aminomethane $[(\text{HOCH}_2)_3\text{CNH}_2]$, known as TRIS, is a weak base used in biochemical experiments to make buffer solutions in the pH range of 7 to 9. A certain TRIS buffer has a pH of 8.10 at 25°C and a pH of 7.80 at 37°C. Why does the pH change with temperature?

19.110 Water flowing through pipes of carbon steel must be kept at pH 5 or greater to limit corrosion. If an 8.0×10^5 lb/h water stream contains 10 ppm sulfuric acid and 0.015% acetic acid, how many pounds per hour of sodium acetate trihydrate must be added to maintain that pH?

19.111 Gout is caused by an error in metabolism that leads to a buildup of uric acid in body fluids, which is deposited as slightly soluble sodium urate ($\text{C}_5\text{H}_3\text{N}_4\text{O}_3\text{Na}$) in the joints. If the extracellular $[\text{Na}^+]$ is 0.15 M and the solubility of sodium urate is 0.085 g/100. mL, what is the minimum urate ion concentration (abbreviated $[\text{Ur}^-]$) that will cause a deposit of sodium urate?

19.112 In the process of cave formation (Section 19.3), the dissolution of CO_2 (equation 1) has a K_{eq} of 3.1×10^{-2} , and the formation of aqueous $\text{Ca}(\text{HCO}_3)_2$ (equation 2) has a K_{eq} of 1×10^{-12} . The fraction by volume of atmospheric CO_2 is 4×10^{-4} . (a) Find $[\text{CO}_2(aq)]$ in equilibrium with atmospheric CO_2 . (b) Determine $[\text{Ca}^{2+}]$ arising from (equation 2) given current levels of atmospheric CO_2 . (c) Calculate $[\text{Ca}^{2+}]$ if atmospheric CO_2 doubles.

19.113 Phosphate systems form essential buffers in organisms. Calculate the pH of a buffer made by dissolving 0.80 mol of NaOH in 0.50 L of 1.0 M H_3PO_4 .

19.114 The solubility of KCl is 3.7 M at 20°C. Two beakers each contain 100. mL of saturated KCl solution: 100. mL of 6.0 M HCl is added to the first beaker and 100. mL of 12 M HCl is added to the second. (a) Find the ion-product constant for KCl at 20°C. (b) What mass, if any, of KCl will precipitate from each beaker?

19.115 It is possible to detect NH_3 gas over 10^{-2} M NH_3 . To what pH must 0.15 M NH_4Cl be raised to form detectable NH_3 ?

19.116 Manganese(II) sulfide is one of the compounds found in the nodules on the ocean floor that may eventually be a primary source of many transition metals. The solubility of MnS is 4.7×10^{-4} g/100. mL solution. Estimate the K_{sp} of MnS.

19.117 The normal pH of blood is 7.40 ± 0.05 and is controlled in part by the $\text{H}_2\text{CO}_3/\text{HCO}_3^-$ buffer system.

(a) Assuming that the K_a value for carbonic acid at 25°C applies to blood, what is the $[\text{H}_2\text{CO}_3]/[\text{HCO}_3^-]$ ratio in normal blood?

(b) In a condition called *acidosis*, the blood is too acidic. What is the $[\text{H}_2\text{CO}_3]/[\text{HCO}_3^-]$ ratio in a patient whose blood pH is 7.20?

19.118 A bioengineer preparing cells for cloning bathes a small piece of rat epithelial tissue in a TRIS buffer (see Problem 19.109). The buffer is made by dissolving 43.0 g of TRIS ($pK_b = 5.91$) in enough 0.095 M HCl to make 1.00 L of solution. What are the molarity of TRIS and the pH of the buffer?

19.119 Sketch a qualitative curve for the titration of ethylenediamine, $\text{H}_2\text{NCH}_2\text{CH}_2\text{NH}_2$, with 0.1 M HCl.

19.120 Amino acids [general formula $\text{NH}_2\text{CH}(\text{R})\text{COOH}$] can be considered polyprotic acids. In many cases, the R group contains additional amine and carboxyl groups.

(a) Can an amino acid dissolved in pure water have a protonated COOH group and an unprotonated NH_2 group (K_a of COOH group = 4.47×10^{-3} ; K_b of NH_2 group = 6.03×10^{-5})? Use glycine, $\text{NH}_2\text{CH}_2\text{COOH}$, to explain why.

(b) Calculate $[\text{NH}_3^+\text{CH}_2\text{COO}^-]/[\text{NH}_3^+\text{CH}_2\text{COOH}]$ at pH 5.5.

(c) The R group of lysine is $-\text{CH}_2\text{CH}_2\text{CH}_2\text{CH}_2\text{NH}_2$ ($pK_b = 3.47$). Draw the structure of lysine at pH 1, physiological pH (~7), and pH 13.

(d) The R group of glutamic acid is $-\text{CH}_2\text{CH}_2\text{COOH}$ ($pK_a = 4.07$). Of the forms of glutamic acid that are shown below, which predominates at (1) pH 1, (2) physiological pH (~7), and (3) pH 13?

19.121 The scene at right depicts a saturated solution of $\text{MCl}_2(s)$ in the presence of dilute aqueous NaCl; each sphere represents 1.0×10^{-6} mol of ion, and the volume is 250.0 mL (solid MCl_2 is shown as green chunks, M^{2+} is blue, and Cl^- is yellow; Na^+ ions and water molecules are not shown). (a) Calculate the K_{sp} of MCl_2 . (b) If $\text{M}(\text{NO}_3)_2(s)$ is added, is there an increase, decrease, or no change in the number of Cl^- particles? In the K_{sp} ? In the mass of $\text{MCl}_2(s)$?

19.122 Tooth enamel consists of hydroxyapatite, $\text{Ca}_5(\text{PO}_4)_3\text{OH}$ ($K_{\text{sp}} = 6.8 \times 10^{-37}$). Fluoride ion added to drinking water reacts with $\text{Ca}_5(\text{PO}_4)_3\text{OH}$ to form the more tooth decay-resistant fluorapatite, $\text{Ca}_5(\text{PO}_4)_3\text{F}$ ($K_{\text{sp}} = 1.0 \times 10^{-60}$). Fluoridated water has dramatically decreased cavities among children. Calculate the solubility of $\text{Ca}_5(\text{PO}_4)_3\text{OH}$ and of $\text{Ca}_5(\text{PO}_4)_3\text{F}$ in water.

19.123 The acid-base indicator ethyl orange turns from red to yellow over the pH range 3.4 to 4.8. Estimate K_a for ethyl orange.

19.124 Use the values obtained in Problem 19.49 to sketch a curve of $[\text{H}_3\text{O}^+]$ vs. mL of added titrant. Are there advantages or disadvantages to viewing the results in this form? Explain.

19.125 Instrumental acid-base titrations use a pH meter to monitor the changes in pH and volume. The equivalence point is found from the volume at which the curve has the steepest slope.

(a) Use the data in Figure 19.6 to calculate the slope ($\Delta\text{pH}/\Delta V$) for all pairs of adjacent points and to calculate the average volume (V_{ave}) for each interval.

(b) Plot $\Delta\text{pH}/\Delta V$ vs. V_{avg} to find the steepest slope, and thus the volume at the equivalence point. (For example, the first pair of points gives $\Delta\text{pH} = 0.22$, $\Delta V = 10.00 \text{ mL}$; hence, $\Delta\text{pH}/\Delta V = 0.022 \text{ mL}^{-1}$, and $V_{\text{avg}} = 5.00 \text{ mL}$.)

19.126 What is the pH of a solution of 6.5×10^{-9} mol of $\text{Ca}(\text{OH})_2$ in 10.0 L of water [K_{sp} of $\text{Ca}(\text{OH})_2 = 6.5 \times 10^{-6}$]?

19.127 Muscle physiologists study the accumulation of lactic acid [$\text{CH}_3\text{CH}(\text{OH})\text{COOH}$] during exercise. Food chemists study its occurrence in sour milk, beer, wine, and fruit. Industrial microbiologists study its formation by various bacterial species from carbohydrates. A biochemist prepares a lactic acid–lactate buffer by mixing 225 mL of 0.85 M lactic acid ($K_a = 1.38 \times 10^{-4}$) with 435 mL of 0.68 M sodium lactate. What is the buffer pH?

19.128 A student wants to dissolve the maximum amount of CaF_2 ($K_{\text{sp}} = 3.2 \times 10^{-11}$) to make 1 L of aqueous solution.

19.129 A 500.-mL solution consists of 0.050 mol of solid NaOH and 0.13 mol of hypochlorous acid (HClO ; $K_a = 3.0 \times 10^{-8}$) dissolved in water.

- (a) Aside from water, what is the concentration of each species that is present?
 - (b) What is the pH of the solution?
 - (c) What is the pH after adding 0.0050 mol of HCl to the flask?

19.130 Calcium ion present in water supplies is easily precipitated as calcite (CaCO_3):

Because the K_{sp} decreases with temperature, heating hard water forms a calcite “scale,” which clogs pipes and water heaters. Find the solubility of calcite in water (a) at 10°C ($K_{\text{sp}} = 4.4 \times 10^{-9}$) and (b) at 30°C ($K_{\text{sp}} = 3.1 \times 10^{-9}$).

19.131 Calculate the molar solubility of $\text{Hg}_2\text{C}_2\text{O}_4$ ($K_{\text{sp}} = 1.75 \times 10^{-13}$) in 0.13 M $\text{Hg}_2(\text{NO}_3)_2$.

19.132 Environmental engineers use alkalinity as a measure of the capacity of carbonate buffering systems in water samples:

$$\text{Alkalinity (mol/L)} = [\text{HCO}_3^-] + 2[\text{CO}_3^{2-}] + [\text{OH}^-] - [\text{H}^+]$$

Find the alkalinity of a water sample that has a pH of 9.5, 26.0 mg/L CO_3^{2-} , and 65.0 mg/L HCO_3^- .

19.133 Human blood contains one buffer system based on phosphate species and one based on carbonate species. Assuming that blood has a normal pH of 7.4, what are the principal phosphate and carbonate species present? What is the ratio of the two phosphate species? (In the presence of the dissolved ions and other species in blood, K_{a1} of $\text{H}_3\text{PO}_4 = 1.3 \times 10^{-2}$, $K_{a2} = 2.3 \times 10^{-7}$, and $K_{a3} = 6 \times 10^{-12}$; K_{a1} of $\text{H}_2\text{CO}_3 = 8 \times 10^{-7}$ and $K_{a2} = 1.6 \times 10^{-10}$.)

19.134 Quantitative analysis of Cl^- ion is often performed by a titration with silver nitrate, using sodium chromate as an indicator. As standardized AgNO_3 is added, both white AgCl and red

Ag_2CrO_4 precipitate, but as long as some Cl^- remains, the Ag_2CrO_4 redissolves as the mixture is stirred. When the red color is permanent, the equivalence point has been reached.

(a) Calculate the equilibrium constant for the reaction

(b) Explain why the silver chromate redissolves.

(c) If 25.00 cm^3 of 0.1000 M NaCl is mixed with 25.00 cm^3 of 0.1000 M AgNO₃, what is the concentration of Ag⁺ remaining in solution? Is this sufficient to precipitate any silver chromate?

19.135 An ecobotanist separates the components of a tropical bark extract by chromatography. She discovers a large proportion of quinidine, a dextrorotatory isomer of quinine used for control of arrhythmic heartbeat. Quinidine has two basic nitrogens ($K_{b1} = 4.0 \times 10^{-6}$ and $K_{b2} = 1.0 \times 10^{-10}$). To measure the concentration of quinidine, she carries out a titration. Because of the low solubility of quinidine, she first protonates both nitrogens with excess HCl and titrates the acidified solution with standardized base. A 33.85-mg sample of quinidine ($M = 324.41$ g/mol) is acidified with 6.55 mL of 0.150 M HCl.

- (a) How many milliliters of 0.0133 M NaOH are needed to titrate the excess HCl?
 - (b) How many additional milliliters of titrant are needed to reach the first equivalence point of quinidine dihydrochloride?
 - (c) What is the pH at the first equivalence point?

19.136 Some kidney stones form by the precipitation of calcium oxalate monohydrate ($\text{CaC}_2\text{O}_4 \cdot \text{H}_2\text{O}$, $K_{\text{sp}} = 2.3 \times 10^{-9}$). The pH of urine varies from 5.5 to 7.0, and the average $[\text{Ca}^{2+}]$ in urine is $2.6 \times 10^{-3} M$.

- (a) If the [oxalic acid] in urine is $3.0 \times 10^{-13} M$, will kidney stones form at pH = 5.5?
 - (b) Will they form at pH = 7.0?
 - (c) Vegetarians have a urine pH above 7. Are they more or less likely to form kidney stones?

19.137 A biochemist needs a medium for acid-producing bacteria. The pH of the medium must not change by more than 0.05 pH units for every 0.0010 mol of H_3O^+ generated by the organisms per liter of medium. A buffer consisting of 0.10 M HA and 0.10 M A^- is included in the medium to control its pH. What volume of this buffer must be included in 1.0 L of medium?

19.138 A 35.00-mL solution of 0.2500 M HF is titrated with a standardized 0.1532 M solution of NaOH at 25°C.

- (a) What is the pH of the HF solution before titrant is added?
 - (b) How many milliliters of titrant are required to reach the equivalence point?
 - (c) What is the pH at 0.50 mL before the equivalence point?
 - (d) What is the pH at the equivalence point?
 - (e) What is the pH at 0.50 mL after the equivalence point?

19.139 Because of the toxicity of mercury compounds, mercury(I) chloride is used in antibacterial salves. The mercury(I) ion (Hg_2^{2+}) consists of two bonded Hg^+ ions.

- (a) What is the empirical formula of mercury(I) chloride?
 - (b) Calculate $[Hg_2^{2+}]$ in a saturated solution of mercury(I) chloride ($K_{sp} = 1.5 \times 10^{-18}$).
 - (c) A seawater sample contains 0.20 lb of NaCl per gallon. Find $[Hg_2^{2+}]$ if the seawater is saturated with mercury(I) chloride.
 - (d) How many grams of mercury(I) chloride are needed to saturate 4900 km³ of pure water (the volume of Lake Michigan)?
 - (e) How many grams of mercury(I) chloride are needed to saturate 4900 km³ of seawater?

19.140 A 35.0-mL solution of 0.075 M CaCl₂ is mixed with 25.0 mL of 0.090 M BaCl₂.

- If aqueous KF is added, which fluoride precipitates first?
- Describe how the metal ions can be separated using KF to form the fluorides.
- Calculate the fluoride ion concentration that will accomplish the separation.

19.141 Rainwater is slightly acidic due to dissolved CO₂. Use the following data to calculate the pH of unpolluted rainwater at 25°C: vol % in air of CO₂ = 0.040 vol %; solubility of CO₂ in pure water at 25°C and 1 atm = 88 mL CO₂/100. mL H₂O; K_{al} of H₂CO₃ = 4.5×10^{-7} .

19.142 Seawater at the surface has a pH of about 8.5.

- Which of the following species has the highest concentration at this pH: H₂CO₃; HCO₃⁻; CO₃²⁻? Explain.
- What are the concentration ratios [CO₃²⁻]/[HCO₃⁻] and [HCO₃⁻]/[H₂CO₃] at this pH?
- In the deep sea, light levels are low, and the pH is around 7.5. Suggest a reason for the lower pH at the greater ocean depth. (*Hint:* Consider the presence or absence of plant and animal life and the effects on carbon dioxide concentrations.)

19.143 Ethylenediaminetetraacetic acid (abbreviated H₄EDTA) is a tetraprotic acid. Its salts are used to treat toxic metal poisoning by forming soluble complex ions that are then excreted. Because EDTA⁴⁻ also binds essential calcium ions, it is often administered as the calcium disodium salt. For example, when Na₂Ca(EDTA) is given to a patient, the [Ca(EDTA)]²⁻ ions react with circulating Pb²⁺ ions and the metal ions are exchanged:

A child has a dangerous blood lead level of 120 µg/100 mL. If the child is administered 100. mL of 0.10 M Na₂Ca(EDTA), what is the final concentration of Pb²⁺ in µg/100 mL blood, assuming that the exchange reaction and excretion process are 100% efficient? (Total blood volume is 1.5 L.)

19.144 Buffers that are based on 3-morpholinopropanesulfonic acid (MOPS) are often used in RNA analysis. The useful pH range of a MOPS buffer is 6.5 to 7.9. Estimate the K_a of MOPS.

19.145 NaCl is purified by adding HCl to a saturated solution of NaCl (317 g/L). Will pure NaCl precipitate when 28.5 mL of 8.65 M HCl is added to 0.100 L of saturated solution?

19.146 Scenes A to D represent tiny portions of 0.10 M aqueous solutions of a weak acid HA (*red and blue*; $K_a = 4.5 \times 10^{-5}$), its conjugate base A⁻ (*red*), or a mixture of the two (only these two species are shown):

(a) Which scene(s) show(s) a buffer?

(b) What is the pH of each solution?

(c) Arrange the scenes in sequence, assuming that they represent stages in a weak acid-strong base titration.

(d) Which scene represents the titration at its equivalence point?

19.147 Scenes A to C represent aqueous solutions of the slightly soluble salt MZ (only the ions of this salt are shown):

(a) Which scene represents the solution just after solid MZ is stirred thoroughly in distilled water?

(b) If each sphere represents an ion concentration of 2.5×10^{-6} M, what is the K_{sp} of MZ?

(c) Which scene represents the solution after Na₂Z(aq) has been added?

(d) If Z²⁻ is CO₃²⁻, which scene represents the solution after the pH has been lowered?

19.148 The solubility of Ag(I) in aqueous solutions containing different concentrations of Cl⁻ is based on the following equilibria:

When solid AgCl is shaken with a solution containing Cl⁻, Ag(I) is present as both Ag⁺ and AgCl₂⁻. The solubility of AgCl is the sum of the concentrations of Ag⁺ and AgCl₂⁻.

(a) Show that [Ag⁺] in solution is given by

$$[\text{Ag}^+] = 1.8 \times 10^{-10}/[\text{Cl}^-]$$

and that [AgCl₂⁻] in solution is given by

$$[\text{AgCl}_2^-] = (3.2 \times 10^{-5}) ([\text{Cl}^-])$$

(b) Find the [Cl⁻] at which [Ag⁺] = [AgCl₂⁻].

(c) Explain the shape of a plot of AgCl solubility vs. [Cl⁻].

(d) Find the solubility of AgCl at the [Cl⁻] of part (b), which is the minimum solubility of AgCl in the presence of Cl⁻.

19.149 EDTA binds metal ions to form complex ions (see Problem 19.143), so it is used to determine the concentrations of metal ions in solution:

A 50.0-mL sample of 0.048 M Co²⁺ is titrated with 0.050 M EDTA⁴⁻. Find [Co²⁺] and [EDTA⁴⁻] after addition of (a) 25.0 mL and (b) 75.0 mL of EDTA⁴⁻ (log K_f of CoEDTA²⁻ = 16.31).

20

Thermodynamics: Entropy, Free Energy, and Reaction Direction

20.1 The Second Law of Thermodynamics: Predicting Spontaneous Change

The First Law Does Not Predict Spontaneous Change
The Sign of ΔH Does Not Predict Spontaneous Change
Freedom of Motion and Dispersal of Kinetic Energy
Entropy and the Number of Microstates
Entropy and the Second Law

Standard Molar Entropies and the Third Law
Predicting Relative S° of a System

20.2 Calculating the Change in Entropy of a Reaction

Standard Entropy of Reaction
Entropy Changes in the Surroundings
Entropy Change and the Equilibrium State
Spontaneous Exothermic and Endothermic Reactions

20.3 Entropy, Free Energy, and Work

Free Energy Change and Reaction Spontaneity
Standard Free Energy Changes
Free Energy and Work
Temperature and Reaction Spontaneity
Coupling of Reactions

20.4 Free Energy, Equilibrium, and Reaction Direction

Source: © Luciano Mortula/Shutterstock.com

Concepts and Skills to Review Before You Study This Chapter

- › internal energy, heat, and work (Section 6.1)
- › state functions (Section 6.1) and standard states (Section 6.6)
- › enthalpy, ΔH , and Hess's law (Sections 6.2 and 6.5)
- › entropy and solution formation (Section 13.3)
- › comparing Q and K to find reaction direction (Section 17.4)

In the last few chapters, we've examined some fundamental questions about change, whether chemical or physical: How fast does it occur? How far does it go toward completion? How is a change affected by concentration and temperature? And we've explored these questions in systems ranging from the stratosphere to a limestone cave to the cells of your body.

But why does the change occur in the first place? Some changes seem to happen *in one direction* but not the other. Copper statues turn green over time as the copper oxidizes (*photo*), but the green oxidation products do not react to re-form the shiny copper. Gasoline burns in air to produce carbon dioxide and water vapor as it runs a car engine, but those products do not react to form the gasoline and oxygen. A cube of sugar dissolves in a cup of coffee after a little stirring, but wait for another millennium and the dissolved sugar won't form the cube again. Chemists call these *spontaneous* changes. Most release energy, but some absorb it.

The principles of thermodynamics, developed almost 200 years ago, explain *why* a spontaneous change occurs. And, as far as we know, they apply to every change in every system in the universe—every working machine, every growing plant, every thinking student, every moving continent, every exploding star.

IN THIS CHAPTER . . . We discuss *why* changes occur and how we can utilize them by focusing on the concepts of entropy and free energy and their relation to the direction of a spontaneous change.

- › We discuss the need for a criterion to predict the *direction* of a spontaneous change.
- › We review the first law of thermodynamics and see that it accounts for the energy of a change but *not* the direction.
- › We see that the sign of the enthalpy change does not predict the direction either.
- › We find the criterion for predicting the direction of a spontaneous change in the second law of thermodynamics, which focuses on entropy (S), a state function based on the natural tendency of a system's energy to become dispersed.
- › We examine entropy changes for exothermic and endothermic processes.
- › We develop the concept of free energy as a simplified criterion for the occurrence of spontaneous change and see how free energy relates to the work a system can do.
- › We explore the key relationship between the free energy change of a reaction and its equilibrium constant.

20.1 THE SECOND LAW OF THERMODYNAMICS: PREDICTING SPONTANEOUS CHANGE

A **spontaneous change** of a system is one that occurs under specified conditions without a continuous input of energy from outside the system. The freezing of water, for example, is spontaneous at 1 atm and -5°C . A spontaneous process, such as burning or falling, may need a little “push” to get started—a spark to ignite gasoline vapors in your car’s engine, a shove to knock a book off your desk—but once the process begins, it supplies the energy needed for it to continue. In contrast, a **nonspontaneous** change occurs only if the surroundings *continuously* supply the system with an input of energy. Under given conditions, *if a change is spontaneous in one direction, it is not spontaneous in the other*. A book falls off your desk spontaneously, but does not spontaneously move from floor to desk.

The term *spontaneous* does not mean “instantaneous” nor does it reveal anything about how long a process takes to occur; it means that, given enough time, the process will happen by itself. Many processes are spontaneous but slow—including ripening, rusting, and aging.

Can we predict the direction of a spontaneous change in cases that are not as obvious as burning gasoline or falling books? In this section, we first briefly consider two concepts that do *not* predict the direction of a spontaneous change and then focus on one that does—the concept of entropy.

The First Law of Thermodynamics Does Not Predict Spontaneous Change

Let’s see whether energy changes can predict the direction of spontaneous change. Recall from Chapter 6 that the first law of thermodynamics (law of energy conservation) states that the internal energy (E) of a system, the sum of the kinetic and potential energies of its particles, changes when heat (q) and/or work (w) are absorbed or released:

$$\Delta E = q + w$$

Whatever is not part of the system (sys) is part of the surroundings (surr); thus, *the change in energy and, therefore, the heat and/or work absorbed by the system are released by the surroundings*, or vice versa:

$$\Delta E_{\text{sys}} = -\Delta E_{\text{surr}} \quad \text{or} \quad (q + w)_{\text{sys}} = -(q + w)_{\text{surr}}$$

Since the system plus the surroundings is the universe (univ), it follows that *the total energy of the universe is constant, so the change in energy of the universe is zero*:*

$$\Delta E_{\text{sys}} + \Delta E_{\text{surr}} = -\Delta E_{\text{surr}} + \Delta E_{\text{surr}} = 0 = \Delta E_{\text{univ}}$$

The first law accounts for the energy, but not the direction, of a process. When gasoline burns in a car engine, the first law states that the potential energy difference between the bonds in the fuel mixture and those in the exhaust gases is converted to the kinetic energy of the moving car and its parts plus the heat released to the environment. But, why doesn’t the heat released in the engine convert exhaust fumes back into gasoline and oxygen? When an ice cube melts in your hand, the first law states that energy from your hand is converted to kinetic energy as the solid changes to a liquid. But, why doesn’t the pool of water in your cupped hand transfer the heat back to your hand and refreeze? Neither of these events violates the first law—if you measure the work and heat in each case, you find that energy is conserved—but these reverse changes never happen. That is, *the first law by itself does not predict the direction of a spontaneous change*.

The Sign of ΔH Does Not Predict Spontaneous Change

Perhaps the sign of the enthalpy change (ΔH), the heat gained or lost at constant pressure (q_P), is the criterion for spontaneity; in fact, leading scientists thought so through most of the 19th century. If so, we would expect exothermic processes ($\Delta H < 0$) to be spontaneous and endothermic processes ($\Delta H > 0$) to be nonspontaneous. Let’s examine some examples to see if this is true.

1. *Spontaneous processes with $\Delta H < 0$.* All freezing and condensing processes are exothermic and spontaneous at certain conditions:

The burning of methane and all other combustion reactions are spontaneous and exothermic:

*Any modern statement of conservation of energy must take into account mass-energy equivalence and the processes in stars, which convert enormous amounts of matter into energy. Thus, the total *mass-energy* of the universe is constant.

Oxidation of iron and other metals occurs spontaneously and exothermically:

Ionic compounds form spontaneously and exothermically from their elements:

2. *Spontaneous processes with $\Delta H > 0$.* In many cases, an exothermic process occurs spontaneously under one set of conditions, whereas the opposite, endothermic, process occurs spontaneously under another set. All melting and vaporizing processes are endothermic and spontaneous at certain conditions:

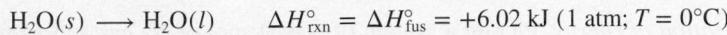

At ordinary pressure, water vaporizes spontaneously:

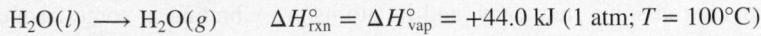

Most soluble salts dissolve endothermically and spontaneously:

Even some endothermic reactions are spontaneous:

In the latter reaction, ionic solids are mixed (Figure 20.1A) and the waters of hydration released by the $\text{Ba}(\text{OH})_2$ solvate the ions. The reaction mixture absorbs heat from the surroundings so quickly that the beaker freezes to a wet board (Figure 20.1B).

Considering just these few examples, we see that, as for the first law, *the sign of ΔH by itself does not predict the direction of a spontaneous change.*

Figure 20.1 A spontaneous endothermic reaction.

Source: © McGraw-Hill Education/Stephen Frisch, photographer

Freedom of Particle Motion and Dispersal of Kinetic Energy

When we look closely at the previous examples of spontaneous *endothermic* processes, they have one major feature in common: in every case, the chemical entities—atoms, molecules, or ions—have more freedom of motion *after* the change. Put another way, after the change, the particles have a wider range of energy of motion (kinetic energy); we say that their energy has become more dispersed, distributed, or spread out:

- The phase changes convert a solid, in which motion is restricted, to a liquid, in which particles have more freedom to move around each other, and then to a gas, in which the particles have much greater freedom of motion. Thus, the energy of motion is more dispersed.
- Dissolving a salt changes a crystalline solid and a pure liquid into separate ions and solvent molecules moving and interacting, so their freedom of motion is greater and their energy of motion more dispersed.
- In the chemical reactions, *fewer* moles of crystalline solids produce *more* moles of gases and/or solvated ions, so once again, the freedom of motion of the particles increases and their energy of motion is more dispersed:

Phase change: $\text{solid} \longrightarrow \text{liquid} \longrightarrow \text{gas}$

Dissolving of salt: $\text{crystalline solid} + \text{liquid} \longrightarrow \text{ions in solution}$

Chemical change: $\text{crystalline solids} \longrightarrow \text{gases} + \text{ions in solution}$

In thermodynamic terms, a change in the freedom of motion of particles in a system, that is, in the dispersal of their energy of motion, is a key factor for predicting the direction of a spontaneous process.

Entropy and the Number of Microstates

Earlier, we discussed the quantized *electronic* energy levels of an atom (Chapter 7) and a molecule (Chapter 11), and mentioned the quantized *kinetic* energy levels—vibrational, rotational, and translational—of a molecule (see Chapter 9, Tools of the Laboratory). Now, we'll see that the energy state of a whole system of atoms or molecules is quantized, too.

Energy Dispersal and the Meaning of Entropy Let's see why freedom of motion and dispersal of energy relate to spontaneous change:

- *Quantization of energy.* Picture a system of, say, 1 mol of N₂ gas and focus on one molecule. At any instant, it is moving through space (translating) at some speed and rotating at some frequency, and its atoms are vibrating at some frequency. In the next instant, the molecule collides with another or with the container, and these motional (kinetic) energy states change to different values. The complete quantum state of the molecule at any instant consists of its electronic states and these translational, rotational, and vibrational states. In this discussion, we focus on the latter three, that is, on the kinetic energy states.
- *Number of microstates.* The energy of all the molecules in a system is similarly quantized. Each quantized state of the system is called a **microstate**, and at any instant, the total energy of the system is dispersed throughout one microstate. In the next instant, it is dispersed throughout a different microstate. The number of microstates possible for a system of 1 mol of molecules is staggering, on the order of 10^{10²³}.
- *Dispersal of energy.* At a given set of conditions, each microstate has the *same* total energy as any other. Therefore, each microstate is equally possible for the system, and the laws of probability say that, over time, all microstates are equally likely. The number of microstates for a system is the number of ways it can disperse (distribute or spread) its kinetic energy among the various motions of all its particles.

In 1877, the Austrian mathematician and physicist Ludwig Boltzmann related the number of microstates (*W*) to the **entropy** (*S*) of a system:

$$S = k \ln W \quad (20.1)$$

where *k*, the *Boltzmann constant*, is the universal gas constant (*R*, 8.314 J/mol·K) divided by Avogadro's number (*N_A*), that is, *R/N_A*, which equals 1.38×10⁻²³ J/K. The term *W* is the number of microstates, so it has no units; therefore, *S* has units of joules/kelvin (J/K). Thus,

- A system with fewer microstates (smaller *W*) has *lower entropy* (*lower S*).
- A system with more microstates (larger *W*) has *higher entropy* (*higher S*).

For our earlier examples of endothermic processes,

Entropy as a State Function If a change results in a greater number of microstates, there are more ways to disperse the energy of the system and the entropy increases:

$$S_{\text{more microstates}} > S_{\text{fewer microstates}}$$

If a change results in a lower number of microstates, the entropy decreases. Like internal energy (*E*) and enthalpy (*H*), *entropy is a state function*, so it depends only on the present state of the system, not on how it arrived at that state (see Chapter 6, pp. 262–263). Therefore, the change in entropy of the system (ΔS_{sys}) depends only on the *difference* between its final and initial values:

$$\Delta S_{\text{sys}} = S_{\text{final}} - S_{\text{initial}}$$

As with any state function, $\Delta S_{\text{sys}} > 0$ when the value of S increases during a change. For example, for the phase change when dry ice sublimes, the entropy increases since gaseous CO₂ has more microstates and higher entropy than solid CO₂:

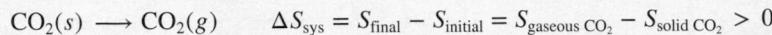

And, $\Delta S_{\text{sys}} < 0$ when the entropy decreases; when water vapor condenses, for example, the entropy decreases since liquid H₂O has fewer microstates and lower entropy than gaseous H₂O:

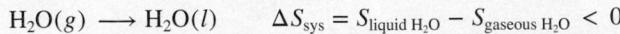

As an example of a reaction during which entropy increases, consider the decomposition of dinitrogen tetroxide (N₂O₄, written here as O₂N—NO₂):

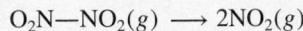

When the N—N bond in 1 mol of dinitrogen tetroxide breaks, the 2 mol of NO₂ molecules have many more possible motions; thus, at any instant, the energy of the system is dispersed into any one of a larger number of microstates. Thus, the change in entropy of the system, which is the change in entropy of the reaction (ΔS_{rxn}), goes up:

$$\Delta S_{\text{sys}} = \Delta S_{\text{rxn}} = S_{\text{final}} - S_{\text{initial}} = S_{\text{products}} - S_{\text{reactants}} = 2S_{\text{NO}_2} - S_{\text{O}_2\text{N}-\text{NO}_2} > 0$$

Quantitative Meaning of an Entropy Change There are two approaches for quantifying an entropy change, but they give the same result. The first is based on counting the number of microstates possible for a system, and the second on the heat absorbed (or released) by the system. We'll examine both with a system of 1 mol of a gas expanding from 1 L to 2 L and behaving ideally, much as neon does at 298 K:

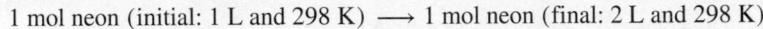

1. *Quantifying ΔS_{sys} from the number of microstates.* Figure 20.2 shows two flasks connected by a stopcock—the right flask is evacuated, and the left flask contains 1 mol of neon. When we open the stopcock, the gas expands until each flask contains 0.5 mol—but why? Opening the stopcock increases the volume, which increases the number of translational energy levels the particles can occupy as they move to more locations. Thus, the number of microstates—and the entropy—increases.

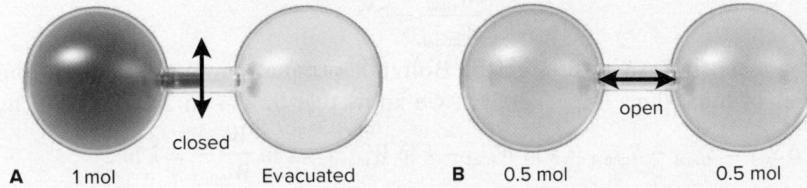

Figure 20.3 presents this idea with particles on energy levels in a box of changeable volume. When the stopcock opens, there are more energy levels, and they are closer together on average, so more distributions of particles are possible.

In Figure 20.4 (next page), the number of microstates is represented by the placement of particles in the left and/or right flasks:

- *One Ne atom.* At a given instant, a Ne atom in the left flask has its energy in one of some number (W) of microstates. Opening the stopcock increases the volume, which increases the number of possible locations and the number of translational energy levels. Thus, the system has 2^1 , or 2, times as many microstates available when the atom moves through both flasks (final state, W_{final}) as when it is confined to the left flask (initial state, W_{initial}).
- *Two Ne atoms.* For atoms A and B moving through both flasks, there are 2^2 , or 4, times as many microstates as when the atoms were initially in the left flask—some number of microstates with both A and B in the left, that many with A in the left and B in the right or with B in the left and A in the right, and that many with both in the right.
- *Three Ne atoms.* Add another atom, and there are 2^3 , or 8, times as many microstates when the stopcock is open.

Figure 20.2 Spontaneous expansion of a gas. **A**, With the stopcock closed, the left flask contains 1 mol of Ne. **B**, With the stopcock open, the gas expands and each flask contains 0.5 mol of Ne.

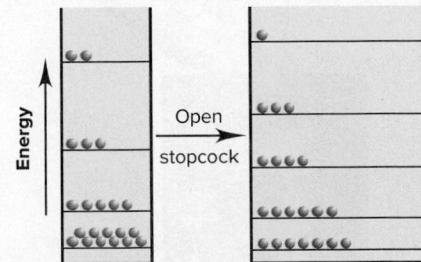

Figure 20.3 The entropy increase due to expansion of a gas. Energy levels are shown as lines in a box of narrow width (left). Each distribution of energies for the 21 particles is one microstate. When the stopcock is opened, the box is wider (volume increases, right), and the particles have more energy levels available.

Figure 20.4 Expansion of a gas and the increase in number of microstates. Each set of particle locations represents a different microstate. When the volume increases (stopcock opens), the relative number of microstates is 2^n , where n is the number of particles.

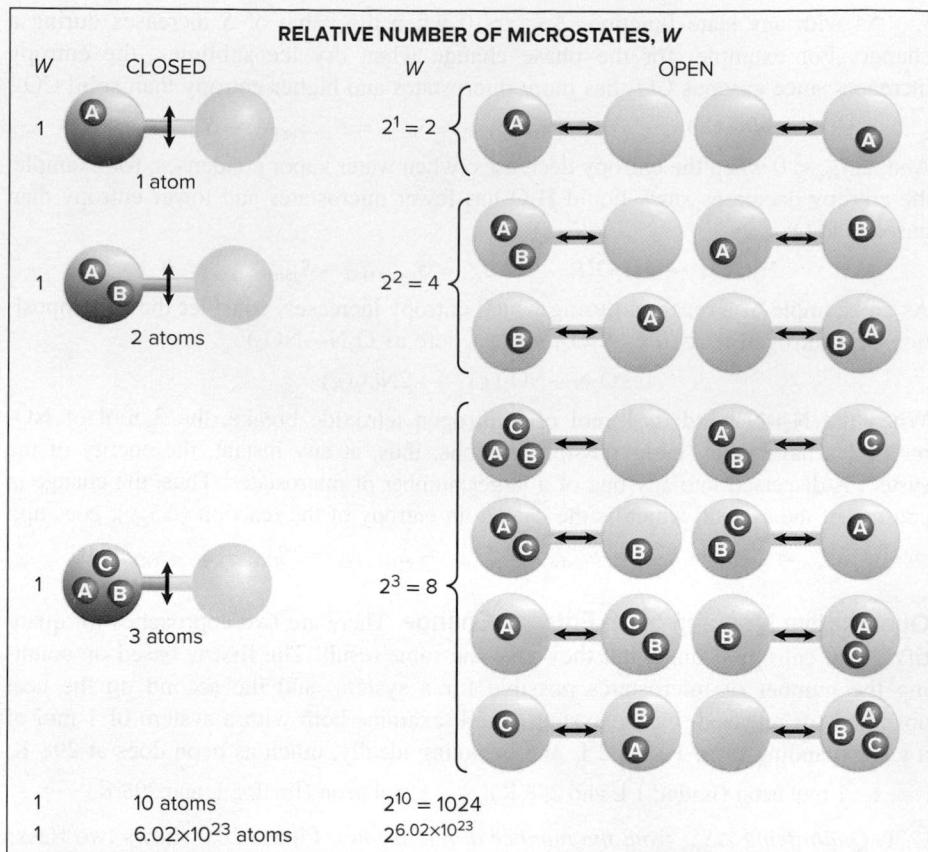

- *Ten Ne atoms.* With 10 Ne atoms, there are 2^{10} , or 1024, times as many microstates for the atoms in both flasks as there were for the 10 atoms in the left flask.
- *One mole of Ne atoms.* With 1 mol (N_A) of Ne, there are 2^{N_A} times as many microstates for the atoms in the larger volume (W_{final}) than in the smaller (W_{initial}):

$$\frac{W_{\text{final}}}{W_{\text{initial}}} = 2^{N_A}$$

Now let's find ΔS_{sys} through the Boltzmann equation, $S = k \ln W$. From the properties of logarithms (Appendix A), we know that $\ln A - \ln B = \ln A/B$. Thus,

$$\Delta S_{\text{sys}} = S_{\text{final}} - S_{\text{initial}} = k \ln W_{\text{final}} - k \ln W_{\text{initial}} = k \ln \frac{W_{\text{final}}}{W_{\text{initial}}} = k \ln 2^{6.02 \times 10^{23}}$$

Also, from Appendix A, $\ln A^y = y \ln A$; so we have

$$\begin{aligned} \Delta S_{\text{sys}} &= k \ln 2^{6.02 \times 10^{23}} = k(6.02 \times 10^{23})(\ln 2) \\ &= (1.38 \times 10^{-23} \text{ J/K})(6.02 \times 10^{23})(0.693) = 5.76 \text{ J/K} \end{aligned}$$

2. *Quantifying ΔS_{sys} from the changes in heat.* Now let's compare the ΔS_{sys} we just found for a gas expanding into an evacuated flask with the ΔS_{sys} for a gas that is heated and does work on the surroundings. This approach uses the relationship

$$\Delta S_{\text{sys}} = \frac{q_{\text{rev}}}{T} \quad (20.2)$$

where T is the temperature at which the heat change occurs and q is the heat absorbed. The subscript “rev” refers to a *reversible process*, one that occurs in such tiny increments that the system remains at equilibrium and the direction of the change can be reversed by an *infinitesimal* reversal of conditions.

We'll approximate a reversible expansion by placing 1 mol of Ne gas in a piston-cylinder assembly within a heat reservoir (to maintain a constant T of 298 K) and start by confining the gas to a volume of 1 L by the “pressure” of a beaker of sand on the piston (Figure 20.5). We remove one grain of sand (an “infinitesimal” decrease in pressure) with a pair of tweezers, and the gas (system) expands a tiny amount, raising the piston and doing work, $-w$. Assuming Ne behaves ideally, it absorbs an

Figure 20.5 Simulating a reversible process.

equivalent tiny increment of heat, q , from the heat reservoir. With each grain of sand removed, the expanding gas absorbs another tiny increment of heat. This process simulates a reversible expansion because we can reverse it by putting back a grain of sand, which causes the surroundings to do a tiny quantity of work compressing the gas, thus releasing a tiny quantity of heat to the reservoir.

If we continue this nearly reversible expansion to 2 L and use calculus to integrate the tiny increments of heat together, q_{rev} is 1718 J. From Equation 20.2,

$$\Delta S_{\text{sys}} = \frac{q_{\text{rev}}}{T} = \frac{1718 \text{ J}}{298 \text{ K}} = 5.76 \text{ J/K}$$

This is the same value we obtained from counting the number of microstates.

Entropy and the Second Law of Thermodynamics

The change in entropy determines the direction of a spontaneous process, but we must consider more than just the entropy change of the *system*. After all, at 20°C, solid water melts spontaneously and ΔS_{sys} goes up, while at -10°C, liquid water freezes spontaneously and ΔS_{sys} goes down. But when we consider *both* the system *and* its surroundings, we find the following:

- All real processes occur spontaneously in the direction that increases the entropy of the universe (system plus surroundings). This is one way to state the **second law of thermodynamics**.

The second law says that *either* the entropy change of the system *or* that of the surroundings may be negative. But, for a process to be spontaneous, the *sum* of the two entropy changes must be positive. If the entropy of the system decreases, the entropy of the surroundings must increase even more to offset that decrease, so that the entropy of the universe (system *plus* surroundings) increases. A quantitative statement of the second law, for any real spontaneous process, is

$$\Delta S_{\text{univ}} = \Delta S_{\text{sys}} + \Delta S_{\text{surr}} > 0 \quad (20.3)$$

(We return to this idea in Section 20.2.)

Standard Molar Entropies and the Third Law

Entropy and enthalpy are state functions, but their values differ in a fundamental way:

- For *enthalpy*, there is no zero point, so we can measure only *changes*.
- For *entropy*, there *is* a zero point, and we can determine *absolute* values by applying the **third law of thermodynamics**: *a perfect crystal has zero entropy at absolute zero*: $S_{\text{sys}} = 0$ at 0 K.

A “perfect” crystal means all the particles are aligned flawlessly. At absolute zero, the particles have minimum energy, so there is only one microstate. Thus, in Equation 20.1,

$$W = 1 \quad \text{so} \quad S = k \ln 1 = 0$$

When we warm the crystal to any temperature above 0 K, the total energy increases, so it can be dispersed into more than one microstate. Thus,

$$W > 1 \quad \text{and} \quad \ln W > 0 \quad \text{so} \quad S > 0$$

In principle, to find S of a substance at a given temperature, we cool it to as close to 0 K as possible. Then we heat it in small increments, dividing q by T to get the increase in S for each increment, and add up all the entropy increases to the temperature of interest, usually 298 K. Therefore, S of a substance at a given temperature is an *absolute* value. As with other thermodynamic variables,

- We compare entropy values for substances at the temperature of interest in their *standard states*: 1 atm for gases, 1 M for solutions, and the pure substance in its most stable form for solids or liquids.
- Because entropy is an *extensive* property—one that depends on the amount of substance—we specify the **standard molar entropy** (S°), in units of J/mol·K (or J mol⁻¹ K⁻¹). (S° values at 298 K for many elements, compounds, and ions appear, with other thermodynamic variables, in Appendix B.)

Figure 20.6 Visualizing the effect of temperature on entropy. **A**, Computer simulations show each particle in a crystal moving about its lattice position. Adding heat increases T and the total energy, so the particles have greater freedom of motion, and their energy is more dispersed. Thus, S increases. **B**, At any T , there is a range of occupied energy levels and, thus, a certain number of microstates. Adding heat increases the total energy (area under curve), so the range of occupied energy levels becomes greater, as does the number of microstates (higher S). **C**, A system consisting of 21 particles that occupy energy levels (lines) in a box whose height represents the total energy. When heat is added, the total energy increases (box is higher) and becomes more dispersed (more lines), so S increases.

Predicting Relative S° of a System

Let's see how the standard molar entropy of a substance is affected by several parameters: temperature, physical state, dissolution, and atomic size or molecular complexity. (Unless stated otherwise, the S° values refer to the system at 298 K.)

Temperature Changes Temperature has a direct effect on entropy:

- For any substance, S° increases as T rises.

This trend is shown by the entropy values for copper metal at three temperatures:

T (K):	273	295	298
S° (J/mol·K):	31.0	32.9	33.2

As heat is absorbed ($q > 0$), temperature, which is a measure of the average kinetic energy of the particles, increases. Recall that the kinetic energies of gas particles are distributed over a range, which becomes wider as T rises (Figure 5.14); liquids and solids behave the same. Thus, at any instant, at a higher temperature, there are more microstates available in which the energy can be dispersed, so the entropy of the substance goes up. Figure 20.6 presents three ways to view the effect of temperature on entropy.

Physical States and Phase Changes In melting or vaporizing, heat is absorbed ($q > 0$). The particles have more freedom of motion, and their energy is more dispersed. Thus,

- S° increases as the physical state of a substance changes from solid to liquid to gas:

$$S^\circ_{\text{solid}} < S^\circ_{\text{liquid}} < S^\circ_{\text{gas}}$$

S° (J/mol·K)	Na	H_2O	C(graphite)
$S^\circ(s$ or $l)$:	51.4(<i>s</i>)	69.9(<i>l</i>)	5.7(<i>s</i>)
$S^\circ(g)$:	153.6	188.7	158.0

Figure 20.7 The increase in entropy during phase changes from solid to liquid to gas. The data shown are for 1 mol of O_2 .

Figure 20.7 plots entropy versus T as solid O_2 is heated and changes to liquid and then to gas, with S° values at various points; this behavior is typical of many substances. At the molecular scale, several stages occur:

- Particles in the solid vibrate about their positions but, on average, remain fixed. The energy of the solid is dispersed least, that is, has the fewest available microstates, so the solid has the lowest entropy.
- As T rises, the entropy increases gradually as the particles' kinetic energy increases.
- When the solid melts, the particles move much more freely between and around each other, so there is an abrupt increase in entropy ($\Delta S^\circ_{\text{fus}}$).
- Further heating of the liquid increases the speed of the particles, and the entropy increases gradually.
- When the liquid vaporizes and becomes a gas, the particles undergo a much larger, abrupt entropy increase ($\Delta S^\circ_{\text{vap}}$); *the increase in entropy from liquid to gas is much larger than from solid to liquid: $\Delta S^\circ_{\text{vap}} >> \Delta S^\circ_{\text{fus}}$* .
- Finally, with further heating of the gas, the entropy increases gradually.

Dissolving a Solid or a Liquid in Water

- Recall from Chapter 13 that, in general,
- *Entropy increases when a solid or liquid solute dissolves in a solvent: $S_{\text{soln}} > (S_{\text{solute}} + S_{\text{solvent}})$.*

But, when water is the solvent, the entropy may also depend on the nature of solute and solvent interactions, which can involve two opposing events:

1. *For ionic solutes*, when the crystal dissolves in water, the ions have much more freedom of motion and their energy is dispersed into more microstates. That is, the entropy of the ions themselves is greater in the solution. However, water molecules become arranged around the ions (Figure 20.8), which limits the molecules' freedom of motion (see also Figure 13.2). In fact, around small, multiply charged ions, H_2O molecules become so organized that their energy of motion becomes *less* dispersed. This negative portion of the total entropy change can lead to *negative S°* values for the ions in solution. In the case of AlCl_3 , the $\text{Al}^{3+}(aq)$ ion has such a negative S° value ($-313 \text{ J/mol}\cdot\text{K}$) that when AlCl_3 dissolves in

Figure 20.8 The entropy change accompanying the dissolution of a salt. The entropy of a salt solution is usually *greater* than that of the solid and of water, but it is affected by water molecules becoming organized around each ion.

Figure 20.9 The small increase in entropy when ethanol dissolves in water. In pure ethanol (**A**) and pure water (**B**), molecules form many H bonds to other like molecules. **C**, In solution, these two kinds of molecules form H bonds to each other, so their freedom of motion does not change significantly.

water, even though S° of $\text{Cl}^-(aq)$ is positive, the entropy of aqueous AlCl_3 is lower than that of solid AlCl_3 .*

$S^\circ \text{ (J/mol}\cdot\text{K)}$	NaCl	AlCl_3	CH_3OH
$S^\circ(s \text{ or } l):$	72.1(s)	167(s)	127(l)
$S^\circ(aq):$	115.1	-148	132

2. For molecular solutes, the increase in entropy upon dissolving is typically much smaller than for ionic solutes. After all, for a solid such as glucose, there is no separation into ions, and for a liquid such as methanol or ethanol (Figure 20.9), there is no breakdown of a crystal structure. Furthermore, in these small alcohols, as in pure water, the molecules form many H bonds, so there is relatively little change in their freedom of motion either before or after they are mixed.

Dissolving a Gas in a Liquid The particles in a gas already have so much freedom of motion—and, thus, such highly dispersed energy—that they lose some when they dissolve in a liquid or solid. Therefore,

- The entropy of a solution of a gas in a liquid or a solid is always *less* than the entropy of the gas itself.

For instance, when gaseous O_2 [$S^\circ(g) = 205.0 \text{ J/mol}\cdot\text{K}$] dissolves in water, its entropy decreases considerably [$S^\circ(aq) = 110.9 \text{ J/mol}\cdot\text{K}$] (Figure 20.10).

When a gas dissolves in another gas, however, the entropy increases as a result of the separation and mixing of the molecules.

Atomic Size and Molecular Complexity Differences in S° values for substances in the same phase are usually based on atomic size and molecular complexity.

- Within a periodic group, energy levels become closer together for heavier atoms, so the number of microstates, and thus the molar entropy, increases:

	Li	Na	K	Rb	Cs
Molar mass (g/mol):	6.941	22.99	39.10	85.47	132.9
$S^\circ(s) \text{ (J/mol}\cdot\text{K):}$	29.1	51.4	64.7	69.5	85.2

The same trend of increasing entropy holds for similar compounds down a group:

	HF	HCl	HBr	HI
Molar mass (g/mol):	20.01	36.46	80.91	127.9
$S^\circ(g) \text{ (J/mol}\cdot\text{K):}$	173.7	186.8	198.6	206.3

- For different forms of an element (allotropes), the entropy is *higher* in the form that allows the atoms more freedom of motion. For example, S° of graphite is 5.69 J/mol·K, whereas S° of diamond is 2.44 J/mol·K. In graphite, covalent bonds extend within a two-dimensional sheet, and the sheets move past each other relatively easily; in

*An S° value for a hydrated ion can be negative because such a value is relative to the S° value for the hydrated proton, $\text{H}^+(aq)$, which is assigned a value of 0. In other words, $\text{Al}^{3+}(aq)$ has a lower entropy than $\text{H}^+(aq)$.

diamond, covalent bonds extend in three dimensions, allowing the atoms little movement (Table 12.6).

3. For compounds, entropy increases with chemical complexity (that is, with number of atoms in the formula), and this trend holds for ionic and covalent substances:

$S^\circ(\text{J/mol}\cdot\text{K})$	NaCl	AlCl_3	P_4O_{10}	NO	NO_2	N_2O_4
$S^\circ(s)$:	72.1	167	229			
$S^\circ(g)$:				211	240	304

The trend is also based on the different motions that are available. Thus, for example, among the three nitrogen oxides listed in the preceding table, the number of different vibrational motions increases with the number of atoms in the molecule (Figure 20.11; see also the Tools of the Laboratory in Chapter 9).

For larger compounds, we also consider the motion of different parts of a molecule. A long hydrocarbon chain can rotate and vibrate in more ways than a short one, so *entropy increases with chain length*. A ring compound, such as cyclopentane (C_5H_{10}), has lower entropy than the chain compound with the same molar mass, pentene (C_5H_{10}), because the ring structure restricts freedom of motion:

$\text{CH}_4(g)$	$\text{C}_2\text{H}_6(g)$	$\text{C}_3\text{H}_8(g)$	$\text{C}_4\text{H}_{10}(g)$	$\text{C}_5\text{H}_{10}(g)$	$\text{C}_5\text{H}_{10}(\text{cyclo, } g)$	$\text{C}_2\text{H}_5\text{OH}(l)$
$S(\text{J/mol}\cdot\text{K})$:	186	230	270	310	348	293

Remember, these trends hold only for *substances in the same physical state*. Gaseous methane (CH_4) has higher entropy than liquid ethanol ($\text{C}_2\text{H}_5\text{OH}$), even though ethanol molecules are more complex. When gases are compared with liquids, *the effect of physical state dominates the effect of molecular complexity*.

SAMPLE PROBLEM 20.1

Predicting Relative Entropy Values

Problem Select the substance with the higher entropy in each pair, and explain your choice [assume constant temperature, except in part (e)]:

- (a) 1 mol of $\text{SO}_2(g)$ or 1 mol of $\text{SO}_3(g)$
- (b) 1 mol of $\text{CO}_2(s)$ or 1 mol of $\text{CO}_2(g)$
- (c) 3 mol of $\text{O}_2(g)$ or 2 mol of $\text{O}_3(g)$
- (d) 1 mol of $\text{KBr}(s)$ or 1 mol of $\text{KBr}(aq)$
- (e) Seawater at 2°C or at 23°C
- (f) 1 mol of $\text{CF}_4(g)$ or 1 mol of $\text{CCl}_4(g)$

Plan In general, particles with more freedom of motion have more microstates in which to disperse their kinetic energy, so they have higher entropy. We know that either raising temperature or having *more* particles increases entropy. We apply the general categories described in the text to choose the member with the higher entropy.

Solution (a) 1 mol of $\text{SO}_3(g)$. For equal numbers of moles of substances with the same types of atoms in the same physical state, the more atoms in the molecule, the more types of motion available, and thus the higher the entropy.

(b) 1 mol of $\text{CO}_2(g)$. For a given substance, entropy increases in the sequence $s < l < g$.

(c) 3 mol of $\text{O}_2(g)$. The two samples contain the same number of oxygen atoms but different numbers of molecules. Despite the greater complexity of O_3 , the greater number of molecules dominates because there are many more microstates possible for 3 mol of particles than for 2 mol.

(d) 1 mol of $\text{KBr}(aq)$. The two samples have the same number of ions, but their motion is more limited and their energy less dispersed in the solid than in the solution.

(e) Seawater at 23°C . Entropy increases with rising temperature.

(f) 1 mol of $\text{CCl}_4(g)$. For similar compounds, entropy increases with molar mass.

FOLLOW-UP PROBLEMS

Brief Solutions to all Follow-up Problems appear at the end of the chapter.

20.1A Select the substance with the *higher* entropy in each pair, and explain your choice (assume 1 mol of each at the same T):

- (a) $\text{PCl}_3(g)$ or $\text{PCl}_5(g)$
- (b) $\text{CaF}_2(s)$ or $\text{BaCl}_2(s)$
- (c) $\text{Br}_2(g)$ or $\text{Br}_2(l)$

Figure 20.11 Entropy, vibrational motion, and molecular complexity.

Student Hot Spot

Student data indicate that you may struggle with entropy trends. Access the Smartbook to view additional Learning Resources on this topic.

20.1B Select the substance with the *lower* entropy in each pair, and explain your choice (assume 1 mol of each at the same T):

(a) LiBr(*aq*) or NaBr(*aq*) (b) quartz or glass (c)

SOME SIMILAR PROBLEMS 20.22–20.29

› Summary of Section 20.1

- › A change is spontaneous under specified conditions if it occurs without a continuous input of energy.
- › Neither the first law of thermodynamics nor the sign of ΔH predicts the direction of a spontaneous change.
- › Many spontaneous processes involve an increase in the freedom of motion of the system's particles and, thus, in the dispersal of the system's energy of motion.
- › Entropy is a state function that measures the extent of energy dispersed into the number of microstates possible for a system. Each microstate consists of the quantized energy levels of the system at a given instant.
- › The second law of thermodynamics states that, in a spontaneous process, the entropy of the universe (system plus surroundings) increases.
- › Absolute entropy values can be determined because perfect crystals have zero entropy at 0 K (third law of thermodynamics).
- › Standard molar entropy, S° (in J/mol·K), is affected by temperature, phase changes, dissolution, and atomic size or molecular complexity.

20.2 CALCULATING THE CHANGE IN ENTROPY OF A REACTION

Chemists are especially interested in learning how to predict the sign *and* calculate the value of the entropy change that occurs during a reaction.

Entropy Changes in the System: Standard Entropy of Reaction ($\Delta S_{\text{rxn}}^\circ$)

The **standard entropy of reaction**, $\Delta S_{\text{rxn}}^\circ$, is the entropy change that occurs when all reactants and products are in their standard states.

Predicting the Sign of $\Delta S_{\text{rxn}}^\circ$ Changes in structure and especially in amount (mol) of a gas help us predict the sign of $\Delta S_{\text{rxn}}^\circ$. Because gases have such great freedom of motion and, thus, high molar entropies, *if the number of moles of gas increases, $\Delta S_{\text{rxn}}^\circ$ is positive; if the number decreases, $\Delta S_{\text{rxn}}^\circ$ is negative*. Here are a few examples:

- *Increase in amount of gas.* When gaseous H_2 reacts with solid I_2 to form gaseous HI , the total number of moles of substance stays the same. Nevertheless, the sign of $\Delta S_{\text{rxn}}^\circ$ is positive (entropy increases) because the number of moles of gas increases:

- *Decrease in amount of gas.* When ammonia forms from its elements, 4 mol of gas produce 2 mol of gas, so $\Delta S_{\text{rxn}}^\circ$ is negative (entropy decreases):

- *No change in amount of gas, but change in structure.* When the amount (mol) of gas doesn't change, we *cannot* predict the sign of $\Delta S_{\text{rxn}}^\circ$. But, a change in one of the structures can make it easier to predict the sign of $\Delta S_{\text{rxn}}^\circ$. For example, when

cyclopropane is heated to 500°C, the ring opens and propene forms. The chain has more freedom of motion than the ring, so $\Delta S_{\text{rxn}}^{\circ}$ is positive:

Keep in mind, however, that in general we cannot predict the sign of the entropy change unless the reaction involves a change in number of moles of gas.

Calculating $\Delta S_{\text{rxn}}^{\circ}$ from S° Values By applying Hess's law (Chapter 6), we combined ΔH_f° values to find $\Delta H_{\text{rxn}}^{\circ}$. Similarly, we combine S° values to find the standard entropy of reaction, $\Delta S_{\text{rxn}}^{\circ}$:

$$\Delta S_{\text{rxn}}^{\circ} = \sum m S_{\text{products}}^{\circ} - \sum n S_{\text{reactants}}^{\circ} \quad (20.4)$$

where m and n are the amounts (mol) of products and reactants, respectively, given by the coefficients in the balanced equation. For the formation of ammonia, we have

$$\Delta S_{\text{rxn}}^{\circ} = [(2 \text{ mol NH}_3)(S^{\circ} \text{ of NH}_3)] - [(1 \text{ mol N}_2)(S^{\circ} \text{ of N}_2) + (3 \text{ mol H}_2)(S^{\circ} \text{ of H}_2)]$$

From Appendix B, we find the S° values:

$$\begin{aligned} \Delta S_{\text{rxn}}^{\circ} &= [(2 \text{ mol})(193 \text{ J/mol}\cdot\text{K})] - [(1 \text{ mol})(191.5 \text{ J/mol}\cdot\text{K}) + (3 \text{ mol})(130.6 \text{ J/mol}\cdot\text{K})] \\ &= -197 \text{ J/K} \end{aligned}$$

As we predicted above from the decrease in number of moles of gas, $\Delta S_{\text{rxn}}^{\circ} < 0$.

SAMPLE PROBLEM 20.2

Calculating the Standard Entropy of Reaction, $\Delta S_{\text{rxn}}^{\circ}$

Problem Predict the sign of $\Delta S_{\text{rxn}}^{\circ}$, if possible, and calculate its value for the combustion of 1 mol of propane at 25°C:

Plan We use the change in the number of moles of gas to predict the sign of $\Delta S_{\text{rxn}}^{\circ}$. To find $\Delta S_{\text{rxn}}^{\circ}$, we apply Equation 20.4.

Solution The amount (mol) of gas decreases (6 mol of reactant gas yields 3 mol of product gas), so the entropy should decrease ($\Delta S_{\text{rxn}}^{\circ} < 0$).

Calculating $\Delta S_{\text{rxn}}^{\circ}$. Using Appendix B values,

$$\begin{aligned} \Delta S_{\text{rxn}}^{\circ} &= [(3 \text{ mol CO}_2)(S^{\circ} \text{ of CO}_2) + (4 \text{ mol H}_2\text{O})(S^{\circ} \text{ of H}_2\text{O})] \\ &\quad - [(1 \text{ mol C}_3\text{H}_8)(S^{\circ} \text{ of C}_3\text{H}_8) + (5 \text{ mol O}_2)(S^{\circ} \text{ of O}_2)] \\ &= [(3 \text{ mol})(213.7 \text{ J/mol}\cdot\text{K}) + (4 \text{ mol})(69.940 \text{ J/mol}\cdot\text{K})] \\ &\quad - [(1 \text{ mol})(269.9 \text{ J/mol}\cdot\text{K}) + (5 \text{ mol})(205.0 \text{ J/mol}\cdot\text{K})] \\ &= -374.0 \text{ J/K} \end{aligned}$$

Check $\Delta S_{\text{rxn}}^{\circ} < 0$, so our prediction is correct. Rounding gives $[3(200) + 4(70)] - [270 + 5(200)] = 880 - 1270 = -390$, close to the calculated value.

Comment Notice that there are 6 mol of reactants and 7 mol of products in the propane combustion reaction; however, we do not count the 4 mol of $\text{H}_2\text{O(l)}$ when we look for an increase or decrease in mol of gas to predict $\Delta S_{\text{rxn}}^{\circ}$.

FOLLOW-UP PROBLEMS

20.2A Balance each equation, predict the sign of $\Delta S_{\text{rxn}}^{\circ}$ if possible, and calculate its value at 298 K:

20.2B Balance each equation, predict the sign of $\Delta S_{\text{rxn}}^{\circ}$ if possible, and calculate its value at 25°C:

SOME SIMILAR PROBLEMS 20.33–20.38

Entropy Changes in the Surroundings: The Other Part of the Total

In the synthesis of ammonia, the combustion of propane, and many other spontaneous reactions, the entropy of the *system* decreases ($\Delta S_{\text{rxn}}^{\circ} < 0$). Remember that the second law dictates that, for a spontaneous process, a *decrease in the entropy of the system is outweighed by an increase in the entropy of the surroundings*. In this section, we examine the influence of the surroundings—in particular, the addition (or removal) of heat and the temperature at which this heat flow occurs—on the *total* entropy change.

The Role of the Surroundings In essence, the surroundings *add heat to or remove heat from the system*. That is, the surroundings function as an enormous heat source or heat sink, one so large that its temperature remains constant, even though its entropy changes. The surroundings participate in the two types of enthalpy changes as follows:

1. *In an exothermic change, heat released by the system is absorbed by the surroundings.* More heat increases the freedom of motion of the particles and makes the energy more dispersed, so the entropy of the surroundings increases:

For an exothermic change: $q_{\text{sys}} < 0$, $q_{\text{surr}} > 0$, and $\Delta S_{\text{surr}} > 0$

2. *In an endothermic change, heat absorbed by the system is released by the surroundings.* Less heat reduces the freedom of motion of the particles and makes the energy less dispersed, so the entropy of the surroundings decreases:

For an endothermic change: $q_{\text{sys}} > 0$, $q_{\text{surr}} < 0$, and $\Delta S_{\text{surr}} < 0$

Temperature at Which Heat Is Transferred The *temperature* of the surroundings when the heat is transferred also affects ΔS_{surr} . Consider the effect of an exothermic reaction at a low or at a high temperature:

- At a low T , such as 20 K, there is little motion of particles in the surroundings because they have relatively low energy. This means there are few energy levels in each microstate and few microstates in which to disperse the energy. Transferring a given quantity of heat to these surroundings causes a relatively large change in how much energy is dispersed.
- At a high T , such as 298 K, the surroundings have a large quantity of energy dispersed among the particles. There are more energy levels in each microstate and a greater number of microstates. Transferring the same given quantity of heat to these surroundings causes a relatively small change in how much energy is dispersed. ↵

In other words, ΔS_{surr} is greater when heat is added at a lower T . Putting these ideas together, ΔS_{surr} is *directly related to an opposite change in the heat of the system (q_{sys}) and inversely related to the temperature at which the heat is transferred*:

$$\Delta S_{\text{surr}} = -\frac{q_{\text{sys}}}{T}$$

For a process at *constant pressure*, the heat (q_P) is ΔH (Section 6.2), so

$$\Delta S_{\text{surr}} = -\frac{\Delta H_{\text{sys}}}{T} \tag{20.5}$$

Thus, we find ΔS_{surr} by measuring ΔH_{sys} and T at which the change takes place.

The main point: If a spontaneous reaction has a negative ΔS_{sys} (fewer microstates into which energy is dispersed), ΔS_{surr} must be positive enough (even more microstates into which energy is dispersed) for ΔS_{univ} to be positive (net increase in number of microstates for dispersing the energy).

A Checkbook Analogy for Heating the Surroundings

If you have \$10 in your checking account, a \$10 deposit represents a 100% increase in your net worth; that is, a given change to a low initial state has a large impact. If, however, you have a \$1000 balance, a \$10 deposit represents only a 1% increase. Thus, the same absolute change to a high initial state has a smaller impact.

SAMPLE PROBLEM 20.3**Determining Reaction Spontaneity**

Problem At 298 K, the formation of ammonia has a negative $\Delta S_{\text{sys}}^{\circ}$:

Calculate ΔS_{univ} , and state whether the reaction occurs spontaneously at this temperature.

Plan For the reaction to occur spontaneously, $\Delta S_{\text{univ}} > 0$, so ΔS_{surr} must be greater than $+197 \text{ J/K}$. To find ΔS_{surr} , we need $\Delta H_{\text{sys}}^{\circ}$, which is the same as $\Delta H_{\text{rxn}}^{\circ}$. We use ΔH_f° values from Appendix B to find $\Delta H_{\text{rxn}}^{\circ}$. Then, we divide $\Delta H_{\text{rxn}}^{\circ}$ by the given T (298 K) to find ΔS_{surr} . To find ΔS_{univ} , we add the calculated ΔS_{surr} to the given $\Delta S_{\text{sys}}^{\circ}$ (-197 J/K).

Solution Calculating $\Delta H_{\text{sys}}^{\circ}$:

$$\begin{aligned}\Delta H_{\text{sys}}^{\circ} &= \Delta H_{\text{rxn}}^{\circ} \\ &= [(2 \text{ mol NH}_3)(\Delta H_f^{\circ} \text{ of NH}_3)] - [(3 \text{ mol H}_2)(\Delta H_f^{\circ} \text{ of H}_2) + (1 \text{ mol N}_2)(\Delta H_f^{\circ} \text{ of N}_2)] \\ &= [(2 \text{ mol NH}_3)(-45.9 \text{ kJ/mol})] - [(3 \text{ mol H}_2)(0 \text{ kJ/mol}) + (1 \text{ mol N}_2)(0 \text{ kJ/mol})] \\ &= -91.8 \text{ kJ}\end{aligned}$$

Calculating ΔS_{surr} :

$$\Delta S_{\text{surr}} = -\frac{\Delta H_{\text{sys}}^{\circ}}{T} = -\frac{-91.8 \text{ kJ} \times \frac{1000 \text{ J}}{1 \text{ kJ}}}{298 \text{ K}} = 308 \text{ J/K}$$

Determining ΔS_{univ} :

$$\Delta S_{\text{univ}} = \Delta S_{\text{sys}}^{\circ} + \Delta S_{\text{surr}} = -197 \text{ J/K} + 308 \text{ J/K} = 111 \text{ J/K}$$

Since $\Delta S_{\text{univ}} > 0$, the reaction occurs spontaneously at 298 K (see margin).

Check Rounding to check the math, we have

$$\begin{aligned}\Delta H_{\text{rxn}}^{\circ} &\approx 2(-45 \text{ kJ}) = -90 \text{ kJ} \\ \Delta S_{\text{surr}} &\approx -(-90,000 \text{ J})/300 \text{ K} = 300 \text{ J/K} \\ \Delta S_{\text{univ}} &\approx -200 \text{ J/K} + 300 \text{ J/K} = 100 \text{ J/K}\end{aligned}$$

Given the negative $\Delta H_{\text{rxn}}^{\circ}$, Le Châtelier's principle says that low T favors NH_3 formation, so the answer is reasonable (see Section 17.6).

Comment 1. Because ΔH° has units of kJ, and ΔS has units of J/K, don't forget to convert kJ to J, or you'll introduce a large error.

2. This example highlights the distinction between thermodynamics and kinetics. NH_3 forms spontaneously, but so slowly that catalysts are required to achieve a practical rate.

FOLLOW-UP PROBLEMS

20.3A Gaseous phosphorus trichloride forms from the elements through this reaction:

Calculate $\Delta H_{\text{rxn}}^{\circ}$, ΔS_{surr} , and $\Delta S_{\text{rxn}}^{\circ}$ to determine if the reaction is spontaneous at 298 K.

20.3B Does the oxidation of $\text{FeO}(s)$ to $\text{Fe}_2\text{O}_3(s)$ occur spontaneously at 298 K? (Show the calculation for 1 mol of Fe_2O_3 .)

SOME SIMILAR PROBLEMS 20.39–20.42

Do Organisms Obey the Laws of Thermodynamics? Taking the surroundings into account is crucial, not only for determining reaction spontaneity, as in Sample Problem 20.3, but also for understanding the relevance of thermodynamics to biology. Let's examine the first and second laws to see if they apply to living systems.

1. *Do organisms comply with the first law?* The chemical bond energy in food and oxygen is converted into the mechanical energy of jumping, flying, crawling, swimming, and countless other movements; the electrical energy of nerve conduction; the

Figure 20.12 A whole-body calorimeter.

In this room-sized apparatus, a person exercises while respiratory gases, energy input and output, and other physiological variables are monitored.

Source: © Vanderbilt University—Clinical Nutrition Research

thermal energy of warming the body; and so forth. Many experiments have demonstrated that the total energy is conserved in these situations. Some of the earliest were performed by Lavoisier, who showed that “animal heat” was produced by slow, continual combustion. In experiments with guinea pigs, he invented a calorimeter to measure the heat released from intake of food and O₂ and output of CO₂ and water, and he included respiration in his new theory of combustion. Modern, room-sized calorimeters measure these and other variables to confirm the conservation of energy for an exercising human (Figure 20.12).

2. *Do organisms comply with the second law?* Mature humans are far more complex than the egg and sperm cells from which they develop, and modern organisms are far more complex than the one-celled ancestral specks from which they evolved. Are the growth of an organism and the evolution of life exceptions to the spontaneous tendency of natural processes to increase freedom of motion and disperse energy? For an organism to grow or a species to evolve, many moles of oxygen and nutrients—carbohydrates, proteins, and fats—undergo exothermic reactions to form many *more* moles of gaseous CO₂ and H₂O. Formation of these waste gases and the accompanying release of heat result in an enormous *increase* in the entropy of the surroundings. Thus, the localization of energy and synthesis of macromolecular structures required for the growth and evolution of organisms (system) cause a far greater dispersal of energy and freedom of motion in the environment (surroundings). When system and surroundings are considered together, the entropy of the universe, as always, increases.

The Entropy Change and the Equilibrium State

For a process approaching equilibrium, $\Delta S_{\text{univ}} > 0$. When the process reaches equilibrium, there is no further *net* change, $\Delta S_{\text{univ}} = 0$, because any entropy change in the system is balanced by an opposite entropy change in the surroundings:

$$\text{At equilibrium: } \Delta S_{\text{univ}} = \Delta S_{\text{sys}} + \Delta S_{\text{surr}} = 0 \quad \text{so} \quad \Delta S_{\text{sys}} = -\Delta S_{\text{surr}}$$

As an example, let's calculate ΔS_{univ} for the vaporization-condensation of 1 mol of water at 100°C (373 K),

First, we find $\Delta S_{\text{sys}}^{\circ}$ for the forward change (vaporization) of 1 mol of water:

$$\begin{aligned} \Delta S_{\text{sys}}^{\circ} &= \Sigma mS_{\text{products}}^{\circ} - \Sigma nS_{\text{reactants}}^{\circ} = S^{\circ} \text{ of H}_2\text{O}(g; 373 \text{ K}) - S^{\circ} \text{ of H}_2\text{O}(l; 373 \text{ K}) \\ &= 195.9 \text{ J/K} - 86.8 \text{ J/K} = 109.1 \text{ J/K} \end{aligned}$$

As we expect, the entropy of the system increases ($\Delta S_{\text{sys}}^{\circ} > 0$) as the liquid absorbs heat and changes to a gas.

For ΔS_{surr} of the vaporization step, we have

$$\Delta S_{\text{surr}} = -\frac{\Delta H_{\text{sys}}^{\circ}}{T}$$

where $\Delta H_{\text{sys}}^{\circ} = \Delta H_{\text{vap}}^{\circ}$ at 373 K = 40.7 kJ/mol = 40.7 × 10³ J/mol. For 1 mol of water, we have

$$\Delta S_{\text{surr}} = -\frac{\Delta H_{\text{vap}}^{\circ}}{T} = -\frac{40.7 \times 10^3 \text{ J}}{373 \text{ K}} = -109 \text{ J/K}$$

The surroundings lose heat, and the negative sign means that the entropy of the surroundings decreases. The two entropy changes have the same magnitude but opposite signs, so they cancel:

$$\Delta S_{\text{univ}} = 109 \text{ J/K} + (-109 \text{ J/K}) = 0$$

For the reverse change (condensation), ΔS_{univ} also equals zero, but $\Delta S_{\text{sys}}^{\circ}$ and ΔS_{surr} have signs opposite those for vaporization.

A similar treatment of a chemical change shows the same result: the entropy change of the forward reaction is *equal in magnitude but opposite in sign* to the

entropy change of the reverse reaction. Thus, *when a system reaches equilibrium, neither the forward nor the reverse reaction is spontaneous*, and so there is no net reaction in either direction.

Spontaneous Exothermic and Endothermic Changes

No matter what its *enthalpy* change, a reaction occurs because the total *entropy* of the reacting system *and* its surroundings increases. There are two ways this can happen:

1. In an exothermic reaction ($\Delta H_{\text{sys}} < 0$), the heat released by the system increases the freedom of motion and dispersal of energy in the surroundings; thus, $\Delta S_{\text{surr}} > 0$.

- If the entropy of the products is *more* than that of the reactants ($\Delta S_{\text{sys}} > 0$), the total entropy change ($\Delta S_{\text{sys}} + \Delta S_{\text{surr}}$) will be positive (Figure 20.13A). For example, in the oxidation of glucose, an essential reaction for all higher organisms,

6 mol of gas yields 12 mol of gas; thus, $\Delta S_{\text{sys}} > 0$, $\Delta S_{\text{surr}} > 0$, and $\Delta S_{\text{univ}} > 0$.

- If the entropy of the products is *less* than that of the reactants ($\Delta S_{\text{sys}} < 0$), the entropy of the surroundings must increase even more ($\Delta S_{\text{surr}} >> 0$) to make the total ΔS positive (Figure 20.13B). For example, when calcium oxide and carbon dioxide form calcium carbonate, an essential reaction for all higher organisms,

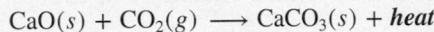

However, even though the system's entropy goes down, the heat released increases the entropy of the surroundings even more; thus, $\Delta S_{\text{sys}} < 0$, but $\Delta S_{\text{surr}} >> 0$, so $\Delta S_{\text{univ}} > 0$.

2. In an endothermic reaction ($\Delta H_{\text{sys}} > 0$), the heat absorbed by the system decreases molecular freedom of motion and dispersal of energy in the surroundings; so $\Delta S_{\text{surr}} < 0$. Thus, the only way an endothermic reaction can occur spontaneously is if ΔS_{sys} is positive and large enough to outweigh the negative ΔS_{surr} (Figure 20.13C).

- In the solution process for many ionic compounds, heat is absorbed to form the solution, so the entropy of the surroundings decreases ($\Delta S_{\text{surr}} < 0$). However, when the crystalline solid becomes freely moving ions, the entropy increase is so large ($\Delta S_{\text{sys}} >> 0$) that it outweighs the negative ΔS_{surr} . Thus, ΔS_{univ} is positive.
- Spontaneous endothermic reactions are similar. Recall the reaction between barium hydroxide octahydrate and ammonium nitrate (Figure 20.1).

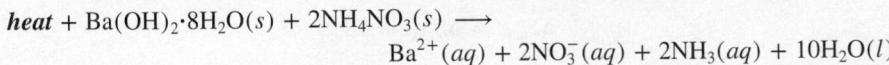

3 mol of crystalline solids absorb heat from the surroundings ($\Delta S_{\text{surr}} < 0$) and yields 15 mol of dissolved ions and molecules, which have much more freedom of motion and, therefore, much greater entropy ($\Delta S_{\text{sys}} >> 0$).

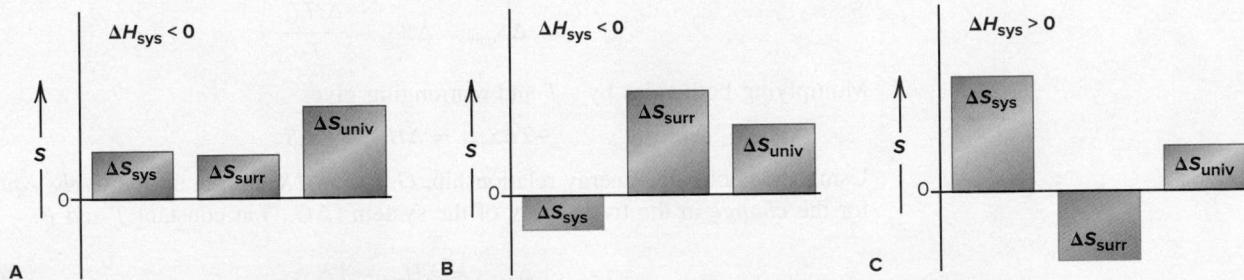

Figure 20.13 Components of ΔS_{univ} for spontaneous reactions. For a reaction to occur spontaneously, ΔS_{univ} must be positive. **A**, An exothermic reaction in which ΔS_{sys} increases; the size of ΔS_{surr} is not important. **B**, An exothermic reaction in which ΔS_{sys} decreases; ΔS_{surr} must be larger than ΔS_{sys} . **C**, An endothermic reaction in which ΔS_{sys} increases; ΔS_{surr} must be smaller than ΔS_{sys} .

› Summary of Section 20.2

- › The standard entropy of reaction, ΔS_{rxn}° , is calculated from S° values.
- › When the amount (mol) of gas increases in a reaction, usually $\Delta S_{rxn}^\circ > 0$.
- › The change in entropy of the surroundings, ΔS_{surr} , is related directly to $-\Delta H_{sys}^\circ$ and inversely to the absolute temperature T at which the change occurs.
- › In a spontaneous change, the entropy of the system can decrease only if the entropy of the surroundings increases even more, so that $\Delta S_{univ} > 0$.
- › The second law is obeyed in living systems when we consider system *plus* surroundings.
- › For a system at equilibrium, $\Delta S_{univ} = 0$, so $\Delta S_{sys}^\circ = -\Delta S_{surr}$.
- › Even if $\Delta S_{sys}^\circ < 0$, an exothermic reaction ($\Delta H_{rxn}^\circ < 0$) is spontaneous ($\Delta S_{univ} > 0$) if $\Delta S_{surr} >> 0$; an endothermic reaction ($\Delta H_{rxn}^\circ > 0$) is spontaneous only if $\Delta S_{sys}^\circ > \Delta S_{surr}$.

20.3 ENTROPY, FREE ENERGY, AND WORK

By measuring *both* ΔS_{sys} and ΔS_{surr} , we can predict whether a reaction will be spontaneous at a particular temperature. It would be useful to have *one* criterion for spontaneity that we can determine by *measuring the system only*. The Gibbs free energy, or simply **free energy (G)**, combines the system's enthalpy and entropy:

$$G = H - TS$$

One of the greatest but least recognized of American scientists, Josiah Willard Gibbs (1839–1903), established chemical thermodynamics as well as major principles of equilibrium and electrochemistry. Although the great European scientists of his time, James Clerk Maxwell and Henri Le Châtelier, realized Gibbs's achievements, he was not recognized by his American colleagues until nearly 50 years after his death!

Free Energy Change and Reaction Spontaneity

The free energy change (ΔG) is a measure of the spontaneity of a process and of the useful energy available from it.

Deriving the Gibbs Equation Let's examine the meaning of ΔG by deriving it from the second law. By definition, the entropy change of the universe is the sum of the entropy changes of the system and the surroundings:

$$\Delta S_{univ} = \Delta S_{sys} + \Delta S_{surr}$$

At constant pressure,

$$\Delta S_{surr} = -\frac{\Delta H_{sys}}{T}$$

Substituting for ΔS_{surr} gives a relationship that relies solely on the system:

$$\Delta S_{univ} = \Delta S_{sys} - \frac{\Delta H_{sys}}{T}$$

Multiplying both sides by $-T$ and rearranging gives

$$-T\Delta S_{univ} = \Delta H_{sys} - T\Delta S_{sys}$$

Using the Gibbs free energy relationship, $G = H - TS$, we obtain the *Gibbs equation* for the *change* in the free energy of the system (ΔG_{sys}) at constant T and P :

$$\Delta G_{sys} = \Delta H_{sys} - T\Delta S_{sys}$$

(20.6)

Combining Equation 20.6 with the one preceding it shows that

$$-T\Delta S_{univ} = \Delta G_{sys} = \Delta H_{sys} - T\Delta S_{sys}$$

Spontaneity and the Sign of ΔG Let's see how the *sign* of ΔG tells if a reaction is spontaneous. According to the second law,

- $\Delta S_{\text{univ}} > 0$ for a spontaneous process
- $\Delta S_{\text{univ}} < 0$ for a nonspontaneous process
- $\Delta S_{\text{univ}} = 0$ for a process at equilibrium

Since the absolute temperature is always positive, for a spontaneous process,

$$T\Delta S_{\text{univ}} > 0 \quad \text{so} \quad -T\Delta S_{\text{univ}} < 0$$

From our derivation above, $\Delta G = -T\Delta S_{\text{univ}}$, so we have

- $\Delta G < 0$ for a spontaneous process
- $\Delta G > 0$ for a nonspontaneous process
- $\Delta G = 0$ for a process at equilibrium

Without incorporating any new ideas, we can now predict spontaneity with one variable (ΔG_{sys}) rather than two (ΔS_{sys} and ΔS_{surr}).

Calculating Standard Free Energy Changes

The *sign* of ΔG reveals *whether* a reaction is spontaneous, but the *magnitude* of ΔG tells *how* spontaneous it is. Because free energy (G) combines three state functions, H , S , and T , it is also a state function. As we do with enthalpy, we focus on the free energy *change* (ΔG). As we do with other thermodynamic variables, to compare the free energy changes of different reactions, we calculate the **standard free energy change** (ΔG°), which occurs when all components of the system are in their standard states.

Using the Gibbs Equation to Find ΔG° One way to calculate ΔG° is by writing the Gibbs equation (Equation 20.6) at standard-state conditions and using Appendix B to find $\Delta H_{\text{sys}}^\circ$ and $\Delta S_{\text{sys}}^\circ$. Adapting the Gibbs equation, we have

$$\Delta G_{\text{sys}}^\circ = \Delta H_{\text{sys}}^\circ - T\Delta S_{\text{sys}}^\circ \quad (20.7)$$

This important relationship is used to find any one of these three variables, given the other two, as in the following sample problem.

SAMPLE PROBLEM 20.4

Calculating $\Delta G_{\text{rxn}}^\circ$ from Enthalpy and Entropy Values

Problem Potassium chlorate, a common oxidizing agent in fireworks (see photo) and matchheads, undergoes a solid-state disproportionation reaction when heated:

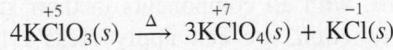

Use ΔH_f° and S° values to calculate $\Delta G_{\text{sys}}^\circ$ (which is $\Delta G_{\text{rxn}}^\circ$) at 25°C for this reaction.

Plan To solve for ΔG° , we need values from Appendix B. We use ΔH_f° values to calculate $\Delta H_{\text{rxn}}^\circ$ ($\Delta H_{\text{sys}}^\circ$), use S° values to calculate $\Delta S_{\text{rxn}}^\circ$ ($\Delta S_{\text{sys}}^\circ$), and then apply Equation 20.7.

Solution Calculating $\Delta H_{\text{sys}}^\circ$ from ΔH_f° values (with Equation 6.10):

$$\begin{aligned} \Delta H_{\text{sys}}^\circ &= \Delta H_{\text{rxn}}^\circ = \sum m \Delta H_f^\circ(\text{products}) - \sum n \Delta H_f^\circ(\text{reactants}) \\ &= [(3 \text{ mol KClO}_4)(\Delta H_f^\circ \text{ of KClO}_4) + (1 \text{ mol KCl})(\Delta H_f^\circ \text{ of KCl})] \\ &\quad - [(4 \text{ mol KClO}_3)(\Delta H_f^\circ \text{ of KClO}_3)] \\ &= [(3 \text{ mol})(-432.75 \text{ kJ/mol}) + (1 \text{ mol})(-436.7 \text{ kJ/mol})] \\ &\quad - [(4 \text{ mol})(-397.7 \text{ kJ/mol})] \\ &= -144.2 \text{ kJ} \end{aligned}$$

Fireworks explode spontaneously.

Source: © Karl Weatherly/PhotoDisc, RF

Calculating $\Delta S_{\text{sys}}^{\circ}$ from S° values (with Equation 20.4):

$$\begin{aligned}\Delta S_{\text{sys}}^{\circ} &= \Delta S_{\text{rxn}}^{\circ} = \sum mS_{\text{products}}^{\circ} - \sum nS_{\text{reactants}}^{\circ} \\ &= [(3 \text{ mol KClO}_4)(S^{\circ} \text{ of KClO}_4) + (1 \text{ mol KCl})(S^{\circ} \text{ of KCl})] \\ &\quad - [(4 \text{ mol KClO}_3)(S^{\circ} \text{ of KClO}_3)] \\ &= [(3 \text{ mol})(151.0 \text{ J/mol}\cdot\text{K}) + (1 \text{ mol})(82.6 \text{ J/mol}\cdot\text{K})] \\ &\quad - [(4 \text{ mol})(143.1 \text{ J/mol}\cdot\text{K})] \\ &= -36.8 \text{ J/K}\end{aligned}$$

Calculating $\Delta G_{\text{sys}}^{\circ}$ at 298 K:

$$\Delta G_{\text{sys}}^{\circ} = \Delta H_{\text{sys}}^{\circ} - T\Delta S_{\text{sys}}^{\circ} = -144.2 \text{ kJ} - \left[(298 \text{ K})(-36.8 \text{ J/K}) \left(\frac{1 \text{ kJ}}{1000 \text{ J}} \right) \right] = -133.2 \text{ kJ}$$

Check Rounding to check the math:

$$\begin{aligned}\Delta H^{\circ} &\approx [3(-433 \text{ kJ}) + (-440 \text{ kJ})] - [4(-400 \text{ kJ})] = -1740 \text{ kJ} + 1600 \text{ kJ} = -140 \text{ kJ} \\ \Delta S^{\circ} &\approx [3(150 \text{ J/K}) + 85 \text{ J/K}] - [4(145 \text{ J/K})] = 535 \text{ J/K} - 580 \text{ J/K} = -45 \text{ J/K} \\ \Delta G^{\circ} &\approx -140 \text{ kJ} - 300 \text{ K}(-0.04 \text{ kJ/K}) = -140 \text{ kJ} + 12 \text{ kJ} = -128 \text{ kJ}\end{aligned}$$

Comment 1. Recall from Section 20.1 that reaction spontaneity tells nothing about rate. Even though this reaction is spontaneous, the rate is very low in the solid. When KClO_3 is heated slightly above its melting point, the ions can move and the reaction occurs readily.

2. Under *any* conditions, a spontaneous reaction has a negative change in free energy: $\Delta G < 0$. Under standard-state conditions, a spontaneous reaction has a negative *standard* free energy change: $\Delta G^{\circ} < 0$.

FOLLOW-UP PROBLEMS

20.4A Use $\Delta H_{\text{rxn}}^{\circ}$ and $\Delta S_{\text{rxn}}^{\circ}$ to calculate $\Delta G_{\text{rxn}}^{\circ}$ at 298 K for this reaction:

20.4B Determine the standard free energy change at 298 K for this reaction:

SOME SIMILAR PROBLEMS 20.53 and 20.54

Using Standard Free Energies of Formation to Find $\Delta G_{\text{rxn}}^{\circ}$ Another way to calculate $\Delta G_{\text{rxn}}^{\circ}$ is with values for the **standard free energy of formation** (ΔG_f°) of the components. Analogous to the standard enthalpy of formation, ΔH_f° (Section 6.6), ΔG_f° is the free energy change that occurs when 1 mol of a compound is made *from its elements*, with all components in their standard states. Because free energy is a state function, we can apply Hess's law and combine ΔG_f° values of reactants and products to calculate $\Delta G_{\text{rxn}}^{\circ}$, no matter how the reaction takes place:

$$\Delta G_{\text{rxn}}^{\circ} = \sum m\Delta G_{\text{f(products)}}^{\circ} - \sum n\Delta G_{\text{f(reactants)}}^{\circ} \quad (20.8)$$

ΔG_f° values have properties similar to ΔH_f° values:

- ΔG_f° of an element in its standard state is zero.
- A coefficient in the reaction equation (m or n in Equation 20.8) multiplies ΔG_f° by that number.
- Reversing a reaction changes the sign of ΔG_f° .

Many ΔG_f° values appear along with those for ΔH_f° and S° in Appendix B.

SAMPLE PROBLEM 20.5**Calculating ΔG_{rxn}° from ΔG_f° Values**

Problem Use ΔG_f° values to calculate ΔG_{rxn}° for the reaction in Sample Problem 20.4:

Plan We apply Equation 20.8 to calculate ΔG_{rxn}° .

Solution Applying Equation 20.8 with values from Appendix B:

$$\begin{aligned}\Delta G_{rxn}^\circ &= \sum m \Delta G_f^\circ(\text{products}) - \sum n \Delta G_f^\circ(\text{reactants}) \\ &= [(3 \text{ mol KClO}_4)(\Delta G_f^\circ \text{ of KClO}_4) + (1 \text{ mol KCl})(\Delta G_f^\circ \text{ of KCl})] \\ &\quad - [(4 \text{ mol KClO}_3)(\Delta G_f^\circ \text{ of KClO}_3)] \\ &= [(3 \text{ mol})(-303.2 \text{ kJ/mol}) + (1 \text{ mol})(-409.2 \text{ kJ/mol})] \\ &\quad - [(4 \text{ mol})(-296.3 \text{ kJ/mol})] \\ &= -134 \text{ kJ}\end{aligned}$$

Check Rounding to check the math:

$$\begin{aligned}\Delta G_{rxn}^\circ &\approx [3(-300 \text{ kJ}) + 1(-400 \text{ kJ})] - 4(-300 \text{ kJ}) \\ &= -1300 \text{ kJ} + 1200 \text{ kJ} = -100 \text{ kJ}\end{aligned}$$

Comment The slight discrepancy between this answer and the one obtained in Sample Problem 20.4 is due to rounding. As you can see, when ΔG_f° values are available, this method is simpler arithmetically than the approach in Sample Problem 20.4.

FOLLOW-UP PROBLEMS

20.5A Use ΔG_f° values to calculate ΔG_{rxn}° at 298 K:

- (a) $2\text{NO}(g) + \text{Cl}_2(g) \longrightarrow 2\text{NOCl}(g)$ (from Follow-up Problem 20.4A)
 (b) $3\text{H}_2(g) + \text{Fe}_2\text{O}_3(s) \longrightarrow 2\text{Fe}(s) + 3\text{H}_2\text{O}(g)$

20.5B Use ΔG_f° values to calculate ΔG_{rxn}° at 25°C:

- (a) $4\text{NH}_3(g) + 5\text{O}_2(g) \longrightarrow 4\text{NO}(g) + 6\text{H}_2\text{O}(g)$ (from Follow-up Problem 20.4B)
 (b) $2\text{C}(\text{graphite}) + \text{O}_2(g) \longrightarrow 2\text{CO}(g)$

SOME SIMILAR PROBLEMS 20.51, 20.52, 20.55(b), and 20.56(b)

The Free Energy Change and the Work a System Can Do

Thermodynamics developed after the invention of the steam engine, a major advance that spawned a new generation of machines. Thus, some of the field's key ideas applied the relationships between the free energy change and the work a system can do:

- ΔG is the *maximum useful work* that can be done *by* a system during a *spontaneous* process at constant T and P :

$$\Delta G = w_{\max} \tag{20.9}$$

- ΔG is the *minimum work* that must be done *to* a system to make a *nonspontaneous* process occur at constant T and P .

The free energy change is the maximum work the system can *possibly* do. But the work it *actually* does is always less and depends on how the free energy is released. Let's consider the work done by two common systems—a car engine and a battery.

1. “Useful” work done by a car engine. When gasoline (represented by octane, C_8H_{18}) is burned in a car engine,

a large amount of energy is released as heat ($\Delta H_{sys} < 0$), and because the number of moles of gas increases, the entropy of the system increases ($\Delta S_{sys} > 0$). Therefore, the reaction is spontaneous ($\Delta G_{sys} < 0$). The free energy released turns the wheels, moves the belts, plays the radio, and so on—all examples of “useful” work. However, the *maximum* work is done by any spontaneous process *only if the free energy is released reversibly*, that is, *in an infinite number of steps*. Of course, in any *real* process, work is performed in a *finite* number of steps, that is, *irreversibly*, so the

maximum work is never done. Any free energy not used for work is lost to the surroundings as heat. For a car engine, much of the free energy released just warms the engine and the outside air, which increases the freedom of motion of the particles in the universe, in accord with the second law.

2. “Useful” work done by a battery. As you’ll see in Chapter 21, a battery is essentially a packaged spontaneous redox reaction that releases free energy in the form of an electric current to the surroundings (flashlight, computer, motor, etc.). If we connect the battery terminals to each other through a short piece of wire, the free energy change is released all at once but does no work—it just heats the wire and battery. If we connect the terminals to a motor, a significant portion of the free energy runs the motor, but some is still converted to heat. If we connect the battery to a more “efficient” device, one that discharges the free energy still more slowly, more of the energy does work and less is converted to heat. However, as with all systems, only when the battery discharges infinitely slowly can it do the maximum work.

Efficiency can be defined as the percentage of work output relative to the energy input. The range of efficiencies among common devices is very large: an incandescent bulb converts <7% of incoming electricity to light, with the rest given off as heat. At the other extreme, an electrical generator converts 95% of the incoming mechanical energy to electricity. Here are the efficiencies of some other devices: home oil furnace, 65%; hand-tool motor, 63%; liquid fuel rocket, 50%; car engine, <30%; compact fluorescent bulb, 18%; solar cell, ~15%. Therefore, all engineers must face the fact that *no real process uses all the available free energy to do work because some is always “wasted” as heat.*

Let’s summarize the relation between the free energy change of a reaction and the work it can do:

- A spontaneous reaction ($\Delta G_{\text{sys}} < 0$) will do work on the surroundings ($-w$). For any real machine, the actual work done is *always less than the maximum* because some of the ΔG is released as heat.
- A nonspontaneous reaction ($\Delta G_{\text{sys}} > 0$) will occur only if the surroundings do work on the system ($+w$). For any real machine, the actual work done on the system is *always more than the minimum* because some of the added free energy is wasted as heat.
- A reaction at equilibrium ($\Delta G_{\text{sys}} = 0$) can no longer do any work.

The Effect of Temperature on Reaction Spontaneity

In most cases, the enthalpy contribution (ΔH) to the free energy change (ΔG) is much *larger* than the entropy contribution ($T\Delta S$). In fact, the reason most exothermic reactions are spontaneous is that the large negative ΔH makes ΔG negative. However, the *temperature of a reaction influences the magnitude of the $T\Delta S$ term*, so, for many reactions, the overall spontaneity depends on the temperature. From the signs of ΔH and ΔS , we can predict how the temperature affects the sign of ΔG . (The values we’ll use below for the thermodynamic variables are standard-state values from Appendix B, but we show them without the degree sign to emphasize that the relationships among ΔG , ΔH , and ΔS are valid at any conditions. Also, we assume that ΔH and ΔS change little with temperature, which is true as long as no phase change occurs.)

Let’s examine the four combinations of positive and negative ΔH and ΔS —two that are independent of temperature and two that are dependent on temperature:

- *Temperature-independent cases.* When ΔH and ΔS have *opposite* signs, the reaction occurs spontaneously either at all temperatures or at none (nonspontaneous).
 1. *Reaction is spontaneous at all temperatures:* an exothermic reaction that has an increase in entropy has $\Delta H < 0$, $\Delta S > 0$. Since ΔS is positive, $-T\Delta S$ is negative; thus, both contributions favor a negative ΔG . Most combustion reactions are in this category. The decomposition of hydrogen peroxide, a common disinfectant, is also spontaneous at all temperatures:

2. *Reaction is nonspontaneous at all temperatures:* an endothermic reaction with a decrease in entropy has $\Delta H > 0$, $\Delta S < 0$. Both contributions oppose spontaneity: ΔH is positive and ΔS is negative, so $-T\Delta S$ is positive; thus, ΔG is always positive. The formation of ozone from oxygen requires a continual energy input, so it is not spontaneous at any temperature:

- *Temperature-dependent cases.* When ΔH and ΔS have the same sign, the relative magnitudes of $-T\Delta S$ and ΔH determine the sign of ΔG . In these cases, the direction of the change in T is crucial.

3. *Reaction becomes spontaneous as temperature increases:* an endothermic reaction with an increase in entropy has $\Delta H > 0$ and $\Delta S > 0$. With a positive ΔH , the reaction will occur spontaneously only when $-T\Delta S$ becomes large enough to make ΔG negative, which will happen as the temperature rises. For example,

The oxidation of N_2O occurs spontaneously at any $T > 994 \text{ K}$.

4. *Reaction becomes spontaneous as temperature decreases:* an exothermic reaction with a decrease in entropy has $\Delta H < 0$ and $\Delta S < 0$. Here, ΔH favors spontaneity, but ΔS does not ($-T\Delta S > 0$). The reaction will occur spontaneously only when $-T\Delta S$ becomes smaller than ΔH , and this happens as the temperature drops. For example,

The production of iron(III) oxide occurs spontaneously at any $T < 3005 \text{ K}$.

Table 20.1 summarizes these four possible combinations of ΔH and ΔS , and Sample Problem 20.6 applies them.

Student Hot Spot

Student data indicate that you may struggle with understanding how temperature affects spontaneity. Access the Smartbook to view additional Learning Resources on this topic.

Table 20.1 Reaction Spontaneity and the Signs of ΔH , ΔS , and ΔG

ΔH	ΔS	$-T\Delta S$	ΔG	Description
—	+	—	—	Spontaneous at all T
+	—	+	+	Nonspontaneous at all T
+	+	—	+ or —	Spontaneous at higher T ; nonspontaneous at lower T
—	—	+	+ or —	Spontaneous at lower T ; nonspontaneous at higher T

SAMPLE PROBLEM 20.6

Using Molecular Scenes to Determine the Signs of ΔH , ΔS , and ΔG

Problem The scenes below represent a familiar phase change for water (blue spheres):

- (a) What are the signs of ΔH and ΔS for this process? Explain.
 (b) Is the process spontaneous at all T , no T , low T , or high T ? Explain.

Plan (a) From the scenes, we determine any change in amount of gas and/or any change in the freedom of motion of the particles, which will indicate the sign of ΔS . Also, since the scenes represent a physical change, freedom of particle motion indicates whether heat is absorbed or released, and thus tells us the sign of ΔH . **(b)** The question refers to the sign of ΔG (+ or -) at the different temperature possibilities, so we apply Equation 20.6 and refer to the previous text discussion and Table 20.1.

Solution (a) The scenes represent the condensation of water vapor, so the amount of gas decreases dramatically, and the separated molecules give up energy as they come closer together. Therefore, $\Delta S < 0$ and $\Delta H < 0$.

(b) With ΔS negative, the $-T\Delta S$ term is positive. In order for $\Delta G < 0$, the magnitude of T must be small. Therefore, the process is spontaneous at low T .

Check The answer in part (b) seems reasonable based on our analysis in part (a). The answer makes sense because we know from everyday experience that water condenses spontaneously, and it does so at low temperatures.

FOLLOW-UP PROBLEMS

20.6A The scenes below represent the reaction of X_2Y_2 to yield X_2 (red) and Y_2 (blue):

(a) What is the sign of ΔS for the reaction?

(b) If the reaction is spontaneous only above 325°C , what is the sign of ΔH ? Explain.

20.6B The scenes below represent the reaction of AB to yield A (gray) and B_2 (red):

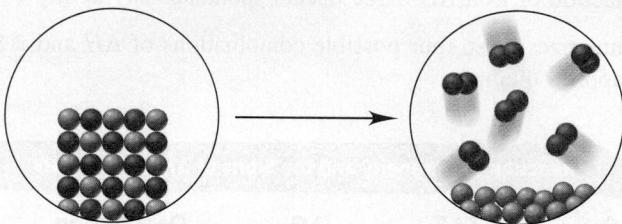

(a) What are the signs of ΔS and ΔH for the reaction?

(b) Is $\Delta G < 0$ at higher T , lower T , all T , or no T ? Explain.

SOME SIMILAR PROBLEMS 20.47 and 20.48

As you saw in Sample Problem 20.4, one way to calculate ΔG is from enthalpy and entropy changes. As long as phase changes don't occur, ΔH and ΔS usually change little with temperature, so we use their values at 298 K in the following sample problem to examine the effect of T on ΔG and, thus, on reaction spontaneity.

SAMPLE PROBLEM 20.7

Determining the Effect of Temperature on ΔG

Problem A key step in the production of sulfuric acid is the oxidation of $\text{SO}_2(g)$ to $\text{SO}_3(g)$:

At 298 K, $\Delta G = -141.6 \text{ kJ}$; $\Delta H = -198.4 \text{ kJ}$; and $\Delta S = -187.9 \text{ J/K}$.

(a) Use the given data to decide if this reaction is spontaneous at 25°C , and predict how ΔG will change with increasing T .

(b) Assuming that ΔH and ΔS are constant with T (no phase change occurs), is the reaction spontaneous at 900°C ?

Plan (a) We note the sign of ΔG to see if the reaction is spontaneous and the signs of ΔH and ΔS to see the effect of T . **(b)** We use Equation 20.7 to calculate ΔG from the given ΔH and ΔS at the higher T (in K).

Solution (a) $\Delta G < 0$, so the reaction is spontaneous at 298 K: SO_2 and O_2 will form SO_3 spontaneously. With $\Delta S < 0$, the term $-T\Delta S > 0$, and this term will become more positive at higher T . Therefore, ΔG will become less negative, and the reaction less spontaneous, with increasing T .

(b) Calculating ΔG at 900°C ($T = 273 + 900 = 1173$ K):

$$\Delta G = \Delta H - T\Delta S = -198.4 \text{ kJ} - [(1173 \text{ K})(-187.9 \text{ J/K})(1 \text{ kJ}/1000 \text{ J})] = 22.0 \text{ kJ}$$

Since $\Delta G > 0$, the reaction is nonspontaneous at the higher T .

Check The answer in part (b) seems reasonable based on our prediction in part (a). The arithmetic seems correct, with considerable rounding:

$$\Delta G \approx -200 \text{ kJ} - [(1200 \text{ K})(-200 \text{ J/K})(1 \text{ kJ}/1000 \text{ J})] = +40 \text{ kJ}$$

FOLLOW-UP PROBLEMS

20.7A For the following reaction at 298 K, $\Delta S = -308.2 \text{ J/K}$ and $\Delta H = -192.7 \text{ kJ}$:

(a) Is the reaction spontaneous at 298 K?

(b) Would the reaction become more or less spontaneous at higher T ?

(c) Assuming that ΔS and ΔH don't change with T , find ΔG at 500°C.

20.7B A reaction is nonspontaneous at room temperature but is spontaneous at -40°C . What can you say about the signs and relative magnitudes of ΔH , ΔS , and $-T\Delta S$?

SOME SIMILAR PROBLEMS 20.57(b) and 20.58(b)

The Temperature at Which a Reaction Becomes Spontaneous As you've just seen, when the signs are the same for ΔH and ΔS of a reaction, it can be nonspontaneous at one temperature and spontaneous at another. The "crossover" temperature occurs when a positive ΔG switches to a negative ΔG because of the magnitude of the $-T\Delta S$ term. We find this temperature by setting ΔG equal to zero and solving for T :

$$\Delta G = \Delta H - T\Delta S = 0$$

Therefore,

$$\Delta H = T\Delta S \quad \text{and} \quad T = \frac{\Delta H}{\Delta S} \quad (\mathbf{20.10})$$

Consider the reaction of copper(I) oxide with carbon. It does *not* occur at very low temperatures but does at higher temperatures and is used to extract copper from one of its ores:

We predict that this reaction has a positive ΔS because the number of moles of gas increases; in fact, $\Delta S = 165 \text{ J/K}$. Furthermore, because the reaction is *nonspontaneous* at lower temperatures, it must have a positive ΔH ; the actual value is 58.1 kJ. As the $-T\Delta S$ term becomes more negative with higher T , it eventually outweighs the positive ΔH term, so ΔG becomes negative and the reaction occurs spontaneously.

SAMPLE PROBLEM 20.8

Finding the Temperature at Which a Reaction Becomes Spontaneous

Problem At 25°C (298 K), the reduction of copper(I) oxide to copper is nonspontaneous ($\Delta G = 8.9 \text{ kJ}$). Calculate the temperature at which the reaction becomes spontaneous.

Plan As just discussed, we want the temperature at which ΔG crosses over from a positive to a negative value. We set ΔG equal to zero, and use Equation 20.10 to solve for T , using the values of ΔH (58.1 kJ) and ΔS (165 J/K) given in the text.

Solution From $\Delta G = \Delta H - T\Delta S = 0$, we have

$$T = \frac{\Delta H}{\Delta S} = \frac{58.1 \text{ kJ} \times \frac{1000 \text{ J}}{1 \text{ kJ}}}{165 \text{ J/K}} = 352 \text{ K}$$

Thus, at any temperature above 352 K (79°C), which is a moderate temperature for extracting a metal from its ore, $\Delta G < 0$, so the reaction becomes spontaneous.

Check Rounding to quickly check the math gives

$$T = \frac{60,000 \text{ J}}{150 \text{ J/K}} = 400 \text{ K}$$

which is close to the answer.

FOLLOW-UP PROBLEMS

20.8A Find the temperature (in °C) above which the reaction in Follow-up Problem 20.7A is no longer spontaneous.

20.8B Use Appendix B values to find the temperature at which the following reaction becomes spontaneous (assume ΔH and ΔS are constant with T):

SOME SIMILAR PROBLEMS 20.59(d), 20.60(d), and 20.61(c)

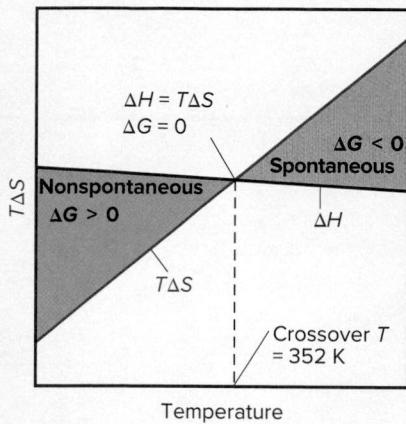

Figure 20.14 The effect of temperature on reaction spontaneity. At low T , $\Delta G > 0$ because ΔH dominates in the reduction of copper(I) oxide to copper. At 352 K, $\Delta H = T\Delta S$, so $\Delta G = 0$. At any higher T , $\Delta G < 0$ because $-T\Delta S$ dominates.

Figure 20.14 shows that the line for $T\Delta S$ rises steadily (and thus the $-T\Delta S$ term becomes more negative) with increasing temperature. This line crosses the relatively constant ΔH line at 352 K for the reduction of copper(I) oxide to copper, as we found in Sample Problem 20.8. At any higher temperature, the $-T\Delta S$ term is greater than the ΔH term, so ΔG is negative.

Coupling of Reactions to Drive a Nonspontaneous Change

In a complex, multistep reaction, we often see a nonspontaneous step driven by a spontaneous step. In such a **coupling of reactions**, one step supplies enough free energy for the other to occur, just as burning gasoline supplies enough free energy to move a car.

Look again at the reduction of copper(I) oxide by carbon. In Sample Problem 20.8, we found that the *overall* reaction becomes spontaneous at any temperature above 352 K. Dividing the reaction into two steps, however, we find that even at a higher temperature, say 375 K, copper(I) oxide does not spontaneously decompose to its elements:

However, the oxidation of carbon to CO at 375 K is quite spontaneous:

Coupling these reactions means having the carbon in contact with the Cu_2O , which allows the reaction with the larger negative ΔG to “drive” the one with the smaller positive ΔG . Adding the reactions together and canceling the common substance ($\frac{1}{2}\text{O}_2$) gives an overall reaction with a negative ΔG :

Many biochemical reactions are also nonspontaneous, including key steps in the syntheses of proteins and nucleic acids, the formation of fatty acids, the maintenance of ion balance, and the breakdown of nutrients. Driving a nonspontaneous step by coupling it to a spontaneous one is a life-sustaining strategy common to all organisms, as you’ll see in the upcoming Chemical Connections essay.

› Summary of Section 20.3

- › The sign of the free energy change, $\Delta G = \Delta H - T\Delta S$, is directly related to reaction spontaneity: a negative ΔG corresponds to a positive ΔS_{univ} .
- › We use the standard free energy of formation (ΔG_f°) to calculate $\Delta G_{\text{rxn}}^\circ$ at 298 K.
- › The maximum work a system can do is never obtained from a real (irreversible) process because some free energy is always converted to heat.
- › The magnitude of T influences the spontaneity of a temperature-dependent reaction (same signs of ΔH and ΔS) by affecting the size of $T\Delta S$. For such a reaction, the T at which the reaction becomes spontaneous can be found by setting $\Delta G = 0$.
- › A nonspontaneous reaction ($\Delta G > 0$) can be coupled to a more spontaneous one ($\Delta G << 0$) to make it occur. For example, in organisms, the hydrolysis of ATP drives many reactions that have a positive ΔG .

CHEMICAL CONNECTIONS TO BIOLOGICAL ENERGETICS

The Universal Role of ATP

Despite their incredible diversity, virtually all organisms use the same amino acids to make their proteins, the same nucleotides to make their nucleic acids, and the same carbohydrate (glucose) to provide energy.

In addition, *all organisms use the same spontaneous reaction to drive a variety of nonspontaneous ones*. This reaction is the hydrolysis of **adenosine triphosphate (ATP)** to adenosine diphosphate (ADP):*

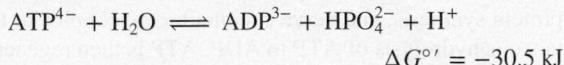

In the metabolic breakdown of glucose, for example, the first step, addition of HPO_4^{2-} to glucose, is nonspontaneous:

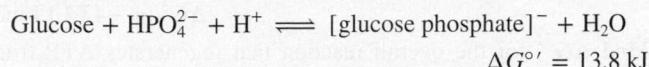

Coupling this nonspontaneous reaction to ATP hydrolysis makes the overall process spontaneous. If we add the two reactions, HPO_4^{2-} , H^+ , and H_2O cancel:

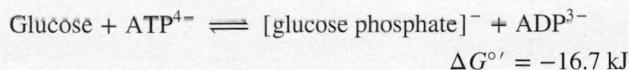

Coupling cannot occur if reactions are physically separated, so these reactions take place on an enzyme (Section 16.7) that simultaneously binds glucose and ATP, and the phosphate group of ATP that will be transferred lies next to the $-\text{OH}$ group of glucose that will bind it (Figure B20.1).

The ADP produced in energy-releasing reactions combines with phosphate to regenerate ATP in energy-absorbing reactions

*In biochemical systems, the standard-state concentration of H^+ is 10^{-7} M , not the usual 1 M , and the standard free energy change is represented by the symbol ΔG° .

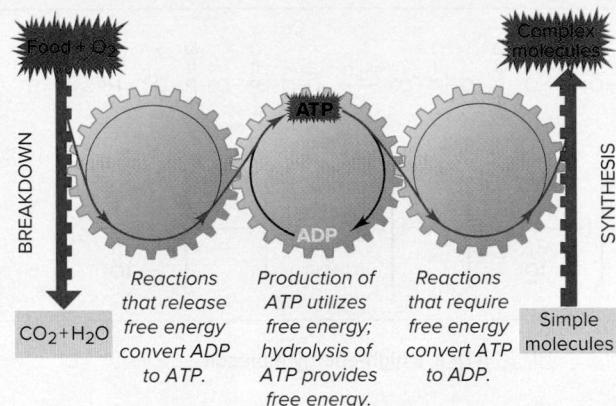

Figure B20.2 The cycling of metabolic free energy.

catalyzed by other enzymes. Thus, there is a continuous cycling of ATP to ADP and back to ATP again to supply energy to the cells (Figure B20.2).

Why is ATP a “high-energy” molecule? By examining the phosphate portions of ATP, ADP, and HPO_4^{2-} , we can see two basic chemical reasons why ATP hydrolysis supplies so much free energy (Figure B20.3, *next page*):

1. *Charge repulsion.* At physiological pH (~7), the triphosphate group of ATP has four negative charges close together. This *high charge repulsion* is reduced in ADP (Figure B20.3A).
2. *Electron delocalization.* Once HPO_4^{2-} is free, there is extensive delocalization and resonance stabilization of the π electrons (Figure B20.3B).

Figure B20.1 The coupling of a nonspontaneous reaction to the hydrolysis of ATP. Glucose lies next to ATP (shown as $\text{ADP}-\text{O}-\text{PO}_3\text{H}$) in the enzyme's active site. ADP (shown as $\text{ADP}-\text{OH}$) and glucose phosphate are released.

Figure B20.3 ATP is a high-energy molecule.

Thus, greater charge repulsion and less electron delocalization make ATP higher in energy (less stable) than the sum of the energies of ADP and HPO_4^{2-} . When ATP is hydrolyzed, some of this additional energy is released and harnessed by the organism to drive metabolic reactions that could not otherwise take place.

Problems

B20.1 The oxidation of 1 mol of glucose supplies enough metabolic energy to form 36 mol of ATP. Oxidation of 1 mol of a typical dietary fat like tristearin ($\text{C}_{57}\text{H}_{110}\text{O}_6$) yields enough energy to form 458 mol of ATP. How many molecules of ATP can form per gram of (a) glucose; (b) tristearin?

B20.2 Nonspontaneous processes like muscle contraction, protein synthesis, and nerve conduction are coupled to the spontaneous hydrolysis of ATP to ADP. ATP is then regenerated by coupling its synthesis to energy-yielding reactions such as

$$\Delta G^\circ = -43.1 \text{ kJ/mol}$$

Find ΔG° for the overall reaction that regenerates ATP from ADP and HPO_4^{2-} by coupling the synthesis with the breakdown of creatine phosphate.

20.4 FREE ENERGY, EQUILIBRIUM, AND REACTION DIRECTION

A chemical reaction proceeding toward equilibrium is a spontaneous change. But why is there a drive to attain equilibrium? And what determines the value of the equilibrium constant?

As you know from earlier discussions, the sign of ΔG is not the only way to predict reaction direction. In Section 17.4, we did so by comparing the values of the reaction quotient (Q) and the equilibrium constant (K). Recall that a reaction is proceeding to the right when $Q < K$, and to the left when $Q > K$; if $Q = K$, the reaction is at equilibrium.

It is easier to see the relation between these two ways to predict reaction spontaneity—the sign of ΔG and the magnitude of Q versus the magnitude of K —when we compare the sign of the natural logarithm of the ratio of Q to K ($\ln Q/K$) with the sign of ΔG (refer to Appendix A if necessary), as shown in Table 20.2.

Table 20.2

Q , K , ΔG , and Reaction Spontaneity

Q	Q/K	$\ln Q/K$	ΔG	Direction of reaction
$Q < K$	$Q/K < 1$	$\ln Q/K < 0$	$\Delta G < 0$	Spontaneously to the right
$Q > K$	$Q/K > 1$	$\ln Q/K > 0$	$\Delta G > 0$	Spontaneously to the left
$Q = K$	$Q/K = 1$	$\ln Q/K = 0$	$\Delta G = 0$	At equilibrium

Note that the signs of ΔG and of $\ln Q/K$ are the same for a given direction; in fact, ΔG equals $\ln Q/K$ multiplied by the proportionality constant RT :

$$\Delta G = RT \ln \frac{Q}{K} = RT \ln Q - RT \ln K \quad (20.11)$$

Q represents the concentrations (or pressures) of a system's components at any time during the reaction, and K represents these quantities at equilibrium. Therefore,

Equation 20.11 says that ΔG is a measure of how different the concentrations at any time, Q , are from the concentrations at equilibrium, K :

- If Q and K are very different, the reaction releases (or absorbs) a *lot* of free energy.
- If Q and K are nearly the same, the reaction releases (or absorbs) *relatively little* free energy.

The Standard Free Energy Change and the Equilibrium Constant When we choose standard-state values for Q (1 atm for gases, 1 M for solutions, etc.), ΔG in Equation 20.11 becomes, by definition, ΔG° and Q equals 1:

Since $\ln 1 = 0$, the term “ $RT \ln Q$ ” drops out, which allows us to find the standard free energy change of a reaction ($\Delta G_{\text{rxn}}^\circ$) from its equilibrium constant, or vice versa:

$$\Delta G^\circ = -RT \ln K \quad (20.12)$$

The following sample problem applies this central relationship.

SAMPLE PROBLEM 20.9

Exploring the Relationship Between ΔG° and K

Problem (a) Use Appendix B to find K at 298 K for the following reaction:

(b) Use the equilibrium constant to calculate ΔG° at 298 K for the following reaction:

Plan (a) We use ΔG_f° values from Appendix B with Equation 20.8 to find ΔG° , and then we use Equation 20.12 to solve for K . **(b)** In this calculation, we do the reverse of the second calculation in part (a): we are given $K = 3.89 \times 10^{-34}$, so we use Equation 20.12 to solve for ΔG° .

Solution (a) Solving for ΔG° using ΔG_f° values from Appendix B and Equation 20.8 (see Sample Problem 20.5):

$$\begin{aligned} \Delta G^\circ &= [(1 \text{ mol NO}_2)(\Delta G_f^\circ \text{ of NO}_2)] - [(1 \text{ mol NO})(\Delta G_f^\circ \text{ of NO}) \\ &\quad + (\frac{1}{2} \text{ mol of O}_2)(\Delta G_f^\circ \text{ of O}_2)] \\ &= [(1 \text{ mol})(51 \text{ kJ/mol})] - [(1 \text{ mol})(86.60 \text{ kJ/mol}) + (\frac{1}{2} \text{ mol})(0 \text{ kJ/mol})] \\ &= -36 \text{ kJ} \end{aligned}$$

Solving for K using Equation 20.12:

$$\Delta G^\circ = -RT \ln K$$

$$\begin{aligned} \text{so} \quad \ln K &= -\frac{\Delta G^\circ}{RT} = -\frac{(-36 \text{ kJ})(1000 \text{ J}/1 \text{ kJ})}{(8.314 \text{ J/mol}\cdot\text{K})(298 \text{ K})} = 14.53 \\ K &= e^{14.53} = 2.0 \times 10^6 \end{aligned}$$

(b) Solving for ΔG° using Equation 20.12:

$$\begin{aligned} K &= 3.89 \times 10^{-34} \quad \text{so} \quad \ln K = -76.9 \\ \Delta G^\circ &= -RT \ln K = -(8.314 \text{ J/mol}\cdot\text{K})(298 \text{ K})(-76.9) \\ &= 1.91 \times 10^5 \text{ J} = 191 \text{ kJ} \end{aligned}$$

Check (a) A negative free energy change is consistent with a large K value ($K > 1$), as both are an indication that a reaction is proceeding to the right. Rounding to confirm the value of ΔG° gives $50 \text{ kJ} - 90 \text{ kJ} = -40 \text{ kJ}$, close to the calculated value. **(b)** A very small value of K ($K < 1$) is consistent with a highly positive ΔG° , as both indicate that a reaction is proceeding to the left. Looking up ΔG_f° values to check the value of ΔG° gives $(0 \text{ kJ} + 0 \text{ kJ}) - [2(-95.30 \text{ kJ})] = 190.6 \text{ kJ}$.

FOLLOW-UP PROBLEMS

20.9A Use Appendix B to find K at 298 K for the following reaction:

20.9B Use the given value of K to calculate ΔG° at 298 K for the following reaction:

SOME SIMILAR PROBLEMS 20.67–20.70

Student Hot Spot

Student data indicate that you may struggle with the relationship between Gibbs free energy and equilibrium. Access the Smartbook to view additional Learning Resources on this topic.

Table 20.3

The Relationship Between ΔG° and K at 298 K

ΔG° (kJ)	K	Significance
200	9×10^{-36}	{ Essentially no forward reaction; reverse reaction goes to completion.
100	3×10^{-18}	
50	2×10^{-9}	
10	2×10^{-2}	
1	7×10^{-1}	
0	1	{ Forward and reverse reactions proceed to same extent.
-1	1.5	
-10	5×10^1	
-50	6×10^8	
-100	3×10^{17}	{ Forward reaction goes to completion; essentially no reverse reaction.
-200	1×10^{35}	

Table 20.3 shows that, due to their logarithmic relationship, a small change in ΔG° causes a large change in K . Note just these two examples:

- As ΔG° becomes more positive, K becomes smaller: if $\Delta G^\circ = +10$ kJ, K is 0.02, so the product terms are $\frac{1}{50}$ the size of the reactant terms (see Figure 17.2A).
- As ΔG° becomes more negative, K becomes larger: if $\Delta G^\circ = -10$ kJ, K is 50, so the product terms are 50 times larger than the reactant terms (see Figure 17.2B).

Finding the Free Energy Change Under Any Conditions In reality, reactions rarely begin with all components in their standard states. By substituting the relationship between ΔG° and K (Equation 20.12) into the expression for ΔG (Equation 20.11), we obtain a relationship that applies to *any starting concentrations*:

$$\Delta G = \Delta G^\circ + RT \ln Q \quad (20.13)$$

Note that, by definition, when the components are in their standard states (1 M, 1 atm, etc.), $\Delta G = \Delta G^\circ$:

$$\begin{aligned} \Delta G &= \Delta G^\circ + RT \ln Q = \Delta G^\circ + RT \ln 1 \\ \Delta G &= \Delta G^\circ \end{aligned}$$

Sample Problem 20.10 uses molecular scenes to explore these ideas, and Sample Problem 20.11 applies them to an important industrial reaction.

SAMPLE PROBLEM 20.10

Using Molecular Scenes to Find ΔG for a Reaction at Nonstandard Conditions

Problem These molecular scenes represent three mixtures in which A_2 (black) and B_2 (green) are forming AB . Each molecule represents 0.10 atm. The equation is

(a) If mixture 1 is at equilibrium, calculate K .

(b) Which mixture has the most negative ΔG , and which has the most positive?

Plan (a) Mixture 1 is at equilibrium, so we first write the expression for Q and then find the partial pressure of each substance from the numbers of molecules and calculate K . **(b)** To find ΔG , we apply Equation 20.13. We are given ΔG° (-3.4 kJ/mol) and know R ($8.314 \text{ J/mol}\cdot\text{K}$), but we still need to find T . We calculate T from Equation 20.12 using K from part (a), and substitute the partial pressure of each substance (by counting particles) to get Q .

Solution (a) Writing the expression for Q and calculating K :

$$\text{A}_2(g) + \text{B}_2(g) \rightleftharpoons 2\text{AB}(g) \quad Q = \frac{(P_{\text{AB}})^2}{P_{\text{A}_2} \times P_{\text{B}_2}} \quad K = \frac{(0.40)^2}{(0.20)(0.20)} = 4.0$$

(b) Calculating T from Equation 20.12 for use in Equation 20.13:

$$\Delta G^\circ = -RT \ln K$$

$$T = \frac{\Delta G^\circ}{-R \ln K} = \frac{-3.4 \text{ kJ}}{-8.314 \text{ J/mol}\cdot\text{K} \times \ln 4.0} = 295 \text{ K}$$

Calculating ΔG from Equation 20.13 for each reaction mixture:

Mixture 1:

$$\begin{aligned} \Delta G &= \Delta G^\circ + RT \ln Q = -3.4 \text{ kJ} + RT \ln 4.0 \\ &= -3.4 \text{ kJ/mol} \left(\frac{1000 \text{ J}}{1 \text{ kJ}} \right) + \left(\frac{8.314 \text{ J}}{\text{mol}\cdot\text{K}} \right) (295 \text{ K}) \ln 4.0 \\ &= -3400 \text{ J/mol} + 3400 \text{ J/mol} = 0.0 \text{ J} \end{aligned}$$

Mixture 2:

$$\begin{aligned} \Delta G &= -3.4 \text{ kJ/mol} + RT \ln \frac{(0.20)^2}{(0.30)(0.30)} \\ &= -3.4 \text{ kJ/mol} \left(\frac{1000 \text{ J}}{1 \text{ kJ}} \right) + \left(\frac{8.314 \text{ J}}{\text{mol}\cdot\text{K}} \right) (295 \text{ K}) \ln 0.44 \\ &= -5.4 \times 10^3 \text{ J/mol} \end{aligned}$$

Mixture 3:

$$\begin{aligned} \Delta G &= -3.4 \text{ kJ/mol} + RT \ln \frac{(0.60)^2}{(0.10)(0.10)} \\ &= -3.4 \text{ kJ/mol} \left(\frac{1000 \text{ J}}{1 \text{ kJ}} \right) + \left(\frac{8.314 \text{ J}}{\text{mol}\cdot\text{K}} \right) (295 \text{ K}) \ln 36 \\ &= 5.4 \times 10^3 \text{ J/mol} \end{aligned}$$

Mixture 2 has the most negative ΔG , and mixture 3 has the most positive ΔG .

Check In part (b), round to check the arithmetic; for example, for mixture 3, $\Delta G \approx -3000 \text{ J/mol} + (8 \text{ J/mol}\cdot\text{K})(300 \text{ K})4 \approx 7000 \text{ J/mol}$, which is in the ballpark.

Comment 1. By using the properties of logarithms, we did *not* have to calculate T and ΔG in part (b). For mixture 2, $Q < 1$, so $\ln Q$ is negative, which makes ΔG more negative. Also, note that $Q(0.44) < K(4.0)$, which tells us that the reaction is proceeding to the right, so $\Delta G < 0$. For mixture 3, $Q > 1$ (and is greater than it is for mixture 1), so $\ln Q$ is positive, which makes ΔG positive. Also, $Q(36) > K(4.0)$, which tells us that the reaction is proceeding to the left, so $\Delta G > 0$.

2. In part (b), the value of zero for ΔG of the equilibrium mixture (mixture 1) makes sense, because a system at equilibrium has released all of its free energy.

3. Note especially that, by definition, when the components are in their standard states, $\Delta G = \Delta G^\circ$:

$$\begin{aligned} \Delta G &= \Delta G^\circ + RT \ln Q = -3.4 \text{ kJ/mol} + RT \ln \frac{(1.0)^2}{(1.0)(1.0)} \\ &= -3.4 \text{ kJ/mol} + RT \ln 1.0 = -3.4 \text{ kJ/mol} \end{aligned}$$

FOLLOW-UP PROBLEMS

20.10A The scenes below depict three mixtures in which A (orange) and B (green) are forming AB_3 in a reaction for which $\Delta G^\circ = -4.6 \text{ kJ/mol}$. Assume that each molecule represents 0.10 mol and the volume is 1.0 L.

- (a) Write a balanced equation for the reaction. (b) If $K = 8.0$, which mixture is at equilibrium? (c) Rank the three mixtures from the highest (most positive) ΔG to the lowest (most negative) ΔG .

20.10B The scenes below depict mixtures in which X_2 (tan) and Y_2 (blue) are forming XY_2 . Each molecule represents 0.10 mol, and the volume is 0.10 L. The equation is

- (a) If $K = 2.0$, which mixture is at equilibrium? (b) Rank the three mixtures from the lowest (most negative) ΔG to highest (most positive) ΔG . (c) What is the sign of ΔG for the change that occurs as each nonequilibrium mixture approaches equilibrium?

SOME SIMILAR PROBLEMS 20.81 and 20.82

SAMPLE PROBLEM 20.11

Calculating ΔG at Nonstandard Conditions

Problem The oxidation of $\text{SO}_2(g)$, $2\text{SO}_2(g) + \text{O}_2(g) \rightarrow 2\text{SO}_3(g)$, is the key reaction in the manufacture of sulfuric acid.

- (a) Calculate K at 298 K. ($\Delta G_{298}^\circ = -141.6 \text{ kJ/mol}$ of reaction as written.)
 (b) A container is filled with 0.500 atm of SO_2 , 0.0100 atm of O_2 , and 0.100 atm of SO_3 and kept at 25°C. In which direction, if any, will the reaction proceed to reach equilibrium?
 (c) Calculate ΔG for the system in part (b).

Plan (a) We know ΔG° , T , and R , so we can calculate K from Equation 20.12 [see Sample Problem 20.9(a)]. (b) To determine if a net reaction will occur, we find Q from the given partial pressures and compare it with K from part (a). (c) These are *not* standard-state pressures, so we find ΔG at 298 K with Equation 20.13, using the values of ΔG° (given) and Q [from part (b)].

Solution (a) Calculating K at 298 K:

$$\Delta G^\circ = -RT \ln K \quad \text{so} \quad K = e^{-(\Delta G^\circ/RT)}$$

At 298 K, the exponent is

$$-(\Delta G^\circ/RT) = -\left(\frac{-141.6 \text{ kJ/mol} \times \frac{1000 \text{ J}}{1 \text{ kJ}}}{8.314 \text{ J/mol}\cdot\text{K} \times 298 \text{ K}}\right) = 57.2$$

so

$$K = e^{-(\Delta G^\circ/RT)} = e^{57.2} = 7 \times 10^{24}$$

(b) Calculating the value of Q :

$$Q = \frac{(P_{\text{SO}_3})^2}{(P_{\text{SO}_2})^2 \times P_{\text{O}_2}} = \frac{0.100^2}{0.500^2 \times 0.0100} = 4.00$$

Because $Q < K$, the denominator will decrease and the numerator will increase—more SO_3 will form—until Q equals K . To reach equilibrium, the reaction will proceed to the right.

(c) Calculating ΔG , the nonstandard free energy change, at 298 K:

$$\begin{aligned}\Delta G_{298} &= \Delta G^\circ + RT \ln Q \\ &= -141.6 \text{ kJ/mol} + \left(8.314 \text{ J/mol}\cdot\text{K} \times \frac{1 \text{ kJ}}{1000 \text{ J}} \times 298 \text{ K} \times \ln 4.00 \right) \\ &= -138.2 \text{ kJ/mol}\end{aligned}$$

Check Note that in parts (a) and (c), we made the free energy units (kJ) consistent with the units in R (J). Applying the rules for significant figures in addition and subtraction, we retain one digit to the right of the decimal place in part (c).

Comment As with the synthesis of NH_3 (Section 17.6), where the *yield* is high but the *rate* is low at a lower temperature, this process is carried out at higher temperature *with a catalyst* to attain a higher *rate*. We discuss the details of the industrial production of sulfuric acid in Chapter 22.

FOLLOW-UP PROBLEMS

20.11A At 298 K, $\Delta G^\circ = -33.5 \text{ kJ/mol}$ for the formation of chloroethane from ethylene and hydrogen chloride:

(a) Calculate K at 298 K.

(b) Calculate ΔG at 298 K if $[\text{C}_2\text{H}_5\text{Cl}] = 1.5 \text{ M}$, $[\text{C}_2\text{H}_4] = 0.50 \text{ M}$, and $[\text{HCl}] = 1.0 \text{ M}$.

20.11B At 298 K, hypobromous acid (HBrO) dissociates in water with $K_a = 2.3 \times 10^{-9}$.

(a) Calculate ΔG° for the dissociation of HBrO .

(b) Calculate ΔG if $[\text{H}_3\text{O}^+] = 6.0 \times 10^{-4} \text{ M}$, $[\text{BrO}^-] = 0.10 \text{ M}$, and $[\text{HBrO}] = 0.20 \text{ M}$.

SOME SIMILAR PROBLEMS 20.79 and 20.80

Student Hot Spot

Student data indicate that you may struggle with the calculation of ΔG under nonstandard conditions. Access the Smartbook to view additional Learning Resources on this topic.

Another Look at the Meaning of Spontaneity At this point, we introduce two terms related to *spontaneous* and *nonspontaneous*:

1. *Product-favored reaction*. For the general reaction

Therefore, the reaction proceeds largely from left to right (Figure 20.15A, *next page*). From pure A to equilibrium, $Q < K$ and the curved green arrow in the figure indicates that the reaction is spontaneous ($\Delta G < 0$). From equilibrium to pure B, the curved red arrow indicates that the reaction is nonspontaneous ($\Delta G > 0$). Similarly, from pure B to equilibrium, $Q > K$ and the reaction is also spontaneous ($\Delta G < 0$), but not thereafter. In either case, *free energy decreases until the reaction reaches a minimum at the equilibrium mixture*: $Q = K$ and $\Delta G = 0$. For the overall reaction $\text{A} \rightleftharpoons \text{B}$ (starting with all components in their standard states), G_B° is smaller than G_A° , so ΔG° is negative, which corresponds to $K > 1$. We call this a *product-favored* reaction because in its final state the system contains mostly product.

2. *Reactant-favored reaction*. For the general reaction

and this reaction proceeds slightly from left to right (Figure 20.15B). Here, too, whether we start with pure C or pure D, the reaction is spontaneous ($\Delta G < 0$) until equilibrium. In this case, however, the equilibrium mixture contains mostly C (the reactant), so we say the reaction is *reactant favored*. Here, G_D° is larger than G_C° , so ΔG° is positive, which corresponds to $K < 1$.

Thus, “spontaneous” refers to that portion of a reaction in which the free energy decreases—from the starting mixture to the equilibrium mixture. A product-favored

Figure 20.15 Free energy and the extent of reaction. Each reaction proceeds spontaneously (curved green arrows) from reactants (A or C) or products (B or D) to the equilibrium mixture, at which point $\Delta G = 0$. After that, the reaction is nonspontaneous (curved red arrows). **A**, For the product-favored reaction $A \rightleftharpoons B$, $G_A^\circ > G_B^\circ$, so $\Delta G^\circ < 0$ and $K > 1$. **B**, For the reactant-favored reaction $C \rightleftharpoons D$, $G_D^\circ > G_C^\circ$, so $\Delta G^\circ > 0$ and $K < 1$.

reaction goes predominantly, but *not* completely, toward product, and a reactant-favored reaction goes relatively little toward product (see Table 20.3).

› Summary of Section 20.4

- › Two ways of predicting reaction spontaneity are from the sign of ΔG or from the value of Q/K . These variables are related to each other by $\Delta G = RT \ln Q/K$. When $Q = K$, $Q/K = 1$ and $\ln Q/K = 0$. Thus, the system is at equilibrium and can release (or absorb) no more free energy.
- › When Q is determined with standard-state values, the free energy change is ΔG° and is related to the equilibrium constant: $\Delta G^\circ = -RT \ln K$.
- › Any nonequilibrium mixture of reactants and products moves spontaneously ($\Delta G < 0$) toward the equilibrium mixture.
- › A product-favored reaction goes predominantly toward product and, thus, has $K > 1$ and $\Delta G^\circ < 0$; a reactant-favored reaction has $K < 1$ and $\Delta G^\circ > 0$.

CHAPTER REVIEW GUIDE

Learning Objectives

Relevant section (§) and/or sample problem (SP) numbers appear in parentheses.

Understand These Concepts

1. How the tendency of a process to occur by itself is distinct from how long it takes to occur (Introduction)
2. The distinction between a spontaneous and a nonspontaneous change (§20.1)
3. Why the first law of thermodynamics and the sign of ΔH° cannot predict the direction of a spontaneous process (§20.1)
4. How the entropy (S) of a system is defined by the number of microstates over which its energy is dispersed (§20.1)
5. How entropy is alternatively defined by the heat absorbed (or released) at constant T in a reversible process (§20.1)
6. The criterion for spontaneity according to the second law of thermodynamics: that a change increases S_{univ} (§20.1)
7. How absolute values of standard molar entropies (S°) can be obtained because the third law of thermodynamics provides a zero point (§20.1)
8. How temperature, physical state, dissolution, atomic size, and molecular complexity influence S° values (§20.1)

9. How ΔS_{rxn}° is based on the difference between the summed S° values for the reactants and those for products (§20.2)
10. How the surroundings add heat to or remove heat from the system and how ΔS_{surr} influences overall ΔS_{rxn}° (§20.2)
11. The relationship between ΔS_{surr} and ΔH_{sys} (§20.2)
12. How reactions proceed spontaneously toward equilibrium ($\Delta S_{univ} > 0$) but proceed no further at equilibrium ($\Delta S_{univ} = 0$) (§20.2)
13. How the free energy change (ΔG) combines a system's entropy and enthalpy changes (§20.3)
14. How the expression for the free energy change is derived from the second law (§20.3)
15. The relationship between ΔG and the maximum work a system can perform and why this quantity of work is never performed in a real process (§20.3)
16. How temperature determines spontaneity for reactions in which ΔS and ΔH have the same sign (§20.3)
17. Why the temperature at which a reaction becomes spontaneous occurs when $\Delta G = 0$ (§20.3)

18. How a spontaneous change can be coupled to a nonspontaneous change to make it occur (§20.3)
19. How ΔG is related to the ratio of Q to K (§20.4)
20. The meaning of ΔG° and its relation to K (§20.4)
21. The relation of ΔG to ΔG° and Q (§20.4)
22. Why G decreases, no matter what the starting concentrations, as a reacting system moves toward equilibrium (§20.4)
23. The distinction between product-favored and reactant-favored reactions (§20.4)

Master These Skills

1. Predicting relative S° values of systems (§20.1 and SP 20.1)
2. Calculating $\Delta S_{\text{rxn}}^\circ$ for a chemical change (SP 20.2)

3. Determining reaction spontaneity from ΔS_{surr} and $\Delta H_{\text{sys}}^\circ$ (SP 20.3)
4. Calculating $\Delta G_{\text{rxn}}^\circ$ from $\Delta H_{\text{f}}^\circ$ and S° values (SP 20.4)
5. Calculating $\Delta G_{\text{rxn}}^\circ$ from $\Delta G_{\text{f}}^\circ$ values (SP 20.5)
6. Using molecular scenes to determine the signs of ΔH , ΔS , and ΔG (SP 20.6)
7. Determining the effect of temperature on ΔG (SP 20.7)
8. Calculating the temperature at which a reaction becomes spontaneous (§20.3 and SP 20.8)
9. Calculating K from ΔG° , and vice versa (§20.4 and SP 20.9)
10. Using ΔG° and Q to calculate ΔG at any conditions (SPs 20.10, 20.11)

Key Terms

Page numbers appear in parentheses.

adenosine triphosphate (ATP) (921)	second law of thermodynamics (901)
coupling of reactions (920)	spontaneous change (895)
entropy (S) (898)	standard entropy of reaction ($\Delta S_{\text{rxn}}^\circ$) (906)
free energy (G) (912)	
microstate (898)	

standard free energy change (ΔG°) (913)
standard free energy of formation ($\Delta G_{\text{f}}^\circ$) (914)

standard molar entropy (S°) (901)
third law of thermodynamics (901)

Key Equations and Relationships

Page numbers appear in parentheses.

- 20.1** Quantifying entropy in terms of the number of microstates (W) over which the energy of a system can be dispersed (898):

$$S = k \ln W$$

- 20.2** Quantifying the entropy change in terms of heat absorbed (or released) in a reversible process (900):

$$\Delta S_{\text{sys}} = \frac{q_{\text{rev}}}{T}$$

- 20.3** Stating the second law of thermodynamics, for a spontaneous process (901):

$$\Delta S_{\text{univ}} = \Delta S_{\text{sys}} + \Delta S_{\text{surr}} > 0$$

- 20.4** Calculating the standard entropy of reaction from the standard molar entropies of reactants and products (907):

$$\Delta S_{\text{rxn}}^\circ = \sum m S_{\text{products}}^\circ - \sum n S_{\text{reactants}}^\circ$$

- 20.5** Relating the entropy change in the surroundings to the enthalpy change of the system and the temperature (908):

$$\Delta S_{\text{surr}} = -\frac{\Delta H_{\text{sys}}}{T}$$

- 20.6** Expressing the free energy change of the system in terms of its component enthalpy and entropy changes (Gibbs equation) (912):

$$\Delta G_{\text{sys}} = \Delta H_{\text{sys}} - T\Delta S_{\text{sys}}$$

- 20.7** Calculating the standard free energy change from standard enthalpy and entropy changes (913):

$$\Delta G_{\text{sys}}^\circ = \Delta H_{\text{sys}}^\circ - T\Delta S_{\text{sys}}^\circ$$

- 20.8** Calculating the standard free energy change from the standard free energies of formation (914):

$$\Delta G_{\text{rxn}}^\circ = \sum m \Delta G_{\text{f(products)}}^\circ - \sum n \Delta G_{\text{f(reactants)}}^\circ$$

- 20.9** Relating the free energy change to the maximum work a system can do (915):

$$\Delta G = w_{\text{max}}$$

- 20.10** Finding the temperature at which a reaction becomes spontaneous (919):

$$T = \frac{\Delta H}{\Delta S}$$

- 20.11** Expressing the free energy change in terms of Q and K (922):

$$\Delta G = RT \ln \frac{Q}{K} = RT \ln Q - RT \ln K$$

- 20.12** Expressing the free energy change with Q at standard-state conditions (923):

$$\Delta G^\circ = -RT \ln K$$

- 20.13** Expressing the free energy change for nonstandard initial conditions (924):

$$\Delta G = \Delta G^\circ + RT \ln Q$$

BRIEF SOLUTIONS TO FOLLOW-UP PROBLEMS

- 20.1A** (a) $\text{PCl}_5(g)$: higher molar mass and more complex molecule; (b) $\text{BaCl}_2(s)$: higher molar mass; (c) $\text{Br}_2(g)$: gases have more freedom of motion and dispersal of energy than liquids.

- 20.1B** (a) $\text{LiBr}(aq)$: same number of ions, but lower molar mass of ions; (b) quartz: the particles have less freedom of motion in the crystalline structure; (c) cyclohexane: molecule with no side chain has less freedom of motion.

- 20.2A** (a) $4\text{NO}(g) \longrightarrow \text{N}_2\text{O}(g) + \text{N}_2\text{O}_3(g)$

$$\Delta n_{\text{gas}} = -2, \text{ so } \Delta S_{\text{rxn}}^\circ < 0$$

$$\Delta S_{\text{rxn}}^\circ = [(1 \text{ mol N}_2\text{O})(219.7 \text{ J/mol}\cdot\text{K})]$$

$$+ [(1 \text{ mol N}_2\text{O}_3)(314.7 \text{ J/mol}\cdot\text{K})]$$

$$- [(4 \text{ mol NO})(210.65 \text{ J/mol}\cdot\text{K})]$$

$$= -308.2 \text{ J/K}$$

BRIEF SOLUTIONS TO FOLLOW-UP PROBLEMS

(continued)

$$\Delta n_{\text{gas}} = 2, \text{ so } \Delta S_{\text{rxn}}^{\circ} > 0$$

$$\begin{aligned}\Delta S_{\text{rxn}}^{\circ} &= [(1 \text{ mol CO})(197.5 \text{ J/mol}\cdot\text{K}) \\ &\quad + (2 \text{ mol H}_2)(130.6 \text{ J/mol}\cdot\text{K}) \\ &\quad - [(1 \text{ mol CH}_3\text{OH})(238 \text{ J/mol}\cdot\text{K})] \\ &= 221 \text{ J/K}\end{aligned}$$

$$\Delta n_{\text{gas}} = -1, \text{ so } \Delta S_{\text{rxn}}^{\circ} < 0$$

$$\begin{aligned}\Delta S_{\text{rxn}}^{\circ} &= [(1 \text{ mol H}_2\text{O})(69.940 \text{ J/mol}\cdot\text{K}) \\ &\quad + (1 \text{ mol Na}_2\text{CO}_3)(139 \text{ J/mol}\cdot\text{K}) \\ &\quad - [(1 \text{ mol CO}_2)(213.7 \text{ J/mol}\cdot\text{K}) \\ &\quad + (2 \text{ mol NaOH})(64.454 \text{ J/mol}\cdot\text{K})] \\ &= -134 \text{ J/K}\end{aligned}$$

$$\Delta n_{\text{gas}} = 0, \text{ so cannot predict sign of } \Delta S_{\text{rxn}}^{\circ}$$

$$\begin{aligned}\Delta S_{\text{rxn}}^{\circ} &= [(1 \text{ mol Fe}_2\text{O}_3)(87.400 \text{ J/mol}\cdot\text{K}) \\ &\quad + (3 \text{ mol H}_2)(130.6 \text{ J/mol}\cdot\text{K}) \\ &\quad - [(2 \text{ mol Fe})(27.3 \text{ J/mol}\cdot\text{K}) \\ &\quad + (3 \text{ mol H}_2\text{O})(188.72 \text{ J/mol}\cdot\text{K})] \\ &= -141.6 \text{ J/K}\end{aligned}$$

20.3A To find ΔS_{surr} , use ΔH_f° values to calculate $\Delta H_{\text{rxn}}^{\circ}$ and divide it by T :

$$\begin{aligned}\Delta H_{\text{rxn}}^{\circ} &= [(4 \text{ mol PCl}_3)(-287 \text{ kJ/mol}) \\ &\quad - [(1 \text{ mol P}_4)(0 \text{ kJ/mol}) + (6 \text{ mol Cl}_2)(0 \text{ kJ/mol})] \\ &= -1148 \text{ kJ} \\ \Delta S_{\text{surr}} &= -\frac{\Delta H_{\text{rxn}}^{\circ}}{T} = -\frac{(-1148 \text{ kJ})(1000 \text{ J}/1 \text{ kJ})}{298 \text{ K}} = 3850 \text{ J/K}\end{aligned}$$

To find ΔS_{univ} , use S° values to calculate $\Delta S_{\text{rxn}}^{\circ}$ and add it to ΔS_{surr} :

$$\begin{aligned}\Delta S_{\text{rxn}}^{\circ} &= [(4 \text{ mol PCl}_3)(312 \text{ J/mol}\cdot\text{K}) \\ &\quad - [(1 \text{ mol P}_4)(41.1 \text{ J/mol}\cdot\text{K}) \\ &\quad + (6 \text{ mol Cl}_2)(223.0 \text{ J/mol}\cdot\text{K})] \\ &= -131 \text{ J/K}\end{aligned}$$

$$\Delta S_{\text{univ}} = \Delta S_{\text{surr}} + \Delta S_{\text{rxn}}^{\circ} = 3850 \text{ J/K} + (-131 \text{ J/K}) = 3719 \text{ J/K}$$

Reaction is spontaneous at 298 K since ΔS_{univ} is positive.

Use S° values to calculate $\Delta S_{\text{rxn}}^{\circ}$ and ΔH_f° values to calculate $\Delta H_{\text{rxn}}^{\circ}$; divide $\Delta H_{\text{rxn}}^{\circ}$ by T to obtain ΔS_{surr} and add that value to $\Delta S_{\text{rxn}}^{\circ}$ to obtain ΔS_{univ} .

$$\begin{aligned}\Delta S_{\text{rxn}}^{\circ} &= [(1 \text{ mol Fe}_2\text{O}_3)(87.400 \text{ J/mol}\cdot\text{K}) \\ &\quad - [(2 \text{ mol FeO})(60.75 \text{ J/mol}\cdot\text{K}) \\ &\quad + (\frac{1}{2} \text{ mol O}_2)(205.0 \text{ J/mol}\cdot\text{K})] \\ &= -136.6 \text{ J/K}\end{aligned}$$

$$\begin{aligned}\Delta H_{\text{rxn}}^{\circ} &= [(1 \text{ mol Fe}_2\text{O}_3)(-825.5 \text{ kJ/mol}) \\ &\quad - [(2 \text{ mol FeO})(-272.0 \text{ kJ/mol}) + (\frac{1}{2} \text{ mol O}_2)(0 \text{ kJ/mol})] \\ &= -281.5 \text{ kJ}\end{aligned}$$

$$\Delta S_{\text{surr}} = -\frac{\Delta H_{\text{sys}}^{\circ}}{T} = -\frac{(-281.5 \text{ kJ})(1000 \text{ J}/1 \text{ kJ})}{298 \text{ K}} = +945 \text{ J/K}$$

$$\Delta S_{\text{univ}} = \Delta S_{\text{rxn}}^{\circ} + \Delta S_{\text{surr}} = -136.6 \text{ J/K} + 945 \text{ J/K} = 808 \text{ J/K}$$

Reaction is spontaneous at 298 K since ΔS_{univ} is positive.

20.4A Using ΔH_f° and S° values from Appendix B:

$$\begin{aligned}\Delta H_{\text{rxn}}^{\circ} &= [(2 \text{ mol NOCl})(51.71 \text{ kJ/mol}) \\ &\quad - [(2 \text{ mol NO})(90.29 \text{ kJ/mol}) \\ &\quad + (1 \text{ mol Cl}_2)(0 \text{ kJ/mol})] \\ &= -77.16 \text{ kJ}\end{aligned}$$

$$\begin{aligned}\Delta S_{\text{rxn}}^{\circ} &= [(2 \text{ mol NOCl})(261.6 \text{ J/mol}\cdot\text{K}) \\ &\quad - [(2 \text{ mol NO})(210.65 \text{ J/mol}\cdot\text{K}) \\ &\quad + (1 \text{ mol Cl}_2)(223.0 \text{ J/mol}\cdot\text{K})] \\ &= -121.1 \text{ J/K}\end{aligned}$$

$$\begin{aligned}\Delta G_{\text{rxn}}^{\circ} &= \Delta H_{\text{rxn}}^{\circ} - T\Delta S_{\text{rxn}}^{\circ} \\ &= -77.16 \text{ kJ} - [(298 \text{ K})(-121.1 \text{ J/K})(1 \text{ kJ}/1000 \text{ J})] \\ &= -41.1 \text{ kJ}\end{aligned}$$

20.4B Using ΔH_f° and S° values from Appendix B:

$$\begin{aligned}\Delta H_{\text{rxn}}^{\circ} &= [(4 \text{ mol NO})(90.29 \text{ kJ/mol}) \\ &\quad + (6 \text{ mol H}_2\text{O})(-241.826 \text{ kJ/mol}) \\ &\quad - [(4 \text{ mol NH}_3)(-45.9 \text{ kJ/mol}) \\ &\quad + (5 \text{ mol O}_2)(0 \text{ kJ/mol})] \\ &= -906.2 \text{ kJ}\end{aligned}$$

$$\begin{aligned}\Delta S_{\text{rxn}}^{\circ} &= [(4 \text{ mol NO})(210.65 \text{ J/mol}\cdot\text{K}) \\ &\quad + (6 \text{ mol H}_2\text{O})(188.72 \text{ J/mol}\cdot\text{K}) \\ &\quad - [(4 \text{ mol NH}_3)(193 \text{ J/mol}\cdot\text{K}) \\ &\quad + (5 \text{ mol O}_2)(205.0 \text{ J/mol}\cdot\text{K})] \\ &= 178 \text{ J/K}\end{aligned}$$

$$\begin{aligned}\Delta G_{\text{rxn}}^{\circ} &= \Delta H_{\text{rxn}}^{\circ} - T\Delta S_{\text{rxn}}^{\circ} \\ &= -906.2 \text{ kJ} - [(298 \text{ K})(178 \text{ J/K})(1 \text{ kJ}/1000 \text{ J})] \\ &= -959 \text{ kJ}\end{aligned}$$

20.5A (a) Using ΔG_f° values from Appendix B:

$$\begin{aligned}\Delta G_{\text{rxn}}^{\circ} &= [(2 \text{ mol NOCl})(66.07 \text{ kJ/mol}) \\ &\quad - [(2 \text{ mol NO})(86.60 \text{ kJ/mol}) \\ &\quad + (1 \text{ mol Cl}_2)(0 \text{ kJ/mol})] \\ &= -41.06 \text{ kJ}\end{aligned}$$

(b) Using ΔG_f° values from Appendix B:

$$\begin{aligned}\Delta G_{\text{rxn}}^{\circ} &= [(2 \text{ mol Fe})(0 \text{ kJ/mol}) \\ &\quad + (3 \text{ mol H}_2\text{O})(-228.60 \text{ kJ/mol}) \\ &\quad - [(3 \text{ mol H}_2)(0 \text{ kJ/mol}) \\ &\quad + (1 \text{ mol Fe}_2\text{O}_3)(-743.6 \text{ kJ/mol})] \\ &= 57.8 \text{ kJ}\end{aligned}$$

20.5B (a) Using ΔG_f° values from Appendix B:

$$\begin{aligned}\Delta G_{\text{rxn}}^{\circ} &= [(4 \text{ mol NO})(86.60 \text{ kJ/mol}) \\ &\quad + (6 \text{ mol H}_2\text{O})(-228.60 \text{ kJ/mol}) \\ &\quad - [(4 \text{ mol NH}_3)(-16 \text{ kJ/mol}) \\ &\quad + (5 \text{ mol O}_2)(0 \text{ kJ/mol})] \\ &= -961 \text{ kJ}\end{aligned}$$

(b) Using ΔG_f° values from Appendix B:

$$\begin{aligned}\Delta G_{\text{rxn}}^{\circ} &= (2 \text{ mol CO})(-137.2 \text{ kJ/mol}) \\ &\quad - [(2 \text{ mol C})(0 \text{ kJ/mol}) \\ &\quad + (1 \text{ mol O}_2)(0 \text{ kJ/mol})] \\ &= -274.4 \text{ kJ}\end{aligned}$$

20.6A (a) More moles of gas are present after the reaction, so $\Delta S > 0$. (b) The problem says the reaction is spontaneous ($\Delta G < 0$) only above 325°C, which implies high T . If $\Delta S > 0$, $-T\Delta S < 0$, so ΔG will become negative at higher T only if $\Delta H > 0$.

20.6B (a) A solid forms a gas and a liquid, so $\Delta S > 0$, and a crystalline array breaks down, so $\Delta H > 0$. (b) For the reaction to occur spontaneously ($\Delta G < 0$), $-T\Delta S$ must be greater than ΔH , which would occur only at higher T .

20.7A (a) $\Delta G = \Delta H - T\Delta S$

$$\begin{aligned}&= -192.7 \text{ kJ} - [(298 \text{ K})(-308.2 \text{ J/K})(1 \text{ kJ}/1000 \text{ J})] \\ &= -100.9 \text{ kJ}\end{aligned}$$

The reaction is spontaneous at 298 K.

(b) As T increases, $-T\Delta S$ becomes more positive, so the reaction becomes less spontaneous.

(c) $\Delta G = \Delta H - T\Delta S$

$$\begin{aligned}&= -192.7 \text{ kJ} - [(500. + 273 \text{ K})(-308.2 \text{ J/K})(1 \text{ kJ}/1000 \text{ J})] \\ &= 45.5 \text{ kJ}\end{aligned}$$

20.7B ΔG becomes negative at lower T , so $\Delta H < 0$, $\Delta S < 0$, and $-T\Delta S > 0$. At the lower T , the negative ΔH value becomes larger than the positive $-T\Delta S$ value.

$$\begin{aligned}\mathbf{20.8A} \quad \Delta G = 0 \text{ when } T &= \frac{\Delta H}{\Delta S} = \frac{(-192.7 \text{ kJ})(1000 \text{ J}/1 \text{ kJ})}{-308.2 \text{ J}/\text{K}} \\ &= 625.2 \text{ K}\end{aligned}$$

$$T (\text{°C}) = 625.2 \text{ K} - 273.15 = 352.0 \text{ °C}$$

20.8B

$$\begin{aligned}\Delta H &= [(1 \text{ mol})(\Delta H_f^\circ \text{ CaCO}_3)] - [(1 \text{ mol})(\Delta H_f^\circ \text{ CaO}) \\ &\quad + (1 \text{ mol})(\Delta H_f^\circ \text{ CO}_2)] \\ &= [(1 \text{ mol})(-1206.9 \text{ kJ/mol})] - [(1 \text{ mol})(-635.1 \text{ kJ/mol}) \\ &\quad + (1 \text{ mol})(-393.5 \text{ kJ/mol})] \\ &= -178.3 \text{ kJ} \\ \Delta S &= [(1 \text{ mol})(S^\circ \text{ CaCO}_3)] - [(1 \text{ mol})(S^\circ \text{ CaO}) + (1 \text{ mol})(S^\circ \text{ CO}_2)] \\ &= [(1 \text{ mol})(92.9 \text{ J/mol·K})] - [(1 \text{ mol})(38.2 \text{ J/mol·K}) \\ &\quad + (1 \text{ mol})(213.7 \text{ J/mol·K})] = -159.0 \text{ J/K} \\ T &= \frac{\Delta H}{\Delta S} = \frac{(-178.3 \text{ kJ})(1000 \text{ J}/1 \text{ kJ})}{-159.0 \text{ J/K}} = 1121 \text{ K}\end{aligned}$$

Reaction becomes spontaneous ($\Delta G < 0$) at any $T < 1121 \text{ K} - 273.15 = 848 \text{ °C}$.

20.9A

$$\begin{aligned}\Delta G^\circ &= [(2 \text{ mol CO})(-137.2 \text{ kJ/mol})] - [(2 \text{ mol C})(0 \text{ kJ/mol}) \\ &\quad + (1 \text{ mol O}_2)(0 \text{ kJ/mol})] \\ &= -274.4 \text{ kJ} \\ \ln K &= -\frac{\Delta G^\circ}{RT} = -\frac{(-274.4 \text{ kJ})(1000 \text{ J}/1 \text{ kJ})}{(8.314 \text{ J/mol·K})(298 \text{ K})} \\ &= 111 \\ K &= e^{111} = 1.61 \times 10^{48}\end{aligned}$$

20.9B

$$\begin{aligned}K &= 2.22 \times 10^{-15}, \text{ so } \ln K = -33.7 \\ \Delta G^\circ &= -RT \ln K = -(8.314 \text{ J/mol·K})(298 \text{ K})(-33.7) \\ &= 8.35 \times 10^4 \text{ J} = 83.5 \text{ kJ}\end{aligned}$$

20.10A

$$\begin{aligned}\text{(a)} \quad A(g) + 3B(g) &\rightleftharpoons AB_3(g); \Delta G^\circ = -4.6 \text{ kJ/mol} \\ \text{(b)} \quad \text{For mixture 1, } Q_1 &= \frac{[\text{AB}_3]}{[\text{A}][\text{B}]^3} = \frac{0.20}{(0.40)(0.80)^3} = 0.98 \\ \text{For mixture 2, } Q_2 &= \frac{(0.30)}{(0.30)(0.50)^3} = 8.0 \\ \text{For mixture 3, } Q_3 &= \frac{0.40}{(0.20)(0.20)^3} = 250\end{aligned}$$

Mixture 2 is at equilibrium.

(c) Since $Q_1 < K$, the reaction is proceeding to the right (it is spontaneous) and so $\Delta G_1 < 0$; $\Delta G_2 = 0$ since this mixture is at equilibrium; $Q_3 > K$, so the reaction is proceeding to the left, not to the right, and $\Delta G_3 > 0$. Therefore, $\Delta G_3 > \Delta G_2 > \Delta G_1$.

20.10B

$$\text{(a) For mixture 1, } Q_1 = \frac{[\text{XY}_2]^2}{[\text{X}_2][\text{Y}_2]^2} = \frac{(5.0)^2}{(2.0)(1.0)^2} = 12.5$$

$$\text{For mixture 2, } Q_2 = \frac{(4.0)^2}{(2.0)(2.0)^2} = 2.0$$

$$\text{For mixture 3, } Q_3 = \frac{(2.0)^2}{(4.0)(2.0)^2} = 0.25$$

Mixture 2 is at equilibrium.

(b) Since $Q_1 > K$, the reaction is proceeding to the left, not to the right, and $\Delta G_1 > 0$; $\Delta G_2 = 0$ since this mixture is at equilibrium; $Q_3 < K$, so the reaction is proceeding to the right (it is spontaneous), so $\Delta G_3 < 0$. Therefore, $\Delta G_3 < \Delta G_2 < \Delta G_1$.

(c) Any reaction mixture moves spontaneously toward equilibrium, so both changes have a negative ΔG .

20.11A

$$\text{(a) } \Delta G^\circ = -RT \ln K, \text{ so} \\ \ln K = -\frac{\Delta G^\circ}{RT} = -\frac{(-33.5 \text{ kJ})(1000 \text{ J}/1 \text{ kJ})}{(8.314 \text{ J/mol·K})(298 \text{ K})} = 13.521$$

$$K = e^{13.521} = 7.45 \times 10^5$$

$$\text{(b) } Q = \frac{[\text{C}_2\text{H}_5\text{Cl}]}{[\text{C}_2\text{H}_4][\text{HCl}]} = \frac{1.5}{(0.50)(1.0)} = 3.0$$

$$\begin{aligned}\Delta G &= \Delta G^\circ + RT \ln Q \\ &= -33.5 \text{ kJ} + [(8.314 \text{ J/mol·K})(1 \text{ kJ}/1000 \text{ J})(298 \text{ K})(\ln 3.0)] \\ &= -30.8 \text{ kJ}\end{aligned}$$

20.11B

$$\begin{aligned}\text{(a) } \Delta G^\circ &= -RT \ln K \\ &= -8.314 \text{ J/mol·K} \times \frac{1 \text{ kJ}}{1000 \text{ J}} \times 298 \text{ K} \\ &\quad \times \ln (2.3 \times 10^{-9}) \\ &= 49 \text{ kJ/mol}\end{aligned}$$

$$\text{(b) } Q = \frac{[\text{H}_3\text{O}^+][\text{BrO}^-]}{[\text{HBrO}]} = \frac{(6.0 \times 10^{-4})(0.10)}{0.20} = 3.0 \times 10^{-4}$$

$$\begin{aligned}\Delta G &= \Delta G^\circ + RT \ln Q \\ &= 49 \text{ kJ/mol} \\ &\quad + [(8.314 \text{ J/mol·K})(1 \text{ kJ}/1000 \text{ J})(298 \text{ K})(\ln 3.0 \times 10^{-4})] \\ &= 29 \text{ kJ/mol}\end{aligned}$$

PROBLEMS

Problems with **colored** numbers are answered in Appendix E and worked in detail in the Student Solutions Manual. Problem sections match those in the text and give the numbers of relevant sample problems. Most offer Concept Review Questions, Skill-Building Exercises (grouped in pairs covering the same concept), and Problems in Context. The Comprehensive Problems are based on material from any section or previous chapter.

Note: Unless stated otherwise, problems refer to systems at 298 K (25°C). Solving these problems may require values from Appendix B.

The Second Law of Thermodynamics: Predicting Spontaneous Change

(Sample Problem 20.1)

Concept Review Questions

20.1 Distinguish between the terms *spontaneous* and *instantaneous*. Give an example of a process that is spontaneous but very slow, and one that is very fast but not spontaneous.

20.2 Distinguish between the terms *spontaneous* and *nonspontaneous*. Can a nonspontaneous process occur? Explain.

20.3 State the first law of thermodynamics in terms of (a) the energy of the universe; (b) the creation or destruction of energy; (c) the energy change of system and surroundings. Does the first law reveal the direction of spontaneous change? Explain.

20.4 State qualitatively the relationship between entropy and freedom of particle motion. Use this idea to explain why you will probably never (a) suffocate because all the air near you has moved to the other side of the room; (b) see half the water in your cup of tea freeze while the other half boils.

20.5 Why is ΔS_{vap} of a substance always larger than ΔS_{fus} ?

20.6 How does the entropy of the surroundings change during an exothermic reaction? An endothermic reaction? Other than the examples in text, describe a spontaneous endothermic process.

- 20.7** (a) What is the entropy of a perfect crystal at 0 K?
 (b) Does entropy increase or decrease as the temperature rises?
 (c) Why is $\Delta H_f^\circ = 0$ but $S^\circ > 0$ for an element?
 (d) Why does Appendix B list ΔH_f° values but not ΔS_f° values?

Skill-Building Exercises (grouped in similar pairs)

20.8 Which of these processes are spontaneous? (a) Water evaporates from a puddle. (b) A lion chases an antelope. (c) An isotope undergoes radioactive disintegration.

20.9 Which of these processes are spontaneous? (a) Earth moves around the Sun. (b) A boulder rolls up a hill. (c) Sodium metal and chlorine gas form solid sodium chloride.

20.10 Which of these processes are spontaneous? (a) Methane burns in air. (b) A teaspoonful of sugar dissolves in a cup of hot coffee. (c) A soft-boiled egg becomes raw.

20.11 Which of these processes are spontaneous? (a) A satellite falls to Earth. (b) Water decomposes to H_2 and O_2 at 298 K and 1 atm. (c) Average car prices increase.

20.12 Predict the sign of ΔS_{sys} for each process: (a) A piece of wax melts. (b) Silver chloride precipitates from solution. (c) Dew forms on a lawn in the morning.

20.13 Predict the sign of ΔS_{sys} for each process: (a) Gasoline vapors mix with air in a car engine. (b) Hot air expands. (c) Humidity condenses in cold air.

20.14 Predict the sign of ΔS_{sys} for each process: (a) Alcohol evaporates. (b) A solid explosive converts to a gas. (c) Perfume vapors diffuse through a room.

20.15 Predict the sign of ΔS_{sys} for each process: (a) A pond freezes in winter. (b) Atmospheric CO_2 dissolves in the ocean. (c) An apple tree bears fruit.

20.16 Without using Appendix B, predict the sign of ΔS° for

- (a) $2K(s) + F_2(g) \rightarrow 2KF(s)$
 (b) $NH_3(g) + HBr(g) \rightarrow NH_4Br(s)$
 (c) $NaClO_3(s) \rightarrow Na^+(aq) + ClO_3^-(aq)$

20.17 Without using Appendix B, predict the sign of ΔS° for

- (a) $H_2S(g) + \frac{1}{2}O_2(g) \rightarrow \frac{1}{8}S_8(s) + H_2O(g)$
 (b) $HCl(aq) + NaOH(aq) \rightarrow NaCl(aq) + H_2O(l)$
 (c) $2NO_2(g) \rightarrow N_2O_4(g)$

20.18 Without using Appendix B, predict the sign of ΔS° for

- (a) $CaCO_3(s) + 2HCl(aq) \rightarrow CaCl_2(aq) + H_2O(l) + CO_2(g)$
 (b) $2NO(g) + O_2(g) \rightarrow 2NO_2(g)$
 (c) $2KClO_3(s) \rightarrow 2KCl(s) + 3O_2(g)$

20.19 Without using Appendix B, predict the sign of ΔS° for

- (a) $Ag^+(aq) + Cl^-(aq) \rightarrow AgCl(s)$
 (b) $KBr(s) \rightarrow KBr(aq)$

20.20 Predict the sign of ΔS for each process:

- (a) $C_2H_5OH(g)$ (350 K and 500 torr) \longrightarrow $C_2H_5OH(g)$ (350 K and 250 torr)
 (b) $N_2(g)$ (298 K and 1 atm) \longrightarrow $N_2(aq)$ (298 K and 1 atm)
 (c) $O_2(aq)$ (303 K and 1 atm) \longrightarrow $O_2(g)$ (303 K and 1 atm)

20.21 Predict the sign of ΔS for each process:

- (a) $O_2(g)$ (1.0 L at 1 atm) \longrightarrow $O_2(g)$ (0.10 L at 10 atm)
 (b) $Cu(s)$ (350°C and 2.5 atm) \longrightarrow $Cu(s)$ (450°C and 2.5 atm)
 (c) $Cl_2(g)$ (100°C and 1 atm) \longrightarrow $Cl_2(g)$ (10°C and 1 atm)

20.22 Predict which substance has greater molar entropy. Explain.

- (a) Butane $CH_3CH_2CH_2CH_3(g)$ or 2-butene $CH_3CH=CHCH_3(g)$
 (b) $Ne(g)$ or $Xe(g)$
 (c) $CH_4(g)$ or $CCl_4(l)$

20.23 Predict which substance has greater molar entropy. Explain.

- (a) $NO_2(g)$ or $N_2O_4(g)$
 (b) $CH_3OCH_3(l)$ or $CH_3CH_2OH(l)$
 (c) $HCl(g)$ or $HBr(g)$

20.24 Predict which substance has greater molar entropy. Explain.

- (a) $CH_3OH(l)$ or $C_2H_5OH(l)$
 (b) $KClO_3(s)$ or $KClO_3(aq)$
 (c) $Na(s)$ or $K(s)$

20.25 Predict which substance has greater molar entropy. Explain.

- (a) $P_4(g)$ or $P_2(g)$
 (b) $HNO_3(aq)$ or $HNO_3(l)$
 (c) $CuSO_4(s)$ or $CuSO_4 \cdot 5H_2O(s)$

20.26 Without consulting Appendix B, arrange each group in order of *increasing* standard molar entropy (S°). Explain.

- (a) Graphite, diamond, charcoal
 (b) Ice, water vapor, liquid water
 (c) O_2 , O_3 , O atoms

20.27 Without consulting Appendix B, arrange each group in order of *increasing* standard molar entropy (S°). Explain.

- (a) Glucose ($C_6H_{12}O_6$), sucrose ($C_{12}H_{22}O_{11}$), ribose ($C_5H_{10}O_5$)
 (b) $CaCO_3$, $Ca + C + \frac{3}{2}O_2$, $CaO + CO_2$
 (c) $SF_6(g)$, $SF_4(g)$, $S_2F_{10}(g)$

20.28 Without consulting Appendix B, arrange each group in order of *decreasing* standard molar entropy (S°). Explain.

- (a) $ClO_4^-(aq)$, $ClO_2^-(aq)$, $ClO_3^-(aq)$
 (b) $NO_2(g)$, $NO(g)$, $N_2(g)$
 (c) $Fe_2O_3(s)$, $Al_2O_3(s)$, $Fe_3O_4(s)$

20.29 Without consulting Appendix B, arrange each group in order of *decreasing* standard molar entropy (S°). Explain.

- (a) Mg metal, Ca metal, Ba metal
 (b) Hexane (C_6H_{14}), benzene (C_6H_6), cyclohexane (C_6H_{12})
 (c) $PF_2Cl_3(g)$, $PF_5(g)$, $PF_3(g)$

Calculating the Change in Entropy of a Reaction

(Sample Problems 20.2 and 20.3)

Concept Review Questions

- 20.30** In the reaction depicted in the molecular scenes, X is red and Y is green.

- (a) Write a balanced equation.
 (b) Determine the sign of ΔS_{rxn} .
 (c) Which species has the highest molar entropy?

- 20.31** Describe the equilibrium condition in terms of the entropy changes of a system and its surroundings. What does this description say about the entropy change of the universe?

- 20.32** For the reaction $\text{H}_2\text{O}(g) + \text{Cl}_2\text{O}(g) \rightarrow 2\text{HClO}(g)$, you know $\Delta S_{\text{rxn}}^{\circ}$ and S° of $\text{HClO}(g)$ and of $\text{H}_2\text{O}(g)$. Write an expression that can be used to determine S° of $\text{Cl}_2\text{O}(g)$.

Skill-Building Exercises (grouped in similar pairs)

- 20.33** For each reaction, predict the sign and find the value of $\Delta S_{\text{rxn}}^{\circ}$:

- (a) $3\text{NO}(g) \rightarrow \text{N}_2\text{O}(g) + \text{NO}_2(g)$
 (b) $3\text{H}_2(g) + \text{Fe}_2\text{O}_3(s) \rightarrow 2\text{Fe}(s) + 3\text{H}_2\text{O}(g)$
 (c) $\text{P}_4(s) + 5\text{O}_2(g) \rightarrow \text{P}_4\text{O}_{10}(s)$

- 20.34** For each reaction, predict the sign and find the value of $\Delta S_{\text{rxn}}^{\circ}$:

- (a) $3\text{NO}_2(g) + \text{H}_2\text{O}(l) \rightarrow 2\text{HNO}_3(l) + \text{NO}(g)$
 (b) $\text{N}_2(g) + 3\text{F}_2(g) \rightarrow 2\text{NF}_3(g)$
 (c) $\text{C}_6\text{H}_{12}\text{O}_6(s) + 6\text{O}_2(g) \rightarrow 6\text{CO}_2(g) + 6\text{H}_2\text{O}(g)$

- 20.35** Find $\Delta S_{\text{rxn}}^{\circ}$ for the combustion of ethane (C_2H_6) to carbon dioxide and gaseous water. Is the sign of $\Delta S_{\text{rxn}}^{\circ}$ as expected?

- 20.36** Find $\Delta S_{\text{rxn}}^{\circ}$ for the combustion of methane to carbon dioxide and liquid water. Is the sign of $\Delta S_{\text{rxn}}^{\circ}$ as expected?

- 20.37** Find $\Delta S_{\text{rxn}}^{\circ}$ for the reaction of nitrogen monoxide with hydrogen to form ammonia and water vapor. Is the sign of $\Delta S_{\text{rxn}}^{\circ}$ as expected?

- 20.38** Find $\Delta S_{\text{rxn}}^{\circ}$ for the combustion of ammonia to nitrogen dioxide and water vapor. Is the sign of $\Delta S_{\text{rxn}}^{\circ}$ as expected?

- 20.39** (a) Find $\Delta S_{\text{rxn}}^{\circ}$ for the formation of $\text{Cu}_2\text{O}(s)$ from its elements.
 (b) Calculate ΔS_{univ} , and state whether the reaction is spontaneous at 298 K.

- 20.40** (a) Find $\Delta S_{\text{rxn}}^{\circ}$ for the formation of $\text{HI}(g)$ from its elements.

- (b) Calculate ΔS_{univ} , and state whether the reaction is spontaneous at 298 K.

- 20.41** (a) Find $\Delta S_{\text{rxn}}^{\circ}$ for the formation of $\text{CH}_3\text{OH}(l)$ from its elements.
 (b) Calculate ΔS_{univ} , and state whether the reaction is spontaneous at 298 K.

- 20.42** (a) Find $\Delta S_{\text{rxn}}^{\circ}$ for the formation of $\text{N}_2\text{O}(g)$ from its elements.

- (b) Calculate ΔS_{univ} , and state whether the reaction is spontaneous at 298 K.

Problems in Context

- 20.43** Sulfur dioxide is released in the combustion of coal. Scrubbers use aqueous slurries of calcium hydroxide to remove the SO_2 from flue gases. Write a balanced equation for this reaction and calculate $\Delta S_{\text{rxn}}^{\circ}$ at 298 K [S° of $\text{CaSO}_3(s) = 101.4 \text{ J/mol}\cdot\text{K}$].

- 20.44** Oxyacetylene welding is used to repair metal structures, including bridges, buildings, and even the Statue of Liberty. Calculate $\Delta S_{\text{rxn}}^{\circ}$ for the combustion of 1 mol of acetylene (C_2H_2).

Entropy, Free Energy, and Work

(Sample Problems 20.4 to 20.8)

Concept Review Questions

- 20.45** What is the advantage of calculating free energy changes rather than entropy changes to determine reaction spontaneity?

- 20.46** Given that $\Delta G_{\text{sys}} = -T\Delta S_{\text{univ}}$, explain how the sign of ΔG_{sys} correlates with reaction spontaneity.

- 20.47** (a) Is an endothermic reaction more likely to be spontaneous at higher temperatures or lower temperatures? Explain.
 (b) The change depicted below occurs at constant pressure. Explain your answers to each of the following: (1) What is the sign of ΔH_{sys} ? (2) What is the sign of ΔS_{sys} ? (3) What is the sign of ΔS_{surr} ? (4) How does the sign of ΔG_{sys} vary with temperature?

- 20.48** Explain your answers to each of the following for the change depicted below. (a) What is the sign of ΔH_{sys} ? (b) What is the sign of ΔS_{sys} ? (c) What is the sign of ΔS_{surr} ? (d) How does the sign of ΔG_{sys} vary with temperature?

- 20.49** With its components in their standard states, a certain reaction is spontaneous only at high T . What do you know about the signs of ΔH° and ΔS° ? Describe a process for which this is true.

- 20.50** How can ΔS° for a reaction be relatively independent of T if S° of each reactant and product increases with T ?

Skill-Building Exercises (grouped in similar pairs)

- 20.51** Calculate ΔG° for each reaction using ΔG_f° values:

- (a) $2\text{Mg}(s) + \text{O}_2(g) \rightarrow 2\text{MgO}(s)$
 (b) $2\text{CH}_3\text{OH}(g) + 3\text{O}_2(g) \rightarrow 2\text{CO}_2(g) + 4\text{H}_2\text{O}(g)$
 (c) $\text{BaO}(s) + \text{CO}_2(g) \rightarrow \text{BaCO}_3(s)$

- 20.52** Calculate ΔG° for each reaction using ΔG_f° values:

- (a) $\text{H}_2(g) + \text{I}_2(s) \rightarrow 2\text{HI}(g)$
 (b) $\text{MnO}_2(s) + 2\text{CO}(g) \rightarrow \text{Mn}(s) + 2\text{CO}_2(g)$
 (c) $\text{NH}_4\text{Cl}(s) \rightarrow \text{NH}_3(g) + \text{HCl}(g)$

20.53 Find ΔG° for the reactions in Problem 20.51 using ΔH_f° and S° values.

20.54 Find ΔG° for the reactions in Problem 20.52 using ΔH_f° and S° values.

20.55 Consider the oxidation of carbon monoxide:

(a) Predict the signs of ΔS° and ΔH° . Explain.

(b) Calculate ΔG° by two different methods.

20.56 Consider the combustion of butane gas:

(a) Predict the signs of ΔS° and ΔH° . Explain.

(b) Calculate ΔG° by two different methods.

20.57 For the gaseous reaction of xenon and fluorine to form xenon hexafluoride:

(a) Calculate ΔS° at 298 K ($\Delta H^\circ = -402$ kJ/mol and $\Delta G^\circ = -280$ kJ/mol).

(b) Assuming that ΔS° and ΔH° change little with temperature, calculate ΔG° at 500 K.

20.58 For the gaseous reaction of carbon monoxide and chlorine to form phosgene (COCl_2):

(a) Calculate ΔS° at 298 K ($\Delta H^\circ = -220$ kJ/mol and $\Delta G^\circ = -206$ kJ/mol).

(b) Assuming that ΔS° and ΔH° change little with temperature, calculate ΔG° at 450 K.

20.59 One reaction used to produce small quantities of pure H_2 is

(a) Determine ΔH° and ΔS° for the reaction at 298 K.

(b) Assuming that these values are relatively independent of temperature, calculate ΔG° at 28°C, 128°C, and 228°C.

(c) What is the significance of the different values of ΔG° ?

(d) At what temperature (in K) does the reaction become spontaneous?

20.60 A reaction that occurs in the internal combustion engine is

(a) Determine ΔH° and ΔS° for the reaction at 298 K.

(b) Assuming that these values are relatively independent of temperature, calculate ΔG° at 100°C, 2560°C, and 3540°C.

(c) What is the significance of the different values of ΔG° ?

(d) At what temperature (in K) does the reaction become spontaneous?

Problems in Context

20.61 As a fuel, $\text{H}_2(g)$ produces only nonpolluting $\text{H}_2\text{O}(g)$ when it burns. Moreover, it combines with $\text{O}_2(g)$ in a fuel cell (Chapter 21) to provide electrical energy.

(a) Calculate ΔH° , ΔS° , and ΔG° per mole of H_2 at 298 K.

(b) Is the spontaneity of this reaction dependent on T ? Explain.

(c) At what temperature does the reaction become spontaneous?

20.62 The U.S. government requires automobile fuels to contain a renewable component. Fermentation of glucose from corn yields ethanol, which is added to gasoline to fulfill this requirement:

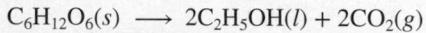

Calculate ΔH° , ΔS° , and ΔG° for the reaction at 25°C. Is the spontaneity of this reaction dependent on T ? Explain.

Free Energy, Equilibrium, and Reaction Direction

(Sample Problems 20.9 to 20.11)

Concept Review Questions

20.63 (a) If $K \ll 1$ for a reaction, what do you know about the sign and magnitude of ΔG° ? (b) If $\Delta G^\circ \gg 0$ for a reaction, what do you know about the magnitude of K ? Of Q ?

20.64 How is the free energy change of a process related to the work that can be obtained from the process? Is this quantity of work obtainable in practice? Explain.

20.65 The scenes and the graph relate to the reaction of $\text{X}_2(g)$ (black) with $\text{Y}_2(g)$ (orange) to form $\text{XY}(g)$.

(a) If reactants and products are in their standard states, what quantity is represented on the graph by x ?

(b) Which scene represents point 1? Explain.

(c) Which scene represents point 2? Explain.

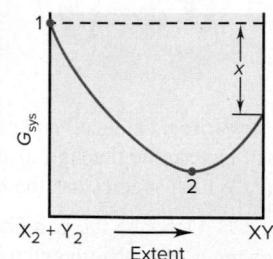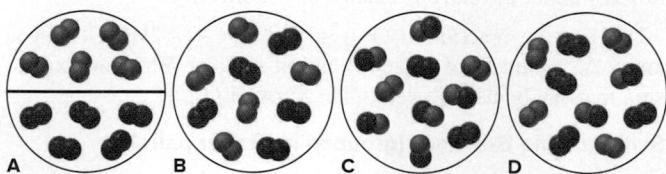

20.66 What is the difference between ΔG° and ΔG ? Under what circumstances does $\Delta G = \Delta G^\circ$?

Skill-Building Exercises (grouped in similar pairs)

20.67 Calculate K at 298 K for each reaction:

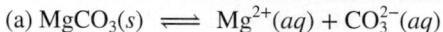

20.68 Calculate ΔG° at 298 K for each reaction:

20.69 Calculate K at 298 K for each reaction:

20.70 Calculate ΔG° at 298 K for each reaction:

20.71 Use ΔH° and ΔS° values for the following process at 1 atm to find the normal boiling point of Br_2 :

20.72 Use ΔH° and ΔS° values to find the temperature at which these sulfur allotropes reach equilibrium at 1 atm:

20.73 Use Appendix B to determine the K_{sp} of Ag_2S .

20.74 Use Appendix B to determine the K_{sp} of CaF_2 .

20.75 For the reaction $\text{I}_2(g) + \text{Cl}_2(g) \rightleftharpoons 2\text{ICl}(g)$, calculate K_p at 25°C [ΔG_f° of $\text{ICl}(g) = -6.075$ kJ/mol].

20.76 For the reaction $\text{CaCO}_3(s) \rightleftharpoons \text{CaO}(s) + \text{CO}_2(g)$, calculate the equilibrium P_{CO_2} at 25°C.

20.77 The K_{sp} of PbCl_2 is 1.7×10^{-5} at 25°C . What is ΔG° ? Is it possible to prepare a solution that contains $\text{Pb}^{2+}(aq)$ and $\text{Cl}^-(aq)$, at their standard-state concentrations?

20.78 The K_{sp} of ZnF_2 is 3.0×10^{-2} at 25°C . What is ΔG° ? Is it possible to prepare a solution that contains $\text{Zn}^{2+}(aq)$ and $\text{F}^-(aq)$ at their standard-state concentrations?

20.79 The equilibrium constant for the reaction

is $K_c = 9.1 \times 10^{-6}$ at 298 K .

(a) What is ΔG° at this temperature?

(b) If standard-state concentrations of the reactants and products are mixed, in which direction does the reaction proceed?

(c) Calculate ΔG when $[\text{Fe}^{3+}] = 0.20\text{ M}$, $[\text{Hg}_2^{2+}] = 0.010\text{ M}$, $[\text{Fe}^{2+}] = 0.010\text{ M}$, and $[\text{Hg}^{2+}] = 0.025\text{ M}$. In which direction will the reaction proceed to achieve equilibrium?

20.80 The formation constant for the reaction

is $K_f = 5.6 \times 10^8$ at 25°C .

(a) What is ΔG° at this temperature?

(b) If standard-state concentrations of the reactants and products are mixed, in which direction does the reaction proceed?

(c) Determine ΔG when $[\text{Ni}(\text{NH}_3)_6^{2+}] = 0.010\text{ M}$, $[\text{Ni}^{2+}] = 0.0010\text{ M}$, and $[\text{NH}_3] = 0.0050\text{ M}$. In which direction will the reaction proceed to achieve equilibrium?

20.81 The scenes below depict three gaseous mixtures in which A is reacting with itself to form A_2 . Assume that each particle represents 0.10 mol and the volume is 0.10 L.

(a) If $K = 0.33$, which mixture is at equilibrium? (b) Rank the mixtures from the most positive ΔG to the most negative ΔG .

20.82 The scenes below depict three gaseous mixtures in which X (orange) and Y₂ (black) are reacting to form XY and Y. Assume that each gas has a partial pressure of 0.10 atm.

(a) If $K = 4.5$, which mixture is at equilibrium? (b) Rank the mixtures from the most positive ΔG to the most negative ΔG .

Problems in Context

20.83 High levels of ozone (O_3) cause rubber to deteriorate, green plants to turn brown, and many people to have difficulty breathing.

(a) Is the formation of O_3 from O_2 favored at all T , no T , high T , or low T ?

(b) Calculate ΔG° for this reaction at 298 K .

(c) Calculate ΔG at 298 K for this reaction in urban smog where $[\text{O}_2] = 0.21\text{ atm}$ and $[\text{O}_3] = 5 \times 10^{-7}\text{ atm}$.

20.84 A BaSO_4 slurry is ingested before the gastrointestinal tract is x-rayed because it is opaque to x-rays and defines the contours of the tract. Ba^{2+} ion is toxic, but the compound is nearly insoluble. If ΔG° at 37°C (body temperature) is 59.1 kJ/mol for the dissolution,

what is $[\text{Ba}^{2+}]$ in the intestinal tract? (Assume that the only source of SO_4^{2-} is the ingested slurry.)

Comprehensive Problems

20.85 According to advertisements, “a diamond is forever.”

(a) Calculate ΔH° , ΔS° , and ΔG° at 298 K for the phase change

(b) Given the conditions under which diamond jewelry is normally kept, argue for and against the statement in the ad.

(c) Given the answers in part (a), what would need to be done to make synthetic diamonds from graphite?

(d) Assuming ΔH° and ΔS° do not change with temperature, can graphite be converted to diamond spontaneously at 1 atm ?

20.86 Replace each question mark with the correct information:

	ΔS_{rxn}	ΔH_{rxn}	ΔG_{rxn}	Comment
(a)	+	-	-	?
(b)	?	0	-	Spontaneous
(c)	-	+	?	Not spontaneous
(d)	0	?	-	Spontaneous
(e)	?	0	+	?
(f)	+	+	?	$T\Delta S > \Delta H$

20.87 Among the many complex ions of cobalt are the following:

where “en” stands for ethylenediamine, $\text{H}_2\text{NCH}_2\text{CH}_2\text{NH}_2$. Six Co—N bonds are broken and six Co—N bonds are formed in this reaction, so $\Delta H_{rxn}^\circ \approx 0$; yet $K > 1$. What are the signs of ΔS° and ΔG° ? What drives the reaction?

20.88 What is the change in entropy when 0.200 mol of potassium freezes at 63.7°C ($\Delta H_{fus} = 2.39\text{ kJ/mol}$)?

20.89 Is each statement true or false? If false, correct it.

(a) All spontaneous reactions occur quickly.

(b) The reverse of a spontaneous reaction is nonspontaneous.

(c) All spontaneous processes release heat.

(d) The boiling of water at 100°C and 1 atm is spontaneous.

(e) If a process increases the freedom of motion of the particles of a system, the entropy of the system decreases.

(f) The energy of the universe is constant; the entropy of the universe decreases toward a minimum.

(g) All systems disperse their energy spontaneously.

(h) Both ΔS_{sys} and ΔS_{surr} equal zero at equilibrium.

20.90 Hemoglobin carries O_2 from the lungs to tissue cells, where the O_2 is released. The protein is represented as Hb in its unoxygenated form and as $\text{Hb}\cdot\text{O}_2$ in its oxygenated form. One reason CO is toxic is that it competes with O_2 in binding to Hb:

(a) If $\Delta G^\circ \approx -14\text{ kJ}$ at 37°C (body temperature), what is the ratio of $[\text{Hb}\cdot\text{CO}]$ to $[\text{Hb}\cdot\text{O}_2]$ at 37°C with $[\text{O}_2] = [\text{CO}]$?

(b) How is Le Châtelier’s principle used to treat CO poisoning?

20.91 Magnesia (MgO) is used for fire brick, crucibles, and furnace linings because of its high melting point. It is produced by decomposing magnesite (MgCO_3) at around 1200°C .

(a) Write a balanced equation for magnesite decomposition.

(b) Use ΔH° and S° values to find ΔG° at 298 K.

(c) Assuming that ΔH° and S° do not change with temperature, find the minimum temperature at which the reaction is spontaneous.

(d) Calculate the equilibrium P_{CO_2} above MgCO_3 at 298 K.

(e) Calculate the equilibrium P_{CO_2} above MgCO_3 at 1200°C .

20.92 To prepare nuclear fuel, U_3O_8 ("yellow cake") is converted to $\text{UO}_2(\text{NO}_3)_2$, which is then converted to UO_3 and finally UO_2 . The fuel is enriched (the proportion of the ^{235}U is increased) by a two-step conversion of UO_2 into UF_6 , a volatile solid, followed by a gaseous-diffusion separation of the ^{235}U and ^{238}U isotopes:

Calculate ΔG° for the overall process at 85°C :

	ΔH_f° (kJ/mol)	S° (J/mol·K)	ΔG_f° (kJ/mol)
$\text{UO}_2(s)$	-1085	77.0	-1032
$\text{UF}_4(s)$	-1921	152	-1830.
$\text{UF}_6(s)$	-2197	225	-2068

20.93 Methanol, a major industrial feedstock, is made by several catalyzed reactions, such as $\text{CO}(g) + 2\text{H}_2(g) \longrightarrow \text{CH}_3\text{OH}(l)$.

(a) Show that this reaction is thermodynamically feasible.

(b) Is it favored at low or at high temperatures?

(c) One concern about using CH_3OH as an auto fuel is its oxidation in air to yield formaldehyde, $\text{CH}_2\text{O}(g)$, which poses a health hazard. Calculate ΔG° at 100°C for this oxidation.

20.94 (a) Write a balanced equation for the gaseous reaction between N_2O_5 and F_2 to form NF_3 and O_2 . (b) Determine $\Delta G_{\text{rxn}}^\circ$. (c) Find $\Delta G_{\text{rxn}}^\circ$ at 298 K if $P_{\text{N}_2\text{O}_5} = P_{\text{F}_2} = 0.20$ atm, $P_{\text{NF}_3} = 0.25$ atm, and $P_{\text{O}_2} = 0.50$ atm.

20.95 Consider the following reaction:

Given that S° of $\text{NOBr}(g) = 272.6 \text{ J/mol}\cdot\text{K}$ and that $\Delta S_{\text{rxn}}^\circ$ and $\Delta H_{\text{rxn}}^\circ$ are constant with temperature, find

- | | |
|--|--|
| (a) $\Delta S_{\text{rxn}}^\circ$ at 298 K | (b) $\Delta G_{\text{rxn}}^\circ$ at 373 K |
| (c) $\Delta H_{\text{rxn}}^\circ$ at 373 K | (d) ΔH_f° of NOBr at 298 K |
| (e) $\Delta G_{\text{rxn}}^\circ$ at 298 K | (f) ΔG_f° of NOBr at 298 K |

20.96 Hydrogenation is the addition of H_2 to double (or triple) carbon-carbon bonds. Peanut butter and most commercial baked goods include hydrogenated oils. Find ΔH° , ΔS° , and ΔG° for the hydrogenation of ethene (C_2H_4) to ethane (C_2H_6) at 25°C .

20.97 Styrene is produced by catalytic dehydrogenation of ethylbenzene at high temperature in the presence of superheated steam. (a) Find $\Delta H_{\text{rxn}}^\circ$, $\Delta G_{\text{rxn}}^\circ$, and $\Delta S_{\text{rxn}}^\circ$, given these data at 298 K:

Compound	ΔH_f° (kJ/mol)	ΔG_f° (kJ/mol)	S° (J/mol·K)
Ethylbenzene, $\text{C}_6\text{H}_5-\text{CH}_2\text{CH}_3$	-12.5	119.7	255
Styrene, $\text{C}_6\text{H}_5-\text{CH}=\text{CH}_2$	103.8	202.5	238

(b) At what temperature is the reaction spontaneous?

(c) What are $\Delta G_{\text{rxn}}^\circ$ and K at 600°C ?

(d) With 5.0 parts steam to 1.0 part ethylbenzene in the reactant mixture and the total pressure kept constant at 1.3 atm, what is ΔG at 50% conversion, that is, when 50% of the ethylbenzene has reacted?

20.98 Propylene (propene; $\text{CH}_3\text{CH}=\text{CH}_2$) is used to produce polypropylene and many other chemicals. Although most propylene is obtained from the cracking of petroleum, about 2% is produced by catalytic dehydrogenation of propane ($\text{CH}_3\text{CH}_2\text{CH}_3$):

Because this reaction is endothermic, heaters are placed between the reactor vessels to maintain the required temperature.

(a) If the molar entropy, S° , of propylene is $267.1 \text{ J/mol}\cdot\text{K}$, find its entropy of formation, S_f° .

(b) Find ΔG_f° of propylene (ΔH_f° for propylene = 20.4 kJ/mol).

(c) Calculate $\Delta H_{\text{rxn}}^\circ$ and $\Delta G_{\text{rxn}}^\circ$ for the dehydrogenation.

(d) What is the theoretical yield of propylene at 580°C if the initial pressure of propane is 1.00 atm?

(e) Would the yield change if the reactor walls were permeable to H_2 ? Explain.

(f) At what temperature is the dehydrogenation spontaneous, with all substances in the standard state?

Note: Problems 20.99 and 20.100 relate to the thermodynamics of adenosine triphosphate (ATP). Refer to the Chemical Connections essay at the end of Section 20.3.

20.99 Find K for (a) the hydrolysis of ATP, (b) the dehydration-condensation to form glucose phosphate, and (c) the coupled reaction between ATP and glucose. (d) How does each K change when T changes from 25°C to 37°C ?

20.100 Energy from ATP hydrolysis drives many nonspontaneous cell reactions:

Energy for the reverse process comes ultimately from glucose metabolism:

(a) Find K for the hydrolysis of ATP at 37°C .

(b) Find $\Delta G_{\text{rxn}}^\circ$ for metabolism of 1 mol of glucose.

(c) How many moles of ATP can be produced by metabolism of 1 mol of glucose?

(d) If 36 mol of ATP is formed, what is the actual yield?

20.101 From the following reaction and data, find (a) S° of SOCl_2 and (b) the T at which the reaction becomes nonspontaneous:

$\text{SO}_3(g)$	$\text{SCl}_2(l)$	$\text{SOCl}_2(l)$	$\text{SO}_2(g)$
ΔH_f° (kJ/mol)	-396	-50.0	-245.6
S° (J/mol·K)	256.7	184	—

20.102 Write equations for the oxidation of Fe and of Al. Use ΔG_f° to determine whether either process is spontaneous at 25°C .

20.103 The molecular scene depicts a gaseous equilibrium mixture at 460°C for the reaction of H_2 (blue) and I_2 (purple) to form HI. Each molecule represents 0.010 mol and the container volume is 1.0 L. (a) Is $K_c > 1$, $= 1$, or < 1 ? (b) Is $K_p > K_c$, $= K_c$, or $< K_c$? (c) Calculate $\Delta G_{\text{rxn}}^\circ$. (d) How would the value of $\Delta G_{\text{rxn}}^\circ$ change if the purple molecules represented H_2 and the blue I_2 ? Explain.

20.104 A key step in the metabolism of glucose for energy is the isomerization of glucose-6-phosphate (G6P) to fructose-6-phosphate (F6P): $\text{G6P} \rightleftharpoons \text{F6P}; K = 0.510$ at 298 K. (a) Calculate ΔG° at 298 K.

- (b) Calculate ΔG when Q , the [F6P]/[G6P] ratio, equals 10.0.
 (c) Calculate ΔG when $Q = 0.100$.
 (d) Calculate Q if $\Delta G = -2.50 \text{ kJ/mol}$.

20.105 A chemical reaction, such as HI forming from its elements, can reach equilibrium at many temperatures. In contrast, a phase change, such as ice melting, is in equilibrium at a given pressure and temperature. Each of the graphs below depicts G_{sys} vs. extent of change. (a) Which graph depicts how G_{sys} changes for the formation of HI? Explain. (b) Which graph depicts how G_{sys} changes as ice melts at 1°C and 1 atm? Explain.

20.106 When heated, the DNA double helix separates into two random coil single strands. When cooled, the random coils re-form the double helix: double helix \rightleftharpoons 2 random coils.

- (a) What is the sign of ΔS for the forward process? Why?
 (b) Energy must be added to break H bonds and overcome dispersion forces between the strands. What is the sign of ΔG for the forward process when $T\Delta S$ is smaller than ΔH ?
 (c) Write an expression for T in terms of ΔH and ΔS when the reaction is at equilibrium. (This temperature is called the *melting temperature* of the nucleic acid.)

20.107 In the process of respiration, glucose is oxidized completely. In fermentation, O_2 is absent and glucose is broken down to ethanol and CO_2 . Ethanol is oxidized to CO_2 and H_2O .

- (a) Balance the following equations for these processes:

- (b) Calculate $\Delta G_{\text{rxn}}^\circ$ for respiration of 1.00 g of glucose.

- (c) Calculate $\Delta G_{\text{rxn}}^\circ$ for fermentation of 1.00 g of glucose.

- (d) Calculate $\Delta G_{\text{rxn}}^\circ$ for oxidation of the ethanol from part (c).

20.108 Consider the formation of ammonia:

- (a) Assuming that ΔH° and ΔS° are constant with temperature, find the temperature at which $K_p = 1.00$.
 (b) Find K_p at 400°C , a typical temperature for NH_3 production.
 (c) Given the lower K_p at the higher temperature, why are these conditions used industrially?

20.109 Kyanite, sillimanite, and andalusite all have the formula Al_2SiO_5 . Each is stable under different conditions (see the graph below). At the point where the three phases intersect:

- (a) Which mineral, if any, has the lowest free energy?
 (b) Which mineral, if any, has the lowest enthalpy?
 (c) Which mineral, if any, has the highest entropy?
 (d) Which mineral, if any, has the lowest density?

20.110 Acetylene is produced commercially by the partial oxidation of methane. At 1500°C and pressures of 1–10 bar, the yield of acetylene is about 20%. The major side product is carbon monoxide, and some soot and carbon dioxide also form.

- (a) At what temperature is the desired reaction spontaneous?

- (b) Acetylene can also be made by the reaction of its elements, carbon (graphite) and hydrogen. At what temperature is this formation reaction spontaneous?

- (c) Why must this reaction mixture be immediately cooled?

20.111 Synthesis gas, a mixture that includes the fuels CO and H_2 , is used to produce liquid hydrocarbons and methanol. It is made at pressures up to 100 atm by oxidation of methane followed by the steam re-forming and water-gas shift reactions. Because the process is exothermic, temperatures reach 950 – 1100°C , and the conditions are such that the amounts of H_2 , CO, CO_2 , CH_4 , and H_2O leaving the reactor are close to the equilibrium amounts for the steam re-forming and water-gas shift reactions:

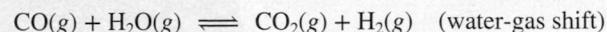

- (a) At 1000°C , what are ΔG° and ΔH° for the steam re-forming reaction and for the water-gas shift reaction?

- (b) By doubling the steam re-forming step and adding it to the water-gas shift step, we obtain the following combined reaction:

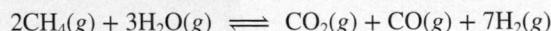

Is this reaction spontaneous at 1000°C in the standard state?

- (c) Is it spontaneous at 98 atm and 50% conversion (when 50% of the starting materials have reacted)?

- (d) Is it spontaneous at 98 atm and 90% conversion?

21

Electrochemistry: Chemical Change and Electrical Work

21.1 Redox Reactions and Electrochemical Cells

Oxidation-Reduction Review
Half-Reaction Method for Balancing
Redox Reactions
Electrochemical Cells

21.2 Voltaic Cells: Using Spontaneous Reactions to Generate Electrical Energy

Cell Construction and Operation
Cell Notation
Why Does the Cell Work?

21.3 Cell Potential: Output of a Voltaic Cell

Standard Cell Potential (E_{cell}°)

Strengths of Oxidizing and Reducing Agents

Writing Spontaneous Redox Reactions
Explaining the Activity Series

21.4 Free Energy and Electrical Work

E_{cell}° and the Equilibrium Constant
Effect of Concentration on E_{cell}
Following Changes in E_{cell}
Concentration Cells

21.5 Electrochemical Processes in Batteries

Primary (Nonrechargeable) Batteries
Secondary (Rechargeable) Batteries
Fuel Cells

21.6 Corrosion: An Environmental Voltaic Cell

Corrosion of Iron
Protecting Against Corrosion

21.7 Electrolytic Cells: Using Electrical Energy to Drive Nonspontaneous Reactions

Cell Construction and Operation
Predicting Electrolysis Products
Stoichiometry of Electrolysis

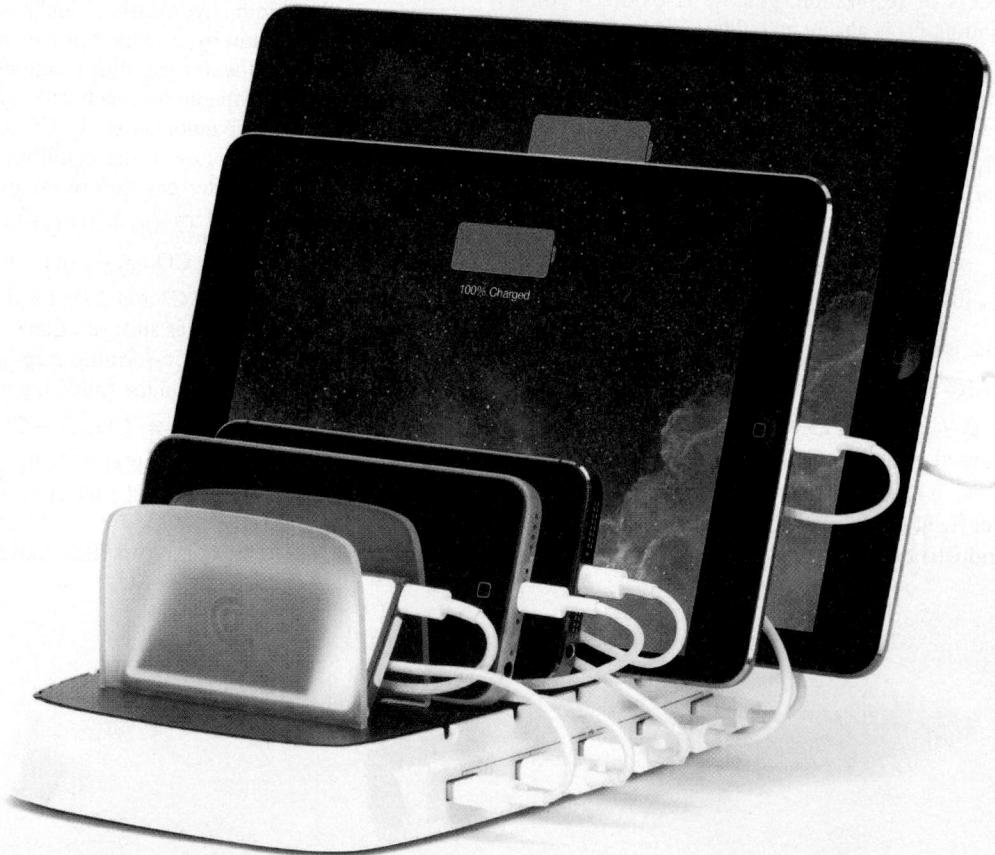

Source: © Griffin Technology

Concepts and Skills to Review Before You Study This Chapter

- › redox terminology (Section 4.5)
- › activity series of the metals (Section 4.6)
- › trends in ionization energy (Section 8.3) and electronegativity (Section 9.5)
- › free energy, work, and equilibrium (Sections 20.3 and 20.4)
- › Q vs. K (Section 17.4) and ΔG vs. ΔG° (Section 20.4)

Thermodynamics has countless applications. Some are probably at your fingertips right now: a laptop computer or tablet, MP3 player, or smart phone. These are a few of the objects you use every day that rely on a major field in applied thermodynamics called **electrochemistry**, the study of the relationship between chemical change and electrical work. This field relies on **electrochemical cells**, systems that incorporate a redox reaction to produce or utilize electrical energy.

IN THIS CHAPTER . . . We examine the essential features of electrochemical cells and quantify the relationship between free energy and electrical work.

- › We review oxidation-reduction (redox) reactions and describe a method for balancing redox reactions that take place in electrochemical cells.
- › We highlight key differences between the two types of electrochemical cells.
- › We focus on voltaic cells, which *release* free energy to do electrical work, and see how they operate as a combination of two half-cells.
- › We calculate the voltage, the cell's electrical potential, which is the sum of the voltages of the half-cells.
- › We use half-cell voltages to determine the relative strengths of redox couples and to write spontaneous redox equations.
- › We examine the interdependence of the standard free energy change, the standard cell potential, and the equilibrium constant.
- › We follow the change in voltage as a voltaic cell operates.
- › We see how differences in concentration between the solutions in the half-cells can be harnessed to generate electricity.
- › We analyze the makeup and operation of some major types of batteries.
- › We describe the problem of corrosion, which has key similarities to the operation of voltaic cells.
- › We examine electrolytic cells, which *absorb* free energy from an external source to do electrical work. We predict the products that form under different conditions and quantify the relation between charge and amount of substance.
- › We explore the redox system that generates energy in living cells.

21.1 REDOX REACTIONS AND ELECTROCHEMICAL CELLS

To begin, we review the oxidation-reduction process that we covered in Chapter 4 and describe the *half-reaction method* of balancing redox reactions. Then we see how redox reactions are used in the two types of electrochemical cells.

A Quick Review of Oxidation-Reduction Concepts

All electrochemical processes involve the *movement of electrons from one chemical species to another* in an oxidation-reduction (redox) reaction. In any redox process:

- *Oxidation* is the loss of electrons, and *reduction* is the gain of electrons. Oxidation and reduction occur *simultaneously*.

- The *oxidizing agent* does the oxidizing by *taking electrons* from the substance being oxidized. The *reducing agent* does the reducing by *giving electrons* to the substance being reduced. Therefore:

The oxidizing agent is reduced, and the reducing agent is oxidized.

- The oxidized substance ends up with a *higher* (more positive or less negative) oxidation number (O.N.), and the reduced substance ends up with a *lower* (less positive or more negative) O.N.
- The total number of electrons gained by the atoms/ions of the oxidizing agent equals the total number lost by the atoms/ions of the reducing agent.

Figure 21.1 presents these ideas for the aqueous reaction between zinc metal and H⁺ from a strong acid. Be sure you can identify the oxidation and reduction parts of a redox process. You may want to review the full discussion in Section 4.5.

Figure 21.1 A summary of redox terminology, as applied to the reaction of zinc with hydrogen ion.

Source: © McGraw-Hill Education/Stephen Frisch, photographer

PROCESS	$\begin{array}{ccccccc} 0 & +1 & & +2 & 0 \\ & & & & \\ \text{Zn(s)} & + 2\text{H}^+(\text{aq}) & \longrightarrow & \text{Zn}^{2+}(\text{aq}) & + \text{H}_2(\text{g}) \end{array}$	
OXIDATION	<ul style="list-style-type: none"> One reactant loses electrons. Reducing agent is oxidized. Oxidation number increases. 	Zinc loses electrons. Zinc is the reducing agent and becomes oxidized . The oxidation number of Zn increases from 0 to +2.
REDUCTION	<ul style="list-style-type: none"> Other reactant gains electrons. Oxidizing agent is reduced. Oxidation number decreases. 	Hydrogen ion gains electrons. Hydrogen ion is the oxidizing agent and becomes reduced . The oxidation number of H decreases from +1 to 0.

Half-Reaction Method for Balancing Redox Reactions

In Chapter 4, you learned how to determine the oxidation number of each element in a compound, how to identify oxidizing and reducing agents, and how to decide if a chemical change is a redox reaction. Now, let's see how to balance redox reactions. The **half-reaction method** is especially useful for studying electrochemistry:

- It *divides the overall redox reaction* into oxidation and reduction *half-reactions*, which, as you'll see, reflect their actual physical separation in electrochemical cells.
- It applies well to reactions in acidic or basic solution, which are common in cells.
- It (usually) does *not* require assigning O.N.s. (In cases where the half-reactions are not obvious, we assign O.N.s to determine which atoms undergo a change and write half-reactions with the species that contain those atoms.)

Steps in the Half-Reaction Method The balancing process begins with a "skeleton" ionic reaction that consists of only species that are oxidized and reduced. Here are the steps in the half-reaction method:

- Step 1. Divide the skeleton reaction into two half-reactions. Each half-reaction contains the oxidized and reduced forms of one of the species: *if the oxidized form of a species is on the left side, the reduced form must be on the right, and vice versa.*
- Step 2. Balance the atoms and charges in each half-reaction.
 - Atoms are balanced *in this order*: atoms other than O and H, then O, then H.
 - Charge is balanced by *adding electrons (e⁻) to the left side in the reduction half-reaction* because the reactant gains them and *to the right side in the oxidation half-reaction* because the reactant loses them.
- Step 3. If necessary, multiply one or both half-reactions by an integer so that

$$\text{number of e}^- \text{ gained in reduction} = \text{number of e}^- \text{ lost in oxidation}$$
- Step 4. Add the balanced half-reactions, and include states of matter.
- Step 5. Check that the atoms and charges are balanced.

Let's balance a redox reaction that occurs in acidic solution and then see how to balance one in basic solution in Sample Problem 21.1.

Balancing Redox Reactions in Acidic Solution For a reaction in acidic solution, H₂O molecules and H⁺ ions are present for the balancing. We've usually used H₃O⁺ to represent the proton in water, but we use H⁺ in this chapter because it makes the balancing simpler. To make that point, we'll also balance this first reaction with H₃O⁺ to show that the only difference is in the number of water molecules.

The reaction between dichromate ion and iodide ion to form chromium(III) ion and solid iodine occurs in acidic solution (see photo). The skeleton ionic reaction is

Step 1. Divide the reaction into half-reactions. Each half-reaction contains the oxidized and reduced forms of one species:

Step 2. Balance atoms and charges in each half-reaction. We use H₂O to balance O, H⁺ to balance H, and e⁻ to balance charges.

For the Cr₂O₇²⁻/Cr³⁺ half-reaction:

- a. *Balance atoms other than O and H.* We balance the two Cr in Cr₂O₇²⁻ on the left with a coefficient of 2 on the right:

- b. *Balance O atoms by adding H₂O molecules.* Each H₂O has one O atom, so we add seven H₂O on the right to balance the seven O in Cr₂O₇²⁻:

- c. *Balance H atoms by adding H⁺ ions.* Each H₂O contains two H, and we added seven H₂O, so we add 14 H⁺ ions on the left:

- d. *Balance charge by adding electrons.* Each H⁺ ion has a 1+ charge, and 14 H⁺ plus the 2- of Cr₂O₇²⁻ gives 12+ on the left. Two Cr³⁺ give 6+ on the right. There is an excess of 6+ on the left, so we add six e⁻ on the left:

This half-reaction is balanced. We note that

- it is the *reduction* because electrons appear on the *left, as a reactant*;
- Cr₂O₇²⁻ gains electrons (is reduced), so Cr₂O₇²⁻ is the *oxidizing agent*;
- the O.N. of Cr decreases from +6 on the left to +3 on the right.

For the I⁻/I₂ half-reaction:

- a. *Balance atoms other than O and H.* Two I atoms on the right require a coefficient of 2 on the left:

- b. *Balance O atoms with H₂O.* Not needed; there are no O atoms.

- c. *Balance H atoms with H⁺.* Not needed; there are no H atoms.

- d. *Balance charge with e⁻.* To balance the 2- on the left, we add two e⁻ on the right:

This half-reaction is balanced. We see that

- it is the *oxidation* because electrons appear on the *right, as a product*;
- the reactant I⁻ loses electrons (is oxidized), so I⁻ is the *reducing agent*;
- the O.N. of I increases from -1 to 0.

Step 3. Multiply each half-reaction, if necessary, by an integer so that the number of e⁻ lost in the oxidation equals the number of e⁻ gained in the reduction. Two e⁻ are

Dichromate ion (left) and iodide ion (center) form chromium(III) ion and solid iodine (right).

Source: © McGraw-Hill Education/Stephen Frisch, photographer

lost in the oxidation and six e^- are gained in the reduction, so we multiply the oxidation by 3:

Step 4. Add the half-reactions, canceling species that appear on both sides, and include states of matter. In this example, only the electrons cancel:

Step 5. Check that atoms and charges balance:

Using H_3O^+ , Instead of H^+ , to Balance H Now let's see what happens if we use H_3O^+ to supply H atoms, instead of H^+ . In step 2 for the reduction half-reaction, balancing Cr atoms and balancing O atoms with H_2O are the same as before, so we have

Now we use H_3O^+ to balance H atoms. Because each H_3O^+ is an H^+ bonded to an H_2O , we balance the 14 H on the right with 14 H_3O^+ on the left and immediately add 14 more H_2O on the right:

Taking the sum of the H_2O molecules on the right gives

None of this affects the redox change, so balancing the charge still requires six e^- on the left, and we obtain the balanced reduction half-reaction:

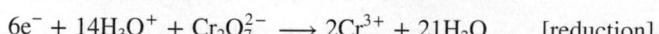

Adding the balanced oxidation half-reaction gives the balanced redox equation:

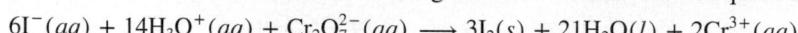

Note that, as mentioned earlier, the only difference is the number of H_2O molecules: 21 H_2O instead of 7 H_2O . So, even though this approach uses H_3O^+ , which shows more accurately how H^+ exists, only the number of water molecules changes and the balancing involves more steps. Therefore, we'll continue to use H^+ to balance H atoms in these equations.

Balancing Redox Reactions in Basic Solution In acidic solution, H_2O molecules and H^+ ions are available to balance a redox reaction, but in basic solution, H_2O molecules and OH^- ions are available.

We need only one additional step to balance a redox reaction that takes place in basic solution. It appears after we balance the half-reactions *as if they occur in acidic solution* and are combined (step 4). At this point, *we add one OH^- to both sides of the equation for every H^+ present*. (This step is labeled “4 Basic” in Sample Problem 21.1.) The OH^- ions added on the side with H^+ ions combine with them to form H_2O molecules, while the OH^- on the other side remain in the equation, and then excess H_2O is canceled.

Student Hot Spot

Student data indicate that you may struggle with balancing redox reactions in basic solution. Access the Smartbook to view additional Learning Resources on this topic.

SAMPLE PROBLEM 21.1

Balancing a Redox Reaction in Basic Solution

Problem Permanganate ion reacts in basic solution with oxalate ion to form carbonate ion and solid manganese dioxide. Balance the skeleton ionic equation for the reaction between $NaMnO_4$ and $Na_2C_2O_4$ in basic solution:

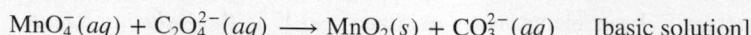

Plan We follow the numbered steps as described in text, and proceed through step 4 as if this reaction occurs in acidic solution. Then, we add the appropriate number of OH^- ions and cancel excess H_2O molecules (see “4 Basic”).

Solution

1. Divide into half-reactions.

2. Balance.

- a. Atoms other than O and H.
Not needed.

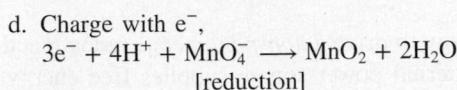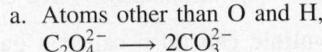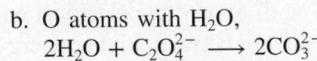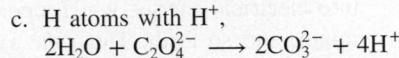

3. Multiply each half-reaction, if necessary, by some integer to make e^- lost equal e^- gained.

4. Add half-reactions, and cancel species appearing on both sides.

The six e^- cancel, eight H^+ cancel to leave four H^+ on the right, and four H_2O cancel to leave two H_2O on the left:

- 4 Basic. Add OH^- to both sides to neutralize the H^+ present, and cancel excess H_2O .

Adding four OH^- to both sides forms four H_2O on the right. Two of those cancel the two H_2O on the left and leave two H_2O on the right:

Including states of matter gives the final balanced equation:

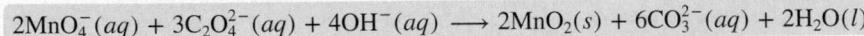

5. Check that atoms and charges balance.

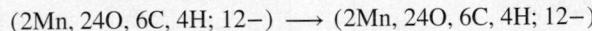

Comment As a final step, let's see how to obtain the balanced *molecular* equation for this reaction. We note the amount (mol) of each anion in the balanced ionic equation and add the correct amount (mol) of spectator ions (in this case, Na^+ , as given in the problem statement) to obtain neutral compounds. The balanced molecular equation is

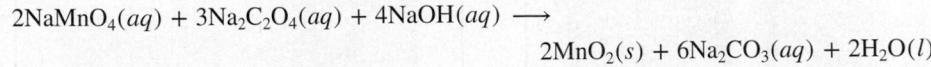**FOLLOW-UP PROBLEMS**

Brief Solutions to all Follow-up Problems appear at the end of the chapter.

21.1A Write a balanced molecular equation for the reaction between KMnO_4 and KI in basic solution. The skeleton ionic reaction is

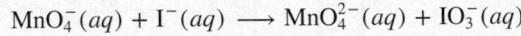

21.1B Write a balanced molecular equation for the reaction between chromium(III) hydroxide and sodium iodate in basic solution. The skeleton ionic reaction is

SOME SIMILAR PROBLEMS 21.12–21.19

An Overview of Electrochemical Cells

The fundamental difference between the two types of electrochemical cells is based on whether the overall redox reaction in the cell is spontaneous (free energy is released) or nonspontaneous (free energy is absorbed):

1. A **voltaic cell** (also called a **galvanic cell**) uses a *spontaneous* redox reaction ($\Delta G < 0$) to generate electrical energy. In the cell reaction, some of the difference in free energy between higher energy reactants and lower energy products is converted into electrical energy, which operates the load—flashlight, MP3 player, car starter motor, and so forth. Thus, *the system does work on the surroundings (load)*. All batteries contain voltaic cells.
2. An **electrolytic cell** uses electrical energy to drive a *nonspontaneous* redox reaction ($\Delta G > 0$). In the cell reaction, an external power source supplies free energy to convert lower energy reactants into higher energy products. Thus, *the surroundings (power supply) do work on the system*. Electroplating and the recovery of metals from ores utilize electrolytic cells.

The two types of cell have several similarities. Two **electrodes**, which conduct the electricity between cell and surroundings, are dipped into an **electrolyte**, a mixture of ions (usually in aqueous solution) that are involved in the reaction or that carry the charge (Figure 21.2). An electrode is identified as either **anode** or **cathode** depending on the half-reaction that takes place there:

- *The oxidation half-reaction occurs at the anode.* Electrons lost by the substance being oxidized (reducing agent) *leave the oxidation half-cell* at the anode.
- *The reduction half-reaction occurs at the cathode.* Electrons gained by the substance being reduced (oxidizing agent) *enter the reduction half-cell* at the cathode. ↪

Note that, for reasons we discuss shortly, *the relative charges of the electrodes are opposite in sign* in the two types of cell.

Figure 21.2 General characteristics of (A) voltaic cells and (B) electrolytic cells.

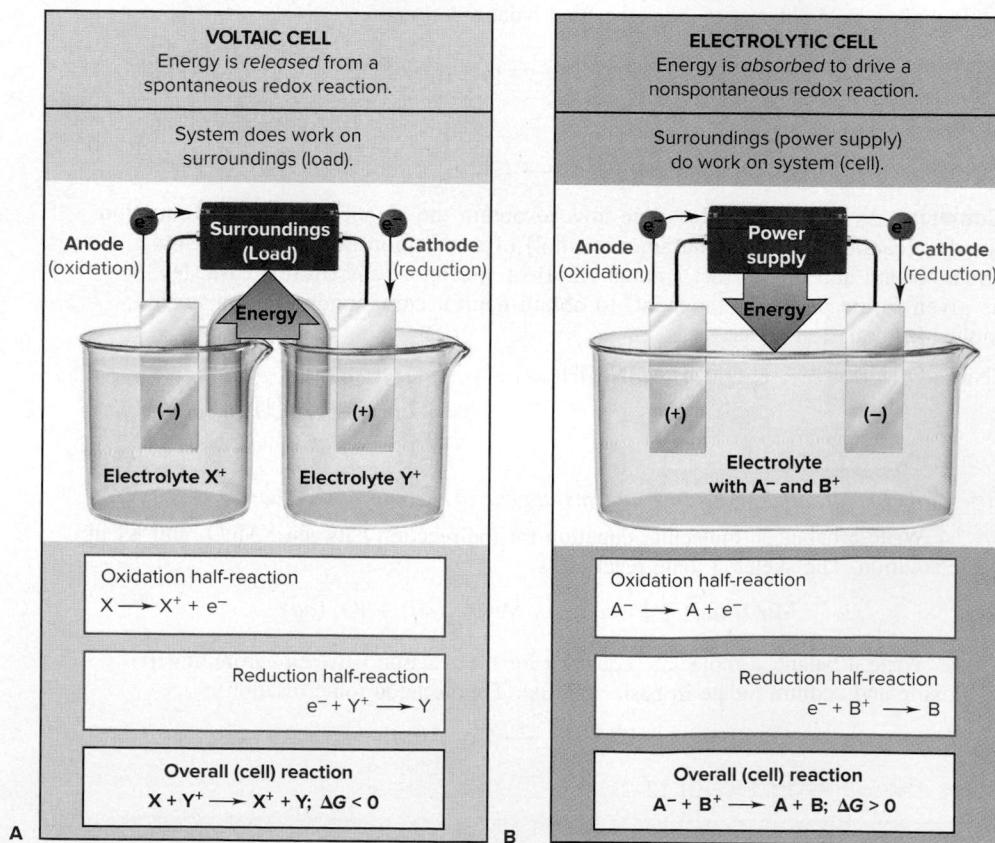

Which Half-Reaction Occurs at Which Electrode?

Here are some memory aids to help you remember which half-reaction occurs at which electrode:

1. The words *anode* and *oxidation* start with vowels; the words *cathode* and *reduction* start with consonants.
2. Alphabetically, the *A* in anode comes before the *C* in cathode, and the *O* in oxidation comes before the *R* in reduction.
3. Look at the first syllables and use your imagination:
ANode, OXidation; REDUction,
CAThode \Rightarrow AN OX and a RED CAT

› Summary of Section 21.1

- › An oxidation-reduction (redox) reaction involves the transfer of electrons from a reducing agent to an oxidizing agent.
- › The half-reaction method of balancing divides the overall reaction into half-reactions that are balanced separately and then recombined.
- › There are two types of electrochemical cells. In a voltaic cell, a spontaneous reaction generates electricity and does work on the surroundings. In an electrolytic cell, the surroundings supply electricity that does work to drive a nonspontaneous reaction.
- › In both types of cell, two electrodes dip into electrolyte solutions; oxidation occurs at the anode, and reduction occurs at the cathode.

21.2 VOLTAIC CELLS: USING SPONTANEOUS REACTIONS TO GENERATE ELECTRICAL ENERGY

When you put a strip of zinc metal in a solution of Cu^{2+} ion, the blue color of the solution fades and a brown-black crust of copper metal forms on the zinc strip (Figure 21.3). During this spontaneous reaction, Cu^{2+} ion (blue in color) is reduced to Cu metal, while Zn metal is oxidized to Zn^{2+} ion (colorless). The overall reaction consists of two half-reactions:

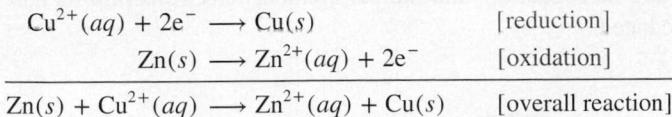

Let's examine this spontaneous reaction as the basis of a voltaic cell.

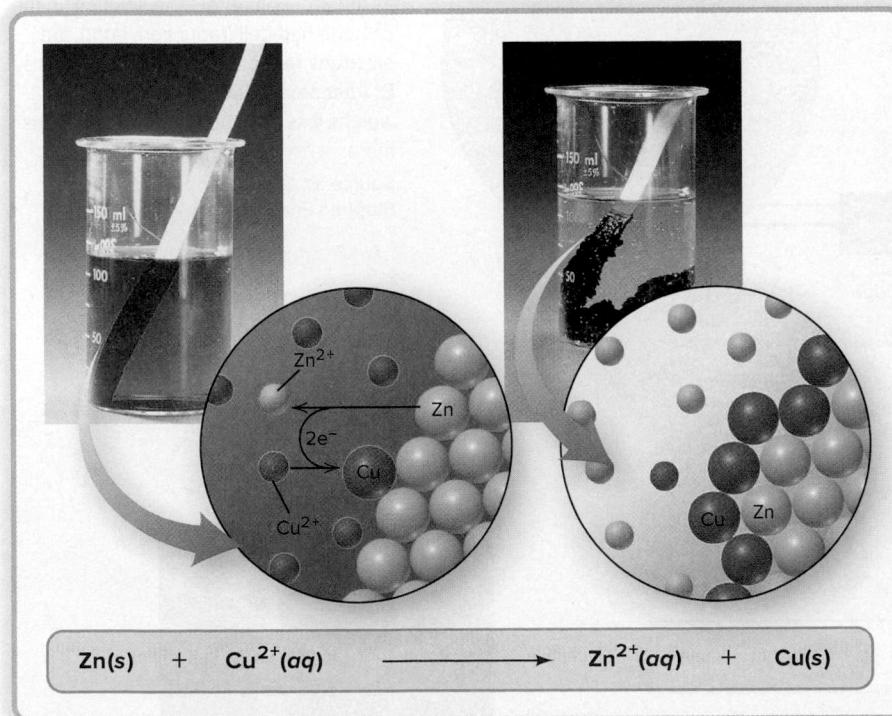

Figure 21.3 The spontaneous reaction between zinc and copper(II) ion. When zinc metal is placed in a solution of Cu^{2+} ion (left), zinc is oxidized to Zn^{2+} , and Cu^{2+} is reduced to copper metal (right). (The very finely divided Cu appears black.)

Source: © McGraw-Hill Education/Stephen Frisch, photographer

Construction and Operation of a Voltaic Cell

Electrons are being transferred in the Zn/Cu²⁺ reaction, but the system does not generate electrical energy because the oxidizing agent (Cu²⁺) and the reducing agent (Zn) are in the *same* beaker. If, however, we physically separate the half-reactions and connect them by an external circuit, the electrons lost by the zinc produce an electric current as they travel through the circuit toward the copper ions that gain them.

Basis of the Voltaic Cell: Separation of Half-Reactions In any voltaic cell, the components of each half-reaction are placed in a separate container, or **half-cell**, which consists of one electrode dipping into an electrolyte solution (Figure 21.4A). The two half-cells are joined by the external circuit, and a voltmeter measures the voltage generated. A switch (not shown) closes (completes) or opens (breaks) the circuit. Here are some key points about the half-cells of the Zn/Cu²⁺ voltaic cell:

1. *Oxidation half-cell (anode compartment, always shown on the left).* The anode compartment consists of a bar of zinc (the anode) immersed in a Zn²⁺ electrolyte (such as aqueous zinc sulfate, ZnSO₄). Zinc metal is the reactant in the oxidation half-reaction, and the bar loses electrons *and* conducts them *out of* this half-cell.
2. *Reduction half-cell (cathode compartment, always shown on the right).* The cathode compartment consists of a bar of copper (the cathode) immersed in a Cu²⁺ electrolyte [such as aqueous copper(II) sulfate, CuSO₄]. Copper is the product in the reduction half-reaction, and the bar conducts electrons *into* its half-cell, where Cu²⁺ is reduced.

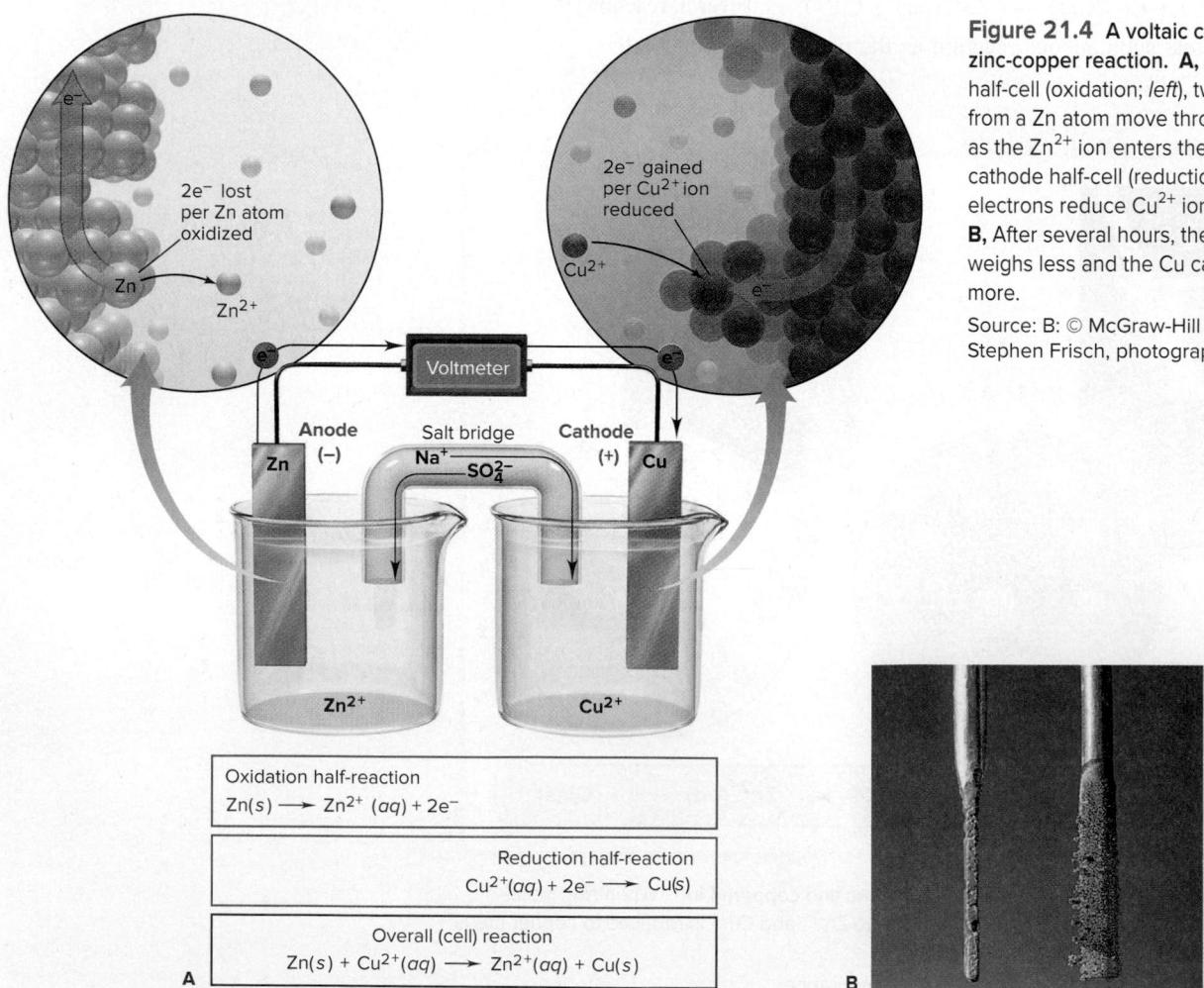

Figure 21.4 A voltaic cell based on the zinc-copper reaction. **A**, In the anode half-cell (oxidation; *left*), two electrons from a Zn atom move through the Zn bar as the Zn²⁺ ion enters the solution. In the cathode half-cell (reduction; *right*), the electrons reduce Cu²⁺ ions to Cu atoms. **B**, After several hours, the Zn anode weighs less and the Cu cathode weighs more.

Source: B: © McGraw-Hill Education/
Stephen Frisch, photographer

Charges of the Electrodes The charges of the electrodes are determined by the source of electrons and the direction of electron flow through the circuit. In this cell, Zn atoms are oxidized at the anode to Zn^{2+} ions and are the source of electrons. The Zn^{2+} ions enter the half-cell's electrolyte, while the electrons move through the bar and into the wire. The electrons flow left to right through the wire to the cathode, where Cu^{2+} ions in this half-cell's electrolyte are reduced to Cu atoms. As the cell operates, electrons are continuously generated at the anode and consumed at the cathode. Therefore, the anode has an excess of electrons and the cathode has a deficit of electrons: *in any voltaic cell, the anode is negative relative to the cathode.*

Completing the Circuit with a Salt Bridge A cell cannot operate unless the circuit is complete. The oxidation half-cell initially contains a neutral solution of Zn^{2+} and SO_4^{2-} ions, but as Zn atoms in the bar lose electrons, the Zn^{2+} ions that form enter the solution and would give it a net positive charge. Similarly, in the reduction half-cell, the initial neutral solution of Cu^{2+} and SO_4^{2-} ions would develop a net negative charge as Cu^{2+} ions leave the solution and form Cu atoms. If allowed to occur, such a charge imbalance between the half-cells would stop cell operation.

This situation is avoided by use of a **salt bridge**. It joins the half-cells and acts like a “liquid wire,” allowing ions to flow through both compartments and complete the circuit while keeping the electrolyte solutions neutral. The salt bridge is an inverted U tube containing nonreacting ions, such as Na^+ and SO_4^{2-} , dissolved in a gel, which does not flow out of the tube but allows ions to diffuse into or out of the half-cells:

- *Maintaining a neutral reduction half-cell (right; cathode compartment).* As Cu^{2+} ions change to Cu atoms, Na^+ ions move from the salt bridge into the electrolyte solution (and some SO_4^{2-} ions move from the solution into the salt bridge).
- *Maintaining a neutral oxidation half-cell (left; anode compartment).* As Zn atoms change to Zn^{2+} ions, SO_4^{2-} ions move from the salt bridge into the electrolyte solution (and some Zn^{2+} ions move from the solution into the salt bridge).

Thus, the wire and the salt bridge complete the circuit:

- Electrons move left to right through the wire.
- Anions move right to left through the salt bridge into the anode half-cell.
- Cations move left to right through the salt bridge into the cathode half-cell.

Active vs. Inactive Electrodes The electrodes in the Zn/Cu^{2+} cell are *active* because the metals themselves are components of the half-reactions. As the cell operates, the mass of the zinc bar gradually decreases, as the $[Zn^{2+}]$ in the anode half-cell increases. At the same time, the mass of the copper bar increases as the $[Cu^{2+}]$ in the cathode half-cell decreases and the ions form atoms that “plate out” on the electrode (Figure 21.4B).

In many cases, however, there are no reaction components that can be physically used as an electrode, so *inactive* electrodes are used. Most commonly, inactive electrodes are rods of *graphite* or *platinum*. In a voltaic cell based on the following half-reactions, for instance, the reacting species cannot be made into electrodes:

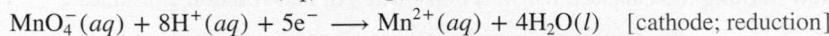

Each half-cell consists of an inactive electrode immersed in an electrolyte that contains all the reactant species involved in that half-reaction (Figure 21.5):

- In the *anode half-cell*, I^- ions are oxidized to solid I_2 , and the released electrons flow into the graphite (C) electrode and through the wire.
- From the wire, the electrons enter the graphite electrode in the *cathode half-cell* and reduce MnO_4^- ions to Mn^{2+} ions. (A KNO_3 salt bridge is used.)

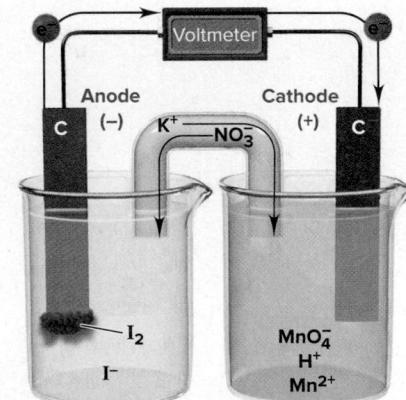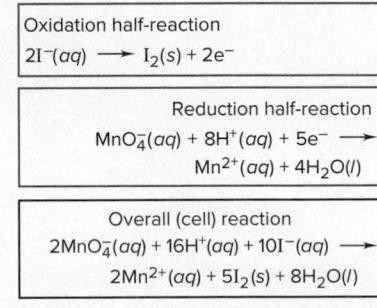

Figure 21.5 A voltaic cell using inactive electrodes.

Diagram of a Voltaic Cell As Figures 21.4A and 21.5 show, there are certain consistent features in the *diagram* of any voltaic cell:

- Components of the half-cells include electrode materials, electrolyte ions, and other species involved in the reaction.
- Electrode name (anode or cathode) and charge are shown. By convention, the anode compartment appears *on the left*.
- Each half-reaction and the overall cell reaction are given.
- Direction of electron flow in the external circuit is from left to right.
- Nature of ions and direction of ion flow in the salt bridge are shown, with cations moving right and anions moving left.

Notation for a Voltaic Cell

A useful shorthand notation describes the components of a voltaic cell. The notation for the Zn/Cu²⁺ cell is

Key parts of the notation are as follows:

- The components of the anode compartment (oxidation half-cell) are written *to the left* of the components of the cathode compartment (reduction half-cell).
- A double vertical line indicates the half-cells are physically separated.
- A single vertical line represents a phase boundary. For example, $\text{Zn}(s) \mid \text{Zn}^{2+}(aq)$ indicates that *solid* Zn is a *different* phase from *aqueous* Zn²⁺.
- A comma separates the half-cell components that are in the *same* phase. For example, the notation for the voltaic cell shown in Figure 21.5 is

That is, in the cathode compartment, MnO₄⁻, H⁺, and Mn²⁺ ions are in an aqueous solution with solid graphite immersed in it.

- If needed, the concentrations of dissolved components are given in parentheses; for example, if the concentrations of Zn²⁺ and Cu²⁺ are 1 M, we write

- Half-cell components usually appear in the same order as in the half-reaction, and electrodes appear at the far left (anode) and far right (cathode) of the notation.
- Ions in the salt bridge are not part of the reaction so they are not in the notation.

SAMPLE PROBLEM 21.2

Describing a Voltaic Cell with a Diagram and Notation

Problem Draw a diagram, show balanced half-cell and cell equations, and write the notation for a voltaic cell that consists of one half-cell with a Cr bar in a Cr(NO₃)₃ solution, another half-cell with an Ag bar in an AgNO₃ solution, and a KNO₃ salt bridge. Measurement indicates that the Cr electrode is negative relative to the Ag electrode.

Plan From the given contents of the half-cells, we write the half-reactions. To determine which is the anode compartment (oxidation) and which is the cathode (reduction), we note the relative electrode charges (which are based on the direction of the spontaneous redox reaction). Electrons are released into the anode during oxidation, so it has a negative charge. We are told that Cr is negative, so it is the anode and Ag is the cathode.

Solution Writing the balanced half-reactions. The Ag half-reaction consumes e⁻:

The Cr half-reaction releases e⁻:

Writing the balanced overall cell equation. We triple the reduction half-reaction to balance e⁻ and combine the half-reactions:

Determining direction of electron and ion flow. The released e^- in the Cr electrode (negative) flow through the external circuit to the Ag electrode (positive). As Cr^{3+} ions enter the anode electrolyte, NO_3^- ions enter from the salt bridge to maintain neutrality. As Ag^+ ions leave the cathode electrolyte and plate out on the Ag electrode, K^+ ions enter from the salt bridge to maintain neutrality. The cell diagram is shown in the margin. Writing the cell notation with the oxidation components on the left and the reduction components on the right:

Check Always be sure that the half-reactions and the cell reaction are balanced, the half-cells contain *all* components of the half-reactions, and the electron and ion flow are shown. You should be able to write the half-reactions from the cell notation as a check.

Comment The diagram of a voltaic cell relies on the *direction of the spontaneous reaction* to give the oxidation (anode; negative) and reduction (cathode; positive) half-reactions.

FOLLOW-UP PROBLEMS

21.2A In one half-cell of a voltaic cell, a graphite rod dips into an acidic solution of $\text{K}_2\text{Cr}_2\text{O}_7$ and $\text{Cr}(\text{NO}_3)_3$; in the other half-cell, a tin bar dips into a $\text{Sn}(\text{NO}_3)_2$ solution. A KNO_3 salt bridge joins the half-cells. The tin electrode is negative relative to the graphite. Diagram the cell, and write the balanced half-cell and cell equations and the cell notation.

21.2B In one half-cell of a voltaic cell, a graphite rod dips into an acidic solution of KClO_3 and KCl ; in the other half-cell, a nickel bar dips into a $\text{Ni}(\text{NO}_3)_2$ solution. A KNO_3 salt bridge joins the half-cells, and the graphite is positive relative to the nickel. Diagram the cell, and write balanced half-cell and cell equations and the cell notation.

SOME SIMILAR PROBLEMS 21.29–21.34

Why Does a Voltaic Cell Work?

What principles explain *how* the Zn/Cu^{2+} cell reaction takes place and *why* electrons flow in the direction they do? Let's examine what is happening when the switch is open and no reaction is occurring. In each half-cell, the metal electrode is in equilibrium with the metal ions in the electrolyte and the electrons within the metal:

Given the direction of the overall spontaneous reaction, Zn gives up its electrons more easily than Cu does; that is, Zn is a stronger reducing agent. Therefore, the equilibrium position of the Zn half-reaction lies farther to the right. We can think of the electrons in the Zn electrode as being subject to a greater “pressure” than those in the Cu electrode, a greater potential energy (referred to as *electrical potential*) ready to “push” them through the circuit. Close the switch, and electrons flow from the Zn to the Cu electrode to equalize this difference in electrical potential. The flow disturbs the equilibrium at each electrode. The Zn half-reaction shifts to the right to restore the electrons flowing out, and the Cu half-reaction shifts to the left to remove the electrons flowing in. Thus, *the spontaneous reaction occurs as a result of the different abilities of these metals to give up their electrons.*

Summary of Section 21.2

- › A voltaic cell consists of oxidation (anode) and reduction (cathode) half-cells, connected by a wire to conduct electrons and a salt bridge to maintain charge neutrality.
- › Electrons move from the anode (left) to the cathode (right), while cations move from the salt bridge into the cathode half-cell and anions move from the salt bridge into the anode half-cell.
- › The cell notation shows the species and their phases in each half-cell, as well as the direction of current flow.
- › A voltaic cell operates because species in the two half-cells differ in the tendency to lose electrons (strength as a reducing agent).

Electron Flow and Water Flow

Consider this analogy between electron “pressure” and water pressure. A U tube (cell) is separated into two arms (two half-cells) by a stopcock (switch), and the two arms contain water at different heights (the half-cells have different electrical potentials). Open the stopcock (close the switch), and the different heights (potential difference) become equal as water flows (electrons flow and current is generated).

21.3

CELL POTENTIAL: OUTPUT OF A VOLTAIC CELL

A voltaic cell converts the free energy change of a spontaneous reaction into the kinetic energy of electrons moving through an external circuit (electrical energy). This electrical energy is proportional to the *difference in electrical potential between the two electrodes*, which is called the **cell potential (E_{cell})**, the **voltage** of the cell, or the **electromotive force (emf)**.

Electrons flow spontaneously from the negative to the positive electrode, that is, toward the electrode with the more positive electrical potential. Thus, when the cell operates *spontaneously*, there is a *positive* cell potential:

$$E_{\text{cell}} > 0 \text{ for a spontaneous process}$$

(21.1)

- $E_{\text{cell}} > 0$ for a spontaneous reaction. The more positive E_{cell} is, the more work the cell can do, and the farther the reaction proceeds to the right as written.
- $E_{\text{cell}} < 0$ for a *nonspontaneous* cell reaction.
- $E_{\text{cell}} = 0$ when the reaction has reached equilibrium, so the cell can do no more work. (We return to these ideas in Section 21.4.)

Table 21.1 Voltages of Some Voltaic Cells

Voltaic Cell	Voltage (V)
Common alkaline flashlight battery	1.5
Lead-acid car battery (6 cells \approx 12 V)	2.1
Calculator battery (mercury)	1.3
Lithium-ion laptop battery	3.7
Electric eel (\sim 5000 cells in 6-ft eel = 750 V)	0.15
Nerve of giant squid (across cell membrane)	0.070

Standard Cell Potential (E_{cell}°)

The SI unit of electrical potential is the **volt (V)**, and the SI unit of electrical charge is the **coulomb (C)**. By definition, if two electrodes differ by 1 volt of electrical potential, 1 joule of energy is released (that is, 1 joule of work can be done) for each coulomb of charge that moves between the electrodes. That is,

$$1 \text{ V} = 1 \text{ J/C}$$

(21.2)

Table 21.1 lists the voltages of some commercial and natural voltaic cells.

The *measured* cell potential is affected by changes in concentration as the reaction proceeds and by energy losses from heating the cell and external circuit. Therefore, as with other thermodynamic quantities, to compare potentials of different cells, we obtain a **standard cell potential (E_{cell}°)**, which is measured at a specified temperature (usually 298 K) with no current flowing* and *all components in their standard states*: 1 atm for gases, 1 M for solutions, the pure solid for electrodes. For example, the zinc-copper cell produces 1.10 V when it operates at 298 K with $[\text{Zn}^{2+}] = [\text{Cu}^{2+}] = 1 \text{ M}$ (Figure 21.6):

Standard Electrode (Half-Cell) Potential ($E_{\text{half-cell}}^{\circ}$) Just as each half-reaction makes up part of the overall reaction, each half-cell (electrode) potential makes up a part of the overall cell potential. The **standard electrode potential ($E_{\text{half-cell}}^{\circ}$)** (or **standard half-cell potential**) is the electrical potential of a given half-reaction (half-cell compartment) with all components in their standard states.

By convention (and as reference tables list them), *standard electrode potentials refer to the half-reactions written as reductions*. (A list of these potentials, like that in Appendix D, is called an *emf series* or a *table of standard electrode potentials*.) For example, for the zinc-copper reaction, both the zinc half-reaction (E_{zinc}° , anode compartment) and the copper half-reaction ($E_{\text{copper}}^{\circ}$, cathode compartment) are written as reductions:

But, since the overall cell reaction involves the *oxidation* of zinc, not the *reduction* of Zn^{2+} , we can show what is actually occurring by reversing the zinc (anode) half-reaction:

*The tiny current required to operate modern digital voltmeters makes a negligible difference in the value of E_{cell}° .

Figure 21.6 Measuring the standard cell potential of a zinc-copper cell.

Source: © Richard Megna/Fundamental Photographs, NYC

Calculating E_{cell}° from $E_{\text{half-cell}}^{\circ}$ The overall redox reaction for the zinc-copper cell is the sum of its half-reactions:

Because electrons flow spontaneously from the negative to the positive electrode, the copper electrode (cathode) has a more positive $E_{\text{half-cell}}^{\circ}$ than the zinc electrode (anode). As you'll see shortly, to obtain a positive E_{cell}° for this spontaneous redox reaction, we subtract E_{zinc}° from $E_{\text{copper}}^{\circ}$:

$$E_{\text{cell}}^{\circ} = E_{\text{copper}}^{\circ} - E_{\text{zinc}}^{\circ}$$

We can generalize this result for any voltaic cell: *the standard cell potential is the standard electrode potential of the cathode (reduction) half-cell minus the standard electrode potential of the anode (oxidation) half-cell*:

$$E_{\text{cell}}^{\circ} = E_{\text{cathode(reduction)}}^{\circ} - E_{\text{anode(oxidation)}}^{\circ} \quad (21.3)$$

For a *spontaneous* reaction at standard conditions, this calculation gives $E_{\text{cell}}^{\circ} > 0$.

SAMPLE PROBLEM 21.3

Using $E_{\text{half-cell}}^{\circ}$ Values to Find E_{cell}°

Problem Balance the following skeleton ionic reaction, and calculate E_{cell}° to decide whether the reaction is spontaneous:

Plan We balance the skeleton reaction (see Sample Problem 21.1). Then, we look up the $E_{\text{half-cell}}^{\circ}$ values in Appendix D and use Equation 21.3 to find E_{cell}° . If E_{cell}° is positive, the reaction is spontaneous.

Solution Balancing the skeleton reaction:

Using $E_{\text{half-cell}}^{\circ}$ values to find E_{cell}° :

$$E_{\text{cell}}^{\circ} = E_{\text{cathode(reduction)}}^{\circ} - E_{\text{anode(oxidation)}}^{\circ} = 1.07 \text{ V} - 1.51 \text{ V} \\ = -0.44 \text{ V}; \text{not spontaneous}$$

Check Rounding to check the calculation: $1.00 \text{ V} - 1.50 \text{ V} = -0.50 \text{ V}$. A negative E_{cell}° indicates a nonspontaneous reaction.

FOLLOW-UP PROBLEMS

21.3A Balance the following skeleton ionic reaction, and calculate E_{cell}° to decide whether the reaction is spontaneous:

21.3B Balance the following skeleton ionic reaction, and calculate E_{cell}° to decide whether the reaction is spontaneous:

SOME SIMILAR PROBLEMS 21.42–21.45

Determining $E_{\text{half-cell}}^{\circ}$ with the Standard Hydrogen Electrode To compare half-cell potentials, we need to know the portion of E_{cell}° contributed by each half-cell. But, how can we find individual half-cell potentials if we can measure only the potential of the overall cell? We can do so because half-cell potentials, such as E_{zinc}° and $E_{\text{copper}}^{\circ}$, are measured *relative to* a standard reference half-cell, which has a standard electrode potential defined as zero ($E_{\text{reference}}^{\circ} \equiv 0.00 \text{ V}$). To find an unknown standard electrode potential ($E_{\text{unknown}}^{\circ}$), we construct a voltaic cell consisting of this reference half-cell and the unknown half-cell. Since $E_{\text{reference}}^{\circ}$ is zero, the overall E_{cell}° gives $E_{\text{unknown}}^{\circ}$.

The **standard reference half-cell** is a **standard hydrogen electrode**, which consists of a platinum electrode that has H_2 gas at 1 atm bubbling through it and is immersed in 1 M strong acid, which means 1 M $\text{H}^+(aq)$ [or $\text{H}_3\text{O}^+(aq)$]. Thus, the reference half-reaction is

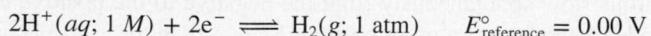

Depending on the unknown half-cell, the reference half-cell can be the anode or the cathode:

- When H_2 is oxidized, the reference half-cell is the anode, and so *reduction* occurs at the unknown half-cell:

$$E^\circ_{\text{cell}} = E^\circ_{\text{cathode}} - E^\circ_{\text{anode}} = E^\circ_{\text{unknown}} - E^\circ_{\text{reference}} = E^\circ_{\text{unknown}} - 0.00 \text{ V} = E^\circ_{\text{unknown}}$$

- When H^+ is reduced, the reference half-cell is the cathode, and so *oxidation* occurs at the unknown half-cell:

$$E^\circ_{\text{cell}} = E^\circ_{\text{cathode}} - E^\circ_{\text{anode}} = E^\circ_{\text{reference}} - E^\circ_{\text{unknown}} = 0.00 \text{ V} - E^\circ_{\text{unknown}} = -E^\circ_{\text{unknown}}$$

Figure 21.7 shows a voltaic cell that has the Zn/Zn^{2+} half-reaction in one compartment and the H^+/H_2 (or $\text{H}_3\text{O}^+/\text{H}_2$) half-reaction in the other. The zinc electrode is negative relative to the hydrogen electrode, so we know that the zinc is being oxidized and is the anode. The measured E°_{cell} is +0.76 V (the reaction is spontaneous), and we use this value to find the unknown standard electrode potential, E°_{zinc} :

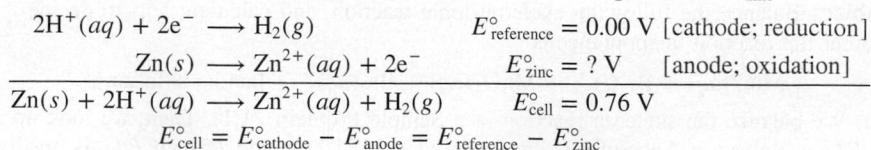

Solving for E°_{zinc} , the standard half-cell potential for $\text{Zn}^{2+} + 2\text{e}^- \longrightarrow \text{Zn}$, gives

$$E^\circ_{\text{zinc}} = E^\circ_{\text{reference}} - E^\circ_{\text{cell}} = 0.00 \text{ V} - 0.76 \text{ V} = -0.76 \text{ V}$$

Now we can return to the zinc-copper cell and use the measured E°_{cell} (1.10 V) and the value we just found for E°_{zinc} to calculate E°_{copper} :

$$\begin{aligned} E^\circ_{\text{cell}} &= E^\circ_{\text{cathode}} - E^\circ_{\text{anode}} = E^\circ_{\text{copper}} - E^\circ_{\text{zinc}} \\ \text{and,} \quad E^\circ_{\text{copper}} &= E^\circ_{\text{cell}} + E^\circ_{\text{zinc}} = 1.10 \text{ V} + (-0.76 \text{ V}) = 0.34 \text{ V} \end{aligned}$$

By continuing this process of constructing cells with one known and one unknown electrode potential, we find other standard electrode potentials.

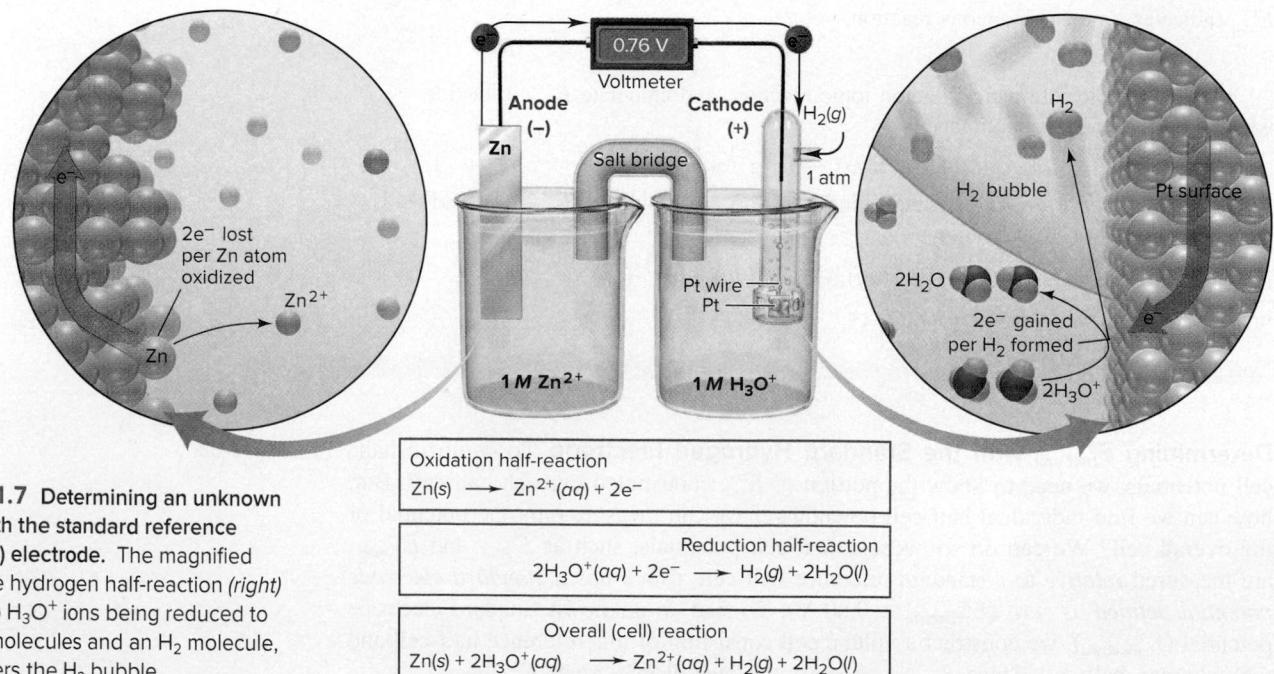

Figure 21.7 Determining an unknown $E^\circ_{\text{half-cell}}$ with the standard reference (hydrogen) electrode. The magnified view of the hydrogen half-reaction (right) shows two H_3O^+ ions being reduced to two H_2O molecules and an H_2 molecule, which enters the H_2 bubble.

SAMPLE PROBLEM 21.4**Calculating an Unknown $E_{\text{half-cell}}^{\circ}$ from E_{cell}°**

Problem A voltaic cell houses the reaction between aqueous bromine and zinc metal:

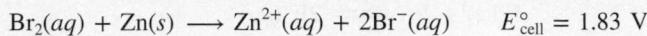

Calculate $E_{\text{bromine}}^{\circ}$, given $E_{\text{zinc}}^{\circ} = -0.76 \text{ V}$.

Plan E_{cell}° is positive, so the reaction is spontaneous as written. By dividing the reaction into half-reactions, we see that Br_2 is reduced and Zn is oxidized; thus, the zinc half-cell contains the anode. We use Equation 21.3 and the known E_{zinc}° to find $E_{\text{unknown}}^{\circ}$ ($E_{\text{bromine}}^{\circ}$).

Solution Dividing the reaction into half-reactions:

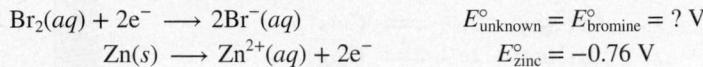

Calculating $E_{\text{bromine}}^{\circ}$:

$$\begin{aligned} E_{\text{cell}}^{\circ} &= E_{\text{cathode}}^{\circ} - E_{\text{anode}}^{\circ} = E_{\text{bromine}}^{\circ} - E_{\text{zinc}}^{\circ} \\ E_{\text{bromine}}^{\circ} &= E_{\text{cell}}^{\circ} + E_{\text{zinc}}^{\circ} = 1.83 \text{ V} + (-0.76 \text{ V}) = 1.07 \text{ V} \end{aligned}$$

Check A good check is to make sure that calculating $E_{\text{bromine}}^{\circ} - E_{\text{zinc}}^{\circ}$ gives E_{cell}° : $1.07 \text{ V} - (-0.76 \text{ V}) = 1.83 \text{ V}$.

Comment Keep in mind that, whichever half-cell potential is unknown, reduction is the cathode half-reaction and oxidation is the anode half-reaction. Always subtract E_{anode}° from $E_{\text{cathode}}^{\circ}$ to get E_{cell}° . (We use $E_{\text{bromine}}^{\circ}$ in Follow-up Problem 21.4A.)

FOLLOW-UP PROBLEMS

21.4A A voltaic cell based on the reaction between aqueous Br_2 and vanadium(III) ions has $E_{\text{cell}}^{\circ} = 0.73 \text{ V}$:

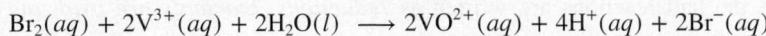

What is $E_{\text{vanadium}}^{\circ}$, the standard electrode potential for the reduction of VO^{2+} to V^{3+} ?

21.4B A voltaic cell based on the reaction between vanadium(III) and nitrate ions has $E_{\text{cell}}^{\circ} = 0.62 \text{ V}$:

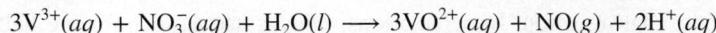

Use the value for $E_{\text{vanadium}}^{\circ}$ you obtained in Follow-up Problem 21.4A to find $E_{\text{nitrate}}^{\circ}$, the standard electrode potential for the reduction of NO_3^- to NO.

SOME SIMILAR PROBLEMS 21.38 and 21.39

Relative Strengths of Oxidizing and Reducing Agents

We learn the relative strengths of oxidizing and reducing agents from measuring cell potentials. Three oxidizing agents we just discussed are Cu^{2+} , H^+ , and Zn^{2+} . Let's rank, from high (*top*) to low (*bottom*), their relative oxidizing strengths by writing each half-reaction as a reduction (gain of electrons), with its corresponding standard electrode potential:

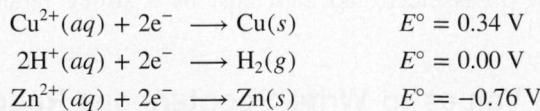

The more positive the E° value, the more readily the reaction (as written) occurs; thus, Cu^{2+} gains two e^- more readily than H^+ , which gains them more readily than Zn^{2+} :

- Strength as an oxidizing agent *decreases* top to bottom: $\text{Cu}^{2+} > \text{H}^+ > \text{Zn}^{2+}$.
- Strength as a reducing agent *increases* top to bottom: $\text{Zn} > \text{H}_2 > \text{Cu}$.

By continuing this process with other half-cells, we create a list of reduction half-reactions in *decreasing* order of standard electrode potential (from most positive

Table 21.2

Selected Standard Electrode Potentials (298 K)

Half-Reaction	$E^\circ_{\text{half-cell}} (\text{V})$
\uparrow Strength of oxidizing agent	
$\text{F}_2(\text{g}) + 2\text{e}^- \rightleftharpoons 2\text{F}^-(\text{aq})$	+2.87
$\text{Cl}_2(\text{g}) + 2\text{e}^- \rightleftharpoons 2\text{Cl}^-(\text{aq})$	+1.36
$\text{MnO}_2(\text{s}) + 4\text{H}^+(\text{aq}) + 2\text{e}^- \rightleftharpoons \text{Mn}^{2+}(\text{aq}) + 2\text{H}_2\text{O}(\text{l})$	+1.23
$\text{NO}_3^-(\text{aq}) + 4\text{H}^+(\text{aq}) + 3\text{e}^- \rightleftharpoons \text{NO}(\text{g}) + 2\text{H}_2\text{O}(\text{l})$	+0.96
$\text{Ag}^+(\text{aq}) + \text{e}^- \rightleftharpoons \text{Ag}(\text{s})$	+0.80
$\text{Fe}^{3+}(\text{aq}) + \text{e}^- \rightleftharpoons \text{Fe}^{2+}(\text{aq})$	+0.77
$\text{O}_2(\text{g}) + 2\text{H}_2\text{O}(\text{l}) + 4\text{e}^- \rightleftharpoons 4\text{OH}^-(\text{aq})$	+0.40
$\text{Cu}^{2+}(\text{aq}) + 2\text{e}^- \rightleftharpoons \text{Cu}(\text{s})$	+0.34
$2\text{H}^+(\text{aq}) + 2\text{e}^- \rightleftharpoons \text{H}_2(\text{g})$	0.00
$\text{N}_2(\text{g}) + 5\text{H}^+(\text{aq}) + 4\text{e}^- \rightleftharpoons \text{N}_2\text{H}_5^+(\text{aq})$	-0.23
$\text{Fe}^{2+}(\text{aq}) + 2\text{e}^- \rightleftharpoons \text{Fe}(\text{s})$	-0.44
$\text{Zn}^{2+}(\text{aq}) + 2\text{e}^- \rightleftharpoons \text{Zn}(\text{s})$	-0.76
$2\text{H}_2\text{O}(\text{l}) + 2\text{e}^- \rightleftharpoons \text{H}_2(\text{g}) + 2\text{OH}^-(\text{aq})$	-0.83
$\text{Na}^+(\text{aq}) + \text{e}^- \rightleftharpoons \text{Na}(\text{s})$	-2.71
$\text{Li}^+(\text{aq}) + \text{e}^- \rightleftharpoons \text{Li}(\text{s})$	-3.05
\downarrow Strength of reducing agent	

to most negative), as in Appendix D; a few examples are presented in Table 21.2. There are several key points to keep in mind:

- All values are relative to the standard hydrogen (reference) electrode.
- Since the half-reactions are written as *reductions*, reactants are oxidizing agents and products are reducing agents.
- The more positive the $E^\circ_{\text{half-cell}}$, the more readily the half-reaction occurs, as written.
- Half-reactions are shown with an equilibrium arrow because each can occur as a reduction (at the cathode) or an oxidation (at the anode), depending on the $E^\circ_{\text{half-cell}}$ of the other half-reaction. In calculations, always use $E^\circ_{\text{half-cell}}$ for the half-reaction *written as a reduction*.
- As Appendix D (or Table 21.2) is arranged, the strength of the oxidizing agent (reactant) *increases going up (bottom to top)*, and the strength of the reducing agent (product) *increases going down (top to bottom)*.

Thus, $\text{F}_2(\text{g})$ is the strongest oxidizing agent (has the largest positive E°), which means $\text{F}^-(\text{aq})$ is the weakest reducing agent. Similarly, $\text{Li}^+(\text{aq})$ is the weakest oxidizing agent (has the most negative E°), which means $\text{Li}(\text{s})$ is the strongest reducing agent: a *strong oxidizing agent forms a weak reducing agent*, and vice versa. Rely on your knowledge of the redox behavior of the elements (see Section 8.4) if you forget the ranking in the table:

- F_2 is very electronegative and occurs naturally as F^- , so it is easily reduced (gains electrons) and must be a strong oxidizing agent (high, positive E°).
- Li metal has a low ionization energy and occurs naturally as Li^+ , so it is easily oxidized (loses electrons) and must be a strong reducing agent (low, negative E°).

Using $E^\circ_{\text{half-cell}}$ Values to Write Spontaneous Redox Reactions

Every redox reaction is the sum of two half-reactions, so there is a reducing agent and an oxidizing agent on each side. In the zinc-copper reaction, for instance, Zn and Cu are the reducing agents, and Cu^{2+} and Zn^{2+} are the oxidizing agents. The stronger oxidizing and reducing agents react spontaneously to form the weaker oxidizing and reducing agents:

Based on the order of the E° values in Appendix D, and as we just saw for the Cu^{2+}/Cu , H^+/H_2 , and Zn^{2+}/Zn redox pairs (or redox *couples*), *the stronger oxidizing agent (species on the left) has a half-reaction with a larger (more positive or less negative) E° value, and the stronger reducing agent (species on the right) has a half-reaction with a smaller (less positive or more negative) E° value*. Therefore, we can use Appendix D to choose a redox reaction for constructing a voltaic cell.

Writing a Spontaneous Reaction with Appendix D A spontaneous reaction ($E_{\text{cell}}^\circ > 0$) will occur between an oxidizing agent and any reducing agent that lies *below* it in the list of standard electrode potentials in Appendix D. In other words:

- *For a spontaneous reaction to occur, the half-reaction higher in the list proceeds at the cathode as written, and the half-reaction lower in the list proceeds at the anode in reverse.*

This pairing ensures that the stronger oxidizing agent (higher on the left) and stronger reducing agent (lower on the right) will be the reactants. For example, two half-reactions in the order they appear in Appendix D are

Here are the steps we follow to write a spontaneous reaction between these reactants:

- Reverse the nickel half-reaction (it is lower in the list):

Note, however, that *we do not reverse the sign of $E_{\text{half-cell}}^\circ$* because the arithmetic operation of subtraction in Equation 21.3 (cathode – anode) will do that.

- Make sure that e^- lost equals e^- gained; if not, multiply one or both half-reactions by a coefficient to accomplish this. In this case, both e^- lost and e^- gained are $2e^-$, so we skip this step.
- Add the half-reactions to get the balanced equation:

- Apply Equation 21.3 to find E_{cell}° :

$$E_{\text{cell}}^\circ = E_{\text{cathode}}^\circ - E_{\text{anode}}^\circ = E_{\text{chlorine}}^\circ - E_{\text{nickel}}^\circ = 1.36 \text{ V} - (-0.25 \text{ V}) = 1.61 \text{ V}$$

Writing a Spontaneous Reaction Without Appendix D Even when a list like Appendix D is not available, we can write a spontaneous redox reaction from a given pair of half-reactions. For example, here are two half-reactions:

Two steps are required:

1. Reverse one of the half-reactions into an oxidation step so that the difference of the electrode potentials (cathode *minus* anode) gives a *positive* E_{cell}° . (Remember that when we reverse the half-reaction, we do *not* reverse the sign of $E_{\text{half-cell}}^\circ$.)
2. Multiply by one or more coefficients to make e^- lost equal e^- gained, add the rearranged half-reactions to get a balanced overall equation, and cancel species common to both sides.

We want the reactants to be the stronger oxidizing and reducing agents:

- The larger (more positive) E° value for the silver half-reaction means that Ag^+ is a stronger oxidizing agent (gains electrons more readily) than Sn^{2+} .
- The smaller (more negative) E° value for the tin half-reaction means that Sn is a stronger reducing agent (loses electrons more readily) than Ag.

For step 1, we reverse the tin half-reaction (but *not* the sign of E_{tin}°):

because when we subtract $E_{\text{half-cell}}^{\circ}$ of the tin half-reaction (anode, oxidation) from $E_{\text{half-cell}}^{\circ}$ of the silver half-reaction (cathode, reduction), we get a positive E_{cell}° :

$$0.80 \text{ V} - (-0.14 \text{ V}) = 0.94 \text{ V}$$

For step 2, the number of electrons lost in the oxidation must equal the number gained in the reduction, so we double the silver (reduction) half-reaction. Adding the half-reactions and applying Equation 21.3 gives

A very important point to note is that, when we double the coefficients of the silver half-reaction, we do *not* double its $E_{\text{half-cell}}^{\circ}$. *Changing the coefficients of a half-reaction does not change its $E_{\text{half-cell}}^{\circ}$* because a standard electrode potential is an intensive property, one that does *not* depend on the amount of substance. Let's see why. The potential is the ratio of energy to charge. When we change the coefficients to change the amounts, the energy *and* the charge change proportionately, so their ratio stays the same. (Similarly, density does not change with the amount of substance because the mass *and* the volume change proportionately.)

Student Hot Spot

Student data indicate that you may struggle with using electrode potentials to determine spontaneity. Access the Smartbook to view additional Learning Resources on this topic.

SAMPLE PROBLEM 21.5

Writing Spontaneous Redox Reactions and Ranking Oxidizing and Reducing Agents by Strength

Problem (a) Combine pairs of the balanced half-reactions (1), (2), and (3) into three spontaneous reactions A, B, and C, and calculate E_{cell}° for each. **(b)** Rank the relative strengths of the oxidizing and reducing agents.

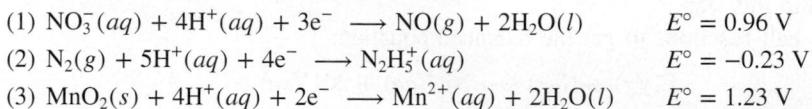

Plan (a) To write spontaneous redox reactions, we combine the possible pairs of half-reactions: (1) and (2) give reaction A, (1) and (3) give B, and (2) and (3) give C. They are all written as reductions, so the oxidizing agents appear as reactants and the reducing agents appear as products. For each pair, we reverse the half-reaction that has the smaller (less positive or more negative) E° value to an oxidation (without changing the sign of E°) to obtain a positive E_{cell}° . We make e^- lost equal e^- gained (without changing the E° value), add the half-reactions together, and then apply Equation 21.3 to find E_{cell}° . **(b)** Because each reaction is spontaneous as written, the stronger oxidizing and reducing agents are the reactants. To obtain the overall ranking, we first rank the relative strengths within each equation and then compare them.

Solution (a) Combining half-reactions (1) and (2) gives equation A. The E° value for half-reaction (1) is larger (more positive) than that for (2), so we reverse (2) to obtain a positive E_{cell}° :

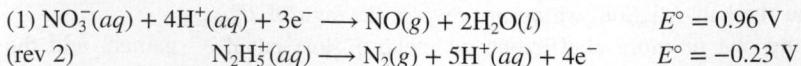

To make e^- lost equal e^- gained, we multiply (1) by four and the reversed (2) by three; then add half-reactions and cancel appropriate numbers of common species (H^+ and e^-):

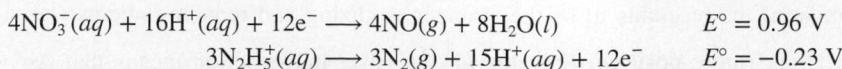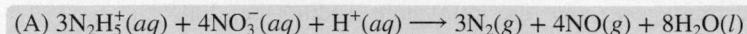

$$E_{\text{cell}}^{\circ} = 0.96 \text{ V} - (-0.23 \text{ V}) = 1.19 \text{ V}$$

Combining half-reactions (1) and (3) gives equation B. Half-reaction (1) has a smaller E° , so it is reversed:

We multiply reversed (1) by two and (3) by three, then add and cancel:

$$E_{\text{cell}}^\circ = 1.23 \text{ V} - 0.96 \text{ V} = 0.27 \text{ V}$$

Combining half-reactions (2) and (3) gives equation C. Half-reaction (2) has a smaller E° , so it is reversed:

We multiply reaction (3) by two, add the half-reactions, and cancel:

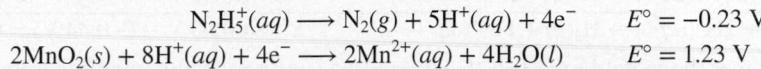

$$E_{\text{cell}}^\circ = 1.23 \text{ V} - (-0.23 \text{ V}) = 1.46 \text{ V}$$

(b) Ranking the oxidizing and reducing agents within each reaction:

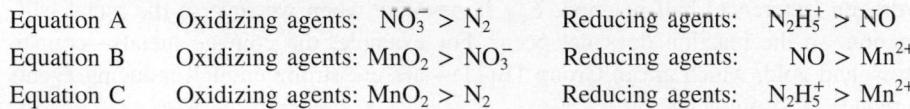

Determining the overall ranking of oxidizing and reducing agents. Comparing the relative strengths from the three balanced equations gives

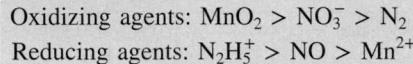

Check As always, check that atoms and charges balance on both sides of each equation. A good way to check the ranking and equations is to list the given half-reactions in order of decreasing E° value:

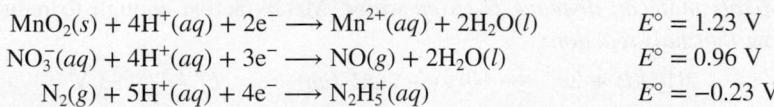

Then the oxidizing agents (reactants) decrease in strength going down the list, so the reducing agents (products) decrease in strength going up. Moreover, each of the equations for the spontaneous reactions (A, B, and C) should combine a reactant with a product that is lower down on this list.

FOLLOW-UP PROBLEMS

21.5A (a) Combine pairs of the balanced half-reactions (1), (2), and (3) into three spontaneous reactions A, B, and C, and calculate E_{cell}° for each:

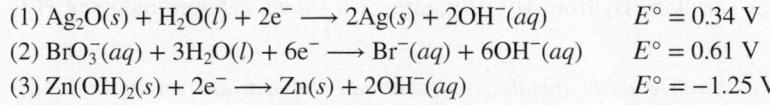

(b) Rank the relative strengths of the oxidizing and reducing agents.

21.5B Is the following reaction spontaneous as written (see Appendix D)?

If not, write the equation for the spontaneous reaction, calculate E_{cell}° , and rank the three species of iron in order of decreasing strength as reducing agents.

SOME SIMILAR PROBLEMS 21.46–21.49

Explaining the Activity Series of the Metals

In Chapter 4, we discussed the activity series of the metals (see Figure 4.24), which ranks metals by their ability to “displace” one another from aqueous solution. Now you’ll see why this displacement occurs, as well as why many, but not all, metals react with acid to form H₂, and why a few metals form H₂ even in water.

1. Metals that can displace H₂ from acid. The standard hydrogen half-reaction represents the reduction of H⁺ ions from an acid to H₂:

To see which metals reduce H⁺ (referred to as “displacing H₂”) from acids, choose a metal, write its half-reaction as an oxidation, combine this half-reaction with the hydrogen half-reaction, and see if E_{cell}° is positive. We find that the metals Li through Pb, those that lie *below* the standard hydrogen (reference) half-reaction in Appendix D, give a positive E_{cell}° when reducing H⁺. Iron, for example, reduces H⁺ from an acid to H₂:

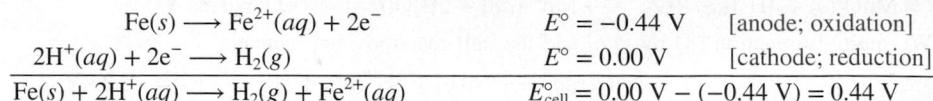

The lower the metal in the list, the stronger it is as a reducing agent; therefore, *if E_{cell}° for the reduction of H⁺ is more positive with metal A than with metal B, metal A is a stronger reducing agent than metal B and a more active metal.*

2. Metals that cannot displace H₂ from acid. For metals that are *above* the standard hydrogen (reference) half-reaction, E_{cell}° is negative when we reverse the metal half-reaction, so the reaction does not occur. For example, the coinage metals—copper, silver, and gold, which are in Group 1B(11)—are not strong enough reducing agents to reduce H⁺ from acids:

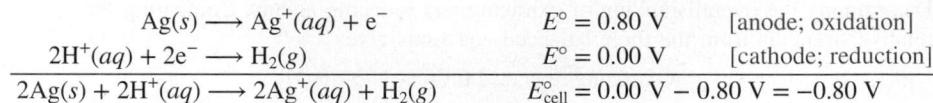

The *higher* the metal in the list, the *more negative* is its E_{cell}° for the reduction of H⁺ to H₂, the *lower* is its reducing strength, and the *less active* it is. Thus, gold is less active than silver, which is less active than copper.

3. Metals that can displace H₂ from water. Metals active enough to reduce H₂O lie below that half-reaction:

For example, consider the reaction of sodium in water (with the Na⁺/Na half-reaction reversed and doubled):

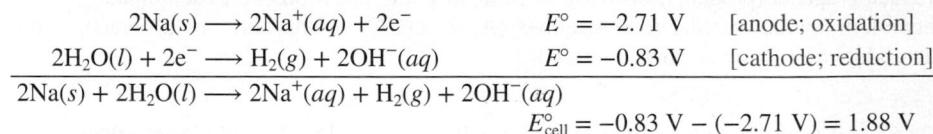

The alkali metals [Group 1A(1)] and the larger alkaline earth metals [Group 2A(2)] can reduce water (displace H₂ from H₂O). Figure 21.8 shows calcium reducing H₂O to H₂.

4. Metals that displace other metals from solution. We can also predict whether one metal can reduce the aqueous ion of another metal. Any metal that is lower in the list in Appendix D can reduce the ion of a metal that is higher up, and thus displace that metal from solution. For example, zinc can displace iron from solution:

This particular reaction has tremendous economic importance in protecting iron from rusting, as we’ll discuss in Section 21.6.

Oxidation half-reaction
 $\text{Ca}(\text{s}) \longrightarrow \text{Ca}^{2+}(\text{aq}) + 2\text{e}^-$

Reduction half-reaction
 $2\text{H}_2\text{O}(\text{l}) + 2\text{e}^- \longrightarrow \text{H}_2(\text{g}) + 2\text{OH}^-(\text{aq})$

Overall (cell) reaction
 $\text{Ca}(\text{s}) + 2\text{H}_2\text{O}(\text{l}) \longrightarrow \text{Ca}(\text{OH})_2(\text{aq}) + \text{H}_2(\text{g})$

Figure 21.8 The reaction of calcium in water.

Source: © McGraw-Hill Education/Stephen Frisch, photographer

A common incident involving the reducing power of metals occurs when you bite down with a filled tooth on a scrap of aluminum foil left on a piece of food. The foil acts as an active anode ($E_{\text{aluminum}}^{\circ} = -1.66 \text{ V}$), saliva as the electrolyte, and the filling (usually a silver/tin/mercury alloy) as an inactive cathode at which O_2 is reduced ($E_{\text{O}_2}^{\circ} = 1.23 \text{ V}$) to water. The circuit between the foil and the filling creates a current that is sensed as pain by the nerve of the tooth (Figure 21.9).

› Summary of Section 21.3

- › The output of a voltaic cell is the cell potential (E_{cell}), measured in volts ($1 \text{ V} = 1 \text{ J/C}$).
- › With all substances in their standard states, the output is the standard cell potential (E_{cell}°).
- › $E_{\text{cell}} > 0$ for a spontaneous reaction at standard-state conditions.
- › By convention, a standard electrode potential ($E_{\text{half-cell}}^{\circ}$) refers to the *reduction* half-reaction.
- › E_{cell}° equals $E_{\text{half-cell}}^{\circ}$ of the cathode minus $E_{\text{half-cell}}^{\circ}$ of the anode.
- › A standard hydrogen (reference) electrode ($E_{\text{reference}}^{\circ} = 0 \text{ V}$) is used to measure $E_{\text{half-cell}}^{\circ}$ values and to rank oxidizing (or reducing) agents.
- › Spontaneous redox reactions combine stronger oxidizing and reducing agents to form weaker reducing and oxidizing agents, respectively.
- › A metal can reduce another species (H^+ , H_2O , or an ion of another metal) if E_{cell}° for the overall reaction is positive.

Figure 21.9 A dental “voltaic cell.”

21.4 FREE ENERGY AND ELECTRICAL WORK

Following up on our discussion in Chapter 20, in this section, we examine the relationship of useful work, free energy, and the equilibrium constant in the context of electrochemical cells and see the effect of concentration on cell potential.

Standard Cell Potential and the Equilibrium Constant

The signs of ΔG and E_{cell} are *opposite* for a spontaneous reaction: a *negative* free energy change ($\Delta G < 0$; Section 20.3) and a *positive* cell potential ($E_{\text{cell}} > 0$). These two indicators of spontaneity are proportional to each other:

$$\Delta G \propto -E_{\text{cell}}$$

Let's determine this proportionality constant. The electrical work done (w , in joules) is the product of the potential (E_{cell} , in volts) and the charge that flows (in coulombs). Since E_{cell} is measured with no current flowing and, thus, no energy lost as heat, it is the maximum voltage possible, and, thus, determines the maximum work possible (w_{max}).^{*} Work done *by* the cell *on* the surroundings has a negative sign:

$$w_{\text{max}} = -E_{\text{cell}} \times \text{charge}$$

The maximum work done *on* the surroundings is equal to ΔG (Equation 20.9):

$$w_{\text{max}} = \Delta G = -E_{\text{cell}} \times \text{charge}$$

The charge that flows through the cell equals the amount (mol) of electrons transferred (n) times the charge of 1 mol of electrons (which has the symbol F):

$$\text{Charge} = \text{amount (mol)} \times \frac{\text{charge}}{\text{mol e}^-} \quad \text{or} \quad \text{charge} = nF$$

The charge of 1 mol of electrons is the **Faraday constant (F)**, named for Michael Faraday, the 19th-century British scientist who pioneered the study of electrochemistry:

$$F = \frac{96,485 \text{ C}}{\text{mol e}^-}$$

^{*}Recall from Chapter 20 that only a reversible process can do maximum work. For no current to flow and the process to be reversible, E_{cell} must be opposed by an equal potential in the measuring circuit: if the opposing potential is infinitesimally smaller, the cell reaction goes forward; if it is infinitesimally larger, the reaction goes backward.

Figure 21.10 The interrelationship of ΔG° , E_{cell}° , and K . **A**, Any one parameter can be used to find the other two. **B**, The signs of ΔG° , K , and E_{cell}° determine reaction direction.

Reaction Parameters at the Standard State			
ΔG°	K	E_{cell}°	Reaction at standard-state conditions
<0	>1	>0	Spontaneous
0	1	0	At equilibrium
>0	<1	<0	Nonspontaneous

Because $1 \text{ V} = 1 \text{ J/C}$, we have $1 \text{ C} = 1 \text{ J/V}$, and

$$F = 9.65 \times 10^4 \frac{\text{J}}{\text{V} \cdot \text{mol e}^-} \quad (3 \text{ sf}) \quad (21.4)$$

Substituting for charge, the proportionality constant is nF :

$$\Delta G = -nFE_{\text{cell}} \quad (21.5)$$

And, when all components are in their standard states, we have

$$\Delta G^\circ = -nFE_{\text{cell}}^\circ \quad (21.6)$$

Using this relationship, we can relate the standard cell potential to the equilibrium constant of the redox reaction. Recall from Equation 20.12 that

$$\Delta G^\circ = -RT \ln K$$

Substituting for ΔG° from Equation 21.6 gives

$$-nFE_{\text{cell}}^\circ = -RT \ln K$$

Solving for E_{cell}° gives

$$E_{\text{cell}}^\circ = \frac{RT}{nF} \ln K \quad (21.7)$$

Figure 21.10 summarizes the interconnections among the standard free energy change, the equilibrium constant, and the standard cell potential. In Chapter 20, we determined K from ΔG° , which we found either from ΔH° and ΔS° values or from ΔG_f° values. Now, for redox reactions, we have a direct *experimental* method for determining K and ΔG° : measure E_{cell}° .

In calculations, we adjust Equation 21.7 as follows:

- Substitute $8.314 \text{ J}/(\text{mol rxn} \cdot \text{K})$ for the constant R .
- Substitute $9.65 \times 10^4 \text{ J}/(\text{V} \cdot \text{mol e}^-)$ for the constant F .
- Substitute 298.15 K for T , keeping in mind that the cell can run at other temperatures.
- Multiply by 2.303 to convert the natural logarithm to the common (base-10) logarithm. This conversion shows that a *10-fold change in K makes E_{cell}° change by 1*.

Thus, when n moles of e^- are transferred per mole of reaction, based on the balanced equation, we have

$$E_{\text{cell}}^\circ = \frac{RT}{nF} \ln K = 2.303 \times \frac{8.314 \frac{\text{J}}{\text{mol rxn} \cdot \text{K}} \times 298.15 \text{ K}}{\frac{n \text{ mol e}^-}{\text{mol rxn}} \left(9.65 \times 10^4 \frac{\text{J}}{\text{V} \cdot \text{mol e}^-} \right)} \log K$$

And this becomes

$$E_{\text{cell}}^\circ = \frac{0.0592 \text{ V}}{n} \log K \quad \text{or} \quad \log K = \frac{nE_{\text{cell}}^\circ}{0.0592 \text{ V}} \quad (\text{at } 298.15 \text{ K}) \quad (21.8)$$

SAMPLE PROBLEM 21.6**Calculating K and ΔG° from E_{cell}°**

Problem Silver occurs in trace amounts in some ores of lead, and lead can displace silver from solution:

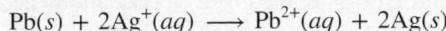

As a consequence, silver is a valuable byproduct in the industrial extraction of lead from its ores. Calculate K and ΔG° at 298.15 K for this reaction.

Plan We divide the spontaneous redox reaction into half-reactions and use values from Appendix D to calculate E_{cell}° . Then, we substitute this result into Equations 21.7 and 21.8 to find K and into Equation 21.6 to find ΔG° .

Solution Writing the half-reactions with their E° values:

- (1) $\text{Ag}^+(aq) + \text{e}^- \longrightarrow \text{Ag}(s) \quad E^\circ = 0.80 \text{ V}$
 (2) $\text{Pb}^{2+}(aq) + 2\text{e}^- \longrightarrow \text{Pb}(s) \quad E^\circ = -0.13 \text{ V}$

Calculating E_{cell}° : We double half-reaction (1) to obtain a gain of 2 mol of electrons, reverse (2) since this is the oxidation half-reaction, add the half-reactions, and subtract E_{lead} from E_{silver}° :

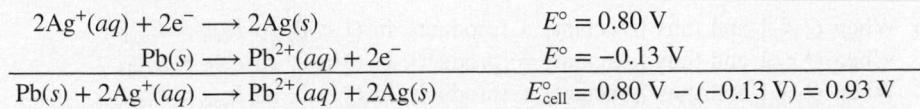

Calculating K with Equations 21.7 and 21.8: The adjusted half-reactions show that 2 mol of e^- are transferred per mole of reaction as written, so $n = 2$. Then, performing the substitutions for R and F that we just discussed, changing to common logarithms, and running the cell at 25°C (298.15 K), we have

$$E_{\text{cell}}^\circ = \frac{RT}{nF} \ln K = \frac{0.0592 \text{ V}}{n} \log K = \frac{0.0592 \text{ V}}{2} \log K = 0.93 \text{ V}$$

$$\text{So, } \log K = \frac{0.93 \text{ V} \times 2}{0.0592 \text{ V}} = 31.42 \quad \text{and} \quad K = 10^{31.42} = 2.6 \times 10^{31}$$

Calculating ΔG° (Equation 21.6):

$$\Delta G^\circ = -nFE_{\text{cell}}^\circ = -\frac{2 \text{ mol e}^-}{\text{mol rxn}} \times \frac{96.5 \text{ kJ}}{\text{V} \cdot \text{mol e}^-} \times 0.93 \text{ V} = -1.8 \times 10^2 \text{ kJ/mol rxn}$$

Check The three variables are consistent with the reaction being spontaneous at standard-state conditions: $E_{\text{cell}}^\circ > 0$, $\Delta G^\circ < 0$, and $K > 1$. Be sure to round and check the order of magnitude: to find ΔG° , for instance, $\Delta G^\circ \approx -2 \times 100 \times 1 = -200$, so the overall math seems right. Another check would be to obtain ΔG° directly from its relation with K :

$$\begin{aligned} \Delta G^\circ &= -RT \ln K = -8.314 \text{ J/mol rxn} \cdot \text{K} \times 298.15 \text{ K} \times \ln(2.6 \times 10^{31}) \\ &= -1.8 \times 10^5 \text{ J/mol rxn} = -1.8 \times 10^2 \text{ kJ/mol rxn} \end{aligned}$$

FOLLOW-UP PROBLEMS

21.6A Calculate K and ΔG° for the following reaction at 298.15 K:

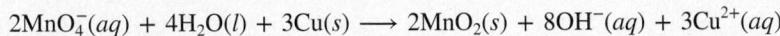

21.6B When cadmium metal reduces Cu^{2+} in solution, Cd^{2+} forms in addition to copper metal. Given that $\Delta G^\circ = -143 \text{ kJ/mol rxn}$, calculate K at 25°C. What is E_{cell}° of a voltaic cell that uses this reaction?

SOME SIMILAR PROBLEMS 21.56–21.67

The Effect of Concentration on Cell Potential

So far, we've considered cells at standard-state conditions, but most cells don't start with those concentrations, and even if they did, concentrations change as the cell operates. Moreover, in all batteries, reactant concentrations are far from the standard state.

To determine E_{cell} , the cell potential under *nonstandard* conditions, we'll derive an expression for the relation between E_{cell} and concentration based on the relation between ΔG and concentration. Recall from Chapter 20 (Equation 20.13) that

$$\Delta G = \Delta G^\circ + RT \ln Q$$

ΔG is related to E_{cell} , and ΔG° is related to E_{cell}° (Equations 21.5 and 21.6); substituting, we get

$$-nFE_{\text{cell}} = -nFE_{\text{cell}}^\circ + RT \ln Q$$

Dividing both sides by $-nF$, we obtain the equation developed by the great German chemist Walther Hermann Nernst when he was only 25 years old. (In his career, which culminated in the 1920 Nobel Prize in chemistry, he also formulated the third law of thermodynamics and established the concept of the solubility product.) The **Nernst equation** says that E_{cell} depends on E_{cell}° and a term for the potential at any ratio of concentrations:

$$E_{\text{cell}} = E_{\text{cell}}^\circ - \frac{RT}{nF} \ln Q \quad (21.9)$$

How do changes in Q affect cell potential? From Equation 21.9, we see that

- When $Q < 1$ and thus [reactant] > [product], $\ln Q < 0$, so $E_{\text{cell}} > E_{\text{cell}}^\circ$.
- When $Q = 1$ and thus [reactant] = [product], $\ln Q = 0$, so $E_{\text{cell}} = E_{\text{cell}}^\circ$.
- When $Q > 1$ and thus [reactant] < [product], $\ln Q > 0$, so $E_{\text{cell}} < E_{\text{cell}}^\circ$.

As before, to obtain a form we can use for calculations, we substitute known values of R and F , operate the cell at 298.15 K, and convert to the common (base-10) logarithm:

$$\begin{aligned} E_{\text{cell}} &= E_{\text{cell}}^\circ - \frac{RT}{nF} \ln Q \\ &= E_{\text{cell}}^\circ - 2.303 \times \frac{\frac{8.314 \frac{\text{J}}{\text{mol rxn} \cdot \text{K}} \times 298.15 \text{ K}}{\frac{n \text{ mol e}^-}{\text{mol rxn}} \left(9.65 \times 10^4 \frac{\text{J}}{\text{V} \cdot \text{mol e}^-} \right)}}{\log Q} \end{aligned}$$

We obtain

$$E_{\text{cell}} = E_{\text{cell}}^\circ - \frac{0.0592 \text{ V}}{n} \log Q \quad (\text{at } 298.15 \text{ K}) \quad (21.10)$$

Remember that the expression for Q contains only those species with concentrations (and/or pressures) that can vary; thus, pure liquids do not appear nor do solids, even when they are the electrodes. For example, in the reaction between cadmium and silver ion, the Cd and Ag electrodes do not appear in the expression for Q :

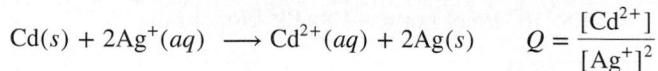

Student Hot Spot

Student data indicate that you may struggle with calculations involving the Nernst equation. Access the Smartbook to view additional Learning Resources on this topic.

SAMPLE PROBLEM 21.7

Using the Nernst Equation to Calculate E_{cell}

Problem In a test of a new reference electrode, a chemist constructs a voltaic cell consisting of a Zn/Zn²⁺ half-cell and an H₂/H⁺ half-cell under the following conditions:

$$[\text{Zn}^{2+}] = 0.010 \text{ M} \quad [\text{H}^+] = 2.5 \text{ M} \quad P_{\text{H}_2} = 0.30 \text{ atm}$$

Calculate E_{cell} at 298.15 K.

Plan To apply the Nernst equation and determine E_{cell} , we must know E_{cell}° and Q . We write the spontaneous reaction and calculate E_{cell}° from standard electrode potentials (Appendix D). Then we substitute into Equation 21.10.

Solution Determining the cell reaction and E_{cell}° :

Calculating Q :

$$Q = \frac{P_{\text{H}_2} \times [\text{Zn}^{2+}]}{[\text{H}^{+}]^2} = \frac{0.30 \times 0.010}{2.5^2} = 4.8 \times 10^{-4}$$

Solving for E_{cell} at 25°C (298.15 K), with $n = 2$:

$$\begin{aligned} E_{\text{cell}} &= E_{\text{cell}}^{\circ} - \frac{0.0592 \text{ V}}{n} \log Q \\ &= 0.76 \text{ V} - \frac{0.0592 \text{ V}}{2} \log (4.8 \times 10^{-4}) = 0.76 \text{ V} - (-0.098 \text{ V}) = 0.86 \text{ V} \end{aligned}$$

Check After you check the arithmetic, reason through the answer: $E_{\text{cell}} > E_{\text{cell}}^{\circ}$ (0.86 > 0.76) because the $\log Q$ term was negative, which is consistent with $Q < 1$.

FOLLOW-UP PROBLEMS

21.7A A voltaic cell consists of a Cr/Cr³⁺ half-cell and an Sn/Sn²⁺ half-cell, with [Sn²⁺] = 0.20 M and [Cr³⁺] = 1.60 M. Use Appendix D to calculate E_{cell} at 298.15 K.

21.7B Consider a voltaic cell based on the following reaction:

If [Cu²⁺] = 0.30 M, what must [Fe²⁺] be to increase E_{cell} by 0.25 V above E_{cell}° at 25°C?

SOME SIMILAR PROBLEMS 21.68–21.71

Following Changes in Potential During Cell Operation

As with any voltaic cell, the potential of a zinc-copper cell changes during cell operation because the concentrations of the components do. Because both of the other components are solids, the only variables are [Cu²⁺] and [Zn²⁺]:

In this section, we follow the potential as the zinc-copper cell operates.

1. *Starting point of cell operation.* The positive E_{cell}° (1.10 V) means that this reaction proceeds *spontaneously* to the right at standard-state conditions, [Zn²⁺] = [Cu²⁺] = 1 M ($Q = 1$). But, if we start the cell when [Zn²⁺] < [Cu²⁺] ($Q < 1$), for example, when [Zn²⁺] = 1.0 × 10⁻⁴ M and [Cu²⁺] = 2.0 M, the cell potential starts out *higher* than the standard cell potential, because $\log Q < 0$:

$$\begin{aligned} E_{\text{cell}} &= E_{\text{cell}}^{\circ} - \frac{0.0592 \text{ V}}{2} \log \frac{[\text{Zn}^{2+}]}{[\text{Cu}^{2+}]} = 1.10 \text{ V} - \left(\frac{0.0592 \text{ V}}{2} \log \frac{1.0 \times 10^{-4}}{2.0} \right) \\ &= 1.10 \text{ V} - \left[\frac{0.0592 \text{ V}}{2} (-4.30) \right] = 1.10 \text{ V} + 0.127 \text{ V} = 1.23 \text{ V} \end{aligned}$$

2. *Key stages during cell operation.* Using Equation 21.10, we identify four key stages of operation. Figure 21.11A on the next page shows the first three. The main point is that *as the cell operates, its potential decreases*. As product concentration ([P] = [Zn²⁺]) increases and reactant concentration ([R] = [Cu²⁺]) decreases, Q becomes larger, the term $[0.0592 \text{ V}/n] \log Q$ becomes less negative (more positive), and E_{cell} decreases:

Stage 1. $E_{\text{cell}} > E_{\text{cell}}^{\circ}$ when $Q < 1$: when the cell begins operation, [Cu²⁺] > [Zn²⁺], so $(0.0592 \text{ V}/n) \log Q < 0$ and $E_{\text{cell}} > E_{\text{cell}}^{\circ}$.

Stage 2. $E_{\text{cell}} = E_{\text{cell}}^{\circ}$ when $Q = 1$: at the point when [Cu²⁺] = [Zn²⁺], $Q = 1$, so $(0.0592 \text{ V}/n) \log Q = 0$ and $E_{\text{cell}} = E_{\text{cell}}^{\circ}$.

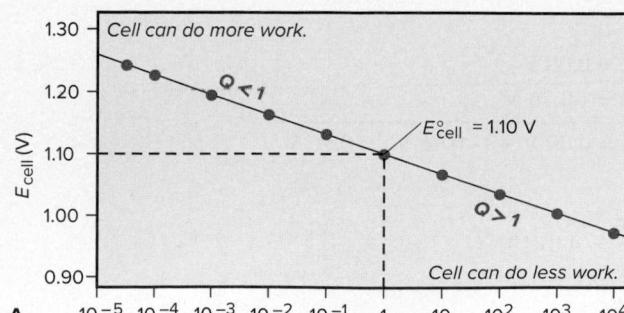

$$Q = \frac{[\text{Zn}^{2+}]}{[\text{Cu}^{2+}]} = \frac{[\text{P}]}{[\text{R}]}$$

Changes in E_{cell} and Concentration			
Stage in cell operation	Q	Relative $[\text{P}]$ and $[\text{R}]$	$\frac{0.0592 \text{ V}}{n} \log Q$
1. $E > E^{\circ}$	< 1	$[\text{P}] < [\text{R}]$	< 0
2. $E = E^{\circ}$	$= 1$	$[\text{P}] = [\text{R}]$	$= 0$
3. $E < E^{\circ}$	> 1	$[\text{P}] > [\text{R}]$	> 0
4. $E = 0$	$= K$	$[\text{P}] \gg [\text{R}]$	$= E^{\circ}$

B

Figure 21.11 The relation between E_{cell} and $\log Q$ for the zinc-copper cell. **A**, A plot of E_{cell} vs. Q (on a logarithmic scale) decreases linearly. When $Q < 1$ (left), the cell does relatively more work. When $Q = 1$, $E_{\text{cell}} = E_{\text{cell}}^{\circ}$. When $Q > 1$ (right), the cell does relatively less work. **B**, A summary of the changes in E_{cell} as this or any voltaic cell operates. ($[\text{Zn}^{2+}]$ is $[\text{P}]$ for [product], and $[\text{Cu}^{2+}]$ is $[\text{R}]$ for [reactant].)

Stage 3. $E_{\text{cell}} < E_{\text{cell}}^{\circ}$ when $Q > 1$: as the $[\text{Zn}^{2+}]/[\text{Cu}^{2+}]$ ratio continues to increase, $(0.0592 \text{ V}/n) \log Q > 0$, so $E_{\text{cell}} < E_{\text{cell}}^{\circ}$.

Stage 4. $E_{\text{cell}} = 0$ when $Q = K$: eventually, $(0.0592 \text{ V}/n) \log Q$ becomes so large that it equals E_{cell}° , which means that E_{cell} is zero. This occurs when the system reaches equilibrium: no more free energy is released, so the cell can do no more work. At this point, we say that a battery is “dead.”

Figure 21.11B summarizes these four key stages during operation of a voltaic cell.

3. *Q/K and the work the cell can do.* At equilibrium, Equation 21.10 becomes

$$0 = E_{\text{cell}}^{\circ} - \frac{0.0592 \text{ V}}{n} \log K, \quad \text{which rearranges to} \quad E_{\text{cell}}^{\circ} = \frac{0.0592 \text{ V}}{n} \log K$$

Note that this result is identical to Equation 21.8, which we obtained from ΔG° . Solving for K of the zinc-copper cell ($E_{\text{cell}}^{\circ} = 1.10 \text{ V}$),

$$\log K = \frac{2 \times E_{\text{cell}}^{\circ}}{0.0592 \text{ V}} \quad \text{so} \quad K = 10^{(2 \times 1.10 \text{ V})/0.0592 \text{ V}} = 10^{37.16} = 1.4 \times 10^{37}$$

As you can see, this cell does work until $[\text{Zn}^{2+}]/[\text{Cu}^{2+}]$ is very high.

The three relations between initial Q/K and E_{cell} are

- If $Q/K < 1$, E_{cell} is positive for the reaction as written. The smaller Q/K is, the greater the value of E_{cell} , and the more electrical work the cell can do.
- If $Q/K = 1$, $E_{\text{cell}} = 0$. The cell is at equilibrium and can no longer do work.
- If $Q/K > 1$, E_{cell} is negative for the reaction as written. The reverse reaction will take place, and the cell will do work until Q/K equals 1 at equilibrium.

Concentration Cells

If you mix a concentrated solution of a substance with a dilute solution of it, the final solution has an intermediate concentration. A **concentration cell** employs this simple, spontaneous change to generate electrical energy: different concentrations of species involved in the same half-reaction are in separate half-cells, and the cell does work until the concentrations become equal.

Finding E_{cell} for a Concentration Cell Suppose a voltaic cell has the Cu/Cu^{2+} half-reaction in both compartments. The cell reaction is the sum of identical half-reactions, written in opposite directions. The *standard* cell potential, E_{cell}° , is zero because the *standard* electrode potentials are both based on 1 M Cu^{2+} , so they cancel. As we said, however, in a concentration cell, the concentrations are *different*. Thus, even though

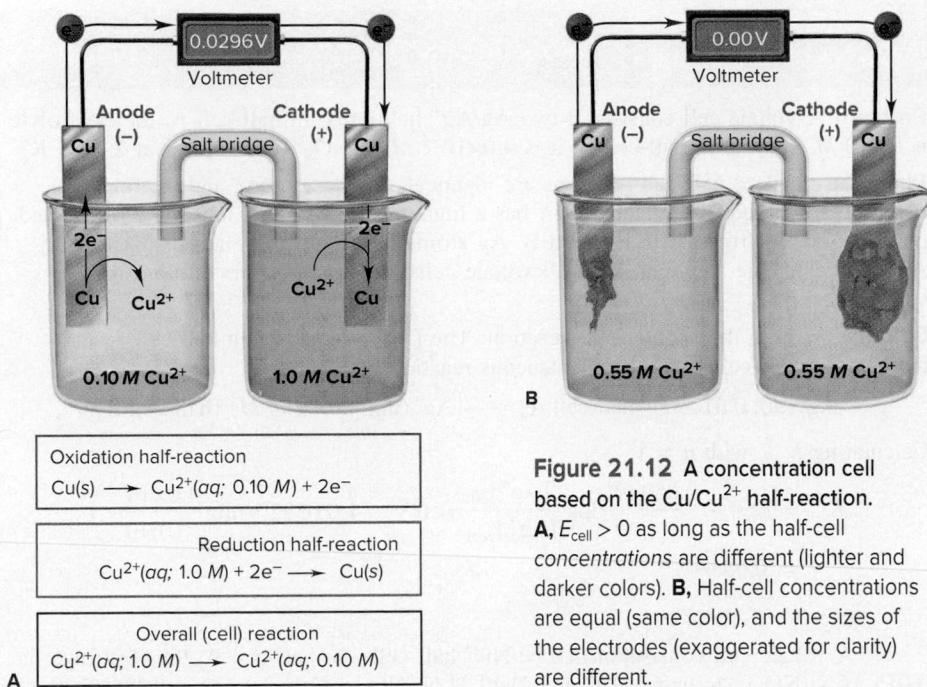

Figure 21.12 A concentration cell based on the Cu/Cu²⁺ half-reaction.

A, $E_{\text{cell}} > 0$ as long as the half-cell concentrations are different (lighter and darker colors). **B**, Half-cell concentrations are equal (same color), and the sizes of the electrodes (exaggerated for clarity) are different.

E_{cell}° is still zero, the *nonstandard* cell potential, E_{cell} , depends on the *ratio of concentrations*, so it is *not* zero.

For the final concentrations to be equal, a concentration cell must have the dilute solution in the anode compartment and the concentrated solution in the cathode compartment. For example, let's use 0.10 M Cu²⁺ in the anode half-cell and 1.0 M Cu²⁺, a 10-fold higher concentration, in the cathode half-cell (Figure 21.12A):

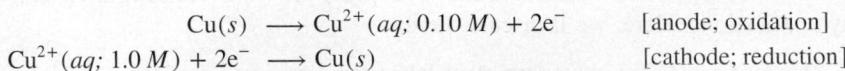

The overall cell reaction is the sum of the half-reactions:

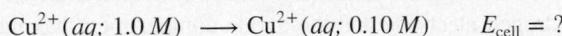

The cell potential at the initial concentrations of 0.10 M (dilute) and 1.0 M (concentrated), with $n = 2$, is obtained from the Nernst equation:

$$\begin{aligned} E_{\text{cell}} &= E_{\text{cell}}^\circ - \frac{0.0592\text{ V}}{2} \log \frac{[\text{Cu}^{2+}]_{\text{dil}}}{[\text{Cu}^{2+}]_{\text{conc}}} = 0\text{ V} - \left(\frac{0.0592\text{ V}}{2} \log \frac{0.10\text{ M}}{1.0\text{ M}} \right) \\ &= 0\text{ V} - \left[\frac{0.0592\text{ V}}{2} (-1.00) \right] = 0.0296\text{ V} \end{aligned}$$

Since E_{cell}° is zero, E_{cell} depends entirely on the term $[(0.0592\text{ V}/n) \log Q]$.

How a Concentration Cell Works Let's see what is happening as this concentration cell operates:

- In the anode (dilute) half-cell, Cu atoms in the electrode give up electrons and the resulting Cu²⁺ ions enter the solution and make it *more* concentrated.
- In the cathode (concentrated) half-cell, Cu²⁺ ions gain the electrons and the resulting Cu atoms plate out on the electrode, which makes that solution *less* concentrated.

As in any voltaic cell, E_{cell} decreases until equilibrium is attained, which happens when [Cu²⁺] is the same in both half-cells (Figure 21.12B). The same final concentration would result if we mixed the two solutions, but no electrical work would be done.

SAMPLE PROBLEM 21.8

Calculating the Potential of a Concentration Cell

Problem A voltaic cell consists of two Ag/Ag⁺ half-cells. In half-cell A, the electrolyte is 0.010 M AgNO₃; in half-cell B, it is 4.0×10⁻⁴ M AgNO₃. What is E_{cell} at 298.15 K?

Plan The standard half-cell reactions are identical, so E_{cell}° is zero, and we find E_{cell} from the Nernst equation. Half-cell A has a higher [Ag⁺], so Ag⁺ ions are reduced and plate out on electrode A. In half-cell B, Ag atoms of the electrode are oxidized and Ag⁺ ions enter the solution. As in all voltaic cells, reduction occurs at the cathode, so it is positive.

Solution Writing the spontaneous reaction: The [Ag⁺] decreases in half-cell A and increases in half-cell B, so the spontaneous reaction is

Calculating E_{cell} , with $n = 1$:

$$E_{\text{cell}} = E_{\text{cell}}^{\circ} - \frac{0.0592 \text{ V}}{1} \log \frac{[\text{Ag}^{+}]_{\text{dil}}}{[\text{Ag}^{+}]_{\text{conc}}} = 0 \text{ V} - \left(0.0592 \text{ V} \log \frac{4.0 \times 10^{-4}}{0.010} \right) \\ = 0.083 \text{ V}$$

FOLLOW-UP PROBLEMS

21.8A A voltaic cell consists of two Ni/Ni²⁺ half-cells. In half-cell A, the electrolyte is 0.015 M Ni(NO₃)₂; in half-cell B, it is 0.40 M Ni(NO₃)₂. Calculate E_{cell} at 298.15 K.

21.8B A voltaic cell is built using two Au/Au³⁺ half-cells. In half-cell A, [Au³⁺] = 7.0×10⁻⁴ M, and in half-cell B, [Au³⁺] = 2.5×10⁻² M. What is E_{cell} , and which electrode is negative?

SOME SIMILAR PROBLEMS 21.72 and 21.73

Applications of Concentration Cells The principle of a concentration cell has many applications. Here, we'll discuss three:

1. *Measuring pH.* The most important laboratory application of this principle is in measuring [H⁺]. If we construct a concentration cell in which the cathode compartment is the standard hydrogen electrode and the anode compartment has the same apparatus dipping into a solution of unknown [H⁺], the half-reactions and overall reaction are

E_{cell}° is zero, but E_{cell} is *not* because the half-cells differ in [H⁺]. From the Nernst equation, with $n = 2$, we have

$$E_{\text{cell}} = E_{\text{cell}}^{\circ} - \frac{0.0592 \text{ V}}{2} \log \frac{[\text{H}^{+}]_{\text{unknown}}^2}{[\text{H}^{+}]_{\text{standard}}^2}$$

Substituting 1 M for [H⁺]_{standard} and 0 V for E_{cell}° gives

$$E_{\text{cell}} = 0 \text{ V} - \frac{0.0592 \text{ V}}{2} \log \frac{[\text{H}^{+}]_{\text{unknown}}^2}{1^2} = -\frac{0.0592 \text{ V}}{2} \log [\text{H}^{+}]_{\text{unknown}}^2$$

Because $\log x^2 = 2 \log x$ (see Appendix A), we obtain

$$E_{\text{cell}} = -\left[\frac{0.0592 \text{ V}}{2} (2 \log [\text{H}^{+}]_{\text{unknown}}) \right] = -0.0592 \text{ V} \times \log [\text{H}^{+}]_{\text{unknown}}$$

Substituting $-\log [\text{H}^{+}] = \text{pH}$, we have

$$E_{\text{cell}} = 0.0592 \text{ V} \times \text{pH}$$

Thus, by measuring E_{cell} , we can find the pH.

Figure 21.13 Laboratory measurement of pH. **A**, An older style pH meter includes a glass electrode (left) and a reference calomel electrode (right). **B**, Modern pH meters use a combination electrode.

For routine lab measurement of pH, a concentration cell made of two hydrogen electrodes is too bulky and difficult to maintain. Instead, we use a pH meter (Figure 21.13A). In a common, but older, design, two separate electrodes dip into the solution being tested:

- The *glass electrode* consists of an Ag/AgCl half-reaction immersed in HCl solution (usually 1.000 M) and enclosed by a thin (~0.05 mm) membrane made of a glass that is very sensitive to H⁺ ions.
- The *reference electrode*, usually a *saturated calomel electrode*, consists of a platinum wire immersed in calomel (Hg₂Cl₂) paste, liquid Hg, and saturated KCl solution.

The glass electrode monitors the solution's [H⁺] relative to its own fixed internal [H⁺], and the instrument converts the potential difference between the glass and reference electrodes into a measure of pH. In modern instruments, a *combination electrode* houses both electrodes in one tube (Figure 21.13B).

2. *Measuring ions selectively*. The pH electrode is one type of *ion-selective* (or *ion-specific*) electrode. These electrodes are designed with specialized membranes to selectively measure certain ion concentrations in a mixture of many ions, as in natural waters and soils. Biologists can implant a tiny ion-selective electrode in a single cell to study ion channels and receptors (Figure 21.14). Recent advances allow measurement in the femtomolar (10⁻¹⁵ M) range. Table 21.3 lists a few of the ions studied.

3. *Concentration cells in nerves*. A nerve cell membrane is embedded with enzyme “gates” that use the energy of one-third of the body’s ATP to create an ion gradient of low [Na⁺] and high [K⁺] inside and high [Na⁺] and low [K⁺] outside. As a result of these differences, the outside of a nerve cell is more positive than the inside. (The 1997 Nobel Prize in chemistry was shared by Jens C. Skou for elucidating this mechanism.) When the nerve membrane is stimulated, an electrical impulse is created as Na⁺ ions rush in spontaneously and the inside becomes more positive than the outside. This event is followed by K⁺ ions spontaneously rushing out, and the outside becomes more positive again; the whole process takes about 0.002 s! These large changes in charge in one membrane region stimulate the neighboring region and the electrical impulse moves along the cell.

› Summary of Section 21.4

- › A spontaneous process has a negative ΔG and a positive E_{cell} : $\Delta G = -nFE_{\text{cell}}$. The ΔG of the cell reaction represents the maximum electrical work the voltaic cell can do.
- › The standard free energy change, ΔG° , is related to E_{cell}° and to K .
- › For nonstandard conditions, the Nernst equation shows that E_{cell} depends on E_{cell}° and a correction term based on Q . E_{cell} is high when Q is small (high [reactant]), and it decreases as the cell operates. At equilibrium, ΔG and E_{cell} are zero, which means that $Q = K$.
- › Concentration cells have identical half-reactions, but solutions of differing concentration. They generate electrical energy as the concentrations become equal.
- › Ion-specific electrodes, such as the pH electrode, measure the concentration of one species.
- › The principle of the concentration cell—spontaneous movement of ions “down” a concentration gradient—creates an electrical impulse in a nerve cell.

Figure 21.14 Microanalysis. A microelectrode records electrical impulses of a single neuron in a monkey's visual cortex.

Source: Photo © F. W. Goro

Some Ions Measured with Ion-Specific Electrodes

Table 21.3

Species Detected	Typical Sample
NH ₃ /NH ₄ ⁺	Industrial wastewater, seawater
CO ₂ /HCO ₃ ⁻	Blood, groundwater
F ⁻	Drinking water, urine, soil, industrial stack gases
Br ⁻	Grain, plant tissue
I ⁻	Milk, pharmaceuticals
NO ₃ ⁻	Soil, fertilizer, drinking water
K ⁺	Blood serum, soil, wine
H ⁺	Laboratory solutions, soil, natural waters

21.5 ELECTROCHEMICAL PROCESSES IN BATTERIES

Because of their compactness and mobility, batteries play a major role in everyday life, and in our increasingly wireless world, that role is growing. In general, a **battery** consists of self-contained voltaic cells arranged in series (plus-to-minus-to-plus, and so on), so that the individual voltages are added. In this section, we examine the three categories of batteries—primary, secondary, and fuel cells (flow batteries).

Primary (Nonrechargeable) Batteries

A *primary battery* cannot be recharged, so the initial amounts of reactants are as far from equilibrium as is practical. This type of battery is discarded when the cell reaction has reached equilibrium, that is, when the battery is “dead.” We’ll discuss the alkaline battery, mercury and silver “button” batteries, and the primary lithium battery.

Alkaline Battery Invented in the 1860s, the common dry cell was a familiar item into the 1970s, but has now been replaced by the ubiquitous alkaline battery. The electrode materials are zinc and manganese dioxide, and the electrolyte is a basic paste of KOH and water (Figure 21.15). The half-reactions are

Overall (cell) reaction:

The alkaline battery powers portable radios, toys, flashlights, and so on, is safe, and comes in many sizes. It has no voltage drop, a long shelf life, and reliable performance in terms of power capability and stored energy.

Figure 21.15 Alkaline battery.

Source: © Jill Braaten

Mercury and Silver (Button) Batteries Both mercury and silver batteries use a zinc container as the anode (reducing agent) in a basic medium. The mercury battery employs HgO as the oxidizing agent, the silver uses Ag₂O, and both have a steel can around the cathode. The solid reactants are compacted with KOH and separated with moist paper. The half-reactions are

Overall (cell) reaction (mercury):

Overall (cell) reaction (silver):

Both cells are manufactured as button-sized batteries. The mercury cell, valued for its long life and stability, has been used in calculators, watches, and cameras; due to the toxicity of discarded mercury, the sale of mercury batteries is banned in many countries. The silver cell (Figure 21.16) is used in watches, cameras, heart pacemakers, and hearing aids because of its very steady output; its disadvantage is the high cost of silver.

Figure 21.16 Silver button battery.

Source: © McGraw-Hill Education/Pat Watson, photographer

Primary Lithium Batteries The primary lithium battery is also widely used in watches and implanted medical products, and more recently in numerous remote-control devices. It offers an extremely high energy/mass ratio, producing 1 mol of e^- ($1 F$) from less than 7 g of metal (\mathcal{M} of Li = 6.941 g/mol). The anode is lithium foil in a nonaqueous electrolyte. The cathode is one of several metal oxides in which lithium ions lie between oxide layers. Some pacemakers have a silver vanadium oxide (SVO; $AgV_2O_{5.5}$) cathode and can provide power (1.5 to 3.5 V) for several years, but at a low rate because energy storage is limited (Figure 21.17). The half-reactions are

Secondary (Rechargeable) Batteries

In contrast to a primary battery, a *secondary battery* is *rechargeable*; when it runs down, *electrical energy is supplied to reverse the cell reaction* and form more reactant. In other words, in a secondary battery, the voltaic cells are periodically converted to electrolytic cells to restore the starting *nonequilibrium* concentrations of the cell components. We'll discuss the common car battery, the nickel–metal hydride battery, and the lithium-ion battery, a secondary lithium battery.

Lead-Acid Battery A typical lead-acid car battery has six cells connected in series, each of which delivers about 2.1 V for a total of about 12 V. Each cell contains two lead grids packed with high-surface-area (spongy) Pb in the anode and high-surface-area PbO_2 in the cathode. The grids are immersed in a solution of $\sim 4.5\text{ M H}_2SO_4$. Fiberglass sheets between the grids prevent shorting due to physical contact (Figure 21.18, *next page*).

1. *Discharging.* When the cell discharges as a voltaic cell, it generates electrical energy:

Both half-reactions form Pb^{2+} ions, one through oxidation of Pb, the other through reduction of PbO_2 . The Pb^{2+} forms $PbSO_4(s)$ at both electrodes by reacting with HSO_4^- .

Overall (cell) reaction (discharge):

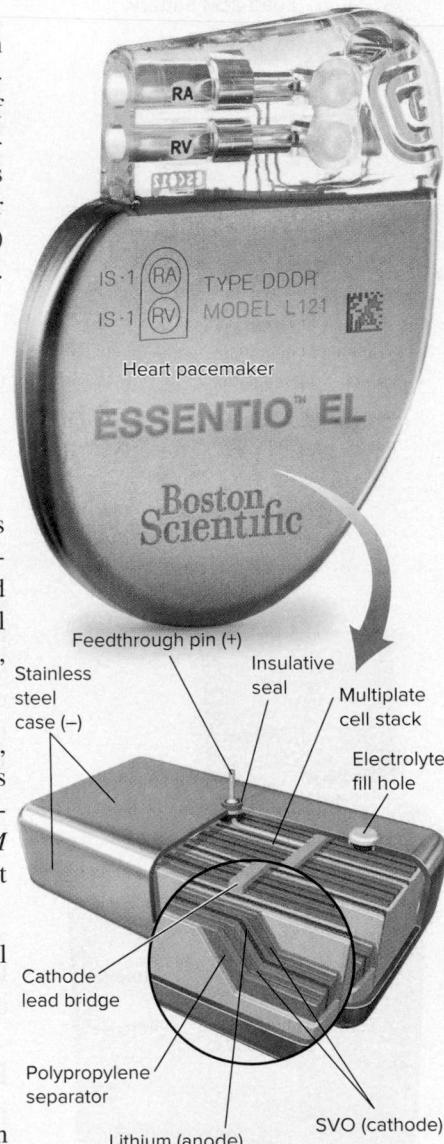

Figure 21.17 Primary lithium battery.

Source: © 2015 Boston Scientific Corporation or its affiliates. All rights reserved.

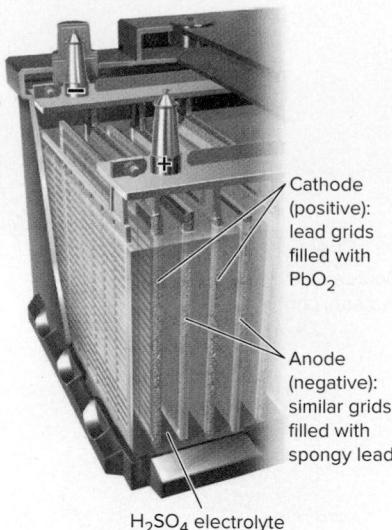

Figure 21.18 Lead-acid battery.

2. Recharging. When the cell recharges as an electrolytic cell, it uses electrical energy and the half-cell and overall reactions are reversed.

Overall (cell) reaction (recharge):

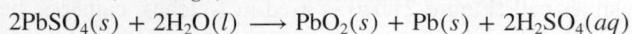

Car and truck owners have relied on the lead-acid battery for over a century to provide the large burst of current needed to start the engine—and to do so for years, in hot and cold weather. The main problems with the lead-acid battery are loss of capacity due to corrosion of the positive (Pb) grid, detachment of the active material due to normal mechanical bumping, and formation of large PbSO_4 crystals that hinder recharging.

Nickel–Metal Hydride (Ni–MH) Battery Concerns about the toxicity of cadmium in the once popular nickel–cadmium (nicad) battery have led to its replacement by the nickel–metal hydride (Ni–MH) battery. The anode half-reaction oxidizes the hydrogen absorbed within a metal alloy (such as LaNi_3 ; designated M) in a basic (KOH) electrolyte, while nickel(III) in the form of NiO(OH) is reduced at the cathode (Figure 21.19):

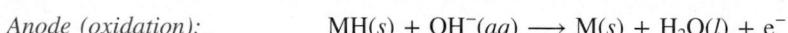

$$E_{\text{cell}} = 1.4 \text{ V}$$

The cell reaction is reversed during recharging. The Ni–MH battery is common in cordless razors, camera flash units, and power tools. It is lightweight, has high power, and is nontoxic, but it discharges significantly during storage.

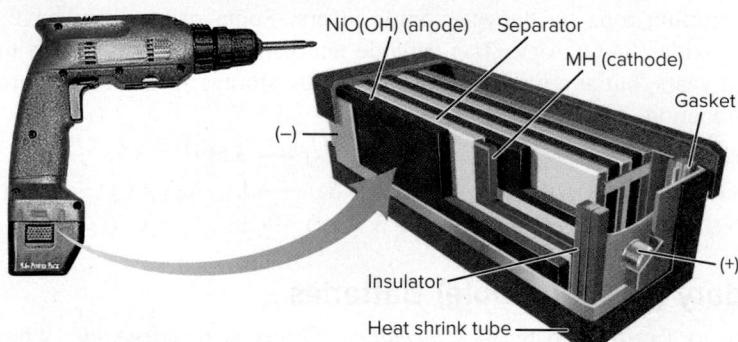

Figure 21.19 Nickel–metal hydride battery.

Source: © McGraw-Hill Education/Stephen Frisch, photographer

Lithium-Ion Battery The secondary lithium-ion battery has an anode of Li atoms that lie between sheets of graphite (designated Li_xC_6). The cathode is a lithium metal oxide, such as LiMn_2O_4 or LiCoO_2 , and a typical electrolyte is 1 M LiPF_6 in an organic solvent, such as dimethyl carbonate mixed with methylethyl carbonate. Electrons flow through the circuit, while solvated Li^+ ions flow from anode to cathode within the cell (Figure 21.20). The cell reactions are

$$E_{\text{cell}} = 3.7 \text{ V}$$

The cell reaction is reversed during recharging. The lithium-ion battery powers countless laptop computers, tablets, cell phones, and camcorders. Its key drawbacks are cost and flammability of the organic solvent.

Figure 21.20 Lithium-ion battery.

Source: © AP/Wide World Photos

Fuel Cells

In contrast to primary and secondary batteries, a **fuel cell**, sometimes called a *flow battery*, is not self-contained. The reactants (usually a fuel and oxygen) enter the cell, and the products leave, *generating electricity through controlled combustion (oxidation)* of the fuel. The fuel does not burn because, as in other voltaic cells, the half-reactions are separated, and the electrons move through an external circuit.

The most common fuel cell being developed for use in cars is the *proton exchange membrane (PEM) cell*, which uses H₂ as the fuel and has an operating temperature of around 80°C (Figure 21.21). The cell reactions are

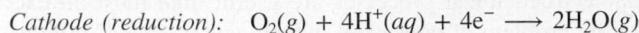

Figure 21.21 Proton exchange membrane cell: a hydrogen fuel cell.

How H₂ Fuel Cells Work Reaction rates are lower in fuel cells than in other batteries, so an *electrocatalyst* is used to decrease the activation energy (Section 16.7). The PEM cell's electrodes are made of a nanocomposite consisting of a Pt-based catalyst deposited on graphite. These are embedded in a polymer electrolyte membrane having a perfluoroethylene backbone ($-\text{[F}_2\text{C}-\text{CF}_2\text{]}_n-$) with attached sulfonic acid groups (RSO_3^-) that play a key role in ferrying protons from anode to cathode.

- At the anode, two H₂ molecules adsorb onto the catalyst and are split and oxidized. From each H₂, two e⁻ travel through the wire to the cathode, while two H⁺ are hydrated and migrate through the electrolyte as H₃O⁺.
- At the cathode, an O₂ molecule is believed to adsorb onto the catalyst, which provides an e⁻ to form O₂⁻. One H₃O⁺ donates its H⁺ to the O₂⁻, forming HO₂ (that is, HO—O). The O—O bond stretches and breaks as another H₃O⁺ gives its H⁺ and the catalyst provides another e⁻: the first H₂O has formed. In similar fashion, a third H⁺ and e⁻ attach to the freed O atom to form OH, and a fourth H⁺ and e⁻ are transferred to form the second H₂O. Both water molecules desorb and leave the cell.

Applications of Fuel Cells Hydrogen fuel cells have been used for years to provide electricity and water during space flights. Similar ones have begun to supply electric power for residential needs, and every major car manufacturer has a fuel-cell model. Fuel cells produce no pollutants and convert about 75% of a fuel's bond energy into power, compared to 40% for a coal-fired power plant and 25% for a gasoline engine.

› Summary of Section 21.5

- Batteries are voltaic cells arranged in series and are classified as primary (e.g., alkaline, mercury, silver, and lithium), secondary (e.g., lead-acid, nickel–metal hydride, and lithium-ion), or fuel cells.
- Supplying electricity to a rechargeable (secondary) battery reverses the redox reaction, re-forming reactant.
- Fuel cells generate a current through the controlled oxidation of a fuel such as H₂.

21.6 CORROSION: AN ENVIRONMENTAL VOLTAIC CELL

If you think all spontaneous electrochemical processes are useful, like those in batteries and fuel cells, consider the problem of **corrosion**, which causes tens of billions of dollars of damage to cars, ships, buildings, and bridges each year. This natural process, which oxidizes metals to their oxides and sulfides, shares many similarities with the operation of a voltaic cell. We focus on the corrosion of iron, but several other metals, such as copper and silver, also corrode.

The Corrosion of Iron

The most common and economically destructive form of corrosion is the rusting of iron. About 25% of the steel produced in the United States each year is for replacing steel in which the iron has corroded. Rust is *not* a direct product of the reaction between iron and oxygen but arises through a complex electrochemical process. Let's look at the facts concerning iron corrosion and then use the features of a voltaic cell to explain them:

- Fact 1. Iron does not rust in dry air; moisture must be present.
- Fact 2. Iron does not rust in air-free water; oxygen must be present.
- Fact 3. Iron loss and rust formation occur at *different* places on the *same* object.
- Fact 4. Iron rusts more quickly at low pH (high $[H^+]$).
- Fact 5. Iron rusts more quickly in ionic solutions (aqueous salt solutions).
- Fact 6. Iron rusts more quickly in contact with a less active metal (such as Cu) and more slowly in contact with a more active metal (such as Zn).

Two separate redox processes occur during corrosion:

1. *The loss of iron.* Picture the surface of a piece of iron (Figure 21.22). A strain, ridge, or dent in contact with water is typically the site of iron loss (fact 1). This site is called an *anodic region* because the following oxidation half-reaction occurs there:

Once the iron atoms lose electrons, the damage to the object has been done, and a pit forms where the iron is lost.

The freed electrons move through the external circuit—the piece of iron itself—until they reach a region of relatively high $[O_2]$ (fact 2), usually the air near the edge of a water droplet that surrounds the newly formed pit. At this *cathodic region*, the electrons released from the iron atoms reduce O_2 :

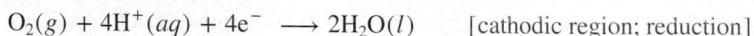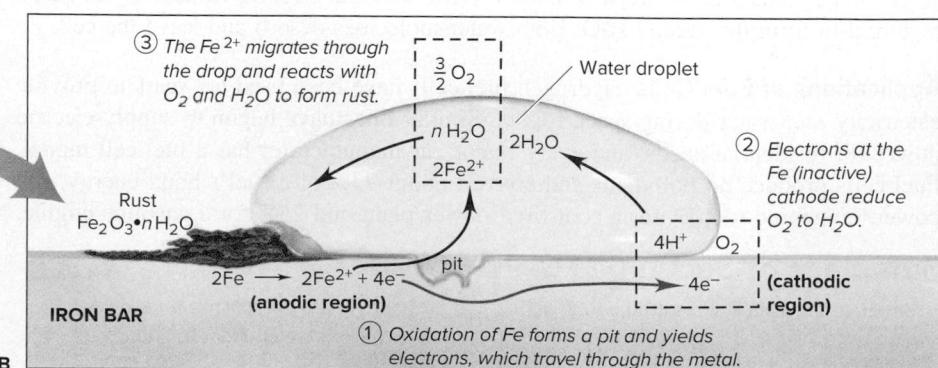

Figure 21.22 The corrosion of iron. **A**, Close-up view of an iron surface. Corrosion usually occurs at a surface irregularity. **B**, A small area of the surface, showing the steps in the corrosion process.

Source: A: © Vincent Roy mastweb/Alamy

This portion of the corrosion process (the sum of these two half-reactions) occurs without any rust forming:

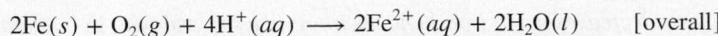

2. The rusting process. Rust forms in another redox reaction. The Fe^{2+} ions formed at the anodic region disperse through the water and react with O_2 , often away from the pit, to form the Fe^{3+} in rust (fact 3). The overall reaction for this step is

[The coefficient n for H_2O appears because rust, $\text{Fe}_2\text{O}_3 \cdot n\text{H}_2\text{O}$, may have a variable number of waters of hydration.] The rust deposit is incidental to the real damage, which is the loss of iron that weakens the strength of the object. Adding the two previous equations gives the overall equation for the loss and rusting of iron:

Other species (2Fe^{2+} and $2\text{H}_2\text{O}$) also cancel, but we showed the canceled H^+ ions to emphasize that they act as a catalyst: they speed the process as they are used up in one step and created in another. For this reason, rusting is faster at low pH (high $[\text{H}^+]$) (fact 4). Ionic solutions speed rusting by improving the conductivity of the aqueous medium near the anodic and cathodic regions (fact 5). The effect of ions is especially evident on ocean-going vessels (Figure 21.23) and on the underbodies and around the wheel wells of cars driven in cold climates, where salts are used to melt ice on slippery roads. (We discuss fact 6 in the next subsection.)

Thus, in some key ways, corrosion resembles the operation of a voltaic cell:

- Anodic and cathodic regions are physically separated.
- The regions are connected via an external circuit through which the electrons travel.
- In the anodic region, iron behaves like an active electrode, whereas in the cathodic region, it is inactive.
- The moisture surrounding the pit functions somewhat like an electrolyte and salt bridge, a solution of ions and a means for them to move and keep the solution neutral.

Protecting Against the Corrosion of Iron

Corrosion is prevented by eliminating corrosive factors. Washing road salt off automobile bodies removes ions. Painting an object keeps out O_2 and moisture. Plating chromium on plumbing fixtures is a more permanent method, as is “blueing” of gun barrels and other steel objects, in which a coating of Fe_3O_4 (magnetite) is bonded to the surface.

The final point regarding corrosion (fact 6) concerns the relative activity of other metals in contact with iron. The essential idea is that *iron functions as both anode and cathode in the rusting process, but it is lost only at the anode*. Thus,

1. Corrosion increases when iron behaves more like the anode. When iron is in contact with a *less* active metal (weaker reducing agent), such as copper, it loses electrons more readily (its anodic function is enhanced; Figure 21.24A). For example, when iron plumbing is connected directly to copper plumbing, the iron pipe corrodes

Figure 21.23 Enhanced corrosion at sea. The high ion concentration of seawater enhances the corrosion of iron in hulls and anchors.

Source: © David Weintraub/Science Source

Figure 21.24 The effect of metal-metal contact on the corrosion of iron. **A**, Fe in contact with Cu corrodes faster. **B**, Fe in contact with Zn does not corrode. This method of preventing corrosion is known as *cathodic protection*.

Figure 21.25 The use of a sacrificial anode to prevent iron corrosion. In cathodic protection, an active metal, such as zinc, magnesium, or aluminum, acts as the anode and is sacrificed instead of the iron.

rapidly. Nonconducting rubber or plastic spacers are placed between the metals to avoid this problem.

2. *Corrosion decreases when iron behaves more like the cathode.* In *cathodic protection*, the most effective way to prevent corrosion, iron makes contact with a *more* active metal (stronger reducing agent), such as zinc. The iron becomes the cathode and remains intact, while the zinc acts as the anode and loses electrons (Figure 21.24B). Coating steel with a “sacrificial” layer of zinc is called *galvanizing*. In addition to blocking physical contact with H₂O and O₂, the zinc (or other active metal) is “sacrificed” (oxidized) instead of the iron. Sacrificial anodes are placed underwater and underground to protect iron and steel pipes, tanks, oil rigs, and so on. Magnesium and aluminum are often used because they are much more active than iron and, thus, act as the anode (Figure 21.25). Moreover, they form adherent oxide coatings, which slow their own corrosion.

› Summary of Section 21.6

- › Corrosion damages metal structures through a natural electrochemical process.
- › Iron corrosion occurs in the presence of oxygen and moisture and is increased by high [H⁺], high [ion], or contact with a less active metal, such as Cu.
- › Fe is oxidized and O₂ is reduced in one redox reaction, while Fe²⁺ is oxidized and O₂ is reduced to form rust (hydrated form of Fe₂O₃) in another redox reaction that often takes place at a different location.
- › Because Fe functions as both anode and cathode in the corrosion process, an iron object can be protected by physically coating it or by joining it to a more active metal (such as Zn, Mg, or Al), which acts as the anode in place of the Fe.

21.7

ELECTROLYTIC CELLS: USING ELECTRICAL ENERGY TO DRIVE NONSPONTANEOUS REACTIONS

In contrast to a voltaic cell, which generates electrical energy from a spontaneous reaction, *an electrolytic cell requires electrical energy from an external source to drive a nonspontaneous redox reaction.* (Industrial electrolysis is discussed in Chapter 22.)

Construction and Operation of an Electrolytic Cell

Let's see how an electrolytic cell operates by constructing one from a voltaic cell. Consider a tin-copper voltaic cell (Figure 21.26A). The Sn anode will gradually be oxidized to Sn²⁺ ions, which enter the electrolyte, and the Cu²⁺ ions will gradually be reduced and plate out on the Cu cathode because the cell reaction is spontaneous in that direction.

For the voltaic cell:

Therefore, the *reverse* cell reaction is *nonspontaneous* and cannot happen on its own. But, we can make it happen by supplying an electric potential *greater than E_{cell}[°]* from an external source. In effect, we convert the voltaic cell into an electrolytic cell—anode becomes cathode, and cathode becomes anode (Figure 21.26B).

For the electrolytic cell:

In an electrolytic cell, as in a voltaic cell, *oxidation takes place at the anode and reduction takes place at the cathode.* Note, however, that *the direction of electron flow and the signs of the electrodes are reversed.*

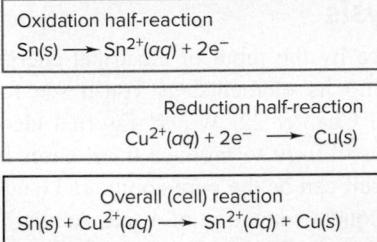**A Voltaic cell**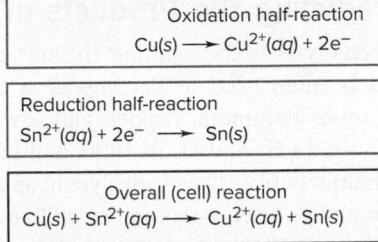**B Electrolytic cell**

Figure 21.26 The tin-copper reaction as the basis of a voltaic and an electrolytic cell.
A. The spontaneous reaction between Sn and Cu²⁺ generates 0.48 V in a voltaic cell. **B.** If more than 0.48 V is supplied, the nonspontaneous (reverse) reaction between Cu and Sn²⁺ occurs. Note the changes in electrode charges and direction of electron flow.

- To understand these differences, we focus on the *cause* of the electron flow:
- In a voltaic cell, electrons are generated *in* the anode, so it is *negative*, and they are *removed from* the cathode, so it is *positive*.
 - In an electrolytic cell, an external power source supplies electrons *to* the cathode, so it is *negative*, and removes them *from* the anode, so it is *positive*.

A rechargeable battery is a voltaic cell when it is discharging and an electrolytic cell when it is recharging. Let's compare these two functions in a lead-acid car battery (Figure 21.27; see also Figure 21.18):

- In the discharge mode (voltaic cell), oxidation occurs at electrode I, thus making that *negative* electrode the anode and the *positive* electrode (electrode II) the cathode.
- In the recharge mode (electrolytic cell), reduction occurs at electrode I, making that *negative* electrode the cathode and the *positive* electrode (electrode II) the anode.

Figure 21.27 The processes occurring during the discharge (top) and recharge (bottom) of a lead-acid battery.

Source: © Jill Braaten

Table 21.4

Comparison of Voltaic and Electrolytic Cells

Cell Type	ΔG	E_{cell}	Electrode		
			Name	Process	Sign
Voltaic	<0	>0	Anode	Oxidation	-
Voltaic	<0	>0	Cathode	Reduction	+
Electrolytic	>0	<0	Anode	Oxidation	+
Electrolytic	>0	<0	Cathode	Reduction	-

Table 21.4 summarizes the processes and signs in the two types of cells.

Predicting the Products of Electrolysis

Electrolysis is the splitting (lysing) of a substance by the input of electrical energy and is often used to decompose a compound into its elements, as you'll see for chlorine, aluminum, copper, and several others in Chapter 22. Water was first electrolyzed to H₂ and O₂ in 1800, and the process is still used to produce these gases in ultrahigh purity. The electrolyte in an electrolytic cell can be the pure compound (such as a molten salt), a mixture of molten salts, or an aqueous solution of a salt. As you'll see, the products depend on atomic properties and several other factors.

Electrolysis of Pure Molten Salts If the salt is pure, predicting the products of its electrolysis is straightforward: *the cation will be reduced and the anion oxidized*. The electrolyte is the molten salt itself, and the ions are attracted by the oppositely charged electrodes.

Consider the electrolysis of molten (fused) calcium chloride. The two species present are Ca²⁺ and Cl⁻, so Ca²⁺ ion is reduced and Cl⁻ ion is oxidized:

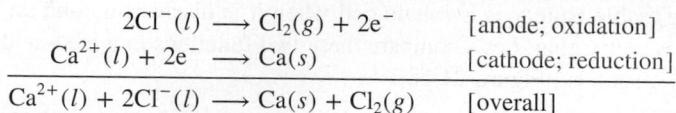

Calcium is prepared industrially this way, as are several other active metals, such as Na and Mg, and the halogens Cl₂ and Br₂.

Electrolysis of Mixed Molten Salts More typically, the electrolyte is a mixture of molten salts being electrolyzed to obtain one of the metals. How can we tell which species will react at which electrode? The general rule for all electrolytic cells identifies them:

- *The more easily reduced species (stronger oxidizing agent) is reduced at the cathode.*
- *The more easily oxidized species (stronger reducing agent) is oxidized at the anode.*

Unfortunately, for molten salts, we *cannot* use E° values to tell the relative strength of the oxidizing and reducing agents, because those values refer to the reduction of the *aqueous ion to the free element*, Mⁿ⁺(aq) + ne⁻ → M(s), under standard-state conditions. Instead, we use periodic trends of atomic properties to predict which ion gains or loses electrons more easily (Sections 8.3 and 9.5):

- If a metal holds its electrons *more* tightly than another, it has a higher ionization energy (IE). Thus, as a cation, it gains electrons more easily, so it is the stronger oxidizing agent and is reduced at the cathode.
- If a nonmetal holds its electrons *less* tightly than another, it has a lower electronegativity (EN). Thus, as an anion, it loses electrons more easily, so it is the stronger reducing agent and is oxidized at the anode.

To summarize, in a mixture of molten salts, the metal with the higher IE is the cation that is reduced, while the nonmetal with the lower EN is the anion that is oxidized.

SAMPLE PROBLEM 21.9**Predicting the Electrolysis Products of a Molten Salt Mixture**

Problem A chemical engineer melts a naturally occurring mixture of NaBr and MgCl₂ and decomposes it in an electrolytic cell. Predict the substance formed at each electrode, and write balanced half-reactions and the overall cell reaction.

Plan We have to determine which metal and nonmetal will form more easily at each electrode. We list the ions as oxidizing or reducing agents and then use periodic trends to determine which metal ion is more easily reduced and which nonmetal ion more easily oxidized.

Solution Listing the ions as oxidizing or reducing agents:

The possible oxidizing agents are Na⁺ and Mg²⁺; these cations may undergo reduction.

The possible reducing agents are Br⁻ and Cl⁻; these anions may undergo oxidation.

Determining the cathode product (more easily reduced cation): Mg is to the right of Na in Period 3. IE increases from left to right, so it is harder to remove e⁻ from Mg. Thus, Mg²⁺ has a greater attraction for e⁻ and is more easily reduced (stronger oxidizing agent). Mg²⁺ will be reduced preferentially at the cathode:

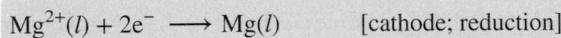

Determining the anode product (more easily oxidized anion): Br is below Cl in Group 7A(17). EN decreases down the group, so Br accepts e⁻ less readily. Thus, Br⁻ loses its e⁻ more easily and is more easily oxidized (stronger reducing agent). Br⁻ will be oxidized preferentially at the anode:

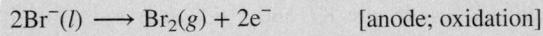

Writing the overall cell reaction:

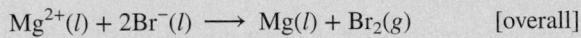

Comment The cell temperature must be high enough to keep the salt mixture molten. In this case, the temperature is greater than the melting point of Mg, so it appears as a liquid in the equation, and greater than the boiling point of Br₂, so it appears as a gas.

FOLLOW-UP PROBLEMS

21.9A The most ionic and least ionic of the common alkali halides are, respectively, CsF and LiI. A solid mixture of these compounds is melted and electrolyzed. Determine which metal and nonmetal form at the electrodes, and write the overall cell reaction.

21.9B A sample of AlBr₃ contaminated with KF is melted and electrolyzed. Determine the electrode products, and write the overall cell reaction.

SOME SIMILAR PROBLEMS 21.89–21.92

Electrolysis of Water and Nonstandard Half-Cell Potentials Before we analyze the electrolysis products of aqueous salt solutions, let's examine the electrolysis of water itself. Very pure water is difficult to electrolyze because so few ions are present to conduct a current. However, if we add a small amount of a salt that cannot be electrolyzed (such as Na₂SO₄), electrolysis proceeds rapidly. An electrolytic cell with separate compartments for H₂ and O₂ is used (Figure 21.28). At the anode, water is oxidized; note that the oxidation number (O.N.) of O changes from -2 in H₂O to 0 in O₂:

Oxidation half-reaction
$2\text{H}_2\text{O}(l) \longrightarrow \text{O}_2(g) + 4\text{H}^+(aq) + 4\text{e}^-$
Reduction half-reaction
$2\text{H}_2\text{O}(l) + 2\text{e}^- \longrightarrow \text{H}_2(g) + 2\text{OH}^-(aq)$
Overall (cell) reaction
$2\text{H}_2\text{O}(l) \longrightarrow 2\text{H}_2(g) + \text{O}_2(g)$

Figure 21.28 The electrolysis of water. Twice as much H₂ forms as O₂.
Source: © McGraw-Hill Education/Stephen Frisch, photographer

At the cathode, water is reduced; note that the O.N. of H changes from +1 in H_2O to 0 in H_2 :

Doubling the cathode half-reaction to make e^- lost equal e^- gained, adding the half-reactions (which involves combining the H^+ and OH^- into H_2O and canceling e^- and excess H_2O), and calculating E_{cell} gives the overall reaction:

Note that, because $[\text{H}^+]$ and $[\text{OH}^-]$ are $1.0 \times 10^{-7} \text{ M}$ rather than the standard-state value of 1 M , these electrode potentials are *not* standard electrode potentials and are designated with E , not E° . In aqueous ionic solutions, $[\text{H}^+]$ and $[\text{OH}^-]$ are also approximately 10^{-7} M , so we use these nonstandard $E_{\text{half-cell}}$ values to predict electrode products.

Electrolysis of Aqueous Salt Solutions and the Effect of Overvoltage Aqueous salt solutions are mixtures of ions *and* water, so we have to compare the electrode potentials of the ions and of water to predict the electrode products.

1. *Predicting the electrode products.* When two half-reactions are possible at an electrode:

- *The reduction with the less negative (more positive) electrode potential occurs.*
- *The oxidation with the less positive (more negative) electrode potential occurs.*

What happens, for instance, when a solution of potassium iodide is electrolyzed?

- The possible *oxidizing agents* are K^+ and H_2O ; their reduction half-reactions are

The less *negative* electrode potential for water means that it is much easier to reduce H_2O than K^+ , so H_2 forms at the cathode. No potassium metal forms at the cathode.

- The possible *reducing agents* are I^- and H_2O ; their oxidation half-reactions are

The less *positive* electrode potential for iodide ion means that it is easier to oxidize I^- than H_2O , so I_2 forms at the anode.

2. *The effect of overvoltage.* The products predicted from a comparison of electrode potentials are not always the actual products. For gases to be produced at metal electrodes, additional voltage is required. This increment above the expected voltage is the **overvoltage**. It is 0.4–0.6 V for $\text{H}_2(\text{g})$ or $\text{O}_2(\text{g})$ and is due to the large activation energy (Section 16.5) required for a gas to form at the electrode.

Overvoltage has major practical significance. A multibillion-dollar example is the industrial production of chlorine from concentrated NaCl solution. Water is easier to reduce than Na^+ , so H_2 forms at the cathode, even *with* an overvoltage of 0.6 V:

But Cl_2 *does* form at the anode, even though a comparison of the electrode potentials alone would lead us to predict that O_2 should form:

An overvoltage of ~ 0.6 V for O_2 makes Cl_2 the product that is easier to form. Keeping $[Cl^-]$ high also favors its formation. Thus, Cl_2 , one of the 10 most heavily produced chemicals, is formed from plentiful natural sources of aqueous sodium chloride (Chapter 22).

3. A summary: which product at which electrode. Experiments have shown the elements that can be prepared electrolytically from aqueous solutions of their salts:

- Cations of less active metals, including gold, silver, copper, chromium, platinum, and cadmium, *are* reduced to the metal.
- Cations of more active metals, including those in Groups 1A(1) and 2A(2) and Al from 3A(13), *are not* reduced. Water is reduced to H_2 and OH^- instead.
- Anions that *are* oxidized, because of overvoltage from O_2 formation, include the halides ($[Cl^-]$ must be high), except for F^- .
- Anions that *are not* oxidized include F^- and common oxoanions, such as SO_4^{2-} , CO_3^{2-} , NO_3^- , and PO_4^{3-} because the central nonmetal in these oxoanions is already in its highest oxidation state. Water is oxidized to O_2 and H^+ instead.

Student Hot Spot

Student data indicate that you may struggle with determining the products of electrolysis. Access the Smartbook to view additional Learning Resources on this topic.

SAMPLE PROBLEM 21.10

Predicting the Electrolysis Products of Aqueous Salt Solutions

Problem Use half-reactions to show which product forms at each electrode during the electrolysis of aqueous solutions of the following salts:

Plan We identify the reacting ions and compare their electrode potentials with those of water, taking the additional 0.4–0.6 V overvoltage into account. The reduction half-reaction with the less negative electrode potential occurs at the cathode, and the oxidation half-reaction with the less positive electrode potential occurs at the anode.

Solution

Despite the overvoltage, which makes E for the reduction of water between -0.8 V and -1.0 V, H_2O is still easier to reduce than K^+ , so $H_2(g)$ forms at the cathode.

Because of the overvoltage, which makes E for the oxidation of water between 1.2 V and 1.4 V, Br^- is easier to oxidize than water, so $Br_2(l)$ forms at the anode (see photo).

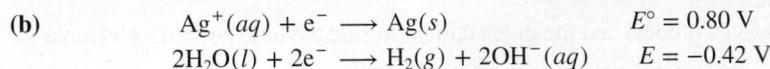

As the cation of an inactive metal, Ag^+ is a better oxidizing agent than H_2O , so $Ag(s)$ forms at the cathode. NO_3^- cannot be oxidized, because N is already in its highest (+5) oxidation state. Thus, $O_2(g)$ forms at the anode:

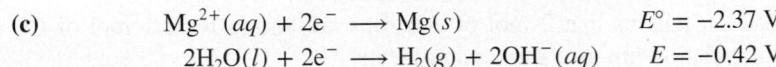

Like K^+ in part (a), Mg^{2+} cannot be reduced in the presence of water, so $H_2(g)$ forms at the cathode. The SO_4^{2-} ion cannot be oxidized because S is in its highest (+6) oxidation state. Thus, H_2O is oxidized, and $O_2(g)$ forms at the anode:

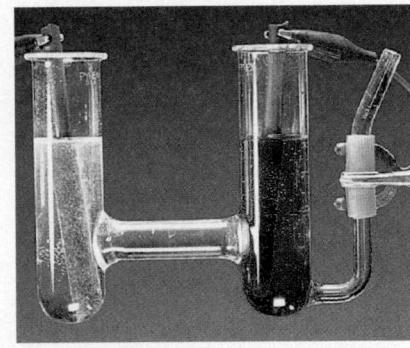

Electrolysis of aqueous KBr .

Source: © McGraw-Hill Education/Stephen Frisch, photographer

FOLLOW-UP PROBLEMS

21.10A Use half-reactions to show which product forms at each electrode when an aqueous solution of lead(II) nitrate is electrolyzed.

21.10B Use half-reactions to show which product forms at each electrode in the electrolysis of aqueous $AuBr_3$.

SOME SIMILAR PROBLEMS 21.97–21.100

Stoichiometry of Electrolysis: The Relation Between Amounts of Charge and Products

Since charge flowing through an electrolytic cell yields products at the electrodes, it makes sense that more product forms when more charge flows. This relationship was first determined experimentally in the 1830s by Michael Faraday:

- *Faraday's law of electrolysis: the amount of substance produced at each electrode is directly proportional to the quantity of charge flowing through the electrolytic cell.*

Each balanced half-reaction shows the amounts (mol) of reactant, electrons, and product involved in the change, so it contains the information we need to answer such questions as “How much material will form from a given quantity of charge?” or, conversely, “How much charge is needed to produce a given amount of material?”

Measuring Current to Find Charge We cannot measure charge directly, but we can measure *current*, the charge flowing per unit time. The SI unit of current is the **ampere (A)**, which is defined as a charge of 1 coulomb (C) flowing through a conductor in 1 second (s):

$$\text{Current (A)} = \text{charge (C)}/\text{time (s)} \quad \text{or} \quad 1 \text{ A} = 1 \text{ C/s} \quad (21.11)$$

Thus, the current multiplied by the time gives the charge:

$$\text{Current} \times \text{time} = \text{charge} \quad \text{or} \quad A \times s = \frac{C}{s} \times s = C$$

Therefore, by measuring the current *and* the time during which the current flows, we find the charge, which relates to the amount of product (Figure 21.29).

Faraday's Law and the Stoichiometry of Electrolysis Problems based on Faraday's law often ask you to calculate current, mass of material, or time. As we said, the electrode half-reaction provides the key to solving these problems because it relates the mass of product to a certain quantity of charge. To apply Faraday's law:

1. Balance the half-reaction to find the amount (mol) of electrons needed per mole of product.
2. Use the Faraday constant ($F = 9.65 \times 10^4 \text{ C/mol e}^-$) to find the quantity of charge.
3. Depending on the question, do one of the following:
 - a. Use the molar mass to find the charge needed for a given mass of product, or vice versa.
 - b. Use the mass of product and the given current to find the time needed, or vice versa.

Here is a typical problem in practical electrolysis: how long does it take to produce 3.0 g of $\text{Cl}_2(g)$ by electrolysis of aqueous NaCl using a power supply with a current of 12 A? The problem asks for the time needed to produce a certain mass, so let's first relate mass to amount (mol) of electrons to find the charge needed. Then, we'll relate the charge to the current to find the time.

The half-reaction tells us that 2 mol of electrons are lost to form 1 mol of Cl_2 and we'll use this relationship as a conversion factor:

We convert the given mass of Cl_2 to amount (mol) of Cl_2 , use the conversion factor from the half-reaction, and multiply by the Faraday constant to find the total charge:

$$\begin{aligned} \text{Charge (C)} &= 3.0 \text{ g Cl}_2 \times \frac{1 \text{ mol Cl}_2}{70.90 \text{ g Cl}_2} \times \frac{2 \text{ mol e}^-}{1 \text{ mol Cl}_2} \times \frac{9.65 \times 10^4 \text{ C}}{1 \text{ mole e}^-} \\ &= 8.2 \times 10^3 \text{ C} \end{aligned}$$

Figure 21.29 A summary diagram for the stoichiometry of electrolysis.

Now we use the relationship between charge and current to find the time needed:

$$\begin{aligned}\text{Time (s)} &= \frac{\text{charge (C)}}{\text{current (A, or C/s)}} = 8.2 \times 10^3 \text{ C} \times \frac{1 \text{ s}}{12 \text{ C}} \\ &= 6.8 \times 10^2 \text{ s} (\sim 11 \text{ min})\end{aligned}$$

Note that the entire calculation follows Figure 21.29 until the last step, which asks for the time that the given current must flow:

grams of $\text{Cl}_2 \Rightarrow$ moles of $\text{Cl}_2 \Rightarrow$ moles of $e^- \Rightarrow$ coulombs \Rightarrow seconds

Sample Problem 21.11 applies these ideas in an important industrial setting.

SAMPLE PROBLEM 21.11

Applying the Relationship Among Current, Time, and Amount of Substance

Problem A technician plates a faucet with 0.86 g of Cr metal by electrolysis of aqueous $\text{Cr}_2(\text{SO}_4)_3$. If 12.5 min is allowed for the plating, what current is needed?

Plan To find the current, we divide charge by time, so we need to find the charge. We write the half-reaction for the Cr^{3+} reduction to get the amount (mol) of e^- transferred per mole of Cr. To find the charge, we convert the mass of Cr needed (0.86 g) to amount (mol) of Cr. Then, we use the Faraday constant ($9.65 \times 10^4 \text{ C/mol e}^-$) to find the charge and divide by the time (12.5 min, converted to seconds) to obtain the current (see the road map).

Solution Writing the balanced half-reaction [$\text{Cr}_2(\text{SO}_4)_3$ contains the Cr^{3+} ion]:

Combining steps to find amount (mol) of e^- transferred for the mass of Cr needed:

$$\text{Amount (mol) of } e^- \text{ transferred} = 0.86 \text{ g Cr} \times \frac{1 \text{ mol Cr}}{52.00 \text{ g Cr}} \times \frac{3 \text{ mol } e^-}{1 \text{ mol Cr}} = 0.050 \text{ mol } e^-$$

Calculating the charge using the Faraday constant as a conversion factor between moles of electrons transferred and charge:

$$\text{Charge (C)} = 0.050 \text{ mol } e^- \times \frac{9.65 \times 10^4 \text{ C}}{1 \text{ mol } e^-} = 4.8 \times 10^3 \text{ C}$$

Calculating the current:

$$\text{Current (A)} = \frac{\text{charge (C)}}{\text{time (s)}} = \frac{4.8 \times 10^3 \text{ C}}{12.5 \text{ min}} \times \frac{1 \text{ min}}{60 \text{ s}} = 6.4 \text{ C/s} = 6.4 \text{ A}$$

Check Rounding gives

$$(\sim 0.9 \text{ g})(1 \text{ mol Cr}/50 \text{ g})(3 \text{ mol } e^-/1 \text{ mol Cr}) = 5 \times 10^{-2} \text{ mol } e^-$$

Then

$$(5 \times 10^{-2} \text{ mol } e^-)(\sim 1 \times 10^5 \text{ C/mol } e^-) = 5 \times 10^3 \text{ C}$$

and

$$(5 \times 10^3 \text{ C}/12 \text{ min})(1 \text{ min}/60 \text{ s}) = 7 \text{ A}$$

Comment In order to introduce Faraday's law, we have neglected some details about actual electroplating. In practice, electroplating chromium has an efficiency of only 30–40% and must be run at a specific temperature range for the plate to appear bright. Nearly 10,000 metric tons (2×10^8 mol) of chromium are used annually for electroplating.

FOLLOW-UP PROBLEMS

21.11A Using a current of 4.75 A, how many minutes does it take to plate a sculpture with 1.50 g of Cu from a CuSO_4 solution?

21.11B To protect it from corrosion, a section of iron pipe is electrogalvanized with zinc from a basic solution of $\text{Na}_2\text{Zn}(\text{OH})_4$. The half-reaction is

If the process takes 8.75 min with a current of 7.03 A, what mass of Zn is deposited on the pipe?

SOME SIMILAR PROBLEMS 21.101–21.106

Road Map

The following Chemical Connections essay links several themes of this chapter to the generation of energy in a living cell.

Biological cells apply the principles of electrochemical cells to generate energy. The complex multistep process can be divided into two parts:

1. Bond energy in food generates an electrochemical potential.
2. That potential creates the bond energy of ATP (see Chemical Connections in Chapter 20.)

These steps are part of the *electron-transport chain* (ETC), which lies on the inner membranes of *mitochondria*, the subcellular particles that produce energy (Figure B21.1).

The ETC is a series of large molecules (mostly proteins), each of which contains a *redox couple* (the oxidized and reduced forms of a species), such as $\text{Fe}^{3+}/\text{Fe}^{2+}$, that passes electrons along the chain. At three points in this chain, large potential differences supply enough free energy to convert adenosine diphosphate (ADP) into ATP.

Bond Energy to Electrochemical Potential

Cells utilize the energy in food by releasing it in controlled steps rather than all at once. The reaction that ultimately powers the ETC is the oxidation of hydrogen to form water: $\text{H}_2 + \frac{1}{2}\text{O}_2 \rightarrow \text{H}_2\text{O}$. But, instead of H_2 gas, which does not occur in organisms, the hydrogen takes the form of two H^+ ions and two e^- . The biological oxidizing agent NAD^+ (*nicotinamide adenine dinucleotide*) acquires these protons and electrons in the process of oxidizing molecules in food. To show this process, we use this half-reaction (without canceling an H^+ on both sides):

At the mitochondrial inner membrane, the NADH and H^+ transfer the two e^- to the first redox couple of the ETC and release the two H^+ . The electrons are transported down the chain of redox couples, where they finally reduce O_2 . The overall process, with standard electrode potentials,* is

Thus, for every 2 mol of e^- , 1 mol of NADH enters the ETC, and the free energy equivalent of 1.130 V is available:

$$\begin{aligned} \Delta G^{\circ'} &= -nFE^{\circ'} \\ &= -(2 \text{ mol } e^-/\text{mol NADH})(96.5 \text{ kJ/V} \cdot \text{mol } e^-)(1.130 \text{ V}) \\ &= -218 \text{ kJ/mol NADH} \end{aligned}$$

Note that this aspect of the process functions like a voltaic cell: a spontaneous reaction, the reduction of O_2 to H_2O , is used to generate a potential. In contrast to the operation of a voltaic cell, this process occurs in many small steps. Figure B21.2 is a highly simplified diagram showing the three steps in the ETC that generate a high enough potential to form ATP from ADP.

Each step consists of several components, in which electrons are passed from one redox couple to the next. Since most of the ETC components are iron-containing proteins, the redox change

*In biological systems, standard potentials are designated $E^{\circ'}$ and the standard states include a pH of 7.0 ($[\text{H}^+] = 1 \times 10^{-7} \text{ M}$).

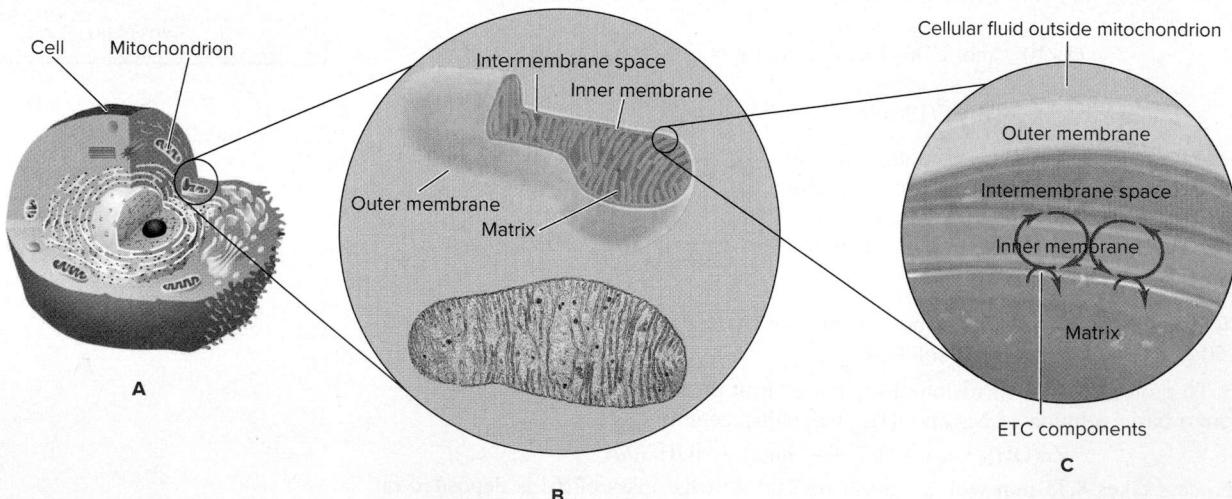

Figure B21.1 The mitochondrion. **A**, Mitochondria are subcellular particles outside the cell nucleus. **B**, They have a smooth outer membrane and a highly folded inner membrane, shown schematically and in an electron micrograph. **C**, The components of the electron-transport chain are attached to the inner membrane, which is in contact with the matrix, a relatively viscous aqueous mixture of small organic molecules, enzymes, and other macromolecules.

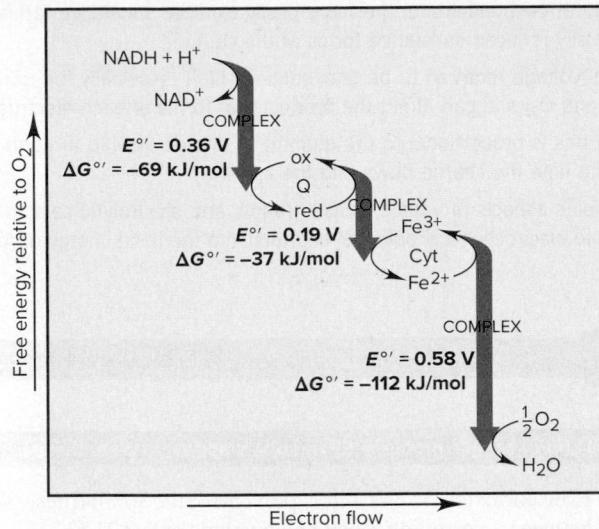

Figure B21.2 The main energy-yielding steps in the electron-transport chain (ETC). At the three points shown, $E^{\circ'}$ (or $\Delta G^{\circ'}$) is large enough to form ATP from ADP. (A complex consists of many components; Q is a large organic molecule; Cyt stands for a cytochrome, a protein that contains a metal-ion redox couple.)

consists of the oxidation of Fe^{2+} to Fe^{3+} in one component accompanied by the reduction of Fe^{3+} to Fe^{2+} in the other:

In other words, metal ions bound within the ETC proteins are the actual species undergoing the redox reactions.

Electrochemical Potential to Bond Energy

Formation of ATP requires a lot of energy:

Note that, at each of the three points in Figure B21.2, the free energy *released* exceeds the 30.5 kJ needed to form 1 mol of ATP. Thus, as in an electrolytic cell, an electrochemical potential is supplied to drive a nonspontaneous reaction.

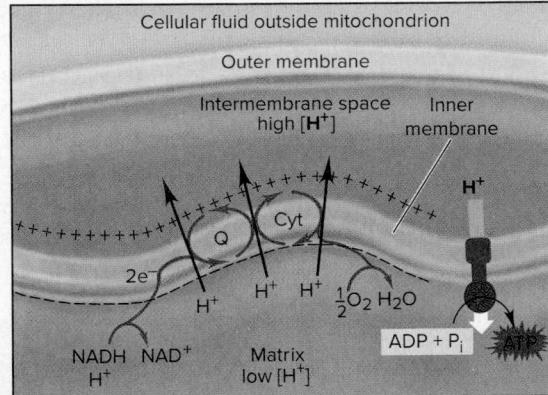

Figure B21.3 Coupling electron transport to proton transport to ATP synthesis. Electrons are transported along the ETC (curved yellow arrows). Protons pumped into the intermembrane space create an $[H^+]$ difference that generates a potential across the inner membrane. When that difference is large enough, H^+ flows back into the inner space, and the free energy drives the formation of ATP.

We've followed the flow of *electrons* through the ETC. To see how electrochemical potential is converted to bond energy in ATP, we focus on the released *protons*. The free energy released at the three key steps is used to force the H^+ ions into the intermembrane space; as a result, $[H^+]$ of the intermembrane space becomes higher than $[H^+]$ of the matrix, the aqueous mixture that fills the spaces between the folds of the inner membrane (Figure B21.3). This part of the process uses the free energy released by the three steps to *create an H^+ concentration cell across the inner membrane*.

When the $[H^+]$ difference across the inner membrane reaches a "trigger" point of about 2.5-fold, H^+ ions spontaneously flow back through the membrane (in effect, closing the switch and allowing the concentration cell to operate). The free energy released in this spontaneous process drives the nonspontaneous ATP formation via an enzyme-catalyzed mechanism.

Thus, the mitochondrion uses the "electron-motive force" of redox couples on its inner membrane to generate a "proton-motive force" across the membrane, which converts a potential difference into bond energy.

Problems

- B21.1** In the final steps of the ETC, iron and copper ions in a large protein complex interact with each other.
- Write balanced equations for the one-electron half-reactions of Fe^{3+} and of Cu^{+} .
 - Write a balanced overall equation for this redox reaction.

- B21.2** As the ETC proceeds, a difference in $[H^+]$ develops across the inner mitochondrial membrane. The "proton-motive force," which is used to form ATP, is based largely on this difference and is equivalent to an electrical potential of 0.224 V. What is the free energy change (in kJ/mol) associated with the "proton-motive force"?

› Summary of Section 21.7

- › An electrolytic cell uses electrical energy to drive a nonspontaneous reaction.
- › Oxidation occurs at the anode and reduction at the cathode, but the direction of electron flow and the charges of the electrodes are opposite those in voltaic cells.
- › When two products could form at each electrode, the more easily oxidized substance forms at the anode and the more easily reduced substance forms at the cathode.
- › Overvoltage causes the actual voltage required to be unexpectedly high (especially for producing gases, such as H₂ and O₂) and can affect the product that forms at each electrode.
- › The amount of product that forms is proportional to the quantity of charge flowing through the cell, which is related to the time the charge flows and the current.
- › Biological redox systems combine aspects of voltaic, concentration, and electrolytic cells to convert bond energy in food into electrochemical potential and then into the bond energy of ATP.

CHAPTER REVIEW GUIDE

Learning Objectives

Relevant section (§) and/or sample problem (SP) numbers appear in parentheses.

Understand These Concepts

1. The meanings of *oxidation* and *reduction*; why an oxidizing agent is reduced and a reducing agent is oxidized (§21.1)
2. How the half-reaction method is used to balance redox reactions in acidic or basic solution (§21.1)
3. The distinction between voltaic and electrolytic cells in terms of the sign of ΔG (§21.1)
4. How voltaic cells use a spontaneous reaction to release electrical energy (§21.2)
5. The physical makeup of a voltaic cell: arrangement and composition of half-cells, relative charges of electrodes, and purpose of a salt bridge (§21.2)
6. How the difference in reducing strength of the electrodes determines the direction of electron flow in a voltaic cell (§21.2)
7. The correspondence between a positive E_{cell} and a spontaneous cell reaction (§21.3)
8. The usefulness and significance of standard electrode potentials (E°_{half-cell}) (§21.3)
9. How E°_{half-cell} values are combined to give E°_{cell} (§21.3)
10. How the standard reference electrode is used to find an unknown E°_{half-cell} (§21.3)
11. How an emf series (e.g., Table 21.2 or Appendix D) is used to write spontaneous redox reactions (§21.3)
12. How the relative reactivity of a metal is determined by its reducing power and is related to the negative of its E°_{half-cell} (§21.3)
13. How E_{cell} (the nonstandard cell potential) is related to ΔG (maximum work) and the charge (moles of electrons times the Faraday constant) flowing through the cell (§21.4)
14. The interrelationship of ΔG°, E°_{cell}, and K (§21.4)
15. How E_{cell} changes as the cell operates (as Q changes) (§21.4)
16. Why a voltaic cell can do work until Q = K (§21.4)
17. How a concentration cell does work until the half-cell concentrations are equal (§21.4)
18. The distinction between primary (nonrechargeable) and secondary (rechargeable) batteries and the nature of fuel cells (§21.5)

19. How corrosion occurs and is prevented; the similarities between a corroding metal and a voltaic cell (§21.6)
20. How electrolytic cells use nonspontaneous redox reactions driven by an external source of electricity (§21.7)
21. How atomic properties (ionization energy and electronegativity) determine the products of the electrolysis of molten salt mixtures (§21.7)
22. How the electrolysis of water influences the products of aqueous electrolysis; the importance of overvoltage (§21.7)
23. The relationship between the quantity of charge flowing through the cell and the amount of product formed (§21.7)

Master These Skills

1. Balancing redox reactions by the half-reaction method (§21.1 and SP 21.1)
2. Describing a voltaic cell with a diagram and notation (§21.2 and SP 21.2)
3. Combining E°_{half-cell} values to obtain E°_{cell} (§21.3 and SP 21.3)
4. Using E°_{cell} and a known E°_{half-cell} to find an unknown E°_{half-cell} (SP 21.4)
5. Manipulating half-reactions to write a spontaneous redox reaction and calculate its E°_{cell} (SP 21.5)
6. Ranking the relative strengths of oxidizing and reducing agents in a redox reaction (SP 21.5)
7. Predicting whether a metal can displace hydrogen or another metal from solution (§21.3)
8. Using the interrelationship of ΔG°, E°_{cell}, and K to calculate two of the three given the third (§21.4 and SP 21.6)
9. Using the Nernst equation to calculate the nonstandard cell potential (E_{cell}) (SP 21.7)
10. Calculating E_{cell} of a concentration cell (SP 21.8)
11. Predicting the products of the electrolysis of a mixture of molten salts (SP 21.9)
12. Predicting the products of the electrolysis of aqueous salt solutions (SP 21.10)
13. Calculating the current (or time) needed to produce a given amount of product by electrolysis (SP 21.11)

Key Terms

Page numbers appear in parentheses.

- anode (944)
ampere (A) (980)
battery (968)
cathode (944)
cell potential (E_{cell}) (950)
concentration cell (964)
coulomb (C) (950)
corrosion (972)

- electrochemical cell (939)
electrochemistry (939)
electrolytic cell (944)
electrode (944)
electrolyte (944)
electromotive force (emf) (950)
electrolysis (976)
Faraday constant (F) (959)

- fuel cell (970)
half-cell (946)
half-reaction method (940)
Nernst equation (962)
overvoltage (978)
salt bridge (947)
standard cell potential (E_{cell}°) (950)

- standard electrode (half-cell) potential ($E_{\text{half-cell}}^{\circ}$) (950)
standard reference half-cell (standard hydrogen electrode) (952)
volt (V) (950)
voltaic (galvanic) cell (944)
voltage (950)

Key Equations and Relationships

Page numbers appear in parentheses.

21.1 Relating the spontaneity of a process to the sign of the cell potential (950):

$$E_{\text{cell}} > 0 \text{ for a spontaneous process}$$

21.2 Relating electric potential to energy and charge in SI units (950):

$$\text{Potential} = \text{energy/charge} \quad \text{or} \quad 1 \text{ V} = 1 \text{ J/C}$$

21.3 Relating standard cell potential to standard electrode potentials in a voltaic cell (951):

$$E_{\text{cell}}^{\circ} = E_{\text{cathode(reduction)}}^{\circ} - E_{\text{anode(oxidation)}}^{\circ}$$

21.4 Defining the Faraday constant (960):

$$F = 9.65 \times 10^4 \frac{\text{J}}{\text{V} \cdot \text{mol e}^{-}} \quad (3 \text{ sf})$$

21.5 Relating the free energy change to the cell potential (960):

$$\Delta G = -nFE_{\text{cell}}$$

21.6 Finding the standard free energy change from the standard cell potential (960):

$$\Delta G^{\circ} = -nFE_{\text{cell}}^{\circ}$$

BRIEF SOLUTIONS TO FOLLOW-UP PROBLEMS

21.2A

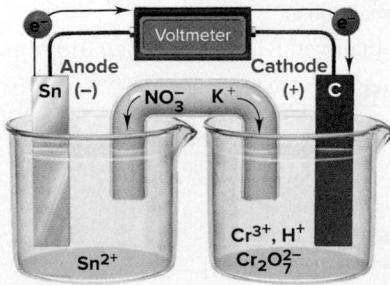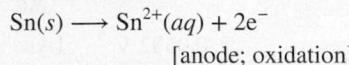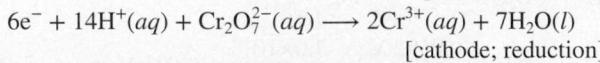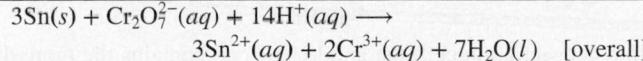

Cell notation:

$\text{Sn}(s) | \text{Sn}^{2+}(aq) || \text{H}^{+}(aq), \text{Cr}_2\text{O}_7^{2-}(aq), \text{Cr}^{3+}(aq) | \text{graphite}$

21.7 Finding the equilibrium constant from the standard cell potential (960):

$$E_{\text{cell}}^{\circ} = \frac{RT}{nF} \ln K$$

21.8 Substituting known values of R , F , and T into Equation 21.7 and converting to a common logarithm (960):

$$E_{\text{cell}}^{\circ} = \frac{0.0592 \text{ V}}{n} \log K \quad \text{or} \quad \log K = \frac{nE_{\text{cell}}^{\circ}}{0.0592 \text{ V}} \quad (\text{at } 298.15 \text{ K})$$

21.9 Calculating the nonstandard cell potential (Nernst equation) (962):

$$E_{\text{cell}} = E_{\text{cell}}^{\circ} - \frac{RT}{nF} \ln Q$$

21.10 Substituting known values of R , F , and T into the Nernst equation and converting to a common logarithm (962):

$$E_{\text{cell}} = E_{\text{cell}}^{\circ} - \frac{0.0592 \text{ V}}{n} \log Q \quad (\text{at } 298.15 \text{ K})$$

21.11 Relating current to charge and time (980):

$$\text{Current (A)} = \text{charge (C)}/\text{time (s)} \quad \text{or} \quad 1 \text{ A} = 1 \text{ C/s}$$

21.2B

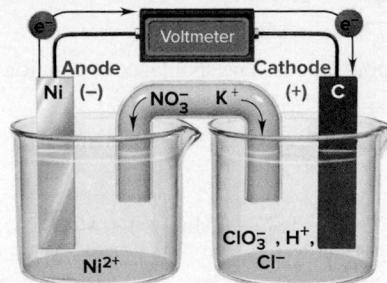

[anode; oxidation]

[cathode; reduction]

Cell notation:

$\text{Ni}(s) | \text{Ni}^{2+}(aq) || \text{H}^{+}(aq), \text{ClO}_3^{-}(aq), \text{Cl}^{-}(aq) | \text{graphite}$

$$E_{\text{cell}}^{\circ} = E_{\text{cathode(reduction)}}^{\circ} - E_{\text{anode(oxidation)}}^{\circ}$$

$$= E_{\text{copper}}^{\circ} - E_{\text{silver}}^{\circ} = 0.34 \text{ V} - 0.80 \text{ V}$$

= -0.46 V; not spontaneous

BRIEF SOLUTIONS TO FOLLOW-UP PROBLEMS

(continued)

$$E_{\text{cell}}^\circ = E_{\text{cathode (reduction)}}^\circ - E_{\text{anode (oxidation)}}^\circ$$

$$= E_{\text{chlorine}}^\circ - E_{\text{iron}}^\circ = 1.36 \text{ V} - 0.77 \text{ V}$$

= 0.59 V; spontaneous

21.5A (a) Combine (2) and reversed (1) to obtain equation A:

$$E_{\text{cell}}^\circ = 0.61 \text{ V} - 0.34 \text{ V} = 0.27 \text{ V}$$

Combine (1) and reversed (3) to obtain equation B:

$$E_{\text{cell}}^\circ = 0.34 \text{ V} - (-1.25 \text{ V}) = 1.59 \text{ V}$$

Combine (2) and reversed (3) to obtain equation C:

$$E_{\text{cell}}^\circ = 0.61 \text{ V} - (-1.25 \text{ V}) = 1.86 \text{ V}$$

(b) Oxidizing agents: $\text{BrO}_3^- > \text{Ag}_2\text{O} > \text{Zn}(\text{OH})_2$

Reducing agents: $\text{Zn} > \text{Ag} > \text{Br}^-$

$$E_{\text{cell}}^\circ = -0.44 \text{ V} - 0.77 \text{ V} = -1.21 \text{ V}$$

The reaction is nonspontaneous. The spontaneous reaction is

Reducing agents: $\text{Fe} > \text{Fe}^{2+} > \text{Fe}^{3+}$

21.6A From Appendix D,

$$E_{\text{cell}}^\circ = 0.59 \text{ V} - 0.34 \text{ V} = 0.25 \text{ V}$$

We use Equations 21.6 and 21.8 with $n = 6 \text{ mol e}^-/\text{mol rxn}$ and

$$E_{\text{cell}}^\circ = 0.25 \text{ V}$$

$$\Delta G^\circ = -nFE_{\text{cell}}^\circ = -\frac{6 \text{ mol e}^-}{\text{mol rxn}} \times \frac{96.5 \text{ kJ}}{\text{V} \cdot \text{mol e}^-} \times 0.25 \text{ V}$$

$$= -1.4 \times 10^2 \text{ kJ/mol rxn}$$

$$E_{\text{cell}}^\circ = 0.25 \text{ V} = \frac{0.0592 \text{ V}}{n} \log K$$

$$\log K = \frac{0.25 \text{ V} \times 6}{0.0592 \text{ V}} = 25.34; K = 10^{25.34} = 2.2 \times 10^{25}$$

$$n = 2 \text{ mol e}^-/\text{mol rxn}$$

$$\Delta G^\circ = -RT \ln K$$

$$\ln K = -\frac{\Delta G^\circ}{RT} = -\frac{-1.43 \times 10^5 \text{ J/mol rxn}}{8.314 \text{ J/mol rxn} \cdot \text{K} \times 298 \text{ K}} = 57.72$$

$$K = e^{57.72} = 1.2 \times 10^{25}$$

$$E_{\text{cell}}^\circ = \frac{0.0592 \text{ V}}{n} \log K = \frac{0.0592 \text{ V}}{2} \log (1.2 \times 10^{25}) = 0.742 \text{ V}$$

21.7A From Appendix D,

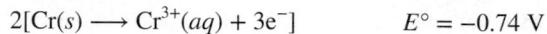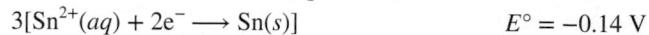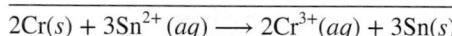

$$E_{\text{cell}}^\circ = -0.14 \text{ V} - (-0.74 \text{ V}) = 0.60 \text{ V}; \quad n = 6 \text{ mol e}^-/\text{mol rxn}$$

$$Q = \frac{[\text{Cr}^{3+}]^2}{[\text{Sn}^{2+}]^3} = \frac{(1.60)^2}{(0.20)^3} = 320$$

$$E_{\text{cell}}^\circ = E_{\text{cell}}^\circ - \frac{0.0592 \text{ V}}{n} \log Q = 0.60 \text{ V} - \frac{0.0592 \text{ V}}{6} \log 320 \\ = 0.58 \text{ V}$$

21.7B From Appendix D,

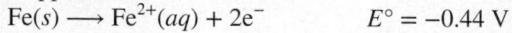

$$\text{So, } E_{\text{cell}}^\circ = 0.34 \text{ V} - (-0.44 \text{ V}) = 0.78 \text{ V}$$

Therefore, $E_{\text{cell}} = 0.78 \text{ V} + 0.25 \text{ V} = 1.03 \text{ V}; n = 2 \text{ mol e}^-/\text{mol rxn}$.

$$E_{\text{cell}} = E_{\text{cell}}^\circ - \frac{0.0592 \text{ V}}{n} \log Q$$

$$1.03 \text{ V} = 0.78 \text{ V} - \frac{0.0592 \text{ V}}{2} \log \frac{[\text{Fe}^{2+}]}{[0.30]}$$

$$-8.45 = \log \frac{[\text{Fe}^{2+}]}{[0.30]}$$

$$10^{-8.45} = 3.6 \times 10^{-9} = \frac{[\text{Fe}^{2+}]}{[0.30]}$$

$$[\text{Fe}^{2+}] = 3.6 \times 10^{-9} \times 0.30 \text{ M} = 1.1 \times 10^{-9} \text{ M}$$

21.8A The cell reaction is

$$E_{\text{cell}} = E_{\text{cell}}^\circ - \frac{0.0592 \text{ V}}{n} \log \frac{[\text{Ni}^{2+}]_{\text{dil}}}{[\text{Ni}^{2+}]_{\text{conc}}}$$

$$= 0 \text{ V} - \frac{0.0592 \text{ V}}{2} \log \frac{0.015}{0.40} = 0.042 \text{ V}$$

21.8B The cell reaction is

$$E_{\text{cell}} = E_{\text{cell}}^\circ - \frac{0.0592 \text{ V}}{n} \log \frac{[\text{Au}^{3+}]_{\text{dil}}}{[\text{Au}^{3+}]_{\text{conc}}}$$

$$= 0 \text{ V} - \frac{0.0592 \text{ V}}{3} \log \frac{7.0 \times 10^{-4}}{2.5 \times 10^{-2}} = 0.031 \text{ V}$$

In a concentration cell, the anode half-cell contains the more dilute solution, which is the solution in half-cell A. Since the anode has the negative charge, the electrode in A is negative.

21.9A Oxidizing agents: Cs^+ and Li^+ . Li, at the top of Group 1A(1), has a higher IE, so it is more easily reduced:

Reducing agents: F^- and I^- . I, near the bottom of Group 7A(17), has a lower EN, so it is more easily oxidized:

21.9B Oxidizing agents: K^+ and Al^{3+} . Al is above and to the right of K in the periodic table, so it has a higher IE:

Reducing agents: F^- and Br^- . Br is below F in Group 7A(17), so it has a lower EN:

21.10A The possible reduction (cathode) half-reactions are

The possible oxidation (anode) half-reactions are

Thus, Pb^{2+} is reduced and Pb forms at the cathode, and H_2O is oxidized and O_2 forms at the anode.

21.10B The possible reduction (cathode) half-reaction are

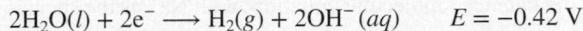

Since Au^{3+} has the more positive reduction potential, Au forms at the cathode.

Because of overvoltage, O_2 will not form at the anode, so Br_2 will form:

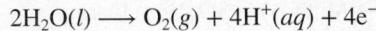

$$E = 0.82 \text{ V} \quad (\sim 1.4 \text{ V with overvoltage})$$

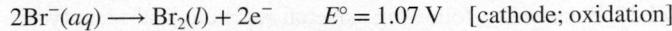

21.11A $\text{Cu}^{2+}(\text{aq}) + 2\text{e}^- \longrightarrow \text{Cu}(\text{s})$; therefore,

$$2 \text{ mol e}^- / 1 \text{ mol Cu} = 2 \text{ mol e}^- / 63.55 \text{ g Cu}$$

$$\begin{aligned} \text{Time (min)} &= 1.50 \text{ g Cu} \times \frac{2 \text{ mol e}^-}{63.55 \text{ g Cu}} \\ &\quad \times \frac{9.65 \times 10^4 \text{ C}}{1 \text{ mol e}^-} \times \frac{1 \text{ s}}{4.75 \text{ C}} \times \frac{1 \text{ min}}{60 \text{ s}} \\ &= 16.0 \text{ min} \end{aligned}$$

21.11B The half-reaction shows 2 mol e⁻/1 mol Zn. Thus,

$$\text{Charge (C)} = 8.75 \text{ min} \times \frac{60 \text{ s}}{1 \text{ min}} \times \frac{7.03 \text{ C}}{\text{s}} = 3691 \text{ C}$$

$$\begin{aligned} \text{Mass (g) of Zn} &= 3691 \text{ C} \times \frac{1 \text{ mol e}^-}{9.65 \times 10^4 \text{ C}} \times \frac{1 \text{ mol Zn}}{2 \text{ mol e}^-} \times \frac{65.38 \text{ g Zn}}{1 \text{ mol Zn}} \\ &= 1.25 \text{ g Zn} \end{aligned}$$

PROBLEMS

Problems with **colored** numbers are answered in Appendix E and worked in detail in the Student Solutions Manual. Problem sections match those in the text and give the numbers of relevant sample problems. Most offer Concept Review Questions, Skill-Building Exercises (grouped in pairs covering the same concept), and Problems in Context. The Comprehensive Problems are based on material from any section or previous chapter.

Note: Unless stated otherwise, all problems refer to systems at 298 K (25°C).

Redox Reactions and Electrochemical Cells

(Sample Problem 21.1)

Concept Review Questions

21.1 Define *oxidation* and *reduction* in terms of electron transfer and change in oxidation number.

21.2 Why must an electrochemical process involve a redox reaction?

21.3 Can one half-reaction in a redox process take place independently of the other? Explain.

21.4 Water is used to balance O atoms in the half-reaction method. Why can't O^{2-} ions be used instead?

21.5 During the redox balancing process, what step is taken to ensure that e^- lost equals e^- gained?

21.6 How are protons removed when balancing a redox reaction in basic solution?

21.7 Are spectator ions used to balance the half-reactions of a redox reaction? At what stage might spectator ions enter the balancing process?

21.8 Which type of electrochemical cell has $\Delta G_{\text{sys}} < 0$? Which type shows an increase in free energy?

21.9 Which statements are true? Correct any that are false.

- (a) In a voltaic cell, the anode is negative relative to the cathode.
- (b) Oxidation occurs at the anode of a voltaic or electrolytic cell.
- (c) Electrons flow into the cathode of an electrolytic cell.
- (d) In a voltaic cell, the surroundings do work on the system.
- (e) A metal that plates out of an electrolytic cell appears on the cathode.
- (f) In an electrochemical cell, the electrolyte provides a solution of mobile electrons.

Skill-Building Exercises (grouped in similar pairs)

21.10 Consider the following balanced redox reaction:

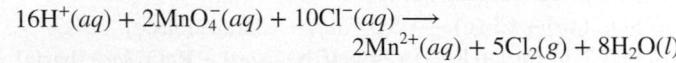

- (a) Which species is being oxidized?
- (b) Which species is being reduced?
- (c) Which species is the oxidizing agent?
- (d) Which species is the reducing agent?
- (e) From which species to which does electron transfer occur?
- (f) Write the balanced molecular equation, with K^+ and SO_4^{2-} as the spectator ions.

21.11 Consider the following balanced redox reaction:

- (a) Which species is being oxidized?
- (b) Which species is being reduced?
- (c) Which species is the oxidizing agent?

- (d) Which species is the reducing agent?
 (e) From which species to which does electron transfer occur?
 (f) Write the balanced molecular equation, with Na^+ as the spectator ion.

21.12 Balance the following skeleton reactions and identify the oxidizing and reducing agents:

- (a) $\text{ClO}_3^-(aq) + \text{I}^-(aq) \rightarrow \text{I}_2(s) + \text{Cl}^-(aq)$ [acidic]
 (b) $\text{MnO}_4^-(aq) + \text{SO}_3^{2-}(aq) \rightarrow \text{MnO}_2(s) + \text{SO}_4^{2-}(aq)$ [basic]
 (c) $\text{MnO}_4^-(aq) + \text{H}_2\text{O}_2(aq) \rightarrow \text{Mn}^{2+}(aq) + \text{O}_2(g)$ [acidic]

21.13 Balance the following skeleton reactions and identify the oxidizing and reducing agents:

- (a) $\text{O}_2(g) + \text{NO}(g) \rightarrow \text{NO}_3^-(aq)$ [acidic]
 (b) $\text{CrO}_4^{2-}(aq) + \text{Cu}(s) \rightarrow \text{Cr(OH)}_3(s) + \text{Cu(OH)}_2(s)$ [basic]
 (c) $\text{AsO}_4^{3-}(aq) + \text{NO}_2^-(aq) \rightarrow \text{AsO}_2^-(aq) + \text{NO}_3^-(aq)$ [basic]

21.14 Balance the following skeleton reactions and identify the oxidizing and reducing agents:

- (a) $\text{Cr}_2\text{O}_7^{2-}(aq) + \text{Zn}(s) \rightarrow \text{Zn}^{2+}(aq) + \text{Cr}^{3+}(aq)$ [acidic]
 (b) $\text{Fe(OH)}_2(s) + \text{MnO}_4^-(aq) \rightarrow \text{MnO}_2(s) + \text{Fe(OH)}_3(s)$ [basic]
 (c) $\text{Zn}(s) + \text{NO}_3^-(aq) \rightarrow \text{Zn}^{2+}(aq) + \text{N}_2(g)$ [acidic]

21.15 Balance the following skeleton reactions and identify the oxidizing and reducing agents:

- (a) $\text{BH}_4^-(aq) + \text{ClO}_3^-(aq) \rightarrow \text{H}_2\text{BO}_3^-(aq) + \text{Cl}^-(aq)$ [basic]
 (b) $\text{CrO}_4^{2-}(aq) + \text{N}_2\text{O}(g) \rightarrow \text{Cr}^{3+}(aq) + \text{NO}(g)$ [acidic]
 (c) $\text{Br}_2(l) \rightarrow \text{BrO}_3^-(aq) + \text{Br}^-(aq)$ [basic]

21.16 Balance the following skeleton reactions and identify the oxidizing and reducing agents:

- (a) $\text{Sb}(s) + \text{NO}_3^-(aq) \rightarrow \text{Sb}_4\text{O}_6(s) + \text{NO}(g)$ [acidic]
 (b) $\text{Mn}^{2+}(aq) + \text{BiO}_3^-(aq) \rightarrow \text{MnO}_4^-(aq) + \text{Bi}^{3+}(aq)$ [acidic]
 (c) $\text{Fe(OH)}_2(s) + \text{Pb(OH)}_3^-(aq) \rightarrow \text{Fe(OH)}_3(s) + \text{Pb}(s)$ [basic]

21.17 Balance the following skeleton reactions and identify the oxidizing and reducing agents:

- (a) $\text{NO}_2(g) \rightarrow \text{NO}_3^-(aq) + \text{NO}_2^-(aq)$ [basic]
 (b) $\text{Zn}(s) + \text{NO}_3^-(aq) \rightarrow \text{Zn(OH)}_4^{2-}(aq) + \text{NH}_3(g)$ [basic]
 (c) $\text{H}_2\text{S}(g) + \text{NO}_3^-(aq) \rightarrow \text{S}_8(s) + \text{NO}(g)$ [acidic]

21.18 Balance the following skeleton reactions and identify the oxidizing and reducing agents:

- (a) $\text{As}_4\text{O}_6(s) + \text{MnO}_4^-(aq) \rightarrow \text{AsO}_4^{3-}(aq) + \text{Mn}^{2+}(aq)$ [acidic]
 (b) $\text{P}_4(s) \rightarrow \text{HPO}_3^{2-}(aq) + \text{PH}_3(g)$ [acidic]
 (c) $\text{MnO}_4^-(aq) + \text{CN}^-(aq) \rightarrow \text{MnO}_2(s) + \text{CNO}^-(aq)$ [basic]

21.19 Balance the following skeleton reactions and identify the oxidizing and reducing agents:

- (a) $\text{SO}_3^{2-}(aq) + \text{Cl}_2(g) \rightarrow \text{SO}_4^{2-}(aq) + \text{Cl}^-(aq)$ [basic]
 (b) $\text{Fe(CN)}_6^{3-}(aq) + \text{Re}(s) \rightarrow \text{Fe(CN)}_6^{4-}(aq) + \text{ReO}_4^-(aq)$ [basic]
 (c) $\text{MnO}_4^-(aq) + \text{HCOOH}(aq) \rightarrow \text{Mn}^{2+}(aq) + \text{CO}_2(g)$ [acidic]

Problems in Context

21.20 In many residential water systems, the aqueous Fe^{3+} concentration is high enough to stain sinks and turn drinking water light brown. The iron content is analyzed by first reducing the Fe^{3+} to Fe^{2+} and then titrating with MnO_4^- in acidic solution. Balance the skeleton reaction of the titration step:

21.21 *Aqua regia*, a mixture of concentrated HNO_3 and HCl , was developed by alchemists as a means to “dissolve” gold. The process is a redox reaction with this simplified skeleton reaction:

- (a) Balance the reaction by the half-reaction method.
 (b) What are the oxidizing and reducing agents?
 (c) What is the function of HCl in aqua regia?

Voltaic Cells: Using Spontaneous Reactions to Generate Electrical Energy

(Sample Problem 21.2)

Concept Review Questions

21.22 Consider the following general voltaic cell:

Identify the following:

- (a) Anode
 (b) Cathode
 (c) Salt bridge
 (d) Electrode from which e^- leave the cell
 (e) Electrode with a positive charge
 (f) Electrode that gains mass as the cell operates (assuming that a metal plates out)

21.23 Why does a voltaic cell not operate unless the two compartments are connected through an external circuit?

21.24 What purpose does the salt bridge serve in a voltaic cell, and how does it accomplish this purpose?

21.25 What is the difference between an active and an inactive electrode? Why are inactive electrodes used? Name two substances commonly used for inactive electrodes.

21.26 When a piece of metal A is placed in a solution containing ions of metal B, metal B plates out on the piece of A.

- (a) Which metal is being oxidized?
 (b) Which metal is being displaced?
 (c) Which metal would you use as the anode in a voltaic cell incorporating these two metals?
 (d) If bubbles of H_2 form when B is placed in acid, will they form if A is placed in acid? Explain.

Skill-Building Exercises (grouped in similar pairs)

21.27 Consider the following voltaic cell:

- (a) In which direction do electrons flow in the external circuit?
 (b) In which half-cell does oxidation occur?
 (c) In which half-cell do electrons enter the cell?

- (d) At which electrode are electrons consumed?
 (e) Which electrode is negatively charged?
 (f) Which electrode decreases in mass during cell operation?
 (g) Suggest a solution for the electrolyte in the cathode compartment.
 (h) Suggest a pair of ions for the salt bridge.
 (i) For which electrode could you use an inactive material?
 (j) In which direction do anions within the salt bridge move to maintain charge neutrality?
 (k) Write balanced half-reactions and the overall cell reaction.

21.28 Consider the following voltaic cell:

- (a) In which direction do electrons flow in the external circuit?
 (b) In which half-cell does reduction occur?
 (c) In which half-cell do electrons leave the cell?
 (d) At which electrode are electrons generated?
 (e) Which electrode is positively charged?
 (f) Which electrode increases in mass during cell operation?
 (g) Suggest a solution for the electrolyte in the anode compartment.
 (h) Suggest a pair of ions for the salt bridge.
 (i) For which electrode could you use an inactive material?
 (j) In which direction do cations within the salt bridge move to maintain charge neutrality?
 (k) Write balanced half-reactions and the overall cell reaction.

21.29 A voltaic cell is constructed with an Sn/Sn²⁺ half-cell and a Zn/Zn²⁺ half-cell. The zinc electrode is negative.

- (a) Write balanced half-reactions and the overall cell reaction.
 (b) Diagram the cell, labeling electrodes with their charges and showing the directions of electron flow in the circuit and of cation and anion flow in the salt bridge.

21.30 A voltaic cell is constructed with an Ag/Ag⁺ half-cell and a Pb/Pb²⁺ half-cell. The silver electrode is positive.

- (a) Write balanced half-reactions and the overall cell reaction.
 (b) Diagram the cell, labeling electrodes with their charges and showing the directions of electron flow in the circuit and of cation and anion flow in the salt bridge.

21.31 A voltaic cell is constructed with an Fe/Fe²⁺ half-cell and an Mn/Mn²⁺ half-cell. The iron electrode is positive.

- (a) Write balanced half-reactions and the overall cell reaction.
 (b) Diagram the cell, labeling electrodes with their charges and showing the directions of electron flow in the circuit and of cation and anion flow in the salt bridge.

21.32 A voltaic cell is constructed with a Cu/Cu²⁺ half-cell and an Ni/Ni²⁺ half-cell. The nickel electrode is negative.

- (a) Write balanced half-reactions and the overall cell reaction.
 (b) Diagram the cell, labeling electrodes with their charges and showing the directions of electron flow in the circuit and of cation and anion flow in the salt bridge.

21.33 Write the cell notation for the voltaic cell that incorporates each of the following redox reactions:

21.34 Write a balanced equation from each cell notation:

Cell Potential: Output of a Voltaic Cell

(Sample Problems 21.3 to 21.5)

Concept Review Questions

21.35 How is a standard reference electrode used to determine unknown $E_{\text{half-cell}}^{\circ}$ values?

21.36 What does a negative E_{cell}° indicate about a redox reaction? What does it indicate about the reverse reaction?

21.37 The standard cell potential is a thermodynamic state function. How are E° values treated similarly to ΔH° , ΔG° , and S° values? How are they treated differently?

Skill-Building Exercises (grouped in similar pairs)

21.38 In basic solution, Se²⁻ and SO₃²⁻ ions react spontaneously:
 $2\text{Se}^{2-}(\text{aq}) + 2\text{SO}_3^{2-}(\text{aq}) + 3\text{H}_2\text{O}(l) \rightarrow 2\text{Se}(\text{s}) + 6\text{OH}^{-}(\text{aq}) + \text{S}_2\text{O}_3^{2-}(\text{aq}) \quad E_{\text{cell}}^{\circ} = 0.35 \text{ V}$

- (a) Write balanced half-reactions for the process.
 (b) If $E_{\text{sulfite}}^{\circ}$ is -0.57 V , calculate $E_{\text{selenium}}^{\circ}$.

21.39 In acidic solution, O₃ and Mn²⁺ ions react spontaneously:
 $\text{O}_3(\text{g}) + \text{Mn}^{2+}(\text{aq}) + \text{H}_2\text{O}(l) \rightarrow \text{O}_2(\text{g}) + \text{MnO}_2(\text{s}) + 2\text{H}^{+}(\text{aq}) \quad E_{\text{cell}}^{\circ} = 0.84 \text{ V}$

- (a) Write the balanced half-reactions.
 (b) Using Appendix D to find E_{ozone}° , calculate $E_{\text{manganese}}^{\circ}$.

21.40 Use the emf series (Appendix D) to arrange each set of species.

- (a) In order of *decreasing* strength as *oxidizing* agents: Fe³⁺, Br₂, Cu²⁺
 (b) In order of *increasing* strength as *oxidizing* agents: Ca²⁺, Cr₂O₇²⁻, Ag⁺

21.41 Use the emf series (Appendix D) to arrange each set of species.

- (a) In order of *decreasing* strength as *reducing* agents: SO₂, PbSO₄, MnO₂
 (b) In order of *increasing* strength as *reducing* agents: Hg, Fe, Sn

21.42 Balance each skeleton reaction, use Appendix D to calculate E_{cell}° , and state whether the reaction is spontaneous:

- (a) Co(s) + H⁺(aq) → Co²⁺(aq) + H₂(g)
 (b) Hg₂²⁺(aq) → Hg²⁺(aq) + Hg(l)

21.43 Balance each skeleton reaction, use Appendix D to calculate E_{cell}° , and state whether the reaction is spontaneous:

- (a) Mn²⁺(aq) + Co³⁺(aq) → MnO₂(s) + Co²⁺(aq) [acidic]
 (b) AgCl(s) + NO(g) → Ag(s) + Cl⁻(aq) + NO₃⁻(aq) [acidic]

21.44 Balance each skeleton reaction, use Appendix D to calculate E_{cell}° , and state whether the reaction is spontaneous:

- (a) Cd(s) + Cr₂O₇²⁻(aq) → Cd²⁺(aq) + Cr³⁺(aq)
 (b) Ni²⁺(aq) + Pb(s) → Ni(s) + Pb²⁺(aq)

21.45 Balance each skeleton reaction, use Appendix D to calculate E_{cell}° , and state whether the reaction is spontaneous:

21.46 Use the following half-reactions to write three spontaneous reactions, calculate E_{cell}° for each reaction, and rank the strengths of the oxidizing and reducing agents:

21.47 Use the following half-reactions to write three spontaneous reactions, calculate E_{cell}° for each reaction, and rank the strengths of the oxidizing and reducing agents:

21.48 Use the following half-reactions to write three spontaneous reactions, calculate E_{cell}° for each reaction, and rank the strengths of the oxidizing and reducing agents:

Problems in Context

21.50 When metal A is placed in a solution of a salt of metal B, the surface of metal A changes color. When metal B is placed in acid solution, gas bubbles form on the surface of the metal. When metal A is placed in a solution of a salt of metal C, no change is observed in the solution or on the surface of metal A.

- (a) Will metal C cause formation of H_2 when placed in acid solution?
 (b) Rank metals A, B, and C in order of *decreasing* reducing strength.

21.51 When a clean iron nail is placed in an aqueous solution of copper(II) sulfate, the nail becomes coated with a brownish-black material.

- (a) What is the material coating the iron?
 (b) What are the oxidizing and reducing agents?
 (c) Can this reaction be made into a voltaic cell?
 (d) Write the balanced equation for the reaction.
 (e) Calculate E_{cell}° for the process.

Free Energy and Electrical Work

(Sample Problems 21.6 to 21.8)

Concept Review Questions

21.52 (a) How do the relative magnitudes of Q and K relate to the signs of ΔG and E_{cell}° ? Explain.
 (b) Can a cell do work when $Q/K > 1$ or $Q/K < 1$? Explain.

21.53 A voltaic cell consists of A/A⁺ and B/B⁺ half-cells, where A and B are metals and the A electrode is negative. The initial $[\text{A}^+]/[\text{B}^+]$ is such that $E_{\text{cell}} > E_{\text{cell}}^{\circ}$.

- (a) How do $[\text{A}^+]$ and $[\text{B}^+]$ change as the cell operates?
 (b) How does E_{cell} change as the cell operates?
 (c) What is $[\text{A}^+]/[\text{B}^+]$ when $E_{\text{cell}} = E_{\text{cell}}^{\circ}$? Explain.
 (d) Is it possible for E_{cell} to be less than E_{cell}° ? Explain.

21.54 Explain whether E_{cell} of a voltaic cell will increase or decrease with each of the following changes:

- (a) Decrease in cell temperature
 (b) Increase in [active ion] in the anode compartment
 (c) Increase in [active ion] in the cathode compartment
 (d) Increase in pressure of a gaseous reactant in the cathode compartment

21.55 In a concentration cell, is the more concentrated electrolyte in the cathode or the anode compartment? Explain.

Skill-Building Exercises (grouped in similar pairs)

21.56 What is the value of the equilibrium constant for the reaction between each pair at 25°C?

- (a) $\text{Ni}(s)$ and $\text{Ag}^+(aq)$ (b) $\text{Fe}(s)$ and $\text{Cr}^{3+}(aq)$

21.57 What is the value of the equilibrium constant for the reaction between each pair at 25°C?

- (a) $\text{Al}(s)$ and $\text{Cd}^{2+}(aq)$ (b) $\text{I}_2(s)$ and $\text{Br}^-(aq)$

21.58 What is the value of the equilibrium constant for the reaction between each pair at 25°C?

- (a) $\text{Ag}(s)$ and $\text{Mn}^{2+}(aq)$ (b) $\text{Cl}_2(g)$ and $\text{Br}^-(aq)$

21.59 What is the value of the equilibrium constant for the reaction between each pair at 25°C?

- (a) $\text{Cr}(s)$ and $\text{Cu}^{2+}(aq)$ (b) $\text{Sn}(s)$ and $\text{Pb}^{2+}(aq)$

21.60 Calculate ΔG° for each of the reactions in Problem 21.56.

21.61 Calculate ΔG° for each of the reactions in Problem 21.57.

21.62 Calculate ΔG° for each of the reactions in Problem 21.58.

21.63 Calculate ΔG° for each of the reactions in Problem 21.59.

21.64 What are E_{cell}° and ΔG° of a redox reaction at 25°C for which $n = 1$ and $K = 5.0 \times 10^4$?

21.65 What are E_{cell}° and ΔG° of a redox reaction at 25°C for which $n = 1$ and $K = 5.0 \times 10^{-6}$?

21.66 What are E_{cell}° and ΔG° of a redox reaction at 25°C for which $n = 2$ and $K = 65$?

21.67 What are E_{cell}° and ΔG° of a redox reaction at 25°C for which $n = 2$ and $K = 0.065$?

21.68 A voltaic cell consists of a standard reference half-cell and a Cu/Cu²⁺ half-cell. Calculate $[\text{Cu}^{2+}]$ when E_{cell} is 0.22 V.

21.69 A voltaic cell consists of an Mn/Mn²⁺ half-cell and a Pb/Pb²⁺ half-cell. Calculate $[\text{Pb}^{2+}]$ when $[\text{Mn}^{2+}]$ is 1.4 M and E_{cell} is 0.44 V.

21.70 A voltaic cell with Ni/Ni²⁺ and Co/Co²⁺ half-cells has the following initial concentrations: $[\text{Ni}^{2+}] = 0.80 \text{ M}$; $[\text{Co}^{2+}] = 0.20 \text{ M}$.

- (a) What is the initial E_{cell}° ?
 (b) What is $[\text{Ni}^{2+}]$ when E_{cell} reaches 0.03 V?
 (c) What are the equilibrium concentrations of the ions?
- 21.71** A voltaic cell with Mn/Mn²⁺ and Cd/Cd²⁺ half-cells has the following initial concentrations: $[\text{Mn}^{2+}] = 0.090 \text{ M}$; $[\text{Cd}^{2+}] = 0.060 \text{ M}$.

- (a) What is the initial E_{cell} ?
 (b) What is E_{cell} when $[\text{Cd}^{2+}]$ reaches 0.050 M ?
 (c) What is $[\text{Mn}^{2+}]$ when E_{cell} reaches 0.055 V ?
 (d) What are the equilibrium concentrations of the ions?

21.72 A voltaic cell consists of two H_2/H^+ half-cells. Half-cell A has H_2 at 0.95 atm bubbling into 0.10 M HCl . Half-cell B has H_2 at 0.60 atm bubbling into 2.0 M HCl . Which half-cell houses the anode? What is the voltage of the cell?

21.73 A voltaic cell consists of two Sn/Sn^{2+} half-cells, A and B. The electrolyte in A is $0.13 \text{ M Sn}(\text{NO}_3)_2$. The electrolyte in B is $0.87 \text{ M Sn}(\text{NO}_3)_2$. Which half-cell houses the cathode? What is the voltage of the cell?

Electrochemical Processes in Batteries

Concept Review Questions

21.74 What is the direction of electron flow with respect to the anode and the cathode in a battery? Explain.

21.75 In the everyday batteries used in flashlights, toys, and so forth, no salt bridge is evident. What is used in these cells to separate the anode and cathode compartments?

21.76 Both a D-sized and an AAA-sized alkaline battery have an output of 1.5 V . What property of the cell potential allows this to occur? What is different about these two batteries?

Problems in Context

21.77 Many common electrical devices require the use of more than one battery.

- (a) How many alkaline batteries must be placed in series to light a flashlight with a 6.0-V bulb?
 (b) What is the voltage requirement of a camera that uses six silver batteries?
 (c) How many volts can a car battery deliver if two of its anode/cathode cells are shorted?

Corrosion: An Environmental Voltaic Cell

Concept Review Questions

21.78 During reconstruction of the Statue of Liberty, Teflon spacers were placed between the iron skeleton and the copper plates that cover the statue. What purpose do these spacers serve?

21.79 Why do steel bridge-supports rust at the waterline but not above or below it?

21.80 After the 1930s, chromium replaced nickel for corrosion resistance and appearance on car bumpers and trim. How does chromium protect steel from corrosion?

21.81 Which of the following metals are suitable for use as sacrificial anodes to protect against corrosion of underground iron pipes? If any are not suitable, explain why:

- (a) Aluminum (b) Magnesium (c) Sodium (d) Lead
 (e) Nickel (f) Zinc (g) Chromium

Electrolytic Cells: Using Electrical Energy to Drive Nonspontaneous Reactions

(Sample Problems 21.9 to 21.11)

Concept Review Questions

Note: Unless stated otherwise, assume that the electrolytic cells in the following problems operate at 100% efficiency.

21.82 Consider the following general electrolytic cell:

- (a) At which electrode does oxidation occur?
 (b) At which electrode does elemental M form?
 (c) At which electrode are electrons being released by ions?
 (d) At which electrode are electrons entering the cell?

21.83 A voltaic cell consists of Cr/Cr^{3+} and Cd/Cd^{2+} half-cells with all components in their standard states. After 10 minutes of operation, a thin coating of cadmium metal has plated out on the cathode. Describe what will happen if you attach the negative terminal of a dry cell (1.5 V) to the cathode and the positive terminal to the anode.

21.84 Why are $E_{\text{half-cell}}$ values for the oxidation and reduction of water different from $E_{\text{half-cell}}^\circ$ values for the same processes?

21.85 In an aqueous electrolytic cell, nitrate ions never react at the anode, but nitrite ions do. Explain.

21.86 How does overvoltage influence the products in the electrolysis of aqueous salts?

Skill-Building Exercises (grouped in similar pairs)

21.87 In the electrolysis of molten NaBr :

- (a) What product forms at the anode?
 (b) What product forms at the cathode?

21.88 In the electrolysis of molten BaI_2 :

- (a) What product forms at the negative electrode?
 (b) What product forms at the positive electrode?

21.89 In the electrolysis of a molten mixture of KI and MgF_2 , identify the product that forms at the anode and at the cathode.

21.90 In the electrolysis of a molten mixture of CsBr and SrCl_2 , identify the product that forms at the negative electrode and at the positive electrode.

21.91 In the electrolysis of a molten mixture of NaCl and CaBr_2 , identify the product that forms at the anode and at the cathode.

21.92 In the electrolysis of a molten mixture of RbF and CaCl_2 , identify the product that forms at the negative electrode and at the positive electrode.

21.93 Which of the following elements can be prepared by electrolysis of their aqueous salts: copper, barium, aluminum, bromine?

21.94 Which of the following elements can be prepared by electrolysis of their aqueous salts: strontium, gold, tin, chlorine?

21.95 Which of the following elements can be prepared by electrolysis of their aqueous salts: lithium, iodine, zinc, silver?

21.96 Which of the following elements can be prepared by electrolysis of their aqueous salts: fluorine, manganese, iron, cadmium?

21.97 Write a balanced half-reaction for the product that forms at each electrode in the aqueous electrolysis of the following salts: (a) LiF; (b) SnSO₄.

21.98 Write a balanced half-reaction for the product that forms at each electrode in the aqueous electrolysis of the following salts: (a) ZnBr₂; (b) Cu(HCO₃)₂.

21.99 Write a balanced half-reaction for the product that forms at each electrode in the aqueous electrolysis of the following salts: (a) Cr(NO₃)₃; (b) MnCl₂.

21.100 Write a balanced half-reaction for the product that forms at each electrode in the aqueous electrolysis of the following salts: (a) FeI₂; (b) K₃PO₄.

21.101 Electrolysis of molten MgCl₂ is the final production step in the isolation of magnesium from seawater by the Dow process (Section 22.4). Assuming that 45.6 g of Mg metal forms:

- (a) How many moles of electrons are required?
- (b) How many coulombs are required?
- (c) How many amps will produce this amount in 3.50 h?

21.102 Electrolysis of molten NaCl in a Downs cell is the major isolation step in the production of sodium metal (Section 22.4). Assuming that 215 g of Na metal forms:

- (a) How many moles of electrons are required?
- (b) How many coulombs are required?
- (c) How many amps will produce this amount in 9.50 h?

21.103 How many grams of radium can form by passing 235 C through an electrolytic cell containing a molten radium salt?

21.104 How many grams of aluminum can form by passing 305 C through an electrolytic cell containing a molten aluminum salt?

21.105 How many seconds does it take to deposit 65.5 g of Zn on a steel gate when 21.0 A is passed through a ZnSO₄ solution?

21.106 How many seconds does it take to deposit 1.63 g of Ni on a decorative drawer handle when 13.7 A is passed through a Ni(NO₃)₂ solution?

Problems in Context

21.107 A professor adds Na₂SO₄ to water to facilitate its electrolysis in a lecture demonstration. (a) What is the purpose of the Na₂SO₄? (b) Why is the water electrolyzed instead of the salt?

21.108 Subterranean brines in parts of the United States are rich in iodides and bromides and serve as an industrial source of these elements. In one recovery method, the brines are evaporated to dryness and then melted and electrolyzed. Which halogen is more likely to form from this treatment? Why?

21.109 Zinc plating (galvanizing) is an important means of corrosion protection. Although the process is done customarily by dipping the object into molten zinc, the metal can also be electroplated from aqueous solutions. How many grams of zinc can be deposited on a steel tank from a ZnSO₄ solution when a 0.855-A current flows for 2.50 days?

Comprehensive Problems

21.110 The MnO₂ used in alkaline batteries can be produced by an electrochemical process of which one half-reaction is

If a current of 25.0 A is used, how many hours are needed to produce 1.00 kg of MnO₂? At which electrode is the MnO₂ formed?

21.111 Car manufacturers are developing engines that use H₂ as fuel. In Iceland, Sweden, and other parts of Scandinavia, where hydroelectric plants produce inexpensive electric power, the H₂ can be made industrially by the electrolysis of water.

- (a) How many coulombs are needed to produce 3.5×10^6 L of H₂ gas at 12.0 atm and 25°C? (Assume that the ideal gas law applies.)
- (b) If the coulombs are supplied at 1.44 V, how many joules are produced?

(c) If the combustion of oil yields 4.0×10^4 kJ/kg, what mass of oil must be burned to yield the number of joules in part (b)?

21.112 The overall cell reaction occurring in an alkaline battery is

- (a) How many moles of electrons flow per mole of reaction?
- (b) If 4.50 g of zinc is oxidized, how many grams of manganese dioxide and of water are consumed?
- (c) What is the total mass of reactants consumed in part (b)?
- (d) How many coulombs are produced in part (b)?
- (e) In practice, voltaic cells of a given capacity (coulombs) are heavier than the calculation in part (c) indicates. Explain.

21.113 An inexpensive and accurate method of measuring the quantity of electricity flowing through a circuit is to pass the current through a solution of a metal ion and weigh the metal deposited. A silver electrode immersed in an Ag⁺ solution weighs 1.7854 g before the current has passed and weighs 1.8016 g after the current has passed. How many coulombs have passed?

21.114 Brass, an alloy of copper and zinc, can be produced by simultaneously electroplating the two metals from a solution containing their 2+ ions. If 65.0% of the total current is used to plate copper, while 35.0% goes to plating zinc, what is the mass percent of copper in the brass?

21.115 A thin circular-disk earring 4.00 cm in diameter is plated with a coating of gold 0.25 mm thick from an Au³⁺ bath.

- (a) How many days does it take to deposit the gold on one side of one earring if the current is 0.013 A (*d* of gold = 19.3 g/cm³)?
- (b) How many days does it take to deposit the gold on both sides of the pair of earrings?
- (c) If the price of gold is \$1595 per troy ounce (31.10 g), what is the total cost of the gold plating?

21.116 (a) How many minutes does it take to form 10.0 L of O₂ measured at 99.8 kPa and 28°C from water if a current of 1.3 A passes through the electrolytic cell?

(b) What mass of H₂ forms?

21.117 Trains powered by electricity, including subways, use direct current. One conductor is the overhead wire (or “third rail” for subways), and the other is the rails upon which the wheels run. The rails are on supports in contact with the ground. To minimize corrosion, should the overhead wire or the rails be connected to the positive terminal? Explain.

21.118 A silver button battery used in a watch contains 0.75 g of zinc and can run until 80% of the zinc is consumed.

- (a) For how many days can the battery produce a current of 0.85 microamp (10^{-6} amp)?

(b) When the battery dies, 95% of the Ag₂O has been consumed. How many grams of Ag were used to make the battery?

- (c) If Ag costs \$23.00 per troy ounce (31.10 g), what is the cost of the Ag consumed each day the watch runs?

21.119 Like any piece of apparatus, an electrolytic cell operates at less than 100% efficiency. A cell depositing Cu from a Cu²⁺ bath

operates for 10 h with an average current of 5.8 A. If 53.4 g of copper is deposited, at what efficiency is the cell operating?

21.120 Commercial electrolysis is performed on both molten NaCl and aqueous NaCl solutions. Identify the anode product, cathode product, species reduced, and species oxidized for the electrolysis of (a) molten NaCl and (b) an aqueous solution of NaCl.

21.121 To examine the effect of ion removal on cell voltage, a chemist constructs two voltaic cells, each with a standard hydrogen electrode in one compartment. One cell also contains a Pb/Pb²⁺ half-cell; the other contains a Cu/Cu²⁺ half-cell.

(a) What is E° of each cell at 298 K?

(b) Which electrode in each cell is negative?

(c) When Na₂S solution is added to the Pb²⁺ electrolyte, solid PbS forms. What happens to the cell voltage?

(d) When sufficient Na₂S is added to the Cu²⁺ electrolyte, CuS forms and [Cu²⁺] drops to $1 \times 10^{-16} M$. Find the cell voltage.

21.122 Electrodes used in electrocardiography are disposable, and many of them incorporate silver. The metal is deposited in a thin layer on a small plastic “button,” and then some is converted to AgCl:

(a) If the surface area of the button is 2.0 cm² and the thickness of the silver layer is 7.5×10^{-6} m, calculate the volume (in cm³) of Ag used in one electrode.

(b) The density of silver metal is 10.5 g/cm³. How many grams of silver are used per electrode?

(c) If Ag is plated on the button from an Ag⁺ solution with a current of 12.0 mA, how many minutes does the plating take?

(d) If bulk silver costs \$28.93 per troy ounce (31.10 g), what is the cost (in cents) of the silver in one disposable electrode?

21.123 Commercial aluminum production is done by electrolysis of a bath containing Al₂O₃ dissolved in molten Na₃AlF₆. Why isn't it done by electrolysis of an aqueous AlCl₃ solution?

21.124 Comparing the standard electrode potentials (E°) of the Group 1A(1) metals Li, Na, and K with the negative of their first ionization energies reveals a discrepancy:

Ionization process reversed: $\text{M}^+(g) + \text{e}^- \rightleftharpoons \text{M}(g)$ $(-\text{IE})$

Electrode reaction: $\text{M}^+(aq) + \text{e}^- \rightleftharpoons \text{M}(s)$ (E°)

Metal	$-\text{IE}$ (kJ/mol)	E° (V)
Li	-520	-3.05
Na	-496	-2.71
K	-419	-2.93

Note that the electrode potentials do not decrease smoothly down the group, while the ionization energies do. You might expect that if it is more difficult to remove an electron from an atom to form a gaseous ion (larger IE), then it would be less difficult to add an electron to an aqueous ion to form an atom (smaller E°), yet Li⁺(aq) is *more* difficult to reduce than Na⁺(aq). Applying Hess's law, use an approach similar to a Born-Haber cycle to break down the process occurring at the electrode into three steps and label the energy involved in each step. How can you account for the discrepancy?

21.125 In Appendix D, standard electrode potentials range from about +3 V to -3 V. Thus, it might seem possible to use a half-cell from each end of this range to construct a cell with a voltage of approximately 6 V. However, most commercial aqueous voltaic

cells have E° values of 1.5–2 V. Why are there no aqueous cells with significantly higher potentials?

21.126 Tin is used to coat “tin” cans used for food storage. If the tin is scratched, exposing the iron of the can, will the iron corrode more or less rapidly than if the tin were not present? Inside the can, the tin itself is coated with a clear varnish. Explain.

21.127 Commercial electrolytic cells for producing aluminum operate at 5.0 V and 100,000 A.

(a) How long does it take to produce exactly 1 metric ton (1000 kg) of aluminum?

(b) How much electrical power (in kilowatt-hours, kW·h) is used ($1 \text{ W} = 1 \text{ J/s}$; $1 \text{ kW}\cdot\text{h} = 3.6 \times 10^3 \text{ kJ}$)?

(c) If electricity costs \$0.123 per kW·h and cell efficiency is 90.%, what is the cost of electricity to produce exactly 1 lb of aluminum?

21.128 Magnesium bars are connected electrically to underground iron pipes to serve as sacrificial anodes.

(a) Do electrons flow from the bar to the pipe or the reverse?

(b) A 12-kg Mg bar is attached to an iron pipe, and it takes 8.5 yr for the Mg to be consumed. What is the average current flowing between the Mg and the Fe during this period?

21.129 Bubbles of H₂ form when metal D is placed in hot H₂O. No reaction occurs when D is placed in a solution of a salt of metal E, but D is discolored and coated immediately when placed in a solution of a salt of metal F. What happens if E is placed in a solution of a salt of metal F? Rank metals D, E, and F in order of increasing reducing strength.

21.130 In addition to reacting with gold (see Problem 21.21), aqua regia is used to bring other precious metals into solution. Balance the skeleton equation for the reaction with Pt:

21.131 The following reactions are used in batteries:

Reaction I is used in fuel cells, II in the automobile lead-acid battery, and III in an experimental high-temperature battery for powering electric vehicles. The aim is to obtain as much work as possible from a cell, while keeping its weight to a minimum.

(a) In each cell, find the moles of electrons transferred and ΔG .
(b) Calculate the ratio, in kJ/g, of w_{max} to mass of reactants for each of the cells. Which has the highest ratio, which the lowest, and why? (Note: For simplicity, ignore the masses of cell components that do not appear in the cell as reactants, including electrode materials, electrolytes, separators, cell casing, wiring, etc.)

21.132 A current is applied to two electrolytic cells in series. In the first, silver is deposited; in the second, a zinc electrode is consumed. How much Ag is plated out if 1.2 g of Zn dissolves?

21.133 You are investigating a particular chemical reaction. State all the types of data available in standard tables that enable you to calculate the equilibrium constant for the reaction at 298 K.

21.134 In an electric power plant, personnel monitor the O₂ content of boiler feed water to prevent corrosion of the boiler tubes. Why does Fe corrode faster in steam and hot water than in cold water?

21.135 A voltaic cell using Cu/Cu²⁺ and Sn/Sn²⁺ half-cells is set up at standard conditions, and each compartment has a volume of 345 mL. The cell delivers 0.17 A for 48.0 h.

- (a) How many grams of Cu(s) are deposited?
 (b) What is the [Cu²⁺] remaining?

21.136 If the E_{cell} of the following cell is 0.915 V, what is the pH in the anode compartment?

21.137 From the skeleton equations below, create a list of balanced half-reactions in which the strongest oxidizing agent is on top and the weakest is on the bottom:

21.138 You are given the following three half-reactions:

- (1) $\text{Fe}^{3+}(\text{aq}) + \text{e}^- \rightleftharpoons \text{Fe}^{2+}(\text{aq})$
 (2) $\text{Fe}^{2+}(\text{aq}) + 2\text{e}^- \rightleftharpoons \text{Fe}(s)$
 (3) $\text{Fe}^{3+}(\text{aq}) + 3\text{e}^- \rightleftharpoons \text{Fe}(s)$

- (a) Calculate ΔG° for (1) and (2) from their $E_{\text{half-cell}}^\circ$ values.
 (b) Calculate ΔG° for (3) from (1) and (2).
 (c) Calculate $E_{\text{half-cell}}^\circ$ for (3) from its ΔG° .

21.139 Use the half-reaction method to balance the equation for the conversion of ethanol to acetic acid in acid solution:

21.140 When zinc is refined by electrolysis, the desired half-reaction at the cathode is

A competing reaction, which lowers the yield, is the formation of hydrogen gas:

If 91.50% of the current flowing results in zinc being deposited, while 8.50% produces hydrogen gas, how many liters of H₂, measured at STP, form per kilogram of zinc?

21.141 A chemist designs an ion-specific probe for measuring [Ag⁺] in an NaCl solution saturated with AgCl. One half-cell has an Ag wire electrode immersed in the unknown AgCl-saturated NaCl solution. It is connected through a salt bridge to the other half-cell, which has a calomel reference electrode [a platinum wire immersed in a paste of mercury and calomel (Hg₂Cl₂)] in a saturated KCl solution. The measured E_{cell} is 0.060 V.

- (a) Given the following standard half-reactions, calculate [Ag⁺].

Calomel: $\text{Hg}_2\text{Cl}_2(s) + 2\text{e}^- \longrightarrow 2\text{Hg}(l) + 2\text{Cl}^-(\text{aq}) \quad E^\circ = 0.24 \text{ V}$

Silver: $\text{Ag}^+(\text{aq}) + \text{e}^- \longrightarrow \text{Ag}(s) \quad E^\circ = 0.80 \text{ V}$

(Hint: Assume that [Cl⁻] is so high that it is essentially constant.)

- (b) A mining engineer wants an ore sample analyzed with the Ag⁺-selective probe. After pretreating the ore sample, the chemist measures the cell voltage as 0.53 V. What is [Ag⁺]?

21.142 Use Appendix D to calculate the K_{sp} of AgCl.

21.143 Black-and-white photographic film is coated with silver halides. Because silver is expensive, the manufacturer monitors the Ag⁺ content of the waste stream, [Ag⁺]_{waste}, from the plant with an Ag⁺-selective electrode at 25°C. A stream of known Ag⁺ concentration, [Ag⁺]_{standard}, is passed over the electrode in turn with the waste stream and the data recorded by a computer.

- (a) Write the equations relating the nonstandard cell potential to the standard cell potential and [Ag⁺] for each solution.

(b) Combine these into a single equation to find [Ag⁺]_{waste}.

- (c) Rewrite the equation from part (b) to find [Ag⁺]_{waste} in ng/L.
 (d) If E_{waste} is 0.003 V higher than E_{standard} , and the standard solution contains 1000. ng/L, what is [Ag⁺]_{waste}?

- (e) Rewrite the equation from part (b) to find [Ag⁺]_{waste} for a system in which T changes and T_{waste} and T_{standard} may be different.

21.144 Calculate the K_f of Ag(NH₃)₂⁺ from

21.145 Even though the toxicity of cadmium has become a concern, nickel-cadmium (nicad) batteries are still used commonly in many devices. The overall cell reaction is

A certain nicad battery weighs 18.3 g and has a capacity of 300. mA·h (that is, the cell can store charge equivalent to a current of 300. mA flowing for 1 h).

- (a) What is the capacity of this cell in coulombs?
 (b) What mass of reactants is needed to deliver 300. mA·h?
 (c) What percentage of the cell mass consists of reactants?

21.146 The zinc-air battery is a less expensive alternative to silver batteries for use in hearing aids. The cell reaction is

A new battery weighs 0.275 g. The zinc accounts for exactly $\frac{1}{10}$ of the mass, and the oxygen does not contribute to the mass because it is supplied by the air.

- (a) How much electricity (in C) can the battery deliver?
 (b) How much free energy (in J) is released if E_{cell} is 1.3 V?

21.147 Use Appendix D to create an activity series of Mn, Fe, Ag, Sn, Cr, Cu, Ba, Al, Na, Hg, Ni, Li, Au, Zn, and Pb. Rank these metals in order of decreasing reducing strength, and divide them into three groups: those that displace H₂ from water, those that displace H₂ from acid, and those that cannot displace H₂.

21.148 Both Ti and V are reactive enough to displace H₂ from water; of the two metals, Ti is the stronger reducing agent. The difference in their $E_{\text{half-cell}}^\circ$ values is 0.43 V. Given

use Appendix D to calculate the $E_{\text{half-cell}}^\circ$ values for V²⁺/V and Ti²⁺/Ti half-cells.

21.149 For the reaction

- (a) Identify the oxidizing and reducing agents. (b) Calculate E_{cell}° .
 (c) For the reduction half-reaction, write a balanced equation, give the oxidation number of each element, and calculate $E_{\text{half-cell}}^\circ$.

21.150 Two concentration cells are prepared, both with 90.0 mL of 0.0100 M Cu(NO₃)₂ and a Cu bar in each half-cell.

- (a) In the first concentration cell, 10.0 mL of 0.500 M NH₃ is added to one half-cell; the complex ion Cu(NH₃)₄²⁺ forms, and E_{cell} is 0.129 V. Calculate K_f for the formation of the complex ion.

(b) Calculate E_{cell} when an additional 10.0 mL of 0.500 M NH₃ is added.

(c) In the second concentration cell, 10.0 mL of 0.500 M NaOH is added to one half-cell; the precipitate Cu(OH)₂ forms ($K_{\text{sp}} = 2.2 \times 10^{-20}$). Calculate E_{cell}° .

(d) What would the molarity of NaOH have to be for the addition of 10.0 mL to result in an E_{cell}° of 0.340 V?

21.151 Two voltaic cells are to be joined so that one will run the other as an electrolytic cell. In the first cell, one half-cell has Au foil in 1.00 M $\text{Au}(\text{NO}_3)_3$, and the other half-cell has a Cr bar in 1.00 M $\text{Cr}(\text{NO}_3)_3$. In the second cell, one half-cell has a Co bar in 1.00 M $\text{Co}(\text{NO}_3)_2$, and the other half-cell has a Zn bar in 1.00 M $\text{Zn}(\text{NO}_3)_2$.

- (a) Calculate E_{cell}° for each cell.
- (b) Calculate the total potential if the two cells are connected as voltaic cells in series.
- (c) When the electrode wires are switched in one of the cells, which cell will run as the voltaic cell and which as the electrolytic cell?
- (d) Which metal ion is being reduced in each cell?
- (e) If 2.00 g of metal plates out in the voltaic cell, how much metal ion plates out in the electrolytic cell?

21.152 A voltaic cell has one half-cell with a Cu bar in a 1.00 M Cu^{2+} salt, and the other half-cell with a Cd bar in the same volume of a 1.00 M Cd^{2+} salt.

- (a) Find E_{cell}° , ΔG° , and K .

(b) As the cell operates, $[\text{Cd}^{2+}]$ increases; find E_{cell} and ΔG when $[\text{Cd}^{2+}]$ is 1.95 M.

(c) Find E_{cell} , ΔG , and $[\text{Cu}^{2+}]$ at equilibrium.

21.153 Gasoline is a mixture of hydrocarbons, but the heat released when it burns is close to that of octane, $\text{C}_8\text{H}_{18}(l)$ ($\Delta H_f^{\circ} = -250.1 \text{ kJ/mol}$). Research is underway to use H_2 from the electrolysis of water in fuel cells to power cars instead of gasoline.

- (a) Calculate ΔH° when 1.00 gal of gasoline ($d = 0.7028 \text{ g/mL}$) burns to produce carbon dioxide gas and water vapor.
- (b) How many liters of H_2 at 25°C and 1.00 atm must burn to produce this quantity of energy?
- (c) How long would it take to produce this amount of H_2 by electrolysis with a current of $1.00 \times 10^3 \text{ A}$ at 6.00 V?
- (d) How much power in kilowatt-hours (kW·h) is required to generate this amount of H_2 (1 W = 1 J/s, 1 J = 1 C·V, and 1 kW·h = $3.6 \times 10^6 \text{ J}$)?
- (e) If the cell is 88.0% efficient and electricity costs \$0.123 per kW·h, what is the cost of producing the amount of H_2 equivalent to 1.00 gal of gasoline?

22

The Elements in Nature and Industry

22.1 How the Elements Occur in Nature

Earth's Structure and Elements'
Abundance
Sources of the Elements

22.2 The Cycling of Elements Through the Environment

Carbon Cycle
Nitrogen Cycle
Phosphorus Cycle

22.3 Metallurgy: Extracting a Metal from Its Ore

Pretreating the Ore
Converting Mineral to Element
Refining and Alloying

22.4 Tapping the Crust: Isolation and Uses of Selected Elements

Sodium and Potassium
Iron, Copper, and Aluminum
Magnesium
Hydrogen

22.5 Chemical Manufacturing: Two Case Studies

Sulfuric Acid
Chlor-Alkali Process

Source: © Oleksiy Maksymenko
Photography/Alamy

Concepts and Skills to Review Before You Study This Chapter

- › trends in atomic properties (Sections 8.3, 8.4, 9.2, and 9.5)
- › catalysts and reaction rate (Section 16.7)
- › Le Châtelier's principle (Section 17.6)
- › acid-base equilibria (Sections 18.3 and 18.4)
- › solubility and complex-ion equilibria (Sections 19.3 and 19.4)
- › temperature and reaction spontaneity (Section 20.3)
- › free energy and equilibrium (Section 20.4)
- › standard electrode potentials (Section 21.3)
- › electrolysis of molten salts and aqueous salt solutions (Section 21.7)

To make that sports car you may have dreamed of owning, manufacturers need chemical elements. Iron, in the form of steel, accounts for about 55% of the weight of a typical car and aluminum about 8%. Zinc is used to galvanize some of the metal parts, lead is used in the battery, and copper is needed for the wiring. To make your dream car (or your old, trusty, college-student car) a reality, we need to extract elements from their source, Earth. Chemical principles aid in answering practical questions about this process: how much of the element is present in nature, in what form does it occur, how do organisms affect its distribution, and how do we isolate it for our own use? We'll apply concepts of kinetics, equilibrium, thermodynamics, and electrochemistry from previous chapters to explain some major chemical processes in nature and industry.

IN THIS CHAPTER . . . We examine the distribution of elements on Earth and the natural cycles of three key elements. Then, we apply concepts of kinetics, equilibrium, thermodynamics, and electrochemistry from previous chapters to explain the methods that have been developed to extract, purify, and utilize several important elements.

- › We identify the abundances and sources of elements in the various regions of Earth.
- › We consider how three essential elements—carbon, nitrogen, and phosphorus—cycle through the environment and focus on how humans influence these processes.
- › We focus on the isolation and purification of metals, discussing general redox and metallurgical procedures for extracting an element from its ore.
- › We examine in detail the isolation and uses of seven key elements: sodium, potassium, iron, copper, aluminum, magnesium, and hydrogen.
- › We take a close look at two of the most important processes in chemical manufacturing: the production of sulfuric acid and the isolation of chlorine.

22.1 HOW THE ELEMENTS OCCUR IN NATURE

To begin our examination of how we use the elements, let's take inventory of our elemental stock—the distribution and relative amounts of the elements on Earth, especially that thin outer portion of our planet that we can reach.

Earth's Structure and the Abundance of the Elements

Any attempt to isolate an element must begin with a knowledge of its **abundance**, the amount of the element in a particular region of the natural world. The abundances of the elements result from details of our planet's evolution.

Formation and Layering of Earth About 4.5 billion years ago, vast clouds of cold gases and interstellar debris from exploded older stars gradually coalesced into the Sun and planets. At first, Earth was a cold, solid sphere of uniformly distributed elements and simple compounds. In the next billion years or so, heat from radioactive decay and continuous meteor impacts raised the planet's temperature to around 10^4 K, sufficient to form an enormous molten mass. Any

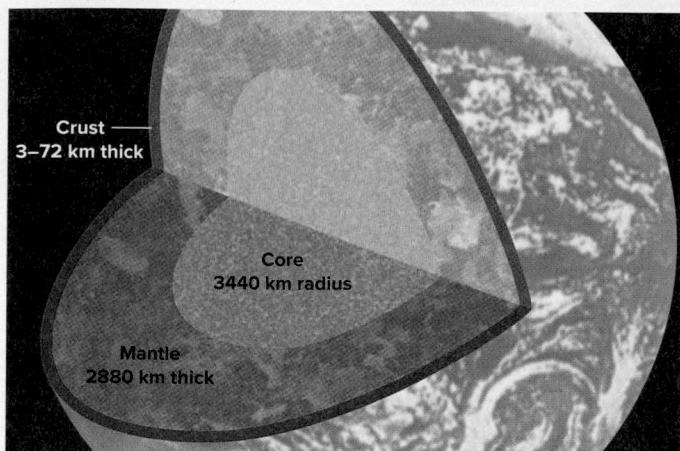

Figure 22.1 The layered internal structure of Earth.

remaining gaseous elements, such as the cosmically abundant and very light hydrogen and helium, were lost to space.

As Earth cooled, chemical and physical processes resulted in its **differentiation**, the formation of regions of different composition and density. Differentiation gave Earth an internal structure consisting of three layers (Figure 22.1):

- The dense **core** ($d = 10\text{--}15 \text{ g/cm}^3$) is composed of a molten outer core and a solid Moon-sized inner core. Remarkably, the inner core is nearly as hot as the surface of the Sun and spins within the molten outer core slightly faster than Earth itself does!
- The thick, homogeneous **mantle** lying around the core has an overall density of $4\text{--}6 \text{ g/cm}^3$.
- A thin, heterogeneous **crust** lies on top of the mantle. The average density of the crust, on which all the comings and goings of life take place, is 2.8 g/cm^3 .

Table 22.1 compares the abundance of some key elements in the universe, the whole Earth (actually core plus mantle only, which account for more than 99% of Earth's mass), and Earth's three regions. (Because the deepest terrestrial sampling can penetrate only a few kilometers into the crust, some of these data represent extrapolations from meteor samples and from seismic studies of earthquakes.) Several points stand out:

- Cosmic and whole-Earth abundances are very different, particularly for H and He; these two elements account for the majority of the mass of the universe but are not abundant in elemental form on Earth.
- The elements O, Si, Fe, and Mg are abundant both cosmically and on Earth. Together, they account for more than 90% of Earth's mass.
- The core is particularly rich in the dense Group 8B(8) through 8B(10) metals: Co, Ni, and especially Fe, the most abundant element in the whole Earth.

Table 22.1 **Cosmic and Terrestrial Abundances (Mass %) of Selected Elements***

Element	Universe	Earth	Crust	Mantle	Core
O	1.07	29.5	49.5	43.7	—
Si	0.06	15.2	25.7	21.6	—
Al	—	1.1	7.5	1.8	—
Fe	0.19	34.6	4.7	13.3	88.6
Ca	0.007	1.1	3.4	2.1	—
Mg	0.06	12.7	2.8	16.6	—
Na	—	0.6	2.6	0.8	—
K	—	0.07	2.4	0.2	—
H	73.9	—	0.87	—	—
Ti	—	0.05	0.58	0.18	0.01
Cl	—	—	0.19	—	—
P	—	—	0.12	—	—
Mn	—	—	0.09	—	—
C	0.46	—	0.08	—	—
S	0.04	1.9	0.06	>2	—
Ni	0.006	2.4	0.008	0.3	8.5
Co	—	0.13	0.003	0.04	0.6
He	24.0	—	—	—	—

*A missing abundance value indicates either that reliable data are not available or that the value is less than 0.001% by mass.

- Crustal abundances are very different from whole-Earth abundances. The crust makes up only 0.4% of Earth's mass, but has the largest share of nonmetals, metalloids, and light, active metals: Al, Ca, Na, and K. The mantle contains much smaller proportions of these, and the core has none. Oxygen is the most abundant element in the crust and mantle but is absent from the core.

These differences in Earth's major layers arose from the effects of thermal energy. When Earth was molten, gravity and convection caused more dense materials to sink and less dense materials to rise, yielding several compositional *phases*:

- Most of the Fe sank to form the core, or *iron phase*.
- In the light outer phase, oxygen combined with Si, Al, Mg, and some Fe to form silicates, the material of rocks. This *silicate phase* later separated into the mantle and crust.
- The *sulfide phase*, intermediate in density and insoluble in the other two, consisted mostly of iron sulfide and mixed with parts of the silicate phase above and the iron phase below.
- The thin, primitive atmosphere, probably a mixture of water vapor (which gave rise to the oceans), carbon monoxide, and nitrogen (or ammonia), was produced by *outgassing* (the expulsion of trapped gases).

The distribution of the remaining elements (discussed here using only the new periodic table group numbers) was controlled by their chemical affinity for one of the three phases. In general terms, as Figure 22.2 shows:

- Elements with low or high electronegativity—active metals (those in Groups 1 through 5, Cr, and Mn) and nonmetals (O, lighter members of Groups 13 to 15, and all of Group 17)—tended to congregate in the silicate phase as ionic compounds.
- Metals with intermediate electronegativities (many from Groups 6 to 10) dissolved in the iron phase.
- Lower-melting transition metals and many metals and metalloids in Groups 11 to 16 became concentrated in the sulfide phase.

The Impact of Life on Crustal Abundances At present, the crust is the only physically accessible layer of Earth, so only crustal abundances have practical significance. The crust is divided into the **lithosphere** (the solid region of the crust), the **hydrosphere** (the liquid region), and the **atmosphere** (the gaseous region). Over billions of years, weathering and volcanic upsurges have dramatically altered the composition of the crust. The **biosphere**, which consists of the living systems that inhabit and have

Figure 22.2 Geochemical differentiation of the elements.

A Banded-iron formations containing Fe_2O_3

B Fossil of early multicellular organism

Figure 22.3 Ancient effects of an O_2 -rich atmosphere.

Source: (A) © Doug Sherman/Geofile RF; (B) © University of Cambridge, Department of Earth Sciences

Dolomite Mountains, Italy.

Source: © Ruth Melnick

inhabited the planet, has been another *major influence on crustal element composition and distribution*.

When the earliest rocks were forming and the ocean basins were filling with water, binary inorganic molecules in the atmosphere were reacting to form first simple, and then more complex, organic molecules. The energy for these (mostly) endothermic changes was supplied by lightning, solar radiation, geologic heating, and meteoric impacts. In an amazingly short period of time, probably no more than 500 million years, the first organisms appeared. It took less than another billion years for these to evolve into simple algae that could derive metabolic energy from photosynthesis, converting CO_2 and H_2O into organic molecules and releasing O_2 as a byproduct.

Let's look at some of the essential ways the evolution of organisms affected the chemistry of the crust:

1. *Increase in O_2 .* Due to photosynthesis, the atmosphere gradually became richer in O_2 over the 300 million years following the emergence of algae. Thus, *oxidation became the major source of free energy in the crust and biosphere*. As a result of this oxidizing environment, the predominating $\text{Fe}(\text{II})$ -containing minerals were oxidized to $\text{Fe}(\text{III})$ -containing minerals, such as hematite, Fe_2O_3 , shown in Figure 22.3A in ancient banded-iron formations (red beds). The increase in oxygen also led to an explosion of O_2 -utilizing life forms, a few of which evolved into the organisms of today. Figure 22.3B shows a fossil of one of the multicellular organisms whose appearance coincided with the increase in O_2 .

2. *K^+ vs. Na^+ .* The K^+ concentration of the oceans is much lower than the Na^+ concentration. Forming over eons from outgassed water vapor condensing into rain and streaming over the land, the oceans became complex ionic solutions with 30 times as much Na^+ as K^+ . One reason for this is that plants require K^+ for growth, so they absorbed dissolved K^+ that would otherwise have washed down to the sea.

3. *Buried organic carbon.* Enormous subterranean deposits of organic carbon formed when ancient plants, buried deeply and decomposing under high pressure and temperature in the absence of free O_2 , gradually turned into coal. Animals buried under similar conditions turned into petroleum. Crustal deposits of this organic carbon provide the fuels that move our cars, heat our homes, and electrify our cities.

4. *Fossilized CaCO_3 .* Carbon and oxygen, together with calcium, the fifth most abundant element in the crust, occur in vast sedimentary deposits all over the world as limestone, dolomite (*see photo*), marble, and chalk, all of which are the fossilized skeletal remains of countless early marine organisms.

Table 22.2 compares selected elemental abundances in the whole crust, the three crustal regions, and the human body, a representative portion of the biosphere. Note the quantities of the four major elements of life— O , C , H , and N . Oxygen is either the first or second most abundant element in all cases. The biosphere contains large amounts of carbon in its biomolecules and large amounts of hydrogen as water. Nitrogen is abundant in the atmosphere as free N_2 and in organisms as part of their proteins. Phosphorus and sulfur also occur in high amounts in organisms.

One striking difference among the lithosphere, hydrosphere, and biosphere (human) is in the abundances of the transition metals vanadium through zinc. Their relatively insoluble oxides and sulfides make them much scarcer in water than on land. Yet organisms, which evolved in the seas, developed the ability to concentrate the trace amounts of these elements present in their aqueous environment. In every case, the biological concentration is at least 100 times the concentration in the hydrosphere, with Mn increasing about 1000-fold, and Cu, Zn, and Fe even more. These elements perform essential roles in living systems (see Chemical Connections at the end of Chapter 23).

Sources of the Elements

Given an element's abundance in a region of the crust, we still need to determine its **occurrence**, or **source**, the form(s) in which the element exists. Practical considerations often determine the commercial source. Oxygen, for example, is abundant in

Table 22.2

Abundances of Selected Elements in the Crust, Its Regions, and the Human Body as Representative of the Biosphere (Mass %)

Element	Crust	Crustal Regions			
		Lithosphere	Hydrosphere	Atmosphere	Human
O	49.5	45.5	85.8	23.0	65.0
C	0.08	0.018	—	0.01	18.0
H	0.87	0.15	10.7	0.02	10.0
N	0.03	0.002	—	75.5	3.0
P	0.12	0.11	—	—	1.0
Mg	1.9	2.76	0.13	—	0.50
K	2.4	1.84	0.04	—	0.34
Ca	3.4	4.66	0.05	—	2.4
S	0.06	0.034	—	—	0.26
Na	2.6	2.27	1.1	—	0.14
Cl	0.19	0.013	2.1	—	0.15
Fe	4.7	6.2	—	—	0.005
Zn	0.013	0.008	—	—	0.003
Cr	0.02	0.012	—	—	3×10^{-6}
Co	0.003	0.003	—	—	3×10^{-6}
Cu	0.007	0.007	—	—	4×10^{-4}
Mn	0.09	0.11	—	—	1×10^{-4}
Ni	0.008	0.010	—	—	3×10^{-6}
V	0.015	0.014	—	—	3×10^{-6}

all three crustal regions, but the atmosphere is its primary industrial source because it occurs there as the free element. Nitrogen and the noble gases (except helium) are also obtained from the atmosphere. Several other elements occur uncombined, formed in large deposits by prehistoric biological action, such as sulfur in caprock salt domes and nearly pure carbon in coal. The relatively unreactive elements gold and platinum also occur in an uncombined (or *native*) state.

The overwhelming majority of elements, however, occur in **ores**, natural compounds or mixtures of compounds from which an element can be extracted economically (*see photo*): *the financial costs of mining, isolating, and purifying must be considered when choosing a process to obtain an element*.

Figure 22.4 on the next page shows the most useful sources of the elements. Note that elements with the same types of ores tend to be grouped together in the periodic table:

- Alkali metal halides are ores for both groups of their component elements, Group 1A(1) and Group 7A(17).
- Group 2A(2) metals occur as carbonates in the marble and limestone of mountain ranges, although magnesium is very abundant in seawater (making that the preferred source, as we discuss later).
- Even though many elements occur as silicates, most of these compounds are very stable thermodynamically. Thus, the cost that would be incurred in processing them prohibits their use—aside from silicon, only lithium and beryllium are obtained from their silicates.
- The ores of most industrially important metals are either oxides, which dominate the left half of the transition series, or sulfides, which dominate the right half of the transition series and a few of the main groups beyond.

The reasons for the prominence of oxide and sulfide ores of metallic elements are complex and include weathering processes, selective precipitation (Section 19.3), and relative solubilities. Certain atomic properties are relevant as well. Metals toward the left side of the periodic table have lower ionization energies and electronegativities,

Deposit of borate (tufa), the ore of boron.

Source: © Robert Holmes/Corbis

Figure 22.4 Sources of the elements.

1A (1)		Oxides	Carbonates/Sulfates	8A (18)
H	2A (2)	Halide salts or brines	Sulfides	
Li	Be	Phosphates	Uncombined	
Na	Mg	3B (3) 4B (4) 5B (5) 6B (6) 7B (7) 8B (8) (9) (10)	1B (11) 2B (12)	3A (13) 4A (14) 5A (15) 6A (16) 7A (17) He
K	Ca	Sc Ti V Cr Mn Fe Co Ni Cu Zn Ga Ge As Se Br Kr	Al Si P S Cl Ar	
Rb	Sr	Y Zr Nb Mo	Ag Cd In Sn Sb Te I Xe	
Cs	Ba	La Hf Ta W Re	Pt Au Hg Tl Pb Bi	
Ce	Pr	Nd Pm Sm Eu Gd Tb Dy Ho Er Tm Yb Lu		
		U		

so they tend to give up electrons or hold them loosely in bonds. The O^{2-} ion is small enough to approach a metal cation closely, which results in a high lattice energy for the metal oxide. In contrast, metals toward the right side have higher ionization energies and electronegativities. Thus, they tend to form bonds that are more covalent, which suits the larger, more polarizable S^{2-} ion.

› Summary of Section 22.1

- › As the young Earth cooled, the elements became differentiated into a dense metallic core, a silicate-rich mantle, and a low-density crust.
- › High abundances of light metals, metalloids, and nonmetals are concentrated in the crust, which has three regions: lithosphere (solid), hydrosphere (liquid), and atmosphere (gaseous).
- › The biosphere (living systems) profoundly affected crustal chemistry by producing free O_2 , and thus an oxidizing environment.
- › Some elements occur in their native state, but most are combined in ores. The ores of most important metallic elements are oxides or sulfides.

22.2 THE CYCLING OF ELEMENTS THROUGH THE ENVIRONMENT

The distributions of many elements change at widely differing rates. The physical, chemical, and biological paths that atoms of an element take through the three regions of the crust—atmosphere, hydrosphere, and lithosphere—constitute the element's **environmental cycle**. In this section, we consider the cycles for carbon, nitrogen, and phosphorus and highlight the effects of humans on them.

The Carbon Cycle

Carbon is one of a handful of elements that appear in all three regions of Earth's crust.

- In the lithosphere, it occurs in elemental form as graphite and diamond, in fully oxidized form in carbonate minerals, in fully reduced form in petroleum hydrocarbons, and in complex mixtures, such as coal and living matter.
- In the hydrosphere, it occurs in living matter, in carbonate minerals formed by the action of coral-reef organisms, and in dissolved CO_2 and related oxoanions.
- In the atmosphere, it occurs principally in gaseous CO_2 , a minor (0.04%) but essential component that exists in equilibrium with the aqueous fraction.

Key Interactions Within the Cycle Figure 22.5 depicts the complex interplay of sources and the effect of the biosphere on carbon's environmental cycle. It provides

Figure 22.5 The carbon cycle.

Numbers in boxes refer to the size of the source; numbers along arrows refer to the annual movement of the element from source to source. Both sets of values are in 10^9 t of C (1 t = 1000 kg = 1.1 tons).

an estimate of the size of each source and, where possible, the amount of carbon moving annually between sources. Note these key points:

- The portions of the cycle are linked by the atmosphere—one link between oceans and air, the other between land and air. The 2.6×10^{12} metric tons of CO_2 in air cycles through the oceans and atmosphere about once every 300 years but spends a much longer time in carbonate minerals.
- Atmospheric CO_2 accounts for only 0.04% of crustal carbon but moves the element through the other regions. A CO_2 molecule spends, on average, 3.5 years in the atmosphere.
- The land and oceans are in contact with the largest sources of carbon, immobilized as carbonates, coal, and oil in rocky sediment beneath the soil.
- Photosynthesis, respiration, and decomposition* are major factors in the cycle. **Fixation** is the process of converting a gaseous substance into a condensed form. Via photosynthesis, marine plankton and terrestrial plants use sunlight to fix atmospheric CO_2 into carbohydrates. Plants release CO_2 by respiration at night and, much more slowly, when they decompose. Animals eat the plants and release CO_2 by respiration and decomposition.
- Fires and volcanoes also release CO_2 into the air.

Buildup of CO₂ and Global Warming For hundreds of millions of years, the carbon cycle maintained a relatively constant amount of atmospheric CO₂, resulting in a relatively constant planetary temperature range. But over the past century and a half, and especially since World War II, atmospheric CO₂ has increased. The principal cause is the combustion of coal, wood, and oil for fuel and the decomposition of limestone to make cement, coupled with the clearing of forests and jungles for lumber, paper, and agriculture. And the principal effect is climate change. The 1990s and 2000s were the hottest decades ever recorded, and 2011–2016 continued this trend. Overwhelming evidence is showing that these activities have led to global warming through the greenhouse effect (see Chemical Connections in Chapter 6). Higher temperatures, alterations in dry and rainy seasons, melting of polar ice, and increasing ocean acidity, with associated changes in carbonate equilibria, are clearly occurring. Nearly all science policy experts are pressing for programs that combine conservation of carbon-based fuels, an end to deforestation, and development of alternative energy sources.

The Nitrogen Cycle

In contrast to the carbon cycle, the nitrogen cycle includes a *direct* interaction between land and sea (Figure 22.6). All nitrites and nitrates are soluble, so rain and runoff from the land contribute huge amounts of nitrogen to lakes, rivers, and oceans. Human activity, through the use of fertilizer, plays a major role in this cycle.

Like carbon dioxide, atmospheric nitrogen must be fixed. However, whereas CO₂ can be incorporated by plants in either its gaseous or aqueous form, the great stability of N₂ prevents plants from using it directly. Fixation of N₂ requires a great deal of energy and occurs through atmospheric, industrial, and biological processes.

Figure 22.6 The nitrogen cycle. Numbers in boxes are in 10⁹ metric tons of N and refer to the size of the source; numbers along arrows are in 10⁶ metric tons of N and refer to the annual movement of the element between sources.

Atmospheric Fixation Lightning causes the high-temperature endothermic reaction of N₂ and O₂ to form NO, which is then oxidized by ozone exothermically to NO₂:

During the day, NO₂ reacts with hydroxyl radical to form HNO₃:

At night, a multistep reaction between NO₂ and ozone is involved. In either case, rain dissociates the nitric acid, and NO₃⁻(aq) enters both sea and land to be utilized by plants.

Industrial Fixation Most human-caused fixation occurs industrially during ammonia synthesis via the Haber process (Section 17.6):

The process takes place on an enormous scale, and NH₃ ranks first, on a mole basis, among compounds produced industrially. Some of this NH₃ is converted to HNO₃ in the Ostwald process (Section 14.7), but most is used as fertilizer, either directly or in the form of urea and ammonium salts (sulfate, phosphate, and nitrate), which enter the biosphere when taken up by plants (as discussed in the next subsection).

In recent decades, high-temperature combustion in electric power plants and in car, truck, and plane engines has become an important contributor to total fixed nitrogen. High engine operating temperatures mimic lightning to form NO from the N₂ and O₂ in the air taken in to burn the hydrocarbon fuel. The NO in exhaust gases reacts to form nitric acid in the atmosphere, which adds to the nitrate load that reaches the ground.

The overuse of fertilizers and automobiles presents an increasingly serious water pollution problem in many areas. Leaching of the land by rain causes nitrate from fertilizer use and vehicle operation to enter lakes, rivers, and coastal estuaries and leads to *eutrophication*, the depletion of O₂ and the death of aquatic animal life from excessive algal and plant growth and decomposition. Excess nitrate also spoils nearby drinkable water.

Biological Fixation The biological fixation of atmospheric N₂ occurs in blue-green algae and in nitrogen-fixing bacteria that live on the roots of leguminous plants (such as peas, alfalfa, and clover). These microbial processes dwarf the previous two, fixing more than seven times as much nitrogen as the atmosphere and six times as much as industry. Root bacteria fix N₂ by enzymatically reducing it to NH₃ and NH₄⁺. Enzymes in other soil bacteria catalyze the multistep oxidation of NH₄⁺ to NO₂⁻ and finally NO₃⁻, which the plants reduce again to make proteins. When the plants die, still other soil bacteria oxidize the proteins to NO₃⁻.

Animals eat the plants, break down the plant proteins to make their own proteins, and excrete nitrogenous wastes, such as urea [(H₂N)₂C=O]. The nitrogen in the proteins is released when the animals die and decompose, and is converted by soil bacteria to NO₂⁻ and NO₃⁻ again. This central pool of inorganic nitrate has three main fates: some enters marine and terrestrial plants, some enters the enormous sediment store of mineral nitrates, and some is reduced by denitrifying bacteria to NO₂⁻ and then reduced further to N₂O and N₂, which re-enter the atmosphere to complete the cycle.

The Phosphorus Cycle

Virtually all the mineral sources of phosphorus contain the phosphate group, PO₄³⁻. The most commercially important ores are **apatites**, compounds of general formula Ca₅(PO₄)₃X, where X is usually F, Cl, or OH. The cycling of phosphorus through the environment involves three interlocking subcycles (Figure 22.7, *next page*). Two rapid biological cycles—a land-based cycle (*yellow arrows in figure*) completed in a matter of years and a water-based cycle (*blue arrows*) completed in weeks to years—are superimposed on an inorganic cycle (*pink arrows*) that takes millions of years to complete. Unlike the carbon and nitrogen cycles, the phosphorus cycle has no gaseous component and thus does *not* involve the atmosphere.

Figure 22.7 The phosphorus cycle.

The Inorganic Cycle Although most phosphorus occurs in phosphate rock formed when Earth's lithosphere solidified, a sizeable amount has come from outer space in meteorites. About 100 metric tons of meteorites enter Earth's atmosphere every day, and with an average P content of 0.1% by mass, they have contributed about 10^{11} metric tons of phosphorus to the crust over Earth's lifetime. The most important components of phosphate rock are nearly insoluble phosphate salts:

$$K_{sp} \text{ of } \text{Ca}_3(\text{PO}_4)_2 \approx 10^{-29}$$

$$K_{sp} \text{ of } \text{Ca}_5(\text{PO}_4)_3\text{OH} \approx 10^{-51}$$

$$K_{sp} \text{ of } \text{Ca}_5(\text{PO}_4)_3\text{F} \approx 10^{-60}$$

Weathering slowly leaches phosphates from the soil and carries the ions through rivers to the sea. Plants in the land-based biological cycle speed up this process. In the ocean, some phosphate is absorbed by organisms in the water-based biological cycle, but the majority is precipitated again by Ca^{2+} ion and deposited on the continental shelf. Geologic activity lifts the continental shelves, returning the phosphate to the land.

The Land-Based Biological Cycle The biological cycles involve the incorporation of phosphate into organisms (biomolecules, bones, teeth, and so forth) and the release of phosphate through their excretion and decomposition. In the land-based cycle, plants continually remove phosphate from the inorganic cycle. Recall that there are three phosphate oxoanions, which exist in equilibrium in aqueous solution:

In topsoil, phosphates occur as insoluble compounds of Ca^{2+} , Fe^{3+} , and Al^{3+} . Because they can absorb only the water-soluble dihydrogen phosphate, plants have evolved the ability to secrete acids near their roots to convert the insoluble salts gradually into the soluble ion:

Animals that eat the plants excrete soluble phosphate, which is used by newly growing plants. As plants and animals excrete, die, and decompose, some phosphate

is washed into rivers and the oceans. Most of the 2 million metric tons of phosphate that washes from land to sea each year comes from this biological source. Thus, the biosphere greatly increases the movement of phosphate from lithosphere to hydrosphere.

The Water-Based Biological Cycle Various phosphate oxoanions continually enter the aquatic environment. Studies that incorporate trace amounts of radioactive phosphorus into H_2PO_4^- and monitor its uptake show that, within 1 minute, 50% of the ion is taken up by photosynthetic algae, which use it to synthesize their biomolecules (denoted by the top curved arrow in the equation, which shows the overall process):

(The complex formula on the right represents the total composition of algal biomolecules, not some particular compound.)

As on land, animals eat the plants and are eaten by other animals, and they all excrete phosphate, die, and decompose (denoted by the bottom curved arrow in the preceding equation). Some of the released phosphate is used by other aquatic organisms, and some returns to the land when fish-eating animals (mostly humans and birds) excrete phosphate, die, and decompose. In addition, some aquatic phosphate precipitates with Ca^{2+} , sinks to the seabed, and returns to the long-term mineral deposits of the inorganic cycle.

Human Effects on Phosphorus Movement From prehistoric through preindustrial times, these interlocking phosphorus cycles were balanced. Modern human activity, however, alters the movement of phosphorus considerably. Annually, we use more than 100 million tons of phosphate rock. Figure 22.8 shows the major end products, with box height proportional to the mass % of phosphate rock used annually. Removal of phosphate rock has minimal influence on the inorganic cycle, but the end products have unbalanced the two biological cycles.

The imbalance arises from our overuse of *soluble phosphate fertilizers*, such as $\text{Ca}(\text{H}_2\text{PO}_4)_2$ and $\text{NH}_4\text{H}_2\text{PO}_4$, the end products from about 85% of the phosphate rock

Figure 22.8 Industrial uses of phosphorus.

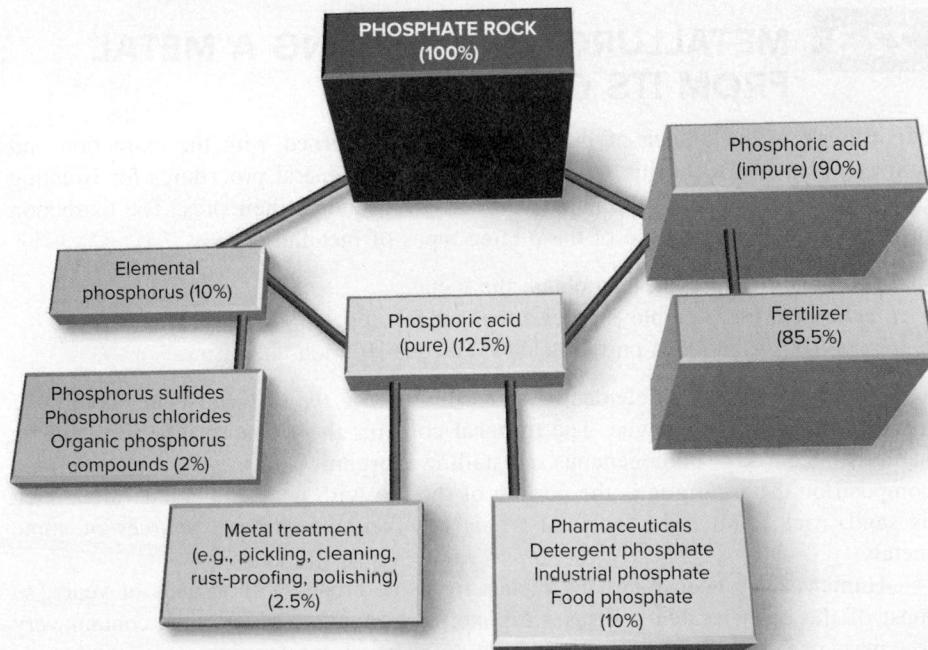

mined. Some fertilizer finds its way into rivers, lakes, and oceans to enter the water-based cycle. Much larger pollution sources, however, are the crops grown with the fertilizer and the detergents made from phosphate rock. The great majority of this phosphate arrives eventually in cities as crops, as animals that were fed crops, and as consumer products, such as the tripolyphosphates in detergents. Human garbage, excrement, wash water with detergents, and industrial wastewater containing phosphate are carried through sewers to the aquatic system. This human contribution equals the natural contribution—another 2 million metric tons of phosphate per year. The increased concentration in rivers and lakes causes eutrophication, which robs the water of O₂ so that it cannot support life. Such “dead” rivers and lakes are no longer usable for fishing, drinking, or recreation.

A century ago, in 1912, Lake Zurich in Switzerland had been choked with algae and become devoid of fish. Treatment with FeCl₃ precipitated enough phosphate to gradually return the lake to its natural state. Soluble aluminum compounds have the same effect:

› Summary of Section 22.2

- › The environmental distribution of many elements changes cyclically with time and is affected in major ways by organisms.
- › Carbon occurs in all three regions of Earth’s crust, with atmospheric CO₂ linking the other two regions. Photosynthesis and decomposition of organisms alter the amount of carbon in the land and oceans. Human activity has increased atmospheric CO₂, leading to climate change.
- › Nitrogen is fixed by lightning, by industry, and primarily by microorganisms. When plants or animals decompose, bacteria convert proteins to nitrites and nitrates and eventually to N₂, which returns to the atmosphere. Through extensive use of fertilizers, humans have added excess nitrogen to freshwaters.
- › The phosphorus cycle has no gaseous component. Inorganic phosphates leach slowly into land and water, where biological cycles interact. When plants and animals decompose, they release phosphate to natural waters, where it is then absorbed by other plants and animals. Through overuse of phosphate fertilizers and detergents, humans double the amount of phosphorus entering the aqueous environment.

22.3 METALLURGY: EXTRACTING A METAL FROM ITS ORE

Metallurgy is the branch of materials science concerned with the extraction and utilization of metals. In this section, we discuss the general procedures for isolating metals and, occasionally, the nonmetals that are found in their ores. The extraction process applies one or more of these three types of metallurgy:

- *Pyrometallurgy* uses heat to obtain the metal.
- *Electrometallurgy* employs an electrochemical step.
- *Hydrometallurgy* relies on the metal’s aqueous solution chemistry.

The extraction of an element begins with *mining the ore*. Most ores consist of a mineral attached to gangue. The **mineral** contains the element; it is defined as a naturally occurring, homogeneous, crystalline inorganic solid, with a well-defined composition. The **gangue** is the portion of the ore with no commercial value, such as sand, rock, and clay. Table 22.3 lists the common mineral sources of some metals.

Humans have been removing metals from the crust for thousands of years, so most of the concentrated sources are gone, and, in many cases, ores contain very low mass percents of a metal. The general procedure for extracting most metals (and

Common Mineral Sources of Some Elements

Table 22.3

Element	Mineral, Formula
Al	Gibbsite (in bauxite), Al(OH) ₃
Ba	Barite, BaSO ₄
Be	Beryl, Be ₃ Al ₂ Si ₆ O ₁₈
Ca	Limestone, CaCO ₃
Fe	Hematite, Fe ₂ O ₃
Hg	Cinnabar, HgS
Na	Halite, NaCl
Pb	Galena, PbS
Sn	Cassiterite, SnO ₂
Zn	Sphalerite, ZnS

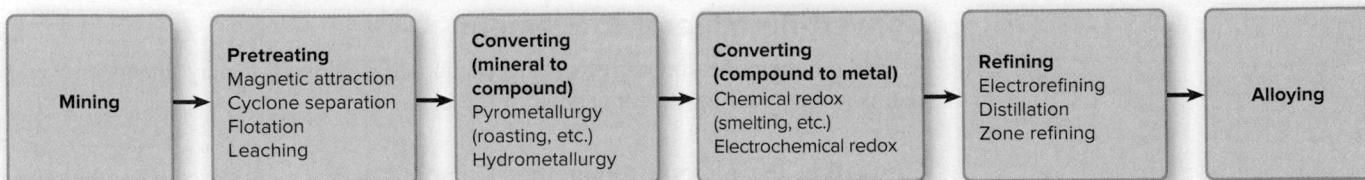**Figure 22.9** Steps in metallurgy.

some nonmetals) involves a few basic steps, described in the upcoming subsections (Figure 22.9).

Pretreating the Ore

Following a crushing, grinding, or pulverizing step, which can be very expensive, pretreatment uses some physical or chemical difference to separate mineral from gangue. The following are common pretreatment techniques:

- **Magnetic attraction.** For magnetic minerals, such as magnetite (Fe_3O_4), a magnet can remove the mineral and leave the gangue behind.
- **Density separation.** When large density differences exist, a *cyclone separator* blows high-pressure air through the pulverized mixture to separate the particles. The lighter silicate-rich gangue is blown away, while the denser mineral-rich particles hit the walls of the separator and fall through the open bottom (Figure 22.10).
- **Flotation.** In **flotation**, an oil-detergent mixture is stirred with the pulverized ore in water to form a slurry (Figure 22.11). The surfaces of mineral and of gangue become wet to different extents with water and detergent. Rapid mixing with air produces an oily, mineral-rich froth that floats, while the silicate particles sink. Skimming, followed by solvent removal, isolates the concentrated mineral fraction.
- **Leaching.** Some metals are extracted by a hydrometallurgical process known as **leaching**, usually accomplished via formation of a complex ion. The modern extraction of gold is a good example of this technique. The crushed ore, which often contains as little as 25 ppm of gold, is contained in a plastic-lined pool, treated with a cyanide ion solution, and aerated. In the presence of CN^- , the O_2 in air oxidizes gold metal to gold(I) ion, Au^+ , which forms the soluble complex ion, $\text{Au}(\text{CN})_2^-$:

(This method is controversial because cyanide enters streams and lakes, where it poisons fish and birds.)

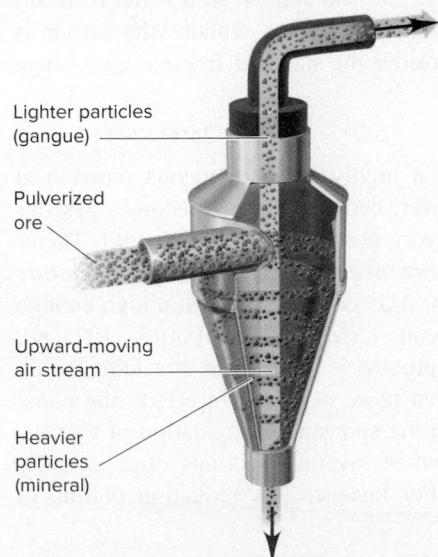**Figure 22.10** The cyclone separator.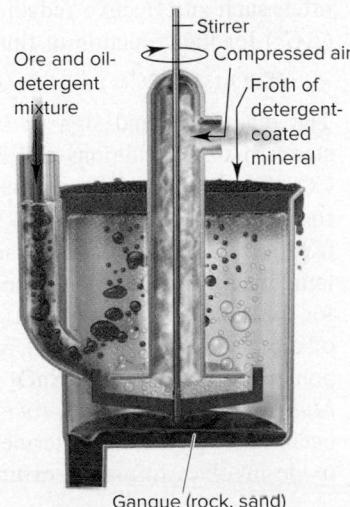**Figure 22.11** The flotation process.

Converting Mineral to Element

After the mineral has been freed of debris and concentrated, it may undergo several chemical steps during its conversion to the element.

Converting the Mineral to Another Compound First, the mineral is often converted to another compound, one that has different solubility properties, is easier to reduce, or is free of an impurity. Conversion to an oxide is common because oxides can be reduced easily. Carbonates are heated to convert them to the oxide:

Metal sulfides, such as ZnS, can be converted to oxides by **roasting** in air:

In most countries, hydrometallurgical methods are now used to avoid the atmospheric release of SO₂ from roasting. One way of processing copper, for example, is by bubbling air through an acidic slurry of insoluble Cu₂S, which completes both the pretreatment and conversion steps:

Converting Compound to Element Through Chemical Redox The next step converts the new mineral form (usually an oxide) to the free element by either chemical or electrochemical redox methods. Let's consider the chemical methods first. In these processes, a reducing agent reacts directly with the compound. The most common reducing agents are carbon, hydrogen, and a more active metal.

1. *Reduction with carbon.* Because of its low cost and ready availability, carbon, in the form of coke (a porous material obtained from incomplete combustion of coal) or charcoal, is a common reducing agent. Heating an oxide with a reducing agent such as coke to obtain the metal is called **smelting**. Many metal oxides, such as zinc oxide and tin(IV) oxide, are smelted with carbon to free the metal, which then may need to be condensed and solidified (note the physical states of the metal products):

Several nonmetals that occur with positive oxidation states in minerals can be reduced with carbon as well. Phosphorus, for example, is produced from calcium phosphate:

(Metallic calcium is a much stronger reducing agent than carbon, so it is not formed.)

- *Thermodynamic considerations.* Thermodynamic principles explain why carbon is often such an effective reducing agent. Consider the standard free energy change (ΔG°) for the reduction of tin(IV) oxide:

The magnitude and sign of ΔG° indicate a highly *nonspontaneous* reaction at standard-state conditions and 298 K. However, because solid C becomes gaseous CO, the standard molar entropy change is very positive ($\Delta S^\circ \approx 380 \text{ J/K}$). Therefore, *the $-T\Delta S^\circ$ term of ΔG° becomes more negative with higher temperature* (Section 20.3). As the temperature increases, ΔG° decreases, and at a high enough temperature, the reaction becomes spontaneous ($\Delta G^\circ < 0$). At 1000°C (1273 K), for example, $\Delta G^\circ = -62.8 \text{ kJ}$. The actual process is carried out at a temperature of around 1250°C (1523 K), so ΔG° is even more negative. In effect, the nonspontaneous reduction of SnO₂ is coupled to the spontaneous oxidation of C.

- *Multistep nature of the process.* As you know, overall reactions often actually occur through several intermediate steps. For instance, the reduction of tin(IV) oxide involves formation of tin(II) oxide:

[Molten tin (mp = 232 K) is obtained at this temperature.] The second step is thought to be composed of others, in which CO, not C, is the actual reducing agent:

Other pyrometallurgical processes are similarly complex. For instance, shortly you'll see that the overall reaction for the smelting of iron is

However, the actual process is a multistep one with CO as the reducing agent. The advantage of CO over C is the far greater physical contact the gaseous reducing agent can make with the other reactant, which speeds the process.

2. Reduction with hydrogen. For oxides of some metals, especially some members of Groups 6B(6) and 7B(7), reduction with carbon forms metal carbides that are difficult to convert further, so hydrogen is used as the reducing agent instead, especially for less active metals, such as tungsten:

One step in the purification of the metalloid germanium also uses hydrogen:

3. Reduction with a more active metal. If a metal oxide forms both an undesirable carbide and an undesirable hydride, it is reduced by a more active metal. In the *thermite reaction*, aluminum powder reduces the metal oxide in a spectacular exothermic reaction to give the molten metal (Figure 22.12). The reaction for chromium is

Reduction by an active metal is also used when the mineral of the element is not an oxide. In the extraction of gold, after the pretreatment by leaching, the gold(I) complex ion is reduced with zinc:

In some cases, an active metal, such as calcium, is used to recover an even more active metal, such as rubidium, from its molten salt:

A similar process (detailed in Section 22.4) is used to recover sodium.

4. Oxidation to obtain a nonmetal. Just as *reduction* of a mineral is used to obtain the metal, *oxidation* of a mineral can be used to obtain a nonmetal. A stronger oxidizing agent removes electrons from the nonmetal anion to give the free nonmetal, as in the production of iodine from concentrated brines:

Converting Compound to Element Through Electrochemical Redox In electrochemical redox processes, the minerals are converted to the elements in an electrolytic cell (Section 21.7). Sometimes, the *pure* mineral, in the form of the molten halide or oxide, is used to prevent unwanted side reactions. The cation is reduced to the metal at the cathode, and the anion is oxidized to the nonmetal at the anode:

High-purity hydrogen gas is prepared by electrochemical reduction:

Specially designed cells separate the products to prevent recombination. An inexpensive source of electricity is used for large-scale methods. The current and voltage requirements depend on the electrochemical potential and any necessary overvoltage (Section 21.7).

Figure 22.13 on the next page shows the most common redox step used in obtaining each free element from its mineral.

Figure 22.12 The thermite reaction.

Source: © Richard Megna/Fundamental Photographs, NYC

Figure 22.13 The redox step in converting a mineral to the element.

1A (1)																	8A (18)
H	2A (2)																He
Li	Be																
Na	Mg	3B (3)	4B (4)	5B (5)	6B (6)	7B (7)	8B (8) (9) (10)			1B (11)	2B (12)	Al	Si	P	S	Cl	Ar
K	Ca	Sc	Ti	V	Cr	Mn	Fe	Co	Ni	Cu	Zn	Ga	Ge	As	Se	Br	Kr
Rb	Sr	Y	Zr	Nb	Mo	Tc	Ru	Rh	Pd	Ag	Cd	In	Sn	Sb	Te	I	Xe
Cs	Ba	La	Hf	Ta	W	Re	Os	Ir	Pt	Au	Hg	Tl	Pb	Bi			
	Ra	Ac															
Ce	Pr	Nd	Pm	Sm	Eu	Gd	Tb	Dy	Ho	Er	Tm	Yb	Lu				
Th	Pa	U															

- Uncombined in nature
- Reduction of molten halide (or oxide) electrolytically
- Reduction of halide with active metal (e.g., Na, Mg, Ca)
- Reduction of oxide/halide with Al or H₂
- Reduction of oxide with C (coke or charcoal)
- Oxidation of anion (or oxoanion) chemically and/or electrolytically

Refining and Alloying the Element

After being isolated, the element typically still contains impurities, so it must be refined to purify it further. Then, metallic elements are often alloyed to improve their properties.

Refining (Purifying) the Element Refining is often carried out by one of three common methods:

1. **Electrorefining.** An electrolytic cell is employed in **electrorefining**, in which the *impure metal acts as the anode and the pure metal as the cathode*. As the reaction proceeds, the anode disintegrates, and the metal ions are reduced to deposit on the cathode. In some cases (as with copper, discussed shortly), impurities that fall beneath the anode are the source of several valuable and less abundant elements.
2. **Distillation.** Metals with relatively low boiling points, such as zinc and mercury, are refined by *distillation*.

3. **Zone refining.** In the process of **zone refining**, a rod of an impure metal or metalloid (such as silicon) is passed slowly through a heating coil in an inert atmosphere. The first narrow zone of the impure solid melts, and as the next zone melts, the dissolved impurities from the first zone lower the freezing point, so the solvent (purer solid of first zone) refreezes. The process continues, zone by zone, for the entire rod. After several passes through the coil, in which each zone's impurities move into the adjacent zone, the refrozen solid at the end of the rod becomes extremely pure (Figure 22.14). Metalloids used in electronic semiconductors, such as silicon and germanium, are zone refined to greater than 99.99999% purity.

Figure 22.14 Zone refining of silicon.

Alloying the Purified Element An **alloy** is a metal-like mixture consisting of solid phases of two or more pure elements (a solid solution) or, in some cases, distinct intermediate phases (these alloys are sometimes referred to as *intermetallic compounds*) that are so finely divided they can only be distinguished microscopically. Alloying a metal with other metals (and, in some cases, nonmetals) is done to alter the metal's melting point and to enhance properties such as luster, conductivity, malleability, ductility, and strength.

Iron is used only when alloyed. In pure form, it is soft and corrodes easily. However, when alloyed with carbon and other metals, such as Mo for hardness and Cr and Ni for corrosion resistance, it forms various steels. Copper stiffens when zinc is added to it to make brass. Mercury solidifies when alloyed with sodium, and

Table 22.4**Some Important Alloys and Their Composition**

Name	Composition (Mass %)	Uses
Mostly Fe		
Stainless steel	73–79 Fe, 14–18 Cr, 7–9 Ni	Cutlery, instruments
Nickel steel	96–98 Fe, 2–4 Ni	Cables, gears
High-speed steels	80–94 Fe, 14–20 W (or 6–12 Mo)	Cutting tools
Mostly Cu		
Bronzes	70–95 Cu, 1–25 Zn, 1–18 Sn	Statues, castings
Brasses	50–80 Cu, 20–50 Zn	Plating, ornamental objects
Mostly precious metals		
Sterling silver	92.5 Ag, 7.5 Cu	Jewelry, tableware
14-carat gold	58 Au, 4–28 Ag, 14–28 Cu	Jewelry
18-carat white gold	75 Au, 12.5 Ag, 12.5 Cu	Jewelry
Dental amalgam	69 Ag, 18 Sn, 12 Cu, 1 Zn (dissolved in Hg)	Dental fillings
Other		
Permalloy	78 Ni, 22 Fe	Ocean cables
Typical tin solder	67 Pb, 33 Sn	Electrical connections

vanadium becomes extremely tough with some carbon added. Table 22.4 shows the composition and uses of some common alloys.

The simplest alloys, called *binary alloys*, contain only two elements, which can combine in two ways:

- *The added element enters interstices*, spaces between the parent metal atoms in its crystal structure (Section 12.6). In vanadium carbide, for instance, carbon atoms occupy holes of a face-centered cubic vanadium unit cell (Figure 22.15A).
- The *added element substitutes for atoms of the parent*. In many types of brass, for example, relatively few zinc atoms substitute randomly for copper atoms in the face-centered cubic copper unit cell (see Figure 13.4A). On the other hand, β -brass is an intermediate phase that crystallizes as the Zn/Cu ratio approaches 1/1 in a body-centered cubic structure with a central Zn atom surrounded by eight Cu atoms (Figure 22.15B). In one alloy of copper and gold, Cu atoms occupy the faces of a face-centered cube, and Au atoms lie at the corners (Figure 22.15C).

Atomic properties, including size, electron configuration, and number of valence electrons, determine which metals form stable alloys. For example, transition metals from the left half of the *d* block [Groups 3B(3) to 5B(5)] often form alloys with metals from the right half [Groups 8B(9) to 1B(11)]; electron-poor Zr, Nb, and Ta form strong alloys with electron-rich Ir, Pt, and Au; an example is the very stable $ZrPt_3$.

Figure 22.15 Three binary alloys.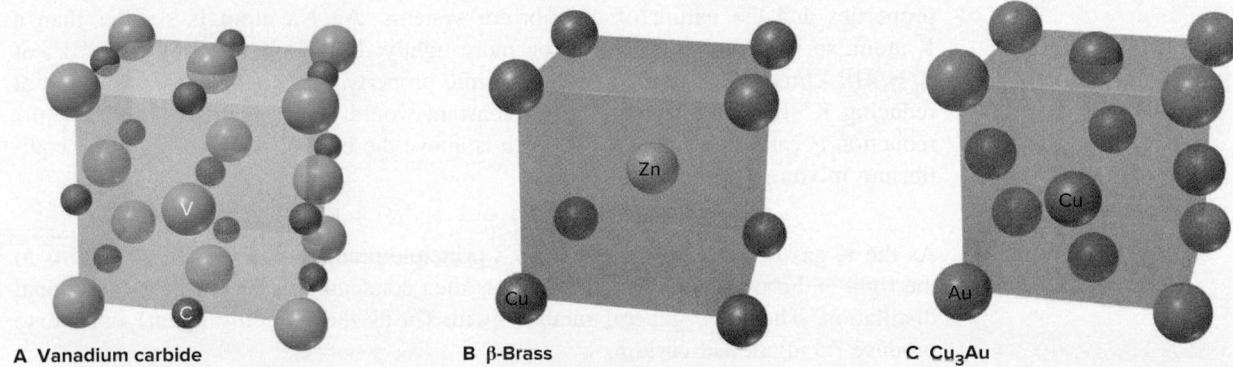

› Summary of Section 22.3

- › Metallurgy involves mining an ore, separating it from debris, pretreating it to concentrate the mineral source, converting the mineral to another compound that is easier to process further, reducing this compound to the metal, purifying the metal, and in many cases, alloying it to obtain a more useful material.

22.4 TAPPING THE CRUST: ISOLATION AND USES OF SELECTED ELEMENTS

The isolation process depends on the physical and chemical properties of the source: we isolate an element that occurs uncombined in the air differently from one dissolved in the sea or one found in a rocky ore. In this section, we detail methods for recovering some important elements.

Producing the Alkali Metals: Sodium and Potassium

The alkali metals are among the most reactive elements and thus are always found as ions in nature, either in solid minerals or in aqueous solution. The two most important of these metals are sodium and potassium. Their abundant, water-soluble compounds are used throughout industry and research, and the Na^+ and K^+ ions are essential to organisms.

Industrial Production of Sodium and Potassium Different methods are employed in the industrial production of these two metals:

1. *Production of sodium.* The sodium ore is *halite* (largely NaCl), which is obtained either by evaporation of concentrated salt solutions called *brines* (see photo) or by mining vast salt deposits formed from the evaporation of prehistoric seas. The Cheshire salt field in Britain, for example, is 60 km by 24 km by 400 m thick and contains more than 90% NaCl . Other large deposits occur in New Mexico, Michigan, New York, and Kansas.

The brine is evaporated and the solid crushed and fused (melted) for use in an electrolytic apparatus called the **Downs cell** (Figure 22.16). To reduce heating costs, 1 part NaCl ($\text{mp} = 801^\circ\text{C}$) is mixed with $1\frac{1}{2}$ parts CaCl_2 to form a mixture that melts at only 580°C . Reduction of the metal ions to Na and Ca takes place at a cylindrical steel cathode, with the molten metals floating on the denser molten salt mixture. As they rise through a short collecting pipe, the liquid Na is siphoned off, while a higher melting Na/Ca alloy solidifies and falls back into the molten electrolyte. Chloride ions are oxidized to Cl_2 gas at a large anode within an inverted cone-shaped chamber that separates the metals from the Cl_2 to prevent their explosive recombination. The Cl_2 is purified and sold as a valuable byproduct.

2. *Production of potassium.* Sylvite (mostly KCl) is the major ore of potassium. The metal is too soluble in molten KCl to be obtained by a method similar to that used for sodium. Instead, chemical reduction of K^+ ions by Na is based on atomic properties and the nature of equilibrium systems. An Na atom is smaller than a K atom, so it holds its outer electron more tightly: IE_1 of Na = 496 kJ/mol; IE_1 of K = 419 kJ/mol. Thus, based on this atomic property, Na would not be effective at reducing K^+ because the equilibrium constant would favor reactants. However, the reduction is carried out at 850°C , which is above the boiling point of K, so the equilibrium mixture contains *gaseous* K:

As the K gas is removed, Le Châtelier's principle predicts that the reaction shifts to the right and produces more K. The gas is then condensed and purified by fractional distillation. The same general method (with Ca as the reducing agent) is used to produce rubidium and cesium.

Evaporative salt beds near Redwood City, California.

Source: © Natasha Kramskaya/Shutterstock.com

Figure 22.16 The Downs cell for production of sodium.

Uses of Sodium and Potassium The compounds of Na and K (and indeed, of all the alkali metals) have many more uses than the elements themselves. Nevertheless, there are some interesting uses of the metals that take advantage of their strong reducing power:

1. *Uses of sodium.* Large amounts of Na were used as an alloy with lead to make gasoline antiknock additives, such as tetraethyllead:

The toxic effects of environmental lead have limited this use to aviation fuel in the United States. Moreover, although leaded gasoline is still used in several developing countries, the global market for tetraethyllead is declining more than 15% annually.

If certain types of nuclear reactors, called *breeder reactors* (Chapter 24), become a practical way to generate energy in the United States, Na production would increase enormously. Its low melting point, viscosity, and interaction with neutrons, combined with its high thermal conductivity and heat capacity, make it perfect for cooling the reactor and exchanging heat to the steam generator.

2. *Uses of potassium.* The major use of potassium at present is in an alloy with sodium for use as a heat exchanger in chemical and nuclear reactors. Another application relies on production of its superoxide, which it forms by direct contact with O₂:

This material is employed as an emergency source of O₂ in breathing masks for miners, divers, submarine crews, and firefighters (*see photo*):

The Indispensable Three: Iron, Copper, and Aluminum

Their innumerable applications make iron (in the form of steel), copper, and aluminum indispensable metals in an industrial society.

Metallurgy of Iron: From Ore to Pig Iron Although people have practiced iron smelting for more than 3000 years, it was not even 250 years ago that iron assumed

Firefighter with KO₂ breathing mask.

Source: © Bruce Ando/Photolibrary/Getty Images

Table 22.5

Important Minerals of Iron

Mineral Type	Mineral, Formula
Oxide	Hematite, Fe_2O_3
	Magnetite, Fe_3O_4
	Ilmenite, FeTiO_3
Carbonate	Siderite, FeCO_3
Sulfide	Pyrite, FeS_2
	Pyrrhotite, FeS

its current dominant role. In 1773, an inexpensive process to convert coal to carbon in the form of coke was discovered, and the coke process made iron smelting cheap and efficient and led to large-scale iron production, which ushered in the Industrial Revolution.

Modern society rests, quite literally, on the various alloys of iron known as **steel**. Although steel production has obviously grown enormously since the 18th century, the process of recovering iron from its ores still employs *reduction by carbon in a blast furnace*. The most abundant minerals of iron are listed in Table 22.5. Only the first four are used for steelmaking, because traces of sulfur from the sulfide minerals make steel brittle.

The conversion from ore to metal involves a series of redox and acid-base reactions that appear simple, even though their detailed chemistry is not completely understood even today. A modern **blast furnace** (Figure 22.17) is a tower made of brick, about 14 m wide by 40 m high. The *charge*, which usually consists of hematite, coke, and limestone, is fed through the top. More coke is burned in air at the bottom. The charge falls and meets a *blast* of rapidly rising hot air created by the burning coke:

At the bottom of the furnace, the temperature exceeds 2000°C, while at the top, it reaches only 200°C. Because the blast of hot air passes through the entire furnace in only 10 s, the various gas-solid reactions do *not* reach equilibrium, and many intermediate products form. As a result, different stages of the overall reaction process occur at different heights:

1. In the upper part of the furnace (200°C to 700°C), the charge is preheated, and a *partial reduction* occurs. The hematite (Fe_2O_3) is reduced to magnetite (Fe_3O_4) and then to iron(II) oxide (FeO) by CO, which is the actual reducing agent. Carbon dioxide is formed as well. Limestone (CaCO_3) also decomposes to form CO_2 and the basic oxide CaO .
2. Lower down, at 700°C to 1200°C, a *final reduction* step occurs, as some of the coke reduces CO_2 to form more CO, which reduces the FeO to Fe.

Figure 22.17 The major reactions in a blast furnace.

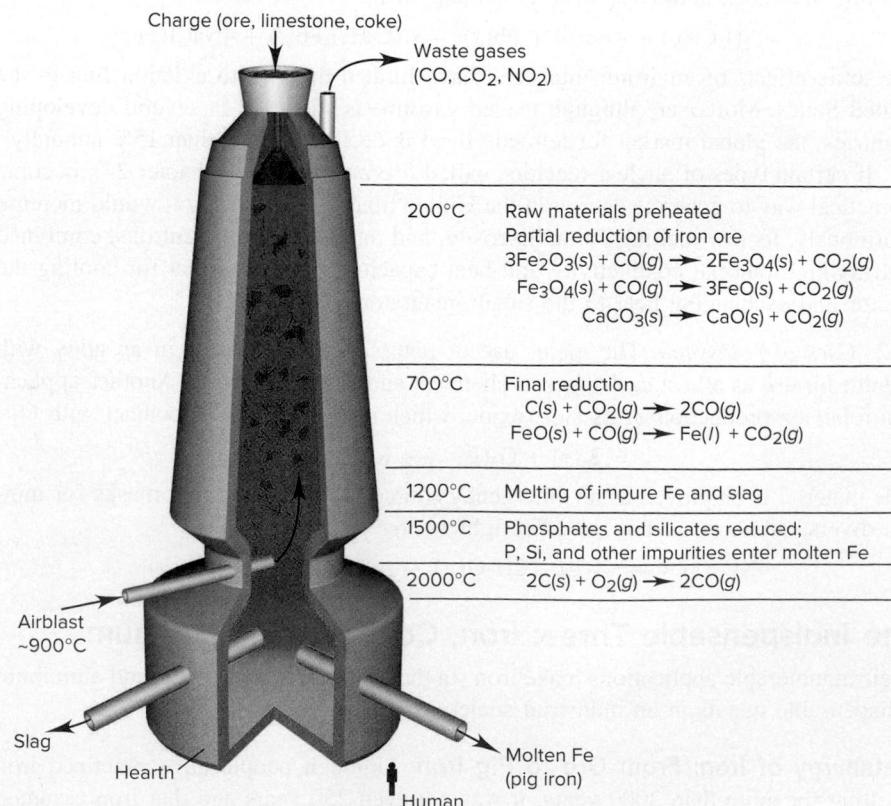

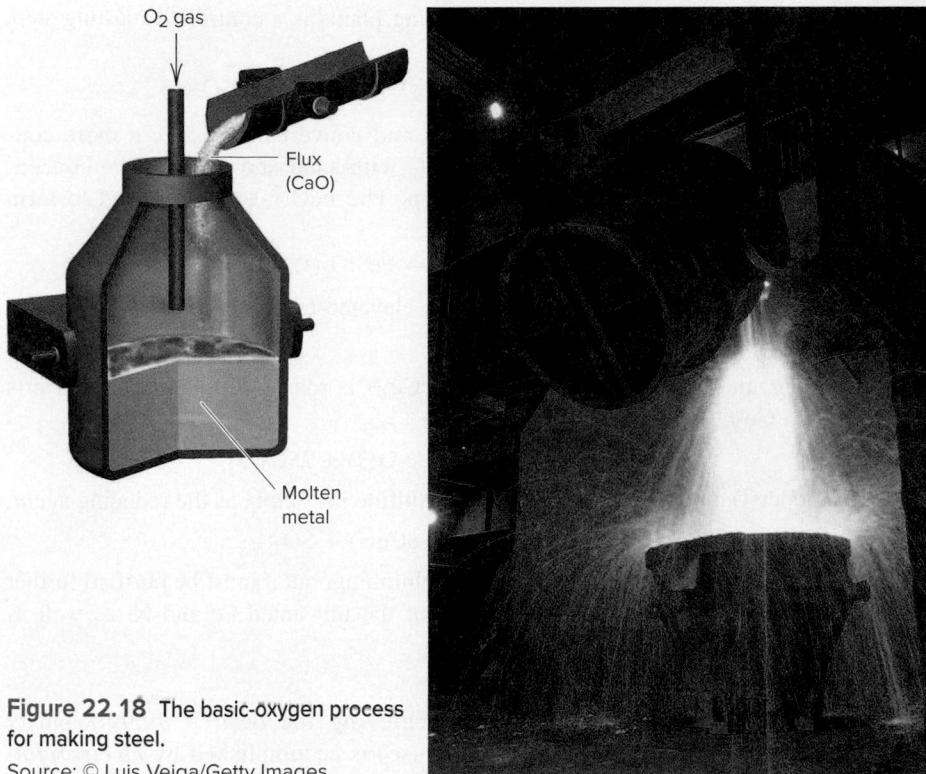

Figure 22.18 The basic-oxygen process for making steel.

Source: © Luis Veiga/Getty Images

- At temperatures between 1200°C and 1500°C, the iron melts and drips to the bottom of the furnace. Acidic silica particles from the gangue react with the CaO in a Lewis acid-base reaction to form a molten waste product called **slag**:

The slag drips down and floats on the denser iron.

- Some unwanted reactions occur between 1500°C and 2000°C. Any remaining phosphates and silicates are reduced to P and Si, and some Mn and traces of S dissolve into the molten iron along with carbon. The resulting impure product is called *pig iron* and contains about 3% to 4% C. A small amount of pig iron is used to make *cast iron*, but most is purified and alloyed to make various kinds of steel.

Metallurgy of Iron: From Pig Iron to Steel Pig iron is converted to steel in a separate furnace by means of the **basic-oxygen process** (Figure 22.18). High-pressure O₂ is blown over and through the molten iron, so that impurities (C, Si, P, Mn, and S) are oxidized rapidly. The highly negative standard enthalpies of formation of the carbon and silicon oxides (ΔH_f° of CO₂ = -394 kJ/mol; ΔH_f° of SiO₂ = -911 kJ/mol) raise the temperature, which speeds the reaction. A lime (CaO) flux is added, which converts the oxides to a molten slag [primarily CaSiO₃ and Ca₃(PO₄)₂] that is decanted from the molten steel. The product is **carbon steel**, which contains 1% to 1.5% C and other impurities. It is alloyed with metals that prevent corrosion and increase its strength or flexibility.

Metallurgy of Copper: From Ore to Impure Metal After many centuries of being mined to make bronze and brass, copper ores have become much less plentiful and less rich in copper. Despite this, more than 2.5 billion pounds of copper is produced in the United States annually. The most common ore is chalcopyrite, CuFeS₂, a mixed sulfide of FeS and CuS (see photo). Most remaining deposits contain less than 0.5% Cu by mass. To “win” this small amount of copper requires several metallurgical steps:

- Flotation.* The low copper content in chalcopyrite must be enriched by removing the iron. The first step is pretreatment by flotation (see Figure 22.11), which concentrates the ore to around 15% Cu by mass.

Mining chalcopyrite.

Source: © Lee Prince/Shutterstock.com

2. *Roasting.* The next step in many processing plants is a controlled roasting step, which oxidizes the FeS but not the CuS:

3. *Heating with sand.* To remove the FeO and convert the CuS to a more convenient form, the mixture is heated to 1100°C with sand and more of the concentrated ore. Several reactions occur in this step. The FeO reacts with sand to form a molten slag:

The CuS is thermodynamically unstable at the elevated temperature and decomposes to yield Cu₂S, which is drawn off as a liquid.

4. *Smelting.* In the final smelting step, the Cu₂S is roasted in air, which converts some of it to Cu₂O:

The two copper(I) compounds then react, with sulfide ion acting as the reducing agent:

The copper obtained at this stage is usable for plumbing, but it must be purified further for electrical wiring applications by removal of the unwanted Fe and Ni as well as the valuable byproducts Ag, Au, and Pt.

Metallurgy of Copper: Electrorefining Achieving the desired 99.99% purity needed for wiring (copper's most important use) is accomplished by *electrorefining*, which involves the oxidation of Cu to form Cu²⁺ ions in solution, followed by their reduction and the plating out of Cu metal (Figure 22.19). The impure copper obtained from smelting is cast into plates to be used as anodes, and cathodes are made from already purified copper. The electrodes are immersed in acidified CuSO₄ solution, and a voltage is applied that accomplishes two tasks simultaneously:

- Copper and the more active impurities (Fe, Ni) are oxidized to their cations, while the less active ones (Ag, Au, Pt) are not. As the anode slabs react, these unoxidized metals fall off as valuable "anode mud" and are purified separately. Sale of the precious metals in the anode mud nearly offsets the cost of electricity to operate the cell, making Cu wire inexpensive.
- Because Cu is much less active than the Fe and Ni impurities, Cu²⁺ ions are reduced at the cathode, but Fe²⁺ and Ni²⁺ ions remain in solution:

Figure 22.19 The electrorefining of copper.

Source: © Tom Hollyman/Science Source

Metallurgy of Aluminum: From Ore to Metal Aluminum is the most abundant metal in Earth's crust by mass and the third most abundant element (after O and Si). It is found in numerous aluminosilicate minerals, such as feldspars, micas, and clays, and in the rare gems garnet, beryl, spinel, and turquoise. Corundum, pure aluminum oxide (Al_2O_3), is extremely hard; mixed with traces of transition metals, it exists as ruby and sapphire. Impure Al_2O_3 is used in sandpaper and other abrasives.

Through eons of weathering, certain clays became *bauxite*, the major ore of aluminum. This mixed oxide-hydroxide occurs in enormous surface deposits in Mediterranean and tropical regions (see photo), but with world aluminum production near 100 million tons annually, it may someday be scarce. In addition to hydrated Al_2O_3 (about 75%), industrial-grade bauxite also contains Fe_2O_3 , SiO_2 , and TiO_2 , which are removed during the extraction. The overall two-step process combines hydro- and electrometallurgical techniques:

1. *Isolating Al_2O_3 from bauxite.* After mining, bauxite is pretreated by boiling in 30% NaOH in the *Bayer process*, which involves acid-base, solubility, and complex-ion equilibria. The acidic SiO_2 and the amphoteric Al_2O_3 dissolve in the base, but the basic Fe_2O_3 and TiO_2 do not:

Further heating precipitates the $\text{Na}_2\text{Si}(\text{OH})_6$ as an aluminosilicate, which is filtered out with the insoluble Fe_2O_3 and TiO_2 ("red mud").

Acidifying the filtrate precipitates Al^{3+} as $\text{Al}(\text{OH})_3$. Recall that the aluminate ion, $\text{Al}(\text{OH})_4^-(aq)$, is actually the complex ion $\text{Al}(\text{H}_2\text{O})_2(\text{OH})_4^-(aq)$ (see Figure 19.19). Weakly acidic CO_2 is added to produce a small amount of H^+ ion, which reacts with this complex ion to form $\text{Al}(\text{H}_2\text{O})_3(\text{OH})_3$. Cooling supersaturates the solution, and the solid that forms is filtered out:

[Recall that we usually write $\text{Al}(\text{H}_2\text{O})_3(\text{OH})_3$ more simply as $\text{Al}(\text{OH})_3$.]

Drying at high temperature converts the hydroxide to the oxide:

2. *Converting Al_2O_3 to the free metal: the Hall-Heroult process.* Aluminum is an active metal, much too strong a reducing agent to be formed at the cathode from aqueous solution (Section 21.7), so the oxide itself is electrolyzed.

The melting point of Al_2O_3 is very high (2030°C), so it is dissolved in molten *cryolite* (Na_3AlF_6) to give a mixture that electrolyzes at ~1000°C. Using cryolite provides a major energy (and thus, cost) savings, but the only sizeable cryolite mines cannot supply enough of the mineral, so production of synthetic cryolite has become a major subsidiary industry in aluminum manufacture.

The electrolytic step, called the *Hall-Heroult process*, takes place in a graphite-lined furnace, with the lining itself acting as the cathode. Anodes of graphite dip into the molten $\text{Al}_2\text{O}_3\text{-Na}_3\text{AlF}_6$ mixture (Figure 22.20, *next page*). The cell typically operates at a moderate voltage of 4.5 V, but with an enormous current flow of 1.0×10^5 to 2.5×10^5 A.

The process is complex and its details are still not entirely known. The specific reactions shown below are among several other possibilities. Molten cryolite contains several ions (including AlF_6^{3-} , AlF_4^- , and F^-), which react with Al_2O_3 to form fluoro-oxy ions (including AlOF_3^{2-} , $\text{Al}_2\text{OF}_6^{2-}$, and $\text{Al}_2\text{O}_2\text{F}_4^{2-}$) that dissolve in the mixture. For example,

Al forms at the cathode (reduction), shown here with AlF_6^{3-} as reactant:

Mining bauxite.

Source: © Howard Davies/Alamy

Figure 22.20 The electrolytic cell in the manufacture of aluminum.

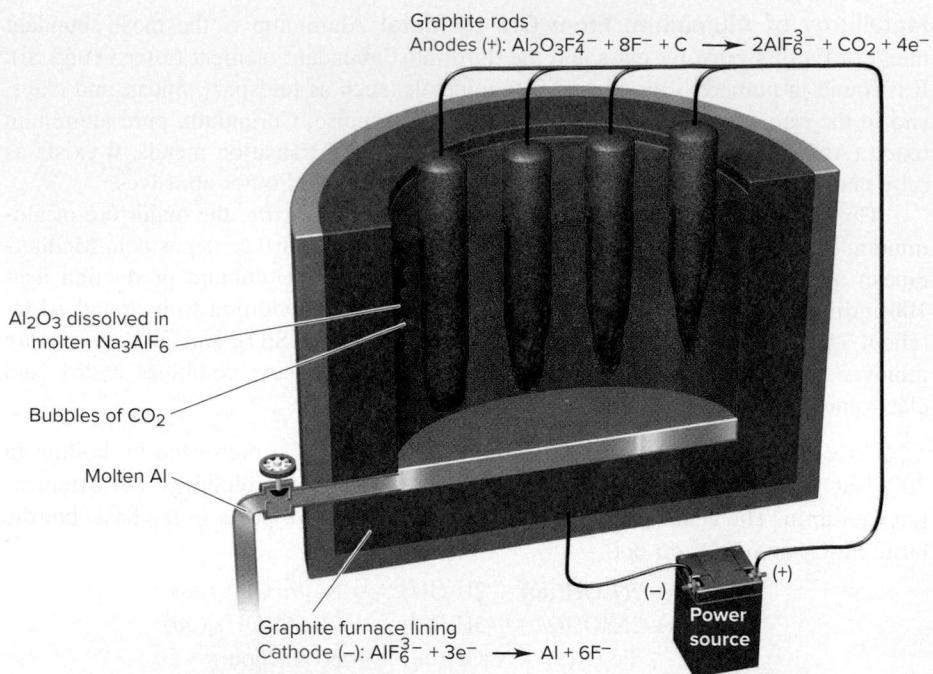

The graphite anodes are oxidized and form carbon dioxide gas. Using one of the fluoro-oxy species as an example, the anode reaction is

Thus, the *graphite anodes themselves are consumed* in this half-reaction and must be replaced frequently.

Combining the three preceding equations and making sure that e^- gained at the cathode equal e^- lost at the anode gives the overall reaction:

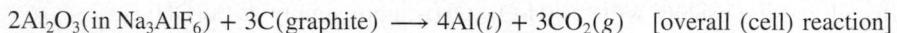

3. Energy considerations. The Hall-Heroult process uses an enormous quantity of energy: aluminum production accounts for more than 5% of total U.S. electrical usage. The most basic reason for such high energy consumption is the electron configuration of Al ($[\text{Ne}] 3s^2 3p^1$). Each Al^{3+} ion needs 3e^- to form an Al atom, and the atomic mass of Al is so low (~ 27 g/mol) that 1 mol of e^- (96,500 C) produces only 9 g of Al. An aluminum-air battery can turn this disadvantage around. Once produced, Al represents a concentrated form of electrical energy that can deliver a high output per gram: 1 mol of e^- for every 9 g of Al consumed in the battery.

Metallurgy of Aluminum: Uses and Recycling Aluminum is a superb decorative, functional, and structural metal. It is lightweight, attractive, easy to work, and forms strong alloys. Although Al is very active, it does not corrode readily because of an adherent oxide layer that forms rapidly in air and prevents more O_2 from penetrating. Nevertheless, when it is in contact with less active metals such as Fe, Cu, and Pb, aluminum becomes the anode in a voltaic-like arrangement and deteriorates rapidly (Section 21.6). To prevent this, aluminum objects are often *anodized*, that is, made to act as the anode in an electrolytic cell that coats them with an oxide layer. The object is immersed in a 20% H_2SO_4 bath and connected to a graphite cathode:

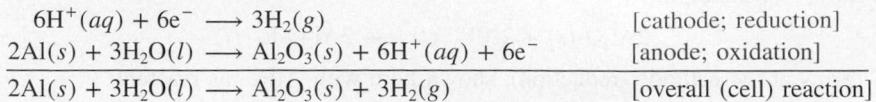

Figure 22.21 The many familiar and essential uses of aluminum.

The Al_2O_3 layer deposited is typically from 10μ to 100μ thick, depending on the object's intended use. Figure 22.21 presents a breakdown of the many uses of aluminum.

More than 4.0 billion pounds (1.8 million metric tons) of aluminum cans and packaging are discarded each year—a waste of one of the most useful materials in the world *and* the energy used to make it. A quick calculation of the energy needed to prepare 1 mol of Al from *purified* Al_2O_3 , compared with the energy needed for recycling, conveys a clear message. For the overall cell reaction in the Hall-Heroult process, $\Delta H^\circ = 2272 \text{ kJ}$ and $\Delta S^\circ = 635.4 \text{ J/K}$. If we consider *only* the standard free energy change of the reaction at 1000°C , for 1 mol of Al, we obtain

$$\Delta G^\circ = \Delta H^\circ - T\Delta S^\circ = \frac{2272 \text{ kJ}}{4 \text{ mol Al}} - \left(1273 \text{ K} \times \frac{0.6354 \text{ kJ/K}}{4 \text{ mol Al}} \right) = 365.8 \text{ kJ/mol Al}$$

The molar mass of Al is nearly 2.5 times the mass of a soft-drink or beer can, so the electrolysis step requires nearly 150 kJ of energy for each can!

When aluminum is recycled, the major energy input (which is for melting the cans and foil) has been calculated as $\sim 26 \text{ kJ/mol Al}$. The ratio of these energy inputs is

$$\frac{\text{Energy to recycle 1 mol Al}}{\text{Energy for electrolysis of 1 mol Al}} = \frac{26 \text{ kJ}}{365.8 \text{ kJ}} = 0.071$$

Based on just these portions of the process, recycling uses about 7% as much energy as electrolysis. Recent energy estimates for the entire manufacturing process (including mining, pretreating, maintaining operating conditions, electrolyzing, and so forth) are about 6000 kJ/mol Al, which means recycling requires less than 1% as much energy as manufacturing. The economic advantages, not to mention the environmental ones, are obvious, and recycling of aluminum has become common in the United States (*see photo*).

Mining the Sea for Magnesium

As terrestrial sources of certain elements become scarce or too costly to mine, the oceans will become an important source. In fact, despite the abundant distribution of magnesium on land, it is already obtained from the sea.

Isolation of Magnesium The *Dow process* for isolating magnesium from the sea involves steps similar to those used for rocky ores (Figure 22.22, *next page*):

1. *Mining*. Intake of seawater and straining the debris are the “mining” steps. No pretreatment is needed.

2. *Converting to mineral*. The dissolved Mg^{2+} ion is converted to the mineral $\text{Mg}(\text{OH})_2$ with $\text{Ca}(\text{OH})_2$, which is generated on-site (at the plant). Seashells (CaCO_3) are crushed, decomposed to CaO by heating, and mixed with water to make slaked lime [$\text{Ca}(\text{OH})_2$]. This is pumped into the intake tank to precipitate the Mg^{2+} as the hydroxide ($K_{\text{sp}} \approx 10^{-9}$):

Crushed aluminum cans ready for recycling.

Source: © Monty Rakusen/Cultura/Getty Images RF

Figure 22.22 The Dow process for isolation of elemental Mg from seawater.

3. *Converting to compound.* The solid $\text{Mg}(\text{OH})_2$ is filtered and mixed with excess HCl , which is also made on-site, to form aqueous MgCl_2 :

The water is evaporated in stages to give solid, hydrated $\text{MgCl}_2 \cdot n\text{H}_2\text{O}$.

4. *Electrochemical redox.* Heating above 700°C drives off the water of hydration and melts the MgCl_2 . Electrolysis gives chlorine gas and the molten metal, which floats on the denser molten salt:

The Cl_2 that forms is recycled to make the HCl used in step 3.

Uses of Magnesium Magnesium is the lightest structural metal available (about one-half the density of Al and one-fifth that of steel). Although Mg is quite reactive, it forms an extremely adherent, high-melting oxide layer (MgO) that prevents further reaction with the free metal beneath it; thus, magnesium finds many uses in metal alloys and can be machined into any form. Magnesium alloys occur in everything from aircraft bodies to camera bodies, and from luggage to auto engine blocks. The pure metal is a strong reducing agent, which makes it useful for sacrificial anodes (Section 21.6) and in the metallurgical extraction of other metals, such as Be, Ti, Zr, Hf, and U. For example, titanium, an essential component of jet engines (see photo), is made from its major ore, ilmenite, in two steps:

The Sources and Uses of Hydrogen

Although hydrogen accounts for 90% of the atoms in the universe, it makes up only 15% of the atoms in Earth's crust. Moreover, hydrogen exists elsewhere in the universe mostly as H_2 molecules and free H atoms, but virtually all hydrogen in the crust is combined with other elements, either oxygen in natural waters or carbon in biomass and petroleum.

Industrial Production of Hydrogen Hydrogen gas (H_2) is produced on an industrial scale worldwide: 250,000 metric tons (3×10^{12} L at STP; equivalent to $\sim 1 \times 10^{11}$ mol)

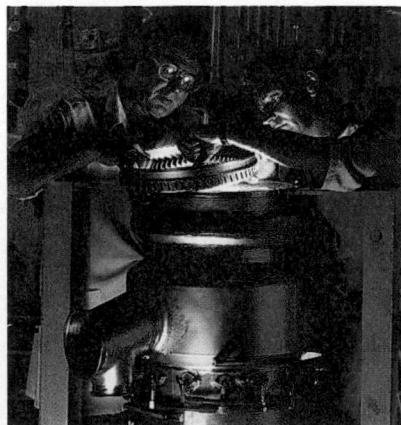

Jet engine assembly.

Source: © Ken Whitmore/Getty Images

are produced annually in the United States alone. All production methods are energy intensive, so the choice is determined by energy costs. In Scandinavia, where hydroelectric power is plentiful, electrolysis is used; on the other hand, where natural gas from oil refineries is plentiful, as in the United States and Great Britain, thermal methods are used.

1. Electrolysis. Very pure H₂ is prepared through electrolysis of water with Pt (or Ni) electrodes:

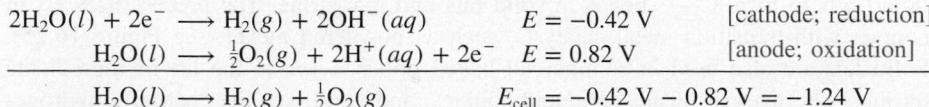

Oversoltage makes the cell potential about -2 V (Section 21.7). Therefore, under typical operating conditions, it takes about 400 kJ of energy to produce 1 mol of H₂:

$$\Delta G = -nFE = (-2 \text{ mol e}^-) \left(\frac{96.5 \text{ kJ}}{\text{V} \cdot \text{mol e}^-} \right) (-2 \text{ V}) = 4 \times 10^2 \text{ kJ/mol H}_2$$

High-purity O₂ is a valuable byproduct of this process that offsets some of the costs of isolating H₂.

2. Thermal methods. The most common thermal methods use water and a simple alkane like methane, which has the highest H/C atom ratio of any hydrocarbon. The reactants are heated to around 1000°C over a nickel-based catalyst in the endothermic *steam-reforming process*:

Heat is supplied by burning methane. To generate more H₂, the product mixture (called *water gas*) is heated with steam at 400°C over an iron or cobalt oxide catalyst in the exothermic *water-gas shift reaction*, and the CO reacts (see also Chemical Connections at the end of Section 6.6):

The reaction mixture is recycled several times, which decreases the CO to around 0.2% by volume. Passing the mixture through liquid water removes the more soluble CO₂ (solubility = 0.034 mol/L), leaving a higher proportion of H₂ (solubility < 0.001 mol/L). Calcium oxide can also be used to remove CO₂ by formation of CaCO₃. By removing CO₂, these steps shift the equilibrium position to the right and produce H₂ that is about 98% pure. To filter out nearly all molecules larger than H₂ and attain greater purity (~99.9%), the gas mixture is passed through a *synthetic zeolite*. This material is an aluminosilicate whose framework of polyhedra contains small cavities of various sizes that trap some molecules and allow others to pass through.

Industrial Uses of Hydrogen Typically, an industrial plant produces H₂ to make some other product. More than 95% of the H₂ produced is consumed in ammonia or petrochemical facilities.

1. Ammonia synthesis. In a plant that synthesizes NH₃, the reactant gases, N₂ and H₂, are formed through a series of reactions that involve methane. Here is a typical reaction series in an ammonia plant:

- The steam-reforming reaction is performed with excess CH₄, which depletes the reaction mixture of H₂O:

- An excess of the product mixture (CH₄, CO, and H₂) is burned in an amount of air (N₂ + O₂) that is insufficient for complete combustion, but is enough to consume the O₂, heat the mixture to 1100°C, and form additional H₂O:

- Any remaining CH₄ reacts by the steam-reforming reaction, the remaining CO reacts by the water-gas shift reaction (H₂O + CO \rightleftharpoons CO₂ + H₂) to form more H₂, and then the CO₂ is removed with CaO (CaO + CO₂ \longrightarrow CaCO₃).
- The amounts are carefully adjusted to produce a final mixture that contains a 1/3 mole ratio of N₂ (from the added air) to H₂ (with traces of CH₄, Ar, and CO). This mixture is used directly in the synthesis of ammonia (Section 17.6).

2. *Hydrogenation.* A second major use of H₂ is *hydrogenation* of C=C bonds in liquid oils to form C—C bonds in solid fats and margarine. The process uses H₂ in contact with transition metal catalysts, such as powdered nickel (see Figure 16.25). Solid fats are also used in commercial baked goods. Look at the list of ingredients on most packages of bread, cake, and cookies, and you'll see the "partially hydrogenated vegetable oils" made by this process.

3. *Bulk chemicals and energy production.* Hydrogen is also essential in the manufacture of numerous "bulk" chemicals, those produced in large amounts because they have many further uses. One application that has been gaining great attention is the production of methanol. In this process, carbon monoxide reacts with hydrogen over a copper-zinc oxide catalyst:

Methanol is already being used as a gasoline additive. As less expensive sources become available, hydrogen will also be used increasingly in fuel cells on a major scale (Section 21.5).

Production and Uses of Deuterium; Kinetic Isotope Effect In addition to ordinary hydrogen (¹H), or protium, there are two other naturally occurring isotopes of significantly lower abundance. Deuterium (²H or D) has one neutron, and rare, radioactive tritium (³H or T) has two. Like H₂, both occur as diatomic molecules: D₂ (or ²H₂) and T₂ (or ³H₂). Table 22.6 compares some of their molecular and physical properties. As you can see from these data, the heavier the isotope is and, thus, the higher the molar mass of the molecule, the higher the melting point, boiling point, and heats of phase change.

Because hydrogen is so light, the relative difference in mass of its isotopes is enormous compared with that of isotopes of other common, heavier elements. For example, ²H has 2 times the mass of ¹H, whereas ¹³C has only 1.08 times the mass of ¹²C. *The mass difference leads to different bond energies, which affect reactivity.* As a result, an H atom bonded to a given atom vibrates at a higher frequency than a D atom does, so the bond to H is higher in energy. Thus, *it is weaker and easier to break.* Therefore, any reaction that includes breaking a bond to H or D in the rate-determining step occurs *faster with H than with D.* This phenomenon, called a *kinetic isotope effect*, is also used to isolate deuterium.

Deuterium and its compounds are produced from D₂O (heavy water), which is present as a minor component (0.016 mol %) in normal water and is isolated on the

Table 22.6 Some Molecular and Physical Properties of Diatomic Protium, Deuterium, and Tritium

Property	H ₂	D ₂	T ₂
Molar mass (g/mol)	2.016	4.028	6.032
Bond length (pm)	74.14	74.14	74.14
Melting point (K)	13.96	18.73	20.62
Boiling point (K)	20.39	23.67	25.04
ΔH _{fus} ^o (kJ/mol)	0.117	0.197	0.250
ΔH _{vap} ^o (kJ/mol)	0.904	1.226	1.393
Bond energy (kJ/mol at 298 K)	432	443	447

multiton scale by *electrolytic enrichment*. Due to the kinetic isotope effect, there is a higher rate of bond breaking for O—H bonds compared to O—D bonds, and thus a higher rate of electrolysis of H₂O compared with D₂O.

For example, with Pt electrodes, H₂O is electrolyzed about 14 times faster than D₂O. As some of the liquid decomposes to the elemental gases, the remainder becomes enriched in D₂O. Thus, by the time the volume of water has been reduced to 1/20,000 of its original volume, the remaining water is around 99% D₂O. By combining samples and repeating the electrolysis, water that is more than 99.9% D₂O is obtained.

Deuterium gas is produced by electrolysis of D₂O or by any of the chemical reactions that produce hydrogen gas from water, such as

Compounds containing deuterium (or tritium) are produced from reactions that give rise to the corresponding hydrogen-containing compound; for example,

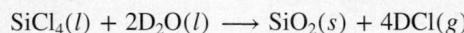

Compounds with acidic protons undergo hydrogen/deuterium exchange:

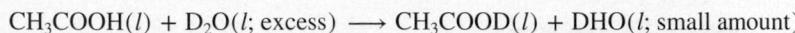

We discuss the natural and synthetic formation of tritium in Chapter 24.

› Summary of Section 22.4

Production highlights of key elements are as follows:

- › Na is isolated by electrolysis of molten NaCl in the Downs process; Cl₂ is a byproduct.
- › K is produced by reduction with Na in a thermal process.
- › Fe is produced through a multistep high-temperature process in a blast furnace. The crude pig iron is converted to carbon steel in the basic-oxygen process and then alloyed with other metals to make different steels.
- › Cu is produced by concentration of the ore through flotation, reduction to the metal by smelting, and purification by electroweighting. The metal has extensive electrical and plumbing uses.
- › Al is extracted from bauxite by pretreating the ore with concentrated base, followed by electrolysis of the product Al₂O₃ mixed with molten cryolite. Al alloys are widely used in homes and industry. The total energy required to extract Al from its ore is over 100 times that needed for recycling it.
- › The Mg²⁺ in seawater is converted to Mg(OH)₂ and then to MgCl₂, which is electrolyzed to obtain the metal; Mg forms strong, lightweight alloys.
- › H₂ is produced by electrolysis of water or in the formation of gaseous fuels from hydrocarbons. It is used in NH₃ production, in hydrogenation of vegetable oils, and in energy production. The isotopes of hydrogen differ significantly in atomic mass and thus in the rate at which their bonds to other atoms break (kinetic isotope effect). This difference is used to obtain D₂O from water.

22.5 CHEMICAL MANUFACTURING: TWO CASE STUDIES

In this final section, we examine the interplay of theory and practice in two of the most important processes in the inorganic chemical industry: the contact process for the production of sulfuric acid and the chlor-alkali process for the production of chlorine.

Sulfuric Acid, the Most Important Chemical

Because it has countless uses, sulfuric acid is produced throughout the world on a gigantic scale—more than 150 million tons a year. The modern **contact process** is based on the *catalyzed oxidation of SO₂*. Here are the key steps.

Figure 22.23 The Frasch process for mining elemental sulfur.

Source: (C) © Nathan Benn/Corbis

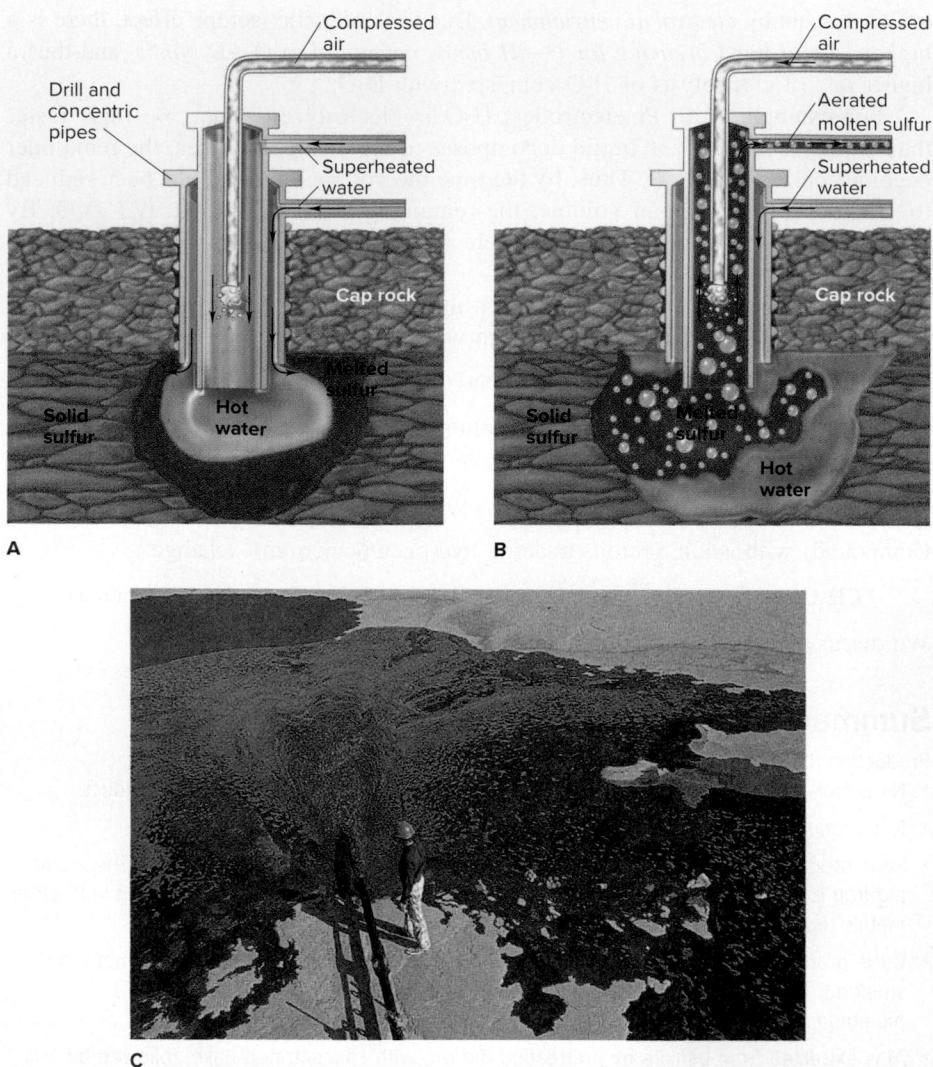

1. *Obtaining sulfur.* In most countries today, the production of sulfuric acid starts with the production of elemental sulfur, often by the *Claus process*, in which the H₂S in “sour” natural gas is chemically separated and then oxidized:

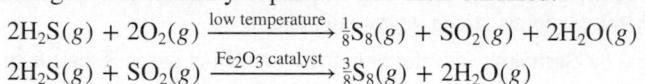

Where natural deposits of sulfur are found, it is obtained by a nonchemical method called the *Frasch process*. A hole is drilled to the deposit, and superheated water (about 160°C) is pumped down two outer concentric pipes to melt the sulfur (Figure 22.23A). Then, a combination of the hydrostatic pressure in an outermost pipe and the pressure of compressed air sent through a narrow inner pipe forces the sulfur to the surface (Figure 22.23B and C). The costs of drilling, pumping, and supplying water (5×10^6 gallons per day) are balanced somewhat by the purity of the product (~99.7% sulfur). About 90% of processed sulfur is used in making sulfur dioxide for production of sulfuric acid. Indeed, this end product is so important that a nation’s level of sulfur production is a reliable indicator of its overall industrial capacity: the United States, Canada, China, Russia, Japan, and Germany are the top six sulfur producers.

2. *From sulfur to sulfur dioxide.* The sulfur is burned in air to form SO₂:

Some SO₂ is also obtained by roasting metal sulfide ores and from the Claus process.

3. From sulfur dioxide to trioxide. The contact process oxidizes SO_2 to SO_3 :

The reaction is *exothermic* and very *slow* at room temperature. From Le Châtelier's principle (Section 17.6), the yield of SO_3 can be increased by (1) changing the temperature, (2) increasing the pressure (more moles of gas are on the left than on the right), or (3) adjusting the concentrations (adding excess O_2 and removing SO_3). In this case, the pressure effect is small and economically not worth exploiting. Let's examine the other two effects:

- *Effect of changing the temperature.* Adding heat (raising the temperature) increases the frequency and energy of $\text{SO}_2\text{--O}_2$ collisions and thus increases the *rate* of SO_3 formation. However, because the formation is exothermic, removing heat (lowering the temperature) shifts the equilibrium position to the right and thus increases the *yield* of SO_3 . This is a classic situation that calls for use of a catalyst. By lowering the activation energy, a *catalyst allows equilibrium to be reached more quickly and at a lower temperature*; thus, rate and yield are optimized (Section 16.7). The catalyst in the contact process is V_2O_5 on inert silica, which is active between 400°C and 600°C.
- *Effect of changing the concentration.* Providing an excess of O_2 as a 5/1 mixture of air to SO_2 , which is about 1/1 O_2 to SO_2 , supplies about twice as much O_2 as in the balanced equation. The mixture is passed over catalyst beds in four stages, and the SO_3 is removed to shift the reaction toward more SO_3 formation. The overall yield of SO_3 is 99.5%.

4. From sulfur trioxide to acid. Sulfur trioxide is the anhydride of sulfuric acid. However, SO_3 cannot be added to water because, at the operating temperature, it would first meet water vapor, which catalyzes its polymerization to $(\text{SO}_3)_x$, and results in a smoke of solid particles that yields little acid (reaction 1). To avoid this, previously formed H_2SO_4 absorbs the SO_3 (reaction 2) and forms pyrosulfuric acid (or disulfuric acid, $\text{H}_2\text{S}_2\text{O}_7$; *see margin*), which is then hydrolyzed with sufficient water (reaction 3):

The industrial uses of sulfuric acid are legion, as Figure 22.24 indicates.

Sulfuric acid is remarkably inexpensive (about \$150/ton), largely because each step in the process is exothermic—burning S ($\Delta H^\circ = -297 \text{ kJ/mol}$), oxidizing SO_2 ($\Delta H^\circ = -99 \text{ kJ/mol}$), hydrating SO_3 ($\Delta H^\circ = -132 \text{ kJ/mol}$)—and the heat is a valuable

disulfuric acid

Figure 22.24 The many indispensable applications of sulfuric acid.

byproduct. Three-quarters of the heat is sold as steam, and the rest of it is used to pump gases through the plant. A typical plant making 825 tons of H_2SO_4 per day produces enough steam to generate 7×10^6 watts of electric power.

The Chlor-Alkali Process

Chlorine is produced and used in amounts many times greater than all the other halogens combined, ranking among the top 10 chemicals produced in the United States. The **chlor-alkali process**, which forms the basis of one of the largest inorganic chemical industries, *electrolyzes concentrated aqueous NaCl to produce Cl_2 , along with several other important chemicals*. There are three versions of this process.

Diaphragm-Cell Method As you learned in Section 21.7, the electrolysis of aqueous NaCl does not yield both of the component elements. Because of the overvoltage, Cl^- ions rather than H_2O molecules are oxidized at the anode. However, Na^+ ions are not reduced at the cathode because the half-cell potential (-2.71 V) is much more negative than that for reduction of H_2O (-0.42 V), even with the normal overvoltage (around -0.6 V). Therefore, the half-reactions for electrolysis of aqueous NaCl are

To obtain commercially meaningful amounts of Cl_2 , however, a voltage almost twice this value and a current in excess of 3×10^4 A are used.

When we include the spectator ion Na^+ , the total ionic equation shows that the process yields another important product, NaOH :

As Figure 22.25 shows, the sodium salts in the cathode compartment exist as an aqueous mixture of NaCl and NaOH ; the NaCl is removed by fractional crystallization. Thus, in this version of the chlor-alkali process, which uses an *asbestos diaphragm* to separate the anode and cathode compartments, electrolysis of NaCl brines yields Cl_2 , H_2 , and industrial-grade NaOH , a useful base. Like other reactive products, H_2 and Cl_2 are kept apart to prevent explosive recombination. Note the higher liquid level in the anode (*left*) compartment. This slight hydrostatic pressure difference minimizes backflow of NaOH , which prevents the disproportionation reactions of Cl_2 that occur in the presence of OH^- (Section 14.9), such as

Figure 22.25 A diaphragm cell for the chlor-alkali process.

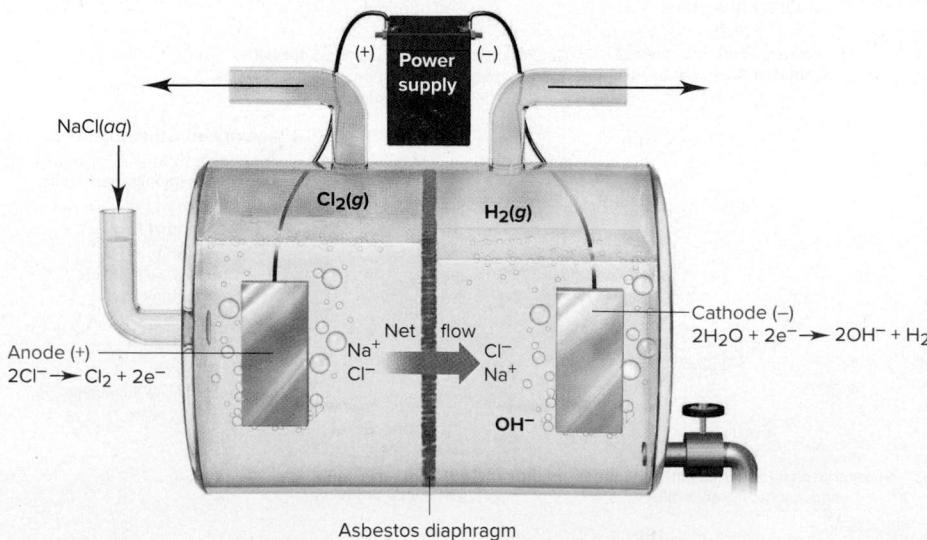

Mercury-Cell Method If high-purity NaOH is desired, a slightly different version, called the *chlor-alkali mercury-cell process*, is employed. Mercury is used as the cathode, which creates such a large overvoltage for reduction of H₂O to H₂ that the process *does* favor reduction of Na⁺. The sodium dissolves in the mercury to form sodium amalgam, Na(Hg). In the mercury-cell version, the half-reactions are

To obtain sodium hydroxide, the sodium amalgam is pumped out of the system and treated with H₂O, which is reduced by the Na:

The mercury released in this step is recycled back to the electrolysis bath. Therefore, *the products are the same in both versions* of the chlor-alkali process, but the purity of NaOH from the mercury-cell method is much higher.

The mercury-cell method is being steadily phased out because, as the mercury is recycled, small amounts are lost in the industrial wastewater. On average, 200 g of Hg is lost per ton of Cl₂ produced. In the 1980s, annual U.S. production via the mercury-cell method was 2.75 million tons of Cl₂; thus, during that decade, 550,000 kg of mercury, a toxic heavy metal, was flowing into U.S. waterways each year!

Membrane-Cell Method The *chlor-alkali membrane-cell process* replaces the asbestos diaphragm used in the diaphragm-cell method to separate the cell compartments with a polymeric membrane. The membrane allows only cations to move through it and only from anode to cathode compartments. Thus, as Cl⁻ ions are removed at the anode through oxidation to Cl₂, Na⁺ ions in the anode compartment move through the membrane to the cathode compartment and form an NaOH solution. In addition to forming purer NaOH than the older diaphragm-cell method, the membrane-cell method uses less electricity and eliminates the problem of Hg pollution. As a result, it has been adopted throughout much of the industrialized world.

› Summary of Section 22.5

- › Sulfuric acid production starts with the extraction of sulfur, either by the oxidation of H₂S or the mining of sulfur deposits. The sulfur is roasted to SO₂ and oxidized to SO₃ by the catalyzed contact process, which optimizes the yield at lower temperatures. Absorption of the SO₃ into H₂SO₄, followed by hydration, forms sulfuric acid.
- › In the diaphragm-cell method for the chlor-alkali process, aqueous NaCl is electrolyzed to form Cl₂, H₂, and low-purity NaOH. The mercury-cell method produces high-purity NaOH but has been almost completely phased out because of mercury pollution. The membrane-cell method requires less electricity and does not use Hg.

CHAPTER REVIEW GUIDE

Learning Objectives

Relevant section (§) numbers appear in parentheses.

Understand These Concepts

1. How gravity, thermal convection, and elemental properties led to the silicate, sulfide, and iron phases and the predominance of certain elements in Earth's crust, mantle, and core (§22.1)
2. How organisms affect crustal abundances of elements, especially oxygen, carbon, calcium, and some transition metals; the onset of oxidation as an energy source (§22.1)
3. How atomic properties influence which elements have oxide ores and which have sulfide ores (§22.1)
4. The central role of CO₂ and the importance of photosynthesis, respiration, and decomposition in the carbon cycle (§22.2)

5. The central role of N₂ and the importance of atmospheric, industrial, and biological fixation in the nitrogen cycle (§22.2)
6. The absence of a gaseous component and the interactions of the inorganic and biological cycles in the phosphorus cycle; the impact of humans on this cycle (§22.2)
7. How pyro-, electro-, and hydrometallurgical processes are employed to extract a metal from its ore; the importance of the reduction step from compound to metal; refining and alloying processes (§22.3)
8. Functioning of the Downs cell for Na production and the application of Le Châtelier's principle to K production (§22.4)

Learning Objectives (continued)

Relevant section (§) numbers appear in parentheses.

9. How iron ore is reduced in a blast furnace and how pig iron is purified by the basic-oxygen process (§22.4)
10. How Fe is removed from copper ore and impure Cu is electrorefined (§22.4)
11. The importance of amphotericism in the Bayer process for isolating Al_2O_3 from bauxite; the significance of cryolite in the electrolytic step; the energy advantage of Al recycling (§22.4)
12. The steps in the Dow process for the extraction of Mg from seawater (§22.4)
13. How H_2 production, whether by chemical or electrolytic means, is tied to NH_3 production (§22.4)
14. How the kinetic isotope effect is applied to produce deuterium (§22.4)
15. How the Frasch process is used to obtain sulfur from natural deposits (§22.5)
16. The importance of equilibrium and kinetic factors in H_2SO_4 production (§22.5)
17. How overvoltage allows electrolysis of aqueous NaCl to form Cl_2 gas in the chlor-alkali process; coproduction of NaOH ; comparison of diaphragm-cell, mercury-cell, and membrane-cell methods (§22.5)

Key Terms

Page numbers appear in parentheses.

abundance (997)	chlor-alkali process (1028)	fixation (1003)	mineral (1008)
alloy (1012)	contact process (1025)	flotation (1009)	occurrence (source) (1000)
apatites (1005)	core (998)	gangue (1008)	ore (1001)
atmosphere (999)	crust (998)	hydrosphere (999)	roasting (1010)
basic-oxygen process (1017)	differentiation (998)	leaching (1009)	slag (1017)
biosphere (999)	Downs cell (1014)	lithosphere (999)	smelting (1010)
blast furnace (1016)	electrorefining (1012)	mantle (998)	steel (1016)
carbon steel (1017)	environmental cycle (1002)	metallurgy (1008)	zone refining (1012)

PROBLEMS

Problems with **colored** numbers are answered in Appendix E and worked in detail in the Student Solutions Manual. Problem sections match those in the text and offer Concept Review Questions and Problems in Context. The Comprehensive Problems are based on material from any section or previous chapter.

How the Elements Occur in Nature**Concept Review Questions**

22.1 Hydrogen is by far the most abundant element cosmically. In interstellar space, it exists mainly as H_2 . In contrast, on Earth, it exists very rarely as H_2 and is ninth in abundance in the crust. Why is hydrogen so abundant in the universe? Why is hydrogen so rare as a diatomic gas in Earth's atmosphere?

22.2 Metallic elements can be recovered from ores that are oxides, carbonates, halides, or sulfides. Give an example of each type.

22.3 The location of elements in the regions of Earth has enormous practical importance. (a) Define *differentiation*, and explain which physical property of a substance is primarily responsible for this process. (b) What are the four most abundant elements in the crust? (c) Which element is abundant in the crust and mantle but not the core?

22.4 How does the position of a metal in the periodic table relate to whether it occurs primarily as an oxide or as a sulfide in nature?

Problems in Context

22.5 What material is the source for commercial production of each of the following elements: (a) aluminum; (b) nitrogen; (c) chlorine; (d) calcium; (e) sodium?

22.6 Aluminum is widely distributed throughout the world in the form of aluminosilicates. What property of these minerals prevents them from being a source of aluminum?

22.7 Describe two ways in which the biosphere has influenced the composition of Earth's crust.

The Cycling of Elements Through the Environment**Concept Review Questions**

22.8 Use atomic and molecular properties to explain why life is based on carbon rather than some other element, such as silicon.

22.9 Define *fixation*. Name two elements that undergo environmental fixation. What natural forms of them are fixed?

22.10 Carbon dioxide enters the atmosphere by natural processes and from human activity. Why is the latter a cause of concern?

22.11 Diagrams of environmental cycles are simplified to omit minor contributors. For example, the production of lime from limestone is not shown in the cycle for carbon (Figure 22.5). Which labeled category in the figure includes this process? Name two other processes that contribute to this category.

22.12 Describe three pathways for the fixation of atmospheric nitrogen. Is human activity a significant factor? Explain.

22.13 Why don't the N-containing species in Figure 22.6 include rings or long chains with N—N bonds?

22.14 (a) Which region of Earth's crust is not involved in the phosphorus cycle? (b) Name two roles organisms play in the cycle.

Problems in Context

22.15 Nitrogen fixation requires a great deal of energy because the N₂ bond is strong.

(a) How do the processes of atmospheric and industrial fixation reflect this energy requirement?

(b) How do the thermodynamics of the two processes differ? (*Hint:* Examine the respective heats of formation.)

(c) In view of the mild conditions for biological fixation, what must be the source of the “great deal of energy”? (d) What would be the most obvious environmental result of a low activation energy for N₂ fixation?

22.16 The following steps are *unbalanced* half-reactions involved in the nitrogen cycle. Balance each half-reaction to show the number of electrons lost or gained, and state whether it is an oxidation or a reduction (all occur in acidic conditions):

- | | |
|--|---|
| (a) N ₂ (g) → NO(g) | (b) N ₂ O(g) → NO ₂ (g) |
| (c) NH ₃ (aq) → NO ₂ ⁻ (aq) | (d) NO ₃ ⁻ (aq) → NO ₂ ⁻ (aq) |
| (e) N ₂ (g) → NO ₃ ⁻ (aq) | |

22.17 The use of silica to form slag in the production of phosphorus from phosphate rock was introduced by Robert Boyle more than 300 years ago. When fluorapatite [Ca₅(PO₄)₃F] is used in phosphorus production, most of the fluorine atoms appear in the slag, but some end up in the toxic and corrosive gas SiF₄.

(a) If 15% by mass of the fluorine in 100. kg of Ca₅(PO₄)₃F forms SiF₄, what volume of this gas is collected at 1.00 atm and the industrial furnace temperature of 1450.°C?

(b) In some facilities, the SiF₄ is used to produce sodium hexafluorosilicate (Na₂SiF₆) which is sold for water fluoridation:

How many cubic meters of drinking water can be fluoridated to a level of 1.0 ppm of F⁻ using the SiF₄ produced in part (a)?

22.18 An impurity sometimes found in Ca₃(PO₄)₂ is Fe₂O₃, which is removed during the production of phosphorus as *ferrophosphorus* (Fe₂P). (a) Why is this impurity troubling from an economic standpoint? (b) If 50. metric tons (t) of crude Ca₃(PO₄)₂ contain 2.0% Fe₂O₃ by mass and the overall yield of phosphorus is 90.%, how many metric tons of P₄ can be isolated?

Metallurgy: Extracting a Metal from Its Ore

Concept Review Questions

22.19 Define: (a) ore; (b) mineral; (c) gangue; (d) brine.

22.20 Define: (a) roasting; (b) smelting; (c) flotation; (d) refining.

22.21 What factors determine which reducing agent is selected for producing a specific metal?

22.22 Use atomic properties to explain the reduction of a less active metal by a more active one: (a) in aqueous solution; (b) in the molten state. Give a specific example of each process.

22.23 What class of element is obtained by oxidation of a mineral? What class of element is obtained by reduction of a mineral?

Problems in Context

22.24 Which set of elements gives each of the following alloys:

- (a) brass; (b) stainless steel; (c) bronze; (d) sterling silver?

- | | | |
|---------------|---------------|-----------|
| 1. Cu, Ag | 2. Cu, Sn, Zn | 3. Ag, Au |
| 4. Fe, Cr, Ni | 5. Fe, V | 6. Cu, Zn |

Tapping the Crust: Isolation and Uses of Selected Elements

Concept Review Questions

22.25 How are each of the following involved in iron metallurgy: (a) slag; (b) pig iron; (c) steel; (d) basic-oxygen process?

22.26 What are the distinguishing features of each extraction process: pyrometallurgy, electrometallurgy, and hydrometallurgy? Explain briefly how the types of metallurgy are used in the production of (a) Fe; (b) Na; (c) Au; (d) Al.

22.27 What property allows copper to be purified in the presence of iron and nickel impurities? Explain.

22.28 Why is cryolite used in the electrolysis of aluminum oxide?

22.29 (a) What is a kinetic isotope effect?

(b) Do compounds of hydrogen exhibit a relatively large or small kinetic isotope effect? Explain.

(c) Carbon compounds also exhibit a kinetic isotope effect. How do you expect it to compare in magnitude with that for hydrogen compounds? Why?

22.30 How is Le Châtelier’s principle involved in the production of elemental potassium?

Problems in Context

22.31 Elemental Li and Na are prepared by electrolysis of a molten salt, whereas K, Rb, and Cs are prepared by chemical reduction.

(a) In general terms, explain why the alkali metals cannot be prepared by electrolysis of their aqueous salt solutions.

(b) Use ionization energies (see the Family Portraits for Group 1A(1) in Section 14.3 and for Group 2A(2) in Section 14.4) to explain why calcium should *not* be able to isolate Rb from molten RbX (X = halide).

(c) Use physical properties to explain why calcium *is* used to isolate Rb from molten RbX.

(d) Can Ca be used to isolate Cs from molten CsX? Explain.

22.32 A Downs cell operating at 77.0 A produces 31.0 kg of Na.

(a) What volume of Cl₂(g) is produced at 1.0 atm and 540.°C?

(b) How many coulombs were passed through the cell?

(c) How long did the cell operate?

22.33 (a) In the industrial production of iron, what is the reducing substance loaded into the blast furnace?

(b) In addition to furnishing the reducing power, what other function does this substance serve?

(c) What is the formula of the active reducing agent in the process?

(d) Write equations for the stepwise reduction of Fe₂O₃ to iron in the furnace.

22.34 One of the substances loaded into a blast furnace is limestone, which produces lime in the furnace.

(a) Give the chemical equation for the reaction forming lime.

(b) Explain the purpose of lime in the furnace. The term *flux* is often used as a label for a substance acting as the lime does. What is the derivation of this word, and how does it relate to the function of the lime?

(c) Write a chemical equation describing the action of lime flux.

22.35 The last step in the Dow process for the production of magnesium metal involves electrolysis of molten MgCl₂.

(a) Why isn’t the electrolysis carried out with aqueous MgCl₂? What are the products of this aqueous electrolysis?

(b) Do the high temperatures required to melt MgCl₂ favor products or reactants? (*Hint:* Consider the ΔH_f of MgCl₂.)

22.36 Iodine is the only halogen that occurs in a positive oxidation state, in NaIO_3 impurities within Chile saltpeter, NaNO_3 . (a) Is this mode of occurrence consistent with iodine's location in the periodic table? Explain.

(b) In the production of I_2 , IO_3^- reacts with HSO_3^- :

Identify the oxidizing and reducing agents.

(c) If 0.78 mol % of an NaNO_3 deposit is NaIO_3 , how much I_2 (in g) can be obtained from 1.000 ton (2000. lb) of the deposit?

22.37 Selenium is prepared by the reaction of H_2SeO_3 with gaseous SO_2 .

(a) What redox process does the sulfur dioxide undergo? What is the oxidation state of sulfur in the product?

(b) Given that the reaction occurs in acidic aqueous solution, what is the formula of the sulfur-containing species?

(c) Write the balanced redox equation for the process.

22.38 F_2 and Cl_2 are produced by electrolytic oxidation, whereas Br_2 and I_2 are produced by chemical oxidation of the halide ions in a concentrated aqueous solution (brine) by a more electronegative halogen. Give two reasons why Cl_2 isn't prepared this way.

22.39 Silicon is prepared by the reduction of K_2SiF_6 with Al. Write the equation for this reaction. (*Hint:* Can F^- be oxidized in this reaction? Can K^+ be reduced?)

22.40 What is the mass percent of iron in each of the following iron ores: Fe_2O_3 , Fe_3O_4 , FeS_2 ?

22.41 Phosphorus is one of the impurities present in pig iron that is removed in the basic-oxygen process. Assuming that phosphorus is present as P atoms, write equations for its oxidation and subsequent reaction in the basic slag.

22.42 The final step in the smelting of CuFeS_2 is

(a) Give the oxidation states of copper in Cu_2S , Cu_2O , and Cu.
(b) What are the oxidizing and reducing agents in this reaction?

22.43 Use equations to show how acid-base properties are used to separate Fe_2O_3 and TiO_2 from Al_2O_3 in the Bayer process.

22.44 A piece of Al with a surface area of 2.5 m^2 is anodized to produce a film of Al_2O_3 that is $23 \mu\text{m}$ ($23 \times 10^{-6} \text{ m}$) thick. (a) How many coulombs flow through the cell in this process (assume that the density of the Al_2O_3 layer is 3.97 g/cm^3)? (b) If it takes 18 min to produce this film, what current must flow through the cell?

22.45 The production of H_2 gas by the electrolysis of water typically requires about 400 kJ of energy per mole.

(a) Use the relationship between work and cell potential (Section 21.4) to calculate the minimum work needed to form 1.0 mol of H_2 gas at a cell potential of 1.24 V.

(b) What is the energy efficiency of the cell operation?

(c) Find the cost of producing 500. mol of H_2 if electricity is \$0.06 per kilowatt-hour (1 watt-second = 1 joule).

22.46 (a) What are the components of the reaction mixture following the water-gas shift reaction? (b) Explain how zeolites are used to purify the H_2 formed.

22.47 Metal sulfides are often first converted to oxides by roasting in air and then reduced with carbon to produce the metal. Why aren't the metal sulfides reduced directly by carbon to yield CS_2 ? Give a thermodynamic analysis of both processes for ZnS .

Chemical Manufacturing: Two Case Studies

Concept Review Questions

22.48 Explain in detail why a catalyst is used to produce SO_3 .

22.49 Among the exothermic steps in the manufacture of sulfuric acid is the process of hydrating SO_3 . (a) Write two chemical reactions that show this process. (b) Why is the direct reaction of SO_3 with water not feasible?

22.50 Why is commercial H_2SO_4 so inexpensive?

22.51 (a) What are the three commercial products formed in the chlor-alkali process?

(b) State an advantage and a disadvantage of using the mercury-cell method for this process.

Problems in Context

22.52 Consider the reaction of SO_2 to form SO_3 at standard conditions.

(a) Calculate ΔG° at 25°C . Is the reaction spontaneous?

(b) Why is the reaction not performed at 25°C ?

(c) Is the reaction spontaneous at 500°C ? (Assume that ΔH° and ΔS° are constant with changing T .)

(d) Compare K at 500°C and at 25°C .

(e) What is the highest T at which the reaction is spontaneous?

22.53 If a chlor-alkali cell used a current of $3 \times 10^4 \text{ A}$, how many pounds of Cl_2 would be produced in a typical 8-h operating day?

22.54 The products of the chlor-alkali process, Cl_2 and NaOH , are kept separated.

(a) Why is this necessary when Cl_2 is the desired product?

(b) ClO^- or ClO_3^- may form by disproportionation of Cl_2 in basic solution. What determines which product forms?

(c) What mole ratio of Cl_2 to OH^- will produce ClO^- ? ClO_3^- ?

Comprehensive Problems

22.55 The key step in the manufacture of sulfuric acid is the oxidation of sulfur dioxide in the presence of a catalyst, such as V_2O_5 . At 727°C , 0.010 mol of SO_2 is injected into an empty 2.00-L container ($K_p = 3.18$).

(a) What is the equilibrium pressure of O_2 that is needed to maintain a 1/1 mole ratio of SO_3 to SO_2 ?

(b) What is the equilibrium pressure of O_2 needed to maintain a 95/5 mole ratio of SO_3 to SO_2 ?

22.56 Tetraphosphorus decoxide (P_4O_{10}) is made from phosphate rock and used as a drying agent in the laboratory.

(a) Write a balanced equation for its reaction with water.

(b) What is the pH of a solution formed from the addition of 8.5 g of P_4O_{10} to sufficient water to form 0.750 L? (See Table 18.5, for additional information.)

22.57 Heavy water (D_2O) is used to make deuterated chemicals.

(a) What major species, aside from the starting compounds, do you expect to find in a solution of CH_3OH and D_2O ?

(b) Write equations to explain how these various species arise. (*Hint:* Consider the autoionization of both components.)

22.58 A blast furnace uses Fe_2O_3 to produce 8400. t of Fe per day.

(a) What mass of CO_2 is produced each day?

(b) Compare this amount of CO_2 with that produced by 1.0 million automobiles, each burning 5.0 gal of gasoline a day. Assume that gasoline has the formula C_8H_{18} and a density of 0.74 g/mL, and that it burns completely. (Note that U.S. gasoline consumption is over 4×10^8 gal/day.)

22.59 A major use of Cl_2 is in the manufacture of vinyl chloride, the monomer of poly(vinyl chloride). The two-step sequence for formation of vinyl chloride is depicted below.

- (a) Write a balanced equation for each step.
 (b) Write the overall equation.
 (c) What type of organic reaction is shown in step 1?
 (d) What type of organic reaction is shown in step 2?
 (e) If each molecule depicted in the initial reaction mixture represents 0.15 mol of substance, what mass (in g) of vinyl chloride forms?

22.60 In the production of magnesium, $\text{Mg}(\text{OH})_2$ is precipitated by using $\text{Ca}(\text{OH})_2$, which itself is “insoluble.” (a) Use K_{sp} values to show that $\text{Mg}(\text{OH})_2$ can be precipitated from seawater in which $[\text{Mg}^{2+}]$ is initially 0.052 M. (b) If the seawater is saturated with $\text{Ca}(\text{OH})_2$, what fraction of the Mg^{2+} is precipitated?

22.61 Step 1 of the Ostwald process for nitric acid production is

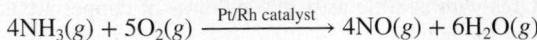

An unwanted side reaction for this step is

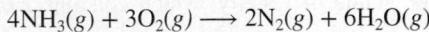

- (a) Calculate K_p for these two NH_3 oxidations at 25°C.
 (b) Calculate K_p for these two NH_3 oxidations at 900°C.
 (c) The Pt/Rh catalyst is one of the most efficient in the chemical industry, achieving 96% yield in 1 millisecond of contact with the reactants. However, at normal operating conditions (5 atm and 850°C), about 175 mg of Pt is lost per metric ton (t) of HNO_3 produced. If the annual U.S. production of HNO_3 is 1.01×10^7 t and the market price of Pt is \$1557/troy oz, what is the annual cost of the lost Pt (1 kg = 32.15 troy oz)?
 (d) Because of the high price of Pt, a filtering unit composed of ceramic fiber is often installed, which recovers as much as 75% of the lost Pt. What is the value of the Pt captured by a recovery unit with 72% efficiency?

22.62 Several transition metals are prepared by reduction of the metal halide with magnesium. Titanium is prepared by the Kroll method, in which the ore (ilmenite) is converted to the gaseous chloride, which is then reduced to Ti metal by molten Mg (see the discussion on the isolation of magnesium in Section 22.4). Assuming yields of 84% for step 1 and 93% for step 2, and an excess of the other reactants, what mass of Ti metal can be prepared from 21.5 metric tons of ilmenite?

22.63 The production of S_8 from the $\text{H}_2\text{S}(\text{g})$ found in natural gas deposits occurs through the Claus process (Section 22.5):

- (a) Use these two unbalanced steps to write an overall balanced equation for this process:
 (1) $\text{H}_2\text{S}(\text{g}) + \text{O}_2(\text{g}) \longrightarrow \text{S}_8(\text{g}) + \text{SO}_2(\text{g}) + \text{H}_2\text{O}(\text{g})$
 (2) $\text{H}_2\text{S}(\text{g}) + \text{SO}_2(\text{g}) \longrightarrow \text{S}_8(\text{g}) + \text{H}_2\text{O}(\text{g})$
 (b) Write the overall reaction with Cl_2 as the oxidizing agent instead of O_2 . Use thermodynamic data to show whether $\text{Cl}_2(\text{g})$ can be used to oxidize $\text{H}_2\text{S}(\text{g})$.
 (c) Why is oxidation by O_2 preferred to oxidation by Cl_2 ?

22.64 Acid mine drainage (AMD) occurs when geologic deposits containing pyrite (FeS_2) are exposed to oxygen and moisture. AMD is generated in a multistep process catalyzed by acidophilic (acid-loving) bacteria. Balance each step and identify those that increase acidity:

- (1) $\text{FeS}_2(\text{s}) + \text{O}_2(\text{g}) \longrightarrow \text{Fe}^{2+}(\text{aq}) + \text{SO}_4^{2-}(\text{aq})$
- (2) $\text{Fe}^{2+}(\text{aq}) + \text{O}_2(\text{g}) \longrightarrow \text{Fe}^{3+}(\text{aq}) + \text{H}_2\text{O}(\text{l})$
- (3) $\text{Fe}^{3+}(\text{aq}) + \text{H}_2\text{O}(\text{l}) \longrightarrow \text{Fe}(\text{OH})_3(\text{s}) + \text{H}^+(\text{aq})$
- (4) $\text{FeS}_2(\text{s}) + \text{Fe}^{3+}(\text{aq}) \longrightarrow \text{Fe}^{2+}(\text{aq}) + \text{SO}_4^{2-}(\text{aq})$

22.65 Below 912°C, pure iron crystallizes in a body-centered cubic structure (ferrite) with $d = 7.86 \text{ g/cm}^3$; from 912°C to 1394°C, it adopts a face-centered cubic structure (austenite) with $d = 7.40 \text{ g/cm}^3$. Both types of iron form interstitial alloys with carbon. The maximum amount of carbon is 0.0218 mass % in ferrite and 2.08 mass % in austenite. Calculate the density of each alloy.

22.66 Why isn't nitric acid produced by oxidizing N_2 as follows?

- (1) $\text{N}_2(\text{g}) + 2\text{O}_2(\text{g}) \longrightarrow 2\text{NO}(\text{g})$
 - (2) $3\text{NO}(\text{g}) + \text{H}_2\text{O}(\text{l}) \longrightarrow 2\text{HNO}_3(\text{aq}) + \text{NO}(\text{g})$
 - (3) $2\text{NO}(\text{g}) + \text{O}_2(\text{g}) \longrightarrow 2\text{NO}_2(\text{g})$
-
- $$3\text{N}_2(\text{g}) + 6\text{O}_2(\text{g}) + 2\text{H}_2\text{O}(\text{l}) \longrightarrow 4\text{HNO}_3(\text{aq}) + 2\text{NO}(\text{g})$$

(Hint: Evaluate the thermodynamics of each step.)

22.67 Before the development of the Downs cell, the Castner cell was used for the industrial production of Na metal. The Castner cell was based on the electrolysis of molten NaOH .

- (a) Write balanced cathode and anode half-reactions for this cell.
- (b) A major problem with this cell was that the water produced at one electrode diffused to the other and reacted with the Na. If all the water produced reacted with Na, what would be the maximum efficiency of the Castner cell expressed as moles of Na produced per mole of electrons flowing through the cell?

22.68 When gold ores are leached with CN^- solutions, gold forms a complex ion, $\text{Au}(\text{CN})_2^-$.

- (a) Find E_{cell} for the oxidation in air ($P_{\text{O}_2} = 0.21$) of Au to Au^+ in basic (pH 13.55) solution with $[\text{Au}^+] = 0.50 \text{ M}$. Is the reaction $\text{Au}^+(\text{aq}) + \text{e}^- \longrightarrow \text{Au}(\text{s})$, $E^\circ = 1.68 \text{ V}$, spontaneous?
- (b) How does formation of the complex ion change E° so that the oxidation can be accomplished?

22.69 Nitric oxide occurs in the tropospheric nitrogen cycle, but it destroys ozone in the stratosphere.

- (a) Write equations for its reaction with ozone and for the reverse reaction.
- (b) Given that the forward and reverse steps are first order in each component, write general rate laws for them.
- (c) Calculate ΔG° for this reaction at 280 K, the average temperature in the stratosphere. (Assume that the ΔH° and S° values in Appendix B do not change with temperature.)
- (d) What ratio of rate constants is consistent with K at this temperature?

22.70 A key part of the carbon cycle is the fixation of CO_2 by photosynthesis to produce carbohydrates and oxygen gas.

- (a) Using the formula $(\text{CH}_2\text{O})_n$ to represent a carbohydrate, write a balanced equation for the photosynthetic reaction.
- (b) If a tree fixes 48 g of CO_2 per day, what volume of O_2 gas measured at 1.0 atm and 78°F does the tree produce per day?
- (c) What volume of air (0.040 mol % CO_2) at the same conditions contains this amount of CO_2 ?

22.71 Farmers use ammonium sulfate as a fertilizer. In the soil, nitrifying bacteria oxidize NH_4^+ to NO_3^- , a groundwater contaminant that causes methemoglobinemia (“blue baby” syndrome). The World Health Organization standard for maximum $[\text{NO}_3^-]$ in groundwater is 45 mg/L. A farmer adds 210. kg of $(\text{NH}_4)_2\text{SO}_4$ to a field and 37% is oxidized to NO_3^- . What is the groundwater $[\text{NO}_3^-]$ (in mg/L) if 1000. m^3 of the water is contaminated?

22.72 The key reaction (unbalanced) in the manufacture of synthetic cryolite for aluminum electrolysis is

Assuming a 95.6% yield of dried, crystallized product, what mass (in kg) of cryolite can be obtained from the reaction of 365 kg of Al(OH)_3 , 1.20 m^3 of 50.0% by mass aqueous NaOH ($d = 1.53 \text{ g/mL}$), and 265 m^3 of gaseous HF at 305 kPa and 91.5°C? (Assume that the ideal gas law holds.)

22.73 Because of their different molar masses, H_2 and D_2 effuse at different rates (Section 5.5).

(a) If it takes 16.5 min for 0.10 mol of H_2 to effuse, how long does it take for 0.10 mol of D_2 to do so in the same apparatus at the same T and P ?

(b) How many effusion steps does it take to separate an equimolar mixture of D_2 and H_2 to 99 mol % purity?

22.74 The disproportionation of CO to graphite and CO_2 is thermodynamically favored but slow.

(a) What does this mean in terms of the magnitudes of the equilibrium constant (K), rate constant (k), and activation energy (E_a)?

(b) Write a balanced equation for the disproportionation of CO.

(c) Calculate K_c at 298 K.

(d) Calculate K_p at 298 K.

22.75 The overall cell reaction for aluminum production is

(a) Assuming 100% efficiency, how many metric tons (t) of Al_2O_3 are consumed per metric ton of Al produced?

(b) Assuming 100% efficiency, how many metric tons of the graphite anode are consumed per metric ton of Al produced?

(c) Actual conditions in an aluminum plant require 1.89 t of Al_2O_3 and 0.45 t of graphite per metric ton of Al. What is the percent yield of Al with respect to Al_2O_3 ?

(d) What is the percent yield of Al with respect to graphite?

(e) What volume of CO_2 (in m^3) is produced per metric ton of Al at operating conditions of 960.°C and exactly 1 atm?

22.76 World production of chromite (FeCr_2O_4), the main ore of chromium, was 1.97×10^7 metric tons in 2006. To isolate chromium, a mixture of chromite and sodium carbonate is heated in air to form sodium chromate, iron(III) oxide, and carbon dioxide. The sodium chromate is dissolved in water, and this solution is acidified with sulfuric acid to produce the less soluble sodium dichromate. The sodium dichromate is filtered out and reduced with carbon to produce chromium(III) oxide, sodium carbonate, and carbon monoxide. The chromium(III) oxide is then reduced to chromium with aluminum metal.

(a) Write balanced equations for each step.

(b) What mass of chromium (in kg) could be prepared from the 2006 world production of chromite?

22.77 Like heavy water (D_2O), “semi-heavy” water (HDO) undergoes H/D exchange. The molecular scenes depict an initial mixture of HDO and H_2 reaching equilibrium.

(a) Write the balanced equation for the reaction.

(b) Is the value of K greater or less than 1?

(c) If each molecule depicted represents 0.10 M, calculate K .

22.78 Even though most metal sulfides are sparingly soluble in water, their solubilities differ by several orders of magnitude. This difference is sometimes used to separate the metals by controlling the pH. Use the following data to find the pH at which you can separate 0.10 M Cu^{2+} and 0.10 M Ni^{2+} :

$$\text{Saturated H}_2\text{S} = 0.10 \text{ M}$$

$$K_{\text{a1}} \text{ of H}_2\text{S} = 9 \times 10^{-8}$$

$$K_{\text{sp}} \text{ of NiS} = 1.1 \times 10^{-18}$$

$$K_{\text{a2}} \text{ of H}_2\text{S} = 1 \times 10^{-17}$$

$$K_{\text{sp}} \text{ of CuS} = 8 \times 10^{-34}$$

22.79 Ores with as little as 0.25% by mass of copper are used as sources of the metal.

(a) How many kilograms of such an ore would be needed to construct another Statue of Liberty, which contains 2.0×10^5 lb of copper?

(b) If the mineral in the ore is chalcopyrite (CuFeS_2), what is the mass % of chalcopyrite in the ore?

22.80 How does acid rain affect the leaching of phosphate into groundwater from terrestrial phosphate rock? Calculate the solubility of $\text{Ca}_3(\text{PO}_4)_2$ in each of the following:

(a) Pure water, pH 7.0 (Assume that PO_4^{3-} does not react with water.)

(b) Moderately acidic rainwater, pH 4.5 (Hint: Assume that all the phosphate exists in the form that predominates at this pH.)

22.81 The lead(IV) oxide used in car batteries is prepared by coating an electrode plate with PbO and then oxidizing it to lead dioxide (PbO_2). Despite its name, PbO_2 has a nonstoichiometric mole ratio of lead to oxygen of about 1/1.98. In fact, the holes in the PbO_2 crystal structure due to missing O atoms are responsible for the oxide’s conductivity.

(a) What is the mole % of O missing from the PbO_2 structure?

(b) What is the molar mass of the nonstoichiometric compound?

22.82 Chemosynthetic bacteria reduce CO_2 by “splitting” $\text{H}_2\text{S}(g)$ instead of the $\text{H}_2\text{O}(g)$ used by photosynthetic organisms. Compare the free energy change for splitting H_2S with that for splitting H_2O . Is there an advantage to using H_2S instead of H_2O ?

22.83 Silver has a face-centered cubic structure with a unit cell edge length of 408.6 pm. Sterling silver is a substitutional alloy that contains 7.5% copper atoms. Assuming the unit cell remains the same, find the density of silver and of sterling silver.

22.84 Earth's mass is estimated to be 5.98×10^{24} kg, and titanium represents 0.05% by mass of this total.

(a) How many moles of Ti are present?

(b) If half of the Ti is found as ilmenite (FeTiO_3), what mass of ilmenite is present?

(c) If the airline and auto industries use 1.00×10^5 tons of Ti per year, how many years will it take to use up all the Ti (1 ton = 2000 lb)?

22.85 In 1790, Nicolas Leblanc found a way to form Na_2CO_3 from NaCl . His process, now obsolete, consisted of three steps:

(a) Write a balanced overall equation for the process.

(b) Calculate the ΔH_f° of CaS if $\Delta H_{\text{rxn}}^\circ$ is 351.8 kJ/mol.

(c) Is the overall process spontaneous at standard-state conditions and 298 K?

(d) How many grams of Na_2CO_3 form from 250. g of NaCl if the process is 73% efficient?

22.86 Limestone (CaCO_3) is the second most abundant mineral on Earth after SiO_2 . For many uses, it is first decomposed thermally to quicklime (CaO). MgO is prepared similarly from MgCO_3 .

(a) At what T is each decomposition spontaneous?

(b) Quicklime reacts with SiO_2 to form a slag (CaSiO_3), a by-product of steelmaking. In 2010, the total steelmaking capacity of the U.S. steel industry was 2,236,000 tons per week, but only 84% of this capacity was utilized. If 50. kg of slag is produced per ton of steel, what mass (in kg) of limestone was used to make slag in 2010?

23

Transition Elements and Their Coordination Compounds

23.1 Properties of the Transition Elements

Electron Configurations
Atomic and Physical Properties
Chemical Properties

23.2 The Inner Transition Elements

The Lanthanides
The Actinides

23.3 Coordination Compounds

Complex Ions
Formulas and Names
Isomerism

23.4 Theoretical Basis for the Bonding and Properties of Complex Ions

Valence Bond Theory
Crystal Field Theory

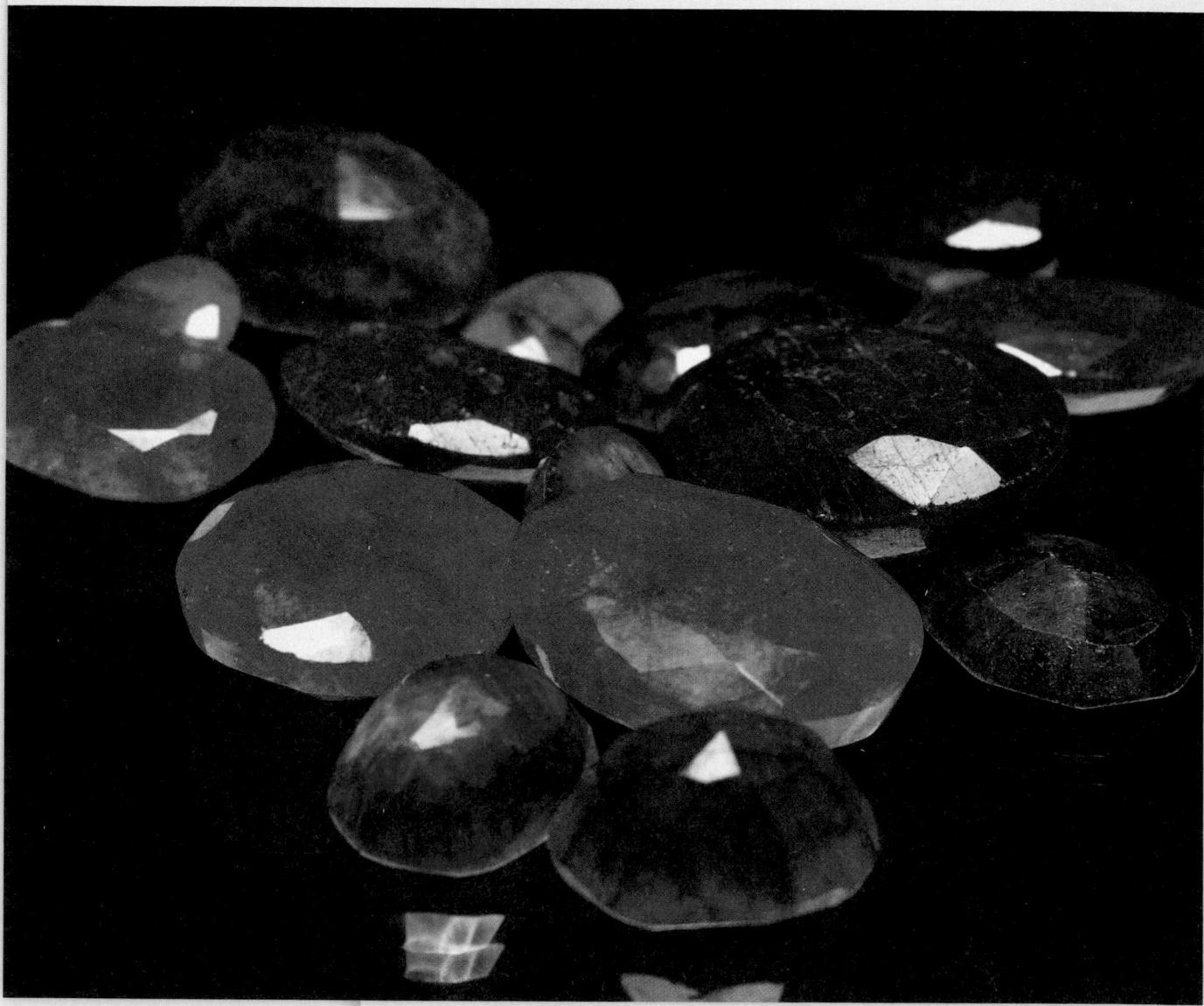

Source: © PjrStudio/Alamy

Concepts and Skills to Review Before You Study This Chapter

- › properties of light (Section 7.1)
- › electron shielding of nuclear charge (Section 8.1)
- › electron configuration, ionic size, and magnetic behavior (Sections 8.2 to 8.4)
- › valence bond theory (Section 11.1)
- › constitutional, geometric, and optical isomerism (Section 15.2)
- › Lewis acid-base concepts (Section 18.9)
- › complex-ion formation (Section 19.4)
- › redox behavior and standard electrode potentials (Section 21.3)

Though almost at the end of the text, we still haven't discussed the majority of the elements *and* some of the most familiar. The **transition elements** (*transition metals*) make up the *d* block (B groups) and *f* block (*inner transition elements*) of the periodic table (Figure 23.1, *next page*) and have crucial uses in industry and biology.

Aside from essential copper and iron (Chapter 22), some other indispensable transition elements are chromium (plumbing fixtures), gold and silver (jewelry and electronics), platinum (automobile catalytic converters), titanium (bicycle and aircraft parts and artificial joints), nickel (coins and catalysts), and zinc (batteries), to mention a few of the better known ones. There are also the lesser known zirconium (nuclear-reactor liners), vanadium (axles and crankshafts), molybdenum (boiler plates), tantalum (organ-replacement parts), palladium (telephone-relay contacts)—the list goes on and on.

Transition metal cations occupy the centers of many complex ions. In addition to providing fundamental insights into bonding and structure, these species play vital roles in organisms and give color to gems— Cr^{3+} ions make emeralds green and rubies red, and a mixture of Fe^{2+} , Fe^{3+} , and Ti^{4+} ions makes sapphires blue (*see photo*).

IN THIS CHAPTER . . . We focus on the transition elements and their properties, and especially on the bonding and structure of their coordination compounds.

- › We discuss key atomic, physical, and chemical properties of transition and inner transition elements—with attention to the effects of filling inner sublevels—and contrast them with properties of the main-group elements.
- › For most of the chapter, we concentrate on the nomenclature, structure, and isomerism of transition elements' coordination compounds, species that contain complex ions.
- › We use valence bond theory to explain the bonding and molecular shape of complex ions.
- › We use crystal field theory to explain the colors and magnetic properties of coordination compounds, which relate directly to structure.
- › We end with some examples of the roles of transition metal ions in biochemistry.

23.1 PROPERTIES OF THE TRANSITION ELEMENTS

The transition elements differ considerably in physical and chemical behavior from the main-group elements:

- All transition elements are metals, whereas the main-group elements in each period change from metal to nonmetal.
- Many transition metal compounds are colored and paramagnetic, whereas most main-group ionic compounds are colorless and diamagnetic.

Figure 23.1 The transition elements (*d* block) and inner transition elements (*f* block) in the periodic table.

	1A (1)	2A (2)	TRANSITION ELEMENTS <i>d</i> block										8A (18)					
1			3B (3)	4B (4)	5B (5)	6B (6)	7B (7)	8B (8)	(9)	(10)	1B (11)	2B (12)	3A (13)	4A (14)	5A (15)	6A (16)	7A (17)	
2																		
3			21 Sc	22 Ti	23 V	24 Cr	25 Mn	26 Fe	27 Co	28 Ni	29 Cu	30 Zn						
4			39 Y	40 Zr	41 Nb	42 Mo	43 Tc	44 Ru	45 Rh	46 Pd	47 Ag	48 Cd						
5			57 La	72 Hf	73 Ta	74 W	75 Re	76 Os	77 Ir	78 Pt	79 Au	80 Hg						
6			89 Ac	104 Rf	105 Db	106 Sg	107 Bh	108 Hs	109 Mt	110 Ds	111 Rg	112 Cn						
7																		
INNER TRANSITION ELEMENTS <i>f</i> block																		
58 Ce	59 Pr	60 Nd	61 Pm	62 Sm	63 Eu	64 Gd	65 Tb	66 Dy	67 Ho	68 Er	69 Tm	70 Yb	71 Lu					
90 Th	91 Pa	92 U	93 Np	94 Pu	95 Am	96 Cm	97 Bk	98 Cf	99 Es	100 Fm	101 Md	102 No	103 Lr					

We first discuss electron configurations of the atoms and ions of transition elements and then examine these elements' key properties to see how they contrast with the same properties of main-group elements.

Electron Configurations of the Transition Metals and Their Ions

As with all the elements, the properties of the transition elements and their compounds arise largely from the electron configurations of their atoms (Section 8.2) and ions (Section 8.4). As Figure 23.1 shows, *d*-block (B-group) elements occur in four series that lie within Periods 4 through 7 between the last *ns*-block element [Group 2A(2)] and the first *np*-block element [Group 3A(13)]. Each of the four series contains ten elements based on the filling of five *d* orbitals, for a total of 40 transition elements. Lying between the first and second members of the series in Periods 6 and 7 are the inner transition elements, in which *f* orbitals are filled. Several points are important to review:

1. *Electron configurations of the atoms.* Despite several exceptions, in general, the condensed ground-state electron configuration for the atoms in each *d*-block series is

$$[\text{atomic noble gas}] \text{ } ns^2(n-1)d^x, \text{ with } n=4 \text{ to } 7 \text{ and } x=1 \text{ to } 10$$

In Periods 6 and 7, the condensed configuration includes the *f* sublevel:

$$[\text{atomic noble gas}] \text{ } ns^2(n-2)f^{14}(n-1)d^x, \text{ with } n=6 \text{ or } 7$$

The *partial* (valence-level) electron configuration for the *d*-block elements excludes the noble gas core and the filled inner *f* sublevel:

$$ns^2(n-1)d^x$$

Figure 23.2 The Period 4 transition metals. The ten elements appear in periodic-table order across pages 1038–1039.

Source: © McGraw-Hill Education/Stephen Frisch, photographer

Scandium, Sc; 3B(3)

Titanium, Ti; 4B(4)

Vanadium, V; 5B(5)

Chromium, Cr; 6B(6)

Manganese, Mn; 7B(7)

Table 23.1**Orbital Occupancy of the Period 4 Transition Metals**

Element	Partial Orbital Diagram			Unpaired Electrons
	4s	3d	4p	
Sc	↑↓	↑		1
Ti	↑↓	↑↑		2
V	↑↓	↑↑↑		3
Cr	↑	↑↑↑↑↑		6
Mn	↑↓	↑↑↑↑↑		5
Fe	↑↓	↑↓↑↑↑		4
Co	↑↓	↑↓↑↓↑↑		3
Ni	↑↓	↑↓↑↓↑↓↑		2
Cu	↑	↑↓↑↓↑↓↑↓		1
Zn	↑↓	↑↓↑↓↑↓↑↓↑		0

2. *Filling pattern in Period 4.* The first (Period 4) transition series consists of scandium (Sc) through zinc (Zn) (Figure 23.2 and Table 23.1). Scandium has the electron configuration [Ar] 4s²3d¹, and the addition of one electron at a time first half-fills, then fills, the 3d orbitals, up to zinc. Recall that chromium and copper are exceptions to this pattern:

- The 4s and 3d orbitals in Cr are half-filled to give [Ar] 4s¹3d⁵.
- The 4s orbital in Cu is half-filled to give [Ar] 4s¹3d¹⁰.

These exceptions are due to the relative energies of the 4s and 3d sublevels as electrons are added and to the unusual stability of half-filled and filled sublevels (see Figure 8.26).

3. *Electron configurations of the ions.* Transition metal ions form through the loss of ns electrons before (n - 1)d electrons. Thus, Ti loses the two 4s electrons to form the Ti²⁺ ion:

Ti²⁺ is referred to as a d² ion. Ions of different metals with the same configuration often have similar properties. For example, Mn²⁺ and Fe³⁺ are d⁵ ions:

Both have pale colors in solution and form complex ions with similar magnetic properties.

Table 23.1 shows partial orbital box diagrams for the Period 4 elements. In general for all periods of the transition elements, the number of unpaired electrons (or half-filled orbitals) increases in the first half of the series and, when pairing begins, decreases in the second half. A key point to note in upcoming discussions is that the electron configuration of the atom (O.N. = 0) correlates with the physical properties

Iron, Fe; 8B(8)

Cobalt, Co; 8B(9)

Nickel, Ni; 8B(10)

Copper, Cu; 1B(11)

Zinc, Zn; 2B(12)

of the *element*, whereas the electron configuration of the *ion* (and other species of higher O.N.) correlates with the chemical properties of the *compounds*.

SAMPLE PROBLEM 23.1
Writing Electron Configurations of Transition Metal Atoms and Ions

Problem Write condensed electron configurations for the following: (a) Zr; (b) V³⁺; (c) Mo³⁺. (Assume that transition elements in higher periods behave like those in Period 4.)

Plan We locate the element in the periodic table and count its position in the respective transition series. These elements are in Periods 4 and 5, so the general configuration is [noble gas] $ns^2(n - 1)d^x$. For the ions, we recall that ns electrons are lost first.

Solution (a) Zr is the second element in the 4d series: [Kr] $5s^24d^2$.

(b) V is the third element in the 3d series: [Ar] $4s^23d^3$. In forming V³⁺, three electrons are lost (two 4s and one 3d), so V³⁺ is a d² ion: [Ar] $3d^2$.

(c) Mo lies below Cr in Group 6B(6), so we expect the same exception as for Cr. Thus, Mo has the electron configuration [Kr] $5s^14d^5$. To form the ion, Mo loses the one 5s and two of the 4d electrons, so Mo³⁺ is a d³ ion: [Kr] $4d^3$.

Check Figure 8.9 shows we're correct for the atoms. Be sure that charge plus number of d electrons in the ion equals the sum of outer s and d electrons in the atom.

FOLLOW-UP PROBLEMS

Brief Solutions for all Follow-up Problems appear at the end of the chapter.

23.1A Write partial electron configurations (no noble gas core or filled inner sublevels) for the following: (a) Ag⁺; (b) Cd²⁺; (c) Ir³⁺.

23.1B Find the charge of each of the following ions, given the condensed electron configuration: (a) Ta^{x+}: [Xe] $4f^{14}5d^2$; (b) Mn^{x+}: [Ar] $3d^3$; (c) Os^{x+}: [Xe] $4f^{14}5d^5$.

SOME SIMILAR PROBLEMS 23.10–23.15

Atomic and Physical Properties of the Transition Elements

Properties of the transition elements contrast in several ways with properties of the main-group elements.

Trends Across a Period Consider the variations in atomic size, electronegativity, and ionization energy across Period 4 (Figure 23.3):

A Atomic radius (pm)

• **Atomic size.** Atomic size decreases overall across the period (Figure 23.3A). There is a smooth, steady decrease across the main groups because the electrons are added to *outer ns* or *np* orbitals, which shield the increasing nuclear charge poorly.

This decrease is not steady in the transition series, where *atomic size decreases at first but then remains relatively constant*. The reason is that the d electrons fill *inner* orbitals, so they shield outer electrons very efficiently; therefore, the outer 4s electrons are *not* pulled closer.

• **Electronegativity (EN).** Electronegativity generally increases across the period, but, once again, the main groups show a steady, steep increase between the metal potassium (0.8) and the nonmetal bromine (2.8), whereas the transition elements

B Electronegativity

have *relatively constant EN* (Figure 23.3B), consistent with their relatively constant size. The transition elements all have intermediate electronegativity values, much like the large, metallic members of Groups 3A(13) to 5A(15).

• **Ionization energy (IE_1).** The ionization energies of the Period 4 main-group elements rise steeply from left to right, more than tripling from potassium (419 kJ/mol) to krypton (1351 kJ/mol), as electrons become more difficult to remove from the poorly shielded, increasing nuclear charge. In the transition metals, IE_1 values *increase relatively little* because the inner 3d electrons shield more effectively (Figure 23.3C). [Recall from Section 8.3 that the drop at Group 3A(13) occurs because it is relatively easy to remove the first electron from the outer np orbital.]

C First ionization energy (kJ/mol)

Figure 23.3 Trends in key atomic properties of Period 4 elements. Relative sizes of atomic radius (A), electronegativity (B), and first ionization energy (C) for all Period 4 elements are indicated by the heights of the bars, with darker shading on the transition series.

Trends Within a Group Vertical trends for transition elements are also different from main-group trends.

1. **Atomic size.** As expected, atomic size increases from Period 4 to 5, as it does for the main-group elements, but there is virtually *no size increase from Period 5 to 6* (Figure 23.4A). Since the lanthanides, with their buried 4f sublevel, appear between the 4d (Period 5) and 5d (Period 6) series, an element in Period 6 is separated from the one above it by 32 elements (ten 4d, six 5p, two 6s, and fourteen 4f electrons) instead of just 18. The fourteen 4f electrons shield the outer electrons poorly from the increase in nuclear charge due to fourteen additional protons, resulting in a shrinkage in atomic size called the **lanthanide contraction**. By coincidence, this size *decrease* is about equal to the normal *increase* between periods, so Periods 5 and 6 transition elements have about the same atomic sizes.

2. **Electronegativity.** The vertical trend in electronegativity is opposite the decreasing trend in the main groups. Electronegativity *increases* from Period 4 to Period 5, but there is no further increase in Period 6 (Figure 23.4B). The heavier elements, especially gold ($\text{EN} = 2.4$), become quite electronegative, with values higher than most metalloids and even some nonmetals (e.g., EN of Te and of P = 2.1). (In fact, with the very electropositive cesium, which has $\text{EN} = 0.7$, gold forms the saltlike CsAu .) Although atomic size increases slightly from top to bottom in a group, the nuclear charge increases much more. Therefore, the heavier transition metals form bonds with more covalent character because they attract electrons more strongly than do main-group metals.

3. **Ionization energy.** The small increase in size combined with the large increase in nuclear charge also explains why IE_1 values *generally increase* down a transition group (Figure 23.4C). This trend also runs counter to the main-group trend, where heavier members are so much larger that the outer electron is easier to remove.

4. **Density.** Atomic size, and therefore volume, is inversely related to density. Across a period, densities increase, then level off, and finally dip a bit at the end of

Figure 23.4 Vertical trends in key properties within the transition elements. The trends are unlike those for the main-group elements.

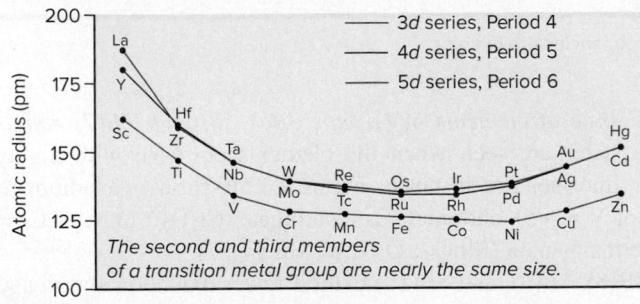

A

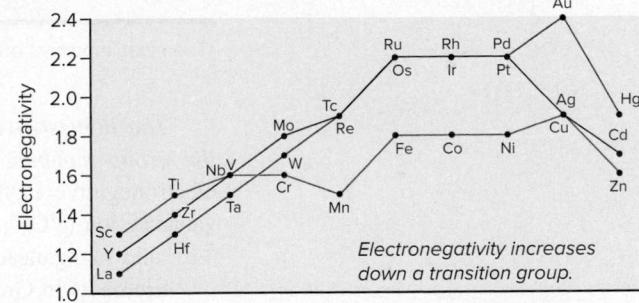

B

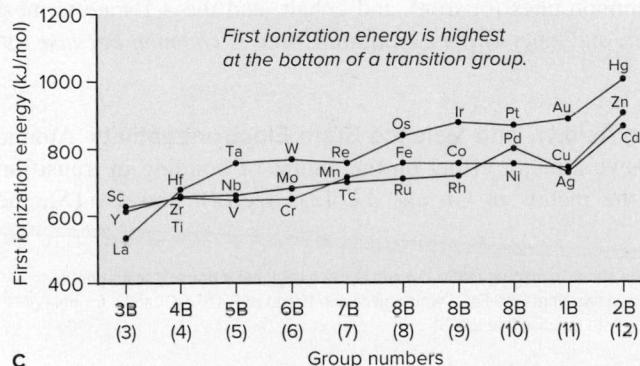

C

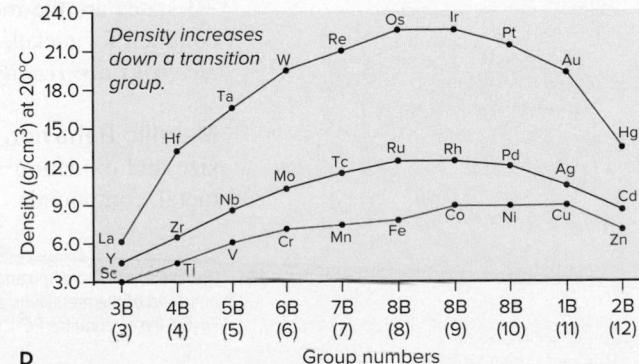

D

A

B

Figure 23.5 Aqueous oxoanions of transition elements.

Source: © McGraw-Hill Education/Stephen Frisch, photographer

a series (Figure 23.4D). Down a transition group, densities increase dramatically because atomic volumes change little from Period 5 to 6, but atomic masses increase significantly. As a result, the Period 6 series contains some of the densest elements known: tungsten, rhenium, osmium, iridium, platinum, and gold have densities about 20 times that of water and twice that of lead.

Chemical Properties of the Transition Elements

Like their atomic and physical properties, the chemical properties of transition elements are very different from those of main-group elements. Let's examine key properties in the Period 4 series and then see how behavior changes within a group.

Multiple Oxidation States One of the most characteristic chemical properties of the transition metals is the occurrence of *multiple oxidation states*; main-group metals display one or, at most, two states. For example, chromium and manganese (Figure 23.5A) have three common oxidation states and many others that are less common (Table 23.2). Since the ns and $(n-1)d$ electrons are so close in energy, transition elements can use all or most of these electrons in bonding.

Oxidation States and d-Orbital Occupancy of the Period 4 Transition Metals*

Table 23.2

Oxidation State	3B (3) Sc	4B (4) Ti	5B (5) V	6B (6) Cr	7B (7) Mn	8B (8) Fe	8B (9) Co	8B (10) Ni	1B (11) Cu	2B (12) Zn
0	d^1	d^2	d^3	d^5	d^5	d^6	d^7	d^8	d^{10}	d^{10}
+1			d^3	d^5	d^5	d^6	d^7	d^8	d^{10}	
+2		d^2	d^3	d^4	d^5	d^6	d^7	d^8	d^9	d^{10}
+3	d^0	d^1	d^2	d^3	d^4	d^5	d^6	d^7	d^8	
+4		d^0	d^1	d^2	d^3	d^4	d^5	d^6		
+5			d^0	d^1	d^2		d^4			
+6				d^0	d^1	d^4				
+7					d^0					

*The most important orbital occupancies are in color.

The highest oxidation state of elements in Groups 3B(3) through 7B(7) equals the group number. These states are seen when the elements combine with highly electronegative oxygen or fluorine. For instance, Figure 23.5B shows vanadium as vanadate ion (VO_4^{3-} ; O.N. of V = +5), chromium as dichromate ($\text{Cr}_2\text{O}_7^{2-}$; O.N. of Cr = +6), and manganese as permanganate (MnO_4^- ; O.N. of Mn = +7).

Elements in Groups 8B(8), 8B(9), and 8B(10) exhibit fewer oxidation states, and the highest state is less common and never equal to the group number. For example, we never encounter iron in the +8 state and only rarely in the +6 state. The +2 and +3 states are the most common ones for iron* and cobalt, and the +2 state is most common for nickel, copper, and zinc. *The +2 oxidation state is common because ns^2 electrons are readily lost.*

Metallic Behavior, Oxide Acidity, and Valence-State Electronegativity Atomic size and oxidation state have a major effect on the nature of bonding in transition metal compounds. Like the metals in Groups 3A(13), 4A(14), and 5A(15), the

*Iron seems to have unusual oxidation states in magnetite (Fe_3O_4) and pyrite (FeS_2), but it doesn't. In magnetite, one-third of the metal ions are Fe^{2+} and two-thirds are Fe^{3+} , which gives a 1/1 ratio of $\text{FeO}/\text{Fe}_2\text{O}_3$ and a formula of Fe_3O_4 . Pyrite contains Fe^{2+} combined with the disulfide ion, S_2^{2-} .

transition elements in their *lower* oxidation states behave chemically more like metals. That is, *ionic bonding is more prevalent for the lower oxidation states, and covalent bonding is more prevalent for the higher states*. For example, at room temperature, TiCl_2 (O.N. = +2) is an ionic solid, whereas TiCl_4 (O.N. = +4) is a molecular liquid (see also Figure 14.11). In the higher oxidation states, the atoms have higher charge densities (higher ratio of charge to volume, Section 13.3), so they polarize the electron clouds of the nonmetal ions more strongly and the bonding becomes more covalent. For the same reason, the oxides become less basic (more acidic) as the oxidation state increases: TiO is weakly basic in water, whereas TiO_2 is amphoteric (reacts with both acid and base).

Why does oxide acidity increase with oxidation state? And, how can a metal like chromium or manganese, in addition to forming oxides, form an oxoanion in which it uses covalent bonds? The answers involve a type of “effective” electronegativity called *valence-state electronegativity*, which also has numerical values. A metal atom with a positive oxidation state has a greater attraction for the bonded electrons, that is, a higher electronegativity, than it does when it has a zero oxidation state. Thus, for example, the electronegativity of elemental chromium is 1.6, close to that of aluminum (1.5), another active metal. For chromium(III), the value increases to 1.7, still characteristic of a metal. But, for chromium(VI), the value is 2.3, close to the values of some nonmetals, such as phosphorus (2.1) and sulfur (2.5). Thus, like P in PO_4^{3-} and S in SO_4^{2-} , Cr in CrO_4^{2-} is covalently bonded at the center of an oxoanion of a relatively strong acid, H_2CrO_4 , and manganese(VII) in MnO_4^- behaves similarly in the strong acid HMnO_4 .

Reducing Strength Table 23.3 shows the standard electrode potentials of the Period 4 transition metals in their +2 oxidation state in acid solution. Note that, in general, reducing strength decreases across the series. All the Period 4 transition metals, except copper, are active enough to reduce H^+ from aqueous acid to form hydrogen gas. In contrast to the rapid reaction at room temperature of the Group 1A(1) and 2A(2) metals with water, however, most transition metals have an oxide coating that allows rapid reaction only with hot water or steam.

Color and Magnetism of Compounds Most main-group ionic compounds are colorless because the metal ion has a filled outer level (noble gas electron configuration, ns^2 or ns^2np^6). With only much higher energy orbitals available to receive an excited electron, the ion does not absorb visible light. In contrast, electrons in a partially filled *d* sublevel can absorb visible wavelengths and move to slightly higher energy orbitals. As a result, many transition metal compounds have striking colors. Exceptions are the compounds of scandium, titanium(IV), and zinc, which are colorless because their metal ions have either an empty *d* sublevel (Sc^{3+} or Ti^{4+} : [Ar] $3d^0$) or a filled one (Zn^{2+} : [Ar] $3d^{10}$) (Figure 23.6).

Standard Electrode Potentials of M^{2+} Ions of Period 4 Transition Metals

Table 23.3

Half-Reaction	E° (V)
$\text{Ti}^{2+}(aq) + 2e^- \rightleftharpoons \text{Ti}(s)$	-1.63
$\text{V}^{2+}(aq) + 2e^- \rightleftharpoons \text{V}(s)$	-1.19
$\text{Cr}^{2+}(aq) + 2e^- \rightleftharpoons \text{Cr}(s)$	-0.91
$\text{Mn}^{2+}(aq) + 2e^- \rightleftharpoons \text{Mn}(s)$	-1.18
$\text{Fe}^{2+}(aq) + 2e^- \rightleftharpoons \text{Fe}(s)$	-0.44
$\text{Co}^{2+}(aq) + 2e^- \rightleftharpoons \text{Co}(s)$	-0.28
$\text{Ni}^{2+}(aq) + 2e^- \rightleftharpoons \text{Ni}(s)$	-0.25
$\text{Cu}^{2+}(aq) + 2e^- \rightleftharpoons \text{Cu}(s)$	0.34
$\text{Zn}^{2+}(aq) + 2e^- \rightleftharpoons \text{Zn}(s)$	-0.76

Figure 23.6 Colors of representative compounds of the Period 4 transition metals.

Source: © McGraw-Hill Education/Stephen Frisch, photographer

Table 23.4

Some Properties of Group 6B(6) Elements

Element	Atomic Radius (pm)	IE_1 (kJ/mol)	$E^\circ (\text{V})$ for $\text{M}^{3+}(\text{aq}) \mid \text{M(s)}$
Cr	128	653	-0.74
Mo	139	685	-0.20
W	139	770	-0.11

Magnetic properties are also related to sublevel occupancy (Section 8.4). *Most main-group metal ions are diamagnetic* for the same reason they are colorless: all their electrons are paired. In contrast, *many transition metal compounds are paramagnetic because of their unpaired d electrons*. Transition metal ions with a d^0 or d^{10} configuration are also colorless and diamagnetic.

Chemical Behavior Within a Group The *increase* in reactivity going down a group of main-group metals due to the *decrease* in IE_1 does *not* occur going down a group of transition metals. The chromium (Cr) group [6B(6)] shows a typical pattern (Table 23.4). IE_1 *increases* down the group, which makes the two heavier members *less* reactive than the lightest one. Chromium is also a much stronger reducing agent than molybdenum (Mo) or tungsten (W), as shown by the standard electrode potentials.

The similarity in atomic size of members of Periods 5 and 6 leads to similar chemical behavior, which has some important consequences. Because Mo and W compounds behave similarly, their ores often occur together in nature, which makes these elements very difficult to separate. The same situation occurs with zirconium and hafnium in Group 4B(4) and with niobium and tantalum in Group 5B(5).

› Summary of Section 23.1

- › All transition elements are metals.
- › Atoms of the *d*-block elements have $(n - 1)d$ orbitals being filled, and their ions have an empty ns orbital.
- › Unlike the trends for the main-group elements, the atomic size, electronegativity, and first ionization energy change relatively little across a transition series. Because of the lanthanide contraction, atomic size changes little from Period 5 to 6 in a transition metal group; thus, electronegativity, first ionization energy, and density *increase* down such a group.
- › Transition metals typically have several oxidation states, with the +2 state most common. The elements exhibit less metallic behavior in their higher states, as they have higher valence-state electronegativity.
- › Most Period 4 transition metals are active enough to reduce hydrogen ion from acid solution.
- › Many transition metal compounds are colored and paramagnetic because the metal ion has unpaired *d* electrons.
- › In contrast to main-group metals, transition metals show decreasing reactivity down a group.

23.2 THE INNER TRANSITION ELEMENTS

The 14 **lanthanides** in Period 6 [cerium (Ce; $Z = 58$) through lutetium (Lu; $Z = 71$)] and the 14 **actinides** in Period 7 [thorium (Th; $Z = 90$) through lawrencium (Lr; $Z = 103$)] are called **inner transition elements** because their seven inner $4f$ or $5f$ orbitals are being filled.

The Lanthanides

The lanthanides are also known as the *rare earth elements*, but many are not rare: cerium (Ce), for instance, ranks 26th in abundance (by mass %) and is five times more abundant than lead. All the lanthanides are silvery, high-melting metals.

As with other transition elements, atomic properties vary little across the period. As a result, chemical properties are so similar that the two ores of lanthanides, ceria and yttria, are mixtures of compounds of all 14 of them. This natural co-occurrence arises because the elements exist as M^{3+} ions of very similar radii. Most lanthanides have the ground-state electron configuration $[Xe] 6s^2 4f^x 5d^0$, where x varies across the series. The three exceptions (Ce, Gd, and Lu) have a single electron in one of their $5d$ orbitals: cerium ($[Xe] 6s^2 4f^1 5d^1$) forms a stable $4+$ ion with an empty (f^0) sublevel, and the Gd^{3+} and Lu^{3+} ions have a stable half-filled (f^7) or filled (f^{14}) sublevel.

Lanthanide compounds are used in tinted glass, electronic devices (magnets, batteries, and lasers), and high-quality camera lenses, but two industrial applications account for over 60% of the total usage. In gasoline refining, catalysts used to “crack” hydrocarbons into smaller molecules are 5% by mass rare earth oxides. In steelmaking, a mixture of lanthanides, called *misch metal*, removes carbon impurities from molten iron and steel. Recently, shortages of some lanthanides used for certain electronic applications have been a concern.

SAMPLE PROBLEM 23.2

Finding the Number of Unpaired Electrons

Problem The alloy SmCo_5 forms a permanent magnet because both samarium and cobalt have unpaired electrons. How many unpaired electrons are in Sm ($Z = 62$)?

Plan We write the condensed electron configuration of Sm and then, using Hund’s rule and the aufbau principle, place the electrons in a partial orbital diagram and count the unpaired electrons.

Solution Samarium is the eighth element after Xe. Two electrons go into the $6s$ sublevel. In general, the $4f$ sublevel fills before the $5d$ (among the lanthanides, only Ce, Gd, and Lu have $5d$ electrons), so the remaining electrons go into the $4f$. Thus, the condensed configuration of Sm is $[Xe] 6s^2 4f^6$. There are seven f orbitals, so each of the six f electrons enters a separate orbital:

Thus, Sm has six unpaired electrons.

Check Six $4f$ e⁻ plus two $6s$ e⁻ plus the 54 e⁻ in Xe gives 62 , the atomic number of Sm.

FOLLOW-UP PROBLEMS

23.2A How many unpaired electrons are in the Er^{3+} ion?

23.2B How many unpaired electrons are in the Dy^{3+} ion?

SOME SIMILAR PROBLEMS

23.30–23.34

The Actinides

All actinides are radioactive. Like the lanthanides, they have very similar physical and chemical properties. Thorium and uranium occur in nature, but the transuranium elements, those with Z greater than 92 , have been synthesized in particle accelerators (as we discuss in Section 24.3). The actinides are silvery and chemically reactive and, like the lanthanides, form highly colored compounds. The actinides and lanthanides have similar outer-electron configurations. Although the $+3$ oxidation state is characteristic of the actinides, as it is for the lanthanides, other states also occur. For example, uranium exhibits $+3$ through $+6$ states, with the $+6$ state the most prevalent; thus, the most common oxide of uranium is UO_3 .

› Summary of Section 23.2

- › There are two series of inner transition elements. The lanthanides ($4f$ series) have a common $+3$ oxidation state and exhibit very similar properties.
- › The actinides ($5f$ series) are radioactive. All actinides have a $+3$ oxidation state; several, including uranium, have higher states as well.

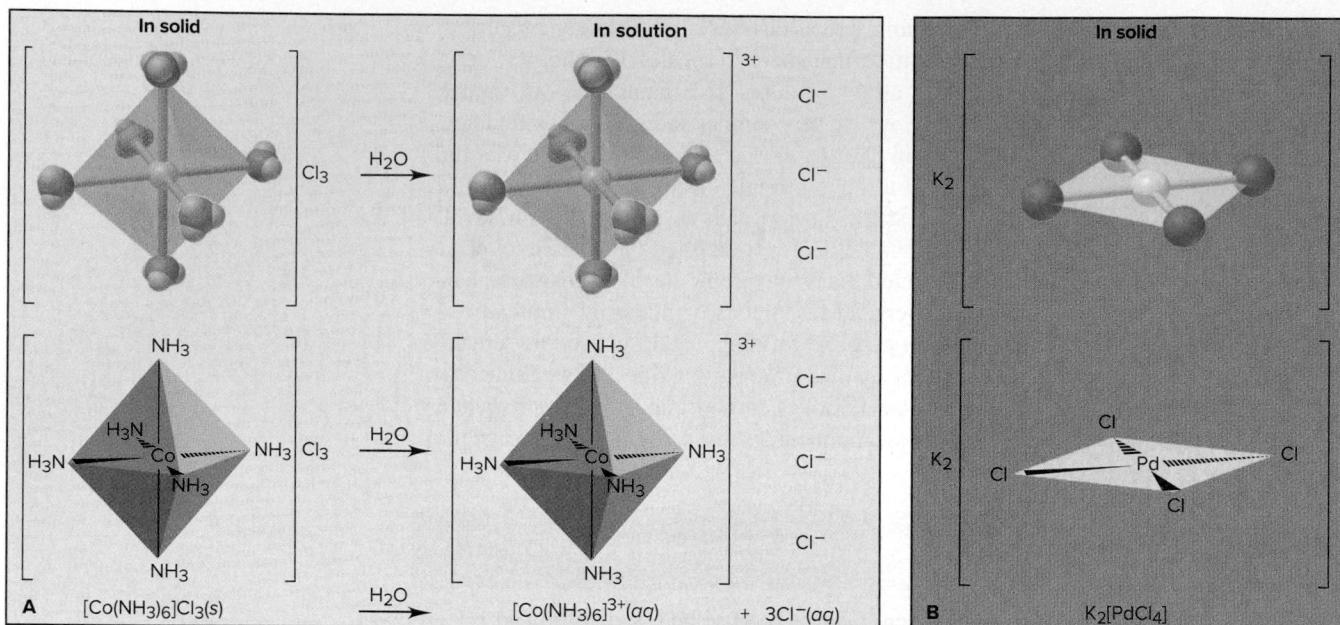

Figure 23.7 Components of a coordination compound. Coordination compounds are shown as models (top), wedge-bond perspective drawings (middle), and formulas (bottom). **A**, When $[\text{Co}(\text{NH}_3)_6]\text{Cl}_3$ dissolves in water, the six ligands remain bound in the complex ion. **B**, $\text{K}_2[\text{PdCl}_4]$ has four Cl^- ligands and two K^+ counter ions.

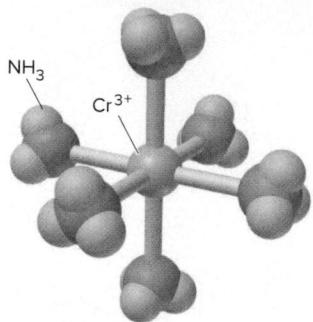

The complex ion $[\text{Cr}(\text{NH}_3)_6]^{3+}$ has a central Cr^{3+} ion bonded to six NH_3 ligands.

23.3 COORDINATION COMPOUNDS

The most distinctive feature of transition metal chemistry is the common occurrence of **coordination compounds** (or *complexes*). These species contain at least one **complex ion**, which consists of a *central metal cation bonded to molecules and/or anions called ligands* (see margin). To maintain charge neutrality, the complex ion is associated with **counter ions**. In the coordination compound $[\text{Co}(\text{NH}_3)_6]\text{Cl}_3$ (Figure 23.7A), the complex ion (in square brackets) is $[\text{Co}(\text{NH}_3)_6]^{3+}$, the six NH_3 molecules bonded to the Co^{3+} are ligands, and the three Cl^- ions are counter ions. The coordination compound $\text{K}_2[\text{PdCl}_4]$ in Figure 23.7B consists of two K^+ counter ions and the complex ion $[\text{PdCl}_4]^{2-}$, in which Pd^{2+} is bonded to four Cl^- ion ligands.

A coordination compound behaves like an electrolyte in water: the complex ion and counter ions separate, but the complex ion behaves like a polyatomic ion because the ligands and central metal ion remain attached. Thus, as Figure 23.7 shows, 1 mol of $[\text{Co}(\text{NH}_3)_6]\text{Cl}_3$ yields 1 mol of $[\text{Co}(\text{NH}_3)_6]^{3+}$ ions and 3 mol of Cl^- counter ions while 1 mol of $\text{K}_2[\text{PdCl}_4]$ yields 2 mol of K^+ counter ions and 1 mol of $[\text{PdCl}_4]^{2-}$ ions. This section covers the structure, naming, and properties of complex ions.

Complex Ions: Coordination Numbers, Geometries, and Ligands

A complex ion is described by the metal ion and the number and types of ligands attached to it. The ion's structure is related to coordination number and geometry.

Coordination Numbers The **coordination number** is the *number of ligand atoms bonded directly to the central metal ion in a complex ion*. It is *specific* for a given metal ion in a particular oxidation state and in a particular complex ion. The coordination number of the Co^{3+} ion in $[\text{Co}(\text{NH}_3)_6]^{3+}$ is 6 because six ligand atoms (N atoms of NH_3 molecules) are bonded to it. The coordination number of the Pt^{2+} ion in many of its complex ions is 4, whereas that of the Pt^{4+} ion in its complex ions is 6. Copper(II) may have a coordination number of 2, 4, or 6 in different complex ions. In general, the most common coordination number in complex ions is 6, but 2 and 4 are often seen, and some higher ones are known.

Student Hot Spot

Student data indicate that you may struggle with the concept of coordination compounds and their features. Access the Smartbook to view additional Learning Resources on this topic.

Table 23.5

Coordination Numbers and Shapes of Some Complex Ions

Coordination Number	Shape	Examples
2	Linear	$[\text{CuCl}_2]^-$, $[\text{Ag}(\text{NH}_3)_2]^+$, $[\text{AuCl}_2]^-$
4	Square planar	$[\text{Ni}(\text{CN})_4]^{2-}$, $[\text{PdCl}_4]^{2-}$, $[\text{Pt}(\text{NH}_3)_4]^{2+}$
4	Tetrahedral	$[\text{Cu}(\text{CN})_4]^{3-}$, $[\text{Zn}(\text{NH}_3)_4]^{2+}$, $[\text{CdCl}_4]^{2-}$, $[\text{MnCl}_4]^{2-}$
6	Octahedral	$[\text{Ti}(\text{H}_2\text{O})_6]^{3+}$, $[\text{V}(\text{CN})_6]^{4-}$, $[\text{Cr}(\text{NH}_3)_6\text{Cl}_2]^+$, $[\text{Mn}(\text{H}_2\text{O})_6]^{2+}$, $[\text{FeCl}_6]^{3-}$, $[\text{Co}(\text{en})_3]^{3+}$

Geometries The geometry (shape) of a complex ion depends on the coordination number and the metal ion. Table 23.5 shows the geometries for coordination numbers 2, 4, and 6. A complex ion whose metal ion has a coordination number of 2, such as $[\text{Ag}(\text{NH}_3)_2]^+$, is *linear*. The coordination number 4 gives rise to either of two geometries. Most d^8 metal ions form *square planar* complex ions (Figure 23.7B). The d^{10} ions form *tetrahedral* complex ions. A coordination number of 6 results in an *octahedral* geometry, as shown by $[\text{Co}(\text{NH}_3)_6]^{3+}$ (Figure 23.7A). Note the similarity with some of the molecular shapes in VSEPR theory (Section 10.2).

Ligands The ligands of complex ions are *molecules or anions* with one or more **donor atoms**. Each *donates a lone pair of electrons* to the metal ion, thus forming a covalent bond. Because they must have at least one lone pair, donor atoms often come from Group 5A(15), 6A(16), or 7A(17). (As you learned in Section 18.9, ligands are Lewis bases.)

Ligands are classified in terms of their number of donor atoms, or “teeth”:

- **Monodentate** (Latin, “one-toothed”) ligands bond through a single donor atom.
- **Bidentate** ligands have two donor atoms, each of which bonds to the metal ion.
- **Polydentate** ligands have more than two donor atoms.

Bidentate and polydentate ligands give rise to *rings* in the complex ion. For instance, ethylenediamine (abbreviated *en*) has a chain of four atoms ($:\text{N}-\text{C}-\text{C}-\text{N}:)$, so it forms a five-membered ring, with the two electron-donating N atoms bonding to the metal ion (Figure 23.8A). Such ligands seem to grab the metal ion like claws, so a complex ion that contains them is also called a **chelate** (pronounced “KEY-late”; Greek *chela*, “crab’s claw”). With its six donor atoms, the ethylenediaminetetraacetate (EDTA^{4-}) ion forms very stable complexes with metal ions (Figure 23.8B). This property makes EDTA useful in treating *heavy-metal poisoning*. Ingested by the patient, the EDTA^{4-} ion removes lead and other heavy-metal ions from the blood and other body fluids.

A

B

Figure 23.8 Chelates. Structure (left) and model (right) of (A) the bidentate ligand ethylenediamine (*en*) complexed with a Co^{3+} ion and (B) the chelate $[\text{Pb}(\text{EDTA})]^{2-}$.

Table 23.6

Some Common Ligands in Coordination Compounds

Ligand Type	Examples		
Monodentate	H ₂ O: water		
	:NH ₃ ammonia		
Bidentate			
 ethylenediamine (en)			
 oxalate ion			
Polydentate	 diethylenetriamine		
	 triprophosphate ion		
		 ethylenediaminetetraacetate ion (EDTA ⁴⁻)	

The EDTA⁴⁻ ion is often added to products such as shampoos as it removes Mg²⁺ and Ca²⁺ ions from hard water, allowing the shampoo to clean more efficiently.

Table 23.6 shows some common ligands in coordination compounds. Note that each ligand has one or more donor atoms (colored type), each with a lone pair of electrons to donate, thereby forming a covalent bond to the metal ion. Since the bidentate ligand ethylenediamine has two atoms that form bonds to the metal ion, the complex ion [Co(en)₃]³⁺ has a coordination number of 6 (two covalent bonds per ligand); the complex ion [Pb(EDTA)]²⁻ has one polydentate ligand with six donor atoms, so it also has a coordination number of 6.

Formulas and Names of Coordination Compounds

The combination of ions in a coordination compound is the key to writing its formula and name. A coordination compound can consist of a complex cation with simple anionic counter ions, a complex anion with simple cationic counter ions, or even a complex cation with complex anion as counter ion.

Determining the Charge of the Metal Ion The charge of the complex ion can be determined from the charge of its counter ion(s) and basic arithmetic can be used to find the charge of the metal ion:

$$\text{Charge of metal ion} = \text{charge of complex ion} - \text{total charge of ligands} \quad (23.1)$$

- For a compound with a *complex anion*, say, K₂[Co(NH₃)₂Cl₄], the two K⁺ counter ions (written outside the brackets) have a total charge of $2 \times 1+ = 2+$ and balance the charge of the complex anion, which must have a charge of 2 $-$; the complex ion contains two NH₃ molecules and four Cl⁻ ions as ligands. The two NH₃ are neutral, the four Cl⁻ have a total charge of 4 $-$. We can use Equation 23.1 to determine the charge of the central metal ion:

$$\begin{aligned} \text{Charge of metal ion} &= \text{charge of complex ion} - \text{total charge of ligands} \\ &= (2-) - [(2 \times 0) + (4 \times 1-)] \\ &= (2-) - (4-) = 2+; \text{ that is, Co}^{2+} \end{aligned}$$

- For a compound with a *complex cation*, say [Co(NH₃)₄Cl₂]Cl, the Cl⁻ ion outside the brackets is the counter ion and the complex cation has a charge of 1 $+$ to balance the 1 $-$ charge of that counter ion. The complex ion [Co(NH₃)₄Cl₂]⁺ has four NH₃ ligands that are neutral and two Cl⁻ ligands with a total charge of 2 $-$, so the central metal ion must be Co³⁺:

$$\begin{aligned} \text{Charge of metal ion} &= \text{charge of complex ion} - \text{total charge of ligands} \\ &= (1+) - [(4 \times 0) + (2 \times 1-)] = 3+ \end{aligned}$$

Rules for Writing Formulas There are four rules for writing formulas of coordination compounds (the first two are the same as those for the formula of any ionic compound):

1. *The cation is written before the anion.*
2. *The charge of the cation(s) is balanced by the charge of the anion(s).*
3. *For the complex ion, neutral ligands are written (in alphabetical order) before anionic ligands (written in alphabetical order), and the formula of the whole ion is placed in brackets.*
4. *Counter ions are written outside the brackets.*

SAMPLE PROBLEM 23.3

Finding the Coordination Number and Charge of the Central Metal Ion in a Coordination Compound

Problem Give the coordination number and the charge of the central metal ion in each coordination compound:

Plan To find the coordination number, we use Table 23.6 to determine the number of ligand atoms bonded to the central metal ion in the complex ion (in square brackets). Counter ions (those ions outside the brackets) are not included when determining the coordination number. We know that the charge of the complex ion must balance the charge of the counter ions; the charge of the metal ion is equal to the charge of the complex ion minus the total charge of the ligands.

Solution (a) Each of the four monodentate OH^- ligands forms one bond to the metal ion for a coordination number of 4. Since the two Na^+ counter ions have a total charge of 2+, the charge of the complex ion is 2–; the four OH^- ligands have a total charge of 4–. The charge of the zinc ion is

$$\begin{aligned}\text{Charge of metal ion} &= \text{charge of complex ion} - \text{total charge of ligands} \\ &= (2-) - (4-) = 2+\end{aligned}$$

(b) There are two monodentate H_2O ligands, each forming one bond to the metal ion; since the two $\text{C}_2\text{O}_4^{2-}$ ligands are bidentate, each of them forms two bonds to the metal ion, for a total of four bonds. Thus, the coordination number is 6. Since the K^+ counter ion has a charge of 1+, the charge of the complex ion is 1–. The H_2O ligands are neutral, and the two $\text{C}_2\text{O}_4^{2-}$ ligands have a total charge of 4–. The charge of the cobalt ion is

$$\text{Charge of metal ion} = (1-) - [0 + (4-)] = 3+$$

(c) The complex has two H_2O , two NH_3 , and two Cl^- ligands, each of which forms one bond to the metal ion for a coordination number of 6. Since the Br^- counter ion has a 1– charge, the complex ion has a charge of 1+. The H_2O and NH_3 ligands are neutral, and the two Cl^- ligands have a total charge of 2–. The charge of the ruthenium ion is

$$\text{Charge of metal ion} = (1+) - [0 + 0 + (2-)] = 3+$$

Check Be sure that the coordination number equals the sum of the number of monodentate ligands and twice the number of bidentate ligands. Be sure that the charges of the metal ion, ligands, and counter ions sum to zero.

FOLLOW-UP PROBLEMS

23.3A Give the coordination number and the charge of the central metal ion in each coordination compound:

23.3B Write the formula of the coordination compound composed of the following:

- (a) A Mn^{2+} central ion with a coordination number of 6, cyanide ligands, and potassium counter ions
- (b) A Cu^{2+} central ion with a coordination number of 4, ethylenediamine ligands, and sulfate as the counter ion

SOME SIMILAR PROBLEMS

23.47, 23.48, 23.51, and 23.52

Table 23.7 Names of Some Neutral and Anionic Ligands

Neutral		Anionic	
Name	Formula	Name	Formula
Aqua	H ₂ O	Fluoro	F ⁻
Ammine	NH ₃	Chloro	Cl ⁻
Carbonyl	CO	Bromo	Br ⁻
Nitrosyl	NO	Iodo	I ⁻
		Hydroxo	OH ⁻
		Cyano	CN ⁻

Names of Some Metal Ions in Complex Anions**Table 23.8**

Metal	Name in Anion
Iron	Ferrate
Copper	Cuprate
Lead	Plumbate
Silver	Argentate
Gold	Aurate
Tin	Stannate

Rules for Naming Coordination Compounds Originally named after their discoverer or color, coordination compounds are named systematically according to a set of rules. Let's see how to name $[\text{Co}(\text{NH}_3)_4\text{Cl}_2]\text{Cl}$ and $\text{K}_2[\text{Co}(\text{H}_2\text{O})\text{Br}_3\text{Cl}_2]$. As we go through the naming steps, refer to Tables 23.7 and 23.8.

1. *The cation is named before the anion.* Thus, we name the $[\text{Co}(\text{NH}_3)_4\text{Cl}_2]^+$ ion before the Cl^- counter ion.
2. *Within the complex ion, the ligands are named in alphabetical order before the metal ion.* In the $[\text{Co}(\text{NH}_3)_4\text{Cl}_2]^+$ ion, four NH_3 and two Cl^- are named before Co^{3+} .
3. *Neutral ligands generally have the molecule name, but there are a few exceptions (Table 23.7). Anionic ligands drop the -ide and add -o after the root name; thus, the anion name fluoride for an F^- ion becomes the ligand name fluoro.* The two ligands in $[\text{Co}(\text{NH}_3)_4\text{Cl}_2]^+$ are *ammine* (NH_3) and *chloro* (Cl^-) with *ammine* coming before *chloro* alphabetically.
4. *A numerical prefix indicates the number of ligands of a particular type.* For example, *tetraammine* denotes four NH_3 , and *dichloro* denotes two Cl^- . Other prefixes are *tri-*, *penta-*, and *hexa-*. But prefixes do *not* affect the alphabetical order: *tetraammine* comes before *dichloro*. For ligand names that include a numerical prefix (such as *ethylenediamine*), we use *bis* (2), *tris* (3), or *tetrakis* (4) to indicate the number of such ligands, followed by the ligand name in parentheses. For example, a complex ion that has two *ethylenediamine* ligands has *bis(ethylenediamine)* in its name.
5. *The oxidation state of the metal ion has a roman numeral (in parentheses) only if the metal ion can have more than one state.* Since cobalt can have +2 and +3 states, we add a III to name the complex ion. Thus, the compound is

The only typographical space in the name comes between cation and anion.

6. *If the complex ion is an anion, we drop the ending of the metal name and add -ate.* Thus, the name for $\text{K}_2[\text{Co}(\text{H}_2\text{O})\text{Br}_3\text{Cl}_2]$ is potassium aquatribromodichlorocobaltate(III). There are two K^+ counter ions, so the complex anion has a charge of 2-. The three Br^- and two Cl^- ligands have a total charge of 5-, so Co must be in the +3 oxidation state. For some metals, we use the Latin root with the -ate ending (Table 23.8). For example, the name for $\text{Na}_4[\text{FeBr}_6]$ is sodium hexabromoferate(II).

Student Hot Spot

Student data indicate that you may struggle with naming coordination compounds. Access the Smartbook to view additional Learning Resources on this topic.

SAMPLE PROBLEM 23.4

Writing Names and Formulas of Coordination Compounds

Problem (a) What is the systematic name of $\text{Na}_3[\text{AlF}_6]?$

(b) What is the systematic name of $[\text{Co}(\text{en})_2\text{Cl}_2]\text{NO}_3?$

(c) What is the formula of tetraamminebromochloroplatinum(IV) chloride?

(d) What is the formula of hexaamminecobalt(III) tetrachloroferrate(III)?

Plan We use the rules presented above and the information in Tables 23.7 and 23.8.

Solution (a) The complex ion is $[\text{AlF}_6]^{3-}$. There are six (*hexa-*) F^- ions (*fluoro*) as ligands, so we have *hexafluoro*. The complex ion is an anion, so the ending of the

metal ion (aluminum) must be changed to *-ate*: hexafluoroaluminate. Aluminum has only the +3 oxidation state, so we do *not* use a roman numeral. The positive counter ion is named first and separated from the name of the anion by a space: sodium hexafluoroaluminate.

(b) Listed alphabetically, there are two Cl^- (*dichloro*) and two en [*bis(ethylenediamine)*] as ligands. The complex ion is a cation, so the metal name is unchanged, but we specify its oxidation state because cobalt can have several. One NO_3^- balances the 1+ cation charge. With 2– for two Cl^- and 0 for two en, the metal must be *cobalt(III)*. The word *nitrate* follows a space: *dichlorobis(ethylenediamine)cobalt(III) nitrate*.

(c) The central metal ion is written first, followed by the neutral ligands and then (in alphabetical order) by the negative ligands. *Tetraammine* is four NH_3 , *bromo* is one Br^- , *chloro* is one Cl^- , and *platinate(IV)* is Pt^{4+} , so the complex ion is $[\text{Pt}(\text{NH}_3)_4\text{BrCl}]^{2+}$. Its 2+ charge is the sum of 4+ for Pt^{4+} , 0 for four NH_3 , 1– for one Br^- , and 1– for one Cl^- . To balance the 2+ charge, we need two Cl^- counter ions: $[\text{Pt}(\text{NH}_3)_4\text{BrCl}]\text{Cl}_2$.

(d) This compound consists of two different complex ions. In the cation, *hexaammine* is six NH_3 and *cobalt(III)* is Co^{3+} , so the cation is $[\text{Co}(\text{NH}_3)_6]^{3+}$. The 3+ charge is the sum of 3+ for Co^{3+} and 0 for six NH_3 . In the anion, *tetrachloro* is four Cl^- , and *ferrate(III)* is Fe^{3+} , so the anion is $[\text{FeCl}_4]^-$. The 1– charge is the sum of 3+ for Fe^{3+} and 4– for four Cl^- . In the neutral compound, one 3+ cation must be balanced by three 1– anions: $[\text{Co}(\text{NH}_3)_6][\text{FeCl}_4]_3$.

Check Reverse the process to be sure you obtain the name or formula in the problem.

FOLLOW-UP PROBLEMS

23.4A (a) What is the name of $[\text{Cr}(\text{H}_2\text{O})_5\text{Br}]\text{Cl}_2$? (b) What is the formula of barium hexacyanocobaltate(III)?

23.4B (a) What is the formula of diaquabis(ethylenediamine)cobalt(III) sulfate? (b) What is the name of $\text{Mg}[\text{Cr}(\text{NH}_3)_2\text{Cl}_4]_2$?

SOME SIMILAR PROBLEMS 23.45, 23.46, 23.49, 23.50, 23.53, 23.54, 23.57, and 23.58

Isomerism in Coordination Compounds

Isomers are compounds with the same chemical formula but different properties. Recall the discussion of isomerism in organic compounds (Section 15.2); coordination compounds exhibit the same two broad categories—constitutional isomers and stereoisomers.

Constitutional Isomers: Atoms Connected Differently Compounds with the same formula, but with the atoms connected differently, are **constitutional (structural) isomers**. Coordination compounds exhibit two types, *coordination* and *linkage* isomers:

1. **Coordination isomers** occur when the composition of the complex ions, but not of the compounds, is different. This type of isomerism occurs in two ways:

- *Exchange of ligand and counter ion*. The roles of the Cl^- ions and the NO_2^- ions are reversed in the following example:

In $[\text{Pt}(\text{NH}_3)_4\text{Cl}_2](\text{NO}_2)_2$, the Cl^- ions are the ligands, and the NO_2^- ions are counter ions; In $[\text{Pt}(\text{NH}_3)_4(\text{NO}_2)_2]\text{Cl}_2$, the NO_2^- ions are the ligands, and the Cl^- ions are counter ions.

A common test to see whether Cl^- is a ligand or a counter ion is to treat a solution of the compound with AgNO_3 ; the Cl^- counter ion will form a white precipitate of AgCl , but the Cl^- ligand won't. Thus, a solution of $[\text{Pt}(\text{NH}_3)_4\text{Cl}_2](\text{NO}_2)_2$ does not form AgCl because Cl^- is bound to the metal ion, but a $[\text{Pt}(\text{NH}_3)_4(\text{NO}_2)_2]\text{Cl}_2$ solution forms 2 mol of AgCl per mole of compound.

- *Exchange of ligands*. This type of isomerism occurs in compounds consisting of two complex ions. For example, in $[\text{Cr}(\text{NH}_3)_6][\text{Co}(\text{CN})_6]$ and $[\text{Co}(\text{NH}_3)_6][\text{Cr}(\text{CN})_6]$, NH_3 is a ligand of Cr^{3+} in one compound and of Co^{3+} in the other.

Figure 23.9 A pair of linkage (constitutional) isomers.

Source: © McGraw-Hill Education/Charles Winters/Timeframe Photography, Inc.

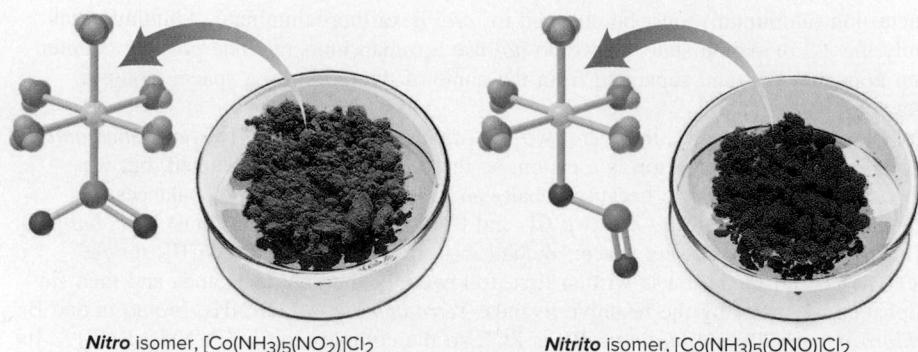

2. **Linkage isomers** occur when the composition of the complex ion is the same but the ligand donor atom is different. Some ligands can bind to the metal ion through *either of two donor atoms*. For example, the nitrite ion can bind through the N atom (*nitro*, O_2N^-) or either of the O atoms (*nitrito*, ONO^-) to give linkage isomers, such as pentaamminenitrocobalt(III) chloride $[\text{Co}(\text{NH}_3)_5(\text{NO}_2)]\text{Cl}_2$ and pentaamminenitritocobalt(III) chloride $[\text{Co}(\text{NH}_3)_5(\text{ONO})]\text{Cl}_2$ (Figure 23.9).

Other examples of ligands that have more than one donor atom are the cyanate ion, which can attach via the O atom (*cyanato*, NCO^-) or the N atom (*isocyanato*, OCN^-), and the thiocyanate ion, which can attach via the S atom (*thiocyanato*, NCS^-) or the N atom (*isothiocyanato*, SCN^-):

Stereoisomers: Atoms Arranged Differently in Space Stereoisomers are compounds that have the same atomic connections but different spatial arrangements of the atoms. *Geometric* and *optical* isomers, which we discussed for organic compounds, occur with coordination compounds as well:

1. **Geometric isomers** (also called *cis-trans* isomers, or *diastereomers*) occur when atoms or groups of atoms are arranged differently in space relative to the central metal ion. For example, the square planar $[\text{Pt}(\text{NH}_3)_2\text{Cl}_2]$ has two arrangements, which give rise to two different compounds (Figure 23.10A). The isomer with identical ligands

Figure 23.10 Geometric (*cis-trans*) isomerism. **A**, The *cis* and *trans* isomers of $[\text{Pt}(\text{NH}_3)_2\text{Cl}_2]$. **B**, The *cis* and *trans* isomers of $[\text{Co}(\text{NH}_3)_4\text{Cl}_2]^+$. The colored shapes indicate the actual colors of the species.

next to each other is *cis*-diamminedichloroplatinum(II), and the one with identical ligands across from each other is *trans*-diamminedichloroplatinum(II).

These isomers have remarkably different biological behaviors. In the mid-1960s, Barnett Rosenberg and his colleagues found that $\text{cis}[\text{Pt}(\text{NH}_3)_2\text{Cl}_2]$ (cisplatin) was an antitumor agent. It and several closely related platinum(II) complexes are still used to treat certain types of cancer. In contrast, $\text{trans}[\text{Pt}(\text{NH}_3)_2\text{Cl}_2]$ has no antitumor effect. Cisplatin may work by becoming oriented within a cancer cell so that a donor atom on each DNA strand can replace a Cl^- ligand and bind to the platinum strongly, preventing DNA replication (Section 15.6).

Octahedral complexes also exhibit *cis-trans* isomerism (Figure 23.10B). The *cis* isomer of the $[\text{Co}(\text{NH}_3)_4\text{Cl}_2]^+$ ion has the two Cl^- ligands at any two adjacent positions of the ion's octahedral shape, whereas the *trans* isomer has these ligands across from each other. Tetrahedral complexes do not exhibit this type of isomerism.

2. Optical isomers (also called *enantiomers*) occur when a molecule and its mirror image cannot be superimposed (see Figures 15.8 to 15.10). Unlike other types of isomers, which have distinct physical properties, optical isomers are physically identical except for the direction in which they rotate the plane of polarized light. Many octahedral complex ions show optical isomerism, which we can determine by rotating one isomer and seeing if it is superimposable on the other isomer (its mirror image). For example, in Figure 23.11A, the two structures (I and II) of $\text{cis}[\text{Co}(\text{en})_2\text{Cl}_2]^+$, the *cis*-dichlorobis(ethylenediamine)cobalt(III) ion, are mirror images of each other. Rotate structure I clockwise 180° around a vertical axis, and you obtain III. The Cl^- ligands of III match those of II, but the en ligands do not: II and III (which is I rotated) are not superimposable: they are optical isomers. One isomer is designated *d*- $[\text{Co}(\text{en})_2\text{Cl}_2]^+$ and the other is *l*- $[\text{Co}(\text{en})_2\text{Cl}_2]^+$, indicating whether the isomer rotates polarized light to the right (*d*- for “dextro-”) or to the left (*l*- for “levo-”). (The *d*- or *l*- designation can only be determined by experiment.)

In contrast, as shown in Figure 23.11B, the two structures of the *trans*-dichlorobis(ethylenediamine)cobalt(III) ion are *not* optical isomers: rotate I 90°

Figure 23.11 Optical isomerism in an octahedral complex ion. **A**, Structure I and its mirror image, structure II, are optical isomers of *cis*- $[\text{Co}(\text{en})_2\text{Cl}_2]^+$. (The curved wedges represent the bidentate ligand ethylenediamine, $\text{H}_2\text{N}-\text{CH}_2-\text{CH}_2-\text{NH}_2$.) **B**, The *trans* isomer does not have optical isomers.

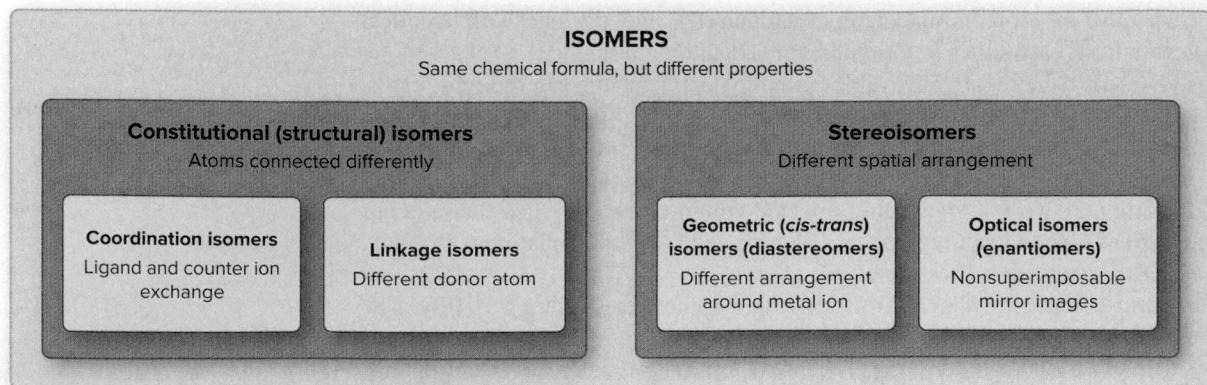

Figure 23.12 Important types of isomerism in coordination compounds.

counterclockwise around a vertical axis and you obtain III, which *is* superimposable on II.

Figure 23.12 is an overview of the most common types of isomerism in coordination compounds.

SAMPLE PROBLEM 23.5 Determining the Type of Stereoisomerism

Problem Draw stereoisomers for each of the following and state the type of isomerism:

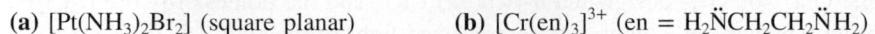

Plan We determine the geometry around each metal ion and the nature of the ligands. If there are different ligands that can be placed in different positions relative to each other, geometric (*cis-trans*) isomerism occurs. Then, we see whether the mirror image of an isomer is superimposable on the original. If it is *not*, optical isomerism also occurs.

Solution (a) The square planar Pt(II) complex has two different monodentate ligands. Each pair of ligands can lie next to or across from each other (*see margin*). Thus, geometric isomerism occurs. Each isomer *is* superimposable on a mirror image of itself, so there is no optical isomerism.

(b) Ethylenediamine (en) is a bidentate ligand. The Cr^{3+} has a coordination number of 6 and an octahedral geometry, like Co^{3+} . The three bidentate ligands are identical, so there is no geometric isomerism. However, the complex ion has a nonsuperimposable mirror image (*see margin*). Thus, optical isomerism occurs.

FOLLOW-UP PROBLEMS

23.5A What stereoisomers, if any, are possible for the $[\text{Co}(\text{NH}_3)_2(\text{en})\text{Cl}_2]^+$ ion?

23.5B Draw all of the stereoisomers of the $[\text{Ru}(\text{H}_2\text{O})_2(\text{NH}_3)_2\text{Cl}_2]^+$ ion.

SOME SIMILAR PROBLEMS 23.63–23.66

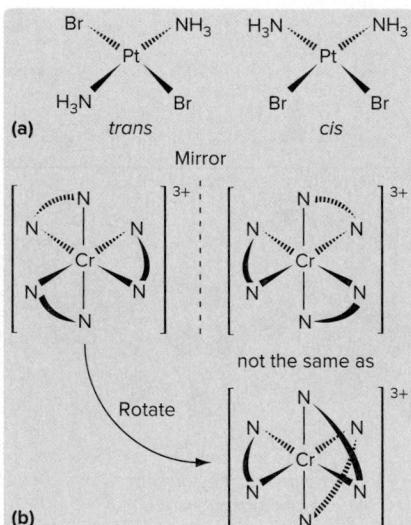

› Summary of Section 23.3

- › Coordination compounds consist of a complex ion and charge-balancing counter ions. The complex ion has a central metal ion bonded to neutral and/or anionic ligands, which have one or more donor atoms that each have a lone pair of electrons.
- › The most common complex-ion geometry is octahedral (six ligand atoms bonding).
- › Formulas and names of coordination compounds follow systematic rules.
- › Coordination compounds can exhibit constitutional isomerism (coordination and linkage) and stereoisomerism (geometric and optical).

23.4 THEORETICAL BASIS FOR THE BONDING AND PROPERTIES OF COMPLEX IONS

In this section, we consider valence bond theory and crystal field theory, which address different features of complex ions: how metal-ligand bonds form, why certain geometries are preferred, and why these ions are brightly colored and often paramagnetic.

Applying Valence Bond Theory to Complex Ions

Valence bond (VB) theory, which helps explain bonding and structure in main-group compounds (Section 11.1), can also be used to describe bonding in complex ions. In the formation of a complex ion, the *filled* ligand orbital overlaps an *empty* metal-ion orbital: *the ligand (Lewis base) donates an electron pair, and the metal ion (Lewis acid) accepts it to form a covalent bond in the complex ion (Lewis adduct)* (Section 18.9). A bond in which one atom contributes both electrons is a **coordinate covalent bond**; once formed, it is identical to any covalent single bond.

Recall that the VB concept of hybridization proposes mixing particular combinations of *s*, *p*, and *d* orbitals to obtain sets of hybrid orbitals, which have specific geometries. For coordination compounds, the model proposes that *the type of metal-ion orbital hybridization determines the geometry of the complex ion*. Let's discuss orbital combinations that lead to octahedral, square planar, and tetrahedral geometries.

Octahedral Complexes The hexaamminechromium(III) ion, $[\text{Cr}(\text{NH}_3)_6]^{3+}$, is an *octahedral complex* (Figure 23.13). The six lowest-energy, *empty* orbitals of the Cr^{3+} ion—two $3d$, one $4s$, and three $4p$ —mix and become six equivalent d^2sp^3 hybrid orbitals that point toward the corners of an octahedron.* Six NH_3 molecules donate lone pairs from their N atoms to form six metal-ligand bonds. Three unpaired $3d$ electrons of the central Cr^{3+} ion ($[\text{Ar}] 3d^3$) remain in unhybridized orbitals and make the complex ion paramagnetic.

Orbital contour depiction of $[\text{Cr}(\text{NH}_3)_6]^{3+}$

Six d^2sp^3 hybrid orbitals form and are filled with six NH_3 lone pairs (red).

Square Planar Complexes Metal ions with a d^8 configuration usually form *square planar complexes* (Figure 23.14, next page). In the $[\text{Ni}(\text{CN})_4]^{2-}$ ion, for example, the model proposes that one $3d$, one $4s$, and two $4p$ orbitals of Ni^{2+} mix and form four dsp^2 hybrid orbitals, which point to the corners of a square and accept one electron pair from each of four CN^- ligands.

A look at the ground-state electron configuration of the Ni^{2+} ion, however, raises a key question: how can the Ni^{2+} ion ($[\text{Ar}] 3d^8$) offer an empty $3d$ orbital for accepting a lone pair, if its eight $3d$ electrons lie in three filled and two half-filled orbitals? Apparently, in the d^8 configuration of Ni^{2+} , electrons in the half-filled orbitals *pair up* and leave one $3d$ orbital empty. This explanation is consistent with the fact that

*Note the difference between hybrid-orbital designations here and in Chapter 11, even though both designations give the orbitals in energy order. In $[\text{Cr}(\text{NH}_3)_6]^{3+}$, the $3d$ orbitals have a *lower n* value than the $4s$ and $4p$ orbitals, so the hybrid orbitals are d^2sp^3 . But, for SF_6 , the $3d$ orbitals have the same *n* value as the $3s$ and $3p$ orbitals of S, so the designation is sp^3d^2 .

Figure 23.13 Hybrid orbitals and bonding in the octahedral $[\text{Cr}(\text{NH}_3)_6]^{3+}$ ion.

Figure 23.14 Hybrid orbitals and bonding in the square planar $[\text{Ni}(\text{CN})_4]^{2-}$ ion.

the complex is diamagnetic (no unpaired electrons). Moreover, it means that the energy *gained* by using a $3d$ orbital for bonding in the hybrid orbital is greater than the energy *required* to overcome repulsions from pairing the $3d$ electrons.

Tetrahedral Complexes Metal ions that have a filled d sublevel, such as Zn^{2+} ($[\text{Ar}] 3d^{10}$), often form diamagnetic *tetrahedral complexes* (Figure 23.15). In the $[\text{Zn}(\text{OH})_4]^{2-}$ ion, for example, VB theory proposes that the lowest *empty* Zn^{2+} orbitals—one $4s$ and three $4p$ —mix to become four sp^3 hybrid orbitals that point to the corners of a tetrahedron and are occupied by lone pairs, one from each of four OH^- ligands.

Figure 23.15 Hybrid orbitals and bonding in the tetrahedral $[\text{Zn}(\text{OH})_4]^{2-}$ ion.

Crystal Field Theory

The VB model is easy to picture and rationalizes bonding and shape, but it treats the orbitals as little more than empty “slots” for accepting electron pairs. Moreover, it gives no insight into the colors of complex ions and sometimes predicts their magnetic properties incorrectly. For this reason, other models are applied more often. Although **crystal field theory** provides little insight about metal-ligand bonding, it explains color and magnetism by highlighting the *effect on d-orbital energies of the metal ion as the ligands approach*. Before we discuss the theory, let’s consider why a substance is colored.

What Is Color? White light consists of all wavelengths (λ) in the visible range (Section 7.1) and can be dispersed into colors of a narrower wavelength range. Objects appear colored in white light because they absorb only certain wavelengths: an opaque object *reflects* the other wavelengths, and a clear one *transmits* them. If an object absorbs all visible wavelengths, it appears black; if it reflects all, it appears white.

Each color has a *complementary* color; for example, green and red are complementary colors. Figure 23.16 shows these relationships on an artist’s color wheel in which complementary colors are wedges opposite each other. A mixture of complementary colors absorbs all visible wavelengths and appears black.

An object has a particular color for one of two reasons:

- It reflects (or transmits) light of *that* color. Thus, if an object absorbs all wavelengths *except* green, the reflected (or transmitted) light is seen as green.
- It absorbs light of the *complement* of green. Thus, if the object absorbs only red, the *complement* of green, the remaining mixture of reflected (or transmitted) wavelengths is also seen as green.

Figure 23.16 An artist’s wheel. Colors, with approximate wavelength ranges (in nm), are shown as wedges.

Table 23.9 Relation Between Absorbed and Observed Colors

Absorbed Color	λ (nm)	Observed Color	λ (nm)
Violet	400	Green-yellow	560
Blue	450	Orange	600
Blue-green	490	Red	620
Yellow-green	570	Violet	410
Yellow	580	Dark blue	430
Orange	600	Blue	450
Red	650	Green	520

Table 23.9 lists the color absorbed and the resulting color observed. The relation between absorbed and observed colors is demonstrated by the seasonal colors of deciduous trees. In the spring and summer, leaves contain high concentrations of the photosynthetic pigment *chlorophyll* and lower concentrations of other pigments called *xanthophylls*. Chlorophyll absorbs strongly in the blue and red regions, reflecting mostly green. In the fall, photosynthesis slows, so the leaf no longer makes chlorophyll. The green fades as the chlorophyll decomposes, revealing the xanthophylls that were present but masked by the chlorophyll. Xanthophylls absorb green and blue strongly, reflecting bright yellows and reds (see photo).

Splitting of *d* Orbitals in an Octahedral Field of Ligands The crystal field model explains that the properties of complex ions result from the splitting of *d*-orbital energies, which arises from *electrostatic attractions between the metal cation and the negative charge of the ligands*. This negative charge is either partial, as in a polar covalent ligand like NH_3 , or full, as in an anionic ligand like Cl^- . Picture six ligands approaching a metal ion along the mutually perpendicular *x*, *y*, and *z* axes, to form an octahedral arrangement (Figure 23.17A). Let's follow the orientation of ligand and orbital and how the approach affects orbital energies.

1. *Orientation of ligand and metal-ion orbitals.* As ligands approach, their electron pairs repel electrons in the five *d* orbitals of the metal ion. In the isolated ion, the *d* orbitals have different orientations but *equal* energies. But, in the negative field of

Foliage changing color in autumn.

Source: © Pete Turner/The Image Bank/Getty Images

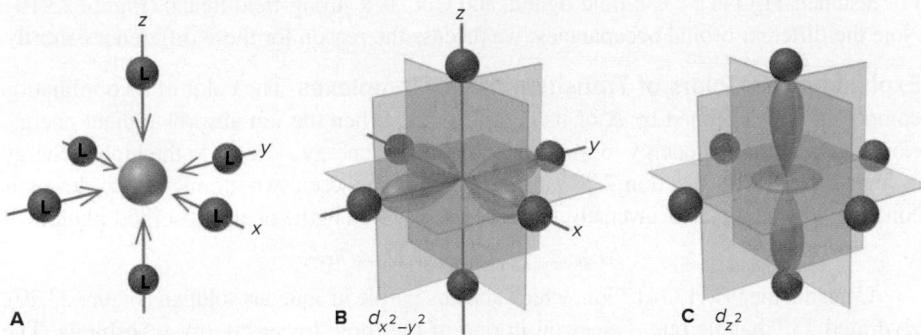Figure 23.17 The five *d* orbitals in an octahedral field of ligands.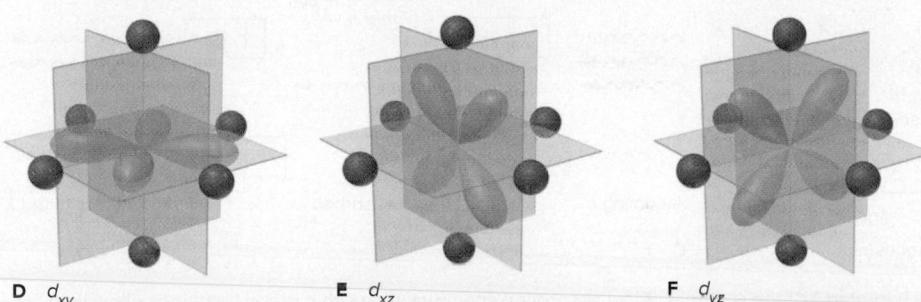The d_{xy} , d_{xz} , and d_{yz} orbitals point **between** the ligands.

Figure 23.18 Splitting of *d*-orbital energies in an octahedral field of ligands.

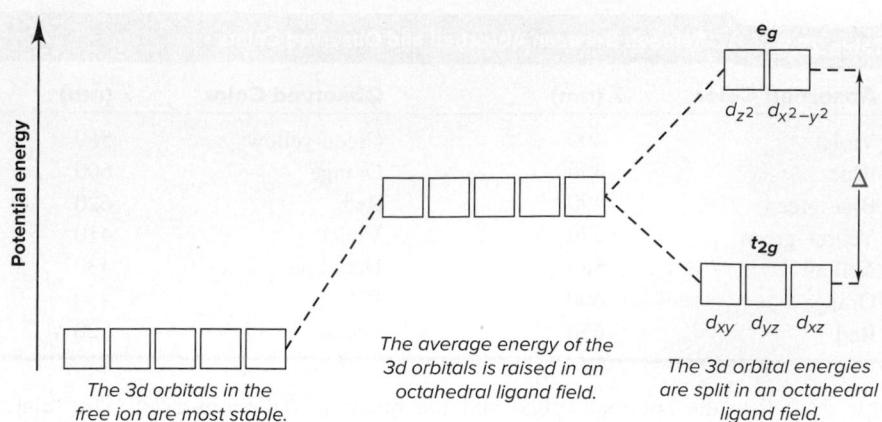

ligands, the *d* electrons are *repelled unequally because of their different orbital orientations*. The ligands moving *along* the *x*, *y*, and *z* axes approach

- Directly toward the lobes of the $d_{x^2-y^2}$ and d_z^2 orbitals (Figure 23.17B and C).
- Between the lobes of the d_{xy} , d_{xz} , and d_{yz} orbitals (Figure 23.17D to F).

2. *Effect on d-orbital energies.* As a result of these different orientations, electrons in the $d_{x^2-y^2}$ and d_z^2 orbitals experience *stronger repulsions* than do electrons in the d_{xy} , d_{xz} , and d_{yz} orbitals. An energy diagram shows that the five *d* orbitals have the same energy and are most stable in the free ion and their *average energy* is higher in the ligand field. But the *orbital energies split*, with two *d* orbitals higher in energy and three lower (Figure 23.18):

- The two higher energy orbitals are **e_g orbitals** and arise from the $d_{x^2-y^2}$ and d_z^2 orbitals.
- The three lower energy orbitals are **t_{2g} orbitals** and arise from the d_{xy} , d_{xz} , and d_{yz} orbitals.

3. *The crystal field effect.* This splitting of orbital energies is called the *crystal field effect*, and the energy difference between e_g and t_{2g} orbitals is the **crystal field splitting energy (Δ)**. Different ligands create crystal fields of different strength:

- **Strong-field ligands** lead to a *larger* splitting energy (larger Δ).
- **Weak-field ligands** lead to a *smaller* splitting energy (smaller Δ).

For instance, H_2O is a weak-field ligand, and CN^- is a strong-field ligand (Figure 23.19). Note the different orbital occupancies; we discuss the reason for these differences shortly.

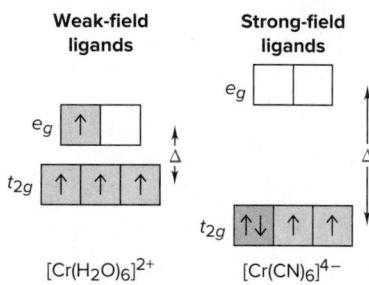

Figure 23.19 The effect of ligands on splitting energy and orbital occupancy.

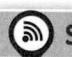

Student Hot Spot

Student data indicate that you may struggle with the concept of crystal field theory. Access the Smartbook to view additional Learning Resources on this topic.

Explaining the Colors of Transition Metal Complexes The color of a coordination compound is determined by Δ of its complex ion. When the ion absorbs radiant energy, electrons can use that energy to move from the lower energy t_{2g} level to the higher energy e_g level. Recall from Section 7.2 that the *difference* between two atomic energy levels is equal to the energy (and inversely related to the wavelength) of the absorbed photon:

$$\Delta E_{\text{electron}} = E_{\text{photon}} = h\nu = hc/\lambda$$

Consider the $[Ti(H_2O)_6]^{3+}$ ion, which appears purple in aqueous solution (Figure 23.20). Hydrated Ti^{3+} has its one *d* electron in one of the three lower energy t_{2g} orbitals. The

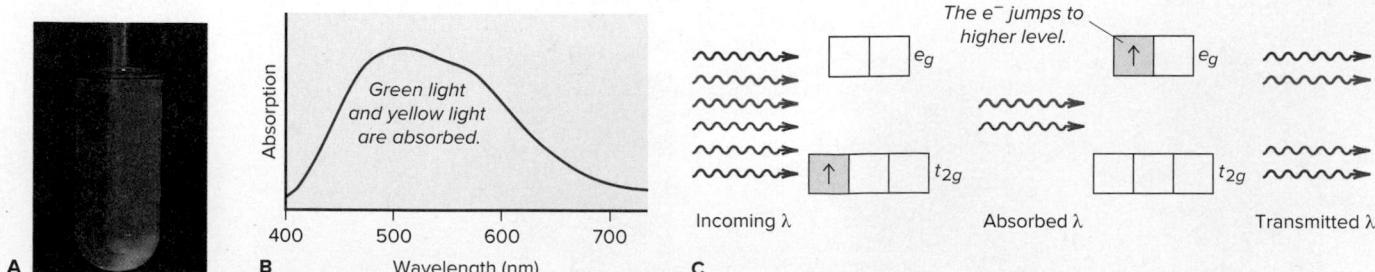

Figure 23.20 The color of $[Ti(H_2O)_6]^{3+}$. **A**, The hydrated Ti^{3+} ion is purple. **B**, An absorption spectrum shows that green light and yellow light are absorbed and other wavelengths are transmitted. **C**, An orbital diagram depicts the colors absorbed when the *d* electron jumps to the higher level. Source: (A) © McGraw-Hill Education/Pat Watson, photographer

energy difference (Δ) between the t_{2g} and e_g orbitals in this ion corresponds to the energy of photons in the green-to-yellow range of visible light. When white light shines on the solution, these colors of light are absorbed, and the electron uses that energy to jump to one of the e_g orbitals. Red, blue, and violet light are transmitted, so the solution appears purple.

Absorption spectra can show the wavelengths absorbed by (1) different metal ions with the same ligand and (2) a metal ion with different ligands. Such data allow us to relate the energy of the absorbed light to Δ and make two key observations:

- For a given ligand, color depends on the *oxidation state of the metal ion*. The higher a metal's oxidation state, the larger the crystal field splitting energy and the greater the energy of visible light that must be absorbed to move an electron from the t_{2g} level to the e_g level. For example, $[\text{V}(\text{H}_2\text{O})_6]^{2+}(aq)$, with vanadium in an oxidation state of +2, absorbs in the yellow range and is violet in color, while $[\text{V}(\text{H}_2\text{O})_6]^{3+}(aq)$ with vanadium in an oxidation state of +3 absorbs in the higher energy violet range and is yellow in color (Figure 23.21A).
- For a given metal ion, color depends on the *ligand*. A single ligand substitution can affect the wavelengths absorbed and, thus, the color. For example, replacing one NH_3 ligand in the yellow $[\text{Cr}(\text{NH}_3)_6]^{3+}$ ion with a Cl^- ligand results in a purple $[\text{Cr}(\text{NH}_3)_5\text{Cl}]^{2+}$ ion (Figure 23.21B).

The Spectrochemical Series The fact that color depends on the ligand allows us to create a **spectrochemical series**, which ranks the ability of a ligand to split d -orbital energies (Figure 23.22). Using this series, we can predict the *relative magnitude* of Δ for a series of octahedral complexes of a *given* metal ion. As Δ increases, higher energies (shorter wavelengths) of light must be absorbed to excite electrons. Although we cannot predict the actual color of a given complex ion, we can determine whether it will absorb longer or shorter wavelengths than other complexes with different ligands.

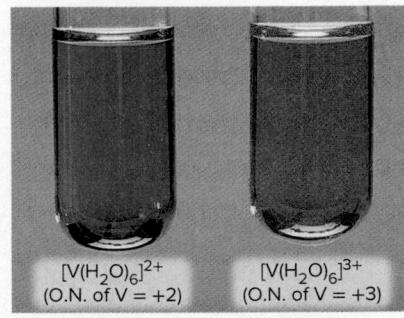

A

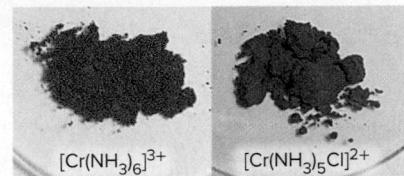

B

Figure 23.21 Effects of oxidation state and ligand on color. **A**, Solutions of two hydrated vanadium ions. **B**, A change in one ligand can influence the color.

Source: © McGraw-Hill Education/Stephen Frisch, photographer

Figure 23.22 The spectrochemical series. For reference, water is a weak-field ligand.

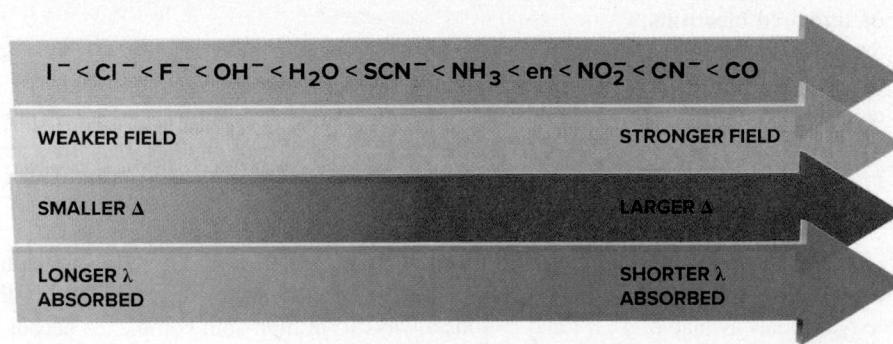

SAMPLE PROBLEM 23.6

Ranking Crystal Field Splitting Energies (Δ) for Complex Ions of a Metal

Problem Rank $[\text{Ti}(\text{H}_2\text{O})_6]^{3+}$, $[\text{Ti}(\text{CN})_6]^{3-}$, and $[\text{Ti}(\text{NH}_3)_6]^{3+}$ in terms of Δ and of the energy of visible light absorbed.

Plan The formulas show that Ti has the same oxidation state (+3) in the three ions. Using Figure 23.22, we rank the ligands by crystal field strength: the stronger the ligand, the greater the splitting, and the higher the energy of light absorbed.

Solution The ligand field strength is in the order $\text{CN}^- > \text{NH}_3 > \text{H}_2\text{O}$, so the relative size of Δ and energy of light absorbed is

$$[\text{Ti}(\text{CN})_6]^{3-} > [\text{Ti}(\text{NH}_3)_6]^{3+} > [\text{Ti}(\text{H}_2\text{O})_6]^{3+}$$

FOLLOW-UP PROBLEMS

23.6A Which complex ion absorbs visible light of higher energy, $[\text{V}(\text{H}_2\text{O})_6]^{3+}$ or $[\text{V}(\text{NH}_3)_6]^{3+}$?

23.6B Some of the complex ions that Co^{3+} forms are $[\text{Co}(\text{en})_3]^{3+}$, $[\text{Co}(\text{NH}_3)_5\text{Cl}]^{2-}$, $[\text{Co}(\text{NH}_3)_4\text{Cl}_2]^+$, and $[\text{Co}(\text{NH}_3)_5(\text{H}_2\text{O})]^{3+}$. The observed colors of these ions (listed in arbitrary order) are red, green, purple, and yellow. Match each complex ion with its color.

SOME SIMILAR PROBLEMS 23.92–23.95, 23.97, and 23.98

Explaining the Magnetic Properties of Transition Metal Complexes Splitting of energy levels gives rise to magnetic properties based on the number of *unpaired* electrons in the metal ion's *d* orbitals. Based on Hund's rule, electrons occupy orbitals of equal energy one at a time. When all lower energy orbitals are half-filled, one of two situations occurs:

- The next electron can enter a half-filled orbital and pair up by overcoming a repulsive *pairing energy* (E_{pairing}).
- The next electron can enter an empty, higher energy orbital by overcoming Δ .

Thus, the relative sizes of E_{pairing} and Δ determine the occupancy of *d* orbitals, which determines the number of unpaired electrons and, thus, the magnetic behavior of the ion.

As an example, the isolated Mn^{2+} ion ([Ar] $3d^5$) has five unpaired electrons of equal energy (Figure 23.23A). In an octahedral field of ligands, orbital occupancy is affected by the ligand in one of two ways:

- Weak-field ligands and high-spin complexes.* Weak-field ligands, such as H_2O in $[\text{Mn}(\text{H}_2\text{O})_6]^{2+}$, cause a *small* splitting energy, so it takes *less* energy for *d* electrons to jump to the e_g set and stay unpaired than to pair up in the t_{2g} set (Figure 23.23B). Thus, for weak-field ligands, $E_{\text{pairing}} > \Delta$. Therefore, the number of unpaired electrons in the complex ion is the same as in the free ion: weak-field ligands create **high-spin complexes**, those with the maximum number of unpaired electrons.
- Strong-field ligands and low-spin complexes.* In contrast, strong-field ligands, such as CN^- in $[\text{Mn}(\text{CN})_6]^{4-}$, cause a *large* splitting energy, so it takes *more* energy for electrons to jump to the e_g set than to pair up in the t_{2g} set (Figure 23.23C). Thus, for strong-field ligands, $E_{\text{pairing}} < \Delta$. Therefore, the number of unpaired electrons in the complex ion is less than in the free ion. Strong-field ligands create **low-spin complexes**, those with fewer unpaired electrons.

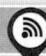

Student Hot Spot

Student data indicate that you may struggle with determining the number of unpaired electrons in high-spin vs. low-spin complex ions. Access the Smartbook to view additional Learning Resources on this topic.

Orbital diagrams for d^1 through d^9 ions in octahedral complexes show that high-spin and low-spin options are possible only for d^4 , d^5 , d^6 , and d^7 ions (Figure 23.24). With three t_{2g} orbitals available, d^1 , d^2 , and d^3 ions always form high-spin complexes because there is no need to pair up. Similarly, d^8 and d^9 ions always form high-spin complexes because the t_{2g} set is filled with six electrons, so the e_g orbitals must have either two (d^8) or one (d^9) unpaired electron(s).

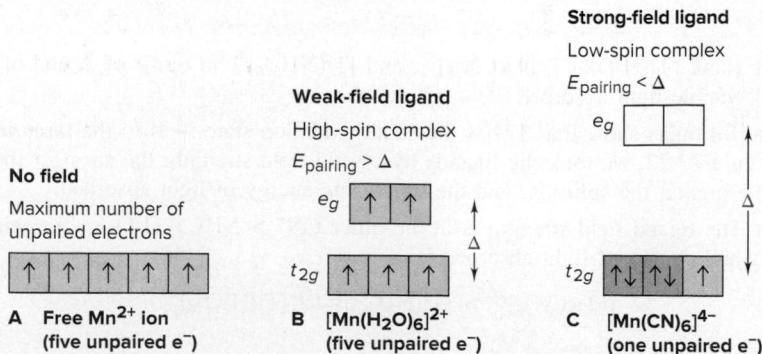

Figure 23.23 High-spin and low-spin octahedral complex ions of Mn^{2+} .

SAMPLE PROBLEM 23.7**Identifying High-Spin and Low-Spin Complex Ions**

Problem Iron(II) forms a complex in hemoglobin. For each of the two octahedral complex ions $[\text{Fe}(\text{H}_2\text{O})_6]^{2+}$ and $[\text{Fe}(\text{CN})_6]^{4-}$, draw an energy diagram showing orbital splitting, predict the number of unpaired electrons, and identify the ion as low spin or high spin.

Plan The Fe^{2+} electron configuration shows the number of d electrons, and the spectrochemical series (Figure 23.22) shows the relative ligand strengths. We draw energy diagrams, in which the t_{2g} and e_g orbital sets are farther apart (larger energy difference) for the strong-field ligand. Then we add electrons, noting that a weak-field ligand gives the *maximum* number of unpaired electrons and a high-spin complex, whereas a strong-field ligand gives the *minimum* number of unpaired electrons and a low-spin complex.

Solution Fe^{2+} has the $[\text{Ar}] 3d^6$ configuration. H_2O produces smaller splitting than CN^- . The energy diagrams are shown below. The $[\text{Fe}(\text{H}_2\text{O})_6]^{2+}$ ion has four unpaired electrons (high spin), and the $[\text{Fe}(\text{CN})_6]^{4-}$ ion has no unpaired electrons (low spin).

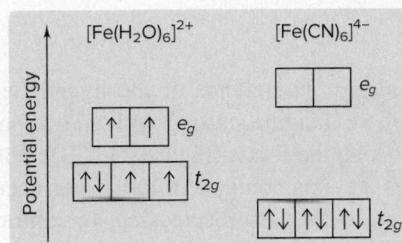

Comment 1. H_2O is a weak-field ligand, so it forms high-spin complexes. 2. We cannot confidently predict the spin of a complex without having actual values for Δ and E_{pairing} . 3. Cyanide ions and carbon monoxide are toxic because they bind to the iron complexes in proteins involved in cellular energy (see the Chemical Connections at the end of Chapter 21 and the upcoming Chemical Connections).

FOLLOW-UP PROBLEMS

23.7A How many unpaired electrons do you expect for $[\text{Mn}(\text{CN})_6]^{3-}$? Is this a high-spin or low-spin complex ion?

23.7B How many unpaired electrons do you expect for $[\text{CoF}_6]^{3-}$? Is this a high-spin or low-spin complex ion?

SOME SIMILAR PROBLEMS 23.88–23.91

Crystal Field Splitting in Tetrahedral and Square Planar Complexes Four ligands around a metal ion also cause d -orbital splitting, but the magnitude and pattern of the splitting depend on whether the ligands approach from a tetrahedral or a square planar orientation.

1. **Tetrahedral complexes.** When the ligands approach from the corners of a tetrahedron, none of the five d orbitals is directly in their paths (Figure 23.25A, *next page*). Thus, the overall attraction of ligand and metal ion is weaker, so the splitting of d -orbital energies is *less* in a tetrahedral than in an octahedral complex with the same ligands:

$$\Delta_{\text{tetrahedral}} < \Delta_{\text{octahedral}}$$

Repulsions are minimized when the ligands approach the d_{xy} , d_{xz} , and d_{yz} orbitals closer than they do the $d_{x^2-y^2}$ and d_z^2 orbitals. This situation is the *opposite of the octahedral case*, so the relative d -orbital energies are reversed: the d_{xy} , d_{xz} , and d_{yz} orbitals become *higher* in energy than the $d_{x^2-y^2}$ and d_z^2 orbitals. *Only high-spin tetrahedral complexes are known* because the magnitude of Δ is always smaller than E_{pairing} , regardless of the ligand.

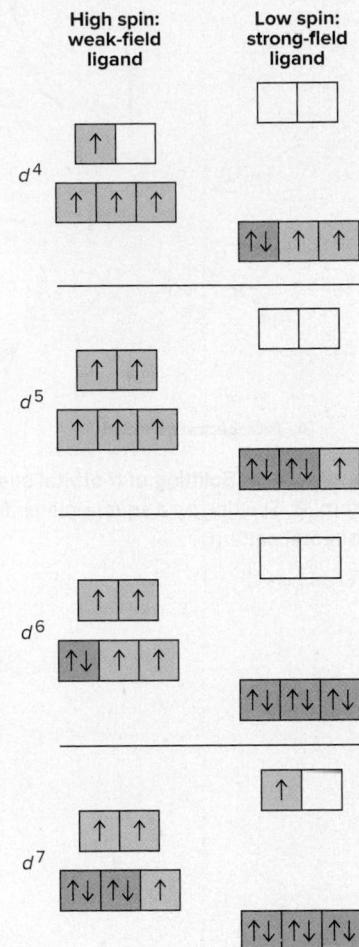

Figure 23.24 Orbital occupancy for high-spin and low-spin octahedral complexes of d^4 through d^7 metal ions.

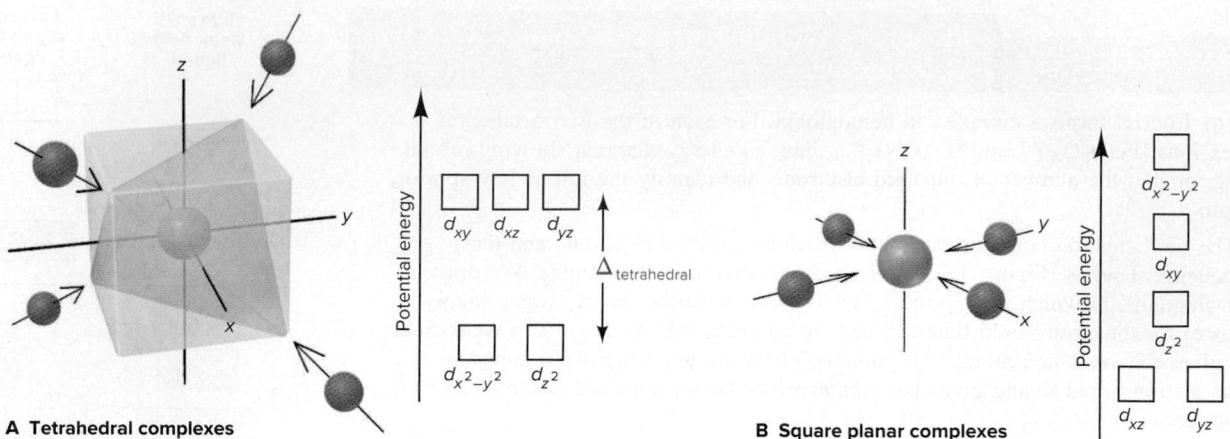

Figure 23.25 Splitting of d -orbital energies. **A**, The pattern of splitting by a tetrahedral field of ligands is the opposite of the octahedral pattern. **B**, Splitting by a square planar field of ligands decreases the energies of d_{xz} , d_{yz} , and especially d_z^2 orbitals relative to the octahedral pattern.

2. *Square planar complexes.* The effects of the ligand field in the square planar case are easier to picture if we imagine starting with an octahedral geometry and then removing the two ligands along the z -axis (Figure 23.25B). With no z -axis interactions present, any d orbital with a z -axis component has lower energy, with the d_z^2 orbital decreasing most, and the d_{xz} and d_{yz} also decreasing. In contrast, the two d orbitals in the xy -plane interact strongly with the ligands, and because the $d_{x^2-y^2}$ orbital has its lobes *on* the axes, its energy is highest. The d^8 metal ions form square planar complexes, such as $[\text{PdCl}_4]^{2-}$. They are *low spin* and usually *diamagnetic* because the four pairs of d electrons fill the four lowest-energy orbitals.

A Final Word About Bonding Theories As you have seen in several other cases, no one model is satisfactory in every respect. For complex ions, VB theory offers a simple picture of bond formation but does not even attempt to explain spectral and magnetic behavior of complexes. Crystal field theory predicts those two behaviors but offers no insight into the covalent nature of metal-ligand bonding. Thus, chemists now rely on the more comprehensive and quantitative *ligand field theory*, which combines aspects of the previous two models with MO theory (Section 11.3). While beyond the scope of this text, this powerful model predicts bond properties from the overlap of metal ion and ligand orbitals as well as the spectral and magnetic properties resulting from the splitting of the metal ion's d orbitals.

In addition to their important chemical applications, complexes of the transition elements play vital roles in living systems, as the following Chemical Connections essay describes.

› Summary of Section 23.4

- › According to valence bond theory, complex ions have coordinate covalent bonds between ligands (Lewis bases) and metal ions (Lewis acids).
- › Ligand lone pairs occupy hybridized metal-ion orbitals, leading to the characteristic shapes of complex ions.
- › According to crystal field theory, the surrounding field of ligands splits a metal ion's d -orbital energies. The crystal field splitting energy (Δ) depends on the charge of the metal ion and the crystal field strength of the ligands.
- › Δ influences the color (energy of the photons absorbed) and paramagnetism (number of unpaired d electrons) of a complex ion. Strong-field ligands create a large Δ and produce low-spin complexes that absorb light of higher energy (shorter wavelength); the reverse is true of weak-field ligands.
- › Several transition metals, including iron and zinc, are essential dietary components in trace amounts because they are crucial to the biochemical function of key proteins.

Living things consist primarily of water and complex organic compounds made of four *building-block elements* C, O, H, and N. They also contain seven other elements, known as *macronutrients* because of their fairly high concentrations. These macronutrients are (listed in order of atomic number): Na, Mg, P, S, Cl, K, and Ca. In addition, organisms contain a large number of elements in low concentrations, and most of these *micronutrients*, or *trace elements*, are transition metals.

With the exception of scandium and titanium, all Period 4 transition elements are essential to organisms (Table B23.1, *next page*), and plants also require molybdenum (from Period 5). A transition metal ion typically lies next to a protein chain covalently bonded to surrounding amino acid R groups whose N and O atoms act as ligands. Despite the complexity of biomolecules, the principles of bonding and *d*-orbital splitting are the same as in simple inorganic systems. In this discussion, we focus on iron and zinc.

Iron and the Heme Group

Iron plays a crucial role in oxygen transport in all vertebrates. The oxygen-transporting protein hemoglobin (Figure B23.1A) consists of four folded protein chains called *globins*, each cradling the iron-containing complex *heme*. Each heme complex has an Fe^{2+} ion at the center of a tetradentate ring ligand *porphin* and bonded to the ligand's four N lone pairs to form a *square planar* complex. When heme is bound in hemoglobin, the complex becomes *square*

pyramidal, with an N atom from a nearby amino acid (histidine) as the fifth ligand. Hemoglobin exists in two forms, depending on the presence of O_2 , which acts as a sixth ligand:

- *In the lungs*, where $[\text{O}_2]$ is high, heme binds O_2 to form *oxyhemoglobin*, which is transported in the arteries to tissues. With O_2 bound, heme exists as part of an *octahedral* complex (Figure B23.1B). Since O_2 is a strong-field ligand, the $d^6 \text{Fe}^{2+}$ ion is part of a low-spin complex. Because of the relatively large *d*-orbital splitting, oxyhemoglobin absorbs blue (high-energy) light, so arterial blood is bright red.
- *At the tissues*, where $[\text{O}_2]$ is low, the bound O_2 is released, and *deoxyhemoglobin* forms, which is transported in the veins back to the lungs. Without the O_2 , the Fe^{2+} ion is part of a high-spin complex, which has relatively small *d*-orbital splitting. Thus, deoxyhemoglobin absorbs red (low-energy) light, and venous blood is dark, purplish red.

The relative position of Fe^{2+} in the plane of the porphin ring also depends on the presence of the sixth ligand. Bound to O_2 , Fe^{2+} moves *into* the porphin plane; when O_2 is released, it moves slightly *out of* the plane. This tiny (60 pm) change due to the binding or release of O_2 alters the shape of the globin chain. And this change in shape alters the shape of the next globin chain, triggering the release or attachment of its O_2 , and so on to the other two globin chains. This “cooperation” among the four globin chains allows hemoglobin to rapidly pick up O_2 from the lungs and unload it rapidly in the tissues.

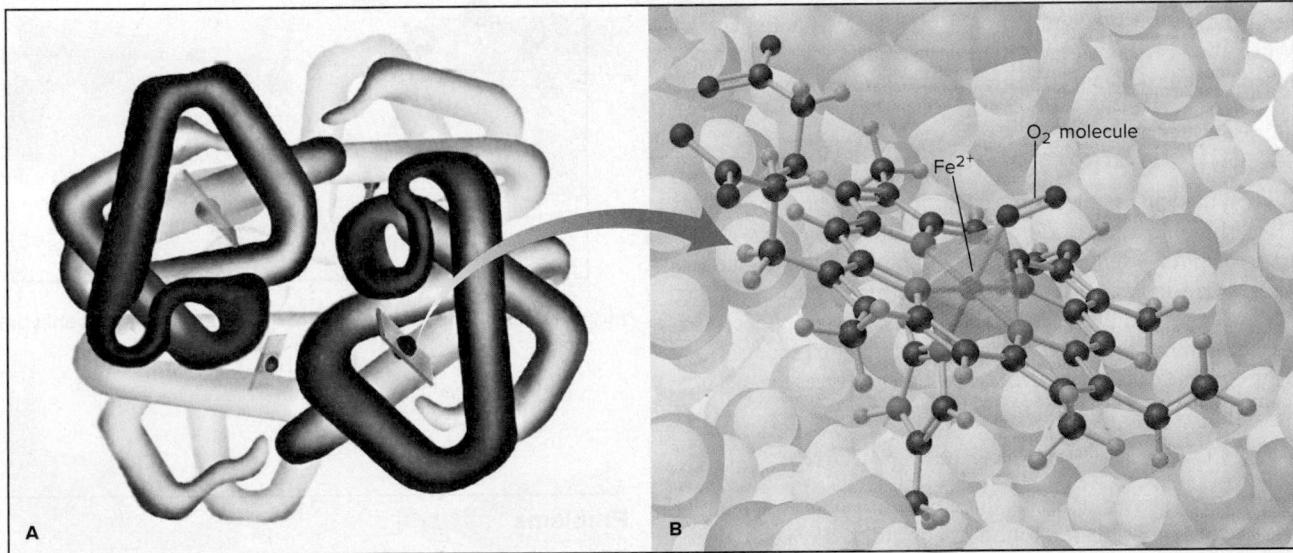

Figure B23.1 Hemoglobin and the octahedral complex in heme. **A**, Hemoglobin consists of four protein chains, each with a bound heme. **B**, In oxyhemoglobin, the octahedral complex in heme has an O_2 molecule as the sixth ligand of iron(II).

B23.1A: Illustration, Irving Geis. Image from the Irving Geis Collection, Howard Hughes Medical Institute. Rights owned by HHMI. Not to be reproduced without permission.

(continued)

Table B23.1 Some Transition Metal Trace Elements in Humans

Element	Biomolecule(s) Containing Element	Function(s) of Biomolecule(s)
Vanadium	Protein (?)	Redox couple in fat metabolism (?)
Chromium	Glucose tolerance factor	Glucose utilization
Manganese	Isocitrate dehydrogenase	Cell respiration
Iron	Hemoglobin and myoglobin Cytochrome <i>c</i> Catalase	Oxygen transport Cell respiration; ATP formation Decomposition of H ₂ O ₂
Cobalt	Cobalamin (vitamin B ₁₂)	Development of red blood cells
Copper	Ceruloplasmin Cytochrome oxidase	Hemoglobin synthesis Cell respiration; ATP formation
Zinc	Carbonic anhydrase Carboxypeptidase A Alcohol dehydrogenase	Elimination of CO ₂ Protein digestion Metabolism of ethanol

Heme binding of O₂ is an equilibrium process. Carbon monoxide is toxic because it binds to Fe²⁺ about 200 times more tightly than O₂ does; each CO that binds eliminates one heme group from functioning. Like O₂, CO is a strong-field ligand and produces a bright red, “healthy” look in the poisoned individual. Because binding is reversible, breathing high concentrations of O₂ displaces CO from the heme:

Porphyrin is a very common biological ligand. Chlorophyll has Mg²⁺ and vitamin B₁₂ has Co³⁺ at the center of a very similar ring system. Heme itself is found not only in hemoglobin, but also in proteins called *cytochromes* that are involved in energy metabolism (see Chemical Connections at end of Chapter 21).

Zinc and the Enzyme Active Site

The zinc ion occurs at the active sites of several enzymes. With its d¹⁰ configuration, Zn²⁺ forms tetrahedral complexes with the N atoms of three amino acid groups at three positions, and the fourth position is free to interact with the molecule undergoing reaction (Figure B23.2). In its role as Lewis acid, Zn²⁺ accepts a lone pair from the reactant as a step in the catalytic process. Consider the enzyme carbonic anhydrase, which catalyzes the reaction between H₂O and CO₂ during respiration:

The Zn²⁺ at the active site binds three histidine N atoms, and the O of the reactant H₂O is the fourth donor atom. By withdrawing electron density from the O—H bonds, the Zn²⁺ makes the H₂O acidic enough to lose a proton. In the rate-determining step, the bound OH⁻ ion is attracted to the partially positive C of CO₂ much more strongly than the lone pair of a free water molecule would be; thus, the reaction rate is higher. One reason Cd²⁺ is toxic is that it competes with Zn²⁺ for the carbonic anhydrase active site.

Figure B23.2 The tetrahedral Zn²⁺ complex in carbonic anhydrase.

Problems

B23.1 (a) Identify each compound’s central metal ion and give its oxidation state: chlorophyll, heme, and vitamin B₁₂. (b) What similarity in structure do these compounds have?

B23.2 Suggest a structural reason why carbonic anhydrase synthesized with Ni²⁺, Fe²⁺, or Mn²⁺ in place of Zn²⁺ has less catalytic efficiency.

CHAPTER REVIEW GUIDE

Learning Objectives

Relevant section (S) and/or sample problem (SP) numbers appear in parentheses.

Understand These Concepts

- The positions of the *d*- and *f*-block elements and the general forms of their atomic and ionic electron configurations (§23.1)
- How atomic size, ionization energy, and electronegativity vary across a period and down a group of transition elements and how these trends differ from those of the main-group elements; why the densities of Period 6 transition elements are so high (§23.1)
- Why the transition elements often have multiple oxidation states and why the +2 state is common (§23.1)
- Why metallic behavior (prevalence of ionic bonding and basic oxides) of transition elements decreases as oxidation state increases; how valence-state electronegativity explains transition metal atoms in oxoanions (§23.1)
- Why many transition metal compounds are colored and paramagnetic (§23.1)
- The common +3 oxidation state of the lanthanides and the similarity of the radii of their M³⁺ ions; the radioactivity of the actinides (§23.2)
- The coordination numbers, geometries, and ligand structures of complex ions (§23.3)
- How coordination compounds are named and their formulas written (§23.3)
- The types of constitutional isomerism (coordination and linkage) and stereoisomerism (geometric and optical) of complex ions (§23.3)
- How valence bond theory uses hybridization to account for the shapes of octahedral, square planar, and tetrahedral complexes (§23.4)
- How crystal field theory explains that approaching ligands cause *d*-orbital energies to split (§23.4)
- How the relative crystal field strength of ligands (spectrochemical series) affects the *d*-orbital splitting energy (Δ) (§23.4)

- How the magnitude of Δ accounts for the energy of light absorbed and, thus, the color of a complex ion (§23.4)
- How the relative sizes of pairing energy and Δ determine the occupancy of *d* orbitals and, thus, the magnetic properties of complex ions (§23.4)
- How *d*-orbital splitting in tetrahedral and square planar complexes differs from that in octahedral complexes (§23.4)

Master These Skills

- Writing electron configurations of transition metal atoms and ions (SP 23.1)
- Using a partial orbital diagram to determine the number of unpaired electrons in a transition metal atom or ion (SP 23.2)
- Recognizing the structural components of complex ions (§23.3)
- Determining the coordination number and charge of the central metal ion in a coordination compound (SP 23.3)
- Naming and writing formulas of coordination compounds (SP 23.4)
- Determining the type of stereoisomerism in complexes (SP 23.5)
- Correlating a complex ion's shape with the number and type of hybrid orbitals of the central metal ion (§23.4)
- Using the spectrochemical series to rank complex ions in terms of Δ and the energy of visible light absorbed (SP 23.6)
- Using the spectrochemical series to determine if a complex ion is high spin or low spin (SP 23.7)

Key Terms

Page numbers appear in parentheses.

actinides (1044)
chelate (1047)
complex ion (1046)
constitutional (structural) isomers (1051)
coordinate covalent bond (1055)
coordination compound (1046)
coordination isomers (1051)

coordination number (1046)
counter ion (1046)
crystal field splitting energy (Δ) (1058)
crystal field theory (1056)
donor atom (1047)
e_g orbital (1058)
geometric (*cis-trans*) isomers (1052)

high-spin complex (1060)
inner transition elements (1044)
isomer (1051)
lanthanide contraction (1041)
lanthanides (1044)
ligand (1046)
linkage isomers (1052)

low-spin complex (1060)
optical isomers (1053)
spectrochemical series (1059)
stereoisomers (1052)
strong-field ligand (1058)
t_{2g} orbital (1058)
transition elements (1037)
weak-field ligand (1058)

Key Equation and Relationship

Page number appears in parentheses.

23.1 Finding the charge of the metal ion in a complex anion or cation (1048):

$$\text{Charge of metal ion} = \text{charge of complex ion} - \text{total charge of ligands}$$

BRIEF SOLUTIONS TO FOLLOW-UP PROBLEMS

23.1A (a) Ag: $5s^14d^{10}$; Ag^+ : $4d^{10}$ (b) Cd: $5s^24d^{10}$; Cd^{2+} : $4d^{10}$
 (c) Ir: $6s^25d^7$; Ir^{3+} : $5d^6$

23.1B (a) Ta: [Xe] $6s^24f^{14}5d^3$; three electrons have been lost: Ta^{3+}
 (b) Mn: [Ar] $4s^23d^5$; four electrons have been lost: Mn^{4+}
 (c) Os: [Xe] $6s^24f^{14}5d^6$; three electrons have been lost: Os^{3+}

23.2A Er: [Xe] $6s^24f^{12}$; Er^{3+} is [Xe] $4f^{11}$; three unpaired electrons

23.2B Dy: [Xe] $6s^24f^{10}$; Dy^{3+} is [Xe] $4f^9$; five unpaired electrons

23.3A (a) Each en bidentate ligand forms two bonds to the metal ion, for a total of four bonds; the two monodentate Br^- ligands form a total of two bonds; coordination number = 6. The complex ion has a charge of 1+:

Charge of metal ion = charge of complex ion

$$\begin{aligned} &\quad \text{— total charge of ligands} \\ &= (1+) - [(2 \times 0) + (2 \times 1-)] = 3+; \text{Co}^{3+} \end{aligned}$$

(b) The complex has six monodentate ligands; coordination number = 6; three Mg^{2+} counter ions have a total charge of 6+; each of the two complex ions has a charge of 3-:

Charge of metal ion = charge of complex ion

$$\begin{aligned} &\quad \text{— total charge of ligands} \\ &= (3-) - [(6 \times 1-)] = 3+; \text{Cr}^{3+} \end{aligned}$$

23.3B (a) $\text{K}_4[\text{Mn}(\text{CN})_6]$ (b) $[\text{Cu}(\text{en})_2]\text{SO}_4$

23.4A (a) Five (*penta-*) H_2O (*aqua*) ligands, one Br^- (*bromo*) ligand, and the Cr^{3+} ion in the complex ion with Cl^- counter ions: Penta aquabromochromium(III) chloride

(b) Hexacyano: $[\text{CN}]_6$; charge of complex ion = 3+ [from Co(III)] + (6-) [from $[\text{CN}]_6$] = 3-; three 2+ barium counter ions are needed to balance the charge of two 3- complex ions: $\text{Ba}_3[\text{Co}(\text{CN})_6]_2$

23.4B (a) Two (*di-*) water (*aqua*) and two (*bis*) en ligands; charge of complex ion = 3+ [from Co(III)] + 2(0) [from $(\text{H}_2\text{O})_2$] and 2(0) [from $(\text{en})_2$] = 3+; three SO_4^{2-} counter ions are needed to balance the charge of two 3+ complex ions: $[\text{Co}(\text{H}_2\text{O})_2(\text{en})_2]_2(\text{SO}_4)_3$

(b) Two (*di-*) NH_3 (*ammine*) and four (*tetra-*) Cl^- (*chloro*) ligands and the Cr^{3+} ion with Mg^{2+} as the counter ion: magnesium diamminetetrachlorochromate(III)

23.5A Two sets of *cis-trans* isomers, and the two *cis* isomers are optical isomers.

23.5B Five geometric isomers; the *cis* isomer has an optical isomer.

23.6A Both metal ions are V^{3+} ; in terms of ligand field energy, $\text{NH}_3 > \text{H}_2\text{O} > \text{Cl}^-$, so $[\text{V}(\text{NH}_3)_6]^{3+}$ absorbs light of higher energy.

23.6B In terms of ligand field energy and energy of light absorbed, en > $\text{NH}_3 > \text{H}_2\text{O} > \text{Cl}^-$; $[\text{Co}(\text{en})_3]^{3+}$ is yellow (violet light absorbed), $[\text{Co}(\text{NH}_3)_5(\text{H}_2\text{O})]^{3+}$ is red (green light absorbed), $[\text{Co}(\text{NH}_3)_5\text{Cl}]^{2+}$ is purple (yellow light absorbed), and $[\text{Co}(\text{NH}_3)_4\text{Cl}_2]^+$ is green (red light absorbed). As weaker field ligands replace stronger field ligands, the energy of light absorbed decreases.

23.7A The metal ion is Mn^{3+} : [Ar] $3d^4$; CN^- is a strong-field ligand:

Two unpaired *d* electrons; low-spin complex

23.7B The metal ion is Co^{3+} : [Ar] $3d^6$; F^- is a weak-field ligand:

Four unpaired *d* electrons; high-spin complex

PROBLEMS

Problems with **colored** numbers are answered in Appendix E and worked in detail in the Student Solutions Manual. Problem sections match those in the text and give the numbers of relevant sample problems. Most offer Concept Review Questions, Skill-Building Exercises (grouped in pairs covering the same concept), and Problems in Context. The Comprehensive Problems are based on material from any section or previous chapter.

Note: In these problems, the term *electron configuration* refers to the condensed, ground-state electron configuration.

Properties of the Transition Elements

(Sample Problem 23.1)

Concept Review Questions

23.1 How is the *n* value of the *d* sublevel of a transition element related to the period number of the element?

23.2 Write the general electron configuration of a transition element (a) in Period 5; (b) in Period 6.

23.3 (a) What is the general rule concerning the order in which electrons are removed from a transition metal atom to form an ion? Give an example from Group 5B(5). (b) Name two types of measurements used to study electron configurations of ions.

23.4 What is the maximum number of unpaired *d* electrons that an atom or ion can possess? Give an example of an atom and an ion that have this number.

23.5 How does the variation in atomic size across a transition series contrast with the change across the main-group elements of the same period? Why?

23.6 (a) What is the lanthanide contraction? (b) How does it affect atomic size down a group of transition elements? (c) How does it influence the densities of the Period 6 transition elements?

23.7 (a) What is the range in electronegativity across the first (*3d*) transition series? (b) What is the range across Period 4 of the main-group elements? (c) Explain the difference.

23.8 (a) Explain the major difference between the number of oxidation states of most transition elements and that of most main-group elements. (b) Why is the +2 oxidation state so common among transition elements? (c) What is valence-state electronegativity? Is the electronegativity of Cr different in CrO , Cr_2O_3 , and CrO_3 ? Explain.

23.9 (a) What behavior distinguishes paramagnetic and diamagnetic substances? (b) Why are paramagnetic ions common among transition elements but not main-group elements? (c) Why are colored solutions of metal ions common among transition elements but not main-group elements?

Skill-Building Exercises (grouped in similar pairs)

23.10 Using the periodic table to locate each element, write the electron configuration of (a) V; (b) Y; (c) Hg.

23.11 Using the periodic table to locate each element, write the electron configuration of (a) Ru; (b) Cu; (c) Ni.

23.12 Using the periodic table to locate each element, write the electron configuration of (a) Os; (b) Co; (c) Ag.

23.13 Using the periodic table to locate each element, write the electron configuration of (a) Zn; (b) Mn; (c) Re.

23.14 Give the electron configuration and the number of unpaired electrons for (a) Sc^{3+} ; (b) Cu^{2+} ; (c) Fe^{3+} ; (d) Nb^{3+} .

23.15 Give the electron configuration and the number of unpaired electrons for (a) Cr^{3+} ; (b) Ti^{4+} ; (c) Co^{3+} ; (d) Ta^{2+} .

23.16 What is the highest oxidation state for (a) Ta; (b) Zr; (c) Mn?

23.17 What is the highest oxidation state for (a) Nb; (b) Y; (c) Tc?

23.18 Which transition metals have a maximum O.N. of +6?

23.19 Which transition metals have a maximum O.N. of +4?

23.20 In which compound does Cr exhibit greater metallic behavior, CrF_2 or CrF_6 ? Explain.

23.21 VF_5 is a liquid that boils at 48°C , whereas VF_3 is a solid that melts above 800°C . Explain this difference in properties.

23.22 Is it more difficult to oxidize Cr or Mo? Explain.

23.23 Is MnO_4^- or ReO_4^- a stronger oxidizing agent? Explain.

23.24 Which oxide, CrO_3 or CrO , is more acidic in water? Why?

23.25 Which oxide, Mn_2O_3 or Mn_2O_7 , is more basic in water? Why?

Problems in Context

23.26 The green patina of Cu-alloy roofs results from corrosion in the presence of O_2 , H_2O , CO_2 , and sulfur compounds. The other members of Group 1B(11), Ag and Au, do not form a patina. Corrosion of Cu and Ag in the presence of sulfur compounds leads to a black tarnish, but Au does not tarnish. This pattern is different from that in Group 1A(1), where ease of oxidation *increases* down the group. Explain these different group patterns.

The Inner Transition Elements

(Sample Problem 23.2)

Concept Review Questions

23.27 What atomic property of the lanthanides leads to their remarkably similar chemical properties?

23.28 (a) What is the maximum number of unpaired electrons in a lanthanide ion? (b) How does this number relate to occupancy of the *4f* subshell?

23.29 Which of the actinides are radioactive?

Skill-Building Exercises (grouped in similar pairs)

23.30 Give the electron configuration of (a) La; (b) Ce^{3+} ; (c) Es; (d) U^{4+} .

23.31 Give the electron configuration of (a) Pm; (b) Lu^{3+} ; (c) Th; (d) Fm^{3+} .

23.32 Only a few lanthanides show an oxidation state other than +3. Two of these, europium (Eu) and terbium (Tb), are found near the middle of the series, and their unusual oxidation states can be associated with a half-filled *f* subshell. (a) Write the electron configurations of Eu^{2+} , Eu^{3+} , and Eu^{4+} . Why is Eu^{2+} a common ion,

whereas Eu^{4+} is unknown? (b) Write the electron configurations of Tb^{2+} , Tb^{3+} , and Tb^{4+} . Would you expect Tb to show a +2 or a +4 oxidation state? Explain.

23.33 Cerium (Ce) and ytterbium (Yb) exhibit some oxidation states in addition to +3. (a) Write the electron configurations of Ce^{2+} , Ce^{3+} , and Ce^{4+} . (b) Write the electron configurations of Yb^{2+} , Yb^{3+} , and Yb^{4+} . (c) In addition to the 3+ ions, the ions Ce⁴⁺ and Yb²⁺ are stable. Suggest a reason for this stability.

Problems in Context

23.34 Which lanthanide has the maximum number of unpaired electrons in both its atom and its 3+ ion? Give the number of unpaired electrons in the atom and in the ion.

Coordination Compounds

(Sample Problems 23.3 to 23.5)

Concept Review Questions

23.35 Describe the makeup of a complex ion, including the nature of the ligands and their interaction with the central metal ion. Explain how a complex ion can be positive or negative and how it occurs as part of a neutral coordination compound.

23.36 What electronic feature must a donor atom of a ligand have?

23.37 What is the coordination number of a metal ion in a complex ion? How does it differ from the oxidation number?

23.38 What structural feature is characteristic of a chelate?

23.39 What geometries are associated with the coordination numbers 2, 4, and 6?

23.40 What are the coordination numbers of cobalt(III), platinum(II), and platinum(IV) in complexes?

23.41 How is a complex ion a Lewis adduct?

23.42 What does the ending *-ate* in the name of a complex ion signify?

23.43 In what order are the metal ion and ligands identified in the name of a complex ion?

23.44 Is a linkage isomer a type of constitutional isomer or stereoisomer? Explain.

Skill-Building Exercises (grouped in similar pairs)

23.45 Give systematic names for the following formulas:

- (a) $[\text{Ni}(\text{H}_2\text{O})_6]\text{Cl}_2$ (b) $[\text{Cr}(\text{en})_3](\text{ClO}_4)_3$ (c) $\text{K}_4[\text{Mn}(\text{CN})_6]$

23.46 Give systematic names for the following formulas:

- (a) $[\text{Co}(\text{NH}_3)_4(\text{NO}_2)_2]\text{Cl}$ (b) $[\text{Cr}(\text{NH}_3)_6][\text{Cr}(\text{CN})_6]$
 (c) $\text{K}_2[\text{CuCl}_4]$

23.47 What are the charge and coordination number of the central metal ion(s) in each compound in Problem 23.45?

23.48 What are the charge and coordination number of the central metal ion(s) in each compound in Problem 23.46?

23.49 Give systematic names for the following formulas:

- (a) $\text{K}[\text{Ag}(\text{CN})_2]$ (b) $\text{Na}_2[\text{CdCl}_4]$ (c) $[\text{Co}(\text{NH}_3)_4(\text{H}_2\text{O})\text{Br}]\text{Br}_2$

23.50 Give systematic names for the following formulas:

- (a) $\text{K}[\text{Pt}(\text{NH}_3)\text{Cl}_5]$ (b) $[\text{Cu}(\text{en})(\text{NH}_3)_2][\text{Co}(\text{en})\text{Cl}_4]$
 (c) $[\text{Pt}(\text{en})_2\text{Br}_2](\text{ClO}_4)_2$

23.51 What are the charge and coordination number of the central metal ion(s) in each compound in Problem 23.49?

23.52 What are the charge and coordination number of the central metal ion(s) in each compound in Problem 23.50?

23.53 Give formulas corresponding to the following names:

- (a) Tetraamminezinc sulfate
 (b) Pentaamminechlorochromium(III) chloride
 (c) Sodium bis(thiosulfato)argentate(I)

23.54 Give formulas corresponding to the following names:

- (a) Dibromobis(ethylenediamine)cobalt(III) sulfate
 (b) Hexaamminechromium(III) tetrachlorocuprate(II)
 (c) Potassium hexacyanoferrate(II)

23.55 What is the coordination number of the metal ion and the number of individual ions per formula unit in each of the compounds in Problem 23.53?

23.56 What is the coordination number of the metal ion and the number of individual ions per formula unit in each of the compounds in Problem 23.54?

23.57 Give formulas corresponding to the following names:

- (a) Hexaaquachromium(III) sulfate
 (b) Barium tetrabromoferrate(III)
 (c) Bis(ethylenediamine)platinum(II) carbonate

23.58 Give formulas corresponding to the following names:

- (a) Potassium tris(oxalato)chromate(III)
 (b) Tris(ethylenediamine)cobalt(III) pentacyanoiodomanganate(II)
 (c) Diamminediaquabromochloroaluminum nitrate

23.59 Give the coordination number of the metal ion and the number of ions per formula unit in each compound in Problem 23.57.

23.60 Give the coordination number of the metal ion and the number of ions per formula unit in each compound in Problem 23.58.

23.61 Which of these ligands can participate in linkage isomerism: (a) NO_2^- ; (b) SO_2 ; (c) NO_3^- ? Explain with Lewis structures.

23.62 Which of these ligands can participate in linkage isomerism: (a) SCN^- ; (b) $\text{S}_2\text{O}_3^{2-}$ (thiosulfate); (c) HS^- ? Explain with Lewis structures.

23.63 For any of the following that can exist as isomers, state the type of isomerism and draw the structures:

- (a) $[\text{Pt}(\text{CH}_3\text{NH}_2)_2\text{Br}_2]$ (b) $[\text{Pt}(\text{NH}_3)_2\text{FCI}]$ (c) $[\text{Pt}(\text{H}_2\text{O})(\text{NH}_3)\text{FCI}]$

23.64 For any of the following that can exist as isomers, state the type of isomerism and draw the structures:

- (a) $[\text{Zn}(\text{en})\text{F}_2]$ (b) $[\text{Zn}(\text{H}_2\text{O})(\text{NH}_3)\text{FCI}]$ (c) $[\text{Pd}(\text{CN})_2(\text{OH})_2]^{2-}$

23.65 For any of the following that can exist as isomers, state the type of isomerism and draw the structures:

- (a) $[\text{PtCl}_2\text{Br}_2]^{2-}$ (b) $[\text{Cr}(\text{NH}_3)_5(\text{NO}_2)]^{2+}$ (c) $[\text{Pt}(\text{NH}_3)_4\text{I}_2]^{2+}$

23.66 For any of the following that can exist as isomers, state the type of isomerism and draw the structures:

- (a) $[\text{Co}(\text{NH}_3)_5\text{Cl}]\text{Br}_2$ (b) $[\text{Pt}(\text{CH}_3\text{NH}_2)_3\text{Cl}]\text{Br}$
 (c) $[\text{Fe}(\text{H}_2\text{O})_4(\text{NH}_3)_2]^{2+}$

Problems in Context

23.67 Chromium(III), like cobalt(III), has a coordination number of 6 in many of its complex ions. Before Alfred Werner, in the 1890s, established the idea of a complex ion, coordination compounds had traditional formulas. Compounds are known that have the traditional formula $\text{CrCl}_3 \cdot n\text{NH}_3$, where $n = 3$ to 6. Which of

these compounds has an electrical conductivity in aqueous solution similar to that of an equimolar NaCl solution?

23.68 When $\text{MCl}_4(\text{NH}_3)_2$ is dissolved in water and treated with AgNO_3 , 2 mol of AgCl precipitates immediately for each mole of $\text{MCl}_4(\text{NH}_3)_2$. Give the coordination number of M in the complex.

23.69 Palladium, like its group neighbor platinum, forms four-coordinate Pd(II) and six-coordinate Pd(IV) complexes. Write formulas for the complexes with these compositions:

- (a) $\text{PdK}(\text{NH}_3)\text{Cl}_3$ (b) $\text{PdCl}_2(\text{NH}_3)_2$ (c) PdK_2Cl_6 (d) $\text{Pd}(\text{NH}_3)_4\text{Cl}_4$

Theoretical Basis for the Bonding and Properties of Complexes

(Sample Problems 23.6 and 23.7)

Concept Review Questions

23.70 (a) What is a coordinate covalent bond?

(b) Is such a bond involved when FeCl_3 dissolves in water? Explain.

(c) Is such a bond involved when HCl gas dissolves in water? Explain.

23.71 According to valence bond theory, what set of orbitals is used by a Period 4 metal ion in forming (a) a square planar complex; (b) a tetrahedral complex?

23.72 A metal ion uses d^2sp^3 orbitals when forming a complex. What is its coordination number and the shape of the complex?

23.73 A complex in solution absorbs green light. What is the color of the solution?

23.74 In terms of the theory of color absorption, explain two ways that a solution can be blue.

23.75 (a) What is the crystal field splitting energy (Δ)?

(b) How does it arise for an octahedral field of ligands?

(c) How is it different for a tetrahedral field of ligands?

23.76 What is the distinction between a weak-field ligand and a strong-field ligand? Give an example of each.

23.77 Is a complex with the same number of unpaired electrons as the free gaseous metal ion termed high spin or low spin?

23.78 How do the relative magnitudes of E_{pairing} and Δ affect the paramagnetism of a complex?

23.79 Why are there both high-spin and low-spin octahedral complexes but only high-spin tetrahedral complexes?

Skill-Building Exercises (grouped in similar pairs)

23.80 Give the number of d electrons (n of d^n) for the central metal ion in (a) $[\text{TiCl}_6]^{2-}$; (b) $\text{K}[\text{AuCl}_4]$; (c) $[\text{RhCl}_6]^{3-}$.

23.81 Give the number of d electrons (n of d^n) for the central metal ion in (a) $[\text{Cr}(\text{H}_2\text{O})_6](\text{ClO}_3)_2$; (b) $[\text{Mn}(\text{CN})_6]^{2-}$; (c) $[\text{Ru}(\text{NO})(\text{en})_2\text{Cl}] \text{Br}$.

23.82 How many d electrons (n of d^n) are in the central metal ion in (a) $\text{Ca}[\text{IrF}_6]$; (b) $[\text{HgI}_4]^{2-}$; (c) $[\text{Co}(\text{EDTA})]^{2-}$?

23.83 How many d electrons (n of d^n) are in the central metal ion in (a) $[\text{Ru}(\text{NH}_3)_5\text{Cl}] \text{SO}_4$; (b) $\text{Na}_2[\text{Os}(\text{CN})_6]$; (c) $[\text{Co}(\text{NH}_3)_4\text{CO}_3\text{I}]$?

23.84 Sketch the orientation of the orbitals relative to the ligands in an octahedral complex to explain the splitting and the relative energies of the d_{xy} and the $d_{x^2-y^2}$ orbitals.

23.85 The two e_g orbitals are identical in energy in an octahedral complex but have different energies in a square planar complex, with the d_{z^2} orbital being much lower in energy than the $d_{x^2-y^2}$. Explain with orbital sketches.

23.86 Which of these ions *cannot* form both high- and low-spin octahedral complexes: (a) Ti^{3+} ; (b) Co^{2+} ; (c) Fe^{2+} ; (d) Cu^{2+} ?

23.87 Which of these ions *cannot* form both high- and low-spin octahedral complexes: (a) Mn^{3+} ; (b) Nb^{3+} ; (c) Ru^{3+} ; (d) Ni^{2+} ?

23.88 Draw orbital-energy splitting diagrams and use the spectrochemical series to show the orbital occupancy for each of the following (assuming that H_2O is a weak-field ligand):
 (a) $[\text{Cr}(\text{H}_2\text{O})_6]^{3+}$ (b) $[\text{Cu}(\text{H}_2\text{O})_4]^{2+}$ (c) $[\text{FeF}_6]^{3-}$

23.89 Draw orbital-energy splitting diagrams and use the spectrochemical series to show the orbital occupancy for each of the following (assuming that H_2O is a weak-field ligand):
 (a) $[\text{Cr}(\text{CN})_6]^{3-}$ (b) $[\text{Rh}(\text{CO})_6]^{3+}$ (c) $[\text{Co}(\text{OH})_6]^{4-}$

23.90 Draw orbital-energy splitting diagrams and use the spectrochemical series to show the orbital occupancy for each of the following (assuming that H_2O is a weak-field ligand):
 (a) $[\text{MoCl}_6]^{3-}$ (b) $[\text{Ni}(\text{H}_2\text{O})_6]^{2+}$ (c) $[\text{Ni}(\text{CN})_4]^{2-}$

23.91 Draw orbital-energy splitting diagrams and use the spectrochemical series to show the orbital occupancy for each of the following (assuming that H_2O is a weak-field ligand):
 (a) $[\text{Fe}(\text{C}_2\text{O}_4)_3]^{3-}$ ($\text{C}_2\text{O}_4^{2-}$ creates a weaker field than H_2O does.)
 (b) $[\text{Co}(\text{CN})_6]^{4-}$ (c) $[\text{MnCl}_6]^{4-}$

23.92 Rank the following in order of *increasing* Δ and energy of light absorbed: $[\text{Cr}(\text{NH}_3)_6]^{3+}$, $[\text{Cr}(\text{H}_2\text{O})_6]^{3+}$, $[\text{Cr}(\text{NO}_2)_6]^{3-}$.

23.93 Rank the following in order of *decreasing* Δ and energy of light absorbed: $[\text{Cr}(\text{en})_3]^{3+}$, $[\text{Cr}(\text{CN})_6]^{3-}$, $[\text{CrCl}_6]^{3-}$.

23.94 A complex ion, $[\text{ML}_6]^{2+}$, is violet. The same metal forms a complex with another ligand, Q, that creates a weaker field. What color might $[\text{MQ}_6]^{2+}$ be expected to show? Explain.

23.95 The complex ion $[\text{Cr}(\text{H}_2\text{O})_6]^{2+}$ is violet. Another CrL_6 complex is green. Can ligand L be CN^- ? Can it be Cl^- ? Explain.

Problems in Context

23.96 Octahedral $[\text{Ni}(\text{NH}_3)_6]^{2+}$ is paramagnetic, whereas planar $[\text{Pt}(\text{NH}_3)_4]^{2+}$ is diamagnetic, even though both metal ions are d^8 species. Explain.

23.97 The hexaaqua complex $[\text{Ni}(\text{H}_2\text{O})_6]^{2+}$ is green, whereas the hexaammonia complex $[\text{Ni}(\text{NH}_3)_6]^{2+}$ is violet. Explain.

23.98 Three of the complex ions that are formed by Co^{3+} are $[\text{Co}(\text{H}_2\text{O})_6]^{3+}$, $[\text{Co}(\text{NH}_3)_6]^{3+}$, and $[\text{CoF}_6]^{3-}$. These ions have the observed colors (listed in arbitrary order) yellow-orange, green, and blue. Match each complex with its color. Explain.

Comprehensive Problems

23.99 When neptunium (Np) and plutonium (Pu) were discovered, the periodic table did not include the actinides, so these elements were placed in Groups 7B(7) and 8B(8). When americium (Am) and curium (Cm) were synthesized, they were placed in Groups 8B(9) and 8B(10). However, during chemical isolation procedures, Glenn Seaborg and his colleagues, who had synthesized these elements, could not find their compounds among other compounds of members of the same groups, which led Seaborg to suggest they were part of a new inner transition series.

(a) How do the electron configurations of these elements support Seaborg's suggestion?

(b) The highest fluorides of Np and Pu are hexafluorides, and the highest fluoride of uranium is also the hexafluoride. How does

this chemical evidence support the placement of Np and Pu as *inner* transition elements rather than transition elements?

23.100 How many different formulas are there for octahedral complexes with a metal M and four ligands A, B, C, and D? Give the number of isomers for each formula and describe the isomers.

23.101 At one time, it was common to write the formula for copper(I) chloride as Cu₂Cl₂, instead of CuCl, analogously to Hg₂Cl₂ for mercury(I) chloride. Use electron configurations to explain why Hg₂Cl₂ and CuCl are both correct.

23.102 For the compound [Co(en)₂Cl₂]Cl, give:

- (a) The coordination number of the metal ion
- (b) The oxidation number of the central metal ion
- (c) The number of individual ions per formula unit
- (d) The moles of AgCl that precipitate when 1 mol of compound is dissolved in water and treated with AgNO₃

23.103 Hexafluorocobaltate(III) ion is a high-spin complex. Draw the energy diagram for the splitting of its *d* orbitals.

23.104 A salt of each of the ions in Table 23.3 is dissolved in water. A Pt electrode is immersed in each solution and connected to a 0.38-V battery. All of the electrolytic cells are run for the same amount of time with the same current.

- (a) In which cell(s) will a metal plate out? Explain.
- (b) Which cell will plate out the least mass of metal? Explain.

23.105 Criticize and correct the following statement: strong-field ligands always give rise to low-spin complexes.

23.106 Some octahedral complexes have distorted shapes. In some, two metal-ligand bonds that are 180° apart are shorter than the other four. In [Cu(NH₃)₆]²⁺, for example, two Cu—N bonds are 207 pm long, and the other four are 262 pm long. (a) Calculate the longest distance between two N atoms in this complex. (b) Calculate the shortest distance between two N atoms.

23.107 In many species, a transition metal has an unusually high or low oxidation state. Write balanced equations for the following and find the oxidation state of the transition metal in the product:

- (a) Iron(III) ion reacts with hypochlorite ion in basic solution to form ferrate ion (FeO₄²⁻), Cl⁻, and water.
- (b) Potassium hexacyanomanganate(II) reacts with K metal to form K₆[Mn(CN)₆].
- (c) Heating sodium superoxide (NaO₂) with Co₃O₄ produces Na₄CoO₄ and O₂ gas.
- (d) Vanadium(III) chloride reacts with Na metal under a CO atmosphere to produce Na[V(CO)₆] and NaCl.
- (e) Barium peroxide reacts with nickel(II) ions in basic solution to produce BaNiO₃.
- (f) Bubbling CO through a basic solution of cobalt(II) ion produces [Co(CO)₄]⁻, CO₃²⁻, and water.
- (g) Heating cesium tetrafluorocuprate(II) with F₂ gas under pressure gives Cs₂CuF₆.
- (h) Heating tantalum(V) chloride with Na metal produces NaCl and Ta₆Cl₁₅, in which half of the Ta is in the +2 state.
- (i) Potassium tetracyanonickelate(II) reacts with hydrazine (N₂H₄) in basic solution to form K₄[Ni₂(CN)₆] and N₂ gas.

23.108 Draw a Lewis structure with lowest formal charges for MnO₄⁻.

23.109 The coordination compound [Pt(NH₃)₂(SCN)₂] displays two types of isomerism. Name the types, and give names and structures for the six possible isomers.

23.110 An octahedral complex with three different ligands (A, B, and C) can have formulas with three different ratios of the ligands: [MA₄BC]ⁿ⁺, such as [Co(NH₃)₄(H₂O)Cl]²⁺; [MA₃B₂C]ⁿ⁺, such as [Cr(H₂O)₃Br₂Cl]⁺; [MA₂B₂C₂]ⁿ⁺, such as [Cr(NH₃)₂(H₂O)₂Br₂]⁺. For each example, give the name, state the type(s) of isomerism present, and draw all isomers.

23.111 In [Cr(NH₃)₆]Cl₃, the [Cr(NH₃)₆]³⁺ ion absorbs visible light in the blue-violet range, and the compound is yellow-orange. In [Cr(H₂O)₆]Br₃, the [Cr(H₂O)₆]³⁺ ion absorbs visible light in the red range, and the compound is blue-gray. Explain these differences in light absorbed and compound color.

23.112 The actinides Pa, U, and Np form a series of complex ions, such as the anion in the compound Na₃[UF₈], in which the central metal ion has an unusual geometry and oxidation state. In the crystal structure, the complex ion can be pictured as resulting from interpenetration of simple cubic arrays of uranium and fluoride ions. (a) What is the coordination number of the metal ion in the complex ion? (b) What is the oxidation state of uranium in the compound? (c) Sketch the complex ion.

23.113 Several coordination isomers, with both Co and Cr as 3+ ions, have the molecular formula CoCrC₆H₁₈N₁₂. (a) Give the name and formula of the isomer in which the Co complex ion has six NH₃ groups. (b) Give the name and formula of the isomer in which the Co complex ion has one CN and five NH₃ groups.

23.114 Consider the square planar complex shown at right. Which of the structures A–F are geometric isomers of it?

A

B

C

D

E

F

23.115 A shortcut to finding optical isomers is to see if the complex has a *plane of symmetry*—a plane passing through the metal atom such that every atom on one side of the plane is matched by an identical one at the same distance from the plane on the other side. Any planar complex has a plane of symmetry, since all atoms lie in one plane. Use this approach to determine whether these exist as optical isomers: (a) [Zn(NH₃)₂Cl₂] (tetrahedral); (b) [Pt(en)₂]²⁺; (c) *trans*-[PtBr₄Cl₂]²⁻; (d) *trans*-[Co(en)₂F₂]⁺; (e) *cis*-[Co(en)₂F₂]⁺.

23.116 Alfred Werner (see Problem 23.67) prepared two compounds by heating a solution of PtCl₂ with triethyl phosphine, P(C₂H₅)₃, which is a ligand for Pt. Both compounds have, by mass, Pt, 38.8%; Cl, 14.1%; C, 28.7%; P, 12.4%; and H, 6.02%. Write formulas, structures, and systematic names for the two isomers.

23.117 Two bidentate ligands used extensively in analytical chemistry are bipyridyl (bipy) and *ortho*-phenanthroline (*o*-phen):

bipyridyl

o-phenanthroline

Draw structures and discuss the possibility of isomers for

- (a) $[\text{Pt}(\text{bipy})\text{Cl}_2]$ (b) $[\text{Fe}(o\text{-phen})_3]^{3+}$
 (c) $[\text{Co}(\text{bipy})_2\text{F}_2]^+$ (d) $[\text{Co}(o\text{-phen})(\text{NH}_3)_3\text{Cl}]^{2+}$

23.118 The effect of entropy on reactions is demonstrated by the stabilities of certain complexes. (a) Based on the numbers of reactant and product particles, predict which of the following reactions will be favored in terms of $\Delta S_{\text{rxn}}^\circ$:

(b) Given that the Cu–N bond strength is approximately the same in both complexes, which complex will be more stable with respect to ligand exchange in water? Explain.

23.119 You know the following about a coordination compound:

- (1) The partial empirical formula is $\text{KM}(\text{CrO}_4)\text{Cl}_2(\text{NH}_3)_4$.
 (2) It has A (red) and B (blue) crystal forms.
 (3) When 1.0 mol of A or B reacts with 1.0 mol of AgNO_3 , 0.50 mol of a red precipitate forms immediately.
 (4) After the reaction in (3), 1.0 mol of A reacts very slowly with 1.0 mol of silver oxalate ($\text{Ag}_2\text{C}_2\text{O}_4$) to form 2.0 mol of a white precipitate. (Oxalate can displace other ligands.)
 (5) After the reaction in (3), 1.0 mol of B does not react further with 1.0 mol of AgNO_3 .

From this information, determine the following:

- (a) The coordination number of M
 (b) The group(s) bonded to M ionically and covalently
 (c) The stereochemistry of the red and blue forms

23.120 The extent of crystal field splitting is often determined from spectra. (a) Given the wavelength (λ) of maximum absorption, find the crystal field splitting energy (Δ), in kJ/mol, for each of the following complex ions:

Ion	λ (nm)	Ion	λ (nm)
$[\text{Cr}(\text{H}_2\text{O})_6]^{3+}$	562	$[\text{Fe}(\text{H}_2\text{O})_6]^{2+}$	966
$[\text{Cr}(\text{CN})_6]^{3-}$	381	$[\text{Fe}(\text{H}_2\text{O})_6]^{3+}$	730
$[\text{CrCl}_6]^{3-}$	735	$[\text{Co}(\text{NH}_3)_6]^{3+}$	405
$[\text{Cr}(\text{NH}_3)_6]^{3+}$	462	$[\text{Rh}(\text{NH}_3)_6]^{3+}$	295
$[\text{Ir}(\text{NH}_3)_6]^{3+}$	244		

- (b) Write a spectrochemical series for the ligands in the Cr complexes. (c) Use the Fe data to state how oxidation state affects Δ . (d) Use the Co, Rh, and Ir data to state how period number affects Δ .

23.121 Ionic liquids have many applications in engineering and materials science. The dissolution of the metavanadate ion in chloroaluminate ionic liquids has been studied:

- (a) What is the oxidation number of V and Al in each ion?
 (b) In reactions of V_2O_5 with HCl, acid concentration affects the product. At low acid concentration, VO_2Cl_2^- and VO_3^- form:

$$\text{V}_2\text{O}_5 + \text{HCl} \longrightarrow \text{VO}_2\text{Cl}_2^- + \text{VO}_3^- + \text{H}^+$$

At high acid concentration, VOCl_3 forms:

Balance each equation, and state which, if either, is a redox process.

- (c) What mass of VO_2Cl_2^- or VOCl_3 can form from 12.5 g of V_2O_5 and the appropriate concentration of acid?

23.122 The orbital occupancies for the d orbitals of several complex ions are diagrammed below.

- (a) Which diagram corresponds to the orbital occupancy of the cobalt ion in $[\text{Co}(\text{CN})_6]^{3-}$?
 (b) If diagram D depicts the orbital occupancy of the cobalt ion in $[\text{CoF}_6]^{n-}$, what is the value of n ?
 (c) $[\text{NiCl}_4]^{2-}$ is paramagnetic and $[\text{Ni}(\text{CN})_4]^{2-}$ is diamagnetic. Which diagrams correspond to the orbital occupancies of the nickel ions in these species?
 (d) Diagram C shows the orbital occupancy of V^{2+} in the octahedral complex VL_6 . Can you determine whether L is a strong- or weak-field ligand? Explain.

24

Nuclear Reactions and Their Applications

24.1 Radioactive Decay and Nuclear Stability

Chemical vs. Nuclear Change
Components of the Nucleus
Types of Radioactive Emissions
Modes of Radioactive Decay;
Nuclear Equations
Nuclear Stability and Mode of Decay

24.2 The Kinetics of Radioactive Decay

Detection and Measurement of Radioactivity
Rate of Radioactive Decay
Radioisotopic Dating

24.3 Nuclear Transmutation: Induced Changes in Nuclei

Early Transmutation Experiments;
Nuclear Shorthand Notation
Particle Accelerators and
Transuranium Elements

24.4 Ionization: Effects of Nuclear Radiation on Matter

Effects of Ionizing Radiation on Living Tissue
Background Sources of Ionizing Radiation
Assessing the Risk from Ionizing Radiation

24.5 Applications of Radioisotopes

Radioactive Tracers
Additional Applications of Ionizing Radiation

24.6 The Interconversion of Mass and Energy

Mass Difference Between a Nucleus and Its Nucleons
Nuclear Binding Energy and Binding Energy per Nucleon

24.7 Applications of Fission and Fusion

Nuclear Fission
Nuclear Fusion

Source: © Johnny Greig/E+/Getty Images

- › discovery of the atomic nucleus (Section 2.4)
- › half-life and first-order reaction rate (Section 16.4)
- › protons, neutrons, mass number, and the ${}^A_Z X$ notation (Section 2.5)

Up to this point in the text, we have focused on the atom's electrons, treating the nucleus as their electrostatic anchor and examining the effect of its positive charge on atomic properties and, ultimately, chemical behavior. In this chapter, for the most part, we ignore the surrounding electrons and focus on the atom's tiny, dense core, which is held together by the strongest force in the universe. Scientists studying the structure and behavior of the nucleus encounter great mystery and wonder but also uncover a great number of applications. To cite just one example, modern medicine relies, to an ever-increasing extent, on diagnoses based on the emission of radiation from unstable nuclei. In fact, more than one in four hospital admissions now involve imaging tests such as stress tests, bone scans, and PET scans (*see photo*) that utilize *radioisotopes*.

But society is ambivalent about some applications of nuclear research. The promise of abundant energy and effective treatments for diseases is offset by the threat of nuclear waste contamination, reactor accidents, and unimaginable destruction from nuclear war or terrorism. Can the power of the nucleus be harnessed for our benefit, or are the risks too great? In this chapter, you'll learn the principles that can help you consider this vital question.

IN THIS CHAPTER . . . We survey the field of nuclear chemistry, examining radioactive nuclei and their decay processes, especially the effects and applications of radioactivity and the interconversion of matter and energy.

- › We investigate nuclear stability to determine why some nuclei are stable and others undergo radioactive decay.
- › We learn how radioactivity is detected and how the kinetics of decay is applied.
- › We see how nuclei synthesized in particle accelerators have extended the periodic table.
- › We consider the effects of radioactive emissions on matter, especially living tissue, and focus on some major uses of radioisotopes in science, technology, and medicine.
- › We discuss the mass difference that arises when a nucleus forms from its subatomic particles and the energy that is equivalent to this difference.
- › We explore current and future attempts to harness the energy released when heavy nuclei split or lighter ones fuse.
- › We look at the nuclear processes in stars that continually create chemical elements.

24.1 RADIOACTIVE DECAY AND NUCLEAR STABILITY

A stable nucleus remains intact indefinitely, but *the great majority of nuclei are unstable*. An unstable nucleus exhibits **radioactivity**, the spontaneous disintegration of a nucleus by the emission of radiation. In Section 24.2, you'll see that each type of unstable nucleus has its own characteristic *rate* of radioactive decay. In this section, we cover important terms and notation for nuclei, discuss some key events in the discovery of radioactivity, define the types of emission, describe various modes of radioactive decay, and see how to predict which occurs for a given nucleus. Let's begin, however, with a brief comparison of chemical change and nuclear change.

Table 24.1 Comparison of Chemical and Nuclear Reactions

Chemical Reactions	Nuclear Reactions
1. One substance is converted into another, but atoms never change identity.	1. Atoms of one element typically are converted into atoms of another element.
2. Electrons in orbitals are involved as bonds break and form; nuclear particles do not take part.	2. Protons, neutrons, and other nuclear particles are involved; electrons in orbitals take part much less often.
3. Reactions are accompanied by relatively small changes in energy and no measurable changes in mass.	3. Reactions are accompanied by relatively large changes in energy and measurable changes in mass.
4. Reaction rates are influenced by temperature, concentration, catalysts, and the compound in which an element occurs.	4. Reaction rates depend on number of nuclei, but are not affected by temperature, catalysts, or, except on rare occasions, the compound in which an element occurs.

Comparing Chemical and Nuclear Change

The changes that occur in atomic nuclei differ strikingly from chemical changes (Table 24.1). In chemical reactions, electrons are shared or transferred to form *compounds*, while nuclei remain unchanged. In nuclear reactions, the roles are reversed: electrons take part much less often, while nuclei undergo changes that, in nearly every case, form different *elements*. Nuclear reactions are often accompanied by energy changes a million times greater than those for chemical reactions, energy changes so large that the accompanying changes in mass *are* detectable. Moreover, nuclear reaction yields and rates are *not* subject to the effects of pressure, temperature, and catalysis that influence chemical reactions.

The Components of the Nucleus: Terms and Notation

Recall from Chapter 2 that the nucleus contains essentially all the atom's mass but accounts for only about 10^{-5} times its radius and, therefore, 10^{-15} times its volume, making the nucleus incredibly dense: about 10^{14} g/mL. \blacktriangleleft *Protons* and *neutrons*, the elementary particles that make up the nucleus, are called **nucleons**. A **nuclide** is a nucleus with a particular composition, that is, with specific numbers of the two types of nucleons. Most elements occur in nature as a mixture of **isotopes**, atoms with the characteristic number of protons of the element but different numbers of neutrons. For example, oxygen has three naturally occurring isotopes, and carbon also has three, but tin has ten, the most of any element. *Thus, each isotope of an element has a different nuclide.*

The relative mass and charge of a particle—elementary particle or nuclide—are described by the notation ${}^A_Z X$ where *X* is the *symbol* for the particle, *A* is the *mass number*, or the total number of nucleons making up the particle, and *Z* is the *charge* of the particle; for nuclei, *A* is the *sum of protons and neutrons* and *Z* is the *number of protons* (atomic number). With this notation, the three subatomic elementary particles are represented as follows:

(A proton is also sometimes represented as ${}^1 H^+$.) The number of neutrons (*N*) in a nucleus is the mass number (*A*) minus the atomic number (*Z*): $N = A - Z$. For example, the two naturally occurring stable isotopes of chlorine are

Nuclides can also be designated with the element name followed by the mass number, for example, chlorine-35 and chlorine-37. In naturally occurring samples of an element or its compounds, the *isotopes of the element are present in specific proportions* that vary only very slightly (see Chapter 2). Thus, in a sample of sodium chloride (or any Cl-containing substance), 75.77% of the Cl atoms are chlorine-35 and the remaining 24.23% are chlorine-37.

To understand this chapter, you need to be comfortable with nuclear notations, so please take a moment to review Sample Problem 2.4 and Problems 2.39 to 2.46.

Big Atom with a Tiny, Massive Core

If you could strip the electrons from the atoms in an object and compress the nuclei together, the object would lose only a fraction of a percent of its mass, but it would shrink to 0.000000000001% ($10^{-13}\%$) of its volume!

The Discovery of Radioactivity and the Types of Emissions

In 1896, the French physicist Antoine-Henri Becquerel accidentally discovered that uranium minerals emit a penetrating radiation that can expose a photographic plate. Becquerel also found that the radiation creates an electric discharge in air, thus providing a means for measuring its intensity.

Curie and Rutherford: The Nature of Radioactivity and Element Identity Based on Becquerel's discovery, in 1898, a young doctoral student named Marie Skłodowska Curie began a search for other minerals that behaved like uranium minerals. She found that thorium minerals also emit radiation and, most importantly, that *the intensity of the radiation is directly proportional to the concentration of the element in the mineral, not to the formula of the mineral or compound*. Curie named the emissions **radioactivity** and showed that they are *unaffected by temperature, pressure, or other physical and chemical conditions*.

After months of painstaking chemical work, Curie and her husband, physicist Pierre Curie, showed clear evidence of two new elements in pitchblende, the principal ore of uranium: polonium (Po; $Z = 84$), the most metallic member of Group 6A(16), and radium (Ra; $Z = 88$), the heaviest alkaline earth metal.

Then, focusing on obtaining a measurable amount of radium, Curie started with several tons of pitchblende residues from which the uranium had been extracted and worked arduously for four years to isolate 0.1 g of radium chloride, which she melted and electrolyzed to obtain pure metallic radium. Curie is the only person to have received two Nobel Prizes in science, one in physics for her research into radioactivity and the other in chemistry for her discoveries of polonium and radium.

During the next few years, Becquerel, the Curies, and Paul Villard in France and Ernest Rutherford and his coworkers in England studied the nature of radioactive emissions. A key finding was the observation of Rutherford and his colleague Frederick Soddy that elements other than radium were formed when radium decayed. In 1902, they proposed that radioactive emissions result in the change of one element into another. This explanation seemed like a return to alchemy and was met with disbelief and ridicule. We now know it to be true: *when a nuclide of one element decays, it emits radiation and usually changes into a nuclide of a different element*.

Types of Radioactive Emissions There are three natural types of radioactive emissions:

- **Alpha particles** (symbolized α , ${}^4_2\alpha$, or ${}^4\text{He}^{2+}$) are identical to helium-4 nuclei.
- **Beta particles** (symbolized β , β^- , or sometimes ${}^{-1}_1\beta$) are high-speed electrons. (The emission of an electron from a nucleus may seem strange, but as you'll see shortly, it results from a nuclear reaction.)
- **Gamma rays** (symbolized γ , or sometimes ${}^0_0\gamma$) are very high-energy photons.

Figure 24.1 illustrates the behavior of these emissions in an electric field: the positively charged α particles curve to a small extent toward the negative plate, the negatively charged β particles curve to a greater extent toward the positive plate (because they have lower mass), and the uncharged γ rays are not affected by the electric field.

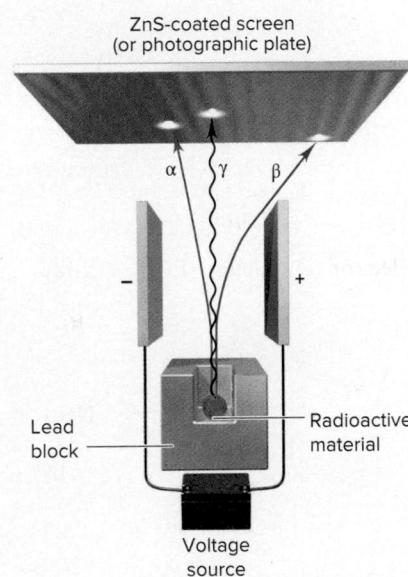

Figure 24.1 How the three types of radioactive emissions behave in an electric field.

Modes of Radioactive Decay; Balancing Nuclear Equations

When a nuclide decays, it becomes a nuclide of lower energy, and the excess energy is carried off by the emitted radiation and the recoiling nucleus. The decaying, or reactant, nuclide is called the *parent*; the product nuclide is called the *daughter*. Nuclides can decay in several ways. As each of the major modes of decay is introduced (Table 24.2, *next page*), we'll show examples of that mode and apply the key principle used to balance nuclear reactions: *the total Z (charge, number of protons) and the total A (sum of protons and neutrons) of the reactants equal those of the products*:

$$\frac{\text{Total } A}{\text{Total } Z} \text{ Reactants} = \frac{\text{Total } A}{\text{Total } Z} \text{ Products}$$

(24.1)

Table 24.2 Modes of Radioactive Decay*

Mode	Emission	Decay Process	Change in		
			A	Z	N
α Decay	$\alpha ({}_2^4\text{He}^{2+})$		+4	-2	-2
		α expelled			
β^- Decay [†]	$\beta^- ({}_{-1}^0\beta)$		0	+1	-1
		nucleus with $x\text{p}^+$ and $y\text{n}^0$ nucleus with $(x + 1)\text{p}^+$ and $(y - 1)\text{n}^0$	β^- expelled		
Net:					
Positron (β^+) emission [†]	$\beta^+ ({}_{1}^0\beta)$	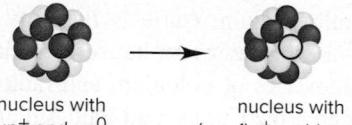	0	-1	+1
		nucleus with $x\text{p}^+$ and $y\text{n}^0$ nucleus with $(x - 1)\text{p}^+$ and $(y + 1)\text{n}^0$	β^+ expelled		
Net:		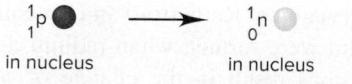			
Electron (e^-) capture (EC) [†]	x-ray	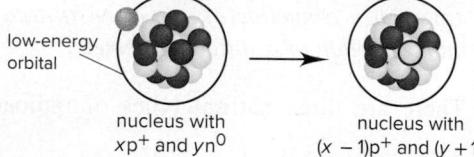	0	-1	+1
		low-energy orbital nucleus with $x\text{p}^+$ and $y\text{n}^0$ nucleus with $(x - 1)\text{p}^+$ and $(y + 1)\text{n}^0$			
Net:		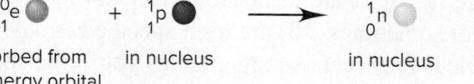			
Gamma (γ) emission	γ	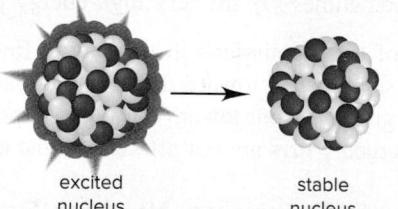	0	0	0
		excited nucleus stable nucleus γ photon radiated			

*Nuclear chemists consider β^- decay, positron emission, and electron capture to be three decay modes of the more general process known as beta decay (see text).

[†]Neutrinos (ν) or antineutrinos ($\bar{\nu}$) are also formed during the three modes of beta decay. Although we will not include them in other equations in the chapter, keep in mind that antineutrinos are always expelled during β^- decay, and neutrinos are expelled during β^+ emission and e^- capture. The mass of a neutrino or antineutrino is estimated to be less than 10^{-4} the mass of an electron.

1. **Alpha (α) decay** involves the loss of an α particle from a nucleus. For each α particle emitted by the parent, A decreases by 4 and Z decreases by 2 in the daughter. Every element beyond bismuth (Bi; $Z = 83$) is radioactive and exhibits α decay, which is *the most common means for a heavy, unstable nucleus to become more stable*. For example, radium undergoes α decay to yield radon (Rn; $Z = 86$):

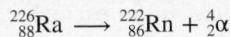

Note that the A value for Ra equals the sum of the A values for Rn and α ($226 = 222 + 4$), and that the Z value for Ra equals the sum of the Z values for Rn and α ($88 = 86 + 2$).

2. **Beta (β) decay** is a general class of radioactive decay that encompasses three modes: β^- decay, β^+ emission, and electron capture.

- **β^- decay** (or *negatron emission*) occurs through the ejection of a β^- particle (high-speed electron) from the nucleus. This change does not involve expulsion of a β^- particle that was in the nucleus; rather, *a neutron is converted into a proton, which remains in the nucleus, and a β^- particle, which is expelled immediately*:

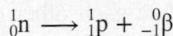

As always, the totals of the A and the Z values for reactant and products are equal. Radioactive nickel-63 becomes stable copper-63 through β^- decay:

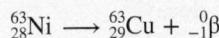

Another example is the β^- decay of carbon-14, used in radiocarbon dating:

Note that β^- decay results in a product nuclide with the same A but with Z one greater (one more proton) than in the reactant nuclide. In other words, an atom of the element with the next *higher* atomic number is formed. Although equations in this chapter do not include it, a neutral particle called an antineutrino ($\bar{\nu}$) is also emitted during β^- decay. The mass of the antineutrino is thought to be much less than 10^{-4} times that of an electron.

- **Positron (β^+) emission** is the emission of a β^+ particle from the nucleus. A key idea of modern physics is that most fundamental particles have corresponding *antiparticles* with the same mass but opposite charge. The **positron** is the antiparticle of the electron. Positron emission occurs through a process in which *a proton in the nucleus is converted into a neutron and a positron, which is expelled*:

Also emitted during this process is a *neutrino* (ν), the antiparticle of the antineutrino. In terms of the effect on A and Z , *positron emission has the opposite effect of β^- decay: the daughter has the same A but Z is one less (one fewer proton) than for the parent*. Thus, an atom of the element with the next *lower* atomic number forms. Carbon-11, a synthetic radioisotope, decays to a stable boron isotope through β^+ emission:

- **Electron (e^-) capture (EC)** occurs when the nucleus draws in an electron from a low atomic energy level. The net effect is that *a proton is transformed into a neutron*:

(We use the symbol e^- , or $^0_{-1}\text{e}$, to distinguish an orbital electron from a beta particle β^- , or $^0_{-1}\beta$.) The orbital vacancy is quickly filled by an electron that moves down from a higher energy level, and that process continues through still higher energy levels, with x-ray photons and neutrinos carrying off the energy difference in each step. Radioactive iron becomes stable manganese through electron capture:

Even though the processes are different, *electron capture has the same net effect as positron emission: Z reduced by 1, A unchanged*.

Table 24.3

**Changes in A and Z
During Radioactive Decay**

Mode of Decay	Change in	
	A	Z
α decay	-4	-2
β^- decay	0	+1
β^+ decay	0	-1
Electron capture	0	-1
Gamma emission	0	0

3. Gamma (γ) emission involves the radiation of high-energy γ photons (also called γ rays) from an excited nucleus. Just as an atom in an excited *electronic state* reduces its energy by emitting photons, usually in the UV and visible ranges (see Section 7.2), a nucleus in an excited state lowers its energy by emitting γ photons, which are of much higher energy (much shorter wavelength) than UV photons. Many nuclear processes leave the nucleus in an excited state, so γ emission accompanies many other (mostly β) types of decay. Several γ photons of different energies can be emitted from an excited nucleus as it returns to the ground state. Some of Marie Curie's experiments involved the release of γ rays, as in the decay of polonium-215:

Gamma emission often accompanies β^- decay:

Because γ rays have no mass or charge, γ emission does not change A or Z. Two gamma rays are emitted when a particle and an antiparticle annihilate each other. In the medical technology known as *positron-emission tomography* (see Section 24.5), a positron and an electron annihilate each other (with all A and Z values shown):

Table 24.3 summarizes the changes in mass number and atomic number that result from the various modes of decay.

SAMPLE PROBLEM 24.1
Writing Equations for Nuclear Reactions

Problem Write balanced equations for the following nuclear reactions:

- Naturally occurring thorium-232 undergoes α decay.
- Zirconium-86 undergoes electron capture.

Plan We first write a skeleton equation that includes the mass numbers, atomic numbers, and symbols of all the particles on the correct sides of the equation, showing the unknown product particle as ${}_Z^AX$. Then, because the total of mass numbers and the total of atomic numbers must be equal on the left and right sides, we solve for A and Z, and use Z to determine X from the periodic table.

Solution (a) Writing the skeleton equation, with the α particle as a product:

Solving for A and Z and balancing the equation: For A, $232 = A + 4$, so $A = 228$. For Z, $90 = Z + 2$, so $Z = 88$. From the periodic table, we see that the element with $Z = 88$ is radium (Ra). Thus, the balanced equation is

(b) Writing the skeleton equation, with the captured electron as a reactant:

Solving for A and Z and balancing the equation: For A, $86 + 0 = A$, so $A = 86$. For Z, $40 + (-1) = Z$, so $Z = 39$. The element with $Z = 39$ is yttrium (Y), so we have

Check Always read across superscripts and then across subscripts, with the yield arrow as an equal sign, to check your arithmetic. In part (a), for example, $232 = 228 + 4$, and $90 = 88 + 2$.

FOLLOW-UP PROBLEMS

Brief Solutions for all Follow-up Problems appear at the end of the chapter.

24.1A Write a balanced equation for the nuclear reaction in which fluorine-20 undergoes β^- decay.

24.1B Write a balanced equation for the reaction in which a nuclide undergoes β^+ decay and changes to tellurium-124.

SOME SIMILAR PROBLEMS 24.8–24.15

Student Hot Spot

Student data indicate that you may struggle with writing nuclear reactions. Access the Smartbook to view additional Learning Resources on this topic.

Nuclear Stability and the Mode of Decay

Can we predict how, and whether, an unstable nuclide will decay? Our knowledge of the nucleus is much less complete than that of the whole atom, but some patterns emerge by observing naturally occurring nuclides.

The Band of Stability Two key factors determine the stability of a nuclide:

1. The number of neutrons (N), the number of protons (Z), and their ratio (N/Z), which we calculate from $(A - Z)/Z$. This factor relates primarily to nuclides that undergo one of the three modes of β decay.
2. The total mass of the nuclide, which mostly relates to nuclides that undergo α decay.

A plot of number of neutrons vs. number of protons for all stable nuclides (Figure 24.2A) shows:

- The points form a narrow **band of stability** that gradually curves above the line for $N = Z$ ($N/Z = 1$).
- The only stable nuclides with $N/Z < 1$ are ^1H and ^2He .
- Many lighter nuclides with $N = Z$ are stable, such as ^4He , ^{12}C , ^{16}O , and ^{20}Ne ; the heaviest of these is ^{40}Ca . Thus, for lighter nuclides, one neutron for each proton ($N = Z$) is enough to provide stability.
- The N/Z ratio of stable nuclides gradually increases as Z increases. For example, for ^{56}Fe , $N/Z = 1.15$; for ^{107}Ag , $N/Z = 1.28$; for ^{184}W , $N/Z = 1.49$, and, finally, for ^{209}Bi , $N/Z = 1.52$. Thus, for heavier stable nuclides, $N > Z$ ($N/Z > 1$), and N increases faster than Z . As we discuss shortly, and show in Figure 24.2B, if N/Z of a nuclide is either too high (above the band) or not high enough (below the band), the nuclide is unstable and undergoes one of the three modes of beta decay.

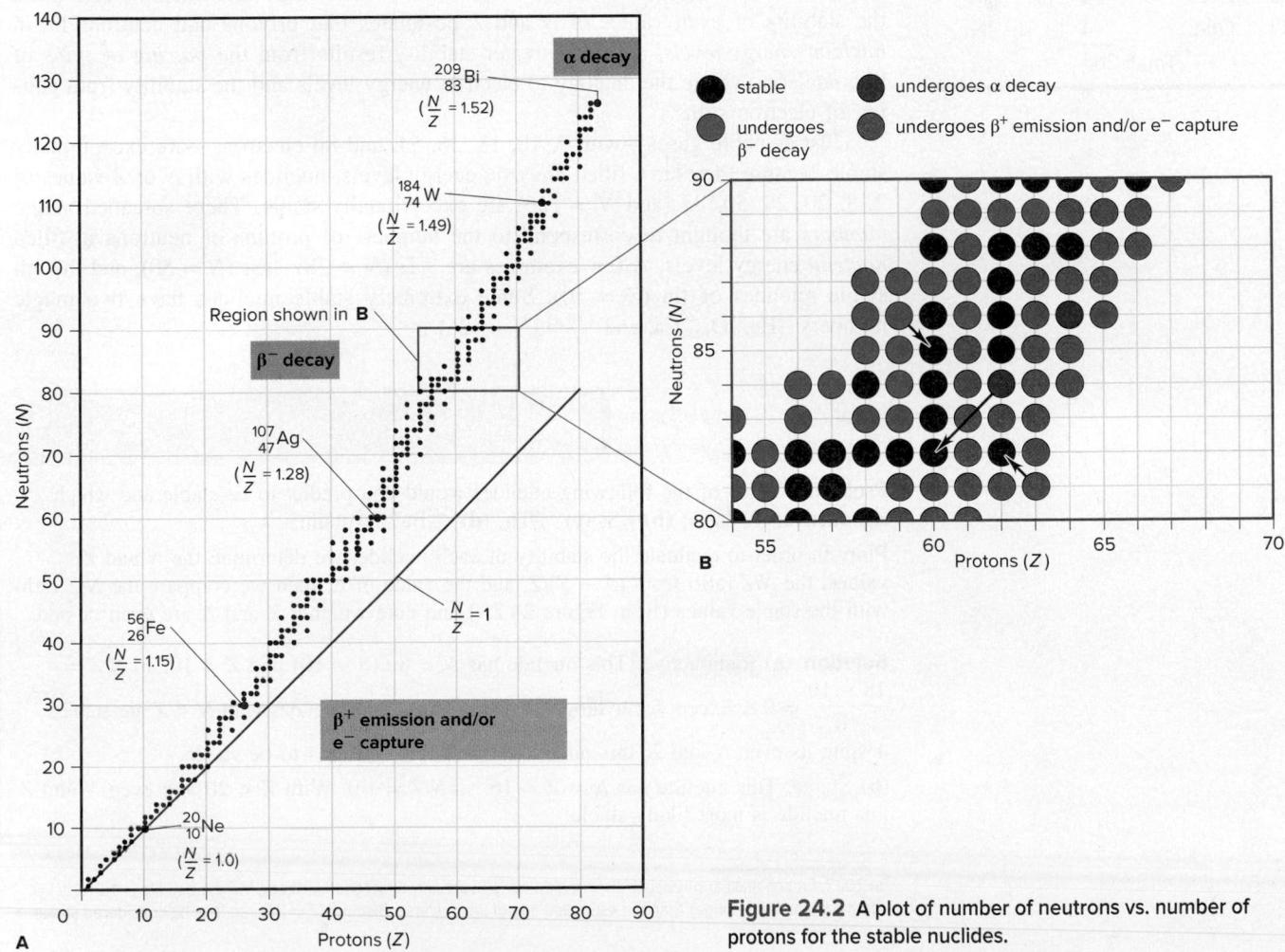

Figure 24.2 A plot of number of neutrons vs. number of protons for the stable nuclides.

Table 24.4

**Number of Stable
Nuclides for Elements
48 to 54***

Element	Atomic Number of Number (Z)	Nuclides
Cd	48	8
In	49	2
Sn	50	10
Sb	51	2
Te	52	8
I	53	1
Xe	54	9

*Even values of Z are shown in **boldface**.

Table 24.5

**An Even-Odd
Breakdown of the
Stable Nuclides**

Z	N	Number of Nuclides	Example
Even	Even	157	$^{84}_{38}\text{Sr}$
Even	Odd	53	$^{29}_{14}\text{Si}$
Odd	Even	50	$^{39}_{19}\text{K}$
Odd	Odd	4	$^{14}_{7}\text{N}$
Total		264	

- All nuclides with $Z > 83$ are unstable.* Thus, the largest members of Groups 1A(1) through 8A(18), actinium and the actinides ($Z = 89$ –103), and the other elements of the fourth ($6d$) transition series ($Z = 104$ –112), are radioactive and (as discussed shortly) undergo α decay.

Stability and Nuclear Structure Nuclear structure is related to nuclear stability in several ways:

1. *The effect of the strong force.* Given that protons are positively charged and neutrons are uncharged, the first question that arises is: why does the nucleus stay together? Nuclear scientists answer this question and explain the importance of N and Z values in terms of two opposing forces: electrostatic repulsive forces between protons would break the nucleus apart if not for an attractive force called the **strong force**, which exists between all nucleons (protons and neutrons). This force is 137 times stronger than the repulsive force but *operates only over the short distances within the nucleus*. Thus, the *attractive* strong force overwhelms the much weaker *repulsive* electrostatic force and keeps the nucleus together.

2. *Odd and even numbers of nucleons.* The oddness or evenness of N and Z values is related to some important patterns of nuclear stability. Two interesting points become apparent when we classify the known stable nuclides:

- Elements with an even Z (number of protons) usually have a larger number of stable nuclides than elements with an odd Z . Table 24.4 demonstrates this point for cadmium ($Z = 48$) through xenon ($Z = 54$).
- Well over half the stable nuclides have *both* even N and even Z (Table 24.5). Only four nuclides with odd N and odd Z are stable: ^2_1H , ^6_3Li , $^{10}_5\text{B}$, and $^{14}_7\text{N}$.

3. *Nucleon energy levels.* One model of nuclear structure that attempts to explain the stability of even values of N and Z postulates that protons and neutrons lie in *nucleon energy levels*, and that greater stability results from the *pairing of spins* of like nucleons. (Note the analogy to electron energy levels and the stability from pairing of electron spins.)

Just as noble gases—with 2, 10, 18, 36, 54, and 86 electrons—are exceptionally stable because they have filled *electron energy levels*, nuclides with N or Z values of 2, 8, 20, 28, 50, 82 (and $N = 126$) are exceptionally stable. These so-called *magic numbers* are thought to correspond to the numbers of protons or neutrons in filled *nucleon energy levels*. A few examples are $^{50}_{22}\text{Ti}$ ($N = 28$), $^{88}_{38}\text{Sr}$ ($N = 50$), and the ten stable nuclides of tin ($Z = 50$). Some extremely stable nuclides have two magic numbers: ^4_2He , $^{16}_8\text{O}$, $^{40}_{20}\text{Ca}$, and $^{208}_{82}\text{Pb}$ ($N = 126$).

SAMPLE PROBLEM 24.2

Predicting Nuclear Stability

Problem Which of the following nuclides would you predict to be stable and which radioactive: (a) $^{18}_{10}\text{Ne}$; (b) $^{32}_{16}\text{S}$; (c) $^{236}_{90}\text{Th}$; (d) $^{123}_{56}\text{Ba}$? Explain.

Plan In order to evaluate the stability of each nuclide, we determine the N and Z values, the N/Z ratio from $(A - Z)/Z$, and the value of Z ; then we compare the N/Z ratio with the stable values (from Figure 24.2A) and note whether Z and N are even or odd.

Solution (a) **Radioactive.** This nuclide has $N = 8$ ($18 - 10$) and $Z = 10$, so $N/Z = \frac{18 - 10}{10} = 0.8$. Except for hydrogen-1 and helium-3, no nuclides with $N < Z$ are stable; despite its even N and Z , this nuclide has too few neutrons to be stable.

(b) **Stable.** This nuclide has $N = Z = 16$, so $N/Z = 1.0$. With $Z < 20$ and even N and Z , this nuclide is most likely stable.

*In 2003, French nuclear physicists discovered that $^{209}_{83}\text{Bi}$ actually undergoes α decay, but the half-life is 1.9×10^{19} yr, about a billion times longer than the estimated age of the universe. Bismuth ($Z = 83$) can thus be considered stable.

(c) **Radioactive.** This nuclide has $Z = 90$, and every nuclide with $Z > 83$ is radioactive.

(d) **Radioactive.** This nuclide has $N = 67$ and $Z = 56$, so $N/Z = 1.20$. For Z values of 55 to 60, Figure 24.2A shows $N/Z \geq 1.3$ for stable nuclides, so this nuclide has too few neutrons to be stable.

Check By consulting a table of isotopes, such as the one in the *CRC Handbook of Chemistry and Physics*, we find that our predictions are correct.

FOLLOW-UP PROBLEMS

24.2A Predict whether each of the following nuclides is stable or radioactive, and explain your prediction: (a) $^{10}_{\text{B}}$; (b) $^{58}_{\text{V}}$.

24.2B Why is $^{31}_{\text{P}}$ stable but $^{30}_{\text{P}}$ unstable?

SOME SIMILAR PROBLEMS 24.16–24.19

Predicting the Mode of Decay An unstable nuclide generally decays in a mode that shifts its N/Z ratio toward the band of stability. This fact is illustrated in Figure 24.2B, which expands the small region of $Z = 54$ to 70 in Figure 24.2A to show the stable *and* many of the unstable nuclides in that region, as well as their modes of decay. Note the following points:

1. *Neutron-rich nuclides.* Nuclides with too many neutrons for stability (a high N/Z ratio) lie above the band of stability. They undergo β^- decay, which converts a neutron into a proton, thus reducing the value of N/Z . For example, C-14 undergoes β^- decay to produce a nuclide with a lower N/Z ratio:

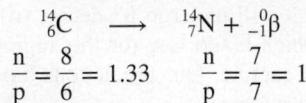

2. *Proton-rich nuclides.* Nuclides with too many protons for stability (a low N/Z ratio) lie below the band of stability. They undergo β^+ emission and/or e^- capture, both of which convert a proton into a neutron, thus increasing the value of N/Z . (The rate of e^- capture increases with Z , so β^+ emission is more common among lighter elements and e^- capture more common among heavier elements.) The following nuclear reactions show the decay processes for two nuclides with low N/Z ratios:

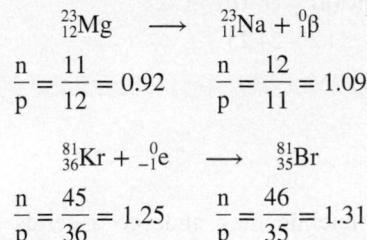

3. *Heavy nuclides.* Nuclides with $Z > 83$ (shown in Figure 24.2A) are too heavy to be stable and undergo α decay, which reduces their Z and N values by two units per emission.

With the information in Figure 24.2, predicting the mode of decay of an unstable nuclide involves simply comparing its N/Z ratio with those in the nearby region of the band of stability. But, even without Figure 24.2, we can often make an educated guess about mode of decay. The atomic mass of an element is the weighted average of its naturally occurring isotopes. Therefore,

- The mass number A of a *stable* nuclide will be relatively close to the atomic mass.
- If an *unstable* nuclide of an element (given Z) has an A value much higher than the atomic mass, *it is neutron rich and will probably decay by β^- emission.*
- If, on the other hand, an unstable nuclide has an A value much lower than the atomic mass, *it is proton rich and will probably decay by β^+ emission and/or e^- capture.*

In the next sample problem, we predict the mode of decay of some unstable nuclides.

Student Hot Spot

Student data indicate that you may struggle with predicting a radioactive nuclide's mode of decay. Access the Smartbook to view additional Learning Resources on this topic.

SAMPLE PROBLEM 24.3

Predicting the Mode of Nuclear Decay

Problem Use the atomic mass of the element to predict the mode(s) of decay of the following radioactive nuclides: (a) $^{12}_5\text{B}$; (b) ^{234}U ; (c) $^{81}_{33}\text{As}$; (d) $^{127}_{57}\text{La}$.

Plan If the nuclide is too heavy to be stable ($Z > 83$), it undergoes α decay. For other cases, we use the Z value to obtain the atomic mass from the periodic table. If the mass number of the nuclide is higher than the atomic mass, the nuclide has too many neutrons: N too high $\Rightarrow \beta^-$ decay. If the mass number is lower than the atomic mass, the nuclide has too many protons: Z too high $\Rightarrow \beta^+$ emission and/or e^- capture.

Solution (a) This nuclide has $Z = 5$, which is boron (B), and the atomic mass is 10.81. The nuclide's A value of 12 is significantly higher than its atomic mass, so this nuclide is neutron rich. It will probably undergo β^- decay.

(b) This nuclide has $Z = 92$, so it will undergo α decay and decrease its total mass.

(c) This nuclide has $Z = 33$, which is arsenic (As), and the atomic mass is 74.92. The A value of 81 is much higher, so this nuclide is neutron rich and will probably undergo β^- decay.

(d) This nuclide has $Z = 57$, which is lanthanum (La), and the atomic mass is 138.9. The A value of 127 is much lower, so this nuclide is proton rich and will probably undergo β^+ emission and/or e^- capture.

Check To confirm our predictions in parts (a), (c), and (d), let's compare each nuclide's N/Z ratio to those in the band of stability: (a) This nuclide has $N = 7$ and $Z = 5$, so $N/Z = 1.40$, which is too high for this region of the band, so it will undergo β^- decay. (c) This nuclide has $N = 48$ and $Z = 33$, so $N/Z = 1.45$, which is too high for this region of the band, so it will undergo β^- decay. (d) This nuclide has $N = 70$ and $Z = 57$, so $N/Z = 1.23$, which is too low for this region of the band, so it will undergo β^+ emission and/or e^- capture. Our predictions based on N/Z values were the same as those based on atomic mass.

Comment Both possible modes of decay are observed for the nuclide in part (d).

FOLLOW-UP PROBLEMS

24.3A Use the A value for the nuclide and the atomic mass from the periodic table to predict the mode of decay of (a) $^{61}_{26}\text{Fe}$; (b) $^{241}_{95}\text{Am}$.

24.3B Use the A value for the nuclide and the atomic mass from the periodic table to predict the mode of decay of (a) $^{40}_{22}\text{Ti}$; (b) $^{65}_{27}\text{Co}$.

SOME SIMILAR PROBLEMS 24.20–24.23

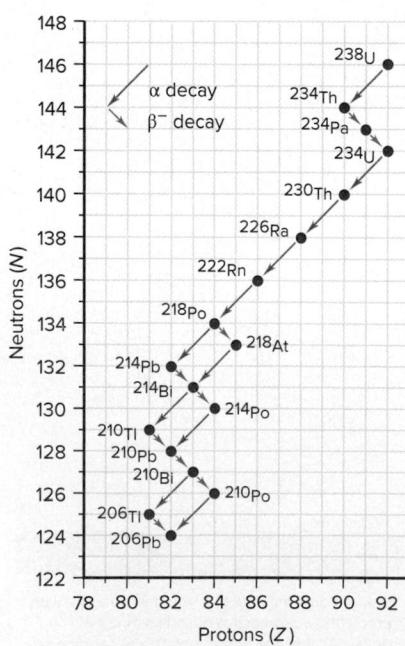

Figure 24.3 The ^{238}U decay series.

Decay Series A parent nuclide may undergo a series of decay steps before a stable daughter nuclide forms. The succession of steps is called a **decay series**, or **disintegration series**, and is typically depicted on a gridlike display. Figure 24.3 shows the decay series from uranium-238 to lead-206. Number of neutrons (N) is plotted against number of protons (Z) to form the grid, which displays a series of α and β^- decays. The typical zigzag pattern arises because $N > Z$, which means that α decay, which reduces both N and Z by two units, decreases Z slightly more than it does N . Therefore, α decays result in neutron-rich daughters, which undergo β^- decay to gain more stability. Note that a given nuclide can undergo both modes of decay. (Gamma emission accompanies many of these steps but does not affect the type of nuclide.)

The series in Figure 24.3 is one of three that occur in nature. All end with isotopes of lead whose nuclides all have one ($Z = 82$) or two ($N = 126$, $Z = 82$) magic numbers. A second series begins with uranium-235 and ends with lead-207, and a third begins with thorium-232 and ends with lead-208. (Neptunium-237 began a fourth series, but its half-life is so much less than the age of Earth that only traces of it remain today.)

› Summary of Section 24.1

- › In dramatic contrast to chemical reactions, nuclear reactions involve particles *within* the nucleus, usually result in atoms of different elements, are accompanied by measurable changes in mass, and are not affected by temperature, pressure, catalysis, or the nature of the compound.
- › To become more stable, a radioactive nuclide may emit α particles (${}_2^4\text{He}^{2+}$; helium-4 nuclei), β particles (β^- or ${}_{-1}^0\beta$; high-speed electrons), positrons (β^+ or ${}_{+1}^0\beta$), or γ rays (high-energy photons) or may capture an orbital electron (${}_{-1}^0e$).
- › A narrow band of neutron-to-proton ratios (N/Z) includes those of all the stable nuclides.
- › Even values of N and Z are associated with stable nuclides, as are certain “magic numbers” of neutrons and protons.
- › By comparing a nuclide’s mass number with the atomic mass and its N/Z ratio with those in the band of stability, we can predict that, in general, neutron-rich nuclides undergo β^- decay and proton-rich nuclides undergo β^+ emission and/or e^- capture. Heavy nuclides ($Z > 83$) undergo α decay.
- › Three naturally occurring decay series all end in isotopes of lead.

24.2 THE KINETICS OF RADIOACTIVE DECAY

Both chemical and nuclear systems tend toward maximum stability. Just as the concentrations in a chemical system change in a predictable direction to give a stable equilibrium ratio, the type and number of nucleons in an unstable nucleus change in a predictable direction to give a stable N/Z ratio. As you know, however, the tendency of a chemical system to become more stable tells nothing about how long that process will take, and the same holds true for nuclear systems. In this section, we first see how radioactivity is detected and measured and then examine the kinetics of nuclear change; later, we’ll examine the energetics of nuclear change.

Detection and Measurement of Radioactivity

Radioactive emissions interact with surrounding atoms. To determine the rate of nuclear decay, we measure radioactivity by observing the effects of these interactions over time. Because these effects can be electrically amplified billions of times, it is possible to detect the decay of a single nucleus. Ionization counters and scintillation counters are two devices used to measure radioactive emissions.

Ionization Counters An *ionization counter* detects radioactive emissions as they ionize a gas. Ionization produces free electrons and gaseous cations, which are attracted to electrodes that conduct a current to a recording device. The most common type of ionization counter is a **Geiger-Müller counter** (Figure 24.4, *next page*). It consists of a tube filled with an argon-methane mixture; the tube housing acts as the cathode, and a thin wire in the center of the tube acts as the anode. Emissions from the sample enter the tube through a thin window and strike argon atoms, producing Ar^+ ions that migrate toward the cathode and free electrons that are accelerated toward the anode. These electrons collide with other argon atoms and free more electrons in an *avalanche effect*. The current created is amplified and appears as a meter reading and/or an audible click. An initial release of 1 electron can release 10^{10} electrons in a microsecond, giving the Geiger-Müller counter great sensitivity.

Scintillation Counters In a *scintillation counter*, radioactive emissions are detected by their ability to excite atoms and cause them to emit light. The light-emitting substance in the counter, called a *phosphor*, is coated onto part of a *photomultiplier tube*, a device that increases the original electrical signal. Incoming radioactive particles strike the phosphor, which emits photons. Each photon, in turn, strikes a cathode, releasing an electron through the photoelectric effect (Section 7.1). This electron hits other portions of the tube that release increasing numbers of electrons, and the

Figure 24.4 Detection of radioactivity by an ionization counter.

Source: © Hank Morgan/Science Source

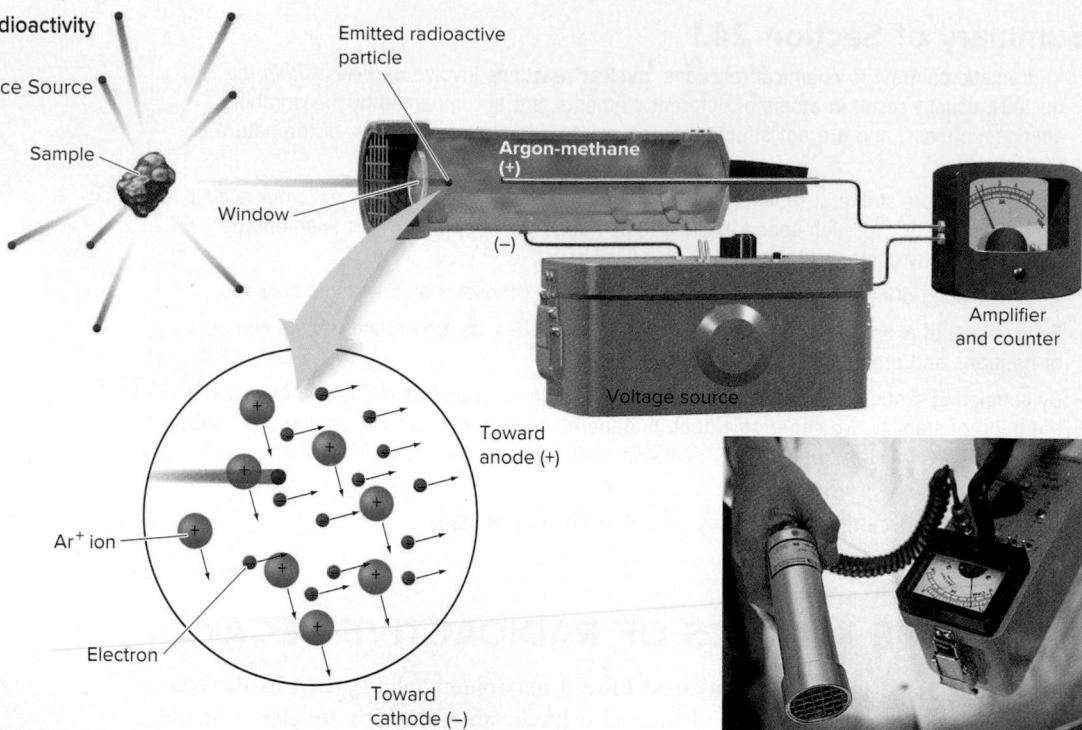

Figure 24.5 A scintillation “cocktail” in tubes to be placed in the counter.

Source: © Meridian Biotechnologies Ltd.

resulting current is recorded. Liquid scintillation counters employ an organic mixture that contains a phosphor and a solvent (Figure 24.5). This “cocktail” dissolves the radioactive sample and emits pulses of light when excited by the emission. The number of pulses is proportional to the concentration of the radioactive substance. These counters are often used to measure β^- emissions from dissolved biological samples, particularly those containing compounds of ^3H and ^{14}C .

The Rate of Radioactive Decay

Radioactive nuclei decay at a characteristic rate, regardless of the chemical substance in which they occur.

Activity and the Decay Constant The *decay rate*, or **activity** (\mathcal{A}), of a radioactive sample is the change in number of nuclei (\mathcal{N}) divided by the change in time (t). As with a chemical reaction rate (Section 16.2), because the number of nuclei is *decreasing*, a minus sign precedes the expression to obtain a positive decay rate:

$$\text{Decay rate } (\mathcal{A}) = -\frac{\Delta \mathcal{N}}{\Delta t}$$

There are two common units of radioactivity:

- The SI unit of radioactivity is the **becquerel (Bq)**, defined as one disintegration per second (d/s): $1 \text{ Bq} = 1 \text{ d/s}$.
- A much larger and more common unit of radioactivity is the **curie (Ci)**, which was originally defined as the number of disintegrations per second in 1 g of radium-226, but is now a fixed quantity: $1 \text{ Ci} = 3.70 \times 10^{10} \text{ d/s}$. Because the curie is so large, the millicurie (mCi) and microcurie (μCi) are commonly used.

The radioactivity of a sample is often given as a *specific activity*, the decay rate per gram.

An activity is meaningful only when we consider the large number of nuclei in a macroscopic sample. Suppose there are 1×10^{15} radioactive nuclei of a particular type in a sample and they decay at a rate of 10% per hour. Although any particular nucleus in the sample might decay in a microsecond or in a million hours, the *average* of all decays results in 10% of the entire collection of nuclei disintegrating each hour.

During the first hour, 10% of the *original* number, or 1×10^{14} nuclei, will decay. During the next hour, 10% of the remaining 9×10^{14} nuclei, or 9×10^{13} nuclei, will decay. During the next hour, 10% of those remaining will decay, and so forth. Thus, for a large collection of radioactive nuclei, *the number decaying per unit time is proportional to the number present*:

$$\text{Decay rate } (\mathcal{A}) \propto \mathcal{N} \quad \text{or} \quad \mathcal{A} = k\mathcal{N}$$

where k is called the **decay constant** and is characteristic of each type of nuclide. The larger the value of k , the higher the decay rate: larger $k \Rightarrow$ higher \mathcal{A} .

Combining the two expressions for decay rate just given, we obtain

$$\mathcal{A} = -\frac{\Delta \mathcal{N}}{\Delta t} = k\mathcal{N} \quad (24.2)$$

Note that the activity depends only on \mathcal{N} raised to the first power (and on the constant value of k). Therefore, *radioactive decay is a first-order process* (Section 16.4), but first order with respect to the *number* of nuclei rather than their concentration.

SAMPLE PROBLEM 24.4

Calculating the Specific Activity and the Decay Constant of a Radioactive Nuclide

Problem A sample of 2.6×10^{-12} mol of antimony-122 (^{122}Sb) emits $2.76 \times 10^8 \beta^-$ particles per minute.

- Calculate the specific activity of the sample (in Ci/g).
- Find the decay constant for ^{122}Sb .

Plan (a) The activity (\mathcal{A}) is the number of nuclei (\mathcal{N}) emitting a particle in a given time (t), and the specific activity is the activity per gram of sample. We are given \mathcal{A} , which is equal to the number of particles emitted per minute ($2.76 \times 10^8 \beta^-$ particles), and we know the amount (mol) of sample. Because the sample is an isotope, we use the mass number in g/mol (122 g/mol) to find the mass (g). Converting \mathcal{A} (in d/min) to curies (in d/s) and dividing by the mass gives the specific activity (in Ci/g). (b) The decay constant (k) relates the activity to the number of nuclei (\mathcal{N}). We know \mathcal{A} (number of nuclei disintegrating/min) and the amount (in mol), so we use Avogadro's number to find \mathcal{N} (number of nuclei) and apply Equation 24.2 to get k .

Solution a. Finding the mass of the sample:

$$\begin{aligned} \text{Mass (g)} &= (2.6 \times 10^{-12} \text{ mol}^{122}\text{Sb}) \left(\frac{122 \text{ g}^{122}\text{Sb}}{1 \text{ mol}^{122}\text{Sb}} \right) \\ &= 3.2 \times 10^{-10} \text{ g}^{122}\text{Sb} \end{aligned}$$

Using the activity and the mass to find the specific activity:

$$\begin{aligned} \text{Specific activity (Ci/g)} &= \left(\frac{2.76 \times 10^8 \text{ d}}{\text{min}} \right) \left(\frac{1 \text{ min}}{60 \text{ s}} \right) \left(\frac{1 \text{ Ci}}{3.70 \times 10^{10} \text{ d/s}} \right) \left(\frac{1}{3.2 \times 10^{-10} \text{ g}} \right) \\ &= 3.9 \times 10^5 \text{ Ci/g} \end{aligned}$$

b. Using the activity and the amount to find the decay constant (Equation 24.2):

$$\begin{aligned} \text{Decay constant (k)} &= \frac{\mathcal{A}(\text{nuclei/min})}{\mathcal{N}(\text{nuclei})} = \frac{2.76 \times 10^8 \text{ nuclei/min}}{(2.6 \times 10^{-12} \text{ mol})(6.022 \times 10^{23} \text{ nuclei/mol})} \\ &= 1.8 \times 10^{-4} \text{ min}^{-1} \end{aligned}$$

Check With so many exponents in the values, rounding is a good way to check the math. In part (b), for example,

$$k = \frac{3 \times 10^8 \text{ nuclei/min}}{(3 \times 10^{-12} \text{ mol})(6 \times 10^{23} \text{ nuclei/mol})} = 2 \times 10^{-4} \text{ min}^{-1}$$

FOLLOW-UP PROBLEMS

24.4A Arsenic-76 decays by β^- emission. If 3.4×10^{-8} mol of ^{76}As emits 1.53×10^{11} β^- particles per second, find the specific activity in (a) Ci/g; (b) Bq/g.

24.4B Chlorine-36 disintegrates by β^- decay. If 6.50×10^{-2} mol of ^{36}Cl emits 9.97×10^{12} β^- particles per hour, find the decay constant.

SOME SIMILAR PROBLEMS 24.33–24.40

Figure 24.6 Decrease in number of ^{14}C nuclei over time.

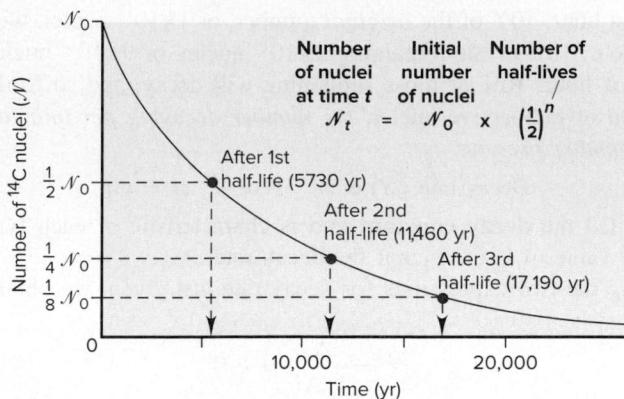

Half-Life of Radioactive Decay Decay rates are also commonly expressed in terms of the fraction of nuclei that decay over a given time interval. The **half-life** ($t_{1/2}$) of a nuclide has the same meaning as for a chemical change (Section 16.4) and can be expressed in terms of number of nuclei, mass of radioactive substance, and activity:

- *Number of nuclei.* Half-life is the time it takes for half the nuclei in a sample to decay—the number of nuclei remaining is halved after each half-life. Figure 24.6 shows the decay of carbon-14, which has a half-life of 5730 years (yr), in terms of number of ^{14}C nuclei remaining:

- *Mass.* As ^{14}C decays, the mass of ^{14}C decreases while the mass of ^{14}N increases. If we start with 1.0 g of ^{14}C , half that mass of ^{14}C (0.50 g) will be left after 5730 yr, half of that mass (0.25 g) after another 5730 yr, and so on.
- *Activity.* The activity depends on the number of nuclei, so the activity is halved after each succeeding half-life.

We determine the half-life of a nuclear reaction from its rate constant. Rearranging Equation 24.2 and integrating over time gives an expression for finding the number of nuclei remaining, \mathcal{N}_t , after a given time t :

$$\ln \frac{\mathcal{N}_t}{\mathcal{N}_0} = -kt \quad \text{or} \quad \mathcal{N}_t = \mathcal{N}_0 e^{-kt} \quad \text{and} \quad \ln \frac{\mathcal{N}_0}{\mathcal{N}_t} = kt \quad (24.3)$$

where \mathcal{N}_0 is the number of nuclei at $t = 0$. (Note the similarity to Equation 16.4.) To calculate the half-life ($t_{1/2}$), we set \mathcal{N}_t equal to $\frac{1}{2}\mathcal{N}_0$ and solve for $t_{1/2}$:

$$\ln \frac{\mathcal{N}_0}{\frac{1}{2}\mathcal{N}_0} = kt_{1/2} \quad \text{so} \quad t_{1/2} = \frac{\ln 2}{k} \quad (24.4)$$

Exactly analogous to the half-life of a first-order chemical change, *this half-life is not dependent on the number of nuclei and is inversely related to the decay constant:*

large $k \Rightarrow$ short $t_{1/2}$ and small $k \Rightarrow$ long $t_{1/2}$

The decay constants and half-lives of many radioactive nuclides vary over a very wide range, even for a given element (Table 24.6).

Table 24.6

Decay Constants (k) and Half-Lives ($t_{1/2}$) of Beryllium Isotopes

Nuclide	k	$t_{1/2}$
${}^7\text{Be}$	$1.30 \times 10^{-2}/\text{day}$	53.3 days
${}^8\text{Be}$	$1.0 \times 10^{16}/\text{s}$	$6.7 \times 10^{-17} \text{ s}$
${}^9\text{Be}$	Stable	
${}^{10}\text{Be}$	$4.3 \times 10^{-7}/\text{yr}$	$1.6 \times 10^6 \text{ yr}$
${}^{11}\text{Be}$	$5.02 \times 10^{-2}/\text{s}$	13.8 s

SAMPLE PROBLEM 24.5

Finding the Number of Radioactive Nuclei

Problem Strontium-90 is a radioactive byproduct of nuclear reactors that behaves biologically like calcium, the element above it in Group 2A(2). When ${}^{90}\text{Sr}$ is ingested by mammals, it is found in their milk and eventually in the bones of those drinking the milk. If a sample of ${}^{90}\text{Sr}$ has an activity of $1.2 \times 10^{12} \text{ d/s}$, what are the activity and the fraction of nuclei that have decayed after 59 yr ($t_{1/2}$ of ${}^{90}\text{Sr} = 29 \text{ yr}$)?

Plan The fraction of nuclei that have decayed is the change in number of nuclei, expressed as a fraction of the starting number. The activity of the sample (\mathcal{A}) is proportional to the number of nuclei (\mathcal{N}), so we know that

$$\text{Fraction decayed} = \frac{\mathcal{N}_0 - \mathcal{N}_t}{\mathcal{N}_0} = \frac{\mathcal{A}_0 - \mathcal{A}_t}{\mathcal{A}_0}$$

We are given \mathcal{A}_0 (1.2×10^{12} d/s), so we find \mathcal{A}_t from the integrated form of the first-order rate equation (Equation 24.3), in which t is 59 yr. To solve that equation, we first need k , which we can calculate from the given $t_{1/2}$ (29 yr) using Equation 24.4.

Solution Calculating the decay constant k :

$$t_{1/2} = \frac{\ln 2}{k} \quad \text{so} \quad k = \frac{\ln 2}{t_{1/2}} = \frac{0.693}{29 \text{ yr}} = 0.024 \text{ yr}^{-1}$$

Applying Equation 24.3 to calculate \mathcal{A}_t , the activity remaining at time t :

$$\ln \frac{\mathcal{N}_0}{\mathcal{N}_t} = \ln \frac{\mathcal{A}_0}{\mathcal{A}_t} = kt \quad \text{or} \quad \ln \mathcal{A}_0 - \ln \mathcal{A}_t = kt$$

$$\text{So, } \ln \mathcal{A}_t = -kt + \ln \mathcal{A}_0 = -(0.024 \text{ yr}^{-1} \times 59 \text{ yr}) + \ln (1.2 \times 10^{12} \text{ d/s})$$

$$\ln \mathcal{A}_t = -1.4 + 27.81 = 26.4$$

$$\mathcal{A}_t = 2.9 \times 10^{11} \text{ d/s}$$

(All the data contain two significant figures, so we retained two in the answer.)

Calculating the fraction decayed:

$$\text{Fraction decayed} = \frac{\mathcal{A}_0 - \mathcal{A}_t}{\mathcal{A}_0} = \frac{1.2 \times 10^{12} \text{ d/s} - 2.9 \times 10^{11} \text{ d/s}}{1.2 \times 10^{12} \text{ d/s}} = 0.76$$

Check The answer is reasonable: t is about 2 half-lives, so \mathcal{A}_t should be about $\frac{1}{4}\mathcal{A}_0$, or about 0.3×10^{12} ; therefore, the activity should have decreased by about $\frac{3}{4}$.

Comment 1. A substitution in Equation 24.3 is useful for finding \mathcal{A}_t , the activity at time t : $\mathcal{A}_t = \mathcal{A}_0 e^{-kt}$.

2. Another way to find the fraction of activity (or nuclei) remaining uses the number of half-lives ($t/t_{1/2}$). By combining Equations 24.3 and 24.4 and substituting $(\ln 2)/t_{1/2}$ for k , we obtain

$$\ln \frac{\mathcal{N}_0}{\mathcal{N}_t} = \left(\frac{\ln 2}{t_{1/2}} \right) t = \frac{t}{t_{1/2}} \ln 2 = \ln 2^{\frac{t}{t_{1/2}}}$$

Inverting the ratio gives

$$\ln \frac{\mathcal{N}_t}{\mathcal{N}_0} = \ln \left(\frac{1}{2} \right)^{\frac{t}{t_{1/2}}}$$

Taking the antilog gives

$$\text{Fraction remaining} = \frac{\mathcal{N}_t}{\mathcal{N}_0} = \left(\frac{1}{2} \right)^{\frac{t}{t_{1/2}}} = \left(\frac{1}{2} \right)^{\frac{59}{29}} = 0.24$$

$$\text{So, } \text{Fraction decayed} = 1.00 - 0.24 = 0.76$$

FOLLOW-UP PROBLEMS

24.5A Sodium-24 ($t_{1/2} = 15$ h) is used to study blood circulation. If a patient is injected with an aqueous solution of $^{24}\text{NaCl}$ whose activity is 2.5×10^9 d/s, how much of the activity is present in the patient's body and excreted fluids after 4.0 days?

24.5B Iron-59 ($t_{1/2} = 44.5$ days) is a β^- emitter used to monitor spleen function during disease or after trauma. If an accident victim receives a $5.6\text{-}\mu\text{Ci}$ dose, what fraction of the ^{59}Fe nuclei will have decayed after 17 days?

SOME SIMILAR PROBLEMS 24.41 and 24.42

Radioisotopic Dating

The historical record fades rapidly with time and is virtually nonexistent for events of more than a few thousand years ago. Much knowledge of prehistory comes from **radioisotopic dating**, which uses unstable isotopes, or **radioisotopes**, to determine the ages of objects. This technique supplies data in fields such as art history, archeology, geology, and paleontology.

The technique of *radiocarbon dating*, for which the American chemist Willard F. Libby won the Nobel Prize in chemistry in 1960, is based on measuring the amounts

of ^{14}C and ^{12}C in materials of biological origin. The accuracy of the method falls off after about six half-lives of ^{14}C ($t_{1/2} = 5730$ yr), so it is used to date objects up to about 36,000 years old.

Here is how radiocarbon dating works:

1. High-energy cosmic rays, consisting mainly of protons, enter the atmosphere from outer space and initiate a cascade of nuclear reactions, some of which produce neutrons that bombard ordinary ^{14}N atoms to form ^{14}C :

Through the competing processes of formation and radioactive decay, the amount of ^{14}C in the atmosphere has remained nearly constant.*

2. The ^{14}C atoms combine with O_2 , diffuse throughout the lower atmosphere, and enter the total carbon pool as gaseous $^{14}\text{CO}_2$ and aqueous $\text{H}^{14}\text{CO}_3^-$. They mix with ordinary $^{12}\text{CO}_2$ and $\text{H}^{12}\text{CO}_3^-$, reaching a constant $^{12}\text{C}/^{14}\text{C}$ ratio of about $10^{12}/1$.
3. The CO_2 is taken up by plants during photosynthesis, and then taken up and excreted by animals that eat the plants. Thus, the $^{12}\text{C}/^{14}\text{C}$ ratio of a living organism is the same as the ratio in the environment.
4. When an organism dies, it no longer absorbs or releases CO_2 , so the $^{12}\text{C}/^{14}\text{C}$ ratio steadily increases because *the amount of ^{14}C decreases as it decays*:

The difference between the $^{12}\text{C}/^{14}\text{C}$ ratio in a dead organism and the ratio in living organisms reflects the time elapsed since the organism died.

As you saw in Sample Problem 24.5, the first-order rate equation can be expressed in terms of a ratio of activities:

$$\ln \frac{\mathcal{N}_0}{\mathcal{N}_t} = \ln \frac{\mathcal{A}_0}{\mathcal{A}_t} = kt$$

We use this expression in radiocarbon dating, where \mathcal{A}_0 is the activity in a living organism and \mathcal{A}_t is the activity in the object whose age is unknown. Solving for t gives the age of the object:

$$t = \frac{1}{k} \ln \frac{\mathcal{A}_0}{\mathcal{A}_t} \quad (24.5)$$

A graphical method used in radioisotopic dating shows a plot of the natural logarithm of the specific activity vs. time, which gives a straight line with a slope of $-k$, the negative of the decay constant. Using such a plot and measuring the ^{14}C specific activity of an object, we can determine its age; examples appear in Figure 24.7.

One well-known example of the use of radiocarbon dating was in the determination of the age of the Shroud of Turin (*see photo*). One of the holiest Christian relics, the shroud is a piece of linen that bears a faint image of a man's body and was thought to be the burial cloth used to wrap the body of Jesus Christ. However, three labs in Europe and the United States independently measured the $^{12}\text{C}/^{14}\text{C}$ ratio of a 50-mg piece of the linen and determined that the flax from which the cloth was made was grown between 1260 A.D. and 1390 A.D.

To determine the ages of more ancient objects or of objects that do not contain carbon, different radioisotopes are measured. For example, comparing the ratio of ^{238}U ($t_{1/2} = 4.5 \times 10^9$ yr) to its final decay product, ^{206}Pb , in meteorites gives 4.7 billion years for the age of the Solar System, and therefore Earth. From this and other isotope ratios, such as $^{40}\text{K}/^{40}\text{Ar}$ ($t_{1/2}$ of $^{40}\text{K} = 1.3 \times 10^9$ yr) and $^{87}\text{Rb}/^{87}\text{Sr}$ ($t_{1/2}$ of $^{87}\text{Rb} = 4.9 \times 10^{10}$ yr), Moon rocks collected by Apollo astronauts have been dated at 4.2 billion years old.

The Shroud of Turin.

Source: © Copyright 1978 by Vernon Miller.
For use by permission for Business Wire
via Getty Images.

*Cosmic ray intensity does vary slightly with time, which affects the amount of atmospheric ^{14}C . From ^{14}C activity in ancient trees, we know the amount fell slightly about 3000 years ago to current levels. Recently, nuclear testing and fossil-fuel combustion have also altered the fraction of ^{14}C slightly. Taking these factors into account improves the accuracy of the dating method.

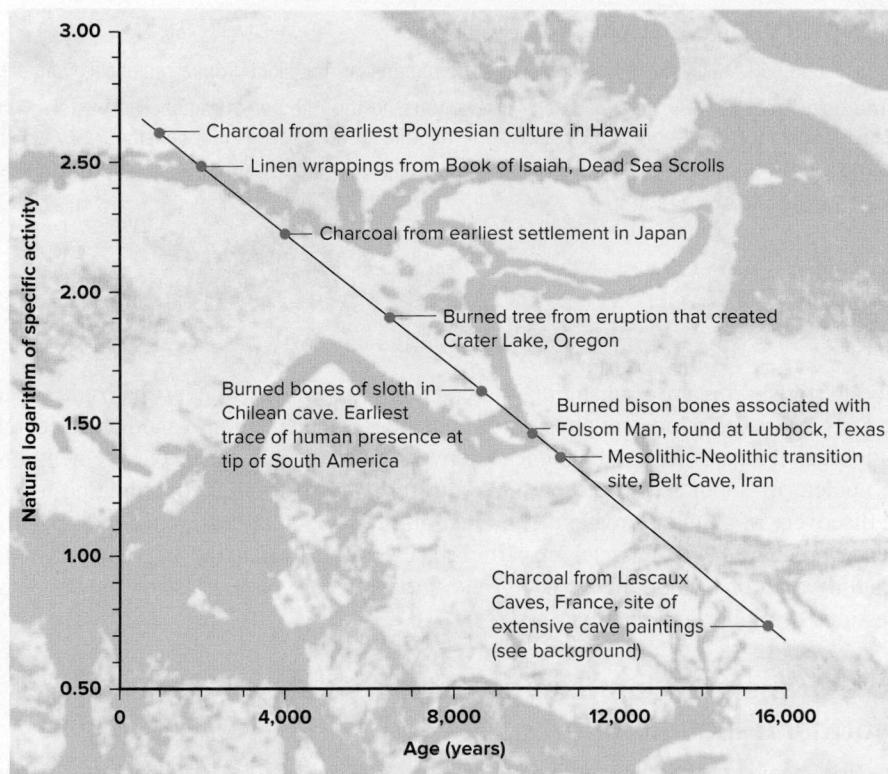

Figure 24.7 Ages of several objects determined by radiocarbon dating.

SAMPLE PROBLEM 24.6

Applying Radiocarbon Dating

Problem The charred bones of a sloth in a cave represent the earliest evidence of human presence at the southern tip of South America. A sample of the bone has a specific activity of 5.22 disintegrations per minute per gram of carbon ($d/min \cdot g$). If the $^{12}\text{C}/^{14}\text{C}$ ratio for living organisms results in a specific activity of 15.3 $d/min \cdot g$, how old are the bones ($t_{1/2}$ of $^{14}\text{C} = 5730$ yr)?

Plan We calculate k from the given $t_{1/2}$ (5730 yr). Then we apply Equation 24.5 to find the age (t) of the bones, using the given activities of the bones ($\mathcal{A}_t = 5.22 d/min \cdot g$) and of a living organism ($\mathcal{A}_0 = 15.3 d/min \cdot g$).

Solution Calculating k for ^{14}C decay:

$$k = \frac{\ln 2}{t_{1/2}} = \frac{0.693}{5730 \text{ yr}} \\ = 1.21 \times 10^{-4} \text{ yr}^{-1}$$

Calculating the age (t) of the bones:

$$t = \frac{1}{k} \ln \frac{\mathcal{A}_0}{\mathcal{A}_t} = \frac{1}{1.21 \times 10^{-4} \text{ yr}^{-1}} \ln \left(\frac{15.3 \text{ d/min} \cdot \text{g}}{5.22 \text{ d/min} \cdot \text{g}} \right) \\ = 8.89 \times 10^3 \text{ yr}$$

The bones are about 8890 years old.

Check The activity of the bones is between $\frac{1}{2}$ and $\frac{1}{4}$ of the activity of a living organism, so the age of the bones should be between one and two half-lives of ^{14}C (from 5730 to 11,460 yr).

FOLLOW-UP PROBLEMS

24.6A A sample of wood from an Egyptian mummy case has a specific activity of 9.41 $d/min \cdot g$. How old is the case ($t_{1/2}$ of $^{14}\text{C} = 5730$ yr)?

24.6B A fragment of a woolen tunic found in an ancient cemetery in Africa has a specific activity of 12.87 $d/min \cdot g$. How old is the tunic ($t_{1/2}$ of $^{14}\text{C} = 5730$ yr)?

SOME SIMILAR PROBLEMS

24.43 and 24.44

› Summary of Section 24.2

- › Ionization and scintillation counters measure the number of emissions from a radioactive sample.
- › The decay rate (activity) of a sample is proportional to the number of radioactive nuclei. Nuclear decay is a first-order process, so the half-life of the process is a constant.
- › Radioisotopic methods, such as ^{14}C dating, determine the age of an object by measuring the ratio of specific isotopes in it.

24.3

NUCLEAR TRANSMUTATION: INDUCED CHANGES IN NUCLEI

The alchemists' dream of changing base metals into gold was never realized, but in the early 20th century, nuclear physicists *did* change one element into another. Research on **nuclear transmutation**, the *induced* conversion of the nucleus of one element into the nucleus of another, was closely linked to research on atomic structure and led to the discovery of the neutron and the production of artificial radioisotopes. Later, high-energy bombardment of nuclei in particle accelerators began the ongoing effort to create new nuclides and new elements, and, most recently, to understand fundamental questions of matter and energy.

Early Transmutation Experiments; Nuclear Shorthand Notation

The first recognized transmutation occurred in 1919, when Ernest Rutherford showed that α particles emitted from radium bombarded atmospheric nitrogen to form a proton and oxygen-17:

By 1926, experimenters had found that α bombardment transmuted most elements with low atomic numbers to the next higher element, with ejection of a proton.

Notation for Transmutation Reactions A shorthand notation used specifically for nuclear transmutation reactions shows the reactant (target) nucleus to the left and the product nucleus to the right of a set of parentheses, within which a comma separates the projectile particle from the ejected particle(s):

reactant nucleus (particle in, particle(s) out) product nucleus

(24.6)

Using this notation, we write the previous reaction as ${}^{14}\text{N} (\alpha, p) {}^{17}\text{O}$.

The Neutron and the First Artificial Radioisotope An unexpected finding in a transmutation experiment led to *the discovery of the neutron*. When lithium, beryllium, and boron were bombarded with α particles, they emitted highly penetrating radiation that could not be deflected by a magnetic or electric field. Unlike γ radiation, these emissions were massive enough to eject protons from the substances they penetrated. In 1932, James Chadwick, a student of Rutherford, proposed that the emissions consisted of neutral particles with a mass similar to that of a proton, which he named *neutrons*. He received the Nobel Prize in physics in 1935 for his discovery.

In 1933, Irene and Frederic Joliot-Curie (*see photo*), daughter and son-in-law of Marie and Pierre Curie, created the first artificial radioisotope, phosphorus-30. When they bombarded aluminum foil with α particles, phosphorus-30 and neutrons were formed:

Since then, other techniques for producing artificial radioisotopes have been developed. In fact, the majority of the nearly 1000 known radioactive nuclides have been produced artificially.

The Joliot-Curies in their laboratory.

Source: © Hulton Archive/Getty Images

Particle Accelerators and the Transuranium Elements

During the 1930s and 1940s, researchers probing the nucleus bombarded elements with neutrons, α particles, protons, and **deuterons** (nuclei of the stable hydrogen isotope deuterium, ^2H). Neutrons are especially useful as projectiles because they have no charge and thus are not repelled as they approach a target nucleus. The other particles are all positive, so early researchers found it difficult to give them enough energy to overcome the repulsion of the target nuclei. Beginning in the 1930s, however, **particle accelerators** were able to impart high kinetic energies to particles by placing them in an electric field, usually in combination with a magnetic field. In the simplest and earliest design, protons are introduced at one end of a tube and attracted to the other end by a potential difference.

Linear Accelerator A major advance was the *linear accelerator*, a series of separated tubes of increasing length that, through a source of alternating voltage, change their charge from positive to negative in synchrony with the movement of the particle through them (Figure 24.8).

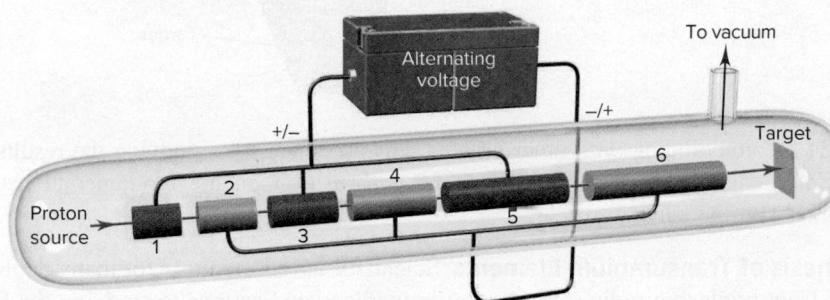

Figure 24.8 Schematic diagram of a linear accelerator.

A proton, for example, exits the first tube just when that tube becomes positive and the next tube negative. Repelled by the first tube and attracted by the second, the proton accelerates across the gap between them. The process is performed in stages to achieve high particle energies without having to apply a single very high voltage. A 40-ft linear accelerator with 46 tubes, built in California after World War II, accelerated protons to speeds several million times faster than earlier accelerators.

Other Early Particle Accelerators Two other early accelerators represented important design advances:

- The *cyclotron* (Figure 24.9, *next page*) was invented by E. O. Lawrence in 1930. Typically 1–2 m in diameter, it applies the principle of the linear accelerator but uses electromagnets to give the particle a spiral path to save space. The magnets lie within an evacuated chamber above and below two “dees,” open, D-shaped electrodes that act like the tubes in the linear design. The particle is accelerated as it passes from one dee, which is momentarily positive, to the other, which is momentarily negative. Its speed and path radius increase until it is deflected toward the target nucleus.
- The *synchrotron* uses a synchronously increasing magnetic field to make the particle’s path circular rather than spiral.

Powerful Modern Accelerators Some very powerful accelerators that are used to study the physics of high-energy particle collisions include both a linear section and a synchrotron section. The *tevatron* at the Fermi Lab near Chicago has a circumference of 3.9 miles and can accelerate particles to an energy slightly less than 1×10^{12} electron volts (1 TeV) before colliding them.

The world’s most powerful accelerator is the Large Hadron Collider (LHC) near Geneva, Switzerland (*see photo*). The first successful collision of protons in the LHC was achieved in early 2010. When operating at peak capacity, the LHC accelerates protons to an energy of up to 13 TeV as they travel around the main ring at a speed of 11,000 revolutions per second, attaining a final speed about 99.99% of the speed

A small section of the Large Hadron Collider.

Source: © James Brittain/View Pictures/
age fotostock

Figure 24.9 Schematic diagram of a cyclotron.

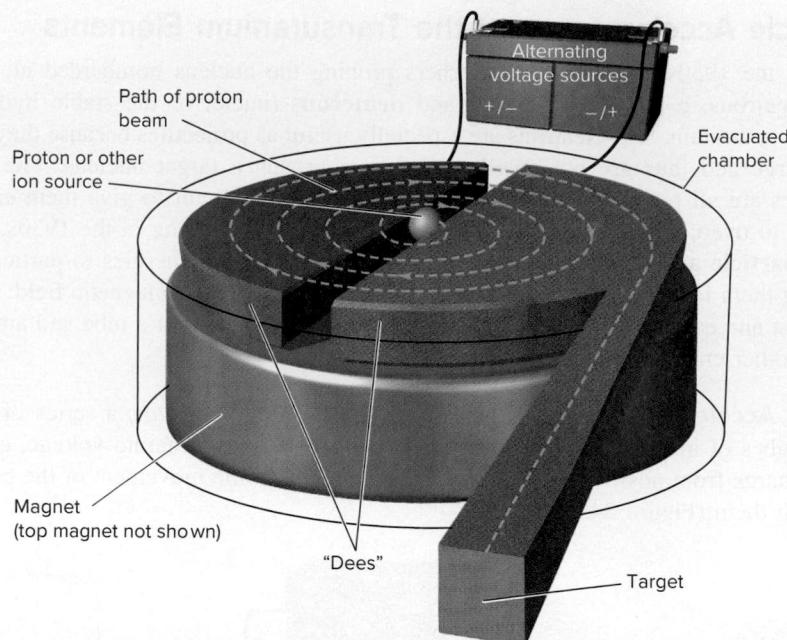

of light before colliding with other protons. Physicists are now studying the results of these high-energy subatomic collisions for information on the fundamental nature of matter and the early universe.

Synthesis of Transuranium Elements Scientists use accelerators for many applications, from producing radioisotopes used in medical applications to studying the fundamental nature of matter. Perhaps the most specific application for chemists is the synthesis of **transuranium elements**, those with atomic numbers higher than uranium, the heaviest naturally occurring element. Some reactions that were used to form several of these elements appear in Table 24.7. The transuranium elements include the remaining actinides ($Z = 93$ to 103), in which the $5f$ sublevel is filled; the elements in the fourth transition series ($Z = 104$ to 112), in which the $6d$ sublevel is filled; and the remaining elements in the $7p$ sublevel ($Z = 113$ to 118).

Table 24.7 Formation of Some Transuranium Nuclides*

Z	Name (Symbol)	Reaction				Half-life of Product			
		$^{239}_{94}\text{Pu}$	$+$	$^{20}_0\text{n}$	\longrightarrow	$^{241}_{95}\text{Am}$	$+$	$^{-1}\beta$	
104	rutherfordium (Rf)	$^{239}_{94}\text{Pu}$	$+$	$^{4}_2\alpha$	\longrightarrow	$^{242}_{96}\text{Cm}$	$+$	^1_0n	163 days
105	dubnium (Db)	$^{241}_{95}\text{Am}$	$+$	$^{4}_2\alpha$	\longrightarrow	$^{243}_{97}\text{Bk}$	$+$	$^{20}_0\text{n}$	4.5 h
106	seaborgium (Sg)	$^{242}_{96}\text{Cm}$	$+$	$^{4}_2\alpha$	\longrightarrow	$^{245}_{98}\text{Cf}$	$+$	^1_0n	45 min
107	bohrium (Bh)	$^{253}_{99}\text{Es}$	$+$	$^{4}_2\alpha$	\longrightarrow	$^{256}_{101}\text{Md}$	$+$	^1_0n	76 min
108	hassium (Hs)	$^{243}_{95}\text{Am}$	$+$	$^{18}_8\text{O}$	\longrightarrow	$^{256}_{103}\text{Lr}$	$+$	$^{50}_0\text{n}$	28 s

*Like chemical reactions, nuclear reactions may occur in several steps. For example, the first reaction here is actually an overall process that occurs in three steps:

Conflicting claims of discovery by scientists in the United States and the former Soviet Union led to controversies about names for some of the more recently synthesized elements. To provide interim names until the disputes could be settled, the International Union of Pure and Applied Chemistry (IUPAC) adopted a system that uses the atomic number as the basis for a Latin name. Thus, for example, element 104 was named unnilquadium ($un = 1$, $nil = 0$, $quad = 4$, $ium =$ metal suffix), with the symbol Unq. After much compromise, IUPAC has finalized the names of the new elements (*margin*).

› Summary of Section 24.3

- › One nucleus can be transmuted to another through bombardment with high-energy particles.
- › Accelerators increase the kinetic energy of particles in nuclear bombardment experiments and are used to produce transuranium elements and radioisotopes for medical use.

24.4 IONIZATION: EFFECTS OF NUCLEAR RADIATION ON MATTER

In 1986, an accident at the Chernobyl nuclear facility in the former Soviet Union released radioactivity that, according to the World Health Organization, will eventually cause thousands of cancer deaths. In the same year, isotopes used in medical treatment emitted radioactivity that prevented thousands of cancer deaths. In this section and Section 24.5, we examine radioactivity's harmful and beneficial effects.

The key to both types of effects is that *nuclear changes cause chemical changes in surrounding matter*. In other words, even though the nucleus of an atom may undergo a reaction with little or no involvement of the atom's electrons, the emissions from that reaction *do* affect the electrons of nearby atoms.

Virtually all radioactivity causes **ionization** in surrounding matter, as the emissions collide with atoms and dislodge electrons:

From each ionization event, a cation and a free electron result, and the number of such *cation-electron pairs* produced is directly related to the energy of the incoming **ionizing radiation**.

Many applications of ionizing radiation depend not only on the ionizing event itself, but also on secondary processes. For example, in a Geiger-Müller counter, the free electron of the cation-electron pair often collides with another atom, which ejects a second electron, and in a scintillation counter, the initial ionization eventually results in the emission of light. In nuclear power plants (Section 24.7), the initial process as well as several secondary processes cause the release of heat that makes the steam used to generate electricity.

Effects of Ionizing Radiation on Living Tissue

Ionizing radiation has a destructive effect on living tissue, and if the ionized atom is part of a key biological macromolecule or cell membrane, the results can be devastating to the cell and perhaps the organism.

The danger from a radioactive nuclide depends on three factors:

- the type of radiation emitted,
- the half-life of the radioactive nuclide, and
- most importantly, the biological behavior of the radioactive nuclide.

For example, both ^{235}U and ^{239}Pu emit α particles and have long half-lives, but uranium is rapidly excreted by the body, whereas plutonium behaves like calcium and, thus, is incorporated into bones and teeth. One of the most dangerous radioactive nuclides, even worse than plutonium, is $^{90}\text{Sr}^{2+}$ (formed during a nuclear explosion) because it behaves very similarly to Ca^{2+} and is absorbed rapidly by bones. Let's first see how to measure radiation dose and then look in more detail at the damaging power of ionizing radiation.

Units of Radiation Dose and Its Effects To measure the effects of ionizing radiation, we need a unit for radiation dose. Units of radioactive decay, such as the becquerel and curie, measure the number of decay events in a given time but

not their energy or absorption by matter. However, the number of cation-electron pairs produced in a given amount of living tissue *is* a measure of the energy absorbed by the tissue. Two pairs of related units are used to quantify this absorbed energy:

- The SI unit for energy absorption is the **gray (Gy)**; it is equal to 1 joule of energy absorbed per kilogram of body tissue:

$$1 \text{ Gy} = 1 \text{ J/kg}$$

- A more widely used unit is the **rad (radiation-absorbed dose)**, which is one-hundredth as large as the gray:

$$1 \text{ rad} = 0.01 \text{ J/kg} = 0.01 \text{ Gy}$$

To measure actual tissue damage, we must account for differences in the strength of the radiation, the exposure time, and the type of tissue. To do this, we multiply the absorbed dose by a *relative biological effectiveness* (RBE) factor, which depends on the effect a given type of radiation has on a given tissue or body part. The product is expressed in one of two units:

- The **rem (roentgen equivalent for man)** is the unit of radiation dosage equivalent to a given amount of tissue damage in a human:

$$\text{no. of rems} = \text{no. of rads} \times \text{RBE}$$

Doses are often expressed in millirems (10^{-3} rem).

- The SI unit for dosage equivalent is the **sievert (Sv)**. It is defined in the same way as the rem but with absorbed dose in grays; thus, $1 \text{ Sv} = 100 \text{ rem}$.

Figure 24.10 Penetrating power of radioactive emissions.

Penetrating Power of Emissions The effect on living tissue of a radiation dose depends on the penetrating power *and* ionizing ability of the radiation. Since water is the main component of living tissue, penetrating power is often measured in terms of the depth of water that stops 50% of incoming radiation. In Figure 24.10, the average values of the penetrating distances are shown in actual size for the three common types of emissions. Note, in general, that *penetrating power is inversely related to the mass, charge, and energy of the emission*. In other words, if a particle interacts strongly with matter, it penetrates only slightly, and vice versa.

1. *Alpha particles.* Alpha particles are massive and highly charged, which means that they interact with matter most strongly of the three common emissions. As a result, they penetrate so little that a piece of paper, light clothing, or the outer layer of skin can stop α radiation from an external source. However, if ingested, an α emitter can cause grave localized internal damage through extensive ionization. For example, in the early 20th century, wristwatch and clock dials were painted by hand with paint containing radium so that the numbers would glow in the dark. To write numbers clearly, the women who applied the paint “tipped” fine brushes repeatedly between their lips. Small amounts of ingested $^{226}\text{Ra}^{2+}$ were incorporated into their bones along with normal Ca^{2+} , which led to numerous cases of bone fracture and jaw cancer.

2. *Beta particles and positrons.* Beta particles (β^-) and positrons (β^+) have less charge and much less mass than α particles, so they interact less strongly with matter. Even though a given particle has less chance of causing ionization, a β^- (or β^+) emitter is a more destructive external source because the particles penetrate deeper. Specialized heavy clothing or a thick (0.5 cm) piece of metal is required to stop these particles. The relative danger from α and β^- emissions is shown by two international incidents involving poisoning. In 1957, an espionage agent was poisoned by thallium-204, a β^- emitter, but he survived because β^- particles do relatively little radiation damage. In contrast, in 2006, another agent was poisoned with polonium-210, an α emitter, and died in three weeks because of the much greater radiation damage.

3. *Gamma rays.* Neutral, massless γ rays interact least with matter and, thus, penetrate most. A block of lead several inches thick is needed to stop them. Therefore, an external γ ray source is the most dangerous because the energy can ionize many layers of living tissue.

The extent of interaction with matter is variable for emitted *neutrons*, which are neutral and massive. Outside a nucleus, neutrons decay with a half-life of 10.6 min into a proton and an electron (and an antineutrino). With energies ranging from very low to very high, they may be scattered or captured by interaction with nuclei.

Molecular Interactions How does the damage take place on the molecular level? When ionizing radiation interacts with molecules, it causes the *loss of an electron from a bond or a lone pair*. The resulting charged species go on to form **free radicals**, molecular or atomic species with one or more unpaired electrons, which, as you know, are very reactive (Section 10.1). They form electron pairs by attacking bonds in other molecules, often forming more free radicals. Two types of materials are especially vulnerable to free-radical attack:

1. *Water.* When γ radiation strikes living tissue, for instance, the most likely molecule to absorb it is water, yielding an electron and a water ion-radical:

The products collide with other water molecules to form more free radicals:

These free radicals attack more H_2O molecules and surrounding biomolecules, whose bonding and structure are intimately connected with their function (Section 15.6).

2. *Membranes and macromolecules.* The double bonds in membrane lipids are highly susceptible to free-radical attack:

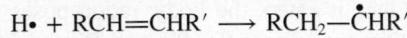

In this reaction, one electron of the π bond forms a C—H bond between one of the double-bonded carbons and the $\text{H}\cdot$, and the other electron resides on the other carbon to form a free radical. Changes to lipid structure cause damage that results in leakage through cell membranes and destruction of the protective fatty tissue around organs. Changes to critical bonds in enzymes lead to their malfunction as catalysts of metabolic reactions. Changes in the nucleic acids and proteins that govern the rate of cell division can cause cancer. Genetic damage and mutations may occur when bonds in the DNA of sperm and egg cells are altered by free radicals.

Background Sources of Ionizing Radiation

We are continuously exposed to ionizing radiation from natural and artificial sources (Table 24.8). Indeed, life evolved in the presence of natural ionizing radiation, called **background radiation**. Ionizing radiation can alter bonds in DNA and cause harmful mutations but also causes the beneficial ones that allow species to evolve.

Background radiation has several natural sources:

1. *Cosmic radiation* increases with altitude because of decreased absorption by the atmosphere. Thus, people in Denver absorb twice as much cosmic radiation as people in Los Angeles; even a single jet flight involves measurable absorption.

2. Thorium and uranium minerals are present in rocks and soil. Radon, the heaviest noble gas [Group 8A(18)], is a radioactive product of uranium and thorium decay. Its concentration in the air we breathe is related to the presence of trace minerals in building materials and to the uranium content of local soil and

Table 24.8

Typical Radiation Doses from Natural and Artificial Sources

Source of Radiation	Average Adult Exposure
Natural	
Cosmic radiation	30–50 mrem/yr
Radiation from the ground	
From clay soil and rocks	~25–170 mrem/yr
In wooden houses	10–20 mrem/yr
In brick houses	60–70 mrem/yr
In concrete (cinder block) houses	60–160 mrem/yr
Radiation from the air (mainly radon)	
Outdoors, average value	20 mrem/yr
In wooden houses	70 mrem/yr
In brick houses	130 mrem/yr
In concrete (cinder block) houses	260 mrem/yr
Internal radiation from minerals in tap water and daily intake of food (^{40}K , ^{14}C , Ra)	~40 mrem/yr
Artificial	
Diagnostic x-ray methods	
Lung (local)	0.04–0.2 rad/film
Kidney (local)	1.5–3 rad/film
Dental (dose to the skin)	≤ 1 rad/film
Therapeutic radiation treatment	Locally $\leq 10,000$ rad
Other sources	
Jet flight (4 h)	~1 mrem
Nuclear testing	<4 mrem/yr
Nuclear power industry	<1 mrem/yr
Total average value	100–200 mrem/yr

rocks (Figure 24.11). Once it enters the body, radon poses a serious potential hazard as it decays to radioactive nuclides of Po, Pb, and Bi, through α , β^- , and γ emissions. The emissions damage lung tissue, and the heavy-metal atoms formed aggravate the problem. Recent EPA estimates indicate that radon contributes to 15% of annual lung cancer deaths.

3. About 150 g of K^+ ions is dissolved in the water in the tissues of an average adult, and 0.0118% of these ions are radioactive ^{40}K . The presence of these substances and of atmospheric $^{14}\text{CO}_2$ makes *all* food, water, clothing, and building materials slightly radioactive.

The largest artificial source of radiation, and the one that is easiest to control, is from medical diagnostic techniques, especially x-rays. The radiation dosage from nuclear testing and radioactive waste disposal is minuscule for most people, but exposures for those living near test sites or disposal areas may be much higher.

Assessing the Risk from Ionizing Radiation

How much radiation is too much? To answer this question, we must ask several others: How strong is the exposure? How long is the exposure? Which tissue is exposed? Are children being exposed? One reason we lack clear data to answer these questions is that scientific ethical standards forbid the intentional exposure of humans in an experimental setting. However, accidentally exposed radiation workers and Japanese atomic bomb survivors have been studied extensively.

1. *Human studies.* Table 24.9 summarizes the immediate effects on humans of an acute single dose of ionizing radiation to the whole body. The severity of the effects increases with dose; a dose of 500 rem will kill about 50% of the exposed population within a month.

Table 24.9**Acute Effects of a Single Dose of Whole-Body Irradiation**

Dose (rem)	Effect	Lethal Dose	
		Population (%)	Number of Days
5–20	Possible late effect; possible chromosomal aberrations	—	—
20–100	Temporary reduction in white blood cells	—	—
50+	Temporary sterility in men (100+ rem = 1-yr duration)	—	—
100–200	“Mild radiation sickness”: vomiting, diarrhea, tiredness in a few hours	—	—
	Reduction in infection resistance		
	Possible bone growth retardation in children		
300+	Permanent sterility in women	—	—
500	“Serious radiation sickness”: marrow/intestine destruction	50–70	30
400–1000	Acute illness, early deaths	60–95	30
3000+	Acute illness, death in hours to days	100	2

2. *Animal studies.* Most data on radiation risk come from laboratory animals, whose biological systems may differ greatly from ours. Nevertheless, studies with mice and dogs show that lesions and cancers appear after massive whole-body exposure, with rapidly dividing cells affected first. In an adult animal, these are cells of the bone marrow, organ linings, and reproductive organs, but many other tissues are affected in an immature animal or fetus.

3. *Models of risk assessment.* Studies in both animals and humans show an increase in the incidence of cancer from either a high, single exposure or a low, chronic exposure. Two current models of radiation risk are shown in Figure 24.12:

- The *linear response model* proposes that radiation effects, such as cancer risks, accumulate over time regardless of dose and that populations should not be exposed to any radiation above background levels.
- The *S-shaped response model* implies there is a threshold above which the effects are more significant: very low risk at low dose and high risk at high dose.

4. *Hereditary effects.* Reliable data on hereditary (genetic) effects of radiation are few. Studies on fruit flies show a linear increase in genetic defects with both dose and exposure time. However, in the mouse, whose genetic system is obviously much more similar to ours than is the fruit fly's, a total dose given over a long period created one-third as many genetic defects as the same dose given over a short period. Therefore, rate of exposure is a key factor. The children of atomic bomb survivors show higher-than-normal childhood cancer rates, implying that their parents' reproductive systems were affected.

› Summary of Section 24.4

- › All radioactive emissions cause ionization.
- › The effect of ionizing radiation on living matter depends on the quantity of energy absorbed and the extent of ionization in a given type of tissue. Radiation dose for the human body is measured in rem.
- › Ionization forms free radicals, some of which proliferate and destroy biomolecular function.
- › All organisms are exposed to varying quantities of natural ionizing radiation.
- › Studies show that either a large acute dose or a chronic small dose is harmful.

Figure 24.12 Two models of radiation risk.

24.5 APPLICATIONS OF RADIOISOTOPES

Radioisotopes are powerful tools for studying processes in biochemistry, medicine, materials science, environmental studies, and many other scientific and industrial fields. Such uses depend on the fact that *isotopes of an element exhibit very similar chemical and physical behavior*. In other words, except for having a less stable nucleus, a radioisotope has nearly the same properties as a nonradioactive isotope of the same element.* For example, the fact that $^{14}\text{CO}_2$ is utilized by a plant in the same way as $^{12}\text{CO}_2$ forms the basis of radiocarbon dating.

Radioactive Tracers

Just think how useful it could be to follow a substance through a complex process or from one region of a system to another. A tiny amount of a radioisotope mixed with a large amount of a stable isotope of the same element can act as a **tracer**, a chemical “beacon” emitting radiation that signals the presence of the substance.

Reaction Pathways Tracers are used to study simple and complex reaction pathways.

1. *Inorganic systems: the periodate-iodide reaction.* One well-studied pathway is that of the reaction between periodate and iodide ions:

Is IO_3^- the result of IO_4^- reduction or I^- oxidation? When “cold” (nonradioactive) IO_4^- is added to a solution of I^- that contains some “hot” (radioactive, indicated in red) $^{131}\text{I}^-$, the I_2 is the radioactive product, not the IO_3^- :

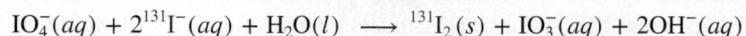

These results show that IO_3^- forms through the reduction of IO_4^- , and that I_2 forms through the oxidation of I^- . To confirm this pathway, IO_4^- containing some $^{131}\text{IO}_4^-$ is added to a solution of I^- . As expected, in this case, the IO_3^- is radioactive, not the I_2 :

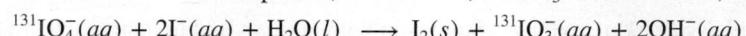

Thus, tracers act like “handles” we can “hold” to follow the changing reactants.

2. *Biochemical pathways: photosynthesis.* Far more complex pathways can be followed with tracers as well. The photosynthetic pathway, in which energy from sunlight is used to form the chemical bonds of glucose, is the most essential and widespread metabolic process on Earth. It has an overall reaction that looks quite simple:

However, the actual process is extremely complex: 13 enzyme-catalyzed steps are required to incorporate each C atom from CO_2 , so the six CO_2 molecules needed to form a molecule of $\text{C}_6\text{H}_{12}\text{O}_6$ require six repetitions of the pathway. Melvin Calvin and his coworkers took seven years to determine the pathway, using ^{14}C in CO_2 as the tracer and chromatography as the means of separating the products formed after different times of light exposure. Calvin won the Nobel Prize in chemistry in 1961 for this remarkable achievement.

Physiological Studies Tracers are used in many studies of physiological function. Some recent studies examine challenges of living in outer space. In an animal study of red blood cell loss during extended space flight, blood plasma volume was measured with ^{125}I -labeled albumin (a blood protein), and red blood cells labeled with

*Although this statement is generally correct, differences in isotopic mass *can* influence bond strengths and therefore reaction rates. Such behavior is called a *kinetic isotope effect* and is particularly important for isotopes of hydrogen— ^1H , ^2H , and ^3H —because their masses differ by such large proportions. Section 22.4 discussed how the kinetic isotope effect is employed in the industrial production of heavy water, D_2O .

^{51}Cr as a trace substitute for Fe were used to assess the survival rate of blood cells. In another study, blood flow in skin under long periods of microgravity was monitored using injected ^{133}Xe .

Material Flow Tracers are used in studies of solid surfaces and the flow of materials. Metal atoms hundreds of layers deep within a solid have been shown to exchange with metal ions from the surrounding solution within a matter of minutes. Chemists and engineers use tracers to study material movement in semiconductor chips, paint, and metal plating, in detergent action, and in the process of corrosion, to mention just a few of many applications.

Hydrologic engineers use tracers to study the volume and flow of large bodies of water. By following radioactive nuclides that formed during atmospheric nuclear bomb tests (^3H in H_2O , $^{90}\text{Sr}^{2+}$, and $^{137}\text{Cs}^+$), scientists have mapped the flow of water from land to lakes and streams to oceans. They also use tracers to study the surface and deep ocean currents that circulate around the globe, the mechanisms of hurricane formation, and the mixing of the troposphere and stratosphere.

Various industries employ tracers to study material flow during manufacturing processes, such as the flow of ore pellets in smelting kilns, the paths of wood chips and bleach in paper mills, the diffusion of fungicide into lumber, and in a particularly important application, the porosity and leakage of oil and gas wells in geological formations.

Activation Analysis Another use of tracers is in *neutron activation analysis* (NAA). In this method, neutrons bombard a nonradioactive sample, converting a small fraction of its atoms to radioisotopes, which exhibit characteristic decay patterns, such as γ -ray spectra, that reveal the elements present. Unlike chemical analysis, NAA leaves the sample virtually intact, so the method can be used to determine the composition of a valuable object or a very small sample. For example, a painting thought to be a 16th-century Dutch masterpiece was shown through NAA to be a 20th-century forgery, because a microgram-sized sample of its pigment contained much less silver and antimony than the pigments used by the Dutch masters. Forensic chemists use NAA to detect traces of ammunition on a suspect's hand or traces of arsenic in the hair of a victim of poisoning.

Automotive engineers employ NAA and γ -ray detectors to measure friction and wear of moving parts without having to take an engine apart. For example, when a steel surface that has been neutron-activated to form some radioactive ^{59}Fe moves against a second steel surface, the amount of radioactivity on the second surface indicates the amount of material rubbing off. The radioactivity appearing in a lubricant placed between the surfaces can demonstrate the lubricant's ability to reduce wear.

Medical Diagnosis The largest use of radioisotopes is in medical science. Tracers with half-lives of a few minutes to a few days are employed to observe specific organs and body parts.

For example, a healthy thyroid gland incorporates dietary I^- into iodine-containing hormones at a known rate. To assess thyroid function, the patient drinks a solution containing a trace amount of Na^{131}I ; the thyroid gland absorbs $^{131}\text{I}^-$ ions, which undergo β^- decay, and the emissions produce an image of the gland (Figure 24.13A, *next page*). Technetium-99 ($Z = 43$) is also used for imaging the thyroid (Figure 24.13B, *next page*), as well as the heart, lungs, and liver. Technetium does not occur naturally, so the radioisotope (actually a metastable form, ^{99m}Tc) is prepared from radioactive molybdenum just before use:

Tracers are also used to measure physiological processes, such as blood flow. The rate at which the heart pumps blood, for example, can be observed by injecting ^{59}Fe , which becomes incorporated into the hemoglobin of blood cells. Several radioisotopes used in medical diagnosis are listed in Table 24.10.

Some Radioisotopes Used as Tracers in Medical Diagnosis

Table 24.10

Isotope	Body Part or Process
^{11}C , ^{18}F , ^{13}N , ^{15}O	PET studies of brain, heart
^{60}Co , ^{192}Ir	Cancer therapy
^{64}Cu	Metabolism of copper
^{59}Fe	Blood flow, spleen
^{67}Ga	Tumor imaging
^{123}I , ^{131}I	Thyroid
^{111}In	Brain, colon
^{42}K	Blood flow
^{81m}Kr	Lung
^{99m}Tc	Heart, thyroid, liver, lung, bone
^{201}Tl	Heart muscle
^{90}Y	Cancer, arthritis

Figure 24.13 The use of radioisotopes to image the thyroid gland. **A**, This ^{131}I scan shows an asymmetric image that is indicative of disease. **B**, A ^{99}Tc scan of a healthy thyroid.

Source: (A) © Scott Camazine/Science Source
Source: (B) © Chris Priest/Science Source

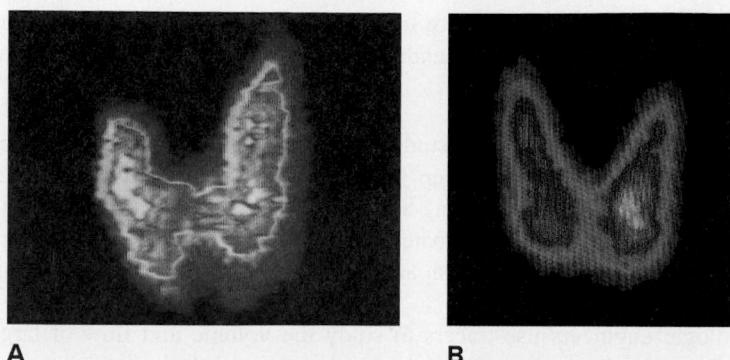

Positron-emission tomography (PET) is a powerful imaging method for observing brain structure and function. A biological substance is synthesized with one of its atoms replaced by an isotope that emits positrons. The substance is injected into a patient's bloodstream, from which it is taken up into the brain. The isotope emits positrons, each of which annihilates a nearby electron. In this process, two γ photons are emitted simultaneously 180° from each other:

An array of detectors around the patient's head pinpoints the sites of γ emission, and the image is analyzed by computer. Two of the isotopes used are ^{15}O , injected as H_2^{15}O to measure blood flow, and ^{18}F bonded to a glucose analog to measure glucose uptake, which is an indicator of energy metabolism.

Among many fascinating findings revealed by PET are those that show how changes in blood flow and glucose uptake accompany normal or abnormal brain activity (Figure 24.14). Also, substances incorporating ^{11}C and ^{15}O are being investigated using PET to learn how molecules interact with and move along the surface of a catalyst.

Figure 24.14 PET and brain activity. These PET scans show brain activity in a normal person (*left*) and in a patient with Alzheimer's disease (*right*). Red and yellow indicate relatively high activity within a region.

Source: © Dr. Robert Friedland/SPL/Science Source

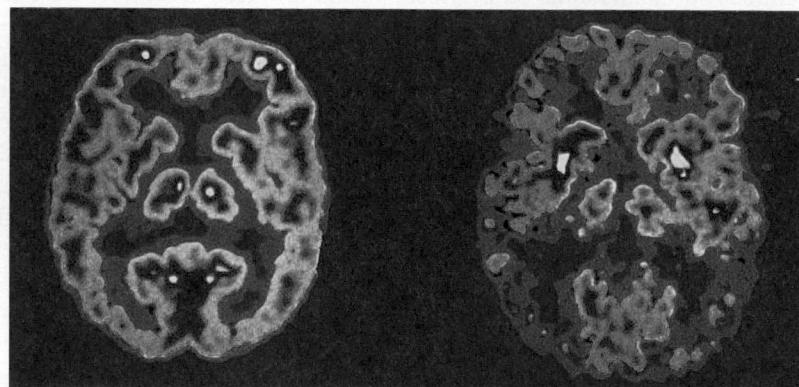

Additional Applications of Ionizing Radiation

Many other uses of radioisotopes involve higher-energy ionizing radiation.

1. *Radiation therapy.* Cancer cells divide more rapidly than normal cells, so radioisotopes that interfere with cell division kill more cancer cells than normal ones. Implants of ^{198}Au or of ^{90}Sr , which decays to the γ -emitting ^{90}Y , have been used to destroy pituitary and breast tumor cells, and γ rays from ^{60}Co have been used to destroy tumors of the brain and other organs.

2. *Destruction of microbes.* Irradiation of food increases shelf life by killing microorganisms that cause rotting or spoilage (Figure 24.15), but the practice is controversial. Advocates point to the benefits of preserving fresh foods, grains, and seeds for

Figure 24.15 The increased shelf life of irradiated food.

Source: Iowa State University

long periods, whereas opponents suggest that irradiation might lower the food's nutritional content or produce harmful byproducts. Irradiation also provides a way to destroy newer, more resistant bacterial strains that survive the increasing use of the more common antibiotics in animal feed. The United Nations has approved irradiation for potatoes, wheat, chicken, and strawberries, and the U.S. Food and Drug Administration has approved it for these and other food items as well.

3. Insect control. Ionizing radiation has been used to control harmful insects. Captured males are sterilized by radiation and released to mate, thereby reducing the number of offspring. This method has been used to control the Mediterranean fruit fly in California and certain disease-causing insects, such as the tsetse fly and malarial mosquito, in other parts of the world.

4. Power for spacecraft instruments. A nonharmful use of ionizing radiation relies on its secondary processes. Most spacecraft use solar energy to provide power for instruments. In deep-space missions, when solar energy is too weak, however, a radioisotope heater unit (RHU) has been used. It consists of a $^{238}\text{PuO}_2$ fuel pellet the size of a pencil eraser that is clad within a multilayered graphite and metal shell a little smaller than a flashlight battery. The whole RHU weighs only 40 g.

› Summary of Section 24.5

- › Radioisotopic tracers have been used to study reaction mechanisms, material flow, elemental composition, and medical conditions.
- › Ionizing radiation has been used in devices that destroy cancer tissue, kill organisms that spoil food, control insect populations, and power spacecraft instruments.

24.6 THE INTERCONVERSION OF MASS AND ENERGY

Most of the nuclear processes we've considered so far have involved radioactive decay, in which a nucleus emits one or a few small particles or photons to become a more stable and, usually, slightly lighter nucleus. Two other nuclear processes cause much greater mass changes. In nuclear **fission**, a heavy nucleus splits into two much lighter nuclei. In nuclear **fusion**, the opposite process occurs: two lighter nuclei combine to form a heavier one. Both fission and fusion release enormous quantities of energy. Let's look at the origins of this energy by examining the change in mass that accompanies the breakup of a nucleus into its nucleons and then determine the energy that is equivalent to this mass change.

The Mass Difference Between a Nucleus and Its Nucleons

For most of the 20th century, we knew that mass and energy are interconvertible. The separate mass and energy conservation laws are combined to state that *the total quantity of mass-energy in the universe is constant*. Therefore, when *any* reacting system releases or absorbs energy, it also loses or gains mass.

Mass Difference in Chemical Reactions The interconversion of mass and energy is not important for chemical reactions because the energy changes involved in breaking or forming chemical bonds are so small that the mass changes are negligible. For example, when 1 mol of water breaks up into its atoms, heat is absorbed and we have:

We find the mass that is equivalent to this energy from *Einstein's equation*:

$$E = mc^2 \quad \text{or} \quad \Delta E = \Delta mc^2 \quad \text{so} \quad \Delta m = \frac{\Delta E}{c^2} \quad (24.7)$$

where Δm is the mass difference between reactants and products:

$$\Delta m = m_{\text{products}} - m_{\text{reactants}}$$

Substituting the enthalpy of reaction (in J/mol) for ΔE and the numerical value for c (2.9979×10^8 m/s), we obtain

$$\Delta m = \frac{9.34 \times 10^5 \text{ J/mol}}{(2.9979 \times 10^8 \text{ m/s})^2} = 1.04 \times 10^{-11} \text{ kg/mol} = 1.04 \times 10^{-8} \text{ g/mol}$$

(Units of kg/mol are obtained because the joule includes the kilogram: $1 \text{ J} = 1 \text{ kg} \cdot \text{m}^2/\text{s}^2$.) The mass of 1 mol of H_2O molecules (reactant) is about 10 ng *less* than the combined masses of 2 mol of H atoms and 1 mol of O atoms (products), a change difficult to measure with even the most advanced balance. Such minute mass changes when bonds break or form allow us to assume that, for all practical purposes, mass is conserved in *chemical* reactions.

Mass Difference in Nuclear Reactions The much larger mass change that accompanies a *nuclear* process is related to the enormous energy required to bind the nucleons together in a nucleus. In an analogy with the calculation above involving the water molecule, consider the change in mass that occurs when one ^{12}C nucleus breaks apart into its nucleons—six protons and six neutrons:

We calculate this mass difference in a special way. By combining the mass of six H *atoms* and six neutrons and then subtracting the mass of one ^{12}C *atom*, the masses of the electrons cancel: six e^- (in six ^1H atoms) cancel six e^- (in one ^{12}C atom). The mass of one ^1H atom is 1.007825 amu, and the mass of one neutron is 1.008665 amu, so

Mass of six ^1H atoms	= 6×1.007825 amu	= 6.046950 amu
	Mass of six neutrons	= 6×1.008665 amu
		Total mass = 12.098940 amu

The mass of the reactant, one ^{12}C atom, is 12 amu (exactly). The mass difference (Δm) we obtain is the total mass of the nucleons minus the mass of the nucleus:

$$\begin{aligned} \Delta m &= 12.098940 \text{ amu} - 12.000000 \text{ amu} \\ &= 0.098940 \text{ amu}/^{12}\text{C} = 0.098940 \text{ g/mol } ^{12}\text{C} \end{aligned}$$

Two key points emerge from these calculations:

- *The mass of the nucleus is less than the combined masses of its nucleons:* there is always a mass decrease when nucleons form a nucleus.
- The mass change of this nuclear process (9.89×10^{-2} g/mol $\approx 10 \times 10^{-2}$, or 0.10 g/mol) is nearly 10 million times what we found earlier for the chemical process of breaking the bonds in water (10.4×10^{-9} g/mol) and could be measured easily on any laboratory balance.

Nuclear Binding Energy and Binding Energy per Nucleon

Einstein's equation for the relation between mass and energy allows us to find the energy equivalent of any mass change. For 1 mol of ^{12}C , after converting grams to kilograms, we have

$$\begin{aligned} \Delta E &= \Delta mc^2 = (9.8940 \times 10^{-5} \text{ kg/mol})(2.9979 \times 10^8 \text{ m/s})^2 \\ &= 8.8921 \times 10^{12} \text{ J/mol} = 8.8921 \times 10^9 \text{ kJ/mol} \end{aligned}$$

This quantity of energy is called the **nuclear binding energy** for carbon-12, and the positive value means *energy is absorbed*. *The nuclear binding energy is the energy required to break 1 mol of nuclei of an element into individual nucleons:*

Thus, the nuclear binding energy is *qualitatively* analogous to the sum of bond energies of a covalent compound or the lattice energy of an ionic compound. But, *quantitatively*, nuclear binding energies are typically several million times greater.

The Electron Volt as the Unit of Binding Energy We use joules to express the binding energy per mole of nuclei, but the joule is much too large a unit to express the binding energy of a single nucleus. Instead, nuclear scientists use the **electron**

volt (eV), the energy an electron acquires when it moves through a potential difference of 1 volt:

$$1 \text{ eV} = 1.602 \times 10^{-19} \text{ J}$$

Binding energies are commonly expressed in millions of electron volts, that is, in *mega-electron volts (MeV)*:

$$1 \text{ MeV} = 10^6 \text{ eV} = 1.602 \times 10^{-13} \text{ J}$$

A particularly useful factor converts the atomic mass unit to its energy equivalent in electron volts:

$$1 \text{ amu} = 931.5 \times 10^6 \text{ eV} = 931.5 \text{ MeV} \quad (24.8)$$

Nuclear Stability and Binding Energy per Nucleon Earlier we found the mass change when ^{12}C breaks apart into its nucleons to be 0.098940 amu. The binding energy per ^{12}C nucleus, expressed in MeV, is

$$\frac{\text{Binding energy}}{^{12}\text{C nucleus}} = 0.098940 \text{ amu} \times \frac{931.5 \text{ MeV}}{1 \text{ amu}} = 92.16 \text{ MeV}$$

We can compare the stability of nuclides of different elements by determining the *binding energy per nucleon*. For ^{12}C , we have

$$\text{Binding energy per nucleon} = \frac{\text{binding energy}}{\text{no. of nucleons}} = \frac{92.16 \text{ MeV}}{12 \text{ nucleons}} = 7.680 \text{ MeV/nucleon}$$

SAMPLE PROBLEM 24.7

Calculating the Binding Energy per Nucleon

Problem Iron-56 is an extremely stable nuclide. Compute the binding energy per nucleon for ^{56}Fe and compare it with that for ^{12}C (mass of ^{56}Fe atom = 55.934939 amu; mass of ^1H atom = 1.007825 amu; mass of neutron = 1.008665 amu).

Plan Iron-56 has 26 protons and 30 neutrons. We calculate the mass difference, Δm , when the nucleus forms by subtracting the given mass of one ^{56}Fe atom from the sum of the masses of 26 ^1H atoms and 30 neutrons. To find the binding energy per nucleon, we multiply Δm by the equivalent in MeV (931.5 MeV/amu) and divide by the number of nucleons (56).

Solution Calculating the mass difference, Δm :

$$\begin{aligned} \text{Mass difference} &= [(26 \times \text{mass } ^1\text{H atom}) + (30 \times \text{mass neutron})] - \text{mass } ^{56}\text{Fe atom} \\ &= [(26)(1.007825 \text{ amu}) + (30)(1.008665 \text{ amu})] - 55.934939 \text{ amu} \\ &= 0.52846 \text{ amu} \end{aligned}$$

Calculating the binding energy per nucleon:

$$\text{Binding energy per nucleon} = \frac{0.52846 \text{ amu} \times 931.5 \text{ MeV/amu}}{56 \text{ nucleons}} = 8.790 \text{ MeV/nucleon}$$

An ^{56}Fe nucleus would require more energy per nucleon to break up into its nucleons than would a ^{12}C nucleus (7.680 MeV/nucleon), so ^{56}Fe is more stable than ^{12}C .

Check The answer is consistent with the great stability of ^{56}Fe . Given the number of decimal places in the values, rounding to check the math is useful only to find a *major* error. The number of nucleons (56) is exact, so we retain four significant figures.

FOLLOW-UP PROBLEMS

24.7A Enormous amounts of nickel and iron make up Earth's core, and nickel-58 is a very stable nuclide. Find the binding energy per nucleon for ^{58}Ni (mass of ^{58}Ni atom = 57.935346 amu), and compare it with the value for ^{56}Fe (8.790 MeV/nucleon).

24.7B Uranium-235 is an essential component of the fuel in nuclear power plants. Calculate the binding energy per nucleon for ^{235}U (mass of ^{235}U atom = 235.043924 amu). Is this nuclide more or less stable than ^{12}C (whose value is 7.680 MeV/nucleon)?

SOME SIMILAR PROBLEMS 24.79–24.82

Student Hot Spot

Student data indicate that you may struggle with binding energy calculations. Access the Smartbook to view additional Learning Resources on this topic.

Figure 24.16 The variation in binding energy per nucleon.

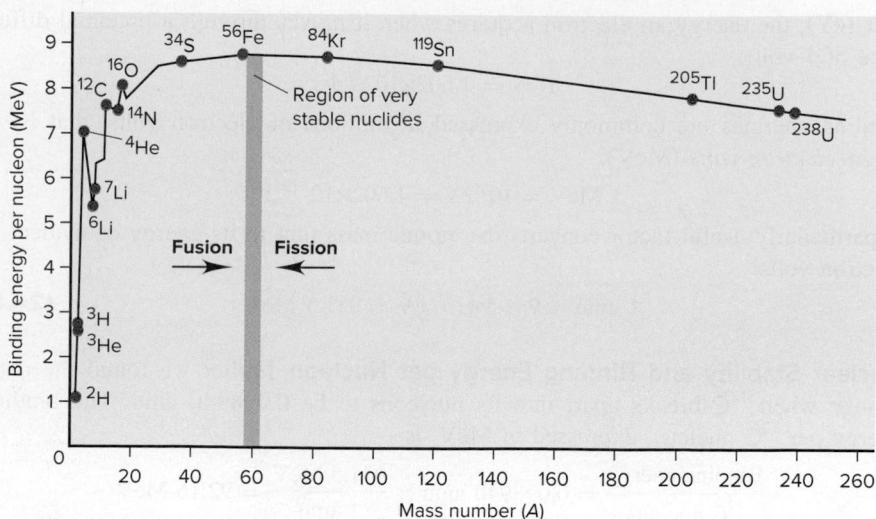

Fission or Fusion: Increasing the Binding Energy per Nucleon Calculations similar to those in Sample Problem 24.7 for other nuclides show that the binding energy per nucleon varies considerably. The essential point is that *the greater the binding energy per nucleon, the more stable the nuclide is*.

Figure 24.16 shows a plot of the binding energy per nucleon vs. mass number. It provides information about nuclide stability and the two possible processes—fission and fusion—that nuclides undergo to form more stable nuclides. Most nuclides with fewer than 10 nucleons have a relatively small binding energy per nucleon. The ${}^4\text{He}$ nucleus is an exception—it is stable enough to be emitted intact as an α particle. Above $A = 12$, the binding energy per nucleon varies from about 7.6 to 8.8 MeV.

The most important observation is that *the binding energy per nucleon peaks at elements with $A \approx 60$* . In other words, nuclides become more stable with increasing mass number up to around 60 nucleons and then become less stable with higher numbers of nucleons. The existence of a peak of stability suggests that there are two ways nuclides can increase their binding energy per nucleon:

- *Fission.* A heavier nucleus can *split into lighter nuclei (closer to $A \approx 60$)* by undergoing fission. The product nuclei have greater binding energy per nucleon (are more stable) than the reactant nucleus, and the difference in *energy is released*. Nuclear power plants generate energy through fission, as do atomic bombs (Section 24.7).
- *Fusion.* Lighter nuclei, on the other hand, can *combine to form a heavier nucleus (closer to $A \approx 60$)* by undergoing fusion. Once again, the product is more stable than the reactants, and *energy is released*. The Sun and other stars generate energy through fusion, as do thermonuclear (hydrogen) bombs. In these examples and in all current research efforts for developing fusion as a useful energy source, hydrogen nuclei fuse to form the very stable helium-4 nucleus.

In Section 24.7, we examine fission and fusion and their applications.

› Summary of Section 24.6

- The mass of a nucleus is less than the sum of the masses of its nucleons. The energy equivalent to this mass difference is the nuclear binding energy, often expressed in units of MeV.
- The binding energy per nucleon is a measure of nuclide stability and varies with the number of nucleons. Nuclides with $A \approx 60$ are most stable.
- Lighter nuclides join (fusion) or heavier nuclides split (fission) to create more stable products.

24.7 APPLICATIONS OF FISSION AND FUSION

Of the many beneficial applications of nuclear reactions, the greatest is the potential for abundant quantities of energy, which is based on the multimillion-fold increase in energy yield of nuclear reactions over chemical reactions. Our experience with nuclear

energy from power plants in the last quarter of the 20th century, however, has shown that we must improve ways to tap this energy source safely and economically and deal with the waste generated. In this section, we discuss how fission and fusion occur and how we are applying them.

The Process of Nuclear Fission

During the mid-1930s, Enrico Fermi and coworkers bombarded uranium ($Z = 92$) with neutrons in an attempt to synthesize transuranium elements. Many of the unstable nuclides produced were tentatively identified as having $Z > 92$, but other scientists were skeptical. Four years later, the German chemist Otto Hahn and his associate F. Strassmann showed that one of these unstable nuclides was an isotope of barium ($Z = 56$). The Austrian physicist Lise Meitner, a coworker of Hahn, and her nephew Otto Frisch proposed that barium resulted from the *splitting* of the uranium nucleus into *smaller* nuclei, a process that they called *fission* as an analogy to cell division in biology. Element 109 was named *meitnerium* in honor of this extraordinary physicist who proposed the correct explanation of nuclear fission and discovered the element protactinium (Pa; $Z = 91$) as well as numerous radioisotopes.

The ^{235}U nucleus can split in many different ways, giving rise to various daughter nuclei, but all routes have the same general features. Figure 24.17 depicts *one* of these fission patterns, the production of isotopes of Kr and Ba:

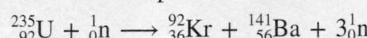

Neutron bombardment results in a highly excited ^{236}U nucleus, which splits apart in 10^{-14} s. The products are two nuclei of unequal mass, two to four neutrons (average of 2.4), and a large quantity of energy. A single ^{235}U nucleus releases 3.5×10^{-11} J when it splits; 1 mol of ^{235}U (about $\frac{1}{2}$ lb) releases 2.1×10^{13} J—a billion times as much energy as burning $\frac{1}{2}$ lb of coal (2×10^4 J)!

Chain Reaction and Critical Mass We harness the energy of nuclear fission, much of which eventually appears as heat, by means of a **chain reaction** (Figure 24.18, *next page*): the few neutrons that are released by the fission of one nucleus collide with other fissionable nuclei and cause them to split, releasing more neutrons, and so on, in a self-sustaining process (in Figure 24.18, vertical dashed lines separate the steps). In this manner, the energy released increases rapidly because each fission event in a chain reaction releases about two-and-a-half times as much energy as the preceding one.

Whether a chain reaction occurs depends on the mass (and thus the volume) of the fissionable sample. If the piece of uranium is large enough, the product neutrons strike another fissionable nucleus *before* flying out of the sample, and a chain reaction takes place. The mass required to achieve a chain reaction is called the **critical mass**. If the sample has less than the critical mass (a *subcritical mass*), too many product

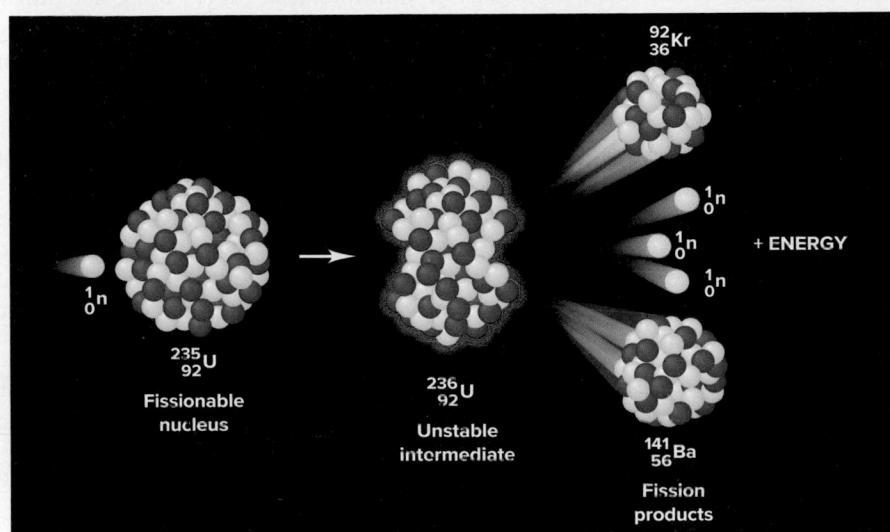

Figure 24.17 Fission of ^{235}U caused by neutron bombardment.

Figure 24.18 A chain reaction involving fission of ^{235}U .

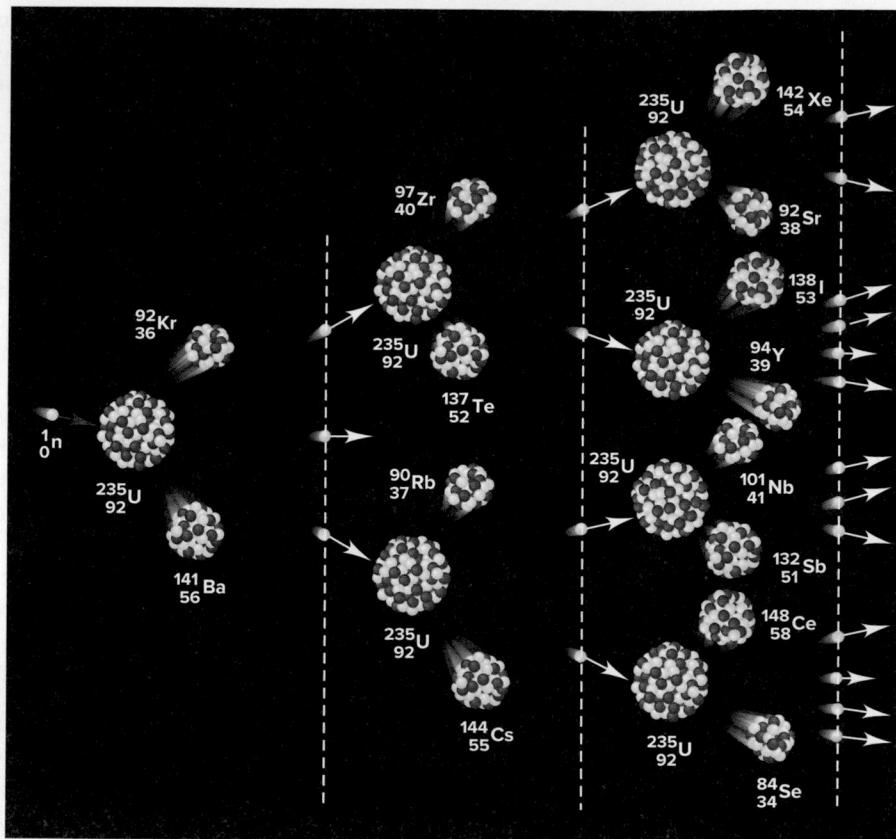

neutrons leave the sample before they collide with, and cause the fission of, another ^{235}U nucleus, and thus a chain reaction does not occur.

Uncontrolled Fission: The Atomic Bomb An uncontrolled chain reaction can be adapted to make an extremely powerful explosive, as several of the world's leading atomic physicists hypothesized just prior to World War II. In August 1939, Albert Einstein wrote the president of the United States, Franklin Delano Roosevelt, to this effect, warning of the danger of allowing the Nazi government of Germany to develop this power first. It was this concern that led to the Manhattan Project, an enormous scientific effort to develop a bomb based on nuclear fission, which was initiated in 1941.* In August 1945, the United States detonated two atomic bombs over Japan, and the horrible destructive power of these bombs was a major factor in the surrender of the Japanese a few days later.

In an atomic bomb, small explosions of trinitrotoluene (TNT) bring subcritical masses of fissionable material together to exceed the critical mass, and the ensuing chain reaction brings about the explosion (Figure 24.19). The proliferation of nuclear power plants, which use fissionable materials to generate energy for electricity, has increased concern that more countries (and unscrupulous individuals) may have access to such material for making bombs. Since the devastating terrorist attacks of September 11, 2001 in the United States, this concern has been heightened.

Controlled Fission: Nuclear Energy Reactors Like a coal-fired power plant, a nuclear power plant generates heat to produce steam, which turns a turbine attached to an electric generator. But a nuclear plant has the potential to produce electric power much more cleanly than by the combustion of coal.

1. *Operation of a nuclear power plant.* Heat generation takes place in the **reactor core** of a nuclear plant (Figure 24.20). The core contains the **fuel rods**, which consist

*For an excellent scientific and historical account of the development of the atomic bomb, see R. Rhodes, *The Making of the Atomic Bomb*, New York, Simon and Schuster, 1986.

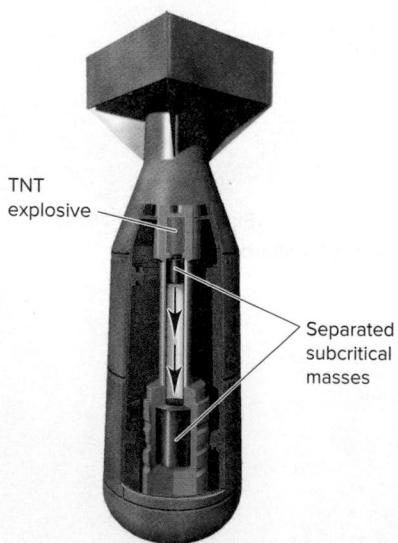

Figure 24.19 An atomic bomb based on ^{235}U .

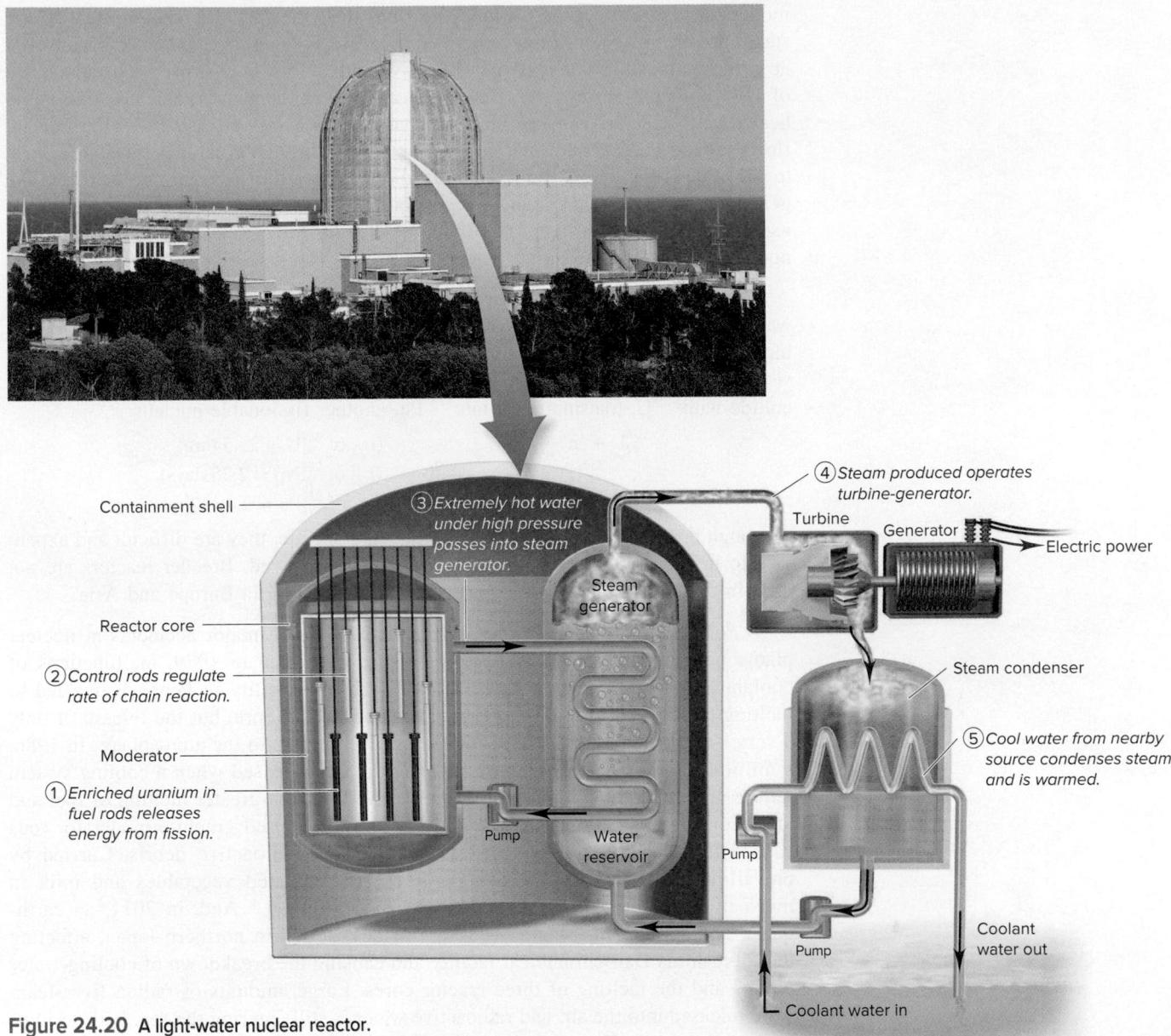

Figure 24.20 A light-water nuclear reactor.

Source: © Philip Lange/Shutterstock.com

of fuel enclosed in tubes of a corrosion-resistant zirconium alloy. The fuel is uranium(IV) oxide (UO_2) that has been *enriched* from 0.7% ^{235}U , the natural abundance of this fissionable isotope, to the 3% to 4% ^{235}U required to sustain a chain reaction in a practical volume. (Enrichment of nuclear fuel is the most important application of Graham's law; see Section 5.5.) Sandwiched between the fuel rods are movable *control rods* made of cadmium or boron (or, in nuclear submarines, hafnium), substances that absorb neutrons very efficiently. For example, a neutron absorption reaction for boron is

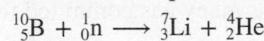

When the control rods are lowered between the fuel rods, the chain reaction slows because fewer neutrons are available to bombard uranium atoms; when they are raised, the chain reaction speeds up. Neutrons that leave the fuel-rod assembly collide with a *reflector*, usually made of a beryllium alloy, which absorbs very few neutrons. Reflecting the neutrons back to the fuel rods speeds the chain reaction.

Flowing around the fuel and control rods in the reactor core is the *moderator*, a substance that slows the neutrons, making them much better at causing fission than the fast ones emerging directly from the fission event. In most modern reactors, the

moderator also acts as the *coolant*, the fluid that transfers the released heat to the steam-producing region. *Light-water reactors* use H_2O as the moderator because ^1H absorbs neutrons to some extent; in *heavy-water reactors*, D_2O is used. The advantage of D_2O is that it absorbs very few neutrons, leaving more available for fission, so *heavy-water reactors* can use uranium that has been *less enriched*. As the coolant flows around the encased fuel, pumps circulate it through coils that transfer its heat to the water reservoir. Steam formed in the reservoir turns the turbine that runs the generator. The steam then enters a condenser, where water from a lake or river is used to cool it back to liquid that is returned to the water reservoir. Often (although not shown here), large cooling towers aid in this step (see Figure 13.20).

2. Breeder reactors. Because ^{235}U is not an abundant isotope, the *breeder reactor* was designed to consume one type of nuclear fuel as it produces another. Outside the moderator, fuel rods are surrounded by natural U_3O_8 , which contains 99.3% *nonfissionable* ^{238}U atoms. As neutrons formed during ^{235}U fission escape the fuel rod, they collide with ^{238}U , transmuting it into ^{239}Pu , another fissionable nucleus:

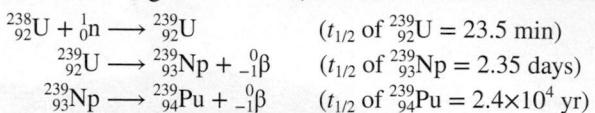

Although breeder reactors can make fuel as they operate, they are difficult and expensive to build, and ^{239}Pu is extremely toxic and long lived. Breeder reactors are not used in the United States, although several are operating in Europe and Asia.

3. Power plant accidents and other concerns. Some major accidents at nuclear plants have caused decidedly negative public reactions. In 1979, malfunctions of coolant pumps and valves at the Three-Mile Island facility in Pennsylvania led to melting of some of the fuel and damage to the reactor core, but the release of only a very small amount (about 1 Ci) of radioactive gases into the atmosphere. In 1986, a million times as much radioactivity (1 MCi) was released when a cooling system failure at the Chernobyl plant in Ukraine caused a much greater melting of fuel and an uncontrolled reaction. High-pressure steam and ignited graphite moderator rods caused the reactor building to explode and expel radioactive debris. Carried by prevailing winds, the radioactive particles contaminated vegetables and milk in much of Europe. Severe health problems have resulted.* And, in 2011, an earthquake and subsequent tsunami caused vast destruction in northern Japan, affecting the Fukushima Dai-ichi nuclear facility and causing the breakdown of cooling-water pumps and the melting of three reactor cores. Large amounts of radioactive steam were released into the air, and radioactive water is still entering the sea, with serious, long-term health effects expected.

4. Current use of nuclear power. Despite potential safety problems, nuclear power remains an important source of electricity. In the late 1990s, nearly every European country employed nuclear power, and it is the major power source in some countries—Sweden creates 50% of its electricity this way and France almost 80%. Currently, the United States obtains about 20% of its electricity from nuclear power, and Canada slightly less. As our need for energy grows and climate change from fossil-fuel consumption worsens, safer reactors will be designed and built. However, as a result of the disaster in Japan, many countries are reevaluating their use of nuclear energy. For example, Germany has committed to closing all its nuclear power plants by 2022.

5. Thermal pollution and waste disposal. Even a smoothly operating nuclear power plant has certain inherent problems. The problem of *thermal pollution* is common to all power plants. Water used to condense the steam is several degrees warmer when returned to its source, which can harm aquatic organisms (Section 13.4). A more serious problem

*An even greater release of radioactivity (1.1 MCi), involving several radioisotopes including the extremely dangerous ^{90}Sr , occurred in 1957 in Kyshtym, a town in the South Ural Mountains of Russia. As a result, radioactivity spread globally, but the accident was kept secret by the former Soviet government until 1980.

is *nuclear waste disposal*. Many of the fission products formed in nuclear reactors have long half-lives, and no satisfactory plan for their permanent disposal has yet been devised. Proposals to place the waste in containers and bury them in deep bedrock cannot possibly be field-tested for the thousands of years the material will remain harmful. Leakage of radioactive material into groundwater is a danger, and earthquakes can occur even in geologically stable regions. It remains to be seen whether we can operate fission reactors and dispose of the waste safely and economically.

The Promise of Nuclear Fusion

Nuclear fusion in the Sun is the ultimate source of nearly all the energy—and chemical elements—on Earth. In fact, *all the elements heavier than hydrogen were formed in fusion and decay processes within stars*, as the upcoming Chemical Connections essay describes.

Much research is being devoted to making nuclear fusion a practical, direct source of energy on Earth. To understand the advantages of fusion, let's consider one of the most discussed fusion reactions, in which deuterium and tritium react:

This reaction produces 1.7×10^9 kJ/mol, an enormous quantity of energy with no radioactive byproducts. Moreover, the reactant nuclei are relatively easy to come by. We obtain deuterium from the electrolysis of water (Section 22.4). In nature, tritium forms through the cosmic (neutron) irradiation of ${}^{14}\text{N}$:

However, this process results in a natural abundance of only $10^{-7}\%$ ${}^3\text{H}$. More practically, tritium is produced in nuclear accelerators by bombarding lithium-6 or by surrounding the fusion reactor itself with material containing lithium-6:

Thus, in principle, fusion *seems* promising and may represent an ideal source of power. However, some extremely difficult technical problems remain. Fusion requires enormous energy in the form of heat to give the positively charged nuclei enough kinetic energy to force themselves together. The fusion of deuterium and tritium, for example, occurs at practical rates at about 10^8 K, a temperature hotter than the Sun's core! How can such conditions be achieved?

Two current research approaches have promise. In one, atoms are stripped of their electrons at high temperatures, which results in a gaseous *plasma*, a neutral mixture of positive nuclei and electrons. Because of the extreme temperatures needed for fusion, no *material* can contain the plasma. The most successful approach to date has been to enclose the plasma within a magnetic field. The *tokamak* design has a donut-shaped container in which a helical magnetic field confines the plasma and prevents it from contacting the walls (Figure 24.21). Scientists at the Princeton University Plasma Physics facility have achieved some success in generating energy from fusion this way. In another approach, the required high temperature is reached by using many focused lasers to compress and heat the fusion reactants. In any event, one or more major breakthroughs are needed before fusion will be a practical, everyday source of energy.

Figure 24.21 The tokamak design for magnetic containment of a fusion plasma.

Source: Dietmar Krause/Princeton Plasma Physics Lab

› Summary of Section 24.7

- › In nuclear fission, neutron bombardment causes a nucleus to split into two smaller nuclei and release neutrons that split other nuclei, giving rise to a chain reaction.
- › A nuclear power plant controls the rate of the chain reaction to produce heat that creates steam, which is used to generate electricity.
- › Potential hazards, such as radiation leaks, thermal pollution, and disposal of nuclear waste, remain current concerns.
- › Nuclear fusion holds great promise as a source of clean abundant energy, but it requires extremely high temperatures and is not yet practical.
- › The elements were formed through a complex series of nuclear reactions in evolving stars.

How did the universe begin? Where did matter come from? How were the elements formed? The most accepted model proposes that a sphere of unimaginable properties—diameter of 10^{-28} cm, density of 10^{96} g/mL (density of a nucleus $\approx 10^{14}$ g/mL), and temperature of 10^{32} K—exploded in a “Big Bang,” for reasons not yet known, and distributed its contents through the void of space. Cosmologists consider this moment the beginning of time.

One second later, the universe was an expanding mixture of neutrons, protons, and electrons, denser than rock and hotter than an exploding hydrogen bomb (about 10^{10} K). In the next few minutes, it became a gigantic fusion reactor creating the first atomic nuclei other than ^1H : ^2H , ^3He , and ^4He . After 10 min, more than 25% of the mass of the universe existed as ^4He , and only about 0.025% as ^2H . About 100 million years later, or almost 14 billion years ago, gravitational forces pulled this cosmic mixture into primitive, contracting stars.

This account of the origin of the universe is based on the observation of spectra from the Sun, other stars, nearby galaxies, and cosmic (interstellar) dust. Spectral analysis of planets and chemical analysis of Earth and Moon rocks, meteorites, and cosmic-ray particles furnish data about isotope abundance. From these, a model has been developed for **stellar nucleosynthesis**,

the creation of the elements in stars. The overall process occurs in several stages during a star’s evolution, and the entire sequence of steps occurs only in very massive stars, having 10 to 100 times the mass of the Sun. Each step involves a contraction of the volume of the star that results in higher temperature and yields heavier nuclei. Such events are forming elements in stars today. The key stages in the process are shown in Figure B24.1 and described below:

1. Hydrogen burning produces He. The initial contraction of a star heats its core to about 10^7 K, at which point a fusion process called *hydrogen burning* begins. Through three possible reactions (one is shown below), helium nuclei are produced from the abundant protons:

2. Helium burning produces C, O, Ne, and Mg. After several billion years of hydrogen burning, about 10% of the ^1H is consumed, and the star contracts further. The ^4He forms a dense core, hot enough (2×10^8 K) to fuse ^4He nuclei. The energy released during *helium burning* expands the remaining ^1H into a vast envelope: the star becomes a *red giant*, more than 100 times its original diameter. Within its core, pairs of ^4He nuclei (α particles) fuse into

Figure B24.1 Element synthesis in the life cycle of a star.

unstable ^8Be nuclei ($t_{1/2} = 7 \times 10^{-17}$ s), which play the role of an activated complex in chemical reactions. A ^8Be nucleus collides with another alpha particle to form ^{12}C . Then, further fusion with more alpha particles creates nuclei up to ^{24}Mg :

3. Elements through Fe and Ni form. For another 10 million years, ^4He is consumed, and the heavier nuclei created form a core. This core contracts and heats, expanding the star into a *supergiant*. Within the hot core (7×10^8 K), *carbon and oxygen burning* occur:

Absorption of α particles forms nuclei up to ^{40}Ca :

Further contraction and heating to a temperature of 3×10^9 K allow reactions in which nuclei release neutrons, protons, and α particles and then recapture them. As a result, nuclei with lower binding energies supply nucleons to create those with higher binding energies. In stars of moderate mass, less than 10 times the mass of the Sun, this process stops at iron-56 and nickel-58, the nuclei with the highest binding energies.

4. Heavier elements form. In very massive stars, the next stage is the most spectacular. With all the fuel consumed, the core collapses within a second. Many Fe and Ni nuclei break down into neutrons and protons. Protons capture electrons to form neutrons, and the entire core forms an incredibly dense *neutron star*. (An Earth-sized star that became a neutron star would fit in the Houston Astrodome!) As the core implodes, the outer layers explode in a *supernova*, which expels material throughout space. A supernova

occurs an average of every few hundred years in each galaxy or once every second somewhere in the universe. The heavier elements are formed during supernova events and are found in *second-generation stars*, those that coalesce from interstellar ^1H and ^4He and the debris of exploded first-generation stars.

Heavier elements form through *neutron-capture processes*. In the *s-process* (*slow* neutron-capture process), a nucleus captures a neutron, at some point over a period of 10 to 1000 years. If the resulting nucleus is unstable, it undergoes β^- decay to form the next element, as in this conversion of ^{68}Zn to ^{70}Ge :

The stable isotopes of most heavy elements up to ^{209}Bi form by the *s-process*.

Less stable isotopes and those with A greater than 230 cannot form by the *s-process* because their half-lives are too short. These form by the *r-process* (*rapid* neutron-capture process) during the fury of the supernova. Many neutron captures, followed by many β^- decays, occur in a second, as when ^{56}Fe is converted to ^{79}Br :

We know from the heavy elements present in the Sun that it is at least a second-generation star presently undergoing hydrogen burning. Together with its planets, it was formed from the dust of exploded stars about 4.6×10^9 years ago. This means that many of the atoms on Earth, including some within you, came from exploded stars and are older than the Solar System itself!

Any theory of element formation must be consistent with the element abundances we observe (Section 22.1). Although local compositions, such as those of Earth and the Sun, differ, and mineral grains in meteorites may have abnormal isotopic compositions, large regions of the universe have, on average, similar compositions. Scientists believe element forming reaches a dynamic equilibrium, resulting in *relatively constant amounts of the isotopes*.

Problems

B24.1 Compare the *s*- and *r*-processes of stellar nucleosynthesis in terms of rate, number of neutrons absorbed, and types of isotopes formed.

B24.2 The overall reaction taking place during hydrogen burning in a young star is

How much energy (in MeV) is released per He nucleus formed? Per mole of He formed? (Mass of ^1H atom = 1.007825 amu; mass of ^4He atom = 4.00260 amu; mass of positron = 5.48580×10^{-4} amu.)

B24.3 Cosmologists modeling the origin of the elements postulate nuclides with very short half-lives. One of these

short-lived nuclides, ^8Be ($t_{1/2} = 7 \times 10^{-17}$ s), is thought to play a key role in stellar nucleosynthesis by fusing with ^4He to form ^{12}C . Another model proposes the simultaneous fusion of three ^4He nuclei to form ^{12}C . Comment on the validity of this alternative mechanism.

B24.4 The *s*-process produces isotopes of elements up to ^{209}Bi . This process is terminated when ^{209}Bi captures a neutron to produce ^{210}Bi , which subsequently undergoes β^- decay to produce nuclide A, which then decays by emitting an α particle to form nuclide B. This nuclide captures three neutrons to produce nuclide C, which undergoes β^- decay to produce nuclide D, starting the cycle again. Write balanced nuclear equations for the formation of nuclides A through D.

CHAPTER REVIEW GUIDE

Learning Objectives

Relevant section (§) and/or sample problem (SP) numbers appear in parentheses.

Understand These Concepts

- How nuclear changes differ, in general, from chemical changes (§24.1)
- The meanings of *radioactivity*, *nucleon*, *nuclide*, and *isotope* (§24.1)
- Characteristics of three types of radioactive emissions: α , β , and γ (§24.1)
- The various modes of radioactive decay and how each changes the values of A and Z (§24.1)
- How the N/Z ratio, the even-odd nature of N and Z , and magic numbers correlate with nuclear stability (§24.1)
- How an unstable nuclide's mass number or N/Z ratio correlates with its mode of decay (§24.1)
- How a decay series combines numerous decay steps and ends with a stable nuclide (§24.1)
- How ionization and scintillation counters detect and measure radioactivity (§24.2)
- Why radioactive decay is a first-order process; the meanings of *decay rate* and *specific activity* (§24.2)
- The meaning of *half-life* in the context of radioactive decay (§24.2)
- How the specific activity of an isotope in an object is used to determine the object's age (§24.2)
- How particle accelerators and reactors are used to synthesize new nuclides (§24.3)
- The units of radiation dose; the effects on living tissue of various dosage levels; the inverse relationship between the mass and charge of an emission and its penetrating power (§24.4)
- How ionizing radiation creates free radicals that damage tissue; sources and risks of ionizing radiation (§24.4)
- How radioisotopes are used in research, analysis, and medical diagnosis (§24.5)

- Why the mass of a nucleus is less than the total mass of its nucleons and how this mass difference is related to the nuclear binding energy (§24.6)
- How nuclear stability is related to binding energy per nucleon (§24.6)
- How heavy nuclides undergo fission and lighter ones undergo fusion to increase the binding energy per nucleon (§24.6)
- The current application of fission and potential application of fusion to produce energy (§24.7)

Master These Skills

- Expressing the mass and charge of a particle with the ${}^A_Z X$ notation (§24.1; see also §2.5)
- Using changes in the values of A and Z to write and balance nuclear equations (SP 24.1)
- Using the N/Z ratio, the even-odd nature of N and Z , and the presence of magic numbers to predict nuclear stability (SP 24.2)
- Using the atomic mass of the element to predict the mode of decay of an unstable nuclide and checking the prediction with the N/Z ratio (SP 24.3)
- Converting units of radioactivity (§24.2)
- Calculating specific activity, decay constant, half-life, and number of radioactive nuclei (§24.2 and SPs 24.4 and 24.5)
- Estimating the age of an object from the specific activity and half-life of carbon-14 (SP 24.6)
- Writing notations for nuclear transmutations (§24.3)
- Calculating radiation dose and converting units (§24.4)
- Calculating the mass difference between a nucleus and its nucleons and the energy equivalent (§24.6)
- Calculating the binding energy per nucleon and using it to compare stabilities of nuclides (SP 24.7)

Key Terms

Page numbers appear in parentheses.

activity (\mathcal{A}) (1084)	decay (disintegration) series (1082)
alpha (α) decay (1077)	deuteron (1091)
alpha (α) particle (1075)	electron (e^-) capture (EC) (1077)
background radiation (1095)	electron volt (eV) (1102)
band of stability (1079)	fission (1101)
becquerel (Bq) (1084)	free radical (1095)
beta (β) decay (1077)	fusion (1101)
β^- decay (1077)	gamma (γ) emission (1078)
beta (β) particle (1075)	gamma ray (γ) (1075)
chain reaction (1105)	Geiger-Müller counter (1083)
critical mass (1105)	gray (Gy) (1094)
curie (Ci) (1084)	
decay constant (1085)	

half-life ($t_{1/2}$) (1086)	radioisotopic dating (1087)
ionization (1093)	rad (radiation-absorbed dose) (1094)
ionizing radiation (1093)	reactor core (1106)
isotope (1074)	rem (roentgen equivalent for man) (1094)
nuclear binding energy (1102)	scintillation counter (1083)
nuclear transmutation (1090)	sievert (Sv) (1094)
nucleon (1074)	stellar nucleosynthesis (1110)
nuclide (1074)	strong force (1080)
particle accelerator (1091)	tracer (1098)
positron (1077)	transuranium element (1092)
positron (β^+) emission (1077)	
radioactivity (1073)	
radioisotope (1087)	

Key Equations and Relationships

Page numbers appear in parentheses.

24.1 Balancing a nuclear equation (1075):

$$\text{Total } {}^A_Z \text{Reactants} = \text{Total } {}^A_Z \text{Products}$$

24.2 Expressing the decay rate (activity) for radioactive nuclei (1085):

$$\text{Decay rate } (\mathcal{A}) = -\frac{\Delta \mathcal{N}}{\Delta t} = k \mathcal{N}$$

24.3 Finding the number of nuclei remaining after a given time, \mathcal{N}_t (1086):

$$\ln \frac{\mathcal{N}_t}{\mathcal{N}_0} = -kt \quad \text{or} \quad \mathcal{N}_t = \mathcal{N}_0 e^{-kt}$$

24.4 Finding the half-life of a radioactive nuclide (1086):

$$t_{1/2} = \frac{\ln 2}{k}$$

24.5 Calculating the time to reach a given specific activity (age of an object in radioisotopic dating) (1088):

$$t = \frac{1}{k} \ln \frac{\mathcal{A}_0}{\mathcal{A}_t}$$

24.6 Writing a transmutation in shorthand notation (1090): reactant nucleus (particle in, particle(s) out) product nucleus

24.7 Adapting Einstein's equation to calculate mass difference and/or nuclear binding energy (1101):

$$\Delta m = \frac{\Delta E}{c^2} \quad \text{or} \quad \Delta E = \Delta mc^2$$

24.8 Relating the atomic mass unit to its energy equivalent in MeV (1103):

$$1 \text{ amu} = 931.5 \times 10^6 \text{ eV} = 931.5 \text{ MeV}$$

BRIEF SOLUTIONS TO FOLLOW-UP PROBLEMS

24.2A (a) Stable. Like many light nuclides (those with $Z < 20$) for which $N = Z$, this one ($Z = 5$) is stable (one of four stable nuclides with both an odd Z and an odd N). (b) Radioactive. This nuclide has both odd N (35) and odd Z (23) and $N/Z = 1.52$, which is too high for this region of the band of stability.

24.2B ${}^{31}\text{P}$ has an even N (16), but ${}^{30}\text{P}$ has both N and Z odd. ${}^{31}\text{P}$ also has a slightly higher N/Z ratio that is closer to the band of stability.

24.3A (a) Iron (Fe) has an atomic mass of 55.85 amu. The A value of 61 is higher: β^- decay. (b) $Z > 83$, which is too high for stability: α decay will occur.

24.3B (a) Titanium's atomic mass is 47.87 amu, which is much higher than the A value of 40; this nuclide most likely decays by electron capture or β^+ emission. (b) Cobalt's atomic mass is 58.93 amu, which is much lower than the A value of 65; it will probably undergo β^- decay.

24.4A (a) Mass (g) = $3.4 \times 10^{-8} \text{ mol} \times 76 \text{ g/mol} = 2.6 \times 10^{-6} \text{ g}$

Specific activity (Ci/g) = $1.53 \times 10^{11} \text{ d/s}$

$$\times \frac{1 \text{ Ci}}{3.70 \times 10^{10} \text{ d/s}} \times \frac{1}{2.6 \times 10^{-6} \text{ g}} = 1.6 \times 10^6 \text{ Ci/g}$$

(b) Specific activity (Bq/g) = $1.53 \times 10^{11} \text{ d/s}$

$$\times \frac{1 \text{ Bq}}{1 \text{ d/s}} \times \frac{1}{2.6 \times 10^{-6} \text{ g}} = 5.9 \times 10^{16} \text{ Bq/g}$$

24.4B $k = \frac{\mathcal{A} (\text{nuclei/h})}{\mathcal{N} (\text{nuclei})}$

$$= \frac{9.97 \times 10^{12} \text{ nuclei/h}}{(6.50 \times 10^{-2} \text{ mol})(6.022 \times 10^{23} \text{ nuclei/mol})} = 2.55 \times 10^{-10} \text{ h}^{-1}$$

24.5A $\ln \mathcal{A}_t = -kt + \ln \mathcal{A}_0$

$$= -\left(\frac{\ln 2}{15 \text{ h}} \times 4.0 \text{ days} \times \frac{24 \text{ h}}{1 \text{ day}}\right) + \ln(2.5 \times 10^9 \text{ d/s})$$

$$= 17.20$$

$$\mathcal{A}_t = 3.0 \times 10^7 \text{ d/s}$$

24.5B $\mathcal{A}_0 = 5.6 \times 10^{-6} \text{ Ci} \times \frac{3.70 \times 10^{10} \text{ d/s}}{1 \text{ Ci}} = 2.1 \times 10^5 \text{ d/s}$

$$\begin{aligned} \ln \mathcal{A}_t &= -kt + \ln \mathcal{A}_0 \\ &= -\left(\frac{\ln 2}{44.5 \text{ days}} \times 17 \text{ days}\right) + \ln(2.1 \times 10^5 \text{ d/s}) \\ &= -0.265 + 12.25 \text{ d/s} = 11.99 \text{ d/s} \\ \mathcal{A}_t &= 1.6 \times 10^5 \text{ d/s} \end{aligned}$$

$$\text{Fraction decayed} = \frac{2.1 \times 10^5 \text{ d/s} - 1.6 \times 10^5 \text{ d/s}}{2.1 \times 10^5 \text{ d/s}} = 0.23$$

24.6A $t = \frac{1}{k} \ln \frac{\mathcal{A}_0}{\mathcal{A}_t} = \frac{5730 \text{ yr}}{\ln 2} \ln \left(\frac{15.3 \text{ d/min} \cdot \text{g}}{9.41 \text{ d/min} \cdot \text{g}} \right) = 4.02 \times 10^3 \text{ yr}$

The mummy case is about 4000 years old.

24.6B $t = \frac{1}{k} \ln \frac{\mathcal{A}_0}{\mathcal{A}_t} = \frac{5730 \text{ yr}}{\ln 2} \ln \left(\frac{15.3 \text{ d/min} \cdot \text{g}}{12.87 \text{ d/min} \cdot \text{g}} \right) = 1430 \text{ yr}$

24.7A ${}^{58}\text{Ni}$ has 28 ${}_1^1\text{p}$ and 30 ${}_0^1\text{n}$.

$$\begin{aligned} \Delta m &= [(28 \times 1.007825 \text{ amu}) + (30 \times 1.008665 \text{ amu})] \\ &\quad - 57.935346 \text{ amu} \\ &= 0.543704 \text{ amu} \end{aligned}$$

$$\begin{aligned} \text{Binding energy} &= \frac{0.543704 \text{ amu} \times \frac{931.5 \text{ MeV}}{1 \text{ amu}}}{\text{nucleon}} \\ &= \frac{58 \text{ nucleons}}{8.732 \text{ MeV/nucleon}} \end{aligned}$$

Therefore, ${}^{56}\text{Fe}$ (8.790 MeV/nucleon) is slightly more stable than ${}^{58}\text{Ni}$.

24.7B ${}^{235}\text{U}$ has 92 ${}_1^1\text{p}$ and 143 ${}_0^1\text{n}$.

$$\begin{aligned} \Delta m &= [(92 \times 1.007825 \text{ amu}) + (143 \times 1.008665 \text{ amu})] \\ &\quad - 235.043924 \text{ amu} \\ &= 1.9151 \text{ amu} \end{aligned}$$

$$\begin{aligned} \text{Binding energy} &= \frac{1.9151 \text{ amu} \times \frac{931.5 \text{ MeV}}{1 \text{ amu}}}{\text{nucleon}} \\ &= \frac{235 \text{ nucleons}}{7.591 \text{ MeV/nucleon}} \end{aligned}$$

Therefore, ${}^{235}\text{U}$ is less stable than ${}^{12}\text{C}$ (7.680 MeV/nucleon).

PROBLEMS

Problems with **colored** numbers are answered in Appendix E and worked in detail in the Student Solutions Manual. Problem sections match those in the text and give the numbers of relevant sample problems. Most offer Concept Review Questions, Skill-Building Exercises (grouped in pairs covering the same concept), and Problems in Context. The Comprehensive Problems are based on material from any section or previous chapter.

Radioactive Decay and Nuclear Stability

(Sample Problems 24.1 to 24.3)

Concept Review Questions

24.1 How do chemical and nuclear reactions differ in

- (a) Magnitude of the energy change?
- (b) Effect on rate of increasing temperature?
- (c) Effect on rate of higher reactant concentration?
- (d) Effect on yield of higher reactant concentration?

24.2 Sulfur has four naturally occurring stable isotopes. The one with the lowest mass number is sulfur-32, which is also the most abundant (95.02%).

- (a) What percentage of the S atoms in a matchhead are ^{32}S ?
- (b) The isotopic mass of ^{32}S is 31.972070 amu. Is the atomic mass of S larger, smaller, or equal to this mass? Explain.

24.3 What led Marie Curie to draw the following conclusions?

- (a) Radioactivity is a property of the element and not the compound in which it is found. (b) A highly radioactive element, aside from uranium, occurs in pitchblende.

24.4 Which of the following processes produce an atom of a *different* element: (a) α decay; (b) β^- decay; (c) γ emission; (d) β^+ emission; (e) e^- capture? Show how Z and N change, if at all, with each process.

24.5 Why is ^3He stable, but ^2He has never been detected?

24.6 How do the modes of decay differ for a neutron-rich nuclide and a proton-rich nuclide?

24.7 Why might it be difficult to use only a nuclide's N/Z ratio to predict whether it will decay by β^+ emission or by e^- capture? What other factor is important?

Skill-Building Exercises (grouped in similar pairs)

24.8 Write balanced nuclear equations for the following:

- (a) Alpha decay of $^{234}_{92}\text{U}$
- (b) Electron capture by neptunium-232
- (c) Positron emission by $^{12}_7\text{N}$

24.9 Write balanced nuclear equations for the following:

- (a) β^- decay of sodium-26
- (b) β^- decay of francium-223
- (c) Alpha decay of $^{212}_{83}\text{Bi}$

24.10 Write balanced nuclear equations for the following:

- (a) β^- emission by magnesium-27
- (b) β^+ emission by $^{23}_{12}\text{Mg}$
- (c) Electron capture by $^{103}_{46}\text{Pd}$

24.11 Write balanced nuclear equations for the following:

- (a) β^- decay of silicon-32
- (b) Alpha decay of polonium-218
- (c) Electron capture by $^{110}_{49}\text{In}$

24.12 Write balanced nuclear equations for the following:

- (a) Formation of $^{48}_{22}\text{Ti}$ through positron emission
- (b) Formation of silver-107 through electron capture
- (c) Formation of polonium-206 through α decay

24.13 Write balanced nuclear equations for the following:

- (a) Formation of $^{241}_{95}\text{Am}$ through β^- decay
- (b) Formation of $^{228}_{89}\text{Ac}$ through β^- decay
- (c) Formation of $^{203}_{83}\text{Bi}$ through α decay

24.14 Write balanced nuclear equations for the following:

- (a) Formation of $^{186}_{80}\text{Ir}$ through electron capture
- (b) Formation of francium-221 through α decay
- (c) Formation of iodine-129 through β^- decay

24.15 Write balanced nuclear equations for the following:

- (a) Formation of $^{52}_{25}\text{Mn}$ through positron emission
- (b) Formation of polonium-215 through α decay
- (c) Formation of $^{81}_{35}\text{Kr}$ through electron capture

24.16 Which nuclide(s) would you predict to be stable? Why?

- (a) $^{20}_{8}\text{O}$
- (b) $^{59}_{27}\text{Co}$
- (c) $^{9}_{3}\text{Li}$

24.17 Which nuclide(s) would you predict to be stable? Why?

- (a) $^{146}_{60}\text{Nd}$
- (b) $^{114}_{48}\text{Cd}$
- (c) $^{88}_{42}\text{Mo}$

24.18 Which nuclide(s) would you predict to be stable? Why?

- (a) ^{127}I
- (b) tin-106
- (c) ^{68}As

24.19 Which nuclide(s) would you predict to be stable? Why?

- (a) ^{48}K
- (b) ^{79}Br
- (c) argon-32

24.20 What is the most likely mode of decay for each nuclide?

- (a) $^{238}_{92}\text{U}$
- (b) $^{48}_{24}\text{Cr}$
- (c) $^{50}_{25}\text{Mn}$

24.21 What is the most likely mode of decay for each nuclide?

- (a) $^{111}_{47}\text{Ag}$
- (b) $^{41}_{17}\text{Cl}$
- (c) $^{110}_{44}\text{Ru}$

24.22 What is the most likely mode of decay for each nuclide?

- (a) ^{15}C
- (b) ^{120}Xe
- (c) ^{224}Th

24.23 What is the most likely mode of decay for each nuclide?

- (a) ^{106}In
- (b) ^{141}Eu
- (c) ^{241}Am

24.24 Why is $^{52}_{24}\text{Cr}$ the most stable isotope of chromium?

24.25 Why is $^{40}_{20}\text{Ca}$ the most stable isotope of calcium?

Problems in Context

24.26 ^{237}Np is the parent nuclide of a decay series that starts with α emission, followed by β^- emission, and then two more α emissions. Write a balanced nuclear equation for each step.

24.27 Why is helium found in deposits of uranium and thorium ores? What kind of radioactive emission produces it?

24.28 In a natural decay series, how many α and β^- emissions per atom of uranium-235 result in an atom of lead-207?

The Kinetics of Radioactive Decay

(Sample Problems 24.4 to 24.6)

Concept Review Questions

24.29 What electronic process is the basis for detecting radioactivity in (a) a scintillation counter; (b) a Geiger-Müller counter?

24.30 What is the reaction order of radioactive decay? Explain.

24.31 After 1 min, three radioactive nuclei remain from an original sample of six. Is it valid to conclude that $t_{1/2}$ equals 1 min? Is this conclusion valid if the original sample contained 6×10^{12} nuclei and 3×10^{12} remain after 1 min? Explain.

24.32 Radioisotopic dating depends on the constant rate of decay and formation of various nuclides in a sample. How is the proportion of ^{14}C kept relatively constant in living organisms?

Skill-Building Exercises (grouped in similar pairs)

24.33 What is the specific activity (in Ci/g) if 1.65 mg of an isotope emits $1.56 \times 10^6 \alpha$ particles per second?

24.34 What is the specific activity (in Ci/g) if 2.6 g of an isotope emits $4.13 \times 10^8 \beta^-$ particles per hour?

24.35 What is the specific activity (in Bq/g) if 8.58 μg of an isotope emits $7.4 \times 10^4 \alpha$ particles per minute?

24.36 What is the specific activity (in Bq/g) if 1.07 kg of an isotope emits $3.77 \times 10^7 \beta^-$ particles per minute?

24.37 If one-trillionth of the atoms of a radioactive isotope disintegrate each day, what is the decay constant of the process?

24.38 If $2.8 \times 10^{-10}\%$ of the atoms of a radioactive isotope disintegrate in 1.0 yr, what is the decay constant of the process?

24.39 If 1.00×10^{-12} mol of ^{135}Cs emits $1.39 \times 10^5 \beta^-$ particles in 1.00 yr, what is the decay constant?

24.40 If 6.40×10^{-9} mol of ^{176}W emits $1.07 \times 10^{15} \beta^+$ particles in 1.00 h, what is the decay constant?

24.41 The isotope ^{212}Bi has a half-life of 1.01 yr. What mass (in mg) of a 2.00-mg sample will remain after 3.75×10^3 h?

24.42 The half-life of radium-226 is 1.60×10^3 yr. How many hours will it take for a 2.50-g sample to decay to the point where 0.185 g of the isotope remains?

24.43 A rock contains 270 μmol of ^{238}U ($t_{1/2} = 4.5 \times 10^9$ yr) and 110 μmol of ^{206}Pb . Assuming that all the ^{206}Pb comes from decay of the ^{238}U , estimate the rock's age.

24.44 A fabric remnant from a burial site has a $^{14}\text{C}/^{12}\text{C}$ ratio of 0.735 of the original value. How old is the fabric?

Problems in Context

24.45 Due to decay of ^{40}K , cow's milk has a specific activity of about 6×10^{-11} mCi per milliliter. How many disintegrations of ^{40}K nuclei are there per minute in an 8.0-oz glass of milk?

24.46 Plutonium-239 ($t_{1/2} = 2.41 \times 10^4$ yr) represents a serious nuclear waste hazard. If seven half-lives are required to reach a tolerable level of radioactivity, how long must ^{239}Pu be stored?

24.47 A rock that contains 3.1×10^{-15} mol of ^{232}Th ($t_{1/2} = 1.4 \times 10^{10}$ yr) has 9.5×10^4 fission tracks, each track representing the fission of one atom of ^{232}Th . How old is the rock?

24.48 A volcanic eruption melts a large chunk of rock, and all gases are expelled. After cooling, ^{40}Ar accumulates from the ongoing decay of ^{40}K in the rock ($t_{1/2} = 1.25 \times 10^9$ yr). When a piece of rock is analyzed, it is found to contain 1.38 mmol of ^{40}K and 1.14 mmol of ^{40}Ar . How long ago did the rock cool?

Nuclear Transmutation: Induced Changes in Nuclei

Concept Review Questions

24.49 Irene and Frederic Joliot-Curie converted ^{27}Al to ^{30}P in 1933. Why was this transmutation significant?

24.50 Early workers mistakenly thought neutron beams were γ radiation. Why? What evidence led to the correct conclusion?

24.51 Why must the electrical polarity of the tubes in a linear accelerator be reversed at very short time intervals?

24.52 Why does bombardment with protons usually require higher energies than bombardment with neutrons?

Skill-Building Exercises (grouped in similar pairs)

24.53 Determine the missing species in these transmutations, and write a full nuclear equation from the shorthand notation:

- (a) ^{10}B (α, n) _____
- (b) ^{28}Si ($d, \underline{\hspace{2cm}}$) ^{29}P (where d is a deuteron, ^2H)
- (c) _____ ($\alpha, 2n$) ^{244}Cf

24.54 Name the unidentified species, and write each transmutation process in shorthand notation: (a) gamma irradiation of a nuclide yields a proton, a neutron, and ^{29}Si ; (b) bombardment of ^{252}Cf with ^{10}B yields five neutrons and a nuclide; (c) bombardment of ^{238}U with a particle yields three neutrons and ^{239}Pu .

Problems in Context

24.55 Elements 104, 105, and 106 have been named rutherfordium (Rf), dubnium (Db), and seaborgium (Sg), respectively. These elements are synthesized from californium-249 by bombarding with carbon-12, nitrogen-15, and oxygen-18 nuclei, respectively. Four neutrons are formed in each reaction as well. (a) Write balanced nuclear equations for the formation of these elements. (b) Write the equations in shorthand notation.

Ionization: Effects of Nuclear Radiation on Matter

Concept Review Questions

24.56 The effects on matter of γ rays and α particles differ. Explain.

24.57 What is a cation-electron pair, and how does it form?

24.58 Why is ionizing radiation more harmful to children than adults?

24.59 Why is $\cdot\text{OH}$ more dangerous than OH^- in an organism?

Skill-Building Exercises (grouped in similar pairs)

24.60 A 135-lb person absorbs 3.3×10^{-7} J of energy from radioactive emissions. (a) How many rads does she receive? (b) How many grays (Gy) does she receive?

24.61 A 3.6-kg laboratory animal receives a single dose of 8.92×10^{-4} Gy. (a) How many rads did the animal receive? (b) How many joules did the animal absorb?

24.62 A 70.-kg person exposed to ^{90}Sr absorbs $6.0 \times 10^5 \beta^-$ particles, each with an energy of 8.74×10^{-14} J. (a) How many grays does the person receive? (b) If the RBE is 1.0, how many millirems is this? (c) What is the equivalent dose in sieverts (Sv)?

24.63 A laboratory rat weighs 265 g and absorbs $1.77 \times 10^{10} \beta^-$ particles, each with an energy of 2.20×10^{-13} J. (a) How many rads does the animal receive? (b) What is this dose in Gy? (c) If the RBE is 0.75, what is the equivalent dose in Sv?

Problems in Context

24.64 If 2.50 pCi [1 pCi (picocurie) = 1×10^{-12} Ci] of radioactivity from ^{239}Pu is emitted in a 95-kg human for 65 h, and each disintegration has an energy of 8.25×10^{-13} J, how many grays does the person receive?

24.65 A small region of a cancer patient's brain is exposed for 24.0 min to 475 Bq of radioactivity from ^{60}Co for treatment of a tumor. If the brain mass exposed is 1.858 g and each β^- particle emitted has an energy of 5.05×10^{-14} J, what is the dose in rads?

Applications of Radioisotopes

Concept Review Questions

24.66 What two ways are radioactive tracers used in organisms?

24.67 Why is neutron activation analysis (NAA) useful to art historians and criminologists?

24.68 Positrons cannot penetrate matter more than a few atomic diameters, but positron emission of radiotracers can be monitored in medical diagnosis. Explain.

24.69 A steel part is treated to form some iron-59. Oil used to lubricate the part emits 298 β^- particles (with the energy characteristic of ^{59}Fe) per minute per milliliter of oil. What other information would you need to calculate the rate of removal of the steel from the part during use?

Problems in Context

24.70 The oxidation of methanol to formaldehyde can be accomplished by reaction with chromic acid:

The reaction can be studied with the stable isotope tracer ^{18}O and mass spectrometry. When a small amount of $\text{CH}_3^{18}\text{OH}$ is present in the alcohol reactant, CH_2^{18}O forms. When a small amount of $\text{H}_2\text{Cr}^{18}\text{O}_4$ is present, H_2^{18}O forms. Does chromic acid or methanol supply the O atom to the aldehyde? Explain.

The Interconversion of Mass and Energy

(Sample Problem 24.7)

Note: Data for problems in this section: mass of ^1H atom = 1.007825 amu; mass of neutron = 1.008665 amu.

Concept Review Questions

24.71 Many scientists at first reacted skeptically to Einstein's equation, $E = mc^2$. Why?

24.72 How does a change in mass arise when a nuclide forms from nucleons?

24.73 When a nucleus forms from nucleons, is energy absorbed or released? Why?

24.74 What is the binding energy per nucleon? Why is the binding energy per nucleon, rather than per nuclide, used to compare nuclide stability?

Skill-Building Exercises (grouped in similar pairs)

24.75 A ^3H nucleus decays with an energy of 0.01861 MeV. Convert this energy into (a) electron volts; (b) joules.

24.76 Arsenic-84 decays with an energy of 1.57×10^{-15} kJ per nucleus. Convert this energy into (a) eV; (b) MeV.

24.77 How many joules are released when 1.5 mol of ^{239}Pu decays, if each nucleus releases 5.243 MeV?

24.78 How many MeV are released per nucleus when 3.2×10^{-3} mol of chromium-49 releases 8.11×10^5 kJ?

24.79 Oxygen-16 is one of the most stable nuclides. The mass of a ^{16}O atom is 15.994915 amu. Calculate the binding energy (a) per nucleon in MeV; (b) per atom in MeV; (c) per mole in kJ.

24.80 Lead-206 is the end product of ^{238}U decay. One ^{206}Pb atom has a mass of 205.974440 amu. Calculate the binding energy (a) per nucleon in MeV; (b) per atom in MeV; (c) per mole in kJ.

24.81 Cobalt-59 is the only stable isotope of this transition metal. One ^{59}Co atom has a mass of 58.933198 amu. Calculate the binding energy (a) per nucleon in MeV; (b) per atom in MeV; (c) per mole in kJ.

24.82 Iodine-131 is one of the most important isotopes used in the diagnosis of thyroid cancer. One atom has a mass of 130.906114 amu. Calculate the binding energy (a) per nucleon in MeV; (b) per atom in MeV; (c) per mole in kJ.

Problems in Context

24.83 The ^{80}Br nuclide decays either by β^- decay or by electron capture. (a) What is the product of each process? (b) Which process releases more energy? (Masses of atoms: $^{80}\text{Br} = 79.918528$ amu; $^{80}\text{Kr} = 79.916380$ amu; $^{80}\text{Se} = 79.916520$ amu; neglect the mass of electrons involved because these are atomic, not nuclear, masses.)

Applications of Fission and Fusion

Concept Review Questions

24.84 What is the minimum number of neutrons from each fission event that must be absorbed by other nuclei for a chain reaction to be sustained?

24.85 In what main way is fission different from radioactive decay? Are all fission events in a chain reaction identical? Explain.

24.86 What is the purpose of enrichment in the preparation of fuel rods? How is it accomplished?

24.87 Describe the nature and purpose of these components of a nuclear reactor: (a) control rods; (b) moderator; (c) reflector.

24.88 State an advantage and a disadvantage of heavy-water reactors compared to light-water reactors.

24.89 What are the expected advantages of fusion reactors over fission reactors?

24.90 Why is iron the most abundant element in Earth's core?

Problems in Context

24.91 The reaction that will probably power the first commercial fusion reactor is

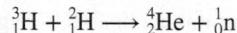

How much energy would be produced per mole of reaction? (Mass of $^3\text{H} = 3.01605$ amu; mass of $^2\text{H} = 2.0140$ amu; mass of $^4\text{He} = 4.00260$ amu; mass of $^1\text{n} = 1.008665$ amu.)

Comprehensive Problems

24.92 Some ^{243}Am was present when Earth formed, but it all decayed in the next billion years. The first three steps in this decay series are emissions of an α particle, a β^- particle, and another α particle. What other isotopes were present on the young Earth in a rock that contained some ^{243}Am ?

24.93 Curium-243 undergoes α decay to plutonium-239:

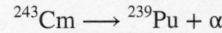

(a) Find the change in mass, Δm (in kg). (Mass of $^{243}\text{Cm} = 243.0614$ amu; mass of $^{239}\text{Pu} = 239.0522$ amu; mass of $^4\text{He} = 4.0026$ amu; 1 amu = 1.661×10^{-24} g.)

(b) Find the energy released in joules.

(c) Find the energy released in kJ/mol of reaction, and comment on the difference between this value and a typical heat of reaction for a chemical change, which is a few hundred kJ/mol.

24.94 Plutonium “triggers” for nuclear weapons were manufactured at the Rocky Flats plant in Colorado. An 85-kg worker inhaled a dust particle containing 1.00 µg of ^{239}Pu , which resided in his body for 16 h ($t_{1/2}$ of $^{239}\text{Pu} = 2.41 \times 10^4$ yr; each disintegration released 5.15 MeV). (a) How many rads did he receive? (b) How many grays?

24.95 Archeologists removed some charcoal from a Native American campfire site, burned it in O_2 , and bubbled the CO_2 formed into $\text{Ca}(\text{OH})_2$ solution (limewater). The CaCO_3 that precipitated was filtered and dried. If 4.58 g of the CaCO_3 had a radioactivity of 3.2 d/min, how long ago was the campfire burning?

24.96 A 5.4-µg sample of $^{226}\text{RaCl}_2$ has a radioactivity of 1.5×10^5 Bq. Calculate $t_{1/2}$ of ^{226}Ra .

24.97 How many rads does a 65-kg human receive each year from the approximately 10^{-8} g of ^{14}C naturally present in her body ($t_{1/2} = 5730$ yr; each disintegration releases 0.156 MeV)?

24.98 A sample of AgCl emits 175 nCi/g. A saturated solution prepared from the solid emits 1.25×10^{-2} Bq/mL due to radioactive Ag^+ ions. What is the molar solubility of AgCl ?

24.99 The scene below depicts a neutron bombarding ^{235}U :

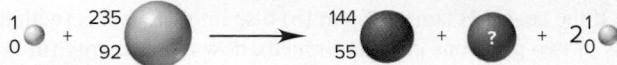

(a) Is this an example of fission or of fusion?

(b) Identify the other nuclide formed.

(c) What is the most likely mode of decay of the nuclide with $Z = 55$?

24.100 What fraction of the ^{235}U ($t_{1/2} = 7.0 \times 10^8$ yr) created when Earth was formed would remain after 2.8×10^9 yr?

24.101 ^{238}U ($t_{1/2} = 4.5 \times 10^9$ yr) begins a decay series that ultimately forms ^{206}Pb . The scene below depicts the relative number of ^{238}U atoms (red) and ^{206}Pb atoms (green) in a mineral. If all the Pb comes from ^{238}U , calculate the age of the sample.

24.102 Technetium-99m is a metastable nuclide used in numerous cancer diagnostic and treatment programs. It is prepared just before use because it decays rapidly through γ emission:

Use the data below to determine (a) the half-life of $^{99\text{m}}\text{Tc}$; (b) the percentage of the isotope that is lost if it takes 2.0 h to prepare and administer the dose.

Time (h)	γ Emission (photons/s)
0	5000.
4	3150.
8	2000.
12	1250.
16	788
20	495

24.103 How many curies are produced by 1.0 mol of ^{40}K ($t_{1/2} = 1.25 \times 10^9$ yr)? How many becquerels?

24.104 The fraction of a radioactive isotope remaining at time t is $(\frac{1}{2})^{t/t_{1/2}}$, where $t_{1/2}$ is the half-life. If the half-life of carbon-14 is 5730 yr, what fraction of carbon-14 in a piece of charcoal remains after (a) 10.0 yr; (b) 10.0×10^3 yr; (c) 10.0×10^4 yr? (d) Why is radiocarbon dating more reliable for the fraction remaining in part (b) than that in part (a) or in part (c)?

24.105 The isotopic mass of ^{210}Rn is 209.989669 amu. When this nuclide decays by electron capture, it emits 2.368 MeV. What is the isotopic mass of the resulting nuclide?

24.106 Exactly 0.1 of the radioactive nuclei in a sample decay per hour. Thus, after n hours, the fraction of nuclei remaining is $(0.900)^n$. Find the value of n equal to one half-life.

24.107 In neutron activation analysis (NAA), stable isotopes are bombarded with neutrons. Depending on the isotope and the energy of the neutron, various emissions are observed. What are the products when the following neutron-activated species decay? Write an overall equation in shorthand notation for the reaction starting with the stable isotope before neutron activation.

- (a) $^{52}_{23}\text{V}^* \longrightarrow [\beta^- \text{ emission}]$ (b) $^{64}_{29}\text{Cu}^* \longrightarrow [\beta^+ \text{ emission}]$
 (c) $^{28}_{13}\text{Al}^* \longrightarrow [\beta^- \text{ emission}]$

24.108 In the 1950s, radioactive material was spread over the land from aboveground nuclear tests. A woman drinks some contaminated milk and ingests 0.0500 g of ^{90}Sr , which is taken up by bones and teeth and not eliminated. (a) How much ^{90}Sr ($t_{1/2} = 29$ yr) is present in her body after 10 yr? (b) How long will it take for 99.9% of the ^{90}Sr that she ingested to decay?

24.109 The scene below represents a reaction (with neutrons gray and protons purple) that occurs during the lifetime of a star. (a) Write a balanced nuclear equation for the reaction. (b) If the mass difference is 7.7×10^{-2} amu, find the energy (in kJ) released.

24.110 What volume of radon will be produced per hour at STP from 1.000 g of ^{226}Ra ($t_{1/2} = 1599$ yr; 1 yr = 8766 h; mass of one ^{226}Ra atom = 226.025402 amu)?

24.111 ^{90}Kr ($t_{1/2} = 32$ s) is used to study respiration. How soon after being made must a sample be administered to the patient if the activity must be at least 90% of the original activity?

24.112 Which isotope in each pair is more stable? Why?

- (a) $^{140}_{55}\text{Cs}$ or $^{133}_{55}\text{Cs}$ (b) $^{79}_{35}\text{Br}$ or $^{78}_{35}\text{Br}$
 (c) $^{28}_{12}\text{Mg}$ or $^{24}_{12}\text{Mg}$ (d) $^{14}_{7}\text{N}$ or $^{18}_{7}\text{N}$

24.113 A bone sample containing strontium-90 ($t_{1/2} = 29$ yr) emits 7.0×10^4 β^- particles per month. How long will it take for the emission to decrease to 1.0×10^4 particles per month?

24.114 The 23rd-century starship *Enterprise* uses a substance called “dilithium crystals” as its fuel.

- (a) Assuming that this material is the result of fusion, what is the product of the fusion of two ^6Li nuclei?
 (b) How much energy is released per kilogram of dilithium formed? (Mass of one ^6Li atom is 6.015121 amu.)
 (c) When four ^1H atoms fuse to form ^4He , how many positrons are released?

(d) To determine the energy potential of the fusion processes in parts (b) and (c), compare the changes in mass per kilogram of dilithium and of ${}^4\text{He}$.

(e) Compare the change in mass per kilogram in part (b) to that for the formation of ${}^4\text{He}$ by the method used in current fusion reactors (see Section 24.7). (For masses, see Problem 24.91.)

(f) Using early 21st-century fusion technology, how much tritium can be produced per kilogram of ${}^6\text{Li}$ in the following reaction: ${}^7\text{Li} + {}_0^1\text{n} \longrightarrow {}_2^4\text{He} + {}_1^3\text{H}$? When this amount of tritium is fused with deuterium, what is the change in mass? How does this quantity compare with the use of dilithium in part (b)?

24.115 Uranium and radium are found in many rocky soils throughout the world. Both undergo radioactive decay, and one of the products is radon-222, the heaviest noble gas ($t_{1/2} = 3.82$ days). Inhalation of this gas contributes to many lung cancers. According to the Environmental Protection Agency, the level of radioactivity from radon in homes should not exceed 4.0 pCi/L of air.

(a) What is the safe level of radon in Bq/L of air?

(b) A home has a radon measurement of 41.5 pCi/L. The owner vents the basement in such a way that no more radon enters the living area. What is the activity of the radon remaining in the room air (in Bq/L) after 9.5 days?

(c) How many more days does it take to reach the EPA recommended level?

24.116 Nuclear disarmament could be accomplished if weapons were not “replenished.” The tritium in warheads decays to helium with a half-life of 12.26 yr and must be replaced or the weapon is useless. What fraction of the tritium is lost in 5.50 yr?

24.117 A decay series starts with the synthetic isotope ${}^{239}_{92}\text{U}$. The first four steps are emissions of a β^- particle, another β^- , an α particle, and another α . Write a balanced nuclear equation for each step. Which natural series could start by this sequence?

24.118 How long can a 54-lb child be exposed to 1.0 mCi of radiation from ${}^{222}\text{Rn}$ before accumulating 1.0 mrad if the energy of each disintegration is 5.59 MeV?

24.119 An earthquake in the area of present-day San Francisco is to be dated by measuring the ${}^{14}\text{C}$ activity ($t_{1/2} = 5730$ yr) of parts of a tree uprooted during the event. The tree parts have an activity of 12.9 d/min \cdot g C, and a living tree has an activity of 15.3 d/min \cdot g C. How long ago did the earthquake occur?

24.120 Were organisms a billion years ago exposed to more or less ionizing radiation than similar organisms today? Explain.

24.121 Tritium (${}^3\text{H}$; $t_{1/2} = 12.26$ yr) is continually formed in the upper troposphere by interaction of solar particles with nitrogen. As a result, natural waters contain a small amount of tritium. Two samples of wine are analyzed, one known to be made in 1941 and another made earlier. The water in the 1941 wine has 2.23 times as much tritium as the water in the other. When was the other wine produced?

24.122 Even though plutonium-239 ($t_{1/2} = 2.41 \times 10^4$ yr) is one of the main fission fuels, it is still a radiation hazard present in spent uranium fuel from nuclear power plants. How many years does it take for 99% of the plutonium-239 in spent fuel to decay?

24.123 Carbon from the remains of an extinct Australian marsupial, called *Diprotodon*, has a specific activity of 0.61 pCi/g. Modern carbon has a specific activity of 6.89 pCi/g. How long ago did the *Diprotodon* apparently become extinct?

24.124 The reaction that allows radiocarbon dating to be performed is the continual formation of carbon-14 in the upper atmosphere:

What is the energy change that is associated with this process in eV/reaction and in kJ/mol reaction? (Masses of atoms:

${}^14_7\text{N} = 14.003074$ amu; ${}^14_6\text{C} = 14.003241$ amu; ${}^1_1\text{H} = 1.007825$ amu; mass of ${}^1_0\text{n} = 1.008665$ amu.)

24.125 What is the nuclear binding energy of a lithium-7 nucleus in units of kJ/mol and eV/nucleus? (Mass of a lithium-7 atom = 7.016003 amu.)

24.126 Gadolinium-146 undergoes electron capture. Identify the product, and use Figure 24.2 to find the modes of decay and the two intermediate nuclides in the series:

24.127 Using 21st-century technology, hydrogen fusion requires temperatures around 10^8 K. But, lower initial temperatures are used if the hydrogen is compressed. In the late 24th century, the starship *Leinad* uses such methods to fuse hydrogen at 10^6 K.

(a) What is the kinetic energy of an H atom at 1.00×10^6 K?

(b) How many H atoms are heated to 1.00×10^6 K from the energy of one H and one anti-H atom annihilating each other?

(c) If the heated H atoms of part (b) fuse into ${}^4\text{He}$ atoms (with the loss of two positrons per ${}^4\text{He}$ formed), how much energy (in J) is generated?

(d) How much more energy is generated by the fusion in part (c) than by the hydrogen-antihydrogen collision in part (b)?

(e) Should the captain of the *Leinad* change the technology and produce ${}^3\text{He}$ (mass = 3.01603 amu) instead of ${}^4\text{He}$?

24.128 A metastable (excited) form of ${}^{50}\text{Sc}$ changes to its stable form by emitting γ radiation with a wavelength of 8.73 pm. What is the change in mass of 1 mol of the isotope when it undergoes this change?

24.129 A sample of cobalt-60 ($t_{1/2} = 5.27$ yr), a powerful γ emitter used to treat cancer, was purchased by a hospital on March 1, 2012. The sample must be replaced when its activity reaches 70% of the original value. On what date must it be replaced?

24.130 Uranium-233 decays to thorium-229 by α decay, but the emissions have different energies and products: 83% emit an α particle with an energy of 4.816 MeV and give ${}^{229}\text{Th}$ in its ground state; 15% emit an α particle of 4.773 MeV and give ${}^{229}\text{Th}$ in excited state I; and 2% emit a lower energy α particle and give ${}^{229}\text{Th}$ in the higher excited state II. Excited state II emits a γ ray of 0.060 MeV to reach excited state I.

(a) Find the γ -ray energy and wavelength that would convert excited state I to the ground state. (b) Find the energy of the α particle that would raise ${}^{233}\text{U}$ to excited state II.

24.131 Uranium-238 undergoes a slow decay step ($t_{1/2} = 4.5 \times 10^9$ yr) followed by a series of fast steps to form the stable isotope ${}^{206}\text{Pb}$. Thus, on a time scale of billions of years, ${}^{238}\text{U}$ effectively decays “directly” to ${}^{206}\text{Pb}$, and the relative amounts of these isotopes are used to find the age of some rocks. Two students derive equations relating number of half-lives (n) since the rock formed to the amounts of the isotopes:

$$\text{Student 1: } \left(\frac{1}{2}\right)^n = \frac{{}^{238}_{92}\text{U}}{{}^{206}_{82}\text{Pb}}$$

Student 2:
$$\left(\frac{1}{2}\right)^n = \frac{{}^{238}_{\text{92}}\text{U}}{{}^{238}_{\text{92}}\text{U} + {}^{206}_{\text{82}}\text{Pb}}$$

(a) Which equation is correct, and why?

(b) If a rock contains exactly twice as much ${}^{238}\text{U}$ as ${}^{206}\text{Pb}$, what is its age in years?

24.132 In the naturally occurring thorium-232 decay series, the steps emit this sequence of particles: α , β^- , β^- , α , α , α , α , β^- , β^- , and α . Write a balanced equation for each step.

24.133 At death, a nobleman in ancient Egypt was mummified and his body contained 1.4×10^{-3} g of ${}^{40}\text{K}$ ($t_{1/2} = 1.25 \times 10^9$ yr), 1.2×10^{-8} g of ${}^{14}\text{C}$ ($t_{1/2} = 5730$ yr), and 4.8×10^{-14} g of ${}^3\text{H}$ ($t_{1/2} = 12.26$ yr). Which nuclide would give the most accurate estimate of the mummy's age? Explain.

24.134 Assuming that many radioactive nuclides can be considered safe after 20 half-lives, how long will it take for each of the following nuclides to be safe: (a) ${}^{242}\text{Cm}$ ($t_{1/2} = 163$ days); (b) ${}^{214}\text{Po}$ ($t_{1/2} = 1.6 \times 10^{-4}$ s); (c) ${}^{232}\text{Th}$ ($t_{1/2} = 1.39 \times 10^{10}$ yr)?

24.135 An ancient sword has a blade from the early Roman Empire, around 100 AD, but the wooden handle, inlaid wooden decorations, leather ribbon, and leather sheath have different styles. Given the following activities, estimate the age of each part. Which part was made near the time of the blade ($t_{1/2}$ of ${}^{14}\text{C} = 5730$ yr; $\mathcal{A}_0 = 15.3 \text{ d/min}\cdot\text{g}$)?

Part	$\mathcal{A}_t \text{ (d/min}\cdot\text{g)}$
Handle	10.1
Inlaid wood	13.8
Ribbon	12.1
Sheath	15.0

24.136 The starship *Voyager*, like many other vessels of the newly designed 24th-century fleet, uses antimatter as fuel.

(a) How much energy is released when 1.00 kg each of antimatter and matter annihilate each other?

(b) When the antimatter is atomic antihydrogen, a small amount of it is mixed with excess atomic hydrogen (gathered from interstellar space during flight). The annihilation releases so much heat that the remaining hydrogen nuclei fuse to form ${}^4\text{He}$. If each hydrogen-antihydrogen collision releases enough heat to fuse 1.00×10^5 hydrogen atoms, how much energy (in kJ) is released per kilogram of antihydrogen?

(c) Which produces more energy per kilogram of antihydrogen, the procedure in part (a) or that in part (b)?

24.137 Use Einstein's equation, the mass in grams of 1 amu, and the relation between electron volts and joules to find the energy equivalent (in MeV) of a mass difference of 1 amu.

24.138 Determine the age of a rock containing 0.065 g of uranium-238 ($t_{1/2} = 4.5 \times 10^9$ yr) and 0.023 g of lead-206. (Assume that all the lead-206 came from ${}^{238}\text{U}$ decay.)

24.139 Plutonium-242 decays to uranium-238 by emission of an α particle with an energy of 4.853 MeV. The ${}^{238}\text{U}$ that forms is unstable and emits a γ ray ($\lambda = 0.02757$ nm). (a) Write balanced equations for these reactions. (b) What would be the energy of the α particle if ${}^{242}\text{Pu}$ decayed directly to the more stable ${}^{238}\text{U}$?

24.140 Seaborgium-263 (Sg), the first isotope of element 106 synthesized, was produced, along with four neutrons, by bombarding californium-249 with oxygen-18. The ${}^{263}\text{Sg}$ then underwent a series of decays starting with three α emissions. Write balanced equations for the synthesis and the three α emissions of ${}^{263}\text{Sg}$.

24.141 Some nuclear power plants use plutonium-239, which is produced in breeder reactors. The rate-determining step is the second β^- emission. How long does it take to make 1.00 kg of ${}^{239}\text{Pu}$ if the reaction is complete when the product is 90% ${}^{239}\text{Pu}$?

24.142 A random-number generator can be used to simulate the probability of a given atom decaying over a given time. For example, the formula “=RAND()” in an Excel spreadsheet returns a random number between 0 and 1; thus, for one radioactive atom and a time of one half-life, a number less than 0.5 means the atom decays and a number greater than 0.5 means it doesn't.

(a) Place the “=RAND()” formula in cells A1 to A10 of an Excel spreadsheet. In cell B1, place “=IF(A1<0.5, 0, 1).” This formula returns 0 if A1 is <0.5 (the atom decays) and 1 if A1 is >0.5 (the atom does not decay). Place analogous formulas in cells B2 to B10 (using the “Fill Down” procedure in Excel). To determine the number of atoms remaining after one half-life, sum cells B1 to B10 by placing “=SUM(B1:B10)” in cell B12. To create a new set of random numbers, click on an empty cell (e.g., B13) and hit “Delete.” Perform 10 simulations, each time recording the total number of atoms remaining. Do half of the atoms remain after each half-life? If not, why not? (b) Increase the number of atoms to 100 by placing suitable formulas in cells A1 to A100, B1 to B100, and B102. Perform 10 simulations, and record the number of atoms remaining each time. Are these results more realistic for radioactive decay? Explain.

24.143 In the following Excel-based simulation, the fate of 256 atoms is followed over five half-lives. Set up formulas in columns A and B, as in Problem 24.142, and simulate the fate of the sample of 256 atoms over one half-life. Cells B1 to B256 should contain 1 or 0. In cell C1, enter “=IF(B1=0, 0, RAND()).” This returns 0 if the original atom decayed in the previous half-life or a random number between 0 and 1 if it did not. Fill the formula in C1 down to cell C256. Column D should have formulas similar to those in B, but with modified references, as should columns F, H, and J. Columns E, G, and I should have formulas similar to those in C, but with modified references. In cell B258, enter “=SUM(B1:B256).” This records the number of atoms remaining after the first half-life. Put formulas in cells D258, F258, H258, and J258 to record atoms remaining after subsequent half-lives.

(a) Ideally, how many atoms should remain after each half-life? (b) Make a table of the atoms remaining after each half-life in four separate simulations. Compare these outcomes to the ideal outcome. How would you make the results more realistic?

24.144 Representations of three nuclei (with neutrons gray and protons purple) are shown below. Nucleus 1 is stable, but 2 and 3 are not. (a) Write the symbol for each isotope. (b) What is (are) the most likely mode(s) of decay for 2 and 3?

1

2

3

Common Mathematical Operations in Chemistry

In addition to basic arithmetic and algebra, four mathematical operations are used frequently in general chemistry: manipulating logarithms, using exponential notation, solving quadratic equations, and graphing data. Each is discussed briefly in this appendix.

MANIPULATING LOGARITHMS

Meaning and Properties of Logarithms

A *logarithm* is an exponent. Specifically, if $x^n = A$, we can say that the logarithm to the base x of the number A is n , and we can denote it as

$$\log_x A = n$$

Because logarithms are exponents, they have the following properties:

$$\begin{aligned}\log_x 1 &= 0 \\ \log_x (A \times B) &= \log_x A + \log_x B \\ \log_x \frac{A}{B} &= \log_x A - \log_x B \\ \log_x A^y &= y \log_x A\end{aligned}$$

Types of Logarithms

Common and natural logarithms are used in chemistry and the other sciences.

1. For *common* logarithms, the base (x in the examples above) is 10, but they are written without specifying the base; that is, $\log_{10} A$ is written more simply as $\log A$; thus, the notation *log* means base 10. The common logarithm of 1000 is 3; in other words, you must raise 10 to the 3rd power to obtain 1000:

$$\log 1000 = 3 \quad \text{or} \quad 10^3 = 1000$$

Similarly, we have

$$\begin{array}{lll}\log 10 = 1 & \text{or} & 10^1 = 10 \\ \log 1,000,000 = 6 & \text{or} & 10^6 = 1,000,000 \\ \log 0.001 = -3 & \text{or} & 10^{-3} = 0.001 \\ \log 853 = 2.931 & \text{or} & 10^{2.931} = 853\end{array}$$

The last example illustrates an important point about significant figures with all logarithms: *the number of significant figures in the number equals the number of digits to the right of the decimal point in the logarithm*. That is, the number 853 has three significant figures, and the logarithm 2.931 has three digits to the right of the decimal point.

To find a common logarithm with an electronic calculator, press the LOG button, enter the number, and press ENTER.

2. For *natural* logarithms, the base is the number e , which is 2.71828 . . . , and $\log_e A$ is written $\ln A$; thus, the notation *ln* means base e . The relationship between the common and natural logarithms is easily obtained:

$$\log 10 = 1 \quad \text{and} \quad \ln 10 = 2.303$$

Therefore, we have

$$\ln A = 2.303 \log A$$

To find a natural logarithm with an electronic calculator, press the LN button, enter the number, and press ENTER. If your calculator does not have an LN button, press the LOG button, enter the number, press ENTER, and multiply that result by 2.303.

Antilogarithms

The *antilogarithm* is the base raised to the logarithm:

$$\text{antilogarithm (antilog) of } n \text{ is } 10^n$$

Using two of the earlier examples, the antilog of 3 is 1000, and the antilog of 2.931 is 853. To obtain the antilog with a calculator, press the 10^x button, enter the number, and press ENTER. Similarly, to obtain the natural antilogarithm, press the e^x button, enter the number, and press ENTER. [On some calculators, enter the number and first press INV and then the LOG (or LN) button.]

USING EXPONENTIAL (SCIENTIFIC) NOTATION

Many quantities in chemistry are very large or very small. For example, in the conventional way of writing numbers, the number of gold atoms in 1 gram of gold is

$$59,060,000,000,000,000,000,000 \text{ atoms (to four significant figures)}$$

As another example, the mass in grams of one gold atom is

$$0.00000000000000000000003272 \text{ g (to four significant figures)}$$

Exponential (scientific) notation provides a much more practical way of writing such numbers. In exponential notation, we express numbers in the form

$$A \times 10^n$$

where A (the coefficient) is greater than or equal to 1 and less than 10 (that is, $1 \leq A < 10$), and n (the exponent) is an integer.

If the number we want to express in exponential notation is larger than 1, the exponent is positive ($n > 0$); if the number is smaller than 1, the exponent is negative ($n < 0$). The size of n tells the number of places the decimal point (in conventional notation) must be moved to obtain a coefficient A greater than or equal to 1 and less than 10 (in exponential notation). In exponential notation, 1 gram of gold contains 5.906×10^{22} atoms, and each gold atom has a mass of 3.272×10^{-22} g.

Changing Between Conventional and Exponential Notation

In order to use exponential notation, you must be able to convert to it from conventional notation, and vice versa.

1. To change a number from conventional to exponential notation, move the decimal point to the left for numbers equal to or greater than 10 and to the right for numbers between 0 and 1:

$75,000,000$ changes to 7.5×10^7 (decimal point moves 7 places to the left)

0.006042 changes to 6.042×10^{-3} (decimal point moves 3 places to the right)

2. To change a number from exponential to conventional notation, move the decimal point the number of places indicated by the exponent to the right for numbers with positive exponents and to the left for numbers with negative exponents:

1.38×10^5 changes to 138,000 (decimal point moves 5 places to the right)

8.41×10^{-6} changes to 0.00000841 (decimal point moves 6 places to the left)

3. An exponential number with a coefficient greater than 10 or less than 1 can be changed to the standard exponential form by converting the coefficient to the standard form and adding the exponents:

$$582.3 \times 10^6 \text{ changes to } 5.823 \times 10^2 \times 10^6 = 5.823 \times 10^{(2+6)} = 5.823 \times 10^8$$

$$0.0043 \times 10^{-4} \text{ changes to } 4.3 \times 10^{-3} \times 10^{-4} = 4.3 \times 10^{[(-3)+(-4)]} = 4.3 \times 10^{-7}$$

Using Exponential Notation in Calculations

In calculations, you can treat the coefficient and exponents separately and apply the properties of exponents (see earlier discussion of logarithms).

1. To multiply exponential numbers, multiply the coefficients, add the exponents, and reconstruct the number in standard exponential notation:

$$(5.5 \times 10^3)(3.1 \times 10^5) = (5.5 \times 3.1) \times 10^{(3+5)} = 17 \times 10^8 = 1.7 \times 10^9$$

$$(9.7 \times 10^{14})(4.3 \times 10^{-20}) = (9.7 \times 4.3) \times 10^{[14+(-20)]} = 42 \times 10^{-6} = 4.2 \times 10^{-5}$$

2. To divide exponential numbers, divide the coefficients, subtract the exponents, and reconstruct the number in standard exponential notation:

$$\frac{2.6 \times 10^6}{5.8 \times 10^2} = \frac{2.6}{5.8} \times 10^{(6-2)} = 0.45 \times 10^4 = 4.5 \times 10^3$$

$$\frac{1.7 \times 10^{-5}}{8.2 \times 10^{-8}} = \frac{1.7}{8.2} \times 10^{[(-5)-(-8)]} = 0.21 \times 10^3 = 2.1 \times 10^2$$

3. To add or subtract exponential numbers, change all numbers so that they have the same exponent, then add or subtract the coefficients:

$$(1.45 \times 10^4) + (3.2 \times 10^3) = (1.45 \times 10^4) + (0.32 \times 10^4) = 1.77 \times 10^4$$

$$(3.22 \times 10^5) - (9.02 \times 10^4) = (3.22 \times 10^5) - (0.902 \times 10^5) = 2.32 \times 10^5$$

SOLVING QUADRATIC EQUATIONS

A *quadratic equation* is one in which the highest power of x is 2. The general form of a quadratic equation is

$$ax^2 + bx + c = 0$$

where a , b , and c are numbers. For given values of a , b , and c , the values of x that satisfy the equation are called *solutions* of the equation. We calculate x with the quadratic formula:

$$x = \frac{-b \pm \sqrt{b^2 - 4ac}}{2a}$$

We commonly require the quadratic formula when solving for some concentration in an equilibrium problem. For example, we might have an expression that is rearranged into the quadratic equation

$$\begin{array}{ccc} 4.3x^2 & + 0.65x & - 8.7 = 0 \\ a & b & c \end{array}$$

Applying the quadratic formula, with $a = 4.3$, $b = 0.65$, and $c = -8.7$, gives

$$x = \frac{-0.65 \pm \sqrt{(0.65)^2 - 4(4.3)(-8.7)}}{2(4.3)}$$

The “plus or minus” sign (\pm) indicates that there are always two possible values for x . In this case, they are

$$x = 1.3 \quad \text{and} \quad x = -1.5$$

In any real physical system, however, only one of the values will have any meaning. For example, if x were $[\text{H}_3\text{O}^+]$, the negative value would give a negative concentration, which has no physical meaning.

GRAPHING DATA IN THE FORM OF A STRAIGHT LINE

Visualizing changes in variables by means of a graph is used throughout science. In many cases, it is most useful if the data can be graphed in the form of a straight line. Any equation will appear as a straight line if it has, or can be rearranged to have, the following general form:

$$y = mx + b$$

where y is the dependent variable (typically plotted along the vertical axis), x is the independent variable (typically plotted along the horizontal axis), m is the slope of the line, and b is the intercept of the line on the y axis. The intercept is the value of y when $x = 0$:

$$y = m(0) + b = b$$

The slope of the line is the change in y for a given change in x :

$$\text{Slope } (m) = \frac{y_2 - y_1}{x_2 - x_1} = \frac{\Delta y}{\Delta x}$$

The *sign* of the slope tells the *direction* in which the line slants. If y increases as x increases, m is positive, and the line slopes upward with higher values of x ; if y decreases as x increases, m is negative, and the line slopes downward with higher values of x . The *magnitude* of the slope indicates the *steepness* of the line. A line with $m = 3$ is three times as steep (y changes three times as much for a given change in x) as a line with $m = 1$.

Consider the linear equation $y = 2x + 1$. A graph of this equation is shown in Figure A.1. In practice, you can find the slope by drawing a right triangle for which the line is the hypotenuse. Then, one leg gives Δy , and the other gives Δx . In the figure, $\Delta y = 8$ and $\Delta x = 4$.

At several places in the text, an equation is rearranged into the form of a straight line in order to determine information from the slope and/or the intercept. For example, in Chapter 16, we obtained the following expression:

$$\ln \frac{[A]_0}{[A]_t} = kt$$

Based on the properties of logarithms, we have

$$\ln [A]_0 - \ln [A]_t = kt$$

Rearranging into the form of an equation for a straight line gives

$$\begin{aligned} \ln [A]_t &= -kt + \ln [A]_0 \\ y &= mx + b \end{aligned}$$

Thus, a plot of $\ln [A]_t$ vs. t is a straight line, from which you can see that the slope is $-k$ (the negative of the rate constant) and the intercept is $\ln [A]_0$ (the natural logarithm of the initial concentration of A).

At many other places in the text, linear relationships occur that were not shown in graphical terms. For example, the conversion of temperature scales in Chapter 1 can also be expressed in the form of a straight line:

$$T(\text{in } ^\circ\text{F}) = \frac{9}{5}T(\text{in } ^\circ\text{C}) + 32$$

$$y = mx + b$$

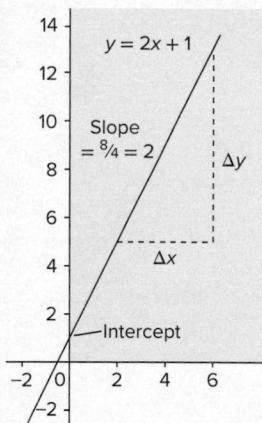

Figure A.1

Standard Thermodynamic Values for Selected Substances*

Substance or Ion	ΔH_f° (kJ/mol)	ΔG_f° (kJ/mol)	S° (J/mol·K)	Substance or Ion	ΔH_f° (kJ/mol)	ΔG_f° (kJ/mol)	S° (J/mol·K)
e ⁻ (g)	0	0	20.87	CaO(s)	-635.1	-603.5	38.2
Aluminum				Ca(OH) ₂ (s)	-986.09	-898.56	83.39
Al(s)	0	0	28.3	Ca ₃ (PO ₄) ₂ (s)	-4138	-3899	263
Al ³⁺ (aq)	-524.7	-481.2	-313	CaSO ₄ (s)	-1432.7	-1320.3	107
AlCl ₃ (s)	-704.2	-628.9	110.7	Carbon			
Al ₂ O ₃ (s)	-1676	-1582	50.94	C(graphite)	0	0	5.686
Barium				C(diamond)	1.896	2.866	2.439
Ba(s)	0	0	62.5	C(g)	715.0	669.6	158.0
Ba(g)	175.6	144.8	170.28	CO(g)	-110.5	-137.2	197.5
Ba ²⁺ (g)	1649.9	—	—	CO ₂ (g)	-393.5	-394.4	213.7
Ba ²⁺ (aq)	-538.36	-560.7	13	CO ₂ (aq)	-412.9	-386.2	121
BaCl ₂ (s)	-806.06	-810.9	126	CO ₃ ²⁻ (aq)	-676.26	-528.10	-53.1
BaCO ₃ (s)	-1219	-1139	112	HCO ₃ ⁻ (aq)	-691.11	587.06	95.0
BaO(s)	-548.1	-520.4	72.07	H ₂ CO ₃ (aq)	-698.7	-623.42	191
BaSO ₄ (s)	-1465	-1353	132	CH ₄ (g)	-74.87	-50.81	186.1
Boron				C ₂ H ₂ (g)	227	209	200.85
B(β-rhombo-hedral)	0	0	5.87	C ₂ H ₄ (g)	52.47	68.36	219.22
BF ₃ (g)	-1137.0	-1120.3	254.0	C ₂ H ₆ (g)	-84.667	-32.89	229.5
BCl ₃ (g)	-403.8	-388.7	290.0	C ₃ H ₈ (g)	-105	-24.5	269.9
B ₂ H ₆ (g)	35	86.6	232.0	C ₄ H ₁₀ (g)	-126	-16.7	310
B ₂ O ₃ (s)	-1272	-1193	53.8	C ₆ H ₆ (l)	49.0	124.5	172.8
H ₃ BO ₃ (s)	-1094.3	-969.01	88.83	CH ₃ OH(g)	-201.2	-161.9	238
Bromine				CH ₃ OH(l)	-238.6	-166.2	127
Br ₂ (l)	0	0	152.23	HCHO(g)	-116	-110	219
Br ₂ (g)	30.91	3.13	245.38	HCOO ⁻ (aq)	-410	-335	91.6
Br(g)	111.9	82.4	174.90	HCOOH(l)	-409	-346	129.0
Br ⁻ (g)	-218.9	—	—	HCOOH(aq)	-410	-356	164
Br ⁻ (aq)	-120.9	-102.82	80.71	C ₂ H ₅ OH(g)	-235.1	-168.6	282.6
HBr(g)	-36.3	-53.5	198.59	C ₂ H ₅ OH(l)	-277.63	-174.8	161
Cadmium				CH ₃ CHO(g)	-166	-133.7	266
Cd(s)	0	0	51.5	CH ₃ COOH(l)	-487.0	-392	160
Cd(g)	112.8	78.2	167.64	C ₆ H ₁₂ O ₆ (s)	-1273.3	-910.56	212.1
Cd ²⁺ (aq)	-72.38	-77.74	-61.1	C ₁₂ H ₂₂ O ₁₁ (s)	-2221.7	-1544.3	360.24
CdS(s)	-144	-141	71	CN ⁻ (aq)	151	166	118
Calcium				HCN(g)	135	125	201.7
Ca(s)	0	0	41.6	HCN(l)	105	121	112.8
Ca(g)	192.6	158.9	154.78	HCN(aq)	105	112	129
Ca ²⁺ (g)	1934.1	—	—	CS ₂ (g)	117	66.9	237.79
Ca ²⁺ (aq)	-542.96	-553.04	-55.2	CS ₂ (l)	87.9	63.6	151.0
CaF ₂ (s)	-1215	-1162	68.87	CH ₃ Cl(g)	-83.7	-60.2	234
CaCl ₂ (s)	-795.0	-750.2	114	CH ₂ Cl ₂ (l)	-117	-63.2	179
CaCO ₃ (s)	-1206.9	-1128.8	92.9	CHCl ₃ (l)	-132	-71.5	203
				CCl ₄ (g)	-96.0	-53.7	309.7

*All values at 298 K.

(continued)

A-6 Appendix B • Standard Thermodynamic Values for Selected Substances

Substance or Ion	ΔH_f° (kJ/mol)	ΔG_f° (kJ/mol)	S° (J/mol·K)	Substance or Ion	ΔH_f° (kJ/mol)	ΔG_f° (kJ/mol)	S° (J/mol·K)
CCl ₄ (<i>l</i>)	-139	-68.6	214.4	FeCl ₃ (<i>s</i>)	-399.5	-334.1	142
COCl ₂ (<i>g</i>)	-220	-206	283.74	FeO(<i>s</i>)	-272.0	-251.4	60.75
Cesium				Fe ₂ O ₃ (<i>s</i>)	-825.5	-743.6	87.400
Cs(<i>s</i>)	0	0	85.15	Fe ₃ O ₄ (<i>s</i>)	-1121	-1018	145.3
Cs(<i>g</i>)	76.7	49.7	175.5	Lead	Pb(<i>s</i>)	0	64.785
Cs ⁺ (<i>g</i>)	458.5	427.1	169.72		Pb ²⁺ (<i>aq</i>)	1.6	21
Cs ⁺ (<i>aq</i>)	-248	-282.0	133		PbCl ₂ (<i>s</i>)	-359	-314
CsF(<i>s</i>)	-554.7	-525.4	88		PbO(<i>s</i>)	-218	-198
CsCl(<i>s</i>)	-442.8	-414	101.18		PbO ₂ (<i>s</i>)	-276.6	-219.0
CsBr(<i>s</i>)	-395	-383	121		PbS(<i>s</i>)	-98.3	-96.7
CsI(<i>s</i>)	-337	-333	130		PbSO ₄ (<i>s</i>)	-918.39	-811.24
Chlorine					Lithium		147
Cl ₂ (<i>g</i>)	0	0	223.0		Li(<i>s</i>)	0	29.10
Cl(<i>g</i>)	121.0	105.0	165.1		Li(<i>g</i>)	161	128
Cl ⁻ (<i>g</i>)	-234	-240	153.25		Li ⁺ (<i>g</i>)	687.163	649.989
Cl ⁻ (<i>aq</i>)	-167.46	-131.17	55.10		Li ⁺ (<i>aq</i>)	-278.46	-293.8
HCl(<i>g</i>)	-92.31	-95.30	186.79		LiF(<i>s</i>)	-616.9	-588.7
HCl(<i>aq</i>)	-167.46	-131.17	55.06		LiCl(<i>s</i>)	-408	-384
ClO ₂ (<i>g</i>)	102	120	256.7		LiBr(<i>s</i>)	-351	-342
Cl ₂ O(<i>g</i>)	80.3	97.9	266.1		LiI(<i>s</i>)	-270	-270
Chromium				Magnesium			85.8
Cr(<i>s</i>)	0	0	23.8	Mg(<i>s</i>)	0	0	32.69
Cr ³⁺ (<i>aq</i>)	-1971	—	—	Mg(<i>g</i>)	150	115	148.55
CrO ₄ ²⁻ (<i>aq</i>)	-863.2	-706.3	38	Mg ²⁺ (<i>g</i>)	2351	—	—
Cr ₂ O ₇ ²⁻ (<i>aq</i>)	-1461	-1257	214	Mg ²⁺ (<i>aq</i>)	-461.96	-456.01	118
Copper				MgCl ₂ (<i>s</i>)	-641.6	-592.1	89.630
Cu(<i>s</i>)	0	0	33.1	MgCO ₃ (<i>s</i>)	-1112	-1028	65.86
Cu(<i>g</i>)	341.1	301.4	166.29	MgO(<i>s</i>)	-601.2	-569.0	26.9
Cu ⁺ (<i>aq</i>)	51.9	50.2	-26	Mg ₃ N ₂ (<i>s</i>)	-461	-401	88
Cu ²⁺ (<i>aq</i>)	64.39	64.98	-98.7	Manganese			
Cu ₂ O(<i>s</i>)	-168.6	-146.0	93.1	Mn(<i>s, ∞</i>)	0	0	31.8
CuO(<i>s</i>)	-157.3	-130	42.63	Mn ²⁺ (<i>aq</i>)	-219	-223	-84
Cu ₂ S(<i>s</i>)	-79.5	-86.2	120.9	MnO ₂ (<i>s</i>)	-520.9	-466.1	53.1
CuS(<i>s</i>)	-53.1	-53.6	66.5	MnO ₄ ⁻ (<i>aq</i>)	-518.4	-425.1	190
Fluorine				Mercury			
F ₂ (<i>g</i>)	0	0	202.7	Hg(<i>l</i>)	0	0	76.027
F(<i>g</i>)	78.9	61.8	158.64	Hg(<i>g</i>)	61.30	31.8	174.87
F ⁻ (<i>g</i>)	-255.6	-262.5	145.47	Hg ²⁺ (<i>aq</i>)	171	164.4	-32
F ⁻ (<i>aq</i>)	-329.1	-276.5	-9.6	Hg ₂ ²⁺ (<i>aq</i>)	172	153.6	84.5
HF(<i>g</i>)	-273	-275	173.67	HgCl ₂ (<i>s</i>)	-230	-184	144
Hydrogen				Hg ₂ Cl ₂ (<i>s</i>)	-264.9	-210.66	196
H ₂ (<i>g</i>)	0	0	130.6	HgO(<i>s</i>)	-90.79	-58.50	70.27
H(<i>g</i>)	218.0	203.30	114.60	Nitrogen			
H ⁺ (<i>aq</i>)	0	0	0	N ₂ (<i>g</i>)	0	0	191.5
H ⁺ (<i>g</i>)	1536.3	1517.1	108.83	N(<i>g</i>)	473	456	153.2
Iodine				N ₂ O(<i>g</i>)	82.05	104.2	219.7
I ₂ (<i>s</i>)	0	0	116.14	NO(<i>g</i>)	90.29	86.60	210.65
I ₂ (<i>g</i>)	62.442	19.38	260.58	NO ₂ (<i>g</i>)	33.2	51	239.9
I(<i>g</i>)	106.8	70.21	180.67	N ₂ O ₃ (<i>g</i>)	86.6	142.4	314.7
I ⁻ (<i>g</i>)	-194.7	—	—	N ₂ O ₄ (<i>g</i>)	9.16	97.7	304.3
I ⁻ (<i>aq</i>)	-55.94	-51.67	109.4	N ₂ O ₅ (<i>g</i>)	11	118	346
HI(<i>g</i>)	25.9	1.3	206.33	N ₂ O ₅ (<i>s</i>)	-43.1	114	178
Iron				NH ₃ (<i>g</i>)	-45.9	-16	193
Fe(<i>s</i>)	0	0	27.3	NH ₃ (<i>aq</i>)	-80.83	26.7	110
Fe ³⁺ (<i>aq</i>)	-47.7	-10.5	-293	N ₂ H ₄ (<i>l</i>)	50.63	149.2	121.2
Fe ²⁺ (<i>aq</i>)	-87.9	-84.94	113	NO ₃ ⁻ (<i>aq</i>)	-206.57	-110.5	146

(continued)

Substance or Ion	ΔH_f° (kJ/mol)	ΔG_f° (kJ/mol)	S° (J/mol·K)	Substance or Ion	ΔH_f° (kJ/mol)	ΔG_f° (kJ/mol)	S° (J/mol·K)
HNO ₃ (<i>l</i>)	-173.23	-79.914	155.6	AgF(<i>s</i>)	-203	-185	84
HNO ₃ (<i>aq</i>)	-206.57	-110.5	146	AgCl(<i>s</i>)	-127.03	-109.72	96.11
NF ₃ (<i>g</i>)	-125	-83.3	260.6	AgBr(<i>s</i>)	-99.51	-95.939	107.1
NOCl(<i>g</i>)	51.71	66.07	261.6	AgI(<i>s</i>)	-62.38	-66.32	114
NH ₄ Cl(<i>s</i>)	-314.4	-203.0	94.6	AgNO ₃ (<i>s</i>)	-45.06	19.1	128.2
Oxygen				Ag ₂ S(<i>s</i>)	-31.8	-40.3	146
O ₂ (<i>g</i>)	0	0	205.0	Sodium			
O(<i>g</i>)	249.2	231.7	160.95	Na(<i>s</i>)	0	0	51.446
O ₃ (<i>g</i>)	143	163	238.82	Na(<i>g</i>)	107.76	77.299	153.61
OH ⁻ (<i>aq</i>)	-229.94	-157.30	-10.54	Na ⁺ (<i>g</i>)	609.839	574.877	147.85
H ₂ O(<i>g</i>)	-241.826	-228.60	188.72	Na ⁺ (<i>aq</i>)	-239.66	-261.87	60.2
H ₂ O(<i>l</i>)	-285.840	-237.192	69.940	NaF(<i>s</i>)	-575.4	-545.1	51.21
H ₂ O ₂ (<i>l</i>)	-187.8	-120.4	110	NaCl(<i>s</i>)	-411.1	-384.0	72.12
H ₂ O ₂ (<i>aq</i>)	-191.2	-134.1	144	NaBr(<i>s</i>)	-361	-349	86.82
Phosphorus				NaOH(<i>s</i>)	-425.609	-379.53	64.454
P ₄ (<i>s</i> , white)	0	0	41.1	Na ₂ CO ₃ (<i>s</i>)	-1130.8	-1048.1	139
P(<i>g</i>)	314.6	278.3	163.1	NaHCO ₃ (<i>s</i>)	-947.7	-851.9	102
P(<i>s</i> , red)	-17.6	-12.1	22.8	NaI(<i>s</i>)	-288	-285	98.5
P ₂ (<i>g</i>)	144	104	218	Strontium			
P ₄ (<i>g</i>)	58.9	24.5	280	Sr(<i>s</i>)	0	0	54.4
PCl ₃ (<i>g</i>)	-287	-268	312	Sr(<i>g</i>)	164	110	164.54
PCl ₃ (<i>l</i>)	-320	-272	217	Sr ²⁺ (<i>g</i>)	1784	—	—
PCl ₅ (<i>g</i>)	-402	-323	353	Sr ²⁺ (<i>aq</i>)	-545.51	-557.3	-39
PCl ₅ (<i>s</i>)	-443.5	—	—	SrCl ₂ (<i>s</i>)	-828.4	-781.2	117
P ₄ O ₁₀ (<i>s</i>)	-2984	-2698	229	SrCO ₃ (<i>s</i>)	-1218	-1138	97.1
PO ₄ ³⁻ (<i>aq</i>)	-1266	-1013	-218	SrO(<i>s</i>)	-592.0	-562.4	55.5
HPO ₄ ²⁻ (<i>aq</i>)	-1281	-1082	-36	SrSO ₄ (<i>s</i>)	-1445	-1334	122
H ₂ PO ₄ ⁻ (<i>aq</i>)	-1285	-1135	89.1	Sulfur			
H ₃ PO ₄ (<i>aq</i>)	-1277	-1019	228	S(rhombic)	0	0	31.9
H ₃ PO ₄ (<i>l</i>)	-1271.7	-1123.6	150.8	S(monoclinic)	0.3	0.096	32.6
Potassium				S(<i>g</i>)	279	239	168
K(<i>s</i>)	0	0	64.672	S ₂ (<i>g</i>)	129	80.1	228.1
K(<i>g</i>)	89.2	60.7	160.23	S ₈ (<i>g</i>)	101	49.1	430.211
K ⁺ (<i>g</i>)	514.197	481.202	154.47	S ²⁻ (<i>aq</i>)	41.8	83.7	22
K ⁺ (<i>aq</i>)	-251.2	-282.28	103	HS ⁻ (<i>aq</i>)	-17.7	12.6	61.1
KF(<i>s</i>)	-568.6	-538.9	66.55	H ₂ S(<i>g</i>)	-20.2	-33	205.6
KCl(<i>s</i>)	-436.7	-409.2	82.59	H ₂ S(<i>aq</i>)	-39	-27.4	122
KBr(<i>s</i>)	-394	-380	95.94	SO ₂ (<i>g</i>)	-296.8	-300.2	248.1
KI(<i>s</i>)	-328	-323	106.39	SO ₃ (<i>g</i>)	-396	-371	256.66
KOH(<i>s</i>)	-424.8	-379.1	78.87	SO ₄ ²⁻ (<i>aq</i>)	-907.51	-741.99	17
KClO ₃ (<i>s</i>)	-397.7	-296.3	143.1	HSO ₄ ⁻ (<i>aq</i>)	-885.75	-752.87	126.9
KClO ₄ (<i>s</i>)	-432.75	-303.2	151.0	H ₂ SO ₄ (<i>l</i>)	-813.989	-690.059	156.90
Rubidium				H ₂ SO ₄ (<i>aq</i>)	-907.51	-741.99	17
Rb(<i>s</i>)	0	0	69.5	Tin			
Rb(<i>g</i>)	85.81	55.86	169.99	Sn(white)	0	0	51.5
Rb ⁺ (<i>g</i>)	495.04	—	—	Sn(gray)	3	4.6	44.8
Rb ⁺ (<i>aq</i>)	-246	-282.2	124	SnCl ₄ (<i>l</i>)	-545.2	-474.0	259
RbF(<i>s</i>)	-549.28	—	—	SnO ₂ (<i>s</i>)	-580.7	-519.7	52.3
RbCl(<i>s</i>)	-435.35	-407.8	95.90	Titanium			
RbBr(<i>s</i>)	-389.2	-378.1	108.3	Ti(<i>s</i>)	0	0	30.7
RbI(<i>s</i>)	-328	-326	118.0	TiCl ₄ (<i>l</i>)	-804.2	-737.2	252.3
Silicon				TiO ₂ (<i>s</i>)	-944.0	-888.8	50.6
Si(<i>s</i>)	0	0	18.0	Zinc			
SiF ₄ (<i>g</i>)	-1614.9	-1572.7	282.4	Zn(<i>s</i>)	0	0	41.6
SiO ₂ (<i>s</i>)	-910.9	-856.5	41.5	Zn(<i>g</i>)	130.5	94.93	160.9
Silver				Zn ²⁺ (<i>aq</i>)	-152.4	-147.21	-106.5
Ag(<i>s</i>)	0	0	42.702	ZnO(<i>s</i>)	-348.0	-318.2	43.9
Ag(<i>g</i>)	289.2	250.4	172.892	ZnS(<i>s</i> , zinc blende)	-203	-198	57.7
Ag ⁺ (<i>aq</i>)	105.9	77.111	73.93				

APPENDIX C

Equilibrium Constants for Selected Substances*

Dissociation (Ionization) Constants (K_a) of Selected Acids

Name and Formula	Lewis Structure [†]	K_{a1}	K_{a2}	K_{a3}
Acetic acid CH_3COOH		1.8×10^{-5}		
Acetylsalicylic acid $\text{CH}_3\text{COOC}_6\text{H}_4\text{COOH}$			3.6×10^{-4}	
Adipic acid $\text{HOOC}(\text{CH}_2)_4\text{COOH}$		3.8×10^{-5}	3.8×10^{-6}	
Arsenic acid H_3AsO_4		6×10^{-3}	1.1×10^{-7}	3×10^{-12}
Ascorbic acid $\text{H}_2\text{C}_6\text{H}_6\text{O}_6$		1.0×10^{-5}	5×10^{-12}	
Benzoic acid $\text{C}_6\text{H}_5\text{COOH}$		6.3×10^{-5}		
Carbonic acid H_2CO_3		4.5×10^{-7}	4.7×10^{-11}	
Chloroacetic acid ClCH_2COOH			1.4×10^{-3}	
Chlorous acid HClO_2			1.1×10^{-2}	

*All values at 298 K, except for acetylsalicylic acid, which is at 37°C (310 K) in 0.15 M NaCl.

[†]Acidic (ionizable) proton(s) shown in red. Structures have lowest formal charges. Benzene rings show one resonance form.

(continued)

Dissociation (Ionization) Constants (K_a) of Selected Acids

Name and Formula	Lewis Structure [†]	K_{a1}	K_{a2}	K_{a3}
Citric acid <chem>HOOCCH2C(OH)(COOH)CH2COOH</chem>		7.4×10^{-4}	1.7×10^{-5}	4.0×10^{-7}
Formic acid <chem>HCOOH</chem>		1.8×10^{-4}		
Glyceric acid <chem>HOCH2CH(OH)COOH</chem>		2.9×10^{-4}		
Glycolic acid <chem>HOCH2COOH</chem>		1.5×10^{-4}		
Glyoxylic acid <chem>HC(O)COOH</chem>			3.5×10^{-4}	
Hydrocyanic acid <chem>HCN</chem>	<chem>H-C#N</chem>		6.2×10^{-10}	
Hydrofluoric acid <chem>HF</chem>	<chem>H-F</chem>		6.8×10^{-4}	
Hydrosulfuric acid <chem>H2S</chem>	<chem>H-S-H</chem>		9×10^{-8}	1×10^{-17}
Hypobromous acid <chem>HBrO</chem>	<chem>H-O-Br</chem>		2.3×10^{-9}	
Hypochlorous acid <chem>HClO</chem>	<chem>H-O-Cl</chem>		2.9×10^{-8}	
Hypoiodous acid <chem>HIO</chem>	<chem>H-O-I</chem>		2.3×10^{-11}	
Iodic acid <chem>HOI</chem>	<chem>H-O-I=O</chem>		1.6×10^{-1}	
Lactic acid <chem>CH3CH(OH)COOH</chem>		1.4×10^{-4}		
Maleic acid <chem>HOOCCH=CHCOOH</chem>		1.2×10^{-2}	4.7×10^{-7}	

(continued)

Dissociation (Ionization) Constants (K_a) of Selected Acids (continued)

Name and Formula	Lewis Structure [†]	K_{a1}	K_{a2}	K_{a3}
Malonic acid HOOCCH ₂ COOH		1.4×10^{-3}	2.0×10^{-6}	
Nitrous acid HNO ₂		7.1×10^{-4}		
Oxalic acid HOOCOOH		5.6×10^{-2}	5.4×10^{-5}	
Phenol C ₆ H ₅ OH		1.0×10^{-10}		
Phenylacetic acid C ₆ H ₅ CH ₂ COOH			4.9×10^{-5}	
Phosphoric acid H ₃ PO ₄		7.2×10^{-3}	6.3×10^{-8}	4.2×10^{-13}
Phosphorous acid HPO(OH) ₂		3×10^{-2}	1.7×10^{-7}	
Propanoic acid CH ₃ CH ₂ COOH		1.3×10^{-5}		
Pyruvic acid CH ₃ C(O)COOH		2.8×10^{-3}		
Succinic acid HOOCCH ₂ CH ₂ COOH		6.2×10^{-5}	2.3×10^{-6}	
Sulfuric acid H ₂ SO ₄		Very large	1.0×10^{-2}	
Sulfurous acid H ₂ SO ₃		1.4×10^{-2}	6.5×10^{-8}	

(continued)

Dissociation (Ionization) Constants (K_b) of Selected Amine Bases

Name and Formula	Lewis Structure [†]	K_{b1}	K_{b2}
Ammonia NH_3	H—	1.76×10^{-5}	
Aniline $\text{C}_6\text{H}_5\text{NH}_2$		4.0×10^{-10}	
Diethylamine $(\text{CH}_3\text{CH}_2)_2\text{NH}$		8.6×10^{-4}	
Dimethylamine $(\text{CH}_3)_2\text{NH}$		5.9×10^{-4}	
Ethanolamine $\text{HOCH}_2\text{CH}_2\text{NH}_2$		3.2×10^{-5}	
Ethylamine $\text{CH}_3\text{CH}_2\text{NH}_2$		4.3×10^{-4}	
Ethylenediamine $\text{H}_2\text{NCH}_2\text{CH}_2\text{NH}_2$		8.5×10^{-5}	7.1×10^{-8}
Methylamine CH_3NH_2		4.4×10^{-4}	
<i>tert</i> -Butylamine $(\text{CH}_3)_3\text{CNH}_2$		4.8×10^{-4}	
Piperidine $\text{C}_5\text{H}_{10}\text{NH}$			1.3×10^{-3}
<i>n</i> -Propylamine $\text{CH}_3\text{CH}_2\text{CH}_2\text{NH}_2$		3.5×10^{-4}	

[†]Blue type indicates the basic nitrogen and its lone pair.

(continued)

Dissociation (Ionization) Constants (K_b) of Selected Amine Bases (continued)

Name and Formula	Lewis Structure [†]	K_{b1}	K_{b2}
Isopropylamine $(\text{CH}_3)_2\text{CHNH}_2$		4.7×10^{-4}	
1,3-Propylenediamine $\text{H}_2\text{NCH}_2\text{CH}_2\text{CH}_2\text{NH}_2$		3.1×10^{-4}	3.0×10^{-6}
Pyridine $\text{C}_5\text{H}_5\text{N}$			1.7×10^{-9}
Triethylamine $(\text{CH}_3\text{CH}_2)_3\text{N}$		5.2×10^{-4}	
Trimethylamine $(\text{CH}_3)_3\text{N}$			6.3×10^{-5}

Dissociation (Ionization) Constants (K_a) of Some Hydrated Metal Ions

Free Ion	Hydrated Ion	K_a
Fe^{3+}	$\text{Fe}(\text{H}_2\text{O})_6^{3+}(\text{aq})$	6×10^{-3}
Sn^{2+}	$\text{Sn}(\text{H}_2\text{O})_6^{2+}(\text{aq})$	4×10^{-4}
Cr^{3+}	$\text{Cr}(\text{H}_2\text{O})_6^{3+}(\text{aq})$	1×10^{-4}
Al^{3+}	$\text{Al}(\text{H}_2\text{O})_6^{3+}(\text{aq})$	1×10^{-5}
Cu^{2+}	$\text{Cu}(\text{H}_2\text{O})_6^{2+}(\text{aq})$	3×10^{-8}
Pb^{2+}	$\text{Pb}(\text{H}_2\text{O})_6^{2+}(\text{aq})$	3×10^{-8}
Zn^{2+}	$\text{Zn}(\text{H}_2\text{O})_6^{2+}(\text{aq})$	1×10^{-9}
Co^{2+}	$\text{Co}(\text{H}_2\text{O})_6^{2+}(\text{aq})$	2×10^{-10}
Ni^{2+}	$\text{Ni}(\text{H}_2\text{O})_6^{2+}(\text{aq})$	1×10^{-10}

Formation Constants (K_f) of Some Complex Ions

Complex Ion	K_f
$\text{Ag}(\text{CN})_2^-$	3.0×10^{20}
$\text{Ag}(\text{NH}_3)_2^+$	1.7×10^7
$\text{Ag}(\text{S}_2\text{O}_3)_2^-$	4.7×10^{13}
AlF_6^{3-}	4×10^{19}
$\text{Al}(\text{OH})_4^-$	3×10^{33}
$\text{Be}(\text{OH})_4^-$	4×10^{18}
CdI_4^{2-}	1×10^6
$\text{Co}(\text{OH})_4^{2-}$	5×10^9
$\text{Cr}(\text{OH})_4^{2+}$	8.0×10^{29}
$\text{Cu}(\text{NH}_3)_4^{+}$	5.6×10^{11}
$\text{Fe}(\text{CN})_6^{4-}$	3×10^{35}
$\text{Fe}(\text{CN})_6^{3-}$	4.0×10^{43}
$\text{Hg}(\text{CN})_4^{2-}$	9.3×10^{38}
$\text{Ni}(\text{NH}_3)_6^{2+}$	2.0×10^8
$\text{Pb}(\text{OH})_3^-$	8×10^{13}
$\text{Sn}(\text{OH})_3^-$	3×10^{25}
$\text{Zn}(\text{CN})_4^{2-}$	4.2×10^{19}
$\text{Zn}(\text{NH}_3)_4^{2+}$	7.8×10^8
$\text{Zn}(\text{OH})_4^{2-}$	3×10^{15}

Solubility-Product Constants (K_{sp}) of Slightly Soluble Ionic Compounds

Name, Formula	K_{sp}	Name, Formula	K_{sp}
Carbonates		Cobalt(II) hydroxide, $\text{Co}(\text{OH})_2$	1.3×10^{-15}
Barium carbonate, BaCO_3	2.0×10^{-9}	Copper(II) hydroxide, $\text{Cu}(\text{OH})_2$	2.2×10^{-20}
Cadmium carbonate, CdCO_3	1.8×10^{-14}	Iron(II) hydroxide, $\text{Fe}(\text{OH})_2$	4.1×10^{-15}
Calcium carbonate, CaCO_3	3.3×10^{-9}	Iron(III) hydroxide, $\text{Fe}(\text{OH})_3$	1.6×10^{-39}
Cobalt(II) carbonate, CoCO_3	1.0×10^{-10}	Magnesium hydroxide, $\text{Mg}(\text{OH})_2$	6.3×10^{-10}
Copper(II) carbonate, CuCO_3	3×10^{-12}	Manganese(II) hydroxide, $\text{Mn}(\text{OH})_2$	1.6×10^{-13}
Lead(II) carbonate, PbCO_3	7.4×10^{-14}	Nickel(II) hydroxide, $\text{Ni}(\text{OH})_2$	6×10^{-16}
Magnesium carbonate, MgCO_3	3.5×10^{-8}	Zinc hydroxide, $\text{Zn}(\text{OH})_2$	3×10^{-16}
Mercury(I) carbonate, Hg_2CO_3	8.9×10^{-17}	Iodates	
Nickel(II) carbonate, NiCO_3	1.3×10^{-7}	Barium iodate, $\text{Ba}(\text{IO}_3)_2$	1.5×10^{-9}
Strontium carbonate, SrCO_3	5.4×10^{-10}	Calcium iodate, $\text{Ca}(\text{IO}_3)_2$	7.1×10^{-7}
Zinc carbonate, ZnCO_3	1.0×10^{-10}	Lead(II) iodate, $\text{Pb}(\text{IO}_3)_2$	2.5×10^{-13}
Chromates		Silver iodate, AgIO_3	3.1×10^{-8}
Barium chromate, BaCrO_4	2.1×10^{-10}	Strontium iodate, $\text{Sr}(\text{IO}_3)_2$	3.3×10^{-7}
Calcium chromate, CaCrO_4	1×10^{-8}	Zinc iodate, $\text{Zn}(\text{IO}_3)_2$	3.9×10^{-6}
Lead(II) chromate, PbCrO_4	2.3×10^{-13}	Oxalates	
Silver chromate, Ag_2CrO_4	2.6×10^{-12}	Barium oxalate dihydrate, $\text{BaC}_2\text{O}_4 \cdot 2\text{H}_2\text{O}$	1.1×10^{-7}
Cyanides		Calcium oxalate monohydrate, $\text{CaC}_2\text{O}_4 \cdot \text{H}_2\text{O}$	2.3×10^{-9}
Mercury(I) cyanide, $\text{Hg}_2(\text{CN})_2$	5×10^{-40}	Strontium oxalate monohydrate, $\text{SrC}_2\text{O}_4 \cdot \text{H}_2\text{O}$	5.6×10^{-8}
Silver cyanide, AgCN	2.2×10^{-16}	Phosphates	
Halides		Calcium phosphate, $\text{Ca}_3(\text{PO}_4)_2$	1.2×10^{-29}
Fluorides		Magnesium phosphate, $\text{Mg}_3(\text{PO}_4)_2$	5.2×10^{-24}
Barium fluoride, BaF_2	1.5×10^{-6}	Silver phosphate, Ag_3PO_4	2.6×10^{-18}
Calcium fluoride, CaF_2	3.2×10^{-11}	Sulfates	
Lead(II) fluoride, PbF_2	3.6×10^{-8}	Barium sulfate, BaSO_4	1.1×10^{-10}
Magnesium fluoride, MgF_2	7.4×10^{-9}	Calcium sulfate, CaSO_4	2.4×10^{-5}
Strontium fluoride, SrF_2	2.6×10^{-9}	Lead(II) sulfate, PbSO_4	1.6×10^{-8}
Chlorides		Radium sulfate, RaSO_4	2×10^{-11}
Copper(I) chloride, CuCl	1.9×10^{-7}	Silver sulfate, Ag_2SO_4	1.5×10^{-5}
Lead(II) chloride, PbCl_2	1.7×10^{-5}	Strontium sulfate, SrSO_4	3.2×10^{-7}
Silver chloride, AgCl	1.8×10^{-10}	Sulfides	
Bromides		Cadmium sulfide, CdS	1.0×10^{-24}
Copper(I) bromide, CuBr	5×10^{-9}	Copper(II) sulfide, CuS	8×10^{-34}
Silver bromide, AgBr	5.0×10^{-13}	Iron(II) sulfide, FeS	8×10^{-16}
Iodides		Lead(II) sulfide, PbS	3×10^{-25}
Copper(I) iodide, CuI	1×10^{-12}	Manganese(II) sulfide, MnS	3×10^{-11}
Lead(II) iodide, PbI_2	7.9×10^{-9}	Mercury(II) sulfide, HgS	2×10^{-50}
Mercury(I) iodide, Hg_2I_2	4.7×10^{-29}	Nickel(II) sulfide, NiS	3×10^{-16}
Silver iodide, AgI	8.3×10^{-17}	Silver sulfide, Ag_2S	8×10^{-48}
Hydroxides		Tin(II) sulfide, SnS	1.3×10^{-23}
Aluminum hydroxide, $\text{Al}(\text{OH})_3$	3×10^{-34}	Zinc sulfide, ZnS	2.0×10^{-22}
Cadmium hydroxide, $\text{Cd}(\text{OH})_2$	7.2×10^{-15}		
Calcium hydroxide, $\text{Ca}(\text{OH})_2$	6.5×10^{-6}		

APPENDIX D

Standard Electrode (Half-Cell) Potentials*

Half-Reaction	$E^\circ(V)$
$F_2(g) + 2e^- \rightleftharpoons 2F^-(aq)$	+2.87
$O_3(g) + 2H^+(aq) + 2e^- \rightleftharpoons O_2(g) + H_2O(l)$	+2.07
$Co^{3+}(aq) + e^- \rightleftharpoons Co^{2+}(aq)$	+1.82
$H_2O_2(aq) + 2H^+(aq) + 2e^- \rightleftharpoons 2H_2O(l)$	+1.77
$PbO_2(s) + 3H^+(aq) + HSO_4^-(aq) + 2e^- \rightleftharpoons PbSO_4(s) + 2H_2O(l)$	+1.70
$Ce^{4+}(aq) + e^- \rightleftharpoons Ce^{3+}(aq)$	+1.61
$MnO_4^-(aq) + 8H^+(aq) + 5e^- \rightleftharpoons Mn^{2+}(aq) + 4H_2O(l)$	+1.51
$Au^{3+}(aq) + 3e^- \rightleftharpoons Au(s)$	+1.50
$Cl_2(g) + 2e^- \rightleftharpoons 2Cl^-(aq)$	+1.36
$Cr_2O_7^{2-}(aq) + 14H^+(aq) + 6e^- \rightleftharpoons 2Cr^{3+}(aq) + 7H_2O(l)$	+1.33
$MnO_2(s) + 4H^+(aq) + 2e^- \rightleftharpoons Mn^{2+}(aq) + 2H_2O(l)$	+1.23
$O_2(g) + 4H^+(aq) + 4e^- \rightleftharpoons 2H_2O(l)$	+1.23
$Br_2(l) + 2e^- \rightleftharpoons 2Br^-(aq)$	+1.07
$NO_3^-(aq) + 4H^+(aq) + 3e^- \rightleftharpoons NO(g) + 2H_2O(l)$	+0.96
$2Hg^{2+}(aq) + 2e^- \rightleftharpoons Hg_2^{2+}(aq)$	+0.92
$Hg^{2+}(aq) + 2e^- \rightleftharpoons Hg(l)$	+0.85
$Ag^+(aq) + e^- \rightleftharpoons Ag(s)$	+0.80
$Hg_2^{2+}(aq) + 2e^- \rightleftharpoons 2Hg(l)$	+0.79
$Fe^{3+}(aq) + e^- \rightleftharpoons Fe^{2+}(aq)$	+0.77
$O_2(g) + 2H^+(aq) + 2e^- \rightleftharpoons H_2O_2(aq)$	+0.68
$MnO_4^-(aq) + 2H_2O(l) + 3e^- \rightleftharpoons MnO_2(s) + 4OH^-(aq)$	+0.59
$I_2(s) + 2e^- \rightleftharpoons 2I^-(aq)$	+0.53
$O_2(g) + 2H_2O(l) + 4e^- \rightleftharpoons 4OH^-(aq)$	+0.40
$Cu^{2+}(aq) + 2e^- \rightleftharpoons Cu(s)$	+0.34
$AgCl(s) + e^- \rightleftharpoons Ag(s) + Cl^-(aq)$	+0.22
$SO_4^{2-}(aq) + 4H^+(aq) + 2e^- \rightleftharpoons SO_2(g) + 2H_2O(l)$	+0.20
$Cu^{2+}(aq) + e^- \rightleftharpoons Cu^+(aq)$	+0.15
$Sn^{4+}(aq) + 2e^- \rightleftharpoons Sn^{2+}(aq)$	+0.13
$2H^+(aq) + 2e^- \rightleftharpoons H_2(g)$	0.00
$Pb^{2+}(aq) + 2e^- \rightleftharpoons Pb(s)$	-0.13
$Sn^{2+}(aq) + 2e^- \rightleftharpoons Sn(s)$	-0.14
$N_2(g) + 5H^+(aq) + 4e^- \rightleftharpoons N_2H_5^+(aq)$	-0.23
$Ni^{2+}(aq) + 2e^- \rightleftharpoons Ni(s)$	-0.25
$Co^{2+}(aq) + 2e^- \rightleftharpoons Co(s)$	-0.28
$PbSO_4(s) + H^+(aq) + 2e^- \rightleftharpoons Pb(s) + HSO_4^-(aq)$	-0.31
$Cd^{2+}(aq) + 2e^- \rightleftharpoons Cd(s)$	-0.40
$Fe^{2+}(aq) + 2e^- \rightleftharpoons Fe(s)$	-0.44
$Cr^{3+}(aq) + 3e^- \rightleftharpoons Cr(s)$	-0.74
$Zn^{2+}(aq) + 2e^- \rightleftharpoons Zn(s)$	-0.76
$2H_2O(l) + 2e^- \rightleftharpoons H_2(g) + 2OH^-(aq)$	-0.83
$Cr^{2+}(aq) + 2e^- \rightleftharpoons Cr(s)$	-0.91
$Mn^{2+}(aq) + 2e^- \rightleftharpoons Mn(s)$	-1.18
$Al^{3+}(aq) + 3e^- \rightleftharpoons Al(s)$	-1.66
$Mg^{2+}(aq) + 2e^- \rightleftharpoons Mg(s)$	-2.37
$Na^+(aq) + e^- \rightleftharpoons Na(s)$	-2.71
$Ca^{2+}(aq) + 2e^- \rightleftharpoons Ca(s)$	-2.87
$Sr^{2+}(aq) + 2e^- \rightleftharpoons Sr(s)$	-2.89
$Ba^{2+}(aq) + 2e^- \rightleftharpoons Ba(s)$	-2.90
$K^+(aq) + e^- \rightleftharpoons K(s)$	-2.93
$Li^+(aq) + e^- \rightleftharpoons Li(s)$	-3.05

*All values at 298 K. Written as reductions; E° value refers to all components in their standard states: 1 M for dissolved species; 1 atm pressure for the gas behaving ideally; the pure substance for solids and liquids.

Answers to Selected Problems

Chapter 1

1.2 Gas molecules fill the entire container; the volume of a gas is the volume of the container. Solids and liquids have a definite volume. The volume of the container does not affect the volume of a solid or liquid. (a) gas (b) liquid (c) liquid **1.4** Physical property: a characteristic shown by a substance itself, without any interaction with or change into other substances. Chemical property: a characteristic of a substance that appears as it interacts with, or transforms into, other substances. (a) Color (yellow-green and silver to white) and physical state (gas and metal to crystals) are physical properties. The interaction between chlorine gas and sodium metal is a chemical change. (b) Color and magnetism are physical properties. No chemical changes. **1.6(a)** Physical change; there is only a temperature change. (b) Chemical change; the change in appearance indicates an irreversible chemical change. (c) Physical change; there is only a change in size, not composition. (d) Chemical change; the wood (and air) become different substances with different compositions. **1.8(a)** fuel (b) wood **1.13** Lavoisier measured the total mass of the reactants and products, not just the mass of the solids, and this total mass remained constant. His measurements showed that a gas was involved in the reaction. He called this gas *oxygen* (one of his key discoveries). **1.16** A well-designed experiment must have the following: (1) at least two variables that are related; (2) a way to control all the variables, so that only one at a time may be changed; (3) reproducible results.

1.20(a) increases (b) remains the same (c) decreases (d) increases (e) remains the same **1.23** An extensive property depends on the amount of material present. An intensive property is the same regardless of how much material is present. (a) extensive property (b) intensive property (c) extensive property (d) intensive property **1.24(a)** $(2.54 \text{ cm})^2/(1 \text{ in})^2$ and $(1 \text{ m})^2/(100 \text{ cm})^2$

(b) $(1000 \text{ m})^2/(1 \text{ km})^2$ and $(100 \text{ cm})^2/(1 \text{ m})^2$ (c) $(1.609 \times 10^3 \text{ m}/\text{mi})$ and $(1 \text{ h}/3600 \text{ s})$ (d) $(1000 \text{ g}/2.205 \text{ lb})$ and $(3.531 \times 10^{-5} \text{ ft}^3/\text{cm}^3)$

1.26 1.43 nm **1.28** 3.94×10^3 in **1.30** (a) $2.07 \times 10^{-9} \text{ km}^2$

(b) \$10.43 **1.32** Answers will vary, depending on the person's mass.

1.34(a) $5.52 \times 10^3 \text{ kg/m}^3$ (b) 345 lb/ft^3 **1.36(a)** $2.56 \times 10^{-9} \text{ mm}^3$

(b) 10^{-10} L **1.38(a)** 9.626 cm³ (b) 64.92 g **1.40** 2.70 g/cm³

1.42(a) 20.°C; 293 K (b) 109 K; -263°F (c) -273°C; -460.°F

1.45(a) $2.47 \times 10^{-7} \text{ m}$ (b) 67.6 Å **1.52(a)** none (b) none

(c) 0.0410 (d) 4.0100×10^4 **1.54(a)** 0.00036 (b) 35.83 (c) 22.5

1.56 6×10^2 **1.58(a)** 1.34 m (b) 21,621 mm³ (c) 443 cm

1.60(a) 1.310000×10^5 (b) 4.7×10^{-4} (c) 2.10006×10^5

(d) 2.1605×10^3 **1.62(a)** 5550 (b) 10,070. (c) 0.000000885

(d) 0.003004 **1.64(a)** 8.025×10^4 (b) 1.0098×10^{-3} (c) 7.7×10^{-11}

1.66(a) $4.06 \times 10^{-19} \text{ J}$ (b) 1.61×10^{24} molecules (c) $1.82 \times 10^5 \text{ J/mol}$

1.68(a) Height measured, not exact. (b) Planets counted, exact.

(c) Number of grams in a pound is not a unit definition, not exact. (d) Definition of a millimeter, exact. **1.70** $7.50 \pm 0.05 \text{ cm}$

1.72(a) $I_{\text{avg}} = 8.72 \text{ g}$; $II_{\text{avg}} = 8.72 \text{ g}$; $III_{\text{avg}} = 8.50 \text{ g}$; $IV_{\text{avg}} = 8.56 \text{ g}$; sets I and II are most accurate. (b) Set III is the most precise but is the least accurate. (c) Set I has the best combination of high accuracy and high precision. (d) Set IV has both low accuracy and low precision.

1.74(a)

(b)

1.76 7.7/1 **1.78(a)** density = 0.21 g/L, will float (b) CO₂ is

denser than air, will sink (c) density = 0.30 g/L, will float

(d) O₂ is denser than air, will sink (e) density = 1.38 g/L, will

sink (f) 0.55 g for empty ball; 0.50 g for ball filled with

hydrogen **1.80(a)** $8.0 \times 10^{12} \text{ g}$ (b) $4.1 \times 10^5 \text{ m}^3$ (c) $\$4.1 \times 10^{14}$

1.82(a) -195.79°C (b) -320.42°F (c) 5.05 L **1.83(a)** 2.6 m/s

(b) 16 km (c) 12:45 pm **1.85** freezing point = -3.7°X; boiling

point = 63.3°X **1.86** $2.3 \times 10^{25} \text{ g}$ oxygen; $1.4 \times 10^{25} \text{ g}$ silicon;

$5 \times 10^{15} \text{ g}$ ruthenium and rhodium

Chapter 2

Answers to Boxed Reading Problems: **B2.1(a)** 5 peaks (b) *m/e* value for heaviest particle = 74; *m/e* value for lightest particle = 35

B2.3(a) Since salt dissolves in water and pepper does not, add water to mixture and filter to remove solid pepper. Evaporate water to recover solid salt. (b) Distillation purifies the water and leaves

the soot behind. (c) Warm the mixture; filter to remove glass; freeze the filtrate to obtain ice. (d) Heat the mixture; the ethanol will boil off (distill), while the sugar will remain behind. (e) Use column chromatography to separate the pigments.

• 2.1 Compounds contain different types of atoms; there is only one type of atom in an element. **2.4(a)** The presence of more than one element makes pure calcium chloride a compound. (b) There is only one kind of atom, so sulfur is an element. (c) The presence of more than one compound makes baking powder a mixture. (d) The presence of more than one type of atom means cytosine cannot be an element. The specific, not variable, arrangement means it is a compound. **2.12(a)** elements, compounds, and mixtures (b) compounds (c) compounds

2.14(a) Law of definite composition: the composition is the same regardless of its source. (b) Law of mass conservation: the total quantity of matter does not change. (c) Law of multiple proportions: two elements can combine to form two different compounds that have different proportions of those elements. **2.16(a)** No, the percent by mass of each element in a compound is fixed.

(b) Yes, the *mass* of each element in a compound depends on the amount of compound. **2.18** The two experiments demonstrate the law of definite composition. The unknown compound decomposes the same way both times. The experiments also demonstrate the law of conservation of mass since the total mass before reaction equals the total mass after reaction. **2.20(a)** 1.34 g F

(b) 0.514 Ca; 0.486 F (c) 51.4 mass % Ca; 48.6 mass % F

2.22(a) 0.603 (b) 322 g Mg **2.24** 3.498×10^6 g Cu; 1.766×10^6 g S

2.26 compound 1: 0.905 S/Cl; compound 2: 0.451 S/Cl; ratio: 2.00/1.00 **2.29** Coal A **2.31** Dalton postulated that atoms of an element are identical and that compounds result from the chemical combination of specific ratios of different elements.

2.32 If you know the ratio of any two quantities and the value of one of them, the other can always be calculated; in this case, the charge and the mass/charge ratio were known. **2.36** The atomic number is the number of protons in an atom's nucleus. When the atomic number changes, the identity of the element changes. The mass number is the total number of protons and neutrons in the nucleus. The identity of an element is based on the number of protons, not the number of neutrons. The mass number can vary (by a change in number of neutrons) without changing the identity of the element. **2.39** All three isotopes have 18 protons and 18 electrons. Their respective mass numbers are 36, 38, and 40, with the respective numbers of neutrons being 18, 20, and 22.

2.41(a) These have the same number of protons and electrons, but different numbers of neutrons; same Z. (b) These have the same number of neutrons, but different numbers of protons and electrons; same N. (c) These have different numbers of protons, neutrons, and electrons; same A. **2.43(a)** $^{38}_{18}\text{Ar}$ (b) $^{55}_{25}\text{Mn}$ (c) $^{109}_{47}\text{Ag}$

2.45(a) $^{48}_{22}\text{Ti}$ (b) $^{79}_{34}\text{Se}$ (c) $^{11}_{5}\text{B}$

2.47 69.72 amu **2.49** $^{35}\text{Cl} = 75.774\%$, $^{37}\text{Cl} = 24.226\%$

2.52(a) In the modern periodic table, the elements are arranged in order of increasing atomic number. (b) Elements in a group (or family) have similar chemical properties. (c) Elements can be classified as metals, metalloids, or nonmetals. **2.55** The alkali metals [Group 1A(1)] are metals and readily lose one electron to form cations; the halogens [Group 7A(17)] are nonmetals and readily gain one electron to form anions.

2.56(a) germanium; Ge; 4A(14); metalloid (b) phosphorus; P; 5A(15); nonmetal (c) helium; He; 8A(18); nonmetal

(d) lithium; Li; 1A(1); metal (e) molybdenum; Mo; 6B(6); metal **2.58(a)** Ra; 88 (b) Si; 14 (c) Cu; 63.55 amu (d) Br; 79.90 amu **2.60** Atoms of these two kinds of substances will form ionic bonds in which one or more electrons are transferred from the metal atom to the nonmetal atom to form a cation and an anion, respectively. **2.63** Coulomb's law states the energy of attraction in an ionic bond is directly proportional to the product of charges and inversely proportional to the distance between charges. The product of charges in MgO [(+2)(-2)] is greater than that in LiF [(+1)(-1)]. Thus, MgO has stronger ionic bonding. **2.66** The Group 1A(1) elements form cations, and the Group 7A(17) elements form anions.

2.68 Each potassium atom loses one electron to form an ion with a 1+ charge. Each sulfur atom gains two electrons to form an ion with a 2- charge. Two potassium atoms, losing one electron each, are required for each sulfur atom, which gains two electrons. The oppositely charged ions attract each other to form an ionic solid, K₂S. **2.70** K⁺; Br⁻ **2.72(a)** oxygen; 17; 6A(16); 2 (b) fluorine; 19; 7A(17); 2 (c) calcium; 40; 2A(2); 4 **2.74** Lithium forms the Li⁺ ion; oxygen forms the O²⁻ ion. Number of O²⁻ ions = 4.2×10^{21} O²⁻ ions. **2.76** NaCl

2.78 The subscripts in a formula give the numbers of ions in a formula unit of the compound. The subscripts indicate that there are two F⁻ ions for each Mg²⁺ ion. Using this information and the mass of each element, we can calculate percent mass of each element in the compound. **2.80** The two samples are similar in that both contain 20 billion oxygen atoms and 20 billion hydrogen atoms. They differ in that they contain different types of molecules: H₂O₂ molecules in the hydrogen peroxide sample, and H₂ and O₂ molecules in the mixture. In addition, the mixture contains 20 billion molecules (10 billion H₂ and 10 billion O₂), while the hydrogen peroxide sample contains 10 billion molecules. **2.84(a)** Na₃N, sodium nitride (b) SrO, strontium oxide (c) AlCl₃, aluminum chloride

2.86(a) MgF₂, magnesium fluoride (b) ZnS, zinc sulfide (c) SrCl₂, strontium chloride **2.88(a)** SnCl₄ (b) iron(III) bromide (c) CuBr (d) manganese(III) oxide **2.90(a)** sodium hydrogen phosphate (b) NH₄ClO₄ (c) lead(II) acetate trihydrate (d) NaNO₂ **2.92(a)** BaO (b) Fe(NO₃)₂ (c) MgS

2.94(a) H₂CO₃; carbonic acid (b) HIO₄; periodic acid (c) HCN; hydrocyanic acid (d) H₂S; hydrosulfuric acid **2.96(a)** ammonium ion, NH₄⁺; ammonia, NH₃ (b) magnesium sulfide, MgS; magnesium sulfite, MgSO₃; magnesium sulfate, MgSO₄ (c) hydrochloric acid, HCl; chloric acid, HClO₃; chlorous acid, HClO₂ (d) cuprous bromide, CuBr; cupric bromide, CuBr₂ **2.98** Disulfur tetrafluoride, S₂F₄

2.100(a) calcium chloride (b) copper(I) oxide (c) stannic

- fluoride (d) hydrochloric acid **2.102**(a) $(\text{NH}_4)_2\text{SO}_4$; 132.14 amu
 (b) NaH_2PO_4 ; 119.98 amu (c) KHCO_3 ; 100.12 amu
2.104(a) 108.02 amu (b) 331.2 amu (c) 72.08 amu
2.106(a) 12 oxygen atoms; 342.14 amu (b) 9 hydrogen atoms; 132.06 amu (c) 8 oxygen atoms; 344.69 amu **2.108**(a) SO_3 ; sulfur trioxide; 80.06 amu (b) C_3H_8 ; propane; 44.09 amu
2.112 Separating the components of a mixture requires physical methods only; that is, no chemical changes (no changes in composition) take place, and the components maintain their chemical identities and properties throughout. Separating the components of a compound requires a chemical change (change in composition). **2.115**(a) compound (b) homogeneous mixture (c) heterogeneous mixture (d) homogeneous mixture (e) homogeneous mixture **2.117**(a) filtration
 (b) chromatography **2.119**(a) fraction of volume = 5.2×10^{-13}
 (b) mass of nucleus = 6.64466×10^{-24} g; fraction of mass = 0.999726 **2.120** strongest ionic bonding: MgO ; weakest ionic bonding: RbI **2.124**(a) I = NO ; II = N_2O_3 ; III = N_2O_5 (b) I has 1.14 g O per 1.00 g N; II, 1.71 g O; III, 2.86 g O **2.128**(a) Cl^- , 1.898 mass %; Na^+ , 1.056 mass %; SO_4^{2-} , 0.265 mass %; Mg^{2+} , 0.127 mass %; Ca^{2+} , 0.04 mass %; K^+ , 0.038 mass %; HCO_3^- , 0.014 mass % (b) 30.72% (c) Alkaline earth metal ions, total mass % = 0.17%; alkali metal ions, total mass % = 1.094%
 (d) Anions (2.177 mass %) make up a larger mass fraction than cations (1.26 mass %). **2.131** Molecular formula, $\text{C}_4\text{H}_6\text{O}_4$; molecular mass, 118.09 amu; 40.68% by mass C; 5.122% by mass H; 54.20% by mass O **2.134**(a) Formulas and masses in amu: $^{15}\text{N}_2^{18}\text{O}$, 48; $^{15}\text{N}_2^{16}\text{O}$, 46; $^{14}\text{N}_2^{18}\text{O}$, 46; $^{14}\text{N}_2^{16}\text{O}$, 44; $^{15}\text{N}^{14}\text{N}^{18}\text{O}$, 47; $^{15}\text{N}^{14}\text{N}^{16}\text{O}$, 45 (b) $^{15}\text{N}_2^{18}\text{O}$, least common; $^{14}\text{N}_2^{16}\text{O}$, most common **2.136** 58.091 amu **2.138** nitroglycerin, 39.64 mass % NO; isoamyl nitrate, 22.54 mass % NO
2.139 0.370 lb C; 0.0222 lb H; 0.423 lb O; 0.185 lb N
2.144 (1) chemical change (2) physical change (3) chemical change (4) chemical change (5) physical change

Chapter 3

- 3.2**(a) 12 mol C atoms (b) 1.445×10^{25} C atoms **3.7**(a) left (b) left (c) left (d) neither **3.8**(a) 121.64 g/mol (b) 76.02 g/mol (c) 106.44 g/mol (d) 152.00 g/mol **3.10**(a) 134.7 g/mol (b) 175.3 g/mol (c) 342.14 g/mol (d) 125.84 g/mol **3.12**(a) 22.6 g Zn (b) 3.16×10^{24} F atoms (c) 4.28×10^{23} Ca atoms
3.14(a) 1.1×10^2 g KMnO_4 (b) 0.188 mol O atoms (c) 1.5×10^{20} O atoms **3.16**(a) 9.72 g MnSO_4 (b) 44.6 mol $\text{Fe}(\text{ClO}_4)_3$ (c) 1.74×10^{21} N atoms **3.18**(a) 1.56×10^3 g Cu_2CO_3 (b) 0.0725 g N_2O_5 (c) 0.644 mol NaClO_4 ; 3.88×10^{23} formula units NaClO_4 (d) 3.88×10^{23} Na^+ ions; 3.88×10^{23} ClO_4^- ions; 3.88×10^{23} Cl atoms; 1.55×10^{24} O atoms **3.20**(a) 6.375 mass % H (b) 71.52 mass % O **3.22**(a) 0.1252 mass fraction C (b) 0.3428 mass fraction O **3.25**(a) 0.9507 mol cisplatin (b) 3.5×10^{24} H atoms **3.27**(a) 195 mol $\text{Fe}_2\text{O}_3 \cdot 4\text{H}_2\text{O}$ (b) 195 mol Fe_2O_3 (c) 2.18×10^4 g Fe **3.29** $\text{CO}(\text{NH}_2)_2 > \text{NH}_4\text{NO}_3 > (\text{NH}_4)_2\text{SO}_4 > \text{KNO}_3$ **3.30**(a) 883 mol PbS (b) 1.88×10^{25} Pb atoms **3.34** (b) From the mass percent, determine the empirical formula. Add up the total number of atoms in the empirical formula, and divide that number into the total number of atoms in the molecule. The result is the multiplier that converts the empirical formula into the molecular formula.

(c) Find the empirical formula from the mass percents. Compare the number of atoms given for the one element to the number in the empirical formula. Multiply the empirical formula by the factor that is needed to obtain the given number of atoms for that element.

First three steps are the same as in road map for part (b).

(e) Count the numbers of the various types of atoms in the structural formula and put these into a molecular formula.

- 3.36**(a) CH_2 ; 14.03 g/mol (b) CH_3O ; 31.03 g/mol (c) N_2O_5 ; 108.02 g/mol (d) $\text{Ba}_3(\text{PO}_4)_2$; 601.8 g/mol (e) TeI_4 ; 635.2 g/mol **3.38** Disulfur dichloride; SCl_2 ; 135.02 g/mol **3.40**(a) C_3H_6 (b) N_2H_4 (c) N_2O_4 (d) $\text{C}_5\text{H}_5\text{N}_5$ **3.42**(a) Cl_2O_7 (b) SiCl_4 (c) CO_2 **3.44**(a) NO_2 (b) N_2O_4 **3.46**(a) 1.20 mol F (b) 24.0 g M (c) calcium **3.48** $\text{C}_{10}\text{H}_{20}\text{O}$ **3.51** $\text{C}_{21}\text{H}_{30}\text{O}_5$ **3.53** A balanced equation provides information on 1) the identities of reactants and products by showing their chemical formulas; 2) the physical states of reactants and products by using the symbols for the various phases of matter; 3) the molar ratios between reactants and products with coefficients. **3.56** b
3.58(a) $16\text{Cu}(s) + \text{S}_8(s) \longrightarrow 8\text{Cu}_2\text{S}(s)$
 (b) $\text{P}_4\text{O}_{10}(s) + 6\text{H}_2\text{O}(l) \longrightarrow 4\text{H}_3\text{PO}_4(l)$
 (c) $\text{B}_2\text{O}_3(s) + 6\text{NaOH}(aq) \longrightarrow 2\text{Na}_3\text{BO}_3(aq) + 3\text{H}_2\text{O}(l)$
 (d) $4\text{CH}_3\text{NH}_2(g) + 9\text{O}_2(g) \longrightarrow 4\text{CO}_2(g) + 10\text{H}_2\text{O}(g) + 2\text{N}_2(g)$
3.60(a) $2\text{SO}_2(g) + \text{O}_2(g) \longrightarrow 2\text{SO}_3(g)$
 (b) $\text{Sc}_2\text{O}_3(s) + 3\text{H}_2\text{O}(l) \longrightarrow 2\text{Sc}(\text{OH})_3(s)$
 (c) $\text{H}_3\text{PO}_4(aq) + 2\text{NaOH}(aq) \longrightarrow \text{Na}_2\text{HPO}_4(aq) + 2\text{H}_2\text{O}(l)$
 (d) $\text{C}_6\text{H}_{10}\text{O}_5(s) + 6\text{O}_2(g) \longrightarrow 6\text{CO}_2(g) + 5\text{H}_2\text{O}(g)$

3.67 Balance the equation for the reaction: $aA + bB \longrightarrow cC$.

Since A is the limiting reactant, A is used to determine the amount of C. Divide the mass of A by its molar mass to obtain the amount (mol) of A. Use the molar ratio from the balanced equation to find the amount (mol) of C. Multiply the amount (mol) of C by its molar mass to obtain the mass of C.

3.69(a) 0.455 mol Cl_2 (b) 32.3 g Cl_2 **3.71(a)** 1.42×10^3 mol KNO_3 (b) 1.43×10^5 g KNO_3 **3.73** 195.8 g H_3BO_3 ; 19.16 g H_2

3.75 2.60×10^3 g Cl_2

3.79(a) B_2 (b) 4 AB_3 molecules **3.81** 3.6 mol **3.83(a)** 0.105 mol CaO (b) 0.175 mol CaO (c) calcium (d) 5.88 g CaO

3.85 1.36 mol HIO_3 , 239 g HIO_3 ; 44.9 g H_2O in excess

3.87 4.40 g CO_2 ; 4.80 g O_2 in excess **3.89** 12.2 g $\text{Al}(\text{NO}_3)_3$, no NH_4Cl , 48.7 g AlCl_3 , 30.7 g N_2 , 39.5 g H_2O **3.91** 50.0%

3.93 90.5% **3.95** 24.0 g CH_3Cl **3.97** 39.7 g CF_4 **3.98(a)** A

(b) $2\text{Cl}_2\text{O}(g) \longrightarrow 2\text{Cl}_2(g) + \text{O}_2(g)$ (c) 1.8×10^{23} Cl_2O molecules

3.105 $x = 3$ **3.106** ethane > propane > cetyl palmitate > ethanol > benzene **3.111(a)** $\text{Fe}_2\text{O}_3(s) + 3\text{CO}(g) \longrightarrow 2\text{Fe}(s) + 3\text{CO}_2(g)$

(b) 3.39×10^7 g CO **3.113** 89.8% **3.115(a)** $2\text{AB}_2 + \text{B}_2 \longrightarrow 2\text{AB}_3$

(b) AB_2 (c) 5.0 mol AB_3 (d) 0.5 mol B_2 **3.116** B, C, and D

have the same empirical formula, $\text{C}_2\text{H}_4\text{O}$; 44.05 g/mol

3.117 44.3% **3.126(a)** 586 g CO_2 (b) 10.5% CH_4 by mass

3.127 10.0/0.66/1.0 **3.132(a)** 192.12 g/mol; $\text{C}_6\text{H}_8\text{O}_7$ (b) 0.549 mol

3.133(a) $\text{N}_2(g) + \text{O}_2(g) \longrightarrow 2\text{NO}(g)$

3.134 A **3.136(a)** 0.039 g heme (b) 6.3×10^{-5} mol heme

(c) 3.5×10^{-3} g Fe (d) 4.1×10^{-2} g hemin **3.138(a)** 46.65 mass % N in urea; 31.98 mass % N in arginine; 21.04 mass % N in ornithine (b) 28.45 g N **3.140** 29.54% **3.142(a)** 89.3% (b) 1.47 g ethylene **3.144(a)** 125 g hydrochloride salt (b) 65.6 L H_2O

Chapter 4

4.2 Ionic or polar covalent compounds **4.3** Ions must be present, and they come from electrolytes such as ionic compounds, acids, and bases. **4.6** B **4.13** No, the instructions should read: “Take

100.0 mL of the 10.0 M solution and, with stirring, add water until the total volume is 1000. mL.” **4.14(a)** Benzene is likely to be insoluble in water because it is nonpolar and water is polar.

(b) Sodium hydroxide, an ionic compound, is likely to be very soluble in water. (c) Ethanol ($\text{CH}_3\text{CH}_2\text{OH}$) is likely to be soluble in water because the alcohol group ($-\text{OH}$) is polar, like the water molecule. (d) Potassium acetate, an ionic compound, is likely to be very soluble in water. **4.16(a)** Yes, CsBr is a soluble salt. (b) Yes, HI is a strong acid. **4.18(a)** 0.64 mol

(b) 0.242 mol (c) 1.18×10^{-4} mol **4.20(a)** 3.0 mol (b) 7.57×10^{-5} mol

(c) 0.148 mol **4.22(a)** 7.85 g $\text{Ca}(\text{C}_2\text{H}_3\text{O}_2)_2$ (b) 0.254 M KI

(c) 124 mol NaCN **4.24(a)** 4.65 g K_2SO_4 (b) 0.0653 M CaCl_2

(c) 1.11×10^{20} Mg^{2+} ions **4.26(a)** 0.058 mol Al^{3+} ; 3.5×10^{22} Al^{3+} ions; 0.18 mol Cl^- ; 1.1×10^{23} Cl^- ions (b) 4.62×10^{-4} mol Li^+ ; 2.78×10^{20} Li^+ ions; 2.31×10^{-4} mol SO_4^{2-} ; 1.39×10^{20} SO_4^{2-} ions

(c) 1.50×10^{-2} mol K^+ ; 9.02×10^{21} K^+ ions; 1.50×10^{-2} mol Br^- ; 9.02×10^{21} Br^- ions **4.28(a)** 0.0617 M KCl (b) 0.00363 M $(\text{NH}_4)_2\text{SO}_4$ (c) 0.138 M Na^+ **4.30(a)** 9.87 g HNO_3/L (b) 15.7 M HNO_3 **4.33(a)** Instructions: Be sure to wear goggles to protect your eyes! Pour approximately 2.0 gal of water into the container. Add to the water, slowly, and with mixing, 0.90 gal of concentrated HCl. Dilute to 3.0 gal with more water. (b) 22.6 mL

4.36 Spectator ions do not appear in a net ionic equation because they are not involved in the reaction and serve only to balance charges. **4.40** Assuming that the left beaker contains AgNO_3 (because it has gray Ag^+ ions), the right beaker must contain NaCl . Then, NO_3^- is blue, Na^+ is brown, and Cl^- is green.

Molecular equation: $\text{AgNO}_3(aq) + \text{NaCl}(aq) \longrightarrow$

Total ionic equation: $\text{Ag}^+(aq) + \text{NO}_3^-(aq) + \text{Na}^+(aq) + \text{Cl}^-(aq) \longrightarrow \text{AgCl}(s) + \text{Na}^+(aq) + \text{NO}_3^-(aq)$

Net ionic equation: $\text{Ag}^+(aq) + \text{Cl}^-(aq) \longrightarrow \text{AgCl}(s)$

4.41(a) Molecular: $\text{Hg}_2(\text{NO}_3)_2(aq) + 2\text{KI}(aq) \longrightarrow$

Total ionic:

Net ionic: $\text{Hg}_2^{2+}(aq) + 2\text{I}^-(aq) \longrightarrow \text{Hg}_2\text{I}_2(s)$

Spectator ions are K^+ and NO_3^- .

(b) Molecular: $\text{FeSO}_4(aq) + \text{Sr}(\text{OH})_2(aq) \longrightarrow$

Total ionic: $\text{Fe}^{2+}(aq) + \text{SO}_4^{2-}(aq) + \text{Sr}^{2+}(aq) + 2\text{OH}^-(aq) \longrightarrow \text{Fe}(\text{OH})_2(s) + \text{SrSO}_4(s)$

Net ionic: This is the same as the total ionic equation, because there are no spectator ions.

4.43(a) No precipitate will form. (b) A precipitate will form because silver ions, Ag^+ , and bromide ions, Br^- , will combine to form a solid salt, silver bromide, AgBr . The ammonium and nitrate ions do not form a precipitate.

Molecular: $\text{NH}_4\text{Br}(aq) + \text{AgNO}_3(aq) \longrightarrow$

Total ionic: $\text{NH}_4^+(aq) + \text{Br}^-(aq) + \text{Ag}^+(aq) + \text{NO}_3^-(aq) \longrightarrow \\ \text{AgBr}(s) + \text{NH}_4^+(aq) + \text{NO}_3^-(aq)$

Net ionic: $\text{Ag}^+(aq) + \text{Br}^-(aq) \longrightarrow \text{AgBr}(s)$

4.45(a) No precipitate will form. (b) BaSO_4 will precipitate.

Molecular: $(\text{NH}_4)_2\text{SO}_4(aq) + \text{BaCl}_2(aq) \longrightarrow$

Total ionic:

Net ionic: $\text{SO}_4^{2-}(\text{aq}) + \text{Ba}^{2+}(\text{aq}) \longrightarrow \text{BaSO}_4(\text{s})$

4.47 0.0354 M Pb^{2+} **4.49** 0.88 g BaSO_4 **4.51(a)** PbSO_4

(b) $\text{Pb}^{2+}(\text{aq}) + \text{SO}_4^{2-}(\text{aq}) \longrightarrow \text{PbSO}_4(\text{s})$ (c) 1.5 g PbSO_4

4.53 Potassium carbonate, K_2CO_3 **4.55** 2.206 mass % Cl^-

4.61(a) Formation of a gas, $\text{SO}_2(\text{g})$, and of a nonelectrolyte, water, will cause the reaction to go to completion. (b) Formation of a precipitate, $\text{Ba}_3(\text{PO}_4)_2(\text{s})$, and of a nonelectrolyte, water, will cause the reaction to go to completion. **4.63(a)** 0.035 mol H^+ (b) 6.3×10^{-3} mol H^+ (c) 0.22 mol H^+

4.65(a) Molecular equation:

Total ionic equation:

Net ionic equation: $\text{OH}^-(\text{aq}) + \text{H}^+(\text{aq}) \longrightarrow \text{H}_2\text{O}(\text{l})$

The spectator ions are $\text{K}^+(\text{aq})$ and $\text{Br}^-(\text{aq})$.

(b) Molecular equation: $\text{NH}_3(\text{aq}) + \text{HCl}(\text{aq}) \longrightarrow \text{NH}_4\text{Cl}(\text{aq})$

Total ionic equation:

NH_3 , a weak base, is written in the molecular (undissociated) form. HCl , a strong acid, is written as dissociated ions. NH_4Cl is a soluble compound because all ammonium compounds are soluble. Net ionic equation: $\text{NH}_3(\text{aq}) + \text{H}^+(\text{aq}) \longrightarrow \text{NH}_4^+(\text{aq})$ Cl^- is the only spectator ion.

4.67 Total ionic equation: $\text{CaCO}_3(\text{s}) + 2\text{H}^+(\text{aq}) + 2\text{Cl}^-(\text{aq}) \longrightarrow \\ \text{Ca}^{2+}(\text{aq}) + 2\text{Cl}^-(\text{aq}) + \text{H}_2\text{O}(\text{l}) + \text{CO}_2(\text{g})$

Net ionic equation: $\text{CaCO}_3(\text{s}) + 2\text{H}^+(\text{aq}) \longrightarrow \\ \text{Ca}^{2+}(\text{aq}) + \text{H}_2\text{O}(\text{l}) + \text{CO}_2(\text{g})$

4.69 845 mL **4.71** 0.05839 M CH_3COOH

4.82(a) S has O.N. = +6 in SO_4^{2-} (i.e., H_2SO_4) and O.N. = +4 in SO_2 , so S has been reduced (and I^- oxidized); H_2SO_4 acts as an oxidizing agent. (b) The oxidation numbers remain constant throughout; H_2SO_4 transfers an H^+ to F^- to produce HF, so it acts as an acid. **4.84(a)** +4 (b) +3 (c) +4 (d) -3 **4.86(a)** -1 (b) +2 (c) -3 (d) +3 **4.88(a)** -3 (b) +5 (c) +3 **4.90(a)** +6 (b) +3 (c) +7

4.92(a) MnO_4^- is the oxidizing agent; $\text{H}_2\text{C}_2\text{O}_4$ is the reducing agent. (b) Cu is the reducing agent; NO_3^- is the oxidizing agent.

4.94(a) Oxidizing agent is MnO_4^- ; reducing agent is Sn.

(b) Oxidizing agent is NO_3^- ; reducing agent is Cl^- .

4.96(a) 4.54×10^{-3} mol MnO_4^- (b) 0.0113 mol H_2O_2 (c) 0.386 g H_2O_2 (d) 2.61 mass % H_2O_2 (e) H_2O_2 **4.102** A combination reaction that is also a redox reaction is $2\text{Mg}(\text{s}) + \text{O}_2(\text{g}) \longrightarrow 2\text{MgO}(\text{s})$. A combination reaction that is not a redox reaction is

4.103(a) $\text{Ca}(\text{s}) + 2\text{H}_2\text{O}(\text{l}) \longrightarrow \text{Ca}(\text{OH})_2(\text{aq}) + \text{H}_2(\text{g})$; displacement (b) $2\text{NaNO}_3(\text{s}) \longrightarrow 2\text{NaNO}_2(\text{s}) + \text{O}_2(\text{g})$; decomposition

(c) $\text{C}_2\text{H}_2(\text{g}) + 2\text{H}_2(\text{g}) \longrightarrow \text{C}_2\text{H}_6(\text{g})$; combination

4.105(a) $2\text{Sb}(\text{s}) + 3\text{Cl}_2(\text{g}) \longrightarrow 2\text{SbCl}_3(\text{s})$; combination

(b) $2\text{AsH}_3(\text{g}) \longrightarrow 2\text{As}(\text{s}) + 3\text{H}_2(\text{g})$; decomposition

(c) $\text{Zn}(\text{s}) + \text{Fe}(\text{NO}_3)_2(\text{aq}) \longrightarrow$

4.107(a) $\text{Sr}(\text{s}) + \text{Br}_2(\text{l}) \longrightarrow \text{SrBr}_2(\text{s})$

(b) $2\text{Ag}_2\text{O}(\text{s}) \xrightarrow{\Delta} 4\text{Ag}(\text{s}) + \text{O}_2(\text{g})$

(c) $\text{Mn}(\text{s}) + \text{Cu}(\text{NO}_3)_2(\text{aq}) \longrightarrow \text{Mn}(\text{NO}_3)_2(\text{aq}) + \text{Cu}(\text{s})$

4.109(a) $\text{N}_2(\text{g}) + 3\text{H}_2(\text{g}) \longrightarrow 2\text{NH}_3(\text{g})$

(b) $2\text{NaClO}_3(\text{s}) \xrightarrow{\Delta} 2\text{NaCl}(\text{s}) + 3\text{O}_2(\text{g})$

(c) $\text{Ba}(\text{s}) + 2\text{H}_2\text{O}(\text{l}) \longrightarrow \text{Ba}(\text{OH})_2(\text{aq}) + \text{H}_2(\text{g})$

4.111(a) $2\text{Cs}(\text{s}) + \text{I}_2(\text{s}) \longrightarrow 2\text{CsI}(\text{s})$

(b) $2\text{Al}(\text{s}) + 3\text{MnSO}_4(\text{aq}) \longrightarrow \text{Al}_2(\text{SO}_4)_3(\text{aq}) + 3\text{Mn}(\text{s})$

(c) $2\text{SO}_2(\text{g}) + \text{O}_2(\text{g}) \longrightarrow 2\text{SO}_3(\text{g})$

(d) $2\text{C}_4\text{H}_{10}(\text{g}) + 13\text{O}_2(\text{g}) \longrightarrow 8\text{CO}_2(\text{g}) + 10\text{H}_2\text{O}(\text{g})$

(e) $2\text{Al}(\text{s}) + 3\text{Mn}^{2+}(\text{aq}) \longrightarrow 2\text{Al}^{3+}(\text{aq}) + 3\text{Mn}(\text{s})$

4.113 315 g O_2 ; 3.95 kg Hg **4.115(a)** O_2 is in excess.

(b) 0.117 mol Li_2O (c) 0 g Li, 3.49 g Li_2O , and 4.63 g O_2

4.117 67.2 mass % KClO_3 **4.119** 2.79 kg Fe **4.120** 99.9 g compound B, which is FeCl_2 **4.125** The reaction is $2\text{NO} + \text{Br}_2 \rightleftharpoons 2\text{NOBr}$, which can proceed in either direction. If NO and Br_2 are placed in a container, they will react to form NOBr ; if NOBr is placed in the container, it will decompose to form NO and Br_2 . In either case, the concentrations of NO, Br_2 , and NOBr adjust so that the rates of the forward and reverse reactions become equal, and equilibrium is reached.

4.127(a) $\text{Fe}(\text{s}) + 2\text{H}^+(\text{aq}) \longrightarrow \text{Fe}^{2+}(\text{aq}) + \text{H}_2(\text{g})$

O.N.: 0 +1 +2 0

(b) $3.1 \times 10^{21} \text{ Fe}^{2+}$ ions

4.129 5.11 g $\text{C}_2\text{H}_5\text{OH}$; 24.9 L CO_2

4.131(a) $\text{Ca}^{2+}(\text{aq}) + \text{C}_2\text{O}_4^{2-}(\text{aq}) \longrightarrow \text{CaC}_2\text{O}_4(\text{s})$

(b) $5\text{H}_2\text{C}_2\text{O}_4(\text{aq}) + 2\text{MnO}_4^-(\text{aq}) + 6\text{H}^+(\text{aq}) \longrightarrow$

$10\text{CO}_2(\text{g}) + 2\text{Mn}^{2+}(\text{aq}) + 8\text{H}_2\text{O}(\text{l})$

(c) KMnO_4 (d) $\text{H}_2\text{C}_2\text{O}_4$ (e) 55.06 mass % CaCl_3

4.134 2.809 mass % $\text{CaMg}(\text{CO}_3)_2$ **4.136(a)** Step 1: oxidizing agent is O_2 ; reducing agent is NH_3 . Step 2: oxidizing agent is O_2 ; reducing agent is NO. Step 3: oxidizing agent is NO_2 ; reducing agent is NO_2 . (b) 1.2×10^4 kg NH_3 **4.139** 627 L air

4.144(a) 4 mol IO_3^- (b) 12 mol I_2 ; IO_3^- is oxidizing agent and I^- is reducing agent. (c) 12.87 mass % thyroxine **4.147(a)** 3.0×10^{-3} mol CO_2

(b) 0.11 L CO_2 **4.149(a)** $\text{C}_7\text{H}_5\text{O}_4\text{Bi}$ (b) $\text{C}_{21}\text{H}_{15}\text{O}_{12}\text{Bi}_3$

(c) $\text{Bi}(\text{OH})_3(\text{s}) + 3\text{HC}_7\text{H}_5\text{O}_3(\text{aq}) \longrightarrow \text{Bi}(\text{C}_7\text{H}_5\text{O}_3)_3(\text{s}) + 3\text{H}_2\text{O}(\text{l})$

(d) 0.490 mg $\text{Bi}(\text{OH})_3$ **4.151(a)** Ethanol: $\text{C}_2\text{H}_5\text{OH}(\text{l}) + 3\text{O}_2(\text{g}) \longrightarrow 2\text{CO}_2(\text{g}) + 3\text{H}_2\text{O}(\text{l})$; Gasoline: $2\text{C}_8\text{H}_{18}(\text{l}) + 25\text{O}_2(\text{g}) \longrightarrow 16\text{CO}_2(\text{g}) + 18\text{H}_2\text{O}(\text{g})$ (b) 2.50×10^3 g O_2 (c) 1.75×10^3 L O_2 (d) 8.38×10^3 L air **4.153** yes

Chapter 5

Answers to Boxed Reading Problems: **B5.1** The density of the atmosphere decreases with increasing altitude. High density causes more drag and frictional heating on the aircraft. At high altitudes, the low density of the atmosphere means that there are relatively few gas particles present to collide with an aircraft.

B5.3 0.934%, 7.10 torr

- **5.1(a)** The volume of the liquid remains constant, but the volume of the gas increases to the volume of the larger container.
- The volume of the container holding the gas sample increases when heated, but the volume of the container holding the liquid sample remains essentially constant when heated.
- The volume of the liquid remains essentially constant, but the volume of the gas is reduced. **5.6** 990 cm H_2O **5.8(a)** 566 mmHg (b) 1.32 bar (c) 3.60 atm (d) 107 kPa **5.10** 0.9408 atm

5.12 0.966 atm **5.18** At constant temperature and volume, the pressure of a gas is directly proportional to number of moles of

the gas. **5.20**(a) Volume decreases to one-third of the original volume. (b) Volume increases by a factor of 3.0. (c) Volume increases by a factor of 4. **5.22**(a) Volume decreases by a factor of 2. (b) Volume increases by a factor of 1.48. (c) Volume decreases by a factor of 3. **5.24** 1.84 L **5.26** –144°C **5.28** 278 atm

5.30 6.95 L **5.32** 35.3 L **5.34** 0.085 mol Cl₂ **5.36** 1.16 g ClF₃

5.39 yes **5.41** Beaker is inverted to collect H₂ and upright for CO₂. The molar mass of CO₂ is greater than the molar mass of air, which, in turn, has a greater molar mass than H₂. **5.45** 5.86 g/L

5.47 1.78×10⁻³ mol AsH₃; 3.48 g/L **5.49** 51.1 g/mol **5.51** 1.33 atm

5.53 39.2 g P₄ **5.55** 41.2 g PH₃ **5.57** 0.0249 g Al **5.61** C₅H₁₂

5.63(a) 0.90 mol (b) 6.76 torr **5.64** 286 mL SO₂ **5.66** 0.0997 atm

5.71 At STP, the volume occupied by a mole of any gas is the same. At the same temperature, all gases have the same average kinetic energy, resulting in the same pressure. **5.74**(a) P_A > P_B > P_C

(b) E_A = E_B = E_C (c) rate_A > rate_B > rate_C (d) total E_A > total E_B > total E_C (e) d_A = d_B = d_C (f) collision frequency in A > collision frequency in B > collision frequency in C

5.75 13.21 **5.77**(a) curve 1 (b) curve 1 (c) curve 1; fluorine and argon have about the same molar mass **5.79** 14.9 min **5.81** 4 atoms per molecule **5.84** negative deviations; N₂ < Kr < CO₂

5.86 At 1 atm; at lower pressures, the gas molecules are farther apart and intermolecular forces are less important.

5.89 6.81×10⁴ g/mol **5.92**(a) 22.1 atm (b) 20.9 atm

5.96(a) N₂, 597 torr; O₂, 159 torr; CO₂, 0.3 torr; H₂O, 3.5 torr

(b) 74.9 mol % N₂; 13.7 mol % O₂; 5.3 mol % CO₂; 6.2 mol % H₂O

(c) 1.6×10²¹ molecules O₂ **5.98**(a) 4×10² mL (b) 0.013 mol N₂

5.99 35.7 L NO₂ **5.104** Al₂Cl₆ **5.106** 1.52×10⁻² mol SO₃

5.110(a) 1.95×10³ g Ni (b) 3.5×10⁴ g Ni (c) 63 m³ CO

5.112(a) 9 volumes of O₂(g) (b) CH₅N **5.115** The lungs would expand by a factor of 4.86; the diver can safely ascend 52.5 ft to a depth of 73 ft. **5.117** 6.07 g H₂O₂ **5.122** 6.53×10⁻³ g N₂

5.126(a) xenon (b) water vapor (c) mercury vapor (d) water vapor

5.130 17.2 g CO₂; 17.8 g Kr **5.136** Ne, 676 m/s; Ar, 481 m/s;

He, 1.52×10³ m/s **5.138**(a) 0.052 g (b) 1.1 mL **5.145**(a) 16.5 L

CO₂ (b) P_{H₂O} = 48.8 torr; P_{O₂} = P_{CO₂} = 3.7×10² torr

5.150 332 steps **5.152** 1.4 **5.156** P_{total} = 245 torr; P_{I₂} = 25.2 torr

Chapter 6

Answers to Boxed Reading Problems: **B6.2**(a) 2H₂O(g) →

CH₄(g) + CO₂(g) (b) 12 kJ (c) –3.30×10⁴ kJ

• **6.4** Increase: eating food, lying in the sun, taking a hot bath.

Decrease: exercising, taking a cold bath, going outside on a cold day. **6.6** The amount of the change in internal energy is the same for both heater and air conditioner. Since both devices consume the same amount of electrical energy, the change in energy of the heater equals that of the air conditioner. **6.9** 0 J **6.11** 1.54×10³ J

6.13(a) 6.6×10⁷ kJ (b) 1.6×10⁷ kcal (c) 6.3×10⁷ Btu **6.15** –51 J

6.18 8.8 h **6.19** Measuring the heat transfer at constant pressure is more convenient than measuring it at constant volume.

6.21(a) exothermic (b) endothermic (c) exothermic (d) exothermic (e) endothermic (f) endothermic (g) exothermic

6.24

6.26(a) Combustion of ethane:

(b) Freezing of water: H₂O(l) → H₂O(s) + heat

6.28(a) 2CH₃OH(l) + 3O₂(g) → 2CO₂(g) + 4H₂O(g) + heat

(b) $\frac{1}{2}\text{N}_2(g) + \text{O}_2(g) + \text{heat} \longrightarrow \text{NO}_2(g)$

6.30(a) This is a phase change from the solid phase to the gas phase. Heat is absorbed by the system, so q_{sys} is positive. (b) The volume of the system increases, as more moles of gas are present after the phase change than before. So the system has done work of expansion, and w is negative. Since ΔE_{sys} = q + w, q is positive, and w is negative, the sign of ΔE_{sys} cannot be predicted. It will be positive if q > w and negative if q < w. (c) ΔE_{univ} = 0. If the system loses energy, the surroundings gain an equal quantity of energy. The sum of the energy of the system and the energy of the surroundings remains constant. **6.33** To determine the specific heat capacity of a substance, you need its mass, the heat added (or lost), and the change in temperature. **6.35** Heat capacity is the quantity of heat required to raise the temperature of an object 1 K. Specific heat capacity is the quantity of heat required to raise 1 g of a substance or material by 1 K. Molar heat capacity is the quantity of heat required to raise the temperature of 1 mol of a substance by 1 K. **6.37** 6.9×10³ J **6.39** 295°C **6.41** 77.5°C

6.43 45°C **6.45** 36.6°C **6.47** –55.8 kJ/mol H₂O **6.49** –2805 kJ/mol **6.55** The reaction has a positive ΔH, because it requires an input of energy to break the oxygen-oxygen bond. **6.56** ΔH is negative; it is opposite in sign and half as large as ΔH for the vaporization of 2 mol of H₂O.

6.57(a) exothermic (b) 20.2 kJ (c) –4.2×10² kJ (d) –15.7 kJ

6.59(a) $\frac{1}{2}\text{N}_2(g) + \frac{1}{2}\text{O}_2(g) \longrightarrow \text{NO}(g)$ ΔH = 90.29 kJ

(b) –10.5 kJ **6.61** –1.88×10⁶ kJ **6.65**(a) C₂H₄(g) + 3O₂(g) →

2CO₂(g) + 2H₂O(l); ΔH_{rxn} = –1411 kJ (b) 1.39 g C₂H₄

6.69 -110.5 kJ **6.70** -813.4 kJ **6.72** $\text{N}_2(g) + 2\text{O}_2(g) \longrightarrow 2\text{NO}_2(g)$
 $\Delta H_{\text{overall}} = 66.4 \text{ kJ}$; equation 1 is A, equation 2 is B, and equation 3 is C. **6.74** 44.0 kJ **6.77** The standard enthalpy of reaction, $\Delta H_{\text{rxn}}^{\circ}$, is the enthalpy change for a reaction when all substances are in their standard states. The standard enthalpy of formation, ΔH_f° , is the enthalpy change that accompanies the formation of 1 mol of a compound in its standard state from elements in their standard states.

Chapter 7

Answers to Boxed Reading Problems: **B7.1(a)** slope = $1.3 \times 10^4/M$; intercept = 0.00

(b) diluted solution = $1.8 \times 10^{-5} \text{ M}$; original solution = $1.4 \times 10^{-4} \text{ M}$

• **7.2(a)** x-ray < ultraviolet < visible < infrared < microwave < radio waves (b) radio < microwave < infrared < visible < ultraviolet < x-ray (c) radio < microwave < infrared < visible < ultraviolet < x-ray **7.7** 316 m; $3.16 \times 10^{11} \text{ nm}$; $3.16 \times 10^{12} \text{ }^{\circ}\text{A}$

7.9 $2.5 \times 10^{-23} \text{ J}$ **7.11** red < yellow < blue **7.13** $1.3483 \times 10^7 \text{ nm}$; $1.3483 \times 10^8 \text{ }^{\circ}\text{A}$ **7.16(a)** $1.24 \times 10^{15} \text{ s}^{-1}$; $8.21 \times 10^{-19} \text{ J}$ (b) $1.4 \times 10^{15} \text{ s}^{-1}$; $9.0 \times 10^{-19} \text{ J}$ **7.18** Bohr's key assumption was that the electron in an atom does not radiate energy while in a stationary state, and it can move to a different orbit only by absorbing or emitting a photon whose energy is equal to the difference in energy between two states. These differences in energy correspond to the wavelengths in the known line spectra for the hydrogen atom.

A Solar System model would not allow for the movement of electrons between levels. **7.20(a)** absorption (b) emission

(c) emission (d) absorption **7.22** Yes, the predicted line spectra are accurate. The energies could be predicted from

$E_n = \frac{-(Z^2)(2.18 \times 10^{-18} \text{ J})}{n^2}$, where Z is the atomic number for the atom or ion. The energy levels for Be^{3+} will be greater by a factor of 16 ($Z = 4$) than those for the hydrogen atom. This means that the pattern of lines will be similar, but the lines will be at different wavelengths. **7.23** 434.17 nm **7.25** 1875.6 nm

7.27 $-2.76 \times 10^5 \text{ J/mol}$ **7.29** d < a < c < b **7.31** $n = 4$

7.37 Macroscopic objects do exhibit a wavelike motion, but the wavelength is too small for humans to perceive.

7.39(a) $7.10 \times 10^{-37} \text{ m}$ (b) $1 \times 10^{-35} \text{ m}$ **7.41** $2.2 \times 10^{-26} \text{ m/s}$

7.43 $3.75 \times 10^{-36} \text{ kg}$ **7.47** The total probability of finding the 1s electron in any distance r from the H nucleus is greatest when the value of r is 0.529 \AA . The probability is greater for the 1s orbital.

7.48(a) principal determinant of the electron's energy or distance from the nucleus (b) determines the shape of the orbital (c) determines the orientation of the orbital in three-dimensional space **7.49(a)** one (b) five (c) three (d) nine

7.51(a) $m_l: -2, -1, 0, +1, +2$ (b) $m_l: 0$ (if $n = 1$, then $l = 0$)

(c) $m_l: -3, -2, -1, 0, +1, +2, +3$

7.55

Sublevel	Allowable m_l values	No. of orbitals
(a) d ($l = 2$)	-2, -1, 0, +1, +2	5
(b) p ($l = 1$)	-1, 0, +1	3
(c) f ($l = 3$)	-3, -2, -1, 0, +1, +2, +3	7

7.57(a) $n = 5$ and $l = 0$; one orbital (b) $n = 3$ and $l = 1$; three orbitals (c) $n = 4$ and $l = 3$; seven orbitals **7.59(a)** no; $n = 2$, $l = 1$, $m_l = -1$; $n = 2$, $l = 0$, $m_l = 0$ (b) allowed (c) allowed (d) no; $n = 5$, $l = 3$, $m_l = +3$; $n = 5$, $l = 2$, $m_l = 0$

7.62(a) $E = -(2.180 \times 10^{-18} \text{ J})/(1/n^2)$. This is identical to the expression from Bohr's theory. (b) $3.028 \times 10^{-19} \text{ J}$ (c) 656.1 nm

7.63(a) The attraction of the nucleus for the electrons must be overcome. (b) The electrons in silver are more tightly held by the nucleus. (c) silver (d) Once the electron is freed from the atom, its energy increases in proportion to the frequency of the light.

7.66 Li^{2+} **7.68** 2 \longrightarrow 1 (b) 5 \longrightarrow 2 (c) 4 \longrightarrow 2 (d) 3 \longrightarrow 2

(e) 6 \longrightarrow 3 **7.72(a)** $l = 1$ or 2 (b) $l = 1$ or 2 (c) $l = 3, 4, 5$, or 6 (d) $l = 2$ or 3

7.74(a) $\Delta E =$

$$(-2.18 \times 10^{-18} \text{ J}) \left(\frac{1}{\infty^2} - \frac{1}{n_{\text{initial}}^2} \right) Z^2 \left(\frac{6.022 \times 10^{23}}{1 \text{ mol}} \right)$$

(b) $3.28 \times 10^7 \text{ J/mol}$ (c) 205 nm (d) 22.8 nm

7.76(a) $5.293 \times 10^{-11} \text{ m}$ (b) $5.293 \times 10^{-9} \text{ m}$ **7.78** $6.4 \times 10^{27} \text{ photons}$

7.80(a) no overlap (b) overlap (c) two (d) At longer wavelengths, the hydrogen atom line spectrum begins to become a continuous band. **7.82(a)** $7.56 \times 10^{-18} \text{ J}$; $2.63 \times 10^{-8} \text{ m}$ (b) $5.122 \times 10^{-17} \text{ J}$; $3.881 \times 10^{-9} \text{ m}$ (c) $1.2 \times 10^{-18} \text{ J}$; $1.66 \times 10^{-7} \text{ m}$ **7.84(a)** $1.87 \times 10^{-19} \text{ J}$ (b) $3.58 \times 10^{-19} \text{ J}$ **7.86(a)** red; green (b) 5.89 kJ (Sr); 5.83 kJ (Ba)

7.88(a) As the wavelength of maximum absorbance, it provides the highest sensitivity. (b) ultraviolet region (c) $1.93 \times 10^{-2} \text{ g}$ vitamin A/g oil **7.92** $1.0 \times 10^{18} \text{ photons/s}$ **7.95** 3s \longrightarrow 2p; 3d \longrightarrow 2p; 4s \longrightarrow 2p; 3p \longrightarrow 2s

Chapter 8

8.1 Elements are listed in the periodic table in a systematic way that correlates with a periodicity of their chemical and physical properties. The theoretical basis for the table in terms of sequential atomic number and electron configuration does not allow for a “new element” between Sn and Sb.

8.3(a) predicted atomic mass = 54.23 amu **(b)** predicted melting point = 6.3°C

8.6 The spin quantum number, m_s , relates to the electron only; all the others describe the orbital. **8.9** Shielding occurs when electrons protect, or shield, other electrons from the full nuclear attraction. The effective nuclear charge is the nuclear charge an electron actually experiences. As the number of electrons, especially inner electrons, increases, the effective nuclear charge decreases. **8.11(a)** 6 **(b)** 10 **(c)** 2

8.13(a) 6 **(b)** 2 **(c)** 14 **8.16** Hund’s rule states that electrons will occupy empty orbitals in a given sublevel (with parallel spins) before filling half-filled orbitals. The lowest energy arrangement has the maximum number of unpaired electrons with parallel spins.

8.18 Main-group elements from the same group have similar outer electron configurations, and the A-group number equals the number of outer electrons. Outer electron configurations vary in a periodic manner within a period, with each succeeding element having an additional electron. **8.20** The maximum number of electrons in any energy level n is $2n^2$, so the $n = 4$ energy level holds a maximum of $2(4^2) = 32$ electrons. **8.21(a)** $n = 5$, $l = 0$, $m_l = 0$, $m_s = +\frac{1}{2}$ **(b)** $n = 3$, $l = 1$, $m_l = -1$, 0 or $+1$, and $m_s + \frac{1}{2}$ or $-\frac{1}{2}$. **(c)** $n = 5$, $l = 0$, $m_l = 0$, $m_s = +\frac{1}{2}$

8.23(a) Rb: $1s^2 2s^2 2p^6 3s^2 3p^6 4s^2 3d^{10} 4p^6 5s^1$

(b) Ge: $1s^2 2s^2 2p^6 3s^2 3p^6 4s^2 3d^{10} 4p^2$

(c) Ar: $1s^2 2s^2 2p^6 3s^2 3p^6$

8.25(a) Cl: $1s^2 2s^2 2p^6 3s^2 3p^5$ **(b)** Si: $1s^2 2s^2 2p^6 3s^2 3p^2$

(c) Sr: $1s^2 2s^2 2p^6 3s^2 3p^6 4s^2 3d^{10} 4p^6 5s^2$

8.27(a) Ti: [Ar] $4s^2 3d^2$

(b) Cl: [Ne] $3s^2 3p^5$

(c) V: [Ar] $4s^2 3d^3$

8.29(a) Mn: [Ar] $4s^2 3d^5$

(b) P: [Ne] $3s^2 3p^3$

(c) Fe: [Ar] $4s^2 3d^6$

8.31(a) O; Group 6A(16); Period 2

(b) P; Group 5A(15); Period 3

8.33(a) Cl; Group 7A(17); Period 3

(b) As; Group 5A(15); Period 4

8.35(a) [Ar] $4s^2 3d^{10} 4p^1$; Group 3A(13) **(b)** [He] $2s^2 2p^6$; Group 8A(18)

	Inner Electrons	Outer Electrons	Valence Electrons
(a) O	2	6	6
(b) Sn	46	4	4
(c) Ca	18	2	2
(d) Fe	18	2	8
(e) Se	28	6	6

8.39(a) B; Al, Ga, In, and Tl **(b)** S; O, Se, Te, and Po **(c)** La; Sc, Y, and Ac

8.41(a) C; Si, Ge, Sn, and Pb **(b)** V; Nb, Ta, and Db **(c)** P; N, As, Sb, and Bi

8.43 Na (first excited state): $1s^2 2s^2 2p^6 3p^1$

8.50 A high IE₁ and a very negative EA₁ suggest that the elements are halogens, in Group 7A(17), which form 1⁻ ions.

8.53(a) K < Rb < Cs **(b)** O < C < Be **(c)** Cl < S < K

(d) Mg < Ca < K **8.55(a)** Ba < Sr < Ca **(b)** B < N < Ne

(c) Rb < Se < Br **(d)** Sn < Sb < As **8.57** 1s²2s²2p¹ (boron, B)

8.59(a) Na **(b)** Na **(c)** Be **8.61(1)** Metals conduct electricity; nonmetals do not. **(2)** Metal ions have a positive charge; nonmetal ions have a negative charge. **(3)** Metal oxides are mostly ionic and act as bases; nonmetal oxides are mostly covalent and act as acids. **8.62** Metallic character increases down a group and decreases to the right across a period. These trends are the same as those for atomic size and opposite those for ionization energy.

8.65 Possible ions are 2+ and 4+. The 2+ ions form by loss of the outermost two p electrons; the 4+ ions form by loss of these and the outermost two s electrons. **8.69(a)** Rb **(b)** Ra **(c)** I

8.71(a) As **(b)** P **(c)** Be **8.73** acidic solution; SO_{2(g)} + H₂O(l) → H₂SO_{3(aq)}

8.75(a) Cl⁻: 1s²2s²2p⁶3s²3p⁶

(b) Na⁺: 1s²2s²2p⁶ **(c)** Ca²⁺: 1s²2s²2p⁶3s²3p⁶

8.77(a) Al³⁺: 1s²2s²2p⁶ **(b)** S²⁻: 1s²2s²2p⁶3s²3p⁶ **(c)** Sr²⁺:

1s²2s²2p⁶3s²3p⁶4s²3d¹⁰4p⁶ **8.79(a)** O **(b)** 3 **(c)** 0 **(d)** 1

8.81 a, b, and d **8.83(a)** V³⁺: [Ar] 3d², paramagnetic **(b)** Cd²⁺:

[Kr] 4d¹⁰, diamagnetic **(c)** Co³⁺: [Ar] 3d⁶, paramagnetic

(d) Ag⁺: [Kr] 4d¹⁰, diamagnetic **8.85** For palladium to be diamagnetic, all of its electrons must be paired. **(a)** You might first write the condensed electron configuration for Pd as

[Kr] 5s²4d⁸. However, the partial orbital diagram is not consistent with diamagnetism.

(b) This is the only configuration that supports diamagnetism, [Kr] 4d¹⁰.

(c) Promoting an s electron into the d sublevel still leaves two electrons unpaired.

8.87(a) Li⁺ < Na⁺ < K⁺ **(b)** Rb⁺ < Br⁻ < Se²⁻ **(c)** F⁻ < O²⁻ < N³⁻

8.90 Ce: [Xe] 6s²4f¹5d¹; Ce⁴⁺: [Xe]; Eu: [Xe] 6s²4f⁷; Eu²⁺: [Xe] 4f⁷. Ce⁴⁺ has a noble-gas configuration; Eu²⁺ has a half-filled f subshell. **8.91(a)** Cl₂O, dichlorine monoxide **(b)** Cl₂O₃, dichlorine trioxide **(c)** Cl₂O₅, dichlorine pentoxide **(d)** Cl₂O₇, dichlorine heptoxide **(e)** SO₃, sulfur trioxide **(f)** SO₂, sulfur dioxide **(g)** N₂O₅, dinitrogen pentoxide **(h)** N₂O₃, dinitrogen trioxide **(i)** CO₂, carbon dioxide **(j)** P₄O₁₀, tetraphosphorus decoxide **8.94(a)** SrBr₂, strontium bromide **(b)** CaS, calcium sulfide **(c)** ZnF₂, zinc fluoride **(d)** LiF, lithium fluoride

8.95(a) 2009 kJ/mol **(b)** -549 kJ/mol **8.97** All ions except Fe⁸⁺ and Fe¹⁴⁺ are paramagnetic; Fe⁺ and Fe³⁺ would be most strongly attracted.

Chapter 9

Answers to Boxed Reading Problems: **B9.1** The C=C bond shows IR absorption at a shorter wavelength (higher energy) because it is a stronger bond than C—C. The C≡C bond would show absorption at a shorter wavelength (higher energy) than the C=C bond, since the triple bond has a higher bond energy than the double bond. **B9.2(a)** 7460 nm (symmetric stretch), 1.50×10^4 nm (bending), 4260 nm (asymmetrical stretch) **(b)** 2.66×10^{-20} J (symmetric stretch), 1.33×10^{-20} J (bending), 4.67×10^{-20} J (asymmetrical stretch); bending requires the least amount of energy.

- **9.1(a)** Greater ionization energy decreases metallic character.
- (b) Larger atomic radius increases metallic character. (c) Higher number of outer electrons decreases metallic character. (d) Larger effective nuclear charge decreases metallic character. **9.4(a)** Cs (b) Rb (c) As **9.6(a)** ionic **(b)** covalent **(c)** metallic **9.8(a)** covalent **(b)** ionic **(c)** covalent **9.10(a)** Rb⁺ **(b)** : $\ddot{\text{S}}\text{:}$ **(c)** : $\ddot{\text{I}}\text{:}$ **9.12(a)** : $\ddot{\text{S}}\text{r}^-$ **(b)** : $\ddot{\text{P}}\text{:}$ **(c)** : $\ddot{\text{S}}\text{:}$ **9.14(a)** 6A(16); [noble gas] ns²np⁴ **(b)** 3(A)13; [noble gas] ns²np¹ **9.17(a)** Because the lattice energy is the result of electrostatic attractions among the oppositely charged ions, its magnitude depends on several factors, including ionic size, ionic charge, and the arrangement of ions in the solid. For a particular arrangement of ions, the lattice energy increases as the charges on the ions increase and as their radii decrease.
- (b) A < B < C **9.20(a)** Ba²⁺, [Xe]; Cl⁻, [Ne] 3s²3p⁶, : $\ddot{\text{Cl}}^-$; BaCl₂ **(b)** Sr²⁺, [Kr]; O²⁻, [He] 2s²2p⁶, : $\ddot{\text{O}}^{2-}$; SrO **(c)** Al³⁺, [Ne]; F⁻, [He] 2s²2p⁶, : $\ddot{\text{F}}^-$; AlF₃ **(d)** Rb⁺, [Kr]; O²⁻, [He] 2s²2p⁶, : $\ddot{\text{O}}^{2-}$; Rb₂O **9.22(a)** 2A(2) **(b)** 6A(16) **(c)** 1A(1) **9.24(a)** 3A(13) **(b)** 2A(2) **(c)** 6A(16) **9.26(a)** BaS; the charge on each ion is twice the charge on the ions in CsCl. **(b)** LiCl; Li⁺ is smaller than

Cs⁺. **9.28(a)** BaS; Ba²⁺ is larger than Ca²⁺. **(b)** NaF; the charge on each ion is less than the charge on Mg and O. **9.30** 788 kJ; the lattice energy for NaCl is less than that for LiF, because the Na⁺ and Cl⁻ ions are larger than the Li⁺ and F⁻ ions. **9.33** -336 kJ

9.34 When two chlorine atoms are far apart, there is no interaction between them. As the atoms move closer together, the nucleus of each atom attracts the electrons of the other atom. The closer the atoms, the greater this attraction; however, the repulsions between the two nuclei and between the electrons also increase at the same time. The final internuclear distance is the distance at which maximum attraction is achieved in spite of the repulsions. **9.35** The bond energy is the energy required to break the bond between H atoms and Cl atoms in 1 mol of HCl molecules in the gaseous state. Energy is needed to break bonds, so bond breaking is always endothermic and $\Delta H_{\text{bond breaking}}^\circ$ is positive. The quantity of energy needed to break the bond is released upon its formation, so $\Delta H_{\text{bond forming}}^\circ$ has the same magnitude as $\Delta H_{\text{bond breaking}}^\circ$ but is opposite in sign (always exothermic and negative). **9.39(a)** I—I < Br—Br < Cl—Cl **(b)** S—Br < S—Cl < S—H **(c)** C—N < C=N < C≡N **9.41(a)** C—O < C=O; the C=O bond (bond order = 2) is stronger than the C—O bond (bond order = 1). **(b)** C—H < O—H; O is smaller than C so the O—H bond is shorter and stronger than the C—H bond. **9.43** Less energy is required to break weak bonds. **9.45** Both are one-carbon molecules. Since methane contains no carbon-oxygen bonds, it will have the greater enthalpy of reaction per mole for combustion.

9.47 -168 kJ **9.49** -22 kJ **9.50** -59 kJ **9.51** Electronegativity increases from left to right and increases from bottom to top within a group. Fluorine and oxygen are the two most electronegative elements. Cesium and francium are the two least electronegative elements. **9.53** Ionic bonds occur between two elements of very different electronegativity, generally a metal with low electronegativity and a nonmetal with high electronegativity. Although electron sharing occurs to a very small extent in some ionic bonds, the primary force in ionic bonds is attraction of opposite charges resulting from electron transfer between the atoms. A nonpolar covalent bond occurs between two atoms with identical electronegativity values where the sharing of bonding electrons is equal. A polar covalent bond is between two atoms (generally nonmetals) of different electronegativities so that the bonding electrons are unequally shared. The H—O bond in water is polar covalent. The bond is between two nonmetals so it is covalent and not ionic, but atoms with different electronegativity values are involved. **9.56(a)** Si < S < O **(b)** Mg < As < P **9.58(a)** N > P > Si **(b)** As > Ga > Ca

9.62 a, d, and e **9.64(a)** nonpolar covalent **(b)** ionic **(c)** polar covalent **(d)** polar covalent **(e)** nonpolar covalent **(f)** polar covalent; $\text{SCl}_2 < \text{SF}_2 < \text{PF}_3$

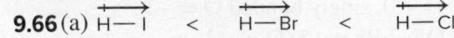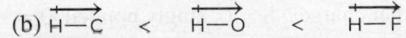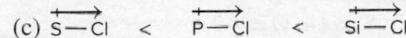

- 9.69(a)** Shiny, conducts heat, conducts electricity, and is malleable. **(b)** Metals lose electrons to form positive ions, and metals form basic oxides. **9.73(a)** 800. kJ/mol, which is lower than the value in Table 9.2 **(b)** -2.417×10^4 kJ **(c)** 1690. g CO_2 **(d)** 65.2 L O_2 **9.75(a)** -125 kJ **(b)** yes, since ΔH_f° is negative **(c)** -392 kJ **(d)** No, ΔH_f° for MgCl_2 is much more negative than that for MgCl . **9.77(a)** 406 nm **(b)** 2.93×10^{-19} J **(c)** 1.87×10^4 m/s **9.80** C—Cl: 3.53×10^{-7} m; bond in O_2 : 2.40×10^{-7} m **9.81** XeF_2 : 132 kJ/mol; XeF_4 : 150. kJ/mol; XeF_6 : 146 kJ/mol **9.83(a)** The presence of the very electronegative fluorine atoms bonded to one of the carbons makes the C—C bond polar. This polar bond will tend to undergo heterolytic rather than homolytic cleavage. More energy is required to achieve heterolytic cleavage. **(b)** 1420 kJ **9.86** 13,286 kJ **9.88** 8.70×10^{14} s⁻¹; 3.45×10^{-7} m; the UV region **9.90(a)** $\text{CH}_3\text{OCH}_3(g)$: -326 kJ; $\text{CH}_3\text{CH}_2\text{OH}(g)$: -369 kJ **(b)** The formation of gaseous ethanol is more exothermic. **(c)** 43 kJ

Chapter 10

Answers to Boxed Reading Problem: **B10.1** resonance form on the left: trigonal planar around C, trigonal pyramidal around N; resonance form on the right: trigonal planar around both C and N.

• **10.1** He cannot serve as a central atom because it does not bond. H cannot because it forms only one bond. Fluorine cannot because it needs only one electron to complete its valence level, and it does not have *d* orbitals available to expand its valence level. Thus, it can bond to only one other atom. **10.3** X obeys the octet rule in all the structures except c and g.

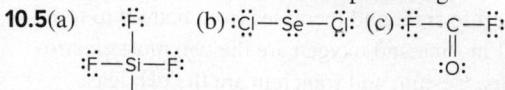

- 10.19(a)** B has 6 valence electrons in BH_3 , so the molecule is electron deficient. **(b)** As has an expanded valence level with 10 electrons. **(c)** Se has an expanded valence level with 10 electrons.

- 10.21(a)** Br expands its valence level to 10 electrons. **(b)** I has an expanded valence level of 10 electrons. **(c)** Be has only 4 valence electrons in BeF_2 , so the molecule is electron deficient.

- 10.26** structure A **10.28** The molecular shape and the electron-group arrangement are the same when no lone pairs are present on the central atom. **10.30** tetrahedral, AX_4 ; trigonal pyramidal, AX_3E ; bent or V shaped, AX_2E_2

- 10.34(a)** trigonal planar, bent, 120° **(b)** tetrahedral, trigonal pyramidal, 109.5° **(c)** tetrahedral, trigonal pyramidal, 109.5°

- 10.36(a)** trigonal planar, trigonal planar, 120° **(b)** trigonal planar, bent, 120° **(c)** tetrahedral, tetrahedral, 109.5° **10.38(a)** trigonal planar, AX_3 , 120° **(b)** trigonal pyramidal, AX_3E , 109.5° **(c)** trigonal bipyramidal, AX_5 , 90° and 120° **10.40(a)** bent, 109.5° , less than 109.5° **(b)** trigonal bipyramidal, 90° and 120° , angles are ideal **(c)** seesaw, 90° and 120° , less than ideal **(d)** linear, 180° , angle is ideal **10.42(a)** C: tetrahedral, 109.5° ; O: bent, $< 109.5^\circ$ **(b)** N: trigonal planar, 120° **10.44(a)** C in CH_3 : tetrahedral, 109.5° ; C in $\text{C}=\text{O}$: trigonal planar, 120° ; O with H: bent, $< 109.5^\circ$ **(b)** O: bent, $< 109.5^\circ$ **10.46** $\text{OF}_2 < \text{NF}_3 < \text{CF}_4 < \text{BF}_3 < \text{BeF}_2$

- 10.48(a)** The C and N each have three electron groups, so the ideal bond angles are 120° ; the O has four electron groups, so the ideal bond angle is 109.5° . The N and O have lone pairs, so the bond angles are less than ideal. **(b)** All central atoms have four electron groups, so the ideal bond angles are 109.5° . The lone pairs on the O reduce this value. **(c)** The B has three electron groups and an ideal bond angle of 120° . All the O's have four electron groups (ideal bond angles of 109.5°), two of which are lone pairs that reduce the bond angle.

In the gas phase, PCl_5 is AX_5 , so the shape is trigonal bipyramidal, and the bond angles are 120° and 90° . The PCl_4^+ ion is AX_4 , so the shape is tetrahedral, and the bond angles are 109.5° . The PCl_6^- ion is AX_6 , so the shape is octahedral, and the bond angles are 90° . **10.52** Molecules are polar if they have polar bonds that are not arranged to cancel each other. A polar bond is present any time there is a bond between elements with differing electronegativities. **10.55(a)** CF_4 **(b)** BrCl and SCl_2 **10.57(a)** SO_2 , because it is polar and SO_3 is not. **(b)** IF has a greater electronegativity difference between its atoms. **(c)** SF_4 , because it is polar and SiF_4 is not. **(d)** H_2O has a greater electronegativity difference between its atoms.

Yes, compound Y has a dipole moment.

The single N—N bond (bond order = 1) is weaker and longer than the others. The triple bond (bond order = 3) is stronger and shorter than the others. The double bond (bond order = 2) has an intermediate strength and length.

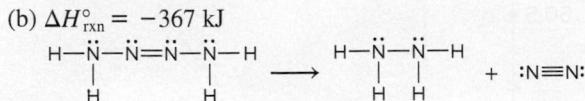

10.65(a) formal charges: Al = -1, end Cl = 0, bridging Cl = +1; I = -1, end Cl = 0, bridging Cl = +1 (b) The iodine atoms are each AX_4E_2 , and the shape around each is square planar. These square planar portions are adjacent, giving a planar molecule.

10.70

(a) In propylene oxide, the shape around each C is tetrahedral, with ideal angles of 109.5° . (b) The C that is not part of the three-membered ring should have close to the ideal angle. The atoms in the ring form an equilateral triangle, so the angles around the two C's in the ring are reduced from the ideal 109.5° to nearly 60° . **10.75(a)** -1267 kJ/mol (b) -1226 kJ/mol (c) -1234.8 kJ/mol . The two answers differ by less than 10 kJ/mol . This is very good agreement since average bond energies were used to calculate answers a and b. (d) -37 kJ

10.80 CH_4 : -409 kJ/mol O_2 ; H_2S : -398 kJ/mol O_2

10.82(a) The O in the OH species has only 7 valence electrons, which is less than an octet, and 1 electron is unpaired. **(b)** 426 kJ
(c) 508 kJ **10.84(a)** The F atoms will substitute at the axial positions first. **(b)** PF_5 and PCl_3F_2

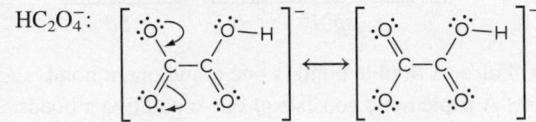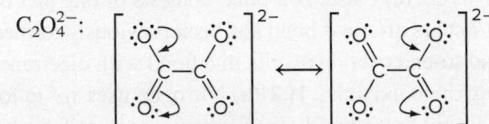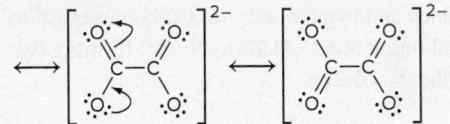

In $\text{H}_2\text{C}_2\text{O}_4$, there are two shorter and stronger $\text{C}=\text{O}$ bonds and two longer and weaker $\text{C}-\text{O}$ bonds. In HC_2O_4^- , the carbon-oxygen bonds on the side retaining the H remain as one long, weak $\text{C}-\text{O}$ and one short, strong $\text{C}=\text{O}$. The carbon-oxygen bonds on the other side of the molecule have resonance forms with a bond order of 1.5, so they are intermediate in length and strength. In $\text{C}_2\text{O}_4^{2-}$, all the carbon-oxygen bonds have a bond order of 1.5.

10.90 22 kJ **10.91** Trigonal planar molecules are nonpolar, so AY_3 cannot have that shape. Trigonal pyramidal molecules and T-shaped molecules are polar, so AY_3 could have either of these shapes. **10.95(a)** 339 pm **(b)** 316 pm and 223 pm
(c) 270 pm

Chapter 11

- 11.1(a)** sp^2 **(b)** sp^3d^2 **(c)** sp **(d)** sp^3 **(e)** sp^3d **11.3** C has only 2s and 2p atomic orbitals, allowing for a maximum of four hybrid orbitals. Si has 3s, 3p, and 3d atomic orbitals, allowing it to form more than four hybrid orbitals. **11.5(a)** six, sp^3d^2 **(b)** four, sp^3 **11.7(a)** sp^2 **(b)** sp^2 **(c)** sp^2 **11.9(a)** sp^3 **(b)** sp^3 **(c)** sp^3 **11.11(a)** Si: one s and three p atomic orbitals form four sp^3 hybrid orbitals. **(b)** C: one s and one p atomic orbital form two sp hybrid orbitals. **(c)** S: one s, three p, and one d atomic orbital mix to form five sp^3d hybrid orbitals. **(d)** N: one s and three p atomic orbitals mix to form four sp^3 hybrid orbitals. **11.13(a)** B ($sp^3 \longrightarrow sp^3$) **(b)** A ($sp^2 \longrightarrow sp^3$)

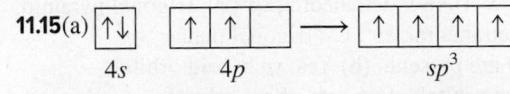

- 11.20**(a) False. A double bond is one σ and one π bond.
 (b) False. A triple bond consists of one σ and two π bonds.
 (c) True (d) True (e) False. A π bond consists of one pair of electrons; it occurs after a σ bond has been previously formed.
 (f) False. End-to-end overlap results in a bond with electron density along the bond axis. **11.21**(a) Nitrogen uses sp^2 to form three σ bonds and one π bond. (b) Carbon uses sp to form two σ bonds and two π bonds. (c) Carbon uses sp^2 to form three σ bonds and one π bond. **11.23**(a) N: sp^2 , forming two σ bonds and one π bond $\ddot{\text{N}}=\ddot{\text{N}}=\ddot{\text{O}}$:

- The single bonds are all σ bonds. The double bond is one σ bond and one π bond. **11.26** Four MOs form from the four p atomic orbitals. The total number of MOs must equal the number of atomic orbitals. **11.28**(a) Bonding MOs have lower energy than antibonding MOs. Lower energy means more stable. (b) Bonding MOs do not have a node between the nuclei. (c) Bonding MOs have higher electron density between the nuclei than antibonding MOs do. **11.30**(a) two (b) two (c) four **11.32**(a) A is π_{2p}^* , B is σ_{2p} , C is π_{2p} , and D is σ_{2p}^* . (b) π_{2p}^* in A, σ_{2p} in B, and π_{2p} in C have at least one electron. (c) π_{2p}^* in A has only one electron. **11.34**(a) stable (b) paramagnetic (c) $(\sigma_{2s})^2(\sigma_{2s}^*)^1$ **11.36**(a) $\text{C}_2^+ < \text{C}_2 < \text{C}_2^-$ (b) $\text{C}_2^- < \text{C}_2 < \text{C}_2^+$ **11.40**(a) C (ring): sp^2 ; C (all others): sp^3 ; O (all): sp^3 ; N: sp^3 (b) 26 (c) 6 **11.42**(a) 17 (b) All carbons are sp^2 ; the ring N is sp^2 , the other N's are sp^3 . **11.44**(a) B changes from sp^2 to sp^3 . (b) P changes from sp^3 to sp^3d . (c) C changes from sp to sp^2 . Two electron groups surround C in C_2H_2 , and three electron groups surround C in C_2H_4 . (d) Si changes from sp^3 to sp^3d^2 . (e) no change for S **11.46** P: tetrahedral, sp^3 ; N: trigonal pyramid, sp^3 ; C₁ and C₂: tetrahedral, sp^3 ; C₃: trigonal planar, sp^2 **11.51**(a) B and D are present. (b) Yes, sp hybrid orbitals. (c) Two sets of sp orbitals, four sets of sp^2 orbitals, and three sets of sp^3 orbitals. **11.52** Through resonance, the C—N bond gains some double-bond character, which hinders rotation about that bond.

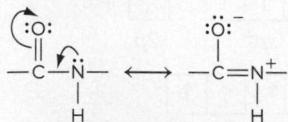

- 11.56**(a) C in $-\text{CH}_3$: sp^3 ; all other C atoms: sp^2 ; O in two C—O bonds: sp^3 ; O in two C=O bonds: sp^2 (b) two (c) eight; one
11.57(a) four (b) eight

Chapter 12

Answer to Boxed Reading Problem: **B12.1** $1.76 \times 10^{-10} \text{ m}$

- **12.1** In a solid, the energy of attraction of the particles is greater than their energy of motion; in a gas, it is less. Gases have high compressibility and the ability to flow, while solids have neither. **12.4**(a) Because the intermolecular forces are only partially overcome when fusion occurs but need to be totally overcome in vaporization. (b) Because solids have greater intermolecular forces than liquids do. (c) $\Delta H_{\text{vap}} = -\Delta H_{\text{cond}}$ **12.5**(a) intermolecular (b) intermolecular (c) intramolecular (d) intramolecular **12.7**(a) condensation (b) fusion (c) vaporization **12.9** The gas molecules slow down as the gas is compressed. Therefore, much of the kinetic energy lost by the propane molecules is released to the surroundings. **12.13** At first, the vaporization of liquid molecules from the surface predominates, which increases the number of gas molecules and hence the vapor pressure. As more molecules enter the gas phase, more gas molecules hit the surface of the liquid and "stick" more frequently, so the condensation rate increases. When the vaporization and condensation rates become equal, the vapor pressure remains constant. **12.14** As the strength of intermolecular forces increases, (a) critical temperature increases, (b) boiling point increases, (c) vapor pressure decreases, and (d) heat of vaporization increases. **12.18** because the condensation of the vapor supplies an additional 40.7 kJ/mol

12.19 $7.67 \times 10^3 \text{ J}$ **12.21** 0.777 atm **12.23** $2 \times 10^4 \text{ J/mol}$

12.25

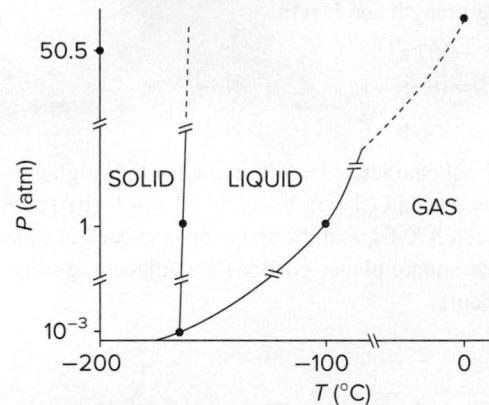

Solid ethylene is more dense than liquid ethylene.

- 12.27**(a) Rhombic sulfur will sublime when it is heated at a pressure less than 1×10^{-4} atm. (b) At 90°C and 1 atm, sulfur is in the solid (rhombic) form. As it is heated at constant pressure, it passes through the solid (monoclinic) phase, starting at 114°C. At about 120°C, the solid melts to form the liquid. At about 445°C, the liquid evaporates and changes to the gas. **12.30** 32 atm **12.34** O is smaller and more electronegative than Se; thus, the electron density of O is greater, which attracts H more strongly. **12.36** All particles (atoms and molecules) exhibit dispersion forces, but the total force is weak for small molecules. Dipole-dipole forces between small polar molecules dominate dispersion forces between those molecules. **12.39**(a) hydrogen bonding (b) dispersion forces (c) dispersion forces **12.41**(a) dipole-dipole forces (b) dispersion forces (c) H bonding

12.43(a)

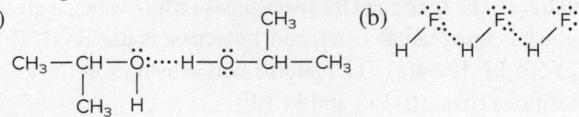

12.45(a) dispersion forces (b) H bonding (c) dispersion forces
12.47(a) I^- (b) $CH_2=CH_2$ (c) H_2Se . In (a) and (c) the larger particle has the higher polarizability. In (b), the less tightly held π electron clouds are more easily distorted. **12.49**(a) C_2H_6 ; it is a smaller molecule exhibiting weaker dispersion forces than C_4H_{10} . (b) CH_3CH_2F ; it has no H—F bonds, so it exhibits only dipole-dipole forces, which are weaker than the H bonds of CH_3CH_2OH . (c) PH_3 ; it has weaker intermolecular forces (dipole-dipole) than NH_3 (hydrogen bonding). **12.51**(a) HCl ; it has dipole-dipole forces, and there is stronger ionic bonding in $LiCl$. (b) PH_3 ; it has dipole-dipole forces, and there is stronger H bonding in NH_3 . (c) Xe ; it exhibits weaker dispersion forces since its smaller size results in lower polarizability than for the larger I_2 molecules. **12.53**(a) C_4H_8 (cyclobutane), because it is more compact than C_4H_{10} . (b) PBr_3 ; the dipole-dipole forces in PBr_3 are weaker than the ionic bonds in $NaBr$. (c) HBr ; the dipole-dipole forces in HBr are weaker than the H bonds in water.

12.55 As atomic size decreases and electronegativity increases, the electron density of an atom increases. Thus, the attraction to an H atom on another molecule increases while its bonded H atom becomes more positive. Fluorine is the smallest of the three and the most electronegative, so the H bonds in hydrogen fluoride are the strongest. Oxygen is smaller and more electronegative than nitrogen, so H bonds in water are stronger than H bonds in ammonia. **12.59** The cohesive forces in water and mercury are stronger than the adhesive forces to the nonpolar wax on the floor. Weak adhesive forces result in spherical drops. The adhesive forces overcome the even weaker cohesive forces in the oil, and so the oil drop spreads out. **12.61** Surface tension is defined as the energy needed to increase the surface area by a given amount, so units of energy per area are appropriate.

12.63 $CH_3CH_2CH_2OH < HOCH_2CH_2OH < HOCH_2CH(OH)CH_2OH$. More H bonding means greater attraction between molecules, so more energy is needed to increase surface area.

12.65 $HOCH_2CH(OH)CH_2OH > HOCH_2CH_2OH > CH_3CH_2CH_2OH$. More H bonding means greater attraction between molecules, so the liquid flows less easily.

12.70 Water is a good solvent for polar and ionic substances and a poor solvent for nonpolar substances. Water is a polar molecule and dissolves polar substances because their intermolecular forces are of similar strength. **12.71** A single water molecule can form four H bonds. The two hydrogen atoms each form one H bond to oxygen atoms on neighboring water molecules. The two lone pairs on the oxygen atom form H bonds with hydrogen atoms on two neighboring molecules. **12.74** Water exhibits strong capillary action, which allows it to be easily absorbed by the plant's roots and transported upward to the leaves. **12.80** simple cubic **12.83** The energy gap is the energy difference between the highest filled energy level (valence band) and the lowest unfilled energy level (conduction band). In conductors and superconductors, the energy gap is zero because the valence band overlaps the conduction band. In semiconductors, the energy gap is small. In insulators, the gap is large. **12.85** atomic mass and atomic radius **12.86**(a) face-centered cubic (b) body-centered cubic (c) face-centered cubic **12.88** 1.54 g/cm^3 **12.90**(a) The change in unit cell is from a sodium chloride structure in CdO to a zinc blende structure in $CdSe$. (b) Yes, the coordination number

of Cd changes from 6 in CdO to 4 in $CdSe$. **12.92** 524 pm

12.94(a) Nickel forms a metallic solid since it is a metal whose atoms are held together by metallic bonds. (b) Fluorine forms a molecular solid since the F_2 molecules are held together by dispersion forces. (c) Methanol forms a molecular solid since the CH_3OH molecules are held together by H bonds. (d) Tin forms a metallic solid since it is a metal whose atoms are held together by metallic bonds. (e) Silicon is under carbon in Group 4A(14); it exhibits similar bonding properties to carbon. Since diamond and graphite are both network covalent solids, it makes sense that Si forms a network covalent solid as well. (f) Xe is an atomic solid since its individual atoms are held together by dispersion forces. **12.96** four **12.98**(a) four Se^{2-} ions, four Zn^{2+} ions (b) 577.48 amu (c) $1.77 \times 10^{-22}\text{ cm}^3$ (d) $5.61 \times 10^{-8}\text{ cm}$

12.100(a) insulator (b) conductor (c) semiconductor

12.102(a) Conductivity increases. (b) Conductivity increases. (c) Conductivity decreases. **12.104** $1.68 \times 10^{-8}\text{ cm}$ **12.111** A substance whose properties are the same in all directions is isotropic; otherwise, the substance is anisotropic. Liquid crystals have a degree of order only in certain directions, so they are anisotropic. **12.117**(a) n-type semiconductor (b) p-type semiconductor **12.119** $n = 3.4 \times 10^3$ **12.121** 8.4 pm

12.124(a) 19.8 torr (b) 0.0485 g **12.130** 259 K ($-14^\circ C$)

12.132(a) $2.23 \times 10^{-2}\text{ atm}$ (b) 6.23 L

12.135(a) furfuryl alcohol

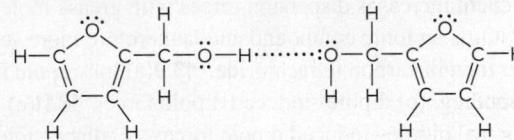

2-furoic acid

(b) furfuryl alcohol

2-furoic acid

12.136(a) 49.3 metric tons H_2O (b) $-1.11 \times 10^8\text{ kJ}$ **12.137** 2.9 g/m³

12.142(a) 1.1 min (b) 10. min

(c)

12.143 $2.98 \times 10^5\text{ g BN}$ **12.146** 45.98 amu

Chapter 13

Answer to Boxed Reading Problem: B13.1(a) The colloidal particles in water generally have negatively charged surfaces and so repel each other, slowing the settling process. Cake alum, $\text{Al}_2(\text{SO}_4)_3$, is added to coagulate the colloids. The Al^{3+} ions neutralize the negative surface charges on the particles, allowing them to aggregate and settle. (b) Water that contains large amounts of divalent cations (such as Ca^{2+} and Mg^{2+}) is called hard water. If this water is used for cleaning, these ions combine with the fatty-acid anions in soaps to produce insoluble deposits. (c) In reverse osmosis, a pressure greater than the osmotic pressure is applied to the solution, forcing the water back through the membrane, leaving the ions behind. (d) Chlorine may give the water an unpleasant odor, and it can form carcinogenic chlorinated organic compounds. (e) The high concentration of Na^+ in the saturated solution of NaCl displaces the divalent and polyvalent ions from the ion-exchange resin.

• **13.2** When a salt such as NaCl dissolves, ion-dipole forces cause the ions to separate, and many water molecules cluster around each ion in hydration shells. Ion-dipole forces bind the first shell to an ion. The water molecules in that shell form H bonds to others to create the next shell, and so on. **13.4** Sodium stearate is a more effective soap because the hydrocarbon chain in the stearate ion is longer than that in the acetate ion. The longer chain increases dispersion forces with grease molecules. **13.7** KNO_3 is an ionic compound and is therefore more soluble in water than in carbon tetrachloride. **13.9**(a) ion-dipole forces (b) H bonding (c) dipole-induced dipole forces **13.11**(a) H bonding (b) dipole-induced dipole forces (c) dispersion forces **13.13**(a) $\text{HCl}(g)$, because the molecular interactions (dipole-dipole forces) in ether are more like those in HCl than is the ionic bonding in NaCl . (b) $\text{CH}_3\text{CHO}(l)$, because the molecular interactions with ether (dipole-dipole forces) can replace those between CH_3CHO molecules, but not the H bonds between water molecules. (c) $\text{CH}_3\text{CH}_2\text{MgBr}(s)$, because the molecular interactions (dipole-dipole and dispersion forces) with ether are greater than those between ether molecules and the ions in MgBr_2 . **13.16** Gluconic acid is soluble in water due to the extensive H bonding involving the —OH groups attached to five of its carbons. The dispersion forces involving the nonpolar tails of caproic acid are more similar to the dispersion forces in hexane; thus, caproic acid is soluble in hexane. **13.18** The nitrogen-containing bases form H bonds to their complementary bases. The flat, N-containing bases stack above each other, which allows extensive dispersion forces. The exterior, negatively charged, sugar-phosphate chains experience ion-dipole forces and form H bonds with water molecules in the aqueous surroundings, which also stabilizes the structure.

13.21 Dispersion forces are present between the nonpolar tails of the lipid molecules within the bilayer. The polar heads interact with the aqueous surroundings through H bonds and ion-dipole forces. **13.25** The enthalpy changes needed to separate the solvent particles ($\Delta H_{\text{solvent}}$) and to mix the solvent and solute particles (ΔH_{mix}) combine to give $\Delta H_{\text{solution}}$.

13.29 The compound is very soluble in water, because a decrease in enthalpy and an increase in entropy both favor the formation of a solution.

13.30

13.32(a) The volume of Na^+ is smaller. (b) Sr^{2+} has a larger ionic charge and a smaller volume. (c) Na^+ is smaller than Cl^- . (d) O^{2-} has a larger ionic charge. (e) OH^- has a smaller volume than SH^- . (f) Mg^{2+} has a smaller volume. (g) Mg^{2+} has both a smaller volume and a larger ionic charge. (h) CO_3^{2-} has a larger ionic charge. **13.34**(a) Na^+ (b) Sr^{2+} (c) Na^+ (d) O^{2-} (e) OH^- (f) Mg^{2+} (g) Mg^{2+} (h) CO_3^{2-} **13.36**(a) -704 kJ/mol (b) The K^+ ion contributes more because it is smaller and, therefore, has a greater charge density. **13.38**(a) increases (b) decreases (c) increases **13.41** Add a pinch of X to each solution. Addition of a “seed” crystal of solute to a supersaturated solution causes the excess solute to crystallize immediately, leaving behind a saturated solution. The solution in which the added X dissolves is the unsaturated solution. The solution in which the added X remains undissolved is the saturated solution. **13.44**(a) increase (b) decrease **13.46**(a) 0.102 g O_2 (b) 0.0214 g O_2 **13.49** 0.20 mol/L

13.52(a) molarity and % w/v or % v/v (b) parts-by-mass (% w/w) (c) molality **13.54** With just this information, you can convert between molality and molarity, but you need to know the molar mass of the solvent to convert to mole fraction.

13.56(a) $0.944 \text{ M C}_{12}\text{H}_{22}\text{O}_{11}$ (b) 0.167 M LiNO_3 **13.58**(a) 0.0749 M NaOH (b) 0.36 M HNO_3 **13.60**(a) Add 4.25 g KH_2PO_4 to enough water to make 365 mL of aqueous solution. (b) Add 125 mL of 1.25 M NaOH to enough water to make 465 mL of solution.

13.62(a) Weigh out 48.0 g KBr , dissolve it in about 1 L distilled water, and then dilute to 1.40 L with distilled water. (b) Measure 82.7 mL of the 0.264 M LiNO_3 solution and add distilled water to make a total of 255 mL. **13.64**(a) 0.896 m glycine (b) 1.21 m glycerol **13.66** $4.48 \text{ m C}_6\text{H}_6$ **13.68**(a) Add 2.39 g $\text{C}_2\text{H}_6\text{O}_2$ to 308 g H_2O . (b) Add 0.0508 kg of 22.0% HNO_3 by mass to 1.15 kg H_2O to make 1.20 kg of 2.20% HNO_3 by mass. **13.70**(a) 0.29 (b) 58 mass % (c) $23 \text{ m C}_3\text{H}_7\text{OH}$ **13.72** 42.6 g CsBr ; mole fraction = 7.16×10^{-3} ; 7.84% by mass **13.74** 5.11 m NH_3 ; 4.53 M NH_3 ; mole fraction = 0.0843 **13.76** 2.5 ppm Ca^{2+} ; 0.56 ppm Mg^{2+} **13.80** Its solution conducts a “strong” current. A strong electrolyte dissociates completely into ions in solution.

13.82 The boiling point is higher and the freezing point is lower for the solution than for the pure solvent. **13.85** A dilute solution of an electrolyte behaves more ideally than a concentrated one. With increasing concentration, the effective concentration deviates from the molar concentration because of ionic attractions. Thus, 0.050 m NaF has a boiling point closer to its predicted value.

13.88(a) strong electrolyte (b) strong electrolyte (c) nonelectrolyte (d) weak electrolyte **13.90**(a) 0.6 mol of solute particles (b) 0.13 mol (c) $2 \times 10^{-4} \text{ mol}$ (d) 0.06 mol **13.92**(a) CH_3OH in H_2O (b) H_2O in CH_3OH solution **13.94**(a) $\Pi_{\text{II}} < \Pi_{\text{I}} < \Pi_{\text{III}}$ (b) $\text{bp}_{\text{II}} < \text{bp}_{\text{I}} < \text{bp}_{\text{III}}$ (c) $\text{fp}_{\text{III}} < \text{fp}_{\text{I}} < \text{fp}_{\text{II}}$ (d) $\text{vp}_{\text{III}} < \text{vp}_{\text{I}} < \text{vp}_{\text{II}}$ **13.96** 23.4 torr **13.98** -0.467°C **13.100** 79.5°C **13.102** $1.18 \times 10^4 \text{ g C}_2\text{H}_6\text{O}_2$

13.104 2.44×10^{-3} atm **13.106** 342 g/mol **13.108** -14.6°C

13.110(a) NaCl: 0.173 m and $i = 1.84$ (b) CH₃COOH: 0.0837 m and $i = 1.02$ **13.113** 209 torr for CH₂Cl₂; 48.1 torr for CCl₄

13.114 The fluid inside a bacterial cell is both a solution and a colloid. It is a solution of ions and small molecules and a colloid of large molecules (proteins and nucleic acids). **13.118** Soap micelles have nonpolar tails pointed inward and anionic heads pointed outward. The like charges on the heads of one micelle repel those on the heads of a neighboring micelle. This repulsion between micelles keeps them from coagulating. Soap is more effective in freshwater than in seawater because the divalent cations in seawater combine with the anionic heads to form a precipitate. **13.122** 3.4×10^9 L **13.126** 0.0°C: 4.53×10^{-4} M O₂; 20.0°C: 2.83×10^{-4} M O₂; 40.0°C: 2.00×10^{-4} M O₂

13.128(a) 89.9 g/mol (b) C₂H₅O; C₄H₁₀O₂

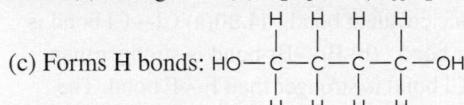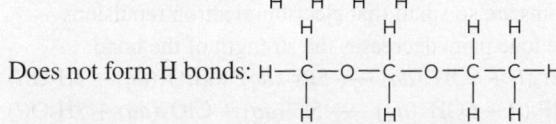

13.132(a) 9.45 g NaF (b) 0.0017 g F⁻ **13.135**(a) 68 g/mol

(b) 2.1×10^2 g/mol (c) The molar mass of CaN₂O₆ is 164.10 g/mol. This value is less than the 2.1×10^2 g/mol calculated when the compound is assumed to be a strong electrolyte and is greater than the 68 g/mol calculated when the compound is assumed to be a nonelectrolyte. Thus, the compound forms a nonideal solution because the ions interact and therefore do not dissociate completely in solution. (d) $i = 2.4$ **13.139**(a) 1.82×10^4 g/mol (b) 3.41×10^{-5} °C

13.140 8.2×10^5 ng/L **13.144**(a) 0.02 (b) 5×10^{-3} atm·L/mol (c) yes

13.146 Weigh 3.11 g of NaHCO₃ and dissolve in 247 g of water.

13.150 $M = m(\text{kg solvent/L solution}) = m \times d_{\text{solution}}$. Thus, for very dilute solutions, molality \times density = molarity. For an aqueous solution, the number of liters of solution is approximately the same as the kg of solvent because the density of water is close to 1 kg/L, so $m = M$. **13.152**(a) 2.5×10^{-3} M SO₂ (b) The base reacts with the sulfur dioxide to produce calcium sulfite. This removal of sulfur dioxide allows more sulfur dioxide to dissolve.

13.157(a) 7.83×10^{-3} mol/L·atm (b) 4×10^{-5} M (c) 3×10^{-6} (d) 1 ppm

13.161(a) 0.0212 mol/L·atm (b) 8.86 ppm (c) k_H : C₆F₁₄ > C₆H₁₄ > ethanol > water. To dissolve oxygen in a solvent, the solvent molecules must be moved apart to make room for the gas. The stronger the intermolecular forces in the solvent, the more difficult it is to separate solvent particles and the lower the solubility of the gas. Both C₆F₁₄ and C₆H₁₄ have weak dispersion forces, with C₆F₁₄ having the weaker forces due to the electro-negative fluorine atoms repelling each other. In both ethanol and water, the molecules are held together by strong H bonds with those bonds being stronger in water, as the boiling point indicates.

13.163(a) Yes, the phases of water can still coexist at some temperature and can therefore establish equilibrium. (b) The triple point would occur at a lower pressure and lower temperature because the dissolved air would lower the vapor pressure of the solvent. (c) Yes, this is possible because the gas-solid phase boundary exists below the new triple point. (d) No; at both temperatures, the presence of the solute lowers the vapor pressure of the liquid. **13.165**(a) 2.8×10^{-4} g/mL (b) 81 mL

Chapter 14

14.1 The outermost electron is attracted by a smaller effective nuclear charge in Li because of shielding by the inner electrons, and it is farther from the nucleus than the electron of H is. Both of these factors lead to a lower ionization energy for Li.

14.3(a) NH₃ will hydrogen bond.

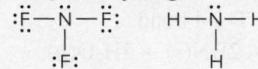

(b) CH₃CH₂OH will hydrogen bond.

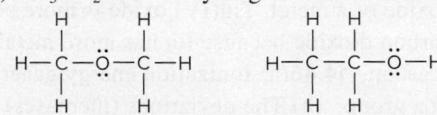

14.5(a) $2\text{Al}(s) + 6\text{HCl}(aq) \rightarrow 2\text{AlCl}_3(aq) + 3\text{H}_2(g)$

(b) $\text{LiH}(s) + \text{H}_2\text{O}(l) \rightarrow \text{LiOH}(aq) + \text{H}_2(g)$

14.7(a) NaBH₄: +1 for Na, +3 for B, -1 for H; Al(BH₄)₃: +3 for Al, +3 for B, -1 for H; LiAlH₄: +1 for Li, +3 for Al, -1 for H (b) tetrahedral

14.10 For Groups 1A(1) to 4A(14), the number of covalent bonds equals the A-group number. For Groups 5A(15) to 7A(17), it equals 8 minus the A-group number. There are exceptions in Period 3 to Period 6 because it is possible for the 3A(13) to 7A(17) elements to use *d* orbitals and form more bonds. **14.13**(a) Group 3A(13) or 3B(3) (b) If E is in Group 3B(3), the oxide will be more basic and the fluoride will be more ionic; if E is in Group 3A(13), the oxide will be more acidic and the fluoride will be more covalent. **14.16**(a) reducing agent (b) Alkali metals have relatively low ionization energies, which means they easily lose the outermost electron.

(c) $2\text{Na}(s) + 2\text{H}_2\text{O}(l) \rightarrow 2\text{Na}^+(aq) + 2\text{OH}^-(aq) + \text{H}_2(g)$

$2\text{Na}(s) + \text{Cl}_2(g) \rightarrow 2\text{NaCl}(s)$

14.18 Density and ionic size increase down a group; the other three properties decrease down a group.

14.20 $2\text{Na}(s) + \text{O}_2(g) \rightarrow \text{Na}_2\text{O}_2(s)$

14.22 $\text{K}_2\text{CO}_3(s) + 2\text{HI}(aq) \rightarrow 2\text{KI}(aq) + \text{H}_2\text{O}(l) + \text{CO}_2(g)$

14.26 Group 2A(2) metals have an additional valence electron to increase the strength of metallic bonding, which leads to higher melting points, and also higher boiling points, greater hardness, and greater density.

14.27(a) $\text{CaO}(s) + \text{H}_2\text{O}(l) \rightarrow \text{Ca}(\text{OH})_2(s)$

(b) $2\text{Ca}(s) + \text{O}_2(g) \rightarrow 2\text{CaO}(s)$

14.30(a) $\text{BeO}(s) + \text{H}_2\text{O}(l) \rightarrow$ no reaction

(b) $\text{BeCl}_2(l) + 2\text{Cl}^-(\text{solvated}) \rightarrow \text{BeCl}_4^{2-}(\text{solvated})$

Be behaves like other Group 2A(2) elements in reaction (b).

14.33 The electron removed from Group 2A(2) atoms occupies the outer *s* orbital, whereas in Group 3A(13) atoms, the electron occupies the outer *p* orbital. For example, the electron configuration for Be is $1s^2 2s^2$ and for B it is $1s^2 2s^2 2p^1$. It is easier to remove the *p* electron of B than an *s* electron of Be, because the energy of a *p* orbital is higher than that of the *s* orbital of the same level. Even though atomic size decreases because of increasing Z_{eff} , IE decreases from 2A(2) to 3A(13).

14.34(a) Most atoms form stable compounds when they complete their outer shell (octet). Some compounds of Group 3A(13) elements, like boron, have only six electrons around the central

atom. Having fewer than eight electrons is called *electron deficiency*.

14.36 $\text{In}_2\text{O}_3 < \text{Ga}_2\text{O}_3 < \text{Al}_2\text{O}_3$ **14.38** Apparent O.N., +3; actual O.N., +1. $[\ddot{\text{I}}-\ddot{\text{I}}-\ddot{\text{I}}]^-$ The anion I_3^- has the general formula AX_2E_3 and bond angles of 180° . $(\text{TI}^{3+})(\text{I}^-)_3$ does not exist because of the low strength of the $\text{TI}-\text{I}$ bond.

(b) $1.30 \times 10^2 \text{ kJ}$ (c) 5.3 kg borax **14.44** Basicity in water is greater for the oxide of a metal. Tin(IV) oxide is more basic in water than carbon dioxide because tin has more metallic character than carbon. **14.46(a)** Ionization energy generally decreases down a group. (b) The deviations (increases) from the expected trend are due to the presence of the first transition series between Si and Ge and of the lanthanides between Sn and Pb. (c) Group 3A(13) **14.49** Atomic size increases down a group. As atomic size increases, ionization energy decreases, and so it is easier to form a positive ion. An atom that is easier to ionize exhibits greater metallic character.

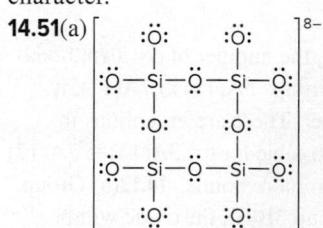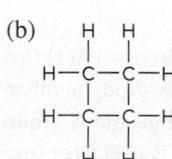

14.54(a) diamond, C **(b)** calcium carbonate, CaCO_3 **(c)** carbon dioxide, CO_2 **(d)** carbon monoxide, CO **(e)** silicon, Si

14.58(a) -3 to +5 **(b)** For a group of nonmetals, the oxidation states range from the lowest, equal to the A-group number -8, or $5 - 8 = -3$ for Group 5A, to the highest, equal to the A-group number, or +5 for Group 5A.

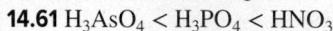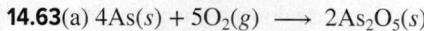

14.67 trigonal bipyramidal, with axial F atoms and equatorial Cl atoms;

14.75(a) Boiling point and conductivity vary in similar ways down both groups. (b) Degree of metallic character and types of bonding vary in similar ways down both groups. (c) Both P and S have allotropes, and both bond covalently with almost every other nonmetal. (d) Both N and O are diatomic gases at normal temperatures and pressures. (e) O_2 is a reactive gas, whereas N_2 is not. Nitrogen can have any of six oxidation states, whereas oxygen has two.

14.77(a) $\text{NaHSO}_4(aq) + \text{NaOH}(aq) \longrightarrow \text{Na}_2\text{SO}_4(aq) + \text{H}_2\text{O}(l)$

14.79(a) acidic **(b)** acidic **(c)** basic **(d)** amphoteric **(e)** basic

14.81 $\text{H}_2\text{O} < \text{H}_2\text{S} < \text{H}_2\text{Te}$ **14.84(a)** O_3 , ozone **(b)** SO_3 , sulfur trioxide **(c)** SO_2 , sulfur dioxide **(d)** H_2SO_4 , sulfuric acid **(e)** $\text{Na}_2\text{S}_2\text{O}_3 \cdot 5\text{H}_2\text{O}$, sodium thiosulfate pentahydrate

14.86 $\text{S}_2\text{F}_{10}(g) \longrightarrow \text{SF}_4(g) + \text{SF}_6(g)$; O.N. of S in S_2F_{10} is +5; O.N. of S in SF_4 is +4; O.N. of S in SF_6 is +6. **14.88(a)** -1, +1, +3, +5, +7 **(b)** The electron configuration for Cl is $[\text{Ne}] 3s^2 3p^5$. By gaining one electron, Cl achieves an octet. When forming covalent bonds, Cl completes or expands its valence level by maintaining electron pairs in bonds or as lone pairs. **(c)** Fluorine has only the -1 oxidation state because its small size and absence of *d* orbitals prevent it from forming more than one covalent bond. **14.90(a)** Cl-Cl bond is stronger than Br-Br bond. **(b)** Br-Br bond is stronger than I-I bond. **(c)** Cl-Cl bond is stronger than F-F bond. The fluorine atoms are so small that electron-electron repulsions between the lone pairs decreases the strength of the bond.

14.92(a) $3\text{Br}_2(l) + 6\text{OH}^-(aq) \longrightarrow 5\text{Br}^-(aq) + \text{BrO}_3^-(aq) + 3\text{H}_2\text{O}(l)$

14.95 $\text{HIO} < \text{HBrO} < \text{HClO} < \text{HClO}_2$ **14.99** $\text{I}_2 < \text{Br}_2 < \text{Cl}_2$,

because Cl_2 is able to oxidize Re to the +6 oxidation state, Br_2 only to the +5 state, and I_2 only to the +4 state **14.100** helium; argon **14.102** Only dispersion forces hold atoms of the noble gases together. **14.106** $\Delta H_{\text{soln}} = -411 \text{ kJ}$ **14.110(a)** Second ionization energies for alkali metals are so high because the electron being removed is from the next lower energy level and these are very tightly held by the nucleus. Also, the alkali metal would lose its noble gas electron configuration.

14.112(a) hyponitrous acid, $\text{H}_2\text{N}_2\text{O}_2$; nitroxyl, HNO

(c) In both species the shape is bent about the N atoms.

14.116 13 t **14.118** In a disproportionation reaction, a substance acts as both a reducing agent and an oxidizing agent because atoms of an element within the substance attain both higher and lower oxidation states in the products. The disproportionation reactions are b, c, d, e, and f. **14.120(a)** Group 5A(15)

(b) Group 7A(17) **(c)** Group 6A(16) **(d)** Group 1A(1)

(e) Group 3A(13) **(f)** Group 8A(18) **14.122** 117.2 kJ

The nitronium ion (NO_3^+) has a linear shape because the central N atom has two surrounding electron groups, which achieve minimum repulsion at 180° . The nitrite ion (NO_2^-) bond angle is

more compressed than the nitrogen dioxide (NO_2) bond angle because the lone pair of electrons takes up more space than the lone electron. **14.129** 2.29×10^4 g UF_6 **14.133** O^+ , O^- , and O^{2+} **14.134(a)** 39.96 mass % in CuHAsO_3 ; As, 62.42 mass % in $(\text{CH}_3)_3\text{As}$ **(b)** 0.35 g CuHAsO_3

Chapter 15

Answers to Boxed Reading Problems: **B15.1** butane, 2 peaks; 2-methylpropane, 2 peaks; pentane, 3 peaks; 2-methylbutane, 4 peaks; 2,2-dimethylpropane, 1 peak **B15.2** 0.08 J/mol

• 15.2(a) Carbon's electronegativity is midway between the most metallic and most nonmetallic elements of Period 2. To attain a filled outer shell, carbon forms covalent bonds to other atoms in molecules, network covalent solids, and polyatomic ions. **(b)** Since carbon has four valence shell electrons, it forms four covalent bonds to attain an octet. **(c)** To reach the He electron configuration, a carbon atom must lose four electrons, requiring too much energy to form the C^{4+} cation. To reach the Ne electron configuration, the carbon atom must gain four electrons, also requiring too much energy to form the C^{4-} anion. **(d)** Carbon is able to bond to itself extensively because its small size allows for close approach and great orbital overlap. The extensive orbital overlap results in a strong, stable bond. **(e)** The C—C σ bond is short enough to allow sideways overlap of unhybridized p orbitals of neighboring C atoms. The sideways overlap of p orbitals results in the π bonds that are part of double and triple bonds.

15.3(a) H, O, N, P, S, and halogens **(b)** Heteroatoms are atoms of any element other than carbon and hydrogen. **(c)** More electronegative than C: N, O, F, Cl, and Br; less electronegative than C: H and P. Sulfur and iodine have the same electronegativity as carbon. **(d)** Since carbon can bond to a wide variety of heteroatoms and to other carbon atoms, it can form many different compounds.

15.6 The C—H and C—C bonds are unreactive because electronegativities are close and the bonds are short. The C—I bond is somewhat reactive because it is long and weak. The C=O bond is reactive because oxygen is more electronegative than carbon and the partially positive C atom attracts electron-rich atoms. The C—Li bond is also reactive because the bond polarity results in an electron-rich region around carbon and an electron-poor region around lithium. **15.7(a)** An alkane and a cycloalkane are organic compounds that consist of carbon and hydrogen and have only single bonds. A cycloalkane has a ring of carbon atoms. An alkene is a hydrocarbon with at least one double bond. An alkyne is a hydrocarbon with at least one triple bond. **(b)** alkane = $\text{C}_n\text{H}_{2n+2}$, cycloalkane = C_nH_{2n} , alkene = C_nH_{2n} , alkyne = $\text{C}_n\text{H}_{2n-2}$ **(c)** Alkanes and cycloalkanes are saturated hydrocarbons. **15.10** a, c, and f

15.15(a)

15.52 Both groups react by addition to the π bond. The very polar C=O bond attracts the electron-rich O of water to the partially positive C. There is no such polarity in the alkene, so either C atom can be attacked, and two products result.

15.55 Esters and acid anhydrides form through dehydration-condensation reactions, and water is the other product.

15.57(a) alkyl halide (b) nitrile (c) carboxylic acid (d) aldehyde

15.73(a) propanoic acid **(b)** ethylamine **15.77** addition reactions and condensation reactions **15.80** Dispersion forces are responsible for strong attractions between the long, unbranched chains of high-density polyethylene (HDPE). Low-density polyethylene (LDPE) has branching in the chains that prevents packing and weakens these attractions. **15.82** An amine and a carboxylic acid react to form a nylon; a carboxylic acid and an alcohol form a polyester.

15.87(a) condensation **(b)** addition **(c)** condensation **(d)** condensation

15.89 The amino acid sequence in a protein determines its shape and structure, which determine its function. **15.92** The DNA base sequence determines the RNA base sequence, which determines the protein amino acid sequence.

15.93(a) **(b)** **(c)**

15.97(a) AATCGG **(b)** TCTGTA **15.99** ACAATGCCT; this sequence codes for three amino acids. **15.101(a)** Both R groups are from cysteine, which can form a disulfide bond (covalent bond). (b) Lysine and aspartic acid give a salt link. (c) Asparagine and serine will hydrogen bond. (d) Valine and phenylalanine interact through dispersion forces. **15.106(a)** Perform an acid-catalyzed dehydration of the alcohol followed by addition of Br₂. (b) Oxidize 1 mol of ethanol to acetic acid, then react 1 mol of acetic acid with 1 mol of ethanol to form the ester.

15.108

15.109 (a)

- (b) Carbon 1 is sp^2 hybridized. Carbon 2 is sp^3 hybridized.
Carbon 3 is sp^3 hybridized. Carbon 4 is sp^2 hybridized.
Carbon 5 is sp^3 hybridized. Carbons 6 and 7 are sp^2 hybridized.
(c) Carbons 2, 3, and 5 are chiral centers, as they are each bonded to four different groups. **15.113** The resonance structures show that the bond between carbon and nitrogen will have some double bond character that restricts rotation around the bond.

- 15.116(a)** Hydrolysis requires the addition of water to break the peptide bonds. (b) glycine, 4; alanine, 1; valine, 3; proline, 6; serine, 7; arginine, 49 (c) 10,700 g/mol **15.117** When 2-butanone is reduced, equal amounts of both isomers are produced because the reaction does not favor the production of one over the other. The mixture is not optically active since the rotation of light to the right by one isomer cancels the rotation of light to the left by the other isomer.

Chapter 16

Answers to Boxed Reading Problems:

- B16.2** (a) Step 1 $\text{NO(g)} + \text{O}_3\text{(g)} \rightarrow \text{NO}_2\text{(g)} + \text{O}_2\text{(g)}$
Step 2 $\text{NO}_2\text{(g)} + \text{O(g)} \rightarrow \text{NO(g)} + \text{O}_2\text{(g)}$
Overall $\text{O}_3\text{(g)} + \text{O(g)} \rightarrow 2\text{O}_2\text{(g)}$
(b) rate = 3×10^7 molecule/s

B16.3 (a) Step 1 with Cl will have the higher value for the *p* factor. Since Cl is a single atom, no matter how it collides with the ozone molecule, the two particles should react, if the collision has enough energy. NO is a molecule. If the O₃ molecule collides with the N atom in the NO molecule, reaction can occur as a bond can form between N and O; if the O₃ molecule collides with the O atom in the NO molecule, reaction will not occur as the bond between N and O cannot form. The probability of a successful collision is smaller with NO. (b) :Cl.....O.....O=O

• **16.2** Reaction rate is proportional to concentration. An increase in pressure will increase the concentration of gas-phase reactants, resulting in an increased rate. **16.3** The addition of water will lower the concentrations of all dissolved solutes, and the rate will decrease. **16.5** An increase in temperature increases the rate by increasing the number of collisions between particles, but more importantly, it increases the energy of collisions. **16.8(a)** The instantaneous rate is the rate at one point in time during the reaction. The average rate is the average over a period of time. On a graph of reactant concentration vs. time, the instantaneous rate is the slope of the tangent to the curve at any point. The average rate is the slope of the line connecting two points on the curve. The closer together the two points (the shorter the time interval), the closer the average rate is to the instantaneous rate. (b) The initial rate is the instantaneous rate at the point on the graph where *t* = 0, that is, when reactants are mixed.

16.10

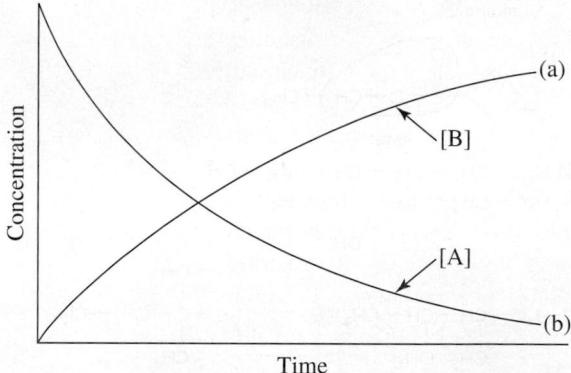

$$\begin{aligned} \text{16.12(a)} \text{ rate} &= -\left(\frac{1}{2}\right) \frac{\Delta[\text{AX}_2]}{\Delta t} \\ &= -\left(\frac{1}{2}\right) \frac{(0.0088 \text{ mol/L} - 0.0500 \text{ mol/L})}{(20.0 \text{ s} - 0 \text{ s})} \\ &= 0.0010 \text{ mol/L} \cdot \text{s} \end{aligned}$$

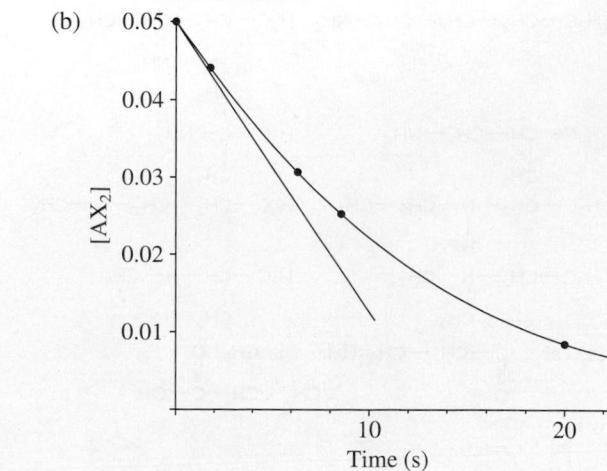

Estimated initial rate = 0.004 mol/L·s. The initial rate is higher than the average rate because the rate decreases as reactant concentration decreases.

$$\text{16.14 rate} = -\frac{1}{2} \frac{\Delta[\text{A}]}{\Delta t} = \frac{\Delta[\text{B}]}{\Delta t} = \frac{\Delta[\text{C}]}{\Delta t}; 4 \text{ mol/L}\cdot\text{s}$$

$$\text{16.16 rate} = -\frac{\Delta[\text{A}]}{\Delta t} = -\frac{1}{2} \frac{\Delta[\text{B}]}{\Delta t} = \frac{\Delta[\text{C}]}{\Delta t}; 0.2 \text{ mol/L}\cdot\text{s}$$

$$\text{16.21 rate} = -\frac{\Delta[\text{N}_2]}{\Delta t} = -\frac{1}{3} \frac{\Delta[\text{H}_2]}{\Delta t} = \frac{1}{2} \frac{\Delta[\text{NH}_3]}{\Delta t}$$

$$\text{16.22(a) rate} = -\frac{1}{3} \frac{\Delta[\text{O}_2]}{\Delta t} = \frac{1}{2} \frac{[\Delta\text{O}_3]}{\Delta t}$$

$$(b) 1.45 \times 10^{-5} \text{ mol/L}\cdot\text{s}$$

16.23(a) k is the rate constant, the proportionality constant in the rate law; it is specific to the reaction and that temperature at which the reaction occurs. (b) m represents the order of the reaction with respect to [A], and n represents the order of the reaction with respect to [B]. The order of a reactant does not necessarily equal its stoichiometric coefficient in the balanced equation. (c) L²/mol²·min **16.25**(a) Rate doubles. (b) Rate decreases by a factor of 4. (c) Rate increases by a factor of 9.

16.26 first order in BrO₃⁻; first order in Br⁻; second order in H⁺; fourth order overall **16.28**(a) Rate doubles. (b) Rate is halved.

(c) The rate increases by a factor of 16. **16.30** second order in NO₂; first order in Cl₂; third order overall **16.32**(a) Rate increases by a factor of 9. (b) Rate increases by a factor of 8. (c) Rate is halved.

16.34(a) second order in A; first order in B (b) rate = $k[\text{A}]^2[\text{B}]$

(c) $5.00 \times 10^3 \text{ L}^2/\text{mol}^2\cdot\text{min}$ **16.36**(a) time⁻¹ (b) L/mol·time

(c) L²/mol²·time (d) L^{3/2}/mol^{3/2}·time **16.39** The integrated rate law can be used to plot a graph. If the plot of [reactant] versus time is linear, the order is zero. If the plot of ln[reactant] versus time is linear, the order is first. If the plot of inverse concentration (1/[reactant]) versus time is linear, the order is second. (a) first order (b) second order (c) zero order **16.41** 7 s **16.43** 22 minutes

16.45(a) $k = 0.0660 \text{ min}^{-1}$ (b) 21.0 min

16.47(a)	x-axis (time, s)	[NH ₃]	y-axis (ln [NH ₃])
0		4.000 M	1.38629
1.000		3.986 M	1.38279
2.000		3.974 M	1.37977

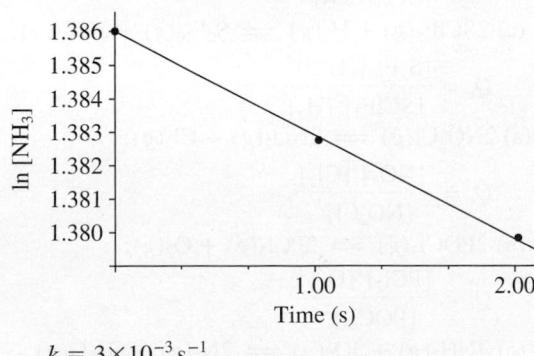

$$k = 3 \times 10^{-3} \text{ s}^{-1}$$

$$(b) t_{1/2} = 2 \times 10^2 \text{ s}$$

16.49 No, other factors that affect the rate are the energy and orientation of the collisions. **16.52** Measure the rate constant at a series of temperatures and plot ln k versus 1/T. The slope of the line equals $-E_a/R$. **16.55** No, reaction is reversible and will

eventually reach a state where the forward and reverse rates are equal. When this occurs, there are no concentrations equal to zero. Since some reactants are reformed from EF, the amount of EF will be less than 4×10^{-5} mol. **16.56** At the same temperature, both reaction mixtures have the same average kinetic energy, but the reactant molecules do not have the same average velocity. The trimethylamine molecule has greater mass than the ammonia molecule, so trimethylamine molecules will collide less often with HCl molecules. Moreover, the bulky groups bonded to nitrogen in trimethylamine mean that collisions with HCl having the correct orientation occur less frequently. Therefore, the rate of the reaction between NH₃ and HCl is higher. **16.57** 12 unique collisions **16.59** 2.96×10^{-18} **16.61** 0.033 s⁻¹

16.63(a)

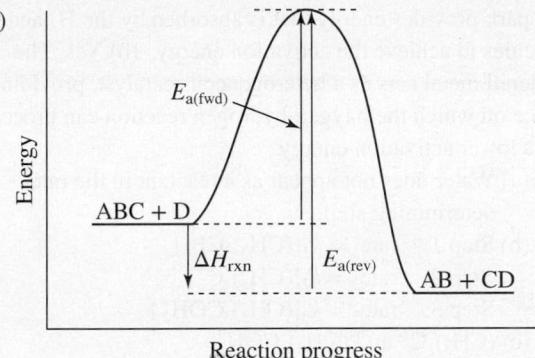

Reaction progress

$$(b) 2.70 \times 10^2 \text{ kJ/mol}$$

(c)

16.66(a) Because the enthalpy change is positive, the reaction is endothermic.

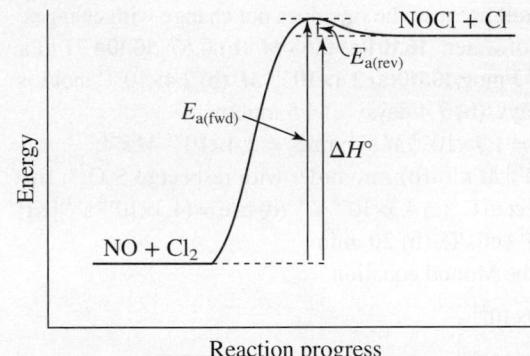

Reaction progress

$$(b) 3 \text{ kJ} \quad (c) :\ddot{\text{C}}\text{l}\cdots\ddot{\text{C}}\text{l}\cdots\ddot{\text{N}}=\ddot{\text{O}}:$$

16.67 The rate of an overall reaction depends on the rate of the slowest step. The rate of the overall reaction will be lower than the average of the individual rates because the average includes higher rates as well. **16.71** The probability of three particles colliding with one another with the proper energy and orientation is much less than the probability of two particles doing so.

16.72 No, the overall rate law must contain only reactants (no intermediates), and the overall rate is determined by the slow step.

16.74(a) A(g) + B(g) + C(g) → D(g)

(b) X and Y are intermediates.

(c) Step	Molecularity	Rate Law
$A(g) + B(g) \rightleftharpoons X(g)$	bimolecular	rate ₁ = $k_1[A][B]$
$X(g) + C(g) \rightarrow Y(g)$	bimolecular	rate ₂ = $k_2[X][C]$
$Y(g) \rightarrow D(g)$	unimolecular	rate ₃ = $k_3[Y]$

(d) yes (e) yes **16.76** The proposed mechanism is valid because the individual steps are chemically reasonable, they add to give the overall equation, and the rate law for the mechanism matches the observed rate law. **16.79** No. A catalyst changes the mechanism of a reaction to one with lower activation energy. Lower activation energy means a faster reaction. An increase in temperature does not influence the activation energy, but increases the fraction of collisions with sufficient energy to equal or exceed the activation energy. **16.80(a)** No. The spark provides energy that is absorbed by the H₂ and O₂ molecules to achieve the activation energy. (b) Yes. The powdered metal acts as a heterogeneous catalyst, providing a surface on which the oxygen-hydrogen reaction can proceed with a lower activation energy.

16.85(a) Water does not appear as a reactant in the rate-determining step.

- (b) Step 1: rate₁ = $k_1[(CH_3)_3CBr]$
 Step 2: rate₂ = $k_2[(CH_3)_3C^+]$
 Step 3: rate₃ = $k_3[(CH_3)_3COH^+]$

(c) (CH₃)₃C⁺ and (CH₃)₃COH⁺

(d) The rate-determining step is step 1. The rate law for this step agrees with the rate law observed with $k = k_1$.

16.87 4.61×10^4 J/mol **16.91(a)** Rate increases 2.5 times. (b) Rate is halved. (c) Rate decreases by a factor of 0.01. (d) Rate does not change. **16.92** second order **16.95** 57 yr **16.98(a)** 0.21 h^{-1} ; 3.3 h (b) 6.6 h (c) If the concentration of sucrose is relatively low, the concentration of water remains nearly constant even with small changes in the amount of water. This gives an apparent zero-order reaction with respect to water. Thus, the reaction is first order overall because the rate does not change with changes in the amount of water. **16.101(a)** 0.68 M (b) 0.57 **16.104** 71 kPa

16.108 7.3×10^3 J/mol **16.110(a)** $2.4 \times 10^{-15}\text{ M}$ (b) $2.4 \times 10^{-11}\text{ mol/L}\cdot\text{s}$

16.113(a) 2.8 days (b) 7.4 days (c) 4.5 mol/m^3

16.116(a) rate₁ = $1.7 \times 10^{-5}\text{ M s}^{-1}$; rate₂ = $3.4 \times 10^{-5}\text{ M s}^{-1}$; rate₃ = $3.4 \times 10^{-5}\text{ M s}^{-1}$ (b) zero order with respect to S₂O₈²⁻; first order with respect to I⁻ (c) $4.3 \times 10^{-4}\text{ s}^{-1}$ (d) rate = $(4.3 \times 10^{-4}\text{ s}^{-1})[KI]$

16.118(a) 7×10^4 cells/L (b) 20. min

16.121(a) Use the Monod equation.

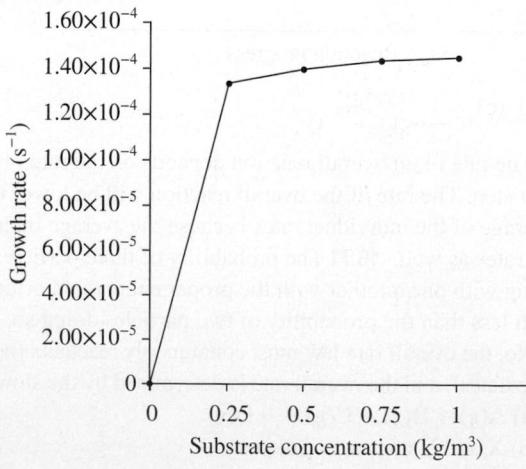

(b) 8.2×10^3 cells/m³ (c) 8.4×10^3 cells/m³

16.126(a) 8.0×10^1 s (b) 59 s (c) 2.6×10^2 s

Chapter 17

Answers to Boxed Reading Problems: **B17.1(a)** Enzyme 3

(b) Enzyme 6 (c) If F inhibited enzyme 1, neither branch of the pathway would occur when enough F was made and product I would be lacking. (d) If F inhibited enzyme 6, the second branch would not take place when enough F was made, and more F would build up.

• **17.1** If the change is in concentration, it results temporarily in more products and less reactants. After equilibrium is re-established, K_c remains unchanged because the ratio of products and reactants remains the same. **17.7** The equilibrium constant expression is $K = [O_2]$. If the temperature remains constant, K remains constant. If the initial amount of Li₂O₂ present is sufficient to reach equilibrium, the amount of O₂ obtained will be constant.

$$\text{17.8(a)} Q = \frac{[\text{HI}]^2}{[\text{H}_2][\text{I}_2]}$$

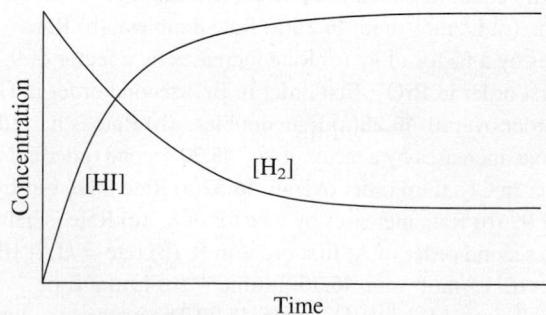

The value of Q increases as a function of time until it reaches the value of K . (b) no **17.11** Yes. If Q_1 is for the formation of 1 mol NH₃ from H₂ and N₂, and Q_2 is for the formation of NH₃ from H₂ and 1 mol of N₂, then $Q_2 = Q_1^2$.

17.12(a) $4\text{NO}(g) + \text{O}_2(g) \rightleftharpoons 2\text{N}_2\text{O}_3(g)$;

$$Q_c = \frac{[\text{N}_2\text{O}_3]^2}{[\text{NO}]^4[\text{O}_2]}$$

(b) $\text{SF}_6(g) + 2\text{SO}_3(g) \rightleftharpoons 3\text{SO}_2\text{F}_2(g)$;

$$Q_c = \frac{[\text{SO}_2\text{F}_2]^3}{[\text{SF}_6][\text{SO}_3]^2}$$

(c) $2\text{SClF}_5(g) + \text{H}_2(g) \rightleftharpoons \text{S}_2\text{F}_{10}(g) + 2\text{HCl}(g)$;

$$Q_c = \frac{[\text{S}_2\text{F}_{10}][\text{HCl}]^2}{[\text{SClF}_5]^2[\text{H}_2]}$$

17.14(a) $2\text{NO}_2\text{Cl}(g) \rightleftharpoons 2\text{NO}_2(g) + \text{Cl}_2(g)$;

$$Q_c = \frac{[\text{NO}_2]^2[\text{Cl}_2]}{[\text{NO}_2\text{Cl}]^2}$$

(b) $2\text{POCl}_3(g) \rightleftharpoons 2\text{PCl}_3(g) + \text{O}_2(g)$;

$$Q_c = \frac{[\text{PCl}_3]^2[\text{O}_2]}{[\text{POCl}_3]^2}$$

(c) $4\text{NH}_3(g) + 3\text{O}_2(g) \rightleftharpoons 2\text{N}_2(g) + 6\text{H}_2\text{O}(g)$;

$$Q_c = \frac{[\text{N}_2]^2[\text{H}_2\text{O}]^6}{[\text{NH}_3]^4[\text{O}_2]^3}$$

17.16(a) 7.9 (b) 3.2×10^{-5}

17.18(a) $2\text{Na}_2\text{O}_2(s) + 2\text{CO}_2(g) \rightleftharpoons 2\text{Na}_2\text{CO}_3(s) + \text{O}_2(g)$;

$$Q_c = \frac{[\text{O}_2]}{[\text{CO}_2]^2}$$

$$Q_c = \frac{[\text{H}_2\text{O}]^2}{[\text{H}_2]^2}$$

$$Q_c = \frac{1}{[\text{SO}_3]}$$

$$(b) Q_{\text{overall}} = Q_1 Q_2 = \frac{[\text{ClF}_3]^2}{[\text{Cl}_2][\text{F}_2]} \times \frac{[\text{ClF}_3]^2}{[\text{ClF}]^2[\text{F}_2]^2} \\ = \frac{[\text{ClF}_3]^2}{[\text{Cl}_2][\text{F}_2]^3}$$

17.26 K_c and K_p are equal when $\Delta n_{\text{gas}} = 0$; K_c and K_p are not equal when Δn_{gas} does not equal 0. **17.27(a)** smaller (b) Assuming that $RT > 1$ ($T > 12.2$ K), $K_p > K_c$ if there are more moles of products than reactants at equilibrium, and $K_p < K_c$ if there are more moles of reactants than products. **17.28(a)** 3 (b) -1 (c) 3

17.30(a) 3.2 (b) 28.5 **17.32(a)** 0.15 (b) 3.6×10^{-7} **17.34** The reaction quotient (Q) and equilibrium constant (K) are determined by the ratio [products]/[reactants]. When $Q < K$, the reaction proceeds to the right to form more products. **17.36** no; to the left. **17.39** At equilibrium, equal concentrations of CFCl_3 and HCl exist, regardless of starting reactant concentrations, because the product coefficients are equal. **17.41(a)** The approximation applies when the change in concentration from initial concentration to equilibrium concentration is so small that it is insignificant; this occurs when K is small and initial concentration is large. (b) This approximation should not be used when the change in concentration is greater than 5%. This can occur when [reactant]_{initial} is very small or when change in [reactant] is relatively large due to a large K . **17.42** 50.8

Initial	0.075	0	0
Change	$-x$	$+x$	$+x$
Equilibrium	$0.075 - x$	x	x

17.56 6.01×10^{-6} **17.59** Equilibrium position refers to the specific concentrations or pressures of reactants and products that exist at equilibrium, whereas equilibrium constant is the overall ratio of equilibrium concentrations or pressures. Equilibrium position changes as a result of a change in reactant (or product) concentration.

17.60(a) B, because the amount of product increases with temperature (b) A, because the lowest temperature will give the least product **17.64(a)** shifts toward products (b) shifts toward products (c) does not shift (d) shifts toward reactants

17.66(a) more F and less F_2 (b) more C_2H_2 and H_2 and less CH_4

17.68(a) no effect (b) less H_2 and O_2 and more H_2O **17.70(a)** no change (b) increase volume **17.72(a)** amount decreases

(b) amounts increase (c) amounts increase (d) amount decreases **17.74** 2.0 **17.77(a)** lower temperature, higher pressure (b) Q decreases; no change in K (c) Reaction rates are lower at lower temperatures, so a catalyst is used to speed up the reaction.

(b) $P_{\text{N}_2} = 18$ atm; $P_{\text{H}_2} = 111$ atm; $P_{\text{total}} = 179$ atm; not a valid suggestion **17.82** 0.204 atm **17.85(a)** 3×10^{-3} atm (b) high pressure; low temperature (c) 2×10^5 (d) No, because water condenses at a higher temperature. **17.87(a)** 0.016 atm (b) $K_c = 5.6 \times 10^2$; $P_{\text{SO}_2} = 0.16$ atm **17.89** 12.5 g CaCO_3

17.93 Both concentrations increased by a factor of 2.2.

(b) 1.76×10^{29} (c) 3.19×10^{23} (d) 48 atm **17.100(a)** 4.0×10^{-21} atm (b) 5.5×10^{-8} atm (c) 29 N atoms/L; 4.0×10^{14} H atoms/L

(d) The more reasonable step is $\text{N}_2(g) + \text{H}(g) \rightarrow \text{NH}(g) + \text{N}(g)$. With only 29 N atoms in 1.0 L, the first reaction would produce virtually no $\text{NH}(g)$ molecules. There are orders of magnitude more N_2 molecules than N atoms, so the second reaction is the more reasonable step. **17.103(a)** $P_{\text{N}_2} = 0.780$ atm; $P_{\text{O}_2} = 0.210$ atm; $P_{\text{NO}} = 2.67 \times 10^{-16}$ atm (b) 0.990 atm (c) $K_c = K_p = 4.35 \times 10^{-31}$ **17.105(a)** 1.26×10^{-3} (b) 794 (c) -51.8 kJ (d) 1.2×10^4 J/mol **17.109(a)** 1.52 (b) 0.9626 atm (c) 0.2000 mol CO (d) 0.01097 M

Chapter 18

18.2 All Arrhenius acids have H in their formula and produce hydronium ion (H_3O^+) in aqueous solution. All Arrhenius bases have OH in their formula and produce hydroxide ion (OH^-) in aqueous solution. Neutralization occurs when each H_3O^+ ion combines with an OH^- ion to form two molecules of H_2O . Chemists found the reaction of any strong base with any strong acid always had $\Delta H = -56$ kJ/mol H_2O produced. **18.4** Strong acids and bases dissociate completely into ions when dissolved in water. Weak acids and bases dissociate only partially. The characteristic property of all weak acids is that a great majority of the acid molecules are undissociated in aqueous solution.

18.5 a, c, and d **18.7 b and d**

$$18.9(a) K_a = \frac{[\text{CN}^-][\text{H}_3\text{O}^+]}{[\text{HCN}]}$$

$$(b) K_a = \frac{[\text{CO}_3^{2-}][\text{H}_3\text{O}^+]}{[\text{HCO}_3^-]}$$

$$(c) K_a = \frac{[\text{HCOO}^-][\text{H}_3\text{O}^+]}{[\text{HCOOH}]}$$

$$18.11(a) K_a = \frac{[\text{NO}_2^-][\text{H}_3\text{O}^+]}{[\text{HNO}_2]}$$

$$(b) K_a = \frac{[\text{CH}_3\text{COO}^-][\text{H}_3\text{O}^+]}{[\text{CH}_3\text{COOH}]}$$

$$(c) K_a = \frac{[\text{BrO}_2^-][\text{H}_3\text{O}^+]}{[\text{HBrO}_2]}$$

18.15(a) weak acid (b) strong base (c) weak acid (d) strong acid

- 18.17**(a) strong base (b) strong acid (c) weak acid (d) weak acid
18.22(a) The acid with the smaller K_a (4×10^{-5}) has the higher pH, because less dissociation yields fewer hydronium ions.
(b) The acid with the larger pK_a (3.5) has the higher pH, because it has a smaller K_a and, thus, lower $[H_3O^+]$. (c) The solution of lower concentration (0.01 M) contains fewer hydronium ions.
(d) A 0.1 M weak acid solution contains fewer hydronium ions.
(e) The 0.01 M base solution contains more hydroxide ions, so fewer hydronium ions. (f) The solution that has $pOH = 6.0$ has the higher pH: $pH = 14.0 - 6.0 = 8.0$. **18.23**(a) 12.05; basic
(b) 11.13; acidic **18.25**(a) 2.212; acidic (b) -0.708; basic
18.27(a) $[H_3O^+] = 1.4 \times 10^{-10} M$, $[OH^-] = 7.1 \times 10^{-5} M$, $pOH = 4.15$
(b) $[H_3O^+] = 2.7 \times 10^{-5} M$, $[OH^-] = 3.7 \times 10^{-10} M$, $pH = 4.57$
18.29(a) $[H_3O^+] = 1.7 \times 10^{-5} M$, $[OH^-] = 5.9 \times 10^{-10} M$, $pOH = 9.23$
(b) $[H_3O^+] = 4.5 \times 10^{-9} M$, $[OH^-] = 2.2 \times 10^{-6} M$, $pH = 8.36$
18.31 4.8×10^{-4} mol OH^-/L **18.33** 1.4×10^{-4} mol OH^-
18.36(a) $2H_2O(l) + \text{heat} \rightleftharpoons H_3O^+(aq) + OH^-(aq)$. As the temperature increases, the reaction shifts to the formation of products; rising temperature increases the value of K_w .
(b) $K_w = 2.5 \times 10^{-14}$; $pOH = 6.80$; $[OH^-] = 1.6 \times 10^{-7} M$

18.37 The Brønsted-Lowry model defines acids as proton donors and bases as proton acceptors, while the Arrhenius model defines acids as species containing ionizable hydrogen atoms and bases as species containing hydroxide ions. In both definitions, an acid produces H_3O^+ ions and a base produces OH^- ions when added to water. Ammonia and carbonate ion are two Brønsted-Lowry bases that are not Arrhenius bases because they do not contain OH^- ions. Brønsted-Lowry acids must contain an ionizable hydrogen atom in order to be proton donors, so a Brønsted-Lowry acid is also an Arrhenius acid. **18.40** An amphiprotic species is one that can lose a proton to act as an acid or gain a proton to act as a base. The dihydrogen phosphate ion, $H_2PO_4^-$, is an example.

$$K_a = \frac{[H_3O^+][H_2PO_4^-]}{[H_3PO_4]}$$

$$K_a = \frac{[H_3O^+][C_6H_5COO^-]}{[C_6H_5COOH]}$$

$$K_a = \frac{[H_3O^+][SO_4^{2-}]}{[HSO_4^-]}$$

acid base base acid

Conjugate acid-base pairs: HCl/Cl^- and H_3O^+/H_2O

acid base base acid

Conjugate acid-base pairs: $HClO_4/ClO_4^-$ and $H_3SO_4^+/H_2SO_4$

base acid acid base

Conjugate acid-base pairs: H_2SO_4/HSO_4^- and $H_2PO_4^-/HPO_4^{2-}$

- 18.49(a)** $NH_3 + H_3PO_4 \rightleftharpoons NH_4^+ + H_2PO_4^-$
- | | | | |
|------|------|------|------|
| base | acid | acid | base |
|------|------|------|------|
- Conjugate acid-base pairs: $H_3PO_4/H_2PO_4^-$ and NH_4^+/NH_3
- 18.51(a)** $OH^-(aq) + H_2PO_4^-(aq) \rightleftharpoons H_2O(l) + HPO_4^{2-}(aq)$
- | | | | |
|------|------|------|------|
| base | acid | acid | base |
|------|------|------|------|
- Conjugate acid-base pairs: $H_2PO_4^-/HPO_4^{2-}$ and H_2O/OH^-
- 18.53** $K_c > 1: HS^- + HCl \rightleftharpoons H_2S + Cl^-$
 $K_c < 1: H_2S + Cl^- \rightleftharpoons HS^- + HCl$
- 18.55** $K_c > 1$ for both a and b **18.57** $K_c < 1$ for both a and b
- 18.59**(a) A strong acid is 100% dissociated, so the acid concentration will be very different after dissociation. (b) A weak acid dissociates to a very small extent, so the acid concentration before and after dissociation is nearly the same. (c) The acid concentration is nearly the same, but the extent of dissociation is greater than for a concentrated solution. (d) The acid concentration will be very different after dissociation.
- 18.60** No. HCl is a strong acid and dissociates to a greater extent than the weak acid CH_3COOH . The K_a of the acid, not the concentration of H_3O^+ , determines the strength of the acid. **18.61** scene 1 **18.64** 1.5×10^{-5} **18.66** $[H_3O^+] = [NO_2^-] = 2.1 \times 10^{-2} M$; $[OH^-] = 4.8 \times 10^{-13} M$ **18.68** $[H_3O^+] = [ClCH_2COO^-] = 0.041 M$; $[ClCH_2COOH] = 1.21 M$; $pH = 1.39$
- 18.70**(a) $[H_3O^+] = 6.0 \times 10^{-3} M$; $pH = 2.22$; $[OH^-] = 1.7 \times 10^{-12} M$; $pOH = 11.78$ (b) 1.9×10^{-4} **18.72** 2.2×10^{-7} **18.74**(a) 2.37
(b) 11.53 **18.76**(a) 2.290 (b) 12.699 **18.78** 1.1% **18.80** $[H_3O^+] = [HS^-] = 9 \times 10^{-5} M$; $pH = 4.0$; $[OH^-] = 1 \times 10^{-10} M$; $pOH = 10.0$; $[H_2S] = 0.10 M$; $[S^{2-}] = 1 \times 10^{-17} M$ **18.83** 1.5% **18.84** As a nonmetal becomes more electronegative, the acidity of its binary hydride increases. The electronegative nonmetal attracts the electrons more strongly in the polar bond, shifting the electron density away from H, thus making H^+ more easily transferred to a water molecule to form H_3O^+ . **18.87** Chlorine is more electronegative than iodine, and $HClO_4$ has more oxygen atoms than HIO . **18.88**(a) H_2SeO_4 (b) H_3PO_4 (c) H_2Te **18.90**(a) H_2Se (b) $B(OH)_3$ (c) $HBrO_2$ **18.92**(a) 0.5 M $AlBr_3$ (b) 0.3 M $SnCl_2$
- 18.94**(a) 0.2 M $Ni(NO_3)_2$ (b) 0.35 M $Al(NO_3)_3$ **18.96** All Brønsted-Lowry bases contain at least one lone pair of electrons, which binds an H^+ and allows the base to act as a proton acceptor.
- 18.99(a)** $C_5H_5N(aq) + H_2O(l) \rightleftharpoons OH^-(aq) + C_5H_5NH^+(aq)$
- $$K_b = \frac{[C_5H_5NH^+][OH^-]}{[C_5H_5N]}$$
- 18.101(a)** $HONH_2(aq) + H_2O(l) \rightleftharpoons OH^-(aq) + HONH_3^+(aq)$
- $$K_b = \frac{[HONH_3^+][OH^-]}{[HONH_2]}$$

$$K_b = \frac{[\text{H}_2\text{PO}_4^-][\text{OH}^-]}{[\text{HPO}_4^{2-}]}$$

18.103 11.79 **18.105** 11.45 **18.107(a)** 5.6×10^{-10} (b) 2.5×10^{-5}

18.109(a) 12.04 (b) 10.77 **18.111(a)** 11.19 (b) 5.56

18.113(a) 8.78 (b) 4.66 **18.115** $[\text{OH}^-] = 5.5 \times 10^{-4} M$; pH = 10.74

18.118 NaF contains the anion of the weak acid HF, so F⁻ acts as a base. NaCl contains the anion of the strong acid HCl.

18.120(a) $\text{KBr}(s) \xrightarrow{\text{H}_2\text{O}} \text{K}^+(aq) + \text{Br}^-(aq)$; neutral

18.122(a) $\text{Na}_2\text{CO}_3(s) \xrightarrow{\text{H}_2\text{O}} 2\text{Na}^+(aq) + \text{CO}_3^{2-}(aq)$

18.124(a) $\text{SrBr}_2(s) \xrightarrow{\text{H}_2\text{O}} \text{Sr}^{2+}(aq) + 2\text{Br}^-(aq)$; neutral

18.126(a) $\text{NH}_4^+(aq) + \text{H}_2\text{O}(l) \rightleftharpoons \text{NH}_3(aq) + \text{H}_3\text{O}^+(aq)$

$K_b > K_a$; basic

Na⁺ gives no reaction; basic

Li⁺ gives no reaction; basic

18.128(a) $\text{Fe}(\text{NO}_3)_2 < \text{KNO}_3 < \text{K}_2\text{SO}_3 < \text{K}_2\text{S}$

(b) $\text{NaHSO}_4 < \text{NH}_4\text{NO}_3 < \text{NaHCO}_3 < \text{Na}_2\text{CO}_3$

18.130 Since both bases produce OH⁻ ions in water, both bases appear equally strong. $\text{CH}_3\text{O}^-(aq) + \text{H}_2\text{O}(l) \rightarrow \text{OH}^-(aq) + \text{CH}_3\text{OH}(aq)$ and $\text{NH}_2^-(aq) + \text{H}_2\text{O}(l) \rightarrow \text{OH}^-(aq) + \text{NH}_3(aq)$.

18.132 Ammonia, NH₃, is a more basic solvent than H₂O. In a more basic solvent, weak acids such as HF act like strong acids and are 100% dissociated.

18.134 A Lewis acid is an electron-pair acceptor, while a Brønsted-Lowry acid is a proton donor. The proton of a Brønsted-Lowry acid is a Lewis acid because it accepts an electron pair when it bonds with a base. All Lewis acids are not Brønsted-Lowry acids. A Lewis base is an electron-pair donor, and a Brønsted-Lowry base is a proton acceptor. All Brønsted-Lowry bases are Lewis bases, and vice versa. **18.135(a)** No, $\text{Ni}(\text{H}_2\text{O})_6^{2+}(aq) + 6\text{NH}_3(aq) \rightleftharpoons \text{Ni}(\text{NH}_3)_6^{2+} + 6\text{H}_2\text{O}(l)$; NH₃ is a weak Brønsted-Lowry base, but a strong Lewis base.

(b) cyanide ion and water (c) cyanide ion **18.138(a)** Lewis acid (b) Lewis base (c) Lewis acid (d) Lewis base **18.140(a)** Lewis acid (b) Lewis base (c) Lewis base (d) Lewis acid

18.142(a) Lewis acid: Na⁺; Lewis base: H₂O (b) Lewis acid: CO₂; Lewis base: H₂O (c) Lewis acid: BF₃; Lewis base: F⁻

18.144(a) Lewis (b) Brønsted-Lowry and Lewis (c) none (d) Lewis **18.147** 3.5×10^{-8} to $4.5 \times 10^{-8} M$ H₃O⁺; 5.2×10^{-7} to $6.6 \times 10^{-7} M$ OH⁻

18.148(a) Acids vary in the extent of dissociation depending on the acid-base character of the solvent. (b) Methanol is a weaker base than water since phenol dissociates less in methanol than in water.

18.151(a) SnCl₄ is the Lewis acid; (CH₃)₃N is the Lewis base.

(b) 5d **18.152** pH = 5.00, 6.00, 6.79, 6.98, 7.00 **18.158** 3×10^{18}

18.161 10.48 **18.163** 2.41 **18.166** amylase, $2 \times 10^{-7} M$; pepsin, $1 \times 10^{-2} M$; trypsin, $3 \times 10^{-10} M$ **18.170** 1.47×10^{-3}

18.172(a) Ca²⁺ does not react with water;

$\text{OH}^-(aq)$; basic (b) 9.08 **18.178** 4.5×10^{-5} **18.181(a)** The concentration of oxygen is higher in the lungs, so the equilibrium shifts to the right. (b) In an oxygen-deficient environment, the equilibrium shifts to the left to release oxygen. (c) A decrease in [H₃O⁺] shifts the equilibrium to the right. More oxygen is absorbed, but it will be more difficult to remove the O₂.

(d) An increase in [H₃O⁺] shifts the equilibrium to the left.

Less oxygen is bound to Hb, but it will be easier to remove it. **18.183(a)** 1.012 M (b) 0.004 M (c) 0.4% **18.184(a)** 10.0

(b) The pK_b for the N in the 3° amine group is much smaller than that for the N in the aromatic ring; thus, the K_b for the former is significantly larger (yielding a much greater amount of OH⁻). (c) 4.7 (d) 5.1

Chapter 19

Answers to Boxed Reading Problems: **B19.2(a)** 65 mol (b) 6.28

(c) $4.0 \times 10^3 \text{ g } \text{HCO}_3^-$

• **19.2** The acid component neutralizes added base, and the base component neutralizes added acid, so the pH of the buffer solution remains relatively constant. The components of a buffer do not neutralize one another because they are a conjugate acid-base pair. **19.6** The buffer range, the pH range over which the buffer acts effectively, is consistent with a buffer-component concentration ratio from 10 to 0.1. This gives a pH range equal to $pK_a \pm 1$. **19.8(a)** Ratio and pH increase; added OH⁻ reacts with HA. (b) Ratio and pH decrease; added H⁺ reacts with A⁻. (c) Ratio and pH increase; added A⁻ increases [A⁻]. (d) Ratio and pH decrease; added HA increases [HA]. **19.10(a)** buffer 3 (b) All of the buffers have the same pH range. (c) buffer 2

19.12 $[\text{H}_3\text{O}^+] = 5.6 \times 10^{-6} M$; pH = 5.25 **19.14** $[\text{H}_3\text{O}^+] = 5.2 \times 10^{-4} M$;

pH = 3.28 **19.16** 3.89 **19.18** 10.03 **19.20** 9.47 **19.22(a)** K_{a2}

(b) 10.55 **19.24** 3.6 **19.26** 0.20 **19.28** 3.37 **19.30** 8.82

19.32(a) 4.81 (b) 0.66 g KOH **19.34(a)** HOOC(CH₂)₄COOH/HOOC(CH₂)₄COO⁻ or C₆H₅NH₃⁺/C₆H₅NH₂ (b) H₂PO₄⁻/HPO₄²⁻

or $\text{H}_2\text{AsO}_4^-/\text{HAsO}_4^{2-}$ **19.36(a)** $\text{HOCH}_2\text{CH}(\text{OH})\text{COOH}/\text{HOCH}_2\text{CH}(\text{OH})\text{COO}^-$ or $\text{CH}_3\text{COOC}_6\text{H}_4\text{COOH}/\text{CH}_3\text{COOC}_6\text{H}_4\text{COO}^-$ (b) $\text{C}_5\text{H}_5\text{NH}^+/\text{C}_5\text{H}_5\text{N}$ **19.39** 1.6
19.41(a) initial pH: strong acid-strong base < weak acid-strong base < weak base-strong acid (b) pH at equivalence point: weak base-strong acid < strong acid-strong base < weak acid-strong base **19.43** At the midpoint of the buffer region, the concentrations of weak acid and conjugate base are equal, so the pH = pK_a of the acid. **19.45** To see a distinct color in a mixture of two colors, you need one color to have about 10 times the intensity of the other. For this to be the case, the concentration ratio $[\text{HIn}]/[\text{In}^-]$ has to be greater than 10/1 or less than 1/10. This occurs when $\text{pH} = pK_a - 1$ or $\text{pH} = pK_a + 1$, respectively, giving a pH range of about 2 units. **19.47** The equivalence point in a titration is the point at which the number of moles of base is stoichiometrically equivalent to the number of moles of acid. The end point is the point at which the indicator changes color. If an appropriate indicator is selected, the end point is close to the equivalence point, but they are not usually the same. The pH at the end point, or at the color change, may precede or follow the pH at the equivalence point, depending on the indicator chosen.

19.49(a) 1.0000 (b) 1.6368 (c) 2.898 (d) 3.903 (e) 7.00 (f) 10.10 (g) 12.05 **19.51(a)** 2.91 (b) 4.81 (c) 5.29 (d) 6.09 (e) 7.41 (f) 8.76 (g) 10.10 (h) 12.05 **19.53(a)** 8.54 and 59.0 mL (b) 4.39 and 66.0 mL, 9.68 and total 132.1 mL **19.55(a)** 5.17 and 123 mL (b) 5.80 and 194 mL **19.57** pH range from 7.5 to 9.5 **19.59(a)** bromothymol blue (b) thymol blue or phenolphthalein **19.61(a)** methyl red (b) bromothymol blue **19.64** Fluoride ion is the conjugate base of a weak acid and reacts with H_2O : $\text{F}^-(aq) + \text{H}_2\text{O}(l) \rightleftharpoons \text{HF}(aq) + \text{OH}^-(aq)$. As the pH increases, the equilibrium shifts to the left and $[\text{F}^-]$ increases. As the pH decreases, the equilibrium shifts to the right and $[\text{F}^-]$ decreases. The changes in $[\text{F}^-]$ influence the solubility of BaF_2 . Chloride ion is the conjugate base of a strong acid, so it does not react with water and its concentration is not influenced by pH. **19.66** The ionic compound precipitates. **19.67(a)** $K_{sp} = [\text{Ag}^+]^2[\text{CO}_3^{2-}]$ (b) $K_{sp} = [\text{Ba}^{2+}][\text{F}^-]^2$ (c) $K_{sp} = [\text{Cu}^{2+}][\text{S}^{2-}]$ **19.69(a)** $K_{sp} = [\text{Ca}^+][\text{CrO}_4^{2-}]$ (b) $K_{sp} = [\text{Ag}^+][\text{CN}^-]$ (c) $K_{sp} = [\text{Ag}^+]^3[\text{PO}_4^{3-}]$ **19.71** 1.3×10^{-4} **19.73** 2.8×10^{-11} **19.75(a)** $2.3 \times 10^{-5} M$ (b) $4.2 \times 10^{-9} M$ **19.77(a)** $1.7 \times 10^{-3} M$ (b) $2.0 \times 10^{-4} M$ **19.79(a)** $\text{Mg}(\text{OH})_2$ (b) PbS (c) Ag_2SO_4 **19.81(a)** CaSO_4 (b) $\text{Mg}_3(\text{PO}_4)_2$ (c) PbSO_4 **19.83(a)** $\text{AgCl}(s) \rightleftharpoons \text{Ag}^+(aq) + \text{Cl}^-(aq)$. The chloride ion is the anion of a strong acid, so it does not react with H_3O^+ . No change with pH. (b) $\text{SrCO}_3(s) \rightleftharpoons \text{Sr}^{2+}(aq) + \text{CO}_3^{2-}(aq)$

The strontium ion is the cation of a strong base, so pH will not affect its solubility. The carbonate ion acts as a base: $\text{CO}_3^{2-}(aq) + \text{H}_2\text{O}(l) \rightleftharpoons \text{HCO}_3^-(aq) + \text{OH}^-(aq)$ also $\text{CO}_2(g)$ forms and escapes: $\text{CO}_3^{2-}(aq) + 2\text{H}_3\text{O}^+(aq) \rightarrow \text{CO}_2(g) + 3\text{H}_2\text{O}(l)$. Therefore, the solubility of SrCO_3 will increase with addition of H_3O^+ (decreasing pH).

19.85(a) $\text{Fe}(\text{OH})_2(s) \rightleftharpoons \text{Fe}^{2+}(aq) + 2\text{OH}^-(aq)$ The OH^- ion reacts with added H_3O^+ : $\text{OH}^-(aq) + \text{H}_3\text{O}^+(aq) \rightarrow 2\text{H}_2\text{O}(l)$. The added H_3O^+ consumes the OH^- , driving the equilibrium toward the right to dissolve more $\text{Fe}(\text{OH})_2$. Solubility increases with addition of H_3O^+ (decreasing pH).

(b) $\text{CuS}(s) \rightleftharpoons \text{Cu}^{2+}(aq) + \text{S}^{2-}(aq)$ S^{2-} is the anion of a weak acid, so it reacts with added H_3O^+ . Solubility increases with

addition of H_3O^+ (decreasing pH). **19.87** yes **19.89** yes

19.92(a) $\text{Fe}(\text{OH})_3$ (b) The two metal ions are separated by adding just enough NaOH to precipitate iron(III) hydroxide. (c) $2.0 \times 10^{-7} M$ **19.95** No, because it indicates that a complex ion forms between the zinc ion and hydroxide ions, such as $\text{Zn}^{2+}(aq) + 4\text{OH}^-(aq) \rightleftharpoons \text{Zn}(\text{OH})_4^{2-}(aq)$

19.125(a)

V (mL)	pH	$\Delta \text{pH}/\Delta V$	V_{avg} (mL)
0.00	1.00		
10.00	1.22	0.022	5.00
20.00	1.48	0.026	15.00
30.00	1.85	0.037	25.00
35.00	2.18	0.066	32.50
39.00	2.89	0.18	37.00
39.50	3.20	0.62	39.25
39.75	3.50	1.2	39.63
39.90	3.90	2.7	39.83
39.95	4.20	6	39.93
39.99	4.90	18	39.97
40.00	7.00	200	40.00
40.01	9.40	200	40.01
40.05	9.80	10	40.03
40.10	10.40	10	40.08
40.25	10.50	0.67	40.18
40.50	10.79	1.2	40.38
41.00	11.09	0.60	40.75
45.00	11.76	0.17	43.00
50.00	12.05	0.058	47.50
60.00	12.30	0.025	55.00
70.00	12.43	0.013	65.00
80.00	12.52	0.009	75.00

(b)

Maximum slope (equivalence point) is at $V_{\text{avg}} = 40.0 \text{ mL}$.

19.127 4.05 **19.133** $\text{H}_2\text{CO}_3/\text{HCO}_3^-$ and $\text{H}_2\text{PO}_4^{2-}/\text{HPO}_4^{2-}$;

- $[\text{HPO}_4^{2-}]/[\text{H}_2\text{PO}_4^-] = 5.8$ **19.135(a)** 58.2 mL (b) 7.85 mL (c) 6.30
19.137 170 mL **19.141** 5.63 **19.143** 3.9×10^{-9} $\mu\text{g Pb}^{2+}/100 \text{ mL blood}$
19.145 No NaCl will precipitate. **19.146(a)** A and D (b) $\text{pH}_A = 4.35$; $\text{pH}_B = 8.67$; $\text{pH}_C = 2.67$; $\text{pH}_D = 4.57$ (c) C, A, D, B (d) B

Chapter 20

Answer to Problem: B20.2 -12.6 kJ/mol

• **20.2** A spontaneous process occurs by itself, whereas a nonspontaneous process requires a continuous input of energy to make it happen. It is possible to cause a nonspontaneous process to occur, but the process stops once the energy input is removed. A reaction that is nonspontaneous under one set of conditions may be spontaneous under a different set of conditions.

20.5 The transition from liquid to gas involves a greater increase in dispersal of energy and freedom of motion than does the transition from solid to liquid. **20.6** For an exothermic reaction, $\Delta S_{\text{surr}} > 0$. For an endothermic reaction, $\Delta S_{\text{surr}} < 0$. A chemical cold pack for injuries is an example of an application using a spontaneous endothermic process. **20.8** a, b, and c

20.10 a and b **20.12(a)** positive (b) negative (c) negative

20.14(a) positive (b) positive (c) positive

20.16(a) negative (b) negative (c) positive

20.18(a) positive (b) negative (c) positive

20.20(a) positive (b) negative (c) positive

20.22(a) Butane; the double bond in 2-butene restricts freedom of rotation. (b) $\text{Xe}(g)$; it has the greater molar mass. (c) $\text{CH}_4(g)$; gases have greater entropy than liquids. **20.24(a)** $\text{C}_2\text{H}_5\text{OH}(l)$; it is a more complex molecule. (b) $\text{KClO}_3(aq)$; ions in solution have their energy more dispersed than ions in a solid. (c) $\text{K}(s)$; it has a greater molar mass. **20.26(a)** Diamond < graphite < charcoal. Freedom of motion is least in the network solid, increases for graphite sheets, and is greatest in the amorphous solid. (b) Ice < liquid water < water vapor. Entropy increases as a substance changes from solid to liquid to gas. (c) O atoms < O_2 < O_3 . Entropy increases with molecular complexity.

20.28(a) $\text{ClO}_4^-(aq) > \text{ClO}_3^-(aq) > \text{ClO}_2^-(aq)$; decreasing molecular complexity (b) $\text{NO}_2(g) > \text{NO}(g) > \text{N}_2(g)$. N_2 has lower standard molar entropy because it consists of two of the same atoms; the other species have two different types of atoms. NO_2 is more complex than NO. (c) $\text{Fe}_3\text{O}_4(s) > \text{Fe}_2\text{O}_3(s) > \text{Al}_2\text{O}_3(s)$. Fe_3O_4 is more complex and more massive. Fe_2O_3 is more massive than Al_2O_3 . **20.31** For a system at equilibrium, $\Delta S_{\text{univ}} = \Delta S_{\text{sys}} + \Delta S_{\text{surr}} = 0$. For a system moving to equilibrium, $\Delta S_{\text{univ}} > 0$.

20.32 $S_{\text{Cl}_2\text{O}(g)}^\circ = 2S_{\text{HClO}(g)}^\circ - S_{\text{H}_2\text{O}(g)}^\circ - \Delta S_{\text{rxn}}^\circ$

20.33(a) negative; $\Delta S^\circ = -172.4 \text{ J/K}$ (b) positive;

$\Delta S^\circ = 141.6 \text{ J/K}$ (c) negative; $\Delta S^\circ = -837 \text{ J/K}$

20.35 $\Delta S^\circ = 93.1 \text{ J/K}$; yes, the positive sign of ΔS is expected because there is a net increase in the number of gas molecules.

20.37 $\Delta S^\circ = -311 \text{ J/K}$; yes, the negative entropy change matches the decrease in moles of gas. **20.39(a)** -75.6 J/K ; (b) 490. J/K; because ΔS_{univ} is positive, the reaction is spontaneous at 298 K. **20.41(a)** -242 J/K (b) 559 J/K; because ΔS_{univ} is positive, the reaction is spontaneous at 298 K.

20.44 -97.2 J/K **20.46** A spontaneous process has $\Delta S_{\text{univ}} > 0$. Since the absolute temperature is always positive, ΔG_{sys} must be negative ($\Delta G_{\text{sys}} < 0$) for a spontaneous process.

20.48(a) ΔH_{sys} is negative. Bonds are being formed, which is an exothermic process. (b) ΔS_{sys} is negative. As molecules form from atoms, the total number of particles decreases and, with it, the entropy of the system. (c) Since ΔH_{sys} is negative, heat is released, so ΔS_{surr} will be positive. (d) Because both ΔH_{sys} and ΔS_{sys} are negative, this reaction will become more spontaneous (ΔG_{sys} will become more negative) as temperature decreases. **20.49** ΔH° is positive and ΔS° is positive. Melting is an example. **20.50** The entropy changes little within a phase. As long as a substance does not change phase, the value of ΔS° is relatively unaffected by temperature. **20.51(a)** -1138.0 kJ (b) -1379.4 kJ (c) -224 kJ **20.53(a)** -1138 kJ (b) -1379 kJ (c) -226 kJ **20.55(a)** Entropy decreases (ΔS° is negative) because the number of moles of gas decreases. The combustion of CO releases energy (ΔH° is negative). (b) -257.2 kJ (using Equation 20.8) or -257.3 kJ (using Equation 20.7). **20.57(a)** $-0.409 \text{ kJ/mol}\cdot\text{K}$ (b) -197 kJ/mol **20.59(a)** $\Delta H_{\text{rxn}}^\circ = 90.7 \text{ kJ}$; $\Delta S_{\text{rxn}}^\circ = 221 \text{ J/K}$ (b) At 28°C , $\Delta G^\circ = 24.3 \text{ kJ}$; at 128°C , $\Delta G^\circ = 2.2 \text{ kJ}$; at 228°C , $\Delta G^\circ = -19.9 \text{ kJ}$ (c) For the substances in their standard states, the reaction is nonspontaneous at 28°C , near equilibrium at 128°C , and spontaneous at 228°C . (d) $410. \text{ K}$ **20.61(a)** $\Delta H_{\text{rxn}}^\circ = -241.826 \text{ kJ}$, $\Delta S_{\text{rxn}}^\circ = -44.4 \text{ J/K}$, $\Delta G_{\text{rxn}}^\circ = -228.60 \text{ kJ}$ (b) Yes. The reaction will become nonspontaneous at higher temperatures. (c) The reaction is spontaneous below $5.45 \times 10^3 \text{ K}$. **20.63(a)** ΔG° is a relatively large positive value. (b) $K >> 1$. Q depends on initial conditions, not equilibrium conditions. **20.66** The standard free energy change, ΔG° , applies when all components of the system are in their standard states; $\Delta G^\circ = \Delta G$ when all concentrations equal 1 M and all partial pressures equal 1 atm. **20.67(a)** 2.0×10^{-8} (b) 1.27×10^{21} **20.69(a)** 3.46×10^4 (b) 8.2×10^{-7} **20.71** $\Delta H^\circ = 30910 \text{ J}$, $\Delta S^\circ = 93.15 \text{ J/K}$, $T = 331.8 \text{ K}$ **20.73** 1.7×10^{-49} **20.75** 3.36×10^5 **20.77** $2.7 \times 10^4 \text{ J/mol}$; no **20.79(a)** $2.9 \times 10^4 \text{ J/mol}$ (b) The reverse direction, formation of reactants, is spontaneous, so the reaction proceeds to the left. (c) $7.0 \times 10^3 \text{ J/mol}$; the reaction proceeds to the left to reach equilibrium. **20.81(a)** scene 1 (b) scene 3 > scene 1 > scene 2 **20.83(a)** no T (b) 163 kJ (c) $1 \times 10^2 \text{ kJ/mol}$ **20.86(a)** spontaneous (b) + (c) + (d) - (e) -, not spontaneous (f) - **20.90(a)** 2.3×10^2 (b) The treatment is to administer oxygen-rich air; increasing the concentration of oxygen shifts the equilibrium to the left, in the direction of $\text{Hb}\cdot\text{O}_2$. **20.92** $-370. \text{ kJ}$ **20.94(a)** $2\text{N}_2\text{O}_5(g) + 6\text{F}_2(g) \longrightarrow 4\text{NF}_3(g) + 5\text{O}_2(g)$ (b) $\Delta H_{\text{rxn}}^\circ = -569 \text{ kJ}$ (c) $\Delta G_{\text{rxn}}^\circ = -5.60 \times 10^2 \text{ kJ/mol}$ **20.96** $\Delta H_{\text{rxn}}^\circ = -137.14 \text{ kJ}$; $\Delta S_{\text{rxn}}^\circ = -120.3 \text{ J/K}$; $\Delta G_{\text{rxn}}^\circ = -101.25 \text{ kJ}$ **20.104(a)** $1.67 \times 10^3 \text{ J/mol}$ (b) $7.37 \times 10^3 \text{ J/mol}$ (c) $-4.04 \times 10^3 \text{ J/mol}$ (d) 0.19 **20.108(a)** 465 K (b) 6.59×10^{-4} (c) The reaction rate is higher at the higher temperature. The shorter time required (kinetics) overshadows the lower yield (thermodynamics).

Chapter 21

Answers to Boxed Reading Problems: B21.1(a) reduction:

• **21.1** Oxidation is the loss of electrons and results in a higher oxidation number; reduction is the gain of electrons and results

in a lower oxidation number. **21.3** No, one half-reaction cannot take place independently because there is a transfer of electrons from one substance to another. If one substance loses electrons, another substance must gain them. **21.6** To remove H⁺ ions from an equation, add an equal number of OH⁻ ions to both sides to neutralize the H⁺ ions and produce water. **21.8** Spontaneous reactions, for which ΔG_{sys} < 0, take place in voltaic cells (also called galvanic cells). Nonspontaneous reactions, for which ΔG_{sys} > 0, take place in electrolytic cells. **21.10**(a) Cl⁻

Oxidizing agent is ClO₃⁻ and reducing agent is I⁻.

Oxidizing agent is MnO₄⁻ and reducing agent is SO₃²⁻.

Oxidizing agent is MnO₄⁻ and reducing agent is H₂O₂.

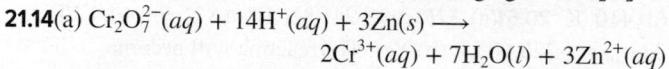

Oxidizing agent is Cr₂O₇²⁻ and reducing agent is Zn.

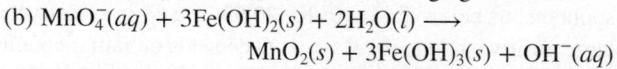

Oxidizing agent is MnO₄⁻ and reducing agent is Fe(OH)₂.

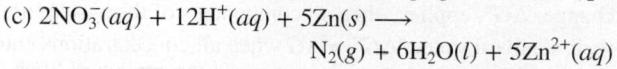

Oxidizing agent is NO₃⁻ and reducing agent is Zn.

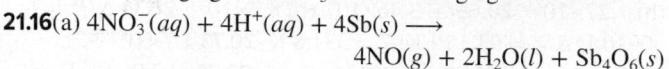

Oxidizing agent is NO₃⁻ and reducing agent is Sb.

Oxidizing agent is BiO₃⁻ and reducing agent is Mn²⁺.

Oxidizing agent is Pb(OH)₃⁻ and reducing agent is Fe(OH)₂.

Oxidizing agent is MnO₄⁻ and reducing agent is As₄O₆.

P₄ is both the oxidizing agent and the reducing agent.

Oxidizing agent is MnO₄⁻ and reducing agent is CN⁻.

(b) Oxidizing agent is NO₃⁻ and reducing agent is Au. (c) HCl provides chloride ions that combine with the gold(III) ion to form the stable AuCl₄⁻ complex ion. **21.22**(a) A (b) E (c) C

(d) A (e) E (f) E **21.25** An active electrode is a reactant or product in the cell reaction. An inactive electrode does not take part in the reaction and is present only to conduct a current.

Platinum and graphite are commonly used for inactive electrodes.

21.26(a) metal A (b) metal B (c) metal A (d) Hydrogen bubbles will form when metal A is placed in acid. Metal A is a better reducing agent than metal B, so if metal B reduces H⁺ in acid, then metal A will reduce it also. **21.27**(a) left to right (b) left (c) right (d) Ni (e) Fe (f) Fe (g) 1 M NiSO₄ (h) K⁺ and NO₃⁻ (i) neither (j) from right to left

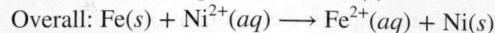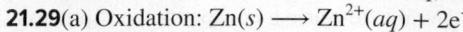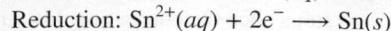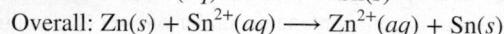

(b)

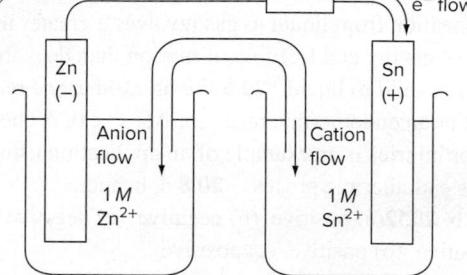

(b)

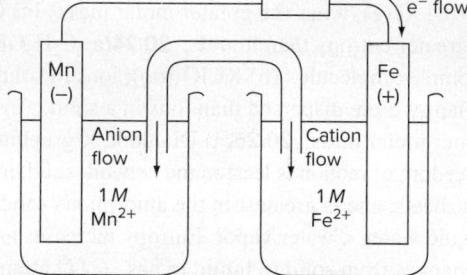

21.36 A negative E°_{cell} indicates that the redox reaction is not spontaneous at the standard state, that is, ΔG° > 0. The reverse reaction is spontaneous with E°_{cell} > 0.

21.37 Similar to other state functions, E° changes sign when a reaction is reversed. Unlike ΔG°, ΔH°, and S°, E° (the ratio of energy to charge) is an intensive property. When the coefficients in a reaction are multiplied by a factor, the values of ΔG°, ΔH°, and S° are multiplied by that factor. However, E° does not change because both the energy and charge are multiplied by the factor and thus their ratio remains unchanged.

$$(b) E_{\text{anode}}^{\circ} = E_{\text{cathode}}^{\circ} - E_{\text{cell}}^{\circ} = -0.57 \text{ V} - 0.35 \text{ V} \\ = -0.92 \text{ V}$$

$$E_{\text{cell}}^{\circ} = 0.28 \text{ V}; \text{ spontaneous}$$

$$E_{\text{cell}}^{\circ} = -0.13 \text{ V}; \text{ not spontaneous}$$

$E_{\text{cell}}^{\circ} = 1.73 \text{ V}$; spontaneous

$E_{\text{cell}}^{\circ} = -0.12 \text{ V}$; not spontaneous

$E_{\text{cell}}^{\circ} = 0.867 \text{ V} - (-1.66 \text{ V}) = 2.53 \text{ V}$

$E_{\text{cell}}^{\circ} = 2.59 \text{ V}$

$E_{\text{cell}}^{\circ} = 0.06 \text{ V}$

Oxidizing agents: $\text{Al}^{3+} < \text{N}_2\text{O}_4 < \text{SO}_4^{2-}$

Reducing agents: $\text{SO}_3^{2-} < \text{NO}_2^- < \text{Al}$

$E_{\text{cell}}^{\circ} = 0.43 \text{ V}$

$E_{\text{cell}}^{\circ} = 1.94 \text{ V}$

$E_{\text{cell}}^{\circ} = 1.51 \text{ V}$

Oxidizing agents: $\text{PbSO}_4 < \text{Pt}^{2+} < \text{HClO}$

Reducing agents: $\text{Cl}_2 < \text{Pt} < \text{Pb}$

21.50(a) yes (b) $C > A > B$ **21.53** $A(s) + \text{B}^+(aq) \longrightarrow \text{A}^+(aq) + \text{B}(s)$ with $Q = [\text{A}^+]/[\text{B}^+]$. (a) $[\text{A}^+]$ increases and $[\text{B}^+]$ decreases.

(b) E_{cell} decreases. (c) $E_{\text{cell}} = E_{\text{cell}}^{\circ} - (RT/nF) \ln ([\text{A}^+]/[\text{B}^+])$; $E_{\text{cell}} = E_{\text{cell}}^{\circ}$ when $(RT/nF) \ln ([\text{A}^+]/[\text{B}^+]) = 0$. This occurs when $\ln ([\text{A}^+]/[\text{B}^+]) = 0$, that is, $[\text{A}^+]$ equals $[\text{B}^+]$. (d) Yes, when $[\text{A}^+] > [\text{B}^+]$. **21.55** In a concentration cell, the overall reaction decreases the concentration of the more concentrated electrolyte because that electrolyte is reduced in the cathode compartment.

21.56(a) 3×10^{35} (b) 4×10^{-31} **21.58(a)** 1×10^{-67} (b) 6×10^9

21.60(a) $-2.03 \times 10^5 \text{ J}$ (b) $1.74 \times 10^5 \text{ J}$ **21.62(a)** $3.82 \times 10^5 \text{ J}$

(b) $-5.6 \times 10^4 \text{ J}$ **21.64** $E_{\text{cell}}^{\circ} = 0.28 \text{ V}$; $\Delta G^\circ = -2.7 \times 10^4 \text{ J}$

21.66 $E_{\text{cell}}^{\circ} = 0.054 \text{ V}$; $\Delta G^\circ = -1.0 \times 10^4 \text{ J}$ **21.68** $8.8 \times 10^{-5} \text{ M}$

21.70(a) 0.05 V (b) 0.50 M (c) $[\text{Co}^{2+}] = 0.91 \text{ M}$; $[\text{Ni}^{2+}] = 0.09 \text{ M}$

21.72 half-cell A; 0.083 V **21.74** Electrons flow from the anode, where oxidation occurs, to the cathode, where reduction occurs.

The electrons always flow from the anode to the cathode no matter what type of battery. **21.76** A D alkaline battery is larger than an AAA one, so it contains greater amounts of the cell components. The cell potential is an intensive property and does not depend on the amounts of the cell components. The total charge, however, does depend on the amount of cell components, so the D battery produces more charge. **21.78** The Teflon spacers keep the two metals separated so that the copper cannot conduct electrons that would promote the corrosion (rusting) of the iron skeleton. **21.81** Sacrificial anodes are made of metals that have E° less than that of iron, -0.44 V , so they are more easily oxidized than iron. Only (b), (f), and (g) will work for iron: (a) will form an oxide coating that prevents further oxidation; (c) will react with groundwater quickly; (d) and (e) are less easily oxidized than iron. **21.83** To reverse the reaction requires 0.34 V with the cell in its standard state. A 1.5-V cell supplies more than enough potential, so the Cd metal is oxidized to Cd^{2+} and Cr

metal plates out. **21.85** The oxidation number of N in NO_3^- is +5, the maximum O.N. for N. In the nitrite ion, NO_2^- , the O.N. of N is +3, so nitrogen can be further oxidized. **21.87(a)** Br_2 (b) Na **21.89** I₂ gas forms at the anode; magnesium (liquid) forms at the cathode. **21.91** Bromine gas forms at the anode; calcium metal forms at the cathode.

21.93 copper and bromine **21.95** iodine, zinc, and silver

21.97(a) Anode: $2\text{H}_2\text{O}(l) \longrightarrow \text{O}_2(g) + 4\text{H}^+(aq) + 4\text{e}^-$

Cathode: $2\text{H}_2\text{O}(l) + 2\text{e}^- \longrightarrow \text{H}_2(g) + 2\text{OH}^-(aq)$

(b) Anode: $2\text{H}_2\text{O}(l) \longrightarrow \text{O}_2(g) + 4\text{H}^+(aq) + 4\text{e}^-$

Cathode: $\text{Sn}^{2+}(aq) + 2\text{e}^- \longrightarrow \text{Sn}(s)$

21.99(a) Anode: $2\text{H}_2\text{O}(l) \longrightarrow \text{O}_2(g) + 4\text{H}^+(aq) + 4\text{e}^-$

Cathode: $\text{NO}_3^-(aq) + 4\text{H}^+(aq) + 3\text{e}^- \longrightarrow$

$\text{NO}(g) + 2\text{H}_2\text{O}(l)$

(b) Anode: $2\text{Cl}^-(aq) \longrightarrow \text{Cl}_2(g) + 2\text{e}^-$

Cathode: $2\text{H}_2\text{O}(l) + 2\text{e}^- \longrightarrow \text{H}_2(g) + 2\text{OH}^-(aq)$

21.101(a) 3.75 mol e^- (b) $3.62 \times 10^5 \text{ C}$ (c) 28.7 A

21.103 0.275 g Ra **21.105** $9.20 \times 10^3 \text{ s}$ **21.107(a)** The sodium and sulfate ions conduct a current, facilitating electrolysis. Pure water, which contains very low (10^{-7} M) concentrations of H^+ and OH^- , conducts electricity very poorly. (b) The reduction of H_2O has a more positive half-potential than does the reduction of Na^+ ; the oxidation of H_2O is the only reaction possible because SO_4^{2-} cannot be oxidized. Thus, it is easier to reduce H_2O than Na^+ and easier to oxidize H_2O than SO_4^{2-} . **21.109** 62.6 g Zn **21.111(a)** $3.3 \times 10^{11} \text{ C}$ (b) $4.8 \times 10^{11} \text{ J}$ (c) $1.2 \times 10^4 \text{ kg}$ **21.114** 64.3 mass % Cu

21.115(a) 8 days (b) 32 days (c) \$940 **21.118(a)** $2.4 \times 10^4 \text{ days}$

(b) 2.1 g (c) $6.1 \times 10^{-5} \text{ dollars}$ **21.121(a)** Pb/Pb^{2+} : $E_{\text{cell}}^{\circ} = 0.13 \text{ V}$; Cu/Cu^{2+} : $E_{\text{cell}}^{\circ} = 0.34 \text{ V}$ (b) The anode (negative electrode) is Pb. The anode in the other cell is platinum in the standard hydrogen electrode. (c) The precipitation of PbS decreases $[\text{Pb}^{2+}]$, which increases the potential. (d) -0.13 V **21.124** The three steps equivalent to the overall reaction

(1) $\text{M}^+(aq) \longrightarrow \text{M}'(g)$ ΔH is $-\Delta H_{\text{hydration}}$

(2) $\text{M}'(g) + \text{e}^- \longrightarrow \text{M}(g)$ ΔH is $-\text{IE}$

(3) $\text{M}(g) \longrightarrow \text{M}(s)$ ΔH is $-\Delta H_{\text{atomization}}$

The energy for step 3 is similar for all three elements, so the difference in energy for the overall reaction depends on the values for $\Delta H_{\text{hydration}}$ and IE. The Li^+ ion has a greater hydration energy than Na^+ and K^+ because it is smaller, with a larger charge density that holds the water molecules more tightly. The energy required to remove the waters surrounding Li^+ offsets the lower ionization energy, making the overall energy for the reduction of Li^+ ion larger than expected. **21.125** The very high and very low standard electrode potentials involve extremely reactive substances, such as F_2 (a powerful oxidizer) and Li (a powerful reducer). These substances react directly with water because any aqueous cell with a voltage of more than 1.23 V has the ability to electrolyze water into hydrogen and oxygen.

21.127(a) $1.073 \times 10^5 \text{ s}$ (b) $1.5 \times 10^4 \text{ kW}\cdot\text{h}$ (c) 0.92 c **21.129 If** metal E and a salt of metal F are mixed, the salt is reduced, producing metal F because E has the greatest reducing strength of the three metals; $F < D < E$.

21.131(a) Cell I: 4 mol electrons; $\Delta G = -4.75 \times 10^5 \text{ J}$

Cell II: 2 mol electrons; $\Delta G = -3.94 \times 10^5 \text{ J}$

Cell III: 2 mol electrons; $\Delta G = -4.53 \times 10^5 \text{ J}$

(b) Cell I: -13.2 kJ/g

Cell II: -0.613 kJ/g

Cell III: -2.63 kJ/g

Cell I has the highest ratio (most energy released per gram) because the reactants have very low mass, while cell II has the lowest ratio because the reactants have large masses.

21.135(a) 9.7 g Cu (b) 0.56 M Cu^{2+} **21.136** 2.94

21.137 $\text{Sn}^{2+}(aq) + 2\text{e}^- \rightarrow \text{Sn}(s)$

21.141(a) $3.6 \times 10^{-9} \text{ M}$ (b) 0.3 M

21.143(a) Nonstandard cell:

$$E_{\text{waste}} = E_{\text{cell}}^{\circ} - (0.0592 \text{ V}/1) \log [\text{Ag}^+]_{\text{waste}}$$

Standard cell:

$$E_{\text{standard}} = E_{\text{cell}}^{\circ} - (0.0592 \text{ V}/1) \log [\text{Ag}^+]_{\text{standard}}$$

$$(b) [\text{Ag}^+]_{\text{waste}} = \text{antilog} \left(\frac{E_{\text{standard}} - E_{\text{waste}}}{0.0592} \right) [\text{Ag}^+]_{\text{standard}}$$

$$(c) C_{\text{Ag}^+, \text{waste}} = \text{antilog} \left(\frac{E_{\text{standard}} - E_{\text{waste}}}{0.0592} \right) C_{\text{Ag}^+, \text{standard}},$$

where C is concentration in ng/L

(d) 900 ng/L

(e) $[\text{Ag}^+]_{\text{waste}} =$

$$\text{antilog} \left[\frac{(E_{\text{standard}} - E_{\text{waste}}) \frac{nF}{2.303R} + T_{\text{standard}} \log [\text{Ag}^+]_{\text{standard}}}{T_{\text{waste}}} \right]$$

21.145(a) $1.08 \times 10^3 \text{ C}$ (b) 0.629 g Cd, 1.03 g NiO(OH) , 0.202 g H_2O ; total mass of reactants = 1.86 g (c) 10.1%

21.147 Li > Ba > Na > Al > Mn > Zn > Cr > Fe > Ni > Sn > Pb > Cu > Ag > Hg > Au. Metals with potentials lower than that of water (-0.83 V) can displace H_2 from water: Li, Ba, Na, Al, and Mn. Metals with potentials lower than that of hydrogen (0.00 V) can displace H_2 from acid: Li, Ba, Na, Al, Mn, Zn, Cr, Fe, Ni, Sn, and Pb. Metals with potentials greater than that of hydrogen (0.00 V) cannot displace H_2 : Cu, Ag, Hg, and Au.

21.150(a) 5.3×10^{-11} (b) 0.20 V (c) 0.43 V (d) $8.2 \times 10^{-4} \text{ M}$

NaOH **21.153**(a) $-1.18 \times 10^5 \text{ kJ}$ (b) $1.20 \times 10^4 \text{ L}$ (c) $9.43 \times 10^4 \text{ s}$ (d) 157 kW·h (e) 22.0¢

Chapter 22

22.2 Fe from Fe_2O_3 ; Ca from CaCO_3 ; Na from NaCl ; Zn from ZnS **22.3**(a) Differentiation refers to the processes involved in the formation of Earth into regions (core, mantle, and crust) of differing composition. Substances separated according to their densities, with the more dense material in the core and the less dense in the crust. (b) O, Si, Al, and Fe (c) O **22.7** Plants produced O_2 , slowly increasing the oxygen concentration in the atmosphere and creating an environment for oxidizing metals. The oxygen-free decay of plant and animal material created large fossil fuel deposits. **22.9** Fixation refers to the process of converting a substance in the atmosphere into a form more readily usable by organisms. Carbon and nitrogen; fixation of carbon dioxide gas by plants and fixation of nitrogen gas by nitrogen-fixing bacteria. **22.12** Atmospheric nitrogen is fixed by three pathways: atmospheric, industrial, and biological.

Atmospheric fixation requires high-temperature reactions (e.g., initiated by lightning) to convert N_2 into NO and other oxidized species. Industrial fixation involves mainly the formation of ammonia, NH_3 , from N_2 and H_2 . Biological fixation occurs in nitrogen-fixing bacteria that live on the roots of legumes. Human activity is an example of industrial fixation. It contributes about 17% of the fixed nitrogen. **22.14**(a) the atmosphere (b) Plants excrete acid from their roots to convert PO_4^{3-} ions into more soluble H_2PO_4^- ions, which the plant can absorb. Through excretion and decay, organisms return soluble phosphate compounds to the cycle. **22.17**(a) $1.1 \times 10^3 \text{ L}$ (b) $4.2 \times 10^2 \text{ m}^3$ **22.18**(a) The iron(II) ions form an insoluble salt, $\text{Fe}_3(\text{PO}_4)_2$, that decreases the yield of phosphorus. (b) 8.8 t **22.20**(a) Roasting consists of heating a mineral sulfide in air at high temperatures to convert it to the oxide. (b) Smelting is the reduction of the metal oxide to the free metal using heat and a reducing agent such as coke. (c) Flotation is a separation process in which the ore is removed from the gangue by exploiting the difference in density in the presence of detergent. The gangue sinks to the bottom and the lighter ore-detergent mix is skimmed off the top. (d) Refining, using electricity or heat, is the final step in the process to yield the pure element. **22.25**(a) Slag is a byproduct of steel-making and contains the impurity SiO_2 . (b) Pig iron is the impure product of iron metallurgy (containing 3–4% C and other impurities). (c) Steel refers to iron that has been alloyed with other elements to give the metal desirable properties. (d) The basic-oxygen process is used to purify pig iron and obtain carbon steel. **22.27** Iron and nickel are more easily oxidized and less easily reduced than copper. They are separated from copper in the roasting step and converted to slag. In the electrorefining process, all three metals are in solution, but only Cu^{2+} ions are reduced at the cathode to form $\text{Cu}(s)$. **22.30** Le Châtelier's principle says that the system shifts toward formation of K as the gaseous metal leaves the cell. **22.31**(a) $E_{\text{half-cell}}^{\circ} = -3.05 \text{ V}$, -2.93 V , and -2.71 V for Li^+ , K^+ , and Na^+ , respectively. In all of these cases, it is energetically more favorable to reduce H_2O to H_2 than to reduce M^+ to M . (b) $2\text{RbX} + \text{Ca} \rightarrow \text{CaX}_2 + 2\text{Rb}$ where $\Delta H = \text{IE}_1(\text{Ca}) + \text{IE}_2(\text{Ca}) - 2\text{IE}_1(\text{Rb}) = 929 \text{ kJ/mol}$. Based on the IEs and positive ΔH for the forward reaction, it seems more reasonable that Rb metal will reduce Ca^{2+} than the reverse. (c) If the reaction is carried out at a temperature greater than the boiling point of Rb, the product mixture will contain gaseous Rb, which can be removed from the reaction vessel; this would cause a shift in equilibrium to form more Rb as product. (d) $2\text{CsX} + \text{Ca} \rightarrow \text{CaX}_2 + 2\text{Cs}$, where $\Delta H = \text{IE}_1(\text{Ca}) + \text{IE}_2(\text{Ca}) - 2\text{IE}_1(\text{Cs}) = 983 \text{ kJ/mol}$. This reaction is less favorable than for Rb, but Cs has a lower boiling point. **22.32**(a) $4.5 \times 10^4 \text{ L}$ (b) $1.30 \times 10^8 \text{ C}$ (c) $1.69 \times 10^6 \text{ s}$ **22.35**(a) Mg^{2+} is more difficult to reduce than H_2O , so $\text{H}_2(g)$ would be produced instead of Mg metal. $\text{Cl}_2(g)$ forms at the anode due to overvoltage. (b) The ΔH_f° of $\text{MgCl}_2(s)$ is -641.6 kJ/mol . High temperature favors the reverse (endothermic) reaction, the formation of magnesium metal and chlorine gas. **22.37**(a) Sulfur dioxide is the reducing agent and is oxidized to the +6 state (SO_4^{2-}). (b) $\text{HSO}_4^-(aq)$ (c) $\text{H}_2\text{SeO}_3(aq) + 2\text{SO}_2(g) + \text{H}_2\text{O}(l) \rightarrow \text{Se}(s) + 2\text{HSO}_4^-(aq) + 2\text{H}^+(aq)$ **22.42**(a) O.N. for Cu: in Cu_2S , +1; in Cu_2O , +1; in Cu, 0 (b) Cu_2S is the reducing agent, and Cu_2O is the oxidizing agent.

22.47 $2\text{ZnS}(s) + \text{C}(\text{graphite}) \longrightarrow 2\text{Zn}(s) + \text{CS}_2(g)$; $\Delta G_{\text{rxn}}^{\circ} = 463 \text{ kJ}$. Since $\Delta G_{\text{rxn}}^{\circ}$ is positive, this reaction is not spontaneous at standard-state conditions. $2\text{ZnO}(s) + \text{C}(s) \longrightarrow 2\text{Zn}(s) + \text{CO}_2(g)$; $\Delta G_{\text{rxn}}^{\circ} = 242.0 \text{ kJ}$. This reaction is also not spontaneous, but is less unfavorable. **22.48** The formation of sulfur trioxide is very slow at ordinary temperatures. Increasing the temperature can speed up the reaction, but because the reaction is exothermic, increasing the temperature decreases the yield. Adding a catalyst increases the rate of the reaction, allowing a lower temperature to be used to enhance the yield. **22.51(a)** Cl_2 , H_2 , and NaOH **(b)** The mercury-cell method yields higher purity NaOH , but releases some Hg , which is harmful in the environment.

22.52(a) $\Delta G^{\circ} = -142 \text{ kJ}$; yes **(b)** The rate of the reaction is very low at 25°C . **(c)** $\Delta G_{500}^{\circ} = -53 \text{ kJ}$, so the reaction is spontaneous. **(d)** $K_{25} = 7.8 \times 10^{24} > K_{500} = 3.8 \times 10^3$ **(e)** $1.05 \times 10^3 \text{ K}$

22.53 $7 \times 10^2 \text{ lb Cl}_2$ **22.56(a)** $\text{P}_4\text{O}_{10}(s) + 6\text{H}_2\text{O}(l) \longrightarrow 4\text{H}_3\text{PO}_4(l)$ **(b)** 1.52 **22.58(a)** $9.006 \times 10^9 \text{ g CO}_2$ **(b)** The $4.3 \times 10^{10} \text{ g CO}_2$ produced by automobiles is much greater than that from the blast furnace. **22.60(a)** If $[\text{OH}^-] > 1.1 \times 10^{-4} \text{ M}$ (i.e., if $\text{pH} > 10.04$), $\text{Mg}(\text{OH})_2$ will precipitate. **(b)** 1 (To the correct number of significant figures, all the magnesium precipitates.)

22.61(a) $K_{25}(\text{step 1}) = 1 \times 10^{168}$; $K_{25}(\text{side rxn}) = 7 \times 10^{228}$ **(b)** $K_{900}(\text{step 1}) = 4.5 \times 10^{49}$; $K_{900}(\text{side rxn}) = 1.4 \times 10^{63}$ **(c)** $8.8 \times 10^7 \text{ dollars}$ **(d)** $6.4 \times 10^7 \text{ dollars}$ **22.64(1)** $2\text{H}_2\text{O}(l) + 2\text{FeS}_2(s) + 7\text{O}_2(g) \longrightarrow 2\text{Fe}^{2+}(aq) + 4\text{SO}_4^{2-}(aq) + 4\text{H}^+(aq)$ increases acidity **(2)** $4\text{H}^+(aq) + 4\text{Fe}^{2+}(aq) + \text{O}_2(g) \longrightarrow 4\text{Fe}^{3+}(aq) + 2\text{H}_2\text{O}(l)$ **(3)** $\text{Fe}^{3+}(aq) + 3\text{H}_2\text{O}(l) \longrightarrow \text{Fe}(\text{OH})_3(s) + 3\text{H}^+(aq)$ increases acidity **(4)** $8\text{H}_2\text{O}(l) + \text{FeS}_2(s) + 14\text{Fe}^{3+}(aq) \longrightarrow 15\text{Fe}^{2+}(aq) + 2\text{SO}_4^{2-}(aq) + 16\text{H}^+(aq)$ increases acidity

22.65 density of ferrite: 7.86 g/cm^3 ; density of austenite: 7.55 g/cm^3 **22.67(a)** Cathode: $\text{Na}^+(l) + e^- \longrightarrow \text{Na}(l)$ Anode: $4\text{OH}^-(l) \longrightarrow \text{O}_2(g) + 2\text{H}_2\text{O}(g) + 4e^-$ **(b)** 50% **22.70(a)** $n\text{CO}_2(g) + n\text{H}_2\text{O}(l) \longrightarrow (\text{CH}_2\text{O})_n(s) + n\text{O}_2(g)$ **(b)** 27 L **(c)** $6.7 \times 10^4 \text{ L}$ **22.71** 73 mg/L **22.72** 891 kg Na_3AlF_6 **22.73(a)** 23.2 min **(b)** 14 effusion steps **22.75(a)** 1.890 t Al_2O_3 **(b)** 0.3339 t C **(c)** 100% **(d)** 74% **(e)** $2.813 \times 10^3 \text{ m}^3$ **22.80** Acid rain increases the leaching of phosphate into the groundwater, due to the protonation of PO_4^{3-} to form HPO_4^{2-} and H_2PO_4^- . As shown in calculations for parts (a) and (b), solubility of $\text{Ca}_3(\text{PO}_4)_2$ increases more than 10^4 from the value in pure water to the value in acidic rainwater. **(a)** $6.4 \times 10^{-7} \text{ M}$ **(b)** $1.1 \times 10^{-2} \text{ M}$ **22.81(a)** 1.00 mol % **(b)** 238.9 g/mol **22.83** density of silver = 10.51 g/cm^3 ; density of sterling silver = 10.2 g/cm^3

Chapter 23

Answers to Boxed Reading Problems B23.2 Zinc forms tetrahedral complex ions. The other ions listed form ions of other geometries (Ni^{2+} forms square planar complex ions while Fe^{2+} and Mn^{2+} form octahedral complex ions). If these ions are placed in a tetrahedral environment in place of the zinc, they cannot function as well as zinc since the enzyme catalyst would have a different shape.

• **23.2(a)** $1s^2 2s^2 2p^6 3s^2 3p^6 4s^2 3d^{10} 4p^6 5s^2 4d^x$ **(b)** $1s^2 2s^2 2p^6 3s^2 3p^6 4s^2 3d^{10} 4p^6 5s^2 4d^{10} 5p^6 6s^2 4f^{14} 5d^x$ **23.4** Five; examples are Mn : $[\text{Ar}] 4s^2 3d^5$ and Fe^{3+} : $[\text{Ar}] 3d^5$. **23.6(a)** The elements should increase in size as they increase in mass from Period 5 to Period 6. Because there are 14 inner transition elements in Period 6, the effective nuclear charge increases

significantly; so the atomic size decreases, or “contracts.” This effect is significant enough that Zr^{4+} and Hf^{4+} are almost the same size but differ greatly in atomic mass. **(b)** The atomic size increases from Period 4 to Period 5, but stays fairly constant from Period 5 to Period 6. **(c)** Atomic mass increases significantly from Period 5 to Period 6, but atomic radius (and thus volume) increases slightly, so Period 6 elements are very dense.

23.9(a) A paramagnetic substance is attracted to a magnetic field, while a diamagnetic substance is slightly repelled by one. **(b)** Ions of transition elements often have half-filled d orbitals whose unpaired electrons make the ions paramagnetic. Ions of main-group elements usually have a noble-gas configuration with no partially filled levels. **(c)** Some d orbitals in the transition element ions are empty, which allows an electron from one d orbital to move to a slightly higher energy one. The energy required is small and falls in the visible range, so the ion is colored. All orbitals are filled in ions of main-group elements, so enough energy would have to be added to move an electron to the next principal energy level, not just another orbital within the same energy level. This amount of energy is very large and much greater than the visible range of wavelengths.

23.10(a) $1s^2 2s^2 2p^6 3s^2 3p^6 4s^2 3d^3$ or $[\text{Ar}] 4s^2 3d^3$ **(b)** $1s^2 2s^2 2p^6 3s^2 3p^6 4s^2 3d^{10} 4p^6 5s^2 4d^1$ or $[\text{Kr}] 5s^2 4d^1$ **(c)** $[\text{Xe}] 6s^2 4f^{14} 5d^{10}$ **23.12(a)** $[\text{Xe}] 6s^2 4f^{14} 5d^6$ **(b)** $[\text{Ar}] 4s^2 3d^7$ **(c)** $[\text{Kr}] 5s^1 4d^{10}$ **23.14(a)** $[\text{Ar}]$, no unpaired electrons **(b)** $[\text{Ar}] 3d^9$, one unpaired electron **(c)** $[\text{Ar}] 3d^5$, five unpaired electrons **(d)** $[\text{Kr}] 4d^2$, two unpaired electrons **23.16(a)** +5 **(b)** +4 **(c)** +7 **23.18** Cr, Mo, and W **23.20** in CrF_2 , because Cr is in a lower oxidation state in that compound **23.22** Atomic size increases slightly down a group of transition elements, but nuclear charge increases much more, so the first ionization energy generally increases. Since the ionization energy of Mo is higher than that of Cr, so it is more difficult to remove electrons from Mo. Also, the reduction potential for Mo is less negative, so it is more difficult to oxidize Mo than Cr. **23.24** CrO_3 , with Cr in a higher oxidation state, yields a more acidic aqueous solution.

23.28(a) seven **(b)** The number corresponds to a half-filled f subshell. **23.30(a)** $[\text{Xe}] 6s^2 5d^1$ **(b)** $[\text{Xe}] 4f^1$ **(c)** $[\text{Rn}] 7s^2 5f^{11}$ **(d)** $[\text{Rn}] 5f^2$ **23.32(a)** Eu^{2+} : $[\text{Xe}] 4f^7$; Eu^{3+} : $[\text{Xe}] 4f^6$; Eu^{4+} : $[\text{Xe}] 4f^5$. The stability of the half-filled f subshell makes Eu^{2+} most stable. **(b)** Tb^{2+} : $[\text{Xe}] 4f^9$; Tb^{3+} : $[\text{Xe}] 4f^8$; Tb^{4+} : $[\text{Xe}] 4f^7$. Tb should show a +4 oxidation state because that corresponds to a half-filled subshell. **23.34** Gd has the electron configuration $[\text{Xe}] 6s^2 4f^7 5d^1$ with eight unpaired electrons. Gd^{3+} has seven unpaired electrons: $[\text{Xe}] 4f^7$. **23.37** The coordination number indicates the number of ligand atoms bonded to the metal ion. The oxidation number represents the number of electrons lost to form the ion. The coordination number is unrelated to the oxidation number. **23.39** 2, linear; 4, tetrahedral or square planar; 6, octahedral **23.42** The complex ion has a negative charge.

23.45(a) hexaaquanickel(II) chloride **(b)** tris(ethylenediamine) chromium(III) perchlorate **(c)** potassium hexacyanomanganate(II) **23.47(a)** 2+, 6 **(b)** 3+, 6 **(c)** 2+, 6 **23.49(a)** potassium dicyanoargentate(I) **(b)** sodium tetrachlorocadmite(II) **(c)** tetraammineaquabromocobalt(III) bromide **23.51(a)** 1+, 2 **(b)** 2+, 4 **(c)** 3+, 6 **23.53(a)** $[\text{Zn}(\text{NH}_3)_4]\text{SO}_4$ **(b)** $[\text{Cr}(\text{NH}_3)_5\text{Cl}]\text{Cl}_2$ **(c)** $\text{Na}_3[\text{Ag}(\text{S}_2\text{O}_3)_2]$ **23.55(a)** 4, two ions **(b)** 6, three ions

(c) 2, four ions **23.57(a)** $[\text{Cr}(\text{H}_2\text{O})_6]_2(\text{SO}_4)_3$ (b) $\text{Ba}[\text{FeBr}_4]_2$
 (c) $[\text{Pt}(\text{en})_2]\text{CO}_3$ **23.59(a)** 6, five ions (b) 4, three ions
 (c) 4, two ions **23.61(a)** The nitrite ion forms linkage isomers because it can bind to the metal ion through the lone pair on the N atom or any lone pair on either O atom. $[\ddot{\text{O}}-\ddot{\text{N}}=\ddot{\text{O}}]^-$
 (b) Sulfur dioxide molecules form linkage isomers because the lone pair on the S atom or any lone pair on either O atom can bind the central metal ion. $\ddot{\text{O}}=\ddot{\text{S}}=\ddot{\text{O}}$ (c) Nitrate ions have an N atom with no lone pair and three O atoms, all with lone pairs that can bind to the metal ion. But all of the O atoms are equivalent, so these ions do not form linkage isomers.

23.63(a) geometric isomerism

(b) geometric isomerism

(c) geometric isomerism

23.65(a) geometric isomerism

(b) linkage isomerism

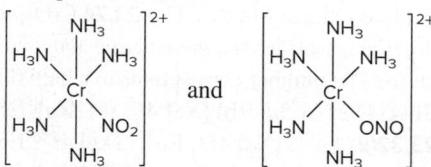

(c) geometric isomerism

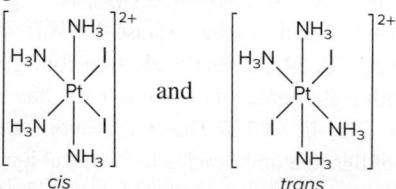

23.67 The compound with the traditional formula is $\text{CrCl}_3 \cdot 4\text{NH}_3$; the modern formula is $[\text{Cr}(\text{NH}_3)_4\text{Cl}_2]\text{Cl}$. **23.69(a)** $\text{K}[\text{Pd}(\text{NH}_3)\text{Cl}_3]$
 (b) $[\text{PdCl}_2(\text{NH}_3)_2]$ (c) $\text{K}_2[\text{PdCl}_6]$ (d) $[\text{Pd}(\text{NH}_3)_4\text{Cl}_2]\text{Cl}_2$

23.71(a) dsp^2 (b) sp^3 **23.74** Absorption of orange light or absorption of all colors of light except blue will give a solution a blue color. **23.75(a)** The crystal field splitting energy (Δ) is the energy difference between the two sets of d orbitals that result from electrostatic effects of ligands on a central transition metal atom. (b) In an octahedral field of ligands, the ligands approach along the x , y , and z axes. The $d_{x^2-y^2}$ and d_z^2 orbitals are located along the x , y , and z axes, so ligand interactions there are higher

in energy. The other ligand interactions are lower in energy because the d_{xy} , d_{yz} , and d_{zx} orbitals are located between the x , y , and z axes. (c) In a tetrahedral field of ligands, the ligands do not approach along the x , y , and z axes. The ligand interaction is greater for the d_{xy} , d_{yz} , and d_{zx} orbitals and lesser for the $d_{x^2-y^2}$ and d_z^2 orbitals. Therefore, the crystal field splitting is reversed, and the d_{xy} , d_{yz} , and d_{zx} orbitals are higher in energy than the $d_{x^2-y^2}$ and d_z^2 orbitals. **23.78** If Δ is greater than E_{pairing} , electrons will pair their spins in the lower energy set of d orbitals before entering the higher energy set of d orbitals. **23.80(a)** no d electrons (b) eight d electrons (c) six d electrons **23.82(a)** five (b) ten (c) seven

23.84

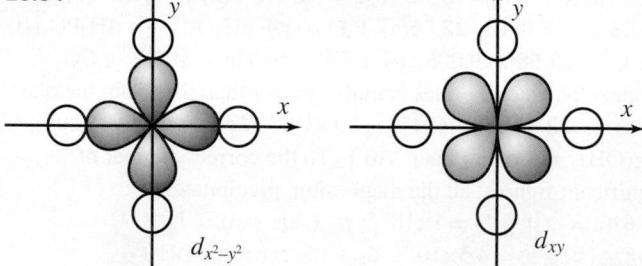

In an octahedral field of ligands, the ligands approach along the x , y , and z axes. The lobes of the $d_{x^2-y^2}$ orbital lie along the x and y axes, so ligand interaction is greater. The lobes of the d_{xy} orbital lie between the x and y axes, so ligand interaction is less. The greater interaction of the $d_{x^2-y^2}$ orbital results in its higher energy. **23.86** a and d

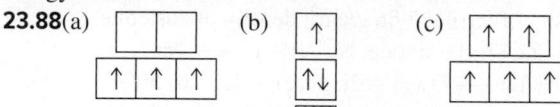

23.92 $[\text{Cr}(\text{H}_2\text{O})_6]^{3+} < [\text{Cr}(\text{NH}_3)_6]^{3+} < [\text{Cr}(\text{NO}_2)_6]^{3+}$

23.94 A violet complex absorbs yellow-green light. The light absorbed by a complex with a weaker field ligand would have a lower energy and a higher wavelength. Light of lower energy than yellow-green light is yellow, orange, or red. The color observed would be blue or green. **23.97** H_2O is a weak-field ligand, somewhat weaker than NH_3 . A weak-field ligand results in a lower splitting energy, and the complex absorbs visible light of lower energy. The hexaaqua complex appears green because it absorbs red light. The hexammine complex appears violet because it absorbs yellow light, which has higher energy (shorter λ) than red light. **23.101** Hg^+ is $[\text{Xe}] 6s^1 4f^{14} 5d^{10}$ and Cu^+ is $[\text{Ar}] 3d^{10}$. The mercury(I) ion has one electron in the $6s$ orbital that can form a covalent bond with the electron in the $6s$ orbital of another mercury(I) ion. In the copper(I) ion there are no electrons in the s orbital, so these ions cannot bond with one another. **23.102(a)** 6 (b) +3 (c) two (d) 1 mol

23.109 geometric (*cis-trans*) and linkage isomerism

23.110 $[\text{Co}(\text{NH}_3)_4(\text{H}_2\text{O})\text{Cl}]^{2+}$

tetraammineaquachlorocobalt(III) ion

2 geometric isomers

$[\text{Cr}(\text{H}_2\text{O})_3\text{Br}_2\text{Cl}]$
triaquadibromochlorochromium(III)

3 geometric isomers

$[\text{Cr}(\text{NH}_3)_2(\text{H}_2\text{O})_2\text{Br}_2]^+$
diamminediaquadibromochromium(III) ion

6 isomers (5 geometric)

23.115(a) no optical isomers (b) no optical isomers

(c) no optical isomers (d) no optical isomers (e) optical isomers

23.116 $\text{Pt}[\text{P}(\text{C}_2\text{H}_5)_3]_2\text{Cl}_2$

cis-dichlorobis(triethylphosphine)platinum(II)

trans-dichlorobis(triethylphosphine)platinum(II)

23.118(a) The first reaction shows no change in the number of particles. In the second reaction, the number of reactant particles is greater than the number of product particles. A decrease in the number of particles means a decrease in entropy. Based on entropy change only, the first reaction is favored. (b) The ethylenediamine complex will be more stable with respect to ligand exchange in water because the entropy change for that exchange is unfavorable (negative).

Chapter 24

Answers to Boxed Reading Problems: **B24.1** In the *s*-process, a nucleus captures a neutron at some point over a long period of time. Then the nucleus emits a β^- particle to form another element. The stable isotopes of most heavy elements up to ^{209}Bi form by the *s*-process. The *r*-process very quickly forms less stable isotopes and those with *A* greater than 230 by multiple neutron captures, followed by multiple β^- decays. **B24.3** The simultaneous fusion of three nuclei is a termolecular process. Termolecular processes have a very low probability of occurring. The bimolecular fusion of ^8Be with ^4He is more likely.

B24.4 $^{210}_{83}\text{Bi} \longrightarrow {}_{-1}\beta + {}^{210}_{84}\text{Po}$ (nuclide A); ${}^{210}_{84}\text{Po} \longrightarrow {}_2\alpha + {}^{206}_{82}\text{Pb}$ (nuclide B); ${}^{206}_{82}\text{Pb} + {}_3\text{n} \longrightarrow {}^{209}_{82}\text{Pb}$ (nuclide C); ${}^{209}_{82}\text{Pb} \longrightarrow {}_{-1}\beta + {}^{209}_{83}\text{Bi}$ (nuclide D)

• **24.1**(a) Chemical reactions are accompanied by relatively small changes in energy; nuclear reactions are accompanied by relatively large changes in energy. (b) Increasing temperature increases the rate of a chemical reaction but has no effect on a nuclear reaction. (c) Chemical reaction rates increase with higher reactant concentrations, while nuclear reaction rates increase with increasing number of nuclei. (d) If the reactant is limiting in a chemical reaction, then more reactant produces more product and the yield increases. The presence of more radioactive reactant results in more decay product, so a higher reactant concentration increases the yield. **24.2**(a) 95.02% (b) The atomic mass is larger than the isotopic mass of ^{32}S . Sulfur-32 is the lightest isotope. **24.4**(a) *Z* down by 2, *N* down by 2 (b) *Z* up by 1, *N* down by 1 (c) no change in *Z* or *N* (d) *Z* down by 1, *N* up by 1 (e) *Z* down by 1, *N* up by 1. A different element is produced in all cases except (c). **24.6** A neutron-rich nuclide decays by β^- decay. A neutron-poor nuclide undergoes positron decay or electron capture. **24.8**(a) ${}^{234}_{92}\text{U} \longrightarrow {}_2^4\alpha + {}^{230}_{90}\text{Th}$ (b) ${}^{232}_{93}\text{Np} + {}_0^1\text{e} \longrightarrow {}^{232}_{92}\text{U}$ (c) ${}^{12}_7\text{N} \longrightarrow {}_1^0\beta + {}^{12}_6\text{C}$

24.10(a) ${}^{27}_{12}\text{Mg} \longrightarrow {}_{-1}\beta + {}^{27}_{13}\text{Al}$ (b) ${}^{23}_{12}\text{Mg} \longrightarrow {}_1^0\beta + {}^{23}_{11}\text{Na}$ (c) ${}^{103}_{46}\text{Pd} + {}_{-1}\text{e} \longrightarrow {}^{103}_{45}\text{Rh}$ **24.12**(a) ${}^{48}_{23}\text{V} \longrightarrow {}^{48}_{22}\text{Ti} + {}_{-1}\beta$ (b) ${}^{107}_{48}\text{Cd} + {}_{-1}\text{e} \longrightarrow {}^{107}_{47}\text{Ag}$ (c) ${}^{210}_{86}\text{Rn} \longrightarrow {}^{206}_{84}\text{Po} + {}_2^4\alpha$

(c) $^{129}_{52}\text{Te} \longrightarrow {}^{129}_{53}\text{I} + {}_{-1}^0\beta$ **24.16**(a) Appears stable because its N and Z values are both magic numbers, but its N/Z ratio (1.50) is too high; it is unstable. (b) Appears unstable because its Z value is an odd number, but its N/Z ratio (1.19) is in the band of stability, so it is stable. (c) Unstable because its N/Z ratio is too high. **24.18**(a) The N/Z ratio for ^{127}I is 1.4; it is stable. (b) The N/Z ratio for ^{106}Sn is 1.1; it is unstable because this ratio is too low. (c) The N/Z ratio is 1.1 for ^{68}As . The ratio is within the range of stability, but the nuclide is most likely unstable because there are odd numbers of both protons and neutrons.

- 24.20**(a) alpha decay (b) positron decay or electron capture (c) positron decay or electron capture **24.22**(a) β^- decay (b) positron decay or electron capture (c) alpha decay

24.24 Stability results from a favorable N/Z ratio, even N and/or Z , and the occurrence of magic numbers. The N/Z ratio of ^{52}Cr is 1.17, which is within the band of stability. The fact that Z is even does not account for the variation in stability because all isotopes of chromium have the same Z . However, ^{52}Cr has 28 neutrons, so N is both an even number and a magic number for this isotope only. **24.28** seven alpha emissions and four β^- emissions

24.31 No, it is not valid to conclude that $t_{1/2}$ equals 1 min because the number of nuclei is so small. Decay rate is an average rate and is only meaningful when the sample is macroscopic and contains a large number of nuclei. For the sample containing 6×10^{12} nuclei, the conclusion is valid. **24.33** 2.56×10^{-2} Ci/g

24.35 1.4×10^8 Bq/g **24.37** 1×10^{-12} day $^{-1}$ **24.39** 2.31×10^{-7} yr $^{-1}$

24.41 1.49 mg **24.43** 2.2×10^9 yr **24.45** 30 d/min **24.47** 1.0×10^6 yr

24.50 Neither γ radiation nor neutron beams have charge, so neither is deflected by a magnetic or electric field. Neutron beams differ from γ radiation in that a neutron has a mass approximately equal to that of a proton. It was observed that a neutron beam induces the emission of protons from a substance; γ radiation does not cause such emission. **24.52** Protons are repelled from the target nuclei due to interaction with like (positive) charges. Higher energy is required to overcome the repulsion. **24.53**(a) $^{10}_5\text{B} + {}^4_2\alpha \longrightarrow {}^1_0\text{n} + {}^{13}_7\text{N}$ (b) $^{28}_{14}\text{Si} + {}^2_1\text{H} \longrightarrow {}^1_0\text{n} + {}^{29}_{15}\text{P}$ (c) $^{242}_{96}\text{Cm} + {}^4_2\alpha \longrightarrow {}^2_0\text{n} + {}^{244}_{98}\text{Cf}$ **24.58** Ionizing radiation is more dangerous to children because they have rapidly dividing cells, so there is more chance for radiation to cause cell damage or mutation. **24.60**(a) 5.4×10^{-7} rad (b) 5.4×10^{-9} Gy

24.62(a) 7.5×10^{-10} Gy (b) 7.5×10^{-5} mrem (c) 7.5×10^{-10} Sv

24.65 1.86×10^{-3} rad **24.67** NAA does not destroy the sample, while chemical analyses do. Neutrons bombard a nonradioactive

sample, inducing some atoms within the sample to be radioactive. The radioisotopes decay by emitting radiation characteristic of each isotope. **24.73** Energy is released when a nucleus forms from nucleons. The nuclear binding energy is the quantity of energy holding 1 mol of nuclei together. This energy must be absorbed to break up the nucleus into nucleons and is released when nucleons come together. **24.75**(a) 1.861×10^4 eV (b) 2.981×10^{-15} J

24.77 7.6×10^{11} J **24.79**(a) 7.976 MeV/nucleon (b) 127.6 MeV/atom (c) 1.231×10^{10} kJ/mol **24.81**(a) 8.768 MeV/nucleon (b) 517.3 MeV/atom (c) 4.99×10^{10} kJ/mol

24.85 Radioactive decay is a spontaneous process in which unstable nuclei emit radioactive particles and energy. Fission occurs as the result of high-energy bombardment of nuclei that cause them to break into smaller nuclei, radioactive particles, and energy. All fission events are not the same. The nuclei split in a number of ways to produce several different products.

24.88 The water serves to slow the neutrons so that they are better able to cause a fission reaction. Heavy water is a better moderator because it does not absorb neutrons as well as light water does; thus, more neutrons are available to initiate the fission process. However, D_2O does not occur naturally in great abundance, so its production adds to the cost of a heavy-water reactor. **24.93**(a) 1.1×10^{-29} kg (b) 9.9×10^{-13} J (c) 5.9×10^8 kJ/mol; this is approximately 1 million times larger than a typical heat of reaction. **24.95** 8.0×10^3 yr

24.98 1.35×10^{-5} M **24.100** 6.2×10^{-2} **24.102**(a) 5.99 h (b) 21% **24.104**(a) 0.999 (b) 0.298 (c) 5.58×10^{-6} (d) Radiocarbon dating is more reliable for the fraction in part (b) because a significant amount of ^{14}C has decayed and a significant amount remains. Therefore, a change in the amount of ^{14}C will be noticeable. For the fraction in part (a), very little ^{14}C has decayed, and for (c) very little ^{14}C remains. In either case, it will be more difficult to measure the change, so the error will be relatively large. **24.106** 6.58 h **24.110** 4.904×10^{-9} L/h **24.113** 81 yr

24.115(a) 0.15 Bq/L (b) 0.27 Bq/L (c) 3.3 days; for a total of 12.8 days **24.118** 7.4 s **24.121** 1926 **24.124** 6.27×10^5 eV/ reaction, 6.05×10^7 kJ/mol reaction **24.127**(a) 2.07×10^{-17} J (b) 1.45×10^7 H atoms (c) 1.4960×10^{-5} J (d) 1.4959×10^{-5} J (e) No, the captain should continue using the current technology. **24.130**(a) 0.043 MeV, 2.9×10^{-11} m (b) 4.713 MeV

24.134(a) 3.26×10^3 days (b) 3.2×10^{-3} s (c) 2.78×10^{11} yr

24.136(a) 1.80×10^{17} J (b) 6.15×10^{16} kJ (c) The procedure in part (b) produces more energy per kilogram of antihydrogen. **24.137** 9.316×10^2 MeV **24.141** 7.81 days

GLOSSARY

A

absolute scale (See *Kelvin scale*.)

absorption spectrum The spectrum produced when atoms absorb specific wavelengths of incoming light and become excited from lower to higher energy levels.

abundance The amount of an element in a particular region of the natural world.

accuracy The closeness of a measurement to the actual value.

acid In common laboratory terms, any species that produces H⁺ ions when dissolved in water. (See also *Arrhenius*, *Brønsted-Lowry*, and *Lewis acid-base* definitions.)

acid anhydride A compound, usually formed by a dehydration-condensation reaction of an oxoacid, that yields two molecules of the acid when it reacts with water.

acid-base buffer (also *buffer*) A solution that resists changes in pH when a small amount of either strong acid or strong base is added.

acid-base indicator An organic molecule whose color is different in acid and in base; the color is used to monitor the equivalence point of a titration or the pH of a solution.

acid-base reaction Any reaction between an acid and a base. (See also *neutralization reaction*.)

acid-base titration curve A plot of the pH of a solution of acid (or base) versus the volume of base (or acid) added to the solution.

acid-dissociation (acid-ionization) constant (K_a) An equilibrium constant for the dissociation of an acid (HA) in H₂O to yield the conjugate base (A⁻) and H₃O⁺:

$$K_a = \frac{[\text{H}_3\text{O}^+][\text{A}^-]}{[\text{HA}]}$$

actinides The Period 7 elements that constitute the second inner transition series (5f block), which includes thorium (Th; Z = 90) through lawrencium (Lr; Z = 103).

activated complex (See *transition state*.)

activation energy (E_a) The minimum energy with which molecules must collide to react.

active site The region of an enzyme formed by specific amino acid side chains at which catalysis occurs.

activity (\mathcal{A}) (also *decay rate*) The change in number of nuclei (N) of a radioactive sample divided by the change in time (t).

activity series of the metals A listing of metals arranged in order of decreasing strength of the metal as a reducing agent in aqueous reactions.

actual yield The amount of product actually obtained in a chemical reaction.

addition polymer (also *chain-reaction*, or *chain-growth*, *polymer*) A polymer formed when monomers (usually containing C=C) combine through an addition reaction.

addition reaction A type of organic reaction in which atoms linked by a multiple bond become bonded to more atoms.

adduct The product of a Lewis acid-base reaction, a species that contains a new covalent bond.

adenosine triphosphate (ATP) A high-energy molecule that serves most commonly as a store and source of energy in organisms.

alcohol An organic compound (ending, -ol) that contains a $-\text{C}-\ddot{\text{O}}-\text{H}$ functional group.

aldehyde An organic compound (ending, -al) that contains the carbonyl functional group (C=O) in which the carbonyl C is also bonded to H.

alkane A hydrocarbon that contains only single bonds (general formula, C_nH_{2n+2}).

alkene A hydrocarbon that contains at least one C=C bond (general formula, C_nH_{2n}).

alkyl group A saturated hydrocarbon chain with one bond available.

alkyl halide (See *haloalkane*.)

alkyne A hydrocarbon that contains at least one C≡C bond (general formula, C_nH_{2n-2}).

allotrope One of two or more crystalline or molecular forms of an element. In general, one allotrope is more stable than another at a particular pressure and temperature.

alloy A mixture with metallic properties that consists of solid phases of two or more pure elements, a solid-solid solution, or distinct intermediate phases.

alpha (α) decay A radioactive process in which an alpha particle is emitted from a nucleus.

alpha particle (α , $\frac{1}{2}\alpha$, or ${}^4\text{He}^{2+}$) A positively charged particle, identical to a helium-4 nucleus, that is one of the common types of radioactive emissions.

amide An organic compound that contains the $-\text{C}(=\text{O})-\text{N}-$ functional group.

amine An organic compound (general formula, $-\text{C}(=\text{O})-\text{N}(\text{H})(\text{R})-$) derived structurally by replacing one or more H atoms of ammonia with organic groups; a weak organic base.

amino acid An organic compound [general formula, H₂N—CH(R)—COOH] with at least one carboxyl and one amine group on the same molecule; the monomer unit of a protein.

amorphous solid A solid that has a poorly defined shape because its particles do not have an orderly arrangement throughout a sample.

ampere (A) The SI unit of electric current; 1 ampere of current results when 1 coulomb of charge flows through a conductor in 1 second.

amphoteric Able to act as either an acid or a base.

amplitude The height of the crest (or depth of the trough) of a wave; related to the intensity of the energy (brightness of the light).

angular momentum quantum number (l) An integer from 0 to $n - 1$ that is related to the shape of an atomic orbital.

anion A negatively charged ion.

anode The electrode at which oxidation occurs in an electrochemical cell. Electrons are given up by the reducing agent and leave the cell at the anode.

antibonding MO A molecular orbital formed when wave functions are subtracted from each other, which decreases electron density between the nuclei and leaves a node. Electrons occupying such an orbital destabilize the molecule.

apatite A compound of general formula Ca₅(PO₄)₃X, where X is generally F, Cl, or OH; a source of phosphorus.

aqueous solution A solution in which water is the solvent.

aromatic hydrocarbon A compound of C and H with one or more rings of C atoms (often drawn with alternating C—C and C=C bonds), in which there is extensive delocalization of π electrons.

Arrhenius acid-base definition A model of acid-base behavior in which an acid is a substance that has H in its formula and dissociates in water to yield H_3O^+ , and a base is a substance that has OH in its formula and produces OH^- in water.

Arrhenius equation An equation that expresses the exponential relationship between temperature and the rate constant: $k = Ae^{-E_a/RT}$.

atmosphere The mixture of gases that extends from a planet's surface and eventually merges with outer space; the gaseous region of Earth's crust. (For the unit, see *standard atmosphere*.)

atom The smallest unit of an element that retains the chemical nature of the element. A neutral, spherical entity composed of a positively charged central nucleus surrounded by one or more negatively charged electrons.

atomic mass (also *atomic weight*) The average of the masses of the naturally occurring isotopes of an element weighted according to their abundances.

atomic mass unit (amu) (also *dalton, Da*) A mass exactly equal $\frac{1}{12}$ to the mass of a carbon-12 atom.

atomic number (Z) The unique number of protons in the nucleus of each atom of an element (equal to the number of electrons in the neutral atom). An integer that expresses the positive charge of a nucleus or subatomic particle in multiples of the electronic charge.

atomic orbital (also *wave function*) A mathematical expression that describes the motion of the electron's matter-wave in terms of time and position in the region of the nucleus. The term is used qualitatively to mean the region of space in which there is a high probability of finding the electron.

atomic size A measure of how closely one atom lies next to another, atomic size is determined from the distances between nuclei of adjacent atoms. (See also *metallic radius* and *covalent radius*.)

atomic solid A solid consisting of individual atoms held together by dispersion forces; the frozen noble gases are the only examples.

atomic symbol (also *element symbol*) A one- or two-letter abbreviation for the English, Latin, or Greek name of an element.

aufbau principle The conceptual approach for building up atoms by adding one proton at a time to the nucleus and one electron to the lowest energy sublevel that is available, to obtain the ground-state electron configurations of the elements.

autoionization (also *self-ionization*) A reaction in which two molecules of a substance react to give ions. The most important example is for water: $2\text{H}_2\text{O}(l) \rightleftharpoons \text{H}_3\text{O}^+(aq) + \text{OH}^-(aq)$

average rate The change in concentration of reactants (or products) divided by a finite time period.

Avogadro's law The gas law stating that, at fixed temperature and pressure, equal volumes of any ideal gas contain equal numbers of particles, and, therefore, the volume of a gas is directly proportional to its amount (mol): $V \propto n$.

Avogadro's number A number (6.022×10^{23} to four significant figures) equal to the number of atoms in exactly 12 g of carbon-12; the number of atoms, molecules, or formula units in one mole of an element or compound.

axial group An atom (or group) that lies above or below the trigonal plane of a trigonal bipyramidal molecule, or a similar structural feature in a molecule.

B

background radiation Natural ionizing radiation, the most important form of which is cosmic radiation.

balancing coefficient (also *stoichiometric coefficient*) A numerical multiplier of all the atoms in the formula immediately following it in a balanced chemical equation.

band of stability The band of stable nuclides that appears on a plot of number of neutrons vs. number of protons for all nuclides.

band theory An extension of molecular orbital (MO) theory that explains many properties of metals and other solids, in particular, the differences in conductivity of metals, metalloids, and nonmetals.

barometer A device used to measure atmospheric pressure. Most commonly, a tube open at one end, which is filled with mercury and inverted into a dish of mercury.

base In common laboratory terms, any species that produces OH^- ions when dissolved in water. (See also *Arrhenius, Brønsted-Lowry*, and *Lewis acid-base definitions*.)

base pair Two complementary mononucleotide bases that are H bonded to each other; guanine (G) always pairs with cytosine (C), and adenine (A) always pairs with thymine (T) (or uracil, U, in RNA).

base unit (also *fundamental unit*) A unit that defines the standard for one of the seven physical quantities in the International System of Units (SI).

base-dissociation (base-ionization) constant (K_b) An equilibrium constant for the reaction of a base (B) with H_2O to yield the conjugate acid (BH^+) and OH^- :

$$K_b = \frac{[\text{BH}^+][\text{OH}^-]}{[\text{B}]}$$

basic-oxygen process The method used to convert pig iron to steel, in which O_2 is blown over and through molten pig iron to oxidize impurities and decrease the content of carbon.

battery A group of voltaic cells arranged in series; primary and secondary types are self-contained, but flow batteries are not.

becquerel (Bq) The SI unit of radioactivity; 1 Bq = 1 d/s (disintegration per second).

bent shape (also *V shape*) A molecular shape that arises when a central atom is bonded to two other atoms and has one or two lone pairs; occurs as the AX_2E shape class (bond angle $< 120^\circ$) in the trigonal planar arrangement and as the AX_2E_2 shape class (bond angle $< 109.5^\circ$) in the tetrahedral arrangement.

beta (β) decay A radioactive change that encompasses any of three specific processes: β^- decay, β^+ emission, or e^- capture.

beta β^- decay (also *negatron emission*) A radioactive process in which a high-speed electron is emitted from a nucleus.

beta particle (β , β^- , or $\text{-}\beta$) A negatively charged particle, identified as a high-speed electron, that is one of the common types of radioactive emissions.

bimolecular reaction An elementary reaction involving the collision of two reactant species.

binary covalent compound A compound that consists of atoms of two elements, typically nonmetals, in which bonding occurs primarily through electron sharing.

binary ionic compound A compound that consists of the oppositely charged ions of two elements.

biomass conversion The process of applying chemical and biological methods to convert plant or animal matter into fuels.

biosphere The living systems that inhabit Earth.

blast furnace A tower-shaped furnace made of brick material in which intense heat and blasts of air are used to convert iron ore and coke to iron metal and carbon dioxide.

body-centered cubic unit cell A unit cell in which a particle lies at each corner and in the center of a cube.

boiling point (bp or T_b) The temperature at which the vapor pressure inside bubbles forming in a liquid equals the external (atmospheric) pressure.

boiling point elevation (ΔT_b) The increase in the boiling point of a solvent caused by the presence of dissolved solute.

bond angle The angle formed by the bonds joining the nuclei of two surrounding atoms to the nucleus of the central atom, which is at the vertex.

bond energy (BE) (also *bond enthalpy* or *bond strength*) The standard enthalpy change (always > 0) accompanying the breakage of a given bond in 1 mol of gaseous molecules.

bond length The distance between the nuclei of two bonded atoms.

bond order The number of electron pairs shared by two bonded atoms.

bonding MO A molecular orbital formed when wave functions are added to each other, which increases electron density between the nuclei. Electrons occupying such an orbital stabilize the molecule.

bonding pair (also *shared pair*) An electron pair shared by two nuclei; the mutual attraction between the nuclei and the electron pair forms a covalent bond.

Born-Haber cycle A series of hypothetical steps and their enthalpy changes that converts elements to an ionic compound; it is used to calculate the lattice energy.

Boyle's law The gas law stating that, at constant temperature and amount of gas, the volume occupied by a gas is inversely proportional to the applied (external) pressure: $V \propto 1/P$.

branch A side chain appended to a polymer backbone or to the longest sequence of atoms in an organic compound.

bridge bond (also *three-center, two-electron bond*) A covalent bond in which three atoms are held together by two electrons.

Bronsted-Lowry acid-base definition A model of acid-base behavior based on proton transfer, in which an acid and a base are defined, respectively, as a species that donates a proton and one that accepts a proton.

buffer (See *acid-base buffer*.)

buffer capacity A measure of the ability of a buffer to resist a change in pH; related to the total concentrations and relative proportions of buffer components.

buffer range The pH range over which a buffer acts effectively.

C

calibration The process of correcting for systematic error of a measuring device by comparing it to a known standard.

calorie (cal) A unit of energy defined as exactly 4.184 joules; originally defined as the heat needed to raise the temperature of 1 g of water 1°C (from 14.5°C to 15.5°C).

calorimeter A device used to measure the heat released or absorbed by a physical or chemical process taking place within it.

capillarity (or *capillary action*) The rising of a liquid through a narrow space against the pull of gravity.

carbon steel The steel that is produced by the basic-oxygen process, contains about 1% to 1.5% C and other impurities, and is alloyed with metals that prevent corrosion and increase strength or flexibility.

carbonyl group The C=O grouping of atoms.

carboxylic acid An organic compound (ending, *-oic acid*) that

contains the $\text{—C}\overset{\parallel}{\text{—}}\text{O}\text{H}$ group.

catalyst A substance or mixture that increases the rate of a reaction without being used up in the process.

catenation The process by which atoms of an element bond to each other in chains; most common with carbon in organic compounds but also occurs with boron, silicon, sulfur, and several other elements.

cathode The electrode at which reduction occurs in an electrochemical cell. Electrons enter the cell and are acquired by the oxidizing agent at the cathode.

cathode ray The ray of light emitted by the cathode (negative electrode) in a gas discharge tube; travels in a straight line, unless deflected by magnetic or electric fields.

cation A positively charged ion.

cell potential (E_{cell}) (also *electromotive force*, or *emf*; *cell voltage*) The difference in electrical potential between the two electrodes of an electrochemical cell.

Celsius scale (formerly *centigrade scale*) A temperature scale in which the freezing and boiling points of water are defined as 0°C and 100°C, respectively.

ceramic A nonmetallic, nonpolymeric solid that is hardened by heating it to high temperatures and, in most cases, consists of silicate microcrystals suspended in a glassy cementing medium.

chain reaction In nuclear fission, a self-sustaining process in which neutrons released by splitting of one nucleus cause other nuclei to split, which releases more neutrons, and so on.

change in enthalpy (ΔH) The change in the system's internal energy plus the product of the constant pressure and the change in volume: $\Delta H = \Delta E + P\Delta V$; alternatively, the heat lost or gained at constant pressure: $\Delta H = q_p$.

charge density The ratio of the charge of an ion to its volume.

Charles's law The gas law stating that at constant pressure, the volume occupied by a fixed amount of gas is directly proportional to its absolute temperature: $V \propto T$.

chelate A complex ion in which the metal ion is bonded to a bidentate or polydentate ligand.

chemical bond The force that holds two atoms together in a molecule (or formula unit).

chemical change (also *chemical reaction*) A change in which one or more substances are converted into one or more substances with different composition and properties.

chemical equation A statement that uses chemical formulas to express the identities and quantities of the substances involved in a chemical or physical change.

chemical formula A notation of atomic symbols and numerical subscripts that shows the type and number of each atom in a molecule or formula unit of a substance.

chemical kinetics The study of the rates of reactions and the factors that affect them.

chemical property A characteristic of a substance that appears as it interacts with, or transforms into, other substances.

chemical reaction (See *chemical change*.)

chemistry The scientific study of matter and its properties, the changes it undergoes, and the energy associated with those changes.

chiral molecule One that is not superimposable on its mirror image; an optically active molecule. In organic compounds, a chiral molecule typically contains a C atom bonded to four different groups (an asymmetric carbon).

chlor-alkali process An industrial method that electrolyzes concentrated aqueous NaCl and produces Cl₂, H₂, and NaOH.

chromatography A separation technique in which a mixture is dissolved in a fluid (gas or liquid), and the components are separated through differences in adsorption to (or solubility in) a solid surface (or viscous liquid).

cis-trans isomers (See *geometric isomers*.)

Clausius-Clapeyron equation An equation that expresses the linear relationship between vapor pressure P of a liquid and temperature T ; in two-point form, it is

$$\ln \frac{P_2}{P_1} = \frac{-\Delta H_{\text{vap}}}{R} \left(\frac{1}{T_2} - \frac{1}{T_1} \right)$$

coal gasification An industrial process for altering the large molecules in coal to sulfur-free gaseous fuels.

colligative property A property of a solution that depends on the number, not the identity, of solute particles. (See also *boiling point elevation*, *freezing point depression*, *osmotic pressure*, and *vapor pressure lowering*.)

collision frequency The average number of collisions per second that a particle undergoes.

collision theory A model that explains reaction rate as based on the number, energy, and orientation of colliding particles.

colloid A heterogeneous mixture in which a dispersed (solute-like) substance is distributed throughout a dispersive (solvent-like) substance.

combustion The process of burning in air, often with release of heat and light.

combustion analysis A method for determining the formula of a compound from the amounts of its combustion products; used commonly for organic compounds.

common-ion effect The shift in the position of an ionic equilibrium away from an ion involved in the process that is caused by the addition or presence of that ion.

complex (See *coordination compound*.)

complex ion An ion consisting of a central metal ion covalently bonded to two or more anions or molecules, called ligands.

composition The types and amounts of simpler substances that make up a sample of matter.

compound A substance composed of two or more elements that are chemically combined in fixed proportions.

concentration A measure of the quantity of solute dissolved in a given quantity of solution (or of solvent).

concentration cell A voltaic cell in which both compartments contain the same components but at different concentrations.

condensation The process of a gas changing into a liquid.

condensation polymer A polymer formed from monomers with two functional groups that are linked together in a dehydration-condensation reaction.

conduction band In band theory, the empty, higher energy portion of the band of molecular orbitals into which electrons move when conducting heat and electricity.

conductor A substance (usually a metal) that conducts an electric current well.

conjugate acid-base pair Two species related to each other through the gain or loss of a proton; the acid has one more proton than its conjugate base.

constitutional isomers (also *structural isomers*) Compounds with the same molecular formula but different arrangements of atoms.

contact process An industrial process for the manufacture of sulfuric acid based on the catalyzed oxidation of SO_2 .

controlled experiment An experiment that measures the effect of one variable at a time by keeping other variables constant.

conversion factor A ratio of equivalent quantities that is equal to 1 and used to express a quantity in different units.

coordinate covalent bond A covalent bond formed when one atom donates both electrons to provide the shared pair; once formed, this bond is identical to any covalent single bond.

coordination compound (also *complex*) A substance containing at least one complex ion and counter ion(s).

coordination isomers Two or more coordination compounds with the same composition in which the complex ions have different ligand arrangements.

coordination number In a crystal, the number of nearest neighbors surrounding a particle. In a complex ion, the number of ligand atoms bonded to the central metal ion.

copolymer A polymer that consists of two or more types of monomer.

core The dense, innermost region of Earth.

core electrons (See *inner electrons*.)

corrosion The natural redox process that results in unwanted oxidation of a metal.

coulomb (C) The SI unit of electric charge. One coulomb is the charge of 6.242×10^{18} electrons; one electron possesses a charge of 1.602×10^{-19} C.

Coulomb's law A law stating that the electrostatic energy between particles A and B is directly proportional to the product of their charges and inversely proportional to the distance between them:

$$\text{electrostatic energy} \propto \frac{\text{charge A} \times \text{charge B}}{\text{distance}}$$

counter ion A simple ion associated with a complex ion in a coordination compound.

coupling of reactions The pairing of reactions of which one releases enough free energy for the other to occur.

covalent bond A type of bond in which atoms are bonded through the sharing of electrons; the mutual attraction of the nuclei and an electron pair that holds atoms together in a molecule.

covalent bonding The idealized bonding type that is based on localized electron-pair sharing between two atoms with little difference in their tendencies to lose or gain electrons (most commonly nonmetals).

covalent compound A compound that consists of atoms bonded together by shared electron pairs.

covalent radius One-half the shortest distance between nuclei of identical covalently bonded atoms.

critical mass The minimum mass of a fissionable substance needed to achieve a chain reaction.

critical point The point on a phase diagram above which the vapor cannot be condensed to a liquid; the end of the liquid-gas curve.

crosslink A branch that covalently joins one polymer chain to another.

crust The thin, light, heterogeneous outer layer of Earth, which consists of gasous, liquid, and solid regions.

crystal defect Any of a variety of disruptions in the regularity of a crystal structure.

crystal field splitting energy (Δ) The difference in energy between two sets of metal-ion d orbitals that results from electrostatic interactions with the surrounding ligands.

crystal field theory A model that explains the color and magnetism of complex ions and their coordination compounds based on the effects of ligands on metal-ion d -orbital energies.

crystalline solid Solid with a well-defined shape because of the orderly arrangement of the atoms, molecules, or ions.

crystallization A technique used to separate and purify the components of a mixture through differences in solubility, resulting in a component coming out of solution as crystals.

cubic closest packing A crystal structure based on the face-centered cubic unit cell in which the layers have an *abcabc...* pattern.

cubic meter (m^3) The derived SI unit of volume.

curie (Ci) The most common unit of radioactivity, originally defined as the number of nuclei disintegrating each second in 1 g of radium-226; now a fixed quantity, $1 \text{ Ci} = 3.70 \times 10^{10} \text{ d/s}$ (disintegrations per second).

cyclic hydrocarbon A hydrocarbon with one or more rings in its structure.

D

d orbital An atomic orbital with $l = 2$.

dalton (Da) A unit of mass identical to *atomic mass unit (amu)*.

Dalton's law of partial pressures A gas law stating that, in a mixture of unreacting gases, the total pressure is the sum of the partial pressures of the individual gases: $P_{\text{total}} = P_1 + P_2 + P_3 + \dots$.

data Pieces of quantitative information obtained by observation.

de Broglie wavelength The wavelength of a moving particle obtained from the de Broglie equation: $\lambda = h/mu$.

decay constant The rate constant k for radioactive decay.

decay series (also *disintegration series*) The succession of steps a parent nuclide undergoes as it decays into a stable daughter nuclide.

degree of polymerization (n) The number of repeat units in a polymer chain.

dehydration-condensation reaction A reaction in which an H_2O molecule is lost for every pair of groups that join.

delocalization (See *electron-pair delocalization*.)

density (d) An intensive physical property of a substance at a given temperature and pressure, defined as the ratio of the mass to the volume: $d = m/V$.

deposition The process of changing directly from a gas to a solid.

derived unit Any of various combinations of the seven SI base units.

desalination A process used to remove large amounts of ions from seawater, usually by reverse osmosis.

deuterons Nuclei of the stable hydrogen isotope deuterium, 2H .

diagonal relationship Physical and chemical similarities between a Period 2 element and one located diagonally down and to the right in Period 3.

diamagnetism The tendency of a species not to be attracted (or to be slightly repelled) by a magnetic field as a result of its electrons being paired.

diastereomers (See *geometric isomers*.)

differentiation The geochemical process by which regions in Earth were formed based on differences in composition and density.

diffraction The phenomenon in which a wave striking the edge of an object bends around it. A wave passing through a slit as wide as its wavelength forms a circular wave.

diffusion The movement of one fluid through another.

dimensional analysis (also *factor-label method*) A calculation method in which arithmetic steps are accompanied by canceling units that represent physical dimensions.

dipole moment (μ) A measure of molecular polarity; the magnitude of the partial charges on the ends of a molecule (in coulombs) times the distance between them (in meters).

dipole-dipole force The intermolecular attraction between oppositely charged poles of nearby polar molecules.

dipole-induced dipole force The intermolecular attraction between a polar molecule and the oppositely charged pole it induces in a nearby molecule.

disaccharide An organic compound formed by a dehydration-condensation reaction between two simple sugars (monosaccharides).

disintegration series (See *decay series*.)

dispersion force (also *London force*) The intermolecular attraction between all particles as a result of instantaneous polarizations of their electron clouds; the intermolecular force primarily responsible for the condensed states of nonpolar substances.

disproportionation reaction A redox reaction in which one substance acts as both the oxidizing and reducing agents.

distillation A separation technique in which a more volatile component of a mixture vaporizes and condenses separately from the less volatile components.

donor atom An atom that donates a lone pair of electrons to form a covalent bond, usually from ligand to metal ion in a complex ion.

doping Adding small amounts of other elements into the crystal structure of a semiconductor to enhance a specific property, usually conductivity.

double bond A covalent bond that consists of two bonding pairs; two atoms sharing four electrons in the form of one σ and one π bond.

double helix The two intertwined polynucleotide strands held together by H bonds that form the structure of DNA (deoxyribonucleic acid).

Downs cell An industrial apparatus that electrolyzes molten NaCl to produce sodium and chlorine.

dynamic equilibrium The condition at which the forward and reverse reactions are taking place at the same rate, so there is no net change in the amounts of reactants or products.

E

effective collision A collision in which the particles meet with sufficient energy and an orientation that allows them to react.

effective nuclear charge (Z_{eff}) The nuclear charge an electron actually experiences as a result of shielding effects due to the presence of other electrons.

effusion The process by which a gas escapes from its container through a tiny hole into an evacuated space.

e_g orbitals The set of orbitals (composed of $d_{x^2-y^2}$ and d_{z^2}) that results when the energies of the metal-ion d orbitals are split by a ligand field. This set is higher in energy than the other (t_{2g}) set in an octahedral field of ligands and lower in energy in a tetrahedral field.

elastomer A polymeric material that can be stretched and springs back to its original shape when released.

electrochemical cell A system that incorporates a redox reaction to produce or use electrical energy.

electrochemistry The study of the relationship between chemical change and electrical work.

electrode The part of an electrochemical cell that conducts the electricity between the cell and the surroundings.

electrolysis The nonspontaneous lysing (splitting) of a substance, often to its component elements, by the input of electrical energy.

electrolyte A substance that conducts a current when it dissolves in water. A mixture of ions, in which the electrodes of an electrochemical cell are immersed, that conducts a current.

electrolytic cell An electrochemical system that uses electrical energy to drive a nonspontaneous chemical reaction ($\Delta G > 0$).

electromagnetic radiation (also *electromagnetic energy* or *radiant energy*) Oscillating, perpendicular electric and magnetic fields moving simultaneously through space as waves and manifested as visible light, x-rays, microwaves, radio waves, and so on.

electromagnetic spectrum The continuum of radiant energy arranged in order of increasing wavelength.

electromotive force (emf) (See *cell potential*.)

electron (e^-) capture (EC) A type of radioactive decay in which a nucleus draws in an orbital electron, usually one from the lowest energy level, and releases energy.

electron (e^-) A subatomic particle that possesses a unit negative charge (-1.60218×10^{-19} C) and occupies the space around the atomic nucleus.

electron affinity (EA) The energy change (in kJ) accompanying the addition of 1 mol of electrons to 1 mol of gaseous atoms or ions.

electron cloud depiction An imaginary representation of an electron's rapidly changing position around the nucleus over time.

electron configuration The distribution of electrons within the levels and sublevels of the atoms of an element; also the notation for such a distribution.

electron deficient Referring to a bonded atom, such as Be or B, that has fewer than eight valence electrons.

electron density diagram (also *electron probability density diagram*) The pictorial representation for a given energy sublevel of the quantity ψ^2 (the probability density of the electron lying within a particular tiny volume) as a function of r (distance from the nucleus).

electron volt (eV) The energy (in joules, J) that an electron acquires when it moves through a potential difference of 1 volt; $1\text{ eV} = 1.602 \times 10^{-19}\text{ J}$.

electron-pair delocalization (also *delocalization*) The process by which electron density is spread over several atoms rather than remaining between two.

electron-sea model A qualitative description of metallic bonding proposing that metal atoms pool their valence electrons in a delocalized "sea" of electrons in which the metal ions (nuclei and core electrons) are submerged in an orderly array.

electronegativity (EN) The relative ability of a bonded atom to attract shared electrons.

electronegativity difference (ΔEN) The difference in electronegativities between two bonded atoms.

electrorefining An industrial, electrolytic purification process in which a sample of impure metal acts as the anode and a sample of the pure metal acts as the cathode.

element The simplest type of substance with unique physical and chemical properties. An element consists of only one kind of atom, so it cannot be broken down into simpler substances.

element symbol (See *atomic symbol*.)

elementary reaction (also *elementary step*) A simple reaction that describes a single molecular event in a proposed reaction mechanism.

elimination reaction A type of organic reaction in which C atoms are bonded to fewer atoms in the product than in the reactant, which creates a multiple bond between the C atoms.

emission spectrum The line spectrum produced when excited atoms return to lower energy levels and emit photons characteristic of the element.

empirical formula A chemical formula that shows the lowest relative number of atoms of each element in a compound.

enantiomers (See *optical isomers*.)

end point The point in a titration at which the indicator changes color permanently.

endothermic process A process that occurs with an absorption of heat from the surroundings and therefore an increase in the enthalpy of the system ($\Delta H > 0$).

energy The ability to do work, that is, to move matter. [See also *kinetic energy* (E_k) and *potential energy* (E_p).]

enthalpy (H) A thermodynamic quantity that is equal to the system's internal energy plus the product of the pressure and volume.

enthalpy diagram A graphic depiction of the enthalpy change of a system.

Enthalpy of formation (ΔH_f) (also *heat of formation*) The enthalpy change occurring when 1 mol of a compound forms from its elements. When all components are in their standard states, this is called the standard enthalpy of formation (ΔH_f°).

Enthalpy of fusion (See *heat of fusion*.)

Enthalpy of hydration (See *heat of hydration*.)

Enthalpy of reaction (ΔH_{rxn}) (also *heat of reaction*) The enthalpy change that occurs during a reaction. When all components are in their standard states, this is called the *standard enthalpy of reaction* (ΔH_{rxn}°).

Enthalpy of solution (See *heat of solution*.)

Enthalpy of sublimation (See *heat of sublimation*.)

Enthalpy of vaporization (See *heat of vaporization*.)

entropy (S) A thermodynamic quantity related to the number of ways the energy of a system can be dispersed through the motions of its particles.

environmental cycle The physical, chemical, and biological paths through which the atoms of an element move within Earth's crust.

enzyme A biological macromolecule (usually a protein) that acts as a catalyst.

enzyme-substrate complex (ES) The intermediate in an enzyme-catalyzed reaction, which consists of enzyme and substrate(s) and whose concentration determines the rate of product formation.

equatorial group An atom (or group) that lies in the trigonal plane of a trigonal bipyramidal molecule, or a similar structural feature in a molecule.

equilibrium constant (K) The value obtained when equilibrium concentrations are substituted into the reaction quotient.

equilibrium vapor pressure (See *vapor pressure*.)

equivalence point The point in a titration when the number of moles of the added species is stoichiometrically equivalent to the original number of moles of the other species.

ester An organic compound that contains the $\text{—C}\overset{\parallel}{=}\text{O}\text{—}\ddot{\text{O}}\text{—C}\text{—}$ group.

exact number A quantity, usually obtained by counting or based on a unit definition, that has no uncertainty associated with it and, therefore, contains as many significant figures as a calculation requires.

exchange reaction (See *metathesis reaction*.)

excited state Any electron configuration of an atom (or ion or molecule) other than the lowest energy (ground) state.

exclusion principle A principle developed by Wolfgang Pauli stating that no two electrons in an atom can have the same set of four quantum numbers. The principle arises from the fact that an orbital has a maximum occupancy of two electrons and their spins are paired.

exothermic process A process that occurs with a release of heat to the surroundings and therefore a decrease in the enthalpy of the system ($\Delta H < 0$).

expanded valence shell A valence level that can accommodate more than eight electrons by using available *d* orbitals; occurs only with central nonmetal atoms from Period 3 or higher.

experiment A set of procedural steps that tests a hypothesis.

extensive property A property, such as mass, that depends on the quantity of substance present.

F

f orbital An atomic orbital with $l = 3$.

face-centered cubic unit cell A unit cell in which a particle occurs at each corner and in the center of each face of a cube.

Faraday constant (F) The physical constant representing the charge of 1 mol of electrons: $F = 96,485 \text{ C/mol e}^-$.

fatty acid A carboxylic acid that has a long hydrocarbon chain and is derived from a natural source.

filtration A method of separating the components of a mixture on the basis of differences in particle size.

first law of thermodynamics (See *law of conservation of energy*.)

fission The process by which a heavier nucleus splits into two much lighter nuclei, with the release of a large quantity of energy.

fixation A chemical or biochemical process that converts a gaseous substance in the environment into a condensed form that can be used by organisms.

flame test A procedure for identifying the presence of metal ions in which a granule of a compound or a drop of its solution is placed in a flame to observe a characteristic color.

flotation A metallurgical process in which an oil-detergent mixture is stirred with pulverized ore in water to create a slurry, followed by rapid mixing of the slurry with air to produce an oily, mineral-rich froth that floats, separating the mineral from the gangue.

formal charge The hypothetical charge on an atom in a molecule or ion, equal to the number of valence electrons minus the sum of all the unshared and half the shared valence electrons.

formation constant (K_f) An equilibrium constant for the formation of a complex ion from the hydrated metal ion and ligands.

formation equation An equation in which 1 mole of a compound forms from its elements.

formula mass The sum (in amu) of the atomic masses of a formula unit of a (usually ionic) compound.

formula unit The chemical unit of a compound that contains the relative numbers of the types of atoms or ions expressed in the chemical formula.

fossil fuel Any fuel, including coal, petroleum, and natural gas, derived from the products of the decay of dead organisms.

fraction by mass (also *mass fraction*) The portion of a compound's mass contributed by an element; the mass of an element in a compound divided by the mass of the compound.

fractional distillation A physical process involving numerous vaporization-condensation steps used to separate two or more volatile components.

free energy (G) A thermodynamic quantity that is the difference between the system's enthalpy and the product of the absolute temperature and the system's entropy: $G = H - TS$.

free energy change (ΔG) The change in free energy that occurs during a reaction.

free radical A molecular or atomic species with one or more unpaired electrons, which typically make it very reactive.

freezing The process of cooling a liquid until it solidifies.

freezing point depression (ΔT_f) The lowering of the freezing point of a solvent caused by the presence of dissolved solute particles.

frequency (v) The number of complete waves, or cycles, that pass a given point per second, expressed in units of 1/second, or s^{-1} [also called *hertz* (Hz)]; related inversely to wavelength.

frequency factor (A) The product of the collision frequency Z and an orientation probability factor p that is specific for a reaction.

fuel cell (also *flow battery*) A battery that is not self-contained and in which electricity is generated by the controlled oxidation of a fuel.

functional group A specific combination of bonded atoms, typically containing a carbon-carbon multiple bond and/or a carbon-heteroatom bond, that reacts in a characteristic way no matter what molecule it occurs in.

fundamental unit (See *base unit*.)

fusion (See *melting*.)

fusion (nuclear) The process by which light nuclei combine to form a heavier nucleus with the release of energy.

G

galvanic cell (See *voltaic cell*.)

gamma emission The type of radioactive decay in which gamma rays are emitted from an excited nucleus.

gamma ray (γ) A very high-energy photon.

gangue In an ore, the debris, such as sand, rock, and clay, attached to the mineral.

gas One of the three states of matter. A gas fills its container regardless of the shape because its particles are far apart.

Geiger-Müller counter An ionization counter that detects radioactive emissions through their ionization of gas atoms within the instrument.

genetic code The set of three-base sequences that is translated into specific amino acids during the process of protein synthesis.

geometric isomers (also *cis-trans isomers* or *diastereomers*) Stereoisomers in which the molecules have the same connections between atoms but differ in the spatial arrangements of the atoms. The *cis* isomer has identical groups on the same side of a double bond (or of a central metal atom); the *trans* isomer has them on opposite sides.

Graham's law of effusion A gas law stating that the rate of effusion of a gas is inversely proportional to the square root of its density (or molar mass):

$$\text{rate} \propto \frac{1}{\sqrt{\mathcal{M}}}$$

gray (Gy) The SI unit of absorbed radiation dose; $1 \text{ Gy} = 1 \text{ J/kg}$ tissue.

green chemistry Field that is focused on developing methods to synthesize compounds efficiently and reduce or prevent the release of harmful products into the environment.

ground state The electron configuration of an atom (or ion or molecule) that is lowest in energy.

group A vertical column in the periodic table; elements in a group usually have the same outer electron configuration and, thus, similar chemical behavior.

H

H bond (See *hydrogen bond*.)

Haber process An industrial process used to form ammonia from its elements.

half-cell A portion of an electrochemical cell in which a half-reaction takes place.

half-life ($t_{1/2}$) In chemical processes, the time required for the reactant concentration to reach half of its initial value. In nuclear processes, the time required for half the initial number of nuclei in a sample to decay.

half-reaction method A method of balancing redox reactions by treating the oxidation and reduction half-reactions separately.

haloalkane (also *alkyl halide*) A hydrocarbon with one or more halogen atoms (X) in place of H; contains a $\text{—C}(\text{—H})\text{—}\ddot{\text{X}}$ group.

hard water Water that contains large amounts of divalent cations, especially Ca^{2+} and Mg^{2+} .

heat (*q*) (also *thermal energy*) The energy transferred between objects because of a difference in their temperatures only.

heat capacity (C) The quantity of heat required to change the temperature of an object by 1 K.

heat of formation (See *enthalpy of formation*.)

heat of fusion ($\Delta H_{\text{fus}}^{\circ}$) (also *enthalpy of fusion*) The enthalpy change occurring when 1 mol of a solid substance melts; designated ($\Delta H_{\text{fus}}^{\circ}$) at the standard state.

heat of hydration (ΔH_{hydr}) (also *enthalpy of hydration*) The enthalpy change occurring when 1 mol of a gaseous species (often an ion) is hydrated. The sum of the enthalpies from separating water molecules and mixing the gaseous species with them; designated $\Delta H_{\text{hydr}}^{\circ}$ at the standard state.

heat of reaction (ΔH_{rxn}) (See *enthalpy of reaction*.)

heat of solution (ΔH_{soln}) (also *enthalpy of solution*) The enthalpy change occurring when a solution forms from solute and solvent. The sum of the enthalpies from separating solute and solvent substances and mixing them; designated ($\Delta H_{\text{soln}}^{\circ}$) at the standard state.

heat of sublimation ($\Delta H_{\text{subl}}^{\circ}$) (also *enthalpy of sublimation*) The enthalpy change occurring when 1 mol of a solid substance changes directly to a gas. The sum of the heats of fusion and vaporization; designated $\Delta H_{\text{subl}}^{\circ}$ at the standard state.

heat of vaporization ($\Delta H_{\text{vap}}^{\circ}$) (also *enthalpy of vaporization*) The enthalpy change occurring when 1 mol of a liquid substance vaporizes; designated ($\Delta H_{\text{vap}}^{\circ}$) at the standard state.

heating-cooling curve A plot of temperature vs. time for a sample when heat is absorbed or released at a constant rate.

Henderson-Hasselbalch equation An equation for calculating the pH of a buffer system:

$$\text{pH} = \text{p}K_a + \log \left(\frac{[\text{base}]}{[\text{acid}]} \right)$$

Henry's law A law stating that the solubility of a gas in a liquid is directly proportional to the partial pressure of the gas above the liquid: $S_{\text{gas}} = k_H \times P_{\text{gas}}$.

Hess's law A law stating that the enthalpy change of an overall process is the sum of the enthalpy changes of the individual steps.

heteroatom Any atom in an organic compound other than C or H.

heterogeneous catalyst A catalyst that occurs in a different phase from the reactants, usually a solid interacting with gaseous or liquid reactants.

heterogeneous mixture A mixture that has one or more visible boundaries among its components.

hexagonal closest packing A crystal structure based on the hexagonal unit cell in which the layers have an *abab...* pattern.

high-spin complex Complex ion that has the same number of unpaired electrons as in the isolated metal ion; contains weak-field ligands.

homogeneous catalyst A catalyst (gas, liquid, or soluble solid) that exists in the same phase as the reactants.

homogeneous mixture (also *solution*) A mixture that has no visible boundaries among its components.

homologous series A series of organic compounds in which each member differs from the next by a $-\text{CH}_2-$ (methylene) group.

homonuclear diatomic molecule A molecule composed of two identical atoms.

Hund's rule A principle stating that when orbitals of equal energy are available, the electron configuration of lowest energy has the maximum number of unpaired electrons with parallel spins.

hybrid orbital An atomic orbital postulated to form during bonding by the mathematical mixing of specific combinations of non-equivalent orbitals in a given atom.

hybridization A postulated process of orbital mixing to form hybrid orbitals.

hydrate A compound in which a specific number of water molecules are associated with each formula unit.

hydration Solvation in water.

hydration shell The oriented cluster of water molecules that surrounds an ion in aqueous solution.

hydrocarbon An organic compound that contains only H and C atoms.

hydrogen bond (H bond) A type of dipole-dipole force that arises between molecules that have an H atom bonded to a small, highly electronegative atom with lone pairs, usually N, O, or F.

hydrogenation The addition of hydrogen to a carbon-carbon multiple bond to form a carbon-carbon single bond.

hydrolysis Cleaving a molecule by reaction with water; one part of the molecule bonds to water's $-\text{OH}$ and the other to water's other H.

hydronium ion (H_3O^+) A proton covalently bonded to a water molecule.

hydrosphere The liquid region of Earth's crust.

hypothesis A testable proposal made to explain an observation. If inconsistent with experimental results, a hypothesis is revised or discarded.

I

ideal gas A hypothetical gas that exhibits linear relationships among volume, pressure, temperature, and amount (mol) at all conditions; approximated by simple gases at ordinary conditions.

ideal gas law (also *ideal gas equation*) An equation that expresses the relationships among volume, pressure, temperature, and amount (mol) of an ideal gas: $PV = nRT$.

ideal solution A solution that follows Raoult's law at any concentration.

indicator (See *acid-base indicator*.)

induced-fit model A model of enzyme action that pictures the binding of the substrate as inducing the active site to change its shape and become catalytically active.

infrared (IR) The region of the electromagnetic spectrum between the microwave and visible regions.

infrared (IR) spectroscopy An instrumental technique for determining the types of bonds in a covalent molecule by measuring the absorption of IR radiation.

initial rate The instantaneous rate at the moment the reactants are mixed, that is, at $t = 0$.

inner electrons (also *core electrons*) Electrons that fill all the energy levels of an atom except the valence level; electrons also present in atoms of the previous noble gas and any completed transition series.

inner transition elements The elements of the periodic table in which the seven inner *f* orbitals are being filled; the lanthanides and the actinides.

instantaneous rate The reaction rate at a particular time, given by the slope of a tangent to a plot of reactant concentration vs. time.

insulator A substance (usually a nonmetal) that does not conduct an electric current.

integrated rate law A mathematical expression for reactant concentration as a function of time.

intensive property A property, such as density, that does not depend on the quantity of substance present.

interhalogen compound A compound consisting entirely of halogens.

intermolecular forces (also *interparticle forces*) The attractive and repulsive forces among the particles—molecules, atoms, or ions—in a sample of matter.

internal energy (E) The sum of the kinetic and potential energies of all the particles in a system.

ion A charged particle that forms from an atom (or covalently bonded group of atoms) when it gains or loses one or more electrons.

ion-dipole force The intermolecular attractive force between an ion and a polar molecule (dipole).

ion exchange A process of softening water by exchanging one type of ion (usually Ca^{2+}) for another (usually Na^+) by binding the ions on a specially designed resin.

ion-induced dipole force The attractive force between an ion and the dipole it induces in the electron cloud of a nearby nonpolar molecule.

ion pair A gaseous ionic molecule, formed when an ionic compound vaporizes.

ion-product constant for water (K_w) The equilibrium constant for the autoionization of water; equal to 1.0×10^{-14} at 298 K. $K_w = [\text{H}_3\text{O}^+] [\text{OH}^-]$

ionic atmosphere A cluster of ions of net opposite charge surrounding a given ion in solution.

ionic bonding The idealized type of bonding based on the attraction of oppositely charged ions that arise through electron transfer between atoms with large differences in their tendencies to lose or gain electrons (typically metals and nonmetals).

ionic compound A compound that consists of oppositely charged ions.

ionic radius The size of an ion as measured by the distance between the nuclei of adjacent ions in a crystalline ionic compound.

ionic solid A solid whose unit cell contains cations and anions.

ionization In nuclear chemistry, the process by which an atom absorbs energy from a high-energy radioactive particle and loses an electron to become ionized.

ionization energy (IE) The energy (in kJ) required for complete removal of 1 mol of electrons from 1 mol of gaseous atoms or ions.

ionizing radiation The high-energy radiation from natural and artificial sources that forms ions in a substance by causing electron loss.

isoelectronic Having the same number and configuration of electrons as another species.

isomer One of two or more compounds with the same molecular formula but different properties, often as a result of different arrangements of atoms.

isotopes Atoms of a given atomic number (that is, of a specific element) that have different numbers of neutrons and therefore different mass numbers.

isotopic mass The mass (in amu) of an isotope relative to the mass of carbon-12.

J

joule (J) The SI unit of energy; $1 \text{ J} = 1 \text{ kg}\cdot\text{m}^2/\text{s}^2$.

K

kelvin (K) The SI base unit of temperature. The kelvin is the same size as the Celsius degree.

Kelvin scale (also *absolute scale*) The preferred temperature scale in scientific work, which has absolute zero (0 K, or -273.15°C) as the lowest temperature.

ketone An organic compound (ending, *-one*) that contains a carbonyl group bonded to two other C atoms, $\begin{array}{c} & \text{:O:} \\ & || \\ \text{---C} & -\text{C} & --- \\ & | & | \end{array}$.

kilogram (kg) The SI base unit of mass.

kinetic energy (E_k) The energy an object has because of its motion.

kinetic-molecular theory The model that explains macroscopic gas behavior in terms of particles in random motion whose volumes and interactions are negligible.

L

lanthanide contraction The additional decrease in atomic and ionic size, beyond the expected trend, caused by the poor shielding of the increasing nuclear charge by f electrons in the elements following the lanthanides.

lanthanides (also *rare earth elements*) The Period 6 (4f) series of inner transition elements, which includes cerium (Ce; $Z = 58$) through lutetium (Lu; $Z = 71$).

lattice The three-dimensional arrangement of points created by choosing each point to be at the same location within each particle of a crystal; thus, the lattice consists of all points with identical surroundings.

lattice energy ($\Delta H_{\text{lattice}}^\circ$) The enthalpy change (always positive) that accompanies the separation of 1 mol of a solid ionic compound into gaseous ions.

law (See *natural law*.)

law of chemical equilibrium (also *law of mass action*) The law stating that when a system reaches equilibrium at a given temperature, the ratio of quantities that make up the reaction quotient has a constant numerical value.

law of conservation of energy (also *first law of thermodynamics*) A basic observation that the total energy of the universe is constant; thus, $\Delta E_{\text{universe}} = \Delta E_{\text{system}} + \Delta E_{\text{surroundings}} = 0$.

law of definite (or constant) composition A mass law stating that, no matter what its source, a particular compound is composed of the same elements in the same parts (fractions) by mass.

law of mass action (See *law of chemical equilibrium*.)

law of mass conservation A mass law stating that the total mass of substances does not change during a chemical reaction.

law of multiple proportions A mass law stating that if elements A and B react to form two or more compounds, the different masses of B that combine with a fixed mass of A can be expressed as a ratio of small whole numbers.

Le Châtelier's principle A principle stating that if a system in a state of equilibrium is disturbed, it will undergo a change that shifts its equilibrium position in a direction that reduces the effect of the disturbance.

leaching A hydrometallurgical process that extracts a metal selectively, usually through formation of a complex ion.

level (also *shell*) A specific energy state of an atom given by the principal quantum number n .

leveling effect The inability of a solvent to distinguish the strength of an acid (or base) that is stronger than the conjugate acid (or conjugate base) of the solvent.

Lewis acid-base definition A model of acid-base behavior in which acids and bases are defined, respectively, as species that accept and donate an electron pair.

Lewis electron-dot symbol A notation in which the element symbol represents the nucleus and inner electrons and surrounding dots represent the valence electrons.

Lewis structure (also *Lewis formula*) A structural formula consisting of electron-dot symbols, with lines as bonding pairs and dots as lone pairs.

ligand A molecule or anion bonded to a central metal ion in a complex ion.

like-dissolves-like rule An empirical observation stating that substances having similar kinds of intermolecular forces dissolve in each other.

limiting reactant (also *limiting reagent*) The reactant that is consumed when a reaction occurs and, therefore, the one that determines the maximum amount of product that can form.

line spectrum A series of separated lines of different colors representing photons whose wavelengths are characteristic of an element. (See also *emission spectrum*.)

linear arrangement The geometric arrangement obtained when two electron groups maximize their separation around a central atom.

linear shape A molecular shape formed by three atoms lying in a straight line, with a bond angle of 180° (shape class AX_2 or AX_2E_3).

linkage isomers Coordination compounds in which the complex ions have the same composition but with different ligand donor atoms linked to the central metal ion.

lipid Any of a class of biomolecules, including fats, that are soluble in nonpolar solvents and not soluble in water.

lipid bilayer An extended sheetlike double layer of phospholipid molecules that forms in water and has the charged heads of the molecules on the surfaces of the bilayer and the nonpolar tails within the interior.

liquid One of the three states of matter. A liquid fills a container to the extent of its own volume and thus forms a surface.

liquid crystal A substance that flows like a liquid but packs like a crystalline solid at the molecular level.

liter (L) A non-SI unit of volume equivalent to 1 cubic decimeter (0.001 m^3).

lithosphere The solid region of Earth's crust.

lock-and-key model A model of enzyme function that pictures the enzyme active site and the substrate as rigid shapes that fit together as a lock and key, respectively.

London force (See *dispersion force*.)

lone pair (also *unshared pair*) An electron pair that is part of an atom's valence level but not involved in covalent bonding.

low-spin complex Complex ion that has fewer unpaired electrons than in the free metal ion because of the presence of strong-field ligands.

M

macromolecule (See *polymer*.)

magnetic quantum number (*m*) An integer from $-l$ through 0 to $+l$ that specifies the orientation of an atomic orbital in the three-dimensional space about the nucleus.

manometer A device used to measure the pressure of a gas in a laboratory experiment.

mantle A thick homogeneous layer of Earth's internal structure that lies between the core and the crust.

mass The quantity of matter an object contains. Balances are designed to measure mass.

mass-action expression (See *reaction quotient*.)

mass fraction (See *fraction by mass*.)

mass number (*A*) The total number of protons and neutrons in the nucleus of an atom.

mass percent (also *mass %* or *percent by mass*) The fraction by mass expressed as a percentage. (45) A concentration term [% (w/w)] expressed as the mass of solute dissolved in 100. parts by mass of solution.

mass spectrometry An instrumental method for measuring the relative masses of particles in a sample by creating charged particles and separating them according to their mass/charge ratios.

matter Anything that possesses mass and occupies volume.

mean free path The average distance a particle travels between collisions at a given temperature and pressure.

melting (also *fusion*) The change of a substance from a solid to a liquid.

melting point (mp or T_f) The temperature at which the solid and liquid forms of a substance are at equilibrium.

metabolic pathway A biochemical reaction sequence that flows in one direction, with each reaction catalyzed by an enzyme.

metal A substance or mixture that is relatively shiny and malleable and is a good conductor of heat and electricity. In reactions, metals tend to transfer electrons to nonmetals and form ionic compounds.

metallic bonding An idealized type of bonding based on the attraction between metal ions and their delocalized valence electrons. (See also *electron-sea model*.)

metallic radius One-half the shortest distance between the nuclei of adjacent individual atoms in a crystal of an element.

metallic solid A solid whose individual atoms are held together by metallic bonding.

metalloid (also *semimetal*) An element with properties between those of metals and nonmetals.

metallurgy The branch of materials science concerned with the extraction and utilization of metals.

metathesis reaction (also *double-displacement reaction*) A reaction in which atoms or ions of two compounds exchange bonding partners. Precipitation and acid-base reactions are examples.

meter (m) The SI base unit of length. The distance light travels in a vacuum in $1/299,792,458$ second.

methanogenesis The process of producing methane by anaerobic biodegradation of plant and animal waste.

microstate An instantaneous, quantized state of a system of particles throughout which the total energy of the system is dispersed.

milliliter (mL) A volume (0.001 L) equivalent to 1 cm^3 .

millimeter of mercury (mmHg) A unit of pressure based on the difference in the heights of mercury in a barometer or manometer. Renamed the *torr* in honor of Torricelli.

mineral The portion of an ore that contains the element of interest; a naturally occurring, homogeneous, crystalline inorganic solid, with a well-defined composition.

miscible Soluble in any proportion.

mixture Two or more elements and/or compounds that are physically intermingled but not chemically combined.

MO bond order One-half the difference between the number of electrons in bonding MOs and the number in antibonding MOs.

model (also *theory*) A simplified conceptual picture based on experiment that explains how a natural phenomenon occurs.

molality (*m*) A concentration term expressed as number of moles of solute dissolved in 1000 g (1 kg) of solvent.

molar heat capacity (C_m) The quantity of heat required to change the temperature of 1 mol of a substance by 1 K .

molar mass (M) The mass of 1 mol of entities (atoms, molecules, or formula units) of a substance, in units of g/mol .

molarity (*M*) A unit of concentration expressed as the moles of solute dissolved in 1 L of solution.

mole (mol) The SI base unit for amount of a substance. The amount that contains a number of entities equal to the number of atoms in exactly 12 g of carbon-12 (which is 6.022×10^{23}).

mole fraction (*X*) A concentration term expressed as the ratio of number of moles of solute to the total number of moles (solute plus solvent).

molecular equation A chemical equation showing a reaction in solution in which reactants and products appear as intact, undisassociated compounds.

molecular formula A formula that shows the actual number of atoms of each element in a molecule of a compound.

molecular mass (also *molecular weight*) The sum (in amu) of the atomic masses of the elements in a molecule (or formula unit) of a compound.

molecular orbital (MO) An orbital of given energy and shape that extends over a molecule and can be occupied by no more than two paired electrons.

molecular orbital (MO) diagram A depiction of the relative energy and number of electrons in each MO, as well as the atomic orbitals from which the MOs form.

molecular orbital (MO) theory A model that describes a molecule as a collection of nuclei and electrons in which the electrons occupy orbitals that extend over the entire molecule.

molecular polarity The overall distribution of electronic charge in a molecule, determined by its shape and bond polarities.

molecular shape The three-dimensional arrangement of the atomic nuclei in a molecule.

molecular solid A solid held together by intermolecular forces between individual molecules.

molecular weight (See *molecular mass*.)

molecularity The number of reactant particles involved in an elementary step.

molecule A structure consisting of two or more atoms that are bound chemically and behave as an independent unit.

monatomic ion An ion derived from a single atom.

monomer A small molecule, linked covalently to others of the same or similar type to form a polymer; the repeat unit of the polymer.

mononucleotide A monomer unit of a nucleic acid, consisting of an N-containing base, a sugar, and a phosphate group.

monosaccharide A simple sugar; a polyhydroxy ketone or aldehyde with three to nine C atoms.

N

nanotechnology The science and engineering of nanoscale systems (size range of 1–100 nm).

natural law (also *law*) A summary, often in mathematical form, of a universal observation.

Nernst equation An equation stating that the voltage of an electrochemical cell under any conditions depends on the standard cell voltage and the concentrations of the cell components:

$$E_{\text{cell}} = E_{\text{cell}}^{\circ} - \frac{RT}{nF} \ln Q$$

net ionic equation A chemical equation of a reaction in solution in which spectator ions have been eliminated to show the actual chemical change.

network covalent solid A solid in which all the atoms are bonded covalently so that individual molecules are not present.

neutralization Process that occurs when an H^+ ion from an acid combines with an OH^- ion from a base to form H_2O .

neutralization reaction An acid-base reaction that yields water and a solution of a salt; when the H^+ ions of a strong acid react

with an equivalent amount of the OH^- ions of a strong base, the solution is neutral.

neutron (*n*⁰) An uncharged subatomic particle found in the nucleus, with a mass slightly greater than that of a proton.

nitrile An organic compound containing the $-\text{C}\equiv\text{N}$: group.

node A region of an orbital where the probability of finding the electron is zero.

nonbonding MO A molecular orbital that is not involved in bonding.

nonelectrolyte A substance whose aqueous solution does not conduct an electric current.

nonmetal An element that lacks metallic properties. In reactions, nonmetals tend to share electrons with each other to form covalent compounds or accept electrons from metals to form ionic compounds.

nonpolar covalent bond A covalent bond between identical atoms in which the bonding pair is shared equally.

nuclear binding energy The energy required to break 1 mol of nuclei of an element into individual nucleons.

nuclear magnetic resonance (NMR) spectroscopy An instrumental technique used to determine the molecular environment of a given type of nucleus, most often ^1H , from its absorption of radio waves in a magnetic field.

nuclear transmutation The induced conversion of one nucleus into another by bombardment with a particle.

nucleic acid An unbranched polymer of mononucleotides that occurs as two types, DNA and RNA (deoxyribonucleic and ribonucleic acids), which differ chemically in the nature of the sugar portion of their mononucleotides.

nucleon An elementary particle found in the nucleus of an atom; a proton or neutron.

nucleus The tiny central region of the atom that contains all the positive charge and essentially all the mass.

nuclide A nuclear species with specific numbers of protons and neutrons.

O

observation A fact obtained with the senses, often with the aid of instruments. Quantitative observations provide data that can be compared.

occurrence (also *source*) The form(s) in which an element exists in nature.

octahedral arrangement The geometric arrangement obtained when six electron groups maximize their space around a central atom; when all six groups are bonding groups, the molecular shape is octahedral (AX_6 ; ideal bond angle = 90°).

octet rule The observation that when atoms bond, they often lose, gain, or share electrons to attain a filled outer level of eight electrons (or two for H and Li).

optical isomers (also *enantiomers*) A pair of stereoisomers consisting of a molecule and its mirror image that cannot be superimposed on each other.

optically active Able to rotate the plane of polarized light.

orbital diagram A depiction of orbital occupancy in terms of electron number and spin shown by means of arrows in a series of small boxes or on a series of short lines.

ore A naturally occurring compound or mixture of compounds from which an element can be profitably extracted.

organic compound A compound in which carbon is nearly always bonded to one or more other carbons and to hydrogen, and often to other elements.

organometallic compound An organic compound in which a carbon (in an R group) has a polar covalent bond to a metal atom.

osmosis The process by which solvent flows through a semipermeable membrane from a dilute to a concentrated solution.

osmotic pressure (Π) The pressure that results from the ability of solvent, but not solute, particles to cross a semipermeable membrane. The pressure required to prevent the net movement of solvent across the membrane.

outer electrons Electrons that occupy the highest energy level (highest n value) and are, on average, farthest from the nucleus.

overall (net) equation A chemical equation that is the sum of two or more balanced sequential equations in which a product of one becomes a reactant for the next.

overvoltage The additional voltage, usually associated with gaseous products forming at an electrode, that is required above the standard cell voltage to accomplish electrolysis.

oxidation The loss of electrons by a species, accompanied by an increase in oxidation number.

oxidation number (O.N.) (also *oxidation state*) A number equal to the magnitude of the charge an atom would have if its shared electrons were transferred to the atom that attracts them more strongly.

oxidation-reduction reaction (also *redox reaction*) A process in which there is a net movement of electrons from one reactant (reducing agent) to another (oxidizing agent).

oxidation state (See *oxidation number*.)

oxidizing agent The substance that accepts electrons in a reaction and undergoes a decrease in oxidation number.

oxoanion An anion in which an element, usually a nonmetal, is bonded to one or more oxygen atoms.

P

p orbital An atomic orbital with $l = 1$.

packing efficiency The percentage of the total volume occupied by atoms, ions, or molecules in a unit cell.

paramagnetism The tendency of a species with unpaired electrons to be attracted by an external magnetic field.

partial ionic character An estimate of the actual charge separation in a bond (caused by the electronegativity difference of the bonded atoms) relative to complete separation.

partial pressure The portion of the total pressure contributed by a gas in a mixture of gases.

particle accelerator A device used to impart high kinetic energies to nuclear particles.

pascal (Pa) The SI unit of pressure; $1 \text{ Pa} = 1 \text{ N/m}^2$.

penetration The phenomenon in which an outer electron moves through the region occupied by the core electrons to spend part of its time closer to the nucleus; penetration increases the average effective nuclear charge for that electron.

percent by mass (mass %) (Also *mass percent*) The fraction by mass expressed as a percentage.

percent yield (% yield) The actual yield of a reaction expressed as a percentage of the theoretical yield.

period A horizontal row of the periodic table.

periodic law A law stating that when the elements are arranged by atomic mass, they exhibit a periodic recurrence of properties.

periodic table of the elements A table in which the elements are arranged by atomic number into columns (groups) and rows (periods).

pH The negative of the common logarithm of $[\text{H}_3\text{O}^+]$.

phase A physically distinct and homogeneous part of a system.

phase change A physical change from one phase to another, usually referring to a change in physical state.

phase diagram A diagram used to describe the stable phases and phase changes of a substance as a function of temperature and pressure.

photoelectric effect The observation that when monochromatic light of sufficient frequency shines on a metal, an electric current is produced.

photon A quantum of electromagnetic radiation.

photovoltaic cell A device capable of converting light directly into electricity.

physical change A change in which the physical form (or state) of a substance, but not its composition, is altered.

physical property A characteristic shown by a substance itself, without interacting with or changing into other substances.

pi (π) bond A covalent bond formed by sideways overlap of two atomic orbitals that has two regions of electron density, one above and one below the internuclear axis.

pi (π) MO A molecular orbital formed by combination of two atomic (usually p) orbitals whose orientations are perpendicular to the internuclear axis.

Planck's constant (\hbar) A proportionality constant relating the energy and frequency of a photon, equal to $6.626 \times 10^{-34} \text{ J}\cdot\text{s}$.

plastic A material that, when deformed, retains its new shape.

polar covalent bond A covalent bond in which the electron pair is shared unequally, so the bond has partially negative and partially positive poles.

polar molecule A molecule with an unequal distribution of charge as a result of its polar bonds and shape.

polarimeter A device used to measure the rotation of plane-polarized light by an optically active compound.

polarizability The ease with which a particle's electron cloud can be distorted.

polyatomic ion An ion in which two or more atoms are bonded covalently.

polymer (also *macromolecule*) An extremely large molecule that results from the covalent linking of many simpler molecular units (monomers).

polyprotic acid An acid with more than one ionizable proton.

polysaccharide A macromolecule composed of many monosaccharides linked covalently.

positron (β^+) The antiparticle of an electron.

positron emission A type of radioactive decay in which a positron is emitted from a nucleus.

potential energy (E_p) The energy an object has as a result of its position relative to other objects or because of its composition.

precipitate The insoluble product of a precipitation reaction.

precipitation reaction A reaction in which two soluble ionic compounds form an insoluble product, a precipitate.

precision (also *reproducibility*) The closeness of a measurement to other measurements of the same phenomenon in a series of experiments.

pressure (P) The force exerted per unit of surface area.

pressure-volume work (PV work) A type of mechanical work done when a volume change occurs against an external pressure.

principal quantum number (n) A positive integer that specifies the energy and relative size of an atomic orbital; a number that specifies an energy level in an atom.

probability contour A shape that defines the volume around an atomic nucleus within which an electron spends a given percentage of its time.

product A substance formed in a chemical reaction.

property A characteristic that gives a substance its unique identity.

protein A natural, unbranched polymer composed of any of about 20 types of amino acid monomers linked together by peptide bonds.

proton (p^+) A subatomic particle found in the nucleus that has a unit positive charge (1.60218×10^{-19} C).

proton acceptor A species that accepts an H^+ ion; a Brønsted-Lowry base.

proton donor A species that donates an H^+ ion; a Brønsted-Lowry acid.

pseudo-noble gas configuration The $(n - 1)d^{10}$ configuration of a *p*-block metal ion that has an empty outer energy level.

Q

quantum A packet of energy equal to $h\nu$. The smallest quantity of energy that can be emitted or absorbed.

quantum mechanics The branch of physics that examines the wave nature of objects on the atomic scale.

quantum number A number that specifies a property of an orbital or an electron.

R

rad (radiation-absorbed dose) The quantity of radiation that results in 0.01 J of energy being absorbed per kilogram of tissue; 1 rad = 0.01 J/kg tissue = 10^{-2} Gy.

radial probability distribution plot The graphic depiction of the total probability distribution (sum of ψ^2) of an electron in the region near the nucleus.

radioactivity The emissions resulting from the spontaneous disintegration of an unstable nucleus.

radioisotope An isotope with an unstable nucleus that decays through radioactive emissions.

radioisotopic dating A method for determining the age of an object based on the rate of decay of a particular radioactive nuclide relative to a stable nuclide.

radius of gyration (R_g) A measure of the size of a coiled polymer chain, expressed as the average distance from the center of mass of the chain to its outside edge.

random coil The shape adopted by most polymer chains and caused by random rotation about the bonds joining the repeat units.

random error Error that occurs in all measurements (with its size depending on the measurer's skill and the instrument's precision) and results in values *both* higher and lower than the actual value.

Raoult's law A law stating that the vapor pressure of solvent above a solution equals the mole fraction of solvent times the vapor pressure of pure solvent: $P_{\text{solvent}} = X_{\text{solvent}} \times P^0_{\text{solvent}}$.

rare earths (See *lanthanides*.)

rate constant (k) The proportionality constant that relates reaction rate to reactant (and product) concentrations.

rate law (also *rate equation*) An equation that expresses the rate of a reaction as a function of reactant (and product) concentrations and temperature.

rate-determining step (also *rate-limiting step*) The slowest step in a reaction mechanism and therefore the step that limits the overall rate.

reactant A starting substance in a chemical reaction.

reaction energy diagram A graph that shows the potential energy of a reacting system as it progresses from reactants to products.

reaction intermediate A substance that is formed and used up during the overall reaction and therefore does not appear in the overall equation.

reaction mechanism A series of elementary steps that sum to the overall reaction and is consistent with the rate law.

reaction order The exponent of a reactant concentration in a rate law that shows how the rate is affected by changes in that concentration.

reaction quotient (Q) (also *mass-action expression*) A ratio of terms for a given reaction consisting of product concentrations multiplied together and divided by reactant concentrations multiplied together, with each concentration raised to the power of its balancing coefficient. The value of Q changes until the system reaches equilibrium, at which point it equals K .

reaction rate The change in the concentrations of reactants (or products) with time.

reactor core The part of a nuclear reactor that contains the fuel rods and generates heat from fission.

redox reaction (See *oxidation-reduction reaction*.)

reducing agent The substance that donates electrons in a redox reaction and undergoes an increase in oxidation number.

reduction The gain of electrons by a species, accompanied by a decrease in oxidation number.

refraction A phenomenon in which a wave changes its speed and therefore its direction as it passes through a phase boundary into a different medium.

rem (roentgen equivalent for man) The unit of radiation dosage for a human based on the product of the number of rads and a factor related to the biological tissue; 1 rem = 10^{-2} Sv.

reproducibility (See *precision*.)

resonance hybrid The weighted average of the resonance structures for a species.

resonance structure (also *resonance form*) One of two or more Lewis structures for a species that cannot be adequately depicted by a single structure. Resonance structures differ only in the position of bonding and lone electron pairs.

reverse osmosis A process for preparing drinkable water that uses an applied pressure greater than the osmotic pressure to remove ions from an aqueous solution, typically seawater.

rms (root-mean-square) speed (v_{rms}) The speed of a molecule having the average kinetic energy; very close to the most probable speed.

roasting A pyrometallurgical process in which metal sulfides are converted to oxides.

round off The process of removing digits based on a series of rules to obtain an answer with the proper number of significant figures (or decimal places).

S

s orbital An atomic orbital with $l = 0$.

salt An ionic compound that results from an acid-base reaction after solvent is removed.

salt bridge An inverted U tube containing a solution of nonreacting ions that connects the compartments of a voltaic cell and maintains neutrality by allowing ions to flow between compartments.

saturated hydrocarbon A hydrocarbon in which each C is bonded to four other atoms.

saturated solution A solution that contains the maximum amount of dissolved solute at a given temperature (prepared with undissolved solute present).

scanning tunneling microscopy An instrumental technique that uses electrons moving across a minute gap to observe the topography of a surface on the atomic scale.

Schrödinger equation An equation that describes how the electron matter-wave changes in space around the nucleus. Solutions of the equation provide energy states associated with the atomic orbitals.

scientific method A process of creative proposals and testing aimed at objective, verifiable discoveries of the causes of natural events.

scintillation counter A device used to detect radioactive emissions through their excitation of atoms, which subsequently emit light.

screening (See *shielding*.)

second (s) The SI base unit of time.

second law of thermodynamics A law stating that a process occurs spontaneously in the direction that increases the entropy of the universe.

seesaw shape A molecular shape caused by the presence of one equatorial lone pair in a trigonal bipyramidal arrangement (AX_4E).

selective precipitation The process of separating ions through differences in the solubility of their compounds with a given precipitating ion.

self-ionization (See *autoionization*.)

semiconductor A substance whose electrical conductivity is poor at room temperature but increases significantly with rising temperature.

semimetal (See *metalloid*.)

semipermeable membrane A membrane that allows solvent, but not solute, to pass through.

shared pair (See *bonding pair*.)

shell (See *level*.)

shielding (also *screening*) The ability of other electrons, especially those occupying inner orbitals, to lessen the nuclear attraction for an outer electron.

SI unit A unit composed of one or more of the base units of the Système International d'Unités, a revised form of the metric system.

side reaction An undesired chemical reaction that consumes some of the reactant and reduces the overall yield of the desired product.

sievert (Sv) The SI unit of human radiation dosage; 1 Sv = 100 rem.

sigma (σ) bond A type of covalent bond that arises through end-to-end orbital overlap and has most of its electron density along an imaginary line joining the nuclei.

sigma (σ) MO A molecular orbital that is cylindrically symmetrical about an imaginary line that runs through the nuclei of the component atoms.

significant figures The digits obtained in a measurement. The greater the number of significant figures, the greater the certainty of the measurement.

silicate A type of compound found throughout rocks and soil and consisting of repeating —Si—O— groupings and, in most cases, metal cations.

silicone A type of synthetic polymer containing —Si—O repeat units, with organic groups and crosslinks.

simple cubic unit cell A unit cell in which a particle occupies each corner of a cube.

single bond A bond that consists of one electron pair.

slag A molten waste product formed in a blast furnace by the reaction of acidic silica with a basic metal oxide.

smelting Heating an oxide form of a mineral with a reducing agent, such as coke, to obtain a metal.

soap The salt formed in a reaction between a fatty acid and a strong base, usually a Group 1A(1) or 2A(2) hydroxide.

solid One of the three states of matter. A solid has a fixed shape that does not conform to the container shape.

solubility (S) The maximum amount of solute that dissolves in a fixed quantity of a particular solvent at a specified temperature.

solubility-product constant (K_{sp}) An equilibrium constant for a slightly soluble ionic compound dissolving in water.

solute The substance that dissolves in the solvent.

solution (See *homogeneous mixture*.)

solvated Surrounded closely by solvent molecules.

solvation The process of surrounding a solute particle with solvent particles.

solvent The substance in which one or more solutes dissolve.

source (See *occurrence*.)

sp hybrid orbital An orbital formed by the mixing of one s and one p orbital of a central atom.

sp^2 hybrid orbital An orbital formed by the mixing of one s and two p orbitals of a central atom.

sp^3 hybrid orbital An orbital formed by the mixing of one s and three p orbitals of a central atom.

sp^3d hybrid orbital An orbital formed by the mixing of one s , three p , and one d orbital of a central atom.

sp^3d^2 hybrid orbital An orbital formed by the mixing of one s , three p , and two d orbitals of a central atom.

specific heat capacity (c) The quantity of heat required to change the temperature of 1 gram of a substance or material by 1 K.

spectator ion An ion that is present as part of a reactant but is not involved in the chemical change.

spectrochemical series A ranking of ligands in terms of their ability to split d -orbital energies.

spectrometry Any instrumental technique that uses a portion of the electromagnetic spectrum to measure the atomic and molecular energy levels of a substance.

speed of light (c) A fundamental constant giving the speed at which electromagnetic radiation travels in a vacuum: $c = 2.99792458 \times 10^8$ m/s.

spin quantum number (m_s) A number, either $+\frac{1}{2}$ or $-\frac{1}{2}$, that indicates the direction of electron spin.

spontaneous change A change that occurs under specified conditions without an ongoing input of external energy.

square planar shape A molecular shape (AX_4E_2) caused by the presence of two lone pairs at opposite vertices in an octahedral electron-group arrangement.

square pyramidal shape A molecular shape (AX_5E) caused by the presence of one lone pair in an octahedral electron-group arrangement.

standard atmosphere (atm) The average atmospheric pressure measured at sea level and 0°C, defined as 1.01325×10^5 Pa.

standard cell potential (E_{cell}°) The potential of a cell measured with all components in their standard states and no current flowing.

standard electrode potential ($E_{\text{half-cell}}^{\circ}$) (also *standard half-cell potential*) The standard potential of a half-cell, with the half-reaction written as a reduction.

standard enthalpy of formation (ΔH_f°) (also *standard heat of formation*) The enthalpy change occurring when 1 mol of a compound forms from its elements with all components in their standard states.

standard enthalpy of reaction ($\Delta H_{\text{rxn}}^{\circ}$) (also *standard heat of reaction*) The enthalpy change that occurs during a reaction when all components are in their standard states.

standard entropy of reaction ($\Delta S_{\text{rxn}}^{\circ}$) The entropy change that occurs when all components are in their standard states.

standard free energy change (ΔG°) The free energy change that occurs when all components of a system are in their standard states.

standard free energy of formation (ΔG_f°) The standard free energy change that occurs when 1 mol of a compound is made from its elements with all components in their standard states.

standard half-cell potential (See *standard electrode potential*.)
standard heat of formation (See *standard enthalpy of formation*.)
standard heat of reaction (See *standard enthalpy of reaction*.)
standard hydrogen electrode (See *standard reference half-cell*.)
standard molar entropy (S°) The entropy of 1 mol of a substance in its standard state.

standard molar volume The volume of 1 mol of an ideal gas at standard temperature and pressure: 22.4141 L.

standard reference half-cell (also *standard hydrogen electrode*) A specially prepared platinum electrode immersed in 1 M $\text{H}^+(aq)$ through which H_2 gas at 1 atm is bubbled. $E^\circ_{\text{half-cell}}$ is defined as 0 V.
standard state A set of specific conditions used to compare thermodynamic data: 1 atm for gases behaving ideally, 1 M for dissolved species, or the pure substance for liquids and solids.

standard temperature and pressure (STP) The reference conditions for a gas: 0°C (273.15 K) and 1 atm (760 torr)

state function A property of a system determined only by the system's current state, regardless of how it arrived at that state.

state of matter One of the three physical forms of matter: solid, liquid, or gas.

stationary state In the Bohr model, one of the allowable energy levels of the atom in which it does not release or absorb energy.

steel An alloy of iron with small amounts of carbon and usually other metals.

stellar nucleosynthesis The process by which elements are formed in the stars through nuclear fusion.

stereoisomers Molecules with the same arrangement of atoms but different orientations of groups in space. (See also *geometric isomers* and *optical isomers*.)

stoichiometric coefficient (See *balancing coefficient*.)

stoichiometry The study of the mass-mole-number relationships of chemical formulas and reactions.

strong force An attractive force that exists between all nucleons and is many times stronger than the electrostatic repulsive force.

strong-field ligand A ligand that causes larger crystal field splitting energy and therefore is part of a low-spin complex.

structural formula A formula that shows the actual number of atoms, their relative placement, and the bonds between them.

structural isomers (See *constitutional isomers*.)

sublevel (also *subshell*) An energy substate of an atom within a level. Given by the n and l values, the sublevel designates the size and shape of the atomic orbitals.

sublimation The process by which a solid changes directly into a gas.

substance A type of matter, either an element or a compound, that has a fixed composition.

substitution reaction An organic reaction that occurs when an atom (or group) from one reactant substitutes for one attached to a carbon in another reactant.

substrate A reactant that binds to the active site in an enzyme-catalyzed reaction.

superconductivity The ability to conduct a current with no loss of energy to resistive heating.

supersaturated solution An unstable solution in which more solute is dissolved than in a saturated solution.

surface tension The energy required to increase the surface area of a liquid by a given amount.

surroundings All parts of the universe other than the system being considered.

suspension A heterogeneous mixture containing particles that are visibly distinct from the surrounding fluid.

synthetic natural gas (SNG) A gaseous fuel mixture, mostly methane, formed from coal.

system The defined part of the universe under study.

systematic error A type of error producing values that are all either higher or lower than the actual value, often caused by faulty equipment or a consistent flaw in technique.

T

T shape A molecular shape caused by the presence of two equatorial lone pairs in a trigonal bipyramidal arrangement (AX_3E_2).

t_{2g} orbitals The set of orbitals (composed of d_{xy} , d_{yz} , and d_{zx}) that results when the energies of the metal-ion d orbitals are split by a ligand field. This set is lower in energy than the other (e_g) set in an octahedral field and higher in energy in a tetrahedral field.

temperature (T) A measure of how hot or cold a substance is relative to another substance. A measure of the average kinetic energy of the particles in a sample.

tetrahedral arrangement The geometric arrangement formed when four electron groups maximize their separation around a central atom; when all four groups are bonding groups, the molecular shape is tetrahedral (AX_4 ; ideal bond angle 109.5°).

theoretical yield The amount of product predicted by the stoichiometrically equivalent molar ratio in the balanced equation.

theory (See *model*.)

thermochemical equation A balanced chemical equation that includes the enthalpy change for the reaction.

thermochimistry The branch of thermodynamics that focuses on the heat involved in chemical and physical change.

thermodynamics The study of energy and its transformations.

thermometer A device for measuring temperature that contains a fluid that expands or contracts within a graduated tube.

third law of thermodynamics A law stating that the entropy of a perfect crystal is zero at 0 K.

titration A method of determining the concentration of a solution by monitoring the amount of a solution of known concentration needed to react with it.

torr A unit of pressure identical to 1 mmHg.

total ionic equation An equation for an aqueous reaction that shows all the soluble ionic substances dissociated into ions.

tracer A radioisotope that signals the presence of the species of interest via radioactive emissions.

transcription The process of producing messenger RNA from DNA.

transition element An element that occupies the d block or the f block (inner transition element) of the periodic table.

transition state (also *activated complex*) An unstable species formed in an effective collision of reactants that exists momentarily when the system is highest in energy and that can either form products or reform reactants.

transition state theory A model that explains how the energy of reactant collisions is used to form a high-energy transitional species that can change to reactant or product.

translation The process by which messenger RNA specifies the sequence of amino acids to synthesize a protein.

transuranium element An element with atomic number higher than that of uranium ($Z = 92$).

trigonal bipyramidal arrangement The geometric arrangement formed when five electron groups maximize their separation around a central atom. When all five groups are bonding groups, the molecular shape is trigonal bipyramidal (AX_5 ; ideal bond angles, axial-center-equatorial 90° and equatorial-center-equatorial 120°).

trigonal planar arrangement The geometric arrangement formed when three electron groups maximize their separation around a central atom. When all three groups are bonding groups, the molecular shape is trigonal planar (AX_3 ; ideal bond angle 120°).

trigonal pyramidal shape A molecular shape (AX_3E) caused by the presence of one lone pair in a tetrahedral arrangement.

triple bond A covalent bond that consists of three bonding pairs, two atoms sharing six electrons; one σ and two π bonds.

triple point The pressure and temperature at which three phases of a substance are in equilibrium. In a phase diagram, the point at which three phase-transition curves meet.

Tyndall effect The scattering of light by a colloid.

U

ultraviolet (UV) Radiation in the region of the electromagnetic spectrum between the visible and the x-ray regions.

uncertainty A characteristic of every measurement that results from the inexactness of the measuring device and the need to estimate when taking a reading.

uncertainty principle The principle stated by Heisenberg that it is impossible to know simultaneously the exact position and velocity of a particle; the principle becomes important only for particles of very small mass.

unimolecular reaction An elementary reaction that involves the decomposition or rearrangement of a single particle.

unit cell The smallest portion of a crystal that, if repeated in all three directions, yields the crystal.

universal gas constant (R) A proportionality constant that relates the energy, amount of substance, and temperature of a system; $R = 0.0820578 \text{ atm}\cdot\text{L/mol}\cdot\text{K} = 8.31447 \text{ J/mol}\cdot\text{K}$.

unsaturated hydrocarbon A hydrocarbon with at least one carbon-carbon multiple bond; one in which at least two C atoms are bonded to fewer than four atoms.

unsaturated solution A solution in which more solute can be dissolved at a given temperature.

unshared pair (See *lone pair*.)

V

V shape (See *bent shape*.)

valence band In band theory, the lower energy portion of the band of molecular orbitals, which is filled with valence electrons.

valence bond (VB) theory A model that attempts to reconcile the shapes of molecules with those of atomic orbitals through the concepts of orbital overlap and hybridization.

valence electrons The electrons involved in compound formation; in main-group elements, the electrons in the valence (outer) level.

valence-shell electron-pair repulsion (VSEPR) theory A model explaining that the shapes of molecules and ions result from minimizing electron-pair repulsions around a central atom.

van der Waals constants Experimentally determined positive numbers used in the van der Waals equation to account for the interparticle attractions and particle volume of real gases.

van der Waals equation An equation that accounts for the behavior of real gases.

van der Waals radius One-half of the closest distance between the nuclei of identical nonbonded atoms.

vapor pressure (also *equilibrium vapor pressure*) The pressure exerted by a vapor at equilibrium with its liquid in a closed system.

vapor pressure lowering (ΔP) The lowering of the vapor pressure of a solvent caused by the presence of dissolved solute particles.

vaporization The process of changing from a liquid to a gas.

variable A quantity that can have more than a single value. (See also *controlled experiment*.)

viscosity A measure of the resistance of a fluid to flow.

volatility The tendency of a substance to become a gas.

volt (V) The SI unit of electric potential: $1 \text{ V} = 1 \text{ J/C}$.

voltage (See *cell potential*.)

voltaic cell (also *galvanic cell*) An electrochemical cell that uses a spontaneous redox reaction to generate electric energy.

volume (V) The amount of space occupied by a sample of matter.

volume percent [% (v/v)] A concentration term defined as the volume of solute in 100. volumes of solution.

W

wastewater Used water, usually containing industrial and/or residential waste, that is treated before being returned to the environment.

water softening The process of replacing the hard-water ions Ca^{2+} and Mg^{2+} with Na^+ ions.

wave function (See *atomic orbital*.)

wave-particle duality The principle stating that both matter and energy have wavelike and particle-like properties.

wavelength (λ) The distance between any point on a wave and the corresponding point on the next wave, that is, the distance a wave travels during one cycle.

weak-field ligand A ligand that causes smaller crystal field splitting energy and therefore is part of a high-spin complex.

weight The force that is exerted by a gravitational field on an object and is directly proportional to the object's mass.

work (w) The energy transferred when an object is moved by a force.

X

x-ray diffraction analysis An instrumental technique used to determine dimensions of a crystal structure by measuring the diffraction patterns caused by x-rays impinging on the crystal.

Z

zone refining A process used to purify metals and metalloids in which impurities are removed from a bar of the element by concentrating them in a thin molten zone.

INDEX

Page numbers followed by *f* indicate figures; *mn*, marginal notes; *n*, footnotes; and *t*, tables. Page numbers preceded by "A—" indicate pages in the *Appendix*. Page numbers preceded by "G—" indicate pages in the *Glossary*.

A

AB block copolymers, 518
 Absolute temperature scale. *See* Kelvin temperature scale
 Absolute zero, 26, 213
 Absorption spectrum, 308–309, G-1
 Abundance of elements, 997–1000, 998*t*, 1001*t*, G-1
 Accuracy, 32–33, 33*f*, G-1
 Acetaldehyde. *See* Ethanal
 Acetamide, 655*r*
 Acetaminophen, 664*f*
 Acetate ions, 72*t*, 844–845, 844*t*, 845*f*
 Acetic acid
 acid-dissociation constant for, 796–797*t*, 801*t*, A-8
 as base, 827
 boiling point elevation constant, 560*t*
 buffer action and, 844–845, 844*t*, 845*f*
 formula and model, 110*t*
 freezing point depression constant, 560*t*
 functions of, 110*t*
 molecular structure of, 655*t*, 662
 reaction with bases, 170, 170*t*, 171*f*
 reversible dissociation of, 189
 uses of, 793*t*
 Acetone
 bonds and orbitals of, 454
 molecular shape of, 427
 molecular structure of, 655*t*, 660*f*
 nuclear magnetic resonance spectroscopy of, 649, 649*f*
 Acetonitrile, 484*f*, 655*r*
 Acetylene
 bonds in, 451, 453, 453*f*
 electron density and bond order in, 454*f*
 molecular shape, 451
 molecular structure of, 655*t*
 production of, 228
 Acetyl salicylic acid, A-8
 Acid anhydrides, 663, 666, 666*f*, G-1
 Acid-base behavior of oxides, 354–355, 354*f*
 Acid-base buffers, 843–852
 actions of, 843–844*f*, 843–846
 buffer capacity, 849, 849*f*
 buffer range, 849–850
 common-ion effect and, 844
 concentration of components, 845–846, 845*f*, 848, 848*f*
 defined, 843, G-1
 Henderson-Hasselbalch equation and, 848–849
 molecular scene representation of, 850–851
 preparing, 851–852
 Acid-base equilibria, 792–830
 acid-base indicators and, 803, 803*f*, 860–862
 acid-dissociation constant and, 796–797*t*, 796–798,
 A-8–A-10
 acidic salt solutions and, 823–824, 825*t*
 amphiprotic anions and, 825
 autoionization of water and, 798–803, 799*f*, 827
 base-dissociation constant and, 818–822, 819*t*,
 A-11–A-12
 basic salt solutions and, 824, 825*t*
 Brønsted-Lowry acid-base definition and, 803–808,
 804*f*, 827, 830
 concentration and, 809–813
 conjugate acid-base pairs and, 804–807, 805*t*, 806*f*, 844,
 844*f*, 851
 hydrated metal ions and, 817, A-12
 hydronium ions and, 794, 799–803, 799*f*
 ion-product constant for water, 799–803, 799*f*
 Lewis acid-base definition and, 827–830, 877
 neutral salt solutions and, 823, 825*t*
 pH and, 800–803, 800*f*, 802*f*
 polyprotic acids and, 813–815, 814*t*
 relationship between weak bases and weak acids,
 818–822
 salt solutions and, 823–826

variation in acid strength, 795–796*f*, 795–798
 weak-acid equilibria problem solving, 808–815
 of weakly acidic cations and weakly basic anions,
 824–825
 Acid-base indicators
 acid-base titration and, 173–174, 173*f*
 acid-base titration curves and, 860–862
 color changes of, 860–861, 861*f*
 defined, 803, 860, G-1
 monitoring pH with, 860–862
 pH paper, 803, 803*f*
 Acid-base reactions, 165–174
 acid-base indicators and, 173–174, 173*f*, 860–862
 defined, 165, G-1
 end point in, 173, 173*f*
 equivalence point in, 173
 gas-forming reactions, 169–170, 171*f*, 189–190
 heat change during, 270–271
 key events in, 167
 of oxides, 354–355, 354*f*
 proton transfer in, 168–171, 169*f*
 reaction direction in, 805–808
 salt formation in, 167
 stoichiometry of, 172–174
 titration curves and, 853–863
 titrations, 172–174, 173*f*
 water formation in, 167
 writing ionic equations for, 167–168
 Acid-base titration, 172–174, 173*f*
 Acid-base titration curves, 853–863
 acid-base indicators and, 860–862
 defined, 853, G-1
 end point and, 861
 equivalence point and, 853*f*, 854–857, 855*f*, 859*f*, 863*f*
 for polyprotic acids, 862–863, 863*f*
 for strong acid–strong base, 853–855, 853*f*
 for weak acid–strong base, 855–859, 855*f*
 for weak base–strong acid, 859–860, 859*f*
 Acid-dissociation constant
 defined, 796, G-1
 of hydrated metal ions, A-12
 range of values for, 796, 796–797*t*
 relation with base-dissociation constant in conjugate
 pairs, 821–822
 relation with pK_a, 801*t*
 tables of, A-8–A-10
 weak acid equilibria problem solving and, 808–815
 Acidic solutions, balancing redox reactions in, 941–942
 Acid rain
 carbonates as protection from effects of, 603, 876
 components of, 281
 effects of, 875–876
 formation of, 875, 876*f*
 Hess's law as applied to, 275–276
 pH of, 875
 preventing, 876
 sulfuric acid and, 616, 616*mn*, 875, 876
 Acids. *See also* Acid-base reactions
 Arrhenius, 794, 830
 balancing redox reactions in, 941–942
 Brønsted-Lowry acids, 169, 803–808, 804*f*, 827, 830
 buffers, 843–852
 concentration, finding from titration, 173–174
 conjugate acid-base pairs, 804–807, 805*t*, 806*f*, 844,
 844*f*, 851
 defined, 165, 169, 794, 828, G-1
 dissociation of, 165–166, 189, 747, 795–798, 795*f*,
 811–813, 844*f*
 as electrolytes, 165–166, 166*f*
 equilibria (*See* Acid-base equilibria)
 indicators (*See* Acid-base indicators)
 leveling effect on, 827
 Lewis acids, 827–830, 877
 monoprotic, 796, 797*f*
 names, 74
 polyprotic, 813–815, 814*t*, 862–863, 863*f*
 sour taste from, 793
 strong (*See* Strong acids)
 structural features of, 166
 titration curves, 853–863
 titrations, 173–174
 uses of, 793*t*
 in water, 747, 794–798
 weak (*See* Weak acids)
 Acid strength. *See also* Strong acids; Weak acids
 acid-dissociation constant and, 796–797*t*, 796–798
 classifying, 797–798
 direction of reaction and, 805–808
 of hydrated metal ions, 817, 817*f*
 molecular properties and, 816–818
 of nonmetal hydrides, 816, 816*f*
 of oxoacids, 816–817, 817*f*
 Acrylonitrile, 385*f*, 602*f*
 Actin, arrangement of filaments, 511*f*
 Actinides
 defined, 1044, G-1
 electron configuration, 341*f*, 342
 properties of, 1045
 Actinium, 342
 Activated complex, 718
 Activated state, 716, 716*f*
 Activation energy
 calculating, 717, 717*f*, 717*t*
 catalysis and, 728, 728*f*, 729, 732
 defined, 716, G-1
 importance of, 716
 transition state theory and, 718–721
 Active metals
 activity series of metals, 184–186, 958–959, G-1
 displacing hydrogen from water, 184, 185*f*
 reactivity of, 958
 reduction with, 1011, 1011*f*
 Active site, 730–731, 731*f*, 781, 781*f*, G-1
 Activity in radioactive decay, 1084, G-1
 Activity series of halogens, 186, 186*f*
 Activity series of metals, 184–186, 958–959, G-1
 Actual yield, 128, G-1
 Addition, significant figures and, 30–31
 Addition polymers, 668, 668*f*, 669*f*, G-1
 Addition reactions
 with benzene, 660
 defined, 651, G-1
 organic, 651, 660, 668
 polymers in, 668
 Adduct, 828–829, G-1
 Adenine, 657*f*, 675
 Adenosine triphosphate (ATP)
 defined, G-1
 production of, 611, 982–983
 universal role of, 921–922
 Adhesive forces, 489–490, 490*f*
 Adhesives, 518
 Adipic acid, A-8
 Advanced materials, 507–520
 ceramic materials, 512–513, 512*t*, 513*f*
 electronic materials, 507–509, 508*f*
 liquid crystals, 509–511
 nanotechnology and, 519–520
 polymeric materials, 514–518, 514*t*, 515–517*f*, 518*f*
 Aerosol, 568*f*
 Air bags, 205
 Air composition, 205, 207, 239, 239*t*
 Airplane de-icers, 566
 Air pollution
 acid rain (*See* Acid rain)
 automobile exhaust and, 276–277
 chlorofluorocarbons and, 602, 602*f*, 732
 smog and, 224, 414, 609, 609*mn*
 thermal pollution, 550, 551*f*, 1108–1109
 Alanine, 643, 643*f*, 644, 672*f*
 Alchemy, 10, 10*f*, 50
 Alcohols
 defined, 654, G-1
 as functional group, 654, 654*f*, 655*t*, 656
 grain alcohol density, 24*t*
 solubility of, 535–536, 536*f*, 536*t*

- Aldehydes, 655t, 660–661, 660f, G-1
 Alizarin, 861f
 Alizarin yellow R, 861f
 Alkali metals. *See also* Halides
 anomalous behavior of, 587, 590
 atomic radius of, 348f
 comparison with alkaline earth metals, 593
 electron configuration, 343, 355, 591, 592
 industrial production and uses of, 1014–1015, 1015f
 ionization energy of, 349f
 melting point of, 396, 396f
 oxidation number for, 176t
 in periodic table, 63
 properties of, 590–592
 reactivity of, 230, 343f, 591, 592, 592mn
 sources of elements, 1001, 1002f
 Alkaline batteries, 968, 968f
 Alkaline earth metals
 anomalous behavior of, 590, 590f
 comparison with alkali metals, 593
 diagonal relationships and, 595, 595f
 electron configuration, 355, 593, 594
 melting point of, 396, 396f
 oxidation number for, 176t
 in periodic table, 63
 properties of, 592–595
 reactivity of, 594
 Alkanes
 chiral molecules and, 643–644
 constitutional isomerism and, 641–642, 642t
 cycloalkanes, 640, 641f
 defined, G-1
 depicting with formulas and models, 639–641f
 functions of, 76
 general formula for, 639
 as homologous series, 639
 naming, 76, 76t, 639, 639–640t, 646–647
 optical isomers of, 642–644
 properties of, 641, 641f
 as saturated hydrocarbons, 639
 straight-chain, 76, 76t
 Alkenes
 defined, 644, G-1
 as functional group, 655t, 659–660
 general formula for, 644
 geometric isomerism and, 645–646, 645t, 646f
 naming, 644, 646–647
 reactivity of, 659–660
 Alkyl group, 651, G-1
 Alkyl halides, 656–657, 659, G-1
 Alkynes, 646, 655t, 666, G-1
 Allotropes
 of carbon, 600–601, 600f
 defined, 600, G-1
 entropy and, 904–905
 of oxygen, 612
 of phosphorus, 606, 606f
 of selenium, 612, 614
 of sulfur, 612, 650
 of tin, 601
 Alloying, 507
 Alloys
 binary, 1013, 1013f
 composition and uses of, 1013t
 crystal defects in, 507
 defined, 396, 1012, G-1
 interstitial, 538, 538f
 magnesium, 1022
 metallurgy, 1012–1013, 1013f, 1013t
 samarium-cobalt, 1045
 as solid-solid solutions, 538, 538f
 substitutional, 538, 538f
 Alpha decay, 1076t, 1077, G-1
 Alpha helix, 673f, 674
 Alpha particles
 behavior in electric field, 1075, 1075f
 de Broglie wavelength of, 311t
 defined, G-1
 nuclear reactions and, 1090
 penetrating power of, 1094, 1094f
 radioactive decay, 1076t, 1077
 Rutherford's α -scattering experiment, 54–55, 54f
 transmutation by, 1090
 -al (suffix), 655t, 660
- Aluminate, 598
 Aluminosilicates, 876
 Aluminum
 acid strength of hydrated ions and, 817, 817f
 from bauxite, 274, 1019
 bond type, 598t
 density of, 24t
 diagonal relationship with beryllium, 598
 diffraction pattern, 311, 311f
 electron configuration, 338t, 339
 hydrogen displacement by, 185
 isolation of, 1019
 melting point of, 598t
 metallic radius, 345f
 metallurgy of, 1019–1021, 1020f
 mineral sources of, 1008t
 properties of, 354, 355, 595–598
 recycling, 1021, 1021mn
 specific heat capacity of, 268r
 uses of, 1021, 1021f
 Aluminum-air batteries, 1020
 Aluminum chloride
 dimeric structure of, 595, 595f
 dissolution of, 828, 903–904
 electron density distribution, 394f
 ionic properties, 394
 Aluminum hydroxide, 866t, 881, 882f
 Aluminum ions, 69t
 Aluminum oxide, 181, 355, 1019–1020
 Aluminum salts, 793t
 Aluminum sulfate, 570
 Amides, 655t, 662, 664–665, 664f, G-1
 -amide (suffix), 655t, 664
 Amines
 base-dissociation constant of, 818–819, 819t
 defined, 657, 818, G-1
 as functional group, 655t, 657–658, 657f
 as weak bases, 797
 -amine (suffix), 655t, 657
 Amino acids. *See also* Proteins
 defined, 539, 672, G-1
 optical isomers of, 643, 643f, 644
 physiological form of, 539f
 polarity of side chains, 539–540, 539f
 as polyprotic acids, 863
 structure of, 539–540, 672–673, 672f
 Ammonia
 base-dissociation constant of, 818, 819t, A-11
 in complex ion formation, 877–878
 as covalent hydride, 586
 dissociation of, 167, 189
 fixed mass ratio of, 44
 formation of, 181, 607, 751, 906, 907, 909
 Haber process for synthesis of, 779–780, 779t, 780f, 1005
 hybrid orbitals and, 447, 447f
 hydrogen sulfide and, 804
 Lewis structure of, 819t
 molecular shape of, 429
 mole fraction of air at sea level, 239t
 nitric acid from, 280
 polarity of, 429
 properties of, 607
 synthesis of, 1023–1024
 titration of, 859–860, 859f
 uses of, 779, 793t
 as weak base, 797
 Ammonium carbonate, 101–102
 Ammonium cyanide, 824–825
 Ammonium ions, 72t, 421, 804
 Ammonium nitrate
 dissolving, 546, 546f
 mass of elements in, 102–104
 solubility of, 550
 spontaneous change in, 897, 911
 in water, 549
 Ammonium perchlorate, 621–622
 Amontons's law, 213
 Amorphous solids, 493, 504, 504f, G-1
 Amount-mass-number conversions
 of chemical entities, 97–102
 in solutions, 151–152, 151f, 162f
 Amount-mass-number relationships
 of chemical entities, 97–102
 in chemical equations, 118f
 for compounds, 100f
 for elements, 98f
 overview, 127f
 Amount (mol) of gases
 Avogadro's law and, 214–215, 214f, 223, 231, 231, 234, 234f
 pressure and, 218–219
 volume and, 214–215, 214f, 218–219, 223
 Amount of substance, 14t
 Ampere (A), 14t, 980, G-1
 Amphiprotic anions, 825
 Amphoteric, defined, 354, G-1
 Amphoteric hydroxides, 881–882, 882f
 Amphoteric nature of water, 804
 Ampicillin, 111, 111f
 Amplitude, 296, 296f, G-1
 Analysis. *See* Chemical analysis
 -ane (suffix), 76, 639, 640t
 Angstroms (\AA), 296
 Angular momentum quantum number, 316, 317, 317t, 332t, G-1
 Anhydrides, acid, 663, 666, 666f
 Aniline, 189, 819t, A-11
 Animal radiation studies, 1097
 Anionic ligands, 1050, 1050t
 Anions
 amphiprotic, 825
 complex, 1048, 1050, 1050t
 defined, 64, G-1
 electron configuration and, 355
 ionic radius of, 359, 359f
 monatomic, 69t
 names, 74
 oxoanions, 72, 72f
 polyatomic, 72t
 salts of weakly acidic cations and weakly basic anions, 824–825
 of weak acids as weak bases, 820–821
 Anisotropic, 509
 Anodes
 defined, 944, G-1
 half-reactions at, 944, 944mn
 sacrificial, 974, 974f
 Antacids, 172
 Antarctic ozone hole, 732, 732f
 Antibiotics, dual polarity of, 542, 543f
 Antibonding MOs, 456, 456f, 457, G-1
 Anticancer drugs, 1053
 Antifluorite structure, 503
 Antifreeze, 561, 566, 567
 Antilogarithms, A-2
 Antimony
 bond type, 598t
 melting point of, 598t
 properties of, 353, 355, 604–607
 Antineutrino, 1077, 1095
 Antioxidants, 414
 Apatites, 1005, G-1
 Aqueous equilibria, 842–882
 of acid-base buffers, 843–852
 acid-base titration curves and, 853–863
 complex ions and, 877–882
 of slightly soluble ionic compounds, 864–875
 Aqueous heats of solution, 545–547, 546f
 Aqueous ionic reactions, 155–157, 156f
 Aqueous solutions
 defined, 81, G-2
 electrolysis of, 978–979
 molecular scenes to depict ionic compounds in, 148–149
 salts in, 823–824, 825t
 standard state for, 277
 Arginine, 672f
 Argon
 cubic closest packing in, 502, 502f
 electron configuration, 338t, 339
 heats of vaporization and fusion, 471f
 in ionization counters, 1083, 1084f
 mole fraction in air at sea level, 239t
 properties of, 622–624
 Aristotle, 43
 Arithmetic operations, 18, 30–31
 Aromatic hydrocarbons, 647–648, 648f, 659–660, 660f, G-2
 Array, 4

- Arrhenius, Svante, 715, 794–795
 Arrhenius acid-base definition, 794–795, 830, G-2
 Arrhenius acids, 794, 830
 Arrhenius bases, 794, 830
 Arrhenius equation, 715, 717, 718, G-2
Arsenic
 bond type, 598t
 electron configuration, 340t
 melting point of, 598t
 properties of, 353, 355, 604–607
Arsenic acid, 814t, A-8
Aryl halides, 657
Asbestos, 604
Asbestos diaphragm, 1028, 1028f
Ascorbic acid, 793t, 814–815, A-8
Asparagine, 672f
Aspartic acid, 672f
Aspirin, 80t
Astatine, 617–622
-ate (suffix), 72, 72f, 74, 1050
Atmosphere (atm), 209, 209t
Atmosphere of Earth
 abundance of elements in, 1001t
 carbon cycle and, 1002–1004, 1003f
 composition of, 205, 239, 239t
 convection in, 240
 defined, 239, 999, G-2
 impact of life on, 999–1000
 mixing of gases in, 470
 nitrogen cycle and, 1004–1005, 1004f
 ozone (*See Ozone*)
 pressure variation with altitude, 239, 239f
 regions of, 239–240, 239f
 temperature of, 239–240, 239f, 282–283
Atmospheric pressure
 altitude and, 208
 boiling point and, 479
 effects of, 207, 207f
 measurement of, 208, 208–209f
 units of measurement for, 209–210, 209t
 variation in, 239, 239f
Atom economy, 129–130
Atomic bomb, 1106, 1106f, 1106n
Atomic clock, 18
Atomic mass, 57–59, 61, 96, G-2
Atomic-mass interval, 59, 61
Atomic mass unit (amu), 56n, 57, 96, G-2
Atomic nucleus. *See Nucleus*
Atomic number
 defined, 56, G-2
 identification of elements from, 63–64
 periodic table organization by, 61, 331
Atomic orbitals, 314–322
 defined, 314, G-2
d orbitals (*See d orbitals*)
 energy levels and, 317–318
 filling order, 341–342, 341f
f orbitals, 321–322, 322f, 322t
g orbitals, 322
 hybrid orbitals, 444–451
 Pauli exclusion principle and, 333
p orbitals, 319–321, 320f, 322r, 458–459f, 458–460
 quantum numbers and, 316–318, 317t
Schrödinger equation and, 314
 shape of, 319–322
s orbitals, 319, 320f, 322t, 444
Atomic properties
 of alkali metals, 591
 of alkaline earth metals, 594
 of boron family elements, 595–597
 of carbon family elements, 599
 as central theme in chemistry, 8
 chemical reactivity and, 353–360
 of halogens, 618
 of nitrogen family elements, 605
 of noble gases, 623
 of oxygen family elements, 613
 of Period 2 elements, 587–590
 periodic trends in, 345–352, 352f
 of transition elements, 1040–1041f, 1040–1042
Atomic radius. *See also* Atomic size
 of alkali metals, 591
 of alkaline earth metals, 594
 of boron family elements, 596
- calculation from bond length, 381
 of carbon family elements, 599
 covalent, 345, 345f
 crystal structure, determining from, 498
 of halogens, 618
 ionic radius comparison, 359–360, 360f
 main-group elements, 346–347, 346f
 metallic, 345, 345f
 of nitrogen family elements, 605
 of noble gases, 623
 of oxygen family elements, 613
 of Period 2 elements, 589t
 periodic trends, 346–347, 346f
 transition elements, 346f, 347, 1040–1041f
 unit cell, determining from, 499
 van der Waals radius comparison, 482, 482f
- Atomic size**. *See also* Atomic radius
 bond length relationship with, 381, 381f
 comparison with ionic size, 359–360, 360f
 covalent radius and, 482, 482f
 defined, 345, 345f, G-2
 electronegativity and, 390, 391f
 entropy and, 904–905
 of main-group elements, 346–347, 346f
 periodic trends in, 345–346f, 345–347, 348f, 352f
 ranking elements by, 347
 of transition elements, 346f, 347, 1040,
 1040–1041f, 1041
- Atomic solids**, 501t, 502, 502f, G-2
- Atomic spectra**, 302–307
 Bohr model of the hydrogen atom and, 303–305, 305f
 energy levels of hydrogen atom and, 305–307, 305f
 excited state and, 304
 ground state and, 304
 line spectra, 302–305
 quantum staircase analogy and, 304, 304f
 Rydberg equation and, 302–303
 stationary states and, 304
- Atomic structure**
 Bohr model of, 303–305, 305f
 general features of, 55–56, 56f, 56t
 quantum-mechanical model and, 335–345
 quantum-mechanical model of, 314–322
- Atomic symbol**, 56, 57f, G-2
- Atomic theory**
 Dalton's theory, 50–51
 electron discovery and, 52–54
 law of definite (constant) composition and, 47–48,
 48f, 50
 law of mass conservation and, 46–47, 47f, 50
 law of multiple proportions and, 49–51
 Millikan's oil drop experiment and, 53–54, 53f
 modern, 55–59, 61
 nuclear atom model, 52–55
 nucleus discovery and, 54–55, 54f
 Rutherford's α -scattering experiment and, 54–55, 54f
- Atomic wave functions**, 455–456, 456f
- Atomic weight**. *See* Atomic mass
- Atomization**, 374
- Atoms**
 billiard-ball model of, 52
 chemical bonding and properties of, 369–372, 370f
 defined, 50, 55, G-2
 of elements, 44, 44f
 energy of, 301
 general features of, 55–56, 56f, 56t
 history of concept, 43
 mass of (*See* Atomic mass)
 plum-pudding model of, 54
 structure of (*See* Atomic structure)
- ATP**. *See* Adenosine triphosphate
- Aufbau principle**, 335, G-2
- Aurora borealis**, 53, 53mn
- Autoionization of water**, 798–803, 799f, 827, G-2
- Automobiles**
 batteries in, 969–970, 970f, 975, 975f
 catalytic converter in, 729, 876
 exhaust from, 276–277
 motor oil viscosity in, 491
 tire pressure, 213
- Autumn foliage**, 1057, 1057mn
- Avalanche effect**, 1083
- Average reaction rate**, 695, G-2
- Avogadro, Amedeo**, 96
- Avogadro's law**
 breathing and, 215, 215f
 defined, 214, G-2
 Earth's atmosphere and, 239
 ideal gas law and, 216f
 kinetic-molecular theory and, 231, 234, 234f
 molecular view of, 234, 234f
 volume-amount relationship and, 214–215,
 214f, 223
- Avogadro's number**
 Boltzmann constant and, 898
 as conversion factor, 98–102, 98f, 100f
 defined, 96, G-2
 symbol for, 235
- Axel, Richard**, 431
- Axial groups**, in VSEPR theory, 421, G-2
- B**
- Background radiation**, 1095–1096, G-2
- Bacterium**, approximate composition of, 533, 533t
- Baking soda**, 171
- Balanced equations**
 gas laws to determine, 221–222
 information contained in, 117, 117t
 from molecular scenes, 115–116
 nuclear equations, 1078
 reaction quotient and, 751, 752–753
 redox reactions, 940–943
 sequence to obtain overall equation, 120–121
 states of matter and, 113–114
 steps for balancing, 111–115
 stoichiometrically equivalent molar ratios from,
 116–120
- Balances**, 17
- Balancing (stoichiometric) coefficient**, 112–113, G-2
- Ball-and-stick models**, 79, 80t, 639, 640f
- Band of stability**, 1079, G-2
- Band theory**, 504–506, G-2
- Barite**, 493f
- Barium**
 atomic radius of, 498
 ionic compounds of, 353
 isotope of, 1105
 mineral sources of, 1008t
 properties of, 353, 593–594
- Barium hydroxide**, 167, 897, 911
- Barium ions**, 69t
- Barium nitrate**, 76
- Barium sulfate**, 869, 869mn
- Barometers**, 208, 208f, G-2
- Bartlett, Neil**, 624
- Bar (unit of measurement)**, 209, 209t
- Baseball quantum numbers**, 333mn
- Base-dissociation constant**
 of ammonia and amines, 818–820, 819t
 anions of weak acids as weak bases, 820–821
 defined, 818, G-2
 pH determination from, 818–820
 relation to acid-dissociation constant in conjugate pairs,
 821–822
 tables of, A-11–A-12
- Base pairs**, 675, G-2
- Bases**. *See also* Acid-base reactions
 Arrhenius, 794, 830
 bitter taste from, 793
 Brønsted-Lowry acids, 169, 803–808, 804f, 827, 830
 buffers, 843–852
 conjugate acid-base pairs, 804–807, 805t, 806f, 844,
 844f, 851
 defined, 165, 169, 794, 828, G-2
 dissociation of, 165–166
 as electrolytes, 165–166, 166f
 equilibria (*See* Acid-base equilibria)
 indicators (*See* Acid-base indicators)
 leveling effect on, 827
 Lewis bases, 827–830, 877
 strong (*See* Strong bases)
 structural features of, 167
 titration curves, 853–863
 uses of, 793t
 in water, 794–798
 weak (*See* Weak bases)
- Base units of SI system**, 13, 14t, G-2
- Basic-oxygen process**, 1017, 1017f, G-2

- Basic solutions, balancing redox reactions in, 942
 Batteries
 alkaline, 968, 968f
 aluminum, 1020
 button, 968–969, 969f
 defined, 968, G-2
 dry cell, 968
 flow, 970
 free energy change and, 916
 fuel cells, 970–971, 971f
 lead-acid, 969–970, 970f, 975, 975f
 lithium, 969, 969f
 lithium-ion, 970, 970f
 mercury, 968–969
 nickel-cadmium, 970
 nickel-metal hydride, 970, 970f
 nonrechargeable, 968–969
 primary, 968–969
 rechargeable, 969–970
 secondary, 969–970
 silver, 968–969, 969f
 Bauxite, 274, 1019, 1019mn
 Bayer process, 1019
 BE. *See* Bond energy
 Becquerel, Antoine-Henri, 1075
 Becquerel (Bq), 1084, G-2
 Beeswax, 538
 Bends (decompression sickness), 551, 551mn
 Bent shape
 defined, G-2
 of polar molecules, 146, 146f
 in VSEPR theory, 419, 419–420f, 421, 424f, 447
 Benzaldehyde, 660f
 Benzene
 addition reaction and, 660
 boiling point elevation constant, 560t
 dissolution of, 829
 freezing point depression constant, 560t
 heats of vaporization and of fusion, 471f
 molecular orbitals of, 463, 463f
 resonance structures of, 410
 solubility of, 150
 stability of, 660, 660f
 structure of, 647–648, 648f
 substitution reaction and, 660
 volatile component of solution, 564
 Benzoic acid, 662f, A-8
 Beryl, 493f, 603, 603f
 Beryllate, 598
 Beryllium
 anomalous behavior of, 590, 590f
 diagonal relationship with aluminum, 598
 diatomic, 458, 458f
 electron configuration, 336, 338f
 electron-deficient atoms in, 413
 ionization energy, 350f, 351t
 isotopes, decay constants and half-lives of, 1086t
 mineral sources of, 1008t
 properties of, 353, 413n, 588t, 593–594
 Beryllium chloride
 electron deficiency in, 590, 590f
 hybrid orbitals and, 444–446, 445f
 Lewis structure of, 413
 molecular shape of, 419
 Beta decay, 1076n, 1076t, 1077, G-2
 Beta particles
 behavior in electric field, 1075, 1075f
 defined, G-2
 penetrating power of, 1094, 1094f
 radioactive decay, 176n, 1076t, 1077
 Bicarbonate ions, 72t
 Bideterminate ligands, 1047, 1048t
 Billiard-ball model of atoms, 52
 Bimolecular reactions, 722, 722t, G-2
 Binary acids, 74
 Binary alloys, 1013, 1013f
 Binary covalent compounds, 73t, 74–76, G-2
 Binary ionic compounds
 defined, 64, G-2
 formation of, 64–65, 181
 formulas for, 68–71
 naming, 69–70
 oxidation numbers and, 176
 Binding energy. *See* Nuclear binding energy
 Binnig, Gerd, 500
 Biodiesel, 281–282
 Biological antifreeze, 567
 Biological catalysts, 730–731, 731f
 Biological energetics, 921–922, 982–983
 Biological fixation. *See* Fixation
 Biological macromolecules, 670–678
 amino acids (*See* Amino acids)
 base pairs, 675
 cellulose, 671
 chromosomes, 675
 disaccharides, 671, 671f
 DNA, 80t, 542–544, 543f, 675–680
 fibrous proteins, 674, 674f
 globular proteins, 674
 glycogen, 672
 intermolecular forces and, 539–544
 mononucleotides, 543, 675
 monosaccharides, 671, 671f
 as natural polymers, 670
 nucleic acids, 542–543, 674–680
 nucleotides, 674–675, 679, 680
 peptide bonds and, 539, 539f, 540, 664, 673
 phospholipids, 542, 542f
 polysaccharides, 671–672, 671mn
 proteins (*See* Proteins)
 ribosomes, 677–678, 677f
 RNA, 675, 677–678, 677f
 starch, 671–672
 sugars, 670–672, 671f
 Biological receptors, 431
 Biological systems, 187, 215, 215f, 485
 Biomass conversion, 281–282, G-2
 Biopolymers, 514
 Biosensors, 520
 Biosphere, 999–1000, 1001t, 1007, G-2
 Bismuth
 bond type, 598f
 electron configuration, 356
 ionic compounds of, 353
 melting point of, 598t
 oxides of, 355
 properties of, 353, 604–607
 Bisulfate ions, 72t, 616
 Bisulfite ions, 616
 Bitter taste from bases, 793
 Blackbody radiation, 299–300, 300f, 300n
 Blast furnaces, 1016–1017, 1016f, G-3
 Bleach, 619
 Block copolymers, 518
 Blood cells, 312f
 Blood pressure monitor, 208mn
 Body-centered cubic unit cell, 494, 495f, 496–497, 497f, G-3
 Bohr, Niels, 303–304, 310
 Bohrium, 1092
 Bohr model of the hydrogen atom, 303–305, 305f
 Boiling point
 of alkali metals, 591
 alkaline earth metals, 593, 594
 of alkanes, 641, 641f
 of boron family elements, 596
 of carbon family elements, 599
 defined, 479, G-3
 dipole moment and, 483–484, 484f
 dispersion forces and, 641
 of halogens, 618
 hydrogen bonds and, 484–485, 484f
 of ionic compounds, 378, 378f
 of metals, 396, 396f
 molar mass and, 486, 486f
 molecular shape and, 487, 487f
 of nitrogen family elements, 605
 of noble gases, 623
 of oxygen family elements, 613
 solubility and, 537, 537t
 of solutions, 559–560, 560f, 560t
 vapor pressure and, 479
 of water, 26, 26f, 27t
 Boiling point elevation, 559–560, 560f, 560t, G-3
 Boltzmann, Ludwig, 231, 898
 Boltzmann constant, 898
 Boltzmann equation, 898, 900
 Bomb calorimeter, 271–273, 272f
 Bond angle, 418, 418f, 420, 424f, 428–429, G-3
 Bond energy (BE)
 average energies of common bonds, 381, 381t
 cellular electrochemistry and, 982–983, 983f
 chemical change and, 386–390
 defined, 380–381, G-3
 enthalpy of reaction calculated from, 387–390, 388f
 in fuels and foods, 389–390, 389f, 390t
 of halogens, 617, 617f
 in hydrogen, 379f
 orbital overlap and, 444
 relationship with bond order and length, 382, 382t
 Bonding
 alkali metals and, 591
 alkaline earth metals and, 594
 atomic properties and, 369–372, 370f
 bond polarity, 146, 392–394
 in boron family elements, 595, 596, 598t
 in carbon family elements, 598–601, 598t
 comparison with intermolecular forces, 482, 483t
 of compounds, 64–67
 covalent (*See* Covalent bonds)
 electronegativity and, 390–394
 electron-pair delocalization in, 410
 electrostatic interactions in, 65
 gradation across periods, 394
 halogens and, 617, 617f
 in homonuclear diatomic molecules, 458–462
 hydrogen (*See* Hydrogen bonds)
 ionic (*See* Ionic bonds)
 Lewis electron-dot symbols and, 371–372, 371f
 metallic (*See* Metallic bonds)
 molecular orbital band theory and, 504–506
 in nitrogen family elements, 598t
 octet rule and, 372
 in organic molecules, 634
 oxygen family and, 613
 partial, 410, 411
 physical properties, impact on, 598, 600–601
 types of, 369–371, 483t
 Bonding MOs, 456, 456f, G-3
 Bonding pairs, 380, G-3
 Bonding theories
 molecular orbital theory, 455–463
 valence bond theory, 443–451
 Bond length
 in covalent bonds, 379f, 381–382, 381f
 defined, G-3
 halogens and, 617, 617f
 Bond-line formulas, 79, 80t
 Bond order
 defined, 380, G-3
 fractional, 411
 molecular orbital, 457
 relationship with bond energy and length, 382, 382t
 Bond polarity, 146, 392–394, 428–429
 Bonds, chemical, 64. *See also* Bonding
 Bond strength. *See* Bond energy (BE)
 Boranes, 590, 597–598, 598f, 604, 648
 Borates, 1001mn
 Borax, 597
 Borazon, 513f
 Boric acid, 597, 604
 Born-Haber cycle, 374–375, 374f, G-3
 Boron
 bond type, 598f
 chemistry of, 597–598
 diagonal relationship with silicon, 604
 diatomic molecules of, 460, 460f
 electron configuration, 336, 338f
 electron-deficient atoms in, 413
 ionization energy, 351, 351t
 melting point of, 598t
 properties of, 588t, 595–598
 Boron family elements
 heat of fusion of, 598t
 ionization energy of, 349f
 properties of, 595–598
 Boron nitride, 512, 513, 513f
 Boron oxide, 597
 Boron trifluoride
 electron pair acceptance in, 828
 hybrid orbitals and, 446, 446f
 Lewis structure of, 413–414
 molecular shape of, 419
 polarity of, 429

- Borosilicate glass, 597, 597*mn*
- Boyle, Robert, 43, 211
- Boyle's law
- application of, 217–218
 - breathing and, 215, 215*f*
 - combined gas law and, 214
 - defined, 212, G-3
 - Earth's atmosphere and, 239, 240
 - ideal gas law and, 216*f*
 - kinetic-molecular theory and, 231, 232, 233*f*
 - molecular view of, 232, 233*f*
 - volume-pressure relationship and, 211–212, 211*f*, 217–218, 223
- Bragg, W. H., 500
- Bragg, W. L., 500
- Bragg equation, 500
- Brain tumor, MRI scan of, 650, 650*f*
- Branches, of polymers, 517–518, G-3
- Brass, 507, 538, 538*f*, 1013, 1013*t*
- Bread, gases and rising of, 215
- Breathing. *See* Respiration
- Breeder reactors, 1015, 1108
- Bridge bonds, 598, 598*f*, G-3
- Brines, 1014
- British thermal unit (Btu), 262
- Bromide ions, 69*t*
- Bromine
- chemistry of, 619–622
 - electron configuration, 340*t*, 355
 - oxoacids, 622*t*
 - physical states of, 206*f*
 - properties of, 617–622, 617*f*
 - reactivity, 343*f*
 - standard enthalpies of formation, 278*t*
 - standard state of, 278
 - in voltaic cells, 953
- Bromine trifluoride, 422
- Bromobenzene, 660
- Bromobutane, 656
- Bromocresol green, 861*f*
- 2-bromo-2-methylpropane, 699, 700
- Bromophenol blue, 861*f*
- Bromothymol blue, 861, 861*f*
- Brønsted, Johannes, 169, 803
- Brønsted-Lowry acid-base definition, 169, 803–808, 804*f*, 827, 830, G-3
- Bronze, 1013*t*
- Brownian motion, 569
- Buck, Linda B., 431
- Buckminsterfullerene (“buckyball”), 600, 600*f*
- Buffer capacity, 849, 849*f*, G-3
- Buffer range, 849–850, G-3
- Buffers. *See* Acid-base buffers
- Butane
- boiling point of, 641*f*, 642*t*
 - combustion of, 186
 - constitutional isomers of, 110, 642, 642*t*
 - formula and model, 76*t*, 80*t*, 642*t*
 - properties of, 641, 641*f*
- Butanoic acid, 662, 662*f*
- Butanol
- infrared spectrum of, 385*f*
 - solubility of, 536*t*
 - structure of, 656
 - surface tension of, 489*t*
 - viscosity of, 489*t*, 490
- Butanone, 656, 660*f*
- Butene, 645–646, 645*t*
- But- (numerical root), 639*t*
- Button batteries, 968–969, 969*f*
- Butylamine, A-11
- Butyric acid, 662, 662*f*
- C**
- Cadmium, in batteries, 970
- Cadmium ions, 69*t*
- Cadmium telluride cells, 284
- Calcium
- abundance of, 1000, 1001*t*
 - electron configuration, 339, 340*t*
 - mineral sources of, 1008*t*
 - properties of, 593–594
 - reaction in water, 958, 958*f*
 - redox titrations and ion concentration in blood, 180
 - standard enthalpies of formation, 278*t*
- Calcium bromide, 68, 148, 546–547
- Calcium carbide, 228
- Calcium carbonate
- acid rain and, 876
 - in antacids, 602
 - decomposition of, 752
 - formation of, 911
 - law of definite composition and, 47–48, 48*f*
 - limestone and, 210, 871
 - polyatomic ion in, 67, 67*f*
 - reversibility of decomposition of, 188–189, 189*f*
 - solvability of, 869–870
 - uses of, 593
- Calcium chloride, 76, 157, 158*f*, 553–554, 567
- Calcium fluoride
- crystal structure of, 503, 503*f*
 - precipitation of, 157, 158*f*, 871*mn*
- Calcium hydroxide, 162–163, 171, 867, 868*t*, 869
- Calcium ions, 69*t*, 570–571, 571*f*
- Calcium oxide, 188–189, 189*f*, 354, 354*f*, 593, 1017, 1023
- Calcium phosphate, 865, 1010
- Calcium sulfate, 865
- Calculations
- significant figures in, 28–32
 - units and conversion factors in, 18–23
- Calculators, significant figures and, 30, 31
- Calibration, 33, 33*f*, G-3
- Calomel, 967, 967*f*
- Calorie (cal), 261
- Calorie (nutritional unit), 262, G-3
- Calorimeters
- bomb, 271–273, 272*f*
 - coffee-cup, 269–271, 269*f*
 - defined, 269, G-3
 - room-sized, 910, 910*f*
- Calorimetry
- constant-pressure, 269–271, 269*f*
 - constant-volume, 271–273, 272*f*
 - specific heat-capacity and, 268, 268*t*, 270
- Calvin, Melvin, 1098
- Calx (metal oxide), 11
- Cameroon, carbon dioxide suffocation in, 224
- Cancer, 1053, 1100
- Candela (cd), 14*t*
- Capillarity, 489–490, 489*f*, 492, G-3
- Carbohydrates
- combustion and energy from, 390, 390*t*
 - defined, 670
 - disaccharides, 671, 671*f*
 - monosaccharides, 671, 671*f*
 - optical isomers of, 644
 - polysaccharides, 671–672, 671*mn*
- Carbon. *See also* Diamond; Graphite
- abundance of, 1000, 1000*t*
 - allotropes of, 600–601, 600*f*
 - bond type, 598*t*
 - chemistry of, 601–603
 - diatomic molecules of, 460, 460*f*
 - electron configuration, 336–337, 338*f*, 634
 - fixation, 1003
 - granular activated, 570
 - ionization energy, 351*t*
 - isotopes of, 57
 - melting point of, 598*t*
 - molecular stability of, 634
 - nanotubes, 520
 - as network covalent solid, 504, 504*t*
 - oxidation of, 920
 - periodic table position, 634*f*
 - phase diagram of, 481, 600*f*
 - properties of, 588*t*, 598–601, 634
 - radioactive decay of ^{14}C , 1086, 1086*f*
 - in radiocarbon dating, 1087–1089, 1089*f*
 - reduction with, 1010
 - sources of, 1001
 - standard enthalpies of formation, 278*t*
 - standard state of, 278
- Carbonate buffers, 851–852
- Carbonate ions, 67, 67*f*, 72*t*, 411
- Carbonates
- conversion to oxides, 1010
 - in coral reefs, 491
 - as protection from effects of acid rain, 603, 876
- reaction with acids, 169–170
- solubility-product constant for, A-13
- sources of elements, 1001, 1002*f*
- test for presence of, 870, 870*f*
- uses of, 593, 602–603
- Carbon capture and storage (CCS), 283
- Carbon cycle, 1002–1004, 1003*f*
- Carbon dioxide
- atmospheric, 1002–1004
 - as blowing agent, 223
 - in carbon cycle, 1002–1004, 1003*f*
 - carbon monoxide formation from, 761
 - from coal burning, 281
 - CO-shift reaction and, 281
 - dipole moment, 428
 - dissolution in water, 491
 - as dry ice, 471, 479, 899
 - formation from limestone decomposition, 752
 - formation from methane and oxygen, 8*mn*
 - from gas-forming reactions, 169–170
 - greenhouse effect and global warming due to, 282–283
 - infrared radiation absorption and, 384
 - law of multiple proportions and, 49–51
 - molecular shape of, 419, 428
 - mole fraction in air at sea level, 239*t*
 - phase changes in, 471
 - phase diagram of, 480, 480*f*
 - release from limestone, 210
 - sequestration of, 283
 - in soda pop, 551
 - solvability of, 537
 - suffocation from, 224
 - supercritical, 480
 - uses of, 603
- Carbon disulfide, 560*t*
- Carbon family elements
- allotropes of, 600–601, 600*f*
 - heat of fusion of, 598*t*, 600
 - properties of, 598–604, 634
 - reactivity of, 599
- Carbon fixation, 1003
- Carbonic acid, 814*t*, 870, A-8
- Carbonic anhydrase, 1064, 1064*f*
- Carbon monoxide
- atmospheric concentration in volume percent, 554
 - in automobile exhaust, 276–277
 - boiling point of, 537*t*
 - CO-shift reaction, 281
 - formation of, 603, 761
 - formula and model, 80*t*
 - law of multiple proportions and, 49–51
 - mole fraction of air at sea level, 239*t*
 - nitrogen dioxide and, 705–706, 723–724
 - as reducing agent, 1011
 - solubility in water, 537*t*
 - toxicity from, 1064
 - uses of, 603
- Carbon-skeleton formula, 639–640, 640*f*
- Carbon skeletons, 636–637*f*, 636–638
- Carbon steel, 538, 538*f*, 1017, G-3
- Carbon tetrachloride
- boiling point elevation constant, 560*t*
 - freezing point depression constant, 560*t*
 - polarity of, 428–429
 - specific heat capacity of, 268*t*
- Carbonyl functional group, 660–661, G-3
- Carbonyl sulfide, 429
- Carboxylate ions, 663
- Carboxylic acids
- defined, 662, G-3
 - as functional group, 655*t*, 662–663, 662*f*
 - molecular structure of, 662, 662*f*
 - odor of, 664, 664*mn*
 - reactivity of, 662–663
 - strength of, 797
- Carnauba wax, 538
- Cars. *See* Automobiles
- Cast iron, 1017
- Catalysis
- basis of, 728, 728*f*
 - in biological systems, 730–731, 731*f*
 - heterogeneous, 729, 730*f*, 732
 - homogeneous, 728–729, 729*f*, 732
 - ozone depletion and, 732

- Catalysts
 biological (enzymes), 730–731, 731f
 defined, 727, G-3
 heterogeneous, 729, 730f, 732
 homogeneous, 728–729, 729f, 732
 lack of effect on equilibrium, 777, 777t
 Ziegler-Natta, 668
- Catalytic converter, 729, 876
- Catalytic hydrogenation, 729, 730f
- Catenation, 602, 634, 648, 650, G-3
- Cathode rays, 52–53, 52f, G-3
- Cathodes, 944, 944mn, G-3
- Cathodic protection, 973–974f, 974
- Cation-electron pairs, 1093
- Cations
 complex, 1048
 defined, 64, G-3
 electron configuration and, 355
 ionic radius of, 359, 359f
 metal cations as Lewis acids, 829
 monatomic, 69r
 polyatomic, 72f
 salts of weakly acidic cations and weakly basic anions, 824–825
- Caves, limestone, 870–871, 870f
- CCS (carbon capture and storage), 283
- Cell membrane structure, 542, 542f
- Cell potential, 950–967
 concentration and, 961–967
 defined, 950, G-3
 standard cell potential, 950–953, 950f
 of voltaic cells, 950–959
- Cell shape, osmotic pressure and, 567, 567f
- Cellular electrochemistry, 982–983
- Cellular metabolism, 781, 781f
- Cellulose, 671
- Celsius temperature scale, 25–27, 26f, 27t, G-3
- Cement, specific heat capacity of, 268t
- Centi- (prefix), 14t
- Ceramic materials
 defined, 512, G-3
 preparing, 512–513
 structure of, 513, 513f
 uses of, 512t, 513
- Cerium, 1044, 1045
- Cesium
 atomic clock and, 18
 electronegativity of, 392
 properties of, 590–592
- Cesium ions, 69f
- Cetyl palmitate, 663f
- CFCs (chlorofluorocarbons), 103, 602, 602f, 657, 732
- CFBs (compact fluorescent lamps), 285
- Chadwick, James, 55, 1090
- Chain-reaction (chain-growth) polymers, 668, 668f, 669f
- Chain reactions, 1105–1106, 1106f, G-3
- Chair conformation of cyclohexane, 640
- Chalcocite, 118, 120, 121
- Chalcopyrite, 1017, 1017mn
- Change in enthalpy. *See* Enthalpy change
- Charcoal, as amorphous solid, 504
- Charge
 of electrons, 53–54, 53f, 55, 56f, 56t
 in ionic bonding, 65
 of protons, 55, 56f, 56t
- Charge density, 545, G-3
- Charge distribution, unequal, 146, 146f
- Charge-induced dipole forces, 486, 534
- Charles, J. A. C., 212, 224
- Charles's law
 breathing and, 215, 215f
 combined gas law and, 214
 defined, 213, G-3
- Earth's atmosphere and, 240
- ideal gas law and, 216f
- kinetic-molecular theory and, 231, 233, 233f
- molecular view of, 233, 233f
- pressure-temperature relationship in, 213–214
- volume-temperature relationship in, 212–213, 212f, 223
- Chelate, 1047, 1047f, G-3
- Chemical analysis
 nuclear magnetic resonance spectroscopy, 649–650
 scanning tunneling microscopy, 500–501, 501f
 spectrometry in, 308–309
 x-ray diffraction analysis, 500, 500f
- Chemical bonds, 64, G-3. *See also* Bonding
- Chemical changes. *See also* Chemical reactions
 bond energy and, 386–390
 comparison with physical changes, 5, 5f, 6, 7–8
 defined, 5, G-3
- Chemical equations
 amount-mass-number relationships in, 118f
 aqueous ionic reactions, 155–157, 156f
 calculating amounts of reactant and product, 116–130
 defined, 111, G-3
 formation, 277–278
 molecular (*See* Molecular equations)
 molecular scenes and, 115–116
 net ionic (*See* Net ionic equations)
 thermochemical, 273–274
 total ionic (*See* Total ionic equations)
 writing and balancing, 111–116
- Chemical equilibrium. *See* Equilibrium
- Chemical formulas
 alkanes, 639–641f
 for binary covalent compounds, 74–76
 combustion analysis, determination from, 108–109, 108f
 for coordination compounds, 1049, 1050–1051
 defined, 68, G-3
 empirical formulas, 104–108, 110, 370
 for ionic compounds, 68–73
 isomers and, 110–111, 110t
 mass percent and, 102–103
 molecular (*See* Molecular formulas)
 molecular masses from, 76–78
 molecular structure and, 110–111, 110t
 representation of molecules with, 78–79, 80t
 for straight-chain alkanes, 76f
 structural, 79, 105, 110–111
 of unknown compounds, 104–111
- Chemical kinetics
 defined, 691, G-3
 reactions rate (*See* Reaction rate)
 theories of, 715–721
- Chemical names. *See* Nomenclature
- Chemical problem solving. *See* Problem solving
- Chemical properties. *See also* specific elements
 defined, 5, G-3
 of Period 2 elements, 587–590
 of transition metals, 1042–1043f, 1042–1044
- Chemical reactions. *See also* Chemical equations; specific reactions
 acid-base reactions, 165–174
 addition reactions, 651, 660, 668
 alkyl group, 651
 aqueous ionic reactions, 155–157, 156f
 bimolecular, 722, 722t
 combination reactions, 181–182, 182f
 comparison with nuclear reactions, 1074, 1074t
 coupling of reactions to drive nonspontaneous change, 920, 921, 921f
 decomposition reactions, 182–183, 183f
 defined, 5, G-3
 dehydration-condensation (*See* Dehydration-condensation reactions)
 displacement reactions, 159, 167, 184–185f, 184–186
 disproportionation, 609, 614, 618, 619, 621
 elementary, 721–723, 722t
 elimination reactions, 651–652
 enthalpy of reaction, 386–390, 388f
 equilibrium and, 188–190, 189f
 ideal gas law and stoichiometry, 228–230, 229f
 limiting reactants and, 122–127, 123f
 mass conservation during, 46–47, 47f, 50
 mass difference in, 1101–1102
 metathesis, 159, 167, 184
 neutralization, 793, 794
 organic (*See* Organic reactions)
 overall (net) equation and, 120–121, 121f
 precipitation reactions, 157–164, 190
 in radioactive tracer use, 1098
 redox (*See* Redox reactions)
 reversibility of, 188–190, 747
 in sequences, 120–121
 side reactions, 128, 128f
 spontaneous direction of, 896
 standard entropy of reaction, 906–907
- substitution reactions, 652, 660
 termolecular, 722, 722t
 unimolecular, 722, 722t
 yield in, 128–129, 129f
- Chemical reactivity, atomic structure and, 353–360
- Chemical shift, 649
- Chemical system, 258, 258f
- Chemistry
 central theme in, 8
 defined, 4, G-3
 electrochemistry (*See* Electrochemistry)
 in everyday life, 3
 inorganic, 63
 mathematical operations in, A-1–A-4
 modern materials and applications, 12, 12f
 organic, 63, 633
 prechemical traditions, 10–11, 10f
 quantitative theories of, 12
 thermochemistry (*See* Thermochemistry)
- Chernobyl disaster, 1093, 1108
- Chiral molecules, 643–644, G-3
- Chitin, 671, 671mn
- Chlor-alkali process, 1028–1029, 1028f, G-4
- Chlorate ions, 72t
- Chloride ions, 69t
- Chlorides, 394, 394–395f
- Chlorine
 abundance of, 1001t
 chemistry of, 619–622
 covalent radius, 345, 345f
 electron configuration, 338r, 339
 industrial production of, 1028–1029, 1028f
 oxoacids, 621–622, 622t
 ozone depletion and, 732, 732f
 properties of, 44, 45t, 354, 617–622, 617f
 reactivity, 343f
 standard enthalpies of formation, 278t
 standard state of, 278
 in water treatment, 570
- Chlorine dioxide, 621, 621f
- Chlorine gas, 230, 230mn
- Chlorine oxides, 621–622, 621f
- Chlorine trifluoride, 123–124, 415
- Chloride ions, 72t
- Chloroacetic acid, A-8
- Chloroethane, 658
- Chlorofluorocarbons (CFCs), 103, 602, 602f, 657, 732
- Chloroform
 boiling point elevation constant, 560t
 formation of, 389
 freezing point depression constant, 560t
 intermolecular forces, 534f
 polarity of, 428–429
- Chloromethane, 655f
- Chlorophyll, 308–309, 309f, 829, 829f, 1057
- Chlorous acid, 796–797t, A-8
- Cholesterol phase, 510, 510f
- Cholesterol, molecular structure of, 654f
- Chromate ions, 72t, 868, 868f
- Chromates, A-13
- Chromatography, 83, 83f, G-4
- Chromium
 abundance of, 1001t
 appearance of, 1038f
 chromium(II) and chromium(III), 71t
 as dietary trace element, 1064t
 electron configuration, 339, 340r, 343, 1039, 1039t
 oxidation state, 1042, 1042t
 properties of, 1044, 1044t
 purification of, 1011
 in voltaic cells, 948–949
- Chromium(III) ions, 941–942, 941mn
- Chromosomes, 675
- CIGS (copper indium gallium selenide) cells, 284
- Cisplatin, 1053
- cis-trans isomers, 430, 645, 645t, 646f, 1052, 1052f
- Citric acid, 793t, A-9
- Clausius-Clapeyron equation, 478–479, G-4
- Claus process, 281, 1026
- Clay ceramics, 512
- Climate change, 282–283
- Clock, atomic, 18
- Closed-end manometers, 208, 209f
- Coal, 281, 876, 1000, 1001, 1003
- Coal gasification, 281, G-4

- Cobalt
abundance of, 1001*t*
appearance of, 1039*f*
cobalt(II) and cobalt(III), 71*t*
as dietary trace element, 1064*t*
electron configuration, 340*r*, 1039*t*
oxidation state, 1042, 1042*t*
- Cobalt(II) carbonate, 866*t*
- Cobalt(II) chloride hexahydrate, 1043*t*
- Cocaine, molecular structure of, 657*f*
- Coefficients, balancing in thermochemical equations, 274
- Coffee-cup calorimeter, 269–271, 269*f*
- Cohesive forces, 489–490, 490*f*
- Coke, 1016
- Cola, carbon dioxide in can of, 551
- Cold packs, 546
- Collagen, 674, 674*f*
- Colligative properties of solutions, 557–567
applications of, 566–567, 567*f*
boiling point elevation, 559–560, 560*f*, 560*t*
defined, 557, G-4
electrolytes, 557, 557*f*, 564–566, 565*f*
fractional distillation and, 564, 567, 567*f*
freezing point depression, 560–561, 560*r*, 566–567
nonelectrolytes, 557, 557*f*, 558–566
osmotic pressure, 562, 562*f*, 567, 567*f*, 571
solute molar mass and, 563
underlying theme of, 562–563
vapor pressure lowering, 558–559, 558*f*
- Collision frequency
defined, G-4
in Earth's atmosphere, 240
kinetic-molecular theory and, 238, 238*mn*
reaction rate and, 692, 693, 716
- Collisions
effective, 718, 718*f*
elasticity of, 231
energy of, 693, 693*f*, 716–717, 716*f*, 717*t*
gas laws and, 231–234
- Collision theory, 715–718, 717*t*, G-4
- Colloids
Brownian motion in, 569
defined, 533, G-4
stability of, 569
structure and properties of, 568–569
Tyndall effect and, 569, 569*f*
types of, 568, 568
in water purification, 570–571
- Color, 1056–1057, 1056*f*, 1057*t*, 1058–1059
- Column chromatography, 83, 83*f*
- Combination reactions, 181–182, 182*f*
- Combined gas law, 214
- Combustion. *See also* Fuels
biodiesel from, 281–282
calculating heat of reaction, 272–273
of coal, 281
defined, 11, 186, G-4
of gasoline, 114–115, 262, 915–916
of hydrogen, 281–282, 697–698
Lavoisier's theory of, 11, 13
mass conservation and, 46
of methane, 387–388, 388*f*
of octane, 114–115, 263, 263*f*, 915–916
phlogiston theory and, 11
of propane, 117, 117*t*, 907
respiration and, 187, 910
spontaneous change and, 896
- Combustion analysis, 108–109, 108*f*, G-4
- Combustion reactions, 186–187
- Common-ion effect, 844, 868–869, 868*f*, G-4
- Compact fluorescent lamps (CFLs), 285
- Complementary color, 1056
- Complex ions
of amphoteric hydroxides, 881–882, 882*f*
calculating concentration of, 878–879
in coordination compounds, 1046–1054, 1046*f*, 1047*t*
defined, 877, 1046, G-4
formation of, 877–878, 878*f*, 878*t*
geometry of, 1047, 1047*t*
isomerism and, 1051–1054
names and formulas for, 1048–1051, 1050*r*
octahedral complexes and, 1055, 1055*f*
solubility of precipitates and, 879–881
square planar complexes and, 1055, 1056*f*
structure of, 877, 877*f*
- table of formation constants, A-12
tetrahedral complexes and, 1056, 1056*f*
valence bond theory for, 1055–1056
- Composition of matter, 4, G-4
- Compounds
amount-mass-number conversions of, 100–102, 100*f*
atomic-scale view of, 44, 44*f*
bonding, 64–67
calculating molecular mass of, 76–78
comparison with mixtures, 45, 81, 81*f*
covalent (*See* Covalent compounds)
defined, 44, G-4
determining formula of unknown compounds, 104–111
elemental mass in, 48–49
fixed ratio, 44
formulas, names, and masses, 68–79
inorganic, 602–603, 659, 662
ionic (*See* Ionic compounds)
law of definite composition and, 47–48, 48*f*, 50
law of multiple proportions and, 49–51
mass fraction and, 47–48
mass of elements in, 104
mass percent and, 47–48, 48*f*, 102–103
molar mass of, 97
molecular mass and, 76–78
molecules of, 44, 44*f*
organic (*See* Organic compounds)
properties of, 44
specific heat capacity of, 268*r*
standard state for, 277
- Compton, Arthur, 312
- Computer-aided magnetic resonance imaging, 649–650, 650*f*
- Concentration
acid dissociation and, 811–813
of buffer components, 845–846, 845*f*, 848, 848*f*
cell potential and, 961–967
defined, 552, 553*t*, G-4
dilution, 152–154, 153*f*
effect of change on equilibrium, 770–773, 772*t*, 777*t*
equilibrium constant and, 756–757
expressing as molarity, 150
as intensive property, 150
interconverting terms, 556–557
mass percent and, 554
molarity and, 553–554, 553*t*
molarity and, 552–553, 553*t*
mole fraction and, 553*t*, 554–555
parts by mass, 553*t*, 554, 555
parts by volume, 553*t*, 554, 555
reaction rate and, 692, 696–698, 696*f*
redox titration for finding, 180
visualizing changes in, 154–155
volume percent and, 554
weak-acid equilibria problem solving and, 809–813
- Concentration cells
action of, 965, 965*f*
applications of, 966–967, 967*f*
calculating potential of, 964–966
defined, 964, G-4
- Condensation. *See also* Dehydration-condensation reactions
defined, 471, G-4
as exothermic and spontaneous process, 896
liquid-gas equilibria and, 476–477, 476*f*
process of, 474
- Condensation polymers, 669–670, 670*f*, G-4
- Condensed electron configuration, 338*t*, 339, 340*t*
- Condensed formula, 639, 640*f*
- Condensed states, 469
- Conduction bands, 505, 505–506*f*, 506, G-4
- Conductivity. *See* Electrical conductivity
- Conductometric methods for reaction rate measurement, 699
- Conductors, 397, 506, 506*f*, G-4
- Conjugate acid-base pairs
acid-base buffers and, 844, 844*f*, 851
Brønsted-Lowry acid-base definition and, 804, 805*t*
defined, 804, G-4
identifying, 805
ranking, 806–807
relation between acid- and base-dissociation constants, 821–822
strength of, 805–808, 806*f*
- Conservation of energy, 9, 261, 284–285, 896, 896*n*
- Constant-pressure calorimetry, 269–271, 269*f*
- Constant-volume calorimetry, 271–273, 272*f*
- Constitutional (structural) isomers
in alkanes, 641–642, 642*f*
in coordination compounds, 1051–1052, 1052*f*, 1054*f*
defined, 1051, G-4
properties of, 110–111, 110*t*
- Constructive interference, 443
- Contact process, 1025–1026, G-4
- Controlled experiments, 12, G-4
- Controlled orientation, in polymers, 519
- Control rods, 1107
- Convective mixing, 240
- Conversion factors
Avogadro's number as, 98–102, 98*f*, 100*f*
choosing, 18–19
constructing, 18
converting between unit systems, 19
defined, 18, G-4
interconverting wavelength and frequency, 297–298, 301–302
for units raised to a power, 23
- Coordinate covalent bond, 1055, G-4
- Coordinate compounds
bidentate ligands and, 1047, 1048*f*
chelate and, 1047, 1047*f*
complex ions in, 1046–1054, 1046*f*, 1047*f*
components of, 1046, 1046*f*
constitutional isomers in, 1051–1052, 1052*f*, 1054*f*
coordination isomers in, 1051
coordination numbers and, 1046, 1047*t*, 1049
counter ions in, 1046, 1049, 1050
crystal field theory and, 160–1062*f*, 1056–1059*f*, 1056–1062, 1057*f*
defined, 1046, G-4
donor atoms and, 1047
formulas and names of, 1048–1051, 1050*f*
geometric isomers and, 1052–1053, 1052*f*
isomerism in, 1051–1054
ligands and, 1046, 1047–1048, 1048*f*
linkage isomers in, 1052, 1052*f*
magnetic properties of, 1060–1061
monodentate ligands and, 1047, 1048*f*
optical isomers and, 1053–1054, 1053*f*
polydentate ligands and, 1047, 1048*f*
stereoisomers and, 1052–1054*f*
valence bond theory and, 1055–1056
- Coordination isomers, 1051, G-4
- Coordination number
in coordination compounds, 1046, 1047*t*, 1049
in crystalline solids, 494, 495–496, 495*f*
defined, G-4
- Copernicium, 1092
- Copolymers, 518, 669, G-4
- Copper
abundance of, 1000, 1001*t*
alloys, 1013, 1013*f*, 1013*t*
appearance of, 1039*f*
in concentration cells, 965, 965*f*
conductivity of, 397, 538
copper(I) and copper(II), 71*t*, 72, 72*f*
cubic crystal structure of, 499, 503*f*
as dietary trace element, 1064*t*
in displacement reactions, 185, 185*f*
in electrolytic cells, 974, 975*f*
electron configuration, 339–340, 340*r*, 358, 1039, 1039*t*
electrorefining, 1018, 1018*f*
flame tests with, 308*f*
isolation of, 1010, 1017
metallurgy of, 1017–1018, 1018*f*
oxidation state, 1042, 1042*t*
properties of, 6, 7*t*
roasting, 118–120
sources of, 118
specific heat capacity of, 268*r*
in voltaic cells, 945–946, 945–949, 953, 963–964, 964*f*
- Copper(II) chloride, 874
- Copper(II) hydroxide, 874
- Copper(II) sulfate pentahydrate, 1043*f*
- Copper indium gallium selenide (CIGS) cells, 284
- Copper(I) oxide, 118, 120, 121, 919–920
- Copper(I) sulfide, 118, 119, 1010, 1017–1018
- Core electrons, 342, 350
- Core of Earth, 998, 998–999*f*, 998*t*, G-4
- Corrosion, 972–974, G-4
- Corundum, 1019
- CO-shift reactions, 281

- Cosmic radiation, 1088, 1095
 Cosmology, element synthesis and, 1110–1111, 1110f
 Cottrell precipitator, 569
 Coulomb (C), 54, 56n, 950, G-4
 Coulomb's law
 charge density and, 545
 defined, 65, G-4
 on intermolecular forces, 469–470, 482, 535
 lattice energy and, 375–376
 nuclear charge and, 333
 Counter ions, 1046, 1049, 1050, G-4
 Counters, for detection of radioactive emissions, 1083–1084, 1084f
 Coupling of reactions, 920, 921, 921f, G-4
 Covalent bonds
 bonding pairs, 380
 bond order in, 380, 382t, 411
 coordinate, 1055
 defined, 66, 370, G-4
 double (*See Double bonds*)
 electron sharing and, 370, 370f, 379
 formation of, 66–67, 66f, 175, 175f, 379, 379f
 in intermolecular force comparison, 483t
 lone pairs, 380
 model of, 379–383, 386
 nonpolar, 392, 392f
 pi bond, 452–454, 453f, 455, 455f, 644
 polar, 390, 390f, 392, 393f
 in polyatomic ions, 67, 67f
 sigma bond, 452, 452–453f, 453, 455
 single (*See Single bonds*)
 triple (*See Triple bonds*)
 Covalent bond theories
 molecular orbital theory, 455–463
 valence bond theory, 443–451
 Covalent compounds
 binary, 73t, 74–76
 comparison with ionic compounds, 67
 defined, 64, G-4
 formation of, 66–67, 66f
 names and formulas, 74–76
 network covalent solids, 383, 383f, 386
 nonelectrolytes, 150
 oxidation number and, 176
 properties of, 383, 386
 redox reactions and, 175, 175f, 181–182, 182f
 in water, 150
 Covalent hydrides, 586
 Covalent radius, 345, 345f, 381f, 482, 482f, G-4
 Cracking, of ionic compounds, 377, 377f
 Cristobalite, 504f
 Critical mass, 1106, G-4
 Critical point, 480, 480f, G-4
 Critical pressure, 480
 Critical temperature, 480
 Crosslinks, in polymers, 518, G-4
 Crude oil refining, 567, 567f
 Crust of Earth, 998–999f, 998–1000, 998t, 1001t, G-4
 Crutzen, Paul J., 732
 Cryolite, 619, 1019
 Crystal defects, in electronic materials, 507, G-4
 Crystal field splitting energy, 1058, 1059–1060, G-4
 Crystal field theory, 1056–1062
 chlorophyll in, 1057
 color and, 1056–1057, 1056f, 1057t, 1058–1059
 complementary color and, 1056
 defined, 1056, G-4
 high-spin complexes and, 1060–1061
 low-spin complexes and, 1060–1061
 magnetic properties and, 1060–1061
 octahedral complexes in, 1057–1058
 spectrochemical series and, 1059, 1059f
 splitting *d* orbitals in octahedral field of ligands, 1057–1058
 square planar complexes in, 1062, 1062f
 strong-field ligands in, 1058, 1058f, 1060, 1060–1061f
 tetrahedral complexes in, 1061, 1062f
 weak-field ligands in, 1058, 1058f, 1060, 1060–1061f
 Crystal lattice, 493–494, 493f
 Crystalline solids
 atomic, 501t, 502, 502f
 atomic radius determination, 498
 coordination number in, 494, 495–496, 495f
 crystal lattice of, 493–494, 493f
 defined, G-5
 dissolution and, 904, 904f
 entropy and, 904, 904f
 ionic, 501t, 502–503
 metallic, 501t, 503, 503f
 molecular, 501t, 502, 502f
 network covalent, 501t, 503–504, 504t
 packing efficiency in, 496–498, 497f
 structural features of, 493, 493f
 types and properties of, 501–504, 501t
 unit cell of, 493–499, 497f, 499f
 x-ray diffraction analysis of, 500, 500f
 Crystallinity of polymers, 516, 516f
 Crystallization, 83, G-5
 Crystals and crystal structures. *See Crystalline solids*
 Crystal violet, 861f
 Cubic centimeter (cm³), 15, 16f
 Cubic closest packing, 497f, 498, G-5
 Cubic decimeter (dm³), 15, 16f
 Cubic meter (m³), 15, G-5
 Cubic unit cell, 494–499, 495f, 497f, 499f
 Curie, Marie Skłodowska, 1075, 1078, 1090
 Curie, Pierre, 1075, 1090
 Curie (Ci), 1084, G-5
 Current. *See also Electrical conductivity*
 electrical, 14t, 52
 measuring to find charge, 980
 in photoelectric effect, 301, 301f
 in strong electrolytes, 557, 557f
 Cyanate ions, 412, 824
 Cyanide ions
 formula for, 72t
 in gold leaching, 1009, 1011
 isoelectronic nature of, 603
 triple bonds in, 666
 Cyanides, A-13
 Cyclic hydrocarbons, 640, 641f, G-5
 Cycloalkanes, 640, 641f
 Cyclobutane, 641f, 708–709
 Cyclobutanone, 661
 Cyclohexane, 640, 641f, 660f
 Cyclohexanol, 656
 Cyclohexene, 656, 660, 660f
 Cyclone separator, 1009, 1009f
 Cyclopentane, 641f
 Cyclopropane, 641f, 713, 907
 Cyclo-S₈, 612, 612f
 Cyclotron accelerator, 1091, 1092f
 Cysteine, 540, 672f
 Cytochromes, 1064
 Cytosine, 675
- D**
- Dacron, 670
 DAF (dissolved air flotation), 570
 Dalton, John, 50–51, 225
 Dalton (Da), 57, G-5
 Dalton's law of partial pressures
 application of, 226–227
 defined, 225–226, G-5
 discovery of, 225
 Earth's atmosphere and, 239
 kinetic-molecular theory and, 231, 233, 233f
 molecular view of, 233, 233f
 Darmstadtium, 343, 1092
 Data, 12, G-5
 Davission, C., 311
 d block, 595, 1037, 1038, 1038f. *See also Transition elements*
 De Broglie, Louis, 310
 De Broglie wavelength, 311, 311, G-5
 Debye, Peter, 428n
 Debye (D), 428
 Decane, 76t, 641f
 Deca- (prefix), 72, 73t
 Decay constant, 1085, 1086t, G-5
 Decay rate, 1084–1087, 1086f, 1086t
 Decay series, 1082, 1082f, G-5
 Decimal places, significant figures and, 29
 Decimal prefixes, 14, 14n, 14t
 Deci- (prefix), 14t
 Deci- (numerical root), 639f
- Decomposition reactions, 182–183, 183f, 1003, 1005, 1006
 Decompression sickness, 551, 551mn
 Definite composition, law of, 47–48, 48f, 50
 Degree of polymerization, 514, 514t, G-5
 Dehydration-condensation reactions
 acid anhydrides and, 663
 defined, 611, G-5
 disaccharide formation from, 671
 esters and, 664
 halogens and, 621
 in monomers of condensation polymers, 669
 nucleoside triphosphates and, 675
 peptide bond formation from, 673
 polyphosphates and, 611
 Dehydration of alcohols, 656
 De-icers, 566, 567
 Deka- (prefix), 14t
 Delocalized electrons, 371, 397, 410, 647, 659
 Democritus, 43, 50
 Dendrimers, 518
 Denitrification, 571, 1005
 Density
 of alkali metals, 590, 591
 of alkaline earth metals, 593, 594
 of boron family elements, 596
 calculating from mass and volume, 24–25
 of carbon family elements, 599
 of common substances, 24t
 defined, 23, G-5
 electron density, 379, 380f, 394, 635
 gases and, 24, 24t, 206, 222–224
 of halogens, 618
 as intensive property, 27, 27f
 of nitrogen family elements, 605
 of noble gases, 623
 of oxygen family elements, 613
 SI units, 24
 of transition elements, 1041–1042, 1041f
 of water, 24, 492
 Dental amalgam, 1013t
 Dental fillings, 959, 959f
 Deoxyhemoglobin, 1063
 Deoxyribonucleic acid. *See DNA*
 Deoxyribose, 675
 Deposition, 471, 471f, G-5
 Derived units of SI system, 13–14, G-5
 Desalination, 571, G-5
 Desulfurization, 281
 Detergents, 569, 1008
 Deuterium, 1024–1025, 1024t, 1091, 1109
 Deuterons, 1091, G-5
 Dextrorotatory isomers, 643
 Diagonal relationships in periodic table, 595, 595f, 598, 604, G-5
 Diamagnetism, 357, 358f, 460–461, 460f, 1037, 1044, G-5
 Diamond
 allotropism, 600
 covalent bonding in, 383, 383f
 light refraction and dispersion in, 298
 properties of, 504, 504t
 standard molar entropy and, 905
 standard state of, 277
 Diaphragm-cell method, 1028–1029, 1028f
 Diastereomers. *See Geometric isomers*
 Diatomic molecules
 beryllium, 458, 458f
 bond polarity of, 428
 defined, 44
 of halogens, 343
 heteronuclear, 462–463, 462f
 homonuclear, 458–462
 lithium, 458, 458f
 orbital overlap in, 443f, 444
 oxygen, 44, 97
 vibration of, 384, 384f
 Diberyllium, 458, 458f
 Diborane, 597, 598f
 Dichlorine heptoxide, 621, 621f
 Dichlorine monoxide, 621, 621f
 Dichloroethylene, 430, 455, 455f
 Dichromate ions, 72t, 941–942, 941mn
 Dietary trace elements, 1063–1064, 1064t
 Diethylamine, 657, 658, 819t, A-11

- D**
- Diethyl ether
boiling point elevation constant, 560t
freezing point depression constant, 560t
heats of vaporization and of fusion, 471f
infrared spectrum of, 385f
surface tension of, 489t
vapor pressure of, 478, 478f
viscosity of, 489t
- Differentiation, geochemical, 998–999, 999f, G-5
- Diffraction
defined, 299, G-5
electron, 311, 311f
of waves, 299, 299f
of x-rays, 311, 311f, 500, 500f
- Diffraction pattern, 299, 299f, 311, 311f
- Diffusion, 237–238, 238f, G-5
- Dihydrogen phosphate ions, 72t
- Dilithium, 458, 458f
- Dilution, 152–154, 153f
- Dimensional analysis, 19, G-5
- Dimers, 595, 595f
- Dimethoxymethane, 649, 649f
- Dimethylamine, 657, 819–820, 819t, A-11
- Dimethylbenzene, 385f, 648
- Dimethylbutane, 487–488, 640
- Dimethyl ether, 110t, 484f
- Dimethylformamide, 664f
- Dimethylmethanamide, 664f
- Dinitrogen monoxide, 239t, 608, 608t
- Dinitrogen pentoxide, 354, 608t, 710–711, 752–753
- Dinitrogen tetroxide
decomposition of, 899
equilibrium with nitrogen dioxide, 748–751, 748f, 750t, 751f, 759–760
- Lewis structure of, 414
properties of, 608t, 609
in rocket fuel, 125–127
- Dinitrogen trioxide, 608t
- Dinitrophenol, 861f
- Diphosphate ions, 611, 611f
- Diphosphoric acid, 666
- Dipole-dipole forces, 483–484, 483t, 534, 534f, G-5
- Dipole-induced dipole forces, 483t, 486, 534f, 535, G-5
- Dipole moment
boiling point and, 483–484, 484f
defined, 428, G-5
molecular polarity and, 428–429
- Di- (prefix), 73t
- Direction of reaction. *See* Reaction direction
- Disaccharides, 671, 671f, G-5
- Discoveries, chronology of, 295mn
- Disintegration series, 1082, 1082f
- Dissodium hydrogen phosphate, 825
- Dispersion, 298
- Dispersion (London) forces
alkanes and, 641
boiling points and, 641
defined, G-5
intermolecular, 483t, 486–487
in proteins, 540, 540f
in soaps, 541
in solutions, 534f, 535, 548
- Displacement reactions
double, 159, 167, 184
in redox reactions, 184–185f, 184–186
single, 184
- Disproportionation reaction, 609, 614, 618, 619, 621, G-5
- Dissociation. *See also* Acid-dissociation constant; Base-dissociation constant
of acids, 165–166, 189, 747, 795–798, 795f, 811–813, 844f
of bases, 165–166, 170, 189
of ionic compounds, 146–147, 146f
- Dissolution
of covalent compounds, 150
enthalpy change and, 544, 545–546f, 548–549, 548f
entropy change and, 547–549, 897, 903–904
of ionic compounds, 146–147, 146f
solution process and, 544–549
solvent properties of water and, 491
- Dissolved air flotation (DAF), 570
- Dissolved polymers, 516–517
- Distillation
defined, G-5
fractional, 83, 564, 567, 567f
in metallurgy, 1012
as separation technique, 83, 83f
- Disulfide bridge, 540f, 541
- Disulfuric acid, 666, 1027, 1027mn
- Division, significant figures and, 30
- DNA (deoxyribonucleic acid)
molecular depiction, 80f
replication of, 678, 678f
structure of, 542–544, 543f, 675, 676f
transcription functions of, 677, 677f
- DNA fingerprinting, 680, 680f
- DNA polymerase, 678
- DNA sequencing, 679–680, 679f
- Dolomite, 1000, 1000mn
- Donor atoms, 1047, G-5
- Doped semiconductors, 507–509, 508f
- Doping, defined, 508, G-5
- d orbitals
defined, G-5
hybridization of, 451
orbital overlap and, 444
quantum mechanics and, 321, 321f, 322t
splitting in octahedral field of ligands, 1057–1058
- Double bonds
in alkenes, 644
bond angle and, 420
bond energy of, 382, 382t
bond order and, 380
cis and *trans* structures of, 455, 455f
color test for, 651, 651f
defined, G-5
in fatty acids, 663
functional groups with, 659–666
inorganic compounds with, 662
Lewis acids with, 829
Lewis structures for, 408–409
pi bond and, 452, 453f
restricted rotation by, 637, 644
sigma bond and, 452, 453f
strength of, 453–454
- Double-displacement reactions, 159, 167, 184
- Double helix in DNA, 543–544, 543f, 675, 676f, G-5
- Downs cell, 1014, 1015f, G-5
- Dow process, 1021–1022, 1022f
- Dry cell batteries, 968
- Dry ice, 471, 479, 899
- Dual polarity
of alcohols, 535–536
of antibiotics, 542, 543f
effects on solubility, 535–537
of membranes, 542, 542f
of soaps, 541, 541f
- Dubnium, 1092
- Ductile, 396–397
- Dynamic equilibrium, 188–190, 477, G-5
- Dynamite, 215
- E**
- EA. *See* Electron affinity
- Earth
abundance of elements on, 997–1000, 998t, 1001t
atmosphere of (*See* Atmosphere of Earth)
biosphere, 999–1000, 1001t, 1007
core of, 998, 998–999f, 998t
crust of, 998–999f, 998–1000, 998t, 1001t
de Broglie wavelength of, 311t
differentiation of, 998–999, 999f
element cycling on, 1002–1008
formation and layering of, 997–999, 998f, 998t
hydrosphere, 999, 1001t
impact of life on, 999–1000
lithosphere, 999, 1001t
mantle of, 998, 998–999f, 998t
oceans, Earth without, 268, 268mn
water and temperature of, 268
- EDTA (ethylenediaminetetraacetate) ion, 1047–1048
- Effective collisions, 718, 718f, G-5
- Effective nuclear charge, 333–334, 334f, 346–347, 352, 359, G-5
- Effusion, 236–237, 236f, G-5
- e_g orbitals, 1058, G-5
- Einstein, Albert
on atomic bomb, 1106
on mass-energy relationship, 47, 1101
photon theory and, 301, 310
theory of relativity, 310
- Elastomers, 518, 518t, G-5
- Electrical charges, effects of, 52, 52mn
- Electrical conductivity
band theory and, 505, 506, 506f
colligative of solutions, 557, 557f
of covalent substances, 386
of ionic substances, 147–148, 147f, 378, 378f
ion mobility and, 378f
of metals, 397
of Period 3 chlorides, 395f
- Electrical currents, 14t, 52
- Electrical potential, 949, 949mn
- Electrocatalysts, 971
- Electrochemical cells, 939, 944, 944f, G-5
- Electrochemical potential, 982–983
- Electrochemical redox, 1011, 1022
- Electrochemistry, 938–984
in batteries, 968–971
biological energetics and, 982–983
cellular, 982–983
corrosion and, 972–974
defined, 939, G-5
electrochemical cells, 939, 944, 944f
electrolysis, 976–981, 977f, 979–980f
free energy and electrical work, 959–967
half reactions in, 940–943, 944mn, 965, 965f
microanalysis and, 967f
- Electrodes
active vs. inactive, 947, 947f
charges of, 947
defined, 944, G-5
half-reactions occurring at, 944mn
ion-specific, 967, 967f
microelectrode for microanalysis, 967f
pH, 803, 967, 967f
- Electrolysis
in aluminum production, 1019–1020, 1020f
of aqueous ionic solutions, 978–979
in chlorine production, 1028–1029, 1028f
defined, 976, G-5
of mixed molten salts, 976–977
overvoltage in, 978
of pure molten salts, 976
stoichiometry of, 980–981, 980f
of water, 183, 283, 977–978, 977f, 1023
- Electrolytes
acids and bases as, 165–166, 166f
defined, 148, 944, G-5
electrical conductivity of, 557, 557f
ionic compounds as, 148
strong, 557, 557f, 564–566, 565f
weak, 557, 557f
- Electrolytic cells
in aluminum manufacture, 1020f
aqueous ionic solutions and, 978–979
comparison with voltaic cells, 944, 944f, 974–975, 976f
construction and operation of, 974–975
defined, 944, G-5
in lead-acid batteries, 975, 975f
mixed molten salts, 976–977
nonstandard half-cell potentials, 977–978
overvoltage and, 978
pure molten salts, 976
stoichiometry of electrolysis and, 980–981, 980f
water and, 977–978, 977f
- Electrolytic decomposition, 183
- Electrolytic enrichment, 1025
- Electromagnetic radiation, 295–297, G-6
- Electromagnetic spectrum, 296–297, 297f, G-6
- Electrometallurgy, 1008
- Electromotive force, 950
- Electron affinity (EA)
comparison with electronegativity, 390n
defined, 351, G-6
magnesium oxide and, 377
as positive value, 352n
trends in, 351–352, 352f
- Electron capture, 1076t, 1077, G-6
- Electron cloud depictions, 315, 319, 320–321f, G-6

- Electron configuration
 alkali metals, 343, 355, 591, 592
 alkaline earth metals, 355, 593, 594
 atomic properties and, 345–352
 aufbau principle and, 335
 boron family elements, 596
 carbon family elements, 599, 634f
 chemical reactivity and, 343f
 condensed, 338t, 339, 340t
 defined, 331, G-6
 determining, 344–345
 filling order and, 335f, 339–342, 341f, 342mn, 343, 456–457
 within groups, 343
 halogens, 618
 Hund's rule and, 336–337, 457, 587
 magnetic properties and, 357–358, 358f
 of main-group ions, 355–356, 355f
 in many-electron atoms, 332–335
 of molecules, 456–457
 nitrogen family elements, 605
 noble gases, 623
 notation for, 335, 338
 orbital diagrams and, 335–337, 336f, 338f, 338t, 340t
 oxygen family elements, 613
 Period 1 elements, 335–336, 338f, 341f
 Period 2 elements, 336, 336f, 338f, 341f
 Period 3 elements, 338, 338t, 341t
 Period 4 elements, 339–340, 340t, 341f
 periodic table and, 335–345, 335f, 341f, 356–357
 principles of, 340–342
 transition elements, 339–340, 340t, 341f, 342–343, 1038–1040, 1039t
 of transition metal ions, 356–357
- Electron deficiency
 boron and, 597
 defined, G-6
 Lewis acids and, 828–829
 Lewis structures and, 413–414
- Electron density, 379, 380f, 394, 635
 Electron density contour maps, 379, 380f
 Electron density diagram, 315, 315f, G-6
 Electron density relief maps, 319, 320f, 379, 380f, 392, 392f, 394, 394f
 Electron-dot formulas, 79
 Electron-dot symbols. *See* Lewis electron-dot symbols
- Electronegativity difference, 392–393, 393f, G-6
- Electronegativity (EN)
 of alkali metals, 591
 of alkaline earth metals, 594
 atomic size and, 390, 391f
 bond polarity and, 392–393
 of boron family elements, 596
 of carbon family elements, 599, 634
 comparison with electron affinity, 390t
 defined, 390, 390n, G-6
 of halogens, 617, 618, 622
 of nitrogen family elements, 605
 of noble gases, 623
 oxidation number and, 392, 412
 of oxygen family elements, 613
 Pauling scale and, 390, 391f
 of Period 2 elements, 589t
 of transition elements, 1040, 1040–1041f, 1041t
 trends in, 390, 392
 valence-state, 1042–1043
- Electron-group arrangements, 418, 418f
- Electronic (analytical) balances, 17
- Electronic materials
 crystal defects in, 507
 doped semiconductors, 507–509, 508f
 doping, 508
 p-n junction manufacture, 508–509, 508f
 solar cells, 509
- Electron microscope, 311–312, 312f
- Electron-pair delocalization, 410, G-6
- Electron pair donation, 827–830
- Electron pooling, 370f, 371
- Electrons
 categories of, 342
 cathode rays and, 52–53, 52f
 charge of, 53–54, 53f, 55, 56f, 56t, 176
 as current, 301, 301f
 de Broglie wavelength of, 311, 311t
 defined, G-6
- delocalized, 371, 397, 410, 647, 659
- diffraction pattern, 311, 311f
- discovery of, 52–54
- energy of, 304
- filling order, 335f, 339–342, 341f, 342mn, 343, 456–457
- inner (core), 342, 350
- mass of, 53–54, 56t
- in molecular orbitals, 455–457
- movement in oxidation-reduction reactions, 174–175, 175f
- outer, 342, 350
- predicting number lost or gained, 65
- probable location of, 314–316, 315f
- properties of, 52–54, 56t
- quantum numbers and, 316–317, 317t
- quantum numbers of, 332, 332f
- repulsions, 333–334
- sharing, 64
- transferring, 64, 65
- valence, 342, 350, 396, 405, 406
- wave nature of, 310–312, 310f
- Electron-sea model, 395–396, G-6
- Electron sharing, covalent bonding and, 370, 370f, 379
- Electron spin, 443, 443f
- Electron-spin quantum number, 332–333, 332f
- Electron transfer, ionic bonding and, 175, 175f, 370, 370f, 372–373, 373f
- Electron transport chain (ETC), 982–983, 983f
- Electron volt (eV), 1102–1103, G-6
- Electrophoresis, 680
- Electrorefining, 1012, 1018, 1018f, G-6
- Electrostatic interactions
 in bonding, 65
 Coulomb's law and, 375–376
 electronegativity and, 390
 energy-level splitting and, 333–335
 lattice energy and, 375
 nuclear stability and, 1080
 potential and kinetic energy in, 9–10
- Elementary reactions, 721–723, 722t, G-6
- Elements. *See also specific elements*
 abundance of, 997–1000, 998t, 1001t
 alloying, 1012–1013, 1013f, 1013t
 amount-mass-number conversions involving, 98–100, 98f
 atomic masses of, 57–59, 61, 96
 atomic number of, 56, 61, 63–64
 atomic-scale view of, 44, 44f
 atomic theory and, 50–51
 atoms of, 44, 44f
 in carbon cycle, 1002–1004, 1003f
 classification of, 62–63, 63f
 converting minerals to, 1010–1011, 1012f
 defined, 43, 44, G-6
 emission and absorption spectra of, 308, 308f
 in environmental cycles, 1002–1008
 formation in nuclear reaction, 1074
 geochemical differentiation of, 998–999, 999f
 history of, 43
 ionization energy of, 348–350, 349f, 351t
 isolation and uses of, 1014–1025
 isotopes of, 57
 law of multiple proportions and, 49–51
 line spectra of, 302, 303f
 mass determination from mass fraction, 103–104
 mass-mole-number relationships for, 98f
 mass of element in compound, 48–49
 mass percent and, 47–48, 48f
 mass percent in compounds, 102–103
 metallurgy and, 1008–1013
 minerals as sources of, 1008, 1008t
 molar mass of, 97
 as molecules, 44, 44f, 66, 67f, 97
 in nitrogen cycle, 1004–1005, 1004f
 number of, 61
 oxidation number and, 176
 oxides of, 354–355, 354f
 periodic table of (*See* Periodic table of the elements)
 in phosphorus cycle, 1005–1008, 1006f
 properties of, 44
 ranking by atomic size, 347
 in redox reactions, 181–188
 refining, 1012, 1012f
 sources of, 1000–1001, 1002f, 1008, 1008t
 specific heat capacity of, 268t
- standard state for, 277
 in stars, 1110–1111, 1110f
- symbols for, 56, 57f
- trace, 1063–1064, 1064t
- Element symbol, 56, 57f
- Elimination reactions, 651–652, G-6
- Emission of photons, 304, 304f
- Emission spectrum, 308, 308f, G-6
- Empirical formulas
 defined, 104, G-6
 determination of, 105–106
 different compounds with same formula, 110, 110t
 of ionic compounds, 70
 molecular formulas obtained from, 106–108
- Emulsions, 568t, 569
- EN. *See* Electronegativity
- Enantiomers. *See* Optical isomers
- Endothermic processes
 bond energy, 381, 387
 defined, 266
 enthalpy and, 266–267, 266f
 entropy change in surroundings, 908
 phase changes, 471
 solution process, 544, 545f
 spontaneous reactions, 896–897, 897f, 911, 911f
- End point, 173, 173f, 179, 179f, 861, G-6
- End-product feedback inhibition, 781, 781f
- End-to-end overlap, 452
- Energy
 activation (*See* Activation energy)
 of atoms, 301, 305–307, 305f
 from blackbody radiation, 299–300, 300f, 300n
 of collisions, 693, 693f, 716–717, 716f, 717t
 common quantities of, 262f
 conservation of, 9, 261, 284–285, 896, 896n
 conversion of mass into, 47
 conversion of potential energy to kinetic energy, 9–10, 9f
 crystal-field splitting, 1058, 1059–1060
 defined, 8, G-6
 dispersal of, 897, 898, 908
 distinction from matter, 298–299
 electromagnetic, 295–297
 as extensive property, 28
 flow to and from a system, 258–260
 forms and interconversion, 257–264
 free (*See* Free energy)
 future use of, 281–285
 heat, 258, 259, 260f
 importance in study of matter, 8–10
 interconversion of mass and, 1101–1104
 internal, 258–260, 262, 896
 ionization (*See* Ionization energy (IE))
 kinetic (*See* Kinetic energy)
 lattice (*See* Lattice energy)
 levels of, 317–318
 nuclear, 284 (*See also* Nuclear fission; Nuclear fusion)
 nuclear binding energy, 1102–1104, 1104f
 potential (*See* Potential energy)
 quantization of, 898
 quantum theory of, 299–300
 radiant, 295–297
 renewable, 281
 solar, 284
 as state functions, 262–263
 of systems, 258–260, 306mn
 thermal, 258
 units of, 261–262
 wave-particle duality of, 310–313, 310f
 work, 258, 259–260, 260f
- Energy efficiency, 916
- Energy-level diagrams, 716f
- Energy-level splitting, 333–335
- Energy threshold, 716
- Energy transfer
 as heat, 258, 259, 260f
 path independence of, 262–263, 263f
 sign conventions, 261t
 as work, 259–260, 260f
- ene (suffix), 644, 655f
- English unit system, 14, 15t, 19
- Enthalpy
 defined, 265, G-6
 endothermic processes and, 266–267, 266f
 exothermic processes and, 266, 266f

- Hess's law of heat summation and, 275–277
 lattice energy and, 373–376
 as state function, 266
Enthalpy change
 comparison with energy change, 265–266
 defined, 265, G-3
 free energy change and, 916–920, 917t, 920f
 Hess's law of heat summation and, 275–277
 phase changes and, 470–472
 in solution process, 544, 545–546f, 548–549, 548f
 spontaneous, 896–897
 standard enthalpy of formation and, 277–280, 278t, 279f
 standard enthalpy of reaction and, 277–280
 in thermochemical equations, 273–274
 using to find amount of substances, 274
Enthalpy diagrams, 266, 266f, 267, 546, 546f, G-6
Enthalpy of formation, 277–280, 278t, 279f
Enthalpy of hydration. *See Heat of hydration*
Enthalpy of reaction, 386–390, 388f
Enthalpy of solution. *See Heat of solution*
Enthalpy of sublimation. *See Heat of sublimation*
Enthalpy of vaporization. *See Heat of vaporization*
Entropy
 defined, 898, G-6
 as extensive property, 901
 number of microstates and, 898–901
 second law of thermodynamics and, 901
 standard molar entropy, 901–905
 as state function, 898–899
Entropy change
 with atomic size or molecular complexity, 904–905, 905f
 calculating in reactions, 906–912
 equilibrium state and, 910–911
 with gases dissolved in liquids, 904, 904f
 gas expansion and, 899–900f, 899–901
 of physical states and phase changes, 902–903, 903f
 predicting relative values, 905–906
 quantitative meaning of, 899–901
 signs of, 906–907, 916–920, 917t, 920f
 with solids and liquids dissolved in water, 903–904
 in solution process, 547–549
 spontaneous, 909, 911, 911f
 standard entropy of reaction, 906–907
 in surroundings, 908–910
 with temperature changes, 902, 902f
Environmental cycles, 1002–1008
 carbon, 1002–1004, 1003f
 defined, 1002, G-6
 nitrogen, 1004–1005, 1004f
 phosphorus, 1005–1008, 1006f
Environmental issues
 acid rain (*See Acid rain*)
 chlorofluorocarbons, 602, 602f, 732
 fuels and, 281–285
 global warming, 282–283, 384, 1004
 greenhouse effect, 282–283, 1004
 ozone depletion, 732, 732f
 phosphates and pollution, 1008
 pollution (*See Pollution*)
 polychlorinated biphenyls and, 602
 smog, 224, 414, 609, 609mn
Enzymes
 as catalysts, 730–731, 731f, G-6
 defined, 730, G-6
 hydrogen bonding in, 485
 in metabolic pathways, 781, 781f
 molecular shape of, 431, 432f
 optical isomers and, 644, 644f
Enzyme-substrate complex (ES), 731, 731f, G-6
Epinephrine, molecular structure of, 657f
Epsom salt, 72, 593
Equations. *See Chemical equations*
Equatorial groups, in VSEPR theory, 421, G-6
Equilibrium, 746–781
 comparison with kinetics, 747
 concentration changes and, 770–773, 772t, 777t
 dynamic, 188–190, 477
 entropy change and, 910–911
 expressing with pressure terms, 756–757
 free energy change and, 922–928
 heterogeneous, 752, 752f
 homogeneous, 752
 lack of catalysts and, 777, 777t
 law of chemical equilibrium, 750
 Le Châtelier's principle and, 770–780
 liquid-gas equilibria, 476–478, 476f
 macroscopic view of, 748, 748f
 in metabolic pathways, 781
 molecular view of, 748, 748f
 phase changes and, 476–479
 pressure changes and, 773–775, 774f, 777t
 problem solving involving, 760–769, 770f
 quantitative view of, 748–749
 reaction direction and, 753, 757–760, 758f, 768–769
 reaction quotient and, 750–755
 reversible reactions and, 188–190
 simultaneous, 874–875
 solid-gas equilibria, 479
 solid-liquid equilibria, 479
 solubility and, 549–552
 state of, 188–190, 189f
 temperature changes and, 775–777, 777t
Equilibrium constant
 concentration and, 756–757
 defined, 749, G-6
 free energy change and, 922–928, 924t, 959–961, 960f
 as measure of reaction extent, 749
 pressure and, 756–757
 problem solving involving, 760–769, 770f
 range of, 749, 749f
 reaction direction and, 753, 757–760, 758f, 768–769
 reaction quotient and, 750–755, 922–923, 922t
 standard cell potential and, 959–961, 960f
 tables of, A-8–A-13
 as unitless number, 751
 in van't Hoff equation, 776–777
Equilibrium vapor pressure. *See Vapor pressure*
Equivalence point, 173, 179, 853f, 854–857, 855f, 859f, 863f, G-6
Error, 12, 32–33, 33f
Erythroose, 110t
ES (enzyme-substrate complex), 731, 731f, G-6
Esterification, 664
Esters, 655t, 662, 663–664, 663f, 664mn, G-6
ETC (electron transport chain), 982–983, 983f
Ethanal
 boiling point of, 484, 484f
 dipole moment of, 484, 484f
 intermolecular forces, 534f
 molecular structure of, 655t, 660, 660f
Ethanamide, 655t
Ethanamine, 655t, 657, 664
Ethane
 boiling point of, 641f
 bonds in, 451, 452, 452f
 electron density and bond order in, 454f
 formula and model, 76t
 molecular shape of, 426, 427f, 451
 oxidation of, 653
Ethanenitrile, 655t
Ethanoic acid. *See Acetic acid*
Ethanol
 boiling point elevation constant, 560t
 constitutional isomers of, 110t
 dissolution in water, 904, 904f
 entropy and, 905
 freezing point depression constant, 560t
 gasohol and, 281
 heats of vaporization and of fusion, 471f
 molecular shape of, 426–427, 427f
 solubility of, 536t
 specific heat capacity of, 268t
 surface tension of, 489t
 vapor pressure of, 478, 478f
 viscosity of, 489t, 490
Ethanolamine, 281, A-11
Ethene. *See Ethylene*
Eth- (numerical root), 639t
Ethyl alcohol. *See Ethanol*
Ethylamine, 655t, 658, 664, A-11
Ethylammonium chloride, 658
Ethylene
 bonds in, 451, 452, 453f
 from cyclobutane decomposition, 708–709
 double and single bonds of, 380
 electron density and bond order in, 454f
 free-radical polymerization of, 668, 668f
 hydrogenation of, 729, 730f
 Lewis structure for, 409
 molar mass of, 514
 molecular shape, 451
 molecular structure of, 655t
 ozone and, 694–696
 reaction with HCl, 651
Ethylenediamine, A-11
Ethylenediaminetetraacetate (EDTA) ion, 1047–1048
Ethylene glycol
 antifreeze, 561, 566, 567
 de-icers, 566, 567
 molecular structure of, 654f
 solubility of, 150
 specific heat capacity of, 268t
Ethyne. *See Acetylene*
Eutrophication, 1005
Evaporative salt beds, 1014, 1014mn
Exact numbers, 31, G-6
Excited state, 304, 316, G-6
Exclusion principle, 333, 443, G-6
Exosphere, 239f, 240
Exothermic processes
 bond energy, 381, 387
 collision theory and, 716, 716f
 defined, 266, G-6
 enthalpy and, 266, 266f
 entropy change in surroundings, 908
 phase changes, 471
 in sodium bromide formation, 373f
 solution process, 544, 545f
 spontaneous reactions, 896–897, 911, 911f
 temperature effects on, 908
Expanded formula, 639, 640f
Expanded valence shells, 414–416, G-6
Expansion of gases, 206
Experiments, 12, 13f, G-6
Exponential (scientific) notation, 14, 14t, A-2–A-3
Extensive properties, 27–28, 27f, G-6
- F**
- Face-centered cubic unit cell, 494, 495f, 497–498, G-6
 Fahrenheit temperature scale, 25–27, 26f, 27t
 Faraday, Michael, 959, 980
 Faraday constant, 959, 980, G-6
 Fats, 390, 390t, 663, 663f
 Fatty acids, 541, 542, 663, G-6
 f block, 595, 1037, 1038f. *See also* Inner transition elements
 Feedback inhibition, 781, 781f
 Feedstocks, hydrocarbons as, 636
 Feldspar, 604
 Femto- (prefix), 14t
 Fenn, John B., 60
 Fermi, Enrico, 1105
 Ferrofluid, 519–520, 520f
 Fertilizer, 586, 609, 611, 779, 1005, 1007–1008
 Fibrous proteins, 674, 674f
 Filtration, 83, 570, G-6
 Fire extinguishers, 224
 Fireworks, 308, 308f, 621, 913–914, 913mn
First ionization energy
 of alkali metals, 591
 of alkaline earth metals, 594
 of boron family elements, 596
 of carbon family elements, 599
 defined, 348
 of halogens, 618
 in ionic bonding, 373
 of nitrogen family elements, 605
 of noble gases, 623
 of oxygen family elements, 613
 of Period 2 elements, 589t
 periodicity of, 348–350
 of transition elements, 1040, 1040–1041f, 1041
First law of thermodynamics, 261, 896, 909–910, G-7
First-order reactions
 comparison with zero- and second-order reactions, 714t
 defined, 699
 half-life of, 711–713
 integrated rate law and, 708, 709, 710f, 714t
 radioactive decay, 1085
 rate constant for, 704f
 rate law and, 699, 700, 700f
 rate vs. reactant concentration in, 700f
 reactant concentration vs. time in, 700f
Fischer-Tropsch process, 281
Fission. *See Nuclear fission*

- Fixation**
 of carbon, 1003
 defined, 1003, G-7
 of nitrogen, 605, 779, 1004f, 1005
- Fixed mass ratio**, 44
- Flame tests**, 308, 308f, G-7
- Flasks**, volumetric, 15, 16f
- Flerovium**, 598–601, 1092
- Floc**, 570
- Flotation process**, 1009, 1009f, 1017, G-7
- Flow**, environmental, 470mn
- Flow batteries**, 970
- Fluoride ions**, 69t
- Fluorinating agents**, 620
- Fluorine**
 chemistry of, 619–622
 diatomic molecules of, 443f, 444, 460f, 461
 electron configuration, 337, 338f, 355
 electron density of, 392, 392f
 ionic bonding and, 372–376, 372f, 374f, 376f
 ionization energy, 351t
 nitrogen dioxide and, 724, 726, 727f
 orbital overlap, 443f, 444
 oxidation number for, 176t
 as oxidizing agent, 619
 oxoacids, 622t
 properties of, 589r, 590, 617–622, 617f
 reactivity, 343f
- Fluorite**, 503, 503f, 867mn
- Fluoro-oxy ions**, 1020
- Foams**, 568r, 569
- Food**
 bond energy and, 390, 390t
 cooking at elevation, 479
 freeze-dried, 471
 irradiation of, 1100–1101, 1100f
 preservation of, 567
- f orbitals**, 321–322, 322f, 322t, G-6
- Formal charge**, 411–416, G-7
- Formaldehyde**
 formula and model, 110t
 functions of, 110t
 molecular shape of, 420
 molecular structure of, 660f
- Formate ions**, 851
- Formation constant**, 877–878, 878t, A-12, G-7
- Formation equations**, 277–278, G-7
- Formic acid**, 662, 662f, 797t, 851, A-9
- Formula mass**, 76, G-7
- Formulas**. *See Chemical formulas; Molecular formulas;*
 Structural formulas
- Formula unit**, 68, 78–79, G-7
- Fossil fuels**, 281–283, G-7
- Fossils**, 1000, 1000f
- Fractional bond orders**, 411
- Fractional distillation**, 83, 564, 567, 567f, G-7
- Fractional reaction order**, 701
- Fraction by mass (mass fraction)**, 47–48, G-7
- Francium**, 590–592, 590n
- Frasch process**, 1026, 1026f
- Free energy**
 in biological systems, 921–922
 defined, 912, G-7
 electrical work and, 959–967
 in electrochemistry, 959–967
 Gibbs free energy, 912
- Free energy change**
 calculating, 913–915, 926–927
 defined, 912
 equilibrium constant and, 922–928, 924t
 extent of reaction and, 927–928, 928f
 reaction direction and, 927–928, 928f
 reaction spontaneity and, 912–913, 916–920, 917t, 920f
- standard cell potential and, 959–961, 960f
 standard free energy change, 913–915, 923–924, 924t
- standard free energy of formation, 914–915
 temperature and, 916–920, 917t, 920f
 work and, 915–916
- Free-radical polymerization**, 668, 668f
- Free radicals**
 defined, 414, 668, 1095, G-7
 ionizing radiation and, 1095
- Lewis structures** and, 414
- ozone depletion** and, 732
- Freezing**
 defined, 471, G-7
 as exothermic and spontaneous process, 896
 process of, 474
- Freezing point depression**, 560–561, 560, 566–567, G-7
- Freezing point of water**, 26, 26f, 27t
- Freons**, 602, 602f
- Frequency**
 defined, G-7
 of electromagnetic radiation, 296, 296–297f, 297–298
 interconverting wavelength and, 297–298, 301–302
 threshold, 301
- Frequency factor**, 718, G-7
- Frisch, Otto**, 1105
- Fructose**, 671, 671f
- Fuel cells**, 970–971, 971f, G-7
- Fuel rods**, 1106–1107
- Fuels**. *See also Combustion*
 biomass conversion to, 281–282
 bond energy and, 389, 389f
 coal, 281
 fossil, 281–283
 gasoline, 114–115, 262
 greenhouse effect and global warming due to, 282–283
 hydrogen, 283–284, 697
 methanol, 408, 449–450
 nuclear, 237
 rocket, 125–127
 syngas, 281, 603
 wood, 281
- Fuller, R. Buckminster**, 600
- Fullerene ends**, 600
- Functional groups**
 alcohols, 654, 654f, 655, 656
 aldehydes, 655f, 660–661, 660f
 alkenes, 655, 659–660
 alkynes, 646, 655t, 666
 amides, 655t, 662, 664–665, 664f
 amines, 655t, 657–658, 657f
 carbonyl, 660–661
 carboxylic acids, 655t, 662–663, 662f
 defined, 635, G-7
 with double bonds, 659–666
 esters, 655t, 662, 663–664, 663f, 664mn
 haloalkanes, 655t, 656–657, 657f
 ketones, 655t, 660–661, 660f
 nitriles, 655t, 666
 overview, 655t
 recognizing, 667
 with single bonds, 654, 656–659, 662–666
 with triple bonds, 666
- Fundamental units of SI system**, 13, 14t
- Fusion**. *See Melting; Nuclear fusion*
- G**
- GAC (granular activated carbon)**, 570
- Galileo Galilei**, 208
- Gallium**
 bond type, 598t
 conversion between number of entities and amount, 99
 as doped semiconductor, 508, 508f
 electron configuration, 340t
 melting point of, 598t
 properties of, 396, 595–598
 quantum dots, 519
- Gallium arsenide cells**, 284
- Galvanic cells**. *See Voltaic cells*
- Galvanizing process**, 974
- Gamma emission**, 1076t, 1078, G-7
- Gamma rays**
 behavior in electric field, 1075, 1075f
 defined, G-7
 penetrating power of, 1094f, 1095
 radioactive decay, 1076t, 1078
 wavelength of, 296, 297f
- Gangue**, 1008, 1009, 1009f, 1017, G-7
- Gases**. *See also Gas laws*
 Amontons's law and, 213
 Avogadro's law and, 214–215, 214f
 behavior at standard conditions, 215
 Boyle's law and, 211–212, 211f
 Charles's law and, 212–213, 212f
 collecting over water, 227–228, 227f
 comparison with physical states of solids and liquids, 205–207, 206f
- Dalton's law of partial pressures** and, 225–227, 231, 233, 233f, 239
- defined, 4, G-7
- density and, 24, 24t, 206, 222–224
- deviation from ideal behavior, 241–244
- diffusion, 237–238, 238f
- dissolution and entropy change, 904, 904f
- effusion, 236–237, 236f
- entropy of, 547
- expansion of, 206
- extreme conditions and, 241–243
- free flowing nature of, 206
- ideal, 211, 215, 215f
- kinetic-molecular theory and, 231–238, 470
- molar mass and, 223, 224–225
- molar volume of common gases, 241t
- noble (*See Noble gases*)
- particle arrangement in, 4, 4f
- pressure and, 206, 207–210, 218, 239, 241–243, 242f
- properties of, 470, 470t
- solubility and, 550, 551–552
- solutions, ability to form, 207
- solving for unknown variable at fixed conditions, 220–221
- spontaneous expansion of, 899–900f, 899–901
- standard state for, 277, 277n
- temperature and, 206, 212–213, 212f, 218, 239–240, 239f
- universal gas constant, 216
- van der Waals equation and, 243–244, 243f
- volume-amount relationship and, 214–215, 214f, 218–219
- volume-pressure relationship, 206, 211–212, 211f, 217–218
- volume-temperature relationship, 206, 212–213, 212f, 218
- Gas-forming reactions**, 169–170, 171f, 189–190
- Gas-gas solutions**, 537–538
- Gasification**, 281
- Gas laws**, 210–238
 Amontons's, 213
 Avogadro's (*See Avogadro's law*)
 Boyle's (*See Boyle's law*)
 Charles's (*See Charles's law*)
 combined, 214
 Dalton's law of partial pressures, 225–227, 231, 233, 233f, 239
 Henry's, 551–552
 ideal, 211, 216, 216f, 222–230
 kinetic-molecular theory, 231–238
 molecular view of, 232–234
 overview, 210–211
 solving problems involving, 217–222
- Gas-liquid chromatography (GLC)**, 83, 83f
- Gas-liquid equilibria**, 476–478, 476f
- Gas-liquid solutions**, 537
- Gasohol**, 281
- Gasoline**, combustion of, 114–115, 262, 915–916
- Gas pressure**. *See Pressure*
- Gas-solid equilibria**, 479
- Gas-solid solutions**, 538
- Gay-Lussac, J. L.**, 212, 224
- Geiger-Müller counter**, 1083, 1084f, G-7
- Genes**, 675
- Genetic code**, 677, G-7
- Geochemical differentiation**, 998–999, 999f
- Geometric isomers**, 645–646, 645t, 646f, 1052–1053, 1052f, G-7
- Germanium**
 bond type, 598t
 electron configuration, 340t
 melting point of, 598t
 properties of, 598–601
 purification of, 1011
 zone refining of, 1012
- Germer, L.**, 311
- Gibbs, Josiah Willard**, 912
- Gibbs equation**, 912, 913
- Gibbs free energy**, 912
- Giga- (prefix)**, 14t
- Glass**
 as amorphous solid, 504, 504f
 borosilicate, 597, 597mn
 polymer, 517
 specific heat capacity of, 268t
- Glass electrodes**, 967, 967f
- Glass transition temperature**, 517
- Glassware**, volumetric, 15, 16f
- GLC (gas-liquid chromatography)**, 83, 83f
- Global warming**, 282–283, 384, 1004

- Globular proteins, 674
 Glucose
 combustion and, 187
 formula and model, 110t
 functions of, 110t
 information contained in chemical formula of, 97, 97t
 metabolism of, 46, 121, 921, 921f
 optical isomers of, 644
 oxidation of, 911
 structure of, 671, 671f
 Glutamic acid, 540, 672f, 863
 Glutamine, 672f
 Glyceric acid, A-9
 Glycerol, 559, 567, 663, 664
 Glycine, 150, 672f, 863
 Glycogen, 671
 Glycolic acid, A-9
 Glyoxylic acid, A-9
 Gold
 alchemy and, 10
 alloys, 1013, 1013f, 1013t
 density of, 24t, 1042
 leaching, 1009, 1011
 malleability of, 396–397
 molar mass of, 97
 sources of, 1001
 specific heat capacity of, 268t
 Gold leaf, 397mn
 g orbitals, 322
 Graham, Thomas, 236
 Graham's law of effusion, 236–237, 1107, G-7
 Grain alcohol, density of, 24t
 Gramicidin A, 542, 543f
 Gram-molecular weight. *See* Molar mass
 Grams (g), 96
 Granite, specific heat capacity of, 268t
 Granular activated carbon (GAC), 570
 Graphene, 600f, 601
 Graphing data, A-4
 Graphite
 allotropism, 600
 carbon monoxide formation from, 761
 in electrolytic cell for aluminum manufacture, 1020, 1020f
 as inactive electrode, 947
 properties of, 504, 504t
 specific heat capacity of, 268t
 standard molar entropy, 904–905
 standard state of, 277
 in voltaic cells, 947
 Gray (Gy), 1094, G-7
 Grease, 541
 Green chemistry
 applications of, 223–224
 atom economy and, 129–130
 defined, 129, G-7
 examples of, 121
 Greenhouse effect, 282–283, 1004
 Ground state, 304, 316, G-7
 Group 1A(1) elements. *See* Alkali metals
 Group 2A(2) elements. *See* Alkaline earth metals
 Group 3A(13) elements. *See* Boron family elements
 Group 4A(14) elements. *See* Carbon family elements
 Group 5A(15) elements. *See* Nitrogen family elements
 Group 6A(16) elements. *See* Oxygen family elements
 Group 7A(17) elements. *See* Halogens
 Group 8A(18) elements. *See* Noble gases
 Group 1B(11) elements, mechanical properties of, 396–397
 Groups. *See also* specific groups
 defined, G-7
 electron affinities of, 352, 352f
 electron configurations within, 342, 343
 ionization energy trends in, 348–349, 349f
 metallic behavior, 353–354f, 353–355
 of periodic table, 61, 63
 reactivities within, 338
 Guanine, 675
 Guitar string vibrations, 310, 310f
 Guldberg, Cato, 750
 Gypsum, 281, 593
 Gyration, radius of, 515–516, 515n
- H**
 Haber, Fritz, 779
 Haber process, 605, 779–780, 779f, 780f, 1005, G-7
 Hafnium, 1044
- Hahn, Otto, 1105
 Halates, 621, 622t
 Half-cell potentials, 950–956, 952f, 954t, 977–978, A-14
 Half-cells, 944, 946, G-7
 Half-life
 defined, 1086, G-7
 of first-order reactions, 711–713
 of radioactive decay, 1086, 1086f, 1086t
 of reactions, 711–714, 711f
 of second-order reactions, 714
 of zero-order reactions, 714
 Half-reaction method for balancing redox reactions, 940–943, G-7
 Half reactions, 940–943, 944mn, 965, 965f
 Halic acid, 622, 622t
 Halides
 alkyl, 656–657, 659
 formation of, 182
 halogen, 620
 hydrogen, 619–620, 762
 ionic, 591
 lattice energy of alkali-metal halides, 376
 nitrogen family elements, 605, 607
 oxygen family elements, 613, 615
 reactions involving, 659
 solubility-product constant for, A-13
 sources of elements, 1001, 1002f
 Halites, 621, 622t, 1014
 Hall-Heroult process, 1019–1020
 Haloalkanes, 655f, 656–657, 657f, G-7
 Halogens
 activity series of, 186, 186f
 chemistry of, 619–622
 combination reactions and, 182
 diatomic molecules of, 343
 electron configuration, 343
 in hypohalous acids, 816
 oxidation number for, 176t
 in periodic table, 63
 properties of, 617–622, 617f
 reactivity of, 230, 343f, 617–619
 standard state of, 278
 Halo- (prefix), 655f
 Halous acid, 622t
 Hamiltonian operator, 314
 Hard water, 570–571, G-7
 Hassium, 1092
 H-bonds. *See* Hydrogen bonds
 HDPE (high-density polyethylene), 518
 Heat
 calorimetry and, 268–273
 defined, 25, 258, G-7
 endothermic processes and, 266–267, 266f
 energy transfer as, 258, 259, 260f
 exothermic processes and, 266, 266f
 as extensive property, 27–28
 finding quantity from temperature change, 269
 in phase changes, 473–476
 release with gasoline combustion, 262
 sign conventions, 261t
 in surroundings, 908–910, 908mn
 Heat capacity
 defined, 268, G-7
 molar, 268
 specific heat capacity, 268, 268t, 270, 491
 of water, 491
 Heating-cooling curve, 473–474, 473f, G-8
 Heating systems, residential, 284
 Heat of formation, standard, 277–280, 278t, 279f
 Heat of fusion
 in boron, carbon, and nitrogen family elements, 598t, 600
 defined, G-7
 phase changes and, 471, 471–472f, 474
 Heat of hydration, 545–546, 545t, 592, G-7
 Heat of reaction
 standard, 277–280
 stoichiometry of thermochemical equations and, 273–274
 Heat of solution, 544, 545–546f, 545–547, G-7–G-8
 Heat of sublimation, 472, 472f, G-8
 Heat of vaporization, 471, 471–472f, 491–492, G-8
 Heat summation, Hess's law of, 275–277
 Heavy-metal ions, 571
 Heavy-metal poisoning, 1047
 Hecto- (prefix), 14t
 Heisenberg, Werner, 313
 Heisenberg's uncertainty principle, 313
- Helium
 boiling point of, 537t
 burning of, 1110–1111
 effusion rate of, 236–237
 electron configuration, 333, 336, 338f
 liquid, 506
 molecular orbitals of, 457, 457f
 mole fraction in air at sea level, 239t
 properties of, 622–624
 solubility in water, 537t
 Hematite, 1000, 1000f, 1016, 1016t
 Heme group, 1063–1064, 1063f
 Hemimorphite, 603, 603f
 Hemoglobin, 563, 863, 1061, 1063–1064, 1063f
 Henderson-Hasselbalch equation, 848–849, G-8
 Henry's law, 551–552, G-8
 Heptane, 76t, 641f
 Hepta- (prefix), 72, 73t
 Hept- (numerical root), 639t
 Hereditary effects of radiation, 1097
 Hertz (Hz), 296
 Hess's law
 Born-Haber cycle and, 374
 defined, G-8
 heat of fusion and, 474
 heat of solution and, 544
 heat of sublimation and, 472
 standard entropy of reaction and, 907
 standard free energy of formation and, 914
 in thermochemistry, 275–277
 Heteroatoms, 635, 635f, G-8
 Heterogeneous catalysis, 729, 730f, 732, G-8
 Heterogeneous equilibrium, 752, 752f
 Heterogeneous mixtures, 81, 533, 568, G-8
 Heteronuclear diatomic molecules, 462–463, 462f
 Hexaamminechromium(III) ion, 1055, 1055f
 Hexagonal closest packing, 497f, 498, G-8
 Hexagonal cubic unit cell, 497–498, 497f
 Hexane
 boiling point of, 641f
 formula and model, 76t
 intermolecular forces, 487–488, 534f
 as solvent, 535, 536, 536t, 548, 548f
 Hexanol, 536t
 Hexa- (prefix), 73t
 Hex- (numerical root), 639t
 High-density polyethylene (HDPE), 518
 High-performance liquid chromatography (HPLC), 83
 High-resolution polyacrylamide-gel electrophoresis, 680
 High-spin complexes, 1060–1061, G-8
 High-surface-area materials, 520
 Histidine, 672f
 Homogeneous catalysis, 728–729, 729f, 732, G-8
 Homogeneous equilibrium, 752
 Homogeneous mixtures, 81, 533, 568, G-8
 Homologous series, 639, G-8
 Homonuclear diatomic molecules, 458–462
 atomic p orbital combinations, 458–459f, 458–460
 bonding in p -block, 460–461, 460f
 defined, G-8
 elements of, 458
 s-block bonding of, 458, 458f
 Homopolymers, 518
 Hot packs, 546
 HPLC (high-performance liquid chromatography), 83
 Human radiation studies, 1096
 Hund's rule, 336–337, 457, 587, G-8
 Hybridization, 444–452, G-8
 Hybrid orbitals, 444–451
 complex ions and, 1055–1056
 composition and orientation of, 449t
 defined, 444, G-8
 molecular formulas and, 449, 449f
 sp hybridization, 444–446, 445f, 449f
 sp² hybridization, 446, 446f, 449t
 sp³ hybridization, 447, 447f, 449t
 sp³d hybridization, 447–448, 448f, 449f
 sp³d² hybridization, 448, 449f, 449t
 Hydrated ions, 592
 Hydrated metal ions
 acid strength of, 817, 817f
 dissociation constants table for, A-12
 formation of, 88f, 877–878
 Hydrates, 72, 73t, G-8
 Hydration, defined, 545, G-8
 Hydration, heat of, 545–546, 545t, 592

- Hydration shells, 534, 535f, G-8
 Hydrazine, 125–127, 607
 Hydride ions, 69, 586
 Hydrides
 boranes, 590, 597–598, 598f, 604
 bridge bonds, 598, 598f
 catenated inorganic, 648, 650
 covalent, 586
 ionic, 586, 591, 592
 metal, 586–587, 586f
 nitrogen family elements, 605, 607
 oxygen family elements, 614
 trends in acid strength, 816, 816f
 VSEPR theory and, 451
 Hydroiodic acid, 171
 Hydrocarbons, 636–650
 alkanes (*See* Alkanes)
 alkenes, 644–646, 645f, 646f, 655f, 659–660
 alkynes, 646, 655f, 666
 aromatic, 647–648, 648f, 659–660, 660f
 constitutional isomerism and, 641–642, 642t
 cyclic, 640, 641f
 defined, 636, G-8
 double bonds in, 644, 651, 651f
 drawing, 637–638, 637f
 entropy and, 905
 geometric isomerism and, 645–646, 645t, 646f
 naming, 639, 639–640t, 646–648
 optical isomers of, 642–644
 saturated, 639
 single bonds in, 639–640
 structure and classes of, 636–637f, 636–638
 triple bonds in, 646, 666
 unsaturated, 644
 Hydrochloric acid. *See* Hydrogen chloride
 Hydrocyanic acid, 796, 796–797t, A-9
 Hydrofluoric acid, 797t, 806, A-9
 Hydrogen
 abundance of, 1001t
 burning of, 1110
 chemistry of, 586–587
 combustion of, 281–282, 697–698
 covalent bonding and, 66–67, 66f
 covalent bonding of, 379–380
 density of, 24t
 deuterium, 1024–1025, 1024t
 displacement by metals, 184, 185f
 electron density of, 379, 380f, 392, 392f
 electron spin and, 443, 443f
 as fuel, 283–284, 697
 in fuel cells, 971, 971f
 iodine and, 696–697, 696f, 906
 isotopes of, 1024–1025, 1024t
 molecular orbitals of, 456, 456f
 mole fraction in air at sea level, 239t
 nitric oxide and, 700
 orbital overlap, 443, 443f
 oxidation number for, 176t
 periodic table placement, 585–586, 585f
 production of, 283–284, 1022–1023
 reduction with, 1011
 standard enthalpies of formation, 278t
 transportation and storage of, 284
 tritium, 1024, 1024t
 uses of, 1023–1024
 Hydrogenation
 of benzene, 660
 catalytic, 729, 730f
 defined, 729, G-8
 of liquid oils, 1024
 reactions involving, 274
 Hydrogen atoms
 Bohr model of, 303–305, 305f
 electron configuration, 336, 338f
 energy levels of, 305–307, 305f, 322, 322f
 ionization energy of, 348
 line spectra of, 302–303, 303f, 304–305, 305f
 quantum number, 332–333, 336
 stationary states of, 304
 Hydrogen bisulfate ions, 616
 Hydrogen bonds
 in biological systems, 485
 boiling point and, 484–485, 484f
 defined, 484, G-8
 in DNA, 543–544, 543f
 intermolecular forces, 483t, 484–485, 484f
 in proteins, 540, 540f
 significance of, 484–485
 in solutions, 534, 534f
 surface tension and, 489, 489t
 in water, 491, 491f
 Hydrogen bromide, 165, 699
 Hydrogen carbonate ions, 72t
 Hydrogen chloride
 in acid-base reactions, 167–170
 formation of, 175, 175f, 619
 reaction with ethene, 651
 in stomach, 171, 172
 titration of, 853f, 854, 859–860, 859f
 uses of, 620
 in water, 804, 804f
 Hydrogen fluoride
 bonding pair in, 380
 bond polarity of, 392, 392f
 covalent bonding in, 66–67
 electronegativity of, 390
 formation of, 111, 112f, 386, 387, 388f
 molecular orbitals of, 462–463, 462f
 orbital overlap, 443f, 444
 orientation in electric field, 428f
 polarity of, 428, 428f
 properties of, 619
 Hydrogen halides, 619–620, 762
 Hydrogen iodide, 696–697, 696f, 760–762
 Hydrogen ions
 in acids, 165
 concentration measurement of, 966–967, 967f
 formula for, 69t
 number in solution, 166
 release in neutralization, 794–795
 Hydrogen peroxide
 concentration calculations, 556
 decomposition of, 699, 729, 729f
 disproportionation of, 614
 empirical formula of, 104–105
 molecular formula for, 105, 106
 structural formula for, 105
 uses of, 614
 Hydrogen phosphate ions, 72t
 Hydrogen “skin” on carbon skeletons, 636, 637, 637f
 Hydrogen sulfate ions, 72t, 616, 801t
 Hydrogen sulfide
 acid rain and, 876
 ammonia and, 804
 formation of, 614
 on Io (Jupiter’s moon), 7
 mole fraction in air at sea level, 239t
 removal from coal and natural gas, 772–773
 simultaneous equilibria and, 874–875
 VSEPR theory and, 451
 Hydrogen sulfide ions, 804, 874–875
 Hydrohalic acids, 619–620, 797
 Hydrolases, 731
 Hydrolysis, 664, 730, G-8
 Hydrolysis constant, 820n
 Hydrometallurgy, 1008
 Hydronium ions
 calculating concentration in aqueous solution, 800
 balancing redox reactions using, 942
 defined, 794, G-8
 formation of, 165, 616
 formula for, 72t
 in ion-product constant for water, 799, 799f
 pH scale and, 800–803, 802f
 water and, 794
 Hydro- (prefix), 74
 Hydrosphere, 999, 1001t, G-8
 Hydro sulfuric acid, 814t, A-9
 Hydroxide ions
 in bases, 165
 calculating concentration in aqueous solution, 800
 formula for, 72t
 in ion-product constant for water, 799, 799f
 number in solution, 166
 pOH, 801–802, 802f
 release in neutralization, 794–795
 Hydroxides, 881–882, 882f, A-13
 Hydroxyapatite, 519
 Hypertonic solutions, 567, 567f
 “Hypo,” 880, 880mn
 Hypobromous acid, 801t, A-9
 Hypochlorite ions, 72t
 Hypochlorous acid, 797t, 812–813, A-9
 Hypofluorous acid, 619
 Hypohalites, 621, 622t
 Hypohalous acids, 622t, 816
 Hypoiodous acid, A-9
 Hypo- (prefix), 72, 72f, 74
 Hypothesis, 12, 13f, G-8
 Hypotonic solutions, 567, 567f
 I
 Ice, 473f, 492, 492f
 -ic (suffix), 70, 74
 Ideal gases
 defined, 211, G-8
 root-mean-square speed for, 235n
 standard molar volume and, 215, 215f
 Ideal gas law
 defined, 211, 216, G-8
 equation for, 216, 216f
 reaction stoichiometry and, 228–230, 229f
 rearrangements of, 222–230
 relationship to individual gas laws, 216f
 van der Waals equation and, 243–244
 Ideal solutions, 558, G-8
 -ide (suffix), 68, 74
 IE. *See* Ionization energy
 IGCC (integrated gasification combined cycle), 281
 Ilmenite, 1016t
 India, Union Carbide disaster in, 224
 Indicators, 173–174, 173f, 179
 Indium
 bond type, 598t
 electron configuration, 356
 melting point of, 598t
 properties of, 595–598
 Induced dipole forces, 485–486
 Induced-fit model of enzyme action, 731, 731f, G-8
 Inert pair configuration, 356
 Inert-pair effect, 597
 Infrared (IR) radiation, 296, 297f, G-8
 Infrared spectroscopy, 384–385, 385f, G-8
 Initial reaction rate, 696, 699, G-8
 Inner (core) electrons, 342, 350, G-8
 Inner transition elements
 actinides, 341f, 342, 1044, 1045
 defined, 1044, G-8
 electron configuration, 341f, 342
 lanthanides, 341f, 342, 1044–1045
 in periodic table, 61, 62f, 1038, 1038f
 Inorganic chemistry, 63
 Inorganic compounds, 602–603, 659, 662, 666
 Inorganic polymers, 670
 Insects, irradiation of, 1101
 Insoluble compounds, 147, 159t
 Instantaneous reaction rate, 695, G-8
 Instrument calibration, 33, 33f
 Insulators, 506, 506f, G-8
 Integrated gasification combined cycle (IGCC), 281
 Integrated rate law, 707–714
 defined, 707, G-8
 first-order reactions and, 708, 709, 710f, 714t
 half-life and, 711–714, 711f
 reaction order determination from, 709–710, 710f
 second-order reactions and, 708, 709–710, 710f, 714t
 zero-order reactions and, 708, 710, 710f, 714t
 Intensive properties, 27–28, 27f, 150, G-8
 Interference, 299, 311
 Interhalogen compounds, 620, 620f, G-8
 Intermetallic compounds, 1012
 Intermolecular forces, 468–520
 advanced materials and, 507–520
 biological macromolecules and, 539–544
 comparison with bonding forces, 482, 483f
 in covalent compounds, 383, 383f
 defined, 469, G-8
 dipole-dipole forces, 483–484, 483t
 dipole-induced dipole forces, 483t, 486
 dispersion (London) forces, 483t, 486–487
 enzyme action and, 730
 hydrogen bonds, 483t, 484–485, 484f
 identifying types of, 487–488
 ion-dipole forces, 483, 483t, 491
 ion-induced dipole forces, 483t, 485–486

- liquids, 488–491
 membrane structure and, 542, 542f
 phase changes and, 469–472
 polarizability and, 486
 solids, 493–499, 501–506
 in solution, 534–535
 strength of, 482
 summary diagram for analyzing samples, 487f
 types of, 482–488
 van der Waals radius, 482, 482f
 vapor pressure and, 477f, 478
 viscosity and, 489t, 490
- Internal energy, 258–260, 262, 896, G-8
 International System of Units. *See SI units*
 International Union of Pure and Applied Chemistry (IUPAC), 59, 1092
 Interparticle attractions, 241–243, 242f
 Interstitial alloys, 538, 538f
 Interstitial hydrides, 586–587, 586f
 Intramolecular forces, 470, 482. *See also Bonding*
 Iodates, A-13
 Iodic acid, A-9
 Iodide ions, 69t, 941–942, 941mn
 Iodine
 electron configuration, 356
 hydrogen and, 696–697, 696f, 906
 oxoacids, 622t
 properties of, 617–622, 617f
 radioactive tracers and, 1099, 1100f
 reactivity, 343f
 sublimation of, 479, 479f
 Iodine pentafluoride, 423
 Io (Jupiter's moon), 7
 Ion-dipole forces
 attractions in, 483, 483t
 defined, 483, G-8
 in proteins, 540, 540f
 in soaps, 541
 in solutions, 534, 534–535f
 solvent properties of water and, 491
 Ion exchange, 570–571, 571f, G-8
 Ionic atmosphere, 565, 565f, G-9
 Ionic bonds
 Born-Haber cycle and, 374–375, 374f
 charge in, 65
 Coulomb's law and, 375–376
 Coulomb's law on, 65
 defined, 370, G-9
 electron transfer and, 175, 175f, 370, 370f, 372–373, 373f
 in intermolecular force comparison, 483t
 lattice energy and, 373–377, 376f
 model of, 372–378
 strength of, 65, 66f
 Ionic charge, 176, 376
 Ionic compounds
 binary, 64–65
 bonding (*See* Ionic bonds)
 comparison with covalent compounds, 67
 crystal structure of, 501t, 502–503
 defined, 64, G-9
 electrical conductivity of, 147–148, 147f
 entropy change with dissolution, 903–904, 903f
 equilibria of slightly soluble ionic compounds, 864–875
 formation of, 64–66, 175, 175f
 formula mass of, 76–78
 heats of solution, 545–546, 546f
 hydrated, 72, 73t
 molar mass of, 97
 names and formulas of, 68–73
 properties of, 377, 377–378f, 378f
 redox reactions and, 175, 175f, 181, 182f
 solubility-product constant for, A-13
 solubility rules, 159t
 spontaneous change in, 897
 temperature and solubility, 550, 550f
 in water, 146–149, 146f, 159t
- Ionic equations. *See also Net ionic equations; Total ionic equations*
- for acid-base reactions, 167–171, 170t, 171f
 - for aqueous ionic reactions, 155–157, 156f
 - Ionic equilibria, 842–882
 - of acid-base buffers, 843–852
 - acid-base titration curves and, 853–863
 - complex ions and, 877–882
 - of slightly soluble ionic compounds, 864–875
- Ionic halides, 591
 Ionic hydrides, 586, 591, 592
 Ionic radius
 of alkali metals, 591, 592
 of alkaline earth metals, 594
 of anions, 359, 359f
 of boron family elements, 596
 of carbon family elements, 599
 of cations, 359, 359f
 comparison with atomic size, 359–360, 360f
 defined, 359, G-9
 lattice energy and, 376f
 of nitrogen family elements, 605
 of oxygen family elements, 613
- Ionic size, 375–376
- Ionic solids, 501t, 502–503, G-9. *See also Ionic compounds*
- Ionic solutions
 corrosion of iron and, 973, 973f
 electrical conductivity of, 147–148, 147f
- Ion-induced dipole forces, 483t, 485–486, 534, 534f, G-9
- Ionization counters, 1083, 1084f
- Ionization energy (IE)
 of alkali metals, 591, 592
 of alkaline earth metals, 593, 594
 of boron family elements, 595, 596
 of carbon family elements, 599
 defined, 348, G-9
 first (*See First ionization energy*)
 of halogens, 618
 of hydrogen atoms, 306
 of nitrogen family elements, 605
 of noble gases, 623
 of oxygen family elements, 613
 periodic trends in, 348–350, 349f, 351t, 352f
 successive, 350–351, 350f, 351t
 of transition elements, 1040, 1040–1041f, 1041
- Ionizing radiation
 applications of, 1100–1101
 background sources of, 1095–1096, 1096f, 1096t
 defined, 1093, G-9
 effects on matter, 1093–1095
 molecular interactions, 1095
 penetrating power of emissions, 1094–1095, 1094f
 risk from, 1096–1097, 1097f, 1097t
 units of radiation dose, 1093–1094
- Ion pairs, 378, 378f, 541, G-9
- Ion-product constant for water, 799–803, 799f, G-9
- Ion-product expression, 864–865
- Ions. *See also Anions; Cations*
- calculating amount in solution, 149
 - charge density of, 545
 - complex (*See Complex ions*)
 - counter, 1046, 1049, 1050
 - defined, 64, G-8
 - depicting formation of, 372–373, 372f
 - formation of, 357
 - heats of hydration, 545, 545f
 - monatomic (*See Monatomic ions*)
 - names and formulas for, 68–69, 69f, 69t
 - noble gases and formation of, 65–66, 66f
 - polyatomic (*See Polyatomic ions*)
 - predicting formation from elements, 66
 - selective precipitation and, 874–875
 - solvated, 147, 157, 165, 165f
 - spectator, 156, 159, 160, 167
 - Ion-selective (ion-specific) electrodes, 967, 967t
- Iridium, 1042
- IR (infrared) radiation, 296, 297f, G-8
- Iron
 abundance of, 1000, 1001t
 alloy, 1012, 1013t
 appearance of, 1039f
 changes in state, 7
 corrosion of, 972–974
 as dietary trace element, 1064t
 electron configuration, 340t, 358, 1039, 1039t
 hematite, 1000, 1000f
 in heme, 1063–1064, 1063f
 iron(II) and iron(III), 70, 71t
 mass-number conversion of, 99
 metallurgy, 1015–1017, 1016f, 1016t
 minerals, 1008t
 minerals of, 1016t
- oxidation reactions involving, 897
 oxidation state, 1042, 1042n, 1042t
 radioactive, 1103
 smelting, 1011
 specific heat capacity of, 268t
- Iron(II) hydroxide, 865, 866f
- Iron(III) chloride, 163–164, 570
- Iron(III) hydroxide, 163–164
- Iron(II) sulfide, 879
- Iron phase, 999, 999f
- Irradiation of food, 1100–1101, 1100f
- Isobutane, 642, 642t, 732
- Isoelectronic ions, 355, 358, G-9
- Isoleucine, 672f, 781, 781f
- Isomers
 chirality of, 643–644
 cis-trans isomerism, 430, 645, 645t, 646f, 1052, 1052f
 constitutional, 110–111, 110t, 641–642, 642t, 1051–1052, 1052f, 1054f
 coordination, 1051
 in coordination compounds, 1051–1054
 defined, 110, 641, G-9
 geometric, 645–646, 645t, 646f, 1052–1053, 1052f
 linkage, 1052, 1052f
 molecular polarity and, 430
 optical, 642–644, 1053–1054, 1053f
 stereoisomers, 642–643, 1052–1054f
- Isopentane, 642, 642t
- Isopropylamine, A-12
- Isotonic solutions, 567, 567f
- Isotope enrichment, 237
- Isotopes. *See also Radioisotopes*
- calculating atomic mass from, 58–59
 - defined, 57, 1074, G-9
 - hydrogen, 1024–1025, 1024t
 - mass spectrometry and, 60, 60f
 - uranium, 237
- Isotopic mass, 58, G-9
- Isotropic, 509
- ite (suffix), 72, 72f, 74
- IUPAC (International Union of Pure and Applied Chemistry), 59, 1092
- J**
- Jet engines, 1022, 1022mn
- Joliot-Curie, Frederic, 1090, 1090mn
- Joliot-Curie, Irene, 1090, 1090mn
- Joule (J), 261, G-9
- Jupiter (planet), 7
- K**
- Kaolinite, 512
- Kelvin (absolute) temperature scale, 25–27, 26f, 27t, 213, G-9
- Kelvin (K), 14t, 25, G-9
- Ketobutyrate, 781
- Ketones, 655t, 660–661, 660f, G-9
- Kevlar, 510
- Kilocalorie (kcal), 262
- Kilogram (kg), 14t, 17, G-9
- Kilojoule (kJ), 262
- Kilo- (prefix), 14, 14t
- Kinetic energy
 in chemical reactions, 386
 defined, 8, G-9
 dispersal of, 470, 897
 kinetic-molecular theory and, 231, 234–235, 234f
 potential energy converted to, 9–10, 9f, 257
 temperature and, 234–235, 240, 470
- Kinetic isotope effect, 1024, 1098n
- Kinetic-molecular theory, 231–238
- collision frequency and, 238, 238mn
 - defined, 231, G-9
 - diffusion and, 237–238, 238f
 - effusion and, 236–237, 236f
 - mean free path, 238
 - molecular speed and, 232, 232f, 234, 234f
 - molecular view of gas laws, 232–234
 - on origin of pressure, 231, 232
 - phase changes and, 470, 470t, 473–474
 - postulates of, 231–232, 232f
 - root-mean-square speed, 235–236, 235n
- Kinetics, 730, 747. *See also Chemical kinetics*

Krypton

electron configuration, 340, 340
mole fraction in air at sea level, 239t
properties of, 622–624

L

Laboratory glassware, 15, 16f

Lactic acid, 107, 110t, A-9

Lanthanide contraction, 1041, G-9

Lanthanides

defined, G-9
electron configuration, 341f, 342
properties of, 1044–1045
uses of, 1045

Lanthanum, 342

Large Hadron Collider, 1091–1092, 1092f

Lattice, 493–494, 493f, G-9

Lattice energy

of alkali metal chlorides, 592, 592f
of alkaline earth metals, 592f, 593

defined, 374, G-9

ionic bonding and, 373–377, 376f

periodic trends in, 375–376, 375f

in solution process, 545–546, 546f

Lavoisier, Antoine

classification of elements by, 61
combustion theory developed by, 11, 13, 46, 910
on law of mass conservation, 46, 50

metric system and, 13

on scientific method, 12, 13

thermal decomposition and, 183

Law of chemical equilibrium, 750, G-9

Law of conservation of energy, 261, 896, G-9

Law of definite (constant) composition, 47–48, 48f, 50, G-9

Law of heat summation, Hess's, 275–277

Law of mass action, 750, G-9

Law of mass conservation, 46–47, 47f, 50, G-9

Law of multiple proportions, 49–51, G-9

Lawrence, E. O., 1091

Laws of thermodynamics

first, 261, 896, 909–910

living systems and, 909–910

second, 901, 910

third, 901

LCDs (liquid crystal displays), 511, 511f

LDPE (low-density polyethylene), 518

Leaching, 1005, 1006, 1009, 1011, G-9

Lead

bond type, 598t

density of, 24t

electron configuration, 344

lead(II) and lead(IV), 71t

melting point of, 598t

mineral sources of, 1008t

properties of, 598–601, 601f

silver displacement by, 961

Lead-acid batteries, 969–970, 970f, 975, 975f

Lead(II) chloride, 865, 873

Lead(II) chromate, 868, 868f

Lead(II) fluoride, 866–867, 866t

Lead(II) iodide, 158–159, 159f

Lead(II) nitrate, 159, 159f

Lead(II) sulfate, 866, 866t

Le Châtelier, Henri, 912

Le Châtelier's principle, 770–780

in ammonia synthesis, 779–780, 779t, 780f

applications of, 770, 770mn, 1027

common-ion effect and, 868

concentration changes and, 770–773, 772t, 777t

defined, 770, G-9

lack of catalysts and, 777, 777t

pressure changes and, 773–775, 774f, 777t

reaction direction and, 1014

solubility and, 869

temperature changes and, 775–777, 777t

van't Hoff equation and, 776–777

Lecithin, 542f, 663, 663f

LEDs (light-emitting diodes), 285

Length

converting units of, 20–21

English equivalents, 15t

examples of, 17f

SI units, 14–15t, 15

Leucine, 540, 672f

Leveling effect, 827, G-9

Levels of energy, 317–318, 334–335, G-9

Levorotatory isomers, 643

Lewis, Gilbert Newton, 371, 372, 827

Lewis acid-base definition, 827–830, 877, G-9

Lewis acids, 827–830, 877

Lewis bases, 827–830, 877

Lewis electron-dot symbols, 371–372, 371f, G-9

Lewis structures, 405–417

defined, 405, G-9

electron-deficient atoms and, 413–414

electron-pair delocalization and, 410

exceptions to octet rule for, 413–417

expanded valence shells and, 414–416

formal charge and, 411–416

free radicals and, 414

limitations of, 416

for multiple bond molecules, 408–409

octet rule for, 405–409

odd-electron atoms and, 414

resonance and, 409–413

for single bond molecules, 406–408

terminology considerations, 405n

valence-shell electron-pair repulsion theory and, 417, 421, 421f

Libby, Willard F., 1087

Ligand field theory, 1062

Ligands

anionic, 1050, 1050t

bidentate, 1047, 1048t

coordination compounds and, 1046, 1047–1048, 1048t

defined, 877, 1046, G-9

donor atoms and, 1047

monodentate, 1047, 1048t

polydentate, 1047, 1048t

spectrochemical series and, 1059, 1059f

splitting *d* orbitals in octahedral field of, 1057–1058

strong-field, 1058, 1058f, 1060, 1060–1061f

weak-field, 1058, 1058f, 1060, 1060–1061f

Light

as electromagnetic radiation, 295–297

particle nature of, 299–301, 300f

photon theory of, 301

rainbows and, 298, 298mn

refraction and dispersion of, 298, 298f

speed of, 296

wave nature of, 296–297f, 296–298

Light bulbs, efficiency of, 285

Light-emitting diodes (LEDs), 285

Lightning, 1005

Light-water reactors, 1107f, 1108

Like-dissolves-like rule, 534, 535, 536f, 544, G-9

Lime, 593, 752, 1021

Limestone

acid rain and, 876

caves, 870–871, 870f

decomposition of, 752

in desulfurization, 281

gases released from, 210

Liming, 876

Limiting-reactant problems

precipitation reactions and, 163–164

reactant and product amount calculations, 125–127

reaction table use in, 122–123

solving with molecular depictions, 123–124

Limiting reactants

chemical reactions involving, 122–127, 123f

defined, 122, G-9

determining, 122

in everyday life situations, 122mn

Linear accelerators, 1091, 1091f

Linear arrangement

of complex ions, 1047, 1047t

defined, 419, G-9–G-10

of hybrid orbitals, 444, 446, 449f

VSEPR theory and, 418–419f, 419, 422, 422f, 424f

Linear response model of radiation risk, 1097

Line spectra, 302–305, G-9

Linkage isomers, 1052, 1052f, G-10

Lipid bilayers, 542, 542f, G-10

Lipids, 663, 663f, G-10

Liquid crystal displays (LCDs), 511, 511f

Liquid crystals

applications of, 511, 511f

defined, 509, G-10

molecular characteristics of, 509–510, 509f

ordering of particles in, 509–511

phases, 510–511

Liquid-gas equilibria, 476–478, 476f

Liquids

capillarity, 489–490, 489f

comparison with physical states of solids and gases, 205–207, 206f

defined, 4, G-10

density of, 24, 24t

diffusion of gas through, 237–238

entropy change with dissolution, 903–904

entropy of, 547

intermolecular forces, 488–491

kinetic-molecular view of, 470

particle arrangement in, 4, 4f

properties of, 470, 470t, 488–491

solutions and molecular polarity, 535–537

surface tension of, 489, 489f, 489mn, 489t

viscosity, 490–491, 490t

volatile, 224–225

Liquid-solid equilibria, 479

Liter (L), 15, G-10

Lithium

anomalous behavior of, 587, 590

in batteries, 969, 969f

density of, 24–25

diagonal relationship with magnesium, 595, 595f

diatomic, 458, 458f

electron configuration, 333, 334, 336, 336f, 338f

hydrogen displacement from water, 184f

ionic bonding and, 372–376, 372f, 374f, 376f

ionization energy, 351t

molecular orbitals in, 505, 505f

nuclear fusion and, 1109

in organometallic compounds, 661

properties of, 588t, 590–592, 590mn

reactivity, 343f

soaps, 541

Lithium batteries, 969, 969f

Lithium fluoride

Born-Haber cycle and, 374–375, 374f

ionic bonding and, 372–376, 372f, 374f, 376f

lattice energy and, 373–376, 376f

percent ionic character of, 393f

Lithium hydroxide, 229

Lithium-ion batteries, 970, 970f

Lithium ions, 69t

Lithosphere, 999, 1001t, G-10

Livermorium, 612–615, 1092

Lock-and-key model of enzyme action, 730, 731f, G-10

Logarithms, A-1–A-2

London, Fritz, 486

London forces. *See* Dispersion forces

Lone pairs

defined, 380, G-10

Lewis structures and, 408

orbital hybridization and, 446–448

in VSEPR theory, 419–423

Low-density polyethylene (LDPE), 518

Lowry, Thomas M., 169, 803

Low-spin complexes, 1060–1061, G-10

LSD (lysergic acid diethylamide), 664f

Luminous intensity, 14t

Luster, 505

Lyotropic phases, 510

Lysergic acid diethylamide (LSD), 664f

Lysine, 540, 602f, 657f, 672f

M

Macromolecules. *See also* Biological macromolecules; Polymers

defined, 79, 774

free radical attack on, 1095

synthetic, 668–670

Macroscopic properties, 8, 44

Magnesium

abundance of, 1001, 1001t

diagonal relationship with lithium, 595, 595f

electron configuration, 338t, 339

hexagonal closest packing in, 503f

industrial extraction of, 162–163

isolation of, 1021–1022, 1022f

magnesium oxide formed from, 112–114, 113f

metallurgy of, 1021–1022, 1022f

- properties of, 353, 593–595
uses of, 1022
- Magnesium carbonate, 865
- Magnesium chloride
depicting solutions of, 565–566
electrolysis and, 183
electron density distribution, 394f
intermolecular forces, 487–488
ionic properties of, 394
in precipitation reactions, 162–163
selective precipitation and, 874
- Magnesium hydroxide, 172, 874
- Magnesium ions, 69, 570–571, 829, 829f
- Magnesium oxide, 112–114, 113f, 175, 175f, 377
- Magnetic properties
of coordination compounds, 1060–1061
crystal field theory and, 1060–1061
diamagnetism, 357, 358f, 460–461, 460f, 1037, 1044
paramagnetism, 357, 358–359, 358f, 460–461, 460f, 1037, 1044
of transition elements, 1037, 1044
of transition metal ions, 357–358, 358f
- Magnetic quantum number, 316, 317, 317t, 332t, G-10
- Magnetic resonance imaging (MRI), 649–650, 650f
- Magnetite, 520, 520f, 973, 1009, 1016t, 1017
- Main-group elements. *See also specific elements*
acid-base behavior of oxides, 354–355, 354f
atomic size of, 346–347, 346f
electron affinity of, 352f
electron configuration, 341f
ionization energy of, 349f
Lewis electron-dot symbols for, 371–372, 371f
metallic behavior of, 353, 354, 354f
monatomic ion names and formulas, 68–69, 69f, 69t
oxidation number of, 354, 354f
periodic patterns in, 584–624
in periodic table, 61, 62f
redox behavior of, 354
- Main-group ions, electron configuration of, 355–356, 355f
- Malathion, 611
- Maleic acid, A-9
- Malleability, 396–397, 505
- Malonic acid, A-10
- Manganese
abundance of, 1000, 1001t
appearance of, 1038f
in batteries, 968, 968f
complex ions of, 1060, 1060f
as dietary trace element, 1064t
electron configuration, 339, 340t, 1039, 1039t
oxidation state, 1042, 1042t
- Manganese(II) chloride tetrahydrate, 1043f
- Manhattan Project, 1106
- Manometers, 208mn, 209f, 699, G-10
- Mantle of Earth, 998, 998–999f, 998t, G-10
- Many-electron atoms, 332–335, 348
- Mass
amount-mass-number conversions, 97–98, 151–152, 151f, 162f
atomic, 57–59, 61
conservation of, 46–47, 47f, 50
conversion to energy, 47
converting units of, 22
defined, 17, G-10
English equivalents, 15t
examples of, 17f
as extensive property, 27, 27f
interconversion of energy and, 1101–1104
isotopic, 58
law of definite composition and, 47–48, 48f, 50
molality and, 553
molar (*See* Molar mass)
molecular, 76–78
SI units, 14–15t, 17, 17f, 17n
weight vs., 17
- Mass action, law of, 750
- Mass-action expression. *See* Reaction quotient
- Mass/charge ratio (m/e), 53, 60, 60f
- Mass difference
in chemical reactions, 1101–1102
explain by atomic theory, 50–51
mass conservation and, 46–47, 47f, 50
multiple proportions and, 49–51
in nuclear reactions, 1102
visualization of, 51
- Mass-energy equivalence, 896n
- Mass fraction, 47–48
- Mass number
atomic notation for, 57f
defined, 56, G-10
nuclide, 1074, 1081
- Mass percent (mass %), 47–48, 48f, 102–103, 554, G-10
- Mass ratio, fixed, 44
- Mass spectrometry, 58, 60, 60f, G-10
- Matches, 611, 621
- Material flow tracers, 1099
- Materials, advanced. *See* Advanced materials
- Mathematical operations, A-1–A-4
- Matter
ancient Greek views of, 43
classification of, 81, 82f
composition of, 4
conservation of, 46
de Broglie wavelength of, 311, 311t
defined, 4, G-10
distinction from, 298–299
effects of nuclear radiation on, 1093–1095
energy, importance in study of, 8–10
entropy and states of, 547
extensive and intensive properties of, 27–28, 27f
properties of, 5–7, 7t
states of (*See* States of matter)
types of, 44–46
wave-particle duality of, 310–313, 310f
- Maxwell, James Clerk, 231, 912
- Mean free path, 238, G-10
- Measurement. *See also SI units*
accuracy and, 32–33, 33f
density, 23–25, 24t
historical standards of, 13
length, 14–15t, 15, 17f
mass, 14–15t, 17, 17f
precision and, 32–33, 33f
significant figures in, 28–32, 29f
temperature, 25–27, 26f, 27t
time, 14t, 18
uncertainty in, 28–33
volume, 15, 15t, 16–17f
- Mechanical balances, 17
- Medical diagnosis, radioactive tracer use in, 1099–1100, 1099t, 1100f
- Medical tradition, history of, 11
- Mega- (prefix), 14t
- Meitner, Lise, 1105
- Meitnerium, 1092, 1105
- Melting
defined, 471, G-10
as endothermic and spontaneous process, 897
solid-liquid equilibria and, 479
sublimation and, 472, 472f
- Melting point
of alkali metals, 396, 396f, 591
alkaline earth metals, 593, 594
of alkaline earth metals, 396, 396f
of boron family elements, 596, 598t
of carbon family elements, 598t, 599
defined, 479, G-10
of halogens, 618
of ionic compounds, 378, 378t
of metals, 396, 396f, 396t
of nitrogen family elements, 598t, 605
of noble gases, 623
of oxygen family elements, 613
of Period 3 chlorides, 395f
- Membrane-cell process, of chlorine production, 1029
- Membranes
dual polarity of, 542, 542f
free radical attack on, 1095
proton exchange, 971, 971f
semipermeable, 562, 571, G-14
structure of, 542, 542f
- Mendeleev, Dmitri, 61, 331
- Meniscus, 16f, 489–490, 490f
- Mercury
in barometers, 208, 208f
in batteries, 968–969
Boyle's experiments with, 211–212, 211f
calx, 11
heats of vaporization and of fusion, 471f
Lavoisier's experiments with, 11
- line spectra of, 303f
in manometers, 208, 209f
meniscus shape in glass, 490, 490f
mercury(I) and mercury(II), 71t
mineral sources of, 1008r
as neurotoxin, 281
standard enthalpies of formation, 278t
standard state of, 278
surface tension of, 489t
viscosity of, 489t
- Mercury-cell process, 1029
- Mercury(I) iodide, 866t
- Mercury(II) oxide, 183, 183f
- Mesosphere, 239f, 240
- Messenger RNA (mRNA), 677–678, 677f
- Metabolic pathways, 121, 781, 781f, G-10
- Metallic bonds
alkali metals and, 591
alkaline earth metals and, 594
band theory and, 506
defined, 371, G-10
electron pooling and, 370f, 371
electron-sea model and, 395–396
in intermolecular force comparison, 483t
in mercury, 490
- Metallic (interstitial) hydrides, 586–587, 586f
- Metallic radius, 345, 345f, G-10
- Metallic solids, 501t, 503, 503f, G-10
- Metalloids
defined, G-10
examples of, 63f
oxides of, 355
in periodic table, 62, 62f
properties of, 62, 353
as semiconductors, 506
zone refining of, 1012
- Metallurgy, 1008–1022
alloying, 1012–1013, 1013f, 1013t
aluminum, 1019–1021, 1020f
converting minerals to elements, 1010–1011, 1012f
copper, 1017–1018, 1018f
defined, 1008, G-10
iron, 1015–1017, 1016f, 1016t
magnesium, 1021–1022, 1022f
ore pretreatment, 1009
potassium, 1014–1015
process overview, 1009f
redox reactions in, 1010–1011, 1012f
refining (purifying) elements, 1012, 1012f
sodium, 1014–1015, 1015f
- Metal oxide (calx), 11
- Metals
acid-base behavior of oxides, 354–355, 354f
acid strength of hydrated metal ions, 817, 817f
activity series, 184–186, 958–959
alloys (*See* Alloys)
boiling point of, 396, 396t
bonding (*See* Metallic bonds)
calx, 11
combination reactions and, 181, 182f
comparison with nonmetals, 370–371
conductivity of, 397, 506
crystal structure of, 503, 503f
defined, G-10
displacement reactions and, 184–186
electron affinity of, 352
electron configuration of, 356–359
electronegativity of, 390, 394
electron-sea model and, 395–396
examples of, 63f
forming more than one ion, 70, 71t
ionic bonding and, 181, 370
ionization energy of, 352
Lewis electron-dot symbols for, 371
magnetic properties of, 357–358, 358f
mechanical properties of, 396–397, 397f
melting point of, 396, 396f, 396t
metal cations as Lewis acids, 829
metallic radius for, 345, 345f
in periodic table, 62, 62f
properties of, 62, 353
tendency to lose or gain electrons, 353–354, 353f
trends in metallic behavior, 353–354f, 353–355
- Metal sulfides, 616, 1010
- Metathesis reactions, 159, 167, 184, G-10

- Meteorites, 1006, 1088
 Meter (m), 14–15*t*, 15, 296, G-10
 Methanal. *See* Formaldehyde
 Methane
 boiling point of, 641/*f*
 carbon dioxide and water formed from, 8*mnn*
 chlorination of, 389
 combustion of, 387–388, 388/*f*
 conversion to hydrogen fuel, 763
 cubic closest packing in, 502, 502/*f*
 effusion rate of, 236–237
 entropy and, 905
 formation equation for, 277
 formula and model, 76*t*
 heats of vaporization and of fusion, 471/*f*
 hybrid orbitals and, 444, 447, 447/*f*
 for hydrogen production, 1023
 molecular shape of, 420
 mole fraction in air at sea level, 239/*t*
 in residential heating systems, 284
 syngas and, 281
 Methanogenesis, 281, G-10
 Methanoic acid, 662, 662/*f*
 Methanol
 hybrid orbitals and, 449–450
 intermolecular forces, 534/*f*
 Lewis structure for, 408
 molecular structure of, 654/*f*, 655*t*, 664
 production of, 1024
 solubility of, 536, 536/*f*, 536*t*
 Methionine, 672/*f*
 Meth- (numerical root), 639/*t*
 Methyl acetate, 655*t*, 664
 Methylamine, 189, 818, 819/*f*, 819*t*, A-11
 Methylbenzene, 647–648
 Methyl bromide, 718–719, 719/*f*
 Methyl chloride, 483–484, 484/*f*, 655/*t*
 Methyl cyanide, 655*t*
 Methyl ethanoate, 655*t*, 664
 Methyl ethyl ketone, 660/*f*
 Methylhexane, 643, 643/*f*
 Methylisocyanate, 224
 Methylpropane, 110*t*, 642, 642/*t*
 Methylpropene, 656
 Methyl red, 861–862
 Metric system, 13
 Mica, 604
 Micelles, 569
 Microanalysis, 967/*f*
 Micro- (prefix), 14/*t*
 Microscope, electron, 311–312, 312/*f*
 Microstates, 898–901, 908, G-10
 Millikan, Robert, 53–54
 Millikan's oil-drop experiment, 53–54, 53/*f*
 Milliliter (mL), 15, G-10
 Millimeter of mercury (mmHg), 208, 209,
 209/*t*, G-10
 Milli- (prefix), 14, 14/*t*
 Minerals
 converting to elements, 1010–1011, 1012/*f*
 defined, 1008, G-10
 as element source, 1008, 1008/*t*
 of iron, 1016/*t*
 Misch metal, 1045
 Miscibility, 534, G-10
 Mitochondrion, 982, 982/*f*
 Mixing, convective, 240
 Mixtures, 532–571. *See also* Colloids; Solutions
 atomic-scale view of, 44*f*, 45
 classification of, 81, 82/*f*
 comparison with compounds, 45, 81, 81/*f*
 defined, 45, 533, G-10
 heterogeneous, 81, 533, 568
 homogeneous, 81, 533, 568
 partial pressure of gas in mixture of gas, 225–227
 particle size and, 568
 racemic, 643
 reaction direction and, 768–769
 separation techniques for, 83, 83/*f*
 m- (meta), 648
 mmHg (millimeter of mercury), 208, 209, 209/*t*, G-10
 Mobile phase of chromatography, 83, 83/*f*
 MO bond order, 457, G-10
 Model (theory), in the scientific method, 13,
 13/*f*, G-10
- Molar boiling point elevation constant, 560, 560/*t*
 Molar freezing point depression constant, 560, 561
 Molality, 553–554, 553*t*, G-10
 Molar heat capacity, 268, G-10
 Molarity, 150, 552–553, 553*t*, G-10
 Molar mass
 boiling point and, 486, 486/*f*
 of compounds, 97
 defined, 96, G-10
 dispersion (London) forces and, 486, 486/*f*
 of elements, 97
 entropy and, 904
 gases and, 223, 224–225
 Graham's law of effusion and, 236–237
 in molecular formula determination, 107–108
 molecular speed and, 234, 234/*f*
 of polymers, 514, 514/*t*
 solute molar mass from colligative properties, 563
 Molar ratio, stoichiometrically equivalent, 116–120
 Molar solubility, 866–867, 868/*t*
 Molar volume, of common gases, 241/*r*
 Molecular complexity, entropy and, 904–905, 905/*f*
 Molecular depictions
 ball-and-stick models, 79, 80/*t*
 determination of formula, name, and mass using, 77–78
 of DNA, 80/*t*
 in limiting-reactant problems, 123–124
 in precipitation reactions, 160–161
 space-filling models, 79, 80/*r*
 of straight-chain alkanes, 76/*t*
 Molecular equations
 for acid-base reactions, 167–171, 170*t*, 171/*f*
 for aqueous ionic reactions, 156, 156/*f*, 158/*f*, 159
 defined, 156, G-10
 Molecular formulas
 combustion analysis, determination from, 108–109, 108/*f*
 of covalent compounds, 370
 defined, 78–79, 105, G-10
 different compounds with same formula,
 110–111, 110/*r*
 elemental analysis and molar mass, determination from,
 107–108
 hybrid orbitals and, 449, 449/*f*
 Lewis structures, converting to, 406–408, 406/*f*
 molecular shape, converting to, 423, 424/*f*, 425–426
 Molecular hydrides, 586
 Molecularity, 721–723, 722/*t*, G-11
 Molecular mass, 76–78, G-11
 Molecular orbital band theory, 504–506
 Molecular orbital diagrams, 457–458, 457/*f*, G-11
 Molecular orbitals (MOs)
 antibonding, 456, 456/*f*, 457
 bonding, 456, 456/*f*
 bond order, 457
 defined, 455, G-11
 electrons in, 455–457
 energy and shape of, 456, 456/*f*
 formation of, 455–456
 of hydrogen, 456, 456/*f*
 of lithium, 505, 505/*f*
 nonbonding, 462
 Molecular orbital theory, 455–463
 antibonding MOs in, 456, 456/*f*, 457
 atomic $2p$ orbital combinations in, 458–459/*f*,
 458–460
 bonding MOs in, 456, 456/*f*
 central themes of, 455–457
 defined, 455, G-11
 formation of molecular orbitals in, 455–456
 heteronuclear diatomic molecules in, 462–463, 462/*f*
 homonuclear diatomic molecules in, 458–462
 MO bond order, 457
 nonbonding MOs in, 462
 pi MOs in, 458–459/*f*, 458–460
 polyatomic molecules in, 463, 463/*f*
 sigma MOs, 456, 456/*f*
 Molecular polarity
 bond angle and, 428–429
 bond polarity and, 428–429
 defined, 428, G-11
 dipole moment and, 428–429
 effect on behavior, 430, 430/*f*
 liquid solutions and, 535–537
 molecular shape and, 146, 428–430
 pi bonds and, 455
- Molecular scene problems
 balancing equations from, 115–116
 buffers and, 850–851
 enthalpy change and free energy change from,
 917–918
 equilibrium parameter determination from,
 778–779
 finding quantities at various times with, 712–713
 free energy change calculation from, 924–926
 heat of phase change and, 475–476
 ionic compounds in aqueous solutions, 148–149
 precipitate formation and, 872–873
 predicting net direction of acid-base reactions using,
 807–808
 reaction direction determination and, 758–759
 reaction order determination from, 706–707
 Molecular shape, 404–432
 bent, 146, 146/*f*, 419, 419–420/*f*, 421, 424/*f*, 447
 biological significance of, 431, 431–432/*f*
 boiling point and, 487, 487/*f*
 converting molecular formula to, 423, 424/*f*, 425–426
 defined, 417, G-11
 of electron-deficient atoms, 413–414
 electron-group arrangements and, 418, 418/*f*
 expanded valence shells and, 414–416
 formal charge and, 411–416
 Lewis structures and (*See* Lewis structures)
 linear arrangement, 418–419/*f*, 419, 422, 422/*f*, 424/*f*
 molecular polarity and, 146, 428–430
 of molecules with multiple central atoms,
 426–427, 427/*f*
 of multiple bond molecules, 408–409
 octahedral arrangement, 418/*f*, 422–424/*f*
 of odd-electron atoms, 414
 of organic molecules, 634
 resonance structures and, 409–413
 seesaw, 422, 422/*f*, 424/*f*
 of single bond molecules, 406–408
 square planar, 423, 423–424/*f*, 448
 square pyramidal, 423, 423–424/*f*, 448
 tetrahedral arrangement, 418/*f*, 420–421, 420/*f*, 424/*f*
 trigonal bipyramidal arrangement, 418/*f*, 421–422,
 422/*f*, 424/*f*
 trigonal planar arrangement, 418–419/*f*, 419–420, 424/*f*
 trigonal pyramidal shape, 420–421, 420/*f*,
 424/*f*, 447
 T shape, 422, 422/*f*, 424/*f*
 using VSEPR to determine, 423, 425–426
 viscosity and, 490
 VSEPR theory and (*See* Valence-shell electron-pair
 repulsion theory)
 Molecular solids, 501*t*, 502, 502/*f*, G-11
 Molecular speed
 molar mass and, 234, 234/*f*
 temperature and, 232, 232/*f*, 477–478, 477/*f*
 Molecular wave functions, 456, 456/*f*
 Molecular weight. *See* Molecular mass
 Molecules
 bonding (*See* Bonding)
 chemical formula and structure of, 110–111, 110/*t*
 of compounds, 44, 44/*f*
 defined, 44, G-11
 depictions of (*See* Molecular depictions)
 diatomic, 44
 electron configuration of, 456–457
 elements as, 44, 44/*f*, 66, 67/*f*, 97
 as Lewis acids, 828–829
 Lewis structures of (*See* Lewis structures)
 orbitals of (*See* Molecular orbitals (MOs))
 organic (*See* Organic molecules)
 polarity of (*See* Molecular polarity)
 polyatomic, 463, 463/*f*
 reaction rate and structure of, 718, 718/*f*
 shape of (*See* Molecular shape)
 Mole fraction, 226, 553*t*, 554–555, G-10
 Mole (mol)
 in amount-mass-number relationships, 97–102, 98/*f*,
 100, 118/*f*
 Avogadro's number and, 96, 98–102, 98/*f*, 100/*f*
 of common substances, 96, 96/*f*, 96*mn*
 defined, 95–96, G-10
 ions in aqueous ionic solutions, 149
 molar mass, 96–97, 97*n*
 relationship with energy transferred as heat during
 reactions, 274, 274/*f*

- as SI base unit, 14^t
standard molar volume, 215, 215^f
- Molina, Mario J., 732
- Molybdenum, 343, 1044, 1044^t
- Monatomic elements, molar mass of, 97
- Monatomic ions
defined, 65, G-11
metals that form more than one monatomic ion, 70, 71^t
names and formulas, 68–69, 69^f, 69^t
properties of, 355–360
- Monochromatic light, 296
- Monodentate ligands, 1047, 1048^t
- Monomers, 514, G-11
- Mononucleotides, 543, 675, G-11
- Mono- (prefix), 73^t
- Monoprotic acids, 796, 797^t
- Monosaccharides, 671, 671^f, G-11
- Moon rocks, radioisotopic dating of, 1088
- MOs. *See* Molecular orbitals
- Moscovium, 1092
- Moseley, Henry G. J., 331
- Motor oil, viscosity of, 491
- Motor vehicles. *See* Automobiles
- MRI (magnetic resonance imaging), 649–650, 650^f
- mRNA (messenger RNA), 677–678, 677^f
- Mulliken, Robert S., 392^t
- Multiple proportions, law of, 49–51
- Multiplication, significant figures and, 30
- Mylar, 670
- Myosin, arrangement of filaments, 511^f
- N**
- NAA (neutron activation analysis), 1099
- NAD (nicotinamide adenine dinucleotide), 982
- Naming. *See* Nomenclature
- Nanocomposites, 519
- Nanomachines, 520, 520^f
- Nanometers (nm), 296
- Nano- (prefix), 14^t
- Nanostructuring, 519–520
- Nanotechnology, 519–520, G-11
- Nanotubes, 520, 600–601, 600^f
- Naproxen, 644, 644^{mn}
- Natta, Giulio, 668
- Natural gas, 281
- Natural law, 12, G-11
- Negative reaction order, 701
- Negatron emission, 1077
- Nematic phase, 510, 510^f
- Neon
boiling point of, 537^t
diatomic molecules of, 460^f, 461
electron configuration, 337, 338^f
ionization energy, 351^t
line spectra of, 302, 303^f
mass/charge ratio of, 60, 60^f
molar mass of, 97
mole fraction in air at sea level, 239^t
properties of, 589^t, 622–624
solubility in water, 537^t
- Neon signs, 53
- Neopentane
constitutional isomers of, 642, 642^t
formula and model, 642^t
molecular shape of, 487, 487^f
- Neoprene, 518^t
- Nernst, Walther Hermann, 962
- Nernst equation, 962–963, G-11
- Nerve cells, concentration cells in, 967
- Net ionic equations
for acid-base reactions, 167–171, 170^r, 171^f
for aqueous ionic reactions, 156^f, 157, 158–159, 158^f
defined, 157, G-11
- Network covalent solids, 383, 383^f, 386, 501^t, 503–504, 504^t, G-11
- Neutralization, 793, 794, 852, G-11
- Neutralization reactions. *See* Acid-base reactions
- Neutrino, 1076^r, 1077
- Neutron activation analysis (NAA), 1099
- Neutron-capture processes, 1111
- Neutrons
defined, G-11
discovery of, 55, 1090
mass of, 56^t
- nuclide and, 1074
properties of, 56^t
- Neutron star, 1110^r, 1111
- Neutron-to-proton (*N/Z*) ratio, 1079, 1079^f
- Nickel
abundance of, 1001^t
appearance of, 1039^f
displacement of hydrogen from acid by, 185, 185^f
electron configuration, 339, 340^r, 343, 1039^t
oxidation state, 1042, 1042^t
- Nickel-cadmium (nicad) batteries, 970
- Nickel(II) hydroxide, 873
- Nickel(II) nitrate hexahydrate, 152, 1043^t
- Nickel-metal hydride (Ni-MH) batteries, 970, 970^f
- Nicotinamide adenine dinucleotide (NAD), 982
- Nihonium, 1092
- Nile River, 569, 569^f
- Niobium, 1044
- Nitrate ions
formula for, 72^t
molecular shape of, 419
properties of, 609, 609^f
resonance structure of, 412–413
- Nitrates, 609–610
- Nitric acid
acid rain and, 875
fixation and, 1005
number of ions in solution, 166
production from ammonia, 280
properties of, 609–610, 609^f
- Nitric oxide
boiling point of, 537^t
hydrogen and, 700
molecular orbitals of, 462^f, 463
mole fraction in air at sea level, 239^t
oxygen and, 703–704, 703^t, 724–726, 727^f
ozone and, 692, 693, 693^f, 699, 700
properties of, 608–609, 608^f
redox reactions involving, 182
solubility in water, 537^t
- Nitride ions, 69^t
- Nitrides, 611
- Nitrification, 571
- Nitriles, 655^t, 666, G-11
-nitrile (suffix), 655^t
- Nitrite ions, 72^t, 609^f, 610
- Nitrogen
abundance of, 1000, 1001^t
bond type, 598^t
chemistry of, 607–610
critical temperature of, 480
diatomic molecules of, 460^f, 461
electron configuration, 337, 338^f
fixation of, 605, 779, 1004^f, 1005
ionization energy, 351^t
irradiation of, 1109
Lewis structure for, 409
Lewis symbol for, 371
liquid, 506
mean free path of, 238
melting point of, 598^t
mole fraction in air at sea level, 239^t
pollutants, 876
properties of, 353, 589^t, 604–607
sources of, 1001
standard enthalpies of formation, 278^t
triple bond in, 380
- Nitrogen cycle, 1004–1005, 1004^f
- Nitrogen dioxide
atmospheric concentration of, 609
carbon monoxide and, 705–706, 723–724
equilibrium with dinitrogen tetroxide, 748–751, 748^f, 750^r, 751^f, 759–760
- fluorine and, 724, 726, 727^f
formation of, 115–116, 609
- formula and model, 80^r
- Lewis structure of, 414
- mass-number conversion of, 100–101
- mass of oxygen in, 104
- mole fraction in air at sea level, 239^t
- structures and properties of, 608^t, 609
- Nitrogen family elements
acid-base behavior of, 354–355, 354^f
comparison with oxygen family, 612, 614–615
- halides, 605, 607
heat of fusion of, 598^t
- oxides, 606–607
- oxoacids, 605
- properties of, 604–611
- reactivity of, 605, 606–607
- tendency to lose or gain electrons, 353–354, 353^f
- Nitrogen fixation, 605, 779, 1004^f, 1005
- Nitrogen gas, 537^t, 551
- Nitrogen monoxide. *See* Nitric oxide
- Nitrogen oxides, 608–609, 608^r, 875, 905, 905^f
- Nitrogen trifluoride, 406–407
- Nitrous acid, 609^r, 610, 797^t, 801^t, 823, A-10
- Nitrous oxide, 276–277, 608, 608^t
- NMR (nuclear magnetic resonance) spectroscopy, 649–650, G-11
- Noble gases
atomic radius of, 348^f
as atomic solids, 502
- electron affinity of, 352
- electron configuration, 343
- electron configuration of, 355–356, 355^f
- ion formation and, 65–66, 66^f
- ionization energy of, 349^f, 352
- in periodic table, 63
- properties of, 622–624
- reactivity of, 624
- sources of, 1001
- Nodes, 319, G-11
- Nomenclature
acids, 74
- alkanes, 76, 76^r, 639, 639–640^r, 646–647
- alkenes, 644, 646–647
- aromatic hydrocarbons, 647–648
- binary covalent compounds, 74–76
- binary ionic compounds, 68–71
- coordination compounds, 1050–1051, 1050^r
- hydrates, 72, 73^t
- ionic compounds, 68–73
- metals forming more than one ion, 70, 71^t
- numerical roots, 639, 639–640^r
- organic compounds, 76, 76^r, 639, 639–640^r
- oxoanions, 72, 72^f
- Roman numerals for metal ions, 70, 71^t
- transuranium elements, 1092, 1092^t
- Nonane, 76^r, 641^f
- Non-a- (prefix), 73^t
- Nonbonding MOs, 462, G-11
- Nonelectrolytes
colligative properties of, 557, 557^f, 558–566
- defined, 150, G-11
- non-conductivity of, 557, 557^f
- nonvolatile solutions, 558–563
- volatile solutions, 564
- Nonmetal hydrides, acid strength of, 816, 816^f
- Nonmetals
comparison with metals, 370–371
- covalent bonding in, 181, 370, 370^r
- covalent radius for, 345, 345^f
- defined, G-11
- electron affinity of, 352
- electronegativity of, 390, 394
- examples of, 63^f
- as insulators, 506
- ionic bonding in, 181, 370, 370^r
- ionization energy of, 352
- Lewis electron-dot symbols for, 371
- oxides of, 355
- oxoacids, esters, and amides of, 666, 666^f
- in periodic table, 62, 62^r
- properties of, 62, 353
- Non- (numerical root), 639^t
- Nonpolar covalent bonds, 392, 392^f, G-11
- Nonrechargeable batteries, 968–969
- Nonstandard half-cell potentials, 977–978
- Nonvolatile nonelectrolyte solutions, 558–563
- Northern lights, 53, 53^{mn}
- n-type semiconductors, 508–509, 508^f
- Nuclear atom model, 52–55
- Nuclear binding energy, 1102–1104, 1104^f, G-11
- Nuclear charge, effect on sublevel energy, 333, 333^f
- Nuclear energy, 284. *See also* Nuclear fission; Nuclear fusion
- Nuclear energy reactors, 1106–1109, 1107^f
- Nuclear equations, 1078

Nuclear fission

atomic bomb, 1106, 1106f, 1106n
binding energy per nucleon and, 1104, 1104f
chain reactions and, 1105–1106, 1106f
defined, 1101, G-7
energy from, 284
nuclear energy reactors, 1106–1109, 1107f
process of, 1105–1109

Nuclear fuel, 237

Nuclear fusion

binding energy per nucleon and, 1104, 1104f
defined, 1101, G-7
energy from, 284
promise of, 1109

Nuclear magnetic resonance (NMR) spectroscopy, 649–650, G-11

Nuclear reactions, 1072–1110

atomic bomb, 1106, 1106f, 1106n
balancing, 1078
chain reactions and, 1105–1106, 1106f
comparison with chemical reactions, 1074, 1074r
effects on matter, 1093–1095
fission (*See* Nuclear fission)
fusion (*See* Nuclear fusion)
mass difference in, 1102
nuclear binding energy in, 1102–1104, 1104f
nuclear energy reactors, 1106–1109, 1107f
nuclear stability, 1079–1082, 1079f, 1080f
radioactive decay and (*See* Radioactive decay)
transuranium elements and, 1092, 1092r, 1105

Nuclear stability, 1079–1082, 1079f, 1080f

Nuclear transmutation, 1090–1092, 1092t, G-11

Nuclear waste disposal, 1108–1109

Nucleic acids, 542–543, 674–680, G-11. *See also* DNA (deoxyribonucleic acid); RNA (ribonucleic acid)

Nucleons

binding energy per, 1102–1104, 1104f
defined, 1074, G-11
energy levels of, 1080

Nucleoside triphosphates, 675, 675f, 679, 679f

Nucleotides, 674–675, 679, 680

Nucleus

components of, 55–56, 56f, 56t, 1074
defined, 55, G-11
discovery of, 54–55, 54f
notation for, 1074
size of, 55, 55mn, 1074mn
strong force and, 1080

Nuclide

defined, 1074, G-11
notation for, 1074
parent and daughter, 1075
predicting mode of decay, 1081–1082
stability of, 1079–1082, 1079f, 1080f

Number, amount-mass-number conversions, 151–152, 151f, 162f

Nutrient turnover in lakes, 492

Nylons, 669–670, 670f

Nylon-66, 80t, 669–670, 670f

O

-oate (suffix), 655t, 663

Observations, 12, 13f, G-11

Occurrence of elements, 1000–1001, 1002f, 1008t, G-11

Oceans, 1000, 1003, 1003f

Octadecanoic acid, 662f

Octahedral arrangement

of complex ions, 1047, 1047t

defined, 422, G-11

hybrid orbitals and, 448, 449f, 449t

VSEPR theory and, 418f, 422–424f

Octahedral complexes

in coordination compounds, 1053, 1053f
in crystal field theory, 1057–1058

hemoglobin, 1063

valence bond theory and, 1055, 1055f

Octane

boiling point of, 641f

combustion of, 114–115, 263, 263f, 915–916

formula and model, 76t

in hexane, 548, 548f

intermolecular forces, 534f

solubility of, 150

Octa- (prefix), 73t

Octet rule

defined, 372, G-11
exceptions to, 413–417
for Lewis structures, 405–409

Oct- (numerical root), 639t

Odd-electron atoms, 414

Odor

molecular shape and, 431, 431f
of organic compounds, 664, 664mn

Oganesson, 1092

-oic acid (suffix), 655t, 662, 664

Oil, solubility of, 535

Olfaction, 431, 431f

-ol (suffix), 654, 655t

-one (suffix), 655t, 660

o- (ortho), 648

Open-end manometers, 208, 209f

Optical isomers, 642–644, 1053–1054, 1053f, G-11

Optically active substances, 643, 643f, G-11

Orbital diagrams, 335–337, 336f, 338f, 338t, 340t, G-11

Orbital overlap

features of, 443–444, 443f

molecular rotation and, 455, 455f

in single and multiple bonds, 451–454

Ores, 1001–1002, 1002mn, 1008–1009, G-11

Organic chemistry, 63, 633

Organic compounds, 632–681. *See also* Organic molecules;

Organic reactions

alcohols, 654, 654f, 655t, 656

aldehydes, 655t, 660–661, 660f

alkanes (*See* Alkanes)

alkenes, 644–646, 645t, 646f, 655t, 659–660

alkynes, 646, 655t, 666

amides, 655t, 662, 664–665, 664f

amines, 655t, 657–658, 657f

aromatic compounds, 647–648, 648f, 659–660, 660f

carbon and, 602, 602f

carbonyl group, 660–661

carboxylic acids, 655t, 662–663, 662f

chemical diversity of, 634–635, 635f

combustion analysis of, 108–109, 108f

defined, 633, G-11

esters, 655t, 662, 663–664, 663f, 664mn

haloalkanes, 655t, 656–657, 657f

hydrocarbons (*See* Hydrocarbons)

ketones, 655t, 660–661, 660f

naming, 639, 639–640, 646–648

nitriles, 655t, 666

odor of, 664, 664mn

organic synthesis, 661

organometallic compounds, 661

vital force of, 633

Organic molecules. *See also* Organic compounds

bond properties of, 634

chemical diversity of, 634–635, 635f

electron configuration, 634

functional groups of (*See* Functional groups)

heteroatoms, 635, 635f

molecular stability of, 634

reactivity of, 635

structural complexity of, 634

Organic reactions

addition reactions, 651, 660, 668

alkyl group, 651

elimination reactions, 651–652

predicting sequence of, 661–662

redox process in, 653–654

substitution reactions, 652, 660

types of, 651–653

Organic synthesis, 661

Organisms, reaction sequences in, 121

Organometallic compounds, 661, G-11

Orientation probability factor, 718

Orthosilicate grouping, 603

Osmium, 1042

Osmosis

defined, 562, G-11

reverse, 571, 571f

Osmotic pressure, 562, 562f, 567, 567f, 571, G-11

Ostwald process, 609, 1005

-ous (suffix), 70, 74

Outer electrons, 342, 350, G-11

Outgassing, 999, 1000

Overall (net) equation, 120–121, 121f, G-11

Overtoltage, 978, G-12

Oxalate ions, 179, 179f

Oxalates, A-13

Oxalic acid, 814t, A-10

Oxidation. *See also* Redox reactions

with active metal, 1011

of alcohols, 656

of carbon, 920

defined, 175, 939–940, 940f, G-12

in early Earth atmosphere, 1000

of glucose, 911

half-reactions, 944

as increase in oxidation number, 177

of organic molecules, 653–654

Oxidation half-cells, 944, 946

Oxidation number

defined, 176, G-12

determining, 177

electronegativity and, 392, 412

formal charge vs., 412

identifying redox reactions and oxidizing and reducing agents, 177–178

of main-group elements, 354, 354f

rules for assigning, 176, 176t

Oxidation-reduction reactions. *See* Redox reactionsOxidation state. *See also* Oxidation number

alkali metals and, 591

alkaline earth metals and, 594

boron family elements, 596, 597

carbon family elements and, 599, 601

color and, 1059, 1059f

coordination compound and, 1050

of halogens, 618, 620–622

nitrogen family elements, 605, 606–607

noble gases, 623

of oxygen family elements, 613–615

of transition elements, 1042, 1042–1043t

Oxide acidity, 1042–1043

Oxide ions, 69t

Oxides

acid-base behavior of, 354–355, 354f

alkali metals, 591

alkaline earth metal, 593, 594

boron family elements, 596, 597

carbon, 603

carbonates converted to, 1010

combination reactions and, 182

halogen, 621–622

nitrogen, 608–609, 608t

nitrogen family elements, 606–607

phosphorus, 610, 610f

properties of, 615

sources of elements, 1001, 1002f

sulfur, 615

Oxide superconductors, 506, 512, 513

Oxidizing agents

in combination reactions, 181

defined, 176, 940, G-12

halogens, 617–619, 619f, 621–622

identifying, 177–178

loss or gain of electrons and, 354

in metal displacement reactions, 184

in redox titration, 179

relative strengths of, 953–957

Oxoacids

acid strength of, 816–817, 817f

bonds in, 659

formation of, 605

halogen, 621–622, 622f

inorganic, 666

names, 74

nitrogen, 609–610, 609f

nitrogen family elements, 605

phosphorus, 610–611

strength of, 797

sulfur, 615–616

Oxoanions

defined, G-12

halogen, 621–622

naming, 72, 72f

nitrogen, 609–610, 609f

phosphorus, 610–611

of transition elements, 1042f

Oxygen

abundance of, 998t, 999, 1000–1001, 1001t

allotropes of, 612

- atmospheric, 1000, 1000f
 boiling point of, 537t
 chemistry of, 615
 in combustion reactions, 186
 critical temperature of, 480
 density of, 24t
 diatomic molecules of, 44, 460f, 461
 diffusion from lungs to blood, 238
 dissolution in water, 904
 electron configuration, 337, 338f
 formation of carbon dioxide and water from, 8mn
 ionization energy, 351t
 Lavoisier's naming of, 11
 molar mass of, 97
 mole fraction in air at sea level, 239t
 nitric oxide and, 703–704, 703t, 724–726, 727f
 oxidation number for, 176t
 paramagnetic properties of diatomic oxygen, 460f, 461
 properties of, 589t, 612–615
 solubility in water, 537, 537t, 550
 standard enthalpies of formation, 278t
 standard state of, 278
 thermal decomposition of potassium chlorate, 183
 uptake by muscle at high altitude, 226–227
- Oxygen family elements
 allotropes of, 612, 614
 comparison with nitrogen family, 612, 614–615
 in periodic table, 63
 properties of, 612–616
 reactivity of, 613
- Oxyhemoglobin, 1063, 1063f
- Ozone
 breakdown of, 722, 732, 732f
 decomposition of, 612
 depletion of, 732, 732f
 as disinfectant, 570
 ethylene and, 694–696
 formal charge and, 411, 412
 formation of, 240
 hybrid orbitals and, 446
 Lewis structures of, 409–410
 molecular orbitals of, 463, 463f
 mole fraction of air at sea level, 239t
 nitric oxide and, 692, 693, 693f, 699, 700
 nitrogen fixation and, 1005
 resonance structures of, 410–412
 stratospheric, 239f, 240, 612, 732
- P**
- Packing efficiency of unit cells, 496–498, 497f, G-12
- Pairing energy, 1060
- Palladium, 343, 538
- Paracelsus, 11
- Paramagnetism
 defined, 357, 358f, G-12
 homonuclear diatomic molecules and, 460–461, 460f
 predicting, 358–359
 of transition elements, 1037, 1044
- Partial bonding, 410, 411
- Partial ionic character, 392, 393f, G-12
- Partial pressure
 Dalton's law of, 225–227, 231, 233, 233f, 239
 defined, G-12
 of gas in mixture of gas, 225–227
- Particle accelerators, 1091–1092, G-12
- Particle nature of light, 299–301, 300f
- Particle nature of photons, 312
- Particles
 dispersal of energy, 897
 freedom of motion, 897
 uncertainty principle and, 313
 wave behavior compared to behavior of, 299, 299f
 wave-particle duality, 312, 312f
- Particle volume, gas pressure and, 243, 243f
- Parts by mass, 553t, 554, 555
- Parts by volume, 553t, 554, 555
- Parts per billion, 554
- Parts per million, 554
- Pascal (Pa), 209, 209t, G-12
- Path independence of energy change, 262–263, 263f
- Pauli, Wolfgang, 333
- Pauli exclusion principle, 333, 443
- Pauling, Linus, 390, 444
- Pauling electronegativity scale, 390, 391f
- p-block, 460–461, 460f, 595
- PCBs (polychlorinated biphenyls), 602, 602f, 657, 657f
- PEM (proton exchange membrane), 971, 971f
- Penetration, 334, 334f, 339, G-12
- Pentane
 boiling point of, 641f, 642t
 constitutional isomers of, 642, 642t
 formula and model, 76t, 642t
 molecular shape of, 487, 487f
 properties of, 641, 641f
- Pentanol, 536t
- Pentanone, 660
- Penta- (prefix), 72, 73t
- Pent (numerical root), 639t
- Peptide bonds, 539, 539f, 540, 664, 673
- Percent by mass (mass percent, mass %), 47–48, 48f, G-12
- Percent ionic character, 393, 393f
- Percent yield (% yield), 128–129, G-12
- Perchlorate ions, 72t
- Perchlorates, 106, 621–622
- Perhalates, 621–622, 622t
- Perhalic acid, 622t
- Period 1 elements, 335–336, 338f, 341f
- Period 2 elements
 electron configuration of, 336, 336f, 338f, 341f
 homonuclear diatomic molecules, 458–462
 properties of, 587–590
- Period 3 elements, 338, 338t, 341t
- Period 4 elements, 339–340, 340t, 341f
- Periodic law, 331, G-12
- Periodic table of the elements. *See also specific elements and groups*
 atomic number organization of, 61, 331
 atomic properties and, 345–352
 chemical reactivity and, 338, 343f
 comparison of metals and nonmetals, 370–371
 defined, G-12
 electron configuration and, 335–345, 335f, 341f, 356–357
 filling order, 341–342, 341f
 groups, 342, 343
 history and development of, 61, 331
 inner transition elements, 61, 62f, 1038, 1038f
 lattice energy and, 375–376, 375f
 molar mass and, 96–97, 97n
 organization of, 61–63, 62f
 Pauling electronegativity scale and, 391f
 Period 1, 335–336, 338f, 341f
 Period 2, 336, 336f, 338f, 341f, 587–590
 Period 3, 338, 338t, 341t
 Period 4, 339–340, 340t, 341f
 period number, 342
 quantum-mechanical model and, 335–345
 transition elements, 339–340, 340t, 341f, 342–343, 1038, 1038f
- Periodic trends
 acid strength, 816, 816f
 in atomic size, 345–346f, 345–347, 348f, 352f
 covalent and van der Waals radii, 482, 482f
 in electron affinity, 351–352, 352f
 entropy and, 904
 gradation of bonding across periods, 394
 in heat of hydration, 545, 545t
 in ionic size, 359–360, 360f
 in ionization energies, 348–350, 349f, 351t, 352f
 in lattice energy, 375–376, 375f
 in metallic behavior, 353–354f, 353–355
 Period 2 elements, 587–590
- Periods, 61, G-12. *See also* Periodic trends
- Permalloy, 1013t
- Permanganate ions, 72t, 179, 179f, 942–943
- Peroxide ions, 72t
- Per- (prefix), 72, 72f, 74
- Perspective drawings, 420
- Pesticides, 611
- PET (positron-emission tomography), 1078, 1100, 1100f
- Petroleum, 281, 567, 567f
- pH
 acid-base equilibria and, 800–803, 800f, 802f
 buffer capacity and change in, 849, 849f
 calculation of, 801–803, 856, 860–861
 of common aqueous solutions, 800f
 defined, 800, G-12
 determination from base-dissociation constant, 818–820
- measurement of, 803, 803f, 966–967, 967f
 monitoring with acid-base indicators, 860–862
 pH meters, 803, 803f, 967, 967f
 relation with pOH and pK_w, 801, 801t
 scale, 800, 800f
 solubility and, 869–870
- Phase, defined, 469, G-12
- Phase changes
 boiling, 479
 condensation, 471, 474, 476–477, 476f
 critical point in, 480, 480f
 defined, 470, G-12
 deposition, 471, 471f
 diagrams of, 480–481, 480f
 entropy change and, 547, 898–899
 equilibrium nature of, 476–479
 freedom of particle motion and dispersal of particle energy in, 897
 freezing, 474
 heat involved in, 473–476
 kinetic-molecular view of, 470, 470r, 473–474
 liquid-gas equilibria in, 476–478, 476f
 melting, 471, 479
 quantitative aspects of, 472–481
 solid-gas equilibria, 479
 solid-liquid equilibria, 479
 standard molar entropy and, 902–903, 903f
 sublimation, 471, 479, 479f
 temperature and, 470–471, 474
 triple point in, 480, 480f, 481
 types of, 470–472
 vaporization, 471, 471–472f, 476–478, 476f
 vapor pressure and, 476–478f, 477–479
- Phase diagrams
 of boiling and freezing points of solvent and solution, 559, 560f
 carbon, 481, 600f
 carbon dioxide, 480, 480f
 defined, 480, G-12
 water, 480–481, 480f
- Phenol, 801t, A-10
- Phenolphthalein, 173, 860–862
- Phenol red, 861f
- Phenylacetic acid, 809–810, 809mn, A-10
- Phenylalanine, 672f
- Phenylketonuria, 809
- Pheromones, 554
- Phlogiston theory, 11
- pH meters, 803, 803f, 967, 967f
- Phosgene, 224, 766–768
- Phosphate fertilizers, 1007–1008
- Phosphate ions, 72t, 611
- Phosphates
 element cycling, 1005–1008, 1006f
 polyphosphates, 611, 611f
 solubility-product constant for, A-13
 sources of elements, 1002f
 uses of, 611
- Phosphite ions, 610
- Phosphodiester bonds, 675, 676f
- Phospholipids, 542, 542f
- Phosphor, 1083
- Phosphoric acid, 607, 610–611, 813, 814t, A-10
- Phosphorous acid, 610, A-10
- Phosphorus
 abundance of, 1001t
 allotropes of, 606, 606f
 bond type, 598t
 chemistry of, 610–611
 as doped semiconductor, 508, 508f
 electron configuration, 338t, 339
 industrial uses of, 1007–1008, 1007f
 melting point of, 598t
 produced from calcium phosphate, 1010
 properties of, 353, 354, 604–607
 radioisotope of, 1090
 sulfides and nitrides, 611
- Phosphorus cycle, 1005–1008, 1006f
- Phosphorus decoxide, 354, 354f
- Phosphorus pentachloride, 414–415, 422, 448, 448f
- Phosphorus trichloride, 181
- Photochemical smog, 609, 609mn
- Photoelectric effect, 301, 301f, 1083, G-12
- Photoelectrochemical approach, 283
- Photomultiplier tubes, 1083

- Photons
defined, 301, G-12
emission of, 304, 304*f*
energy of, 304
particle nature of, 312
ping-pong analogy for, 301*mn*
- Photon theory of light, 301
- Photosynthesis, 261, 1000, 1003, 1098
- Photovoltaic cells, 284, G-12
- Photovoltaic thermal (PVT) hybrid cells, 284
- pH paper, 803, 803*f*
- pH scale, 800, 800*f*
- Physical changes
comparison with chemical changes, 5, 5*f*, 6, 7–8
defined, 5, G-12
on Io (Jupiter's moon), 7
reversal of, 7
temperature and, 6–7
- Physical properties
of alkali metals, 591
alkaline earth metals, 593, 594
bonding, impact on, 598, 600–601
of carbon family elements, 598–601
defined, 5, G-12
of halogens, 617, 617*f*, 618
of nitrogen family elements, 605–606
of noble gases, 622–624
of oxygen family elements, 612–614
of Period 2 elements, 587–590
of transition elements, 1040–1041*f*, 1040–1042
- Physical states
characteristics of, 4, 4*f*, 205–207, 206*f*
kinetic-molecular view of, 470, 470*t*
reaction rate and, 693
- Pi bond, 452–454, 453*f*, 455, 455*f*, 644, G-12
- Picometers (pm), 296
- Pico- (prefix), 14*t*
- Pig iron, 1017
- Pi MOs, 458–460, G-12
- Piperidine, A-11
- Pipets, 15, 16*f*
- Piston-cylinder assembly, 214–215, 221–222, 774
- Pitchblende, 48–49, 1075
- Planck, Max, 300
- Planck's constant, 300, G-12
- Plasma, fusion of, 1109, 1109*f*
- Plastics, 517, 619, G-12
- Platinum
density of, 1042
as electrode, 947
electron configuration, 343
sources of, 1001
- Pleated sheet structure, 673*f*, 674
- Plum-pudding model of atoms, 54
- Plutonium, 1093
- p-n junction, 508–509, 508*f*
- pOH, 801–802, 802*f*
- Polar arrow, 146, 392
- Polar bonds, 146
- Polar covalent bonds, 390, 390*f*, 392, 393*f*, G-12
- Polarimeter, 643, 643*f*, G-12
- Polarity, 539–540. *See also* Molecular polarity
- Polarizability, 486, G-12
- Polar molecules
defined, G-12
dipole-dipole forces and, 483, 483*f*
water as, 146
- Pollution
air (*See* Air pollution)
phosphates and, 1008
thermal, 550, 551*f*, 1108–1109
- Polonium
decay of, 1078
discovery of, 1075
properties of, 612–615
radioactive poison from, 1094
- Polyamides, 669–670, 670*f*
- Polyatomic ions
compounds containing, 71–73
defined, 67, G-12
hydrates, 72, 73*t*
Lewis structures for, 406, 407
oxoanions, 72, 72*f*
- Polyatomic molecules, 463, 463*f*
- Polyybutadiene, 518*t*
- Polychlorinated biphenyls (PCBs), 602, 602*f*, 657, 657*f*
- Polychloroprene, 518*t*
- Polychromatic light, 296
- Polydentate ligands, 1047, 1048*r*
- Poly(dimethyl siloxane), 518*t*, 604
- Polyesters, 670
- Polyethylene, 514–516, 514*t*, 515*f*, 518, 668, 669*t*
- Polyisoprene, 518*t*
- Polymer glass, 517
- Polymeric viscosity improvers, 491
- Polymers
addition polymers, 668, 668*f*, 668*t*
biopolymers, 514
branches of, 517–518
chain dimensions, 514–516
condensation polymers, 669–670, 670*f*
copolymers, 518, 669
crosslinks, 518
crystallinity of, 516, 516*f*
defined, 514, G-12
degree of polymerization, 514, 514*t*
dendrimers, 518
dissolved, 516–517
elastomers, 518, 518*t*
homopolymers, 518
inorganic, 670
liquid crystal and, 511
molar mass of, 514, 514*t*
monomers, 514
naming, 668
nucleic acids, 542–543, 674–680
plasticity of, 517
proteins (*See* Proteins)
pure, 517
radius of gyration, 515–516, 515*n*
random coil, 515, 515*f*
silicone, 604
synthetic, 668–670
thermoplastic, 518
thermoset, 518, 518*mn*
viscosity of, 516–517, 517*f*
- Polyphosphates, 611, 611*f*
- Polyphosphazene, 611, 670
- Poly- (prefix), 668
- Polypropylenes, 668, 669*t*
- Polyprotic acids
acid-base titration curves for, 862–863, 863*f*
acid-dissociation constant for, 813, 814*t*
amino acids as, 863
calculating equilibrium concentrations for, 814–815
defined, 813, G-12
- Polysaccharides, 671–672, 671*mn*, G-12
- Polystyrene, 223–224, 668, 669*t*
- Poly sulfanes, 650
- Poly(vinylchloride) (PVC), 619, 668, 669*t*
- p* orbitals
defined, G-12
molecular orbitals from, 458–459*f*, 458–460
orbital overlap and, 443*f*, 444
quantum mechanics and, 319–321, 320*f*, 322*t*
- Porphin, 1063
- Positron emission, 1076*r*, 1077, 1094, G-12
- Positron-emission tomography (PET), 1078, 1100, 1100*f*
- Positrons, 1077, 1094, G-12
- Potassium
abundance of, 1000, 1001*t*
distribution of, 1000
effective nuclear charge of, 334, 334*t*
electron configuration, 339, 340*r*, 344, 356
industrial production of, 1014
properties of, 590–592, 592*mn*
radioactive, 1096
reaction with chlorine gas, 230, 230*mn*
reactivity, 343*f*
soaps, 541
uses of, 1015
- Potassium bromide, 148, 159, 979, 979*mn*
- Potassium carbonate, 169
- Potassium chlorate, 183, 913–914
- Potassium chloride, 181, 182*f*
- Potassium dichromate, 653, 656
- Potassium ethoxide, 656
- Potassium ferricyanide, 1043*t*
- Potassium hydrogen sulfite, 826
- Potassium hydroxide, 171
- Potassium ions, 69, 967
- Potassium nitrate, 158
- Potassium sulfate, 148–149
- Potassium sulfide, 97
- Potassium superoxide, 1015, 1015*mn*
- Potential energy
bonding and, 369, 379, 381
in chemical reactions, 386
conversion to kinetic energy, 9–10, 9*f*, 257
defined, 8, G-12
intermolecular forces as, 469
- Pounds per square inch (lb/in² or psi), 209*t*
- p-(para), 648
- Prechemical traditions, 10–11, 10*f*
- Precipitates
complex ions and solubility of, 879–881
defined, 157, G-12
predicting formation of, 871–873, 871*mn*
- Precipitation, selective, 874–875
- Precipitation reactions, 157–164
in aqueous ionic reactions, 157–161, 158*f*
defined, 157, G-12
key events in, 157
metathesis reactions, 159
molecular depictions in, 160–161
predicting, 159–160, 159*t*
reversibility of, 190
stoichiometry of, 162–164
- Precipitator, Cottrell, 569
- Precision, 32–33, 33*f*, G-12
- Prefixes
acids, 74
alkanes, 76
coordination compounds, 1050
decimal, 14, 14*n*, 14*r*
hydrates, 72, 73*t*
numerical, 72, 73*t*
organic compound, 639, 639–640*t*
oxoanions, 72, 72*f*
for units of mass, 17, 17*n*
- Pressure
Amontons's law and, 213
amount and, 218–219
atmospheric, 207–208*f*, 207–209, 209*t*, 239, 239*f*
Boyle's law and, 211–212, 211*f*, 217–218
critical, 480
defined, 207, G-12
effect of change on equilibrium, 773–775, 774*f*, 777*t*
equilibrium constant based on, 756–757
extreme, 241–243, 242*f*
gases and, 206, 207–210, 218, 239, 241–243, 242*f*
origin of, 231, 232
pressure-volume work, 263–264, 264*f*
solubility and, 551–552, 551*f*
temperature and, 213–214, 218
units of, 209–210, 209*t*
volume and, 206, 211–212, 211*f*, 217–218
- Pressure-volume work (PV work), 263–264, 264*f*, G-12
- Primary batteries, 968–969
- Primary structure of proteins, 673, 673*f*
- Principal energy level, 335
- Principal quantum number, 316, 317, 317*t*, 332*t*, G-12
- Prisms, 298, 302
- Probability contour, 315, 315*f*, 320–321*f*, G-12
- Probability density, 314–315, 315*f*, 319, 320*f*
- Problem solving
conversion factors in, 18–23
dilution problems, 153–154
equilibrium and, 760–769, 770*f*
gas laws and, 217–222
systematic approach to, 19–20
weak-acid equilibria and, 808–815
- Product-favored reactions, 927, 928*f*
- Products
calculating amount of, 116–130
calculating amounts in limiting-reactant problems, 125–127
defined, 112, G-12
determining heat of reaction from heat of formation for, 279–280, 279*f*
expressing reaction rate in terms of concentration of, 696–698, 696*f*
gaseous, 227–228, 227*f*

- gas variables to find amounts of, 229–230
in precipitation reactions, 162–163
- Proline, 672*f*
- Propane
boiling point of, 484*f*, 641*f*
combustion of, 117, 117, 907
dipole moment of, 484*f*
formula and model, 76*t*, 640
- Propanoic acid
acid-dissociation constant of, 797*t*, A-10
determining concentration and pH, 810–811
titration of, 855–859, 855*f*
- Propanol, 536*t*, 653
- Propanone, 653, 655*t*, 660*f*, 661
- Properties
chemical (*See* Chemical properties)
defined, 5, G-12
of matter, 5–7, 7*t*
physical (*See* Physical properties)
- Prop- (numerical root), 639*t*
- Propylamine, A-11
- Propylenediamine, A-12
- Proteins. *See also* Amino acids
defined, 539, 672, G-12
fibrous, 674, 674*f*
globular, 674
intermolecular forces and shape of, 540–541, 540*f*
mass spectrometry studies of, 60
polarity of amino acid side chains, 539–540
structure of, 539–540*f*, 539–541, 672–673*f*, 672–674
synthesis of, 677–678, 677*f*
- Protein synthesis, 677–678, 677*f*
- Protium, 1024*t*
- Proton acceptors, 803, G-12
- Proton donors, 803, G-12
- Proton exchange membrane (PEM), 971, 971*f*
- Protons
atomic number and, 56
charge of, 55, 56*f*, 56*t*
defined, 55, G-12
discovery of, 55
in Large Hadron Collider, 1091–1092
in linear accelerator, 1091, 1091*f*
mass of, 56*t*
nuclide and, 1074
properties of, 56*t*
solvated, 165
transfer in acid-base reactions, 168–171, 169*f*
- Proton transfer, in Brønsted-Lowry acid-base definition, 803–808
- p-scale, 800, 801
- Pseudo-noble gas configuration, 355–356, G-12
- p-type semiconductors, 508–509, 508*f*
- Purines, 675
- PVC, 619, 668, 669*t*
- PVT (photovoltaic thermal) hybrid cells, 284
- PV work (pressure-volume work), 263–264, 264*f*, G-12
- Pyridine, 819*t*, 820, A-12
- Pyrimidines, 675
- Pyrite, 1016*t*
- Pyrometallurgy, 1008
- Pyrhotite, 1016*t*
- Pyruvic acid, A-10
- Q**
- Quadratic formula, 765, A-3
- Quantitative theories of chemistry, 12
- Quantum, 300, G-13
- Quantum dots, 284, 519, 519*f*
- Quantum mechanics
atomic orbital (wave function), 314–322
defined, 314, G-13
electron cloud depictions and, 315, 319, 320–321*f*
electron density diagram and, 315, 315*f*
energy levels in hydrogen atoms and, 322, 322*f*
level (shell), 317
molecular orbital model and, 455
nodes and, 319
orbital overlap and, 443
periodic table and, 335–345
probability contour and, 315, 315*f*, 320–321*f*
radial probability distribution plot and, 315,
315*f*, 315*mn*
- Schrödinger equation and, 314, 314*n*
sublevel (subshell), 317–318
- Quantum numbers
angular momentum, 316, 317, 317*t*, 332*t*
of atomic orbital, 316–318, 317*t*
baseball, 333*mn*
correlation with orbital diagrams, 337
defined, G-13
electron orbit and, 304
of electrons, 332, 332*t*
identifying incorrect numbers, 318–319
magnetic, 316, 317, 317*t*, 332*t*
principal, 316, 317, 317*t*, 332*t*
in quantum theory, 300
spin, 332–333, 332*f*, 332*t*
- Quantum staircase, 304, 304*f*
- Quantum theory, 299–300, 312*f*
- Quartz
covalent bonding in, 383, 383*f*
crystal structure of, 493*f*, 504, 504*f*, 604, 604*f*
- Quaternary structure of proteins, 673*f*, 674
- R**
- Racemic mixtures, 643
- Radial probability distribution plot
defined, G-13
d orbital and, 321*f*
order of filling and, 339
p orbital and, 320*f*
quantum mechanics and, 315, 315*f*, 315*mn*
s orbital and, 319, 320*f*
sublevel energy and, 334, 334*f*
- Radiant energy, 295–297
- Radiation
applications of, 1100–1101
background, 1095–1096
background radiation, 1096
blackbody, 299–300, 300*f*, 300*n*
cosmic, 1088, 1095
counters for detection of, 1083–1084, 1084*f*
effects on matter, 1093–1095
electromagnetic, 295–297
free radical formation and, 1095
infrared, 296, 297*f*
intensity of, 296
ionizing (*See* Ionizing radiation)
penetrating power of, 1094–1095, 1094*f*
risk from, 1096–1097, 1097*f*, 1097*t*
sources of, 1095–1096, 1096*t*
ultraviolet (*See* Ultraviolet radiation)
units of radiation dose, 1093–1094
- Radiation-absorbed dose (rad), 1094, G-13
- Radiation therapy, 1100
- Radioactive decay
decay series, 1082, 1082*f*
as first-order process, 711
half-life of, 1086, 1086*f*, 1086*t*
kinetics of, 1083–1090
nuclear equations for, 1078
nuclear stability and, 1079–1082, 1079*f*, 1080*t*
predicting mode of, 1081–1082
radioisotopic dating, 1087–1089, 1089*f*
rate of, 1084–1087, 1086*f*, 1086*t*
types of, 1075–1078, 1076*t*
- Radioactive emissions
alpha particles (*See* Alpha particles)
behavior in electric field, 1075, 1075*f*
beta particles (*See* Beta particles)
detection of, 1083–1084, 1084*f*
gamma rays (*See* Gamma rays)
ionization of, 1093–1097
penetrating power of, 1094–1095, 1094*f*
positron emission, 1076*n*, 1076*t*, 1077, 1094
- Radioactive tracers, 1098–1100, 1099*t*, 1100*f*
- Radioactivity. *See also* Nuclear reactions
of actinides, 1045
defined, 1073, G-13
detection and measurement of, 1083–1084, 1084*f*
discovery of, 1075
- Radiocarbon dating, 1087–1089, 1088*n*, 1089*f*
- Radioisotope heater unit (RHU), 1101
- Radioisotopes
applications of, 1098–1101
artificial, 1090
dating, 1087–1089, 1089*f*
defined, 1087, G-13
ionizing radiation and, 1100–1101
- tracers, 1098–1100, 1099*t*, 1100*f*
- Radioisotopic dating, 1087–1089, 1089*f*, G-13
- Radium
discovery of, 1075
in paint, 1094
properties of, 593–594
radioactive decay, 1077
Rutherford's experiment and, 54
- Radius
atomic (*See* Atomic radius)
covalent, 345, 345*f*, 381*f*, 482, 482*f*
of gyration, 515–516, 515*n*, G-13
ionic (*See* Ionic radius)
van der Waals, 482, 482*f*
- Radon, 622–624, 1095–1096, 1096*f*, 1096*t*
- Rad (radiation-absorbed dose), 1094, G-13
- Rainbows, 298, 298*mn*
- Random coil, 515, 515*f*, G-13
- Random error, 32–33, 33*f*, G-13
- Raoult's law, 558–559, 564, G-13
- Rare earth elements. *See* Lanthanides
- Rate constant
defined, 698, G-13
determining, 704–706
temperature and, 715, 715*f*
units, 704, 704*t*
- Rate-determining step, 723–724, 723*mn*, G-13
- Rate law (rate equation)
collision theory and, 715–718, 717*f*
defined, 698, G-13
for elementary reactions, 722*t*
integrated, 707–714, 710*f*
rate constant and, 698, 704–706
reaction mechanisms and, 724–726, 727*f*
reaction order and, 698–707
- Rate-limiting step, 723–724
- Rate of reaction. *See* Reaction rate
- Reactant-favored reactions, 927–928, 928*f*
- Reactants
calculating amount of, 116–130
calculating amounts in limiting-reactant problems, 125–127
concentration determination after a given time, 708–709
defined, 111–112, G-13
determining heat of reaction from heat of formation for, 279–280, 279*f*
expressing reaction rate in terms of concentration of, 696–698, 696*f*
gas variables to find amounts of, 229–230
limiting, 122–127, 123*f*
in precipitation reactions, 162–163
- Reaction direction
in acid-base reactions, 805–808
equilibrium state and, 753, 757–760, 758*f*, 768–769
- Reaction energy diagrams, 719–721, 720*f*, 726,
727–728*f*, G-13
- Reaction intermediate, 723, G-13
- Reaction mechanisms
defined, 721, G-13
elementary reactions and, 721–723, 722*t*
moleculararity and, 721–723, 722*t*
rate-determining step of, 723–724
rate law and, 724–726, 727*f*
- Reaction order
changing reactant concentrations for determining, 702–703*t*, 702–704
defined, 698, G-13
first-order reactions, 699, 700, 700*f*, 704*t*, 708, 709,
710*f*, 714*t*
fractional, 701
integrated rate law in determination of, 709–710, 710*f*
molecular scale problems for determining, 706–707
negative, 701
rate constant and, 704, 704*t*
rate data for determining, 705–706
rate law and, 698–707
rate laws for determining, 701
second-order reactions, 699, 700, 700*f*, 704*t*, 708,
709–710, 710*f*, 714*t*
third-order reactions, 704, 704*t*
zero-order reactions, 699, 700, 700*f*, 704*t*, 708, 710,
710*f*, 714*t*

- Reaction quotient
 from balanced equation, 751, 752–753
 based on concentrations, 751
 changing value of, 750–751, 750r, 751f
 defined, 750, G-13
 for equation multiplied by a common factor, 754
 equilibrium constant and, 750–755, 922–923, 922t
 law of mass action and, 750
 for overall reaction, 754–755
 reaction direction and, 753, 757–760, 758f
 for reaction involving pure liquids or solids, 752
 as unitless number, 751
 variations in form, 752–755, 755t
 writing, 751–755, 755t
- Reaction rate, 691–699
 average, 695
 catalysis and, 727–731
 collision energy and, 693, 693f, 716–717, 716f, 717t
 concentration and, 692, 696–698, 696f
 conductometric methods for measuring, 699
 defined, 691, 692f, G-13
 expressing, 694–698
 initial, 696, 699
 instantaneous, 695
 manometric methods of determining, 699
 measurement of, 699
 molecular structure and, 718, 718f
 physical state and, 693
 range of, 691, 692f
 spectrometric methods of determining, 699
 surface area and, 693, 693f
 temperature and, 693, 715, 715f, 717t
 terminology, 698
- Reactions. *See* Chemical reactions; Nuclear reactions;
 Organic reactions
- Reaction tables, 122–123, 761–762
- Reactivity. *See also* Chemical reactions
 alkali metals, 230, 343f, 591, 592, 592mn
 alkaline earth metals, 594
 carbon family elements, 599
 halogens, 230, 343f, 617–619
 nitrogen family elements, 605, 606–607
 noble gases, 624
 organic molecules, 635
 oxygen family elements, 613
 Reactor core, 1106–1107, 1107f, G-13
- Real gases
 extreme conditions and, 241–243, 242f
 interparticle attractions and, 241–243, 242f
 particle volume and, 243, 243f
 van der Waals equation and constant, 243–244, 243t
- Receptors, biological, 431
- Receptor sites, 431, 431f
- Rechargeable batteries, 969–970
- Rectifiers, 508
- Recycling, 1021, 1021mn
- Red blood cells, 863, 863f
- Redox behavior of main-group elements, 354
- Redox couple, 982
- Redox reactions, 174–188
 in acidic solutions, 941–942
 activity series of metals and, 958–959
 balancing, 940–943
 in basic solutions, 942
 combination reactions, 181–182, 182f
 combustion reactions, 186–187
 decomposition reactions, 182–183, 183f
 defined, 174, G-12
 displacement reactions, 184–185f, 184–186
 electrochemical, 1011, 1022
 electrolytic cells in, 944, 944f
 elements in, 181–188
 half-reaction method for balancing, 940–943
 identifying, 177–178, 187–188
 key events in, 174–175, 175f
 in metallurgy, 1010–1011, 1012f
 movement of electrons between reactants in, 174–175, 175f
 organic reactions and, 653–654
 oxidation in, 175, 177
 oxidation numbers to monitor electron change, 176–179, 176f
- oxidizing agents in (*See* Oxidizing agents)
 redox titrations, 179–180, 179f
 reducing agents in (*See* Reducing agents)
 reduction in, 175, 177
 spontaneous, 945–949, 945f, 954–957
 stoichiometry of, 179–180
 terminology, 175–176, 179f, 939–940, 940f
 voltaic cells and, 945–949, 945f
 voltaic cells in, 944, 944f
 writing spontaneous reactions by combining half-reactions, 955–957
- Redox titrations, 179–180, 179f
- Red phosphorus, 606, 606f
- Reducing agents
 alkali metals, 591, 592
 alkaline earth agents, 593, 594
 defined, 176, 940, G-13
 identifying, 177–178, 180
 loss or gain of electrons and, 354
 metals as, 181, 184
 relative strengths of, 953–957
- Reduction. *See also* Redox reactions
 in converting compounds to elements, 1010–1011
 as decrease in oxidation number, 177
 defined, 175, 940, 940f, G-13
 half-reactions, 944
 of organic molecules, 653–654, 665
- Reduction half-cells, 944, 946
- Reference electrodes, 967, 967f
- Refining elements, 1012, 1012f
- Refining petroleum, 567, 567f
- Refraction, 298, 298f, G-13
- Relativity, theory of, 310
- Relief maps. *See* Electron density relief maps
- Rem (roentgen equivalent for man), 1094, G-13
- Renewable energy, 281
- Replication of DNA, 678, 678f
- Reproducibility, 12, 32
- Resonance arrow, 410
- Resonance hybrids
 of benzene, 647, 648f
 characteristics of, 410mn
 defined, 410, G-13
 formal charges and, 411–412
- Resonance structures
 choosing more important form, 411–412
 defined, 410, G-13
 formal charge and, 411–412
 need for, 409–410
 writing, 412–413
- Respiration, 187, 215, 215f, 910, 910f, 1003
- Restricted rotation, 455, 455f
- Retinal, 645–646, 646f
- Reverse osmosis, 571, 571f, G-13
- Reversible processes, 900–901, 900f
- R group
 of amino acids, 672, 672f, 673, 674
 as general alkyl group, 651
- Rhenium, 1042
- Rhodopsin, 645
- RHU (radioisotope heater unit), 1101
- Ribonucleic acid (RNA), 675, 677–678, 677f
- Ribose, 110t, 675
- Ribosomes, 677–678, 677f
- RNA (ribonucleic acid), 675, 677–678, 677f
- Roasting, in metallurgy, 1010, 1018, G-13
- Rocket fuel, 125–127
- Roentgen equivalent for man (rem), 1094, G-13
- Roentgenium, 1092
- Rohrer, Heinrich, 500
- Roman numerals, in compound names, 70, 71t
- Root-mean-square speed, 235–236, 235n, G-13
- Roots, in organic compound naming, 639, 639–640r
- Rosenberg, Barnett, 1053
- Rounding off, 31, 32, G-13
- Rowland, F. Sherwood, 732
- r-process, 1111
- Rubber, as amorphous solid, 504
- Rubidium, 590–592, 1011
- Runners, change in position with time, 694mn
- Rusting of iron, 972–974
- Rutherford, Ernest, 54–55, 303, 1075, 1090
- Rutherfordium, 1092
- Rutherford's α -scattering experiment, 54–55, 54f
- Rydberg, Johannes, 302
- Rydberg equation, 302–303
- S**
- Sacrificial anodes, for prevention of corrosion, 974, 974f
- Salt bridges, 947, G-13
- Saltlike hydrides, 586
- Salt link, 540f, 541
- Salts
 acid-base properties of salt solutions, 823–826
 acidic solutions from, 823–824, 825t
 of amphiprotic anions, 825
 basic solutions from, 824, 825t
 corrosion and, 973, 973f
 defined, 167, G-13
 dissolution and entropy change, 903–904, 903f
 dissolution and entropy change in, 897
 electrolysis of, 976–977
 formation of, 167
 mixed molten, 976–977
 neutral solutions from, 823, 825t
 pure, 976
 solubility of, 535
 of weakly acidic cations and weakly basic anions, 824–825
- Saltwater, 45
- Samarium, 1045
- Sanger chain-termination method of DNA sequencing, 679–680, 679f
- Saponification, 664
- Saturated calomel electrodes, 967, 967f
- Saturated hydrocarbons, 639, G-13
- Saturated solutions, 549, 549f, G-13
- s block bonding, 458, 458f
- Scale deposits, 570
- Scandium
 appearance of, 1038f
 electron configuration, 339, 340t, 356–357, 1039, 1039t
 oxidation state, 1042t
- Scandium oxide, 1043f
- Scanning electron microscope (SEM), 311–312
- Scanning tunneling microscopy, 500–501, 501f, G-13
- SCF (supercritical fluid), 480
- Schrödinger, Erwin, 314
- Schrödinger equation, 314, 314n, 332, G-13
- Scientific (exponential) notation, 14, 14t, A-2–A-3
- Scientific method, 12–13, 13f, G-13
- Scintillation cocktail, 1084, 1084f
- Scintillation counter, 1083–1084, G-13
- Screening. *See* Shielding
- Scrubbers, 281, 876
- Scuba divers, decompression sickness in, 551, 551mn
- Seaborgium, 343, 1092
- Seawater, desalination of, 571
- Secondary batteries, 969–970
- Secondary structure of proteins, 673f, 674
- Second ionization energy, 348, 351t
- Second law of thermodynamics, 901, 910, G-14
- Second-order reactions
 comparison with zero- and first-order reactions, 714t
 defined, 699
 half-life of, 714
 integrated rate law and, 708, 709–710, 710f, 714t
 rate constant for, 704t
 rate law and, 699, 700, 700f
 rate vs. reactant concentration in, 700f
 reactant concentration vs. time in, 700f
- Second (s), 14t, 18, G-13
- Seesaw shape, in VSEPR theory, 422, 422f, 424f, G-14
- Selective precipitation, 874–875, G-14
- Selenium
 allotropes of, 612, 614
 electron configuration, 340t
 properties of, 612–615
- Self-assembly, 519
- Semiconductors
 band theory and, 506, 506f
 defined, 506, G-14
 doped, 507–509, 508f
 n-type, 508–509, 508f
 p-n junction, 508–509, 508f
 p-type, 508–509, 508f
- Semicrystallinity of polymers, 516
- Semimetals. *See* Metalloids

- Semipermeable membranes, 562, 571, G-14
 SEM (scanning electron microscope), 311–312
 Sense of smell (olfaction), 431, 431f
 Separation techniques, 83, 83f
 Sequestration of carbon dioxide, 283
 Serine, 540, 654f, 672f
 Sertraline, 129, 129f
 Shape. *See* Molecular shape
 Shared electron pairs, 380
 Shells, 317
 Shielding, 333–334, 334f, 339, 347, G-14
 Short tandem repeat (STR) analysis, 680, 680f
 Shroud of Turin, radiocarbon dating of, 1088, 1088nn
 Sickle cell anemia, 863, 863f
 Side chains, amino acid, 539–540, 539f, 673
 Side reactions, 128, 128f, G-14
 Siderite, 1016t
 Side-to-side overlap, 452–454
 Sievert (Sv), 1094, G-14
 Sigma (σ) bond, 452, 452–453f, 453, 455, G-14
 Sigma (σ) MOs, 456, 456f, G-14
 Significant figures, 28–32
 in arithmetic operations, 30–31
 calculator use and, 30, 31
 defined, 28, G-14
 determining number of, 28–30, 29f
 exact numbers and, 31
 measuring devices and, 31, 31f
 rounding off, 31, 32
 Silanes, 604, 650
 Silicate phase, 999, 999f
 Silicates
 in ceramics, 512
 chemistry of, 603–604
 defined, G-14
 as network covalent solids, 504
 sources of elements, 1001, 1002f
 Silicic acid, 604
 Silicon
 atomic mass of, 58
 bond type, 598t
 catenation of, 650
 chemistry of, 603–604
 diagonal relationship with boron, 604
 electron configuration, 338t, 339
 isotopes of, 57
 melting point of, 598t
 properties of, 354, 598–601
 refining, 567
 in semiconductors, 507–508, 508f
 zone refining of, 1012, 1012f
 Silicon carbide, 128–129, 512, 513, 513f
 Silicon dioxide, 355, 504, 504f, 597
 Silicone polymers, 604
 Silicones, 603, 604, 611, 670, G-14
 Silicon nitride, 512, 513
 Silk fibroin, 674, 674f
 Silver
 amount-mass conversion of, 98
 in batteries, 968–969, 969f
 in concentration cells, 966, 967, 967f
 in displacement reactions, 185, 185f, 961
 electron configuration, 357
 isotopes of, 58–59
 standard enthalpies of formation, 278t
 in voltaic cells, 948–949
 Silver bromide, 159, 880–881
 Silver carbonate, 872–873
 Silver chloride, 147, 534, 870
 Silver chromate, 155–156, 156f
 Silver ions, 69t
 Silver nitrate, 155–156, 156f
 Silver sulfide, 865, 866f
 Simple cubic unit cell, 494, 495f, 496, 497f, G-14
 Simultaneous equilibrium, 874–875
 Single bonds
 in alkanes, 639–640
 bond energy of, 382, 382t
 bond length of, 382, 382t
 bond order and, 380
 defined, G-14
 functional groups with, 654, 656–659, 662–666
- Lewis structures for molecules with, 406–408
 orbital overlap in, 451–454
 strength of, 453–454
 Single-displacement reactions, 184
 SI units
 base (fundamental), 13, 14t
 charge, 950
 current, 980
 decimal prefixes, 14, 14t
 defined, 13, G-14
 density, 23–25, 24t
 derived, 13–14
 energy, 261–262
 English equivalents, 14, 15t
 exponential notation, 14, 14t, A-2–A-3
 features of, 13–14
 length, 14–15t, 15, 17f
 mass, 14–15t, 17, 17f, 17f
 temperature, 25–27, 26f, 27t
 time, 14t, 18
 volume, 15, 15t, 16–17f
 Skou, Jens C., 967
 Slag, 1017, G-14
 Slightly soluble ionic compounds, 864–875
 common ion effect on solubility, 868–869, 868f
 ion-product expression and, 864–865
 molar solubility of, 866–867, 868t
 pH effect on solubility, 869–870
 precipitates and, 871–875, 871mn
 solubility-product constant and, 864–868, 866t, 868t, A-13
 Smectic phase, 510f, 511
 Smell, sense of, 431, 431f
 Smelting, 1010, 1011, 1018, G-14
 Smog, 224, 414, 609, 609mn
 SNG (synthetic natural gas), 281, G-15
 Snowflakes, 492, 492f
 Soaps
 defined, 541, G-14
 dual polarity of, 541, 541f
 emulsion formation, 569
 saponification and, 664
 Soddy, Frederick, 1075
 Sodium
 abundance of, 1000, 1000t
 electron configuration, 338t, 339, 355
 industrial production of, 1014, 1015f
 ionization energy, 351t
 light from vaporization of, 295
 mineral sources of, 1008t
 properties of, 44, 45t, 353, 590–592
 reactivity, 343f
 soaps, 541
 standard enthalpies of formation, 278t
 standard state of, 278
 uses of, 1015
 Sodium acetate, 549f, 824
 Sodium atoms, emission and absorption spectra of, 308, 308f
 Sodium borate, 597
 Sodium bromide, 373f
 Sodium carbonate, 793t
 Sodium chloride
 crystal structure of, 502, 502f
 as de-icer, 567
 diluting solutions of, 153–154
 dissolving, 546, 546f
 electrolysis of, 980–981
 electron density distribution, 394f
 formation of, 65, 65f
 in hexane, 548, 548f
 isotonic, 567
 properties of, 44, 45t, 394
 solubility of, 147, 534
 uses of, 567
 Sodium chromate, 155–156, 156f, 868, 868f, 1043f
 Sodium diphosphate, 611
 Sodium fluoride, 570
 Sodium formate, 851
 Sodium hydrogen carbonate, 171, 793t
 Sodium hydrogen phosphate, 151, 611
 Sodium hydroxide
 dissolving, 546, 546f, 550, 823
 in precipitation reactions, 163
- reaction with acetic acid, 170, 170t
 in titrations, 853f, 855–858
 uses of, 793t
 Sodium hypochlorite, 619
 Sodium iodide, 158
 Sodium ions, 69, 535f, 567, 570–571, 571f, 967
 Sodium nitrate, 156, 156f
 Sodium perchlorate, 106, 622
 Sodium phosphate, 793t
 Sodium stearate, 541
 Sodium sulfate, 284
 Sodium thiosulfate, 880
 Soil formation, 492
 Solar cells, 509
 Solar energy, 284
 Solar system, age of, 1088
 Solder, 1013t
 Solid foams, 568t, 569
 Solid-gas equilibria, 479
 Solid-liquid equilibria, 479
 Solids
 advanced materials, 507–520
 amorphous, 493, 504, 504f
 ceramics, 512–513, 512t, 513f
 comparison with physical states of liquids and gases, 205–207, 206f
 crystalline (*See* Crystalline solids)
 defined, 4, G-14
 density of, 24, 24t
 electronic materials, 507–509, 508f
 entropy change with dissolution, 903–904, 903f
 entropy of, 547
 kinetic-molecular view of, 470
 liquid crystals, 509–511
 molecular orbital band theory and, 504–506
 nanotechnology and, 519–520
 particle arrangement in, 4, 4f
 phase changes of, 479, 479f
 polymeric materials, 514–518, 514t, 515–517f, 518t
 properties of, 470, 470t
 semiconductors, 507–509, 508f
 solubility and temperature, 550, 550f
 structural features of, 493
 Solid-solid solutions, 538, 538f
 Sols, 568t, 569
- Solubility
 of alcohols, 535–536, 536f, 536t
 boiling point and, 537, 537t
 common ion effect on, 868–869, 868f
 comparing with K_{sp} values, 868
 complex ions, effect on, 879–881
 defined, 83, 534, G-14
 dual polarity and, 535–537
 equilibria of slightly soluble ionic compounds, 864–875
 as equilibrium process, 549–552
 gas-gas solutions and, 537–538
 gas-liquid solutions and, 537
 gas-solid solutions and, 538
 of ionic compounds, 146–149, 146f, 159t
 like-dissolves-like rule and, 534, 535, 536f, 544
 pH and, 869–870
 of precipitates, 871–875, 871mn
 pressure and, 551–552, 551f
 of proteins, 541
 solid-solid solutions and, 538, 538f
 temperature and, 549–550, 550f
 Solubility-product constant, 864–868, 866t, 868t, A-13, G-14
 Solubility rules for ionic compounds in water, 159t
 Solutes
 defined, 145, 534, G-14
 entropy change and, 903–904, 903f
 molar mass determination from colligative properties, 563
 parts of solute by parts of solution, 554–555
 vapor pressure and, 558–559, 558f
 Solution process, 544–549. *See also* Solubility; Solutions
 enthalpy change in, 544, 545–546f, 548–549, 548f
 entropy change in, 547–549
 heat of hydration and, 545–546, 545t
 heat of solution and, 544, 545–546f, 545–547

- Solutions. *See also* Solubility; Solutes; Solution process; Solvents
 acidic solutions, balancing redox reactions in, 941–942
 amount-mass-number conversions for, 151–152, 151f
 aqueous (*See* Aqueous solutions)
 basic solutions, balancing redox reactions in, 942
 boiling point elevation and, 559–560, 560f, 560t
 colligative properties of, 557–567
 concentration of, 552–557
 covalent, 150
 defined, 533
 diluting, 152–154, 153f
 electrolyte, 557, 557f, 564–566, 565f
 formation from gases, 207
 freezing point depression and, 560–561, 560t, 566–567
 gas-gas, 537–538
 gas-liquid, 537
 gas-solid, 538
 heat of, 544, 545–546f, 545–547
 ideal, 558
 intermolecular forces in, 534–535
 ionic, 146–149
 mixtures (*See Mixtures*)
 molarity of, 150
 molecular polarity and, 535–537
 nonelectrolyte, 557, 557f, 558–566
 osmotic pressure and, 562, 562f, 567, 567f, 571
 particle size and, 568
 preparing, 152–154, 152f
 salt solutions, acid-base properties of, 823–824, 825t
 saturated, 549, 549f
 solid-solid, 538, 538f
 solute molar mass from colligative properties, 563
 solution process, 544–549
 supersaturated, 549, 549f
 tonicity of, 567
 unsaturated, 549
 vapor pressure lowering and, 558–559, 558f
 water purification and, 570–571
- Solvation
 defined, 545, G-14
 of ions, 147, 157, 165, 165f
 of protons, 165
- Solvents
 defined, 145, 534, G-14
 hexane as, 535, 536, 536f, 548, 548f
 water as, 145–155, 491, 535–536, 536f, 536t, 903–904
- s* orbitals, 319, 320f, 322t, 444, G-13
- Sources of elements, 1000–1001, 1002f, 1008, 1008t
- Sour taste from acids, 793
- Space-filling models, 79, 80t, 639, 640f
- Specific heat capacity, 268, 268t, 270, 491, G-14
- Specific rotation of optical isomers, 643
- Spectator ions, 156, 159, 160, 167, G-14
- Spectra
 absorption, 308–309
 atomic, 302–307
 emission, 308, 308f
 line, 302–305
- Spectrochemical series, 1059, 1059f, G-14
- Spectrometers, 308, 308f
- Spectrometry, 308–309, 699, G-14
- Spectroscopy, infrared, 384–385, 385f
- Speed of light, 296, G-14
- sp* hybridization, 444–446, 445f, 449t
- sp*² hybridization, 446, 446f, 449t
- sp*³ hybridization, 447, 447f, 449t
- sp*³*d* hybridization, 447–448, 448f, 449t
- sp*³*d*² hybridization, 448, 449f, 449t
- sp* hybrid orbitals, 444–446, 445f, G-14
- sp*² hybrid orbitals, 446, 446f, 449t, G-14
- sp*³ hybrid orbitals, 447, 447f, 449t, G-14
- sp*³*d* hybrid orbitals, 447–448, 448f, 449t, G-14
- sp*³*d*² hybrid orbitals, 448, 449f, 449t, G-14
- Spin quantum number, 332–333, 332f, 332t, G-14
- Spontaneous change
 defined, 895, 927–928, G-14
 determining, 909
 enthalpy change and, 896–897
 exothermic and endothermic reactions, 896–897, 897f, 911, 911f
 free energy change and, 912–913
 predicting, 895–906
 redox reactions and, 945–949, 945f, 954–957
 second law of thermodynamics and, 901
- temperature and, 916–920, 917t, 920f
 in voltaic cells, 945–949, 945f, 954–957
- s*-process, 1111
- Square brackets [], 694, 751
- Square planar complexes
 in crystal field splitting, 1062, 1062f
 hemoglobin, 1063
 in valence bond theory, 1055, 1056f
- Square planar shape, 423, 423–424f, 448, 1047, G-14
- Square pyramidal shape, 423, 423–424f, 448, G-14
- S-shaped response model of radiation risk, 1097
- Stalactites, 871
- Stalagmites, 871
- Standard atmosphere (atm), 209, 209t, G-14
- Standard cell potential, 950–953, 950f, 959–966, G-14
- Standard electrode potential, 950–956, 952f, 954t, A-14, G-14
- Standard enthalpy of formation, 277–280, 278t, 279f, G-14
- Standard enthalpy of reaction, 277–280, G-14
- Standard entropy of reaction, 906–907, G-14
- Standard free energy change, 913–915, 923–924, 924t, G-14
- Standard free energy of formation, 914–915, G-14
- Standard heat of reaction. *See* Standard enthalpy of reaction
- Standard hydrogen electrode, 951–952, 952f, G-14
- Standard molar entropy, 901–905, G-14
- Standard molar volume, 215, 215f, G-14
- Standard reference half-cell, 951–952, 952f, G-14
- Standard states, 277, 277n, G-15
- Standard temperature and pressure (STP), 215, G-15
- Starch, 671–672
- Stars, element synthesis in, 1110–1111, 1110f
- State functions, 262–263, 263mn, 266, G-15
- States of matter
 balanced equations and, 113–114
 changes in, 5–7, 5f, 7mn
 defined, 4, G-15
 entropy and, 547
 kinetic-molecular view of, 470, 470t
 physical, 4, 4f, 205–207, 206f
- Stationary phase of chromatography, 83, 83f
- Stationary states, 304, G-15
- Steam-carbon reactions, 281
- Steam-reforming process of hydrogen production, 283, 1023
- Stearic acid, 662f
- Steel
 alloy composition, 1012, 1013t
 defined, 1016, G-15
 metallurgy, 1016–1017
 specific heat capacity of, 268t
- Stellar nucleosynthesis, 1110, G-15
- Stereoisomers, 642–643, 1052–1054f, G-15
- Stereoselective catalysts, 668
- Sterling silver, 1013t
- Stoichiometry
 of acid-base reactions, 172–174
 balancing (stoichiometric) coefficient, 112–113
 defined, 95, G-15
 of electrolysis, 980–981, 980f
 equivalent molar ratios from balanced equations, 116–120
 ideal gas law and, 228–230, 229f
 of precipitation reactions, 162–164
 of redox reactions, 179–180
 of thermochemical equations, 273–274
- STP (standard temperature and pressure), 215, G-15
- Straight-chain alkanes, 76, 76t
- Strassmann, F., 1105
- Stratosphere, 239f, 240
- Strong acids. *See also* Acid strength
 calculating pH for, 801–803
 categorization of, 165, 165t, 797
 concentration of buffer components in, 845, 845f, 848, 848f
- direction of reactions involving, 806
 dissociation extent, 795, 795f
- levelling effect on, 827
- reactions involving, 170–171, 170t
- strong acid–strong base titration curves, 853–855, 853f
- structural features of, 166–167
- in water, 794–798
- weak base–strong acid titration curves, 859–860, 859f
- Strong bases
 calculating pH for, 801–803
 categorization of, 165, 165t, 797
 concentration of buffer components in, 845–846, 845f, 848, 848f
- levelling effect on, 827
- reactions involving, 170–171, 170t
- strong acid–strong base titration curves, 853–855, 853f
- structural features of, 166–167
- in water, 794–798
- weak acid–strong base titration curves, 855–859, 855f
- Strong electrolyte solutions, 557, 557f, 564–566, 565f
- Strong-field ligands, 1058, 1058f, 1060, 1060–1061f, G-15
- Strong force, 1080, G-15
- Strontium
 flame tests with, 308f
 line spectra of, 303f
 properties of, 593–594
 radioisotopes of, 1086–1087
- Strontium ions, 69t
- STR (short tandem repeat) analysis, 680, 680f
- Structural formulas
 defined, 79, 105, G-15
 isomers and, 110–111
- Structural isomers. *See* Constitutional isomers
- Styrofoam, 569
- Subcritical mass, 1106
- Sublevel energy
 aufbau principle and, 335
 crossover of, 357, 357f
 defined, G-15
 electron repulsion and, 333–334
 nuclear charge and, 333, 333f
 orbital shape and, 334
 penetration and, 334, 334f, 339
 shielding and, 333–334, 334f, 339
- Sublevels
 defined, 317
 order of filling, 335f, 339–342, 341f, 342mn, 456–457
 quantum numbers and energy level in, 317–318
 splitting levels into, 334–335
- Sublimation
 defined, 471, G-15
 heat of, 472, 472f
 of iodine, 479, 479f
- Submicroscopic properties, 44
- Substances
 defined, 4, 44, G-15
 mixtures distinguished from, 45
 standard state of, 277
- Substituents, 647
- Substitutional alloys, 538, 538f
- Substitution reactions, 652, 660, G-15
- Substrates, 730–731, 731f, G-15
- Subtraction, significant figures and, 30–31
- Succinic acid, A-10
- Sucrose, 671, 671f
- Suction pumps, 208
- Suffixes
 acids, 74
 alkanes, 76
 binary ionic compounds, 68
 metal ions, 70
 organic compound, 639, 639–640t
 oxoanions, 72, 72f
- Sugars. *See also* Carbohydrates
 dehydration by sulfuric acid, 616, 616f
 properties of, 670–672, 671f
- Sulfanilamide, 666f
- Sulfate ions, 72t, 415, 616
- Sulfates, A-13
- Sulfide ions, 69t
- Sulfide phase, 999, 999f
- Sulfides, 611, 616, 1001, 1002f, 1010, A-13
- Sulfite ions, 72t, 616
- Sulfites, reaction with acids, 169–170
- Sulfonamides, 666, 666f
- Sulfur
 abundance of, 1000, 1001t
 acid-base behavior of, 355
 allotropes of, 612, 650
 catenation of, 650
 chemistry of, 615–616
 in coal, 281
 electron configuration, 338, 339

- on Io (Jupiter's moon), 7
oxidation to sulfur trioxide, 275–276
pollutants, 876
production of, 1025–1026, 1026f
properties of, 354, 612–615
sources of, 1001
standard enthalpies of formation, 278t
standard state of, 278
- Sulfur dioxide**
acid rain and, 875, 876
from coal burning, 281
formation of, 615
Lewis structure of, 416
molar mass of, 97
mole fraction in air at sea level, 239t
oxidation of, 753, 918–919, 926–927
release during roasting, 1010
roasting copper and, 118, 119
- Sulfur hexafluoride**
hybrid orbitals and, 448, 449f
Lewis structure of, 415
molecular shape of, 423
- Sulfuric acid**
acid-dissociation constant for, A-10
in acid rain, 616, 616mn, 875, 876
chemical manufacturing, 1025–1028
formation of, 616
Lewis structure of, 415
manufacture of, 728–729
production of, 918–919, 926–927
properties of, 616
uses of, 616, 1027–1028, 1027f
- Sulfurous acid**
acid-dissociation constant for, 814t, A-10
acid rain and, 875
Lewis acid and, 829
properties of, 615–616
titration of, 862, 863f
- Sulfur tetrafluoride**, 415, 422, 449–450
- Sulfur trioxide**, 275–276, 416, 615, 753
- Superconducting oxides**, 506, 512, 513
- Superconductivity**, 506, G-15
- Supercooled liquids**, 504
- Supercritical fluid (SCF)**, 480
- Supernova**, 1110f, 1111
- Supersaturated solutions**, 549, 549f, G-15
- Surface area**, reaction rate and, 693, 693f
- Surface tension**, 489, 489f, 489mn, 489t, 492, G-15
- Surfactants**, 489
- Surroundings**
defined, 258, G-15
entropy change in, 908–910
- Suspensions**, 568, G-15
- Sweating**, 471, 471f
- Sylvite**, 1014
- Synchrotron**, 1091
- Synthesis gas (syngas)**, 281, 603
- Synthetic macromolecules**, 668–670
- Synthetic natural gas (SNG)**, 281, G-15
- System**
defined, 258, G-15
determining energy change in, 262, 896, 906–907
energy flow to and from, 258–260
- Systematic error**, 32–33, 33f, G-15
- System energy**, 258–260, 306mn
- T**
- Table salt, density of, 24t
- Talc, 604
- Tanaka, Koichi, 60
- Tantalum, 1044
- TCDD (tetrachlorodibenzodioxin), 554
- Technetium, 344, 1099, 1100f
- Technological tradition, history of, 11
- Tellurium, 612–615
- Temperature**. *See also* Endothermic processes; Exothermic processes
absolute scale, 213
Amontons's law and, 213
atmospheric, 239–240, 239f, 282–283
Celsius scale, 25–27, 26f, 27t
changes in matter and, 6–7
Charles's law and, 212–213, 212f
collision energy and, 716–717, 716f, 717t
converting units of, 26–27
- critical, 480
defined, 25, G-15
effect of change on equilibrium, 775–777, 777t
entropy of surroundings and, 908
examples of, 25f
Fahrenheit scale, 25–27, 26f, 27t
gases and, 206, 212–213, 212f, 218, 239–240, 239f
glass transition, 517
heat vs., 25
as intensive property, 27–28
Kelvin scale, 25–27, 26f, 27t
kinetic energy and, 234–235, 240, 470
molecular speed and, 232, 232f, 477–478, 477f
phase changes and, 470–471, 474
pressure and, 213–214, 218
reaction rate and, 693, 715, 715f, 717t
reaction spontaneity, effect on, 916–920, 917t, 920f
SI units, 14t, 25–27, 26f, 27t
solubility and, 549–550, 550f
standard molar entropy and, 902, 902f
vapor pressure and, 477–478
vapor pressure of water and, 227, 227t
viscosity and, 490, 490t
volume and, 212–213, 212f, 218, 219–220
- Temperature inversion**, 240
- TEM** (transmission electron microscope), 311
- Tennessee, 1092
- Tera- (prefix), 14t
- Termolecular reactions**, 722, 722t
- Tertiary structure of proteins**, 673f, 674
- Tetrachlorodibenzodioxin (TCDD)**, 554
- Tetrafluoroborate ions**, 406–407
- Tetrahedral arrangement**
of complex ions, 1047, 1047t
defined, 420, G-15
hybrid orbitals and, 447, 449t
VESPR theory and, 418f, 420–421, 420f, 424f
- Tetrahedral complexes**
carbonic anhydrase, 1064, 1064t
in crystal field splitting, 1061, 1062f
in valence bond theory, 1056, 1056f
- Tetramethylsilane**, 649
- Tetraphosphorus decoxide**, 354, 354f, 610
- Tetraphosphorus hexoxide**, 610
- Tetra- (prefix), 73t
- TeVatron**, 1091
- t_{2g} orbitals, 1058, G-15
- Thalidomide**, 644
- Thallium**
bond type, 598t
electron configuration, 356
melting point of, 598t
properties of, 595–598
radioactive poison from, 1094
- Theoretical yield, 128, G-15
- Theory**, in the scientific method, 13, 13f
- Thermal conductivity**, 397, 505
- Thermal decomposition**, 183
- Thermal energy**, 258
- Thermal pollution**, 550, 551f, 1108–1109
- Thermals**, 240
- Thermite**, 119, 120
- Thermite reaction**, 1011, 1011f
- Thermochemical equation**, 273–274, G-15
- Thermochemical equivalence**, 274
- Thermochemical solution cycle**, 544
- Thermochemistry**, 256–285
calorimetry, 268–273
defined, 257, G-15
energy forms and interconversion, 257–264
enthalpy, 265–267
future use of energy and, 281–285
Hess's law of heat summation in, 275–277
standard heats of reaction in, 277–280
stoichiometry of thermochemical equations, 273–274
- Thermodynamics**, 894–928
of carbon reduction, 1010–1011
defined, 257, G-15
first law of, 261, 896, 909–910
kitchen appliances and, 259mn
living things and, 909–910
predicting spontaneous change and, 895–906
second law of, 901, 910
standard values for common substances, A-5–A-7
third law of, 901
- Thermometers**, 25, 29f, 511, G-15
- Thermoplastic elastomers**, 518
- Thermoplastic polymers**, 518
- Thermoset polymers**, 518, 518mn
- Thermosphere**, 239f, 240
- Thermotropic phases**, 510
- Thiosulfate ion**, 613
- Third law of thermodynamics, 901, G-15
- Third-order reactions, 704, 704t
- Thomson, J. J., 53, 54
- Thomson, William (Lord Kelvin), 213
- Thorium, 1045, 1078, 1095
- Three-Mile Island nuclear facility, 1108
- Threonine, 672f, 781, 781f
- Threshold frequency, 301
- Thymine**, 675
- Thymol blue**, 861f
- Tie-line**, in redox equations, 177
- Time**, 14t, 18
- Tin**
allotropes of, 601
bond type, 598t
in electrolytic cells, 974, 975f
electron configuration, 356
melting point of, 598t
mineral sources of, 1008t
properties of, 598–601, 601f
solder, 1013t
tin(II) and tin(IV), 71t
- Tin(II) chloride**, 419
- Tin(IV) oxide**, 1010
- Tire pressure**, 213
- Titanium**
appearance of, 1038f
electron configuration, 340t, 356–358, 1039, 1039t
oxidation state, 1042t
- Titanium(IV) oxide**, 1043f
- Titration**. *See also* Acid-base titration curves
acid-base, 172–174, 173f
defined, 172, G-15
end point and, 861
equivalence point in, 853f, 854–857, 855f, 859f, 863f
redox, 179–180, 179f
- TNT (trinitrotoluene)**, 648, 1106
- Tobacco mosaic virus**, 511f
- Tokamak design**, 1109, 1109f
- Toluene**, 564, 648, 829
- Tonicity**, 567
- Torr**, 209, 209t, G-15
- Torricelli**, Evangelista, 208
- Total ionic equations**
for acid-base reactions, 167–171, 170t, 171f
for aqueous ionic reactions, 156, 156f, 158f, 159
defined, 156, G-15
- Trace elements**, 1063–1064, 1064t
- Tracers**, radioactive, 1098–1100, 1099t, 1100f, G-15
- Traffic flow**, rate-determining step for, 723mn
- Transcription**, 677, 677f, G-15
- Transfer RNA (tRNA)**, 677f, 678
- trans isomers**. *See cis-trans isomers*
- Transistors**, 508
- Transition elements**
appearance of, 1038–1039f
atomic size of, 346f, 347
behavior within groups, 1044, 1044t
chemical properties of, 1042–1043f, 1042–1044
color of, 1043, 1043f
complexes (*See Coordination compounds*)
coordination compounds, 1046–1054
defined, 339, 1037, G-15
as dietary trace elements, 1063–1064, 1064t
electron configuration, 339–340, 340t, 341f, 342–343,
1038–1040, 1039f
influence on Boron family properties, 595
inner (*See Inner transition elements*)
lanthanide contraction and, 1041
metallic behavior of, 1042–1043
metallic hydrides and, 586
oxidation state of, 1042, 1042–1043t
in periodic table, 339–340, 340t, 341f, 342–343,
1038, 1038f
physical and atomic properties, 1040–1041f,
1040–1042
properties of, 1037–1044
reducing strength, 1043, 1043t

- Transition metal ions, 356–358, 358*f*
 Transition states, 718–721, G-15
 Transition state theory, 718–721, G-15
 Translation, 677–678, 677*f*, G-15
 Transmission electron microscope (TEM), 311
 Transuranium elements, 1092, 1092*r*, 1105, G-15
 Trees, absorption of water by, 567
 Trends, 12. *See also* Periodic trends
 Trial and error, 12
 Triatomic molecules, vibration of, 384, 384*f*
 Triethylamine, A-12
 Triglycerides, 663, 664
 Trigonal bipyramidal arrangement
 defined, 421, G-15
 hybrid orbitals and, 447, 449*t*
 VSEPR theory and, 418*f*, 421–422, 422*f*, 424*f*
 Trigonal planar arrangement
 of alkenes, 644
 defined, 419, G-15
 of hybrid orbitals, 446, 449*t*
 VSEPR theory and, 418–419*f*, 419–420, 424*f*
 Trigonal pyramidal shape, 420–421, 420*f*, 424*f*, 447, 657, G-15
 Triiodide ions, 422
 Trimethylamine, 657, A-12
 Trinitrotoluene (TNT), 648, 1106
 Triple bonds
 in alkynes, 646
 bond energy of, 382, 382*t*
 bond order and, 380
 defined, G-15
 functional groups with, 666
 molecular shape of, 453
 pi bond and, 453, 453*f*
 rotation and, 455
 sigma bond and, 453, 453*f*
 strength of, 453–454
 Triple point, 480, 480*f*, 481, G-15
 Tri-(prefix), 73*t*
 Tristearin, 663*f*
 Tritium, 1024, 1024*r*, 1109
 tRNA (transfer RNA), 677*f*, 678
 Troposphere, 239, 239*f*
 Tryptophan, 672*f*
 T shape, in VSEPR theory, 422, 422*f*, 424*f*, G-15
 Tungsten
 density of, 1042
 electron configuration, 343
 properties of, 1044, 1044*r*
 purification of, 1011
 Twisted nematic phase, 510, 510*f*
 Tyndall effect, 569, 569*f*, G-15
 Tyrosine, 672*f*
- U**
- Ultraviolet (UV) radiation
 absorption by stratospheric ozone, 240
 defined, G-16
 on electromagnetic spectrum, 296, 297*f*
 ozone as absorber of, 409, 732
 in water purification, 570
 Uncertainty in measurement, 28–33, G-16
 Uncertainty principle, 313, G-16
 Unimolecular reactions, 722, 722*r*, G-16
 Union Carbide plant, release of poisonous gas from, 224
 Unit cells, 493–499
 body-centered cubic, 494, 495*f*, 496–497, 497*f*
 defined, 494, G-16
 edge length, 499, 499*f*
 face-centered cubic, 494, 495*f*, 497–498
 hexagonal, 497–498, 497*f*
 packing efficiency, 496–498, 497*f*
 simple cubic, 494, 495*f*, 496, 497*f*
 Units, in conversions and calculations, 18–19, 23
 Universal gas constant, 216, G-16
 Universe, origins of, 1110
 Unsaturated hydrocarbons, 644, G-16
 Unsaturated solutions, 549, G-16
 Unshared electron pairs, 380, G-16
 Uracil, 675
 Uranium
 in atomic bomb, 1106*f*
 calculating mass in pitchblende, 48–49
 decay series, 1082, 1082*f*
 enrichment, 237
 fission of, 1105, 1105–1106*f*
 isotopes, 237
 in nuclear energy reactors, 1107–1108, 1107*f*
 oxidation state, 1045
 pitchblende, 1075
 radioactivity of, 711, 1075, 1093
 sources of, 1095
 Urea, 1005
 Urease, 730
 UV radiation. *See* Ultraviolet radiation
- V**
- Vacancies and crystal defects, 507
 Valence bands, 505, 505–506*f*, 506, G-16
 Valence bond (VB) theory, 443–451
 central themes of, 443–444
 complex ions and, 1055–1056
 defined, 443, G-16
 hybrid orbitals and, 444–451, 449*t*
 molecular rotation and, 455, 455*f*
 orbital overlap and, 443–444, 443*f*, 451–455
 single and multiple bonds in, 451–454
 Valence electrons
 defined, 342, G-16
 ionization energies and, 350
 in metallic bonding, 396
 octet rule and, 405, 406
 Valence-shell electron-pair repulsion (VSEPR) theory, 417–427
 bent shape in, 419, 419–420*f*, 421, 424*f*, 447
 defined, 417, G-16
 electron-group arrangements, 418, 418*f*
 hydrides and, 451
 limitations of, 443
 linear arrangement, 418–419*f*, 419, 422, 422*f*, 424*f*
 molecules with multiple central atoms, 426–427, 427*f*
 octahedral arrangement, 418*f*, 422–424*f*
 seesaw shape in, 422, 422*f*, 424*f*
 square planar shape, 423, 423–424*f*
 square pyramidal shape, 423, 423–424*f*
 tetrahedral arrangement, 418*f*, 420–421, 420*f*, 424*f*
 trigonal bipyramidal arrangement, 418*f*, 421–422, 422*f*, 424*f*
 trigonal planar arrangement, 418–419*f*, 419–420, 424*f*
 trigonal pyramidal shape, 420–421, 420*f*, 424*f*
 T shape in, 422, 422*f*, 424*f*
 using to determine molecular shape, 423, 425–426
 Valence shell expansion, 414–416
 Valence-state electronegativity, 1042–1043
 Valine, 672*f*, 863
 Vanadium
 abundance of, 1000, 1001*r*
 appearance of, 1038*f*
 as dietary trace element, 1064*r*
 electron configuration, 339, 340*r*, 1039*r*
 oxidation state, 1042, 1042*r*
 Vanadium carbide, 1013, 1013*f*
 Vanadyl sulfate dihydrate, 1043*f*
 van der Waals, Johannes, 243
 van der Waals constants, 243, 243*f*, G-16
 van der Waals equation, 243–244, G-16
 van der Waals forces. *See* Intermolecular forces
 van der Waals radius, 482, 482*f*, G-16
 van't Hoff, Jacobus, 564
 van't Hoff equation, 776–777
 van't Hoff factor, 564, 565*f*
 Vaporization
 defined, 471, G-16
 as endothermic and spontaneous process, 897
 heat of, 471, 471–472*f*, 491–492
 liquid-gas equilibria and, 476–478, 476*f*
 sweating and, 471, 471*f*
 Vapor pressure
 boiling point and, 479
 defined, 477, G-16
 equilibrium, 476*f*, 477
 solute effect on vapor pressure of solution, 558–559, 558*f*
 temperature and intermolecular forces impacting, 477–478
 of water, 227, 227*t*
 Vapor pressure lowering, 558–559, 558*f*, G-16
 Variables, 12, G-16
 VB theory. *See* Valence bond theory
- Vehicles. *See* Automobiles
 Vibration, infrared spectroscopy and, 384, 384–385*f*
 Vibrational motion, entropy and, 905, 905*f*
 Villard, Paul, 1075
 Vinegar, 171, 793
 Vinyl chloride, 619
 Viscosity
 defined, 490, G-16
 factors affecting, 490, 490*t*
 intermolecular forces and, 489*t*, 490
 of liquid crystal phase, 509–510
 of polymers, 516–517, 517*f*
 Vision, chemistry of, 645–646, 646*f*
 Vitalism, 633
 Vitamin B₁₂, 829
 Vitamin C, 108–109, 814–815
 Vitamin E, 414
 Volatile liquids, finding molar mass of, 224–225
 Volatile nonelectrolyte solutions, 564
 Volatility, defined, 83, G-16
 Voltage, 950, 950*t*. *See also* Cell potential
 Voltaic cells. *See also* Batteries
 action of, 949, 949*mn*
 activity series of metals and, 958–959
 cell potential of, 950–959
 comparison with electrolytic cells, 944, 944*f*, 974–975, 976*t*
 construction and operation of, 946–947
 corrosion of iron and, 972–974
 defined, 944, G-16
 dental fillings and, 959, 959*f*
 diagramming, 948–949
 electrodes and, 944, 944*mn*
 notation for, 948–949
 relative strengths of oxidizing and reducing agents and, 953–957
 spontaneous redox reactions and, 945–949, 945*f*, 954–957
 standard cell potential of, 950–953, 950*f*, 959–966
 standard electrode potential, 950–956, 952*f*, 954*f*
 standard hydrogen electrode and, 951–952, 952*f*
 Voltmeters, 950*n*
 Volt (V), 950, G-16
 Volume
 amount and, 214–215, 214*f*, 218–219, 223
 Avogadro's law and, 214–215, 214*f*, 223
 Boyle's law and, 211–212, 211*f*, 217–218
 Charles's law and, 212–213, 212*f*
 converting units of, 21–22
 defined, 15, G-16
 effect of change on equilibrium, 773–775, 774*f*, 777*f*
 English equivalents, 15*f*
 examples of, 17*f*
 as extensive property, 27, 27*f*
 gases and, 206, 211–212, 211*f*, 217–218
 laboratory glassware for working with, 15, 16*f*
 pressure and, 206, 211–212, 211*f*, 217–218
 SI units, 15, 15*f*, 16*f*
 standard molar, 215, 215*f*
 temperature and, 212–213, 212*f*, 218, 219–220
 Volume percent, 554, G-16
 Volumetric glassware, 15, 16*f*
 VSEPR theory. *See* Valence-shell electron-pair repulsion theory
 V shape, in VSEPR theory, 419, 419–420*f*, 421, 424*f*, 447
- W**
- Waage, Peter, 750
 Wastewater, 571, G-16
 Water
 acid-base reactions and formation of, 167
 acids and bases in, 747, 794–798
 alkali metal reactions with, 592, 592*mn*
 amphiprotic nature of, 804
 aqueous ionic reactions, 155–157, 156*f*
 autoionization of, 798–803, 799*f*, 827
 behavior of salts in, 823–824, 825*f*
 bent shape of, 146, 146*f*, 447, 447*f*
 boiling point elevation constant, 560*t*
 boiling point of, 26, 26*f*, 27*t*
 capillarity of, 489–490, 490*f*, 492
 chemical changes in, 5, 5*f*
 collecting gas over, 227–228, 227*f*
 cooling curve for, 473*f*
 covalent bonds in, 67

- covalent compounds in, 150
density of, 24*t*, 492
dipole moment, 428
dissociation of, 167
Earth's temperature and, 268
electrolysis of, 183, 283, 977–978, 977*f*, 1023
formation from methane and oxygen, 8mn
freezing point depression constant, 560*t*
freezing point of, 26, 26*f*, 27*t*
gas solubility in, 550
hard, 570–571
heat of fusion, 471, 471*f*
heat of vaporization, 471, 471*f*
heat of vaporization of, 491–492
in hydrates, 72
hydrogen bonds in, 491, 491*f*
hydrogen displacement from, 184, 184*f*
intermolecular forces, 534*f*
ionic compounds in, 146–149, 146*f*, 159*f*
ion-product constant for, 799–803, 799*f*
ion-radical, 1095
meniscus shape in glass, 489–490, 490*f*
molecular mass of, 76
molecular shape of, 421, 428
phase changes of, 471, 473–474, 473*f*
phase diagram for, 480–481, 480*f*
physical changes in, 5, 5*f*, 6–7
polar nature of, 146, 146*f*, 428
solvent properties of, 145–155, 491, 535–536, 536*f*, 536*t*, 903–904
specific heat capacity of, 268, 268*t*, 491
supercritical, 480
surface tension of, 489, 489*t*, 492
thermal properties of, 491–492
triple point of, 481
uniqueness of, 491–492, 493*f*
vapor pressure of, 227, 227*t*
viscosity of, 489–490*t*
Water gas, 281, 1023
Water-gas shift reactions, 281, 1023
Water purification, 570–571
Water softening, 570–571, 571*f*, G-16
Water striders, 489mn
Water treatment plants, 570, 570*f*
Water vapor, 6, 472
Wave behavior, comparison of particle behavior to, 299, 299*f*
Wave function, 314
Wavelength
de Broglie, 311, 311*t*
defined, G-16
in electromagnetic radiation, 296, 296–297*f*, 297–298
of electron transition, 307
interconverting frequency and, 297–298, 301–302
line spectra and, 302–303, 306
Wave motion in restricted systems, 310, 310*f*
Wave nature of electrons, 310–312, 310*f*
Wave nature of light, 296–298
Wave-particle duality, 312, 312*f*, G-16
- Waxes, 538
Weak-acid equilibria problem solving, 808–815
concentration and, 809–813
general approach for, 808
notation system for, 809
polyprotic acids in, 813–815, 814*t*
Weak acids. *See also* Acid strength
acid-dissociation constant values for, 796, 796*t*
anions as weak bases, 820–821
categorization of, 165, 165*t*, 797
direction of reactions involving, 806
dissociation of, 189, 795–796, 795*f*
reactions involving, 170–171, 170*t*
relation to weak bases, 818–822
structural features of, 166–167
weak-acid equilibria, 808–815
weak acid–strong base titration curves, 855–859, 855*f*
Weak bases
anions of weak acids as, 820–821
categorization of, 165, 165*t*, 797
dissociation of, 189
reactions involving, 170–171, 170*t*
relation to weak acids, 818–822
structural features of, 166–167
weak base–strong acid titration curves, 859–860, 859*f*
Weak-field ligands, 1058, 1058*f*, 1060, 1060–1061*f*, G-16
Weathering, 1006
Weight, 17, G-16
Welding, 507
Whiskers of silicon carbide, 513
White phosphorus, 606, 606*f*
Wöhler, Friedrich, 633
Wood
cellulose in, 671
as fuel, 281
specific heat capacity of, 268*t*
Work
defined, 259, G-16
done on (or by) a system, 259–260, 260*f*
energy transfer as, 259–260, 260*f*
free energy and electrical work, 959–967
free energy change and, 915–916
pressure-volume work, 263–264, 264*f*
sign conventions, 261*t*
unit of, 261
Wulfenite, 493*f*
- X**
Xanthophylls, 1057
Xenon
intermolecular forces, 534*f*
mole fraction of air at sea level, 239*t*
properties of, 622–624
Xenon tetrafluoride, 423, 624, 624*f*
X-ray diffraction analysis, 500, 500*f*, G-16
X-ray photons, 1077
X-rays
diffraction, 311, 311*f*, 500, 500*f*
opacity of barium sulfate suspension, 869, 869mn
- radiation dose from, 1096, 1096*t*
wavelength of, 296, 297*f*
Xylenes, 648
- Y**
Yield
actual, 128
green chemistry perspective on, 129–130
in multistep syntheses, 129, 129*f*
percent, 128–129
side reactions and, 128, 128*f*
theoretical, 128
-yl (suffix), 639, 640*t*
-yne (suffix), 646, 655*t*
- Z**
Zeolites, 1023
Zero, absolute, 26
Zero-order reactions
comparison with first- and second-order reactions, 714*t*
defined, 699
half-life of, 714
integrated rate law and, 708, 710, 710*f*, 714*t*
rate constant for, 704*t*
rate law and, 699, 700, 700*f*
rate vs. reactant concentration in, 700*f*
reactant concentration vs. time in, 700*f*
Zewail, Ahmed H., 718
Ziegler, Karl, 668
Ziegler-Natta catalysts, 668
Zinc
abundance of, 1000, 1001*t*
alloys, 1013, 1013*f*, 1013*t*
appearance of, 1039*f*
in batteries, 968, 968*f*
as dietary trace element, 1064*t*
electron configuration, 340, 340*t*, 358, 1039, 1039*f*
enzyme function and, 1064
in galvanizing process, 974
mineral sources of, 1008*t*
oxidation state, 1042, 1042*t*
reaction with a strong and a weak acid, 796, 796*f*
redox reactions involving, 940*f*
in voltaic cells, 945–946*f*, 945–949, 952–953, 952*f*, 962–964, 964*f*
Zinc blende, 503, 503*f*
Zinc chloride, 151–152
Zinc formate, 826
Zinc hydroxide, 882
Zinc iodate, 866*t*
Zinc ions, 69*t*
Zinc oxide, 512, 1010
Zinc sulfate heptahydrate, 1043*f*
Zircon, 603, 603*f*
Zirconia, 513
Zirconium, 1044, 1078
Zone refining, 599, 1012, 1012*f*, G-16
Zwitterion, 863

Useful Data and Information

Atomic and Molecular Properties

Atomic radii	Figure 8.13, p. 346
Bond energies	Table 9.2, p. 381
Bond lengths	Table 9.2, p. 381
Ground-state electron configurations	Figure 8.9, p. 341
Electronegativity values	Figure 9.21, p. 391
Ionic radii	Figure 8.29, p. 360
First ionization energies	Figure 8.16, p. 349
Molecular shapes	Figure 10.10, p. 424

Equilibrium Constants and Thermodynamic Data

K_a of hydrated metal ions	Appendix C, p. A-12
K_a of selected acids	Appendix C, pp. A-8 to A-10
Strengths of conjugate acid-base pairs	Figure 18.8, p. 806
K_b of amine bases	Appendix C, p. A-11
K_f of complex ions	Table 19.4, p. 878, and Appendix C, p. A-12
K_{sp} of slightly soluble ionic compounds	Appendix C, p. A-13
Standard electrode potentials, $E_{\text{half-cell}}^\circ$	Appendix D, p. A-14
Standard free energies of formation, ΔG_f°	Appendix B, pp. A-5 to A-7
Standard heats of formation, ΔH_f°	Appendix B, pp. A-5 to A-7
Standard molar entropies, S°	Appendix B, pp. A-5 to A-7

Names and Formulas

Ligands	Table 23.7, p. 1050
Metal ions in complex anions	Table 23.8, p. 1050
Metals with more than one monatomic ion	Table 2.4, p. 71
Monatomic ions	Table 2.3, p. 69
Organic functional groups	Table 15.5, p. 655
Polyatomic ions	Table 2.5, p. 72

Properties of the Elements

Group 1A(1): Alkali metals	p. 591
Group 2A(2): Alkaline earth metals	p. 594
Group 3A(13): Boron family	p. 596
Group 4A(14): Carbon family	p. 599
Group 5A(15): Nitrogen family	p. 605
Group 6A(16): Oxygen family	p. 613
Group 7A(17): Halogens	p. 618
Group 8A(18): Noble gases	p. 623
Period 4 transition metals, atomic properties	Figure 23.3, p. 1040
Period 4 transition metals, oxidation states	Table 23.2, p. 1042

Miscellaneous

Rules for assigning an oxidation number	Table 4.4, p. 176
SI-English equivalent quantities	Table 1.4, p. 15
Solubility rules for ionic compounds in water	Table 4.1, p. 159
Vapor pressure of water	Table 5.2, p. 227

The Elements

Name	Symbol	Atomic Number	Atomic Mass*	Name	Symbol	Atomic Number	Atomic Mass*
Actinium	Ac	89	(227)	Mendelevium	101	(256)	
Aluminum	Al	13	26.98	Mercury	Hg	80	200.6
Americium	Am	95	(243)	Molybdenum	Mo	42	95.94
Antimony	Sb	51	121.8	Moscovium	Mc	115	(288)
Argon	Ar	18	39.95	Neodymium	Nd	60	144.2
Arsenic	As	33	74.92	Neon	Ne	10	20.18
Astatine	At	85	(210)	Neptunium	Np	93	(244)
Barium	Ba	56	137.3	Nickel	Ni	28	58.70
Berkelium	Bk	97	(247)	Nihonium	Nh	113	(284)
Beryllium	Be	4	9.012	Niobium	Nb	41	92.91
Bismuth	Bi	83	209.0	Nitrogen	N	7	14.01
Bohrium	Bh	107	(267)	Nobelium	No	102	(253)
Boron	B	5	10.81	Oganesson	Og	118	(294)
Bromine	Br	35	79.90	Osmium	Os	76	190.2
Cadmium	Cd	48	112.4	Oxygen	O	8	16.00
Calcium	Ca	20	40.08	Palladium	Pd	46	106.4
Californium	Cf	98	(249)	Phosphorus	P	15	30.97
Carbon	C	6	12.01	Platinum	Pt	78	195.1
Cerium	Ce	58	140.1	Plutonium	Pu	94	(242)
Cesium	Cs	55	132.9	Polonium	Po	84	(209)
Chlorine	Cl	17	35.45	Potassium	K	19	39.10
Chromium	Cr	24	52.00	Praseodymium	Pr	59	140.9
Cobalt	Co	27	58.93	Promethium	Pm	61	(145)
Copernicium	Cn	112	(285)	Protactinium	Pa	91	(231)
Copper	Cu	29	63.55	Radium	Ra	88	(226)
Curium	Cm	96	(247)	Radon	Rn	86	(222)
Darmstadtium	Ds	110	(281)	Rhenium	Re	75	186.2
Dubnium	Db	105	(262)	Rhodium	Rh	45	102.9
Dysprosium	Dy	66	162.5	Roentgenium	Rg	111	(272)
Einsteinium	Es	99	(254)	Rubidium	Rb	37	85.47
Erbium	Er	68	167.3	Ruthenium	Ru	44	101.1
Europium	Eu	63	152.0	Rutherfordium	Rf	104	(263)
Fermium	Fm	100	(253)	Samarium	Sm	62	150.4
Flevorium	Fl	114	(289)	Scandium	Sc	21	44.96
Fluorine	F	9	19.00	Seaborgium	Sg	106	(266)
Francium	Fr	87	(223)	Selenium	Se	34	78.96
Gadolinium	Gd	64	157.3	Silicon	Si	14	28.09
Gallium	Ga	31	69.72	Silver	Ag	47	107.9
Germanium	Ge	32	72.61	Sodium	Na	11	22.99
Gold	Au	79	197.0	Strontium	Sr	38	87.62
Hafnium	Hf	72	178.5	Sulfur	S	16	32.07
Hassium	Hs	108	(277)	Tantalum	Ta	73	180.9
Helium	He	2	4.003	Technetium	Tc	43	(98)
Holmium	Ho	67	164.9	Tellurium	Te	52	127.6
Hydrogen	H	1	1.008	Tennesseine	Ts	117	(294)
Indium	In	49	114.8	Terbium	Tb	65	158.9
Iodine	I	53	126.9	Thallium	Tl	81	204.4
Iridium	Ir	77	192.2	Thorium	Th	90	232.0
Iron	Fe	26	55.85	Thulium	Tm	69	168.9
Krypton	Kr	36	83.80	Tin	Sn	50	118.7
Lanthanum	La	57	138.9	Titanium	Ti	22	47.88
Lawrencium	Lr	103	(257)	Tungsten	W	74	183.9
Lead	Pb	82	207.2	Uranium	U	92	238.0
Lithium	Li	3	6.941	Vanadium	V	23	50.94
Livermorium	Lv	116	(293)	Xenon	Xe	54	131.3
Lutetium	Lu	71	175.0	Ytterbium	Yb	70	173.0
Magnesium	Mg	12	24.31	Yttrium	Y	39	88.91
Manganese	Mn	25	54.94	Zinc	Zn	30	65.41
Meitnerium	Mt	109	(268)	Zirconium	Zr	40	91.22

*All atomic masses are given to four significant figures. Values in parentheses represent the mass number of the most stable isotope.

Data Tables

Fundamental Physical Constants (six significant figures)

Avogadro's number	$N_A = 6.02214 \times 10^{23}/\text{mol}$
atomic mass unit	$\text{amu} = 1.66054 \times 10^{-27} \text{ kg}$
charge of the electron (or proton)	$e = 1.60218 \times 10^{-19} \text{ C}$
Faraday constant	$F = 9.64853 \times 10^4 \text{ C/mol}$
mass of the electron	$m_e = 9.10939 \times 10^{-31} \text{ kg}$
mass of the neutron	$m_n = 1.67493 \times 10^{-27} \text{ kg}$
mass of the proton	$m_p = 1.67262 \times 10^{-27} \text{ kg}$
Planck's constant	$h = 6.62607 \times 10^{-34} \text{ J}\cdot\text{s}$
speed of light in a vacuum	$c = 2.99792 \times 10^8 \text{ m/s}$
standard acceleration of gravity	$g = 9.80665 \text{ m/s}^2$
universal gas constant	$R = 8.31447 \text{ J}/(\text{mol}\cdot\text{K})$ $= 8.20578 \times 10^{-2} (\text{atm}\cdot\text{L})/(\text{mol}\cdot\text{K})$

SI Unit Prefixes

p pico- 10^{-12}	n nano- 10^{-9}	μ micro- 10^{-6}	m milli- 10^{-3}	c centi- 10^{-2}	d deci- 10^{-1}	k kilo- 10^3	M mega- 10^6	G giga- 10^9
--------------------------	-------------------------	------------------------------	--------------------------	--------------------------	-------------------------	----------------------	----------------------	----------------------

Conversions and Relationships

Length

SI unit: meter, m

1 km	= 1000 m
	= 0.62 mile (mi)
1 inch (in)	= 2.54 cm
1 m	= 1.094 yards (yd)
1 pm	= $10^{-12} \text{ m} = 0.01 \text{ \AA}$

Volume

SI unit: cubic meter, m^3

1 dm^3	= 10^{-3} m^3
	= 1 liter (L)
	= 1.057 quarts (qt)
1 cm^3	= 1 mL
1 m^3	= 35.3 ft ³

Pressure

SI unit: pascal, Pa

1 Pa	= 1 N/m ²
	= 1 kg/m·s ²
1 atm	= $1.01325 \times 10^5 \text{ Pa}$
	= 760 torr
1 bar	= $1 \times 10^5 \text{ Pa}$

Mass

SI unit: kilogram, kg

1 kg	= 10^3 g
	= 2.205 lb
1 metric ton (t)	= 10^3 kg

Energy

SI unit: joule, J

1 J	= $1 \text{ kg}\cdot\text{m}^2/\text{s}^2$
	= 1 coulomb·volt (1 C·V)
1 cal	= 4.184 J
1 eV	= $1.602 \times 10^{-19} \text{ J}$

Math relationships

$$\pi = 3.1416$$

$$\text{volume of sphere} = \frac{4}{3}\pi r^3$$

$$\text{volume of cylinder} = \pi r^2 h$$

Temperature

SI unit: kelvin, K

0 K	= -273.15°C
mp of H ₂ O	= 0°C (273.15 K)
bp of H ₂ O	= 100°C (373.15 K)
T (K)	= T (°C) + 273.15
T (°C)	= [T (°F) - 32] $\frac{5}{9}$
T (°F)	= $\frac{9}{5}T$ (°C) + 32